S0-CAE-455

JOSEPH CORNELL

Master of Dreams

DIANE WALDMAN

HARRY N. ABRAMS, INC.

Publishers

OSEPH CORNELL

Master of Dreams

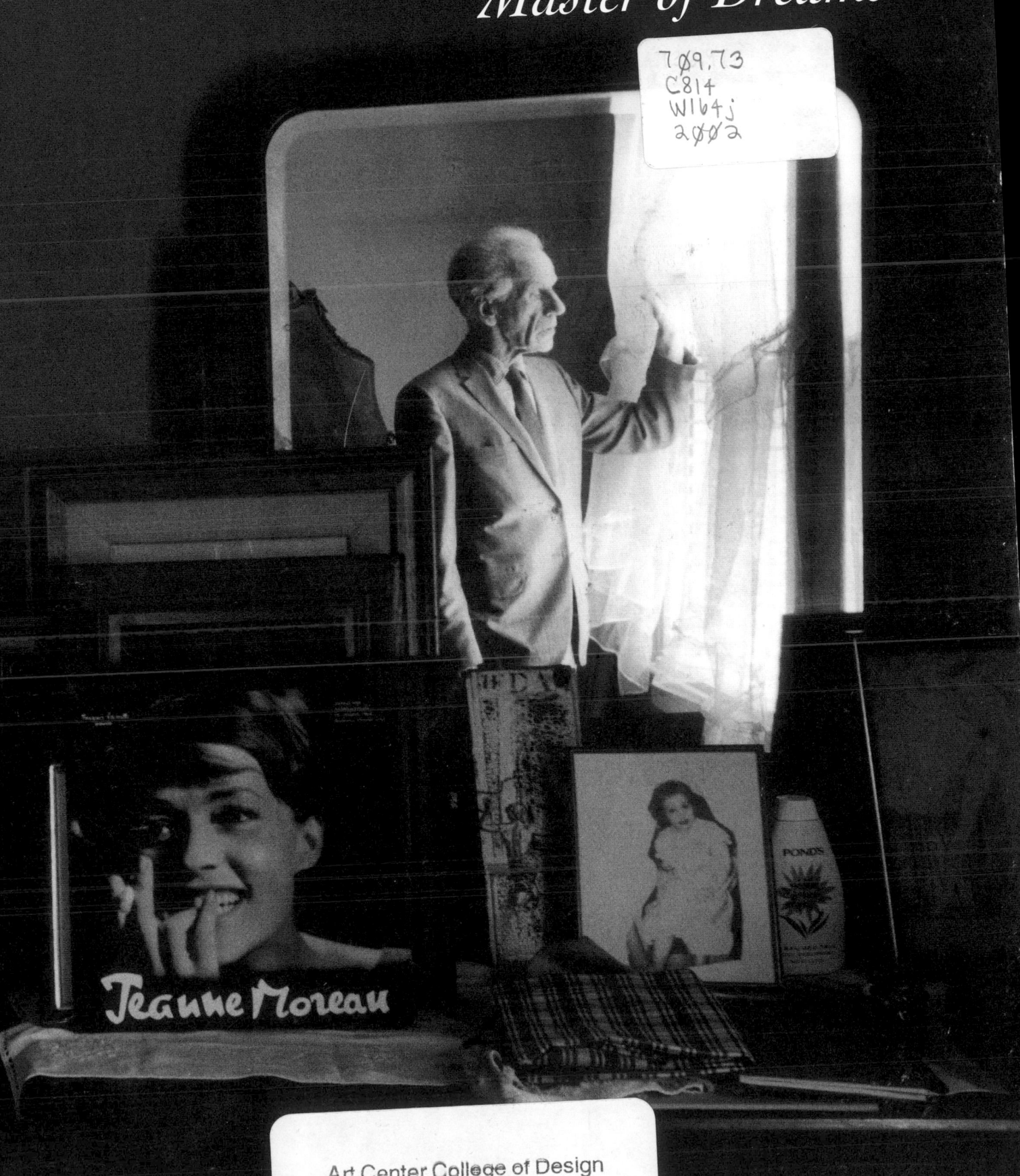

Jeanne Moreau

PAGES 2–3:
Cornell in his bedroom, 1970
Photograph by Duane Michals

PROJECT DIRECTOR: Margaret L. Kaplan
EDITOR: Nicole Columbus
DESIGNER: Judith Michael
RIGHTS AND REPRODUCTIONS: Barbara Lyons

LIBRARY OF CONGRESS CATALOGING-IN-PUBLICATION DATA

Waldman, Diane.
Joseph Cornell : master of dreams / Diane Waldman.
p. cm.
Includes bibliographical references and index.
ISBN 0–8109–1227–9
1. Cornell, Joseph—Criticism and interpretation.
I. Cornell, Joseph. II. Title.

N6537.C66 W343 2002
730'.92—dc21

2001056610

Published in 2002 by Harry N. Abrams, Incorporated, New York.
All rights reserved. No part of the contents of this book may be reproduced
without the written permission of the publisher.
Printed and bound in Italy
10 9 8 7 6 5 4 3 2 1

Harry N. Abrams, Inc.
100 Fifth Avenue
New York, N.Y. 10011
www.abramsbooks.com

Abrams is a subsidiary of

CONTENTS

PREFACE

When I first entered the New York art world in the fall of 1956, Joseph Cornell was known only to a small group of artists and writers. Although a few of his pieces were on view at The Museum of Modern Art, it was not until his exhibition at the Stable Gallery in December of 1957 that I was able to see a larger body of work. The gallery was located in an old stable on 58th Street and Seventh Avenue. Cornell's works were displayed in a darkened room, a setting that enhanced their object-like quality. In contrast to the Abstract Expressionists, whose work was expansive, Cornell's world was compressed. Each of his works made reference to an experience, a person, or a thing that had captivated him, whether it was a Medici prince, the night sky, a particular ballerina or movie star, a hotel in France, or a cockatoo. Enthralled by his work, I continued to follow his career, and shortly thereafter I saw another exhibition of his art at the Loeb Student Center, New York University. In December 1963 I contacted Cornell.

Cornell invited me to his home at 3708 Utopia Parkway in Queens. The artist greeted me, showed me into the modest living quarters, and introduced me to his mother and invalid brother, Robert. A short time later, I met his sisters, Helen Jagger and Elizabeth (Betty) Benton, and his niece, Helen Batcheller. Cornell and I formed a friendship that lasted until his death. I came to know him as Joe, the name his family called him.

Cornell was a tall, thin man with a large head, graying hair, and hooded but piercing blue eyes. He was slightly stooped and wore a thick sweater, slacks, and loafers. His was a formidable presence, made more so by the shape of his head, which resembled a bird. His hands were rough and callused, the hands of a worker, and his grip was like a vise. He was invariably polite and seldom laughed. In the times that I visited him he rarely ate anything other than tea and sweets.

Cornell's brother, Robert, was ensconced in the front room of the house, normally the living room, which faced onto a porch. The dining room, adjacent to Robert's room, was rarely used. Cornell's bedroom was on the second floor, and it was painted, like some of his boxes, the blue of the night sky. Cornell's working studio was in the basement, but his boxes were everywhere: stored in the attic, placed in the garage, or propped up on a window ledge in the cold pantry adjacent to the kitchen. His studio was cluttered with works, some finished, many in progress.

He rarely worked in his cellar when I visited him, preferring to carry on passionate and learned discourses on art, literature, and music, rummaging all the while in one of his "dossiers" for something he could never find or proudly showing off his stacks of books on one or more artists he treasured.

His family life centered on the kitchen, and it was there that I spent the better part of a year. Up until that time, no research had been done on either his life or his work. I visited Cornell with the objective of establishing a context for his work, a chronology of his life and key events, in order to write my master's thesis on his art. During many visits, Cornell would place one of his boxes on the kitchen table and then await my response. I would begin our dialogue by asking him a question about its date. Cornell, however, had little patience for details and abhorred questions about dates. He felt that dating his boxes robbed them of their validity. After we discussed one or more themes related to the box in question, he would retreat to the kitchen window, pull the curtain aside, and stand staring out into the backyard. Lost in thought, he was now engaged in one of his reveries.

On one occasion, he disappeared from the kitchen, returning soon after with a "special" box stored in a blanket chest in Robert's room. Once again I asked him about the date of the work, and again his thoughts drifted away. He often engaged in a form of self-hypnosis, allowing his mind to free associate. I thought then as I do now that this dreamlike state was more surreal than his so-called Surrealist work.

(When he left the room, I unscrewed the tops of the boxes with a screwdriver I brought with me. I also measured them. Sometimes I found a date on the inside top edge of the box or a note with instructions about the care of a box, and I felt vindicated.)

I visited Cornell once a week, and I cannot recall ever meeting anyone other than a family member or a studio assistant. I stayed for lunch, which usually consisted of a cup of Campbell's soup and a particular sweet (often stale) that his mother brought home from church. The house had minimal heat, and in the wintertime he would offer me one of his sweaters to throw over my shoulders, while he positioned himself near an open oven in order to keep warm. Standing there, quietly musing, he would forget where he was and suddenly jump away from the stove because it was too hot. When I was ready to leave, he always insisted on giving me a token for the bus to Main Street, Flushing.

Cornell communicated with me by telephone and in writing, sending notes filled with arcane references, personal inscriptions, exotic stamps, magazine clippings, a poem by John Donne, and other ephemera. I received greetings from him every Christmas and postcards in the summertime, when he vacationed with his sister Betty in Westhampton, and he came to visit my garden ·with his sisters. One time I saw him standing on the platform of the Long Island Rail Road; when he saw me he ducked. I put it down to shyness, but he obviously thought better of his action because he then came up to me. We exchanged greetings and chatted for a few moments. He later sent me a note apologizing for his behavior, but I found the moment endearing.

He communicated with my husband Paul as well. When I told Cornell that my husband was painting nude studies, he telephoned Paul because he was curious about nude photography. Sometimes he sent me his erotic dreams, which he hoped I would interpret, and he was disappointed when I could not. He asked me to be his assistant and live in his home. When I declined, he requested that I run errands for him, going to galleries or museums to pick up or deliver one of his works or some books that he needed. I brought him catalogues of Manet and Brancusi, books on nude photography, and pastry. I was happy to do small tasks for him, knowing that it was a means of communication between us. I learned from these experiences that the ordinary sentiment and the trivial event were just as important to him as the extraordinary insight.

Cornell could be waspish; he was a stickler for language, in the habit of correcting me when he felt that I used a word or a phrase incorrectly. He disapproved of my French pronunciation of the word *assemblage*, insisting that I use the English pronunciation. On the other hand, his own remarks were hard to follow. He would digress from the most insignificant comment to the most meaningful one, following a train of thought that abruptly shifted gears, precise at one moment, obscure the next. His working method was related to his manner of thinking: his abrupt shifts in thought corresponded to images and objects that shifted in time and in meaning.

Cornell was the subject of my first article (for *Art News*), my first exhibition at the Solomon R. Guggenheim Museum, my first book. It goes without saying that he occupied a special place in my heart. He could be dour, but he was also funny. One time we sat together on Robert's bed, after Robert had died, and Cornell suddenly pulled the blanket over his head. I heard him laughing, but he frightened me because his behavior was so odd. Some moments later he resurfaced and, by way of apology, he said, "It was a comic aside." His brother, Robert, had never been moody, he was only sweet and joyful. Mrs. Cornell was irritated by my presence; I came between her and her son. When he and I sat in his bedroom, she would move loudly about downstairs. Cornell was annoyed at her intrusions on our conversation, but his anger was followed by guilt. To placate her, he asked me to hang her laundry out in the yard.

Cornell's imagery and his formal innovations continue to astound and move, but it is his involvement in other disciplines that has lately taken on new meaning. This current book owes a great deal to my 1977 book, *Joseph Cornell*, published by George Braziller. However, I have discovered much more about his influences and researched his art more deeply and widely in the intervening years. My involvement with younger artists keeps me returning to him, and it is once again to his memory that this book is dedicated.

ACKNOWLEDGMENTS

This monograph on Cornell's life and work could not have been accomplished without the help of many individuals.

Many people shared their recollections of Joseph Cornell with me beginning in the 1960s. Among them are Ruth Bowman, Julien Levy, Donald Droll, Eleanor Ward, Donald Windham, Sandy M. Campbell, Lincoln Kirstein, James Merrill, Jeanne Reynal, Parker Tyler, John Bernard Myers, Marcel Duchamp, Max Ernst, Robert Motherwell, Annalee Newman, Thomas B. Hess, Eugene C. Goossen, James T. Demetrion, Richard Feigen, Allan Frumkin, Herbert Ferber, Alexander Lieberman, Joseph Shapiro, Ed Bergman, and Rhett Brown. Cornell's sisters, Elizabeth Benton and Helen Jagger, and his niece, Helen Batcheller, provided invaluable advice, support, and assistance. Dawn Ades, Dore Ashton, Carter Ratcliff, Mary Ann Caws, Lynda Roscoe Hartigan, Jodi Hauptman, P. Adams Sitney, Sandra Leonard Starr, Dickran Tashjian, Deborah Solomon, and many others have contributed important research and significant insights into Cornell's work and diaries. I am especially grateful to Lynda Roscoe Hartigan, Chief Curator, Smithsonian American Art Museum, Lisa Jacobs, Jennifer Vorbach, C & M Arts, Jill Weinberg, and Lennon Weinberg Gallery for aiding me in my research. Special thanks are due to the Joseph and Robert Cornell Memorial Foundation for permission to reproduce Cornell's work.

I would like to thank Nancy Zey, Mary Bryant, and Eileen Costello for their assistance on the manuscript, chronology, and bibliography, and Nicole Columbus for superbly editing the manuscript and supplementary material. Thanks to the New York City Ballet, Anthology Film Archives, and the Wadsworth Atheneum, the Balanchine Trust, and the museums, galleries, and collectors for graciously providing illustrations and documentation for the publication. I also express my gratitude to Barbara Lyons for her assistance in acquiring photographs, to Judith Michael for her splendid book design, and to fellow museum professionals for their insightful comments and advice so thoughtfully and generously given.

Without the help of my husband, Paul, and my dear friends David and Judy, this book would not have been possible.

DIANE WALDMAN

INTRODUCTION

Greeting to all:
birds of the air
birds of the field
birds of the brooder houses
(including Mme. Hibou)
lately arrived
flowers of the fields & woods
flowers of the skies
remaining crickets
flora & fauna of little deep woods
wandering dogs
domestic dogs
nocturnaliana
neighbors

and to our hosts.

This stop-gap salute.[1]

Joseph Cornell has often been described as a recluse who lived on the periphery of the art world. Yet he was far from a loner, constantly receiving visitors — artists, critics, curators and collectors, poets, dancers, and movie stars — to the modest home on Utopia Parkway in Queens that he shared with his mother and younger brother, Robert. He was a reticent man, but he had a sense of humor and enjoyed ironic plays on words and the occasional bon mot. He preferred the company of women to men and would often keep his male visitors waiting while he received their wives or companions.[2] Cornell delighted in talking to groups of children about his work and often made his work with them in mind. He collaborated with photographers and filmmakers, and presented his film collection on numerous occasions. He lunched with Marcel Duchamp, and went behind the scenes to visit his beloved ballerinas in their dressing rooms. While not exactly a man about town, he was social when the mood struck him, but he was also incredibly shy and enormously introspective.

Cornell thrived on the excitement of Manhattan, but he lived out his entire adult life in a simple frame house in Queens. He was never formally trained as an artist, nor did he travel to Europe, yet his works are filled with recondite references to obscure figures of the past. He could not afford to attend college and worked full-time to support his family. Evenings and weekends, however, were devoted to working on his box constructions and collages, listening to music,

reading, writing in his diaries, and attending the theater, the ballet, the opera, and the movies. He admired movie stars of his time such as Hedy Lamarr, Greta Garbo, Lauren Bacall, and Marilyn Monroe, and he cherished images from the past, especially those of the Renaissance and Victorian eras. Fascinated by the world of images and in love with literature, music, and dance, he worked in the basement of his home to combine these separate disciplines into the very personal poetry that is his art.

Despite his reclusive legend, he was remarkably active in the art world. From the beginning of the 1930s on into the 1960s, Cornell was well aware of the changes that were occurring in Europe and New York, from Dada and Surrealism to Pop art. He revered Marcel Duchamp above all, considering him the greatest intellectual he knew, and admired Max Ernst, André Breton, Matta, Willem de Kooning, Robert Motherwell, Mark Rothko, and Barnett Newman. But he was outraged by Pop art—Andy Warhol was too tawdry for his taste, his art too kitsch. Warhol trivialized and sensationalized the common objects of daily life for which Cornell had great respect.

Cornell exhibited at the most avant-garde galleries of his day. He showed with Marcel Duchamp and the Surrealists at the Julien Levy Gallery, and at Peggy Guggenheim's Art of This Century, where his work was exhibited with the Surrealists as well as with Jackson Pollock, Motherwell, William Baziotes, Rothko, and Clyfford Still. Cornell's boxes were exhibited at the Charles Egan Gallery in the late 1940s and early 1950s with the paintings of de Kooning and Franz Kline, and in the mid-1950s he joined the Stable Gallery, where he showed with several of his colleagues from the Egan Gallery and with younger artists Robert Rauschenberg and Cy Twombly.

When Cornell died at the age of sixty-nine on December 29, 1972, he was largely unknown outside the small circle of artists and poets, museum directors, curators and critics, dealers and collectors who constituted the avant-garde art world of his time. Originally associated with the Surrealist painters and poets during the 1930s, Cornell, like Arshile Gorky, was regarded by many as an anomaly, an artist on the fringes of the Abstract Expressionist movement rather than an integral part of it. Both the Abstract Expressionists and their critics sought to define the new painting and sculpture in terms of large scale and abstract vocabulary of images, neither of which suited Cornell.

On the other hand, many of these same artists, de Kooning, Motherwell, and Newman among them, thought of Cornell as a colleague. Cornell agreed, noting that the only time he felt he belonged was in the Egan days.[5] Cornell shared with them an interest in the improvisational, the painterly, and the sublime that is as consequential to their work as scale and abstraction. Cornell may have seemed "out of his time"; perhaps he was born a few decades too late, or perhaps his art was a few decades too early. Beginning in the mid- to late 1980s, however, when movements were on the decline, Cornell's work emerged from a fashionable obscurity—helped considerably by his 1980–81 exhibition at The Museum of Modern Art in New York—to find ever greater appreciation and consistently larger audiences.

Cornell had a tremendous influence on younger artists during his lifetime. His evocative arrangements of objects inspired Robert Rauschenberg's early-1950s paintings, collages, and assemblages. In the late 1950s and early 1960s, an entire generation of assemblage artists emerged, including Lucas Samaras, who elaborated on Cornell's use of box constructions. Cornell's innovative use of film influenced artists such as Warhol, whereas younger artists admire his conceptual approach and use of reproductions. Cornell was both a conceptualist and an appropriator who was in thrall to his emotions and his fantasies.

Cornell's art gives full expression to the many aspects of his personality. His principal contribution—and the central focus of this study—lies in the development of his "shadow boxes," small-scale box constructions in which pasted papers, reproductions, sand, pipes, and other found objects are assembled in a kind of collage with depth, framed in wood, and usually sealed with glass. Cornell produced a great number of these boxes, many of them undated, as well as numerous variations on individual boxes and repetitions of a single theme in more than one work. Cornell worked in an elliptical rather than linear fashion. Except for the earlier boxes, which tended to be singular, he worked in series that often played out over a decade or more. He did not discard much, but he was selective. The themes of Cornell's box constructions also reappear in other mediums: collages, film, articles in the magazines *Dance Index* and *View*, and the writings in his diary. In addition to these are the accumulations of materials that Cornell called "explorations," containing notations, clippings, photographs, engravings, and three-dimensional objects. Cornell's deeply reverential attitude toward the universe as a mirror of mysterious truths is conveyed in each and every one of his box constructions. The distillation of all of these interests into the spare but poetic fantasy of his boxes transformed the box construction into a realm of both precise and enigmatic existence.

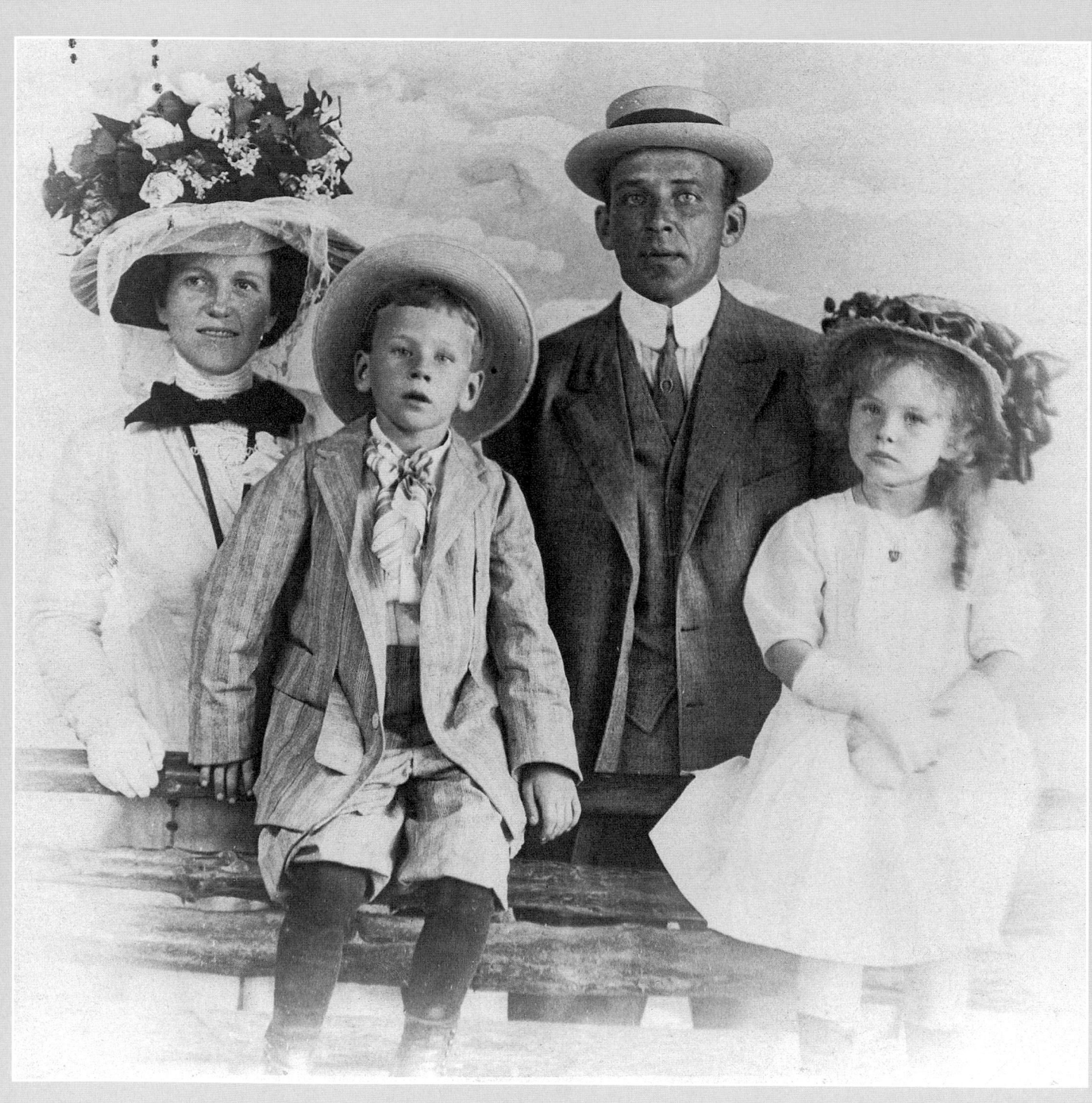

THE EARLY YEARS 1

Joseph Cornell was born on Christmas Eve, 1903, in Nyack, New York. His parents, Joseph I. Cornell and Helen Ten Broeck Storms, were both descended from Old Dutch New York families. His maternal great-grandfather was Commodore William R. Voorhis, founder of Nyack's water company, who owned schooners and prize-winning yachts.[4] Voorhis's brother, John, was a well-known New York politician. The sixth Joseph I. Cornell grew up in Nyack along with his two younger sisters, Elizabeth (Betty) and Helen, and younger brother, Robert, who by the age of one displayed signs of cerebral palsy. The Cornell family lived in several houses in Nyack, the last one at 137 South Broadway, on the corner of Voorhis Avenue.

The Cornell family house
at 137 South Broadway,
Nyack, New York, c. 1915

The "big house on the hill," as it was called, was a large Victorian house filled with comfortable overstuffed furniture and pieces by Stickley. Cornell's parents loved acting and performed in Nyack's amateur arts club. At home Cornell's mother played piano while his father sang. The family visited Manhattan frequently and went on excursions to see vaudeville acts at the Palace, spectacles at the Hippodrome, and the penny arcades in Coney Island. Cornell and his siblings learned to read at an early age and devoured fairy tales by the brothers Grimm and Hans Christian Andersen. Cornell's mother had been a classmate of Edward Hopper, and his sister Betty took art lessons from him; the loneliness and isolation found in Hopper's paintings would later become elements in Cornell's own work.

Cornell's father was first a salesman and later a textile designer for George E. Kundhardt, a manufacturer of fine woolen goods. Cornell accompanied his father on his rounds and went with him to SoHo, then a district of small textile manufacturers.[5] The neighborhood was filled with manufacturers who sold cardboard boxes, dolls, and textiles. In 1917, when Cornell was thirteen years old, his father died of leukemia, leaving behind enormous debts. The following year the family moved to a smaller house in Douglaston, Long Island, and Cornell's mother took on the burden of supporting her young family.

Cornell's mother enrolled him in the Phillips Academy in Andover, Massachusetts, in the fall of 1917. He earned pocket money by waiting on tables and worked for a summer in Kundhardt's textile mill in Lawrence, Massachusetts. He began acquiring early American Sandwich glass, a first clue

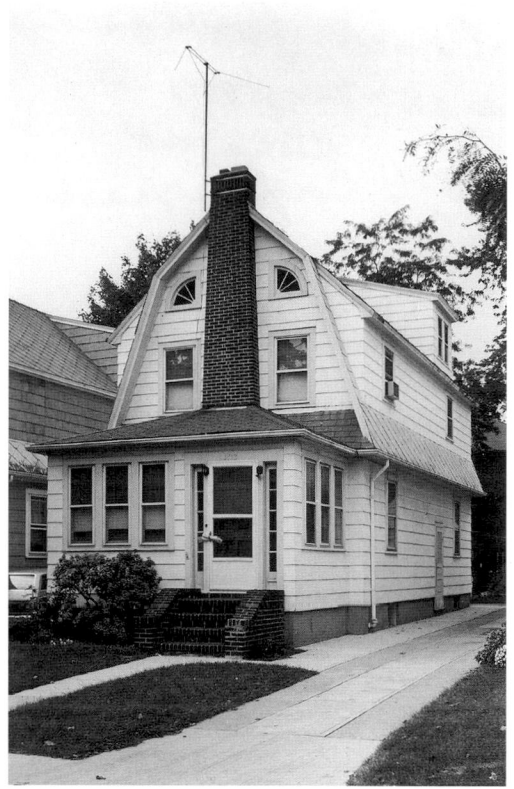

3708 Utopia Parkway, Queens, 1976
Photograph by Mary Donlon

to his developing interest in collecting. At school Cornell developed the first in a lifelong series of nervous crises and stomach ailments. At home for Christmas during school recess, Cornell confided in Betty that he had studied astronomy at school and was frightened by the concept of infinity. He took many courses in science and languages, but he received no formal training in art. His interest in French literature developed into a lifelong passion for the Symbolist poets Charles Baudelaire and Stéphane Mallarmé, and assumed particular importance as Cornell developed his own visual metaphors. He admired and identified with the solitary sensibilities of Edgar Allan Poe and Charles Lamb, and he read the Protestant mystics Jakob Boehme and John Woolman, and poets William Wordsworth, Emily Dickinson, and Novalis (Friedrich von Hardenberg).

In 1919 the family moved to Queens, in New York City, where they lived in three houses in succession until 1929, when Mrs. Cornell bought the modest frame house at 3708 Utopia Parkway, where Cornell resided for the rest of his life. Cornell's mother managed to support the four children through a number of odd jobs until 1921 when Cornell left school and went to work as a salesman for the William Whitman Company, a Boston-based textile wholesaler with offices near Madison Square Park. During the decade he worked at Whitman's, he managed to scrape up enough money to attend the opera regularly, waiting in line for standing-room tickets. Early in 1931, during the Depression, Cornell lost his job with Whitman and was out of work for several years. His mother arranged a job for him at the Traphagen Commercial Textile School, where he worked from 1934 to 1940, when at the age of thirty-seven he left his job to concentrate fully on his art.

The house on Utopia Parkway was a simple wooden structure painted white with blue trim, encompassing the cramped living quarters of the family and Cornell's basement studio. Cornell was devoted to his brother and later included Robert's charming drawings in his own work. The house was overrun with memorabilia, much of it collected by Cornell on his excursions into Manhattan, but he was especially proud of a nineteenth-century painting of a schooner, which had been owned by his great-grandfather. Cornell's own work gradually took over more and more of the house, especially after his two sisters married and moved away. Attic, garage, dining room, and basement were cluttered with works, some finished, many in progress. Despite the pressures of his daily life and frequent family tensions, Cornell insisted that his art was the result of a loving and understanding home life. He spoke warmly of Sunday afternoons when, after church, members of the family listened to Protestant services on the radio, and he felt enveloped in the great sense of religion that permeated every aspect of his life at home.

At the age of twenty-two, Cornell found relief from a serious stomach condition through the practice of Christian Science. His brother, Robert, and his sister Betty converted as well, but his mother and sister Helen did not. In 1926 Cornell joined the Mother Church in Boston and the First Church of Christ, Scientist, in Great Neck. He became a founding member of the church in Bayside and attended noonday meetings in Manhattan. Christian Science sus-

tained him through a number of crises and greatly influenced his interests and the themes in his art. Christian Science affirmed Cornell's belief that the entire universe is spiritual, and the religion even provided a framework for his understanding of Surrealism: Mary Baker Eddy, who founded Christian Science in the nineteenth century, emphasized the importance of spontaneity in the process of perception and inspiration, similar to the Surrealist belief in the power of the unconscious to generate ideas. Cornell found Christian Science just a few years before he encountered Surrealism. The confluence of these two beliefs, both of which dealt with the metaphysical nature of existence, provided him with a life-long framework for his art.

During the 1920s Cornell immersed himself in the life and culture of New York, absorbing classical music and modern French art, attending the theater, opera, ballet, and movies, visiting museums and galleries. He frequented The Metropolitan Museum of Art, the Brooklyn Museum, the Morgan Library, the Museum of Natural History, and the Hayden Planetarium. He made photostats of his favorite images from the Public Library Pictures Collection and the Bettman Archives. He scoured the Asian shops between 25th and 32nd Streets, where he found Japanese prints and the first small boxes for his objects, and he frequented a taxidermy shop in the Village and a pet store near Radio City Music Hall. Many of his favorite objects came from Woolworth's, the five-and-dime store from which he purchased stamps, wine glasses, marbles, gold-colored bracelets, and painted wooden birds. He hunted down clay pipes, specifically those that were Dutch in origin. What began as a pastime became an obsession that fed his everyday life and his creative imagination.

Cornell delved deeply into his interests, discovering new shops, new obsessions, and expanding his knowledge. In notes that he wrote in 1968, Cornell described this as "a terrain encompassed as vast as the starry expanse stretched out in the night, caught, just now, in a part[icular] glory—PERSEUS & ANDROMEDA in the wake of VEGA, CYGNUS & CASSIOPEIA"[6]

In these notes he listed people he admired, including Thurston the Magician; Harry Houdini; the actress Jeanne Eagels, whom he had seen onstage in *Rain*; Anna Pavlova, whom he saw dance three times during her farewell visit to New York; Odilon Redon; and Claude Debussy. Among the places he frequented were Washington Square Park, Madison Square Garden, St. Mark's in the Bouwerie, Brentano's, the Metropolitan Opera, and the John Wanamaker stores.

In the Madison Square area he admired the Flatiron Building and visited the Old Print Shop on Lexington Avenue, Renwick C. Hurry's Antiques, horse auctions at Doerr, Fiske and Carroll, and the toystore F. A. O. Schwartz. In Greenwich Village he frequented Bigelow's Pharmacy, which had a soda fountain, the Whitney Studio (later the Whitney Museum of American Art) at 8th Street, the Christian Science Reading Room on Macdougal Street, and the Washington Square Bookshop.

He recalled memorable events and things he valued, among them Charles Lindbergh's homecoming parade, Christian Science lectures around town, and his father's heavy brown overcoat. But the richest, most significant of all his

experiences was his "Grand Tour," week in and week out over a span of twenty-five years, of the Fourth Avenue bookstalls. For Cornell this decade was "truly a golden age . . . yielding some transcendent dreams"[7]

Over the years Cornell assembled dossiers that contained writings by him and others, newspaper clippings, and reproductions of images he admired. Among the artists whose images he collected were Watteau, Hogarth, Dosso Dossi, Parmagianino, Dürer, Pinturicchio, Picasso, Bronzino, John Singleton Copley, Goya, Marie-Victoire Lemoine, Bruegel, Rachel Ruysch, Manet, Pollaiuolo, Balthus, Vigée-Lebrun, Sofonisba Anguissola, Piero della Francesca, Benozzo Gozzoli, Giotto, Juan Gris, Vermeer, Leonardo, Giovanni Bellini, Dante Gabriel Rossetti, and Caravaggio. He also "collected" poets and writers, musicians and composers, photographers and filmmakers, ballerinas and opera stars, stage and screen actresses, mathematicians and scientists, aviators, constellations, carousels, hotels, penny arcades, parakeets, clay pipes and toys, in addition to other clippings and objects. His dossiers and "explorations," as he called them, were kept in the basement, and he often drew upon them for inspiration.

SURREALISTS IN NEW YORK

In November 1931 Cornell wandered into the Julien Levy Gallery at 602 Madison Avenue and watched Julien Levy himself unpack several Surrealist works. The gallery had just opened, and it soon became a magnet for avant-garde photography, art, poetry, and film. Levy's first exhibition was a tribute to Alfred Stieglitz, whose gallery 291 had supported modern American and European photography, before closing in 1917.[8] The exhibition included works by Stieglitz and five of Stieglitz's photographers, among them Gertrude Käsebier, Edward Steichen, and Paul Strand. The Julien Levy Gallery exhibited many European photographers, including Eugène Atget and Nadar, whom Cornell especially admired. Levy premiered work by Salvador Dalí, Max Ernst, Alberto Giacometti, Frida Kahlo, René Magritte, and many others. He also showed films, including Luis Buñuel's *L'Âge d'or* (1930) and *Un Chien andalou* (1928) made with Dalí.

The Surrealist movement was officially launched in Paris in 1924 with the publication of André Breton's *Manifesto of Surrealism*. The brilliant group of painters and poets who rallied to the Surrealist banner under Breton's energetic leadership included several members of the Dada movement—among them its creator, Tristan Tzara, as well as Ernst, Jean Arp, and Man Ray. The general spirit of Dada, especially its antirational character and its exhibitionism, became a basic part of Surrealism. Like the Dadaists before them, the Surrealists exploited the bizarre, the irrational, and the accidental in an outright assault on the formal and rational order of Cubism, which they felt to be a major barrier to the subconscious. Breton, however, eschewed the open-ended nature of the Dada movement and instituted in its place a more didactic program. Whereas Dada, founded in 1916 in reaction to World War I, was basically an art of protest aimed at the destruction of the existing political, social, and aesthetic sys-

tem, Surrealism proclaimed a constructive mission in the belief that its doctrines could structure a new order for art and society. Convinced that the unconscious was the essential source of art and life, the Surrealists set out to explore the hidden recesses of the mind. In 1924 the first issue of the official organ of the Surrealists, *La Révolution surréaliste*, edited by Pierre Naville and Benjamin Péret, proclaimed the importance of the dream. In his essay "L'Esprit contre la raison," René Crevel wrote:

> *Is it not for the mind a truly magnificent and almost unhoped for victory, to possess this new liberty, this leaping of the imagination, triumphant over reality, over relative values, smashing the bars of reason's cage, and bird that it is, obedient to the voice of the wind, detach itself from the earth to soar higher, farther O, wonderful responsibility of poets. In the canvas wall they have pierced the window of Mallarmé's dream. With one thrust of the fist they pushed back the horizon and there in the midst of space have just discovered an Island. We touch this Island with our finger.*[9]

Breton also believed in the ultimate unification of two seemingly contradictory states, the dream and reality, into "surreality." Apollinaire, a major source of inspiration for both Dadaists and Surrealists, in 1917 had coined the term *surreal* to describe man's ability to transform reality. The Surrealists were opposed

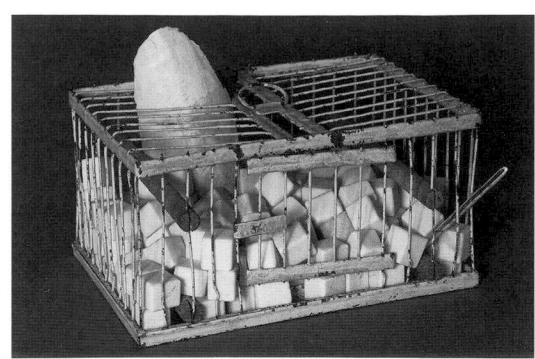

Marcel Duchamp, *Why Not Sneeze Rose Sélavy?*, 1921
Assisted readymade: painted birdcage with paper
tape lettering, containing marble cubes,
thermometer, wood, and cuttlebone,
4 ½ x 8 ⅝ x 6 ¼ inches
Philadelphia Museum of Art;
Louise and Walter Arensberg Collection

not to reality as such but to reason and logic. To rid the mind of preconceived ideas, to free words (and later objects) from the cliché-ridden contexts to which they had long been relegated, to renovate poetic imagery, the Surrealist poets employed the illogical mix of words—always surprising and often shocking.

The Surrealists believed that the function of the poet or artist was to communicate the immaculate primary concept (the moment of intuition), not by describing it but by selecting the appropriate word or image as symbol, which would act as stimulus or irritant to the senses of the spectator. This in turn would arouse multiple images and emotions, differing according to the sensibility of each viewer, corresponding to the power and magic of the myths, parables, and metaphors of the past.

The estrangement of the object, particularly its separation from the objects generally associated with it and from any form of narrative, became the basic technique of Surrealism. Objects that formerly belonged to separate planes, both spatial and conceptual, were placed in unexpected juxtaposition. Paul Nougé wrote that the Surrealist paints the "bewildering object and the accidental encounter . . . by isolating the object . . . breaking off its ties with the rest of the world We may cut off a hand and place it on the table or we may paint the image of a cut-off hand on the wall."[10]

Cornell often said that Max Ernst's collage-novel, *La Femme 100 têtes* (1929), inspired him to make his own early collages.[11] Ernst was a pioneer of Dada collage. He cut up and combined late-nineteenth-century engravings into compositions whose elements differ radically in scale. Instead of adding separate collage pieces to the picture plane, as the Cubists had done, Ernst created a unified image from the collage fragments and assembled them so that they appeared to be a single entity. Ernst was so skilled at manipulating his material that it was often impossible to tell whether or not a work was indeed a collage. Although Ernst achieved this effect by cutting and pasting as little as possible, he subsequently decided to improve upon his technique by reproducing his images photographically so that the cut edges were no longer visible. Ernst's invention in the medium of photocollage constitutes one of his most important contributions to Dada collage. By adding some lines or a little color to these illustrations of scientific, commercial, and natural phenomena, Ernst could alter their meaning and, in his words, "transform the banal pages of advertisement into dramas, which reveal my most secret desires."[12]

Soon after Cornell saw Ernst's work he showed his first small efforts, montages on cardboard done in the photocollage technique of Ernst, to Julien Levy. Levy included them in a group show, *Surréalisme*, at his gallery in January 1932. This landmark exhibition launched the Surrealist movement in New York. The show was similar to *Newer Super-Realism* organized by A. Everett (Chick) Austin, Jr., at the Wadsworth Atheneum in 1931, but Levy added more artists and showed fewer works. Chick Austin was the first person to organize a major exhibition of Surrealism in the United States. He was also an advocate of important new trends in music, architecture, decorative arts, theater, dance, and film. Some years later, Austin began to collect and exhibit Cornell's work.

Levy asked Cornell to design the cover of the catalogue for the show, which included paintings by Dalí, Ernst, Picasso, Man Ray, and Pierre Roy and photographs by Eugène Atget, Jacques-André Boiffard, Man Ray, George Platt Lynes, and László Moholy-Nagy. Marcel Duchamp's *Why Not Sneeze Rose Sélavy?* (1921) and Man Ray's *Snowball (Boule de neige)* (1927) were also featured in the exhibition, but Dalí's *The Persistence of Memory* (1931) was the highlight of the show for Cornell. He was flattered that the very first work of his to be shown "shared the walls with the premiere of Dalí's famous watch piece."[13]

Surréalisme also included Cornell's *Glass Bell* (c. 1932), which contains a mannequin's hand holding a collage of a rose. The rose is similar to the silk roses of the Victorian era, but Cornell has also included an eye, a Surrealist symbol of the subconscious. Behind these props lay a Japanese fan, which has since been lost. Possible influences for this work are Ernst's collage *The Wheel of Light*, from the collage-novel *Histoire naturelle* (1926), and Magritte's painting *The False Mirror* (1928). Redon's lithograph *The Eye Like a Strange Balloon Mounts toward Infinity* (1882), from his series dedicated to Edgar Allan Poe, was a source for both Ernst and Magritte.

The glass bell was a popular Victorian conceit often used for displaying clocks, model ships, dried flowers, stuffed birds, or other objects. Glass bells were also used to advertise a shopkeeper's line of work. Ernst featured several glass objects in *La Femme 100 têtes*. In *And the Butterflies Began to Sing*, he depicts a street lamp whose light attracts beetles and butterflies.

This first exhibited object by Cornell also contains similarities to Ernst's collage *The Chinese Nightingale (Le Rossignol chinois)* (1920), a photomontage featuring a pair of arms, an open fan, and a mask with an eye. Hands also figure prominently in Ernst's *La Femme 100 têtes*. The "found object" of a hand or a limb from a mannequin appeared in the proto-Surrealist works of Giorgio de Chirico, before becoming a favorite Surrealist device. In Victorian times a hand was used on signs as a means of direction, pointing the way to a shop or a corridor, and in the Victorian game "Chiromagica," an engraving of a hand would spin in a circle and point to the answer.[14]

At Levy's gallery Cornell met and befriended many of the painters, writers, and photographers associated with the Surrealist movement who came to the United States prior to and during World War II. The first American exhibition of Dalí took place at Levy's in 1933. In 1934, for his second exhibition, Dalí arrived in New York to much acclaim, followed shortly thereafter by other leading Surrealists. Cornell also later met André Breton, Ernst, Matta, Lee Miller, Yves Tanguy, and Dorothea Tanning. Cornell befriended Miller about the time of her first solo show, which opened at the Julien Levy Gallery on December 30, 1932. (This was Miller's only solo show during her lifetime.) One of the great beauties of the European-American arts scene, Miller was one of the most distinctive and accomplished photographers of her generation. She was also Man Ray's model, lover, and photographic collaborator in Surrealist Paris before establishing herself in New York. In addition to taking photographs of Cornell's artworks, she made several striking portraits of him.

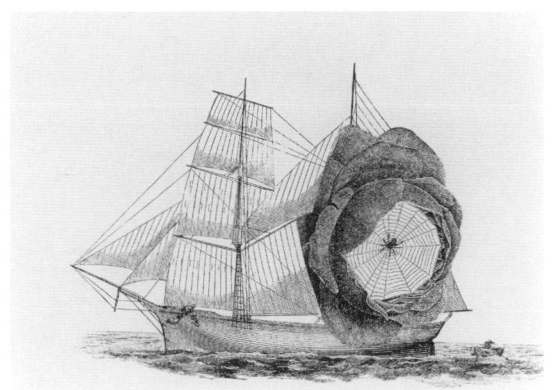

Untitled (Schooner), 1931
Collage, 4 ½ x 5 ¾ inches
Hirshhorn Museum and Sculpture Garden,
Smithsonian Institution, Washington, D.C.;
Fractional and promised gift from the collection
of June W. Schuster, Given in her memory
by her daughter Pamela McCormick, 2001

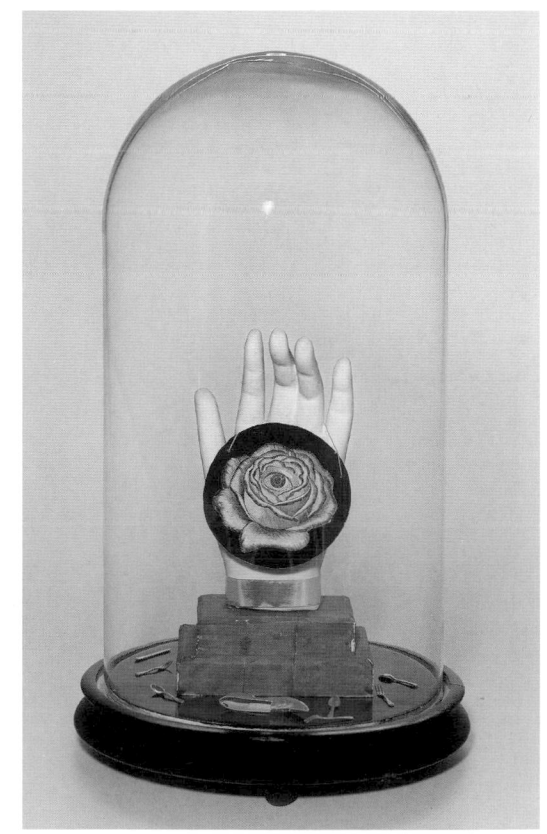

Glass Bell, c. 1932
Assemblage, 16 x 9 x 9 inches
The Lindy and Edwin Bergman
Joseph Cornell Collection, Chicago

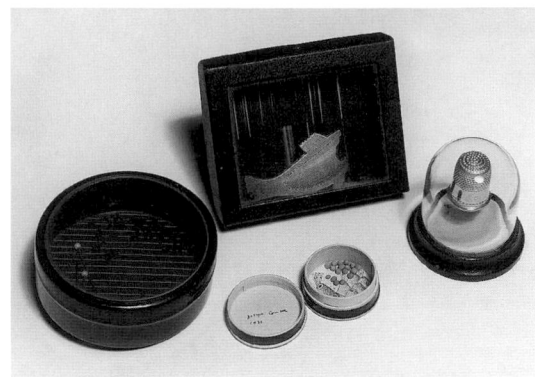

Untitled, 1933
4 constructions, 2 ⅜ x 3 ⅛ x ¾ inches (above);
1 x 2 ¾ inches diam. (left); 2 x 2 ⁹⁄₁₆ inches diam.
(right); ½ x 1 ¼ inches diam. (center)
Collection Mark Kelman

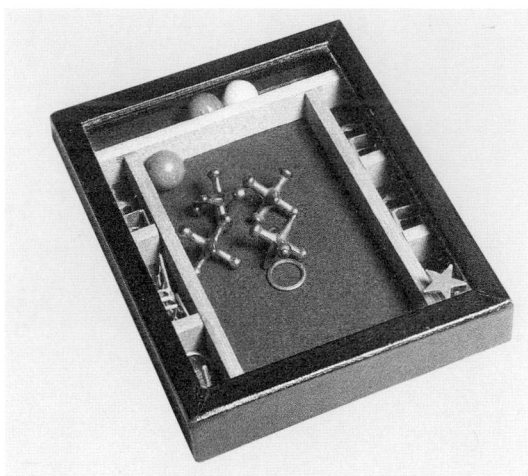

Untitled (Jacks), 1933
Construction, 4 ⅛ x 5 ½ x ⅜ inches
The Lindy and Edwin Bergman
Joseph Cornell Collection, Chicago

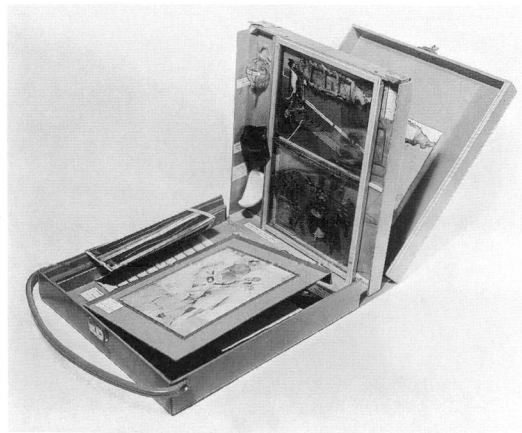

Marcel Duchamp, *Boîte-en-valise*, 1935–41
Leather valise containing miniature replicas,
photographs, and color reproductions
of works by Duchamp,
16 x 15 x 4 inches
The Museum of Modern Art, New York

Cornell's alliance with the Surrealists can be easily understood in the context of his time. The arrival of the Surrealist expatriates in New York City before and during World War II dramatically altered an art scene that, in the late 1920s and early 1930s, was dominated by Social Realism. Cornell believed in the Surrealists' notion of the freedom of imagination, but his concepts and imagery were more closely related to Surrealist poets than painters, with few exceptions other than Max Ernst.

Association with the Surrealists came at a defining moment for Cornell. Like Gorky, Baziotes, Motherwell, and countless others, he benefited from both the movement and from association with the Surrealists. Cornell rejected the label "American Surrealist," but he also stressed the movement's importance, and he cited individual members as a major source of inspiration and support. The elation that Cornell felt from the presence of the Surrealists during the formative years of his career was important, but, as he took pains to point out, he also found inspiration in the teachings of Christian Science and in other forms of art, music, literature, and dance. Ultimately, his work, like that of the New York School artists, succeeds as a highly personal achievement.

By 1932 Cornell was already fully committed to art and had managed to launch a career in the art world, earning small sums of money from the sales of his work. Cornell's first solo show took place at the Julien Levy Gallery in November of that year. The exhibition was titled *Objects by Joseph Cornell: Minutiae, Glass Bells, Shadow Boxes, Coups d'Oeil, Jouets Surréalistes*, and it opened less than one month after Max Ernst's first solo show in the United States, also at Levy's gallery. The term *coups d'oeil* was a tribute to the imagery of Ernst, Dalí, and Buñuel. Buñuel and Dalí's sensational film, *Un Chien andalou*, with its stunning scene of an eyeball being sliced, was screened at the gallery just a few weeks earlier; the scene was probably a takeoff on Ernst's image of a pierced eye, which appeared on the cover of Paul Eluard's 1922 book, *Répétitions*.

Cornell's earliest shadow boxes were small, fragile, and modest in ambition. The largest measured five by nine inches. They were complemented by thimbles propped on needles, bisque angels and minuscule silver balls placed under small glass bells, brightly colored sequins, sewing pins, cut-up engravings of fish and butterflies, colored sand, and brass springs. These objects all moved about freely in small rectangular or round boxes resembling compass cases. Both the objects and their containers varied little from their original state. They were "transformed," in the manner of Marcel Duchamp and the style of the period, with only slight alterations to the "found" object.

Construction, along with collage, was a principal Surrealist means of juxtaposing unrelated images and objects. By extension, the work of art itself came to be treated as an irrational, isolated "object." It was in this context that Kurt Schwitters and Duchamp, especially with his portable museum, the *Boîte-en-valise*, experimented with the box as a type of object whose detailed and often intricate construction belied an underlying absence of "rational" function. Dalí experimented with boxes in a 1929 work, *Illumined Pleasures*, in which three rectagular boxes of images inhabit a surreal dream landscape. The Dada and

Surrealist artists made great use of the box format, but Cornell also looked to other precedents. Boxes appear in eighteenth- and nineteenth-century still-life painting, and boxes were popular in Victorian homes. The box is a treasure chest, one containing many of life's secrets and mysteries, and it is this that most appealed to Cornell. Ultimately all of his objects were to be placed in the warmth and security of a box where they could be cherished and protected.

All of Cornell's creations of this period have a particular charm and a distinctive individuality that set them apart from the more sophisticated work of the European Surrealists. Cornell's montages of the early 1930s are Surrealist in their disorienting mix of images.[15] Yet despite the presence of a spiderweb, the 1931 *Untitled (Schooner)* (page 21) reveals a disarming innocence and naiveté, a "white humor," that distinguishes this and other collages of the period from the black humor and disturbing, often grotesque, effects and sexual innuendo cultivated by the Surrealists. *Schooner* harks back to the painting that hung in Cornell's dining room, the first of many works to make reference to his family. In another early work, *Untitled* (c. 1932), Cornell visually paraphrased Lautréamont's famous phrase, "Beautiful as the chance meeting of a sewing machine and an umbrella on a dissecting table," a description well loved by the Surrealists.

In 1936 Cornell was included in the landmark exhibition *Fantastic Art, Dada, Surrealism*, held at The Museum of Modern Art, New York. *Soap Bubble Set* (1936) was exhibited with another box, numerous bottles, and glass bell jars, and shown in a large display case labeled "The Elements of Natural Philosophy." *Soap Bubble Set* is Cornell's first large-format work and it enjoys a new sense of

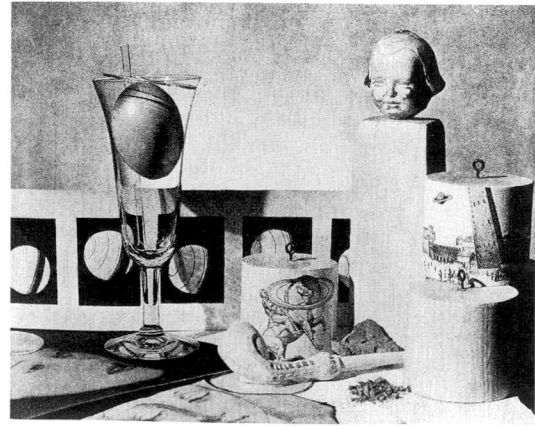

Installation view of "The Elements of Natural Philosophy,"
from the exhibition *Fantastic Art, Dada, Surrealism*,
December 7, 1936—January 17, 1937,
at The Museum of Modern Art, New York

Soap Bubble Set, 1936,
"photographed with additional effects
by George Platt Lynes"
From the catalogue of the exhibition
Fantastic Art, Dada, Surrealism

form, scale, and structure. In many of his small objects dating from 1932 to 1933, such as *Untitled (Jacks)* (1933; page 22), Cornell wanted the viewer to handle the work and cause the chance recombination of the elements within it. In *Soap Bubble Set*, Cornell decided to forgo movement and to locate each of the objects in a separate compartment and in fixed relationship to the others. It was Cornell's most successful attempt to date to group disparate objects into a coherent unity.

Soap Bubble Set was reproduced in the catalogue without the box and listed as an arrangement of objects "photographed with additional effects by George Platt Lynes." Both it and the box itself continue in the mode of nineteenth-century trompe l'oeil painting. William Michael Harnett and John Frederick Peto, two of its leading practitioners, treated ordinary, everyday objects with a reverence that Cornell emulated in his work. Harnett created many variations of his favorite subjects, still lifes that often included a reference to the outside world, such as *Emblems of Peace* (1890). Both Harnett and Cornell explored the tactile world of material things. Their objects inhabit a solitary world, and mundane genre subjects are elevated to the realm of the extraordinary.

In all probability, Lynes photographed the objects before the box was completed and may have had a hand in their arrangement. Nonetheless, the presen-

tation shares certain features with the work of other artists. Louis-Jacques-Mandé Daguerre, the inventor of the daguerreotype, might have influenced Cornell's choice of objects. His first photograph, *Still Life* (1837), includes a pair of heads similar to the one that Cornell used in *Soap Bubble Set*. Daguerre's still-life arrangement is derived from the eighteenth-century paintings of Jean-Baptiste-Siméon Chardin, whom Cornell also thought of as an important forebear. But what is most striking about Daguerre's photograph is its nostalgic reference to a classical past in combination with everyday objects.

"The Elements of Natural Philosophy," the label accompanying Cornell's display at The Museum of Modern Art, was a term first used in the nineteenth century when scientific theory was viewed in terms of its religious and aesthetic import. In addition to *Soap Bubble Set*, the display included a box, *Cabinet of Natural History (Object)*, containing fifty-five glass bottles labeled in French with references to Edgar Allan Poe, rainbows, frogs, photography, shadows, and the solar system. Cornell worked on the box in 1934 and again between 1936 and 1940, at which time he made a similar work, *L'Égypte de Mlle Cléo de Mérode: cours élémentaire d'histoire naturelle* (1940; see page 40). *Cabinet of Natural History (Object)* is the precursor to the *Pharmacy* and *Museum* boxes of the following decade. The Wadsworth Atheneum acquired *Soap Bubble Set*, the first work of Cornell's to enter a museum, in 1938.

Objects that would recur throughout Cornell's work appear for the first time in *Soap Bubble Set*: clay pipes, glasses, engravings, and maps. The pipe is associated with memories of downtown Manhattan and old houses near the water; the egg is a symbol of life; the glass represents the cradle of life; the four cylinders are his family; and the doll's head stands for Cornell himself. The moon, placed above the clay pipe, is both soap bubble and world.

Cornell found the clay pipes for these works at the New York World's Fair, which he visited on several occasions during the summer of 1939. Cornell was deeply awed by several exhibitions that he saw there, one of which, *Masterpieces of Art*, contained many paintings that he admired or used in his work: Bronzino's *Portrait of Fernando de' Medici*, Perugino's *Portrait of Piero de' Medici*, Raphael's *Giuliano de' Medici, Duke of Nemours*, Dosso Dossi's *Circe and Her Lovers*, Vermeer's *A Lady Writing*, Chardin's *Soap Bubbles*, Velázquez's *Infanta Maria Theresa*, Goya's *Don Manuel Osorio de Zuniga*, and Hogarth's *The Graham Children*. The Medici portraits clearly inspired his series of Medici boxes, the first of which appeared a scant three years later. The Dosso Dossi, Velázquez, Goya, and Hogarth occur at a later date, and the Vermeer influenced other important works. The clay pipes and the Chardin could not have appeared at a more fortuitous moment; the combination generated two new series that followed in the wake of the original *Soap Bubble Set* (1936).

The pipe, positioned in front of a "carte géographique de la lune," can be compared to Man Ray's *Ce qui manque à nous tous* of the same year. Although Cornell was influenced by Man Ray's choice of objects, his formal arrangement is clearly related to Magritte's work of the 1920s and 1930s. In *The Key of Dreams* (1930) the Belgian artist compartmented objects, two of which—an egg and a

William M. Harnett,
Emblems of Peace, 1890
Oil on canvas, 27 ½ x 33 ¾ inches
Springfield Museum of Fine Arts, Massachusetts;
Gift of Charles T. and Emilie Shean

Louis-Jacques-Mandé Daguerre,
Still Life, 1837
Daguerreotype, 6 ½ x 8 ½ inches
Société Française de Photographie, Paris

Soap Bubble Set, 1936
Construction,
15 ¾ x 14 ¼ x 5 ½ inches
Wadsworth Atheneum,
Hartford, Connecticut;
Gift of Henry and
Walter Keney

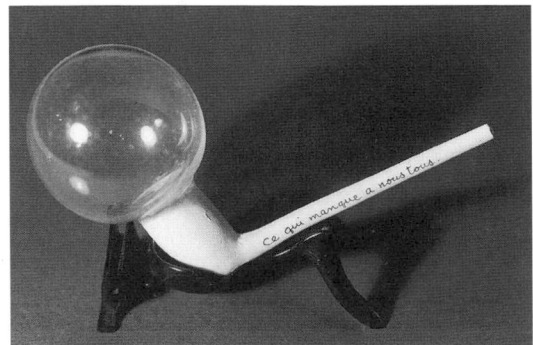

Man Ray, *Ce qui manque à nous tous*, 1936
Mixed media (original object destroyed;
photograph by the artist)

OPPOSITE:
Object (Soap Bubble Set), 1941
Construction, 12 ⅜ x 18 ¼ x 3 ¾ inches
Collection Robert Lehrman, Washington, D.C.

glass—Cornell used in this work. In his painting, Magritte inscribed each image with a totally irrelevant name, calling into question not only its identification but also the way in which we are taught to see reality. Cornell, in contrast, used these objects to symbolize the universe. He relished the many roles of an object, cherishing it for its ordinariness as well as for its symbolic meaning or reference to an earlier work of art. *Soap Bubble Set* is the key work of the 1930s, setting the tone for all of Cornell's work to follow.

Cornell followed *Soap Bubble Set* with a number of relatively small and almost two-dimensional works that he began in the late 1930s. These shallow boxes contain clay pipes and engravings of shells overlaid with glass disks. In a typical example, *Object (Soap Bubble Set)* (1941), the glass partitions of the earlier work have disappeared, and each of the glass disks and its engraving is a soap bubble gracefully spiraling upward from the bowl of the pipe. The last *Soap Bubble* variants date from the mid-1940s and include works such as *Soap Bubble Set* (1947–48), which features cork balls, cordial glasses, and marbles in front of astronomical maps.

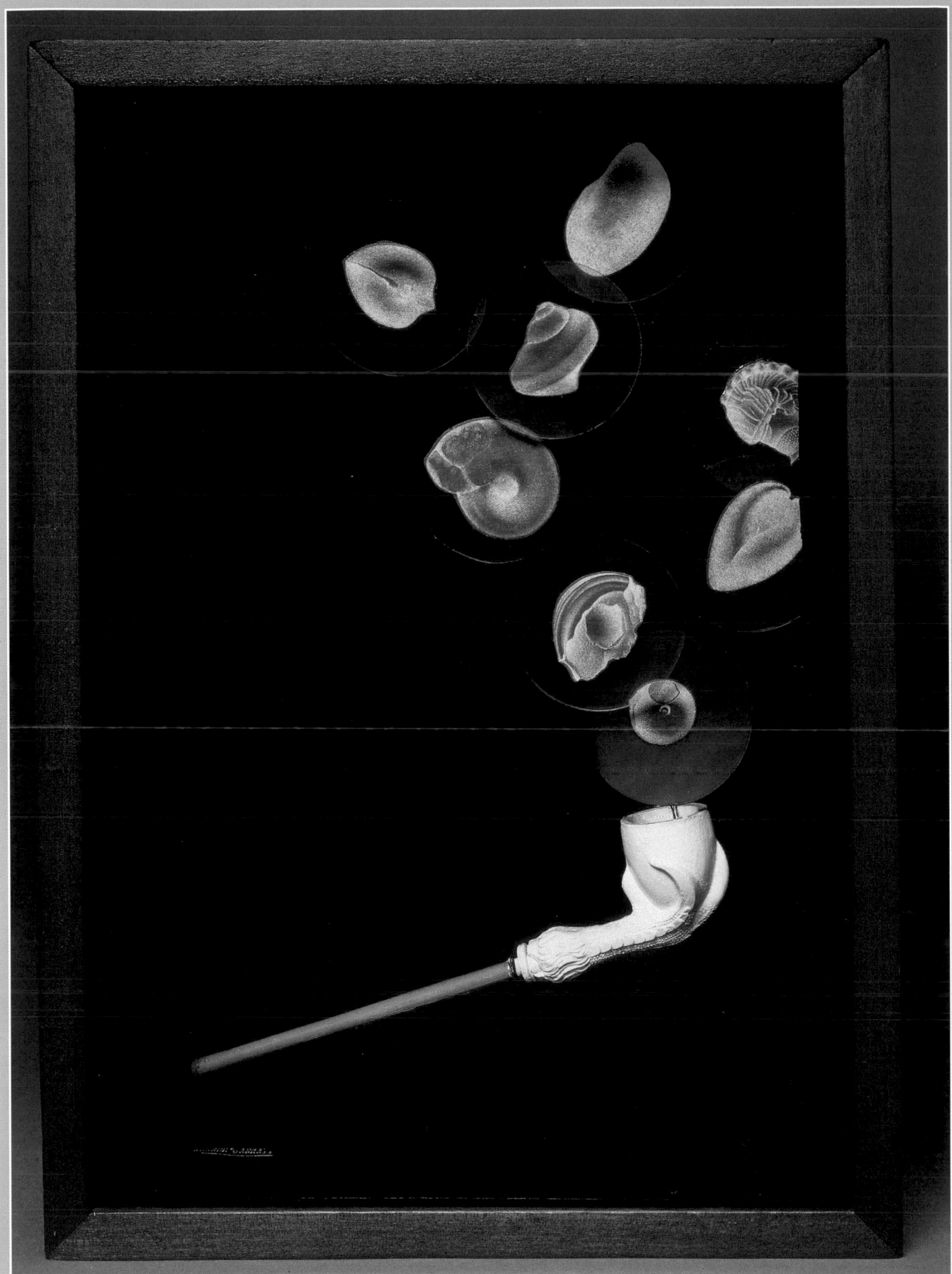

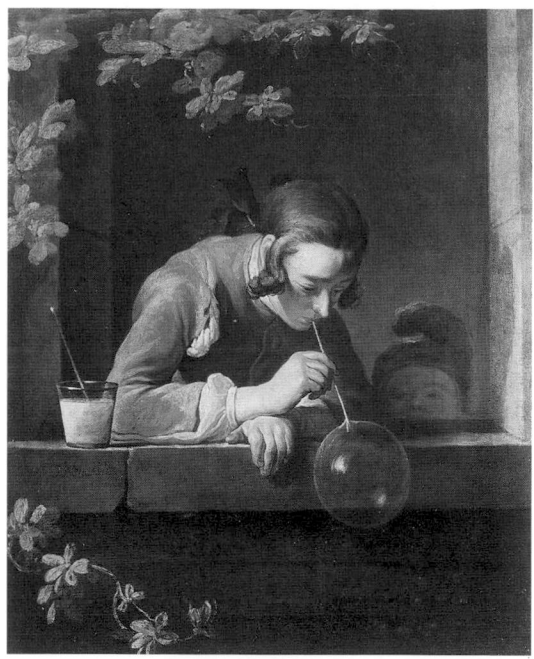

Jean-Baptiste-Siméon Chardin, *Soap Bubbles*, c. 1734
Oil on canvas, 36⅝ x 29⅞ inches
National Gallery of Art, Washington, D.C.;
Gift of Mrs. John W. Simpson, 1942

Soap Bubble Set, 1947–48
Construction, 12¾ x 18⅜ x 3 inches
Collection Robert Lehrman, Washington, D.C.

The one constant in the series is the inclusion of a clay pipe. The pipe recalls Man Ray as well as Magritte's famous *Ceci n'est pas une pipe*. His *La trahison des images* (1935), containing the English words "this is not a pipe," was shown at the Julien Levy Gallery in January 1936, the artist's first solo show in America. As noted earlier, Cornell also knew and admired the work of Jean-Baptiste-Siméon Chardin. Chardin's *Soap Bubbles* (c. 1734; also called *Young Man Blowing Bubbles*), in the collection of The Metropolitan Museum of Art, is one of three versions. The bubble motif was popular in seventeenth-century Dutch genre painting, as a metaphor for the transitory nature of life and the vanity of all earthly things. Edouard Manet, inspired by Chardin's painting, also treated the subject in his canvas *The Soap Bubble* (1867–69), in which a child is portrayed blowing a bubble. Cornell's real interest in these paintings lies in the charm with which Chardin and Manet portrayed both a simple moment and a spiritual belief.

Cornell later wrote about the theme of his series of *Soap Bubble Sets*:

Shadow boxes become poetic theatres or settings wherein are metamorphosed the elements of a childhood pastime. The fragile, shimmering globules become the shimmering but more enduring planets—a connotation of moon and tides—the association of water less subtle, as when driftwood pieces make up a proscenium to set off the dazzling white of sea-foam and billowy cloud crystalized [sic] *in a pipe of fancy.*[16]

Cornell's approach to the universe was one of innocent wonder, in which he saw nature unfolding in all its strength and fragility, revealing itself through the seasons in an unending series of events. Cornell was evidently familiar with medieval illuminated manuscripts, in which each of the months of the year is illustrated in intricate and loving detail. *Soap Bubble Set* is the key work of the 1930s for in it Cornell establishes his deeply reverential view of the universe as a mirror of mysterious truths, a belief that is implicit in each and every one of the constructions and collages that follow.

The 1947–48 *Soap Bubble Set* was included in an exhibition at the Copley Gallery. In September 1948 William Copley, a dedicated Surrealist painter, opened the short-lived gallery bearing his name in Los Angeles with his brother-in-law, John Ployardt. Copley met Cornell through Alexander Iolas[17] at the Hugo Gallery and decided to do a survey of his works dating from the 1930s and 1940s. (Cornell is mentioned in the catalogue as an American Surrealist, although by the date of this show Cornell had moved well beyond Surrealism.) A spare yet elegant box with diagrams of the moon attached to the rear wall, this *Soap Bubble Set* is a study in deep blue velvet, which lines the bottom of the box, two blue marbles resting on glass shelves, a white pipe and eight cork balls that are hung from the top of the box. The "floating" corks refer to the cork stoppers that are found in bottles washed up by the sea. Subtle touches like these abound in Cornell's work, the residue of his fanciful boxes of the early 1940s, such as *A Pantry Ballet (for Jacques Offenbach)* (1942; see page 63).

Other *Soap Bubble Sets* of the period contain sprigs of coral, seashells, pieces of sponge, and driftwood, some of which were finds from Cornell's walks along the beach in Westhampton, near his sister Betty's home. Cornell sometimes wrote the date in pencil on the inside of the top of the box, and he occasionally gave specific instructions, typed on the back of the box, stating how these objects could be "set in order." As is the case with his boxes, two screws on the top of the box can be removed and the contents put in proper sequence.

Cornell's choice of subject matter may have been partially responsible for his designation as a Surrealist. The objects that he included in his 1936 *Soap Bubble Set* are similar to those used by Pierre Roy, whose proto-Surrealist painting *The Electrification of the Country* (c. 1930) containing glasses, eggs, and clay pipes was also included in The Museum of Modern Art's exhibition *Fantastic Art, Dada, Surrealism*. In echoing the paintings of Harnett and Peto, Cornell proved an understanding beyond that of the Surrealists: the dissimilar idioms of nineteenth-century American trompe l'oeil and twentieth-century Surrealism had a metaphysical connection.

Cornell was also intrigued with Giorgio de Chirico, a major precursor of Surrealism, early in his career. In December 1927 the Gallery of Living Art opened at New York University featuring works by Braque, de Chirico, Miró, and Picasso from the Albert E. Gallatin collection. Cornell may have seen this exhibition as well as de Chirico's first American exhibition, which was held at the Valentine Gallery in New York in 1928. In works such as *The Mystery and Melancholy of a Street* (1914), de Chirico used sharp perspectives and strongly

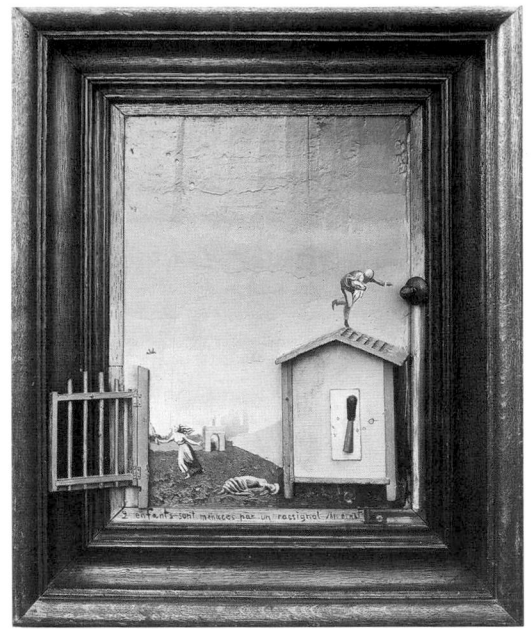

Max Ernst,
Two Children are Threatened by a Nightingale
(Deux enfants sont menacés par un rossignol), 1924
Oil on wood with wooden construction,
27 ½ x 22 ½ x 4 ½ inches
The Museum of Modern Art, New York

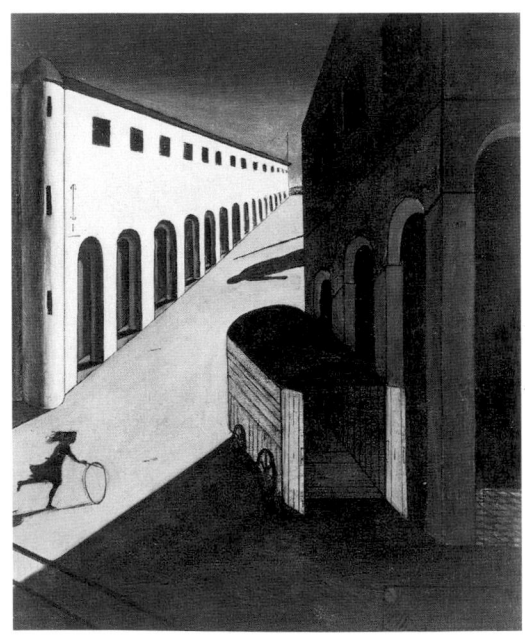

Giorgio de Chirico,
The Mystery and Melancholy of a Street, 1914
Oil on canvas, 34 ⅜ x 28 ⅛ inches
Private Collection

cast shadows to create an illusion of isolation and silence, of stillness and a remote nostalgia. In this and related works de Chirico created a sense of time stopped, a vacuum in which sparse objects pause, shedding their known identities for new ones that must be guessed. De Chirico began a series of *Metaphysical Interiors* in about 1915. The series abounds with T-squares, carpenter's rules, geographical maps, mannequin torsos and arms, biscuits, and candies placed in tightly sealed rooms in which there is an occasional glimpse of windows or portholes. Cornell soon found his own vocabulary of images, but he recaptured the hermetic space of de Chirico's interiors and the unexpected associations between objects in the sealed interiors of his box constructions. Just as Max Ernst made the transition from collage to relief, in works such as *Two Children Are Threatened by a Nightingale* (1924), so Cornell moved from the two-dimensional medium of collage into box constructions. From these three-dimensional objects he created a unique plastic expression and a vivid, memorable realm of both a real and imagined existence. But although Cornell greatly admired Ernst, he later said, ". . . even the Max Ernst influence was quickly transcended in favor of the shadow box technique and into a different world than Ernst."[18]

Cornell's first exhibition to receive some notices in the press opened on December 6, 1939. Levy wrote the press release, which states that "his objects derive from a completely pure subconscious poetry unmixed with any attempt to shock or surprise. They are essentially pure creation, no professionalism, no ulterior motive but the concrete expression of Cornell's personal lyricism. They are useless for any purpose except to delight the eye and everyone's desire for a loveable object." An *Art News* review commented: "Much, if not all, is done with mirrors . . . and the reflections which do not have the aid of actual quicksilver are images drawn from the unconscious." The objects were placed in a darkened room; they included "bubble pipes, thimbles, and china dolls showered with confetti, in and out of shadow boxes . . . birds, books and balls suspended on strings, and its strange alchemy of bottles, artificial green leaves and bits of broken glass."[19]

The New York Times mentioned a ". . . whirling eyeball under a bell jar, or a book which is a box in which things slide and kaleidoscope"[20] At least one object played tunes like a music box. *The New York Herald Tribune* treated the show as a "holiday toy shop of art for sophisticated enjoyment, and intriguing as well as amusing."[21]

Cornell was upset by the newspaper reviews for he felt that the critics misconstrued his intention. Julien Levy had used the term "toys for adults" to describe the works, probably derived from Breton's phrase "tragic toys for adults" that he used to describe Picasso's work.[22] Although Levy intended his description of Cornell's work to be complimentary, it was too sophisticated a term for an audience unaccustomed to Cornell's innocent sorcery.

Cornell may inadvertently have played into the critics' hands by building objects to order as Christmas gifts for five dollars each, in addition to the pieces on exhibit. Approximately five inches high, six inches wide, and one inch deep, these objects or "daguerreotypes," as they were called, were forerunners of the *Sand Boxes* (which were horizontal in format) and the *Medici* boxes (which were

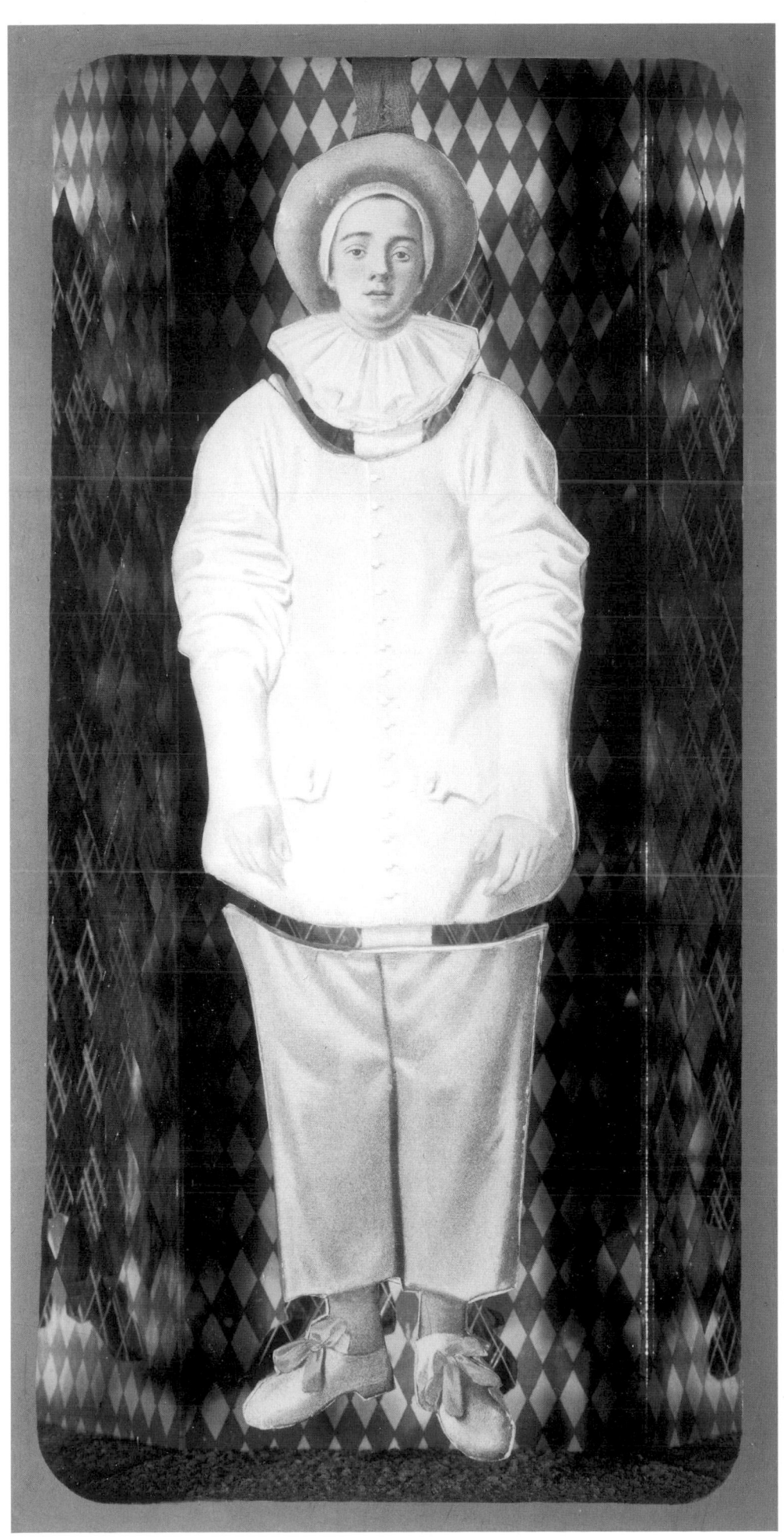

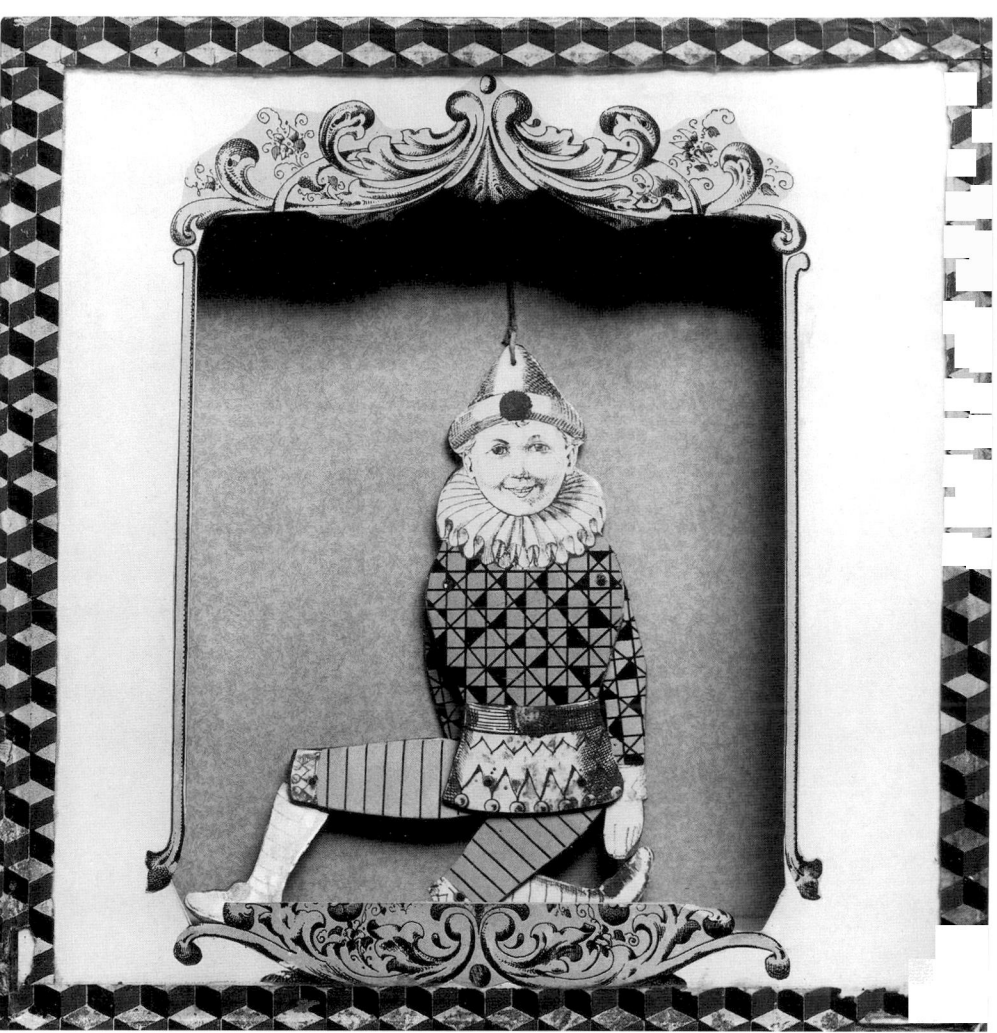

Untitled (Harlequin), 1935–38
Construction, 13 ⅛ x 12 ⅝ x 2 ¾ inches
The Lindy and Edwin Bergman
Joseph Cornell Collection, Chicago

compartmentalized). The "daguerreotypes" featured the client's photo fastened to the rear of the box overlaid with glass tinted blue or brown. Some were hung on a string and were meant to be worn as a locket.

During the Victorian era the daguerreotype was popular with the bourgeoisie, often replacing the painted portrait as a status symbol. To re-create the look of the daguerreotype Cornell inserted a tinted mirror, cut to silhouette the sitter, over the photograph. Between the mirror and the photograph he scattered particles of colored sand, slivers of glass, and tiny seashells, which moved freely about when the box was handled. Cornell used a photograph of Julien Levy in one of his daguerreotypes. Cornell expanded upon the concept of the daguerrotype by substituting other objects in place of photographs.

Untitled (Jacks) (1933; page 22) is Cornell's version of the game motif that was so popular among the Surrealists. To the actual jacks Cornell added other toy objects, such as a chair from a dollhouse, a star, and rubber balls, to create his own version of the theme.

During the mid- to late 1930s, Cornell produced a number of one-of-a-kind boxes. They are similar to one another in that each contains one or more figures, sometimes suspended like puppets with string from the top of the box. His first shadow boxes are comparable to a popular type of Victorian shadow box that Cornell would have known from his youth. They are made of paperboard cov-

ered in marbled paper, of a kind that Cornell may have had at home or purchased on one of his trips to Manhattan.

A Dressing Room for Gille (1939; page 31) is based on Watteau's *Gilles*, but Cornell has replaced Gilles's head with another image and substituted a theater setting for the French painter's landscape. Cornell's *Gille* also has a precedent in a Pierrot figure by Juan Gris that Julien Levy included in his 1933 exhibition *Twenty-five Years of Russian Ballet from the Collection of Serge Lifar*. Nadar's compelling photographs of the mime Charles Debureau may have served as an additional association. In his version of Pierrot, Cornell cut the figure into three segments and suspended it from the top of the box. The Pierrot figure is replicated on the back wall of the box as a silhouette formed from a pattern of diamond shapes. Cornell's clever use of mirrors creates a magic theater, his version of the fanciful entertainments that captivated artists like Watteau in the eighteenth century.

In his frequent trips to Paris, Julien Levy came across objects and toys that he brought back to New York. At the Paris flea markets, Levy found small round boxes in which objects were placed; he later mentioned that these boxes suggested shadow boxes and pillboxes to Cornell. Even if Levy did not know of Cornell's fondness for toys, he certainly knew of the Surrealists' penchant for games and Cornell's love of all things French. Cornell delighted in the games and toys of his childhood, and when he made his first objects, he drew upon these childhood pastimes for images and ideas.

One Victorian's children's game, "Rubber Ball Shooting Gallery," contains two rows of figures, among them several clowns, a cutout of a rabbit, and the figure of Humpty Dumpty. Each of the figures is a target and can be hit with a rubber ball. The largest image in the center of the second row is a bull's-eye target. The objects are set in a vertical shallow box that has a figural border framing the front. The clowns resemble the figure that Cornell used in *Untitled (Harlequin)* (1935–38), but they were also found in puppet theaters popular in Europe and America in the late nineteenth century.

The issue here is not decoding his work or giving it a literal meaning but rather recognizing Cornell's attachment to the games of his childhood, and his use and manipulation of these objects well into the 1950s.

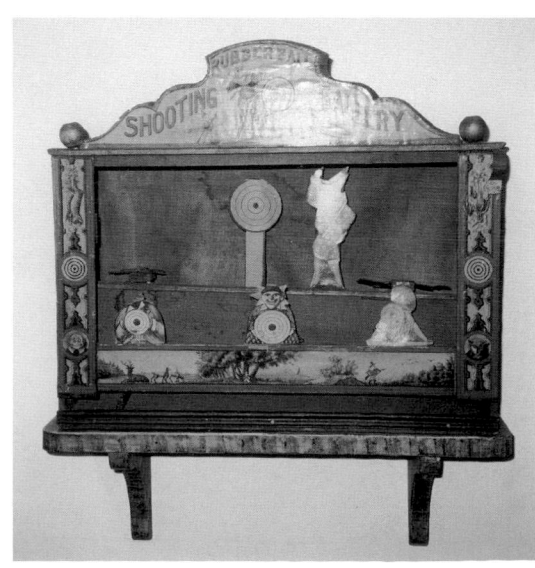

"Rubber Ball Shooting Gallery,"
a Victorian children's game

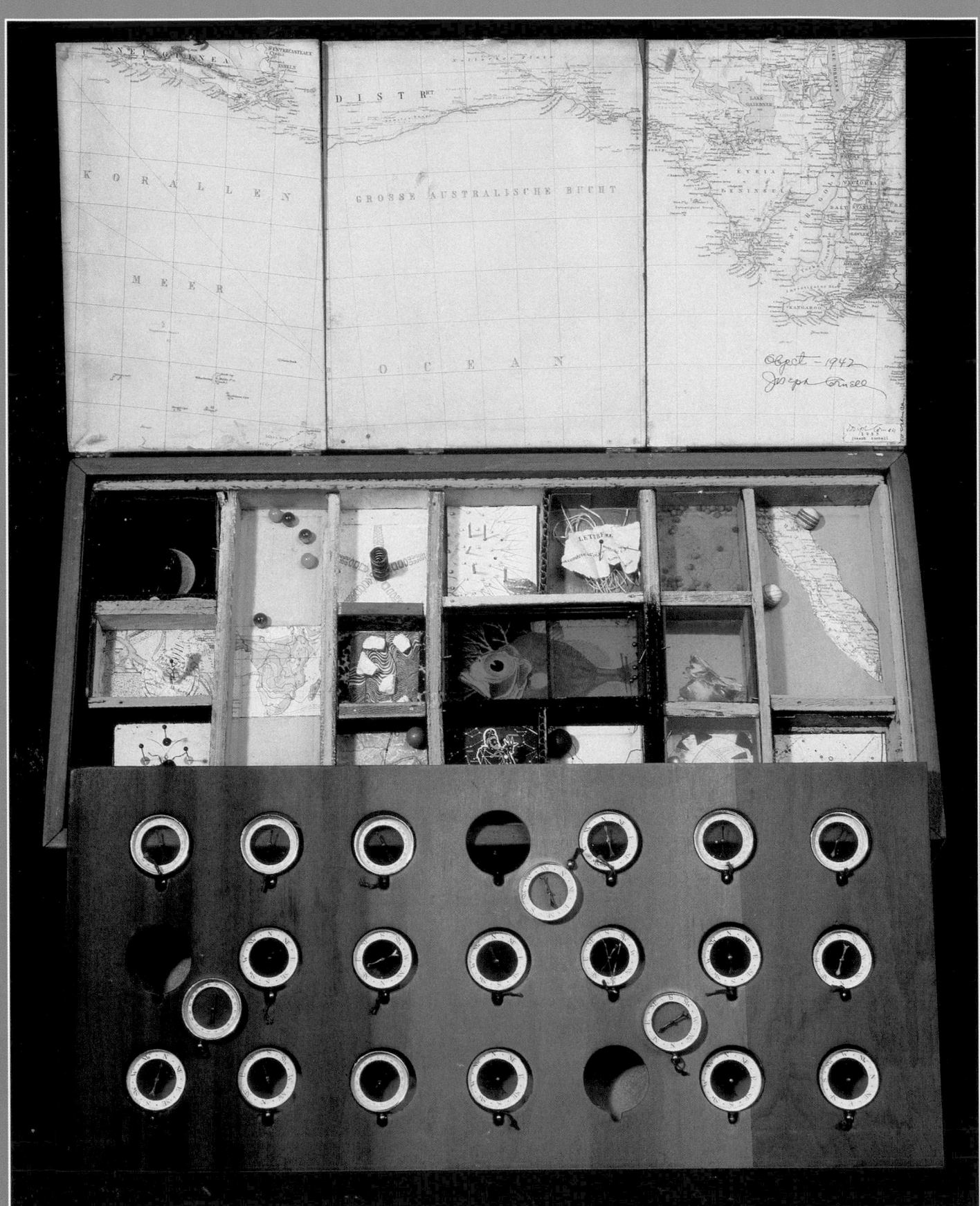

The 1940s were a time of great experimentation for Cornell. During the mid- to late 1930s Surrealism was the major artistic influence on his work, but its impact lessened as other ideas and movements came into play. Cornell continued to exhibit with Julien Levy in the 1940s and was friendly with Surrealists such as Matta, Ernst, and Dorothea Tanning. In 1941 Cornell began contributing to *View*, a New York–based periodical that was a forum for debates concerning Surrealism and its influences in America. The editor of *View*, Charles Henri Ford, became his friend and confidante. The avant-garde writer Parker Tyler, another longtime friend, also contributed to the magazine.

Cornell branched out in the 1940s, meeting artists like Piet Mondrian and developing a more formal structure for his work. He became fascinated with ballet, making collages and writing essays on dance for the avant-garde magazine *Dance Index*, and he met the ballerinas Tamara Toumanova and Renée (Zizi) Jeanmaire. He assisted Duchamp in the assembly of his *Boîte-en-valise* series and exhibited with him at Peggy Guggenheim's Art of This Century gallery. During World War II, Cornell took a job at a radio assembly plant and then worked briefly at the Garden Center in Flushing, owned by a fellow Christian Scientist. He supplemented his meager income from art by freelancing for *Vogue* and *House and Garden*, designing covers and illustrating articles and advertisements. (He continued this work until 1957.) In 1944 he began a major "exploration" initially inspired by the Garden Center, entitled *GC44*. By the time of his death in 1970, the file contained innumerable clippings, art reproductions, notes on events or quotations from books, dried leaves and flowers. This investigation, this collection, presents Cornell's own methodology: an attempt to preserve memory through intense accumulation of objects and ephemera that speak to the artist.

Cornell continued to pursue many of the Victorian conceits that he first used in the 1930s. He utilized several formats, one of which, a lidded horizontal wooden box, he used for *Object (Roses des Vents)* (1942–53). "Rose des vents" is the French term for a compass dial. The box contains German maps of the Coral Sea and the Great Australian Bight on the inside lid. A panel containing compasses slides out to reveal maps, diagrams of the constellations, shells, marbles, spirals, a beetle, and paper fish. The box is similar in appearance to eighteenth-century medicine chests or Victorian parlor games, which contained compartments filled with the kind of objects Cornell loved—apothecary jars, silk roses, cordial glasses, spools of thread, and rubber and wooden balls. But

OPPOSITE:
Object (Roses des Vents), c. 1942–53
Construction, 2 ⅝ x 21 ¼ x 10 ⅜ inches
The Museum of Modern Art, New York;
Mr. and Mrs. Gerald Murphy Fund

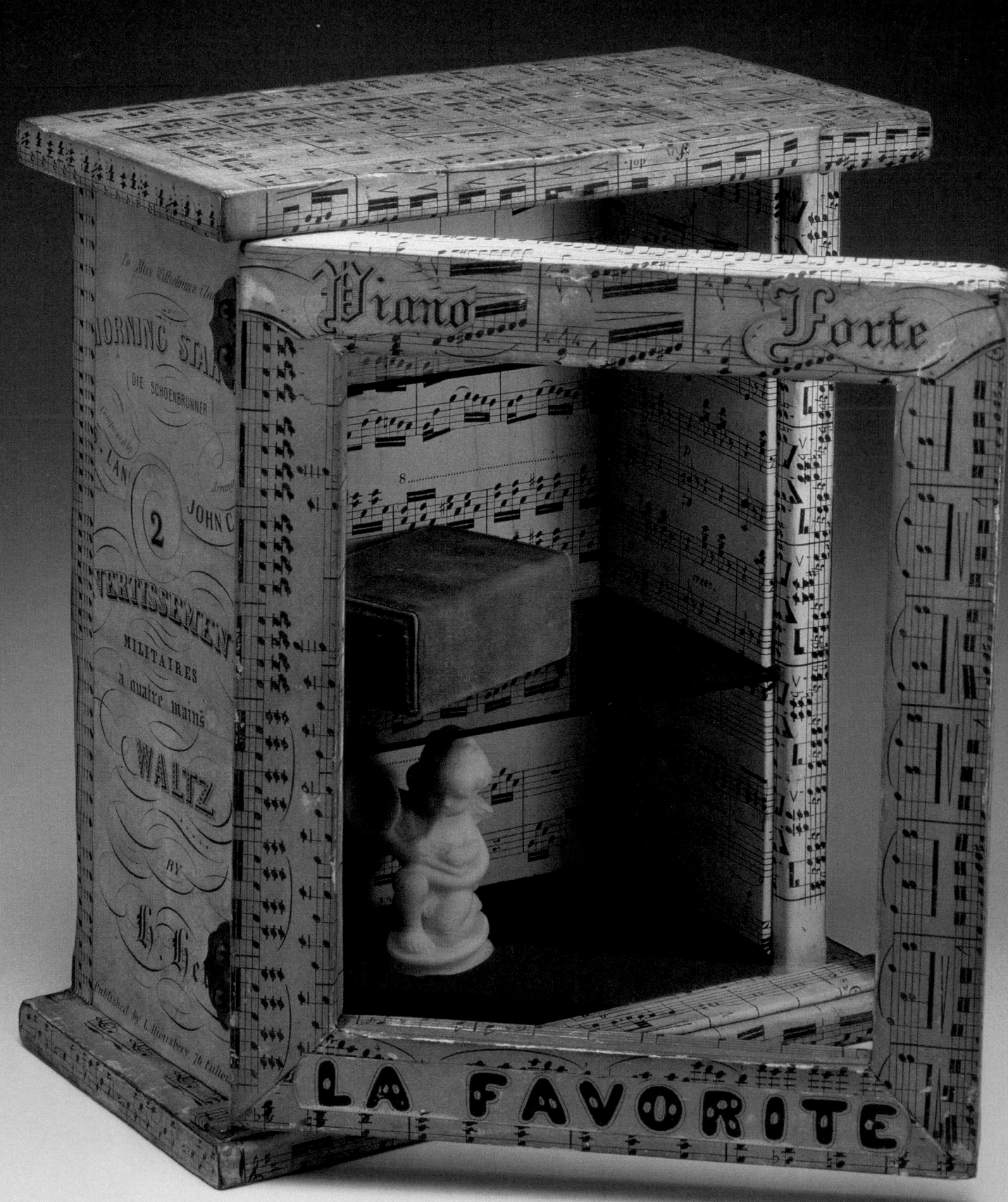

Cornell fashioned this box into something more meaningful to him: a reverie on space and time.

In all probability, Cornell's inspiration for this box was the French poet and novelist Philippe Soupault. Active in the Dada movement, Soupault founded the Surrealist movement with André Breton. Among his works is the volume of poetry *Rose des vents* (1920). Soupault traveled in the United States after World War II, and it is likely that Cornell met him before he returned to France. Cornell's use of the phrase *Roses des Vents* thus has a double meaning; as a compass rose it is a symbol of the solar system, its usage is his tribute to the French poet.

Later boxes such as *La Favorite* from 1948 are vertical cabinets whose interiors are embellished with bisque angels and velvet-covered boxes. The exterior of *La Favorite* is decorated with fragments of musical scores. Other hinged verti-

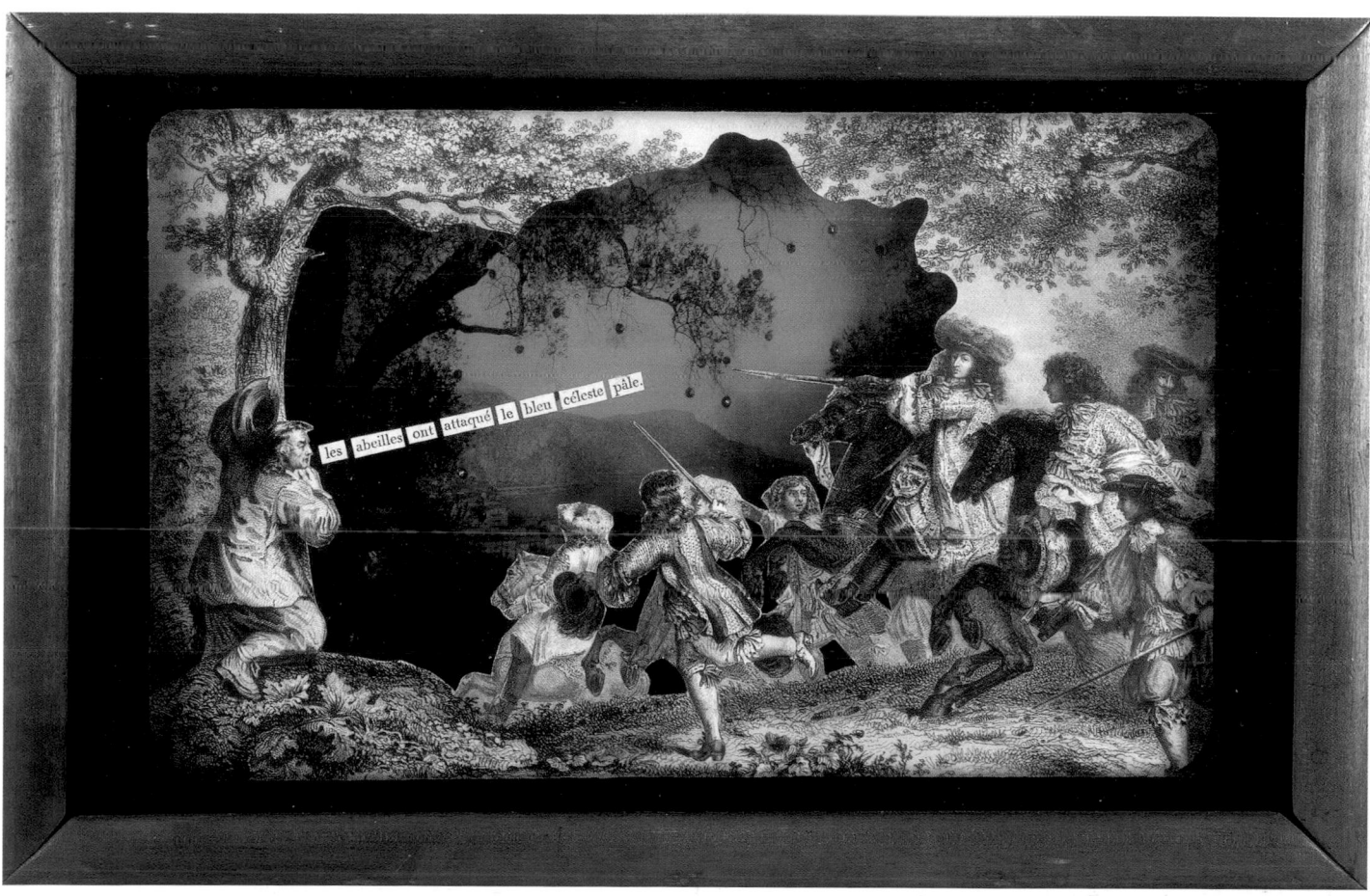

cal boxes contain a variety of childhood favorites, including habitats for birds, rabbits, and butterflies, castles, and dolls. Frequently the subject is identified only by a generic term—as in *Object (Les Abeilles)*—even though its imagery and a brief inscription clearly establish the mood of the piece. Here Cornell creates a stage space similar to the puppet theaters of his childhood: men are shown on horseback, brandishing swords, beneath a sky in which rhinestones double as both stars and bees. In ancient tradition the bee is a metaphor for the soul and a "symbol of eloquence, poetry and the mind."[23]

Cornell's use of the term *object* is a carryover from the Surrealist phase of his work; the neutral term *untitled* similarly found favor in the later 1940s and 1950s

Object (Les Abeilles), 1940
Construction, 9 ⅛ x 14 ¼ x 3 ⅞ inches
Collection Robert Lehrman,
Washington, D.C.

OPPOSITE:
La Favorite, 1948
Construction, 10 x 8 ⅝ x 4 ⅝ inches
The Lindy and Edwin Bergman
Joseph Cornell Collection, Chicago

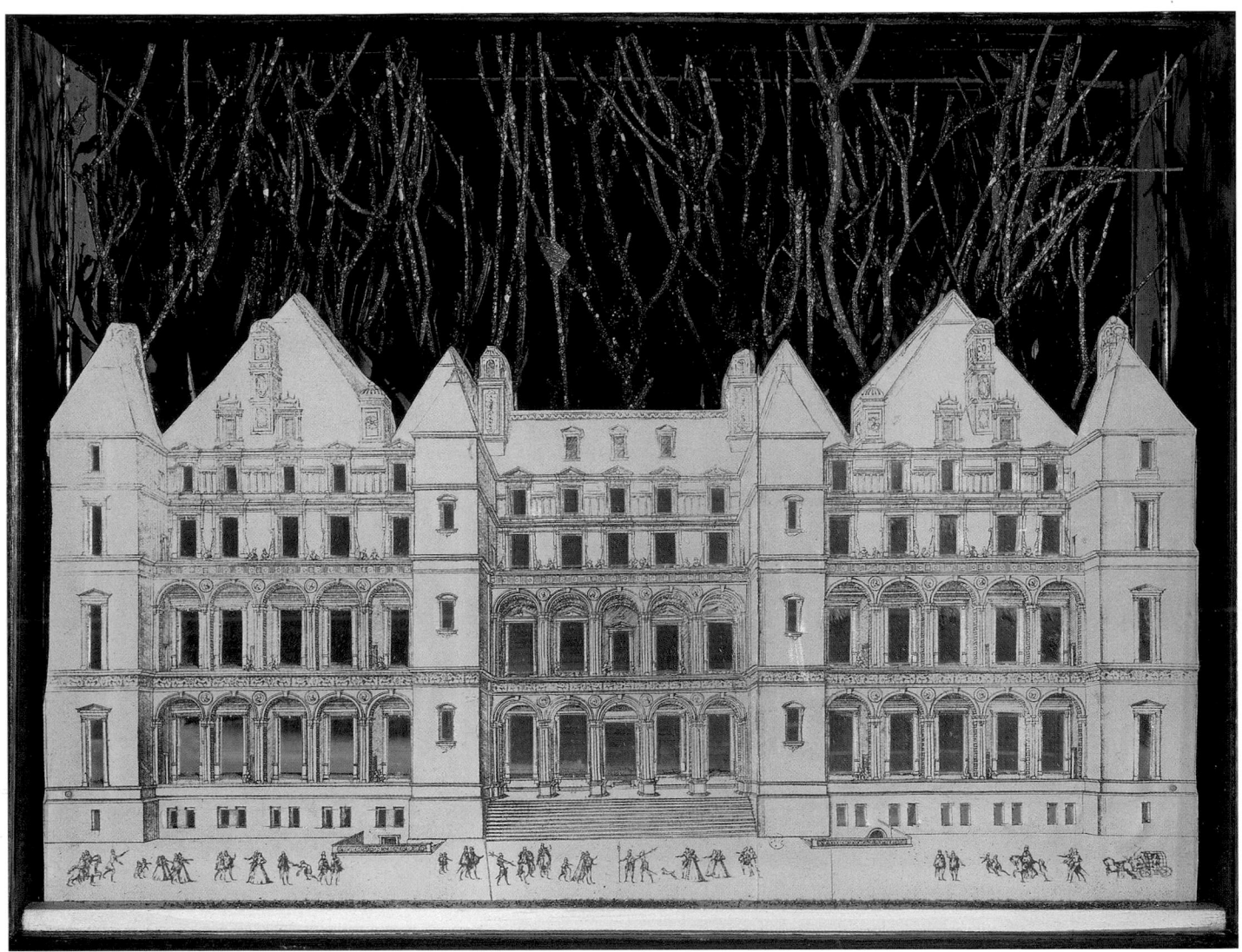

Untitled (Rose Castle), 1945
Construction, 11½ x 15 x 4 inches
Whitney Museum of American Art,
New York; Bequest of Kay Sage Tanguy

OPPOSITE:
Untitled (Butterfly Habitat), c. 1940
Construction, 12 x 9 ¼ x 3 ¼ inches
The Art Institute of Chicago; The Lindy and Edwin
Bergman Joseph Cornell Collection, Chicago

with many New York School artists. Although Cornell's later work is grouped in series such as *Aviaries*, *Soap Bubble Sets*, *Dovecotes*, or *Hotels*, he often preferred to give his boxes individual designations.

A number of works of the 1940s, among them *A Pantry Ballet (for Jacques Offenbach)* (1942; see page 63) and the later, equally lighthearted *Untitled (Rose Castle)* (1945), continue in the fanciful vein of the 1930s. Delicately frivolous in spirit, they invoke references to the theater and reminiscences of children's puppet theaters or fairy tales. In *A Pantry Ballet*, red plastic lobsters cavort gaily with their partners, little silver spoons, while seashells and crockery nod in merry amusement. In *Untitled (Rose Castle)*, real twigs accompany cardboard cutouts of pink palaces, and in *La Favorite*, sheet music graces the exterior of a box in which an angel is playing in a world of lyric enchantment. *Rose Castle* features an engraving by Jacques Androuet du Cerceau entitled *Le Château de Boulogne, dit Madrit*, first printed in the sixteenth century; Cornell probably used a nineteenth-century version. In a diary notation of September 8, 1943, Cornell wrote that the Plaza Hotel looks like a large French château—it is likely that the "Rose Castle" refers to the Plaza.[24]

Untitled (Butterfly Habitat) (c. 1940) contains six compartments covered with frosted glass, each of which holds a paper butterfly. Each of the butterflies

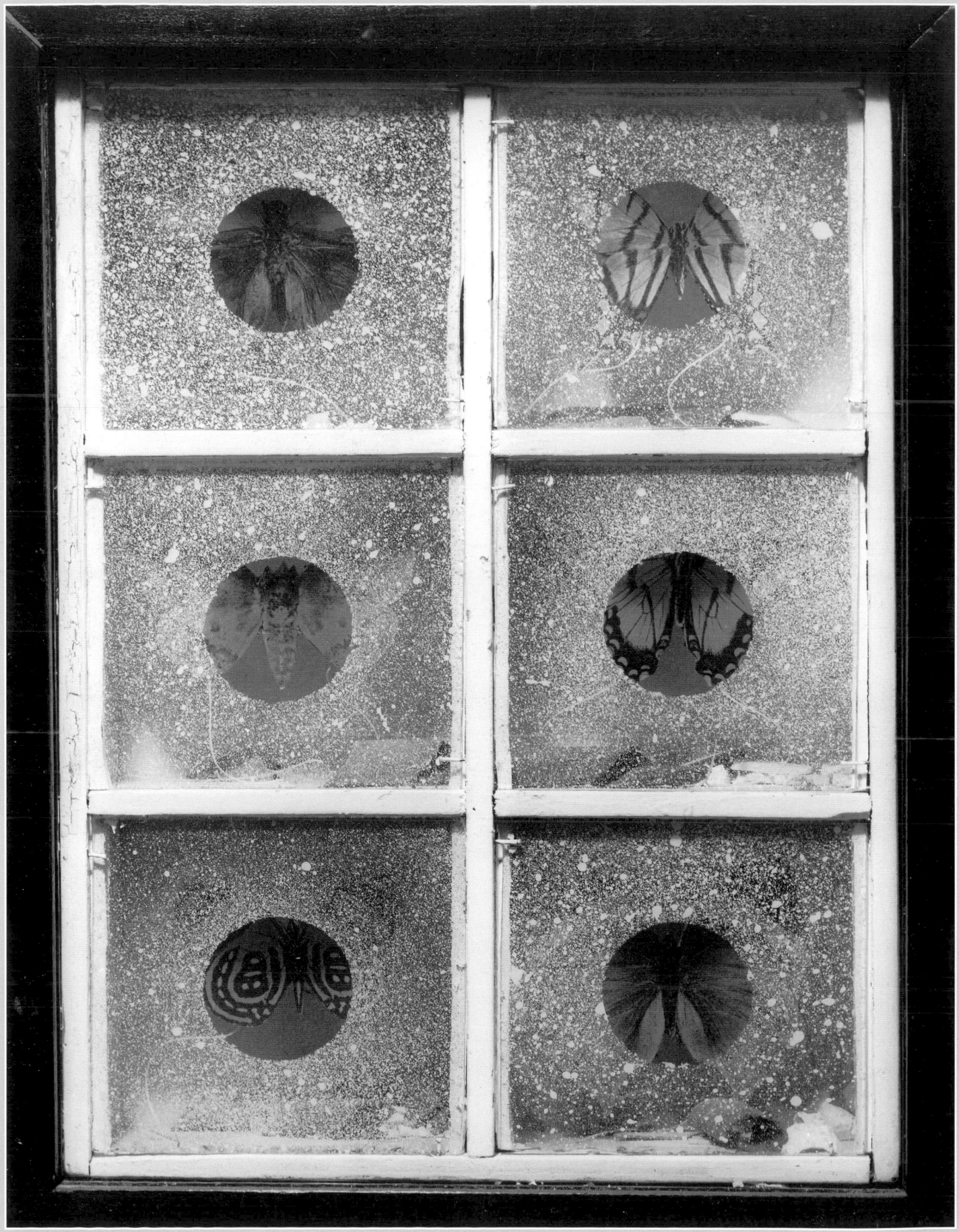

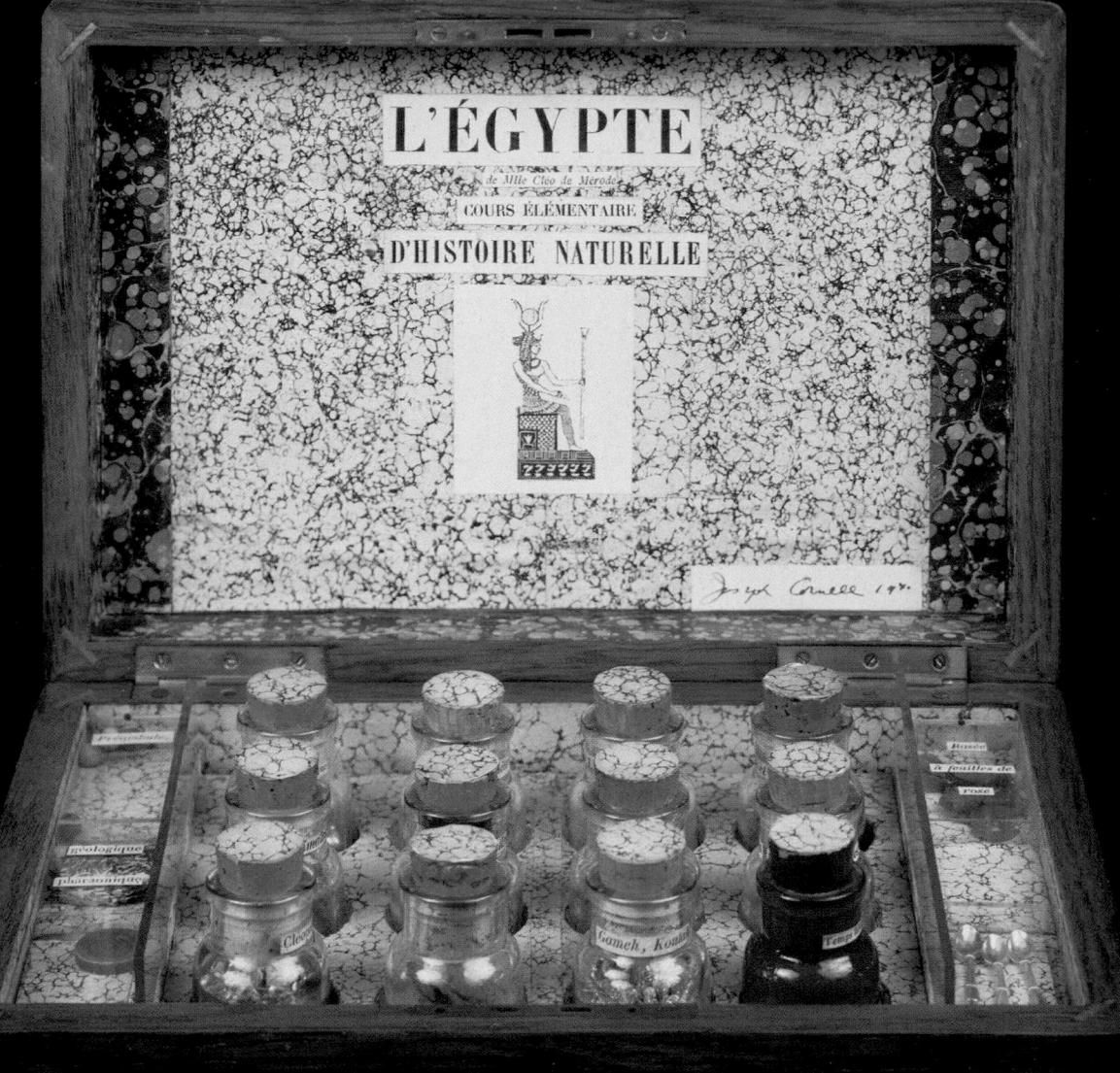

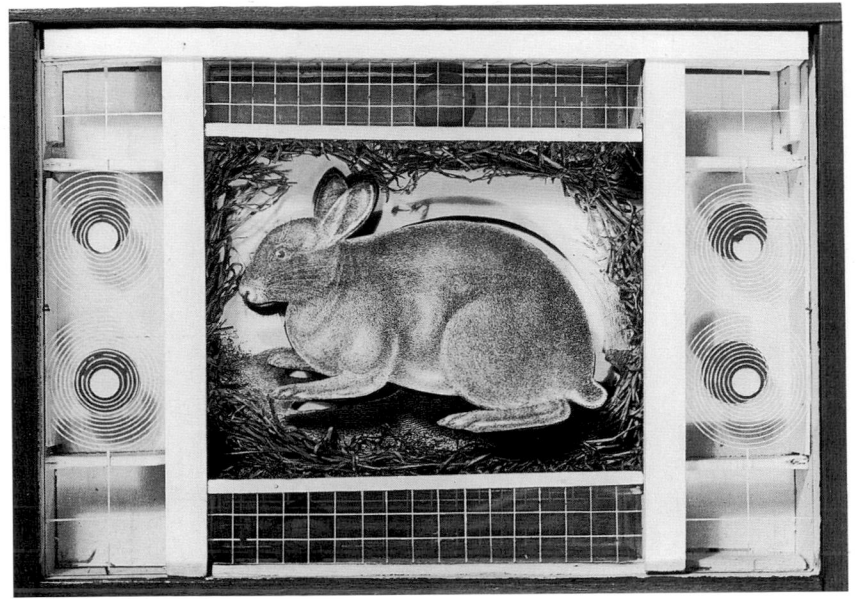

American Rabbit, 1945–46
Construction, 11 ⅛ x 15 ½ x 2 ¾ inches
Robert H. Bergman, Chicago

is positioned behind a circular opening of clear glass within the frosted pane. In Greek and Japanese symbology, the butterfly refers to the soul. *The Dictionary of Symbols* states that "the Japanese make the butterfly an emblem of womanhood" because of "its grace and airy lightness." Two butterflies, however, represent marital happiness: "Their airy lightness is rarefied, for butterflies are wandering spirits and to see them presages a visitor or a death in the family."[25] In Christian symbology the butterfly is the resurrected soul. As the butterfly emerges from the cocoon, so the soul emerges from the body after death. In secular imagery butterfly wings are used on figures to suggest nature spirits such as fairies, sprites, and elves. Butterflies also figure prominently in Symbolist literature. Cornell's reenactment of these traditions in art and literature stems from his commitment to Christian Science and the belief in matter transformed into spirit, which is at the heart of all of his work.

An equally structured box, *American Rabbit* (1945–46) contains an image of a rabbit similar to those found in Victorian children's games. The work is an homage to family and nature. Cornell kept rabbit figurines in his garden, which were manufactured at the Garden Center in Bayside, where he worked in 1944. His brother, Robert, often drew rabbits, which Cornell included in his collages after Robert died in 1965. *American Rabbit* contains the natural element of grass; however, the grid painted on the glass — a reference to the rabbit's cage — much like the grid in *Butterfly Habitat*, doubles as a reference to the pure abstraction in vogue in New York beginning in 1936, when the Association of American Abstract Artists was founded.

Cornell's interests in the early 1940s ranged far and wide. Particular individuals, usually women, captivated him with their beauty like the butterfly. One such woman was a famous personality of the 1890s, Cléo de Mérode. The most beautiful belle of La Belle Époque, she was an aristocrat by birth, a ballerina by profession, and linked romantically with King Leopold II, the aging bon vivant of Belgium. He saw her perform at the Paris Opéra, in Verdi's Egyptian opera *Aïda*, when she was in her early twenties and he was more than sixty years old. When she died in 1966, her obituary in *The New York Times* cited her notoriety

OPPOSITE:
L'Égypte de Mlle Cléo de Mérode:
cours élémentaire d'histoire naturelle, 1940
Construction, 4 ¹¹⁄₁₆ x 10 ¹³⁄₁₆ x 7 ¹³⁄₁₆ inches
Collection Robert Lehrman, Washington, D.C.

more than her accomplishments. She belonged to a long line of noted beauties who captured the imagination of kings, politicians, and artists—such as Degas, who often sketched her. Cléo de Mérode was a celebrity, and in this respect a precursor to the stars of the silver screen. She danced in New York, where she was criticized in the press, and before King Edward II of England, the Danish Court, and the Tsar of Russia. She was a dark-haired beauty whose hairdo—parted in the middle, pulled straight back, and wound into a chignon—was widely copied by her admirers and called "à la Cléo de Mérode." In later years she taught ballet and wrote her memoirs, *Le ballet de ma vie*. For Cornell, she was the muse of one of his most notable boxes, *L'Égypte de Mlle Cléo de Mérode: cours élémentaire d'histoire naturelle* (1940).

The work is made from a Victorian writing box or strongbox of dark-stained oak. The interior, covered with marbled paper and rows of bottles and side compartments, recalls the display cases in a museum or department store. Mounted about one and one-half inches from the bottom is a piece of glass that acts as a supporting rack for the bottles. Underneath the glass is a layer of red sand with a broken piece of comb, slivers of plain and frosted glass, and a porcelain doll's hand and arm broken at the elbow. The side trays on the left are labeled, from top to bottom: "Préambule," "géologique," and "pharaonique," and contain seven small balls and a rock specimen. The tray to the right has a compartment labeled "Rosée à feuilles de rose," which contains plastic rose petals. The two unlabeled compartments contain a plastic disc and three tiny metal spoons. All but one of the glass bottles bear a label, and each contains different objects.

Each label refers to an aspect of Egyptian life: *Sauterelles* refers to grasshoppers and locusts; *Nilomètre* is an instrument used to measure the Nile's waters, especially during floods. Another bottle, bearing the caption CLEO DE MERODE/*momie/sphinx*, contains a photo, set in yellow sand, of a woman with hair parted in the middle and pulled back into a loose bun; she wears a choker and a dress with a revealingly low neckline and puffed sleeves. She is Cléo de Mérode herself, as captured by Nadar and preserved in this bottle for eternity.

Playing upon the name Cléo as a reference to the queen Cleopatra, Cornell gave the box an Egyptian theme. The Egyptian goddess Hathor, goddess of the sky, is pictured on the inside lid; she is also the goddess of love, happiness, dancing, and music. The composition of the box relates to Egyptian burial practices, to the custom of securing in the tomb the articles most required by the deceased in her life after death, as well as a description of her life on earth. The objects also offer clues to the essence and mystery of *woman*, whether Cléo de Mérode or Cleopatra, as Cornell defined her. Through the connection between the famous dancer and the Egyptian queen, Cornell alludes to de Mérode as both courtesan and sphinx—woman as mysterious and out of reach. This box, however, is more impersonal than Cornell's later boxes dedicated to women. *Cléo de Mérode* is a portrait that delights in the anecdotal and is remarkably devoid of the sense of longing and loss that typifies the later works.

Cornell's fascination with ancient Egypt stems from events in Victorian New York. In the mid-nineteenth century Egyptian mummies were brought to the city for the first time for exhibition, and individual collections of Egyptian antiques were later exhibited and subsequently sold or donated to the Brooklyn Museum and The Metropolitan Museum of Art. In 1881 the obelisk known as Cleopatra's Needle was placed in Central Park. Cornell was familiar with the stories of these exciting events, and he visited the museum collections. He alludes to the museums through his presentation of the objects, displayed in bottles in a manner similar to the 1936 Museum of Modern Art exhibition, in which *Cabinet of Natural History (Object)* was included with *Soap Bubble Set*, under the title "The Elements of Natural Philosophy" (see page 24). The French and Latin descriptions add a sense of drama and context to the whole, to which he added references to nature (the Nile), agriculture (wheat), animal life (a camel), and human life (a Bedouin), to give a picture of life in Egypt.

Cornell responded to his Egyptian subject through an acquaintance with the work of nineteenth-century writers, composers, choreographers, artists, and photographers. Cornell knew of Delacroix's painting *Cléopatre et le paysan*, and another of his favorites, Giacomo Meyerbeer, premiered his opera *Crusader in Egypt* in London in 1825. The opera starred Maria Malibran, who later inspired Cornell to create the pamphlet *Maria* (1954), which was designed as a "bouquet" to the performer and contained texts, cutouts, and reproductions. Giuditta Pasta later took on the role; her photograph was included in Cornell's 1946 exhibition *Romantic Museum: Portraits of Women* held at the Hugo Gallery. In the world of dance, Gautier's first ballet libretto, written for Fanny Elssler, features Cleopatra, as does Michel Fokine's ballet *Une Nuit d'Égypte* (1908), which opened in Paris as *Cleopatra* (1909) with Anna Pavlova in the role of Ta-hor. Serge Diaghilev's ballets included one titled *Cléopatre*. Following the invention of the daguerreotype, photographers in Europe rushed off to distant lands. An image of the Colossus of Abu Simbel taken by Maxime du Camp in 1850 and an 1858 photograph of the Pyramids of Dashur by Francis Frith were included in Beaumont Newhall's landmark exhibition *Photography 1839–1937* held at The Museum of Modern Art in 1937. In all probability some or all of these associations were the mise-en-scène for Cornell's presentation of Cléo de Mérode.

For *Mémoires inédites de Madame la Marquise de la Rochejaquelein* (1943) Cornell turned to an epic battle that took place during the French Revolution. In her published *Mémoires*, Marie-Louise-Victoire de Donnissan, married for the second time to Louis de la Rochejaquelein, describes the insurrection in the Vendée (the area in the Loire Valley that encompasses Poitou, Anjou, Maine, Brittany, and Normandy), which took place between 1792 and 1800. Peasants and nobles fought together against the armies of the Revolution for religious freedom. The Marquise was noted for her beauty, but Cornell has elected to substitute an engraving of Madame La Farge to hint at the Republicans' victory over the Royalists.

Cornell's *Mémoires* are later larger versions of his early 1930s round cardboard boxes. They are still quite small, measuring little more than four inches in

Untitled Object (Mona Lisa), c. 1940–42
Construction, 1⅜ x 3 inches diam.
Collection Marguerite and Robert Hoffman

*Mémoires inédites de Madame la Marquise
de la Rochejaquelein*, 1943
Construction, 2 x 4¼ inches diam.
San Francisco Museum of Modern Art;
Gift of Leo Castelli, Richard L. Feigen,
and James Corcoran

diameter, a size that befits the intimacy of their subject. Cornell made two ver-
sions of *Mémoires inédites de Madame la Marquise de la Rochejaquelein*, one with a
reproduction in negative and one positive. In both boxes the image is pasted on
the lid along with French sentence fragments glued to movable glass strips. The
bottom interior is sealed with glass and contains patterned paper, glass, sand,
beads, and ribbons of fabric.

Royalty of another sort is shown in *Untitled Object (Mona Lisa)* (c. 1940–42).
Cornell chose the famous image by Leonardo, which had already been notori-

ously altered by Duchamp in *L.H.O.O.Q* (1930); but whereas Duchamp subversively added a moustache, Cornell's box is an homage to both artists.

Although Cornell used the generic term *object* for many of his boxes, he also enjoyed titling his works, in some instances using a lengthy inscription, other descriptive matter, or a leitmotif. This is seen in works such as *L'Égypte de Mlle Cléo de Mérode: cours élémentaire d'histoire naturelle*. More rarely, as in *Mémoires inédites de Madame la Marquise de la Rochejaquelein*, such "documents" become an integral, rather than additive, part of the form itself. These inscriptions were intended to offer clues to the meaning of each work. They are the literary equivalent of the toy blocks, jacks, and marbles that give nuance and meaning to other images in the 1940s.

Untitled (The Life of Ludwig II of Bavaria) (c. 1941–52), another historical construction, is a suitcase made out of paperboard—a format derived from Duchamp's *Boîte-en-valise*. Cornell was probably inspired by the character of King Ludwig in the Ballets Russes production *Bacchanale*, a ballet featuring libret-

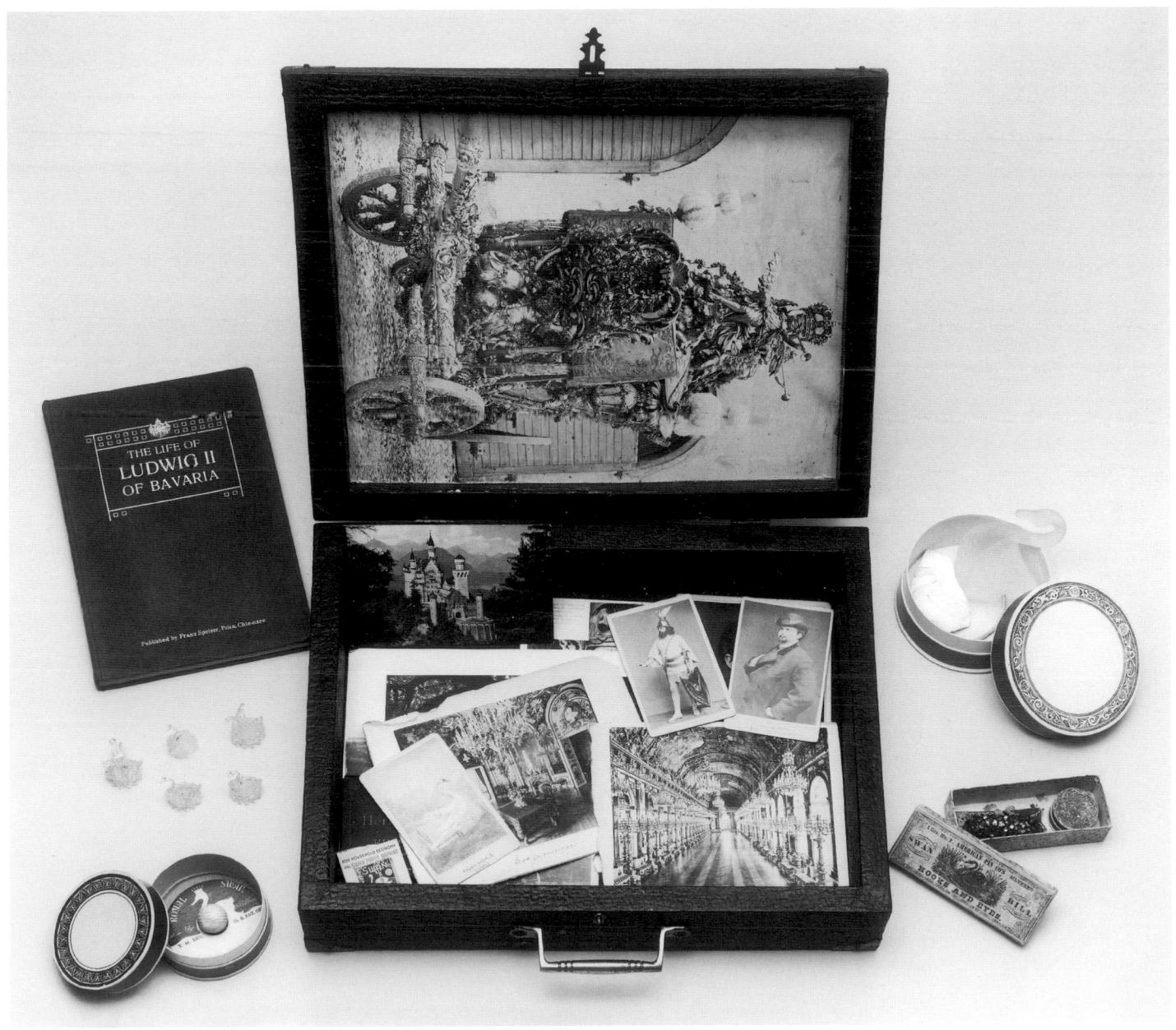

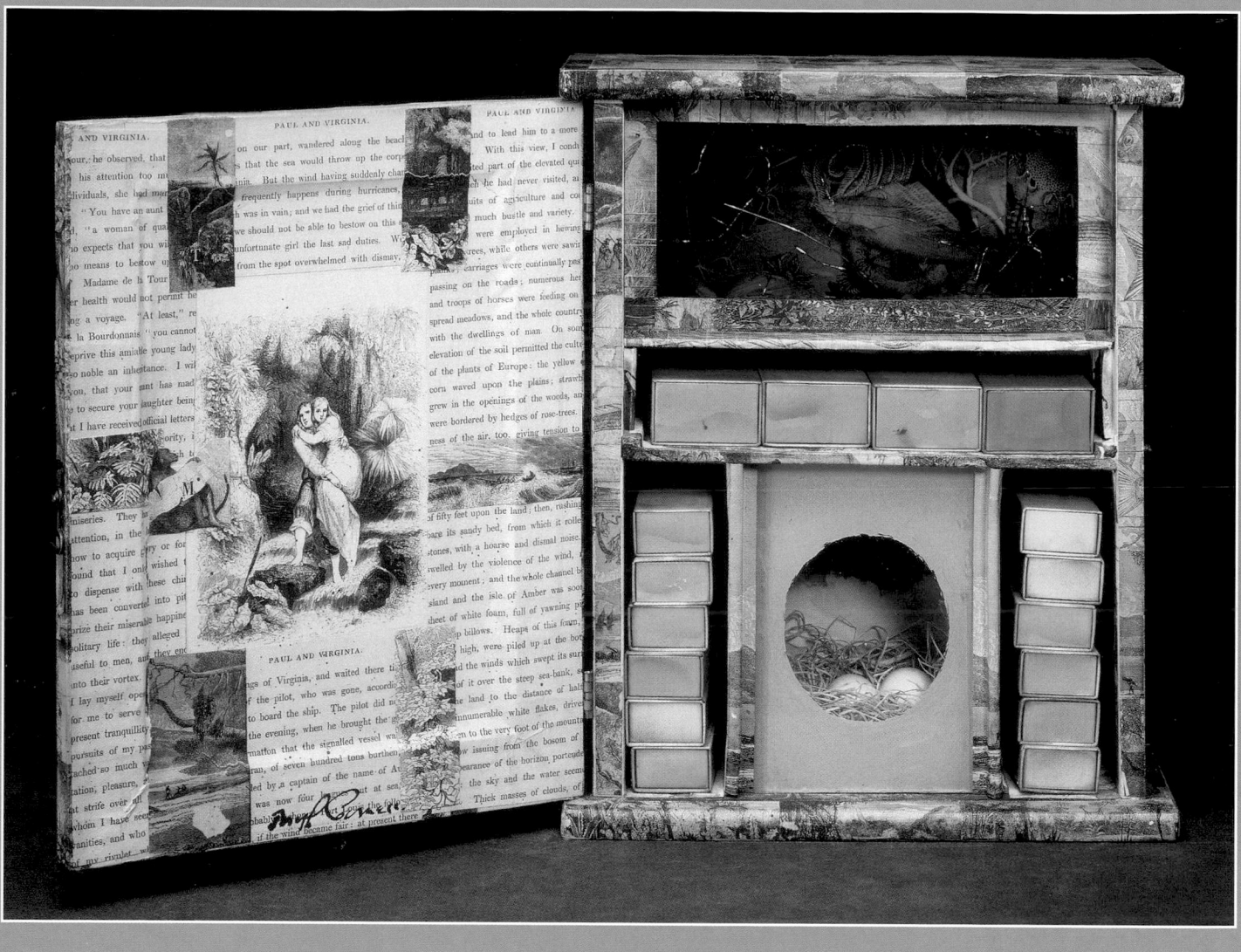

to and set design by Dalí, which premiered in November 1939 in New York. The construction contains a copy of a biography of Ludwig II and original photographs of him. Printed images of swans, several miniature glass swans, and an empty rectangular box labeled "American Pin Co., Swan Bill Hooks and Eyes" refer to the king's nickname, the "Swan King," and his passion for swans. Other items included in the suitcase are photographs of his residence at Königs-Schloss and other estates, clippings from the *Christian Science Monitor* dating from 1941–52, and R. H. Macy newspaper ads. Cornell's somewhat shabby valise is a container for the relics of a nobleman. Unlike Duchamp's rather arch self-portrait, Cornell's *boîte-en-valise* alludes to the King's human frailty and mortality through the inclusion of the empty box and glass swans.

Cornell continued to use the Victorian images of quaint beauties, exotic papers, and elegant fabrics that were reminders of his happy childhood, but in the mid-1940s he turned to a new theme: doomed love. *Untitled (Paul and Virginia)* (c. 1946–48) refers to a French romance by Bernardin de St. Pierre, *Paul et Virginie*,

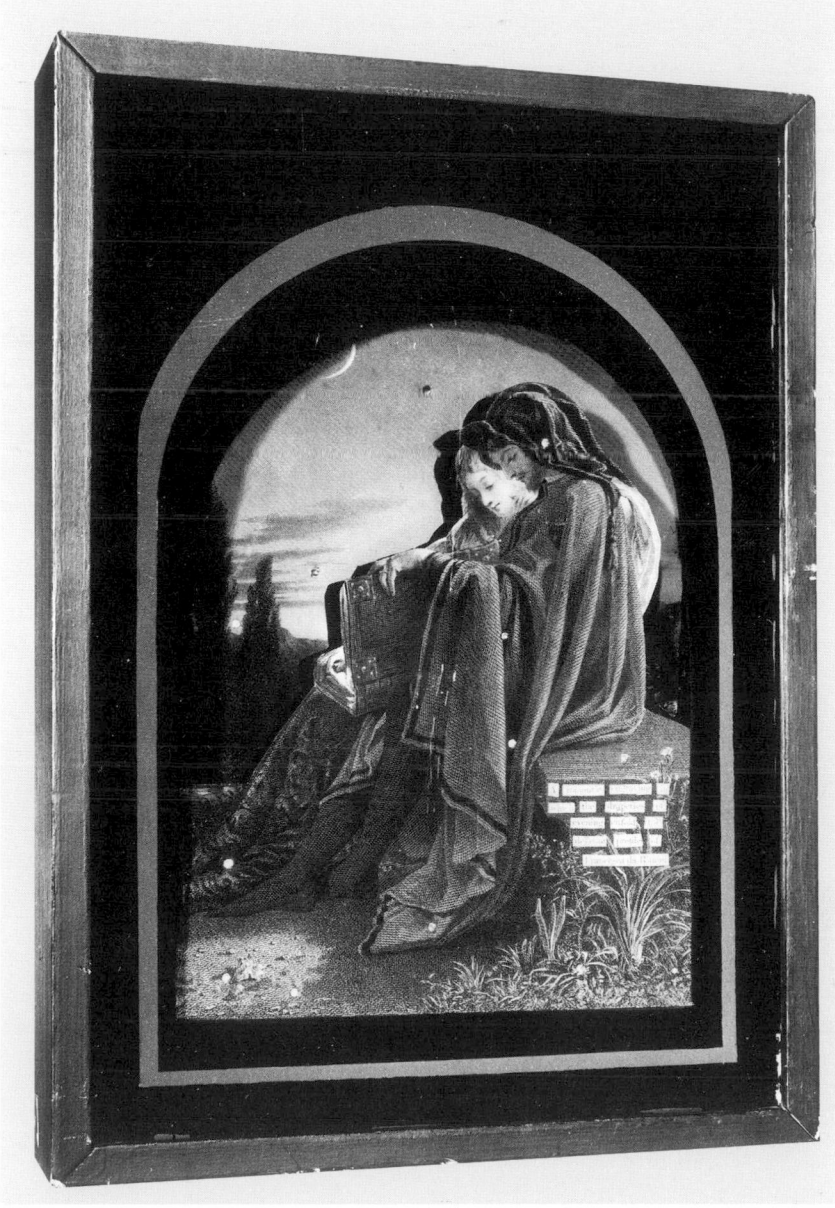

Paolo and Francesca, 1943–48
Construction, 15 x 11 ¼ x 3 ⅞ inches
Collection Robert Lehrman, Washington, D.C.

published in 1788. Roland Petit choreographed a ballet of the same name for Serge Lifar at the Paris Opera, which premiered on April 15, 1943. However, the most likely source for Cornell's box is the ballet-pantomime *Paul et Virginie* by Pierre Gardel, first performed on June 12, 1806, which Cornell would have known about from his exhaustive studies of nineteenth-century ballet. Bernardin's novel was first adapted to the stage as an opera with a score by Rodolphe Kreutzer, who later composed the score for the ballet.

Atypically, Cornell used fragments from the English edition of the Bernardin romance, published in 1838. The tale of a young couple who "possess love, innocence, and piety" and find happiness in nature on the island of Mauritius was well suited to Cornell's own sensibility. In a box that is collaged with text and engravings, to suggest the European civilization that the writer disdained, Cornell placed sixteen small empty boxes in robin's egg blue. The boxes frame a circular opening in which are placed two eggs nesting on a bed of straw. The top portion of the box is sealed with turquoise glass in which copper wire is embedded. The interior contains engraved images of fish shells and aquatic forms. The nest is an allusion to the young couples habit of gathering birds nests while the marine forms are suggestive of the island in the Indian Ocean where the story takes place.

Paolo and Francesca (1943–48) is similar in format to earlier works such as *Black Hunter* (c. 1939), but in subject the two are worlds apart. Francesca da Rimini was a contemporary of Dante's who fell in love with her husband's brother, Paolo Malatesta. The husband, Gianciotto, discovered them together and killed them both. In Dante's story of the lovers, recounted in the fifth canto of *The Divine Comedy*, the couple is relegated to the second circle of hell along with other doomed lovers. Dante's story inspired Leigh Hunt's poem "The Story of Rimini" (c. 1815), Alexander Munro's neo-Gothic marble sculpture *Paolo and Francesca* (1851–52), and an 1855 watercolor by the Pre-Raphaelite painter Dante Gabriel Rossetti. Cornell's library included an autobiography of Hunt and volumes of his writings, as well as a volume of Rossetti's poems.

In *Paolo and Francesca* Cornell used an image from a Victorian steel engraving overlaid with blue glass to give it a "dream dimension."[26] The lovers are seated side by side in a garden enclosed by a curved arch. Both Rossetti's and Cornell's lovers are reading the story of Lancelot and Guinevere, but Rossetti's lovers share a discreet kiss while Cornell's lovers are shown in intimate but chaste proximity. Whereas Rossetti's ill-fated lovers are condemned to float eternally through the flames of hell, Cornell's doomed lovers appear to be sharing a tranquil moment before they are discovered, sitting quietly reading in a garden underneath skies glittering with rhinestone constellations.

The link between *Paolo and Francesca* and *Paul and Virginia* is their common heritage in ballet. The story of Francesca da Rimini was first performed as a ballet at the Mariinski Theater in St. Petersburg in 1915. In 1937, a few years before Cornell began his box, it was performed at London's Covent Garden.

About the same time that Cornell was preoccupied with sophisticated themes such as *Cléo de Mérode*, he began creating works related to nature. In

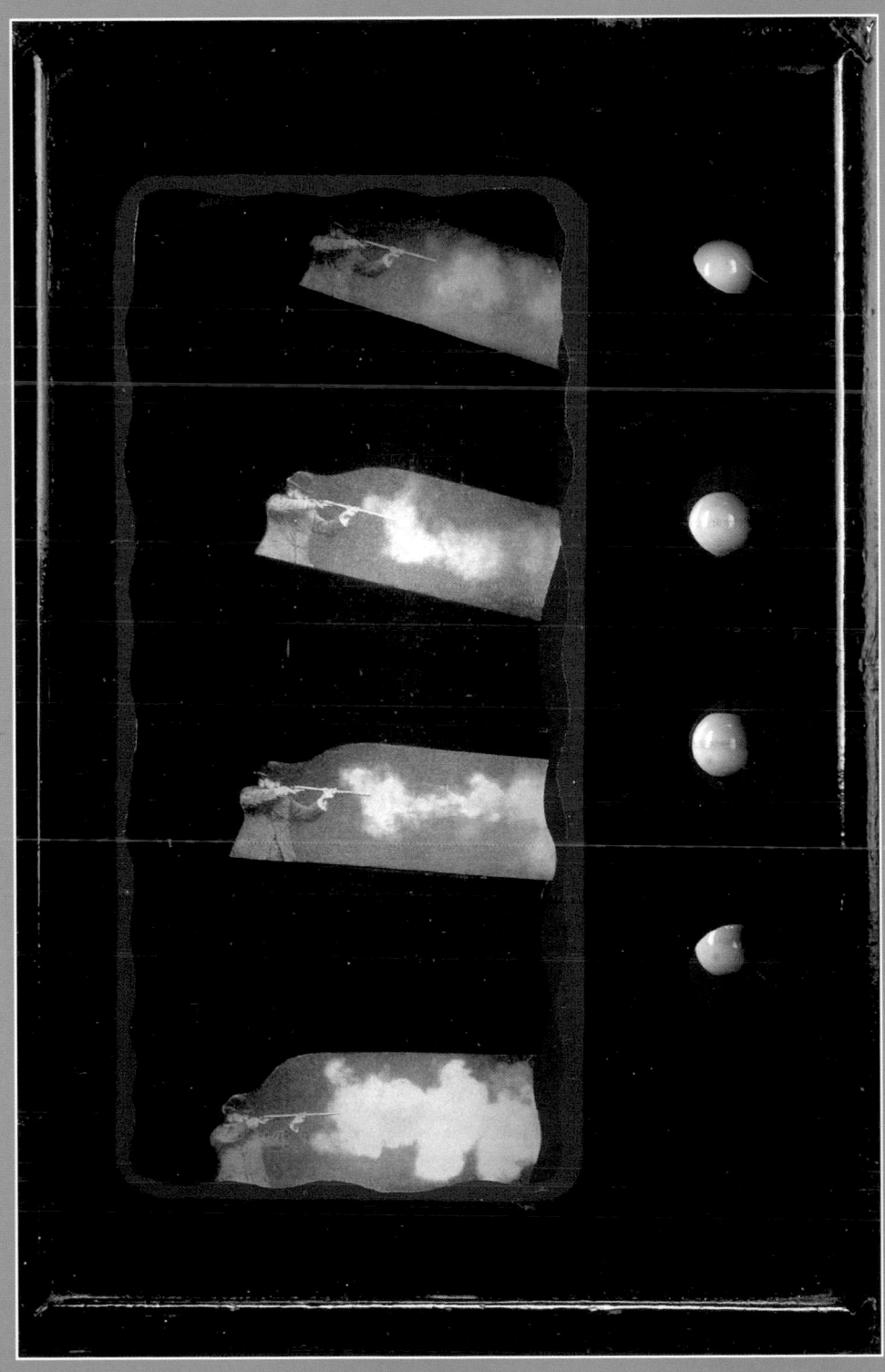

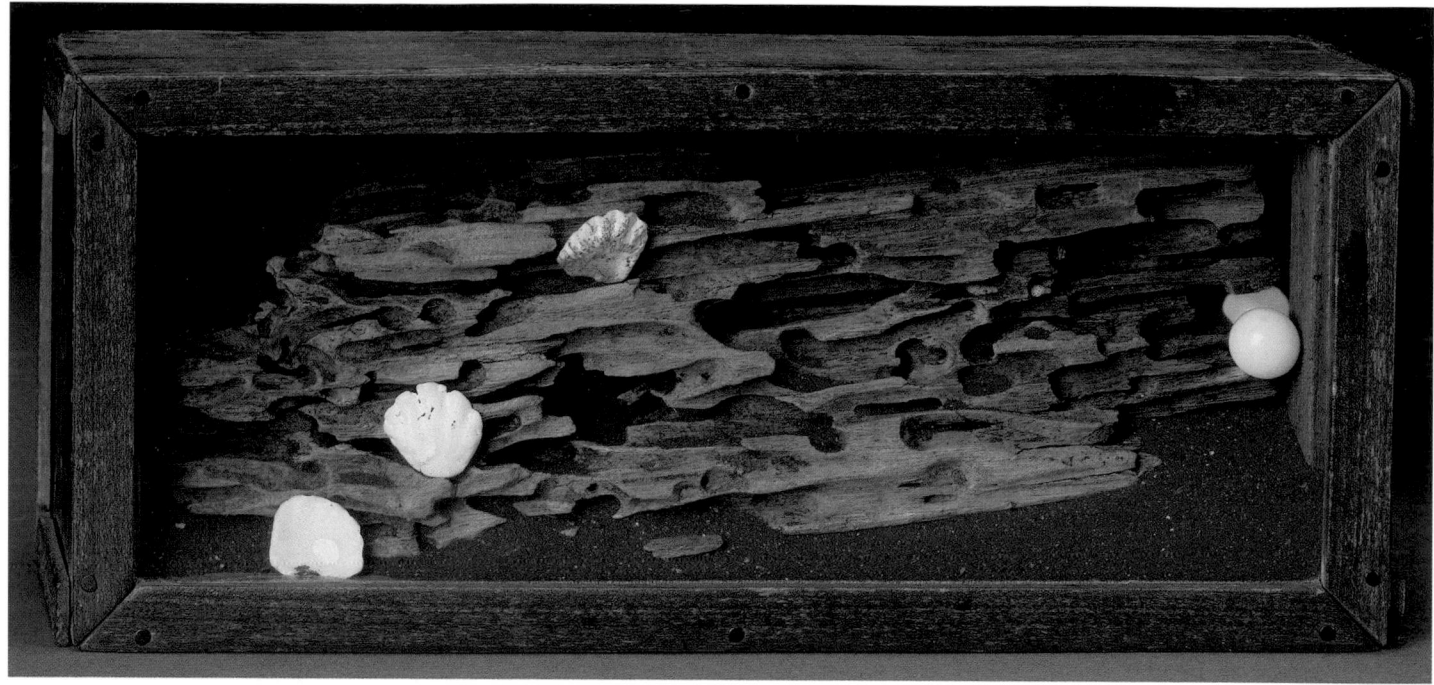

Untitled (Red Sandbox), c. 1940
Construction, 4 ½ x 10 ¾ x 2 ⅞ inches
Collection Robert Lehrman,
Washington, D.C.

Untitled (Red Sandbox) (c. 1940) shifting sands suggest the movement of waves and the passage of time, with seashells trapped on a piece of driftwood. This is one of the few boxes of the period containing an explicit reference to time. The use of the single large piece of driftwood implies the strength of the forces of nature and death; the delicate and fragile seashell attests to the ephemeral quality of life.

As stark in its presentation as many of the earlier works are fanciful, this particular work is unique in several respects. In his use of driftwood, sand, and shells that he collected on his long and solitary walks along the beaches of Long Island, Cornell reveals a fondness for natural, rather than man-made "found objects." These elements coalesce here into a virtually abstract statement of the type that was to recur in the sand boxes of the late 1950s.

The elongated shape of the box is an unusual feature, more suited to the ruggedness of its contents than other box constructions of the time. When it does occur in other works of the period, such as *Untitled (Bébé Marie)* (see page 80) from the early 1940s, it is used for equally rugged images. Cornell used the shape again in *Sand Fountains* such as *Untitled (Sand Fountain "Pour Valéry")* (c. 1955), and it too is more dense and more complicated, even though it contains delicate imagery, than others in the series.

Cornell's unusual combination of natural elements, his most abstract yet, heralds the many innovations that were to come. Cornell departed from Duchamp by incorporating natural materials and by adding to his readymades. Like many of the Surrealists, such as Max Ernst, Joan Miró, and Yves Tanguy, he took pleasure in using tactile materials and altering his found objects.

Nowhere is Cornell's admiration of Duchamp more evident than in *Pharmacy* (1943), of which there are at least five versions extant. Duchamp's own *Pharmacy*, a "rectified readymade" of gouache on a commercial print, was produced in an edition of three in January 1914 in Rouen, France. Duchamp

painted two small red and green marks onto a print of a winter landscape—his subtle comments on the bottles of colored liquid common in pharmacy windows of that time. Cornell's constructions consist of a hinged cabinet, its interior lined with mirrors, creating echoing reflections of the apothecary jars that sit on shelves. Cork, sand, feathers, dried leaves, copper wire, shells, butterflies, tin foil, and tulle are the ephemeral stand-ins for the magical essences of the pharmacist, as well as a tribute to Duchamp's interest in alchemy. Whereas Duchamp's work is a conceptual approach to a kitsch subject, Cornell's approach is one of genuine interest and affection.

Cornell fashioned several boxes based on the theme of museums, similar in concept to *Pharmacy*. *Museum* (c. 1944–48) contains twenty bottles whose tops are shrouded with blue cloth and tied, a reference to the warehousing and preservation of art. The bottles, which can be removed from their slots, contain a variety of objects and materials, but the label affixed to the inside top of the box is the most interesting element. The label lists the museum's holdings as "Watchmaker's Sweepings, Juggling Act, Souvenir of Monte Carlo, Chimney-sweeper's relic, Thousand & One Nights, Mayan Feathers, White Landscape, From the Golden Temple of Dobayba (conquistador), Sailor's Game, Venetian Map, Mouse Material." The chimney sweep, because of his connection with fire and hearth, is considered a very lucky person to meet by chance, and it is customary to make a wish upon seeing him. Cornell kept a file of material on chimney sweeps, including clippings about the marriage of Queen Elizabeth II and Prince Phillip on November 20, 1947. Rumor has it that the day before the wedding the groom saw a chimney sweep pass by his home, and he went outside to shake hands with him.

Swiss Shoot-the-Chutes (1941), on the other hand, is a precursor for game boxes such as *Penny Arcade Portrait of Lauren Bacall* (1945–46; see page 78) and *Forgotten Game* (c. 1949; see page 99). These boxes evoke the slot machines that Cornell saw in his frequent visits to 42nd Street, an area that he loved for its penny arcades, cafeterias, and movie theaters (with their cashiers enclosed in glass boxes). The title *Swiss Shoot-the-Chutes* derives from a Coney Island amusement-park ride, "Shooting the Chutes." A collage of the map of Switzerland is interrupted by circular openings, which feature images of the Romantic ballerina Fanny Elssler, Little Red Riding Hood and the wolf, snow-capped mountains, cows, a peasant girl, and a label that reads "Hôtel de l'Ange"—a hint of the *Hotel* boxes to come in the 1950s. *Swiss Shoot-the-Chutes* contains twelve bells mounted at intervals on a four-part ramp. When a small wooden ball is dropped through an opening in the top right-hand corner of the box, it strikes the bells as it descends the ramp, exiting the box at the lower right-hand corner.

OVERLEAF, LEFT:
Untitled (Pharmacy), 1943
Construction, 15⅞ x 11⅞ x 4⅜ inches
The Menil Collection, Houston;
Gift of Alexander Iolas

OVERLEAF, RIGHT:
Untitled (Pharmacy), 1943
Construction, 15⅜ x 12 x 3¼ inches
Private Collection

PAGE 54:
Museum, c. 1944–48
Construction, 2¼ x 8⅝ x 7 inches
The Menil Collection, Houston;
Bequest of Jermayne MacAgy

PAGE 55:
Swiss Shoot-the-Chutes, 1941
Construction, 21 9/16 x 13⅞ x 4⅛ inches
The Peggy Guggenheim Collection, Venice;
The Solomon R. Guggenheim Foundation

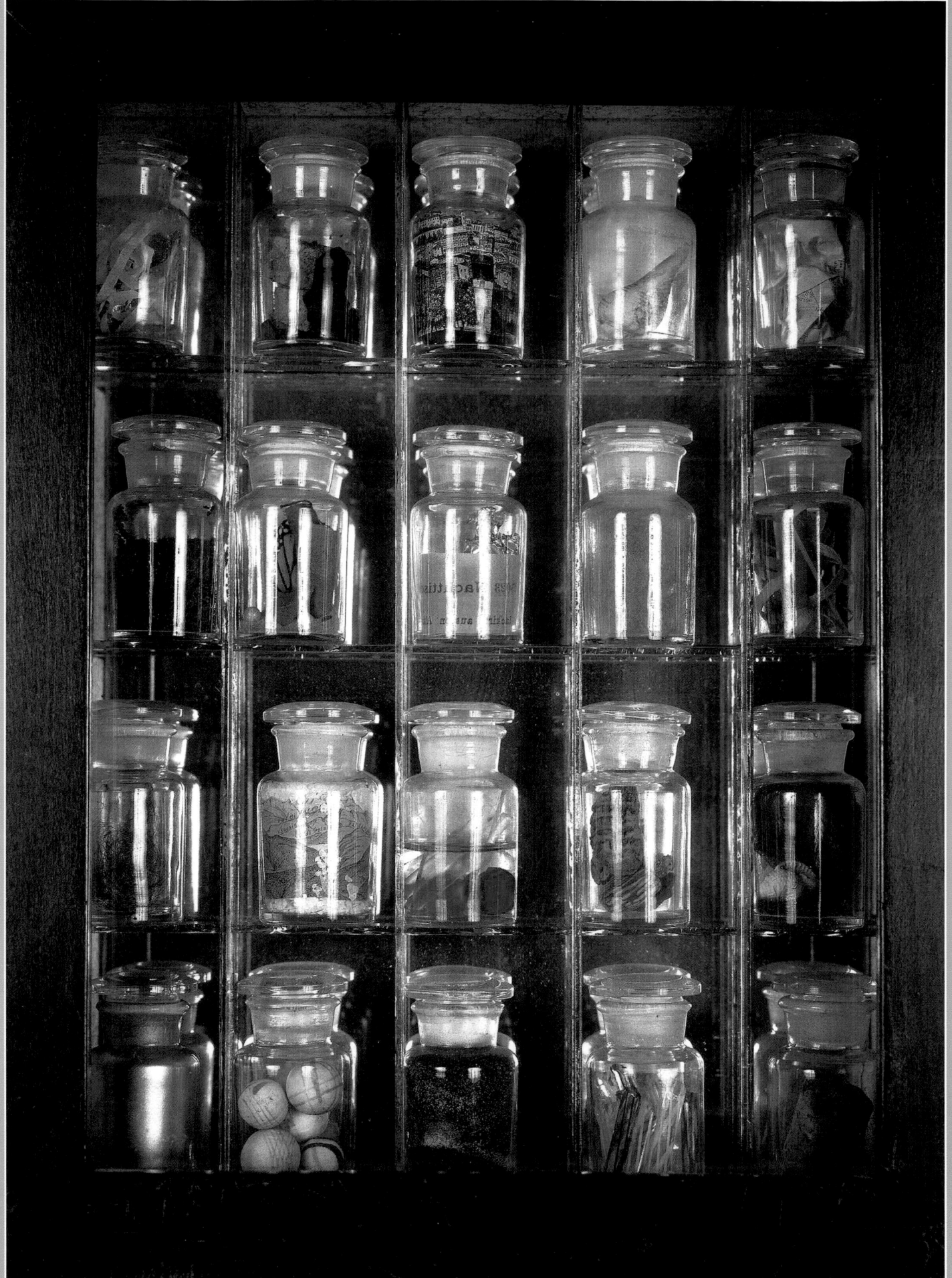

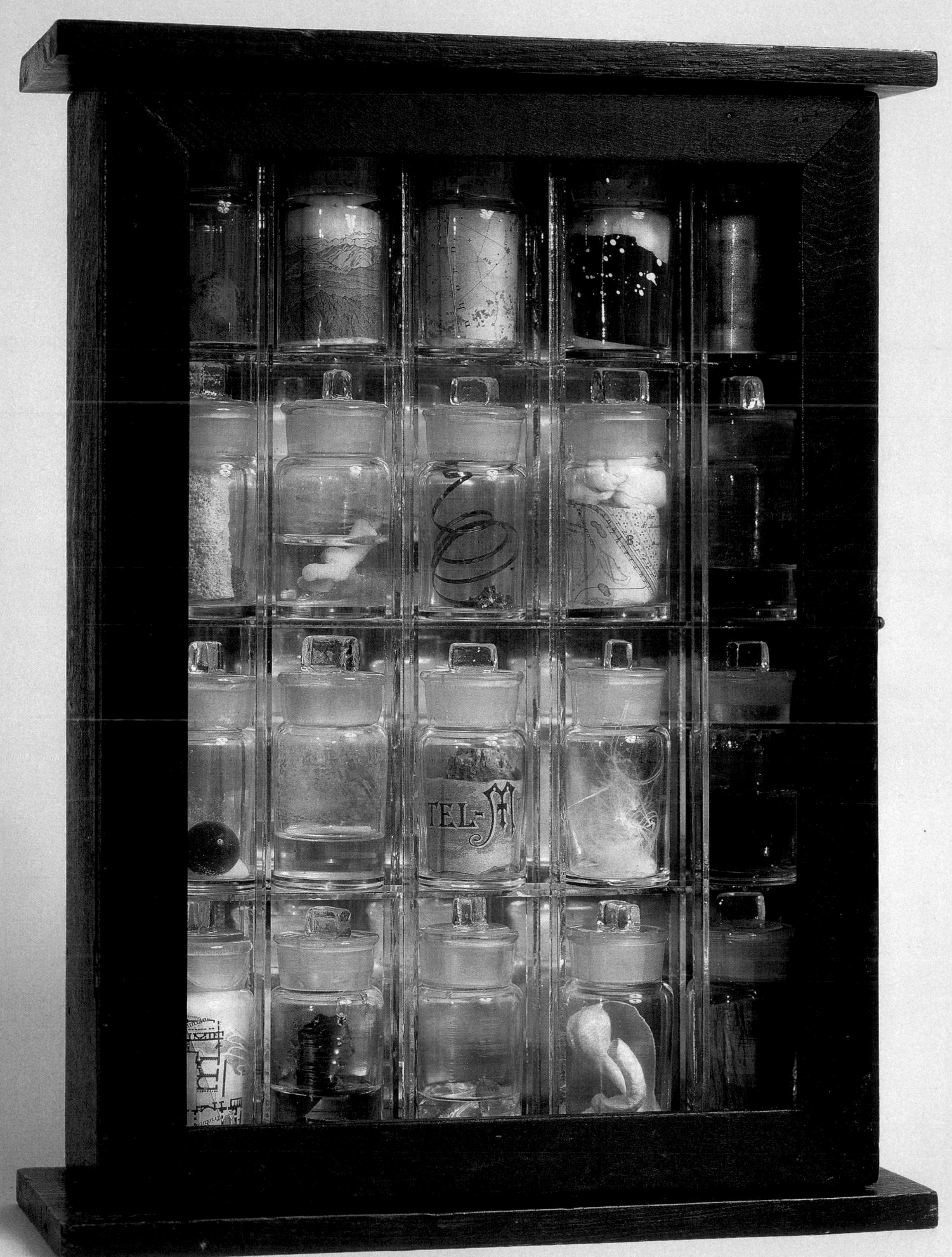

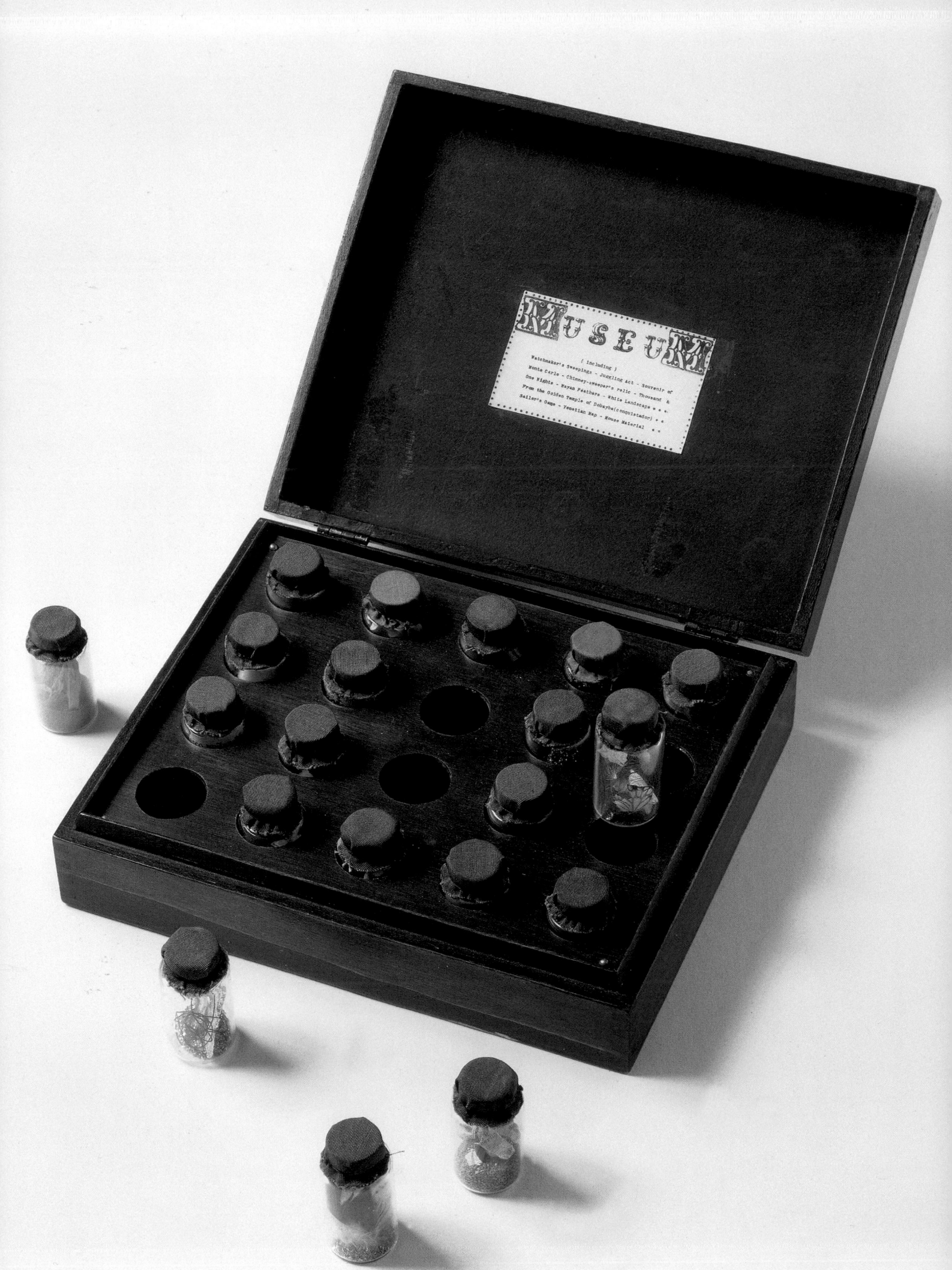

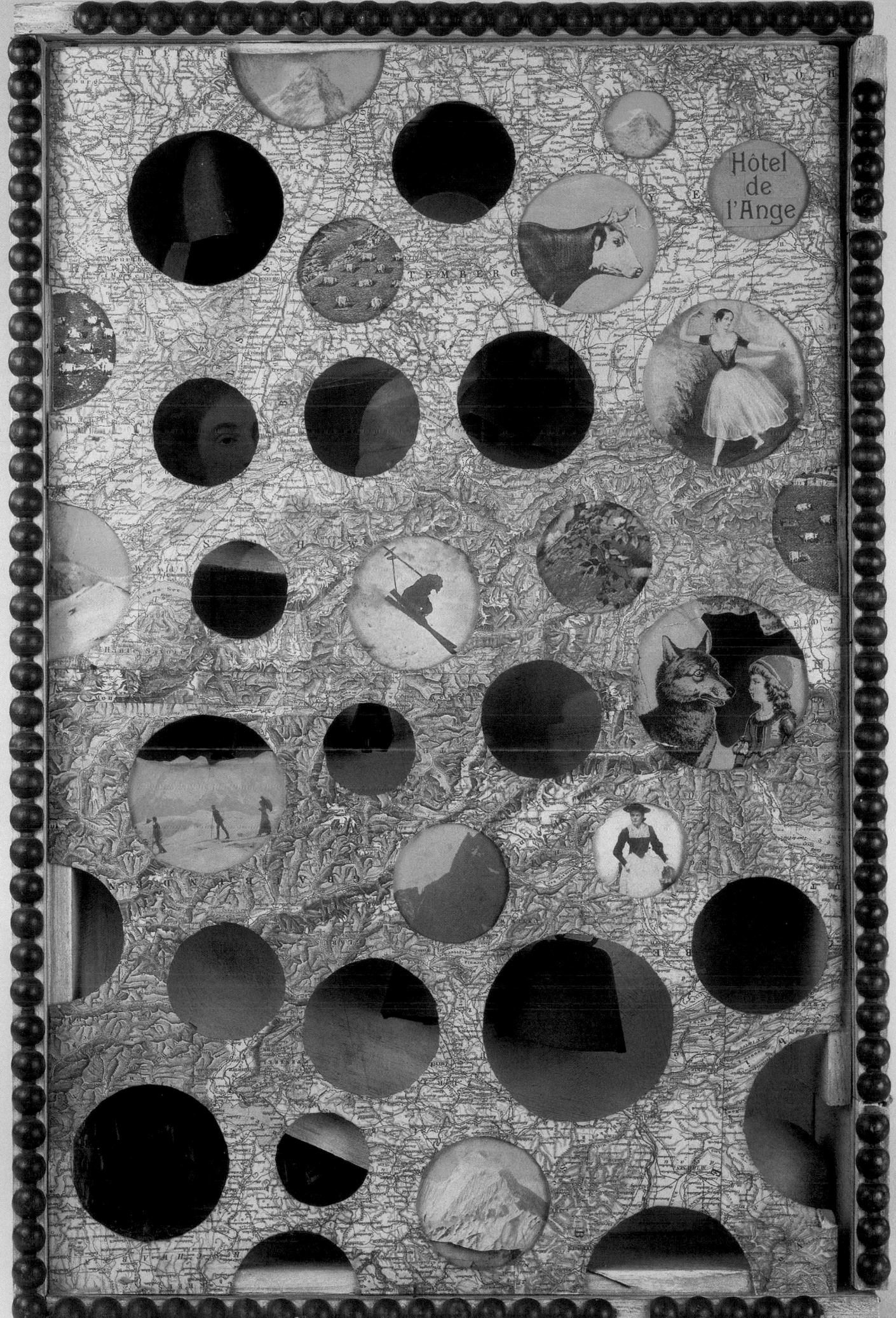

Hôtel
de
l'Ange

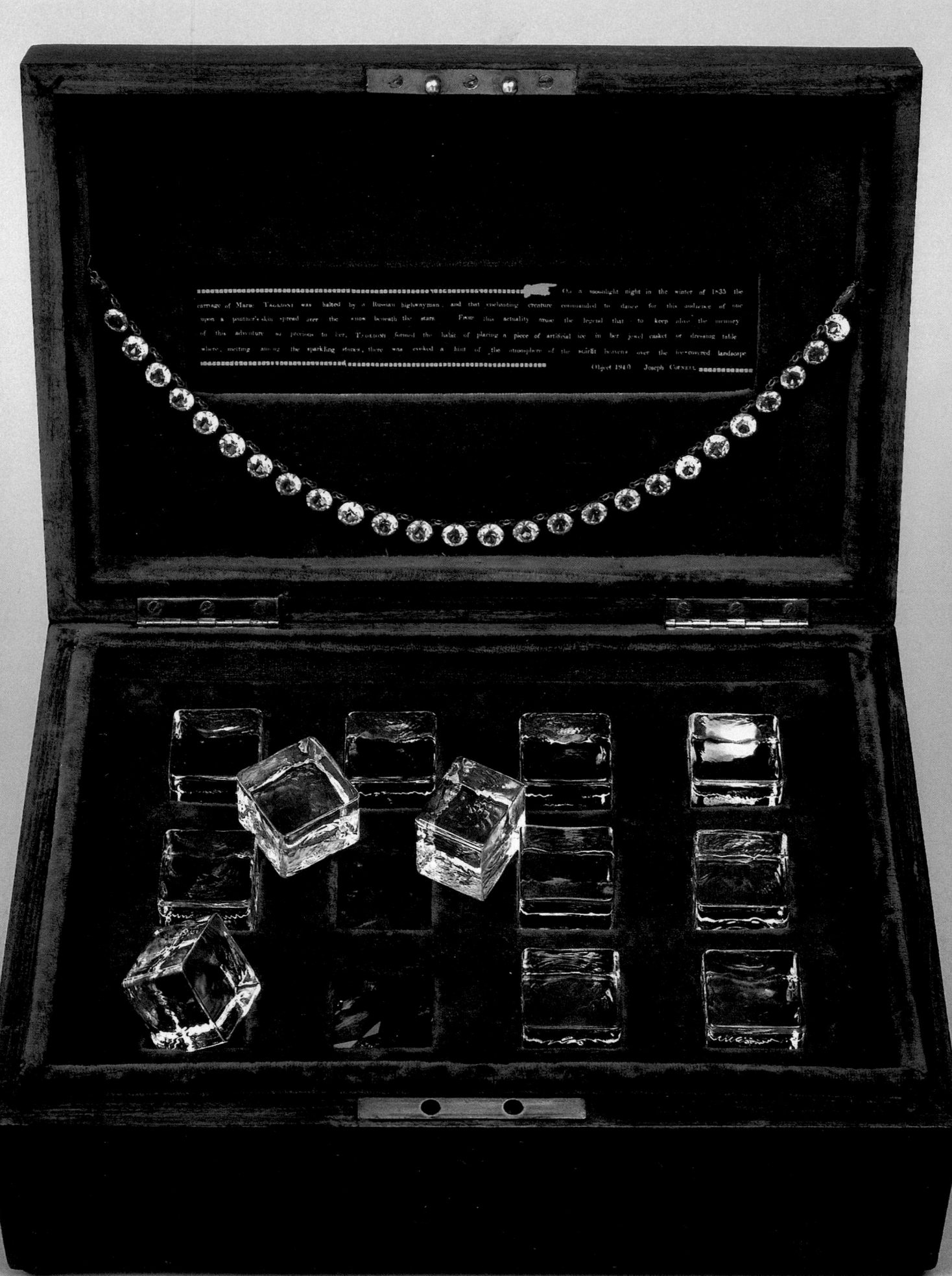

On a moonlight night in the winter of 1835 the carriage of Marie Taglioni was halted by a Russian highwayman, and that enchanting creature commanded to dance for this audience of one upon a panther's skin spread over the snow beneath the stars. From this actuality arose the legend that to keep alive the memory of this adventure so precious to her, Taglioni formed the habit of placing a piece of artificial ice in her jewel casket or dressing table where, melting among the sparkling stones, there was evoked a hint of the atmosphere of the starlit heavens over the ice-covered landscape.

Object 1940 Joseph Cornell

THE ROMANTIC BALLET 3

Cornell's lifelong love affair with the ballet began in the early 1920s. He attended three performances given by the great Russian ballerina Anna Pavlova during her farewell tour in New York in 1924–25. In 1933 Julien Levy exhibited Serge Lifar's important collection of costume and set designs. Cornell's response to the exhibition was a collage, which depicts Lifar as a figure in motion. In 1934 Cornell met Pavel Tchelitchew, a noted painter as well as set and costume designer for George Balanchine. Balanchine and Lincoln Kirstein founded the short-lived American Ballet that same year, Ballet Caravan in 1936, and Ballet Society in 1946 (it became the New York City Ballet in 1948). Cornell began to frequent the Dance Archives at The Museum of Modern Art shortly after it opened in October 1939 but his commitment to the ballet began in earnest in 1940 when he met Tamara Toumanova, a principal dancer for Balanchine, and paired her with the great ballerinas of the Romantic era. From 1940 on, many of the titles of his boxes, and the boxes themselves, were inspired by ballets past or present.

The Romantic ballet debuted on March 12, 1832, when *La Sylphide* premiered at the Paris Opéra. The ballet was choreographed by Filippo Taglioni, and the star was his daughter, Marie. Taglioni danced *en pointe* and in a white tutu made of tarlatan—two important features of the Romantic ballet. The poet and balletomane Théophile Gautier was one of many critics who waxed ecstatic over the ballet and noted that it marked the end of the marble palaces and gods of earlier ballets. He was enthralled by Taglioni and said of her, "This was dance itself." Gautier wrote extensively about ballet for *La Presse* and championed the Romantic ideal of youthful innocence and beauty, love betrayed, and the demonic. His enthusiasm for the Romantic ballet was echoed by cheering audiences at the Paris Opéra theater and in Copenhagen, where the great Danish choreographer August Bournonville created his own version of *La Sylphide* for his protégée, Lucille Grahn.

The quintessential Romantic ballet, *Giselle*, premiered on June 28, 1841, at the Paris Opéra. The libretto was written by Gautier and his friend Vernoy de Saint-Georges and danced by Carlotta Grisi. Gautier was inspired by Victor Hugo's poem "Les Fantômes," from *Les Orientales*, in which dancers in a ballroom are condemned to dance all night, and Heinrich Heine, who provided him with the inspiration for the Wilis, the lost souls of young maidens who died

OPPOSITE:
Taglioni's Jewel Casket, 1940
Construction,
4¾ x 11⅞ x 8¼ inches
The Museum of Modern Art,
New York;
Gift of James Thrall Soby

betrayed in love. The ballet celebrated the ideal of female beauty and downplayed the role of the male ballet dancer.

In the Romantic era, Cornell found the fantasy, longing, and escape that he so eagerly sought in his own life. He became an avid fan and immersed himself in reading about the nineteenth-century Romantic ballet. He read Cyril Beaumont and Théophile Gautier and collected photographs, letters, and memorabilia relating to the ballet. In a letter to Charles Henri Ford, the editor of *View* magazine, dated January 14, 1940, Cornell mentions his new interest in dance and cites Fanny Cerrito in her most famous role as the naiad Ondine. Cerrito became the subject of one of his extensive "explorations," *Portrait of Ondine*, which was shown at The Museum of Modern Art in 1945. Ondine was the Romantic era's version of the Greek and Roman siren. She and other immortals—the sylphs, dryards, peris, and wilis, captured Cornell's imagination because they were timeless spirits. Reflecting the intensity with which Cornell pursued his obsessions, he even had a vision of Cerrito on West 52nd Street— in the windows of the Manhattan Storage and Warehouse Company.

In the same letter to Charles Henri Ford, Cornell also refers to a new box based on Marie Taglioni, which, from his description, might well be *Taglioni's Jewel Casket* (1940). The box is labeled with the following anecdote, adapted from Albert D. Vandam's book, *An Englishman in Paris*, published in New York in 1892:

> *On a moonlight night in the winter of 1835 the / carriage of Marie* TAGLIONI *was halted by a Russian highwayman, and that enchanting creature commanded to dance for this audience of one / upon a panther's skin spread over the snow beneath the stars. From this actuality arose the legend that to keep alive the memory / of this adventure so precious to her,* TAGLIONI *formed the habit of placing a piece of artificial ice in her jewel casket or dressing table / where, melting among the sparkling stones, there was evoked a hint of the atmosphere of the starlit heavens over the ice-covered landscape.*[27]

Cornell fashioned *Taglioni's Jewel Casket* from the simplest of means, necklaces purchased from Woolworth's, and glass cubes ordered from a neighborhoood lumber store. Like many others of this period, the box is a Victorian strongbox, lined in brown velvet. A rhinestone necklace is strung along the inside of the lid to represent Taglioni's jewels. Twelve glass cubes are placed in compartments in the body of the construction or scattered on top of the velvet lining, like the artificial ice Taglioni placed in her jewel box. The freely moving cubes introduce the element of chance through random movement and allude to Stéphane Mallarmé's famous saying, "A throw of the dice will never abolish chance." In the innermost recesses of the jewel box Cornell placed another necklace, necklace fragments, and slivers of glass. This work is the first in a series of memorable boxes in which Cornell paid homage to the great ballerinas of the Romantic era.

Five great dancers emerged during the Romantic era: Taglioni, Lucille Grahn, Fanny Elssler, Carlotta Grisi, and Fanny Cerrito. All five ballerinas figure in Cornell's box constructions from 1940 onward or are featured in numerous issues

of *Dance Index* magazine to which he contributed cover designs, articles, and selections of memorabilia from his vast archives. As late as 1956, Cornell recorded in his diaries that he was working on a new Lucille Grahn box and was delighted that "a white butterfly flew over it while the sun dried its whiteness on front steps to-day."[28]

Cornell's knowledge of ballet so impressed Lincoln Kirstein that he hired him to design covers for the newly founded magazine *Dance Index*. Kirstein also wrote about art, and in 1947 he published the first of two studies on Tchelitchew. Tchelitchew was an early admirer of Surrealism who not only designed sets and costumes for Balanchine but also made portraits of luminaries of the ballet world such as Kirstein and the poet and writer Charles Henri Ford, editor of *View*, who was Tchelitchew's lifelong companion. For Ford, Cornell designed several important works, among them *Story without a Name—for Max Ernst* (1942) and *3/4 Bird's-Eye View of "A Watch-Case for Marcel Duchamp"* (1945). For Kirstein, he contributed many designs on dance and a cover design, a film scenario, and illustrations for *Hans Christian Andersen* (who was also a ballet afficionado) that were published in *Dance Index* in 1945.

Tchelitchew, Eugene Berman, and Christian Bérard formed a group known as the Neo-Romantics and designed sets for the ballet. Bérard's work was included in Levy's 1933 exhibition of costume and set designs from Lifar's collection. His Harlequin costume helped inspire Cornell's *Harlequin* of 1935–38. Bérard may well have designed the installation for Cornell's *Portraits of Women* at the Hugo Gallery in December 1946.[29] Tchelitchew was friendly with the poet and art critic Parker Tyler, and introduced Tyler and the ballerina Tamara Toumanova to Cornell. In the spirit of Man Ray, Cornell made a "boule de neige," a snowball, with an image of Toumanova in it for Tchelitchew.

Cornell met Toumanova late in 1940. Toumanova, Tchelitchew, and Balanchine went to Cornell's opening at the Julien Levy Gallery in December of that year, when he showed his first works devoted to the Romantic ballet. She visited him at Utopia Parkway with Tchelitchew. In his diary on July 15, 1941, an elated Cornell noted that Toumanova ". . . sends a ticket for her performance at the Stadium of 'Swan Lake' this Thursday and invites me to the dressing room after. Have never seen her dance this but she has told me before that it is one of her favorites."[30] Cornell and Toumanova formed a lasting friendship.

Cornell often mused about his favorite ballerinas for long periods of time after he met them or before he created one of his boxes dedicated to them, and Toumanova was no exception. In his diary notes of November 30, 1945, for example, written four years after he met Toumanova, he writes: "1st snow . . . Met Dalí Transcendent feeling about swan box—outdoors bright clear air white clouds etc. reflected in mirrors of box with blue glass and white fluffy feathers."[31]

Cornell saw Toumanova perform in *Swan Lake*, and after the performance he went backstage to see her and met her mother. He returned the following Saturday and confessed in a letter to Tchelitchew that he enjoyed his visit backstage even more than the ballet. Cornell watched her prepare for her performance in *Spectre de la Rose* and obtained some feathers from her costumes, which

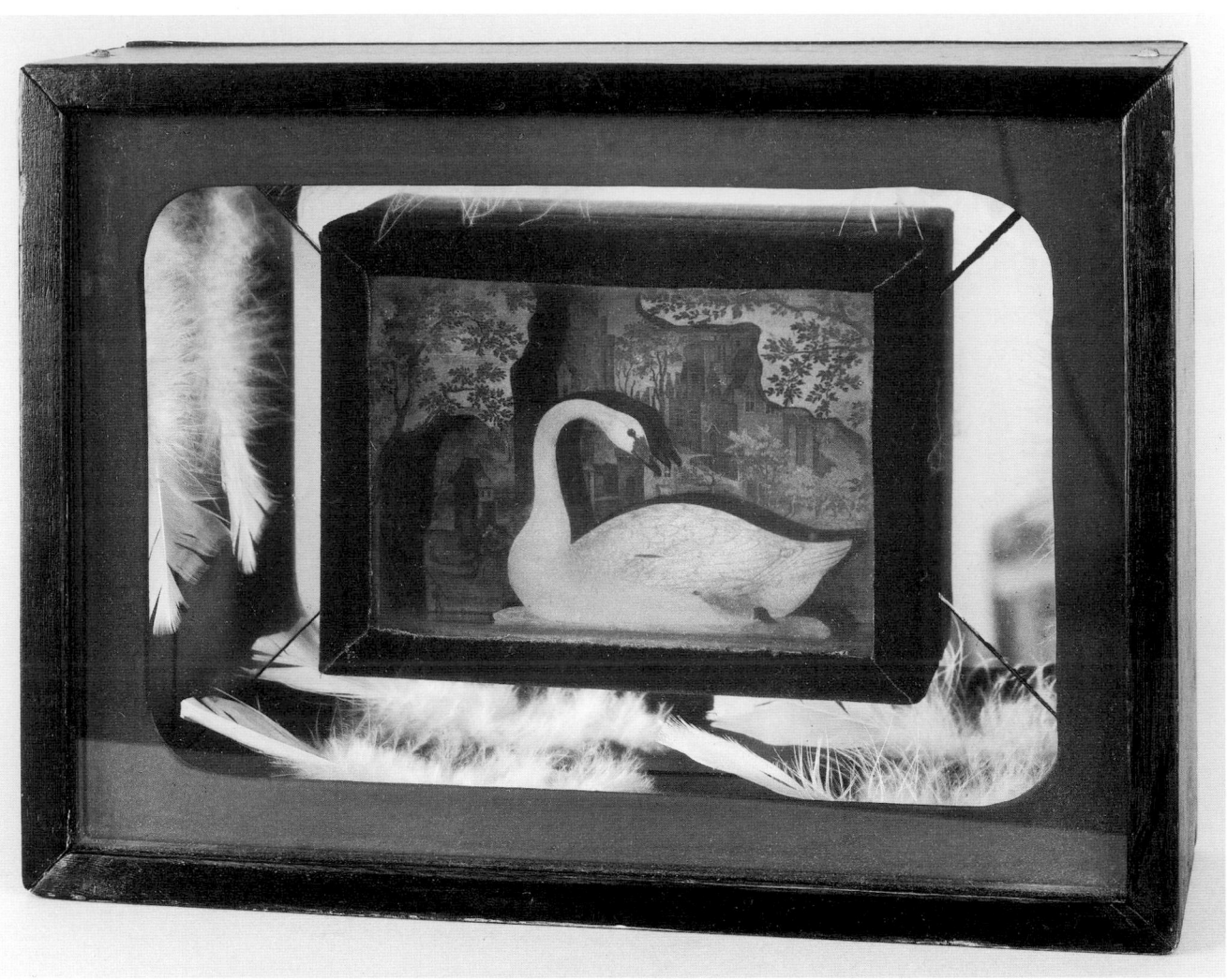

A Swan Lake for Tamara Toumanova, 1946
Construction, 9½ x 13 x 4 inches
Private Collection, New York

he later placed in a box he constructed for her, *A Swan Lake for Tamara Toumanova* (1946). The inscription on the back of the box reads:

> A SWAN FOR TAMARA TOUMANOVA / *Bordered by feather / flowers into which / have drifted wisps / from a white crown / which once graced / the raven tresses / of the Queen Swan. An actual wisp or two of a white feather / from a head-piece worn by Toumanova in / "Swan Lake" mingled with the larger ones / bordering the box.*

Cornell had paid homage to Toumanova earlier, as well as Carlotta Grisi, in one of his *Homage to the Romantic Ballet* boxes (1941). Creating a continuum between the Romantic and modern eras, he linked Toumanova with Carlotta Grisi. A typed inscription on the inside lid accompanies an image of Grisi:

> *Dream fragments loosened by the breezes from the floating form of the fairy, Carlotta Grisi. Gold rain shed from garments of the dark fairy, Tamara Toumanova in the "Nutcracker Suite."*

The second *Homage to the Romantic Ballet* (1941) is dedicated to Toumanova alone and has two inscriptions, one on the interior lid and one on the exterior. The exterior reads:

Little Mysteries of the Ballet

Into a souvenir-case guarding its sealed treasure of costume fragments from "La Spectre de la Rose"—how explain the intrusion of bejewelled and faded tokens of a ballerina of an earlier day, accented with a renegade blonde hairpin loosed from the chevelure of some Cinderella in her midnight haste Reward.

The interior inscription lists:

pink slipper-lace, silver hairpin, white rose—actual pieces from the ballet costume of Tamara Toumanova, the flower worn in "La Spectre de la Rose."

In a diary entry dated March 26, 1941, Cornell noted that despite the rainy weather that made the basement damp, he continued working; he eagerly anticipates his forthcoming meeting with Duchamp; he ventures into Manhattan bringing flowers to the Ninth Church Reading Room and has a chat with the librarian. That same day he mails the Grisi and Toumanova "souvenir" to Toumanova in Hollywood (this is the first *Homage to the Romantic Ballet* box); visits the Julien Levy Gallery; browses in bookstores and finds five *New Yorker* magazines with pictures of Toumanova in them. He has a glass of iced tea in one of the cafeterias he frequents and strolls through Central Park for half an hour before heading home.[52]

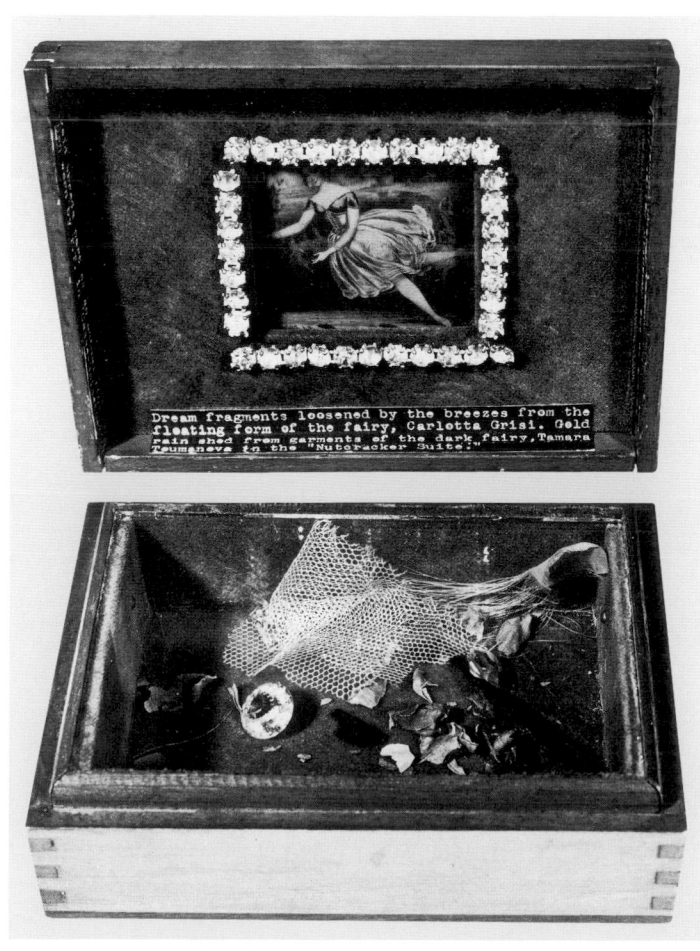

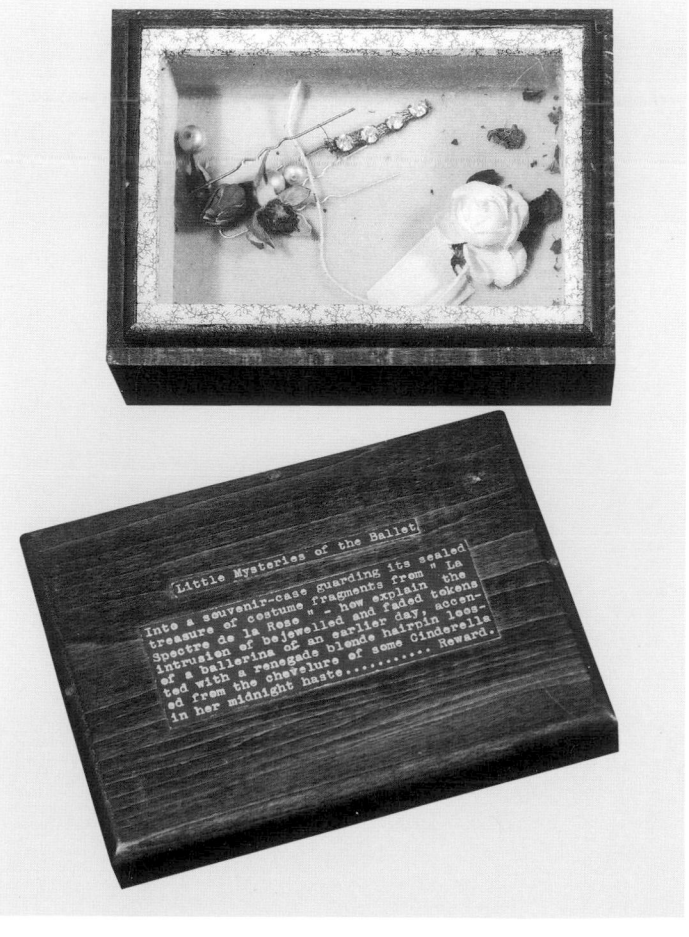

In his journals, as in his boxes, Cornell mixed the worlds of fantasy and reality, story and illusion. As his diary indicates, a random occurrence or event would strike Cornell with such a powerful feeling that he would immediately seize it and seek to contain it. The way in which he contained it was to associate it with other thoughts and feelings, relating it to a specific individual, be it a painter, poet, composer, or performer. This was an infinite rather than finite process, and it seemed to suit Cornell, probably because he found it so difficult to accept closure. Closure would have meant leaving his family and accepting loss. It meant breaking his ties with his happy childhood, accepting the loss of his father, and going out on his own.

Cornell's use of visual metaphor was inspired by his love of art, literature, music, ballet, and film. The Symbolist poet Charles Baudelaire's belief in writing as part of a larger life experience affirmed Cornell's own Christian Science beliefs. In *Correspondences* Baudelaire declared the essential equivalence of all things in nature and the capacity of any one thing to symbolize something altogether different. In his signature box constructions, composed of evanescent ballerinas and Medici princes and princesses, colorful aviaries and empty hotels, filled with figures joined by tinted glass, mirrors, coiled springs, jacks, and cork balls, Cornell evokes Baudelaire's world of allusion and association.

In the fanciful *A Pantry Ballet (for Jacques Offenbach)* (1942) Cornell combines elements of domesticity with ballet and the opera. The painted black and red velvet borders framing the glass face of the box recall the Victorian mountings used in period photographs. Within these borders is yet another frame containing engraved images of snails, seashells, and fish. Fragments of paper doilies become the curtains for the theater contained within. The interior of the box holds ten red plastic lobsters embellished with necklaces and bits of tulle. They are accompanied by miniature spoons, forks, and pans suspended along with the lobsters from the top of the box.

The nineteenth-century composer Jacques Levy Offenbach was renowned for his operettas. In 1855 he founded the Théâtre des Bouffes Parisiens, a theater company that staged many of his operettas. In 1880, shortly before his death, Offenbach composed his one serious opera, *Tales of Hoffmann*, based upon stories by E. T. A. Hoffmann. It tells the tale of a poet and his three loves. One love is a mechanical doll that comes to life when viewed through a pair of magic spectacles; another is a courtesan who is in league with the Devil; and the third is a singer who approaches death every time she sings. The first tale in particular is representative of the fantasies Cornell loved and emulated in his boxes.

The lobsters are a reference to "The Lobster Quadrille" in Lewis Carroll's *Alice's Adventures in Wonderland*.[33] Cornell admired Charles Lutwidge Dodgson (Carroll's real name), whose tales *Alice's Adventures in Wonderland* and *Through the Looking Glass* were devised as entertainment for Alice Liddell, a young child Dodgson befriended at Oxford University, where he was a mathematician. A bachelor like Cornell, he grew up in a happy household of eleven children. Dodgson developed a passion for photography, photographing Alice and other young children (usually girls) of his colleagues at Oxford. In the Victorian age,

OPPOSITE, TOP:
A Pantry Ballet (for Jacques Offenbach),
Summer 1942
Construction, 10 ½ x 18 ⅛ x 6 inches
The Nelson–Atkins Museum of Art,
Kansas City; Gift of the Friends of Art

OPPOSITE, BOTTOM:
Zizi Jeanmaire Lobster Ballet Box, 1949
Construction, 8 ⅜ x 15 ⅛ x 3 ⅞ inches
Sandra and Gerald Fineberg Collection

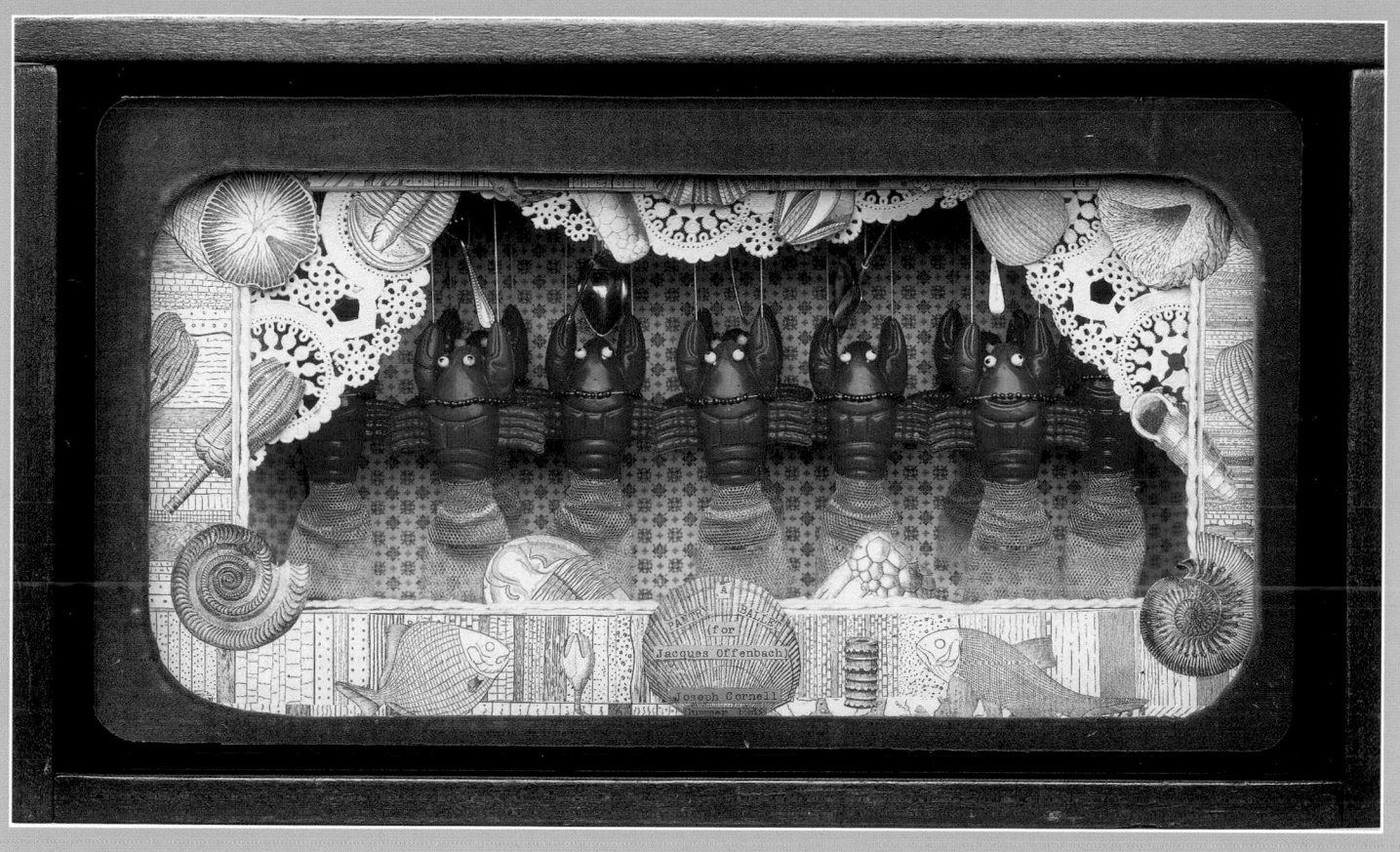

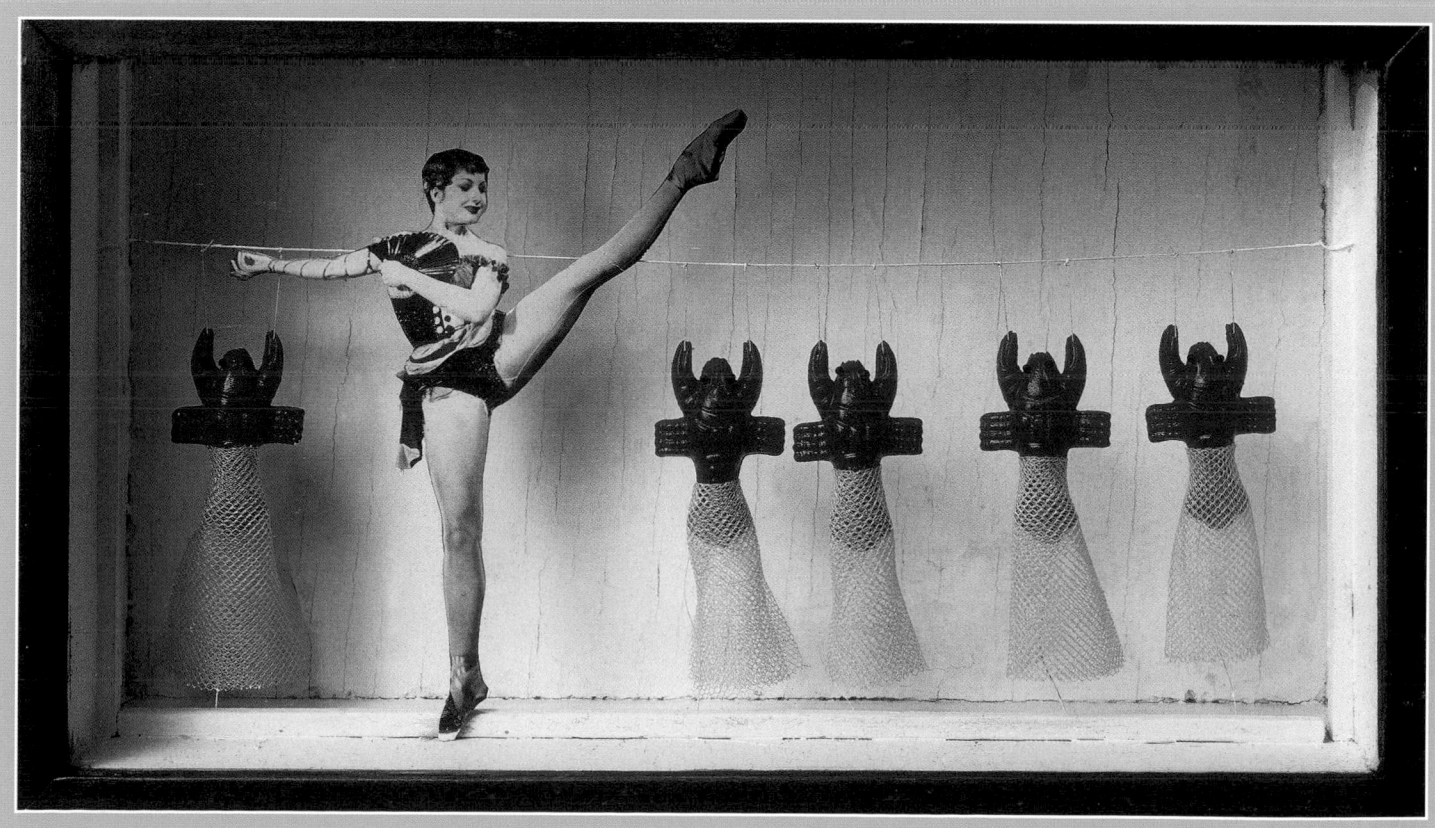

Salvador Dalí, *Lobster Telephone*, c. 1936
Telephone with painted lobster,
15 x 30 x 17 centimeters
Tate Gallery, London

in which children were regarded as pure, Dodgson's nude photographs were not considered salacious. Today some of the photographs appear suggestive, but others are reminiscent of the angelic children who appear in the art of Dodgson's Pre-Raphaelite friends, the painter Dante Gabriel Rossetti, the poet Leigh Hunt, and the sculptor Alexander Munro.

In *Alice's Adventures in Wonderland*, the Mock Turtle and the Gryphon claim that lobsters perform the quadrille, a square dance for four couples, in two lines at the edge of the seashore. (The turtle and gryphon then perform it for Alice themselves.) Cornell followed suit by placing his lobsters in two rows—and included tin forks, spoons, and pans in the box as well. In a variation on the lobster theme, made in December of that year, Cornell eliminated the forks and pans but included an engraving of a teapot, a reference to the Mad Hatter's tea party. The lobsters might also be a tribute to Dalí's *Lobster Telephone* (c. 1936), a painted lobster placed on top of a rotary phone. Cornell was also fond of J. J. Grandville's illustrations and de la Fontaine's fables, which he may have come across through his knowledge of Max Ernst's work. Grandville satirized the Romantic ballet in his book *Un Autre Monde* (1843), which pictured dancing crabs. Cornell's approach to his subject was without ridicule. He delighted in the whimsy of lobsters wearing tutus, like the costumed circus bears that delighted him as a child.

A new ballerina entered Cornell's life in 1944. Tilly Losch was a Viennese ballet dancer and actress married for a time to Edward James, an important collector of Surrealist art. Soon after Cornell and Losch met, she acquired a box of his dating to the mid-1930s. *Untitled (Tilly Losch)* is a typical 1930s box that features an enchanting cutout of a girl suspended above an engraving of snow-covered mountains. In the Romantic era ballerinas were supported by wires that enabled them to appear as if they were floating above the stage. The mountains are pictured in depth, thus creating a trompe l'oeil spatial effect. The figure is mounted over a book of matches, which becomes her skirt, and she holds a red ball between her hands. Losch appeared to be the perfect match for the little girl in Cornell's box. Despite the charm of the figure, the setting and the matches suggest a parable on the ephemerality of life, an underlying theme in the majority of Cornell's work.

Cornell met the dancer Renée "Zizi" Jeanmaire, in 1949, when she performed in New York with Les Ballets de Paris de Roland Petit (her husband) in *Carmen*, based on Bizet's opera. To celebrate the arrival of the ballet company in New York, Alexander Iolas, the director of the Hugo Gallery, planned an exhibition for November that featured decor from Les Ballets de Paris along with Cornell's interpretation of the Romantic ballet, a display entitled *La Lanterne Magique du Ballet Romantique*. Cornell fell in love with the ballerina and made several works in her honor. *Zizi Jeanmaire Lobster Ballet Box* (1949) shows her performing with a corps de ballet made up of red plastic lobsters like the ones in *A Pantry Ballet*.

The critic and writer Parker Tyler was a leading advocate of Cornell's work, which he wrote about frequently. He owned Cornell's *The Crystal Palace* (1949; page 67) (later destroyed in a fire), which was undoubtedly inspired by *Palais de*

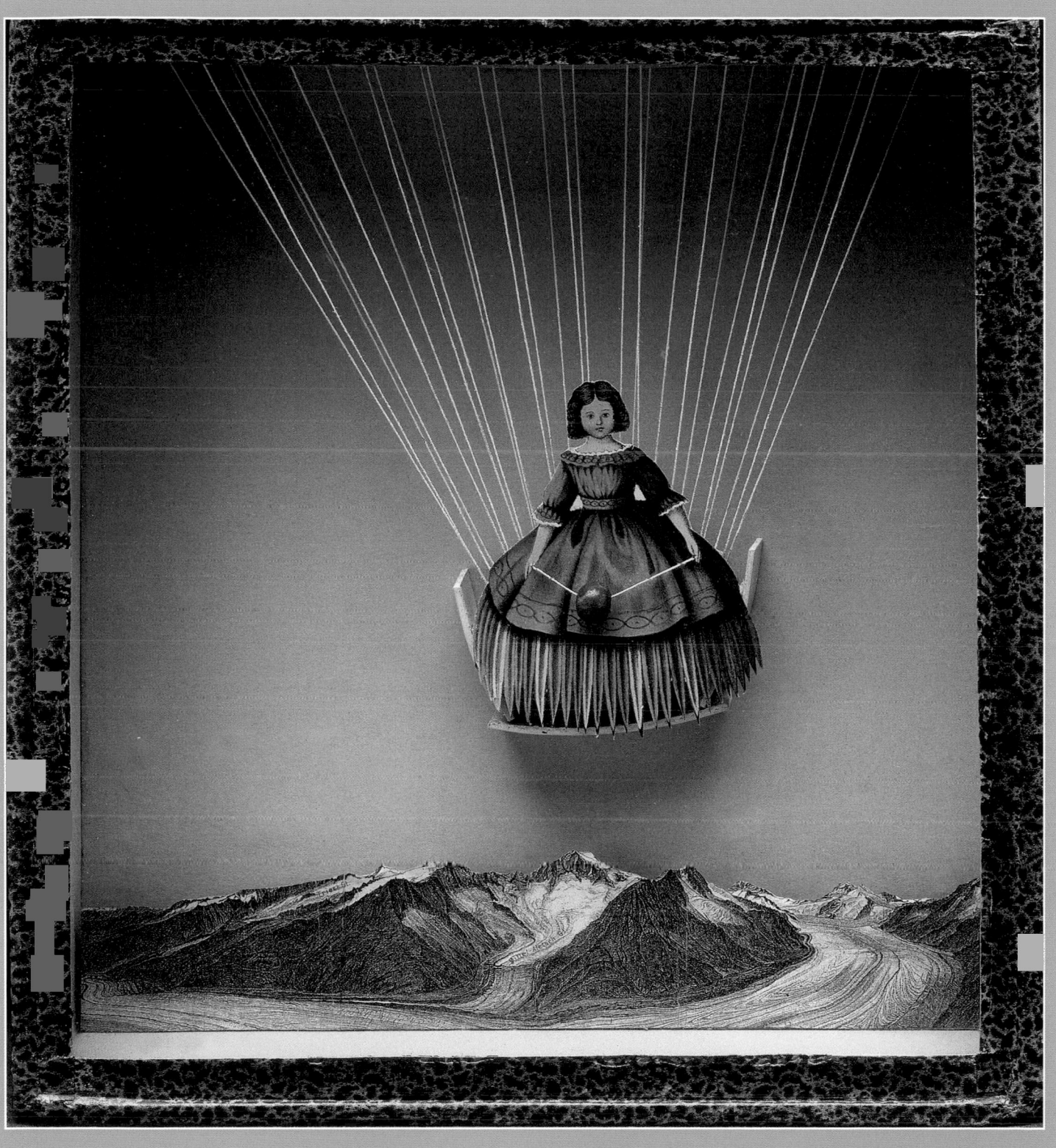

Cristal, a ballet choreographed by Balanchine for the Paris Opéra Ballet, which premiered on July 7, 1947, and in which Toumanova danced the second movement. Renamed by Balanchine *Symphony in C*, after the original title of the musical score by Georges Bizet, it opened at the New York City Ballet on October 11, 1948, with Tanaquil LeClercq in the role created by Toumanova. Cornell referred to this ballet as "one of pièces de résistance of the ballerinas."[34] *The Crystal Palace* also refers to London's famed Crystal Palace, where the first World's Fair took place in 1851.

In a diary notation of October 11, 1944, Cornell mentions a talk he had with Tennessee Williams and Donald Windham. Windham was the editor of *Dance Index* and an ardent fan of Cornell's work, as well as a lifelong friend.[35] Tennessee Williams's play *The Glass Menagerie* premiered on Broadway in March 1945. Both *The Glass Menagerie* and *The Crystal Palace* are about loneliness and loss. The tender lyricism and human decency of Williams's characters corresponded with the feelings Cornell had about his own family. In *The Crystal Palace* the windows reflect back on an empty cage, the bird flown, the nest empty. The theme of the box is about escape. Similarly Amanda Wingfield, the mother in *The Glass Menagerie*, is concerned that her son, Tom, who is trapped at home with her and her invalid daughter, Laura, will leave home as her husband did years before. Tom is looking for an escape and finds it in the movies and in drinking. Laura, on the other hand, escapes into an inner world of fantasy by playing with her glass menagerie. The father, whose picture is hanging on the wall, symbolizes the only member of the family who has escaped. Like Cornell, the mother's way of escaping is to hold on to the past and use the father's photograph as a reminder of a more innocent and happier time. Cornell identified not with Tom, who left home, but with Laura, who could not.

The last of the ballerinas to enchant Cornell was Allegra Kent, whom he met in 1957, when she was nineteen. He had contacted the New York City Ballet seeking a ballerina to appear in one of his films. Kent declined his offer, but they corresponded, and in 1964 they met again. They grew to be friends, and she became the subject of several works. Cornell chose not to associate her with the Romantic era; instead, she appeared as a figure from the Mannerist painter Parmigianino's *Portrait of a Lady Called "Antea,"* whom she very much resembled.

Cornell's friendship with Allegra Kent revolved not only around his role as an artist and hers as a ballerina but also around the interests they shared. In addition, Kent's mother was a Christian Scientist, and she knew the church's philosophy well. In a reminiscence about Cornell dated January 22, 1976, Kent recalled a conversation they had on August 13, 1969: "I went out to see Joseph and we lost ourselves talking about music, nature, and shells. I have a passion for shells; they possess the dynamic spiral." Cornell had requested a book on erotic art, which she brought him together with a mocha cake. She wrote, "We sat out in the garden while he ate most of it. I remember making a newspaper hat because the sun was so bright and wearing it in the garden. Later he sent me a spoon, a plate, and a napkin." Kent was as delighted with these exchanges as

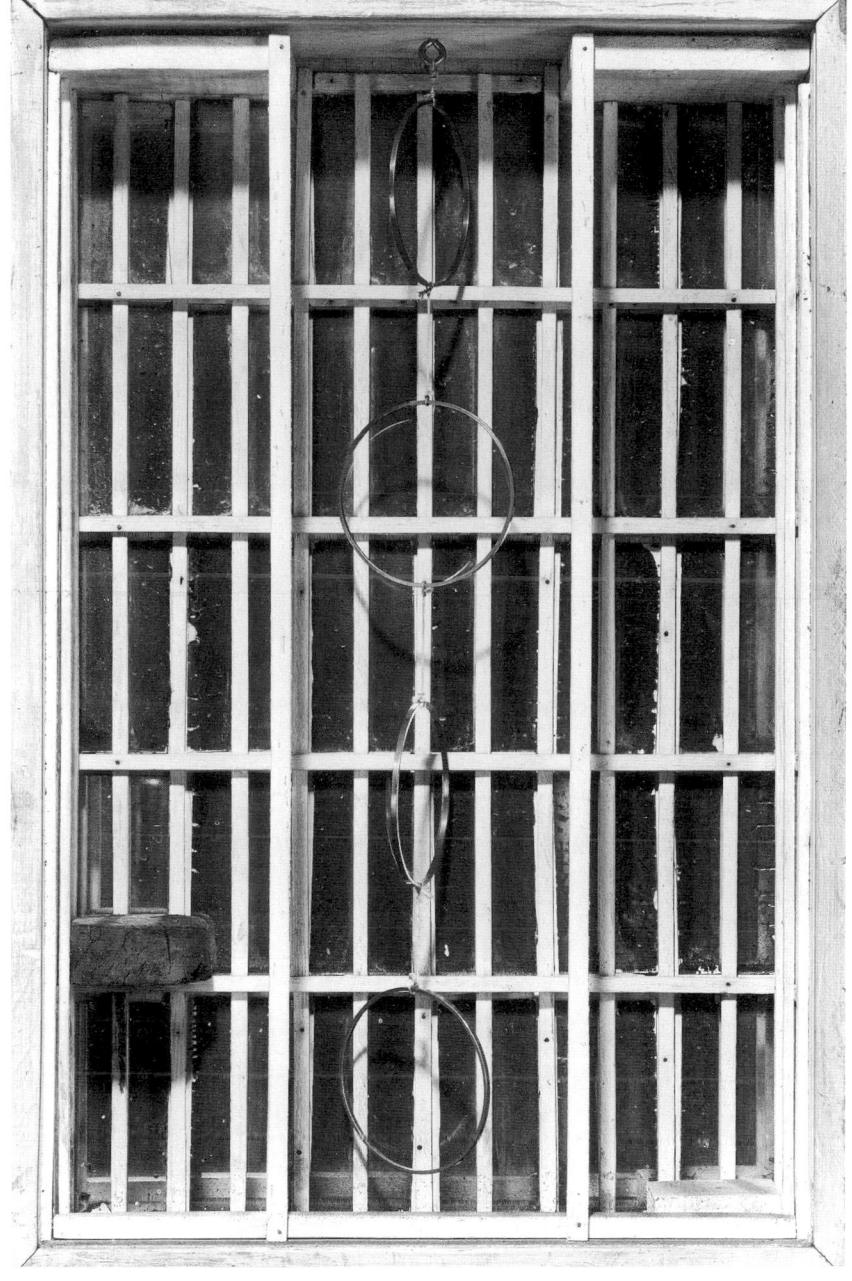

The Crystal Palace, 1949
Construction, 18 x 11¾ x 3¾ inches
(original object destroyed)

Cornell must have been, for in his imagination he turned this occasion into a tea party right out of *Alice in Wonderland*. She noted, "that day in August we were in a 'twilight' zone together."[36]

Cornell continued the theme of the Romantic ballet in works of the 1960s. He made several collages featuring a coffeepot from a Schrafft's advertisement, one of the many quaint contemporary images that he used to take the subject "out of its time." One of these works was dedicated to Philoxene Boyer, a little-known French poet and playwright and generous patron of the arts, who was passionate about the Romantic ballet. On the verso of his collage Cornell mounted a reproduction of a nineteenth-century hotel advertisement printed in French, to which he added an inscription: "Théophile/Gautier Boyer/ pour 'la jeune sylphide Italienne'/ pour Fanny Cerrito/ 1817–1907." In this collage Cornell memorialized Boyer, Gautier, and Cerrito and the moment when they came together for him in his imagination.

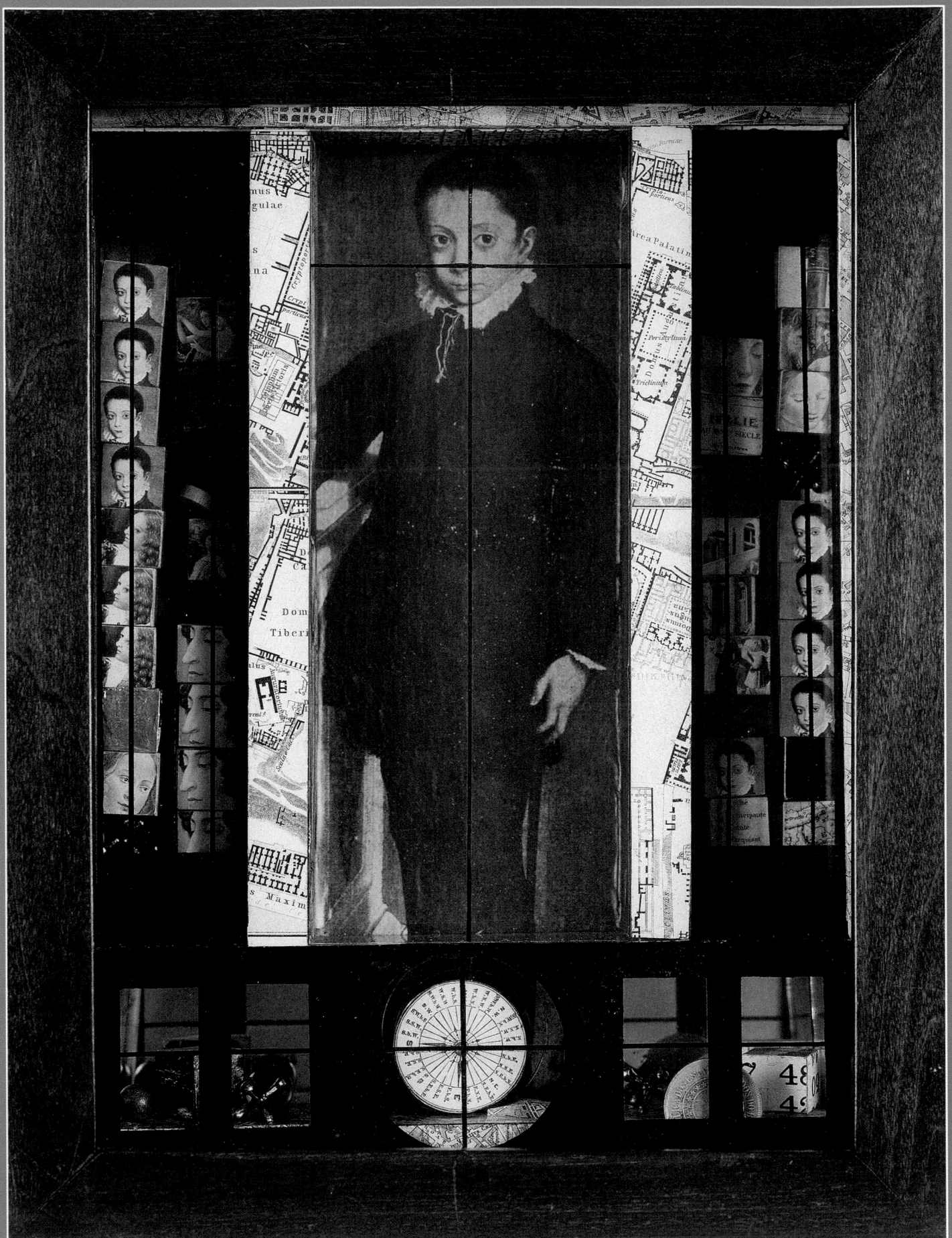

The transition from the fanciful boxes and objects of the 1930s to Cornell's major work of the 1940s could not have been more startling. In the *Medici* series Cornell confronts identity and sexuality. His earlier works dealt with art, literature, music, dance, and the everyday, combined in the fanciful manner of an operetta, along with a Victorian ideal of innocent youthful beauty—completely removed from the psychosexual imagery of the Surrealists. His Renaissance prince and princess are more flesh and blood, and the *Medici* boxes are more assured and assertive. The power of his Medici narrative is made more poignant by the inclusion of objects—the toy blocks and the jacks—that occupy such an important place in Cornell's own memory. The toys render the bloody history and tragedy of the Medicis obsolete; in its place is a history that is part invention and part reality. Cornell superimposed memories of his own happy childhood upon that of the Medici prince and princess, with the recognition that these happy times were lost to them and to him.

In *Medici Slot Machine* of 1942, a reproduction of Sofonisba Anguissola's *Portrait of Marchese Massimiliano Stampa* is viewed as though through a telescopic lens, juxtaposing both near and far distances. The spiral placed at the boy's feet evokes multiple associations: in the natural world, ocean currents, snails, roses, and DNA chromosomes are all variations on a spiral form; the spiral is a metaphor for time and an allusion to life repeating itself in a cycle of seasons and generations; spirals also often occur in the works of Leonardo da Vinci and Duchamp.

The space around the central image in *Medici Slot Machine* is fragmented into small segments that appear to commingle, separate, and fuse again in kaleidoscopic effect. The black lines that crisscross the surface act as connective tissue, organizing both the multiple images and the several spatial levels. This diagrammatic pattern of horizontal and vertical lines, superimposed on the surface rather than functioning as the substructure for the image, creates a sense of order and calm in keeping with the spirit of the Renaissance subject. The transformation of the object and the emphasis on the picturesque that is so prominent in Cornell's work of the 1930s is here superseded by a far more ambitious goal. The object becomes both symbol and form, as Cornell heightens the contrast between the container and the images and objects it contains, narrows the choice of subjects, and introduces a more cohesive range of color.

Medici Slot Machine, Cornell's earliest *Medici* box, employs the game theme in its title, but later versions of the box are untitled and usually bear the generic term *Medici Prince* or *Princess*. In the manila folders and cardboard boxes labeled "Medici Slot Machine" that he stored in his basement, Cornell included reproductions of the Anguissola portrait as well as copies of other paintings he

decided not to use. This was Cornell's first attempt to focus a series around just a few images.

For *Untitled (Medici Princess)* (c. 1948), Cornell turned to Agnolo Bronzino. A photostat image of Bronzino's portrait *Bia di Cosimo de' Medici* is centered in the box, with an orange wooden ball placed before it. The girl is separated from her other toys by two vertical pilasters covered with Baedeker maps. The side compartments to her left and right contain loose wooden blocks with images of the princess and of Bernardino Pinturicchio's *Portrait of a Boy* (1480–85). The compartments contain a marble and several jacks as well as other blocks with stars and numerals. The opaque orange ball, clear red marble, metal jacks and spirals, panes of glass, and mirrors, as well as areas of blue paint, are effective foils for the large tinted image of the princess. The drawer beneath the princess contains Baedeker maps, a purple feather, a fan wrapped in a map and foil, and a pink and silver foil ball, among other objects. Cornell used these to contextualize the princess. The purple feather and fan suggest the woman and monarch she would become, but Cornell clearly preferred the innocence of her youth.

For another *Medici* box, *Untitled (Pinturicchio Boy)* (1942–52), Cornell again chose Pinturicchio's *Portrait of a Boy*. As in other *Medici* boxes, space is fragmented into small rectangles and bisected by black lines crossing the surface. The inner sides and bottom of the box are covered with Baedeker maps of Venice and augmented by the ubiquitous spiral and two freestanding "toy" blocks. Both this box and a companion, *Untitled (Medici Princess)* (c. 1952–54) are notable for their tinted glass: brown for the young boy, blue for the young girl. The colors contribute to the tone of solemnity and purity, an ideal of innocent, youthful beauty. In the blue-tinted *Penny Arcade Machine* (1950), the glass covers a reproduction of *Head of a Boy*, once thought to be by Caravaggio but which has recently been reattributed to the French School. Strips of marbleized paper covering the columns and Baedeker maps allude to the young man's patrimony.

Cornell constructed the imaginary history of a Renaissance prince and princess, locating them in the past by using Renaissance images and placing them behind glass tinted blue or brown, like antique daguerreotypes. In his own daguerrotypes, Cornell centered a figure or face in a shallow casing and arranged a number of objects in the surrounding space. He followed suit in the *Medici* boxes, juxtaposing the images with diagrams of European cities fashioned from pieced-together Baedeker maps and combining them with such real-life objects as marbles, jacks, and cork balls, so that the Renaissance child became a real and contemporary child, alive and very much in the present. Cornell contrasted the three-dimensional toys and the two-dimensional images and heightened the impact of the objects with color or sheen. He further enhanced their difference by contrasting the movement of the objects with the static image of the prince or princess. Cornell then began to play with the notion of dimensionality by pasting his two-dimensional images onto such three-dimensional objects as wooden blocks. Cornell conveyed a physical sense of space in his three-dimensional structures by using overlapping planes and diminishing forms.

Is the Medici prince a surrogate for Cornell? Indeed, the lean figure of the

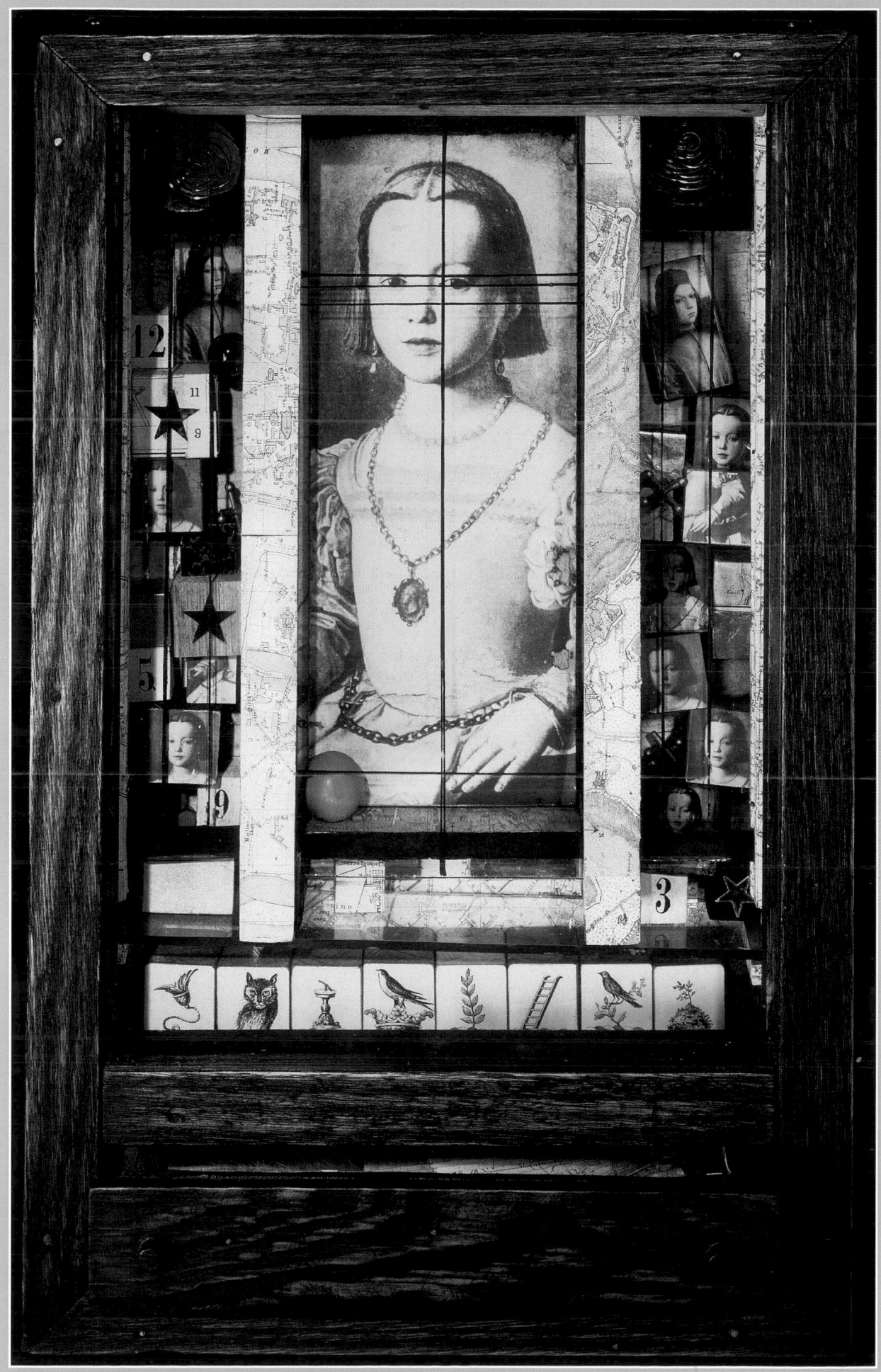

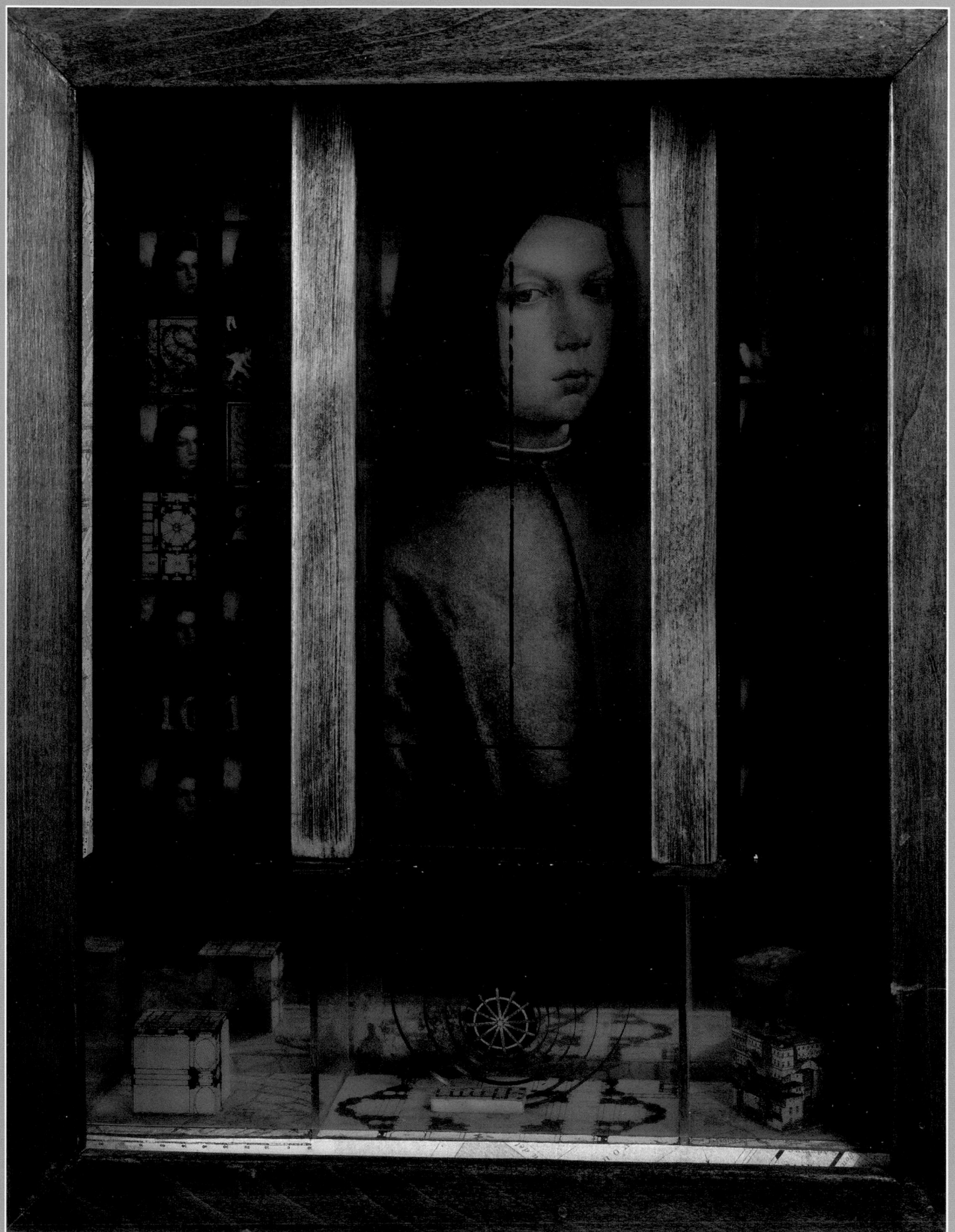

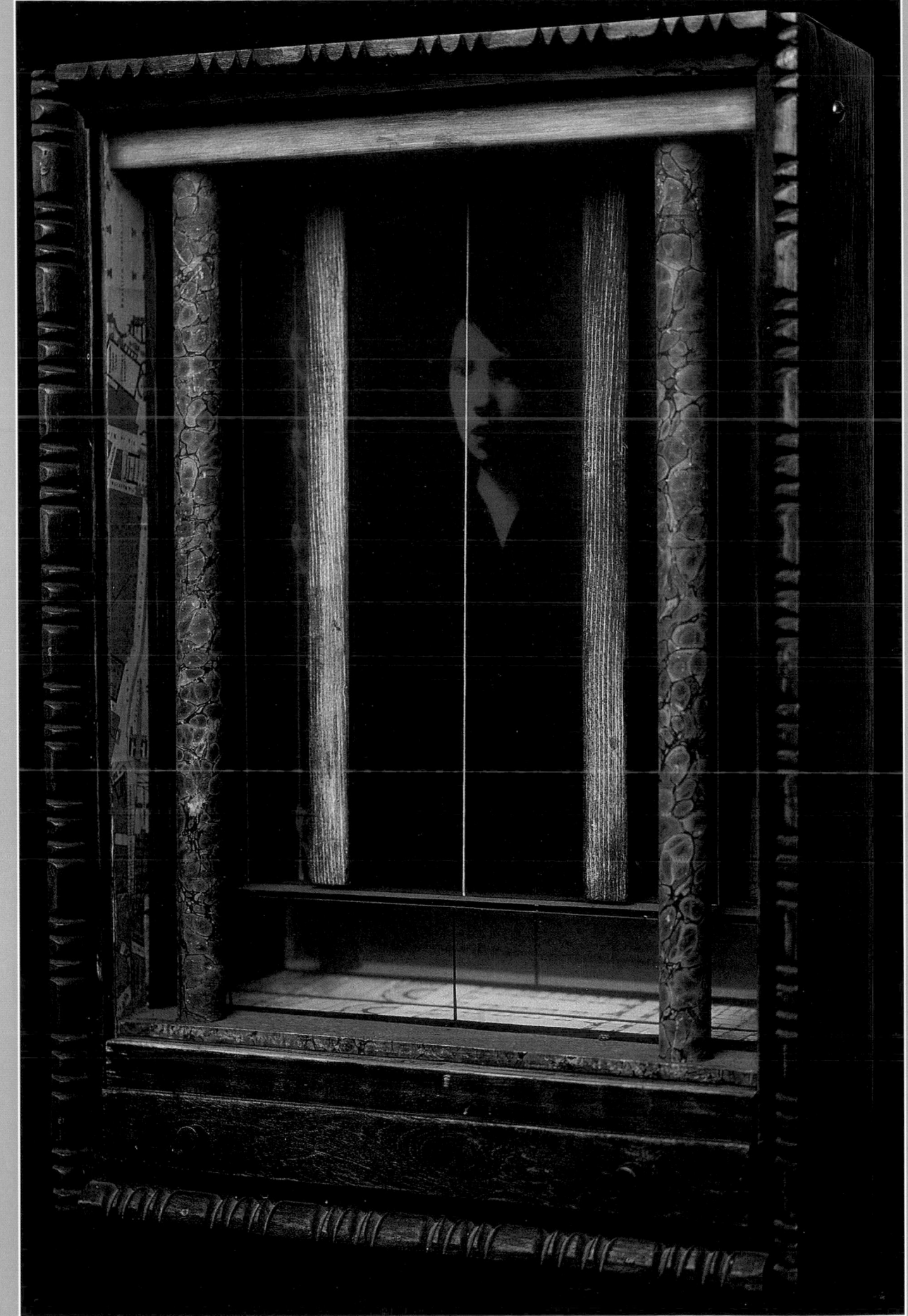

Marchese resembles the young Cornell. In an article in the October 14, 1939, issue of *Art News*, the sitter was identified as possibly Piero de' Medici, whose mother died when he was eight years old. The fatherless Cornell might have felt a connection with this early tragedy. The summer before, the paintings of the Medici's on view at the World's Fair had made a powerful impression upon him. The *Medici Slot Machine* dates to a critical time in Cornell's life, when America was at war, and Cornell's job in a war defense plant provided him with a temporary reprieve from the claustrophobic environment of his home and the preciosity of the art and ballet worlds. He continued to feel responsible for his mother and brother, especially after his two sisters married and moved away.

During this time Cornell recorded in his diary thoughts of dating. He met a young woman at his factory job. Frustrated by his inability to do more than admire her from afar, he turned to his work for fulfillment. Could the Medici princess be the result of those thoughts, those yearnings for a companion? In Bronzino's portrait of Bia de' Medici we recognize a young woman of the nobility. She is the ideal of youth and innocence but as royalty she is unattainable. Cornell, recognizing the futility of his longings, situates her behind glass, making her even more distant in time and place.

The *Medici* series coheres more, both formally and emotionally, than any of his earlier work, and it became the standard for what was to follow. There is an element of gravitas in the series that he explored further in the more austere boxes of the 1940s and 1950s. The *Medici* boxes owe a great deal to Johannes Vermeer, whose paintings *The Milkmaid* and *A Lady Writing* were also on view at the World's Fair. Cornell understood the fundamentals of Vermeer's art, especially the rigor with which the Dutch master structured his images, his interest in perspective, color, and light, and his painstaking attention to detail. Vermeer created domestic interiors in which the everyday and the commonplace take on the aura of the transcendental and the sublime. One can almost sense the air and feel the light in the room, and his female subjects seem both palpable and inaccessible. Following in Vermeer's path, Cornell underscored the structural component of his shadow boxes to give free rein to his own highly developed poetic imagery. Cornell emulated Vermeer's use of genre subjects as well as, in many boxes, the Dutch master's palette of blue, yellow, and white. A later work, *Grand Hôtel Bon Port* (1952), even features a Vermeer image, *Girl with a Pearl Earring* (c. 1665–66).

Cornell shared Vermeer's interest in scientific invention, cartography, astronomy, and optics. Art historians believe that Vermeer used a camera obscura, a precursor of the modern camera, as a tool in creating his paintings. The camera obscura (in Latin, "dark chamber") is a pinhole box fitted with a lens. Images of external objects, received through the pinhole opening, are projected inverted and reversed onto the interior surface opposite the pinhole. Its origin dates at least to Aristotle, who mentions it in his treatise *Problems*. The Arabian philosopher Ibn al-Haytham used it for viewing eclipses and Vasari mentions it in his diaries, but it was the astronomer Johannes Kepler who gave it its present name in the seventeenth century. In the eighteenth century it became something of a craze among artists and connoisseurs, along with Claude glass, a small

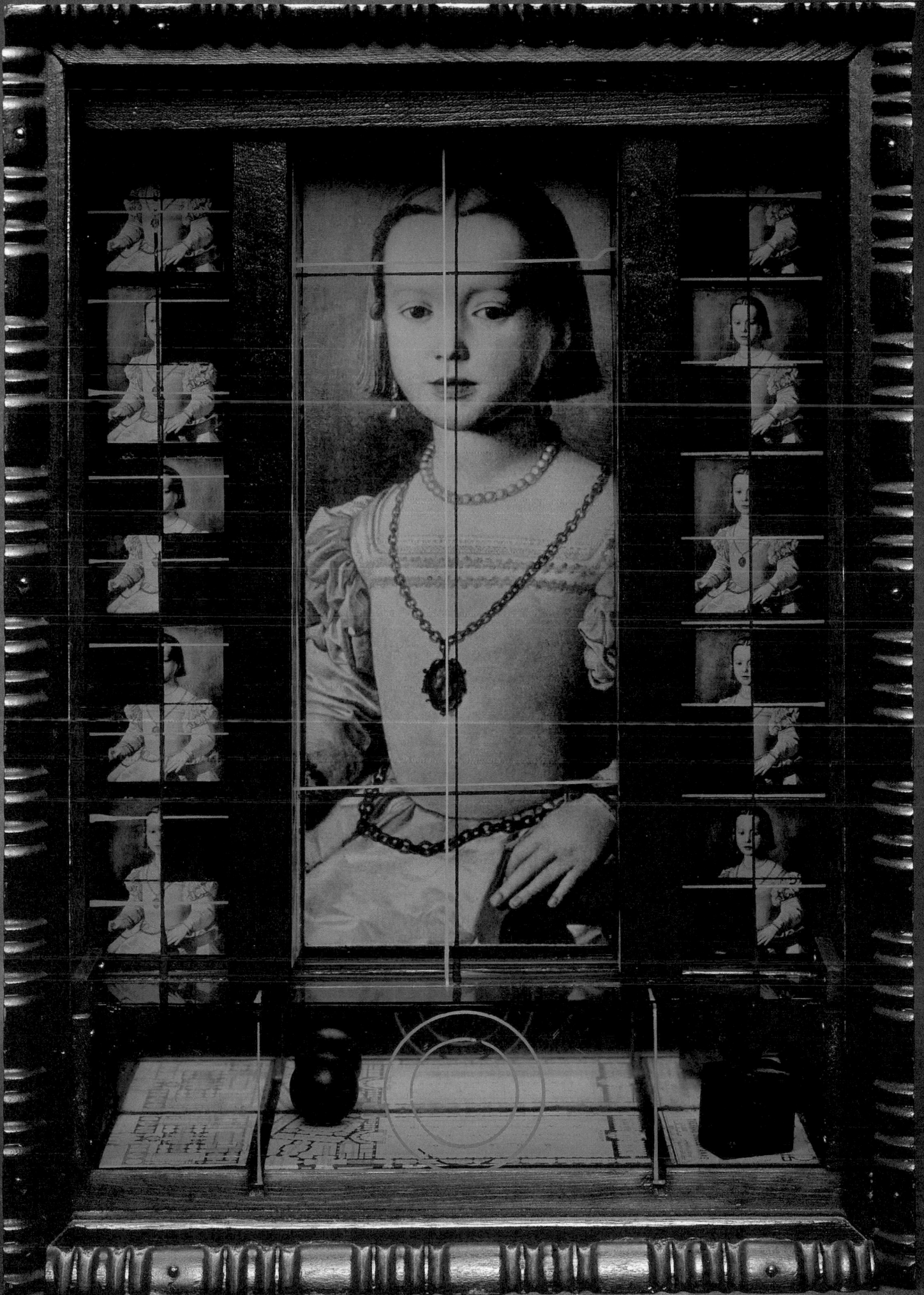

convex mirror with a dark tint used for reflecting landscapes in miniature, show-ing their broad tonal values, and giving them a painterly quality. A tent-size cam-era obscura was briefly a Central Park tourist attraction in the 1860s or 1870s, allowing viewers to regard the park—and other park visitors—without being seen themselves.

CORNELL AND PHOTOGRAPHY

The *Medici* boxes contain multiple reproductions of the same picture, recalling many of the earliest explorations in photography. The photographer Eadweard Muybridge used sequential imagery of human and animal models to convey movement. He invented the "zoopraxiscope," a precursor of the movie projector, which, like a flip-book, projected images in rapid succession.

Untitled (Flemish Princess) (early 1950s) developed out of the *Medici* series. The image of a young girl, from the fifteenth century painting *Mlle. de Moulins* by J. Piel, is repeated sixteen times without variation. The box lacks a central figure, as seen in the *Medici* series. The Flemish princess holds her hands in prayer, but she is provided with a toy, a small wooden ball, in all but two of the compartments.

Cornell objected to any suggestion that his use of multiple imagery was derived from film. Yet the way in which he spliced images and repeated them in differing sizes in the *Medici* series conveys the impression of movement. The tint-ed imagery refers back to daguerrotypes, but they also suggest motion photog-raphy, a medium whose history is linked to film.

Cornell's repetitive imagery foreshadows Andy Warhol's silkscreen multiple images of celebrities such as Elizabeth Taylor, Marilyn Monroe, and Elvis Presley. For Cornell, the repeated image is the starting point for a series of com-plex developments. For Warhol, on the other hand, the repetition of the image is the point. By restating the image Warhol makes a point about the cult of celebrity, as well as suggesting that boredom is a by-product of repetition.

In many ways photography was Cornell's ideal medium. He grew up in an era in which scientific invention was seen as "truth," not viewed with today's skepticism. Photography was a democratic medium, well suited to the tastes of the nineteenth- and twentieth-century middle classes that emerged during the Industrial Revolution. Photography was an invention of both science and art, and it captivated the imagination of artists as diverse as Edgar Degas and Eugène Delacroix, two of Cornell's favorite painters (perhaps because of their devotion to ballet).

One of the great nineteenth-century photographers was the French painter Charles Nègre, whose work was included in the landmark exhibition *Photography 1839–1937* at The Museum of Modern Art in 1937. Many of his pho-tographs are double images for use in a stereoscope, which would combine the two images to create an illusion of depth. Cornell also admired Nadar (Gaspard-Félix Tournachon) for his portraits of Baudelaire, Delacroix, Sarah Bernhardt, Offenbach, George Sand, Jules Verne, and others. In his *"Revolving" Self-Portrait*

(c. 1865), created before Muybridge's motion studies, Nadar placed photographs of himself, shot from different angles, in a sequence that suggests motion.

Cornell explored repetition by using the same imagery and subjects in multiple boxes. This seemed to be in direct contradiction to the care he brought to his work. Cornell explained that he did not make facsimiles, but he did make variations on a theme. His method is not to be confused with that of the Dadaists, for whom mechanical replication was one way to downplay the significance of the unique work of art. Replication was central to Dada—one need only think of Duchamp's multiple versions of the *Boite-en-valise*. Jean Arp, in 1918 to 1919, traced the same drawing over and over again with variations occurring automatically. Whereas many of the Dadaists made use of repetition to disclaim the importance of the unique object, Cornell, without surrendering the concept of the readymade or the altered found object, invested all of his variations on a theme with the characteristics of a unique work.

Repetition was widely popular in painting long before it made an appearance in photography and film. Prior to the nineteenth century, multiple paintings using the same image were common. Chardin and other still-life artists often used the same motifs in several paintings. Cornell deliberately made repetition a feature of his work and unwittingly influenced a generation of artists that followed in his wake.

Cornell's working method necessitated the making of variations. He often began with a recollection of a dream, which inspired him to note it in his diary or gather materials from different sources, the whole taking shape after a long period of gestation in his mind. This process stemmed from the Surrealist belief in using the inner imagination as the starting point for conscious thought. Cornell often spoke of his inability to capture all but a small portion of extravisual material (poetic, emotional—what he termed "ephemera") in his boxes. Variation on a theme became a natural way of working out his frustration. Cornell's reiteration of certain objects such as driftwood, seashells, cordial glasses, nails, stamps, toy blocks, clay pipes, and forms such as circles, cubes, spirals, and arcs was his way of capturing ephemera and holding it fast.

The Surrealists gave Cornell poetic license, as it were, to indulge in a fondness for the esoteric and the commonplace, a taste that should not be confused with the indiscriminate. They systematically stripped an object of its meaning only to replace it with another, more suggestive one. Cornell appealed to the later generation of Pop artists for reasons other than his use of repetitive imagery. They saw in his work, mistakenly it would seem, declassified and desanctified common objects, which is more appropriate to the Surrealists' approach to imagery. But they also admired his work for its poetic resonance, and the way in which he established a dialogue between past and present. Although Cornell's images anticipate the 1960s, his reverence for his subjects and his sense of structure were neither blasphemous like the Surrealists' work, nor kitsch like the Pop artists' ideas. During the 1940s, as Cornell's interest in the anecdotal and the illustrative diminished, the object or image, its texture, color, and structure, gave new meaning to his work. Nowhere is this more evident than in the *Medici* series, which represents Cornell's coming of age as an artist.

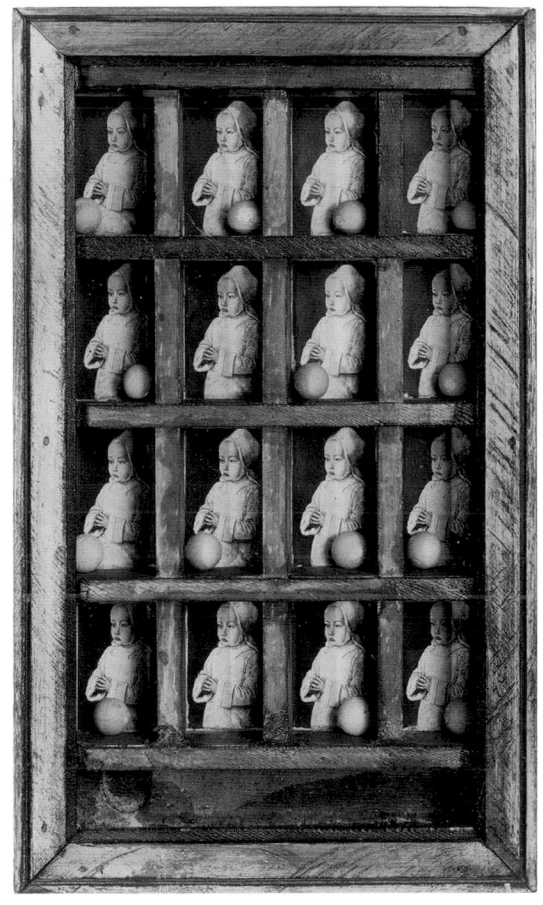

Untitled (Flemish Princess), early 1950s
Construction, 17 x 10 x 2 ½ inches
Private Collection

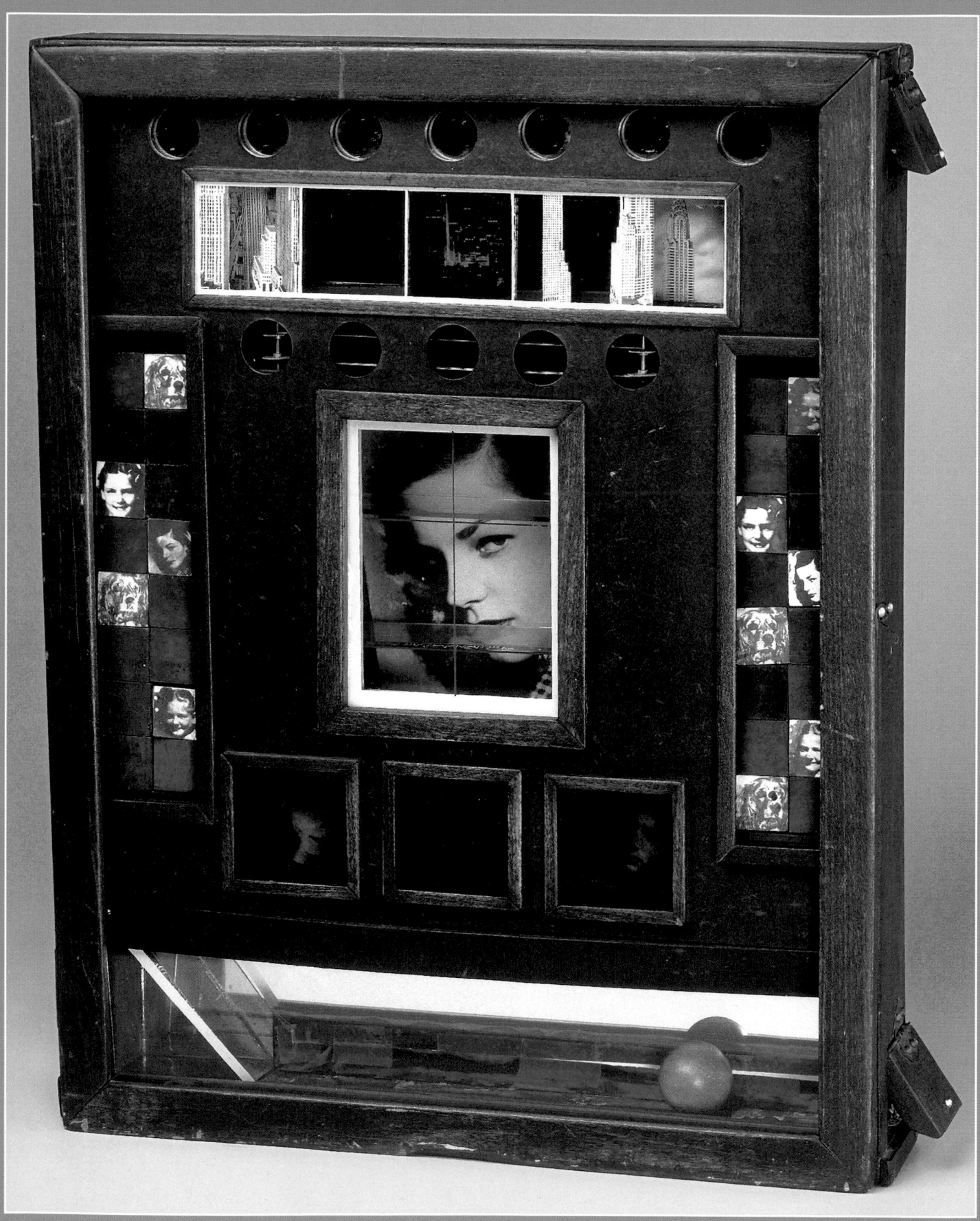

PORTRAITS OF WOMEN 5

In December 1946 the Hugo Gallery held the exhibition *Portraits of Women: Constructions and Arrangements by Joseph Cornell*. Cornell decorated the space with blue velvet, flowers, and birdcages with live songbirds, and renamed the gallery "The Romantic Museum." He also designed the announcement for the show, in which he mentioned the works included. The front cover features a photograph of a young woman, captioned "Unknown (The Crystal Cage)." A youthful photograph of the actress Lauren Bacall is placed inside the announcement, and the back cover features a close-up photo of Bébé Marie, a Victorian doll that had belonged to his cousin.

The exhibition consisted of portraits of opera singers Giuditta Pasta and Maria Malibran, ballerinas Marie Taglioni and Fanny Cerrito, as well as stage and screen luminaries Eleanora Duse, Jeanne Eagles, Greta Garbo, Jennifer Jones, and Lauren Bacall. The portraits took the form of box constructions, objects, or dossiers. The portrait of Malibran was a small construction containing a music box that played music from *La Traviata* with a twirling stuffed bird. The most "finished" works, the boxes, were dedicated to movie stars.

Cornell loved the movies, and like so many others he found them to be a pleasurable escape from home life and the everyday. He enjoyed the comedies of Buster Keaton and Charlie Chaplin, but he was most taken with movies featuring beautiful actresses. He researched their lives in detail, collecting articles and photographs of them. His dossier on Lauren Bacall, entitled *Penny Arcade Portrait of Lauren Bacall (Working Model Based upon "To Have and Have Not")*, was added to and modified from the mid-1940s to 1970. Like his other dossiers, it contains newspaper and magazine clippings as well as publicity photographs, photostats, and working notes related to the actress.

The box construction *Untitled (Penny Arcade Portrait of Lauren Bacall)* (1945–46) combines three of Cornell's interests: the penny arcade, the actress, and the cinema. The penny arcade was one of his favorite childhood pastimes; Lauren Bacall and the cinema his most recent. He saw a poster of Bacall outside the Hollywood Movie Theater on Broadway and 51st Street and was mesmerized by her sultry good looks. In 1944, at the age of nineteen, Bacall became a star after her debut film performance in *To Have and Have Not*. In his diary entry of February 20, 1945, Cornell records that he likes certain close-ups of Bacall in

OPPOSITE:
Untitled (Penny Arcade Portrait of Lauren Bacall), 1945–46
Construction,
20 ½ x 16 x 3 ½ inches
The Lindy and Edwin Bergman
Joseph Cornell Collection, Chicago

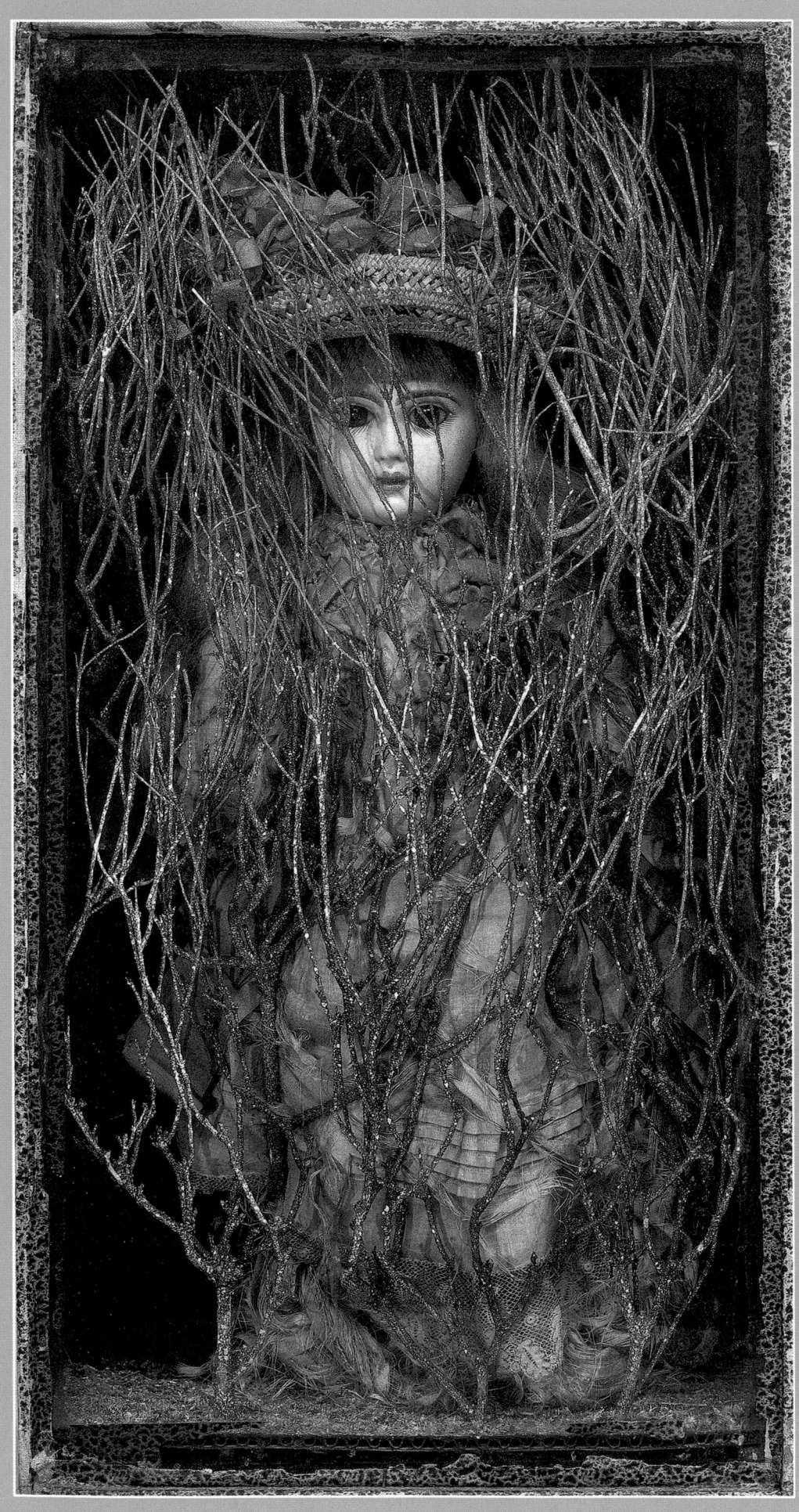

the film and in particular a profile of her face. (He concludes with a note that he bought himself a treat, a rum ring with icing on top, and that his mood was better than average.)[37] From another jotting well over a year later it seems that the box had lain dormant but that Cornell "retrieved" it and became involved with it again, continuing to work on it for some time.[38]

Cornell chose to see Bacall as an innocent, idealized figure. Although she clearly appears sultry and glamorous in the film, and Cornell noted a sullenness in her subsequent films, he described her as having a "Botticellian slenderness . . . with a touch of jeune fille awkwardness." Before and after his *Portraits of Women* exhibition, he paid homage to numerous stars and starlets, including Hedy Lamarr, Marlene Dietrich, Marilyn Monroe, Claire Bloom, Sheree North, France Nyuen, Shirley MacLaine, Jean Seberg, Eva Marie Saint, Mylène Demongeot, and Jacqueline Bisset. Largely because of his preference for silent films, he was particularly drawn to actresses whose faces and mannerisms suggested to him that era's aesthetic taste.

Several years before *Portraits of Women*, Cornell "discovered" Hedy Lamarr in the films *Comrade X* (1938) and *Come Live with Me* (1941). For a 1941 issue of

OPPOSITE:
Untitled (Bébé Marie), 1940s
Construction,
23 ½ x 12 ⅜ x 5 ¼ inches
The Museum of Modern Art,
New York;
Acquired through the
Lillie P. Bliss Bequest

"ENCHANTED WANDERER"

★ Excerpt from a Journey Album for Hedy Lamarr ★

By
JOSEPH CORNELL

Among the barren wastes of the talking films there occasionally occur passages to remind one again of the profound and suggestive power of the silent film to evoke an ideal world of beauty, to release unsuspected floods of music from the gaze of a human countenance in its prison of silver light. But aside from evanescent fragments unexpectedly encountered, how often is there created a superb and magnificent imagery such as brought to life the portraits of Falconetti in "Joan of Arc," Lillian Gish in "Broken Blossoms," Sibirskaya in "Menilmontant," and Carola Nehrer in "Dreigroschenoper?"

And so we are grateful to Hedy Lamarr, the enchanted wanderer, who again speaks the poetic and evocative language of the silent film, if only in whispers at times, beside the empty roar of the sound track. Amongst screw-ball comedy and the most superficial brand of clap-trap drama she yet manages to retain a depth and dignity that enables her to enter this world of expressive silence.

Who has not observed in her magnified visage qualities of a gracious humility and spirituality that with circumstance of costume, scene, or plot conspire to identify her with realms of wonder, more absorbing than the artificial ones, and where we have already been invited by the gaze that she knew as a child.

Her least successful roles will reveal something unique and intriguing — a disarming candor, a naivete, an innocence, a desire to please, touching in its sincerity. In implicit trust she would follow in whatsoever direction the least humble of her audience would desire.

"She will walk only when not bid to, arising from her bed of nothing, her hair of time falling to the shoulder of space. If she speak, and she will only speak if not spoken to, she will have learned her words yesterday and she will forget them to-morrow, if to-morrow come, for it may not."

(Or the contrasted and virile mood of "Comrade X" where she moves through the scenes

* Parker Tyler

like the wind with a storm-swept beauty fearful to behold).

• • • • • • • •

At the end of "Come Live With Me" the picture suddenly becomes luminously beautiful and imaginative with its nocturnal atmosphere and incandescence of fireflies, flashlights, and an aura of tone as rich as the silver screen can yield. Her arms and shoulders always covered, our gaze is held to her features, where her eyes glow dark against the pale skin and

her earrings gleam white against the black hair. Her tenderness finds a counterpart in the summer night. In a world of shadow and subdued light she moves, clothed in a white silk robe trimmed with dark fur, against dim white walls. Through the window fireflies are seen in the distance twinkling in woods and pasture. There is a long shot (as from the ceiling) of her enfolded in white covers, her eyes glisten in the semi-darkness like the fireflies. The reclining form of Snow White was not protected more

lovingly by her crystal case than the gentle fabric of light that surrounds her. A closer shot shows her against the whiteness of the pillows, while a still closer one shows an expression of ineffable tenderness as, for purposes of plot, she presses and intermittently lights a flashlight against her cheek, as though her features were revealed by slow-motion lightning.

In these scenes it is as though the camera had been presided over by so many apprentices of Caravaggio and Georges de la Tour to create for her this benevolent chiaroscuro . . . the studio props fade out and there remains a drama of light of the *tenebroso* painters . . . the thick night of Caravaggio dissolves into a tenderer, more star-lit night of the Nativity . . . she will become enveloped in the warmer shadows of Rembrandt . . . a youth of Giorgione will move through a drama evolved from the musical images of "Also Sprach Zarathustra" of Strauss, from the opening sunburst of sound through the subterranean passages into the lyrical soaring of the theme (apotheosis of compassion) and into the mystical night . . . the thunderous procession of the festival clouds of Debussy passes . . . the crusader of "Comrade X" becomes the "Man in Armor" of Carpaccio . . . in the half lights of a prison dungeon she lies broken in spirit upon her improvised bed of straw, a hand guarding her tear-stained features . . . the bitter heartbreak gives place to a radiance of expression that lights up her gloomy surroundings . . . she has carried a masculine name in one picture, worn masculine garb in another, and with her hair worn shoulder length and gentle features like those portraits of Renaissance youths she has slipped effortlessly into the role of a painter herself . . . le chasseur d'images . . . out of the fullness of the heart the eyes speak . . . are alert as the eye of the camera to ensnare the subtleties and legendary loveliness of her world. . . .

[The title of this piece is borrowed from a biography of Carl Maria von Weber who wrote in the horn quartet of the overture to "Der Freischutz" a musical signature of the Enchanted Wanderer.]

"Enchanted Wanderer":
Excerpt from a Journey Album for Hedy Lamarr
Published in *View*, ser. I, nos. 9–10
(December 1941–January 1942)
Joseph Cornell Study Center,
Smithsonian American Art
Museum, Washington, D.C.;
Gift of Mr. and Mrs. John A. Benton

View he created "'Enchanted Wanderer': Excerpt from a Journey Album for Hedy Lamarr."[39] In this work an essay pays tribute to Lamarr and film in general, accompanied by a montage of the actress. In the essay Cornell compares the nighttime setting and luminosity of *Come Live with Me* to the chiaroscuro in paintings by Caravaggio and Georges de La Tour. Those qualities also inform the photomontage, which features a stock publicity photograph of Lamarr's face superimposed onto a portrait of a young man by Giorgione. Sometime in the summer of 1941 Cornell noted in his diary that he made a trip to The Metropolitan Museum of Art in connection with the article, and he called the picture "the Quattrocento Montage portrait of Hedy Lamarr."[40]

Cornell's diary entries and correspondence are germane to his box constructions, offering clues to the way in which his mind worked. In a letter to Parker Tyler dated July 2, 1941, he claims to have seen Hedy Lamarr bicycle by dressed in fin-de-siècle garb.[41] In other jottings he notes a particularly delicious pastry, mentions the time he spent with the artist Matta (two hours), and a girl that he saw in a window. On another occasion, he dreamt that he showed a collection of old sepia photographs to Eugene Berman, and one of the photographs came to life. In his dream he saw a very young girl posed like a dancer leaning "against a wall holding a long pole at the end of which a pack of cotton glowed with a luminous whiteness."[42] In another note that captures the essence of other boxes and collages he writes: "Yesterday I was trying to fit Hedy Lamarr into Dante Gabriel Rossetti's pre-Raphaelite garden, without success. She was more at-one today with the night sky of the Planetarium."[43] From his dreams and thoughts—from an inanimate object that he found when scavenging, from listening to Debussy or reading Coleridge, from attending ballets or collecting memorabilia about his Romantic ballerinas—Cornell fashioned boxes in which different worlds and different time frames coexist in exquisite harmony.

Cornell created memorials for actresses whom he admired and mourned. He made a number of boxes dedicated to Judy Tyler, a young actress who was a Christian Scientist and was killed in an automobile collision on July 4, 1957. He also mourned the suicide of Marilyn Monroe in the boxes *The Nearest Star* (1962) and *Custodian II (Silent Dedication to MM)* (1963). Monroe does not appear in *Custodian II*, which contains a map of the constellations, a piece of driftwood, a red rubber ball, and a brass ring and chain. The ball evokes Monroe's unhappy childhood; the constellations allude to her life as a "star," and her afterlife as part of the cosmos. Cornell tenderly attempted to mitigate her painful mortal life by creating a new existence for her in the universe.

Marilyn Monroe was a subject for other artists in the 1950s and 1960s. Willem de Kooning was fascinated by Monroe and titled a 1954 canvas after her. Andy Warhol created some of his most famous paintings using her image. He saw Monroe as the ultimate emblem of pop culture and celebrity. The popular image of Monroe is close to de Kooning's many images of women: breathless and chatty, sexual and vulnerable, and hardly ever innocent. De Kooning accentuated the eyes, lips, breasts, and genitals, using active brushstrokes to delineate the ferocious sexuality of the female form. Warhol's and de Kooning's

OPPOSITE:
Custodian II (Silent Dedication to MM), 1963
Construction, 17 ⅞ x 12 ⅛ x 4 ¹⁵⁄₁₆ inches
Private Collection

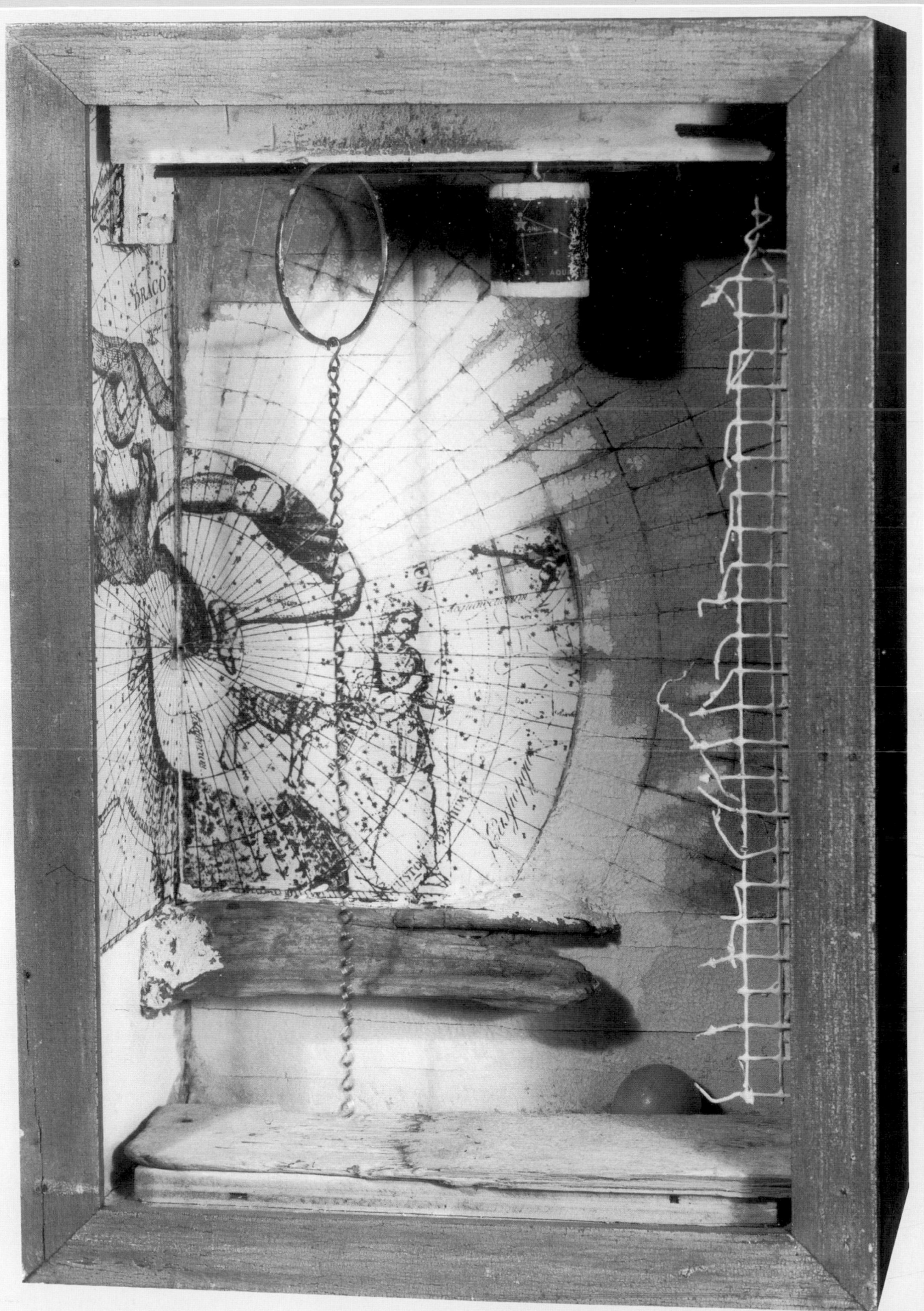

images of Monroe could hardly be more different from Cornell's sad and touching work.

Cornell's portraits of women also included works dedicated to personalities other than actresses and dancers, such as the poet Emily Dickinson. A kindred spirit, Dickinson never married and lived a secluded life. Her work was heavily influenced by her Puritan upbringing and the Book of Revelation as well as by the Metaphysical poets of seventeenth-century England. She admired the poetry of Robert and Elizabeth Barrett Browning and John Keats. When she was in her thirties, Dickinson began to withdraw from people around her, communicating with friends through her letters, often enclosing poems. Her poems were short, often obscure, and deceptively simple. Her poetry reflects her loneliness and despair, and the conflict in her between the prison of her existence and the sensual delights of the flesh, which she relates in her poem "Blue Peninsula."

Cornell's *"Toward the Blue Peninsula" (for Emily Dickinson)* (1953) is as spare as Dickinson's poem, which he used as the dedication for his box. It consists of an empty cage occupied only by a piece of wire mesh, a dowel, and two pieces of wood, all painted white as is the box interior itself. The mesh, which often was featured in Cornell's constructions of this time, is a visual metaphor for the poet's reclusive, solitary life. However, into the rear wall of the box Cornell has cut an aperture into the blue sky. He frees his beloved Emily from her confinement, as he might have wished to free himself.

The "Unknown" woman on the cover of the *Portraits of Women* announcement refers to *The Crystal Cage (Portrait of Berenice)* — an exploration that Cornell assembled about an imaginary child whom he named Berenice. In 1942 he had created a collage portrait of Berenice that was published in *View* in January 1943 (see Chapter 9 for discussion of this work). For this exhibition, Cornell promised new "documents, photographs, prints and memorabilia" relating to subjects such as aerial flights, balloons, constellations, Queen Mab, dovecotes, tropical birds, chains of glass, and camera obscura. A photomontage of film stills of the young star Deanna Durbin is part of the portrait of Berenice in *The Crystal Cage*. Cornell rendered Berenice "real" by creating a montage of images he cherished: children, angels, hot-air balloons, zeppelins, cats, and stars, centered around an engraving of a female child caught in the act of drawing. Also included were newspaper articles featuring headlines about the war, a blackout in Brooklyn, a rabbit, and a new star exploding in the heavens. In addition to the hot-air balloon and the zeppelin, Cornell added a handwritten note listing Naples, Amalfi, Rome, Florence, and Bologna, as if to suggest places where Berenice might have traveled. All of these items were kept in a papered wood valise.

Portrait of Berenice echoes the photographs Charles Lutwidge Dodgson (Lewis Carroll) took of Alice Liddell. His most famous photograph of Alice dressed as a beggar reveals the young girl in a state of innocence and suggestiveness. The eroticism in his photographs is far more evident than in any of Cornell's work, but both the Victorian Dodgson and the latter-day Victorian Cornell were undeniably attracted to the compelling sexual promise of young girls on the verge of puberty. Neither artist acted on his feelings but the sense of

OPPOSITE:
"Toward the Blue Peninsula"
(for Emily Dickinson), 1953
Construction, 14 ½ x 10 ¼ x 5 ½ inches
Collection Robert Lehrman,
Washington, D.C.

repressed desire toward the child-woman is evident in their work. Cornell, it seems, with some regret and much anguish, put aside his longings only to have them resurface in his work. All of his work is tinged with desire, none more than his portraits of movie stars, ballerinas, and children.

At first glance, Cornell's choice of images for the Hugo Gallery brochure seems innocuous. Closer inspection, however, reveals a connection between Bébé Marie, Lauren Bacall, and the unknown woman. They represent three stages of development: the doll represents childhood, Bacall youth, and the unknown woman maturity. In the Victorian era and in Christian Science thought, children existed in a state of grace. Cornell saw his own childhood as a state of grace and perpetuated his memories of that time in his work. He bid farewell to his childhood when he "buried" Bébé Marie by enclosing her in a box construction (page 80).

Cornell's relationship to women was one of intensity and distance. He desired them from afar, and he idealized and objectified them by including their image or their surrogate in his boxes. Movie stars were his ideal inamoratas. Those that he occasionally saw in the flesh, like Marlene Dietrich, excited him, but the moment was fleeting and he could only possess the memory of her. He formed friendships with the ballerinas Tamara Toumanova and Allegra Kent, and he created portraits of them as well, but his most fulfilling artworks were dedicated to women about whom he could only dream.

OPPOSITE:

Collage for *The Crystal Cage*
(Portrait of Berenice), c. 1942
Reproduced in *View*, ser. 2, no. 4 (January 1943)
Collection Richard L. Feigen, New York

THE AVIARY SERIES

In December 1949 Cornell showed twenty-six constructions in the exhibition *Aviary by Joseph Cornell* at the Egan Gallery. In his preface for the exhibition brochure, Donald Windham writes that birds are "remarkable for the distances they travel, for their faculty, incomprehensible to man, of knowing the relations between remote places."[44] Having explored Renaissance Italy in his *Medici* boxes, and in keeping with his interests in natural phenomena, Cornell turned at this time to an exploration of birds in their habitats and in their travels. Windham sees in these birds "caught and caged girls from Ovid's Metamorphoses: Arne, turned into a black-winged, black-footed daw the color of the gold she sought, and in the white, seemingly abstract and empty cages, Semiramis, the Queen of Babylon transformed into a pure white dove, or Cygnus, his limbs hidden in snowy plumage. . . ."[45]

Although Cornell had featured engravings of birds or actual birds that he purchased from taxidermy shops in earlier boxes, such as *Untitled* (1942) and *Untitled (The Hotel Eden)* (c. 1945; page 91), this was his first exhibition devoted solely to the subject. The 1942 box resembles exhibits at the Museum of Natural History; *The Hotel Eden*, with its music box and hotel advertisement, is a precursor to the late 1940s and early 1950s constructions. The boxes in the Egan Gallery exhibition focused on birds in a habitat or arcade, or simply the birdcage itself.

Cornell was familiar with the symbolic meanings of birds. Their flight path links heaven and earth; like butterflies, small birds symbolize souls (more specifically children's souls) freed from their earthly bonds and flying back to their heavenly home. The bird is a symbol of heaven, in opposition to the serpent, a symbol of earth. Birds also at times represent angels because of their wings. The innumerable bluebirds in Chinese literature of the Han period are fairies, immortals, and heavenly messengers.[46] They can also symbolize freedom.

Cornell was also familiar with the Surrealist symbolism of both the bird and the birdcage. Max Ernst created a bird alter ego, Loplop, which he often included in his artwork. Magritte painted a birdcage in place of an upper torso and a head (intellect) in *Therapeutic II*, 1937. The birdcage is used to symbolize a kept woman, which may very well be the meaning of Andre Masson's *Mannequin* (1938), a female mannequin that featured a birdcage placed on her head and a G-string embellished with glass eyes.

In the nineteenth century British artists William Hogarth and William Holman Hunt, artists Cornell admired, and others used birdcages in their paintings. Cornell had seen Hogarth's painting *The Graham Children* (1742), at the 1939 World's Fair, in which a birdcage is prominently depicted. Given the death of the youngest child in the Graham family, who is portrayed alive in the painting, it seems likely that the birdcage represents a kind of inner world, in this case the fragile shelter of childhood, where youth (the bird) is threatened by both time

OPPOSITE:
Untitled, 1942
Construction, 13 ⅛ x 10 x 3 ½ inches
Collection Robert Lehrman,
Washington, D.C.

(the clock on the mantle) and mortality (the clock features Cupid holding a scythe; next to it is an hourglass).

Both *Aviary (Parrot Music Box)* (c. 1949) and *Untitled (Aviary Parrot Box with Drawers)* (1949) are created out of a type of cabinet used to house hardware, which may account for the machine parts, music box, clock faces, drawers, small boxes, and dowels. Each contains a colorful engraving of a bird, mounted on wood, which is perched on a branch. A box made after the Egan Gallery exhibition, *Grand Hôtel Semiramis* (1950; page 94) was undoubtedly inspired by Windham's description of the Queen of Babylon transformed into a pure white dove. According to legend, Semiramis was a mythical Assyrian queen noted for her beauty and wisdom who, after a long and prosperous reign on earth, took on the form of a dove.

Semiramis is a myth that attracted artists as diverse as the eighteenth-century composer Christoph Willibald von Gluck and the twentieth-century Symbolist poet Paul Valéry. In Cornell's interpretation, a parrot, known as love's messenger, replaces the dove. Into a stark white habitat with white-wire mesh Cornell introduced the green parrot, three blue marbles, and a bowl with blue liquid. All that he needed to add was a label, "Grand Hôtel Semiramis," to conjure up an exotic hotel in a far away place linked to the flight path of birds.

Cornell's art was generally apolitical, but the *Aviary* series features two political works. *Habitat Group for a Shooting Gallery* (1943; page 95) is an emotional response to World War II. A bullet has shattered the glass, and behind the birds splashes of vivid color represent blood. Fragments of newspapers and feathers lie at the bottom of the box. The bullet hole acts as the unifying factor in the formal composition, tying the multiple elements together. It controls the direction the eye takes, guiding it clockwise to all four corners of the box. An illusion of depth, produced by the overlapping of the birds on the printed matter, is denied by the two-dimensionality of the birds themselves. *Isabelle (Dien Bien Phu)* (1954; page 96) recounts the French defeat in Indochina. On the lower left corner of the back of the box, Cornell attached a newspaper clipping that details the massacre of 2,000 French Legionnaires at the hands of the Communists at the outpost Isabelle. Inside the box, a parrot is trapped behind shattered glass. Evidence of the massacre is seen in the stains and spots on the rear wall. Unlike the serene birds of contemporaneous boxes, this parrot's beak is open as if to cry out against the devastation.

To Cornell the birdcage was a symbol of loss—loss of innocence and loss of freedom. *Deserted Perch* (1949; page 97) and other works (such as *Chocolat Menier*, 1952) are notable for their incorporation of emptiness—the vacuum of an action that has occurred, of birds that have flown from the cage. A few feathers in the *Deserted Perch* are all that is left of the departed bird. Color is almost nonexistent, kept to small touches in the use of print, string, and feathers. The austerity of these *Aviaries* contrasts with the lively and colorful role of birds in *Grand Hôtel Semiramis* and other constructions.

Untitled (Forgotten Game) (c. 1950; page 99) restates the game theme of earlier works such as *Swiss Shoot-the-Chutes* and *Penny Arcade Portrait of Lauren Bacall*

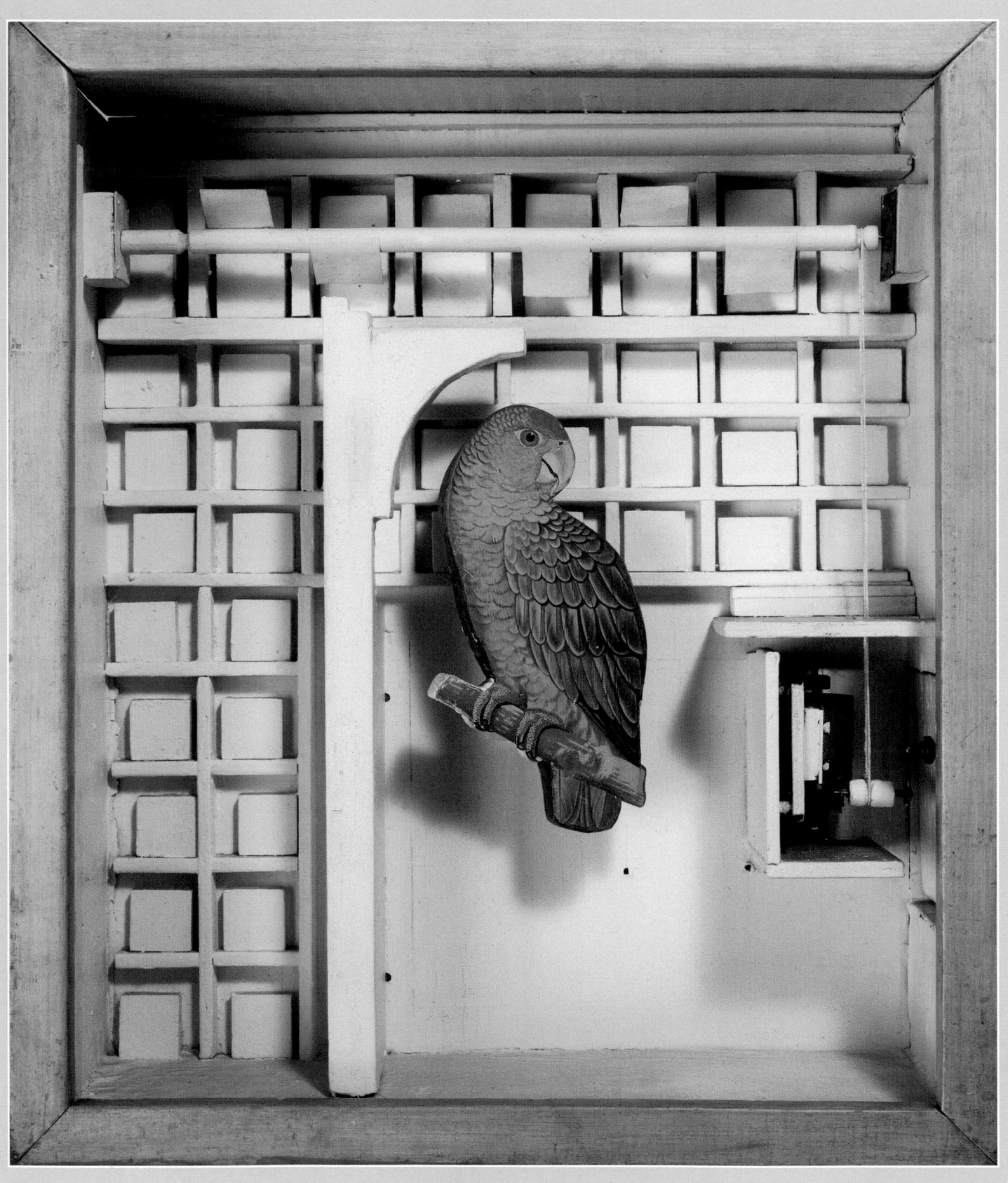

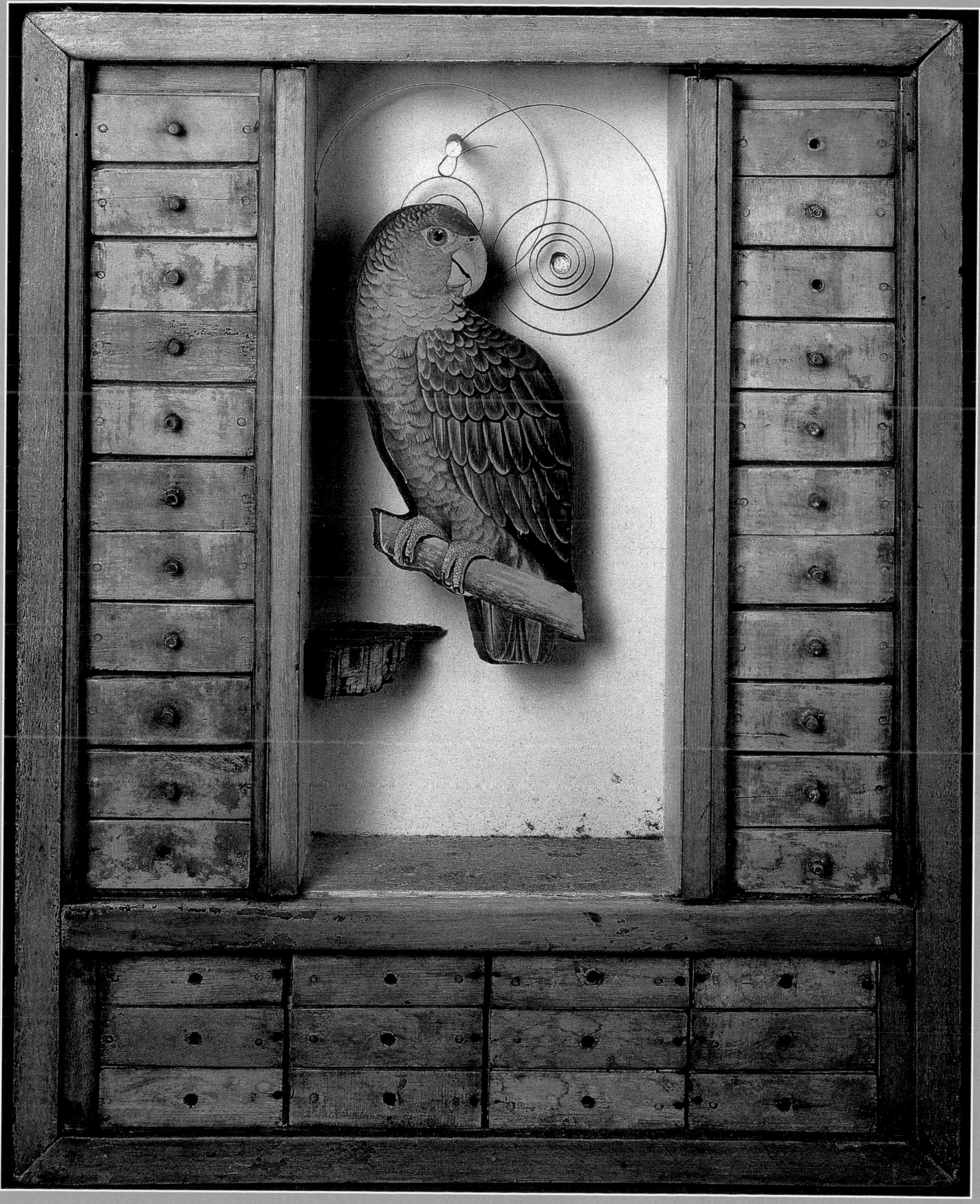

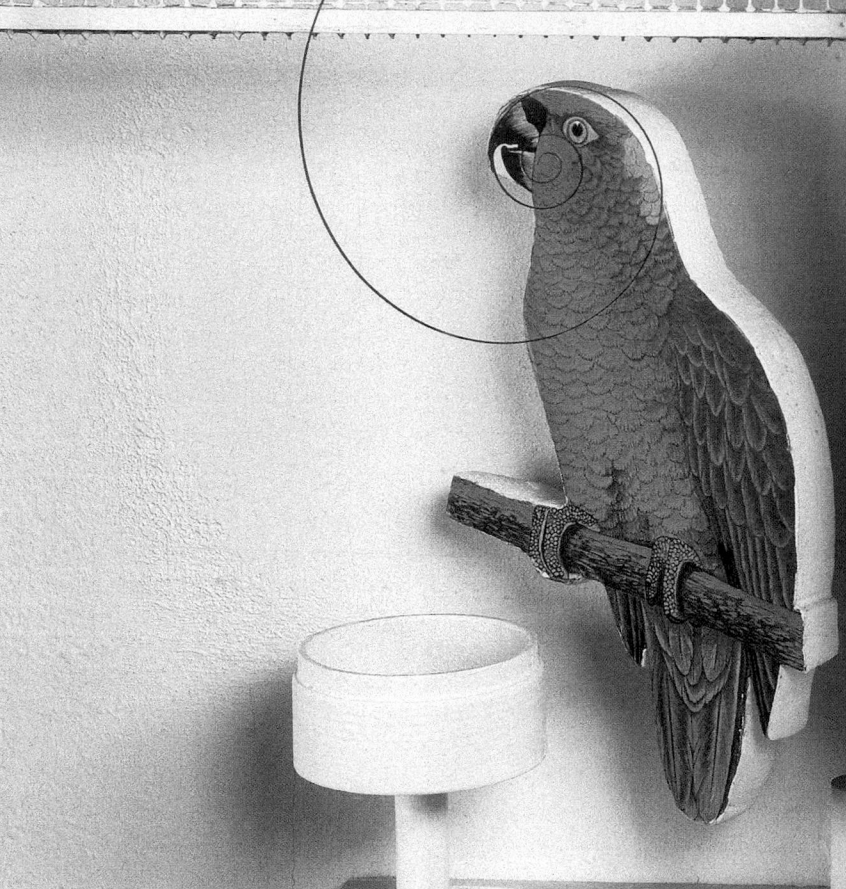
Grand Hôtel Semiramis

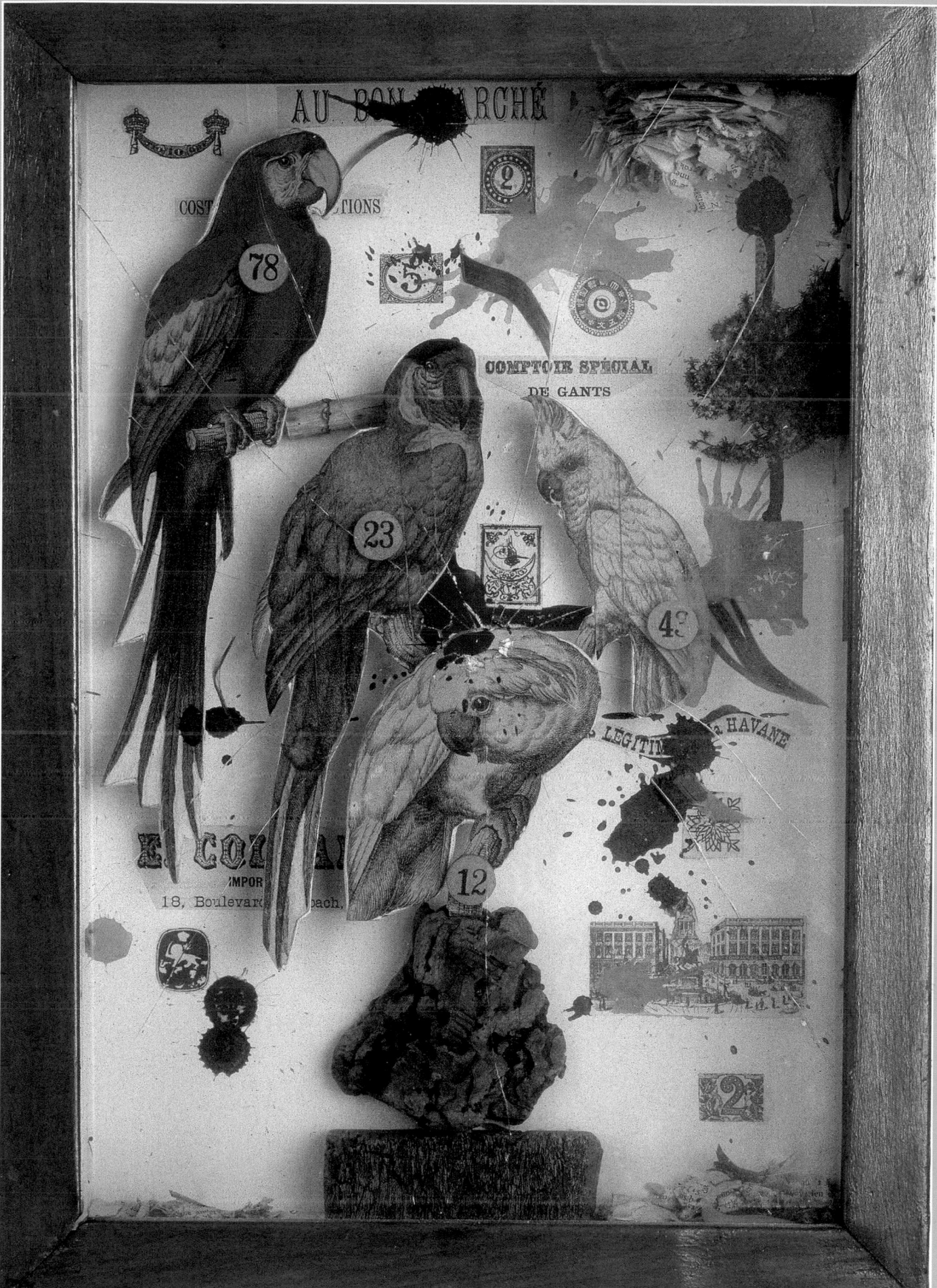

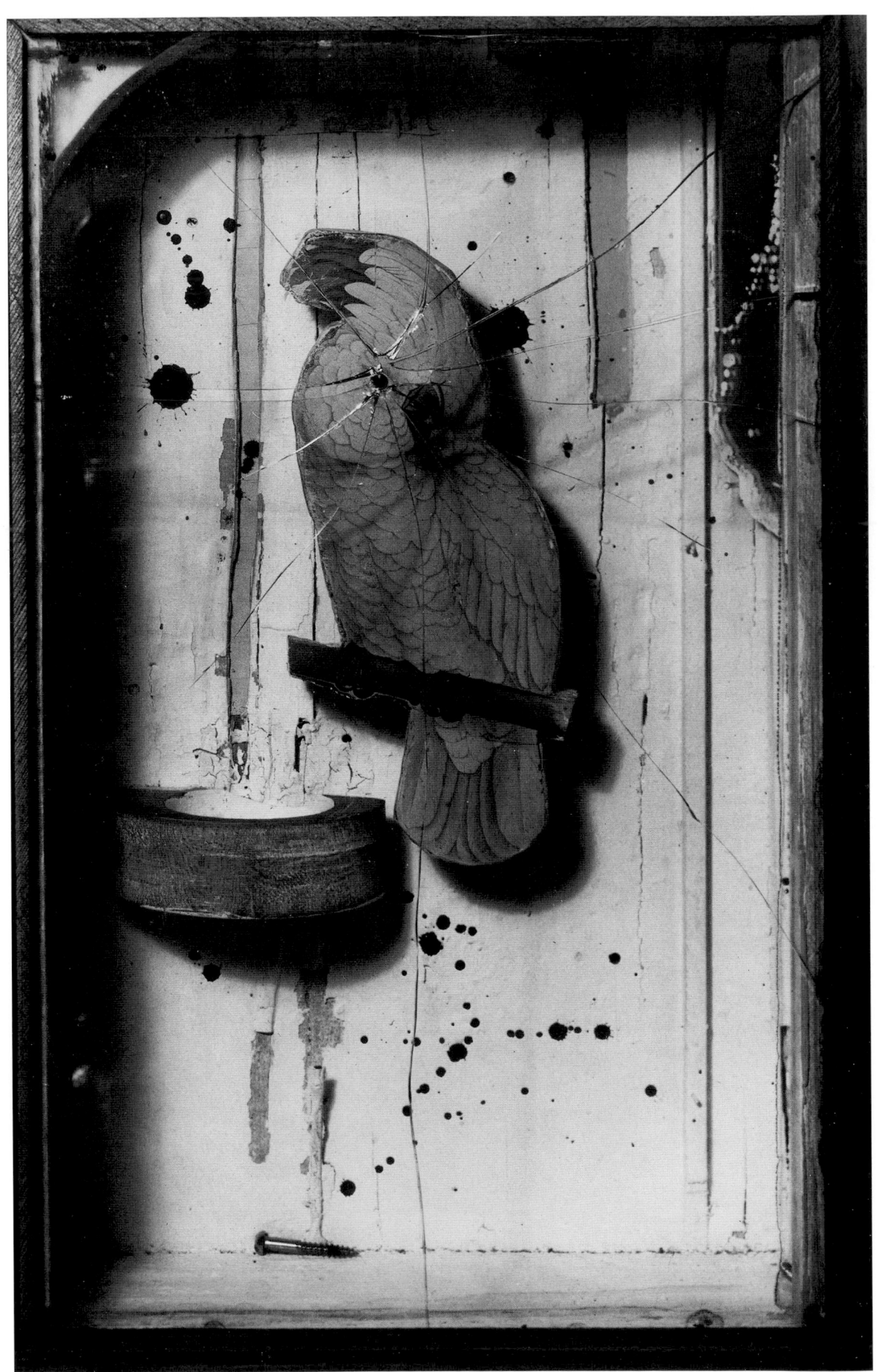

Isabelle (Dien Bien Phu), 1954
Construction,
18 x 12 x 6 inches
The Saint Louis
Art Museum;
Funds given by
the Schoenberg
Foundation, Inc.

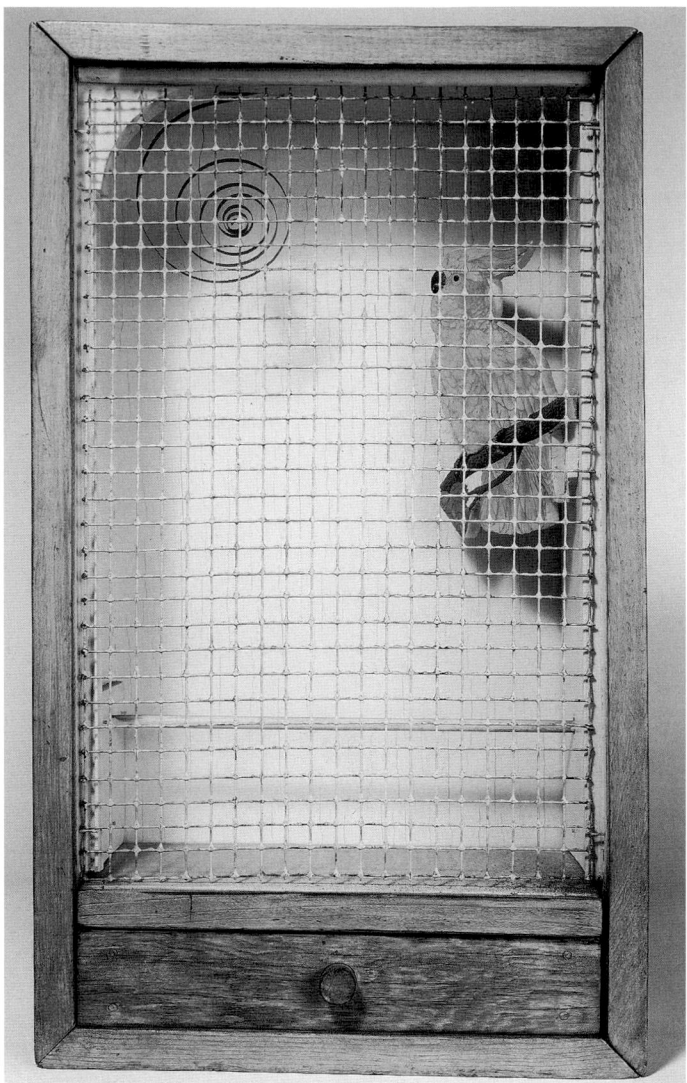

Keepsake Parakeet, c. 1949–53
Construction, 20 ¼ x 12 x 5 inches
Collection Donald Windham,
New York

PAGE 97:
Deserted Perch, 1949
Construction, 16 ½ x 13 x 4 inches
Private Collection

(see pages 55, 78). In the interior of *Forgotten Game,* Cornell constructed a ramp that a ball descends, striking a series of bells in its path until it reaches the bottom of the box. By the late 1920s Alexander Calder created his first mechanized work, a hand-cranked sculpture of two wire goldfish, but Cornell was very early in incorporating sound, light, and movement into the narrow confines of his constructions. The blue rubber ball contrasts with the yellow of the birds, in a composition that reflects Cornell's favorite color scheme.

The birds in *Forgotten Game* and the 1942 *Untitled* are reproductions of nineteenth-century engravings by John James Audubon. The precise repetition of the graded circles is offset by the peeling surface that surrounds them. Cornell often left his boxes outside to weather. He also spoke fondly of buildings in the process of demolition, finding beauty in the fading colors, in the warmth of human association, and in the fragments of decay and destruction. In this respect he echoes Kurt Schwitters, for both had a fascination with the found object and used bits of glass, threads, old papers, labels, and other discards to convey the dimension of time in their work.

In the mid-1940s, like many of his colleagues in the art world, Cornell began to explore pure abstraction. *Multiple Cubes* (1946–48) is one of the earliest works to come out of these investigations, and it shows references to Mondrian's grid paintings. Mondrian arrived in New York in October 1940. He moved in the same circles as Cornell and knew many of the same artists, including Ernst, Matta, Masson, Berman, and Tchelitchew. Cornell's attraction to the Dutch artist was probably enhanced by Mondrian's interest in theosophy. The classical purity of Cornell's box constructions and their gridlike structure reflects Mondrian's signature style, as well as his frequent use of white as the dominant color and the primaries blue and yellow as secondary elements. As Robert Motherwell noted in 1942, Mondrian used color and space to communicate feeling, and "a definite and specific and concrete poetry breaks through his bars, a poetry of constructiveness . . . and, above all, of an implacable honesty."[47] Motherwell's description of Mondrian represented a sensibility—his own, Cornell's, and others'—that sought to combine space and color relations with the alchemy of strange symbols that speak to one another.

In *Multiple Cubes,* white wooden cubes move freely about in their separate cubicles, a series of compartments created by a skeleton of horizontal strips bisected by smaller vertical ones. This grid structure, an extension of the reticulated black lines superimposed on the Medici boy, here functions in a purely plastic context. The strict formality of the grid, however, is relieved somewhat by the fact that the cubes are not attached to each compartment, introducing the elements of chance and movement. In a diary notation from August 15–17, 1946, Cornell writes, "Mondrian feeling strong." Cornell was working on his "box with 35 identical 3/4" <u>white</u> cubes . . . ,"[48] which might be a reference to this work, although the number of cubes is different.

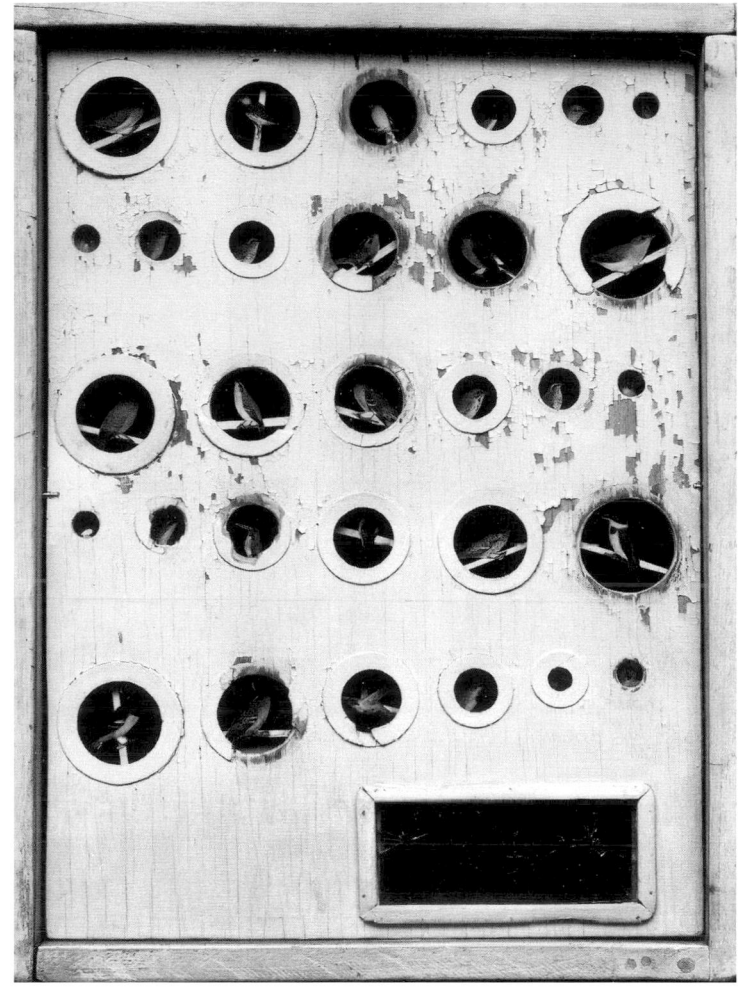 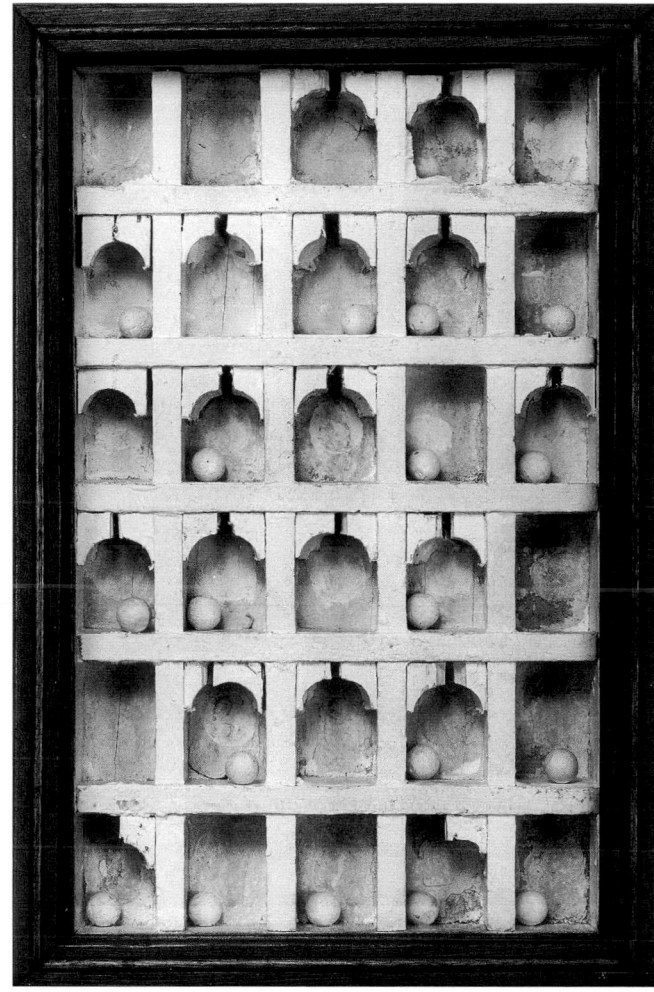

LEFT:
Untitled (Forgotten Game), c. 1949
Construction, 21 ⅛ x 15 ⁹⁄₁₆ x 3 ⅞ inches
The Art Institute of Chicago;
The Lindy and Edwin Bergman
Joseph Cornell Collection, Chicago

RIGHT:
"Dovecote" (American Gothic), 1954–56
Construction, 17 ¾ x 11 ½ x 2 ¹¹⁄₁₆ inches
Private Collection

Among other major works of the 1950s are the *Dovecotes*, a series of severely ordered and abstract boxes whose formal purity is often offset by the element of play. Cornell said that Emily Dickinson's writing inspired the *Dovecotes*. In the 1952 *Dovecote* (page 103) three wooden balls offset the placement of open and closed holes. Painted white, the balls roll around the interior recesses of the white box and finally come to rest, as they would in an actual game. A similar box, *"Dovecote" (American Gothic)* (1954), consists of thirty compartments, many of which contain a small ball. These too move around within their compartments when the box is handled.

The rectilinear construction of the *Dovecote* boxes, like *Multiple Cubes*, also resembles the grid paintings of Mondrian that were executed while he lived in New York. Mondrian's paintings are decidedly architectonic and were influenced by buildings he saw in Manhattan. In a diary notation of January 2–3, 1950, Cornell writes, "the <u>whiteness</u> and imagery of the Thibault supplemented thoughts about working on the bird boxes with their 'architecture,'"[49] referring to Jean-Thomas Thibault, who wrote a book on perspective in the nineteenth century. In an *Art News* review, Tom Hess wrote, "[T]hese sunbleached and white-washed boxes filled with drawers and birds and little springs and mirrors have a strict honesty, a concentration on texture and ordering of space"[50] The earlier interest that Cornell displayed in literary detail was replaced by an abstract arrangement of forms, a play of line, volume, and shape that is breathtaking in its

Untitled (Multiple Cubes), 1946–48
Construction, 14 x 10⅜ x 2⁹⁄₁₆ inches
Robert H. Bergman, Chicago

A Parrot for Juan Gris, Winter 1953–54
Construction, 17¾ x 12³⁄₁₆ x 4⅝ inches
Collection Robert Lehrman,
Washington, D.C.

beauty and simplicity. Cornell was pleased to hear de Kooning comment favorably on the structure of these boxes.

In the 1950s Cornell created a series of bird constructions in honor of Juan Gris, whose work he became immersed in at this time. He had seen the Spanish artist's *Figure Seated in a Café* (1914) at the Sidney Janis Gallery. The Cubist paintings and collages of Gris, which are as structured as those of Mondrian, are notable for their planar dimension, drastic simplification of forms, and rectilinear symmetry of horizontals and verticals offset by a curve. The deliberate ambiguity between the object and its surroundings that Gris cultivated in his works was an important part of their attraction.

In *A Parrot for Juan Gris* (1953–54), Cornell papered over the inside walls with French newsprint. The main actor in this drama is a white cockatoo surrounded by some of Cornell's favorite toys: a metal ring, a piece of string, a wooden dowel, and a cork ball. In this and other works in the series, Cornell created subtle accents with texture and color, but the two-dimensional image of the bird is confounded by the piece of wood with which it is backed and the dowel on which it is perched. Cornell backed all of his birds, but in this series the image of the cockatoo seems compatible with the newsprint until one is apprised of the wood backing and the "cast shadow" that Cornell created from a piece of black paper.

In his *Juan Gris* series, of which there are at least fifteen boxes and several collages extant, he addresses his own and Gris's formal concerns, cleverly appropriating details from Gris's paintings to make his own statement about *papier collé*. Even so, Cornell could not resist a little bit of whimsy, adding a metal or plastic ring, stamps or hotel advertisements, a billowing blue sky or a piece of pink paper, a dangling cork or rubber ball. In other boxes dedicated to Gris, Cornell used mirror fragments to enhance the dimension of space and to multiply images. The double image that results from his use of mirror removes his beloved cockatoos and parakeets from the realm of the tangible world and situates them in the realm of enlightenment. As Chevalier and Gheerbrant have noted,

> *The mirror's task is not simply to reflect an image. When the soul becomes a perfect mirror, it becomes part of the image and, through becoming part, undergoes transformation. There therefore exists a relationship between the object contemplated and the mirror which contemplates it. In the end the soul becomes part of that beauty to which it exposes itself.*[51]

In Cornell's work the mirror represented much more than an aesthetic device. He was fully aware of the role that the mirror played in art, signify-

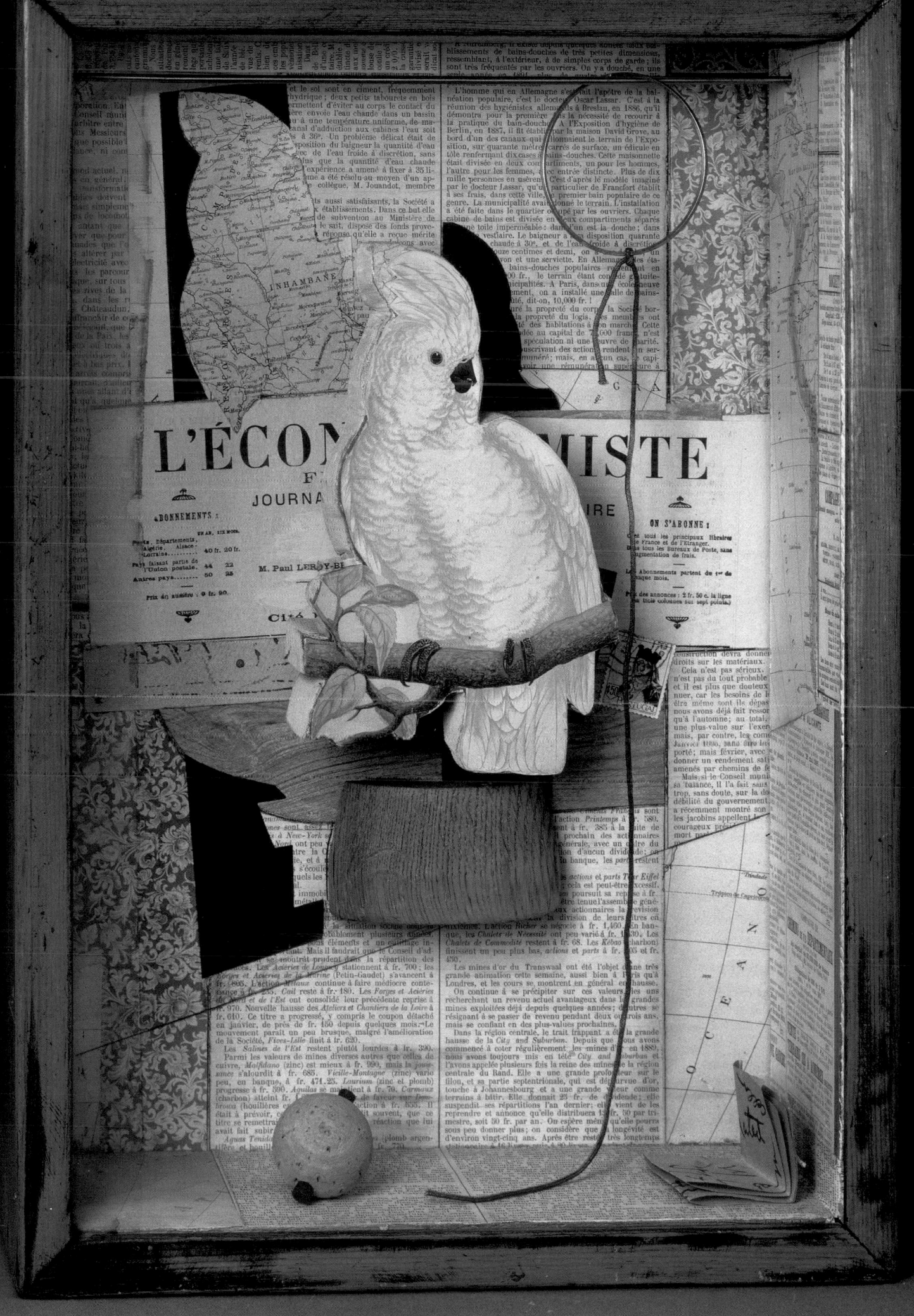

Untitled (Owl), c. 1948–50
Construction, 11 ¼ x 5 inches
The Lindy and Edwin Bergman
Joseph Cornell Collection, Chicago

ing such disparate subjects as vanity and the soul. If the bird symbolizes the soul, and the soul becomes a perfect mirror, then the transformation from substance to spirit in Cornell's work is complete.

Cornell's *Owl* boxes date from the mid-1940s and form a subset within the larger group of bird boxes. On one of his many trips into the countryside from his home in Queens he gathered wood, bark, and grasses. In a diary entry Cornell excitedly recorded one of these trips:

> . . . *the many trips made by bicycle gathering dried grasses of different kinds, the fantastic aspect of arriving home almost hidden on the vehicle by the loads piled high. The transcendent experiences of threshing in the cellar, stripping the stalks onto newspapers, the sifting of the dried seeds, then the pulverizing by hand and storing in boxes. These final siftings were used for habitat (imaginative) boxes of birds, principally owls. The boxes were given a coating of glue on the insides then the grass dust thrown in and shaken around until all the sides had an even coating*[52]

As in the other boxes, *Untitled (Owl)* (c. 1948–50), features a paper cutout of an owl mounted on wood and perched on a piece of bark with fungi, creating a setting that evokes its natural habitat, the forest. A nocturnal bird, the owl is often equated with ghosts and with the souls of the dead. It is also a symbol of wisdom; in ancient China the owl was sacred to the solstices and to metal workers, presiding over the days on which the metalsmiths made magic mirrors.[53] Both the box and its inhabitant evoke a sense of the earth, nature's wonders, and the mystery of the forest.

In a letter to the poet Marianne Moore dated November 1, 1946,[54] Cornell thanks her for reminding him of the power of enchantment that the mind possesses. He felt that some of that enchantment is captured in the *Owls*, a number of which were slated for exhibition at the Hugo Gallery later that year. In an earlier diary notation from that spring, Cornell described a "'discovery' for the owl* boxes in progress—particularly fine example of rotted tree from which a piece of bark and clinging trailing shrubbery branches had fallen. Took off by the handful the wood from outer part of trunk which was in powder state—lined box that evening and added powdered wood to Natural History boxes (working materials). Gave me great deal of happiness the spontaneity of this experience."[55]

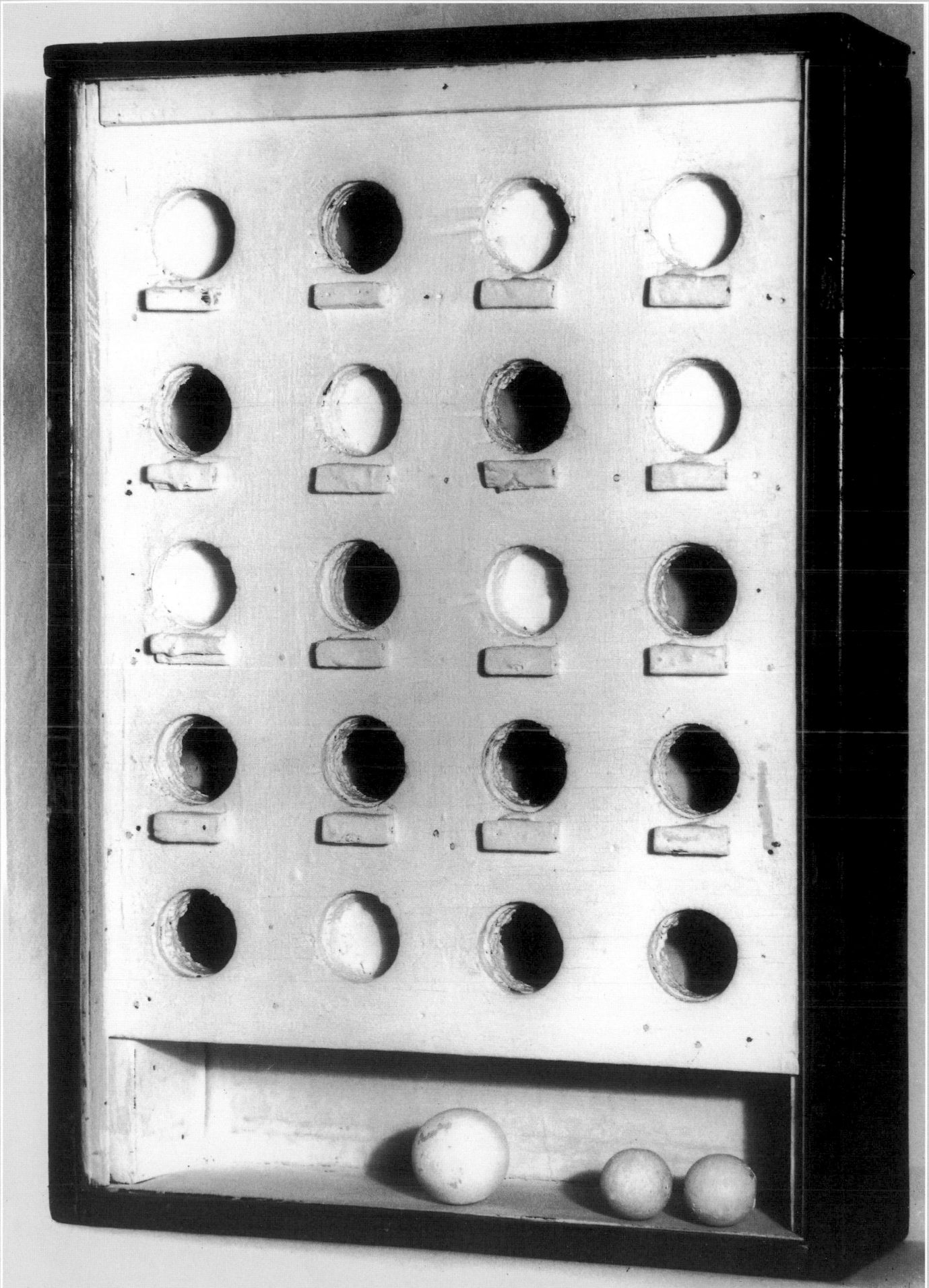

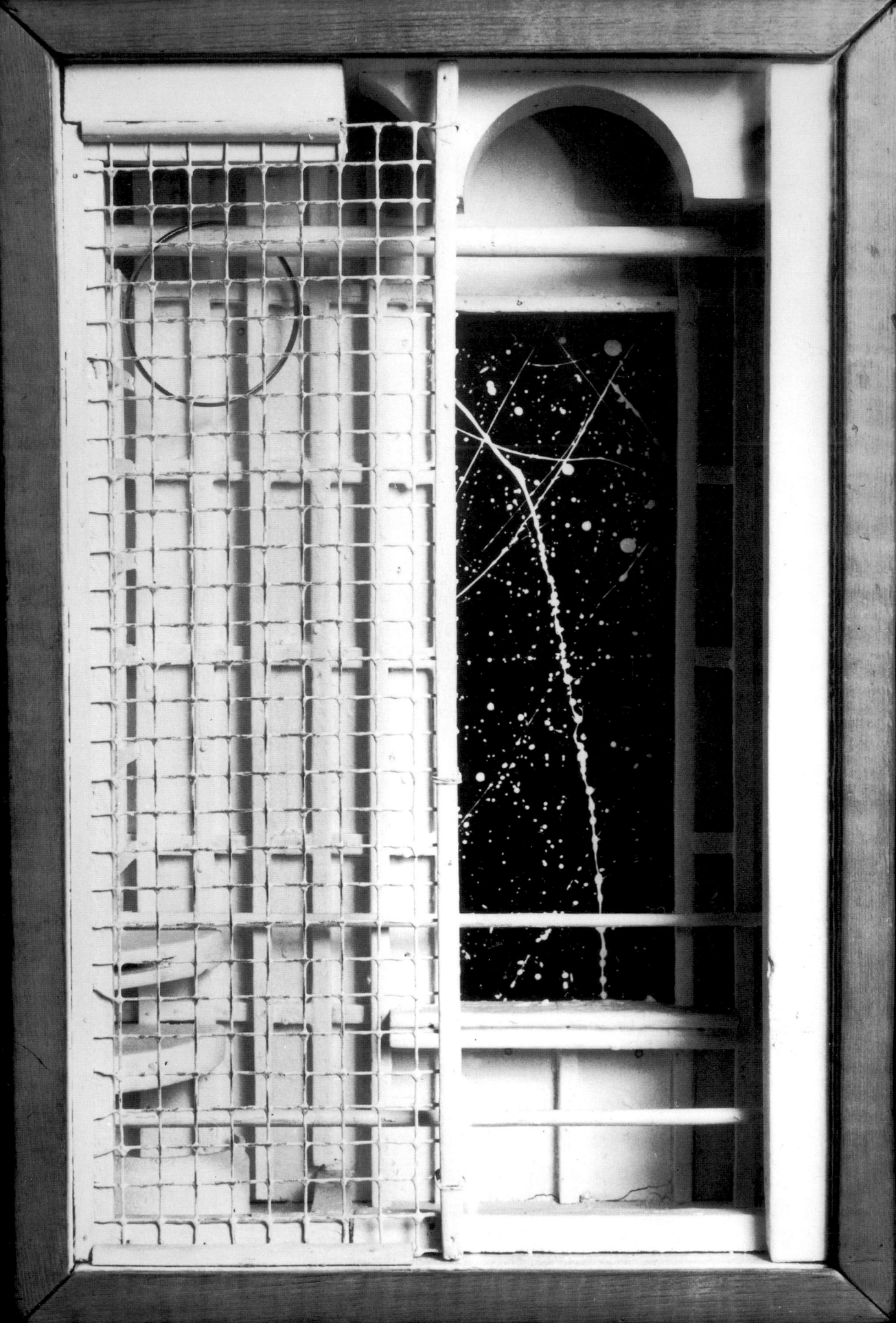

Although Cornell continued to work on bird themes well into the 1950s, he began to focus on several new series. His *Observatories*, *Night Skies*, and *Hotels*, which date from the early to mid-1950s, are richer, more sensual, and more painterly than the bird habitats. As in all of Cornell's mature work, these boxes have a clarity of structure and image that serves to reinforce rather than undermine their dreamlike feeling of unreality—a trait that Cornell's boxes share with the paintings of Magritte. Their surfaces are coated with thick white paint, and placed inside, with an impeccable sense of order, are pieces of wire mesh, mirror fragments, stamps, and advertisements for hotels and pensiones. The back walls, like windows looking out on the heavens, show astronomical maps or starry skies.

Cornell was very interested in the studies of Johannes Kepler. At the end of the sixteenth century, Kepler was in contact with Galileo, who had made a number of celestial discoveries with the telescope. Both men believed in the Copernican system that the earth and the other planets revolve around the sun. Kepler advanced his own theories about the planets in *Astronomia Nova*, published in Prague in 1609. Kepler refuted the idea that the planets rotated on circular orbits. Instead he stated that the planets move in simple elliptical paths, and the sun occupies one of the foci of each elliptical orbit.

He posited the theory, compatible with observations, that "a single geometric curve, not combined with any other curves, and a single law of motion were sufficient to allow the positions of the planets to be predicted." Equally important to Cornell was Kepler's initial belief that souls move the planets. Although Kepler later modified this view, substituting the word *force* for *soul*, his correlation between science and divinity was a cornerstone of Mary Baker Eddy's Christian Science movement.

Both of Kepler's positions resonated with Cornell. Kepler's belief in a divine force behind the movement of the planets was based upon medieval concepts. The planets had souls; they were not merely matter, they were magical. Even when he states that "the heavenly machine is not a kind of divine, live being, but a kind of clockwork, insofar as nearly all the manifold motions are caused by a most simple, magnetic, and material force, just as all motions of the clock are caused by a simple weight," he manages to convey a sense of awe.[56] The universe was indeed awesome and scientific discoveries in the seventeenth century were tied to religion, as they were for Eddy and Cornell in the twentieth century.

Planets and souls are the themes of Antoine de Saint-Exupéry's legendary fable, *Le Petit Prince*, published in 1943. Cornell met the French author and aviator when Saint-Exupéry visited New York that same year, probably through

OPPOSITE:
Observatory Corona Borealis Casement, 1950
Construction, 18 ⅛ x 11 ¹³⁄₁₆ x 5 ½ inches
The Lindy and Edwin Bergman
Joseph Cornell Collection, Chicago
(Movable panel can be adjusted
to reveal a painted night sky
or a printed astronomical map)

Julien Levy, who had met him in Paris. *Le Petit Prince* tells the story of a little prince who travels the planets and recounts his story to the author. The little hero is a sage who questions the pronouncements of grown-ups, much like Lewis Carroll's Alice. The little prince gives his new friend, whose plane had crashed in the Sahara desert, a great gift, telling him, "For some, who are travelers, the stars are guides."[57] The stars were indeed guides for Cornell—a youthful pastime that served him well as an adult. Every reader can identify with the incredible loneliness that beset the little prince. For Cornell, this loneliness only grew in adulthood, and one can well understand why he chose to capture his rare moments of rapture in his boxes.

Saint-Exupéry's *Le Petit Prince* was published one year before he disappeared on a reconnaissance flight over southern France. Although it appears to be a simple children's tale, it is actually a profound and deeply moving book written in riddles and laced with philosophy and poetic metaphors: a children's fantasy meant for adults, much like Cornell's work.

Cornell exhibited his *Observatories* in *Night Songs and other New Work* at Charles Egan's Gallery in the winter of 1950–51 and again in the spring of 1953. In *Observatory Corona Borealis Casement* (1950), an opening in the rear wall accommodates either of two panels, an astronomical map or a splattered-paint rendition of a starry sky. Cornell experimented with dripping paint as early as 1941. Ernst, who poured paint in the mid-1930s, and Hans Hoffman, who experimented with this method in the mid-1940s, may very well have inspired him. But certainly the work refers to Jackson Pollock, whose dripping paint and mural-size canvases became the standard by which the new American painting was known.

Despite the small size of these works, Cornell created spaces within his boxes that were as limitless as those of Pollock, Rothko, Newman, and other artists of the New York School. Cornell conveyed the illusion of deep space, in a manner reminiscent of trompe-l'oeil perspective in painting, with his subtle placement of wire mesh at the front left of the box. The mesh creates an enclosure, but it also leads the eye directly to the window placed to the right in the rear wall of the box. The rhythm created by this trio—the screen, the opening, and the space beyond—is measured with all the acumen of an artist who studied Renaissance art and perspective. Cornell's subtle placement of pilasters, columns, colonnettes, windows, and mirrors is also reminiscent of Renaissance architecture. A new feature in Cornell's work, these measured spaces and the windows from which one can gaze out into the limitless expanse of the heavens are the dominant formal structure of the *Hotel*, *Pavilion*, and *Carrousel* boxes of this period.

In a work related to the *Observatories*, *Central Park Carrousel—1950, In Memoriam* (1950), Cornell placed a fragment of a sky chart with diagrams of the constellations behind a column—actually a sawed-off wooden dowel—and a piece of wire mesh. To create the illusion of depth, Cornell also placed wire mesh in the right foreground of the box. He positioned the column to the left side within the box and placed a map of the constellations featuring the figure of Orion behind it. He added a mirror to the interior to double the grid pattern cre-

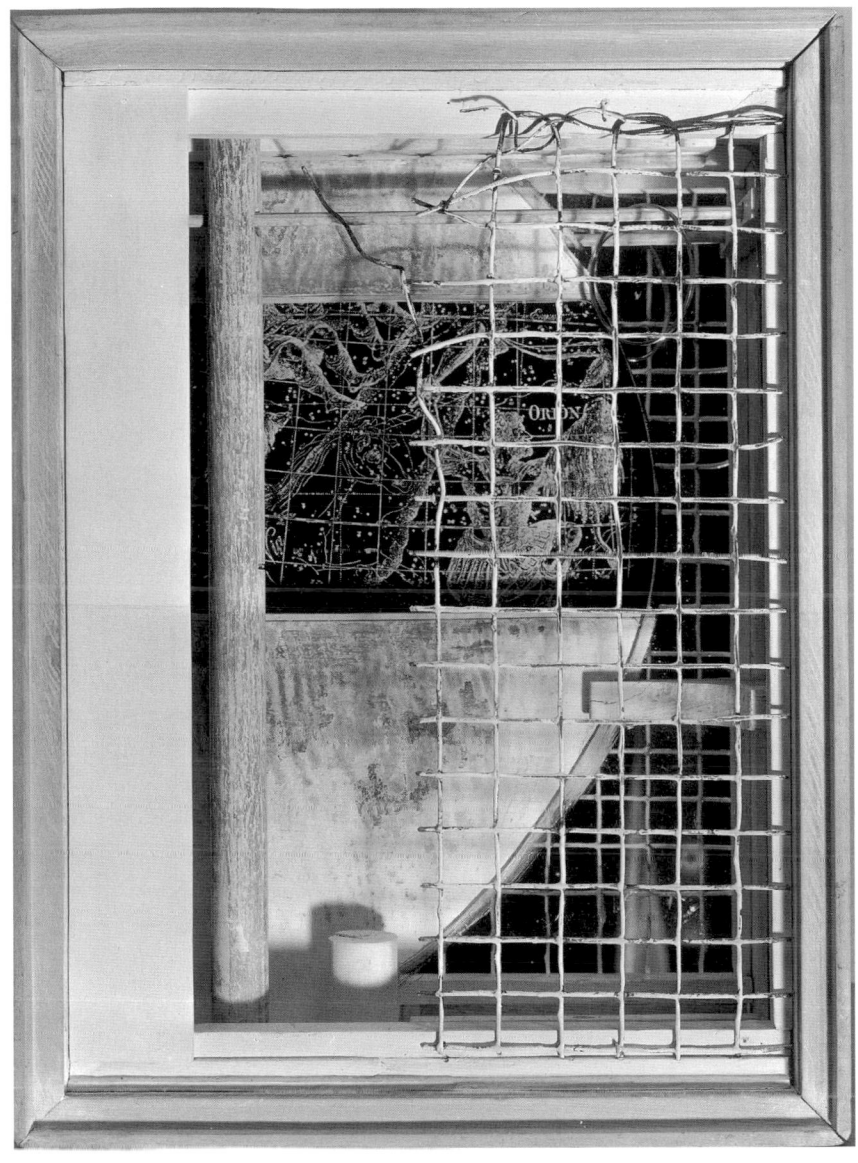

Central Park Carrousel —1950, In Memoriam, 1950
Construction, 20 ¼ x 14 ½ x 6 ¾ inches
The Museum of Modern Art, New York;
Katherine Cornell Fund

ated by the wire mesh and further enhance the grids of the constellation placed at the rear of the box. The frayed ends of the wire mesh, and the empty perch, placed in the lower right-hand corner, imply the destruction of the Central Park Carousel, which took place in the fall of 1950. The circular movement of the carousel, the revolving planets, and the flight paths of the bird are suggested by the curve that sweeps from the lower to the upper left side of the rear wall. Sometime after Cornell finished this project he was pleased to read in *Scientific American* confirmation of his intuition that the flight path of birds does indeed follow the movement of the stars. The mood of this piece, like so many others, is one of loneliness and loss. Cornell mourns the loss of the carousel as symbolic of his loss of childhood and innocence.

Cornell's last show at the Egan Gallery opened on February 10, 1953. It was during his association with Egan that he had met the younger artist Robert Rauschenberg who later suggested to Cornell that he submit a box construction to Eleanor Ward, owner of the Stable Gallery, for inclusion in its 1954 *Third Annual Exhibition of Painting and Sculpture.* Rauschenberg, influenced by the older artist's poetic combinations of common objects and images appropriated from

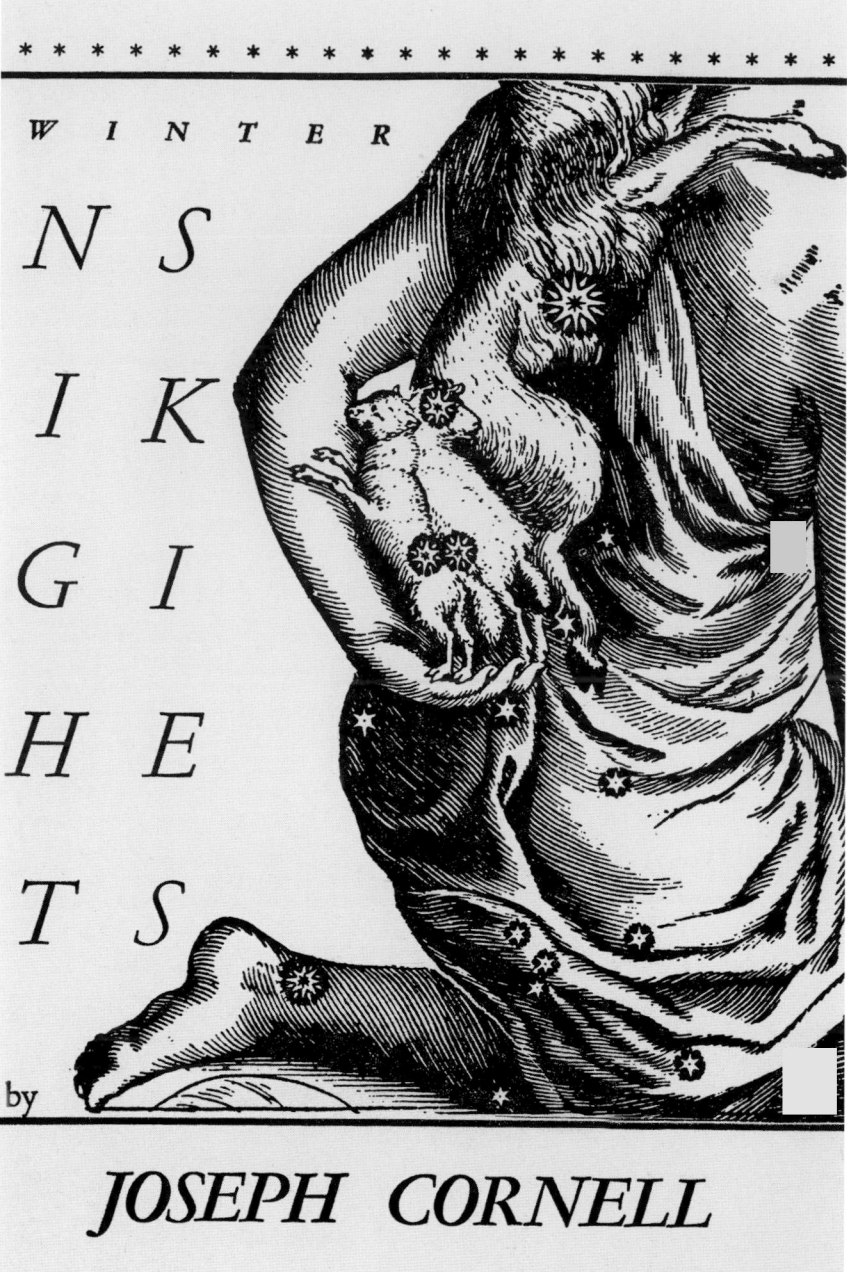

WINTER
NIGHT
SKIES
by
JOSEPH CORNELL

painters of the past, also rummaged through the past, combining silkscreen images from paintings by Peter Paul Rubens with contemporary events gleaned from newspapers. Cornell's structure and imagery, his juxtaposition of new and old, and the element of time conveyed in his work by references to past and present played a decisive role in Rauschenberg's paintings and combines of the early and mid-1950s. In contrast to Cornell, however, Rauschenberg used the idealized imagery of the past as an ironic commentary on the tumultuous and unruly present. Sensual, sensory, and sensational, Rauschenberg's objects have an immediacy that Cornell's could not. However varied his sources, Cornell oriented all of his objects, old or new, toward history and memory in order to create a dream history, the child of his imagination.

In the 1953 Egan show, entitled *Night Voyage by Joseph Cornell*, the artist included his *Observatories* and introduced a new series, the *Hotels*. A number of the objects that he used in his bird habitats—metal rings and chains, wooden

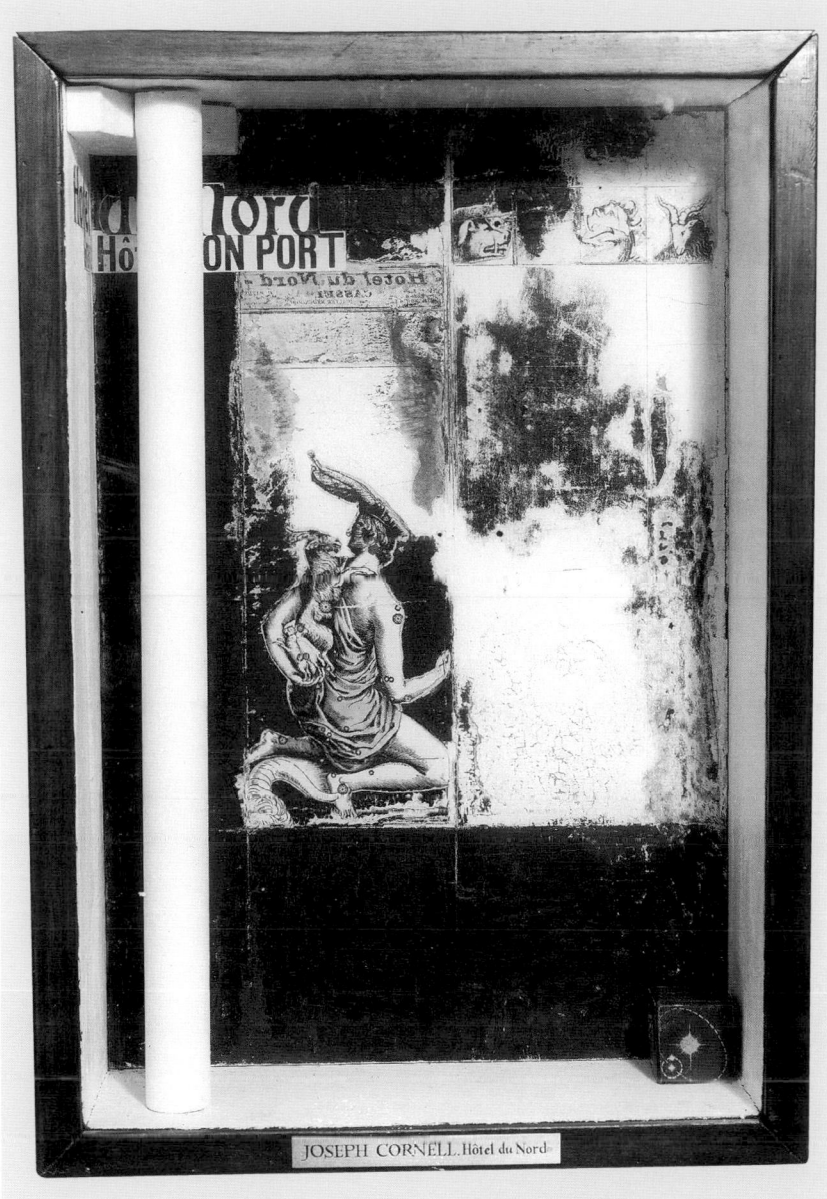

Hôtel du Nord, c. 1953
Construction, 19 x 13 ¼ x 5 ⅛ inches
Whitney Museum of American Art,
New York

perches, even the stray colorful cockatoo—found their way into these boxes. More likely, Cornell meant to create hotels rather than natural habitats for his beloved creatures, for some of them, in actuality, graced many a hotel lobby. Most characteristic of the *Hotel* boxes is their sparseness; many of them are unoccupied save for a column or a label with their name or a window looking out into the night.

The theme for Cornell's first one-man show in 1955–56 at Eleanor Ward's Stable Gallery on West 58th Street in New York was *Winter Night Skies*. The exhibition consisted of box constructions based on the constellations Auriga, Andromeda, and Camelopardalis. Cornell incorporated the constellations in works such as *Hôtel du Nord* (c. 1953) and *Untitled (Grand Hôtel de l'Observatoire)* (1954), combining the figures of Auriga and Andromeda with the ubiquitous column, thereby bringing the heavens into the interior of each box. On the other hand, when Cornell combined the figure of Auriga with a column and a window, as he does in *Untitled (Hotel de l'Etoile: Night Skies, Auriga)* (1954), he adds another note to the complex, almost surreal nature of existence.

OVERLEAF LEFT:
Untitled (Grand Hôtel de l'Observatoire), 1954
Construction, 18 ⁵⁄₁₆ x 12 ¹⁵⁄₁₆ x 3 ⅞ inches
The Solomon R. Guggenheim Museum,
New York; Partial Gift, C. and B.
Foundation, by exchange, 1980

OVERLEAF RIGHT:
Untitled (Hotel de l'Etoile: Night Skies, Auriga), 1954
Construction, 19 x 13 ½ x 7 ¹⁄₁₆ inches
The Lindy and Edwin Bergman
Joseph Cornell Collection, Chicago

ANDROMEDA

Grand Hôtel de l'Observatoire

AND... ...EL DE L'UNIVERS

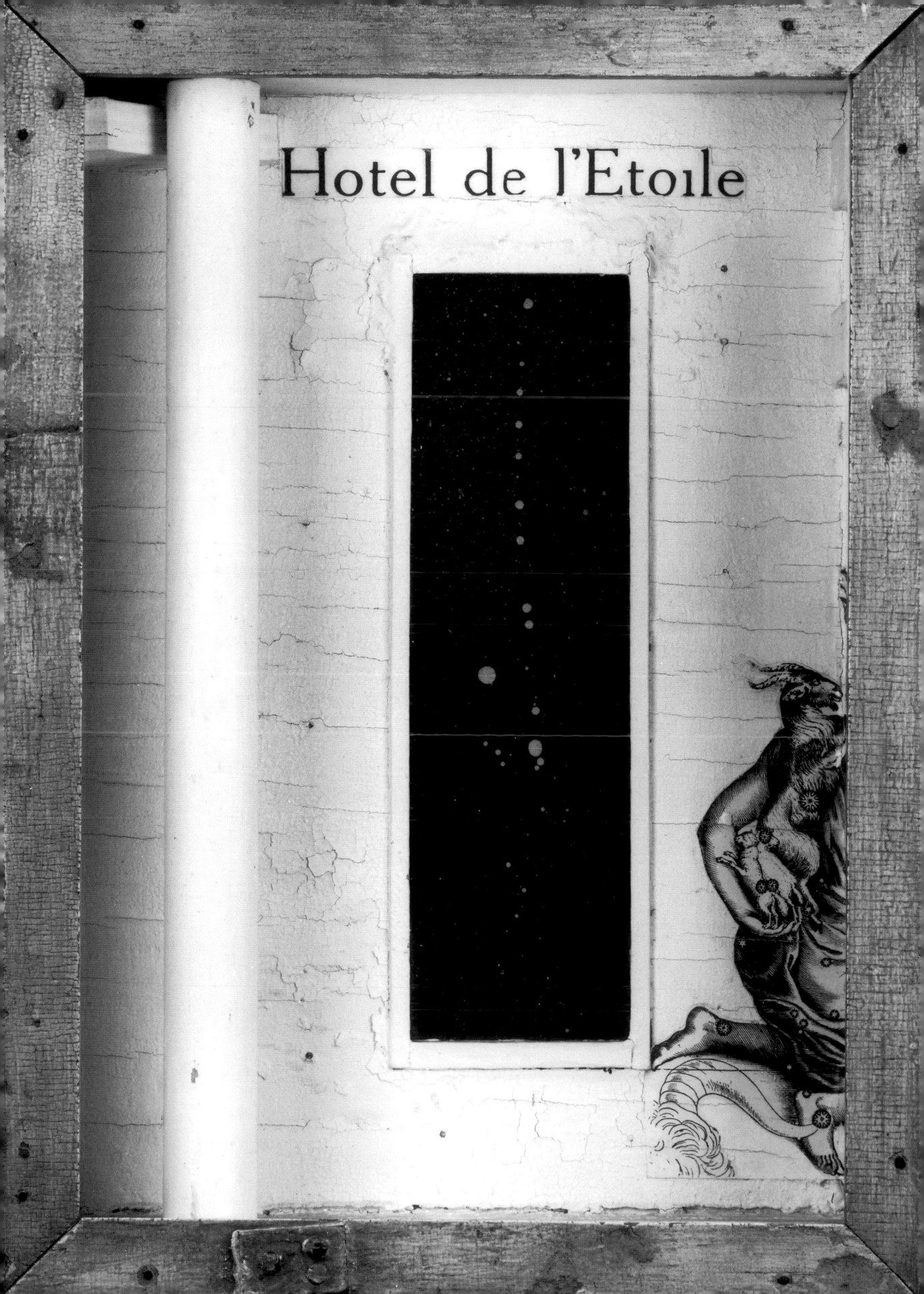

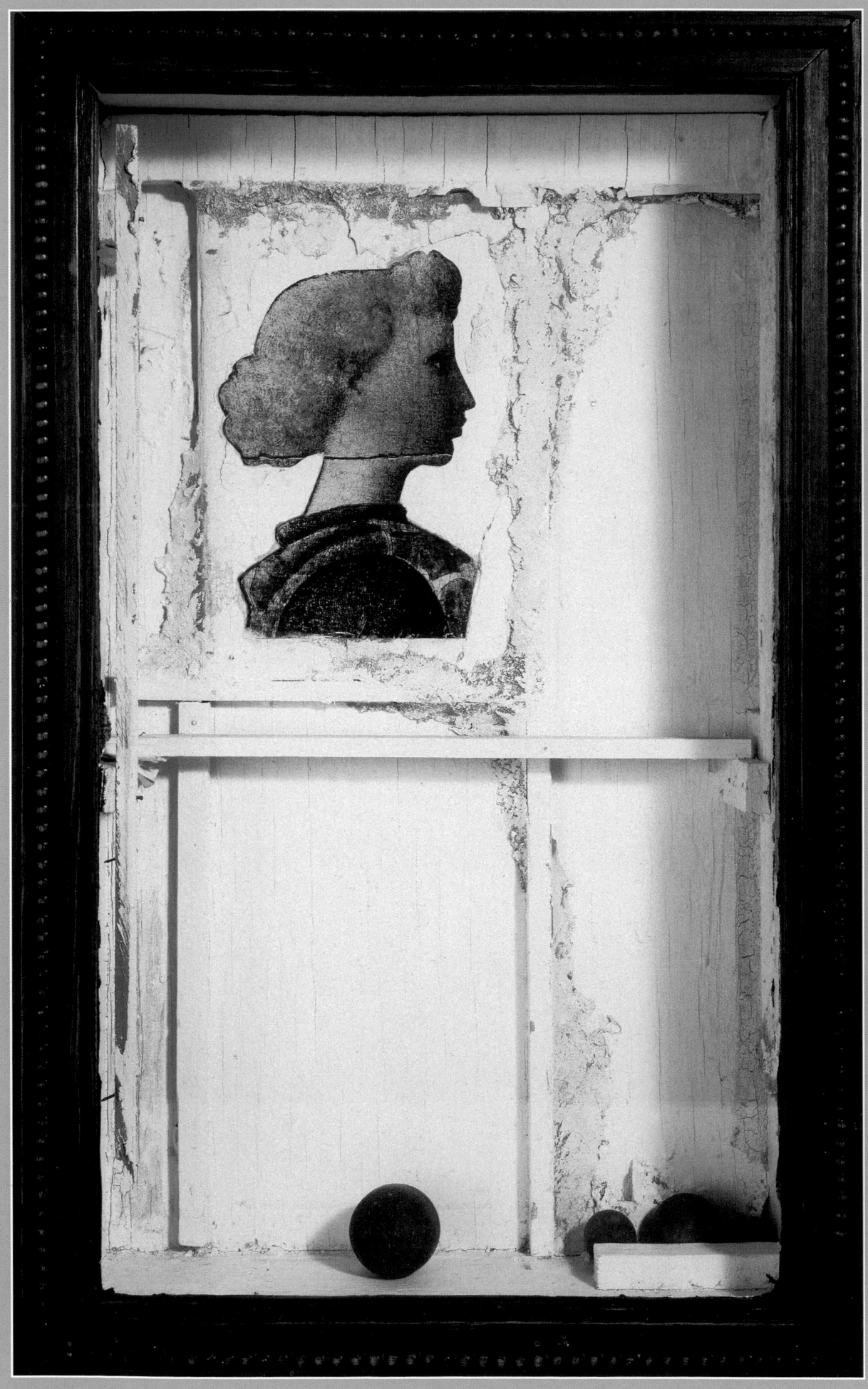

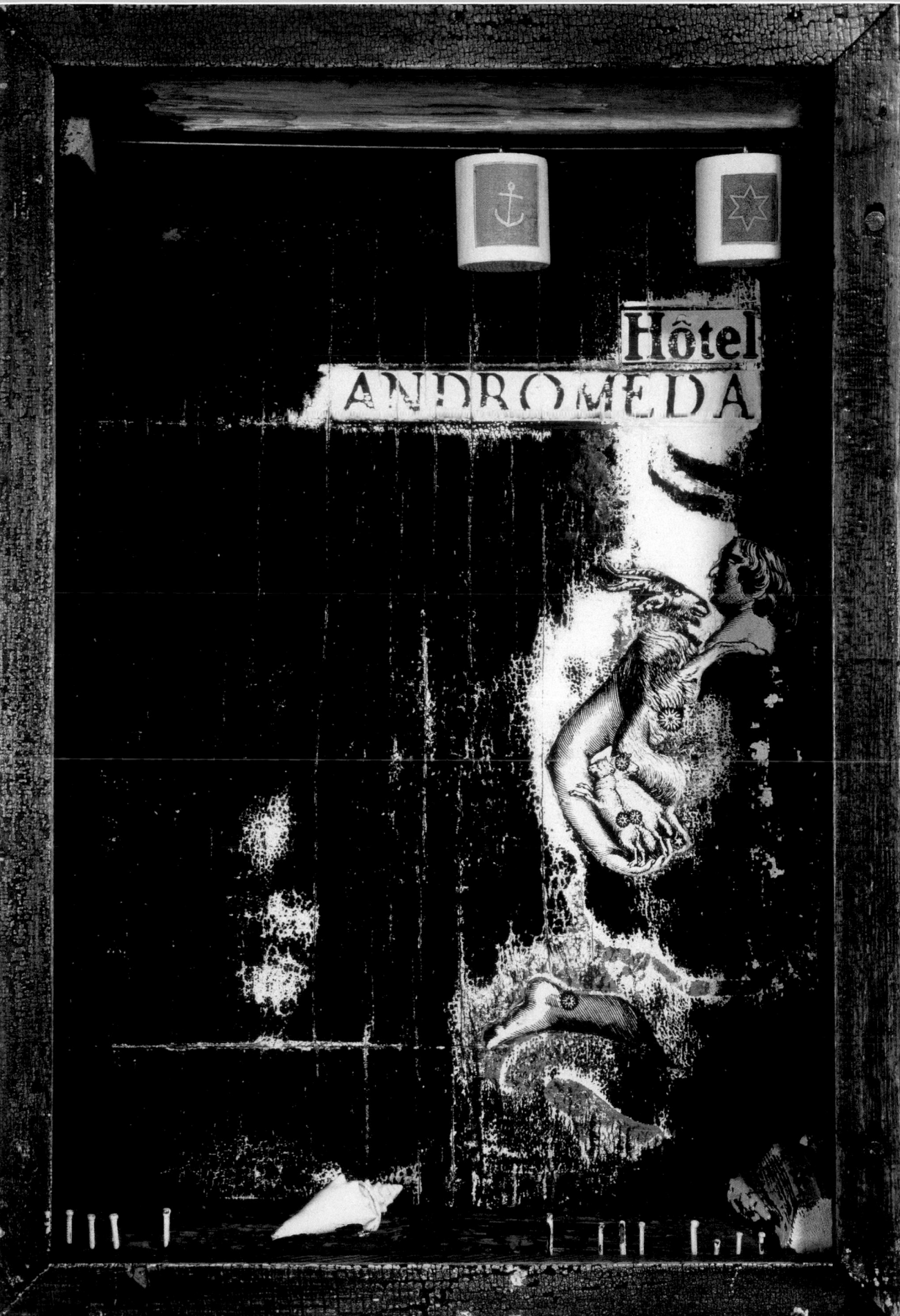

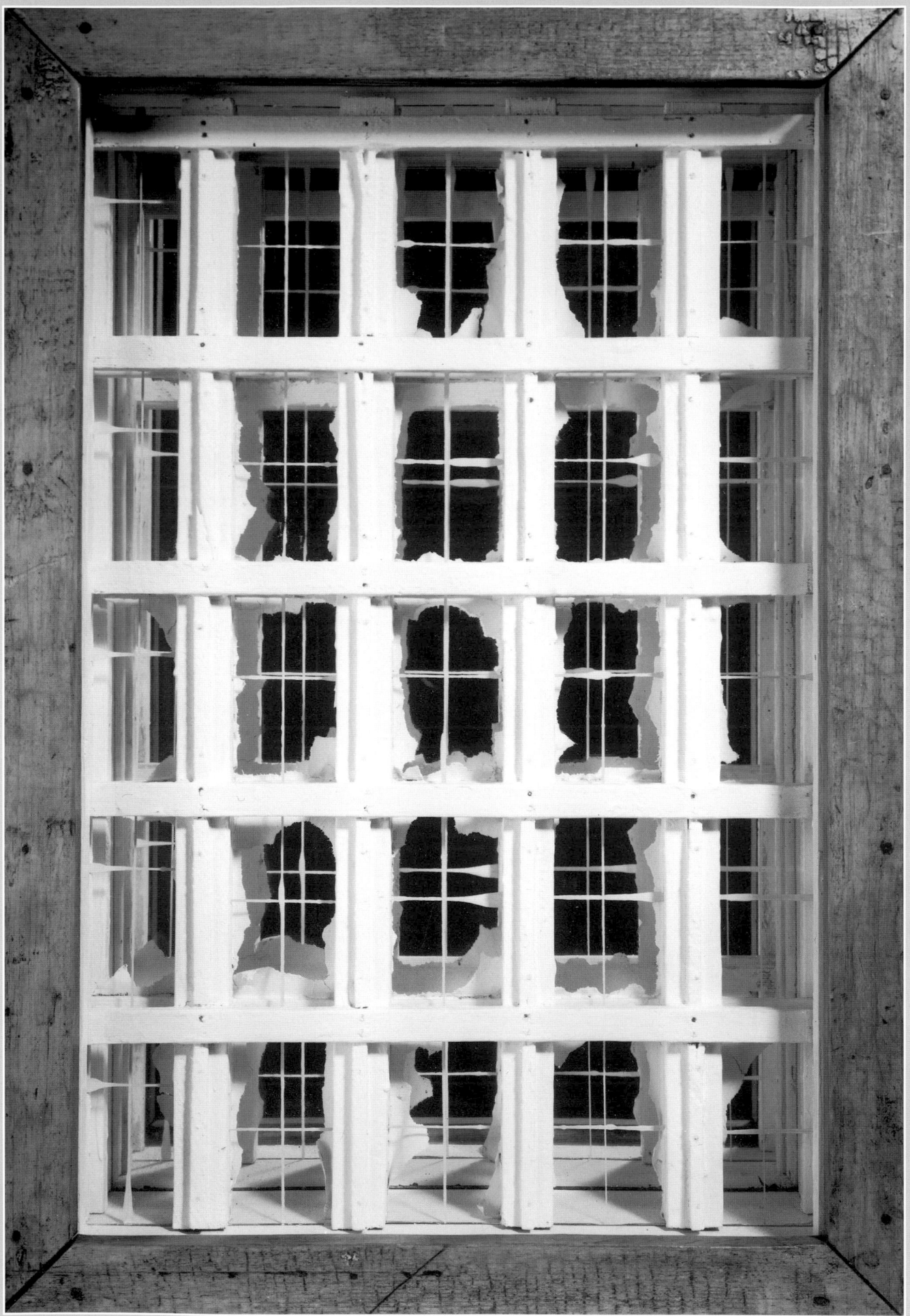

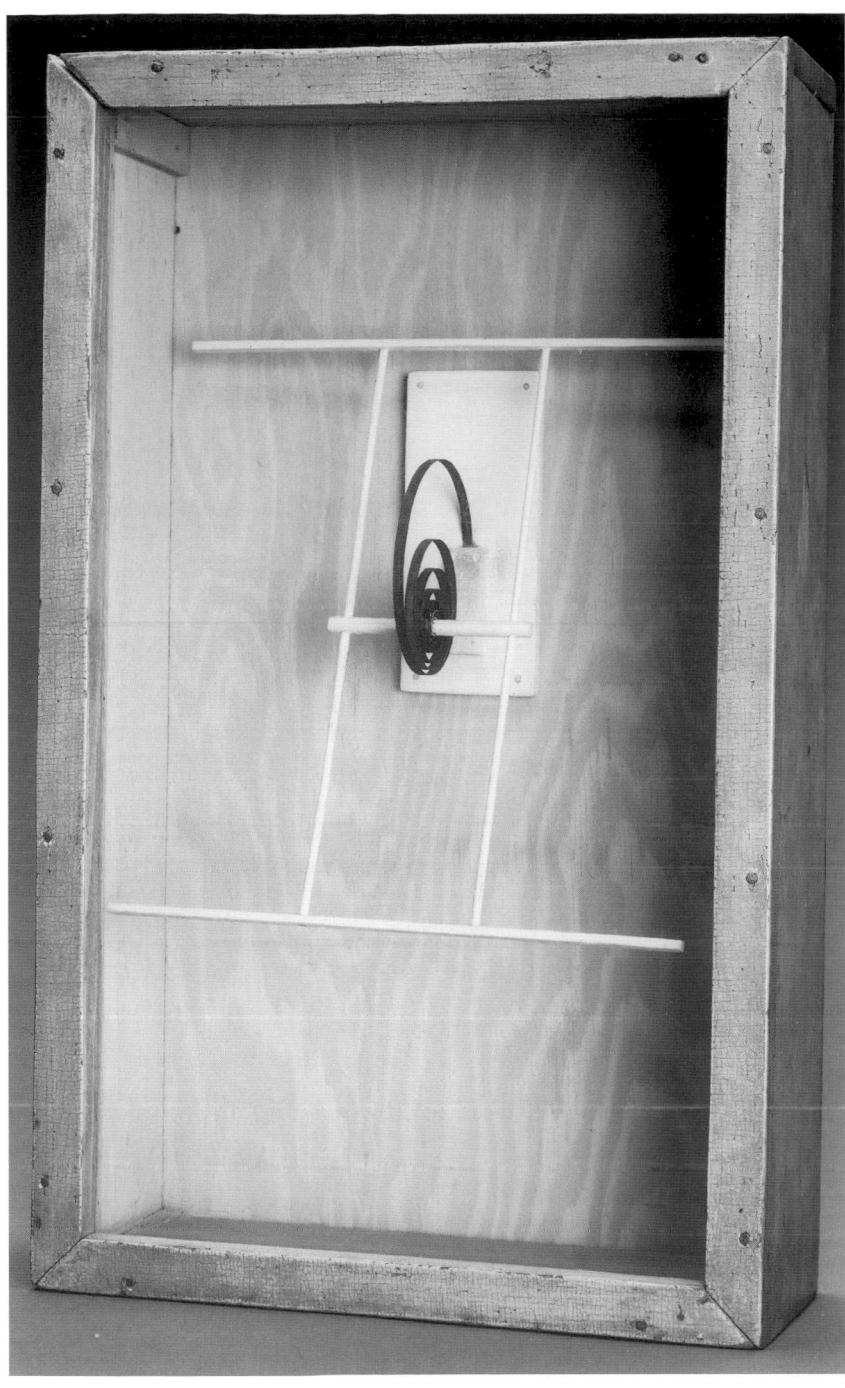

Cornell adorned each of his *Hotel* boxes with a title that referred directly to a constellation or used a name that he had come across in his searches. The constellation Auriga, for example, in the box of the same name, appears as a youth with a goat (Cappella) and her two kids. With a whip and reins in his hands, the Charioteer bounds from the confines of the box into the heavens. A trail of spattered white paint on a dark blue background evokes a constellation of stars seen through an open night window and is a reflection of the painterly abstraction that dominated the New York art world during the 1950s.

By incorporating the names of French hotels, using print he fancied and occasionally postage stamps cut and pasted like mementos for souvenir albums, Cornell could evoke another time and place. In *Hotel de l'Etoile*, he inserted a printed legend with that name, which he said alluded to the star of the Magi,[58] on both

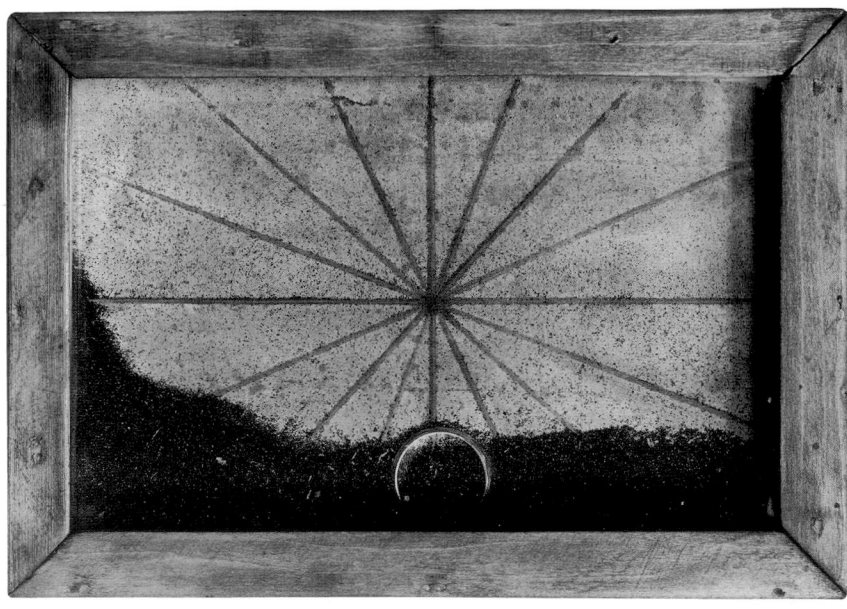

the rear and right side walls of the interior. *Hôtel du Nord* offers the viewer many possible interpretations. Cornell's obsession with the Romantic era had lessened in the 1950s, but he nonetheless remained a romantic until the end of his life. Meyerbeer's 1854 opera, *Étoile du nord*, set in Peter the Great's Russia, might have come to mind when he created both *Hôtel du Nord* and *Hotel de l'Etoile*. Travel to distant places, the planets, and movies were three of the most important avenues that allowed his imagination to take flight. Auriga then becomes a symbol of this flight and a surrogate for Cornell himself. And to make sure that the charioteer is safe, Cornell provides him with a fitting home, the *Hôtel du Nord*. Hans Christian Andersen had stayed in the Copenhagen hotel of the same name. *Hôtel du Nord* was the name of Marcel Carné's 1938 film. It is also the name of a hotel near the famed Gare du Nord railway station in Paris. Given Cornell's love of correspondences, any or all of these associations may have been in his thoughts.

In several of his first *Hotel* boxes, such as *Grand Hotel Bon Port* (1952) and *Untitled (Uccello)* (c. 1950–52; page 112), Cornell used photostat images of Vermeer's *Girl with a Pearl Earring* and Uccello's *Battle of San Romano*. He remained faithful to the severe geometry extrapolated from Mondrian a decade earlier, but, like de Kooning in his contemporaneous canvases, Cornell lavished paint on the interior surfaces of his boxes. In the majority of his *Hotels*, the walls are coated with layers of thick white paint. Areas are deliberately made to look old, cracked and peeling, revealing soft yellows underneath. Cornell's painterliness also applies to the later *Hôtel du Nord* and *Untitled (Grand Hôtel de l'Observatoire)*, in which the constellations Auriga and Andromeda replace the images of Vermeer and Uccello. Here, too, the walls are peeling, but in these examples, they reveal a midnight blue underpainting rather than the soft yellows that Cornell favored in the earlier *Hotels*.

Many New York School painters looked to Leonardo as a precursor for their invention of abstract painting. In the widely read *Beyond Painting*, published in 1936 and again in 1948, Max Ernst attributed his invention of frottage to Leonardo's ability to see in a spot or a stain images of animals or men, landscapes or monsters, devils and other fantastic things. It was common in the 1950s for artists to derive their

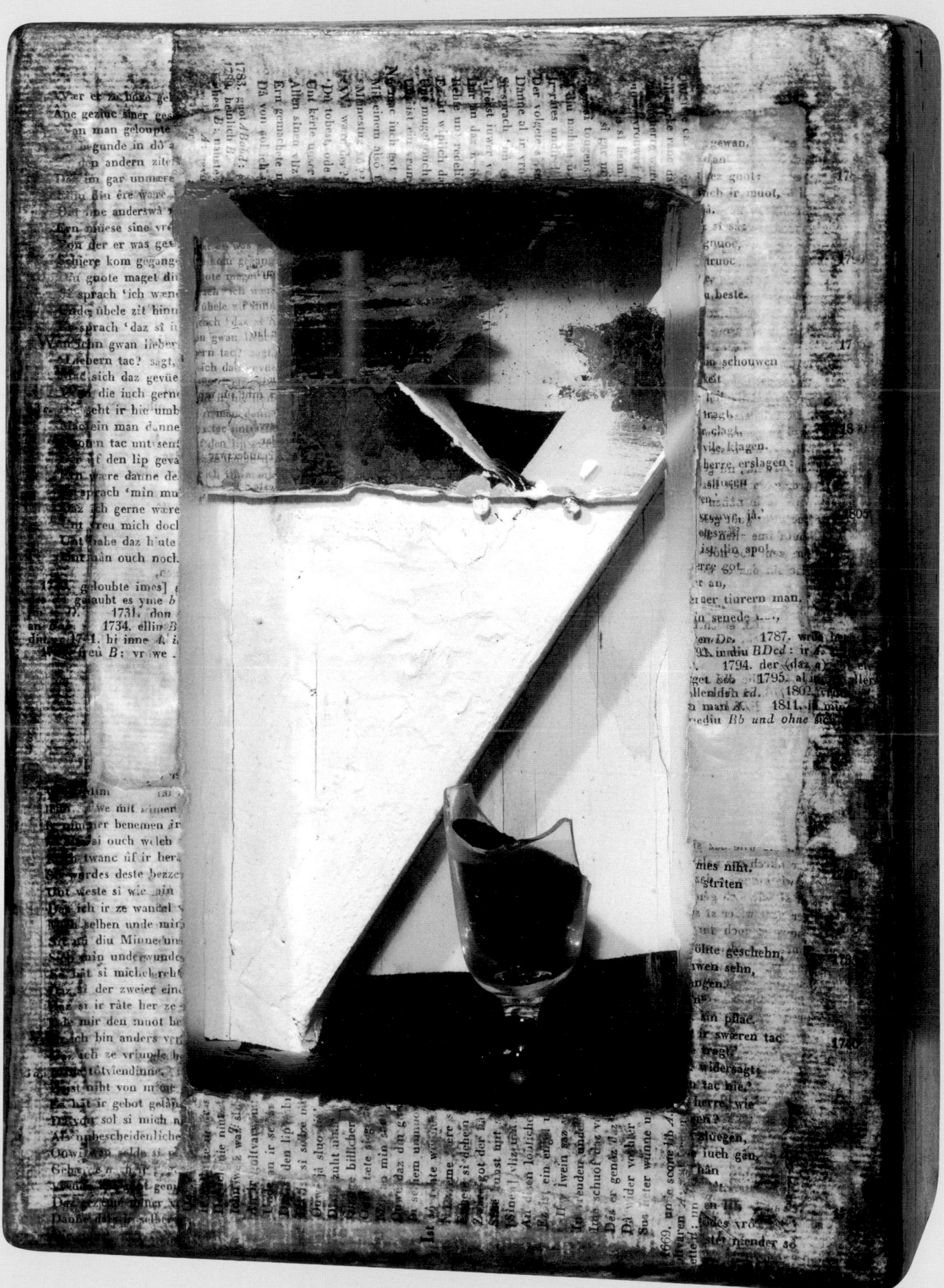

abstract imagery from the stained and cracked walls of buildings being demolished. Cornell was subject to these same influences but for him the peeling walls were about process and continuity. His admiration of Leonardo was such that he emulated his use of mirror writing when he signed some of his boxes.

Untitled (Window Façade) (c. 1951), departs from the *Hotel* boxes in several significant ways. Although it is as spare as some of Cornell's *Hotel* boxes, it is even more reductive in format. Cornell has minimized its structure to a simple grid. It is one of the purest of Cornell's constructions, composed of strips of wood placed in strict horizontal and vertical formation. Within this network of strips are pieces of mirror, the ever-changing images reflected in them, and splashes of paint left by the artist. This and other similar boxes of the early 1950s are a variation on *The Crystal Palace* (1949; see page 67). This series touches upon the seasons, depicting winter frost in a box whose windowpanes are partially obscured by thick white paint, and the cracked glass in other boxes represents time and decay. The cracked glass in these and other boxes may very well be a sendoff to Marcel Duchamp, whose *The Bride Stripped Bare by Her Bachelors, Even (the Large Glass)* (1915–23), Cornell had an opportunity to see in 1926 when it was first shown at the Brooklyn Museum.

An equally spare box, *Homage to Blériot* (1956; page 115), was named after the famous flyer, Louis Blériot, who in 1909 was the first person to cross the English Channel. In it a coiled metal spring begins to quiver when the trapeze-like structure on which it is balanced is set in motion. This arrangement suggests that the flyer, like a bird, has left on a long journey, but it is also reminiscent of a circus trapeze. Cornell's sense of play and his interest in games are still very much alive even at this late date in his career. Although this construction is, like the *Window Façades*, one of Cornell's most minimal expressions, its interior touches not so much upon Mondrian but upon Ernst whose frottages—rubbings over surfaces like wooden floorboards—are its nearest precursor. In *Blériot* Cornell appears to bid a fond farewell to a much-loved emblem of natural phenomena and the machine age—the watch and clock spring used by Duchamp and other Dadaists.

Cornell lamented the dearth of material to be found on Fourth Avenue after the war, but Woolworth's in Flushing continued to be a plentiful resource for him. In the fall of 1951, Cornell and his brother, Robert, visited for a month at his sister Betty's house in Westhampton, Long Island. There he spent time reading and took long walks on the beach collecting driftwood, starfish, and seashells that he used in numerous boxes from the mid- to late 1950s and early 1960s.

During this period of time Cornell made a series of rugged *Sand Boxes* (i.e., horizontal trays rather than vertical standing boxes) and *Sand Fountains*, a late adaptation of the *Untitled (Red Sandbox)* (c. 1940; see page 50). The *Sand Boxes* usually contain several layers of glass with different colored sands trapped between them. Mixed in with the sand are bits of seashells, slivers of glass, small ball bearings, and brass or silver rings. When a tray is handled, these objects shift about and commingle, they appear and disappear, creating ever-changing patterns. The rustling sound of the sand as it moves is like the sound of waves. *Untitled (Sand Fountain)* (c. 1957–59), contains dark blue sand that pours into a wineglass;

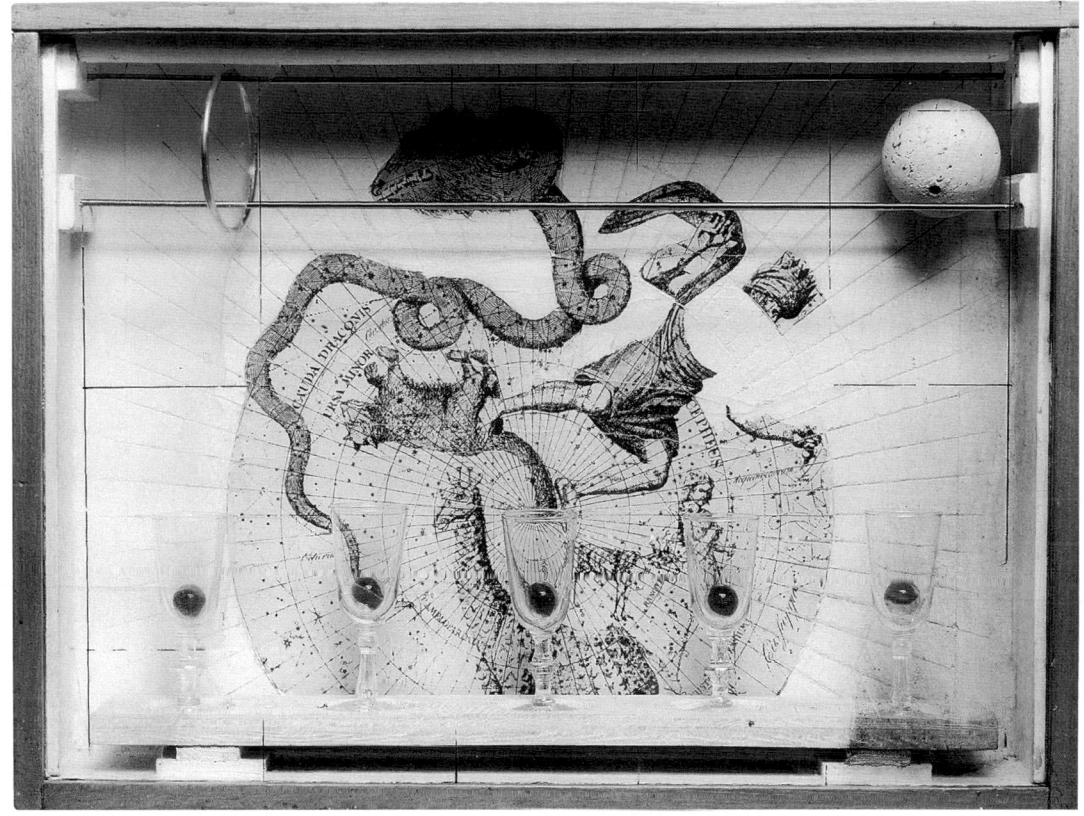

Cauda Draconis, 1958
Construction,
13 ⅜ x 18 x 4 inches
Private Collection

Parker Tyler described the *Sand Fountains* as "an ironic trope on halved Eternity."[59] The *Sand Fountains* feature broken wineglasses, through which sand passes when turned upside down, like hourglasses measuring the passage of time. The word *pour* in a similar work, *Sand Fountain (Pour Valéry)* (c. 1959), has a double meaning: *pour* refers not only to the movement of sand through the "hourglass" but to the English translation of the French word, "for," in tribute to the French poet. In his use of the double entendre Cornell has, for the moment at least, once again resorted to a play on words in tribute not only to Valéry but also to his own past affiliation with the Surrealists.

Cornell continued to explore the forces of nature in *Cauda Draconis* (1958). The white cork ball is symbolic of the moon, the silver ring is the orbit of the planets around the sun; they also comprise a game in which the ball can be rolled through the ring. Included in the box are five cordial glasses, each containing a blue marble and an astronomy chart. The constellations are among Cornell's favorites: Cauda Draconis, the dragon, Ursa Minor, the little bear, and Camelopardalis, the giraffe. To offset the blue marbles he tinted the figures and the front left and right sides of the glass front. In discussing the concept of space as it related to his constructions, Cornell said that he tried to capture some of the spirit of the scientific discoveries of our time in his boxes, but he would be delighted if some humor were caught as well.

Cornell stopped making new boxes sometime in the early 1960s. After that, as he said numerous times, he worked on "refurbishing" his older boxes, ripping them apart and partially reconstituting them. The vacuum was more than filled by his renewed interest in collage and in film beginning in the mid-1950s, at the very time that the boxes began to shed some of their sense of depth.

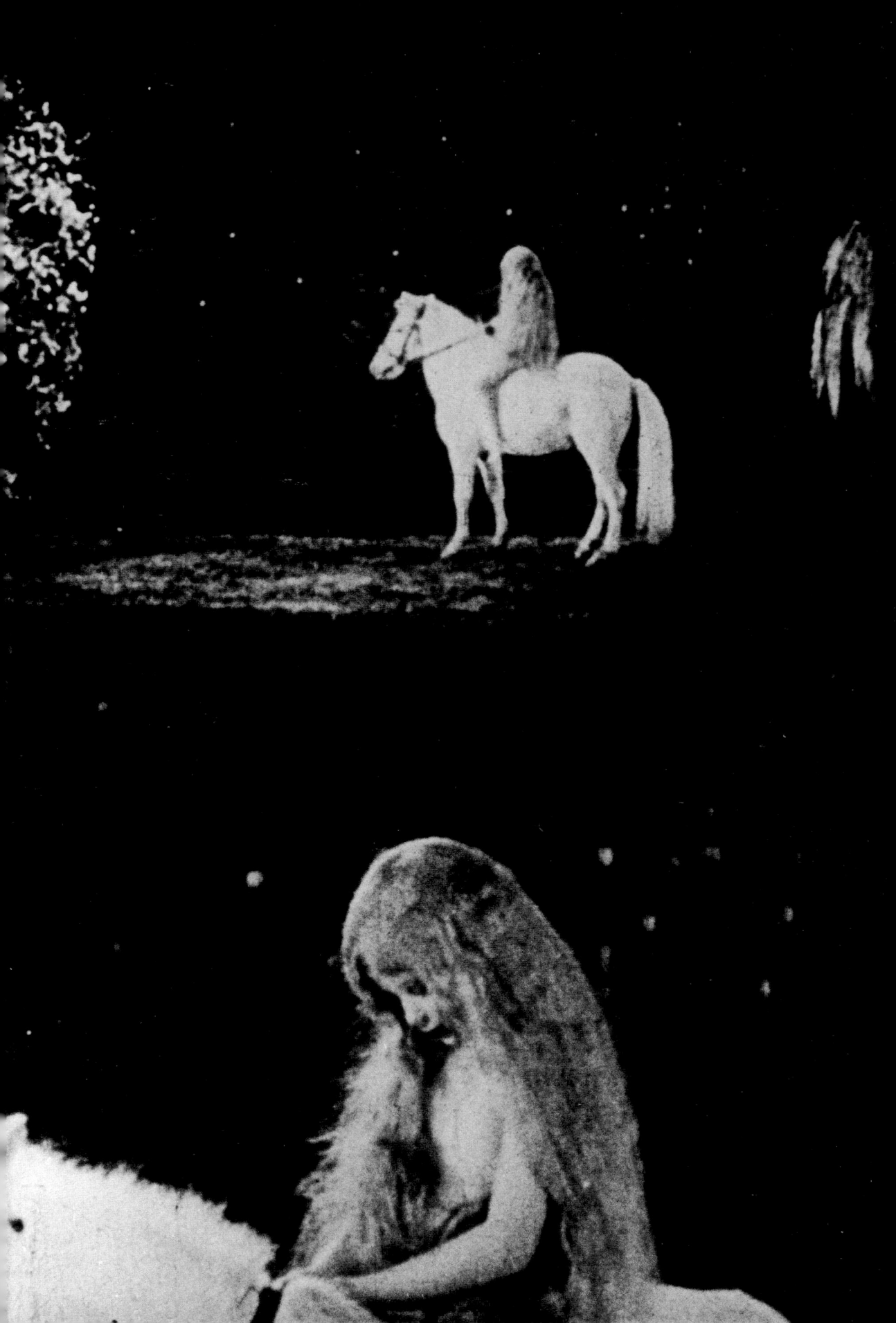

EXPERIMENTS IN FILM

In Madame de Richochet's salon
The mirrors are beads of crushed dew
The console is made of an arm plunged into ivy
And the carpet dies like waves.[60]

In 1955 the Third Avenue El was about to be torn down, and Cornell hired Stan Brakhage to film the event. Unsatisfied with Brakhage's resulting film, *Wonder Ring*, Cornell reversed it, printing it backward and adding at the end the title, "The End Is the Beginning." He titled his reedited version *Gnir Rednow*. Cornell saw the process of life encapsulated in the El's transition from a shiny new feat of engineering, a landmark of New York City, to its final phase of decay and dissolution. It brought back poignant memories of riding the train and looking out the windows, glimpsing faces and fragments of life in the tenements facing the El. Those moments were among the many everyday inspirations for his art, bringing into focus an idea already in the process of formation.

Film technique influenced Cornell's art from the outset of his career, as he incorporated cinematic devices into a number of his constructions. Like the Surrealists, he found that film offered new possibilities of fantasy and illusion, abrupt changes in time, sequence, and event, and illogical juxtapositions. When he was a boy, the New Jersey based film industry made many movies in Bayside, Queens, not far from where Cornell lived. Pearl White, Francis X. Bushman, W. C. Fields, and Buster Keaton lived in Bayside, and D. W. Griffith filmed in the vicinity. Like many youngsters he grew up with silent films and then talkies, and in the 1930s he became an avid film collector and astute student of Méliès, Zecca, and Charlie Chaplin.

Cornell's earliest foray into the world of film was a script he wrote in 1933 entitled *Monsieur Phot (Seen through the Stereoscope)*, which was included in Julien Levy's 1936 book *Surrealism*. The story takes place in the winter of 1871, in New York City, and revolves around a photographer in formal dress, a group of urchins, a pheasant, a maid with a feather duster, and an eccentric pianist. The script calls for props such as a basket of laundry, a large mirror, an equestrian statue, and a Victorian horse-car, all of which have as vivid a presence as the main characters. The directions in the script state that the film begins in black and white, shifts to color, and then continues to shift back and forth—color film, of course, did not yet exist at this time (films were either hand painted or colored by technical means). The film is silent, accompanied by a soundtrack that includes pieces by Strauss, Stravinsky, Tchaikovsky, and Debussy. Cornell disliked the introduction of sound into film, stating that the talkies lacked the ability to capture "the profound and suggestive power of the silent film to evoke an ideal world of beauty."[61] The action shifts abruptly from scene to scene as well, beginning in Union Square Park,

OPPOSITE:
Film sequence from *The Midnight Party*, c. 1940s–68
Courtesy Anthology Film Archives,
New York,
and by permission of
The Museum of Modern Art,
New York

then moving to a hotel ballroom with chandeliers reflected in a large mirror. The reflection changes into the interior of a "large, sumptuous glass and china establishment," a "forest of exquisite glass and ceramics" through which a pheasant of gorgeous plumage flies as if through the "branches of his native wood."[62] Suddenly, in a dream sequence, revolver shots ring out shattering the glass into a million crystal fragments.

Phot, of course, is short for *photographer*, but the character and the title suggest other associations as well. The name sounds like *faux*, the French word for "false." The role of the photographer reads much like Cornell himself, spending time in the park with one of his beloved birds. The urchin playing a harp appears to be a nod to Harpo Marx. The mirrored reflections and shattered glass are reminiscent of the work of the Surrealists. Among the striking features of the scenario is Cornell's use of repetition, close-up and distance shots, freeze-frame and motion, silence and sound. One or more of these traits can be found in the majority of his boxes—and all of them are found in his *Medici* boxes of the 1940s and 1950s.

Cornell's decision to set the film in 1871 might be an early nod to Lewis Carroll's *Through the Looking Glass*, which was published that year. Alice's passage through the mirror into another world is echoed in the scene in *Monsier Phot* when the scene moves from a reflection of chandeliers into another setting on the *other* side of the mirror.

Much of the imagery in *Monsieur Phot* appears in Cornell's assemblages of the 1930s. Sequences of a flying pheasant and the sound of revolver shots found form in a 1939 construction, *Black Hunter* (see page 49), one of Cornell's earliest experiments with movement. In this painted black box, a hunter is shown firing a rifle. The image comes from a series of photographs taken in about 1900 by the Naya studio, *Pigeon Shooting at the Hotel Excelsior, Venice Lido*, which depict a man taking aim at a group of clay pigeons. In Cornell's box, the image occurs four times. Each image is slightly different, conveying a sense of movement similar to that found in the motion photography of Muybridge and Jules Etienne Marley.

When *Black Hunter* is tilted to the side, four circular glass disks—with images of a seashell, a bird being born, a bird in flight, and a shot bird—roll across the images of the hunter. Four white balls are suspended from black string on the right inside of the box; they are the targets in this penny arcade game. The box is a study in black, red, and white, a color arrangement that suggests black-and-white film as well as the geometric abstraction of Mondrian's *Composition in White, Black and Red* (1936).

In 1940 Cornell paid homage to his film character in a work titled *Object (Hotel Theatricals by the Grandson of Monsieur Phot Sunday Afternoons)*. In his wooden cabinet, Cornell arranged the likeness of the "grandson" in a sequence of stills. Three of the registers contain the image of a male figure caught in a series of arrested movements, which are also based on Marley's and Muybridge's studies. The images are arranged in sets of four, except for the bottom row, which contains only three. Each group is self-contained and subtitled with a caption that playfully subverts the imagery. The stylized movements of the figure correspond to the epilogue of the film script, in which Cornell notes that the

OPPOSITE:
Film sequence from *Rose Hobart*, c. 1936
Courtesy Anthology Film Archives,
New York, and by permission
of The Museum of Modern Art,
New York

Object (Hotel Theatricals by the Grandson
of Monsieur Phot Sunday Afternoons), 1940
Construction, 11 ¾ x 7 ⅞ x 2 ⅝ inches
Yokohama Museum of Art

action is to be choreographed as in a ballet. Underlying both *Monsieur Phot* and
his grandson is the artistry of the ballet and silent film.

Although *Monsieur Phot* never moved beyond the script stage, Cornell made
several movies, beginning with *Rose Hobart* in 1936. The film was collaged from
a Hollywood B-movie, *East of Borneo* (Columbia Pictures, 1931), and named after
its star. The original movie captured Cornell's attention because of its fantastic
imagery and because of Hobart herself. Cornell cut out all but thirteen minutes,
stripped the film of its sound, and projected it at the speed of silent film, tinting
the film with blue glass and adding Brazilian music. He also added other film
clips, including the climactic sequence: a lunar eclipse, after which the moon falls
out of the sky and into a pool, creating ripples on the surface.

The film was first shown at the Julien Levy Gallery in December 1936 as
part of a program of "Goofy Newsreels." According to Levy, at the screening
Dalí flew into a rage because Cornell's film included many concepts that Dalí
himself had wanted to explore.[63] In *L'Âge d'or* (1930), which borrowed from
Magritte's *The False Mirror* (1928), Luis Buñuel used the montage technique,

Film still from *Nymphlight*, 1957
Courtesy Anthology Film Archives,
New York, and by permission
of The Museum of Modern Art,
New York

inserting film clips from other movies. The brilliance of Cornell's film, however, is not so much in his borrowed technique but in the other formal devices that he invented for *Rose Hobart*. Cornell's "collage" films are cinematic paraphrases of the Duchampian concept of the "Readymade" and Cornell's own collages: the images are preexisting, but combined by the artist to create something altogether new that reflects his own vision. The nostalgia that permeates all of Cornell's work and is evident in these films, however, is not Duchampian.

Many of Cornell's collage films and those with original footage that he directed and edited feature young women or children (primarily girls). *Cotillion*, collaged from old Hollywood movies, documentaries, and the "Little Rascals" and "Our Gang" series, formed part of a trilogy with *The Children's Party* (also the title of a nineteenth-century ballet) and *The Midnight Party*. These films were begun in the 1930s and completed in 1968 by Larry Jordan according to Cornell's instructions. One sequence in *The Midnight Party* shows a naked young girl, long fair hair covering her body, riding a pony across a stage. In *Nymphlight*, twelve-year-old ballet student Gwen Thomas, the daughter of the painter Yvonne Thomas, dances around the fountain in Bryant Park, dressed in Victorian costume and carrying a parasol. The young actress Suzanne Miller, whom Cornell had befriended, appears in *A Legend for Fountains*, filmed in Little Italy in Manhattan.

In the summer of 1955, the same year as *Gnir Rednow*, Cornell directed Brakhage in the filming of *Centuries of June*, named after a phrase from a Dickinson poem. Similar to the El film, *Centuries of June* shows images of an old house before it was torn down. In other films under Cornell's direction, Brakhage and Rudy Burckhardt shot in and around the artist's beloved Union Square Park and in a Long Island cemetery. Innocence and loss are once again the themes of these films. Like his shadow boxes, Cornell's films transmute experience into memory, the tangible into the intangible, an image caught before it floats off into the heavens.

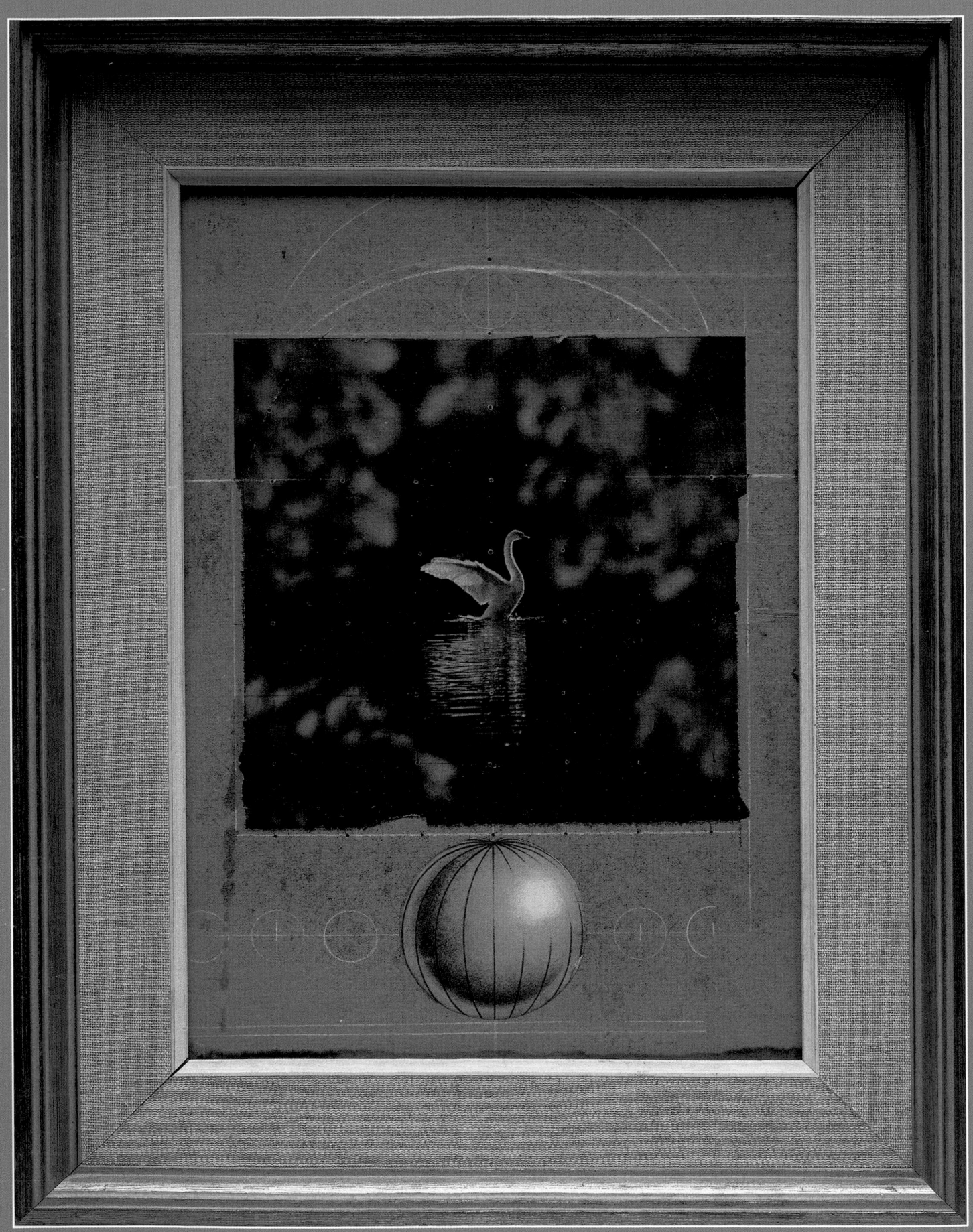

Cornell continued to make collages after the 1930s, but he did so intermittently, preoccupied as he was with the box constructions that constitute the largest part of his production. The collages that were produced in the early 1940s, such as *Story without a Name—for Max Ernst* (1942) and *Americana Fantastica* (1943), were made for publication in *View* magazine.

 Story without a Name—for Max Ernst consisted of sixteen montages conceived in the manner of Ernst's collage-novels. Like Ernst, Cornell relied on the unexpected juxtaposition of objects to imbue his collages with a new symbolic imagery, and he too used nineteenth-century engravings that he cut up and pasted together. Some of the imagery was clearly chosen and arranged in response

OPPOSITE:
Untitled (Vierge Vivace), 1970
Collage, 14 x 12 ⅛ inches
Collection Robert Lehrman,
Washington, D.C.

Story without a Name—for Max Ernst, c. 1942
Published in *View*, ser. 2, no. 1 (April 1942)
16 collages, 3 x 3¾ to 7 ⁷⁄₁₆ x 6 ⁷⁄₁₆ inches
Private Collection; Courtesy the
Menil Collection, Houston

The Crystal Cage

Collages for *The Crystal Cage: Portrait of Berenice*
Published in *View*, ser. 2, no. 4 (January 1943)
Joseph Cornell Study Center, Smithsonian
American Art Museum, Washington, D.C.

to Ernst's imagery—a lit candle, a butterfly, harbor scenes, a shipwreck—but Cornell's delight in the toys of his childhood, his gentle touch, and, above all, his idealism contrast with Ernst's darker vision. Ernst's photomontages are arranged in a sequence similar to Victorian novels. Ernst emulated their melodrama, with overtones of danger and eroticism. Cornell's montages, on the other hand, are closer to the children's fables of the same era.

Cornell designed the front and back covers for the "Americana Fantastica" issue of *View* in January 1943, collaging old engravings and recent photographs of scenes from American life and the country's natural and man-made wonders. The most important work in the issue was Cornell's *The Crystal Cage (Portrait of Berenice)*, which unfolds in a sequence of seven pages. Cornell relates the story of the imaginary Berenice as follows:

> From newspaper clippings dated 1871 and printed as curiosa we learn of an American child becoming so attached to an abandoned chinoiserie while visiting France that her parents arranged for its removal and establishment in her native New England meadows. In the glistening sphere the little proprietress, reared in a severe atmosphere of scientific research, became enamored of the rarified realms of constellations, balloons, and distant panoramas bathed in light, and drew upon her background to perform her own experiments, miracles of ingenuity and poetry.[64]

On one page the chinoiserie is formed by a word poem that relates to Cornell's own interests and influences; another page shows a photograph of the pagoda, built for the Duc de Choiseul in the Loire Valley in 1778. A photograph of the imaginary child accompanies the montage *Portrait of Berenice* (see page 87). Included as well is a portrait of Émile Blondin, who in 1859 successfully crossed Niagara Falls walking a tightrope.

In naming the child Berenice, Cornell had in mind the constellation Coma Berenices, whose name refers to a classical story about Berenice, the wife of Ptolemy III and queen of ancient Cyrene and Egypt. In the myth, Berenice has her hair clipped and left in a temple as a gift to Aphrodite. The hair soon disappears, and the astronomer Conon of Samos discovers that Aphrodite has accepted the gift and placed it high in the heavens next to Leo.

Other sources for Berenice include Edgar Allan Poe, whose tale "Berenice" was published in the *Southern Literary Messenger* in 1835. Poe's macabre tale deals with a narrator, Egaeus, Berenice's cousin, who is given to long periods of obsessive staring at objects of little importance. Baudelaire translated this tale of hypnagogic visions and paranoia into French and Max Ernst painted his own version of the tale, *Berenice* (1935), in which Berenice takes on the role of sexual predator. Cornell's Berenice is an innocent who resembles neither Poe's nor Ernst's characters but as if in complicit acknowledgement of Poe's tale, he dedicated one of the images accompanying Berenice in *View* to Edgar Allan Poe, titling his piece *Spent Meteor, Night of Feb. 10, 1843 (For E. A. Poe)*. Berenice also has a source in ballet. In Michel Fokine's ballet *Cléopatre*, mentioned earlier, which was performed in St. Petersburg in 1908, the central role of Ta-hor that Pavlova danced in Paris in 1909

was called Berenice in the Russian production. Both the ballerina and Poe were cosmic figures for Cornell, and he might well have related Pavlova to Poe's description of his Berenice as a sylph and naiad, and both of them to his creation of the mind and the imagination, the legendary Berenice of *The Crystal Cage*.

Cornell's research on Hans Christian Andersen for the September 1945 issue of *Dance Index* was stimulated by an exhibition of two of the Danish author's cutouts at the Children's Reading Room of the New York Public Library in April 1945. Because Andersen was a devotee of the Romantic ballet and the ballerina Lucille Grahn, Cornell included engravings of the dancer along with illustrations by the Danish author. For this issue Cornell wrote a movie scenario, titled "Theatre of Hans Christian Andersen," and he reproduced a collage fragment on the front page of the article. This fragment is from Andersen's "Great Screen," an eight-panel fire-screen of montaged images, begun in 1873. Each of the panels has a different heading: "Childhood," "Danes" (where this fragment comes from), "Denmark," "Sweden-Norway," "Germany-Austria," "France," "England," and "The Orient." The screen is full of references to Andersen's travels and personages such as the singer Jenny Lind, Tennyson, and Beethoven, images that relate

Hans Christian Andersen, *Great Screen*
(4 panels), c. 1874
Hans Christian Andersen Museum,
Odense, Denmark

THE LATE COLLAGES / 129

MISSING GIRL

From the cozy intimacy of a "Dutch interior" a tike equipped with pipe & bowl for blowing soap bubbles finds herself in a nocturnal phantasmagoria of light & color. Though the metropolis is deserted & rainy ~~& it is late~~ the play of shifting lights make a wonderland for the wandering, wondering tot.

Have you seen this girl?

Name: Edith Kiecorius

Age: 4½ years

Height: 3 feet, 4 inches

Weight: 45 lbs.

Hair: Blond, to shoulders

Eyes: Hazel

Complexion: fair

* * *

Scar: cigaret burn, rt. cheek

Clothing: Purple snow suit of coat and leggings, green dress, white anklets, black suede shoes.

Other: Gold round ear rings in pierced ears.

Last seen: Front of 170 Eighth Av., 4:45 p.m. Wednesday.

* * *

If you have any information, call the Missing Persons Bureau, CA 6-2000, the police special number, WA 9-7307, or The Post City Desk, WH 4-9000.

to his friend Charles Dickens and Dickens's novels, as well as some of his own and Cornell's favorite subjects: owls, ballerinas, cupids, flowers, and fairies. Cornell identified with Andersen because of his love of the ballet, his interest in children, his writing and cutouts, illustrations and montages.

Cornell temporarily abandoned collage for the next decade. In the fall of 1955 he took it up again, stating that the medium was freer and more spontaneous than box construction. Cornell brought to his new collages a superb understanding of the medium, substituting a subtle two-dimensional arrangement of his images for the sense of infinite space conveyed by real objects in the three-dimensional boxes. In place of the black-and-white engravings that Cornell used in the 1930s and 1940s, he drew images for his new collages from contemporary magazines and book illustrations. Although his collages often lack the transcendental quality of his boxes, they retain the same symbolic connections between images.

The twenty-year-old actress Suzanne Miller met Cornell in 1955 when she was appearing in Moss Hart's Off-Broadway play *Climate of Eden*. She later described their first meeting: "I played an eleven-year-old boy named Berton. Joseph came to see the performance and stayed to see the actors. We became friends, although it was a whole year before I understood who this odd and delightful person was. The path from my performance as a little boy in a play to the Hogarth image which he has placed so joyously in the desert is not a direct one, but rather one of those leaps of association executed by the artist."[65] The little boy in Hogarth's *The Graham Children*, which Cornell saw at the 1939 World's Fair, appeared for the first and only time in this collage.

After his collage inspired by Miller, Cornell dedicated another work to an actress. The collage *The Sister Shades* (1956) featured the starlet Jackie Lane. The back of the collage includes a typewritten note by Cornell, a printed scrap, pages from a German theological map, and a handwritten message by Cornell: "amber glass for maximum effect." As in his *Medici* boxes, Cornell used the amber glass to visually remove Lane from the present day and into the past.

The early 1960s were eventful for Cornell. In the fall of 1961 he was included in William Seitz's historic exhibition *The Art of Assemblage*, held at The Museum of Modern Art in New York. Of the many artists featured, including Arp, Braque, Dove, Ernst, Gris, Man Ray, Picasso, Rauschenberg, and Jasper Johns, only three— Duchamp, Schwitters, and Cornell—had rooms dedicated solely to them.

Missing Girl, dated October 10, 1962, is an excellent example of Cornell's later work in collage. The figure to the right, a place often reserved in his box constructions for a colonnette or wire mesh, is cut out from a reproduction of Piero della Francesca's *Madonna and Child with Four Angels* (c. 1460–70). The painting was reproduced on the cover of the December 1957 issue of *Art News*, which also contained an article on Cornell. It is "enhanced" only by the addition of two celestial motifs, which may refer to the Christ Child as well as the constellation Cassiopeia (which is a title given to another version of the work). Other elements include a rabbit and a manhole cover on a city street. The cir-

cular device of the manhole cover, reiterated in the circle created by scoring the surface of the reproduction, successfully fuses the flattened-out form of the figure and the dimension of depth suggested by the reflections in the street.

On the back of the work, Cornell collaged an article from *The New York Post*, dated February 24, 1961, about a missing girl. To this he has added a reproduction of J. Piel's *Mlle. de Moulins*, a portion of the constellations featuring Leo and Virgo, and an inscription:

> *From the cozy intimacy of a "Dutch interior" a tike* [sic]
> *Equipped with pipe & bowl for blowing soap bubbles*
> *finds herself in a nocturnal phantasmagoria of light and*
> *color. Though the metropolis is deserted and rainy the play of*
> *shifting lights make a wonderland for the wandering, wondering tot.*

Cornell also penned a note on the back to Tina, his affectionate name for Joyce Hunter, an aspiring actress whom he met in February 1962 when she was waitressing in a coffee shop on Sixth Avenue in Manhattan. Cornell befriended her, as he did so many young women. In September 1964 Joyce Hunter, her boyfriend, and another friend were arrested for stealing nine boxes from Cornell. The boxes were brought to Richard Feigen, a dealer and collector of Cornell's work. He notified the police, and Hunter was arrested. Until this event Cornell had been in the

Mica Magritte II, c. 1965
Collage with pencil drawing, 12 x 9 inches
Collection Robert Lehrman, Washington, D.C.

Hans Christian Andersen, *Stork*
Hans Christian Andersen Museum,
Odense, Denmark

habit of leaving open the doors to his garage, where he stored many of his boxes. Cornell was distraught at learning of her betrayal, but he refused to press charges against her. On December 18, 1964, Hunter was murdered. Cornell, despondent over her death, memorialized Hunter by inscribing her name in many of his collages, as well as his thoughts about her. Cornell idealized Hunter as he did most of the women he read about, met, or saw in films or on stage.

Just as he had idealized Lauren Bacall and Hedy Lamarr in the 1940s, refusing to acknowledge their sexuality in his writings or in his work, so he idealized every female to whom he was attracted. These women were his life partners, but only in his imagination. They were, like the Medici Princess, the young women that he, as the Prince, was courting. One can read in his images of them a repressed eroticism, but where it truly flowered was in his dreams. Cornell often alluded to his dreams in his diaries, but he wrote down some of his erotic dreams on vellum and occasionally sent them to a female friend to read.

Cornell used both old and new images in his late collages. Among his new resources were Dosso Dossi's *Circe and Her Lovers* and details from paintings by Goya, Brueghel, and Manet. Cornell had first seen Dosso Dossi's *Circe and Her*

Lovers at the World's Fair in the summer of 1939. Reproductions of the work became the centerpiece of his collage series *Mathematics in Nature*, initiated about 1964. In many of these collages Cornell incised a circle into the composition. The circle may stand for the moon and the stars, the flight pattern of birds, a lens or a soap bubble, but it is most impressive as the organizing force for all of the collages in which it is used.

In April 1963, Cornell presented *Comedy Americana: A Series of Film Programs from the Collection of Joseph Cornell*, at the loft of artists Walter de Maria and Robert Whitman in lower Manhattan. That same year Charles Henri Ford brought Robert Indiana, James Rosenquist, and Andy Warhol for a visit to Cornell's home on Utopia Parkway. On December 3, an exhibition of his boxes and collages opened at Loeb Student Center, New York University. Cornell called this show a "Christmas present to the students of New York University."

On February 26, 1965, Cornell's brother, Robert, died. Robert had recently moved with their mother to their sister Betty's home in Westhampton. Cornell arranged an exhibition early in 1966 as a memorial to his brother at the Robert Schoelkopf Gallery, in which Cornell's collages, some of them containing Robert's drawings, were shown. *Mica Magritte II* (c. 1965) is one of several collages that commemorate his beloved brother. Magritte's *Time Transfixed* (1938) occupies the center of the collage. The train refers to Robert's set of toy trains, an important fixture of the Cornell household on Utopia Parkway.

Cornell addressed some of his early loves in his 1960s collages. In *Couleur de Pêche* (1967) and *Untitled (Vierge Vivace)* (1970), Cornell reinterpreted his bird theme; *Penny Arcade (Re-Autumnal)* (1964) returns to one of his favorite games. Cornell's reawakened interest in the penny arcade was probably occasioned by his friendship with Joyce Hunter and his renewed interest in Times Square.

In *Couleur de Pêche*, a white egret watches over her young offspring. The two are set in tall grasses, the egret's long graceful feathers contrasting with the dark marshy surroundings. The incised circle surrounding the birds is the shape of a magnifying glass and the path that the bird travels. *Vierge Vivace* is inscribed to the actress Jacqueline Bisset. Its title comes from Stéphane Mallarmé's poem "Le Vierge, le Vivace et le Bel Aujourd'hui," and the collage is accompanied by a prose translation:

> *The virginal, vigorous and beautiful today, will it tear for us with a/blow of its drunken wing this hard, forgotten lake haunted under the/frost by the transparent glacier of flights that have not flown! A swan/of former days remembers that it is he who magnificent but without/hope frees himself because he did not sing of the country in which to/live when the tedium of sterile winter shone. His whole neck will shake/off the white agony inflicted by space on the bird that denies it, but not/the horror of the soil in which his feathers are caught. A phantom whose/pure brilliance relegates to this place, he remains immobile in the cold/dream of scorn that in his useless exile dons the swan.*

CONCLUSION

Cornell's mother died in the fall of 1966, and his own decline began shortly thereafter. In 1966 and 1967 he was the subject of two retrospectives, the first of which was organized by Walter Hopps for the Pasadena Art Museum in California; I organized the second exhibition for the Solomon R. Guggenheim Museum in New York. Despite these and many other honors, Cornell became increasingly despondent. The deaths of his mother and brother ended the unity of his family. Although his strength was failing, he continued to work and write in his diaries. In June of 1972 he had prostrate surgery. While he recuperated at his sisters' homes in Northport and Westhampton, he continued to correspond with old friends such as Allegra Kent. In November he returned home to Utopia Parkway, and near the end of December he attended a Christian Science meeting in Bayside; there, for the first time, he spoke of his gratitude for his membership in the church. Cornell died at his home on December 29, 1972, five days after his sixty-ninth birthday.

The younger American artists who sought out Cornell did so for a number of reasons. The Americana side of Cornell appealed to Pop artists, whereas the poetic and Minimalist aspect of his work attracted artists such as de Maria and Whitman. Cornell appreciated the company of younger artists, and he learned from them. Several atypical collages from the 1960s recall Rosenquist's billboard imagery and his particular way of montaging his subjects. Cornell's late method of collaging together commercial advertisements with more artistic subjects probably derived from Pop art. He made his aversion to Pop art clear, but the new movement clearly fascinated him.

Cornell kept a diary until shortly before his death. In his diaries he minutely recorded everyday occurrences, his most fanciful feelings, and a thing or two about his work. The stream of consciousness evident in them parallels the episodic nature of his work and the way in which he strung thoughts and feelings into the concrete reality of his shadow boxes.

Cornell was obsessed with color, texture, and reflection. One day he made a lemon butter cream cake at two o'clock in the morning, and another day he worked on a cabinet with a music box and a lemon-colored cockatoo. He loved blue glass, pink plush, and bits of brown bark. He altered the original condition

of the objects he used: the majority of his surfaces were painted or in other ways reworked. Sometimes he applied eighteen or twenty coats of white paint for density, constantly going over even his finished boxes. He liked to set some of his boxes out in the sun—"to christen them." He often took pleasure in destroying a box and then redoing it, as he said, "to take up the slack in it."[66] Sometimes he would glimpse the box's perfection in the process of destruction.

He worked on several series at once, each category deriving invariably from a long-meditated and engrossing basic idea. Concerning *Dovecote*, for example, Cornell talked fondly about people who kept pigeons thirty years ago and mourned the fact that this was now less common. He kept a dossier of photographs, postcards, and associative images—and from these materials came his memorials to dovecotes, his spare whitewashed boxes in which white balls descend a ramp and finally come to rest.

He saw, he dreamed, he imagined, and if a dream did not turn out as he wished and he was disillusioned—as he was when he read about Hedy Lamarr's troubled later life, or if he was heartbroken, as he was when Joyce Hunter was murdered—then he would find other dreams and other paths to follow. They all led back home, for home was the safe haven in which to nurture his visions and actualize his dreams. The boxes were his way of preserving his dreams. His home was Utopia Parkway: what better place for a man with so many dreams.

Cornell was caught up in so many simple things, which to him were his precious treasures. He hoarded them diligently, trusting them to his diary and only rarely discussing them with others. On August 21, 1947, Cornell summed up his feelings:

> *This part of my journal is the most profuse and overflowing*
> *so cluttered in memory received with endlessly unfolding*
> *experience the mecca of a hundred rides (each with their*
> *rich "cross-indexing" of varying mood). Although not the*
> *"first love" it—this house—now stands a lone surviving*
> *sentinel (from its vantage point) a sanctuary for all my*
> *chaotic treasure—a celestial repository.*[67]

Cornell was a master appropriator, using the images of artists he admired as his way of engaging them in a meaningful dialogue. He altered his found objects in a desire to enhance their identity, whereas later artists have often preferred to use the unaltered object as a way of questioning its role in society. Issues of gender and politics held little or no interest for Cornell. Every ballet or concert that he attended, every image by Vermeer, Gris, Duchamp, every ball, jack, and cockatoo had something unique to say to him. These images and objects could be used over and over again, but each represented a different thought process and a different set of emotions. Each box relates to the others— they are complete in and of themselves, but indispensable to one another.

Cornell's impact upon the artists Rauschenberg and Warhol has been noted earlier, but his spare box constructions can also be seen as a valid precursor to

Minimalist art. Boxes such as *The Crystal Palace* and his series of *Window Façades* and *Dovecotes* are reductive and repetitive; they may differ in intent from the work of later generations, but structurally they form a link between artists such as Mondrian and Brancusi and the Minimalists. Donald Judd referred to the sculpture of the mid-1960s as "neither painting nor sculpture" and pointed out that "the new work obviously resembles sculpture more than it does painting, but it is nearer to painting."[68] This description applies equally to Cornell's own work.

Cornell's life was a series of film clips not necessarily connected in sequential order. His days were composed of fragments, many of which worked their way into his boxes. On one of his many visits to Manhattan, he would stop at one of his favorite cafeterias or coffee shops for a bite to eat and a sweet. There he could observe the activity around him, or he might get on the Madison Avenue bus and spot a young girl about eight years old, who reminded him of a child he had seen three years earlier. He recalled the experience in his diary, this child who was "the little dancer, same age, of the dream three years back recalled. There was about the little girl all that was needed to extend it. Watched her cross Madison and disappear through the crowds in the opposite direction to which I was going."[69]

His life and work were an extended attempt at capturing transient experience and expanding upon it. He described this achievement in his diary, commenting on a poem by Mallarmé:

> *Note to Mallarmé poem: The rower becomes aware*
> *that he is in the grounds of a woman he knows. She may*
> *be there, close to him: raising his eyes he might see her.*
> *The silence throbs with every possibility. And to the poet*
> *comes the idea of not raising his eyes, of keeping the*
> *possibilities intact and going away with the memory of*
> *that moment.*[70]

Cornell captured the memory of the moment in his work. It was his gift to us.

1 Joseph Cornell, n.d.

2 Annalee Newman, in conversation with the author, n.d.

3 Vivien Raynor, "In the Galleries: Joseph Cornell, Willem de Kooning," *Arts Magazine*, 39:6 (March 1965), p. 53.

4 David Bourdon, "Enigmatic Bachelor of Utopia Parkway: Boxed Art of Joseph Cornell," *Life*, 163:24 (December 15, 1967), pp. 52–66.

5 In conversation with the author, 1963.

6 From photocopies of notes given to the author by Cornell, dated June 23, 1968.

7 From photocopies of notes given to the author by Cornell, dated June 23, 1968.

8 Established in January 1907 by Stieglitz and Steichen, The Little Gallery of the Photo-Secession at 291 Fifth Avenue was better known as "291."

9 Anna Balakian, *Surrealism: The Road to the Absolute* (New York: Noonday, 1959), p. 14.

10 Julien Levy, *Surrealism* (New York: Black Sun Press, 1936), p. 22.

11 In conversations between the artist and the author, 1963–64.

12 Quoted from "Au delà de la peinture," "Cahiers d'Art," vol. II, no. 6–7, 1936, n.p.

13 In letter to Thomas M. Messer from Cornell, undated (1966–67?).

14 A photomontage by Herbert Bayer, *Lonely Metropolitan* (1932), which shows a pair of hands with eyes in their palms, was included in Levy's show. Cornell probably saw the work before the exhibition opened and made his own object based upon it.

15 Cornell told me that he used the term *montage* for his early 1930s work. In the 1940s he began to call them collages.

16 Exhibition catalogue, *Joseph Cornell: Objects*, Copley Galleries, Beverly Hills, September 28, 1948.

17 Iolas was also Magritte's dealer in the United States.

18 Cornell Papers, AAA, 1059:833, July 20, 1953. Quoted by Lynda Roscoe Hartigan, in Kynaston McShine, ed., *Joseph Cornell* (New York: The Museum of Modern Art, 1980), p. 100.

19 J.L., "Joseph Cornell's Concoctions from the Unconscious," *Art News*, 38:12 (December 23, 1939), p. 8.

20 H.D., "Here, There, Elsewhere," *The New York Times*, December 10, 1939, Section X, p. 12.

21 Carlyle Burrows, "Playful Objects," *The New York Herald Tribune*, December 10, 1939, Section VI, p. 8.

22 André Breton in "What is Surrealism," 1936, p. 17.

23 "Bee" in Jean Chevalier and Alain Gheerbrant, transl. John Buchanan-Brown, *A Dictionary of Symbols* (London: Penguin Books, 1994), p. 79.

24 Mary Ann Caws, ed., *Joseph Cornell's Theater of the Mind* (New York: Thames and Hudson, 1993) p. 101.

25 "Butterfly" in Chevalier, et al., p. 140.

26 Statement by Cornell in the announcement for his exhibition, *Objects by Joseph Cornell*, held at the Copley Galleries, Beverly Hills, Los Angeles, September 28, 1948.

27 Cornell adapted the tale from Albert D. Vandham's book *An Englishman in Paris*, published in New York in 1892. Christine Hennessey, "Joseph Cornell: A Balletomane," *Archives of American Art Journal*, 23:3 (1983), p. 9.

28 Caws, ed., p. 210.

29 Caws, ed., p. 228.

30 Caws, ed., p. 95.

31 Caws, ed., p. 126.

32 Caws, ed., p. 98.

33 Cornell might also have been thinking of one of his favorite authors, Gérard de Nerval, who was famous for parading through the gardens of the Palais Royal with a lobster on a blue ribbon.

34 Caws, ed., p. 159.

35 Donald Windham wrote the preface for Cornell's 1949 *Aviary* exhibition at the Egan Gallery. In 1972 Windham published a work of fiction, *Tanaquil*, in which the character of William Dickinson was based on Cornell. "Tanaquil" refers to Tanaquil LeClerq, the noted ballerina of the New York City Ballet who was Balanchine's muse and fifth wife. Among her many roles was that of *Ondine*, a role that Fanny Cerrito originated a century before.

36 "Joseph Cornell: A Reminiscence by Allegra Kent," in Sandra Leonard Starr, ed., *Joseph Cornell Portfolio* (New York: Castelli Feigen Corcoran, 1976).

37 Caws, ed., p. 120.

38 Caws, ed., p. 128.

39 *View*, Series I, no. 9–10 (December 1941–January 1942), p. 3.

40 Caws, p. 95.

41 Caws, ed., p. 94.

42 Caws, ed., p. 115.

43 Caws, ed., p. 96.

44 *Aviary by Joseph Cornell*, at the Egan Gallery, held December 7, 1949–January 7, 1950.

45 *Ibid*.

46 "Bird" in Chevalier, et al., p. 90.

47 *VVV*, no. 1 (June 1942), p. 59.

48 Caws, ed., p. 131.

49 Caws, ed., p. 167.

50 T[homas] B. H[ess], "Reviews and Previews," *Art News*, 48:9 (January 1950), p. 45.

51 Chevalier, et al., p. 660.

52 Caws, ed., p. 117.

53 "Owl" in Chevalier, et al., p. 730.

54 Caws, ed., pp. 133–134.

55 Caws, ed., p. 128.

56 Arthur Koestler, *The Sleepwalkers* (London: Arkana Books, 1989), p. 345.

57 Antoine de Saint-Exupéry, *The Little Prince* (New York: Harcourt, Brace & World, Inc.), p. 104.

58 Letter from Cornell to John I. H. Baur regarding his participation in the Whitney Annual of 1962.

59 Parker Tyler, "Joseph Cornell," *Art News*, 56:9 (January 1959), pp. 18–19.

60 André Breton, "World," quoted in Marcel Jean, *The History of Surrealist Painting* (New York: Grove, 1960), p. 146.

61 "'Enchanted Wanderer': Excerpt from a Journey Album for Hedy Lamarr," *View*, Series 1, no. 9–10 (December 1941–January 1942), p. 3.

62 *Monsier Phot*, in Julien Levy, *Surrealism*, pp. 83–84.

63 Julien Levy, *Memoir of an Art Gallery* (New York: G. P. Putnam's Sons, 1977), pp. 230–31.

64 *View*, Series 2, no. 4 (January 1943), p. 12.

65 Comments by Suzanne Miller made at the time of an exhibition *Collages by Joseph Cornell* held at the University of California at Santa Barbara from October 24–November 11, 1975.

66 In conversation with the author, 1963–64.

67 Caws, ed., p. 146.

68 Donald Judd, "Specific Objects," *Arts Yearbook*, 8, 1965, pp. 74, 77.

69 Caws, ed., pp. 143–44.

70 Caws, ed., p. 149.

CHRONOLOGY

compiled by Mary Bryant; several entries are from Philadelphia Museum of Art, *Joseph Cornell/ Marcel Duchamp . . . in resonance*, 1998

1903
December 24: Joseph I. Cornell is born in Nyack, New York, the sixth of that name, to Joseph I. Cornell, a textile salesman and designer, and Helen Ten Broeck Storms. His three younger siblings are Elizabeth (b. 1905), Helen (b. 1906), and Robert (b. 1910). By the age of one, Robert shows signs of muscular and neurological problems, later diagnosed as cerebral palsy. In 1911 the family moves to "the big house on the hill" at 137 South Broadway in Nyack.

1912
Cornell's father develops leukemia.

1915
Duchamp arrives in New York in June, joining Picabia and Man Ray. They become the center of the New York Dada movement. Duchamp leaves the U.S. in 1918 but returns periodically before his final immigration in June 1942.

1917
April 29: Cornell's father dies, leaving his family in difficult financial condition.
Fall: Cornell enrolls in Phillips Academy, Andover, Massachusetts. He chooses a scientific curriculum and also takes French, Spanish, and Latin.

1918
The Cornell family moves to Douglaston, Queens, New York.

1919
Fall: The Cornell family relocates to Bayside, Queens.

1921
Fall: Cornell leaves Phillips Academy before completing his fourth year and returns home to assume the primary financial responsibility for the family. He works for the William Whitman Company, Inc., a Boston-based textile wholesaler with offices at 25 Madison Avenue, near Madison Square. Cornell begins exploring lower Manhattan for used books, photographs, old recordings, engravings, and other ephemera. He attends opera, theater, music, and ballet performances, visits museums and art galleries, and develops an interest in film (eventually accumulating a vast collection of film and movie memorabilia).

1924
André Breton publishes his first Surrealist manifesto in Paris. The magazine *La Révolution surréaliste* is founded. Members of the movement include Paul Eluard, Réne Crevel, Max Ernst, André Masson, and Joan Miró. Yves Tanguy and Hans Arp join within the next year. Francis Picabia and Tristan Tzara choose not to be affiliated. The method of automatic drawing and writing is introduced at this time.

1925
Tanguy and Arp become Surrealist members. The Galerie Pierre in Paris shows *La Peinture surréaliste* with works by Arp, de Chirico, Ernst, Klee, Masson, Miró, Picasso, Man Ray, and Pierre Roy.

1926
Marc Allégret, Duchamp, and Man Ray make the film *Anemic Cinema*. Max Ernst publishes *Histoire naturelle (frottages)*.
January: Cornell attends the memorial exhibition of modern art collector John Quinn's collection at the Art Center, New York, which includes Georges Seurat's *Le Cirque* and Henri Rousseau's *Sleeping Gypsy*, Pablo Picasso's *Mother and Child Seated by the Sea*, and André Derain's *Window on the Park*. (In the June 1946 issue of *Dance Index*,

Cornell will incorporate a reproduction of *Le Cirque* in his cover design.)
January: First issue of *Cahiers d'Art*, founded by Christian Zervos, is published in Paris: an important link for American artists to European avant-garde. In this year, articles appear on Giorgio de Chirico, Fernand Léger, Joan Miró, and Pablo Picasso.
Cornell begins clipping articles about art, music, literature, and philosophy from newspapers and magazines and assembling them in binders.
May 10: Cornell attends the New York debut of Spanish opera star Raquel Meller. His collection of clippings about her will provide the foundation for one of his first dossiers related to a performer.
September: Cornell becomes a Christian Scientist and joins the Mother Church in Boston, and First Church of Christ, Scientist, in Great Neck, Long Island.
November 19, 1926–January 1, 1927: The Brooklyn Museum, *An International Exhibition of Modern Art*. Organized by the Société Anonyme. Three hundred and seven works by artists from 23 countries, including Arp, Braque, de Chirico, Kandinsky, Klee, Miró, and Picasso. First showing of Duchamp's *Large Glass*. Ninety-one of these paintings shown at Anderson Galleries, New York, *44th Exhibition of the Société Anonyme*, January 25–February 5, 1927.

1927
Breton publishes *Introduction au discours sur le peu de réalité*, in which he discusses Surrealist objects.
April: First issue of *Transition* is published in Paris: devoted to contemporary literature, drama, cinema, art; subsequent issue includes first English translation of poems by Paul Eluard. Reproductions of work by de Chirico, André Masson, and Miró appear in late 1920s and 1930s.
December: The Gallery of Living Art, New York University, opens at Washington Square: Albert E. Gallatin's collection of works by artists "living or recently deceased" includes Georges Braque, Giorgio de Chirico, Joan Miró, and Pablo Picasso.

1928
January: Wildenstein & Co., New York, presents *Loan Exhibition of Paintings by Paul Cézanne*.
January 23–February 11: Dudensing Gallery, New York, presents *De Chirico*, the artist's first solo exhibition in the United States.

1929
May: Mrs. Cornell purchases a home at 3708 Utopia Parkway, Queens, which remains Cornell's residence until his death. His sisters, Helen and Elizabeth, marry in June 1929 and August 1931 respectively and move to neighboring communities. • Robert Desnos, Joan Miró, André Masson, and Jacques Prévert leave the Surrealist group, while Alberto Giacometti, Salvador Dalí, Luis Buñuel, René Char, and Tristan Tzara join it. Max Ernst publishes his collage-novel *La Femme 100 têtes*.
November 8: The Museum of Modern Art opens, with the loan exhibition: *Cézanne, Gauguin, Seurat, Van Gogh*. Two months later *Paintings in Paris* opens, which includes 15 Picassos, 11 Matisses, several de Chiricos, Légers, and Mirós.

1930
October 20–November 8: Valentine Gallery (formerly Dudensing Gallery), New York, presents *Joan Miró*, his first solo exhibition in the United States.

1931
Early in year: Cornell loses his job at Whitman's because of the Depression and begins taking a series of part-time jobs to support his mother and brother.

January: *Abstractions of Picasso* at Valentine Gallery, New York.

February 3–21: *Fernand Léger* at Durand-Ruel, Inc., New York.

November 2: Julien Levy Gallery opens at 602 Madison Avenue with *American Photography Retrospective Exhibition*, which was arranged with Alfred Stieglitz. The exhibition includes Mathew Brady, Gertrude Käsebier, Charles Sheeler, Edward Steichen, Alfred Stieglitz, Paul Strand, and Clarence White.

November 18: Whitney Museum of American Art, New York, opens.

• Cornell shows his collages to Julien Levy. They consist of original and reproductions of black-and-white engravings and woodcuts from turn-of-the-20th-century books, similar to those of Ernst in his collage-novel, *La Femme 100 têtes*. Levy invites Cornell to join the gallery, and Cornell remains affiliated with the Julien Levy Gallery until its closing in April 1949.

November 16: *Newer Super-Realism*, the first major Surrealist exhibition in the United States, organized by "Chick" Austin, opens at the Wadsworth Atheneum, Hartford, Connecticut. The exhibition includes work by de Chirico, Dalí, Ernst, Masson, Miró, Picasso, and Pierre Roy.

1932

January 9–29: An abbreviated version of the Wadsworth exhibition travels to the Julien Levy Gallery, New York, as *Surréalisme*. Levy adds more artists, among them Cornell, who is represented by several collages and an object, *Glass Bell* (c. 1932), and also designs the gallery announcement. The gallery holds its first film screening, which includes Fernand Léger's *Ballet Mécanique* and Man Ray's *L'Étoile de Mer*. This exhibition launches the Surrealism movement in New York.

April 9–May 30: *Photographs by Man Ray*, the artist's first solo photography show in New York, is held at the Julien Levy Gallery.

November 5–December 3: *Exhibition Surréaliste by Max Ernst*, Ernst's first solo show in the United States, is held at the Julien Levy Gallery.

November 26–December 30: *Objects by Joseph Cornell: Minutiae, Glass Bells, Shadow Boxes, Coups d'Oeil, Jouets Surréalistes*, Cornell's first solo show, is presented in the back room of the Julien Levy Gallery.

December 30–January 25, 1933: *Lee Miller, Exhibition of Photographs* is presented at the Julien Levy Gallery. Cornell meets and becomes friendly with Miller, who photographs his work and makes several portraits of him.

1933

March 19: New York Film Society screens *L'Age d'Or* (1929), directed by Luis Buñuel with a screenplay by Dalí. On October 9 the Society presents *Un Chien andalou* (1929), also directed by Buñuel with a screenplay by Dalí. Cornell attends both screenings.

• Cornell writes a film scenario entitled *Monsieur Phot*. Cornell assembles as many as 20 handmade copies of the scenario, each typed on 13 pages of red paper and containing 5 stereopticon photographs mounted on black paper, which are enclosed in a black folder. The copies are given to friends over a period of years.

November 2–18: *Twenty-five Years of Russian Ballet from the Collection of Serge Lifar: Paintings, Drawings, Designs, Models* is shown at the Julien Levy Gallery, New York. Among the artists are Christian Bérard, de Chirico, Ernst, Gris, Matisse, Miró, Picasso, and Tchelitchew.

November 9: Cornell sends Miller's photograph of one of his bell jar objects to André Breton in Paris, inscribed *A André Breton En Hommage Joseph Cornell November 9, 1933*.

November 17–January 13, 1934: A Brancusi exhibition is presented at Brummer Gallery, organized and installed by Duchamp. Cornell and Duchamp meet briefly for the first time.

December 12–January 3, 1934: *Objects by Joseph Cornell, Posters by Toulouse-Lautrec, Watercolors by Perkins Harnley, Montages by Harry Brown* is presented at the Julien Levy Gallery, New York.

1934

Cornell begins acquiring photographs and ephemera that will later be included in the "exploration" *The Crystal Cage (Portrait of Berenice)* (c. 1934–67).

January: Duchamp presents Cornell with the advertisement for the *International Exhibition of Modern Art*, Société Anonyme, published in *ARTnews* (vol. 25, May 14, 1927, n.p.). The exhibition, which was held at the Brooklyn Museum, features Duchamp's *Large Glass*. The announcement is inscribed *Marcel Duchamp/for Joseph Cornell/New York Jan. 1934*.

January: Cornell presents Duchamp with copy no. 12 of his film scenario *Monsieur Phot*, inscribed *à Marcel Duchamp/En Hommage/Joseph Cornell/Jan. 1934*. (2, fn)

April 3–28: Julien Levy Gallery presents Dalí's illustrations for Lautréamont's *Les Chants de Maldoror*.

November 21–December 10: Julien Levy Gallery presents an exhibition of Dalí's paintings. Dalí makes first trip to New York.

December 1–January 1, 1935: Alberto Giacometti's first solo show in the United States is presented at the Julien Levy Gallery.

Fall: Cornell is employed as a textile designer at Traphagen Commercial Textile Studio, New York, remaining in their employ until 1940. He uses his free time to visit the New York Public Library, at 42nd Street and Fifth Avenue, and watch rehearsals at the American Ballet.

1935

January 29–February 19: Cornell appears in his first museum exhibition, *American Painting and Sculpture of the 18th, 19th & 20th Centuries*, at the Wadsworth Atheneum.

1936

January 3–20: *René Magritte, Paintings*, the artist's first solo show in the United States, is presented at the Julien Levy Gallery.

Fall: Levy publishes *Surrealism* (New York: The Black Sun Press), with a cover design by Cornell. Included in the book is a transcript of Cornell's *Monsieur Phot* scenario (pp. 77–88).

December: Julien Levy Gallery presents a film matinee, featuring Duchamp's *Anemic Cinema* and Man Ray's *L'Étoile de Mer*. The film program also includes *Goofy Newsreels*, a selection from Cornell's film collection, and Cornell's first film, *Rose Hobart*. Dalí, who attends the screening, claims Cornell stole his idea for a particular effect.

December 9–January 17, 1937: *Fantastic Art, Dada, Surrealism*, organized by Alfred H. Barr, Jr., is presented at The Museum of Modern Art, New York. Cornell is represented by two boxes, *Cabinet of Natural History (Object)* (1934, 1936–40) and *Untitled (Soap Bubble Set)* (1936), and 10 small bell jar objects. A. Everett Austin, director of the Wadsworth Atheneum, purchases Cornell's *Untitled (Soap Bubble Set)* for $60 in 1938. This is the first museum acquisition of a Cornell work.

1937

Cornell begins freelance work for client publications, supplying photographs and ephemera from his growing collection.

February: In an article entitled "The Pulse of Fashion," *Harper's Bazaar* reproduces two Cornell untitled montages (both c. 1932) featuring sewing machines.

October 16–November 14: *Photography 1839–1937*, organized by Beaumont Newhall, is held at the Museum of Modern Art. Among the photographers in the exhibition is Charles Nègre.

Winter: the French publication *Minotaure* reproduces a work by Cornell, *Glass Bell* (c. 1932), in the winter 1937 issue.

1938

January 17–February: *Exposition Internationale du Surréalisme*, organized by André Breton and Paul Eluard, is presented at Galerie Beaux-Arts, Paris. Cornell is represented by one object lent by Levy, *Untitled* (1932), a montage of a Victorian paper doll on a sewing machine, which is reproduced in the gallery's catalogue, *Dictionnaire Abrégé du Surréalisme*.

Summer: Cornell begins a series of photographs and installations using his cousin's French Victorian doll (from the Jumeau factory, c. 1885–95). *Harper's Bazaar* reproduces Cornell's photograph of the doll, *Bébé Marie*. By 1943 he creates a box construction featuring the doll.

1939

Cornell becomes friendly with Charles Henri Ford, the Russian émigré painter Pavel Tchelitchew, and the critic Parker Tyler, all of whom are supportive of Cornell's work. Ford writes to Cornell, asking him to collaborate on the design of his forthcoming book of poems, *ABC's for the Children of No One, Who Grows Up to Look Like Everyone's Son*.

May: First U.S. exhibition of Picasso's *Guernica* at the Valentine Gallery.

Summer: Cornell repeatedly visits the New York World's Fair, Flushing Meadows, Queens, New York. He is impressed by Dalí's underwater fantasia, the *Dream of Venus* Pavilion, and by *The Masterpieces of Art* Pavilion, where he sees Dosso Dossi's painting *Circe and Her Lovers* (c. 1525), which he uses in his series of collages *Mathematics in Nature*. He buys quantities of Dutch clay pipes, which he later uses in his *Soap Bubble Sets* and their variants.

December 6–January 9, 1940: *Exhibition of Objects (Bilboquet) by Joseph Cornell* is presented at the Julien Levy Gallery, with an announcement designed by Cornell and an essay by Parker Tyler. This is Cornell's first show to attract some attention. Works include bubble pipes, thimbles, and China dolls showered with confetti (in and out of shadow boxes).

1939–42

Amédée Ozenfant, Léger, Breton, Matta Echaurren, Tanguy, Man Ray, André Masson, Kurt Seligmann, and Piet Mondrian seek refuge in America during World War II. Max Ernst is imprisoned repeatedly, but with the help of Peggy Guggenheim, arrives in New York in 1941.

1940

April 16–May 7: Matta's first solo show in the United States is held at the Julien Levy Gallery.

September: The first issue of *View*, the Surrealist magazine founded by Charles Henri Ford and Parker Tyler, is published.

December 10–26: *Joseph Cornell: Exhibition of Objects: Daguerreotypes, Miniature Glass Bells, Soap Bubble Sets, Shadow Boxes, Homage to the Romantic Ballet* is held at the Julien Levy Gallery. Foldout announcement designed by Cornell.

• Cornell begins freelance design and artwork for *Mademoiselle, House and Garden, Vogue, Good Housekeeping*, and *Harper's Bazaar*, which he continues into the early 1950s. (*Mademoiselle*: 18:5 [March 1944], 31:3 [July 1950], 44:4 [February 1957]; *House and Garden*: 87:5 [May 1945], 93:11 [November 1948]; *Vogue*: 110:6 [September 15,

1947]; *Good Housekeeping*: 127:1 [July 1948]; *Harper's Bazaar*: December 1947.)

1941

Peggy Guggenheim returns to the U.S. after living in Europe for 20 years.

Early in year: After leaving his job at Traphagen in fall 1940, Cornell works full-time as an artist, using the basement of his house as his studio. He also begins freelance work for *View* magazine, and contributes until its final issues in early 1947.

December: Cornell contributes photomontage and essay titled "'Enchanted Wanderer': Excerpt from a Journey Album for Hedy Lamarr" to *View*.

1942

Early in year: Cornell meets Matta, Robert Motherwell, and Ernst.

January: Lincoln Kirstein founds *Dance Index*, with offices at 637 Madison Avenue, New York. Donald Windham fills in as editor when Kirstein enters the Army. Cornell designs the first three covers: "Hommage à Isadora," The Parker Sisters," and "Loïe Fuller." Cornell contributes work to *Dance Index* until 1947. Cornell and Windham develop a lifelong friendship.

Early March: On Duchamp's advice, Peggy Guggenheim purchases *Fortune Telling Parrot* (c. 1937–38), *Thimble Box* (1938), and *Revolving Book with Red Ball* (1934) from Cornell. The last two artworks are later sold or given away by Guggenheim.

April: In homage to Ernst, Cornell contributes 16 montages, *Story without a Name—for Max Ernst*, to an issue of *View* devoted entirely to Ernst.

June: The first issue of *VVV*, a Surrealist-oriented review, is published. The magazine is edited by Breton and David Hare, Ernst acts as editorial advisor, and it features articles by Breton, Lévi-Strauss, Motherwell, and Harold Rosenberg.

June 25: Duchamp arrives in New York from Marseilles, France.

July 31: Duchamp, Cornell, and his brother, Robert, lunch together at Cornell's house. The two artists spend the afternoon looking at an example of the *Boîte-en-valise*. Soon after, Cornell begins assisting in the assembly of a *Boîte* edition, which they work on until January 1946. Between 1942 and 1946, Cornell aids in the assembly of as many as 11 *Boîtes-en-valise* and between 25 and 30 *Boîtes*.

Late summer: Peggy Guggenheim publishes *Art of This Century: Objects—Drawings—Photographs—Paintings—Sculpture—Collages, 1910 to 1942* (New York: Art of This Century). Two of Cornell's artworks, *Ball and Book* (1934) and *Thimble Box* (1938), are listed but not reproduced.

October 14–November 7: *First Papers of Surrealism*, an exhibition organized by Duchamp and Breton, sponsored by the Coordinating Council of French Relief Societies, Inc., is held at the Whitelaw Reid Mansion, 451 Madison Avenue, New York. Young American artists such as Baziotes, Calder, Motherwell, and David Hare join Surrealists Duchamp, Ernst, Giacometti, Magritte, Miró, and Masson.

October 20–November: Peggy Guggenheim's gallery Art of This Century, at 30 West 57th Street, opens with *Exhibition of the Collection*, which includes the works by Cornell that she has previously purchased. Cornell is affiliated with the gallery until its closing in 1947.

December: *Objects by Joseph Cornell; Marcel Duchamp: Box-Valise; Laurence Vail: Bottles* opens at Art of This Century, New York.

1943

Cornell meets Antoine de Saint-Exupéry, author of *Le Petit Prince*, in New York.

Early in year: Art dealer Pierre Matisse purchases an untitled *Pharmacy* box by Cornell. The box

remains with his wife, Alexina "Teeny" Sattler after their divorce in 1949. Teeny marries Duchamp in 1954.

Early in year: Cornell begins correspondence with poet Marianne Moore, and visits her and her mother at their home. He asks her for a recommendation for a Guggenheim Fellowship in 1945, and, with reservations, she does so. He is unsuccessful in receiving the fellowship.

January: Duchamp presents Cornell with an envelope, inscribed *New Year's intentions*, into which Cornell places several fragments of materials related to the assembly of the *Boîte* edition.

January: Cornell contributes essays and collages to *View* magazine's "Americana Fantastica" issue. Cornell designs the front and back covers and contributes a collage and poem titled *Ballet for Tamara Toumanova*, the collage-story *The Crystal Cage (Portrait of Berenice)*, and an homage to Edgar Allan Poe titled *Spent Meteor, Night of Feb. 10, 1843 (For E. A. Poe)*.

April: Cornell contributes a cover montage, *Portrait of Allen Dodsworth* (1847), to the April issue of Dance Index.

April 16–May 15: *Exhibition of collage* is held at Art of This Century. Pollock and Motherwell exhibit their first collages. Cornell, Duchamp, Ernst, Gris, Miró, and other artists shown earlier by Julien Levy are included in the exhibition.

May 20–November 1: Cornell works on the radio manufacturing assembly line of the Allied Control Company, Long Island City, New York.

November 9–27: *First Exhibition. Jackson Pollock. Paintings and Drawings* is held at Art of This Century.

November 30–December 31: Cornell participates in the group exhibition *Natural, Insane, Surrealist Art* at Art of This Century.

December 7–28: *Through the Big End of the Opera Glass* opens at the Julien Levy Gallery, now at 42 East 57th Street, showing Duchamp, Tanguy, and Cornell. Cornell designs the announcement with contributions from Duchamp and Tanguy. Works by Cornell include "Medici Slot Machines, Roses of the Wind, A Feathered Constellation (for Toumanova), Habitat Parakeets (Shooting Gallery), American Rabbit."

1944

February: Sidney Janis publishes *Abstract & Surrealist Art in America* (New York: Reynal & Hitchcock). Includes reproduction of Cornell's *Medici Slot Machine* (1941). In conjunction with the book, an exhibition, also organized by Janis, travels to five American cities from February through July. Cornell is represented by a box construction *Pipe and Cut Out* (1940).

March: *Mademoiselle* features four of Cornell's boxes, including *Untitled (Bébé Marie)*, in fashion layout photographed at the Julien Levy Gallery.

Spring to winter: Cornell works intermittently at the Garden Center, a large nursery on Northern Boulevard and 194th Street in Flushing, owned by a Christian Science practitioner. He begins a major "exploration," *GC44*, centered around his love of nature.

April: *Dorothea Tanning*, her first solo show, is held at the Julien Levy Gallery.

May–September: Cornell designs several covers for *Dance Index*: "European Dance Teachers in America, Le Quatuor Dansé à Londres par Taglioni, Carlotta Grisi, Cerrito et Fanny Elsler [sic]," and "Three or Four Graces."

October 24–November 11, *Robert Motherwell*, his first solo show, is presented at Art of This Century.

1945

Cornell designs a Christmas card based on a 19th-century astronomical engraving for The Museum of Modern Art, New York.

January 9–February 4: *Mark Rothko Paintings* is presented at Art of This Century.

March: Cornell makes a collage illustration, *3/4 Bird's-Eye View of "A Watch-Case for Marcel Duchamp,"* for a special issue of *View* devoted to Duchamp.

March 6–31: *Arshile Gorky, Paintings*, his first solo exhibition, is held at the Julien Levy Gallery.

March 6: Peggy Guggenheim purchases *Untitled (Pharmacy)* (c.1942) from Cornell.

May–December: Cornell's graphic designs for *Dance Index* include the May cover, the June cover of dancers Annetta Galletti, Louise Lamoureaux, Ermesilda Diana, Kate Penoyer, and Josephine De Rosa, and the October cover *Around a Scene from Sadler Wells' 1945 revival of Swan Lake*.

September: Cornell designs the cover, a film scenario, and illustrations for the *Dance Index* issue on Hans Christian Andersen.

November 15: Hugo Gallery opens at 26 East 55th Street.

November 26–February 17, 1946: Cornell designs a special installation for his exploration *Portrait of Ondine* (c. 1940s–late 1960s), exhibited in the Auditorium Gallery at The Museum of Modern Art, New York.

1946

February: Charles Egan opens Egan Gallery at 63 East 57th Street, New York.

March 15: *"From the Dawn of Diamonds": An Art Exhibit which Traces the Origins of our Oldest Bridal Traditions, Created by Joseph Cornell* opens at the Park Lane Hotel, at Park Avenue and 48th Street, New York, for De Beers Consolidated Mines.

March 2 and 16: *Film Soirée: Selected Rarities from the Collection of Joseph Cornell* is presented at the Norlyst Gallery, 59 West 56th Street, New York. The first program is devoted to early French films and includes "Magic, fantasy, cartoons, Max Linder, fin de siècle." The second program is exclusively American and features "Pearl White, Valentino, Clara Kimball Young, King Baggott, Chaplin, etc."

September: Cornell designs the cover and composes the contents and layout for the "Americana Romantic Ballet" issue of *Dance Index*.

December 3: *Romantic Museum at the Hugo Gallery/Portraits of Women: Constructions and Arrangements by Joseph Cornell*. Cornell designs the four-page brochure for the exhibition. The brochure includes three collage inserts of Cornell's *Unknown (the Crystal Cage)*, *Penny Arcade Portrait of Lauren Bacall*, *Bébé Marie*, and Cornell's descriptive texts on other works.

1948

April–May: Willem de Kooning has his first one-man show at Egan Gallery, New York.

June 1: Under Cornell's direction, Ernst Beadle photographs him in Central Park posed to look as though he were supporting a boulder overhanging a small standing doll.

September 28: *Objects by Joseph Cornell* opens at the Copley Galleries, Beverly Hills, California. Forty-two works from the 1930s and 1940s are featured, the first survey of Cornell's work. The brochure cites Cornell's *Taglioni Jewel Case, Soap Bubble Set (Moon Map), Owl (Habitat Setting), Book with Marble, Paolo and Francesca (Romantic Paysage), Beehives*, and *Palace of Windows*.

Fall: William Baziotes, David Hare, Robert Motherwell, and Mark Rothko establish a small cooperative school, called Subjects of the Artist, New Art School, at 35 East Eighth Street in Greenwich Village. A gathering place for artists, poets, and critics, Subjects of the Artist closes May 1949.

1949

January 21 and March 4: Cornell presents a program of film and music, "Early Films from the

January: *Abstractions of Picasso* at Valentine Gallery, New York.

February 3–21: *Fernand Léger* at Durand-Ruel, Inc., New York.

November 2: Julien Levy Gallery opens at 602 Madison Avenue with *American Photography Retrospective Exhibition*, which was arranged with Alfred Stieglitz. The exhibition includes Mathew Brady, Gertrude Käsebier, Charles Sheeler, Edward Steichen, Alfred Stieglitz, Paul Strand, and Clarence White.

November 18: Whitney Museum of American Art, New York, opens.

• Cornell shows his collages to Julien Levy. They consist of original and reproductions of black-and-white engravings and woodcuts from turn-of-the-20th-century books, similar to those of Ernst in his collage-novel, *La Femme 100 têtes*. Levy invites Cornell to join the gallery, and Cornell remains affiliated with the Julien Levy Gallery until its closing in April 1949.

November 16: *Newer Super-Realism*, the first major Surrealist exhibition in the United States, organized by "Chick" Austin, opens at the Wadsworth Atheneum, Hartford, Connecticut. The exhibition includes work by de Chirico, Dalí, Ernst, Masson, Miró, Picasso, and Pierre Roy.

1932

January 9–29: An abbreviated version of the Wadsworth exhibition travels to the Julien Levy Gallery, New York, as *Surréalisme*. Levy adds more artists, among them Cornell, who is represented by several collages and an object, *Glass Bell* (c. 1932), and also designs the gallery announcement. The gallery holds its first film screening, which includes Fernand Léger's *Ballet Mécanique* and Man Ray's *L'Étoile de Mer*. This exhibition launches the Surrealism movement in New York.

April 9–May 30: *Photographs by Man Ray*, the artist's first solo photography show in New York, is held at the Julien Levy Gallery.

November 5–December 3: *Exhibition Surréaliste by Max Ernst*, Ernst's first solo show in the United States, is held at the Julien Levy Gallery.

November 26–December 30: *Objects by Joseph Cornell: Minutiae, Glass Bells, Shadow Boxes, Coups d'Oeil, Jouets Surréalistes*, Cornell's first solo show, is presented in the back room of the Julien Levy Gallery.

December 30–January 25, 1933: *Lee Miller, Exhibition of Photographs* is presented at the Julien Levy Gallery. Cornell meets and becomes friendly with Miller, who photographs his work and makes several portraits of him.

1933

March 19: New York Film Society screens *L'Age d'Or* (1929), directed by Luis Buñuel with a screenplay by Dalí. On October 9 the Society presents *Un Chien andalou* (1929), also directed by Buñuel with a screenplay by Dalí. Cornell attends both screenings.

• Cornell writes a film scenario entitled *Monsieur Phot*. Cornell assembles as many as 20 handmade copies of the scenario, each typed on 13 pages of red paper and containing 5 stereopticon photographs mounted on black paper, which are enclosed in a black folder. The copies are given to friends over a period of years.

November 2–18: *Twenty-five Years of Russian Ballet from the Collection of Serge Lifar: Paintings, Drawings, Designs, Models* is shown at the Julien Levy Gallery, New York. Among the artists are Christian Bérard, de Chirico, Ernst, Gris, Matisse, Miró, Picasso, and Tchelitchew.

November 9: Cornell sends Miller's photograph of one of his bell jar objects to André Breton in Paris, inscribed *A André Breton En Hommage Joseph Cornell November 9, 1933*.

November 17–January 13, 1934: A Brancusi exhibition is presented at Brummer Gallery, organized and installed by Duchamp. Cornell and Duchamp meet briefly for the first time.

December 12–January 3, 1934: *Objects by Joseph Cornell, Posters by Toulouse-Lautrec, Watercolors by Perkins Harnley, Montages by Harry Brown* is presented at the Julien Levy Gallery, New York.

1934

Cornell begins acquiring photographs and ephemera that will later be included in the "exploration" *The Crystal Cage (Portrait of Berenice)* (c. 1934–67).

January: Duchamp presents Cornell with the advertisement for the *International Exhibition of Modern Art*, Société Anonyme, published in *ARTnews* (vol. 25, May 14, 1927, n.p.). The exhibition, which was held at the Brooklyn Museum, features Duchamp's *Large Glass*. The announcement is inscribed *Marcel Duchamp/for Joseph Cornell/New York Jan. 1954*.

January: Cornell presents Duchamp with copy no. 12 of his film scenario *Monsieur Phot*, inscribed *à Marcel Duchamp/En Hommage/Joseph Cornell/Jan. 1954*. (2, fn)

April 3–28: Julien Levy Gallery presents Dalí's illustrations for Lautréamont's *Les Chants de Maldodor*.

November 21–December 10: Julien Levy Gallery presents an exhibition of Dalí's paintings. Dalí makes first trip to New York.

December 1–January 1, 1935: Alberto Giacometti's first solo show in the United States is presented at the Julien Levy Gallery.

Fall: Cornell is employed as a textile designer at Traphagen Commercial Textile Studio, New York, remaining in their employ until 1940. He uses his free time to visit the New York Public Library, at 42nd Street and Fifth Avenue, and watch rehearsals at the American Ballet.

1935

January 29–February 19: Cornell appears in his first museum exhibition, *American Painting and Sculpture of the 18th, 19th & 20th Centuries*, at the Wadsworth Atheneum.

1936

January 3–20: *René Magritte, Paintings*, the artist's first solo show in the United States, is presented at the Julien Levy Gallery.

Fall: Levy publishes *Surrealism* (New York: The Black Sun Press), with a cover design by Cornell. Included in the book is a transcript of Cornell's *Monsieur Phot* scenario (pp. 77–88).

December: Julien Levy Gallery presents a film matinee, featuring Duchamp's *Anemic Cinema* and Man Ray's *L'Étoile de Mer*. The film program also includes *Goofy Newsreels*, a selection from Cornell's film collection, and Cornell's first film, *Rose Hobart*. Dalí, who attends the screening, claims Cornell stole his idea for a particular effect.

December 9–January 17, 1937: *Fantastic Art, Dada, Surrealism*, organized by Alfred H. Barr, Jr., is presented at The Museum of Modern Art, New York. Cornell is represented by two boxes, *Cabinet of Natural History (Object)* (1934, 1936–40) and *Untitled (Soap Bubble Set)* (1936), and 10 small bell jar objects. A. Everett Austin, director of the Wadsworth Atheneum, purchases Cornell's *Untitled (Soap Bubble Set)* for $60 in 1938. This is the first museum acquisition of a Cornell work.

1937

Cornell begins freelance work for client publications, supplying photographs and ephemera from his growing collection.

February: In an article entitled "The Pulse of Fashion," *Harper's Bazaar* reproduces two Cornell untitled montages (both c. 1932) featuring sewing machines.

October 16–November 14: *Photography 1839–1937*, organized by Beaumont Newhall, is held at the Museum of Modern Art. Among the photographers in the exhibition is Charles Nègre.

Winter: the French publication *Minotaure* reproduces a work by Cornell, *Glass Bell* (c. 1932), in the winter 1937 issue.

1938

January 17–February: *Exposition Internationale du Surréalisme*, organized by André Breton and Paul Eluard, is presented at Galerie Beaux-Arts, Paris. Cornell is represented by one object lent by Levy, *Untitled* (1932), a montage of a Victorian paper doll on a sewing machine, which is reproduced in the gallery's catalogue, *Dictionnaire Abrégé du Surréalisme*.

Summer: Cornell begins a series of photographs and installations using his cousin's French Victorian doll (from the Jumeau factory, c. 1885–95). *Harper's Bazaar* reproduces Cornell's photograph of the doll, *Bébé Marie*. By 1943 he creates a box construction featuring the doll.

1939

Cornell becomes friendly with Charles Henri Ford, the Russian émigré painter Pavel Tchelitchew, and the critic Parker Tyler, all of whom are supportive of Cornell's work. Ford writes to Cornell, asking him to collaborate on the design of his forthcoming book of poems, *ABC's for the Children of No One, Who Grows Up to Look Like Everyone's Son*.

May: First U.S. exhibition of Picasso's *Guernica* at the Valentine Gallery.

Summer: Cornell repeatedly visits the New York World's Fair, Flushing Meadows, Queens, New York. He is impressed by Dalí's underwater fantasia, the *Dream of Venus* Pavilion, and by *The Masterpieces of Art* Pavilion, where he sees Dosso Dossi's painting *Circe and Her Lovers* (c. 1525), which he uses in his series of collages *Mathematics in Nature*. He buys quantities of Dutch clay pipes, which he later uses in his *Soap Bubble Sets* and their variants.

December 6–January 9, 1940: *Exhibition of Objects (Bilboquet) by Joseph Cornell* is presented at the Julien Levy Gallery, with an announcement designed by Cornell and an essay by Parker Tyler. This is Cornell's first show to attract some attention. Works include bubble pipes, thimbles, and China dolls showered with confetti (in and out of shadow boxes).

1939–42

Amédée Ozenfant, Léger, Breton, Matta Echaurren, Tanguy, Man Ray, André Masson, Kurt Seligmann, and Piet Mondrian seek refuge in America during World War II. Max Ernst is imprisoned repeatedly, but with the help of Peggy Guggenheim, arrives in New York in 1941.

1940

April 16–May 7: Matta's first solo show in the United States is held at the Julien Levy Gallery.

September: The first issue of *View*, the Surrealist magazine founded by Charles Henri Ford and Parker Tyler, is published.

December 10–26: *Joseph Cornell: Exhibition of Objects: Daguerreotypes, Miniature Glass Bells, Soap Bubble Sets, Shadow Boxes, Homage to the Romantic Ballet* is held at the Julien Levy Gallery. Foldout announcement designed by Cornell.

• Cornell begins freelance design and artwork for *Mademoiselle, House and Garden, Vogue, Good Housekeeping*, and *Harper's Bazaar*, which he continues into the early 1950s. (*Mademoiselle*: 18:5 [March 1944], 31:3 [July 1950], 44:4 [February 1957]; *House and Garden*: 87:5 [May 1945], 93:11 [November 1948]; *Vogue*: 110:6 [September 15,

1947]; *Good Housekeeping*: 127:1 [July 1948]; *Harper's Bazaar*: December 1947.)

1941

Peggy Guggenheim returns to the U.S. after living in Europe for 20 years.

Early in year: After leaving his job at Traphagen in fall 1940, Cornell works full-time as an artist, using the basement of his house as his studio. He also begins freelance work for *View* magazine, and contributes until its final issues in early 1947.

December: Cornell contributes photomontage and essay titled "'Enchanted Wanderer': Excerpt from a Journey Album for Hedy Lamarr" to *View*.

1942

Early in year: Cornell meets Matta, Robert Motherwell, and Ernst.

January: Lincoln Kirstein founds *Dance Index*, with offices at 637 Madison Avenue, New York. Donald Windham fills in as editor when Kirstein enters the Army. Cornell designs the first three covers: "Hommage à Isadora," "The Parker Sisters," and "Loïe Fuller." Cornell contributes work to *Dance Index* until 1947. Cornell and Windham develop a lifelong friendship.

Early March: On Duchamp's advice, Peggy Guggenheim purchases *Fortune Telling Parrot* (c. 1937–38), *Thimble Box* (1938), and *Revolving Book with Red Ball* (1934) from Cornell. The last two artworks are later sold or given away by Guggenheim.

April: In homage to Ernst, Cornell contributes 16 montages, *Story without a Name—for Max Ernst*, to an issue of *View* devoted entirely to Ernst.

June: The first issue of *VVV*, a Surrealist-oriented review, is published. The magazine is edited by Breton and David Hare, Ernst acts as editorial advisor, and it features articles by Breton, Lévi-Strauss, Motherwell, and Harold Rosenberg.

June 25: Duchamp arrives in New York from Marseilles, France.

July 31: Duchamp, Cornell, and his brother, Robert, lunch together at Cornell's house. The two artists spend the afternoon looking at an example of the *Boîte-en-valise*. Soon after, Cornell begins assisting in the assembly of a *Boîte* edition, which they work on until January 1946. Between 1942 and 1946, Cornell aids in the assembly of as many as 11 *Boîtes-en-valise* and between 25 and 30 *Boîtes*.

Late summer: Peggy Guggenheim publishes *Art of This Century: Objects—Drawings—Photographs—Paintings—Sculpture—Collages, 1910 to 1942* (New York: Art of This Century). Two of Cornell's artworks, *Ball and Book* (1934) and *Thimble Box* (1938), are listed but not reproduced.

October 14–November 7: *First Papers of Surrealism*, an exhibition organized by Duchamp and Breton, sponsored by the Coordinating Council of French Relief Societies, Inc., is held at the Whitelaw Reid Mansion, 451 Madison Avenue, New York. Young American artists such as Baziotes, Calder, Motherwell, and David Hare join Surrealists Duchamp, Ernst, Giacometti, Magritte, Miró, and Masson.

October 20–November: Peggy Guggenheim's gallery Art of This Century, at 30 West 57th Street, opens with *Exhibition of the Collection*, which includes the works by Cornell that she has previously purchased. Cornell is affiliated with the gallery until its closing in 1947.

December: *Objects by Joseph Cornell; Marcel Duchamp: Box-Valise; Laurence Vail: Bottles* opens at Art of This Century, New York.

1943

Cornell meets Antoine de Saint-Exupéry, author of *Le Petit Prince*, in New York.

Early in year: Art dealer Pierre Matisse purchases an untitled *Pharmacy* box by Cornell. The box

remains with his wife, Alexina "Teeny" Sattler after their divorce in 1949. Teeny marries Duchamp in 1954.

Early in year: Cornell begins correspondence with poet Marianne Moore, and visits her and her mother at their home. He asks her for a recommendation for a Guggenheim Fellowship in 1945, and, with reservations, she does so. He is unsuccessful in receiving the fellowship.

January: Duchamp presents Cornell with an envelope, inscribed *New Year's intentions*, into which Cornell places several fragments of materials related to the assembly of the *Boîte* edition.

January: Cornell contributes essays and collages to *View* magazine's "Americana Fantastica" issue. Cornell designs the front and back covers and contributes a collage and poem titled *Ballet for Tamara Toumanova*, the collage-story *The Crystal Cage (Portrait of Berenice)*, and an homage to Edgar Allan Poe titled *Spent Meteor, Night of Feb. 10, 1843 (For E. A. Poe)*.

April: Cornell contributes a cover montage, *Portrait of Allen Dodsworth* (1847), to the April issue of Dance Index.

April 16–May 15: *Exhibition of collage* is held at Art of This Century. Pollock and Motherwell exhibit their first collages. Cornell, Duchamp, Ernst, Gris, Miró, and other artists shown earlier by Julien Levy are included in the exhibition.

May 20–November 1: Cornell works on the radio manufacturing assembly line of the Allied Control Company, Long Island City, New York.

November 9–27: *First Exhibition. Jackson Pollock. Paintings and Drawings* is held at Art of This Century.

November 30–December 31: Cornell participates in the group exhibition *Natural, Insane, Surrealist Art* at Art of This Century.

December 7–28: *Through the Big End of the Opera Glass* opens at the Julien Levy Gallery, now at 42 East 57th Street, showing Duchamp, Tanguy, and Cornell. Cornell designs the announcement with contributions from Duchamp and Tanguy. Works by Cornell include "Medici Slot Machines, Roses of the Wind, A Feathered Constellation (for Toumanova), Habitat Parakeets (Shooting Gallery), American Rabbit."

1944

February: Sidney Janis publishes *Abstract & Surrealist Art in America* (New York: Reynal & Hitchcock). Includes reproduction of Cornell's *Medici Slot Machine* (1941). In conjunction with the book, an exhibition, also organized by Janis, travels to five American cities from February through July. Cornell is represented by a box construction *Pipe and Cut Out* (1940).

March: *Mademoiselle* features four of Cornell's boxes, including *Untitled (Bébé Marie)*, in fashion layout photographed at the Julien Levy Gallery.

Spring to winter: Cornell works intermittently at the Garden Center, a large nursery on Northern Boulevard and 194th Street in Flushing, owned by a Christian Science practitioner. He begins a major "exploration," *GC44*, centered around his love of nature.

April: *Dorothea Tanning*, her first solo show, is held at the Julien Levy Gallery.

May–September: Cornell designs several covers for *Dance Index*: "European Dance Teachers in America, Le Quatuor Dansé à Londres par Taglioni, Carlotta Grisi, Cerrito et Fanny Elsler [sic]," and "Three or Four Graces."

October 24–November 11, *Robert Motherwell*, his first solo show, is presented at Art of This Century.

1945

Cornell designs a Christmas card based on a 19th-century astronomical engraving for The Museum of Modern Art, New York.

January 9–February 4: *Mark Rothko Paintings* is presented at Art of This Century.

March: Cornell makes a collage illustration, *3/4 Bird's-Eye View of "A Watch-Case for Marcel Duchamp,"* for a special issue of *View* devoted to Duchamp.

March 6–31: *Arshile Gorky, Paintings*, his first solo exhibition, is held at the Julien Levy Gallery.

March 6: Peggy Guggenheim purchases *Untitled (Pharmacy)* (c.1942) from Cornell.

May–December: Cornell's graphic designs for *Dance Index* include the May cover, the June cover of dancers Annetta Galletti, Louise Lamoureaux, Ermesilda Diana, Kate Penoyer, and Josephine De Rosa, and the October cover *Around a Scene from Sadler Wells' 1943 revival of* Swan Lake.

September: Cornell designs the cover, a film scenario, and illustrations for the *Dance Index* issue on Hans Christian Andersen.

November 15: Hugo Gallery opens at 26 East 55th Street.

November 26–February 17, 1946: Cornell designs a special installation for his exploration *Portrait of Ondine* (c. 1940s–late 1960s), exhibited in the Auditorium Gallery at The Museum of Modern Art, New York.

1946

February: Charles Egan opens Egan Gallery at 63 East 57th Street, New York.

March 15: *"From the Dawn of Diamonds": An Art Exhibit which Traces the Origins of our Oldest Bridal Traditions, Created by Joseph Cornell* opens at the Park Lane Hotel, at Park Avenue and 48th Street, New York, for De Beers Consolidated Mines.

March 2 and 16: *Film Soiree: Selected Rarities from the Collection of Joseph Cornell* is presented at the Norlyst Gallery, 59 West 56th Street, New York. The first program is devoted to early French films and includes "Magic, fantasy, cartoons, Max Linder, fin de siècle." The second program is exclusively American and features "Pearl White, Valentino, Clara Kimball Young, King Baggott, Chaplin, etc."

September: Cornell designs the cover and composes the contents and layout for the "Americana Romantic Ballet" issue of *Dance Index*.

December 3: *Romantic Museum at the Hugo Gallery/ Portraits of Women: Constructions and Arrangements by Joseph Cornell*. Cornell designs the four-page brochure for the exhibition. The brochure includes three collage inserts of Cornell's *Unknown (the Crystal Cage)*, *Penny Arcade Portrait of Lauren Bacall*, *Bébé Marie*, and Cornell's descriptive texts on other works.

1948

April–May: Willem de Kooning has his first one-man show at Egan Gallery, New York.

June 1: Under Cornell's direction, Ernst Beadle photographs him in Central Park posed to look as though he were supporting a boulder overhanging a small standing doll.

September 28: *Objects by Joseph Cornell* opens at the Copley Galleries, Beverly Hills, California. Forty-two works from the 1930s and 1940s are featured, the first survey of Cornell's work. The brochure cites Cornell's *Taglioni Jewel Case*, *Soap Bubble Set (Moon Map)*, *Owl (Habitat Setting)*, *Book with Marble*, *Paolo and Francesca (Romantic Paysage)*, *Beehives*, and *Palace of Windows*.

Fall: William Baziotes, David Hare, Robert Motherwell, and Mark Rothko establish a small cooperative school, called Subjects of the Artist, New Art School, at 35 East Eighth Street in Greenwich Village. A gathering place for artists, poets, and critics, Subjects of the Artist closes May 1949.

1949

January 21 and March 4: Cornell presents a program of film and music, "Early Films from the

Books and Catalogues on Corne[...]

Ashton, Dore. *A Joseph Cornell Alb[...]* The Viking Press, 1974; reprint [...] includes special contributions b[...] and Peter Bazeley, texts also by [...] Bishop, Denise Hare, Richard [...] Kunitz, Jonas Mekas, Duane [...] Bernard Myers, Octavio Paz, a[...] With assorted ephemera, readin[...] and reproductions of works by [...]

Blair, Lindsay. *Joseph Cornell's Visu[...] Order.* London: Reaktion Books,[...]

Book, Box, Word. North Miami, Fl[...] Miami Center of Contemporary [...] catalogue of an exhibition held [...] 1992–January 23, 1993. Text by [...] and Bianca Lanza.

Caws, Mary Ann, ed. *Joseph Corne[...] Mind: Selected Diaries, Letters, and [...]* Thames and Hudson, 1993. Intr[...] Mary Ann Caws; foreword by [...]

Hartigan, Lynda Roscoe. *Joseph C[...] Exploration of Sources.* Washingto[...] Museum of American Art, Smit[...] Institution, 1982. Catalogue of [...] November 19, 1982–February [...]

Hauptman, Jodi. *Joseph Cornell: S[...] Cinema.* New Haven, Conn.: Ya[...] Press, 1999.

Hopps, Walter. *An Exhibition of W[...] Cornell.* Pasadena, Calif.: Pasade[...] 1966. Catalogue of an exhibition [...] 27, 1966–February 11, 1967. Ca[...] and acknowledgments by Jame[...] by Fairfield Porter (a revision o[...] *Art and Literature,* no. 8, Spring [...] excerpt from a letter by Cornell [...] 16, 1942.

Jaguer, Edouard. *Joseph Cornell.* P[...] Galerie 1900–2000, 1989. Catalc[...] tion held March 13–April 8, 19[...] French.

Joseph Cornell. New York: ACA G[...] Catalogue of an exhibition held [...] Text by John Bernard Myers.

Joseph Cornell. Madrid, Spain: Fun[...] March, 1984. Catalogue of an e[...] April–May 1984. Text by Ferna[...] Printed in Spanish.

Joseph Cornell. New York: The Pac[...] Catalogue of an exhibition held [...] 1986–January 31, 1987. Text by [...] O'Doherty.

Joseph Cornell. Tokyo, Japan: Gato[...] Catalogue of an exhibition held [...] 18, 1987. Text by Sandra Leona[...] by Kazuko Matsuoka. Text in E[...] Japanese. 2 vols.

Joseph Cornell: 1903–1972. Paris: G[...] Greve, 1992. Catalogue of an ex[...] July 9–October 7, 1992. Text by [...] Ellen H. Johnson, and Robert [...] extracts from the diaries of Cornell [...] German, English, and French.

Joseph Cornell (1903–1972), Paris, [...] Lebon, 1980. Catalogue of an ex[...] *Cornell (1903–1972): Boîtes,* held a[...] Lebon, Paris, May 29–July 5, 1[...] *Cornell (1903–1972): Boîtes et Coll[...]* Musée de Toulon, Toulon, Fran[...] September 1, 1980. Catalogue w[...] Marie-Claude Béaud, Jean Le [...] Motherwell (1953 text originally [...] *Joseph Cornell* exhibition catalogu[...] Arts Center, Minneapolis, catalc[...] lished). Printed in French.

Joseph Cornell: Años Cincuenta y Sese[...] N.L., México: Museo de Arte C[...] Monterrey, 1992. Catalogue of a[...] October 1992–January 1993. T[...]

Unique Collection of Joseph Cornell," at the Subjects of the Artist. (Cornell has a falling out with Robert Motherwell, one of the founders of the school, who embarrasses him by insisting he speak to the audience.)

November 14–December 5: The Hugo Gallery presents *La Lanterne Magique du Ballet Romantique of Joseph Cornell.* The exhibition is shown concurrently with "Décors for Ballets Choreographed by Roland Petit."

December 7–January 7, 1950: *Aviary by Joseph Cornell* is shown at the Egan Gallery, New York. Cornell exhibits *Chocolat Menier, Forgotten Game, Crystal Palace, Cockatoo and Corks, Shooting Gallery, Penny Arcade Cockatoo,* and others related to the aviary theme.

Close of 1949: The Artists Club, better known simply as The Club, opens at 35 West Eighth Street, a New York gathering place for artists, poets, and critics. Members include de Kooning, Guston, Kline, Tworkov, Reinhardt, and Newman. Panels and parties are held for established artists such as Alexander Calder, Max Ernst, and the poet Dylan Thomas. It closes in 1962.

• Motherwell introduces Cornell to the photographer Rudy Burckhardt.

1950

June 5–November 4: An installation of Cornell's work, *The Fairy Tale World,* is organized by librarian Maria Cimino for the Central Children's Room at the New York Public Library. The presentation includes seven unidentified boxes, two castles, a *Swan Lake* box, and *Ondine on Seashell.*

December 1–January 13, 1951: *Night Songs and Other New Work—1950 by Joseph Cornell* is presented at the Egan Gallery. Included are "Observatories, Glass Sets, Villa Violetta, High Wire Act, Hotel Dominici, and Chambre Gothique." The Museum of Modern Art acquires the box *Central Park Carrousel—1950—In Memoriam* (1950) in January 1951 for $300.

1951

Cornell and his brother, Robert, visit their sister Elizabeth at her chicken farm in Westhampton, Long Island. They continue to visit her regularly for summer vacations.

1952

Cornell becomes a founding member of the First Church of Christ, Scientist, in Bayside.

1953

February 10–March 28: *Night Voyage by Joseph Cornell* is presented at the Egan Gallery. Cornell shows: "Observatories—Night Windows—Grand Hotel du Nord—Carousels—Taglioni—Penny Arcade—Portraits—Figureheads—Argus—Parmigianino—Andromeda—Camelopardalis."

July 12–August 30: *Joseph Cornell,* Walker Arts Center, Minneapolis, Minnesota. The exhibition, organized by H. H. Arnason, is Cornell's first solo show in a museum. Unpublished essay by Robert Motherwell.

November: James Thrall Soby donates Cornell's *Taglioni's Jewel Casket* (1940) to The Museum of Modern Art, New York.

• Cornell is included in the Whitney Museum of American Art Annual. He exhibits annually from 1953 to 1966.

1954

Parker Tyler introduces filmmaker Stan Brakhage to Cornell.

• Cornell publishes a limited edition of *Maria* (a pamphlet inspired by the 19th-century opera singer Maria Malibran-Garcia), and the following year he publishes a limited edition of *The Bel Canto Pet* (a pamphlet inspired by the nineteenth-century opera singer Julia Grisi). Comprising excerpts from the translated writings of German author Elise Polko and American author Nathaniel Parker Willis, respectively, the individual examples include collage inserts, personalized inscriptions, and Cornell's signature and date. He will distribute them, primarily to friends, until his death.

• Cornell directs three films with photographer Rudy Burckhardt as cameraman: *The Aviary; Joanne, Union Sq.;* and *A Legend for Fountains.*

January 27–February 20: Cornell begins exhibiting at Eleanor Ward's Stable Gallery, New York, in the gallery's *Third Annual Exhibition of Painting and Sculpture.* Robert Rauschenberg, who had met Cornell at Egan Gallery, encouraged him to submit a box construction for the occasion.

December: Cornell designs The Museum of Modern Art's Christmas card, "Constellation."

1955

April 2–June: Cornell lends boxes and memorabilia for the exhibition marking the 150th anniversary of the birth of Hans Christian Andersen at the New York Public Library Children's Room.

May: Cornell directs two films, *GniR RednoW [Wonder Ring]* and *Centuries of June,* based on the scheduled demolition of the Third Avenue El and a Flushing homestead, respectively. Stan Brakhage is the cameraman.

Fall: Cornell resumes making collages as independent, two-dimensional works. They are based on clippings from contemporary books, magazines, and commercial art reproductions.

December 12–January 13, 1956: *Winter Night Skies by Joseph Cornell* is presented at Stable Gallery, New York. Works include "Auriga I, Auriga II, Auriga III, Andromeda I, Andromeda II, Andromeda III, Camelopardalis, Etc."

1956

November 1–15: Cornell presents his exploration *Portrait of Ondine* in revised form at the One-Wall Gallery, Wittenborn Bookstore, 1018 Madison Avenue, New York.

1957

Cornell directs two films, *Nymphlight* and *Angel,* with Burckhardt as cameraman.

January 17–March 3: Cornell receives the M.V. Kohnstamm Prize of $250 for his construction *Pavilion* at The Art Institute of Chicago's *62nd American Exhibition.*

May 7–June 8: Cornell participates in the *Sixth Annual Exhibition of Painting and Sculpture* at Stable Gallery, New York.

December: Cornell designs The Museum of Modern Art's Christmas card, "Carrousel." He also presents a special screening of his films to the staff of the Picture Collection, New York Public Library.

December 2–31: *Joseph Cornell: Selected Works* is presented at Stable Gallery, New York.

1958

Cornell hires assistants to reorganize his work and storage areas and to help build his boxes.

January 9–February 16: *The Disquieting Muse: Surrealism* at the Contemporary Arts Museum, Houston, Texas. Works shown: *The Medici Slot Machine* (1942) and *The View of Ostend* (1957).

• Later in the year: Cornell directs the film *Seraphina's Garden* with Burckhardt as cameraman.

1959

Marcel Jean publishes *Histoire de la peinture surréaliste [History of Surrealist Painting]* (Paris: Editions de Seuil; an English translation follows a year later) in which he discusses both Duchamp and Cornell. Jean contacts Cornell at Duchamp's suggestion after seeing Cornell's artwork in Duchamp's apartment.

March 2: Cornell and Duchamp attend the opening of a René Magritte exhibition at the Alexander Iolas Gallery, 123 East 55 Street, New York.

November 20–December 15: *Selected Works by Joseph Cornell: "Bonitas Solstitialis" and an "Exploration of the Colombier"* is presented at Bennington College, Vermont. It is Cornell's first opportunity to share his source materials with students, a goal he had formulated during the early 1940s.

December 2–January 31, 1960: Cornell receives the Ada S. Garrett Prize of fifteen hundred dollars for his construction, *Orion,* at The Art Institute of Chicago's *63rd American Exhibition.*

1960

November 28–January 14, 1961: *Surrealist Intrusion in the Enchanters' Domain,* organized by Duchamp and Breton, is presented at D'Arcy Galleries, New York. Duchamp includes examples of Cornell's boxes in the exhibition.

1961

October 2–November 12: The Museum of Modern Art presents *The Art of Assemblage,* organized by William Seitz, who devotes individual rooms to Cornell, Duchamp, and Kurt Schwitters.

1962

Early in the year Cornell meets Joyce Hunter, a cashier at Ripley's Believe It or Not Museum on Times Square. Cornell renews his interest in the Times Square theme of the penny arcade.

December 10: *Joseph Cornell* is presented at the Ferus Gallery, Los Angeles, California.

1963

December 3–18: *Joseph Cornell,* organized by Ruth Bowman, is presented at Loeb Student Center, New York University. Cornell calls this show of 12 assemblage boxes and collages a "Christmas present to the students of New York University."

• Charles Henri Ford brings Robert Indiana, James Rosenquist, and Andy Warhol for a visit to Cornell's house in Flushing.

April 26–27: "Comedy Americana: A Series of Film Programs from the Collection of Joseph Cornell" is shown at artists Walter de Maria and Robert Whitman's loft, 9 Great Jones Street, New York.

1964

September: Joyce Hunter and two friends are arrested for stealing nine boxes from Cornell. He refuses to prosecute. In December, Joyce Hunter is found stabbed to death in New York.

• Cornell starts incorporating autobiographical images into his collages. He also begins to inscribe Hunter's name and observations on collages as memorials to Hunter.

1965

February 26: Cornell's brother, Robert, dies at their sister Elizabeth's home in Westhampton, where Robert had recently moved with their mother.

1966

January 4–29: Cornell arranges the exhibition *Robert Cornell: Memorial Exhibition, Drawings by Robert Cornell, Collages by Joseph Cornell, Related Varia* at the Robert Schoelkopf Gallery, New York.

February–March: *Joseph Cornell: Boxes and Collages* is presented at the Allan Stone Gallery.

March 12–early fall: *Loan Exhibition of Joseph Cornell Boxes* is presented at the Allen Memorial Art Museum, Oberlin College, Ohio.

October 19: Cornell's mother dies.

December 27–February 11, 1967: *An Exhibition of Works by Joseph Cornell,* his first retrospective, organized by Walter Hopps, is presented at the

CREDITS

Photographs of works of art reproduced in this book have for the most part been provided by the owners or custodians of the works identified in the captions. The following list refers to photographs for which an additional acknowledgment is due. Every effort has been made to locate, and obtain permission from, rights owners. Please contact the publisher with any possible oversights. Page numbers follow credits.

Unique Collection of Joseph Cornell," at the Subjects of the Artist. (Cornell has a falling out with Robert Motherwell, one of the founders of the school, who embarrasses him by insisting he speak to the audience.)

November 14–December 5: The Hugo Gallery presents *La Lanterne Magique du Ballet Romantique of Joseph Cornell*. The exhibition is shown concurrently with "Décors for Ballets Choreographed by Roland Petit."

December 7–January 7, 1950: *Aviary by Joseph Cornell* is shown at the Egan Gallery, New York. Cornell exhibits *Chocolat Menier, Forgotten Game, Crystal Palace, Cockatoo and Corks, Shooting Gallery, Penny Arcade Cockatoo,* and others related to the aviary theme.

Close of 1949: The Artists Club, better known simply as The Club, opens at 35 West Eighth Street, a New York gathering place for artists, poets, and critics. Members include de Kooning, Guston, Kline, Tworkov, Reinhardt, and Newman. Panels and parties are held for established artists such as Alexander Calder, Max Ernst, and the poet Dylan Thomas. It closes in 1962.

• Motherwell introduces Cornell to the photographer Rudy Burckhardt.

1950

June 5–November 4: An installation of Cornell's work, *The Fairy Tale World*, is organized by librarian Maria Cimino for the Central Children's Room at the New York Public Library. The presentation includes seven unidentified boxes, two castles, a *Swan Lake* box, and *Ondine on Seashell*.

December 1–January 13, 1951: *Night Songs and Other New Work—1950 by Joseph Cornell* is presented at the Egan Gallery. Included are "Observatories, Glass Sets, Villa Violetta, High Wire Act, Hotel Dominici, and Chambre Gothique." The Museum of Modern Art acquires the box *Central Park Carrousel—1950—In Memoriam* (1950) in January 1951 for $300.

1951

Cornell and his brother, Robert, visit their sister Elizabeth at her chicken farm in Westhampton, Long Island. They continue to visit her regularly for summer vacations.

1952

Cornell becomes a founding member of the First Church of Christ, Scientist, in Bayside.

1953

February 10–March 28: *Night Voyage by Joseph Cornell* is presented at the Egan Gallery. Cornell shows: "Observatories—Night Windows—Grand Hotel du Nord—Carousels—Taglioni—Penny Arcade—Portraits—Figureheads—Argus—Parmigianino—Andromeda—Camelopardalis."

July 12–August 30: *Joseph Cornell*, Walker Arts Center, Minneapolis, Minnesota. The exhibition, organized by H. H. Arnason, is Cornell's first solo show in a museum. Unpublished essay by Robert Motherwell.

November: James Thrall Soby donates Cornell's *Taglioni's Jewel Casket* (1940) to The Museum of Modern Art, New York.

• Cornell is included in the Whitney Museum of American Art Annual. He exhibits annually from 1953 to 1966.

1954

Parker Tyler introduces filmmaker Stan Brakhage to Cornell.

• Cornell publishes a limited edition of *Maria* (a pamphlet inspired by the 19th-century opera singer Maria Malibran-Garcia), and the following year he publishes a limited edition of *The Bel Canto Pet* (a pamphlet inspired by the nineteenth-century opera

singer Julia Grisi). Comprising excerpts from the translated writings of German author Elise Polko and American author Nathaniel Parker Willis, respectively, the individual examples include collage inserts, personalized inscriptions, and Cornell's signature and date. He will distribute them, primarily to friends, until his death.

• Cornell directs three films with photographer Rudy Burckhardt as cameraman: *The Aviary; Joanne, Union Sq.;* and *A Legend for Fountains*.

January 27–February 20: Cornell begins exhibiting at Eleanor Ward's Stable Gallery, New York, in the gallery's *Third Annual Exhibition of Painting and Sculpture*. Robert Rauschenberg, who had met Cornell at Egan Gallery, encouraged him to submit a box construction for the occasion.

December: Cornell designs The Museum of Modern Art's Christmas card, "Constellation."

1955

April 2–June: Cornell lends boxes and memorabilia for the exhibition marking the 150th anniversary of the birth of Hans Christian Andersen at the New York Public Library Children's Room.

May: Cornell directs two films, *GniR RednoW [Wonder Ring]* and *Centuries of June*, based on the scheduled demolition of the Third Avenue El and a Flushing homestead, respectively. Stan Brakhage is the cameraman.

Fall: Cornell resumes making collages as independent, two-dimensional works. They are based on clippings from contemporary books, magazines, and commercial art reproductions.

December 12–January 13, 1956: *Winter Night Skies by Joseph Cornell* is presented at Stable Gallery, New York. Works include "Auriga I, Auriga II, Auriga III, Andromeda I, Andromeda II, Andromeda III, Camelopardalis, Etc."

1956

November 1–15: Cornell presents his exploration *Portrait of Ondine* in revised form at the One-Wall Gallery, Wittenborn Bookstore, 1018 Madison Avenue, New York.

1957

Cornell directs two films, *Nymphlight* and *Angel*, with Burckhardt as cameraman.

January 17–March 3: Cornell receives the M.V. Kohnstamm Prize of $250 for his construction *Pavilion* at The Art Institute of Chicago's *62nd American Exhibition*.

May 7–June 8: Cornell participates in the *Sixth Annual Exhibition of Painting and Sculpture* at Stable Gallery, New York.

December: Cornell designs The Museum of Modern Art's Christmas card, "Carrousel." He also presents a special screening of his films to the staff of the Picture Collection, New York Public Library.

December 2–31: *Joseph Cornell: Selected Works* is presented at Stable Gallery, New York.

1958

Cornell hires assistants to reorganize his work and storage areas and to help build his boxes.

January 9–February 16: *The Disquieting Muse: Surrealism* at the Contemporary Arts Museum, Houston, Texas. Works shown: *The Medici Slot Machine* (1942) and *The View of Ostend* (1957).

• Later in the year: Cornell directs the film *Seraphina's Garden* with Burckhardt as cameraman.

1959

Marcel Jean publishes *Histoire de la peinture surréaliste [History of Surrealist Painting]* (Paris: Editions de Seuil; an English translation follows a year later) in which he discusses both Duchamp and Cornell. Jean contacts Cornell at Duchamp's suggestion after seeing Cornell's artwork in Duchamp's apartment.

March 2: Cornell and Duchamp attend the opening of a René Magritte exhibition at the Alexander Iolas Gallery, 123 East 55 Street, New York.

November 20–December 15: *Selected Works by Joseph Cornell: "Bonitas Solstitalis" and an "Exploration of the Colombier"* is presented at Bennington College, Vermont. It is Cornell's first opportunity to share his source materials with students, a goal he had formulated during the early 1940s.

December 2–January 31, 1960: Cornell receives the Ada S. Garrett Prize of fifteen hundred dollars for his construction, *Orion*, at The Art Institute of Chicago's *63rd American Exhibition*.

1960

November 28–January 14, 1961: *Surrealist Intrusion in the Enchanters' Domain*, organized by Duchamp and Breton, is presented at D'Arcy Galleries, New York. Duchamp includes examples of Cornell's boxes in the exhibition.

1961

October 2–November 12: The Museum of Modern Art presents *The Art of Assemblage*, organized by William Seitz, who devotes individual rooms to Cornell, Duchamp, and Kurt Schwitters.

1962

Early in the year Cornell meets Joyce Hunter, a cashier at Ripley's Believe It or Not Museum on Times Square. Cornell renews his interest in the Times Square theme of the penny arcade.

December 10: *Joseph Cornell* is presented at the Ferus Gallery, Los Angeles, California.

1963

December 3–18: *Joseph Cornell*, organized by Ruth Bowman, is presented at Loeb Student Center, New York University. Cornell calls this show of 12 assemblage boxes and collages a "Christmas present to the students of New York University."

• Charles Henri Ford brings Robert Indiana, James Rosenquist, and Andy Warhol for a visit to Cornell's house in Flushing.

April 26–27: "Comedy Americana: A Series of Film Programs from the Collection of Joseph Cornell" is shown at artists Walter de Maria and Robert Whitman's loft, 9 Great Jones Street, New York.

1964

September: Joyce Hunter and two friends are arrested for stealing nine boxes from Cornell. He refuses to prosecute. In December, Joyce Hunter is found stabbed to death in New York.

• Cornell starts incorporating autobiographical images into his collages. He also begins to inscribe Hunter's name and observations on collages as memorials to Hunter.

1965

February 26: Cornell's brother, Robert, dies at their sister Elizabeth's home in Westhampton, where Robert had recently moved with their mother.

1966

January 4–29: Cornell arranges the exhibition *Robert Cornell: Memorial Exhibition, Drawings by Robert Cornell, Collages by Joseph Cornell, Related Varia* at the Robert Schoelkopf Gallery, New York.

February–March: *Joseph Cornell: Boxes and Collages* is presented at the Allan Stone Gallery.

March 12–early fall: *Loan Exhibition of Joseph Cornell Boxes* is presented at the Allen Memorial Art Museum, Oberlin College, Ohio.

October 19: Cornell's mother dies.

December 27–February 11, 1967: *An Exhibition of Works by Joseph Cornell*, his first retrospective, organized by Walter Hopps, is presented at the

Pasadena Art Museum, California. Catalogue with essay by Fairfield Porter.

1967

May 4–June 25: *Joseph Cornell*, a retrospective exhibition, organized by Diane Waldman, is presented at the Solomon R. Guggenheim Museum, New York. The exhibition catalogue with essay by Waldman provides the first scholarly discussion of the chronology and themes of Cornell's work. The exhibition travels to the Rose Art Museum, Brandeis University, Massachusetts.

1968

Cornell experiences a period of serious emotional distress.

• Cornell receives the Award of Merit for sculpture from the American Academy of Arts and Letters.

March 27–June 9: Cornell is included in *Dada, Surrealism, and Their Heritage*, organized by William S. Rubin at The Museum of Modern Art, New York. Cornell shows seven works, including *A Pantry Ballet (for Jacques Offenbach)*, *Mémoires inédites de Madame La Marquise de la Rochejacquelein*, and *Pharmacy*.

October 2: Duchamp dies at home in Neuilly-sur-Seine.

1969

October 18–February 8, 1970: *New York Painting and Sculpture, 1940–1970*, organized by Henry Geldzahler at The Metropolitan Museum of Art, New York, includes a room of Cornell boxes.

1970

December 10–January 24, 1971: *Collages of Joseph Cornell* is presented at The Metropolitan Museum of Art, New York.

1971

October 15–November 13: *Joseph Cornell* is presented at Galleria Galatea in Turin, Italy. This is Cornell's first solo exhibition in Europe.

1972

February 10–March 2: An exhibition for children of Cornell's constructions, organized by Dore Ashton, is held at the Cooper Union School of Art and Architecture. Cornell answers questions about his work, and shares brownies and cherry coke with the young audience.

June: After prostate surgery, Cornell goes to Westhampton to recover. In early November he returns to his home in Flushing. A week before his death, he gives testimony at the Christian Science Wednesday service.

December 29: Cornell dies of heart failure at his home in Flushing.

1973

January 15: Memorial service at The Metropolitan Museum of Art. Speakers include ballerina Allegra Kent.

Mr. and Mrs. John A. Benton (Cornell's sister Betty and her husband) lend Cornell's papers and a selection of his source materials and library to the Archives of American Art, Smithsonian Institution, Washington, D.C.

December 23–June 2, 1974: A memorial exhibition, *Joseph Cornell 1903–1973*, organized by Hopps, is presented at the National Collection of Fine Arts (now Smithsonian American Art Museum), Smithsonian Institution, Washington, D.C.

1976

Castelli/Feigen/Corcoran Gallery, New York, is chosen to handle the estate of Cornell. The gallery is registered as "American Dovecote and Shooting Gallery" in honor of Cornell and is active until 1982.

1977

February 15–March 12: The Joan Washburn Gallery opens in the quarters once occupied by the Julien Levy Gallery at 42 East 57th Street, New York. With Levy's help, Washburn recreates the 1943 exhibition *'Through the Big End of the Opera Glass,' II, Marcel Duchamp, Yves Tanguy, Joseph Cornell* as her inaugural show, which also marks the occasion of the publication of Levy's *Memoir of an Art Gallery* (New York: G. P. Putnam's Sons).

1978

The National Museum of American Art, Smithsonian Institution, Washington, D.C., establishes the Joseph Cornell Study Center with the Bentons' donation of works by Cornell and the bulk of his source materials and library.

1980

The Museum of Modern Art, New York, purchases *Untitled (Bébé Marie)*.

November 17–January 20, 1981: *Joseph Cornell*, a major exhibition of his work, is presented at The Museum of Modern Art, New York, organized by Kynaston McShine. The exhibition travels to London, Paris, Düsseldorf, and Chicago.

1982

November 19–February 27, 1983: *Joseph Cornell: An Exploration of Sources*, organized by Lynda Roscoe Hartigan, is presented at the National Museum of American Art, Smithsonian Institution, Washington, D.C. The exhibition is the first posthumous investigation of Cornell's explorations, dossiers, and source materials in conjunction with his boxes and collages.

1985

The Joseph and Robert Cornell Memorial Foundation donates the exploration *Portrait of Ondine* to the National Museum of American Art, Smithsonian Institution, Washington, D.C., as part of a larger gift of works to the museum.

1987

June 22–July 18: *The Crystal Cage (Portrait of Berenice)* is presented at Gatodo Gallery, Tokyo. It is the first exhibition and catalogue devoted solely to an exploration.

1990

The Joseph and Robert Cornell Memorial Foundation donates the *Duchamp Dossier* to the Philadelphia Museum of Art. A second gift, the exploration *Untitled (The Life of Ludwig II of Bavaria)* (1941–52), is made by the foundation to the museum in 1997.

Books and Catalogues on Cornell

Ashton, Dore. *A Joseph Cornell Album*. New York: The Viking Press, 1974; reprinted 1989. Book includes special contributions by John Ashbery and Peter Bazeley, texts also by Elizabeth Bishop, Denise Hare, Richard Howard, Stanley Kunitz, Jonas Mekas, Duane Michals, John Bernard Myers, Octavio Paz, and Terry Schutté. With assorted ephemera, readings, decorations, and reproductions of works by Joseph Cornell.

Blair, Lindsay. *Joseph Cornell's Vision of Spiritual Order*. London: Reaktion Books, 1998.

Book, Box, Word. North Miami, Florida: North Miami Center of Contemporary Art, 1992. Box catalogue of an exhibition held December 17, 1992–January 23, 1993. Text by Steven Estok and Bianca Lanza.

Caws, Mary Ann, ed. *Joseph Cornell's Theater of the Mind: Selected Diaries, Letters, and Files*. New York: Thames and Hudson, 1993. Introduction by Mary Ann Caws; foreword by John Ashbery.

Hartigan, Lynda Roscoe. *Joseph Cornell: An Exploration of Sources*. Washington, D.C.: National Museum of American Art, Smithsonian Institution, 1982. Catalogue of exhibition held November 19, 1982–February 27, 1983.

Hauptman, Jodi. *Joseph Cornell: Stargazing in the Cinema*. New Haven, Conn.: Yale University Press, 1999.

Hopps, Walter. *An Exhibition of Works by Joseph Cornell*. Pasadena, Calif.: Pasadena Art Museum, 1966. Catalogue of an exhibition held December 27, 1966–February 11, 1967. Catalogue preface and acknowledgments by James Demetrion, text by Fairfield Porter (a revision of an article from *Art and Literature*, no. 8, Spring 1966), and an excerpt from a letter by Cornell dated September 16, 1942.

Jaguer, Edouard. *Joseph Cornell*. Paris: Filipacchi; Galerie 1900–2000, 1989. Catalogue of an exhibition held March 13–April 8, 1989. Printed in French.

Joseph Cornell. New York: ACA Galleries, 1975. Catalogue of an exhibition held May 3–31, 1975. Text by John Bernard Myers.

Joseph Cornell. Madrid, Spain: Fundación Juan March, 1984. Catalogue of an exhibition held April–May 1984. Text by Fernando Huici. Printed in Spanish.

Joseph Cornell. New York: The Pace Gallery, 1986. Catalogue of an exhibition held December 5, 1986–January 31, 1987. Text by Brian O'Doherty.

Joseph Cornell. Tokyo, Japan: Gatodo Gallery, 1987. Catalogue of an exhibition held June 22–July 18, 1987. Text by Sandra Leonard Starr, transl. by Kazuko Matsuoka. Text in English and Japanese. 2 vols.

Joseph Cornell: 1903–1972. Paris: Galerie Karsten Greve, 1992. Catalogue of an exhibition held July 9–October 7, 1992. Text by Bernd Growe, Ellen H. Johnson, and Robert Motherwell. With extracts of the diaries of Cornell. Printed in German, English, and French.

Joseph Cornell (1903–1972), Paris, France: Baudoin Lebon, 1980. Catalogue of an exhibition, *Joseph Cornell (1903–1972): Boîtes*, held at Baudoin Lebon, Paris, May 29–July 5, 1980; *Joseph Cornell (1903–1972): Boîtes et Collages*, traveled to Musée de Toulon, Toulon, France, July 14–September 1, 1980. Catalogue with text by Marie-Claude Béaud, Jean Le Gac, and Robert Motherwell (1953 text originally written for *Joseph Cornell* exhibition catalogue of the Walker Arts Center, Minneapolis, catalogue never published). Printed in French.

Joseph Cornell: Años Cincuenta y Sesenta. Monterrey, N.L., México: Museo de Arte Contemporáneo de Monterrey, 1992. Catalogue of an exhibition held October 1992–January 1993. Text in Spanish and English. Text by Fernando Treviño Lozano, Jr., Walter Hopps, and a poem by Octavio Paz written for Joseph Cornell in 1973, "Objects and Apparitions."

Joseph Cornell: Box Constructions and Collages. New York: C & M Arts, Inc., 1996. Catalogue of an exhibition held January 17–March 2, 1996. Essay by Donald Windham.

Joseph Cornell: Box Constructions and Collages. West Palm Beach, Fl.: Norton Museum of Art, 1997. Unpaged, box catalogue of exhibition held March 7–May 4, 1997. Text by Christina Orr-Cahall, Elizabeth Richebourg Rea, and Donald Windham.

Joseph Cornell: Dovecotes, Hotels, and Other White Spaces. New York: The Pace Gallery, 1989. Catalogue of an exhibition held October 20–November 25, 1989. Essay by Brian O'Doherty.

Joseph Cornell/Marcel Duchamp . . . in Resonance. Houston, Texas: Menil Foundation; [Philadelphia:] Philadelphia Museum of Art; Ostfildern-Ruit, Germany: Cantz; New York: Distributed in North and South America by D.A.P., Distributed Art Publishers, 1998. Catalogue accompanying an exhibition held October 8, 1998–January 3, 1999, at the Philadelphia Museum of Art, Penn.; and The Menil Collection, Houston, Tx., January 29–May 16, 1999. Texts by Ecke Bonk, Lynda Roscoe Hartigan, Walter Hopps, Don Quaintance, and Ann Temkin; introduction by Anne d'Harnoncourt.

McShine, Kynaston, ed. *Joseph Cornell*. New York: The Museum of Modern Art, 1980. Catalogue of an exhibition held November 17, 1980–January 20, 1981. Essays by Dawn Ades, Carter Ratcliff, P. Adams Sitney, and Lynda Roscoe Hartigan.

Richebourg, Betsy. *Joseph Cornell: Collages, 1931–1972*. New York: Leo Castelli, Richard L. Feigen, James Corcoran, 1978. Catalogue of an exhibition held May 6–June 3, 1978. With texts by Donald Windham and Howard Hussey, acknowledgments by Betsy Richebourg, introduction by Richard L. Feigen.

Roseman, Harry. *Inside the Box: A Photographic Portrait of Joseph Cornell by Harry Roseman*. New York: Davis & Langdale Company, Incorporated, 1997. Essay by Molly Nesbit. Catalogue of an exhibition held March 22–April 26, 1997.

Simic, Charles. *Dime-Store Alchemy: The Art of Joseph Cornell*. Hopewell, N.J.: Ecco Press, 1992.

Solomon, Deborah. *Utopia Parkway: The Life and Work of Joseph Cornell*. New York: Farrar, Straus and Giroux, 1997.

Starr, Sandra Leonard. *Joseph Cornell: Art and Metaphysics*. New York: Leo Castelli, Richard L. Feigen, James Corcoran, 1982. Catalogue of an exhibition held May 11–June 18, 1982.

Starr, Sandra Leonard, ed. *Joseph Cornell Portfolio*. New York: Castelli, Feigen, Corcoran, 1976. Catalogue of an exhibition held February 28–March 20, 1976 at the Leo Castelli Gallery. Text by Donald Barthelme, Bill Copley, Tony Curtis, Howard Hussey, Allegra Kent, Julien Levy, Jonas Mekas, and Robert Motherwell.

Tashjian, Dickran. *Joseph Cornell: Gifts of Desire*. Miami Beach, Fl.: Grassfield Press, 1992.

Waldman, Diane. *Joseph Cornell*. New York: Solomon R. Guggenheim Museum, 1967. Catalogue of an exhibition selected and presented by Diane Waldman held May 4–June 25, 1967. Preface by Thomas M. Messer.

———. *Joseph Cornell*. New York: George Braziller, 1977.

———. *Joseph Cornell: Memories*. New York: Joseph Helman Gallery, 1999. Catalogue of an exhibition held March 31–April 24, 1999.

General Books and Catalogues

American Art at Mid-Century, I. Washington, D.C.: National Gallery of Art, 1973. Catalogue of

exhibition held October 28, 1973–January 6, 1974. Introduction by William C. Seitz.

Ashton, Dore. "Cornell, Joseph (1903-73)," *Britannica Encyclopedia of American Art* (New York: Simon and Schuster, Chanticleer Press Edition, 1973), pp. 124–26.

Balakian, Anna. *Surrealism: The Road to the Absolute.* The University of Chicago Press, 1986.

Baur, John I(reland) H(owe). *Revolution and Tradition in Modern American Art.* Cambridge, Mass.: Harvard University Press, 1951, p. 31.

Breton, André. *Le Surréalisme et la peinture.* Paris: Gallimard, 1928; enlarged version of material that appeared originally in *La Révolution Surréaliste,* 1:4 (July 15, 1925), pp 26–30; 2:6 (March 1, 1926), pp. 30–32; and 3:9–10 (October 1, 1927), pp. 36–43.

———. *Le Surréalisme et la peinture,* 2nd ed. rev. Paris: Gallimard, 1965.

———. *Qu'est-ce que le Surréalisme?* Brussels, Belgium: René Henriquez, 1934; *What is Surrealism?* Transl. by David Gascoyne. London: Faber & Faber, 1936.

Calas, Elena and Nicolas. *The Peggy Guggenheim Collection of Modern Art.* New York: Harry N. Abrams, Inc., 1966, pp. 122–23.

Dictionnaire Abrégé du Surréalisme. Paris: Galerie Beaux-Arts, 1938. Includes the catalogue of the *Exposition Internationale du Surréalisme* held at the Galerie Beaux-Arts, January 17–February 1938. Organized by André Breton and Paul Eluard.

Fantastic Art, Dada, Surrealism. New York: The Museum of Modern Art, 1936. Catalogue of an exhibition held December 9, 1936–January 17, 1937. Catalogue ed. by Alfred H. Barr, Jr., texts by Georges Hugnet and Elodie Courter Osborn, annotated by Monroe Wheeler.

Geldzahler, Henry. *New York Painting and Sculpture: 1940–1970.* New York: E. P. Dutton & Company, Inc., in association with the Metropolitan Museum of Art, 1969. Catalogue of an exhibition held October 18, 1969–February 8, 1970. Foreword by Thomas P.F. Hoving, text by Henry Geldzahler; reprints of essays by Harold

Rosenberg, Robert Rosenblum, Clement Greenberg, William Rubin, and Michael Fried, pp. 31, 42–43, 431–32, 457.

Goldwater, Robert. "Joseph Cornell," *Dictionary of Modern Sculpture,* ed. Robert Maillard. New York: Tudor Publishing Company, 1960, pp. 64–65, transl. from French by Bettina Wadia; rev. ed., *New Dictionary of Modern Sculpture* (1971), pp. 71–72.

Grohman, Will, ed. *New Art Around the World: Painting and Sculpture.* New York: Harry N. Abrams, Inc., 1966.

Hunter, Sam. *American Art of the Twentieth Century: Painting Sculpture Architecture,* rev. ed. New York: Harry N. Abrams, Inc., 1974.

———. *Modern American Painting and Sculpture.* New York: Dell Publishing Company, 1959.

Janis, Harriet, and Rudi Blesh, *Collage: Personalities, Concepts, Techniques.* Philadelphia, Penn.: Chilton Company, Book Division, 1962, pp. 86–87, 253.

Janis, Sidney. *Abstract and Surrealist Art in America.* New York: Reynal & Hitchcock, 1944.

Jean, Marcel, and Arpad Mezei, *The History of Surrealist Painting,* transl. Simon Watson Taylor. New York: Grove Press, 1960, pp. 260, 273, 289, 307, 313–317, 349, 350; originally published as *Histoire de la Peinture Surréaliste.* Paris: Editions de Seuil, 1959.

Johnson, Ellen H. *Modern Art and the Object: A Century of Changing Attitudes.* London: Thames & Hudson, 1976. Revised and enlarged ed. (New York: Icon Editions, 1995).

Keller, Marjorie. *The Untutored Eye: Childhood in the Films of Cocteau, Cornell, and Brakhage.* Rutherford, New Jersey: Fairleigh Dickinson University Press; London: Associated University Presses, 1986.

Levy, Julien. *Memoirs of an Art Gallery* New York: G. P. Putnam, 1977.

———. *Surrealism.* New York: Black Sun Press, 1936; reprinted New York: Arno/Worldwide, 1968.

Modern Artists in America. New York: Wittenborn Schultz, 1952. 1st Series: ed. by Robert

Motherwell and Ad Reinhardt; photography by Aaron Siskind; documentation by Bernard Karpel.

Mogelon, Alex, and Norman Laliberté, *Art in Boxes.* New York: Van Nostrand Reinhold, 1974, pp. 76–84.

Myers, John Bernard. *Tracking the Marvelous: A Life in the New York Art World.* New York: Random House, 1983.

O'Doherty, Brian. *American Masters: The Voice and the Myth.* New York: Random House, A Ridge Press Book, 1973, pp. 254–83.

Read, Herbert. *A Concise History of Modern Sculpture.* New York: Praeger, 1964, p. 264.

Rubin, William S. *Dada, Surrealism, and Their Heritage.* New York: The Museum of Modern Art, 1968. Catalogue of an exhibition held at The Museum of Modern Art, New York, March 27–June 9, 1968. Traveled to the Los Angeles County Museum of Art, California, July 16–September 8, 1968; The Art Institute of Chicago, Illinois, October 19–December 8, 1968. Distributed by New York Graphic Society, Greenwich, Conn., 1968.

Seitz, William C. *The Art of Assemblage.* New York: The Museum of Modern Art, 1961. Distributed by Doubleday, Garden City, New York. Catalogue published on the occasion of the exhibition at The Museum of Modern Art, October 2–November 12, 1961. Traveled to the Dallas Museum for Contemporary Arts, Texas, January 9–February 11, 1962; San Francisco Museum of Art, California, March 5–April 15, 1962. Bibliographies by Bernard Karpel; Cornell entry by Kynaston L. McShine.

Seuphor, Michael. *La sculpture de ce Siècle: Dictionnaire de la Sculpture Moderne.* Neuchâtel: Éditions du Griffon, 1959.

———. *Dada and Surrealist Art.* New York: Harry N. Abrams, Inc., 1969, pp. 266, 468.

Waldman, Diane. *Collage, Assemblage, and the Found Object.* New York: Harry N. Abrams, Inc., 1992.

Windham, Donald. *Tanaquil.* New York: Popular Library, 1972. The character of William Dickinson in this novel is based upon Cornell.

CREDITS

Photographs of works of art reproduced in this book have for the most part been provided by the owners or custodians of the works identified in the captions. The following list refers to photographs for which an additional acknowledgment is due. Every effort has been made to locate, and obtain permission from, rights owners. Please contact the publisher with any possible oversights. Page numbers follow credits.

Copyright © 2002 The Art Institute of
 Chicago/Bergman: 39, 49, 78, 115
Copyright © ARS, N.Y., Tate Gallery, London,
 Photo Courtesy Art Resource, N.Y.: 64
Courtesy Helen Batcheller: 14, 15, 16
Photo Will Brown, Philadelphia: 20
Photo Mel McLean: 63 (top)
Photograph copyright © The Museum of Modern
 Art, N.Y.: 34, 56, 80, 107
Photo Schambach und Pottkämper, Krefeld:
 19 (bottom)
Copyright © 2002 The Solomon R. Guggenheim
 Foundation, N.Y.: jacket back, 55, 110
Courtesy Diane Waldman: 33
Photograph copyright © 2002 Whitney Museum
 of American Art: 38, 109

Egypt Moulids saints sufis

Gary Schwartz | SDU & Kegan Paul International

MOULIDS SAINTS SUFIS
Egypt

Nicolaas H. Biegman

© Nicolaas H. Biegman and Gary Schwartz | SDU publishers, The Hague
No part of this book may be reproduced in any form without permission of the
publisher, except for the quotation of brief passages in criticism.

British Library Cataloguing in Publication Data

Biegman, Nicolaas H.
Egypt: moulids saints sufis
1. Islamic festivals
I. Title II. Egypt. English
297.36

ISBN 90-6179-122-7 Gary Schwartz | SDU publishers
ISBN 0-7103-0415-3 Kegan Paul International

US Library of Congress Cataloguing in Publication Data Applied for

Design SDU design Irma Boom

Photography by Nicolaas H. Biegman

Editing by Sarah Vernon Hunt and H.J. Scheepmaker
Set in Trinité by Joh. Enschedé en Zonen, Haarlem
Printing by Snoeck–Ducaju & Zoon, Ghent
Bound by Albracht BV, Montfoort
Produced in the Netherlands and Belgium

First English edition published in 1990 by Gary Schwartz | SDU
and Kegan Paul International Ltd

First published in Dutch in 1990 by Gary Schwartz | SDU, The Hague

Kegan Paul International Ltd
P.O. Box 256
London WC1B 3SW
England

Distributed in United Kingdom by
John Wiley & Sons Ltd
Southern Cross Trading Estate
1 Oldlands Way, Bognor Regis
West Sussex, PO22 9SA
England

Routledge, Chapman & Hall Inc
29 West 35th Street
New York, NY 10001
USA

The Canterbury Press Pty Ltd
Unit 2, 71 Rushdale Street
Scoresby, Victoria 3179, Australia

Gary Schwartz | SDU publishers
P.O. Box 30446
2500 GK The Hague
The Netherlands

Contents

Rifa'i dervishes leaving the al-Azhar mosque during the moulid of
al-Husayn. I took the picture in 1965. In those days one could still see
dervishes dressed in patched frocks.

This book has crystallized around a steadily growing pile of photographs taken mostly during religious fairs, or moulids, in Cairo and elsewhere in Egypt. It is essentially a collection of impressions and it pretends to give neither a full account of popular religious practice, nor a complete elucidation of what is described. There are excellent books about mysticism, saints and popular beliefs; the bibliography contains a list of those which I know of. My main aim was to enable the reader to understand some of the things he or she will see or hear when visiting a moulid.

I had witnessed my first moulids during the sixties, when I lived in Cairo for a period of three years. They had impressed me very much, but at the time I was writing my thesis and did not have the opportunity to take up other subjects. I returned in 1984, fearing that by then the moulids would probably be a thing of the past, but found to my surprise that they were more numerous than ever. This time I stayed for four and a half years and I was in a position to make a better study of this very Egyptian phenomenon.

This book is divided into three main chapters: Moulids, Saints and Sufis, but the three are intimately though loosely interwoven. At the popular level it is hardly possible to talk about one without mentioning the other two: all the rural mystics or sufis worship saints, and the sufis form the core of the visitors at the Muslim moulids, where the saint cult reaches its climax. There is no moulid without a saint, even though there are (minor) saints without moulids.

Yet, one does not have to be a sufi to ask for a saint's assistance, nor does one have to be one to celebrate a saint's birthday. Also it is perfectly possible to be a sufi without making much of the saints, let alone mingling with the moulid crowds. Besides, sufism is an exclusively Muslim phenomenon, which is totally absent at Christian celebrations. Moreover, though a large number of Muslim saints have a sufi background, this is by no means true of all. Numerous saints lived at a time when no sufism existed as yet, and many later ones acquired sainthood without ever treading the path of the mystic.

There is no end to the Egyptian moulids and saints, and there is no end to the miracle stories that form part and parcel of the ambiance. Since it was impossible for me to check these stories, my only criterion for including them was that those who told them obviously believed in them themselves. I give them in their original and sometimes somewhat shocking details, in order to demonstrate the characteristic and perfect mix of the sublime and the pedestrian. Since most of the people in my pictures are still alive, I have largely kept to stories about saints whose witnesses are still alive as well, besides stories about older saints that are still being told.

Apart from tales told to me by people I met, two printed collections of miracles have mainly been used: those connected with the Muslim sheikh Ahmad Radwan and those ascribed to the Coptic Pope Kyrillos VI. (Sheikh is a title of respect given to Muslim men, either because of their age or because of their religious background. Saints and members of their families, even while still young, are called sheikh, as are men with a higher religious education.) Both saints were at their most active in the 1960s, and both are still vividly remembered. Moreover, I have used a book published recently by Radwan's son Sheikh Muhammad, containing quotations from what the former said to his followers, which gives an excellent insight into the philosophy of present-day mainstream sufism in Egypt.

The photographs were taken at random first, and a little more systematically by the end of my stay in Egypt. In the beginning, listening to the music and looking at the scenes full of life and colour was sufficient for me. Gradually, however, I started asking questions and collecting stories and remarks. Still, the research had to remain of a rather haphazard nature, and my motto could have been like Picasso's: 'Je ne cherche pas, je trouve!' And when I did look for something particular, I often found something quite different.

For many of my sophisticated Egyptian friends, this will be their first contact with the world of saints, sufis and moulids. It is a world apart, which can easily be missed by those who find themselves in the top levels of society, and by foreigners who do not know the language. Or perhaps it is the upper-crust and the foreigners who are the world apart, for what is described here is nothing short of a mass phenomenon. Some moulids attract up to a million visitors and the membership of the sufi orders is estimated at several million people. Nearly every village has its saint's tomb, cities and towns have several, and Cairo has dozens. Since the Christians celebrate their moulids in a slightly less spectacular way and the bigger ones are held in faraway monasteries in the countryside, I only became aware of them at a somewhat later stage. I then came to realize how much the Muslim and Christian traditions with regard to saints and miracles have in common. Some of these common features are universal and are found outside Egypt as well as within, but some must have their roots in the Pharaonic background which the Muslims and Christians share. The country and its history are indeed of great relevance to the religious phenomena described in this book. Egypt may perhaps be considered the 'cradle of monotheism', as a tourist poster from the 1970s proclaimed, showing a picture of the face of Pharaoh Akhenaton; it certainly developed a thriving, decentralized polytheism, elements of which survive in the popular religion of today. Egypt also features prominently in the stories of those religions. One cradle found in Egypt, according to the Old Testament, was that of Moses. The New Testament speaks of the refuge which the Holy Family found here while Jesus was an infant.

Though Egypt did not play a very important role in the rise and development of Islam, it is mentioned eighteen times in the Koran, and today it possesses the focal point of Sunni Islam, the University of al-Azhar in Cairo. It also contains one of Islam's most numerous and active sufi communities, which preserves the methods of meditation that led the Muslim mystics to enlightenment over a thousand years ago.

One of Egypt's claims to fame is that it has existed as a well-defined country for five millennia. Even under foreign domination, Egypt was a separate and identifiable entity. Egypt's spectacular artistic heritage is well known and needs no elucidation here.

Besides this, however, the Egyptian people possess a living heritage as important as its artistic relics, with a poetic content that pervades their entire existence. This poetry does not as a rule consist of simple and pleasant rhymes only. It has frightening and cruel aspects. It is of such authenticity and continuity that many Egyptians tend to overlook it. The non-Egyptian has to look for it at first, but after a while he finds it everywhere without even trying.

If the inextricable mix of the sacred and the secular in the Egyptian moulids strikes us as medieval, just as the world of saints, visions and miracles reminds us of the days of Gregory of Tours, the term 'medieval' should be used to indicate the primordial rather than the primitive.

To end this introduction, a few words about the politics of it all. With the example of other Muslim countries in mind, it took me some time to realize that there is no conflict between the Egyptian government and the mystic orders. On the contrary, there seems to be a more or less tacit understanding, which extends to the Coptic Church as well, that the common enemy is Muslim fundamentalism and this effectively has made them all allies.

So, even though the sufis receive their share of criticism from both the progressive thinkers and the Muslim orthodox, their relationship with the authorities is immeasurably better than it used to be, say, fifty years ago. They constitute a rural mass of people who are very largely impervious to fundamentalist propaganda. If Egypt does not become fundamentalist, this will be partly thanks to the solid sufi presence.

It is not possible to mention everyone who at some stage or another helped me along or encouraged me in making this book. Apart from Sheikh Zahir and Father Maksimos, who are quoted in various parts and who supplied me with very precious first-hand information, I should like to thank Mrs. Annemarie Schimmel, who was kind enough to read the manuscript and to make some valuable suggestions, and from whose excellent book *Mystical Dimensions of Islam* I borrowed a number of terms, notions and quotations.

Bert Nienhuis, a professional photographer in Amsterdam, helped me with a number of problems of technique and composition. Elizabeth Wickett of the University of Pennsylvania supplied me with very useful references.

The Netherlands Institute for Archaeology and Arabic Studies, its director Dr. Cees Versteegh and his staff were extremely helpful as well. The same goes for the American University in Cairo, its president Dr. Richard Pedersen and the staff of its library.

Raouf Musaad accompanied me on numerous moulid expeditions and his help was invaluable where the interpretation of Arabic and colloquial Egyptian texts was concerned.

In particular my wife Mira, to whom this book is dedicated, gave me the initial idea of writing it and subsequently dragged me out of a number of logical and textual pitfalls when she read the manuscript.

<div style="text-align:center">Many thanks to all of them!</div>

Cairo, June 1988

The circumcision booth of 'Abdul Ghani Khalil at the moulid of
al-Husayn, Cairo
16.8.1966

Invitation to the moulid of Sheikh Zahir's grandfather Ahmad Abu
Zaghlal, whose picture is on the right. His son 'Abdallah, Sheikh
Zahir's father, is on the left. Sheikh 'Abdallah worked miracles too,
and was buried in the same maqam as Sheikh Ahmad.

One night in the summer of 1965, I rounded a corner in the old city of Cairo and could not believe my eyes. In the middle of a narrow street four or five men were dancing, turning their bodies left and right. A woman was singing, accompanied by a flute and drums, in a strong rhythm totally different from the Arabic music I was accustomed to. People were sitting around, watching and drinking tea. I had stumbled upon my first *moulid* and witnessed my first *zikr*, or mystic dance.

Moulids (*mawlid* in Classical Arabic, pl. *mawalid*) are birthday celebrations for saints; mostly dead ones, but occasionally living ones as well, as demonstrated by the case of Sheikh Mousa of Karnak, for whom a big moulid was held at the beginning of the Muslim month of Ragab while he was still alive. Even though some moulids attract close to a million visitors, it is possible to live in Egypt for years without ever seeing one. This is because they tend to take place in popular quarters of the cities or in places far from the better-known monuments and resorts, and only for periods of up to one or two weeks, sometimes less, each one at its own time of the year. The day after the 'Great Night' the moulid disappears without leaving a trace. Yet, whoever starts looking for them soon realizes that there must be literally thousands of these fairs, of all conceivable sizes. Egypt has between 5,000 and 6,000 villages and there is hardly a village without a saint's shrine or *maqam*. There are many more in the cities and towns. Most of these shrines are the centre of a moulid at least once a year, so we can safely assume that there is hardly a day without a Muslim moulid somewhere in Egypt. The Christian moulids are a chapter apart and will be treated separately.

A moulid is what the medieval saints' fairs must have been in Europe. Centred around the saint's shrine they generate an influx of pilgrims and visitors and a great deal of religious and non-religious activity: visits to the shrine, processions, trade, amusement, eating, drinking and begging. No meaningful separation can be made between the secular and the religious elements in the moulid, even though every moulid possesses its own characteristic mixture of the two, and certain aspects prominent in one can be completely absent in another.

Generally, and especially as a result of the unrestrained amplification of the music, the noise at night is deafening. In popular parlance, the word 'moulid' can be used with the meaning of 'utter chaos'.

The main celebrators at the Muslim moulids are the sufis or dervishes, organized nation-wide in sixty-eight orders or brotherhoods (*tariqas*) and locally in groups headed by a *khalifa*, which will be described in more detail in the third chapter. Each of these groups visits a number of moulids of their choice, possibly but not exclusively belonging to their own tariqa; some close to their homes and others at the other end of the country. There they find a house or a mosque to stay in, or they put up a tent. In this tent, mosque or house if it provides enough room, and otherwise in the adjacent street or square, they perform their ritual dances (*zikr*) and receive their visitors.

Sheikh Zahir, whom we shall meet in the chapter on sufis, for instance, goes with his people for a number of days to the great Cairo moulids of al-Husayn and Sayyida Zaynab; to those of Sidi Abu Misallam and Abu Khalil, both in his own province of

Sharqiya; and to Sidi 'Abdel Rahim's in Qena, deep in Upper Egypt. Since he belongs to the Rifa'i tariqa, he visits the moulid of Ahmad al-Rifa'i in Cairo as a matter of course. He also goes to the moulid of Ahmad al-Badawi in Tanta and tries from time to time to visit the shrine of Abul Hasan al-Shazli in the far southeast of the country. Apart from that, he organizes his grandfather's moulid in his village of Kafr Ibrahim.

Apart from the sufis or dervishes, the moulids are frequented by sympathizers or *muhibbin*, who also can take part in a zikr; pilgrims looking for the saint's *baraka* – *baraka* is the beneficent force or blessing inherent, for example, in saints and holy places – and his intercession with God or the Prophet; many people simply looking for a good time; and also professionals who make money at the moulids selling nuts and sweets, clothes, toys and kitchenware, or manning swings, merry-go-rounds, shows and circuses. There are often one or more specialists in circumcision (*mutahirs*), who can be either travelling craftsmen or local barbers. Those who make their living going from moulid to moulid are called the 'moulid-people', or *mawalidiya*. A special class of mawalidiya are those who consecrate themselves to handing out water and burning incense; not very remunerative activities, which are close to begging. At many moulids there is some hashish, at some there is beer, but no one gets drunk and there is a great difference between the friendly and good-natured crowds in Egypt and the much more boisterous and aggressive public at carnivals in Europe.

All in all, it can be said that both in the cities and in the villages the moulids have stood up remarkably well to modern influences, television included. They seem to respond to a genuine need of both a religious and a social nature.

Every moulid has its own identity, depending on its location, the preponderance or otherwise of religious activity, and the numbers of people attending. For instance, the moulids of al-Sayyida Nafisa and especially Sidi 'Ali Zayn al-'Abidin, held in the middle of cemeteries in tents which stand over the graves, so that people use the graves for kitchen tables and sometimes dance on them, look quite different from those of the Sayyida Zaynab, al-Husayn and Ahmad al-Badawi, which are spread over the streets, squares and alleys of extensive neighbourhoods in cities. That of Sidi Hasan al-Anwar is marked by very little sufi activity, but has the character of a community feast, with three or four little orchestras playing religious music on carts, for people drinking tea in the street who pay for the musicians. At Sayyida Sukayna and Hasan al-Anwar there are horses dancing to the music of oboe-like instruments called *mizmar* at the end of the afternoon.

Rural moulids, like those of Abu Misallam and Abul Ma'ati, consist of big tented camps. At Abu Khalil's in Zagazig, most activities take place in the square in front of the great mosque. Tanta's Ahmad al-Badawi has the most attractions in the field of shows and circuses, complete with the 'Flying Lady', lions and tigers.

Mit al-Siba', 'Azab and Abul Qumsan have *dosas*, where the sheikh walks over his followers. Mit al-Siba' and a number of Upper Egyptian moulids have processions with one or more camels carrying *mahmals*. At the moulid of Sheikh Idris in Kom Ombo there is a great deal of gambling and both here and at Abul Hasan al-Shazli's there are zikrs before midday. The little shrine of Sheikh Mansour at Aswan gets a new green flag.

The moulid of Abul Hasan, which takes place as far as one can travel in Egypt, high in the barren mountains near the Red Sea, not very far from the border with Sudan, is a special case. For a few days, most of the traffic along the southern few hundred miles of the Red Sea coast and on the desert road linking it to Edfu consists of trucks, lorries and taxis, bedecked with flags of the various tariqas and each with a loudspeaker up front, broadcasting to the desert the music of the sheikhs who are in fashion in Upper Egypt. The tomb of Sheikh Salim, which stands at the crossroads where one turns southeast for the last hundred kilometres before Abul Hasan's shrine, is circled three times by the cars, for baraka and to avoid this saint's jealousy; a custom which is followed in the same way at the shrine of Sheikh Sallam, which is itself on the track to that of Abu Sari' in the desert behind Helwan, where a moulid used to take place in the month of October. The 'Ababdas of the coastal plains stop all other activity and trek to Wadi Humaysara, where Abul Hasan was buried by the Prophet and where the moulid takes place. There the trucks and cars are parked along improvised streets, with the tents for the zikr pitched in between. Even in this faraway place there is a fair amount of commerce. People walk up and down the mountain where the Prophet disappeared after burying the great sheikh, making little heaps of stones as souvenirs of their visit and taking some dust home for baraka.

The moulid of Abul 'Abbas in Alexandria is famous for its zikr at dawn at the end of the Great Night, at the foot of the stairs leading up to the mosque. In a number of shrine mosques, such as Ahmad al-Badawi's, many people spend the night and much of the day sleeping, waiting for a vision.

Most moulids, though different in detail, follow a general pattern: they usually run for about a week; but some last for up to two and a half and some only for two days. They are officially opened with a modest ceremony, consisting mostly of speeches and readings from the Koran, in the case of bigger moulids attended by representatives from the government such as the governor of the province or the Minister of Religious Affairs. Another modest ceremony, hardly noticed by anyone, marks the end.

After the opening, and sometimes already before it, the village or the quarter of the city where the moulid is being held fills up gradually with dervishes camping and sitting around with their mobile kitchens, women and children; swings and shooting booths, the odd circus or Punch and Judy show (qaragoz); sellers of colourful paper hats – the most frequently exhibited item, even though few people seem to wear them – and crowds and more crowds, which reach their highest numbers on the Great Night (al layla al-kabira): the last, culminating night of the moulid when the zikr goes on until dawn.

This usually marks the end of the moulid, and immediately the fakka sets in; everything is loaded on cars, carts and beasts of burden and taken to the next moulid, and by noon hardly anything is left. Some very dedicated dervishes put in another night of zikr after the Great Night, but they are exceptions to the rule. Sheikh Zahir practises this at the moulids of Sayyidna al-Husayn and the Sayyida Zaynab in Cairo.

Sometimes there may also be a procession in the afternoon of the day before, or around midday of the day after, the Great

Night. During the days of the moulid generally no zikrs take place before the afternoon prayer of about 4 p.m., and people either sleep – the nightly zikr can cause a condition close to exhaustion – or sit quietly in their tents and *khidmas*, offering tea and food to any guests who may come in. Hospitality is a major characteristic of the sufis, who not only share whatever they possess among themselves, but seem to be most happy when they can share it with others as well. Food is an important element of the moulids and at many it is distributed to the poor. Both the giving and the receiving of food, drinks and sweets contains *baraka*, the blessing especially associated with saints. One night while the Koran was being read during the opening of the moulid of Sayyida Nafisa, I saw a man emerge with an enormous bag of sweetmeats, which distracted the attention of many of those present and angered some others.

The least a moulid visitor has to accept from his dervish hosts is a glass of strong tea with a lot of sugar.

At night the moulids are illuminated by the lamps fitted into triumphal arches and other luminous decorations. It is at this time also, that the *munshids* who sing at the zikr test their microphones with 'Allah', 'Allah-two-three-four'. They tend to use this amplification to the maximum extent and the distance between zikrs can be rather small. It is a pity they do this, because the music, which can be extremely beautiful, often comes out distorted almost beyond recognition. Fortunately, a large number of cassettes is sold with *inshad* executed by very able sheikhs, so after returning home it is possible to listen to the music again, and hear it properly. At any rate, any of these minor inconveniences is outweighed by the immense cordiality and friendliness of the sufis and their sympathizers, irrespective of whether there is a zikr going on or not. Anyone is welcome to enter a tent and witness the zikr.

Moulids, the owner of a cafe in Desouq explained, are built on *homos* and *fisikh*. Fisikh is salted fish, and especially Desouq, close to the fishing port of Rosetta (*Rashid*), was full of it. Roasted chick-peas, or homos, are extremely common at the moulids in Lower Egypt and Cairo, so much so that there is an adage pertaining to anyone who has failed to make a profit, that he has 'returned from the moulid without homos'.

In Upper Egypt ground nuts are more common as a moulid treat. There, moreover, no moulid exists without stalls of sugar dolls (*'arousas*), mostly representing girls in long gowns or the hero Abu Zayd al-Hilali seated on his horse, sword in hand. Such dolls are somewhat less common in Cairo, except for the Prophet's moulid, when dolls of all sizes are made in wooden moulds in the Husayniya quarter near Bab al-Futouh, and beautifully dressed up in garments of coloured paper.

Another feature of the moulids in Upper Egypt is the *mirmah* or horse race, in which the horses do not race one another but where each rider shows off his horsemanship in individual runs of which a quick start and an abrupt finish are the main components. Upper Egypt is also the land of the *tahtib*, a mock fight with sticks to the music of drums and mizmars and sometimes *rababas*, stringed instruments that rest on the knee of the musician. The same musicians accompany the mirmah. The tahtib can be very elegant, the sticks lightly touching, if at all. In Cairo, one-man tahtibs are prevalent.

A frequently followed custom, especially with the moulids of saints associated with a specific tariqa, is the holding of a procession (zaffa, in Upper Egypt called dora or tofa) towards and/or around the shrine, in which either the Sheikh al-Saggada, the supreme head of the order, or his deputy or the shrine's khalifa is the main figure; seated on a horse or, sometimes, under the cloth cover of the saint's tomb which has been placed on a camel.

In Cairo, the great zaffas are the very big one of the Rifa'i tariqa which parades from the mosque of the Sayyida Zaynab to the Rifa'i mosque and figures the deputy of the tariqa, who is received by the Sheikh al-Saggada at the entrance of the mosque; and that of Sidi 'Ali al-Bayoumi, which is highly picturesque on account of the red colour of the turbans, flags and banners and because it passes from al-Husayn through the medieval part of the city and under the city-gate of Bab al-Futouh, up the narrow street of al-Husayniya to the mosque where the saint's grave is. In the Husayniya, the exultant crowds are such that the Sheikh al-Saggada, who rides himself at the end of the procession, can hardly pass at all; protecting himself with an umbrella from a rain of enormous candies (arwah) thrown at him for baraka by people standing on the balconies of their apartments.

The processions take place either at the end of the afternoon of the day of the Great Night, or just before or after the midday prayers on the next day. It is my impression that the former mode is followed especially in the north, while the latter is more generally practised in Upper Egypt. In Alexandria, zaffas are held after the evening prayer, around 8 or 9 p.m., at the start of the Great Night. Miniature zaffas are held for little boys to celebrate their circumcision. Sometimes they may also ride along for a while in a big procession, like Bayoumi's.

One day around dawn after the Great Night of the Sayyida Zaynab, when the call to prayer had already been heard and the last zikrs came to an end, I was sitting in a little square talking to some smokers of hashish who would not yet go home, when all of a sudden a window opened above us and a rain of heavy sweets came down, together with five-piaster notes, each one neatly inscribed in Arabic: 'Congratulations on the moulid of the Generous Saint – 24.3.1987'. Baraka again! Only ten days later I found among my change another five-piaster bill, distributed on 1 February 1987 at the moulid of Sa'id Diya' al-Sayyid Sayf, but though I kept looking out for them, this was the only other one I encountered. Most people keep these notes 'to bless their purse'.

Moulids take place all year round, even during the month of Ramadan. I used to think that no moulids were celebrated during Ramadan. However, the April, 1989 issue of the sufi magazine al-Tasawwuf al-Islami features a list of no fewer than eighteen moulids to be held in Alexandria at various days of Ramadan 1409.

The Muslim lunar year is about eleven days shorter than the solar year, so that lunar dates move backwards through our year, coming full circle after approximately thirty-three years. For the peasants especially, this is highly impractical, and they have kept the solar year in its Coptic configuration, which determines the seasons for sowing, reaping and irrigating their land. Most of the older moulids are determined by the Muslim, lunar year, while many new ones are fixed at a date in the (non-Coptic) solar year. Solar dates are also a feature of the moulids belonging to the Ahmadi tariqa and its affiliates.

However, the dates of many moulids are rather irregular, which is partly due to a preference for a certain day of the week for the Great Night and partly to incidental factors like the wish – for 'solar' moulids – to avoid an overlap with the month of Ramadan or the birthday of the Prophet. Furthermore, the date of a moulid may be dependent on the availability of land to hold it on, such as Sheikh Zahir's, which is accordingly organized in October when there is a short spell during which the land is not used for agriculture; or that of Sidi Daw' al-Haggag in Kinayyiset al-Dahriya, which is held after the cotton harvest' (*ba'd al-qutn*). The big southern moulid of al-Sultan Farghal in Abu Tig starts on the last day of the high-school certificate exams and lasts for two weeks. Finally, bedouin moulids like al-nabi Salih's in Sinai are fixed every year rather arbitrarily by the tribes concerned.

It follows that it is impossible to draw up a reliable moulid calendar, even after one has sorted out the lunar moulids from the solar ones following a few years' experience. Some, however, are stable enough, like Sayyida Zaynab where the Great Night invariably falls on the last Tuesday of the month of Ragab; and the moulids of Abul Haggag and 'Abdel Rahim in Upper Egypt, which fall invariably on 13 and 14 Sha'ban respectively. Some moulids come in regional clusters, much to the delight of the mawalidiya, who can then more easily move their swings and other apparatus from town to town.

There is a season in October and November during which the moulids, with intervals of one or two weeks, move north from Tanta (Ahmad al-Badawi) through Basyoun (Sidi Basyouni), Desouq (Ibrahim al-Desouqi), Mahmoudiya and Fuwa to Rashid. 'Asem al-Mahdi, the 'magnetic hypnotizer' whom I saw making a lady fly in the air at the moulid of the Imam al-Shafe'i and elsewhere, told me that after Ramadan he intended to perform in Minya al-Qamh, Hihya, Sidi Selim Abu Misallam, Bilbeis (Abu 'Isa and Abu 'Alwan), Zagazig (Abu Khalil) and al-'Aziziya, in that order, all in Sharqiya province.

The main moulids of Cairo cover a period comprising the five consecutive months of Rabi' al-Thani, Gumada al-Ula and al-Thaniya, Ragab and Sha'ban. In that period fall successively the moulids of Fatima al-Nabawiya, al-Sultan Abul 'Ela, al-Husayn, al-Sayyida Sukayna, the Sayyidas Nafisa and Ruqayya, 'Ali Zayn al-'Abidin, Ahmad al-Rifa'i, al-Sayyida Zaynab, al-Imam al-Shafe'i, Hasan al-Anwar and al-Sayyida 'Ayesha, to mention only the major ones.

In Alexandria, there are five moulids in five consecutive weeks. Abul 'Abbas al-Mursi is followed at a week's distance by Sidi Gabir which starts on the morning after the Great Night of Abul 'Abbas. Sidi Gabir is followed by Sidi Bishr, Sidi Kamal and Sidi Mohammed al-Rahhal. In 1987, they were held in July and August. Sha'ban, the last month before Ramadan, and more especially the middle of the month which carries additional baraka, is so crowded with moulids that any trip either to the countryside or to the old parts of Cairo is bound to yield a few.

In Upper Egypt between Qena and Luxor, the full moon of Sha'ban witnesses six sizeable moulids in three days (13-15 Sha'ban): Abul Haggag in Luxor; Abu Yazid al-Bistami in Kubaniya across from Aswan; al-Sheikh 'Azab in 'Azab between Qurna and Qena; 'Abdel Rahim al-Qenawi in Qena; al-Amir Ghanem in Asfun near Esna; and Sidi 'Amer in Draw; apart from a number of smaller

ones such as Sidi 'Ali near Aswan. In 1988 this festive season was added to by Qurna's Abul Qumsan which, fixed on 29 March, happened almost to coincide with the middle of Sha'ban.

Moulids go in and out of favour. The moulid of Ahmad al-Rifa'i for instance, which was described around 1880 as one of the most remarkable festivals that occurred during the year, and which is one of the biggest Cairo moulids now again, was noted as 'quite extinct' by McPherson around 1940 in his book *The Moulids of Egypt*. The same applies to the Sayyida Nafisa, whose moulid was scarcely worth mentioning in 1940, but is one of the important ones today. On the other hand, a number of moulids among the 126 mentioned by McPherson have now disappeared.

It can perhaps be assumed that many of the moulids have taken the place of old Egyptian festivals connected with the Nile and its inundations, fertility, and the numerous Gods both national and local. In Pharaonic times, the religious festivals were nearly as numerous as the moulids are today. According to documents from the period, there were 162 days per year with some celebration or other in the reign of Ramses III. Then as now, processions were an important feature in the festivals, in which boats sometimes played a major part. Numerous Gods possessed their own boat. The boat stood on a pedestal in the Holy of Holies in the temple and on festive occasions was drawn in procession by the priests. The divine boat was often called 'the one who raises on high the beauty (of the God)', that is, the one who instills the God with new life. At the Opet festival, three boats were carried or hauled from the Karnak temple to the temple in Luxor: a big one for Amon and smaller ones for his consort Mut and his son Khonsu. Today likewise, three boats are drawn in the procession for the moulid of Abul Haggag, whose shrine is within the Luxor temple. A similar custom existed until recently at the moulid of Sidi 'Abdel Rahim in Qena. It is tempting, and not completely improbable, to imagine that the present-day custom is a direct continuation of the Pharaonic one, even though the people of Luxor claim the boats are connected with Abul Haggag's arrival from Morocco or with his pilgrimages to Mecca. To verify this, one would have to be sure that the boats were also used during the Greco-Roman and subsequent Christian periods. In a number of shrines, little boats also have been hung, but it seems that this custom is disappearing. I saw such boats only in Akhmim, Mahamid near Esna, and Beni Sueif.

The *sari* poles, which are at the physical centre of many moulids, are also supposed to be of Pharaonic origin. This pole, which carries the banner of the tariqa associated with the maqam, is either permanent, as in Tanta, or planted for a specific period, which may exceed the duration of the moulid itself. It is believed that the departed saints congregate around the sari. In Cairo I never saw saris, but apart from Tanta they exist in places such as Basyoun, Kafr Abu Misallam, Kubaniya near Aswan, Mit al-Siba' and Kafr Ibrahim al-'Aydi, the home of Sheikh Zahir. There used to be one in Luxor until a few years ago.

There is an extremely interesting parallel to be drawn here with the Pharaonic custom of erecting a pole for ithyphallic fertility gods like Min. At festivals not exceeding one day, the god's statue could be removed from the temple to be present there. However,

at the start of the agricultural season, the festivities lasted longer. Since it was not considered desirable for the statue to leave the temple for too long, a mobile shrine was then put up in the form of a tent, the central pole of which was consecrated to the god, whose spirit inhabited the pole for the duration of the festival. It also happened that the pole alone was set up and one ancient drawing has been preserved where the pole carries a flag exactly like the present-day saris do.

That undoubtedly pagan traditions endured well into the twentieth century becomes clear from a passage in *The Moulids of Egypt*, where McPherson relates what he saw in the procession of Abu Harera in Giza in 1908 and recorded in a letter written shortly afterwards:

'After the usual "Turuq" with their banners, music, sashes, and insignia, came endless carts bearing groups dressed up to represent some guild or some fancy, and others drawn by one horse or donkey and bearing thirty or more children and women in gala attire. Then I noticed approaching a large cart with a raised platform at the front. At the centre of this was a throne, and before it was standing a very handsome lad of fourteen or fifteen, perfectly naked except for a little crown, and an open bolero of crimson stuff embroidered in gold, and bearing little epaulettes, through which almost invisible cords passed. Brightly coloured circles had been painted round his navel and nipples. A "Wazir" in gorgeous robes adopted from syces' costumes stood on each side of the monarch, one holding a gilt chamber pot and the other a basin, which with low obeisance they presented to him at intervals. Musicians beat tars, toblas, and darabukas on a somewhat lower platform behind. But the amazing thing was that the little man's virile organ was dancing to the music in seeming excitement, turning to the right and left, dipping down, and then flying up and down as though actuated by a spring. The royal car paused for a minute or more a few yards from where I was, and I could detect a fine cord attached to the anterior portion of this marionette of flesh and blood, passing under one of the epaulettes and descending from behind to the lower part of the cart, where obviously a string-puller was concealed.

'I did not witness any of the subsequent proceedings, but as far as I am aware, they were such as are common to any moulid.

'Though I witnessed the zeffa on two or three rather more recent occasions, but before the war, I saw nothing of the royal car. I do not know if it was officially suppressed.

'It is worth noting that the Moulid of Sheikh al-Harera does not (now at any rate) follow the Moslim Calendar observed by nearly all the others, but is held on Sham el-Nesim, the Easter Monday of the Coptic and Greek churches and I suspect the Zeffa, with its phallic elements, dates back to pre-Islamic, and pre-Christian festivals in honour of Spring.'

Another custom which is very old, but more in the bedouin tradition, is that of the *mahmal*, *hawdig* or *tabout*, carried on a camel in the procession. It consists of a framework of wooden sticks or palm leaves over which the cover (*kiswa*) is placed which normally is found on the saint's tomb, or it consists of a new one to replace the old cover. Under the kiswa there is either nothing at all, or a Koran, or a relative or representative of the saint, who during the procession dispenses baraka to people who touch the kiswa and to

children who are lifted up to him. In Luxor, there used to be a large number of tabouts being carried around for Abul Haggag and various other local saints, including one for Sheikh Mousa of Karnak, who was still alive. Large numbers are still being carried around at the procession of al-Sultan Farghal in Abu Tig. During moulids and special days, people sometimes burn lamps and candles in or near the maqams; a very old custom which is even more widespread among the Christians than among the Muslims.

Another deed of piety towards the saint is sweeping his maqam. It is also possible to sweep a saint's maqam against ('ala) somebody one wants to hurt, as a kind of black magic; just as people read the Yasin chapter of the Koran back to front against their enemies. The Surat Yasin is frequently sold at moulids and elsewhere.

To end my exposition on historical continuity, let me mention the chasm, especially in the cultural and religious fields, between the elite and the masses of the people, which has been an Egyptian characteristic from the times of the Pharaohs until now. The religious world of the Pharaonic elite was entirely different from that of the common people, who had their own Gods and cults. Even though official Islam makes no difference between the rich and the poor and has done away with the mysteries preserved for the few, and even though compulsory education has removed people's illiteracy, much the same is still true in our age. It explains the virtual ignorance and the total lack of interest of the Egyptian elite with regard to saints and moulids.

In a later chapter the necessity for Islamic customs to be founded on the Prophet's example will be touched upon. Not even the fiercest defenders of the moulids, however, can claim that these festivals were already organized during the time of the Prophet. It seems that no moulids were held during the first Muslim centuries and that the beginning of moulid celebrations, starting with the Prophet's birthday on 12 Rabi' al-Awwal, occurred during Fatimid times in Cairo and in the twelfth and thirteenth centuries elsewhere. Any ancient moulid features must up till then have been preserved by the Christians, of whom there were still many. Moulids are consequently a novelty (bid'a) in Islam and there is some controversy over the question whether they can be called a bid'a husana, or commendable bid'a, or not. Needless to say, the Islamic fundamentalists would like to see the moulids banned, supported by progressives who find them a waste of time.

In the 1930s and '40s, this current of opinion was rather strong in Egypt and resulted in constant harassment of the moulids and especially of their non-religious components by the police. McPherson's book, written in those days, contains a passionate plea in favour of these fairs. Today, with the newly-found sympathy of the government for the sufis and their tariqas has come a great deal of tolerance for the moulids as well. The government not only does not hinder them, but recognizes them and is represented at the major ones. There we find a tent put up by the governing 'National Democratic Party', and candidates for the Parliament include visits to the moulids in their campaigns.

Compared with the Muslim moulids, the Christian ones, which are less frequently linked to birthdays and more often commemorate a saint's death, are few and far between. Viaud, in his Les Pèlerinages coptes en Egypte, counts sixty-two in all and many of

them are only small affairs. The number of saints for whom important moulids are held is even smaller than the number of the moulids themselves, because various moulids take place in the honour of the same saint. St. George is the patron of two big moulids, one in Mit Damsis on the Damietta branch of the Nile (August) and one in Riziq near Armant south of Qurna (November), as well as of a number of smaller ones.

Feasts for the Holy Virgin are held at Gabal al-Tayr near Minya (Ascension), Mustorod near Cairo, and Deir (i.e., monastery) al-Muharraq and Deir Dronka near Asiout (all in August). The many moulids for the Virgin held at different places can be explained by the lengthy travels which according to tradition the Holy Family undertook on their flight to Egypt. Generally, Deir al-Muharraq is held to be the southernmost place that was reached on this journey. How is it, then, that the new, large and rather commercial monastery of Dronka, lying to the south beyond Asiout, also boasts a Cave of the Virgin and organizes a huge pilgrimage in August? 'Who am I to say that this is untrue?' said one of the monks at Deir al-Muharraq. 'Maybe they visited Dronka on the way back.'

The Holy Damiana with her forty virgins and St. Barsoum the Naked have one big moulid each, in May near Mansoura and in September near Cairo respectively.

The Christian moulids resemble the Muslim ones in the number of people attending, as well as in the secular activities in the fields of amusement and commerce. A trade which is prevalent at Christian moulids but absent in Muslim ones, where Korans and rosaries are the only religious items sold, consists of specifically religious souvenirs, such as cheap jewellery, copper plates and framed pictures depicting the patron saint, the Virgin, St. George or the contemporary saint Pope Kyrillos VI. At St. Damiana's special pottery is sold with the inscription 'Happy returns, Damiana' (wa bi-'awda ya Damyana).

Another activity which is only met with at Christian moulids but which is invariably performed by Muslims who inherit their skills from their fathers, is tattooing. Many Christians have a small cross tattooed on their wrist, but the customer may choose from many motifs exhibited in small framed paintings behind glass; such as St. George, the hero Abu Zayd, Christ on the Cross, snakes, birds or alternatively his own name and address.

The crowds at Christian moulids are of a different structure than the Muslim ones because, for lack of the sufi element which favours larger groups, they mostly consist of families who may spend up to a week or ten days in small tents rented from the monastery where the moulid takes place. Moreover, the Christians tend to dress up for their moulids. The men mostly wear long trousers instead of a galabiya and the women tend to wear western-style dresses. Boy scouts look after public order. All this gives the Christian moulids, compared with the Muslim ones, a decidedly bourgeois appearance. Though Christians, unlike the Muslims, are in principle allowed to drink alcohol, I never saw any drunks at them.

As there are no sufis, there is no music either, apart from church services that are relayed by loudspeaker. Besides these, pilgrims have short litanies called tamgid sung in front of the grave or the relics of the saint, composed of songs of praise in Coptic

for the saint and ending in 'agios – agios – agios, pi-agios …', i.e., holy – holy – holy St. … Neither is there as much hospitality shown towards visitors, who instead usually have their tea in enormous tea houses put up for the purpose, with names like 'Love' or 'The Blessed Virgin'.

Masses mostly take place in the morning and on the Great Night, and I saw the icon of the patron saint paraded in a zaffa at the end of the afternoon, carried backward so the bishop could follow it and incense it, at the moulids of Damiana, St. George and St. Barsoum.

At the entrance of the church or monastery, there is a 'box-office' where people can against a receipt pay sums of money they have vowed to spend during the year (nazr, pl. nuzour) in the event of a cure, success in love or business, and the like.

At St. George's in Riziq many people brought live animals, which were slaughtered by voluntary workers in a special slaughterhouse (salakhana); a quarter of the meat as well as the skin and the intestines to be sold by the monastery, the rest being divided between the poor and those who had offered the animal. The salakhana at St. George closed at 10 p.m. and a quarter of an hour before this an enormous ox was still hurrying towards it through the dense crowds. He may have had to wait until the next day.

All through the day and night, small processions made their way to the monastery with embroidered banners, mostly red or rose-coloured. These banners were nuzour as well, and really pieces of cloth which the monastery was to use as curtains and frontals for the altars and icons.

As in the case of the Muslim moulids, many circumcisions take place: at St. George's, this constituted the main activity of an emergency clinic donated by the Netherlands government. Government clinics only operate on boys, but professional circumcisers treat the girls as well. Baptisms are frequent, too. At St. Damiana's, horses were waiting outside for the baptized who would be paraded with their godfather.

Though my taxi driver believed that St. George was actually buried in Riziq, the monks did not claim to possess the saint's body, or even a relic; but they hoped that they would get part of a relic kept in the United States. At moulids for the Virgin or a female saint like St. Damiana, it is believed that she appears at night, disguised as one of the many pigeons that are around, and recognized by a special trajectory she flies. Such appearances, and appearances in general, are an exclusively Christian phenomenon. Muslims have dreams about their saints, but with very few exceptions the latter do not appear to the crowds or to individuals, as happens at Christian moulids and as the Virgin did on top of a Cairo church for a while in the 1970s.

In common with the Muslims, Christians also sleep at the shrines during the moulids, hoping for visions or cures. They also write little notes to their saints and write their names and wishes with a candle on the icon before the candle is lighted. Most icons for this reason have a glass pane to protect them.

Exorcizing evil spirits is done by specialized priests at a number of moulids, although this can take place at other times also. At certain sites of pilgrimage, Christians like to leave a memento of their visit behind. Thus, St. Anthony's cave in the hills overlooking his monastery is surrounded with wooden crosses, apparently made on the spot from wood left lying around when a wooden staircase leading up to the cave was built. Most crosses bear the inscription 'Lord, remember thy servant so-and-so'.

The baraka-laden bonbons of the Muslim moulids are present at Christian festivals as well. One afternoon, I entered the monastery of St. Barsoum the Naked while heavy fighting took place among the believers in front of the church. The fight was for sweets which the bishop was throwing in small quantities from his balcony.

There is only one Jewish moulid in Egypt: that of Abu Khatzeira, held for two days in January in and around his grave at Damanhour. It resembles Christian moulids because of the absence of a sufi component and the western appearance of the participants. The circumstances in which it is held – one thousand security police for a few thousand guests, Egyptian non-Jews being resolutely kept outside in order to protect the visitors from terrorism – do not permit this moulid to develop into the festival it must once have been. The key to the shrine is symbolically sold at auction for a few thousand dollars at the start of the first night, the money being used for the upkeep of the shrine. The visitors, mostly from Israel and France and a few from Morocco, burn candles near the grave, take bottles of water to it to receive 'barakha' – a custom I observed also at Ibn 'Arabi's grave in Damascus – and slaughter sheep for their own use. They bring sick relatives to be cured and ask for the saint's intercession in having their wishes fulfilled. Above all, a lot of eating, drinking, singing and merry-making takes place in the tent next to the shrine.

Though the anti-Israeli-minded opposition press in Egypt claims that the local population is antagonistic to this Jewish moulid, it was my impression that most were taking a rather relaxed view. 'Been to Abu Khatzeira? Everybody drunk again?' was the strongest comment I got. So in this case as in others the proverbial tolerance that holds Egypt together seems to have the final word.

Five piaster bills from the moulids of Diya' al-Sayyid Sayf and Sayyida Zaynab.

1

« 1 Sari pole in Mit al-Siba', with the flag of the Rifa'i order to which the *khadim al-maqam* belongs. The sari is planted during the moulid of Muhammad al-'Iraqi, whose tomb is in the background, and stays for about three months, until the birthday of the Prophet.

The old sycamore tree near the tomb is sacred. When a branch is cut off, the tree makes a whining sound (*titsawwat*), and it is said that under it two saints live, without arms and legs. The trunk is full of nails knocked into it by visitors. On another, smaller tree behind the wall, people who want to be cured leave bits of cloth.

Sycamores are often found near shrines and have long been considered as sacred. In graves from the Pharaonic period, they are sometimes, for instance in those of Thutmosis III and Sennedjem, depicted as breast-feeding the dead person.

24.7.1987/27.11.1407

‹ 2 Making paper hats for a local moulid in the Souq al-Silah, Cairo.

› 3 Bayoumi zaffa. The atmosphere around the procession was somewhat like St. Nicholas entering Amsterdam, with the difference that this was real. Through cheering crowds along the Husayniya, a popular street running north from the old city gate of Bab al-Futouh, sufi groups with their sheikhs all belonging to the Bayoumiya order formed a long procession preceding Sheikh Hamid al-Bayoumi, Sheikh al-Saggada of the Bayoumiya order, mounted on a horse.

The zaffa takes place on the day of the Great Night of the moulid of Sidi 'Ali al-Bayoumi, who founded a separate branch of the Ahmadiya around 1700. It runs from al-Husayn through the old city to the grave of Sidi 'Ali in the Husayniya. People on the balconies of the surrounding buildings throw heavy sweets for baraka, from which Sheikh Hamid protects himself with an umbrella. At the end of his ride, he could hardly push through the crowd, and showed serious irritation.

18.2.1988

› 4 Crowds at al-Husayn, on the afternoon before the Great Night of the moulid of 'Sayyidna al-Husayn'.

Some Rifa'i banners are carried around the square, and at the left against the façade of the mosque, where Husayn's head is kept in a shrine, some important orders, as well as the general sufi authorities (*al-mashyakha al-'amma*) and the organization of descendants of the Prophet (*ashraf*), have erected their tents. (On the other side of the square, there was a tent belonging to the friends (*ahbab*) of Sheikh Mousa and the friends of Abul Haggag, from Karnak and Luxor.)

The moulid of al-Husayn is the biggest in Cairo, and on the Great Night there may well be a million people around.

15.12.1987/23.4.1408

5 A Rifa'i zaffa passes under the Nile bridges of Abul 'Ela during the moulid. The munshid, though keeping the essential of his praises for the Lord, also mentioned the Minister of the Interior, Zaki Badr, the scourge of the fundamentalists; 'And, Minister of the Interior, God keep you for me! (*wa-wizir id-dakhiliya, rabbina yikhallik liya*).'
10.12.1987/18.4.1408

› 6, 7 Dora. In the Upper Egyptian town of Asfun, north of Esna, a camel with a *mahmal* carrying the new cloth (*kiswa*) for the grave of Sheikh al-Amir Ghanem is led around in a procession, called *dora* (circumambulation) in this area. In the mahmal there is the *naqib*, a member of the family looking after the tomb, who dispenses baraka to those who touch him.

It is said that al-Amir (prince or commander) Ghanem was called Ghali before, a Christian name which could indicate that a Christian saint, and possibly a Pharaonic god, was worshipped here before. It is also said that Ghanem fought the Christians after the conquest of Egypt, probably during a revolt. Al-Amir Ghanem's moulid is the third largest in the province of Qena, after Abdel Rahim of Qena and Abul Haggag of Luxor. All three are held during the middle of the month of Sha'ban, just before Ramadan. Al-Amir Ghanem is sometimes seen on a white horse, a sword in his hand, by peasants in the fields around sunrise.

The police with the long sticks are a common feature at Upper Egyptian moulids. Their main task is protecting the moulid against attacks by anti-sufi fundamentalists.

2.4.1988/15.8.1408

7

› 8, 9 Nubian women during a *tofa* or procession on the day after the Great Night of the moulid of Sidi Abu Zayd al-Bistami at Kubaniya in the deep south.

The Nubians came walking from their village of Gharb-Aswan in the morning, and walked around the grave seven times. After that, a number of camels was made to gallop round the maqam seven times as well. In the afternoon, boys did their own tofa on donkeys, as did a sheikh under a mahmal on a camel, followed by another camel with two brass kettle drums and a man beating them, which was led through the village, and seven times around the maqam.

Many stories were told about Sidi Abu Zayd, whose name resembles one of the greatest Persian sufi masters of the classical period, but who is claimed here to be originally a Moroccan from a village named Bistam.

Abu Zayd had promised his mother never to tell a lie, and promptly declared the money hidden in the seam of his garment to a band of robbers who were plundering his travelling companions. The robbers were so impressed that they converted to Islam. Another conversion, this time of one thousand Christian monks, was wrought by Abu Zayd at Deir Sam'an at Gharb-Aswan. He entered the monastery unseen, but the superior 'smelled a stranger' and challenged him: if he could not answer ninety-nine questions put to him he would convert to Christianity, and if the monks could not answer ninety-nine questions to be put by Abu Zayd they would convert to Islam. Needless to say Abu Zayd answered all the monks' questions (one of them being: 'Who walked in his grave?', the answer being: 'Jonah'), and then only asked one question himself: 'What is written over the door of Paradise?' This was a tricky one, because, as the superior knew already, over the door to Paradise is written: 'There is no God but Allah and Muhammad is his messenger', which is the Muslim credo. The superior gave the correct answer, but the whole monastery converted to Islam. Abu Zayd miraculously made one thousand turbans for them out of his own.

Not all Christians at Gharb-Aswan were converted, however, and one of them wanted to kill Abu Zayd. Being blind, he asked his daughter to help aim his catapult at the man while he was doing his ablutions for prayer, and shot him in his privates. Abu Zayd walked to Kubaniya, where he died. The people of Kubaniya then set out to bury him on an island in the Nile, but because the island was sometimes inundated the saint did not agree; so when they were on the point of lowering him into the grave, they heard the clapping of hands in the sky; they looked up, and when they looked down again the body had disappeared.

After many centuries, Abu Zayd appeared in someone's dream and told him where his remains could be found. They were duly dug up and a maqam was built.

Abu Zayd was such a great saint that other saints became jealous of him and challenged him to equal their piety. One of the challengers prostrated himself in prayer for a full year: 'The flies entered through his arse and left through his mouth', but the archangel Gabriel nevertheless declared Abu Zayd the winner.

1.4.1988/14.8.1408

10, 11 Professional dancers of the Mahdi clan whirl around with their *tannouras* in front of a Rifa'i zaffa at the moulid of Sayyida Zaynab. They and their colleagues of the clan of Abul Ghayt can be hired for festive occasions such as weddings and circumcisions. Some of the Abul Ghayt people also perform at zars.
22.3.1987/21.7.1407

« 12 Incense being burned by a visitor of Sheikh Zahir's tent in the mosque of Sarghitmish, during the Great Night of the moulid of Sayyida Zaynab. The man came in uninvited and was soon dismissed.
8.3.1988/30.7.1408

‹ 13 Barber giving his client the finishing touch at the moulid of Abu Misallam. Some barbers belong to the mawalidiya, travelling from one moulid to another.
19.7.1987/22.11.1407

14 Woman making tea during one of the many moulids celebrated in summer in the cemetery of Khanka, on the northeastern outskirts of Cairo.

15 Circumcision is carried out during the moulids by *mutahirs* who are either exclusively circumcisers or barbers doing it as an extra to their normal trade. Both boys and girls (the latter only in Egypt and elsewhere in Africa) are subjected to this treatment.

 Here, the local barber near the mosque of Abul 'Ela in Cairo has fixed a circumciser's sign to his shop for the duration of the moulid. The sign reads: 'Sultan Abul 'Ela Salon - the famous mutahir Hagg Muhammad and sons - tel. 767193.'
6.12.1987/14.4.1408

16 Trade. At the moulids, everything made of iron, plastic, sugar, aluminium, ceramic and other materials is sold; mostly toys and household goods, but also chick-peas (*homos*), sweets, incense, paper hats, sugar dolls and salted fish (*fisikh*).

 Here, a woman is selling plastic toys at the moulid of Sidi Ahmad al-Rifa'i in Cairo, next to a tent belonging to a Rifa'i group who have exhibited a portrait of their sheikh.
12.3.1987/11.7.1407

14

15

16

«« 17 Seller of sweets at the moulid of Sidi Ahmad al-Rifaʿi.
11.3.1987/10.7.1407

«« 18 Woman watching the zikr at the moulid of Abul Haggag in Luxor.

« 19 Woman dancing in Cairo near al-Husayn to the music which normally accompanies the stick dance or tahtib done by the men. She paid the band just like anybody else and got her five minutes of music.

 People wanting to watch the tahtib were allowed into the tent on the condition that they paid 50 piasters for their tea, instead of 10 or 15. Others stayed outside and watched through the gaps.

‹ 20 Tahtib, a highly ritualized mock fight with sticks, which no Upper Egyptian moulid can do without. The fight, which is close to a dance, is carried out to the music of oboe-like instruments (*mizmar*) and a drum.

 At Abul Qumsan's moulid, the tahtib started after the afternoon prayer around 4 p.m. and ended at sunset. These two men were among the last performers.

 In Cairo, people from Upper Egypt mostly dance on their own with a stick to the same music.
29.3.1988

21 Tahtib pictured on a shooting booth at the moulid van Abul Haggag in Luxor. The text reads: 'Mahmoud ʿArabi – Esna – the monastery (*al-dayr*).'

22 Rababa player at the moulid of Abul Hasan al-Shazli.
3.8.1987/7.12.1407

23 Mirmah or horse racing is a common feature of Upper Egyptian moulids such as those of ʿAzab, Abul Qumsan and Abul Haggag. Horses do not race one another, but the riders show off their horsemanship one by one, making quick starts and abrupt finishes.

 Here at Abul Haggag's in Luxor as elsewhere, there were large numbers of expert observers and their sons. The mirmah lasted from the afternoon prayer until sunset.
11.4.1987/11.8.1407

24 Mirmah at the moulid of Abul Qumsan in Qurna.
29.3.1988

25 Mirmah at the moulid of Sheikh 'Azab in 'Azab, north of Qurna.
12.4.1987/12.8.1407

› 26 Mawalidiya, moulid people, are taking it easy near their shooting booth, waiting for the night to set in at the moulid of Sayyida Nafisa in Cairo.
1.2.1987/1.6.1407

» 27 Shooting booths being set up at the moulid of al-Sultan Abul 'Ela in Cairo.
6.12.1987/14.4.1408

28 While I was visiting the tomb of Sheikh Nour, one of the numerous recent saints in the cemetery of Khanka on the northeastern outskirts of Cairo, this man set up shop for the moulid which was having its Great Night the next day.

Around the picture of Mickey Mouse, called 'the bride of the province of Qalyoubiya', religious slogans have been written, such as 'I trust in God', 'God is generous', 'I walk by the light of God, I pray and I say: O Lord!'

8.4.1987/8.8.1407

29 The Flying Lady. The 'magnetic hypnotist' 'Asim al-Mahdi makes a lady fly during his show at the moulid of the Imam al-Shafe'i in Cairo. The lady is wrapped in a blanket on a little couch. When 'Asim has raised her a little into the air, the couch is drawn aside. Once she is suspended, 'Asim leaves her there for a while to address the public, and demonstrates with the red hoop that she is not in any way attached to anything.

'Asim says he can raise her as high as he can raise his hands. The blanket gives some protection in case the balance is somehow disturbed. In such a situation she would as it were 'fall from her bed', and then he could, with luck, grab her in time.

I asked him if he could make me fly in the same fashion, and he answered that he could make anyone fly but that it took about three months of preparation.

That was all 'Asim al-Mahdi was prepared to divulge. A year later, during one of the nights of Ramadan when a huge fair is held near al-Husayn, 'Asim's colleague Baghdadi explained the trick in more rational terms. The lady lies on a metal bed, connected to a lever behind stage by an iron rod bent in such a way that it passes between the curtains without disturbing them. The rod is hidden from view by the lady and her blanket.

22.3.1987/21.7.1408

30 Boy flying at the moulid of Ahmad al-Badawi in Tanta.
21.10.1987

31 Moulid of Sidi Ahmad al-Rifa'i. The enormous tents are put up by
the Rifa'i authorities and rented by visiting groups for the duration of
the moulid.
25.2.1988/7.7.1408

32 Early morning at the moulid of Sidi 'Ali Zayn al-'Abidin in one of
the Cairo cemeteries.
 Members of the Khalwati order from al-Manzala have set up a
khidma on one of the graves (the text on the stone reads: 'Grave of the
al-'Asi family at Zayn al-'Abidin') where they give tea with milk to
passers-by.
13.2.1988/24.6.1408

« 33 Moulid of Zayn al-'Abidin. Rifa'i dervishes from Sohag have claimed a grave in the cemetery which surrounds the mosque of Sidi 'Ali Zayn al-'Abidin.

There is no zikr during the day. The cassette player plays a tape of one of their favorite *munshids*. Other graves are behind the half-open door. Our driver Mustafa, whose brother had died not long before, complained that the family had great difficulty entering the building for an hour or so to remember him, since dervishes had settled in it for the duration of the moulid.
16.2.1987/16.6.1407

‹ 34 Sufi camp in Tanta. During the early days of the moulid of Sidi Ahmad al-Badawi various orders are setting up their tents in an open square around the sari pole in Tanta.

The flags are used in the procession on the day of the Great Night, and as decoration for the tents. The red ones belong to Bayoumi groups, the black ones to Rifa'is.
18.10.1987

35 Children playing under Ahmadi banners at the moulid of Abul 'Abbas al-Mursi in Alexandria.
23.7.1987/26.11.1407

36 The moulid is built on homos and fisikh, as somebody told me in Desouq. In the northern parts of Egypt, there is no moulid, whether Christian or Muslim, without these small roasted chick-peas.

At the Christian moulid of Barsoum al-'Aryan, not far from Cairo, a homos vendor stressed his religious affiliation by placing his ware under the sign of the Cross.
26.9.1987

« 37 Pilgrims at Abul Hasan al-Shazli's moulid in Wadi Humaysara.
 The nearest village – Mersa 'Alam on the Red Sea – is 150 kilometres away, but most visitors come from the Nile Valley between Aswan and Qena, a drive of 300-400 kilometres.
 The 'Ababda region between Mersa 'Alam and Berenice comes to a virtual standstill during the moulid.
 The red hands on the car have been made with the blood of a goat or sheep, slaughtered as a sacrifice. They protect against the evil eye.
3.8.1987/7.12.1407

‹ 38 Christian families camping at the moulid of Sitt Damiana.
 Christians come to the moulid with their family, not in village groups like the Muslim sufis. The tents are rented from the monastery.
19.5.1987

39 Icon of St. Damiana being incensed during a procession at the saint's moulid.
19.5.1987

40 Reaching for the Cross during a procession at the moulid of Sitt Damiana in the Delta.

Sitt Damiana's moulid became famous through Durrell's *Alexandria Quartet*, where it is described as a wild fair full of music and dervishes. The author used his imagination rather liberally in transposing the features of an old-fashioned Rifa'i moulid as described in McPherson's *The Moulids of Egypt* to one of the best-behaved of Christian pilgrimages, a family affair without any excess whatsoever.

The wrists of the boys in this picture all carry a tattooed cross.
19.5.1987

41 Christian mawalidiya with their cart in one of the streets of Gabal al-Tayr, where the Holy Family is supposed to have lived for some time during their stay in Egypt.

There is a fourth-century church in Gabal al-Tayr founded by the Empress Helena. The moulid takes place just before Ascension Day. An enormous fair is then in operation in the surrounding desert.
28.5.1987

42 Tattooing is an activity which I have only seen at Christian moulids, though the tattooers themselves are invariably Muslims. The profession is generally inherited from the father and passed on to the son.

Many Christians have a small cross tattooed on the inside of their wrist. The tattooers have a wide variety of motifs including St. George, the Virgin, Christ, figures from the popular epic *Sirat Bani Hilal*, and numerous animals and birds.

« 43 Portraits of the Holy Virgin grace a swing at the moulid of
Barsoum al-'Aryan, south of Cairo.
26.9.1987

‹ 44 The fair forms an integral part of every moulid. Multi-coloured
swings, merry-go-rounds and shooting booths are always there, taken
by the *mawalidiya* or moulid people from one feast to another.
 This device was functioning at the Christian moulid at Gabal
al-Tayr, not far from Minya in Upper Egypt. The texts written on it are
of a truly ecumenical nature: for the Christians 'O mother of the
Redeemer, O purest one', for the Muslims 'God is great (allahu akbar)'
and for both 'A piece of wood in the eye of envy' – signed Ibrahim.
On the wings, the names of Arab countries: Jordan, Tunisia and
Morocco.
28.5.1987

45 At Gabal al-Tayr the moulid has ended and the fair is being
dismantled.

46 At Abu Khatzeira's moulid, the only Jewish moulid in Egypt, a
sheep is ritually slaughtered, though not, I believe, for a religious
purpose.
 This moulid has been revived since the establishment of relations
between Egypt and Israel, and is visited only by Jews, mostly from
Israel, France and Morocco, and by some of the few remaining
Egyptian Jews.
9.1.1988

47 Souvenir stall at the Christian moulid of Dayr Dronka.
 The Dronka monastery with facilities for visitors overlooking the
city of Asyout is being developed in a spectacular way.
August 1987

45

Twentieth-century saints. From left to right: Sheikh Ahmad Radwan, Sheikh Abul Qumsan, Pope Kyrillos VI and the monk Fanous.

The phenomenon of the 'holy man' who has intimate knowledge of a special kind about God and who can act – even, and especially, after his death – as an intermediary between man and God, is shared by a number of religions. In Christianity, the Roman Catholic and Orthodox churches have a wealth of saints, recognized by the hierarchy on the basis of more or less elaborate rules. Only the Protestants repudiated the notion of saints, stressing the direct relationship between God and man.

In this respect, orthodox Islam resembles Protestantism. Through the message of the Prophet and through his example (*sunna*), man has received a complete set of rules to study and to follow. There is no need, and indeed no possibility, for further intercession or intermediary between man and God. All man has to do is conform to the holy law, or *shari'a*. Praying is possible, but no personal answer should be expected. Also, there is no question of a special enlightenment to be found in this world, as eastern religions offer. One studies the rules, follows them as well as one can, and counts on a reward in the Other World.

At the popular level especially, the distance between humble man and almighty God was felt to have been made too great. There was, and is, a feeling firstly that a greater degree of intimacy both with God and with the spirit of the Prophet should be possible; this became the basis of sufism. Secondly, it was felt that between God and man there should be intermediary or intercession; just like an ordinary citizen does not call on the Head of State, but approaches an official or a lawyer. This is were the saints came in.

In Egypt the notion of saints was (and is) very much alive in the Coptic church. Conversion from Christianity to Islam occurred only gradually over a period of many centuries, and the cult of saints naturally entered Islam during that time. Much the same happened elsewhere. Apart from Saudi Arabia, where the holy graves have been systematically destroyed by a puritanical regime, there is hardly a Muslim country which is not sprinkled with the domes of 'maqams'; shrines which can, but do not have to, contain a saint's mortal remains and where people come looking for intercession between their Maker and themselves.

Sunni Islam lacks a hierarchy of priests. Any righteous Muslim with the necessary knowledge of the Koran and ritual can, for example, lead the prayers and give the Friday sermon. There is, consequently, no central ecclesiastical authority, though there are institutions with prestige and influence such as al-Azhar. It follows that there is no authority either to canonize saints or to reject anyone's sainthood. This, coupled with the absence of interest in saints inherent in the orthodoxy of many religious men of authority, has helped to lead to an approach of benign neglect towards a proliferation of saints which continues even today. In the cemetery of Khanka on the outskirts of Cairo are the tombs of at least six saints, all of whom died during the last few years. Both in the Delta and in Upper Egypt, surprising numbers of saints belong to the '60s, '70s and '80s. The fact that in Egypt new shrines have to be officially registered does not seem to have much of a limiting effect.

The Koran speaks in a number of passages of 'friends of God', though no special functions are assigned to these friends (*wali*, pl. *awliya'*). God himself is, together with the Prophet and the righteous believers, called the 'wali' of man as well. According to the

Koran, these 'walis' know neither fear nor grief. Subsequently, 'wali' acquired the more special meaning of 'saint', so that these passages, supplemented by tradition (*hadith*) about the Prophet and his contemporaries, could provide a foundation for the cult of saints in Islam.

A saint is bearer of the 'Light of Muhammad', and *'arif billah*, which means that he possesses direct knowledge about God which goes beyond what can be learned from books. Sheikh Ahmad Radwan, who lived and died near Luxor, where he was buried in 1967, and who is the most famous contemporary saint in Upper Egypt, said that there is knowledge of two kinds: the ordinary one 'and another one which fills the heart and delights the spirit'. In his case as in many others, much of that knowledge was gained during protracted periods in the desert, where 'remembrance of God was his food and reflection his sleep'.

The saints are generally not known as such during their lives, even though there are exceptions such as Sheikh Mousa, who lived at Karnak and dispensed baraka and counsel from his room.

Sheikh Zahir says that God has concealed five things in five others:
- in Friday, He concealed the exact time when prayers are heard and responded to (*sa'at al-igaba*);
- in the last ten days of Ramadan, He concealed the *Laylat al-Qadr*, a night with special blessings, when the Koran was revealed;
- in a man's life, He concealed the moment when the spirit will leave the body;
- in eternity, He concealed the Day of Judgement;
- and among the people, He concealed His saints.

The saints do, however, know one another and they are in contact with one another, both dead and alive. Mystic writers have developed systems according to which there are various categories of saints who, led by the *qutb* (pole) or *ghawth* (succour) of their time, govern the world. In a book of his quotations, compiled by Ahmad Radwan's son Sheikh Muhammad, he described how after forty-five years of trial and affliction he became ghawth himself: 'One ghawth died, and then another, and then the Prophet introduced me to all the saints; he took my hand and introduced me so that the saints would know that it was not his servant Ahmad Radwan who had appointed himself, but that it was the Prophet who had appointed him'.

The biography of Sheikh Ahmad Radwan contains some examples of his contacts with other saints and his knowledge of their whereabouts:

'One day I (i.e., the writer) visited (the tomb of) the great Qutb, Sheikh Abul Haggag (who died in the thirteenth century) with one of the brothers and this brother said to me: "Sheikh Abul Haggag is not present; do you know why he went out?" I said: "I do not know anything about this." He asked me again and I said: "I do not know." He remained obsessed with the problem and decided to ask Sheikh Radwan about it.

We looked him up after our visit to Sheikh Abul Haggag, which had been at a quarter past five, and my friend explained the matter to Sheikh Radwan and the latter said: "You visited Sheikh Abul Haggag after five o'clock, when he was at 'Idrous in southern

Yemen, because a saint (wali allah), Sheikh al-'Idrous, died tonight. Sheikh Abul Haggag was present at the deathbed of this great scholar."'

A saint radiates *baraka*, or blessing – a beneficial power, which can be transferred to his descendants, followers and visitors. If a saint dies young, his father can inherit some of his baraka as well; as in the case of the father of Sheikh Sayyid Zukri of Qirqatan, who reads the Fatiha for visitors to his son's maqam. The prime source of baraka is God, through His Prophet Muhammad. Inanimate objects too, if connected to a saint or prophet, such as his grave or the dust and even the whole area around it, can carry baraka. Baraka, or *madad*, 'assistance' of a more immediate kind, can be obtained or increased by – among other things – visiting a holy grave, preferably during specific times of the year or on certain days of the week.

Apart from the rather diffuse benefits of baraka, visitors can invoke the saint's intercession with God or the Prophet: instead of praying directly to the Almighty, one asks the saint to lend his good offices to obtain something, or to avoid or ward off something else. As Sheikh Ahmad Radwan put it: 'The saints can get anything they want from their Lord, so it is all right to ask for their assistance in front of God to receive a benefit or to ward off evil; asking for their help is useful as long as God has not yet irrevocably carried out his decision in another sense; because then, the saint (wali) will be silent.' Asking for a saint's intercession is often accompanied by a vow: if my son is cured, or if I get pregnant, I will, for instance, slaughter a sheep at the next festive day or moulid. A shipper may hang a model boat over the tomb after returning safely from a difficult voyage. Over the tomb of Sidi Abul Qasim in Akhmim there even hangs an old-fashioned aeroplane, next to two river boats.

Sometimes intercession stories sound very much like everyday bureaucracy:

'After sunset, our brother Ismail Hasan came to us and Sheikh Radwan told him: "You are coming from a visit to (the tomb of) Sheikh Abul Haggag." "Yes", he said. Then the sheikh said: "He has already raised your matter before God Almighty." Then the sheikh mentioned the matter to him and described it exactly, and asked God Almighty to take a (positive) decision. And our brother Ismail confirmed that what the sheikh had mentioned was exactly what he had said during his visit to Abul Haggag.'

A certain parallel can be seen in the Pharaonic forms of intermediary for the uninitiated who were barred from entering the temples and communicating with the Gods. They had to address images outside the sacred precincts and this God would pass their petitions on to the great God of the temple. At Karnak, a 'Temple of the Hearing Ear' was actually built for this very purpose and the forecourts of sacred buildings were sometimes crowded with icons that competed for the privilege of 'hearing prayer'.

There is a danger that the aspect of intercession fades into the distance if people perceive that it is the saint himself, instead of God through the saint, who performs cures and miracles. At that stage especially, these habits are held by the orthodox to constitute the supreme sin of *shirk*, that is association of other beings with God; but even the quest for intercession as such is frowned upon by the religious authorities.

The main criteria for establishing sainthood are miracles (*karamat*) happening during or after the saint's lifetime, and his

appearance in dreams and visions. Once sainthood is thus established, it tends to be remembered as long as the occurrence of karamat is confirmed by the wali's visitors. The hagiographies will of course emphasize the positive personal qualities of the saint, but on the whole such qualities appear to be of secondary importance. One is or becomes a saint through God's grace and not by doing one's best.

Some saints go through the stages of sufi enlightenment and earn their reputation during their lifetime, surrounding themselves with followers. One such saint was Sheikh Ahmad Radwan, born in 1895, who belonged to a well-established family of landowners who were deeply involved with religion as well. They were descended from the Prophet through al-Hasan. The sheikh received a good Islamic education, including the study of jurisprudence, and memorized the Koran at an early age. At the age of twelve, he made his first retreats of one to two months, in a cave or in an isolated room in his father's house. He was initiated into the Khalwati order of sufis.

Al-Hagg Ahmad 'Abdel Malik, who knew Sheikh Radwan intimately, describes in some detail the three stages he saw him pass through on his way to sainthood.

The first one, which lasted at least four years, was one of extreme restlessness, characterized by contradictory dispositions succeeding one another. It was the time when Radwan detached himself from human logic, from 'how' and 'where', and started to devote himself exclusively to his love for God. He received revelations and inspirations which he found difficult to sustain physically, and in such states he took off most of his clothes. Sometimes he spoke with people, sometimes he could not suffer their presence. In his ecstasies (wagd) he spent long periods standing, sitting and getting up again, and he wept frequently. He slept little, if at all. At this stage already, some learned men came to take advantage of his insight. 'Some people think that sainthood is easily acquired', Radwan said later, 'but this is not the case. You have to be tried and to suffer until you delight in every affliction that descends on you from God.'

During the second stage, he started to speak 'Suryani' – not to be confused with Syrian or Syriac – which is supposed to be the language of the supreme saints. He was heard calling other saints in all corners of the earth and sometimes he received news from them which was later confirmed in the newspapers. He also spoke a great deal about the dead, knowing their names, their appearance and the way they had died.

In the third stage, Radwan came back among his people in a more permanent manner. He founded the 'Radwan school' just outside Luxor and dispensed wisdom to his friends and followers. One of his most conspicuous activities was the interpretation of passages from the Koran, directly inspired by God Himself. As Radwan put it: 'God has given me dispensation from thinking about jurisprudence and interpretation. I only say what occurs to my heart'. Even during this stage, he found the closeness of God difficult to sustain and his son says that he was extremely frail and thin.

Radwan, who was gifted with striking clairvoyance – he knew people's names and problems as soon as they came in, and,

according to Sheikh Muhammad, could speak in the manner of their father or mother without ever having met either – worked a number of miracles and died in 1967, twenty years after founding his school. The 'saha al-Radwaniya', the centre of the movement which contains the grave of the sheikh, is now run by his four sons, and accepts and feeds large numbers of pilgrims and visitors. There is another saha Radwaniya in Alexandria.

Sheikh Radwan had a close relationship with important members of the Nasser regime and, it seems, with the President himself. Of his involvement with the preparation for the disastrous war of June 1967, there are different assessments. Some hold that he talked Nasser into it, but others such as Sheikh Zahir, who is a great admirer of Radwan, hold the opposite view. According to them the sheikh, in Cairo at the time, tried to discourage Nasser, and when his advice was not followed, uttered the wish that he would not witness the defeat. He packed his trunk and returned to his village, where he died on 4 June, just before the war began.

Sheikh Muhammad says that in 1966 Nasser sent his secretary down to prepare for a visit with Sheikh Radwan, but the latter preferred to visit the President in Cairo: 'If I receive him here, I have to be nice to him, but if I am the visitor instead of the host, I can give him real advice.' During his audience with Nasser, the sheikh allegedly told him that his future held no victory, but apparently this was not enough to deter the President from launching the war.

Sheikh Ahmad Radwan is the model of the respectable saint: a member of a good and saintly family, well educated and held in high esteem by the learned and the mighty. His family has of course gained enormous prestige through the saint, but they do not need the money of their visitors, who receive presents instead: at the end of my visit, Sheikh Muhammad gave me his book containing quotations from his father and a twenty-dollar bill as a souvenir.

Sheikh Ahmad al-Tayyib, also of the Khalwati order, who died around 1950 in Qurna, must have been in the same category of saints, though there is no mention of miracles ('his whole life was a miracle') and his followers do not feel a need for them. His descendants also are at the head of a well-appointed saha with a mosque and visitors' quarters.

At the other end of the social spectrum there are the saints with little or no learning, who are held by the simple people to be close to God. Their main claims to sainthood are their miracles and their eccentric ways of behaviour. The attachment of their followers to them is of a highly emotional character, and they are both trusted and feared for their powers. One of these saints of the poor was Abul Qumsan, who died in Qurna in March 1984, and around whose maqam sizeable moulids have since been held every year during the same month. Abul Qumsan's cult is ignored by the followers of Ahmad al-Tayyib, as no doubt Abul Qumsan himself would have been ignored by the saint himself, as well as by his son Muhammad, who is old but still alive. In some of Abul Qumsan's miracle stories, however, Sheikh Tayyib plays an important role, sometimes being the one who refuses a favour and is punished or at least upstaged as a result.

For instance, Sheikh Tayyib did not want to give Abul Qumsan a ride in his car to a certain place, but when he arrived Abul Qumsan was already there; just as Abul Qumsan traversed the Nile on his handkerchief when the ferry did not accept him because

he was being nasty to the tourists, speaking his mind about their morals as he had already done to King Farouq, whom he told to marry off his mother and his daughter to keep them from sin.

Sheikh al-Tayyib went on pilgrimage on a yearly basis (he had money) and Abul Qumsan, who had not, joined him there through miracles. One morning, Abul Qumsan asked his wife for some bread for al-Tayyib, who was already in Mecca, and shortly afterwards he delivered it, warm and fresh. At another time, Abul Qumsan had a quarrel with one of al-Tayyib's sons. He threw a loaf of bread into the air and the loaf landed in front of al-Tayyib, inscribed with all the details of the quarrel. When the son came home, his father told him to stop quarrelling with Abul Qumsan.

Concerning the origin of Abul Qumsan's sainthood there is a story which, as told by his daughter Umm Yousef, runs as follows: For one minute every year, the Nile is completely still; it sleeps, and then abruptly starts to flow again. Whoever drinks from the river at that moment will be a saint. Abul Qumsan's brother had built a hut near the Nile in order to watch it and catch it sleeping, but had not been successful for a number of years. Then Abul Qumsan came to see him. His brother wanted to fetch some water from the river, but Abul Qumsan went by himself and came back, saying: 'I just had a strange experience. While I was taking the water, the river did not move at all, and as soon as I had finished, the waves started to dance!'

Abul Qumsan wandered a great deal around Egypt, but he knew that he would die in his native Qurna and that his family would be well provided for after his death. In a dream, his granddaughter saw lights, flags, drums, cake and sugar, and Abul Qumsan with light shining out of him, along the road where the moulid is now held every year around his grave, or rather maqam, for Abul Qumsan disappeared during his funeral. The family had laid him on a bier at his home, but the bier had been very light to carry (this is said about many saints: the bier floats on the shoulders of the bearers and often chooses its own destination), and when the wind lifted the cover, the space under it turned out to be empty.

Abul Qumsan's dream about his family being provided for has come true. Gifts from visitors to the maqam are welcome, and plentiful. His sons ride on motorbikes, while one of his daughters dispenses baraka by grabbing the visitor's head and making a loud, growling noise. They would like to build a saha, but claim they are prohibited from doing so by the powerful Antiquities Department.

Stranger than Abul Qumsan's is the case of the very famous Sheikh Mousa, who died in Karnak in May 1988, over seventy years old. He lived in a windowless room with only one door giving on to a corridor in his modest saha ('al-saha al-Mousawiya'), which he had not left for more than twenty years. (The preceding twenty years had been spent in the same way in a mud-brick house in the same street.) In front of the saha, a maqam with a cupola had been built to receive Sheikh Mousa when he should die.

Late in the morning and late at night, Sheikh Mousa received the visitors who had been waiting, sitting on the floor in the narrow corridor, hoping for a cure or some advice, or just wanting to receive baraka. The son of the sheikh's sister, a man in his thirties who sat in front of the door, introduced each one, every time the sheikh opened his door for a few inches. The visitor was

then allowed to kiss Sheikh Mousa's right hand, while the left one stroked his hair. If the visitor had a question, he put it through the sheikh's nephew, and received the answer either directly or through the nephew. If the answer to a question ('Shall I go on this journey?') was meant to be negative, the sheikh said: 'Do as you like' (*inta horr*). In the positive case it was: 'Trust in God' (*itwakkal 'ala 'llah*). All that was visible were the two hands, and even his family claimed never to see the sheikh.

Apart from the man who brought him his water in a heavy jar, the only one who saw him was the barber, who came three times a week to shave his beard. I saw the man, who runs the 'Salon al-Sheikh Mousa' in the Luxor souk, but he was very reluctant to talk about the sheikh, even after his death; fearing the latter's wrath in case he should consider him to be indiscreet.

In the morning at 8.30, I once saw Sheikh Mousa being given his breakfast through the partly open door, a copious meal of which he ate only a small portion, sending the rest back, presumably laden with baraka. Likewise, a portable water-pipe was handed in and out for a puff each time.

It was said that Sheikh Mousa too had crossed the Nile on his handkerchief and that he occasionally and miraculously left his locked room and wandered around (*yitla' sayih*) in various shapes. He had been born a saint and from the start had been an exceptional child, sucking milk from his own finger instead of his mother's breast. No one had ever seen him pray.

I found it extremely difficult to have the family accept any money at all. Rather, they gave me a box of biscuits to present to the sheikh, who gave me back another box, blessed with his baraka.

As soon as he had died, the rumour circulated in Cairo that at the funeral he had directed his bearers back to his own room to be buried there. In Luxor, it was said that there had been some controversy between the people of the village where the sheikh had been born and those at the saha as to where he should be buried, and that he 'had made himself heavy' for ten minutes, after which he had decided for the maqam.

I went to the saha and the keepers told me that of course Sheikh Mousa had 'buried himself', but that there had been no hesitation on his part: from the mosque of Sheikh Yousef, where the funeral prayers were performed, he had gone straight to the maqam. Sheikh Mousa's character as a saint is similar to that of Sheikh Selim, who recurs in the diaries of nineteenth-century travellers in Upper Egypt, sitting day and night stark naked on the bank of the Nile near the village of Hiw, his knees drawn up under his chin. He remained there for more than fifty years, dying in 1891. All boatmen stopped to greet the sheikh, bring him some tobacco and kiss his hand; those who did not soon found themselves stuck on a sandbank. Most western travellers found him repulsive, but did not doubt that after his death a maqam would be built for him.

The shrine of 'Sheikh Selim the Naked' is there all right, on the Nile bank where the sheikh used to sit not far from the present aluminium factory near Nag' Hamadi, its doors adorned with the horns of rams slaughtered in the sheikh's honour. 'Was he really naked?' I asked the keeper of the holy place. 'Of course not', was the reply. 'That was only his nickname.'

Sheikh Zahir, a rural Rifa'i sheikh whom we will meet more frequently in the next chapter, finds himself, along with his

forefathers, somewhere in the middle of the kinds of saints discussed above. Neither his grandfather Ahmad Abu Zaghlal nor his father 'Abdallah, both buried at the saha in Kafr Ibrahim, not far from Bilbeis in the eastern Delta, was a man of letters, but they both went down the sufi path of renunciation and suffering, they performed useful miracles (Sheikh Ahmad put an end to a cholera epidemic shortly after his arrival in the village), and they cared for their *muridin*. Their memory is perpetuated by Sheikh Zahir, who acts as a spiritual father to roughly 2,000 people, and may develop into a saint in his own right if he lives to reach that stage.

In Upper Egypt in particular, it seems to be a sign of sainthood if someone's body stays intact after death. This is told about many saints, such as Sidi Sayf in Asfun near Esna, whose body was touched by chance by somebody who was digging in the ground, and who found blood from the body on his hoe; Sheikh Muslim in Akhmim, whose body was found and paraded through the streets a few years ago; and the seventy-seven saints who share a shrine in Aswan, and who also derive their sainthood from the fact that their bodies are still in their original state.

In short, there are saints of many kinds. Ahmad Radwan said: There was a time when I longed to see the saints. Now I look and I see all the saints, those who live, those who died, etc. … By God, there is a Christian who became a saint today only by uttering the words "la ilaha illa 'llah"! The mind is anguished these days, and I shall not tell you all I see and hear…'

Even though from its beginning there have been currents in Islam rejecting miracles altogether (except those mentioned in the Koran, which no Muslim can deny but which are deemed to form a separate category because they happened through prophets), the majority of orthodox opinion has accepted them, mainly on the grounds that God is omnipotent, and that He distinguishes whomever He wants by whatever means He may choose. The sufis especially have never doubted the ability of their saints to work miracles, but sober mystics like Junayd did not hold them in high esteem, considering an excessive interest in miracles – and especially one's own – as a sign that a person's attention was still directed towards worldly approval and not exclusively towards God. Once, on being told about a saint who flew up in the air, Junayd commented that it was a pity that a serious man should waste his time at such futilities.

Karamat, Junayd learned, constituted one of three veils that could cover the heart of the elect, the other two being an exaggerated attention to the obligatory works of obedience ('ibadat), and hope for heavenly reward.

Entire books have been filled with karamat since very early times and new miracles are claimed to happen all the time. Many of them relate to the saint's ability to see and know things that are concealed to others and which he could not know through 'normal' means: thoughts, intentions, identity and background of those present, the well-being, sickness or death of the absent. He foresees accidents (and protects his followers from them), heals diseases, facilitates pregnancies. Sometimes he confounds those who do not believe in saints or in mysticism. Many, but not all, of the saints are related to a specific sufi brotherhood.

I will mention only a few examples, mostly of a recent date. They give some impression of the world of saints and miracles which is still relevant to a great number of people, by no means all uneducated.

The mayor ('omda) of a small village in the Delta told me: 'I was twenty years old and a criminal. One evening I was on my way with my partners to rob a person. We passed the house of (the saint) Ahmad Abu Zaghlal and he called me in. Of course, I left my knife outside. He scolded me, told me about my intentions and said it was no use hiding my knife. He knew everything! I decided then and there to change my life and I became a member of the (saint's) Rifa'i brotherhood.'

At a later stage, Sheikh Abu Zaghlal was leading the prayer, while the 'omda was praying in the last row, thinking of some woman. After the prayer, the sheikh called him and said: 'Are you with God or with the women? You were really bothering me while I was praying.'

Other stories are told about the miracles of this saint.

One day, his followers complained about the cold in which they had to wash their sheep by the canal to prepare them to be slaughtered for the Feast. 'Go pray to the Archangel Michael to change the weather!' the sheikh said, and indeed after the prayer the sun appeared and it was nice and warm weather for seven days, in the middle of winter.

After his death in 1975, the sheikh appeared in many dreams – to remind people to go and feed the dogs of the village, which had been neglected because of heavy rains (1980), or to tell a group of dervishes to hurry up in putting their tent in order at a moulid (1987).

One evening, years after the saint's death, at the moulid of Abu Misallam, situated in a small village without any facilities, the latrines which his followers had dug for themselves but also put at the disposal of other visitors were on the point of overflowing. Instead of restricting them to their own use, the group decided to go through the unpleasant task of emptying them into a canal the next morning. But the next morning, the pits turned out to be empty.

In Ahmad Radwan's biography there is a list of miracles numbered 1 – 100. There are a great number of stories of a telepathic nature, in which the sheikh knows the name, profession and problems of people he has never met, and sees what happens far away.

'While Sheikh Radwan was in Qena, he was overtaken by a strange condition. It happened during a meal, and everybody kept silent for a long while. Then after he had calmed down, he returned to his food and said: "The daughter of brother al-Hagg Mahmoud 'Abdel Wahhab was giving birth in Ismailia. She was in distress and I could not eat anything until after God had comforted her. Now, thank God, the delivery is over and God has given her a son." Then he gave a precise description of the baby. After a few hours, a telegram arrived with congratulations for the family in Qena. As for the eminent Hagg Mahmoud 'Abdel Wahhab, he is one of the most talented scholars in Qena, authorized to perform marriages (ma'zoun), and he was present during this miracle.'

In the presentation of the sheikh's miracles, there is sometimes a touch of irony with regard to official Muslim scholars, who are the representatives of non-esoteric knowledge, obtained from books only. Quite a few of the stories are concerned with sensing someone's being in a state of ritual impurity which should prevent him from performing his prayers. According to the circumstances, the sheikh either punishes him by sending him away, or he helps him to avoid embarrassment.

'A well-known scholar told me that together with Sheikh Radwan, he spent the night in Karnak and during the night the eminent scholar had a pollution. Now, Sheikh Radwan used to ask him to lead the prayer, so he spent a long time under his blanket pondering what to do; he was ashamed to talk about this with his host, and besides, it was very cold. But what was he to do if he did not say anything, but was then asked by the sheikh to lead the morning prayer. So while he was distracted in his thoughts, the sheikh came to wake him up and said: "I will ask our host to heat some water so you can take a bath." The scholar answered "yes" and washed himself.'

In many cases, sometimes after having seen the Prophet in a dream, Sheikh Radwan told sick people that they would get well and live on, not always however without a catch.

'Sheikh Radwan was with our brother Isma'il Hasan who was clearly worried about something important, so the sheikh asked him about the reason. He answered that his brother by the name of Haridi Hasan was acutely ill in the hospital of Luxor, that he feared he would die and that he was tired because of the distance between Luxor and his village of Hilal, and all the inconveniences which one encounters in such circumstances. Then the sheikh said: "Your brother has another twenty years to live. Go and bring him the good news about his recovery and tell him what I just told you. Do not fear what people will say. I have not learned this from my father and mother, but He who knows the divine secrets has inspired me." So brother Isma'il went to his brother in the hospital and informed him of everything the sheikh had said, and the signs of health and vitality appeared on him and he left the hospital. Since then, he has counted every passing year and he is afraid now because most is gone and little is left.'

Apart from this, the sheikh could influence the behaviour of animals: dogs stopped barking after he told them: 'Allahu akbar.' Lice did not bite him.

In 1984, Sheikh Sayyid Zukri died at the age of thirty in Saudi Arabia and was buried in Riyad. Subsequently, he appeared three times in a dream to somebody previously unknown to him, with the message that he wanted a maqam to be erected for him in the village of Qirqatan, on the west bank of the Nile north of Luxor, where his family lived. The shrine was duly built and someone in the village who considered that this was all nonsense found both his cows dead when he came home. Since then, there has been a zikr at his grave at the end of the afternoon every Thursday and a moulid every year immediately after the Big Feast in the month of Dhu 'l-Higga. People consult the sheikh about their problems through one of his brothers, who covers himself with a blanket and then acts as a medium. Very similar stories are told in Aswan about Sheikh 'Adil from the suburb of Hakrob, who died at the age of twenty, and Sheikha Sa'diya who lived for only sixteen years.

Sheikh Abu Shinab in Hakrob told me that four days after Sheikh 'Adil's death he saw three stones standing in a triangle with candles burning in between. This dream was interpreted as a sign that Sheikh 'Adil should get a shrine, which was subsequently built.

A similar dream – four candles on a stone, a green leaf in between – led to the building of a maqam for Sidi 'Ali Abul 'Ebeyd al-Rifa'i in Kom Ombo, next to the older shrines of Sheikh Idris and Sidi Muhammad ibn Selim al-Shazli; this was supplemented by another dream of the sheikh's son, who perceived the three saints standing next to one another.

Other cases of saints choosing their place or method of burial include Sheikh Abul Ma'ati, buried at Nub Taha in 1984, and his wife, buried in 1987. It is said that during their burials they directed their bearers to the place where they wanted their maqams. The same is said about the Misallami Sheikh 'Abdallah al-Amin, who died in 1986. During his funeral, his bier remained suspended in the air for hours, before he went to join his grandfather in his grave. On the evening before he died, he appeared in a friend's dream in another village, asking him to come over the next day and wash him.

'Karamat', Sheikh Zahir once explained, 'are the fuel of our work. It often happens that the heart says that something is possible, whereas our intelligence says it is impossible. When the intelligence refuses to cooperate, it is helped along by a karama. If there were no miracles, no one would bother (ma kansh fih karama, ma kansh fih had mishi).'

This practical view of someone who is in many respects the equivalent of a village priest or clergyman in a Christian environment ties in very well with the rather practical and down-to-earth nature of many of the miracles. I have already mentioned that the higher-level mystics, while not denying their occurrence, tend to play miracles down as a rather unimportant means God uses to boost the faith of the many.

Apart from working miracles, it is said that the walis know the 100th name of God, which guarantees entry into paradise (an interesting parallel with the magic formulas prescribed in Pharaonic times to secure passage to the other world) and confers important powers on those who know it

Magic is never far away in any case, even if the visitors to the maqams, let alone the sufis, would object to the accusation that they try to compel God or the saint to do certain things by uttering or carrying certain formulae. The Bayoumi litany (wird), which very precisely prescribes the use of specific 'names of God' or other formulas on specific days – on the first day (of the week) 'la ilaha illa 'llah' 165 x 9,073 times after every prayer; on the second 'allah', 66 x 17.434 times; on the third 'hu', 11 x 14,641 times; on the fourth, 'haqq' 108 x 11,664 times, etc. – seems at first sight to come close to it, but is in fact an exaggeratedly exact recipe for reaching enlightenment.

Many sheikhs, however, including Sheikh Zahir, also write protective amulets (higab) against headaches, other illnesses, or the (evil) Eye which is also called 'envy' (hasad). It is said that hasad splits stones. Hasad is mentioned in one of the older suras in the Koran, the surat al-Falaq, which is much like an amulet text itself. Anyone can cast it without even knowing it and it can be

countered, apart from by written higabs, by the sign of the hand with the five fingers (*khamsa wa-khmaysa*), which the Muslims call 'the hand of Fatima'. It is seen on humans, domestic animals and appliances which can be dangerous such as automobiles, and swings at the moulids. Instead of a hand, the number 5 can be drawn, often in combination with a blue eye.

Even though the saints may work impressive miracles both during and after their lifetime, it would be wrong to assimilate them with the prophets, of whom, according to Islam, Muhammad was the last: 'Prophethood starts where sainthood ends.'

The people's relationship with their saints is much as if they were older and respected relatives. They are often called 'Mother' (*mama* or *ma*), 'Father' (*ba*) or 'Uncle' (*'amm*). They are visited and promised presents if they live up to their visitors' expectations. Sometimes, the saints respond to reproaches, as in the case of 'Amm 'Awad in Asfun. Next to his shrine lived a family who considered themselves to be under his protection, and looked after his grave in return. One day, however, all their rugs were stolen and the father loudly proclaimed his displeasure with the saint and vowed that he would at once stop cleaning the maqam. This happened at night; the next morning the rugs were found in the maqam and the family resumed their services.

Some but by no means all saints also receive letters. A case in point is Abul Su'oud and another the Imam al-Shafe'i, both in Cairo. Generally, the maqams are contained in a modest square building covered with a round, conical or pointed dome. The more important ones have in the course of time been incorporated into mosques, but in such cases also a dome marks the room where the grave is found. They contain a sarcophagus-like structure (*tabout*), which can have a stela often covered with a turban at the end where the head is supposed to be. The tabout is covered with a coloured or embroidered cloth (*kiswa*), usually green – the Prophet's colour – or white, and often surrounded by a grille (*maqsoura*) made from wood or metal. Around the maqsoura there is room to walk about the grave, to sit, pray or lie down.

Some maqams have a holy tree attached, where people hang a bit of cloth belonging to someone who needs to be cured. Visits to saints are undertaken by both men and women. Women tend to be in the majority, both because a number of saints specialize in women's problems such as pregnancies, and because women do not usually take part in communal prayer at the mosque. Visits to saints and moulids are a way for women to participate in the religious life of the community. Also, there is no segregation or discrimination with regard to the religion of the visitor. Many Christians visit Muslim saints and shrines, just as many Muslims see Christian priests for specific cures and amulets. A visit properly executed generally includes greeting the saint when entering his shrine, in the case of a Muslim visiting a Muslim saint reading the opening chapter of the Koran, touching the maqsoura or the tabout itself while going around it anti-clockwise, and possibly performing a votive offering or depositing some money. Sometimes, people spend a night at the shrine.

The saints are pleased to be visited and resent being neglected, as shown by another example from Sheikh Radwan's list of miracles.

'After many years, one of my children still could not walk. Then Sheikh Radwan said: 'in the cemetery in your village there lies a saint, a descendant of the Prophet (*sherif*) from Morocco, who blames you people, saying: "They do not pay me special visits, even though I belong to those whose prayers are heard. If they came to me with the child that cannot walk, God would cure him."' So did the blessing by the Prophet occur! It happened in Luxor, so we talked on the telephone to our brother al-Hagg 'Abdallah 'Abdel Malik and he took the child and went with him to the saint, Sheikh Younis, and the visit was successful. The child walked normally and healthily during the same week in which the visit had taken place. And Sheikh Radwan told us about the (other) miracles of this sherif and about his knowledge during his lifetime and his special relationship with God Almighty.'

Different saints are visited for different purposes. One of the most frequent specializations – because it constitutes one of the most acute personal problems, even in a country with a birth rate as high as Egypt's – is the curing of infertility. One saint who is said to be effective in this field is Sheikh Mansour, who according to some lived during the time of the Prophet and who has a tiny maqam with a green flag on a rock in the Nile at Aswan, just opposite the Oberoi Hotel. Women visiting the sheikh bring him sweet rice porridge, which they throw into the river. Sheikh Mansour is also visited by newly-married couples.

Similar powers are ascribed to al Sheikha Badawiya, a female saint in the Khanka cemetery who died in the 1970s. Women mostly bring sugar as a present and touch their heads and bellies with the cloth covering the tabout. On the wall there are dozens of votive offerings consisting of earthen pots with plastic flowers.

Not all holy graves belong to saints in the strict meaning of the word, as far as there is a strict meaning to the word. The *sahib al-maqam* can also be a prophet (*nabi*) like Nabi Salih in central Sinai and the prophets Daniel and Luqman al-Hakim in Alexandria. The grave may also be that of a contemporary of the Prophet (*ansari* or *ashabi*), who often helped 'Amr ibn al-'As to conquer Egypt in and after A.D. 640, such as Sidi 'Uqba, Sidi Muhammad al-Nakhkhal and many others in the Southern Cemetery in Cairo; Sheikh Idris in Kom Ombo; Sheikh 'Amir and many others in Draw; Sidi Shibl with his seven sisters and forty companions in el-Shuhada; and the fourteen Muhammads, buried together in Alexandria not far from the mosque of the Shazli saint Abul 'Abbas al-Mursi.

Prominent members of the Prophet's family (the *Ahl al-bayt*), male or female, may also be revered as saints. In the cult of saints, the Ahl al-bayt occupy an important place, based on the idea that some of the father's baraka is transferred to the son. It is one of the sayings attributed to the Prophet that 'the people of my house (*ahlu bayti*) are like Noah's ark; whoever clings to them is saved and whoever leaves them is drowned'. Cairo especially is rich in shrines for the Ahl al-bayt. Moulids are held for the Prophet's grandson, Sayyidna al-Husayn, whose head is buried in Cairo; the *sayyida's* (female saints) Sukayna, Nafisa, Ruqayya, Zaynab, 'Ayesha and Fatima al-Nabawiya, Sayyida Nafisa's father and uncle Hasan and Muhammad al-Anwar, and Sidi 'Ali Zayn al-'Abidin. It should be added that many of the later saints, too, were *ashraf* or descendants of the Prophet. The present-day ashraf are organized under a *naqib al-ashraf* and sometimes manifest themselves at a moulid with a reception tent of their own.

Cairo is rich in saints' graves of all kinds. It is said that in the Southern Cemetery alone, near the Imam al-Shafe'i, there are 1,500. Among the most famous saints, some are founders of sufi orders, like Ahmad al-Badawi in Tanta, Ibrahim al-Desouqi in Desouq, Abul Hasan al-Shazli in Wadi Humaysara in the eastern desert (all three belonging to the thirteenth century), or Sidi 'Ali al-Bayoumi in Cairo. Such great saints, and some of the better-known ahl al-bayt as well, have more than one maqam.

Al-Sayyida Zaynab not only has a maqam (probably empty) in Cairo, but one in Qurna near Luxor, too; Sidi Ahmad al-Badawi has one in Esna; and practically all the above-mentioned ahl al-bayt as well as the founders of the main sufi orders are to be found in the cemetery south of Aswan. Their maqams are mostly the result of someone having a vision or a dream in which the saint asks him or her to found a maqam for him or her at a certain spot. Such maqams also contain a tabout and there is no way to distinguish them at first sight from real graves.

There is no proliferation of Christian saints at present, not only because the number of Egyptian Christians is about one-tenth of that of the Muslims, but for two other reasons as well: sainthood in the Coptic church is restricted to martyrs and monks, and besides, there is a central authority, the Coptic Pope, who has to approve of new saints being proclaimed. As a rule, though for Popes there is an exception, the saint does not enter the official list (synaxarium) until fifty years have passed after his death. If at that stage he is declared a saint on a permanent basis, he will be remembered in masses all over the country and his remains are put in the church, where the faithful can touch the reliquary and derive blessing from it.

In the meantime, if sainthood is claimed for a monk by his own monastery, the Pope can give his authorization to exhume his body and put it into a reliquary, but he cannot rest in the church itself and he will be mentioned only in the monastery where he is venerated. For instance, this happened in December 1987 to Father Yustus, who will be mentioned further below, who had built up a great reputation as a saint in his monastery of St. Anthony near the Red Sea and died there in 1976.

Most of the older saints are martyrs. The Coptic Church suffered persecution under three Roman emperors – Decius (249-251), Diocletianus (285-305), and Julian the Apostate (361-363) – and has its own era, the 'era of the martyrs' beginning 29 August 284. As a rule, it seems, martyrdom was voluntary, the saint making a confession of his faith to the Roman governor and being subsequently tortured and put to death.

In Esna is the shrine of the 'Three Peasants'. Their martyrdom happened on the eleventh day of the month of Tut of the year 2 (285), when the Roman governor Erianus exterminated 160,000 Christians in the town on orders from Emperor Diocletian, in one day. At the end of the day, Erianus and his soldiers grew sick of the killing and vowed they would not use their swords any more. At that moment the three peasants returned from their fields where they had been working while the massacres were taking place, and demanded that they be killed as well. The soldiers had to keep to their vow, but in the end they slaughtered the peasants with their own hoes.

During the nineteenth century, an inhabitant of Esna had a dream in which he saw himself digging up their bones and building a shrine. He received permission to do so from the governor, who at first had been reluctant but then had a dream of his own, and duly found the remains of the Peasants and built the grave for them.

Around 1930, the town council wished to widen the road and decided to demolish the forecourt of the shrine for the purpose. The keeper of the place then had a dream in which one of the Peasants asked him to dig a grave in the forecourt, which he did at once; and the next morning, the body of the Peasant was found there. The widening of the street was called off. The present keeper of the shrine, who has a shop next door, claims that his grandmother found that the body of the Peasant had not decomposed.

De Lacy O'Leary writes in his book *The Saints of Egypt* (concerned only with Christian saints) about the development of the martyr cult:

'When the persecutions became things of the past this cult (i.e., that of the martyrs) began to assume greater proportions, the relics of the martyrs and the festal observance of the anniversaries of their martyrdoms became of great prominence, so that the martyrs seemed to be little less than the demi-gods, or at least the heroes, who had been honoured in the days of paganism. In one respect especially the cult did reproduce pagan conditions in that it provided a special local patron and festival very much on the lines familiar in pre-Christian times, and very often these were connected with the same places and the same days as had been observed in pagan times.

'In Egypt the development of this martyr cult was peculiarly prominent and in the course of the fifth century the great monastic reformer Shenoute criticised the development very adversely. Then, it would appear from Shenoute's words, every village had to have its martyr's shrine enclosing the bones of some nameless dead which were disinterred and assumed to be the relics of martyrs and honoured accordingly, without any reliable evidence that they were even the remains of Christians: these were honoured under fictitious names and the sick were brought to their shrines and laid there to obtain healing. The very outspoken words of Shenoute show how recklessly the Christian villagers were inventing patron saints and erecting shrines for the bones discovered and assumed to be those of martyrs, and at the same time disclose that the movement was viewed very unfavourably by a more serious and thoughtful type of churchman. In most cases the identification of the remains as those of martyrs and the naming of the relics was due to a dream or vision by some priest, monk, or devout layman, a feature by no means peculiar to the Church of Egypt.

'These criticisms, however, did little to check the popular movement and every village erected its martyr's shrine, just as now it has the shrine of a Muslim sheikh, and in earlier times had the shrine of a pagan deity. The occupation of these sacred sites was more or less continuous: where the sick were laid before the god's shrine, there they were laid before the martyr's tomb, and there they are still placed before the sheikh's tomb. It is very tempting to suppose that deity, martyr and sheikh are the same person under changed names and titles: but when traditions are examined in detail this identification usually involves a great straining of

tradition and results in very precarious theories. The Christian martyr occupied the place of the pagan deity and his place is now occupied by a Muslim sheikh: but the Christian martyr's life and character, probably totally fictitious, does not correspond with the life or character of the pre-Christian deity, nor with that of the later sheikh; each belongs to its own cultural group and attempts at identification do not convince. The life and character of the Christian martyr belong to the Greek world, they have nothing in common with ancient Egypt: the sheikh belongs to a Semitic culture, he may replace, but he does not correspond with his Christian predecessor. These characters, mechanical dolls as they seem and totally devoid of any definite personality, are the special products of a particular culture which has its own ideals, pagan, Christian, or Muslim: they belong to their own class and follow their own cultural type, only the place, the feast, the performance of miracles, passed on from one religion to another. The Christian martyr occupied the home of a pagan deity whom he displaced, but when the people wanted to hear the life and suffering of their martyr they ordered a ready made biography from a wholesale furnisher of martyr's lives in Alexandria where such biographies were produced under Greek influence. The apocryphal matter which forms so large a padding to these legendary lives belongs to the world of Greek thought, though there are some Egyptian elements which have filtered through the Greek medium: it is not the life of the local deity re-edited in Christian form.'

In India, too, certain characteristics pass from one religion to another. Here, Muslim saints have, though not completely, taken the place of the divinities of the Hindu pantheon, in such matters as the security and fertility of the area and the defence against diseases. Analogous rites can, according to Gaborieau, be observed at Muslim shrines and at Hindu temples.

Besides the old martyrs, there is a small number of 'new martyrs', who suffered death at the hands of the Muslims after the Arab conquest of Egypt in A.D. 640. There was, however, no regular or consistent persecution of the Christians, who as a rule did not fare ill under Arab domination, retaining most of the civil service jobs for a long period after the conquest. Apostasy from Islam, whether to Christianity or to any other religion, was, however, punishable by death under Islamic law.

The second category of saints are the holy monks. In heaven, as Father Samuel, the librarian of St. Anthony's Monastery, explained to me, they come after the martyrs, who themselves follow the Virgin (Christ being, in monophysite Christianity to which the Copts belong, the same as God Himself): 'Some stars are brighter than others.' Almost all of the more recent saints belong to this category, and some important early saints such as St. Anthony and St. Paul were monks too.

Christian monasticism originated and developed in Egypt in the third and fourth centuries; near the Red Sea (monasteries of St. Paul and St. Anthony) first and soon afterwards around Luxor and Akhmim (St. Pachom and St. Shenouda) and in the desert of Wadi Natroun or Scetis, roughly half-way between Cairo and Alexandria (St. Makarios). From Scetis it rapidly spread as far as Spain and Ireland.

The holy monks include patriarchs (only monks can make a career in the Coptic Church), anchorites (*sayih*, pl. *suwwah*) and even a few women who were successful in dissimulating their sex and lived in the monasteries for years.

Pope Kyrillos VI is one of the best-known saints in the category of holy monks, and he may be the most actively venerated saint in this century. At the monasteries, especially during moulids and festive days, souvenir shops abound with his portraits, mounted in frames, on pendants, rings, clocks and thermometers. Pope Kyrillos was buried in the crypt of the Monastery of St. Menas (Abu Mina), which he restored during his reign from 1959 until 1971. The place is visited by sizeable crowds both on Fridays, the weekly holiday for most people, and on Sundays. The marble grave, which reaches about waist-height, serves as a writing table. Paper and ball-points are provided, for all those who have a request to the saint.

Writing 'tilbas' is a very frequent custom with the Copts, who fill the frames of icons, the cracks in the cave of St. Anthony, and any such place connected with the saint of their choice with scraps of paper, neatly folded up, carrying either the simple text 'Remember, Lord, your servant x' (*udhkur ya rabb 'abdak …*) or with more specific demands. According to one of the monks at St. Anthony's, they most frequently invoke the saint's assistance in court cases, marriage problems and diseases.

Kyrillos (or Kyrollos) VI was held in high esteem even during his lifetime, and his miracles have been collected in 11 booklets, one of which has been translated into English. He either worked the miracles by himself, or he 'sent St. Menas', who died 1600 years ago, with whom Kyrillos, who started as Father Menas (Mina in Arabic), had an intimate relationship. Kyrillos had the same quality of clairvoyance as Sheikh Ahmad Radwan. Most of his miracles are, like those of the Muslim saints, of a practical nature, and but for some minor details connected with the Christian liturgy, such as the frequent use of oil, the Cross and blessed bread, could have been performed by any saint of either religion.

Pope Kyrillos' miracles include the curing of an impressive list of complaints and diseases, such as slipped discs, fits, polio, various heart conditions, diabetes, infant mortality, warts, eye disease, kidney stones, chronic chest disease, boils, mental illness, paralysis, spinal fever, cysts, headaches, asthma, lung tumours and post-natal fever. The following quotes are from the booklet mentioned above.

'In the year 1961', Asmy Zaki writes, 'I suffered from an acute headache while working at Deshna Post Office. The headache was getting worse till I lost my sight completely. I travelled to Cairo during the last days of Lent. I was examined by well-known specialists but they simply said there was very little hope in regaining my sight.

'During that time, my only hope was to meet His Holiness Pope Kyrillos VI after what I had heard about his miracles. God granted me my wish and I met the Pope in the sanctuary after mass. Before I had told him about my case, he blessed my eyes with the sign of the Cross. I then asked him to pray for my recovery. He said: "Jesus Christ will enlighten your eyes." I returned home and after one day, I noticed a remarkable improvement in my sight. It gradually got better till my sight became as before.'

'Mr. Phillopos al-Kommos Yohanna was suffering from paralysis and stayed in hospital for five months. His brother-in-law, Mr. Aziz Sarkis, was frequently visiting Pope Kyrillos VI, asking for his prayers that Mr. Phillopos might recover. Once, during the raising of incense at Vespers, the Pope surprised Mr. Aziz by asking him: "How is your relative? I am going to send St. Menas to

him to-night." The same night, during his sleep, Mr. Phillopos saw a youth in white standing in front of him. He woke up frightened and in the morning his brother-in-law visited him and told him what the Pope had said the day before. Mr. Phillopos told him about his dream and they realized that the youth must be St. Menas, the Martyr. Afterwards, life started to go through his body till he recovered completely.'

The Pope sometimes assisted in examinations:

'Mr. Sherif Mikhael, a student in the Faculty of Architecture, Alexandria, wrote saying: "I went with my father to Pope Kyrillos VI to receive his blessings. My mother suggested that I take some books for the Pope to open them for me, as I was in the high school certificate at that time. My father supported the idea. So I had to take the books although I did not like the idea of using the Pope for any materialistic gain. We managed to meet the Pope although it was very crowded. While he was praying for me, he saw the books and asked: 'What are these?' My father told him of their wish to have them opened by His Holiness. The Pope finished his prayer and while he was giving me a piece of blessed bread, he said: 'At home, son, open the books and God's name will be glorified.'

'"I opened each of the books three times, according to the Holy Trinity. When the exams started, I found out that the questions were on the topics of the parts that I had previously opened. God's name was glorified as the Pope had said, and I passed with a high degree."'

Like Sheikh Radwan, Pope Kyrillos also could sense when someone was ritually impure:

'One of the priests tells how he was, at one time, in charge of the church services at the prisons. One day, a prisoner told him that he wanted to receive the Holy Communion. On the day of the visit to the prison, the priest went to ask the Pope's permission to take the Holy Communion with him. But the Pope said to him: "There is no need… he has had breakfast… there he is eating!" When the priest went to the prison, the prisoner came to him apologising that he was not prepared to receive it, as he had been hungry and had breakfast.'

While he was still known as Father Mina, Pope Kyrillos drove out evil spirits:

'Mr. Habib says that during the Easter fast, he went to the mass held by Father Mina at St. Menas' Church, Old Cairo. There, he found people gathering around a youth who was lying on the ground and four men holding him. The saint was pointing the Cross to the youth, saying: "Leave him!" Then the young man said: "I'll leave through his eye!", but the saint firmly said: "Leave through his toe, otherwise St. Menas will burn you!" The youth got mad but the saint rebuked him. After some time, the evil spirit left the youth through his toe.'

Christians blame possession by evil spirits ('ifrit, pl. 'afarit, or arwah nagisa) mostly on mistakes made during baptism, but the manner in which the spirit is exorcized, involving a negotiation with the 'ifrit, is exactly the way the Muslims do it. It is important that the spirit leaves through the toe or the finger, because if it leaves through the eye, the patient will be blind. Instead of using

the Cross, however, specialized Muslim exorcists like Abdel Rashid, who works with Sheikh Zahir, read their order's litany, in his case the Rifa'i *hizb*.

Finally, a Mr. F.S. recounts that he possesses a few of Pope Kyrillos' hairs which had fallen from his head while he was combing. The hairs not only, after the Pope's death, cured his wife of acute pain in her left arm, but since he has put one of them in his wallet he has noticed an undeniable increase in his income. For example, he returned to an additional job he had left before, for three times the previous wage.

The preparation and handling of relics, whether hairs or bones, is typically Christian. Even the Muslims most given to the cult of saints will never disturb their bodies, let alone use them in the way the Christians do: packed in a wooden cylinder which is covered with some cloth, the relics are passed over any part of the body in need of a cure, for three Fridays or Sundays in succession. Many of the clients of this treatment, which is given at the nunnery of al-Amir Tadros near Bab Zuwayla in Cairo and at many other places, are Muslims, though; likewise, many Muslims go to Christian priests to get rid of an evil spirit, and Christian women visit certain Muslim shrines to bring about pregnancies.

In this context what Lane wrote 150 years ago in his *Manners and Customs of the Modern Egyptians* is still valid today:

'It is a remarkable trait in the character of the people of Egypt and other countries of the East, that Muslims, Christians and Jews adopt each other's superstitions, while they abhor the leading doctrines of each other's faith. In sickness, the Muslim sometimes employs Christian and Jewish priests to pray for him; the Christians and Jews, in the same predicament, often call in Muslim saints for the like purpose. Many Christians are in the frequent habit of visiting Muslim saints here; kissing their hands; begging their prayers, counsels or prophecies; and giving them money and other presents.'

Father Maksimos al-Antuni, Father Yustus' biographer, confirmed that many Muslims turned to Christian saints and priests. 'And many Christians visit Muslim shrines', I said. Father Maksimos looked glum: 'Some do, but not for long. They soon find out that it does not help at all', he replied.

The above-mentioned Father Yustus is one holy monk who never made a career in the Church, but acquired a great reputation of sainthood during his life. He was from the monastery of St. Anthony, where he lived in a solitary room between 1941 and 1979 in an unassuming and ascetic manner, dividing his time between his cell and service in the church, rarely saying a word except when reading the Gospel. He never took off his clothes, either to wash them – the only thing he did in this respect, and rarely, was to immerse himself, clothes and all, in the water reservoir and dry himself in the sun afterwards – or to put on new ones: whenever he received new clothes from the head of the monastery, he put them on over the old ones. 'The saint gave us an example', writes his biographer Father Maksimos, 'that the needs of the body with regard to clothes should not impede our love for God or our devotion, and that God will not ask us to account for our neglected and unclean clothes, but that he will ask us to account for our impure heart, because God looks at the heart …' His meat rations went to his cat. He slept in trees and on the ground at first, and later on a chair in a sitting position.

Yustus, while keeping his silence, sometimes offered certain verses from the Scriptures as advice. Some visitors to the monastery saw a strong light shining from his cell as soon as he entered it, and after his death, a column of light appeared in the cemetery of the monastery where he had been buried.

Several stories of miracles are told about Father Yustus, but Father Maksimos only mentions a few, which have been duly confirmed; the monastery did not register his miracles, and frankly, according to Father Maksimos, none of the monks had much of an interest in them.

It seems, for instance, that Father Yustus entered the monastery's visitors quarters a few times without opening the doors, which had been locked for the night; a soldier who had cursed the silent monk for not returning his greeting found the monastery's water reservoir empty and had to present his apologies before the water came back; Father Yustus cured a child's scorpion bite by having water on which he had prayed sprinkled over him; and he was somehow informed of the forthcoming visit of another holy monk, Father Abdel Mesih al-Habashi who lived in a cave in Wadi Natroun, and the two acted as if they had known one another for a long time, even though this was the first time they met; just like St. Anthony, when he went to see St. Paul shortly before the latter's death.

The Coptic Church also has its share of naked saints like Islam; such as Barsoum al-'Aryan who around 1300 spent twenty-five years with a snake in a cave under the church of Abu Sayfayn in Cairo, and the anchorite Onophrios (Abu Nofr), who as his icons show wore nothing but his beard and to whom a well is dedicated in the nunnery of al-Amir Tadros, likewise in Cairo.

Another famous Christian saint of the twentieth century, who died in 1969, is Abdel Mesih al-Menaheri, who after a spell as a monk in the St. Makarios Monastery worked as a priest in the village of Menahera, north of Minya, where he is buried. The miracle stories about Abdel Mesih have a rural flavour. In one he restores to life a poor woman's dead duck.

A contemporary popular saint is the holy monk Fanous from the Monastery of St. Paul's, born in Upper Egypt in the early '30s. When he was about fifty, he began showing clairvoyance and working miracles, and his reputation became so great that his numerous visitors grew into a nuisance for his monastery. He was therefore transferred to the monastery's dependency in Boush near Beni Sueif, where he is now confined to a room which he seldom leaves and where hardly anyone is allowed to visit him; obviously disliked by the local clergy who, exceptionally, do not even sell his picture in their bookshop. The picture is, however, sold at other places and is held to have miraculous qualities. Many people claim that they have been visited by Fanous who came to their assistance in various situations of distress.

The secret world of the Muslim walis, living and dead, who know one another but are generally not known to others, is mirrored by the 'sayihs' (sa'ih, pl. suwwah) of the Christians. It is believed that those who reach the highest spiritual stage turn into sayihs, meaning people who roam around, hermits or anchorites; they can but do not have to live in the desert, and they can move into any place whether open or closed. They often come to people's rescue. In this sense, both Pope Kyrillos and Yustus, as well as

Fanous, are held to be sayihs. Generally speaking, as Father Maksimos says, all sayihs are saints, but not all saints are sayihs. The sayihs can congregate for mass, unseen, in any church. Since the altar can be used only once a day, the Copts leave some water on it after mass to warn the sayihs that they should go somewhere else.

It is extremely rare for a non-sayih to get in touch with this group. Father Maksimos says that it happened as an exception to Father Bishoi in Alexandria, who for years had seen an old man coming to his church for holy bread on the eve of Good Friday. He asked him who he was and the stranger replied he could not tell. Father Bishoi insisted and was promised that the next year he would be taken to where the man lived. When one year had passed, the stranger told Father Bishoi to take him in his car to the Cairo desert road. There, they got out and flew away, Father Bishoi holding on to the sayih's cassock. They reached a garden where old men were sitting. After a while, Father Bishoi found himself again sitting alone in his car on the side of the road.

As far as I know, only one Jewish saint is buried in Egypt. It is the tsaddik Yaakov Abu Khatzeira, called Abu Hasira in Arabic. We encountered his moulid in the previous chapter.

Abu Khatzeira, who owed his nickname, meaning 'the man of the mat', to a miracle he performed on a mat (flying on it according to some and floating ashore on it according to others), was born in Morocco and lived for thirty years in Damanhour, where he died in 1885. He is credited with various miracles, including cures and pregnancies.

Abu Khatzeira

48

‹ 48 Continuity. In the middle of the Amon temple of Luxor there is a mosque with the shrine of Abul Haggag, a thirteenth-century saint born in Morocco and a contemporary of Abdel Rahim in Qena. The part of the temple situated under the mosque has not been excavated, out of respect for the saint and his followers.

During the moulid, after the midday prayer on the day after the Great Night, there is a procession in which three boats are carried. Many scholars believe that this custom dates back to Pharaonic times, when boats were carried in a yearly procession from Karnak to Luxor.

Apart from the boats, there are camels carrying mahmals with new cloth covers for the tombs of Abul Haggag and two other saints buried in the mosque. More mahmals used to be carried a few years ago, one of them being for Sheikh Mousa, who was then still alive at Karnak.

49 Kinayyiset al-Dahriya in the province of Beheira boasts the tombs of thirty-nine saints, and hopes that the magic number of forty may be reached some day.

This is the maqam of Sheikh Hammouda and Sidi Ahmad al-Zekayri, and opposite is the tomb of Sidi Hinaysh whose special merit is that he helps animals to get pregnant.

The strangest of the saints of Kinayyiset al-Dahriya is a tree called Sidi Khadr, where candles and lamps are burned every Monday and Thursday evening.

The moulid is held *ba'd al-qutn*, when the cotton harvest is over.

50 Tomb of an unknown saint in Kinayyiset al-Dahriya.

In the neighbourhood is another maqam which belongs to a saint of whom only the name is known: Sidi Nassar. An old woman dreamt that he wished to have a maqam; on this spot forty skulls were found. The building carries the inscription: '1981. Maqam belonging to Sidi Mohammed Nasar and the martyrs (who were) with him.'

51 Tomb of Sheikh Muhammad al-Hilali in Edfina.

There is another sheikh buried under the bush in front of the maqam (some say, Sheikh Hilali's father). People have tried from time to time to build a shrine for him, too, but whenever they did the building was destroyed. Obviously, and exceptionally, this sheikh does not wish to rest in a maqam.

« 52 Sheikhs' tombs near Ballas (al-Mahrousa) not far from Qena.

‹ 53 Sheikh Haridi, one of the best-known saints of Upper Egypt, has a shrine in the cliffs on the east side of the Nile between Akhmim and Asyout. Opposite is the grave of his son Hasan.

The saint appears as a snake at irregular intervals, either at his own shrine or at Sheikh Hasan's.

Sick people come to sleep in the maqam on Thursday night and wake up cured. A blind woman fetches water for the shrine and brings it up at night without falling into any of the crevices in the mountain.

Sheikh Haridi, pursued by his (no doubt Christian) enemies, split the rock in order to escape and to establish himself on the spot. Halfway up the ravine leading to the tomb there is a small cave called the path watcher (*ghafir al-darb*). Whoever does anything wrong at the grave cannot pass this point on his way down.

According to some, Sheikh Haridi was the first to cross the Suez Canal in 1973, during the October war against Israel.

54 The maqam of Abul Qumsan in Qurna near Luxor, built after his death in 1979.

55 Tomb of Sheikh 'Adil at Hakrob near Aswan.

56 Grave of Abu Khatzeira, the Jewish saint, near Damanhour.

57 The tomb of Abul Hasan al-Shazli, founder of the Shazliya order in Wadi Humaysara, deep in Egypt's southeastern corner.

As Sheikh Zahir told me, Abul Hasan had asked God to die at a place without sin, and every year on his way to Mecca carried his shroud along, rightly expecting that the place without sin would be situated in the desert.

On his way, he usually passed through Qena, and one year a mother came to him with her ailing son and promised that he would serve Abul Hasan if he got better. The next year, the son was better and he went along with the caravan towards Mecca.

In Wadi Humaysara, a few days' journey from the Red Sea, the boy suddenly died and was buried in Abul Hasan's shroud. The next day, Abul Hasan felt he would be dying soon. He told his son-in-law and main disciple al-Mursi Abul 'Abbas that the latter should give his body to a veiled man on a horse who would show up, wash and bury him and leave by a path up a steep hill, where Abul 'Abbas was not allowed to follow him.

Everything happened as predicted, but Abul 'Abbas did follow the rider up the hill. There, he saw his face, which was that of Abul Hasan himself, who told him to go back and then disappeared; but in fact it was the Prophet, who had come to bury this great saint and to pray over his body.

The picture was taken from the hill where the Prophet disappeared. A small Shazli zaffa is making its way towards the tomb with white, yellow and green banners. From the hill at night, true believers see light shining out of the Prophet's tomb at Medina, which lies to the east, just across the Red Sea.

There is a well with brackish water near the shrine. According to Sheikh Zahir, Abul Hasan spat into it so that the water became drinkable, but only just. This is why, during the moulid, the government sends down a few tankers with decent drinking water.

The moulid culminates on the 'Day of 'Arafat', during the annual Meccan pilgrimage; but since the day of the Big Feast, when the sacrifice is made, is the next day and no slaughtering takes place at Wadi Humaysara, many visitors leave before the Great Night in order to be home in time to kill their sheep.

3.8.1987/7.12.1407

57

58 The maqam of the seventy-seven saints in Aswan. At the far end, visitors have left little heaps of bricks as mementos.

59 Sheikh Mansour has a minuscule maqam on a rocky island in the Nile at Aswan where he lived as a hermit, just opposite the present-day Oberoi Hotel.

Newly married couples visit the shrine in order to bring about pregnancy. They bring rice cooked in milk, which they throw into the Nile. Candles are burned under the dome.

At the moulid, the tomb is painted and gets a new flag: green with a crescent and stars, the pre-revolutionary flag of Egypt, which is seen at other southern moulids as well.

60 Holy tree connected with the tomb of Sheikh Abul Qasim Abu 'Ali in Akhmim. Visitors, probably suffering from headaches, have knocked heavy nails in the trunk.

59

60

61

62

« 61 Tabout and maqsoura of Ibrahim al-Desouqi in Desouq.

« 62 Tabout and maqsoura of Abul Haggag in Luxor.

‹ 63 Votive ships and one aeroplane hanging over the grave of Sidi Abul Qasim Abu 'Ali in Akhmim.

The custom of hanging model boats in the domes of maqams is not very frequent now, and may have gone out of fashion. Apart from Akhmim, I saw them only at Sitt Houriya's in Beni Sueif and at the tomb of Sheikh Uweis on the hill behind Mahamid. There used to be paper boats at Abul Haggag's at Luxor, but I never saw any there.

Before he died at the age of fifteen, Sheikh Abul Qasim had been very effective in praying for his family, when they were in a dispute with the local authorities, and after his death he cured various ailments and became especially helpful in cases of headache. Next to his grave there is a nabaq tree supposed to be four hundred years old, where those suffering from a headache leave a nail with one of their hairs wound around it.

Even though called 'Abul' Qasim, the sheikh could not have been anybody's father. It happens more often that childless sheikhs are called 'Abu' (father) instead of 'Ibn' (son) of their father's name. One other case is that of Sheikh Mousa Abu 'Ali, the saint of Karnak, who died without offspring in 1988. 'It sounds better', said his nephew.

64 The Three Peasants, a Christian place of pilgrimage at Esna. The story is told on page 86-87.

65 The 'Ababda Sheikh Sliman is buried on the Red Sea coast between Mersa 'Alam and Berenice.

The 'Ababda, a non-Arabic-speaking people like the Bisharin and the Hadendoa further along the coast in Sudan, place a flag upon tombs, whether belonging to a saint or not, when visiting. Inside, there was sugar, dates, homos and sandalwood, obviously offerings.

The custom of placing a flag on a saint's tomb is also met with in the oasis of Bahariya in the western desert, where the population is Arabic speaking.

Daily News, Dar es-Salaam
20.12.'88

WHAT a hair-raising traditional dance called "maulita" from Angoche in the south of Nampula Province in Mozambique! (Picture by Fernando Lima of AIM)

I happened to be in Dar es-Salaam, Tanzania, when the local newspaper published this photograph. It shows that dervishes and their moulids extend as far south as coastal Mozambique.

The desire to move closer to God, not through someone else's baraka but by one's own efforts, is the moving force for the sufis or dervishes: the mystics in Islam. Islam does not have a monopoly on mysticism any more than it has one on saints and miracles. Love of the Absolute is an element inherent in most religions, and the Near East especially had had a wealth of experience with both ascetic and gnostic schools of thought and practice before the advent of Islam.

A certain measure of early Christian and possibly also Buddhist and Indian influence on the mystical movement in Islam can be assumed. Still, the prevalent view is nowadays that essentially sufism was an authentic development within Islam itself, and an important development as well. At some stage, and not very long ago, a majority of Muslims may have been affiliated to one of the sufi orders. Now, sufism has fallen into disgrace in a number of countries and gone out of fashion elsewhere, but Egypt still holds millions of adherents, who regularly make themselves highly visible. The Egyptian sufis mostly manifest themselves in groups at times of saints' festivals or *moulids*, as discussed in the first chapter.

At the moulid of Sayyida Zaynab in 1987, I came by chance across a group of sufis encamped in one of the most beautiful mosques of Cairo: that of Sarghitmish, adjacent to the mosque of Ibn Touloun and designed in the fourteenth century by the architect who also built the Sultan Hasan mosque. The courtyard of the mosque had been covered with a canvas ceiling. Around the sides, women and children were sitting or moving around, cooking, talking. In the centre sat a rather tall and lean man with a short beard, dressed in white robes and turban and surrounded by a few dozen men, mostly in white as well. It was about 3 p.m., and tea was given round by an elderly, quick-moving man walking back and forth between the group and his gas stove. They were members of the Rifa'i order (tariqa) from a village in the eastern Delta, bound by common allegiance to their sheikh, Zahir by name. On one of the pillars of the mosque there was a photograph of their 'Great Sheikh', the grandfather of Sheikh Zahir, Ahmad Abu Zaghlal; on another, one of the Great Sheikh's son, 'Abdallah.

They made me welcome, gave me tea, and told me that once a year they came to the Sarghitmish mosque to celebrate the moulid of Sayyida Zaynab, with their families, provisions, pots and pans, lighting and amplification equipment. They did the same at five or six other moulids, spread over the year, apart from organizing their own moulid in the honour of Sheikh Ahmad and Sheikh 'Abdallah, the founder saints of the group. Sheikh Zahir had become their head upon the death of his father, Sheikh 'Abdallah, when he was not even thirty years old. He was thirty-seven now.

Apart from their being extremely friendly and hospitable, common sufi characteristics, these people were good company because a number of the brothers, Sheikh Zahir himself among them, turned out to be rather articulate and willing to explain the essentials of sufism as they saw them; moreover, a few of them had a higher education and a good knowledge of English. I subsequently went to look them up at their 'saha' in their village and made a point of visiting them at the various moulids where they established themselves temporarily; bringing a box of sweets for Sheikh Zahir, which he reciprocated with fruits from their garden, cakes or nuts.

Ich bin von Kopf bis Fuss
Auf Liebe eingestellt
Und das ist meine Welt
Und sonst gar nichts

Before an attempt is made at elucidating some of the mystic phenomena, it has to be pointed out that mysticism is action rather than theory and that no amount of theory can lead to a mystic experience. 'The heir of the Prophet is he who follows the Prophet with his actions, not he who blackens the face of paper', as the Persian poet Jami said. 'Reading about wine does not result in drunkenness.' This is an approach radically different from that of the orthodox jurists whose views are predominant in contemporary Islam and whose activities are essentially concerned with studying texts and commentaries on texts. This is not to say that a mystic could not be a jurist as well, just as he could combine his mysticism with any other profession, and many of the mystics did have a profound knowledge of Islamic law; just as up till the nineteenth century many of the sheikhs of al-Azhar belonged to a sufi tariqa.

For the mystic, love predominates over law, and the spirit over the letter. It is held that both the holy texts and the religious duties have an outward appearance (*zahir*) and an inward meaning (*batin*). These are notions that extend to all apparent phenomena, which are held to be real only to a certain degree, the real truth (*haqiqa*) being with God, the object of knowledge or gnosis (*ma'rifa*) which can only be gained through specific action, meditation and illumination.

'"Gnosis" and "union"', writes Ernst in his book on pronouncements made during ecstasy, the *shathiyat*, 'are formulations of a relationship that is, strictly speaking, inconceivable. It is not possible to explain how a limited being can possess omniscience or be united with an Essence that is, by definition, independent and absolute.

'The sufi expression posits gnosis and union as limiting functions, as intuitive symbols for a relationship that is incapable of being adequately symbolized. It would be a mistake to think that gnosis and union in this sense are "things" that one could appropriate. There is an ineffable mystery of participation, but as Hallaj concludes in his *Bustan al-Ma'rifa*: "God is real (*al-haqq haqq*) and creation is created (*al-khalq khalq*) and there is nothing to fear."'

Even though nevertheless a great amount of theory has been produced by the classical masters of mysticism, practising sheikhs like Sheikh Zahir seem to need only very little of it. Replying to questions, he used a limited number of texts from the Koran and the sayings of the Prophet, and he often had to ask one of the brothers when precise details were needed. Nevertheless, he is a very serious mystic, who may reach sainthood at a later stage in his life. One of his favourite sayings, ascribed to God, is: 'Neither My earth nor My heaven contains Me, but I am contained by the heart of My servant who is a believer.'

In some respects, Islamic mysticism at the popular level is rather close to the religious conceptions of Pharaonic Egypt, as described by Bleeker in his *Religious Festivals*: in contrast to the speculative theological thinking evolved by the great monotheistic religions, Egyptian religion was a matter of pious wisdom, which enabled man to understand the course of the divine order of life and to conform with it in order to promote the salvation of the individual and of the community. The priests were no logically thinking theologians, but guardians of a largely incoherent treasure of myths and cults, which were moulded into a coherent system only later, by the Greeks.

The highlights of the cultic ritual were the festivals. The ancient Egyptian religious consciousness did not manifest itself in a wealth of ideas, as in Mesopotamia, but in the pathos of the cultic act which arose from a powerful mythical conception. The myths themselves had little substance, but were, rather, deduced from the rite and the cult. Moreover, in contrast to semitic religious thought, the Egyptian saw no chasm between God and man, but considered them as affiliated, though distinct. Especially in death, a certain relationship manifested itself, and there was a firm belief that the deceased possessed something of the power that enabled the Gods to triumph over death. This conviction was one of the prerequisites of the cult of the dead. It would be far-fetched and an over-simplification to claim that present popular mysticism and the associated cult of the saints is a direct continuation of the creeds of the Egyptian neolithic, but I found the similarities between one and the other too striking to leave them unmentioned.

When the first dervish order (tariqa, pl. turuq) came into being, Islamic mysticism had already developed to maturity during a period of more than five hundred years. I shall allude only briefly to the history of this movement, which centred around sufi masters with greater or smaller groups of disciples, who developed the notions of love and gnosis and the different ways to attain those goals.

The early sufis – souf means wool and the mystics were called sufi after the coarse woollen garments they used to wear – usually operated in the margins of society; they were not interested in the world, but in God only and, up to a point, in one another. The first mystics seem to have been ascetics, and asceticism remained an element in sufism, if only as a temporary station on the Path. Hasan al-Basri, who died in 728, was an example of this kind of mystic: 'Be with this world as if you had never been there, and with the next world as if you would never leave it', is one of his famous sayings. The notion of pure and disinterested love of God was introduced into sufism by the female saint Rabi'a al-Adawiya (d. 801). She taught her brethren to love God only for His own sake, and not for fear of hell or hope for paradise.

Dhul-Nun the Egyptian (d. 859) added the notion of ma'rifa, intuitive knowledge of God, gnosis, as distinct from 'ilm, discursive learning and knowledge: 'The gnostics see without knowledge, without sight, without information received and without observation, without description, without veiling and without veil.'

Abu Yazid (Bayezid) Bistami (d. 874) felt himself so close to God that in a state of rapture he exclaimed: 'Praise be to Me!' (subhani); much like al-Hallaj (d. 922) exclaimed: 'I am the Absolute Truth' (ana' l-haqq) and was eventually executed for heresy.

Al-Tirmidhi (d. early tenth century) contributed the notion of a hierarchy of saints, lead by the qutb, pole or pivot, or ghawth, 'help'; later theory added to the number of aqtab (pl. of qutb) until they numbered four, five or seven.

Junayd (d. tenth century) of Baghdad was, compared with most sufis of his time, a sober intellectual. Most initiation chains of the present sufi orders pass through him. He stressed constant purification and mental struggle: 'We did not take sufism from talk and words, but from hunger and renunciation of the world and cutting off the things to which we were accustomed and which we found agreeable.' He emphasized the state of sobriety (sahw) over intoxication (sukr) as practised by Bayezid Bistami.

The Great Master (*al-Sheikh al-Akbar*) Ibn 'Arabi from Murcia (d. Damascus 1240) systematized sufism in large volumes of theoretical prose. His main contribution lies in the notion of the oneness of being (*wahdat al-wugoud*), meaning approximately that God is not only everywhere, but in everything, though it would be going too far to interpret the wahdat al-wugoud as pantheism, proclaiming that everything *is* God: the concept does not involve a substantial continuity between God and creation. Ibn 'Arabi visualized the divine essence as a large green ocean out of which the fleeting forms emerge like waves, to fall again and disappear in the fathomless depths. Central to Ibn 'Arabi's system is the veneration of the Prophet Muhammad as the Perfect Man, the medium through which God is known and manifested. Elements of these ideas were derived from neoplatonic speculation.

All this was ready to be inherited by the sufi orders, or *turuq*, as they came into being in the twelfth and thirteenth centuries. How this happened is still obscure. There had been a tendency for sufis to congregate in *ribats* and *khanqahs*, which still had the character of collections of individuals each pursuing his own way. The development of the turuq, however, centred around one man at a time, who started initiating followers into his teaching and techniques, which were perpetuated in his name, after his death, by sheikhs who considered themselves to be his spiritual heirs. Sufi experimentation became in this way confined within the bonds of each tariqa, and it is no wonder that under the new regime the golden age of sufism was in this respect over. Maybe it had intellectually gone as far as it could go, anyway.

The ready recipes of tariqa teaching made sufism, which had always been a matter for a select few, accessible to the masses, however, and whatever was lost in terms of originality was gained in numbers of adherents. The mystic experience was, so to speak, democratized, just as in a more gradual process immortality had been democratized in Pharaonic times. There obviously had been a widely felt need for a more intimate and emotional profession of Islam than the orthodox schools could offer, and this need may have been related to the suppression of the more emotionally expressive Shi'a sects in both Egypt and Iraq in the eleventh and twelfth centuries. All the tariqas kept to Sunni orthodoxy, though, and neither stressed their difference with non-sufi worship nor, as a rule, with one another. It is perhaps the strict master-pupil relationship which persisted also after initiation, which led to the establishment of a very un-Sunni hierarchy in the turuq, still to be found today.

The main orders which are at present active in Egypt originated either there (the Ahmadiya, the Burhamiya and the Shazliya) or in Iraq (the Rifa'iya and the Qadiriya), though the founders of the Ahmadiya and the Shazliya came originally from the Muslim west: the Maghrib and Spain respectively. The Khalwatiya, which is highly decentralized and in many respects dissimilar to the other turuq, originated in Turkey, as did the Mewlewiya, which, like the Bektashiya, has virtually died out in Egypt.

At the popular level, the most numerous and active of the tariqas is the Rifa'iya (also pronounced Rufa'iya), which derives from one of the earliest founder-saints, Ahmad al-Rifa'i. Rifa'i lived between 1106 and 1182 in the marshes behind Basra, which he left only once to go on pilgrimage. The order made its way into Egypt through members of his family and other initiates, but it still exists also in Iraq and in other countries, such as Yugoslavia. Rifa'i was neither a writer nor an original thinker, but his fame was based on his extraordinary personality and he attracted great numbers of sufis to his retreat in the village of Umm 'Abida. He was a

descendant from the Prophet through both his father and his mother, whose family trees were rooted in Muhammad's grandsons Husayn and Hasan respectively. This is the reason why he is often called Abu 'l-'alamayn, 'the man with the two flags'. Right from the start, and probably taking their example from the sheikh himself, this tariqa became known for performing unusual feats like walking on burning coal and piercing pieces of iron through various parts of their bodies. Moreover, the Rifa'is have a certain power over snakes and scorpions, which will not bite them. Most snake-charmers in Egypt are Rifa'is.

(In keeping with the caution with which the sufi leaders preserve their orthodoxy and respectability in the eyes of the non-sufis, the Sheikh al-Saggada of the Rifa'iya, Sheikh Kamel Mahmoud Yasin, told me that all this was nonsense, which he discouraged; that there had been a miracle connected with Ahmad al-Rifa'i, whose enemies – the government – had placed a venomous snake beside him while he was praying, which however would not bite him; but that this had been a personal miracle, which had not been passed on to his successors and followers.)

Partly because the Rifa'iya has hardly suffered any splits, but has kept together by allowing the local organizations (bayt or qadam) a measure of autonomy, they appear to be very numerous, and are much in evidence at the moulids; easy to recognize because they are the only tariqa that has adopted black as their distinctive colour. They hold a national moulid at the beginning of the Muslim month of Ragab around the Rifa'i mosque in Cairo, where their supreme sheikhs, descendants of Rifa'i's brother, are buried. The centre of the order as such is in Iraq.

Another man of action, Ahmad al-Badawi, nicknamed Sheikh al-'Arab, founded the Ahmadiya tariqa. Badawi, born in Fes in 1199, came to Arabia as a child, became an accomplished horseman and developed an interest in religion in his thirties. He joined the Rifa'i order and received his training in the Basra marshes. In 1234, he was sent to Egypt as the order's representative, and settled in Tanta. Here, he performed impressive acts of asceticism, sitting for long periods on the roof of a house and staring into the sun, as well as miracles which won him a large number of followers. He founded his own order, and died in 1278.

In the course of time, the Ahmadiya split into a great number of orders which, however, retained certain common characteristics like the red colour of their turbans and insignia, and the fact that most of their festivals, like that of Ahmad al-Badawi in Tanta, are at fixed times in the solar year. It is not impossible that the Tanta moulid, which is held in October, took the place of a pre-Islamic and even pre-Christian festival. At any rate, the Ahmadiya is a typically Egyptian order of a rather rustic nature, which never made any headway beyond the Egyptian borders.

Ibrahim al-Desouqi (1246-1288), the only native Egyptian founder of a big tariqa, was initiated into both the Rifa'i and the Ahmadi tariqa, but eventually founded his own order, generally called the Burhamiya (after Ibrahim), and sometimes Burhaniya or Desouqiya. Desouqi wrote a book of instructions to murids, but little is known about his life, apart from his reputation as a linguist: according to Sha'rani, he knew Persian, Syriac (or Suryani?), Hebrew, the Negro languages and all languages of the birds and wild animals. The colour of the many orders evolved from his path is green, and the moulid follows, like that of Ahmad al-Badawi, the solar calendar.

The Shazliya order passed, so to speak, through Egypt in its formative years. Abul Hasan al-Shadhili, who gave his name to the order, was born in 1196 or 1197 either near Ceuta or in Tunis, and belonged to the sufi tradition of Abu Madyan (Boumédienne) of Tlemcen (d. 1198), who was born near Muslim Sevilla. Abul Hasan received his first initiation in the west and his second into the Rifa'i order, whose centre in the Iraqi marshes he visited around 1220. Afterwards, he lived in Alexandria, and died in 1258. He left us some ritual prayers (the *hizb al-bahr* and the *hizb al-barr*) which are still used and held to have magical properties, but his doctrine was elaborated by his son-in-law Abul 'Abbas from Murcia and further developed by Ibn 'Atallah of Alexandria, whose work was in its turn enlarged by Ibn 'Abbad of Ronda. Ibn 'Atallah became famous especially through his *hikam*, a collection of 262 short sayings with some commentary, which are seen as the finest expression of the Shazli ideas.

The main expansion of the Shazli tariqa occurred in North Africa, and in Egypt it remained an essentially middle-class phenomenon. The Shazlis introduced coffee-drinking to stay awake at night for litanies and vigils, and are vehemently opposed to the use of alcohol and drugs. They use various colours, white, green, yellow and blue, and are not much in evidence at the moulids, even though they celebrate some, for instance those of Abul Hasan in Wadi Humaysara where he died on his way to Mecca, and al-Mursi Abul 'Abbas in Alexandria.

A branch of the Shazliya, the Hamidiya Shazliya, is famous in the western academic world because of the monograph on their emergence by Gilsenan. They do manifest themselves at some moulids, where they are eager to make a well-organized impression. At that of Abul 'Ela in Cairo they monopolize the mosque, largely because their centre is in the same quarter of the city. The Shazlis believe that the membership of their order is predestined and that the Shazliya had already existed for thousands of years before al-Shadhili was born. Abul Hasan al-Shadhili was not the only saint belonging to the western dervish tradition. Two other great saints originated from the Maghrib: 'Abdel Rahim al-Qenawi (died in 1196) in Qena and Yusuf Abul Haggag (died in 1244) in Luxor.

The most conspicuous activity of the sufi groups present anywhere consists of the communal *zikr*, a ritual dance performed to the music of one or more singers (*munshids*), often but not always assisted by players of drums, tambourines and flutes, and designed, like other forms of zikr, to polish the heart of the *zakir* and prepare it to receive the Lord. The men, and sometimes a few women, typically stand in two, four or six rows facing one another, and move forwards and backwards first, then as the rhythm of the music becomes faster swing from left to right, their feet remaining on the ground. In the centre, between the rows, the sheikh or his representative leads the dance by clapping his hands and indicating changes in the rhythm. Sometimes, a zakir passes out in his excitement, but this is not the objective, and it mostly happens to young boys with little zikr experience.

After gradually moving faster and faster for ten, fifteen or twenty minutes, the music falls still and starts again, but slowly. The munshid remains at the head of the rows of dancers. The sessions can go on for hours, but the participants are free to join and leave as they like, and the leading sheikhs also alternate. The word zikr means remembrance; remembrance of God or the Prophet Muhammad. It can be opened or closed with the tariqa's specific litany, called *wird* or *hizb*, such as the hizb of Sidi Ahmad al-Rifa'i,

which is held to possess certain magic properties as well: for instance, if read by a dervish over a glass of water, the water will cure a disease.

Zikr, which takes many forms and can be performed either individually or collectively, with or without movement, represents the core of the sufis' efforts, and aims at emptying the mind (or spirit, or heart, for the terminology is by no means consistent or uniform) of anything else but God. Breath control is one of the characteristics of the zikr. With the exaggeration usual in maxims like this, the great mystic master Abu Yazid al-Bistami is held to have said: 'For gnostics, worship is observance of the breaths.' Even though the zikr techniques, which consist mainly of the repetition of certain formulae, were probably developed autonomously, they have much in common with similar practices in early Christianity (the 'Jesus prayer') and the Namu Amida Butsu in Japanese Buddhism. Contemporary transcendental meditation is close to it in certain respects.

Apart from taking part in collective zikr sessions, the members (murids) of a sufi community will perform their own zikr according to a programme established by their sheikh (murshid), consisting of the repetition of the la ilaha illa 'llah (there is no God but God) formula, or the word 'Allah' (God), or 'hu' (He) or any of the ninety-nine 'Most Beautiful Names' (of God) for several thousand or tens of thousands of times.

Such personal zikrs take place mostly during the night, since the murid normally has his work to attend to during the day. The time allotted to them varies with the individual's zeal and the prescriptions of his order. According to some, one should not overdo it: 'One third of the night is for your wife, one third for yourself, and one third is for God', as the Khalwati sheikh from Qurna, Muhammad al-Tayyib, put it. Others, but only a few, go all-out and 'fast by day and stay up (for zikr) by night'.

Apart from festive occasions such as the moulids or the Prophet's birthday, the collective zikr is held, according to the custom of the group, once or twice a week or every evening, either at the saha, where they have their focal point around the grave of the founder-saint, or at the homes of the murids. Sheikh Zahir convenes with his murids for zikr at the saha after the midday prayers on Friday, and so do many others. Zikr meetings, or hadras, are also held at the shrines of certain saints on certain days of the week, such as the graves of Sayyida Nafisa, Fatima al-Nabawiya and Abul Su'oud in Cairo, which are visited on Sundays, Mondays and Tuesdays respectively. Hadras in such places happen mostly between the afternoon and sunset prayers, i.e., between 4 and 6, or after the evening prayer, i.e., after 8. Some dervishes, like the Misallamis in Bandara, hold 'dancing' sessions only occasionally, but convene twice a week to recite from the Burda, a religious poem which like the hizb al-Rifa'i is believed to have certain magical qualities. The exuberance of the zikr sessions varies according to the tariqa, and also according to the social class to which the participants belong.

In Egypt, the Naqshbandis and the Khalwatis are the most restrained. As a rule, they do not hold dancing sessions at all but, in their collective activities, recite certain prayers or litanies in unison while sitting on the ground. They count a number of very highly educated people among their ranks, they are not very numerous and they tend to despise the rustic orders. 'In the Khalwatiya', said Sheikh Ahmad al-Tayyib, himself a pharmacist in Qurna, 'all the sheikhs have been educated at al-Azhar, and all

of them have money. The zikr needs respectable people at a respectable place.' The Shazliya, like the Khalwatiya, concentrates on individual zikr, but a sub-order like the Hamidiya Shazliya, which has mostly lower middle-class urban adherents, does hold collective zikrs with music, moving backwards and forwards holding hands. According to their regulations they have, however, to perform their zikr with gentility and dignity, and dancing and swaying are completely prohibited.

At the other end of the spectrum there are the tariqas of a more peasant nature, chief among which are the Rifa'is, who not only aim to dance themselves into a frenzy, but some of whom also perform rituals in which their cheeks are pierced by iron pins, or where the sheikh walks on swords held on the necks, in the mouths or on the bellies of their murids (dosa). Contrary to what one might think, such rituals are not performed at night, but at the end of the afternoon, between the afternoon and sunset prayers. They are frowned upon by the supreme sufi sheikhs, including the Rifa'i, and have become rather rare. The violent dancing, however, is extremely common not only among the Rifa'iya but among the Burhamiya, the Ahmadiya, the Bayoumiya and many other tariqas as well.

Sheikh Zahir finds himself somewhere in the middle. Though a Rifa'i and an ecstatic dancer whenever he leads the zikr, he does not indulge in dosas and his group is prohibited from using musical instruments to support their munshids. There is a prohibition, too, upon smoking, which is considered to form an additional 'veil' between man and God; the only exception being for the carpenter 'Abdel Rashid because it is his exacting task to drive out evil spirits. Most of the sheikh's murids are peasants, but there are also a surgeon, a dentist, an officer in the navy and several bigger and smaller traders.

During the zikr, and especially in the beginning, his people often recite the formula 'la ilaha illa 'llah', which when the music goes into a faster rhythm can become 'allah' or one of the shorter Most Beautiful Names like 'hayy' (the living one), and finally the characteristic and at first hearing rather frightening barking sound which is typical of the 'howling dervishes', as the Rifa'is used to be called. For a while, I thought that it stood for 'hu' (He), but Sheikh Zahir explained that it was an unarticulated mentioning of God, coming straight from the heart. 'With the sufis, the full name (of God) is a deficiency', said the sheikh, because whoever understands does not need more than a symbolic indication, and the articulation of the name distracts the heart from its objective, i.e., God Himself.

'In the beginning, all souls were one', the sheikh says, 'and they became separated from one another when they went into different bodies. During the zikr, they again become one.'

Islam has an excessive aversion to 'innovation' (bid'a), which in principle involves anything which cannot be traced back at least by analogy to the Koran or the Prophet's example. Therefore, it was of the greatest importance to establish precedents for the zikr either in the Holy Book or in the collections of traditions or sayings of the Prophet (hadith) which were compiled during the first centuries of Islam; the more so since the orthodox have their doubts about these practices and about sufism as a whole.

Fortunately, the Koran is no exception to the rule that in Holy Books everyone can find what he is looking for, even though it is doubtful that the word 'remembrance' (zikr, or *dhikr* in classical Arabic), and the related verb 'remember' used here and there, originally applied to what is now called a 'zikr'. Moreover, sufism developed early enough for a number of sayings of the Prophet on the subject of zikr to be included in the collections of hadith which are considered as truthful; even though the authenticity of each one might not stand up to critical analysis. A distinctive category within the hadith embraces the *hadith qudsi*, which are sayings of God revealed to the Prophet but not included in the Koran.

'Remember' and 'remembrance' of God are mentioned in nine verses of the Koran, the main ones of which say 'remember God with frequent remembrance'; 'remember Me and I shall remember you'; and 'after performing prayers, remember God standing up, sitting or (laying) on your side'.

In the hadith literature, relevant to sufism, the most prominent text is the hadith qudsi, which is commonly called the *hadith al-nawafil. Nawafil,* pl. of *nafila,* are additional efforts over and above those prescribed as obligatory such as the five daily prayers, and foremost among the nawafil is the zikr: 'My servant draws continually closer to Me by nawafil, until I love him, and when I love him I am the hearing by which he hears, and the sight by which he sees, and the hand with which he strikes and the leg on which he walks.'

According to a hadith rendered by al-Tirmidhi, a man asked the Prophet: 'There is too much Islamic legislation for me. I have grown so old, so tell me what I should adhere to?' And the Prophet said: 'Let your tongue be unceasingly tied to the remembrance of God.'

Another saying of the Prophet, handed down by his wife 'Ayesha, reads: 'There is not an hour in which a man has not remembered God which he will not regret on the Day of Final Judgement.'

In another, the Prophet said: 'Everything has its polish, and the polish of the heart is remembrance of God, and there is nothing but remembrance of God that saves us from His punishment.' They asked: 'Not even holy war?' and the Prophet said: 'Not even if the sword broke in two.'

Also, the Prophet has said: 'The difference between those who remember God and those who do not is like that between the living and the dead.'

In al-Tirmidhi's collection, again, the Prophet said: 'If you happen to pass by the gardens of Paradise, eat from their fruits.' They asked: 'What are the gardens of Paradise?' and he said: 'The zikr-circles.'

To end this short selection of recognized texts, I shall quote one more hadith qudsi which is frequently referred to:

The Prophet said that God says: 'I am with him when he remembers Me. And if he comes closer to Me by the span of a hand, I come closer to him by an arm's length, and if he comes closer to Me by an arm's length, I come closer to him by a fathom, and if he comes to Me walking, I come to him running.'

On the basis of these texts one might get the mistaken impression that all man needs is zikr. This would be wrong, because if this is an additional effort, it means that there must be a solid basis to which the superstructure is added. This basis consists in the faithful execution of one's religious and moral duties, 'being just before being generous', and in the words of the early mystic Antaki, 'to abstain from evil before performing pious works'; because it is a duty to refrain from all evil, whereas no one is held to do all good. So, as the Prophet has said, 'be compassionate to those who are on earth, and He who is in heaven will be compassionate toward you'. In short, conventional 'Islam' is a prerequisite for pure faith or *iman*, even though 'one mustard seed of love is better than seventy years of worship without love.' The religious duties have to be performed with the utmost concentration: 'whoever knows who is sitting to his left and right during prayer, his prayer is invalid.'

It is true, though, that there have been sufis who advocated the performance of certain duties in a less literal sense. Hallaj, who was later executed for his heretical pronouncements, advised spending one's money saved up for the obligatory pilgrimage to Mecca inviting orphans, feeding and dressing them and making them happy for the day of the Feast of the Pilgrimage.

Apart from subduing the 'lower' tendencies of one's personality, certain qualities have to be enhanced and others suppressed. As Sheikh Ahmad al-Tayyib told me, God loves generosity, especially in the poor; modesty, especially in the rich; and repentance, especially in the young; whereas He hates stinginess, especially in the rich; arrogance, especially in the poor; and disobedience, especially in the old.

Notwithstanding the merits of the collective zikr, the individual silent zikr, if it is performed 'with the heart' and permeates the sufi's whole being, is generally considered to be of a superior nature. During such solitary meditations, the zakir can have the sensation that all things around him join in his prayer; this was the case with Sheikh Ahmad Radwan during his retreats in the desert, as described by al-Hagg Ahmad 'Abdel Malik:

'Sheikh Radwan told me that he lived in this way in the desert for a long time, and that when he performed the zikr he heard 'la ilaha illa 'llah' from the pebbles, the plants, the dust and the water; once, he wanted to urinate and could not find a place which was not engaged in praising the Creator, so he sought the mediation of the Prophet and implored even God's help to silence that inorganic matter.'

God is seen as shrouded in veils, which have to be removed one by one. This process entails a purification of the heart, by suppressing (and eventually killing, says Sheikh Zahir, though other speak of training) the lower self, the *nafs*, with its base propensities and proclivities; allowing faith, *iman*, to take its place. 'The nafs is prone to evil', Sheikh Zahir says, quoting from the Koran the words of the Egyptian married woman who tried to seduce Joseph.

This purification is described as a path (*tariq*) along which the murid has to advance, step by step, under the guidance of his sheikh. This sheikh, in whose hands the murid must be 'like a corpse in the hands of an undertaker', is essential to the wayfarer; not only to prevent him from deviating ('he who has no sheikh, his sheikh is Satan'), but also because, unless he is illuminated by

Khidr, the ever-living guide of the saints, he would never get where he wants to be during the short span of his life: 'Whoever travels without a guide needs two hundred years for a two days' journey.'

The average murid is during a longer or shorter period initiated by a qualified sheikh into one of the tariqas, each of which has a chain (*silsila*) of tradition going back to 'Ali, the Prophet's son-in-law, and ultimately to the Prophet Himself. One of the main things he is instructed in is the individual zikr. 'Start with one hour for God', as Hagg Ibrahim, the keeper of the mosque of Sidi 'Ali al-Bayoumi in Cairo told me, 'and repeat one of His names, one for every day of the week. Increase this gradually, and continue as long as your spirit is open; stop it when you get restless. Do not hurry, but taste every name. In the end you will attain the numbers prescribed by Sidi 'Ali (we encountered them in the previous chapter). These numbers should be regarded as the teeth of a key: you do not need more, and not less, either. You will see angels and spirits. All this is about, is love and affection (*hobb u-hanan*).'

When the murid has learned enough, there follows a ceremony during which he grabs the hand of his sheikh (*qabda*), some passages from the Koran are read, and the murid promises the sheikh to follow the prescriptions of the Koran and the Prophet's example. This practice is based on the sourat al-Fath in the Koran, the tenth verse of which reads: 'Those who swear allegiance (*yubayi'una*) to you swear allegiance to God; God's hand is over their hands. Whoever breaks his oath breaks it to his own disadvantage, and who keeps his oath toward God will receive a great remuneration.'

The orders would not have millions of adherents – they claim to encompass up to ten per cent of the total population of Egypt – if the path of most of them went much beyond this. For the serious dervish, however, there are a number of stages or stations (*maqam*) to traverse, which eventually may culminate in al-fana' fi'llah, or disappearance (of one's own identity) in God: the taking on of God's attributes by annihilation of one's own qualities, and the immersion in the existence of God. Fana' combined with the following stage of baqa' is also called *ihsan*.

Ahmad Radwan says: 'I was in a (zikr) session with some of the brothers, when my soul and my heart went to my Lord (a stage called 'ihsan') and He revealed His beauty to me, and I went out of my self (*nafs*) toward Him. This is a condition (*hal*) that occurs to the people of (God's) presence, and then they are seemingly (*zahiran*) with other people, but really (*batinan*) with their Lord. This is what is popularly known as 'vision' (*shuhoud*), a condition which is received by grace and not acquired through one's own efforts.'

After fana', there may follow the end station of baqa', a return into the world as a leader with saintly qualities and 'knowledge of God'. At that enlightened stage, the saint 'goes in and out amongst the people and eats and sleeps with them and buys and sells in the market and takes part in social intercourse, and never forgets God for a single moment'; or, as related in connection with Ahmad Radwan, 'whoever comes back from God tells people about God by God, he sees and hears by Him, he speaks by Him, by Him he stands and by Him he sits'. According to Radwan, God then makes people love him, and even the dead hurry to attend his zikr sessions and to listen to his words.

Before reaching fana', the dervish will have gone through stages like repentance, renunciation, trust in God, poverty, patience, gratitude and contentment (*rida*).

In this connection it is also worth mentioning the *magazib* (pl. of *magzoub*), people 'attracted' by God and whose mental faculties appear to be limited. In Sheikh Zahir's group there is a number of magazib, and we came to speak about this phenomenon because of Hagga 'Ayesha, a plump woman dressed in white who used to move about in the zikr sessions without saying a word, with two wooden rifles over her shoulders. 'She is in a state of *gazb*', said Sheikh Zahir, and explained that this can be one of the stages on the path towards sainthood, which his father and grandfather had gone through as well; in his grandfather's case, this had lasted for a period of twelve years which he had passed wandering around Suez, Ismailia and other places, and sitting in the Cairo mosques of al-Husayn and the Sayyida Zaynab.

During his early years, Sheikh Ahmad Radwan was called by one of his own sheikhs 'the leader of the magazib of Upper Egypt'.

'Gazb', Radwan says, 'is a divine abduction and can be either interrupted so that the magzoub wakes up again, or complete, without a reawakening. The magazib are those whom God has taken from themselves, and they do not belong to the world of ordinary people.

'Even though they are not of any use to anyone but themselves, they should be treated with kindness, but it is prudent to keep them at a distance: if any of them comes to you, give him what he asks for, but if he asks for money, do not give it, because for them money and dust are the same, and wearing clothes and going naked are the same. Do not accept anything from the magazib and do not ask them to pray for you, because they will pray against you for poverty and disease, because that is what they wish to befall all Muslims, because through them God makes the Muslims enter Paradise. If a magzoub gives you (e.g.) a lemon, there will be affliction and disease in it. Do not dress in their clothes or eat with them.

'Some of them are always on the road, going from one place to another, and others stay in one spot. After this period of gazb, the magzoub wakes up, but during that period his mind is unstable.

'However, the Prophet has said: "I have seen Paradise, and most of its inhabitants were imbeciles."'

Not everyone passes beyond this stage to the next, however, and those who do not remain magzoub for the rest of their lives. Those who do get over their gazb reach the stage of the 'preparation for sainthood' (*ta'hil lilwilaya*), during which they are tested in a manner which can be very unpleasant.

'It happened at this stage to my grandfather Ahmad', Sheikh Zahir said, 'that on a festive day he found himself on a path where other people were walking with their children. For a moment, this made him think of his own children. When he subsequently went to sleep in a small prayer-house, he had a dream in which the four supreme saints (the *aqtab*) said: "Strike Ahmad from the registers of the saints." But the Sayyida Zaynab (one of the great saints venerated in Cairo) said: "Ahmad is my son. I know him." He awoke and once and for all deleted his family from his heart, where there was room for God only. God is jealous, and one can love only one at a time.'

Sheikh Ahmad Radwan recounts how he spent thirty years of affliction. The people of his village found him repugnant and some of them wanted his death, 'but I never got angry with them, and never prayed against them, but I prayed for them at night that God might soften their hearts and hands'.

Though Islam as such is rather in favour of marrying, and the Prophet gave a good example in this respect, the family has been seen as one of the greatest obstacles on the way to God since the earliest times of Islamic mysticism. Fudayl, who died in Mecca in 803, was seen smiling only once during thirty years: when his son died. The serious mystic cannot but see his family in terms of distraction from the only love he has permitted himself.

Since Sheikh Zahir has five children whom he obviously loves, I asked him whether the same could happen to him, too, but he understandably regarded the question as indiscreet and did not answer it; to the regret of Dr. Gamal, the dentist, who had been listening in and said in English: 'Insist! Press on! This is what we all want to know!'

The Egyptian sufis are organized in sixty-eight recognized orders, each headed by a 'Sheikh of the Prayer-rug' (Sheikh al-Saggada), who is responsible for the affairs of his tariqa nation-wide; the prayer-rug being the equivalent of the throne, which he has inherited from his predecessors. He is assisted by one or more deputies (na'ib or wakil) and has his local and regional substitutes (khalifa, pl. khulafa', c.q. khalifat al-khulafa') at the level of districts and provinces. The Sheikh al-Saggada has to confirm their appointments, but most of these sufi leaders are not recruited from the rank and file of the murids, but inherit the title and the function from their fathers. The function of Sheikh al-Saggada, too, is hereditary. Inheriting the leadership of a group of dervishes can, if taken seriously, be extremely onerous.

The khalifa looks after the spiritual and social welfare of his followers. He is present at their hadras, he solves problems within their families, and resolves controversies arising between them: none of the brethren will take a member of his own group to court. 'The turuq are a state within the state', Sheikh Zahir says. 'It is order without politics.'

If his followers live in various villages, the sheikh will try to visit them whenever he is invited to their hadras. In Sheikh Zahir's case, this means that he is on the road most days of the week, seeing his family only for a few hours on Friday. It often happens that he has more than one hadra per day. He would never be able to follow his schedule, which is added to his regular work for the Ministry of Education, if he did not have a car, financed by some of his richer murids. All the sheikh gets in return are small gifts and, of course, great prestige. When the sheikh himself is not there, he is represented by the brothers of the 'old sheikh', his uncles, or by his own brothers. They all are held in high esteem, their hands are kissed and they often lead the zikr, also when the sheikh is present but is engaged in other responsibilities, like receiving guests.

Most of the founders of the local khalifa-families and all the founders of the tariqas are held to be saints and are venerated as such. Their birthdays, or other days of remembrance, have become the occasion for the moulids which we encountered in a previous chapter. Both locally and nationally, their peculiarities and preferences live on in the traditions and practices of the members of their organizations.

Egypt is, with Yugoslavia, unique in having provided a legal framework for the functioning of the dervish orders. Since the nineteenth century, they have been subject to the decisions of the 'Supreme Sufi Council', consisting at present of ten tariqa sheikhs and five members appointed by government departments, the Mufti's office and al-Azhar. It convenes once a month and its sessions are prepared by an executive committee from their midst, consisting of six tariqa sheikhs only. The council confirms appointments both with respect to the orders and the 'tariqa-affiliated institutions', such as the saints' maqams, and keeps a register of saints and moulids. They have the power to recognize or to refuse the recognition of newly established orders, and have kept the number so far (1988) to sixty-eight, with a total estimated membership of between three and five million. In every province and district, there is a representative of this 'mashyakha' who keeps an eye on sufi activities.

This not only means that the Egyptian sufis have a high degree of autonomy in directing their affairs, but also that their existence and organization are fully recognized by the government. In many other Muslim countries the sufis are regarded as backward and unorthodox, and barely tolerated, while in Turkey the tariqas have been banned altogether. The attitude of the Egyptian government is evident from the participation of government representatives at the opening of the more important moulids, and from the official interest in sufi processions, which sometimes march past the Governor of the province on occasions such as the Prophet's birthday. There is a tacit understanding between government and sufis that there is an objective alliance between both, against the extreme Islamic groups, who wish to topple the government and establish a regime based on their vision of Islam, and also to do away with all the practices they regard as novelties, such as the veneration of saints, the celebration of moulids and the various practices of sufism in general. Even though participation in political party activity is anathema to the spirit of sufism, the existence of a large bloc of Muslims impermeable to fundamentalist propaganda is very precious to a government whose main preoccupation is internal stability.

The main objections of the virulent fundamentalists and of the broader *salafiya* movement (*salaf* are ancestors and the salafis want to return to the good old times of early Islamic practice) concern the cult of saints and tombs, and the notion that the saints or even the Prophet himself can act as an intermediary between man and God. Sufism as such and its central practice of zikr are much less objectionable, at least to the salafis' great example Ibn Taymiya (d. 1328) and some of his disciples. Recently, a book has been published setting out the merits of the zikr, which no doubt deliberately draws its main arguments from Ibn Taymiya and his pupil Ibn al-Qayyim (d. 1350). One contrast between sufis and fundamentalists is that the latter are forcefully active in the political field, whereas the former are essentially apolitical and almost antipolitical, being indifferent to this world as well as the next one as a matter of principle.

Notwithstanding some animosity between orders with a different social background, such as the Shazliya and the Rifa'iya, there is a great deal of mutual sympathy and tolerance, and it is difficult to find a dervish who claims that his own tariqa is better

than the others. The main differences between most of the orders are of a symbolic and secondary nature, such as the colours of the standards and banners and the formulas of the litanies. Sufis participate in one another's zikrs, and quite a few are members of more than one tariqa.

Moving from one tariqa to another requires the consent of the former's sheikh, which sometimes assumes a special character. Dr. Gamal, a dentist and one of Sheikh Zahir's companions, told me that he had been a Khalili (the Khaliliya are an offshoot of the Ahmadiya), when one evening he met Sheikh Zahir's father, Sheikh 'Abdallah, who welcomed him, knowing his name already, and mentioning that in a dream he had seen Ahmad al-Rifa'i asking Ahmad al-Badawi's permission to take Dr. Gamal over. This was one of the miracles of Sheikh 'Abdallah.

The language of the mystics is the language of love; a love which according to the Koran ('whoever turns away from his religion, (let him know that) God will bring (forth) people who love Him and whom He will love') can be reciprocal.

'Religious language', as Ruthven says in his *Islam in the World*, 'by definition, attempts to express something which defies expression, and to evoke a perception of something which lies beyond the realm of human comprehension.' Hundreds of abstract notions have been formulated in attempts to describe the indescribable, and especially to make it possible for the dervishes to discuss their experiences with one another; without ever quite reaching the goal. Perhaps the closest approximation was realized by the poets, whose medium is closer to the world of mysticism than any prose could be. A few examples will give an idea of the way in which they expressed themselves.

There is an immense wealth of mystical poetry, of which I know only a tiny part. From that, I have selected a few passages by two poets whose verse is still used by present-day munshids in compiling their songs: the Egyptian 'Omar Ibn al-Farid, who lived in the second half of the twelfth and the first half of the thirteenth century, and his Spanish-born contemporary Muhyi al-Din Ibn 'Arabi.

Ibn al-Farid lived a solitary life in Cairo and Hijaz, and his Arabic odes, small in number, 'resemble the choicest and finest jewel-work of a fastidious artist rather than the first fruits of divine inspiration', to quote one of his interpreters, Reynold A. Nicholson. When reading the following parts taken from different odes, the reader may wish to keep in mind that the gender of the loved one in Arabic poetry is often masculine, even when a lady is meant; and that, anyway, God, who is the real object, is beyond definition in terms of sex.

'Ice-cool are his deep-red lips, and sweet his mouth to kiss in the morning,
yea, even before the toothpick's cleansing excelling the musk in fragrance
and investing it with its own perfume.
Of his mouth and his glances cometh my intoxication; nay, but I see a
vintner in his every limb.
When the silence of the rings upon his fingers vexeth him,
then the girdles about his waist speak forth to the uttermost of his desire:
Delicate are those girdles, and fine that waist: the former is akin to my
love-song, and the latter draweth out the excellence of its meaning, so that it
vies with it therein.
Like the bough of a tree he is in stature, and like the dawn in beauty; his hair
is dark as the night, reaching down even to the middle of his back …'

'Mine eye hath grown rusty with seeing others than her: to kiss her dust
with my eyelids – this would polish the rust away.
My people know well that I am slain by her glances: for in every limb of her
she possesses a whetted point.
Ancient the tale is of my passion for her: it hath no after, and no before,
despite what the wit may say.
None other is like to me in my passionate love of her, as she too unequalled
is in her ravishing loveliness …'

'She swayed as she moved; and I imagined each side, as she swang it, a twig
on a sand-hill, and, above it, a moon at the full;
And my every member had, as it were, its several heart, the which as she
glanced, was pierced by its showers of arrows.
And had she laid bare my body, we would have beheld every essence there,
therein every heart contained, possessing all yearning love.
And when I attain her, a year to me is but as a moment: and an hour of my
banishment seemeth for me a year.
And when we did meet at evening, drawn together by the paths running
straight, the one to her dwelling, the other to my tent,
And we swerved thus a little away from the tribe, where neither was Watcher
to spy, nor Slanderer with his lying talk,
I laid down my cheek upon the soil for her to tread on; and she cried, "Good
tidings to thee! Thou mayest kiss my veil."
But to that my spirit would not consent, out of jealous zeal to guard my
honour and the high object of my desire:
So we passed the night as my choice willed and my heart aspired, and I saw
the world my kingdom, and Time itself my slave.'

Ibn 'Arabi, the Great Master of the sufis, the author of an enormous oeuvre of mystical theory written in prose, was more visible to
the public eye of his time, and his mystic poems were in greater danger of being misinterpreted – or, as the case may well have been,
interpreted correctly – as inspired by earthly love for a beautiful Persian woman he encountered in Mecca in 1201. At any rate, he
deemed it prudent at a later stage to publish a commentary setting out verse by verse the allegorical meaning of the erotic words he
had used. This curious collection, called the *Interpreter of Desires* (Tarjuman al-Ashwaq), has been edited by Nicholson, who translated
the poems in full and gave an abridged version of the commentary.

From ode XIII:

(12) *None blames me for desiring her, for she is beloved and beautiful wherever she may be.*

Commentary:

'The aspirations and desires of all seekers are attached to Her, yet She is essentially unknown to them hence they all love Her, yet none blames another for loving Her. Similarly, every individual soul and the adherents of every religion seek salvation, but since they do not know it they are also ignorant of the way that leads to it, though everyone believes that he is on the right way. All strife between people of different religions and sects is about the way that leads to salvation, not about salvation itself. If anyone knew that he was taking the wrong way, he would not persevere in his error.' Accordingly the author says that She manifests Herself everywhere, like the sun, and that every person who beholds Her deems that She is with him in Her essence, so that envy and jealousy are removed from their hearts.

From ode XX:

(1) *My lovesickness is from her of the lovesick eyelids: console me by the mention of her, console me!*

(2) *The grey doves fluttered in the meadows and wailed: the grief of these doves is from that which grieved me.*

(3) *May my father be the ransom of a tender playful girl, one of the maidens guarded in howdahs, advancing swayingly among the married women!*

(4) *She rose, plain to see, like a sun, and when she vanished she shone in the horizon of my heart.*

Commentary:

(1) By 'Her of the lovesick eyelids', is meant the Presence desired by gnostics. Although she is too sublime to be known and loved, she inclines towards them in mercy and kindness and descends into their hearts by a sort of manifestation.

'Console me by the mention of her': there is no cure for his malady but remembrance (zikr). He says 'console me' twice, i.e. by my remembrance of God and by God's remembrance of me.

(2) 'The grey doves', i.e. the spirits of the intermediate world.

'And wailed', because their souls cannot join the spirits which have been released from imprisonment in this earthly body.

(3) 'A tender playful girl', i.e. a form of Divine wisdom, essential and holy, which fills the heart with joy.

'One of the maidens guarded in howdahs': she is a virgin, because none has ever known her before; she was veiled in modesty and jealousy during all her journey from the Divine Presence to the heart of this gnostic.

'The married women', i.e. the forms of Divine wisdom already realized by gnostics who preceded him.

(4) 'And when she vanished', etc., i.e. when she set in the world of evidence she rose in the world of the Unseen.

From ode XXIII:

(11) *Look on us again with pity! For we were robbed, a little after dawn, a little before sunrise,*

(12) *Of a bright-faced lissome damsel sweet of breath, diffusing a perfume like shredded musk,*

(13) *Swaying drunkenly to and fro like the branches, fresh as raw silk, which the winds have bent,*

(14) *Shaking, like the hump of a stallion-camel, fearsome hips huge as sand-hills.*

(15) *No censor blamed me for loving her, and my friend did not blame me for loving her.*

(16) *If any censor had blamed me for loving her, my sobbing would have been my answer to him.*

(17) *My desire is my troop of camels and my grief is my garment and my passion is my morning drink and my tears are my evening drink.*

Commentary:

(11) 'A little before sunrise', i.e. the hour of the ascent that succeeds the Divine descent into the terrestrial heaven, which descent occurs in the last third of the night.

(12) 'A bright-faced lissome damsel', i.e. the Essential attribute which is his object of desire. She is called 'lissome' because of her descent towards us, yet from it nothing is derived that can be grasped by knowledge or understanding or imagination.
'Diffusing a perfume', etc., i.e. leaving Divine impressions in the hearts of her worshippers.
(13) 'Which the winds have bent', i.e. the aspirations by seeking her cause her to incline, as God says, 'if anyone comes a span nearer to Me, I will come a cubit nearer to him'.

(14) This verse refers to the infinite bounties, spiritual and other, which God has heaped upon His servants.
(15) Inasmuch as she is like the sun, which is common to all, she does not excite jealousy.
(16) 'My sobbing', i.e. my ecstasy would make me deaf to his reproaches.
(17) 'My desire is my troop of camels', which bear me to my Beloved.

Modern popular sufi poetry is most accessible in the form of *inshads*, the songs sung by munshids during the zikrs. A great and still rapidly growing number are available on cassettes. Sheikhs like 'Abdel Nebi al-Rannan, Sayyid Imam, Bilbeisi and Deshnawi have gained nation-wide renown with their inshad, and younger munshids like Sayyid and Musa, who sing together, and al-Sayyid Khamis are following their example.

Below, I will give an only slightly abbreviated translation of the inshad 'One of the Nights of al-Sayyid al-Badawi' by Sheikh Ma'lawi, which covers both sides of a cassette, that is around forty minutes. After an introduction which is recitative, the rhythm gradually develops from slow to very fast. The text, which is completely in colloquial Egyptian and thus contains no fragments of old poetry, gives a fair impression of the half-composed, half-improvised nature of these songs, frequently interrupted by the invocation of various saints, and largely consisting of disconnected bits of popular wisdom and statements about the condition of the dervish.

The '(little) girl' (*bunayya*) is the symbol for the mystic's beloved, i.e., God. Contentment and Patience are stages on the mystic path. There are more repetitions of verses or passages than I could render, and the rhyme and rhythm have, of course, had to be sacrificed.

(Introduction)
'Lord, I have no support but You, and I have no one.
Be generous to us all, O Lord, and do not make one depend on the other.
Be generous to us all, O Lord, and there are of course no bounds to your generosity.

My soul, go straight along your way, you do not need anyone.
Because in the hour of misfortune nobody is of any use to anyone else.
Neither is the son of any use to the father, nor is the son's son of use to the grandfather.
(Let us say) "Allah is great" for those who have entered the grave, and the grave is closed over them!'

(The music goes into a slow rhythm, and the dancers in the zikr would start their movements at this point.)

'God is great! My destiny threw me into love,
and I became ill, afflicted by my destiny,
I found only the beloved one, the Prophet
who is the origin of my happiness.
Many people have loved the beloved one, the Prophet, before me
and people will love the beloved one after me, too.
When I was in the cradle, the love for him filled my existence.
Now that you are in the clinic, O my soul (rouh),
we shall operate on you
and we'll see who injured you with this wound.
Was it by the hand of Zayn al-'Abidin, or of all the saints?
Many people are poor, but they are really saints,
and people who do not possess a millime
are rich in love.

If he held up his hand to his Lord
he would find all his wishes fulfilled!
You, worker of good things, bring us good tidings always!
The most important thing is not the deeds, my boy,
it is not the deeds, O Abu Siba', Abu Gawhari, Sidi Muhammad al-'Iraqi,
no, the most important is the intention.
The girl is very pretty, Abu 'Azim, and she has many children,
The girl is very pretty, Ma Zaynab, and you have many children.
She has a very wide river.
Many, many boatmen have drowned.
The river is very wide, O Father Badawi
and many boatmen have drowned
and whoever drowns in the love for the little girl,
if he dies there is no blood-money for his relatives.'

(Here, the music goes into a faster rhythm, and every subsequent part has its own melody, ever faster and faster.)

'You, who have a high maqam,
Taha, dear Prophet,
praising you is sweet to me.
You with your divine light,
my beloved, O Prophet,
my guarantor, O Prophet.
Let us pray for the Prophet!
(He said:) Come, (and I said:) I am at your service!
(I went) up to his house.
Until he revealed himself to me
I called him with tears,

my beloved, O Prophet,
my guarantor, O Prophet,
my mediator, O Prophet!
How lucky who visits him,
he becomes sweeter through his light.
If only I could see his light
I would fill my eyes with the scene of the Haram,
my beloved, O Prophet,
my guarantor, O Prophet.
Let us pray for the Prophet!

The secret is inside, but inside there is someone who knows it
and He who created the people knows their minds.
Boy, the beloved one, the Prophet loves him, O Father Badawi,
and the sign has appeared upon him.
As long as the sign is clear it leads him to the Prophet.
And the river is very wide, O man of light, O Husni,
and all have drowned in it.
Who wishes to reach Contentment, come, pray for him!

I keep calling you, Ma Zaynab,
why do you not answer me?
Do you not like me?
Everyone who puts on a turban is called a dervish
but we say, the important thing is the deed, O Sayyid,
because (being a dervish) is not empty talk!

They have said about the afflicted: they are insane,
their minds show that they have drunk from the cup, and are intoxicated,
but they are godly people,
far removed from the crowd, O 'Ali!
O Sidi 'Ali Zayn al-'Abidin!
And at the time of prayer they are awake.
They are the people of Contentment, among the best in the world!

Love has thrown the wounded, confused, into solitude,
standing in love for my beloved Muhammad,
in love of the beloved one, the Prophet,
lost since a long time, wishing to visit the Prophet
and to be filled with Contentment.
But our arms are too short, mama (Zaynab),
and cannot reach the ways of the prominent.

Lord, give us Contentment
and we shall see the perfect light.
Patience comes before affliction, O my soul,
or comes affliction after it?
I am afraid to apply the remedy,
because affliction will appear after it.
Do not be angry, friends, after tomorrow comes another one!
Whoever is afflicted has to have patience on his destiny.
It is written on my forehead,
where can I escape it?
My destiny has been written.
My eyes will have to see it.

Come, people of affliction,
let us complain to one another about our condition,
let us sit together, since your condition is like ours.
O Lord, you have shown the way!
O priest, O Hanna, open the door for us[1]!
Let us look at our condition:
we have been branded by love, until we dried out in the process.

O you who are far from my eyes,
but whom I see with my heart,
how could I forget your love and the smile on your lips?
When will you, too, have sleepless nights,
so you will understand me, you with your empty heart?

The little girl loved me, O Abu Siba',
and asked for contact with me.
The little girl, the girl – she fascinated me!

[1] This sentence is very difficult to make out on the cassette, and may be an incorrect interpretation.

She is Knowledge, she is the Truth, she is the Light, she is Divine Law,
she, she!
She is my passion
and her love for me stays only a short while!
Mama, I am sick, Mama, take care of me, Mama,
O my soul, Mama, I am wounded, Mama!
The girl loved me, Abu Siba',
and wanted contact with me.
I came closer to her, but she drew back from me.
I told her: Girl, why do you draw back from me?
She closed her ears and said: Your words weigh heavy on me, boy,
they cause me pain.
Look, O Gawhari, O 'Afifi, O Mansour, O Sidi 'Ali!
I told her: Girl, why do you draw back from me?
She closed her ears and said: Your words weigh heavy on me, boy,
they cause me pain.
If you want union with me, and to stay near to me,
take a representative for you, and one for me[2],
but there are (other) people in the district who love me.
Take care not to become jealous of them if they take me in their arms!

The girl spread the sheets and said: come!
Shall I go or not?
Come, come,
with your soul and your heart and your tongue
but do not get arrogant[3]!

Towards whom should I get arrogant?
Does she think I'm an idiot or still immature?

How could I, made out of mud, be arrogant towards the poor?
No one can ever be arrogant
but He, praised be He, the Exalted!

Many hands have wounded us; can anyone cure us?
Whoever does not (yet) love, let our afflictions not touch you!
When your bodies are full of damage
nobody can cure them.

By God, the children of the Prophet are beautiful,
our Lord Hasan and al-Husayn
and Sidi 'Ali Zayn al-'Abidin,
the Prophet is, my soul, their grandfather!

Come quickly, 'Aziza,
come, my soul, come,
my intelligence, come, my dear, come,
come quickly, 'Aziza, and fill the cups on the table!
Come quickly, Nafisa, Mushira, Khadiga,
fill the cups on the table
and call Zayn Abu Nafisa and Sidi Zayn al-'Abidin!

Love plays with the souls
love love – take care you do not fall into it!
It makes the tears flow from the eyes,
and whoever loves, where will he find rest?
I was lost and my thinking was lost
I went down to the sea of Madad[4]
to see who was inside.
I found the children of the Prophet roaming and weeping in it.

[2] Meaning: make the preparations for us to get married.
[3] A word-play between 'come' (ta'ala) and 'be arrogant' (tit'ala), which ends
in the tit'ala running away with the action.

[4] Assistance invoked from the saints.

66

68 Litany being recited at the end of a Friday zikr at the saha.

69 Followers of Sheikh Zahir during the afternoon prayer at the
Sarghitmish mosque, Cairo.
23.3.1987/22.7.1407

70 Moulid al-Nabi at the saha of Sheikh Zahir. The sheikh is leading
the zikr, watched by his younger son 'Abdallah.
 On the wall, the picture of Sheikh Ahmad Abu Zaghlal, the
founder of the group.
3.11.1987/11.3.1408

71

«71 Zikr of Sheikh Zahir's followers in the Silihdar mosque in Cairo at the end of the moulid of al-Husayn.

The boy in the foreground is Sheikh Zahir's eldest son Ahmad, presumably the future sheikh of the group. At the extreme right sitting on the ground is al-Hagga 'Ayesha, the magzouba.

16.12.1987/24.4.1408

‹72 Sheikh Zahir in the zikr. I hardly ever saw a more ecstatic dancer than Sheikh Zahir. Here, he is leading a zikr of his Rifa'i group at the moulid of Sayyida Zaynab, in the Sarghitmish mosque where they were living for the week.

I visited them with some friends late during the Great Night. The sheikh received us, had tea with us and then could wait no longer and joined the zikr. We waited and watched for about an hour and then asked one of the brothers to give our regards to Sheikh Zahir who was still dancing, but an old magzouba thought that the sheikh would be offended if we left without greeting him personally. She went into the feverishly dancing group, put one of her black veils over him and gently led him away, sat him on a cushion on the ground, and wrapped a blanket all around him. There he remained, perspiring profusely, for about five minutes before he became aware of his surroundings. Then he stood up and bade us farewell. He had been far away.

8.3.1988/30.7.1408

73 Wird, a rhythmic litany which is read before, after or instead of a zikr.

Here, Rifa'is belonging to Sheikh Zahir's group are rounding off their zikr for the Prophet's birthday with *al-hizb al-Rifa'i*, late at night.

The hizb is supposed to have magical properties as well and can cure diseases if used in the right way.

3.11.1987/11.3.1408

74 Followers of Sheikh Zahir at a hadra in Qal'a near Qift in Upper Egypt.

That morning, I visited Sheikh Zahir and his people in Qena, where they were celebrating the moulid of 'Abdel Rahim al-Qenawi. The moulid had ended, the zaffa due to take place in the morning had been forbidden by the governor for reasons of public order, and the sheikh and his company had been invited by Mr. Dunqul, the mayor ('omda) of Qal'a. They asked me to come along, and after the noon prayer we set out in several cars and a bus. When all had assembled at the 'omda's house, a short litany was intoned. A copious luncheon followed, and just before five o'clock the zikr started with the usual *la illaha illa 'llah*, in the open central area of the house, adorned with the portraits of previous 'omdas, forefathers of Mr. Dunqul.

I watched it for a while with Sheikh Zahir and Sheikh al-Fadl al-Dandarawi, deputy head of the Dandarawiya order, who was also present. The sheikhs did not take part in the zikr. Around sunset, one of the 'omda's cousins drove me to the bus station in Qous, and I returned to Luxor.

13.4.1987/13.8.1407

75, 76 Peasants doing a zikr in Bandara. Some Misallami sufis from the Delta village of Bandara whom I met during the moulid of Sayyida Nafisa in Cairo asked me to visit them in their village the next week, when they were to have a 'night' in the honour of their sheikh.

They received me lavishly with a lot of meat and the ceremony began after the evening prayer at seven. First, there was a long common recital from the Burda, the Fatiha was read for the sheikh and the owner of the house, and finally there was a repetition of the formula *la ilaha illa 'llah*, the music started up and the zikr commenced. Sheikh Ahmad, who lives in Sharqiya and visits the village once a year for two days – one night in the courtyard of this wealthy man and the other night in another's – did not join in the zikr himself, but sat with his brother and his uncle, who had come over as well. When I left for Cairo around 11 p.m., the zikr was still in full swing. Because of the thick mud on the village road I almost ended up, together with my car, in an irrigation canal, but all ended well.

These people read from the Burda every Monday and Thursday evening, but they do a dancing zikr only on special occasions.

4.2.1988/15.6.1408

75, 76

«77, ‹78 Zikr at Zayn al-'Abidin. This man joined the zikr a few minutes before I took the photograph and almost passed out a few minutes afterwards. He had to be held by the shoulders to keep on his feet, but he soon regained his balance and went on dancing in a trance.

12.2.1988/23.6.1408

79 An Ahmadi in Tanta. During the Tanta moulid of Ahmad al-Badawi, this man was dancing on his own in the middle of a zikr of the Ahmadiya Maraziqa order.

I was taking the American ambassador around, accompanied by his usual five bodyguards and a growing number of local police and dignitaries. At the end, there were fifteen of us, accompanied by two police on horseback. It was the night before the Great Night, the crowd was not yet very dense, and nobody seemed to mind.

21.10.1987

80 Burhami dervishes from Toukh. Sheikh 'Ali Shehata and a small group of his followers were sitting near the mosque of Ibn Touloun in Cairo one afternoon in March during the moulid of Sayyida Zaynab, camping in an alley on some mats. They had hung their procession banners on the wall behind them.

They were sitting exactly like this when I came by, only the sheikh himself insisted on getting up for the photograph.

Later during the same afternoon I met Sheikh Zahir, who had set up in the adjacent mosque of Sarghitmish.

23.3.1987/22.7.1407

«81 Musicians at a morning zikr of the Sa'diya at the moulid of Sheikh Idris in Kom Ombo.
5.8.1987/9.12.1407

‹ 82 Sheikh Diya' Muhammad from Beni Sueif, with his red Ahmadi turban, resting with other dervishes on the steps of the mosque of Abul 'Abbas al-Mursi in Alexandria, at sunrise after the Great Night of the moulid of Abul 'Abbas.
24.7.1987/27.11.1407

83 Muhammad 'Abdel Rahman, a Bayoumi dervish from Alexandria, whom I met at the moulid of Ahmad al-Rifa'i in Cairo.

Making up one's eyes with *kohl* is not an exclusively feminine affair. According to tradition, one of the *mukhallafat al-nabi*, the possessions of the Prophet found upon his death, was his kohl-box.
12.3.1987/11.7.1407

84 Muhammad Yahya, a Rifa'i sheikh from Beni Sueif, and his wife at the moulid of the Imam al-Shafe'i in Cairo.

Sheikh Yahya has one of the most important tents at the moulid of Sayyida Houriya at Beni Sueif, and can be seen at all the major moulids in Cairo and no doubt elsewhere as well. I ran into him, always by chance, at those of al-Husayn, al-Rifa'i and here, at the Imam al-Shafe'i, where he was leading a zikr.

He introduced me to al-muqaddis 'Ali, an old magzoub who had visited Jerusalem (in Arabic: al-Quds) twice during the October war of 1973 in a miraculous fashion, and whom I had seen with Sheikh Yahya at the Rifa'i moulid as well.

Sheikh Yahya was a very good source for dates of forthcoming moulids.

83, 84›

85 Ahmadi dervishes from Bulaq, Cairo, resting at the moulid of Abul Hasan al-Shazli.

Originally, it was the woman who was smoking, but the man preferred it this way for the picture.

On their banner is written: 'Help us (*madad*), O Sidi, O Ahmad, O Badawi!'

› 86 Dervishes marching past the governor of Qalyoubiya at Benha, during the procession for the Prophet's birthday.
3.11.1987/11.3.1408

»87 Sheikh Hamid al-Bayoumi, head of the Bayoumiya, riding in the yearly procession of his order. The umbrella protects him from the sweets which, on account of the baraka, are thrown from the surrounding houses.
18.2.1988

« 88, 89, 90 Prophet's birthday. On the eve of the Moulid al-Nabi a great procession was held for the Governor of the province of Qalyoubiya in Benha at the end of the afternoon.

First came a military band which played the national anthem in front of the Governor, then came soldiers, fire brigade, the ambulance service, the boys of the gliding club, and finally all the dervish orders of the province, each group with their sheikh on a horse. They got off their horses to greet and pray for the Governor, and then rode on with their supporters.

First came the Hamidiya Shazliya, then the Burhamiya, the Ahmadiya and Bayoumiya, and at the rear – the most important place – a great number of Rifa'is.

There were dense crowds all along the route. In the distance a train went slowly past with a row of people standing on its roof to watch the spectacle.

3.11.1987/11.3.1408

91 Zaffa at Mit al-Siba' at the moulid of Muhammad al-'Iraqi.

The man singing into the microphone behind the violin is Sheikh 'Abdel Rahman Sharaf al-Din, who acts as munshid during the zikrs of the group.

I happened upon this procession while on my way to another moulid in Zagazig, and was not aware of the fact that it was to end in a very interesting dosa.

9.7.1987/12.11.1407

92 Musicians at the weekly zikr held on Friday in Mit al-Siba', in a building adjacent to the tomb of Muhammad al-'Iraqi. They are not from the village, but they are present at every hadra and accompany Sheikh Ahmad's group to Cairo when they go to celebrate the moulid of Ahmad al-Rifa'i.

They are, from left to right, Muhsin, Sheikh 'Abdel Rahman Sharaf al-Din the Munshid, and Fawzi the drummer. The fourth man is just a friend. They are at this moment playing the introductory part of the inshad, before the dervishes start dancing.

Rather exceptionally, they always sit while playing. Behind the wooden screen, the women are having a zikr of their own to the same music.

93 Zaffa in Mit al-Siba' being cheered on by Sheikh Selim. On the Prophet's birthday, a Rifa'i zaffa was organized in the village of Mit al-Siba'. Here as elsewhere, the sheikh came last with his banners. In front, there was a group of men dancing with swords and *dababis*, long iron pins with a bulbous handle. This was the warming-up for a dosa in which the *sheikh al-dosa*, Sheikh Selim, walked over the swords which the dervishes, kneeling down, held on their necks.

The *dababis* were meant to pierce their cheeks, but this time they were not used. It was said that this was only done during the local moulid of Muhammad al-'Iraqi which had been held three months before.

4.11.1987/12.3.1408

94 Sheikh Selim doing a dosa on the birthday of the Prophet at Mit al-Siba'.

4.11.1987/12.3.1408

95 Sheikh 'Abdallah preparing to do a dosa at the moulid of Abul Qumsan.

29.3.1988

96 Dosa. At the moulid of Abul Qumsan in Qurna, Sheikh ʿAbdallah stands on a knife which one of his dervishes holds in his mouth. There were three Rifaʿis and Saʿdis, who first held their knives on their belly, then in their mouth, and finally bent over so that the point touched their abdomen.Every time, Sheikh ʿAbdallah walked over them and their knives, supported by two men. Before, they all had been dancing around with their knives to the sound of two heavy wooden drums, which were played all through the dosa; some with a thin pin through a cheek.

Sheikh ʿAbdallah told me later that this had been an excellent dosa, and he thought that a saint had been present and possibly even the Prophet Himself.

Asked about the philosophy underlying this practice, he said that the patron saint Sidi Ahmad al-Rifaʿi had originally done this and that his order had continued the custom. One of the participants said it was a test of one's sincerity as a dervish: if one was insincere, one's tongue would be cut in two by the knife and one's cheek would bleed when pierced by a dabbous. They read the Fatiha for Ahmad al-Rifaʿi before they started and then were sure of his support.

I had expected to hear something about the triumph of the spirit over the flesh, or the absolute submission to the sheikh, but this was all that was said in the way of comment.

Sidi Ahmad al-Rifaʿi, Sheikh ʿAbdallah said, at some stage melted in a large basin, for love of God. His daughter saw the basin, did not know what it was and took out something black. When Rifaʿi became solid again, he was missing an eye.

Dosas such as this one and the piercing of cheeks and other parts of the body (*darb silah*) are frowned upon and even forbidden in many places. At the moulid of Abul Qumsan there is no restriction since Abul Qumsan appeared in a dream to the head of the local police, saying that at his moulid everything was permitted, with the exception of dealing in drugs and shooting with rifles.

29.3.1988

› 97 Wooden drums being beaten during the dosa at the moulid of Abul Qumsan in Qurna.
The dervish lying on the ground is waiting for Sheikh ʿAbdallah to step on the sword which he holds on his belly.
29.3.1988

I should like to add a footnote on the *zar*, not only because this practice is sometimes, though wrongly, mentioned in the same breath as the zikr, but also because the saints play a certain role here.

It has been mentioned that both Muslims and Christians try to get rid of evil spirits (*'afarit*) through exorcism. There is another category of spirits, the 'zar spirits' (*sayyid*, pl. *asyad al-zar*) or 'kings' (*malik*, pl. *mulouk*) which are not exorcized. The zar ceremonies aim at cultivating a good relationship between a person and the zar spirit that is upon (*'ala*) him, or (more frequently) her. To this end, a sheikha who is specialized in this field first determines through the interpretation of the patient's dreams, who the spirit is and then placates it by offering it its favourite food (pigeons, chickens, rabbits and the like) at a 'big zar', a rather bloody affair that can last more than a day. After that, the person comes from time to time to a small zar, or *hadra*, to dance for the spirit to his special song.

The zar was introduced into Egypt and Arabia from Ethiopia, where it originated, passing through Sudan, and it is still very African both in much of its music and, presumably, in its philosophy; even though the belief in spirits is very widespread in Egypt, much wider than the zar itself, which seems to be on the decline.

In Cairo, zars for richer customers are held at private homes, and the poor go to more or less public ones, held on certain days of the week; for instance, on Monday evening at al-Hagga Anhar's house in the Darb al-Ahmar quarter and on Tuesday during the day near Abu Su'oud. They are mostly frequented by women, and even though some of the music is played by men, men are not always admitted.

I discovered the zar rather late in the day and never attended a big one. The hadras at Sheikha Anhar's were, however, interesting enough. They are held in a small concrete building, maybe 4 x 5 metres, and this cubicle is often so full that there is hardly a place left to dance. Visitors sit on the ground. They pay an entrance fee, and some extra money to have their own song played.

Anhar was born in Cairo and is about seventy years old. She learned the ritual from her mother, who came from Sudan. Anhar is assisted by her daughter Karima, who will take over in due time, and two other women. Together, they sing and play the songs for the spirits, accompanying themselves on big tambourines and darabukas in a syncopated rhythm, Anhar singing solo and the others repeating the chorus. For some songs, a small harp-like instrument, the *tamboura*, is added to the percussion instruments. The songs executed by the visiting troupe of 'Osman Abul Ghayt are in the Egyptian zikr-style.

At the hadra, each song lasts for about five minutes. The lady whose sayyid's song is played gets up and dances, sometimes helped by a professional male dancer, and quickly gets into a trance as the rhythm accelerates. At the end of the song she is exhausted and satisfied. Another song is played and another lady goes through the same motions.

Of the zar spirits there are several dozens. Littmann has published a list based on written material from 1911 and 1930, and Hagga Anhar confirmed most of the names. The Mamma family headed by Basha Mamma (a male spirit) is the most important.

Then there are several with names like al-'Arabi and al-Turki, and there is one jinn (a separate category of spirits) called the Sultan of the Red Jinn.

Then there is Yawra Bey, also present in the old lists, with his daughter Rukush. He is a refined and perfumed ladies' man, wearing a tarboush and elegantly smoking cigarettes. Yawra Bey possesses the more frivolous kinds of women, and is flattered and pampered in his song: 'Indulge yourself, Bey, you brown one, you beautiful one, play, Bey, you are the moon and the stars are around you, you with your eyes made up with kohl, O kohl-eyed one, Yawra Bey. Here is a beautiful (woman) for the Bey. If I said: "I love you, Yawra", what would happen?' Etc.

Then the music goes into a very fast rhythm and Hagga Anhar sings: 'Play, ladies, play all night long, play', but the song soon reaches its end and the dancers sit down again on the floor.

Outside the zar, Yawra's help is sometimes asked for on behalf of women who cannot find a husband.

The Muslim saints are often called upon to mediate between a person and his sayyid, and figure in a number of the songs. In the case of Christians, or of people possessed by a Christian sayyid, prophets are invoked, like Moses, Jacob and Jesus, including imaginary ones like Gimyan and Dimyan, probably corruptions of the holy Damiana who has her big moulid in the Delta.

‹ 98 Zar, or hadra. Hagga Anhar, in black, her daughter Karima, in pink, and other musicians beat an African rhythm for someone's sayyid, in order to restore harmony. The woman in green is one of Anhar's regular clients.

99 Woman in green being made to dance for her sayyid at a zar by Hagga Anhar's drums, helped by a professional dancer from Sudan with *shakhshakhas* in his hands, who wears a belt with hundreds of sheeps' hooves making a rhythmic rattling sound.

› 100 Musicians from Sudan playing the stringed *tamboura* and drums during a zar at Hagga Anhar's.

» 101 Returning from the moulid at Gabal al-Tayr. 28.5.1987

99

I had come as far as this when I was posted back to The Hague on July 1st, 1988. That was the end of a voyage of exploration which during the last one and a half years had taken all my spare time, and which all in all provided me with the greatest challenge of a by no means challenge-free period of more than four years in Egypt.

My departure at that stage meant that I missed out on the great moulid of Sultan Farghal at Abu Tig and its procession of numerous camels which, according to a local Christian source, causes something of a disturbance in front of the bishop's palace; the moulid of Muhammad al-'Iraqi at Mit al-Siba', where in another procession some of the dervishes pierce their cheeks with iron pins, as I had witnessed at a moulid in Qaransho in 1966; that of Sheikh Zahir, supposed to end with a procession consisting of tractors and carts, with the sheikh in the rear, on a white horse; the Christian moulid of St. George at Mit Damsis, where evil spirits are exorcized by specialized priests; and many others which I do not know and will never know about, either. I would have liked to continue my conversations with Sheikh Zahir and with other sheikhs I had recently met. On the other hand, I considered myself lucky not to have been transferred before, which might easily have happened.

I have often had the feeling that I had been born too late. I would have loved to tread the virgin bush in the nineteenth century or before, looking for whatever I was to find and which nobody had previously seen or described. There is still enough to be seen and enjoyed nowadays, but the bush has lost its virginity. So there is not much room any more for exploration in the usual sense; no new horizons are waiting to be discovered.

The surprise of Egypt was that within a ten minutes' walk, or at most a ten hours' drive from my home, there turned out to be scope for exploration in the vertical sense; in depth so to speak, even though that depth was not very great: I only had to scratch the surface to find a world which, God knows why, hardly anybody had bothered with during the last half-century. At first sight this looked like an incomprehensible and unpenetrable world, where poor people indulged in strange rituals and told one another tales that were even stranger. Gradually, however, I found great cordiality and openness, an impressive goodness, a rich tradition and an honest striving for the sublime. Both the sufis and the people around them proved to be hospitable and tolerant. I have never had to pose as a Muslim in order to be admitted anywhere. Taking photographs was hardly ever a problem. People were proud of their sheikhs and of themselves.

Having been part of the 'mawalidiya' for more than a year, I found it difficult to leave my dervish friends. Perhaps my book will inspire someone to continue an exploration for which there will be room for years to come. Moulids, popular mysticism and the veneration of saints are very much alive in Egypt, and a phenomenon which I feel will survive well into the modern age.

Amsterdam, January 1989

'Abd el-Malik, al-Hajj Ahmad.
Al-madrasa al-Radwaniya fi 'l-ahwal al-rabbaniya wa 'l-asrar el-ilahiya lilqutb al-'arif billah ta'ala al-Hajj Ahmad Radwan. Kom Ombo.

Anawati, G.-C., et Louis Gardet. *Mystique musulmane.* Paris, 1968.

Bieler, Ludwig. *Theios Aner, Das Bild des 'göttlichen Menschen' in Spätantike und Frühchristentum.* Wien, 1935-36; Darmstadt, 1967.

Bleeker, C.J. *Egyptian Festivals: Enactments in Religious Renewal.* Leiden, 1967.

Dale, M.W. (ed.). *Al Majdhubiyya and al Mikashfiyya: Two Sufi Tariqas in the Sudan.* Khartoum, 1985.

De Lacy O'Leary. *The Saints of Egypt.* London, New York, 1937; Amsterdam, 1974.

Dubler, Cesar E. 'Über Islamischen Grab- und Heiligenkult' in *Schweizerisches Archiv für Volkskunde.*

Ernst, Carl W. *Words of Ecstasy in Sufism.* State University of New York Press, Albany, 1985.

Gaborieau, Marc. 'Sous-continent Indien' in *Les Ordres mystiques dans l'Islam.* Paris, 1986.

Gilsenan, Michael. *Saint and Sufi in Modern Egypt.* Oxford, 1973.

Gramlich, Richard. *Die Wunder der Freunde Gottes.* Wiesbaden, 1987.

Jong, F. de. *Turuq and Turuq-linked Institutions in Nineteenth-Century Egypt.* Leiden, 1978.

Jong, F. de. 'Aspects of the Political Involvement of Sufi Orders in Twentieth-Century Egypt (1907-1970)' in *Islam, Nationalism and Radicalism in Egypt and the Sudan,* ed. by Warburg and Kupferschmidt.

New York, 1983.

Jong, F. de. 'Die mystischen Bruderschaften und der Volksislam' in *Der Islam in der Gegenwart.* Munich, 1984.

Jong, F. de. 'Cairene ziyara-days' in *Die Welt des Islams XVII* (1976-77).

Kriss, Rudolf, and Hubert Kriss-Heinrich. *Volksglaube im Bereich des Islam I und II.* Wiesbaden, 1960-62.

Lane, Edward W. *An Account of the Manners and Customs of the Modern Egyptians* (1st ed. 1836). New York, Dover, 1973.

Littmann, Enno. *Arabische Geisterbeschwörungen aus Egypten.* Leipzig, 1950.

McPherson, J.W. *The Moulids of Egypt (Egyptian Saints-Days).* Cairo, 1941.

Meinardus, Otto. *Monks and Monasteries of the Egyptian Deserts.* Cairo, 1962.

Nicholson, R.A. *The Tarjuman al-Ashwaq, a Collection of Mystical Odes.* London (Or. Trans. Fund.), 1911.

Nie, Giselle de. *Views from a Many-windowed Tower, Studies of Imagination in the Works of Gregory of Tours.* Amsterdam, 1987.

Radwan, al-Hajj Muhammad Ahmad. *Al-nafahat al-rabbaniya min ahadith wa-aqwal wa-tawjihat mawlana al-'arif billah al-Hajj Ahmad Muhammad Radwan. Kom Ombo, 1986.*

Ruthven, Malise. *Islam in the World.* Harmondsworth, 1984.

Sackville-West, V. *The Eagle and the Dove, a Study in Contrasts. St. Teresa of Avila – St. Thérèse of Lisieux.* London, 1943/1988.

Sauneron, Serge. *Villes et légendes d'Egypte.* Cairo, 1983.

Schimmel, Annemarie. *Mystical Dimensions of Islam.* University of North Carolina Press, 1975.

Shehata, Mahmoud Mustafa. *Ahammiyat al-dhikr 'anda 'l-sufiya,* 1987.

Shehata, Mahmoud Mustafa. *Iqamat al-mawalid wa mada shar'iyatiha min khilal al-kitab wa'l-sunna.* 1987

Smith, Margaret. *Readings from the Mystics of Islam.* London, 1950.

Sons of Pope Kyrillos VI. *The Miracles of Pope Kyrillos (Cyril) VI.* Part I. Cairo.

Trimingham, J. Spencer. *The Sufi Orders in Islam.* Oxford, 1971.

Vermeulen, J.E. 'Waar de God woont als hij niet thuis is' in *Feestbundel Heerma van Voss.* Amsterdam, 1988.

Viaud, Gérard. *Les Pèlerinages coptes en Egypte.* Cairo, 1979.

Since this book is not in the first place written for orientalists, I have tried to render the Arabic words optically in as simple a manner as possible, refraining from the use of ā , ī , ū, ḥ, ṣ, ṭ, ḍ and the like. The long stressed u is written ou.

To those who know Arabic, most words will be clear anyway, and those who do not will on the whole not be interested in the details of pronunciation. So d stands for d and ḍ, h for h and ḥ, s for s, ṣ and sometimes th, t for t, ṭ and sometimes th, z for z, ẓ and dh. A and i can be both long and short.

G stands for a sound which is pronounced like j in 'jam' in classical Arabic, but which most Egyptians pronounce like g in 'go'. The reader is free to read j for g and to pronounce e.g. gazb, Abu Haggag and Abu Tig as jazb (or jadhb), Abu Hajjaj and Abu Tij, in accordance with the classical or Upper Egyptian pronunciation.

Likewise, q will, depending on whether the speaker is a Cairene or an Upper Egyptian, be pronounced either as a glottal stop or as g in 'go'. The city of Qena is known in Cairo as Ena and as Gena in Qena.

Kh sounds like ch in German 'ach'.

In place names, personal names and familiar words, I have kept to the usual spelling as far as there is one, writing Selim, Esna, Luxor, Zagazig and sheikh where Arabists might prefer Salim, Isna, al-Uqsur, Zaqaziq and shaykh.

DUDEN-TASCHENBÜCHER

Herausgegeben vom Wissenschaftlichen Rat der Dudenredaktion: Dr. Günther Drosdowski · Professor Dr. Paul Grebe · Dr. Rudolf Köster · Dr. Wolfgang Müller

Band 1: Komma, Punkt und alle anderen Satzzeichen
Sie finden in diesem Taschenbuch Antwort auf alle Fragen, die im Bereich der deutschen Zeichensetzung auftreten können. 208 Seiten.

Band 2: Wie sagt man noch?
Hier ist der Ratgeber, wenn Ihnen gerade das passende Wort nicht einfällt oder wenn Sie sich im Ausdruck nicht wiederholen wollen. 224 Seiten.

Band 3: Die Regeln der deutschen Rechtschreibung
Dieses Buch stellt die Regeln zum richtigen Schreiben der Wörter und Namen sowie die Regeln zum richtigen Gebrauch der Satzzeichen dar. 232 Seiten.

Band 4: Lexikon der Vornamen
Mehr als 3 000 weibliche und männliche Vornamen enthält dieses Taschenbuch. Sie erfahren, aus welcher Sprache ein Name stammt, was er bedeutet und welche Persönlichkeiten ihn getragen haben. 237 Seiten.

Band 5: Satzanweisungen und Korrekturvorschriften
Dieses Taschenbuch enthält nicht nur die Vorschriften für den Schriftsatz und die üblichen Korrekturvorschriften, sondern auch Regeln für Spezialbereiche. 203 Seiten.

Band 6: Wann schreibt man groß, wann schreibt man klein?
In diesem Taschenbuch finden Sie in mehr als 7500 Artikeln Antwort auf die Frage „groß oder klein"? 256 Seiten.

Band 7: Wie schreibt man gutes Deutsch?
Dieses Duden-Taschenbuch enthält alle sprachlichen Erscheinungen, die für einen schlechten Stil charakteristisch sind und die man vermeiden kann, wenn man sich nur darum bemüht. 163 Seiten.

Band 8: Wie sagt man in Österreich?
Das Buch bringt eine Fülle an Informationen über alle sprachlichen Eigenheiten, durch die sich die deutsche Sprache in Österreich von dem in Deutschland üblichen Sprachgebrauch unterscheidet. 268 Seiten.

Band 9: Wie gebraucht man Fremdwörter richtig?
Mit 4 000 Stichwörtern und über 30 000 Anwendungsbeispielen ist dieses Taschenbuch eine praktische Stilfibel des Fremdwortes. 368 Seiten.

Band 10: Wie sagt der Arzt?
Dieses Buch unterrichtet Sie in knapper Form darüber, was der Arzt mit diesem oder jenem Ausdruck meint. 176 Seiten mit ca. 9 000 Stichwörtern.

Band 11: Wörterbuch der Abkürzungen
Berücksichtigt werden 35 000 Abkürzungen, Kurzformen und Zeichen aus allen Bereichen. 260 Seiten.

Band 13: mahlen oder malen?
Hier werden gleichklingende, aber verschieden geschriebene Wörter in Gruppen dargestellt und erläutert. 191 S.

Band 14: Fehlerfreies Deutsch
Viele Fragen zur Grammatik erübrigen sich, wenn man dieses Duden-Taschenbuch besitzt. Es macht grammatische Regeln verständlich und führt zum richtigen Sprachgebrauch. 200 Seiten.

Band 15: Wie sagt man anderswo?
Fleischer oder Metzger? fegen oder kehren? Dieses Buch will allen jenen helfen, die mit den landschaftlichen Unterschieden in Wort- und Sprachgebrauch konfrontiert werden. 159 Seiten.

Band 16: Wortschatz und Regeln des Sports – Ballspiele
Der erste Teil behandelt die Regeln der Sportarten. Der zweite Teil enthält ein Wörterbuch mit etwa 3 700 Stichwörtern, die sowohl aus dem Fachwortgut als auch aus dem Jargon stammen. 377 S.

Band 17: Leicht verwechselbare Wörter
Der Band enthält Gruppen von Wörtern, die auf Grund ihrer lautlichen Ähnlichkeit leicht verwechselt werden: z. B. vierwöchig und vierwöchentlich? real und reell? konvex und konkav? 334 Seiten.

Band 18: Wie schreibt man im Büro?
In fünf Kapiteln werden nützliche Ratschläge und Tips zur Erledigung der täglichen Büroarbeit gegeben. 270 Seiten mit Abbildungen.

Band 19: Wie diktiert man im Büro?
Alles Wesentliche über die Verfahren, Regeln und Techniken des Diktierens. 237 Seiten.

Bibliographisches I

Mannheim/Wien/Zü

DUDEN
Band 1

Der Duden in 10 Bänden
Das Standardwerk
zur deutschen Sprache

Herausgegeben vom Wissenschaftlichen Rat
der Dudenredaktion:
Dr. Günther Drosdowski, Prof. Dr. Paul Grebe,
Dr. Rudolf Köster, Dr. Wolfgang Müller

1. Rechtschreibung
2. Stilwörterbuch
3. Bildwörterbuch
4. Grammatik
5. Fremdwörterbuch
6. Aussprachewörterbuch
7. Etymologie
8. Sinn- und sachverwandte Wörter
9. Zweifelsfälle der deutschen Sprache
10. Bedeutungswörterbuch

DUDEN

Rechtschreibung

der deutschen Sprache und der
Fremdwörter

17., neu bearbeitete und erweiterte Auflage

Herausgegeben von der Dudenredaktion
Im Einvernehmen mit
dem Institut für deutsche Sprache

DUDEN BAND 1

Bibliographisches Institut Mannheim/Wien/Zürich
Dudenverlag

Redaktionelle Leitung: Rudolf Köster
Weitere Mitarbeiter:
Dieter Berger, Gerda Berger, Maria Dose,
Dieter Mang, Charlotte Schrupp

*Auskunft über rechtschreibliche, grammatische
und stilistische Zweifelsfälle erteilt unentgeltlich die
Sprachberatungsstelle der Dudenredaktion,
68 Mannheim 1, Postfach 311, Dudenstraße 6*

Antwort auf viele Fragen und Auskunft über Zweifelsfälle
finden Sie auch im Großen Duden,
Band 9, Zweifelsfälle der deutschen Sprache

Vorwort

Die schnelle Veränderung des allgemeinen und fachsprachlichen Wortschatzes in der heutigen Zeit machte es notwendig, wieder eine Neuauflage der Duden-Rechtschreibung vorzulegen. Die redaktionelle Arbeit war deshalb besonders der Erweiterung gewidmet. Die Anwendung des Lichtsatzes bei der Herstellung des Buches erlaubte uns, etwa 10000 Wörter mehr aufzunehmen und trotzdem den alten Umfang beizubehalten, so daß der Duden weiterhin ein handliches Nachschlagewerk bleibt. Neu aufgenommen wurden Wörter aus allen Bereichen unseres Lebens, vor allem aus Politik, Wirtschaft, Verkehr, Technik und Sport, z. B. Basisgruppe, hinterfragen, Trimm-dich-Pfad, überfischen, Kriechspur, Nulltarif. Einen breiteren Raum nehmen auch die Fremdwörter aus dem Englisch-Amerikanischen ein wie Curriculum, Floating, Innovation und viele andere, denen man in Zeitung, Rundfunk und Fernsehen täglich begegnet. Dem immer stärkeren Eindringen der Umgangssprache in die Schriftsprache haben wir Rechnung getragen, indem wir umgangssprachliches und regionales Wortgut in größerem Umfang aufnahmen. Als Beispiele seien aufmüpfig, kungeln und Remmidemmi genannt. Vermehrt wurde auch der spezifische Wortschatz der DDR, Österreichs und der Schweiz. Unser besonderer Dank gilt hier den Herren Dr. Jakob Ebner, Linz, und Dr. Kurt Meyer, Zürich, die uns immer wieder mit ihrem Rat zur Seite standen.
An den Regeln unserer Rechtschreibung hat sich nichts geändert, da alle Bemühungen um eine Rechtschreibreform bisher ohne Ergebnis geblieben sind.
Bisher im Duden nicht behandelte Zweifelsfälle der Rechtschreibung wurden im Sinne der letzten Rechtschreibreform von 1901 geklärt. Wir verdanken die Hinweise darauf der Arbeit unserer Sprachberatungsstelle, die alle bei ihr eingehenden Anfragen erfaßt und für eine Neuauflage der Duden-Rechtschreibung auswertet.
Die Schreibweisen des „Ökumenischen Verzeichnisses der biblischen Eigennamen nach den Loccumer Richtlinien" haben wir als Nebenformen in das Wörterverzeichnis aufgenommen. Dieses Verzeichnis wurde von den deutschen Bischöfen, dem Rat der Evangelischen Kirche in Deutschland und dem Evangelischen Bibelwerk nach den Weisungen der Ökumenischen Übersetzerkommission herausgegeben. Um Neuem, Wichtigerem Raum zu geben, wurden gänzlich veraltete Wörter entfernt, auch veraltete Fachwörter aus den Anfängen einzelner Wissenschaftsgebiete. Wir bemühten uns

darüber hinaus verstärkt um die Bezeichnung der stilistischen Bewertungen sowie um die Kennzeichnung des sonder- und fachsprachlichen Wortgutes.

Die grammatischen Angaben bei Substantiven, Adjektiven und Verben (z. B. Genus, Flexion, Steigerung) wurden überall in Übereinstimmung mit der neuesten Entwicklung gebracht, ebenso die zahlreichen Aussprachebezeichnungen.

Auch diese Neubearbeitung wurde im Einvernehmen mit dem Institut für deutsche Sprache durchgeführt. Allen Mitgliedern der Kommission für Rechtschreibfragen möchten wir an dieser Stelle herzlich danken.

In letzter Zeit ist verschiedentlich die Forderung erhoben worden, auf Normen in der geschriebenen Sprache weitgehend zu verzichten. Ihre Erfüllung wäre ohne Zweifel ein Irrweg. Wie der heutige Verkehr nur noch mit Hilfe bestimmter, von allen Verkehrsteilnehmern anerkannter Regeln bewältigt werden kann, so ist es auch in einem kulturell und technisch hochentwickelten Land völlig undenkbar, ohne Normen in der geschriebenen und gesprochenen Sprache auszukommen. Wer allerdings Bildung oder Intelligenz mit vollkommener Beherrschung von Rechtschreibregeln gleichsetzt, ist ebenso im Unrecht. Entscheidend bleibt also die Bewertung: Lehrende wie Lernende sollten hier zu einer aufgeschlosseneren Einschätzung gelangen, die Überbewertung von Rechtschreibfehlern abbauen und das Werkzeug Rechtschreibung als das betrachten, was es ausschließlich sein soll: als ein geeignetes Mittel zur Erleichterung der schriftlichen Kommunikation. Daß dieses Instrumentarium von Zeit zu Zeit der Verbesserung bedarf, davon ist die Dudenredaktion stets überzeugt gewesen. Ihr wird zu Unrecht gelegentlich vorgeworfen, sie regele die Rechtschreibung willkürlich und blockiere jede Reform. Dazu wäre zu sagen, daß die heute geltenden Regeln der Rechtschreibung nicht vom Duden, sondern von einer staatlichen Rechtschreibkonferenz festgelegt worden sind. Der Duden wendet diese Regeln seit über siebzig Jahren sinngemäß auf alle neuen Wörter und Wendungen an, die die fortschreitende Entwicklung hervorbringt, er ermittelt die Schreibung, die der amtlich aufgestellten Norm entspricht. Die Dudenredaktion ist sich der großen Verantwortung, die der Duden für die Einheit der deutschen Rechtschreibung trägt, bewußt. Diese Einheit muß unter allen Umständen bewahrt bleiben, um die ungestörte Kommunikation nicht zu gefährden.

Mannheim im April 1973 Die Dudenredaktion

Inhaltsverzeichnis

Zur Einrichtung des Wörterverzeichnisses

I. Zeichen von besonderer Bedeutung

. Untergesetzter Punkt kennzeichnet die kurze betonte Silbe, z. B.
Referent.

_ Untergesetzter Strich kennzeichnet die lange betonte Silbe, z. B.
Fassade (vgl. S. 13, VI).

| Der senkrechte Strich dient zur Angabe der Silbentrennung, z. B.
Mi|kro|be, dar|auf.

⋮ Die senkrechte punktierte Linie dient zur Angabe der Nottrennung, z. B. Nati|on (↑ R 176).

Ⓦ Als Warenzeichen geschützte Wörter sind durch das Zeichen Ⓦ
kenntlich gemacht. Etwaiges Fehlen dieses Zeichens bietet keine Gewähr dafür, daß es sich hier um ein Freiwort handelt, das von jedermann benutzt werden darf.

- Der waagerechte Strich vertritt das Stichwort buchstäblich, z. B.
ab; - und zu; oder: Brett *s*; -[e]s, -er; oder: Allerlei *s*; -s, -s; Leipziger -.

... Drei Punkte stehen bei Auslassung von Teilen eines Wortes, z. B.
Buntdruck (*Mehrz.* ...drucke); oder: Streß *m*; ...sses, ...sse. Über
die Punkte bei Aussprachebezeichnungen vgl. S. 13, VI.

‿ Der Bogen steht innerhalb einer Ableitung oder Zusammensetzung,
um anzuzeigen, daß der vor ihm stehende Wortteil bei den folgenden
Wörtern an Stelle der drei Punkte zu setzen ist, z. B. Augen‿braue,
...diagnose.

[] Die eckigen Klammern schließen Aussprachebezeichnungen (vgl.
S. 13, VI), zusätzliche Trennungsangaben (z. B. Ecke [*Trenn.*:
Ek|ke]), Zusätze zu Erklärungen in runden Klammern (vgl. S. 13, V)
und beliebige Auslassungen (Buchstaben und Silben, wie z. B. in abschnitt[s]weise, Wißbegier[de]) ein.

() Die runden Klammern schließen Erklärungen, Verdeutschungen
(vgl. S. 13, V) und Hinweise zum heutigen Sprachgebrauch ein, z. B.
ausglühen (z. B. einen Draht). Sie enthalten außerdem grammatische
Angaben bei Ableitungen und Zusammensetzungen innerhalb von
Wortgruppen, z. B. Außen‿alster, ...aufnahme (meist *Mehrz.*).

R Die Abschnitte der Vorbemerkungen sind zur besseren Übersicht mit
Randzahlen versehen, auf die mit einem Pfeil verwiesen wird, z. B.
↑ R 121.

II. Auswahl der Stichwörter

Der Duden ist kein vollständiges deutsches Wörterbuch. Das Wörterverzeichnis enthält Erbwörter, Lehnwörter, Fremdwörter[1] und aus nichtdeutschen Sprachen unverändert übernommene Wörter (fremde Wörter)

[1] Wer in diesem Band ein Fremdwort vermißt oder wer sich ausführlich über die Bedeutung eines Fremdwortes unterrichten will, schlage im Duden-Fremdwörterbuch nach.

der Hochsprache und der Umgangssprache, seltener der Mundarten. Es erfaßt auch Wörter aus Fachsprachen, z. B. der Mathematik, Medizin, Chemie und Physik. Für die Auswahl waren hauptsächlich rechtschreibliche und grammatische Gründe maßgebend. Aus dem Fehlen eines Wortes darf also nicht geschlossen werden, daß es ungebräuchlich oder nicht korrekt ist.

Über den Grundwortschatz hinaus konnten von den Ableitungen, den Zusammensetzungen (Komposita) und den Wörtern mit Vorsilbe außer den sehr gebräuchlichen nur folgende aufgenommen werden:

a) von den Zeitwörtern:

1. diejenigen, deren zweiter Bestandteil als selbständiges Zeitwort nicht mehr vorkommt oder selten ist.

Beispiele: abstatten, ablisten, entbehren.

2. diejenigen, deren Bedeutung vom Grundzeitwort stark abweicht.

Beispiele: ausrasten, vorziehen, erfahren.

3. diejenigen, die gleich oder ähnlich lauten.

Beispiele: abblasen, abblassen und ablassen.

4. diejenigen, bei denen über Betonung, getrennte Schreibung usw. etwas Besonderes zu bemerken ist (↑ R 304).

Beispiele: dụrchkreuzen, dụrchgekreuzt (kreuzweise durchstreichen); aber: durchkreụzen, durchkreụzt (zunichte machen).

b) von den Hauptwörtern nur diejenigen, die besonders gebräuchlich sind oder als Beispiele für die Art der Bildung dienen, z. B. für den Gebrauch des Fugen-s (↑ R 332 ff.) oder für die Auslassung des e (↑ R 328).

Beispiele: Hofanlage, aber: Friedhofskapelle; Abriegelung, Abrieglung.

c) von den Verkleinerungsformen auf **-chen** oder **-lein** nur diejenigen, deren Stammwort sich verändert oder von denen es verschiedene Formen gibt.

Beispiele: Hut, Hütchen, Hütlein; Kind, Kindchen s; -s, - u. Kinderchen; Kindlein s; -s, - u. Kinderlein.

III. Anordnung und Behandlung der Stichwörter

1. Allgemeines

a) Die Stichwörter sind **halbfett** gedruckt.

b) Die Anordnung der Stichwörter ist abecelich.

Die Umlaute ä, ö, ü, äu werden wie die nichtumgelauteten Selbstlaute a, o, u, au behandelt. Die Schreibungen ae, oe, ue (in Namen) werden nach ad usw. eingeordnet. Der Buchstabe ß (vgl. S. 81 ff.) wird wie ss, bei gleichlautenden Wörtern vor ss eingeordnet.

Beispiele: Harke God[e]l Faß Neinsager
 Härlein Goedeke Fassade Neiße
 Harlekin Goethe faßbar Neisse
 Harm Gof Faßbinder Nekrobiose

c) Manche Stichwörter sind in Wortgruppen, die denselben Wortstamm haben, zusammengefaßt. Gelegentlich sind jedoch längere Wortgruppen der Übersichtlichkeit wegen in kleinere zerlegt.

d) Gleichlautende Stichwörter werden durch hochgestellte Zahlen unterschieden.

Beispiel: [1]Elf (Naturgeist); [2]Elf (Fluß); [3]Elf (Zahl).

2. Zeitwörter (Verben)

a) Bei den schwachen Zeitwörtern werden im allgemeinen keine Formen angegeben, da sie regelmäßig in der ersten Vergangenheit (Präteritum) auf -te und im 2. Mittelwort (Partizip Perfekt) auf -t ausgehen. Bei den starken und unregelmäßigen Zeitwörtern (↑ R 300 u. R 303) werden im allgemeinen folgende Formen angegeben: die 2. Person der Einzahl der Wirklichkeitsform in der ersten Vergangenheit (Indikativ des Präteritums), die umgelautete 2. Person der Einzahl der Möglichkeitsform in der ersten Vergangenheit (Konjunktiv des Präteritums), das 2. Mittelwort (Partizip Perfekt), die Einzahl der Befehlsform (Imperativ). Andere Besonderheiten werden nach Bedarf angegeben.

> Beispiele: biegen; du bogst; du bögest; gebogen; bieg[e]!; (andere Besonderheiten:) schreien; du schriest; du schrieest (Möglichkeitsform in der 1. Vergangenheit); rasen; du rast, er ra|st (Silbentrennung).

Bei Zeitwörtern, deren Stammvokal e (ä, ö) zu i wechselt, und bei Zeitwörtern, die Umlaut haben, werden ferner angegeben: 2. und 3. Person der Einzahl der Wirklichkeitsform der Gegenwart (Indikativ des Präsens).

> Beispiele: (e/i-Wechsel:) geben; du gibst, er gibt; du gabst; du gäbest; gegeben; gib!; (mit Umlaut:) fallen; du fällst; er fällt; du fielst; du fielest; gefallen; fall[e]!

Bei zusammengesetzten oder mit einer Vorsilbe gebildeten Zeitwörtern werden die obengenannten Formen nicht besonders aufgeführt. Alle grammatischen Hinweise sind also beim einfachen Zeitwort nachzuschlagen.

> Beispiele: vorziehen bei ziehen; behandeln bei handeln; abgrenzen bei grenzen.

b) Bei den Zeitwörtern, deren Stamm mit einem Zischlaut endet (s, ß, sch, z, tz), wird die 2. Person der Einzahl der Wirklichkeitsform der Gegenwart (Indikativ des Präsens) angegeben, weil -e oder -es der Endung gewöhnlich ausfällt.

> Beispiele: zischen; du zischst (zischest); lesen; du liest (liesest); sitzen; du sitzt (sitzest).

Bei den starken Zeitwörtern, deren Stamm mit -ß endet, steht wegen des Wechsels von ss und ß zusätzlich die 1. Person der Einzahl der Wirklichkeitsform der ersten Vergangenheit (Indikativ des Präteritums).

> Beispiel: beißen; du beißt (beißest); ich biß; du bissest.

3. Hauptwörter (Substantive)

a) Bei einfachen Hauptwörtern sind mit Ausnahme der Fälle unter b das Geschlecht (m = männlich [der], w = weiblich [die], s = sächlich [das]), der Wesfall der Einzahl (Genitiv des Singulars) und, soweit gebräuchlich, der Werfall der Mehrzahl (Nominativ des Plurals) angeführt.

> Beispiel: Knabe m; -n, -n (das bedeutet: der Knabe, des Knaben, die Knaben).

Hauptwörter, die nur in der Mehrzahl (Plural) vorkommen, werden durch ein nachgestelltes *Mehrz.* gekennzeichnet.

> Beispiel: Immobilien (Grundstücke, Grundbesitz) *Mehrz.*

b) Die Angabe des Geschlechts und der Beugung **fehlt** meistens bei abgeleiteten Hauptwörtern, die mit folgenden Silben gebildet sind:

1. **deutsche** Ableitungssilben:

-chen:	Mädchen	s; -s, -
-lein:	Brüderlein	s; -s, -
-ei:	Bäckerei	w; -, -en

-er:	Lehrer	*m*; -s, -
	Physiker	
-heit:	Keckheit	*w*; -, -en
-keit:	Ähnlichkeit	*w*; -, -en
-ling:	Jüngling	*m*; -s, -e
-schaft:	Landschaft	*w*; -, -en
-tum:	Besitztum	*s*; -s, ...tümer
-ung:	Prüfung	*w*; -. -en

2. fremdsprachige Ableitungssilben:

-ade:	Fassade	*w*; -, -n
-age:	Etage	*w*; -, -n
-ent:	Referent	*m*; -en, -en
-ion:	Reduktion	*w*; -, -en
-ist:	Pianist	*m*; -en, -en
-[i]tät:	Nationalität	*w*; -, -en

Ausnahmen: Bei Ableitungen, die in Geschlecht und Beugung von diesen Beispielen abweichen, sind die grammatischen Angaben hinzugefügt, z. B. bei all denen, die keine Mehrzahl bilden, wie: Besorgtheit *w*; -. Christentum *s*; -s.

c) Bei zusammengesetzten Hauptwörtern und bei Hauptwörtern, die von zusammengesetzten Zeitwörtern oder von solchen mit Vorsilbe abgeleitet sind, fehlen im allgemeinen Geschlecht und Beugungsendungen. In diesen Fällen ist beim Grundwort oder bei dem vom einfachen Zeitwort abgeleiteten Hauptwort nachzusehen.

Beispiele: Eisenbahn bei Bahn; Fruchtsaft bei Saft; Abschuß (Ableitung von abschießen) und Beschuß (Ableitung von beschießen) bei Schuß (Ableitung von schießen).

Geschlecht und Endung werden nur dann angegeben, wenn sie sich von denen des Grundwortes unterscheiden, wenn von zwei Bildungsmöglichkeiten nur eine zutrifft oder wenn keine augenfällige (inhaltliche) Verbindung zwischen den vom einfachen und vom nichteinfachen Zeitwort abgeleiteten Hauptwörtern besteht.

Beispiele: Stand *m*; -[e]s. Stände; aber: Besitzstand *m*; -[e]s (keine Mehrzahl); Block *m*; -[e]s, Blöcke u. (für: Abreiß-, Häuserblocks u.a.:) -s; aber: Holzblock (*Mehrz.* ...blöcke); Teil *m* od. *s*; aber: Vorteil *m*; Sage *w*; -, -n; aber auch: Absage *w*; -, -n.

4. Eigenschaftswörter (Adjektive)

Bei Eigenschaftswörtern sind Abweichungen und Schwankungen in der Bildung der Steigerungsformen, besonders hinsichtlich des Umlautes, vermerkt.

Beispiele: alt, älter, älteste; glatt, glatter (auch: glätter), glatteste (auch: glätteste).

IV. Herkunft der Wörter

Die Herkunft der Stichwörter ist durch *Kursivschrift* in knapper Form kenntlich gemacht.

Durch den Bindestrich zwischen den Herkunftsangaben wird gezeigt, daß das Wort über die angegebenen Sprachen zu uns gekommen ist.

Beispiel: Bombast *pers.-engl.*

Steht dabei eine Sprachbezeichnung in runden Klammern, so heißt das, daß auch diese Sprache die gebende Sprache gewesen sein kann.

Beispiel: Bronze *it.(-fr.)*

Durch den Strichpunkt zwischen den Herkunftsangaben wird deutlich gemacht, daß es sich um eine Zusammensetzung aus Wortteilen der angegebenen Sprachen handelt.

Beispiel: bipolar *lat.; gr.*

Steht an Stelle der Sprachangabe nach dem Strichpunkt ein Strich, dann heißt das, daß es sich bei dem Grundwort der Zusammensetzung entweder um ein deutsches Wort (auch Lehnwort) handelt oder um ein Fremdwort, für das bereits an entsprechender Stelle die Sprache angegeben worden ist.

Beispiel: Basketball *engl.; -.*

V. Erklärungen und Verdeutschungen

Der Duden ist kein Bedeutungswörterbuch. Er enthält daher keine ausführlichen Bedeutungsangaben. Nur wo es für das Verständnis eines Wortes erforderlich ist, werden kurze Hinweise zur Bedeutung gegeben.

Eine Erklärung zum Stichwort ist in runde Klammern gesetzt. Beispiele und Erläuterungen, die nicht notwendig zu den Erklärungen gehören, stehen innerhalb der runden Klammern in eckigen Klammern.

Beispiel: Amputation *lat.* ([Glied]abtrennung).

Die wörtliche Bedeutung eines Wortes ist in Anführungszeichen an den Anfang einer Erklärung gesetzt.

Beispiel: Abaton *gr.* (Rel.: „das Unbetretbare"; das [abgeschlossene] Allerheiligste, der Altarraum in den Kirchen des orthodoxen Ritus) *s*; -s, ...ta.

VI. Aussprache

1. Aussprachebezeichnungen stehen hinter Fremdwörtern und einigen deutschen Wörtern, deren Aussprache von der sonst üblichen abweicht. Die im Duden verwendete besondere Lautschrift (phonetische Schrift) ergänzt das lateinische Alphabet:

å ist das dem *o* genäherte *a*, z. B. Alderman [*ǻld^erm^en*]
ch ist der am Vordergaumen erzeugte Ich-Laut (Palatal), z. B. Jerez [*ch̯eräß*]
ch ist der am Hintergaumen erzeugte Ach-Laut (Velar), z. B. autochthon [*...ehton̯*]
^e ist das schwache *e*, z. B. Blamage [*...maseh^e*]
ng bedeutet, daß der Vokal davor durch die Nase (nasal) gesprochen wird, z. B. Arrondissement [*arongdiß^emang*]
^r ist das nur angedeutete *r*, z. B. Girl [*gö^rl*]
ⁱ ist das nur angedeutete *i*, z. B. Lady [*leⁱdi*]
s ist das stimmhafte (weiche) *s*, z. B. Diseuse [*disös^e*]
ß ist das stimmlose (harte) *s*, z. B. Malice [*...liß^e*]
sch ist das stimmhafte (weiche) *sch*, z. B. Genie [*sehe...*]
th ist der mit der Zungenspitze hinter den oberen Vorderzähnen erzeugte stimmlose Reibelaut, z. B. Commonwealth [*kom^en^eälth*]
dh ist der mit der Zungenspitze hinter den oberen Vorderzähnen erzeugte stimmhafte Reibelaut, z. B. Rutherford [*radh^erf^erd*]
^u ist das nur angedeutete *u*, z. B. Paraguay [*...g^uai*]

Die Lautschrift steht hinter dem Stichwort in eckigen Klammern. Vorangehende oder nachgestellte Punkte (...) zeigen an, daß der erste oder letzte Teil des Wortes wie im Deutschen ausgesprochen wird.

Beispiele: Abonnement *fr.* [*abon^(e)mang*, schweiz. auch: *...mänt*]

2. Ein unter den Selbstlaut (Vokal) gesetzter Punkt gibt betonte Kürze an, ein Strich betonte Länge (vgl. Zeichen von besonderer Bedeutung S. 9, I).

Beispiele: Aigrette [*ägrät^e*]; Plateau [*...to̱*].

Sollen bei schwieriger auszusprechenden Fremdwörtern zusätzlich unbetonte Längen gekennzeichnet werden, dann wird die Betonung durch einen Akzent angegeben.

Beispiele: Beefsteak [*bíßtek*]; Algier [*álsehir*]; Bulldozer [*búldos'r*].

Die schweizerische Aussprache französischer Wörter und Namen wird durch zwei Betonungszeichen ohne Akzentzeichen angegeben.

Beispiele: Jupon [*sehüpong*]; Dunant [*dünang*].

VII. Im Wörterverzeichnis verwendete Abkürzungen

Die nachstehenden Abkürzungen sind nicht mit den sonst üblichen Abkürzungen (z. B. ADAC = Allgemeiner Deutscher Automobil-Club) zu verwechseln, die an den entsprechenden Stellen im Wörterverzeichnis stehen. Abkürzungen, bei denen nur die Nachsilbe -isch zu ergänzen ist, sind nicht aufgeführt, z. B. ägypt. = ägyptisch. Die Nachsilbe -lich wird ...l. abgekürzt, z. B. ähnl. = ähnlich.

Abk.	Abkürzung	Eigenschaftsw.	Eigenschaftswort (Adjektiv)
afrik.	afrikanisch		
allg.	allgemein	eigtl.	eigentlich
altd.	altdeutsch	Einz.	Einzahl (Singular)
altgr.	altgriechisch	Eisenbahnw.	Eisenbahnwesen
alttest.	alttestamentlich	eskim.	eskimoisch
amerik.	amerikanisch	ev.	evangelisch
Amtsdt.	Amtsdeutsch		
Amtsspr.	Amtssprache	fachspr.	fachsprachlich
angels.	angelsächsisch	fam.	familiär
Anm.	Anmerkung	Familienn.	Familienname
Anthropol.	Anthropologie	Finanzw.	Finanzwesen
aram.	aramäisch	Fliegerspr.	Fliegersprache
argent.	argentinisch	Flugw.	Flugwesen
astron.	astronomisch	Forstw.	Forstwirtschaft
Astron.	Astronomie	fotogr.	fotografisch
Ausspr.	Aussprache	Fotogr.	Fotografie
austr.	australisch	fr.	französisch
		Fürw.	Fürwort (Pronomen)
Bankw.	Bankwesen		
Bauw.	Bauwesen	Gastr.	Gastronomie
Bergmannsspr.	Bergmannssprache	Gaunerspr.	Gaunersprache
bes.	besonders	gebr.	gebräuchlich
Bez.	Bezeichnung	Gegenw.	Gegenwart (Präsens)
bild. Kunst	bildende Kunst	geh.	gehoben
Bindew.	Bindewort (Konjunktion)	Geldw.	Geldwesen
Biol.	Biologie	Geogr.	Geographie
Bot.	Botanik	Geol.	Geologie
bras.	brasil[ian]isch	germ.	germanisch
bret.	bretonisch	Ges.	Gesellschaft
Buchw.	Buchwesen	Ggs.	Gegensatz
byzant.	byzantinisch	gr.	griechisch
chald.	chaldäisch	Handw.	Handwerk
chin.	chinesisch	Hauptw.	Hauptwort (Substantiv)
		hebr.	hebräisch
dicht.	dichterisch	hist.	historisch
Druckerspr.	Druckersprache	hochd.	hochdeutsch
Druckw.	Druckwesen	Hptst.	Hauptstadt
dt.	deutsch	Hüttenw.	Hüttenwesen
ehem.	ehemals, ehemalig	idg.	indogermanisch
Eigenn.	Eigenname	it.	italienisch

Jägerspr.	Jägersprache
jap.	japanisch
jav.	javanisch
Jh.	Jahrhundert
jmd.	jemand
jmdm.	jemandem
jmdn.	jemanden
jmds.	jemandes
kalm.	kalmückisch
kath.	katholisch
Kaufmannsspr.	Kaufmannssprache
Kinderspr.	Kindersprache
Kunstwiss.	Kunstwissenschaft
Kurzw.	Kurzwort
l.	linker, linke, linkes
landsch.	landschaftlich
landw.	landwirtschaftlich
Landw.	Landwirtschaft
langob.	langobardisch
lat.	lateinisch
latinis.	latinisiert
lit.	litauisch
luxemb.	luxemburgisch
m	Wort männlichen Geschlechts (Maskulinum)
m.	männlich
Math.	Mathematik
mdal.	mundartlich
Mech.	Mechanik
med.	medizinisch
Med.	Medizin
Mehrz.	Mehrzahl (Plural)
Meteor.	Meteorologie
mexik.	mexikanisch
mgr.	mittelgriechisch
milit.	militärisch
mitteld.	mitteldeutsch
Mittelw.	Mittelwort (Partizip)
mlat.	mittellateinisch
mong.	mongolisch
Mythol.	Mythologie
nationalsoz.	nationalsozialistisch
neutest.	neutestamentlich
ngr.	neugriechisch
niederd.	niederdeutsch
niederl.	niederländisch
nlat.	neulateinisch
nordamerik.	nordamerikanisch
nordd.	norddeutsch
nordgerm.	nordgermanisch
norw.	norwegisch
od.	oder
offz.	offiziell
ökum.	ökumenisch (Ökumenisches Verzeichnis der biblischen Eigennamen nach den Loccumer Richtlinien. Stuttgart 1971)
Ortsn.	Ortsname
ostd.	ostdeutsch

ostmitteld.	ostmitteldeutsch
ostpr.	ostpreußisch
österr.	österreichisch
Päd.	Pädagogik
palästin.	palästinensisch
Papierdt.	Papierdeutsch
pharm.	pharmazeutisch
Pharm.	Pharmazie
philos.	philosophisch
Philos.	Philosophie
Physiol.	Physiologie
Polizeiw.	Polizeiwesen
port.	portugiesisch
Postw.	Postwesen
Psych.	Psychologie
R	Randzahl
r.	rechter, rechte, rechtes
Rechtsspr.	Rechtssprache
Rechtsw.	Rechtswissenschaft
Rel.	Religion[swissenschaft]
Rhet.	Rhetorik
s	Wort sächlichen Geschlechts (Neutrum)
s.	sächlich
sanskr.	sanskritisch
scherzh.	scherzhaft
Schülerspr.	Schülersprache
schweiz.	schweizerisch
Seemannsspr.	Seemannssprache
Seew.	Seewesen
singhal.	singhalesisch
skand.	skandinavisch
Soldatenspr.	Soldatensprache
Sportspr.	Sportsprache
Sprachw.	Sprachwissenschaft
Stilk.	Stilkunde
Studentenspr.	Studentensprache
südd.	süddeutsch
südwestd.	südwestdeutsch
svw.	soviel wie
Theol.	Theologie
Trenn.	Trennung
turkotat.	turkotatarisch
u.	und
u. a.	und andere
u. ä.	und ähnliches
übertr.	übertragen
ugs.	umgangssprachlich
Umstandsw.	Umstandswort (Adverb)
ung.	ungarisch
urspr.	ursprünglich
veralt.	veraltet
Verhältnisw.	Verhältniswort (Präposition)
Verkehrsw.	Verkehrswesen
Verlagsw.	Verlagswesen
Versicherungsw.	Versicherungswesen
Versl.	Verslehre

vgl. [d.]	vergleiche [dies]	Wenf.	Wenfall (Akkusativ)
Völkerk.	Völkerkunde	Werf.	Werfall (Nominativ)
volksm.	volksmäßig	Wesf.	Wesfall (Genitiv)
Vorn.	Vorname	Wirtsch.	Wirtschaft

w	Wort weiblichen Geschlechts (Femininum)	Zahnmed.	Zahnmedizin
		Zeitungsw.	Zeitungswesen
w.	weiblich	Zeitw.	Zeitwort (Verb)
Wappenk.	Wappenkunde	Zollw.	Zollwesen
Weidw.	Weidwerk	Zool.	Zoologie
Wemf.	Wemfall (Dativ)	Zus.	Zusammensetzung

Vorbemerkungen

(Beachte das Register zu den Vorbemerkungen auf S. 97)

Zeichensetzung (Interpunktion)

Die gesprochene Sprache ist der geschriebenen darin überlegen, daß sie durch Betonung, Satzmelodie, Rhythmus und Tempo gliedern kann. Die geschriebene Sprache gliedert durch Satzzeichen, ohne jene Vorzüge der gesprochenen Sprache zu erreichen. Der Schreibende muß deshalb über unsere im folgenden gegebenen Richtlinien hinaus eine gewisse Freiheit in der Zeichensetzung haben.

I. Punkt

1. Nach Sätzen

a) *Aussagesätze*

Der Punkt steht nach dem Aussagesatz. Er drückt eine längere Pause **R 1** aus und deutet als Satzzeichen im allgemeinen zugleich eine Senkung der Stimme an.

> Beispiele: Es wird Frühling. Wir freuen uns.

Merke: Der Punkt steht nicht, wenn der Aussagesatz als Satzglied oder Beifügung steht.

> Beispiele: „Aller Anfang ist schwer" ist ein erbaulicher Spruch. Der Spruch „Eigener Herd ist Goldes wert" bewahrheitet sich immer.

b) *Frage-, Ausrufe-, Wunsch- und Befehlssätze*

1. Der Punkt steht nach indirekten Fragesätzen und nach abhängigen **R 2** Ausrufe-, Wunsch- und Befehlssätzen.

> Beispiele: Er fragte ihn, wann er kommen wolle. Er rief ihm zu, er solle sich nicht fürchten. Er wünschte, alles wäre vorbei. Er befahl ihm, sofort zu gehen.

2. Der Punkt steht an Stelle des Ausrufezeichens nach Wunsch- und Be- **R 3** fehlssätzen, die ohne Nachdruck gesprochen werden.

> Beispiele: Bitte geben Sie mir das Buch. Vgl. Seite 25 seiner letzten Veröffentlichung.

2. Nach Ordnungszahlen

Der Punkt steht nach Zahlen, um sie als Ordnungszahlen (erster, zweiter, **R 4** dritter usw.) zu kennzeichnen.

> Beispiele: Sonntag, den 15. April; Friedrich II., König von Preußen.

Zum Punkt bei anderen Zahlen ↑ R 230ff.

Merke: Steht eine Ordnungszahl am Satzende, so wird kein besonderer Satzschlußpunkt gesetzt.

> Beispiel: Katharina von Aragonien war die erste Frau Heinrichs VIII.

3. Nach Abkürzungen

a) *Der Punkt steht*

nach Abkürzungen, die im vollen Wortlaut gesprochen werden. **R 5**

> Beispiele: z.B. (gesprochen: *zum Beispiel*), usw. (gesprochen: *und so weiter*), Weißenburg i. Bay. (gesprochen: *Weißenburg in Bayern*).

Das gilt auch für die Abkürzungen von Zahlwörtern und für fremdsprachige Abkürzungen in deutschem Text.

Beispiele: Tsd. (für: Tausend); Mio. (für: Million); Mrd. (für: Milliarde); Mr. Smith (für: Mister Smith).

Merke: Der Punkt steht auch nach einigen Abkürzungen, die heute gewöhnlich – vor allem in der Alltagssprache – nicht mehr im vollen Wortlaut gesprochen werden.

Beispiele: a.D. (für: außer Dienst), i.V. (für: in Vertretung), ppa. (für: per procura).

Die Abkürzung Co., die heute in der Alltagssprache [ko̩] ausgesprochen wird, kann je nach der Schreibung des Firmennamens mit oder ohne Punkt stehen.

b) *Der Punkt steht nicht*

R 6 1. nach Abkürzungen, die als selbständige Wörter gesprochen werden.

Beispiele: BGB (gesprochen: *begebe̩*, für: Bürgerliches Gesetzbuch); KG (gesprochen: *kage̩*, für: Kommanditgesellschaft).

2. nach Abkürzungen der Maße, Gewichte und Himmelsrichtungen, der meisten Münzbezeichnungen und der chemischen Grundstoffe.

Beispiele: m (für: Meter), g (für: Gramm), NO (für: Nordost[en]), DM (für: Deutsche Mark), Na (für: Natrium). Aber bei herkömmlichen Einheiten: Pfd. (für: Pfund); Ztr. (für: Zentner).

Bei ausländischen Maß- und Münzbezeichnungen wird im Deutschen gewöhnlich die landesübliche Schreibung der Abkürzungen gebraucht.

Beispiele: ft (für: Foot); yd. (für: Yard); L (für: Lira; im Bankwesen auch: Lit = italienische Lira); Fr. und sFr. (für: Schweizer Franken; im Bankwesen auch: sfr).

Merke:

1. Steht eine Abkürzung mit Punkt am Satzende, dann steht der Abkürzungspunkt zugleich als Schlußpunkt des Satzes (vgl. aber R 110).

Beispiel: In diesem Buch stehen Gedichte von Goethe, Schiller u.a.

2. Steht am Ende eines Satzes eine Abkürzung, die nach R 6 an sich ohne Punkt steht, dann muß trotzdem der Schlußpunkt gesetzt werden.

Beispiel: Diese Bestimmung steht im BGB.

3. In vielen Fachbereichen werden Abkürzungen von mehrgliedrigen Zusammensetzungen und Fügungen aus technischen Gründen ohne die den Regeln entsprechenden Punkte und Bindestriche (↑ R 154) geschrieben. Außerhalb der Fachsprachen sollte man solche Abkürzungen möglichst vermeiden.

Beispiele: RücklVO (für: Rücklagenverordnung); KuRVO (für: Kassen- und Rechtsverordnung); BStMdI (für: Bayerisches Staatsministerium des Innern).

4. Nach Datumsangaben

R 7 Der Punkt steht nicht nach selbständigen Datumsangaben.

Beispiel: Mannheim, [den od. am] 1. 2. [19]60

5. Nach Unterschriften

R 8 Der Punkt steht nicht nach Grußformeln und Unterschriften unter Briefen und anderen Schriftstücken.

Beispiele: Hochachtungsvoll Mit herzlichem Gruß Mit freundlichen Grüßen
Ihr Peter Müller Dein Peter die Schüler der Klasse 9 b

6. Nach Anschriften

Der Punkt steht **n i c h t** nach der Anschrift[1] in Briefen und auf Umschlägen, **R 9** es sei denn, daß die Anschrift mit einer Abkürzung endet, die einen Punkt verlangt.

Beispiel: Herrn
 Professor Dr. phil. Karl Meier
 Rüdesheimer Straße 29, vorn II
 6200 Wiesbaden

7. Nach Überschriften, Buch- und Zeitungstiteln

Der Punkt steht **nicht** nach Überschriften, Buch- und Zeitungstiteln **R 10** (auch wenn es sich um ganze Sätze handelt), die durch ihre Stellung schon deutlich herausgehoben sind.

Beispiel: Der Friede ist gesichert
Nach den schwierigen Verhandlungen zwischen den Vertragspartnern ...

8. In Abschnittsgliederungen

In Abschnittsgliederungen steht der Punkt nach römischen und arabischen **R 10a** Ziffern und nach Großbuchstaben. Kleinbuchstaben dagegen erhalten gewöhnlich eine Klammer.

Beispiel: I. Groß- und Kleinschreibung
 A. Großschreibung
 1. Satzanfänge
 2. Nach Doppelpunkt und bei Anführungszeichen
 a) Groß schreibt man ...
 b) Groß schreibt man ...

9. Der Punkt in Verbindung mit anderen Satzzeichen

Anführungszeichen ↑ R 102; runde Klammern ↑ R 106.

[1] Die Anschrift ist nach den Bestimmungen der Post (November 1975) wie folgt zu schreiben:

Herrn o d e r : Herrn Kurt Berger
Kurt Berger und Frau
Robert-Mayer-Straße 4, 1, r. (oder: 4 I, r.) 4501 Icker Post Vehrte
6000 Frankfurt am Main

In der Schweiz und in Österreich:

Herrn o d e r : Herrn
Hans Müller Hans Müller
Zollstraße 7 Postfach 77
8260 Stein am Rhein 1121 Wien

Auf Sendungen in die DDR soll den Postleitzahlen das Zeichen × ohne Bindestrich vorangestellt werden:

Herrn
Helmut Schildmann
Jenaer Straße 18
× 5300 Weimar

Auf Postsendungen ins Ausland soll bei Ländern, die ebenfalls Postleitzahlen eingeführt haben, vor der Postleitzahl das jeweils in Frage kommende internationale Kraftfahrzeugkennzeichen mit Bindestrich angegeben werden:

Herrn Mme
Wilhelm Baeren Jeanne Dupont
Münsterplatz 8 12, rue St-Nicole
CH-3000 Bern F-31 Toulouse 01

II. Beistrich (Komma)

Der Beistrich hat im Deutschen in erster Linie die Aufgabe, den Satz grammatisch zu gliedern. Daneben erfüllt er den ursprünglichen Zweck der Satzzeichen, die beim Sprechen entstehenden Pausen zu bezeichnen. Beide Prinzipien, das grammatische und das rhetorische, lassen sich nicht immer in Übereinstimmung bringen. Zuweilen fordert das grammatische Prinzip einen Beistrich, wo der Redende keine Pause macht, und umgekehrt. Darüber hinaus vermag aber auch das grammatische Prinzip, vor allem bei den Mittelwort- und Grundformgruppen, nicht alle Fälle eindeutig zu bestimmen. Aus diesen Gründen muß dem Schreibenden gerade beim Beistrich eine gewisse Freiheit zur Nuancierung seines Ausdrucks bleiben.

A. Der Beistrich zwischen Satzteilen

Alles, was den ungehemmten Fluß eines Satzes unterbricht – Aufzählungen von Wörtern der gleichen Wortart, herausgehobene Satzteile, Einschübe, nachträgliche Zusätze oder die Angabe eines Gegensatzes –, wird durch den Beistrich abgetrennt.

Im einzelnen gelten folgende Richtlinien:

1. Aufzählungen

a) *Aufzählungen von Wörtern der gleichen Wortart oder von gleichen Wortgruppen*

R 11 Der Beistrich steht zwischen Wörtern gleicher Wortart und zwischen gleichen Wortgruppen, wenn sie nicht durch *und* oder *oder* verbunden sind.

> Beispiele: Feuer, Wasser, Luft und Erde. Alles rennet, rettet, flüchtet. Wir gingen bei gutem, warmem Wetter spazieren. Es, es, es und es, es ist ein harter Schluß, weil, weil, weil und weil, weil ich aus Frankfurt muß. Bald ist er hier, bald dort (↑ R 24).

Aber: Der Beistrich steht n i c h t vor dem letzten der aufgezählten Eigenschaftswörter oder Mittelwörter, wenn dieses mit dem Hauptwort einen Gesamtbegriff bildet. Zur Beugung ↑ R 274. Vgl. auch R 21, Merke.

> Beispiel: ein Glas dunkles bayrisches Bier; einige bedeutende, lehrreiche physikalische Versuche.

Gelegentlich hängt es vom Sinn des Satzes ab, ob das unmittelbar vor dem Hauptwort stehende Eigenschaftswort oder Mittelwort mit diesem einen Gesamtbegriff bildet oder nicht.

> Beispiel: die höher liegenden unbewaldeten Hänge (ohne Beistrich, weil es auch tiefer liegende unbewaldete Hänge gibt); die höher liegenden, unbewaldeten Hänge (mit Beistrich, weil die tiefer liegenden bewaldet sind).

b) *Aufzählungen in Wohnungsangaben*

R 12 Bei Aufzählungen in Wohnungsangaben stehen die verschiedenen Bezeichnungen je nach dem Grade ihrer Zusammengehörigkeit mit oder ohne Beistrich.

> Beispiele: Weidendamm 4, Hof r., 1 Tr. l. bei Müller; Herr Gustav Meier in Wiesbaden, Wilhelmstraße 24, I. Stock, links hat diesen Antrag gestellt (↑ R 19; über die Anordnung von Anschriften auf Briefen vgl. S. 19, Anm. 1).

c) *Aufzählungen von Stellenangaben in Büchern, Schriftstücken u. dgl.*

R 13 Bei Aufzählungen von Stellenangaben in Büchern u. dgl. werden die einzelnen Angaben durch Beistrich getrennt.

> Beispiele: Diese Regel ist im Duden, Rechtschreibung, Zeichensetzung, S. 20, R 13 aufgeführt; Hermes, Zeitschrift für klassische Philologie, Bd. 80, Heft 1, S. 46.

Merke: Bei Hinweisen auf Gesetze, Verordnungen usw. pflegt man heute keinen Beistrich mehr zu setzen.

Beispiel: § 6 Abs. 2 Satz 2 der Personalverordnung.

2. Herausgehobene Satzteile

Der Beistrich steht nach herausgehobenen Satzteilen, die durch ein Für- **R 14**
wort oder Umstandswort erneut aufgenommen werden.

Beispiele: Der Tag, er ist nicht mehr fern. Am Brunnen vor dem Tore, da steht ein Lindenbaum. Deinen Vater, den habe ich gut gekannt.

3. Anrede

a) Die Anrede wird vom übrigen Satz durch Beistrich getrennt. **R 15**

Beispiele: Karl, kommst du heute mittag? So hört doch, Kinder, auf mein Wort! Ich habe von dir, lieber Freund, lange nichts gehört.

b) Der Beistrich kann statt des Ausrufezeichens nach der dem Brief voran- **R 16**
gestellten Anrede stehen. In diesem Falle muß das erste Wort des eigent-
lichen Briefes klein geschrieben werden, wenn es kein Hauptwort oder
Anredefürwort ist (↑ R 80).

Beispiel: Sehr geehrter Herr Schmidt,
 gestern erhielt ich …

4. Ausrufe

Das Empfindungswort (Ausrufewort) wird durch Beistrich abgetrennt, **R 17**
wenn es mit besonderem Nachdruck gesprochen wird. Dies gilt auch für
Bejahungen und Verneinungen.

Beispiele: Ach, das ist schade! Oh, das ist schlecht! Ja, daran ist nicht zu zweifeln. Nein, das sollst du nicht tun!

Aber: Das Empfindungswort steht ohne Beistrich, wenn es sich eng an
den folgenden Text des Ausrufes anschließt.

Beispiel: O wunderbares, tiefes Schweigen! Ach Vater, was soll ich nur machen? Ja wenn er nur käme!

5. Einschübe und Zusätze

Über die unter Punkt 1–4 behandelten Fälle hinaus unterbrechen vor
allem die nachstehend aufgeführten Einschübe und Zusätze den unge-
hemmten Fluß des Satzes. Deshalb werden gerade sie vom übrigen Satz
durch den Beistrich abgetrennt.

a) *Beisatz (Apposition)*

Der Beistrich trennt den nachgestellten Beisatz ab. **R 18**

Beispiele: Johannes Gutenberg, der Erfinder der Buchdruckerkunst, wurde in Mainz geboren. In Frankfurt, der bekannten Handelsstadt, befindet sich ein großes Messegelände.

Aber: Der Beistrich steht nicht, wenn der nachgestellte Beisatz zum
Namen gehört.

Beispiele: Friedrich der Große ist der bedeutendste König aus dem Hause Hohen-zollern. Heinrich der Löwe wurde im Dom zu Braunschweig begraben.

Vermeide Mißverständnisse!

Beispiele: Tante Gertrud, die Schwester meiner Mutter, und Onkel Wilhelm sind heute gekommen (2 Personen). Aber: Tante Gertrud, die Schwester meiner Mutter und Onkel Wilhelm sind heute gekommen (3 Personen).

b) *Nachgestellte genauere Bestimmungen*

Nachgestellte genauere Bestimmungen werden durch den Beistrich abge- **R 19**
trennt oder, sofern der Satz weitergeführt wird, in Beistriche eingeschlos-

sen. Dies gilt vor allem für Bestimmungen, die durch *und zwar, und das, nämlich, namentlich, insbesondere, d.h., d.i., z.B.* u.a. eingeleitet werden.

Beispiele: Er liebte die Musik, namentlich die Lieder Schuberts, seit seiner Jugend. Das Schiff kommt wöchentlich einmal, und zwar sonntags. Also schreiben Sie mir ja, und das bald. Herr Meier, Frankfurt, Zeil 120, hat dies veranlaßt. (Aber, wenn die Wohnungsangabe mit einem Verhältniswort angeschlossen ist: Herr Meier in Frankfurt, Zeil 120 hat ...; ↑ R 12). Ich gehe Dienstag, abends [um 20 Uhr], ins Theater. Er hat mit einem Scheck über 2000,— DM, in Worten: zweitausend Deutsche Mark, gezahlt.

In Preislisten, Speisekarten u.ä., die spaltenweise gedruckt sind, steht n a c h der nachgestellten genaueren Bestimmung kein Komma. Bei fortlaufendem Druck muß das Komma aber stehen.

Beispiel: Armband, 18 Karat Gold,
 mit Zuchtperlen, 3reihig 590,— DM

M e r k e :

1. Wird ein beigefügtes Eigenschaftswort durch ein nachgestelltes Eigenschaftswort näher bestimmt, dann setzt man keinen schließenden Beistrich, um den Zusammenhang der Fügung nicht zu stören.

Beispiel: Ausländische, insbesondere holländische [und belgische] Firmen traten als Bewerber auf.

2. Der schließende Beistrich steht auch dann nicht, wenn ein Teil der Satzaussage näher bestimmt und die zugehörige Personalform nur einmal gesetzt wird.

Beispiele: Er verließ den Raum erst, als er sein Herz ausgeschüttet, d.h. alles gesagt hatte.

c) *Dem Hauptwort nachgestellte Eigenschafts- und Mittelwörter*

R 20 1. Der Beistrich steht bei einem nachgestellten gebeugten Eigenschafts- oder Mittelwort [mit Geschlechtswort].

Beispiel: Da bricht der Abend, der frühe, herein.

2. Der Beistrich trennt mehrere nachgestellte Eigenschafts- oder Mittelwörter ab.

Beispiele: Dort tanzen junge Mädchen, zart und schön. Die Hände des Bauern, kräftig und breit, führen den Pflug. Er schaut zum Fenster hinaus, müde und gelangweilt. Er hatte zahlreiche Pinsel, grüne, gelbe, braune, in der Hand.

Aber: Der Beistrich steht n i c h t, wenn in festen oder dichterischen Wendungen ein alleinstehendes Eigenschaftswort nachgestellt ist.

Beispiele: Aal blau; Karl Meyer junior; bei einem Wirte wundermild; Röslein, Röslein, Röslein rot.

R 21 d) Gelegentlich ist es dem Schreibenden freigestellt, ob er einen Satzteil als Einschub werten will oder nicht.

Beispiele: Er wollte seinem Leiden insbesondere durch Verzicht auf Alkohol wirksam begegnen. *Oder:* Er wollte seinem Leiden, insbesondere durch Verzicht auf Alkohol, wirksam begegnen. Der Inspektor, [Herr] Meier, hat dies angeordnet. *Oder:* Der Inspektor [Herr] Meier hat dies angeordnet.

M e r k e : Nicht als Einschübe gelten die Beifügungen, die zwischen dem Geschlechtswort (Fürwort, Zahlwort) und seinem Hauptwort stehen.

Beispiele: der dich prüfende Lehrer; eine wenn auch noch so bescheidene Forderung; diese den Betrieb stark belastenden Ausgaben.

6. Datum

R 22 Das Datum wird von Orts-, Wochentags- und Uhrzeitangaben durch Beistrich getrennt (vgl. auch R 330).

Beispiele: Berlin, den 4. Juli 1960; Dienstag, den 6. 9. 1960; Mittwoch, den 25. Juli, [um] 20 Uhr findet die Sitzung statt. Die Begegnung findet statt in Berlin, Montag, den 9. September, [vormittags] 11 Uhr. Mannheim, im November 1966.

7. Namen und Titel

Mehrere vorangestellte Namen und Titel werden n i c h t durch Beistrich **R 23**
getrennt. Das gilt auch für mehrere Vornamen einer Person.

Beispiele: Hans Albert Schulze (aber: Schulze, Hans Albert); Direktor Professor
Dr. Müller. Unser Stammhalter Heiko Thomas ist angekommen.

In der Regel steht auch kein Beistrich bei *geb.*, *verh.*, *verw.* usw.

Beispiele: Martha Schneider geb. Kühn; doch auch: Frau Martha Schneider, geb.
Kühn, hat… (Der Geburtsname wird in diesem Falle als Beisatz aufgefaßt; ↑ R 18.)
Herr Schneider und Frau Martha [,] geb. Kühn [,] geben sich die Ehre …

8. Von Bindewörtern zwischen Satzteilen

Als Bindewörter werden hier der Einfachheit halber auch die einem Satz-
teil vorangestellten Umstandswörter (z. B. *teils – teils*, *weder – noch*) be-
zeichnet.

a) *Anreihende und ausschließende Bindewörter*

Der Beistrich steht zwischen Satzteilen, die durch die anreihenden Binde- **R 24**
wörter *bald – bald*, *einerseits – and[e]rerseits (anderseits)*, *einesteils – an-
der[e]nteils*, *jetzt – jetzt*, *ob – ob*, *teils – teils*, *nicht nur – sondern auch*, *halb
– halb* u. a. verbunden sind, weil es sich um Aufzählungen handelt (↑ R 11).

Beispiele: Bald ist er in Frankfurt, bald in München, bald in Hannover. Die Kinder
spielten teils auf der Straße, teils im Garten. Er ist nicht nur ein guter Schüler, son-
dern auch ein guter Sportler.

Aber: Der Beistrich steht nicht vor den anreihenden Bindewörtern *und*,
sowie, *wie*, *sowohl – als auch*, *weder – noch* und vor den ausschließenden
Bindewörtern *oder*, *beziehungsweise (bzw.)*, *respektive (resp.)*, *entweder –
oder*, weil sie eng zusammengehörige Satzteile verbinden (vgl. a b e r R 41).

Beispiele: Heute oder morgen will er dich besuchen. Der Becher war innen wie
außen vergoldet. Die Kinder essen sowohl Äpfel als auch Birnen gerne. Weder mir
noch ihm ist es gelungen. Du mußt entweder das eine oder das andere tun. (In Ver-
bindung mit einer Aufzählung:) Ich weiß weder seinen Namen noch seinen Vornamen,
noch sein Alter, noch seine Anschrift.

M e r k e : Der Beistrich steht bei der Aufzählung auch dann nicht vor *und*,
wenn eine Grundform oder ein Gliedsatz (Nebensatz) folgt.

Beispiele: Übe Nächstenliebe ohne Aufdringlichkeit *und* ohne den andern zu verletzen.
Die Mutter kaufte der Tochter einen Koffer, einen Mantel, ein Kleid *und* was sie sonst
noch für die Reise brauchte.

Wird ein übergeordneter Satz nach der Grundformgruppe oder nach dem
Gliedsatz (Nebensatz) weitergeführt, dann ist es dem Schreibenden freige-
stellt, einen Beistrich zu setzen oder nicht.

Beispiele: Der Dichter schildert wahrheitsgetreu und ohne sich auch nur einmal im
Ton zu vergreifen [,] das innige Verhältnis zwischen Herr und Hund. Ich sah ein
Licht, das mich und die mit mir reisten [,] umleuchtete.

b) *Entgegensetzende Bindewörter*

Der Beistrich steht vor den entgegensetzenden Bindewörtern *aber*, *allein*, **R 25**
[je]doch, *vielmehr*, *sondern* u. a., weil der durch sie eingeleitete Gegensatz
den Fluß des Satzes unterbricht.

Beispiele: Du bist klug, aber faul. Nicht mein Wille, sondern dein Wille geschehe!

c) *Die vergleichenden Bindewörter als, wie, denn*

Der Beistrich steht n i c h t vor den vergleichenden Bindewörtern *als*, *wie*, **R 26**
denn, wenn sie nur Satzteile verbinden.

Beispiele: Gisela ist größer als Ingeborg. Karl ist so stark wie Ludwig. Er war
größer als Dichter denn als Maler.

Merke:
1. Der Beistrich steht erst bei vollständigen Vergleichssätzen und bei dem Infinitiv mit *zu*.

Beispiele: Ilse ist größer, als ihre Mutter im gleichen Alter war. Komm so schnell, wie du kannst. Er ist reicher, als du denkst. Ich konnte nichts Besseres tun, als ins Bett zu gehen.

2. Bei den mit *wie* angeschlossenen Fügungen muß es dem Schreibenden gelegentlich überlassen bleiben, ob er die Fügung als eng zum Bezugswort gehörend oder als nachgetragen ansehen will.

Beispiel: Die Auslagen [,] wie Post- und Fernsprechgebühren, Eintrittsgelder, Fahrkosten u. dgl. [,] ersetzen wir Ihnen.

B. Der Beistrich bei Mittelwort- und Grundformgruppen

Mittelwörter und Grundformen bilden mit einer näheren Bestimmung Mittelwort- bzw. Grundformgruppen, die ihrer Wertigkeit nach zwischen Satzglied und Satz stehen. Da sie gliedsatz-(nebensatz-)ähnlichen Charakter haben, werden sie oft „verkürzte Nebensätze" genannt, obwohl sie nicht – wie der Auslassungssatz (↑ R 48 ff.) – aus vollständigen Sätzen entstanden sind. Grundformen mit *zu* ohne eine nähere Bestimmung sind demgegenüber einfache Satzglieder. Sie werden der Übersichtlichkeit wegen in diesem Abschnitt mitbehandelt.

1. Mittelwortgruppe (Partizipialgruppe)

R 27 a) Mittelwörter ohne nähere Bestimmung und Mittelwörter mit einer kurzen näheren Bestimmung stehen ohne Beistrich (vgl. aber R 20).

Beispiele: Lachend kam er auf mich zu. Gelangweilt schaute er zum Fenster hinaus. Schreiend und johlend durchstreiften sie die Straßen. Verschmitzt lächelnd schaute er zu.

R 28 b) In allen anderen Fällen wird das näher bestimmte Mittelwort durch Beistrich abgetrennt, weil die Mittelwortgruppe Eigengewicht hat.

Beispiele: Von der Pracht des Festes angelockt, strömten viele Fremde herbei. Er sank, zu Tode getroffen, zu Boden. Er kam auf mich zu, aus vollem Halse lachend.

Eine Ausnahme machen die mit *entsprechend* gebildeten Gruppen, weil *entsprechend* hier in die Rolle eines Verhältniswortes hineingewachsen ist.

Beispiel: Seinem Vorschlag entsprechend ist das Haus verkauft worden.

Auch *betreffend* ist auf dem Wege, Verhältniswort zu werden. Es fehlt deshalb auch hier schon oft der Beistrich.

Beispiel: Unser letztes Schreiben betreffend den Bruch des Vertrages ... Oder: Unser letztes Schreiben, betreffend den Bruch des Vertrages, ...

R 29 c) Es gibt Wortgruppen, die den Mittelwortgruppen gleichzustellen sind, weil man sich *habend, seiend, werdend, geworden* hinzudenken kann.

Beispiele: Neben ihm saß sein Freund, *den Kopf im Nacken*, und hörte der Unterhaltung zu. *Vom Alter blind*, bettelte er sich durch das Land. *Allmählich kühner*, begann er zu pfeifen.

2. Grundformgruppe (Infinitivgruppe)

Man unterscheidet zwischen erweiterter Grundform und nichterweiterter oder bloßer oder reiner Grundform. Eine Grundform ist bereits erweitert, wenn *ohne zu, um zu, als zu, anstatt zu* an Stelle des bloßen *zu* stehen.

a) Die erweiterte Grundform wird in den meisten Fällen durch Beistrich **R 30** abgetrennt.

Beispiele: Sie ging in die Stadt, um einzukaufen. Er redete, anstatt zu handeln. Die Möglichkeit, selbst zu üben, ist gegeben. Er hatte keine Gelegenheit, sich zu waschen. Es war sein fester Wille, ihn über die Vorgänge aufzuklären und ihn dabei zu warnen. Es ist sinnvoller, ein gutes Buch zu lesen, als einen schlechten Film zu sehen. Alles, was du tun mußt, ist, deinen Namen an die Tafel zu schreiben. Ihm zu folgen, bin ich jetzt nicht bereit. Er befahl, es zu tun. Wir hoffen, Ihren Wünschen entsprochen zu haben, und grüßen Sie ...

Durch Beistrich werden auch die nichterweiterten Grundformen der Tatform in der 2. Vergangenheit und der Leideform abgetrennt, weil sie durch ihre Mehrteiligkeit Eigengewicht haben.

Beispiele: Ich erinnere mich, widersprochen zu haben. Er war begierig, gelobt zu werden. Ich bin der festen Überzeugung, verraten worden zu sein.

Aber: Der Beistrich steht **nicht** bei der erweiterten Grundform,

1. wenn die erweiterte Grundform mit dem Hauptsatz verschränkt ist oder **R 31** wenn die erweiterte Grundform innerhalb der zeitwörtlichen (verbalen) Klammer steht.

Beispiele: *Diesen Vorgang* wollen wir *zu erklären* versuchen (für: Wir wollen versuchen, diesen Vorgang zu erklären). Wir hatten *den Betrag zu überweisen* beschlossen (für: Wir hatten beschlossen, den Betrag zu überweisen).

2. wenn ein Glied der erweiterten Grundform in Spitzenstellung (Aus- **R 32** drucksstellung) tritt und der Hauptsatz dadurch von der erweiterten Grundform eingeschlossen wird.

Beispiele: *Diesen Betrag* bitten wir *auf unser Girokonto zu überweisen* (für: Wir bitten[,] diesen Betrag auf unser Girokonto zu überweisen). *Mit diesem Wagen* verlangte er *abgeholt zu werden* (für: Er verlangte, mit diesem Wagen abgeholt zu werden).

3. wenn die voranstehende erweiterte Grundform den Satzgegenstand **R 33** vertritt.

Beispiel: *Sich selbst zu besiegen* ist der schönste Sieg.

Merke jedoch: Wenn auf die als Satzgegenstand vorangestellte erweiterte Grundform durch ein hinweisendes Wort wie *es, das, dies* u.a. zurückgewiesen wird, steht ein Beistrich (vgl. Beistrich bei herausgehobenen Satzteilen, R 14).

Beispiel: Sich selbst zu besiegen, das ist der schönste Sieg.

4. wenn die erweiterte Grundform Hilfszeitwörtern oder hilfszeitwörtlich **R 34** gebrauchten Zeitwörtern folgt, weil diese Zeitwörter das durch die Grundform bezeichnete Geschehen nur modifizieren. Zeitwort und Grundform gehen dabei eine enge Verbindung ein.

Bei den Zeitwörtern, die hilfszeitwörtlich gebraucht werden, lassen sich drei Gruppen unterscheiden.

a) Immer hilfszeitwörtlich stehen die Zeitwörter *sein, haben; brauchen, pflegen, scheinen.*

Beispiele: Sie haben nichts zu verlieren. Er pflegt uns jeden Sonntag zu besuchen. Sie scheint heute schlecht gelaunt zu sein.

b) Hilfszeitwörtlich oder auch als selbständiges Zeitwort (Vollverb) können die Zeitwörter *drohen, versprechen* u.a. stehen.

Beispiele:

hilfszeitwörtlich: Der Kranke drohte (= lief Gefahr) bei dem Anfall zu ersticken. Er verspricht (= allem Anschein nach) ein tüchtiger Kaufmann zu werden.

als selbständiges Zeitwort: Der Kranke drohte (= sprach die Drohung aus), sich ein Leid anzutun. Er hat versprochen (= gab das Versprechen), mir den Korb zu bringen.

c) Bei der dritten Gruppe dieser Zeitwörter muß es dem Schreibenden überlassen bleiben, ob er einen Beistrich setzen will oder nicht, weil zwischen den beiden Möglichkeiten nicht eindeutig unterschieden werden kann. Hierzu gehören die Zeitwörter *anfangen, aufhören, beginnen, bitten, denken, fürchten, gedenken, glauben, helfen, hoffen, verdienen, verlangen, versuchen, wagen, wünschen* u. a.

Beispiele: Er glaubt(,) mich mit diesen Einwänden zu überzeugen. Wir bitten(,) diesen Auftrag schnell zu erledigen.

Tritt zu diesen Zeitwörtern eine Umstandsangabe oder eine Ergänzung, dann ist es eindeutig, daß es sich um ein selbständiges Zeitwort handelt.

Beispiele: Der Arzt glaubte fest, den Kranken durch eine Operation retten zu können. Er bat mich, morgen wiederzukommen.

Der Beistrich muß gesetzt werden, wenn die erweiterte Grundform als Zwischensatz vor „und" steht, ↑ R 52.

R 35 b) Die reine Grundform mit *zu* wird in den meisten Fällen n i c h t durch Beistrich abgetrennt.

Beispiele: Der Abgeordnete beginnt zu sprechen. Ich befehle dir zu gehen. Zu arbeiten ist er bereit. Einzutreten hatte sie keinen Mut. Die Schwierigkeit unterzukommen war sehr groß. Zu raten und zu helfen war er immer bereit.

Ob eine reine Grundform, die durch einen Gliedsatz (Nebensatz) näher bestimmt wird, durch Beistrich abzutrennen ist oder nicht, hängt davon ab, ob der Sprechende sie zum vorangehenden Hauptsatz oder zum nachfolgenden Gliedsatz zieht.

Beispiele: Ich bin bereit, |einzuspringen, wenn es nötig wird. Oder: Ich bin bereit einzuspringen,| wenn es nötig wird. Er hatte keinen Grund zu glauben|, daß er übervorteilt wurde. Oder: Er hatte keinen Grund|, zu glauben, daß er übervorteilt wurde.

Diese Freiheit besteht jedoch nicht, wenn der reinen Grundform ein hilfszeitwörtlich gebrauchtes Zeitwort vorangeht, weil diese Zeitwörter das durch die Grundform bezeichnete Geschehen nur modifizieren (↑ R 34). In diesen Fällen darf vor der Grundform k e i n Beistrich stehen.

Beispiele: Wir bitten zu entschuldigen, daß ... Er versucht herauszubekommen, ob ... Sie fängt an zu raten, was das sein könne.

Aber: Der Beistrich s t e h t bei der reinen Grundform mit *zu* in folgenden Fällen:

R 36 1. wenn ein hinweisendes Wort wie *es, das, dies, daran, darauf* u. a. auf die vorangestellte reine Grundform mit *zu* hindeutet (↑ R 14).

Beispiele: Zu tanzen, das ist ihre größte Freude. Zu spielen, darauf hatte sich das Kind gefreut.

Folgt die reine Grundform mit *zu* diesen Wörtern, dann ist deren hinweisende Kraft so schwach, daß kein Beistrich gesetzt zu werden braucht.

Beispiel: Ich denke nicht daran einzuwilligen (Auch möglich: Ich denke nicht daran, einzuwilligen). Er liebt es zu nörgeln (Auch möglich: Er liebt es, zu nörgeln).

R 37 2. wenn mehrere reine Grundformen mit *zu* dem Hauptsatz folgen oder in ihn eingeschoben sind.

Beispiele: Er war immer bereit, zu raten und zu helfen. Ohne den Willen, zu lernen und zu arbeiten, wirst du es zu nichts bringen.

R 38 3. wenn in einem Gleichsetzungssatz die reine Grundform mit *zu* der Satzaussage (*ist, war* u. a.) folgt.

Beispiele: Seine Absicht war, zu gewinnen. Meine liebste Beschäftigung ist, zu lesen.

R 39 4. wenn das *zu* der reinen Grundform in der Bedeutung von *um zu* verwendet wird.

Beispiel: Ich komme, [um] zu helfen.

5. wenn Mißverständnisse entstehen können. **R 40**

Beispiel: Wir rieten ihm, zu folgen. Aber: Wir rieten, ihm zu folgen.

Merke: Wenn eine reine und eine erweiterte Grundform zusammenstehen, gelten die Richtlinien für die erweiterte Grundform.

Beispiel: Es ist sein Wunsch, zu arbeiten und in Ruhe zu leben.

C. Der Beistrich zwischen Sätzen

Der Beistrich zwischen Sätzen hat in erster Linie die Aufgabe, den Gliedsatz (Nebensatz) von seinem Hauptsatz und von anderen Gliedsätzen zu trennen. Dabei ist es gleichgültig, ob die Sätze vollständig sind oder nicht. Darüber hinaus trennt der Beistrich aber auch Hauptsätze an Stelle des Punktes oder des Strichpunktes, wenn diese Sätze in enger gedanklicher Verbindung aneinandergereiht sind.

Im einzelnen gelten folgende Richtlinien:

1. Nebengeordnete Hauptsätze

Der Beistrich trennt nebengeordnete Hauptsätze, auch wenn sie durch **R 41**
Bindewörter (*und, oder, beziehungsweise, weder–noch, entweder–oder*) verbunden sind.

Beispiele: Ich kam, ich sah, ich siegte. Das Wasser rauscht', das Wasser schwoll, ein Fischer saß daran. Wir singen ein Lied, und wir trinken den Wein. Ihr müßt euere Aufgaben gewissenhaft erledigen, oder ihr versagt in der Prüfung. Der Vater liest die Zeitung, die Mutter strickt, und Fritz spielt mit den Klötzchen. Er hat ihm weder beruflich geholfen, noch hat er seine künstlerischen Anlagen gefördert. Du bist jetzt entweder lieb, oder du gehst nach Hause. Grüße Deinen lieben Mann vielmals von mir, und sei selbst herzlich gegrüßt ... Willst du mit mir gehen, oder hast du etwas anderes vor?

Aber: Der Beistrich steht nicht

a) bei durch *und* oder *oder* verbundenen Hauptsätzen, wenn diese kurz **R 42**
sind und eng zusammengehören.

Beispiele: Er grübelte und er grübelte. Er lief oder er fuhr. Tue recht und scheue niemand!

b) bei durch *und* oder *oder* verbundenen Hauptsätzen, die einen Satzteil **R 43**
gemeinsam haben.

Beispiele: Sie bestiegen den Wagen und fuhren nach Hause. Ich gehe in das Theater oder besuche ein Konzert. Max geht ins Kino und Karl ins Konzert. Sofort nach dem Aufstehen ging der Vater zum Strand und öffnete die Mutter die Fenster. Aber bei der üblicheren normalen Wortstellung im zweiten Satz: Sofort nach dem Aufstehen ging der Vater zum Strand, und die Mutter öffnete die Fenster.

Dies gilt auch, wenn zwei Hauptsätze einen vorangestellten gemeinsamen Gliedsatz haben:

Beispiel: Als der Mann in den Hof trat, bellte der Hund und schnatterten die Gänse. Aber bei normaler Wortstellung: ..., bellte der Hund, und die Gänse schnatterten.

2. Schaltsatz

Der Beistrich trennt Hauptsätze, die ineinandergeschoben sind (vgl. aber **R 44**
auch R 88 u. R 104).

Beispiel: Eines Tages, es war mitten im Winter, stand ein Reh in unserem Garten.

3. Haupt- und Gliedsatz (Nebensatz)

Der Beistrich steht zwischen Haupt- und Gliedsatz. **R 45**

a) Der Gliedsatz ist Vordersatz.

Beispiele: Wenn es möglich ist, erledigen wir deinen Auftrag sofort. Was er sagt, stimmt nicht. „Ich bin satt", sagte er.

Merke: Es steht kein Beistrich nach der wörtlichen Rede, wenn diese durch ein Fragezeichen oder durch ein Ausrufezeichen abgeschlossen ist und der Hauptsatz unmittelbar anschließt.

Beispiele: „Was ist dies für ein Käfer?" fragte er. „Du bist ein Verräter!" rief er. Aber bei hinweisendem „so, das" o.ä.: „Diese Betrüger, diese Schufte!", so rief er immer wieder.

b) Der Gliedsatz ist Zwischensatz.

Beispiel: Hunde, die viel bellen, beißen nicht. Alles, was du brauchst, ist da.

c) Der Gliedsatz ist Nachsatz.

Beispiele: Es freut mich sehr, daß du gesund bist. Ich weiß, er ist unschuldig. Er fragt, mit welchem Zug du kommst. Sie fragte sofort: „Wo warst du?", als ich hereinkam.

4. Gliedsätze (Nebensätze) gleichen Grades

R 46 Der Beistrich trennt Gliedsätze gleichen Grades, die nicht durch *und* oder *oder* verbunden sind.

Beispiele: Ich höre, daß du nicht nur nichts erspart hast, sondern daß du auch noch dein Erbteil vergeudest. Aber: Du kannst es glauben, daß ich deinen Vorschlag ernst nehme und daß ich ihn sicher verwirkliche. Er sagte, er wisse es und der Vorgang sei ihm völlig klar.

5. Gliedsätze (Nebensätze) verschiedenen Grades

R 47 Der Beistrich trennt Gliedsätze verschiedenen Grades.

Beispiel: Er war zu klug, als daß er in die Falle gegangen wäre, die man ihm gestellt hatte.

6. Auslassungssatz (Ellipse)

Der Beistrich steht wie im vollständigen Satz. Im Auslassungssatz ist nur der Hauptbegriff wiedergegeben, während die übrigen Satzteile weggelassen sind.

R 48 a) Der Hauptsatz ist unvollständig.

Beispiel: Vielleicht [geschieht es], daß er noch eintrifft.

Beachte: Das auffordernd betonte *bitte* kann als Auslassungssatz aufgefaßt werden. Es wird dann durch Beistrich abgetrennt.

Beispiel: Bitte, kommen Sie einmal her! Geben Sie mir, bitte, das Buch.

Hat aber *bitte* nur den Sinn einer Höflichkeitsformel, dann steht kein Beistrich.

Beispiel: Bitte wenden Sie sich an uns. Geben Sie mir bitte das Buch.

R 49 b) Der Gliedsatz (Nebensatz) ist unvollständig.

Beispiel: Ich weiß nicht, was [ich] anfangen [soll].

Beachte: Unvollständige Gliedsätze, die mit *wie* oder *wenn* u. a. eingeleitet sind, stehen oft, besonders am Ende des Satzes, ohne Beistrich, wenn sie formelhaft geworden sind und wie eine einfache Umstandsangabe wirken.

Beispiel: Seine Darlegungen endeten wie folgt (= folgendermaßen). Er legte sich wie üblich (= üblicherweise) um 10 Uhr ins Bett. Er ging wie immer (= gewohntermaßen) nach dem Mittagessen spazieren. Komme doch wenn möglich (= möglichst) schon um 17 Uhr!

R 50 c) Haupt- und Gliedsatz sind unvollständig.

Beispiel: [Wenn die] Ehre verloren [ist], [so ist] alles verloren.

D. Zusammenfassung der Richtlinien über das Setzen des Beistrichs vor *und* oder *oder*

1. Der Beistrich steht,

a) wenn *und* oder *oder* Hauptsätze verbindet (vgl. aber R 56 u. **R 51** R 57), auch wenn es sich um Hauptsätze mit Auslassungen handelt.

> Beispiele: Es wurde immer kälter, und der Südwind türmte Wolken um die Gipfel. Nur noch wenige Minuten, und wir können beginnen.

b) wenn ein Zwischensatz vorausgeht. Als Zwischensatz gilt auch eine **R 52** eingeschobene erweiterte Grundform.

> Beispiele: Wir konnten die Reise im Auto nicht fortsetzen, weil es beschädigt war, und mußten bis in das nächste Dorf zu Fuß gehen. Wir glauben, daß wir richtig gehandelt haben, und werden denen diesen Weg weitergehen. Wir hoffen, Ihnen hiermit gedient zu haben, und grüßen Sie ...

c) wenn *und* oder *oder* ein Satzgefüge anschließt, das mit einem Glied- **R 53** satz oder mit einer erweiterten Grundform beginnt.

> Beispiel: Du hast zuviel gearbeitet, und weil du keine Rücksicht auf dich genommen hast, mußt du jetzt eine Ruhepause einlegen. Ich besuchte ihn oft, und war er zu Hause, dann saßen wir bis in die Nacht beisammen. Es waren schlechte Zeiten, und um zu überleben, verhielten sich manche so gegen ihre Mitmenschen, wie sie es unter normalen Verhältnissen kaum getan hätten.

d) wenn ein Beisatz vorausgeht. **R 54**

> Beispiel: Franz, mein Bruder, und ich gingen spazieren (2 Personen). Aber: Franz, mein Bruder und ich gingen spazieren (3 Personen).

e) wenn *und zwar* oder *und das* nachgestellte genauere Bestimmungen **R 55** einleitet.

> Beispiele: Ich werde kommen, und zwar bald. Er gab nicht nach, und das mit Recht.

2. Der Beistrich steht nicht,

a) wenn *und* oder *oder* kurze und eng zusammengehörende Hauptsätze **R 56** verbindet.

> Beispiele: Er grübelte und er grübelte. Tue recht und scheue niemand!

b) wenn der durch *und* oder *oder* eingeleitete folgende Hauptsatz mit dem **R 57** vorhergehenden einen Satzteil gemeinsam hat.

> Beispiel: Sie bestiegen den Wagen und fuhren nach Hause.

c) wenn *und* oder *oder* Gliedsätze (Nebensätze) gleichen Grades verbindet. **R 58**

> Beispiele: Ich weiß, daß du ihn liebst und daß du auch dieses Opfer bringst. Weil sie die Schwäche ihres Sohnes für den Alkohol kannte und damit er nicht wieder entgleisen sollte, schickte sie ihn schon früh weg. Er erzählte ihm, wie sehr er die britische Verfassung bewundere und daß er gern einmal nach London fahren würde.

d) wenn *und* oder *oder* bei Aufzählungen von Wörtern steht, die der **R 59** gleichen Wortart angehören.

> Beispiel: Feuer, Wasser, Luft und Erde.

e) wenn in einer Aufzählung eine erweiterte Grundform oder ein Glied- **R 60** satz folgt.

> Beispiel: Übe Nächstenliebe ohne Aufdringlichkeit und ohne den anderen zu verletzen. Die Mutter kaufte der Tochter einen Koffer, einen Mantel, ein Kleid und was sie sonst noch für die Reise brauchte.

E. Richtlinien für das Setzen des Beistrichs beim Zusammentreffen eines Bindewortes mit einem Umstandswort, Mittelwort u. a.

Bestimmte Bindewörter (z. B. *daß, weil, wenn*) treffen gelegentlich mit einem Umstandswort, einem Mittelwort u. a. zusammen.

Beispiele: vorausgesetzt, daß; vor allem [,] weil; auch wenn.

Für das Setzen des Beistrichs bei solchen Fügungen gelten folgende Richtlinien:

1. Beistrich vor dem eigentlichen Bindewort

R 61 Haben beide Teile der Fügung ihre Eigenständigkeit erhalten, dann steht ein Beistrich zwischen den Teilen, d. h. vor dem eigentlichen Bindewort.

Beispiele: abgesehen [davon], daß; angenommen, daß; ausgenommen, daß/wenn; es sei denn, daß; gesetzt [den Fall], daß; in der Annahme/Erwartung/Hoffnung, daß; unter der Bedingung, daß; vorausgesetzt, daß u. a.

Beispielsätze: Ich komme gern, es sei denn, daß ich selbst Besuch bekomme. Er befürwortete den Antrag unter der Bedingung, daß die genannten Voraussetzungen erfüllt seien.

2. Beistrich vor der Fügung als Ganzem

R 62 Wird die Fügung als Einheit verstanden, dann steht ein Beistrich nur vor der Fügung als Ganzem, nicht vor dem eigentlichen Bindewort.

Beispiele: als daß; anstatt daß; auch wenn; außer daß/wenn/wo; namentlich wenn; nämlich daß/wenn; ohne daß; selbst wenn; ungeachtet daß, aber (mit Beistrich): ungeachtet dessen, daß u. a.

Beispielsätze: Der Plan ist viel zu einfach, als daß man sich davon Hilfe versprechen könnte. Sie hat uns geholfen, ohne daß sie es weiß.

Beachte: Bei einigen dieser Fügungen tritt gelegentlich ein Komma auf.

Beispiele: Das wußte er, nämlich daß sein Freund verreist war. (Gelegentlich:) Das war der Grund für seinen Umzug, nämlich, daß das gesamte Klima ihm nicht behagte.

3. Schwankender Gebrauch des Beistrichs

R 63 Bei einigen Fügungen schwankt der Gebrauch. Wird das vor dem Bindewort stehende Umstandswort u. a. [als Rest eines Satzes] betont und hervorgehoben, dann sind beide Teile eigenständig; dementsprechend steht ein Beistrich zwischen ihnen, d. h. vor dem eigentlichen Bindewort (vgl. oben 1). Wird jedoch die Fügung als Einheit verstanden, dann steht nur vor der Fügung als Ganzem ein Beistrich (vgl. oben 2).

Beispiele: besonders, wenn n e b e n (häufiger): besonders wenn; geschweige denn, daß; aber: geschweige, daß n e b e n (häufiger): geschweige daß; gleichviel, ob/wenn/wo n e b e n: gleichviel ob/wenn/wo; im Fall[e] (= in dem Fall[e]), daß n e b e n: im Fall[e] daß; insbesondere, wenn n e b e n (häufiger): insbesondere wenn; insofern/insoweit, als n e b e n: insofern/insoweit als; je nachdem, ob/wie n e b e n: je nachdem ob/wie; kaum, daß n e b e n: kaum daß; um so eher/mehr/weniger, als n e b e n: um so eher/mehr/weniger als; vor allem, wenn/weil n e b e n: vor allem wenn/weil u. a.

Beispielsätze: Ich habe ihn nicht gesehen, geschweige, daß ich ihn sprechen konnte. N e b e n: Ich glaube nicht einmal, daß er anruft, geschweige daß er vorbeikommt. Ich werde dies tun, [es ist] gleichviel, ob er darüber böse ist. N e b e n: Ich werde dir schreiben, gleichviel wo ich auch bin.

F. Der Beistrich in Verbindung mit und an Stelle von anderen Satzzeichen

Gedankenstrich ↑ R 89; Anführungszeichen ↑ R 101; Fragezeichen ↑ R 74, Merke; runde Klammern ↑ R 105.

G. Der Beistrich bei Unterführungen ↑ R 159.

H. Der Beistrich bei Zahlen ↑ R 230 ff.

III. Strichpunkt (Semikolon)

Der Strichpunkt vertritt den Beistrich, wenn dieser zu schwach, den Punkt, wenn dieser zu stark trennt. Da das Urteil darüber, ob einer dieser Fälle vorliegt, verschieden sein kann, lassen sich für die Anwendung des Strichpunktes nicht so strenge Richtlinien geben wie für die anderen Satzzeichen.

1. Hauptsätze

Der Strichpunkt kann an Stelle des Punktes stehen, wenn Hauptsätze **R 64** ihrem Inhalt nach eng zusammengehören.

> Beispiel: Die Stellung der Werbeabteilung im Organisationsplan ist in den einzelnen Unternehmen verschieden; sie richtet sich nach den Anforderungen, die an die Werbung gestellt werden.

2. Satzverbindung

Der Strichpunkt kann statt des Beistrichs zwischen den nebengeordneten **R 65** Sätzen einer Satzverbindung stehen, namentlich vor den Bindewörtern oder Umstandswörtern *denn, doch, darum, daher, allein* u. a.

> Beispiele: Ein goldener Becher gibt lieblichen Schein; doch süßeres Labsal gewährt der Wein (Bürger). Die Angelegenheit ist erledigt; darum wollen wir nicht länger streiten.

3. Mehrfach zusammengesetzter Satz (Periode)

Der Strichpunkt steht bei mehrfach zusammengesetzten Sätzen. **R 66**

> Beispiel: Im Verlaufe von zehn Jahren war er zweimal krank gewesen; das eine Mal in folge eines vom Tender einer Maschine während des Vorbeifahrens herabgefallenen Stückes Kohle, welches ihn getroffen und mit zerschmettertem Bein in den Bahngraben geschleudert hatte; das andere Mal einer Weinflasche wegen, die aus dem vorüberrasenden Schnellzuge mitten auf seine Brust geflogen war (Gerhart Hauptmann, Bahnwärter Thiel).

4. Aufzählungen

Der Strichpunkt ist ein Mittel, um bei Aufzählungen Gruppen gleichartiger **R 67** Begriffe kenntlich zu machen.

> Beispiel: Dieser fruchtbare Landstrich trägt Roggen, Gerste, Weizen; Kirschen, Pflaumen, Äpfel; Tabak und Hopfen; ferner die verschiedensten Arten von Nutzhölzern.

IV. Doppelpunkt (Kolon)

(Groß- oder Kleinschreibung nach dem Doppelpunkt ↑ R 113 u. R 128.)

1. Angekündigte wörtliche (direkte) Rede

Der Doppelpunkt steht vor der wörtlichen Rede, wenn diese vorher ange- **R 68** kündigt ist.

> Beispiel: Friedrich der Große sagte: „Ich bin der erste Diener meines Staates."

2. Angekündigte Sätze oder Satzteile

Der Doppelpunkt steht vor Sätzen oder Satzteilen, die ausdrücklich an- **R 69** gekündigt sind.

> Beispiele: Das Sprichwort heißt: Der Apfel fällt nicht weit vom Stamm. Latein: befriedigend.

3. Angekündigte Aufzählungen

Der Doppelpunkt steht vor angekündigten Aufzählungen. **R 70**

> Beispiel: Die Namen der Monate sind folgende: Januar, Februar, März usw.

Aber: Der Doppelpunkt steht nicht, wenn der Aufzählung *d.h.*, *d.i.*, *nämlich* u.a. vorausgehen. In solchen Fällen steht vor *d.h.* usw. ein Beistrich (↑ R 19). Über *wie* ↑ R 26, Merke, 2.

Beispiel: Das Jahr hat zwölf Monate, nämlich Januar, Februar, März usw.

4. Zusammenfassende Sätze

R 71 Der Doppelpunkt steht zweckmäßig vor Sätzen, die eine Zusammenfassung des Vorangegangenen oder eine Folgerung daraus enthalten.

Beispiele: Haus und Hof, Geld und Gut: alles ist verloren. Er ist umsichtig und entschlossen, zuverlässig und ausdauernd, aufrichtig und mutig: man kann ihm alles anvertrauen.

5. Mehrfach zusammengesetzter Satz (Periode)

R 72 Der Doppelpunkt steht vor dem Nachsatz im durchgegliederten mehrfach zusammengesetzten Satz (Periode).

Beispiel: Wo dir Gottes Sonne zuerst schien; wo dir die Sterne des Himmels zuerst leuchteten; wo seine Blitze dir zuerst seine Allmacht offenbarten und seine Sturmwinde dir mit heiligem Schrecken durch die Seele brausten: da ist deine Liebe, da ist dein Vaterland (E.M. Arndt).

6. Doppelpunkt in Verbindung mit Gedankenstrich ↑ R 91.

7. Gedankenstrich statt Doppelpunkt ↑ R 93.

V. Fragezeichen

1. Das Fragezeichen steht

R 73 **a)** nach einem direkten Fragesatz (auch als Überschrift).

Beispiele: Wo wohnst du? Wie heißt du? „Weshalb darf ich das nicht?" fragte er. Woher soll ich wissen, daß er krank ist?

R 74 **b)** nach einzelnen Fragewörtern, wenn sie allein oder im Satzzusammenhang auftreten.

Beispiele: Wie? Warum? Wohin? Auf die Frage wem? steht der dritte, auf die Frage wen? der vierte Fall.

Merke: Wird ein Fragewort nicht besonders hervorgehoben, dann setzt man einen Beistrich dahinter. Das Fragezeichen steht dann erst am Satzende.

Beispiele: Wie, du bist umgezogen? Warum, weshalb, wieso?

R 75 **c)** nach Angaben, denen man keinen Glauben schenkt.

Beispiel: Der Mann behauptete, das Geld gefunden (?) zu haben.

2. Das Fragezeichen steht nicht

R 76 **a)** nach indirekten Fragesätzen (↑ R 2).

R 77 **b)** nach Ausrufen, die die Form einer Frage haben (↑ R 81).

3. Fragezeichen in Verbindung mit anderen Satzzeichen

Anführungszeichen ↑ R 102; Beistrich ↑ R 74, Merke; Gedankenstrich ↑ R 90; runde Klammern ↑ R 106.

VI. Ausrufezeichen

1. Das Ausrufezeichen steht

R 78 **a)** nach Aufforderungssätzen (Wunsch- und Befehlssätzen; vgl. aber R 2 u. R 3).

Beispiele: Wäre er doch schon hier! Komm sofort zu mir! Verlassen Sie sofort den Raum, wenn Sie sich nicht anständig benehmen können!

b) nach Ausrufen [der Gemütsbewegung] (Sätze und einzelne Wörter). **R 79**

Beispiele: Das ist herrlich! Oh! Schade! Achtung! „Pfui!" rief er entrüstet aus.

Folgen mehrere Ausrufewörter aufeinander, dann steht das Ausrufezeichen in der Regel erst hinter dem letzten Ausrufewort.

Beispiel: „Nein, nein!" rief er.

Liegt aber auf jedem Ausrufewort besonderer Nachdruck, dann steht hinter jedem Wort ein Ausrufezeichen.

Beispiel: „Na! Na! So passen Sie doch auf!" tönte es ihm entgegen.

c) nach der Anrede. **R 80**

Das Ausrufezeichen steht meist nach der Anrede am Briefanfang (vgl. aber R 16).

Beispiel: Sehr geehrter Herr Schmidt!
 Gestern erhielt ich …

d) nach Ausrufen in Form einer Frage. **R 81**

Nach Ausrufen, die die Form einer Frage haben, wird kein Fragezeichen, sondern ein Ausrufezeichen gesetzt.

Beispiel: Wie lange ist das her! (Ausruf des Erstaunens.) Aber: Wie lange ist das her? (Antwort: zwei Jahre.)

2. Das Ausrufezeichen steht nicht

am Briefschluß hinter *hochachtungsvoll, mit herzlichem Gruß* oder ähn- **R 82**
lichen Wendungen. Ferner setzt man kein Ausrufezeichen nach abhängi-
gen Ausrufesätzen (↑ R 2), nach unbetontem Empfindungswort (↑ R 17)
und nach Wunsch- und Befehlssätzen, die ohne Nachdruck gesprochen
werden (↑ R 3).

3. Ausrufezeichen in Verbindung mit anderen Satzzeichen

Anführungszeichen ↑ R 102; Beistrich ↑ R 45, a, Merke; Gedankenstrich
↑ R 90; runde Klammern ↑ R 106.

VII. Gedankenstrich

1. Zwischen Sätzen

Der Gedankenstrich zwischen Sätzen bezeichnet den Wechsel der Spre- **R 83**
chenden, den Übergang zu etwas anderem u. ä.

Beispiele: „Mein Sohn, was birgst du so bang dein Gesicht?" — „Siehst, Vater, du den Erlkönig nicht?" (Goethe). Ihren Wunsch können wir also leider nicht erfüllen. — Gestern erhielten wir Nachricht von Herrn Schmidt, daß …

2. Innerhalb eines Satzes

Der Gedankenstrich kann innerhalb eines Satzes zur Bezeichnung einer
längeren Pause stehen, und zwar

a) zwischen Überschriften. **R 84**

Beispiel: Inhalt: Rechnungsarten — Zinsrechnung — Rechenhilfen — Zahlenspiele-reien.

b) zwischen Ankündigungs- und Ausführungskommando. **R 85**

Beispiel: Rumpf vorwärts senken — senkt!

R 86 c) zur Vorbereitung auf etwas Unerwartetes und zur Erhöhung der Spannung.

Beispiele: Plötzlich — ein vielstimmiger Schreckensruf! Paris — das Herz Frankreichs.

R 87 d) bei Abbruch der Rede, beim Verschweigen eines Gedankenabschlusses (vgl. aber R 110).

Beispiel: „Schweig, du —!" schrie er ihn an.

3. Bei eingeschobenen Satzteilen und Sätzen

R 88 Der Gedankenstrich steht vor und nach eingeschobenen Satzteilen und Sätzen, die den Nachdruck des Gesagten erhöhen sollen (vgl. den folgenden Abschnitt 4, a–c).

Beispiel: Wir traten aus dem Walde, und ein wunderbares Bild — die Sonne kam eben durch die Wolken — breitete sich vor uns aus.

Über den Beistrich bei eingeschobenen Sätzen ↑ R 44; über Klammern bei eingeschobenen Sätzen ↑ R 104.

4. Gedankenstrich in Verbindung mit anderen Satzzeichen

a) *Beistrich*

R 89 Der Beistrich steht nach einem eingeschobenen Satzteil oder Satz hinter dem zweiten Gedankenstrich, wenn er auch ohne den eingeschobenen Satzteil oder Satz stehen müßte.

Beispiel: Sie wundern sich — schreiben Sie —, daß ich so selten von mir hören lasse.

Beachte: Schließt der eingeschobene Satz mit einem Gliedsatz, einer nachgestellten genaueren Bestimmung o. ä. (↑ R 18 ff.), dann wird dieser am Ende nicht durch Beistrich abgetrennt, weil der Gedankenstrich bereits die Trennung vom Hauptsatz übernimmt.

Beispiel: Philipp verließ — im Gegensatz zu seinem Vater, der 40 weite Reisen unternommen hatte — Spanien nicht mehr.

b) *Ausrufe- und Fragezeichen*

R 90 Ausrufe- und Fragezeichen stehen nach einem eingeschobenen Satzteil oder Satz vor dem zweiten Gedankenstrich.

Beispiele: Ich fürchte — hoffentlich mit Unrecht! —, daß du krank bist. Er lehrte uns — erinnern Sie sich noch? —, unerbittlich gegen uns, nachsichtig gegen andere zu sein.

c) *Doppelpunkt*

R 91 Der Doppelpunkt steht nach einem eingeschobenen Satz hinter dem zweiten Gedankenstrich.

Beispiel: Verächtlich rief er ihm zu — er wandte kaum den Kopf dabei —: „Was willst du hier?"

5. Gedankenstrich an Stelle des Beistrichs und des Doppelpunktes

R 92 a) Der Gedankenstrich kann statt des *Beistrichs* bei einer besonderen Betonung des Gegensatzes stehen.

Beispiel: Komme bald — aber mit ihm.

R 93 b) Der Gedankenstrich kann an Stelle des *Doppelpunktes* stehen, wenn dieser zu schwach erscheint.

Beispiel: Haus und Hof, Geld und Gut — alles ist verloren.

6. Auslassungspunkte an Stelle des Gedankenstrichs ↑ R 110.

VIII. Anführungszeichen

Die Zeichen „" ,' "" '' werden in der Handschrift und bei der Schreib- **R 94**
maschine verwendet. Im deutschen Schriftsatz erscheinen „" oder »«, in
sprachwissenschaftlichen Arbeiten (Wörterbüchern) außerdem '. Die
Strichzeichen werden umgangssprachlich „Gänsefüßchen" genannt. Vgl.
auch S. 85, 8, a.

1. Wörtliche (direkte) Rede

Anführungszeichen stehen vor und hinter einer wörtlichen Rede. Sie stehen **R 95**
auch bei wörtlich wiedergegebenen Gedanken.

> Beispiele: Friedrich der Große sagte: „Ich bin der erste Diener meines Staates." „Wenn
> nur schon alles vorüber wäre", dachte Karl.

Wird eine angeführte wörtliche Rede unterbrochen, so werden ihre beiden
Teile in Anführungszeichen gesetzt.

> Beispiel: „Wir wollen endlich gehen", drängte Stephan. „Hier ist jede weitere Dis-
> kussion zwecklos."

2. Anführung von Textstellen

Anführungszeichen stehen bei wörtlicher Anführung einer Textstelle aus **R 96**
Büchern, Schriftstücken, Briefen u. a., und zwar am Anfang und am
Ende des Zitats.

> Beispiel: In seinem umfangreichen Bericht führte er u. a. aus: „Die wirtschaftlichen
> Verhältnisse haben sich in den letzten Jahren so verbessert, daß es glücklicherweise keine
> Arbeitslosen mehr gibt."

Wird ein Zitat unterbrochen, so werden die einzelnen Zitatteile in An-
führungszeichen gesetzt.

> Beispiel: „Es ist schön", schrieb er in seinem letzten Brief, „daß wir uns bald wieder-
> sehen."

3. Anführung von einzelnen Wörtern, Aussprüchen, Titeln u. ä.

a) Anführungszeichen stehen, wenn einzelne Wortteile, Wörter oder kurze **R 97**
Aussprüche sowie Titel von Büchern, Gedichten, Zeitungen u. ä. hervor-
gehoben werden sollen.

> Beispiele: fülisch, gebildet in Anlehnung an West„falen". Der Begriff „Existentialis-
> mus" wird heute vielfältig verwendet. „Eile mit Weile!" ist ein altes Sprichwort. Mit
> den Worten „Mehr sein als scheinen" hat Schliffen Moltke charakterisiert. „Laßt uns
> nicht grübeln!", so tönt es immer wieder an unser Ohr. (Ironische Hervorhebung:) Dieser
> „treue Freund" verriet ihn als erster.

Das zu einem Titel von Büchern, Gedichten, Zeitungen u. ä. gehörende
Geschlechtswort wird in die Anführungszeichen einbezogen, wenn es im
Werfall steht. Es kann einbezogen oder ausgeschlossen werden, wenn der
Wenfall wie der Werfall lautet. Es steht außerhalb der Anführungszei-
chen, wenn es sich durch die Beugung vom Werfall unterscheidet.

> Beispiele: „Das Lied von der Glocke" wurde im Jahre 1800 gedichtet. Sie lasen „Das
> Lied von der Glocke". Oder: Sie lasen das „Lied von der Glocke". Sie entnahmen
> diesen Gedanken dem „Lied von der Glocke".

b) Die Anführungszeichen können wegbleiben, wenn es sich um die ein- **R 98**
deutige Angabe eines Buchtitels, einer Gedichtüberschrift u. dgl. handelt.

> Beispiel: Die erste Aufführung von Schillers Tell fand in Weimar statt.

c) Ohne Anführungszeichen können auch hervorzuhebende Wörter, Sil- **R 99**
ben und Buchstaben stehen, besonders im Druck, wenn sie durch Sper-
rung oder durch eine andere Schriftart gekennzeichnet werden.

> Beispiel: Nach dem Verhältniswort *längs* kann der Wesfall oder der Wemfall stehen.

2*

4. Halbe Anführungszeichen

R 100 Wenn in einen mit Anführungszeichen versehenen Satz eine wörtliche Rede oder eine andere Anführung eingeschoben wird, so erhält diese halbe Anführungszeichen.

Beispiele: Goethe schrieb: „Wielands ‚Oberon‘ wird als ein Meisterstück angesehen werden." „Das war ein Satz aus Eichendorffs ‚Ahnung und Gegenwart‘", sagte er.

5. Stellung der Satzzeichen beim Zusammentreffen mit Anführungszeichen

R 101 a) Der *Beistrich* steht immer n a c h dem schließenden Anführungszeichen.

Beispiele: „Das ist vielleicht möglich", sagte er. „Morgen früh", sagte Hans, „komme ich zurück." Als er mich fragte: „Weshalb darf ich das nicht?", war ich sehr verlegen. In einem Bericht heißt es: „Schopenhauers Hauptwerk ‚Die Welt als Wille und Vorstellung‘, das 1817 erschien, fand zunächst keine Beachtung."

R 102 b) *Punkt, Frage-* und *Ausrufezeichen* stehen v o r dem Schlußzeichen, wenn sie zur wörtlichen Rede oder zur Anführung gehören. In allen anderen Fällen stehen sie nach dem Schlußzeichen.

Punkt: Er erwiderte: „Jeder hat sein eigenes Urteil." A b e r: Wir lasen Goethes „Braut von Korinth" und Schillers „Kraniche des Ibykus".

Fragezeichen: „Wie geht es dir?" redete er ihn an. Sie fragte: „Weshalb darf ich das nicht?" und fing an zu weinen. A b e r: Wer kennt das Gedicht „Der Erlkönig"? Kennst du den Roman „Quo vadis?"?

Ausrufezeichen: „Verlaß mich nicht!" rief sie aus. „Niemals, niemals!" ertönte es von ihren Lippen. Immer kommt er mit seinem „Ich kann nicht!" A b e r: Zitiere doch nicht immer das gleiche Wort aus Schillers „Tell"! Laß doch dieses ewige „Ich will nicht!"!

IX. Klammern

A. Runde Klammern

1. Erklärende Zusätze

R 103 In runden Klammern stehen erklärende Zusätze.

Beispiele: Frankenthal (Pfalz); Beil (Werkzeug); Grille (Insekt) — Grille (Laune). Als Hauptwerk Matthias Grünewalds gelten die Gemälde des Isenheimer Hochaltars (vollendet 1511 oder 1515).

In Nachschlagewerken und Wörterbüchern werden für die Einschließung von erklärenden Zusätzen u. ä. oft auch eckige Klammern verwendet.

2. Schaltsätze

R 104 Bei Schaltsätzen, die ohne Nachdruck gesprochen werden, können an die Stelle von Beistrichen († R 44) oder Gedankenstrichen († R 88) runde Klammern treten.

Beispiel: Er verachtete (es sei zu seiner Ehre gesagt) jede Ausrede.

3. Runde Klammern in Verbindung mit anderen Satzzeichen

R 105 a) Nach der zweiten runden Klammer steht jedes Satzzeichen, das auch ohne den eingeklammerten Zusatz stehen müßte.

Beispiele: Sie wohnen in Ilsenburg (Harz). Sie wundern sich (so schreiben Sie), daß ich so selten von mir hören lasse. Lebt er in Cambridge (USA) oder in Cambridge (England)? Er sagte (es war kaum zu hören): „Ich komme wieder."

R 106 b) Vor der zweiten runden Klammer stehen *Ausrufe-* und *Fragezeichen*, wenn sie der eingeklammerte Zusatz verlangt.

Der *Punkt* steht nur dann vor der zweiten runden Klammer, wenn ein
eingeklammerter Satz dem vorhergehenden Satz beigefügt ist.

> Beispiele: Er kommt (glaube es mir!) noch heute nach Hause. Dies war (weißt du es
> noch?) seine größte Leidenschaft. Dies ist das wichtigste Ergebnis meiner Ausführungen.
> (Die Belege für meine Beweisführung finden sich auf Seite 25 dieses Buches.) Aber (wenn
> der eingeklammerte Satz Schaltsatz ist): Er verachtete (es sei zu seiner Ehre gesagt) jede
> Ausrede.

4. Besondere Verwendung der runden Klammern

Zur Klammer hinter Kleinbuchstaben in Gliederungen ↑ R 10a.

B. Eckige Klammern

1. Erläuterungen

Eckige Klammern setzt man, wenn die Erläuterungen zu einem bereits **R 107**
eingeklammerten Zusatz gehören.

> Beispiel: Mit dem Wort Bankrott (vom italienischen *banca rotta* [zusammengebrochene
> Bank]) bezeichnet man die Zahlungsunfähigkeit.

2. Eigene Zusätze

Ebenso verwendet man eckige Klammern, um in Anführungen eigene **R 108**
Zusätze oder bei Abschriften von Texten eigene Ergänzungen nicht les
barer oder zerstörter Stellen kenntlich zu machen.

> Beispiel: Er schrieb: „Als ich die Alpen zum erstenmal von oben sah [er war auf dem
> Fluge von München nach Rom], war ich von der Größe des Anblicks tief bewegt."

3. Auslassung von Buchstaben oder Wortteilen

Die eckigen Klammern deuten an, daß Buchstaben oder Wortteile weg- **R 109**
gelassen werden können.

> Beispiele: Entwick[e]lung, schleif[e]!, acht[und]einhalb.

X. Auslassungspunkte

Um den Abbruch einer Rede, das Verschweigen eines Gedankenabschlus- **R 110**
ses zu bezeichnen, verwendet man statt des Gedankenstriches (↑ R 87)
besser drei Auslassungspunkte. Dies geschieht vor allem dann, wenn in
demselben Satz bereits ein Gedankenstrich verwendet worden ist. Auch
am Schluß eines Satzes stehen nur drei Punkte.

> Beispiele: Der Horcher an der Wand... Er gab den Takt an: „Eins-zwei, eins-zwei ..."

Merke: Ein Abkürzungspunkt darf jedoch nicht in die Auslassungs-
punkte einbezogen werden.

> Beispiel: In Hofheim a.Ts. ...

Die Auslassungspunkte stehen ferner bei Zitaten, um die Weglassung von
Wörtern oder Sätzen zu bezeichnen, die in einem bestimmten Zusammen-
hang als unwesentlich für den Leser betrachtet werden.

> Beispiel: Ohne Auslassungszeichen: „Ich gehe", sagte er mit Entschiedenheit. Er nahm
> seinen Mantel und ging hinaus. Mit Auslassungszeichen: „Ich gehe", sagte er ... und ging
> hinaus.

Zur Rechtschreibung

Es ist das Ziel des Dudens, eine einheitliche Schreibung zu erreichen. Aus diesem Grunde mußten in schwankenden, landschaftlich oder persönlich uneinheitlich gehandhabten Fällen Entscheidungen getroffen werden, die als Vorschläge zu werten sind. Sie sollen denjenigen Benutzern dienen, die eine klare Entscheidung suchen. Persönlicher Schreibung, etwa im Anschluß an die Umgangssprache oder an die Mundart, soll damit durchaus Raum gelassen werden. Dies gilt vor allem für den Künstler.

I. Groß- und Kleinschreibung

R 111 Die Schwierigkeiten der deutschen Groß- und Kleinschreibung bestehen für andere Sprachen nicht in gleichem Maße, weil diese alle Wörter mit Ausnahme der Namen und des Satzanfanges klein schreiben. Die deutsche Rechtschreibung erfordert die nachstehenden umfangreichen Richtlinien, die trotz ihrer Ausführlichkeit nicht alle auftretenden Fälle der Groß- und Kleinschreibung einschließen können. *In Zweifelsfällen, die hier nicht behandelt werden, schreibe man mit kleinen Anfangsbuchstaben.*

A. Großschreibung

1. Satzanfänge

R 112 Groß schreibt man das erste Wort eines Satzganzen (vgl. aber R 125 u. R 126). Das gilt auch für Abkürzungen (↑ S. 84, 5).

> Beispiele: Wer den Charakter eines Volkes ergründen will, kann verschiedene Wege einschlagen. Er kann seine Geschichte durchforschen, sich in seine Kunst vertiefen oder seine Statistiken untersuchen. Überall drückt sich der Volkscharakter aus. Er findet seinen Niederschlag auch in der Sprache eines Volkes. De Gaulle hat sich mit Konrad Adenauer getroffen. Von Gruber erschien zuerst (vgl. aber R 126). Vgl. § 5 der Satzung.

Merke: Der Brauch, alle Verszeilen mit großem Anfangsbuchstaben zu schreiben, ist veraltet.

2. Nach Doppelpunkt und bei Anführungszeichen

R 113 a) Groß schreibt man nach einem Doppelpunkt das erste Wort einer wörtlichen Rede oder eines selbständigen Satzes. (Kleinschreibung nach Doppelpunkt ↑ R 128.)

> Beispiele: Er rief mir zu: „Der Versuch ist gelungen." Gebrauchsanweisung: Man nehme alle 2 Stunden eine Tablette.

R 114 b) Groß schreibt man das erste Wort eines angeführten selbständigen Satzes, eines [angeführten] Buch- oder Zeitschriftentitels, einer Gedichtüberschrift u. dgl. (↑ R 224).

> Beispiele: Sie hatten sich dahin geeinigt, „Tue recht und scheue niemand!" als Sinnspruch zu wählen. Großen Beifall fanden „Die Kraniche des Ibykus", das bekannte Gedicht Schillers. Der Aufsatz stand in der Deutschen Medizinischen Wochenschrift. Jean Anouilh: Beckett oder Die Ehre Gottes.

3. Hauptwörter

R 115 Groß schreibt man alle wirklichen Hauptwörter.

> Beispiele: Himmel, Erde, Kindheit, Verständnis, Verwandtschaft, Reichtum, Verantwortung, Fremdling.

4. Hauptwörtlich gebrauchte Wörter anderer Wortarten

Groß schreibt man Wörter aller Art, wenn sie als Hauptwörter gebraucht werden.

a) *Eigenschafts-* und *Mittelwörter* **R 116**

Beispiele: das Gute, der Abgeordnete, das Nachstehende, das Schaurig-Schöne, Gutes und Böses, Altes und Neues, Ähnliches und Verschiedenes (= Dinge verschiedener Art); er war auf das Äußerste gefaßt, aber († R 134): er erschrak aufs äußerste, es fehlt ihm am Besten, aber († R 134): sie liest am besten; alles in ihrer Macht Stehende; das in Kraft Getretene; das dem Schüler Bekannte; Stoffe in Blau und Gelb; er ist bei Rot über die Kreuzung gefahren.

Groß schreibt man Eigenschafts- und Mittelwörter vor allem dann, wenn sie mit *allerlei, alles, etwas, genug, nichts, viel, wenig* und ähnlichen Wörtern in Verbindung stehen.

Beispiele: allerlei Schönes, alles Gewollte, etwas Wichtiges, etwas derart Banales, nichts Besonderes, wenig Angenehmes.

b) *Fürwörter* **R 117**

Beispiele: jedem das Seine, die Deinigen, das traute Du, das steife Sie, ein gewisser Jemand; aber († R 135): der nämliche, der andere usw.

c) *Zahlwörter* **R 118**

Beispiele: die Acht, ein Dritter (ein Unbeteiligter), die verhängnisvolle Dreizehn, ein Achtel, der Erste (dem Range, der Tüchtigkeit nach), ein Zweites bleibt zu erwähnen; aber († R 135): der erste (der Reihe nach).

d) *Umstands-, Verhältnis-, Binde-* und *Empfindungswörter* **R 119**

Beispiele: das Ja und Nein, das Drum und Dran, das Auf und Nieder, das Wenn und Aber, das Entweder-Oder, das Als-ob, das Weh und Ach, das Bimbam.

e) *Grundformen von Zeitwörtern* **R 120**

Hauptwörtlich gebrauchte Grundformen erkennt man daran, daß sie ein Geschlechtswort, ein Verhältniswort oder eine nähere Bestimmung (Beifügung im Wesfall o. ä.) bei sich haben.

Beispiele: das Ringen, das Lesen, das Schreiben, [das] Verlegen von Rohren, [durch] Anwärmen und Schmieden einer Spitze, im Sitzen und Liegen, das Zustandekommen, zum Verwechseln ähnlich, das Sichausweinen, beim (landsch.: am) Kuchenbacken sein, für Hobeln und Einsetzen [der Türen], das In-den-Tag-hinein-Leben, das Für-sich-haben-Wollen. (Zum Bindestrich † R 156.)

Bei Grundformen ohne Geschlechtswort, ohne Verhältniswort und ohne nähere Bestimmung ist es oft zweifelhaft, ob es sich um ein Zeitwort oder um ein Hauptwort handelt. In diesen Fällen sind Groß- und Kleinschreibung gerechtfertigt.

Beispiele: ..., weil Geben (geben) seliger denn Nehmen (nehmen) ist. Er übte mit den Kindern kopfrechnen (Kopfrechnen). Fritz lernt gehen (Gehen). Sie hörte singen (Singen).

5. Anredefürwörter

a) Groß schreibt man das Anredefürwort in Briefen, feierlichen Aufrufen **R 121** und Erlassen, Grabinschriften, Widmungen, Mitteilungen des Lehrers an einen Schüler unter Schularbeiten, auf Fragebogen, bei schriftlichen Prüfungsaufgaben usw.

Beispiele: Liebes Kind! Ich habe mir Deinetwegen viel Sorgen gemacht und war glücklich, als ich in Deinem ersten Brief las, daß Du gut in Deinem Ferienort eingetroffen bist. Hast Du Dich schon gut erholt? Liebe Eltern! Ich danke Euch für das Päckchen, das Ihr mir geschickt habt. Dieses Buch sei Dir als Dank für treue Freundschaft gewidmet. Mitteilung des Lehrers unter einem Aufsatz: Du hast auf Deine Arbeit viel Mühe verwendet.

Bei der Wiedergabe von Ansprachen, in Prospekten, Lehrbüchern u. ä. wird jedoch klein geschrieben.

Beispiele: Liebe Freunde! Ich habe euch zusammengerufen ... Lies die Sätze langsam vor. Wo machst du eine Pause?

R 122 **b)** Groß schreibt man immer die Höflichkeitsanrede *Sie* und das entsprechende besitzanzeigende Fürwort *Ihr*, gleichviel ob die Anrede einer oder mehreren Personen gilt. Das rückbezügliche Fürwort *sich* wird immer klein geschrieben.

Beispiele: Haben Sie alles besorgen können? Er fragte sofort: „Kann ich Ihnen behilflich sein?" Wie geht es Ihren Kindern? Haben Sie sich gut erholt?

Hierzu gehören auch Höflichkeitsanreden und Titel wie:

Eure Exzellenz, Seine Heiligkeit (der Papst), Ihre Königliche Hoheit.

Veraltet ist die Anrede in der 3. Person Einzahl.

Beispiele: Schweig' Er! Höre Sie!

Mundartlich lebt hier und da noch die Anrede *Ihr* gegenüber einer älteren Person.

Beispiele: Kommt Ihr auch, Großvater? Kann ich Euch helfen, Hofbauer?

6. Einzelbuchstaben

R 123 Groß schreibt man im allgemeinen hauptwörtlich gebrauchte Einzelbuchstaben.

Beispiele: Das A und O; ein X für ein U vormachen.

Meint man aber den Kleinbuchstaben, wie er im Schriftbild vorkommt, dann schreibt man klein.

Beispiele: der Punkt auf dem i, das n in Land, das Dehnungs-h (aber: das Zungen-R), das Fugen-s (aber: der S-Laut).

7. Über die Großschreibung der Eigenschafts-, Mittel-, Verhältnis- und Zahlwörter als Teile von Namen und Titeln

vgl. Familien- und Personennamen (↑ R 179); erdkundliche Namen (↑ R 198); Straßennamen (↑ R 218); Titel und sonstige Namen (↑ R 224).

8. Über die Groß- und Kleinschreibung von Abkürzungen, die als erster Bestandteil einer Zusammensetzung verwendet werden,

↑ R 137.

B. Kleinschreibung

R 124 **Grundregel:** Klein werden mit Ausnahme der Hauptwörter die Wörter aller Wortarten geschrieben, soweit sie nicht unter die in Abschnitt A behandelten Richtlinien fallen.

Im einzelnen sind jedoch nachstehende Richtlinien besonders zu beachten.

1. Satzanfänge

R 125 **a)** Klein schreibt man, wenn am Satzanfang ein Auslassungszeichen steht (↑ R 238).

Beispiele: 's ist unglaublich! 'ne Menge Geld ist das!

R 126 **b)** Klein schreibt man zu Beginn eines Satzes das den Adel bezeichnende abgekürzte Verhältniswort *von* (v.), um Mißverständnisse zu vermeiden.

Beispiel: v. Gruber erschien zuerst. Aber nicht: V. Gruber erschien zuerst (könnte verwechselt werden mit: Viktor, Volkmar usw. Gruber erschien zuerst). Jedoch (↑ R 112): Von Gruber erschien zuerst.

2. Nach Frage- und Ausrufezeichen

Nach Frage- und Ausrufezeichen wird klein geschrieben, wenn diese in- **R 127**
nerhalb des Satzganzen stehen.

Beispiele: „Wohin des Wegs?" erschallt des Wächters Ruf. „Gott grüß' dich!" rief
er ihm zu.

3. Nach Doppelpunkt

Klein schreibt man nach einem Doppelpunkt, der vor einer angekündig- **R 128**
ten Aufzählung, einem angekündigten Satzstück oder vor einer Zusam-
menfassung oder Folgerung steht.

Beispiele: Er hat im Kriege alles verloren: seine Frau und seine Kinder, sein Haus
und seine ganze Habe. Die Kinder mußten schreiben: des großen Mannes. Rechnen:
sehr gut. 1000 DM, in Worten: eintausend DM. Das Haus, die Wirtschaftsgebäude,
die Scheune und die Stallungen: alles war den Flammen zum Opfer gefallen.

4. Nicht hauptwörtlich gebrauchte Hauptwörter

Hauptwörter werden klein geschrieben, wenn sie wie Wörter einer ande-
ren Wortart verwendet werden,

a) als *Umstandswörter* **R 129**

Beispiele: anfangs, rings, teils, spornstreichs, flugs, mitten, morgens, abends, sonntags,
dienstags.

b) als *Verhältniswörter* **R 130**

Beispiele: dank, kraft, laut, statt, trotz, angesichts, wegen, behufs, betreffs.

c) als *unbestimmte Für- und Zahlwörter* **R 131**

Beispiele: ein bißchen (= ein wenig) Brot, aber: ein kleiner Bissen Brot; ein paar
(= einige) Schuhe, aber: ein Paar (= zwei zusammengehörende) Schuhe.

d) in stehenden Verbindungen mit Zeitwörtern, in denen das Hauptwort, **R 132**
meist in verblaßter Bedeutung gebraucht, nicht mehr als solches empfun-
den wird.

Beispiele: schuld sein, feind sein, willens sein; mir ist angst (= mir ist bange), aber:
ich habe keine Angst; das ist schade (= bedauerlich), aber: das ist sein eigener Schaden;
recht bekommen, aber: sein Recht bekommen.

Beachte: Klein schreibt man *bang[e]*, *gram*, *leid*, *weh* in festen Verbin-
dungen mit Zeitwörtern. In diesen Fällen handelt es sich nicht um die
hauptwörtlich gebrauchten Wörter *die Bange, der Gram, das Leid, das Weh*,
sondern um alte Eigenschaftswörter oder Umstandswörter, die im heuti-
gen Sprachgebrauch jedoch gewöhnlich nicht mehr als solche verstanden
werden.

Beispiele: Er macht ihm bange. Aber: Er hat keine Bange. Er ist mir gram.
Aber: Sein Gram war groß. Es tut ihm leid. Aber: Ihm soll kein Leid geschehen. Es
ist mir weh ums Herz. Aber: Es ist sein ständiges Weh und Ach.

Über die unterschiedliche Schreibung von Hauptwörtern in stehenden Ver-
bindungen mit Zeitwörtern, in Beispielen wie *Auto fahren*, *radfahren* u. a.,
↑ R 140.

5. Eigenschafts-, Mittel- und Umstandswörter

Eigenschafts-, Mittel- und Umstandswörter werden auch dann klein ge-
schrieben,

a) wenn sie in unveränderlichen Wortpaaren oder in festen Verbindun- **R 133**
gen [mit Zeitwörtern] stehen.

Beispiele: alt und jung, groß und klein, arm und reich, durch dick und dünn, über
kurz oder lang, im großen und ganzen; den kürzeren ziehen, im reinen sein, auf dem
laufenden bleiben, ins reine bringen; von klein auf.

M e r k e : In einzelnen Fällen schreibt man jedoch noch groß, weil die hauptwörtliche Vorstellung überwiegt.

B e i s p i e l e : ins Schwarze treffen, bis ins Aschgraue, ins Lächerliche ziehen.

R 134 b) wenn [ihnen ein Geschlechtswort oder Fürwort vorangeht und] sie für ein Eigenschafts-, Mittel- oder Umstandswort ohne Geschlechtswort oder Fürwort stehen.

B e i s p i e l e : des weiteren (= weiterhin), am besten (= sehr gut), aufs neue (= wiederum), im allgemeinen (= ganz allgemein), in folgendem od. im folgenden (= weiter unten), im voraus (= vorher), um ein beträchtliches (= sehr), von neuem (= wiederum), von fern (= fernher). Es ist das gegebene (= gegeben). Es ist das beste (= am besten, sehr gut), wenn du dich entschuldigst. Es ist das richtige (= richtig). Aber (↑ R 116): Es fehlt ihm am Besten (= an der besten Sache).

c) Ein Eigenschaftswort oder Mittelwort mit vorangehendem Geschlechtswort u. ä. wird immer klein geschrieben, wenn es sich auf ein vorangehendes oder nachstehendes Hauptwort bezieht, mit dem mehr als eine Person oder Sache bezeichnet wird.

B e i s p i e l e : Er hatte alle Kinder gern. Besonders aber liebte er die fröhlichen und die fleißigen. Er war der aufmerksamste und klügste meiner Zuhörer. Sie ist die schönste aller Frauen, die schönste der Schönen. Er kauft nur das billigste vom Billigen. Vier Enkel, deren jüngster… Aber: Er war ihr Bruder. Sie hat den früh Verstorbenen sehr geliebt.

6. Für- und Zahlwörter

R 135 Für- und Zahlwörter sowie fürwörtlich gebrauchte Eigenschafts- und Mittelwörter werden auch in Verbindung mit einem Geschlechtswort oder einem Fürwort klein geschrieben (vgl. a b e r R 117, R 118 u. R 121f.).

B e i s p i e l e : du, ihr (vgl. a b e r R 121f.), man, jemand, niemand, derselbe, einer, keiner, jeder, zwei, beide; der einzelne, der nämliche, ein jeder, die beiden, die ersten drei, der achtel Liter, der eine, der andere, die übrigen, jeder beliebige, der erste beste, der folgende (der Reihe nach), alle folgenden (= andern), folgendes (= dieses); um ein großes (= viel), das meiste, das mindeste, das wenigste, wir zwei, wir beide, Sie beide. Herzliche Grüße von uns beiden, von uns dreien. Er tut alles mögliche (= viel, allerlei). Aber (↑ R 116): Er bedenkt alles Mögliche (= alle Möglichkeiten).

M e r k e : Im Gegensatz zu der Schreibung von Eigenschafts- und Mittelwörtern (↑ R 116) werden Für- und Zahlwörter auch dann klein geschrieben, wenn sie mit *allerlei, alles, etwas, genug, nichts, viel, wenig* und ähnlichen Wörtern in Verbindung stehen.

B e i s p i e l e : allerlei anderes, etwas anderes, alle übrigen, alle drei, alle beide.

7. Bloße Anführung oder Nennung von Wörtern

R 136 Wird ein nichthauptwörtliches Wort nur angeführt, dann wird es auch in Verbindung mit dem Geschlechtswort klein geschrieben.

B e i s p i e l e : Es ist umstritten, ob „trotzdem" unterordnend gebraucht werden darf. Er hat das „und" in diesem Satz übersehen. Er liebt die daß-Sätze.

8. Abkürzungen und Zeichen in Zusammensetzungen

R 137 Die Groß- oder Kleinschreibung von Abkürzungen und Zeichen bleibt auch dann erhalten, wenn sie als erster Bestandteil von Zusammensetzungen oder in Ableitungen verwendet werden (↑ R 150).

B e i s p i e l e : Tbc-krank, US-amerikanisch, km-Zahl, das n-Eck, das n-fache.

II. Zusammen- und Getrenntschreibung

R 138 Bei der Zusammen- und Getrenntschreibung handelt es sich um einen ständigen Entwicklungsvorgang. Es ist deshalb nicht möglich, feste Richtlinien aufzustellen. Die nachstehenden Beispiele geben den derzeitigen Entwicklungsstand wieder. *In Zweifelsfällen schreibe man getrennt.*

43 Zur Rechtschreibung

Merke: In der Regel zeigt Starkton des ersten Gliedes Zusammenschreibung, Starkton bei beiden Wörtern Getrenntschreibung an.

1. Zusammen schreibt man, wenn ein neuer Begriff entsteht

Z u s a m m e n schreibt man, wenn durch die Verbindung zweier Wörter **R 139** ein neuer Begriff entsteht, den die bloße Nebeneinanderstellung nicht ausdrückt. (Nur das erste Glied der Zusammensetzung trägt Starkton.)
G e t r e n n t schreibt man, wenn zwei zusammengehörige Wörter noch ihren ursprünglichen Sinn bewahrt haben. (Beide Wörter tragen Starkton.)
Dies gilt vor allem für Verbindungen mit einem Zeitwort als zweitem Glied.

B e i s p i e l e :

Zusammenschreibung	Getrenntschreibung
Wenn du nicht fleißiger bist, wirst du sitzenbleiben (d. h. nicht versetzt werden).	Du sollst auf dieser Bank sitzen bleiben.
Du sollst dich nicht gehenlassen (d. h. nicht nachlässig sein).	Du sollst ihn um fünf Uhr gehen lassen.
Er wird dich bei diesem Fest freihalten (d. h. für dich bezahlen).	Er wird seine Rede frei halten.
Er wird dir diese Summe gutschreiben (d. h. anrechnen).	Dieser Schüler kann gut schreiben.
Man sah ihn daherkommen.	Es wird daher kommen, daß …
Wie die Tage dahinfliegen!	Es ist sicher, daß er dahin fliegen wird.

Merke: Es gibt aber auch Verbindungen [von Eigenschaftswort und Zeitwort sowie von Zeitwort und Zeitwort], die man zusammenschreibt, obwohl kein neuer Begriff entsteht. Vgl. im einzelnen das Wörterverzeichnis.

B e i s p i e l e : sauberhalten, totschießen, kennenlernen, spazierengehen.

2. Zusammen schreibt man, wenn das Hauptwort verblaßt

Gerade bei den Verbindungen mit einem Hauptwort zeigt sich, wie wenig es der Entwicklungsvorgang gestattet, einheitliche Richtlinien aufzustellen. Je nach dem Grad der Verblassung des Hauptwortes stehen Getrennt- und Zusammenschreibung sowie Groß- und Kleinschreibung nebeneinander.

a) *Hauptwort + Zeitwort*

Z u s a m m e n schreibt man, wenn die Vorstellung der Tätigkeit vorherrscht **R 140** und die des Hauptwortes verblaßt ist. (Das Hauptwort ist zum „Vorwort" des Zeitwortes geworden.)

G e t r e n n t schreibt man, wenn die Vorstellung des mit dem Hauptwort bezeichneten Dinges noch voll vorhanden ist. (Hauptwort und Zeitwort haben noch eigenen Satzgliedwert.)

B e i s p i e l e :

Zusammenschreibung	Getrenntschreibung
wetterleuchten, es wetterleuchtet, es hat gewetterleuchtet; hohnlachen, er hohnlacht (auch: er lacht hohn), er hat hohngelacht; kopfstehen, er hat kopfgestanden, er steht kopf; radfahren, er ist radgefahren, aber: er fährt Rad; kegelschieben, aber: er schiebt Kegel, er hat Kegel geschoben.	Rat holen, Gefahr laufen, Sorge tragen, Posten stehen, Auto fahren, Schi laufen, Seil ziehen, Klavier spielen, Karten spielen.

Merke: Der Entwicklungsvorgang bringt es mit sich, daß Getrennt- und Zusammenschreibung nebeneinander stehen können.

B e i s p i e l : Dank sagen oder danksagen.

b) *Verhältniswort + Hauptwort*

R 141 Zusammen schreibt man, wenn das verblaßte Hauptwort mit dem vorangestellten Verhältniswort ein neues Verhältniswort oder ein Umstandswort bildet.

Getrennt schreibt man, wenn die ursprüngliche Bedeutung beider Wörter erhalten ist.

Beispiele:

Zusammenschreibung	Getrenntschreibung
zuzeiten (bisweilen), infolge, inmitten, dortzulande, vorderhand, zugunsten, außerstande [sein], imstande [sein], instand [halten, setzen], zustande [bringen, kommen], beiseite [legen], vonnöten [sein], vonstatten [gehen], zugrunde [gehen], zupaß od. zupasse [kommen], zuschulden [kommen lassen].	zu Zeiten [Karls d. Gr.], unter Bezug auf, zu Händen, in Frage, aber bereits mit Kleinschreibung: in bezug auf, in betreff.

Merke: Auch hier stehen in einigen Fällen Getrennt- und Zusammenschreibung auf Grund des Entwicklungsvorganges nebeneinander.

Beispiele: an Stelle oder anstelle, an Hand oder anhand, auf Grund oder aufgrund.

3. Zusammen schreibt man, wenn eine Verbindung eigenschaftswörtlich gebraucht wird

a) *Mittelwort als zweiter Bestandteil*

R 142 Zusammen schreibt man, wenn die Verbindung in eigenschaftswörtlicher Bedeutung gebraucht wird. (Nur das erste Glied trägt Starkton, weil es als Glied einer Zusammensetzung das Grundwort näher bestimmt.)

Getrennt schreibt man, wenn die Vorstellung der Tätigkeit vorherrscht. (Beide Wörter tragen Starkton, weil sie eigenen Satzgliedwert haben.)

Als erster Bestandteil treten vor allem Hauptwörter, Eigenschaftswörter und Umstandswörter auf.

Beispiele: Die laubtragenden Bäume erfreuten mich. (Was für Bäume erfreuten mich?) Aber: Es gibt viele noch Laub tragende Bäume. (Was tun die Bäume noch?) Die reichgeschmückten Häuser ... (Wie sind die Häuser?) Aber: die reich geschmückten Häuser...; die Häuser sind reich geschmückt. (Was geschah mit den Häusern?) Die oben erwähnte Auffassung... (Was geschah mit der Auffassung?) Aber: Die obenerwähnte Auffassung... (Was für eine Auffassung?)

Zu besonderen Fällen vgl. S. 45, Merke.

b) *Eigenschaftswort als zweiter Bestandteil*

R 143 Zusammen schreibt man, wenn die Verbindung in eigenschaftswörtlicher Bedeutung gebraucht wird. (Nur das erste Glied trägt Starkton, weil es als Glied einer Zusammensetzung das Grundwort näher bestimmt.) Vgl. aber R 158.

Getrennt schreibt man, wenn beide Wörter ihren ursprünglichen Sinn bewahren, also noch eigenen Satzgliedwert besitzen. (Jedes Wort trägt Starkton.) Vgl. aber R 158.

Als erster Bestandteil treten vor allem Eigenschaftswörter, Mittelwörter und Hauptwörter auf.

Beispiele: eine leichtverdauliche Speise, (aber „leicht" als selbständige Beifügung zu „verdaulich":) eine leicht verdauliche Speise; die Speise ist leicht verdaulich. Entsprechend: eine schwerverständliche Sprache, aber: eine schwer verständliche Sprache; die Sprache ist schwer verständlich; kochendheißes Wasser, aber: kochend heißes Wasser; das Wasser ist kochend heiß.

Merke (zu R 142 und R 143):

1. Die unter a und b genannten Zusammensetzungen werden immer getrennt geschrieben, wenn eine nähere Bestimmung hinzutritt.

 Beispiele: dieser auffallend hell leuchtende Stern; eine besonders schwer verständliche Sprache; die bereits oben erwähnte Auffassung; heftiges Grauen erregend; die von den Einwohnern reich geschmückten Häuser; die in Deutschland wild lebenden Tiere.

2. Die unter a und b genannten Zusammensetzungen werden immer zusammengeschrieben, wenn der erste Bestandteil den zweiten steigert oder wenn die Zusammensetzung eine Eigenschaft bezeichnet, die vielen Dingen in gleicher Weise eigen ist, d.h., wenn sie klassenbildend gebraucht wird.

 Beispiele: ein hochbetagter Mann – der Mann ist hochbetagt; eisenverarbeitende Industrie – die Industrie ist eisenverarbeitend; reinseidene Stoffe – die Stoffe sind reinseiden; fleischfressende Pflanzen – die Pflanzen sind fleischfressend.

4. Getrennt schreibt man, wenn ein „Vorwort" Satzgliedwert erhält

„Vorwörter" von unfest zusammengesetzten Zeitwörtern werden getrennt **R 144** geschrieben, wenn sie in die Ausdrucksstellung am Anfang des Satzes gebracht werden und dadurch Satzgliedwert erhalten.

 Beispiele: Auf steigt der Strahl ... Aus hielt er, bis er das Ufer gewann. Fest steht, daß ... Auf fällt, daß ... Hinzu kommt, daß ...

5. Zusammen- und Getrenntschreibung des „zu" bei der Grundform (beim Infinitiv) und beim ersten Mittelwort (Partizip Präsens)

a) Zusammen schreibt man, wenn „zu" mit einer unfesten Zusammen- **R 144a** setzung verbunden wird, wenn also auch die einfache Grundform zusammengeschrieben wird.

 Beispiele: Er vergaß, die Tür offenzulassen (Grundform: offenlassen). Er versuchte schwarzzufahren (Grundform: schwarzfahren). Sie wünschte ihn kennenzulernen (Grundform: kennenlernen). Der weiterzuleitende Brief (Grundform: weiterleiten).

b) Getrennt schreibt man, wenn „zu" bei der Grundform einer Verbindung steht, die auch ohne „zu" getrennt geschrieben wird.

 Beispiel: instand setzen – instand zu setzen.

Wird aber das erste Mittelwort mit „zu" als Beifügung gebraucht, dann sind beide Schreibungen möglich (↑ R 142).

 Beispiel: das instandzusetzende – instand zu setzende Gerät.

6. Zusammen- und Getrenntschreibung von Namen und ihren Ableitungen

Vgl. Familien- und Personennamen (↑ R 180ff.); Vornamen (↑ R 194ff.); erdkundliche Namen (↑ R 201ff.); Straßennamen (↑ R 219ff.).

III. Bindestrich

A. Der Ergänzungsbindestrich

Der Ergänzungsbindestrich steht in zusammengesetzten oder abgeleiteten **R 145** Wörtern, wenn ein gemeinsamer Bestandteil nur einmal gesetzt wird.

 Beispiele: Feld- und Gartenfrüchte, Ein- und Ausgang, Lederherstellung und -vertrieb; Geld- und andere Sorgen; ab- und zunehmen (abnehmen und zunehmen), aber: ab und zu nehmen (gelegentlich nehmen); kraft- und saftlos; ein- bis zweimal (mit Ziffern: 1- bis 2mal); herbeirufen und -winken; bergauf und -ab; rad- und Auto fahren, maß- und Disziplin halten, aber (ohne Bindestrich): Auto und radfahren, Disziplin und maßhalten; Privat- und öffentliche Mittel, aber (ohne Bindestrich): öffentliche und Privatmittel; Balkon-, Garten- und Campingmöbel.

Zwei Ergänzungsbindestriche stehen, wenn dreigliedrige Wörter mit mehr als einem gemeinsamen Bestandteil zusammengefaßt werden.

 Beispiele: Warenein- und -ausgang (für: Wareneingang und Warenausgang); Textilgroß- und -einzelhandel; Mondlande- und -erkundungsfahrzeuge.

Nur in Ausnahmefällen wird der Wortteil hinter dem Bindestrich groß geschrieben, nämlich wenn bereits die erste Zusammensetzung einen Bindestrich hat oder wenn zu dem ersten Bestandteil ein erklärender Zusatz tritt.

Beispiele: Haftpflicht-Versicherungsgesellschaft und -Versicherte; Primär-(Haupt-) Strom; Natrium-(Na-)Lampe.

Vgl. S. 87, 11.

B. Der Bindestrich in Zusammensetzungen

1. Zusammensetzungen aus Grundwort und einfachem oder zusammengesetztem Bestimmungswort

R 146 Zusammensetzungen aus Grundwort und einfachem oder zusammengesetztem Bestimmungswort werden im allgemeinen zusammengeschrieben.

Beispiele: Arbeiterbewegung, Windschutzscheibe, Oberstudiendirektor, Kundendienst, Lohnsteuerzahlung, Rotwild, Ichsucht, Jawort.

In folgenden Ausnahmefällen erhalten sie jedoch einen Bindestrich:

R 147 a) um Mißverständnisse zu vermeiden.

Beispiel: Druckerzeugnis kann bedeuten: 1. Erzeugnis einer Druckerei, 2. Zeugnis für einen Drucker. Bei möglichen Mißverständnissen schreibt man: Druck-Erzeugnis oder Drucker-Zeugnis.

R 148 b) beim Zusammentreffen von drei gleichen Selbstlauten in hauptwörtlichen Zusammensetzungen.

Beispiele: Kaffee-Ersatz, Tee-Ernte, Schnee-Eifel, Hawaii-Insel.

Merke: Kein Bindestrich steht

beim Zusammentreffen von zwei gleichen Selbstlauten oder von verschiedenen Selbstlauten.

Beispiele: Klimaanlage, Gewerbeinspektor, Reimport, Gemeindeumlage; Seeufer, Verandaaufgang; Seeaal, Bauausstellung.

beim Zusammentreffen von Selbstlauten in zusammengesetzten Eigenschafts- und Mittelwörtern.

Beispiele: schneeerhellt, seeerfahren; polizeiintern, blauäugig.

R 149 c) bei Zusammensetzungen (auch bei Ableitungen) mit einzelnen Buchstaben und mit Formelzeichen.

Beispiele: I-Punkt, A-Dur, a-Moll, O-Beine, x-beliebig, Zungen-R, Dehnungs-h, Fugen-s; n-Eck, γ-Strahlen; (auch:) n-fach, 2π-fach, n-tel, x-te (aber: 8fach, 32tel; ↑ R 228).

R 150 d) bei Zusammensetzungen mit Abkürzungen (↑ R 137).

Beispiele: Kfz-Papiere, UKW-Sender, Lungen-Tbc, ABC-Staaten, US-amerikanisch, Tbc-krank, Rh-Faktor, km-Zahl.

R 151 e) bei bestimmten zweigliedrigen Zusammensetzungen.

Beispiele: Ich-Laut, Ich-Roman (aber: Ichform, ichbezogen), Ist-Stärke, Soll-Bestand, daß-Satz.

R 152 f) bei Zusammensetzungen, die aus mehr als drei Wortgliedern bestehen, wenn sie unübersichtlich sind. Der Bindestrich ist dort zu setzen, wo sich bei sinngemäßer Auflösung der Zusammensetzung die Fuge ergibt.

Beispiele: Arbeiter-Unfallversicherungsgesetz (Unfallversicherungsgesetz für Arbeiter), Donau-Dampfschiffahrtsgesellschaft, Gemeindegrundsteuer-Veranlagung; aber (wenn bei kurzen Wortgliedern die Übersichtlichkeit nicht leidet): Eisenbahnfahrplan, Steinkohlenbergwerk, Fußballbundestrainer, Eishockeyländerspiel.

g) bei Zusammensetzungen, die an sich zusammengeschrieben werden, **R 153**
deren Bestimmungs- oder Grundwort jedoch in seiner ursprünglichen Be-
deutung sichtbar gemacht werden soll.

Beispiele: Hoch-Zeit, Inter-esse.

h) bei abgekürzten Zusammensetzungen. **R 154**

Beispiele: Kl.-A. (= Klassenaufsatz), Masch.-Schr. (= Maschine[n]schreiben), Reg.-
Rat (= Regierungsrat), Abt.-Leiter (= Abteilungsleiter), röm.-kath. (= römisch-katho-
lisch).

2. Aneinanderreihungen

(Über die Großschreibung des ersten Gliedes einer Aneinanderreihung
↑ R 120.)

a) Besteht die Bestimmung zu einem Grundwort aus mehreren Wörtern, **R 155**
dann werden alle Wörter durch Bindestriche verbunden.

Beispiele: September-Oktober-Heft, Magen-Darm-Katarrh, Ritter-und-Räuber-Ro-
mane, Rhein-Main-Halle, Frage-und-Antwort-Spiel, Do-it-yourself-Bewegung, In-dubio-
pro-reo-Grundsatz, Warschauer-Pakt-Staaten, Sankt-Josefs-Kirche, Ost-West-Gespräch;
Chrom-Molybdän-legiert.

Dies gilt auch, wenn ein einzelner Buchstabe an Stelle eines Wortes steht.

Beispiele: A-Dur-Tonleiter, Vitamin-C-haltig, D-Zug-artig; Blitz-K.-o.; aber (weil
Buchstabe und Ziffer eine Einheit bilden): DIN-A4-Blatt.

Merke: Übersichtliche Bildungen dieser Art schreibt man jedoch meist
zusammen.

Beispiele: Armsünderglocke, Loseblattausgabe.

b) Besteht die Bestimmung zu einer hauptwörtlich verwendeten Grund- **R 156**
form aus mehreren Wörtern, dann werden alle Wörter durch Binde-
striche verbunden.

Beispiele: das An-den-Haaren-Herbeiziehen, das Ins-Blaue-Fahren, das In-den-April-
Schicken, das Für-sich-haben-Wollen, zum Aus-der-Haut-Fahren; aber (bei übersichtli-
chen und als Hauptwörter geläufigen Aneinanderreihungen): das Außerachtlassen, das
Inkrafttreten.

Merke: Unübersichtliche Bildungen mit der hauptwörtlich verwendeten
Grundform werden besser durch eine Grundformgruppe (↑ R 30) ersetzt.

Beispiele: das Gefühl, es noch nicht über die Lippen zu bringen; aber nicht: das Ge-
fühl des Noch-nicht-über-die-Lippen-Bringens.

c) Aneinanderreihungen mit Zahlen (in Ziffern) werden durch Binde- **R 157**
striche verbunden (vgl. aber R 228).

Beispiele: 10-Pfennig-Briefmarke, $^3/_4$-Liter-Flasche, 2-kg-Dose, 70-PS-Motor, 110-kV-
Bahnstromleitung, 400-m-Lauf, 4 × 100-m-Staffel, 4mal-100-Meter-Staffel, 5-km-Gehen;
Formel-I-Wagen, 1.-Klasse-Kabine, 4- bis 5-Zimmer-Wohnung, 4—5-Zimmer-Wohnung;
aber (bei Zahlen in Buchstaben): Dreiklassenwahlrecht, Zehnpfennigmarke.

Als Aneinanderreihungen gelten auch Zusammensetzungen mit Bruch-
zahlen und Formeln.

Beispiele: $^3/_8$-Takt, aber (in Buchstaben): Dreiachteltakt; 3:0-Sieg.

3. Zusammensetzungen aus Eigenschaftswörtern (Farbbezeichnungen)

Bei eigenschaftswörtlichen Zusammensetzungen steht der Bindestrich, **R 158**
wenn jedes der beiden Eigenschaftswörter seine Eigenbedeutung bewahrt
hat, beide zusammen aber eine Gesamtvorstellung ausdrücken. Beide
Wörter tragen Starkton.

Beispiele: die schaurig-schöne Erzählung, die südost-nordwestliche Richtung, die
griechisch-orthodoxe Kirche.

Eigenschaftswörtliche Zusammensetzungen werden jedoch zusammenge-
schrieben, wenn das zweite Wort durch das erste näher bestimmt wird.

Dann trägt nur das erste Glied Starkton, es sei denn, daß es steigernd wirkt wie in „bitterböse". Entsteht dabei ein neuer Begriff, dann bleibt die Zusammenschreibung auch in der Satzaussage erhalten (vgl. aber R 143). Hierzu gehören auch die zusammengesetzten *Farbenbezeichnungen*, wenn die Farben vermischt vorkommen, wenn es sich also um **einen** Farbton handelt. Der Bindestrich steht, wenn die Farben unvermischt nebeneinander vorkommen, wenn es sich also um **zwei oder mehr** Farben handelt.

Beispiele: ein altkluges Kind, das Kind ist altklug; aber (obwohl das zweite Wort durch das erste näher bestimmt wird): original-französisch; das blaurote Kleid (mit einer gleichmäßigen bläulichen Abschattung des Rots = 1 Farbe), das Kleid ist blaurot; aber: das blau-rote Kleid (beide Farben in beliebiger Verteilung unvermischt nebeneinander = 2 Farben), das Kleid ist blau-rot. Ebenso: das blau-rot karierte Kleid.

Merke: Wenn das Nebeneinander der Farben unmißverständlich ist, dann schreibt man zusammen. Das gilt besonders für die wappenkundlichen Farben, weil es bei ihnen keine Abschattungen gibt, und für Substantive mit Farbbezeichnungen als Bestimmungswort.

Beispiele: die schwarzrotgoldene Fahne, ein blaugelbes Emblem; ein schwarzweiß verzierter Rand; Schwarzweißfilm, Schwarzweißkunst, Grünrotblindheit, Blauweißporzellan; aber (zur besonderen Hervorhebung): die Fahne Schwarz-Rot-Gold.

C. Auslassung des Binde- und des Beistrichs bei Unterführungen

R 159 Wird in listenartigen Aufführungen der **erste** Bestandteil einer Zusammensetzung unterführt, dann gilt die Unterführung auch für den Bindestrich.

Beispiel: Berlin-Schöneberg
„ Spandau
„ Tempelhof

Auch der Beistrich fällt dann weg.

Beispiel: Kaffee-Ersatz, lose 0,85 DM
„ in Päckchen 1,— DM

Wird der **zweite** Bestandteil einer Zusammensetzung unterführt, dann muß der Bindestrich wiederholt werden.

Beispiel: Ä-Laut
E- „

IV. Silbentrennung

Als Silbentrennungszeichen dient der einfache Bindestrich. Der früher gebräuchliche doppelte Trennungsstrich (=) wird in der heutigen Normalschrift und im Antiquadruck nicht angewandt.

A. Einfache und abgeleitete Wörter

R 160 Mehrsilbige einfache und abgeleitete Wörter trennt man nach Sprechsilben, die sich beim langsamen Sprechen von selbst ergeben.

Beispiele: Freun-de, Män-ner, for-dern, wei-ter, Or-gel, kal-kig, Bes-se-rung.

Nachstehende besondere Richtlinien sind dabei zu beachten:

1. Mitlaute

R 161 a) Ein einzelner Mitlaut kommt in einfachen und abgeleiteten Wörtern auf die folgende Zeile.

Beispiele: tre-ten, nä-hen, Ru-dern, rei-zen, bo-xen.

Beachte: **ch, sch** und **ß** bezeichnen einfache Laute und bleiben daher ungetrennt.

Beispiele: Bü-cher, Hä-scher, schie-ßen.

Steht **ss** als Ersatz für **ß** (z. B. bei einer Schreibmaschine, die kein ß hat), dann wird das Doppel-s wie das ß, also wie ein einfacher Laut behandelt und nicht getrennt (vgl. S. 82 f., 3, b).

Beispiele: Grü sse (für: Grü-ße), hei-ssen (für: hei-ßen).

b) Von mehreren Mitlauten kommt in einfachen oder abgeleiteten Wör- **R 162** tern der letzte auf die folgende Zeile.

Beispiele: An-ker, Fin-ger, war-ten, Fül-lun-gen, Rit-ter, Was-ser, Knos-pen, kämp-fen, Ach-sel, steck-ten, Kat-zen, Städ-ter, Drechs-ler, gest-rig, an-dere, and-re, neh-men, Beß-rung.

Beachte: **ck** wird bei Silbentrennung in k-k aufgelöst (vgl. aber R 189).

Beispiele: Zuk-ker, bak-ken.

st wird nie getrennt.

Beispiele: la-sten, We-sten, Bast-ler, sech-ste, brem-ste, Dien-stes, verwahrlo-stes Kind, sie sau-sten; aber (↑ R 168): Diens-tag.

c) In Ableitungen mit der Nachsilbe **-heit** lebt bei Silbentrennung ein ur- **R 163** sprünglich zum Stamm gehörendes, später abgestoßenes h nicht wieder auf.

Beispiele: Ho-heit, Rau-heit, Ro-heit; also nicht: Rauh-heit.

d) Nachsilben, die mit einem Selbstlaut beginnen, nehmen den ihnen vor- **R 164** angehenden Mitlaut zu sich.

Beispiele: Schaffne-rin, Lehre-rin, Freun-din, Bäcke-rei, Besteue-rung, Lül-tung.

2. Selbstlaute

a) Ein einzelner Selbstlaut wird nicht abgetrennt. **R 165**

Beispiele: Ader, Eber, Uhu, ebenso, Äste; also nicht: A-der, e-benso.

b) Zwei gleiche Selbstlaute, die eine Klangeinheit darstellen, und Zwie- **R 166** laute dürfen nicht getrennt, sondern nur zusammen abgetrennt werden.

Beispiele: Waa-ge, Aa-le, Ei-er, Mau-er, Ei-fel, Eu-le.

Das gilt auch, wenn in den Lautverbindungen ee und ie der zweite Laut als [ᵉ] gesprochen wird.

Beispiele: Seen (nicht: Se-en), knien (nicht: kni-en), Aus-seer (nicht: Ausse-er).

Zwei Selbstlaute dürfen getrennt werden, wenn sie keine Klangeinheit bilden.

Beispiele: Befrei-ung, Trau-ung, be-erben, bö-ig.

Folgt nach solchen Selbstlauten und einem Mitlaut ein weiterer Selbst-laut, dann ist es besser, das Wort erst nach dem zweiten Selbstlaut zu trennen.

Beispiele: böi-ge (weniger gut: bö-ige) Winde; ebenso: et-wai-ge, europäi-sche. Aber (wenn i und i zusammentreffen) nur: einei-ige, unpartei-ische.

3. Dehnungsbuchstaben

Dehnungsbuchstaben bilden mit dem vorangehenden Selbstlaut eine **R 167** Klangeinheit. Die beiden Buchstaben dürfen deshalb nicht getrennt werden.

Beispiele: Coes-feld (nicht: Co-es-feld), Trois-dorf (nicht: Tro-is-dorf).

Dies gilt auch für die Endung -ow.

Beispiele: Tel-tow-er (nicht: Tel-to-wer) Rübchen.

Das Dehnungs-h verhält sich jedoch wie ein Mitlaut.

Beispiele: nä-hen (↑ R 161); neh-men (↑ R 162).

B. Zusammengesetzte Wörter

R 168 Zusammengesetzte Wörter (und Wörter mit einer Vorsilbe) werden nach ihren sprachlichen Bestandteilen, also nach Sprachsilben, getrennt.

> Beispiele: Diens-tag, Empfangs-tag, war-um, dar-auf, dar-in, ge-schwungen, be-treten, Be-treuung, Ver-gnügen.

Die Bestandteile selbst werden wie einfache Wörter nach Sprechsilben getrennt (↑ R 160 ff.).

> Beispiele: Hei-rats-an-zei-gen, voll-en-den; ge-schwun-gen, be-tre-ten.

Man vermeide Trennungen, die zwar den Vorschriften entsprechen, aber den Leseablauf stören.

> Beispiele: Spargel-der (Spargelder), beste-hende (bestehende).

Über die Silbentrennung beim Zusammenstoß von drei gleichen Mitlauten ↑ R 236 f.

C. Besondere Richtlinien für Fremdwörter

↑ R 171 ff.

D. Besondere Richtlinien für Namen

Vgl. Familien- und Personennamen (↑ R 189); erdkundliche Namen (↑ R 217).

V. Fremdwörter

Nachstehend wird unterschieden zwischen reinen Fremdwörtern (fremden Wörtern), die ihre ursprüngliche Gestalt, ihre Aussprache und Betonung unverändert beibehalten haben, und eingedeutschten Fremdwörtern. Zur Schreibung fremdsprachiger Hauptwörter mit großen Anfangsbuchstaben vgl. S. 88 f., 16.

A. Schreibung

1. Reine Fremdwörter (fremde Wörter)

R 169 Reine Fremdwörter werden in der fremden Schreibweise geschrieben.

> Beispiele: Milieu [miliö]; Jalousie [sehalusi]; Refrain [r^efrǟngs].

2. Eingedeutschte Fremdwörter

R 170 Häufig gebrauchte Fremdwörter, vor allem solche, die keine dem Deutschen fremden Laute enthalten, gleichen sich nach und nach der deutschen Schreibweise an.

Übergangsstufe:

> Beispiele: Friseur neben: Frisör, Photograph neben: Fotograf, Telephon neben: Telefon.

Endstufe:

> Beispiele: Bluse für: Blouse, Sekretär für: Secrétaire, Fassade für: Façade, Streik für: Strike, Likör für: Liqueur.

Bei diesem stets in der Entwicklung begriffenen Vorgang der Eindeutschung ist folgende Wandlung in der Schreibung besonders zu beachten:

c wird k oder z

Ob c im reinen Fremdwort im Zuge der Eindeutschung k oder z wird, hängt von seiner ursprünglichen Aussprache ab. Es wird zu k vor a, o, u und vor Mitlauten. Es wird zu z vor e, i, y, ä und ö.

Beispiele: Café, Copie, Procura, Crematorium, Spectrum, Penicillin, Cyclamen, Cäsur; eingedeutscht: Kaffee, Kopie, Prokura, Krematorium, Spektrum, Penizillin, Zyklamen, Zäsur.

Beachte: th in Fremdwörtern aus dem Griechischen und in einigen Lehnwörtern blieb erhalten.

Beispiele: Bibliothek, Mathematik, Pathos, Theke, katholisch, Asthma, Äther, Thron.

B. Silbentrennung

1. Einfache und abgeleitete Fremdwörter

Mehrsilbige einfache und abgeleitete Fremdwörter werden wie die deut- R 171
schen Wörter nach Sprechsilben getrennt († R 160 ff.).

Beispiele: Bal-kon, Fis-kus, Ho-tel, Pla-net, Kon-ti-nent, Aku-stik, Fas-zi-kel, Re-mi-nis-zenz, El-lip-se, Ma-dei-ra.

2. Zusammengesetzte Fremdwörter

Zusammengesetzte Fremdwörter (und Wörter mit einer Vorsilbe) werden R 172
wie die deutschen Wörter nach ihren Bestandteilen, also nach Sprach-
silben, getrennt († R 168).

Beispiele: Atmo-sphäre, Mikro-skop, Inter-esse; Syn-onym, At-traktion, Ex-spektant, De-szendenz, In-szenieren.

Die Bestandteile wiederum werden nach den vorstehenden Richtlinien
für einfache Fremdwörter getrennt.

Beispiel: At-mo-sphä-re, Mi-kro-skop, In-ter-es-se.

Da die den vorstehenden Richtlinien zugrunde liegende Kenntnis der
sprachlichen Gliederung eines Lehn- oder Fremdwortes nicht immer vor-
handen ist, wird im Zuge der Eindeutschung bei häufig gebrauchten zu-
sammengesetzten Fremdwörtern bereits nach Sprechsilben getrennt.

Beispiele: Epi-sode statt: Epis-ode; Tran-sit statt: Trans-it; ab-strakt statt: abs-trakt.

3. Besondere Richtlinien

a) ch, ph, rh, sh, th bezeichnen einfache Laute und bleiben daher un- R 173
getrennt.

Beispiele: Ma-chete, Pro-phet, Myr-rhe, Bu-shel, ka-tholisch.

b) Nach dem Vorbild der klassischen Sprachen bleiben folgende Laut- R 174
verbindungen üblicherweise ungetrennt: bl, pl, fl, gl, cl, kl, phl; br, pr,
dr, tr, fr, vr, gr, cr, kr, phr, str, thr; chth, gn, kn.

Beispiele: Pu-bli-kum, passa-ble Vorschläge, Di-plom, Tri-fle, Re-gle-ment, Zy-klus, Ty-phli-tis; Fe-bru-ar, Le-pra, Hy-drant, neu-tral, Chif-fre, Li-vree, ne-grid, Sa-kra-ment, Ne-phri-tis, In-du-strie, Ar-thri-tis; Ere-chthei-on, Ma-gnet, py-knisch.

c) Selbstlautverbindungen, die eine Klangeinheit darstellen, dürfen nicht R 175
getrennt werden.

Beispiele: Moi-ré [moaré]; Beef-steak [bifßtek].

Das gilt auch, wenn in den Lautverbindungen ee und ie der zweite Laut
als [e] gesprochen wird.

Beispiele: Ar-meen (nicht: Arme-en), Par-tien (nicht: Parti-en).

d) Zwei Selbstlaute bleiben auch besser ungetrennt, wenn sie, ohne eine R 176
Klangeinheit zu bilden, eng zusammengehören. Hierher gehören vor
allem die Selbstlautverbindungen ea, ia, ie, iu, ui, io, oi, ua, äo, eu und
eo. Über das Zeichen für Nottrennung vgl. S. 9, I.

Beispiele: Natio-nen, Flui-dum, kolloi-dal, asia-tisch; ideal, aber: idea-ler Mann, Idea-list.

R 177 e) Zwei Selbstlaute dürfen getrennt werden, wenn sich zwischen ihnen eine deutliche Silbenfuge befindet.

Beispiele: Muse-um, Individu-um, kre-ieren, lini-ieren, Bo-otes, negro-id; partei-ische, aber: europäi-sche, Europäi-sierung († R 166).

4. Die Trennung fremdsprachiger Wörter

R 177 a Treten in einem deutschen Text einzelne fremdsprachige Wörter oder Wortgruppen oder einzelne kurze Sätze in fremder Sprache auf, dann trennt man nach den deutschen Regeln ab:

Beispiele: a po-ste-rio-ri; per as-pe-ra ad astra; Co-ming man; De-fi-cit-spen-ding; Swin-ging Lon-don.

Die Trennungsregeln fremder Sprachen (z.B. as-tra, com-ing, swing-ing) sollten nur bei längeren Zitaten, d.h. bei fortlaufendem fremdsprachigem Text, angewandt werden.

VI. Namen

(Zur Beugung der Namen † R 309 ff.)

A. Familien- und Personennamen

1. Allgemeine Schreibung

R 178 Die Familiennamen unterliegen nicht den allgemeinen Richtlinien der Rechtschreibung. Für sie gilt die standesamtlich jeweils festgelegte Schreibung.

Beispiele: Goethe neben: Götz, Franz Liszt neben: Friedrich List, Schmidt neben: Schmitt.

2. Groß- und Kleinschreibung

a) Zur Kleinschreibung des abgekürzten *von* (*v.*) vor Familiennamen zu Beginn eines Satzes † R 126. Zur Großschreibung von Beinamen (z.B. *Friedrich der Große*) † R 224.

R 179 b) Die von Personennamen abgeleiteten Eigenschaftswörter werden groß geschrieben, wenn sie die persönliche Leistung oder Zugehörigkeit ausdrücken. Sie werden klein geschrieben, wenn sie die Gattung bezeichnen oder wenn sie aussagen, daß etwas nach einer Person benannt worden ist oder ihrer Art, ihrem Geist entspricht. (Im letzteren Falle antworten die abgeleiteten Eigenschaftswörter auf die Frage: was für [ein]?, nach welcher Art?)

Beispiele: Platonische Schriften (von Plato), aber: platonische Liebe (was für eine?); Drakonische Gesetzgebung (von Drako), aber: drakonische Gesetzgebung (nach Drakos Art); der „Erlkönig" ist ein Goethisches Gedicht (von Goethe), aber: ihm gelangen Verse von goethischer Klarheit (was für Verse?); das Ohmsche Gesetz (von Ohm selbst stammend), aber: der ohmsche Widerstand (nach Ohm benannt); die Heinischen Reisebilder (von Heine), aber: eine heinische Ironie (nach der Art von Heine); die Mozartschen Kompositionen (von Mozart), aber: die Kompositionen wirken mozartisch (wie die Kompositionen Mozarts).

Immer klein schreibt man die von Personennamen abgeleiteten Eigenschaftswörter auf **-istisch, -esk** und **-haft,** weil sie die Art angeben, und die Zusammensetzungen mit **vor-, nach-** u. ä.

Beispiele: darwinistische Auffassungen, kafkaeske Gestalten, eulenspiegelhaftes Treiben; vorlutherische Bibelübersetzungen.

3. Zusammen- oder Getrenntschreibung oder Bindestrich

a) *[Familien]name als Bestimmungswort oder Grundwort*

1. Den Bindestrich setzt man bei einer Zusammensetzung aus einem **R 180**
[Familien]namen als Bestimmungswort und einem Grundwort, wenn der
Name hervorgehoben werden soll.
> Beispiele: Schiller-Museum, Paracelsus-Ausgabe, Opel-Vertretung.

Aber: Zusammen schreibt man, wenn der Name mit dem Hauptwort
eine geläufig gewordene Bezeichnung bildet († R 146).
> Beispiele: Dieselmotor, Röntgenstrahlen, Thomasmehl, Litfaßsäule, Schillertheater,
> Kneippkur, Achillesferse.

2. Den Bindestrich setzt man, wenn dem Familiennamen als Bestim- **R 181**
mungswort ein zusammengesetztes Grundwort folgt, um die Übersicht-
lichkeit zu erhöhen († R 152).
> Beispiele: Mozart-Konzertabend, Beethoven-Festhalle.

3. Den Bindestrich setzt man, wenn die Bestimmung zu dem Grund- **R 182**
wort aus mehreren oder aus mehrteiligen Namen besteht († R 155).
> Beispiele: Richard-Wagner-Festspiele, Max-Planck-Gesellschaft, Siemens-Schuckert-
> Werke, Goethe-und-Schiller-Denkmal, Peter-und-Paul-Kirche (aber: Markuskirche),
> Johann-Sebastian-Bach-Gymnasium; Wolfram-von-Eschenbach-Ausgabe, Sankt-(St.-)
> Marien-Kirche, De-Gaulle-Besuch, Van-Allen-Gürtel.

4. Den Bindestrich setzt man, wenn Vor- und Familienname umge- **R 183**
stellt sind und das Geschlechtswort vorangeht. (Der Familienname ist
hier Bestimmungswort zum Vornamen.)
> Beispiele: der Huber-Franz, die Hofer-Marie.

5. Den Bindestrich setzt man, wenn der Name als Grundwort steht. **R 184**
> Beispiele: Möbel-Müller, Bier-Meier.

6. Der Bindestrich kann stehen, wenn dem Familiennamen der Wohn- **R 185**
oder Wahlort als betontes nachgestelltes Bestimmungswort folgt.
> Beispiele: Schulze-Delitzsch, Müller-Franken. Häufig aber auch: Müller (Berlin);
> Müller, Berlin, hat ...

b) *Doppelnamen*

Den Bindestrich setzt man bei Doppelnamen. **R 186**
> Beispiele: Müller-Frankenfeld, Kaiser-Kootz.

c) *Zusammensetzungen von Familiennamen mit einem Eigenschaftswort*

Zusammensetzungen von einteiligen Namen mit einem Eigenschaftswort **R 187**
werden zusammengeschrieben, weil sie nur einen bestimmten Be-
griff bezeichnen.
> Beispiele: goethefreundlich, lutherfeindlich. Aber mit mehrteiligen Namen: de-Gaulle-
> treu, Fidel-Castro-freundlich, McNamara-feindlich, O'Connor-treu.

d) *Eigenschaftswörtlich gebrauchte Zusammensetzungen mit Familiennamen*

Den Bindestrich setzt man bei zusammengesetzten Eigenschaftswör- **R 188**
tern, die aus einem mehrteiligen Namen, aus einem Titel und Namen
oder aus mehreren Namen bestehen.
> Beispiele: das Rudolf-Meiersche Ehepaar, die Dr.-Müllersche Apotheke, die Thurn-
> und-Taxissche Post.

4. Silbentrennung

Die Trennung von Familiennamen ist möglichst zu vermeiden. In Not- **R 189**
fällen trenne man nach den allgemeinen Richtlinien († R 160ff.).

Beachte: Tritt in Namen oder in Ableitungen von Namen **ck** nach einem Mitlaut auf, dann wird ck wie ein einfacher Mitlaut auf die nächste Zeile gesetzt.

Beispiele: Sen-ckenberg, Fran-cke, Bismar-ckisch.

5. Familiennamen, Personennamen und Auslassungszeichen

↑ R 252 ff. u. ↑ R 249.

B. Vornamen

1. Allgemeine Schreibung

R 190 a) Für die Schreibung der Vornamen gelten im allgemeinen die heutigen Rechtschreibregeln. Gewisse Abweichungen sind jedoch zulässig.

Beispiele: Claus neben üblichem Klaus, Clara neben üblichem Klara.

R 191 b) Deutschstämmige Vornamen werden nicht mehr mit dem sprachgeschichtlich falschen **ph**, sondern mit **f** geschrieben.

Beispiele: Rudolf, Adolf.

Deutschstämmige Vornamen können angestammtes **h** bewahren, aber auch aufgeben.

Beispiele: Berthold neben: Bertold, Diether neben: Dieter, Günther neben: Günter, Walther neben: Walter; vereinzelt auch (obwohl das h hier sprachgeschichtlich nicht berechtigt ist): Bertha neben Berta.

Ihr altes **h** behalten nach dem Vorbild von berühmten Namensträgern *Lothar* und *Mathilde* und die aus dem Germanischen stammenden Namen *Theoderich, Theobald.*

R 192 c) Fremde Vornamen werden in der fremden Schreibweise geschrieben.

Beispiele: Jean [schans], Christa, Dorothea. Hierzu gehören auch die aus dem Griechischen stammenden Namen Theodor, Theodora, Theophil.

Volkstümlich gewordene fremde Vornamen gleichen sich nach und nach der deutschen Schreibweise an.

Beispiele: Josef, Zita, Käte, Felizitas.

R 193 d) Die von Vornamen abgeleiteten Eigenschaftswörter werden wie die von Familien- und Personennamen abgeleiteten Eigenschaftswörter geschrieben (↑ R 179).

Beispiele: das Wilhelminische Zeitalter (des Kaisers Wilhelm II.), aber: die ottonische Kunst (die Kunst zur Zeit der Ottonen).

2. Zusammen- oder Getrenntschreibung oder Bindestrich

a) *Doppelnamen*

R 194 Doppelnamen, die nur einen Hauptton tragen, werden im allgemeinen zusammengeschrieben.

Beispiele: Lieselotte, Ingelore, Annemarie, Hansjoachim, Karlheinz; auch Hans-Joachim, Karl-Heinz; aber: Johann Wolfgang, Edith Hildegard.

b) *Hauptwort als Bestimmungswort*

R 195 Der Bindestrich steht immer bei einer Zusammensetzung aus einer Berufsbezeichnung und einem Vornamen, weil die den Namen bestimmende Bezeichnung besonders hervorgehoben werden soll.

Beispiele: Bäcker-Anna, Schuster-Franz.

Zusammen schreibt man bei allen anderen Zusammensetzungen aus einem Hauptwort und einem Vornamen.

Beispiele: Wurzelsepp, Schützenliesel, Suppenkaspar.

c) *Über die Schreibung des ungebeugten Eigenschaftswortes bei Vornamen*
↑ R 224.

d) *Zusammensetzungen aus Familiennamen und Vornamen* ↑ R 183.

C. Erdkundliche Namen

1. Allgemeine Schreibung

a) Für die Schreibung der **deutschen** erdkundlichen Namen gelten im **R 196**
allgemeinen die heutigen Rechtschreibregeln. Die Behörden halten jedoch
gelegentlich an alten Schreibweisen fest.

> Beispiele: Köln, aber: Cottbus; Zell, aber: Celle, Freudental (über Radolfzell),
> aber: Frankenthal (Pfalz); Freiburg im Breisgau, aber: Freyburg/Unstrut.

b) **Fremde** erdkundliche Namen werden in der fremden Schreibweise **R 197**
geschrieben.

> Beispiele: Toulouse, Marseille, Rio de Janeiro, Reykjavik.

Häufig gebrauchte **fremde** erdkundliche Namen sind weitgehend einge-
deutscht.

> Beispiele: Neapel für: Napoli, Rom für: Roma, Belgrad für: Beograd, Kalifornien
> für: California, Kanada für: Canada.

2. Groß- und Kleinschreibung

a) **Groß** schreibt man Eigenschafts- und Mittelwörter als Teile von erd- **R 198**
kundlichen Namen. Dies gilt auch für die Ableitungen auf **-isch** (vgl.
aber R 200).

> Beispiele: das Rote Meer, die Hohen Tauern, der Große Ozean; der Atlantische Ozean,
> das Mittelländische Meer, die Holsteinische Schweiz.

b) **Groß** schreibt man die von erdkundlichen Namen abgeleiteten Wörter **R 199**
auf **-er.**

> Beispiele: das Ulmer Münster, eine Kölner Firma, ein Wiener Schnitzel, die Frank-
> furter Verkehrsverhältnisse, die Schweizer Industrie, der Holländer Käse.

c) **Klein** schreibt man die von erdkundlichen Namen abgeleiteten Eigen- **R 200**
schaftswörter auf **-isch,** wenn sie nicht Teil eines Eigennamens sind
(vgl. aber R 198).

> Beispiele: chinesische Seide, westfälischer Schinken, böhmische Dörfer.

3. Zusammen- oder Getrenntschreibung oder Bindestrich

a) *Erdkundlicher Name als Bestimmungswort*

1. **Zusammen** schreibt man im allgemeinen Zusammensetzungen aus **R 201**
Grundwort und einfachem oder zusammengesetztem erdkundlichem
Namen (↑ R 146).

> Beispiele: Nildelta, Perubalsam, Rheinfall, Manilahanf, Großglocknermassiv; moskau-
> freundlich.

2. Den **Bindestrich** setzt man oft, um die Übersichtlichkeit zu erhöhen **R 202**
(↑ R 152), wenn der erdkundliche Name als Bestimmungswort vor einem
zusammengesetzten Grundwort steht oder wenn der Name hervorgehoben
werden soll.

> Beispiele: Donau-Dampfschiffahrtsgesellschaft; Jalta-Abkommen.

Bleibt die Übersichtlichkeit gewahrt, dann schreibt man zusammen.

> Beispiele: Weserbergland, Alpenvorland, Rheinseitenkanal, Rapallovertrag.

R 203 3. Bindestriche setzt man, wenn die Bestimmung zu dem Grundwort aus mehreren oder mehrteiligen erdkundlichen Namen oder aus einer Namensabkürzung besteht (↑ R 155).

Beispiele: Dortmund-Ems-Kanal, Saar-Nahe-Bergland; Rio-de-la-Plata-Bucht, Sankt-(St.-)Gotthard-Gruppe; USA-feindlich.

4. Über den Bindestrich beim Zusammentreffen von drei gleichen Selbstlauten ↑ R 148.

b) *Ableitungen auf* **-er**

R 204 1. Getrennt schreibt man, wenn die Ableitungen auf **-er** von erdkundlichen Namen die Lage bezeichnen.

Beispiele: Walliser Alpen (die Alpen im Wallis), Glatzer Neiße (die von Glatz kommende Neiße), die Tiroler Ache (Zufluß des Chiemsees), Köln-Bonner Flughafen.

Merke: Besonders in der Schweiz und in Österreich wird in diesen Fällen oft zusammengeschrieben.

Beispiele: Böhmerwald, Wienerwald, Bielersee.

Beachte: Es gibt erdkundliche Namen, die auf **-er** enden und keine Ableitungen der oben genannten Art sind. Diese Namen werden nach R 201 zusammengeschrieben.

Beispiele: Glocknergruppe, Brennerpaß.

R 205 2. Zusammen schreibt man, wenn die Ableitungen auf **-er** von erdkundlichen Namen Personen bezeichnen.

Beispiele: Schweizergarde (päpstliche Garde, die aus Schweizern besteht), Römerbrief (Brief an die Römer), Danaergeschenk (Geschenk der Danaer).

Merke: Wird an einen erdkundlichen Namen auf **-ee** die Silbe **-er** angehängt, dann schreibt man nur zwei e (↑ R 328).

Beispiele: Tegernseer Alpen, Falkenseer Forst.

c) *Eigenschaftswort oder Bezeichnungen für Himmelsrichtungen als Bestimmungswort*

R 206 1. Zusammen schreibt man im allgemeinen Zusammensetzungen aus ungebeugten Eigenschaftswörtern wie *groß, klein, alt, neu* usw. oder Bezeichnungen für Himmelsrichtungen mit erdkundlichen Namen.

Beispiele: Großbritannien, Kleinasien, Mittelfranken, Hinterindien, Oberammergau, Niederlahnstein, Untertürkheim, Ostindien, Südafrika, Norddeutschland.

Aber (bei nichtamtlichen Zusätzen):

Alt-Wien, Groß-Berlin, Alt-Heidelberg, West-Berlin (jedoch bei Ableitungen ohne Bindestrich: Westberliner, altheidelbergisch).

Bezeichnungen politisch geteilter Staaten werden meist zusammengeschrieben.

Beispiele: Nordkorea, Südvietnam.

Die behördliche Schreibung der Ortsnamen schwankt.

Beispiele: Neuruppin, aber: Groß Räschen (auch: Groß Räschener), Klein-Auheim (Klein-Auheimer).

R 207 2. Den Bindestrich setzt man bei Zusammensetzungen aus endungslosen Eigenschaftswörtern auf **-isch,** die von Orts-, Länder- und Völkernamen abgeleitet sind, und erdkundlichen Namen.

Beispiele: Spanisch-Guinea, aber (weil behördlich so vorgeschrieben): Schwäbisch Gmünd, Bayrischzell, Bergisch Gladbach.

R 208 3. Der Bindestrich steht nicht, wenn *Sankt* Teil eines erdkundlichen Namens (vgl. aber R 203) oder seiner Ableitung auf **-er** ist.

Beispiele: Sankt (St.) Blasien, Sankt (St.) Galler.

d) *Familienname oder Vorname [+ Titel] als Bestimmungswort*

1. Den B i n d e s t r i c h setzt man, wenn der Name hervorgehoben werden **R 209** soll.

> B e i s p i e l e : Cook-Insel, Victoria-Land. Ohne Hervorhebung: Cookinsel, Victorialand.

2. Bei manchen Zusammensetzungen ist die Zusammenschreibung fest **R 210** geworden.

> B e i s p i e l e : Beringmeer, Magellanstraße.

3. Bindestriche stehen dann, wenn die Bestimmung zu dem Grundwort **R 211** aus mehreren Wörtern besteht.

> B e i s p i e l e : Kaiser-Franz-Joseph-Land, König-Christian-IX.-Land, Sankt-Lorenz-Strom.

e) *Zusammensetzungen aus erdkundlichen Namen*

Den B i n d e s t r i c h setzt man, wenn ein erdkundlicher Name aus zwei **R 212** erdkundlichen Namen zusammengesetzt ist.

> B e i s p i e l e : Berlin-Schöneberg (der Hauptort ist stets voranzustellen), München-Schwabing, Hamburg-Altona, Wuppertal-Barmen; Rheinland-Pfalz, Nordrhein-Westfalen.

M e r k e : Bei Ableitungen bleibt der Bindestrich erhalten.

> B e i s p i e l e : Schleswig-Holsteiner, schleswig-holsteinisch.

f) *Ortsname in Verbindung mit ,,Bad"*

Ein Bindestrich steht nicht bei Ortsnamen, denen die Bezeichnung ,,Bad" **R 213** vorangeht. Auch bei Kopplung mit einem anderen Ortsnamen wird nur ein Bindestrich zwischen beide Namen gesetzt.

> B e i s p i e l e : Bad Ems, Bad Kreuznach; Stuttgart-Bad Cannstatt.

M e r k e : Bei Ableitungen wird kein Bindestrich gesetzt.

> B e i s p i e l : Bad Kreuznacher Saline.

g) *Eigenschaftswörtliche Zusammensetzungen aus erdkundlichen Namen und Zusammensetzungen aus Länder- und Völkernamen*

1. Den B i n d e s t r i c h setzt man, wenn jedes der beiden Eigenschafts- **R 214** wörter bzw. jeder Bestandteil der Zusammensetzung aus Länder- und Völkernamen seine Eigenbedeutung bewahrt hat, beide zusammen aber eine Gesamtvorstellung ausdrücken. Beide Wörter tragen Starkton († R 158).

> B e i s p i e l e : der deutsch-amerikanische Schiffsverkehr (zwischen Deutschland und Amerika), die deutsch-schweizerischen Wirtschaftsverhandlungen; Anglo-Amerikaner (Sammelname für Engländer und Amerikaner), afro-asiatische Interessen.

M e r k e : Geläufige Zusammensetzungen dieser Art, deren erster Bestandteil auf -o ausgeht, schreibt man zusammen

> B e i s p i e l e : serbokroatisch, tschechoslowakisch, baltoslawisch.

2. Z u s a m m e n schreibt man, wenn das zweite Eigenschaftswort durch **R 215** das erste bzw. der zweite Teil der Zusammensetzung aus Länder- und Völkernamen durch den ersten näher bestimmt wird. Nur ein (meist das erste) Glied trägt Starkton († R 158).

> B e i s p i e l e : das deutschamerikanische Schrifttum (Schrifttum der Deutschamerikaner), die schweizerdeutsche Mundart; frankokanadische Familien, Angloamerikaner, Angloamerikaner (aus England stammender Amerikaner).

h) *Nachgestellte nähere Bestimmungen*

Den B i n d e s t r i c h setzt man im allgemeinen bei näheren Bestimmungen, **R 216** die einem Ortsnamen nachgestellt sind.

> B e i s p i e l e : Frankfurt-Stadt, Frankfurt-Land, Frankfurt-Stadt und -Land.

Ohne Bindestrich schreibt man aber meistens schon nähere Bestimmungen wie:

> Wiesbaden Süd, Köln Hbf.

Zur Rechtschreibung

4. Silbentrennung

R 217 Erdkundliche Namen werden nach den allgemeinen Richtlinien getrennt (↑ R 160 ff.).

Beispiele: Al-ster, Es-sen, Fel-ben, Zwik-kau.

Zusammengesetzte erdkundliche Namen werden nur dann nach Sprachsilben getrennt, wenn sich ihre Bestandteile erkennen lassen. Sonst trennt man nach Sprechsilben.

Beispiele: Main-au, Schwarz-ach; aber: (nach Sprechsilben) Norder-ney (ey = Insel).

D. Straßennamen

1. Großschreibung von Eigenschafts- und Zahlwörtern

R 218 Das erste Wort eines Straßennamens wird groß geschrieben, ebenso alle zum Namen gehörenden Eigenschafts- und Zahlwörter.

Beispiele: Breite Straße, Lange Gasse, In der Mittleren Holdergasse, Am Warmen Damm, An den Drei Pfählen.

2. Zusammen- oder Getrenntschreibung oder Bindestrich

Die Grundwörter in Straßennamen wie ...*allee*, ...*brücke*, ...*chaussee*, ...*damm*, ...*gasse*, ...*graben*, ...*markt*, ...*platz*, ...*promenade*, ...*ring*, ...*steg*, ...*straße*, ...*tor*, ...*ufer*, ...*weg* sind in Verbindung mit dem Bestimmungswort oder einer Beifügung wie folgt zu schreiben:

a) *Hauptwort als Bestimmungswort*

R 219 1. Zusammen schreibt man Zusammensetzungen aus einem einfachen oder zusammengesetzten Hauptwort (auch Namen) und einem der genannten Grundwörter.

Beispiele: Schloßstraße, Brunnenweg, Bahnhofstraße, Rathausgasse, Bismarckring, Beethovenplatz, Augustaanlage, Römerstraße, Wittelsbacherallee, Becksweg.

Merke: Auch Zusammensetzungen aus einem Ortsnamen auf **-er** und einem Grundwort schreibt man zusammen (vgl. aber R 222).

Beispiele: Marienwerderstraße, Drusweilerweg.

Beachte: Familiennamen stehen in Straßennamen ungebeugt, wenn es sich um Ehrenbenennungen handelt.

Beispiele: Herderstraße, Stresemannplatz.

Soll aber ein [altes] Besitzverhältnis ausgedrückt werden, dann tritt oft das Wesfall-s auf. In solchen Fällen ist gelegentlich auch eine Getrenntschreibung möglich.

Beispiele: Becksweg, Brandtstwiete, Oswaldsgarten, Getrenntschreibung: Graffelsmanns Kamp.

R 220 2. Den Bindestrich setzt man, wenn die Bestimmung zum Grundwort aus mehreren Wörtern besteht (↑ R 155).

Beispiele: Albrecht-Dürer-Allee, Paul-von-Hindenburg-Platz, Von-Repkow-Platz (aber: v.-Repkow-Platz; ↑ R 126), Kaiser-Friedrich-Ring, Van-Dyck-Straße, Ernst-Ludwig-Kirchner-Straße, E.-T.-A.-Hoffmann-Straße, Professor-Sauerbruch-Straße, Bad-Kissingen-Straße, Berliner-Tor-Platz, Runde-Turm-Straße. Auch: Sankt-(St.-)Blasien-Straße, Am St.-Georgs-Kirchhof, Bürgermeister-Dr.-Meier-Platz.

b) *Eigenschaftswort als Beifügung oder als Bestimmungswort*

R 221 1. Zusammen schreibt man Zusammensetzungen aus ungebeugtem Eigenschaftswort und einem der genannten Grundwörter.

Beispiele: Altmarkt, Neumarkt, Hochstraße.

R 222 2. Getrennt schreibt man, wenn das Eigenschaftswort als Teil eines Straßennamens gebeugt ist. Dies gilt auch für die Ableitungen von Orts- und Ländernamen auf **-er** und **-isch**.

Beispiele: Kleine Budengasse, Große Bleiche, Langer Graben, Hoher Heckenweg; Saarbrücker Platz, Münchener Straße, Groß-Gerauer Straße. Sankt (St.) Wendeler Straße, Bad Nauheimer Weg, Kalk-Deutzer Straße; Französische Straße.

c) *Zusammenfassung von Straßennamen*

Bei der Zusammenfassung von Straßennamen schreibt man nach den **R 223** vorstehenden Richtlinien wie folgt (vgl. S. 87, 11):

Ecke [der] Ansbacher und Motzstraße, Ecke [der] Motz- und Ansbacher Straße; Ecke [der] Schiersteiner und Wolfram-von-Eschenbach-Straße, Ecke [der] Wolfram von Eschenbach- und Schiersteiner Straße.

E. Titel und sonstige Namen

1. Groß- und Kleinschreibung

Das erste Wort eines Titels oder Namens wird groß geschrieben, ebenso **R 224** alle zum Titel oder Namen gehörenden Eigenschaftswörter, Mittelwörter, Fürwörter und Zahlwörter.

Beispiele: Friedrich der Große, Karl der Fünfte; der Große Kurfürst, der Alte Fritz; Regierender Bürgermeister (als Titel, sonst: regierender Bürgermeister), Erster Vorsitzender (als Titel, sonst: erster Vorsitzender); Klein Dora; Seine Magnifizenz; der Goldene Schnitt, das Blaue Band des Ozeans; die Ewige Stadt (Rom); die Hohe Schule (Reitkunst); die Deutsche Medizinische Wochenschrift; der Schiefe Turm von Pisa; die Medizinische Klinik des Städtischen Krankenhauses Wiesbaden; der Große Bär (Sternbild); das Rheinisch-Westfälische Elektrizitätswerk; die Sieben Schwaben; Hotel Drei Mohren; Zur Alten Post, Zum Grünen Baum, Roter Löwe (Gasthäuser).

Merke:

1. Nicht am Anfang des Titels oder Namens stehende Eigenschaftswörter werden gelegentlich auch klein geschrieben.

Beispiele: Gesellschaft für deutsche Sprache, Institut für deutsche Sprache.

2. In Wortverbindungen wie *italienischer Salat, römisches Bad, westfälischer Schinken, blauer Montag* werden nach den geltenden Regeln die Eigenschaftswörter klein geschrieben, weil diese Verbindungen k e i n e Namen sind.

Verbindungen dieser Art werden jedoch oft, vor allem in der Botanik und in der Zoologie, groß geschrieben, weil das Bedürfnis besteht, Benennungen für typisierte Gattungen von allgemeinen Gattungsbezeichnungen abzuheben.

Beispiele: der Rote Milan, die Weiße Lilie, die Gefleckte Hyäne.

2. Bindestrich

Für den Bindestrich bei Gebäudenamen, bei Namen von Zeitungen, **R 225** Organisationen u. a. gelten die unter R 146–157 angegebenen Richtlinien für das allgemeine Wortgut.

Titel in eigenschaftswörtlich gebrauchten Zusammensetzungen mit Familiennamen ↑ R 188.

Titel in Zusammensetzungen mit Namen und Straßen ↑ R 220.

VII. Zahlen

1. Groß- und Kleinschreibung

Großschreibung ↑ R 118 und R 224.

Kleinschreibung ↑ R 131 und R 135.

2. Zusammen- oder Getrenntschreibung oder Bindestrich

R 226 a) Zusammen schreibt man in Wörtern angegebene Zahlen unter einer Million (vgl. auch S. 88, 15).

Beispiel: neunzehnhundertfünfundfünfzig, dreiundzwanzigtausend.

R 227 b) Getrennt schreibt man Angaben für Zahlen über eine Million.

Beispiel: zwei Millionen dreitausendvierhundertneunzehn.

c) Ableitungen und Zusammensetzungen, die eine Zahl enthalten:

R 228 1. Zusammen schreibt man Ableitungen und Zusammensetzungen, die eine Zahl enthalten, unabhängig davon, ob die Zahl in Buchstaben oder aus sachlichen Gründen in Ziffern geschrieben wird (vgl. S. 87, g und 88, 15).

Beispiele: achtfach, achtmal (mit Ziffer: 8fach, 8mal), Achtpfünder (mit Ziffer: 8pfünder), Achttonner (mit Ziffer: 8tonner), 14karätig, $3^{1}/_{2}$prozentig (oder: $3^{1}/_{2}$%ig), 32eck, 10^{6}fach, 1,5fach, ver307fachen, 103er, 80er Jahre; 48er Raster; Dreikant[stahl] (mit Ziffer: 3kant[stahl]), Elfmeter[marke] (mit Ziffern: 11meter[marke]).

R 229 2. Den Bindestrich setzt man bei Aneinanderreihungen mit Zahlen (↑ R 157).

3. Schreibung in Ziffern

(Vgl. auch R 157, R 228 und S. 88, 15.)

R 230 a) Ganze Zahlen, die sich aus mehr als drei Ziffern zusammensetzen, werden von der Endziffer aus in dreistellige Gruppen zerlegt, die durch einen Zwischenraum oder Punkt (nicht durch einen Beistrich) voneinander abgesetzt werden.

Beispiel: 3 560 783 DM; 10.000.

R 231 b) Bei Zahlen, die eine Nummer darstellen, teilt man meistens keine Gruppen ab.

Beispiel: Nr. 33590 (vgl. aber S. 86, 9, c).

R 232 c) Dezimalstellen werden von den ganzen Zahlen durch einen Beistrich (nicht durch einen Punkt) getrennt, jedoch nicht in Gruppen eingeteilt.

Beispiel: 52,36 m; 8,65432.

R 233 d) Bei Zeitangaben wird die Zahl der Minuten von der Zahl der Stunden nicht durch einen Beistrich, sondern durch einen Punkt oder durch Hochstellung abgehoben.

Beispiel: 6.30 [Uhr] oder 6^{30} [Uhr].

R 234 e) Bei DM wird die Pfennigzahl durch einen Beistrich (nicht durch einen Punkt) abgetrennt.

Beispiel: 3,45 DM, in Aufstellungen und im Zahlungsverkehr auch: DM 3,45.

Volle Markbeträge schreibt man ohne Andeutung der Dezimalstellen.

Beispiele: 5 DM, 157 DM.

Doch kann man auch die Dezimalstellen wie folgt andeuten:

5,00 DM oder 10,— DM.

Beachte: Man schreibt: 10–25000 DM (wenn 10 DM gemeint sind), aber: 10000–25000 DM (wenn 10000 DM gemeint sind).

R 235 f) In der Schweiz steht zwischen Franken- und Rappenzahl immer ein Punkt.

Beispiel: Fr. 4.20.

VIII. Zusammentreffen von drei gleichen Mitlauten

1. Vor folgendem Selbstlaut

Treffen bei Wortbildungen zwei gleiche Mitlaute mit einem dritten gleichen R 236
zusammen, dann setzt man nur zwei Mitlaute, wenn ein Selbstlaut folgt.

Beispiele: Schiffahrt, Brennessel, Balletttheater (th, gr. ϑ, gilt hier als ein Buchstabe!),
wetturnen. (Zu den Ligaturen ↑ S. 83, 4, a; zu ss als Ersatz für ß [Kongressstadt]
↑ S. 82 f., 3, b, 1)

Bei Silbentrennung tritt der dritte Mitlaut wieder ein.

Beispiele: Schiff-fahrt, Brenn-nessel, Ballett-theater, wett-turnen.

Merke:

1. In *dennoch*, *Dritteil* und *Mittag* setzt man den Mitlaut immer nur zwei-
mal, auch bei Silbentrennung:

 den-noch, Drit-teil, Mit-tag.

2. Nach **ck** darf **k** und nach **tz** darf **z** nicht ausfallen.

 Beispiele: Postscheckkonto, Rückkehr, Schutzzoll.

3. Wo ein Mißverständnis möglich ist, kann ein Bindestrich gesetzt werden.

 Beispiel: Bettuch (Laken für das Bett); aber: Bettuch oder Bet-Tuch (Gebetsmantel
 der Juden).

2. Vor folgendem Mitlaut

Folgt auf die drei gleichen Mitlaute noch ein anderer, vierter Mitlaut, R 237
dann darf keiner von ihnen wegfallen.

Beispiele: Auspuffflamme, Pappplakat, Ballettttruppe, fetttriefend.

Bei Silbentrennung trennt man diese zusammengesetzten Wörter nach
ihren Bestandteilen (↑ R 168).

Beispiele: Auspuff-flamme, Papp-plakat, Ballett-truppe.

IX. Auslassungszeichen (Apostroph)

Das Auslassungszeichen (der Apostroph) deutet an, daß Laute (Buch-
staben), die gewöhnlich gesprochen und geschrieben werden, ausgelassen
worden sind.

1. Bei Ausfall von Lauten am Anfang eines Wortes

a) Das Auslassungszeichen steht, wenn Laute am Anfang eines Wortes R 238
ausgelassen werden. Die verkürzten Formen sind auch am Satzanfang
klein zu schreiben (↑ R 125).

Beispiele: In 's (des) Teufels Küche. 's (Es) ist unglaublich! Er macht sich's (es) ge-
mütlich. Wirf die Decken und 's (das) Gepäck ins Auto. Mir geht's (es) gut. So 'n (ein)
Blödsinn! Wir steigen 'nauf (hinauf). (Zum Spatium ↑ S. 86, 9, a.)

Im Gegensatz zu 'nauf, 'naus usw. (statt: hinauf usw.) werden die mit
r- anlautenden Kürzungen heute im allgemeinen ohne Auslassungszeichen
geschrieben.

Beispiele: Runter vom Balkon! Reich mir mal das Buch rüber. Er ließ ihn rauswerfen.
Was für ein Reinfall!

Soll eine solche Form bewußt als Auslassung gekennzeichnet werden,
dann kann man das Auslassungszeichen setzen.

b) Das Auslassungszeichen steht nicht bei *mal* (ugs. für: einmal) und R 239
was (ugs. für: etwas), weil diese Verkürzungen als selbständige Neben-
formen angesehen werden und allgemein üblich sind.

Beispiele: Kommen Sie mal vorbei. Haben Sie noch was auf dem Herzen?

R 240 c) Das Auslassungszeichen s t e h t n i c h t, wenn es sich um Verschmelzungen aus Verhältniswort und Geschlechtswort handelt, die (z. T. auch in der Hochsprache) allgemein gebräuchlich sind.

> B e i s p i e l e : (Verhältniswort + das:) ans, aufs, durchs, fürs, hinters, ins, übers, ums, unters, vors; (Verhältniswort + dem:) am, beim, hinterm, im, überm, unterm, vorm, zum; (Verhältniswort + den:) hintern, übern, untern, vorn; (Verhältniswort + der:) zur.

M e r k e : Umgangssprachliche und mundartliche Verschmelzungen, die zu unüblichen oder unschönen Lautverbindungen führen, werden mit Auslassungszeichen geschrieben.

> B e i s p i e l e : Er sitzt auf'm (für: auf dem) Tisch. Wir gehen in'n (für: in den) Zirkus.

2. Bei Ausfall von Lauten am Ende eines Wortes

a) *Schluß-e bei Hauptwörtern*

R 241 Das Auslassungszeichen s t e h t bei Hauptwörtern für das weggelassene Schluß-e:

> B e i s p i e l e : Lieb', Gebirg', Näh', Freud', Hos', Treu', Sünd', Füß'.

M e r k e : Das Auslassungszeichen s t e h t n i c h t bei Doppelformen oder wenn das Schluß-e eines Hauptwortes, das in einer festen Verbindung oder einem formelhaften Wortpaar steht, ausgelassen wird.

> B e i s p i e l e : Bursch neben Bursche, Hirt neben Hirte; meiner Treu!, auf Treu und Glauben, Hab und Gut, Müh und Not.

B e a c h t e : Diese Regel gilt vereinzelt auch bei Wörtern aus anderen Wortarten.

> B e i s p i e l e : eh', ohn'. Aber: eh und je.

b) *Schluß-e bei Eigenschafts- und Umstandswörtern*

R 242 Das Auslassungszeichen s t e h t n i c h t bei den verkürzten Formen der Eigenschafts- und Umstandswörter auf -e, weil diese als selbständige Nebenformen angesehen werden und (auch in der Hochsprache) allgemein üblich sind.

> B e i s p i e l e : blöd, bös, fad, gern, heut, leis, öd, trüb.

c) *Schluß-e bei Formen des Zeitwortes*

Das Auslassungszeichen steht für das weggelassene -e in folgenden Formen der Zeitwörter:

R 243 1. 1. Person Einzahl der Wirklichkeitsform in der Gegenwart.

> B e i s p i e l e : Das hör' ich gern. Ich schreib' dir bald. Ich lass' dich nicht. Ich werd' kommen.

R 244 2. 1. und 3. Person Einzahl der Wirklichkeitsform in der ersten Vergangenheit.

> B e i s p i e l e : Ich hatt' einen Kameraden. Das Wasser rauscht', das Wasser schwoll...

R 245 3. 1. und 3. Person Einzahl der Möglichkeitsform in der Gegenwart und in der ersten Vergangenheit.

> B e i s p i e l e : Gesteh' ich's nur! Behüt' dich Gott! Könnt' ich (er) das nur erreichen! (Auch:) Hol's der Teufel! (↑ S. 86, 9, a.)

R 246 M e r k e : Das Auslassungszeichen s t e h t n i c h t bei festen Grußformeln.

> B e i s p i e l e : Grüß Gott! (auch: Grüß di[ch] Gott!).

Es s t e h t n i c h t bei den verkürzten Befehlsformen, weil diese als Nebenformen angesehen werden und allgemein üblich sind.

> B e i s p i e l e : bleib!, geh!, trink!, laß!

Es s t e h t aber bei nicht allgemein üblichen kürzeren Nebenformen.

> B e i s p i e l e : Fordr' ihn heraus! Handl' so weiter!

d) *Andere Laute am Ende eines Wortes*

Das Auslassungszeichen s t e h t

1. für andere am Ende eines Wortes ausgelassene Laute oder Beugungs- **R 247** endungen.

Beispiele: Wissen S' (Sie) schon? Er begehrt kein' (keinen) Dank. Er ist gericht' (gerichtet).

2. für das weggelassene -o von *Santo* und für das weggelassene -a von **R 248** *Santa* vor männlichen bzw. weiblichen italienischen Namen, die mit Selbstlaut beginnen.

Beispiele: Sant'Angelo, Sant'Agata.

Das Auslassungszeichen s t e h t n i c h t bei ungebeugten Eigenschaftswörtern und unbestimmten Fürwörtern.

Beispiele: groß Geschrei, gut Wetter, solch Glück, manch tapfrer Held, ein einzig Wort, welch Freude; zwei Mädchen, zart und schön.

3. Bei Ausfall von Lauten im Wortinnern

a) Das Auslassungszeichen s t e h t heute im allgemeinen für das ausgelas- **R 249** sene -i- der mit -ig und -isch gebildeten Eigenschafts- und Fürwörter.

Beispiele: ein'ge Leute, wen'ge Stunden, heil'ge Eide, ew'ger Bund; ird'sche Güter, weib'sches Gejammere, märk'sche Heimat.

M e r k e : Das Auslassungszeichen steht nicht für das ausgelassene -i- der Nachsilbe -isch, wenn es sich um Eigenschaftswörter handelt, die von Eigennamen abgeleitet sind.

Beispiele: Goethesche (oder Goethische) Lyrik, Mozartsche Sonate, Grimmsche Märchen, Hegelsche Schule, Heusssche Schriften. Ausnahme (alter [Firmen]name): Cotta'sche Buchhandlung.

b) Das Auslassungszeichen w i r d (umgangssprachlich) gelegentlich ge- **R 250** setzt, wenn – der Kürze wegen – größere Lautgruppen von Namen weggelassen werden.

Beispiele: Lu'hafen (Ludwigshafen am Rhein), Ku'damm (Kurfürstendamm), D'dorf (Düsseldorf).

c) Das Auslassungszeichen s t e h t n i c h t, wenn im Wortinnern ein un- **R 251** betontes -e- ausfällt und die kürzere von zwei möglichen Wortformen gebraucht wird († R 326 ff.).

Beispiele: stehn (statt: stehen), befrein (statt: befreien), ich wechsle (statt: ich wechsele), auf verlornem (statt: auf verlorenem) Posten; Abrieglung (statt: Abriegelung), Wandrer (statt: Wanderer), Englein (statt: Engelein); wacklig (statt: wackelig), wäßrig (statt: wässerig), edle (statt: edele) Menschen, finstre (statt: finstere) Gestalten, trockner (statt: trockener) Boden, raschste (statt: rascheste); unsre (statt: unsere).

Auch Wörter und Namenformen mundartlicher Herkunft werden ohne Auslassungszeichen geschrieben.

Beispiele: Brettl, Dirndl, Hansl, Rosl.

M e r k e : Das Auslassungszeichen m u ß jedoch dann s t e h e n, wenn es sich nicht um eine kürzere von zwei möglichen Wortformen handelt, sondern das -e- mehr in vereinzeltem Gebrauch gelegentlich ausgelassen wird.

Beispiele: Well'n, g'nug, Bau'r.

4. Bei der Bildung des Wesfalls

a) Das Auslassungszeichen s t e h t zur Kennzeichnung des Wesfalls von **R 252** Namen, die auf s, ss, ß, tz, z, x enden. Auch bei Abkürzungen dieser Namen muß im Wesfall das Auslassungszeichen gesetzt werden († R 310).

Beispiele: Hans Sachs' Gedichte (Hans S.' Gedichte), deutlicher: Hans Sachsens Ge-
dichte (↑ R 310), Aristoteles' Schriften (A.' Schriften), Le Mans' Umgebung; Grass'
Blechtrommel; Voß' Übersetzung; Ringelnatz' Gedichte, Britz' Heimatgeschichte;
Giraudoux' Werke, Bordeaux' Hafenanlage.

R 253 **b)** Das Auslassungszeichen s t e h t heute im allgemeinen auch zur Kenn-
zeichnung des Wesfalls von nichtdeutschen Namen, die im Auslaut [etwa]
so ausgesprochen werden wie Namen, die auf einen Zischlaut enden.

Beispiele: Anatole France' Werke, Mendès-France' Politik, George Meredith' Dich-
tungen, Cyrankiewicz' Staatsbesuch. (A b e r n i c h t bei eindeutschender Schreibung:
Schostakowitschs Musik.)

R 254 **c)** Das Auslassungszeichen s t e h t n i c h t vor dem Wesfall-s von Namen,
auch nicht bei ihren Abkürzungen.

Beispiele: Brechts Dramen (B.s Dramen), Bismarcks Politik, Hamburgs Hafen, Lud-
wig Thomas Erzählungen.

5. Bei Abkürzungen mit der Beugungsendung -s

R 255 Das Auslassungszeichen s t e h t n i c h t bei Abkürzungen mit der Beu-
gungsendung -s (↑ R 323 u. R 324).

Beispiele: Lkws, MGs, GmbHs.

Zur Formenlehre[1]

I. Beugung des Hauptwortes (Deklination des Substantivs)

(Beugung der Fremdwörter ↑ R 306 ff.; Namen ↑ R 309 ff.; Maß-, Mengen- und Münzbezeichnungen ↑ R 321 f.; Abkürzungen ↑ R 323 ff.; Beugung von Ableitungen ↑ S. 11, 3, b.)

1. Wesfall (Genitiv) auf -es oder -s

Bei den stark gebeugten männlichen und sächlichen Hauptwörtern endet **R 256** der Wesfall der Einzahl auf **-es** oder **-s**.

a) Die **volle** Form steht **immer** **R 257** bei Hauptwörtern, die auf **s, ß, x, z, tz** enden.

> Beispiele: des Glases, des Überflusses, des Reflexes, des Gewürzes, des Sitzes.

b) Die **volle** Form ist vorzuziehen **R 258** bei deutschen Hauptwörtern mit betonter Endsilbe (und damit auch bei einsilbigen), die nicht auf die unter a genannten Laute enden, und bei Hauptwörtern auf **-sch** und **-st**.

> Beispiele: des Mannes, des Baches, des Erfolges; des Gebüsches, des Zwistes.

Die kurze Form wird mitunter aus rhythmischen Gründen gewählt.

c) Die **kurze** Form steht **immer** **R 259** bei Hauptwörtern auf **-en, -em, -el** und **-er** und in formelhaften Wendungen.

> Beispiele: des Wagens, des Lesens, des Atems, des Gürtels, des Lehrers; tags darauf, höheren Orts, von Rechts wegen.

d) Die **kurze** Form ist vorzuziehen **R 260** bei mehrsilbigen Hauptwörtern mit unbetonter Endsilbe, die nicht auf die unter a genannten Laute enden, und bei Hauptwörtern, die auf Selbstlaut (Zwielaut) oder auf Selbstlaut + h enden.

> Beispiele: des Urteils, des Urlaubs, des Dornstrauchs; des Uhus, des Baus, des Sees, des Flohs.

Die volle Form wird mitunter aus rhythmischen Gründen gewählt.

2. Wemfall-e (Dativ-e)

Das Wemfall-e der Einzahl starker männlicher und sächlicher Hauptwörter **R 261** ist im heutigen Sprachgebrauch vielfach geschwunden.

Der Wemfall wird **immer ohne e** gebildet:

a) bei Wörtern, die auf Selbstlaut enden. **R 262**

> Beispiele: dem Uhu, dem Echo, dem Hurra.

b) bei den endungslosen Bezeichnungen der Winde oder Himmelsrich- **R 263** tungen.

> Beispiele: vom West getrieben, von Nord nach Süd.

[1] Eine ausführliche Darstellung der Formenlehre befindet sich in der Duden-Grammatik.

R 264 c) bei Wörtern, die ohne Geschlechtswort von einem Verhältniswort oder von einem Mengenbegriff abhängen.

> Beispiele: aus Holz, in Öl malen, von Haß getrieben, von Ast zu Ast, von Kopf bis Fuß; mit einem Glas Bier, aus einem Faß Wein, mit ein wenig Geist.

R 265 d) bei Wörtern auf **-en, -em, -el, -er.**

> Beispiele: dem Garten, dem Atem, dem Gürtel, dem Lehrer.

Der Wemfall wird ü b e r w i e g e n d o h n e **e** gebildet:

R 266 a) bei Wörtern, die auf Zwielaut enden.

> Beispiele: dem Bau, im Heu, dem Ei.

R 267 b) bei mehrsilbigen Wörtern, die nicht auf der letzten Silbe betont werden.

> Beispiele: dem Frühling, dem Ausflug, dem Schicksal.

Sonst hängt der Gebrauch des e weitgehend vom rhythmischen Gefühl des Schreibenden oder Sprechenden ab.

3. Wem- und Wenfall (Dativ und Akkusativ) auf -[e]n

R 268 Männliche Hauptwörter, die nach der schwachen Beugung den Wesfall auf **-[e]n** bilden, behalten diese Endung auch im Wem- und Wenfall bei.

> Beispiele: Der Professor prüfte den Studenten (nicht: den Student). Man wählte ihn zum Präsidenten (nicht: zum Präsident). Er begrüßte den Fabrikanten (nicht: den Fabrikant). Er gab dem Patienten (nicht: dem Patient) eine Spritze.

Das gilt auch, wenn das Hauptwort als Beisatz nach ,,als" steht.

> Beispiele: Er sandte ihn als Boten (nicht: als Bote). Ihm als Ethnologen (nicht: als Ethnologe). Dir als Juristen (nicht: als Jurist) legt man die Frage vor.

Nur in drei Fällen steht hier die endungslose Form:

a) wenn ein solches alleinstehendes Wort in der Einzahl mit ,,von" an ein Hauptwort im Werfall angeschlossen ist.

> Beispiel: Eine Seele von Mensch.

b) bei Kopplung alleinstehender Hauptwörter durch *und.*

> Beispiele: Für Patient und Arzt war die Lage kritisch; die Grenze zwischen Affe und Mensch.

c) wenn das Hauptwort ohne Geschlechtswort oder Beifügung nach einem Verhältniswort steht.

> Beispiele: ein Forstmeister mit Assistent. Am Wortende nach Konsonant.

4. Mehrzahl (Plural)

a) *Hauptwörter auf -el und -er*

R 269 1. Weibliche Hauptwörter haben die schwache Beugung auf **-n.**

> Beispiele: die Kiefern (Bäume), die Adern, die Achseln, die Kartoffeln.
> Ausnahmen (mit Umlaut): die Mütter (aber: die Schraubenmuttern), die Töchter.

R 270 2. Männliche und sächliche Hauptwörter werden stark (mit endungslosem Werfall der Mehrzahl) gebeugt.

> Beispiele: die Kiefer (Schädelknochen), die Gitter, die Würfel, die Gipfel.
> Ausnahmen: die Bauern, die Muskeln, die Pantoffeln, die Stacheln, die Vettern.

b) *Mehrzahl-s*

R 271 Bestimmte Hauptwörter haben das Mehrzahl-s der niederdeutschen Mundart, meist im umgangssprachlichen Gebrauch.

> Beispiele: die Wracks (neben: Wracke), die Uhus, ugs.: die Jungens, die Jungs, die Mädels.

II. Beugung des Eigenschaftswortes (Deklination des Adjektivs) und Beugung des Mittelwortes (Deklination des Partizips)[1]

A. Starke und schwache Beugung

Jedes beigefügte Eigenschafts- oder Mittelwort hat eine starke und eine schwache Beugung.

1. Starke Beugung

Das stark gebeugte Eigenschafts- oder Mittelwort hat dieselben Endun- **R 272** gen wie das gebeugte bestimmte Geschlechtswort.

Die starke Beugung tritt ein, wenn das Eigenschafts- oder Mittelwort allein vor einem Substantiv steht oder wenn ein vorangehendes Geschlechts-, Für- oder Zahlwort selbst keine starke Endung hat (vgl. aber R 275 ff.).

Beispiele: guter Ton, gute Fahrt, gutes Wetter, bei gutem Ton, bei guter Fahrt, bei gutem Wetter; ein (mein, dein, sein, unser[2], euer[2], ihr, kein) an das Amt gerichtetes Schreiben; viel (wenig) frisches Heu; gute Menschen, guter Menschen.

2. Schwache Beugung

Die schwache Beugung des Eigenschafts- oder Mittelwortes ist gekenn- **R 273** zeichnet durch die Endung -en im Wes- und Wemfall der Einzahl und in der ganzen Mehrzahl.

Die schwache Beugung tritt ein, wenn ein Geschlechts-, Für- oder Zahlwort vorangeht, das seinerseits schon starke Endung aufweist (vgl. aber R 276 ff.).

Beispiele: der (dieser, jener, jeder, jedweder, jeglicher) gute Vater, des (dieses, jenes, meines, unseres, keines) guten Vaters, in dem (einem, meinem, unserem, euerem usw.) alten Haus; die (meine, unsere, keine) guten Eltern.

3. Beugung mehrerer beigefügter Eigenschafts- oder Mittelwörter

Mehrere vor einem Hauptwort stehende Eigenschafts- oder Mittelwörter **R 274** werden in gleicher Weise, d. h. parallel, gebeugt, und zwar auch dann, wenn das unmittelbar vor dem Hauptwort stehende Eigenschafts- oder Mittelwort mit dem Hauptwort einen Gesamtbegriff bildet. Zur Setzung des Beistrichs ↑ R 11.

Beispiele: der tiefe, breite Graben; ein tiefer, breiter Graben; bei dunklem bayrischem Bier; der Wert hoher künstlerischer Leistungen.

Im Wemfall der Einzahl bei Eigenschaftswörtern, die vor einem männlichen oder sächlichen Hauptwort stehen, wird jedoch das zweite Eigenschaftswort aus lautlichen Gründen noch häufig schwach gebeugt.

Beispiele: auf schwarzem hölzernen Sockel, eine Flut von weißem elektrischen Licht, mit dunklem bayrischen Bier, mit frischem, roten Gesicht.

4. Besondere Fälle

a) *Ausnahmen*

1. Obwohl nach R 272 die starke Beugung zu erwarten wäre, steht das **R 275** Eigenschafts- oder Mittelwort heute in schwacher Beugung:
im allgemeinen nach den persönlichen Fürwörtern *wir* und *ihr* und nach *mir* und *dir* vor weiblichen Hauptwörtern sowie – neben der starken Beugung – auch vor männlichen und sächlichen Hauptwörtern.

[1] Diese der Duden-Grammatik angeglichene Darstellung der Beugung aller deklinierbaren Wortarten verdankt viele neue Ergebnisse der Abhandlung von Ivar Ljungerud, Zur Nominalflexion in der deutschen Literatursprache nach 1900, Lund 1955.
[2] Das -er in *unser* und *euer* gehört zum Stamm und ist keine Beugungssilbe.

Beispiele: wir bescheidenen Leute, ihr lieben Kinder; dir (mir) alten (selten: alter) Frau; dir (mir) jungem (auch: jungen) Menschen.

im Wesfall der Einzahl vor männlichen und sächlichen Hauptwörtern:

Beispiele: frohen Sinnes (statt: frohes Sinnes), reinen Gemütes (statt: reines Gemütes), voll süßen Weines.

R 276 2. Obwohl nach R 273 die schwache Beugung zu erwarten wäre, steht das Eigenschafts- oder Mittelwort nach *zweier* und *dreier* (Wesfall von zwei und drei) heute meist in starker Beugung.

Beispiel: die Spielsachen dreier kleiner (seltener: kleinen) Kinder.

b) *Schwankungen*

Schwankungen zeigt die Beugung des Eigenschafts- oder Mittelwortes nach unbestimmten Für- und Zahlwörtern.

In der Einzahl:

R 277 1. Auf *all-, folgend-, manch-, sämtlich-* und *welch-* folgt im allgemeinen die schwache Beugung.

Beispiele: aller erwiesene Respekt, folgendes schauderhafte Geschehnis, in mancher langen Stunde, mit sämtlichem gedruckten Material, welches reizende Mädchen.

R 278 2. Auf *solch-* folgt zumeist die schwache Beugung. Im Wes- und Wemfall vor einem weiblichen Hauptwort wird das Eigenschafts- oder Mittelwort gelegentlich auch stark gebeugt.

Beispiele: solcher weiche Stoff, solches herrliche Wetter; aus solcher übelwollenden (gelegentlich: übelwollender) Stimmung heraus.

R 279 3. Auf *ander-* und *wenig-* folgt die starke Beugung. Nur im Wemfall vor einem männlichen oder sächlichen Hauptwort wird das Eigenschafts- oder Mittelwort überwiegend schwach gebeugt.

Beispiele: anderes gedrucktes Material, mit weniger geballter Energie; unter anderem kleinen Privatbesitz, mit wenigem guten Getränk.

R 280 4. Nach *einig-, etlich-* und *viel-* wird das folgende Eigenschafts- oder Mittelwort im Werfall vor einem männlichen Hauptwort und im Wes- wie im Wemfall vor einem weiblichen Hauptwort im allgemeinen stark gebeugt; im Wer- und im Wenfall vor einem sächlichen Hauptwort und im Wemfall vor einem männlichen oder sächlichen Hauptwort wird es im allgemeinen schwach gebeugt.

Beispiele: vieler schöner Putz, nach einiger erfolgloser Überlegung; einiges milde Nachsehen, mit vielem kalten Wasser.

In der Mehrzahl:

R 281 1. Auf *alle* und *welche* folgt heute bis auf wenige Ausnahmen die schwache Beugung.

Beispiele: alle ehrlichen Menschen, aller wahren Deutschen, welche schönen Bilder.

R 282 2. Nach *sämtliche* herrscht im allgemeinen die schwache Form vor. Im Wer- und Wenfall tritt gelegentlich, im Wesfall häufiger die starke Beugung auf. Nach *solcher* überwiegt ebenfalls die schwache Beugung, doch tritt auch die starke auf.

Beispiele: sämtliche stimmfähigen (seltener: stimmfähige) Mitglieder, solcher schönen (auch: schöner) Kleider.

R 283 3. Nach *manche* überwiegt bereits die starke Beugung, doch tritt auch die schwache noch auf.

Beispiel: manche geeignete (auch noch: geeigneten) Einrichtungen.

R 284 4. Nach *folgend* steht das Eigenschafts- oder Mittelwort meist in starker Form.

Beispiel: folgende durchgreifende (seltener: durchgreifenden) Änderungen.

5. Nach *andere* und *wenige* steht im Wer-, Wes- und Wenfall das Eigen- **R 285**
schafts- oder Mittelwort heute in der starken Form.

Beispiele: andere gute Nachbildungen, weniger guter Menschen.

6. Nach *einige, etliche, mehrere, viele* steht das Eigenschafts- oder Mittel- **R 286**
wort im Wer- und Wenfall immer in der starken Form, im Wesfall meist
in der starken, seltener in der schwachen Form.

Beispiele: einige gute Nachbildungen, vieler guter (seltener: guten) Menschen.

B. Das hauptwörtlich gebrauchte Eigenschafts- und Mittelwort

Für die Beugung der hauptwörtlich gebrauchten Eigenschafts- und Mittel-
wörter gelten im wesentlichen die R 272 ff. genannten Richtlinien für die
Beugung der beigefügten Eigenschafts- oder Mittelwörter.

1. Starke Beugung

Die starke Beugung tritt gemäß R 272 ein. **R 287**

Beispiele: ein Guter, Gute *Mehrz.*; viel, wenig Gutes.

2. Schwache Beugung

Die schwache Beugung tritt gemäß R 273 ein. **R 288**

Beispiele: der Gute, die Guten; unsere Bekannten.

3. Beugung nach einem beigefügten Eigenschafts- oder Mittelwort

Die Beugung erfolgt im allgemeinen nach R 274, d. h. parallel. Ist das **R 289**
beigefügte Eigenschafts- oder Mittelwort stark gebeugt, dann überwiegt
jedoch im Wemfall der Einzahl aller drei Geschlechter die schwache Beu-
gung des folgenden, hauptwörtlich gebrauchten Eigenschaftswortes, im
Wesfall der Mehrzahl tritt sie gelegentlich auf.

Beispiele: der gute Bekannte, ein guter Bekannter; ein volles Maß von eigenem
Menschlichen (auch: Menschlichem), von Michaels notwendigem Vertrauen, mit spie-
lender Linken; im Kreise guter Bekannter (auch: Bekannten).

4. Besondere Fälle

Die R 275 ff. genannten Ausnahmen und Schwankungen gelten mit ge- **R 290**
ringen Ausnahmen auch für die hauptwörtlich gebrauchten Eigenschafts-
und Mittelwörter.

Beispiele: wir Armen!, ihr Hilflosen!, die Geliebten (weiblich; selten: Geliebter), mir
Verachtetem (männlich; auch: Verachteten; ↑ R 275); abweichend: die Reden dreier
Abgeordneten (seltener: Abgeordneter; vgl. aber R 276); alles, folgendes, manches,
sämtliches, welches Schöne (↑ R 277); solches Schöne (↑ R 278); weniges Gutes, ab-
weichend: anderes Wirkliche (vgl. aber R 279); mit einigem, vielem Neuen (↑ R 280);
alle, welche Großen (↑ R 281); sämtliche, solche Reisenden (auch: Reisende; ↑ R 282);
manche Stimmberechtigte (auch: Stimmberechtigten; ↑ R 283); einige, etliche, mehrere,
viele Abgeordnete, mehrerer Abgeordneter (seltener: Abgeordneten; ↑ R 286); andere,
wenige Gute (↑ R 285); folgende Abgeordnete (seltener: Abgeordneten; ↑ R 284).

5. Hauptwörtliche oder eigenschaftswörtliche Beugung

Bestimmte hauptwörtlich gebrauchte Eigenschaftswörter werden wie ein **R 291**
Hauptwort gebeugt.

Beispiele: die Kokette; der (ein) Invalide, des Invaliden, zwei (die) Invaliden, ent-
sprechend: der Junge, der Falbe.

Bestimmte hauptwörtlich gebrauchte Eigenschafts- und Mittelwörter
schwanken zwischen hauptwörtlicher und eigenschaftswörtlicher Beugung.

Beispiele: die Parallele, der Parallele, die Parallelen, zwei Parallelen, neben: zwei
Parallele (wie: zwei parallele Linien), entsprechend: die Vertikale, die Horizontale; die
Elektrische, der Elektrischen, die Elektrischen, zwei Elektrische (wie: zwei elektrische
Bahnen), neben: zwei Elektrischen, entsprechend: die Gerade, die Senkrechte, die

Waag[e]rechte; die Illustrierte, der Illustrierten, die Illustrierten, zwei Illustrierte (wie: zwei illustrierte Zeitungen), neben: zwei Illustrierten; *der Angestellte,* des Angestellten, die Angestellten, zwei Angestellte (wie: zwei angestellte Männer), fälschlich auch: zwei Angestellten, entsprechend: *der Beamte, der Gelehrte* usw.; *die Brünette,* der Brünette, zwei Brünetten, neben: die Brünette, der Brünette, zwei Brünette (wie: zwei brünette Frauen).

III. Vergleichsformen (Steigerung) des Eigenschaftswortes (Adjektivs) und des Mittelwortes (Partizips)

1. Zur Höchststufe (Superlativ)

R 292 a) **-est** steht bei einsilbigen oder bei endbetonten mehrsilbigen Eigenschaftswörtern, die auf **d, s, sch, ß, st, t, tz, x, z** enden, und bei den Eigenschaftswörtern auf **-los** und **-haft**.

Beispiele: hold – holdeste, kraus – krauseste, rasch – rascheste, süß – süßeste, bunt – bunteste, spitz – spitzeste; berühmt – berühmteste, verstört – verstörteste, behend – behendeste; lieblos – liebloseste, gewissenhaft – gewissenhafteste.

Die Eigenschaftswörter auf **d, t** und **sch** stehen gelegentlich auch ohne „e" (buntste, holdste, raschste), doch ist dies nicht zu empfehlen.

Beachte: Nicht endbetonte Zusammensetzungen und Bildungen mit einer Vorsilbe zu den unter a genannten Wörtern bilden die Höchststufe wie die einfachen Wörter.

Beispiele: sạnft; ụnsanft – unsanfteste; bereit: kampfbereit – kampfbereiteste.

R 293 b) Eigenschaftswörter, die auf Zwielaut oder auf Selbstlaut (Zwielaut) + h enden, haben überwiegend **-st,** bei besonderer Betonung der Höchststufe jedoch auch **-est.** Dasselbe gilt für Eigenschaftswörter auf **-ff.**

Beispiele: frei – freiste, auch: freieste; froh – frohste, auch: froheste; rauh – rauhste, auch: rauheste; schlaff – schlaffste, auch: schlaffeste.

R 294 c) Alle anderen – vor allem auch mehrsilbige, nicht auf der letzten Silbe betonte – Eigenschaftswörter haben **-st** (vgl. aber R 292, Beachte).

Beispiele: klein – kleinste, edel – edelste, verworren – verworrenste, bitter – bitterste, fleißig – fleißigste; passend – passendste, komisch – komischste, gebildet – gebildetste; wohlgelitten – wohlgelittenste.

2. Zum Umlaut bei den Vergleichsformen (der Steigerung)

R 295 Manche Eigenschaftswörter haben in beiden Vergleichsformen (Steigerungsstufen) den Umlaut.

Beispiele: klug, klüger, am klügsten; dumm, dümmer, am dümmsten.

Bei anderen Eigenschaftswörtern werden die Vergleichsformen (Steigerungsstufen) sowohl mit als auch ohne Umlaut gebildet.

Beispiele: glatt, glatter (auch: glätter), am glattesten (auch: am glättesten); krumm, krummer (auch: krümmer), am krummsten (auch: am krümmsten).

In der Hochsprache werden immer mehr die nichtumgelauteten Formen bevorzugt (abgesehen von „gesund", bei dem die umgelauteten Formen vorherrschen). Im Zweifelsfalle wähle man daher die nichtumgelautete Form.

3. Zusammengesetzte (oder zusammengeschriebene) Eigenschafts- und Mittelwörter

R 296 a) Man setzt bei einem zusammengesetzten oder zusammengeschriebenen Eigenschaftswort den ersten Bestandteil in die Vergleichsform, d. h., man steigert ihn, wenn die beiden Glieder noch ihren eigenen Sinn bewahrt haben.

Beispiele: der vielbietende Käufer – der meistbietende Käufer, in feinverteilter Form – in feinstverteilter Form.

b) Man setzt das Grundwort und damit die ganze Fügung in die Ver- **R 297** gleichsform, wenn die Zusammensetzung e i n e n Begriff ergibt, zumal einen Begriff neuen, übertragenen Sinnes.

Beispiele: die altmodischen Ansichten – die altmodischsten Ansichten, die neuartige Form – die neuartigste Form.

c) Man steigert nach persönlichem Ermessen bei Fügungen, die ver- **R 298** schieden (nach a oder nach b) gedeutet werden können.

Beispiel: schwerwiegendere o d e r schwerer wiegende Bedenken.

d) Vergleichsformen bei beiden Bestandteilen sind unzulässig. **R 299**

Beispiel: das nächstliegende (n i c h t: nächstliegendste) Problem; auch: größtmöglich (n i c h t: größtmöglichst).

IV. Beugung des Zeitwortes (Konjugation des Verbs)

Man unterscheidet starke, schwache und unregelmäßige Verben.

1. Starke oder schwache Beugung

a) *Starke Beugung*

Zeitwörter, die stark gebeugt werden, haben in der ersten Vergangen- **R 300** heit (Präteritum) im Stamm einen anderen Selbstlaut als in der Gegenwart (Präsens). Man nennt dies A b l a u t. Das zweite Mittelwort (Partizip Perfekt) geht auf **-en** aus.

Beispiele: gebe, gab, gegeben; finde, fand, gefunden.

b) *Schwache Beugung*

Zeitwörter, die schwach gebeugt werden, haben keinen Ablaut. Sie bilden **R 301** die erste Vergangenheit (Präteritum) mit **t** und haben im zweiten Mittelwort (Partizip Perfekt) die Endung **-t** oder **-et**.

Beispiele: sprenge, sprengte, gesprengt; bilde, bildete, gebildet.

c) *Schwankungsfälle*

Mitunter haben die schwachen Formen von Zeitwörtern die ursprüng- **R 302** lichen starken Formen verdrängt, vor allem in der ersten Vergangenheit (Präteritum).

Beispiel: mahle, mahlte (schwach), gemahlen (stark).

Einzelne Zeitwörter haben neben starken heute auch schwache Formen.

Beispiel: glimme, glomm, geglommen, heute auch: glimmte, geglimmt.

Das Wörterverzeichnis nennt in solchen Fällen auch die älteren Formen.

2. Unregelmäßige Beugung

Zeitwörter, die weder in die starke noch in die schwache Beugung ein- **R 303** gereiht werden können, nennt man unregelmäßig.

Beispiele: nenne, nannte (Änderung des Stammselbstlauts und Bildung mit „t"), genannt; bringe, brachte, gebracht; bin, war, gewesen.

3. Vorsilbe ge- beim zweiten Mittelwort (Partizip Perfekt)

a) *Die Vorsilbe ge- steht nicht*

bei dem zweiten Mittelwort der einfachen und der mit einer Vorsilbe **R 304** gebildeten Zeitwörter, die nicht auf der ersten Silbe, und bei dem zweiten Mittelwort der zusammengesetzten Zeitwörter, die nicht auf dem ersten Glied betont sind.

Beispiele: studieren, studiert, n i c h t: gestudiert; posaunen, posaunt, n i c h t: geposaunt; prophezeien, prophezeit, n i c h t: geprophezeit; berufen, er hat ihn berufen, n i c h t: geberufen; hintertreiben, hintertrieben, n i c h t: hintergetrieben.

Merke jedoch: Bilden Zeitwörter, die nicht anfangsbetont sind, eine Zusammensetzung, die den Ton auf dem ersten Glied trägt, dann haben auch die zweiten Mittelwörter dieser Zusammensetzungen kein ge-.

Beispiele: studieren – einstudieren: einstudiert; berufen – einberufen: einberufen; kristallisieren – herauskristallisieren: herauskristallisiert.

b) *Die Vorsilbe ge- steht*

bei dem zweiten Mittelwort der einfachen und der abgeleiteten Zeitwörter, die auf der ersten Silbe, und bei dem Mittelwort der zusammengesetzten Zeitwörter, die auf dem ersten Glied betont sind (vgl. jedoch das vorausgehende „Merke jedoch"), und zwar

1. am Anfang des Wortes bei einfachen Zeitwörtern und bei Zeitwörtern, die von zusammengesetzten Hauptwörtern abgeleitet sind.

Beispiele: holen, er hat das Buch geholt; bringen, er hat den Koffer gebracht; maßregeln (von Maßregel), er hat ihn gemaßregelt; wetteifern (von Wetteifer), sie haben miteinander gewetteifert.

2. zwischen den Bestandteilen bei unfest zusammengesetzten Zeitwörtern.

Beispiele: radfahren, er ist radgefahren; anrufen, er hat sie angerufen; vorausgehen, er ist vorausgegangen.

c) *Die Vorsilbe ge- steht oder steht nicht,*

je nachdem die Betonung auf der ersten Silbe der Grundform liegt oder nicht.

Beispiele: mißachten, er hat gemißachtet, aber (häufiger): mißachten, er hat mißachtet; durchkosten, er hat alle Freuden durchgekostet, aber: durchkosten, er hat alle Freuden durchkostet; liebkosen, er hat geliebkost, aber: liebkosen, er hat liebkost; durchkreuzen (kreuzweise durchstreichen), er hat das Schreiben durchgekreuzt, aber: durchkreuzen (im übertragenen Sinne: zunichte machen), er hat den Plan durchkreuzt.

4. Zur Behandlung des „zu" bei der Grundform (beim Infinitiv) und beim ersten Mittelwort (Partizip Präsens)

↑ R 144 a.

5. Grundform (Infinitiv) statt des zweiten Mittelwortes (Partizip Perfekt)

R 305 Bestimmte Zeitwörter bilden heute im allgemeinen in der zweiten und dritten Vergangenheit (Perfekt und Plusquamperfekt) kein zweites Mittelwort (Partizip Perfekt), wenn ihnen eine reine Grundform vorangeht.

Beispiel: Er hat kommen *müssen* (nicht: gemußt).

Der Gebrauch dieses „Ersatzinfinitivs" ist fest bei den modalen Zeitwörtern *dürfen, können, mögen, müssen, sollen, wollen* und gilt auch für das modal verwendete Zeitwort *brauchen.* Die Zeitwörter *heißen, lassen, sehen* stehen überwiegend in der Grundform, *fühlen, helfen* und *hören* sowohl in der Grundform als auch im zweiten Mittelwort, die Verben *lehren, lernen* und *machen* allgemein im zweiten Mittelwort.

Beispiele: Er hat mich kommen *heißen* (selten: geheißen). Er hat ihm waschen *helfen* (neben: *geholfen).* Er hat ihn reiten *gelehrt* (selten: lehren).

V. Beugung der Fremdwörter

1. Zum Wesfall der Einzahl (Genitiv des Singulars)

R 306 Bei seltener gebrauchten stark gebeugten Fremdwörtern wird das Wesfall-s der Einzahl häufiger weggelassen. Besser ist die Form mit -s.

Beispiele: die Schreibung des griechischen Beta[s], der Kampf des Torero[s].

2. Zum Wemfall der Einzahl (Dativ des Singulars)

Stark gebeugte Fremdwörter stehen im allgemeinen ohne Wemfall-e. **R 307**

> Beispiele: im Senat, mit dem Tabak, dem Konfekt.

Über die Unterlassung der Beugung im Wem- und Wenfall bei schwach
gebeugten männlichen Fremdwörtern ↑ R 268.

3. Zur Mehrzahl (Plural)

Viele Fremdwörter haben in der Mehrzahl die Endung -s. Fremdwörter, **R 308**
die sich schon mehr eingebürgert haben, erhalten neben der Endung auf
-s auch die deutsche auf -e.

> Beispiele: die Büros, die Salons; die Ballone neben: die Ballons, die Balkone
> neben: die Balkons.

VI. Beugung der Namen

A. Familien-, Personen- und Vornamen

1. Zum Wesfall der Einzahl (Genitiv des Singulars)

a) Familien-, Personen- und Vornamen o h n e vorangehendes Ge- **R 309**
schlechts- oder Fürwort erhalten in der Regel das Wesfall-s.

> Beispiele: Goethes, Beethovens, Siegfrieds; Kaiser Karls des Großen.

Bei Familiennamen mit vorangehendem *von, van, de, ten* usw. wird heute
gewöhnlich der Familienname gebeugt. Der Vorname wird nur dann ge-
beugt, wenn der Familienname – besonders bei historischen Namen –
als Ortsname erkennbar ist und das übergeordnete Hauptwort vorangeht.

> Beispiele: Friedrich von Schillers, Wolfgang von Goethes; a b e r : die Lieder Wolframs
> von Eschenbach, j e d o c h : Wolfram von Eschenbachs Lieder.

b) Gehen die Familien-, Personen- und Vornamen auf **s, ß, x, z, tz** aus, **R 310**
dann gibt es folgende Möglichkeit, den Wesfall zu bilden oder zu um-
schreiben:

1. seltener durch die altertümliche Endung **-ens.**

> Beispiele: Brahms, Brahmsens; Horaz, Horazens; Götz, Götzens.

2. durch vorgesetztes G e s c h l e c h t s - oder F ü r w o r t mit oder ohne Gat-
tungsnamen.

> Beispiele: des (Geschichtsschreibers) Tacitus, unseres (großen Gelehrten) Paracelsus.

3. durch vorgesetztes v o n .

> Beispiele: die Schriften von Paracelsus, die „Elektra" von Strauss.

4. durch A u s l a s s u n g s z e i c h e n (↑ R 252).

> Beispiele: Demosthenes' Reden, Paracelsus' Schriften, Ringelnatz' Gedichte, France'
> Werke (↑ R 253).

c) Familien-, Personen- und Vornamen m i t Geschlechts- oder Fürwort **R 311**
bleiben im Wesfall ungebeugt, gleichviel ob noch ein anderes Hauptwort
vorangeht.

> Beispiele: des Lohengrin, des Anton Meier, eines Schiller; des Kaisers Karl, des
> Vetters Fritz Frau, die Krönung der Königin Elisabeth, die Reise unseres Onkels Paul;
> a b e r (↑ R 315): die Krönung Königin Elisabeths, die Reise Onkel Pauls.

M e r k e : Ist ein männlicher Personenname völlig zu einem Gattungsnamen
geworden, dann muß er wie ein gewöhnliches Hauptwort die Wesfall-
endung -s erhalten. Schwankungen entstehen, wenn sowohl die Auffas-
sung, daß (noch) ein Name, als auch die Auffassung, daß (schon) eine
Sachbezeichnung vorliegt, vertreten werden kann.

> Beispiele: des Dobermanns, des Zeppelins; schwankend: des Diesel[s].

2. Mehrzahl (Plural)

a) *Familiennamen*

R 312 Die Familiennamen bilden den Plural heute meist auf **-s**. Gelegentlich stehen sie ganz ohne Endung, so besonders die auf **-en, -er, -el.**

> Beispiele: Buddenbrooks, die Rothschilds, die Barrings, aber: die Goethe, die (Brüder) Grimm, die Münchhausen, die Schiller, die beiden Schlegel. In familiärer Ausdrucksweise ohne Artikel: Meiers besuchen Müllers.

b) *Vornamen*

R 313 Männliche Vornamen mit schließendem Mitlaut, ausgenommen die Namen auf **-er** und **-en,** bilden die Mehrzahl auf **-e.**

> Beispiele: die Heinriche (nur ugs.: Heinrichs); aber: die Peter, die Jürgen.

Männliche Vornamen mit schließendem Selbstlaut bilden die Mehrzahl auf **-s,** wenn sie Herrschergeschlechter bezeichnen, auf **-nen.**

> Beispiel: die Ottos; aber: die Ottonen.

Weibliche Vornamen auf **-e** bilden die Mehrzahl mit **-n.**

> Beispiele: die Hilden, die Mariannen.

Weibliche Vornamen auf **-a, -o, -i (-y)** bilden die Mehrzahl mit **-s.**

> Beispiele: die Paulas, die Emmis, die Liddys.

Weibliche Vornamen mit schließendem Mitlaut, ausgenommen die auf S-Laut, bilden die Mehrzahl mit **-en.**

> Beispiele: die Gudrunen, die Diethilden; aber: die beiden Agnes.

Verkleinerungsformen auf **-chen** und **-el** stehen ohne Endung.

> Beispiele: die Gretchen, die Hansel (nur ugs.: Gretchens, Hansels).

B. Titel und Verwandtschaftsbezeichnungen

1. Titel mit Geschlechtswort vor dem Namen

R 314 Steht ein mit dem Geschlechts- oder Fürwort verbundener Titel (eine Ehren-, Rang- oder Berufsbezeichnung) oder eine Verwandtschaftsbezeichnung mit Geschlechts- oder Fürwort vor dem Namen, dann wird der Titel oder die Verwandtschaftsbezeichnung, nie jedoch der Name gebeugt.

> Beispiele: des Herrn Müller, des Professors Lehmann, die Reise unseres Onkels Karl.

Der Titel „Doktor" (Dr.) bleibt jedoch ungebeugt (↑ R 316).

> Beispiel: das Gesuch des Dr. Meier.

2. Titel ohne Geschlechtswort vor dem Namen

R 315 Steht ein Titel oder eine Verwandtschaftsbezeichnung ohne Geschlechtswort vor dem Namen, dann wird im allgemeinen nur der Name und, sofern vorhanden, der Beiname gebeugt.

> Beispiele: Professor Lehmanns Sprechstunde, Kaiser Karls des Großen Krönung, Tante Klaras Brief.

Aber: Der Titel *Herr* wird in Verbindung mit einem Namen auch dann gebeugt, wenn *Herr* ohne Geschlechtswort steht.

> Beispiele: Herrn Müllers Meldung; das müssen Sie Herrn Müller melden; wollen Sie Herrn Müller rufen!

3. Mehrere Titel vor dem Namen

R 316 Stehen mehrere mit dem Geschlechtswort verbundene Titel vor dem Namen, dann wird zumeist nur der erste Titel gebeugt. Der Titel „Doktor" (Dr.) bleibt ungebeugt, weil er als Teil des Namens gilt.

Beispiele: die Sprechstunde des Geheimrats Professor Dr. Lehmann; die Rede des [Ersten] Vorsitzenden Regierungsrat Doktor Pfeifer.

Aber: Ist „Herr" das erste Wort, dann wird der folgende Titel überwiegend gebeugt.

Beispiel: die Akte des Herrn Finanzrats Heller (weniger häufig: ... des Herrn Finanzrat Heller).

Merke: Für die Beugung der Titel in Anschriften gelten dieselben Richtlinien, auch dann, wenn das Verhältniswort und das Geschlechtswort wegfallen.

Beispiele: An den Herrn Regierungspräsidenten Müller (weniger häufig: An den Herrn Regierungspräsident Müller) oder: Herrn Regierungspräsidenten Müller (weniger häufig: Herrn Regierungspräsident Müller).

C. Erdkundliche Namen

Erdkundliche Namen ohne Geschlechtswort erhalten, soweit sie sächlich sind, im Wesfall ein -s. **R 317**

Beispiele: Kölns, Bayerns, Deutschlands, Europas, Amerikas.

Erdkundliche Namen mit Geschlechtswort erhalten im Wesfall zumeist noch ein -s. Das -s wird jedoch, besonders bei fremden Namen, häufig schon weggelassen.

Beispiele: des Brockens, des Rhein[e]s; aber: des heutigen Europas od. Europa, des Mississippis od. des Mississippi.

Erdkundliche Namen auf **s, ß, x, z, tz** bilden den Wesfall wie Familien-, Personen- und Vornamen, die in gleicher Weise enden (↑ R 310).

Beispiele: Bordeaux' Hafenanlage; die Einwohner von Pirmasens, der Schuhstadt Pirmasens; veraltet: Florenzens Kirchen.

D. Buchtitel u. dgl., Firmen-, Gebäude- und Straßennamen

In gutem Deutsch ist die Beugung der Titel von Büchern, Zeitungen, Opern, Gedichten usw. sowie die der Firmennamen, Straßen- und Gebäudenamen usw. auch dann notwendig, wenn sie in Anführungszeichen stehen. **R 318**

Beispiele: Zitate aus Büchmanns „Geflügelten Worten", das Titelbild der „Frankfurter Illustrierten", die Schriftleitung der „Frankfurter Allgemeinen Zeitung", aus Wagners „Meistersingern", die neue Auflage des Dudens, das Verwaltungsgebäude der Vereinigten Stahlwerke, die Leistungen des Rheinisch-Westfälischen Elektrizitätswerkes, der Vorstand des Bibliographischen Instituts AG, auf der Langen Straße, die Öffnungszeiten des Hauses der Kunst, der Senat der Freien Hansestadt Bremen.

Merke: Soll der Titel eines Buches usw. oder ein Firmenname unverändert wiedergegeben werden, dann muß mit einem entsprechenden Hauptwort umschrieben werden.

Beispiele: aus der Zeitschrift „Die Kunst des Orients", aus Wagners Oper „Die Meistersinger", im Hotel „Europäischer Hof", die Maschinen der Luftverkehrsgesellschaften „Deutsche Lufthansa AG" und „Swissair".

E. Monatsnamen

Die Monatsnamen stehen heute schon überwiegend ohne Wesfall-s. Die Namen auf -er bewahren es eher. Das Wesfall-s fehlt immer in Verbindungen ohne Geschlechtswort. **R 319**

Beispiele: die Launen des April oder Aprils, in den Morgenstunden des 20. Mai oder Mai[e]s; Anfang bis Mitte Januar, Ende Juli.

F. Das Geschlecht von Schiffsnamen

R 320 Schiffsnamen sind im allgemeinen weiblich, vor allem bei Schiffen, die nach Städten und Ländern benannt sind.

> Beispiele: die Bremen; die Hessen; die Europa; die Deutschland.

Nach englischem Vorbild sind die Schiffsnamen heute meist auch dann weiblich, wenn ein männlicher Personenname zugrunde liegt.

> Beispiele: die Graf Spee, die Bismarck. Seltener: der Graf Spee. Aber: der „Fliegende Holländer", der „General San Martin".

Bei Sachnamen schwankt das Geschlecht zwischen dem des Namens und dem weiblichen.

> Beispiel: die Seetüchtigkeit des „Pfeils" oder der „Pfeil".

Bei Tiernamen tritt meist das betreffende Geschlecht dieser Namen ein.

> Beispiele: das „Krokodil", der „Kormoran", das „Windspiel", die „Möwe", der „Jaguar".

VII. Beugung bei Maß-, Mengen- und Münzbezeichnungen[1]

1. Beugung der Bezeichnung und des folgenden Hauptwortes

R 321 a) *Im Wesfall der Einzahl*

Folgt ein starkes männliches oder sächliches Substantiv ohne ein Begleitwort, das den Fall erkennen läßt, einer stark gebeugten Maß- oder Mengenangabe, dann wird entweder die Angabe oder das davon abhängende Hauptwort (das Gezählte) gebeugt. Beugung oder Nichtbeugung beider Glieder gilt als nicht korrekt.

> Beispiele: eines Glas Wassers oder eines Glases Wasser, eines Pfund Fleisches oder eines Pfundes Fleisch; nicht: eines Glases Wassers oder eines Pfund Fleisch.

Geht dem Gezählten oder Gemessenen ein Eigenschaftswort voran, dann werden in der Regel sowohl die Angabe als auch das Gezählte (Gemessene) gebeugt.

> Beispiele: der Preis eines Pfundes (selten: eines Pfund) gekochten Schinkens.

b) *In den übrigen Fällen*

In den andern Fällen steht das abhängige Wort im gleichen Fall wie die Maß- und Mengenangabe, wenn nicht der Wesfall gewählt wird, der jedoch im allgemeinen als gehoben (und gespreizt) empfunden wird.

> Beispiele: fünf Sack feinstes Mehl; mit einem Tropfen [warmem] Öl; von einem Sack [schlechten] Nüssen; ein Glas guter Wein (gehoben: guten Wein[e]s).

2. Beugung der Bezeichnung hinter Zahlen, die größer als 1 sind

R 322 a) Bestimmte Maß-, Mengen- und Münzbezeichnungen in Verbindung mit Zahlwörtern bleiben in der Mehrzahl gewöhnlich ungebeugt.

> Beispiele: 10 Faß, 2 Dutzend, 3 Zoll, 2 Fuß, 7 Paar, 9 Sack, 30 Pfennig, 10 Schilling, 324 Dollar, zwanzig Grad Kälte, zwei Handvoll Papier, zehn Schritt; auch: 5 Karton oder Kartons Seife.

b) Fremde Bezeichnungen werden jedoch häufig gebeugt, bei manchen schwankt der Gebrauch. Bezeichnungen, die auf -e ausgehen, werden immer gebeugt.

> Beispiele: 4 Peseten (Einzahl: Peseta), 100 Lei (Einzahl: Leu), 500 Lire (Einzahl: Lira), 100 Centesimi (Einzahl: Centesimo); 10 Inch oder Inches, 5 Yard oder Yards, 20 Bushel oder Bushels; zwanzig norwegische Kronen, zwei Flaschen Wein, drei Tassen Kaffee, drei Tonnen, 5 Ellen, 2 Kannen Wasser, drei Dosen.

[1] Vgl. S. 67. Fußnote 1.

Die Beugung schwankt auch, wenn der Zahl ein Verhältniswort vorangeht, das den Wemfall fordert.

Beispiele: von 10 Meter an, aber auch: von 10 Metern an; eine Summe von 3 Taler, aber auch: von 3 Talern; in einer Entfernung von 125 Kilometern, aber auch: von 125 Kilometer.

c) Die Bezeichnungen werden immer gebeugt, wenn das betreffende Hauptwort den vollen Begriff enthält, d.h. den konkreten, einzeln gezählten Gegenstand u.ä. bezeichnet.

Beispiele: er trank 2 Glas, aber: er zertrümmerte zwei Gläser; er hatte 30 Schuß Munition, aber: es fielen zwei Schüsse.

VIII. Beugung der Abkürzungen und Kurzwörter

1. Abkürzungen

a) Abkürzungen, die als selbständige Wörter gesprochen werden, stehen **R 323** in der Einzahl meist ohne Beugungsendung.

Beispiele: des Pkw (selten: Pkws), des EKG (selten: EKGs).

In der Mehrzahl ist die Beugung häufiger, besonders bei den weiblichen Abkürzungen, weil bei ihnen das Geschlechtswort in der Einzahl und in der Mehrzahl gleich lautet (↑ R 255).

Beispiele: die Lkws neben: die Lkw (weil Einzahl: der Lkw); aber fast immer: die GmbHs neben seltener: die GmbH (weil die Einzahl gleich lautet: die GmbH).

Überall dort, wo die Beugung durch das Geschlechtswort oder den Satzzusammenhang deutlich wird, ist es besser, diese Abkürzungen nicht zu beugen, um sie gegenüber den vollwertigen Hauptwörtern in ihrer dienenden Rolle zu belassen.

b) Bei Abkürzungen, die im vollen Wortlaut gesprochen werden, wird **R 324** die Beugungsendung oft im Schriftbild nicht wiedergegeben.

Beispiele: lfd. J. (= laufenden Jahres), d. M. (= dieses Monats), im Ndl. (= im Niederländischen).

Dort, wo sie auftritt, steht sie meist hinter dem Abkürzungspunkt.

Beispiele: des Jh.s, die Jh.e (= des Jahrhunderts, die Jahrhunderte), B.s Reden (= Bismarcks Reden); aber, weil so üblich geworden: dem Hrn. (= dem Herrn), Bde. (= Bände).

Gelegentlich wird die Mehrzahl durch Buchstabenverdopplung ausgedrückt.

Beispiele: Mss. (= Manuskripte), Jgg. (= Jahrgänge), ff. (= folgende [Seiten]).

2. Kurzwörter

Kurzwörter werden wie volle Hauptwörter gebeugt. **R 325**

Beispiele: der Bus, des Busses, die Busse; der Akku, des Akkus, die Akkus.

IX. Zur Auslassung des *e* bei Endsilben

Bei den nachfolgend aufgeführten Wörtern besteht die Neigung, ein unbe- **R 326** tontes e auszulassen. (Zur Schreibung ↑ R 251.)

a) Bei den Zeitwörtern auf **-eln** wird das e in der 1. Person Einzahl der **R 327** Wirklichkeitsform und in der 1. und 3. Person Einzahl der Möglichkeitsform der Gegenwart sowie in der Befehlsform häufig ausgelassen. Bei den Zeitwörtern auf **-ern** ist der Ausfall seltener.

Beispiele: ich wechsle neben: ich wechsele; aber: ich wandere (seltener: ich wandre).

Die Auslassung des e der Endung -en nach Selbstlaut oder nach h ist umgangssprachlich oder dichterisch.

Beispiele: schrein, stehn, gehn, sehn.

Nicht umgangssprachlich ist die Auslassung des e nach ie.

Beispiel: sie schrieen neben: sie schrien.

R 328 b) Bei Hauptwörtern auf **-ung** und **-er**, die von Zeitwörtern auf **-eln** abgeleitet sind, fällt das e häufig aus. Bei Ableitungen von Zeitwörtern auf **-ern** bleibt es meist erhalten.

Beispiele: Abriegelung neben: Abrieglung, aber: Wanderer (selten: Wandrer) und nur: Wanderung.

Bei manchen häufig gebrauchten Hauptwörtern auf **-ung**, die von Zeitwörtern auf **-eln** abgeleitet sind, ist das e bereits weitgehend geschwunden.

Beispiele: Wandlung, Handlung, Vermittlung.

Ohne e stehen immer die Hauptwörter auf **-ee** und **-ie**.

Beispiele: die Seen (nicht: die Seeen), der Tegernseer (nicht: der Tegernseeer; ↑ R 205), die Knie (nicht: die Kniee).

R 329 c) Eigenschaftswörter auf **-el** werfen als Beifügung das e dieser Silbe aus.

Beispiele: eitle Menschen, ein dunkler Wald.

Eigenschaftswörter auf **-er** und **-en** sowie Fürwörter auf **-er** behalten überwiegend das e dieser Silben. Nur wenn der Stamm auf einen Zwielaut ausgeht, wird das e immer ausgestoßen. Fremde Eigenschaftswörter auf **-er** stoßen das e gleichfalls aus.

Beispiele: ein finsteres (seltener: finstres) Gesicht; die Kinder waren munterer (auch: muntrer); ein ebenes (auch: ebnes) Gelände; in unseren (seltener: unsren oder auch: unsern) Gärten; die anderen (seltener: andren oder auch: andern) Kinder; saure Gurken; teures Essen; eine illustre Gesellschaft; ein makabres Geschehen.

Formen mit drei tonlosen e sind zu vermeiden.

Beispiel: In dieser Woche gab es heiterere Tage als im vergangenen Monat (besser: ... gab es heitrere Tage ... oder ... waren die Tage heiterer als ...).

R 330 **X. Datum mit oder ohne *am***

1. Datumsangabe mit *am*

Steht bei Angabe des Datums der Wochentag im Wemfall mit *am*, dann steht auch der nachfolgende Monatstag im Wemfall (mit Beistrich hinter dem Monatsnamen), wenn er als erklärender Beisatz aufgefaßt wird.

Beispiel: Die Familie kommt am Montag, dem 5. September, an.

Der nachfolgende Monatstag steht aber im Wenfall, wenn er als Glied einer Aufzählung (ohne Beistrich hinter dem Monatsnamen) aufgefaßt wird. Der Monatstag ist dann eine selbständige Zeitangabe im Wenfall.

Beispiel: Die Familie kommt am Montag, den 5. September an.

Beide Formen des Satzes sind korrekt.

2. Datumsangabe ohne *am*

Steht bei Angabe des Datums der Wochentag ohne *am*, dann steht der Monatstag im Wenfall, und zwar als Glied einer Aufzählung (ohne Beistrich hinter dem Monatsnamen) oder als erklärender Beisatz (mit Beistrich hinter dem Monatsnamen). Auch hier sind beide Formen korrekt.

Beispiele: Die Familie kommt Montag, den 5. September an. Die Familie kommt Montag, den 5. September, an.

Zum Beistrich in solchen Sätzen vgl. auch R 22.

Zur Wortbildung

Die Fugenzeichen

1. Allgemeines

Das Fugenzeichen kennzeichnet die Verbindungsstelle einer Zusammen- **R 331**
setzung (Ableitung). In den meisten Fällen handelt es sich um Beugungs-
endungen, die in die Zusammensetzung eingegangen sind. Viele Zu-
sammensetzungen sind jedoch in Anlehnung an bereits bestehende Muster
gebildet worden. So ist z.B. die Bischofskonferenz nicht die Konferenz
eines Bischofs, sondern mehrerer Bischöfe. Umgekehrt ist ein Hühnerei
nicht das Ei mehrerer Hühner, sondern eines Huhnes. Gerade diese Bei-
spiele zeigen, daß es sich bei den Fugensilben oder -lauten nur um
Fugenmerkmale handelt.

2. Das Fugen-s

Die Häufigkeit, mit der in Zusammensetzungen der Wesfall auf -[e]s **R 332**
starker männlicher und sächlicher Hauptwörter beim Bestimmungswort
auftritt, führte dazu, daß das Fugen-s sogar in Zusammensetzungen er-
scheint, deren Bestimmungswort weiblich ist oder in der Mehrzahl steht.

Das Fugen-s haben

a) viele Zusammensetzungen mit starken männlichen und sächlichen Be- **R 333**
stimmungswörtern.

Beispiele: Wolfsmilch, Bootsmann, Glückstag, Friedensbedingung.

b) „Armut" oder Ableitungen auf **-heit, -keit, -schaft, -tum** und **-ung,** **R 334**
meist auch die auf **-ing** und **-ling** als Bestimmungswort.

Beispiele: Armutszeugnis; weisheitsvoll, Kleinigkeitskrämer, Erbschaftssteuer (be-
hördlich: Erbschaftsteuer), Altertumsforschung, Richtungswechsel (aber, wenn das
Bestimmungswort als Wenfall zum Zeitwort steht: achtunggebietend); Zwillingspaar,
Frühlingssturm (aber: frühlinghaft neben frühlingshaft).

c) die fremden Bestimmungswörter auf **-ion** und **-tät.** **R 335**

Beispiele: Funktionstheorie, Universitätsprofessor, aber: Zusammensetzungen mit
Kommunion: Kommunionbank, Kommunionkind.

d) oft bereits zusammengesetzte Bestimmungswörter. **R 336**

Beispiele: Handwerksmeister, vorschriftsmäßig.

e) die als Bestimmungswort stehenden hauptwörtlich gebrauchten Grund- **R 337**
formen.

Beispiele: Schlafenszeit, Schaffensdrang.

f) die meisten Zusammensetzungen mit den Bestimmungswörtern „Hilfe, **R 338**
Geschichte, Liebe".

Beispiele: Hilfszug, hilfsbereit (aber: hilflos), Geschichtslehrer, Liebesbrief (aber:
Liebreiz).

Merke: Bei Zusammensetzungen, bei denen die Bildung mit **-s** noch **R 339**
nicht vorherrschend ist, verwendet man besser die Form ohne **-s.**

Beispiel: Weggenosse (nicht: Wegsgenosse).

Dabei ist jedoch zu beachten, daß in Österreich das Fugen-s häufiger
gebraucht wird.

Beispiele: Fabriksarbeiter, Zugsverkehr.

Merke: Bei Bedeutungsunterschieden sind beide Formen, mit und ohne Fugen-s, gebräuchlich.

Beispiele: Wassersnot und Wassernot, Landsmann und Landmann.

3. Das Fugen-e

R 340 Das alte Fugen-e (noch in „Mauseloch", „Tagedieb") ist mit der Pluralendung zusammengefallen. Im Süddeutschen werden die Formen ohne -e- bevorzugt.

Beispiele: Tageblatt und Tagblatt; Hundehütte, Gänsefeder.

4. Das Fugenzeichen -en-

R 341 Das Fugenzeichen **-en-** entspricht in fast allen Fällen der alten Wesfallendung der schwachen Beugung. Es tritt bei weiblichen Wörtern auf, die früher im Wesfall der Einzahl die Endung -en hatten (früher: der Sonnen), bei schwach gebeugten männlichen Wörtern (des Boten) und solchen, die früher schwach gebeugt wurden, heute aber der starken Beugungsklasse angehören. Es wird heute zumeist als Pluralendung verstanden.

Beispiele: Tannenbaum, Sonnenball, Erdenrund, Seelenruhe, Fahnenstange, Frauenkirche; Botenlohn; Schwanenhals, Hahnenkampf.

Merke: Das **-en** am Bestimmungswort kann auch Stammauslaut sein.

Beispiele: Zeichenstift (von zeichnen, älter: zeichen-en), Rechenheft (von: rechnen, älter: rechen-en).

Vorschriften für den Schriftsatz

Für die Einheitlichkeit des Verfahrens bei der Herstellung von Drucksachen ist die allgemeine Beachtung folgender Vorschriften dringend notwendig.

1. Buchstaben I, i, J, j

a) I (Selbstlaut) und J (Mitlaut) in Druckschriften

In lateinischen Druckschriften wird zwischen dem Selbstlaut I und dem Mitlaut J unterschieden. Daß viele deutsche Druckschriften einen Unterschied zwischen ℑ (Selbstlaut) und 𝔍 (Mitlaut) nicht kennen, ist ein Mangel.

b) Trennung von I, i (Selbstlaut) und J, j (Mitlaut) in Wörterverzeichnissen

Der Selbstlaut I (i) und der Mitlaut J (j) sind, weil sie verschiedenen Lautwert haben, in Wörterverzeichnissen getrennt aufzuführen.

2. S-Laute in Fraktur

Die deutsche Schrift oder Fraktur unterscheidet zwischen ſ, ß, ſſ, s. Wer sie weiterhin verwenden will, muß nachstehende Richtlinien beachten:

a) Das lange ſ

1. Im Anlaut und in der Buchstabenverbindung ſch steht immer ſ.
 Beispiele: ſagen, ſehen, ſieben, ſuchen; ſchaben, Fiſch.
Dies gilt auch für Zusammensetzungen.
 Beispiele: Heldenſage, Höhenſonne.
2. Im Inlaut steht ſ am Anfang einer Silbe, und zwar
a) nach Mitlauten.
 Beispiele: Erbſe, Rätſel, wachſen, Klecksen.
b) zwischen Selbstlauten, wenn ſ den stimmhaften S-Laut bezeichnet.
 Beispiele: leſen, Roſe, Beſen.

Merke:

1. ſ steht in den Lautverbindungen ſp und ſt für den stimmlosen S-Laut.
 Beispiele: Knoſpe, Weſpe, geſtern, Herbſt.
Dies gilt nicht, wenn ß vor dem Beugungs-t steht.
 Beispiele: er beißt, er läßt, gehaßt, am größten.
2. ſ steht auch dann, wenn der S-Laut durch ein ausgefallenes tonloses e in den Auslaut gerät.
 Beispiele: auserleſne (für: auserleſene), Wechſler (zu: wechſeln), Haarträuſler (zu: träuſeln), ich leſ' (für: ich leſe).
3. In Fremdwörtern steht immer ſ am Anfang einer Sprachsilbe.
 Beispiele: Miſzelle, Proſzenium.
Im übrigen gelten die vorstehenden Richtlinien.
 Beispiele: Mikroſkop, Manuſkript, maſchinell (vgl. a, 1); Abſzeß (vgl. a, 2, a); Friſeur, Muſeum (vgl. a, 2, b); Beſper, Optimiſt (vgl. a, Merke, 1).

Beachte: In Zusammensetzungen wie tranſpirieren, tranſtribieren, tranſzenðent gehört das ſ zum zweiten Wortteil. Das **s** von *trans*- ist ausgefallen.

b) ß

ß steht zur Bezeichnung des stimmlosen S-Lautes

1. im Inlaut immer nach langem Selbstlaut

Beispiele: außer, reißen, Blöße, Grüße, Maße, Schöße.

2. im Auslaut aller Stammsilben, die im Inlaut mit ß oder ſſ geschrieben werden.

Beispiele: Gruß (grüßen), Maß (meſſen), haßt (haſſen), eßbar (eſſen), mißachten (miſſen), Kongreß (Kongreſſe), Kompaß (Kompaſſe).

3. für ſſ, wenn ein tonloses e ausfällt.

Beispiele: vergeßne (für: vergeſſene), wäßrig (für: wäſſerig), faß! (für: faſſe!)

c) ſſ

ſſ steht im Inlaut zwischen zwei Selbstlauten, von denen der erste kurz ist.

Beispiele: Maſſe, Miſſetat, Flüſſe, haſſen, eſſen, Gleichniſſe, Diſſertation.

Merke: ſſ steht auch dann, wenn ein tonloses Schluß-e durch ein Auslassungszeichen ersetzt wird.

Beispiele: Ich laſſ'; aber (ohne Auslassungszeichen; vgl. b, 3): laß!

d) Das Schluß-s

steht im Auslaut

1. aller Stammsilben, die im Inlaut mit ſ geschrieben werden.

Beispiele: dies (dieſes), Gans (Gänſe), Häschen (Haſe), Klausner (Klauſe), bösartig (böſe).

Darüber hinaus steht das Schluß-s aber auch im Auslaut weiterer Stammsilben wie

aus, als, bis, das, es, was u. a.

2. aller Beugungsendungen.

Beispiele: Kindes, Vaters, rotes, welches, alles.

3. aller Sprachsilben von Fremdwörtern.

Beispiele: transponieren (vgl. aber a, Merke, 3), Dispens, Desinfektion.

4. von Wörtern auf **-nis, -is, -us, -as, -es**, obwohl im Inlaut ſſ steht.

Beispiele: Gleichnis (Gleichniſſe), Kürbis (Kürbiſſe), Globus (Globuſſe), Atlas (Atlaſſe), Kirmes (Kirmeſſen), wes (weſſen), des (deſſen).

5. Das Schluß-s steht als Fugen-s in zusammengesetzten Wörtern.

Beispiele: Ordnungsliebe, Donnerstag.

6. Das Schluß-s steht ferner in Wörtern wie

Kubismus, Mesner, Arabeske, Schleswig.

3. S-Laute in Antiqua

a) s, ss, ß

Die Latein- oder Antiquaschrift unterscheidet lediglich zwischen **s, ss, ß**. Für den Gebrauch dieser drei Zeichen gelten sinngemäß die unter Punkt 2 aufgestellten Richtlinien, wobei zu beachten ist, daß s für ſ und **s** steht.

b) ss und SS für ß

1. Nur wenn in einer Antiquaschrift, z. B. bei der Schreibmaschine, kein **ß** vorhanden ist, darf als Notbehelf **ss** gesetzt werden.

Beispiel: Reissbrett für: Reißbrett.

Wenn **ss** für **ß** gebraucht wird, dann darf diese Buchstabengruppe **ss**, die einen einfachen Laut darstellt, nicht getrennt werden (↑ R 161).

Beispiele: Bu-sse, Grü-sse, muss-te, grüss-te.

Stoßen **ß** und **s** innerhalb eines Wortes zusammen, so werden drei **s** gesetzt.

Beispiele: Masssachen, Kongressstadt, Reissschiene.

2. **SS** steht für **ß** bei der Verwendung von Großbuchstaben. Nur wenn Mißverständnisse möglich sind, schreibt man **SZ**.

Beispiele: STRASSE; MASSE, aber: MASZE (wenn beide Wörter verwechselt werden können).

Treffen mehrere S-Zeichen zusammen, dann setzt man zweckmäßig den Bindestrich.

Beispiele: SCHLOSS-STRASSE, MASS-STAB.

c) ß in fremdsprachigem Satz

Wenn ein deutsches Wort mit **ß** latinisiert wird, bleibt das **ß** erhalten.

Beispiel: Weißenburg, Weißenburgensis (der Codex Weißenburgensis).

Ebenso wird **ß** gesetzt, wenn deutsche Eigennamen mit **ß** in fremdsprachigem Satz erscheinen.

Beispiel: Monsieur Aßmann était à Paris.

4. Ligaturen

a) Allgemeines

In Antiqua werden im allgemeinen folgende Ligaturen gebraucht: **ff, fi, fl, ß** (das heute aber als ein Buchstabe angesehen wird).

In Fraktur kennen wir nachstehende Ligaturen: ch, ck, ff, fi, fl, ft, ll, fch, fi, ff, ft, ß, tz.

Die Ligatur ist dort anzuwenden, wo sie die sprachliche Richtigkeit nicht stört.

Beispiele: schaffen, schafft, abflauen, streifig.

Sie steht in Zusammensetzungen nicht in der Wortfuge.

Beispiele: Schaffell, Kaufleute, Schilfinsel, vielleicht, entzwei.

Sie steht auch nicht in Fällen wie:

ich tröpfle, ich kaufte; höflich.

Treffen drei Buchstaben zusammen, von denen je zwei eine Ligatur bilden können, so entscheidet die Silbengrenze.

Beispiele: Rohstoff|frage, Af|figkeit, kniff|lig, Souf|fleur, schaff|ten.

Mit zwei Ligaturen setzt man z. B.:

Sauerstoffflasche.

Die Ligatur muß ferner stehen in Wortverschmelzungen wie *Schiffahrt*, wo von drei gleichen Mitlauten einer ausgestoßen worden ist (↑ R 236 f.).

Schließt eine Abkürzung mit zwei Buchstaben, die eine Ligatur bilden können, dann wird diese angewendet.

Beispiele: Aufl. (aber: Auf|lage), gefl. (aber: gefällig, gefälligst).

Im Sperrsatz werden Ligaturen nicht verwendet, ausgenommen in der Fraktur ch, ck, ß und tz.

b) Ligaturen Æ, æ, Œ, œ statt Ae, ae, Oe, oe.

In lateinischen Wörtern sind diese Ligaturen nicht anzuwenden.

Beispiele: Caelius mons, Asa foetida.

In französischen Wörtern, die im deutschen Satz verstreut vorkommen, muß, wie im französischen Satz, Œ und œ gesetzt werden.

Beispiele: Œuvres, sœur.

In dänischen Wörtern ist Æ, æ anzuwenden.

5. Abkürzungen

Vgl. auch R 5 f.

a) Abkürzungen am Satzanfang

Einfache Abkürzungen werden am Satzanfang mit großem Anfangsbuchstaben gesetzt.

Beispiele: Vgl., Cf., Ebd., Ib. (für: vgl., cf., ebd., ib.).

Die Abkürzung v. für das den Adel bezeichnende Verhältniswort *von* schreibt man auch zu Beginn eines Satzes klein (↑ R 126).

Beispiel: v. Haller erschien zuerst.

Mehrteilige Abkürzungen werden zweckmäßig ausgesetzt.

Beispiele: Das ist ... Mit anderen Worten ... Über dem Meeresspiegel ... (für: d. i.; m. a. W.; ü. d. M.).

b) Abkürzungen S., Bd., Nr., Anm.

Wenn die Wörter *Seite, Band, Nummer, Anmerkung* usw. das Geschlechtswort vor sich haben, dann dürfen sie der größeren Vollwertigkeit wegen vor einer folgenden Zahl nicht abgekürzt werden.

Beispiele: die Seite 5, der Band 8, die Nummer 4, die Anmerkung B.

Geht aber kein Geschlechtswort voraus, dann können solche Bezeichnungen abgekürzt werden.

Beispiele: S. 5, Bd. 8, Nr. 4, Anm. B.

Dagegen heißt es bei Voranstellung der Zahl, weil diese dem Hauptwort größeren Wert verleiht, stets:

5. Seite (nicht: 5. S.), 8. Band (nicht: 8. Bd.).

c) usw., etc.

Im deutschen Satz wird der Ausdruck *und so weiter* stets durch **usw.** abgekürzt. Die Abkürzung **etc.** sollte im Deutschen vermieden und durch **usw.** ersetzt werden. Die Franzosen und Engländer, jene jedoch nur in der Schreibschrift, verwenden **&c.,** die Italiener **ecc.** und die Spanier **etc.,** und zwar setzen sie alle einen Beistrich vor diese Abkürzungen.

d) Zusätze bei Ortsnamen[1]

Kürzt man Zusätze bei Ortsnamen ab, dann ist die einfache Abkürzung durch den Punkt anzuwenden.

Beispiele: Bad Homburg v. d. H., Mülheim a. d. Ruhr.

Die Deutsche Bundespost und Bundesbahn wenden in derartigen Fällen folgende Schreibweise an:

Frankfurt (Main), Frankfurt (Oder), Halle (Saale).

Tritt dabei eine Abkürzung auf, dann schreiben Post und Bahn ohne Punkt.

Beispiel: Großauheim (Kr Hanau)

Falsch sind Schreibungen wie:

Mülheim a. Ruhr statt: Mülheim a. d. Ruhr; Frankfurt-Oder statt: Frankfurt (Oder); Frankfurt a/M. statt: Frankfurt a. M.

[1] Über die amtliche Schreibung der Ortsnamen vgl. Duden, Wörterbuch geographischer Namen, Europa.

6. Zeichen

a) Paragraphzeichen (§)

Steht das Wort Paragraph in Verbindung mit einer Zahl, dann setzt man das Zeichen §.

Beispiele: § 9, § 17ff., §§ 10 bis 15 oder: §§ 10—15; der § 9, die §§ 10 bis 15 oder: die §§ 10—15.

b) Et-Zeichen (&)

Das Et-Zeichen & ist gleichbedeutend mit u., darf aber nur bei Firmenbezeichnungen angewendet werden.

Beispiele: Voß & Co., Meyer & Neumann.

Sonst ist als Abkürzung für *und* u. zu setzen.

c) Geborenzeichen (*) usw.

Für familiengeschichtliche Arbeiten empfiehlt sich die Anwendung der folgenden Zeichen statt der mehr Raum beanspruchenden Ausdrücke oder Abkürzungen:

für geboren (geb.): *, für getauft (get.): ∿, für unverheiratet, ledig (led.): ∞, für verheiratet (verh.), vermählt (verm.): ∞, für geschieden (gesch.): ∞, für gestorben (gest.): †, für gefallen (gef.): ⨯, für begraben (begr.): ⊡, für eingeäschert: ⍟

d) Strich für *gegen*, Strich zwischen Zahlen, Gleichheitszeichen, Gradangaben: vgl. S. 86, 9.

e) Streckenstriche: vgl. S. 87, 13.

7. Fußnoten-(Anmerkungs-)Zeichen

Fußnoten-(Anmerkungs-)Zeichen stehen vor den Satzzeichen und besser vor den schließenden Anführungszeichen, und zwar verdienen hochstehende Zahlen ohne Klammern den Vorzug sowohl vor Zahlen mit Klammern als auch vor Sternen oder Kreuzen mit oder ohne Klammern.

8. Anführungszeichen

a) Form der Anführungszeichen im Deutschen und bei Anführungen aus fremden Sprachen (vgl. auch R 94)

Im deutschen Schriftsatz werden vornehmlich die Anführungszeichen „..." und »...« angewendet. Die französische Form «...» ist im Deutschen weniger gebräuchlich; in der Schweiz hat sie sich für den Antiquasatz eingebürgert.

Bei einzelnen aus fremden Sprachen angeführten Wörtern und Wendungen ist die Sprache, in der der Text geschrieben oder gedruckt wird, für die Form der Anführungszeichen bestimmend.

Beispiel: Die »carabinieri« sind mit unseren Gendarmen zu vergleichen.

Werden ganze Sätze oder Absätze aus fremden Sprachen angeführt, dann bedient man sich der in der betreffenden Sprache üblichen Anführungszeichen.

Beispiele: Ein englisches Sprichwort lautet: "Early to bed and early to rise makes a man healthy, wealthy, and wise." «Frate, frate! Libera chiesa in libero stato!» waren Cavours letzte Worte.

b) Unterführungen (vgl. auch R 159)

Zahlen dürfen nicht unterführt werden.

Ist mehr als ein Wort zu unterführen, dann wird das Unterführungszeichen auch dann unter jedes einzelne Wort gesetzt, wenn die Wörter nebeneinanderstehend ein Ganzes bilden.

Beispiel: Unterlauterbach b. Treuen
„ „ „

9. Raumverteilung (Spatiieren)

a) Auslassungszeichen usw.

Dem Auslassungszeichen geht der regelmäßige Zwischenraum voran.

Beispiele: aber 's kam anders, so 'n Mann.

Eine Ausnahme machen nur die üblichen Verbindungen *sich's*, *geht's* usw., weil sie als Ganzes verstanden werden.

b) Strich (-) für *gegen*

Der für das Wort *gegen* verwendete Strich, z. B. in Sportberichten, wird mit Zwischenraum gesetzt.

Beispiel: Schalke 04 - 1. FC. Nürnberg 1 : 3.

c) Fernruf-, Fernschreib- und Postscheckkontonummern

Postamtlich trennt man die in Zweiergruppen zusammengefaßten Ziffern der Fernrufnummern durch 2-Punkt-Spatium wie folgt (die Ortsnetzkennzahl steht in runden Klammern vor der Fernrufnummer):

08, 1 68, 14 28, 142 83, 1428 37, (062 81) 4 91.

Fernschreibnummern bestehen aus Kennzahl und Rufnummer. Die Kennzahl wird ohne Null geschrieben und steht vor der Rufnummer. Die Rufnummer wird von der Endziffer aus jeweils durch ein 2-Punkt-Spatium in Dreiergruppen gegliedert.

Beispiele: 8 582 404 (8 = Kennzahl von Düsseldorf); 4 62 527 (4 = Kennzahl von Mannheim).

Bei den Nummern der Postscheckkonten sind in jedem Falle die beiden letzten Ziffern vor dem Strich durch 2-Punkt-Spatium abzutrennen.

Beispiele: 3 49-603, 640 74-208.

d) Strich zwischen Zahlen (—)

Ein Strich zwischen Zahlen kann sowohl *bis* als auch *weniger* (minus) bedeuten. Wo nach dem Zusammenhang ein Zweifel möglich ist, muß *bis* gesetzt werden. Am Schluß einer Zeile und beim Beginn einer neuen Zeile wird *bis* gesetzt. (Vgl. ferner Stichwort „bis" im Wörterverzeichnis.)

Als Zeichen für *bis* steht der Strich ohne Zwischenraum (kompreß).

Beispiel: Das Buch darf 3—4 Mark kosten.

Das Minuszeichen steht mit 2-Punkt-Spatium zwischen den Zahlen usw.

Beispiele: 7 — 3 = 4; a — b = c.

e) Gleichheitszeichen (=), Pluszeichen (+), Malzeichen (×) u. ä.

Diese werden wie das Minuszeichen behandelt. Bei Nonpareillesatz steht allgemein 1-Punkt-Spatium.

f) Raumverteilung bei Gradangaben

Zwischen dem Minus- oder Pluszeichen und der Zahl ist nur ein Viertelgeviert, vor dem Gradzeichen nichts und hinter diesem nur ein Viertelgeviert zu setzen.

Beispiele: −3° R, +3° C (fachspr. aber auch: 3 °C).

g) $^1/_2$**zöllig, 5pfündig,** $^3/_4$**fach u. ä.**

In solchen Zusammensetzungen wird kein Zwischenraum hinter die Zahl gesetzt. Werden mehrere zusammengefaßt, dann treten Bindestriche hinter die Zahlen, mit Ausnahme der letzten.

Beispiele: $^1/_2$-, $^1/_4$- und $^1/_8$zöllig, 5%ig, 10^6fach.

10. Sperrung

a) Ligaturen bei Sperrung vgl. S. 83, 4, a.

b) Vornamen vor gesperrten Familiennamen sind mit zu sperren; steht der Vorname aber hinter dem Familiennamen (z. B. in Verzeichnissen), dann ist er nicht zu sperren.

Zahlen sind im Sperrsatz nicht mit zu sperren.

c) Im normal gesperrten Satz sind Beistrich, Strichpunkt, Doppelpunkt, Frage- und Ausrufezeichen, Klammern mit zu sperren.

Punkt und Anführungszeichen werden nicht gesperrt.

11. Schreibung von Wortverbindungen, die durch erklärende Zusätze usw. unterbrochen werden

Statt Richtlinien mögen Beispiele zur Veranschaulichung dienen:

Fuhr- usw. Kosten; Gemeinde(amts)vorsteher (= Vorsteher der Gemeinde oder des Gemeindeamts), aber: Gemeinde-(Amts-)Vorsteher (= Gemeindevorsteher oder Amtsvorsteher); Privat-(Haus-)Briefkasten; Magen-(und Darm-)Beschwerden; Sommer-(und Winter-)Schlußverkauf; Friedrich-(Ecke Leipziger)Straße, oder Friedrich-, Ecke Leipziger Straße (↑ R 223); Ostende-Belgrad-(Tauern-)Expreß; die wappen-(oder medaillon-)tragenden Figuren.

12. Schreibung zusammengezogener Worterklärungen

Um Raum zu sparen, werden in Wörterverzeichnissen Erklärungen oft zusammengezogen, z. B. im Duden bei dem Stichwort „3*Band*" die Erklärung [*Gewebe*]*streifen*. Das bedeutet, daß man Band mit *Streifen* und auch mit *Gewebestreifen* erklären kann.

13. Streckenstriche

Bei Streckenangaben, besonders in Fahrplänen, ist statt des Bindestrichs der Streckenstrich anzuwenden, der dem Gedankenstrich ähnlich, aber um ein Drittel kürzer ist.

Beispiele: Hamburg – Berlin, Köln – München.

Zwischen zwei Wörtern, die einen Namen bilden, darf aber nicht der Streckenstrich, sondern muß ein Bindestrich stehen.

Beispiel: Wernigerode – Drei Annen-Hohne – Brocken.

Vor und hinter den Streckenstrich ist ein 1-Punkt-Spatium zu setzen. Im gewöhnlichen Satz genügt der Gedankenstrich.

14. Schriftauszeichnung

a) Auszeichnung des Beugungs-s und der Silbe ...sche hinter Namen

Wenn Eigennamen, die mit einem Beugungs-s oder mit der Silbe ...**sche** versehen sind, ausgezeichnet, d. h. durch Sperrung, Kursivsatz, Fettdruck oder Kapitälchen (vgl. 14, b) hervorgehoben werden, dann gilt folgendes:

1. Das Beugungs-s wird stets mit ausgezeichnet.

Beispiele: Meyers Lexikon, *Meyers* Lexikon, **Meyers** Lexikon, Meyers Lexikon.

2. Die Silbe ...sche usw. wird s t e t s aus der G r u n d s c h r i f t gesetzt.

B e i s p i e l e : der Virchowsche Versuch, ein *Virchow*scher Versuch, ein **Virchow**sches Werk, die Vɪʀcʜowsche Werke. Im Sperrsatz: D i e V i r c h o w s c h e n W e r k e ...

b) Auszeichnung bei Kapitälchensatz

Werden in einem aus Antiqua gesetzten Werke Eigennamen durch Kapitälchen ausgezeichnet, dann sind sie außer in den unter 14, a genannten Fällen nur dann aus Kapitälchen zu setzen, wenn sie allein stehen.

B e i s p i e l : Sᴄʜɪʟʟᴇʀ war der erste, der ..., nicht aber, wenn sie in Zusammensetzungen stehen.

B e i s p i e l : Schillertheater, Schiller-Museum.

15. Schreibung von Zahlen

Vgl. auch R 230 ff. und S. 86 f., 9, c–g.

a) Allgemeines

Die alte Buchdruckerregel, nach der die Zahlen von 1 bis 12 in Buchstaben und die Zahlen von 13 an in Ziffern zu setzen sind, ist einzuschränken. Auch die Zahlen von 1 bis 12 sind in Ziffern zu setzen, wenn in technischen oder wissenschaftlichen Abhandlungen die Zahl und das die Sache bezeichnende Hauptwort die Aufmerksamkeit auf sich lenken sollen.

B e i s p i e l e : Kurbel mit 2 Wellen, Zahnrad mit 2 Spindeln.

Vor Zeichen und Abkürzungen von Maßen, Gewichten, Geldsorten usw. ist die Zahl in Ziffern zu setzen.

B e i s p i e l e : 21,4 kg, 6 DM.

Setzt man diese Bezeichnungen aus, dann kann die Zahl in Ziffern wie in Buchstaben gesetzt werden.

B e i s p i e l : 2 Mark oder zwei Mark.

b) Anwendung des Bindestrichs bei Hausnummern

Bei Hausnummern setzt man den Gedankenstrich.

B e i s p i e l : Burgstraße 14—16.

Zulässig sind auch der Bindestrich (nicht aber der Frakturbindestrich)

B e i s p i e l : Burgstraße 14-16.

und der Schrägstrich.

B e i s p i e l : Burgstraße 14/16.

Folgen die Zahlen unmittelbar aufeinander, dann wird auch **u.** angewendet.

B e i s p i e l : Karlstraße 9 u. 10 (wie auch bei nicht fortlaufenden Hausnummern Karlstraße 8 u. 10 richtig ist).

c) Abgekürztes Datum

Bei abgekürzten Daten schreibt man für Tag und Monat die Zahlen mit Punkten nebeneinander.

B e i s p i e l e : Mannheim, [den] 14. 3. 1967; am 1. 5. 10 geboren.

d) Abgekürzte Jahreszahlen

Bei abgekürzten Jahreszahlen verwendet man den Schrägstrich.

B e i s p i e l e : 1903/04, 1960/61, 1939/45.

16. Fremdsprachige Hauptwörter mit großen Anfangsbuchstaben

Im Deutschen verstreut vorkommende Wörter aus fremden Sprachen sind nach deutschen Regeln zu setzen, sofern sie nicht in Klammern oder zwischen Anführungszeichen stehen oder aber kursiv gesetzt sind.

Beispiele: Das ist ihm eine Terra incognita. Er war ein Agent provocateur. Emilio ist ein Musico senza pari. Aber: Das Wort Thron ($\vartheta\varrho\acute{o}\nu o\varsigma$) ist ein Fremdwort. Der „sitting room" der Engländer entspricht unserem Wohnzimmer.

17. Wichtigere Lautverbindungen in fremdsprachigen Namen

a) Dänisch, Norwegisch, Schwedisch, Finnisch

Das Dänische hat die Zeichen Å, å für älteres Aa, aa (diese Schreibung ist nicht mehr offiziell). Außerdem kommen Æ, æ und Ø, ø (für nicht mehr offizielles Ö, ö) vor.

Im Norwegischen setzt man Å, å für nicht mehr offizielles Aa, aa. Außerdem kommen Æ, æ und Ø, ø (für nicht mehr offizielles Ö, ö) vor.

Im Schwedischen gibt es die Zeichen å, ä, ö. Die Großbuchstaben Å, Ä und Ö müssen stets so (mit Kreis und Punkten) wiedergegeben werden, sie dürfen nicht durch Aa, Ae und Oe ersetzt werden.

Im Finnischen gibt es die Zeichen ä und ö. Bei Silbenlänge werden sie verdoppelt (**ää, öö**).

In Frakturschrift ist in nordischen Personennamen, die auf ⸗ſen und ⸗ſon enden, der vorangehende S-Laut mit s zu schreiben.

Beispiele: Gulbransſen, Jonasſon

b) Polnisch, Tschechisch

In polnischen und tschechischen Namen ist **ck** getrennt zu setzen, denn ck ist hier tzk (nicht: kk) zu sprechen.

Beispiele: Chodowiecki, Palacký.

In Frakturschrift wird in polnischen Namen der Laut **sch** durch ſʒ (nicht: sʒ) bezeichnet, und in der bekannten Endung wird ⸗ſti (nicht: ⸗sti) geschrieben.

Beispiel: Łukasʒewſti.

18. Anwendung der Antiqua im Fraktursatz

a) Alle Fremdwörter romanischen Ursprungs, die nicht durch Annahme deutscher Schreibung, Beugung oder Lautung als eingedeutscht erscheinen, setze man im Fraktursatz stets mit Antiqua.

Beispiele: en avant, en vogue, in praxi, in petto, a conto, dolce far niente.

Ferner Verbindungen wie:

Agent provocateur, Tempi passati, Lapsus linguae, Agnus Dei.

Auch alle italienischen fachwörtlichen Ausdrücke der Tonkunst setze man im Fraktursatz aus Antiqua.

Beispiele: andante, adagio, moderato, vivace.

b) Wenn ein Fremdwort deutsche Schreibung, Beugung oder Lautung annimmt oder mit einem deutschen Wort zusammengesetzt wird, setze man es im Fraktursatz aus Fraktur.

Beispiele: Er spielte das Adagio (nicht: adagio) mit viel Gefühl. Die Firma leistete eine Akontozahlung (nicht: A-conto-Zahlung).

19. Schriftart von fremdsprachigen Personennamen und erdkundlichen Namen im Fraktursatz

Fremdsprachige Personennamen und erdkundliche Namen haben sich im Fraktursatz der Textschrift anzupassen.

Beispiele: Michelangelo Buonarroti war ein berühmter Künstler. Cherbourg ist eine Stadt an der Kanalküste.

20. Schriftart des Bindestrichs in Fraktursatz, der mit Antiqua vermischt ist

Wenn in Fraktursatz bei Wortzusammensetzungen der eine Teil der Zusammensetzung aus Antiqua gesetzt werden muß, dann sind etwa vorkommende Bindestriche aus der Textschrift zu setzen.

Beispiel: Das sinkende Schiff sandte SOS-Rufe.

In besonderen Fällen kann Vermischung von Fraktur- und Antiquabindestrichen stattfinden; denn innerhalb des aus Antiqua gesetzten Wortes müssen auch die Bindestriche aus Antiqua gesetzt werden.

Beispiel: Die Tänze des Staatstheater-Corps-de-ballet wurden begeistert aufgenommen.

Korrekturvorschriften[1]

I. Hauptregel

Jedes eingezeichnete Korrekturzeichen ist auf dem Rand zu wiederholen. Die erforderliche Änderung ist rechts neben das wiederholte Korrekturzeichen zu ~~zeichn~~en, sofern dieses nicht (wie ⌐, ⌐⌐) für sich selbst spricht.

⊢——⊣ *schreib*

II. Wichtigste Korrekturzeichen

1. **Andere Schrift** für Wörter oder Zeilen wird verlangt, indem man die betreffende Stelle unterstreicht und auf dem Rand die gewünschte Schriftart (fett, kursiv usw.) oder den gewünschten Schriftgrad (Korpus, Borgis, Petit usw.) oder beides (fette Petit, Borgis kursiv usw.) vermerkt. Gewünschte Kursivschrift wird oft nur durch eine Wellenlinie unter dem Wort und auf dem Rand bezeichnet.

 __ *halbfett* ⌐__ *kursiv*
 __ *Borgis*
 ___ *Borgis kursiv*

2. **Beschädigte Buchstaben** werden durchgestrichen und auf dem Rand einmal unterstrichen.

 /R

3. **Fälschlich aus anderen Schriften gesetzte Buchstaben** (**Zwiebelfische**) werden durchgestrichen und auf dem Rand zweimal unterstrichen.

 /R ⌐m

4. Um **verschmutzte** Buchstaben und zu **stark** erscheinende Stellen wird eine Linie gezogen. Dies Zeichen wird auf dem Rand wiederholt.

 ◯ ◯

5. **Falsche Buchstaben** oder **Wörter** sowie **auf dem Kopf stehende Buchstaben** ⬛ (**Fliegenköpfe**) werden durchgestrichen und auf dem Rand durch die richtigen ersetzt. Dies gilt auch für quer stehende und umgedrehte Buchstaben. Kommen in einer Zeile mehrere Fehler vor, dann erhalten sie ihrer Reihenfolge nach verschie-

 /a
 L s ⌐h
 7o ⌐e Fi

[1] In einer Gemeinschaftsarbeit zwischen der Dudenredaktion und dem Deutschen Normenausschuß sind einheitliche Korrekturvorschriften festgelegt worden, so daß auch die bisher bestehenden Widersprüche zwischen den Korrekturvorschriften des Dudens und des Normblattes DIN 16511 beseitigt sind.

dene Zeichen. Für ein und denselben falschen Buch-
staben wird aber nur ein Korrekturzeichen verwendet,
das ~~am~~ R~~a~~nde mehrf~~a~~ch vor den richtigen Buchsta-
ben gesetzt wird.

6. **Ligaturen** (zusammengegossene Buchstaben) werden
 verlangt, indem man die fälschlich einzeln nebenein-
 andergesetzten Buchstaben durchstreicht und auf dem
 Rand mit einem Bogen darunter wiederholt, z. B.
 Schi~~ff~~.

 Fälschlich gesetzte Ligaturen werden durchgestrichen,
 auf dem Rand wiederholt und durch einen Strich
 getrennt, z. B. Au~~ff~~age.

7. **Falsche Trennungen** werden am Zeilenschluß und fo-
 genden Zeilenanfang gekennzeichnet.

8. Wird nach **Streichung eines Bindestrichs** oder **Buch-
 stabens** die Schreibung der verbleibenden Teile zweifel-
 haft, dann wird außer dem Tilgungszeichen die Zu-
 sammenschreibung durch einen Doppelbogen, die
 Getrenntschreibung durch das Zeichen Z angezeichnet,
 z. B. blendend-weiß.

9. **Fehlende Buchstaben** werden angezeichnet, indem der
 vorangehnde oder folgende Buchstabe durchgestrichen
 und zusammen mit dem fehlenden wiederholt wird.
 Es kann auch das ganze ~~Wrt~~ oder die Silbe durch-
 ge~~tt~~chen und auf dem Rand berichtigt werden.

10. **Fehlende Wörter (Leichen)** werden in der Lücke durch
 Winkelzeichen ⌐ gemacht und auf dem Rand ange-
 geben.
 Bei größeren Auslassungen wird auf die Manuskript-
 seite verwiesen. Die Stelle ist auf der Manuskriptseite
 zu kennzeichnen.

 Diese Presse bestand aus befestigt war.

11. **Überflüssige Buchstaben** oder **Wörter** werden durch-
 gestrichen und auf ~~auf~~ dem Rand durch ⌐⌐ (für:
 deleatur, d. h. „es werde getilgt") angezeichnet.

12. **Fehlende** oder **überflüssige** Satzzeichen werden wie
 fehlende oder überflüssige Buchstaben angezeichnet.

13. **Verstellte Buchstaben** werden durchgesf/lichen und auf *∏ tr*
 dem Rand in der richtigen Reihenfolge angegeben.
 Verstellte Wörter durch werden das Umstellungszeichen
 gekennzeichnet.
 Die Wörter werden bei größeren Umstellungen be- *⌊d ⌈B 1 - 7*
 ziffert.

 Verstellte Zahlen sind immer ganz durchzustreichen
 und in der richtigen Ziffernfolge auf den Rand zu
 schreiben, z. B. |1684| *⊢─┤ 1864*

14. Für unleserliche oder zweifelhafte Manuskriptstellen,
 die noch nicht blockiert sind, wird vom Korrektor
 eine Blockade verlangt, z. B.
 Hyladen sind Insekten mit unbeweglichem Prothorax (s. S. ─). ⊢─┤ ⊠ ⊢─┘ ⊠

15. **Sperrung** oder **Aufhebung einer Sperrung** wird wie beim
 Verlangen einer anderen Schrift (vgl. S. 91, 1) durch *⌊____ nicht sperren*
 Unterstreichung gekennzeichnet. *____ sperren*

16. **Fehlender Wortzwischenraum** wird mit ⅂ bezeichnet. ⅂
 Zu weiter Zwischenraum wird durch ⌃ , zu enger ⅂
 Zwischenraum durch ⋎ angezeichnet. Soll ⌃ ein **Zwi-**
 schenraum ganz wegfallen, so wird dies durch zwei ⋎ ⌃
 Bogen ohne Strich ⌣ ange⌢deutet. ⌢
 ⌣

17. **Spieße,** d. h. im Satz mitgedruckter Ausschluß, Durch-
 schuß oder ebensolche Quadrate, werden unterstrichen
 und auf dem ▌Rand durch ╪ angezeigt. ╪

18. **Nicht Linie haltende Stellen** werden durch über und ═
 unter der Zeile gezogene parallele Striche angezeichnet. ═
 Fehlender Durchschuß wird durch einen zwischen die
 Zeilen gezogenen Strich mit nach außen offenem Bogen ⟨
 angezeichnet.

 Zu großer Durchschuß wird durch einen zwischen die
 Zeilen gezogenen Strich mit einem nach innen offenen ⟩
 Bogen angezeichnet.

19. Ein **Absatz** wird durch das Zeichen _⌐ im Text und
 auf dem Rand verlangt:

 Die ältesten Drucke sind so gleichmäßig schön ausge-
 führt, daß sie die schönste Handschrift übertreffen. Die
 älteste Druckerpresse scheint von der, die uns Jost _⌐
 Amman im Jahre 1568 im Bilde vorführt, nicht wesent-
 lich verschieden gewesen zu sein.

20. Wegfall eines Absatzes verlangt man durch eine den Ausgang mit dem Einzug verbindende Linie:

> Die Presse bestand aus zwei Säulen, die durch ein Gesims verbunden waren.)
> (In halber Manneshöhe war auf einem verschiebbaren Karren die Druckform befestigt.

21. Zu tilgender Einzug erhält das Zeichen ├──, z. B.

> Die Buchdruckerpresse ist eine Maschine, deren ├─kunstvollen Mechanismus nur der begreift, der selbst daran gearbeitet hat.

22. Fehlender Einzug wird durch └ möglichst genau bezeichnet, z. B. (wenn der Einzug um ein Geviert verlangt wird):

> ... über das Ende des 14. Jahrhunderts hinaus führt keine Art des Metalldruckes.
> Der Holzschnitt kommt in Druckwerken ebenfalls nicht vor dem 14. Jahrhundert vor.

23. Aus Versehen falsch Korrigiertes wird rückgängig gemacht, indem man die Korrektur ~~auf~~ dem Rand durchstreicht und Punkte unter die fälschlich korrigierte Stelle setzt. Ausradieren der Anzeichnung ist unzulässig.

III. Maschinensatzkorrektur

1. Neu zu setzende Zeilen: Sind bei Zeilenguß-Maschinensatz in einer Zeile mehrere schlechte Buchstaben, sogenannte „Kratzer", Buchstaben, die nicht Linie halten, oder andere Schäden, wodurch es nötig wird, die Zeile neu zu setzen, so wird an diese Zeile ein waagerechter Strich (──) gemacht.

2. Aussparen von Raum: Zur Kennzeichnung von unleserlichen Buchstaben oder Wörtern im Manuskript wird bei Maschinensatz oft freier Raum gelassen, weil die Blockade (vgl. S. 93, 14) hier technisch oft unmöglich ist. Besser ist es, auffällige Typen, z. B. ----?----, mmmm, zu verwenden. Noch deutlicher sind, besonders bei Zahlen, auffällige Blockaden in Form von ● oder ▮▮, die meistens als Matrizen vorhanden sind. Einfache Nullen können bei der Richtigstellung leicht übersehen werden.

3. Verstellte Zeilen werden mit waagerechten Rand-
strichen versehen und in der richtigen Reihenfolge
numeriert, z. B.

Sah ein Knab' ein Röslein stehn, —————————————————— *1*

lief er schnell, es nah zu sehn, ——————————————————— *4*

war so jung und morgenschön, ——————————————————— *3*

Röslein auf der Heiden, ——————————————————————— *2*

sah's mit vielen Freuden. —————————————————————— *5*

Goethe ———————————————————— *6*

Register zu den „Vorbemerkungen"

Zahlen mit R (z. B. R 150) verweisen auf die entsprechende Randzahl.
Zahlen mit S. (z. B. S. 83, 4, a) beziehen sich auf die Seiten und Abschnitte der „Vorschriften für den Schriftsatz" (S. 81 ff.).

steht nicht
bei Mittelwörtern ohne nähere Bestimmung R 27
bei Hinweisen auf Gesetze R 13
Betonung
in der Zusammen- und Getrenntschreibung R 138 f., R 142 f.
bei zusammengesetzten Eigenschaftswörtern R 158, R 214
Beugung (Deklination und Konjugation)
der Fremdwörter R 306 ff.
des Eigenschaftswortes (besonders die schwankende Beugung nach den unbestimmten Für- und Zahlwörtern *manche, sämtliche, solche* u. a.) R 272 ff.
des Hauptwortes R 256 ff., R 287 ff.
der Maß- und Mengenangaben R 321 f.
des Mittelwortes (besonders die schwankende Beugung nach den unbestimmten Für- und Zahlwörtern *manche, sämtliche, solche* u. a.) R 272 ff.
der Namen
erdkundliche Namen R 317
Familien-, Personen- und Vornamen R 309 ff.
Monatsnamen R 319
der Titel R 314 ff., R 318
der Verwandtschaftsbezeichnungen R 314 ff.
des Zeitwortes R 300 ff.
Binde-s s. Fugen-s
Bindestrich
bei der hauptwörtlich gebrauchten Grundform in unübersichtlichen Zusammensetzungen R 156
bei mit Ziffern zusammengesetzten Wörtern R 157
bei Namen
erdkundliche Namen R 202 f.
Familien- und Personennamen R 182 f.
Straßennamen R 220
Titel und sonstige Namen R 188, R 225
Vornamen R 195
bei Zusammensetzungen mit Einzelbuchstaben, Formelzeichen und Abkürzungen R 149 f., R 154, R 155
bei Zusammensetzungen mit mehr als drei selbständigen längeren Wortgliedern R 152
bei Zusammensetzungen aus Eigenschaftswörtern R 158
beim Zusammentreffen von drei gleichen Selbstlauten R 148
bei Zusammensetzungen, die mißverständlich sein können R 147

im Schriftsatz S. 88, 15, b; S. 90, 20
Ergänzungsbindestrich R 145
ohne Bindestrich bei Unterführungen R 159
Bindewort (Konjunktion)
mit und ohne Beistrich R 24 ff., R 51 ff.
Großschreibung R 119
„bis"-Zeichen
im Schriftsatz S. 86, 9, d
bitte
mit oder ohne Beistrich R 48
Brief
Anschrift R 9
Datum R 7
Anrede mit Ausrufezeichen R 80
Anrede mit Beistrich R 16
Schlußformel ohne Ausrufezeichen R 82
Unterschrift ohne Schlußpunkt R 8
Buchtitel
ohne Punkt R 10
mit oder ohne Anführungszeichen R 97 f.
Großschreibung in Anführungszeichen R 114
Beugung R 97, R 318
c im Fremdwort
eingedeutscht k oder z R 170
Dativ = Wemfall
Datum
mit Beistrich R 22
mit und ohne Punkt R 7; S. 88. 15, c
mit oder ohne *am* bzw. im Wem- oder Wenfall R 330
Deklination s. Beugung
Doppelpunkt (Kolon) R 68 ff.
und Gedankenstrich R 91 u. 93
mit folgender Großschreibung R 113
mit folgender Kleinschreibung R 128
Eigennamen s. Familien- und Personennamen
Eigenschaftswort (Adjektiv)
mit oder ohne Beistrich
bei nachgestelltem Eigenschaftswort R 20
bei mehreren Eigenschaftswörtern R 11
Groß- und Kleinschreibung R 116, R 133 ff., R 179, R 193, R 198 ff., R 224
Zusammen- oder Getrenntschreibung oder Bindestrich in Zusammensetzungen
mit erdkundlichen Namen R 206 ff.
mit Familiennamen R 187 f.
mit Straßennamen R 221 f.
Eigenschaftswort + Eigenschaftswort R 143, R 158
Eigenschaftswort + Mittelwort R 142

Hauptwort od. Mittelwort + Eigen-
schaftswort R 143
Eigenschaftswort + Zeitwort R 139
Beugung R 272 ff.
Auslassung des *e* in Nachsilben (munt-
rer statt: munterer) R 329
mit Auslassungszeichen für ausgelasse-
nes *i* (ew'ger statt: ewiger) R 249
ohne Auslassungszeichen für ausgelas-
senes *e* (öd statt: öde) R 242, R 248
Vergleichsformen R 292 ff.
Einzelbuchstaben
Groß- und Kleinschreibung R 123
in Zusammensetzungen R 149
Ellipse = Auslassungssatz
Empfindungswort (Interjektion)
mit Ausrufezeichen R 79
mit oder ohne Beistrich R 17
Großschreibung R 119
erdkundliche Namen
allgemeine Schreibung R 196
behördliche Schreibung R 206
Groß- und Kleinschreibung R 198 ff.
Zusammensetzungen und Ableitungen
R 201 ff.
Silbentrennung R 217
die einem Ortsnamen nachgestellten
näheren Bestimmungen R 216
Beugung R 317
Ergänzungsbindestrich s. Bindestrich
Et-Zeichen S. 85, 6, b
familiengeschichtliche Zeichen S. 85, 6, c
Familien- und Personennamen
allgemeine Schreibung R 178
Groß- und Kleinschreibung
bei *von* (*v.*) vor Familiennamen R 126
bei Eigenschaftswörtern, die von Fa-
milien- u. Personennamen abgeleitet
sind R 179
Zusammen- oder Getrenntschreibung
oder Bindestrich in Zusammenset-
zungen R 180 ff., R 209 ff., R 219 f.
Silbentrennung R 189
Beugung R 309 ff.
Auslassungszeichen im Wesfall bei
Namen auf einen S-Laut R 252 ff.
Farben
Zusammensetzungen R 158
Fernruf- u. Fernschreibernummern
im Schriftsatz S. 86, 9, c
Firmennamen
Beugung R 318
Fragesatz
Punkt nach indirektem Fragesatz
R 2
Fragezeichen R 73 ff.
in Verbindung mit
Anführungszeichen R 102
Gedankenstrich R 90
runder Klammer R 106

steht nicht
nach indirekten Fragesätzen R 2
nach Ausrufen in Frageform R 81
Kleinschreibung nach Fragezeichen
R 127
Fremdwort
Schreibung R 169 f.
c, k oder z? R 170
Silbentrennung R 171 ff., R 177 a
Beugung R 306 ff.
Fugen-s in Wortzusammensetzungen
R 332 ff.
Fugenzeichen R 331 ff.
Fürwort (Pronomen)
Großschreibung R 117, R 121 f., R 224
Kleinschreibung der Fürwörter und
fürwörtlich gebrauchten Eigen-
schafts- und Mittelwörter, auch mit
Geschlechtswort (der andere usw.)
R 135
Auslassung des *e* in Nachsilben (unsern,
unsren statt: unseren) R 251, R 329
Fußnotenzeichen
im Schriftsatz S. 85, 7
Gebäudenamen (z. B. Gasthöfe)
Groß- oder Kleinschreibung R 224
Beugung R 318
Gedankenstrich
zwischen Sätzen R 83
innerhalb eines Satzes R 84 ff.
bei eingeschobenen Satzteilen u. Sätzen
R 88
in Verbindung mit anderen Satzzeichen
(Beistrich, Ausrufezeichen usw.)
R 89 ff.
an Stelle des Beistrichs oder Doppel-
punktes R 92 f.
durch runde Klammern ersetzt R 104
Geldbezeichnungen s. Münzbezeich-
nungen
Genitiv = Wesfall
Gesetze
kein Beistrich bei Hinweisen auf Ge-
setze R 13
Getrenntschreibung s. Zusammen- und
Getrenntschreibung
Gleichheitszeichen
im Schriftsatz S. 86, 9, e
Gradangaben
im Schriftsatz S. 86, 9, f
Groß- und Kleinschreibung
hauptwörtlich gebrauchter Wortarten
R 116 ff.
nicht hauptwörtlich gebrauchter
Hauptwörter R 129 ff.
bei Anredefürwörtern R 121 f.
bei Eigenschafts-, Mittel- und Um-
standswörtern in unveränderlichen
Verbindungen, mit vorangehendem
Geschlechtswort R 133 f.

bei Eigenschaftswörtern, die von Personennamen abgeleitet sind R 179

bei Eigenschafts- und Verhältniswörtern in Straßennamen R 218

bei erdkundlichen Namen R 198 ff.

bei Für- und Zahlwörtern mit vorangehendem Geschlechtswort R 135

bei Titeln und sonstigen Namen R 224

bei Satzanfängen R 112, R 125 f.

nach Doppelpunkt und bei Anführungszeichen R 113 f., R 128

nach Frage- und Ausrufezeichen R 127

Grundform (Infinitiv) s. Beistrich und Zeitwort

Grundform mit „zu"
Zusammen- und Getrenntschreibung R 144 a

Grundformgruppe (Infinitivgruppe)
Beistrich bei erweiterter und reiner Grundform R 30 ff.

Hauptwort (Substantiv)
Kleinschreibung nicht hauptwörtlich gebrauchter Hauptwörter R 129 ff.

Großschreibung hauptwörtlich gebrauchter anderer Wortarten R 116 ff.

Zusammen- oder Getrenntschreibung
bei Hauptwort + Mittelwort R 142
bei Hauptwort + Eigenschaftswort R 143
bei Hauptwort + Zeitwort R 140
bei Verhältniswort + Hauptwort R 141

Zusammenschreibung oder Bindestrich bei Hauptwort + Vorname R 195

Beugung R 256 ff.

Auslassung des *e* bei Hauptwörtern auf -ung (Wanderung, Wandrung u. a.) R 251, R 328

fremdsprachiges Hauptwort im Schriftsatz S. 88 f., 16

Hausnummern
im Schriftsatz S. 88, 15, b

Infinitiv = Grundform

Interjektion = Empfindungswort

Interpunktion = Zeichensetzung

Jahreszahl
im Schriftsatz S. 88, 15, d

Klammern (Parenthese)
runde Klammern R 103 ff.
eckige Klammern R 107 ff.

Kleinschreibung s. Groß- und Kleinschreibung

Kolon = Doppelpunkt

Komma = Beistrich

Komparation = Steigerung

Kompositum = zusammengesetztes Wort (s. Zusammensetzung)

Konjugation s. Beugung

Konjunktion = Bindewort

Konsonant = Mitlaut

Korrekturvorschriften S. 91 ff.

Kurzwort s. Abkürzungen

Länder- und Völkernamen
Zusammensetzungen R 214 f.

Ligaturen
im Schriftsatz S. 83 f., 4

Malzeichen
im Schriftsatz S. 86, 9, e

Maß- und Mengenangaben
Beugung R 321 f.

Mehrzahl (Plural)
der Familiennamen R 312
der Fremdwörter R 308
der Münzbezeichnungen R 322
der Vornamen R 313
schwankende Beugung bei Hauptwörtern auf -el u. -er R 269 u. R 270
durch Mehrzahl-s (Jungens u. a.) R 271

Mengenangaben s. Maß- und Mengenangaben

Minuszeichen
im Schriftsatz S. 86, 9, d

Mitlaut (Konsonant)
Zusammentreffen dreier gleicher Mitlaute R 236 u. R 237
Silbentrennung bei Mitlauten R 161 ff.
Ligaturen im Schriftsatz S. 83 f., 4

Mittelwort (Partizip)
Beistrich beim Mittelwort R 27 ff.
Groß- und Kleinschreibung R 116, R 133 ff., R 198, R 224
Beugung R 272 ff.
Vergleichsformen R 292 ff.
Bildung des zweiten Mittelwortes mit und ohne die Vorsilbe *ge-* R 304
Zusammen- oder Getrenntschreibung
bei Hauptwort, Eigenschaftswort od. Umstandswort + Mittelwort R 142
bei Mittelwort + Eigenschaftswort R 143

Monatsnamen
Beugung R 319

Münzbezeichnungen
Beugung R 322

Namen
s. erdkundliche Namen
s. Familien- und Personennamen
s. Gebäudenamen
s. Länder- und Völkernamen
s. Monatsnamen
s. Straßennamen
s. Titel und sonstige Namen
s. Vornamen

Nennform s. Grundform

neuer Begriff
Zusammenschreibung R 139

Ortsangabe
vom Datum durch Beistrich getrennt
R 22
Ortsnamen s. erdkundliche Namen
Paragraphzeichen S. 85, 6, a
Parenthese = Klammern
Partizip = Mittelwort
Personennamen s. Familien- und Personennamen
ph oder f
in Vornamen R 191
Plural = Mehrzahl
Pluszeichen
im Schriftsatz S. 86, 9, e
Postscheckkontonummern
im Schriftsatz S. 86, 9, c
Präposition = Verhältniswort
Pronomen = Fürwort
Punkt (s. auch: Auslassungspunkte)
R 1 ff.
in Verbindung mit
Anführungszeichen R 102
runden Klammern R 106
bei Zeitangaben R 233
Raumverteilung
im Schriftsatz S. 86, 9
Satzzeichen s. Zeichensetzung
Schaltsatz
Beistrich beim Schaltsatz R 44
Gedankenstrich beim Schaltsatz R 88
Klammern beim Schaltsatz R 104, R 108
Schiffsnamen
Beugung R 320
Schriftauszeichnung
im Schriftsatz S. 87 f., 14
Schriftsatz
Vorschriften S. 81 ff.
Selbstlaut (Vokal)
Bindestrich beim Zusammentreffen von
drei gleichen Selbstlauten R 148
Silbentrennung bei Selbstlauten R 165 f.
Semikolon = Strichpunkt
Silbentrennung
besondere Richtlinien für Mitlaute und
Selbstlaute R 161 ff., R 165 f.
bei einfachen und abgeleiteten Wörtern
R 160 ff.
bei zusammengesetzten Wörtern
R 168 ff.
bei Fremdwörtern R 171 ff.
bei fremdsprachigen Wörtern R 177 a
bei erdkundlichen Namen R 217
bei Familien- und Personennamen
R 189
S-Laute
in Antiqua S. 82 f., 3
in Fraktur S. 81 f., 2
Spatieren s. Raumverteilung
Sperrung
im Schriftsatz S. 87, 10

Steigerung s. Vergleichsformen
Stellenangabe s. Zitat
Straßennamen
Groß- oder Kleinschreibung R 218
Zusammen- oder Getrenntschreibung
oder Bindestrich R 219 ff.
Beugung R 318
Streckenstrich (in Fahrplänen)
im Schriftsatz S. 87, 13
Strich für „gegen" (in Sportberichten)
im Schriftsatz S. 86, 9, b
Strich zwischen Zahlen
im Schriftsatz S. 86, 9, d
Strichpunkt (Semikolon) R 65 ff.
Substantiv = Hauptwort
Superlativ s. Vergleichsformen
Tagesangabe
vom Datum durch Beistrich getrennt
R 22
Tageszeiten
Kleinschreibung, wenn als Umstands-
wort gebraucht R 129
th oder t
in Fremdwörtern aus dem Griechischen
und in einigen Lehnwörtern R 170
in erdkundlichen Namen R 196
in Vornamen R 191
Titel und sonstige Namen (s. auch: Buch-
titel)
Anführungszeichen R 97 ff.
Groß- und Kleinschreibung R 224
Bindestrich in Zusammensetzungen
R 188
mit und ohne Beistrich zwischen Namen
und Titeln R 23
Beugung R 314 ff., R 318
Trennung s. Silbentrennung
Überschriften s. Buchtitel
Uhrzeit
Schreibung in Ziffern R 233
Umlaut
bei den Vergleichsformen R 295
Umstandswort (Adverb)
Groß- und Kleinschreibung R 119,
R 129, R 133 f.
Zusammen- und Getrenntschreibung
bei Umstandswort + Zeitwort R 139
bei Umstandswort + Mittelwort
R 142
Unterführungen
Auslassung des Binde- und des Bei-
strichs R 159
im Schriftsatz S. 85 f., 8, b
Verb = Zeitwort
Verblassung des Hauptwortes
Zusammenschreibung R 140 f.
Vergleichsformen
des Eigenschaftswortes R 292 ff.
des Mittelwortes R 292 ff.
Verhältniswort (Präposition)

Eigenschaftswort + Eigenschafts-
wort (leichtverdaulich, altklug)
R 143, R 158
Mittelwort + Eigenschaftswort (ko-
chendheiß) R 143
Umstandswort + Zeitwort (dahin-
fliegen) R 139
Umstandswort + Mittelwort (oben-
erwähnt) R 142
Verhältniswort + Hauptwort (an-
statt) R 141

bei der Grundform mit „zu"
R 144a
bei Namen
erdkundliche Namen R 201 ff.
Familien- und Personennamen
R 180 ff.
Länder- und Völkernamen
R 214 f.
Straßennamen R 219 ff.
Vornamen R 194 f.
bei Zahlen R 226 ff.

A

A (Buchstabe); das A; des A, die A, aber: das a in Land (↑ R 123); der Buchstabe A, a; von A bis Z (ugs. für: alles, von Anfang bis Ende; falsch: von A–Z; vgl. Anm. bei Stichwort „bis"); das A und [das] O (der Anfang und das Ende, das Wesentliche [nach dem ersten und letzten Buchstaben des gr. Alphabets]); A-Laut (↑ R 149)

a = ¹Ar; Atto...

a, A (Tonbezeichnung) s; -, -; a (Zeichen für: a-Moll); in a; A (Zeichen für: A-Dur); in A

A = Ampere

A (röm. Zahlzeichen) = 5000

Å (früher auch: A, AE, ÅE) = Ångström, Ångströmeinheit

Λ, α = Alpha

à fr. (bes. Kaufmannsspr.: zu [je]); 3 Stück à 20 Pfennig, dafür besser: ...zu [je] 20 Pfennig

a. = am (bei Ortsnamen, z. B. Frickenhausen a. Main); vgl. a.d.

a. a. = ad acta

a., (häufiger:) A. = anno, Anno

Aa (Kinderspr.: feste menschliche Ausscheidung) s; -; - machen

AA = Auswärtiges Amt

Aachen (Stadt im Vorland des Hohen Venns); Aachener (↑ R 199)

Aal m; -[e]s, -e; aber: Älchen (vgl. d.), aalen, sich (ugs. für: behaglich ausgestreckt sich ausruhen); aalglatt

Aaltierchen (ein Fadenwurm)

a. a. O. = am angeführten, (auch:) angegebenen Ort

Aar (dicht. für: Adler) m; -[e]s, -e

Aarau (Hptst. des Kantons Aargau); Aare (schweiz. Fluß) w; -; Aargau (schweiz. Kanton) m; -s; aar|gau|er (↑ R 199); aar|gau|isch

Aaron (bibl. m. Eigenn.)

Aas s; -es, (Tierleichen [selten]:) -e u. (als Schimpfwort:) Äser; Aasblume (Pflanze, deren Blütengeruch Aasfliegen anzieht); aasen (ugs. für: verschwenderisch umgehen); du aast (aasest), er aaste; Aasgeier; aasig (ekelhaft; gemein)

A. B. = Augsburger Bekenntnis

ab; Umstandsw.: - und zu, (landsch.:) - und an (von Zeit zu Zeit); von ... ab (ugs. für: von ... an); ab und zu (gelegentlich) nehmen, aber (in Zus.: ↑ R 145):

ab- und zunehmen (abnehmen und zunehmen); Verhältnisw. mit Wemf.. - Bremen, - [unɔɔrɔm] Werk; - erstem März; bei Zeitangaben, Mengenangaben o. ä. auch Wenf.: ab ersten März, - vierzehn Jahre[n], - 50 Exemplare[n]

ab... (in Zus. mit Zeitwörtern, z. B. abschreiben, du schreibst ab, abgeschrieben, abzuschreiben; zum 2. Mittelw. ↑ R 304)

Aba arab. (sackartiger Mantelumhang der Araber; grober Wollstoff) w; -, -s

Abakus gr.· (Rechen- od. Spielbrett der Antike; Säulendeckplatte) m; -, -

Abäilard [...lạr(t), auch: ạb...] (fr. Philosoph)

abändderlich; abändern; Abänderung; Abänderungsvorschlag

Abandon fr. [abaŋdɔŋ] (Rechtsspr.: Abtretung, Preisgabe von Rechten od. Sachen) m; -s, -s; abandonnieren

abarbeiten

Abart; abarten (selten für: von der Art abweichen); abartig; Abartigkeit; Abartung

Abasie gr. (Med.: Gehunfähigkeit) w; -, ...ien

abasten, sich (ugs. für: sich abplagen)

abästen; einen Baum -

Abate it. (kath. Kirche: Titel der Weltgeistlichen in Italien) m; -[n], ...ti od. ...ten

Abaton gr. [auch: ạb...] (Rel.: „das Unbetretbare"; das [abgeschlossene] Allerheiligste; der Altarraum in den Kirchen des orthodoxen Ritus) s; -s, ...ta

Abb. = Abbildung

Abba aram. („Vater!" [neutest. Anrede Gottes im Gebet])

Abbaside (Angehöriger eines aus Bagdad stammenden Kalifengeschlechtes) m; -n, -n (↑ R 268)

Abbate (veralt. für: Abate)

Abbau m; -[e]s, (Bergmannsspr. für: Abbaustellen:) -e u. (landsch. für: abseits gelegenes Anwesen Mehrz.:) -ten; abbauen; Abbau|feld, ...ge|rech|tig|keit, ...recht; abbauwürdig

Abbé (dt. Physiker)

Abbé fr. [abẹ] (kath. Kirche: Titel der niederen Weltgeistlichen in Frankreich) m; -s, -s

abbeißen

abbekommen

abbrüfen; Abheizung

abbestellen; Abbestellung

abbeuteln südd., österr. (abschütteln)

abbezahlen

abbiegen

Abbild; abbilden; Abbildung (Abk.: Abb.)

abbinden

abbitte; - leisten, tun

abblasen

abblättern

abblenden; Abblendlicht (Mehrz. ...lichter)

abblitzen, jmdn. - lassen (ugs. für: jmdn. abweisen)

abblocken [Trenn.: ...blok|ken] (Sportspr.: abwehren)

Abbrand (Hüttenw.: Röstrückstand; Metallschwund durch Oxydation und Verflüchtigung beim Schmelzen); Abbrandler, (mdal.) Abbrändler österr. (durch Brand Geschädigter)

abbrechen

abbremsen; Abbremsung

abbrennen

Abbreviation lat. [...wiazion], Abbreviatur (Abkürzung) w; -, -en; abbreviieren

abbringen; jmdn. von etwas -

abbröckeln [Trenn.: ...brök|keln]; Abbröckelung [Trenn.: ...brök- ke...], Abbröcklung; abbrocken [Trenn.: ...brok|ken] südd., österr. (abpflücken)

Abbruch m, -[e]s, ...brüche; jmdm. - tun; Abbruch.ar|bei|ten (Mehrz.), ...fir|ma; abbruch|reif

abbuchen; Abbuchung

abbürsten

Abc, Abe|cę s; -, -; Abc-Buch, Abece|buch (Fibel); Abc-Code (internationaler Telegrammschlüssel); Abc-Schütz|e, Abece|schütze; ABC-Staaten (Argentinien, Brasilien und Chile) Mehrz. (↑ R 150); ABC-Waffen (atomare, biologische u. chemische Waffen) Mehrz. (↑ R 150)

abdachung; Abdachung

Abdampf; abdampfen (Dampf abgeben; als Dampf abgeschieden werden; ugs. für: abfahren); abdämpfen (etwas [in seiner Wirkung] mildern); Abdampfwärme

abdanken; Abdankung (schweiz. auch für: Trauerfeier)

ab|decken[1]; Ab|decker[1] (Schinder); Ab|decke|rei[1]; Ab|deckung[1]
Ab|de|ra (altgr. Stadt); Ab|de|rit (Bewohner von Abdera; übertr. für: einfältiger Mensch, Schildbürger) m; -en, -en († R 268)
ab|dich|ten; Ab|dich|tung
Ab|di|ka|ti|on lat. [...zion] (veralt. für: Abdankung)
ab|ding|bar (Rechtsspr.: durch freie Vereinbarung ersetzbar)
ab|di|zie|ren lat. (veralt. für: abdanken)
Ab|do|men lat. (Med.: Unterleib, Bauch; auch: Hinterleib der Gliederfüßer) s; -s, - u. ...mina; ab|do|mi|nal
ab|dor|ren; abgedorrte Zweige
ab|drän|gen
ab|dre|hen
Ab|drift vgl. Abtrift
ab|dros|seln; Ab|dros|se|lung, Ab|droß|lung
Ab|druck m; -[e]s, ...drücke (in Gips u. a.) u. (Druckw.:) ...drukke; ab|drucken[1]; ein Buch -; ab|drücken[1]; das Gewehr -
abds. = abends
Ab|duk|ti|on lat. [...zion] (Med.: das Bewegen von Körperteilen von der Körperachse weg, z. B. das Heben des Armes); Ab|duk|tor (Med.: eine Abduktion bewirkender Muskel, Abziehmuskel) m; -s, ...oren; ab|du|zie|ren
ab|eb|ben
Abe|ce vgl. Abc; Abe|ce|buch vgl. Abc-Buch; abe|ce|lich; Abe|ce|schüt|ze vgl. Abc-Schütze; abe|ce|wei|se
ab|ei|sen österr. (abtauen)
Abel (bibl. m. Eigenn.)
Abel|mo|schus arab. [auch: $ab^e l$mo...] (eine Tropenpflanze) m; -, -se
Abend m; -s, -e. I. Großschreibung: des, eines Abends; gegen Abend; den Abend über; es ist, wird Abend; am Abend; diesen Abend; zu Abend essen; guten Abend sagen; guten Abend! (Gruß). II. Kleinschreibung († R 129): abend; [bis, von] gestern, heute, morgen abend; [am] Dienstag abend (an dem bestimmten, einmaligen); abends (Abk.: abds.); von früh bis abends; von morgens bis abends; spätabends, abends spät; [um] 8 Uhr abends, abends [um] 8 Uhr; Dienstag od. dienstags abends (unbestimmt, wiederkehrend). III. Zusammenschreibung: vgl. Dienstagabend; Abend‿brot, ...däm|me|rung; aben|de|lang, aber: drei od. mehrere Abende lang; Abend‿es|sen, ...frie|de[n]

[1] Trenn.: ...k|k...

(m; ...dens); abend|fül|lend; Abend‿gym|na|si|um, ...kurs, ...kur|sus; Abend|land s; -[e]s; Abend|län|der m; abend|län|disch; abend|lich; Abend‿lied, ...mahl (Mehrz. ...mahle); Abend‿mahls‿brot, ...kelch, ...saal, ...wein; Abend‿rot od. ...rö|te; abends (Abk.: abds.); † R 129; vgl. Abend u. Dienstag
Aben|teu|er s; -s, -; Aben|teue|rin, Aben|teu|re|rin w; -, -nen; aben|teu|er|lich; Aben|teu|er|lust w; -; aben|teu|ern; ich ...ere († R 327); geabenteuert; Aben|teu|rer; Aben|teu|re|rin, Aben|teue|rin w; -, -nen; Aben|teu|rer|na|tur
aber; Bindew.: er sah sie, aber ([je]doch) er hörte sie nicht. Umstandsw. in Fügungen wie: aber und abermals (wieder und wiederum); tausend und aber (wieder[um]) tausend (österr. nur: abertausend); Tausende und aber Tausende (österr. nur: Abertausende); tausend- und aber tausendmal. In Zusammenschreibung mit „hundert, tausend": aberhundert (viele hundert) Sterne; abertausend (viele tausend) Vögel; Aberhunderte, Abertausende kleiner Vögel (vgl. hundert, tausend); († R 119:) Aber s; -s, -; es ist ein - dabei; viele Wenn und - vorbringen
Aber|glau|be, (seltener:) Aber|glau|ben, (aber:) aber|gläu|big (kaum noch für: abergläubisch); aber|gläu|bisch; -ste († R 294)
aber|hun|dert vgl. aber
ab|er|ken|nen; ich erkenne ab, (selten:) ich aberkenne; ich erkannte ab, (selten:) ich aberkannte; jmdm. etwas -; Ab|er|ken|nung
aber|ma|lig; aber|mals
Ab|er|ra|ti|on lat. [...zion] (Optik, Astron., Biol.: „Abirrung; Abweichung")
Aber|see vgl. Sankt-Wolfgang-See
aber|tau|send vgl. aber; Aber|witz (Wahnwitz) m; -es; aber|wit|zig
ab|es|sen
Abes|si|ni|en [...i^en] (ältere Bez. für das Kaiserreich Äthiopien); Abes|si|ni|er [...i^er]; abes|si|nisch
Abf. = Abfahrt
ABF = Arbeiter-und-Bauern-Fakultät
ab|fackeln [Trenn.: ...fak|keln] (Technik: überflüssige Gase durch Abbrennen beseitigen)
ab|fä|deln; Bohnen -
ab|fah|ren; Ab|fahrt (Abk.: Abf.); Ab|fahrt[s]‿be|fehl, ...ge|lei|se od. ...gleis; Ab|fahrts‿hang, ...lauf, ...pi|ste, ...ren|nen; Ab|fahrt[s]|si|gnal; Ab|fahrts|strecke [Trenn.: ...strek|ke]; Ab|fahrt[s]‿tag, ...zei|chen, ...zeit

Ab|fall m; Ab|fall|ei|mer; ab|fal|len; Ab|fall‿er|zeug|nis; ab|fäl|lig; - beurteilen; Ab|fall‿produkt, ...quo|te
ab|fäl|schen (Sportspr.)
ab|fan|gen; Ab|fang‿jä|ger (ein Jagdflugzeug), ...sa|tel|lit
ab|fär|ben
ab|fa|sen (abkanten)
ab|fas|sen (verfassen; abfangen); Ab|fas|sung
ab|fau|len
ab|fe|dern
ab|fei|len
ab|fer|ti|gen; Ab|fer|ti|gung; Ab|fer|ti|gungs‿dienst, ...schal|ter
ab|feu|ern
ab|fie|ren (Seemannsspr.: an einem Tau herablassen); das Rettungsboot -
ab|fin|den; Ab|fin|dung; Ab|fin|dungs‿er|klä|rung, ...sum|me
ab|fla|chen; sich -
ab|flau|en (schwächer werden nachlassen; sinken)
ab|flie|gen
ab|flie|ßen
Ab|flug; Ab|flug‿ge|schwin|dig|keit, ...tag, ...zeit
Ab|fluß; Ab|fluß|hahn
Ab|fol|ge
ab|fo|to|gra|fie|ren
ab|fra|gen; jmdn. od. jmdm. et was -
ab|fres|sen
ab|frot|ten, sich (österr. ugs. für sich abmühen)
ab|frot|tie|ren
Ab|fuhr w; -, -en; ab|füh|ren; Ab|führ|mit|tel s; Ab|füh|rung
ab|fül|len
ab|füt|tern; Ab|füt|te|rung
Abg. = Abgeordnete
Ab|ga|be (für: Steuer usw. meis Mehrz.); Ab|ga|ben‿frei, ...pflich tig; Ab|ga|be‿preis (vgl. [2]Preis ...soll (vgl. [2]Soll), ...ter|min
Ab|gang m; Ab|gän|ger (Amtsb von der Schule Abgehender); ab gän|gig; Ab|gän|gig|keits|ar zeige österr. (Meldung, daß j mand vermißt wird); Ab|gangs zeug|nis
Ab|gas (bei Verbrennungsvorgär gen entweichendes Gas); A gas‿ent|gif|tung, ...ver|wer|tung
ABGB = Allgemeines Bürge liches Gesetzbuch (für Öste reich)
ab|ge|ar|bei|tet
ab|ge|ben
ab|ge|blaßt
ab|ge|brannt (ugs. für: ohne Gel mittel; österr. auch: von der Son ne gebräunt); Ab|ge|brann|te u. w; -n, -n († R 287 ff.)
ab|ge|brüht (ugs. für: [sittlich] ab gestumpft, unempfindlich); A ge|brüht|heit

ab|ge|dro|schen; -e (ugs. für: [zu]
oft gebrauchte) Redensart
ab|ge|feimt (durchtrieben); Ab|ge-
feimt|heit
ab|ge|grif|fen
ab|ge|hackt
ab|ge|han|gen
ab|ge|härmt
ab|ge|här|tet
ab|ge|hen
ab|ge|hetzt
ab|ge|kämpft
ab|ge|kar|tet (ugs.); -e Sache
ab|ge|klärt; Ab|ge|klärt|heit w; -,
(selten:) -en
Ab|geld (für: Disagio)
ab|ge|lebt
ab|ge|le|dert landsch. (abgenutzt,
abgerissen); eine -e Hose
ab|ge|le|gen
ab|ge|lei|ert; -e (ugs. für: [zu] oft
gebrauchte, platte) Worte
ab|gel|ten; Ab|gel|tung
ab|ge|macht (ugs.); -e Sache
ab|ge|ma|gert
ab|ge|mat|tet
ab|ge|mer|gelt (erschöpft; abge-
magert); vgl. abmergeln
ab|ge|mes|sen
ab|ge|neigt
ab|ge|ord|net; Ab|ge|ord|ne|te
(Abk.: Abg.) m u. w; -n, -n (↑ R
287 ff.); Ab|ge|ord|ne|ten|haus
ab|ge|plat|tet
ab|ge|rech|net
ab|ge|ris|sen; -e (abgenutzte, zer-
lumpte) Kleider
ab|ge|run|det
ab|ge|sagt; ein -er (ausgesproche-
ner) Feind des Nikotins
Ab|ge|sand|te m u. w; -n, -n (↑ R
287 ff.)
Ab|ge|sang (Verslehre; abschlie-
ßender Strophenteil)
ab|ge|schie|den (geh. für: einsam
[gelegen]; verstorben); Ab|ge-
schie|de|ne (geh.) m u. w; -n, -n
(↑ R 287 ff.); Ab|ge|schie|den|heit
ab|ge|schlafft (müde, erschöpft);
vgl. abschlaffen
ab|ge|schla|gen; Ab|ge|schla|gen-
heit landsch. ([Zustand der] Er-
schöpfung)
ab|ge|schlos|sen; -e Menge
(Math.); -e Schale (Kernphysik);
-es Intervall (Math.)
ab|ge|schmackt; -e (platte) Worte;
Ab|ge|schmackt|heit
ab|ge|se|hen; abgesehen von ...;
abgesehen [davon], daß (↑ R 61)
ab|ge|son|dert
ab|ge|spannt
ab|ge|stan|den
ab|ge|stor|ben
ab|ge|sto|ßen
ab|ge|stuft
ab|ge|stumpft; Ab|ge|stumpft|heit
w; -
ab|ge|ta|kelt (ugs. für: herunterge-

kommen, ausgedient); vgl. abta-
keln
ab|ge|tan; -e (erledigte) Sache; vgl.
abtun
ab|ge|tra|gen
ab|ge|wetzt
ab|ge|win|nen; jmdm. etwas -
ab|ge|wo|gen; Ab|ge|wo|gen|heit
w; -
ab|ge|wöh|nen; jmdm. sich et-
was -
ab|ge|zehrt
ab|ge|zo|gen; -er (geh. für: ab-
strakter) Begriff; vgl. abziehen
ab|gie|ßen
Ab|glanz
ab|glei|ten
ab|glit|schen (ugs.)
Ab|gott m; -[e]s, Abgötter; Ab|göt-
te|rei; ab|göt|tisch; -ste (↑ R 294);
Ab|gott|schlan|ge
ab|gra|ben; jmdm. das Wasser -
ab|gra|sen
ab|grei|fen
ab|gren|zen; Ab|gren|zung
Ab|grund; ab|grün|dig; ab|grund-
tief
ab|gucken [Trenn.: ...guk|ken]
(ugs.); [von od. bei] jmdm. et-
was -
Ab|guß
Abh. = Abhandlung
ab|ha|ben (ugs.); ..., daß er seine
Brille abhat; er soll sein[en] Teil
abhaben
ab|hacken [Trenn.: ...hak|ken]
ab|hä|keln
ab|ha|ken
ab|half|tern
ab|hal|ten; Ab|hal|tung
ab|han|deln; ein Thema -
ab|han|den; - kommen (verloren-
gehen); Ab|han|den|kom|men s; -s
Ab|hand|lung (Abk.: Abh.)
Ab|hang; ¹ab|hän|gen (älter u.
mdal.: abhangen); das hing von
ihm ab, hat von ihm abgehangen;
vgl. ¹hängen; ²ab|hän|gen; er
hängte das Bild ab, hat es abge-
hängt; vgl. ²hängen; ab|hän|gig;
-e (indirekte) Rede; -e Funktio-
nen (Math.); Ab|hän|gig|keit w;
-; Ab|hän|gig|keits|ver|hält|nis
ab|här|men, sich
ab|här|ten; Ab|här|tung
ab|hau|en (ugs. auch für: davon-
laufen); ich hieb den Ast ab; wir
hauten ab
ab|he|ben
ab|he|bern (eine Flüssigkeit mit ei-
nem Heber entnehmen); ich he-
bere ab (↑ R 327)
ab|hef|ten
ab|hel|fen; einem Mangel -
ab|het|zen; sich -
ab|heu|ern; jmdn. -; er hat abge-
heuert
Ab|hil|fe
ab|hit|ze vgl. Abwärme

ab|hold; jmdm., einer Sache - sein
ab|ho|len; Ab|ho|ler
ab|hol|zen
ab|hor|chen
ab|hö|ren; jmdm. od. jmdm. etwas
-; Ab|hör|ge|rät
Abi|djan [...dsehan] (Hptst. von
²Elfenbeinküste)
Abio|ge|ne|se, Abio|ge|ne|sis gr.
[auch: ...gen...] (Annahme, daß
Lebewesen ursprünglich aus un-
belebter Materie entstanden
sind) w; -
ab|ir|ren
Ab|itur lat. (Reifeprüfung) s; -s,
(selten:) -e; Ab|itu|ri|ent (Reife-
prüfling); ↑ R 268; Ab|itu|ri|en-
ten.kurs (österr.), ...lehr|gang
(österr.), ...prü|fung; Ab|itu|ri|en-
tin w; -, -nen
Ab|ju|di|ka|ti|on lat. [...zion] (ver-
alt. für: [gerichtliche] Aberken-
nung); ab|ju|di|zie|ren
Abk. = Abkürzung
ab|käm|men
ab|kan|zeln (ugs. für: scharf ta-
deln); ich kanz[e]le ab (↑ R 327);
Ab|kan|ze|lung, Ab|kanz|lung
(ugs.)
ab|ka|pi|teln (ugs. für: schelten)
ab|kap|seln; ich kaps[e]le ab (↑ R
327); Ab|kap|se|lung, Ab|kaps-
lung
ab|kau|fen
Ab|kehr w; -
ab|keh|ren
ab|kip|pen
ab|klap|pern (ugs. für: suchend,
fragend ablaufen)
ab|klä|ren
ab|klatsch
ab|klin|gen; Ab|kling_kon|stan|te
(Physik), ...zeit (Physik)
ab|klop|fen
ab|knab|bern
ab|knal|len (ugs. für: niederschie-
ßen)
ab|knap|pen landsch. (abknap-
sen); ab|knap|sen; jmdm. etwas
- (ugs. für: entziehen)
ab|knicken [Trenn.: ...knik|ken];
abknickende Vorfahrt
ab|knöp|fen; jmdm. Geld - (ugs.
für: abnehmen)
ab|ko|chen
ab|kom|man|die|ren
Ab|kom|me (geh. für: Nachkom-
me) m; -n, -n (↑ R 268); ab|kom-
men; Ab|kom|men s; -s, -; Ab-
kom|men|schaft w; - (veralt.); ab-
kömm|lich; Ab|kömm|ling (auch
für: Derivat [Chemie])
ab|kön|nen nordd. (aushalten,
vertragen); du weißt doch, daß
ich das nicht abkann
ab|kon|ter|fei|en (veralt. für: ab-
malen, abzeichnen)
ab|kop|peln
ab|kra|gen (Bauw.: abschrägen)

ab|krat|zen (ugs. derb auch für: sterben)
ab|krie|gen
ab|küh|len; Ab|küh|lung
Ab|kunft w; -
ab|kür|zen; Ab|kür|zung (Abk.: Abk.); Ab|kür|zungs|spra|che (Kurzw.: Aküsprache) w; -, (selten:) -n; Ab|kür|zungs_ver|zeichnis, ...zei|chen
ab|la|den; vgl. ¹laden; Ab|la|de|platz; Ab|la|der; Ab|la|dung
Ab|la|ge (schweiz. auch: Annahme-, Zweigstelle); ab|la|gern; Ab|la|ge|rung
ab|lan|dig (Seemannsspr.: vom Lande her wehend)
Ab|laß m; Ablasses, Ablässe; Ablaß|brief; ab|las|sen
Ab|la|ti|on lat. [...zion] (Abschmelzung [von Schnee u. Eis]; Geol.: Abtragung des Bodens; Med.: Wegnahme; Ablösung, bes. der Netzhaut); Ab|la|tiv [auch: ...tif] (Sprachw.: Kasus in idg. Sprachen) m; -s, -e [...wᵉ]; Ab|la|ti|vus ab|so|lu|tus [auch: ...tiwuß -] (Sprachw.: eine bestimmte Konstruktion in der lat. Sprache) m; - -, ...vi ...ti
Ab|lauf; ab|lau|fen; Ab|lauf|rin|ne
ab|lau|gen
Ab|laut (Sprachw.: gesetzmäßiger Selbstlautwechsel in der Stammsilbe etymologisch verwandter Wörter, z. B. ,,singen, sang, gesungen"); ab|lau|ten (Ablaut haben); ab|läu|ten (zur Abfahrt läuten)
Ab|le|ben (Tod) s; -s
ab|lecken [Trenn.: lek|ken]
ab|le|dern (mdal. auch: verprügeln); vgl. abgeledert
ab|le|gen; Ab|le|ger (Pflanzentrieb; ugs. scherzh. für: Sohn, Sprößling)
ab|leh|nen; einen Vorschlag -; Ab|leh|nung
ab|lei|sten; Ab|lei|stung
ab|lei|ten; Ab|lei|tung (Sprachw.: Bildung eines Wortes durch Lautveränderung [Ablaut] oder durch das Anfügen von Nachsilben, z. B. ,,Trank" von ,,trinken", ,,königlich" von ,,König"); Ab|lei|tungs|sil|be
ab|len|ken; Ab|len|kung (Ablenkungs|ma|nö|ver
Ablep|sie gr. (älter für: Amaurose) w; -
ab|le|sen; Ab|le|ser
ab|leug|nen
ab|lich|ten; Ab|lich|tung
ab|lie|fern; Ab|lie|fe|rung; Ab|liefe|rungs_pflicht, ...soll (vgl. ²Soll)
ab|lie|gen (landsch. auch: durch Lagern gut, reif werden); weit -
ab|li|sten; jmdm. etwas -
ab|lo|chen (auf Lochkarten übertragen); Ab|lo|cher; Ab|lo|chung
ab|locken [Trenn.: ...lok|ken]
ab|loh|nen; jmdn. - (bezahlen [u. entlassen])
Ab|lö|se österr. (Ablösungssumme) w; -, -n; ab|lö|sen; Ab|lö|sesum|me; Ab|lö|sung; Ab|lö|sungs|sum|me
ab|luch|sen (ugs.); jmdm. etwas -
Ab|luft (Technik: verbrauchte Luft, die abgeleitet, abgesaugt wird) w; -
ab|ma|chen; Ab|ma|chung
ab|ma|gern; Ab|ma|ge|rung; Ab|ma|ge|rungs|kur
ab|ma|len; ein Bild -
Ab|marsch m; ab|mar|schie|ren
ab|meh|ren schweiz. (abstimmen durch Handerheben)
ab|mei|ern lat.; jmdn. - (hist. für: jmdm. den Meierhof, das Pachtgut, den Erbhof entziehen; veralt. für: jmdn. absetzen); ich meiere ab (↑ R 327); Ab|meie|rung
ab|mel|den; Ab|mel|dung
Ab|melk|wirt|schaft (Rinderhaltung nur zur Milchgewinnung)
ab|mer|geln, sich (ugs. für: sich abmühen, abquälen); ich merg[e]le mich ab (↑ R 327); vgl. abgemergelt
ab|mes|sen; Ab|mes|sung
ab|mon|tie|ren
ab|mü|den, sich (geh.)
ab|mü|hen, sich
ab|murk|sen (ugs. für: umbringen)
ab|mu|stern (Seemannsspr.: entlassen; den Dienst aufgeben); Ab|mu|ste|rung
ab|na|beln; ich nab[e]le ab (↑ R 327)
ab|na|gen
ab|nä|hen; Ab|nä|her
Ab|nah|me w; -, (selten:) -n; ab|neh|men; vgl. ab; Ab|neh|mer; Ab|nehmer|land (Mehrz. ...länder)
Ab|nei|gung
ab|nib|beln landsch. derb (sterben); ich nibb[e]le ab (↑ R 327)
ab|norm (vom Normalen abweichend, regelwidrig; krankhaft); ab|nor|mal [auch: apnormạl] (ugs. für: nicht normal, ungewöhnlich); Ab|nor|mi|tät
ab|nö|ti|gen; jmdm. etwas -
ab|nut|zen, (bes. südd., österr.:) ab|nüt|zen; Ab|nut|zung, (bes. südd., österr.:) Ab|nüt|zung; Ab|nut|zungs|ge|bühr
A-Bom|be; ↑ R 149 (Atombombe)
Abon|ne|ment fr. [abon(ᵉ)mạ̈ŋ, schweiz. auch: ...mänt] (Dauerbezug von Zeitungen u. ä.; Dauermiete für Theater u. ä.) s; -s, -s (schweiz. auch: -e); Abon|ne|ment[s]_kar|te (Anrechtskarte), ...preis (vgl. ²Preis), ...vor|stel|lung; Abon|nent (Inhaber eines Abonnements); ↑ R 268; abon-
nie|ren; abonniert sein auf etwas
ab|ord|nen; Ab|ord|nung
ᶠAb|ort [veralt. auch: ạport] (Klosett) m; -[e]s, -e
²Ab|ort lat. (Med.: Fehlgeburt) m; -s, -e; ab|or|tie|ren; ab|or|tiv (einen ²Abort bewirkend, abtreibend)
ab ọvo lat. (von Anfang an)
ab|packen [Trenn.: ...pak|ken]
ab|par|ken; die Viertelstunde des Vorgängers -
ab|pas|sen
ab|pau|sen; eine Zeichnung -
ab|per|len
ab|pfei|fen; Ab|pfiff (Sportspr.)
ab|pflücken [Trenn.: ...pflük|ken]
ab|pho|to|gra|phie|ren (ältere Schreibung für: abfotografieren)
ab|pla|gen, sich
ab|plat|ten (platt machen)
Ab|prall m; -[e]s, (selten:) -e; ab|pral|len
ab|pres|sen
ab|prot|zen
Ab|putz (Bewurf des Hauses); ab|put|zen
ab|qua|li|fi|zie|ren
ab|rackern [Trenn.: ...rak|kern], sich (ugs. für: sich abarbeiten)
Abra|ham (bibl. m. Eigenn.); Abra|ham s Șan[c]|ta Clạ|ra (dt. Prediger)
ab|rah|men; Milch -
Abra|ka|da|bra [auch: abrakadabra] (Zauberwort; [sinnloses] Gerede) s; -s
Abra|sax vgl. Abraxas
ab|ra|sie|ren
Ab|ra|si|on lat. (Geol.: Abtragung der Küste durch die Brandung; Med.: Ausschabung, Auskratzung)
ab|ra|ten; jmdm. von etwas -
Ab|raum (Bergmannsspr.: Deckschicht über Lagerstätten landsch. für: Abfall) m; -[e]s; ab|räu|men; Ab|raum|salz
Abra|xas, Abra|sax (Zauberwort
ab|rech|nen; Ab|rech|nung; Ab|rech|nungs|ter|min
Ab|rech|te (linke Tuchseite) w;
Ab|re|de; etwas in - stellen
ab|re|gen, sich (ugs. für: sich beruhigen)
ab|rei|ben; Ab|rei|bung
Ab|rei|se (Mehrz. selten); ab|rei|sen
Ab|reiß|block (Mehrz. ...blocks); ab|rei|ßen; vgl. abgerissen; Ab|reiß|ka|len|der
ab|rich|ten; Ab|rich|ter (Dresseur); Ab|rich|tung
Ab|rieb (Technik) m; -[e]s, (abgeriebene Teilchen:) -e; ab|rieb|fest; Ab|rieb|fe|stig|keit

ab|rie|geln; Ab|rie|ge|lung, Ab-
rieg|lung
ab|rin|gen; jmdm. etwas -
Ab|riß m; Abrisses, Abrisse
ab|rol|len
ab|rücken [Trenn.: ...rük|ken]
Ab|ruf (Mehrz. selten); auf -; ab-
ruf|be|reit; sich - halten; ab|ru|fen
ab|run|den; eine Zahl [nach oben,
unten] -; Ab|run|dung
ab|rupt lat. (abgebrochen, zusam-
menhanglos, plötzlich, jäh); vgl.
ex abrupto
ab|rü|sten; Ab|rü|stung; Ab|rü-
stungs|kon|fe|renz
ab|rut|schen
Abruz|zen (Gebiet im südl. Mit-
telitalien; auch für: Abruzzischer
Apennin) Mehrz.; Abruz|zi|scher
Apen|nin (Teil des Apennins)
Abs. = Absatz; Absender
ab|sacken [Trenn.: ...sak|ken] (ugs.
auch für: [ab]sinken)
Ab|sa|ge w; -, -n; ab|sa|gen
ab|sä|gen
ab|sah|nen (die Sahne von der
Milch abschöpfen; ugs. für: an
einer Sache viel verdienen, das
Beste von einer Sache einstecken)
Ab|sa|lom, (ökum.:) Ab|scha|lom
(bibl. m. Eigenn.)
Ab|sam (österr. Ort)
Ab|satz (Abk. [für: Abschnitt]:
Abs.) m; -es, Absätze; Ab-
satz.flau|te, ...ge|biet; ab|satz-
wei|se
ab|sau|fen (ugs.)
ab|scha|ben
ab|schaf|fen; vgl. ¹schaffen; Ab-
schaf|fung
Ab|scha|lom vgl. Absalom
ab|schal|ten; Ab|schal|tung
ab|schat|ten; ab|schat|tie|ren; Ab-
schat|tie|rung; Ab|schat|tung
ab|schät|zen; ab|schät|zig
Ab|schaum m; -[e]s
ab|schei|den; vgl. abgeschieden
ab|sche|ren; den Bart -; vgl. ¹sche-
ren
Ab|scheu m; -[e]s (seltener: w; -);
ab|scheu|er|re|gend, aber (↑ R
142): heftigen Abscheu erregend;
ab|scheu|lich; Ab|scheu|lich|keit
ab|schicken [Trenn.: ...schik|ken]
ab|schie|ben
Ab|schied m; -[e]s, (selten:) -e; Ab-
schieds.be|such, ...brief, ...fei|er,
...schmerz, ...stun|de, ...sze|ne
ab|schie|ßen
ab|schil|fern; Ab|schil|fe|rung (Ab-
schuppung)
ab|schin|den, sich (ugs.)
ab|schir|men; Ab|schir|mung
ab|schir|ren
ab|schlach|ten; Ab|schlach|tung
ab|schlaf|fen (ugs. für: schlaff wer-
den; sich entspannen, weil man
müde, erschöpft ist)
Ab|schlag; auf -; ab|schla|gen; ab-

schlä|gig (Amtsdt.); jmdn. od. et-
was - bescheiden ([jmdm.] etwas
nicht genehmigen); ab|schläg|lich
(veralt.); -e Zahlung; Ab|schlags-
zah|lung (BGB: Abschlagszah-
lung)
ab|schläm|men (Bodenteilchen
wegspülen u. als Schlamm abset-
zen)
ab|schlei|fen
Ab|schlepp|dienst, ab|schlep|pen;
Ab|schlepp|seil
ab|schlie|ßen; Ab|schlie|ßung; Ab-
schluß; zum - bringen; Ab-
schluß.ex|amen, ...fei|er, ...prü-
fung, ...stich|tag, ...trai|ning
ab|schmäl|zen österr. (abschmäl-
zen); ab|schmäl|zen (Teigwaren
o. ä. mit Schmalz zubereiten)
ab|schmecken¹
ab|schmel|zen; das Eis schmilzt ab;
vgl. ¹,²schmelzen
ab|schmie|ren
ab|schmir|geln (durch Schmirgeln
glätten, polieren; durch Schmir-
geln entfernen)
Abschn. = Abschnitt
ab|schnei|den; Ab|schnitt (Abk.:
Abschn.); ab|schnitt[s]|wei|se
Ab|schnit|zel landsch. (abge-
schnittenes [Fleisch-, Papier]-
stückchen) s; -s, -
ab|schnü|ren; Ab|schnü|rung
ab|schöp|fen; Ab|schöp|fung
ab|schra|gen
ab|schrau|ben
ab|schrecken¹; vgl. ²schrecken; ab-
schreckend¹; -ste; Ab|schrek-
kung¹; Ab|schreckungs|stra|fe¹
ab|schrei|ben; Ab|schrei|bung; Ab-
schrift; ab|schrift|lich (Papierdt.)
Ab|schrot (meißelförmiger Am-
boßeinsatz) m; ab|schro|ten (Me-
tallteile auf dem Abschrot ab-
schlagen)
ab|schrub|ben
ab|schuf|ten, sich (ugs. für: sich
abarbeiten)
ab|schup|pen; Ab|schup|pung
ab|schür|fen; Ab|schür|fung
Ab|schuß; Ab|schuß|ba|sis; ab-
schüs|sig; Ab|schuß.li|ste, ...ram-
pe
ab|schüt|teln; Ab|schüt|te|lung,
Ab|schütt|lung
ab|schüt|ten
ab|schwä|chen; Ab|schwä|chung
ab|schwei|fen; Ab|schwei|fung
ab|schwel|len; vgl. ¹schwellen
ab|schwem|men
ab|schwin|gen
ab|schwö|ren
Ab|schwung
ab|seh|bar [auch: apse...]; ab|se-
hen; vgl. abgesehen
ab|sei|len; sich -

¹ Trenn.: ...k|k...

ab|sein (ugs. für: entfernt, getrennt
sein; abgespannt sein); der Knopf
ist ab, ist abgewesen, aber: ...,
daß der Knopf ab ist, war
ab|seit, Ab|seit (österr. Sportspr.
neben: abseits, Abseits)
¹Ab|sei|te landsch. (Nebenraum,
-bau) w; -, -n
²Ab|sei|te (Stoffrückseite); Ab|sei-
ten|stoff (für: Reversible); ab|sei-
tig; Ab|sei|tig|keit; ab|seits; Ver-
hältnisw. mit Wesf.: - des Ortes;
Umstandsw.: - stehen, sein; die
- stehenden Kinder; Ab|seits
(Sportspr.) s; -, -; - pfeifen; Ab-
seits.stel|lung, ...tor s
Ab|sence fr. [...ßạ̃ß] (Med.: Gei-
stesabwesenheit, insbes. epilept.
Anfall mit kurzdauernder Be-
wußtlosigkeit) w; -, -n [...ß*n]
ab|sen|den; Ab|sen|der (Abk.:
Abs.); Ab|sen|dung
ab|sen|ken (auch für: Pflanzen
durch Senker vermehren); Ab-
sen|ker
ab|sen|t[ie]|ren, sich (veralt. für: sich
entfernen); Ab|senz lat. (österr.,
schweiz., sonst veralt. für: Abwe-
senheit, Fehlen; schweiz. auch
svw. Absence) w; -, -en
ab|ser|vie|ren (ugs. für: seines Ein-
flusses berauben)
ab|setz|bar; ab|set|zen; sich -; Ab-
set|zung
ab|si|chern
Ab|sicht w; -, -en; ab|sicht|lich
[auch: ...sicht...]; Ab|sicht|lich-
keit [auch: ...sicht...]; ab-
sichts.los, ...voll
Ab|sin|gen s; -s; unter - (nicht: un-
ter Absingung)
ab|sin|ken
Ab|sinth gr. (Wermutbranntwein)
m; -[e]s, -e
ab|sit|zen
ab|so|lut lat. („losgelöst"); -e At-
mosphäre (Zeichen: ata); -e
(nichteuklidische) Geometrie; -e
Musik (Sprachw.:) -er Ablativ,
Nominativ, Superlativ (vgl. Ela-
tiv); Ab|so|lut|heit w; -; Ab|so|lu-
ti|on [...zion] (Los-, Freispre-
chung, bes. Sündenvergebung);
Ab|so|lu|tis|mus (unbeschränkte
Herrschaft eines Monarchen,
Willkürherrschaft) m; -; Ab|so|lu-
tist (veralt. für: Anhänger des
Absolutismus); ↑ R 268; ab|so|lu-
ti|stisch; -ste (↑ R 294); Ab|so|lu-
to|ri|um (österr., sonst veralt.:
Bescheinigung, daß die für ein
Studium vorgeschriebene Seme-
sterzahl erreicht ist) s; -s, ...ien
[...i*n]; Ab|sol|vent [...wänt]
(Schulabgänger mit Abschluß-
prüfung); ↑ R 268; ab|sol|vie|ren
(Absolution erteilen; erledigen;
ableisten; [Schule] durchlaufen);
Ab|sol|vie|rung w; -

ab|son|der|lich; Ab|son|der|lich-
keit; ab|son|dern; sich -; Ab|son-
de|rung
Ab|sor|bens *lat.* (der bei der Ab-
sorption aufnehmende Stoff) *s*;
-, ...ben|zien [...*i͡ɛⁿn*] u. ...ben|tia
[...*zia*] ; Ab|sor|ber *engl.* (Vorrich-
tung zur Absorption von Gasen,
Strahlen; vgl. Absorbens) *m*; -s,
-; ab|sor|bie|ren *lat.* (aufsaugen;
[gänzlich] beanspruchen); Ab-
sorp|ti|on [...*zi̯on*]; Ab|sorp|ti-
ons|spek|trum; ab|sorp|tiv (zur
Absorption fähig)
ab|spal|ten; Ab|spal|tung
ab|spa|nen (Technik: ein metalli-
sches Werkstück durch Abtren-
nung von Spänen formen)
ab|spä|nen *landsch.* (die Mutter-
milch entziehen)
ab|span|nen; Ab|spann|mast (Elek-
trotechnik) *m*; Ab|span|nung *w*; -
ab|spa|ren, sich; sich etwas am
Munde -
ab|spei|chern (EDV)
ab|spei|sen
ab|spen|stig; jmdm. jmdn. od. et-
was - machen
ab|sper|ren; Ab|sperr_hahn, ...ket-
te, ...kom|man|do, ...mau|er; Ab-
sper|rung
ab|spie|geln; Ab|spie|ge|lung, Ab-
spieg|lung
Ab|spiel *s*; -[e]s; ab|spie|len
ab|split|tern; Ab|split|te|rung
Ab|spra|che (Vereinbarung); ab-
spra|che|ge|mäß; ab|spre|chen
ab|sprin|gen; Ab|sprung; Ab-
sprung|ha|fen (Militär); vgl. ²Ha-
fen
ab|spu|len; ein Tonband -
ab|spü|len; Geschirr -
ab|stam|men; Ab|stam|mung
Ab|stand; von etwas - nehmen (et-
was nicht tun); ab|stän|dig; -er
(Forstw.: dürrer, absterbender)
Baum; Ab|stands|sum|me
ab|stat|ten; jmdm. einen Besuch
- (geh.)
ab|stau|ben; (landsch.:) ab|stäu-
ben; Ab|stau|ber (Sportspr. für:
Zufallstor)
ab|ste|chen; Ab|ste|cher (kleine
Nebenreise)
ab|stecken [*Trenn.*: ...stek|ken];
vgl. ²stecken
ab|ste|hen
ab|stei|fen; Ab|stei|fung
ab|stei|gen; Ab|stei|ge|quar|tier,
(österr.:) Ab|steig|quar|tier; Ab-
stei|ger (Sportspr.)
Ab|stell|bahn|hof; ab|stel|len; Ab-
stell_ge|lei|se od. ...gleis, ...raum;
Ab|stel|lung
ab|stem|peln; Ab|stem|pe|lung,
Ab|stemp|lung
ab|step|pen
ab|ster|ben
Ab|stich

Ab|stieg *m*; -[e]s, -e; ab|stiegs|ge-
fähr|det (Sportspr.)
ab|stil|len
ab|stim|men; Ab|stimm_kreis,
...schär|fe (*w*; -); Ab|stim|mung;
Ab|stim|mungs|er|geb|nis
ab|sti|nent *lat.* (enthaltsam, alko-
hol. Getränke meidend); Ab|sti-
nent (veralt. für: Abstinenzler);
↑ R 268; Ab|sti|nenz *w*; -; Ab|sti-
nenz|ler (enthaltsam lebender
Mensch, bes. in bezug auf Alko-
hol); Ab|sti|nenz|tag (kath. Kir-
che: festgelegter Tag, an dem
Enthaltsamkeit vom Fleischge-
nuß geboten ist)
ab|stop|pen
Ab|stoß *m*; ab|sto|ßen; ab|sto|ßend;
-ste; Ab|sto|ßung
ab|stot|tern (ugs. für: in Raten be-
zahlen)
ab|stra|fen; Ab|stra|fung
ab|stra|hie|ren *lat.* (das All-
gemeine vom Einzelnen absön-
dern, zum Begriff erheben, ver-
allgemeinern)
ab|strah|len
ab|strakt *lat.* (unwirklich, begriff-
lich, nur gedacht); -e (vom Ge-
genständlichen absehende)
Kunst; -es Substantiv (vgl. Ab-
straktum); Ab|strakt|heit; Ab-
strak|ti|on [...*zi̯on*]; Ab|strak|tum
(Philos.: allgemeiner Begriff;
Sprachw.: Hauptwort, das etwas
Nichtgegenständliches benennt,
z. B. „Liebe“) *s*; -s, ...ta
ab|strän|gen ([ein Zugtier] abspan-
nen)
ab|strei|chen; Ab|strei|cher
ab|strei|fen
Ab|strich
ab|strus *lat.* (verworren, schwer
verständlich); -este (↑ R 292)
ab|stu|fen; Ab|stu|fung
ab|stumpf|en; Ab|stumpf|fung
Ab|sturz; ab|stür|zen
ab|stüt|zen
Ab|sud [auch: ...*sut*] (veralt. für:
durch Absieden gewonnene
Flüssigkeit)
ab|surd *lat.* (ungereimt, unver-
nünftig, sinnwidrig, sinnlos); vgl.
ad absurdum; -es Drama (eine
moderne Dramenform); Ab|sur-
di|tät
ab|sze|die|ren *lat.* (Med.: eitern);
Ab|szeß (Med.: Eiteransamm-
lung in einer nicht vorgebildeten
Körperhöhle) *m* (österr. ugs.
auch: *s*); Abszesses, Abszesse
Ab|szis|se *lat.* (Math.: auf der Ab-
szissenachse abgetragene erste
Koordinate eines Punktes) *w*; -,
-n; Ab|szis|sen|ach|se
Abt (Kloster-, Stiftsvorsteher) *m*;
-[e]s, Äbte
Abt. = Abteilung
ab|ta|keln; ein Schiff - (das Takel-

werk entfernen, außer Dienst
stellen); vgl. abgetakelt; Ab|ta-
ke|lung, Ab|tak|lung
ab|ta|sten; Ab|ta|stung
ab|tau|en; einen Kühlschrank -
Ab|tausch; ab|tau|schen
Ab|tei
Ab|teil [ugs. auch: *ap...*] *s*; -[e]s,
-e; ab|teilen; ¹Ab|tei|lung (Abtren-
nung) *w*; -; ²Ab|tei|lung [österr.:
ap...] ([durch Abtrennung ent-
standener] Teil; Abk.: Abt.); Ab-
tei|lungs|lei|ter *m*
ab|teu|fen (Bergmannsspr.); einen
Schacht - (niederbringen)
ab|tip|pen (ugs. für: mit der
Schreibmaschine abschreiben)
Äb|tis|sin (Kloster-, Stiftsvorste-
herin) *w*; -, -nen
Abt.-Lei|ter = Abteilungsleiter
(↑ R 154)
ab|tö|nen; Ab|tö|nung
ab|tö|ten; Ab|tö|tung
Ab|trag *m*; [e]s, Abträge; jmdm.
od. einer Sache - tun (geh. für:
schaden); ab|tra|gen; ab|träg|lich
(schädlich); jmdm. od. einer Sa-
che - sein; Ab|träg|lich|keit; Ab-
tra|gung
ab|trans|port; ab|trans|por|tie|ren
ab|trei|ben; Ab|trei|bung; Ab|trei-
bungs_pa|ra|graph (§ 218 des
Strafgesetzbuches), ...ver|such
ab|tren|nen; ab|tren|nen; Ab|tren-
nung
ab|tre|ten; Ab|tre|ter; Ab|tre|tung
Ab|trieb (auch: Abholzung;
österr. auch: Rührteig)
Ab|trift (Treiben des Viehs von
den Almen; Seemannsspr., Flie-
gerspr.: Versetzung [seitlich zum
Kurs] durch Wind usw.)
Ab|tritt (ugs. für: Abort)
ab|trock|nen
ab|trop|fen
ab|trot|zen
ab|trump|fen (auch: scharf zu-
rechtweisen, abweisen)
ab|trün|nig; Ab|trün|nig|keit *w*; -
Abts.stab, ...wür|de
ab|tun; etwas als Scherz -; vgl. ab-
getan
ab|tup|fen
Abt|wahl
Abu (in arab. Eigenn.: „Vater“);
Abu|kir (ägypt. Stadt)
ab und zu vgl. ab
ab urbe con|di|ta *lat.* [- - *kon...*]
(„seit Gründung der Stadt“
[Rom]; altröm. Zeitrechnung,
beginnend mit 753 v. Chr.; Abk.:
a. u. c.)
ab|ur|tei|len; Ab|ur|tei|lung
Ab|ver|kauf österr. (Ausverkauf);
ab|ver|kau|fen (österr.)
ab|ver|lan|gen
ab|vie|ren (vierkantig zuschnei-
den); Ab|vie|rung
ab|wä|gen; du wägst ab; du wäg-

test, wogst ab; abgewogen, abge-
wägt; ab|wäg|sam (bedächtig);
Ab|wä|gung
Ab|wahl; ab|wäh|len
ab|wäl|zen
ab|wan|deln; Ab|wan|de|lung, Ab-
wand|lung
ab|wan|dern; Ab|wan|de|rung
Ab|wär|me (Technik: nicht ge-
nutzte Warmeenergie)
Ab|wart schweiz. (Hausmeister,
-wart) m; -s, -e; ab|war|ten; Ab-
war|tin schweiz. (Hausmeisterin)
w; -, -nen
ab|wärts; Schreibung in Verbin-
dung mit Zeitwörtern (↑ R 139):
I. Getrenntschreibung in ur-
sprünglicher Bedeutung, z. B. ab-
wärts (nach unten) gehen; er ist
diesen Weg abwärts gegangen.
II. Zusammenschreibung, wenn
durch die Verbindung ein neuer
Begriff entsteht, z. B. abwärtsge-
hen (ugs. für: schlechter werden);
es ist mit ihm abwärtsgegangen
¹Ab|wasch (Geschirrspülen;
schmutziges Geschirr) m; -[e]s;
²Ab|wasch landsch. (Abwasch-
becken) w; -, -en; ab|wa|schen;
Ab|wa|schung; Ab|wasch|was|ser
(Mehrz. ...wässer)
Ab|was|ser (Mehrz. ...wässer)
ab|wech|seln; ab|wech|selnd; Ab-
wech|se|lung, Abwechs|lung; ab-
wechs|lungs_los, ...reich
Ab|weg (meist Mehrz.); ab|we|gig;
Ab|we|gig|keit
Ab|wehr w; -; ab|weh|ren; Ab-
wehr.ge|schütz, ...kampf, ...re-
ak|ti|on, ...spie|ler (Sportspr.)
¹ab|wei|chen; ein Pflaster -; vgl.
¹weichen
²ab|wei|chen; vom Kurs -; vgl.
²weichen; Ab|weich|ler (DDR:
jmd., der von der geltenden Linie
der Partei abweicht); Ab|wei-
chung
ab|wei|den
ab|wei|sen; Ab|wei|ser (Prellstein);
Ab|wei|sung
ab|wend|bar; ab|wen|den; ich
wandte od. wendete mich ab,
habe mich abgewandt od. abge-
wendet; er wandte od. wendete
den Blick ab, hat den Blick abge-
wandt od. abgewendet; ab|wen-
dig (veraltend für: abspenstig, ab-
geneigt); Ab|wen|dung w; -
ab|wer|ben; Ab|wer|ber; Ab|wer-
bung
ab|wer|fen
ab|wer|keln österr. ugs. (abnützen,
ausleiern)
ab|wer|ten; Ab|wer|tung
ab|we|send; Ab|we|sen|de m u. w;
-n, -n (↑ R 287ff.); Ab|we|sen|heit
w; -
ab|wet|tern; einen Sturm - (See-
mannsspr.: auf See überstehen);

einen Schacht - (Bergmannsspr.:
abdichten)
ab|wet|zen (ugs. auch für: schnell
weglaufen)
ab|wickeln [Trenn.: ...wik|keln];
Ab|wicke|lung [Trenn.: ...wik-
ke...], Ab|wick|lung
ab|wie|geln(Ggs. von: aufwiegeln)
ab|wie|gen
ab|wim|meln (ugs. für: mit Aus-
flüchten abweisen)
ab|wind (absteigender Luftstrom)
ab|win|ken
ab|wirt|schaf|ten; abgewirtschaf-
tet
ab|wi|schen
ab|woll|nen
ab|wracken [Trenn.: ...wrak|ken];
ein Schiff - (verschrotten); Ab-
wrack|fir|ma
Ab|wurf; Ab|wurf|vor|rich|tung
ab|wür|gen
abys|sisch gr. (aus der Tiefe der
Erde stammend; zum Tiefseebe-
reich gehörend; abgrundtief);
Abys|sus (veralt. für: Tiefe der
Erde, Abgrund) m; -
ab|zah|len; ab|zäh|len; Ab|zähl-
reim; Ab|zah|lung; ab|zah|lungs-
ge|schäft
ab|zap|fen, Ab|zap|fung
ab|zap|peln, sich
ab|zäu|men
ab|zäu|nen; Ab|zäu|nung
ab|zeh|rung (Abmagerung)
Ab|zei|chen; ab|zeich|nen; sich -
Ab|zieh|bild; ab|zie|hen; vgl. abge-
zogen; Ab|zie|her
ab|zie|len
ab|zir|keln; Ab|zir|ke|lung, Ab-
zirk|lung w; -
Ab|zug; ab|züg|lich (Kaufmanns-
spr.); Verhältnisw. mit Wesf.:-
des gewährten Rabatts; ein
alleinstehendes, stark gebeugtes
Hauptw. steht in der Einz. unge-
beugt: - Rabatt; bei zugs_fä|hig,
...frei; Ab|zugs|ka|nal
ab|zup|fen
ab|zwacken [Trenn.: ...zwak|ken]
(ugs. für: entziehen, abnehmen)
ab|zwecken [Trenn.: ...zwek|ken];
auf eine Sache -
Ab|zweig (Amtsdt.: Abzweigung);
Ab|zweig|dose; ab|zwei|gen; Ab-
zweig|stel|le; Ab|zwei|gung
Ac = chem. Zeichen für: Acti-
nium
a c. = a conto
à c. = à condition
a cap|pel|la it. [- ka...] (Musik: oh-
ne Begleitung von Instrumen-
ten); A-cap|pel|la-Chor (↑ R 155);
vgl. ²Chor
acc. c. inf. = accusativus cum infi-
nitivo; vgl. Akkusativ
ac|cel. = accelerando; ac|ce|le-
ran|do it. [atschelerando] (Musik:
schneller werdend; Abk.: accel.)

Ac|cent ai|gu fr. [akßangtägü]
(Akut; Zeichen: ´, z. B. é) m; - -,
-s -s [akßangtägü]; Ac|cent cir-
con|flexe [akßangßirkongfläkß]
(Zirkumflex; Zeichen: ^, z. B. â)
m; - -, -s -ş [akßangßirkongfläkß];
Ac|cent grave [akßanggraw]
(Gravis; Zeichen: `, z. B. è) m; - -,
-s -s [akßanggraw]
Ac|ces|soires fr. [akßäßoar(ß)]
(modisches Beiwerk) Mehrz.
Ac|cra [akra] (Hauptstadt von
Ghana)
Acel|la Ⓦ [az...] (ein Kunststoff)
s; -
Ace|ro|la|kir|sche arab.-span.
[az...] (Vitamin-C-reiche west-
ind. Frucht)
Ace|tat lat. [az...] (Salz der Essig-
säure; Chemiefaser) s; -s, -e; Ace-
tat|sei|de; Ace|ton (ein Lösungs-
mittel) s; -s; Ace|ty|len (gasförmi-
ger Kohlenwasserstoff) s; -s; Ace-
ty|len|gas
ach!; ach so!; ach ja!; ach je!; ach
und weh schreien; (↑ R 119:) Ach
s; -s, -[s]; mit - und Krach; mit
- und Weh
Achä|er (Angehöriger eines altgr.
Stammes); Achaia [...ja, auch:
aehaia] (gr. Landschaft)
Achä|me|ni|de (Angehöriger einer
altpers. Dynastie) m; -n, -n (↑ R
268)
Achä|ne gr. (Schließfrucht) w; -,
-n
Achat gr. (ein Halbedelstein) m;
-[e]s, -e
Acha|ti|us [...zius], Achaz (m.
Vorn.)
Ache [auch: a...] (Flußname) w; -
acheln jidd. landsch. (essen); ich
ach[e]le (↑ R 327)
Achen|see (See in Tirol) m; -s
Ache|ron (Unterweltsfluß der gr.
Sage) m; -[s]; ache|ron|tisch (un-
terweltlich)
Acheu|lé|en fr. [aschöleäng] (Stufe
der älteren Altsteinzeit) s; -[s]
Achill, Achil|les (Held der gr. Sa-
ge); Achil|le|is (Heldengesang
über Achill, insbes. in Homers
Ilias, bei Statius u. Goethe) w;
-; Achil|les_fer|se (↑ R 180; ver-
wundbare Stelle), ...seh|ne (seh-
niges Ende des Wadenmuskels
am Fersenbein); Achil|leus
[aehileuß]; vgl. Achill
Achim (Kurzform von: Joachim)
Ach-Laut (↑ R 151)
Ach|med (arab. m. Vorn.)
a. Chr. [n.] = ante Christum [na-
tum]
Achro|ma|sie gr. [akro...] (Physik:
Brechung der Lichtstrahlen ohne
Zerlegung in Farben) w; -, ...ien;
Achro|mat (Linsensystem, das
Lichtstrahlen nicht in Farben
zerlegt) m; -[e]s, -e; achro|ma-

tisch (Achromasie aufweisend; unbunt); **Achro|ma|tis|mus** (Achromasie) *m*; -, ...men; **Achromat|op|sie** (Med.: Farbenblindheit) *w*; -, ...ien

Achs.bruch od. Ach|sen|bruch, ...druck (*Mehrz.* ...drücke); **Achse** *w*; -, -n

Ach|sel *w*; -, -n; **Ach|sel.griff**, ...höh|le, ...klap|pe; **ach|sel|ständig** (Bot.: in der Blattachsel stehend); **Ach|sel|zucken**, [*Trenn.*: ...zuk|ken] *s*; -s; **ach|sel|zuckend** [*Trenn.*: ...zuk|kend], aber (↑ R 142): mit den Achseln zuckend

Ach|sen.bruch od. Achs|bruch, ...zy|lin|der [...zül..., auch: ...zil...] (Med.); **ach|si|al** (falsche Schreibung für: axial); **ach|sig** (für: axial); ...ach|sig (z. B. einachsig); **Ach|sig|keit** (für: Axialität); **Achs|ki|lo|me|ter** (Maßeinheit bei der Eisenbahn); **Achs|la|ger** (*Mehrz.* ...lager); **achs|recht** (für: axial)

acht; I. *Kleinschreibung* (↑ R 135): wir sind [unser] acht; eine Familie von achten (ugs.); wir sind zu acht; die ersten, letzten acht; acht und eins macht, ist (nicht: machen, sind) neun; die Zahlen von acht bis zwölf; acht zu vier (8 : 4); mit achten fahren; er ist über acht [Jahre]; ein Kind von acht [bis zehn] Jahren; es ist [um] acht [Uhr]; es schlägt eben acht; ein Viertel auf, vor acht; halb acht; gegen acht [Uhr]; Punkt, Schlag acht [Uhr]; im Jahre acht. II. *Großschreibung* (↑ R 118): die Acht usw. (vgl. ¹Acht [Ziffer, Zahl]). III. *Ableitungen und Zusammensetzungen:* achtens; achtel (vgl. d.); das Achtel (vgl. d.); der Achter (vgl. d.); acht[und]einhalb; achtundzwanzig; achterlei; achtfach; achtjährig (vgl. d.); achtmal (vgl. d.); achtmillionste; Achtpfennigmarke (vgl. d.). IV. *Schreibung mit Ziffer*: 8jährig; 8mal, aber: 8 mal 2; 8-Pfennig-Marke (↑ R 157); ¹Acht (Ziffer, Zahl) *w*; -, -en; die Zahl, Ziffer -; eine - schreiben; eine arab., röm. -; eine - fahren (Eislauf); mit der- (ugs. für: [Straßenbahn]-linie 8) fahren

²**Acht** (Aufmerksamkeit; Fürsorge) *w*; -; (↑ R 132:) [ganz] außer acht lassen; sich in acht nehmen; achtgeben (vgl. d.); achthaben (vgl. d.), aber: aus der Acht, außer aller Acht lassen; das Außerachtlassen (↑ R 120 u. R 156)

³**Acht** (Ausschließung [vom Rechtsschutz]; Ächtung) *w*; -; in Acht und Bann tun

Acht|ach|ser (mit Ziffer: 8achser; ↑ R 228)

acht.ar|mig, ...bän|dig
acht|bar; **Acht|bar|keit** *w*; -
ach|te; I. *Kleinschreibung* (↑ R 135): der achte (der Reihe nach); der achte, den ich treffe; das achte Kind; der achte, am achten Januar; jeder achte. II. *Großschreibung*: a) (↑ R 118:) der Achte (der Leistung nach); der Achte, am Achten [des Monats]; b) (↑ R 224:) Heinrich der Achte; **Achteck**; **acht|eckig** [*Trenn.*: ...ek|kig]; **acht|ein|halb**, acht[und]ein|halb
ach|tel; ein - Zentner, drei - Liter, aber (Maß): ein Achtelliter; **Achtel** *s* (schweiz. meist: *m*); -s, -; ein, das - vom Zentner; ein - des Weges; ein - Mehl; ein - Rotwein; drei - des Ganzen, aber: im Dreiachteltakt (mit Ziffern: im ³/₈-Takt; ↑ R 157); **Ach|tel.fi|na|le** (Sportspr.), ...li|ter (vgl. achtel), ...los, ...no|te, ...pau|se, ...zent|ner (vgl. achtel)
ach|ten
äch|ten
Ach|ten|der (ein Hirsch mit acht Geweihenden); **ach|tens**; **Ach|ter** (Ziffer 8; Form einer 8; ein Boot für acht Ruderer; Wein aus dem Jahre acht [eines Jahrhunderts])
Äch|ter (hist. für: Geächteter)
ach|ter|aus (Seemannsspr.: nach hinten)
Ach|ter|bahn; [auf, mit der] Achterbahn fahren
Ach|ter|deck (Hinterdeck); **achter|la|stig** (Seemannsspr.: achtern tiefer liegend als vorn); ein -es Schiff
ach|ter|lei
ach|ter|lich (Seemannsspr.: von hinten kommend); **ach|tern** (Seemannsspr.: hinten); nach-
Ach|ter|ren|nen (Ruderregatta für Achter [Boote für acht Ruderer])
Ach|ter|ste|ven (Seemannsspr.)
acht|fach; **Acht|fa|che** (mit Ziffer: 8fache) *s*; -n (↑ R 287 ff.); [um] ein -s; um das -; **acht.fal|tig** (acht Falten habend), ...fäl|tig (veralt. für: achtfach); **Acht|flach** = -[e]s, -e, **Acht|fläch|ner** (für: Oktaeder); **Acht|fü|ßer** (für: Oktopode)
acht|ge|ben; er gibt acht (↑ R 132); achtgegeben; achtzugeben; gib acht!; aber: auf etwas größte Acht geben
acht|ha|ben; vgl. achtgeben
acht|hun|dert; vgl. hundert; **acht|jäh|rig** (mit Ziffer: 8jährig); **Acht|jäh|ri|ge** (mit Ziffer: 8jährige) *m* u. *w*; -n, -n (↑ R 287 ff.); **Acht|kampf** (Sportspr.)
acht|los; -este (↑ R 292); **Acht|lo|sig|keit**
acht|mal, aber: acht mal zwei (mit Ziffern: 8 mal 2) ist (nicht: sind)

sechzehn; achtmal so groß wie (seltener: als) ...; acht- bis neunmal (↑ R 145); vgl. bis; **acht|ma|lig**; **acht|mil|li|on|ste**; **Acht|pfennig|mar|ke** (mit Ziffer: 8-Pf-Marke oder 8-Pfennig-Marke; ↑ R 157)

acht|sam; **Acht|sam|keit**
Acht.span|nig, ...stöckig [*Trenn.*: ...stök|kig]
Acht|stun|den|tag; **acht|tau|send** (vgl. tausend); **Acht|ton|ner** (mit Ziffer: 8tonner; ↑ R 228); **Acht|uhr|zug** (mit Ziffer: 8-Uhr-Zug; ↑ R 157); **acht.[und]ein|halb**, ...und|zwan|zig; vgl. acht
Ach|tung *w*; - ; - vor...; Achtung!
Äch|tung
ach|tung|ge|bie|tend, aber (↑ R 142): eine große Achtung gebietende Persönlichkeit; **Achtungs.ap|plaus**, ...be|zei|gung, ...er|folg; **Ach|tung|stel|lung** schweiz. (milit.: Strammstehen) *w*; -; **ach|tungs|voll**

acht|zehn; vgl. acht; im Jahre achtzehnhundert; **Acht|zehn|en|der** (ein Hirsch mit achtzehn Geweihenden); **acht|zehn|jäh|rig** vgl. achtjährig
acht|zig; I. *Kleinschreibung* (↑ R 135): er ist achtzig Jahre alt; mit achtzig [Jahren] (vgl. achtzig, II); im Jahre achtzig [eines Jahrhunderts]; mit achtzig [Sachen] (ugs. für: achtzig Stundenkilometer) fahren; Tempo achtzig; auf achtzig bringen (ugs. für: wütend machen). II. *Großschreibung* (↑ R 118): Mitte [der] Achtzig; der Mensch über Achtzig (auch: achtzig [Jahre]); mit Achtzig (auch: achtzig [Jahren]) kannst du dich nicht mehr; in die Achtzig kommen; vgl. acht; **Acht|zig** (Zahl) *w*; -, -en; vgl. ¹Acht
acht|zi|ger (mit Ziffern: 80er); I. *Kleinschreibung* (↑ R 135): - Jahrgang (aus dem Jahre achtzig [eines Jahrhunderts]); in den achtziger Jahren [des vorigen Jahrhunderts], aber: in den Achtzigerjahren (über achtzig Jahre alt) war er noch rüstig. II. *Großschreibung* (↑ R 118): Mitte der Achtziger; in den Achtzigern (über achtzig Jahre alt) sein; **Acht|zi|ger** (jmd., der [über] 80 Jahre ist; Wein aus dem Jahre achtzig [eines Jahrhunderts]; österr. auch: 80. Geburtstag); **Acht|zi|ge|rin** *w*; -,-nen; **Acht|zi|ger|jah|re** *Mehrz.*; vgl. achtziger, I; **acht|zi|ger|lei**; **acht|zig|fach**; vgl. achtfach; **acht|zig.jäh|rig** (vgl. achtjährig), ...mal (acht|zig|ste; vgl. achte; **Acht|zig|stel** vgl. achtel; **Acht|zig|stel** *s* (schweiz. meist: *m*); -s, -; vgl. Achtel

acht.zöl|lig. (auch:) ...zol|lig;
Acht|zy|lin|der[1] (ugs. für: Achtzylindermotor od. damit ausgerüstetes Kraftfahrzeug); Acht|zylin|der|mo|tor[1]; acht|zy|lin|drig[1]
Achy|lie gr. (Med.: Mangel an Verdauungssäften) w; -, ...ien
äch|zen; du ächzt (ächzest)
a. c. i. = accusativus cum infinitivo; vgl. Akkusativ
Aci|di|tät lat. [azi...] (Säuregrad einer Flüssigkeit) w; -; Aci|do|se (krankhafte Vermehrung des Säuregehaltes im Blut) w; -, -n; Aci|dur ⓦ (säurebeständige Gußlegierung) s, -s
Acker[2] m; -s, Äcker; 30 - Land (↑ R 321 f.); Acker|bau[2] m; -[e]s; Acker|bau|er[2] (veralt. für: Landwirt) m; -n (seltener: -s), -n u. (Bebauer des Ackers:) m; -s, -; acker|bau|trei|bend[2]; die ackerbautreibenden Bewohner, aber (↑ R 142): es gibt viele noch Akkerbau treibende Einwohner[2]; Äcker|chen[2]; Acker|flä|che[2]; Acker|mann vgl. Ackersmann; Acker|men|nig[2], Odermennig (ein Heilkraut) m; -[e]s, -e; akkern; ich ...ere (↑ R 327); Ackernah|rung[2] (Ackerfläche, die zum Unterhalt einer Familie ausreicht) w; -; Acker[s]|mann[2] (veralt.; Mehrz. ...leute u. ...männer)
Ack|ja schwed. (lappische Schlitten in Bootsform; auch: Rettungsschlitten der Bergwacht) m; -[s], -s
à con|di|ti|on fr. [a kongdißjong] („auf Bedingung"; Abk.: à c.)
a con|to lt. [- konto] (auf [laufende] Rechnung von ...; Abk.: a c.); vgl. Akontozahlung
Acquit fr. [akị] (veralt. für: Empfangsbescheinigung) s; -s, -s
Acre engl. [eịkⁱr] (Flächenmaß) m; -s, -s; 7 - [Wiesen]land (↑ R 321 f.)
Acryl|säu|re gr.; dt. [akrül...] (Äthylencarbonsäure [Ausgangsstoff vieler Kunstharze]) w; -
ACS = Automobil-Club der Schweiz
Ac|ti|ni|um [akt...] (chem. Grundstoff; Zeichen: Ac) s; -s
Ac|tion engl. [äkschⁿn] (spannende [Film]handlung) w; -; Ac|tion-pain|ting [...peᵢnting] (moderne Richtung innerhalb der amerik. abstrakten Malerei) s; -
a d = a dato
a. d. = an der (bei Ortsnamen, z. B. Bad Neustadt a. d. Saale)
a. D. = außer Dienst
A. D. = Anno Domini
Ada (w. Vorn.)

[1] ...zül..., auch: ...zil...
[2] Trenn.: ...k|k...

Ada|bei österr. ugs. (jmd., der überall dabeisein will)
ad ab|sur|dum lat.; - - führen (das Widersinnige nachweisen)
ADAC = Allgemeiner Deutscher Automobil-Club
ad ac|ta lat. („zu den Akten"; Abk.: a. a.); - - legen
ada|gio it. [adadscho, auch: adaschio] (Musik: sanft, langsam, ruhig); Ada|gio (langsames Tonstück) s; -s, -s
Adal|bert, Adel|bert (m. Vorn.); Adal|ber|ta, Adel|ber|ta (w. Vorn.)
Adam (m. Vorn.); vgl. [1]Riese; Adamit (Angehöriger einer bestimmten Sekte) m; -en, -en (↑ R 268); adami|tisch; Adams|.ap|fel, ...kostüm
Ad|ap|ta|ti|on lat. [...zion] (Physiol.: Anpassungsvermögen [bes. des Auges an Lichtreize]; Biol.: Anpassung an die Umwelt; österr. auch: Anpassung eines Hauses o. ä. an einen bes. Zweck) w; -, (für: Umarbeitung, Bearbeitung eines literarischen Werkes für Film u. Funk auch Mehrz.:) -en; Ad|ap|ter engl. (Zusatzgerät zu einem Hauptgerät) m; -s, -; ad|ap|tie|ren lat. (anpassen [Biol. und Physiol.]; ein literarisches Werk für Film u. Funk umarbeiten; österr. auch: eine Wohnung, ein Haus o. ä. herrichten); Ad|aptie|rung; Ad|ap|ti|on vgl. Adaptation; ad|ap|tiv
ad|äquat lat. (angemessen; entsprechend); Ad|äquat|heit w; -
a da|to lat. [auch: - da...] (vom Tage der Ausstellung [an]; Abk.: a d.)
ADB = Allgemeine Deutsche Biographie
ad ca|len|das grae|cas lat. [- ka... gräkaß] (niemals)
Ad|den|dum lat. (Zusatz, Nachtrag, Ergänzung) s; -s, ...da (meist Mehrz.); ad|die|ren (zusammenzählen); Ad|dier|ma|schi|ne
Ad|dis Abe|ba [auch: - abeba] (Hptst. Äthiopiens)
Ad|di|ti|on lat. [...zion] (Zusammenzählung); ad|di|tio|nal (zusätzlich); Ad|di|ti|ons|wort (svw. Kopulativum; Mehrz. ...wörter); ad|di|tiv (hinzufügend, auf Addition beruhend); Ad|di|tiv engl. (Zusatz, der einen chem. Stoff verbessert) s; -s, -e [...w⁴]
Ad|di|zie|ren lat. (zusprechen, zuerkennen)
Ad|duk|ti|on lat. [...zion] (Med.: Anziehen eines Gliedes zur Körperachse hin); Ad|duk|tor (eine Adduktion bewirkender Muskel, Anziehmuskel) m; -s, ...oren

ade!; ade sagen; Ade s; -s, -s
...ade (z. B. Fassade w; -, -n)
Ade|bar niederd. (Storch) m; -s, -e
[1]Adel m; -s
[2]Adel mdal., bes. bayr. u. österr. (Mistjauche) m; -s
[1]Ade|laide [ädᵉlid] (Hptst. von Südaustralien)
[2]Ade|la|ide (w. Vorn.); Adel|bert, Adal|bert (m. Vorn.); Adel|berta, Adal|ber|ta (w. Vorn.)
Ade|le (w. Vorn.)
Adel|gund, Adel|gun|de (w. Vorn.); Adel|heid (w. Vorn.); ade|lig, adlig; adeln; ich ...[e]le (↑ R 327), Adels|.brief, ...prä|di|kat; adelsstolz; Ade|lung
Aden (Hafenstadt im Jemen)
Ade|nau|er (erster dt. Bundeskanzler)
Ade|nom gr. (Drüsengeschwulst) s; -s, -e; ade|no|ma|tös
Ad|ept lat. ([als Schüler] in eine Geheimlehre Eingeweihter, bes. Goldmacher) m; -en, -en (↑ R 268)
Ader w; -, -n; Äder|chen, Äder|lein; ad[e]|rig, äd[e]|rig; Ader|laß m; ...lasses, lässe; ädern; ich ...ere (↑ R 327); vgl. geädert; Ade|rung
à deux mains fr. [a dö mäng] (Klavierspiel: mit zwei Händen)
ad|go (Allgemeine Deutsche Gebührenordnung für Ärzte) w; -
ad|hä|rie|ren lat. (anhaften; anhängen [von Körpern od. Geweben]); Ad|hä|si|on (Aneinanderhaften von Körpern); Ad|hä|sions.bahn, ...kraft w
ad hoc lat. [auch: - hok] ([eigens] zu diesem Zweck)
adia|ba|tisch gr. (Physik, Meteor.: ohne Wärmeaustausch)
Adia|pho|ra gr. (Gleichgültiges; Philos.: belanglose Dinge) Mehrz.
adieu! fr. [adjö] („Gott befohlen!"; veralt., landsch.: lebe [lebt] wohl!); jmdm.- sagen; Adieu (veralt. für: Lebewohl) s; -s, -s
Adi|ge [adidsche] (it. Name für: Etsch); vgl. Alto Adige
Ädil (altröm. Beamter) m; -en, -en (↑ R 268); Ädi|li|tät (Ädilenamt, -würde) w; -
ad in|fi|ni|tum, in in|fi|ni|tum lat. („bis ins Grenzenlose"; ohne Ende, unaufhörlich)
Ad|jek|tiv [auch: ...tif] lat. (Sprachw.: Eigenschaftswort, Artwort, z. B. „schön") s; -s, -e [...w⁴]; ad|jek|ti|visch [auch: ...ti...]
Ad|ju|di|ka|ti|on [...zion] lat. (richterl. Zuerkennung); ad|ju|di|zieren
Ad|junkt lat. (veralt. für: [Amts]gehilfe; österr. u. schweiz. Beamtentitel) m; -en, -en (↑ R 268)

adjustieren

ad|ju|stie|ren *lat.* ([Werkstücke]
zurichten; eichen; fein einstellen;
österr. auch: ausrüsten, dienst-
mäßig kleiden); Ad|ju|stie|rung
(österr. auch: Uniform)
Ad|ju|tant *lat.* (beigeordneter Offi-
zier) *m*; -en, -en (↑ R 268); Ad|ju-
tan|tur (Amt, Dienststelle des
Adjutanten) *w*; -, -en; Ad|ju|tum
(veralt. für: [Bei]hilfe; österr.: er-
ste, vorläufige Entlohnung) *s*; -s,
...ten
ad l. = ad libitum
Ad|la|tus *lat.* (Beistand; Helfer) *m*;
-, ...ten (auch: ...ti)
Ad|ler *m*; -s, -; der Hohe Orden
vom Schwarzen -; der Orden vom
Roten -; Ad|ler|blick
ad lib. = ad libitum
ad li|bi|tum *lat.* (nach Belieben;
Abk.: ad l., ad lib., a. l.)
ad|lig, ade|lig; Ad|li|ge *m* u. *w*; -n,
-n (↑ R 287 ff.)
ad maio|rem Dei glo|ri|am, (meist
für:) omnia ad maiorem Dei glo-
riam *lat.* („[alles] zur größeren
Ehre Gottes"; Wahlspruch der
Jesuiten)
Ad|mi|ni|stra|ti|on *lat.* [...*zion*]
(Verwaltung[sbehörde]); ad|mi-
ni|stra|tiv (zur Verwaltung gehö-
rend); Ad|mi|ni|stra|tor (Verwal-
ter) *m*; -s, ...oren; ad|mi|ni|strie-
ren (verwalten)
ad|mi|ra|bel *lat.* (veralt. für: be-
wundernswert); ...a|ble Schriften
Ad|mi|ral *fr.* (Marineoffizier im
Generalsrang; ein Schmetter-
ling) *m*; -s, -e (seltener: ...äle);
Ad|mi|ra|li|tät; Ad|mi|ra|li|täts-
in|seln (Inselgruppe in der Süd-
see) *Mehrz.*; Ad|mi|rals|rang; Ad-
mi|ral|stab (oberster Führungs-
stab einer Kriegsmarine)
Ad|mo|ni|ti|on *lat.* [...*zion*] (Er-
mahnung zur Buße bei der Beich-
te)
ADN = Allgemeiner Deutscher
Nachrichtendienst (DDR)
Ad|nex (Anhang) *m*; -es, -e
ad no|tam *lat.*; - - (zur Kenntnis)
nehmen
ad ocu|los *lat.* [- *ok*...]; - - demon-
strieren („vor Augen" führen,
klar darlegen)
Ado|les|zenz *lat.* (späterer Ab-
schnitt des Jugendalters, etwa
17.–20. Lebensjahr) *w*; -
Adolf (m. Vorn.)
Ado|nai *hebr.* („mein Herr"; alt-
test. Name Gottes)
¹Ado|nis (schöner Jüngling der gr.
Sage); ²Ado|nis (schöner Jüng-
ling, Mann) *m*; -, -se; ado|nisch
(schön wie Adonis); -er Vers (an-
tiker gr. Vers)
ad|op|tie|ren *lat.* (an Kindes Statt
annehmen); Ad|op|ti|on [...*zion*];
Ad|op|tiv|el|tern, ...kind

ad|ora|bel *lat.* (veralt. für: anbe-
tungswürdig); ...a|ble Heilige;
Ad|orant (Anbetender) *m*; -en,
-en (↑ R 268); Ad|ora|ti|on [...*zion*]
(Anbetung; Verehrung; Huldi-
gung); ad|orie|ren (anbeten, ver-
ehren)
Adr. = Adresse
ad rem *lat.* (zur Sache [gehörend])
Adre|ma ⓦ (Kurzw.; eine Adres-
siermaschine) *w*; -, -s
Ad|re|na|lin *gr.* (Hormon des Ne-
bennierenmarks) *s*; -s
Adres|sant *lat.* (Absender) *m*; -en,
-en (↑ R 268); Adres|sat (Empfän-
ger; [bei Wechseln:] Bezogener)
m; -en, -en (↑ R 268); Adreß|buch;
Adres|se (Abk. [für: Anschrift]:
Adr.) *w*; -, -n; Adres|sen|samm-
lung; adres|sie|ren; Adres|sier-
ma|schi|ne (vgl. Adrema)
adrett *fr.* (nett, hübsch, ordentlich,
sauber)
Adria (Adriatisches Meer) *w*; -;
Adri|an (m. Vorn.); vgl. Hadrian;
Adria|na, Adria|ne (w. Vorn.);
Adria|no|pel (alter Name von
Edirne); Adria|ti|sche Meer *s*; -n
-[e]s
ad|rig, ade|rig; äd|rig, äde|rig
Adrio schweiz. (im Netz eines
Schweinebauchfells eingenähte
Bratwurstmasse aus Kalb- od.
Schweinefleisch) *s*; -s, -s
ad|sor|bie|ren *lat.* ([Gase od.
gelöste Stoffe an der Oberfläche
fester Körper] anlagern); Ad-
sorp|ti|on [...*zion*]; ad|sorp|tiv
(zur Adsorption fähig)
Ad|strin|gens *lat.* (zusammenzie-
hendes, blutstillendes Mittel) *s*;
-, ...genzien [...*i⁸n*], (auch:)
...gentia [...*zia*]; ad|strin|gie|ren
Ädu|er (Angehöriger eines gall.
Stammes) *m*; -s, -
Adu|lar [nach dem Adulaalpen in
Graubünden] (ein Feldspat) *m*;
-s, -e
A-Dur [auch: *adur*] (Tonart; Zei-
chen: A) *s*; -; A-Dur-Ton|lei|ter
(↑ R 155)
ad us. = ad usum
ad usum *lat.* („zum Gebrauch";
Abk.: ad us.); - - Del|phi|ni (für
Schüler bestimmt)
Ad|van|tage *engl.* [*ᵉdwᵃntidseh*]
(der erste gewonnene Punkt nach
dem Einstand [40:40] beim Ten-
nis) *m*; -s, -s
Ad|vent *lat.* [...*wänt*, österr. auch:
...*ſ*...] („Ankunft"; Zeit vor
Weihnachten) *m*; -[e]s, (selten:)
-e; Ad|ven|tist *engl.* (Angehöriger
einer bestimmten Sekte) *m*; -en,
-en (↑ R 268); Ad|vent|kranz
(österr.), ...sonntag (österr.); Ad-
vents|kranz, ...sonn|tag
Ad|verb *lat.* [...*wärp*] (Sprachw.:
Umstandswort, z. B. „dort") *s*;

-s, -ien [...*i⁸n*]; ad|ver|bi|al
[...*wärbi*...] (umstandswörtlich);
adverbiale Bestimmung; Ad|ver-
bi|al|be|stim|mung, ...satz; ad-
ver|bi|ell (seltener für: adverbial)
ad|ver|sa|tiv *lat.* [...*wär*...] (gegen-
sätzlich, entgegensetzend); -e
Konjunktion (entgegensetzen-
des Bindewort, z. B. „aber")
Ad|vo|ca|tus Dei *lat.* [*adwokg*...]
(Geistlicher, der im kath. kirchl.
Prozeß für eine Heilig- od. Selig-
sprechung eintritt) *m*; - -, ...ti -i;
Ad|vo|ca|tus Dia|bo|li (Geist-
licher, der im kath. kirchl. Pro-
zeß Gründe gegen die Heilig-
oder Seligsprechung vorbringt;
allg.: überspitzt scharfer Kriti-
ker; Anwalt des Teufels) *m*; - -,
...ti -i; Ad|vo|kat (veralt.; landsch.
[bes. schweiz.]: [Rechts]anwalt)
m; -en, -en (↑ R 268); Ad|vo|ka|tur
(veralt. für: Anwaltschaft; Büro
eines Anwalts) *w*; -, -en; Ad|vo-
ka|tur|bü|ro (schweiz.); Ad|vo-
ka|turs|kanz|lei (österr. veral-
tend)
AdW = Akademie der Wissen-
schaften
Ady|na|mie *gr.* (Med.: Kraftlosig-
keit) *w*; -, ...ien; ady|na|misch
[auch: *adûna*...]
AE, ÅE vgl. Å
AEG ⓦ = Allgemeine Elektrici-
täts-Gesellschaft
ae|ro... *gr.* [*a-ero*] (luft...); Ae|ro...
(Luft...); ae|rob (Biol.: Sauerstoff
zum Leben brauchend); Ae|ro|bi-
er [...*i⁸r*] (Biol.: Organismus, der
nur bei Zutritt von Luftsauer-
stoff leben kann); Ae|ro|bi|ont
(svw. Aerobier) *m*; -en, -en (↑ R
268); Ae|ro|dy|na|mik (Lehre von
der Bewegung gasförmiger Kör-
per); ae|ro|dy|na|misch; Ae|ro-
gramm (Luftpostleichtbrief); Ae-
ro|lith (veralt. für: Meteorstein)
m; -en u. -s, -e[n] (↑ R 268); Ae|ro-
lo|gie (Wissenschaft von der Er-
forschung der höheren Luft-
schichten) *w*; -; Ae|ro|me|cha|nik
(Lehre von dem Gleichgewicht
u. der Bewegung der Gase) *w*;
-; Ae|ro|me|di|zin (Teilgebiet der
Medizin, das sich mit den physi-
schen Einwirkungen der Luft-
fahrt auf den Organismus be-
faßt) *w*; -; Ae|ro|me|ter (Gerät zum
Bestimmen des Luftgewichtes,
der Luftdichte) *s*; -s, -; Ae|ro|naut
(veralt. für: Flieger) *m*; -en,
-en (↑ R 268); Ae|ro|nau|tik (ver-
alt. für: Luftfahrt); Ae|ro|nau-
tisch (veralt.); Ae|ro|plan *gr.*; *lat.*
(veralt. für: Flugzeug) *m*; -[e]s,
-e; Ae|ro|sol (feinste Verteilung
fester oder flüssiger Stoffe in Gas
[z. B. Rauch od. Nebel]) *s*; -s,
-e; Ae|ro|sta|tik *gr.* (Lehre von

den Gleichgewichtszuständen bei Gasen); **ae|ro|sta|tisch; Ae|ro|train** (Luftkissenzug) **Ae|tit** gr. [a-e...] (veralt. für: Adlerstein, Eisenmineral) m; -s, -e
AF = Air France
Af|fä|re fr. (Angelegenheit; [unangenehmer] Vorfall; Streitsache) w; -, -n
Äff|chen, Äff|lein; Äf|fe m; -n -n (↑ R 268)
Af|fekt lat. (Gemütsbewegung, stärkere Erregung) m; -[e]s, -e; **Af|fek|ta|ti|on** [...zion] (selten für: Getue, Ziererei); **af|fek|tiert** (gezierr gekünstelt); **Af|fek|tiert|heit; Af|fek|ti|on** [...zion] (Med.. Reizung durch einen krankhaften Vorgang od. Zustand; veralt. für: Wohlwollen); **af|fek|tio|niert** (veralt. für: wohlwollend, zugetan); **Af|fek|ti|ons|wert** (veralt. für: Liebhaberwert); **af|fek|tiv** (durch Affekte gekennzeichnet; gefühlsbetont); **Af|fek|ti|vi|tät** w; -
äf|fen; Af|fen|art; af|fen|artig; Af|fen|brot|baum (eine afrik. Baumart); vgl. Baobab; **Af|fen|hit|ze** (ugs.); **Af|fen|lie|be** w; -; **Af|fenschan|de** (ugs.); **Äf|fer** (veralt. für: äffende Person); **Äf|fe|rei** (ugs. abwertend für: eitles Gebaren); **Äf|fe|rei** (veralt. für: Irreführung)
Af|fi|che fr. [auch: afisch*] (selten für: Anschlag[zettel], Aushang) w; -, -n; **af|fi|chie|ren** [afischj...]
Af|fi|da|vit lat. [...wit] (eidesstattl. Versicherung) s; -s, -s
af|fig (ugs. abwertend für: eitel); **Af|fig|keit**
Af|fi|lia|ti|on lat. [...zion] (Aufnahme [z. B. in die FreimaurerlogeI; Beigesellung [z. B. einer Tochtergesellschaft]
af|fin lat.; -e Geometrie
Äf|fin w; -, -nen
af|fi|nie|ren fr. (läutern; scheiden [z. B. von Edelmetallen]); **Af|fi|nie|rung**
Af|fi|ni|tät lat. („Verwandtschaft")
Af|fir|ma|ti|on lat. [...zion] (Bejahung, Zustimmung); **af|fir|ma|tiv** (bejahend, zustimmend)
äf|fisch; -ste (↑ R 294)
Af|fix lat. (Sprachw.: an den Wortstamm angefügte Vor- od. Nachsilbe) s; -es, -e; vgl. Präfix und Suffix
af|fi|zie|ren fr. (Med.: reizen; krankhaft verändern)
Äff|lein, Äff|chen
Af|fo|dill, As|pho|dill gr. (ein Liliengewächs) m; -s, -e
Af|fri|ka|ta, Af|fri|ka|te lat. (Sprachw.: Verschlußlaut mit folgendem Reibelaut, z. B. pf) w; -, ...ten

Af|front fr. [afrong, auch: afront] (Schmähung; Beleidigung) m; -s, -s (auch: -e); **af|fron|tie|ren** (veralt.)
Af|gha|ne (Angehöriger eines vorderasiat. Volkes) m; -n, -n (↑ R 268); **Af|gha|ni** (afghan. Münzeinheit) m; -[s], -[s]; **af|gha|nisch; Af|gha|ni|stan** (Staat in Vorderasien)
AFL engl. [e'äfäl] = American Federation of Labor [*'märik*n fäd*re'sch*n e* le'b*r] (amerik. Gewerkschaftsverband)
AFN engl. [e'äfän] = American Forces Network [*'märik*n fo'ßis nätwö'k] (Rundfunkanstalt der außerhalb der USA stationierten amerik. Streitkräfte)
à fonds per|du fr. [a fong pärdü] (auf Verlustkonto; [Zahlung] ohne Aussicht auf Gegenleistung od. Rückerhalt)
AFP = Agence France-Presse
Afra (w. Vorn.)
à fres|co it. [- ...ko] („auf frischem" [Kalk])
Afri|ka [auch: af...]; **Afri|kaan|der, Afri|kan|der** (selten für: weißer Südafrikaner mit Afrikaans als Muttersprache; **afri|kaans**; die -e Sprache (Sprache der Buren) s; -; **Afri|ka|ner** (Eingeborener, Bewohner von Afrika); **afri|ka|nisch; Afri|ka|nist** (Wissenschaftler auf dem Gebiet der Afrikanistik); (↑ R 268; **Afri|ka|ni|stik** (wissenschaftl. Erforschung der Geschichte, Sprachen u. Kulturen Afrikas) w; -;
afro-amerika|nisch, afro-asia|tisch (↑ R 214)
Af|term; -s, -; **Af|ter.le|der** (österr.: Hinterleder des Schuhes), ...**mie|te** (veralt. für: Untermiete), ...**mie|ter** (veralt. für: Untermieter), **re|de** (veralt.); **af|ter|re|den** (veralt. für: nachreden, verleumden); ist afterrede; afterredet; afterzureden
Af|ter-shave-Lo|tion engl. [aft*r sche'w lo"sch*n] (Rasierwasser zum Gebrauch nach der Rasur); ↑ R 155
Ag = Argentum (chem. Zeichen für: Silber)
a. G. = auf Gegenseitigkeit; (beim Theater:) als Gast
AG = Aktiengesellschaft; An das Bibliographische Institut AG
AG = Amtsgericht
Äga|di|sche In|seln (westl. von Sizilien) Mehrz.
Ägä|is (Ägäisches Meer) w; -;
Ägäi|sche Meer (↑ R 198) s; -n -[e]s
Aga Khan türk. (erblicher Oberhaupt der Sekte der mohammed. Hodschas) m; - -s, - -e

Aga|mem|non (sagenhafter König von Mykenä)
Aga|pe gr. (schenkende [Nächsten]liebe) w; -, (für: Liebesmahl auch Mehrz.:) -n; **Aga|pet, Aga|pe|tus** (Papstname)
Agar-Agar malai. (Gallerte aus ostasiat. Algen) m od. s; -s
Aga|the (w. Vorn.); **Aga|thon** [auch: ag...] (m. Eigenn.)
Aga|ve gr. [...w*] (aloeähnl. Pflanze der [Sub]tropen) w; -, -n
...**a|ge** (z. B. Etage [etasch*] w; -, ...n)
AgenceFrance-Pressefr. [aschangß frangß präß] (Name einer fr. Nachrichtenagentur; Abk.: AFP) w; - -
Agen|da lat. (Merkbuch; Aufstellung der Gesprächspunkte bei polit. Verhandlungen) w; -, ...den; **Agen|de** (Gottesdienstordnung) w; -, -n; **Agen|den** (österr. (Obliegenheiten, Aufgaben) Mehrz.
Agens lat. (Philos.: tätiges Wesen od. Prinzip; Med.: wirkendes Mittel; Sprachw.: Träger eines im Zeitw. genannten aktiven Verhaltens) s; -, Agen|zien [...i*n]
Agent (Spion; veralt. für: Geschäftsvermittler, Vertreter; ↑ R 268; **Agen|ten.ring, ..tä|tig|keit; Agen|tie** it. [...zi] (österr. (Geschäftsstelle der Donau-Dampfschiffahrtsgesellschaft) w; -, ...tien [...zi*n]; **agen|tie|ren** österr. (Kunden werben); **Agen|tin** lat. w; -, -nen; **Agent pro|vo|ca|teur** fr. [aschang prowokatör] (Lockspitzel)m; - -, -s -s [aschang ...tör]; **Agen|tur** lat. (Geschäfts[neben]stelle, Vertretung) w; -, -en; **Agen|zi|en** (Mehrz. von: Agens)
Age|si|la|os vgl. Agesilaus; **Age|si|la|os** (König von Sparta)
¹Ag|fa (Actien-Gesellschaft für Anilin-Fabrikation) w; -; **²Ag|fa** ⓦ (fotogr. Erzeugnisse); **Ag|fa|co|lor** ⓦ [...kolor] (Farbfilme, Farbfilmverfahren)
Ag|glo|me|rat lat. (Geol.: Ablagerung von unverfestigten Gesteinsbruchstücken; Anhäufung von Lavabrocken) s; -[e]s, -e; **Ag|glo|me|ra|ti|on** [...zion] (Anhäufung; Zusammenballung); **ag|glo|me|rie|ren**
Ag|glu|ti|na|ti|on lat. [...zion] (Med.: Verklebung, Verklumpung; Sprachw.: Anfügung von Bildungselementen an das unverändert bleibende Wort) w; -, -en; **ag|glu|ti|nie|ren**; -de Sprachen
Ag|gre|gat lat. (Maschinensatz; aus mehreren Gliedern bestehender mathemat. Ausdruck) s; -[e]s, -e; **Ag|gre|ga|ti|on** [...zion] (Vereinigung [von Molekülen]); **Ag-**

gre|gat|zu|stand (Erscheinungsform eines Stoffes)

Ag|gres|si|on. (Angriff[sverhalten], Überfall); Ag|gres|si̱ons̱.krieg, ...trieb; ag|gres|siv (angreifend; angriffslustig); Ag|gres|si|vi|tät; Ag|gres|sor (Angreifer) m; -s, ...oren

Ägid, Ägi|di|us (m. Vorn.); Ägi|de gr. (Schutz, Obhut) w; -; unter der - von ...

agie|ren lat. (handeln; Theater: eine Rolle spielen)

agil lat. (flink, wendig, beweglich); Agi|li|tät w; -

Ägi|na (gr. Insel; Stadt); Ägi|ne|te (Bewohner von Ägina) m; -n, -n (↑ R 268); Ägi|ne|ten (Giebelfiguren des Tempels von Ägina) Mehrz.

Agio it. [a̱dseho, auch: a̱sehio] (Aufgeld) s; -s; Agio|ta|ge fr. [a̱sehiotasehᵉ, österr.: ...tasehᵉ] (Ausnutzung von Kursschwankungen an der Börse); agio|teur [a̱sehiotö̱r] (Börsenmakler) m; -s, -e; agio|ti̱e|ren

Ägir (nord. Mythol.: Meerriese)

Ägis (Schild des Zeus und der Athene) w; -

Agi|ta|ti|on lat. [...zio̱n] (politische Hetze; intensive politische Aufklärungs-, Werbetätigkeit); Agi|ta|tor (jmd., der Agitation betreibt) m; -s, ...oren; agi|ta|to̱risch; agi|tie|ren; Agit|prop (Kurzw. aus: Agitation und Propaganda); Agit|prop|thea|ter (Laientheater in sozialist. Ländern)

Aglaia („Glanz"; eine der drei gr. Göttinnen der Anmut, der Chariten; w. Vorn.)

Agnat lat. (männl. Blutsverwandter der männl. Linie) m; -en, -en (↑ R 268); agna|tisch

Agnes (w. Vorn.)

Ag|ni (ind. Gott des Feuers)

Agno|men lat. (Beiname) s; -s, ...mina

Agno|sie̱ gr. (Med.: Störung des Erkennens; Philos.: Nichtwissen) w; -, ...ien; Agno|sti|ker (Verfechter des Agnostizismus); Agno|sti|zis|mus (philos. Lehre, die das übersinnliche Sein für unerkennbar hält) m; -; agnos|zie̱ren lat. (veraltet. für: anerkennen); (österr. Amtsspr.:) einen Toten - (identifizieren); Agnos|zie̱|rung

Agnus Dei lat. („Lamm Gottes"; Bezeichnung Christi; Gebet; Wachstäfelchen) s; -, - -

Ago|gik gr. (Musik: Lehre von der individuellen Gestaltung des Tempos) w; -; ago|gisch

à go|go fr. [ago̱go̱] (in Hülle u. Fülle, nach Belieben)

Agon gr. (Wettkampf der alten

Griechen; Streitgespräch als Teil der alt. Komödie) m; -s, -e; ago|nal (wettkampfmäßig); Ago|nie (Todeskampf) w; -, ...ien; Agonist (Wettkämpfer); ↑ R 268

¹Ago|ra gr. (Markt u. auch die dort stattfindende Volksversammlung im alten Griechenland) w; -

²Ago|ra hebr. (israel. Währungseinheit) w; -, Agorot

Agraf|fe fr. (Schmuckspange; Bauw.: klammerförmige Rundbogenverzierung; Med.: Wundklammer; schweiz. auch: Krampe) w; -, -n

Agram, (offz.:) Za|greb [sa̱gräp] (jugoslaw. Stadt)

Agra|phie gr. (Med.: Verlust des Schreibvermögens) w; -, ...ien

Agrar|be|völ|ke|rung; Agra|ri|er lat. [...i̱ᵉr] (Großgrundbesitzer, Landwirt; oft mit abwertendem Sinn); agra|risch; Agrar.po|li|tik, ...re|form

Agrasel ostösterr. mdal. (Stachelbeere) s; -s, -n (meist Mehrz.)

Agree|ment engl. [ᵉgri̱mᵉnt] (Politik: formlose Übereinkunft im zwischenstaatl. Verkehr) s; -s, -s; vgl. Gentleman's Agreement); agre|ieren lat. (selten für: genehmigen); Agré|ment fr. [agremą̱ŋ] (Politik: Zustimmung zur Ernennung eines diplomat. Vertreters) s; -s, -s; Agré|ments [agremą̱ŋß] (musik. Verzierungen) Mehrz.

Agri|co|la [...kola], Georgius (dt. Naturforscher)

Agri|kul|tur lat. (Ackerbau, Landwirtschaft); Agri|kul|tur|che|mie

Agrip|pa (röm. m. Eigenn.); Agrip|pi|na (röm. w. Eigenn.)

Agro|nom gr. (wissenschaftlich ausgebildeter Landwirt) m; -en, -en (↑ R 268); Agro|no|mie (Akkerbaukunde, Landwirtschaftswissenschaft) w; -; agro|no|misch; Agro|tech|nik (DDR: Lehre von der Technisierung der Landwirtschaft)

Agru|men, Agru|mi · it. (veraltet. Sammelname für Zitrusfrüchte) Mehrz.

Agryp|nie̱ gr. (Med.: Schlaflosigkeit) w; -

Ägyp|ten (Staat); Arabische Republik Ägypten; Ägyp|ter; ägyptisch; (↑ R 200:) eine -e (tiefe) Finsternis; -e Augenkrankheit; vgl. deutsch; Ägyp|tisch (Sprache) s; -[s]; vgl. Deutsch; Ägyp|ti|sche s; -n; vgl. Deutsche s; Ägyp|to|lo|ge (Wissenschaftler auf dem Gebiet der Ägyptologie) m; -n, -n (↑ R 268); Ägyp|to|lo|gie (wissenschaftl. Erforschung des ägypt. Altertums) w; -; Ägyp|to|lo|gisch

A. H. = Alter Herr (einer student. Verbindung)

Ah = Amperestunde

ah! [auch: a̱]; ah so!; ah was!; Ah s; -s, -s; ein lautes - ertönte; äh! [auch: ä̱]; aha! [auch: aha̱]; Aha-Er|leb|nis [auch: aha̱...] (Psych.); ↑ R 151

Ahas|ver [...we̱r, auch: aha̱s...]; Ahas|ve̱|rus [latinis. Form des hebr. Namens des Xerxes] („Fürst"; der Ewige Jude); ahas|ve̱|risch (ruhelos, umherirrend)

ahd. = althochdeutsch

Ah|le (Pfriem) w; -, -n

Ah|ming (Tiefgangsmarke am Schiff) w; -, -e u. -s

Ahn (Stammvater, Vorfahr) m; -[e]s u. -en, -en (↑ R 268)

ahn|den (geh. für: strafen; rächen); Ahn|dung

¹Ah|ne (geh. Nebenform von: Ahn) m; -n, -n (↑ R 268); ²Ah|ne (Stammutter, Vorfahrin) w; -, -n

äh|neln; ich ...[e]le (↑ R 327)

ah|nen

Ah|nen.bild, ...ga|le|rie, ...kult, ...rei|he, ...ta|fel; Ahn.frau, ...herr

ähn|lich; I. Kleinschreibung (↑ R 135): ähnliches (solches); und vgl. Gentleman's Agreement; und dem ähnliche[s] (Abk.: u. ä.); und dem ähnliche[s] (Abk.: u. d. ä.). II. Großschreibung: a) (↑ R 116:) das Ähnliche; Ähnliches und Verschiedenes; b) (↑ R 116:) etwas, viel, nichts Ähnliches; Ähn|lich|keit

Ah|nung; ah|nungs|los, -este (↑ R 292); Ah|nungs|lo|sig|keit; ah|nungs|voll

ahoi! [aho̱y] (Seemannsspr.: Anruf [eines Schiffes]); Boot ahoi!

Ahorn (ein Laubbaum) m; -s, -e

Ahr (l. Nebenfluß des Rheins) w; -

äh|re|w; -, -n; Äh|ren|le|se; ...äh|rig (z. B. kurzährig)

Ahu|ra Mas|dah („der weise Herr"; Gestalt der iran. Religion); vgl. Ormuzd

AHV = Alters- und Hinterlassenenversicherung (Schweiz)

Ai indian. (Dreifingerfaultier) s; -s, -s

Ai|chin|ger (österr. Schriftstellerin)

Ai|da (Titelgestalt der gleichnamigen Oper von Verdi)

Aide fr. [ä̱t] (Mitspieler, Partner; schweiz. für: Küchengehilfe, Hilfskoch; veralt. für: Gehilfe) m; -n, -n (↑ R 268); Aide-mé|moire [...memoa̱r] (Politik: Niederschrift von mündl. getroffenen Vereinbarungen) s; -, -[s]

Ai|gret|te fr. [ägrä̱t] ([Reiher]federschmuck; Büschelförmiges) w; -, -n

Ai|ki|do jap. (jap. Form der Selbstverteidigung) s; -[s]

Ai|nu (Ureinwohner der jap. Inseln u. Südsachalins) m; -[s], -[s]

Air *fr.* [*är*] (Aussehen, Haltung; Fluidum) *s*; -s, (selten:) -s

Air|bus *engl.* [*är*...] (neben dem Liniendienst bestehende Luftverkehrseinrichtung für den Passagierdienst auf den kurzen Strecken); **Air-Conditioning** [*ärkondisch*e*ning*] (Klimaanlage) *s*; -s, -s

Aire|dale|ter|ri|er *engl.* [*ärde*e*l*...] (eine Hunderasse)

Air France [*är fra͞ngß*] (fr. Luftfahrtges.; Abk.: AF) *w*; - -

Ais|chy|los vgl. Äschylus

Aisne [*än*] (fr. Fluß) *w*; -; **Aisne|tal** *s*; -[e]s

Al|tel südd., österr. schweiz. (svw. ¹Döbel)

Aja *it.* (veralt. für: Erzieherin; Scherzname für Goethes Mutter) *w*; -, -s

Ajax (gr. Sagengestalt)

à jour *fr.* [*a schur*] (bis zum [heutigen] Tag; - - auf dem laufenden sein; [österr. : ajour]: „zutage“ tretend; durchbrochen [von Spitzen u. Geweben]; - - gefaßt: nur am Rande gefaßt [von Edelsteinen]); **Ajour|ar|beit** (durchbrochene Arbeit); **ajourie|ren** österr. (Ajourarbeit machen)

AK = Aktienkapital; Armeekorps

Aka|de|mie *gr.* (gelehrte Gesellschaft; [Fach]hochschule; österr. auch: literar. od. musik. Veranstaltung) *w*; -, ...ien; **Aka|de|miker** (Person mit Hochschulausbildung); **aka|de|misch**; das -e Viertel; vgl. cum tempore

Akan|thit *gr.* (ein Mineral) *m*; -s; **Akan|thus** (stachliges Staudengewächs) *m*; -, -; **Akan|thus|blatt**

Aka|ro|id|harz *gr.*; *dt.* (ein Baumharz)

aka|ta|lek|tisch *gr.* (Verslehre: nicht katalektisch, unverkürzt)

Aka|tho|lik *gr.* [auch: ...lík] (nichtkatholischer Christ) *m*; -en, -en († R 268); **aka|tho|lisch** [auch: ...olisch]

Aka|zie *gr.* [...*i*e*] (trop. Laubbaum od. Strauch) *w*; -, -n

Ake|lei *mlat.* (eine Zierpflanze) *w*; -, -en

Aki (= Aktualitätenkino) *s*; -s, -s

Akk. = Akkusativ

Ak|kad (Hptst. des Reiches Akkad); **ak|ka|disch**; vgl. deutsch; **Ak|ka|disch** (Sprache) *s*; -[s]; vgl. Deutsch; **Ak|ka|di|sche** *s*; -n; vgl. Deutsche *s*

Ak|kla|ma|ti|on *lat.* [...*zion*] (Zuruf; Beifall); **ak|kla|mie|ren**

Ak|kli|ma|ti|sa|ti|on *lat.* [...*zion*] (Anpassung); **ak|kli|ma|ti|sieren**; sich -; **Ak|kli|ma|ti|sie|rung**

Ak|ko|la|de *fr.* (feierliche Umarmung beim Ritterschlag u. a.; Druckw.: Klammer ⌒⌒)

ak|kom|mo|da|bel *fr.* (anpassungsfähig; zweckmäßig); ...a|ble Organe; **Ak|kom|mo|da|ti|on** [...*zion*] (Anpassungsfähigkeit, Angleichung); **Ak|kom|mo|da|tions|fä|hig|keit**; **ak|kom|mo|dieren**

Ak|kom|pa|gne|ment *fr.* [*akompanj*e*mang*] (Musik: Begleitung) *s*; -s, -s; **ak|kom|pa|gnie|ren**

Ak|kord *lat.* (Musik: Zusammenklang; Wirtsch.: Stücklohn; Übereinkommen) *m*; -[e]s, -e; **Akkord|ar|beit**, ...ar|bei|ter; **Akkor|de|on** (Handharmonika) *s*; -s, -s; **ak|kor|deo|ni|stisch**; **ak|kordie|ren** (zusammenstimmen; vereinbaren; veralt. für: einen [polit.] Vertrag abschließen)

ak|kre|di|tie|ren *fr.* (Politik: beglaubigen; bevollmächtigen); *it.* (Kredit einräumen, verschaffen); jmdn. bei einer Bank für eine Betrag-; **Ak|kre|di|tiv** *fr.* (Politik: Beglaubigungsschreiben eines Botschafters; Wirtsch.: Handelsklausel, Kreditbrief) *s*; -s, -e [...*w*e]

Ak|kres|zenz *lat.* (veralt. für: Anwachsen [des Erbteils]) *w*; -, -en; **ak|kres|zie|ren**

Ak|ku (Kurzw. für: Akkumulator) *m*; -s, -s; **Ak|ku|mu|lat** *lat.* (Anhäufung von Gesteinstrümmern) *s*; -[e]s, -e; **Ak|ku|mu|la|tion** [...*zion*] (Anhäufung); **Ak|kumu|la|tor** (ein Stromspeicher; ein Druckwasserbehälter; Kurzw.: Akku) *m*; -s, ...oren; **ak|ku|mulie|ren** (anhäufen; sammeln, speichern)

ak|ku|rat *lat.* (sorgfältig, ordentlich; landsch. für: genau); **Ak|kura|tes|se** *fr.* *w*; -

Ak|ku|sa|tiv *lat.* [auch: ...tíf] (Sprachw.: Wenfall, 4. Fall; Abk.: Akk.) *m*; -s, -e [...*w*e]; **Akkusativ mit Infinitiv**, (lat.:) **accusativus cum infinitivo** (Sprachw.: eine bestimmte grammatische Konstruktion; Abk.: acc. c. inf. od. a. c. i.); **Ak|ku|sa|tiv|ob|jekt** [auch: ...tíf...]

Ak|me *gr.* (Med.: Gipfel; Höhepunkt [einer Krankheit]) *w*; -

Ak|ne *gr.* (Med.: Hautausschlag) *w*; -, -n

Ako|lyth (selten für: Akolyth); **Ako|lyth** *gr.* (kath. Kleriker im 4. Grad der niederen Weihen) *m*; -en († R 268) u. -s, -en

Ako|nit *gr.* (Eisenhut, Sturmhut [Pflanze]) *s*; -s, -e

Akon|to *it.* österr. (Anzahlung) *s*; -s, ...ten u. -s; **Akon|to|zah|lung** (Abschlagszahlung); vgl. a conto

ak|qui|rie|ren *lat.* (als Akquisiteur tätig sein; veralt. für: erwerben); **Ak|qui|si|teur** *fr.* [...*tör*] (Kun-

den-, Anzeigenwerber) *m*; -s, -e; **Ak|qui|si|ti|on** [...*zion*] (Kundenwerbung durch Vertreter; veralt. für: Erwerbung); **Ak|qui|si|tor** österr. (vgl. Akquisiteur) *m*; -s, ...oren; **ak|qui|si|to|risch**

Akri|bie *gr.* (höchste Sorgfalt, Genauigkeit) *w*; -; **akri|bisch**; -ste († R 294)

Akro|bat *gr.* *m*; -en, -en († R 268); **Akro|ba|tik** *w*; -; **Akro|ba|tin** *w*; -, -nen; **akro|ba|tisch**; **Akro|te|ln** (eine chem. Verbindung) *s*; -s;

Akro|me|ga|lie (Riesenwuchs einzelner Körperteile) *w*; -, ...ien;

Akro|nym (aus den Anfangsbuchstaben mehrerer Wörter gebildetes Wort, z. B. „Hanag“) *s*; -s, -e; **Akro|po|lis** (altgr. Stadtburg [von Athen]) *w*; -, ...polen;

Akro|sti|chon (die Anfangsbuchstaben, -silben oder -wörter der Verszeilen eines Gedichtes, die ein Wort oder einen Satz ergeben) *s*; -s, ...chen u. ...cha; **Akroter** *m*; -s, -e, (älter:) **Akro|te|rie** [...*i*e*] *w*; -, -n u. **Akro|te|ri|on**, **Akro|te|ri|um** (Giebelverzierung) *s*; -s, ...ien [...*i*e*n*]; **Akro|zepha|le** (Med.: Hoch-, Spitzkopf) *m* u. *w*; -n, -n († R 268); **Akroze|pha|lie** *w*; -, ...ien

äks! (ugs. für: pfui!)

Akt *lat.* (Abschnitt, Aufzug eines Theaterstückes; Handlung, Vorgang; Stellung u. künstler. Darstellung des nackten Körpers; vgl. Akte) *m*; -[e]s, -e

Ak|tä|on (gr. Heros u. Berggott)

Ak|te *lat.* (Schriftstück; Urkunde) *w*; -, -n, (auch:) Akt *m*; -[e]s, -e u. österr. u. bayr.:) -en; zu den -n (erledigt; Abk.: z. d. A.); **Ak|tei** (Aktensammlung); **ak|ten|kundig**; **Ak|ten.schrank**, ...ta|sche; **Ak|teur** *fr.* [*aktör*] (der Handelnde; [Schau]spieler) *m*; -s, -e; **Aktie** *niederl.* [...*zi*e*] (Anteil[schein]) *w*; -, -n (meist *Mehrz.*); **Ak|tien.ge|sell|schaft** (Abk.: AG), ...ka|pi|tal

...**ak|tig** (z. B. dreiaktig)

Ak|ti|nie *gr.* [...*i*e*] (eine sechsstrahlige Koralle) *w*; -, -n; **ak|ti|nisch** (durch Strahlung hervorgerufen); -e Krankheiten; **Ak|ti|ni|um** vgl. Actinium; **Ak|ti|no|me|ter** (Meteor.: Strahlungsmesser) *s*; -s, -; **ak|ti|no|morph** (Biol.: strahlenförmig); **Ak|ti|no|my|kose** (Med.: Strahlenpilzkrankheit) *w*; -, -n

Ak|ti|on *lat.* [*akzion*] (Unternehmung; Handlung); eine konzertierte -; vgl. konzertieren

Ak|tio|när *fr.* [*akzi*...] (Besitzer von Aktien) *m*; -s, -e; **Ak|tio|närsver|samm|lung**

Ak|tio|nist *lat.* [*akzi*...] (Person,

die bestrebt ist, das Bewußtsein der Menschen oder bestehende Zustände durch provozierende, revolutionäre, künstlerische Aktionen zu verändern); ↑ R 268; **ak|ti|o|ni|stisch**; -ste (↑ R 294)

Ak|ti|ons_art [_akzi̯onß..._] (Sprachw.: Geschehensweise beim Zeitw., z. B. perfektiv: „verblühen"), ...**ra|di|us** (Wirkungsbereich, Reichweite; Fahr-, Flugbereich)

Ak|ti|um [_ạkzium_] (gr. Vorgebirge)

ak|tiv _lat._ [bei Gegenüberstellung zu passiv auch: _ạktif_] (tätig, rührig, im Einsatz; seltener für: aktivisch); -e [..._wᵉ_] Bestechung; -e Bilanz; -er Wortschatz; -es Wahlrecht; ↑R 268 [auch: _aktif_] (Sprachw.: Tat-, Tätigkeitsform) _s_; -s, (selten:) -e [..._wᵉ_]; [2]**Ak|tiv** (DDR: Gruppe von Personen, die gemeinsam an der Lösung bestimmter Aufgaben arbeiten) _s_; -s, -s (seltener: -e [..._wᵉ_]); **Ak|ti|va** [..._wa_], **Ak|ti|ven** [..._wᵉn_] (Summe der Vermögenswerte eines Unternehmens) _Mehrz._; **Ak|tiv|for|de|rung** [_aktif..._] (ausstehende Forderung); **ak|ti|vie|ren** [..._wi̯..._] (in Tätigkeit setzen; Vermögensteile in die Bilanz einsetzen); **ak|ti|visch** _lat._ (Sprachw.: das Aktiv betreffend, in der Tatform stehend); **Ak|ti|vis|mus** (Bereitschaft zu zielstrebigem Handeln) _m_; -; **Ak|ti|vist** (zielbewußt Handelnder; DDR: Arbeiter, dessen Leistungen vorbildlich sind); ↑ R 268; **Ak|ti|vi|sten_be|we|gung**, ...**bri|ga|de** (DDR); **ak|ti|vi|stisch**; **Ak|ti|vi|tas** (Gesamtheit der zur aktiven Betätigung in studentischen Verbindungen Verpflichteten) _w_; -; **Ak|ti|vi|tät** (Tätigkeitsdrang, Wirksamkeit) _w_; -, (einzelne Handlungen, Maßnahmen:) -en; **Ak|tiv_koh|le** [_aktif..._] (staubfeiner, poröser Kohlenstoff), ...**le|gi|ti|ma|ti|on** [..._zion_] (im Zivilprozeßrecht die Feststellung, daß der Kläger zur Klage befugt ist), ...**sal|do** (Einnahmeüberschuß), ...**ver|mö|gen** (wirkliches Vermögen), ...**zin|sen** (_Mehrz._)

Ak|tri|ce _fr._ [_aktrịßᵉ_] (veralt. für: Schauspielerin) _w_; -, -n

ak|tua|li|sie|ren _lat._ (aktuell machen); **Ak|tua|li|tät** (Gegenwartsbezogenheit; Bedeutsamkeit für die unmittelbare Gegenwart); **Ak|tua|li|tä|ten|ki|no** (Abk.: Aki [vgl. d.])

Ak|tu|ar _lat._ (schweiz. auch für: Schriftführer) _m_; -s, -e u. **Ak|tu|a|ri|us** _m_; -, ...ien [..._iᵉn_] (veralt. für: Gerichtsangestellter)

ak|tu|ell _fr._ (im augenblickl. Interesse liegend, zeitgemäß, zeitnah)

aku|punk|tie|ren _lat._; **Aku|punk|tur** (Heilbehandlung durch Nadelstiche) _w_; -, -en

Akü|spra|che (Kurzw. für: Abkürzungssprache) _w_; -, (selten:) -n

Aku|stik _gr._ (Lehre vom Schall, von den Tönen; Klangwirkung) _w_; -; **aku|stisch**

akut _lat._; -e (brennende) Frage; -e (unvermittelt auftretende, heftig verlaufende) Krankheit; **Akut** (ein Betonungszeichen: ´, z. B. é) _m_; -[e]s, -e

Ak|ze|le|ra|ti|on _lat._ [..._zion_] (Beschleunigung, z. B. Zunahme der Umlaufgeschwindigkeit des Mondes); **Ak|ze|le|ra|tor** (Beschleuniger; veralt. für: Gashebel bei Kraftfahrzeugen) _m_; -s, ...oren; **ak|ze|le|rie|ren**

Ak|zent _lat._ (Betonung[szeichen]; Tonfall, Aussprache; Nachdruck) _m_; -[e]s, -e; **Ak|zent|buch|sta|be** (Tonbuchstabe); **Ak|zen|tua|ti|on** [..._zion_] (Betonung); **ak|zen|tu|ie|ren** (Ak|zen|tu|ierung**

Ak|zept _lat._ (Annahmeerklärung des Bezogenen auf einem Wechsel; der akzeptierte Wechsel selbst) _s_; -[e]s, -e; **ak|zep|ta|bel** (annehmbar); ...a|ble Bedingungen; **Ak|zep|tant** (der zur Bezahlung des Wechsels Verpflichtete; Bezogener) _m_; -en, -en (↑ R 268); **Ak|zep|ta|ti|on** [..._zion_] (Annahme); **ak|zep|tie|ren** (annehmen); **Ak|zep|tie|rung; Ak|zep|tor** (Annehmer, Empfänger) _m_; -s, ...oren

Ak|zes|si|on _lat._ (Zugang; Erwerb; Beitritt [zu einem Staatsvertrag]); **Ak|zes|so|rie|tät** [..._i-e..._] (Rechtsw.: Abhängigkeit des Nebenrechtes von dem zugehörigen Hauptrecht); **ak|zes|so|risch** (hinzutretend; nebensächlich, weniger wichtig)

Ak|zi|dens _lat._ (das Zufällige, was einer Sache nicht wesenhaft zukommt) _s_; -, ...denzien [..._iᵉn_] u. ...denzia; **ak|zi|den|t[ell** (zufällig; unwesentlich); **Ak|zi|denz** (Druckarbeit, die nicht zum Buch-, Zeitungs- u. Zeitschriftendruck gehört [z. B. Formulare]) _w_; -, -en (meist _Mehrz._); **Ak|zi|denz_druck** (_Mehrz._ ...drucke), ...**set|zer**

Ak|zi|se _fr._ (Verbrauchs-, Verkehrssteuer; Zoll) _w_; -, -n

Al = chem. Zeichen für: Aluminium

Al. = Alinea

a. l. = ad libitum

à la _fr._ (im Stile von, nach Art von)

Ala. = Alabama

alaaf! (niederrheinischer Hochruf); Kölle -

la baisse _fr._ [_a la bäß_] („nach unten"; auf Fallen der Kurse [spekulieren])

Ala|ba|ma (Staat in den USA; Abk.: Ala.)

Ala|ba|ster _gr._ (eine Gipsart) _m_; -s, (selten:) -; **ala|ba|stern** (aus od. wie Alabaster)

à la bonne heure! _fr._ [_a la bonôr_] (so ist es recht!, bravo!, vortrefflich!)

à la carte _fr._ [_a la kạrt_] (nach der Speisekarte)

Ala|din (m. Eigenn.; Gestalt aus „1001 Nacht")

à la hausse _fr._ [_a la oß_] („nach oben"; auf Steigen der Kurse [spekulieren])

à la mode _fr._ [_a la mọd_] (nach der neuesten Mode); **Ala|mo|de_li|te|ra|tur** (_w_; -), ...**zeit** (_w_; -)

Aland (ein Fisch) _m_; -[e]s, -e

Åland|in|seln [_ọl..._] (finnische Inselgruppe in der Ostsee) _Mehrz._

Ala|ne (Angehöriger eines alten, urspr. iran. Nomadenvolkes) _m_; -n, -n (↑ R 268)

Alant (eine Heilpflanze) _m_; -[e]s, -e

Ala|rich (König der Westgoten)

Alarm _it._ (Warnung[szeichen, -signal]) _m_; -[e]s, -e; **alarm|be|reit**; **Alarm_be|reit|schaft**, ...**ge|rät**; **alar|mie|ren** (Alarm geben, warnen; aufrütteln); **Alarm|si|gnal**

Alas. = Alaska

Alas|ka (nordamerik. Halbinsel; Staat der USA; Abk.: Alas.)

à la suite _fr._ [_a la ßwịt_] (im Gefolge von ...); - - - des ...

Alaun _lat._ (ein Salz) _m_; -s, -e; **alau|ni|sie|ren** (mit Alaun behandeln); **Alaun|stein**

A-Laut (↑ R 149)

[1]**Alb** („Elf"; gespenstisches Wesen; nur noch in den Namen: Alberich, Alboin, Albin); vgl. Alben u. [1]Alp

[2]**Alb** (Gebirge) _w_; -; Schwäbische - (↑ R 198)

Al|ba|ner; **Al|ba|ni|en** [..._iᵉn_] (Balkanstaat); **al|ba|nisch**; vgl. deutsch; **Al|ba|nisch** (Sprache) _s_; -[s]; vgl. Deutsch; **Al|ba|ni|sche** _s_; -n; vgl. Deutsche _s_

Al|ba|nus_tag; vgl. Alban

Al|ba|tros _angloind.-niederl._ (ein Sturmvogel) _m_; -, -se

Alb|druck, Alb|drücken (falsche Schreibung für: Alpdruck, Alpdrücken)

Al|be _lat._ (weißes liturg. Gewand) _w_; -, -n

Al|ben (Rel.: niedere Naturgeister) _Mehrz._; vgl. [1]Alb u. [1]Alp

Al|be|rei

Al|be|rich („Elfenkönig"; den Ni-
belungenhort bewachender
Zwerg); vgl. ¹Alb
¹al|bern; ich ...ere († R 327); ²al-
bern; -es Geschwätz; Al|bern|heit
Al|bert (m. Vorn.); ¹Al|ber|ta
[meist dt. Ausspr., engl. Ausspr.:
älbö″t°] (kanad. Provinz); ²Al-
ber|ta, Al|ber|ti|ne (w. Vorn.); Al-
ber|ti|na (Sammlung graphischer
Kunst in Wien) w; -; Al|ber|ti|ni-
sche Li|nie (sächsische Linie der
Wettiner) w; -n -
Al|bi|gen|ser (Angehöriger einer
mittelalterl. häretischen Gruppe
in Südfrankreich) m; -s, -
Al|bin, Al|bi|nus (m. Vorn.)
Al|bi|nis|mus lat. (Unfähigkeit,
Farbstoffe in Haut, Haaren u.
Augen zu bilden) m; -; Al|bi|no
span. („Weißling"; Mensch, Tier
od. Pflanze mit fehlender Farb-
stoffbildung; vgl. Kakerlak) m;
-s, -s; al|bi|no|tisch
Al|bi|nus vgl. Albin
Al|bi|on kelt.-lat. (alter dicht. Na-
me für: England)
Al|bo|in [...o-in], Al|bu|in [u-in]
(langobard. König)
Al|brecht (m. Vorn.)
Alb|traum (falsche Schreibung
für: Alptraum)
Al|bu|in vgl. Alboin
Al|bu|la (schweiz. Fluß) w; -; Al-
bu|la|bahn (w; -), ...paß (m; ...pas-
ses)
Al|bum lat. („weiße Tafel"; Ge-
denk-, Stamm-, Sammelbuch) s;
-s, ...ben; Al|bu|men (Med., Biol.:
Eiweiß) s; -s; Al|bu|min (ein Ei-
weißstoff) s; -s, -e (meist Mehrz.);
Al|bu|mi|nat (Alkalisalz der
Albumine) s; -[e]s, -e: al|bu|mi-
nös lat. (eiweißhaltig); Al|bu|min-
urie lat.; gr. (Med.: Ausscheidung
von Eiweiß im Harn) w; -, ...ien;
Al|bu|mo|se lat. (Eiweißspal-
tungsprodukt) w; -, -n; Al|bus
(Weißpfennig, alte dt. Silber-
münze) m; -, -se
al|cä|isch [alz...] vgl. alkäisch; Al-
cä|us vgl. Alkäus
Al|ce|ste [alz...] vgl. Alkeste
Al|che|mie usw. vgl. Alchimie usw.
Äl|chen (kleiner Aal; Fadenwurm)
Al|chi|mie arab. (hist.: Chemie des
MA.s; vermeintl. Goldmacher-
kunst; Schwarzkunst) w; -; Al-
chi|mist (ein Alchimie Ausüben-
der); † R 268; al|chi|mi|stisch
Al|ci|bia|des [alzi...] vgl. Alkibia-
des
Al|cyo|ne [auch: alzü...] usw. vgl.
Alkyone usw.
Al|de|ba|ran arab. [auch: ...baran]
(ein Stern) m; -s
Al|de|hyd (eine chem. Verbin-
dung) m; -s, -e
Al|der|man engl. [åld″rm″n] ([älte-
ster] Ratsherr, Vorsteher in an-
gels. Ländern) m; -s, ...men
¹Al|di|ne [nach dem venezian.
Drucker Aldus Manutius]
(Druckwerk des Aldus Manu-
tius) w; -, -n; ²Al|di|ne (halbfette
Antiquaschrift) w; -
Ale engl. [e′l] (helles engl. Bier)
s; -s
alea iac|ta est lat. („der Würfel
ist gefallen"; die Entscheidung ist
gefallen, es ist entschieden)
alea|to|risch lat. (vom Zufall ab-
hängig); -e Verträge (Spekula-
tionsverträge)
Alek|to (eine der drei Erinnyen)
Ale|man|ne (Angehöriger eines
germ. Volksstammes) m; -n, -n
(† R 268); ale|man|nisch; vgl.
deutsch; Ale|man|nisch (dt.
Mundart) s; -[s]; vgl. Deutsch;
Ale|man|ni|sche s; -n; vgl.
Deutsche s
alert it. landsch. (munter, frisch)
Aleu|ron gr. [auch: g...] (Biol.: Re-
serveeiweiß der Pflanzen) s; -s
Aleu|ten [...e-u...] (Inseln zwischen
Beringmeer und Pazifischem
Ozean) Mehrz.
Alex (Kurzform von Alexander);
Alex|an|der (m. Vorn.); Alex|an-
dra (w. Vorn.); Alex|an|dria
[auch: ...ja], Alex|an|dri|en [...i°n]
(ägypt. Stadt); Alex|an|dri|ne (w.
Vorn.); Alex|an|dri|ner (Bewoh-
ner von Alexandria († R 199]; ein
Reimvers); alex|an|dri|nisch
Ale|xia|ner gr. (Angehöriger einer
Laienbruderschaft) m; -s, -
Ale|xi|ne gr. (Schutzstoffe gegen
Bakterien) Mehrz.
Al|fa arab. (aus dem Esparto [vgl.
d.] gewonnener Faserstoff; auch
für: Esparto) w; -; Al|fa|gras
al|fan|zen it. (veralt. für: Possen
reißen, närrisch sein; schwin-
deln); du alfanzt (alfanzest); Al-
fan|ze|rei (veralt.)
Al|fons (m. Vorn.)
Al|fred (m. Vorn.)
al fres|co (häufig für: a fresco)
Al|fried (m. Vorn.)
Al|ge lat. (eine niedere Wasser-
pflanze) w; -, -n
Al|ge|bra arab. [österr.: ...gebra]
(Buchstabenrechnung; Lehre
von math. Gleichungen) w; -,
(für: algebraische Struktur auch
Mehrz.:) ...g|bren; al|ge|bra|isch
Al|ge|nib arab. (ein Stern) m; -s
Al|ge|ri|en [...i°n] (Staat in Nord-
afrika); Al|ge|ri|er [...i°r]; al|ge-
risch; Al|gier [álsehir; schweiz.:
álgir] (Hptst. Algeriens)
Al|gol arab. [auch: ql...] (ein Stern)
m; -s
Al|go|lo|ge lat.; gr. (Algenfor-
scher) m; -n, -n († R 268); Al|go|lo-
gie (Algenkunde) w; -

Al|gon|kin (Sammelbezeichnung
für indian. Stämme in Nordame-
rika, die eine große Sprachfami-
lie bilden) Mehrz.; Al|gon|ki|um
(Abschnitt der erdgeschichtl.
Frühzeit) s; -s
Al|go|rith|mus arab. (nach einem
bestimmten Schema ablaufender
Rechenvorgang) m; -, ...men
Al|gra|phie¹ lat.; gr. (Flachdruck-
verfahren u. danach hergestelltes
Kunstblatt) w; -, ...ien
Al|ham|bra arab. („die Rote"; Pa-
last bei Granada) w; -
Ali [auch: qli, ali] (arab. m. Vorn.)
ali|as lat. (anders; sonst, auch);
Ali|bi („anderswo"; [Nachweis
der] Abwesenheit [vom Tatort
des Verbrechens]; Unschuldsbe-
weis, Rechtfertigung) s; -s, -s; Ali-
bi|be|weis
Ali|ce [alíß°] (w. Vorn.)
Alie|na|ti|on lat. [ali-enazion] (ver-
alt. für: Entfremdung; Verkauf;
Med.: Geisteszerrüttung); alie-
nie|ren
Alig|ne|ment fr. [alinj′mang] ([Ab-
stecken einer] Richtlinie beim
Straßen- od. Eisenbahnbau) s; -s,
-s; ali|gnie|ren
Ali|men|ta|ti|on lat. [...zion] (Le-
bensunterhalt); Ali|men|te (Un-
terhaltsbeiträge, bes. für unehe-
liche Kinder) Mehrz.; ali|men|tie-
ren (Lebensunterhalt gewähren)
Ali|nea lat. (veralt. für: die „von
der [neuen] Linie", d. h. von
vorn, mit Absatz beginnende
neue Druckzeile; Abk.: Al.) s;
-s -s
ali|pha|tisch gr.; -e Verbindungen
(Verbindungen mit offenen Koh-
lenstoffketten in der Strukturfor-
mel)
ali|quant lat. (Math.: mit Rest tei-
lend); ali|quot (Math.: ohne Rest
teilend)
Ali|za|rin arab. (ein [Pflanzen]
farbstoff) s; -s
Alk nord. (arkt. Meeresvogel) m;
-[e]s od. -en, -e[n] († R 268)
Al|kaios vgl. Alkäus; al|kä|isch
(nach Alkäus benannt); -e Stro-
phe
Al|kal|de span. (span. Bürgermei-
ster, Dorfrichter) m; -n, -n († R
268)
Al|ka|li arab. [auch: ql...] (eine lau-
genartige chem. Verbindung) s;
-s, ...alien [...i°n]; Al|ka|li|me|tal-
le (Gruppe chem. Grundstoffe)
Mehrz.; al|ka|lisch (laugenhaft);
Al|ka|lo|id arab.; gr. (eine chem.
Verbindung pflanzlicher Her-
kunft) s; -[e]s, -e
Al|kan|na arab. (Farbstoff liefern-
de Pflanze) w; -

¹ Auch eindeutschend: Algrafie.

Al|kä|us (gr. Dichter)
Al|ka|zar *span.* [...*asar*, auch:
...*asar*] („das Schloß"; Burg,
Schloß, Palast [in Spanien]) *m*;
-s, ...zare
Al|ke, Alk|je (w. Vorn.)
Al|ke|ste (w. Gestalt der gr. My-
thol.)
Al|ki|bia|des (gr. Staatsmann)
Alk|je, Al|ke (w. Vorn.)
Alk|man [auch: *alkman*] (gr. Dich-
ter); alk|ma|nisch; -er Vers
Alk|me|ne (Gattin des Amphi-
tryon, Mutter des Herakles)
Al|ko|hol *arab.* [auch: *alkohol*]
(eine organ. Verbindung; Äthyl-
alkohol [vgl. d.], Bestandteil der
alkohol. Getränke) *m*; -s, -e; al-
ko|hol.arm, ...frei; Al|ko|ho|li|ka
(alkohol. Getränke) *Mehrz.*; Al-
ko|ho|li|ker; al|ko|ho|lisch; al|ko-
ho|li|sie|ren (mit Alkohol verset-
zen; scherzh.: für: unter Alkohol
setzen); al|ko|ho|li|siert (scherzh.
für: betrunken); Al|ko|ho|li|sie-
rung; Al|ko|ho|lis|mus *m*; -
Al|kor *arab.* [auch: *alkor*] (ein
Stern) *m*; -s
Al|ko|ven *arab.* [...*w*e*n*, auch: al...]
(Nebenraum; Bettnische) *m*; -s, -
Al|ku|in [...*u-in*] (angels. Gelehr-
ter)
Al|kyl *arab.*; *gr.* (einwertiger Koh-
lenwasserstoff) *s*; -s, -e; al|ky|lie-
ren (eine Alkylgruppe einführen)
[1]Al|kyo|ne [auch: ...*üone*] (Tochter
des Äolus); [2]Al|kyo|ne (ein Stern)
w; -; al|kyo|nisch (friedlich, wind-
still); -e Tage
all; (nach R 135 immer klein ge-
schrieben:) all und jeder; all der
Schmerz; mit all[er] seiner Habe;
all das Schöne; in, vor, bei allem;
bei, in, mit, nach, trotz, von, zu
allem dem od. all[e]dem, all[em]
diesem; dem allen (häufiger für:
dem allem), diesem allen (auch:
diesem allem); unter allem Gu-
ten; (↑ R 277:) aller erwiesene Re-
spekt; allen Übels (meist für: alles
Übels); allen Ernstes; das Bild
alles (auch schon: allen) geistigen
Lebens; trotz aller vorherigen
Planung; aller guten Dinge sind
drei
alle; diese alle; all[e] diese; alle
beide; alle, die geladen waren; sie
kamen alle; sie alle (als Anrede:
Sie alle); er opferte sich für alle;
(im Brief:) ich grüße Euch alle;
(↑ R 281:) alle ehrlichen Men-
schen; all[e] die Mühe; all[e] die
Fehler; bei, mit all[e] diesem; alle
vier Jahre; alle zehn Schritte; alle
neun[e] (beim Kegeln); (ugs.:) al-
le nase[n]lang, naslang, a b e r : al-
ler Nasen lang; (↑ R 290:) alle Edlen;
alle (ugs. für: zu Ende, aufge-
braucht) sein, werden

alles; alles und jedes; alles oder
nichts; das, dies[es], was, wer al-
les; all[es] das, dies[es]; alles, was;
für, um alles; alles in allem; (↑ R
116:) alles Gute, die Summe alles
Guten, alles Mögliche (er ver-
suchte alles Mögliche [alle Mög-
lichkeiten]), a b e r (↑ R 135:) alles
mögliche (er versuchte alles mög-
liche [viel, allerlei]); alles andere,
beliebige, übrige; mein ein und
[mein] alles
Zusammenschreibung: allemal,
ein für allemal, a b e r : ein für alle
Male; all[e]zeit; allesamt; allen-
falls; allenthalben; allerart (vgl.
d.); allerdings; allerhand (vgl. d.);
allerlei (vgl. d.); allerorten, aller-
orts; all[er]seits; allerwärts; al-
le[r]wege (vgl. d.), allerwegen, al-
lerwegs; alltags (vgl. d.); all-
wöchentlich; allzuoft (vgl. allzu)
All (Weltall) *s*; -s
all|abend|lich; all|abends
al|la bre|ve *it.* [- *brewe*] (Musik:
beschleunigt); All|la-bre|ve-Takt
(↑ R 155)
Al|lah (einziger Gott des Islams)
al|la mar|cia *it.* [- *martscha*] (Mu-
sik: nach Art eines Marsches,
marschmäßig)
al|la po|lac|ca *it.* [- ...*ka*] (Musik:
in der Art der Polonäse)
Al|lasch *russ.* (Kümmellikör) *m*;
-[e]s, -e
all|be|kannt
all|da (veralt.)
all|dem, all|le|dem; bei -
all|die|wei|le, die|wei|l (veralt.)
al|le; vgl. all
al|le|ben|dig [*Trenn.*: all|le..., ↑ R
236]
al|le|dem, all|dem; bei -
Al|lee *fr.* (mit Bäumen eingefaßte
Straße) *w*; -, Al|leen; *Schreibung
in Straßennamen*: ↑ R 219 ff.
Al|le|ghe|nies [*äligänis*] (svw. Al-
leghenygebirge) *Mehrz.*; Al|le-
ghe|ny|ge|bir|ge [*äligäni...*] (nord-
amerikan. Gebirge) *s*; -s
Al|le|go|rie *gr.* (Sinnbild; Gleich-
nis) *w*; -, ...ien; al|le|go|risch; al|le-
go|ri|sie|ren (versinnbildlichen)
al|le|gret|to *it.* (Musik: mäßig
schnell, mäßig lebhaft); Al|le-
gret|to (mäßig schnelles Musik-
stück) *s*; -s, -s u. ...tti; al|le|gro
(Musik: lebhaft); Al|le|gro
(schnelles Musikstück) *s*; -s, -s
u. ...gri
al|lein ; - sein, stehen, bleiben;
jmdn. - lassen; von allein[e]
(ugs.); al|lei|ne (ugs. für: allein);
Al|lein.flug, ...gang *m*, ...gän|ger;
All|ein|heit *w*; -; Al|lein.herr-
schaft, ...herr|scher; al|lei|nig; All-
ei|nig|keit (Rel.) *w*; -; Al-
lein.mäd|chen, ...sein (*s*; -s); al-
lein|se|lig|ma|chend (kath. Kir-

che); al|lein ste|hen, a b e r : al-
lein|ste|hend; All|lein|ste|hen|de
m u. *w*; -n, -n (↑ R 287ff.); Al|lein-
vertrieb
al|lel *gr.*; Al|lel (Biol.: die einander
entsprechenden Erbanlagen ho-
mologer Chromosomen) *s*; -s, -e
(meist *Mehrz.*)
al|le|lu|ja! usw. vgl. halleluja! usw.
al|le|mal; ein für -, a b e r : ein für
alle Male
Al|le|man|de *fr.* [*al*e*mangd*e] (alte
dt. Tanzform) *w*; -, -n
al|len|falls; vgl. Fall *m*; al|lent|hal-
ben
Al|ler (Nebenfluß der Weser) *w*; -
al|ler|al|ler|letzt; vgl. zualleraller-
letzt
al|ler|art (allerlei); allerart Dinge,
a b e r : Dinge aller Art (↑ R 139)
Al|ler|bar|mer (Bez. für: Christus)
m; -s
al|ler|be|ste; (↑ R 134:) am allerbe-
sten; es ist das allerbeste (sehr
gut), daß...; (↑ R 116:) es ist das
Allerbeste, was...
al|ler|christ|lichst; Al|ler|christ-
lich|ste Ma|je|stät (hist.: Titel
der fr. Könige) *w*; -s, - -
al|ler|dings
al|ler|durch|lauch|tigst; Al|ler-
durch|lauch|tig|ster ... (hist.: An-
rede an einen Kaiser)
al|ler|en|den (geh. für: überall)
al|ler|erst; vgl. zuallererst
Al|ler|gie *gr.* (Med.: Überemp-
findlichkeit) *w*; -, ...ien; Al|ler|gi-
ker; al|ler|gisch
al|ler|hand (ugs.); - Neues (↑ R
116); - Streiche; er weiß - (ugs.
für: viel); das ist ja, doch - (ugs.)
Al|ler|hei|li|gen (kath. Fest zu Eh-
ren aller Heiligen) *s*; -; Al|ler|hei-
li|gen|fest; al|ler|hei|ligst, a b e r
(↑ R 224): das Allerheiligste Sa-
krament; Al|ler|hei|lig|ste *s*; -n
(↑ R 287ff.)
al|ler|höchst; allerhöchstens; auf
das, aufs allerhöchste (↑ R 134)
Al|ler|ka|tho|lisch|ste Ma|je|stät
(Titel der span. Könige) *w*; -n - -
al|ler|lei; - Wichtiges (↑ R 116); -
Farben; Al|ler|lei *s*; -s, -s; Leipzi-
ger -
al|ler|letzt; vgl. zuallerletzt
al|ler|liebst; Al|ler|lieb|ste *m* u. *w*;
-n, -n (↑ R 287ff.)
Al|ler|manns|har|nisch (Pflanze)
m; -[e]s
al|ler|meist; vgl. zuallermeist
al|ler|nächst; al|ler|neu[e]|ste; (↑ R
116:) das Allerneu[e]ste
al|ler|or|ten, al|ler|orts
Al|ler|see|len (kath. Gedächtnis-
tag für die Verstorbenen) *s*; -; Al-
ler|see|len|tag
al|ler|seits, all|seits
al|ler|wärts
al|le[r]|we|ge, al|ler|we|gen, al|ler-
wegs (veralt. für: überall, immer)

al|le[r]|weil vgl. allweil

Al|ler|welts_kerl (ugs.), ...wort (ugs.; Mehrz. ...wörter)

al|ler|we|nig|ste; († R 116:) das Allerwenigste, was ...; am allerwenigsten; allerwenigstens

Al|ler|wer|te|ste (ugs. scherzh. für: Gesäß) m; -n, -n († R 287ff.)

al|les; vgl, all

al|le|samt

Al|les_bes|ser|wis|ser, ...fres|ser, ...kle|ber

al|le|we|ge; vgl. alle[r]wege

al|lez! fr. [ale] („gehtl"; vorwärts!)

al|le|zeit, all|zeit (immer)

all|fäl|lig [auch· fäl...,] österr., schweiz. (etwaig, allenfalls [vorkommend], eventuell); All|fäl|lige (österr., schweiz.) s; -n († R 287ff.)

All|gäu („Alpgau"; Alpengebiet) s; -s; All|gäu|er († R 199); all|gäuisch

All|ge|gen|wart

all|ge|mach (veralt. für: allmählich)

all|ge|mein († R 134:) im allgemeinen (gewöhnlich; Abk · i. allg.), aber († R 116): er bewegt sich stets nur im Allgemeinen (beachtet nicht das Besondere); die -e Schul-, Wehrpflicht; -e Geschäfts-, Versicherungsbedingungen. *Großschreibung* († R 224): Allgemeine Deutsche Biographie (Abk.: ADB), Allgemeine Elektricitäts-Gesellschaft (vgl. AEG), Allgemeine Ortskrankenkasse (Abk.: AOK), Allgemeiner Deutscher Automobil-Club (Abk.: ADAC), Allgemeiner Deutscher Nachrichtendienst (DDR; Abk.: ADN), Allgemeiner Studentenausschuß (Abk.: AStA), Allgemeines Bürgerliches Gesetzbuch (in Österreich geltend; Abk.: ABGB); All|ge|mein|be|fin|den; all|ge|meinbil|dend (vgl. S. 45, Merke, 2); die -en Schulen; All|ge|mein|bildung w; -; all|ge|mein|gül|tig; die allgemeingültigen Ausführungen († jedoch R 143), aber: die Ausführungen sind allgemein gültig; All|ge|mein|gut; All|gemein|heit w; -; all|ge|mein|platz (abgegriffene Redensart; meist *Mehrz.*); all|ge|mein|ver|ständlich; vgl. allgemeingültig; All|gemein|wohl

All|ge|walt; all|ge|wal|tig

All|heil|mit|tel s

All|heit w; -

Al|li|anz fr. ([Staaten]bündnis) w; -, -en; die Heilige -

al|lie|bend [Trenn.: all|lie..., † R 236]

Al|li|ga|tor lat. (Panzerechse) m; -s, ...oren

al|li|ie|ren, sich fr. (sich verbünden); Al|li|ier|te m u. w; -n, -n († R 287ff.)

Al|li|te|ra|ti|on lat. [...zion] (Anlaut-, Stabreim); al|li|te|rie|rend (stabreimend, stabend); -e Dichtung

all|jähr|lich

All|macht w; -; all|mäch|tig; Allmäch|ti|ge (Gott) m; -n; Allmächtiger!

all|mäh|lich

All|meind, All|mend schweiz. (svw. Allmende) w; -, -en; All|men|de (gemeinsam genutztes Gemeindegut) w; -, -n; All|mend|recht

All|mo|sen s

all|mut|ter (dicht.) w; -; - Natur

all|nächt|lich

al|lo|chthon gr. [...chton] (Geol.: an anderer Stelle entstanden)

All|lod (mittelalterl. Recht: dem Lehensträger persönlich gehörender Grund und Boden, Freigut) s; -[e]s, -e; al|lo|di|al germ.-mlat. (zum Allod gehörend)

al|lo|gam gr. (Bot.: fremdbestäubt); Al|lo|ga|mie (Bot.: Fremdbestäubung) w. -, ...ien; allo|ga|misch vgl. allogam

Al|lo|ku|ti|on lat. [...zion] (feierliche [päpstliche] Ansprache [an die Kardinäle])

Al|lon|ge fr. [alongseh°] (bes. Verlängerungsstreifen [bei Wechsel]) w; -, -n; Al|lon|ge|pe|rücke [Trenn.: ...rük|ke] (langlockige Perücke des 17. u. 18. Jh.s)

al|lons! fr. [along] („laßt uns gehen!"; vorwärts!, los!)

Al|lo|path gr. (Anhänger der Allopathie) m; -en, -en († R 268); Allo|pa|thie (Heilkunst [Schulmedizin]) w; -; al|lo|pa|thisch

Al|lo|tria gr. (Unfug) Mehrz., heute meist: s; -s

All|rad|an|trieb (beim Kraftwagen)

all right! engl. [ål rait] (richtig!, in Ordnung!)

All|round_man (engl. [ålraundm°n]; jmd., der in vielen Bereichen Bescheid weiß; m; -s, ...men), ...sport|ler (Sportler, der viele Sportarten beherrscht)

all|sei|tig; All|sei|tig|keit; all|seits, al|ler|seits

All|strom|ge|rät (für Gleich- u. Wechselstrom)

all|stünd|lich

All|tag; all|täg|lich [auch: altäk... (= alltags) od. altäk... (= täglich, gewohnt)]; All|täg|lich|keit; all|tags († R 129), aber: des Alltags; alltags wie feiertags; Alltags_be|schäf|ti|gung, ...sor|gen (Mehrz.), ...spra|che (w; -)

all|über|all

Al|lü|re fr. (Gangart des Pferdes) w; -, -n; Al|lü|ren ([schlechte] Umgangsformen) Mehrz.

al|lu|vi|al lat. [...wi...] (Geol.: angeschwemmt, abgelagert); Al|lu|vion (Geol.: angeschwemmtes Land); Al|lu|vi|um (jüngster Abschnitt der Erdg.; neuere Bez.: Holozän) s; -s

Al|lva|ter (Bez. für: Gott, Schöpfer des Alls) m; -s

all|ver|ehrt

all|weil, alle[r]weil österr. mdal. (immer)

All|wet|ter|jä|ger (ein Flugzeugtyp)

all|wis|send; Doktor Allwissend (Märchengestalt); All|wis|senheit w; -

all|wö|chent|lich

all|zeit, al|lezeit (immer)

all|zu; allzubald, allzufrüh, allzugern, allzulange[e], allzuoft, allzusehr, allzuselten, allzuviel, allzuweit, aber (bei deutlich unterscheidbarer Betonung [und Beugung des zweiten Wortes] getrennt): die Last ist allzu schwer, er hatte allzu viele Bedenken

all|zu|mal (veralt. für: alle zusammen); all|zu|sam|men (veralt.)

All|zweck|tuch (*Mehrz.* ...tücher)

[1]Alm (Bergweide) w; -, -en

[2]Alm (Geol.: feiner, weißgrauer Kalkschlamm) m; -[e]s

Al|ma (w. Vorn.)

Al|ma ma|ter lat. („nahrungsspendende Mutter"; Bez. für: Universität, Hochschule) w; - -

Al|ma|nach niederl. (Kalender, [bebildertes] Jahrbuch) m; -s, -e

Al|man|din (Abart des [1]Granats) m; -s, -e

al|men österr. (Vieh auf der [1]Alm halten); Al|men|rausch, Almrausch (Alpenrose) m; -[es]; Almer (Geol.: neben: Senner); Alme|rin w; -, -nen

Al|mo|sen gr. s; -s, -; Al|mo|se|nier (geistl. Würdenträger) m; -s, -e

Alm|rausch vgl. Almenrausch

Alm|ro|se (südd., österr. neben: Alpenrose)

Al|mut (w. Vorn.)

Aloe gr. [glo-e] (eine Zier- u. Heilpflanze) w; -, -n

alo|gisch [auch: alo...] (ohne Logik, vernunftlos, -widrig)

Alois [gloiß], Aloi|si|us (m. Vorn.); Aloi|sia (w. Vorn.)

[1]Alp (gespenstisches Wesen; Alpdrücken) m; -[e]s, -e; vgl. [1]Alb u. Alben

[2]Alp, Al|pe (svw. [1]Alm) w; -, ...pen

[1]Al|pa|ka indian.-span. (Lamaart Südamerikas) s; -s; [2]Al|pa|ka (Wolle vom Alpaka; Reißwolle; als ⓦ m: Gewebe) s; -s; [3]Al|pa|ka (als ⓦ: Alpacca; Neusilber) s; -s

al pa|ri *it.* (zum Nennwert [einer Aktie]); vgl. pari

Alp.druck (*m*; -[e]s, ...drücke), ...drücken [*Trenn.*: ...drük|ken] (*s*; -s)

Al|pe vgl. ²Alp; Al|pen (Gebirge) *Mehrz.*; Al|pen.jä|ger, ...veil|chen; Al|pen|vor|land (↑ R 202)

Al|pha (gr. Buchstabe: *A, α*) *s*; -[s], -s; das - und [das] Omega (geh. für: der Anfang und das Ende); Al|pha|bet (Abc) *s*; -[e]s, -e; al|pha|be|tisch; al|pha|be|ti|sie|ren al|pha|me|risch, al|pha|nu|me|risch *gr.; lat.* (EDV)

Al|phard *arab.* (ein Stern) *m*; -

Al|pha|strah|len, α-Strah|len (Physik: aus reinen Heliumkernen bestehende radioaktive Strahlung) *Mehrz.* (↑ R 149)

Al|phei|os vgl. Alpheus; Al|phe|us (peloponnes. Fluß) *m*; -

Alp|horn (*Mehrz.* ...hörner)

al|pin *lat.* (die Alpen, das Hochgebirge betreffend od. darin vorkommend); -e (auch: ostische) Rasse; -e Kombination (Schisport); Al|pi|ni *it.* (it. Alpenjäger) *Mehrz.*; Al|pi|nis|mus *lat.* (sportl. Bergsteigen) *m*; - Al|pi|nist (sportl. Bergsteiger im Hochgebirge); ↑ R 268; Al|pi|ni|stik (sw. Alpinismus) *w*; -; Al|pi|num (Alpenpflanzenanlage) *s*; -s, ...nen; Al|pler (Alpenbewohner); älp|le|risch

Alp|traum

Al|raun *m*; -[e]s, -e u. Al|rau|ne (menschenähnliche Zauberwurzel; Zauberwesen) *w*; -, -n

als; - ob; sie ist schöner als ihre Freundin, aber (bei Gleichheit): sie ist so schön wie ihre Freundin; (↑ R 26:) er ist größer als Ludwig; er war größer als Maler denn als Dichter; Ilse ist größer, als ihre Mutter im gleichen Alter war; ich konnte nichts Besseres tun, als ins Bett zu gehen; als|bald; als|bal|dig; als|dann; als daß (↑ R 62)

al|so

Als-ob *s*; -

al|so|bald (veralt.)

Als-ob-Phi|lo|so|phie (↑ R 155)

al|so|gleich (veralt. für: sogleich)

Al|ster (r. Nebenfluß der unteren Elbe) *w*; -

alt; älter, älteste; alten Stils (Zeitrechnung; Abk.: a. St.); ein alter Mann; alter Mann (toter Mann; vgl. tot). I. Kleinschreibung: a) (↑ R 135:) er ist immer der alte (derselbe); wir bleiben bei den alten (dieselben); (↑ R 134:) er ist der älteste, das älteste meiner Söhne; (↑ R 133:) alt und jung (jedermann); beim alten bleiben; am alten hängen; es beim alten lassen; aus alt mach neu.

II. *Großschreibung*: a) (↑ R 116:) der Alte (Greis; österr. auch: Wein aus einem vergangenen Jahr), die Alte (Greisin); an das Alte denken; Altes und Neues; Alte und Junge; die Alten (alte Leute, Völker); der Älteste (Kirchenälteste); mein Ältester (ältester Sohn); die Ältesten (der Gemeinde); b) (↑ R 116:) etwas Altes; c) (↑ R 224:) der Ältere (Abk.: d. Ä.; als Ergänzung bei Eigennamen); der Alte Fritz; Alter Herr (Studentenspr. für: Vater u. für: Altmitglied einer student. Verbindung; Abk.: A. H.); die Alte Geschichte (Geschichte des Altertums); das Alte Testament (Abk.: A. T.); die Alte Welt (Europa, Asien u. Afrika im Gegensatz zu Amerika)

Alt *lat.* (tiefe Frauen- od. Knabenstimme; Sängerin mit dieser Stimme) *m*; -s u. der Altstimme, -e u. die Altstimmen

Alt...(z. B. Altbundespräsident; in der Schweiz gewöhnlich klein u. getrennt geschrieben: alt Bundesrat)

Al|tai (Gebirge in Zentralasien) *m*; -[s]

Al|ta|ir vgl. Atair

al|ta|isch; -e Sprachen

Alt|am|mann [auch: altam...]

Al|tan *it.* (Balkon; Söller) *m*; -[e]s, -e

Al|tar *lat. m*; -[e]s, ...täre; Al|tar|bild; Al|ta|rist (kath. Priester, der die Messe an einem bestimmten Altar zu lesen hat); ↑ R 268; Al|tar[s]|sa|kra|ment

alt|backen [*Trenn.*: ...bak|ken]; -es Brot

Alt|bau *m*; -[e]s, -ten; Alt|bau|woh|nung

alt|be|kannt

Alt-Ber|lin (↑ R 206)

alt|be|währt

Alt|bun|des|prä|si|dent

alt|deutsch; -e Bierstube

Alt|dorf (Hauptort von Uri)

Alt|dor|fer (dt. Maler)

Al|te (ugs. für: Vater u. Mutter, Ehemann u. Ehefrau, Chef u. Chefin) *m u. w*; -n, -n (↑ R 287 ff.)

alt|ehr|wür|dig

alt|ein|ge|ses|sen

Alt|ei|sen

Al|te Land (Teil der Elbmarschen) *s*; -n -[e]s

Al|te|na (Stadt im Sauerland); Al|te|na|er (↑ R 199); al|te|na|isch

alt|eng|lisch

Al|ten.heim, ...hil|fe (*w*; -), ...teil *s*

Al|ter *s*; -s, -; (↑ R 129:) seit alters, vor alters, von alters her

al|te|ra pars *lat.*; vgl. audiatur et altera pars

al|te|ra|ti|on *lat.* [...zion] (Med.:

Aufregung; [krankhafte] Veränderung; Musik: chromatische Veränderung eines Tones innerhalb eines Akkords)

Al|ter|chen

Al|ter ego *lat.* [auch: - ego] („das andere Ich"; angenommenes Doppelwesen, vertrauter Freund) *s*; - -

al|te|rie|ren, sich *fr.* (sich aufregen); alterierter Klang (Alteration)

...al|te|rig, ...alt|rig (z. B. gleichalt[e]rig)

al|tern; ich ...ere (↑ R 327); vgl. Alterung

Al|ter|nanz *lat.* (Wechsel zwischen zwei Dingen, Vorgängen) *w*; -, -en; al|ter|na|tiv (wahlweise; zwischen zwei Möglichkeiten die Wahl lassend); Alter|na|ti|ve [...*w°*] (Entscheidung zwischen zwei [oder mehr] Möglichkeiten; die andere, zweite Möglichkeit) *w*; -, -n; al|ter|nie|ren ([ab]wechseln); al|ter|nie|rend; -e Blattstellung (Bot.); -e Reihe (Math.)

Al|tern *w*; -s; Al|terns.for|schung (für: Gerontologie; *w*; -), ...vor|gang

alt|er|probt

al|ters vgl. Alter; Al|ters.be|schwer|den (Mehrz.), ...gen|ze, ...heim, ...jahr (schweiz. für: Lebensjahr), ...ru|he|geld; al|ters|schwach; Al|ters.schwä|che (*w*; -), ...sich|tig|keit (*w*; -), ...ver|si|che|rung, ...ver|sor|gung, ...werk

Al|ter|tum *s*; -s; das klassische -; Al|ter|tü|me|lei; al|ter|tü|meln (das Wesen des Altertums [übertrieben] nachahmen); ich ...[e]le (↑ R 327); Al|ter|tü|mer (Gegenstände aus dem Altertum) *Mehrz.*; Al|ter|tüm|ler (veralt. für: altertümelnde Person); al|ter|tüm|lich; Al|ter|tüm|lich|keit; Al|ter|tums.for|scher, ...for|schung, ...kun|de

Al|te|rung (auch: Reifung; Technik: [bei Metall od. Flüssigkeit] Änderung des Gefüges oder der Zusammensetzung durch Altern)

Äl|te|ste (einer Kirchengemeinde u. a.) *m u. w*; -n, -n (↑ R 287 ff.)

Äl|te|sten|recht (für: Seniorat)

alt|frän|kisch (veralt. für: altmodisch); -ste (↑ R 294)

alt|ge|dient

Alt|gei|ge

Alt|ge|sel|le

alt|ge|wohnt

alt|gold

Alt|grad vgl. Grad

alt|grie|chisch

Alt|händ|ler

Alt|thee *gr.* (Eibisch) *w*; -, -n; Alt|thee.saft, ...wur|zel

Alt-Hei|del|berg (↑ R 206)
alt|her|ge|bracht; alt|her|kömm|lich
Alt|her|ren|mann|schaft (Sportspr.); Alt|her|ren|schaft (Studentenspr.)
alt|hoch|deutsch (Abk.: ahd.); vgl. deutsch; Alt|hoch|deutsch (Sprache) s; -[s]; vgl. Deutsch; Alt-hoch|deut|sche s; -n, vgl. Deutsche s
Al|tist lat. (Knabe mit Altstimme); ↑ R 268; Al|ti|stin w; -, -nen
Alt|jahr[s]|abend [auch: ...jar...] landsch. (Silvesterabend); Alt-jahr|tag [auch: ...jarß...] österr. (Silvester)
alt|jüng|fer|lich; Alt|jüng|fern|stand m; -[e]s
Alt|kanz|ler
Alt|ka|tho|lik[1]; alt|ka|tho|lisch[1]; Alt|ka|tho|li|zis|mus[1]
alt|klug (↑ R 158)
ält|lich
Alt|ma|te|ri|al
Alt|mei|ster (urspr.: Vorsteher einer Innung; ehemaliger, noch als Vorbild geltender Meister, auch in der Wissenschaft)
Alt|mo|tall
Alt|mie|te
alt|mo|disch; -ste (↑ R 294)
alt|nor|disch; vgl. deutsch; Alt|nor|disch (älteste nordgerm. Sprachstufe) s; -[s]; vgl. Deutsch; Alt-nor|di|sche s; -n; vgl. Deutsche s
Al|to Adi|ge [- ádidsehe] (it. Name für: Südtirol)
Al|to|na (Stadtteil von Hamburg); Al|to|na|er (↑ R 199); al|to|na|isch
Alt|pa|pier
Alt|phi|lo|lo|ge
...alt|rig vgl. ...alterig
Alt-Rom (↑ R 206)
Al|tru|is|mus lat. (Selbstlosigkeit) m; -; Al|tru|ist (↑ R 268); al|tru|istisch
Alt|sitz (veralt. für: Altenteil)
alt|sprach|lich; -er Zweig
Alt|stadt|sa|nie|rung (Erneuerung ungesunder u. übervölkerter alter Stadtteile)
Alt|stein|zeit (für: Paläolithikum) w; -
Alt|stim|me
alt|te|sta|men|ta|risch; Alt|te|sta|ment|ler (Erforscher des A. T.); alt|te|sta|ment|lich
Alt|tier (Jägerspr.: Muttertier beim Rot- u. Damwild)
alt|über|lie|fert
alt|vä|te|risch (altmodisch); -ste

[1] Die Kirchengemeinschaft selbst verwendet den Bindestrich: Alt-Katholik, alt-katholisch, Alt-Katholizismus.

(↑ R 294); alt|vä|ter|lich (ehrwürdig)
alt|ver|traut
Alt|vor|dern (geh. für: Vorfahren) Mehrz.
Alt|wa|ren Mehrz.; Alt|wa|ren|händ|ler
Alt|was|ser (ehemaliger Flußarm mit stehendem Wasser) s; -s, ...wasser
Alt|wei|ber|_ge|schwätz (ugs.), ...som|mer (warme Spätherbsttage; vom Wind getragene Spinnweben)
Alt-Wien (↑ R 206); alt|wie|ne|risch; -ste (↑ R 294)
Alu (Kurzw. für: Aluminium) s; -s; Alu|mi|nat lat. (Salz der Aluminiumsäure) s; -[e]s, -e; alu|mi|nie|ren (Metallteile mit Aluminium überziehen); Alu|mi|nit (ein Mineral) m; -s; Alu|mi|ni|um (chem. Grundstoff, Metall; Zeichen: Al) s; -s; Alu|mi|ni|um_druck (Mehrz. ...drucke), ...fo|lie, ...sul|fat
Alum|nat lat. (Schülerheim); österr.: Einrichtung zur Ausbildung von Geistlichen) s; -[e]s, -e; Alum|ne m; -n, -n (↑ R 268) u. Alum|nus (Alumnatszögling) m; -, ...nen
Al|veo|lar lat. [...we...] (Sprachw.: an den Alveolen, den Zahnfächern, gebildeter Laut, z. B. d) m; -s, -e; Al|veo|le (Zahnfach im Kiefer; Lungenbläschen) w; -, -n
Al|weg|bahn [Kurzw. nach dem Schweden Axel Lenhart Wenner-Gren] (Einschienenbahn)
Al|win (m. Vorn.); Al|wi|ne (w. Vorn.)
Am = chem. Zeichen für: Americium
am; ↑ R 240 (an dem; Abk.: a. bei Ortsnamen, z. B. Ludwigshafen a. Rhein]; vgl. an); - [nächsten] Sonntag, dem (od. den) 27. März (↑ R 330); - besten usw. (↑ R 134)
a m. = ante meridiem; ante mortem
Ama|de|us (m. Vorn.)
Ama|ler, Ame|lun|gen (ostgot. Königsgeschlecht) Mehrz.
Amal|gam mlat. (Quecksilberlegierung) s; -s, -e; Amal|ga|ma|ti|on [...zion]; amal|ga|mie|ren (Quecksilberlegierung herstellen; Gold u. Silber mit Quecksilber aus Erzen gewinnen)
Ama|lia, Ama|lie [...i°] (w. Vorn.)
Aman|da (w. Vorn.); Aman|dus (m. Vorn.)
am an|ge|führ|ten, (auch:) an|ge|ge|be|nen Ort (Abk.: a. a. O.)
Ama|rant gr. (eine Zierpflanze; ein Farbstoff) m; -s, -e; ama|rant, ama|ran|ten (dunkelrot); vgl. blau; ama|rant|rot; vgl. blau

Ama|rel|le lat. (Sauerkirsche) w; -, -n
Ama|ryl gr. (künstl. Saphir) m; -s, -e; Ama|ryl|lis (eine Zierpflanze) w; -, ...llen
Ama|teur fr. [...tör] ([Kunst-, Sport]liebhaber; Nichtfachmann) m; -s, -e; Ama|teur_film, ...fo|to|graf, ...sport|ler, ...sta|tus (Sportspr.)
[1]Ama|ti (it. Meister des Geigenbaus); [2]Ama|ti (von der Geigenbauerfamilie Amati hergestellte Geige) w; -, -s
Amau|ro|se gr. (Med.: Erblindung) w; -, -n
Ama|zo|nas (südamerik. Strom) m; -; Ama|zo|ne (Angehörige eines krieger. Frauenvolkes der gr. Sage; auch: Turnierreiterin) w; -, -n; Ama|zo|nen|strom (Amazonas) m; -[e]s
Am|bas|sa|de fr. [auch: ang...] (veralt. für: Botschaft, Gesandtschaft); Am|bas|sa|deur [...dör] (veralt. für: Botschafter, Gesandter) m; -s, -e
Am|be lat. ("beide"; Reihe von zwei gesetzten od. gewonnenen Nummern in der alten Zahlenlotterie) w; -, -n
Am|ber arab. m; -s, -[n] u. Am|bra (Ausscheidung des Pottwals; Duftstoff) w; -, -s
Am|bi|gui|tät lat. [...gu-i...] (Zweideutigkeit, Doppelsinnigkeit, bes. von einzelnen Wörtern); Am|bi|ti|on [...zion] (hohes Streben); am|bi|tio|nie|ren (veralt. für: aus Ehrgeiz erstreben); am|bi|tio|niert bes. österr. (ehrgeizig, strebsam); am|bi|ti|ös (ehrgeizig); -este (↑ R 292)
am|bi|va|lent lat. [...wa...] (doppelwertig); Am|bi|va|lenz (Doppelwertigkeit)
[1]Am|bo lat. österr. (Ambe; Doppeltreffer beim Lotto) m; -s, -s u. ...ben
[2]Am|bo pr. (erhöhtes Lesepult in christl. Kirchen) m; -s, ...onen
Am|boß m; ...bosses, ...bosse; Am-böß|chen; Am|boß|klotz
Am|bra vgl. Amber
Am|bro|sia gr. (dicht.: Götterspeise) w; -
am|bro|sia|nisch, aber (↑ R 179): Am|bro|sia|nisch; -er Lobgesang; -e Liturgie
am|bro|sisch gr. (dicht.: himmlisch)
Am|bro|si|us (Kirchenlehrer)
am|bu|lant lat. (wandernd; ohne festen Sitz); -e Behandlung (bei der der Kranke ihn Arzt aufsucht); -es Gewerbe (Wandergewerbe); Am|bu|lanz (veralt. für: bewegliches Lazarett; Krankentransportwagen; Abteilung

einer Klinik für ambulante Behandlung) w; -, -en; am|bu|la|to|risch; -e Behandlung; Am|bu|la|to|ri|um (Raum, Abteilung für ambulante Behandlung) s; -s, ...ien [...i^en]

Amei|se w; -, -n; Amei|sen_bär, ...hau|fen, ...säu|re (w; -)

Ame|lio|ra|ti|on lat. [...zion] (Verbesserung [bes. des Ackerbodens]); ame|lio|rie|ren

Ame|lun|gen vgl. Amaler

amen hebr.; zu allem ja und - sagen (ugs.); Amen (feierliche Bekräftigung) s; -s, -; sein - (Einverständnis) zu etwas geben (ugs.)

Amen|de|ment fr. [amangdᵉmang] (Zusatz-, Abänderungsantrag zu Gesetzen) s; -s, -s; amen|die|ren [amän...]

Amen|ho|tep, Ame|no|phis (ägypt. Königsname)

Ame|nor|rhö¹, Ame|nor|rhöe gr. (Med.: Ausbleiben der Menstruation) w; -, ...rrhöen; amenor|rho|isch

Ame|ri|ci|um [...zium; nach Amerika] (chem. Grundstoff, Transuran; Zeichen: Am) s; -s

Ame|ri|ka; Ame|ri|ka|deut|sche m u. w; Ame|ri|kg|ner; ame|ri|ka|nisch; vgl. deutsch; ame|ri|ka|ni|sie|ren; Ame|ri|ka|ni|sie|rung; Ame|ri|ka|nis|mus (Spracheigentümlichkeit des amerik. Englisch in einer anderen Sprache; amerik. Lebens- und Arbeitsauffassung) m; -, ...men; Ame|ri|ka|nist (Wissenschaftler auf dem Gebiet der Amerikanistik); ↑ R 268; Ame|ri|ka|ni|stik (Erforschung der Geschichte u. Kultur Amerikas) w; -

a me|tà it. [- ...tạ] („zur Hälfte"; Kaufmannsspr.: Gewinn u. Verlust zu gleichen Teilen)

Ame|thyst gr. (ein Halbedelstein) m; -[e]s, -e

Ame|trie gr. (Ungleichmäßigkeit; Mißverhältnis) w; -, ...ien; ame|trisch; -ste (↑ R 294)

Am|ha|ra (hamit. Volk in Äthiopien) Mehrz.; am|ha|risch; vgl. deutsch; Am|ha|risch (Sprache) s; -[s]; vgl. Deutsch

Ami|ant gr. (eine Asbestart) m; -s

Ami|ne (organ. Stickstoffverbindungen) Mehrz.; Ami|no|säu|ren (Eiweißbausteine) Mehrz.

Ami|to|se gr. (Biol.: einfache Zellkernteilung) w; -

Am|man (Hptst. Jordaniens)

Am|mann (schweiz.) m; -s, ...männer; vgl. Gemeinde-, Landammann

Am|me w; -, -n; Am|men|mär|chen

¹ Vgl. die Anmerkung zu „Diarrhö, Diarrhöe".

¹Am|mer (ein Vogel) w; -, -n

²Am|mer, (im Unterlauf:) Amper (Isarzufluß) w; -

Am|mon (altägypt. Gott); Jupiter -

Am|mo|ni|ak ägypt. [auch: am...]; österr.: amo...] (gasförmige Verbindung von Stickstoff u. Wasserstoff) s; -s

Am|mo|nit ägypt. (Ammonshorn; eine Versteinerung) m; -en, -en (↑ R 268)

Am|mo|ni|ter ägypt. (Angehöriger eines alttest. Nachbarvolks der Israeliten) m; -s, -

Am|mo|ni|um ägypt. (eine Atomgruppe) s; -s

Am|mons|horn ägypt.; dt. (Versteinerung; Mehrz. ...hörner)

Amne|sie gr. (Med.: Gedächtnisschwund) w; -, ...ien; Amne|stie (Begnadigung, Straferlaß) w; -, ...ien; amne|stie|ren

Am|ni|on gr. (Biol., Med.: Embryonalhülle) s; -s

Amö|be gr. (ein Urtierchen) w; -, -n; amö|bo|id (amöbenartig)

Amok malai. [auch: amọk] (Erscheinung des Amoklaufens) m; -s; - laufen (in einem Anfall von Geistesgestörtheit mit einer Waffe umherlaufen und blindwütig töten); Amok_fahrer, ...laufen(s; -s),...läufer,...schüt|ze

a-Moll [auch: amọl] (Tonart; Zeichen: a) s; -; a-Moll-Tonleiter (↑ R 155)

Amom gr. (tropische Gewürzlilie) s; -s, -e

Amor (röm. Liebesgott)

amo|ra|lisch lat. (sich über die Moral hinwegsetzend); Amo|ra|lis|mus (gleichgültige od. feindl. Einstellung gegenüber der geltenden Moral) m; -; Amo|ra|li|tät (amoralische Lebenshaltung) w; -

amorph; Amor|phie gr. (Physik: formloser Zustand [eines Stoffes]) w; -, ...ien

amor|ti|sa|bel fr. (tilgbar); ...a|ble Anleihen; Amor|ti|sa|ti|on lat. [...zion] ([allmähliche] Tilgung; Abschreibung, Abtragung [einer Schuld]); amor|ti|sie|ren

Amos (bibl. Prophet)

amou|rös fr. [amuröß] (veralt. für: Liebes...; verliebt); -este (↑ R 292)

Am|pel (Hängelampe; Hängevase; Verkehrssignal) w; -, -n

Am|per vgl. Ammer

Am|pere [...pär; nach dem fr. Physiker Ampère] (Einheit der elektr. Stromstärke; Zeichen: A) s; -[s], -; Am|pere_me|ter (Strommesser; s;-s,-),...stun|de (Einheit der Elektrizitätsmenge; Zeichen: Ah)

Amp|fer (eine Pflanze) m; -s, -

Am|phet|amin (als Weckamin gebrauchte chemische Verbindung) s; -s, -e

Am|phi|bie gr. [amfịbiᵉ] w; -, -n (meist Mehrz.) u. Am|phi|bi|um („beidlebiges" Tier, Lurch) s; -s, ...ien [...i^en]; Am|phi|bi|en_fahrzeug (Land-Wasser-Fahrzeug), ...pan|zer; am|phi|bisch

Am|phi|bi|um vgl. Amphibie

Am|phi|bol (Hornblende) m; -s, -e; Am|phi|bo|lie (Mehrdeutigkeit; Doppelsinn) w; -, ...ien; am|phi|bo|lisch

Am|phi|go|nie gr. (Biol.: zweigeschlechtige Fortpflanzung) w; -

Am|phi|ktyo|ne gr. (Mitglied einer Amphiktyonie) m; -n, -n; ↑ R 268; Am|phi|ktyo|nie (kultischpolit. Verband altgr. Nachbarstaaten od. -stämme) w; -, ...ien

Am|phi|mi|xis gr. (Biol.: Vermischung der Erbanlagen bei der Befruchtung) w; -

Am|phio|le ⓦ (Glasgefäß mit spritzfertigem Arzneimittel) w; -, -n

Am|phio|xus gr. (Lanzettfisch) m; -

Am|phi|po|den gr. (Flohkrebse) Mehrz.

Am|phi|thea|ter gr. (elliptisches, meist dachloses Theatergebäude mit stufenweise aufsteigenden Sitzen, Rundtheater); am|phi|thea|tra|lisch

Am|phi|tri|te (gr. Meeresgöttin)

Am|phi|try|on (sagenhafter König von Tiryns, Gemahl der Alkmene)

Am|pho|ra, Am|pho|re gr. (zweihenkliges Gefäß der Antike) w; -, ...oren

am|pho|ter gr. („zwitterhaft"; Chemie: teils als Säure, teils als Base sich verhaltend)

Am|pli|fi|ka|ti|on lat. [...zion] (Erweiterung; kunstvolle Ausweitung einer Aussage); am|pli|fi|zie|ren; Am|pli|tu|de (Physik: Schwingungsweite, Ausschlag) w; -, -n

Am|pul|le gr. (Glasröhrchen [bes. mit sterilen Lösungen zum Einspritzen]) w; -, -n

Am|pu|ta|ti|on lat. [...zion] ([Glied]abtrennung); am|pu|tie|ren

Am|rum (Nordseeinsel)

Am|sel w; -, -n

Am|ster|dam [auch: am..] (Hptst. der Niederlande); Am|ster|da|mer (↑ R 199)

Amt s; -[e]s, Ämter; von Amts wegen; ein - bekleiden; Ämt|lein; am|ten (veralt.); Äm|ter|pa|tro|na|ge; am|tie|ren; Ämt|lein; Amt|chen; amt|lich; Amt-

mann (*Mehrz.* ...männer u. ...leute); **Amts_deutsch,** ...ent|he|bung, ...ge|richt (Abk.: AG), ...gerichts|rat (*Mehrz.* ...räte); **amtshal|ber;** **Amts_hand|lung,** ...haupt|mann (veralt.), ...hil|fe, ...kap|pel (österr. ugs. für: engstirniger Beamter; *s;* -s, -n), ...mie|ne; **amts|mü|de; Amts_peron,** ...rioh|tor, ...schim|mel (ugs.; *m;* -s), ...spra|che, ...vor|stand, ...weg

Amu|lett *lat.* (Zauber[schutz]mittel) *s;* -[e]s, -e

Amund|sen (norweg. Polarforscher)

Amur (asiat. Strom) *m;* -[s]

amü|sant *fr.* (unterhaltend; vergnüglich); **Amü|se|ment** [*amüsᵉmãŋ*] *s;* -s, -s; **amü|sie|ren;** sich - **amu|sisch** *gr.* (ohne Kunstverständnis)

Amyg|da|lin *gr.* (Geschmacksstoff in bitteren Mandeln u. ä.) *s;* -s

an (Abk.: a.; bei Ortsnamen, die durch weibl. Flußnamen bezeichnet sind, nur: a. d., z. B. Bad Neustadt a. d. Saale); *Verhältnisw.* mit *Wemf.* und *Wenf.*: an dem Zaun stehen, aber: an den Zaun stellen; es ist nicht an dem; an [und für] sich (eigentlich, im Grunde); am (an dem; vgl. am); ans (an das; vgl. ans); *Umstandsw.*: Gemeinden von an [die] 1000 Einwohnern; ab und an (landsch. für: ab und zu). *Zus.:* anbei, aneinander, bergan

an... (*in Zus. mit Zeitwörtern, z. B.* anbinden, du bindest an, angebunden, anzubinden; zum 2. Mittelw. ↑ R 304)

...**ana,** ...iana *lat.; Mehrz.* (z. B. Goetheana; Kantiana; Afrikana); vgl. Ana; **Ana** (veralt. für: Sammlung von Aussprüchen od. kleinen Beiträgen zur Charakteristik berühmter Männer) *w;* -, -s

Ana|bap|tis|mus *gr.* (Wiedertäuferlehre) *m;* -; **Ana|bap|tist** (Wiedertäufer); ↑ R 268

Ana|ba|sis *gr.* [auch: *ana...*] („Hinaufmarsch"; Geschichtswerk Xenophons) *w;* -

Ana|bio|se *gr.* („Wiederaufleben"; Biol.: das Überstehen ungünstiger Lebensbedingungen bei niederen Tieren) *w;* -

Ana|cho|ret *gr.* [...*cho...*, auch: ...*cho*...] (Klausner, Einsiedler) *m;* -en, -en (↑ R 268)

Ana|chro|nis|mus *gr.* [...*kro*...] (falsche zeitliche Einordnung; durch die Zeit überholte Einrichtung) *m;* -, ...men; **ana|chro|ni|stisch**

Ana|dyo|me|ne *gr.* [auch: ...*mene* od. ...*omene* od. ...*omene*] („die [aus dem Meer] aufgetauchte" Göttin: Aphrodite)

an|ae|rob *gr.* [...*a-eroːp*] (ohne Sauerstoff lebend)

Ana|gramm *gr.* (Buchstabenversetzrätsel) *s;* -s, -e

An|ako|luth *gr.* (Sprachw.: Satzbruch) *s;* -s, -e; **an|ako|lu|thisch**

Ana|kon|da (eine Boaschlange) *w;* -, -s

Ana|kre|on (altgr. Lyriker); **Ana|kre|on|ti|ker** (Nachahmer der Dichtweise Anakreons); **ana|kre|on|tisch,** aber (↑ R 179): **Ana|kre|on|tisch**

anal *lat.* (Med.: den Anus betreffend)

Ana|lek|ten *gr.* (gesammelte Aufsätze, Auszüge) *Mehrz.*

Ana|lep|ti|kum *gr.* (Med.: wiederbelebendes Mittel) *s;* -s, ...ka; **ana|lep|tisch**

An|al|ge|sie, **An|al|gie** *gr.* (Schmerzlosigkeit) *w;* -, ...ien

ana|log *gr.* (ähnlich; entsprechend); -[zu] diesem Fall; **Ana|lo|gie** *w;* -, ...ien; **Ana|lo|gon** [auch: *anaː*...] (ähnlicher Fall) *s;* -s, ...ga

An|al|pha|bet *gr.* [auch: *an*...] (des Lesens u. Schreibens Unkundiger) *m;* -en, -en (↑ R 268); **An|al|pha|be|ten|tum** [auch: *an*...] *s;* -s

Ana|ly|sand *gr.* (Psychoanalyse: die zu analysierende Person) *m;* -en, -en (↑ R 268); **Ana|ly|se** (Zergliederung, Untersuchung) *w;* -, -n; **Ana|ly|sen|waa|ge** (chem. Waage); **ana|ly|sie|ren; Ana|ly|sis** (math. Theorie der reellen Zahlen u. Funktionen; Schulausdruck für die Untersuchung einer geometrischen Aufgabe) *w;* -; **Ana|ly|tik** (Kunst od. Lehre der Analyse) *w;* -; **Ana|ly|ti|ker; ana|ly|tisch;** -e Geometrie

An|ämie *gr.* (Med.: Blutarmut) *w;* -, ...ien; **an|ämisch** (blutarm)

Ana|mne|se *gr.* (Med.: Vorgeschichte einer Krankheit) *w;* -, -n; **ana|mne|stisch**

Ana|nas *indian.-span.* (eine tropische Frucht) *w;* -, - u. -se

Ana|ni|as, (ökum.:) Ha|na|ni|as (bibl. m. Eigenn.)

Ana|päst *gr.* (ein Versfuß) *m;* -[e]s, -e; **ana|pä|stisch**

Ana|pher *w;* -, -n u. **Ana|pho|ra** *gr.* (Rhet.: Wiederholung des Anfangswortes [in aufeinanderfolgenden Sätzen], z. B.: mit all meinen Gedanken, mit all meinen Wünschen ...) *w;* -, ...rä; **ana|pho|risch**

Ana|phy|la|xie *gr.* (Med.: schockartige allergische Reaktion) *w;* -, ...ien

An|ar|chie *gr.* (autoritätsloser Zustand; Herrschafts-, Gesetzlosigkeit) *w;* -, ...ien; **an|ar|chisch;** -ste (↑ R 294); **An|ar|chis|mus** (Lehre, die sich gegen jede Autorität richtet u. für unbeschränkte Freiheit des Individuums eintritt) *m;* -; **An|ar|chist** (Vertreter des Anarchismus); ↑ R 268; **an|ar|chi|stisch**

Ana|sta|sia (w. Vorn.); **Ana|sta|si|us** (m. Vorn.)

ana|sta|tisch *gr.* (wiederauffrischend; neubildend); -er Druck (Nachdruckverfahren)

An|äs|the|sie *gr.* (Med.: Schmerzunempfindlichkeit; Schmerzbetäubung) *w;* -, ...ien; **an|äs|the|sie|ren,** **an|äs|the|ti|sie|ren; An|äs|the|sist** (Narkosefacharzt); ↑ R 268; **An|äs|the|ti|kum** (Med.: schmerzstillendes Mittel) *s;* -s, ...ka; **an|äs|the|tisch; an|äs|the|ti|sie|ren,** an|äs|the|sie|ren

An|astig|mat (ein [fotogr.] Objektiv) *m;* -s, -e; **an|astig|ma|tisch**

Ana|sto|mo|se (Verbindung zwischen Blut- od. Lymphgefäßen od. zwischen Nerven) *w;* -, -n

Ana|them|a *gr.* -s, -e u. **Ana|the|ma** (Verfluchung, Kirchenbann) *s;* -s, ...themata; **ana|the|ma|ti|sie|ren; Ana|the|ma|ti|sie|rung**

ana|tio|nal *lat.* [...*zi*...] (gleichgültig gegenüber der Nation, der man angehört)

Ana|tol (m. Vorn.); **Ana|to|li|en** [...*iᵉn*] („Morgenland"; asiat. Teil der Türkei); **ana|to|lisch**

Ana|tom *gr.* („Zergliederer"; Lehrer der Anatomie) *m;* -en, -en (↑ R 268); **Ana|to|mie** (Lehre von Form u. Körperbau der Lebewesen; [Kunst der] Zergliederung) *w;* -, (für: Forschungsanstalt der Anatomen auch *Mehrz.:*) ...ien; **ana|to|mie|ren** (zergliedern); **ana|to|misch**

Ana|to|zis|mus *gr.* (Zinsverzinsung) *m;* -, ...men

Ana|xa|go|ras (altgr. Philosoph)

an|bah|nen; An|bah|nung

an|ban|deln südd., österr. (anbändeln); **an|bän|deln** (ugs.); ich bänd[el]e an (↑ R 327); **An|bände|lung, An|bänd|lung** (ugs.)

An|bau *m;* -[e]s, (für: Gebäudeteil auch *Mehrz.:*) -ten; **an|bau|en; anbau|fä|hig; An|bau_flä|che, ...möbel**

an|be|ginn; seit-, von - [an] **an|be|hal|ten**

an|bei [auch: *anbeiː*] **an|[be]|lan|gen;** was mich an[be]langt

an|be|rau|men; ich beraum[t]e an, (selten:) ich anberaum[t]e; anberaumt; anzuberaumen; **An|berau|mung**

an|be|tracht; in - dessen, daß ... **an|be|tref|fen;** was mich anbetrifft, so ...

An|be|tung
an|bie|dern, sich; ich biedere mich
an (↑ R 327); An|bie|de|rung
an|bie|ten
an|bin|den; angebunden (vgl. d.)
An|blick; an|blicken [Trenn.:
...blik|ken]
an|boh|ren
An|bot österr. neben: Angebot)
s; -[e]s, -e
an|bre|chen; der Tag bricht an
an|bren|nen
an|brin|gen; etwas am Haus[e] -
An|bruch m; -[e]s, (Bergmannsspr.
für: bloßgelegte Erzgänge auch
Mehrz.:) ...brüche
An|cho|vis [...chowiß]; vgl. An-
schovis
An|ci|en|ni|tät fr. [angßiänität]
(veralt. für: [Reihenfolge nach
dem] Dienstalter); An|ci|en ré|gi-
me [angßiäng resehim] („alte Re-
gierung" [vor der Fr. Revolu-
tion]) s; - -
An|dacht w; -, (für: Gebetsstunde
auch Mehrz.:) -en; an|däch|tig;
An|dachts|übung; an|dachts|voll
An|da|lu|si|en [...i^en] (span. Land-
schaft); An|da|lu|si|er [...i^er]; an-
da|lu|sisch; An|da|lu|sit (ein Mi-
neral) m; -s, -e
an|dan|te it. („gehend"; Musik:
mäßig langsam); An|dan|te (mä-
ßig langsames Tonstück) s; -[s],
-s; an|dan|ti|no (Musik: etwas be-
schleunigter als andante); An-
dan|ti|no (kürzeres Musikstück
im Andante- od. Andantinotem-
po) s; -s, -s u. ...ni
an|dau|en (Med.); angedaute Spei-
sen (Speisen im ersten Abschnitt
des Verdautwerdens)
an|dau|ern; an|dau|ernd
An|dau|ung [zu: andauen] w; -
An|del niederd. (ein Salzgras) m;
-s
An|den (südamerik. Gebirge)
Mehrz.
An|den|ken s; -s, (für: Erinne-
rungsgegenstand auch Mehrz.:) -
an|de|re, and|re; (nach ↑ R 135 im-
mer klein geschrieben:) der, die,
das, eine, keine, alles and[e]re;
die, keine, alle and[e]ren, andern;
ein, kein all[e]rer; ein, kein, et-
was, allerlei, nichts and[e]res; der
eine, der and[e]re; und and[e]re,
und and[e]res (Abk.: u. a.); und
and[e]re mehr, und and[e]res
mehr (Abk.: u. a. m.); von etwas
and[e]rem, anderm sprechen; un-
ter and[e]rem, anderm (Abk.:
u. a.); eines and[e]ren, andern be-
lehren; sich eines and[e]ren, an-
dern besinnen; sich ins and[e]ren,
andern Sinnes; (↑ R 279:) and[e]-
res gedrucktes Material; (↑ R
285:) and[e]re ähnliche Fälle; (↑ R
290:) andere Gute; ein andermal,

aber: ein and[e]res Mal; das
and[e]re Mal; ein um das and[e]re
Mal; ein und das and[e]re Mal;
vgl. anders; an|de|ren|falls¹; vgl.
Fall m; an|de|ren|orts¹, an|der-
orts (geh.); an|de|ren|tags¹; an|de-
ren|teils¹; einesteils ... - ; an|de|rer-
seits, an|der|seits, and|rer|seits;
einerseits ... - ; An|der|ge|schwi-
ster|kind [auch: and^erg^eschwi...]
landsch. (Verwandte, deren
Großväter oder Großmütter Ge-
schwister sind); an|der|lei; an|der-
mal; ein -, aber: ein and[e]res
Mal
An|der|matt (schweiz. Ortsn.)
än|dern; ich ...ere (↑ R 327)
an|dern|falls usw. vgl. anderenfalls
usw.; an|der|orts (geh.), an|de-
ren|orts, an|dern|orts
an|ders; jemand, niemand, wer an-
ders (südd., österr.: and[e]rer);
mit jemand, niemand anders
(südd., österr.: and[e]rem, an-
derm) reden; irgendwo anders
(irgendwo sonst), wo anders? (wo
sonst?; vgl. aber: woanders); an-
ders als - (nicht: anders wie ...);
vgl. andere; an|ders|ar|tig; An-
ders|ar|tig|keit w; -
An|dersch (dt. Schriftsteller)
an|ders|den|kend; An|ders|den-
ken|de m u. w; -n, -n (↑ R 287ff.)
an|der|seits, an|de|rer|seits, and-
rer|seits
An|der|sen (dän. Dichter)
An|der|sen-Ne|xø (Andersen-
Nexö), Martin (dän. Dichter)
an|ders|ge|ar|tet; an|ders|ge|sinn-
te m u. w; -n, -n (↑ R 287ff.); An-
ders|gläu|bi|ge m u. w; -n -n (↑ R
287ff.); an|ders|her|um, an|ders-
rum; an|ders|sein; an|ders|spra-
chig; an|ders|wie; an|ders|wo; an-
ders|wo|her; an|ders|wo|hin
an|dert|halb; in - Stunden; - Pfund;
an|dert|halb|fach; An|dert|halb-
fa|che s; -n; vgl. Achtfache; an-
dert|halb|mal; - so groß wie (selte-
ner: als)
Än|de|rung
An|der|wär|tig; an|der|wärts; an-
der|weit; an|der|wei|tig
An|de|sin [nach dem Andengebir-
ge] (ein Mineral) m; -s; An|de|sit
(ein vulkan. Gestein) m; -s
an|deu|ten; An|deu|tung; an|deu-
tungs|wei|se
an|dich|ten; jmdm. etwas -
an|die|nen (Kaufmannsspr.: [Wa-
ren] anbieten); An|die|nung w; -;
An|die|nungs|pflicht (Versiche-
rungsw.) w; -
an|din (die Anden betreffend; in
den Anden vorkommend)
An|dorn (eine Pflanze) m; -[e]s, -e

An|dor|ra (Staat in den Pyrenäen);
An|dor|ra|ner; an|dor|ra|nisch
An|drang m; -[e]s
and|re; vgl. andere
An|drea (w. Vorn.); An|dre|as (m.
Vorn.); An|dre|as|kreuz, ...or|den
(ehem. höchster russ. Orden)
an|dre|hen; jmdm. etwas - (ugs.
für: jmdm. etwas Minderwertiges
aufschwatzen)
and|rer|seits, an|de|rer|seits, an-
der|seits
An|dres (dt. Erzähler, Dramatiker
u. Lyriker)
an|dro|gyn gr. (Biol.: männliche u.
weibliche Merkmale vereini-
gend; zwittrig); An|dro|gy|nie
w; -
an|dro|hen; An|dro|hung
An|dro|ide gr. (künstlicher
Mensch) m; -n, -n (↑ R 268)
An|dro|ma|che (gr. Sagengestalt,
Gattin Hektors)
¹An|dro|me|da (weibl. gr. Sagenge-
stalt); ²An|dro|me|da (ein Stern-
bild) w; -
An|druck (Druckw.: Probe-, Prüf-
druck) m; -[e]s, -e; an|drucken
[Trenn.: ...druk|ken]
Äne|as (Held der gr.-röm. Sage)
an|ecken [Trenn.: ...ek|ken] (ugs.
für: Anstoß erregen)
Äne|ide, Äne|is (eine Dichtung
Vergils) w; -
an|ei|fern südd., österr. (anspor-
nen); An|ei|fe|rung
an|eig|nen, sich; ich eigne mir an;
An|eig|nung
an|ein|an|der; Schreibung in Ver-
bindung mit Zeitwörtern (↑ R
139): I. Getrenntschreibung, wenn
aneinander [als Ausdruck einer
Wechselbezüglichkeit, einer Ge-
genseitigkeit] seine Selbständig-
keit bewahrt, z. B. weil sie einen
ander (an sich gegenseitig) den-
ken, gedacht haben, oder wenn
aneinander zu einem bereits zu-
sammengesetzten Zeitwort tritt,
z. B. er hat die Teile aneinander
angefügt. II. Zusammenschrei-
bung, wenn aneinander nur den
vom Zeitwort bezeichneten Vor-
gang näher bestimmt, d. h., wenn
es „Vorwort" des Zeitwortes ist,
z. B. an|ein|an|der|fü|gen; er hat
die Teile aneinandergefügt; er hat
die Teile aneinander-, nicht auf-
einandergefügt; an|ein|an|der|ge-
ra|ten (sich streiten); an|ein|an-
der|gren|zen; aneinandergren-
zende Grundstücke; an|ein|an-
der|le|gen; an|ein|an|der|rei|hen
usw.
Äne|is vgl. Äneide
An|ek|do|te gr. (kurze Geschichte
mit überraschender Pointe) w; -,
-n; an|ek|do|ten|haft; an|ek|do-
tisch

¹ Auch: an|dern|...

an|ekeln; der Anblick ekelte mich an
Ane|mo|graph gr. (selbstschreibender Windmesser) m; -en, -en (↑ R 268); Ane|mo|lo|gie (veralt. für: Windkunde) w; -; Ane|mo|me|ter (Windmesser) s; -s, -; Ane|mo|ne (Windröschen) w; -, -n
an|emp|feh|len (besser das einfache Wort: empfohlen); ich empfehle (empfahl) an u. ich anempfehle (anempfahl); anempfohlen; anzuempfehlen
An|epi|gra|pha gr. (veralt. für: unbetitelte Schriften) Mehrz.
An|er|be (veralt. für: bäuerlicher Alleinerbe, Hoterbe) m; An|er|ben.fol|ge, ...recht
an|er|bie|ten, sich; ich erbiete mich an; anerboten; anzuerbieten; vgl. bieten; An|er|bie|ten s; -s, -; An|er|bie|tung
an|er|kann|ter|ma|ßen; an|er|ken|nen; ich erkenne (erkannte) an, (seltener:) ich anerkenne (anerkannte); anerkannt; anzuerkennen; vgl. kennen; an|er|ken|nens|wert; An|er|kennt|nis (Rechtsspr.) s (nichtfachspr. w); An|er|ken|nung; An|er|ken|nungs|schrei|ben
Ane|ro|id gr. s; -[e]s, -e u. Ane|ro|id-ba|ro|me|ter (Gerät zum Anzeigen des Luftdrucks)
An|eu|rys|ma gr. (Med.: Schlagadererweiterung) s; -s, ...men
an|fa|chen; er facht die Glut an
an|fah|ren (auch für: heftig anreden); An|fahrts.stra|ße, ...weg
An|fall m; an|fal|len; an|fäl|lig; An|fäl|lig|keit w; -, (selten:) -en
An|fang m; -[e]s, ...fänge; vgl. anfangs, im -; von - an; zu -; - Januar (↑ R 319); an|fan|gen; An|fän|ger; An|fän|ge|rin w; -, -nen; an|fäng|lich; an|fangs (↑ R 129); An|fangs.buch|sta|be, ...ge|halt s, ...sta|di|um
an|fas|sen; vgl. fassen
an|fecht|bar; An|fecht|bar|keit w; -; an|fech|ten; das ficht mich nicht an; An|fech|tung
an|fein|den; An|fein|dung
an|fer|ti|gen; An|fer|ti|gung
an|feuch|ten; An|feuch|ter; An|feuch|tung
an|feu|ern; An|feue|rung
an|fle|hen; An|fle|hung
an|flie|gen; das Flugzeug hat Frankfurt angeflogen; An|flug
an|for|dern; An|for|de|rung
An|fra|ge; die kleine oder große - [im Parlament]; an|fra|gen; bei jmdm. -, (schweiz.:) jmdm. -
an|freun|den; sich; An|freun|dung
an|fü|gen; An|fü|gung
An|fuhr w; -, -en; an|füh|ren; An|füh|rer; An|füh|rung; An|füh|rungs.strich, ...zei|chen

an|fun|ken (durch Funkspruch anrufen)
An|ga|be (ugs. [nur Einz.] auch für: Prahlerei, Übertreibung)
an|gän|gig
an|geb|bar; an|ge|ben; An|ge|ber (ugs.); An|ge|be|rei (ugs.); an|ge|be|risch (ugs.); -ste (↑ R 294)
An|ge|be|te|te m u. w; -n, -n (↑ R 287 ff.)
an|ge|bin|de (Geschenk) s; -s, -
an|geb|lich
an|ge|bo|ren
An|ge|bot
an|ge|bracht; an|ge|brach|ter|ma|ßen
an|ge|bro|chen; eine Flasche ist -; ein -er Tag
an|ge|bun|den; kurz - (ugs. für: mürrisch, abweisend) sein
an|ge|dei|hen; jmdm. etwas - lassen
An|ge|den|ken (veralt.) s; -s
an|ge|führt; am -en Ort (Abk.: a. a. O.)
an|ge|ge|ben; am -en Ort (Abk.: a. a. O.)
an|ge|grif|fen (auch: erschöpft); An|ge|grif|fen|heit w; -
an|ge|hei|ra|tet
an|ge|hei|tert
an|ge|hen; das geht nicht an; es geht mich [nichts] an; jmdn. um etwas - (bitten); an|ge|hend (künftig)
an|ge|hö|ren; einem Volk[e] -; an|ge|hö|rig; An|ge|hö|ri|ge m u. w; -n, -n (↑ R 287 ff.); An|ge|hö|rig|keit w; -
Angekl. = Angeklagte[r]
An|ge|klag|te (Abk.: Angekl.) m u. w; -n, -n (↑ R 287 ff.)
an|ge|krän|kelt
An|gel w; -, -n
An|ge|la [anggela, it.: andschela] (w. Vorn.)
An|ge|li|na [andschelina] (it. w. Vorn.)
an|geln; ich ...[e]le (↑ R 327)
An|geln (germ. Volksstamm) Mehrz.
An|ge|lo [andschelo] (it. m. Vorn.)
an|ge|lo|ben österr. (feierlich vereidigen); An|ge|lo|bung
An|gel.punkt, ...ru|te
An|gel|sach|se (Angehöriger eines germ. Volksstammes) m; -n, -n; an|gel|säch|sisch; vgl. deutsch; An|gel|säch|sisch (Sprache) s; -[s]; vgl. Deutsch; An|gel|säch|si|sche s; -n; vgl. Deutsche s
An|ge|lus lat. [angge...] (kath. Ge-

bet; Glockenzeichen) m; -, -; An|ge|lus|läu|ten s; -s
an|ge|mes|sen; An|ge|mes|sen|heit w; -
an|ge|nä|hert
an|ge|nehm
an|ge|nom|men; -er Standort; angenommen, daß ... (↑ R 61)
An|ger m; -s, -; An|ger|dorf
an|ge|regt
an|ge|säu|selt (ugs. für: leicht betrunken)
An|ge|schul|dig|te m u. w; -n, -n (↑ R 287 ff.)
an|ge|se|hen (geachtet); -ste
An|ge|sicht (Mehrz. Angesichter u. [österr. nur:] Angesichte); an|ge|sichts (↑ R 130); Verhältnisw. mit Wesf.: - des Todes
an|ge|spannt
an|ge|stammt
An|ge|stell|te m u. w; -n, -n (↑ R 287 ff.); An|ge|stell|ten|ver|si|che|rung; An|ge|stell|ten|ver|si|che|rungs|ge|setz (Abk.: AVG)
an|ge|stie|felt; - kommen (ugs. für: mit großen, schwerfälligen Schritten herankommen)
an|ge|strengt; An|ge|strengt|heit w; -
an|ge|tan
an|ge|trun|ken (leicht betrunken); An|ge|trun|ken|heit w; -
an|ge|wandt; -e Kunst; -e Mathematik, Physik; vgl. anwenden
an|ge|wie|sen; auf eine Person oder eine Sache - sein
an|ge|wöh|nen; ich gewöhne mir etwas an; An|ge|wohn|heit; An|ge|wöh|nung
an|ge|wur|zelt; wie - stehenbleiben
An|gi|na gr. [anggina] (Mandelentzündung) w; -, ...nen; An|gi|na pec|to|ris gr.; lat. [- päk...] (Herzkrampf) w; - -
An|gi|om gr. [anggiom] (Gefäßgeschwulst) s; -s, -e; An|gio|sper|men (bedecktsamige Blüten pflanzen) Mehrz.
An|glaise fr. [anggläs] (,,englischer" Tanz) w; -, -n
an|glei|chen; An|glei|chung
Ang|ler
an|gli|ka|nisch mlat. [anggli...]; -e Kirche (engl. Staatskirche); An|gli|ka|nis|mus (Lehre u. Wesen[s]form] der engl. Staatskirche) m; -; an|gli|sie|ren (englisch machen); englisieren); An|gli|sist (Wissenschaftler auf dem Gebiet der Anglistik); ↑ R 268; An|gli|stik (engl. Sprach- u. Literaturwissenschaft) w; -; An|gli|zis|mus (engl. Spracheigentümlichkeit in einer anderen Sprache) m; -, ...men; An|glo|ame|ri|ka|ner [anglo..., auch: ang...]; ↑ R 215 (aus England stammender Amerikaner); An|glo-Ame|ri|ka|ner;

↑R 214 (Sammelname für Engländer u. Amerikaner); an|glo|fran|zö|sisch [auch: _ạng_...]; An|glo|ma|ne _lat._; _gr._ (Nachäffer des engl. Wesens) _m_; -n, -n (↑R 268); An|glo|ma|nie _w_; -; an|glo|nor|man|nisch [auch: _ạng_...]; an|glo|phil (englandfreundlich); An|glo|phi|lie _w_; -; An|glo|pho|bie (Widerwille gegen engl. Wesen) _w_; -

An|go|la [_anggola_] (portugies. Provinz in Afrika); An|go|la|ner; an|go|la|nisch

An|go|ra⌐kat|ze, ...wol|le [_anggora_...]; nach Angora, dem früheren Namen von Ankara]

An|go|stu|ra ⓦ _span._ [_anggo_...] (ein Likör) _m_; -s, -s

an|grei|fen; vgl. angegriffen; An|grei|fer

an|gren|zen; An|gren|zer; An|gren|zung

An|griff _m_; -[e]s, -e; in - nehmen; an|grif|fig schweiz. (zupackend, angriffslustig); An|griffs|krieg; an|griffs|lu|stig; An|griffs⌐spie|ler (Sportspr.), ...waf|fe; an|griffs|wei|se

Angst _w_; -, Ängste; in Angst, in [tausend] Ängsten sein; Angst haben; aber (↑R 132): angst und bange machen, sein, werden; mir ist, wird angst und bange; äng|sten, sich (nur noch dicht. für: ängstigen); angst|er|füllt; Angst⌐ge|fühl, ...geg|ner (Sportspr.: Gegner, vor dem man besondere Angst hat), ...ha|se (ugs.); äng|sti|gen; Ạng|sti|gung; ạngst|lich; Ạngst|lich|keit _w_; -; ạngst|neu|ro|se (krankhaftes Angstgefühl), ...psy|cho|se, ...röh|re (scherzh. für: Zylinder)

Ạng|ström [_ongßtröm_, auch: _ạngßtröm_] _s_; -[s], - u. Ạng|ström⌐ein|heit (Einheit der Licht- u. Röntgenwellenlänge; Zeichen: Å [früher auch: A, AE, ÅE])

Angst|ruf (österr.); an|voll an|gu|lar _lat._ [_anggu_...] (zu einem Winkel gehörend, Winkel...)

Anh. = Anhang

an|ha|ben (ugs.); ..., daß er nichts anhat, angehabt hat; er kann mir nichts -

an|hä|gern (von Gewässern: Schlamm, Sand ablagern); An|hä|ge|rung

an|hä|keln (hinzuhäkeln); an|ha|ken

¹An|halt (früheres Reichsland); ²An|halt (Anhaltspunkt); an|hal|tend; ¹An|hal|ter, An|hal|ti|ner; ²An|hal|ter (ugs.); per - fahren (Fahrzeuge anhalten, um mitgenommen zu werden); an|hal|tisch (¹Anhalt betreffend); Ạn|halts⌐punkt

an Hạnd, (jetzt häufig:) an|hạnd; mit _Wesf._: an Hand od. anhand des Buches; an Hand od. anhand von Unterlagen; vgl. Hand u. ↑R 141

Ạn|hang (Abk.: Anh.); ¹ạn|hän|gen; er hing mir treulich an; vgl. ¹hängen; ²ạn|hän|gen; er hängte den Zettel [an die Tür] an; vgl. ²hängen; Ạn|hän|ger; Ạn|hän|ger⌐schaft; ạn|hän|gig (Rechtsspr.: beim Gericht zur Entscheidung liegend); eine Klage - machen (Klage erheben); ạn|häng|lich (ergeben); Ạn|häng|lich|keit _w_; -; Ạn|häng|sel _s_; -s, -; ạn|hangs|wei|se

Ạn|hauch _m_; -[e]s; ạn|hau|chen

an|hau|en (ugs. auch für: jmdn. formlos ansprechen; auch: um etwas angehen); wir hauten das Mädchen an

an|häu|len; An|häu|fung

an|he|ben (auch: anfangen); er hob, (veralt.:) hub an (geh. für: begann) zu singen

an|hef|ten; am Hut[e] od. an den Hut -

an|hei|meln; es heimelt mich an

an|heim⌐fal|len (zufallen; es fällt anheim; anheimgefallen; anheimzufallen), ...ge|ben, ...stel|len

an|hei|schig; sich - machen

an|hei|zen; den Ofen -; (übertr.:) die Stimmung -

an|herr|schen; jmdn. -

an|heu|ern; jmdn. -; auf einem Schiff -

An|hi|dro|se _gr._ (Med.: verminderte Schweißabsonderung) _w_; -, -n

Ạn|hieb, nur in: auf -

an|him|meln

an|hin; bis - (schweiz. veraltend: bis jetzt)

Ạn|hö|he

an|hö|ren; An|hö|rung (für: Hearing)

An|hy|drid _gr._ (eine chem. Verbindung) _s_; -s, -e; An|hy|drit (wasserfreier Gips) _m_; -s, -e

Ani|lin _arab.-port._ (Ausgangsstoff für Farben u. Heilmittel) _s_; -s; Ani|lin|far|be

ani|ma|lisch _lat._ (tierisch, den Tieren eigentümlich); Ani|ma|lis|mus (religiöse Verehrung von Tieren) _m_; -; Ani|ma|li|tät (tierisches Wesen) _w_; -; ani|ma|to od. -; (Musik: beseelt, belebt); ani|mie|ren _fr._ (beleben, anregen, ermuntern); Ani|mier|kneipe (ugs.); Ani|mis|mus _lat._ (Lehre von der Beseeltheit aller Dinge) _m_; -; Ani|mo _it._ (österr.: Lust; Vorliebe) _s_; -s; Ani|mo|si|tät _lat._ (Erbitterung; Abneigung) _w_; -; Ani|mus ("Seele"; scherzh. für: Ahnung) _m_; -

An|ion _gr._ (negativ geladenes Ion; vgl. d.)

Anis _gr._ [_aniß_, auch, österr. nur: _aniß_] (eine Gewürz- u. Heilpflanze) _m_; -es, -e; Anis⌐bo|gen od. ...schar|te (österr.: eine Gebäckart); Ani|sẹt|te [...ßẹt] _fr._ (Anisbranntwein) _m_; -s, -s

An|iso|ga|mie _gr._ (Biol.: Befruchtungsvorgang zwischen ungleichen Keimzellen) _w_; -, ...jen

Ani|ta (w. Vorn.)

An|ja (russ. Vorn.)

An|jou [_angsehu_] (altfr. Grafschaft; Fürstengeschlecht)

Ank. = Ankunft

An|ka|ra [_angkara_] (Hptst. der Türkei)

Ạn|kauf; ạn|kau|fen; Ạn|kaufs⌐etat, ...recht

¹Ạn|ke (w. Vorn.)

²Ạn|ke (ein Fisch) _m_; -n, -n (↑R 268)

³Ạn|ke mdal. (Nacken, Genick) _w_; -, -n

an|keh|rig (schweiz. neben: anstellig)

An|ken schweiz. mdal. (buttern); Ạn|ken schweiz. mdal. (Butter) _m_; -s

¹Ạn|ker (früheres Flüssigkeitsmaß) _m_; -s, -

²Ạn|ker _gr._ _m_; -s, -; vor - gehen, liegen; An|ker⌐bo|je, ...ket|te; an|kern; ich ...ere (↑R 327); An|ker⌐platz, ...spill, ...tau (_s_; -[e]s, -e), ...win|de

an|ket|ten

Ạn|kla|ge; An|kla|ge⌐bank (_Mehrz._ ...bänke); ạn|kla|ge|gen; An|kla|ge|schrift

An|klam [_angklam_] (Stadt in Vorpommern)

an|klam|mern; sich -

Ạn|klang - finden

An|klei|de|ka|bi|ne; an|klei|den; sich -; An|klei|de|raum

an|klin|gen

an|knüp|fen; An|knüp|fung; An|knüp|fungs|punkt

an|koh|len; jmdn. - (ugs. für: zum Spaß belügen)

an|kom|men; mich (veralt.: mir) kommt ein Ekel an; es kommt mir nicht darauf an; An|kömm|ling

an|kop|peln

an|kö|ren ([ausgewählte männl. Haustiere] zur Zucht zulassen)

an|kör|nen (metallische Werkstücke mit Hilfe des Körners mit markierten Vertiefungen versehen)

an|krei|den; jmdn. etwas - (ugs. für: zur Last legen)

an|kreis (Geometrie)

an|kreu|zen

an|kün|den, (älter für:) an|kün|di|gen; An|kün|di|gung

An|kunft (Abk.: Ank.) w; -; An|kunfts.stem|pel, ...zeit

an|kur|beln; An|kur|be|lung, An|kurb|lung

An|ky|lo|se *gr.* [*angkü...*] (Med.: Gelenkversteifung) w; -, -n

An|la|ge; etw. als - übersenden; An|la|ge|be|ra|ter (Wirtsch.); An|la|gen|plan (Biol.; vgl. ²Plan); An|la|ge|pa|pier (Wirtsch.)

an|la|gern (Chemie); An|la|ge|rung

an|lan|den; etwas, jmdn. - (an Land bringen); irgendwo - (anlegen); (Geol.:) das Ufer landet an (verbreitert sich durch Sandansammlung); An|lan|dung

an|lan|gen vgl. anbelangen

An|laß (schweiz. auch für: Veranstaltung) *m*; ...lasses, ...lässe; - geben, nehmen; an|las|sen; An|lasser; an|läß|lich (Amtsdt.); *Verhältnisw.* mit *Wesf.:* - des Festes, dafür besser: aus Anlaß des Festes; zum, beim Fest

an|la|sten (aufbürden; zur Last legen)

An|lauf; an|lau|fen; An|lauf.ge|schwin|dig|keit, ...zeit

An|laut; an|lau|ten (von Wörtern, Silben: mit einem bestimmten Laut beginnen); an|läu|ten; jmdm. - (schweiz.: jmdn. [telefonisch] anrufen)

an|le|gen; An|le|ge|platz; An|le|ger (jmd., der sein Geld in fremden Unternehmen anlegt; Druckw.: Papiereinführer); An|le|ge|rin (Druckw.) w; -, -nen; An|le|ge|stel|le

an|leh|nen; ich lehne mich an die Wand an; An|leh|nung; an|leh|nungs|be|dürf|tig

An|lei|he; An|lei|he.ab|lö|sung, ...pa|pier

an|lei|nen

an|lei|nen; den Hund -

an|lei|ten; An|lei|tung

An|lern|be|ruf; an|ler|nen; jmdn. -; das habe ich mir angelernt (ugs.); An|lern|ling; An|lernzeit

an|le|sen

an|lie|fern

an|lie|gen; eng am Körper -; vgl. angelegen; An|lie|gen (Wunsch) *s*; -s, -; an|lie|gend (Kaufmannsspr.); - (anbei, hiermit) der Bericht; An|lie|ger (Anwohner); An|lie|ger.staat (*Mehrz.* ...staaten), ...ver|kehr

an|lie|ken (Seemannsspr.: das Liek an einem Segel befestigen)

an|locken [*Trenn.:* ...lok|ken]

an|lö|ten

an|lü|gen

an|lu|ven [...*luf...*] (Seemannsspr.: Winkel zwischen Kurs u. Windrichtung verkleinern)

Anm. = Anmerkung

an|ma|chen

an|mah|nen

an|ma|len

An|marsch *m*; An|marsch|weg

an|ma|ßen, sich; du maßt (maßest) dir etwas an; an|ma|ßend; -ste; An|ma|ßung

An|mel|de|for|mu|lar; an|mel|den; An|mel|de.pflicht, ...ver|fah|ren; An|mel|dung

an|men|gen (landsch.); Mehl [mit Sauerteig] - (anrühren)

an|mer|ken; ich ließ mir nichts -; An|mer|kung (Abk.: Anm.)

an|mes|sen; jmdm. etwas -

an|mie|ten; An|mie|tung

an|mon|tie|ren

an|mu|stern (Seemannsspr.: anwerben; den Dienst aufnehmen); An|mu|ste|rung

An|mut *w*; -; an|mu|ten; es mutet mich komisch an; an|mu|tig; an|mut[s]|voll; An|mu|tung (veralt. für: Zumutung)

¹An|na (w. Vorn.); Anna selbdritt (Anna, Maria u. das Jesuskind)

²An|na *Hindi* (frühere Münzeinheit in Indien; ¹/₁₆ Rupie) *m*; -[s], -[s]

An|na|bel|la (w. Vorn.)

an|na|deln österr. (mit einer Stecknadel befestigen); ich nad[e]le an († R 327)

an|nä|hern; sich -; an|nä|hernd; An|nä|he|rung; An|nä|he|rungs|ver|such; an|nä|he|rungs|wei|se

An|nah|me *w*; -, -n; - an Kindes Statt; An|nah|me.er|klä|rung, ...ver|merk, ...ver|wei|ge|rung

An|na|len *lat.* ([geschichtliche] Jahrbücher) *Mehrz.*

An|na|ten *lat.* (Jahrgelder an den Papst) *Mehrz.*

Änn|chen (Verkleinerungsform von: Anna); An|ne, Än|ne (für: Anna)

An|ne|do|re (w. Vorn.)

An|ne|gret (w. Vorn.)

an|neh|m|bar; an|neh|men; vgl. angenommen; an|nehm|lich; An|nehm|lich|keit

an|nek|tie|ren *lat.* (sich [gewaltsam] aneignen)

An|ne|li|den (Ringelwürmer) *Mehrz.*

An|ne|liese, An|ne|lo|re, An|ne|ma|rie, An|ne|ro|se; † R 194 (w. Vorn.)

An|net|te (w. Vorn.)

An|nex *lat.* (Zubehör; Anhängsel) *m*; es, -e; An|ne|xi|on ([gewaltsame] Aneignung); An|ne|xio|nis|mus (Bestrebungen, eine Annexion herbeizuführen) *m*; -

An|ni, Än|ni (Koseformen von Anna)

An|ni|ver|sar *lat.* [...*wär...*] *s*; -s, -e u. An|ni|ver|sa|ri|um (kath. Kirche: Jahrgedächtnis, bes. für einen Toten) *s*; -s, ...ien [...*iᵉn*] (meist *Mehrz.*)

an|no, (österr. nur so, sonst häufiger:) An|no *lat.* (im Jahre; Abk.: a. od. A.); - elf; - dazumal; - To|bak (ugs. für: in alter Zeit); An|no Do|mi|ni (im Jahre des Herrn; Abk.: A. D.)

An|non|ce *fr.* [*angɔ̃ßᵉ*, österr.: *anɔ̃ß*] (Zeitungsanzeige) *w*; -, -n, An|non|cen|ex|pe|di|ti|on (An zeigenvermittlung); An|non|ceu|se [...*ßøsᵉ*] (Angestellte im Gaststättengewerbe) *w*; -, -n; an|non|cie|ren

An|no|ne *indian.* (trop. Baum mit Sammelfrüchten) *w*; -, -n

An|no|ta|ti|on *lat.* [...*zion*] (Buchw.: Aufzeichnung, Vermerk [über Neuerscheinungen]) meist *Mehrz.*

an|nu|ell *fr.* (Bot.: einjährig); -e Pflanzen; An|nui|tät *lat.* [...*u-i...*] (jährliche Zahlung zur Tilgung einer Schuld)

an|nul|lie|ren *lat.* (für ungültig erklären); An|nul|lie|rung

An|nun|zia|ten|or|den (ehem. höchster it. Orden)

An|ode *gr.* („Eingang"; positive Elektrode, Pluspol) *w*; -, -n

an|öden (ugs. für: langweilen)

An|oden.bat|te|rie, ...span|nung (*w*; -), ...strah|len (*Mehrz.*)

an|omal *gr.* [auch: *a...*] (unregelmäßig, regelwidrig); An|oma|lie *w*; -, ...ien

an|onym *gr.* (ohne Nennung des Namens, ungenannt); An|ony|mi|tät (Verschweigung, Nichtangabe des Namens, der Unterschrift) *w*; -; An|ony|mus (Ungenannter) *m*; -, ...mi u. ...nymen

An|ophe|les *gr.* (Malariamücke) *w*; -, -

Ano|rak *eskim.* (Kajakjacke; Windbluse mit Kapuze) *m*; -s, -s

an|ord|nen; An|ord|nung

an|or|ga|nisch *gr.* (unbelebt); -e Chemie, Natur

anor|mal *mlat.* (regelwidrig, ungewöhnlich, krankhaft)

An|or|thit *gr.* (ein Mineral) *m*; -s

Anouilh [*anuj*] (fr. Dramatiker)

an|packen [*Trenn.:* ...pak|ken]

An|pad|deln (jährl. Beginn des Paddelsports) *s*; -s

an|pas|sen; An|pas|sung *w*; -, (selten) -en; an|pas|sungs|fä|hig

an|pei|len

an|pfei|fen (ugs. auch für: heftig tadeln); An|pfiff

an|pflan|zen; An|pflan|zung

an|pflau|men (ugs. für: necken, verspotten); An|pflau|me|rei

an|picken [*Trenn.:* ...pik|ken] österr. ugs. (ankleben)

an|pö|beln (in ungebührlicher Weise belästigen)

An|prall; an|pral|len
an|pran|gern; ich prangere an (↑ R
327); An|pran|ge|rung
an|prei|en (Seemannsspr.); die Be-
satzung eines anderen Schiffes -
(anrufen)
an|prei|sen; An|prei|sung
An|pro|be; an|pro|ben; an|pro|bie-
ren
an|pum|pen (ugs.); jmdn. - (sich
von ihm Geld leihen)
an|quas|seln (ugs. für: ungeniert
ansprechen)
an|quat|schen (ugs. für: ohne
Hemmungen ansprechen)
an|rai|nen; An|rai|ner (Rechtsspr.,
auch österr.: Anlieger, Grenz-
nachbar); An|rai|ner|staat
An|rand landsch. [Sportspr.] (ver-
stärkter Anlauf) m; -s
an|ran|zen (ugs. für: hart anfah-
ren); du ranzt (ranzest) an; An-
ran|zer (ugs.)
an|ra|ten; An|ra|ten s; -s; auf -
an|rau|hen; angerauht
an|rech|nen; das rechne ich dir
hoch an; An|rech|nung; (Pa-
pierdt.:) in - bringen, dafür bes-
ser: anrechnen
An|recht; An|recht|ler; An|rechts-
kar|te
An|re|de; An|re|de|fall m (für Vo-
kativ), ...für|wort (z. B. du, Sie);
an|re|den; jmdn. mit Sie, Du -
an|re|gen; an|re|gend; -ste; An|re-
gung; An|re|gungs|mit|tel s
an|rei|chern; ich reichere an (↑ R
327); An|rei|che|rung
an|rei|hen; an|rei|hend (für: kopu-
lativ)
An|rei|se; an|rei|sen; An|rei|se|tag
an|rei|ßen; An|rei|ßer (Vorzeich-
ner in Metallindustrie und
Tischlerei; aufdringlicher Kun-
denwerber); an|rei|ße|risch
(marktschreierisch; aufdring-
lich)
An|reiz; an|rei|zen
an|rem|peln (ugs.); An|rem|pelung,
An|remp|lung
an|ren|nen
An|rich|te w; -, -n; an|rich|ten; An-
rich|te|tisch
An|riß (Technik: Vorzeichnung;
Sport: kräftiges Durchziehen zu
Beginn eines Ruderschlages) m;
...isses, ...isse
an|rü|chig; An|rü|chig|keit
an|rucken [Trenn.: ...ruk|ken] (mit
einem Ruck anfahren); an|rücken
[Trenn.: ...rük|ken] (in einer For-
mation näherkommen)
An|rudern (jährl. Beginn des Ru-
dersports) s; -s
An|ruf; an|ru|fen; An|ru|fung
an|rüh|ren
ans; (↑ R 240 (an das); bis - Ende
An|sa|ge w; -, -n; an|sa|gen
an|sä|gen

An|sa|ger (früher für: Rundfunk-
sprecher)
an|sam|meln; An|samm|lung
an|säs|sig; An|säs|sig|keit w; -
An|satz; An|satz..punkt, ...rohr
(Phonetik), ...stück
an|sau|gen
an|säu|seln; ich säusele mir einen
an (ugs. für: betrinke mich
leicht); vgl. angesäuselt
Ans|bach (Stadt in Mittelfranken)
an|schaf|fen (bayr., österr. auch:
anordnen); vgl. ¹schaffen; An-
schaf|fung; An|schaf|fungs|ko-
sten Mehrz.
an|schäf|ten; Pflanzen - (veredeln);
Stiefel - (mit einem Schaft verse-
hen)
an|schau|en; an|schau|lich; An-
schau|lich|keit w; -; An|schau|ung;
An|schau|ungs..ma|te|ri|al, ...un-
ter|richt
An|schein m; -[e]s; allem, dem -
nach; an|schei|nend; vgl. schein-
bar
an|schei|ßen (derb für: heftig ta-
deln)
an|schicken [Trenn.: ...schik|ken],
sich
an|schie|ben
an|schie|ßen
an|schir|ren; ein Pferd -
An|schiß (derb für: heftiger Tadel)
An|schlag; an|schla|gen; das Essen
schlägt an; er hat angeschlagen
(südd., österr.: das Faß angesto-
chen, angezapft); An|schlä|ger
(Bergmannsspr.); an|schlä|gig
landsch. (schlau, geschickt); An-
schlag|säu|le
an|schlei|chen; sich -
¹an|schlei|fen; er hat das Messer
angeschliffen (ein wenig scharf
geschliffen); vgl. ¹schleifen; ²an-
schlei|fen; er hat den Sack ange-
schleift (ugs. für: schleifend her-
angezogen); vgl. ²schleifen
an|schlie|ßen; an|schlie|ßend; An-
schluß; im - an die Versammlung;
An|schluß..ka|bel, ...strecke
[Trenn.: ...strek|ke]
an|schmei|cheln, sich
an|schmie|gen, sich; an|schmieg-
sam; An|schmieg|sam|keit w; -
an|schmie|ren (ugs. auch für: be-
trügen)
an|schmut|zen; angeschmutzt
an|schnal|len
an|schnau|zen (ugs. für: grob ta-
deln); An|schnau|zer (ugs.)
an|schnei|den; An|schnitt
An|schop|pung (Med.: vermehrte
Ansammlung von Blut in den
Kapillaren)
An|scho|vis gr. [...wiß] ([gesalzene]
kleine Sardelle) w; -, -
an|schrau|ben
an|schrei|ben; An|schrei|ben; An-
schrift; An|schrif|ten|buch

an|schu|hen ([Schäfte] mit neuen
Schuhen versehen)
an|schul|di|gen; An|schul|di|gung
An|schuß (Jägerspr.)
an|schwär|zen (ugs. auch für: ver-
leumden)
an|schwei|ßen
¹an|schwel|len; der Strom schwillt
an, war angeschwollen; vgl.
¹schwellen; ²an|schwel|len; der
Regen hat die Flüsse ange-
schwellt; vgl. ²schwellen; An-
schwel|lung
an|schwem|men; An|schwem|mung
an|schwin|deln
An|se|geln (jährl. Beginn des Se-
gel[flug]sports) s; -s
an|se|hen; vgl. angesehen; An|se-
hen s; -s; ohne - der Person (ge-
recht); an|sehn|lich; An|sehn|lich-
keit w; -
an|sei|len; sich -
an|sein (ugs.); das Licht ist an, ist
angewesen, aber: ..., daß das
Licht an ist, war
An|selm (m. Vorn.); vgl. Anshelm,
An|sel|ma (w. Vorn.)
an|set|zen; am oberen Ende - ;
aber (Wenf.): an die Hose -
Ans|gar (m. Vorn.); Ans|helm (äl-
tere Form von: Anselm)
An|sicht w; -, -en; meiner - nach
(Abk.: m. A. n.); an|sich|tig; mit
Wesf.: des Gebirges - werden
(geh.); An|sichts..kar|te, ...sa|che
...sen|dung
an|sie|deln; An|sie|de|lung, An-
sied|lung; An|sied|ler, ...sied|le-
rin (w; -, -nen)
An|sin|nen s; -s, -; ein - an jmdn
stellen
An|sitz (Jägerspr.; österr. auch: re
präsentativer Wohnsitz)
an|sonst schweiz., österr. (ande
renfalls); an|son|sten (im übrigen
anderenfalls)
an|span|nen; An|span|nung
an|spa|ren
an|spei|en; jmdn. - (anspucken)
An|spiel (Sportspr.) s; -[e]s; an
spie|len; An|spie|lung
an|spin|nen
an|spit|zen
an|sporn m; -[e]s; an|spor|nen
An|spra|che; an|spre|chen; an|spre
chend; am -sten (↑ R 134)
an|sprin|gen
an|sprit|zen
An|spruch; an|spruchs|los; -est
(↑ R 292); An|spruchs|lo|sig|ke
w; -; an|spruchs|voll
An|sprung
an|spucken¹
an|spü|len; An|spü|lung
an|sta|cheln
An|stalt w; -, -en; An|stalts..er|zie
hung (w; -), ...lei|ter m
An|stand; keinen - an der

Vorhaben nehmen (geh. für: keine Bedenken haben); (Jägerspr.:) auf dem - stehen; an|stän|dig; An|stän|dig|keit w; -; an|stands.hal|ber, ...los; An|stands|re|gel

an|star|ren

an|statt; vgl. statt u. Statt (↑ R 141); anstatt daß (↑ R 62)

an|stau|en

an|stau|nen

an|ste|chen; ein Faß - (anzapfen) An|steck|är|mel; an|stecken[1]; vgl. [2]stecken; an|steckend[1]; -e Krankheit; An|steck|na|del; An|steckung[1]; An|steckungs|ge|fahr[1]

an|ste|hen (auch Bergmannsspr. von nutzbaren Mineralien: vorhanden sein; österr. auch: wegen eines Hindernisses nicht mehr weiterkönnen); ich stehe nicht an (habe keine Bedenken); es steht mir nicht an (es geziemt sich nicht für mich); (Geol.:) anstehendes (zutageliegendes) Gestein; auf jmdn. - (österr. für: angewiesen sein)

an Stel|le, (jetzt häufig:) an|stel|le (↑ R 141); mit Wesf.: an Stelle od. anstelle des Vaters; an Stelle od. anstelle von Worten; aber: an die Stelle des Vaters ist der Vormund getreten

an|stel|len; sich -; An|stel|le|rei; an|stel|lig (geschickt); An|stel|lig|keit w; -; An|stel|lung; An|stel|lungs|ver|trag

An|stich (eines Fasses [Bier])

An|stieg m; -[e]s, -e

n|stie|ren

n|stif|ten; An|stif|ter; An|stif|tung

an|stim|men

An|stoß; - nehmen an etwas; an|sto|ßen; An|stö|ßer schweiz. (Grundstücksnachbar); an|stö|ßig; An|stö|ßig|keit

n|strah|len; An|strah|lung

n|strän|gen; ein Pferd -

n|stre|ben; an|stre|bens|wert

n|strei|chen; An|strei|cher

n|stren|gen; sich - (sehr bemühen); einen Prozeß -; an|stren|gend; An|stren|gung

n|strich

n|stücken [Trenn.: ...stük|ken]

n|sturm m; -[e]s; an|stür|men

n|su|chen; um etwas - (Papierdt.: um etwas bitten); An|su|chen (Papierdt.: förmliche Bitte; Gesuch) s; -s, -; auf -; An|su|cher

nt|ago|nis|mus gr. (Widerstreit; Gegensatz) m; -, ...men; Ant|ago|nist (Gegner); ↑ R 268; ant|ago|ni|tisch; -ste (↑ R 294)

n|tail|lieren (Schneiderei: mit leichter Taille versehen); leicht, modisch antailliert

Trenn.: ...k|k...

Ant|ares gr. (ein Stern) m; -

Ant|ark|tis gr. (Südpolgebiet) w; -; ant|ark|tisch

an|ta|sten

an|tau|chen österr. ugs. (anschieben; übertr.: sich mehr anstrengen)

An|tä|us (Gestalt der gr. Sage)

An|te lat. (antikes Bauw.: viereckiger Wandpfeiler) w; -, n (meist Mehrz.)

an|te Chri|stum [na|tum] lat. (veralt. für: vor Christi Geburt; Abk.: a. Chr. [n.])

an|te|da|tie|ren lat. (veralt. für: [ein Schreiben] auf ein zukünftiges, aber auch auf ein vergangenes Datum ausstellen)

an|te|di|lu|via|nisch lat. [...wi...] (vorsintflutlich)

An|teil; - haben, nehmen; an|teilig; An|teil|nah|me w; -; An|teilschein; an|teil[s]|mä|ßig

an|te me|ri|di|em lat. [- ...diäm] (vormittags; Abk.: a. m.)

an|te mor|tem lat. (Med.: kurz vor dem Tode; Abk.: a. m.)

An|ten|ne lat. (Vorrichtung zum Senden od. Empfangen elektromagnet. Wellen; Fühler der Gliedertiere) w; -, -n; An|ten|nen|un|la|ge

An|ten|tem|pel lat. (altgr. Tempel mit Anten)

An|te|pen|di|um lat. (Verkleidung des Altaraufbaus) s; -s, ...ien [...i[e]n]

An|the|mi|on gr. (altgr.] Schmuckfries) s; -s, ...ien [...i[e]n];

An|the|re (Staubbeutel der Blütenpflanzen) w; -, -n; An|tho|lo|gie („Blumenlese"; [Gedicht]sammlung; Auswahl) w; -, ...ien; an|tho|lo|gisch (ausgewählt)

An|thra|cen, (auch:) An|thra|zen gr. (aus Steinkohlenteer gewonnene chem. Verbindung) s; -s, -e; An|thra|zit (glänzende Steinkohle) m; -s, -e; an|thra|zit|far|ben od. ...far|big

an|thro|po|gen gr. (durch den Menschen beeinflußt, verursacht); -e Faktoren; An|thro|po|ge|nie ([Lehre von den] Entstehung des Menschen) w; -; an|thro|po|id (menschenähnlich); An|thro|po|iden (Menschenaffen) Mehrz.; An|thro|po|lo|ge (Wissenschaftler auf dem Gebiet der Anthropologie) m; -n, -n (↑ R 268); An|thro|po|lo|gie (Menschenkunde, Geschichte der Menschenrassen) w; -; an|thro|po|lo|gisch; An|thro|po|me|trie (Lehre von den Maßverhältnissen des menschl. Körpers) w; -; an|thro|po|me|trisch; an|thro|po|morph, an|thro|po|mor|phisch (menschlich gestaltet); An|thro-

po|mor|phis|mus (Vermenschlichung [des Göttlichen]) m; -, ...men; An|thro|po|pha|ge (Menschenfresser) m; -n, -n (↑ R 268); An|thro|po|pha|gie (Menschenfresserei) w; -; An|thro|po|pho|bie (Menschenscheu) w; -; An|thro|po|soph (Vertreter der Anthroposophie) m; -en, -en (↑ R 268); An|thro|po|so|phie („Menschenweisheit"; Lehre Rudolf Steiners) w; -; an|thro|po|so|phisch; an|thro|po|zen|trisch (den Menschen in den Mittelpunkt stellend)

an|ti... gr. (gegen...); An|ti... (Gegen...)

An|ti|al|ko|ho|li|ker gr.; arab. [auch: anti...] (Alkoholgegner)

an|ti|au|to|ri|tär gr.; lat. (sich gegen [mißbrauchte] Autorität auflehnend)

Antibabypille, (auch:) Anti-Baby-Pille gr.; engl.; lat. [...bebi...] (ugs. für ein hormonales Empfängnisverhütungsmittel)

An|ti|bar|ba|rus gr. (ehem. Titel von Werken, die gegen sprachl. Fehler u. Unreinheiten vorgingen) m; -, ...ri

An|ti|bio|ti|kum gr. (Med.: biologischer Wirkstoff gegen Krankheitserreger) s; -s, ...ka

An|ti|bol|sche|wis|mus gr.; russ.

an|ti|cham|brie|ren fr. [...schambrir[e]n] (im Vorzimmer warten; katzbuckeln, dienern)

An|ti|christ m [...krißt] (der Widerchrist, Teufel) m; -[s] u. (Gegner des Christentums:) m; -en, -en (↑ R 268); an|ti|christ|lich an|ti|de|mo|kra|tisch gr. [auch: anti...]

An|ti|dot s; -[e]s, -e u. An|ti|do|ton gr. (Med.: Gegengift) s; -s, ...ta

An|ti|dum|ping|ge|setz gr.; engl.; dt. [...damping...] (Verbot des Dumpings)

An|ti|fa|schis|mus gr.; it. [auch: anti...] (Gegnerschaft gegen Faschismus und Nationalsozialismus [vor allem von den Kommunisten zur Herbeiführung der „Volksfront" propagiert]); An|ti|fa|schist [auch: anti...] (Gegner des Faschismus); ↑ R 268; an|ti|fa|schi|stisch [auch: anti...]

An|ti|fou|ling gr.; engl. [äntifauling] (giftiger Anstrich für den unter Wasser befindlichen Teil des Schiffes, der pflanzl. u. tier. Bewuchs verhindert) s; -s

An|ti|gen s. (artfremder Eiweißstoff, der im Körper die Bildung von Abwehrstoffen gegen sich selbst bewirkt) s; -s, -e

An|ti|go|ne (gr. Sagengestalt, Tochter des Ödipus)

an|tik lat. (altertümlich; dem klass. Altertum angehörend);

An|ti|ke (das klass. Altertum u.
seine Kultur) w; - u. (antikes
Kuns verk:) w; -, -n (meist
Mehrz.); An|ti|ken|samm|lung;
an|ti|kisch (der Antike nachstre-
bend); an|ti|ki|sie|ren (nach der
Art der Antike gestalten; alten
Geschmack nachahmen)
an|ti|kle|ri|kal *gr.* [auch: *anti...*]
(kirchenfeindlich); An|ti|kle|ri-
ka|lis|mus
An|ti|kli|max *gr.* (Rhet., Stilk.:
Übergang vom stärkeren zum
schwächeren Ausdruck)
an|ti|kli|nal *gr.* (sattelförmig [von
geol. Falten]); An|ti|kli|na|le
(Geol.: Sattel) *w*; -, -n
An|ti|klopf|mit|tel (Zusatz zu Ver-
gaserkraftstoffen) *s*
an|ti|kon|zep|tio|nell *gr.*; *lat.*
[...*zio...*] (die Empfängnis verhü-
tend)
An|ti|kör|per (Abwehrstoffe im
Blut gegen artfremde Eiweiße)
Mehrz.
An|ti|kri|tik *gr.* [auch: *anti...*] (Er-
widerung auf eine Kritik)
An|ti|kil|len (westind. Inselgruppe)
Mehrz.
An|ti|lo|pe *fr.* (ein Huftier) *w*; -,
-n
An|ti|ma|chia|vell *gr.*; *it.* [...*makia-
wäll*] (Schrift Friedrichs d. Gr. ge-
gen Machiavelli) *m*; -s
an|ti|me|ta|phy|sisch (der Me-
taphysik entgegengesetzt)
An|ti|mon *arab.* [österr.: *anti...*]
(chem. Grundstoff, Metall; Zei-
chen: Sb [vgl. Stibium]) *s*; -s
an|ti|mon|ar|chisch *gr.* [auch: *anti-
ti...*] (der Monarchie feindlich)
An|ti|no|mie *gr.* (Widerspruch ei-
nes Satzes in sich oder zweier gül-
tiger Sätze) *w*; -, ...ien
An|ti|no|us (schöner gr. Jüngling)
an|tio|che|nisch [...*ehe...*]; An|tio-
chia [auch: ...*ehia*] (altsyr. Stadt);
An|tio|chi|en [...*i*en] (mittelalterl.
Patriarchat in Kleinasien); An-
tio|chi|er [...*i*r]; An|tio|chos, An-
tio|chus (m. Eigenname)
An|ti|pa|thie *gr.* (Abneigung; Wi-
derwille) *w*; -, ...ien; an|ti|pa-
thisch; -ste (↑ R 294)
An|ti|phon *gr.* (liturg. Wechselge-
sang) *w*; -, -en; An|ti|pho|na|le *s*;
-s, ...lien u. An|ti|pho|nar (Samm-
lung von Wechselgesängen) *s*; -s,
-ien [...*i*n]; An|ti|pho|nie (anti-
phonische Singweise) *w*; -, ...ien;
an|ti|pho|nisch
An|ti|po|de *gr.* (auf dem gegen-
überliegenden Punkt der Erde
wohnender Mensch; übertr.:
Gegner) *m*; -n, -n (↑ R 268)
an|tip|pen
An|ti|py|re|ti|kum *gr.* (fiebersen-
kendes Mittel) *s*; -s, ...ka; An|ti-
py|rin ⓦ (ein Fiebermittel) *s*; -s

An|ti|qua *lat.* (Lateinschrift) *w*; -;
An|ti|quar (Händler mit Altertü-
mern, mit alten Büchern) *m*; -s,
-e; An|ti|qua|ri|at (Altbuchhand-
lung, Altbuchhandel) *s*; -[e]s, -e;
an|ti|qua|risch; An|ti|qua|schrift;
an|ti|quiert (veraltet; altertüm-
lich); An|ti|quiert|heit; An|ti|qui-
tät (Altertümliches; Kunstwer-
ke, Möbel, Münzen u. a.) *w*; -,
-en (meist *Mehrz.*); An|ti|qui|tä-
ten_han|del, ...samm|ler
An|ti|[ra|ke|ten|]ra|ke|te
An|ti|se|mit (Judengegner); an|ti-
se|mi|tisch; An|ti|se|mi|tis|mus
m; -
An|ti|sep|sis, An|ti|sep|tik *gr.*
(Med.: Vernichtung von Krank-
heitskeimen [bes. in Wunden]) *w*;
-; An|ti|sep|ti|kum (keimtötendes
Mittel [bes. bei der Wund-
behandlung] *s*; -s, ...ka; an|ti|sep-
tisch
an|ti|spa|stisch (Med. für:
krampflösend)
An|ti|stes *lat.* (kath. Kirche: Eh-
rentitel für Bischof u. Abt; früher
Titel des reformierten Oberpfar-
rers in der Schweiz) *m*; -, ...stites
An|ti|stro|phe *gr.* [auch: *anti...*]
(Gegenstrophe im antiken gr.
Drama)
An|ti|the|se *gr.* [auch: *anti...*] (ent-
gegengesetzte Behauptung); An-
ti|the|tik *w*; -; an|ti|the|tisch
An|ti|to|xin *gr.* (Med. für: Gegen-
gift)
an|ti|zi|pan|do *lat.* (Kaufmanns-
spr. veralt. für: vorwegnehmend,
im voraus); An|ti|zi|pa|ti|on
[...*zion*] („Vorwegnahme", z. B.
von Tönen eines folgenden Ak-
kords); an|ti|zi|pie|ren
an|ti|zy|klisch [auch: ...*zü*..., *an-
ti...*] (einem Konjunkturzustand
entgegenwirkend); An|ti|zy|klo-
ne [auch: *anti...*] (Meteor.: Hoch-
druckgebiet)
Ant|je (w. Vorn.)
Ant|litz *s*; -es, (selten:) -e
An|toi|nette [*angtoanät*] (w.
Vorn.); An|ton (m. Vorn.)
an|tö|nen schweiz. (andeuten)
An|to|nia, An|to|nie [...*i*] (w.
Vorn.); An|to|ni|nus Pi|us (röm.
Kaiser); An|to|ni|us (röm. m. Ei-
genn.; Heiliger)
Ant|onym *gr.* (Sprachw.: Gegen-
[satz]wort, Oppositionswort,
Wort mit entgegengesetzter Be-
deutung, z. B. „gesund – krank")
s; -s, -e
An|trag *m*; -[e]s, ...träge; einen -
auf (österr. auch: über) etwas
stellen; an|tra|gen; An|trags|for-
mu|lar; an|trags|ge|mäß; An|trags-
stel|ler
an|trau|nie|ren
an|trau|en; angetraut

an|tref|fen
an|trei|ben; An|trei|ber; An|trei-
bung
an|tren|zen; sich - (österr. ugs. für:
sich bekleckern)
an|tre|ten
An|trieb; An|triebs_kraft, ...schei-
be, ...sy|stem, ...wel|le
an|trin|ken; sich einen - (ugs.)
An|tritt; An|tritts_be|such, ...re|de
an|tun; jmdm. etwas -; sich etwas
- (österr. auch: sich sehr bemü-
hen; österr. ugs.: sich über etwas
[grundlos] aufregen)
Antw. = Antwort
Ant|wer|pen (belg. Stadt)
Ant|wort (Abk.: Antw.) *w*; -, -en;
um [od. Um] - wird gebeten
(Abk.: u. [od. U.] A. w. g.); ant-
wor|ten; ant|wort|lich; - Ihres
Briefes (Papierdt.: auf Ihren
Brief); Ant|wort|schein (Postw.)
an und für sich [auch: *anundfür-
sich*]
An|urie *gr.* (Med.: Versagen der
Harnausscheidung) *w*; -, ...ien
Anus *lat.* (After) *m*; -, Ani
an|ver|trau|en; jmdm. einen Brief
-; sich jmdm. -; ich vertrau[t]e
an, (seltener:) ich anvertrau[t]e,
anvertraut; anzuvertrauen
an|ver|wan|deln; sich etwas -; An-
ver|wand|lung
An|ver|wand|te *m* u. *w*; -n, -n (↑ R
287 f.)
an|vi|sie|ren
Anw. = Anweisung
an|wach|sen
an|wäh|len (Fernsprechwesen)
An|walt *m*; -[e]s, ...wälte; An|wäl-
tin *w*; -, -nen; An|walt|schaft *w*; -
-, (selten:) -en; An|walts_kam|mer
an|wandeln; An|wan|de|lung, (häu-
figer:) An|wand|lung
an|wär|men
An.wär|ter, ...wart|schaft (*w*; -
[selten:] -en)
an|wei|sen; Geld -; vgl. angewie-
sen; An|wei|sung (Abk.: Anw.)
an|wend|bar; An|wend|bar|keit *w*;
-; an|wen|den; ich wandte od.
wendete die Regel an, habe ange-
wandt od. angewendet; die ar-
gewandte od. angewendete Re
gel; vgl. angewandt; An|wen|dur
be|reich; An|wen|bung
an|wer|fen
An|wert bayr., österr. (Wertschä
zung) *m*; -[e]s; - finden
An|we|sen (Grundstück [m
Wohnhaus, Stall usw.]); an|we
send; An|we|sen|de *m* u. *w*; -n, -
(↑ R 287 f f.); An|we|sen|heit *w*; -
An|we|sen|heits|li|ste
An|we|sen|heit; es widert mich an
an|win|keln
An|woh|ner
An|wuchs
An|wurf

133

Apollo

Ạn|zahl w; -; eine - gute[r] Freunde;
ạn|zah|len; Ạn|zah|lung; Ạn|zah-
lungs|sum|me
ạn|zap|fen; Ạn|zap|fung
ạn|zei|chen
an|zeich|nen
Ạn|zei|ge w; -, -n; ạn|zei|gen; Ạn-
zei|ge[n]|blatt; Ạn|zei|gen|teil;
Ạn|zei|ge|pflicht; ạn|zei|ge|pflich-
tig; -e Krankheit; Ạn|zei|ger
Ạn|zel|ten (jährl. Beginn des Zel-
tens u. des Campings) s; -s
Ạn|zen|gru|ber (österr. Schriftstel-
ler)
ạn|zet|teln (ugs.); Ạn|zet|te|ler,
Ạn|zett|ler; Ạn|zet|te|lung, Ạn-
zett|lung
ạn|zie|hen; sich -; ạn|zie|hend; Ạn-
zie|hung; Ạn|zie|hungs|kraft w
ạn|zie|len (zum Ziel haben)
an|zi|schen
¹Ạn|zucht (Bergmannsspr.: Ab-
wassergraben) w; -, ...züchte
²Ạn|zucht (junger Anwuchs) w; -;
Ạn|zucht|gar|ten
Ạn|zug (schweiz. auch: [Bett]be-
zug, Überzug; schweiz. [Basel]
auch: Antrag [im Parlament]); es
ist Gefahr im -; ạn|züg|lich; Ạn-
züg|lich|keit; Ạn|zugs|kraft; Ạn-
zug|stoff; Ạn|zugs|ver|mö|gen
ạn|zün|den; Ạn|zün|der; Ạn|zün-
dung
an|zwecken [Trenn.: ...zwek|ken]
an|zwei|feln; Ạn|zwei|fe|lung, Ạn-
zweif|lung
ao., a. o. [Prof.] = außerordent-
lich[er Professor]
AOA engl. [e¹o"g¹] = American
Overseas Airlines [ɐˈmärik‿n ó"-
w‿rß̣is ärlains] (amerik. Übersee-
Luftlinien)
AOK = Allgemeine Ortskranken-
kasse
Äo|li|en [...iⁿn] (antike Landschaft
an der Nordwestküste von
Kleinasien); Äo|li|er [...iⁿr]; ¹äo-
lisch [zu Äolien]; -er Dialekt; -e
Tonart; -e Versmaße; Äolische
Inseln vgl. Liparische Inseln; ²äo-
lisch [zu: Äolus] (durch Windein-
wirkung entstanden); -e Sedi-
mente; Äols|har|fe (Windharfe);
Äo|lus (gr. Windgott)
Äon gr. (Zeitraum, Weltalter;
Ewigkeit) m; -s, -en (meist
Mehrz.); äo|nen|lang
Ao|rist gr. (Sprachw.: eine Zeit-
form, bes. im Griechischen) m;
-[e]s, -e
Aọr|ta gr. (Hauptschlagader) w;
-, ...ten; Aọr|ten|klap|pe; Aort|al-
gie (Aortenschmerz) w; -, ...ien
AP = Associated Press
APA = Austria Presse Agentur
(so die von den Richtlinien der
Rechtschreibung abweichende
Schreibung)

Apa|che [apạtsch‿ u. apạeh‿] (An-
gehöriger eines Indianerstam-
mes; [nur: apạeh‿:] Verbrecher,
Zuhälter [in Paris]) m; -n, -n (↑ R
268)
ap|agọ|gisch gr.; -er (indirekter)
Beweis
Apa|na|ge fr. [apangạch‿] (Jahr-
geld; Abfindung; regelmäßige
finanzielle Zuwendung an einen
nichtregierenden Fürsten)
apart fr. (geschmackvoll, reizvoll);
Apart|be|stel|lung (Buchhandel:
Einzelbestellung [eines Heftes
oder Bandes aus einer Reihe]);
¹Apar|te (Reizvolles) s; -n (↑ R
28 / ff.); ²Apạr|te (Theater veralt.:
beiseite Gesprochenes) s; -[s], -s;
Apart|heid afrikaans (völlige
Trennung zwischen Weißen u.
Farbigen in der Republik Süd-
afrika) w; -; Apart|ment engl.
[‿pạ‿tm‿nt] (Kleinstwohnung [in
meist luxuriösem Mietshaus]) s;
-s, -s; vgl. Appartement; Apart-
ment|haus
Apạ|thie gr. (Teilnahmslosigkeit)
w; -, (selten:) ...ien; apạ|thisch;
-ste (↑ R 294)
Apa|tit gr. (ein Mineral) m; -s, -e
Apẹl|les (ultgr. Maler)
Apen|nịn m; -s, (auch:) Apen|nị|nen
(Gebirge in Italien) Mehrz.;
Apen|nị|nen|halb|in|sel w; -; apen-
nị|nisch, aber (↑ R 198): die
Apenninische Halbinsel
aper südd., schweiz., österr.
(schneefrei); -e Wiesen
Aper|çu fr. [apärßü] (geistreicher
Einfall) s; -s, -s
Ape|ri|tif fr. (appetitanregendes
alkohol. Getränk) m; -s, -s
apern [zu: aper] südd., schweiz.,
österr. (schneefrei werden); es
apert (taut)
Aper|tur lat. (Öffnungsverhältnis,
das die Leistung eines optischen
Systems angibt) w; -, -en
Apex lat. (Astron.: Zielpunkt ei-
nes Gestirns; Sprachw.: Zeichen
zur Bezeichnung langer Vokale,
z. B. â od. á) m; -, Apizes
Ạp|fel m; -s, Äpfel; Ạp|fel|baum;
Ạp|fel|chen; ạp|fel|för|mig; Ạp-
fel|most, ...mus, ...saft, ...schim-
mel (vgl. ²Schimmel); Ạp|fel|si|ne
w; -, -n; Ạp|fel|si|nen|scha|le; Ạp-
fel|stru|del, ...wein, ...wick|ler
(ein Kleinschmetterling)
Aph|ä|re|se, Aph|ä|re|sis gr.
(Sprachw.: Abfall eines Anlauts,
einer anlautenden Silbe, z. B. 's
für: „es") w; -, ...resen
Apha|sie gr. (Philos.: Urteilsent-
haltung; Med.: Verlust des
Sprechvermögens) w; -, ...ien
Aph|el gr. [afẹl] (Punkt der größten
Sonnenferne eines Planeten;
Ggs.: Perihel) s; -s, -e

Aphel|ạn|dra gr. (eine Pflanzen-
gattung; z. T. beliebte Zierpflan-
zen) w; -, ...dren
Aphon|ge|trie|be gr.; dt. (geräusch-
armes Schaltgetriebe); Apho|nie
gr. (Med.: Stimmlosigkeit, Flü-
sterstimme) w; -, ...ien
Apho|rịs|mus gr. (Gedankensplit-
ter; geistreicher, knapp formu-
lierter Gedanke) m; -, ...men;
apho|rị|stisch
Aphro|di|si|a|kum gr. (den Ge-
schlechtstrieb anregendes Mit-
tel) s; -s, ...ka; aphro|di|sisch (auf
Aphrodite bezüglich; den Ge-
schlechtstrieb steigernd); Aphro-
di|te (gr. Göttin der Liebe);
aphro|di|tisch
Aph|the gr. (Med.: [schmerzhaf-
tes] kleines Geschwür der Mund-
schleimhaut) w; -, -n (meist
Mehrz.); Aph|then|seu|che
(Maul- u. Klauenseuche)
api|kal lat. (den Apex betreffend)
Apis (heiliger Stier der alten Ägyp-
ter) m; -, Apisstiere
Api|zes (Mehrz. von: Apex)
apl. = außerplanmäßig
Apla|nat gr. (ein fotogr. Linsen-
system) m; -s, -e; apla|na|tisch
Aplomb fr. [aplong] (veralt. für: Si-
cherheit im Auftreten, Nach-
druck; Abfangen einer Bewe-
gung im Ballettanz) m; -s
APO, (auch:) Apo (außerparla-
mentarische Opposition) w; -
Apo|chro|mat gr. [apokromạt] (ein
fotogr. Linsensystem) m; -s, -e;
apo|chro|ma|tisch
apo|dik|tisch gr. (unwiderleglich,
sicher; keinen Widerspruch dul-
dend); -ste (↑ R 294)
Apo|gä|um gr. (Punkt der größten
Erdferne [des Mondes]; Ggs.: Pe-
rigäum) s; -s, ...äen
Apo|ka|lyp|se gr. (Schrift über das
Weltende, bes. die Offenbarung
des Johannes; Unheil, Grauen)
w; -, -n; apo|ka|lyp|tisch, aber
(↑ R 224): die Apokalyptischen
Reiter
Apo|ko|pe gr. [...pe] (Sprachw.:
Abfall eines Auslauts, einer aus-
lautenden Silbe, z. B. „hatt"' für:
„hatte"') w; -, ...kopen; apo|ko-
pie|ren
Apo|kryph gr. [...krüf] (nicht
anerkannte Schrift [der Bibel]) s;
-s, -en (meist Mehrz.); apo|kryph
Apọl|da (Stadt in Thüringen)
apo|li|tisch gr. (unpolitisch, der
Politik gegenüber gleichgültig)
Apọll (geh., dicht. für: ¹Apollo);
Apọl|li|na|ris (Heiliger); apol|lị-
nisch (in der Art Apollos; harmo-
nisch, ausgeglichen, maßvoll);
¹Apọl|lo (gr.-röm. Gott [der
Dichtkunst]); ²Apọl|lo (ein
Schmetterling) m; -s, -s; ³Apọl|lo

(Bez. für ein amerik. Raumfahrt-programm, das die Landung bemannter Raumfahrzeuge auf dem Mond zum Ziel hatte); **Apol|lon** vgl. ¹Apollo; **Apol|lo|nia** (w. Vorn.); **Apol|lo|ni|us** (m. Vorn.); **Apol|lo-Raum|schiff** (vgl. ³Apollo)

Apo|log gr. (veralt. für: Lehrfabel) m; -s, -e; **Apo|lo|get** (Verfechter, Verteidiger) m; -en, -en (↑ R 268); **Apo|lo|ge|tik** (Verteidigung der christl. Lehren) w; -, -en; **apo|lo|ge|tisch; Apo|lo|gie** (Verteidigung[srede, -schrift]) w; -, ...ien **Apo|phtheg|ma** gr. (Aus-, Sinnspruch) s; -s, ...men u. ...mata **Apo|phy|se** gr. (Knochenfortsatz) w; -, -n

Apo|plek|ti|ker gr. (zu Schlaganfällen Neigender; an den Folgen eines Schlaganfalls Leidender); **apo|plek|tisch; Apo|ple|xie** (Schlaganfall) w; -, ...ien

Apo|rie gr. (Unmöglichkeit, eine philos. Frage zu lösen; allg. übertr.: relative Unmöglichkeit, eine richtige Entscheidung zu treffen od. eine passende Lösung zu finden) w; -, ...ien

Apo|sta|sie gr. (Abfall [vom Glauben]) w; -, ...ien; **Apo|stat** (Abtrünniger) m; -en, -en (↑ R 268) **Apo|stel** gr. m; -s, -

a po|ste|rio|ri lat. (aus der Wahrnehmung gewonnen, aus Erfahrung); **Apo|ste|rio|ri** (Erfahrungssatz) s; -, -; **apo|ste|rio|risch** (erfahrungsgemäß)

Apo|stilb gr. (photometr. Einheit der Leuchtdichte; Zeichen: asb) s; -s, -

Apo|sto|lat gr. (Apostelamt) s (Theologie auch: m); -[e]s, -e; **Apo|sto|li|kum** (Apostolisches Glaubensbekenntnis) s; -s; **apo|sto|lisch** (nach Art der Apostel; von den Aposteln ausgehend); die -e Sukzession; die -en Väter; den -en Segen erteilen, aber (↑ R 224); das Apostolische Glaubensbekenntnis; die Apostolische Majestät; der Apostolische Delegat, Nuntius, Stuhl

Apo|stroph gr. (Auslassungszeichen, Häkchen, z. B. in „hatt'‴) m; -s, -e; **Apo|stro|phe** [auch: apóßtrofe] (feierliche Anrede) w; -, ...ophen; **apo|stro|phie|ren** ([feierlich] anreden; [jmdn.] nachdrücklich bezeichnen, sich [auf jmdn., etwas] beziehen); jmdn. als primitiv -; **Apo|stro|phie|rung** **Apo|the|ke** gr. w; -, -n; **Apo|the|ker** **Apo|theo|se** gr. (Vergottung; Verklärung) w; -, -n

Ap|pa|la|chen (nordamerik. Gebirge) Mehrz.

Ap|pa|rat lat. (größeres Gerät, Vorrichtung technischer Art) m; -[e]s, -e; **ap|pa|ra|tiv** (den Apparat[ebau] betreffend); -e Diagnostik; **Ap|pa|rat|schik** (Funktionär im Staats- u. Parteiapparat totalitärer Staaten des Ostens, der Weisungen u. Maßnahmen bürokratisch durchzusetzen sucht) m; -s, -s; **Ap|pa|ra|tur** (Gesamtanlage von Apparaten) w; -, -en **Ap|par|te|ment** fr. [...mãng, schweiz.: ...mänt] (komfortable Wohnung, Zimmerflucht; auch für: Apartment) s; -s, -s (schweiz.: -e); **Ap|par|te|ment-haus**

Ap|pas|sio|na|ta it. (eine Klaviersonate von Beethoven) w; -

Ap|peal engl. [ɛpíl] (Anziehungskraft, Ausstrahlung) m; -s; **Ap|pell** fr. (Aufruf; Mahnruf; Militär: Antreten zur Befehlsausgabe usw.) m; -s, -e; **ap|pel|la|bel** (veralt. für: anfechtbar); ...able Rechtssache; **Ap|pel|lant** lat. (veralt. für: Berufungskläger) m; -en, -en (↑ R 268); **Ap|pel|lat** (veralt. für: Berufungsbeklagter) m; -en, -en (↑ R 268); **Ap|pel|la|ti|on** [...zion] (veralt. für: Berufung); **Ap|pel|la|ti|ons|ge|richt; Ap|pel|la|tiv** (Sprachw.: Gattungsname, Wort, das eine Gattung gleichgearteter Dinge od. Wesen u. zugleich jedes einzelne Wesen od. Ding dieser Gattung bezeichnet, z. B. „Mensch‴) s; -s, -e [...wᵉ]; **ap|pel|lie|ren** (sich mahnend, beschwörend an jmdn. wenden; veralt. für: Berufung einlegen); **Ap|pell|platz**

Ap|pen|dix lat. (Anhängsel) m; - (auch: -es), ...dizes (auch: -e) u. (Med.: Wurmfortsatz des Blinddarms) w; -, ...dices (alltagsspr. auch: m; -, ...dizes) [...zäß]; **Ap|pen|di|zi|tis** (Entzündung des Appendix) w; -, ...itiden

Ap|pen|zell (Ort in der Schweiz); Appenzell Außerrhoden u. Appenzell Innerrhoden (Halbkantone in der Schweiz); **Ap|pen|zel|ler** (↑ R 199); **ap|pen|zel|lisch**

Ap|per|zep|ti|on lat. [...zion] (Psych.: bewußte Wahrnehmung); **ap|per|zi|pie|ren** (bewußt wahrnehmen)

Ap|pe|tenz lat. (Biol.: Trieb) w; -, -en; **Ap|pe|tenz|ver|hal|ten; Ap|pe|tit** m; -[e]s, -e; **ap|pe|tit|an|re|gend**, aber (↑ R 142): den Appetit anregend; **ap|pe|tit|lich; ap|pe|tit|los; Ap|pe|tit|lo|sig|keit** w; -; **Ap|pe|tit[s]|bröt|chen, ...hap|pen** (ugs.); **Ap|pe|tit|züg|ler** (den Appetit zügelndes Medikament) **ap|plau|die|ren** lat. (Beifall klatschen); jmdm. -; **Ap|plaus** (Beifall) m; -es, (selten:) -e

Ap|pli|ka|ti|on lat. [...zion] (Anwendung; Med.: Verabreichung [von Heilmitteln]; Textilindustrie: aufgenähte Verzierung an Geweben); **ap|pli|zie|ren** **ap|port!** fr. ([Anruf an den Hund:] bring es her!); **Ap|port** (Herbeibringen; Zugebrachtes; veralt. für: Sacheinlage [bei Kapitalgesellschaften]) m; -s, -e; **ap|por|tie|ren; Ap|portl** österr. ugs. (geworfener und vom Hund zurückgebrachter Gegenstand) s; -s, -n

Ap|po|si|ti|on lat. [...zion] (Sprachw.: haupt- od. fürwörtl. Beifügung, meist im gleichen Fall wie das Bezugswort, z. B. der große Forscher, „Mitglied der Akademie ...“; einem Mann wie „ihm“); **ap|po|si|tio|nell**

Ap|pre|teur fr. [...tör] (Zurichter, Ausrüster [von Geweben]) m; -s, -e; **ap|pre|tie|ren** ([Gewebe] zurichten, ausrüsten); **Ap|pre|tur** lat. ([Gewebe]zurichtung, -veredelung) w; -, -en

Ap|pro|ba|ti|on lat. [...zion] (staatl. Zulassung als Arzt od. Apotheker); **ap|pro|bie|ren**; approbierter Arzt

Ap|pro|xi|ma|ti|on lat. [...zion] (Annäherung); **ap|pro|xi|ma|tiv** (annähernd, ungefähr)

Apr. = April

Après-Ski fr.; norw. [apräschí] (bequeme Kleidung, die man nach dem Schilaufen trägt) s; -; **Après-Ski-Klei|dung** (↑ R 155) **April|ko|se** lat. w; -, -n; vgl. Marille; **April|ko|sen|mar|me|la|de**

April lat. (vierter Monat im Jahr; Ostermond, Wandelmonat); Abk.: Apr.) m; -[s] (↑ R 319) -e; **April|scherz, ...tag, ...wetter** **a pri|ma vi|sta** it. [- - wißta] (Musik: vom Blatt); vgl. a vista

a prio|ri lat. (von der Wahrnehmung unabhängig, aus Vernunft gründen; von vornherein); **Aprio|ri** (Vernunftsatz) s; -, -; **aprio|risch** (allein durch Denken gewonnen, aus Vernunftgründen [erschlossen]); **Aprio|ris|mus** (philos. Lehre, die eine von der Erfahrung unabhängige Erkenntnis annimmt) m; -

apro|pos fr. [apropó] (veralten für: nebenbei bemerkt; übrigens **Ap|si|de** gr. (Punkt der kleinsten od. größten Entfernung eines Planeten von dem Gestirn, das er umläuft; auch für: Apsis) w; -, -n; **Ap|sis** gr. (halbrunde, auch vieleckige Altarnische; [halbrunde] Nische im Zelt zur Aufnahm von Gepäck u. a.) w; -, ...side

Apu|li|en [...iᵉn] (it. Region) **Aqua de|stil|la|ta** lat. (destilliertes, chemisch reines Wasser) s; -

Aquä|dukt (über eine Brücke geführte antike Wasserleitung) *m*; -[e]s, -e; **Aqua|kul|tur** (Bewirtschaftung des Meeres, z. B. durch Muschelkulturen); **Aquamarin** (ein Edelstein) *m*; -s, -e; **Aquanaut** (jmd., der in einer Unterwasserstation die Umweltbedingungen in größerer Meerestiefe erforscht) *m*; -en, -en († R 268); **Aqua|pla|ning** *lat.*; *engl.* [...plẹ'ning] (das „Aufschwimmen" der Reifen eines Kraftfahrzeugs auf aufgestautem Wasser einer regennassen Straße) *s*; -[s]; **Aqua|rell** *it.* (-*fr.*) (mit Wasserfarben gemaltes Bild) *s*; -s, -e; in - (Wasserfarben) malen; **Aqua|rell|far|be; aqua|rel|lie|ren** (in Wasserfarben malen); **Aqua|ria|ner** *lat.* (Aquarienliebhaber); **Aqua|ri|en|glas** [...*i*ᵉ*n*...] (*Mehrz.* ...gläser); **Aqua|ri|um** (Behälter zur Pflege und Züchtung von kleinen Wassertieren und -pflanzen; Gebäude für diese Zwecke) *s*; -s, ...ien [...*i*ᵉ*n*]; **Aqua|tel** *lat.*; *fr.* (Hotel mit luxuriös eingerichteten Hausbooten) *s*; -s, -s; **Aqua|tin|ta** *it.* (ein Kupferstichverfahren) *w*; -; **aqua|tisch** *lat.* (dem Wasser angehörend, wässerig) **Aqua|tor** *lat.* („Gleicher"; größter Breitenkreis) *m*; -s; **äqua|to|ri|al** (unter dem Äquator befindlich); **Äqua|to|ri|al|gui|nea** (Staat in Afrika); **Äqua|tor|tau|fe Aqua|vit** *lat.* [akwawịt] (ein Branntwein) *m*; -s, -e **Äqui|li|bris|mus** *lat.* (scholast. Lehre vom Gleichgewicht der Motive des freien Willens) *m*; -; **Äqui|li|brist,** Equi|li|brist *fr.* (Gleichgewichtskünstler, bes. Seiltänzer) († R 268; **äqui|li|bri|stisch,** equi|li|bri|stisch; **äqui|nok|ti|al** *lat.* ...zịạl) (das Äquinoktium betreffend); **Äqui|nok|ti|al|stür|me** *Mehrz.*; **Äqui|nok|ti|um** (Tagundnachtgleiche) *s*; -s, ...ien [...*i*ᵉ*n*] **Äqui|ta|ni|en** [...*i*ᵉ*n*] (hist. Landschaft in Südwestfrankreich) **qui|va|lent** *lat.* [...iwa...] (gleichwertig); **Äqui|va|lent** (Gegenwert; Ausgleich) *s*; -[e]s, -e; **Äqui|va|lenz** (Gleichwertigkeit) *w*; -, -en; **äqui|vok** [...wọk] (mehrdeutig, doppelsinnig) **Ạr** *lat.* (ein Flächenmaß; Zeichen: a) *s* (auch: *m*); -s, -e; drei - († R 322) **Ạr** = chem. Zeichen für: Argon **ra,** Ara|ra *indian.* (trop. Langschwanzpapagei) *m*; -s, -s **ra** *lat.* (Zeitalter, -rechnung) *w*; -, (selten:) Ären; christliche - **ra|bel|la** (w. Vorn.) **ra|ber** [auch: *ạr*...; schweiz.:

arạbᵉr] *m*; -s, -; **Ara|bes|ke** *fr.* (Pflanzenornament) *w*; -, -n; **Ara|bi|en** [...*i*ᵉ*n*]; **ara|bisch;** († R 200:) -es Vollblut; -e Ziffern, aber († R 224): Arabische Republik Ägypten; die Vereinigte Arabische Republik (hist.); Arabisches Meer; Arabische Legion, Liga; vgl. deutsch; **Ara|bisch** (eine Sprache) *s*; -[s]; vgl. Deutsch; **Arạ|bi|sche** *s*; -n; vgl. Deutsche *s*; **ara|bi|sie|ren; Ara|bist** (Wissenschaftler auf dem Gebiet der Arabistik); † R 268; **Ara|bi|stik** (Erforschung der arabischen Sprache u. Literatur) *w*; -

Arach|ni|den, Arach|no|iden *gr.* (Spinnentiere) *Mehrz.*; **Arach|no|lo|ge** (Wissenschaftler auf dem Gebiet der Arachnologie) *m*; -n, -n († R 268); **Arach|no|lo|gie** (Wissenschaft von den Spinnentieren) *w*; -

Ara|gón (span. Schreibung für: Aragonien); **Ara|go|ne|se** *m*; -n, -n († R 268), besser: **Ara|go|ni|er** [...*i*ᵉ*r*]; **Ara|go|ni|en** [...*i*ᵉ*n*] (hist. Provinz in Spanien); **ara|go|nisch; Ara|go|nịt** (ein Mineral) *m*; -

Aral Ⓦ (ein Kraftstoff) *s*; -s **Ara|lie** [...*i*ᵉ] (trop. Pflanzengattung) *w*; -, -n **Aral|see** (abflußloser See in Mittelasien) *m*; -s **Ara|mäa** („Hochland"; alter Name für Syrien); **Ara|mä|er** (Angehöriger eines westsemit. Nomadenvolkes) *m*; -s, -; **ara|mä|isch;** vgl. deutsch; **Ara|mä|isch** (eine Sprache) *s*; -[s]; vgl. Deutsch; **Ara|mä|ische** *s*; -n; vgl. Deutsche *s* **Aran|ci|ni, Aran|zi|ni** *pers.-it.* bes. österr. (überzuckerte od. schokoladenüberzogene gekochte Orangenschalen) *Mehrz.* **Aran|ju|ez** [aranchuäß, span. Ausspr.: *aranchuäth*] (span. Stadt) **Ärar** *lat.* (Staatsschatz, -vermögen; österr. für: Fiskus) *s*; -s, -e **Ara|ra** vgl. Ara **Ara|rat** [auch: *ạr*...] (höchster Berg der Türkei) *m*; -[s] **ära|risch** *lat.* (zum Ärar gehörend; staatlich) **Arau|ka|ner** (chilen. u. argentin. Indianer); **Arau|ka|rie** [...*i*ᵉ] (ein Nadelbaum; Zimmertanne) *w*; -, -n **Araz|zo** (it. Bez. für einen Bildteppich [aus Arras]) *m*; -s, ...zzi **Ạr|be** (Nebenform von: Arve) **Ạr|beit** *w*; -, -en; **ạr|bei|ten; Ạr|bei|ter; Ạr|bei|ter|dich|ter,** ...fra|ge; **Ạr|bei|ter|rück|fahr|kar|te; Ạr|bei|ter|schaft** *w*; -; **Ạr|bei|ter-und-Bau|ern-Fa|kul|tät** (Abk.: ABF; in der

DDR); **Ạr|bei|ter-Un|fall|ver|si|che|rungs|ge|setz** († R 152); **Ạr|beit..ge|ber,** ...neh|mer; **ạr|beit|sam; Ạr|beit|sam|keit** *w*; -; **Ạr|beits..amt,** ...be|schaf|fung, ...be|such** (Politik), ...di|rek|tor, ...es|sen** (bes. Politik); **ạr|beits|fä|hig; Ạr|beits..fä|hig|keit** (*w*; -), ...feld, ...gang *m*, ...ge|mein|schaft, ...ge|richt, ...haus, ...ka|me|rad, ...kli|ma, ...kraft *w*, ...lohn; **ạr|beits|los; Ạr|beits|lo|se** *m* u. *w*; -n, -n († R 287ff.); **Ạr|beits|lo|sen|ver|si|che|rung** *w*; -; **Ạr|beits..lo|sig|keit** (*w*; -), ...markt, ...platz, ...recht, ...stät|te; **ạr|beit[s]|su|chend; Ạr|beit[s]|su|chen|de** *m* u, *w*; -n, -n († R 287ff.); **Ạr|beits|tag; ạr|beits|täg|lich; Ạr|beits..tei|lung, ...un|ter|richt** (method. Prinzip der Unterrichtsgestaltung), ...ver|hält|nis; **ạr|beits|wil|lig; Ạr|beits|wil|li|ge** *m* u. *w*; -n, -n († R 287ff.); **Ạr|beits..zeit,** ...zim|mer **Ar|bi|tra|ge** *fr.* [arbitrạseh*ᵉ*] (Schiedsgerichtsvereinbarung im Handelsrecht; [Ausnutzung der] Kursunterschiede an verschiedenen Börsen), **ar|bi|trär** (nach Ermessen, willkürlich) **Ạr|bo|re|tum** *lat.* (Bot.: Sammelpflanzung lebender Hölzer zu Studienzwecken) *s*; -s, ...ten **Ạr|bu|se** *pers.-russ.* (Wassermelone) *w*; -, -n **arc** = Arkus **ARC** = American Red Cross [ᵉmärikᵉn räd krọß] (amerik. Rotes Kreuz) **Ạr|chai|kum, Ạr|chäi|kum** *gr.* (ältestes Zeitalter der Erdgeschichte) *s*; -s; **ạr|cha|isch** (aus sehr früher Zeit [stammend], altertümlich); **ạr|chä|isch** (das Archäikum betreffend); **ạr|chai|sie|ren** (archaische Formen verwenden; altertümeln); **Ạr|cha|is|mus** (altertümliche Ausdrucksform, veraltetes Wort) *m*; -, ...men; **ạr|chai|stisch Ạr|chan|gelsk** (nordruss. Stadt) **Ạr|chäo|lo|ge** *gr.* (Wissenschaftler auf dem Gebiet der Archäologie, Altertumsforscher) *m*; -n, -n († R 268); **Ạr|chäo|lo|gie** (Altertumskunde) *w*; -; **ạr|chäo|lo|gisch,** aber († R 224): das Deutsche Archäologische Institut in Rom; **Ạr|chäo|pte|ryx** (ausgestorbene Vogelgattung) *w* (auch: *m*); -, -e und ...pteryges [...gäß] **Ạr|che** *lat.* („Kasten") *w*; -, -n; - Noah **Ạr|che|typ** [auch: *ạr*...] *m*; -s, -en u. **Ạr|che|ty|pus** *gr.* (Urbild, Urform; älteste erreichbare Gestalt [einer Schrift]) *m*; -, ...pen; **ạr|che|ty|pisch** [auch: *ạr*...] (dem Urbild, der Urform entsprechend)

Ar|chi|bald (m. Vorn.)
Ar|chi..dia|kon gr. (Titel von
Geistlichen [der anglikanischen
Kirche]), ...dia|ko|nat (Amt,
Wohnung eines Archidiakons);
Ar|chi|man|drit (Ostkirche: Klo-
stervorsteher) m; -en, -en (↑ R
268)
Ar|chi|me|des (altgr. Mathemati-
ker); ar|chi|me|disch; -e Spirale,
aber (↑ R 179): Ar|chi|me|disch;
-es Prinzip, -er Punkt (Angel-
punkt)
Ar|chi|pel gr.-it. (Inselmeer,
-gruppe) m; -s, -e; Ar|chi|tekt gr.
m; -en, -en (↑ R 268); Ar|chi|tek-
ten|bü|ro; Ar|chi|tek|to|nik (Wis-
senschaft der Baukunst [nur
Einz.]; Bauart; planmäßiger Auf-
bau) w; -, -en; ar|chi|tek|to|nisch
(baulich; baukünstlerisch); Ar-
chi|tek|tur (Baukunst; Baustil) w;
-, -en; Ar|chi|trav (antikes Bauw.:
Tragbalken) m; -s, -e [...wᵉ]
Ar|chiv gr. (Urkundensammlung;
Titel wissenschaftlicher Zeit-
schriften) s; -s, -e [...wᵉ]; Ar|chi-
va|li|en [...wali̯ᵉn] (Aktenstücke
[aus einem Archiv]) Mehrz.; ar-
chi|va|lisch (urkundlich); Ar|chi-
var (Archivbeamter) m; -s, -e; ar-
chi|vie|ren (in ein Archiv aufneh-
men)
Ar|chont gr. (höchster Beamter im
alten Athen u. in anderen Städten
der Antike) m; -en, -en (↑ R 268)
Ar|cus vgl. Arkus
ARD = Arbeitsgemeinschaft der
öffentlich-rechtlichen Rund-
funkanstalten der Bundesrepu-
blik Deutschland
Ar|den|nen (Gebirge) Mehrz.; Ar-
den|ner Wald (früher für: Arden-
nen) m; - -[e]s
Ar|dey [ardai] (gebirgiger Teil des
Sauerlandes) m; -s
Are schweiz. (¹Ar) w; -, -n; Are|al
([Boden]fläche, Gelände;
schweiz. für: Grundstück) s; -s,
-e
Are|ka|nuß malai.-port.; dt.
(Frucht der Arekapalme)
Ären (Mehrz. von: Ära)
Are|na lat. ([sandbestreuter]
Kampfplatz; Sportplatz; Mane-
ge im Zirkus; österr. veraltend
auch: Sommerbühne) w; -, ...nen
Areo|pag gr. (Gerichtshof im alten
Athen) m; -s
Ares (gr. Kriegsgott)
Arez|zo (it. Ortsn.)
arg; ärger, ärgste. I. Kleinschrei-
bung (↑ R 133): im argen liegen.
II. Großschreibung: a) (↑ R 116:)
der Arge (vgl. d.); zum Ärgsten
kommen; vom den Ärgsten be-
wahren; das Ärgste verhüten; b)
(↑ R 116:) nichts Arges denken;
Arg (geh.) s; -s; ohne -; kein -

an einer Sache finden; es ist kein
- an ihm
Ar|gand|bren|ner [argang...; nach
dem schweiz. Erfinder] (Gasring-
brenner); ↑ R 180
Ar|ge (Teufel) m; -n
Ar|gen|ti|ni|en [...iᵉn] (südamerik.
Staat; Ar|gen|ti|ni|er [...iᵉr]; ar-
gen|ti|nisch; -e Literatur, aber
(↑ R 198): die Argentinische Re-
publik; Ar|gen|tit (Silberglanz;
chem. Silbersulfid) m; -s; Ar|gen-
tum (lat. Bez. für: Silber; Zeichen:
Ag) s; -[s]
Är|ger m; -s; är|ger|lich; är|gern;
ich ...ere (↑ R 327); sich über et-
was -; Är|ger|nis s; ...nisses, ...nis-
se; Arg|list w; -; arg|li|stig; arg|los;
-este (↑ R 292); Arg|lo|sig|keit w;
-
Ar|go gr. (Name des Schiffes der
Argonauten; ein Sternbild) w; -
Ar|go|lis (gr. Landschaft)
Ar|gon gr. [auch: argon] (chem.
Grundstoff, Edelgas; Zeichen:
Ar) s; -s
Ar|go|naut gr. (Held der gr. Sage;
bes. Art des Tintenfisches) m; -en,
-en (↑ R 268)
Ar|gon|nen (fr. Gebirge) Mehrz.
Ar|got fr. [argo] (Bettler- u. Gau-
nersprache, Rotwelsch, Slang,
Jargon [in Frankreich]) s od. m;
-s, -s
Ar|gu|ment lat. (Beweis[mittel,
-grund]) s; -[e]s, -e; ar|gu|men|ta-
ti|on [...zion] (Beweisführung);
ar|gu|men|ta|tiv (Argumente be-
treffend, auf Argumente bezüg-
lich); ar|gu|men|tie|ren
¹Ar|gus (Riese der gr. Sage); ²Ar-
gus (scharfer Wächter) m; -, -se;
Ar|gus|au|gen; ↑ R 180 (scharfe,
wachsame Augen) Mehrz.; ar-
gus|äu|gig
Arg|wohn m; -[e]s; arg|wöh|nen; ich
argwöhne; geargwöhnt; zu -; arg-
wöh|nisch; -ste (↑ R 294)
Arhyth|mie vgl. Arrhythmie
Ari|ad|ne (gr. weibliche Sagenge-
stalt); Ari|ad|ne|fa|den (↑ R 180)
m; -s
Aria|ner (Anhänger des Arianis-
mus); aria|nisch; -e Auffassung,
aber (↑ R 179): Aria|nisch; der
-e Streit; Aria|nis|mus (Lehre des
Arius) m; -
Ari|bert (m. Vorn.)
arid lat. (trocken; dürr [vom Bo-
den]); Ari|di|tät w; -
Arie it. [ariᵉ] (Sologesangstück mit
Instrumentalbegleitung) w; -, -n
Ari|el hebr. [...iäl] (alter Name Je-
rusalems; Name eines Engels;
Luftgeist in Shakespeares
„Sturm"; [m; -s:] Uranusmond)
Ari|er sanskr. [...iᵉr] („Edler"; An-
gehöriger frühgeschichtl. Völker
mit idg. Sprache; nationalsoz.:

Nichtjude, Angehöriger der
nord. Rasse) m; -s, -
Ari|es lat. [griäß; „Widder"] (ein
Sternbild) m; -
Ari|ma|thia, (ökum.:) Ari|ma|täa
(altpalästin. Ort)
Ari|on (altgr. Sänger)
ario|so it. (Musik: liedmäßig [vor-
getragen]); Ario|so (liedmäßiges
Tonstück) s; -s, -s -u. ...si
Ari|ost, Ario|sto (it. Dichter)
Ario|vist [...wißt] (Heerkönig der
Sweben)
arisch [zu: Arier]; ari|sie|ren (na-
tionalsoz.: in arischen Besitz
überführen)
Ari|sti|des (athen. Staatsmann u
Feldherr)
Ari|sto|gei|ton vgl. Aristogiton
Ari|sto|gi|ton (athen. Tyrannen
mörder, Freund des Harmodius
Ari|sto|krat gr. (Angehöriger de
Adels; vornehmer Mensch) m
-en, -en (↑ R 268); Ari|sto|kra|tie
w; -, ...ien; ari|sto|kra|tisch; -st
(↑ R 294)
Ari|sto|pha|nes (athen. Lustspiel
dichter); ari|sto|pha|nisch; vo
-er Laune, aber (↑ R 179): Ari
sto|pha|nisch; die -e Komödie
Ari|sto|te|les (altgr. Philosoph)
Aristoteles' Schriften (↑ R 310
Ari|sto|te|li|ker (Anhänger de
Lehre des Aristoteles); ari|sto|te
lisch, aber (↑ R 179): Ari|sto|te
lisch
Arith|me|tik gr. [auch: ...tik] (Zah
lenlehre, Rechnen mit Zahlen) w
-; Arith|me|ti|ker; arith|me|tise
(auf die Arithmetik bezüglich
-es Mittel (Durchschnittswert)
Ari|us (alexandrin. Presbyter)
Ariz. = Arizona
Ari|zo|na (Staat in den USA
Abk.: Ariz.)
Ark. = Arkansas
Ar|ka|de fr. (Bogen auf zwei Pfe
lern od. Säulen) w; -, -n; Arka
den (Bogenreihe) Mehrz.
Ar|ka|di|en [...iᵉn] (gr. Lan
schaft); Ar|ka|di|er [...iᵉr]; ar|k
disch; -e Poesie (Hirten- u. Sch
ferdichtung)
Ar|kan|sas (Staat in den USA
Abk.: Ark.)
Ar|ka|num lat. (Geheimnis; G
heimmittel) s; -s, ...na
Ar|ke|bu|se niederl. („Hake
büchse" im 15./16. Jh.) w; -, -
Ar|ke|bu|sier (Soldat mit Ark
buse) m; -s, -e
Ar|ko|na (Vorgebirge Rügens)
Ar|ko|se fr. (feldspatreicher San
stein) w; -
Ark|ti|ker gr. (Bewohner der Ar
tis) m; -s, -; Ark|tis (Gebiet u
den Nordpol) w; -; ark|tisch; Ari
tur, Ark|tu|rus („Bärenhüter
ein Stern) m; -

Ạr|kus, (auch:) Ạr|cus *lat.* (Math.: Kreisbogen eines Winkels; Zeichen: arc) *m*; -, - Ạrl|berg (Alpenpaß) *m*; -[e]s; Ạrl|berg|bahn *w*; - Arles (fr. Ortsn.) ạrm; ärmer, ärmste. I. *Kleinschreibung:* a) (↑ R 224:) arme Ritter *(eine Speise)*; b) (↑ R 133:) [bei] arm und reich (veralt. für: jedermann). II. *Großschreibung* (↑ R 116): Arme und Reiche, bei Armen und Reichen, der Arme (vgl. d.) und der Reiche; wir Armen (↑ R 290) Ạrm *m*, -[e]s, -e; vgl. Armvoll Ạr|ma|da *span.* („Rüstung"; [mächtige] Kriegsflotte) *w*; -, ...den u. -s arm|am|pu|tiert; ein -er Mann Ạr|ma|tur *lat. w*; -, -en; Ạr|ma|tu|ren|brett Ạrm|band *s* (Mehrz. ...bänder); Ạrm|band|uhr; Ạrm..heu|ge, ...bin|de, ...blatt (am unteren Ärmelausschnitt angebrachte Schutzanlage) Ạrm|brust *w*; -, ...brüste, (auch:) -e; Ạrm|bru|ster (Armbrustschütze, -macher) Ạrm|chen, Ärm|lein; ạrm|dick; -er Ast, aber: einen Arm dick Ạr|me *m* u. *w*; -n, -n (↑ R 287ff.) Ạr|mee *fr.* (Heer; Heeresabteilung) *w*; -, ...meen; Ạr|mee-Einheit (↑ R 148); Ạr|mee|korps (Abk.: AK) Ạr|mel *m*; -s, -; ...är|me|lig, ...ärmlig (z. B. kurzärm[e]lig); Ạr|mel|ka|nal *m*; -s; Ạr|mel|län|ge (die Länge eines Ärmels) Ạr|men..haus (veralt.), ...häus|ler Ạr|me|ni|en [...*i*ˀn] (Hochland in Vorderasien); Ạr|me|ni|er [...*i*ˀr]; ar|me|nisch Ạr|men.pfle|ger (veralt.), ...recht (*s*; -[e]s); Ạr|men|sün|der|glocke [Trenn.: ...glok|ke] österr. (Armen|vier|tel Ạr|mes|län|ge; auf - an jmdn. herankommen; um - voraus sein Ạr|me|sün|der *m*; Wesf.* des Armensünders, Mehrz.* die Armensünder; ein Armersünder, zwei Armesünder; Ạr|me|sün|der|glocke [Trenn.: ...glok|ke] (vgl. Armsünderglocke, Armensünderglocke) *w*; Wesf.* der Arme[n]sünderglocke, Mehrz.* die Arme[n]sündersünderglocken **r'|mie|ren** (veralt. für: bewaffnen); Technik: ausrüsten, bestükken, bewehren); Ạr|mie|rung; Armie|rungs|ei|sen (Stahlbetonbau: Bewehrungseisen) .ar|mig (z. B. langarmig) .r|min (m. Vorn.); Ạr|mi|ni|us („Cheruskerfürst"; Ạr|mi|nia|ner

(Anhänger des Arminianismus); ar|mi|nia|nisch; Ạr|mi|nia|nis|mus (Lehre des Jacobus Arminius) *m*; - ạrm|lang; -er Stiel, aber: einen Arm lang; Ạrm|län|ge (die Länge eines Armes); Ärm|lein, Ärm|chen; Ạrm|leuch|ter ärm|lich; Ärm|lich|keit *w*; - ...ạrm.llg vgl. ...ärmelig; Ạrm|ling (Ärmel zum Überstreifen) Ạr|mo|ri|ka (kelt. Bez. für die Bretagne); ar|mo|ri|ka|nisch, aber (↑ R 198); das Armorikanische Gebirge (Geol.) Ạrm|reif *m*; -[e]s, -e ạrm|se|lig; Ạrm|se|lig|keit *w*; - Ạrm|sün|der|glocke [Trenn.: ...glok|ke] *w*; -, -n; (auch:) Armesünderglocke, (österr.:) Armensünderglocke; vgl. d. Ạr|mü|re *fr.* (kleingemustertes [Kunst]seidengewebe) *w*; -, -n Ạr|mut *w*; -; Ạr|mu|tei landsch. (Zustand allgemeiner Armut u. daraus erwachsender Verwahrlosung) *w*; -; Ạr|muts|zeug|nis Ạrm|voll *m*; -; (↑ R 139:) zwei - Reisig, aber: er hat den einen Arm voll[er] Reisig Arndt (dt. Dichter) Ạr|ni|ka *gr.* (eine Heilpflanze) *w*; -, -s; Ạr|ni|ka|tink|tur Ạr|nim (märk. Adelsgeschlecht) ¹Ạr|no (it. Fluß) *m*; -[s] ²Ạr|no (Kurzform der mit Arn... gebildeten Vornamen); Ạr|nold (m. Vorn.); Ạr|nulf (m. Vorn.) Arom *gr.* (dicht. für: Aroma) *s*; -s, -e; Arо|ma *s*; -s, ...men, -s u. (älter:) -ta; aro|ma|tisch; -ste (↑ R 294); -e Verbindung (Benzolverbindung); aro|ma|ti|sie|ren Aron[s]|stab *gr.*; *dt.* (eine Pflanze) Arо|sa (schweiz. Ortsn.); Arọ|ser (↑ R 199) Ạr|pad (erster Herzog der Ungarn); Ạr|pa|de (Angehöriger eines ung. Fürstengeschlechtes) *m*; -n, -n (↑ R 268) Ạr|peg|gia|tur *it.* [arpädschatur] (Musik: Reihe gebrochener Akkorde) *w*; -, -en; ar|peg|gie|ren [arpädsehir*e*n] (nach Harfenart spielen); ar|peg|gio [arpädscho] (nach Harfenart); ar|peg|gio *s*; -s, -s u. ...ggien [...*i*ˀn] Ạr|rak *arab.* (Branntwein, bes. aus Reis) *m*; -s, -e u. -s Ạr|ran|ge|ment [arangsehe*e*mang] (Anordnung); Übereinkunft; Einrichtung eines Musikstücks) *s*; -s, -s; Ạr|ran|geur [arangsehör] (wer ein Musikstück einrichtet, einen Schlager instrumentell o.d. allgemein etwas arrangiert) *m*; -s, -e; ar|ran|gie|ren [arangsehir*e*n]; Ạr|ran|gier|pro|be (Theater: Stellprobe)

Ạr|ras (fr. Ortsn.) Ạr|rest *lat.* (Beschlagnahme; Haft; Nachsitzen) *m*; -[e]s, -e; Ạr|re|stant (Häftling) *m*; -en, -en (↑ R 268); Ạr|rest|zel|le; ar|re|tie|ren (anhalten; sperren; veralt. für: verhaften); Ạr|re|tie|rung (Sperrvorrichtung) Ạr|rhe|ni|us (schwed. Chemiker u. Physiker) Ạr|rhyth|mie *gr.* (Mangel an Ebenmaß, Regelmäßigkeit der Bewegungen; Med.: Unregelmäßigkeit des Herzschlags) *w*; -, ...ien ar|ri|vie|ren *fr.* [...wir*e*n] (in der Welt vorwärtskommen); ar|ri|viert (anerkannt; erfolgreich); Ạr|ri|vier|te (anerkannte[r] Künstler[in]; Emporkömmling) *m* u. *w*; -n, -n (↑ R 287ff.) ar|ro|gant *lat.* (anmaßend); Ạr|ro|ganz *w*; - ar|ron|die|ren *fr.* [arongdir*e*n]; Grundbesitz- (abrunden, zusammenlegen); Ạr|ron|die|rung; Ạr|ron|dis|se|ment [arongdiß*e*mang] (Unterabteilung eines Departements; Bezirk) *s*; -s, -s Ạr|row|root *engl.* [är*o*ˀrut] („Pfeilwurz"; ein Stärkemehl) *s*; -s Ạr|sa|ki|de (Angehöriger eines pers. u. armen. Herrschergeschlechtes) *m*; -n, -n (↑ R 268) Arsch (derb) *m*; -[e]s, Ärsche; Arsch..backe [Trenn.: ...bak|ke] (derb), ...krie|cher (derb für: übertrieben schmeichlerischer Mensch), ...le|der (Bergmannsspr.), ...loch (derb), ...pau|ker (ugs. abschätzig für: Lehrer) Ạr|sen *gr.* (chem. Grundstoff; Zeichen: As) *s*; -s ar|se|nal *arab.-it.* (Zeughaus; Geräte-, Waffenlager) *s*; -s, -e ar|se|nig *gr.* (arsenikhaltig); Ạr|senik *gr.* (gift. Arsenverbindung) *s*; -s; ar|se|nik|hal|tig Ạr|sis *gr.* (Verslehre: Hebung) *w*; -, Arsen Art *w*; -, -en; (↑ R 139:) ein Mann [von] der Ạrt (solcher Art), aber: er hat mich derart (so) beleidigt, daß...; vgl. allerart Art. = Artikel Ạrt|an|ga|be (Sprachw.: Umstandsangabe der Art u. Weise) Ạr|te|fakt *lat.* („Kunsterzeugnis"; von Menschen geformter vorgeschichtlicher Gegenstand) *s*; -[e]s, -e Ạr|tel *russ.* [auch: ...tjäl] („Gemeinschaft"; [Arbeiter]genossenschaft im alten Rußland u. in der sowjetischen Kollektivwirtschaft) *s*; -s, -s Ạr|te|mis (gr. Göttin der Jagd) ạr|ten; nach jmdm. -; Ạr|ten|reich|tum *m*; -[e]s; art|er|hal|tend, aber (↑ R 142): die Art erhaltend

Ar|te|rie *gr.* [...*i^e*] (Schlagader) *w;*
-, -n; ar|te|ri|ell; Ar|te|ri|en|ver-
kal|kung; Ar|te|ri|itis (Arterien-
entzündung) *w;* -, ...iit|den; Ar|te-
rio|skle|ro|se (Arterienverkal-
kung); ar|te|rio|skle|ro|tisch
ar|te|sisch [zu Artois; vgl. d.]; -er
Brunnen (Bohrbrunnen, dessen
Wasser unter dem Druck höherer
Grundwasserschichten selbsttä-
tig springt)
Art|ge|nos|se
Ar|thral|gie *gr.* (Gelenkschmerz,
Gliederreißen) *w;* -, ...ien; Ar-
thri|ti|ker (an Arthritis Leiden-
der); Ar|thri|tis (Gelenkentzün-
dung) *w;* -, ...it|den; ar|thri|tisch;
Ar|thro|po|den (Gliederfüßer)
Mehrz.
Ar|thur vgl. Artur
ar|ti|fi|zi|ell *fr.* (künstlich)
...ar|tig (z. B. gleichartig); ar|tig
(gesittet; folgsam); Ar|tig|keit
Ar|ti|kel *lat.* [auch: ...ti...] („klei-
nes Glied"; Geschlechtswort;
Abschnitt [Abk.: Art.]; Ware;
Aufsatz) *m;* -s, -; Ar|ti|kel|se|rie
[auch: ...ti...] (Folge von Artikeln
zu einem Thema); ar|ti|ku|lar
(Med.: zum Gelenk gehörend);
Ar|ti|ku|la|ti|on [...zion] (Biol.:
Gliederung, Gelenkverbindung;
Sprachw.: Lautbildung, Aus-
sprache); ar|ti|ku|la|to|risch; ar-
ti|ku|lie|ren (deutlich ausspre-
chen, formulieren)
Ar|til|le|rie *fr.* *w;* -, ...ien; Ar|til|le-
rist (↑ R 268); ar|til|le|ri|stisch
Ar|ti|schocke [*Trenn.:* ...schok|ke]
it. (eine Zier- u. Gemüsepflanze)
w; -, -n
Ar|tist *fr.* (↑ R 268); Ar|ti|sten|fa-
kul|tät (an den mittelalterl.
Hochschulen: Fach der Freien
Künste); Ar|ti|stik (Kunst der
Artisten) *w;* -; Ar|ti|stin *w;* -, -nen;
ar|ti|stisch
Ar|tois [*artoą*] (hist. Provinz in
Nordfrankreich) *s;* -
Ar|tung (Beschaffenheit, Veranla-
gung, Wesensgestaltung) *w;* -
Ar|tur, Ar|thur (m. Vorn.); Ar|tus
(sagenhafter walis. König); Ar-
tus|hof *m;* -[e]s
art|ver|wandt; Art|wort (für: Ad-
jektiv; *Mehrz.* ...wörter)
Ar|ve [*arw^e*], schweiz.: *arf^e*] ale-
mann. (Zirbelkiefer) *w;* -, -n
Ar|wed (m. Vorn.)
Arz|nei; Arz|nei|buch, ...kun|de (*w;*
-); arz|nei|lich; Arz|nei|mit|tel *s;*
Arz|nei|mit|tel|leh|re; Arzt *m;* -es,
Ärzte; Ärz|te|kam|mer; Ärz|te-
schaft *w;* -; Arzt|frau, ...hel|fe|rin;
Ärz|tin *w;* -, -nen; ärzt|lich; Arzt-
rech|nung
as, ¹As (Tonbezeichnung) *s;* -, -;
as (Zeichen für: as-Moll); in as;
²As (Zeichen für: As-Dur); in As

³As *lat.* (altröm. Gewichts- und
Münzeinheit) *m;* Asses, Asse
⁴As *fr.* (Eins [auf Karten]; das od.
der Beste [z. B. im Sport]; Tennis:
für den Gegner unerreichbarer
Aufschlagball) *s;* Asses, Asse;
vgl. ¹Aß
⁵As = chem. Zeichen für: Arsen
Asa|fö|ti|da *pers.; lat. w;* - u. Asa
foe|ti|da [- *fö*...] *w;* - - u. Asant
pers. (ein Gummiharz; eine Arz-
nei) *m;* -s
A-Sai|te (z. B. bei der Geige)
asb = Apostilb
As|best *gr.* (mineralische Faser) *m;*
-[e]s, -e; As|best|plat|te
Asch ostmitteld. (Napf, [tiefe]
Schüssel) *m;* -[e]s, Äsche
¹Aschan|ti (Angehöriger eines Ne-
gerstammes in Ghana) *m;* -, -;
²Aschan|ti ostösterr. (Erdnuß) *w;*
-, -; Aschan|ti|nuß (ostösterr.)
Asch|be|cher, Aschen|be|cher;
asch.bleich, ...blond; Asche *w;* -,
(techn.:) -n
Äsche (ein Fisch) *w;* -, -n
Asche|ge|halt *m;* aschen|arm;
Aschen|bahn; Asch[en]|be|cher;
Aschen|brö|del (Märchengestalt)
s; -s, die: für: jmd., der ein unschein-
bares Leben führt, auch *Mehrz.*)
-; Aschen|gru|be; aschen|hal|tig;
Aschen|port|tel hess. (Aschen-
brödel) *s;* -s, -; Ascher (ugs. für:
Aschenbecher); Äscher ([Grube,
Faß mit] Aschen- und Kalklau-
ge); Ascher|mitt|woch (Mittwoch
nach Fastnacht); asch.fahl, ...far-
ben od. ...far|big, ...grau, aber
(↑ R 133): bis ins Aschgraue (bis
zum Überdruß); aschig
Asch|ke|na|sim (vgl. Juden: ...sim] hebr.
(Bez. für die ost- u. mitteleuro-
päischen Juden) *Mehrz.*
Asch|ku|chen ostmitteld. (Napf-
kuchen)
Asch|mo|dai vgl. ¹Asmodi
äschy|le|isch, aber (↑ R 179):
Äschy|le|isch; Äschy|lus [auch:
ä...] (altgr. Tragiker)
As|co|na (schweiz. Ort am Lago
Maggiore)
Ascor|bin|säu|re vgl. Askorbin-
säure
As-Dur [auch: *aßdur*] (Tonart; Zei-
chen: As) *s;* -; As-Dur-Tonleiter
(↑ R 155)
Ase (germ. Gottheit) *m;* -n, -n
Mehrz.: ↑ R 268
Ase|bie (Gottlosigkeit) *w;* -
Ase|ga|buch (altfries. Rechtsbuch)
s; -[e]s, ...bücher
äsen; das Rotwild äst (frißt)
Asep|sis *gr.* (Med.: Keimfreiheit)
w; -; asep|tisch (keimfrei)
Äser (*Mehrz.* von: Aas)
Aser|bai|dschan, Aser|bei|dschan
(Landschaft u. Provinz im nord-
westl. Persien; Unionsrepublik

der UdSSR); Aser|bai|dscha|ner,
Aser|bei|dscha|ner; aser|bai-
dscha|nisch, aser|bei|dscha|nisch
Asi|at *lat. m;* -en, -en (↑ R 268);
asia|tisch; (↑ R 200:) -e Grippe;
Asi|en [...*i^en*]
As|ka|ni|er [...*i^er*] (Angehöriger ei-
nes alten dt. Fürstengeschlech-
tes) *m;* -s, -
As|ka|ri *arab.* („Soldat"; eingebo-
rener Soldat im ehemal. Deutsch-
Ostafrika) *m;* -s, -s
As|ka|ris *gr.* (Spulwurm) *w;* -,
...iden (meist *Mehrz.*)
As|ke|se *gr.* (enthaltsame Lebens-
weise) *w;* -; As|ket (enthaltsam
lebender Mensch) *m;* -en, -en (↑ R
268); as|ke|tisch vgl. Aszetik; as-
ke|tisch; -ste (↑ R 294)
As|kle|pi|os, As|kle|pi|us vgl. Äs-
kulap
Askor|bin|säu|re, (chem. fach-
spr.:) Ascor|bin|säu|re (Vitamin
C)
Äs|ku|lap [auch: *äß*...] (gr.-röm.
Gott der Heilkunde); Äs|ku-
lap.schlan|ge, ...stab
¹As|mo|di, (ökum.:) Asch|mo|dai
aram. (ein Dämon im A. T. u.
im jüd. Volksglauben); ²As|mo|di
(dt. Dramatiker)
as-Moll [auch: *aßmoll*] (Tonart;
Zeichen: as *s;* -; as-Moll-Tonlei-
ter (↑ R 155)
As|mus (Kurzform von: Erasmus)
asoma|tisch *gr.* [auch: ...*ma*...]
(Philos.: körperlos, unkörper-
lich)
Äsop (altgr. Fabeldichter); äso-
pisch (auch: witzig), aber (↑ R
179): Äso|pisch; Äso|pus vgl
Äsop
Asow|sche Meer [*asof*... -] (Teil des
Schwarzen Meeres) *s;* -n -[e]s
aso|zi|al *gr.; lat.* [auch: ...*al*] (ge-
meinschaftsschädigend; gemein-
schaftsfremd); Aso|zia|li|tät *w;* -
As|pa|ra|gin *gr.* (chem. Verbin-
dung) *s;* -s; As|pa|ra|gus [auch:
...*pą*... u. ...*raguß*] (Zierspargel)
m; -
As|pa|sia (Geliebte [und spätere
Frau] des Perikles)
As|pekt *lat.* (Ansicht, Gesichts-
punkt; Sprachw.: [den slaw.
Sprachen eigentümliche] gram-
mat. Kategorie, die die subjekti-
ve Sicht u. Auffassung des Ge-
schehens durch den Sprecher
ausdrückt; Astron.: bestimmte
Stellung der Planeten zueinan-
der) *m;* -[e]s, -e
Asper|gill *lat.* (Weihwasserwedel)
s; -s, -e
Asper|si|on *lat.* (Besprengung mit
Weihwasser)
As|phalt *gr.* [auch: *aß*...] *m;* -[e]s
-e; as|phal|tie|ren; as|phal|tisch;
As|phalt.pap|pe, ...stra|ße

As|pho|dill vgl. Affodill

Aspik fr. [auch: aßpik u. aßpik] (Gallert aus Gelatine od. Kalbsknochen) m (österr.: s, auch: m); -s, -e

Aspi|rant lat. (Bewerber; Anwärter; DDR: wissenschaftliche Nachwuchskraft in der Weiterbildung) m, -en, on (↑ R 268); Aspi|ran|tur (DDR: Institution zur Ausbildung des wissenschaftlichen Nachwuchses) w; -, -en; Aspi|ra|ta (Sprachw.: behauchter Verschlußlaut, z. B. gr. ϑ [= tʰ]) w; - - ...ten u. ...tä; Aspi|ra|teur fr. [...tör] (Maschine zum Vorrei nigen des Getreides) m; -s, -e; Aspi|ra|ti|on lat. [...zion] (veralt. für: Bestrebung [meist Mehrz.]; Sprachw.: [Aussprache mit] Behauchung; Med.: Ansaugung); Aspi|ra|tor (Luft-, Gasansauger) m; -s, ...oren; aspi|ra|to|risch (Sprachw.: mit Behauchung gesprochen); aspi|rie|ren (Zeitw. zu: Aspiration; österr. auch: sich um etwas bewerben, etwas anstreben)

Aspi|rin Ⓦ (ein Fiebermittel) s; -s; Aspi|rin|ta|blet|te

¹Aß (österr. neben: ⁴As) s; Asses, Asse

²Aß österr. ugs. (Abszeß) s; Asses, Asse

Ass. = Assessor

As|sa|gai berberisch (Wurfspeer der Kaffern) m; -s, -e

As|sam (Bundesstaat der Republik Indien)

As|sa|nie|rung fr. österr. (Verbesserung der Bebauung von Liegenschaften aus hygienischen, sozialen u. a. Gründen)

As|sas|si|ne arab.-it. (Angehöriger einer mohammedan. religiösen Gemeinschaft; veralt. für: Meuchelmörder) m; -n, -n (↑ R 268)

As|saut fr. [aßo] (Fechten im freien Kampf zur Erprobung der Gelernten) m; -s, -s

As|se|ku|rant lat. (veralt. für: Versicherer) m; -en, -en (↑ R 268); As|se|ku|ranz (veralt. für: Versicherung, Versicherungsgesellschaft) w; -, -en; As|se|ku|rat (veralt. für: Versicherter) m; -en, -en (↑ R 268); as|se|ku|rie|ren (veralt.)

As|sel (ein Krebstier) w; -, -n

As|sem|blee fr. [aßangble] (fr. Bez. für: Versammlung) w; -, ...bleen

as|sen|tie|ren lat. (veralt. für: beizustimmen; österr. veralt.: auf Militärdiensttauglichkeit untersuchen)

As|ser|ti|on lat. [...zion] (Philos.: bestimmte Behauptung); as|ser|to|risch (behauptend, versichernd)

As|ser|vat lat. [...wat] (Rechtsw.: amtlich aufbewahrte Sache) s; -[e]s, -e; As|ser|va|ten|kam|mer

As|ses|sor lat. („Beisitzer"; Anwärter der höheren Beamtenlaufbahn; Abk.: Ass.) m; -s, ...oren; as|ses|so|ral; As|ses|so|rin w; -, -nen; as|ses|so|risch

As|si|bi|la|ti|on lat. [...zion] (Sprachw.: Aussprache eines Verschlußlautes in Verbindung mit einem Zischlaut, z. B. z = ts in „Zahn"; Verwandlung eines Verschlußlautes in einen Zischlaut, z. B. niederd. „Water" = hochd. Wasser"); as|si|bi|lie|ren; As|si|bi|lie|rung

As|siet|te fr. [aßiär°] (veralt. für: flache Schüssel, Teller) w; -, -n

As|si|gna|ten lat. (Papiergeld der ersten fr. Republik) Mehrz.

As|si|mi|la|ti|on lat. [...zion], As|si|mi|lie|rung (Angleichung; Sprachw.: Angleichung eines Mitlautes an einen anderen, z. B. das m in „Lamm" aus mittelhochd. „lamb"); as|si|mi|lie|ren (angleichen); As|si|sen (Schwurgericht in der Schweiz u. in Frankreich) Mehrz.

As|si|si (it. Stadt)

As|si|stent (Gehilfe, Mitarbeiter); ↑ R 268; As|si|sten|tin w; -, -nen; As|si|stenz (Beistand) w; -, -en; As|si|stenz|arzt; as|si|stie|ren (beistehen)

As|so|cia|ted Press engl. [°ßo°'schie'tid-](US-amerik. Nachrichtenbüro; Abk.: AP.) w; - -

As|so|cié fr. [aßoßie] (veralt. für: Teilhaber, Gesellschafter) m; -s, -s

As|so|nanz lat. (Gleichklang nur der Selbstlaute am Versende, z. B. „haben": „klagen") w; -, -en

as|sor|tie|ren fr. (nach Warenarten ordnen und vervollständigen); As|sor|ti|ment (veralt. für: Lager; Auswahl) s; -[e]s, -e

As|so|zia|ti|on lat. [...zion] (Vereinigung; Psych.: Vorstellungsverknüpfung); as|so|zia|tiv (durch Vorstellungsverknüpfung bewirkt); as|so|zi|ie|ren fr. (verknüpfen); sich - (sich [genossenschaftlich] zusammenschließen); assoziierte Staaten; As|so|zi|ie|rung

As|su|an (ägypt. Stadt); As|su|an|stau|damm m; -[e]s; ↑ R 201

As|sump|tio|nist lat. [...zi...] (Angehöriger einer kath. Kongregation); ↑ R 268; As|sump|tio|nist (Mariä Himmelfahrt) w; -, (für: bildliche Darstellung auch Mehrz.:) -en

As|su|ree|li|ni|en [aßüre...] (falsch für: Azureelinien)

As|sy|ri|en [...i°n] (altes Reich in Mesopotamien); As|sy|rer, As|sy|ri|er [...iᵉr]; As|sy|rio|lo|ge (Wissenschaftler auf dem Gebiet der Assyriologie) m; -n, -n (↑ R 268); As|sy|rio|lo|gie (Erforschung der assyrisch-babylon. Kultur u. Sprache; auch für: Keilschriftforschung) w; -; as|sy|risch

a. St. = alten Stils (Zeitrechnung)

Ast m; -[e]s, Äste

Asta (w. Vorn.)

AStA = Allgemeiner Studentenausschuß

Astar|te (altsemit. Liebes- u. Fruchtbarkeitsgöttin)

Asta|sie (Med.: Stehunfähigkeit) w; -, ...ien; Astat, (international fachspr. auch:) Asta|tin (chem. Grundstoff; Zeichen: At) s; -s; asta|tisch (Physik: stets im Gleichgewicht bleibend); -es Nadelpaar

Äst|chen, Äst|lein

asten (ugs. für: sich abmühen); geastet

Aster gr. (Sternblume"; eine Zierpflanze) w; -, -n; aste|risch (sternähnlich); Aste|ris|kus (Druckw.: Sternchen; Zeichen: *) m; -, ...ken; Astern|art; Aste|ro|id (Planetoid) m; -[e]s u. -en, -en (↑ R 268)

Ast|ga|bel

Asthe|nie gr. (Med.: allgemeine Körperschwäche) w; -, ...ien; Asthe|ni|ker (schmaler, schmächtiger Mensch); asthe|nisch; -ste (↑ R 294)

Äs|the|sie gr. (Empfindungsvermögen) w; -; Äs|thet (überfeinerter) Freund des Schönen) m; -en, -en (↑ R 268); Äs|the|tik (Wissenschaft von den Gesetzen der Kunst, bes. vom Schönen) w; -, (selten:) -en; Äs|the|ti|ker (Vertreter od. Lehrer der Ästhetik); äs|the|tisch (auch für: überfeinert); -ste (↑ R 294); äs|the|ti|sie|ren (einseitig) nach den Gesetzen des Schönen urteilen, gestalten); Äs|the|ti|zis|mus (einseitig das Ästhetische betonende Lebenshaltung) m; -

Asth|ma gr. (anfallsweise auftretende Atemnot) s; -s; Asth|ma|ti|ker; asth|ma|tisch; -ste (↑ R 294)

¹Asti (it. Stadt); ²Asti (Wein [von Asti]) m; -[s], -; - spumante (it. Schaumwein)

ästig (selten für: verzweigt, astreich)

astig|ma|tisch gr. (Optik: Punkte strichförmig verzerrend); Astig|ma|tis|mus m; -

ästi|mie|ren (veraltend für: schätzen, würdigen)

Äst|lein, Äst|chen

¹Astra|chan (russ. Stadt); ²Astra|chan (Lammfell eines südruss.

Schafes) *m*; -s, -s; Ạstra|chan|ka|vi|ar (↑ R 201)

astrạl *gr.* (die Gestirne betreffend; Stern...); Astrạl|leib (Okkultismus: feinstofflicher, nach dem Tode fortlebender Leib)

ạst|rein; etwas ist nicht ganz - (ugs. für: ist anrüchig)

Ạstrid (w. Vorn.)

Astro|graph *gr.* (Vorrichtung zur fotograf. Aufnahme von Gestirnen, zum Zeichnen von Sternkarten) *m*; -en, -en (↑ R 268); Astrogra|phie (Sternbeschreibung) *w*; -, ...ien; Astro|la|bi|um (altes astron. Instrument) *s*; -s, ...ien [...*iᵉn*]; Astro|lo|ge (Sterndeuter) *m*; -n, -n (↑ R 268); Astro|lo|gie (Sterndeutung) *w*; -; astro|lo|gisch; Astro|naut (Weltraumfahrer) *m*; -en, -en (↑ R 268); Astro|nau|tik (Wissenschaft von der Raumfahrt, auch: die Raumfahrt selbst) *w*; -; astro|nau|tisch; Astro-nọm (Stern-, Himmelsforscher) *m*; -en, -en (↑ R 268); Astro|no|mie (Stern-, Himmelskunde) *w*; -; astro|nọ|misch; Astro|phy|sik (Lehre von der physikal. Beschaffenheit der Sterne)

Ạstu|ar *lat.* (trichterförmige Flußmündung) *s*; -s, ...rien [...*iᵉn*]

Astu|ri|en [...*iᵉn*] (hist. Provinz in Spanien); Astu|ri|er [...*iᵉr*]; astu-risch

Ạst|werk *s*; -[e]s

Ạsung [zu: äsen]

Asyl *gr.* (Zufluchtsort, Heim) *s*; -s, -e; Asyl|recht *s*; -[e]s

Asym|me|trie *gr.* (Mangel an Ebenmaß; Ungleichmäßigkeit) *w*; -, ...ien; asym|me|trisch; -ste (↑ R 294)

Asym|pto|te *gr.* (Math.: Näherungslinie) *w*; -, -n; asym|pto|tisch (sich wie eine Asymptote verhaltend)

asyn|de|tisch *gr.* (Sprachw.: nicht durch Bindewort verbunden); Asyn|de|ton (Sprachw.: nicht durch ein Bindewort angeschlossener Satz[teil], z. B. „alles rennet, rettet, flüchtet") *s*; -s, ...ta

Aszen|dent *lat.* (Genealogie: Vorfahr; Verwandter in aufsteigender Linie; Astron.: Aufgangspunkt eines Gestirns) *m*; -en, -en (↑ R 268); Aszen|denz (Verwandtschaft in aufsteigender Linie; Aufgang eines Gestirns) *w*; -; aszen|die|ren (von Gestirnen: aufsteigen; veralt. für: befördert werden)

Ạs|ze|se usw. vgl. Askese usw.; Ạs-ze|tik (kath. Kirche: Lehre vom Streben nach christlicher Vollkommenheit) *w*; -

at = technische Atmosphäre

At = chem. Zeichen für: Astat

A. T. = Altes Testament

ata (veralt.) = absolute Atmosphäre

Ata|ir *arab.* (ein Stern) *m*; -s

Ata|man *russ.* (frei gewählter Stammes- u. militär. Führer der Kosaken) *m*; -s, -e

Ata|ra|xie *gr.* (Unerschütterlichkeit, Seelenruhe [in der gr. Philosophie]) *w*; -

Ata|vis|mus *lat.* [...*wiß*...] (plötzl. Wiederauftreten von Eigenschaften der Ahnen) *m*; -, ...men; ata|vi|stisch; -ste (↑ R 294)

Ate (gr. Göttin der Verblendung u. des Unheils)

Ate|brin ⓦ (Heilmittel gegen Malaria) *s*; -s

Ate|lier *fr.* [at*ᵉlie*] ([Künstler]werkstatt; [fotogr.] Aufnahmeraum) *s*; -s, -s; Ate|lier-auf|nah-me, ...fen|ster, ...fest

Atem *m*; -s; - holen; außer - sein; atem|be|rau|bend; Atem|be-schwer|den *Mehrz.*; Atem|ho|len *s*; -s; atem|los; Atem_not, ...pau|se a tempo *it.* (ugs. für: sofort, schnell; Musik: im Anfangstempo)

atem|rau|bend; Atem|zug

Atha|na|sia (w. Vorn.); atha|na-sia|nisch, aber (↑ R 179): Atha-na|sia|nisch; das -e Glaubensbekenntnis

Atha|na|sie *gr.* (Unsterblichkeit) *w*; -

Atha|na|si|us (Kirchenlehrer)

Athe|is|mus *gr.* (Leugnung der Existenz [eines gesellschaftlichen] Gottes, einer von Gott bestimmten Weltordnung) *m*; -; Athe|ist (↑ R 268); athe|istisch

Athen (Hptst. Griechenlands); Athe|nä|um (Tempel der Athene; wissenschaftl. Institut, das sich vor allem mit dem Altertum beschäftigt) *s*; -s, ...äen; Athe|ne (gr. Göttin der Weisheit); Athe|ner (↑ R 199); athe|nisch

Äther *gr.* („Himmelsluft"; feiner Urstoff in der gr. Philosophie; geh. für: Himmel) *m*; -s, (für: Betäubungs-, Lösungsmittel auch *Mehrz.*:) -; äthe|risch (ätherartig; himmlisch; zart); -e Öle, -ste (↑ R 294); äthe|ri|sie|ren (Äther anwenden; mit Äther behandeln)

ather|man *gr.* (für Wärmestrahlen undurchlässig)

Äthio|pi|en *gr.* [...*iᵉn*] (Kaiserreich in Ostafrika); Äthio|pi|er [...*iᵉr*]; äthio|pisch

Ath|let *gr.* („Wettkämpfer") *m*; -en, -en (↑ R 268); Ath|le|tik *w*; -; bes. in: Leichtathletik, Schwerathletik; Ath|le|ti|ker (Mensch von athletischer Konstitution); ath|le|tisch; -ste (↑ R 294)

Ạthos („Heiliger Berg"; auf der SO-Spitze der Chalkidike)

Äthyl *gr.* (Atomgruppe zahlreicher chem. Verbindungen) *s*; -s; Äthyl|al|ko|hol (gewöhnl. Alkohol, Weingeist); Äthy|len (im Leuchtgas enthaltener ungesättigter Kohlenwasserstoff) *s*; -s

Ätio|lo|gie *gr.* (Lehre von den Ursachen, bes. der Krankheiten) *w*; -; ätio|lo|gisch (ursächlich, begründend)

At|lant *gr.* (Bauw.: Gebälkträger in Form einer Männerfigur) *m*; -en, -en (↑ R 268); vgl. ²Atlas; At-lan|tik (Atlantischer Ozean) *m*; -s; At|lan|tik.char|ta [...*kar*...] (1941 abgeschlossene Vereinbarung zwischen Großbritannien u. den USA über die Kriegs- u. Nachkriegspolitik; vgl. ...pakt (NATO), ...wall (im 2. Weltkrieg errichtete dt. Befestigungsanlagen am Atlantik); At|lan|tis (Fabelland); at|lan|tisch; (↑ R 200:) -es Kabel, aber (↑ R 198): der Atlantische Ozean; ¹At|las (gr. Sagengestalt); ²At|las (selten für: Atlant) *m*; - u. ...lasses, ...lasse u. ...lanten; ³At|las (Gebirge in Nordwestafrika) *m*; -; ⁴At|las (geographisches Kartenwerk; Bildtafelwerk) *m*; - u. ...lasses, ...lasse u. ...lanten; ⁵At|las (Med.: erster Halswirbel) *m*; - u. ...lasses ⁶At|las *arab.* (ein Seidengewebe) *m*; - u. -lasses, -lasse; at|las|sen (aus ⁶Atlas)

atm = physikal. Atmosphäre

at|men; ...at|mig (z. B. kurzatmig)

At|mo|sphä|re *gr.* (Lufthülle; Druckmaß [Zeichen für die physikal. A.: atm; für die techn. A.: at]; Stimmung, Umwelt) *w*; -, -n; At|mo|sphä|ren|über|druck (Zeichen: atü; *Mehrz.* ...drücke); at-mo|sphä|ri|li|en [...*iᵉn*] (Bestandteile der Luft) *Mehrz.*; at|mo-sphä|risch

Ạt|mung; at|mungs|ak|tiv

Ạt|na (Vulkan auf Sizilien) *m*; -[s]

Äto|li|en [...*iᵉn*] (altgr. Landschaft; Gebiet im westl. Griechenland); Äto|li|er [...*iᵉr*] (Angehöriger eines altgr. Stammes) *m*; -s, -; äto-lisch

Atoll *drawid.* (ringförmige Koralleninsel) *s*; -s, -e

Atom *gr.* („unteilbar"; kleinster Materieteil eines chem. Grundstoffes) *s*; -s, -e; ato|mar (das Atom, die Kernenergie, die Atomwaffen betreffend; mit Atomwaffen [versehen]); Atom-bom|be (kurz: A-Bombe); Atom-bom|ben|ver|such; Atom_bom-ber, ...ener|gie (*w*; -), ...ge-wicht; Atomiseur [...*sör*] (Zerstäuber) *m*; -s, -e; ato|mi|sie|ren

(in Atome auflösen; völlig zerstören); **Ato|mi|sie|rung**; **Ato|mismus** (Weltanschauung, die alle Vorgänge in der Natur auf Atome und ihre Bewegungen zurückführt) *m*; -; **Ato|mist** (Anhänger des Atomismus); ↑ R 268; **Ato|mistik** (Atomismus) *w*; -; **ato|mistisch**; **Atom.kern**, ...**klub** (ugs. für. Großmächte, die Atomwaffen besitzen; *m*; -s), ...**kraft|werk**, ...**krieg**, ...**macht** (Staat, der im Besitz von Atomwaffen ist), ...**mi|ne**, ...**müll**, ...**phy|sik**, ...**reak|tor**, ...**strom**; **Atom|test|stoppab|kom|men**; **Atom-U-Boot** (↑ R 155); **Atom|wat|te** (meist *Mehrz.*); **Atom|waf|fen|sperr|vertrag** *m*; -[e]s; **Atom..zeit|al|ter** (s; -s), ...**zer|trüm|me|rung** (früher für: Kernreaktion)

ato|nal *gr.* [auch: *atonal*] (Musik: an keine Tonart gebunden); **-e** Musik; **Ato|na|li|tät** *w*; -

Ato|nie *gr.* (Muskelerschlaffung) *w*; -, ...**ien**; **ato|nisch**; **Ato|non** [auch: *a...*] (Sprachw.: unbetontes Wort) *s*; -s, ...**na**

Atos|sa (altpers. Königin)

Atout *fr.* [*atu*] (Trumpf im Kartenspiel) *s*; -s, -s; **à tout prix** [*a tu pri*] (um jeden Preis)

ato|xisch *gr.* [auch: *ato...*] (ungiftig)

Atreus [*atreuß*] (gr. Sagengestalt)

Atri|um *lat.* (hist.: offene [Vor]halle; Architektur: Innenhof) *s*; -s, ...**ien** [...*i*ᵉ*n*]; **Atri|um|haus**

Atro|phie *gr.* („Schwund"; Med.: Schrumpfung von Organen, Geweben, Zellen) *w*; -, ...**ien**, **atrophisch**

Atro|pin *gr.* (Alkaloid der Tollkirsche) *s*; -s

Atro|pos [auch: *at...*] (eine der drei Parzen)

ätsch! (ugs.)

At|ta|ché *fr.* [*atasche*] („Zugeordneter"; Anwärter des diplomatischen Dienstes; Auslandsvertretungen zugeteilter Berater) *m*; -s, -s; **at|ta|chie|ren** (Militär veralt. für: zuteilen); **sich** - (veralt. für: sich anschließen); **At|tacke** [*Trenn.:* ...**tak|ke**] ([Reiter]angriff) *w*; -, -n; **at|tackie|ren** [*Trenn.:* ...**tak|kie**...]

At|ten|tat *fr.* [auch: *a...*] *s*; -[e]s, -e; **At|ten|tä|ter** [auch: *a...*] *m*; -s, -

At|ten|ti|on! *fr.* [*atangßiong*] (Achtung!)

At|ter|see (österr. See) *m*; . -s

At|test *lat.* (ärztl. Bescheinigung; Gutachten; Zeugnis) *s*; -[e]s, -e; **at|te|stie|ren**

Ät|ti *alemann.* (Vater) *m*; -s

At|ti|ka (gr. Halbinsel)

¹**At|ti|la** (Hunnenkönig); vgl. Etzel; ²**At|ti|la** (schnürenbesetzte Husarenjacke) *w*; -, -s

at|tisch (aus Attika; witzig, fein); (↑ R 200:) **-es Salz** (geistreicher Witz)

At|ti|tü|de *fr.* (Haltung; [innere] Einstellung; Ballett: eine [Schluß]figur) *w*; -, -n

At|ti|zis|mus *gr.* (feine Sprechweise der Athener; eine rhet. Bewegung im 2. Jh. v. Chr.) *m*; -, men; **At|ti|zist** (Anhänger des Attizismus); ↑ R 268; **at|ti|zistisch**

Att|nang-Puch|heim (österr. Ort)

Àt|to... *skand.* (ein Trillionstel einer Einheit, z. B. Attofarad = 10⁻¹⁸ Farad; Zeichen: a)

At|trak|ti|on *lat.* [...*zion*]; **at|traktiv**; **At|trak|ti|vi|tät** [...*wi...*] *w*; -

At|trap|pe *fr.* ([täuschend ähnliche] Nachbildung; Schau-, Blindpackung) *w*; -, -n

At|tri|but *lat.* (Sprachw.: Beifügung; auch: Eigenschaft, Merkmal; Beigabe) *s*; -[e]s, -e; **at|tri|butiv** (beifügend); **At|tri|but|satz**

atü (veralt.) = Atmosphärenüberdruck

aty|pisch [auch: *atü...*] (nicht typisch, unregelmäßig)

Ätz|al|ka|li|en (stark ätzende Hydroxyde der Alkalimetalle) *Mehrz.*; **Ätz|druck** (*Mehrz.* ...drucke); **at|zen** (füttern [von Raubvögeln]); **du atzt** (atzest); **ät|zen** (beizen); **du ätzt** (ätzest); **Ätz|flüs|sig|keit**; **Ät|zung** (Fütterung, Nahrung [der jungen Raubvögel]); **Ät|zung** (Beizung; geätzte Druckplatte; Druckerzeugnis einer Ätzplatte)

au!; au Backe!; auweh! (ugs.)

Au = Aurum (chem. Zeichen für: Gold)

Au, **Aue** (landsch. od. dicht.: feuchte Niederung) *w*; -, Auen

AUA = Austrian Airlines (österr. Luftverkehrsgesellschaft)

Au|ber|gi|ne *arab.-fr.* [*obärschin*ᵉ] (Nachtschattengewächs mit gurkenähnlichen Früchten; Eierpflanze) *w*; -, -n

a. u. c. = ab urbe condita

auch; wenn auch; auch wenn (↑ R 62); **Auch|künst|ler**

au|dia|tur et al|te|ra pars *lat.* (röm. Rechtsgrundsatz: auch die Gegenpartei soll angehört werden)

Au|di|enz (feierl. Empfang; Zulassung zu einer Unterredung) *w*;-, -en; **Au|di|max** (stud. Kurzw. für: Auditorium maximum) *s*; -;

Au|di|on (Elektronenröhre in bestimmter Schaltung) *s*; -s, -s u. ...onen; **Au|dio|vi|si|on** (Gebiet der audiovisuellen Technik) *w*; -; **au|dio|vi|su|ell** (zugleich hör- u. sichtbar, Hören u. Sehen ansprechend); -er Unterricht; **Au|di|teur** *fr.* [*auditör*] (früher: Rechtsge-

lehrter bei der dt. Militärgerichten) *m*; -s, -e; **au|di|tiv** *lat.* (Med.: das Hören betreffend; Psych.: vorwiegend mit Gehörsinn begabt); **Au|di|tor** (Beamter der röm. Kurie, Richter im kanonischen Recht; österr. auch: öffentl. Ankläger bei einem Militärgericht; schweiz.: zur prakt. Ausbildung bei einem Gericht zugelassene Person; öffentl. Ankläger beim Militärgericht) *m*; -s, ...**oren**; **Au|di|to|ri|um** (ein Hörsaal [der Hochschule]; Zuhörerschaft) *s*; -s, ...**ien** [...*i*ᵉ*n*]; **Au|di|tori|um ma|xi|mum** (größter Hörsaal einer Hochschule; stud. Kurzw.: Audimax) *s*; --

Aue vgl. Au; **Au|en|land|schaft**; **Au|en|wald**, **Auwald**

Au|er|bach

Au|er|licht [nach dem Erfinder] (ein Gasglühlicht) *s*; -[e]s; **Au|erme|tall** ⓦ *s*; -[e]s; ↑ R 180

Au|er|och|se

Au|er|stedt (Dorf bei Jena)

auf; *Verhältnisw.* mit *Wemf.* u. *Wenf.*: auf dem Tisch liegen, aber: auf den Tisch legen; auf Grund (vgl. Grund); aufs neue (vgl. neu); aufdas, aufs beste (vgl. beste); aufs best vorgesehen; auf seiten (vgl. d.); auf einmal; *Umstandsw.*: auf und ab (vgl. d.), (seltener:) auf und nieder; auf und davon (vgl. d.). *Großschreibung* (↑ R 119): das Auf und Nieder, das Auf und Ab

auf... (in Zus. mit Zeitwörtern, z. B. aufführen, du führst auf, aufgeführt, aufzuführen; zum 2. Mittelw. ↑ R 304)

auf|ad|die|ren

auf|ar|bei|ten; **Auf|ar|bei|tung**

auf|ästen (Baumwipfel kappen; zurückstutzen)

auf|ät|men

auf|bah|ren; **Auf|bah|rung**

auf|bän|ken (landsch.); etwas - (aufschichten); einen Steinblock - (Steinmetzerei: auf zwei Haublöcke legen)

Auf|bau *m*; -[e]s, (für: Gebäude-, Schiffsteil und von *Mehrz.*:) -ten; **Auf|bau|ar|beit**, ...**dar|le|hen**; **auf|bau|en**; eine Theorie auf einer Annahme -; jmdn. - (an jmds. Aufstieg arbeiten)

auf|bau|men (Jägerspr.: sich auf einem Baum niederlassen [vom Federwild]; auf einen Baum klettern [von Luchs, Marder u. a.])

auf|bäu|men, sich

auf|bau|schen (übertreiben)

Auf|bau.schu|le, ...**spie|ler** (Sportspr.), ...**wil|le**

Auf|bau|ten vgl. Aufbau

auf|be|geh|ren

auf|be|hal|ten; den Hut -

auf|be|kom|men; Aufgaben -
auf|be|rei|ten; Auf|be|rei|tung
auf|bes|sern; Auf|bes|se|rung, Auf-
beß|rung
auf|be|wah|ren; Auf|be|wah|rung;
Auf|be|wah|rungs|ort m; -[e]s, -e
auf|bie|ten; Auf|bie|tung w; -; unter
- aller Kräfte
auf|bin|den; jmdm. etwas - (ugs.
für: weismachen)
auf|blä|hen; Auf|blä|hung
auf|bla|sen; vgl. aufgeblasen
auf|blät|tern
auf|blei|ben
auf|blen|den
auf|blicken[1]
auf|blit|zen
auf|blü|hen
auf|bocken[1]
auf|brau|chen
auf|brau|sen; auf|brau|send
auf|bre|chen (Jägerspr. auch: aus-
weiden)
auf|bren|nen
auf|brin|gen (auch für: kapern);
vgl. aufgebracht; Auf|brin|gung
w; -
Auf|bruch (Jägerspr. auch: Ge-
scheide; Bergmannsspr.: senk-
rechter Blindschacht) m; -[e]s,
...brüche; Auf|bruchs|stim|mung
w; -
auf|brü|hen
auf|brül|len
auf|brum|men (ugs. für: auferle-
gen); eine Strafe -
auf|bü|geln
auf|bür|den; Auf|bür|dung
auf|däm|mern; jmdm. dämmert et-
was auf
auf|damp|fen
auf daß (veraltend für: damit)
auf|decken[1]; Auf|deckung[1]
auf|don|nern, sich (ugs. für: sich
auffällig kleiden u. schminken);
ich donnere mich auf (↑ R 327)
auf|drän|geln (ugs.); ich drän-
g[e]le mich auf; auf|drän|gen;
jmdm. etwas -; sich jmdm. -
auf|dre|hen (südd., österr. auch
für: einschalten; zu schimpfen
anfangen, wütend werden)
auf|dring|lich; Auf|dring|lich|keit
auf|drö|seln landsch. ([Gewebe
usw. mühsam] aufdrehen)
Auf|druck m; -[e]s, -e; auf|drucken[1]
auf|drücken[1]
auf|ein|an|der; Schreibung in Ver-
bindung mit Zeitwörtern (↑ R
139): aufeinander (auf sich ge-
genseitig) achten, warten, auf-
einander auffahren usw., aber:
aufeinanderfahren; vgl. aneinan-
der; aufeinanderliegen, aber:
aufeinander liegen (nicht stehen);
auf|ein|an|der|bei|ßen; die Zähne
-; Auf|ein|an|der|fol|ge w; -; auf-

ein|an|der.fol|gen, ...le|gen,
...pral|len, ...pres|sen, ...sto|ßen,
...tref|fen
auf|en|tern; vgl. entern
Auf|ent|halt m; -[e]s, -e; Auf|ent-
hal|ter schweiz. (jmd., der sich
vorübergehend in einer anderen
Gemeinde aufhält); Auf|ent-
halts.ge|neh|mi|gung, ...ort (m;
-[e]s, -e)
auf|er|le|gen; ich erlege ihm etwas
auf, (seltener:) ich auferlege; auf-
erlegt; aufzuerlegen
auf|er|ste|hen; üblich sind nur un-
getrennte Formen, z. B. wenn er
auferstünde, er ist auferstanden;
Auf|er|ste|hung w; -
auf|er|wecken[1]; vgl. auferstehen;
Auf|er|weckung[1]
auf|es|sen
auf|fä|chern; Auf|fä|che|rung
auf|fä|deln; Auf|fä|de|lung, Auf-
fäd|lung
auf|fah|ren; Auf|fahrt (südd. u.
schweiz. auch für: Himmelfahrt);
Auf|fahrts|stra|ße; Auf|fahr|un-
fall
auf|fal|len; auf fällt, daß ... (↑ R
144); auf|fal|lend; -ste; auf|fäl|lig;
Auf|fäl|lig|keit
auf|fan|gen; Auf|fang.la*ger,
...stel|le, ...vor|rich|tung
auf|fas|sen; Auf|fas|sung; Auf|fas-
sungs|ga|be
auf|fin|den; Auf|fin|dung
auf|flackern[1]
auf|flam|men
auf|flat|tern
auf|flie|gen
auf|for|dern; Auf|for|de|rung; Auf-
for|de|rungs|satz
auf|for|sten (Wald [wieder] an-
pflanzen); Auf|for|stung
auf|fres|sen
auf|fri|schen; der Wind frischt auf;
Auf|fri|schung
auf|füh|r|bar; Auf|füh|r|bar|keit w;
-; auf|füh|ren; Auf|füh|rung; Auf-
füh|rungs|recht
auf|fül|len; Auf|fül|lung
Auf|ga|be
auf|ga|beln (ugs. auch für: zufällig
treffen)
Auf|ga|ben.be|reich m, ...samm-
lung, ...stel|lung; Auf|ga|be|stem-
pel
auf|ga|gen [...gäg*n] (mit Gags ver-
sehen, ausstatten)
Auf|ga|lopp (Sportspr.: Galoppie-
ren an den Schiedsrichtern vorbei
zum Start; Auftakt, erste Runde,
Beginn)
Auf|gang m; Auf|gangs|punkt
(Astron.)
auf|ge|ben
auf|ge|bläht
auf|ge|bla|sen; ein -er (eingebilde-

ter) Kerl; Auf|ge|bla|sen|heit w; -
Auf|ge|bot; Auf|ge|bots.schein,
...ver|fah|ren
auf|ge|bracht (erregt, erzürnt)
auf|ge|don|nert vgl. aufdonnern
auf|ge|dreht (ugs. für: angeregt)
auf|ge|dun|sen
auf|ge|hen; es geht mir auf (es wird
mir klar)
auf|gei|en (Seemannsspr.: Segel
mit Geitauen zusammenholen)
auf|gei|len; sich -
auf|ge|klärt; Auf|ge|klärt|heit w; -
auf|ge|knöpft (ugs. für: mitteil-
sam)
auf|ge|kratzt; in -er (ugs. für: fro-
her) Stimmung sein
Auf|geld (für: Agio)
auf|ge|legt (auch für: zu etwas be-
reit, gelaunt; österr. ugs. auch:
klar, offensichtlich); zum Spazie-
rengehen - sein; (österr.:) ein -er
Blödsinn
auf|ge|paßt!
auf|ge|rauht
auf|ge|räumt (auch für: heiter); in
-er Stimmung sein; Auf|ge|räumt-
heit w; -
auf|ge|regt; Auf|ge|regt|heit w; -
Auf|ge|sang (Verslehre: den An-
fang bildender Strophenteil)
auf|ge|schlos|sen; - (mitteilsam)
sein; Auf|ge|schlos|sen|heit w; -
auf|ge|schmis|sen; - (ugs. für: hilf-
los) sein
auf|ge|schos|sen; hoch -
auf|ge|schürzt
auf|ge|schwemmt
auf|ge|ta|kelt (ugs. für: auffällig,
geschmacklos gekleidet)
auf|ge|wärmt
auf|ge|weckt; ein -er (kluger) Jun-
ge; Auf|ge|weckt|heit w; -
auf|ge|wor|fen; eine -e Nase
auf|gie|ßen
auf|glei|sen (auf Gleise setzen); du
gleist (gleisest) auf; er gleis|te auf;
Auf|glei|sung
auf|glie|dern; Auf|glie|de|rung
auf|glim|men
auf|glü|hen
auf|grei|fen
auf Grund, (häufig auch schon:)
auf|grund (vgl. Grund)
Auf|guß; Auf|guß|tier|chen (für:
Infusorium)
auf|ha|ben (ugs.); ..., daß er einen
Hut aufhat; er wird einen Hut
-; für die Schule viel - (als Auf-
gabe)
auf|hacken [Trenn.: ...hak|ken]
(den Boden)
auf|ha|ken (einen Hakenverschluß
lösen)
auf|hal|sen (ugs. für: aufbürden)
auf|hal|ten; Auf|hal|tung
auf|hän|gen; sich -; vgl. [2]hängen;
Auf|hän|ger; Auf|hän|ge|vor|rich-
tung

auf|hau|en (österr. ugs. auch für: prassen, schlemmen)

auf|häu|fen

auf|he|ben; Auf|he|ben s; -s; [ein] großes -, viel -[s] von dem Buch machen; Auf|he|bung w; -

auf|hei|tern; ich heitere auf (↑ R 327); Auf|hei|te|rung

auf|hei|zen

auf|hel|fen

auf|hel|len; Auf|hel|lung

auf|het|zen; Auf|het|zung

auf|heu|len

auf|ho|len, Auf|hol|kon|junk|tur

auf|hor|chen; die Nachricht ließ - auf|hö|ren

auf|hucken [Trenn.: ...huk|ken] (ugs.: auf den Rücken nehmen)

auf|jauch|zen

Auf|kauf; auf|kau|fen; Auf|käu|fer

auf|keh|ren

auf|kei|men

auf|klap|pen

auf|kla|ren (Seemannsspr.: aufräumen; klar werden, sich aufklären [vom Wetter]); es klart auf; auf|klä|ren (erkennen lassen; belehren); der Himmel klärt sich auf (wird klar); Auf|klä|rer; auf|klä|re|risch; Auf|klä|rung; Auf|klä|rungs_ar|beit, ...flug|zeug

auf|klat|schen

auf|klau|ben südd., österr. (aufheben)

auf|kle|ben; Auf|kle|ber

auf|klin|gen

auf|klin|ken

auf|knacken [Trenn.: ...knak|ken]

auf|knöp|fen; vgl. aufgeknöpft

auf|kno|ten

auf|knüp|fen; Auf|knüp|fung

auf|ko|chen (südd., österr. auch: für einen bes. Anlaß reichlich kochen)

auf|kom|men; (↑ R 120:) der Arzt zweifelt an seinem Aufkommen

auf|krat|zen; vgl. aufgekratzt

auf|krei|schen

auf|krem|peln

auf|kreu|zen

auf|krie|gen (ugs.)

auf|kün|den, (älter für:) auf|kün|di|gen; Auf|kün|di|gung

Aufl. = Auflage

auf|la|chen

auf|la|den; vgl. ¹laden; Auf.la|de_platz, ...la|der

Auf|la|ge (Abk.: Aufl.); Auf|la|ge[n]|hö|he

Auf|la|ger (Bauw.)

auf|lan|dig (Seemannsspr.: auf das Land zu wehend)

auf|las|sen (aufsteigen lassen; Bergmannsspr.: Grube stillegen; Rechtsspr.: Grundeigentum übertragen; österr. allgemein: stillegen, schließen, aufgeben); auf|läs|sig (Bergmannsspr.: außer Betrieb); Auf|las|sung

auf|la|sten (für: aufbürden)

auf|lau|ern; jmdm. -

Auf|lauf (Ansammlung; Speise); Auf|lauf|brem|se; auf|lau|fen (anwachsen [von Schulden]; Seemannsspr.: auf Grund geraten); Auf|lauf|form

auf|le|ben

auf|lecken [Trenn.: ...lek|ken]

Auf|le|ge|ma|trat|ze; auf|le|gen; vgl. aufgelegt; Auf.le|ger, ...le|gung

auf|leh|nen, sich; Auf|leh|nung

auf|le|sen

auf|leuch|ten

auf|lich|ten; Auf|lich|tung

Auf|lie|te|rer; auf|lie|fern, Auf|lie|fe|rung

auf|lie|gen (ausliegen; auch: sich wundliegen); Auf|lie|ge|zeit (Ruhezeit der Schiffe)

auf|li|sten; Auf|li|stung

auf|lockern [Trenn.: ...lok|kern]; Auf|locke|rung [Trenn.: ...lok-ke...]

auf|lo|dern

auf|lö|sen; Auf|lö|sung; Auf|lö-sungs|pro|zeß

auf|lüp|fisch schweiz. (rebellisch, aufrührerisch)

auf|lu|ven [...luf°n] (Seemannsspr.: Winkel zwischen Kurs und Windrichtung verkleinern)

auf'm (ugs. für: auf dem); ↑ R 240

auf|ma|chen; auf- und zumachen; Auf|ma|cher (wirkungsvoller Titel, eingängige Schlagzeile für einen Zeitungs- od. Illustriertenartikel); Auf|ma|chung

Auf|marsch m; Auf|marsch|ge|län-de; auf|mar|schie|ren

Auf|maß (Bauw.)

auf|mei|ßeln

auf|mer|ken; auf|merk|sam; jmdn. auf etwas - machen; Auf|merk-sam|keit

auf|mes|sen (Bauw.)

auf|mö|beln (ugs. für: aufmuntern; etw. erneuern); ich möb[e]le auf (↑ R 327)

auf|mon|tie|ren

auf|mucken [Trenn.: ...muk|ken] (ugs.)

auf|mun|tern; ich muntere auf (↑ R 327); Auf|mun|te|rung

auf|müp|fig landsch. (aufsässig, trotzig); Auf|müp|fig|keit

auf|mut|zen landsch. (Vorwürfe machen); jmdm. seine Fehler -

auf'n (ugs. für: auf den); ↑ R 240

auf|nä|hen

Auf|nah|me w; -, -n; auf|nah|me|fä-hig (österr.: aufnahmsfähig); Auf|nah|me.fä|hig|keit, ...ge-bühr, ...lei|ter m, ...prü|fung (österr.: Aufnahmsprüfung), ...tech|nik; auf|neh|men; Auf|neh-mer landsch. (Scheuerlappen)

äuf|nen schweiz. (Güter, Bestän-de, Fonds vermehren); Äuf|nung w; -

auf|ne|steln

auf|nö|ti|gen

auf|ok|troy|ie|ren [...oktroajir°n] (aufdrängen, aufzwingen)

auf|op|fern, sich -; Auf|op|fe|rung w; -, (selten:) -en; auf|op|fe|rungs-voll

auf|packen [Trenn.: ...pak|ken]

auf|päp|peln

auf|pas|sen; Auf|pas|ser

auf|peit|schen

auf|pel|zen österr. (aufbürden)

auf|pflan|zen

auf|pfrop|fen

auf|nicken [Trenn.: ...pik|ken] (österr. ugs. auch: aufkleben)

auf|plat|zen

auf|plu|stern; sich -

auf|po|lie|ren

auf|prä|gen

Auf|prall m; -[e]s, (selten:) -e; auf|pral|len

Auf|preis (Mehrpreis); vgl. ²Preis

auf|pro|be|ren

auf|pul|vern

auf|pum|pen

auf|put|schen

auf|put|zen; sich -

auf|quel|len; vgl. ¹quellen

auf|raf|fen; sich -

auf|ra|gen

auf|rap|peln, sich (ugs. für: sich aufraffen)

auf|räu|feln landsch. (Gestricktes wieder auflösen); ich räuf[e]le auf (↑ R 327)

auf|rau|hen

auf|räu|men; vgl. aufgeräumt; Auf..räu|mer, ...räu|mung; Auf-räu|mungs.ar|bei|ten Mehrz.

auf|rech|nen; Auf|rech|nung

auf|recht; - (gerade, in aufrechter Haltung) halten, sitzen, stehen, stellen; er kann sich nicht - halten; aber: aufrecht|er|hal|ten (weiterbestehen lassen; ↑ R 139); ich erhalte aufrecht, habe -; aufrecht-zuerhalten; vgl. halten; Auf-recht|er|hal|tung w; -

auf|recken [Trenn.: ...rek|ken]

auf|re|gen; auf|re|gend; -ste; Auf-re|gung

auf|rei|ben; auf|rei|bend; -ste

auf|rei|hen; sich -

auf|rei|ßen

auf|rei|zen; auf|rei|zend; -ste; Auf-rei|zung

auf|rib|beln landsch. (svw. aufräufeln)

auf|rich|te schweiz. (Richtfest) w; -, -n; auf|rich|ten; auf|rich|tig; Auf|rich|tig|keit w; -; Auf|rich-tung w; -

Auf|riß (Bauzeichnung, Standriß)

auf|rol|len; Auf|rol|lung w; -

auf|rücken [Trenn.: ...rük|ken]

Auf|ruf; auf|ru|fen

Auf|ruhr m; -[e]s, (selten:) -e; **auf|-
rüh|ren; Auf|rüh|rer; auf|rüh|re-
risch;** -ste (↑ R 294)
auf|run|den (Zahlen nach oben
runden); **Auf|run|dung**
auf|rü|sten; Auf|rü|stung
**auf|rüt|teln; Auf|rüt|te|lung, Auf-
rütt|lung**
aufs; ↑ R 240 (auf das); vgl. auf
auf|sa|gen; Auf|sa|gung (geh. für:
Kündigung)
auf|sam|meln
auf|säs|sig; Auf|säs|sig|keit
Auf|satz; Auf|satz|the|ma
auf|sau|gen
auf|schär|fen (Jägerspr.: [Balg]
aufschneiden)
auf|schau|en
auf|schäu|men
auf|schei|nen österr. (erscheinen,
ersichtlich sein, vorkommen)
auf|scheu|chen
auf|scheu|ern; sich -
auf|schich|ten; Auf|schich|tung
auf|schie|ben; Auf|schieb|ling
(kleiner Aufsatzbalken am
Dachstuhl); **Auf|schie|bung**
auf|schie|ßen
**Auf|schlag; auf|schla|gen; Auf-
schlag|zün|der**
Auf|schläm|mung (Ablagerung
von Schlamm)
auf|schlie|ßen; vgl. aufgeschlos-
sen; **Auf|schlie|ßung**
auf|schlit|zen
**Auf|schluß; auf|schlüs|seln; Auf-
schlüs|se|lung, Auf|schlüß|lung;
auf|schluß|reich**
auf|schmei|ßen österr. ugs. (bloß-
stellen)
auf|schnap|pen
**auf|schnei|den; Auf|schnei|der;
Auf|schnei|de|rei; auf|schnei|de-
risch;** -ste (↑ R 294); **Auf|schnitt;**
kalter -
auf|schnü|ren
auf|schrau|ben
¹**auf|schrecken** [Trenn.: ...schrek-
ken]; sie schrak od. schreckte auf;
sie war aufgeschreckt; vgl.
¹schrecken; ²**auf|schrecken**
[Trenn.: ...schrek|ken]; ich
schreckte ihn auf; sie hatte ihn
aufgeschreckt; vgl. ²schrecken
Auf|schrei; auf|schrei|en
auf|schrei|ben; Auf|schrift
Auf|schub
auf|schür|zen; den Rock -
auf|schüt|teln; das Kopfkissen -
auf|schüt|ten; Auf|schüt|tung
auf|schwat|zen, (landsch.:) **auf-
schwät|zen**
auf|schwei|ßen
¹**auf|schwel|len;** der Leib schwoll
auf, ist aufgeschwollen; vgl.
¹schwellen; ²**auf|schwel|len;** der
Exkurs schwellte das Buch auf,
hat das Buch aufgeschwellt; vgl.
²aufschwellen; **Auf|schwel|lung**

auf|schwem|men
auf|schwin|gen, sich; **Auf|schwung**
auf|se|hen; Auf|se|hen s; -s; **auf|se-
hen|er|re|gend,** aber (↑ R 142):
großes Aufsehen erregend; **Auf|se-
se|her; Auf|se|he|rin** w; -, -nen
auf|sein (ugs. für: geöffnet sein;
außer Bett sein); der Kranke ist
aufgewesen, aber: ..., daß der
Kranke auf ist, war
auf sei|ten (↑ R 141); mit Wesf.:
- - der Regierung
auf|set|zen; Auf|set|zer (Sportspr.)
auf|seuf|zen
Auf|sicht w; -, -en; **auf|sicht|füh-
rend,** aber (↑ R 142): eine strenge
Aufsicht führend; **Auf|sicht|füh-
ren|de** m u. w; -n, -n (↑ R 287ff.);
Auf|sichts_be|am|te, ...be|hör|de;
auf|sicht[s]|los; Auf|sichts|rat
(Mehrz. ...räte); **Auf|sichts-
rats_sit|zung,** ...ver|gü|tung,
...vor|sit|zen|de
auf|sit|zen; jmdn. - lassen (jmdn.
im Stich lassen); jmdm. - (auf
jmdn. hereinfallen); **Auf|sit|zer**
österr. (Reinfall)
auf|spal|ten; Auf|spal|tung
auf|span|nen
auf|spa|ren; Auf|spa|rung
auf|spei|chern; Auf|spei|che|rung
auf|sper|ren
auf|spie|len; sich -
auf|spie|ßen
auf|split|tern; Auf|split|te|rung
auf|spray|en [...ßpre¹-ⁿn]
auf|spren|gen; eine Tür - (mit Ge-
walt öffnen)
auf|sprie|ßen
auf|sprin|gen
auf|sprit|zen
auf|sprü|hen
Auf|sprung
auf|spu|len; ein Tonband -
auf|spü|len; Sand -
auf|spü|ren; Auf|spü|rung
**auf|sta|cheln; Auf|sta|che|lung,
Auf|stach|lung**
auf|stamp|fen
Auf|stand; auf|stän|dern (Technik:
auf Ständern ruhen lassen); ich
ständere auf (↑ R 327); **Auf|stän-
de|rung; auf|stän|disch; auf|stän-
di|sche** m u. w; -n, -n (↑ R 287ff.);
Auf|stands|ver|such
**auf|sta|peln; Auf|sta|pe|lung, Auf-
stap|lung**
Auf|stau (aufgestautes Wasser)
auf|stäu|ben
auf|stau|en
auf|ste|chen
auf|stecken [Trenn.: ...stek|ken];
vgl. ²stecken
auf|ste|hen
auf|stei|gen (österr. auch: in die
nächste Klasse kommen, versetzt
werden); aufsteigendes Grund-
wasser; **Auf|stei|ger** (Sportspr.)
auf|stel|len; Auf|stel|lung

auf|stem|men (mit dem Stemmei-
sen öffnen); sich -
Auf|stieg m; -[e]s, -e; **Auf|stiegs-
mög|lich|keit,** ...spiel (Sportspr.)
auf|stö|bern
auf|stocken [Trenn.: ...stok|ken]
([um ein Stockwerk] erhöhen);
Auf|stockung [Trenn.: ...stok-
kung]
auf|stöh|nen
auf|stö|ren
auf|sto|ßen; mir stößt etwas auf
auf|stre|ben; auf|stre|bend; -ste
auf|strei|chen; Auf|strich
Auf|strom (Technik: aufsteigen-
der Luftstrom) m; -[e]s
auf|stu|fen (höher einstufen); **Auf-
stu|fung**
auf|stül|pen
auf|stüt|zen
auf|su|chen
auf|ta|keln (Seemannsspr.: mit
Takelwerk ausrüsten); sich - (ugs.
für: sich auffällig, geschmacklos
kleiden und schminken); vgl. auf-
getakelt; **Auf|ta|ke|lung, Auf|tak-
lung**
Auf|takt m; -[e]s, -e
auf|tan|ken; ein Auto -; das Flug-
zeug tankt auf
auf|tau|chen
auf|tau|en
auf|tei|len; Auf|tei|lung
auf|ti|schen ([Speisen] auftragen;
meist übertr. ugs. für: vorbrin-
gen)
auf|top|pen (Seemannsspr.: die
Rahen in senkrechter Richtung
bewegen)
Auf|trag m; -[e]s, ...träge; im [-e]
(Abk.: i. A. od. I. A.; vgl. d.);
**auf|tra|gen; Auf|trag|ge|ber; Auf-
trags_be|stand,** ...be|stä|ti|gung;
**auf|trags|ge|mäß; Auf|trags_la-
ge,** ...pol|ster (Wirtsch.: Vorrat
an Aufträgen), ...rück|gang; **Auf-
trag[s]|wal|ze** (Druckw.)
auf|tref|fen
auf|trei|ben
auf|tren|nen
auf|tre|ten; Auf|tre|ten s; -s
Auf|trieb; Auf|triebs|kraft
Auf|tritt; Auf|tritts|ver|bot
auf|trump|fen
auf|tun; sich -
auf|tür|men; sich -
auf und ab; - - - gehen (ohne be-
stimmtes Ziel), aber (in Zus.; ↑ R
145): auf- und absteigen (aufstei-
gen und absteigen); **Auf und Ab**
s; - - -; **Auf|und|ab|ge|hen** s; -s;
ein Platz zum -, aber (↑ R 145
u. R 120): das Auf- und Abstei-
gen (Aufsteigen und Absteigen)
auf und da|von; - - - gehen (ugs.);
sich - - - machen (ugs.)
auf|wa|chen
auf|wach|sen
auf|wal|len; Auf|wal|lung

auf|wäl|ti|gen (Bergmannsspr.: zusammengebrochene Grubenbaue wiederherrichten)

Auf|wand m; -[e]s; auf|wand|reich; **Auf|wands|ent|schä|di|gung**; auf|wär|men; **Auf|wär|mung**

Auf|war|te|frau; auf|war|ten; **Aufwär|ter**; **Auf|wär|te|rin** w; -, -nen auf|wärts; auf- und abwärts. *Schreibung in Verbindung mit Zeitwörtern;* ↑R 139 (vgl. abwärts): aufwärts (nach oben) gehen usw., aber: aufwärtsgehen (besser werden); **Auf|wärts|entwick|lung**; **Auf|wärts|ha|ken**

Auf|war|tung

Auf|wasch (Geschirrspülen; schmutziges Geschirr) m; -[e]s; auf|wa|schen; **Auf|wasch.tisch**, ...was|ser (*Mehrz.* ...wässer)

auf|wecken [*Trenn.:* ...wek|ken]; vgl. aufgeweckt

auf|wei|chen; vgl. [1]weichen; **Aufwei|chung**

Auf|weis m; -es, -e; auf|wei|sen

auf|wen|den; ich wandte oder wendete viel Zeit auf, habe aufgewandt od. aufgewendet; aufgewandte od. aufgewendete Zeit; auf|wen|dig (luxuriös); **Auf|wendung**

auf|wer|ten; sich zum Richter -

auf|wer|ten; **Auf|wer|tung**

auf|wickeln [*Trenn.:* ...wik|keln]; **Auf|wicke|lung** [*Trenn.:* ...wikke...], **Auf|wick|lung**

Auf|wie|ge|lei; auf|wie|geln; **Aufwie|ge|lung**, **Auf|wieg|lung**

auf|wie|gen

Auf|wieg|ler; auf|wieg|le|risch; -ste (↑R 294)

Auf|wind (Segelflugsport: aufsteigender Luftstrom)

auf|wir|beln

auf|wi|schen; **Auf|wisch|lap|pen**

auf|wöl|ben

auf|wöl|ken

Auf|wuchs

auf|wüh|len

Auf|wurf

auf|zah|len südd., österr. (dazuzahlen); **Auf|zah|lung** (Aufpreis)

auf|zäh|len; **Auf|zäh|lung**

auf|zäu|men; das Pferd am od. beim Schwanz - (ugs. für: etwas verkehrt beginnen)

auf|zeh|ren

auf|zeich|nen; **Auf|zeich|nung**

auf|zei|gen (dartun)

auf Zeit (Abk.: a. Z.)

auf|zie|hen; **Auf|zucht;** auf|züchten

auf|zucken [*Trenn.:* ...zuk|ken]

Auf|zug; **Auf|zug|füh|rer;** **Aufzug[s]|schacht**

auf|zün|geln

auf|zwin|gen

Aug. = August (Monat)

auf|ap|fel; **Au|ge** s; -s, -n; - um

-; **Äu|gel|chen,** **Äug|lein;** **äu|geln** (veralt. für: [verstohlen] blicken; auch für: okulieren); ich ...[e]le (↑R 327); **äu|gen** ([angespannt] blicken); **Au|gen.arzt,** ...aufschlag, ...bank (*Mehrz.* ...banken), ...blick[1]; au|gen|blick|lich[1]; au|gen|blicks[1] (veralt.); **Au|genblicks.idee,** ...sa|che; **Au|gen,braue,** ...deckel [*Trenn.:* ...dekkel], ...dia|gno|se; **Au|gen|die|nerei** (veralt.); au|gen|fäl|lig; **Augen.far|be,** ...glas (veraltend; vgl. [1]Glas), ...heil|kun|de, ...kli|nik, ...licht (s; -[e]s), ...lid, ...maß s; ...merk (s; -[e]s), ...op|ti|ker, ...pul|ver (ugs. für: sehr kleine, die Augen anstrengende Schrift; s; -s), ...rin|ge (Schatten unter den Augen; *Mehrz.*), ...schein (m; -[e]s); au|gen|schein|lich [auch: ...schain...]; **Au|gen.trost** (eine Heilpflanze), ...wei|de (w; -), ...zeu|ge; **Au|gen|zeu|gen|bericht;** **Au|gen|zwin|kern** s; -s

Au|gi|as (Gestalt der gr. Sage); **Augi|as|stall** (bildl.: verrottete Zustände)

...äu|glg (z. B. braunäugig)

Au|git *gr.* (ein Mineral) m; -s, -e

Äug|lein, Äu|gel|chen

Aug|ment *lat.* (Sprachw.: Vorsilbe des Zeitwortstammes zur Bezeichnung der Vergangenheit, bes. im Sanskrit u. im Griechischen) s; -s, -e; **Aug|men|ta|ti|on** [...*zion*] (Musik: Vergrößerung der Notenwerte)

Augs|burg (Stadt am Lech); **Augsbur|ger** (↑R 199); - Bekenntnis (Abk. [österr.]: A. B.); **augs|burgisch,** aber (↑R 224): die Augsburgische Konfession

Aug.sproß od. ...spros|se (unterste Sprosse am Hirschgeweih)

Au|gur *lat.* (altröm. Priester u. Vogelschauer; Wahrsager) m; -s u. ...uren, ...uren (meist *Mehrz.*; ↑R 268); **Au|gu|ren|lä|cheln** (wissendes Lächeln der Eingeweihten) s; -s

[1]**Au|gust** *lat.* (achter Monat im Jahr, Ernting, Erntemonat; Abk.: Aug.) m; -[e]s u. - (↑R 319), -e; [2]**Au|gust** (m. Vorn.); der dumme - (Clown); **Au|gu|sta,** **Au|guste** (w. Vorn.); **Au|gust|abend;** **Au|gu|sta|na** (Augsburgische Konfession) w; -; au|gu|ste|isch; ein -es (der Kunst und Literatur günstiges) Zeitalter, aber (↑R 179:) **Au|gu|ste|isch;** das -e Zeitalter (das Zeitalter des Kaisers Augustus); [1]**Au|gu|stin** (m. Vorn.); [2]**Au|gu|stin** vgl. Augustinus; **Augu|sti|ne** (w. Vorn.); **Au|gu|sti|ner** (Angehöriger eines kath. Or

dens) m; -s, -; **Au|gu|sti|nus,** Augu|stin (Heiliger, Kirchenlehrer); **Au|gu|stus** (Beiname des röm. Kaisers Oktavian)

Auk|ti|on *lat.* [...*zion*] (Versteigerung); **Auk|tio|na|tor** (Versteigerer) m; -s, ...oren; auk|tio|nie|ren

Aula *lat.* (Vorhof in besseren gr. u. röm. Häusern; Fest-, Versammlungssaal in [Hoch]schulen) w; -, ...len u. -s

Au|le mitteld. (derb für: Auswurf)

au na|tu|rel *fr.* [o natürä̱l] (Gastr.: ohne künstlichen Zusatz [bei Speisen, Getränken])

au pair *fr.* [o pä̱r] (Leistung gegen Leistung, ohne Bezahlung); **Aupair-Mäd|chen;** **Au-pair-Stel|le** (↑R 155)

au por|teur *fr.* [o portö̱r] (auf den Inhaber lautend [von Wertpapieren])

Au|ra *lat.* („Hauch"; Med.: Unbehagen vor epileptischen Anfällen) w; -

Au|ra|min *nlat.* (gelber Farbstoff) s; -s

Au|rar vgl. Eyrir

Au|re|lia, **Au|re|lie** [...*i^e*] (w, Vorn.); **Au|re|li|an** (röm. Kaiser)

Au|re|li|us (altröm. Geschlechtername)

Au|reo|le *lat.* (Heiligenschein; Hof [um Sonne und Mond]) w; -, -n

Au|reo|my|cin ⓦ *lat.*; *gr.* [...*zin*] (antibiotisches Heilmittel) s; -s

Au|ri|gna|ci|en *fr.* [*orinja̱ßiä̱ng*] (Stufe der jüngeren Altsteinzeit) s; -; **Au|ri|gnac|mensch** [*orinja̱k*...] (Mensch des Aurignacien)

Au|ri|kel *lat.* (eine Zierpflanze) w; -, -n; au|ri|ku|lar (Med.: die Ohren betreffend)

Au|ri|pig|ment *lat.* (ein Mineral, Rauschgelb) s; -[e]s

[1]**Au|ro|ra** (röm. Göttin der Morgenröte); [2]**Au|ro|ra** (ein Schmetterling; Lichterscheinung in der oberen Atmosphäre) w; -, -s; **Au|ro|ra|fal|ter**

Au|rum *lat.* (lat. Bez. für: Gold; Zeichen: Au) s; -[s]

aus; *Verhältnisw.* mit *Wemf.:* - dem Hause; - aller Herren Länder[n]; *Umstandsw.:* aus und ein gehen (verkehren), aber (in Zus.; ↑R 145): aus- und eingehende (ausgehende und eingehende) Waren; weder aus noch ein wissen; **Aus** (Sportspr.: Raum außerhalb des Spielfeldes) s; -

aus... (in Zus. mit Zeitwörtern, z. B. ausbeuten, du beutest aus, ausgebeutet, auszubeuten; zum 2. Mittelw. ↑R 304)

aus|agie|ren (Psych.)

aus|apern (aper werden)

aus|ar|bei|ten; sich -; **Aus|ar|beitung**

aus|ar|ten; Aus|ar|tung
aus|at|men; Aus|at|mung
aus|ba|den; eine Sache - müssen
(ugs.)
aus|bag|gern
aus|ba|ken (mit Baken versehen)
aus|ba|lan|cie|ren; Aus|ba|lan|cie-
rung
aus|bal|do|wern dt.; jidd. (ugs. für:
auskundschaften)
Aus|ball (Sportspr.)
Aus|bau m; -[e]s, (für: Gebäude-
teil, abseits gelegenes Anwesen
auch Mehrz.:) ...bauten
aus|bau|chen; Aus|bau|chung
aus|bau|en; aus|bau|fä|hig; Aus-
bau|woh|nung
aus|be|din|gen; sich etwas -
aus|bei|nen landsch. (Knochen aus
dem Fleisch lösen)
aus|bei|ßen
Aus|bes|se|rin (Flickerin) w; -,
-nen; aus|bes|sern; Aus|bes|se-
rung, (selten:) Aus|beß|rung; aus-
bes|se|rungs|be|dürf|tig
aus|beu|len
Aus|beu|te w; -, -n
aus|beu|teln österr. (ausschütteln)
aus|beu|ten; Aus|beu|ter; Aus|beu-
te|rei; aus|beu|te|risch; -ste (↑ R
294); Aus|beu|ter|klas|se; Aus-
beu|tung
aus|be|zah|len
aus|bie|gen
aus|bie|ten
aus|bil|den; Aus|bil|den|de m u. w;
-n, -n (↑ R 287ff.); Aus|bil|der;
Aus|bild|ner (österr.); Aus|bil-
dung; Aus|bil|dungs_lehr|gang,
...ver|trag
aus|bit|ten; sich etwas -
aus|bla|sen; Aus|blä|ser (aus-
gebranntes, nicht auseinanderge-
sprengtes Artilleriegeschoß)
aus|blei|ben
¹aus|blei|chen (bleich machen); du
bleichtest aus; ausgebleicht; vgl.
¹bleichen; ²aus|blei|chen (bleich
werden); es blich aus; ausgebli-
chen (auch schon: ausgebleicht);
vgl. ²bleichen
aus|blen|den
Aus|blick; aus|blicken [Trenn.:
...blik|ken]
aus|blu|ten
aus|bo|gen; ausgebogte Zacken
aus|boh|ren
aus|bo|jen (ein Fahrwasser mit
Seezeichen versehen)
aus|bom|ben; vgl. Ausgebombte
aus|boo|ten; Aus|boo|tung (ugs.
auch für: Entlassung, Abset-
zung)
aus|bor|gen; sich etwas von
jmdm. -
aus|bre|chen; Aus|bre|cher
aus|brei|ten; Aus|brei|tung
aus|bren|nen
aus|brin|gen; einen Trinkspruch -

Aus|bruch (auch: Wein besonderer
Güte) m; -[e]s, ...brüche; Aus-
bruchs|ver|such
aus|brü|ten
aus|bu|chen (Kaufmannsspr.: aus
dem Rechnungsbuch streichen);
vgl. ausgebucht
aus|buch|ten; Aus|buch|tung
aus|bud|deln (ugs.)
aus|bü|geln
aus|bu|hen (mit Buhrufen an
jmdm. Kritik üben)
aus|bün|dig; aus|bün|dig (ver-
altend für: außerordentlich, sehr)
aus|bür|gern; ich bürgere aus (↑ R
327); Aus|bür|ge|rung
aus|bür|sten
aus|bü|xen landsch. (weglaufen);
du büxt (büxest) aus
Ausch|witz (poln. Stadt; im 2.
Weltkrieg Konzentrationslager
der Nationalsozialisten)
Aus|dau|er; aus|dau|ernd; -ste
aus|deh|nen; sich -; Aus|deh|nung;
Aus|deh|nungs|ko|ef|fi|zi|ent
aus|den|ken; sich etwas -
aus|die|nen; vgl. ausgedient
aus|dif|fe|ren|zie|ren; sich -
aus|docken [Trenn.: ...dok|ken]
(aus dem Dock transportieren)
aus|dör|ren; aus|dör|ren
aus|dre|hen
Aus|druck m; -[e]s, ...drücke u.
(Druckw.:) ...drucke; aus-
drucken [Trenn.: ...druk|ken]
([ein Buch] fertig drucken); aus-
drücken [Trenn.: ...drük|ken];
sich -; aus|drück|lich [auch:
...drük...]; Aus|drucks|kunst
(auch für: Expressionismus) w;
-; aus|drucks|los; -este (↑ R 292);
Aus|drucks|lo|sig|keit w; -; aus-
drucks|voll; Aus|drucks|wei|se
Aus|drusch (Dreschertrag) m;
-[e]s, -e
aus|dün|nen; Obstbäume, Früch-
te -
aus|dun|sten, (häufiger:) aus|dün-
sten; aus|dun|stung, (häufiger:)
Aus|dün|stung
aus|ein|an|der; Schreibung in Ver-
bindung mit Zeitwörtern (↑ R
139): auseinander sein; auseinan-
der (voneinander getrennt) set-
zen, liegen, aber: auseinander-
setzen (erklären); vgl. aneinan-
der; aus|ein|an|der|bre|chen; aus-
ein|an|der|fal|len; aus|ein|an|der-
ge|hen (sich trennen, unterschei-
den; ugs. für: dick werden); aus-
ein|an|der|hal|ten (sondern); aus-
ein|an|der|lau|fen (sich trennen);
sich ausdehnen); aus|ein|an|der-
le|ben, sich; aus|ein|an|der|neh-
men; aus|ein|an|der|rei|ßen; aus-
ein|an|der|set|zen (erklären); sich
mit jmdm. od. etwas -; vgl. aus-
einander; Aus|ein|an|der|set|zung

aus|er|ko|ren (auserwählt)
aus|er|le|sen
aus|er|se|hen
aus|er|wäh|len; aus|er|wählt; Aus-
er|wähl|te m u. w; -n, -n (↑ R
287ff.); Aus|er|wäh|lung
aus|fä|chern
aus|fä|deln, sich (Verkehrsw.)
aus|fah|ren; aus|fah|rend (jäh, be-
leidigend); Aus|fahr|si|gnal
(fachspr.); Aus|fahrt; Aus-
fahrt[s]_er|laub|nis, ...ge|lei|se,
...gleis; Aus|fahrts|schild s; Aus-
fahrt[s]|si|gnal; Aus|fahrts|stra-
ße
Aus|fall m; aus|fal|len; vgl. ausge-
fallen; aus|fäl|len (Chemie:
gelöste Stoffe in Kristalle, Flok-
ken, Tröpfchen überführen;
schweiz.: verhängen [eine Strafe
usw.]); aus|fal|lend od. aus|fäl|lig
(beleidigend); Aus|fall[s]_er-
schei|nung (Med.), ...tor s; Aus-
fall_stra|ße; Aus|fäl|lung (Che-
mie); Aus|fall|zeit
aus|fech|ten
aus|fe|gen; Aus|fe|ger
aus|fei|len
aus|fer|ti|gen; Aus|fer|ti|gung
aus|fil|tern
aus|fin|dig; - machen; Aus|fin|dig-
ma|chen s; -s
aus|flag|gen (mit Flaggen kenn-
zeichnen)
aus|flie|gen
aus|flie|ßen
aus|flip|pen (ugs.: die bürgerliche
Gesellschaft nach Drogenkon-
sum verlassen, ein unbürger-
liches, ungeordnetes Leben füh-
ren); ausgeflippt (auch für: durch
ständigen Drogenkonsum außer
Selbstkontrolle)
aus|flocken [Trenn.: ...flok|ken]
(Flocken bilden)
Aus|flucht w; -, ...flüchte
Aus|flug; Aus|flüg|ler; Aus-
flugs_ort (m; -[e]s, -e), ...schiff,
...ver|kehr, ...ziel
Aus|fluß
aus|fol|gen österr. (übergeben,
aushändigen); Aus|fol|gung
aus|for|men
aus|for|mu|lie|ren; Aus|for|mu|lie-
rung
aus|for|mung
aus|for|schen (österr. auch für:
ausfindig machen); Aus|for-
schung (österr. auch für: [polizei-
liche] Ermittlung)
aus|fra|gen; Aus|fra|ge|rei
aus|fran|sen; vgl. ausgefranst
aus|fres|sen; etwas ausgefressen
(ugs. für: verbrochen) haben
Aus|fuhr w; -, -en; aus|führ|bän|der
(Druckw.) Mehrz.; aus|führ|bar;
Aus|führ|bar|keit w; -; aus|füh-
ren; Aus|füh|rer (für: Exporteur);
Aus|fuhr|land (Mehrz. ...länder)

aus|führ|lich[1]; Aus|führ|li|che|res[1].(↑ R 116); Aus|führ|lich|keit[1] w; -; Aus|fuhr|prä|mie; Aus|füh|rung; Aus|füh|rungs|be|stim|mung; Aus|fuhr|ver|bot aus|fül|len; Aus|fül|lung

Ausg. = Ausgabe

Aus|ga|be (Abk. für Drucke: Ausg.); Aus|ga|be[n]|buch; Aus|ga|ben|po|li|tik; Aus|ga|be|stel|le, ...ter|min

Aus|gang; aus|gangs (Papierdt.; ↑ R 129 u. 130); mit Wesf.: - des Tunnels; Aus|gangs|ba|sis, ...po|si|ti|on, ...punkt, ...sperre, ...stel|lung

aus|ga|ren (Metallurgie: flüssige u. gasförmige Bestandteile entziehen)

aus|gä|ren (fertig gären)

aus|ga|sen

aus|ge|ben; Geld -; sich -

aus|ge|bleicht; vgl. [1]ausbleichen; aus|ge|bli|chen; vgl. [2]ausbleichen

aus|ge|bogt vgl. ausbogen

Aus|ge|bomb|te m u. w; -n, -n (↑ R 287ff.)

aus|ge|bucht (voll besetzt, ohne freie Plätze); ein -es Flugzeug

aus|ge|bufft (ugs. für: raffiniert)

Aus|ge|burt

aus|ge|dehnt

aus|ge|dient; ein -er Soldat; - haben

Aus|ge|din|ge landsch. (Altenteil) s; -s, -; Aus|ge|din|ger

aus|ge|dorrt; aus|ge|dörrt

aus|ge|fal|len (auch für: ungewöhnlich); -e Ideen

aus|ge|feilt

aus|ge|feimt landsch. (abgefeimt)

aus|ge|flippt vgl. ausflippen

aus|ge|franst; eine -e Hose

aus|ge|fuchst (ugs. für: durchtrieben)

aus|ge|gli|chen; ein -er Mensch; Aus|ge|gli|chen|heit w; -

Aus|geh|an|zug; aus|ge|hen; es geht sich aus (österr. für: es reicht, paßt)

aus|ge|hun|gert (sehr hungrig)

Aus|geh|ver|bot

aus|ge|klü|gelt

aus|ge|kocht (ugs. auch für: durchtrieben); ein -er Kerl

aus|ge|las|sen (auch für: übermütig); ein -er Junge; Aus|ge|las|sen|heit w; -, (selten:) -en

aus|ge|la|stet

aus|ge|laugt; -e Böden

aus|ge|lei|ert

aus|ge|lernt; ein -er Schlosser; Aus|ge|lern|te m u. w; -n, -n (↑ R 287ff.)

aus|ge|lit|ten; - haben

aus|ge|macht (feststehend); als - gelten; ein -er (ugs. für: großer) Schwindel

aus|ge|mer|gelt

aus|ge|nom|men; alle waren zugegen, er ausgenommen (od. ausgenommen er); ich erinnere mich aller Vorgänge, ausgenommen dieses einen (od. diesen einen ausgenommen); der Tadel galt allen, ausgenommen ihm (od. ihn ausgenommen); ich weiß alles, ausgenommen diese eine Tatsache (od. diese eine Tatsache ausgenommen); ausgenommen, daß/ wenn (↑ R 61)

aus|ge|picht (ugs. für: gerissen, durchtrieben)

aus|ge|po|wert

aus|ge|prägt; eine -e (stark entwickelte) Vorliebe; Aus|ge|prägt|heit w; -

aus|ge|pumpt (ugs. für: erschöpft)

aus|ge|rech|net

aus|ge|schlos|sen (unmöglich); es ist [nicht] -, daß ...

aus|ge|schnit|ten

aus|ge|spro|chen (entschieden, sehr groß); eine -e Abneigung; aus|ge|spro|che|ner|ma|ßen

aus|ge|stal|ten; Aus|ge|stal|tung

aus|ge|steu|ert; Aus|ge|steu|er|te m u. w; -n, -n (↑ R 287ff.)

aus|ge|sucht ([aus]erlesen; ausgesprochen)

aus|ge|wach|sen (voll ausgereift)

aus|ge|wo|gen (wohl abgestimmt, harmonisch); Aus|ge|wo|gen|heit w; -

aus|ge|zehrt

aus|ge|zeich|net (vorzüglich, hervorragend); -e Leistungen

aus|gie|big (reichlich); Aus|gie|big|keit w; -

aus|gie|ßen; aus|gie|ßung

aus|gleich m; -[e]s, -e; aus|gleich|bar; aus|glei|chen; vgl. ausgeglichen; Aus|gleichs|amt, ...fonds, ...ge|trie|be (für: Differential), ...sport, ...treffer, ...ver|fah|ren; Aus|gleich|ung

aus|glei|ten

aus|glü|hen (z. B. einen Draht)

aus|gra|ben; Aus|grä|ber, ...grabung

aus|grei|fen; Aus|griff

aus|grün|den (Wirtsch.: einen Teil eines Betriebes herausnehmen u. als selbständiges Unternehmen weiterführen); Aus|grün|dung

Aus|guck m; -[e]s, -e; aus|gucken [Trenn.: ...guk|ken]

Aus|guß

aus|ha|ben (ugs.); ..., daß er den Mantel aushat; das Buch -

aus|hacken [Trenn.: ...hak|ken]; Unkraut -

aus|ha|ken (ugs. auch für: zornig werden)

aus|hal|ten; (↑ R 120:) es ist nicht zum Aushalten

aus|han|deln

aus|hän|di|gen; Aus|hän|di|gung

Aus|hang; Aus|hän|ge|bo|gen (Druckw.); [1]aus|hän|gen (älter u. mdal.: aushangen); die Verordnung hat ausgehangen; vgl. [1]hängen; [2]aus|hän|gen; ich habe das Fenster ausgehängt; vgl. [2]hängen; Aus|hän|ger vgl. Aushängebogen; Aus|hän|ge|schild s

aus|här|ten (Technik); Aus|här|tung

aus|hau|chen; sein Leben -

aus|hau|en

aus|häu|sig landsch. (außer Hauses; selten zu Haus); Aus|häu|sig|keit w; -

aus|he|ben (herausheben; zum Heeresdienst einberufen); österr. auch: [einen Briefkasten] leeren; Aus|he|ber (Griff beim Ringen); aus|he|bern (mit einem Heber herausnehmen; bes. den Magen zu Untersuchungszwecken entleeren); ich hebere aus (↑ R 327); Aus|he|be|rung; Aus|he|bung (österr. auch: Leerung des Briefkastens)

aus|hecken [Trenn.: ...hek|ken] (ugs. für: listig ersinnen)

aus|hei|len; Aus|hei|lung

aus|hel|fen; Aus|hel|fer; Aus|hil|fe; Aus|hilfs|ar|beit, ...kraft w, ...stel|lung; aus|hilfs|wei|se

aus|höh|len; Aus|höh|lung

aus|ho|len

aus|hol|zen; Aus|hol|zung

aus|hor|chen; Aus|hor|cher

aus|hor|sten (junge Raubvögel aus dem Horst nehmen)

Aus|hub m; -[e]s

aus|hun|gern; vgl. ausgehungert

aus|hu|sten; sich -

aus|ixen (ugs. für: mit dem Buchstaben x ungültig machen)

aus|jä|ten

aus|käm|men; Aus|käm|mung

aus|kegeln (landsch. auch für: ausrenken)

aus|keh|len; Aus|keh|lung (das Anbringen einer Hohlkehle)

aus|keh|ren; Aus|keh|richt m; -s

Aus|kei|lung (Geol.: Zuspitzung einer Gesteinsschicht)

aus|kei|men

aus|ken|nen, sich

aus|ker|ben; Aus|ker|bung

aus|ker|nen

aus|kip|pen

aus|kla|gen (Rechtsspr.); Aus|kla|gung

aus|klam|mern; Aus|klam|me|rung

aus|kla|mü|sern vgl. klamüsern

Aus|klang

aus|kla|rie|ren (Schiff und Güter vor der Ausfahrt verzollen)

aus|klau|ben landsch. (größere od. wertvollere Stücke mit der Hand auslesen)

aus|klei|den; sich -; Aus|klei|dung

[1] Auch: ...für...

aus|klin|gen
aus|klin|ken
aus|klop|fen; Aus|klop|fer
aus|klü|geln; Aus|klü|ge|lung, Aus-
klüg|lung
aus|knei|fen (ugs. für: feige u.
heimlich weglaufen)
aus|knip|sen
aus|kno|beln (ugs. auch für: aus-
denken)
aus|knocken [Trenn.: ...knok|ken]
engl. [...nokᵉn] (Boxsport: durch
K. o. besiegen; ugs. für: aussste-
chen, besiegen)
aus|knöpf|bar; aus|knöp|fen
aus|ko|chen; vgl. ausgekocht
aus|kof|fern (eine vertiefte Fläche
für den Straßenunterbau schaf-
fen); ich koffere aus (↑ R 327);
Aus|kof|fe|rung
Aus|kol|kung (Geol.: Auswa-
schung)
aus|kom|men; Aus|kom|men s; -s;
aus|kömm|lich
aus|ko|sten
aus|kot|zen (derb); sich -
aus|kra|gen (Bauw.: vorkragen);
Aus|kra|gung
aus|kra|men
aus|krat|zen
aus|krie|chen
aus|krie|gen (ugs.)
aus|kri|stal|li|sie|ren; sich -
aus|ku|geln (ugs. für: ausrenken)
aus|küh|len; Aus|küh|lung
Aus|kul|tant lat. („Zuhörer"; ver-
alt. für: Beisitzer ohne Stimm-
recht) m; -en, -en (↑ R 268); Aus-
kul|ta|ti|on [...ziọn] (Med.: Be-
horchung); Aus|kul|ta|tor (ver-
alt. für: Gerichtsreferendar) m;
-s, ...ọren; aus|kul|ta|to|risch
(Med.: durch Behorchen); aus-
kul|tie|ren (Med.: abhorchen)
aus|kund|schaf|ten; Aus|kund-
schaf|ter
Aus|kunft w; -, ...künfte; Aus|kunf-
tei; Aus|kunfts|stel|le
aus|kup|peln; den Motor -
aus|ku|rie|ren
aus|la|chen
Aus|lad schweiz. (Ausladung [bei
der Eisenbahn]) m; -s; ¹aus|la|den;
Waren -; vgl. ¹laden; ²aus|la|den;
jmdn. -; vgl. ²laden; aus|la|dend
(nach außen ragend); Aus|la|de-
ram|pe; Aus|la|dung
Aus|la|ge
aus|la|gern; Aus|la|ge|rung
Aus|land s; -[e]s; Aus|län|der; Aus-
län|de|rin w; -, -nen; aus|län|disch;
Aus|lands|ab|satz, ...be|zie|hun-
gen (Mehrz.); aus|lands|deutsch;
Aus|lands_deut|sche (m u. w; ↑ R
287 ff.), ...kun|de (w; -), ...kor|re-
spon|dent, ...rei|se, ...sen|dung,
...ver|tre|tung
aus|lan|gen landsch. (zum Schlag
ausholen; ausreichen); Aus|lan-
gen s; -s; das - finden (österr.:
mit etwas auskommen)
Aus|laß m; ...lasses, ...lässe; aus-
las|sen (österr. auch für: frei-, los-
lassen); vgl. ausgelassen; Aus|las-
sung; Aus|las|sungs_punk|te
(Mehrz.), ...satz (für: Ellipse),
...zei|chen (für: Apostroph); Aus-
laß|ven|til (beim Viertaktver-
brennungsmotor)
aus|la|sten; Aus|la|stung
Aus|lauf; Aus|lauf|bahn (Schi-
sport); aus|lau|fen; Aus|läu|fer
aus|lau|gen
Aus|laut; aus|lau|ten
aus|läu|ten
aus|le|ben; sich -
aus|lecken [Trenn.: ...lek|ken]
aus|lee|ren; Aus|lee|rung
aus|le|gen; Aus|le|ger; Aus|le-
ger_boot, ...brücke [Trenn.:
...brük|ke]; Aus|le|ge|wa|re (Tep-
pichstoffe zum Auslegen von
Fußböden); Aus|le|gung
aus|lei|ern
Aus|lei|he; aus|lei|hen; Aus|lei-
hung
aus|ler|nen; vgl. ausgelernt
Aus|le|se; aus|le|sen; Aus|le|se_pro-
zeß
aus|leuch|ten
aus|lich|ten
aus|lie|fern; Aus|lie|fe|rung
aus|lie|gen
aus|lo|ben (Rechtsspr.: öffentlich
eine Belohnung aussetzen); Aus-
lo|bung
aus|löf|feln
aus|lo|gie|ren [...sehirᵉn] (anders-
wo einquartieren)
aus|los|bar
aus|lös|bar
¹aus|lö|schen; er löschte das Licht
aus, hat es ausgelöscht; vgl.
¹löschen; ²aus|lö|schen (veralt.);
das Licht losch (auch: löschte)
aus, ist ausgelöscht; vgl. ²löschen
aus|lo|sen
aus|lo|sen; Aus|lö|ser
Aus|lo|sung (durch das Los getrof-
fene [Aus]wahl)
Aus|lö|sung (das Auslösen, Bewir-
ken; Loskaufen [eines Gefange-
nen])
aus|lo|ten
aus|lüf|ten
Aus|lug (veralt. für: Ausguck) m;
-[e]s, -e; aus|lu|gen
aus'm (ugs. für: aus dem); ↑ R 240
aus|ma|chen; eine Sache -; vgl. aus-
gemacht
aus|mah|len; Aus|mah|lung (z. B.
des Kornes) w; -
aus|ma|len; Aus|ma|lung (z. B. des
Bildes)
aus|ma|nö|vrie|ren
aus|mar|chen schweiz. (mit
Marksteinen abgrenzen; seine
Rechte, Interessen abgrenzen;
sich auseinandersetzen); Aus-
mar|chung (schweiz.)
aus|mä|ren, sich (bes. ostmitteldt.
für: fertig werden, zu trödeln
aufhören)
Aus|maß s
aus|mau|ern; Aus|maue|rung
aus|mei|ßeln
aus|mer|geln; ich mergele aus (↑ R
327); Aus|mer|ge|lung, Aus|merg-
lung
aus|mer|zen (radikal beseitigen);
du merzt (merzest) aus; Aus|mer-
zung
aus|mes|sen; Aus|mes|sung
aus|mie|ten (schweiz. neben: ver-
mieten)
aus|mi|sten
aus|mit|teln (veraltend für: ermit-
teln); ich mittele aus (↑ R 327);
Aus|mit|te|lung, Aus|mitt|lung;
aus|mit|tig, au|ßer|mit|tig (für:
exzentrisch [Technik])
aus|mon|tie|ren
aus|mu|geln österr. (ausfahren,
uneben machen [Schipiste])
aus|mün|den
aus|mün|zen; Aus|mün|zung
(Münzprägung)
aus|mu|stern; Aus|mu|ste|rung
Aus|nah|me w; - (österr. auch für: Al-
tenteil) w; -, -n; Aus|nah|me|fall
(österr.: Ausnahmsfall) m, ...zu-
stand (österr.: Ausnahmszu-
stand); aus|nahms_los, ...wei|se;
aus|neh|men; sich -; vgl. ausge-
nommen; aus|neh|mend (sehr);
Aus|neh|mer österr. (Altenteiler)
aus|neu|en (Jägerspr.: einer [Mar-
der]spur im Neuschnee folgen)
aus|nüch|tern, aus|nüch|te-
rung
aus|nut|zen, (bes. südd., österr.:)
aus|nüt|zen; Aus|nut|zung, (bes.
südd., österr.:) Aus|nüt|zung
aus|packen [Trenn.: ...pak|ken]
aus|par|ken
aus|peit|schen; Aus|peit|schung
Aus|pend|ler (Person, die außer-
halb ihres Wohnortes arbeitet)
aus|pfäh|len (einzäunen; Berg-
mannsspr.: mit Pfählen Gesteins-
massen abstützen); Aus|pfäh-
lung
aus|pfar|ren (einer anderen Pfarre
zuweisen); Aus|pfar|rung
aus|pfei|fen
aus|pflücken [Trenn.: ...pflük|ken]
Au|spi|zi|um lat. („Vogelschau";
Vorbedeutung) s; -s, ...ien [...iᵉn]
(meist Mehrz.); unter jemandes
Auspizien, unter den Auspizien
von... (Oberleitung, Schutz)
aus|plau|dern
aus|plün|dern; Aus|plün|de|rung
aus|pol|stern; Aus|pol|ste|rung
aus|po|sau|nen (ugs. für: etwas [ge-

gen den Willen eines anderen] bekanntmachen)

aus|po|wern *dt.; fr.* (bis zur Verelendung ausbeuten); ich powere aus († R 327); **Aus|po|we|rung**

aus|prä|gen; vgl. ausgeprägt; **Aus|prä|gung**

aus|prei|sen (Waren mit einem ²Preis versehen)

aus|pres|sen

aus|pro|bie|ren

Aus|puff *m;* [e]s, -e; **Aus|puff|flam|me** († R 237); **Aus|puff|topf**

aus|pum|pen; vgl. ausgepumpt

aus|punk|ten (Boxsport: nach Punkten besiegen)

aus|pu|sten

Aus_putz (Zierat); **aus|put|zen; Aus|put|zer**

aus|quar|tie|ren; Aus|quar|tie|rung

aus|quat|schen; sich -

aus|quet|schen

aus|ra|die|ren

aus|ran|gie|ren [...*sehir^e n*] (ugs. für: aussondern; ausschelden)

aus|ra|sie|ren

aus|ra|sten (ugs. auch für: zornig werden; südd., österr. für: ausruhen)

aus|rau|ben; aus|räu|bern

aus|räu|chern

aus|rau|fen

aus|räu|men; Aus_räu|mer, ...räu|mung

aus|rech|nen; Aus|rech|nung

aus|recken [*Trenn.:* ...rek|ken]

Aus|re|de; aus|re|den; jmdm. etwas -

aus|reg|nen, sich

aus|rei|ben (österr. auch für: scheuern); die Küche -; **Aus|reib|tuch** österr. (Scheuertuch)

aus|rei|chen; aus|rei|chend; er hat [die Note] „ausreichend" erhalten; er hat mit [der Note] „ausreichend" bestanden

aus|rei|fen; aus|rei|fung

Aus|rei|se; Aus|rei|se_er|laub|nis, ...ge|neh|mi|gung; aus|rei|sen; Aus|rei|se|sper|re

aus|rei|ßen; Aus|rei|ßer

aus|rei|ten

aus|rei|zen; die Karten -

aus|ren|ken; Aus|ren|kung

aus|reu|ten (veralt. für: ausroden)

aus|rich|ten; etwas -; **Aus|rich|ter; Aus|rich|tung**

aus|rin|gen landsch. (auswringen)

aus|rin|nen

aus|rip|pen (von den Rippen lösen)

Aus|ritt

aus|ro|den; Aus|ro|dung

aus|rol|len

aus|rot|ten; Aus|rot|tung

aus|rücken [*Trenn.:* ...rük|ken] ([die Garnison] verlassen; ugs. für: fliehen)

Aus|ruf; aus|ru|fen; Aus|ru|fer; Aus|ru|fe_satz, ...wort (für: Inter-

jektion; *Mehrz.* ...wörter), ...**zei|chen; Aus|ru|fung; Aus|ru|fungs|zei|chen;** **Aus|ruf|zei|chen** (schweiz. neben Ausrufungszeichen meist für: Ausrufezeichen)

aus|ru|hen

aus|rup|fen

aus|rü|sten; Aus|rü|ster; Aus|rü|stung; Aus|rü|stungs_ge|gen|stand, ...stück

aus|rut|schen; Aus|rut|scher (auch Sportspr.)

Aus|saat; aus|sä|en

Aus|sa|ge *w;* -, -n; **aus|sa|gen**

aus|sä|gen

Aus|sa|ge_kraft, ...satz, ...wei|se (Sprachw. für: Modus) *w,* ...**wort**

Aus|satz (eine Krankheit) *m;* -es; **aus|sät|zig**

aus|sau|fen

aus|sau|gen

Aussch. = Ausschuß

aus|scha|ben; Aus|scha|bung

aus|schach|ten; Aus|schach|tung

aus|scha|len (Verschalung entfernen; verschalen)

aus|schä|len

aus|schal|men; Bäume - (Forstw.: durch Schalmen zum Fallen anweisen)

aus|schal|ten, Aus|schal|ter; Aus_schal|tung

Aus|scha|lung

Aus|schank

Aus|schau *w;* -; - halten; **aus|schau|en**

Aus|scheid (DDR für: Ausscheidungskampf) *m;* -[e]s, -e; **aus|schei|den; Aus|schei|dung; Aus_schei|dungs_kampf, ...spiel**

aus|schel|ten

aus|schen|ken (Bier, Wein usw.)

aus|sche|ren (von Schiffen, Kraftfahrzeugen od. Flugzeugen: die Linie, Spur verlassen); scherte aus; ausgeschert

aus|schicken [*Trenn.:* ...schik|ken]

aus|schie|ßen (Druckw.); **Aus_schieß|plat|te** (Druckw.)

aus|schif|fen; Aus|schif|fung

aus|schil|dern (Verkehrswege mit Verkehrsschildern ausstatten); **Aus|schil|de|rung**

aus|schimp|fen

aus|schir|ren

aus|schlach|ten (ugs. auch für: ausbeuten); **Aus|schlach|te|rei; Aus_schlach|tung**

aus|schla|fen; sich -

Aus|schlag; aus|schla|gen; aus_schlag|ge|bend; -ste

aus|schläm|men (von Schlamm befreien)

aus|schlie|ßen; vgl. ausgeschlossen; **aus|schließ|lich;** *Verhältnisw.* mit *Wesf.:* - des Weines; ein alleinstehendes,

stark gebeugtes Hauptw. steht in der *Einz.* ungebeugt: - Porto; *Wemf.,* wenn bei Mehrzahlformen der Wesf. nicht erkennbar ist: - Getränken; **Aus|schließ|lich|keit[1]** *w;* -, (selten:) -en; **Aus|schlie|ßung**

Aus|schlupf; aus|schlüp|fen

aus|schlür|fen

Aus|schluß; Aus|schluß_fach, ...ka|sten (Druckw.)

aus|schmie|ren

aus|schmücken [*Trenn.:* ...schmük|ken]; **Aus|schmückung** [*Trenn.:* ...schmük|kung]

aus|schnau|ben

aus|schnei|den; Aus|schnei|dung; Aus|schnitt

aus|schnüf|feln

aus|schöp|fen; Aus|schöp|fung

aus|schop|pen österr. ugs. (ausstopfen)

aus|schrei|ben; Aus|schrei|bung

aus|schrei|en

aus|schrei|ten; Aus|schrei|tung (meist *Mehrz.*)

aus|schro|ten österr. ([Fleisch] zerlegen, ausschlachten)

Aus|schu|hen (krankhaftes Abfallen der Hornschuhe bei Huftieren) *s;* -s

aus|schu|len (aus der Schule nehmen); **Aus|schu|lung**

Aus|schuß (Abk. für Kommission: Aussch.); **Aus|schuß_mit_glied, ...sit_zung, ...wa_re**

aus|schüt|teln

aus|schüt|ten; Aus|schüt|tung

aus|schwär|men

aus|schwe|feln

aus|schwei|fen; aus|schwei|fend; -ste; **Aus|schwei|fung**

aus|schwei|gen, sich

aus|schwem|men; Aus_schwem|mung

aus|schwen|ken

aus|schwin|gen (schweiz. auch: den Endkampf im Schwingen kämpfen); **Aus|schwin|get** (schweiz.) *m;* -s

aus|schwit|zen; Aus|schwit|zung

Aus_see, Bad (Solbad in der Steiermark); **Aus|seer** († R 166, 199 u. 205); **Aus|seer_Land** (Gebiet südl. des Toten Gebirges in der Steiermark)

aus|seg|nen; Aus|seg|nung (kirchl. Segnung der Mutter nach einer Geburt; Segnung eines Toten vor dem Hinaustragen aus dem Haus)

aus|se|hen; Aus|se|hen *s;* -s

aus|sein (ugs. für: zu Ende sein); das Theater ist aus, ist ausgewesen, ab er: ..., daß das Theater aus ist, war; auf etwas - (ugs. für: versessen sein)

au|ßen; von - [her]; nach innen und -; nach - [hin]; Farbe für - und

[1] Auch: *außschließ...* od. ...*schließ...*

innen; er spielt - (augenblickliche Position eines Spielers), aber vgl. Außen; Au|ßen (Sportspr.: Außenspieler) *m*; -, -; er spielt - (als Außenspieler), aber vgl. außen; Au|ßen al|ster, ...an|ten|ne, ...ar|bei|ten (*Mehrz.*), ...auf|nah|me (meist *Mehrz.*), ...be|zirk, ...bor|der ([Boot mit] Außenbordmotor), ...bord|mo|tor; au|ßen|bords (außerhalb des Schiffes) aus|sen|den; Aus|sen|dung *w*; - Au|ßen|dienst; Au|ßen|dienst|ler; au|ßen|dienst|lich; Au|ßen el be, ...han|del, ...han|dels|po|li|tik, ...kom|man|do, ...kur|ve; au|ßen|lie|gend; Au|ßen mi|ni|ster, ...mi|ni|ste|ri|um, ...po|li|tik; au|ßen|po|li|tisch; Au|ßen sei|te, ...sei|ter, ...spie|gel, ...stän|de (ausstehende Forderungen; *Mehrz.*), ...ste|hen|de (*m* u. *w*; -n, -n; ↑ R 287ff.), ...stel|le, ...stür|mer, ...tem|pe|ra|tur, ...trep|pe, ...tür, ...wand, ...welt (*w*; -), ...wirt|schaft (*w*; -)

au|ßer; *Bindew.*: - daß/wenn/wo: wir fahren in die Ferien, - [wenn] es regnet (↑ R 62); niemand kann diese Schrift lesen - er selbst; *Verhältnisw.* mit *Wemf.*: niemand kann es lesen - ihm selbst; - [dem] Haus[e]; - allem Zweifel; - Dienst (Abk.: a. D.); - Rand und Band; ich bin - mir (empört); (↑ R 132:) außerstande sein, - acht lassen, aber (↑ R 132): - aller Acht lassen; mit *Wenf.* (bei Zeitwörtern der Bewegung): - Kurs, - allen Zweifel; - Tätigkeit setzen: ich gerate - mich (auch: mir) vor Freude; außerstand setzen; mit *Wesf.* nur in: - Landes gehen, sein; - Hauses (neben: Haus[e]); Au|ßer acht las|sen *s*; -s; ↑ R 120 u. R 156; Au|ßer acht las|sung; au|ßer amt|lich, ...be|ruf|lich; au|ßer daß (↑ R 62); au|ßer|dem; au|ßer|dienst|lich; äu|ße|re; die- Mission, aber (↑ R 198): die Äußere Mongolei; Äu|ße|re *s*; ...r[e]n; im Äußer[e]n; sein -s; ein erschreckendes Äußere[s]; Minister des -n; au|ßer ehe|lich, ...eu|ro|pä|isch; au|ßer ge|richt|lich; -e Kosten; -er Vergleich; au|ßer|ge|wöhn|lich; au|ßer|halb; mit *Wesf.*: - des Lagers; - Münchens; au|ßer ir|disch; Au|ßer kraft set|zung; Au|ßer kurs set|zung; äu|ßer|lich; Äu|ßer|lich|keit

äu|ßerln (österr. ugs.); seinen Hund - (auf die Straße führen) au|ßer|mit|tig sg. ausmittig äu|ßern; ich ...ere (↑ R 327); sich - au|ßer or dent|lich; -er [Professor] (Abk.: ao., a. o. [Prof.]); au|ßer|orts schweiz. (Straßenverkehr:

außerhalb einer Ortschaft); au|ßer|par|la|men|ta|risch; die -e Opposition (Abk.: Apo); au|ßer|plan|mä|ßig (Abk.: apl.); au|ßer|schu|lisch äu|ßerst (auch: sehr, in hohem Grade). I. *Kleinschreibung* (↑ R 134): bis zum äußersten (sehr); auf das, aufs äußerste (sehr) erschrocken sein. II. *Großschreibung* (↑ R 116): das Äußerste befürchten; 20 Mark sind od. ist das Äußerste; das Äußerste, was ...; auf das, aufs Äußerste (auf die schlimmsten Dinge) gefaßt sein; es bis zum Äußersten treiben; es auf das, aufs Äußerste ankommen, zum Äußersten kommen lassen; bis zum Äußersten gehen; es bringt mich zum Äußersten (zur Verzweiflung); vgl. zuäußerst au|ßer|stand [auch: *au*...]; - setzen; vgl. außer; au|ßer|stan|de [auch: *au*...]; - sein; sich - sehen; sich [als] - erweisen; vgl. außer äu|ßer|sten|falls; vgl. Fall *m* au|ßer|tour|lich [...*tur*...] österr. (außerhalb der Reihenfolge; zusätzlich eingesetzt [z. B. von einem Omnibus]) Äu|ße|rung au|ßer wenn/wo (↑ R 62) aus|set|zen; Aus|set|zung Aus|sicht *w*; -, -en; aus|sichts|los; -este (↑ R 292); Aus|sichts|lo|sig|keit *w*; -; Aus|sichts punkt; aus|sichts|reich; Aus|sichts|turm; aus|sichts|voll; Aus|sichts|wa|gen aus|sie|ben aus|sie|deln; Aus|sied|ler; Aus|sied|ler|hof; Aus|sied|lung, Aus|sied|lung aus|söh|nen; sich -; Aus|söh|nung aus|son|dern; Aus|son|de|rung aus|sor|gen; ausgesorgt haben aus|sor|tie|ren aus|spä|hen Aus|spann *m*; -[e]s, -e; aus|span|nen (ugs. auch für: abspenstig machen); Aus|span|nung aus|spa|ren; Aus|spa|rung aus|spei|en aus|sper|ren; Aus|sper|rung aus|spie|len; jmdn. gegen jmdn. - aus|spin|nen aus|spio|nie|ren Aus|spra|che; Aus|spra|che abend, ...be|zeich|nung, ...wör|ter|buch; aus|sprech|bar; aus|spre|chen; sich -; vgl. ausgesprochen aus|spren|gen; ein Gerücht - aus|sprit|zen; Aus|sprit|zung Aus|spruch aus|spucken [*Trenn.*: ...spuk|ken] aus|spü|len; Aus|spü|lung aus|staf|fie|ren (ausstatten); Aus|staf|fie|rung Aus|stand *m*; -[e]s; in den - treten

(streiken); aus|stän|dig südd., österr. (ausstehend); -e Beträge; Aus|ständ|ler (Streikender) aus|stat|ten; Aus|stat|tung aus|ste|chen aus|stecken [*Trenn.*: ...stek|ken]; etwas mit Fähnchen - aus|ste|hen; jmdn. nicht - können; die Rechnung steht noch aus aus|stei|fen (Bauw.); Aus|stei|fung aus|stei|gen aus|stei|nen; Obst - aus|stel|len; Aus|stel|ler; Aus|stel|fen ster (Kfz); Aus|stel|lung; Aus|stel|lungs flä che, ...ge|bäu|de, ...ge|län|de, ...ka|ta|log, ...stand, ...stück Aus|ster|be|etat [...*eta*]; nur noch in festen Wendungen wie: auf dem - stehen, auf den - setzen (ugs.); aus|ster|ben aus|steu|er *w*; aus|steu|ern; Aus|steue|rung Aus|stich (das Beste [vom Wein]; schweiz. Sportspr. auch für: Entscheidungskampf) Aus|stieg *m*; -[e]s, -e; Aus|stieg|lu|ke aus|stop|fen; Aus|stop|fung Aus|stoß (z. B. von Bier) *m*; -es, (selten:) Ausstöße; aus|sto|ßen; jmdn. -; Aus|sto|ßung aus|strah|len; Aus|strah|lung aus|strecken [*Trenn.*: ...strek|ken] aus|strei|chen aus|streu|en; Gerüchte - Aus|strich (Med.) aus|strö|men aus|su|chen; vgl. ausgesucht aus|sü|ßen (zu Süßwasser werden) aus|ta|pe|zie|ren aus|ta|rie|ren (ins Gleichgewicht bringen; österr. auch: [auf der Waage] das Leergewicht feststellen) Aus|tausch *m*; -[e]s; aus|tausch|bar; Aus|tausch|bar|keit; aus|tau|schen; Aus|tausch mo|tor (aus teilweise neuen Teilen bestehender Ersatzmotor), ...schü|ler, ...stoff (künstlicher Roh- u. Werkstoff); aus|tausch|wei|se aus|tei|len; Aus|tei|lung Au|ste|nit [nach dem engl. Forscher Roberts-Austen] (ein Gefügebestandteil des Eisens) *m*; -s, -e Au|ster niederl. (eßbare Meeresmuschel) *w*; -, -n Au|ste ri|ty *engl.* [*åßtäriti*] (engl. Bez. für: Strenge; wirtschaftl. Einschränkung) *w*; - Au|stern bank (*Mehrz.* ...bänke), ...fi|scher (Watvogel), ...scha|le, ...zucht aus|te|sten aus|til|gen aus|to|ben; sich - aus|ton|nen (ausbojen)

Aus|trag (südd. u. österr. auch für: Altenteil) *m*; -[e]s; die Meisterschaften kommen zum -; aus|tra|gen; Aus|träger (Person, die etwas austrägt); Aus|träg|ler südd. u. österr. (Altenteiler); Aus|tragung

aus|trai|niert (völlig trainiert) au|stral *lat*, (veralt. für: auf der südlichen Halbkugel befindlich; Süd...); au|stra|lid (Rassenmerkmale der Australier zeigend); -er Zweig; Au|stra|li|de *m* u. *w*; -n, -n (↑ R 268); Au|stra|li|en [...*iⁱn*] („Südland"); Au|stra|li|er [...*iⁱr*]; au|stra|lisch, ab e r (↑ R 224)· der Australische Bund; au|stra|lo|jd (den Australiern ähnliche Rassenmerkmale zeigend); Au|stra|lo|jde *m* u. *w*; -n, -n (↑ R 268) Au|stra|si|en [...*iⁱn*] (östl. Teil des Frankenreiches)

aus|träu|men; ausgeträumt aus|trei|ben; Aus|trei|bung aus|tre|ten Au|stria („Österreich") aus|trick|sen (Sportspr.: mit einem Trick ausspielen) aus|trin|ken Aus|tritt; Aus|tritts|er|klä|rung au|stro|asia|tisch; -e Sprachen aus|trock|nen; Aus|trock|nung Au|stro|mar|xis|mus (österr. Sonderform des Marxismus) aus|trom|pe|ten (ugs. für: aller Welt verkünden) aus|tüf|teln; Aus|tüf|te|lung, Austüft|lung aus|tun; sich - können (ugs. für: etwas ohne Hemmungen tun können) aus|üben; Aus|übung aus|ufern (über die Ufer treten; das Maß überschreiten); Aus|uferung Aus|ver|kauf; aus|ver|kau|fen aus|ver|schämt landsch. (dreist, unverschämt) aus|wach|sen; (↑ R 120:) es ist zum Auswachsen (ugs.); vgl. ausgewachsen aus|wä|gen (fachspr. für: das Gewicht feststellen, vergleichen) Aus|wahl; mit, nach -; aus|wäh|len; Aus|wahl|mann|schaft, ...möglich|keit, ...sen|dung (Kaufmannsspr.), ...spie|ler aus|wal|len schweiz., auch bayr. ([Teig] ausrollen, -walzen) aus|wal|zen Aus|wan|de|rer; Aus|wan|de|rer|schiff; aus|wan|dern; Aus|wan|de|rung aus|wär|tig; -er Dienst, aber (↑ R 224:) das Auswärtige Amt (Abk.: AA); Minister des Auswärtigen (↑ R 116); aus|wärts; nach, von -; nach - gehen. *Schreibung in Verbindung mit Zeitwörtern;* ↑ R 139

(vgl. abwärts): auswärts (außer dem Hause) essen, a b e r : auswärtsgehen, auswärtslaufen (mit auswärts gerichteten Füßen); Aus|wärts|spiel aus|wa|schen; Aus|wa|schung aus|wech|sel|bar; Aus|wech|selblatt; aus|wech|seln; Aus|wech|selung, Aus|wechs|lung Aus|weg; aus|weg|los; Aus|weg|lo|sig|keit *w*; - Aus|wei|che; aus|wei|chen; auswei|chend; Aus|weich_flug|ha|fen, ...la|ger, ...ma|nö|ver, ...mög|lich|keit, ...stel|le aus|wei|den (Eingeweide entfernen [bei Wild usw.]) aus|wei|nen; sich - Aus|weis *m*; -es, -e; aus|wei|sen; sich -; Aus|weis|kon|trol|le; ausweis|lich (Papierd.: nach Ausweis); *Verhältnisw.* mit *Wesfall:* - der Akten; Aus|weis|pa|pier (meist Mehrz.) aus|wei|ßen (z. B. einen Stall); Aus|wei|ßung Aus|wei|sung aus|wei|ten; Aus|wei|tung aus|wen|dig; - lernen, wissen; Aus|wen|dig|ler|nen *s*; -s aus|wer|fen; Aus|wer|fer (Technik) aus|wer|keln; das Türschloß ist ausgewerkelt (österr. ugs. für: ausgeleiert, stark abgenutzt) aus|wer|ten; Aus|wer|tung aus|wet|zen aus|wickeln [*Trenn.:* ...wik|keln] aus|wie|gen; vgl. ausgewogen aus|win|den landsch. (auswringen) aus|win|tern (über Winter absterben); die Saat wintert aus; Auswin|te|rung *w*; - aus|wir|keln, sich; Aus|wir|kung aus|wi|schen; jmdm. eins - (ugs. für: schaden) aus|wit|tern (aus Mauerwerk u. a. sich ausscheiden) aus|wrin|gen, (landsch. auch:) ausringen Aus|wuchs aus|wuch|ten (bes. Kfz-Technik); Aus|wuch|tung Aus|wurf; aus|wurf|för|dernd; -e Mittel, aber (↑ R 142): Auswurf fördernd; Aus|würf|ling (Geol.: von einem Vulkan ausgeworfenes Magma- od. Gesteinsbruchstück); Aus|wurf[s]|mas|se (Geol.) aus|zah|len; das zahlt sich nicht aus (ugs. für: das lohnt sich nicht); aus|zäh|len; Aus|zah|lung; Aus|zäh|lung aus|zan|ken aus|zeh|ren; Aus|zeh|rung (Schwindsucht; Kräfteverfall) *w*; - aus|zeich|nen; sich -; vgl. ausgezeichnet; Aus|zeich|nung

aus|zie|hen; Aus|zieh|tisch aus|zir|keln; Aus|zir|ke|lung, Aus|zirk|lung aus|zi|schen Aus|zu|bil|den|de *m* u. *w*; *w*; -n, -n (↑ R 287 f.) Aus|zug (südd. auch für: Altenteil; schweiz. auch: erste Altersklasse der Wehrpflichtigen); Aus|zü|ger ¹ Aus|züg|ler schweiz. (Wehrpflichtiger der ersten Altersklasse); ²Aus|züg|ler landsch. (Altenteiler); Aus|zug|mehl; Aus|zugs|bau|er österr. (Altenteiler); aus|zugs|wei|se aus|zup|fen aut|ark *gr.* (sich selbst genügend: wirtschaftlich unabhängig vom Ausland); Aut|ar|kie (wirtschaftliche Unabhängigkeit vom Ausland durch Selbstversorgung) *w*; -, ...ien Au|then|tie *gr.* (svw. Authentizität) *w*; -; au|then|ti|fi|zie|ren *gr.*; *lat.* (die Echtheit bezeugen; beglaubigen) au|then|tisch *gr.* (im Wortlaut verbürgt; rechtsgültig); -ste (↑ R 294); au|then|ti|sie|ren (glaubwürdig, rechtsgültig machen); Au|then|ti|zi|tät (Echtheit; Rechtsgültigkeit) Au|to *gr.* (kurz für: Automobil) *s*; -s, -s; (↑ R 140:) Auto fahren; ich bin Auto gefahren; (↑ R 145:) Auto und radfahren, aber: radund Auto fahren au|to... *gr.* (selbst...); Au|to... (Selbst...) Au|to|bahn; au|to|bahn|ar|tig; Au|to|bahn_kreuz, ...rast|stät|te, ...span|ge, ...über|füh|rung, ...zu|brin|ger Au|to|bio|gra|phie *gr.* (literar. Darstellung des eigenen Lebens) *w*; -, ...ien; au|to|bio|gra|phisch Au|to|bus *gr.*; *lat.* (kurz für: Autoomnibus) *m*; ...busses, ...busse; vgl. auch: Bus Au|to|car *fr.* [*autokar*] schweiz. ([Reise]omnibus) *m*; -s, -s; vgl. Car au|to|chthon *gr.* [...*ehton*] (an Ort und Stelle [entstanden]; eingesessen); Au|to|chtho|ne (Ureinwohner[in], Eingeborene[r]) *m* u. *w*; -n, -n Au|to|coat (kurzer Mantel für den Autofahrer) *m*; -s, -s Au|to-Cross (Geländeprüfung für Autosportler); - Au|to|da|fé *port.* [...*dafé*] („Glaubensakt"; Ketzergericht u. -verbrennung) *s*; -s, -s Au|to|di|dakt *gr.* („Selbstlerner"; durch Selbstunterricht sich Bildender) *m*; -en, -en (↑ R 268); Au|to|di|dak|ten|tum *s*; -s; au|to|di|dak|tisch Au|to|drom *gr.-fr.* (ringförmige

Straßenanlage für Renn- u. Test-
fahrten; österr.: [Fahrbahn für]
Skooter) *s*; -s, -e
Au|to⌣drosch|ke, ...ein|fahrt,
...elek|tri|ker, ...fäh|re, ...fah|ren
(↑ R 120; *s*; -s; aber: Auto fah-
ren), ...fah|rer, ...fahrt, ...fried-
hof (ugs.)
au|to|gen *gr.* (ursprünglich; selbst-
tätig); -e Schweißung (mit heißer
Stichflamme erfolgende Schwei-
ßung); -es Training (eine Metho-
de der Selbstentspannung)
Au|to|gi|ro *span.* [...*sehiro*] (Hub-
schrauber) *s*; -s, -s
Au|to|gramm *gr.* (eigenhändig ge-
schriebener Name) *s*; -s, -e; Au|to-
gramm|jä|ger; Au|to|graph[1] (ei-
genhändig geschriebenes Schrift-
stück) *s*; -s, -en (seltener: -e); Au-
to|gra|phie[1] (Druckw.: Um-
druckverfahren) *w*; -, ...jen; au|to-
gra|phie|ren[1]; au|to|gra|phisch[1]
(durch Umdruckverfahren her-
gestellt; veralt. für: eigenhändig)
Au|to⌣hil|fe, ...hof (Einrichtung
des Güterfernverkehrs)
Au|to|hyp|no|se *gr.* (Selbstein-
schläferung)
Au|to⌣in|du|strie, ...kar|te, ...ki|no
(Freilichtkino, in dem man Filme
vom Auto aus betrachtet)
Au|to|klav *gr.*; *lat.* (Gefäß zum Er-
hitzen unter Druck) *m*; -s, -en
Au|to⌣knacker [*Trenn.:* ...knak-
ker], ...ko|lon|ne, ...kor|so
Au|to|krat *gr.* (Selbstherrscher;
selbstherrlicher Mensch) *m*; -en,
-en (↑ R 268); Au|to|kra|tie
(unumschränkte [Selbst]herr-
schaft) *w*; -, ...jen; au|to|kra|tisch;
-ste (↑ R 294)
Au|to|ly|se *gr.* (Med.: Abbau von
Organeiweiß ohne Bakterienhil-
fe; Selbstverdauung) *w*; -
Au|to⌣mar|ke
Au|to|mat *gr. m*; -en, -en (↑ R 268);
au|to|ma|ten|haft; Au|to|ma-
ten⌣knacker [*Trenn.:* ...knak-
ker], ...re|stau|rant; Au|to|ma|tik
(Vorrichtung, die einen techn.
Vorgang steuert u. regelt) *w*; -,
-en; Au|to|ma|ti|on *engl.* [...*zion*]
(vollautomatische Fabrikation)
w; -; au|to|ma|tisch *gr.* (selbsttä-
tig; selbstregelnd; unwillkürlich;
zwangsläufig); au|to|ma|ti|sie-
ren (auf vollautomatische Fabri-
kation umstellen); Au|to|ma|ti-
sie|rung; Au|to|ma|tis|mus (sich
selbst steuernder, unbewußter,
eigengesetzlicher Ablauf) *m*; -,
...men
Au|to|mi|nu|te (Zeit von einer Mi-
nute, die ein Auto fährt; meist
Mehrz.); zehn -n entfernt

¹ Auch eindeutschend: Autograf
usw.

Au|to|mo|bil *gr.*; *lat. s*; -s, -e; Au|to-
mo|bil⌣aus|stel|lung, ...bau (*m*;
-[e]s), ...in|du|strie; Au|to|mo|bi-
list bes. schweiz. (Autofahrer);
↑ R 268; Au|to|mo|bil|klub, aber:
Allgemeiner Deutscher Automo-
bil-Club (Abk.: ADAC); Auto-
mobilclub von Deutschland
(Abk.: AvD)
au|to|nom *gr.* (selbständig, unab-
hängig; eigengesetzlich); -es Ner-
vensystem; Au|to|no|mie (Selb-
ständigkeit, Unabhängigkeit; Ei-
gengesetzlichkeit) *w*; -, ...jen; Au-
to|no|mist (Vertreter der Autono-
mie); ↑ R 268
Au|to⌣öl
Au|to|pi|lot (automatische Steue-
rung von Flugzeugen, Raketen
u. ä.)
Au|to|pla|stik (Med.: Ersatz von
Gewebsverlusten durch Ver-
pflanzung körpereigenen Gewe-
bes)
Aut|op|sie *gr.* (eigenes Sehen, Au-
genschein; Med.: Leichenöff-
nung) *w*; -, ...jen
Au|tor *lat. m*; -s, ...oren; dem, den
Autor (nicht: Autoren)
Au|to⌣ra|dio, ...rei|fen, ...rei|se|zug
Au|to|ren|abend; Au|to|ren|kor-
rek|tur, (selten für:) Au|tor|kor-
rek|tur; Au|to|ri|sa|ti|on [...*zion*]
(Ermächtigung, Vollmacht); au-
to|ri|sie|ren; au|to|ri|siert ([ein-
zig] berechtigt); au|to|ri|tär (in il-
legitimer] Autoritätsanmaßung
handelnd, regierend; diktato-
risch); ein -er Lehrer; -es Regime;
Au|to|ri|tät (anerkanntes Anse-
hen; bedeutender Vertreter sei-
nes Faches; maßgebende Institu-
tion); au|to|ri|ta|tiv (sich auf ech-
te Autorität stützend, maßge-
bend); au|to|ri|täts|gläu|big; Au-
tor|kor|rek|tur, (selten:) Au|to-
ren|kor|rek|tur; Au|tor|re|fe|rat
(Referat des Autors über sein
Werk); Au|tor|schaft *w*; -
Au|to⌣schlan|ge, ...schlos|ser,
...schlüs|sel, ...ser|vice, ...skoo-
ter, ...stra|ße, ...stun|de (vgl. Au-
tominute)
Au|to|sug|ge|sti|on *gr.*; *lat.* (Selbst-
beeinflussung)
Au|to|te|le|fon
Au|to|to|mie *gr.* (Selbstverstüm-
melung) *w*; -, ...jen
Au|to|to|xin (Eigengift)
au|to|troph *gr.* (sich von anorgan.
Stoffen ernährend [von Pflan-
zen])
Au|to|ty|pie *gr.* (,,Selbstdruck'';
netzartige Bildätzung für Buch-
druck; Netz-, Rasterätzung) *w*;
-, ...jen
Au|to⌣un|fall, ...ver|kehr, ...ver-
leih, ...werk|statt, ...zu|sam|men-
stoß

autsch!
Au|ver|gne [*owärnj*ᵉ] (hist. Prov. im
mittleren Frankreich) *w*; -
Au|wald, Au|en|wald
au|weh!
Au|xi|li|ar|kraft *lat.*; *dt.* (veralt.
für: Hilfskraft)
Au|xin *gr.* (Pflanzenwuchsstoff) *s*;
-s, -e
a v. = a vista
Aval *fr.* [*awạl*] (Wechselbürg-
schaft, Rückgriffsrecht) *m* (selte-
ner: *s*); -s, -e; ava|lie|ren [Wech-
sel] als Bürge unterschreiben)
Avan|ce *fr.* [*awạng̱ß*ᵉ] (veralt. für:
Vorsprung, Gewinn; Geldvor-
schuß) *w*; -, -n; jmdm. Avancen
(Hoffnungen) machen; Avan|ce-
ment [*awang̱ß*ᵉ*mạng̱*, österr.:
awang̱ßmạng̱] (veralt. für: Beför-
derung) *s*; -s, -s; avan|cie|ren
[*awang̱ßir*ᵉ*n*] (befördert werden;
aufrücken)
Avan|ta|ge *fr.* [*awang̱tạsch*ᵉ] (ver-
alt. für: Vorteil; Gewinn); Avant-
gar|de [*awạng̱*..., auch: ...*gạrd*ᵉ]
(veralt. für: Vorhut; die Vor-
kämpfer für eine Idee);
Avant.gar|dis|mus, ...gar|dist
(Vorkämpfer); avant|gar|di-
stisch
avan|ti *it.* [*awạnti*] (ugs. für: ,,vor-
wärts!'')
AvD = Automobilclub von
Deutschland
Ave-Ma|ria *lat.* [*awe*...] (,,Gegrü-
ßet seist du, Maria!''; ein kath.
Gebet) *s*; -[s], -[s]; Ave-Ma|ria-
Läu|ten (↑ R 155) *s*; -s
Aven|tin [*awän*...] (Hügel in Rom)
m; -s; Aven|ti|ni|sche Hü|gel *m*;
-n -s
Aven|tiu|re *fr.* [*awäntür*ᵉ] (,,Aben-
teuer''; mittelhochd. Ritterer-
zählung) *w*; -, -n; (als Personifika-
tion:) Frau -
Aven|tu|rin *lat.* [*awän*...] (gold-
flimmriger Quarzstein) *m*; -s, -e;
Aven|tu|rin|glas
Ave|nue *fr.* [*aw*ᵉ*nü*] (,,Zufahrt'';
Prachtstraße) *w*; -, ...uen [...*ü*ᵉ*n*]
Aver|ro|es [*awäroäß*] (arab. Philo-
soph u. Theologe des Mittelal-
ters)
Avers *fr.* [*awärß*, österr.: *awär*]
(Vorderseite [einer Münze]) *m*;
-es, -e; Aver|si|on *lat.* (Abnei-
gung, Widerwille)
AVG = Angestelltenversiche-
rungsgesetz
Avi|cen|na [*awizäna*] (pers. Philo-
soph u. Arzt des Mittelalters)
Avi|gnon [*awinjong̱*] (fr. Stadt)
Avis *fr.* [*awị*, auch: *awịß*] (Wirtsch.:
Nachricht, Anzeige) *m* od. *s*; (für
[*awị*]:) -, -; (für [*awịß*]:) -es, -e;
avi|sie|ren (anmelden, ankündi-
gen); ¹Avi|so *span.* (leichtbewaff-
netes, kleines, schnelles Kriegs-

schiff) m; -s, -s; ²Avi|so it. österr.
(Avis) s; -s, -s

a vi|sta it. [a wißta] (bei Vorlage zahlbar; Abk.: a v.); vgl. a prima vista; Avi|sta|wech|sel (Sichtwechsel)

Avit|ami|no|se nlat. [awi...] (durch Vitaminmangel hervorgerufene Krankheit) w; -, -n

avi|vie|ren f). [uwiwi:ʀǝⁿ] (Färberei·schönen)

Avo|ca|do vgl. Avocato; Avo|ca|to indian.-span. [awokato] (birnenförmige, eßbare Frucht eines südamerik. Baumes) w; -, -s

Avus [awuß] (Kurzw. für: Automobil-Verkehrs- und -Übungsstraße [Autorennstrecke in Berlin, Teil der Stadtautobahn]) w; -

Awa|re (Angehöriger eines untergegangenen türk.-mongol. Steppennomadenvolkes) m; -n, -n (↑ R 268); awa|risch

Awe|sta pers. (,,Grundtext''; heilige Schriften der Parsen) s; -; awestisch; -e Sprache

¹Axel [Kurzform von: Absalom] (m. Vorn.); ²Axel (kurz für: Axel-Paulsen-Sprung) m; -s, -; doppelter-; Axel-Paul|sen-Sprung (nach dem norw. Eiskunstläufer A. Paulsen benannter Kürsprung); ↑ R 182

Axen|stra|ße (in der Schweiz) w; -

axi|al lat. (in der Achsenrichtung; [längs]achsig; achsrecht); Axia|li|tät (Achsigkeit); Axi|al|ver|schie|bung

axil|lar lat. (Bot.: achsel-, winkelständig); Axil|lar|knos|pe (Achselknospe)

Axi|om gr. (keines Beweises bedürfender Grundsatz) s; -s, -e; Axio|ma|tik (Lehre von den Axiomen) w; -; axio|ma|tisch (auf Axiomen beruhend, zweifellos, gewiß); -es System

Ax|min|ster|tep|pich [äkß...; nach dem engl. Ort]; ↑ R 201

Axo|lotl indian. (mexik. Schwanzlurch) m; -s, -

Axt w; -, Äxte; Axt|helm (Axtstiel); vgl. ²Helm

a. Z. = auf Zeit

Aza|lee gr., (auch:) Aza|lie [...iᵉ] (eine Zierpflanze aus der Familie der Heidekrautgewächse) w; -, -n

Aze|pha|le gr. (Mißgeburt ohne Kopf) m u. w; -n, -n (↑ R 268); Aze|pha|lie w; -, ...ien (Fehlen des Kopfes [bei Mißgeburten])

Aze|tat usw. vgl. Acetat usw.

Azid gr. (Salz der Stickstoffwasserstoffsäure) s; -[e]s, -e

Azid... (chem. fachsprachl. nicht mehr gewünschte Schreibung in Zusammensetzungen, die sich auf die Säure beziehen, z. B. Acidität, Acidose)

Azi|mut arab. (Astron.: eine bestimmte Winkelgröße) s (auch: m); -s, -e

Azo|farb|stoff gr.; dt. (ein Teerfarbstoff); Azo|grup|pe (eine Stickstoffgruppe); Azoi|kum gr. (erdgeschichtl. Urzeit ohne Spuren organ. Lebens) s; -s; azo|isch (Geol.: keine Lebewesen enthaltend); Azoo|sper|mie [azo-oßpärmi] (Fehlen der männl. Samenfäden) w; -, ...ien

Azo|ren (Inselgruppe im Atlantischen Ozean) Mehrz.

Az|te|ke (Angehöriger eines Indianerstammes in Mexiko) m; -n, -n (↑ R 268); Az|tg|ken|reich

Azu|le|jos span. [aßulgehoß] (bunte, bes. blaue Fayenceplatten) Mehrz.

Azur pers. (dicht. für: Himmelsblau) m; -s; azur|blau; Azu|ree|li|ni|en (waagerechte Linienband zur Ausfüllung in Vordrucken [z. B. auf Schecks]) Mehrz.; azu|riert (mit Azureelinien versehen); Azu|rit (ein Mineral) m; -s; azurn (dicht. für: himmelblau)

azy|klisch gr. [auch. uzü...] (ohne Zyklus; bei Blüten: spiralig gebaut)

B

B (Buchstabe); das B; des B, die B, aber: das b in Abend (↑ R 123); der Buchstabe B, b

b, B (Tonbezeichnung) s; -, -; b (Zeichen für: b-Moll); in b; B (Zeichen für: B-Dur); in B

B = Zeichen für: Bel

B = chem. Zeichen für: Bor

B (auch: Kurzzetteln) = Brief (d. h., das Wertpapier wurde zum angegebenen Preis angeboten)

B, β = Beta

b. = bei[m]

B. = Bolivar

Ba = chem. Zeichen für: Barium

Baal hebr. [bạl] (semit. Wetter- und Himmelsgott) m; -[e]s

Baar (Gebiet zwischen dem Schwarzwald u. der Schwäbischen Alb) w; -

Baas niederl. niederd. (Herr, Meister, Aufseher [bes. Seemannsspr.]) m; -es, -e

ba|ba (Kinderspr.); das ist -!

bab|beln (ugs. für: schwatzen); ich ...[e]le (↑ R 327)

Ba|bel vgl. Babylon

Ba|ben|ber|ger (Angehöriger eines Fürstengeschlechtes) m; -s, -

Ba|bet|te (Nebenform von: Barbara od. Elisabeth)

Ba|bu|sche, Pam|pu|sche pers. [auch: ...ụsche] landsch., bes. ostmitteld. (Stoffpantoffel) w; -, -n (meist Mehrz.)

Ba|by engl. [bẹbi] (Säugling, Kleinkind) s; -s, -s

Ba|by|lon, Ba|bel (Ruinenstadt am Euphrat); Ba|by|lo|ni|en [...iᵉn] (antiker Name für das Land zwischen Euphrat u. Tigris); Ba|by|lo|ni|er [...iᵉr]; ba|by|lo|nisch, ↑ Kunst, Religion, aber (↑ R 224): die Babylonische Gefangenschaft; der Babylonische Turm

Ba|by.sit|ter (m; -s, -), ...wä|sche

Bac|cha|nal gr. [baehangl, österr. auch; bạkanal] (altröm. Bacchusfest; wüstes Trinkgelage) s; -s, -e u. -ien [...iᵉn]; Bac|chant (Trinkbruder; trunkener Schwärmer) m; -en, -en (↑ R 268); Bac|chan|tin w; -, -nen; bac|chan|tisch (trunken; ausgelassen); bac|chisch (nach Art des Bacchus); Bac|chi|us (antiker Versfuß) m; -, ...ien; Bac|chus (gr.-röm. Gott des Weines); Bac|chus|fest (↑ R 180)

¹Bach m; -[e]s, Bäche

²Bach, Johann Sebastian (dt. Komponist); vgl. Bach-Werke-Verzeichnis

bach|ab (schweiz.); - gehen (zunichte werden); - schicken (verwerfen, ablehnen)

Ba|che (w. Wildschwein) w; -, -n

Bä|chel|chen, Bäch|lein; Bach.fo|rel|le, ...stel|ze

Bach-Wer|ke-Ver|zeich|nis (so die nicht den Regeln entsprechende Schreibung im Buchtitel; Abk.: BWV); ↑ R 181

bạck (Seemannsspr. u. Seemannsspr.: zurück)

Bạck (Seemannsspr.: [Eß]schüssel; Eßtisch; Tischgemeinschaft; Aufbau auf dem Vordeck) w; -, -en

Bạck|bord (linke Schiffsseite [von hinten gesehen]) s; -[e]s, -e; bạck|bord[s]; Bạck|deck

Bäck|chen; Backe¹ w; -, -n u. Bak|ken (landsch.) m; -s, -

backen¹ (Brot usw.); du bäckst (auch: backst); er bäckt (auch: backt); du backtest (älter: buk[e]st); gebacken; back[e]!; Beugung in der Bedeutung von ,,kleben'' (vgl. ,,festbacken''): der Schnee backt, backte, hat gebackt; ...backen¹ (z. B. altbacken)

Backen|bart¹; Backen|zahn¹; Back|zahn

Bäcker¹; Bäcke|rei¹ (österr. auch: süßes Kleingebäck); Bäcker¹-jun|ge, ...krät|ze, ...la|den; Bäcker[s]|frau¹

¹Trenn.: ...k|k...

Back|fisch (auch: halbwüchsiges Mädchen)

Back|ground engl. [bǟkgraunt] (Hintergrund; übertr.: [Lebens]erfahrung) m; -s

Back|hand engl. [bǟkhänt] (Sportspr.: Rückhandschlag) w; -, -s (auch: m; -[s], -s)

Back|hendl österr. (Backhuhn) s; -s, -[n]; **Back|hendl|sta|ti|on** (österr.)

...backig¹, ...bäckig¹ (z. B. rotbackig, rotbäckig)

Back|obst, ...ofen

Back|pfei|fe (Ohrfeige); **back|pfei|fen**; er backpfeifte ihn, hat ihn gebackpfeift; **Back|pfei|fen|ge|sicht** (ugs.)

Back|pflau|me, ...rohr (österr. für: Backofen), **...röh|re**

Back|schaft (Seemannsspr.: Tischgemeinschaft); **Back|stag** (den Mast von hinten haltendes [Draht]seil)

Back|stein; Back|stein|bau (Mehrz. ...bauten)

Back|wa|re (meist Mehrz.)

Back|zahn, Backen|zahn¹

¹**Ba|con** [bĕ'k^en] (leicht gesalzener u. geräucherter Frühstücksspeck) m; -s; **Ba|con|schwein** (Schwein mit zartem Fleisch und dünner Speckschicht)

²**Ba|con** [bĕ'k^en] (engl. Philosoph) **Bad** s; -[e]s, Bäder; Bad Ems, Bad Homburg v. d. H., Stuttgart-Bad Cannstatt († R 213); **Bad...** südd., österr., schweiz. (in Zusammensetzungen neben: Bade..., z. B. Badanstalt)

Bad Aus|see vgl. Aussee

Ba|de_an|stalt, ...an|zug, ...arzt, ...ho|se, ...man|tel, ...mei|ster; ba|den; - gehen

Ba|den; Ba|den-Ba|den (Badeort im nördl. Schwarzwald); **Ba|de|ner,** (auch:) **Ba|den|ser** († R 199); **Ba|den-Würt|tem|berg;** ↑ R 212 (Land); **ba|den-würt|tem|ber|gisch**

Ba|de|ort m; -[e]s, -e

Ba|der (veraltet für: Barbier; Heilgehilfe; österr. auch für: Kurpfuscher)

Ba|de_sai|son, ...salz, ...tuch, ...wan|ne, ...zeit, ...zim|mer

Bad|ga|stein (österr. Badeort)

ba|disch (aus Baden), aber († R 224): die Badische Anilin- & Soda-Fabrik AG (Abk.: BASF)

Bad Ischl vgl. Ischl

Bad|min|ton [bädmint^n; nach dem Landsitz des Herzogs von Beaufort in England] (Federballspiel) s; -

Bad Oeynhausen vgl. Oeynhausen

¹ *Trenn.:* ...k|k...

Bae|de|ker ⓦ [bä...; nach dem Verleger] (ein Reisehandbuch) m; -s (auch: -), -

Ba|fel jidd. (ugs. für: Ausschußware; landsch. für: letztes Gras auf den Wiesen, das man von den Tieren abfressen läßt; nur Einz.: Geschwätz) m; -s, -

baff (ugs für: verblüfft); - sein

Ba|ga|ge fr. [bagaseh^e] (veralt. für: Gepäck, Troß; ugs. für: Gesindel)

Ba|gas|se fr. (Preßrückstand bei der Rohrzuckergewinnung) w; -, -n

Ba|ga|tel|le fr. (unbedeutende Kleinigkeit; kleines, leichtes Musikstück) w; -, -n; **ba|ga|tel|li|sie|ren** (als unbedeutende Kleinigkeit behandeln); **Ba|ga|tell|sa|che**

Bag|dad [auch: bak...] (Hptst. des Iraks); **Bag|da|der** [auch: bak...] († R 199)

Bag|ger (Gerät zum Wegschaffen von Erdreich od. Geröll) m; -s,-; **Bag|ge|rer; bag|gern;** ich ...ere († R 327); **Bag|ger_füh|rer, ...prahm, ...schau|fel; Bag|ge|rung**

Ba|gno it. [banjo] ("Bad"; früher für: Kerker [in Italien und Frankreich]) s; -s, -s u. ...gni

Bag|stall ostösterr. ("beigestellter" Pfosten, Stützpfosten) m; -s, -e u. ...ställe

bah!, pah (ugs.)

bäh! (ugs.)

Ba|ha|ma|in|seln, Ba|ha|mas (Inselgruppe im Karibischen Meer) *Mehrz.*

bä|hen (mdal.: [durch warme Umschläge] erweichen; südd., österr., schweiz.: [Brot] leicht rösten)

Bahn w; -, -en; sich Bahn brechen (ich breche mir Bahn); **bahn|amt|lich; bahn|bre|chend;** -ste; eine -e Erfindung, aber († R 142): sich eine Bahn brechend, ging er durch die Menge; **Bahn|bre|cher; Bahn|bus** (Kurzw. für: Bahnomnibus); **Bahn|ca|mion|na|ge** dt.; fr. [...kamjongseh^e] schweiz. (Bahn-Haus-Lieferdienst) w; -; **Bahn|ca|mion|neur** [...nör] schweiz. (Bahn-Haus-Spediteur) m; -s, -e; **bahn|ei|gen; bah|nen; bah|nen|wei|se; Bahn|hof** (Abk.: Bf., Bhf.); **Bahn|hofs_buch|hand|lung, ...büffet** od. **...buf|fet** (österr.), **...hal|le, ...ki|osk, ...vorstand** (österr. für: Bahnhofsvorsteher); **Bahn|kor|rek|tur; bahn|la|gernd;** -e Sendungen; **Bahn|li|nie, ...steig; Bahn|steig|kar|te; Bahn|wär|ter**

Ba|höl österr. ugs. (großer Lärm, Tumult) m; -s

Bah|rain (Inselgruppe u. Scheich-

tum im Persischen Golf); **Bah|rai|ner** († R 199); **bah|rai|nisch**

Bah|re w; -, -n; **Bahr|tuch** (*Mehrz.* ...tücher)

Baht (Währungseinheit in Thailand) m; -,-

Bä|hung (Heilbehandlung mit warmen Umschlägen oder Dämpfen)

Bai niederl. (Bucht) w; -, -en

Bai|er vgl. Bayer

Bai|kal|see [auch: baikal...] (See in Südsibirien) m; -s

bai|risch vgl. bay[e]risch

Bai|ser fr. [bäse] ("Kuß"; Schaumgebäck) s; -s, -s

Bais|se fr. [bäß^e] ([starkes] Fallen der Börsenkurse od. Preise) w; -, -n; **Bais|sier** [bäßie] (auf die Baisse Spekulierender) m; -s, -s

Ba|ja|de|re fr. (ind. [Tempel]tänzerin) w; -, -n

Ba|jaz|zo it. (Possenreißer; auch Titel einer Oper von Leoncavallo) m; -s, -s

Ba|jo|nett [nach der Stadt Bayonne in Südfrankreich] (Seitengewehr) s; -[e]s, -e; **ba|jo|net|tie|ren** (mit dem Bajonett fechten); **Ba|jo|nett|ver|schluß** (Schnellverbindung von Rohren, Stangen od. Hülsen)

Ba|ju|wa|re (älterer Name für einen Bayern [vgl. Bayer]; heute scherzh. verwendet) m; -n, -n († R 268); **ba|ju|wa|risch**

Ba|ke (festes Orientierungszeichen für Seefahrt, Luftfahrt, Straßenverkehr; Vorsignal auf Bahnstrecken) w; -, -n

Ba|ke|lit ⓦ [nach dem belg. Chemiker Baekeland] (ein Kunstharz) s; -s; **ba|ke|li|sie|ren** (einen Stoff, z. B. Holz, mit Bakelit durchtränken); **ba|ke|li|tie|ren** (einen Stoff mit Bakelit überziehen)

Ba|ken|ton|ne (ein Seezeichen)

Bak|ka|lau|re|at lat. (unterster akadem. Grad [in Frankreich, England u. Nordamerika]) s; -[e]s, -e; **Bak|ka|lau|re|us** [...e-uß] (Inhaber des Bakkalaureats) m; -, ...rei [...re-i]

Bak|ka|rat fr. [...ra] (ein Kartenglücksspiel) s; -s

Bak|ken norw. (Schisport: Sprungschanze) m; -[s], -

Bak|schisch pers. (Almosen; Trinkgeld; Bestechungsgeld) s; -[e]s, -e

Bak|te|ri|ä|mie gr. (Überschwemmung des Blutes mit Bakterien) w; -, ...ien; **Bak|te|rie** [...i^e] (Spaltpilz) w; -, -n; **bak|te|ri|ell; bak|te|ri|en|be|stän|dig** (widerstandsfähig gegenüber Bakterien); **Bak|te|ri|en_fil|ter, ...trä|ger; Bak|te|rio|lo|ge** (Wissenschaftler auf

155 | **Balte**

dem Gebiet der Bakteriologie) *m*; -n, -n (↑ R 268); **Bak|te|rio|lo|gie** (Lehre von den Bakterien) *w*; -; **bak|te|rio|lo|gisch**; -e Fleischuntersuchung; **Bak|te|rio|ly|se** (Auflösung, Zerstörung von Bakterien) *w*; -, -n; **Bak|te|rio|pha|ge** (Kleinstlebewesen, das Bakterien vernichtet) *m*; -n, -n (↑ R 268); **Bak|te|rig|se** (durch Bakterien verursachte Pflanzenkrankheit) *w*; -, -n; **Bak|te|ri|um** (veralt. für: Bakterie) *s*; -s, ...ien [...*i*ᵉ*n*]; **bak|te|ri|zid** (bakterientötend); **Bak|te|ri|zid** (keimtötendes Mittel) *s*; -s, -e **Bak|tri|en** [...*i*ᵉ*n*] (altpers. Landschaft)

Ba|ku (russ. Stadt am Kaspischen Meer)

Ba|la|lai|ka *russ.* (russ. Saiteninstrument) *w*; -, -s u. ...ken

Ba|lan|ce *fr.* [*balanßᵉ⁽ᵉ⁾*] (Gleichgewicht) *w*; -, -n; **Ba|lan|ce|akt**; **Ba|lan|ce|ment** [*balanßᵉmang*] (Musik: „Bebung" beim Klavichord) *s*; -s; **ba|lan|cie|ren** [*balanßßirᵉn*] (das Gleichgewicht halten, ausgleichen); **Ba|lan|cier|bal|ken**, ...stan|ge

Ba|la|ta indian.-span. [auch: *balata*] (kautschukähnliches Naturerzeugnis) *w*; -

Ba|la|ton ung. [*boloton*] (ung. Name für den Plattensee) *m*; -[s]

Ba|la|tum ⓦ [auch: *balatum*] (ein Fußbodenbelag) *s*; -s

Bal|bier (ugs. für: Barbier) *m*; -s, -e; **bal|bie|ren** (ugs. für: rasieren); jmdn. über den Löffel - [auch: barbieren] (ugs. für: betrügen)

Bal|boa [nach dem gleichnamigen span. Entdecker] (Münzeinheit in Panama) *m*; -[s], -[s]

bald; Steigerung: eher, am ehesten; möglichst - (besser als: baldmöglichst); so - als od. wie möglich; baldigst

Bal|da|chin [*baldachin*, österr. geh. auch: ...*chin*] [nach der Stadt Baldacco, d. h. Bagdad] (Trag-, Betthimmel) *m*; -s, -e; **bal|da|chin|ar|tig**

Bäl|de, nur noch in: in - (Papierdt.: bald); **bal|dig**; -st; **bald|mög|lichst** (dafür besser: möglichst bald)

bal|do|wern (seltener für: ausbaldowern; vgl. d.)

Baldr, **Bal|dur** (nord. Mythol.: Lichtgott)

Bal|dri|an (eine Heilpflanze) *m*; -s, -e; **Bal|dri|an|tee**, ...**tink|tur**, ...**trop|fen** (*Mehrz.*)

Bal|du|in (m. Vorn.)

Bal|dur (m. Vorn.; auch neuisländ. für: Baldr)

Ba|lea|ren (Inselgruppe im westl. Mittelmeer) *Mehrz.*

Balg (Tierhaut; Luftsack; ausge-

stopfter Körper einer Puppe; auch für: Balgen) *m*; -[e]s, Bälge; **²Balg** (ugs. für: unartiges Kind) *m* od. *s*; -[e]s, Bälger

Bal|ge nordd. (Waschfaß, Kufe; Wasserlauf im Watt) *w*; -, -n

bal|gen, sich (ugs. für: raufen); **Bal|gen** (ausziehbare Hülle des Fotografenapparates) *m*; -s, -; **Bal|gen|ka|me|ra**; **Bal|ge|rei**; **Balg.ge|schwulst**, ...**ver|schluß**

Ba|li (westlichste der Kleinen Sundainseln)

Bal|kan (Gebirge; auch für: Balkanhalbinsel) *m*; -s; **Bal|kan|halb|in|sel** (↑ R 201); **bal|ka|nisch**; **bal|ka|ni|oie|ren** (ein Land in Kleinstaaten aufteilen, polit. Verwirrung schaffen); **Bal|ka|ni|sie|rung** *w*; -; **Bal|kan|krieg**; **Bal|ka|no|lo|ge** (Wissenschaftler auf dem Gebiet der Balkanologie) *m*; -n, -n (↑ R 268); **Bal|ka|no|lo|gie** (wissenschaftl. Erforschung der Balkansprachen u. -literaturen) *w*; -

Bälk|chen; **Bal|ken** *m*; -s, -; **Bal|ken.kon|struk|ti|on**, ...**kopf**, ...**schröt|ter** (Zwerghirschkäfer), ...**waa|ge**; **Bal|kon** *fr.* [*balkong*, (fr.:) ...*kong*, (auch, bes. südd.-österr. u. schweiz.:) ...*kon*] *m*; -s, -s u. (bei nichtnasalierter Ausspr.:) -e; **Bal|kon|mö|bel**

¹Ball (runder Körper) *m*; -[e]s, Bälle; Ball spielen (↑ R 140), aber: das Ballspielen (↑ R 120)

²Ball *fr.* (Tanzfest) *m*; -[e]s, Bälle; **Ball|abend**

Ball|ab|ga|be (Sportspr.)

Bal|la|de *gr.* (episch-dramatisches Gedicht); **bal|la|den|haft**; **bal|la|desk**; -e Erzählung; **Bal|la|den|stoff**

Ball|an|nah|me (Sportspr.)

Bal|last [auch, österr. nur: *balaßt*] (tote Last; Bürde) *m*; -[e]s, (selten:) -e

Bal|la|watsch vgl. Pallawatsch

Ball|be|hand|lung (Sportspr.)

Bäll|chen

Bal|lei *lat.* ([Ritter]ordensbezirk) **bal|len**; **Bal|len** *m*; -s, -; **Bal|len|ei|sen** (ein Werkzeug); **Bal|len|stedt** (Stadt am Harz); **Bal|le|rei** (sinnloses, lautes Schießen)

Bal|le|ri|na, **Bal|le|ri|ne** it. (Ballettänzerin) *w*; -, ...nen; **Bal|le|ri|no** (Balletttänzer) *m*; -s, -s u. ...ni

Bal|ler|mann (scherzh. für: Revolver) *m*; -s, ...männer; **bal|lern** (ugs. für: knallen); ich ...ere (↑ R 327)

Bal|le|stern österr. ugs. (Ball spielen) (↑ R 327)

Bal|lett *it.* (Bühnen-, Schautanz; Tanzgruppe) *s*; -[e]s, -e; **Bal|lett|tänzerin** [*Trenn.*: Bal|lett|tän-

ze|rin, ↑ R 236] *w*; -, -nen; **Bal|let|teu|se** *fr.* [*baletös*ᵉ] (Ballettänzerin) *w*; -, -n; **Bal|lett|thea|ter** [*Trenn.*: Bal|lett|thea|ter, ↑ R 236]; **Bal|lett|korps** (Theatertanzgruppe), ...**mei|ster**; **Bal|lett|trup|pe** (↑ R 237)

Ball|füh|rung (Sportspr.), ...**ge|fühl** (Sportspr.)

ball|hor|ni|sie|ren vgl. verballhornen

bal|lig (ballförmig, gerundet); -drehen (Mech.)

Bal|li|ste *gr.* (antikes Wurfgeschütz) *w*; -, -n; **Bal|li|stik** (Lehre von der Bewegung geschleuderter od. geschossener Körper) *w*; -; **Bal|li|sti|ker**; **bal|li|stisch**; -e Kurve (Flugbahn); -es Pendel (Stoßpendel); -e Theorie (Physik); -e Wetterdaten (Meteor.)

Ball|jun|ge (Junge, der beim Tennis die Bälle aufsammelt)

Bal|lo|kal [*Trenn.*: Ball|lo|kal, ↑ R 236]

Bal|lon *fr.* [*balong*, (fr.:) ...*long*, (auch, bes. südd., österr. u. schweiz.:) ...*lon*] (mit Gas gefüllter Ball; Korbflasche; Glaskolben; Luftfahrzeug) *m*; -s, -s u. (bei nichtnasalierter Ausspr.:) -e; **Bal|lo|nett** (Luft-[Gas-]Kammer im Innern von Fesselballons und Luftschiffen) *s*; -[e]s, -e u. -s; **Bal|lon.müt|ze**, ...**rei|fen**, ...**sper|re**; **Bal|lot** [*balo*] (kleiner Warenballen) *s*; -s, -s; **Bal|lo|ta|de** (Sprung des Pferdes bei der Hohen Schule); **Bal|lo|ta|ge** [...*gasch*ᵉ] (geheime Abstimmung mit weißen od. schwarzen Kugeln); **Bal|lo|tie|ren**

Ball|spiel, **Ball|spie|len** *s*; -s, aber (vgl. S. 42, R 140): Ball spielen; **Ball|tech|nik** (Sportspr.)

Bal|lung; **Bal|lungs.ge|biet**, ...**raum**

Ball|wech|sel (Sportspr.)

Bal|ly|hoo engl. [*bälihu* od. *bälihu*] (Reklamerummel) *s*; -

Bal|mung (Name von Siegfrieds Schwert)

Bal|neo|gra|phie *gr.* (Bäderbeschreibung) *w*; -, ...ien; **Bal|neo|lo|gie** (Bäderkunde) *w*; -; **Bal|neo|the|ra|pie** (Heilung durch Bäder) *w*; -

Bal pa|ré *fr.* [*bal pare*] (festlicher Ball) *m*; - -, - -s [*bal pare*]

Bal|sam *hebr.* (Gemisch von Harzen mit ätherischen Ölen, bes. als Linderungsmittel; in gehobener Sprache auch: Linderung, Labsal) *m*; -s, -e; **bal|sa|mie|ren** (einsalben) *w*; -, -n; **Bal|sa|mie|rung**; **Bal|sa|mi|ne** (eine Zierpflanze) *w*; -, -n; **bal|sa|misch** (würzig; lindernd); **Bal|sam|kraut**

Bal|te (Angehöriger der baltischen Sprachfamilie; früherer

[deutscher] Bewohner des Balti-
kums) *m*; -n, -n (↑ R 268); **Bal|ten-
land** *s*; -[e]s
Bal|tha|sar (m. Vorn.)
Bal|ti|kum (die balt. Randstaaten;
Baltenland) *s*; -s
Bal|ti|more [*baltimor*] (Stadt in
den USA)
bal|tisch, a b e r (↑ R 198): der Balti-
sche Höhenrücken; **bal|to|sla-
wisch** (↑ R 214)
Ba|lu|ba (Angehöriger eines Ban-
tustammes in der Demokrat. Re-
publik Kongo) *m*; -[s], -[s]
Ba|lu|ster *fr.* (kleine Säule als Ge-
länderstütze) *m*; -s, -; **Ba|lu|ster-
säu|le**; **Ba|lu|stra|de** (Brüstung,
Geländer)
Balz (Paarungsspiel und Paa-
rungszeit bestimmter Vögel) *w*;
-, -en
Bal|zac [*balsak*] (fr. Schriftsteller)
bal|zen (werben [von bestimmten
Vögeln]); **Balz_ruf**, ...**zeit**
Bam|berg (Stadt an der Regnitz);
Bam|ber|ger (↑ R 199); – Reiter
(bekanntes Standbild im Bam-
berger Dom); **bam|ber|gisch**
Bam|bi (Filmpreis) *m*; -s, -s; **Bam-
bi|no** *it.* („Kindlein"; Jesuskind;
ugs. für: kleines Kind, kleiner
Junge) *m*; -s, ...ni u. (ugs.:) -s
Bam|bus *malai.* (trop. Riesengras)
m; ...busses u. -, ...busse; **Bam-
bus_hüt|te**, ...**rohr**, ...**stab**
Bam|mel (ugs. für: Angst) *m*; -s
bam|meln (ugs. für: baumeln); ich
bamm[e]le (↑ R 327)
Bam|per|letsch, **Pam|per|letsch** *it.*
österr. ugs. (kleines Kind) *m*;
-[e]s, -e
¹**Ban** *m*; -s, -e u. **Ba|nus** („Herr";
ung. u. kroat. Würdenträger) *m*;
-, -
²**Ban** (rumän. Münze) *m*; -[s], Bani
ba|nal *fr.* (alltäglich, fade, flach);
Ba|na|li|tät
Ba|na|ne *afrik.-port.* (eine trop.
Pflanze u. Frucht) *w*; -, -n; **Ba|na-
nen_rei|fe|rei**, ...**stecker** [*Trenn.:*
...**stek|ker**] (Elektrotechnik)
¹**Ba|nat** *serbokroat.* (Banschaft) *s*;
-[e]s, -e; ²**Ba|nat** (Gebiet zwischen
Donau, Theiß u. Maros) *s*; -[e]s
Ba|na|ter (↑ R 199)
Ba|nau|se *gr.* (Mensch ohne
Kunstsinn; Spießbürger) *m*; -n,
-n (↑ R 268); **Ba|nau|sen|tum** *s*; -s;
ba|nau|sisch
¹**Band** (Buch; Abk.: Bd.) *m*; -[e]s,
Bände (Abk.: Bde.); ²**Band** (Fes-
sel) *s*; -[e]s, -e; außer Rand und
-; ³**Band** ([Gewebe]streifen; Ge-
lenkband) *s*; -[e]s, Bänder; auf-
spielen, sprechen, am laufenden
Band
⁴**Band** *engl.* [*bänt*] (Gruppe von
Musikern, bes. Tanzkapelle u.
Jazzband) *w*; -, -s

Ban|da|ge *fr.* [...*aseh*ᵉ] (Stütz- od.
Schutzverband); **ban|da|gie|ren**
[...*sehir*ᵉ*n*] (mit Bandagen verse-
hen); **Ban|da|gist** [...*sehißt*] (Her-
steller von Bandagen u. Heilbin-
den) ↑ R 268
Band|auf|nah|me|ge|rät; **Band-
brei|te**
Bänd|chen *s*; -s, - u. (für: [Gewebe]-
streifen:) Bänderchen; **Bändlein**
¹**Ban|de** (Einfassung, z. B. Bil-
lardbande) *w*; -, -n
²**Ban|de** *fr.* (abwertend für: Schar,
z. B. Räuber-, Schülerbande) *w*;
-, -n
Band_ei|sen; **Ban|del** bayr., österr.
(Bendel) *s*; -s, - u. **Bän|del** schweiz.
(Bendel) *m*; -s, -
Ban|den|spek|trum (Physik)
Bän|der|chen (*Mehrz.* von: Bänd-
chen)
Ban|de|ril|la span. [...*rilja*] (mit
Bändern, Fähnchen u. a. ge-
schmückter Wurfpfeil, den der
Banderillero dem Stier in den
Nacken stößt) *w*; -, -s; **Ban|de|ril-
le|ro** [...*riljero*] (der im Stier-
kampf die Banderillas dem Stier
in den Nacken stößt) *m*; -s, -s
Bän|der|leh|re (Med.); **bän|dern**;
ich ...ere (↑ R 327)
Ban|de|ro|le *fr.* (Steuerband) *w*; -,
-n; **Ban|de|ro|len|steu|er** (Strei-
fensteuer) *w*; **ban|de|ro|lie|ren**
(mit Banderole[n] versehen; ver-
steuern); **Ban|de|ro|lie|rung**
Bän|der|ton (Geol.; *Mehrz.* ...to-
ne); **Bän|de|rung**
Band_för|de|rer, ...**ge|ne|ra|tor**,
...**gras** (*s*; -es)
...**bän|dig** (z. B. vielbändig)
bän|di|gen; **Bän|di|ger**; **Bän|di-
gung**
Ban|dit *it.* ([Straßen]räuber) *m*;
-en, -en (↑ R 268); **Ban|di|ten|we-
sen**
Band|ke|ra|mik (älteste steinzeit-
liche Kultur Mitteleuropas) *w*; -
Band_lea|der *engl.* [*bändljd*ᵉ*r*] (im
traditionellen Jazz der der Füh-
rungsstimme [vgl. Lead] über-
nehmende Kornett- od. Trompe-
tenbläser; [Jazz]kapellmeister)
m; -s, -
Bänd_lein; **Bänd|chen**; **Band_maß**
s, ...**nu|deln** (*Mehrz.*)
Ban|do|ne|on u. **Ban|do|ni|on** [nach
dem dt. Erfinder Band (ein Mu-
sikinstrument) *s*; -s, -s
Band_sä|ge; **Band|schei|ben|scha-
den**; **Bänd|sel** (Seemannsspr.:
dünnes Tau) *s*; -s, -
Ban|dung (Hptst. der indonesi-
schen Provinz Westjava); **Ban-
dung_kon|fe|renz** (Konferenz, auf
der die asiat. u. afrikan. Staaten
kulturelle u. wirtschaftliche
Zusammenarbeit vereinbarten)
w; -; ↑ R 201

Band_wurm; **Band|wurm|be|fall**
Ban|ga|li (Einwohner von Bangla-
desch) *m*; -[s], -[s]; **ban|ga|lisch**
Bang_büx od. ...**bü|xe** od. ...**bu|xe**
nordd. (scherzh. für: Angsthase)
w; -, ...xen; **bang**, **ban|ge**; banger
u. bänger; am bangsten u. am
bängsten (↑ R 134 u. R 295); mir
ist angst u. bang[e] (↑ R 132); ban-
ge machen, a b e r (↑ R 120): das
Bangemachen; Bangemachen
(auch: bange machen) gilt nicht;
Ban|ge landsch. (Angst) *w*; -; **ban-
gen**
bang_frei; -e Rinderbestände
Ban|gig|keit *w*; -
Bang|ka (eine Sundainsel)
Bang|kok (Hptst. von Thailand)
Bang|la_desch (so die Schreibweise
im Verzeichnis der ausländischen
Staatennamen für den amtl. Ge-
brauch in der BRD), (häufig auch
in der engl. Form:) **Ban|gla Desh**,
Ban|gla|desh [*bänggl'däsch*]
(Staat am Golf von Bengalen);
vgl. Bangali
bäng|lich; **Bang|nis** *w*; -, -se
Bang|sche Krank|heit [nach dem
dän. Tierarzt B. Bang] (von
erkrankten Kühen auf Menschen
übertragbare fieberhafte Krank-
heit mit Leber- u. Milzvergröße-
rung) *w*; -n-
Ban|gui [*banggi*] (Hauptstadt der
Zentralafrikanischen Republik)
Ba|ni vgl. Ban
Ban|jo amerik. [auch: *bändscho*]
(ein Musikinstrument) *s*; -s, -s
¹**Bank** (Sitzgelegenheit) *w*; -, Bän-
ke; ²**Bank** *it.*(-*fr.*) (Kreditanstalt)
w; -, -en
Ban|ka vgl. Bangka; **Ban|ka|zinn**
Bank_ak|zept (ein auf eine ²Bank
bezogener Wechsel), ...**be|am|te**,
...**be|am|tin**, ...**buch**; **Bänk|chen**,
Bänk|lein; **Bank|ei|sen** (gelochtes
Flacheisen an Tür- u. Fenster-
rahmen)
Bän|kel_lied, ...**sän|ger**; **bän|kel-
sän|ge|risch**
Ban|ker (ugs. für: Bankier, Bank-
fachmann); **ban|ke|rott** usw. vgl.
bankrott usw.
Ban|kert (abwertend für: unehe-
liches Kind) *m*; -s,-e
¹**Ban|kett** (Festmahl) *s*; -[e]s, -e;
²**Bank|kett** *fr.* *s*; -[e]s, -e, (auch:)
Ban|ket|te *fr.* ([unfester] Rand-
streifen neben einer Straße) *w*;
-, -n
bank_fä|hig; -er Wechsel; **Bank-
_fei|er|tag**, ...**gut|ha|ben**, ...**hal|ter**
(Spielleiter bei Glücksspielen);
Ban|kier *fr.*[*bangkie*]ᵗ Inhaber ei-
nes Bankhauses) *m*; -s, -s; **Bank-
kon|to**; **Bänk|lein**; Bänkchen;
Bank_note, ...**raub**, ...**räuber**
bank_rott *it.* (zahlungsunfähig;
auch übertr.: am Ende, erledigt);

- gehen, sein, werden; Bank|rott *m*; -[e]s, -e; - machen; Bank|rott|er|klä|rung; Bank|rot|teur [...*tör*] (Person, die Bankrott macht) *m*; -s, -e; bank|rot|tie|ren; Bank_tre|sen, ...we|sen

Bann (Ausschluß [aus einer Gemeinschaft]; Gerichtsbarkeit; abgegrenztes Gebiet; zwingende Gewalt) *m*; -[e]s, -e; **Bann_bruch** *m*, ...bul|le *w*; ban|nen

Ban|ner (Fahne) *s*; -s, -; **Ban|ner|trä|ger**

Bann_fluch, ...gut

ban|nig nordd. (ugs. für: sehr)

Bann_kreis, ...mei|le, ...strahl, ...wald (Schutzwald gegen Lawinen), ...wa|re, ...wart (schweiz. (für: Flur- und Waldhüter)

Ban|se mitteld. u. niederd. (Lagerraum in einer Scheune) *w*; -, -n; ban|sen, (auch:) bänseln; Getreide, Holz - (mitteld. u. niederd. für: aufladen, aufschichten); du banst (bansest)

Ban|tam (Ort auf Java); **Ban|tam|ge|wicht** (Körpergewichtsklasse in der Schwerathletik); **Ban|tam|huhn** (Zwerghuhn)

Ban|tu (Angehöriger einer Sprach- u. Völkergruppe in Afrika) *m*; -[s], -[s]; **Ban|tu|ne|ger**

Ba|nus vgl. ¹Ban

Bao|bab afrik. (Affenbrotbaum) *m*; -s, -s

Ba|pho|met arab. ([angebl.] Götzenbild der Tempelherren) *m*; -[e]s

Bap|tis|mus gr. („Taufe"; Lehre evangel. Freikirchen, die nur die Erwachsenentaufe zuläßt) *m*; -; **¹Bap|tist** (m. Vorn.); **²Bap|tist** (Anhänger des Baptismus); ↑ R 268; **Bap|ti|ste|ri|um** (Taufbecken; Taufkirche, -kapelle) *s*; -s, ...ien [*i'n*]

¹bar = ¹Bar

²bar (bloß); aller Ehre[n] -; bar[es] Geld, a b e r: Bargeld; bar zahlen; in -; gegen -; -er Unsinn; barfuß; barhaupt

...bar (z. B. lesbar, offenbar)

¹Bar gr. (Maßeinheit des [Luft]druckes; Zeichen: bar; Meteor. nur: b) *s*; -s, -s; 5 -

²Bar engl. (kleines [Nacht]lokal; Schanktisch) *w*; -, -s

³Bar (Meistersingerlied) *m*; -[e]s, -e

¹Bär *m*; -en, -en; ↑ R 268; (↑ R 224:) der Große, der Kleine - (Sternbilder); **²Bär** (fachspr. für: Maschinenhammer) *m*; -s, -en (fachspr.: -e); vgl. Rammbär

Ba|rab|bas (bibl. Gestalt)

Ba|ra|ber it. österr. ugs. (schwer arbeitender Hilfs-, Bauarbeiter) *m*; -s, -; ba|ra|bern österr. ugs. (schwer arbeiten)

Ba|racke [Trenn.: ...rak|ke] *w*; -, -n (leichtes, meist eingeschossiges Behelfshaus) *w*; -, -n; **Ba|racken|la|ger** [Trenn.: ...rak|ken...] (Mehrz. ...lager); **Ba|rack|ler** (ugs. für: Barackenbewohner)

Ba|rat|te|rie it. (Unredlichkeit od. Verschulden der Schiffsbesatzung [in der Seeversicherung] *w*; -, ...ien

Bar|ba|di|er (Bewohner von Barbados); bar|ba|disch; **Bar|ba|dos** (Inselstaat im Karibischen Meer

Bar|bar gr. (urspr.: Nichtgrieche; jetzt: roher, ungesitteter, wilder Mensch) *m*; -en, -en (↑ R 268); **Bar|ba|ra** (w. Vorn.); **Bar|ba|rei** (Roheit); bar|ba|risch (roh); -ste (↑ R 294); **Bar|ba|ris|mus** (grober sprachlicher Fehler) *m*; -, ...men

Bar|ba|ros|sa („Rotbart"; Beiname des Kaisers Friedrich I.)

Bar|be lat. (Fisch; Spitzenband an Frauenhauben) *w*; -, -n

Bar|be|cue [*bá'bikju*] amerik. (Gartenfest mit Spießbraten) *s*; -[s], -s

bär|bei|ßig (grimmig; verdrießlich); **Bär|bei|ßig|keit**

Bär|bel (Koseform von: Barbara)

Bar|ber [*ba'b'r*], Samuel (amerik. Komponist)

Bar|bier fr. (veralt. für: Haar-, Bartpfleger) *m*; -s, -e; bar|bie|ren (veralt. für: den Bart scheren); vgl. auch: balbieren

Bar|bi|ton gr. (altgr. Saiteninstrument) *s*; -s, -s

bar|bu|sig (busenfrei)

Bar|ce|lo|na [*barze..., barße...*] (span. Stadt)

Bar|chent arab. (Baumwollflanell) *m*; -s, -e

Bar|da|me

bar|dauz!, par|dauz!

¹Bar|de arab.-fr. (Speckscheibe um gebratenes Geflügel) *w*; -, -n

²Bar|de kelt.-fr. ([altkelt.] Sänger u. Dichter; abwertend für: lyr. Dichter) *m*; -n, -n (↑ R 268); **Bar|den|tum** *s*; -s

bar|die|ren (mit ¹Barden umwickeln)

Bar|diet germ.-lat. *s*; -[e]s, -e u. **Bar|di|tus** (Schlachtgeschrei der Germanen vor dem Kampf) *m*; -, -; bar|disch [zu ²Barde]; **Bar|di|tus** vgl. Bardiet

Bar|do|wick [auch: *bar*...] (Ort in Niedersachsen)

Bä|ren|dienst (ugs. für: schlechter Dienst), ...dreck südd., österr. ugs. (Lakritze), ...fang (urspr. ostpr. Honiglikör; *m*; -[e]s), ...fell, ...haut, ...häuter, ...hun|ger (ugs. für: großer Hunger); **Bä|ren|klau** (eine Pflanze) *w*; - oder *m*; -s; bä|ren|mä|ßig; **Bä|ren|na-**

tur (bes. kräftiger, körperlich unempfindlicher Mensch); bä|ren|ru|hig (ugs. für: sehr ruhig); bä|ren|stark (ugs. für: sehr stark); **Bä|ren|trau|be** (eine Heilpflanze); **Bä|ren|trau|ben|blät|ter|tee**

Ba|rents|see [nach dem niederl. Seefahrer W. Barents] (Teil des Nordpolarmeeres) *w*; -

Ba|rett lat. (flache, randlose Kopfbedeckung, meist als Amtstracht) *s*; -[e]s, -e u. (selten:) -s

Bar|frei|ma|chung

Bar|frost landsch. (Kahlfrost)

bar|fuß; - gehen; **Bar|fü|ßer** (barfuß gehender od. nur Sandalen tragender Mönch) *m*; -s, -; **Bar|fü|ße|rin** *w*; -, -nen, bar|fü|ßig; **Bar|füß|ler** (barfuß Gehender); **Bar|füß|le|rin** *w*; -, -nen

Bar|geld *s*; -[e]s; bar|geld|los; -er Zahlungsverkehr

bar|haupt; bar|häup|tig

Bar|hocker [Trenn.: ...hok|ker]

Ba|ri (Hptst. Apuliens)

Ba|ri|bal (nordamerik. Schwarzbär) *m*; -s, -s

bä|rig (landsch.: bärenhaft, stark, robust; westösterr. ugs.: toll, ausgezeichnet)

ba|risch gr. (Meteor.: den Luftdruck betreffend); -es Relief (horizontale Druckverteilung auf der Erdoberfläche); -es Windgesetz

Ba|ri|ton it. (Männerstimme zwischen Tenor u. Baß; auch: Sänger mit dieser Stimme) *m*; -s, -e; **Ba|ri|to|nist** (Baritonsänger); ↑ R 268

Ba|ri|um gr. (chem. Grundstoff, Metall; Zeichen: Ba) *s*; -s

Bark niederl. (ein Segelschiff) *w*; -, -en; **Bar|ka|ro|le, Bar|ke|ro|le** it. (Boot; Gondellied) *w*; -, -n; **Bar|kas|se** niederl. (Motorboot; auf Kriegsschiffen größtes Beiboot) *w*; -, -n

Bar|kauf

Bar|ke (kleines Boot) *w*; -, -n

Bar|kee|per engl. [*bárkip'r*] (Inhaber od. Schankkellner einer ²Bar) *m*; -s, -

Bar|ke|ro|le vgl. Barkarole

Bar|lach (dt. Bildhauer, Graphiker u. Dichter)

Bär|lapp („Bärentatze"; moosähnliche Pflanze) *m*; -s, -e

Bär|lauf (früheres Turnspiel) *m*; -[e]s

Bar|lohn

Bar|mann (svw. Barkeeper) *m*; -[e]s, ...männer

Barm|bek (Stadtteil von Hamburg)

Bär|me nordd. (Hefe) *w*; -

bär|men nord- u. ostd. (abwertend für: klagen)

Bar|men (Stadtteil von Wuppertal); **Bar|mer** (↑ R 199)

barm|her|zig, a b e r (↑ R 224):

Barmherzigkeit

Barmherzige Brüder, Barmherzige Schwestern (religiöse Genossenschaften für Krankenpflege); **Barm|her|zig|keit** w; - **Bar|mi|xer** (Getränkemischer in einer ²Bar) **Bar|na|bas** (urchristlicher Missionar); **Bar|na|bit** (Angehöriger eines kath. Männerordens) m; -en, -en (↑ R 268) **ba|rock** fr. („schief, unregelmäßig"; im Stil des Barocks; verschnörkelt, überladen); **Ba|rock** ([Kunst]stil) s od. m; -s (fachspr. auch: -); **Ba|rock kir|che,** ...**kunst,** ...**per|len** (unregelmäßig geformte Perlen; Mehrz.), ...**stil** (m; -[e]s), ...**zeit** (w; -) **Ba|ro|graph** gr. (Meteor.: selbstaufzeichnender Luftdruckmesser) m; -en, -en (↑ R 268); **Ba|ro|me|ter** (Luftdruckmesser) s; -s, -; **Ba|ro|me|ter|stand;** **ba|ro|me|trisch;** -es Maximum, -es Minimum (höchster, tiefster Luftdruck, das Hoch, das Tief); -e Höhenformel, Höhenmessung, Höhenstufe **Ba|ron** fr. (Freiherr) m; -s, -e; **Ba|ro|neß** w; -, ...essen u. (häufiger:) **Ba|ro|nes|se** (Freifräulein) w; -, -n; **Ba|ro|net** engl. [bǟronät, auch: bä...], engl. Ausspr.: bǟr^enit] (engl. Adelstitel) m; -s, -e; **Ba|ro|nie** fr. (Besitz eines Barons; Freiherrnwürde) w; -, ...ien; **Ba|ro|nin** (Freifrau) w; -, -nen; **ba|ro|ni|sie|ren** (in den Freiherrnstand erheben) **Bar|ras** (Soldatenspr.: Heerwesen; Militär) m; - **Bar|re** fr. (Schranke aus waagerechten Stangen; Sand-, Schlammbank) w; -, -n **Bar|rel** engl. [bä...] (engl. Hohlmaß; Faß, Tonne) s; -s, -s; drei Barrel[s] Weizen (↑ R 322) **Bar|ren** (Turngerät; Handelsform der Metalle in Stangen; südd., österr. auch: Futtertrog) m; -s, - **Bar|ri|e|re** fr. (Schranke; Sperre) w; -, -n; **Bar|ri|ka|de** ([Straßen]sperre, Hindernis); **bar|ri|ka|die|ren** (seltener für: verbarrikadieren) **Bar|ri|ster** engl. [bä...] (Rechtsanwalt bei den englischen Obergerichten) m; -s, - **barsch** (unfreundlich, rauh); -este (↑ R 292) **Barsch** (ein Fisch) m; -[e]s, -e **Bar|schaft;** Bar/scheck (in bar einzulösender Scheck) **Barsch|heit** **Bar|soi** russ. [...seu] (russ. Windhund) m; -s, -s **Bar|sor|ti|ment** (Buchhandelsbetrieb zwischen Verlag u. Einzelbuchhandel)

Bart m; -[e]s, Bärte; **Bärt|chen,** Bärt|lein; **Bar|te** (veralt. für: breites Beil, Axt [als Waffe]; Hornplatte im Oberkiefer der Bartenwale, Fischbein) w; -, -n; **Bar|teln** (Bartfäden bei Fischen) Mehrz.; **Bar|ten|wal;** **Bar|terl** (bayr. u. österr.: Kinderlätzchen) s; -s, -n; **Bart⌣flech|te,** ...**haar** **Bar|thel,** Bar|tho|lo|mä|us (m. Vorn.) **Bär|tier|chen** (mikroskopisch kleine, wurmförmige Tiere) Mehrz. **bär|tig; Bär|tig|keit** w; -; **Bärt|lein,** Bärt|chen; **bart|los; Bart|lo|sig|keit** w; - **Bar|tók** [bartok, ung.: bắrtok], Béla (ungar. Komponist) **Bart⌣pfle|ger,** ...**scher,** ...**sche|rer,** ...**stop|pel,** ...**wisch** (bayr., österr.: Handbesen), ...**wuchs,** ...**zot|tel** (meist Mehrz.) **Ba|ruch** (Gestalt im A. T.) **ba|ry...** gr. (schwer...); **Ba|ry...** (Schwer...); **Ba|ry|on** (schweres Elementarteilchen) s; -s, ...onen; **Ba|ry|sphä|re** (Erdkern) w; -; **Ba|ryt** (Schwerspat; chem. Bariumsulfat) m; -[e]s, -e; **Ba|ry|ton** (einer Gambe ähnliches Saiteninstrument des 18. Jh.s) s; -s, -e; **Ba|ry|to|non** (Sprachw.: Wort mit unbetonter letzter Silbe, z. B. „Jaguar") s; -s, ...na; **Ba|ryt|pa|pier;** **ba|ry|zen|trisch** (auf das Baryzentrum bezüglich); -e Koordinaten; **Ba|ry|zen|trum** (Physik: Schwerpunkt) s; -s, ...tra u. ...tren **Bar|zah|lung** **ba|sal** (die Basis, die Grundlage betreffend) **Ba|salt** gr. (Gestein) m; -[e]s, -e **Ba|sal|tem|pe|ra|tur** (Med.: morgens gemessene Körpertemperatur bei der Frau zur Feststellung des Zyklus) **ba|sal|ten, ba|sal|tig, ba|sal|tisch;** Ba|salt|tuff **Ba|sar** pers. (oriental. Händlerviertel; Warenverkauf zu Wohltätigkeitszwecken; DDR: Verkaufsstätte) m; -s, -e **Bäs|chen,** Bäs|lein **Basch|ki|re** (Angehöriger eines turkotat. Stammes) m; -n, -n (↑ R 268); **Basch|ki|ri|en;** basch|ki|risch** **Basch|lik** turkotat. (kaukasische Wollkapuze) m; -s, -s ¹**Ba|se** (Kusine; österr. veraltet u. schweiz. auch noch: Tante) w; -, -n ²**Ba|se** gr. („Grundlage"; Verbindung, die mit Säuren Salze bildet) w; -, -n; vgl. Basis **Base|ball** engl. [be'ßbál] (amerik. Schlagballspiel) m; -es **Ba|se|dow** [bas^edo] (kurz für: Base-

dow-Krankheit) m; -s; **Ba|se|dow-Krank|heit** [nach dem Arzt K. v. Basedow] (auf vermehrter Tätigkeit der Schilddrüse beruhende Krankheit, Glotzaugenkrankheit) w; -; **Ba|se|dow|sche Krank|heit** w; -n - (veraltet) **Ba|sel** (schweiz. Stadt am Rhein); **Ba|sel|biet; Ba|sel|ler,** Bas|ler (schweiz. nur so; ↑ R 199); Baseler Friede; **Ba|sel-Land|schaft,** (kurz auch:) **Ba|sel-Land** (Halbkanton); **ba|sel|land|schaft|lich;** **Ba|sel-Stadt** (Halbkanton); **ba|sel|städ|tisch** **Ba|sen** (auch Mehrz. von: Basis) **BASF** = Badische Anilin- & Soda-Fabrik AG **Ba|sic Eng|lish** [be'ßik ingglisch] (Kurzw. aus: British-American scientific international commercial English = britisch-amerikanisches wissenschaftliches internationales geschäftliches Englisch; gleichzeitig: Grundenglisch; vereinfachte Form des Englischen mit einem Grundwortschatz von 850 Wörtern u. wenig Sprachlehre) s; - - **ba|sie|ren** fr.; etwas basiert auf der Tatsache (beruht auf der, gründet sich auf die Tatsache) **ba|si|li|a|ner** (nach der Regel des hl. Basilius [4. Jh.] lebender Angehöriger verschiedener Mönchsorden); **Ba|si|li|a|ne|rin** w; -, -nen **Ba|si|lie** (gr. ...i^e] w; -, -n, **Ba|si|li|en|kraut** u. **Ba|si|li|kum** (Gewürzpflanze) s; -s u. ...ken **Ba|si|li|ka** gr. (Halle; Kirchenbauform mit überhöhtem Mittelschiff) w; -, ...ken; **ba|si|li|kal; ba|si|li|ken|för|mig** **Ba|si|li|kum** vgl. Basilie **Ba|si|lisk** gr. (Fabeltier; trop. Echse) m; -en, -en (↑ R 268); **Ba|si|lis|ken|blick** (böser, stechender Blick) **Ba|si|li|us** (gr. Kirchenlehrer) **Ba|sis** gr. (Grundlage, -linie, -fläche; Grundzahl; Fuß[punkt]; Sockel; Unterbau; Stütz-, Ausgangspunkt) w; -, ...sen; **ba|sisch** (Chemie: sich wie eine Base verhaltend); -e Farbstoffe, Salze; -er Stahl; **Ba|sis|grup|pe** (links orientierter politisch aktiver [Studenten]arbeitskreis); **Ba|si|zi|tät** (Chemie) w; - **Bas|ke** (Angehöriger eines Pyrenäenvolkes) m; -n, -n (↑ R 268); **Bas|ken|müt|ze** **Bas|ket|ball** engl. (Korbballspiel]) m; -[e]s **bas|kisch;** -e Sprache; vgl. deutsch; **Bas|kisch** (Sprache) s; -[s]; vgl. Deutsch; **Bas|ki|sche** s; -n; vgl. Deutsche s

Bas|kü|le fr. (Treibriegelverschluß für Fenster u. Türen) w; -, -n; Bas|kü|le|ver|schluß

Bäs|lein, Bäs|chen

Bas|ler (schweiz. nur so), Ba|se|ler (↑ R 199): Basler Leckerli; bas|le|risch

Bas|re|li|ef fr. [báreliäf] (Flachbildwerk, flacherhabene Arbeit) baß (veralt., aber noch scherzh. iron. für: sehr); er war baß erstaunt

Baß it. (tiefe Männerstimme, Sänger; Streichinstrument) m; Basses, Bässe; Baß...blä|ser, ...buf|fo

Bas|se niederd. (Jägerspr. für: [älterer] starker Keiler) m; -n, -n (↑ R 268)

Basse|lisse|stuhl fr.; dt. [baßliß...] (ein Webstuhl)

Bas|se|na it. ostösterr. (Wasserbecken im Flur eines Altbaus für mehrere Mieter) w; -, -s; Bas|se|na|tratsch ostösterr. (Klatsch niedrigsten Niveaus)

Bas|set [fr.: baßé, engl.: bäßit] m; -s, -s (eine Hunderasse)

Bas|sett it. (veralt. für: Cello) m; -s, -c u. -s; Bas|sett|horn (Blasinstrument des 18. Jh.s; Mehrz. ...hörner); Baß|gei|ge

Bas|sin fr. [baßäng] (künstliches Wasserbecken) s; -s, -s

Bas|sist it. (Baßsänger); ↑ R 268; Baß...kla|ri|net|te, ...sai|te, ...sänger, ...schlüs|sel, ...stim|me

Bast (Pflanzenfaser; Haut am Geweih) m; -[e]s, -e

ba|sta it. (ugs. für: genug!); [und] damit -!

Ba|stard fr. (Mischling; uneheliches Kind) m; -[e]s, -e; ba|stardie|ren (Arten kreuzen); Ba|stardie|rung (Artkreuzung); Bastard...pflan|ze, ...schrift (Schrift, die Eigenarten zweier Schriftarten vermischt, bes. die von Fraktur u. Antiqua), ...sprache

Ba|stei fr. (vorspringender Teil an alten Festungsbauten; Einz.: Felsgruppe im Elbsandsteingebirge)

ba|steln ([in der Freizeit, aus Liebhaberei] kleine Arbeiten machen); ich ...[e]le (↑ R 327)

ba|sten (aus Bast); bast|far|ben, bast|far|ben

Ba|sti|an (Kurzform von: Sebastian)

Ba|stil|le fr. [baßtij^e] (festes Schloß, bes. das 1789 erstürmte Staatsgefängnis in Paris) w; -, -n; Ba|sti|on (Bollwerk)

Bast|ler

Ba|sto|na|de fr. (bis ins 19. Jh. im Orient übl. Prügelstrafe mit dem Stock, bes. auf die Fußsohlen) w; -, -n

Ba|su|to (Angehöriger eines Bantustammes) m; -[s], -[s]

Bat. = Bataillon

BAT = Bundesangestelltentarif

Ba|tail|le fr. [batáj^e] (veralt. für Schlacht; Kampf) w; -, -n; Ba|taillon [bataljón] (Truppenabteilung; Abk.: Bat.) s; -s, -e; Ba|taillons...füh|rer, ...kom|man|deur

Ba|ta|te indian. - span. (trop. Knollenpflanze, Süßkartoffel) w; -, -n

Ba|ta|ver [bátaw^er] (Angehöriger eines germ. Stammes) m; -s, -; Ba|ta|via [batgwia] (alter Name von: Djakarta); ba|ta|visch

Bath|se|ba, (ökum.:) Bat|se|ba (bibl. w. Eigenn.)

Ba|thy|scaphe gr. [...skaf] m u. s; -[s], - u. Ba|thy|skaph (Tiefseetauchgerät) m; -en, -en (↑ R 268); Ba|thy|sphä|re (tiefste Schicht des Weltmeeres) w; -

Ba|tik malai. (auf Java geübtes Färbeverfahren mit Verwendung von Wachs [nur Einz.]; gemustertes Gewebe) m; -s, -en (auch: w; -, -en); Ba|tik|druck (Mehrz. ...drucke); ba|ti|ken; gebatikt

Ba|tist (feines Gewebe) m; -[e]s, -e; ba|ti|sten (aus Batist)

Bat|se|ba vgl. Bathseba

Batt., Battr. = Batterie (Militär)

Bat|te|rie fr. (Einheit der Artillerie [Abk.: Batt(r).]; Elektrotechnik: Zusammenschaltung mehrerer Elemente od. Akkumulatorenzellen zu einer Stromquelle) w; -, ...ien

Bat|zen (ugs. für: Klumpen; frühere Münze; schweiz. noch für: Zehnrappenstück) m; -s, -

Bau m; -[e]s, (für: Tierwohnung u. [Bergmannsspr.:] Stollen Mehrz.:) -e u. (für: Gebäude Mehrz.:) -ten; sich im od. in - befinden; Bau...arbeiter, ...art, ...auf|sicht (w; -); Bau|auf|sichtsbe|hör|de; Bau|block (Mehrz. ...blocks)

Bauch m; -[e]s, Bäuche; Bauch|bin|de; Bäu|chel|chen, Bäuchlein; Bauch...fell, ...grim|men (Bauchweh), ...höh|le; bau|chig, bäu|chig; Bauch...knei|pen (landsch. für: Bauchweh; s; -s), ...la|den, ...lan|dung; Bäuch|lein, Bäu|chel|chen; bäuch|lings; bauch|re|den (meist nur in der Grundform gebr.); Bauch...red|ner; Bauchspei|chel|drü|se; Bauch|tanz; bauch|tan|zen (meist nur in der Grundform gebr.); Bau|chung; Bauch|weh s; -s

Bau|cis [báuziß] (Gattin des Philemon [vgl. d.])

Baud [auch: bot; nach dem fr. Ingenieur Baudot] (Maßeinheit der Telegrafiergeschwindigkeit s; -[s], -

Bau|de (Unterkunftshütte im Gebirge, Berggasthof) w; -, -n

Bau|denk|mal s; -[e]s, ...mäler (geh. auch: ...male)

Bau|douin [boduáng ("Balduin"); fr. m. Vorn.)

bau|en; Bau...ele|ment, ...ent|wurf

¹Bau|er (Be-, Erbauer) m; -s, -

²Bau|er (Landmann; Schachfigur; Spielkarte) m; -n (selten: -s), -n

³Bau|er (Käfig) s (seltener: m); -s, -

Bäu|er|chen, Bäu|er|lein; Bäue|rin w; -, -nen; bäue|risch (seltener für: bäurisch); -ste (↑ R 294); Bäu|erlein, Bäu|er|chen; bäu|er|lich; Bau|ern|bur|sche, ...fän|ger (abwertend); Bau|ern|fän|ge|rei; Bau|ern|frau, Bau|ers|frau; Bau|ern...früh|stück (eine Speise), ...haus, ...hof, ...krieg, ...le|gen (hist.: Einziehen von Bauernhöfen durch den Großgrundbesitz; s; -s); Bau|er[n]|same (schweiz. neben: Bauernschaft) w; -; Bau|ern|schaft (Gesamtheit der Bauern) w; -; bau|ern|schlau; Bau|ern|stand (m; -[e]s), ...stu|be, ...tum (s; -s), ...volk; Bau|er|sa|me vgl. Bauernsame; Bau|er|schaft landsch. (Bauernsiedlung); Bau|ers|frau, Bau|ern|frau; Bau|ers_leu|te (Mehrz.), ...mann (m; -[e]s); Bäu|ert schweiz. [Berner Oberland] (Gemeindefraktion); -, -en

Bau|er|war|tungs|land; Bau|fach|wer|ker; bau|fäl|lig; Bau|fäl|ligkeit w; -; Bau_fir|ma, ...flucht (vgl. ¹Flucht), ...füh|rer, ...ge|neh|migung, ...ge|nos|sen|schaft, ...gespann (schweiz.: Stangen, die die Ausmaße eines geplanten Gebäudes anzeigen), ...herr, ...holz, ...hüt|te, ...ka|sten; Bau|klotz m; -es, ...klötze (ugs. auch: ...klötzer): Bauklötze[r] staunen; Bau|ko|sten; Bau|ko|sten|zu|schuß, Bau_kunst (w; -), ...land (auch: bad. Landschaft; s; -[e]s); bau|lich; Bau|lich|keit (Papierdt.; meist Mehrz.); Bau|lücke [Trenn.: ...lük|ke]

Baum m; -[e]s, Bäume

Bau|ma|te|ri|al

Baum|blü|te (w; -); Bäum|chen, Bäum|lein

Bau|mé|grad [bome...; nach dem fr. Chemiker Baumé] (Maßeinheit für das spezifische Gewicht von Flüssigkeiten; ↑ R 180; Zeichen: Bé); 5° Bé (vgl. S. 86, 9, f)

Bau|mei|ster

bau|meln; ich ...[e]le (↑ R 327)

¹bau|men vgl. aufbaumen; ²baumen, ¹bäu|men (mit dem Wiesbaum befestigen); ²bäu|men; sich -; Baum_farn, ...gren|ze (w; -); baum|kan|tig (von beschlagenem Holz: an den Kanten noch die Rinde zeigend); Baum_ku|chen;

baum|lang; Baum|läu|fer (ein Vogel); Bäum|lein, Bäum|chen; baum|reich; Baum...rie|se, ...schere, ...schlag (Darstellungsweise des Laubwerks in der bildenden Kunst; *m*; -[e]s), ...schu|le, ...sperre, ...stamm; baum|stark; Baum...step|pe (Steppe mit einzeln od. gruppenweise stehenden Bäumen), ...strunk, ...stumpf, ...wip|fel, ...wol|le; baum|wol|len (aus Baumwolle); Baum|wol|le|se [*Trenn.*: ...woll|le..., ↑ R 236]; Baum|woll.garn, ...in|du|strie, ...pi|kee, ...spin|ne|rei, ...stoff, ...wa|re, ...zeug

Baun|zerl österr. (längliches, mürbes Milchbrötchen) *s*; -s, -n

Bau...ord|nung, ...plan (vgl. ²Plan), ...platz, ...po|li|zei; baum|po|li|zei|lich; Bau...pro|gramm, ...rat (*Mehrz.* ...räte), ...recht; bau|reif; ein -es Grundstück

bäu|risch, (seltener:) bäue|risch; -ste (↑ R 294)

Bau...rui|ne, ...satz (Fertigteile zum Zusammenbauen)

Bausch *m*; -[e]s, -e u. Bäusche; in - und Bogen (ganz und gar); Bäusch|chen, Bäusch|lein (kleiner Bausch)

Bäu|schel, Päu|schel (Bergmannsspr.: schwerer Hammer) *m* od. *s*; -s, -

Bau|schen (österr. neben: Bausch) *m*; -s, -; bau|schen; du bauschst (bauschest); sich -; bau|schig; Bäusch|lein, Bäusch|chen

bau|spa|ren (fast nur in der Grundform gebräuchlich); bauzusparen; Bau|spar|kas|se; Bau...stein, ...stel|le, ...stil, ...stopp

Bau|ta|stein *altnord.* (Gedenkstein der Wikingerzeit)

Bau|te schweiz. veralt. (Bau[werk], Gebäude) *w*; -, -n; Bau|teil (als Gebäudeteil: *m*; als Bauelement: *s*); Bau|ten vgl. Bau; Bau|trä|ger

Baut|zen (Stadt in der Oberlausitz); Baut|ze|ner (↑ R 199); bautz|nisch

Bau...vor|ha|ben, ...wei|se (vgl. ²Weise), ...werk, ...wer|ker, ...wesen; Bau|wich (Bauw.: Häuserzwischenraum) *m*; -[e]s, -e; bau|wür|dig (Bergmannsspr. von einer Lagerstätte: mit Gewinn abzubauen)

Bau|xerl österr. mdal. (kleines, herziges Kind) *s*; -s, -n

Bau|xit [nach dem ersten Fundort Les Baux (*lä bọ*) in Frankreich] (ein Mineral) *m*; -s, -e

bauz!

Bau|zaun

¹Ba|va|ria *lat.* [...*wg*...] (Bayern); ²Ba|va|ria (Frauengestalt als Sinnbild Bayerns) *w*; -

Ba|yard [*bajar*] (fr. Ritter u. Feldherr)

¹Bay|er ⓦ (chem. u. pharm. Produkte)

²Bay|er, (in der Sprachw. für den Mundartsprecher:) Bai|er *m*; -n, -n (↑ R 268); bay[e]|risch, (in der Sprachw. für die Mundart:) bairisch, aber (↑ R 224:) Bayerische Motorenwerke AG (Abk.: BMW); (↑ R 198:) der Bayerische Wald; Bay|er|land *s*; -[e]s; Bay|ern (Land)

Bay|reuth (Stadt am Roten Main)

Ba|zar vgl. Basar

Ba|zi bayr., österr. ugs. (neckendes Schimpfwort) *m*; -, -

Ba|zil|len|trä|ger *lat.*; *dt.*; Ba|zil|lus *lat.* (sporenbildender Spaltpilz, oft Krankheitserreger) *m*; -, ...llen

BBC: 1. [engl. Aussspr.: *bibißi*] = British Broadcasting Corporation [*britisch brảdkạßting kơ'p℮'re'sch℮n*] (brit. Rundfunkgesellschaft); 2. ⓦ = Brown, Boveri & Cie.

BBk = Deutsche Bundesbank

Bch. = Buch

BCG = Bazillus Calmette-Guérin (nach zwei frz. Tuberkuloseforschern); BCG-Schutz|imp|fung (vorbeugende Tuberkuloseimpfung)

Bd. = Band (Buch); Bde. = Bände

BDA = Bund Deutscher Architekten

BDÜ = Bundesverband der Dolmetscher und Übersetzer

B-Dur [*bedur*, auch: *bẹdur*] (Tonart; Zeichen: B) *s*; -; B-Dur-Ton|lei|ter [*bẹ...*] (↑ R 155)

Be = chem. Zeichen für: Beryllium

Bé = Baumégrad

be... (*Vorsilbe von Zeitwörtern*, z. B. beabsichtigen, du beabsichtigst, beabsichtigt, zu beabsichtigen; zum 2. Mittelw. ↑ R 304)

BEA = British European Airways [*britisch jur℮'pi℮n ℮rwe's*] (brit. Luftfahrtges. in Europa)

be|ab|sich|ti|gen

be|ach|ten; be|ach|tens|wert; be|acht|lich; Be|ach|tung

be|ackern [*Trenn.*: ...ak|kern] (den Acker bestellen; ugs. auch für: gründlich bearbeiten)

be|am|peln; eine beampelte Kreuzung

Be|am|te *m*; -n, -n (↑ R 287 ff.); Be|am|ten.schaft (*w*; -), ...stand (*m*; -[e]s), ...tum (*s*; -s); be|am|tet; Be|am|te|te *m* u. *w*; -n, -n (↑ R 287 ff.); Be|am|tin *w*; -, -nen

be|äng|sti|gend; -ste; Be|äng|sti|gung

be|an|schrif|ten (Amtsdt.)

be|an|spru|chen; Be|an|spru|chung

be|an|stan|den, (österr. meist:) be|an|stän|den; Be|an|stan|dung, (österr. meist:) Be|an|stän|dung

be|an|tra|gen; du beantragtest; beantragt; Be|an|tra|gung

be|ant|wor|ten; Be|ant|wor|tung

be|ar|bei|ten; Be|ar|bei|tung

Beards|ley [*bi℮'dsli*] (engl. Maler)

be|arg|wöh|nen

Beat *engl.* [*bit*] (im Jazz: Schlagrhythmus; betonter Taktteil; die so geartete Musik) *m*; -[s]

Bea|ta, Bea|te (w. Vorn.)

bea|ten *engl.* [*bit'n*] (ugs.: nach dem Beatmusik tanzen); Beat-Fan [*bitfän*] (jmd., der für Beatmusik begeistert ist)

Beat ge|ne|ra|tion *amerik.* [*bit dschen℮'re'sch℮n*] (Bez. für eine Gruppe junger Menschen in den USA [um 1955], die die Gesellschaft mit allen bürgerl. Bindungen ablehnte u. durch gesteigerte Lebensintensität [Sexualität, Jazz, Drogen u. ä.] zur Erkenntnis einer metaphys. Wirklichkeit zu gelangen suchte) *w*; - -

Bea|ti|fi|ka|ti|on *lat.* [...*zion*] (Seligsprechung); bea|ti|fi|zie|ren

Bea|tle *engl.* [*bit'l*] (Name der Mitglieder einer Liverpooler Musikergruppe; allg. für: Jugendlicher mit einer diese Gruppe kennzeichnenden Frisur) *m*; -s, -s

be|at|men (Med.: Luft od. Gasgemische in die Atemwege einführen); Be|at|mung; Be|at|mungs.an|la|ge, ...ge|rät, ...stö|rung

Beat|mu|sik [*bit*...] *w*; -

Beat|nik *amerik.* [*bit*...] (Vertreter der Beat generation, vgl. d.) *m*; -s, -s

Bea|tri|ce [it. Ausspr.: ...*tritsche*; dt. Ausspr.: ...*triß℮*], Bea|trix (w. Vorn.); Bea|tus *lat.* (m. Vorn.)

Beau *fr.* [*bo*] (abwertend für: schöner Mann; Stutzer) *m*; -, -s

Beau|fort|ska|la [*bof℮rt*...; nach dem engl. Admiral] (zwölfteilige Skala für Windstärken; ↑ R 180) *w*; -

be|auf|la|gen (DDR Wirtsch.: eine Auflage erteilen; zu einem Plansoll verpflichten)

be|auf|schla|gen (Technik: vom Wasser- od. Dampfstrahl: [die Turbinenschaufeln] treffen); be|beaufschlagte; beaufschlagt; Be|auf|schla|gung

be|auf|sich|ti|gen; Be|auf|sich|ti|gung

be|auf|tra|gen; du beauftragtest; beauftragt; Be|auf|trag|te *m* u. *w*; -n, -n (↑ R 287 ff.)

be|aug|ap|feln (landsch. scherzh.); ich ...[e]le (↑ R 327); be|äu|geln (ugs. scherzh.); ich ...[e]le (↑ R 327); beäugelt; be|äu|gen; beäugt

be|au|gen|schei|ni|gen (Papierdt.); beaugenscheinigt

Beau|jo|lais fr. [boʃeholä] (ein fr. Rotwein) m; -, -

Beau|mar|chais [bomarschä] (fr. Schriftsteller)

Beau|té fr. [bote] (Schönheit; schöne Frau) w; -, -s

be|bän|dern

be|bar|tet

be|bau|en; Be|bau|ung

Bé|bé fr. [bebe] schweiz. (kleines Kind) s; -s, -s

Be|bel (Mitbegründer der dt. Sozialdemokratischen Partei)

be|ben; Be|ben s; -s, -

be|bil|dern; ich ...ere (↑ R 327), Be|bil|de|rung

Be|bop amerik. [bibop] (Jazzstil der 40er Jahre; Tanz in diesem Stil) m; -[s], -s

be|brillt

be|brü|ten

be|buscht

Bé|cha|mel.kar|tof|feln [beschamäl...; nach dem Marquis de Béchamel], ...so|ße

Be|cher m; -s, -; Be|cher|klang m; -[e]s; be|chern (ugs. scherzh. für: tüchtig trinken); ich ...ere (↑ R 327); Be|cher|werk (Fördergerät)

be|cir|cen [bᵉzirzᵉn; nach der sagenhaften gr. Zauberin Circe] (ugs. für: verführen, bezaubern)

Becken [Trenn.: Bek|ken] s; -s, -; Becken|bruch [Trenn.: Bek-ken...] m

Beck|mes|ser (Gestalt aus Wagners „Meistersingern"; kleinlicher Kritiker); Beck|mes|se|rei; beck|mes|sern (kleinlich tadeln, kritteln); ich beckmessere u. ...meßte (↑ R 327); gebeckmessert

Bec|que|rel [bakᵉräl] (fr. Physikerfamilie)

e|dä|chen (Handw.: mit einem Dach verschen)

e|dacht; auf eine Sache - sein; Be|dacht m; -[e]s; mit -; auf etwas - nehmen (Papierdt.); Be|dacht|te (wem ein Vermächtnis ausgesetzt ist) m u. w; -n, -n (↑ R 287ff.); be|däch|tig; Be|däch|tig|keit w; -; be|dacht|sam; Be|dacht|sam|keit w; -

e|da|chung (Handw.)

e|dan|ken, sich; sei bedankt! habe Dank!)

e|darf m; -[e]s; nach -; - an (Kaufmannsspr. auch: in) etwas; Be|darfs|ar|ti|kel; Be|darfs|fall m; im -[e]; be|darfs|ge|recht; Be|darfs.gü|ter (Mehrz.), ...hal|te|stel|le, ...trä|ger

e|dau|er|lich; be|dau|er|li|cher|wei|se; be|dau|ern; ich ...ere (↑ R 327); Be|dau|ern s; -s; be|dau|erns|wert

deckt; -er Himmel; Be|deckt|sa|mer (Bot.: Pflanze, deren Samenanlage im Fruchtknoten eingeschlossen ist; Ggs.: Nacktsamer) m; -s, - (meist Mehrz.); be|deckt|sa|mig (Bot.); Be|deckung [Trenn.: ...dek|kung]

be|den|ken; bedacht (vgl. d.); sich eines Besser[e]n -; Be|den|ken s; -s, -; be|den|ken|los; -este (↑ R 292); be|den|kens|wert; be|denk|lich; Be|denk|lich|keit; Be|denk|zeit

be|dep|pert (ugs. für: eingeschüchtert, ratlos, gedrückt)

be|deu|ten; be|deu|tend; -ste. I. *Kleinschreibung* (↑ P. 134): am bedeutendsten; um ein bedeutendes (sehr) zunehmen. II. *Großschreibung* (↑ R 116): das Bedeutendste; etwas Bedeutendes; Be|deut|sam; Be|deu|tung; Be|deu|tungs.er|wei|te|rung (Sprachw.), ...leh|re (Sprachw.; w;); be|deu|tungs|los; -este (↑ R 292); Be|deu|tungs|lo|sig|keit; be|deu|tungs|voll; Be|deu|tungs|wan|del (Sprachw.)

Be|die|ner|kraft w; -; be|die|nen, sich eines Kompasses - (geh.); jmdn. (österr. ugs. für: benachteiligen); bedient sein (ugs. für: in einer schwierigen Situation sein); Be|die|ner; Be|die|ne|rin bes. österr. (Aufwartefrau) w; -, -nen; be|dien|stet (in Dienst stehend); Be|dien|ste|te m u. w; -n, -n (↑ R 287ff.); Be|dien|te (veralt. für: Diener) m; -n, -n (↑ R 287ff.); Be|die|nung (österr. auch: Stelle als Bedienerin); Be|die|nungs.auf|schlag, ...feh|ler, ...geld, ...zu|schlag

Be|ding (veralt. für: Bedingung, das Bedungene) m od. s; -[e]s, -e; mit dem -, daß...; be|din|gen; du bedangst u. bedingtest; bedungen (ausbedungen, ausgemacht, z. B. der bedungene Lohn); vgl. bedingt; Be|ding|nis (österr. Amtsspr. für: Bedingung) s; -ses, -se; be|dingt (eingeschränkt, an Bedingungen geknüpft, unter bestimmten Voraussetzungen geltend); -er Befehl (bei Rechenanlagen); -er Reflex; -e Strafaussetzung; Be|dingt.gut (für: Kommissionsgut; s; -[e]s), ...heit (w; -), ...sen|dung (für: Kommissionssendung); Be|din|gung; Be|din|gungs.form (für: Konditional); be|din|gungs|los; Be|din|gungs|satz (für: Konditionalsatz); be|din|gungs|wei|se

be|drän|gen; Be|dräng|nis w; -, -se; Be|dräng|te m u. w; -n, -n (↑ R 287ff.); Be|dräng|ung

be|dräu|en (veralt. u. dicht. für: bedrohen)

be|dripst nordd. (kleinlaut; betrübt)

be|dro|hen; be|droh|lich; Be|dro|hung

be|drucken¹; be|drücken¹; Be|drücker¹; Be|druckung¹ (das Drucken) w; -; Be|drückung¹

Be|dui|ne arab. (arab. Nomade) m; -n, -n (↑ R 268)

be|dun|gen vgl. bedingen

be|dün|ken (veralt.), es will mich -; Be|dün|ken s; -s; meines -s (veralt. für: nach meiner Ansicht)

be|dür|fen (geh.); eines guten Zuspruches -; Be|dürf|nis s; -ses, -se; Be|dürf|nis|an|stalt; be|dürf|nis|los; -este (↑ R 292); be|dürf|tig; mit Wesf.: des Trostes -; Be|dürf|tig|keit

be|du|seln, sich (ugs. für: sich betrinken); er ist beduselt (betrunken)

Beef|steak engl. [bifßtēk] (Rinds-[lenden]stück) s; -s, -s; deutsches - (↑ R 224); Beef|tea [bíftī] (Rindfleischbrühe) m; -s, -s

be|eh|ren; sich -

be|ei|den; be|ei|di|gen (älter für: beeiden, vereidigen); Be|ei|di|gung, Be|ei|dung

be|ei|fern, sich (sich eifrig bemühen); Be|ei|fe|rung (Bemühung)

be|ei|len, sich; Be|ei|lung! (ugs. für: bitte schnell!)

be|ein|drucken [Trenn.: ...druk-ken]; von etwas sehr beeindruckt sein; Be|ein|druckung [Trenn.: ...druk|kung] w; -

be|ein|fluß|bar; Be|ein|fluß|bar|keit w; -; be|ein|flus|sen; du beeinflußt (beeinflussest); Be|ein|flus|sung; Be|ein|flus|sungs|mög|lich|keit

be|ein|träch|ti|gen; Be|ein|träch|ti|gung

be|elen|den schweiz. (nahegehen, dauern); es beelendet mich

Be|el|ze|bub hebr. [auch: bēl...] (Herr der bösen Geister, oberster Teufel im N. T.) m; -

be|en|den; beendet; be|en|di|gen; beendigt; Be|en|di|gung; Be|en|dung

be|en|gen; Be|engt|heit; Be|en|gung

be|er|ben; jmdn. -; Be|er|bung

be|er|den ([Pflanzen] mit Erde versehen); be|er|di|gen; Be|er|di|gung; Be|er|di|gungs|in|sti|tut

Bee|re w; -, -n; Bee|ren|aus|le|se; bee|ren|för|mig; Bee|ren.obst, ...wein

Beet s; -[e]s, -e

Bee|te, (heute hochspr.:) Be|te (vgl. d.)

Beet|ho|ven [...hof⁰n], Ludwig van (dt. Komponist)

¹ Trenn.: ...k|k...

be|fä|hi|gen; ein befähigter Mensch; Be|fä|hi|gung; Be|fä|hi|gungs|nach|weis

be|fahr|bar; Be|fahr|bar|keit w; -; ¹be|fah|ren; -es (Seemannsspr.: im Seedienst erprobtes) Volk; -er (Jägerspr.: bewohnter) Bau; ²be|fah|ren; eine Straße -

Be|fall m; -[e]s; be|fal|len

be|fan|gen (schüchtern; voreingenommen); Be|fan|gen|heit w; -

be|fas|sen; befaßt; sich -; jmdn. mit etwas - (Amtsdt.)

be|feh|den (mit Fehde überziehen, bekämpfen); sich -; Be|feh|dung

Be|fehl m; -[e]s, -e; be|feh|len; du befiehlst; du befahlst; du beföhlest (auch: befählest); befohlen; befiehl!; be|feh|le|risch; -ste (↑ R 294); be|feh|li|gen; be|fehls.aus|ga|be, ...be|reich, ...emp|fang, ...emp|fän|ger, ...form (Imperativ); be|fehls|ge|mäß; Be|fehls.ge|walt, ...ha|ber; be|fehls|ha|be|risch; -ste (↑ R 294); Be|fehls.not|stand, ...satz

be|fein|den; sich -; Be|fein|dung

be|fe|sti|gen; Be|fe|sti|gung

be|feuch|ten; Be|feuch|tung

be|feu|ern; Be|feue|rung

Beff|chen (Doppelstreifen über der Brust bei Amtstrachten, bes. von ev. Geistlichen)

be|fie|dern; ich ...ere (↑ R 327); Be|fie|de|rung

be|fin|den; befunden; den Plan für gut usw. -; sich -; Be|fin|den s; -s; be|find|lich (vorhanden); falsch: sich -; richtig: sich befindend

be|fin|gern (ugs. für: betasten, untersuchen)

be|fi|schen; einen See -; Be|fi|schung

be|flag|gen; Be|flag|gung w; -

be|flecken [Trenn.: ...flek|ken]; Be|fleckung [Trenn.: ...flek|kung]

be|fle|geln österr. (beschimpfen)

be|flei|ßen, sich (veralt., selten noch für: sich befleißigen); du befleißt (befleißest) dich; ich befliß mich, du beflissest dich; beflissen (vgl. d.); befleiß[e] dich!; be|flei|ßi|gen, sich; mit Wesf.: sich eines ordentlichen Betragens -

be|flie|gen; eine Strecke -

be|flis|sen (eifrig bemüht); um Anerkennung -; kunstbeflissen; Be|flis|sen|heit w; -; be|flis|sent|lich (seltener für: geflissentlich)

be|flü|geln

be|flu|ten (unter Wasser setzen); Be|flu|tung

be|fol|gen; Be|fol|gung

be|för|der|bar; Be|för|de|rer, Be|förd|rer; be|för|der|lich (schweiz. für: beschleunigt, rasch); be|för|dern; Be|för|de|rung; Be|för|de|rungs.be|din|gun|gen, ...ko|sten,

...mit|tel s, ...ta|rif; Be|förd|rer, Be|för|de|rer

be|for|sten (forstlich bewirtschaften); be|för|stern (nichtstaatliche Waldungen durch staatliche Forstbeamte verwalten lassen); ↑ R 327; Be|för|ste|rung w; -; Be|for|stung

be|frach|ten; Be|frach|ter; Be|frach|tung

be|frackt (einen Frack tragend)

be|fra|gen; du befragst; du befragtest; befragt; befrag[e]!; (↑ R 120:) auf Befragen; Be|fra|gung

be|franst

be|frei|en; sich -; Be|frei|er; Be|frei|ung; Be|frei|ungs|schlag (Eishockey)

be|frem|den; es befremdet; Be|frem|den s; -s; be|frem|dend; -ste; be|fremd|lich; Be|fremd|ung w; -

be|freun|den, sich; be|freun|det; -e (Math.: verwandte) Zahlen; Be|freun|dung

be|frie|den (Frieden bringen); geh. für: einhegen); befriedet; be|frie|di|gen (zufriedenstellen); be|frie|di|gend; -ste; vgl. ausreichend; Be|frie|di|gung; Be|frie|dung w; -

be|fri|sten; Be|fri|stung; -

be|fruch|ten; Be|fruch|tung

be|fu|gen; Be|fug|nis w; -, -se; be|fugt; - sein

be|füh|len

be|fül|len; einen Tank -

be|fum|meln (ugs. für: untersuchen, befühlen, geschickt bearbeiten)

Be|fund (Feststellung); nach -; ohne - (Med.; Abk.: o. B.)

be|fürch|ten; Be|fürch|tung

be|für|sor|gen österr. (betreuen)

be|für|wor|ten; Be|für|wor|ter; Be|für|wor|tung

Beg (,,Herr''; höherer türk. Titel) m; -s, -s; vgl. Bei

be|gab|ben; be|gabt; Be|gab|te m u. w; -n, -n (↑ R 287ff.); Be|gab|ten|för|de|rung; Be|ga|bung; Be|ga|bungs|re|ser|ve

be|gaf|fen (ugs. abwertend)

Be|gäng|nis (feierliche Bestattung) s; -ses, -se

Be|gard fr. (Angehöriger einer halbklösterl. Männervereinigung im MA.) m; -en, -en (↑ R 268)

be|ga|sen; du begast (begasest); Be|ga|sung (Schädlingsbekämpfung; eine Heilmethode)

be|gat|ten; sich -; Be|gat|tung

be|gau|nern (ugs. für: betrügen)

be|geb|bar; ¹be|ge|ben (Kaufmannsspr.: verkaufen, in Umlauf setzen); einen Wechsel -; ²be|ge|ben, sich (irgendwohin gehen; sich ereignen; verzichten); er begibt sich eines Rechtes (er verzichtet darauf); Be|ge|ben|heit;

Be|ge|ber (für: Girant [eines Wechsels]); Be|geb|nis (veraltend für: Begebenheit, Ereignis) s; -ses, -se; Be|ge|bung; die - des genehmigten Kapitals

be|geg|nen; jmdm. -; Be|geg|nis (veralt.) s; -ses, -se; Be|geg|nung; be|geh|bar; Be|geh|bar|keit; be|ge|hen; Be|ge|hung

Be|gehr (veralt.) m od. s; -s; be|geh|ren; Be|geh|ren s; -s; be|geh|rens|wert; be|gehr|lich; Be|gehr|lich|keit

be|gei|fern (Schmähung)

be|gei|stern; ich ...ere (↑ R 327) sich -; Be|gei|ste|rung w; -; Be|gei|ste|rungs|sturm; vgl. ¹Sturm

be|gich|ten (Erz in den Schachtofen einbringen); Be|gich|tung

Be|gier; Be|gier|de w; -, -n; be|gie|rig

be|gie|ßen; Be|gie|ßung

Be|gi|ne fr. (Angehörige einer halbklösterl. Frauenvereinigung) w; -, -n

Be|ginn m; -[e]s; von - an; zu - be|gin|nen; du begannst; du be gännest (seltener: begönnest); be gonnen; beginn[e]!; Be|gin|ner (Vorhaben) s; -s

be|glän|zen

be|gla|sen (für: glasieren); du be glast (beglasest); er be|gla|ste Be|gla|sung

be|glau|bi|gen; beglaubigte Ab schrift; Be|glau|bi|gung; Be|glau bi|gungs|schrei|ben

be|glei|chen; Be|glei|chung

Be|gleit.adres|se (Begleitschein) ...brief; be|glei|ten (mitgehen) begleitete; Be|glei|te|rin w; -, -nen; Be|gleit.er|schei nung, ...flug|zeug, ...mu|sik ...per|son, ...schein, ...text, ...um stand; Be|glei|tung

Beg|ler|beg türk. (,,Herr der Her ren''; Provinzstatthalter in der al ten Türkei) m; -s, -s

be|glot|zen (ugs. für: anstarren)

be|glücken [Trenn.: ...glük|ken] Be|glücker [Trenn.: ...glük|ker Be|glückung [Trenn.: ...glük kung]; be|glück|wün|schen; be glückwünscht; Be|glück|wün schung

be|gna|den (veraltend: [mit Gna de] beschenken); be|gna|de (meist nur noch für: begabt); be gna|di|gen (Strafe erlassen); B be|gna|di|gung; Be|gna|di|gung recht s; -[e]s

be|gnü|gen, sich

Be|go|nie [...i°; nach dem Franzo sen Michel Bégon] (eine Zie pflanze) w; -, -n

be|gön|nern; ich ...ere (↑ R 327)

be|gö|schen nordd. (beschwicht gen); du begöschst (begösches

begr. (Zeichen: ⌐) = begraben; be|gra|ben (Abk. für das 2. Partizip: begr.; Zeichen: ⌐); Be|gräb|nis s; -ses, -se; Be|gräb|nis_fei|er, ...fei|er|lich|keit, ...ko|sten (Mehrz.), ...stät|te

be|gra|di|gen ([einen ungeraden Weg od. Wasserlauf] geradelegen, [eine gebrochene Grenzlinie] ausgleichen); De|gra|di|gung

be|grannt (mit Grannen versehen)

be|grei|fen; vgl. begriffen; be|greif|lich; be|greif|li|cher|wei|se

be|gren|zen; Be|gren|zer (bei Erreichen eines Grenzwerts einsetzende Unterbrechervorrichtung); be|grenzt; Be|grenzt|heit; Be|gren|zung

Be|griff m; -[e]s, -e; im Begriff[e] sein; be|grif|fen; diese Tierart ist im Aussterben -; be|griff|lich; begriffliches Hauptwort (für: Abstraktum); Be|griffs_be|stim|mung, ...bil|dung, ...form (für: Kategorie), ...in|halt; be|griffs-_mä|ßig, ...stut|zig, ...stüt|zig (österr.); Be|griffs|ver|wir|rung

be|grün|den; be|grün|dend (Sprachw.: kausal); Be|grün|der; Be|grün|dung; Be|grün|dungs_an|ga|be (Sprachw.: Umstandsangabe des Grundes), ...satz (Sprachw.: Kausalsatz), ...wei|se

be|grü|nen (mit Grün bedecken); sich - (grün werden); Be|grü|nung

be|grü|ßen (schweiz. auch: jmdn., eine Stelle ansprechen; Kontakt aufnehmen); be|grü|ßens|wert; Be|grü|ßung; Be|grü|ßungs_an-spra|che, ...kuß, ...trunk

be|gucken [Trenn.: ...guk|ken] (ugs.)

Be|gum angloind. [auch: begam] (Titel ind. Fürstinnen) w; -, -en

be|gün|sti|gen; Be|gün|sti|gung

be|gut|ach|ten; begutachtet; Be-gut|ach|ter; Be|gut|ach|tung

be|gü|tert

be|gü|ti|gen; Be|gü|ti|gung

be|haart; Be|haa|rung

be|hä|big (schweiz. auch für: wohlhabend); Be|hä|big|keit w; -

be|hacken [Trenn.: ...hak|ken] Pflanzen -

be|haf|ten (schweiz.); jmdn. bei etwas - (jmdn. auf eine Äußerung festlegen, beim Wort nehmen); be|haf|tet; mit etwas - sein

be|ha|gen; Be|ha|gen s; -s; be|hag-lich; Be|hag|lich|keit

be|hal|ten; Be|häl|ter; Be|hält|nis s; -ses, -se

be|han|deln

be|hän|di|gen schweiz. (Amtsspr.: an sich nehmen)

Be|hand|lung; Be|hand|lungs-_pflicht, ...stuhl, ...wei|se

be|hand|schuht (Handschuhe tragend)

Be|hang (Jägerspr. auch: Schlappohren) m; -[e]s. Behänge; be|han|gen; der Baum ist mit Äpfeln -; be|hän|gen; vgl. ²hängen; behängt; grün -e Wand

be|har|ren; be|harr|lich; Be|harr-lich|keit w; -; be|harr|sam; Be|har-rung; Be|har|rungs|ver|mö|gen

be|haucht; -e Laute (für: Aspiraten); Be|hau|chung

be|hau|en; ich behaute den Stamm

be|haup|ten; sich -; be|haup|tet (Börse: fest, gleichbleibend); Be-haup|tung

be|hau|sen; Be|haust|sein; Be|hau-sung

Be|ha|vio|ris|mus engl. [bĭhe'wĭ"riß...] (amerik. sozialpsychologische Forschungsrichtung) m; -; be|ha|vio|ri|stisch

be|he|ben (beseitigen; österr. auch für: Geld von der Bank holen); Be|he-bung österr. (Abheben von Geld)

be|hei|ma|ten; be|hei|ma|tet; Be-hei|ma|tung w; -

be|hei|zen; Be|hei|zung w; -

Be|helf m; -[e]s, -e; be|hel|fen. sich; ich behelfe mich; Be|helfs|heim; be|helfs|mä|ßig

be|hel|li|gen (belästigen); Be|hel|li-gung

be|helmt

be|hemdet

Be|he|mot[h] hebr. [auch: be...] („Großtier"; im A. T. Name des Nilpferdes) m; -[e]s, -s

be|hend, be|hen|de (eigtl.: bei der Hand); Be|hen|dig|keit w; -

Be|hen|nuß, Ben|nuß span.; dt. (ölhaltige Frucht eines ostind. Baumes)

be|her|ber|gen; Be|her|ber|gung

Be|herrsch|bar|keit w; -; be|herr-schen; sich -; Be|herr|scher; be-herrscht; Be|herr|schtem u. w (↑ T 287 ff.); Be|herrscht|heit w; -; Be-herr|schung; Be|herr|schungs|ver-trag (Wirtsch.)

be|her|zi|gen; be|her|zi|gens|wert; Be|her|zi|gung; be|herzt (entschlossen); Be|herzt|heit w; -

be|he|xen

be|hilf|lich

be|hin|dern; Be|hin|de|rung; Be-hin|de|rungs|fall m; im -[e]

Behm|lot [nach dem dt. Physiker Behm] (Echolot)

be|ho|beln

be|hor|chen (abhören; belauschen)

Be|hör|de w; -, -n; Be|hör|den|an-ge|stell|te, ...deutsch, ...schrift-ver|kehr; be|hörd|lich; be|hörd|li-cher|seits

be|host (ugs. für: mit Hosen bekleidet)

Be|huf (Papierdt.: Zweck, Erfordernis) m; -[e]s, -e; zum -[e]; zu diesem -[e]; be|hufs (Amtsdt.; ↑ T 130); mit Wesf.: - des Neubaues

be|hum[p]|sen ostmitteld. (übervorteilen, bemogeln)

be|hü|ten; behüt' dich Gott!; be-hut|sam; Be|hut|sam|keit w; -; Be-hü|tung

bei (Abk.: b.); Verhältnisw. mit Wemf.; beim (vgl. d.); bei weitem (↑ R 134); bei all[e]dem; bei dem allen (häufiger für: allem); bei diesem allem (neben: allen); bei der Hand sein; beim Abgang des Schauspielers; beim Eintritt in den Saal; bei aller Bescheidenheit; bei all dem Treiben

Bei türk. (,,Herr"; türk. Titel, oft hinter Namen. z. B. Ali-Bei) m; -s, -e u. -s; vgl. Beg

bei... (in Zus. mit Zeitwörtern, z. B. beidrehen, du drehst bei, beigedreht, beizudrehen; zum 2. Mittelw. ↑ R 304)

bei|be|hal|ten; Bei|be|hal|tung w; -

bei|bie|gen (ugs.: jmdm. etw. beibringen; mit diplomatischem Geschick sagen)

Bei.blatt, ...boot. ...bre|che (Bergmannsspr.: nutzbare Nebengesteine im Gangbetrieb; w; -, -n); bei|brin|gen; jmdm. etwas - (lehren); eine Bescheinigung -

Beich|te südd. (svw. Beichte) w; --en; Beich|te w; -. -n; beich|ten; Beicht|ge|heim|nis; beicht|hö|ren österr. (die Beichte hören); Beich-ti|ger (veralt. für: Beichtvater); Beicht_kind (der Beichtende). ...sie|gel (Pflicht zur Geheimhaltung des Gebeichteten; s; -s). ...stuhl. ...va|ter (der Beichte hörende Priester)

beid|ar|mig (Sportspr.: mit beiden Händen gleich geschickt spielend); -er Stürmer; bei|de; (↑ R 135:) -s; alles -s; - jungen Leute; alle -; wir - (selten: wir -n); ihr -[n] (in Briefen usw.: Ihr -[n]); wir (ihr) -n jungen Leute; sie - (als Anrede: Sie -); die[se] -n; die[se] -s; einer von -n; euer (ihrer) -r Anteilnahme; mit unser -r Hilfe; für uns -; von -r Leben ist nichts bekannt; man bedarf aller -r; bei-de|mal, aber: beide Male; bei-der|lei; - Geschlecht[e]s; bei|der-sei|tig; bei|der|seits; mit Wesf.: des Flusses; Bei|der|wand (grobes Gewebe) w; - od. s; -[e]s; beid|fü-ßig (Sportspr.: mit beiden Füßen gleich geschickt spielend); -er Stürmer; Beid|hän|der (mit l. u. r. Hand gleich Geschickter); beid|hän|dig; Beid|recht (beidseitig gleiches Gewebe) w; -, -[e]s. -e

bei|dre|hen (Seemannsspr.: die Fahrt verlangsamen)

beid|sei|tig; vgl. beiderseitig; beid-seits schweiz. (zu beiden Seiten); - des Rheins

bei|ein|an|der; Schreibung in Ver-

bindung mit Zeitwörtern (↑R 139): beieinander (einer bei dem andern) sein, ab er: beieinandersein (ugs. für: bei Verstand sein; gesund sein); er ist gut -; vgl. aneinander; **bei|ein|an|der_ha|ben,** ...hocken [*Trenn.:* ...hok|ken], ...sit|zen, ...ste|hen
bei|ern westd. (läuten); die Glocke beiert
beif. = beifolgend
Bei|fah|rer; Bei|fah|rer|sitz
Bei|fall *m*; -[e]s; **bei|fal|len** (veralt. für: einfallen, in den Sinn kommen); **bei|fäl|lig; Bei|fall[s]|klat|schen** *s*; -s; **Bei|falls_kund|ge|bung,** ...**sturm** (vgl. ¹Sturm)
Bei|film
bei|fol|gend (Amtsdt.; Abk.: beif.); - (anbei) der Bericht
bei|fü|gen; Bei|fü|gung (auch für: Attribut)
Bei|fuß (eine Gewürz- u. Heilpflanze) *m*; -es
Bei|fut|ter (Zugabe zum gewöhnlichen Futter); vgl. ¹Futter
Bei|ga|be (Zugabe)
beige *fr.* [*bǟsche*, auch: *bĕsch*] (sandfarben); ein - (ugs.: -es) Kleid; vgl. blau, III-IV; ¹**Beige** (ein Farbton) *s*; -, - (ugs.: -s)
²**Bei|ge** südd. u. schweiz. (Stoß, Stapel) *w*; -, -n
bei|ge|ben (auch für: sich fügen); klein -
beige|far|ben [*bǟsche*..., auch: *bĕsch*...]; eine -e Couch
bei|gen südd. u. schweiz. ([auf]schichten, stapeln)
Bei|ge|ord|ne|te *m* u. *w*; -n, -n (↑R 287ff.)
Bei|ge|schmack *m*; -[e]s
bei|ge|sel|len
Bei|gnet *fr.* [*bänje*] (Schmalzgebackenes mit Füllung, Krapfen) *m*; -s, -s
bei|hef|ten; beigeheftet
Bei|hil|fe
Bei|hirsch (Jägerspr.: geringerer Hirsch)
Bei|klang
Bei|koch (Hilfskoch) *m*; **Bei|kö|chin** *w*; -, -nen
bei|kom|men; sich - (ugs. für: einfallen) lassen
Bei|kost (Zugabe zu einer Kost)
Beil (ein Werkzeug) *s*; -[e]s, -e
beil. = beiliegend
bei|la|den; vgl. ¹laden; **Bei|la|dung**
Bei|la|ge, ...la|ger
bei|läu|fig (österr. auch für: ungefähr, etwa); **Bei|läu|fig|keit**
bei|le|gen; Bei|le|gung
bei|lei|be; - nicht
Bei|leid; Bei|leids_be|zei|gung od. ...be|zeu|gung, ...kar|te, ...schrei|ben
bei|lie|gend (Abk.: beil.); **Bei|lie|gen|de** *s*; -n (↑R 287ff.)

Beiln|gries (Stadt in der Oberpfalz)
Beil|picke [*Trenn.:* ...pik|ke]
beim; ↑R 240 (bei dem; Abk.: b.); es - alten lassen (↑R 133); (↑R 120:) beim Singen u. Spielen
bei|men|gen; Bei|men|gung
bei|mes|sen; Bei|mes|sung
bei|mi|schen; Bei|mi|schung
be|imp|fen
Bein *s*; -[e]s, -e
bei|nah, bei|na|he [auch: *bainá*⁽ᵉ⁾, *baing*⁽ᵉ⁾]
Bei|na|me
bein|am|pu|tiert; ein -er Mann
Bein|brech (Ährenlilie; ein Mineral) *m*; -[e]s; **Bein|bruch** *m*; **bei|nern** (aus Knochen); **Bein|fleisch** österr. (Rindfleischspeise)
be|in|hal|ten (Papierdt.: enthalten, umfassen); es beinhaltete; beinhaltet
bein|hart südd., österr. (sehr hart); **Bein|haus** (Haus zur Aufbewahrung ausgegrabener Gebeine); ...**bei|nig** (z. B. hochbeinig); **Bein|kleid; Bein|ling** (Strumpfoberteil; auch: Hosenbein); **bein|mü|de; Bein_pro|the|se,** ...**stumpf; bein|ver|sehrt; Bein|well** (eine Heilpflanze) *m*; -[e]s; **Bein|zeug** (Beinschutz der Rüstung)
bei|ord|nen; bei|ord|nend (für: koordinierend); **Bei|ord|nung**
Bei|pack (zusätzliches Frachtgut; Fernmeldetechnik: dem Mittelleiter liegende Leitungen bei Breitbandkabeln) *m*; -[e]s; **bei|packen** [*Trenn.:* ...pak|ken]; beigepackt
Bei|pferd (das an die rechte Seite des Sattelpferdes gespannte Pferd)
bei|pflich|ten; Bei|pflich|tung (Zustimmung)
Bei|pro|gramm
Bei|rat (*Mehrz.* ...räte)
Bei|ried österr. (Rippen-, Rumpfstück) *s*; -[e]s, u. *w*; -
be|ir|ren; sich nicht - lassen
Bei|rut [auch: *bairut*] Hptst. des Libanons)
bei|sam|men; beisammen sein, ab er(↑R 139): beisammenhaben (z. B. Geld), beisammensein (ugs. für: rüstig sein; bei Verstand sein), beisammenbleiben, -sitzen, -stehen; zum 2. Mittelw. ↑R 304; **Bei|sam|men|sein** *s*; -s
Bei|sas|se (Einwohner ohne Bürgerrecht im MA.; Häusler) *m*; -n, -n (↑R 268)
Bei|satz (für: Apposition)
bei|schie|ßen ([Geld]beitrag leisten)
Bei|schlaf; vgl. ²Schlaf; **Bei|schlä|fe|rin** *w*; -
Bei|schlag (erhöhter Vorbau an Häusern) *m*; -[e]s, Beischläge

bei|schla|gen (Weidw.: in das Verbellen eines Wildes mit einstimmen)
Bei|schluß (das Beigeschlossene; Anlage); unter - von ...
Bei|sein *s*; -s; -s; in seinem Beisein
bei|sei|te (↑R 141); beiseite legen, schaffen, stoßen usw.; **Bei|sei|te_schaf|fung** (*w*; -), ...**set|zung** (*w*; -); **bei|seits** südwestd. (beiseite)
Bei|sel bayr. ugs., österr. (Kneipe) *s*; -s, -[n]
bei|set|zen; Bei_set|zung, ...**sit|zer**
Bei|spiel *s*; -[e]s, -e; zum - (Abk.: z. B.); **bei|spiel_ge|bend,** ...**haft,** ...**los,** -este (↑R 292); **Bei|spiel_satz; Bei|spiels|fall** *m*; **bei|spiels_hal|ber,** ...**wei|se**
bei|sprin|gen (helfen)
Bei|ßel mitteld. (Beitel, Meißel) *m*; -s, -
bei|ßen; du beißt (beißest); ich biß du bissest; gebissen; beiß[e]!; der Hund beißt ihn (auch: ihm) ins Bein; sich - ([von Farben:] nicht harmonieren); **Bei|ßer** (österr. auch: Hebeeisen); **Bei|ße|rei; Beiß|korb; beiß|wü|tig; Beiß|zan|ge**
Bei|stand (österr. auch für: Trauzeuge) *m*; -[e]s, Beistände; **Bei|stands_kre|dit,** ...**pakt; bei|ste|hen**
bei|stel|len österr. (zusätzlich) zu Verfügung stellen); **Bei|stel|lung**
Bei|steu|er *w*; **bei|steu|ern**
bei|stim|men
Bei|strich (für: Komma)
Bei|tel (meißelartiges Werkzeug *m*; -s, -
Bei|trag *m*; -[e]s, ...träge; **bei|tra|gen;** er hat das Seine, sie hat das Ihre dazu beigetragen; **Bei|trä|ger; Bei|trags_be|mes|sungs|gren|ze; Bei|trags_klasse,** ...**rück|erstat|tung,** ...**satz,** ...**zahlung**
bei|trei|ben; Bei|trei|bung ([zwangsmäßige] Einziehung [von Geld])
bei|tre|ten; Bei|tritt; Bei|tritts|er|klä|rung
Bei|wacht vgl. Biwak
Bei|wa|gen; Bei|wa|gen|fah|rer
Bei|werk (Nebenwerk; auch für Unwichtiges)
bei|woh|nen; Bei|woh|nung
Bei|wort (für: Adjektiv; *Mehrz.* ...wörter)
Beiz schweiz. ugs. ([einfache, gemütliche] Gaststätte) *w*; -, -en vgl. Beisel
Bei|zahl (Koeffizient)
Bei|zäu|mung (Pferdesport)
¹**Bei|ze** (chem. Flüssigkeit zum Färben, Gerben u. ä.) *w*; -, -
²**Bei|ze** (Beizjagd) *w*; -, -n
bei|zei|ten (↑R 141)
bei|zen; du beizt (beizest)
Bei|zer (ugs. für: Besitzer eine Kneipe)

bei|zie|hen; Bei|zie|hung w; -
Beiz|jagd
Bei|zung (Behandlung mit ¹Beize)
Beiz|vo|gel (für die Jagd abgerichteter Falke)
be|ja|gen; Be|ja|gung
be|ja|hen; eine bejahende Antwort; be|ja|hen|den|falls; vgl. Fall m
be|jahrt
Be|ja|hung
be|jam|mern; be|jam|merns|wert
be|ju|beln
be|ka|keln nordd. (gemeinsam besprechen)
be|kämp|fen; Be|kämp|fung
be|kannt, *Schreibung in Verbindung mit Zeitwörtern* (↑ R 139): **a)** *Getrenntschreibung* in ursprünglicher Bedeutung, z. B. bekannt machen; er soll mich mit ihm bekannt machen; sich mit einer Sache bekannt (vertraut) machen; einen Schriftsteller bekannt machen; **b)** *Zusammenschreibung*, wenn durch die Verbindung ein neuer Begriff entsteht; vgl. jmdm. bekanntgeben, bekanntmachen, bekanntwerden; **Be|kann|te** m u. w; -n, -n (↑ R 287ff.); jemand s; liebe -; **Be|kann|ten|kreis**; be|kann|ter|ma|ßen; Be|kannt|ga|be w; -; be|kannt|ge|ben (↑ R 139); er hat die Verfügung bekanntgegeben; **Be|kannt|heit; Be|kannt|heits|grad; be|kannt|lich; be|kannt|ma|chen;** ↑ R 139 (veröffentlichen, eröffnen); das Gesetz wurde bekanntgemacht; aber: **bekannt machen:** ich habe meine Schwester mit ihm bekannt gemacht; **Be|kannt|ma|chung, ...schaft; be|kannt|wer|den;** ↑ R 139 (veröffentlicht werden; in die Öffentlichkeit dringen); der Wortlaut ist bekanntgeworden; wenn der Wortlaut bekannt wird; aber: be|kannt wer|den; ich bin bald mit ihm bekannt geworden; das Dorf ist durch eine Schlacht bekannt geworden
be|kan|ten (mit Kanten versehen); Be|kan|tung w; -
Be|kas|si|ne fr. (Sumpfschnepfe) w; -, -n
be|kau|fen, sich (ugs. für: etwas, was den Ansprüchen nicht genügt, kaufen; zu teuer einkaufen)
be|keh|ren; sich -; Be|keh|rer; be|keh|re|rin w; -, -nen; Be|kehr|te m u. w; -n, -n (↑ R 287ff.); Be|keh|rung
be|ken|nen; sich -; Bekennende Kirche (Name einer Bewegung in den dt. ev. Kirchen; ↑ R 224;
Be|kennt|nis (österr. auch für: Steuererklärung) s; ...nisses, ...nisse; Be|kennt|nis_buch, ...frei-

heit w; -; be|kennt|nis|haft; Be|kennt|nis|kir|che (Bekennende Kirche); be|kennt|nis|mä|ßig; Be|kennt|nis|schu|le (Schule mit Unterricht im Geiste eines religiösen Bekenntnisses)
bekiest
be|kla|gen; sich -; be|kla|gens_wert, ...wür|dig; Be|klag|te (jmd., gegen den eine [Zivil]klage erhoben wird) m u. w; -n, -n (↑ R 287ff.); Be|klag|ten|par|tei
be|klat|schen (mit Händeklatschen begrüßen)
be|klau|en (ugs. für: bestehlen)
be|kle|ben; Be|kle|bung
be|kleckern [*Trenn...* ...klek|kern] (ugs. für: beklecksen); sich -; be|kleck|sen; sich -; bekleckst
be|klei|den; ein Amt -; Be|klei|dung; Be|klei|dungs_industrie, ...werk
be|klem|men; beklemmt; be|klem|mend; -ste; Be|klemm|nis w; -, -se; Be|klem|mung; be|klom|men (ängstlich, bedrückt); Be|klom|men|heit w; -
be|klop|fen
be|kloppt (ugs. für: blöd)
be|knab|bern
be|knien (ugs.: jmdn. dringend u. ausdauernd bitten)
be|ko|chen; jmdn. - (ugs.: für jmdn. regelmäßig das Essen kochen)
be|kö|dern (Angelsport: mit einem Köder versehen)
be|koh|len (fachspr. für: mit Kohlen versorgen); Be|koh|lung
be|kom|men; ich habe es -; es ist mir gut -; be|kömm|lich; der Wein ist leicht bekömmlich, aber (↑ R 143): ein leichtbekömmlicher Wein
be|kom|pli|men|tie|ren (jmdm. viele Komplimente machen)
be|kö|sti|gen; Be|kö|sti|gung
be|kräf|ti|gen; Be|kräf|ti|gung
be|krallt (mit Krallen versehen)
be|krän|zen; Be|krän|zung
be|kreu|zen (mit dem Kreuzeszeichen segnen); bekreuzt; be|kreu|zi|gen, sich
be|krie|chen
be|krie|gen
be|krit|teln (bemängeln, [kleinlich] tadeln); Be|krit|te|lung, Be|kritt|lung
be|krö|nen; Be|krö|nung
be|küm|mern; das bekümmert ihn; sich um jmdn. oder etwas -; Be|küm|mer|nis w; -, -se; Be|küm|mert|heit; Be|küm|me|rung
be|kun|den; sich -; Be|kun|dung
Bel [nach dem amerik. Physiologen A. G. Bell] (eine physikal. Zählungseinheit; Zeichen: B) s; -s, -
Bé|la [bela] (ung. m. Vorn.)

be|lä|cheln; be|la|chen
be|la|den; vgl. ¹laden; Be|la|dung
Be|lag m; -[e]s, ...läge
be|la|ge|rer; be|la|gern; Be|la|ge|rung; Be|la|ge|rungs|zu|stand
be|läm|mert (falsch für: belemmert)
Be|lang m; -[e]s, -e; von - sein; be|lan|gen; was mich belangt (veralt. für; anfbelangt); jmdn. - (zur Rechenschaft ziehen; verklagen); be|lang|los; -este (↑ R 292); Be|lang|lo|sig|keit; be|lang|reich; Be|lan|gung; be|lang|voll
be|las|sen; Be|las|sung
be|last|bar; Be|last|bar|keit; be|la|sten; be|la|stend, -ste
be|lä|sti|gen; Be|lä|sti|gung
Be|la|stung; Be|la|stungs_gren|ze, ...ma|te|ri|al, ...pro|be, ...zeu|ge
be|lau|ben, sich; be|laubt; Be|lau|bung
be|lau|ern; Be|lau|e|rung
¹Be|lauf (veralt. für: Betrag, Höhe [der Kosten]) m; -[e]s; ²Be|lauf (Forstbezirk); be|lau|fen; sich -; die Kosten haben sich auf ... belaufen
be|lau|schen
Bel|can|to, (auch:) Bel|kan|to it. („der schöne Gesang"; Kunstgesang in it. Art) m; -s
Bel|chen (Erhebung im südl. Schwarzwald) m; -s; (↑ R 198:) Großer -, Elsässer - (Erhebung in den Vogesen)
be|le|ben; be|lebt; ein -er Platz; Be|lebt|heit; Be|le|bung w; -
be|lecken [*Trenn...:* ...lek|ken]
Be|leg (Beweis[stück]) m; -[e]s, -e; zum -[e]; be|leg|bar; be|le|gen; Be|leg|ex|em|plar; Be|leg|schaft; Be|leg|schafts_aktie, ...stär|ke; Be|leg|stück; be|legt; Be|le|gung w; -; Be|leg|zet|tel
be|leh|nen (in ein Lehen einsetzen); Be|leh|nung
be|lehr|bar; be|leh|ren; (↑ R 135:) eines and[e]ren od. andern -, aber (↑ R 116:) eines Besser[e]n od. Beßren -; Be|leh|rung
be|leibt; Be|leibt|heit w; -
be|lei|di|gen; Be|lei|di|ger; be|lei|digt; Be|lei|di|gung; Be|lei|di|gungs_kla|ge, ...pro|zeß
be|leih|bar; be|lei|hen; Be|lei|hung
be|lem|mern nordd. (mit dauernden Bitten) belästigen); be|lem|mert (ugs. für: schlimm, übel)
be|lem|nit gr. (fossiler Schalenteil von Tintenfischen); -en, -en (↑ R 268)
be|le|sen (unterrichtet; viel wissend); Be|le|sen|heit w; -
Bel|es|prit fr. [bäläßpri] (veralt., noch spöttisch für: Schöngeist) m; -s, -s; Bel|eta|ge [...tasehe] (veralt. für: Ober-, Hauptgeschoß, erster Stock)

be|leuch|ten; Be|leuch|ter; Be-
leuch|tung; Be|leuch|tungs_an|la-
ge, ...ef|fekt, ...kör|per, ...stär|ke,
...tech|nik
be|leum|det, be|leu|mun|det; er ist
gut, übel -
Bel|fast (Hptst. von Nordirland)
bel|fern (ugs. für: laut schimpfen,
zanken); ich ...ere (↑ R 327)
Bel|gi|en [...i*n]; Bel|gi|er [...i*r];
bel|gisch
Bel|grad (Hptst. Jugoslawiens);
vgl. Beograd
Be|li|al, (ökum.:) Be|li|ar hebr.
(„Verderber"; Teufel im N. T.)
m; -[s]
be|lich|ten; Be|lich|tung; Be|lich-
tungs_mes_ser m, ...zeit
be|lie|ben (wünschen): es beliebt
(gefällt) mir; Be|lie|ben s; -s; nach
-; es steht in seinem -; be|lie|big;
x-beliebig (↑ R 149); alles -e (was
auch immer), jeder -e (↑ R 135),
aber (↑ R 116): etwas Beliebiges
(etwas nach Belieben); be|liebt;
-este (↑ R 292); Be|liebt|heit w; -
be|lie|fern; Be|lie|fe|rung w; -
Be|lin|da (w. Vorn.)
Bel|kan|to vgl. Belcanto
Bel|la (w. Vorn.); auch Kurzform
von: Isabella
Bel|la|don|na it. (Tollkirsche) w;
-, ...nnen
Bel|la|gio [beladseho] (nordit.
Kurort)
Bel|la|my [bäl*mi] (amerik.
Schriftsteller)
Belle-Al|li|ance [bälaliangß] (belg.
Schlachtort)
bel|len; Bel|ler
Bel|le|trist fr. (Unterhaltungs-
schriftsteller); ↑ R 268; Bel|le|tri-
stik (Unterhaltungsliteratur) w;
-; bel|le|tri|stisch
¹Belle|vue [bälwü] (veralt. für:
„schöne Aussicht"; Aussichts-
punkt) w; -, -n; ²Belle|vue (Bez.
für: Schloß, Gaststätte mit
schöner Aussicht) s; -[s], -s
Bel|li|ni (it. Malerfamilie; it. Kom-
ponist)
Bel|lin|zo|na (Hptst. des Kantons
Tessin)
Bel|lo (ein Hundename)
Bel|lo|na (röm. Kriegsgöttin)
be|lo|ben (veralt. für: belobigen);
be|lo|bi|gen; Be|lo|bi|gung; Be|lo-
bung (veralt. für: Belobigung)
be|loh|nen; Be|loh|nung
be|lo|rus|sisch (weißrussisch)
Bel-Pae|se (ein it. Weichkäse) m; -
Bel|sa|zar, (ökum.:) Bel|schaz|zar
(babylon. Kronprinz, nach dem
A. T. letzter König von Babylon)
Belt (Meerenge) m; -[e]s, -e; (↑ R
198:) der Große -, der Kleine -
be|lüf|ten; Be|lüf|tung
¹Be|lu|ga russ. (Hausen [vgl. d.];
Weißwal) w; -, -s; ²Be|lu|ga (der

aus dem Rogen des Hausens be-
reitete Kaviar) m; -s
be|lü|gen
be|lu|sti|gen; sich -; Be|lu|sti|gung
Be|lu|tsche (Angehöriger eines
asiat. Volkes) m; -n, -n (↑ R 268);
be|lu|tschisch; Be|lu|tschi|stan
[auch: belu...] (westpakistan.
Hochland)
Bel|ve|de|re it. [...we...] („schöne
Aussicht"; Aussichtspunkt; Bez.
für: Schloß, Gaststätte mit
schöner Aussicht) s; -[s], -s
Belz|nickel [Trenn.: ...nik|kel]
westmitteldt. (vermummte Ge-
stalt der Vorweihnachtszeit, Ni-
kolaus, Knecht Ruprecht) m; -s, -
Bem. = Bemerkung
be|mäch|ti|gen, sich; sich des Gel-
des -; Be|mäch|ti|gung
be|mä|keln (ugs. für: bemängeln,
bekritteln); Be|mä|ke|lung, Be-
mäk|lung
be|ma|len; Be|ma|lung
be|män|geln; ich ...[e]le (↑ R 327);
Be|män|ge|lung, Be|mäng|lung
be|man|nen (ein Schiff); Be|man-
nung
be|män|teln (beschönigen); ich
...[e]le (↑ R 327); Be|män|te|lung,
Be|mänt|lung
Be|ma|ßung (fachspr. für: Maß-
eintragung auf Zeichnungen)
be|ma|sten (mit einem Mast verse-
hen); Be|ma|stung
Bem|berg ⓦ (Textilerzeugnisse)
be|meh|len; Be|meh|lung
be|mei|ern (ugs. für: überlisten);
ich ...ere (↑ R 327)
be|mei|stern, sich (veralt. für: sich
beherrschen)
be|merk|bar; sich - machen; be-
mer|ken; Be|mer|ken s; -s; mit
dem -; be|mer|kens|wert; be-
merk|lich (älter für: bemerkbar);
Be|mer|kung (Abk.: Bem.)
be|mes|sen; sich -; Be|mes|sung
be|mit|lei|den; Be|mit|lei|dung
be|mit|telt (wohlhabend)
Bemm|chen; Bem|me slaw. ostmit-
teld. (Brotschnitte mit Aufstrich,
Belag) w; -, -n
be|mo|geln (ugs. für: betrügen)
be|moost
be|mü|hen; sich -; er ist um sie be-
müht; be|mü|hend schweiz. (uner-
freulich, peinlich); Be|mü|hung
be|mü|ßi|gen (Papierdt.: veranlas-
sen, nötigen); be|mü|ßigt; ich se-
he mich -
be|mu|stern (Kaufmannsspr.: mit
Warenmustern versehen); ein be-
musterter Katalog; Be|mu|ste-
rung
be|mut|tern; ich ...ere (↑ R 327); Be-
mut|te|rung
be|mützt
Ben (bei hebr. u. arab. Eigenna-
men: Sohn od. Enkel)

be|nach|bart
be|nach|rich|ti|gen; Be|nach|rich-
ti|gung
be|nach|tei|li|gen; Be|nach|tei|li-
gung
be|na|geln (mit Nägeln versehen);
Be|na|ge|lung, Be|nag|lung
be|na|gen
be|nam|sen (ugs. u. scherzh. für:
jmdm. einen Namen geben); du
benamst (benamsest); Be|nam-
sung
be|nannt
be|narbt (veralt. für: mit Narben
versehen)
Be|na|res (früherer Name für:
Varanasi)
be|naut nordd. (niedergeschlagen)
Ben|del ([schmales] Band, Schnur)
m od. s; -s, -; vgl. Bändel
Ben|dix (Kurzform von: Bene-
dikt)
be|ne lat. („gut")
be|ne|beln (verwirren, den Ver-
stand trüben); be|ne|belt (ugs.
für: [durch Alkohol] geistig ver-
wirrt); Be|ne|be|lung, Be|neb|lung
w; -
be|ne|dei|en lat. (segnen; seligprei-
sen); du benedeitest (benedeiest);
du benedeitest; benedeit (älter:
gebenedeit); die Gebenedeite
(vgl. d.)
Be|ne|dikt, Be|ne|dik|tus (m.
Vorn.); Be|ne|dik|ta (w. Vorn.)
Be|ne|dikt|beu|ern (Ort u. Kloster
in Bayern)
Be|ne|dik|ten|kraut (eine Heil-
pflanze) s; -[e]s; Be|ne|dik|ti|ner
(Mönch des Benediktinerordens;
auch: Benedik|tiner
ner|or|den (Abk.: OSB [vgl. d.])
m; -s; Be|ne|dik|ti|on [...zion]
(Segnung, kath. kirchl. Weihe);
Be|ne|dik|tus vgl. Benedikt; be-
ne|di|zie|ren (segnen, weihen)
Be|ne|fiz lat. (Vorstellung zugun-
sten eines Künstlers; Ehrenvor-
stellung; veralt. für: Lehen,
Wohltat) s; -es, -e; Be|ne|fi|zi|ant
(von einem Benefiz begünstigter
Künstler) m; -en, -en (↑ R 268);
Be|ne|fi|zi|ar m; -s, -e u. Be|ne|fi-
zi|at (Inhaber eines [kirchl.] Be-
nefiziums) m; -en, -en (↑ R 268);
Be|ne|fi|zi|um (mit einer Pfründe
verbundenes Kirchenamt; mit-
telalterl. Lehen; veralt. für:
Wohltat, Begünstigung) s; -s,
...ien [...i*n]; Be|ne|fiz_kon|zert,
...vor|stel|lung
be|neh|men; Be|neh|men s; -s; sich mit
jmdm. ins - setzen
be|nei|den; be|nei|dens|wert
Be|ne|lux [auch: ...lyx] (Kurzw.
für die seit 1947 in einer Zolluni-
on zusammengefaßten Länder

Belgique [Belgien], Nederland [Niederlande] u. Luxembourg [Luxemburg]); Be|ne|lux|staa|ten *Mehrz.*

be|nẹn|nen; Be|nẹn|nung

be|nẹt|zen; Be|nẹt|zung

Ben|gạ|le (Angehöriger eines indischen Volksstammes) *m;* -n, -n († R 268); Ben|gạ|len (Provinz in Indien); Ben|gạ|li (Sprache) *s;* -[s]; ben|gạ|lisch; -es Feuer (Buntfeuer); -e Beleuchtung

Bẹn|gel (veralt. für: Stock, Prügelholz; auch: [ungezogener] Junge) *m;* -s, - (ugs.: -s; ↑ R 271)

be|nie|sen; etwas -

Be|nị|gna (w. Vorn.); Be|nị|gni|tạt *lat.* (selten für: Güte; Med.: Gutartigkeit einer Krankheit); Be|nị|gnus (m. Vorn.)

Be|nịmm (ugs. für: Betragen, Verhalten) *m;* -s

be|nị|to (it. u. span. m. Vorn.)

[1]Bẹn|ja|min (m. Vorn.); [2]Bẹn|ja|min (übertr. für: Jüngster) *m;* -s, -e

Bẹnn (dt. Dichter)

Rẹn|ne *lat.* schweiz. mdal. (Schubkarren) *w;* -, -n

Bẹn|no (m. Vorn.)

Bẹn|nuß vgl. Behennuß

be|nọm|men (fast betäubt); Be|nọm|men|heit *w;* -

be|nọ|ten; einen Aufsatz -; Be|nọ|tung

be|nọ|ti|gen; einen Vermittler (veralt.: eines Vermittlers) -; Be|nọ|ti|gung

Bẹn|thal *gr.* (Bodenregion eines Gewässers) *s;* -s; Bẹn|thos („Tiefe"; an den Meeresboden gebundene Tier- und Pflanzenwelt) *s;* -

Be|num|mern; Be|num|me|rung

Be|nụtz|bar; Be|nụtz|bar|keit; be|nụt|zen, (bes. südd., österr.:) be|nụt|zen; Be|nụt|zer|kreis; Be|nụt|zung, (bes. sudd., österr.:) Be|nụt|zung; Be|nụt|zungs|ge|bühr

Bẹn|ve|nụ|to (it. m. Vorn.); Bẹn|ve|nụ|ta (it. w. Vorn.)

Bẹnz (dt. Ingenieur)

ẹn|zen vgl. penzen

Ben|zin *arab.* (Treibstoff; Lösungsmittel) *s;* -s, -e; Ben|zin|hahn, ...ka|ni|ster, ...kut|sche (ugs. scherzh. für: Auto), ...preis, ...preis|er|hö|hung, ...tank, ...uhr; Ben|zoe [*benzo-e*] *w;* -a. Bẹn|zoe|harz; Bẹn|zoe|säu|re (Konservierungsmittel); Ben|zọl (Teerdestillat aus Steinkohlen; Lösungsmittel) *s;* -s, -e; Ben|zyl (Atomgruppe in zahlreichen chem. Verbindungen) *s;* -s; Ben|zyl|al|ko|hol (aromat. Alkohol; Grundstoff für Parfüme)

be|ọb|ach|ten; Be|ọb|ach|ter; Be|ọb|ach|tung; Be|ọb|ach|tungs|ga|be, ...ma|te|ri|al

Beọ|grad (jugoslaw. Name für: Belgrad)

be|ọr|dern; ich ...ere († R 327); Be|ọr|de|rung

be|packen [*Trenn.:* ...pak|ken]; Be|packung [*Trenn.:* ...pak|kung]

be|pflạn|zen; Be|pflạn|zung

be|pflạ|stern; Be|pflạ|ste|rung

be|pịn|seln; Be|pịn|se|lung; Be|pịn|slung

be|pụ|dern; Be|pụ|de|rung

be|quạt|schen (ugs. für: bereden)

be|quẹm; be|quẹ|men, sich; be|quẹm|lich (veralt. für: bequem); Be|quẹm|lich|keit

be|rạn|ken; Be|rạn|kung

Be|rạpp (rauher Verputz) *m;* -[e]s;

[1]be|rạp|pen

[2]be|rạp|pen (ugs. für: bezahlen)

be|rạ|ten; beratender Ingenieur; Be|rạ|ter; be|rạt|schla|gen; du beratschlagtest; beratschlagt; Be|rạt|schla|gung; Be|rạ|tung; Be|rạ|tungs_aus|schuß, ...punkt, ...stel|le, ...ver|trag

be|rạu|ben; Be|rạu|bung

be|rạu|chern (auch für: beweihräuchern); Be|rạu|che|rung

be|rạu|schen; sich -; be|rạu|schend; -ste; be|rạuscht; Be|rạuscht|heit *w;* -; Be|rạu|schung

Bẹr|ber (Angehöriger einer Völkergruppe in Nordafrika) *m;* -s, -; Bẹr|be|rẹi (aber Name für die Küstenländer im westl. Nordafrika) *w;* -; bẹr|be|risch

Ber|be|rịt|ze *lat.* (Sauerdorn, ein Zierstrauch) *w;* -, -n

Bẹr|ber|pferd

Ber|ceu|se *fr.* [*bärßös^e*] (Musik: Wiegenlied) *w;* -, -n

Bẹrch|ta (ältere Form für: Berta)

Bẹrch|tes|ga|den (Luftkurort in Oberbayern); Bẹrch|tes|ga|de|ner († R 199); Berchtesgadener Alpen; das Berchtesgadener Land

Bẹrch|told (ältere Form von Bertold)

be|rẹ|chen|bar; Be|rẹ|chen|bar|keit *w;* -; be|rẹch|nen; Be|rẹch|nung

be|rẹch|ti|gen; Be|rẹch|tig|te *m u.* *w;* -n, -n († R 287ff.); be|rẹch|tig|ter|wei|se; Be|rẹch|ti|gung; Be|rẹch|ti|gungs|schein

be|rẹ|den; be|rẹd|sam; Be|rẹd|sam|keit *w;* -; be|rẹdt; auf das, aufs -este († R 134 u. R 292); Be|rẹdt|heit *w;* -; Be|rẹ|dung

be|rẹg|nert (zu einer Reederei gehörend od. von ihr betreut)

be|rẹg|nen; Be|rẹg|nung; Be|rẹg|nungs|an|la|ge

Be|rẹich *m* (seltener *s*); -[e]s, -e

be|rẹi|chern; ich ...ere († R 327); sich -; Be|rẹi|che|rung; Be|rẹi|che|rungs_ab|sicht, ...ver|such

be|rẹi|fen (mit Reifen versehen); bereift

be|rẹift (mit Reif bedeckt)

Be|rẹi|fung

be|rẹi|ni|gen; Be|rẹi|ni|gung

be|rẹi|sen; ein Land -; Be|rẹi|sung

be|rẹit; († R 139:) zu etwas - sein, sich - erklären, sich - finden, sich - halten; vgl. aber: bereithalten, bereitlegen, bereitliegen, bereitmachen, bereitstehen, bereitstellen; [1]be|rẹi|ten (zubereiten); bereitet

[2]be|rẹi|ten (zureiten); beritten; Be|rẹi|ter (Zureiter)

be|rẹit|hal|ten († R 139); ich habe es bereitgehalten; († R 145:) bereit- u. zur Verfügung halten, aber: zur Verfügung u. bereithalten; be|rẹit|le|gen († R 139); ich habe das Buch bereitgelegt; be|rẹit|lie|gen († R 139); die Bücher werden -; be|rẹit|ma|chen († R 139); ich habe alles bereitgemacht; be|rẹits (schon); Be|rẹit|schaft; Be|rẹit|schafts_dienst, ...po|li|zei; be|rẹit|ste|hen († R 139); ich habe bereitgestanden; be|rẹit|stel|len († R 139); ich habe das Paket bereitgestellt; Be|rẹit|stel|lung; Be|rẹi|tung; be|rẹit|wil|lig; -st; Be|rẹit|wil|lig|keit *w;* -

Be|rẹ|ni|ce [...*ize*] vgl. Berenike; Be|rẹ|ni|ke (w. Vorn.); Haar der - (ein Sternbild)

be|rẹn|nen; das Tor - (Sportspr.)

be|rẹn|ten (Amtsdt.: eine Rente zusprechen)

Be|rẹ|si|na [auch: *bere...*] (russ. Fluß) *w;* -

Bé|ret *fr.* [*berä*] schweiz. (Baskenmütze) *s;* -s, -s

be|rẹu|en

[1]Bẹrg (früheres Großherzogtum)

[2]Bẹrg, Alban (österr. Komponist)

[3]Bẹrg *m;* -[e]s, -e; zu -[e] fahren; die Haare stehen einem zu -[e] (ugs.); berg|ạb; - gehen; bẹrg|ạb|wärts; Bẹrg.ad|ler, ...ahorn, ...aka|de|mie

berg|an; - gehen; Bẹrg|ar|bei|ter; berg|auf; - steigen; berg|auf|wärts; Bẹrg.bahn, ...bau (*m;* -[e]s), ...bau|er, ...be|hör|de, ...bewoh|ner; Bẹr|ge (taubes, in der Grube anfallendes Gestein) *Mehrz.*; Bẹrg|hoch, bẹrg|hoch

Bẹrg|lohn; bẹr|gen; sich -; du birgst; du bargst; du bärgest; geborgen; birg!

Bẹr|gen|gruen [...*grün*] (dt. Dichter)

Bẹr|ges|hal|de od. Bẹrg|hal|de,

...hö|he; ber|ge|wei|se (ugs.: in großen Mengen); Berg|fahrt (Fahrt den Strom hinauf; Ggs.: Talfahrt); berg|fern; Berg|fex (leidenschaftlicher Bergsteiger); Berg|fried (Hauptturm auf Burgen; Wehrturm) m; -[e]s, -e; vgl. auch: Burgfried; Berg.füh|rer, ...hal|de od. Ber|ges|halde; berg|hoch, ber|ge|hoch; Berg-ho|tel; ber|gig

ber|gisch (zum Lande Berg gehörend), aber (↑ R 198): das Bergische Land (Gebirgslandschaft zwischen Rhein, Ruhr und Sieg)

Berg Isel m; - - u. (österr. auch:) Berg|isel (Berg bei Innsbruck) m; -

Berg.ket|te, ...knap|pe, ...krankheit, ...krax|ler, ...kri|stall (ein Mineral), ...kup|pe; Berg|ler (im Bergland Wohnender) m; -s, -; Berg|mann (Mehrz. ...leute); berg|män|nisch; Berg|manns-spra|che; Berg.mas|siv, ...meister, ...not, ...par|te (Bergmannsspr.: Paradebeil der Bergleute; w; -, -n), ...pfad, ...pre|digt (w; -), ...pro|bie|rer (Bergwardein [vgl. d.]); berg|reich; Berg.rettungs|dienst, ...rutsch, ...schä|den (durch den Bergbau an der Erdoberfläche hervorgerufene Schäden; Mehrz.), ...schuh; berg-schüs|sig (Bergmannsspr.: reich an taubem Gestein); berg|seits; Berg.spit|ze, ...stei|gen (s; -s), ...stei|ger; berg|stei|ge|risch; Berg|stra|ße (am Westfuß des Odenwaldes zum Oberrheinischen Tiefland); - Wein; Berg.tod (m; -[e]s), ...tour; Berg-und-Tal-Bahn (↑ R 155) w; -, -en

Ber|gung; Ber|gungs.kom|man|do, ...mann|schaft

berg|unter; Berg|wacht; Berg|wardein (Bergprobierer [Bergbeamter, der den Gehalt der Erze bestimmt]); Berg|werk; Berg|werks-ab|ga|be

Be|ri|be|ri singhal. [beríbéri] (eine Krankheit infolge Mangels an Vitamin B₁) w; -

Be|richt m; -[e]s, -e; - erstatten; be|rich|ten: falsch, gut berichtet sein; Be|rich|ter; Be|richt|er|statter; Be|richt|er|stat|tung; be|rich-ti|gen; Be|rich|ti|gung; Be-richts.heft (Heft für wöchentl. Arbeitsberichte von Lehrlingen), ...jahr

be|rie|chen; sich - (ugs. für: vorsichtig Kontakte herstellen)

be|rie|seln; ich ...[e]le (↑ R 327); Be-rie|se|lung. Be|ries|lung; Be|rie-se|lungs|an|la|ge

be|rin|det [zu: Rinde]

be|rin|gen ([Vögel u. a.] mit Ringen [am Fuß] versehen)

Be|ring.meer (nördlichstes Randmeer des Pazifischen Ozeans; s; -[e]s), ...stra|ße (w; -); ↑ R 210

Be|rin|gung (von Vögeln u. a.)

Be|ritt ([Forst]bezirk; [kleine] Abteilung Reiter); be|rit|ten (mit Reittier[en] versehen); Be|ritt-füh|rer

Ber|ke|li|um [nach der Universität Berkeley in den USA] (chem. Grundstoff, Transuran; Zeichen: Bk) s; -s

Ber|lin (Stadt an der Spree; ehem. Hptst. des Deutschen Reiches); Ber|li|na|le (Bez. für die Filmfestspiele in Berlin) w; -, -n; Ber|lin-Char|lot|ten|burg [- schar...]; Ber-lin-Dah|lem; Ber|li|ner; ↑ R 199 (auch kurz für: Berliner Pfannkuchen); ein - Kind; - Bär (Wappen von Berlin); - Pfannkuchen; Ber-li|ner Blau (ein Farbstoff) s; - -s; ber|li|ne|risch vgl. berlinisch; ber-li|nern (berlinerisch sprechen); ich ...ere (↑ R 327); Ber|li|ner-Schrift [nach dem Elektroingenieur E. Berliner] (Tonaufzeichnungsverfahren); ↑ R 180; ber-li|nisch; Ber|lin-Jo|han|nis|thal; Ber|lin-Kö|pe|nick; Ber|lin-Neu-kölln; Ber|lin-Pan|kow [- pangko]; Ber|lin-Prenz|lau|er Berg; Ber|lin-Rei|nicken|dorf [Trenn.: ...nik|ken...]; Ber|lin-Span|dau; Ber|lin-Steg|litz; Ber|lin-Trep-tow [- trepto]; Ber|lin-Wei|ßen-see; Ber|lin-Wil|mers|dorf; Ber-lin-Zeh|len|dorf

Ber|li|oz [bärliós] (fr. Komponist)

Ber|litz|schu|le [nach dem Gründer] (Sprachschule); ↑ R 180

Ber|locke [Trenn.: ...lok|ke] fr. (kleiner Schmuck an [Uhr]ketten) w; -, -n

Ber|me (Böschung, Böschungsabsatz) w; -, -n

Ber|mu|da|in|seln od. Ber|mu|das (Inseln im Atlantik) Mehrz.

Bern (Hptst. der Schweiz und des gleichnamigen Kantons)

Ber|na|dette [...dät] (fr. w. Vorn.)

Ber|na|nos (frz. Schriftsteller)

Ber|nar|di|no (it. Form von: Bernhardin) m; -[s]

Bern|biet; Ber|ner (↑ R 199); die Berner Alpen, das Berner Oberland

Bern|hard (m. Vorn.); Bern|har|de (w. Vorn.); Bern|har|din m; -s, (auch:) Bern|har|din|paß (kurz für: Sankt-Bernhardin-Paß) m; ...passes; vgl. Bernardino; Bern-har|di|ne (w. Vorn.); Bern|har|di-ner (eine Hunderasse) m; -s, -; Bern|har|di|ner.hund, ...kraut (s; -[e]s)

Bern|hild, Bern|hil|de (w. Vorn.)

Ber|ni|na (kurz für: Piz Bernina, höchster Gipfel der Ostalpen, bzw. für: Berninagruppe, -massiv) m; -s (auch: w; -); Ber|ni|na-bahn w; -

ber|nisch [zu: Bern]

¹Bern|stein, Leonard (amerik. Komponist u. Dirigent)

²Bern|stein („Brennstein"; ein fossiles Harz); bern|stei|ne|[r]n (aus Bernstein)

Bern|ward (m. Vorn.); Bern-wards|kreuz s; -es

Be|ro|li|na (Frauengestalt als Sinnbild Berlins) w; -

Ber|sa|glie|re it. [bärßaljár^e] (it. Scharfschütze) m; -[s], ...ri

Ber|ser|ker altnord. [auch: bär...] (wilder Krieger; auch für: blindwütig tobender Mensch) m; -s, -; ber|ser|ker|haft; Ber|ser|ker-wut

ber|sten; du birst (veralt.: du berstest); du barstest; du bärstest; geborsten; (selten:) birst!

Bert (m. Vorn.)

Ber|ta; ↑ R 191 (w. Vorn.); Bert|hil-de (w. Vorn.); Bert|hold vgl. Bertold; Ber|ti (Koseform von: Berta usw.)

Ber|til|lo|na|ge fr. [bärtijonaseh^e] w; - u. Ber|til|lon|sche Sy|stem [...tüjongsch^e -; nach dem Erfinder A. Bertillon) (veralt. Verfahren zur Wiedererkennung rückfälliger Verbrecher durch Aufnahme unveränderlicher Körpermerkmale) s; -n -s

Ber|ti|na, Ber|ti|ne (w. Vorn.)

Ber|told, Bert|hold; ↑ R 191 (m. Vorn.)

Bert|ram (m. Vorn.); Bert|rand (m. Vorn.)

be|rüch|tigt

be|rücken [Trenn.: ...rük|ken] (betören); be|rückend [Trenn.: ...rük|kend]; -ste

be|rück|sich|ti|gen; Be|rück|sich-ti|gung

Be|rückung [Trenn.: ...rük|kung (Überlistung; Bezauberung)

Be|ruf m; -[e]s, -e; be|ru|fen (österr. auch: Berufung einlegen); sich auf jmdn. od. etwas -; be|ruf|lich Be|rufs_auf|bau|schu|le (Schulform des zweiten Bildungsweges zur Erlangung der Fachschulreife), ...aus|bil|dung, ...be|am|te; be-rufs_be|dingt, ...be|glei|tend; d--en Schulen; Be|rufs.be|ra|te ...be|ra|tung, ...be|zeich|nung; be-rufs_bil|dend; die -en Schulen; Be-rufs|ei|gnung; be|rufs|er|fah|ren Be|rufs_er|fah|rung, ...er|zie-hung, ...ethos, ...fach|schul-...fah|rer, ...feu|er|wehr, ...fin dung; be|rufs|fremd; Be|rufs-frem|de, ...ge|heim|nis, ...ge|no sen|schaft, ...heer, ...ka|me|ra

...klas|se, ...kleidung, ...krank|heit, ...lauf|bahn, ...le|ben, ...len|kung (w; -); be|rufs_los, ...mä|ßig; Be|rufs_or|ga|ni|sa|ti|on, ...päd|ago|gik, ...ri|si|ko, ...schu|le, ...spie|ler, ...sport|ler, ...stand; be|rufs_stän|disch, ...tä|tig; Be|rufs|tä|ti|ge m u. w; -n, -n (↑ R 287ff.); Be|rufs_ver|band, ...ver|bot, ...ver|bre|cher, ...ver|kehr, ...wahl (w; -), ...wech|sel, ...wett|be|werb (DDR: Wettbewerb der Jugend um die besten beruflichen Leistungen; Bez. für den gleichen Wettbewerb in der Bundesrepublik: Berufswettkampf), ...wett|kampf (vgl. Berufswettbewerb); Be|ru|fung; Be|ru|fungs_in|stanz, ...recht, ...ver|fah|ren

be|ru|hen; es beruht auf einem Irrtum; etwas auf sich - lassen; be|ru|hi|gen; sich -; Be|ru|hi|gung; Be|ru|hi|gungs_mit|tel s, ...sprit|ze

be|rühmt; be|rühmt-be|rüch|tigt; Be|rühmt|heit

be|rüh|ren; sich -; Be|rüh|rung; Be|rüh|rungs_li|nie, ...punkt

be|ru|ßen; berußt sein

Be|ryll gr. (ein Edelstein) m; -[e]s, -e; Be|ryl|li|um (chem. Grundstoff, Metall; Zeichen: Be) s; -s

bes. = besonders

be|sä|en

be|sa|gen; das besagt nichts; besagt (Amtsdt.: erwähnt); be|sag|ter|ma|ßen

be|sai|ten; besaitet; vgl. zartbesaitet

be|sa|men

be|sam|meln schweiz. (sammeln [von Truppen u. ä.]; auch refl.: sich [ver]sammeln); ich ...[e]le (↑ R 327); Be|samm|lung

Be|sa|mung (Befruchtung); Be|samungs_sta|ti|on, ...zen|trum

Be|san niederl. (Seemannsspr.: Segel am hintersten Mast) m; -s, -e

be|sänf|ti|gen; Be|sänf|ti|gung

Be|san|mast (Seemannsspr.: hinterster Mast eines Segelschiffes)

be|sät; mit etwas - sein

Be|satz m; -es, ...sätze; Be|satz|strei|fen; Be|sat|zung; Be|satzungs_ko|sten (Mehrz.), ...macht, ...sol|dat, ...sta|tut, ...zo|ne

besau|fen, sich (derb für: sich betrinken); besoffen; [1]Be|säuf|nis (ugs. für: Sauferei, Zechgelage) w; -, -se od. s; -ses, -se; [2]Be|säuf|nis (ugs. für: Volltrunkenheit) w; -

be|säu|seln, sich (ugs. für: sich [leicht] betrinken); be|säu|selt

be|schä|di|gen; Be|schä|di|gung

be|schaff|bar; Be|schaf|fen (besorgen); vgl. [1]schaffen; [2]be|schaf|fen (geartet); mit seiner Gesundheit ist es gut beschaffen; Be|schaf|fen|heit; Be|schaf|fung

be|schäf|ti|gen; sich -; beschäftigt sein; Be|schäf|tig|te m u. w; -n, -n (↑ R 287ff.); Be|schäf|ti|gung; Be|schäf|ti|gungs|los; Be|schäf|ti|gungs_stand (m; -[e]s), ...the|ra|pie

be|schä|len (vom Pferd: begatten); Be|schä|ler (Zuchthengst)

be|schal|len (starken Schall eindringen lassen; Technik u. Med.: Ultraschall einwirken lassen); Be|schal|lung

be|schä|men; be|schä|mend; -ste; be|schä|men|der|wei|se; Be|schä|mung

be|schat|ten; Be|schat|tung

Be|schau w; -; be|schau|en; Be|schau|er; be|schau|lich; Be|schau|lich|keit w; -; Be|schau|ung

Be|scheid m; -[e]s, -e; - geben, sagen, tun, wissen; [1]be|schei|den; ein -er Mann; [2]be|schei|den; beschied; beschieden; einen Antrag abschlägig - (Amtsdt.: ablehnen); jmdn. irgendwohin - (geh. für: kommen lassen); sich - (sich zufriedengeben); Be|schei|den|heit w; -; be|schei|dent|lich (veralt.)

be|schei|nen

be|schei|ni|gen; Be|schei|ni|gung

be|schei|ßen (derb für: betrügen); beschissen

be|schen|ken; Be|schenk|te m u. w; -n, -n (↑ R 287ff.)

[1]be|sche|ren (beschneiden); beschoren; vgl. [1]scheren

[2]be|sche|ren (schenken); beschert; jmdm. [etwas] -; die Eltern bescheren den Kindern [Spielwaren]; häufig auch schon für „beschenken": die Kinder wurden [mit vielen Geschenken] beschert; Be|sche|rung (ugs. auch für: unangenehme] Überraschung)

be|scheu|ert (derb für: dumm, schwer von Begriff)

be|schich|ten (fachspr. für: mit einer Schicht versehen); Be|schich|tung

be|schicken [Trenn.: ..schik|ken]; Be|schickung [Trenn.: ...schik|kung]

be|schie|den; das ist ihm beschieden; vgl. [2]bescheiden

be|schie|ßen; Be|schie|ßung

be|schil|dern (mit einem Schild versehen); Be|schil|de|rung

be|schimp|fen; Be|schimp|fung

be|schir|men; Be|schir|mer; Be|schir|mung

Be|schiß (derb für: Betrug) m; ...is|ses; be|schis|sen; vgl. bescheißen; Be|schis|sen|heit w; -

be|schlab|bern, sich (sich beim Essen beschmutzen)

Be|schlächt (hölzerner Uferschutz) s; -[e]s, -e

be|schla|fen; ich muß das noch - Be|schlag m; -[e]s, Beschläge; mit - belegen; in - nehmen, halten; Be|schläg schweiz. (Beschlag, Metallteile an Türen, Fenstern, Schränken) s; -, -s, -e; [1]be|schla|gen; gut - (bewandert; kenntnisreich); [2]be|schla|gen; Pferde -; die Fenster sind -; die Glasscheibe beschlägt [sich] (läuft an); die Hirschkuh ist - [worden] (Jägerspr. für: befruchtet, begattet [worden]); Be|schla|gen|heit [zu: [1]beschlagen]; Be|schlag|nah|me w; -, -n; be|schlag|nah|me|frei; be|schlag|nah|men; beschlagnahmt; Be|schlag|nah|mung

be|schlei|chen

be|schleu|ni|gen; be|schleu|ni|ger (schnellstens); Be|schleu|ni|gung; Be|schleu|ni|gungs_an|la|ge (Kernphysik), ...ver|mö|gen, ...wert

be|schleu|sen (für: kanalisieren); Be|schleu|sung

be|schlie|ßen; Be|schlie|ßer (Aufseher, Haushälter); Be|schlie|ße|rin w; -, -nen; be|schlos|sen; be|schlos|so|ner|ma|ßen; Be|schluß; be|schluß|fä|hig; Be|schluß|fä|hig|keit w; -; Be|schluß_fas|sung, ...or|gan, ...recht

be|schmei|ßen (ugs.)

be|schmie|ren

be|schmut|zen; Be|schmut|zung

be|schnei|den; Be|schnei|dung; - Jesu (kath. Fest)

be|schnei|te Dächer

be|schnüf|feln (ugs. auch für: vorsichtig ergründen)

be|schnup|pern

be|schö|ni|gen; Be|schö|ni|gung

be|schot|tern; Be|schot|te|rung

be|schran|ken; sich -; be|schrankt (mit Schranken versehen); -er Bahnübergang; be|schränkt (beengt; geistesarm); Be|schränkt|heit w; -; Be|schrän|kung

be|schreib|bar; be|schrei|ben; beschreibende Psychologie; Be|schrei|bung; Be|schrieb (schweiz. neben: Beschreibung) m; -s, -e

be|schrif|ten; Be|schrif|tung

be|schu|hen; be|schuht

be|schul|di|gen; eines Verbrechens -; Be|schul|dig|te m u. w; -n, -n (↑ R 287ff.); Be|schul|di|gung

be|schu|len; Be|schu|lung; be|schulungs_ver|trag

be|schum|meln (ugs. für: [in Kleinigkeiten] betrügen)

be|schup|pen vgl. beschupsen

be|schuppt (mit Schuppen bedeckt)

be|schup|sen landsch. (betrügen)

be|schürzt

Be|schuß m; ...schusses

be|schüt|zen; Be|schüt|zer; Be|schüt|zung

be|schwat|zen (ugs.), (landsch.:)
be|schwät|zen
Be|schwer (veralt. für: Anstren-
gung, Bedrückung) s; -[e]s od. w;
-; ohne -; Be|schwer|de w; -, -n;
- führen; be|schwer|de|frei; Be-
schwer|de.füh|ren|de (m u. w; -n,
-n; ↑ R 287ff.), ...füh|rer, ...in-
stanz, ...ord|nung, ...recht; be-
schwe|ren; sich -; be|schwer|lich;
Be|schwer|lich|keit; Be|schwer-
nis w; -, -se (auch: s; -ses, -se);
Be|schwe|rung
be|schwich|ti|gen; Be|schwich|ti-
gung
be|schwin|deln
be|schwin|gen (in Schwung brin-
gen); be|schwingt (hochgemut;
begeistert); Be|schwingt|heit w; -
be|schwipst (ugs. für: leicht be-
trunken); Be|schwip|ste m u. w;
-n, -n (↑ R 287ff.)
be|schwö|ren; du beschwörst (be-
schworest); er beschwor; du be-
schwörest; beschworen; be-
schwör[e]!; Be|schwö|rer; Be-
schwö|rung; Be|schwö|rungs|for-
mel
be|see|len (beleben; mit Seele er-
füllen); be|seelt; -e Natur; Be-
seelt|heit w; -; Be|see|lung
be|se|hen
be|sei|ti|gen; Be|sei|ti|gung
be|se|li|gen (geh.); ein beseligendes
Erlebnis; be|se|ligt; Be|se|li|gung
Be|sen m; -s, -; Be|sen.bin|der,
...kam|mer; be|sen|rein; Be-
sen.schrank, ...stiel; Be|serl|baum
österr. ugs. (unansehnlicher
Baum); Be|serl|park österr. ugs.
(kleiner Park)
be|ses|sen; vom Teufel -; Be|ses|se-
ne m u. w; -n, -n (↑ R 287ff.);
Be|ses|sen|heit w; -
be|set|zen; besetzt; Be|setzt|zei-
chen (Telefon); Be|set|zung; Be-
set|zungs|li|ste (Liste der Rollen-
verteilung für ein Theaterstück)
be|sich|ti|gen; Be|sich|ti|gung
be|sie|deln; Be|sie|de|lung, Be|sied-
lung
be|sie|geln; Be|sie|ge|lung, Be|sieg-
lung
be|sie|gen; Be|sieg|te m u. w; -n,
-n (↑ R 287ff.)
be|sin|gen
be|sin|nen, sich; be|sinn|lich; Be-
sinn|lich|keit w; -; Be|sin|nung w;
-; be|sin|nungs|los
Be|sitz m; -es; be|sitz|an|zei|gend;
-es Fürwort (für: Possessivpro-
nomen); Be|sit|zer.bür|ger, ...bür-
ger|tum; be|sit|zen; Be|sit|zer; Be-
sit|zer|grei|fung; Be|sitz|zer.stolz,
...wech|sel; Be|sitz|ge|sell|schaft;
be|sitz|los; Be|sitz.lo|se (m u. w;
-n, -n; ↑ R 287ff.), ...lo|sig|keit (w;
-), ...nah|me (w; -, -n), ...recht,
...stand (m; -[e]s), ...steu|ern

(Mehrz.), ...tum; Be|sit|zung; Be-
sitz.ver|hält|nis|se (Mehrz.),
...ver|tei|lung, ...wech|sel
Bes|ki|den (Teil der Karpaten)
Mehrz.
be|sof|fen (derb für: betrunken);
Be|sof|fen|heit w; -
be|soh|len; Be|soh|lung
be|sol|den; Be|sol|de|te m u. w; -n,
-n (↑ R 287ff.); Be|sol|dung; Be-
sol|dungs.grup|pe, ...ord|nung,
...recht, ...ta|rif
be|söm|mern (Landw.: den Boden
nur im Sommer nutzen)
be|son|dere; zur -n Verwendung
(Abk.: z. b. V.). I. Kleinschrei-
bung (↑ R 134): im besonder[e]n,
im besondren; insbesond[e]re; bis
aufs einzelne und besond[e]re. II.
Großschreibung (↑ R 116): das Be-
sond[e]re (Seltenes, Außerge-
wöhnliches); (↑ R 116:) etwas,
nichts Besond[e]res; Be|son|der-
heit; beson|ders (Abk.: bes.); be-
sonders[,] wenn (↑ R 63)
¹be|son|nen (überlegt, umsichtig)
²be|son|nen; sich - (von der Sonne
bescheinen) lassen
Be|son|nen|heit w; -
Be|son|nung
be|sor|gen; Be|sorg|nis w; -, -se; be-
sorg|nis|er|re|gend; -ste; aber
(↑ R 142): große Besorgnis erre-
gend; be|sorgt; Be|sorgt|heit w; -;
Be|sor|gung
be|span|nen; Be|span|nung
be|spickt
be|spie|geln; Be|spie|ge|lung, Be-
spieg|lung
be|spiel|bar; be|spie|len; eine
Schallplatte -; einen Ort - (dort
Aufführungen geben)
be|spit|zeln (heimlich beobachten
und aushorchen); Be|spit|ze-
lung, Be|spitz|lung
be|spöt|teln; Be|spöt|te|lung, Be-
spött|lung; be|spot|ten; Be|spot-
tung
be|spre|chen; sich -; Be|spre|cher;
Be|spre|chung
be|spren|gen; mit Wasser -
be|spren|keln
be|stär|ken (begatten [von Tie-
ren])
be|sprit|zen
be|sprü|hen; Be|sprü|hung; Be-
sprü|hungs|bad (Med.)
be|spucken [Trenn.: ...spuk|ken]
Bes|sa|ra|bi|en [...ĭɐn] (Landschaft
nordwestl. vom Schwarzen
Meer)
Bes|se|mer|bir|ne; ↑ R 180 [nach
dem engl. Erfinder] (techn. Anla-
ge zur Stahlgewinnung); bes|se-
mern; ich ...ere (↑ R 327); gebesse-
mert
bes|ser; I. Schreibung in Verbin-
dung mit Zeitwörtern (↑ R 139):
a) Getrenntschreibung in ur-

sprünglicher Bedeutung, z. B.
besser gehen; mit den neuen
Schuhen wird er besser gehen;
b) Zusammenschreibung, wenn
durch die Verbindung ein neuer
Begriff entsteht, z. B. bessersge-
hen; dem Kranken wird es bald
bessergehen, wenn ... II. Klein-
schreibung (↑ R 134): es ist das
bessere (es ist besser), daß ... III.
Großschreibung (↑ R 116): eines
Besser[e]n, (auch:) Beßren beleh-
ren; sich eines Besser[e]n, (auch:)
Beßren besinnen; eine Wendung
zum Besser[e]n, (auch:) Beßren;
das Bessere, (auch:) Beßre ist des
Guten Feind; nichts Besseres,
(auch:) Beßres war zu tun; bes-
ser|ge|hen; vgl. besser I, b; Bes-
ser|ge|stell|te m u. w; -n, -n (↑ R
287ff.); bes|sern; ich bessere,
(auch:) beßre (↑ R 327); sich -;
bes|ser|stel|len; ↑ R 139 (in eine
bessere finanzielle, wirtschaftli-
che Lage versetzen), aber: bes-
ser stel|len; du solltest die Gläser
besser stellen (nicht: legen); Bes-
se|rung, (auch:) Beß|rung; Bes|se-
rungs|an|stalt; Bes|ser|wis|ser;
der Allesbesserwisser; Bes|ser-
wis|se|rei; bes|ser|wis|se|risch;
Best bayr., österr. (ausgesetzter
[höchster] Preis, Gewinn) s; -s,
-e; best... (z. B. bestgehaßt)
be|stal|len ([förmlich] in ein Amt
einsetzen, mit einer Aufgabe be-
trauen); wohlbestallt; Be|stal-
lung; Be|stal|lungs|ur|kun|de
Be|stand m; -[e]s, Bestände; - ha-
ben; von - sein; der zehnjährige
- (österr. für: Bestehen) des Ver-
eins; ein Gut in - (österr. für:
Pacht) haben, nehmen; be|stan-
den (auch für: bewachsen) mit
Wald - sein; be|stand|fä|hig;
be|stän|dig; das Barometer steht
auf „beständig"; Be|stän|dig-
keit; Be|stands.auf|nah|me; Be-
stand[s].ju|bi|lä|um (österr. für:
Jubiläum des Bestehens), ...ver-
trag (österr. Amtsspr. für: Pacht-
vertrag); Be|stand|teil m
be|stär|ken; Be|stär|kung
be|stä|ti|gen; Be|stä|ti|gung
be|stat|ten; Be|stat|ter u. Be|stät-
te|rer südwestdt. (der Ex-
preßgut, Eilgut u. ä. zustellt); Be-
stät|te|rei; Be|stat|tung
be|stau|ben; bestaubt; sich (stau-
big werden); be|stäu|ben; Be-
stäu|bung
be|st.aus|ge|rü|stet, ...be|kannt,
...be|währt, ...be|zahlt; Best|bie-
ter
be|ste; bestens; bestenfalls. I.
Kleinschreibung: a) das beste
[Buch] seiner Bücher; b) (↑ R 133
u. 134:) auf das, aufs beste (aber
[nach II]: seine Wahl ist auf das,

aufs Beste gefallen); am besten; nicht zum besten (nicht gut) gelungen; zum besten dienen, geben, gereichen, haben, halten, kehren, lenken, stehen, wenden; **c)** (↑ R 135:) der erste, nächste beste; **d)** (↑ R 134:) es ist das beste, er hält es für das beste (am besten), daß ... **II.** *Großschreibung* (↑ R 116): das Beste auslesen; auf das (aufs) Beste hoffen, das Beste in seiner Art; das Beste ist für ihn gut genug; das Beste waren noch die Spaziergänge; er sagte etwas, was ich für das Beste (von allem) halte; er hält dies für das Beste (die beste Sache), was er je gesehen hat; er ist der Beste in der Klasse; eine(r) unserer Besten; es fehlt ihm am Besten; zu deinem Besten; zum Besten der Armen; er hat sein Bestes getan; das Beste von allem ist, daß ... (vgl. a b e r : I, d)
be|ste|chen; be|stech|lich; Be|stech|lich|keit w; -; Be|ste|chung; Be|ste|chungs_geld, ...sum|me, ...ver|such
Be|steck s; -[e]s, -e (ugs.: -s); be|stecken [*Trenn.*: ...stck|kcn]; Be|steck|ka|sten
Be|steg (Geol.: eine Lage zwischen Gesteinsschichten) m; -[e]s, -e
be|ste|hen; auf etwas -; ich bestehe auf meiner (heute selten: meine) Forderung; Be|ste|hen s; -s; seit - der Firma; Be|ste|hen|blei|ben; es bleibt bestehen; bestehengeblieben; bestehenzubleiben
be|steh|len
be|stei|gen; Be|stei|gung
be|stel|len; Be|stel|ler; Be|stell|_block (*Mehrz.* ...blocks), ...geld; Be|stell|li|ste [*Trenn.*: Be|stell|li|ste, ↑ R 236] w; -, -n; Be|stell|schein; Be|stel|lung
be|sten|falls; vgl. Fall m; be|stens
be|sternt; ein -er Himmel
be|steu|ern; Be|steue|rung
best_ge|haßt, ...ge|pflegt
be|stia|lisch *lat.* (unmenschlich, viehisch); -ste (↑ R 294); Be|stia|li|tät (tierisches, grausames Verhalten)
be|sticken [*Trenn.*: ...stik|ken]; Be|stick|höhe (Deichbau); Be|stickung [*Trenn.*: ...stik|kung]
Be|stie [...*iᵉ*] (wildes Tier; Unmensch) w; -, -n
be|stie|felt
be|stie|len (mit einem Stiel versehen)
be|stimm|bar; be|stim|men; be|stimmt; an einem -en Tage] bestimmter Artikel; Be|stimmt|heit; Be|stim|mung; Be|stim|mungs|bahn|hof; Be|stim|mungs|ge|mäß; Be|stim|mungs_ha|fen, ...ort, ...wort (Sprachw.: Wort, Vorder-

glied einer Zusammensetzung; das das Grundwort [vgl. d.] näher bestimmt, z. B. „Speise" in „Speisewagen"; *Mehrz.* ...wörter)
be|in|for|miert
be|stirnt; -er Himmel
Best|lei|stung
Best|mann (Seemannsspr.: erfahrener Seemann, der auf kleinen Küstenschiffen den Schiffsführer vertritt) m; -[e]s, ...männer
best|mög|lich, dafür besser: möglichst gut; falsch: bestmöglichst (↑ R 299)
be|stocken[1]; Be|stockung[1] (Bot.: Seitentriebbildung; Forstw.: Aufforstung)
be|sto|ßen (durch Stoßen beschädigen); Be|stoß|zeug (Technik: Vorrichtung zur Metallverarbeitung)
be|stra|fen; Be|stra|fung
be|strah|len; Be|strah|lung; Be|strah|lungs|do|sis, ...feld, ...technik, ...zeit
be|stre|ben, sich; Be|stre|ben s; -s; be|strebt; - sein; Be|stre|bung
be|strei|chen; Be|strei|chung
be|strei|ken; Be|strei|kung; - eines Betriebes
be|strei|ten; Be|strei|tung
best|re|nom|miert; das bestrenommierte Hotel
be|streu|en; Be|streu|ung
[1]be|stricken[1] (bezaubern); [2]be|stricken[1] (für jmdn. stricken); be|strickt[1]; -ste; Be|strickung[1]
be|strumpft
Best|sel|ler *engl.* (Ware [bes. Buch] mit dem größten Absatz) m; -s, -; Best|sel|ler_au|tor, ...li|ste
be|stücken [*Trenn.*: ...stük|ken] (mit Teilstücken ausrüsten, bes. beim Schiff mit Geschützen); Be|stückung [*Trenn.*: ...stük|kung]
Be|stuh|lung
be|stür|men; Be|stür|mung
be|stür|zen; be|stür|zend; -ste; be|stürzt; -sein; Be|stürzt|heit w; -; Be|stür|zung
best|vor|be|rei|tet
Best|wert (für: Optimum), ...zeit, ...zu|stand
Be|such m; -[e]s, -e; auf, zu - sein; be|su|chen; Be|su|cher; Be|such_fre|quenz, ...strom, ...zahl; Be|suchs_er|laub|nis, ...kar|te, ...stun|de, ...tag, ...zeit, ...zim|mer
be|su|deln; Be|su|de|lung, Be|sud|lung
Be|ta (gr. Buchstabe: B, β) s; -[s], -s
be|tagt; vgl. hochbetagt; Be|tagt|heit w; -
be|ta|keln (Seemannsspr.: ein Drahttau mit Garn umwickeln;

[1] *Trenn.*: ...k|k...

österr. ugs. für: beschwindeln); Be|ta|ke|lung, Be|tak|lung
be|tan|ken vgl. Bethanien
be|tan|ken; Be|tan|ker; Be|tan|kung
be|ta|sten
Be|ta|strah|len, β-Strah|len *Mehrz.* (↑ R 149); Be|ta|strah|ler (Med.: Bestrahlungsgerät); Be|ta|strah|lung
Be|ta|stung
be|tä|ti|gen; sich -; Be|tä|ti|gung; Be|tä|ti|gungs|feld
Be|ta|tron (Elektronenschleuder) s; -s, ...one (auch: -s)
be|tat|schen (ugs.)
be|täu|ben; Be|täu|bung; Be|täu|bungs|mit|tel s
Be|ta|zer|fall (Atomphysik)
Bet_bank, ...bru|der
Be|te, (nicht korrekte Nebenform:) Bee|te (Wurzelgemüse; Futterpflanze) w; -, -n; rote - (nordd. für: rote Rübe)
Be|tei|geu|ze *arab.* (ein Stern) m; -
be|tei|len österr. (beschenken); be|tei|li|gen; sich -; Be|tei|lig|te m u. w; -n, -n (↑ R 287 ff.); Be|tei|ligt|sein; Be|tei|li|gung; Be|tei|li|gungs|fi|nan|zie|rung; Be|tei|lung österr. (Beschenkung, Zuteilung)
Be|tel *malai.-port.* (Kau- u. Genußmittel aus der Betelnuß) m; -s; Be|tel|kau|er
Be|tes|da vgl. Bethesda
be|teu|ern; ich ...ere (↑ R 327); Be|teue|rung
be|tex|ten
Be|tha|ni|en, (ökum.:) Be|ta|ni|en [...*iᵉn*] (bibl. Ortsn.)
Be|thel (Heimstätte für körperlich u. geistig Hilfsbedürftige bei Bielefeld)
Be|thes|da, (ökum.:) Be|tes|da (ehem. Teich in Jerusalem) m; -[s]
Beth|le|hem, (ökum.:) Bet|le|hem (paläst. Stadt); beth|le|he|mi|tisch; (↑ R 200:) der -e Kindermord
Be|ting (Seemannsspr.: Gerüst auf Schiffen zur Befestigung der Ankerketten) m; -s, -e od. w; -, -e
be|ti|teln [auch ...tit...]; Be|ti|te|lung, Be|tit|lung
Bet|le|hem vgl. Bethlehem
be|töl|peln; Be|töl|pe|lung
Be|ton *fr.* [betõ, (fr.:) betõ, auch, österr. nur dt. Aussspr.: be|tõ] (Baustoff aus der Mischung von Zement, Wasser, Sand usw.) m; -s, (bei dt. Aussprache:) -e; Be|ton_bau (*Mehrz.* ...bauten), ...block (*Mehrz.* ...blöcke), ...dek|ke [*Trenn.*: ...dek|ke]
be|to|nen
Be|to|nie *lat.* [...*iᵉ*] (eine Wiesenblume; Heilpflanze) w; -, -n
be|to|nie|ren (auch übertr. für:

festlegen, unveränderlich machen); Be|to|nie|rung; Be|ton-misch|ma|schi|ne
be|ton|nen (Seemannsspr.: ein Fahrwasser durch Seezeichen [Tonnen usw.] bezeichnen); Be-ton|nung
be|ton|ter|ma|ßen; Be|to|nung
be|tö|ren; Be|tö|rer; Be|tö|rung
Bẹt|pult
betr. = betreffend, betreffs; Betr. = Betreff
Be|tracht m; -[e]s, nur noch in Fügungen wie: in - kommen, ziehen; außer - bleiben; be|trach|ten; sich -; Be|trach|ter; be|trächt|lich; (↑ R 134:) um ein -es (bedeutend, sehr); Be|trach|tung; Be|trach-tungs_wei|se w, ...win|kel
Be|trag m; -[e]s, Beträge; be|tra-gen; sich -; Be|tra|gen s; -s
be|tram|peln (ugs.)
be|trau|en; mit etwas betraut
be|trau|ern
be|träu|feln
Be|trau|ung
Be|treff (Amtsdt.) m; -[e]s, -e; in dem - (in dieser Beziehung); (↑ R 134 u. R 141:) in betreff, betreffs (vgl. d.) des Bahnbaues; be|tref|fen; vgl. betroffen; was mich betrifft; be|tref|fend (in Betracht kommend; Abk.: betr.); die -e Behörde; den Bahnbau -; (Amtsdt.:) der den Unfall betreffende Bericht od. (↑ R 28) der Bericht[,] betreffend den Unfall ... (besser: der Bericht über den Unfall); Be|tref|fen|de m u. w; -n, -n (↑ R 287ff.); Be|treff|nis schweiz. (Anteil; Summe, die auf jmdn. entfällt) s; -ses, -se; be-treffs (Amtsdt.; Abk.: betr.; ↑ R 130); mit Wesf.: - des Neubaus (besser: wegen)
be|trei|ben (schweiz. auch für: jmdn. durch das Betreibungsamt zur Zahlung einer Schuld veranlassen); Be|trei|ben s; -s; auf mein -; Be|trei|bung (Förderung, das Vorantreiben; schweiz. auch für: Beitreibung)
be|treßt (mit Tressen versehen)
[1]be|tre|ten (verwirrt; verwundert);
[2]be|tre|ten; er hat den Raum -; Be|tre|ten s; -s; Be|tre|ten|heit w; -; Be|tre|tungs|fall m; im -[e] (veralt. für: im Falle des Ertapptwerdens)
be|treu|en; Be|treu|er; Be|treu|te m u. w; -n, -n (↑ R 287ff.); Be|treu-ung w; -; Be|treu|ungs|stel|le
Be|trieb m; -[e]s, -e; in - setzen; die Maschine ist in - (läuft); aber: er ist im - (hält sich an der Arbeitsstelle auf); be|trieb|er-schwerend; be|trieb|lich; be|trieb-sam; be|trieb|sam|keit w; -; Be-triebs_an|ge|hö|ri|ge, ...an|lei-

tung, ...aus|flug, ...aus|schuß; be-triebs_be|reit, ...blind; Be-triebs_blind|heit, ...di|rek|tor, ...ebe|ne; be|triebs|ei|gen; Be-triebs|er|laub|nis; be|triebs|fä-hig; Be|triebs_fe|ri|en (Mehrz.), ...fest, ...form; be|triebs|fremd; Be|triebs_füh|rer, ...ge|mein-schaft, ...ge|werk|schafts|lei|tung (DDR; Abk.: BGL), ...grö|ße, ...in|ha|ber, ...kampf|grup|pe (DDR), ...ka|pi|tal, ...kli|ma, ...kol|lek|tiv_ver|trag (DDR), ...ko|sten (Mehrz.), ...kran|ken-kas|se, ...kü|che, ...lei|ter m, ...lei-tung; be|triebs|neu|tral; Be-triebs_nu|del (ugs.: jmd., der immer Betrieb zu machen versteht), ...ob|mann, ...or|ga|ni|sa|ti|on, ...po|ten|ti|al, ...rat (Mehrz. ...rä-te); Be|triebs_rats_mit|glied, ...vor|sit|zen|de; Be|triebs_ru|he, ...schluß (m; ...schlusses), ...schutz; be|triebs|si|cher; Be-triebs_stoff, ...stö|rung; be|trieb-stö|rend; Be|triebs_tech|nik, ...treue, ...un|fall, ...ver|fas|sung; Be|triebs_ver|fas|sungs_ge|setz; Be|triebs_ver|gleich, ...wirt, ...wirt|schaft; Be|triebs_wirt-schafts|leh|re
be|trin|ken, sich; betrunken
be|trof|fen; Be|trof|fen|heit w; -
be|trü|ben; be|trüb|lich; be|trüb|li-cher_wei|se; Be|trüb|nis w; -, -se; be|trübt; Be|trübt|heit w; -
Be|trug; be|trü|gen; Be|trü|ger; Be-trü|ge|rei; be|trü|ge|risch; -ste (↑ R 294)
be|trun|ken; Be|trun|ke|ne m u. w; -n, -n (↑ R 287ff.); Be|trun|ken-heit w; -
Bẹt_saal, ...schwe|ster (abwertend), ...stuhl, ...stun|de
Bẹtt s; -[e]s, -en; zu -[e] gehen
Bẹt|tag; vgl. Buß- und Bettag
Bẹtt_bank (österr.: auch als Bett benutzbare Couch; Mehrz. ...bänke), ...couch, ...decke [Trenn.: ...dek|ke]
bẹt|tel_arm; Bẹt|te|lei; Bẹt|te|lei; Bẹt|tel_mann (Mehrz. ...leute), ...mönch; bẹt|teln; ich ...[e]le (↑ R 327)
bẹt|ten; sich -; Bẹt|ten_bau (m; -[e]s), ...ma|chen (s; -s), ...man|gel (m; -s); Bẹtt_fe|der, ...ge|her (österr. für: Schlafgänger), ...ge-stell, ...ha|se, ...him|mel, ...hup-ferl (s; -s, -)
Bẹt|ti (dt. Kurzform von: Elisabeth, Babette); Bẹt|ti|na, Bẹt|ti-ne (it. Kurzform von: Elisabeth)
Bẹtt_jacke [Trenn.: ...jak|ke], ...kan|te, ...klei|dung, ...la|de (landsch. für: Bett[stelle]); bẹtt-lä|ge|rig; Bẹtt|la|ken
Bẹtt|ler; Bẹtt|ler_stolz, ...zin|ken
Bẹtt_näs|ser, ...pfo|sten, ...rand;

bẹtt|reif (ugs.); Bẹtt_ru|he, ...schwe|re (ugs.), ...statt (landsch. für: Bett[stelle]; Mehrz. ...stätten), ...stel|le; Bẹtt|tru|he; ↑ R 237; [1]Bẹt|tuch [Trenn.: Bett-tuch, ↑ R 236] s; -[e]s, ...tücher
[2]Bẹt|tuch; ↑ R 236 (beim jüdischen Gottesdienst; Mehrz. ...tücher)
Bẹtt_um|ran|dung; Bẹt|tung; Bẹtt-vor|le|ger, ...wä|sche
Bẹt|ty (engl. Kurzform von: Elisabeth)
Bẹtt|zeug
be|tu|lich jidd. landsch. (still; sicher, vertrauenswert; wohlhabend)
be|tu|lich (in umständlicher Weise freundlich u. geschäftig); Be|tu-lich|keit w; -; be|tun, sich (sich in umständlicher Weise freundlich u. geschäftig benehmen); betan
be|tup|fen
be|tup|sam
Beu|che (Lauge zum Bleichen von Textilien) w; -, -n; beu|chen (in Lauge kochen)
beug|bar (auch für: flektierbar); Beu|ge (Turnübung; selten für: Biegung) w; -, -n; beug|haft o u.; Beu|gel österr. (ein bogenförmiges Gebäck, Hörnchen) s; -s, -; Beu|ge_mus|kel; beu|gen (auch für: flektieren, deklinieren, konjugieren); sich -; Beu|ger (Beugemuskel); beug|sam (veralt.); Beu-gung (auch für: Flexion, Deklination, Konjugation); Beu|gungs-en|dung; Beu|gungs-s (↑ R 149) s; -, -
Beu|le w; -, -n; beu|len (Falten werfen); sich -; Beu|len_pest w; -; beu-lig
be|un_ru|hi|gen; sich -; Be|un|ru|hi-gung w; -
be|ur|kun|den; Be|ur|kun|dung
be|ur|lau|ben; Be|ur|lau|bung
be|ur|tei|len; Be|ur|tei|ler; Be|ur-tei|lung; Be|ur|tei|lungs_maß|stab
Beu|schel österr. ([Gericht aus] Lunge u. Herz) s; -s, -
beut, beutst (veralt. u. dicht. für: bietet, bietest); vgl. bieten
[1]Beu|te (Erbeutetes) w; -
[2]Beu|te (landsch. für: Holzgefäß; Ständer; auch für: Bienenstock) w; -, -n
beu|te_gie|rig; Beu|te_gut
Beu|tel m; -s, -; beu|teln; ich ...[e]le (↑ R 327); das Kleid beutelt [sich]; das Mehl wird gebeutelt (gesiebt); ich habe ihn gebeutelt (tüchtig geschüttelt); Beu-tel_schnei|der, ...tier
beu|te_lü|stern; beu|te_lu|stig
beu|ten; Bienen - (Imkerspr.: einsetzen); du beutst (beutest) -; beutet; gebeutet; Beu|ten_ho|nig
Beu|te_recht, ...stück; beu|te_süch-tig, ...träch|tig; Beu|te|zug

Beut|ler (Beuteltier)

Beut|ner (Bienenzüchter); Beut-
ne|rei w; -

beutst; vgl. beut

be|vet|tern (veralt. für: wie einen
Vetter, vertraulich behandeln);
ich ...ere († R 327)

be|völ|kern; ich ...ere († R 327); Be-
völ|ke|rung; Be|völ|ke|rungs-
ˌdichte, ...ex|plo|si|on, ...grup|pe,
...kreis, ...po|li|tik, ...schicht,
...schwund, ...sta|ti|stik, ...zahl,
...zu|nah|me

be|voll|mäch|ti|gen; Be|voll|mäch-
tig|te m u. w; -n, -n († R 287 ff.);
Be|voll|mäch|ti|gung

be|vor

be|vor|mun|den; Be|vor|mun|dung

be|vor|ra|ten (mit einem Vorrat
ausstatten); be|vor|ra|tung w; -

be|vor|rech|ten (älter für: bevor-
rechtigen); bevorrechtet; be|vor-
rech|ti|gen; bevorrechtigt; Be-
vor|rech|ti|gung; Be|vor|rech-
tung (älter für: Bevorrechtigung)

be|vor|schus|sen; du bevorschußt
(bevorschussest)

be|vor|ste|hen

be|vor|tei|len (veralt. für: übervor
teilen); jemandem einen Vorteil
zuwenden); Be|vor|tei|lung

be|vor|wor|ten (mit einem Vor-
wort versehen)

be|vor|zu|gen; Be|vor|zu|gung

be|wa|chen; Be|wa|cher

Be|wa|chung; Be|wa|chungs|mann-
schaft

be|waff|nen; Be|waff|ne|te m u. w;
-n, -n († R 287 ff.); Be|waff|nung

be|wah|ren (hüten); jmdn. vor
Schaden -; Gott bewahre uns da-
vor! be|wäh|ren, sich; Be|wah|rer;
be|wahr|hei|ten, sich; Be|wahr-
hei|tung; be|wahr|sam; be|währt;
Be|währt|heit w; -; Be|wah|rung
(Hütung); Be|wäh|rung (Erpro-
bung); Be|wäh|rungs|frist, ...hel-
fer, ...pro|be, ...zeit

be|wal|den; be|wal|det; be|wald-
rech|ten (Rundholz baumkantig
beschlagen); Be|wal|dung

be|wäl|ti|gen; Be|wäl|ti|gung

be|wan|dert (erfahren; unterrich-
tet)

be|wandt (veralt. für: gestaltet, be-
schaffen); Be|wandt|nis w; -, -se

be|wäs|sern; Be|wäs|se|rung, Be-
wäs|se|rung

¹be|we|gen (Lage ändern); du be-
wegst; du bewegtest; bewegt;
beweg[e]!; ²be|we|gen (veranlas-
sen); du bewegst; du bewogst; du
bewögest; bewogen; beweg[e]!;
Be|weg|grund; be|weg|lich; Be-
weg|lich|keit w; -; be|wegt; - sein;
Be|wegt|heit w; -; Be|we|gung; Be-
we|gungs_ab|lauf, ...ap|pa|rat,
...drang, ...frei|heit, ...krieg; be-

we|gungs|los; Be|we|gungs_stu-
die, ...the|ra|pie; be|we|gungs|unf-
fä|hig

be|weh|ren (ausrüsten; bewaff-
nen); Be|weh|rung

be|wei|ben, sich (ugs. für: sich ver-
heiraten); ich beweibe mich

be|wei|den

be|weih|räu|chern (auch abwer-
tend für: übertrieben loben); Be-
weih|räu|che|rung

be|wei|nen; Be|wei|nung; - Christi

Be|weis m; -es, -e; unter - stellen
(Amtsdt.; besser: beweisen); Be-
weis_an|trag, ...auf|nah|me; be-
weis|bar; Be|weis|bar|keit w; -; be-
wei|sen; beweisen; Be|weis_er|he-
bung, ...füh|rung, ...kraft; be|weis-
kräf|tig; Be|weis_mit|tel s, ...stel-
le, ...stück

be|wen|den, nur in: - lassen; Be-
wen|den s; -; es hat dabei sein
Bewenden (es bleibt dabei)

Be|werb österr. (Sportspr.: Wett-
bewerb) m; -s, -e; aus dem - wer-
fen; be|wer|ben, sich; sich um eine
Stelle -; Be|wer|ber; Be|wer|bung;
Be|wer|bungs|un|ter|la|gen
Mehrz.

be|wer|fen; Be|wer|fung

be|werk|stel|li|gen; Be|werk|stel-
li|gung

be|wer|ten; Be|wer|tung; Be|wer-
tungs|zif|fer

Be|wet|te|rung (Bergmannsspr.:
Versorgung der Grubenbaue mit
Frischluft)

be|wickeln [Trenn.: wik|keln]; Be-
wicke|lung [Trenn.: ...wik|ke...],
Be|wick|lung

be|wil|li|gen; Be|wil|li|gung

be|will|kom|men; du bewill-
kommnest; bewillkommnet; Be-
will|komm|nung

be|wim|pert

be|wir|ken; Be|wir|kung

be|wir|ten; be|wirt|schaf|ten; Be-
wirt|schaf|ter; Be|wirt|schaf-
tung; Be|wir|tung; Be|wir|tungs-
ver|trag

be|wit|zeln

be|woh|nen, sich; be|wölkt; -er
Himmel; Be|wöl|kung w; -; Be-
wöl|kungs_auf|locke|rung
[Trenn.: ...lok|ke...], ...zu|nah|me

be|wu|chern

Be|wuchs m; -es

Be|wun|de|rer, Be|wund|rer; Be-
wun|de|rin, Be|wund|re|rin w; -,
-nen; be|wun|dern; Be|wun|derns-
wert, be|wun|de|rungs|wert; Be-
wun|de|rung, be|wun|derns|wür-
dig, be|wun|de|rungs|wür|dig; Be-
wund|rer, Be|wun|de|rer; Be-
wund|re|rin, Be|wun|de|rin w; -,
-nen

Be|wurf

be|wur|zeln, sich (Wurzeln bilden)

be|wußt (mit Wesf.); ich bin mir
keines Vergehens -; ich war mir's
(vgl. ²es [alter Wesf.]) od. mir des-
sen -; sich eines Versäumnisses
- werden; vgl. bewußtmachen;
Be|wußt|heit w; -; be|wußt|los; Be-
wußt|lo|sig|keit w; -; be|wußt|ma-
chen; † R 139 (klarmachen); er
hat ihm den Zusammenhang be-
wußtgemacht; aber: be|wußt
(mit Absicht, mit Bewußtsein)
ma|chen; er hat den Fehler be-
wußt gemacht; Be|wußt|ma-
chung; be|wußt|sein s; -s; Be-
wußt|seins_bil|dung, ...in|halt,
...la|ge, ...spal|tung, ...trü|bung,
...zu|stand; Be|wußt|wer|dung

Bey vgl. Bei

bez., bez, bz = bezahlt

bez. = bezüglich

Bez. = Bezeichnung

Bez., Bz. = Bezirk

be|zah|len; eine gut-, schlechtbe-
zahlte Stellung († R 143); aber:
die Stellung ist gut bezahlt; Be-
zah|ler; be|zahlt (Abk.: bez., bez,
bz); sich - machen (lohnen); Be-
zah|lung

be|zähm|bar; be|zäh|men; sich -;
Be|zäh|mung

be|zau|bern; be|zau|bernd; -ste; Be-
zau|be|rung

be|zecht

be|zeich|nen; be|zeich|nend; -ste;
be|zeich|nen|der|wei|se; Be|zeich-
nung (Abk.: Bez.); Be|zeich-
nungs|leh|re (für: Onomasiolo-
gie) w; -

be|zei|gen (zu erkennen geben,
kundgeben); Gunst, Beileid,
Wohlgefallen, Ehren -; Be|zei-
gung

be|zeu|gen (Zeugnis ablegen; aus
eigenem Erleben bekunden); die
Wahrheit -; Be|zeu|gung

be|zich|ti|gen; jemanden eines
Verbrechens -; Be|zich|ti|gung

be|zieh|bar; be|zie|hen; sich auf
eine Sache -; be|zie|hent|lich
(Amtsdt.; mit Bezug auf); mit
Wesf.: - des Unfalles; Be|zie|her;
Be|zie|hung; in - setzen; Be|zie-
hungs_käu|fe (Mehrz.), ...leh|re
(Theorie der Soziologie); be|zie-
hungs|los; Be|zie|hungs|lo|sig-
keit; be|zie|hungs_reich, ...wei|se
(Abk.: bzw.)

be|zif|fern; ich ...ere († R 327); sich
- (dafür besser: sich belaufen) auf
etwas; Be|zif|fe|rung

Be|zirk (Abk.: Bez. od. Bz.) m;
-[e]s, -e; be|zirk|lich; Be-
zirks_amt, ...ge|richt (österr.),
...haupt|mann (österr.), ...haupt-
mann|schaft (österr.), ...ka|bi-
nett (DDR), ...kom|mis|sar
(österr.), ...land|wirt|schafts|rat

(DDR), ...lei|ter (DDR; *m*), ...re-dak|teur (DDR); be|zirks|wei|se be|zir|zen vgl. becircen
Be|zo|ar *pers.* („Gegengift"; Magenstein von Wiederkäuern, in der Volksmedizin gebraucht) *m*; -s, -e; Be|zo|ar|stein (svw. Bezoar)
Be|zo|ge|ne (für: Adressat u. Akzeptant [eines Wechsels]) *m*; -n, -n (↑ R 287 ff.); Be|zo|gen|heit; Be|zug (österr. auch für: Gehalt; vgl. Bezüge); in bezug auf (↑ R 141), a b e r: mit Bezug auf; auf etwas Bezug haben, nehmen (dafür besser: sich auf etwas beziehen); Bezug nehmend auf (dafür besser: mit Bezug auf); Be|zü|ge (Einkommen) *Mehrz.*; Be|zü|ger schweiz. (Bezieher); be|züg|lich; -es Fürwort (für: Relativpronomen); als *Verhältnisw.* mit *Wesf.* (Amtsdt.; Abk.: bez.); - Ihres Briefes; Be|züg|lich|keit; Be|zug|nah|me *w*; -, -n; dafür besser: Beziehung; Be|zugs_per|son, ...preis (vgl. ²Preis), ...punkt, ...quel|le, ...recht; Be|zug[s]_schein, ...stoff, ...sy|stem
be|zu|schus|sen (einen Zuschuß gewähren); du bezuschußt (bezuschussest); Be|zu|schus|sung
be|zwecken [*Trenn.:* ...zwek|ken]
be|zwei|feln; Be|zwei|fe|lung, Be|zweif|lung
be|zwing|bar; be|zwin|gen; be-zwin|gend; Be|zwin|ger; Be|zwin-gung; be|zwun|gen
Bf. = Bahnhof; Brief
BfA = Bundesversicherungsanstalt für Angestellte
bfn. = brutto für netto
bfr vgl. Franc
Bg. = Bogen (Papier)
BGB = Bürgerliches Gesetzbuch
BGBl. = Bundesgesetzblatt
BGL = Betriebsgewerkschaftsleitung
BH [*beha*] (ugs. für: Büstenhalter) *m*; -[s], -[s]
Bha|rat (amtl. Bez. der Republik Indien)
Bhf. = Bahnhof
Bhu|tan (Königreich im Himalaja); Bhu|ta|ner (Einwohner von Bhutan); bhu|ta|nisch
Bi = Bismutum (chem. Zeichen für: Wismut)
bi... *lat.* (in *Zusammensetzungen:* zwei...; doppel[t]...); Bi... (Zwei...; Doppel[t]...)
Bia|fra (Teil von Nigeria)
Bia|ły|stok [*bjaliβstok*] (Stadt in Polen)
Bian|ca [*bjangka*] (it. w. Vorn.); Bian|ka (eingedeutschte Schreibung von: Bianca)
Bi|ath|lon *lat.; gr.* (Kombination aus Schilanglauf u. Scheibenschießen) *s*; -s, -s

bib|bern (ugs. für: zittern); ich ...ere (↑ R 327)
Bi|bel *gr.* („Schriften", „Bücher"; die Hl. Schrift) *w*; -, -n; Bi|bel-druck *m*; -[e]s, -e; bi|bel|fest; Bi-bel_kon|kor|danz, ...lese, ...re|gal (kleine, tragbare Orgel des 16.–18. Jh.s), ...spruch, ...stun|de, ...vers, ...wort (*Mehrz.* ...worte)
¹Bi|ber (ein Nagetier; Pelz) *m*; -s, -; ²Bi|ber (Rohflanell) *m* od. *s*; -s; Bi|ber|bettuch [*Trenn.:* ...bett-tuch]
Bi|ber|ach an der Riß (Stadt in Oberschwaben)
Bi|ber|re|te (Kaninchenfell, auf Biber zugerichtet, auch: pelzartiger Wollplüsch) *w*; -, -n; Bi|ber-geil (Drüsenabsonderung des Bibers) *s*; -[e]s
Bi|ber|nel|le (Nebenform von: Pimpernell) *w*; -, -n
Bi|ber_pelz, ...schwanz (auch: Dachziegelart)
Bi|bi (ugs.: steifer Hut [aus Biberpelz], Baskenmütze) *m*; -s, -s
Bi|blio|graph *gr.* (Bearbeiter einer Bibliographie) *m*; -en, -en (↑ R 268); Bi|blio|gra|phie (Bücherkunde, -verzeichnis) *w*; -, ...ien; bi|blio|gra|phie|ren (den Titel einer Schrift bibliographisch verzeichnen, auch: genau feststellen); Bi|blio|gra|phie|rung *w*; -; bi-blio|gra|phisch (bücherkundlich), a b e r (↑ R 224): das Bibliographische Institut; Bi|blio|ma-ne (Büchernarr) *m*; -n, -n (↑ R 268); Bi|blio|ma|nie (krankhafte Bücherliebe) *w*; -; bi-blio|phil (schöne od. seltene Bücher liebend; auf Bücherliebe bezüglich); eine -e Kostbarkeit; Bi-blio|phi|le (Bücherliebhaber[in]) *m* u. *w*; -n, -n; zwei -[n] (↑ R 291); Bi|blio|phi|lie (Bücherliebhaberei) *w*; -; Bi|blio|thek [wissenschaftliche] Bücherei) *w*; -, -en; Deutsche Bibliothek (in Frankfurt); Bi|blio|the|kar (Beamter od. Angestellter in wissenschaftl. Bibliotheken od. Volksbüchereien) *m*; -s, -e; Bi|blio|the|ka|rin *w*; -, -nen; bi|blio|the|ka|risch; Bi-blio|theks_ge|bäu|de, ...saal, ...we|sen (*s*; -s)
bi|blisch *gr.*; eine biblische Geschichte (Erzählung aus der Bibel), a b e r (↑ R 224): die Biblische Geschichte (Lehrfach)
Bick|bee|re nordd. (Heidelbeere)
bi|der|b (altertümelnd für: bieder; rechtschaffen)
Bi|det *fr.* [*bide*] (längliches Sitzbecken für Spülungen) *s*; -s, -s
Bieb|rich (Vorort von Wiesbaden)
bie|der; Bie|der|keit *w*; -; Bie-der_mann (*Mehrz.* ...männer), ...mei|er ([Kunst]stil in der Zeit

des Vormärz [1815 bis 1848]) *s*; -s (fachspr. auch: -); bie|der|mei-er|lich; Bie|der|mei|er_stil (*m*; -[e]s), ...zeit (*w*; -); Bie|der|sinn *m*; -[e]s
Bie|ge landsch. (Krümmung) *w*; -, -n; bie|gen; du bogst; du bögest; gebogen; bieg[e]!; sich -; (↑ R 120:) es geht auf Biegen oder Brechen (ugs.); bieg|sam; Bieg|sam|keit *w*; -; Bie|gung
Biel (BE) (schweiz. Stadt)
Bie|le|feld (Stadt am Teutoburger Wald); Bie|le|fel|der (↑ R 199); Bielefelder Leinen
Bie|ler See (in der Schweiz) *m*; -s (↑ R 204)
Bien (Gesamtheit des Bienenvolkes) *m*; -s; Bien|chen, Bienlein; Bie|ne *w*; -, -n; Bie|nen_fleiß, bie|nen|haft; Bie|nen_haus, ...ho|nig, ...kö|ni|gin, ...korb, ...schwarm, ...spra|che, ...stich (auch: Kuchenart), ...stock (*Mehrz.* ...stök-ke), ...volk; Bien|lein, Bien|chen
Bi|en|na|le *it.* [*biä...*] (zweijährliche Veranstaltung od. Schau, bes. in der bildenden Kunst u. im Film) *w*; -, -n
Bier *s*; -[e]s, -e; (↑ R 321 f.:) 5 Liter helles -; 3 [Glas] -; untergäriges, obergäriges -; Bier_abend, ...baß, ...bauch (ugs.), ...brau|er, ...dek-kel [*Trenn.:* ...dek|kel], ...do|se, ...ei|fer, ...faß, ...fla|sche, ...glas (*Mehrz.* ...gläser), ...hahn (*Mehrz.* ...hähne), ...ka|sten, ...kel|ler, ...kon|sum (*m*; -s), ...krug, ...lei|che (ugs. scherzh. für: Betrunkener), ...rei|se, ...ru-he (ugs. für das Verhalten eines Menschen, der durch nichts aus der Ruhe zu bringen ist), ...schen-ke, ...sei|del; bier|se|lig; Bier_sie-der (Berufsbez.), ...un|ter|satz, ...zei|tung, ...zelt
Bie|se (farbiger Vorstoß an Uniformen; Säumchen) *w*; -, -n
Bies|flie|ge (Dasselfliege)
¹Biest (derb für: „Vieh" [Schimpfwort]) *s*; -[e]s, -er
²Biest (Biestmilch) *m*; -[e]s
Bie|ste|rei (zu: ¹Biest; ugs.: Gemeinheit); bie|stig (ugs.); eine -e Kälte
Biest|milch [zu: ²Biest] (erste Kuhmilch nach dem Kalben)
Biet schweiz. (Gebiet; meist in Zusammensetzungen wie Baselbiet) *s*; -s, -e
bie|ten; du bietest (selten: bietst); vgl. beut; du botst (geh.: botest); du bötest; geboten; biet[e]!; sich -
bi|fi|lar *lat.* (Technik: zweifädig, zweidrähtig)
Bi|fo|kal|glas *lat.; dt.* (Brillenglas mit Fern- und Nahteil; *Mehrz.* ...gläser)

Bi|ga *lat.* (Streitwagen für zwei Mann in der Antike) w; -, ...gen

BIGA, Bi|ga = Bundesamt für Industrie, Gewerbe und Arbeit (in der Schweiz)

Bi|ga|mie *lat.; gr.* (Doppelehe) w; -, ...ien; bi|ga|misch; Bi|ga|mist (↑ R 268); bi|ga|mi|stisch

Big Band *engl.-amerik.* [- *bänd*] (großes Jazz- od. Tanzorchester) w; - -, - -s

Big Ben *engl.* („großer Benjamin"; Stundenglocke der Uhr im Londoner Parlamentsgebäude) m; - -

Bi|gno|nie [...*iᵉ*; nach dem fr. Abbé Bignon] (eine Zierpflanze) w; -, -n

bi|gott *fr.* (engherzig fromm; scheinheilig; blindgläubig); Bi|got|te|rie w; -, ...ien

Bi|jou *fr.* [*bischu*] (Kleinod, Schmuckstück) m od. s; -s, -s; Bi|jou|te|rie ([Handel mit] Schmuckwaren) w; -, ...ien

Bi|kar|bo|nat, (chem. fachspr.:) Bi|car|bo|nat *lat.* (doppeltkohlensaures Salz)

Bi|ki|ni (nach dem Atoll der Ralikinseln benannter zweiteiliger Badeanzug) m; -s, -s

bi|kon|kav *lat.* (beiderseits hohl [geschliffen])

bi|kon|vex *lat.* [...*wäkß*] (beiderseits gewölbt [geschliffen])

bi|la|bi|al *lat.* (Lautlehre: mit beiden Lippen gebildet); Bi|la|bi|al ([Zwei]lippenlaut, mit Ober- u. Unterlippe gebildeter Laut, z. B. p) m; -s, -e

Bi|lanz *it.* („Gleichgewicht"; Gegenüberstellung von Vermögen und Kapital für ein Geschäftsjahr; übertr. für: Ergebnis) w; -, -en; Bi|lanz|buch|hal|ter; bi|lan|zie|ren (Wirtsch.: sich ausgleichen, sich aufheben; eine Bilanz abschließen); Bi|lan|zie|rung; bi|lanz|si|cher; ein -er Buchhalter

bi|la|te|ral *lat.* [auch: ...*gl*] (zweiseitig); -e Verträge

Bilch *slaw.* (ein Nagetier) m; -[e]s, -e; Bilch|maus

Bild s; -[e]s, -er; im -e sein; Bild|ar|chiv, ...aus|schnitt, ...band m, ...bei|la|ge, ...be|richt, ...be|richt|er|stat|ter, ...be|schrei|bung; Bild|chen s; -s, - u. Bilderchen; Bild|lein; bil|de; sich -; die bildenden Künste (↑ R 224); Bild|er|at|las, ...bo|gen, ...buch; Bil|der|buch|lan|dung (ugs.: genau nach Plan verlaufende Landung [einer Raumkapsel]), ...wet|ter (ugs.); Bil|der|chen (Mehrz. von: Bildchen); Bil|der|chro|nik, ...rah|men, ...rät|sel; bil|der|reich; Bil|der|sturm (m; -[e]s), ...stür|mer; Bil|der|stür|me|rei;

Bild..er|zäh|lung, ...flä|che, ...fol|ge, ...fre|quenz, ...funk, ...ge|schich|te, ...ge|stal|tung; bild|haft; Bild|haf|tig|keit w; -; Bild|hau|er; Bild|haue|rei; bild|haue|risch; Bild|hau|er|kunst; bild|hau|ern; ich ...ere (↑ R 327); gebild|hauert; Bild|hau|er|werk; bild|hübsch; Bild..idee, ...in|halt, ...kraft (w; -); bild|kräf|tig; Bild|le|in; Bild|mi|scher (Fernsehen); Bild|ner; Bild|ne|rei; bild|ne|risch; -ste (↑ R 294); Bild|nis s; -ses, -se; Bild..re|por|ta|ge, ...re|por|ter, ...röh|re; bild|sam; Bild|sam|keit w; -; Bild|säu|le; bild|schirm; bild|schön; Bild..stelle, ...stock (*Mehrz.* ...stöcke), ...strei|fen; bild|syn|chron; -e Tonaufzeichnung; Bild|te|le|gra|fie; Bild-Ton-Ka|me|ra (↑ R 155)

Bil|dung; bil|dungs|be|flis|sen; Bil|dungs|chan|cen (*Mehrz.*), ...er|leb|nis; bil|dungs|fä|hig; Bil|dungs..gang m, ...grad, ...lücke [*Trenn.*: ...lük|ke], ...mög|lich|keit, ...not|stand, ...plan, ...rei|se, ...stufe, ...ur|laub, ...we|sen (s; -s)

Bild..vor|la|ge, ...vor|wurf, ...wer|bung, ...wer|fer (für: Projektionsapparat), ...werk, ...wör|ter|buch

Bil|ge *engl.* (Seemannsspr.: Kielraum eines Schiffes, in dem sich das Leckwasser sammelt) w; -, -n; Bil|ge|was|ser s; -s

bi|lin|guisch *lat.* [*bilingg^uisch*] (zweisprachig)

Bi|li|ru|bin *lat.* (Gallenfarbstoff) s; -s

¹Bill *engl.* (Gesetzentwurf im engl. Parlament) w; -, -s

²Bill (engl. Kurzform von: William)

Bil|lard *fr.* [*biljart*, österr.: *bijar*] (Kugelspiel); dazugehörender Tisch) s; -s, -e (österr.: -s); bil|lar|die|ren (österr.: *bijar*...) (beim Billard in unzulässiger Weise stoßen); Bil|lard|queue [...*kö*] (Spielstock)

Bill|ber|gie [...*iᵉ*; nach dem schwed. Botaniker Billberg] (eine Zimmerpflanze) w; -, -n

Bil|le|teur *fr.* [*biljätör*, österr. *bijätör*] (österr.: Platzanweiser; schweiz.: Schaffner) m; -s, -e; Bil|le|teu|se [...*tös^e*] w; -, -n; Bil|lett [*biljät*, österr. *bijä*] (veralt. für: Zettel; Briefchen; bes. österr.: Glückwunschbriefchen; schweiz., sonst veraltend für: Einlaßkarte, Fahrkarte, -schein) s; -[e]s, -e u. -s

Bil|li|ar|de *fr.* (10¹⁵; tausend Billionen) w; -, -n

bil|lig; um ein -es (↑ R 134); das ist nur recht und ...; bil|lig|den|kend; bil|li|gen; bil|li|ger|ma|ßen;

bil|li|ger|wei|se; Bil|lig|keit w; -; Bil|li|gung; Bil|lig|wa|re

Bil|li|on *fr.* (10¹²; eine Million Millionen od. 1 000 Milliarden); bil|li|on [s]tel; vgl. achtel; Bil|li|on[s]tel s (schweiz. meist: m); -s, -; vgl. Achtel

Bil|lon *fr.* [*biljong*] (Silberlegierung für Münzen mit hohem Kupfergehalt) m od. s; -s

Bill|roth|ba|tist,[↑ R 180 [nach dem Arzt Billroth] (wasserdichter Verbandstoff) m; -[e]s

Bil|sen|kraut (giftiges Kraut) s; -[e]s

Bil|wiß landsch. (Kobold, Zauberer) m; ...isses

bim!; bim bam!; bim, bam, bum!; Bim|bam s; -s; aber: heiliger Bimbam (ugs.)

Bi|me|ster *lat.* (veralt. für: Zeitraum von zwei Monaten) s; -s, -; Bi|me|tall (Elektrotechnik: zwei miteinander verbundene Streifen aus verschiedenem Metall); Bi|me|tall|is|mus (Doppelwährung) m; -

Bim|mel (ugs. für: Glocke) w; -, -n; Bim|mel|bahn (ugs.); Bim|me|lei (ugs.) w; -; bim|meln (ugs.); ich ...[e]le (↑ R 327)

bim|sen (ugs.: schleifen; durch angestrengtes Lernen einprägen); du bimst (bimsest); Bims|stein

bi|nar, bi|när, bi|na|risch *lat.* (fachspr.: aus zwei Einheiten bestehend, Zweistoff...)

Bin|de w; -, -n; Bin|de|ge|we|be; Bin|de|ge|webs.ent|zün|dung, ...fa|ser, ...mas|sa|ge, ...schwä|che; Bin|de|glied, ...haut, ...hautent|zün|dung, ...mit|tel s; bin|den; du bandst (bandest); du bändest gebunden (vgl. d.); bind[e]!; sich -; Bin|der; Bin|de|rei; Bin|de|rin w; -, -nen; Bin|der|schicht (Steinkunde); Bin|des-s (↑ R 149) s; -, -; Bin|de.strich, ...wort (für: Konjunktion; *Mehrz.* ...wörter); Bind|fa|den; bin|dig; Bin|dung

Bin|ge, Pin|ge (Bergmannsspr.: eine durch Einsturz alter Grubenbaue entstandene trichterförmige Vertiefung an der Erdoberfläche) w; -, -n

Bin|ger (Stadt am Rhein); Bin|ger (↑ R 199); das - Loch; bin|ge|risch

Bin|go [*binggo*] (engl. Glücksspiel; eine Art Lotto) s; -[s]

Bin|kel, Binkl bayr., österr. ugs. (Bündel) m; -s, -[n]

bin|nen; mit *Wemf.*: - einem Jahre (geh. auch mit *Wesf.*: - eines Jahres); - drei Tagen (auch: - dreier Tage); - kurzem; - Jahr und Tag; bin|nen|bords (innerhalb des Schiffes); Bin|nen.deut|sche (m u. w; -n, -n), ...han|del, ...land (*Mehrz.* ...länder); Bin|nen|land-

eis; **Bin|nen.markt,** ...**meer,** ...**see** *m,* ...**wäh|rung**

Bin|okel *fr.* (Augenglas, Fernrohr, Mikroskop für beide Augen) *s;* -s, -; **bin|oku|lar** *lat.* (mit beiden Augen, für beide zugleich)

Bi|nom *lat.; gr.* (Math.: jede Summe aus zwei Gliedern) *s;* -s, -e; **Bi|no|mi|al.ko|ef|fi|zi|ent,** ...**rei|he,** ...**satz;** **bi|no|misch** (Math.: zweigliedrig); -er Lehrsatz

Bin|se (grasähnliche Pflanze) *w;* -, -n; in die -n gehen (ugs. für: verlorengehen; unbrauchbar werden); **Bin|sen.wahr|heit** (ugs. für: allbekannte Wahrheit), ...**weis|heit**

bio... *gr.* (leben[s]...); **Bio...** (Leben[s]...); **bio|ak|tiv** (biologisch aktiv); ein -es Waschmittel; **Bio|bi|blio|gra|phie** (Verzeichnis von Schrifttum über eine Persönlichkeit u. seine eigenen Werke); **Bio|che|mie** (Lehre von den chemischen Vorgängen in Lebewesen; heilkundlich angewandte Chemie); **bio|che|mi|ker;** **bio|che|misch;** **bio|gen** (Biol.: von Lebewesen stammend); **Bio|ge|ne|se** (Entwicklung[sgeschichte] der Lebewesen) *w;* -, -n; **bio|ge|ne|tisch;** -es Grundgesetz; **Bio|geo|gra|phie** (Beschreibung der geogr. Verbreitung der Lebewesen) *w;* -; **Bio|geo|zö|no|se** (Wechselbeziehungen zwischen Pflanzen u. Tieren einerseits u. der unbelebten Umwelt andererseits) *w;* -; **Bio|graph** (Verfasser einer Lebensbeschreibung) *m;* -en, -en (↑ R 268); **Bio|gra|phie** (Lebensbeschreibung) *w;* -, ...ien; **bio|gra|phisch;** **Bio|ka|ta|ly|sa|to|ren** (die Stoffwechselvorgänge steuernde biolog. Wirkstoffe wie Hormone, Enzyme, Vitamine) *Mehrz.;* **Bio|lo|ge** *m;* -n, -n (↑ R 268); **Bio|lo|gie** (Lehre von der belebten Natur) *w;* -; **Bio|lo|gie|un|ter|richt;** **biolo|gisch;** -e Schädlingsbekämpfung, aber (↑ R 224): Biologische Anstalt Helgoland; **Bio|ly|se** (chem. Zersetzung organ. Substanz durch lebende Organismen) *w;* -, -n; **bio|ly|tisch;** **Bio|man|tie** (Wahrsagen aus Handlinien, dem Puls u. a.) *w;* -; **Bio|me|teo|ro|lo|gie;** **Bio|me|trie, Bio|me|trik** (Lehre von der Zählung u. [Körper]messung an Lebewesen) *w;* -; **Bio|nik** (Kurzw. aus: Biologie u. Technik; Bereich der Technik, der die Funktionsweise von Organen bei Lebewesen im Hinblick auf ihre Eignung als techn. Vorbilder untersucht) *w;* -; **bio|nisch; Bio|no|mie** (Lehre von den Gesetzen des Lebens) *w;* -; **Bio|phy|sik** (Lehre von den physikalischen Vorgängen in u.

an Lebewesen; heilkundlich angewandte Physik); **Bio|sa|tel|lit** (mit Tieren besetztes kleines Raumfahrzeug zur Erforschung der Lebensbedingungen in der Schwerelosigkeit); **Bio|tech|nik** (Nutzbarmachung biologischer Vorgänge); **bio|tisch** (auf Lebewesen, auf Leben bezüglich); **Bio|top** (durch bestimmte Lebewesen gekennzeichneter Lebensraum) *m u. s;* -s, -e; **Bio|typ, Bio|ty|pus** (Biol.: Erbstamm); **Bio|zö|no|se** (Lebensgemeinschaft von Pflanzen u. Tieren) *w;* -; **bio|zö|no|tisch**

Bi|pe|de *lat.* (Zweifüßer) *m;* -n, -n (↑ R 268); **bi|pe|disch; Bi|pe|di|tät** (Zweifüßigkeit) *w;* -

bi|po|lar *lat.; gr.* (zweipolig); **Bi|po|la|ri|tät**

Bi|qua|drat *lat.* (Math.: Quadrat des Quadrats, vierte Potenz); **bi|qua|dra|tisch;** -e Gleichung (Gleichung vierten Grades)

Bir|cher.mus od. ...**mües|li;** ↑ R 180 (Rohkostgericht nach dem Arzt Bircher-Benner); vgl. Müesli u. Müsli

Bi|re|me *lat.* (,,Zweiruderer''; antikes Kriegsschiff) *w;* -, -n

Bi|rett *lat.* (Kopfbedeckung des kath. Geistlichen) *s;* -[e]s, -e

Bir|ger (schwed. m. Vorn.)

Bir|git, Bir|git|ta (w. Vorn.)

Bir|ke (Laubbaum) *w;* -, -n; **bir|ken** (aus Birkenholz); **Bir|ken.holz,** ...**reis** *s,* ...**scheit,** ...**wald; Birk.hahn,** ...**huhn**

Bir|ma (Staat in Hinterindien); vgl. Burma; **Bir|ma|ne** *m;* -n, -n (↑ R 268); **bir|ma|nisch;** -er Reis, aber (↑ R 198): Birmanische Union

Bir|ming|ham [*bö'ming[e]m*] (engl. Stadt)

Birn|baum; Bir|ne *w;* -, -n; **bir|nen|för|mig, birn|för|mig; Birn|stab** (Stilelement in der got. Baukunst)

bis[1]; - [nach] Berlin; - hierher; - wann?; - jetzt; - nächsten Montag; - ans Ende der Welt; - auf die Haut; - zu 50%; deutsche

[1] Ein Strich (—) darf, muß aber nicht dafür gesetzt werden, wenn ,,bis'' einen Zwischenwert angibt, z. B.: er hat eine Länge von 6—8 Metern, das Buch darf 3—4 Mark kosten, 4—5mal. Der Strich darf nicht gesetzt werden, wenn ,,bis'' in Verbindung mit ,,von'' eine Erstreckung bezeichnet. Also nicht: die Tagung dauerte vom 5.—9. Mai. Bei verkürzter Wiedergabe ohne ,,von'' kann der Strich jedoch gesetzt werden: Sprechstunde täglich 8—10, 15—17. Am Zeilenanfang od. -ende wird ,,bis'' immer ausgeschrieben.

Dichter des 10. bis 15. Jahrhunderts; wir können - zu vier gebundene Exemplare abgeben (,,bis zu'' hier ohne Einfluß auf die folgende Beugung, weil umstandswörtlich gebraucht), aber: Gemeinden - zu 10000 Einwohnern (,,bis zu'' hier Verhältniswort mit Wemfall); vier- bis fünfmal (↑ R 145; mit Ziffern: 4- bis 5mal); - auf weiteres (↑ R 133); - und mit (schweiz.: bis einschließlich); - und mit achtem August

Bi|sam *hebr.* (Moschus [nur *Einz.*]; Pelz) *m;* -s, -e u. -s; **Bi|sam|rat|te** (große Wühlmaus)

bi|schen mitteld. (ein Baby beruhigend auf dem Arm wiegen); du bischst

Bi|schof (kirchl. Würdenträger) *m;* -s, Bischöfe; **bi|schöf|lich; Bi|schofs.hut** *m,* ...**kon|fe|renz; bi|schofs|li|la; Bi|schofs.sitz,** ...**stab,** ...**stuhl**

Bi|se schweiz. (Nord[ost]wind) *w;* -, -n

Bi|sek|trix *lat.* (Kristallphysik: Halbierende) *w;* -, ...**trizes**

bi|se|xu|ell *lat.* [auch: *bi...*] (mit beiden Geschlechtern verkehrend; zweigeschlechtig)

bis|her (bis jetzt); **bis|he|rig;** (↑ R 134:) im bisherigen (im obigen, weiter oben), aber (↑ R 116): das Bisherige (das bisher Gesagte, Erwähnte); vgl. folgend

Bis|ka|ya [...*kaja*] (kurz für: Golf von Biskaya; Bucht des Atlant. Ozeans) *w;* -

Bis|kot|te *it.* österr. (Löffelbiskuit) *w;* -, -n

Bis|kuit *fr.* [...*kwit*] (,,zweimal Gebackenes''; leichtes Gebäck) *s* (auch: *m*); -[e]s, -s (auch: -e)

bis|lang (bis jetzt)

Bis|marck (Gründer und erster Kanzler des Deutschen Reiches); **Bis|marck.ar|chi|pel** (Inselgruppe nordöstl. von Neuguinea; *m;* -s), ...**he|ring; bis|mar|ckisch, bis|marcksch;** ein Politiker von bismarck[i]schem Format; aber (↑ R 179): **Bis|mar|ckisch** [zur Trenn.: ↑ R 189], **Bis|marcksch;** die Bismarck[i]schen Sozialgesetze

Bis|mark (Stadt in der Altmark)

Bis|mu|tit (ein Mineral) *m;* -s; **Bis|mu|tum** vgl. Bi

Bi|son (nordamerik. Büffel) *m;* -s, -s

Biß *m;* Bisses, Bisse; **biß|chen;** (↑ R 131;) das -, ein - (ein wenig); ein klein -, mit ein - Geduld; **Biß|chen, Biß|lein** (kleiner Bissen); **bis|sel, bis|serl** landsch. (bißchen); ein - Brot; **Bis|sen** *m;* -s, -; **bis|sen|wei|se; bis|serl** vgl. bis-

sel; **Biß|gurn** bayr., österr. ugs. (zänkische Frau) w; -, -; **bis|sig; Bis|sig|keit; Biß|lein** vgl. Bißchen **Bi|sten** (Lockruf der Haselhenne) s; -s **Bi|ster** fr. (braune Wasserfarbe) m od. s; -s **Bi|stro** fr. (kleine Schenke od. Kneipe) s; -s, -s **Bis|tum** (Amtsbezirk eines kath. Bischofs) **bis|wei|len Bis|wind** (schweiz., südbad. neben: Bise) m; -[e]s **Bit** engl. [Kurzw. aus: binary digit] (Nachrichtentechnik: Informationseinheit) s; -[s], -[s]; Zeichen: bit **Bi|te|rolf** (m. Eigenn.) **Bi|thy|ni|en** [...iᵉn] (antike Landschaft in Kleinasien); **Bi|thy|ni|er** [...iᵉr]; **bi|thy|nisch Bit|tag** [Trenn.: Bitt|tag, ↑R 236] m; -[e]s, -e; **Bitt|brief; Bit|te** w; -, -n; **bit|ten;** du batst (batest); du bätest; gebeten; bitt[e]!; bitte schön!; bitte wenden! (Abk.: b. w.); geben Sie mir[,] bitte[,] das Buch (↑R 48); du mußt bitte sagen; **Bit|ten** s; -s **bit|ter;** es ist kalt; vgl. aber: bitterkalt; **bit|ter|bö|se; Bit|te|re** m; ...tte|r[e]n, ...tte|r[e]n u. **Bit|te|re** (Schnaps) m; ...ttren, ...ttren (↑R 287 ff.); ein -r, zwei -; **bit|ter|ernst;** es wird - (bitt[e]rer Ernst); **bit|ter|kalt;** ein -r Wintertag, aber: der Tag war bitter kalt; **Bit|ter|keit; Bit|ter|klee; bit|ter|lich; Bit|ter|ling** (Fisch; Pflanze; Pilz); **Bit|ter|man|del|öl; Bit|ter|nis** w; -, -se; **Bit|ter|salz** (Magnesiumsulfat); **bit|ter|süß; Bit|ter‿was|ser** (Mineralwasser mit Bittersalzen; Mehrz. ...wässer), ...wurz od. ...wur|zel **Bit|te|schön** s; -s; er sagte ein höfliches -, vgl. aber: bitten; **Bitt‿gang** m, ...ge|such **Bit|t|re** vgl. Bittere **Bitt‿schrift, ...stel|ler; bitt|wei|se Bi|tu|men** lat. (aus organischen Stoffen natürlich entstandene teerartige Masse, auch bei der Aufarbeitung von Erdöl als Destillationsrückstand gewonnen) s; -s, - (auch: ...mina); **bi|tu|mig; bi|tu|mi|nie|ren** (mit Bitumen behandeln); **bi|tu|mi|nös;** -er Schiefer
¹**bit|zeln** südd. u. westd. (prickeln, [vor Kälte] beißend wehtun); bitzelnder neuer Wein
²**bit|zeln** mitteld. (in kleine Stückchen schneiden, schnitzeln); ich bitz[e]le (↑R 327) **Bj|wak** niederd.-fr. (,,Beiwacht''; Feld[nacht]lager) s; -s, -s u. -e; **bi|wa|kie|ren**

bi|zarr fr. (launenhaft; seltsam); **Bi|zar|re|rie** w; -, ...ien **Bi|zeps** lat. (Beugemuskel des Oberarmes) m; -[es], -e **Bi|zet,** Georges [bisɛ] (fr. Komponist) **bi|zy|klisch,** (chem. fachspr.:) **bicy|clisch** [auch: ...zü...] (einen Kohlenstoffdoppelring enthaltend) **Björn|son, Bjørn|son** (norweg. Dichter) **Bk** = chem. Zeichen für: Berkelium **Bl.** = Blatt (Papier) **Bla|bla** (ugs.: Gerede; lange u. fruchtlose Diskussion um Nichtigkeiten) s; -[s] **Bla|che** (landsch. Nebenform von: Blahe) **Blach|feld** (,,flaches'' Feld) **Black|out** [bläkaut] engl. (Theater: plötzliche Verdunkelung am Szenenschluß; auch: kleiner Sketch; Raumfahrt: Abbrechen des Funkkontakts) s; -[s], -s; **Black Power** [bläk pauᵉr] (,,schwarze Gewalt''; amerik. Freiheitsbewegung der Neger) w; **blad** österr. ugs. (dick); **Bla|de** m u. w; -n, -n (↑R 287 ff.) **blaf|fen** (bellen), **bläf|fen; Blaf|fer, Bläf|fer Blag** s; -s, -en u. **Bla|ge** (ugs. für: kleines, meist unartiges, lästiges Kind) w; -, -n **Bla|he,** (landsch. auch:) **Bla|che,** (österr.:) **Pla|che** (Plane, Wagendecke; grobe Leinwand) w; -, -n **bläh|hen;** sich -; **Blä|hung bläh|ken** niederd. (schwelen, rußen) **blä|ken** (ugs. für: brüllen) **blä|kig** (rußend) **bla|ma|bel** fr. (beschämend); ...a|ble Geschichte; **Bla|ma|ge** [...maᵉsᵉʰ] (Schande; Bloßstellung); **bla|mie|ren;** sich - **Blan|ca** [...ka] (span. Schreibung von: Blanka) **blan|chie|ren** fr. [blãschi...] (Kochk.: abbrühen) **bland** (Med.: milde, reizlos [von einer Diät]; ruhig verlaufend [von einer Krankheit]) **Blan|di|ne** (w. Vorn.) **blank** (rein, bloß); blanker, blankste; (↑R 224:) der -e Hans (stürmische Nordsee). I. *Schreibung in Verbindung mit dem 2. Mittelwort:* die blankpolierte Dose (↑ jedoch R 142), aber: die Dose ist blank poliert. II. *Schreibung in Verbindung mit Zeitwörtern* (↑R 139): blank machen, reiben, polieren usw., vgl. aber: blankziehen; blank (südd., österr. für: ohne Mantel) gehen; **Blan|ka** (w. Vorn.); **Blän|ke** (selten für:

Waldblöße; Moortümpel) w; -, -n; **Blank|eis** ([Gletscher]eis ohne Schneeauflage) **Blan|ke|ne|se** (Stadtteil von Hamburg) **Blan|kett** (unausgefüllter Vollmachtsschein, insbesondere Wechsel) s; -[e]s, -e; **blan|ko** it. (leer, unausgefüllt); **Blan|ko** (teilweise ausgefüllter Vordruck) s; -s, -s, **Blan|ko‿scheck, ...voll|macht** (übertr. für: unbeschränkte Vollmacht); **Blan|ko|vers** engl. (fünffüßiger Jambenvers); **blank|zie|hen** (↑R 139); er hat den Säbel blankgezogen **Bläs|chen, Bläs|lein; Bla|se** w; -, -n; **Bla|se|balg** (Mehrz. ...bälge) **bla|sen;** du bläst (bläsest), er bläst; ich blies, du bliesest; geblasen; blas[e]!; **Bla|sen‿bil|dung, ...kam|mer** (Kernphysik: Gerät zum Sichtbarmachen der Bahnspuren ionisierender Teilchen), **...lei|den, ...stein, ...tang** (eine Braunalgenart); **bla|sen|zie|hend;** -e Mittel; **Bla|ser; Bla|se|rei; Blä|se|rei bla|siert** fr. (hochnäsig, teilnahmslos; hochmütig); **Bla|siert|heit** w; - **bla|sig; Blas|in|stru|ment Bla|si|us** (m. Vorn.) **Bläs|lein, Bläs|chen Blas|mu|sik Bla|son** fr. [blasõg] (Wappen[schild]) m; -s, -s; **bla|so|nie|ren** (Wappen kunstgerecht ausmalen od. erklären); **Bla|so|nie|rung Blas|phe|mie** gr. (Gotteslästerung; verletzende Äußerung über etwas Heiliges) w; -, ...ien; **blas|phe|mie|ren; blas|phe|misch, blas|phe|mi|stisch;** -ste (↑R 294) **Blas|rohr blaß;** (↑R 295:) blasser (auch: blässer), blasseste (auch: blässeste); - sein; - werden; **blaß|blau; Blaß|bock; Bläs|se** (Blaßheit) w; -; vgl. aber: Blesse; **blas|sen** (selten für: blaß werden); du blaßt (blassest); geblaßt; **Bläß|huhn; bläß|lich Bla|sto|ge|ne|se** gr. (Biol.: ungeschlechtliche Entstehung eines Lebewesens) w; -; **Bla|stu|la** (Biol.: Entwicklungsstadium des Embryos) w; - **Blatt** (Jägerspr. auch für: Schulterstück od. Instrument zum Blatten; Abk.: Bl. [Papier]) s; -[e]s, Blätter; 5 - Papier (↑R 321 f.); **Blät|tag** [Trenn.: Blatt|tang, ↑R 236] m; -[e]s, -e; **Blätt|chen** s; -s, - u. Blätterchen; **Blätt|lein; blat|ten** (Jägerspr.: auf einem Blatt [Pflanzenblatt od. Instrument] Rehe anlocken); **Blat|ter** (Instrument zum Blatten [Jägerspr.]); **Blät|ter|chen** (kleine

Blätter); **blät|te|rig,** blätt|rig; **Blät|ter|ma|gen** (der Wiederkäuer)
Blat|tern (Infektionskrankheit) *Mehrz.*
blät|tern; ich ...ere (↑ R 327)
Blat|ter|nar|be; blat|ter|nar|big; Blat|tern|gift
Blät|ter.teig, ...**wald** (scherzh. für: viele Zeitungen verschiedener Richtung); **blät|ter|wei|se, Blät|ter|werk, Blatt|werk** *s;* -[e]s; **Blatt.fel|der,** ...**ge|mü|se,** ...**gold,** ...**grün,** ...**laus; Blätt|lein, Blätt|chen; blatt|los; Blatt|pflan|ze; blätt|rig, blät|te|rig; Blatt|schuß; Blatt|trieb** (↑ R 237); **blatt|wei|se, blät|ter|wei|se; Blatt|werk, Blät|ter|werk** *s;* -[e]s
blau; -er; -[e]ste. *I. Kleinschreibung:* sein blaues Wunder erleben (ugs. für: staunen); die blaue Mauritius; der blaue Planet (die Erde); blauer Montag; jmdm. blauen Dunst vormachen (ugs.); einen blauen Brief (ugs. für: Mahnschreiben der Schule an die Eltern; auch: Kündigungsschreiben) erhalten; Aal blau; unsere blauen Jungs (ugs. für: Marinesoldaten); die blaue Blume (Sinnbild der Romantik); blauer Fleck (ugs. für: Bluterguß). *II. Großschreibung* (↑ R 116): die Farbe Blau; (↑ R 133:) ins blaue fahren; Fahrt ins Blaue; (↑ R 224 u. ↑ R 198:) das Blaue Band des Ozeans; die Blaue Grotte (von Capri); das Blaue Kreuz (Name u. Zeichen eines Bundes zur Rettung Trunksüchtiger); der Blaue Nil; Blauer Eisenhut; der Blaue Reiter (Name einer Künstlergemeinschaft). *III. Schreibung in Verbindung mit Zeitwörtern* (↑ R 139): **a)** *Getrenntschreibung* in ursprünglicher Bedeutung, z. B. blau färben, machen, werden; **b)** *Zusammenschreibung,* wenn durch die Verbindung ein neuer Begriff entsteht, z. B. blaumachen (nicht arbeiten); vgl. d. *IV. In Verbindung mit dem 2. Mittelwort Getrennt- oder Zusammenschreibung:* ein blaugestreifter Stoff (↑ jedoch R 142), a b e r: der Stoff ist blau gestreift; blau u. weiß gestreift. *V. Farbenbezeichnungen:* **a)** *Zusammenschreibung* (↑ R 158:) blaurot usw.; **b)** *Bindestrich* (↑ R 158:) blau-weiß usw.; **Blau** (blaue Farbe) *s;* -s, - (ugs.: -s); mit -; in - gekleidet, gedruckt; mit - bemalt; Stoffe in -; das - des Himmels; **blau|äu|gig** (↑ R 148); **Blau.bart** (Frauenmörder [im Märchen]; *m;* -[e]s, ...bärte); ...**ba|salt,** ...**bee|re** (ostmitteld. für: Heidelbeere); **blau|blü|tig** (ugs. für: adlig); **Blau|druck** (*Mehrz.* ...drucke); **Blaue** *s;* -n (↑ R 116); ins - schießen; das - vom Himmel [herunter]reden; Fahrt ins -; **Bläue** (Himmel[s]blau]) *w;* -; **blau|en** (blau werden); der Himmel blaut; **bläu|en** (blau machen, färben); vgl. a b e r : bleuen; **Blau.erz,** ...**fel|chen,** ...**fuchs,** ...**jacke** [Trenn.: ...jak|ke] (ugs.: Matrose), ...**kraut** (südd., österr. für: Rotkohl; *s;* -[e]s); **bläu|lich;** bläulichgrün, bläulichrot usw. (↑ R 158); **Blau|licht** (*Mehrz.* ...lichter); **Blau|ling, Bläu|ling** (ein Schmetterling; Fisch); **blau|ma|chen** (ugs. für: nicht arbeiten); a b e r: blau ma|chen (blau färben); vgl. blau, III; **Blau.mei|se,** ...**racke** [Trenn.: ...rak|ke] (ein Vogel); (↑ R 158:) **blau|rot;** das blaurote (aus einem bläulichen Rot bestehende) Kleid; **Blau.säu|re** (*w;* -), ...**schim|mel** (Pferd); **blau|sti|chig;** ein -es Farbfoto; **Blau|strumpf** (abschätzig für: einseitig intellektuelle Frau); **Blau|weiß|por|zel|lan** (↑ R 158)
Bla|zer *engl.* [blęᵉr] (Klubjacke [mit auffälligem Klubabzeichen]) *m;* -s, -
Blech *s;* -[e]s, -e; **Blech.büch|se,** ...**do|se,** ...**ei|mer; ble|chen** (ugs. für: zahlen); **ble|chern** (aus Blech); **Blech|mu|sik; Blech|ner** südwestd. (Klempner); **Blech.schach|tel,** ...**scha|den,** ...**sche|re**
blecken [Trenn.: blek|ken]; die Zähne -
¹Blei (svw. Brachse) *m;* -[e]s, -e
²Blei (chem. Grundstoff, Metall; Zeichen: Pb; Richtblei; zollamtlich für: Plombe) *s;* -[e]s, -e; **³Blei** (ugs. kurz für: Bleistift) *m* (auch: *s*); -[e]s, -e; **Blei|asche**
Blei|be (Unterkunft) *w;* -, (selten:) -n; **blei|ben;** du bliebst (bliebest); geblieben; bleib[e]!; andere Verben mit „bleiben" als Grundwort (↑ R 139) wie: hängen-, liegen-, sitzen-, stehenbleiben; a b e r: sitzen bleiben; **Blei|ben|aus|weis** (Mitgliedsausweis für die Übernachtung in Jugendherbergen); **blei|ben|las|sen** (↑ R 139); das sollst du - (unterlassen); er hat es -, (seltener:) bleibengelassen (↑ R 305); a b e r getrennt in ursprünglicher Bedeutung: er wird uns nicht länger hier bleiben las|sen
bleich; Blei|che *w;* -, -n; **¹blei|chen** (bleich machen); du bleichtest; gebleicht; bleich[e]!; **²blei|chen** (bleich werden); du bleichtest (veralt.: blichst); gebleicht (veralt.: geblichen); bleich[e]!; **Blei|che|rei; Blei|chert** (blasser Rotwein) *m;* -s, -e; **Bleich.ge|sicht** (*Mehrz.* ...gesichter), ...**sand** (Geol.: graublaue Sandschicht), ...**sucht** (*w;* -); **bleich|süch|tig**
blei|en (mit Blei versehen); **blei|ern** (aus Blei); **blei|far|ben; Blei|gie|ßen** *s;* -s; **Blei.glanz; blei|hal|tig; Blei|kri|stall; blei|schwer; Blei|stift** *m;* vgl. auch: ³Blei; **Blei|stift.spit|zer,** ...**stum|mel; Blei|weiß** (Bleifarbe)
Blende (auch: blindes Fenster, Nische; Optik: lichtabschirmende Scheibe; Mineral; auch für: Attrappe) *w;* -, -n; **blen|den** (,,blind machen"; Bauw.: [ver]decken); **Blen|den|au|to|ma|tik** (automatische Vorrichtung bei Kamerablenden); **blen|dend;** -ste; ein blendendweißes Kleid (↑ jedoch R 143), a b e r: der Schnee war blendend weiß; **Blen|der; blend|frei; Blend.la|ter|ne,** ...**rah|men,** ...**schutz; Blend|schutz.git|ter,** ...**zaun; Blen|dung; Blend|werk**
Blen|nor|rhö¹, Blen|nor|rhöe *gr.* (Med.: eitrige Schleimhautabsonderung) *w;* -, ...rrhöen
Bles|se (weißer [Stirn]fleck, Tier mit weißem Fleck) *w;* -, -n; vgl. a b e r: Blässe; **Bleß|huhn** vgl. Bläßhuhn
bles|sie|ren *fr.* (veralt. für: verwunden); **Bles|sur** (veralt. für: Verwundung, Verletzung) *w;* -, -en
bleu *fr.* [blö] (blau [leicht ins Grünliche spielend]); **Bleu** *s;* -s, - (ugs.: -s)
Bleu|el (veralt. für: Schlegel [zum Wäscheklopfen]) *m;* -s, -; **bleu|en** (ugs. für: schlagen); vgl. a b e r: bläuen
Blick *m;* -[e]s, -e; **blicken** [Trenn.: blik|ken]; **Blick.fang,** ...**feld; blick|los; Blick.punkt,** ...**rich|tung,** ...**win|kel**
blind; ein -er Mann, -er Alarm; *Schreibung in Verbindung mit Zeitwörtern* (↑ R 139): blind sein, werden, vgl. a b e r: blindfliegen, blindschreiben; **Blind|darm; Blind|darm|ent|zün|dung; Blin|de** *m u. w;* -n, -n (↑ R 287ff.); **Blin|de|kuh;** - spielen; **Blin|den.an|stalt,** ...**füh|rer,** ...**hund,** ...**schrift,** ...**stock; Blin|den|ver|band;** Deutscher -; **blind|flie|gen;** ↑ R 139 (im Flugzeug); er ist blindgeflogen; **Blind.flie|gen** (*s;* -s), ...**flug,** ...**gän|ger; Blind|ge|bo|re|ne, Blind|ge|bor|ne** *m u. w;* -n, -n (↑ R 287ff.); **Blind|heit** *w;* -; **blind|lings; Blind.schacht** (Bergmannsspr.: nicht zu Tage gehender Schacht), ...**schlei|che** (*w;* -, -n); **blind|schrei|ben;** ↑ R 139 (auf der Schreibmaschine); sie hat

¹ Vgl. die Anmerkung zu ,,Diarrhö, Diarrhöe".

blind|geschrieben; **Blind|schreib-ver|fah|ren; blind|spie|len;** ↑ R 139 (Schach: ohne Brett spielen); er hat blind|gespielt; **Blind⌣spie|ler, ...wi|der|stand; blind|wü|tig; Blind|wü|tig|keit** w; -

blink; - und blank; **blin|ken; Blin-ker; Blin|ke|rei;** ich ...ere (↑ R 327); **Blink⌣feu|er** (See-zeichen), **...ge|rät, ...leuch|te, ...licht** (*Mehrz.* ...lichter), **...trupp, ...zei|chen**

blin|zeln; ich ...[e]le (↑ R 327)

Blitz m; -es, -e; **Blitz|ab|lei|ter; blitz|ar|tig; blitz|blank,** (ugs. auch:) **blit|ze|blank; blitz|blau,** (ugs. auch:) **blit|ze|blau; blit|zen** (ugs. auch für: mit Blitzlicht foto-grafieren); es blitzt, du blitzt (blit-zest); **Blitz|an|griff; Blit|zer** (Bergmannsspr.: tragbares elektr. Grubengeleucht mit Scheinwerfer); **Blit|zes|schnel|le** w; -; **Blitz|ge|rät; blitz|ge|scheit; Blitz⌣ge|spräch, ...kar|rie|re, ...krieg, ...lam|pe** (Fototechnik), **...licht** (*Mehrz.* ...lichter); **Blitz-licht|auf|nah|me; blitz|sau|ber; Blitz|schlag; blitz|schnell; Blitz-⌣sieg, ...strahl, ...um|fra|ge, ...wür|fel** (Fototechnik)

Bliz|zard *engl.* [*blíṣˀrt*] (Schnee-sturm [in Nordamerika]) m; -s, -s

Bloch südd. u. österr. (Holzblock, -stamm) m (auch: s); -[e]s, **Blöcher** (österr. meist: Bloche); **Blo|cher** schweiz. (Bohner)

Block m; -[e]s, (für: Beton-, Eisen-, Fels-, Granit-, Hack-, Holz-, Me-tall-, Motor-, Stein-, Zylinder-block:) Blöcke u. (für: Abreiß-, Brief-, Buch-, Formular-, Kalen-der-, Kassen-, Notiz-, Rezept-, Schreib-, Steno[gramm]-, Zei-chenblock, auch meist für: Häu-ser-, Wohnblock:) Blocks; (für: Macht-, Militär-, Währungs-, Wirtschaftsblock u. a.:) Blöcke od. Blocks; **Blocka|de[1]** *fr.* ([See]-sperre, Blockung, Einschlie-ßung; Druckw.: im Satz durch Blockieren gekennzeichnete Stel-le); **Block⌣bil|dung, ...buch; blok-ken; Blocker[1]** landsch. (Bohner-besen); **Block|flö|te; block|frei;** -e Staaten; **Block|haus; blockie|ren[1]** *fr.* (einschließen, blocken, [ab]-sperren; Druckw.: fehlenden Text durch ▮▮ kennzeichnen); **Blockie|rung[1]; blockig[1]** (klotzig); **Block⌣malz** (Hustenbonbon[s] aus Malzzucker), **...po|li|tik Blocks|berg** (in der Volkssage für: Brocken) m; -[e]s

Block⌣schrift, ...si|gnal, ...stel|le, ...stun|de (Schulwesen: Doppel-

stunde [für Arbeitsgemeinschaf-ten, Sport, Kunst u. dgl.]); **Blok-kung; Block|werk** (Eisenbahnw.: Kontrollstelle für einen Strek-kenabschnitt)

blöd, blö|de; Blö|de|lei; blö|deln (ugs. für: Unsinn reden, sich blöde benehmen); ich ...[e]le (↑ R 327); **Blöd|heit** (Dummheit); **Blö-di|an** (dummer Mensch) m; -[e]s, -e, **Blö|dig|keit** (veralt. für: Schwäche; Schüchternheit) w; -; **Blöd|ling** (Dummkopf); **Blöd-mann** (ugs. für: Dummkopf, ein-fältiger Kerl; *Mehrz.* ...männer); **Blöd|sinn** m; -[e]s; **blöd|sin|nig; Blöd|sin|nig|keit**

blö|ken

blond *fr.;* blondgefärbtes Haar (↑ jedoch R 142), aber: ihr Haar war blond gefärbt; [1]**Blon|de** (blonde Frau; blonder Mann) w u. m und (Glas Weißbier, helles Bier:) w u. s; -n, -n; zwei Blonde; ein kühles Blondes (↑ R 287 ff.); [2]**Blon|de** (Seiden-spitze) w; -, -n; **blond|ge|lockt; Blond|haar; blon|die|ren** (blond färben); **Blon|di|ne** (blonde Frau) w; -, -n; zwei reizende Blondinen; **Blond|kopf; blond|lockig** [*Trenn.:* ...lok|kig]

[1]**bloß** (nur); [2]**bloß** (entblößt); **Blö-ße** w; -, -n; **bloß|fü|ßig; bloß⌣le-gen, ...liegen, ...stellen; Bloß|stel-lung; bloß|stram|peln,** sich

Blou|son *fr.* [*blusọng*] (über dem Rock getragene, an den Hüften enganliegende Bluse) s (auch: m); -[s], -s

blub|bern niederd. (glucksen; rasch u. undeutlich sprechen); ich ...ere (↑ R 327)

Blü|cher (preußischer Feldmar-schall)

Blu|denz österr. (Stadt)

Blue jeans *amerik.* [*blúdsehins*] (blaue [Arbeits]hose aus ge-köpertem Baumwollgewebe) *Mehrz.;* **Blues** [*blụs*] (urspr. reli-giöses Lied der nordamerik. Ne-ger, dann langsamer Tanz im ⁴/₄-Takt) m; -, -

Bluff *engl.* [auch noch: *blöf*] (Ver-blüffung; Täuschung) m; -s, -s; **bluf|fen** [auch noch: *blöfˀn*]

blü|hen; Blü|het schweiz. ([Zeit der] Baumblüte) m; -s; **Blüm-chen, Blüm|lein,** (dicht.:) Blü|me-lein; **Blüm|chen|kaf|fee** (ugs. scherzh. für: dünner Kaffee); **Blü|me** w; -, -n; **Blü|me|lein** vgl. Blümchen; **Blu|men⌣beet, ...bu-kett; blu|men|ge|schmückt,** aber (↑ R 142): mit Blumen ge-schmückt; **Blu|men⌣ka|sten, ...kohl, ...ra|bat|te, ...strauß** (*Mehrz.* ...sträuße), **...topf blü|me|rant** *fr.* (ugs. für: schwinde-

lig, flau); es wird mir - [vor den Augen]

blu|mig; Blüm|lein, Blüm|chen

Blun|ze w; -, -n, (auch:) **Blun|zen** bayr., österr. (Blutwurst) w; -, -; das ist mir Blunzen (völlig gleichgültig)

Blüs|chen, Blüs|lein; **Blu|se** *fr.* w; -, -n

Blü|se (Seemannsspr.: Leuchtfeu-er) w; , n

blu|sig; Blüs|lein, Blüs|chen

Blust (südd. u. schweiz., sonst ver-alt. für: Blütezeit, Blühen) m od. s; -[e]s

Blut s; -[e]s, (Med. fachspr.:) -e; Gut und -; **Blut⌣ader, ...al|ko|hol;** [1]**blut|arm** (arm an Blut); [2]**blut|arm** (ugs. für: sehr arm); **Blut⌣ar|mut, ...bahn, ...bank** (*Mehrz.* ...ban-ken); **blut⌣be|schmiert, ...bildend; Blut⌣bu|che, ...druck** (m; -[e]s), **...durst; blut|dür|stig**

Blü|te w; -, -n

Blut⌣egel, ...ei|weiß; blu|ten

Blu|ten⌣ho|nig, ...kelch, ...le|se; blü|ten|los, -e Pflanze; **Blü-ten⌣stand, ...staub; blü|ten|weiß, ...zeit; Blü|ten|zweig**

Blu|ter (ein Mensch, der zu schwer stillbaren Blutungen neigt); **Blut-er|guß; Blu|ter|krank|heit** w; -

Blü|te|zeit

Blut⌣ge|fäß, ...ge|rinn|sel, ...grup-pe; Blut|grup|pen|un|ter|su-chung; Blut⌣hund; blu|tig; ...blü-tig (z. B. heißblütig)

...blü|tig (zu: Blüte) (z. B. langblü-tig)

blut|jung (ugs.: sehr jung); **Blut⌣kon|ser|ve** (Med.: konser-viertes Blut), **...kör|per|chen, ...krebs** (m; -es), **...kreis|lauf, ...la-che; blut|leer** (ohne Blut)

...blüt|ler (z. B. Lippenblütler)

blut⌣mä|ßig, bluts|mä|ßig; Blut-⌣pfropf, ...plas|ma, ...pro|be, ...ra-che, ...rausch, ...reln|helt; blut-⌣rei|ni|gend, ...rot, ...rün|stig, ...sau|gend; Blut|sau|ger; Bluts-brü|der|schaft; Blut|schan|de w; -; **blut|schän|de|risch; Blut⌣sen-kung** (Med.), **...se|rum; bluts|mä-ßig, blut|mä|ßig; Blut⌣spen|der, ...spur, ...stau|ung; blut|stil|lend;** -es Mittel, -e Watte (vgl. S. 45, Merke, 2); **Blut⌣strom; Bluts|trop-fen; Blut|sturz; bluts|verwandt; Bluts⌣ver|wand|te, ...ver|wandt-schaft; Blut⌣tat, ...trans|fu|si|on; blut⌣trie|fend, ...über|strömt; Blut⌣über|tra|gung; Blu|tung; blut⌣un|ter|lau|fen; Blut⌣ver|gif-tung, ...ver|lust; blut⌣ver-schmiert, ...voll; Blut⌣wä|sche, ...wasser; blut|we|nig** (ugs. für: sehr wenig); **Blut⌣wurst, ...zeu|ge** (für: Märtyrer), **...zoll, ...zucker** [*Trenn.:* ...zuk|ker], **...zu|fuhr**

[1] *Trenn.:* ...ok|k...

b. m., br. m. = brevi manu

b-Moll [*bemol*, auch: *bemọl*] (Tonart; Zeichen: b) *s*; -; **b-Moll-Tonleiter** (↑ R 155)

BMWⓌⓄ = Bayerische Motorenwerke AG

Bö, (auch:) **Böe** (heftiger Windstoß) *w*; -, Böen

Boa (Riesenschlange; langer, schmaler Schal aus Pelz oder Federn) *w*; -, -s

BOAC = British Overseas Airways Corporation [*british ọ̈ʷ-*
wᵉrßis ä'weʲs ko'pᵉreʲschᵉn] (Brit. Übersee-Luftverkehrs-Gesellschaft)

Bob (Kurzform für: Bobsleigh) *m*; -s, -s; **Bob|bahn; bob|ben** (beim Bobfahren eine gleichmäßige, ruckweise Oberkörperbewegung zur Beschleunigung der Fahrt ausführen)

Bob|by [*bọbi*; nach dem Reorganisator der engl. Polizei, Robert („Bobby") Peel] (engl. ugs. für: Polizist) *m*; -s, Bobbies [*bọbis*]

Bo|ber (schwimmendes Seezeichen) *m*; -s, -

Bo|bi|ne *fr.* ([Garn]spule an der Baumwollspinnerei; endloser Papierstreifen zur Herstellung von Zigarettenhülsen; Bergmannsspr.: Wickeltrommel für Flachseile an Fördermaschinen) *w*; -, -n; **Bo|bi|net** *engl.* [auch: *...nät*] (Gewebe; engl. Tüll) *m*; -s, -s

Bob|sleigh *engl.* [*bọbßlęʲ*] (Rennschlitten; Kurzform: Bob) *m*; -s, -s

Boc|cac|cio [*bokạtscho*] (it. Dichter)

Boc|cia *it.* [*bọtscha*] (it. Kugelspiel) *s* od. *w*; -, -s

Boche *fr.* [*bosch*] (fr. Schimpfname für den Deutschen) *m*; -, -s

Bo|cholt (Stadt im Münsterland)

Bo|chum (Stadt im Ruhrgebiet); **Bo|chu|mer** (↑ R 199)

Bock *m*; -[e]s, Böcke; - springen; vgl. aber: das Bockspringen; **bock|bei|nig**

Bock|bier

Böck|chen, Böck|lein; **böckeln**[1] mdal. (nach Bock riechen); **bokken; Bockerl**[1] österr. mdal. (Föhrenzapfen) *s*; -s, -n; **bockig**[1]; **Bock|kä|fer; Böck|lein**, Böckchen

Böck|lin (schweiz. Maler)

Bock|mist (ugs.: Blödsinn, Fehler); **Bocks.beu|tel** (bauchige Flasche; Frankenwein in solcher Flasche), **...dorn** (Strauch; *m*; -[e]s), **...horn** (*Mehrz. ...*hörner; laß dich nicht ins - jagen [ugs. für: einschüchtern]), **..hörndl**

[1] *Trenn.:* ...k|k...

(österr. ugs.: Frucht des Johannisbrotbaumes; *s*; -s, -[n]); **Bockshorn|klee** (eine Pflanze) *m*; -s; **Bock..springen** (↑ R 120), **...sprung, ...wurst**

Bod|den niederd. (Strandsee, [Ostsee]bucht) *m*; -s, -

Bo|de|ga *span.* (span. Weinkeller, -schenke) *w*; -, -s

Bo|de-Gym|na|stik; ↑ R 180 (von Rudolf Bode geschaffene Ausdrucksgymnastik) *w*; -

Bo|del|schwingh (dt. ev. Theologe)

Bo|den *m*; -s, Böden; **Bo|den.belag**, **...be|ar|bei|tung**, **...frost**, **...haftung** (Motorsport), **...kam|mer**, **...le|ger** (Berufsbez.); **bo|den|los**, -este (↑ R 292); **Bo|den..ne|bel**, **...per|so|nal**, **...re|form**, **...satz**

Bo|den|see *m*; -s

bo|den|stän|dig; **Bo|den|sta|ti|on**

Bo|den|stedt (dt. Dichter)

Bo|den..tur|nen, **...ver|bes|se|rung**, **...wich|se** (schweiz. für: Bohnerwachs; **bo|di|gen** schweiz. (zu Boden werfen, besiegen); **Bodme|rei** (Schiffsbeleihung, -verpfändung)

Bo|do (m. Vorn.); vgl. Boto

Bo|do|ni [nach dem it. Stempelschneider Bodoni] (klassizistische Antiquadruckschrift) *w*; -; **Bo|do|ni|druck** (*Mehrz. ...*drucke); ↑ R 180

Bo|dy|buil|der *engl.* [*bọdibild'r*] (jmd., der Bodybuilding betreibt) *m*; -s, -; **Bo|dy|buil|ding** (moderne Methode der Körperbildung u. Vervollkommnung der Körperformen) *s*; -[s]; **Bo|dy|check** [*...tschäk*] (erlaubtes Rempeln des Gegners beim Eishockey)

Böe vgl. Bö

Boe|ing [*boᵘing*] (amerik. Flugzeugtyp) *w*; -, -s

Boe|thi|us (spätröm. Philosoph)

Bo|fel (Nebenform von: Bafel)

Bo|fist [auch: *bofißt*], **Bo|vist** [auch: *bowißt*] (ein Pilz) *m*; -[e]s, -e

Bo|gen (Abk. für das „Bogen Papier": Bg.) *m*; -s, - (bes. südd., österr. auch: Bögen); in Bausch und Bogen (alles in allem); **Bogen.füh|rung** (Musik), **...lam|pe**, **...län|ge** (Math.), **...schie|ßen** (*s*; -s), **...schüt|ze**; **bo|gig**

Bo|gis|law (russ. m. Vorn.)

Bo|go|tá (Hptst. von Kolumbien)

Bo|heme [*boạm*, auch: *bohạm*] (ungebunden lebende Künstlerschar) *w*; -; **Bo|he|mi|en** [*boämjạng*] (Angehöriger der Boheme) *m*; -s, -s

Boh|le (starkes Brett) *w*; -, -n; **Bohlen|be|lag**

böh|ma|keln österr. ugs. (radebrechen); **Böh|me** *m*; -n, -n (↑ R 268); **Böh|men; Böh|mer|land** *s*; -[e]s;

Böh|mer|wald (Gebirge) *m*; -[e]s (↑ R 204); **Böh|mer|wäld|ler; Böhmin** *w*; -, -nen; **böh|misch** (auch ugs. für: unverständlich); (↑ R 200:) das kommt mir - vor; das sind mir -e Dörfer, aber (↑ R 198): Böhmisches Mittelgebirge

Böh|nchen, Böhn|lein; **Böh|ne** *w*; -, -n; grüne -n

boh|nen landsch. (bohnern)

Boh|nen.kaf|fee, **...kraut**, **...sa|lat**, **...stan|ge**

Boh|ner (Vorrichtung zum Bohnern); **Boh|ner|be|sen; boh|nern** [Fußboden] mit Wachs glätten); ich ...ere (↑ R 327); **Boh|ner|wachs**

Böhn|lein, Böhn|chen

boh|ren; Boh|rer; Bohr.ham|mer (Bergmannsspr.: Druckluftmaschine zum Bohren von Sprenglöchern), **...in|sel**, **...loch**, **...ma|schi|ne**, **...turm; Bohr|rung**

bö|ig; -er Wind (in kurzen Stößen wehender Wind)

Boi|ler *engl.* [*beul'r*] (Warmwasserbereiter) *m*; -s, -

Bo|jar *russ.* (in Altrußland: hoher Adliger; früher in Rumänien: adliger Großgrundbesitzer) *m*; -en, -en (↑ R 268)

Bo|je (Seemannsspr.: [verankerter] Schwimmkörper, als Seezeichen od. zum Festmachen verwendet) *w*; -, -n; **Bo|jen|ge|schirr**

Bok|mål *norw.* [*bọkmọl*] (vom Dänischen beeinflußte norw. Schriftsprache [früher Riksmål genannt, vgl. d.] im Gegensatz zum Nynorsk [vgl. d.]) *s*; -[s]

Bol vgl. Bolus

Bo|la *span.* (südamerik. Wurf- und Fanggerät) *w*; -, -s; **Bo|le|ro** (Tanz; kurze Jacke) *m*; -s, -s; **Bo|le|ro|jäck|chen**

Bo|lid, **Bo|li|de** (schwerer Rennwagen) *m*; ...iden, ...iden

Bo|li|var [*bọliwar*] (Währungseinheit in Venezuela; Abk.: B.) *m*; -[s], -[s]; **Bo|li|via|ner**, (auch:) **Boli|vi|er** [*...wi'r*]; **bo|li|via|nisch**, (auch:) **bo|li|visch; Bo|li|via|no** (bolivian. Münzeinheit) *m*; -[s], -[s]; **Bo|li|vi|en**[*...i'n*] (südamerik. Staat)

böl|ken (blöken [vom Rind, Schaf])

Böll (dt. Schriftsteller)

Bol|lan|dist (Mitglied der jesuit. Arbeitsgemeinschaft zur Herausgabe von Heiligenleben); ↑ R 268

Bol|le landsch. (Zwiebel) *w*; -, -n

Böl|ler (kleiner Mörser zum Schießen); **bol|lern** landsch. (poltern, krachen); **böl|lern; ich ...ere** (↑ R 327); **Bol|ler|wa|gen** landsch. (Handwagen)

Bol|let|te *it.* österr. (Zoll-, Steuerbescheinigung) *w*; -, -n

181 **bördeln**

Boll|werk
Bo|lo|gna [bolọnja] (it. Stadt); Bo|lo|gne|se m; -n, -n († R 268); Bo|lo|gne|ser († R 199); bo|lo|gne|sisch
Bo|lo|me|ter gr. (Temperatur-, auch Strahlungsmeßgerät) s; -s, -
Bol|sche|wik russ. (Mitglied der Kommunistischen Partei der Sowjetunion) m; -en, -i, (abschätzig für: „Kommunist" auch:) -en († R 268); bol|sche|wi|sie|ren; Bol|sche|wi|sie|rung; Bol|sche|wis|mus m; -; Bol|sche|wist († R 268); bol|sche|wi|stisch; Bol|schoi|thea|ter (führende Opern- u. Ballettbühne in Moskau)
Bolus, Bol gr. (Tonerdesilikat; Med.: Bissen; große Pille) m; -
Bolz (veralt. für: Bolzen) m; -es, -e
Bol|za|no (it. Name von: Bozen)
Bol|zen m; -s, -; bol|zen (Fußball: derb, systemlos spielen); du bolzt (bolzest); bol|zen|ge|ra|de[1], bolz|ge|ra|de[1]; Bol|ze|rei
Bom|ba|ge fr. [...gsehə] (Biegen des Glases im Ofen; Umbördeln von Blech; Hervorwölbung der Deckels von Konservendosen); Bom|bar|de (Steinschleudermaschine des 15. bis 17. Jh.s) w; -, -n; Bom|bar|de|ment [...dᵉmang, österr.: bombardmang] (Beschießung [mit Bomben]) s; -s, -s; bom|bar|die|ren; Bom|bar|dier|kä|fer; Bom|bar|die|rung; Bom|bar|don [...dong] (Baßtrompete) s; -s, -s
Bom|bast pers.-engl. (abwertend für: [Rede]schwulst, Wortschwall) m; -[e]s; bom|ba|stisch; -ste († R 294)
Bom|bay [bọmbe[1]] (Stadt in Indien)
Bom|be fr. (mit Sprengstoff gefüllter Hohlkörper; auch ugs.: sehr kräftiger Stoß mit dem Ball) w; -, -n; bom|ben (ugs.); Bom|ben_an|griff, ...er|folg (ugs. für: großer Erfolg); [1]bom|ben|fest; ein -er Unterstand; [2]bom|ben|fest (ugs. für: ganz sicher); er behauptet es bombenfest; Bom|ben_flug|zeug, ...ge|schä|dig|te, ...ge|schäft (ugs.), ...hit|ze (ugs.), ...krieg, ...last; [1]bom|ben|si|cher; ein -er Keller; [2]bom|ben|si|cher (ugs. für: sehr sicher; er weiß es bombensicher; Bom|ben.stim|mung (ugs.), ...tep|pich, ...ter|ror; Bom|ber; Bom|ber|ver|band
bom|bie|ren (Zeitw. zu: Bombage); bombiertes Blech (Wellblech); Bom|bie|rung
bom|big (ugs. für: gut, ausgezeichnet)
Bom|mel nordd. (Quaste) w; -, -n

Vgl. die Anm. zu „gerade".

Bom|mer|lun|der Ⓦ (ein Schnaps) m; -s, -
Bon fr. [bọng] (Gutschein) m; -s, -s
bo|na fi|de lat. (guten Glaubens, auf Treu u. Glauben)
Bo|na|par|te (Familienn. Napoleons); Bo|na|par|tis|mus m; -; Bo|na|par|tist (Anhänger der Familie Bonaparte); † R 268
Bo|na|ven|tu|ra [...wan...] (Kirchenlehrer)
Bon|bon fr. [bongbọng] (Zuckersteinchen, Zuckerware, -zeug) m od. (österr. nur:) s; -s, -s; bon|bon|far|ben; Bon|bon|nie|re [bongbonịärᵉ] (gut ausgestattete Pralinenpackung) w; -, -n
Bond engl. (engl. Bez. für: Schuldverschreibung mit fester Verzinsung) m; -s, -s
bon|gen fr. (ugs. für: [an der Registrierkasse] einen Bon ausstellen)
Bon|go [bọnggo] (einfellige Trommel kubanischen Ursprungs, paarweise verwendet [im Jazzorchester]) s od. w; -s, -s (meist Mehrz.)
Bon|ha|se niederd. (Pfuscher; nichtzünftiger Handwerker)
Bon|ho|mie fr. [bonomị] (selten für: Gutmütigkeit, Einfalt) w; -, ...ien; Bon|homme [bonọm] (veralt. für: gutmütiger, einfältiger Mensch) m; -s, -s
Bo|ni|fa|ti|us [...ziuß], Bo|ni|faz [auch: boni...] (Verkünder des Christentums in Deutschland; m. Vorn.); Bo|ni|fa|ti|us|brun|nen
Bo|ni|fi|ka|ti|on lat. [...zion] (Vergütung, Gutschrift); bo|ni|fi|zie|ren (vergüten, gutschreiben); Bo|ni|tät (Güte, Wert [in bezug auf Personen u. Firmen in der Wirtschaft u. auf den Boden in der Land- u. Forstwirtschaft]); bo|ni|tie|ren ([Grundstück, Boden, Waren] schätzen); Bo|ni|tie|rung
Bon|mot fr. [bongmọ] (treffende, geistreiche Wendung; Witzwort) s; -s, -s
Bonn (Hptst. der Bundesrepublik Deutschland)
Bon|ne fr. (veralt. für: Kinderwärterin, Erzieherin) w; -, -n
Bon|ner [zu: Bonn] († R 199)
Bon|sels (dt. Dichter)
Bon|tje landsch. (Bonbon) m; -s, -
Bo|nus lat. (im Handel Gutschrift an Kunden od. Vertreter; bei Aktiengesellschaften einmalige Vergütung neben der Dividende) m; - u. Bonusses, -u. Bonusse (auch: ...ni)
Bon|vi|vant fr. [bongwiwạng] (Lebemann) m; -s, -s
Bon|ze jap. ([buddhistischer] Mönch, Priester; verächtlich für:

Parteigröße) m; -n, -n († R 268); Bon|zen|tum s; -s; Bon|zo|kra|tie jap.; gr. (Herrschaft der Bonzen) w; -, ...jen
Boof|ke bes. berlin. (ungebildeter Mensch, Tölpel) m; -s, -s
Boo|gie-Woo|gie amerik. [bụgiwụgi, auch: bụgiwụgi] (Jazzart; ein Tanz) m; -[s], -s
Boom engl. [bụm] ([plötzlicher] Wirtschaftsaufschwung, Hochkonjunktur, Hausse an der Börse) m; -s, -s
Boo|ne|kamp Ⓦ (ein Magenbitter) m; -s, -s
Boot s; -[e]s, -e, (landsch. auch:) Böte; - fahren; Boot|chen (landsch.), Böt|chen, Böt|lein (vgl. d.)
Bo|o|tes gr. („Ochsentreiber"; ein Sternbild) m; -
Bö|o|ti|en [...zi[e]n] (altgr. Landschaft); Bö|o|ti|er [...zi[e]r]; bö|o|tisch (veralt. auch für: denkfaul, unkultiviert)
Boot|leg|ger amerik. [bụt...] (amerik. Bez. für: Alkoholschmuggler) m; -s, -
Boots.bau (Mehrz. bauten), ...gast (Matrose im Bootsdienst; Mehrz. -en), ...ha|ken, ...haus, ...län|ge, ...mann (Mehrz. ...leute); Boots|manns|maat; Boots_mo|tor, ...steg; boot[s]|wei|se
Bor (chem. Grundstoff, Nichtmetall; Zeichen: B) s; -s
Bo|ra it. (Adriawind) w; -, -s
Bo|ra|go arab. (Borretsch) m; -s
Bo|rat pers. (borsaures Salz) s; -[e]s, -e; Bo|rax (Borverbindung) m; -es; Bo|ra|zit (ein Mineral) m; -s
Bor|chardt, Rudolf (dt. Schriftsteller)
Bor|chert, Wolfgang (dt. Schriftsteller)
[1]Bord ([Bücher-, Wand]brett) s; -[e]s, -e; [2]Bord ([Schiffs]rand, -deck, -seite; übertr. auch für: Schiff, Luftfahrzeug) m; -[e]s, -e; heute nur in Fügungen wie: an - gehen; Mann über -!; [3]Bord schweiz. (Rand, [kleiner] Abhang, Böschung) s; -[e]s, -e; Bord|dienst
Bör|de (fruchtbare Ebene) w; -, -n; Magdeburger -
[1]Bor|deaux [bordọ] (fr. Stadt); Bordeaux' [...dọß...] Hafenanlage († R 317); [2]Bor|deaux (ein Wein) m; -, (Sorten:) - [bordọß]; bor|deaux|rot (weinrot); Bor|de|lai|ser [...läsᵉr] († R 199); - Brühe (Mittel gegen [Reben]krankheiten); Bor|de|le|le (Einwohner von Bordeaux) m; -n, -n († R 268); Bor|de|le|sin w; -, -nen
Bor|dell (Dirnenhaus) s; -s, -e
bör|deln (Blech mit einem Rand

versehen; umbiegen); ich ...[e]le (↑ R 327); **Bör|de|lung**

Bor|de|reau fr. [bord^e rɔ], (auch:) **Bor|de|ro** (Versicherungsw.: listenmäßige Zusammenstellung; Speditionsw.: Aufteilungsliste; Bankw. selten für: Postenzusammenstellung) m od. s; -s, -s, -s; **Bor|der|preis** engl.; dt. ([Erdgas]preis frei Grenze)

Bord|funk, ...fun|ker

bor|die|ren fr. (einfassen, besetzen); **Bor|die|rung**

Bord|ka|me|ra, ...kan|te, ...stein

Bor|dü|re fr. (Einfassung, [farbiger] Geweberand, Besatz) w; -, -n; **Bor|dü|ren|kleid**

Bord|waf|fen (Mehrz.), ...zei|tung

bo|re|al gr. (nördlich); [1]**Bo|re|as** (gr. Gottheit [des Nordwindes]); [2]**Bo|re|as** (Nordwind im Gebiet des Ägäischen Meeres) m; -

Boretsch vgl. Borretsch

Borg (das Borgen), nur noch in: auf - kaufen; **bor|gen**

Bor|ghe|se [...ge...] (röm. Adelsgeschlecht); **Bor|ghe|sisch**; der -e Fechter

Bor|gia [bɔrdseha] (Angehöriger eines span.-it. Adelsgeschlechtes) m; -s, -s

Bor|gis fr. (ein Schriftgrad) w; -**borg|wei|se**

Bo|ris (m. Vorn.)

Bor|ke (Rinde) w; -, -n; **Bor|ken.kä|fer**, ...krepp; **bor|kig**

Bor|kum (Insel an der dt. Nordseeküste)

Born (dicht. für: Wasserquelle, Brunnen) m; -[e]s, -e

Bör|ne (dt. Schriftsteller)

Bor|neo (größte der Großen Sundainseln)

Born|holm (eine dän. Insel)

bor|niert fr. (geistig beschränkt, engstirnig); **Bor|niert|heit**

Bor|retsch (ein Küchenkraut) m; -[e]s

Bör|ri|es [...i^e ß] (m. Vorn.)

Bor|ro|mä|us (m. Eigenn.); **Bor|ro|mä|us|ver|ein**; **Bor|ro|mä|isch**; die -e Inseln (im Lago Maggiore)

Bor.sal|be (Heilmittel; w; -), ...säu|re

Bör|se niederl. (Gebäude zur Abhaltung eines regelmäßigen Marktes für Wertpapiere u. vertretbare Waren; Geldbeutel; Einnahme aus einem Wettkampf) w; -, -n; **Bör|sen.bericht**, ...kurs, ...mak|ler, ...spe|ku|la|ti|on, ...tip, ...ver|ein; **Bör|sia|ner** (Börsenspieler)

Bor|ste (starkes Haar) w; -, -n; **Bor|sten|vieh**; **bor|stig**; **Bor|stig|keit**; **Borst|wisch** ostmitteld. (Handfeger)

Bor|te (gemustertes Band als Besatz; Randstreifen) w; -, -n

Bo|rus|se (Preuße) m; -n, -n (↑ R 268); **Bo|rus|sia** (Frauengestalt als Sinnbild Preußens) w; -

Bor|was|ser s; -s

bös, bö|se; böser, böseste; -er Blick, eine -e Sieben; Großschreibung (↑ R 116): das Gute und das Böse unterscheiden; jenseits von Gut und Böse; sich zum Bösen wenden; der Böse (vgl. d.); Kleinschreibung (↑ R 134): im bösen auseinandergehen; **bös|ar|tig**; **Bös|ar|tig|keit**

Bosch, Robert (dt. Erfinder); die Boschsche Zündkerze (↑ R 249)

Bö|schung; **Bö|schungs|win|kel**

Bos|co [bɔßko], Don (kath. Priester u. Pädagoge)

bö|se vgl. bös; **Bö|se** (Teufel; böses Wesen) m; -n, -n (↑ R 287ff.); **Bö|se|wicht** m; -[e]s, -er, (auch, österr. nur:) -e; **bos|haft**; **Bos|haf|tig|keit**; **Bos|heit**

Bos|kett fr. (Gebüsch[pflanzung], Lustwäldchen) s; -s, -e

Bos|kop [nach dem niederl. Ort Boskoop] m; -s, - (Apfelsorte)

bös|lich (veralt. für: böswillig)

Bos|nia|ke m; -n, -n (↑ R 268); vgl. Bosnier

Bos|ni|en [...i^e n] (Landschaft in Jugoslawien); **Bos|ni|er** [...i^e r]; **bos|nisch**

Bos|nigl bayr., österr. mdal. (boshafter Mensch) m; -s, -

Bos|po|rus (Meerenge bei Istanbul) m; -

Boß amerik. ([Betriebs-, Partei]leiter) m; Bosses, Bosse

Bo|ßel niederd. (Kugel) m; -s, -u. w; -, -n

bos|se|lie|ren vgl. bossieren

bos|seln (ugs. für: kleine Arbeiten [peinlich genau] machen; auch für: bossieren); ich bossele u. boßle; **bo|ßeln** niederd. (mit der [dem] Boßel werfen; den Kloot schießen); ich ...[e]le (↑ R 327); **Bos|sen.qua|der**, ...werk (rauh bearbeitetes Mauerwerk); **bos|sie|ren** (die Rohform einer Figur aus Stein herausschlagen; Mauersteine behauen; auch: in Ton, Wachs od. Gips modellieren); **Bos|sier|ei|sen** (Gerät zum Behauen roher Mauersteine); **Bos|sie|rer**; **Bos|sier|wachs**

[1]**Bo|ston** [bɔßt^e n] (Stadt in England und in den USA); [2]**Bo|ston** (ein Kartenspiel) s; -s; [3]**Bo|ston** (ein Tanz) m; -s, -s

bös|wil|lig; **Bös|wil|lig|keit**

Bot, Bott schweiz. (,,Gebot, Vorladung''; Mitgliederversammlung) s; -[e]s, -e

Bo|ta|nik gr. (Pflanzenkunde) w; -; **Bo|ta|ni|ker**; **bo|ta|nisch**; -e Gärten, aber (↑ R 224): der Botanische Garten in München;

bo|ta|ni|sie|ren (Pflanzen sammeln); **Bo|ta|ni|sier|trom|mel**

Böt|chen, Böt|lein (kleines Boot)

Bo|te m; -n, -n (↑ R 268)

Bo|tel (Kurzw. aus: Boot u. Hotel; als Hotel ausgebautes Schiff) s; -s, -s

Bo|ten.dienst, ...frau, ...gang, ...lohn; **Bo|tin** w; -, -nen

Böt|lein, Böt|chen (kleines Boot)

bot|mä|ßig; **Bot|mä|ßig|keit**

Bo|to (ältere Form von: Bodo)

Bo|to|ku|de (bras. Indianer) m; -n, -n (↑ R 268); **bo|to|ku|disch**

Bot|schaft; **Bot|schaf|ter**; **Bot|schaf|ter.ebe|ne**, ...kon|fe|renz, ...po|sten; **Bot|schafts.rat** (Mehrz. ...räte), ...se|kre|tär

Bo|tsua|na, (offz. Landesschreibung:) **Bo|tswa|na** (Staat in Afrika); **Bo|tsua|ner**; **bo|tsua|nisch** od. (offz. Landesschreibung:) **Bo|tswa|ner**; **bo|tswa|nisch**

Bott vgl. Bot

Bött|cher (Bottichmacher); vgl. auch: Büttner u. Küfer; **Bött|cher|ar|beit**; **Bött|che|rei**

Bot|te|lier niederl. m; -s, -s u. Bottler (Kantinenverwalter auf Kriegsschiffen) m; -s, -

Bot|ten landsch. (Stiefel; große, klobige Schuhe) Mehrz.

Bot|ti|cel|li [...tschäli] (it. Maler)

Bot|tich m; -[e]s, -e

Bott|ler vgl. Bottelier

bott|nisch, aber (↑ R 198): der Bottnische Meerbusen

Bo|tu|lis|mus lat. (bakterielle Lebensmittelvergiftung) m; -

[1]**Bou|clé** fr. [bukle] (frotteeartiger Effektzwirn) s; -s, -s; [2]**Bou|clé** (Gewebe u. Teppich aus dieser Zwirn) m; -s, -s

Bou|doir fr. [budoar] (veralt. für: Putzzimmer; Zimmer der Dame) s; -s, -s

Bou|gie fr. [busehi] (Med.: Dehnsonde) w; -, -s; **bou|gie|ren** (Med. mit der Dehnsonde untersuchen, erweitern)

Bouil|lon fr. [buljong, buljong od. bujong] (Kraft-, Fleischbrühe) w; -, -s; **Bouil|lon|wür|fel**

Bou|le|vard fr. [bul^e war] (breite [Ring]straße) m; -s, -s; **Bou|le|var|dier** [...die] (Verfasser von reißerischen Bühnenstücken) m; -[s], -s

Bou|le|var|dis|mus m; -; **Bou|le|vard.pres|se**, ...thea|ter, ...zei|tung

Bou|lez [buläs] (fr. Komponist u. Dirigent)

Bou|lo|gne-Bil|lan|court [bulonji bijangkur] (Stadt im Bereich von Groß-Paris); **Bou|lo|gne-sur-Mer** [- ßür mär] (fr. Stadt)

Bou|quet fr. [buke] s; -s, -s; vgl. Bukett

Bour|bo|ne [*bur*...] (Angehöriger eines fr. Herrschergeschlechtes) *m*; -n, -n (↑ R 268); **bour|bo|nisch**
bour|geois *fr.* [*bursehoa*, in beifügender Verwendung; *bur-sehoas*...] (der Bourgeoisie angehörend, entsprechend); **Bour|geois** [*bursehoa*] (abwertend für: wohlhabender, satter Bürger) *m*; -, -; **Bour|geoi|sie** [*bur-sehoasi*] ([wohlhabender] Bürgerstand; [auch: durch Wohlleben entartetes] Bürgertum) *w*; -, ...jen
Bour|rée *fr.* [*bure*] (alter Tanz; Teil der Orchestersuite) *w*; -, -s
Bour|ret|te *fr.* [*bu*...] (Gewebe aus Abfallseide) *w*; -, -n
Bour|tan|ger Moor [*bur*...] (teilweise trockengelegtes Moorgebiet westl. der mittleren Ems) *s*; - -[e]s
Bou|teille *fr.* [*butäj*] (Flasche) *w*; -, -n
Bou|tique *fr.* [*butik*] (kleiner Laden für [meist exklusive] mod. Neuheiten) *w*; -, -s [...*tikß*] u. -n [...*k⁴n*]
Bou|ton *fr.* [*butonß*] (,,Knospe, Knopf''; Schmuckknopf für das Ohr) *m*; -s, -s
Bo|vist vgl. Bofist
Bow|den|zug; ↑ R 180 [*baud⁴n*...; nach dem engl. Erfinder Bowden] (Drahtkabel zur Übertragung von Zugkräften)
Bo|wie|mes|ser; ↑ R 180 [*bowi*...; nach dem Erfinder James Bowie] ([nordamerik.] Jagdmesser) *s*
Bow|le *engl.* [*bol⁴*] (Getränk aus Wein, Zucker u. Früchten; Gefäß für dieses Getränk) *w*; -, -n; **Bow|len|glas** (Mehrz. ...gläser)
Bow|ling [*bo⁴ling*] (amerik. Art des Kegelspiels mit 10 Kegeln; engl. Kugelspiel auf glattem Rasen) *s*; -s, -s; **Bow|ling|bahn**
Box *engl.* (,,Büchse''; Pferdestand; Unterstellraum; einfache, kastenförmige Kamera) *w*; -, -en
bo|xen *engl.* (mit den Fäusten kämpfen); du boxt (boxest); er boxte ihn (auch: ihm) in den Magen; **Bo|xer** (Faustkämpfer; bes. südd., österr. auch: Faustschlag; Hund einer bestimmten Rasse) *m*; -s, -; **bo|xe|risch**; -es Können; **Bo|xer|na|se**; **Box|hieb**
Box|kalf *engl.* [in engl. Aussprache auch: ...*kąf*] (Kalbleder) *s*; -s, -s; **Box|kalf|schuh**
Box..kampf, ...**ring**, ...**sport**
Boy *engl.* [*beu*] ([Lauf]junge; Diener, Bote) *m*; -s, -s
Boy|kott *engl.* [*beu*...; nach dem geächteten Gutsverwalter Boycott] (Verruf[serklärung], Ächtung; Abbruch der Geschäftsbeziehungen) *m*; -[e]s, -e; **boy|kot|tie|ren**
Boy-Scout [*beußkaut*] (engl. Bez. für: Pfadfinder) *m*; -[s], -s

Bo|zen (Stadt in Südtirol); vgl. Bolzano; **Boz|ner** (↑ R 199)
BP Ⓦ (ein Kraftstoff)
Br = chem. Zeichen für: Brom
Bra|ban|çonne *fr.* [*brabangßon*; nach der belg. Provinz Brabant] (belg. Nationalhymne) *w*; -; **Bra-bant** (belg. Provinz); **Bra|ban|ter** (↑ R 199); Brabanter Spitzen
brab|beln (ugs. für: undeutlich vor sich hin reden), ich ...[e]le (↑ R 327)
brach (unbestellt; unbebaut); brachliegen (vgl. d.); **Bra|che** (Brachfeld) *w*; -, -n; **Bra|chet** (alte Bez. für: Juni) *m*; -s, -e; **Brach|feld**
bra|chi|al *gr.* (den Arm betreffend; mit roher Körperkraft); **Bra|chi|al|ge|walt** (rohe, körperliche Gewalt) *w*; -
brach|lie|gen; ↑ R 139 (nicht bebauen; nicht nutzen); seine Kraft war brachgelegt worden; **brach|lie|gen**; ↑ R 139 (unbebaut liegen); der Acker liegt brach; brachgelegen; brachzuliegen; er hat den Acker brachliegen lassen; **Brach-..mo|nat** od. ...**mond** (vgl. Brachet)
Bräch|se *w*; -, -n u. **Bräch|sen** (ein Fisch) *m*; -s, -; vgl. auch: Brasse u. Brassen
Brach|vo|gel (Schnepfenart)
bra|chy... *gr.* [*braehü*...] (kurz...); **Bra|chy...** (Kurz...); **bra|chy|ke|phal** usw. vgl. brachyzephal usw.; **Bra|chy|lo|gie** (Rhet., Stilk.: Kürze im Ausdruck) *w*; -, ...jen; **bra|chy|ze|phal** (Med.: kurz-, rundköpfig); **Bra|chy|ze|pha|le** (Med.) *m* u. *w*; -n, -n (↑ R 268); **Bra|chy|ze|pha|lie** (Med.) *w*; -, ...jen
Brack niederl. (Gemisch von Süß- u. Salzwasser; Brackwasser[tümpel]) *s*; -[e]s, -s od. -en
Bracke [*Trenn.*: Brak|ke] (Spürhundrasse) *m*; -n, -n, (seltener:) *w*; -, -n
brackig [*Trenn.*: brak|kig] niederl. (mit Brack gemischt, untrinkbar)
Bräckin [*Trenn.*: Bräk|kin] (Hündin) *w*; -, -nen; vgl. Bracke
brackisch [*Trenn.*: brak|kisch] (Geol.: aus Brack abgelagert); **Brack|was|ser** (Brack in den Flußmündungen) *s*; -s, ...wasser
Bra|dy|kar|die *gr.* (Med.: Verlangsamung der Herztätigkeit) *w*; -, ...jen
Brä|gen (Nebenform von: Bregen) *m*; -s, -
Bra|gi (Skalde; nord. Gott der Dichtkunst)
Brah|ma *sanskr.* (ind. Gott); **Brah-ma|huhn** vgl. Brahmaputrahuhn; **Brah|man** (Weltseele) *s*; -s; **Brah-ma|ne** (Angehöriger einer ind. Priesterkaste) *m*; -n, -n (↑ R 268);

brah|ma|nisch; **Brah|ma|nis|mus** (ind. Religion; auch für: Hinduismus) *m*; -; **Brah|ma|pu|tra** [auch: ...*putra*] (südasiat. Strom) *m*; -[s];
Brah|ma|pu|tra|huhn (↑ R 201), (auch:) Brah|ma|huhn; ↑ R 180 (eine Hühnerrasse)
Brahms (dt. Komponist)
Braille|schrift [*braj*...; nach dem fr. Erfinder Braille] (Blindenschrift) *w*; - (↑ R 180)
Brain-Drain *engl.-amerik.* [*bre'n-dre'n*] (Abwanderung von Wissenschaftlern [z. B. nach Amerika]) *m*; -s; **Brain-Trust** [*bre'n-traßt*] ([wirtschaftl.] Beratungsausschuß) *m*; -, -s
Brak|te|at *lat.* (einseitig geprägte mittelalterl. Münze) *m*; -en, -en (↑ R 268)
Bram *niederl.* (Seemannsspr.: zweitoberste Verlängerung der Masten sowie deren Takelung) *w*; -, -en; meist nur als Bestimmungswort von Zusammensetzungen, vgl. z. B. Bramsegel
Bram|mah|schloß [nach dem engl. Erfinder]; ↑ R 180 (Schloß mit Steckschlüssel)
bra|mar|ba|sie|ren (aufschneiden, prahlen)
Bram|bu|ri *tschech.* ostösterr. mdal. (Kartoffeln) *Mehrz.*
Bram|busch niederl. (Ginster)
Bramme (kostbarer Kleiderbesatz) *w*; -, -n
Bram|me (Walztechnik: Eisenblock) *w*; -, -n; **Bram|men|walz|werk**
Bram.se|gel, ...**sten|ge**; vgl. Bram
bram|sig nordd. ugs. (derb; protzig; prahlerisch)
Bran|che *fr.* [*brangsch⁴*] (Wirtschafts-, Geschäftszweig; Fachgebiet) *w*; -, -n; **Bran|che[n]|er|fah|rung**; **bran|che[n]|fremd**; **Bran|che[n]|kennt|nis**; **bran-che[n]|üb|lich**; **Bran|chen|ver-zeich|nis**
Bran|chi|at *gr.* (mit Kiemen atmendes Wirbel- u. Gliedertier) *m*; -en, -en (↑ R 268); **Bran|chi|en** [...*i⁴n*] (Kiemen) *Mehrz.*
Brand *m*; -[e]s, Brände; in - stecken; **brand|ak|tu|ell**; **Brand..bin-de**, ...**bla|se**, ...**bom|be**, ...**brief** (ugs.), ...**di|rek|tor**; **brand|ei|lig** (ugs. für: sehr eilig); **bran|deln** österr. ugs. (brenzlig riechen; auch: viel zahlen müssen); ich ...dle; **bran|den**
Bran|den|burg; **Bran|den|bur|ger** (↑ R 199); **bran|den|bur|gisch**, aber (↑ R 224): die Brandenburgischen Konzerte (von Bach)
Brand..en|te (ein Vogel), ...**fackel** [*Trenn.*: ...**fak|kel**], ...**fleck**, ...**grab** (Archäologie), ...**herd**; **bran|dig**; **Brand..kas|se**, ...**le|ger**

(österr. für: Brandstifter), ...le|gung (österr. für: Brandstiftung), ...mal (*Mehrz.* ...male, seltener: ...mäler); brand|mar|ken; gebrandmarkt; Brand_mau|er, ...mei|ster; brand_neu, ...rot; Brand|sal|be; brand|schat|zen; du brandschatzt (brandschatzest); gebrandschatzt; Brand_schatzung, ...soh|le, ...stät|te, ...stif|ter, ...stif|tung; Bran|dung; Brand_ur|sa|che, ...wa|che, ...wun|de; Brandy *engl.* [*brändi*] ([feiner] Branntwein) *m*; -s, -s; Brand|zei|chen; Brannt_kalk (Ätzkalk), ...wein; Brannt|wei|ner österr. ([Wirt einer] Branntweinschenke); Brannt|wein|steu|er *w*

¹Bra|sil [nach: Brasilien] (Tabak; Kaffeesorte) *m*; -s, -e u. -s; ²Bra|sil (Zigarre) *w*; -, -[s]; Bra|sil|holz, Bra|si|lien|holz (↑ R 201); Bra|si|lia (Hptst. von Brasilien); Bra|si|lig|ner; bra|si|lia|nisch; Bra|si|li|en [...*i*ᵉ*n*] (südamerik. Staat); Bra|si|li|en|holz (↑ R 201), Bra|sil|holz

¹Bras|se *w*; -, -n u. Bras|sen niederd., mitteld. (Brachse) *m*; -s, -

²Bras|se (Seemannsspr.: Tau zum Stellen der Segel) *w*; -, -n

Bras|se|lett *fr.* (Armband; Gaunerspr.: Handschelle) *s*; -s, -e

bras|sen (Seemannsspr.: sich der ²Brassen bedienen); du braßt (brassest)

Bras|sen vgl. ¹Brasse

Brät landsch., bes. schweiz. (feingehacktes [Bratwurst]fleisch) *s*; -s; Brat|ap|fel, Brät|chen, Brätlein; brä|teln u. ...le|le (↑ R 327); bra|ten; du brätst er brät; du brietst (brietest); du brietest; gebraten; brat[e]!; Bra|ten *m*; -s, -; Bra|ten_duft, ...fett, ...rock (scherzh. für: Gehrock), ...so|ße; Brä|ter landsch. (Schmortopf); Brat|hendl südd., österr. (Brathähnchen) *s*; -s, -[n]; Brat_he|ring, ...kar|tof|feln *Mehrz.*; Brät|lein, Brät|chen; Brat|ling (gebratener Kloß aus Gemüse, Hülsenfrüchten); Brät|ling (Fisch; Pilz); Brat_pfan|ne, ...röh|re, ...rost Brat|sche *it.* (ein Streichinstrument) *w*; -, -n; Brat|scher (Bratschenspieler); Brat|schist (↑ R 268)

Brat_spieß, ...spill (Seemannsspr.: Ankerwinde mit waagerechter Welle), ...wurst

Bräu bes. südd. (Bier; Brauerei) *s*; -[e]s, -e u. -s; in Verbindung mit einem Bestimmungswort: Löwenbräu, Schloßbräu u. a.

Brauch *m*; -[e]s, Bräuche; in od. im - sein; brauch|bar; Brauch|bar|keit *w*; -; brau|chen; du brauchst, er braucht; du brauchtest; du

brauchtest (südd. häufig: bräuchtest); gebraucht; er hat es nicht zu tun - (↑ R 305); vgl. aber: gebrauchen; Brauch|tum

Braue *w*; -, -n

brau|en; Brau|er; Braue|rei; Brau-_haus, ...mei|ster; Bräu|stüb|chen südd. (kleines Gasthaus; Gastraum)

braun; vgl. blau; Braun (braune Farbe) *s*; -s, - (ugs. : -s); vgl. blau; braun|äu|gig; Braun|bär; ¹Brau|ne (braunes Pferd) *m*; -n, -n (↑ R 287ff.); ²Brau|ne *s*; -n (↑ R 116); Bräu|ne (braune Färbung; ugs. für: Angina, Diphtherie u. ä. Krankheiten) *w*; -; Braun|ei|sen|_erz (*s*; -es) od. ...stein (*m*; -[e]s); ¹Braun|el|le (Vogel) *w*; -, -n; ²Braun|el|le Brunelle (Pflanze); bräu|nen; braun|ge|brannt; ein braungebrannter Mann (↑ jedoch R 142), aber: die Sonne hat ihn braun gebrannt; Braun_kehl|chen, ...koh|le; Braun|koh|len_berg|werk, ...bri|kett; bräunlich; bräunlichgelb usw. (↑ R 158) Braun|schweig (Stadt im nördl. Vorland des Harzes); Braun|schwei|ger (↑ R 199); braun|schwei|gisch

Braun|stein (ein Mineral) *m*; -[e]s; Bräu|nung

Braus *m*, nur noch in: in Saus und - (verschwenderisch) leben

Brau|sche landsch. (Beule, bes. an der Stirn) *w*; -, -n

Brau|se *w*; -, -n; Brau|se_bad, ...kopf; brau|se|köp|fig; Brau|se|li|mo|na|de; brau|sen; du braust (brausest); er braus|te; Brau|sen *s*; -s; Brau|se|pul|ver

Braut *w*; -, Bräute; Bräut|chen, Bräut|lein; Bräut|füh|rer; Bräu|ti|gam *m*; -s, -e; Braut_jung|fer, ...kleid, ...kranz; Bräut|lein, Bräut|chen; Braut|leu|te; bräutlich; Braut_paar, ...schau; auf - gehen; Braut|stand *m*; -[e]s

brav *fr.* [*braf*] (tapfer; tüchtig; artig, ordentlich); -er, -ste; Brav|heit; bra|vis|si|mo! *it.* [...*wiß*...] (sehr gut!); bra|vo! [...*wo*] (gut!); ¹Bra|vo (Beifallsruf) *s*; -s, -s; ²Bra|vo (it. Bezeichnung für: Meuchelmörder, Räuber) *m*; -s u. ...vi [...*wi*]; Bra|vo|ruf; Bra|vour *fr.* [...*wur*] (Tapferkeit; Schneid) *w*; -; Bra|vour_arie [...*i*ᵉ], ...lei|stung; bra|vou|rös (tapfer, schneidig; meisterhaft); -este (↑ R 292); Bra|vour|stück

Braz|za|ville [...*wil*] (Hptst. der Volksrepublik Kongo)

BRD = Bundesrepublik Deutschland

break! *engl.* [*brék*] („trennt euch"; Trennkommando der Ringrichters beim Boxkampf); Break

(leichter offener Wagen; Sport: unerwarteter Durchbruch; Jazz: kurzes Zwischensolo) *m* od. *s*; -s, -s

Brec|cie *it.* [it.: *brätsche*] od. Brekzie [...*zi*ᵉ] (aus kantigen Gesteinstrümmern gebildetes u. verkittetes Gestein) *w*; -, -n

brech|bar; Brech_boh|ne, ...durch|fall; Bre|che (Gerät zum Zerknicken der Flachsstengel u. a.) *w*; -, -n; Brech|ei|sen; bre|chen; du brichst, er bricht; du brachst; du brächest; gebrochen; brich!; sich -; brechend voll; er brach den Stab über ihn (nicht: ihm); auf Biegen oder Brechen (↑ R 132); Bre|cher (Sturzsee; Grobzerkleinerungsmaschine); Brech_mit|tel *s*, ...reiz, ...stan|ge

Brecht, Bert[olt] (dt. Schriftsteller u. Regisseur)

Bre|chung; Bre|chungs|win|kel Bre|douil|le *fr.* [*bredulj*ᵉ] landsch. (Verlegenheit, Bedrängnis) *w*; -; in der - sein

Bree|ches *engl.* [*britsch*ᵉ*ß*, auch: *bri*...] (Sport-, bes. Reithose) *Mehrz.*

Bre|gen nordd. (Gehirn [vom Schlachttier]) *m*; -s, -; vgl. auch: Brägen

Bre|genz (österr. Stadt; Hptst. des Landes Vorarlberg); Bre|gen|zer (↑ R 199); Bre|gen|zer|wald *m*; -[e]s, (auch:) Bre|gen|zer Wald (Bergland) *m*; - -[e]s (↑ R 204)

Brehm, Alfred (dt. Zoologe u. Schriftsteller)

Brei *m*; -[e]s, -e; brei|ig

Brein österr. mdal. (Hirse, Hirsebrei) *m*; -s

Brei|sach (Stadt am Oberrhein); Breis|gau *m* (landsch.: *s*); -[e]s

breit; groß und - dastehen; weit und -. I. *Kleinschreibung* (↑ R 134): des langen und -en (umständlich), des -er[e]n darlegen; ein langes und -es (viel) sagen. II. *Großschreibung* (↑ R 116): ins Breite fließen. III. *Schreibung in Verbindung mit Zeitwörtern* (↑ R 139): a) *Getrenntschreibung* in ursprünglicher Bedeutung, z. B. breit machen; er soll den Weg breit machen; b) *Zusammenschreibung*, wenn durch die Verbindung ein neuer Begriff entsteht; vgl. breitschlagen, breittreten. IV. *In Verbindung mit dem 2. Mittelw. Getrennt- od. Zusammenschreibung* ein breitgefächertes Angebot (jedoch R 142), aber: die Angebote sind breit gefächert; breit|bei|nig; Brei|te *w*; -, -n; nördliche - (Abk.: n. Br.); südliche - (Abk. s. Br.); in die - gehen; brei|ter (auseinanderdehnen); sich -

Brei|ten.ar|beit, ...grad, ...kreis, ...wir|kung; Breit|ling (Fisch); breit|ma|chen (↑ R 139), sich (ugs.: sich anmaßend benehmen); du hast dich breitgemacht; aber: breit ma|chen; er soll die Schuhe breit machen; breit.na|sig, ...ran|dig; breit|schla|gen; ↑ R 139 (ugs. für: durch Überredung für etwas gewinnen); er hat mich breitgeschlagen; sich - lassen; aber: breit schlagen; er soll den Nagel breit schlagen; breit.schul|te|rig, ...schult|rig; Breit.schwanz (Lammfell), ...sei|te, ...spur; breit|spu|rig; breit|tre|ten; ↑ R 139 (ugs.: weitschweifig darlegen); er hat die Nachricht breitgetreten; aber: breit tre|ten; ich will die Schuhe nicht breit treten; Breit|wand (im Kino); Breit|wand|film

Brek|zie [...zi^e] vgl. Breccie

Bre|me südd. (Stechfliege, Bremse) w; -, -n

Bre|men (Hafenstadt an der Weser); Bre|mer (↑ R 199); Bre|mer|ha|ven [...haf^e n] (Hafenstadt an der Wesermündung); bre|misch

Brems.backe [Trenn.: ...bak|ke], ...be|lag, ...berg (Bergbau); ¹Brem|se (Hemmvorrichtung) w; -, -n

²Brem|se (ein Insekt) w; -, -n

brem|sen; du bremst (bremsest)

Brems.sen.pla|ge, ...stich

Brem|ser; Brem|ser|häus|chen

Brems|flie|ge

Brems.he|bel, ...klotz, ...licht (Mehrz. ...lichter), ...pe|dal, ...pro|be, ...ra|ke|te, ...spur; ...weg

brenn|bar; Brenn|bar|keit w; -; bren|nen; du branntest; (selten:) du brenntest; gebrannt; brenn[e]!; brennend gern (ugs.); Brenn|dau|er; ¹Bren|ner

²Bren|ner (Alpenpaß) m; -s; Bren|ner|bahn w; - (↑ R 201)

Bren|ne|rei; Brennessel [Trenn.: Brenn|nes|sel, ↑ R 236] w; -, -n; Brenn.holz, ...ma|te|ri|al, ...punkt, ...spie|gel, ...spi|ri|tus, ...stoff, ...stoff|fra|ge (↑ R 237), ...wei|te (Optik)

Bren|tag|no (dt. Dichter)

bren|zeln landsch. (nach Brand riechen); brenz|lich (österr. häufiger für: brenzlig); brenz|lig

Bre|sche fr. (gewaltsam gebrochene Lücke; Mauerbruch; Riß) w; -, -n; eine - schlagen

Bresch|new [brjäschnif, dt. auch: bräschn(j)äf] (sowjet. Politiker)

Bres|lau (Stadt an der Oder); vgl. Wrocław; Bres|lau|er (↑ R 199)

brest|haft (schweiz. u. südwestd., sonst veraltet für: mit Gebrechen behaftet)

Bre|ta|gne [br^e tanj^e] (fr. Halbinsel) w; -; Bre|ta|gner; Bre|ton [bretong] ([Stroh]hut mit hochgerollter Krempe) m; -s, -s; Bre|to|ne m; -n, -n (↑ R 268); bre|to|nisch

Brett s; -[e]s, -er; Brett|ter|bu|de; brett|tern (aus Brettern); Bret|ter.wand, ...zaun; brett|tig; -er Stoff; Brettl (Kleinkunstbühne); südd. österr. auch: Schi) s; -s, -; vgl. Brettel; Brett|spiel

Breu|ghel [breug^e l] (niederl. Malerfamilie)

Bre|ve lat. [brewe] ([„kurzes“ päpstliches] Schreiben) s; -s, -n u. -s; Bre|vet [brewä] (früher in Frankreich [...kurzer“] Gnadenbrief an den König; heute: Schutz-, Verleihungs-, Ernennungsurkunde) s; -s, -s; bre|ve|tie|ren (ein Brevet ausstellen); Bre|via|ri|um (veralt. für: kurze Übersicht, Auszug; auch für: Brevier) s; -s, ...ien [...i^e n]; Bre|vier (Gebetbuch der kath. Geistlichen; Stundengebet; kurze Stellensammlung aus den Werken eines Schriftstellers) s; -s, -e; bre|vi ma|nu (kurzerhand; Abk.: b. m., br. m.)

Bre|zel w; -, -n; Bre|zen (österr.) m; -s, - u. w; -, -

Bri|and-Kel|logg-Pakt [briang...; nach dem frz. Außenminister A. Briand u. dem nordamerik. Staatssekretär F. B. Kellogg] (Kriegsächtungspakt von 1928) m; -[e]s; ↑ R 182

Bricke [Trenn.: ...ik|ke] landsch. (Neunauge) w; -, -n

Bridge engl. [bridsch] (Kartenspiel) s; -; Bridge|par|tie

Brief (Abk.: Bf., auf dt. Kurszetteln: B [vgl. d.]) m; -[e]s, -e; Brief.adel, ...be|schwe|rer, ...block (Mehrz. ...blocks), ...bo|gen, ...druck|sa|che, ...kar|te, ...ka|sten (Mehrz. ...kästen), ...kopf; brief|lich; Brief|mar|ke; (↑ R 157:) 10-Pfennig-Briefmarke; Brief.mar|ken.auk|ti|on, ...block (Mehrz. ...blocks), ...kun|de w; -; Brief.öff|ner, ...ord|ner, ...päck|chen, ...pa|pier, ...ro|man, ...schaf|ten (Mehrz.), ...schrei|ber, ...stel|ler, ...ta|sche, ...trä|ger, ...um|schlag, ...ver|kehr, ...wahl, ...wech|sel, ...zu|stel|ler

Brie|käse (↑ R 201)

Bri|enz (BE) (schweiz. Ort); -er See (See im Berner Oberland)

Bries s; -es, -e u. Brie|sel (einem Brustdrüse bei Tieren, bes. beim Kalb) s; -s, -; Bries|chen, (auch:) Brös|chen (Gericht aus Briesen des Kalbes; Kalbsmilch)

Bri|ga|de fr. (größere Truppenabteilung; DDR: kleinste Arbeitsgruppe in einem Produktionsbe-

trieb) w; -, -n; Bri|ga.de.füh|rer, ...lei|ter m, ...lei|te|rin, ...plan (DDR); Bri|ga|dier [...ie] (Befehlshaber einer Truppenabteilung, Brigade) m; -s, -s u. [...ie u. ...ir] (DDR: Leiter einer Arbeitsbrigade) m; -s, -s u. (bei dt. Aussspr.: ...ir:) -e; Bri|ga|die|rin; Bri|gant it. (früher für: [Straßen]räuber in Italien) m; -en, -en (↑ R 268); Bri|gan|ten|tum s; -s; Bri|gan|ti|ne (kleines zweimastiges Segelschiff) w; -, -n; Brigg engl. (zweimastiges Segelschiff) w; -, -s

Briggs (engl. Mathematiker); (↑ R 179·) Briggssche Logarithmen

Bri|git|ta, Bri|git|te (w. Vorn.)

Bri|kett fr. (aus kleinstückigem od. staubförmigem Gut durch Pressen gewonnenes festes Formstück, z. B. Preßkohle) s; -s, -s (selten: -e); bri|ket|tier|bar; bri|ket|tie|ren (zu Briketts formen); Bri|ket|tie|rung; Bri|kett|trä|ger (↑ R 237)

bril|lie|ren fr. (durch Rückprall [von der Billardbande] treffen)

bril|lant fr. (glänzend; fein); ¹Bril|lant (geschliffener Diamant) m; -en, -en (↑ R 268); ²Bril|lant (Schriftgrad) w; -; Bril|lant.bro|sche, ...feu|er|werk; Bril|lan|tin (österr. neben: Brillantine) s; -s, -e; Bril|lan|ti|ne (Haarpomade) w; -, -n; Bril|lant.kol|lier, ...na|del, ...ring, ...schliff, ...schmuck; Bril|lanz (Glanz, Feinheit) w; -

Bril|le w; -, -n; Bril|len.bü|gel, ...etui, ...fut|te|ral, ...glas (Mehrz. ...gläser); bril|len|los; Bril|len.schlan|ge, ...trä|ger

bril|lie|ren [brilijr^e n] (glänzen)

Brim|bo|ri|um lat. (ugs. für: Gerede; Umschweife) s; -s

Brim|sen tschech. österr. (Schafkäse) m; -

Bri|nell|här|te [nach dem schwed. Ingenieur Brinell; ↑ R 180] (Maß der Härte eines Werkstoffes; Zeichen: HB) w; -

brin|gen; du brachtest; du brächtest; gebracht; bring[e]!; mit sich bringen; Brin|ger (älter für: Überbringer); Bring|schuld (Schuld, die dem Gläubiger überbracht werden muß)

Bri|oche w; -, -s [briosch] (ein Gebäck) w; -, -s [briosch]

Brio|ni|sche In|seln (Inselgruppe vor Istrien) Mehrz.

brio|so vgl. con brio

bri|sant fr. (sprengend, hochexplosiv; sehr aktuell); Bri|sanz (Sprengkraft) w; -, -en; Bri|sanz|ge|schoß

Bris|bane [brisbe'n, auch; brisb^e n] (austr. Stadt)

Bri|se *fr.* ([Fahr]wind; Lüftchen) *w*; -, -n
Bri|so|lett *fr. s*; -s, -e u. Bri|so|let|te (gebratenes Fleischklößchen) *w*; -, -n
[1]Bris|sa|go (Ort am Lago Maggiore); [2]Bris|sa|go (Zigarrensorte) *w*; -, -s
Bri|stol [*brĭßt'l*] (engl. Stadt am Avon); Bri|stol.ka|nal (Bucht zwischen Wales u. Cornwall), ...kar|ton (Zeichenkarton aus mehreren Lagen); ↑ R 201
Bri|tan|nia|me|tall (Zinnlegierung) *s*; -s (↑ R 201); Bri|tan|ni|en [...*iᵉn*]; bri|tan|nisch; Bri|te *m*; -n, -n (↑ R 268); Bri|tin *w*; -, -nen; bri|tisch, aber (↑ R 224): die Britischen Inseln, das Britische Museum; Bri|tisch-Ko|lum|bi|en (kanad. Provinz); Bri|ti|zis|mus (Spracheigentümlichkeit des britischen Englisch in einer anderen Sprache) *m*; -, ...men
Britsch|ka *poln.* (leichter offener Reisewagen) *w*; -, -s
Brit|ta (w. Vorn.)
Brit|ten [*brĭt'n*] (engl. Komponist) br. m., b. m. = brevi manu
Broad|way *engl.* [*brădwe'*] (,,breiter Weg''; Hauptstraße in New York) *m*; -s
Broch (österr. Dichter)
Bröck|chen, Bröck|lein; bröck|chen|wei|se; bröck|lig[1], bröcklig; Bröcke|lig|keit[1], Bröck|lig|keit *w*; -; bröckeln[1]; ich ...[e]le (↑ R 327); brocken[1] (einbrocken; österr. auch für: pflücken); [1]Brocken[1] (das Abgebrochene) *m*; -s, -
[2]Brocken[1] (höchster Berg des Harzes) *m*; -s
brocken|wei|se[1]
Brockes[1] (dt. Dichter)
Bröck|lein, Bröck|chen; bröck|lig, bröcke|lig[1]; Bröck|lig|keit vgl. Bröckeligkeit
Brod (österr. Schriftsteller)
bro|deln (dampfend aufsteigen, aufwallen, österr. auch: Zeit vertrödeln); Bro|dem (geh. für: Qualm, Dampf, Dunst) *m*; -s
Bro|de|rie *fr.* (veralt. für: Stickerei; Einfassung) *w*; -, ...ien; bro|die|ren (veralt.)
Brod|ler österr. (jmd., der die Zeit vertrödelt)
Broi|ler *engl.* [*breul'r*] (Hähnchen zum Grillen) *m*; -s, -; Broi|ler|mast
Bro|kat *it.* (kostbares gemustertes Seidengewebe) *m*; -[e]s, -e; Bro|ka|tell *m*; -s, -e u. Bro|ka|tel|le (ein Baumwollgewebe) *w*; -, -n
Bro|ker *engl.* (engl. Bez. für: Börsenmakler) *m*; -s, -

[1] Trenn.: ...k|k...

Brok|ko|li *it.* (Spargelkohl) *Mehrz.*
Brom *gr.* (chem. Grundstoff; Nichtmetall; Zeichen: Br) *s*; -s
Brom|bee|re; Brom|beer|strauch
brom|hal|tig; Bro|mid *gr.* (Salz des Bromwasserstoffs) *s*; -[e]s, -e; [1]Bro|mit (ein Mineral; Bromsilber) *m*; -s; [2]Bro|mit (ein Salz) *s*; -s, -e; Brom.säu|re (*w*; -), ...sil|ber
bron|chi|al *gr.*; Bron|chi|al.asthma, ...ka|tarrh (Luftröhrenkatarrh); Bron|chie [...*iᵉ*] (Luftröhrenast) *w*; -, -n (meist *Mehrz.*); Bron|chi|tis (Bronchialkatarrh) *w*; -, ...itiden; Bron|chus (Med.: Hauptast der Luftröhre) *m*; -, ...chen; vgl. Bronchie
Bronn *m*; -[e]s, -en u. Bron|nen (dicht. für: Brunnen) *m*; -s, -
Bron|ze *it.* (-*fr.*) [*brõngßᵉ*] (Metallmischung; Kunstgegenstand aus Bronze; nur *Einz.*: Farbe) *w*; -, -n; bron|ze.far|ben, ...far|big; Bron|ze.kunst, ...me|dail|le; bron|zen (aus Bronze); Bron|ze|zeit (vorgeschichtl. Kulturzeit) *w*; -; bron|ze|zeit|lich; bron|zie|ren (mit Bronze überziehen); Bron|zit (ein Mineral) *m*; -s
Brook|lyn [*bruklĭn*] (Stadtteil von New York)
Bro|sa|me *w*; -, -n (meist *Mehrz.*); Bro|säm|chen, Bro|säm|lein
brosch. = broschiert; Bro|sche *fr.* (Vorstecknadel; Spange) *w*; -, -n
Brös|chen vgl. Brieschen
bro|schie|ren *fr.* (Druckbogen in einem Papierumschlag heften od. leimen); bro|schiert (Abk.: brosch.); [1]Bro|schur (das Heften od. Leimen) *w*; -; [2]Bro|schur (in Papierumschlag geheftete Druckschrift) *w*; -, -en; Bro|schü|re (leicht gebundenes Heftchen, Druckheft; Flugschrift) *w*; -, -n
Brö|sel (Bröslein) *m* (österr.: *s*); -s, -; Brö|se|lein, Brös|lein (Bröckchen); brö|se|lig, brös|lig; brö|seln (bröckeln); ich ...[e]le (↑ R 327)
Brot *s*; -[e]s, -e; Brot.auf|strich, ...beu|tel; Bröt|chen (ein Gebäck); Bröt|chen|ge|ber (ugs. scherzh. für: Arbeitgeber); Brot..erwerb, ...fa|brik, ...ge|ber, ...ge|trei|de, ...herr, ...korb, ...kru|me, ...laib; brot|los; -e Künste; Brot.neid, ...preis, ...schnit|te, ...stu|di|um, ...sup|pe, ...teig, ...zeit (südd. ugs. für: Zwischenmahlzeit [am Vormittag])
brot|zeln (Nebenform von: brutzeln); ich ...[e]le (↑ R 327)
Brow|ning [*braun...*]; nach dem amerik. Erfinder] (Schußwaffe) *m*; -s, -s
brr! (Ruf an die Pferde: halt!)
BRT = Bruttoregistertonne

[1]Bruch (Brechen; Zerbrochenes) *m*; -[e]s, Brüche; in die Brüche gehen
[2]Bruch [auch: *bruch*] (Sumpfland) *m* u. *s*; -[e]s, Brüche (landsch. auch: Brücher)
Bruch.band (*s*; *Mehrz.* ...bänder), ...bu|de (ugs. für: schlechte, baufällige Hütte; schlechtes, baufälliges Haus); bruch|fest; Bruch|fe|stig|keit *w*; -
bru|chig [auch: *bru*...] (sumpfig)
brü|chig (morsch); Brü|chig|keit; bruch|lan|den (fast nur im 2. Mittelw. gebr.: bruchgelandet); Bruch|lan|dung; bruch|los; bruch|rech|nen (nur in der Grundform üblich); Bruch.rech|nen (*s*; -s), ...rech|nung (*w*; -), ...scha|den, ...schrift (für: Fraktur); bruch|si|cher; - verpackt; Bruch.stein, ...stel|le, ...strich, ...stück; bruch|stück|haft; Bruch.teil, ...zahl
Brück (chem. Brück|lein; Brücke [*Trenn.*: Brük|ke] *w*; -, -n; *Schreibung in Straßennamen:* ↑ R 219ff.; Brücken.bau [*Trenn.*: Brük|ken...] (*Mehrz.* ...bauten), ...bo|gen, ...ge|län|der, ...kopf, ...pfei|ler, ...waa|ge, ...zoll; Brück|lein, Brück|chen
Bruck|ner (österr. Komponist)
Brü|den (Technik: Schwaden, Abdampf) *m*; -s, -; vgl. Brodem
Bru|der *m*; -s, Brüder; die Brüder [nicht: Gebrüder] Grimm; Brü|der|chen, Brü|der|lein; Brü|der|ge|mei|ne (pietistische Freikirche) *w*; -, -n; Bru|der.hand, ...krieg, ...kuß; Brü|derlein; Brü|der|chen; brü|der|lich; Brü|der|lich|keit *w*; -; Bru|der Lu|stig *m*; *Wesf.*: Bruder Lustigs u. Bruder[s] Lustig, *Mehrz.*: Brüder Lustig; Bru|der|mord; Bru|der|schaft (rel. Vereinigung); Brü|der|schaft (brüderliches Verhältnis); - trinken; Bru|der.volk, ...zwist
Brue|g[h]el [*breug'l*] vgl. Breughel
Brüg|ge (belg. Stadt)
Brü|he *w*; -, -n; brü|hen; brüh|heiß; brü|hig; Brüh|kar|tof|feln *Mehrz.*
Brühl (veralt. für: feuchter Platz, erhalten in Straßen- u. Platznamen) *m*; -[e]s, -e
brüh|warm, Brüh|wür|fel, ...wurst
Brüll|af|fe; brül|len; Brül|ler
Bru|maire [*brümär*] (,,Nebelmonat'' der Fr. Revolution: 22. Okt. bis 20. Nov.) *m*; -[s], -s
Brumm.baß, ...baß; brum|meln (ugs. für: leise brummen; undeutlich sprechen); ich ...[e]le (↑ R 327); brum|men; Brum|mer; brum|mig; Brum|mig|keit *w*; -; Brumm.krei|sel, ...och|se, ...schä|del (ugs.)
Bru|nel|le, Brau|nel|le *fr.* (Pflanze)

w; -, -n; **brü|nett** (braunhaarig, -häutig); **Brü|net|te** (brünette Frau) *w*; -, -n; zwei reizende Brünette[n] (↑ R 291)

Brunft (Jägerspr.: beim Wild [bes. Hirsch] svw. Brunst) *w*; -, Brünfte; **brunf|ten**; **Brunft|hirsch**; **brunf|tig**; **Brunft.platz**, ...**schrei**, ...**zeit**

Brun|hild, Brun|hil|de (dt. Sagengestalt; w. Vorn.)

brü|nie|ren *fr.* (Metall bräunen)

Brunn (dicht. für: Brunnen) *m*; -[e]s, -en; vgl. auch: Born u. Bronn; **Brünn|chen, Brünn|lein**

Brün|ne (mittelalterl. Panzerhemd) *w*; -, -n

Brun|nen *m*; -s. -; vgl. auch: Brunn, Bronn u. Born; **Brun|nen_figur**, ...**kres|se** (Salatpflanze), ...**kur**, ...**rand**, ...**röh|re**, ...**ver|gif|ter**, ...**ver|gif|tung**

Brünn|lein, Brünn|chen

Bru|no (m. Vorn.)

Brunst (Periode der geschlechtl. Erregung u. Paarungsbereitschaft bei einigen Tieren) *w*; -, Brünste; vgl. auch: Brunft; **brun|sten, brün|stig, Brunst|zeit**

brüsk (barsch; rücksichtslos); **brüs|kie|ren** (barsch, rücksichtslos behandeln); **Brüs|kie|rung**

Brüs|sel (Hptst. Belgiens); vgl. Bruxelles; **Brüs|se|ler, Brüß|ler** (↑ R 199)

Brust *w*; -, Brüste; **Brust_bein**, ...**beu|tel**, ...**bild**; **Brüst|chen**; **Brüst|lein**; **brü|sten**, sich; **Brust-fell**; **Brust|fell|ent|zün|dung**; **brust|hoch**; **Brust|höh|le**; ...**brü-stig** (z. B. engbrüstig); **Brust_ka-sten** (*Mehrz.* ...kästen), ...**kind**, ...**korb**, ...**krebs**, ...**pul|ver**; **brust-schwim|men** (im allg. nur in der Grundform gebr.); **Brust_schwim|men** (*s*; -s), ...**stim|me**, ...**ta|sche**, ...**tee**, ...**ton** (*Mehrz.* ...töne); **Brü|stung**; **Brust_war|ze**, ...**wehr** *w*, ...**wickel** [*Trenn.*: wik-kel]

Brut *w*; -, -en

bru|tal *lat.* (roh; gefühllos; gewalttätig); **bru|ta|li|sie|ren; Bru|ta|li-sie|rung; Bru|ta|li|tät**

Brut|ap|pa|rat; brü|ten; brü|tend-heiß; ein brütendheißer Tag (↑ jedoch R 143), ab e r : der Tag war brütend heiß; **Brü|ter** (Kernreaktor, der mehr spaltbares Material erzeugt, als er verbraucht); **Brut-hit|ze** (ugs.); **bru|tig** (österr. auch für: brütig); **brü|tig; Brut_ka-sten**, ...**ofen**, ...**pfle|ge**, ...**re|ak|tor** (svw. Brüter), ...**stät|te**

rut|to *it.* (mit Verpackung; ohne Abzug der [Un]kosten; roh; Abk.: btto.); - für netto (Abk.: bfn.); **Brut|to_ein|kom|men**, ...**er-trag** (Rohertrag), ...**ge|halt** *s*,

...**ge|wicht**, ...**re|gi|ster|ton|ne** (Abk.: BRT), ...**so|zi|al|pro|dukt**, ...**ver|dienst** *m*

Bru|tus (röm. Eigenn.)

brut|zeln (ugs. für: in zischendem Fett braten); ich ...[e]le (↑ R 327); vgl. brotzeln

Bru|xelles [*brüßäl*] (fr. Form von: Brüssel)

Bruy|ère|holz *fr.*; dt. [*brüjär*...] (rotes Holz der Baumheide)

Bryo|lo|gie *gr.* (Mooskunde) *w*; -; **Bryo|nie** [...*i^e*] (Zaunrübe, Heil- und Kletterpflanze) *w*; -, -n; **Bryo|zo|on** (Moostierchen) *s*; -s, ...**zoen**

BSA = Bund schweizerischer Architekten

bst! vgl. pst!

btto. = brutto

Bub südd., österr. u. schweiz. (Junge) *m*; -en, -en (↑ R 268); **Büb-chen, Büb|lein; Bu|be** (abwertend für: gemeiner, niederträchtiger Mensch; Spielkartenbezeichnung) *m*; -n, -n; **bu|ben|haft; Buben_streich**, ...**stück; Bü|be|rei; Bu|bi** (Koseform von: Bub) *m*; -s, -s; **Bu|bi|kopf** (weibl. Haartracht); **Bü|bin** *w*; -, -nen; **bu-bisch**; -ste (↑ R 294); **Büb|lein, Büb|chen**

Bu|bo *gr.* (entzündliche Lymphknotenschwellung, bes. in der Leistenbeuge) *m*; -s, ...**onen**

Buch (Abk.: Bch.) *s*; -[e]s, Bücher; -führen; ab e r : die buchführende Geschäftsstelle (↑ R 142); zu -e schlagen

[1]**Bu|cha|ra** (Landschaft u. Stadt in der Usbekischen SSR); [2]**Bu|cha|ra** (handgeknüpfter Teppich) *m*; -[s], -s; **Bu|cha|re** *m*; -n, -n (↑ R 268); **Bu|cha|rei** (alte Bez. für die Länder östl. vom Kaspischen Meer) *w*; -

Buch_aus|stat|tung, ...**bin|der; Buch|bin|de|rei; buch|bin|dern;** ich ...ere (↑ R 327); gebuchbin-dert; **Buch|bin|der|pres|se; Buch-_block** (Buchbinderei; *Mehrz.* ...blocks), ...**druck** (*m*; -[e]s), ...**drucker[1]; Buch|drucke|rei[1]; Buch|drucke|rei|be|sit|zer[1]; Buch|drucker|kunst[1]** *w*; -; **Buch-druck|ge|wer|be** *s*; -s

Bu|che *w*; -, -n; **Buch|ecker** [*Trenn.*: ...ek|ker] *w*; -, -n; **Bu|chel** landsch. (Buchecker) *w*; -, -n

Bü|chel|chen, Büch|lein

[1]**bu|chen** (aus Buchenholz)

[2]**bu|chen** (in ein Rechnungs- od. Vormerkbuch eintragen; Plätze für eine Reise reservieren lassen)

Bu|chen_holz, ...**klo|ben**

Bu|chen|land (dt. Name des Bukowina) *s*; -[e]s; **bu|chen|län|disch**

Bu|chen.scheit, ...**stamm**, ...**wald**

Bü|cher_bord (*s*; -[e]s, -e), ...**brett; Bü|che|rei;** Deutsche Bücherei (in Leipzig); **Bü|cher|kun|de** *w*; -; **bü-cher|kund|lich; Bü|cher_re|gal**, ...**re|vi|sor** (Buchprüfer), ...**schrank**, ...**stu|be**, ...**wand**, ...**wurm** *m*

Buch.fink

Buch_for|de|rung (Rechtsspr.), ...**tuh|rung**, ...**ge|mein|schaft**, ...**ge|wer|be** (*s*; -s); **buch|ge|werb-lich; Buch_hal|ter**, ...**hal|te|rin; buch|hal|te|risch; Buch_hal|tung**, ...**han|del** (vgl. [1]Handel), ...**händ-ler; buch|händ|le|risch; Buch-hand|lung, kri|tik, kunst** ...**lauf|kar|te; Büch|lein, Büchel-chen; Buch_ma|cher** (Vermittler von Rennwetten)

Büch|ner (dt. Dichter)

Buch_prü|fer (Bücherrevisor), ...**we|sen** (*s*; -s), ...**zei|chen**

Buchs *m*; -es, -e; **Buchs_baum**; **Buchs|baum_ra|bat|te**

Büchs|chen, Büchs|lein; Buch|se (Steckdose; Hohlzylinder zur Aufnahme eines Zapfens usw.) *w*; -, -n; **Büch|se** (zylindrisches [Metall]gefäß mit Deckel; Feuerwaffe) *w*; -, -n; **Büch|sen_fleisch**, ...**licht** (zum Schießen ausreichende Helligkeit; *s*; -[e]s), ...**ma-cher**, ...**öff|ner**, ...**schuß**, ...**wa|re; Büchs|lein, Büchs|chen**

buch|sta|be|n *m*; -ns (selten: -n), -n; **buch|sta|ben_ge|treu; Buch|sta-ben.kom|bi|na|tion**, ...**rät|sel**, ...**rech|nung** *w*; -; **buch|sta|bie|ren; buch|stäb|lich** (genau nach dem Wortlaut)

Bucht *w*; -, -en

Buch|tel *tschech.* österr. (eine Mehlspeise) *w*; -, -n

buch|tig

Buch|ti|tel

Bu|chung

Buch_ver|leih, ...**ver|sand**

Buch|wei|zen (Nutzpflanze); **Buch|wei|zen_mehl**

Bu|cin|to|ro *it.* [*butschin*...] (it. Schreibung von: Buzentaur) *m*; -s

[1]**Buckel[1]** (erhabene Metallverzierung) *m*; -s, - (auch: *w*; -, -n); [2]**Buckel[1]** (Höcker, Rücken) *m*; -s, -; **Buckel_flie|ge[1], fug[1], buck|lig; Buckel|kra|xe[1]** bayr., österr. mdal. (eine Rückentrage) *w*; -, -n; **buckel|kra|xen[1]** österr. (huckepack) - tragen; **buckeln[1]** (einen Buckel machen; Metall treiben; auf dem Buckel tragen); ich ...[e]le (↑ R 327); **Buckel|rind[1]** (Zebu)

[1] *Trenn.*: ...druk|ke...
 [1] *Trenn.*: ...k|k...

bücken[1], sich; **Buckerl**[1] österr. ugs. (Verbeugung) s; -s, -n

Bücking[1] (alte, noch landsch. Nebenform von [2]Bückling)

Buck|ing|ham [_bâking^e m_] (engl. Orts- u. Familienn.); **Buck|ing-ham-Pa|last** m; -[e]s

buck|lig, buckelig[1]

[1]**Bück|ling** (scherzh., auch abschätzig für: Verbeugung)

[2]**Bück|ling** (geräucherter Hering)

Buck|ram engl. (Buchbinderleinwand) m; -s

Buck|skin engl. (Streichgarnstoff) m; -s, -e

Bu|cu|re|şti [_bukuręschtj_] (rumän. Form von: Bukarest)

Bu|da|pest (Hptst. Ungarns); **Bu-da|pe|ster** (↑ R 199)

Büd|chen (kleine Bude)

Bud|del, But|tel (ugs. für: Flasche) w; -, -n

Bud|de|lei; bud|deln, (auch:) **pud-deln** (ugs. für: im Sand wühlen, graben); ich ...[e]le (↑ R 327)

Bud|den|brooks (Titel eines Romans von Thomas Mann)

[1]**Bud|dha** (ind. Religionsstifter);

[2]**Bud|dha** (Verkörperung Buddhas) m; -s, -s; **Bud|dhis|mus** (Lehre Buddhas) m; -; **Bud|dhist** (↑ R 268); **bud|dhi|stisch**

Bu|de w; -, -n; **Bu|dei** bayr. u. österr. ugs. (Verkaufstisch) w; -, -[n]; vgl. Pudel; **Bu|den|zau|ber** (ugs. für: ausgelassenes Fest auf der Bude, in der Wohnung)

Bud|get fr. [_büdsche_] (Staatshaushaltsplan, Voranschlag) s; -s, -s; **bud|ge|tär; Bud|get|be|trag; bud|ge|tie|ren** (ein Budget aufstellen); **Bud|ge|tie|rung**

Bu|di|ke usw. (volkstümlich für: Butike usw.)

Büd|ner landsch. (Kleinbauer)

Bu|do jap. (Sammelbegriff f. Judo, Karate u. ä. Sportarten) s; -s

Bue|nos Ai|res (Hptst. Argentiniens)

Bü|fett, Buf|fet fr. [_büfe_] (österr. auch: Büf|fet [_büfe_], schweiz.: Buf|fet [_büfe_]) (Anrichte[tisch]; Geschirrschrank; Schanktisch) s; -[e]s, -s u. (bei dt. Ausspr. von Büfett auch:) -e; kaltes -; **Bü|fet-tier** [...ie] ([Bier]ausgeber, Zapfer) m; -s, -s; **Bü|fett|mam|sell**

Büf|fel (Untergattung der Rinder) m; -s, -; **Büf|fe|lei** (ugs.); **Büf|fel-her|de; büf|feln** (ugs. für: lange u. angestrengt lernen); ich ...[e]le (↑ R 327)

Buf|fet, Büf|fet vgl. Büfett

Buf|fo it. (Sänger komischer Rollen) m; -s u. Buffi; **buf|fo|nesk** (in der Art einer Opera buffa)

Bug (Schulterstück [des Pferdes,

des Rindes]; Schiffsvorderteil) m; -[e]s, (selten:) -e (für Schiffe nur so) u. Büge

Bü|gel m; -s, -; **Bü|gel|ei|sen**, ...fal-te; **bü|gel|fest**, ...frei; **bü|geln**; ich ...[e]le (↑ R 327); **Büg|le|rin** w; -, -nen

bug|sie|ren niederl. ([Schiff] schleppen, ins Schlepptau nehmen; ugs. für: mühsam an einen Ort befördern); **Bug|sie|rer** (Seemannsspr.: Bugsierdampfer)

Bug|spriet (über den Bug hinausragende Segelstange) s u. m; -[e]s, -e; **Bug|wel|le**

buh (Ausruf als Ausdruck des Mißfallens); **Buh** (ugs.) s; -s, -s; es gab viele -s

Bu|hei (ugs.: unnütze Worte, Theater um etw.) s; -s; - machen

Bü|hel vgl. Bühl

bu|hen (ugs. für: durch Buhrufe sein Mißfallen ausdrücken)

Bühl m; -[e]s, -e u. Bü|hel südd. u. österr. (Hügel) m; -s, -

[1]**Buh|le** m; -n, -n (dicht. veralt. für: Geliebter); ↑ R 268; [2]**Buh|le** (dicht. veralt.) w; -, -n; **buh|len; Buh|ler** (veralt.); **Buh|le|rei** (veralt.); **Buh|le|rin** (veralt.) w; -, -nen; **buh|le|risch** (veralt.); -ste (↑ R 294); **Buh|lin** (dicht. veralt.) w; -, -nen; **Buhl|schaft** (veralt. für: Liebesverhältnis)

Buh|mann (familiär für: böser Mann, Schreckgespenst; Mehrz.: ...männer)

Buh|ne (künstlicher Damm zum Uferschutz) w; -, -n

Büh|ne (hölzerne) Plattform; Schaubühne; Spielfläche; südd., schweiz. auch: Dachboden; vgl. Heubühne) w; -, -n; **Büh|nen-.ar-bei|ter**, ...aus|spra|che, ...bild, ...bild|ner, ...fas|sung

Buh|nen|kopf (äußerstes Ende einer Buhne [vgl. d.])

büh|nen|mä|ßig; Büh|nen|mu|sik; büh|nen|reif; Büh|nen|schaf|fen-de m u. w; -n, -n (↑ R 287ff.); **büh|nen|wirk|sam**

Buh|ruf

Buh|urt fr. (mittelalterl. Reiterkampfspiel) m; -[e]s, -e

Bu|ka|ni|er engl. [...ie^r] (westind. Seeräuber im 17. Jh.) m; -s, -

Bu|ka|rest (Hptst. Rumäniens); vgl. Bucureşti; **Bu|ka|re|ster** (↑ R 199)

Bu|ke|pha|los [auch: _buke_...] (Pferd Alexanders des Großen) m; -

Bu|kett fr. ([Blumen]strauß; Duft [des Weines]) s; -[e]s, -e

Bu|ko|li|ker gr. (Hirtenlieddichter); **bu|ko|lisch; -e** Dichtung

Bu|ko|wi|na ("Buchenland"; Karpatenlandschaft) w; -; **Bu|ko|wi-ner; bu|ko|wi|nisch**

Bul|bus (Bot.: Zwiebel; Med.: Augapfel; Anschwellung) m; -, ...bi od. (Bot. nur:) ...ben

Bu|let|te fr. (gebratenes Fleischklößchen) w; -, -n

Bul|ga|re m; -n, -n (↑ R 268); **Bul-ga|ri|en** [...i^e n]; **Bul|ga|rin** w; -, -nen; **bul|ga|risch; Bul|ga|risch** (Sprache) s; -[s]; vgl. Deutsch; **Bul|ga|ri|sche** s; -n; vgl. Deutsche s

Bu|lin, Bu|li|ne (Hilfsleine am Rahsegel) w; -, ...nen

Bulk|car|ri|er engl. [_balkkäri^e r_] (Massengutfrachtschiff) m; -s, -

Bulk|la|dung (Seemannsspr.: Schüttgut)

Bull|au|ge (rundes Schiffsfenster

Bull|dog ⓦ engl. (Zugmaschine m; -s, -s; **Bull|dog|ge** (Hunderasse); **Bull|do|zer** [_búldos^e r_] (schwere Zugmaschine, Bagger) m; -s

[1]**Bul|le** (Stier, männl. Zuchtrind auch männl. Tier verschiedener großer Säugetierarten) m; -n, -r (↑ R 268)

[2]**Bul|le** lat. (mittelalterl. Urkunde feierl. päpstl. Erlaß) w; -, -n; die Goldene - (↑ R 224)

Bul|len|bei|ßer (ein Hund; meist ugs. für: bissiger Mensch); **bul-len|bei|ße|risch; Bul|len|hit|ze** (ugs.); **bul|len|stark** (ugs.)

bul|le|rig, bull|rig (ugs.); **bul|lern** (poltern, dröhnen; ugs. auch schimpfen); ich ...ere (↑ R 327) das Wasser, der Ofen bullert

Bulle|tin fr. [_bültäng_] (amtliche Bekanntmachung; [Tages]bericht Krankenbericht) s; -s, -s

bul|lig

bull|rig, bul|le|rig (ugs.)

Bull|ter|ri|er (engl. Hunderasse)

Bul|ly engl. (das von zwei Spielern ausgeführte Anspiel im [Eis] hockey) s; -s, -s

Bü|low [_bülo_] (Familienn.)

Bult m; -[e]s, Bülte od. Bulten u. Bül-te niederd. (feste, grasbewachse ne [Moor]stelle; Hügelchen) w -, -n; **Bult|sack** (Seemannsspr. tratze)

bum!; bum, bum!; bim, bam, bum

Bum|baß (altes Instrument de Bettelmusikanten) m; ...basses ...basse

Bum|boot (kleines Händlerboc zur Versorgung großer Schiffe

Bum|bum (ugs.: Gepolter) s; -s

Bu|me|rang engl. [auch: _bu_...] (ge krümmtes Wurfholz) m; -s, -e od -s

[1]**Bum|mel** (ugs. für: Spaziergang m; -s, -; [2]**Bum|mel** vgl. Bomme **Bum|me|lant** m; -en, -en (↑ R 268 **Bum|me|lan|ten|tum** s; -s; **Bum me|lei; bum|me|lig, bumm|lig Bum|me|lig|keit, Bumm|lig|ke** w; -; **bum|meln**; ich ...[e]le (↑ R

327); **Bum|mel|streik**, ...**zug** (scherzh.); **Bum|merl** österr. ugs. (Verlustpunkt beim Kartenspiel) s; -s, -n; das - (der Gefoppte, Benachteiligte) sein; **bum|mern** (ugs.: dröhnend klopfen); ich ...ere (↑ R 327); **Bumm|ler**; **bumm|lig**, **bum|me|lig**; **Bumm|lig|keit**, **Bum|me|lig|keit** w; - **bums**!; **Bums** (ugs. für: dumpfer Schlag) m; -es, -e; **bum|sen** (ugs. für: dröhnend aufschlagen; derb für: koitieren; du bumst (bumsest); **Bums.lo|kal** (ugs. für: zweifelhaftes Vergnügungslokal), ...**mu|sik** (ugs. für: laute, dröhnende Musik), **bums|voll** (ugs.: sehr voll)

Bu|na ® (synthet. Gummi) m od. s; -[s]; **Bu|na|rei|fen**

¹**Bund** („das Bindende"; Vereinigung) m; -[e]s, Bünde; der Alte, Neue - (↑ R 224); ²**Bund** („das Gebundene"; Gebinde) s; -[e]s, -e; vier - Stroh (↑ R 321f.)

Bun|da ung. (Schafmantel ung. Bauern) w; -, -s

bund|brü|chig; **Bünd|chen**, Bündlein

Bün|del s; -s, -; **Bün|de|lei**; **bün|deln**; ich ...[e]le (↑ R 327); **Bün|den** (schweiz. Kurzform von: Graubünden); **Bun|des.amt**, ...**an|gestell|ten|ta|rif** (Abk.: BAT), ...**au|to|bahn**, ...**bahn**, ...**be|hör|de**, ...**bru|der**; **bun|des|deutsch**; **Bun|des|deut|sche** m u. w; **Bun|des.ebe|ne**; auf -; **bun|des|ei|gen**; **Bun|des.ge|biet**, ...**ge|nos|se**; **bun|des|ge|nös|sisch**; **Bun|des.ge|richt**, ...**ge|setz|blatt** (Abk.: BGBl.), ...**grenz|schutz**, ...**haus**, ...**ka|bi|nett**, ...**kanz|ler**, ...**kri|mi|nal|amt**, ...**land** (Mehrz. ...länder), ...**li|ga** (in Deutschland die höchste, über den Regionalligen stehende Spielklasse im Fußball u. a.; vgl. Regionalliga), ...**li|gist**, ...**ma|ri|ne**, ...**mi|ni|ster**, ...**post**, ...**prä|si|dent**, ...**pres|se|amt**, ...**rat**, ...**rech|nungs|hof**, ...**re|gie|rung**; **Bun|des|re|pu|blik Deutsch|land** (Abk.: BRD); **bun|des|re|pu|bli|ka|nisch**; **Bun|des.staat** (Mehrz. ...staaten), ...**stadt** (schweiz. für: Bern als Sitz von Bundesregierung u. -parlament) w; -), ...**stra|ße**, ...**tag**, ...**ver|fas|sungs|ge|richt**, ...**ver|samm|lung**, ...**vor|stand**, ...**wehr** (w; -); **bun|des|weit**; **Bun|des|wirt|schafts|rat**; **Bund|ho|se** (Golfhose); **bün|dig** (bindend; Bauw.: in gleicher Fläche liegend); kurz und -; **Bün|dig|keit** w; -; **bün|disch** (veralt. für: verbündet; heute: einem Jugendbund angehörend); die -e Jugend; **Bünd|lein**, Bünd|chen; **Bünd|ner** (veralt. für: Angehöriger eines

Bundes; schweiz. Kurzform von: Graubündner); **Bünd|ner Fleisch** (↑ R 199); **bünd|ne|risch** (schweiz. Kurzform von: graubündnerisch); **Bünd|nis** s; -ses, -se; **Bündnis.block** (Mehrz. ...blocks od. ...blöcke), ...**fall** m, ...**sy|stem**, ...**treue**, ...**ver|trag**; **Bund.schuh** (Bauernschuh im MA.), ...**steg** (Druckw.)

Bun|ga|low Hindi-engl. [bunggalo] (eingeschossiges [Sommer]haus) m; -s, -s

Bun|ge (kleine Fischreuse aus Netzwerk od. Draht) w; -, -n

Bun|ker (Behälter zur Aufnahme u. Abgabe von Massengut [Kohle, Erz]; Betonunterstand; [Golf:] Sandloch) m; -s, -; **bun|kern** (Massengüter in den Bunker füllen; [von Schiffen] Brennstoff aufnehmen); ich ...ere (↑ R 327)

Bun|sen|bren|ner; ↑ R 180 [nach dem Erfinder]

bunt; - bemalen; ein bunter Abend. *Schreibung in Verbindung mit dem 2. Mittelwort*: ein buntgestreiftes Tuch (↑ jedoch R 142), aber: das Tuch ist bunt gestreift; in Bunt gekleidet

Bunt.druck (Mehrz. ...drucke), **Bunt.film**, ...**fo|to**; **bunt_ge|fie|dert**, ...**ge|mischt**; vgl. bunt; **Bunt.heit** (w; -), ...**me|tall**, ...**sand|stein** (Gestein; Geol. nur Einz.: Untergruppe des Mesozoikums); **bunt.schek|kig** [Trenn.: ...schek|kig], ...**schil|lernd**; **Bunt.specht**, ...**stift** m

Bunz|lau (Stadt am Südrand der Niederschlesischen Heide); -er Gut (Geschirr); ↑ R 199

Buo|nar|ro|ti, Michelangelo (it. Künstler)

Burck|hardt (Historiker)

Bür|de w; -, -n

Bu|re („Bauer"; Nachkomme der niederl. u. dt. Ansiedler in Südafrika) m; -n, -n (↑ R 268); **Bu|ren.krieg** (m; -[e]s), ...**staa|ten** (in Südafrika) Mehrz.

Bü|ret|te fr. (Meßröhre für Flüssigkeiten) w; -, -n

Burg w; -, -en

Bür|ge m; -n, -n (↑ R 268); **bür|gen**; **Bur|gen|land** (österr. Bundesland) s; -[e]s; **bur|gen|län|disch**

Bür|ger schweiz. landsch. (Ortsbürger) m; -s, -; **Bür|ger**; **Bür|ger.be|gren** (s; -s, -), ...**haus**; **Bür|ge|rin** w; -, -nen; **Bür|ger.in|itia|ti|ve**, ...**ko|mi|tee**, ...**krieg**; **bür|ger|lich**; **bür|ger|lich**; **bür|ger|li|che** Ehrenrechte; -es Recht, aber (↑ R 224): das Bürgerliche Gesetzbuch (Abk.: BGB); **Bür|ger|lich|keit** w; -; **Bür|ger|mei|ster** [oft auch: ...maißt'r]; **Bür|ger|mei|ste|rei**; **Bür|ger.pflicht**, ...**recht**, ...**schaft**; **bür|ger|schaft|lich**; **Bür|ger|schreck** (Mensch mit provozierendem Verhalten) m; -s; **Bür|gers|mann** , (Mehrz. ...leute); **Bür|ger.steig**, ...**tum** (s; -s); **Burg|fried** vgl. Bergfried; **Burg.frie|de[n]**, ...**graf**; **Burg.hild**, **Burg.hil|de** (w. Vorn.)

Bür|gin w; -, -nen

Burgk|mair (dt. Maler)

Bur|gos (span. Stadt)

Bürg|schaft

Burg|thea|ter (Name des österr. Staatstheaters in Wien)

Bur|gund (fr. Landschaft und früheres Herzogtum); **Bur|gun|de** (Angehöriger eines germ. Volksstammes) m; n, n (↑ R 268); **Bur|gun|der** (Einwohner von Burgund; fr. Weinsorte; auch für: Burgunde); ↑ R 199; **Bur|gun|der|wein** (↑ R 205); **bur|gun|disch**, aber (↑ R 198): die Burgundische Pforte

Burg.ver|lies, ...**vogt**

bu|risch [zu: Bure]

Bur|jä|te (Angehöriger eines mongol. Volksstammes) m; -n, -n (↑ R 268)

Burk|hard (m. Vorn.)

bur|lesk fr. (possenhaft); **Bur|les|ke** (Posse, Schwank) w; -, -n

Bur|ma (engl. und schweiz. Schreibweise von Birma); **Bur|me|se** m; -n, -n (↑ R 268); **bur|me|sisch**

Bur|nus arab. (Beduinenmantel mit Kapuze) m; - u. -ses, -se

Bü|ro fr. s; -s, -s; **Bü|ro_an|ge|stell|te**, ...**be|darf**, ...**haus**, ...**klam|mer**; **Bü|ro|krat** m; -en, -en (↑ R 268); **Bü|ro|kra|tie** w; -, ...ien; **bü|ro|krg|tisch**; -ste (↑ R 294); **bü|ro|kra|ti|sie|ren**; **Bü|ro|kra|ti|sie|rung**; **Bü|ro|kra|tis|mus** m; - **Bü|ro|kra|ti|us** [...ziuß] (scherzh. für: „Heiliger" des Bürokratismus); heiliger-!; **Bü|ro|list** schweiz. veraltend (Büroangestellter); **Bü|ro_ma|te|ri|al**, ...**mensch**, ...**mö|bel**, ...**schluß**, ...**zeit**

Bursch (landsch. für: junger Mann; Studentenspr.: Verbindungsstudent mit allen Rechten) m; -en, -en (↑ R 268); **Bürsch|chen**, Bürsch|lein; **Bur|sche** (Kerl; Studentenspr. auch für: Bursch) m; -n, -n (↑ R 268); ein toller - [**Bür|schen|haft**; **Bur|schen|schaft**; **Bur|schen|schaf|ter**; **bur|schen|schaft|lich**; **bur|schi|kos** (burschenhaft ungezwungen, formlos; flott); -este (↑ R 292); **Burschi|ko|si|tät**; **Bürsch|lein**, Bürsch|chen; **Bur|se** (hist.: Studentenheim) w; -, -n

Bürst|chen, **Bürst|lein**; **Bür|ste** w; -, -n; **bür|sten**; **Bür|sten.ab|zug** (Druckw.: Probeabzug), ...**bin|der**, ...**[haar]schnitt**

...**bür|tig** (z. B. ebenbürtig)

Bu|run|di (Staat in Afrika); **Bu|run|di|er** [...*i^er*]; **bu|run|disch**

Bür|zel (Schwanz[wurzel], bes. von Vögeln) *m*; -s, -

Bus (Kurzform für: Autobus, Omnibus) *m*; Busses, Busse

¹**Busch**, Wilhelm (dt. Humorist); die Buschschen Gedichte (↑ R 249)

²**Busch** *m*; -[e]s, Büsche; **Busch|boh|ne**; **Büsch|chen**, Büsch|lein; **Bü|schel** *s*; -s, -; **bü|sche|lig**, büsch|lig; **bü|scheln** südd. u. schweiz. (zu einem Büschel, Strauß zusammenbinden); ich ...[e]le (↑ R 327); **bü|schel|wei|se**; **Bu|schen** südd., österr. ugs. ([Blumen]strauß) *m*; -s, -; **Bu|schen|schen|ke** österr. (Straußwirtschaft); **bu|schig**; **Busch‿hemd**, ...klep|per (veralt. für: Strauchdieb); **Büsch|lein**, Büsch|chen; **büsch|lig**, bü|sche|lig; **Busch‿mann** (*Mehrz.* ...männer [Restvolk in Südafrika]), ...mes|ser *s*, ...obst, ...werk (*s*; -[e]s), ...wind|rös|chen

Bu|sen *m*; -s, -; **bu|sen|frei**; **Bu|sen|freund**

Bus‿fah|rer, ...hal|te|stel|le

Bu|shel engl. [*busch^e l*] (engl.-amerik. Getreidemaß) *m*; -s, -s; 6 -[s] (↑ R 322)

bu|sig; eine -e Schönheit

Busi|neß engl. [*bisniß*] (Geschäft[sleben]) *s*; -

bus|per alemann. (munter, lebhaft)

Bus|sard fr. (ein Raubvogel) *m*; -s, -e

Bu|ße (auch: Geldstrafe) *w*; -, -n; **bü|ßen** (schweiz. auch: jmdn. mit einer Geldstrafe belegen); du büßt (büßest); **Bü|ßer**; **Bü|ße|rin** *w*; -, -nen

Bus|serl bayr., österr. ugs. (Küßchen) *s*; -s, -[n]

buß|fer|tig; **Buß|fer|tig|keit** *w*; -; **Buß|geld**; **Buß|geld|be|scheid**

Bus|so|le it. (Winkelmeßinstrument) *w*; -, -n

Buß‿pre|di|ger, ...sa|kra|ment (kath.), ...tag; **Buß- und Bet|tag**

Bü|ste *w*; -, -n; **Bü|sten|hal|ter** (Abk.: BH)

Bu|ta|di|en (ungesättigter gasförmiger Kohlenwasserstoff) *s*; -s; **Bu|tan** gr. (gesättigter gasförmiger Kohlenwasserstoff) *s*; -s; **Bu|tan|gas** (Heiz- u. Treibstoff)

bu|ten niederd. (draußen, jenseits [der Deiche])

Bu|ti|ke fr. (kleiner Laden; [schlechte] Kneipe) *w*; -, -n; vgl. auch: Budike u. Boutique; **Bu|ti|ker** (Besitzer einer Butike)

But|ja|din|gen [,,buten der Jade"] (Halbinsel zwischen der Unterweser u. dem Jadebusen)

But|ler engl. [*bat^l er*] (Haushofmeister in vornehmen engl. Häusern) *m*; -s, -

Bu|tor [*bütor*] (fr. Schriftsteller)

Buts|kopf (Schwertwal)

Bütt niederd. (Scholle) *m*; -[e]s, -e

Bütt landsch. (faßförmiges Podium für Karnevalsredner) *w*; -, -en; in die - steigen; **Bütte** südd. u. österr. (Bütte) *w*; -, -n; **Bütte** (Gefäß) *w*; -, -n

Bütt|tel veralt. Buddel

Büt|tel (veralt. für: Häscher; heute nur abwertend gebraucht) *m*; -s, -

Büt|ten [zu: Bütte] (Papierart) *s*; -s; **Büt|ten‿pa|pier**, ...re|de

But|ter *w*; -; **But|ter‿blu|me**, ...brot; **But|ter|brot|pa|pier**

But|ter‿fly|stil engl. [*bat^e rflai...*] (Schwimmsport: Schmetterlingsstil) *m*; -[e]s

but|ter|gelb; **but|te|rig**, butt|rig; **But|ter|milch**; **but|tern**; ich ...ere (↑ R 327); **But|ter|stul|le** (nordostd.); **but|ter|weich**

Butt|je[r] nordd. (Junge, Kind) *m*; -s, -s

Bütt|ner mitteld. (Böttcher, Küfer); **Bütt|ner|tanz** fränk. (Schäfflertanz)

butt|rig, but|te|rig

Bu|tyl|al|ko|hol gr.; arab. (chem. Verbindung); **Bu|ty|ro|me|ter** gr. (Fettgehaltmesser) *s*; -s, -

Butz *m*; -en, -en vgl. ¹Butze; **Bütz|chen** rhein. (Kuß); ¹**Butz|e** landsch. (Kobold; Knirps) *m*; -n, -n; ²**But|ze** niederd. (Verschlag, Wandbett) *w*; -, -n; **But|ze|mann** (Kobold, Kinderschreck; *Mehrz.* ...männer); **Bu|tzen** landsch. (Kerngehäuse; Verdickung [im Glas]; Bergmannsspr.: unregelmäßige Mineralanhäufung im Gestein) *m*; -s, -; **büt|zen** rhein. (küssen); **But|zen|schei|be** ([runde] Glasscheibe mit Buckel in der Mitte); **Butz|kopf** vgl. Butskopf

Büx, **Bu|xe** nordd. (Hose) *w*; -; Büxen u. Buxen

Bux|te|hu|de (Stadt a. d. Este; scherzh. für: Nirgendheim)

Bu|zen|taur gr. (Untier in der gr. Sage; Prunkschiff der Dogen von Venedig) *m*; -en, -en (↑ R 268); vgl. Bucintoro

Bu|ze|pha|lus [auch: *buze...*] vgl. Bukephalos

BV = [schweizerische] Bundesverfassung

BVG = Berliner Verkehrs-Betriebe (früher: Berliner Verkehrs-Gesellschaft); Bundesversorgungsgesetz

b. w. = bitte wenden!

BWV = Bach-Werke-Verzeichnis (vgl. d.)

bye-bye! engl. [*baibai*] (ugs.: auf Wiedersehen!)

By|ron [*bair^e n*] (engl. Dichter)

Bys|sus gr. (feines Gewebe des Altertums; Haftfäden mancher Muscheln) *m*; -

By|zan|ti|ner (Bewohner von Byzanz; veralt. für: Kriecher, Schmeichler); **by|zan|ti|nisch** (aus, in Byzanz; veralt. für: schmeichlerisch; unterwürfig); -e Zeitrechnung, aber (↑ R 224): das Byzantinische Reich; **By|zan|ti|nis|mus** (Kriecherei, unwürdige Schmeichelei) *m*; -; **By|zanz** (alter Name von: Istanbul)

bz, bez, bez. = bezahlt (auf Kurszetteln)

Bz., Bez. = Bezirk

bzw. = beziehungsweise

C

Vgl. auch **K**, **Sch** und **Z**

C (Buchstabe); das C; des C, die C, aber: das c in Cäcilie (↑ R 123); der Buchstabe C, c

c = Cent, Centime; Zenti...

c, C (Tonbezeichnung) *s*; -, -; das hohe C; **c** (Zeichen für: c-Moll); in c; **C** (Zeichen für: C-Dur); in C

C = Carboneum (chem. Zeichen für: Kohlenstoff); Celsius; Coulomb

C (Abk. aus lat. centum) röm. Zahlzeichen) = 100

C. = Cajus; vgl. Gajus

Ca = chem. Zeichen für: Calcium

ca. = circa (vgl. zirka)

Ca. = Carcinoma (vgl. Karzinom)

Cab engl. [*käb*] (einspännige engl. Droschke) *s*; -s, -s

Ca|bal|le|ro span. [*kabaljero*, auch: *kaw...*] (Edelmann, Ritter; Herr) *m*; -s, -s

Ca|ba|ret [*kabare*] vgl. Kabarett

Ca|bo|chon fr. [*kaboschong*] (ein mugelig rund geschliffener Edelstein) *m*; -s, -s

Ca|bo|tage usw. vgl. Kabotage usw.

Cabriolet [*kabriole*] *s*; -s, -s vgl. Kabriolett

Ca|che|lot vgl. Kaschelott

Ca|che|nez fr. [*kasch^(e)ne*] ([seidenes] Halstuch) *s*; - [...*ne(ß)*], - [...*neß*]

Ca|chet fr. [*kaschä*] (veralt. für: Gepräge, Siegel; Eigentümlichkeit) *s*; -s, -s

Cä|ci|lia [*zäzi...*], **Cä|ci|lie** [...*i^e*] (w. Vorn.); **Cä|ci|li|en-Verband** (Vereinigung für kath. Kirchenmusik) *m*; -[e]s

Ca|dil|lac ⓦ [fr.: *kadijak*, engl.: *kädiläk*] (amerik. Kraftfahrzeugmarke)

Cá|diz [kádith] (span. Hafenstadt u. Provinz)

Cad|mi|um vgl. Kadmium

Cae|li|us [zä...] (Hügel in Rom); m; -

Ca|fé fr. [kafé] (Kaffeehaus, -stube) s; -s, -s; vgl. Kaffee; Ca|fé com|plet [kafekonɛplä] schweiz. (Kaffee mit Milch, Brötchen, Butter und Marmelade) m; - -, -s -s; Ca|fé crème [kafekrắm] schweiz. (Kaffee mit Sahne) m; --, -s -; Ca|fe|te|ria amerik.-span. [kafeterja] (Café od. Restaurant mit Selbstbedienung) w; -, -s; Ca|fe|tier fr. [...tie] (veralt. für: Kaffeehausbesitzer) m; -s, -s; Ca|fe|tie|re [...tiär´] (veralt. für: Kaffeehauswirtin; auch für: Kaffeekanne) w; -, -n

Ca|glio|stro [kaljoßtro] (it. Abenteurer)

Ca|is|sa [kaißa] (Göttin des Schachspiels)

Cais|son fr. [käßõ] (Senkkasten für Bauarbeiten unter Wasser) m; -s, -s

Ca|jus (vorklassische Schreibung des altröm. Vornamens Gajus; vgl. d.)

cal = Kalorie

Cal., Calif. = California; vgl. Kalifornien

Ca|lais [kalä] (fr. Stadt)

ca|lan|do it. [ka...] (Musik: an Tonstärke u. Tempo gleichzeitig abnehmend)

Ca|lau [ka...] (Stadt in der Niederlausitz)

Cal|be (Saa|le) (Stadt an der unteren Saale); vgl. aber: Kalbe (Milde)

Cal|ci... usw. vgl. Kalzi... usw.

Cal|cut|ta vgl. Kalkutta

Cal|de|rón [kald´rọn] (span. Dichter)

Ca|lem|bour, Ca|lem|bourg fr. [kalaⁿbur] (veralt. für: Wortspiel; Kalauer); m; -s, -s

Cal|gon Ⓦ [ka...] (Wasserenthärtungsmittel) s; -s

Ca|li|ban [ka..., auch in engl. Aussprache: käliban] vgl. Kaliban

Ca|lif. vgl. Cal.; Ca|li|for|ni|um [kali...] (stark radioaktiver chem. Grundstoff, ein Transuran; Zeichen: Cf) s; -s

Ca|li|gu|la [ka...] (röm. Kaiser)

Ca|lixt, Ca|lix|tus vgl. Kalixt[us]

Call|boy engl. [kálbeu] (männliches Gegenstück zum Callgirl); Call|girl [kálgö´l] (Prostituierte, die auf telef. Anruf hin kommt od. jmdn. empfängt)

Cal|met|te [kalmät] (fr. Bakteriologe); vgl. BCG-Schutzimpfung

Cal|tex Ⓦ (ein Kraftstoff)

Cal|va|dos fr. [kalw...] (ein Apfelbranntwein) m; -, -

Cal|vin [kalwịn, österr.: kál] (Genfer Reformator); cal|vi|nisch usw. vgl. kalvinisch usw.

Calw [kál] (Stadt a. d. Nagold); Cal|wer [kálw´r] (↑ R 199); die - Bibel

Ca|lyp|so [kalị...] (volkstüml. Gesangsform der afro-amerikanischen Musik Westindiens; Stegreifschöpfung im Rumbarhythmus) m; -[s], -s; vgl. aber: Kalypso

Cam|bric vgl. Kambrik

Cam|bridge [ke´mbridsch] (engl. u. nordamerik. Ortsn.)

Cam|burg [kam...] (Stadt a. d. Saale)

Ca|me|lot vgl. Kamelott

Ca|mem|bert fr. [kamaⁿbär, auch: kam´mbär] (ein Weichkäse) m; -s, -s

Ca|me|ra ob|scu|ra lat. [ka... opßkura] (Lochkamera) w; - -, ...rae [...rä] ...rae [...rä]

Ca|mil|la [ka...] (w. Vorn.); Ca|mil|lo [ka...] (it.] m. Vorn.)

Ca|mion fr. [kamjoⁿß] schweiz. (Lastkraftwagen) m; -s, -s; Ca|mion|na|ge [kamjọngseeh´] vgl. Bahncamionnage; Ca|mion|neur [...nör] vgl. Bahncamionneur

Ca|mões [kamoⁿgisch] (port. Dichter)

Ca|mor|ra vgl. Kamorra

Ca|mou|fla|ge fr. [kamuflaseh´] (veralt. für: Mummerei; Tarnung); ca|mou|flie|ren

Camp engl. [kämp] ([Feld-, Gefangenen]lager; auch Kurzform für: Campingplatz) s; -s, -s

Cam|pa|gna [kampanja] (it. Landschaft) w; -

Cam|pa|ri Ⓦ it. [kampari] (ein Bitterlikör) m; -s, -

Cam|pe|che|holz [kampętsch´...] vgl. Kampescheholz

cam|pen engl. [käm...]; Cam|per; Cam|ping (Leben auf Zeltplätzen im Zelt od. Wohnwagen, Zeltleben) s; -s; Cam|ping.ar|ti|kel, ...aus|rü|stung, ...füh|rer, ...platz, ...zu|be|hör; Cam|pus amerik. [ka...; auch in engl. Aussprache: kämp´ß] (Universitätsgelände, bes. in den USA) m; -, -

Ca|mus [kamü] (fr. Dichter)

Ca|na|da (engl. Schreibung von: Kanada)

Ca|nail|le vgl. Kanaille

Ca|na|sta span. [ka...] (aus Uruguay stammendes Kartenspiel) s; -s

Can|ber|ra [känb´r´] (Hptst. des Austral. Bundes)

Can|can fr. [kaⁿgkãg] (ein Tanz) m; -s, -s

cand. = candidatus; vgl. Kandidat

Can|de|la lat. [kan...] (Lichtstärkeeinheit; Zeichen: cd) w; -, -

Ca|net|ti, Elias (deutschsprachiger, in England lebender Schriftsteller)

Candida [ka...] (w. Vorn.); Candidus [ka...] (m. Vorn.)

Ca|ni|si|us|werk [ka...] (kath. Organisation zur Ausbildung von Priestern); ↑ R 180

Can|na vgl. Kanna

Can|na|bis gr.-lat. [ka...] (Hanf; auch [bes. amerik.] für: Haschisch) m; -

Can|nae vgl. Kannä

Cannes [kan] (Seebad an der Côte d'Azur)

Cann|statt, Bad [ka...] (Stadtteil von Stuttgart); Cann|stat|ter (↑ R 199); - Wasen (Volksfest)

Ca|ñon span. [kanjon od. kanjoⁿ] (,,Röhre''; enges, tief eingeschnittenes Tal, bes. im westl. Nordamerika) m; -s, -s; vgl. nöⁿar|tig

Canopus vgl. ²Kanopus

Ca|nos|sa [ka...] (Ort. u. Burg im Nordapennin); vgl. Kanossa

Can|stein|sche Bi|bel|an|stalt [kan...; nach dem Gründer Karl Hildebrand Frhr. von Canstein] w; -n -

Cant engl. [känt] (heuchlerische Sprache; Scheinheiligkeit; auch: Rotwelsch) m; -s

can|ta|bi|le it. [kan...] (Musik: gesangartig, ausdrucksvoll); Can|ta|te vgl. ²Kantate

Can|ter|bu|ry [känt´rb´ri] (engl. Stadt)

Can|tha|ri|din vgl. Kantharidin

Can|to it. [kanto] (Gesang) m; -s, -s; Can|tus fir|mus [kan... -] (,,fester Gesang''; [choralartige] Hauptmelodie eines polyphonen Chor- od. Instrumentalsatzes) m; - -, - [kántuß] ...mi

Cao-Dai annamit. [kaodai] m; - u.

Cao|da|is|mus (eine Religion in Vietnam) m; -

Cape engl. [kẹp] (ärmelloser Umhang) s; -s, -s

Ca|pel|la vgl. Kapella

Ca|pri (Insel im Golf von Neapel)

Ca|pric|cio, (auch:) Ka|pric|cio it. [kapritscho] (scherzhaftes, launiges Musikstück); s; -s, -s; ca|pric|cio|so [kapritschoso] (Musik; scherzhaft, launig, kapriziös); Ca|pri|ce vgl. Kaprice

Cap|ta|tio be|ne|vo|len|tiae lat. [kaptazio benewolǟnziä] (Haschen nach Wohlwollen, Gunstbewerbung) w; - -

Ca|pua (it. Stadt)

Ca|pu|chon fr. [kapüschoⁿg] (Damenmantel mit Kapuze) m; -s, -s

Ca|pu|let|ti [ka...] Mehrz.; vgl. Montecchi

Ca|put mor|tu|um *lat.* [*kạput ...tuum*] (Eisenrot, rote Malerfarbe; veralt. für: Wertloses) *s*; - -

Car *fr.* [*kạr*] schweiz. (Kurzform für: Autocar; Reiseomnibus) *m*; -s, -s

Ca|ra|bi|nie|re vgl. Karabiniere

Ca|ra|cal|la [*karakạla*] (röm. Kaiser)

Ca|ra|cas [*karạkaß*] (Hptst. Venezuelas)

Ca|rac|cio|la [*karatschọla*] (dt. Autorennfahrer)

ca|ram|ba! *span.* [*karạ...*] (ugs. für: Donnerwetter!, Teufel!)

Ca|ra|van *engl.* [*kạrawan*, auch: *kạrawan*, seltener: *kär^ewän* od. *kär^ewän*] (kombinierter Personen- u. Lastenwagen; Wohnwagen) *m*; -s, -s; Ca|ra|va|ner; Ca|ra|va|ning [*kär^ewäning*] (Leben im Wohnwagen) *s*; -s

Car|bid vgl. Karbid

Car|bo... usw. vgl. Karbo... usw.

Car|bo|ne|um *lat.* [*kar...*] (in Deutschland veralt. für: Kohlenstoff, chem. Grundstoff; Zeichen: C) *s*; -s

Car|bo|run|dum ⓦ vgl. Karborund

Car|ci|no|ma vgl. Karzinom

care of *engl.* (in Briefanschriften usw.: bei ...; Abk.: c/o)

Ca|rio|ca *indian.-port.* [*kariọka*] (lateinamerik. Tanz) *w*; -, -s

Ca|ri|tas (Kurzbez. für den Deutschen Caritasverband der kath. Kirche) *w*; -; vgl. Karitas

Car|los [*kạr...*] (span. m. Eigenn.)

Car|lyle [*ka'laịl*] (engl. Schriftsteller u. Historiker)

Car|ma|gno|le [*karmanjọl^e*] Revolutionslied [*Einz.*]; auch: ärmellose, locker tragbare Jacke [der Jakobiner]) *w*; -, -n

Car|men [*kạr...*] (w. Vorn.)

Car|nal|lit vgl. Karnallit

Car|ne|gie [*ka'nặgi*] (nordamerik. Milliardär); Car|ne|gie Hall [- *hål*] (Konzerthalle in New York) *w*; - -

Car|net [de pas|sa|ges] [*karnằ* (*d^e paßạseh^e*)] (Sammelheft von Triptiks, Zollpassierscheinheft für Kraftfahrzeuge) *s*; - - -, -s [*karnằ*...]

Ca|ro|la vgl. Karola

Ca|ros|sa [*ka...*] (dt. Dichter)

Ca|ro|tin vgl. Karotin

Car|pen|ter|brem|se vgl. Karpenterbremse

Car|ra|ra [*ka...*] (it. Stadt); Car|ra|rer; car|ra|risch; -er Marmor († R 224)

Car|sten vgl. Karsten

Carte blanche *fr.* [*kạrt blạngsch*] („weiße Karte"; unbeschränkte Vollmacht) *w*; - -, -s -s [*kạrt blạngsch*]

car|te|sia|nisch, car|te|sisch vgl. kartesianisch, kartesisch; Car|te|si|us [*kar...*[(lat. Schreibung von: Descartes)

Car|tha|min vgl. Karthamin

Car|toon *engl.* [*ka'tụn*] (engl. Bez. für: Karikatur) *m* od. *s*; -[s], -s

Ca|ru|so [*ka...*] (it. Sänger)

Ca|sals [*k...*] (span. Cellovirtuose)

¹Ca|sa|no|va [*kaßanọwa*] (it. Abenteurer, Schriftsteller u. Frauenheld); ²Ca|sa|no|va [*kasa...*] (ugs. für: Frauenheld, -verführer) *m*; -[s], -s

¹Cä|sar [*zä...*] (röm. Feldherr u. Staatsmann; m. Vorn.); ²Cä|sar (Ehrenname der römischen Kaiser) *m*; -en, -en († R 268); Cä|sa|ren|wahn; cä|sa|risch (kaiserlich; selbstherrlich); Cä|sa|ris|mus (Cäsarentum; unbeschränkte Staatsgewalt) *m*; -; Cä|sa|ro|pa|pis|mus (eine Staatsform, bei der der weltl. Herrscher zugleich geistl. Oberhaupt ist) *m*; -

Cash *engl.* [*käsch*] (engl. Bez. für: Kasse, Barzahlung); Cash-and-car|ry-Klau|sel [*käsch^endkäri...*] (Überseehandel: der Käufer muß die Ware bar bezahlen u. im eigenen Schiff abholen) *w*; -

Ca|si|mir vgl. Kasimir

Cä|si|um *lat.* [*zä...*] (chem. Grundstoff, Metall; Zeichen: Cs) *s*; -s

Cas|sa|ta (Speiseeisspezialität) *w*; -, -s

Cas|sio|peia vgl. ²Kassiopeia

Cas|si|us [*kạ...*] (Name eines röm. Staatsmannes)

Ca|stel Gan|dol|fo [*ka...*] (it. Stadt am Albaner See; Sommerresidenz des Papstes)

Ca|stor vgl. Kastor

Ca|stro [*kạ...*], Fidel (kuban. Politiker)

Ca|sua|ri|na vgl. Kasuarina

Ca|sus bel|li *lat.* [*ka... -*] („Kriegsfall"; Grund zum Kriege) *m*; -, - [*kạßụß*] -; Ca|sus ob|li|qu|us (Sprachw.: abhängiger Fall, z. B. Genitiv, Dativ, Akkusativ) *m*; - - [*kạßụß*] ...qui; Ca|sus rec|tus (Sprachw.: unabhängiger Fall, Nominativ) *m*; - -, - [*kạßụß*] ...ti; vgl. Kasus

Ca|tal|pa vgl. Katalpa

Ca|ta|nia [*ka...*] (Stadt auf Sizilien)

Catch-as-catch-can *amerik.* [*kätsch^eskätschkän*] (Freistilringkampf nordamerik. Herkunft) *s*; -; cat|chen [*kätsch'n*]; Cat|cher [*kätsch^er*] (Freistilringkämpfer)

Catch|up vgl. Ketchup

Ca|te|nac|cio it. [*katenạtscho*; „Kette, Riegel"] (Technik des Fußballspiels, bei der sich die gesamte Mannschaft beim Angriff des Gegners kettenartig vor dem

eigenen Strafraum zusammenzieht) *m*; -[s]

Cat|gut vgl. Katgut

Ca|ti|li|na [*ka...*] (röm. Verschwörer); vgl. katilinarisch

Ca|to [*kạto*] (röm. Zensor); vgl. katonisch

Cat|ta|ro [*kạ...*] (it. Schreibung von: Kotor)

Ca|tull, Ca|tul|lus [*ka...*] (röm. Dichter)

Cau|sa *lat.* [*kạusa*] (Grund, Ursache, [Streit]sache) *w*; -, ...sae [*sä*]; Cause cé|lè|bre *fr.* [*kosßeläbr*] (berühmter Rechtsstreit; berüchtigte Angelegenheit) *w*; - -, -s -s [*kosßeläbr*]; Cau|se|rie [*kos^erị*] (veralt. für: unterhaltsame Plauderei) *w*; -, ...ien; Cau|seur [*kosọ̈r*] (veralt. für: unterhaltsamer Plauderer) *m*; -s, -e

ca|ve ca|nem! *lat.* [*kạwe kạnäm*] („hüte dich vor dem Hund!"; Inschrift auf der Tür od. Schwelle altröm. Häuser)

Ca|vour [*kawụr*] (it. Staatsmann)

Ca|yenne [*kajän*] (Hptst. von Französisch-Guayana); Ca|yenne|pfef|fer (ein scharfes Gewürz); † R 201

cbkm, km³ = Kubikkilometer

cbm, m³ = Kubikmeter

ccm, cm³ = Kubikzentimeter

cd = Candela

Cd = chem. Zeichen für: Cadmium

CD = Corps diplomatique

cdm, dm³ = Kubikdezimeter

CDU = Christlich-Demokratische Union (Deutschlands)

C-Dur [*zẹdur*, auch: *zẹdur*] (Tonart; Zeichen: C) *s*; -; C-Dur-Ton|lei|ter [*zẹ*...] († R 155)

Ce = Cer

Ce|bi|on ⓦ [*zẹ*...] (Vitamin-C-Präparat) *s*; -s

Ce|dil|le *fr.* [*ßedịj^e*] (fr. Zeichen für die Ausspr. von c als stimmloses s vor a, o, u: ç) *w*; -, -n

Ce|le|bes [*zele..., auch: zẹle...*] (drittgrößte der Großen Sundainseln)

Ce|le|sta *it.* [*tsche...*] (Stahlplattenklavier) *w*; -, -s u. ...sten

Ce|li|bi|da|che [*tschelibidạke*] (rumän. Dirigent)

Cel|la [*zäla*] (Hauptraum im antiken Tempel; früher für: Mönchszelle; Med. für: Zelle) *w*; -, Cellae [...*ä*]

Cel|le [*zäl^e*] (Stadt an der Aller); Cel|ler († R 199); cel|lisch, (auch:) cel|lesch

Cel|li|ni [*tsche...*] (it. Goldschmied u. Bildhauer)

Cel|list *it.* [*t*)*tschä...*] (Cellospieler); † R 268; Cel|lo (Kurzform für: Violoncello) *s*; -s, -s u. ...lli

Cel|lon ⓦ *lat.* [*zälọn*] (Kunststoff,

s; -[s]; **Cel|lo|phan** Ⓦ [...*fan*] *s*; -s u. **Cel|lo|pha|ne** Ⓦ *lat.*; *gr.* (glasklare Folie, Zellulosehydrat) *w*; -; **cel|lo|pha|nie|ren**

Cel|si|us [*zäl*...]; nach dem Schweden Anders Celsius] (Einheit der Grade beim 100teiligen Thermometer; Zeichen: C); 5° C (vgl. S. 86, 9, f.)

Cem|ba|lo *it.* [*tschäm*,,,] (Kurzform für: Clavicembalo) *s*; -s, -s u. ...li

Ce|no|man [*zeno*...; nach der röm. Stadt Cenomanum = Le Mans] (Geol.: Stufe der Kreideformation) *s*; -s

Cent *engl.* [*ßänt*] (Münze; Abk.: c u. ct; Zeichen: ¢) *m*; -[s], -[s] (Abk.: cts); 5 - (↑ R 322)

Cen|ta|vo *port.* u. *span.* [*ßäntgwo*] (Münze auf den Philippinen, in Portugal, Süd- u. Mittelamerika usw.) *m*; -[s], -[s]

Cen|te|nar usw. vgl. Zentenar usw.

Cen|ter *amerik.* [*ßänt°r*] („Zentrum, Mittelpunkt" als Bez. für größere Läden, Vergnügungsstätten u. a. meist in Zusammensetzungen, z. B. Mode-Center, Eros-Center) *s*; -s, -

Cen|te|si|mo *it.* [*tschän*...] (it. Münze) *m*; -[s], ...mi

Cen|té|si|mo *span.* [*ßäntę*...] (Münze in Chile, Panama, Uruguay) *m*; -[s], -[s]

Cen|time *fr.* [*ßangtim*] (belg., fr., luxemb. usw. Münze; schweiz. veraltend neben: Rappen; Abk.: c, ct, schweiz.: Ct.) *m*; -s, -s [...*tim(ß)*] (Abk.: ct od. cts, schweiz.: Ct.)

Cén|ti|mo *span.* [*ßän*...] (Münze in Spanien, Mittel- u. Südamerika) *m*; -[s], -[s]

Ce|pheus vgl. ²Kepheus

Cer *lat.* [*zęr*] (chem. Grundstoff, Metall; Zeichen: Ce) *s*; -s

Cer|be|rus vgl. Zerberus

Cer|cle *fr.* [*ßärk°l*] (Empfang [bei Hofe]; vornehmer Gesellschaftskreis; österr. auch: die ersten Reihen im Theater u. in einem Konzertsaal) *m*; -s, -s; - halten; **Cer|cle|sitz** österr. (Sitz im Cercle)

Ce|rea|li|en *lat.* [*zereali°n*] (altröm. Fest zu Ehren der Ceres) *Mehrz.*; vgl. aber: Zerealien

Ce|re|bel|lum vgl. Zerebellum; **Ce|re|brum** vgl. Zerebrum

Ce|res [*zęräß*] (röm. Göttin der Feldfrucht u. des Wachstums)

Ce|re|sin vgl. Zeresin

ce|rise *fr.* [*ß°ris*] (kirschrot)

Ce|ro|tin|säu|re vgl. Zerotinsäure

Cer|to|sa *it.* [*tschär*...] („Kartause"; Kloster der Kartäuser in Italien) *w*; -, ...sen

Cer|van|tes [*ßärwąntäß*] (span. Dichter)

Cer|ve|lat *fr.* [*ßärw°la*] schweiz. (Brühwurst aus Rindfleisch mit Schwarten und Speck) *m*; -s, -s; vgl. Servela u. Zervelatwurst

ces, Ces [*zäß*] (Tonbezeichnung) *s*; -,-; **Ces** (Zeichen für: Ces-Dur); in Ces; **Ces-Dur** [auch: *zäßdur*] (Tonart; Zeichen: Ces) *s*; -; **Ces-Dur-Ton|lei|ter** (↑ R 155)

ce|te|ris pa|ri|bus *lat.* [*zę*... -] (unter [sonst] gleichen Umständen od. Bedingungen)

Ce|te|rum cen|seo *lat.* [*zę*... *zän*...] („übrigens meine ich"; stets betonte Ansicht; feste Überzeugung) *s*; - -

Ce|tin|je [*zätinjä*] (montenegrin. Stadt)

Ce|ven|nen [*ßew*...] (frz. Gebirge) *Mehrz.*

Cey|lon [*zailon*, österr.: *zę'lon*] (Inselstaat im Ind. Ozean); **Cey|lo|ne|se** *m*; -n, -n (↑ R 268); **cey|lo|ne|sisch**; **Cey|lon.tee**, ...zimt (Kaneel)

Cé|zanne [*ßesan*] (frz. Maler)

cf = cost and freight *engl.* [*koßt °nd frę't*] (Klausel im Überseehandel: Verladekosten und Fracht sind im Preis eingeschlossen)

Cf = chem. Zeichen für: Californium

cf., cfr. = confer!

cg = Zentigramm

CGS-Sy|stem (intern. Maßsystem, das auf den Grundeinheiten Zentimeter [C], Gramm [G] u. Sekunde [S] aufgebaut ist; vgl. MKS-System) *s*; -s

CH = Confoederatio Helvetica

Cha-Cha-Cha [*tschatschatscha*] (ein Tanz) *m*; -[s], -s

Cha|co vgl. Gran Chaco

Cha|conne *fr.* [*schakon*] *w*; -, -s u. -n [...*n°n*] u. Cia|co|na *it.* [*tschako*na*] (ein Tanz; Instrumentalstück) *w*; -, -s

Cha|gall [*schagal*] (russ. Maler)

Cha|grin *fr.* [*schagräng*] (Narbenleder; verält. für: Gram, Kummer) *s*; -s; **cha|gri|nie|ren** [*schagri*nir*°n*] (Leder künstlich mit Narben versehen); **Cha|grin|le|der** [*schagräng*...]

Chai|ne *fr.* [*schän°*] („Kette" beim Tanz; Kettfaden) *w*; -, -s

Chair|man *engl.* [*tschä°m°n*] (engl. Bez. für den Vorsitzenden eines polit. od. wirtschaftl. Gremiums) *m*; -, ...men

Chai|se *fr.* [*schäs°*] (verält. für: Stuhl, Sessel; [halbverdeckter] Wagen) *w*; -, -n; **Chai|se|longue** [*schäs°longg*] („Langstuhl"; gepolsterte Liegestatt mit Kopflehne, Liege) *w*; -, -n [*schäs°longg°n*] u. -s (ugs. auch: [...*long*] *s*; -s, -s)

Chal|ci|di|ce vgl. Chalkidike

Chal|däa [*kal*...] (Babylonien); **Chal|dä|er** (aramäischer Volksstamm); **chal|dä|isch**

Cha|let *fr.* [*schalę*, ...*lä*] (Sennhütte; Schweizerhäuschen, Landhaus) *s*; -s, -s

Chal|ki|di|ke [*chal*...] (nordgr. Halbinsel) *w*; -

Chal|ko|che|mi|gra|phie[1] *gr.* [*chalko*...] (Metallgravierung) *w*; -; **Chal|ko|gra|phie**[1] (frühere Bez. für: Kupferstechkunst) *w*; -

Chal|ze|don [*kal*...] (ein Mineral) *m*; -s, -e

Cham [*kam*] (Stadt am Regen u. Stadt am Zuger See)

Cha|mä|le|on *gr.* vgl. Schamade

Cha|mä|le|on *gr.* [*ka*...] (bes. auf Bäumen lebende Echse) *s*; -s, -s; **cha|mä|le|on|ar|tig**

Cha|ma|ve [*cha*...] (Angehöriger eines germ. Volksstammes) *m*; -n, -n (↑ R 268)

Cham|ber|lain [*tsche'mb°rlin*] (engl. Familienn.)

Cham|bre sé|pa|rée *fr.* [*schangbr° ßeparę*] (Sonderraum) *s*; - -, -s [*schangbr° ßeparę*]

Cha|mis|so [*schu*...] (dt. Dichter)

cha|mois *fr.* [*schamoą*] (gemsfarben, gelbbräunlich); vgl. blau; **Cha|mois** (chamois Farbe; weiches Gemsen-, Ziegen-, Schafleder) *s*; -; in -; **Cha|mois|le|der**

Cham|pa|gne [*schangpanj°*] (fr. Landschaft) *w*; -; **Cham|pa|gner** [*schampanj°r*] (ein Schaumwein); **cham|pa|gner|far|ben**, **cham|pa|gner|far|big**; **Cham|pa|gner|wein**; **Cham|pi|gnon** [*schangpinjong*, meist *schampinjong*] (ein Edelpilz) *m*; -s, -s; **Cham|pi|on** *engl.* [*tschämpi°n*, auch: *schangpiong*] (Meister in einer Sportart) *m*; -s, -s; **Cham|pio|nat** *fr.* [*scham*...] (Meisterschaft in einer Sportart) *s*; -[e]s, -e

Champs-Ély|sées [*schangselise*] („Elysäische Felder"; eine Hauptstraße in Paris) *Mehrz.*

Chan vgl. Khan

Chan|ce *fr.* [*schangß°*, österr.: *schangß*] (günstige Möglichkeit, Gelegenheit) *w*; -, -n; vgl. auch: ¹Schanze

Chan|cel|lor *engl.* [*tschanß°l°r*] (Bez. für den Kanzler in England) *m*; -s, -s

Change *fr.* u. *engl.* [*schangseh*, engl. Aussspr.: *tsche'ndseh*] (fr. u. engl. Bez. für: Tausch, Wechsel, bes. von Geld; bei fr. Aussspr.) *w*; -, (bei engl. Aussspr.:) *m*; -; **chan|geant** *fr.* [*schangschang*] (von Stoffen: in mehreren Farben schillernd); **Chan|geant** (schillernder Stoff; Edelstein mit schil-

[1] Auch eindeutschend: ...grafie.

194

lernder Färbung) *m*; -[s], -s; **chan|gie|ren** [*schangsehir*ᵉ*n*] (schillern [von Stoffen]; Reitsport: vom Rechts- zum Linksgalopp übergehen; Jägerspr.: die Fährte wechseln [vom Jagdhund])

Chan|son *fr.* [*schangßong*] *s*; -s, -s; **Chan|so|net|te**, (nach fr. Schreibung auch:) **Chan|son|net|te** [*schangßo...*] (Chansonsängerin; kleines Chanson) *w*; -, -n; **Chan|son|nier** [*schangßonie*] (Chansonsänger, -dichter) *m*; -s, -s

Cha|os *gr.* [*kaoß*] *s*; -; **Chao|ten** [*ka...*] (polit. Chaos erstrebende Radikale)*Mehrz.*; **chao|tisch**

Cha|peau *fr.* [*schapo*] (scherzh. für: Hut) *m*; -s, -s; **Cha|peau claque** [*schapoklak*] (Klappzylinder) *m*; - -, -x -s [*schapoklak*]

Chap|lin [*tschäplin*], Charlie (engl. Filmschauspieler, Autor u. Regisseur); **Chap|li|na|de** [*tscha...*] (komischer Vorgang nach Art derjenigen in Chaplins Filmen) *w*; -, -n

Cha|ra|de vgl. Scharade

Cha|rak|ter *gr.* [*ka...*] *m*; -s, ...ere; **Cha|rak|ter...an|la|ge**, ...**bild**, ...**bil|dung**, ...**dar|stel|ler**, ...**ei|gen|schaft**, ...**feh|ler**; **cha|rak|ter|fest**; **Cha|rak|ter|fe|stig|keit** *w*; -; **cha|rak|te|ri|sie|ren**; **Cha|rak|te|ri|sie|rung**; **Cha|rak|te|ri|stik** (Kennzeichnung; [eingehende, treffende] Schilderung; Technik: Kennlinie; Kennziffer eines Logarithmus) *w*; -, -en; **Cha|rak|te|ri|sti|kum** (bezeichnende, hervorstechende Eigenschaft) *s*; -s, ...ka; **cha|rak|te|ri|stisch**; -ste (↑ R 294); -e Funktion (Math.); **cha|rak|te|ri|sti|scher|wei|se**; **Cha|rak|ter|kopf**, ...**kun|de** (für: Charakterologie; *w*; -); **cha|rak|ter|lich**; **cha|rak|ter|los**; -este (↑ R 292); **Cha|rak|ter|lo|sig|keit**; **Cha|rak|te|ro|lo|gie** (Charakterkunde, Persönlichkeitsforschung) *w*; -; **cha|rak|te|ro|lo|gisch**; **Cha|rak|ter...rol|le**, ...**schwä|che**, ...**spie|ler**, ...**stär|ke**, ...**stück** (Klavierstück, dessen Gehalt durch den Titel bezeichnet ist), ...**stu|die**; **cha|rak|ter|voll**; **Cha|rak|ter|zug**

Char|ge *fr.* [*scharseh*ᵉ] (Amt; Würde; Rang; Militär: Dienstgrad, Vorgesetzter; Technik: Ladung, Beschickung [von metallurgischen Öfen]; Theater: [stark ausgeprägte] Nebenrolle) *w*; -, -n; **char|gen|spie|ler**; **char|gie|ren** [*scharsehir*ᵉ*n*] (Technik: beschicken; Theater: eine Charge stark ausgeprägt spielen); **Char|gier|te** (Mitglied des Vorstandes einer stud. Verbindung) *m*; -n, -n (↑ R 287 ff.)

Cha|ris *gr.* [auch: *chariß*] (Anmut)

w; -, (für: gr. Göttinnen der Anmut: Aglaia, Euphrosyne, Thalia:) ...**jten**; **Cha|ris|ma** [auch: *cha...*] (Gnade, Berufung) *s*; -s, ...**ris|men** u. ...**ris|mata**; **cha|ris|ma|tisch**; **Cha|ri|té** *fr.* [*scharite*] („christliche [Nächsten]liebe"; Name von Krankenhäusern) *w*; -, -s; **Cha|ri|ten** vgl. Charis; **Cha|ri|tin** *gr.* [*cha...*] (Göttin der Anmut) *w*; -, -nen

Cha|ri|va|ri *fr.* [*schariwari*] (veralt. für: Durcheinander; Katzenmusik) *s*; -s, -s

Char|kow [*charkof*, auch: *-ch...*] (Stadt in der UdSSR)

Charles [fr.: *scharl*, engl.: *tscha*ᵃ*ls*] (fr. u. engl. Form von: Karl)

Charles|ton *engl.* [*tscha*ᵃ*lßt*ᵉ*n*] (ein Tanz) *m*; -s, -s

Char|ley, **Char|lie** [*tscha*ᵃ*li*] (Koseformen von: Charles [engl.])

Char|lot|te [*schar...*] (w. Vorn.); **Char|lot|ten|burg** (Stadtteil Berlins); vgl. Berlin

char|mant *fr.* [*schar...*], (eindeutschend:) **schar|mant**; **Char|me** [*scharm*], (eindeutschend:) **Schärm** *m*; -s; **Char|meur** [...*ör*] (charmanter Plauderer) *m*; -s, -e; **Char|meuse** [*scharmös*] (maschenfeste Wirkware [aus Kunstseide]) *w*; -

Cha|ron [*charon*] (in der gr. Sage Fährmann in der Unterwelt)

Char|ta *lat.* [*karta*] ([Verfassungs]urkunde, [Staats]grundgesetz) *w*; -, -s; die Magna Charta (vgl. d.); **Char|te** *fr.* [*schart*] (wichtige Urkunde im Staats- u. Völkerrecht) *w*; -, -n; **Char|ter** *engl.* [(t)*schar*...] (Freibrief, Urkunde; Frachtvertrag) *w*; -, -, (auch:) *m*; -s, -s; **Char|te|rer** (Mieter eines Schiffes od. Flugzeuges) *m*; -s, -; **Char|ter|flug**, **Char|ter...flug|zeug**, ...**ge|schäft**, ...**ge|sell|schaft**, ...**ma|schi|ne**; **char|tern** (ein Schiff od. Flugzeug mieten); ich ...ere (↑ R 327); gechartert; **Char|te|rung**

¹Char|treu|se *fr.* [*schartrös*ᵉ] (Hauptkloster des Kartäuserordens) *w*; -; **²Char|treu|se** Ⓦ (urspr. von fr. Kartäusermönchen hergestellter Kräuterlikör) *m*; -; **³Char|treu|se** (Pudding aus Gemüse u. Fleischspeisen) *w*; -, -n

Cha|ryb|dis *gr.* [*cha...*] (bei Homer Seeungeheuer; Meeresstrudel in der Straße von Messina) *w*; -; vgl. Szylla

Chas|se|pot|ge|wehr [*schaß*ᵉ*po...*]; nach dem fr. Erfinder; ↑ R 180 **Chas|sis** *fr.* [*schaßi*] (Fahrgestell des Kraftwagens; Rahmen [eines Rundfunkgerätes]) *s*; - [...*ßi*(*ß*)], - [...*ßiß*]

Cha|suble *fr.* [*schasübl*, auch in

engl. Aussprache: *tschäsjubl*] (ärmelloses [an den Seiten offenes] Überkleid) *s*; -s, -s

Châ|teau *fr.* [*schato*] (fr. Bez. für: Schloß) *s*; -s, -s

Cha|teau|bri|and [*schatobriang*] (fr. Schriftsteller u. Politiker)

Cha|tscha|tur|jan [*chatschaturjan*] (russ. Komponist)

Chat|te [*ka...*] (Angehöriger eines westgerm. Volksstammes) *m*; -n, -n (↑ R 268)

Chau|cer [*tschâß*ᵉ*r*] (engl. Dichter)

Chau|deau *fr.* [*schodo*] (warme Weinschaumsoße) *s*; -[s], -s

Chauf|feur [*schofōr*] *m*; -s, -e; vgl. auch Schofför; **chauf|fie|ren** [*schofir*ᵉ*n*] (veralt.)

Chau|ke [*chauk*ᵉ] (Angehöriger eines westgerm. Volksstammes) *m*; -n, -n (↑ R 268)

Chaul|moo|gra|öl *Bengali*; *lat.* [*tschâlmugra...*] (Heilmittel gegen Hautkrankheiten)

Chaus|see *fr.* [*schoße*] (Landstraße) *w*; -, ...**sseen**; *Schreibung in Straßennamen*: ↑ R 219 ff.; **Chaus|see...baum**, ...**gra|ben**, ...**haus**

Chau|vi|nis|mus *fr.* [*schowi...*] (einseitige, überspitzte Vaterlandsbegeisterung; Kriegshetze) *m*; -; **Chau|vi|nist** (↑ R 268); **chau|vi|ni|stisch**; -ste (↑ R 294)

Che [*tschä*] (volkstüml. Name von: Guevara)

Cheb [*chäp*] (tschechoslowak. Name von: Eger)

Check *engl.* [*tschäk*] (beim Eishockey jede Behinderung des Spielverlaufs) *m*; -s, -s; **checken** [*tschä|k*ᵉ*n*; *Trenn.*: ...**k|k**...] (Eishockey: behindern, [an]rempeln; nachprüfen, kontrollieren); **Check|point** [*tschäkpeunt*] (Kontrollpunkt an Grenzübergangsstellen) *m*; -s, -s

chee|rio! *engl.* [*tschiriо*ᵘ, auch: *tschirio*] (ugs. für: auf Wiedersehen!; prost!, zum Wohl!)

Chef *fr.* [*schäf*, österr.: *schef*] *m*; -s, -s; **Chef|arzt**, ...**ideo|lo|ge**; **Che|fin** *w*; -, -nen; **Chef...in|ge|nieur**, ...**lek|tor**, ...**pi|lot**, ...**re|dak|teur**, ...**se|kre|tä|rin**, ...**trai|ner**

Che|mie *arab.* [*che...*, österr.: *ke...*] *w*; -; **Che|mie..ar|bei|ter**, ...**fa|ser**, ...**in|ge|nieur**, ...**wer|ker**; **Che|mi|graph**¹ *arab.*; *gr.* (Hersteller von Druckplatten) *m*; -en, -en (↑ R 268); **Che|mi|gra|phie**¹ (Herstellung von Druckplatten mit chem. Mitteln) *w*; -; **Che|mi|ka|lie** *w*; -, -ien [...*i*ᵉ*n*] (meist *Mehrz.*); **Che|mi|ker**; **Che|mi|ke|rin** *w*; -, -nen

Che|mi|née *fr.* [*schmine*] schweiz (offener Kamin in modernem Haus) *s*; -s, -s

¹ Auch eindeutschend: ...grafie.

che|misch *arab.*; -e Reinigung; -es Element; -e Verbindungen; **chemisch-tech|nisch** († R 158)
Che|mise *fr.* [*sch^emịs*] (hemdartiges Kleid um 1800) *w*; -, -n; **Chemi|sett** *s*; -[e]s, -s u. -e u. **Che|misett|te** („Hemdchen"; Vorhemd, Hemdbrust; Einsatz an Damenkleidern) *w*; -, -n
che|mi|zie|ren *arab.*; *lat.* [*che...,* österr.: *ke...*] (DDR: in der techn. Entwicklung verstärkt die Chemie anwenden); **Che|mis|mus** (Gesamtheit der chem. Vorgänge bei Stoffumwandlungen [bes. im Tier- od. Pflanzenkörper]) *m*; -
Chem|nitz [*kạm...*] (dt. Stadt am Fuße des Erzgebirges, heute offz.: Karl-Marx-Stadt; **Chemnit|zer** († R 199)
che|mo|tak|tisch *arab.*; *gr.* [*che...*] (die Chemotaxis betreffend); **Che|mo|ta|xis** (durch chem. Reizung ausgelöste Orientierungsbewegung von Tieren u. Pflanzen) *w*, -, ...xen; **Che|mo|tech|niker**; **che|mo|the|ra|peu|tisch**; **Chemo|the|ra|pie** (Behandlung von Infektionskrankheiten mit chemischen Stoffen) *w*; -
...chen (z. B. Mädchen, *s*, -s, -)
Che|nil|le *fr.* [*sch^enịlj*, auch: *sch^enịje*] („Raupe"; haariges, raupenähnliches Garn) *w*; -, -n
Che|ops [*chẹ...*, österr.: *kẹ...*] (altägypt. Herrscher; **Che|ops|pyra|mi|de** *w*; - († R 180)
Cher|bourg [*schärbụr*] (fr. Stadt)
cher|chez la femme! *fr.* [*schärsche la fạm*] („sucht nach der Frau!", d. h., hinter der Sache steckt bestimmt eine Frau)
Cher|ry Bran|dy *engl.* [*(t)schạ̈ri brändi*] (feiner Kirschlikör) *m*; - -s, - -s
Cher|so|nes [*chärsonẹß*] (antiker Name mehrerer griech. Halbinseln) *m* (fachspr. auch: *w*); -, -e
Che|rub *hebr.* [*chẹ...*], (ökum.:) **Ke|rub** (das Paradies bewachender Engel) *m*; -s, -im u. -inen (auch: Cherube); **che|ru|bi|nisch** (engelgleich), aber: der Cherubinische Wandersmann († R 224)
Che|rus|ker [*che...*] (Angehöriger eines westgerm. Volksstammes) *m*; -s, -
Che|ster [*tschäßt^er*] (engl. Stadt); **Che|ster|field** [*tschäßt^erfilt*] (engl. Stadt; engl. Eigenn.) **Che|sterkä|se**, ...stan|ge († R 201)
Cheun *korean.* [*tschụn*] (nordkorean. Scheidemünze) *m*; -, -
che|va|le|resk *fr.* [*sch^ewa...*] (ritterlich); **Che|va|lier** [*sch^ewalie*] („Ritter"; fr. Adelstitel) *m*; -s, -s
Che|vau|le|ger [*sch^ewoleschẹ*] (veralt. für: leichter Reiter) *m*;

Che|vi|ot *engl.* [*(t)schạ̈wiot* od. *schẹ...* od. *schä...* (österr. nur so)] (ein Wollstoff) *m*; -s, -s
Che|vreau *fr.* [*sch^ewrọ,* auch: *schä...*] (Ziegenleder) *s*; -s; **Chevreau|le|der**
Che|vro|let ®️ [*schạ̈wrolät*] (amerik. Kraftfahrzeugmarke)
Che|vron [*sch^ewrọ̈ß*] (Wappenk.: Sparren; fr. Dienstgradabzeichen; Gewebe mit Fischgrätenmusterung) *m*; -s, -s
Chew|ing-gum *engl.* [*tschuinggam*] (Kaugummi) *m*; -[s], -s
Chey|enne [*schaiä̈n*] (Angehöriger eines nordamerik. Indianerstammes) *m*; -,
Chi [*chị*] (gr. Buchstabe: *X, χ*) *s*; -[s], -s
Chi|ang Kai-shek [*tschiang-*] (chin. Marschall)
Chi|an|ti [*ki...*] (it. Rotwein) *m*; -[s]
Chi|as|mus *gr.* [*chi...*] (Sprachw.: Kreuzstellung von Satzgliedern, z. B.: „der Einsatz war groß, gering war der Gewinn") *m*; -
Chi|as|so [*ki...*] (schweiz. Ortsn.)
chi|a|stisch *gr.* [*chi...*] (in der Form des Chiasmus, in Kreuzstellung)
chic usw. vgl. schick usw. (in den gebeugten Formen sollte die Schreibung besser nicht verwendet werden)
Chi|ca|go [*schik...*] (Stadt in den USA)
Chi|co|rée [*schikore,* auch: *...re*] (ein Gemüse) *w*; - (auch: *m*; -s)
Chief *engl.* [*tschif*] (engl. Bez. für: Haupt, Oberhaupt) *m*; -s,-s
Chiem|see [*kịm...*] *m*; -s
Chif|fon *fr.* [*schifọng,* österr. ...*ọn*] (feines Gewebe) *m*; -s, -s (österr.: -e); **Chif|fon|nie|re** [*schifoniär^e*] (veralt. für: Kleiderschrank) *w*; -, -n
Chif|fre *fr.* [*schifr^e* auch: *schif^er*] (Ziffer; Geheimzeichen, -schrift; Kennwort) *w*; -, -n; **Chif|freschrift** (Geheimschrift); **Chiffreur** [*schifrör*] (Entzifferer) *m*; -s, -e; **chif|frie|ren** (in Geheimschrift abfassen); **Chif|frier|kunst** *w*; -
Chi|gnon *fr.* [*schinjọng*] (im Nakken getragener Haarknoten) *m*; -s, -s
Chi|ka|go (dt. Form von: Chicago)
Chi|le [*tschịle,* oft: *chịle*] (südamerik. Staat); **Chi|le|ne** *m*; -n, -n († R 268); **Chi|le|nin** *w*; -, -nen; **chi|lenisch**; **Chi|le|sal|pe|ter** († R 201)
Chi|li|as|mus *gr.* [*chi...*] (Lehre von der Erwartung des Tausendjährigen Reiches Christi) *m*; -; **Chi|liast** (Anhänger des Chiliasmus) *m*; -en, -en († R 268); **chi|li|a|stisch**
Chi|mä|ra, [¹Chi|mä|re *gr.* [*chi...*] (Ungeheuer der gr. Sage) *w*; -;

²**Chi|mä|re** (Landw.: Pfropfbastard) *w*; -, -n; ³**Chi|mä|re** usw. vgl. Schimäre usw.
Chim|bo|ras|so [*tschim...*] (ein südamerik. Berg) *m*; -[s]
Chi|na [*chị...*, österr.: *kị...*]
Chi|na.kohl, ...rin|de [*chị...,* österr.: *kị...*] (eine chininhaltige Droge)
Chin|chil|la *indian.-span.* [*tschintschịla* seltener in span. Aussprp.: *...ịlja*] (Nagetier; Pelz) *w*; -, -s od. (österr. nur so:) *s*; -s, -s
Chi|ne|se [*chi...,* österr.: *ki...*] *m*; -n, -n († R 268); **Chi|ne|sin** *w*; -, -nen; **chi|ne|sisch,** aber († R 224): die Chinesische Mauer; **Chi|nesisch** (Sprache) *s*; -[s]; vgl. Deutsch; **Chi|ne|si|sche** *s*; -n; vgl. Deutsche *s*
Chi|nin *indian.* [*chi...,* österr.: *ki...*] (Alkaloid der Chinarinde; ein Fiebermittel) *s*; -s
Chi|noi|se|rie *fr.* [*schinoas^erị*] (kunstgewerbl. Arbeit in chin. Stil) *w*; -, ...ien
Chintz *Hindi* [*tschịnz*] (bedrucktes [Baumwoll]gewebe) *m*; -[es], -e
Chip *engl.* [*tschịp*] (Spielmarke [bei Glücksspielen]) *m*; -s, -s
Chip|pen|dale [*(t)schịp'nde'l*; nach dem engl. Tischler [Möbel]stil) *s*; -[s]; **Chip|pen|dale|stil** *m*; -[e]s († R 180)
Chips *engl.* [*tschịpß*] (in Fett gebackene Scheibchen roher Kartoffeln) *Mehrz.*
Chir|agra *gr.* [*chị...,* österr.: *kị...*] (Med.: Handgicht) *s*; -s, - (auch -en († R 268); **Chi|ro|man|tie** *w*; -; **Chi|ro|prak|tik** (Heilmethode, Wirbel- u. Bandscheibenverschiebungen durch Massagehandgriffe zu beseitigen) *w*; -;
Chir|urg (Facharzt für operative Medizin) *m*; -en, -en († R 268); **Chir|ur|gie** *w*; -, ...ien; **chir|urgisch**
Chi|tin *semit.* [*chi...,* österr.: *ki...*] (hornähnlicher Stoff im Panzer der Gliederfüßer) *s*; -s; **chi|ti|nig** (chitinähnlich); **Chi|ton** (altgr. Untergewand) *m*; -s, -e
Chlad|ni|sche Klang|fi|gur [*kl...* -; nach dem dt. Physiker Chladni] *w*; -n u. -n -en
Chla|mys *gr.* [auch: *chlạ...*] (altgr. Überwurf für Reiter u. Krieger) *w*; -, -
Chlod|wig [*klọt...*] (fränk. König)
Chloe [*klọe*] (w. Eigenn., bes. in Hirtendichtungen)
Chlor *gr.* [*klọr*] (chem. Grundstoff; Zeichen: Cl) *s*; -s; **Chlo|ral** (eine Chlorverbindung) *s*; -s; **chlo|ren, ¹chlo|rie|ren** (Technik: mit Chlor behandeln u. dadurch keimfrei machen); ²**chlo|rie|ren**

(Chlor in eine chem. Verbindung einführen); chlor|hal|tig; Chlo|rid (eine Chlorverbindung) s; -[e]s. -e; chlo|rig; Chlo|rit (ein Mineral) m; -s, -e, (für Salz:) s; -s, -e; Chlorkalk; Chlo|ro|dont ⓦ (Zahnpaste, Mundwasser) s; -s; Chlo|roform gr.; lat. (Betäubungs-, Lösungsmittel) s; -s; chlo|ro|for|mieren (mit Chloroform betäuben); Chlo|ro|phyll gr. (Blattgrün) s; -s; Chlo|ro|se (Bleichsucht) w; -, -n; Chlo|rung (Technik: Behandlung mit Chlor)

Chlo|tar, Chlo|thar [klo...] (alte Schreibungen von: Lothar)

Chlot|hil|de [klo...] (alte Schreibung von: Klothilde)

Cho|do|wiec|ki [kodowiązki, auch: -ch...] (dt. Kupferstecher)

Choke engl. [tscho"k] (Luftklappe am Vergaser) m; -s, -s; Cho|ker [tscho"k"r] (Bedienungsknopf für den Choke) m; -s, -

Cho|le|ra gr. [ko...] (Med.: eine Infektionskrankheit) w; -; Cholera|an|fall, ...epi|de|mie; Cho|le|riker (leidenschaftlicher, reizbarer, jähzorniger Mensch); Cho|leri|ne (Med.: leichter Brechdurchfall) w; -, -n; cho|le|risch (jähzornig; aufbrausend); -ste (↑ R 294); Cho|le|ste|rin (ein Lipoid. Hauptbestandteil der Gallensteine) s; -s

Chon korean. [tschon] (südkorean. Scheidemünze) m; -, -

Cho|pin [schopäng] (poln. Komponist)

¹Chor gr. [kor] ([erhöhter Kirchenraum mit [Haupt]altar) m (seltener s); -[e]s, -e u. Chöre; ²Chor (Gruppengesangswerk; Gemeinschaft von Sängern) m; -[e]s, Chöre; gemischter-; Cho|ral (Kirchenlied der ev. Gemeinde) m; -s, ...räle; Cho|ral_buch, ...vorspiel; Chör|chen

Cho|rea gr. [ko...] (Med.: Veitstanz) w; -; Cho|reo|graph; Choreo|gra|phie (Tanzbeschreibung, Regieentwurf für die Tanzbewegungen) w; -, ...ien; cho|reogra|phie|ren; ein Ballett -; Choreut [cho...] (Tänzer) m; -en, -en (↑ R 268); cho|reu|tik (Tanzkunst) w; -; Chor_ge|bet, ...gestühl; ...chö|rig (z. B. zwei-, dreichörig); cho|risch [ko...]; Cho|rist ([Berufs]chorsänger); ↑ R 268; Cho|ri|stin w; -, -nen; Chor|knabe; Chör|lein (viereckiger kleiner Erker an mittelalterl. Wohnbauten); Chor_lei|ter m, ...re|gent südd. (Leiter eines kath. Kirchenchors), ...sän|ger; Chorus (veralt. für: Sängerchor; im Jazz das mehrfach wiederholte u. improvisierte, aber in der Har-

monie festliegende Thema) m; -, (für Themen Mehrz.:) -se

Cho|se vgl. Schose

Chou En-lai [tschu -] (chin. Politiker)

Chow-Chow chin.-engl. [tschautschau] (chin. Spitz) m; -s, -s

Chre|sto|ma|thie gr. [kräß...] (Auswahl aus Schriftstellern) w; -, ...ien

Chri|sam gr. [chri...] s od. m; -s u. Chris|ma [chriß...] (Salböl der kath. Kirche) s; -s

¹Christ gr. [kr...] (veralt., geh. für: Christus); ²Christ (Anhänger des Christentums) m; -en, -en (↑ R 268); Chri|sta (w. Vorn.); Christbaum landsch. (Weihnachtsbaum); Chri|stel (w. Vorn.); Christen|glau|be[n]; Chri|sten|heit w; -; Chri|sten|leh|re (kirchl. Unterweisung der konfirmierten ev. Jugend; DDR: ev. Religionsunterricht) w; -; Chri|sten|tum s; -s; Chri|sten|ver|fol|gung; Christfest (veraltend für: Weihnachten); Chri|sti|an (m. Vorn.); Christia|ne (w. Vorn.); Chri|stia|nia (früherer Name von: Oslo; ältere Schreibung von: ¹Kristiania); chri|stia|ni|sie|ren; Chri|stia|nisie|rung; Chri|sti|ne w; -, -nen; Christi|na, Chri|sti|ne (w. Vorn.); christ|ka|tho|lisch schweiz. (altkatholisch); Christ_kind, ...kindchen od. ...kind|lein; christ|lich; -e Seefahrt, aber (↑ R 224): die Christlich-Demokratische Union [Deutschlands] (Abk.: CDU), die Christlich-Soziale Union (Abk.: CSU); Christ|lich|keit w; -; Christ_met|te, ...mo|nat od. ...mond (veralt. für: Dezember); Chri|sto|la|trie ([übermäßige] Verehrung Christi) w; -; Chri|stolo|gie (Christuslehre) w; -, ...ien; chri|sto|lo|gisch; Chri|stoph (m. Vorn.); Chri|sto|phel (m. Vorn.); Chri|sto|pho|rus [auch: ...tof...] (,,Christusträger''; ein Heiliger); Christ_ro|se, ...stol|le[n]; Christus (,,Gesalbter''; Jesus Christus); Christi Himmelfahrt; nach Christo od. nach Christus (Abk.: n. Chr.), nach Christi Geburt (Abk.: n. Chr. G.); vor Christo od. vor Christus (Abk.: v. Chr.), vor Christi Geburt (Abk.: v. Chr. G.); vgl. Jesus Christus; Christus_bild, ...glau|be[n], ...kopf, ...mo|no|gramm, ...or|den (port. geistl. Ritterorden; höchster päpstl. Orden); Christ|wurz (Name mehrerer Pflanzen u. Heilkräuter)

Chrom gr. [krom] (,,Farbe''; chem. Grundstoff, Metall; Zeichen: Cr) s; -s; Chro|ma|tik (Physik: Farbenlehre; Musik: Veränderung

der Grundtöne) w; -; Chro|ma|tin (Bestandteil des Zellkerns, der sich mit basischen Farbstoffen leichter als andere Kernstrukturen anfärben läßt) s; -s, -e; chroma|tisch (die Chromatik betreffend; Musik: in Halbtönen fortschreitend); -e Tonleiter; Chroma|to|me|ter (,,Farbenmesser'') s; -s,-; Chro|ma|to|phor (kugeliger Farbstoffträger in der Pflanzenzelle) s; -s, -en (meist Mehrz.); chrom|blit|zend; Chrom_gelb (eine Farbe), ...grün (eine Farbe); chro|mie|ren (Wolle nach dem Färben mit Chromverbindungen beizen; auch für: verchromen); Chro|mo|lith (unglasiertes, farbig gemustertes Steinzeug) m; -s u. -en, -e[n] (↑ R 268); Chro|mo|litho|gra|phie¹ (Farben[stein]druck); Chro|mo|som (Biol.: in jedem Zellkern vorhandene, für die Vererbung bedeutungsvolle Kernschleife) s; -s, -en (meist Mehrz.); chro|mo|so|mal; Chromo|so|men|zahl; Chro|mo|sphä|re (glühende Gasschicht um die Sonne) w; -; Chrom_rot (eine Farbe)

Chro|nik gr. [kro...] (Aufzeichnung geschichtl. Ereignisse nach ihrer Zeitfolge; in der Einz. auch für: Chronika) w; -, -en; Chro|nika (Geschichtsbücher des A. T.) Mehrz.; chro|ni|ka|lisch; Chronique scan|da|leuse fr. [kronik ßkangdalös] (Skandalgeschichten) w; -, -; chro|nisch gr. (langsam verlaufend, langwierig); Chronist (Verfasser einer Chronik); ↑ R 268; Chro|no|gra|phie (Geschichtsschreibung nach der Zeitenfolge) w; -, ...ien; chro|no|graphisch; Chro|no|lo|gie ([Lehre von der] Zeitrechnung; zeitliche Folge) w; -; chro|no|lo|gisch (zeitlich geordnet); Chro|no|me|ter (,,Zeitmesser''; genau gehende Uhr; Taktmesser) s (ugs. auch: m); -s, -; chro|no|me|trisch; Chro|noskop (Vorrichtung zum Messen kleinster Zeitabschnitte) s; -s, -e

Chru|schtschow [kr...] (sowjet. Politiker)

Chrys|an|the|me gr. [krü...] w; -, -n u. Chrys|an|the|mum [auch: chrü...])(Zierpflanze mit großen strahligen Blüten) s; -s, ...emen

Chrys|ler ⓦ [krajsl"r] (amerik. Kraftfahrzeugmarke)

Chry|so|be|ryll (Edelstein); Chrysoi|din [...o-i...] (ein Farbstoff) s; -s; Chry|so|lith (ein Mineral) m; -s u. -en, -e[n] (↑ R 268); Chry|sopras (ein Halbedelstein) m; -es. -e

¹ Auch eindeutschend: ...grafie.

Chry|so|sto|mus („Goldmund"; gr. Kirchenlehrer)

chtho|nisch *gr.* [*chtọ...*] (der Erde angehörend; unterirdisch)

Chubb|schloß ⓦ [*tschạb...*; nach dem engl. Erfinder] (Sicherheitsschloß)

Chur [*kụr*] (Hptst. von Graubünden)

Chur|chill [*tschö'tschil̄*] (engl. Familienn.)

Chur|fir|sten [*kụr...*] (schweiz. Bergkette) *Mehrz.*

chur|welsch usw. [*kụr...*] (veralt. für: rätoromanisch usw.)

Chuz|pe *hebr.-jidd.* [*ɛhụzpᵉ*] (ugs. verächtlich für: Dreistigkeit, Unverschämtheit) *w*; -

Chy|lus *gr.* [*chü...*] (Med.: fetthaltige, daher milchig aussehende Darmlymphe; resorbierter Speisebrei) *m*; -

Chy|mo|sin *gr.* [*chü...*] (Biol.: Labferment) *s*; -s; Chy|mus (Med.: Speisebrei im Magen) *m*; -

Ci = Curie

CIA [*βiaiẹ'*] = Central Intelligence Agency [*βäntrᵉl intạlidsɛhᵉnß gᵉ'dsɛhᵉnßi̇̄*] (US-amerik. Geheimdienst) *m*; -

Cla|co|na vgl. Chaconne

ciao! *it.* [*tschạu*] svw. tschau

¹Ci|ce|ro [*ziz*ᵉ*ro*] (röm. Redner); ²Ci|ce|ro (ein Schriftgrad) *w* (schweiz.: *m*); -; 3 -; Ci|ce|ro|ne *it.* [*tscherọne*] (scherzh. für: [it.] Fremdenführer, der wegen seiner Redseligkeit mit Cicero verglichen wird) *m*; -[s], -s u. ...ni; Ci|ce|ro|nia|ner *lat.* [*ziz*ᵉ*...*] (Anhänger der mustergültigen Schreibweise Ciceros); ci|ce|ro|nia|nisch, ci|ce|ro|nisch (nach der Art des Cicero; mustergültig, stilistisch vollkommen); ciceronianische Beredsamkeit, aber (↑ R 179): Ci|ce|ro|nia|nisch, Ci|ce|ro|nisch

Ci|cis|beo *it.* [*tschitschißß...*] (Hausfreund) *m*; -[s], -s

Cid [*βit*, auch: *zit*] („Herr"; span. Nationalheld) *m*; -[s]

Cie. (schweiz., sonst veralt. für: Co.)

cif [*zif*, *ßif*] = cost, insurance, freight *engl.* [*koßt*, *inschur*ᵉ*nß*, *frē't*] (Klausel im Überseehandel: frei von Kosten für Verladung, Versicherung, Fracht)

Cil|li [*zili*] (Kurzform von: Cäcilie)

Cin|cho|na [*βintschọna*] (Chinarindenbaum) *w*; -, ...nen; Cin|cho|nin (Alkaloid der Cinchona) *s*; -s

Cin|cin|na|ti [*βinßinäti*] (Stadt in den USA)

Cin|cin|na|tus [*zinzi...*] (röm. Staatsmann)

Ci|ne|ast *gr.* [*βi...*] (Filmfachmann, Filmschaffender; auch für: Filmfan) *m*; -en, -en (↑ R 268)

Ci|ne|cit|tà *it.* [*tschinetschitạ*] (it. Filmproduktionszentrum bei Rom)

Ci|ne|ma|scope ⓦ *engl.* [*βinemaßkọp*] (bes. Breitwand- u. Raumtonverfahren beim Film) *s*; -; Ci|ne|ma|thek *gr.* [*βi...*] (svw. Filmothek) *w*; -, -en; Ci|ne|ra|ma ⓦ (besonderes Breitwand- u. Raumtonverfahren)

Cin|que|cen|tist *it.* [*tschinkwetschän...*] (Dichter, Künstler des Cinquecentos), ↑ R 268; Cin|que|cen|to (Kunstzeitalter in Italien im 16. Jh.) *s*; -[s]

CIO [*βiaiọ*°] = Congress of Industrial Organizations [*kọnggräß°w indạßtri²l o'g°naisᵉ'sch²ns*] (Spitzenverband der amerik. Gewerkschaften)

Ci|pol|lin, Ci|pol|li|no *it.* [*tschi...*] (Zwiebelmarmor) *m*; -s

Cip|pus vgl. Zippus

cir|ca (häufige Schreibung für: zirka; Abk.: ca.)

Cir|ce [*zirze*] (verführerische Frau, die es darauf anlegt, Männer zu betören) *w*; -, -n; vgl. bei: cen

cir|cen|sisch vgl. zirzensisch

Cir|cu|lus vi|tio|sus [*zir... wiz...*] (Zirkelschluß, bei dem das zu Beweisende in der Voraussetzung enthalten ist) *m*; - -, ...li ...si

Cir|cus vgl. Zirkus

¹cis, Cis [*ziß*] (Tonbezeichnung) *s*; -, -; ²cis (Zeichen für: cis-Moll); in cis; Cis (Zeichen für: Cis-Dur); in Cis; Cis-Dur [auch: *zißdụr*] (Tonart; Zeichen: Cis) *s*; -; cis-Dur-Ton|lei|ter (↑ R 155); cis-Moll [auch: *zißmọl̄*] (Tonart; Zeichen: cis) *s*; -; cis-Moll-Ton|lei|ter (↑ R 155)

ci|tis|si|me *lat.* [*zi...*] (sehr eilig); cito [*zịto*] (eilig)

Ci|toy|en *fr.* [*βitoajạ̈ŋ*] (fr. Bez. für: Bürger) *m*; -s, -s

Ci|trat vgl. Zitrat; Ci|trin vgl. Zitrin

Ci|troën ⓦ [*βitroạ̈n*] (fr. Kraftfahrzeugmarke)

Ci|ty *engl.* [*βịti*] (Geschäftsviertel in Großstädten; Innenstadt) *w*; -, -s

Ci|vet *fr.* [*βiwạ̈*] (Ragout von Hasen u. anderem Wild) *s*; -s,-s

Ci|vi|tas Dei *lat.* [*ziw...*] (kommende [jenseitige] Gottesstaat [nach Augustinus]) *w*; - -

Ci|vi|ta|vec|chia [*tschiwitawäkia*] (it. Ortsn.)

cl = Zentiliter

Cl = chem. Zeichen für: Chlor

c. l. = citạto loco [*zi... lọko*] (am angeführten Ort)

Claim *engl.* [*klē'm*] (Anspruch, Besitztitel; Anteil an einer Goldgräberunternehmung) *s*; -[s], -s

Clair-ob|scur *fr.* [*klärọbßkụr*] (bild. Kunst: Helldunkel) *s*; -s

Clair|vaux [*klärwọ*] (ehemalige fr. Abtei)

Clan *fr.* [*klạn*, engl. Ausspr.: *klän*] ([schott.] Lehns-, Stammesverband) *m*; -s, -e u. (bei engl. Ausspr.:) -s

Claque *fr.* [*klạk*] (eine bestellte Gruppe von Claqueuren) *w*; -; Cla|queur [*klakör*] (bezahlter Beifallklatscher) *m*; -s, -e

Clau|del [*klodạl*] (fr. Dichter)

Clau|dia, Clau|di|ne (w. Vorname); Clau|di|us (röm. Kaiser)

Clau|se|witz (preuß. General)

Claus|thal-Zel|ler|feld (Stadt im Harz)

Cla|vi|cem|ba|lo *it.* [*klawitschäm...*] (Kielflügel, Klavizimbel, Tasteninstrument des 14. bis 18. Jh.s) *s*; -s, -s u. ...li; Cla|vi|cu|la vgl. Klavikula

Clea|ring *engl.* [*klịring*] (Verrechnung[sverfahren]) *s*; -s, -s; Clea|ring|ver|kehr *m*; -[e]s

Cle|mens (m. Vorn.), Cle|men|tia [*...zia*] (w. Vorn.); ¹Cle|men|ti|ne (w. Vorn.)

²Cle|men|ti|ne vgl. ²Klementine

Clerk *engl.* [*klạ'k*] (Gerichtsschreiber, Buchhalter u.a. in England u. Amerika) *m*; -s, -s

cle|ver *engl.* [*kläw*ᵉ*r*] (klug, gewitzt; Sport: eine Sportart besonders gut beherrschend)

Cli|burn [*klaibö'n*], Van [*wän*] (amerik. Pianist)

Cli|ché vgl. Klischee

Clinch *engl.* [*klịn(t)sch*] (Umklammerung des Gegners im Boxkampf) *m*; -[e]s

Clip vgl. Klipp, Klips

Clip|per ⓦ *engl.* (Überseeflugzeug der amerik. Luftverkehrsgesellschaft Pan American World Airways); vgl. aber: Klipper

Cli|que *fr.* [*klịkᵉ*, auch: *klịk°*] (Sippschaft; Bande; Klüngel) *w*; -, -n; Cli|quen.bil|dung, ...we|sen (*s*; -s), ...wirt|schaft (*w*; -)

Cli|via [*klịwia*; nach Lady Clive (*klaiw*)] (eine Zierpflanze) *w*; -, ...ien [...i²*n*]; vgl. auch: Klivie

Clo|chard *fr.* [*kloschạr*] (fr. ugs. Bez. für: Landstreicher, Pennbruder) *m*; -[s], -s

Cloi|son|né *fr.* [*kloasọnẹ*] (Art der Emailmalerei; Zellenschmelz) *s*; -s, -s

Clo|qué *fr.* [*klokẹ*] (Damenkleiderstoff, Blasenkrepp) *m*; -[s], -s

Cloth *engl.* [*klọth*, *klọth*] (glänzendes Baumwollgewebe) *m* od. *s*; -

Clou *fr.* [*klụ*] („Nagel"; Glanz-, Höhepunkt; Zugstück; Kernpunkt) *m*; -s, -s

Clown engl. [klaun] (Spaßmacher) m; -s, -s; **Clow|ne|rie** (Betragen nach Art eines Clowns) w; -, ...ien; **clow|nesk** [klaunäßk] (nach Art eines Clowns)

Club vgl. Klub

Clu|ny [klünj] (fr. Stadt; Abtei)

cm = Zentimeter

Cm = chem. Zeichen für: Curium

cm^2, **qcm** = Quadratzentimeter

cm^3, **ccm** = Kubikzentimeter

cmm, mm^3 = Kubikmillimeter

c-Moll [zemol, auch: zemoll] (Tonart; Zeichen: c) s; -; **c-Moll-Tonlei|ter** (↑ R 155)

cm/s, (älter:) **cm/sec** = Zentimeter in der Sekunde

Cn. = Cnaeus [gnäuß] (lat. m. Vorn.)

c/o = care of

Co = Cobaltum (chem. Zeichen für: Kobalt)

Co. = Compagnie, Kompanie vgl. Komp. u. Cie.

Coach engl. [kọ"tsch] (Sportlehrer, Trainer u. Betreuer eines Sportlers) m; -[s], -s; **coa|chen** [kọ"tsch²n] (trainieren, betreuen)

Cob|bler engl. [kọ...] (Cocktail mit Wein, Sekt od. Selters) m; -s, -s

Cobh engl. [kọ"w] (früher: Queenstown; ir. Hafenstadt)

Co|burg [kọ...] (Stadt in Oberfranken); die Veste Coburg

¹**Co|ca** vgl. Koka; ²**Co|ca** (ugs. kurz für: Coca-Cola) s; -[s] u. w; -; **Co|ca-Co|la** ℗ [kokakọla] (Erfrischungsgetränk) s; -[s] u. w; -; 5 [Flaschen] -; **Coca|in** vgl. Kokain

Co|chem [kọ...] (Stadt a. d. Mosel)

Co|che|nil|le [kosch²nịlj²] vgl. Koschenille

Co|chon fr. [koschọng] (fr. Bez. für: Schwein; unanständiger Mensch) m; -s, -s; **Co|chon|ne|rie** [koschon²rị] (Schweinerei) w; -, ...ien

Cocker|spa|niel [Trenn.: Cokker...] engl. [kọk²rßpänj²l] (angeblich aus Spanien stammende engl. Jagdhundeart) m; -s, -s

Cock|pit engl. (vertiefter Sitzraum für die Besatzung von Jachten u. ä.; Pilotenkabine) s; -s, -s

Cock|tail engl. [kọkte'l] (alkohol. Mischgetränk) m; -s, -s; **Cocktail_kleid, ...par|ty, ...schür|ze**

Coc|teau [koktọ] (fr. Dichter)

Co|da vgl. Koda

Code vgl. Kode; **Code ci|vil** [kọd ßiwịl] (bürgerliches Gesetzbuch in Frankreich) m; - -

Co|de|in vgl. Kodein

Code Na|po|lé|on [- napoleọng] (Bez. des Code civil im 1. u. 2. fr. Kaiserreich) m; - -; **Co|dex** usw. vgl. Kodex usw.; **codieren** vgl. kodieren

Coes|feld [kọ...] (Stadt in Nordrhein-Westfalen)

Cœur fr. [kör] (Herz im Kartenspiel) s; -[s], -[s]; **Cœur-As** [kör-aß] s; Cœur-Asses, Cœur-Asse

Cof|fe|in vgl. Koffein

co|gi|to, er|go sum lat. [k... - -] („Ich denke, also bin ich"; Grundsatz des fr. Philosophen Descartes)

¹**Co|gnac** [konjạk] (fr. Stadt); ²**Cognac** ℗ [kọnjak] (fr. Weinbrand) m; -s, -s; vgl. aber: Kognak

Coif|feur fr. [koafọr, (schweiz.:) koafọr] (schweiz., sonst geh. für: Friseur) m; -s, -e; **Coif|feu|se** [koafọs²] w; -, -n; **Coif|fure** [koafür] (fr. Bez. für: Frisierkunst; schweiz. auch: Coiffeursalon; veralt. für: [kunstvoller] Haarputz) w; -, -n

Coir engl. [koịr] (Faser der Kokosnuß) s; -[s] od. w; -

Co|itus usw. vgl. Koitus usw.

Coke ℗ amerik. [kọ"k] (Kurzw. für: Coca-Cola) s; -[s], -s

col. = columna (Spalte)

Col., Colo. = Colorado

Cold Cream engl. [kọ"ld krịm] (Kühlsalbe) w; - od. s; - -s

Co|leo|pter gr. [kọ...] (senkrecht startendes Ringflügelflugzeug) m; -s, -

Cö|le|stin vgl. ²Zölestin; **Cö|le|sti|ne** vgl. Zölestine; **Cö|le|sti|nus** vgl. Zölestinus

Co|li|gny [kolinjị] (fr. Admiral)

Col|la|ge fr. [kolasch²] (aus buntem Papier od. anderem Material geklebtes Bild)

Coll|ar|gol vgl. Kollargol

Col|lege engl. [kọlidsch] (in England u. in den USA höhere Schule, auch Universität) s; -[s], -s; **Col|lège** fr. [koläsch] (höhere Schule in Frankreich, Belgien u. in der Westschweiz) s; -[s], -s; **Col|le|gi|um mu|si|cum** lat. [- ...kum] (freie Vereinigung von Musikliebhabern, bes. an Universitäten) s; - -, ...gia ...ca

Col|li|co ℗ [kọ...] (zusammenlegbare, bahneigene Transportkiste) m; -s, -s; **Col|li|co-Ki|ste**

Col|lie engl. [kọlị] (schott. Schäferhund) m; -s, -s

Col|lier vgl. Kollier

Col|mar [kọ...] (Stadt im Elsaß); **Col|ma|rer** (↑ R 199); **col|ma|risch**

Colo., Col. = Colorado

¹**Co|lom|bo** (it. Namensform von: Kolumbus); ²**Colombo** (Hptst. von Ceylon)

¹**Co|lón** (span. Namensform von: Kolumbus); ²**Colón** (Münzeinheit von Costa Rica [= 100 Céntimos] u. El Salvador [= 100 Centavos] m; -[s], -[s]

Co|lo|nel fr.(-engl.) [kolonäl, in engl. Ausspr.: kö'n²l] (fr. u. engl. Bez. für: Oberst) m; -s, -s

Co|lo|nia|kü|bel, Kolọniakübel ostösterr. (Mülleimer)

Colonna [ko...] (röm. Adelsname)

Co|lo|ra|do [ko...] (Staat in den USA; Abk.: Col., Colo.); **Co|lo|ra|do|kä|fer** vgl. Koloradokäfer

Colt ℗ [kọlt; nach dem amerik. Erfinder Samuel Colt] (Revolver) m; -s, -s

Co|lum|bia vgl. D. C.

Com|bine vgl. Kombine

Com|bo [kọmbo] (kleine Besetzung in der Jazzmusik) w; -, -s

Come|back engl. [kambäk] (Wiederauftreten eines bekannten Künstlers, Sportlers, Politikers nach längerer Pause; auch übertr. auf Sachen bezogen) s; -[s], -s

COMECON, Comecon [kọmekon] = Council for Mutual Economic Assistance/Aid [kaunßil fọ' mjutju²l ik²nomik ²ßißt²nß/e'd] (Rat für gegenseitige Wirtschaftshilfe; Wirtschaftsorganisation der Ostblockstaaten) m od. s; -

Co|me|ni|us [ko...] (tschech. Theologe u. Pädagoge)

Co|mer See [kọ... -] (in Italien) m - -s

Co|me|sti|bles fr. [komäßtịbl] schweiz. (Feinkost, Delikatessen) Mehrz.; vgl. Komestibilien

Co|mics amerik. [kọmikß] (Kurzw für: Comic strips [kọmik ßtripß] primitive Bildserien, meist abenteuerlichen Inhalts) Mehrz.

comme il faut fr. [komilfọ] (wie sich's gehört, musterhaft)

Com|mis voya|geur fr. [komi woa jaschör] (veralt für: Handlungsreisender) m; - -, - -s [- ...schör]

Com|mon|sense engl. [kọm²n ßän²] (gesunder Menschenverstand m; - -

Com|mon|wealth engl. [kọm²n²älth] (Staat; Staatenbund) s; - British Commonwealth of Nations [ng²sch²ns]

Com|mu|ni|qué vgl. Kommuni qué

Com|pa|gnie [kongpanjị] vgl Kompanie

Com|po|ser engl. [kompo"s²r] (Druckw.: elektr. Schreibma schine mit auswechselbarem Ku gelkopf) m; -s -,

Com|pound|ma|schi|ne engl.; fr [kompaund...] (Verbunddampf maschine; Elektrotechnik: Dop pelschlußmaschine)

Com|pret|te ℗ [ko...] (ein Arznei mittel) w; -, -n

Com|pur ℗ [ko...] (fotogra Objektivverschluß) m; -s, -s

Com|pu|ter engl. [kompjut²r] (elek tron. Rechenanlage, Rechner) m -s, -; **Com|pu|ter|ge|ne|ra|ti|on**

com|pu|te|ri|sie|ren (dem Computer eingeben)

Co|na|kry [konakrí] (Hpst. von ¹Guinea)

con|axi|al vgl. koaxial

con brio it. [kon -] (Musik: lebhaft, feurig)

Con|cha vgl. Koncha

Con|cierge fr. [kongßjärseh] (fr. Bez. für: Gefängniswärter[in]; Pförtner[in]) m (od. w); -, -s

Con|cours hip|pique fr. [kongkur ipík] (Reit- u. Fahrturnier) m; - -, - -s [- ipík]

Con|di|tio si|ne qua non lat. [ko... - - -] (unerläßliche Bedingung) w; - - - -

Con|dor [ko...] (chilen. Münzeinheit) m; -[s], -[s]

Con|dot|tie|re vgl. Kondottiere

Con|dui|te vgl. Konduite

conf. = confer

con|fer! lat. [kon...] (vergleiche!; Abk.: cf., cfr., conf.)

Con|fé|rence fr. [kongferangß] (Ansage) w; -; Con|fé|ren|cier [kongferangßie] (Sprecher, Ansager) m; -s, -s

Con|foe|de|ra|tio Hel|ve|ti|ca lat. [konfö... hälwétika] (Schweizerische Eidgenossenschaft; Abk.: CH) w; - -

Conn. = Connecticut; Connec|ti|cut [kᵉnätik̕ᵉt] (Staat in den USA; Abk.: Conn.)

Con|se|cu|tio tem|po|rum lat. [kon... -] (Sprachw.: Zeitenfolge in einem zusammengesetzten Satz) w; - -

Con|si|li|um ab|eun|di lat. [kon...-] (Androhung des Ausschlusses aus der höheren Schule) s; - -

con sor|di|no it. [kon -] (Musik: mit Dämpfer, gedämpft)

Con|stan|ze vgl. Konstanze

Con|sti|tu|an|te fr. [kongßtituängt] w; -, -s [...tüängt] u. Kon|sti|tu|an|te (grundlegende verfassunggebende [National]versammlung, bes. die der Fr. Revolution von 1789) w; -, -n

Con|tact|glas, ...lin|se vgl. Kontakt...

Con|tai|ner engl. [k̕ᵉntᵉi̕nᵉr] (Großbehälter für den Verkehr von Werk zu Werk) m; -s, -; Con|tai|ner.ha|fen, ...schiff, ...verkehr

Con|te|nance vgl. Kontenance

Con|to de Reis port. [kóntu dh̕ᵉ reiß] (brasil. [= 1 000 Cruzeiros] u. port. [= 1 000 Escudos] Rechnungseinheit) m; - - -, -[s] - -

con|tra (lat. Schreibung von: kontra)

con|tre..., Con|tre... [kongtr̕ᵉ...] vgl. konter..., Konter...

Con|vent vgl. Konvent

Con|vey|er engl. [konwe̕ᵉr] (Becherwerk, Förderband) m; -s, -

Cool Jazz amerik. [kul dsehäs] (eine bestimmte Richtung im Jazz) m; - -

co op engl. [ko-op] (Symbol der konsumgenossenschaftlichen Unternehmensgruppe)

Cop amerik. [kop] (amerik. ugs. Bez. für: Polizist) m; -s, -s

Co|pi|lot vgl. Kopilot

Co|py|right engl. [kopirait] (amerik. Verlagsrecht) s; -s, -s

co|ram pu|bli|co lat. [koram ...ko] (vor aller Welt)

Cord vgl. Kord

Cor|de|lia [ko...], Cor|de|lie [...iᵉ] (w. Vorn.)

¹Cór|do|ba [kordoba, auch: ...wa] (span. Stadt); ²Cór|do|ba [nach dem span. Forscher] (Währungseinheit in Nicaragua [= 100 Centavos]) m; -[s], -[s]

Cor|don bleu fr. [kordongblö] (mit einer Käsescheibe u. gekochtem Schinken gefülltes [Filet]steak) s; - -, -s -s [...dongblö]

Cordula [ko...] (w. Vorn.)

Co|rel|li [koreli] (it. Komponist)

Co|rin|na [ko...] (w. Vorn.)

Co|rinth [ko...], Lovis [lowíß] (dt. Maler)

Cor|nea [ko...], (auch:) Kor|nea (Med.: Hornhaut des Auges) w; -, ...neae

Cor|ned beef engl. [ko̕ʳn(ᵉ)d biß] (gepökeltes Büchsenrindfleisch) s; - -; Cor|ned|beef|büch|se

Cor|neille [kornäj] (fr. Dramatiker)

Cor|ne|lia [ko...], Cor|ne|lie [...iᵉ] (w. Vorn.); Cor|ne|li|us (m. Vorn.)

Cor|ner engl. [ko̕ʳn̕ᵉr], (auch:) Kor|ner (Börsenwesen: Aufkäufergruppe; Ringecke [beim Boxen]; österr., sonst veralt. für: Ecke, Eckball beim Fußballspiel) m; -s, -

Corn-flakes engl. [ko̕ʳn̕fle̕̕kß] (Maisflocken) Mehrz.

Cor|ni|chon fr. [kornischong] (kleine Pfeffergurke) s; -s, -s

Corn|wall [ko̕ʳn̕̕ᵘᵉl] (Grafschaft in England)

Corona [ko...] (w. Vorn.)

Cor|po|ra (Mehrz. von: Corpus)

Corps vgl. Korps; Corps de bal|let fr. [kor dᵉ balä] (Ballettgruppe, -korps) s; - - -, - - -; Corps di|plo|ma|tique [- diplomatík] (Diplomatisches Korps; Abk.: CD) s; - -, - - -s

Cor|pus lat. [ko...] s; -, ...pora vgl. ²Korpus; Cor|pus de|lic|ti lat. [ko...-] (Gegenstand od. Werkzeug eines Verbrechers; Beweisstück) s; - -, ...pora -; Cor|pus ju|ris (Gesetzbuch, -sammlung) s; - -

Cor|reg|gio [kored̕̕seho] (it. Maler)

Cor|ri|da [de to|ros] span. [ko...- -] (span. Bez. für: Stierkampf) w; - - -, -s - -

cor|ri|ger la for|tune fr. [korisehę la fortün] (dem Glück nachhelfen; falschspielen)

Corse [korß] (fr. Form von: Korsika); Cor|si|ca [korßika] (it. Schreibung von: Korsika)

Cor|so vgl. Korso

Cor|tes span. u. port. [kortéß] (Volksvertretung in Spanien, früher auch in Portugal) Mehrz.

Cor|tez (span. Schreibung: Cortés) [kortäß] (span. Eroberer Mexikos)

Cor|ti|na d'Am|pez|zo [kor...] (Kurort in den Dolomiten)

Cor|ti|sche Or|gan [nach dem it. Arzt Corti; kor...-] (Teil des inneren Ohres) s; -n -s, -n -e

Cor|vey [korwai] (ehem. Benediktinerabtei bei Höxter)

Co|ry|da|lis vgl. Korydalis

cos = Kosinus

Cosa No|stra it. [ko... -; „Unsere Sache"] (amerik. Verbrechersyndikat)

cosec = Kosekans

co|si fan tut|te it. [kosí - -] („so machen's alle" [Frauen])

Co|si|ma [ko...] (it. w. Vorn.); Co|si|mo (it. m. Vorn.)

Co|stan|za (it. Schreibung von: Konstanze)

Co|sta Ri|ca [ko... rika] (Staat in Mittelamerika); Co|sta|ri|ca|ner; co|sta|ri|ca|nisch

Cos|wig [ko...] (dt. Ortsn.)

cot, cotg, ctg = Kotangens

Côte d'Azur [kot dasür] (fr. Riviera) w; - -; Côte d'Or [kot dår] (Hügelkette in Frankreich) w; --

cotg, cot, ctg = Kotangens

Cot|tage engl. [kotidseh] (engl. Bez. für: Landhaus; Häuschen; österr.: Villenviertel) s; -, -s

Cott|bus [ko...] (Stadt an der Spree); Cott|bus|ser, (auch:) Cott|bu|ser (↑ R 199)

Cot|ti|sche Al|pen [ko...] (Teil der Westalpen) Mehrz.; ↑ R 198

Cot|ton engl. [kot(̕ᵉ)n] (engl. Bez. für: Baumwolle, Katun) m od. s; -s; vgl. auch: Koton usw.; Cot|ton|ma|schi|ne, Cot|ton|stuhl [nach dem Erfinder W. Cotton] (Wirkmaschine zur Herstellung v. Damenstrümpfen); Cot|ton|öl (Öl vom Samen der Baumwollpflanze) s; -s; Cot|ton|stuhl vgl. Cottonmaschine

Couch engl. [kautsch] (Liegestatt) w (schweiz. auch: m); -, -es [...is] (ugs. auch: -en); Couch|tisch

Cou|den|ho|ve-Ka|ler|gi [kud̕ᵉnhó̕-w̕ᵉ kalärgí] (Gründer der Paneuropa-Bewegung)

Coué|is|mus [ku-e-ißmuß]; nach

Couleur 200

dem Franzosen Coué] (Heilverfahren durch Autosuggestion) *m*; -

Cou|leur *fr.* [*kulör*] (fr. Bez. für: Farbe [nur *Einz.*]; Trumpf [im Kartenspiel]; Studentenspr.: Band u. Mütze einer Verbindung) *w*; -, -en u. -s

Cou|loir *fr.* [*kuloar*] (fr. Bez. für: Verbindungs-, Wandelgang, Flur; Alpinistik: Schlucht, schluchtartige Rinne; ovaler Sprunggarten für Pferde) *m*; -s, -s

Cou|lomb [*kulong*; nach dem fr. Physiker] (Maßeinheit für die Elektrizitätsmenge; Zeichen: C) *s*; -s, -; 6 - (↑ R 322)

Count *engl.* [*kaunt*] ([der nichtengl.] Graf) *m*; -s, -s

Count|down *amerik.* [*kauntdaun*] (bis zum Zeitpunkt Null [Startzeitpunkt] zurückschreitende Ansage der Zeiteinheiten, oft übertr. gebraucht) *m* u. *s*; -[s], -s

Coun|ter|part *engl.* [*kauntᵉrpaʳt*] (Ausländer, der im Austausch gegen einen Entwicklungshelfer in die BRD kommt) *m*; -s, -s

Coun|teß *engl.* [*kauntiß*] (Gräfin) *w*; -, ...tessen u. ...tesses [...*tißis*]

Coun|try-Mu|sic *amerik.* [*kántrimjusik*] (ländliche Musik [der Südstaaten in den USA]) *w*; -

Coun|ty *engl.* [*kaunti*] („Grafschaft" Verwaltungsbezirk in England u. in den USA) *w*; -, -ies [*kauntis*]

Coup *fr.* [*ku*] (Schlag; Streich; [Kunst]griff) *m*; -s, -s; **Cou|pé** [*kupe*] (österr., sonst veralt. für: [Wagen]abteil; heute: bestimmte Autokarosserieform) *s*; -s, -s; vgl. auch: Kupee

Cou|plet *fr.* [*kuple*] (Lied [für die Kleinkunstbühne]) *s*; -s, -s

Cou|pon *fr.* [*kupong*] ([Stoff]abschnitt; Zinsschein) *m*; -s, -s; vgl. auch: Kupon

Cour *fr.* [*kur*] (veralt.: feierlicher Empfang am Hof eines Fürsten) *w*; -; jmdm. die - (den Hof) machen

Cou|ra|ge *fr.* [*kurasehᵉ*] (Mut) *w*; -; **cou|ra|giert** [*kurasehirt*] (beherzt)

cou|rant vgl. kurant

Cour|ma|cher [*kur...*] (veraltend: Mann, der einer Dame die Cour macht)

Cour|ta|ge *fr.* [*kurtasehᵉ*] (Maklergebühr bei Börsengeschäften); eindeutschend auch: Kurtage

Courths-Mah|ler [*kurz* -] (dt. Schriftstellerin)

Cour|toi|sie *fr.* [*kurtoasi*] (feines, ritterliches Benehmen) *w*; -, ...ien

Cou|sin *fr.* [*kusäng*] (Vetter) *m*; -s,

-s; **Cou|si|ne** [*kusinᵉ*] (Base) *w*; -, -n; vgl. auch: Kusine

Cou|ture [*kutür*] vgl. Haute Couture

Cou|va|de *fr.* [*kuwadᵉ*] (Männerkindbett; Sitte bes. südamerik. Indianer, nach der der Vater das Verhalten der Wöchnerin nachahmt)

Cou|vert [*kuwär*] *s*; -s, -s usw. vgl. Kuvert usw.

Co|ven|try [*kowᵉntri*] (engl. Stadt)

Co|ver|coat *engl.* [*kawᵉrkoᵘt*] (Wollstoff; Mantel aus diesem Stoff) *m*; -[s], -s; **Co|ver|girl** [*kawᵉrgö'l*] (auf der Titelseite einer Illustrierten abgebildetes Mädchen)

Cow|boy *engl.* [*kaubeu*] („Kuhjunge"; berittener amerik. Rinderhirt) *m*; -s, -s

Cow|per [*kau...*; nach dem engl. Erfinder] (Winderhitzer bei Hochöfen) *m*; -s, -s

Cox' Oran|ge [*koks orangsehᵉ*; nach dem engl. Züchter Cox] (edler Tafelapfel)

Co|yo|te vgl. Kojote

cr. = currentis

Cr = chem. Zeichen für: Chrom

Crack *engl.* [*kräk*] (Sport: Größe; aussichtsreich[st]er Bewerber) *m*; -s, -s; **Cracker** [*Trenn.*: Crak|ker] *engl.* [*kräkᵉr*] (hartes, sprödes Kleingebäck) *m*; -s, -[s] (meist *Mehrz.*)

Cra|nach (dt. Maler)

Cra|que|lé *fr.* [*krakᵉle*] (feine Haarrisse in der Glasur von Keramiken, auch auf Glas) *s*; -s, -s; vgl. auch: Krakelee

Cras|sus (altröm. Staatsmann)

Cray|on|vgl. Krayon; Cray|on|ma|nier vgl. Krayonmanier

Cre|as vgl. Kreas

Cre|do vgl. Kredo

Creek *engl.* [*krik*] ([zeitweise ausgetrockneter] Flußlauf, bes. in Nordamerika u. Australien) *m*; -s, -s

creme *fr.* [*kräm*, auch: *krem*] (mattgelb); vgl. blau; in Creme (↑ R 116); **Creme** (pastenartige auftragbare Masse zur Pflege von Haut, Schuhen, Zähnen; auch für: feine [dickflüssige bis feste] Süßspeise; übertr. für: das Erlesenste [nur *Einz.*]) *w*; -, -s (schweiz.: -n); vgl. auch: Krem; **Creme|far|be; creme.|far|ben** od. **...far|big; cre|men**; die Schuhe -; **cre|mig** (dafür besser: kremig)

Creo|lin ⓦ *nlat.* (ein Desinfektionsmittel) *s*; -s

Creo|so|tal ⓦ *gr.* (ein Arzneimittel) *s*; -s

Crêpe vgl. Krepp; **Crêpe de Chine** *fr.* [*kräp dᵉ schin*] (Seidenkrepp in Taftbindung) *m*; - - -, - -

[*kräp* - -]; **Crêpe Geor|gette** [*kräp sehorsehät*] (zartes, durchsichtiges Gewebe aus Kreppgarn) *m*; - -, -s - [*kräp* -]; **Crepe|line** vgl. Krepeline; **Crêpe Sa|tin** [*kräp ßatäng*] (Seidenkrepp mit einer glänzenden u. einer matten Seite in Atlasbindung) *m*; - -, -s - [*kräp* -]; **Cre|pon** vgl. Krepon

cresc. = crescendo; **cre|scen|do** *it.* [*kräschändo*] (Musik: anschwellend; Abk.: cresc.); **Cre|scen|do,** (auch:) Kre|scen|do *s*; -s, -s u. ...di

Cres|cen|tia vgl. Kreszentia

Cre|tonne *fr.* [*kreton*] (Baumwollstoff) *w* od. *m*; -, -s

Cre|vet|te vgl. Krevette

Crew *engl.* [*kru*] [[Schiffs- u. Flugzeugmannschaft; Kadettenjahrgang der Kriegsmarine) *w*, (älter:) *m*; -, -s

Crime *engl.* [*kraim*] (engl. Bez. für Straftat, Verbrechen) *s*; -; - und Sex

c.r.m. = cand. rev. min.; vgl. Kandidat

Croi|sé *fr.* [*kroase*] (geköpertes Gewebe; Tanzschritt) *s*; -[s], -s

croi|siert [*kroasirt*] (geköpert)

Cro|ma|gnon|ras|se [*kromanjong ...*; nach dem Fundort] (Menschenrasse der jüngeren Altsteinzeit) *w*; -; ↑ R 201

Crom|ar|gan ⓦ (rostfreie: Chrom-Nickel-Stahl der Würt tembergischen Metallwarenfa brik) *s*; -s

Crom|well [*kromwᵉl*] (engl. Staatsmann)

Cro|quet|te vgl. Krokette

Cro|quis vgl. Kroki

Cross-Coun|try *engl.*, (auch: **Croß-Coun|try** [*kroßkäntr*] (Querfeldeinrennen; Jagdren nen) *s*; -[s], -s

Crou|pier *fr.* [*krupie*] (Gehilfe de Bankhalters im Glücksspiel) *m* -s, -s; **Crou|pon** [*krupong*] (Kern Rückenstück einer [gegerbten Haut) *m*; -s, -s

crt. = courant; vgl. kurant

Crux *lat.* („Kreuz"; ugs. für: Leid Kummer) *w*; -

Cru|zei|ro [*kruse'ru*] (Münzeinhe in Brasilien) *m*; -s, -s

Cs = chem. Zeichen für: Cäsiun

Csár|dás *ung.* [*tschárdasch*] *m*; - - u. (eingedeutscht:) Tschardasc (ung. Nationaltanz) *m*; -[es], -[

Csi|kós *ung.* [*tschikosch*] *m*; -, und (eingedeutscht:) Tschikosc (ung. Pferdehirt) *m*; -[es], -[e]

Cso|kor [*tscho...*] (österr. Dichter

ČSSR = Československá sociali stická republika (Name de Tschechoslowakei)

CSU = Christlich-Soziale Unio

c. t. = cum tempore

ct = Centime[s]; Cent[s]

Ct. = Centime

ctg, cot, cotg = Kotangens

cts = Centimes; Cents

Cu = Cuprum; chem. Zeichen für: Kupfer

Cu|ba (span. Schreibung von: Kuba)

Cu|le|mey|er [ku...; nach dem Erfinder] (Straßenroller, auf den ein Eisenbahnwaggon verladen werden kann) m; -s, -

Cul|li|nan engl. [kạlinᵉn] (ein großer Diamant) m; -s

Cu|ma|rin vgl. Kumarin; Cu|ma|ron vgl. Kumaron

cum gra|no sa|lis lat. [kum - -] („mit einem Körnchen Salz"; mit entsprechender Einschränkung, nicht ganz wörtlich zu nehmen)

cum lau|de lat. [kum -] („mit Lob"; drittbeste Note der Doktorprüfung)

cum tem|po|re lat. [kum -] (mit akadem. Viertel [vgl. akademisch], d. h. eine Viertelstunde nach der angegebenen Zeit; Abk.: c. t.)

Cun|ni|lin|gus lat. [ku...] (Lecken am weibl. Geschlechtsorgan, bes. am Kitzler) m; -

Cup engl. [kạp] (Pokal; Ehrenpreis; Schale des Büstenhalters) m; -s, -s

Cu|pi|do [ku...] (röm. Liebesgott, Amor)

Cu|pra|ma ⓦ [ku...] (Kupferzellwolle) w; -; Cu|pre|in vgl. Kuprein; Cu|pre|sa ⓦ (Kupferreyon) w; -; Cu|prum [auch: ku...] (Kupfer; chem. Grundstoff; Zeichen: Cu) s; -s

Cu|ra|çao [kürạßạo] (Insel im Karibischen Meer); ²Cu|ra|çao ⓦ (ein Likör) m; -[s], -s

Cu|ra po|ste|ri|or lat. [kura -] („spätere [zukünftige] Sorge") w; - -

Cu|ra|re vgl. Kurare

Cur|cu|ma vgl. Kurkuma

Cu|ré fr. [küre] (kath. Geistlicher in Frankreich) m; -s, -s

Cu|rie [kürj; nach dem fr. Physikerehepaar] (Maßeinheit der Radioaktivität; Zeichen: Ci) s; -, -;

Cu|ri|um [ku...] (chem. Grundstoff, Transuran; Zeichen: Cm) s; -s

Cur|ling [kö´ling] (schott. Eisspiel) s; -s

cur|ren|tis lat. [ku...] (veralt. für: „[des] laufenden" [Jahres, Monats]; Abk.: cr.); am 15. cr., dafür besser: am 15. d. M.; Cur|ri|cu|lum lat.-engl. [kurik...] (Päd.: Theorie des Lehr- u. Lernablaufs; Lehrplan, -programm) s; -s, ...la; Cur|ri|cu|lum vi|tae [- wj|tä] („Lebenslauf") s; - -

Cur|ry angloind. [kö̈ri, selten: kạri] (Gewürzpulver) m (auch: s); -s

Cu|stard engl. [kạßtᵉrt] (engl. Süßspeise) m; -, -s

Cut engl. [kạt, meist: köt] u. Cut|away [kạtᵉweˀ, meist: kötᵉweˀ] (abgerundet geschnittener Herrenschoßrock) m; -s, -s

Cut|ter engl. [kạtᵉr] (Fleischschneidemaschine zur Wurstbereitung; Film, Rundfunk: Schnittmeister, Tonmeister) m; -s, -; Cut|te|rin w; -, -nen; cut|tern; ich ...ere (↑ R 327)

Cu|vier [küwiẹ] (fr. Zoologe)

Cux|ha|ven [...ˀᵉn] (Hafenstadt a. d. Elbmündung)

CVJM = Christlicher Verein Junger Männer

CVP = Christlichdemokratische Volkspartei (in der Schweiz)

cwt. vgl. Hundredweight

Cy|an vgl. Zyan

cy|clisch [auch: zü...] vgl. zyklisch

Cy|pern usw. vgl. Zypern usw.

Cy|ran|kie|wicz [zirangkjạwitsch] (poln. Politiker); Cyrankiewicz' Staatsbesuch (↑ R 310)

Cy|re|nai|ka [zü...] (Landschaft in Nordafrika) w; -

cy|ril|lisch vgl. kyrillisch

Cy|rus [zü...] vgl. Kyros

Cyst... usw. vgl. Zyst... usw.

D

D (Buchstabe); das D; des D, die D, a b e r: das d in Bude (↑ R 123); der Buchstabe D, d

d = dextrogyr; Denar; Dezi...; Penny, Pence

d, D (Tonbezeichnung) s; -, -; d (Zeichen für: D-Moll); in d; D (Zeichen für: D-Dur); in D

d [in Antiqua- wie in Frakturschrift stets in Kursiv zu setzen] = Durchmesser

D = Deuterium (chem. Zeichen für schweren Wasserstoff)

D = (iran.) Dinar

D (röm. Zahlzeichen) = 500

Δ, δ = Delta

D. = Decimus

D. vgl. Doktor

ℵ = deleatur; vgl. S. 92, 11

da; hier und -, - und dort; da (weil) er krank war, konnte er nicht kommen. Schreibung in Verbindung mit Zeitwörtern (↑ R 139); 1. Getrenntschreibung: a) wenn da, daher, dahin usw. den Umstand des Ortes bezeichnen: da sein (dort sein; vgl. dasein); b) wenn die gen. Umstandswörter hinweisend gebraucht sind, z. B. es wird daher kommen (vgl. daherkommen); 2. Zusammenschreibung (meist nur bei einfa-

chen Zeitwörtern), wenn durch die Verbindung ein neuer Begriff entsteht (↑ R 139), z. B. dasein (gegenwärtig usw. sein; vgl. dasein). Dieselben Gesichtspunkte gelten für die aus dar... mit Verhältniswörtern zusammengesetzten Umstandswörter, z. B. daran (dran), darauf (drauf)

da = Deka...; Deziar

d. Ä. = der Ältere

DAB = Deutsches Arzneibuch

da|be|hal|ten (zurückbehalten, nicht weglassen); sie haben ihn gleich dabehalten; a b e r: da (dort) be|hal|ten; sie sollen ihn da behalten und nicht zurückschicken (↑ da u. R 139)

da|bei [auch: dạ...]; er ist reich und dabei (doch) nicht stolz; da|bei|blei|ben (bei einer Tätigkeit bleiben); er hat mit dem Training begonnen, ist dann aber nicht dabeigeblieben; a b e r: da|bei blei|ben (bei einer Meinung usw. verharren); trotz aller Einwände will er dabei bleiben (↑ da u. R 139); da|bei|ha|ben (ugs. für: bei sich haben; teilnehmen lassen); sie wollten ihn bei der Feier dabeihaben; a b e r: da|bei ha|ben; er müßte eigentlich ein schlechtes Gefühl dabei (bei dieser Manipulation) haben (↑ da u. R 139); da|bei|sein (anwesend, beteiligt sein); er will unter allen Umständen dabeisein (↑ da, 2 u. R 139); da|bei|sit|zen (sitzend zugegen sein); er hat während des Vortrages dabeigesessen; a b e r: da|bei sit|zen (nicht stehen usw.); er muß dabei (bei dieser Arbeit) sitzen und nicht stehen (↑ da u. R 139); da|bei|ste|hen (stehend zugegen sein); er hat bei dem Verkehrsunfall dabeigestanden; a b e r: da|bei ste|hen (nicht sitzen usw.); er muß dabei (bei dieser Arbeit) stehen und nicht sit|zen (↑ da u. R 139)

da|blei|ben (nicht fortgehen; [in der Schule] nachsitzen); er ist während des Vortrages dageblieben; a b e r: da (dort) blei|ben; er soll da bleiben und nicht hierherkommen (↑ da u. R 139)

da ca|po it. [- kạpo] (Musik: noch einmal von Anfang an; Abk.: d. c.); vgl. Dakapo

Dac|ca [dạka] (Hptst. von Bangladesch)

d'ac|cord fr. [dakọr] (veralt. für: übereinstimmend; einer Meinung)

Dach s; -[e]s, Dächer; dach|ar|tig

Dach|au (Stadt in Bayern; Konzentrationslager der Nationalsozialisten)

Dach⏜bo|den, ...decker [Trenn.: ...dek|ker]; **Dä|chel|chen** (*Mehrz.*
- und Dächerchen), **Däch|lein**; **dä|chen** (veralt. für: mit einem
Dach versehen); **Dach⏜fen|ster**, ...first, ...gar|ten, ...ge|bälk, ...ge-
schoß, ...ge|sell|schaft (Spitzen-, Muttergesellschaft), ...glei|che
(österr. svw. Dachgleichenfeier; *w*; -, -n); **Dach|glei|chen|fei|er**
österr. (Richtfest); **Dach⏜hal|se** (ugs. scherzh. für: Katze), ...haut
(Bauw.: äußerste Schicht der Dachkonstruktion), ...kam|mer,
...lat|te; **Däch|lein**, **Dä|chel|chen** (vgl. d.); **Dach⏜lu|ke**, ...or|ga|ni-
sa|ti|on, ...pap|pe, ...pfan|ne, ...rei|ter, ...rin|ne, ...scha|den
(ugs. für: geistiger Defekt), ...schin|del

Dachs *m*; -es, -e; **Dachs|bau** (*Mehrz.* -e); **Dächs|chen**, Dächs-
lein; **dach|sen** landsch. (fest u. lange schlafen); du dachst (dach-
sest); **Dachs⏜fell**, ...haar, ...hund; **Däch|sin** *w*; -, -nen; **Dächs|lein**,
Dächs|chen; **Dachs|pin|sel** (Rasierpinsel aus Dachshaar; ein
Hutschmuck)

Dach⏜spar|ren, ...stock, ...stu|be, ...stuhl

Dach|tel (ugs. für: Ohrfeige) *w*; -, -n

Dach⏜traufe, ...ver|band, ...wohnung, ...zie|gel, ...zim|mer

Dackel [*Trenn.*: Dak|kel] (Dachshund, Teckel) *m*; -s, -

Da|da|js|mus [nach kindersprachl. „dada"] (Kunstrichtung nach
dem 1. Weltkrieg) *m*; -; **Da|da|ist** (↑ R 268); **da|da|istisch**

Dä|da|lus (Baumeister u. Erfinder in der gr. Sage)

Daddy engl. [*dädi*] (engl. ugs. Bez. für: Vater) *m*; -s, -s od. Daddies
[*dädis*]

da|durch [auch: *dʌ*...]; es geschah -, daß er zu spät kam; dadurch,
daß u. dadurch, weil (↑ R 61)

Daff|ke (berliner.); nur in: aus - (Trotz)

da|für [auch: *dʌ*...]; das Mädchen ist häßlich, - aber reich; ich kann
nicht dafür sein (kann nicht zustimmen); **da|für|hal|ten** (mei-
nen); er hat dafürgehalten; aber: **da|für hal|ten** (jmdn. für etwas
halten); er wird ihn dafür halten (↑ da u. R 139); **Da|für|hal|ten** *s*;
-s; nach meinem -; **da|für|kön|nen**; nichts -; **da|für|ste|hen** (veralt.
für: für etwas bürgen; österr.: sich lohnen); es steht [nicht] dafür

DAG = Deutsche Angestellten-Gewerkschaft

da|ge|gen [auch: *dʌ*...]; die Prüfung der anderen war gut, seine -
schlecht; - sein; wenn sie nichts - haben; **da|ge|gen|hal|ten** (vor-

halten, erwidern); er hat seine Meinung daggegengehalten;
aber: **da|ge|gen hal|ten** (gegen etwas halten); er wird den Stein
dagegen halten (↑ da u. R 139); **da|ge|gen|set|zen** (entgegenset-
zen, gegen etwas vorbringen); er hatte nichts daggegenzusetzen;
aber: **da|ge|gen set|zen** (gegen etwas setzen); du mußt das Holz
dagegen setzen (↑ da u. R 139); **da|ge|gen|stel|len**, sich (sich wi-
dersetzen); es nützt dir nichts, dich daggegenzustellen; aber: **da-
ge|gen stel|len** (gegen etwas stellen); du mußt eine Stütze dagegen
stellen (↑ da u. R 139)

Dag|hild (w. Vorn.); **Dag|mar** (w. Vorn.); **Da|go|bert** (m. Vorn.)

Da|gon (Hauptgott der Philister)

Da|guerre [*dagär*] (Erfinder der Fotografie); **Da|guer|reo|ty|pie**
(fotogr. Verfahren mit Metallplatten) *w*; -

da|heim; - bleiben, sein, sitzen; **Da|heim** *s*; -s; **Da|hei|m|ge|blie|be|ne**
m u. *w*; -n, -n (↑ R 287ff.)

da|her [auch: *dʌ*...]; - (von da) bin ich; daher, daß u. daher, weil (↑ R
61); **da|her|brin|gen** südd., österr. (herbeibringen); **da|her|flie|gen**;
es kam dahergeflogen (↑ da, 2 u. R 139); **da|her|lau|fen**; ein - er
Kerl; **Da|her|ge|lau|fe|ne** *m* u. *w*; -n, -n (↑ R 287ff.); **da|her|kom-
men**; man sah ihn daherkommen; aber: **da|her kom|men**; es wird
daher kommen, daß... (↑ da u. R 139); **da|her|re|den**; dumm -

da|hier (veralt. u. Papierdt. für: an diesem Ort)

da|hin [auch: *dʌ*...]; wie weit ist es bis -?; etwas - auslegen; er hat
es bis - gebracht; dahin|ab, dahin|auf, dahin|aus, dahin|ein, dahin-
gegen, dahin|unter, dahin|wärts; da- und dorthin (↑ R 145); **da|hin-
däm|mern**; ich dämmere dahin (↑ R 327); **da|hin|fah|ren** (geh. ver-
hüll. für: sterben); er ist dahinge-
fahren; aber: **da|hin fah|ren** (an einen bestimmten Ort); wir wer-
den auch dahin fahren (↑ da u. R 139); **da|hin|fal|len** schweiz.
(als erledigt, als überflüssig wegfallen, entfallen); **da|hin|flie|gen**
(vergehen); die Zeit ist dahingeflogen; aber: **da|hin flie|gen** (an
einen bestimmten Ort); er wird dahin fliegen und nicht nach
London (↑ da u. R 139)

da|hin|ge|gen [auch: *dʌ*...]

da|hin|ge|hen (vergehen); wie schnell sind die Tage dahin-
gegangen; aber: **da|hin ge|hen** (an ein bestimmtes Ziel); ein da-
hin gehender Antrag; er äußert sich dahin gehend (↑ da u. R 139);
da|hin|ge|stellt; - bleiben; - sein

lassen; **da|hin|le|ben**; **da|hin|raf-
fen**; **da|hin|se|geln**; **da|hin|sie-
chen**; bei dieser Krankheit wird er elend dahinsiechen (↑ da, 2 u.
R 139); **da|hin|ste|hen** (nicht sicher, noch fraglich sein)

da|hin|ten [auch: *dʌ*...]; - auf der Heide; **da|hin|ter** [auch: *dʌ*...]; der
Bleistift liegt -; **da|hin|ter|her**; - sein (ugs. für: eifrig erstreben);
da|hin|ter|knien, sich (ugs. für: sich bei etwas anstrengen); du
mußt dich schon etwas dahinterknien; aber: **da|hin|ter knien**;
sie wollte [sich] dahinter knien (hinter der Säule) knien (↑ da u. R
139); **da|hin|ter|kom|men** (erkennen, erfahren); er ist endlich da-
hintergekommen; aber: **da|hin-
ter kom|men**; dahinter kommen erst die Wiesen (↑ da u. R 139);
da|hin|ter|set|zen, sich (ugs. für: sich bei etwas anstrengen); jetzt
mußt du dich aber dahinterset-
zen; aber: **da|hin|ter set|zen**, sich; wir werden uns dahinter
(hinter die anderen) setzen (↑ da u. R 139); **da|hin|ter|stecken**
[*Trenn.*: ...stek|ken] (ugs. für: zu bedeuten haben); da muß doch
etwas dahinterstecken; vgl. ¹stek-
ken; aber: **da|hin|ter stecken**
[*Trenn.*: - stek|ken]; ich werde die Karte dahinter (hinter den Spie-
gel) stecken (↑ da u. R 139); vgl. ²stecken; **da|hin|ter|ste|hen** (un-
terstützen, helfen); sei zuver-
sichtlich, wir werden dahinterste-
hen; aber: **da|hin|ter ste|hen**;
der Schrank wird dahinter stehen (↑ da u. R 139)

Däh|le, Dä|le (westschweiz. neben: Föhre) *w*; -, -n

Dah|lie [...*iᵉ*] nach dem schwed. Botaniker Dahl (Zierpflanze) *w*
-, -n; vgl. Georgine

Da|ho|me, (offz. Landesschreibung:) **Da|ho|mey** [...*mä*] (Staat
in Afrika); **Da|ho|me|er**, **da-
ho|me|isch** od. (bei offz. Landesschreibung:) **Da|ho|mey|er**
[...*mä*r*], da|ho|mey|isch [...*mä*isch]

Dail Ei|reann [*dail ä̃*r*ᵉn*] (das ir. Abgeordnetenhaus) *m*; - -

Daim|ler-Benz Ⓦ (Kraftfahrzeugmarke) *m*; -, -

Dai|na lett. (weltl. lett. Volkslied; lyr. Charakters) *w*; -, -s

Dai|sy [*dé'si*] (w. Vorn.)

Da|ka|po it. (Musik: Wiederholung) *s*; -s, -s; vgl. da capo; **Da|ka|po|arie**

Da|kar [fr. Ausspr.: *dakar*] (Hptst des Staates Senegal)

Da|ker; **Da|ki|en** (im Altertum da Land zwischen Theiß, Donau
und Dnjestr); **da|kisch**, aber (↑ R 224): die Dakischen Kriege

¹**Da|ko|ta** (Angehöriger eines nordamerik. Indianerstammes) *m*; -[s], -[s]
²**Da|ko|ta** (Staaten in den USA [Nord- u. Süddakota]
dak|ty|lisch *gr.* (aus Daktylen bestehend [vgl. Daktylus]); **Dak|ty|lo** (schweiz. Kurzform von: Daktylographin) *w*; -, -s; **Dak|ty|lo|gramm** (Fingerabdruck) *s*; -s, -e, **Dak|ty|lo|gra|phin** schweiz. (Maschinenschreiberin) *w*; -, -nen; **Dak|ty|lo|sko|pie** (Fingerabdruckverfahren) *w*; -, ...ien; **Dak|ty|lus** (,,Finger"; Versfuß) *m*; -, ...ylon
Da|lai-La|ma tibet. (weltl. Oberhaupt des Lamaismus) *m*; -[s], -s
da|las|sen; er hat seinen Mantel dagelassen; aber: **da las|sen** (dort zurücklassen); er soll seinen Mantel da (an der bestimmten Stelle) lassen (↑ da u. R 139)
Dal|be (Kurzw. für: Duckdalbe); **Dal|be|rei** (ugs. für: Alberei); **dal|be|rig, dal|brig** (ugs. für: albern); **dal|bern** (ugs. für: sich albern verhalten); Ich ...ere (↑ R 327)
Dä|le vgl. Dähle
da|lie|gen (hingestreckt liegen); er hat völlig erschöpft dagelegen; aber: **da lie|gen**; laß es da (dort) liegen, wo es liegt (↑ da u. R 139)
Da|li|la vgl. Delila
da|lisch (der dalischen Rasse angehörend); vgl. fälisch
Dalk südd., österr. ugs. (ungeschickter Mensch) *m*; -[e]s, -e; **dal|ken** österr. (kindisch, dumm reden); **dal|kert** österr. (dumm, ungeschickt; nichtssagend)
Dal|le landsch. (Delle) *w*; -, -n
Dal|les jidd. (ugs. für: Armut; Not) *m*; -
dal|li! poln. (ugs. für: schnell!)
Dal|ma|ti|en [...zi⁴n] (Küstenland an der Adria); **Dal|ma|tik, Dal|ma|ti|ka** (liturg. Gewand) *w*; -, ...ken; **Dal|ma|ti|ner**; ↑ R 199 (auch: Hunderasse, Wein); **dal|ma|ti|nisch, dal|ma|tisch**
Dal|to|nis|mus [nach dem engl. Physiker J. Dalton] (Med.: angeborene Rot- od. Grünblindheit) *m*; -
dam = Dekameter
da|ma|lig; da|mals
Da|mas|kus (Hptst. von Syrien); **Da|mast** (ein Gewebe) *m*; -[e]s, -e; **da|mast|ar|tig; Da|mast|be|zug; da|ma|sten** (aus Damast); **Da|mas|ze|ner** (↑ R 199) - Klinge, Stahl; **da|mas|ze|nisch; da|mas|zie|ren** (Stahl mit flammigen, aderigen Zeichnungen versehen); **Da|mas|zie|rung**
Dam|bock
Däm|chen, Däm|lein; Da|me fr. *w*; -, -n; **Da|me|brett**

Dä|mel (ugs. für: Dummkopf, alberner Kerl) *m*; -s, -
Da|men|ein|zel (Sportspr.); **da|men|haft; Da|men.hut** *m*, ...schnei|der, ...wahl (beim Tanz); ...spiel, ...stein
Dam|hirsch
dä|misch bayr.-schwäb., österr. ugs. (dumm, albern; schwindelig; sehr), -ste (↑ R 294)
¹**da|mit** [auch: da...]; [und] - basta! (ugs.); was soll ich - tun?
²**da|mit**; er sprach langsam, - es alle verstanden
Dam|lack (ugs. für: Dummkopf) *m*; -s, -e u. -s
dam|le|dern (aus Damleder)
Däm|lein, Däm|chen
däm|lich (ugs. für: dumm, albern)
Damm *m*; -[e]s, Dämme
Dam|mar (Harz südostasiat. Bäume) *s*; -s; **Dam|ma|ra.fich|te, ...lack; Dam|mar|harz**
Damm|bruch *m*; -[e]s, ...brüche
däm|men (auch für: Isolieren)
Däm|mer (dicht. für: Dämmerung) *m*; -s; **däm|me|rig, dämm|rig; Däm|mer|licht** *s*; -[e]s; **däm|mern**; es dämmert; **Däm|mer.schein, ...schlaf** (*m*; -[e]s), ...schop|pen, ...stun|de; **Däm|me|rung; Däm|mer|zu|stand; dämm|rig, dam|me|rig**
Damm.riß (Med.), ...schutz (Med.)
Däm|mung (auch für: Isolierung)
dam|na|tur lat. (,,[das Buch] wird verdammt"; lat. Formel der früheren Zensur, die besagte, daß ein Buch nicht gedruckt werden durfte); **Dam|no** lat. *m*. od. *s*; -s, -s u. **Dam|num** lat. (Kaufmannsspr.: Abzug vom Nennwert eines Darlehens) *s*; -s, ...na
Da|mo|kles (gr. m. Eigenn.); **Da|mo|kles|schwert** *s*; -[e]s (↑ R 180)
Dä|mon gr. *m*; -s, ...onen; **dä|mo|nen|haft; Dä|mo|nie** *w*; -, ...ien; **dä|mo|nisch**; -ste (↑ R 294); **dä|mo|ni|sie|ren; Dä|mo|nis|mus** (Glaube an Dämonen) *m*; -; **Dä|mo|ni|um** (die warnende innere Stimme [der Gottheit] bei Sokrates) *s*; -s, ...ien [...i⁴n]; **Dä|mo|no|lo|gie** (Lehre von den Dämonen) *w*; -, ...ien
Dampf *m*; -[e]s, Dämpfe; **Dampf-.bad, ...druck** (Mehrz. meist: ...drücke); **damp|fen**; die Speise dampft, hat gedampft; **dämp|fen**; ich dämpfe die Glut, das Gemüse usw., habe gedämpft; **Damp|fer** ([Dampf]schiff); **Dämp|fer**; einen - aufsetzen (ugs. für: mäßigen); **Dampf|fer|an|le|ge|stel|le; Dampf|hei|zung; damp|fig** (voll Dampf); **dämp|fig** mdal. (schwül; [bes. vom Pferd:] kurzatmig); **Dämp|fig|keit** (Atembeschwerde

bei Pferden) *w*; -; **Dampf.kes|sel, ...koch|topf, ...lo|ko|mo|ti|ve, ...ma|schi|ne, ...nu|del** südd. (eine Speise; meist Mehrz.), ...schiff, ...schiffahrt [*Trenn.*: ...schiff-fahrt, ↑ R 236]; **Dämp|fung; Dampf|wal|ze**
Dam|wild
da|nach [auch: da...]; sich - richten
Da|nae [...na-e] (Mutter des Perseus); **Da|na|er|ge|schenk** [...nu⁴r...]; ↑ R 205 (unheilbringendes Geschenk [der Danaer = Griechen]); **Da|na|ide** (Tochter des Danaus) *w*; -, -n (meist *Mehrz.*); **Da|na|iden.ar|beit, ...faß; Da|na|us** [...na uß] (sagenhafter König, Stammvater der Griechen)
Dancing engl. [*dänßing*] (Tanzbar, Tanzlokal) *s*; -s, -s
Dan|dy engl. [*dändi*] (Stutzer, Geck, Modenarr) *m*; -s, -s; **dan|dy|haft; Dan|dy|is|mus** (svw. Dandytum) *m*; -; **Dan|dy|tum** *s*; -s
Dä|ne *m*; -n, -n (↑ R 268)
da|ne|ben [auch: da...]; **da|ne|ben.be|neh|men, sich** (ugs. für: sich unpassend benehmen); ↑ da, 2 u R 139; **da|ne|ben|fal|len**, er ist danebengefallen (↑ da, 2 u. R 139); **da|ne|ben|ge|hen** (ugs. für: mißlingen); es ist danebengegangen; aber: **da|ne|ben ge|hen** (neben jmdm. gehen); er wird daneben gehen (↑ da u. R 139); **da|ne|ben|grei|fen** (vorbeigreifen; einen Fehlgriff tun); beim Klavierspielen danebengreifen; er hat mit seiner Bemerkung ein wenig danebengegriffen; ↑ da, 2 u. R 139; **da|ne|ben|hau|en** ([am Nagel] vorbeihauen; ugs. für: aus der Rolle fallen, sich irren); ↑ da, 2 u. R 139; **da|ne|ben|schie|ßen** (vorbeischießen; ugs. für: sich irren); ↑ da, 2 u. R 139
Da|ne|brog dän. (,,Dänentuch"; dän. Flagge) *m*; -; **Dä|ne|mark; Dä|ne|werk** (dän. Grenzwall) *s*; -[e]s
da|nie|den (veralt. u. dicht. für: unten auf der Erde, danieder); **da|nie|der; da|nie|der|lie|gen** (↑ da, 2 u. R 139); die Wirtschaft hat daniedergelegen
Da|ni|el [...iäl] (m. Vorname; bibl. Prophet); **Da|nie|la** (w. Vorn.)
Dä|nin *w*; -, -nen; **dä|nisch**; (↑ R 200:) -e Dogge, aber (↑ R 198): Dänischer Wohld (Halbinsel in Schleswig-Holstein); vgl. deutsch; **Dä|nisch** (Sprache) *s*; -[s]; vgl. Deutsch; **Dä|ni|sche** *s*; -n; vgl. Deutsche *s*; **dä|ni|sie|ren** (dänisch machen)
dank (↑ R 130); mit Wemf. od. Wesf., in der *Mehrz.* überwiegend mit Wesf.: - meinem Fleiße;

- eures guten Willens; - raffinierter Verfahren; **Dank** *m*; -[e]s; Gott sei -!; vielen -!; tausend -! hab[t] Dank!; jmdm. etwas zu -[e] machen; er weiß dir dafür (auch: dessen) gar keinen -; jmdm. - sagen (vgl. danksagen); - schulden, wissen; **Dank|adres|se; dank|bar; Dank|bar|keit** *w*; -; **dan|ken;** danke!; du mußt danke sagen; danke schön!; ich möchte ihm danke schön sagen; er sagte: „Danke schön!", vgl. aber: Dankeschön; **dan|kens|wert; dan|kens|wer|ter|wei|se; dank|er|füllt; Dan|kes|be|zei|gung** (nicht: ...bezeugung); **Dan|ke|schön** *s*; -s; er sagte ein herzliches -, vgl. aber: danken; **Dan|kes_for|mel, ...schuld, ...worte** (*Mehrz.*); **Dank|ge|bet**

Dank|mar, Thank|mar (m. Vorn.); **Dank|rad** (m. Vorn.)

dank|sa|gen u. **Dank sa|gen** (↑ R 140); du danksagtest u. du sagtest Dank; dankgesagt u. Dank gesagt; dankzusagen u. Dank zu sagen; aber: ich sage vielen Dank; vgl. Dank; **Dank|sa|gung; Dank|schrei|ben**

Dank|ward (m. Vorn.)

dann; - und wann; vgl. dannzumal und dazumal

dan|nen, nur in: von - (veralt. für: von hier weg; von - gehen, schreiten, ziehen

dann|zu|mal schweiz. (dann, in jenem Augenblick)

Danse ma|cabre *fr.* [*daṅß makabr*] (Totentanz) *m*; - -, -s -s [*daṅß makabr*]

Dan|te Ali|ghie|ri [- *aligiǟri*] (it. Dichter)

Dan|tes, Tan|tes (veralt. für: Spielmarken) *Mehrz.*

dan|tesk (nach Art der Schöpfungen Dantes); **dan|tisch,** aber (↑ R 179): **Dan|tisch**

Dan|ton [*daṅtoṅg*] (fr. Revolutionär)

Dan|zig (Hafenstadt an der Ostsee); **Dan|zi|ger** (↑ R 199); - Goldwasser (Likör)

¹**Daph|ne** (w. Vorn.); ²**Daph|ne** *gr.* (Seidelbast, Zierstrauch) *w*; -, -n; **Daph|nia, Daph|nie** [...*iᵉ*] (Wasserfloh) *w*; -, ...ien [...*iᵉn*]

dar... (*in Zus. mit Zeitwörtern*, z. B. dartun, du tust dar, dargetan, darzutun; zum 2. Mittelw. ↑ R 304)

dar|an [auch: *dar*...], (ugs.:) dran; vgl. dran u. die Zusammensetzungen mit dran; daran sein (an etwas sein); er ist daran gewesen (↑ da u. R 139); daran glauben; gut daran tun; er soll nicht daran kommen, sondern hieran; **dar|an|ge|ben** (geh. für: opfern); er

wollte alles darangeben; ↑ da, 2 u. R 139; **dar|an|ge|hen** (mit etwas beginnen); er ist endlich darangegangen; aber: **dar|an ge|hen;** er soll daran gehen, nicht hieran (↑ da u. R 139); **dar|an|hal|ten,** sich (sich anstrengen, beeilen); du mußt dich schon etwas daranhalten, wenn du fertig werden willst; aber: du sollst dich daran halten, nicht hieran; ↑ da u. R 139; **dar|an|ma|chen,** sich (ugs. für: mit etwas beginnen); aber: **dar|an ma|chen;** was können wir schon daranmachen; ↑ da u. R 139; **dar|an|set|zen** (für etwas einsetzen); er hat alles darangesetzt, um dies Ziel zu erreichen; aber: **dar|an set|zen;** er soll sich daran (an diesen Tisch) setzen (↑ da u. R 139)

dar|auf [auch: *dar*...], (ugs.:) drauf; vgl. drauf und die Zusammensetzungen mit drauf; darauf ausgehen (erstreben), gehen, eingehen, kommen usw., aber: draufgehen (vgl. d.); darauf losgehen (auf ein Ziel), aber: drauflosgehen (vgl. d.); darauf folgen; das Schreiben und der darauf folgende Briefwechsel, aber: am darauffolgenden (nächsten) Tage (↑ da u. R 139); **dar|auf|hin** [auch: *dar*...] (demzufolge, danach, darauf, unter diesem Gesichtspunkt); sein Vermögen wurde daraufhin beschlagnahmt; wir haben alles daraufhin überprüft, ob ...; aber: darauf hindeuten; alles deutet darauf hin; darauf hinweisen; er wies darauf hin, daß ...

dar|aus [auch: *dar*...], (ugs.:) draus; sich nichts daraus machen; es wird nichts daraus werden; daraus, daß (↑ R 61)

dar|ben

dar|bie|ten; Dar|bie|tung; Dar|bie|tungs|kunst

dar|brin|gen; Dar|brin|gung

Dar|da|nel|len (Meerenge zwischen Ägäis u. Marmarameer) *Mehrz.*

dar|ein [auch: *dar*...], (ugs.:) drein; **dar|ein|fin|den,** sich, (ugs.:) drein|finden, sich; er hat sich dareingefunden (vgl. da, 2); **dar|ein|mi|schen,** (ugs.:) dreinmischen, sich; du darfst dich nicht überall dareinmischen; (vgl. da, 2); **dar|ein|re|den,** (ugs.:) drein|re|den; er hat dareingeredet (vgl. da, 2)

Dar|es|sa|lam (Hptst. von Tansania)

Darg, Dark niederd. (fester Moor-, torfartige Schicht) *m*; -s, -e

Dar|ge|bot (die einer Anlage zur Verfügung stehende [Wasser-] menge) *s*; -[e]s

dar|ge|tan; vgl. dartun

dar|in [auch: *da*...], (ugs.:) drin; wir können alle darin (im Wagen) sitzen, aber drinsitzen (vgl. d.); der Schlüssel bleibt darin (im Schloß) stecken, aber: drinstecken (vgl. d.); **dar|in|nen,** (ugs.:) drin|nen

Da|ri|us (pers. König)

Dark vgl. Darg

dar|le|gen; Dar|le|gung

Dar|le|hen, Dar|lehn *s*; -s, -; **Dar|le|hens_kas|se** od. Dar|lehns|kasse, ...sum|me od. Dar|lehns|summe, ...ver|trag od. Dar|lehns|vertrag, ...zins od. Dar|lehns|zins; **Dar|lehn** usw. vgl. Darlehen usw.; **Dar|lei|her** (BGB)

Dar|ling engl. (Liebling) *m*; -s, -s

Darm *m*; -[e]s, Därme; **Darm_bakte|ri|en** (die die Darmflora [vgl. d.] bildenden Bakterien; *Mehrz.*), ...blu|tung, ...bruch *m*, ...ent|lee|rung, ...er|kran|kung, ...flo|ra (Sammelbez. für die Bakterien im Darm), ...in|fek|ti|on, ...ka|nal, ...ka|tarrh, ...krank|heit, ...krebs, ...pa|ra|sit, ...sai|te, ...spü|lung

Darm|stadt (Stadt a. d. Bergstraße); **Darm|städ|ter** (↑ R 199); **darm|städ|tisch**

Darm_tä|tig|keit, ...träg|heit, ...ver|en|gung, ...ver|schlin|gung, ...ver|schluß, ...wand

dar|nach, dar|ne|ben, dar|nie|der (älter für: danach usw.)

dar|ob [auch: *dar*...], drob

Dar|re (Trocken- od. Röstvorrichtung; Tierkrankheit) *w*; -, -n; **dar|rei|chen; Dar|rei|chung**

dar|ren (Technik: dörren, trocknen, rösten); **Darr_ge|wicht, ...ofen, ...sucht** (Tierkrankheit. *w*; -); **Dar|rung**

Darß (Halbinsel an der Ostseeküste) *m*; -es; -er Ort

dar|stel|len; darstellende Geometrie; **Dar|stel|ler; Dar|stel|le|rin** *w*; -, -nen; **dar|stel|le|risch; Dar|stel|lung; Dar|stel|lungs_form ...gabe, ...kunst, ...mit|tel** *s*, ...sti| ...wei|se

dar|strecken [*Trenn.*: ...strek|ken] (veralt. für: hinstrecken, darbieten)

dar|tun (zeigen, beweisen); dargetan

dar|über [auch: *dar*...], (ugs.:) drüber; er ist - sehr böse; - hinaus er wird längst darüber hinaus sein; er hat darüber hinaus vor Neues zu sagen; darüber hinaus gehende Informationen; aber: **dar|über|fah|ren** (über etwas streichen); er wollte mit der Hand darüberfahren; aber: **dar|über fah|ren;** er soll darüber fahren nicht hierüber; (↑ da u. R 139) **dar|über|ma|chen,** sich (ugs. für mit etwas beginnen); er wollt

sich gleich darübermachen; a b e r: dar|über ma|chen; er soll sich keine Gedanken darüber (über diese Sache) machen; (↑ da u. R 139); dar|über|schrei|ben; er hat eine Bemerkung darübergeschrieben; a b e r: dar|über schrei|ben; er hat ein Buch darüber (über dieses Thema) geschrieben; (↑ da u. R 139); dar|über|ste|hen (überlegen sein); er hat mit seiner Anschauung weit darübergestanden; a b e r: dar|über ste|hen; darüber stehen erst die Bücher (↑ da u. R 139)

dar|um [auch: dar...], (ugs.:) drum; er läßt darum bitten; ei wild es darum tun; - herum; nicht darum herumkommen; er hat nur darum herumgeredet; darum, daß u. darum, weil (↑ R 61); dar|um|kom|men (nicht bekommen); er ist darumgekommen; a b e r: dar|um kom|men; darum (aus diesem Grunde) kommen sie alle (↑ da u. R 139); dar|um|le|gen (um etwas legen); er hat den Verband darumgelegt (↑ da, 2 u. R 139); dar|um|ste|hen (um etwas stehen); er sah den Verunglückten und die Leute, die darumstanden (↑ da, 2 u. R 139)

dar|un|ter [auch: dar...], (ugs.:) drun|ter; es waren gute Kinder -; dar|un|ter|fal|len (zu etwas od. jmdm. gehören); ich kenne die Bestimmung, er wird auch darunterfallen (↑ da, 2 u. R 139); dar|un|ter|lie|gen (unter etwas liegen); er hat daruntergelegen; a b e r: dar|un|ter lie|gen; er soll darunter liegen und nicht hierunter (↑ da u. R 139)

Dar|win (engl. Naturforscher); dar|wi|nisch, dar|winsch, a b e r (↑ R 179): Dar|wi|nisch, Dar|winsch; -sche Lehre, Dar|wi|nis|mus (Lehre Darwins) m; -; Dar|wi|nist (↑ R 268); dar|wi|ni|stisch

das; ↑ R 135 (Werf. u. Wenf.); vgl. der; alles das, was ich gesagt habe

da|sein (gegenwärtig, zugegen, vorhanden sein); man muß vor allen Dingen dasein (zugegen sein); so etwas ist noch nicht dagewesen (vorgekommen); (immer getrennt:) ob er auch wirklich da ist, da war?; a b e r: da sein; sage ihm, er soll um 5 Uhr da (besser: dort [an der bezeichneten Stelle]) sein; ich bin schon da (dort) gewesen; Da|sein s; -s; Da|seins|angst; da|seins|be|din|gend; Da|seins_be|din|gung, ...be|rech|ti|gung, ...form, ...freu|de; da|seins|hung|rig; Da|seins|kampf m; -[e]s; da|seins|mä|ßig (für: existentiell); Da|seins_recht, ...wei|se w, ...zweck

da|selbst (veralt., noch landsch. für: dort)

Dash engl. [däsch] (Spritzer, kleinste Menge [bei der Bereitung eines Cocktails]) m; -s, -s

das heißt (Abk.: d. h.); ↑ R 19; wir werden ihn am 27. August, d. h. an seinem Geburtstag, besuchen; wir teilen ihm mit, daß der Teilnehmerkreis gemischt ist, d. h., daß ein Teil bereits gute Fachkenntnisse besitzt

da|sig südd., österr. mdal. (verwirrt, schüchtern); - machen (sudd., österr. mdal. für: einschüchtern)

das ist (Abk.: d. i.); ↑ R 19

da|sit|zen; wenn ihn so dasitzt...; a b e r: da (dort) sit|zen (nicht stehen); ↑ da u. R 139

das|je|ni|ge (↑ R 135); Wesf.: desjenigen, Mehrz.: diejenigen

daß; so daß (immer getrennt); aufdaß (veralt.); bis daß (veralt.); ich glaube, daß ...; daß-Satz (↑ R 151)

das|sel|be (↑ R 135); Wesf.: desselben, Mehrz.: dieselben; es ist alles ein und dasselbe

Das|sel_beu|le, ...flie|ge, ...lar|ve, ...pla|ge

daß-Satz (↑ R 151)

da|ste|hen (gelten, wert sein); wie wird er nach diesem Vorgang dastehen; wie hat er dagestanden; ein einmalig dastehender Fall; a b e r: da (dort) ste|hen (nicht sitzen); ↑ da u. R 139

Da|sy|me|ter gr. (Gasdichtemesser) s; -s, -

dat. = datum

Dat. = Dativ

Da|tei (Speichereinrichtung bei der Datenverarbeitung); Da|ten (Mehrz. von: Datum; Angaben, Tatsachen) Mehrz.; Da|ten_bank (Mehrz. ...banken), ...er|fas|sung, ...trä|ger, ...über|tra|gung; da|ten|ver|ar|bei|tend; -e Maschine (vgl. S. 45, Merke, 2), aber (vgl. S. 45, Merke, 1): eine alle Daten verarbeitende Maschine; Da|ten|ver|ar|bei|tung; elektronische- (Abk.: EDV); Da|ten|ver|ar|bei|tungs|an|la|ge; da|tie|ren fr. ([Brief usw.] mit Zeitangabe versehen); einen Brief [auf den 5. Mai] -; die Handschrift datiert (stammt) aus dem 4. Jahrhundert; der Brief datiert (trägt das Datum) vom 1. Oktober; Da|tie|rung

Da|tiv lat. (Sprachw.: Wemfall, 3. Fall; Abk.: Dat.) m; -s, -e [...w⁴]; freier - (Sprachw.); Da|tiv|ob|jekt; Da|ti|vus ethi|cus [...jwuß ...kuß] (Sprachw.) m; - -, ...vi ...ci [...wi ...zi]

da|to it. (Kaufmannsspr.: heute); bis - (bis heute); Da|to|wech|sel (der auf eine bestimmte Zeit nach dem Ausstellungstag zahlbar gestellte Wechsel)

Dat|scha russ. w; -, -s od. ...schen u. Dat|sche (russ. Holzhaus; Sommerhaus, Sommerwohnung) w; -, -n

Dat|tel lat.; Dat|tel_pal|me, ...pflau|me

da|tum lat. („gegeben"; veralt. für: geschrieben; Abk.: dat.); Da|tum s; -s, ...ten; vgl. Daten; Da|tums_an|ga|be, ...gren|ze; Da|tum[s]|stem|pel

Dau, Dhau arab. (arab. Segelschiff) w; - -en

Dau|be (Seitenbrett eines Fasses; hölzernes Zielstück beim Eisschießen) w; -, -n; Dau|bel österr. (Fischnetz) w; -; Dau|ben|rei|ßer (ein Werkzeug zur Herstellung von Faßdauben)

¹Dau|er w; -, (fachspr. gelegentlich:) -n; Dau|er_auf|trag, ...aus|stel|lung, ...aus|weis, ...be|la|stung, ...be|schäf|ti|gung, ...bren|ner, ...ein|rich|tung, ...gast, ...ge|schwin|dig|keit; dau|er|haft; Dau|er|haf|tig|keit w; -; Dau|er_lauf, lei|stung, ...lut|scher; ¹dau|ern; es dauert mich lange

²dau|ern (leid tun); es dauert mich; mich dauert jeder Pfennig

dau|ernd; Dau|er_re|gen, ...ritt, ...test, ...wel|le, ...wurst, ...zu|stand

Däum|chen, Däum|lein; Däu|me|lin|chen (Märchengestalt); Däu|men m; -s, -; Dau|men_ab|druck, ...bal|len; dau|men|breit, ...dick; Dau|men_lut|scher, ...na|gel, ...re|gi|ster, ...schrau|be

Dau|mier [domje] (fr. Graphiker, Zeichner u. Maler)

Däum|lein, Däum|chen; Däum|ling

Dau|ne (Flaumfeder) w; -, -n; Dau|nen_bett, ...decke [Trenn.: ...dek|ke], ...fe|der, ...kis|sen; dau|nen|weich

Dau|phin fr. [dofäng] (ehem. fr. Thronfolger) m; -s, -s; Dau|phi|né [dofine] (fr. Landschaft) w; -

¹Daus (Teufel), nur noch in: was der -!; ei der -! (veralt.)

²Daus lat. (zwei Augen im Würfelspiel; As in der Spielkarte) s; -es, Däuser, (auch:) -e

Da|vid [daf...] (m. Vorn.; bibl. König); Da|vid[s]|stern; vgl. ²Stern

Da|vis-Pokal, Da|vis-Cup [de'-wiß..., ...kap; nach dem amerik. Stifter); ↑ R 180 (internationaler Tenniswanderpreis) m; -s

Da|vis|stra|ße [de'wiß...; nach dem Entdecker]; ↑ R 210 (Durchfahrt zwischen Grönland u. Nordamerika) w; -

Da|vit *engl.* [dɛ̣'wit] (drehbarer Schiffskran) *m*; -s, -s

da|von [auch: dą̣...]; er will etwas, viel, nichts davon haben; auf und davon laufen; da|von|blei|ben (nicht anfassen); er ist davongeblieben; aber: da|von blei|ben; davon bleibt gar nichts (↑ da u. R 139); da|von, daß (↑ R 61); da|von|ge|hen (weggehen); er ist davongegangen; aber: auf und davon gehen (↑ da u. R 139); da|von|kom|men (auch übertr. für: Glück haben); er ist noch einmal davongekommen; aber: da|von kom|men; davon kommen alle Laster (↑ da u. R 139); da|von|las|sen; er soll die Finger davonlassen (sich nicht damit abgeben); aber: da|von las|sen; er mußte schließlich davon lassen (↑ da u. R 139); da|von|lau|fen (weglaufen); er ist davongelaufen; (↑ R 120:) es ist zum Davonlaufen; aber: auf und davon laufen (↑ da u. R 139); da|von|ma|chen, sich (ugs. für: davonlaufen, auch für: sterben); er hat sich davongemacht; aber: da|von ma|chen; davon machst du dir die Finger schmutzig (↑ da u. R 139); da|von|tra|gen (wegtragen); er hat den Sack davongetragen; aber: da|von tra|gen; davon trägt er zwei Säcke auf einmal (↑ da u. R 139); da|von, weil (↑ R 61)

da|vor [auch: dą̣...]; ich fürchte mich -; - war alles gut; da|vor|hän|gen; sie soll einen Vorhang davorhängen; aber: da|vor hän|gen; sie soll den Vorhang davor hängen, nicht hiervor (↑ da u. R 139); da|vor|lie|gen; der Teppich hat davorgelegen; aber: da|vor lie|gen; der Teppich soll davor liegen, nicht hiervor (↑ da u. R 139); da|vor|ste|hen; er hat schweigend davorgestanden; aber: da|vor ste|hen; davor stehen viele Blumen (↑ da u. R 139)

Da|vos [dawọ̈ß] (Kurort in der Schweiz); Da|vo|ser (↑ R 199)

Da|vy [dɛ̣'wi] (engl. Chemiker); Da|vysch (↑ R 179); -e Lampe

da|wai! *russ.* (los!); dawai, dawai! (los, los!)

Dawes [dầß] (amerik. Finanzmann); Dawes|plan *m*; -[e]s (↑ R 180)

da|wi|der; - sein; wenn sie nichts - haben; er wird dawider stoßen; da|wi|der|re|den (das Gegenteil behaupten); er hat dawidergeredet (↑ da u. R 139)

Da|zi|en [...iᵉn] vgl. Dakien; Da|zi|er [...iᵉr] vgl. Daker; da|zisch vgl. Dakisch

da|zu [auch: dą̣...]; dazu bin ich gut; er ist dazu bereit; die

Entwicklung wird dazu führen, daß ...; da|zu|ge|hö|ren (zu jmdm. od. etw. gehören); ich weiß, daß er auch dazugehört; aber: dazu ge|hö|ren; ich weiß, daß viel Mut dazu (zu dieser Sache) gehört (↑ da, 2 u. R 139); da|zu|ge|hö|rig; da|zu|hal|ten, sich (heranhalten, beeilen); er hat sich nach Kräften dazugehalten; aber: da|zu hal|ten; dazu halte ich dir das Licht nicht (↑ da u. R 139); da|zu|kom|men (hinzukommen); er ist endlich dazugekommen; aber: da|zu kom|men; dazu komme ich nicht (↑ da u. R 139); da|zu|mal; Anno (österr.: anno) -; da|zu|rech|nen (rechnend hinzuzählen); er hat den Betrag dazugerechnet; aber: da|zu rech|nen; dazu rechne ich nicht diese schwierige Aufgabe (↑ da u. R 139); da|zu|schau|en österr. (sich dazuhalten, beeilen); er muß dazuschauen, daß er fertig wird (↑ da, 2 u. R 139); da|zu|schrei|ben (hinzufügen); er hat einige Zeilen dazugeschrieben; aber: da|zu schrei|ben; dazu schreibe ich nicht diesen ausführlichen Brief (↑ da u. R 139); da|zu|tun (hinzutun); er hat viele Äpfel dazugetan; aber: da|zu tun; was kann ich noch dazu tun? (↑ da u. R 139); Da|zu|tun (Hilfe, Unterstützung) *s*, noch in: ohne mein -

da|zwi|schen [auch: dą̣...]; da|zwi|schen|fah|ren (sich in etwas einmischen; Ordnung schaffen); du mußt mal ordentlich dazwischenfahren (↑ da, 2 u. R 139); da|zwi|schen|kom|men (auch übertr. für: sich in etwas einmischen); er ist dazwischengekommen; aber: da|zwi|schen kom|men; dazwischen kommen wieder Wiesen (↑ da u. R 139); Da|zwi|schen|kunft (veralt.) *w*; -, ...künfte; da|zwi|schen|ru|fen; er hat ständig dazwischengerufen; aber: da|zwi|schen ru|fen; dazwischen rufen immer wieder Kinder (↑ da u. R 139); da|zwi|schen|tre|ten (auch übertr. für: schlichten, ausgleichen); er ist dazwischengetreten (↑ da u. R 139); Da|zwi|schen|tre|ten *s*; -s

dB = Zeichen für: Dezibel

DB = Deutsche Bundesbahn

DBB = Deutscher Beamtenbund

DBD = Demokratische Bauernpartei Deutschlands (DDR)

DBGM = Deutsches Bundes-Gebrauchsmuster

DBP = Deutsche Bundespost; Deutsches Bundespatent

d. c. = da capo

D. C. = District of Columbia [dị̈ßtrikt ᵉw kᵉlạmbiᵉ] (dem Bundes-

kongreß unterstellter Bundesdistrikt der USA um Washington)

d. d. = de dato

Dd. = doctorạndus; vgl. Doktorand

DDR = Deutsche Demokratische Republik

DDT ⓦ = Dichlordiphenyltrichloräthan (Mittel zur Ungezieferbekämpfung) *s*; -

D-Dur [dɛ̣dur, auch: dɛdụr] (Tonart; Zeichen: D) *s*; -; D-Dur-Ton|lei|ter [dɛ...] (↑ R 155)

DEA ⓦ (ein Kraftstoff)

Dea|ler *engl.* [dị̈'lʳ] (Rauschgifthändler) *m*; -s, -

De|bą̣|kel *fr.* (Zusammenbruch; blamable Niederlage) *s*; -s, -

De|bar|deur *fr.* [...dọ̈r] (Schiffs-, Holzauslader) *m*; -s, -e; de|bar|die|ren (eine Schiffsladung löschen)

de|bar|kie|ren *fr.* (veralt. für: ausschiffen, ausladen)

De|bat|te *fr.* *w*; -, -n; de|bat|te|los; De|bat|ten|schrift (Eilschrift); De|bat|ter; de|bat|tie|ren

De|bauche *fr.* [debọsch] (veralt. für: Ausschweifung) *w*; -, -n; de|bau|chie|ren [deboschir'n] (veralt.)

De|bet *lat.* (die linke Seite, Sollseite eines Kontos) *s*; -s, -s

de|bil *lat.* (Med.: schwach; leicht geistesschwach); De|bi|li|tät (Med.: Schwäche, leichter Grad des Schwachsinns) *w*; -

De|bit *fr.* [debị] (veralt. für: Kleinhandelsvertrieb, Ausschank) *m*; -s; de|bi|tie|ren (jmdn., ein Konto belasten); De|bi|tor *lat.* (Schuldner, der Waren von einem Lieferer auf Kredit bezogen hat) *m*; -s, ...oren (meist *Mehrz.*)

De|bo|ra (bibl. w. Eigenn.); De|bo|rah (w. Vorn.)

De|bre|cen [dẹ̈brätzän] (ung. Schreibung von: Debrezin); De|bre|zin, (dt. auch:) De|brec|zin (ung. Stadt); De|bre|zi|ner (dt. auch:) De|brec|zi|ner (stark gewürzte Würstchen) *Mehrz.*

De|bus|sy [dᵉbüßị] (fr. Komponist)

De|büt *fr.* [debü̈] (erstes Auftreten) *s*; -s, -s; De|bü|tant (erstmalig Auftretender; Anfänger) *m*; -en, -en (↑ R 268); De|bü|tan|tin *w*; -, -nen; De|bü|tan|tin|nen|ball; de|bü|tie|ren

Dec|ame|ro|ne *it.* vgl. Dekameron

De|cha|nat *lat.* [dɛcha...], auch: [decha...], De|ka|nat (Amt od. Sprengel eines Dechanten, Dekans) *s*; -[e]s, -e; De|cha|nei, De|ka|nei (Wohnung eines Dechanten); De|chant [auch, vor allem österr.: dɛch...] (höherer kath. Geistlicher, Vorsteher eines kath. Kirchenbezir-

kes innerhalb der Diözese u. a.) *m*; -en, -en (↑ R 268 u. Dekan); **De|chan|tei** österr. (Amtsbereich eines Dechanten)

De|char|ge *fr.* [*descharsehᵉ*] (veralt. für: Entlastung [von Vorstand und Aufsichtsrat bei Aktiengesellschaften]) *w*; -, -n; **de|char|gie|ren** [*descharsehir̃ᵉn*]

De|ehor *lat.* (früheres deutsches Maß für Felle u. Rauchwaren) *s* od. *m*; -s, -

de|chif|frie|ren *fr.* [*deschifrir̃ᵉn*] (entziffern; Klartext herstellen); **De|chif|frie|rung**

Dech|sel (Querbeil) *w*; -, -n

De|ci|mus [*dezimuß*] (röm. m. Vorn.; Abk.: D.)

Deck *s*; -[e]s, -s (selten: -e); **Deck_adres|se,** ...**an|schrift,** ...**bett,** ...**blatt; Deckel¹** *w*; -, -n; **Deckel¹** *m*; -s, -; **Deckel¹_glas** (*Mehrz.* ...gläser), ...**kan|ne,** ...**krug; deckeln¹**; ich ...[e]le (↑ R 327); **decken¹; Decken¹_gemäl|de,** ...**kon|struk|ti|on,** ...**lam|pe,** ...**ma|le|rei; Deck_far|be,** ...**haar,** ...**man|tel,** ...**na|me** (*m*; -ns, -n); **Deck|of|fi|zier; Decks|_last,** ...**plan|ke; Deckung; Deckungs-feh|ler¹** (Sportspr.); **deckungs-gleich¹** (für: kongruent); **Deckungs_mit|tel** (*Mehrz.*), ...**sum-me,** ...**vor|la|ge; Deck_weiß,** ...**wort** (*Mehrz.* ...wörter)

de|co|die|ren vgl. dekodieren

De|col|la|ge *fr.* [*dekolaseh*] (Kunstwerk, das durch Abtragung, Abreißen oder Schneiden von Collagen [vgl. d.], durch Zerstören der Oberfläche entsteht)

Dé|colle|té vgl. Dekolleté

de|cou|ra|giert *fr.* [*dekurasehirt*] (mutlos, verzagt)

de|cresc. = decrescendo; **de|cre-scen|do** *it.* [*dekreschändo*] (Musik: abnehmend; Abk.: decresc.); **De|cre|scen|do,** (auch:) **De|kre-scen|do** *s*; -s, -s u. ...di

de da|to *lat.* (veralt. für: vom Tage der Ausstellung; Abk.: d.d.); vgl. a dato

De|di|ka|ti|on *lat.* [...*zion*] (Widmung; Geschenk); **De|di|ka|ti-ons|ex|em|plar; de|di|zie|ren** (widmen; schenken)

De|duk|ti|on *lat.* [...*zion*] (Herleitung des Besonderen aus dem Allgemeinen; Beweis); **de|duk|tiv** [auch: *de*...]; **de|du|zier|bar; de-du|zie|ren**

Deep-free|zer *engl.-amerik.* [*dip-frisᵉr*] (Tiefkühlvorrichtung, Tiefkühltruhe) *m*; -s, -

De|es|ka|la|ti|on *fr.-engl.* [...*zion*] (stufenweise Abschwächung, Verringerung); **de|es|ka|lie|ren**

¹ Trenn.: ...ek|k...

DEFA = Deutsche Film-AG (DDR)

de fac|to *lat.* (tatsächlich [bestehend]); **De-fac|to-An|er|ken|nung** (↑ R 155)

De|fä|ka|ti|on *lat.* [...*zion*] (Med.: Reinigung, Klärung; auch: Kotentleerung); **de|fä|kie|ren**

De|fä|tis|mus, (schweiz. auch:) **De|fai|tis|mus** [..*fä*...] *fr.* (Miesmacherei) *m*; -, **De|fä|tist,** (schweiz. auch:) **De|fai|tist** [..*fä*...] (Miesmacher); ↑ R 268; **de|fä|tis|tisch,** (schweiz. auch:) **de|fai|ti|stisch** [*fä*...]

de|fekt *lat.* (schadhaft; fehlerhaft); **De|fekt** *m* -[e]s, -e; **de|fek|tiv** (mangelhaft); **De|fek|ti|vum** [...*wum*] (Sprachw.: nicht an allen grammatischen Möglichkeiten seiner Wortart teilnehmendes Wort, z. B. „Leute" [ohne Einzahl]) *s*; -s, ...va [...*wa*]

de|fen|siv *lat.* (verteidigend); **De-fen|si|ve** [...*wᵉ*] (Verteidigung, Abwehr) *w*; -, -n; **De|fen-siv_krieg,** ...**spiel** (Sportspr.), ...**spie|ler** (Sportspr.), ...**stel|lung,** ...**tak|tik; De|fen|sor** (Verteidiger; Sachwalter, z. B. in: Defensor fidei = Verteidiger des Glaubens [Ehrentitel des engl. Königs]) *m*; -s, ...oren

De|fer|gen|tal (österr. Alpental) *s*; -s; **De|fer|eg|gen|tal**

De|fi|lee *fr.* [schweiz. *de*...] ([parademäßiger] Vorbeimarsch) *s*; -s, -s (auch: ...leen) od. ...s; **de|fi|lie|ren** (parademäßig od. feierlich vorbeiziehen)

de|fi|ni|er|bar; de|fi|nie|ren; de-fi|nit (bestimmt); -e Größen (Math.: Größen, die immer das gleiche Vorzeichen haben); **De|fi-ni|ti|on** [...*zion*]; - eines Dogmas (unfehlbare Entscheidung); **de|fi-ni|tiv** (endgültig, abschließend; ein für allemal); **De|fi|ni|ti|vum** [...*wum*] (endgültiger Zustand) *s*; -s, ...va [...*wa*]; **de|fi|ni|to|risch**

De|fl|zi|ent *lat.* (veralt. für: Dienstunfähiger, bes. [südd. u. österr.:] durch Alter od. Krankheit geschwächter kath. Geistlicher); ↑ R 268; **De|fi|zit** *s*; -s, -e; **De|fi|zit|po|li|tik; De|fi|zi|tär**

De|fla|ti|on *lat.* [...*zion*] (Geol.: Abblasung lockeren Gesteins durch Wind; Wirtsch.: unzureichende Versorgung einer Volkswirtschaft mit Geld); **de|fla|tio-när; de|fla|tio|ni|stisch; de|fla|to-risch**

De|flek|tor *lat.* (Saug-, Rauchkappe, Schornsteinaufsatz; Elektrode am Zyklotron) *m*; -s, ...oren

De|flo|ra|ti|on *lat.* [...*zion*] (Zerstörung des Jungfernhäutchens beim ersten Geschlechtsverkehr;

Entjungferung); **De|flo|ra|ti|ons-an|spruch** (Kranzgeld); **de|flo|rie-ren; De|flo|rie|rung**

De|foe [*dᵉfo*] (engl. Schriftsteller)

De|for|ma|ti|on *lat.* [...*zion*], **De-for|mie|rung** (Formänderung; Verunstaltung); **de|for|mie|ren; De|for|mi|tät** (selten für: [Zustand der] Mißbildung)

De|frau|dant *lat.* (Betrüger; Unterschlagent) *m*; -en, -en (↑ R 268); **De|frau|da|ti|on** [...*zion*] (Unterschlagung, Hinterziehung [bes. von Zollabgaben]); **de|frau|die-ren**

De|freg|ger (Tiroler Maler)

De|fro|ster *engl.,* **De|fro|ster|an-la|ge** *engl., di.* (Anlage im Kraftfahrzeug, die das Beschlagen od. Vereisen der Windschutzscheibe verhütet)

def|tig (ugs. für: derb, saftig; tüchtig, sehr); **Def|tig|keit** (ugs.)

De|ga|ge|ment *fr.* [*degaseh°mang*] (Zwanglosigkeit; Befreiung [von einer Verbindlichkeit]) *s*; -s, -s; **de|ga|gie|ren** [*degasehir̃n*] ([von einer Verbindlichkeit] befreien); **de|ga|giert** (zwanglos, frei)

de Gaulle [*dᵉ gol*]; vgl. Gaulle, de, **De-Gaulle-Besuch** [...*gol*...] (↑ R 182); **de-Gaulle-freund|lich** (↑ R 187)

¹**De|gen** (dicht. u. altertüml. für: [junger] Held; Krieger) *m*; -s, - ; ²**De|gen** (eine Stichwaffe) *m*; -s, -

De|ge|ne|ra|ti|on *lat.* [...*zion*] (Ent-, Ausartung); **De|ge|ne|ra-ti|ons|er|schei|nung; de|ge|ne|ra-tiv; de|ge|ne|rie|ren**

De|gen_fech|ten, ...**griff,** ...**gurt**

De|gen|hard (m. Vorn.)

De|gen_klin|ge, ...**stoß**

De|goût *fr.* [*degu*] (Ekel, Widerwille, Abneigung) *m*; -s; **de|gou|tant** (ekelhaft); **de|gou|tie|ren** (anekeln, anwidern; ekelhaft finden)

De|gra|da|ti|on *lat.* [...*zion*] (Ausstoßung eines kath. Geistlichen aus dem geistl. Stand; Umwandlung aller vorhandenen Energie in Wärme [Wärmetod]); **de|gra-die|ren; De|gra|die|rung** (Rangverlust; Landw.: Veränderung eines guten Bodens zu einem schlechten [durch Auswaschung, Kahlschlag u. a.])

De|gras *fr.* [*degra*] (Gerberfett) *s*; -

de|gres|siv *lat.* (abnehmend, sich stufenweise vermindernd [z. B. Schulden]); -e Kosten, Preise

De|gu|sta|ti|on *lat.* [...*zion*] (bes. schweiz. neben: Kostprobe); **de-gu|sti|bus non est dis|pu|tan|dum** („über den Geschmack ist nicht zu streiten"); **de|gu|stie|ren** (bes. schweiz. neben: proben, kosten)

dehn|bar; Dehn|bar|keit *w*; -; **deh-**

nen; **Dehn∖fä∖hig∖keit**, ...son∖de;
Dehnung; **Dehnungs-h** (↑ R 149)
s; -, -; **Dehnungs∖zei∖chen**
De∖hors fr. [deor] (äußerer Schein;
gesellschaftlicher Anstand)
Mehrz.
De∖hy∖dra∖ti∖on lat.; gr. [...zion]
(Entzug von Wasser, Trocknung
[z. B. von Lebensmitteln]); **de∖hy-**
drie∖ren (einer chem. Verbindung
Wasserstoff entziehen); **De∖hy-**
drie∖rung vgl. Dehydration
Dei∖bel vgl. Deiwel
Deich (Damm) m; -[e]s, -e; **Deich-**
∖bau (m; -[e]s), ...bö∖schung,
...bruch m; **dei∖chen**; **Deich∖fuß**,
...graf, ...haupt∖mann, ...kro∖ne
[1]**Deich∖sel** (Wagenteil) w; -, -n
[2]**Deich∖sel** (Nebenform von:
Dechsel) w; -, -n
Deich∖sel∖bruch, ...ga∖bel, ...stange
deich∖seln (ugs. für: [etwas Schwie-
riges] zustande bringen); ich
...[e]le (↑ R 327)
Dei∖fi∖ka∖ti∖on lat. [de-ifikazion]
(Vergottung eines Menschen od.
Dinges); **dei∖fi∖zie∖ren** [de-ifi...];
Dei gra∖tia [-...zia] (von Gottes
Gnaden; Abk.: D. G.)
deik∖tisch [auch: de-ik...] (hin-
weisend; auf Beispiele gegründet)
[1]**dein** (in Briefen usw. [↑ R 121]:
Dein usw.), deine, dein *Werf.*
(dein Tisch usw.); Wessen Buch
ist das? Ist es dein[e]s?; ein Streit
über mein und dein; mein und
dein verwechseln, aber (↑R 117):
das Mein und Dein; (↑ R 133:)
tue dein möglichstes; [2]**dein**,
deiner *Wesf.* (von du); ich geden-
ke dein[er]; **dei∖ne**, deinige; der,
die, das dein[ig]e (außer in Brie-
fen klein geschrieben, wenn ein
vorausgegangenes Hauptwort zu
ergänzen ist, z. B.: Wessen Gar-
ten ist das? Ist es der dein[ig]e?);
Großschreibung (↑ R 117): die
Dein[ig]en (deine Angehörigen);
das Dein[ig]e (deine Habe, das
dir Zukommende); du mußt das
Dein[ig]e tun; **dei∖ner**[1]; vgl. [2]**dein**
Wesf.; **dei∖ner∖seits**[1]; **dei∖nes∖glei-**
chen[1]; **dei∖nes∖teils**[1]; **dei∖net∖hal-**
ben[1]; **dei∖net∖we∖gen**[1]; **dei∖net∖wil-**
len[1]; um ...**dei∖ni∖ge**[1] vgl. deine
De∖is∖mus lat. (Gottesglaube [aus
Vernunftgründen]) m; -; **De∖ist**
(↑ R 268); **de∖is∖tisch**
Dei∖wel, Dei∖xel (ugs. für: Teufel)
m; -s; pfui -!
De∖jekt lat. (Med.: Ausgeworfe-
nes, Auswurfstoff [bes. Kot]) s;
-[e]s, -e
De∖jeu∖ner fr. [desehöne] (veralt.
für: Frühstück) s; -s, -s; **de∖jeu-**
nie∖ren (veralt.)

[1] Als Anrede in Briefen stets **groß**
geschrieben (↑ R 121).

de∖ju∖re lat. (von Rechts wegen);
De-ju∖re-An∖er∖ken∖nung (↑ R
155)
De∖ka gr. österr. (Kurzform für:
Dekagramm) s; -[s], -; **de∖ka...**
(zehn...); **De∖ka...** (Zehn...; das
Zehnfache einer Einheit, z. B.
Dekameter = 10[1] Meter; Zei-
chen: da); **De∖ka∖brist** gr.-russ.
(Teilnehmer an dem Aufstand
von 1825 in Rußland); ↑ R 268;
De∖ka∖de gr. (Zehnzahl; zehn
Stück; Zeitraum von zehn Tagen,
Wochen, Monaten oder Jahren)
w; -, -n
de∖ka∖dent lat. (verfallen; entar-
tet); **De∖ka∖denz** (Verfall; Entar-
tung) w; -
de∖ka∖disch gr. (zehnteilig); -er
Logarithmus; -es System
(Math.); -es Zählrohr (Physik);
De∖ka∖eder (Zehnflächner) s; -s,
-; **De∖ka∖gramm** (10 g; Zeichen:
Dg [in Österreich: dkg]); vgl. De-
ka; **De∖ka∖li∖ter** (10 l; Zeichen: Dl,
dkl)
De∖kal∖kier∖pa∖pier lat.; gr. (für
den Druck von Abziehbildern)
De∖ka∖log gr. (die Zehn Gebote)
m; -[e]s
Dek∖ame∖ron it. (Boccaccios Er-
zählungen mit „zehn Tage") s;
-s
De∖ka∖me∖ter gr. (10 m; Zeichen:
dam; veralt.: Dm, dkm)
De∖kan lat. (Vorsteher einer Fa-
kultät; Amtsbezeichnung für
Geistliche) m; -s, -e; vgl. Dechant;
De∖ka∖nat (Amt, Bezirk eines De-
kans) s; -[e]s, -e; vgl. Dechanat;
De∖ka∖nei (Wohnung eines De-
kans); vgl. Dechanei
de∖kan∖tie∖ren fr. ([eine Flüssigkeit
vom Bodensatz] abgießen)
de∖ka∖pie∖ren fr. ([Metalle] abbei-
zen; entzundern)
De∖ka∖po∖de gr. (Zehnfußkrebs)
m; -n, -n (meist *Mehrz.*); ↑ R 268
Dek∖ar lat. (10 Ar) s; -s, -e
de∖kar∖tel∖li∖sie∖ren fr., (seltener:)
de∖kar∖tel∖lie∖ren (Kartelle ent-
flechten, auflösen); **De∖kar∖tel∖li-**
sie∖rung
De∖ka∖ster gr. (10 Ster = 10 Ku-
bikmeter) m; -s, -e
De∖ka∖teur fr. [dekatör] (Fach-
mann, der dekatiert) m; -s, -e;
de∖ka∖tie∖ren fr. ([Wollstoffe durch
Dämpfen krumpffrei und bügel-
echt machen); **De∖ka∖tie∖rer** vgl.
Dekateur; **De∖ka∖tur** (Vorgang
des Dekatierens) w; -, -en
De∖kla∖ma∖ti∖on lat. [...zion]; **De-**
kla∖ma∖tor m; -s, ...oren; **de∖kla-**
ma∖to∖risch; **de∖kla∖mie∖ren**
De∖kla∖ra∖ti∖on lat. [...zion] (im
Rechtsw. Erklärung grundsätz-
licher Art; abzugebende Erklä-
rung eines Außenhandelskauf-

mannes gegenüber den Außen-
handelsbehörden [meist Zollbe-
hörden]); **de∖kla∖ra∖to∖risch**; -e
Urkunde; **de∖kla∖rie∖ren**
de∖klas∖sie∖ren lat. (herabsetzen);
De∖klas∖sie∖rung
de∖kli∖na∖bel lat. (veränderlich,
beugbar); ...a∖ble Wörter; **De∖kli-**
na∖ti∖on [...zion] (Sprachw.: Beu-
gung des Haupt-, Eigenschafts-,
Für- u. Zahlwortes; Abweichung
der Richtung einer Magnetnadel
von der wahren Nordrichtung;
Abweichung, Winkelabstand ei-
nes Gestirns vom Himmelsäqua-
tor); **De∖kli∖na∖tor** m; -s, ...oren
u. **De∖kli∖na∖to∖ri∖um** (Gerät zur
Bestimmung [zeitlicher Ände-
rungen] der Deklination) s; -s,
...ien[...ien];**de∖kli∖nier∖bar**(beug-
bar); **de∖kli∖nie∖ren** (Sprachw.:
[Haupt-, Eigenschafts-, Für-
und Zahlwörter] beugen)
de∖ko∖die∖ren (in der Technik
meist:)de∖co∖die∖ren(einen Kode
entschlüsseln); **De∖ko∖die∖rung**
De∖kokt lat. (Abkochung, Absud
[von Arzneimitteln]) s; -[e]s, -e
De∖kol∖le∖té,(schweiz.:) Dé∖col∖le∖té
fr. [dekolte] (tiefer [Kleid]aus-
schnitt) s; -s, -s; **de∖kol∖le∖tie∖ren**;
de∖kol∖le∖tiert; **De∖kol∖le∖tie∖rung**
de∖kom∖po∖nie∖ren lat. (zerlegen,
auflösen [in die Grundbestand-
teile]); **De∖kom∖po∖si∖ti∖on**
[...zion]; **De∖kom∖po∖si∖tum**
(Sprachw.: Neu- od. Weiterbil-
dung aus einer Zusammenset-
zung, entweder in Form einer
Ableitung [z. B. „wetteifern" von
„Wetteifer"] od. in Form einer
mehrgliedrigen Zusammenset-
zung [z. B. „Armbanduhr"]) s;
-s, ...ta
De∖kon∖ta∖mi∖na∖ti∖on nlat. [...zion]
(Entgiftung, [radioaktive] Ent-
seuchung); **De∖kon∖ta∖mi∖na∖ti-**
ons∖an∖la∖ge; **de∖kon∖ta∖mi∖nie-**
ren; **De∖kon∖ta∖mi∖nie∖rung**
De∖kon∖zen∖tra∖ti∖on nlat. [...zion]
(Zerstreuung, Zersplitterung,
Auflösung); **de∖kon∖zen∖trie∖ren**
De∖kor fr. ([farbige] Verzierung,
Ausschmückung, Vergoldung) m
(auch: s); -s, -s u. -e; **De∖ko∖ra∖teur**
[...tör] m; -s, -e; **De∖ko∖ra∖teu∖rin**
[...törin] w; -, -nen; **De∖ko∖ra∖ti∖on**
[...zion]; **De∖ko∖ra∖ti∖ons∖ma∖ler**
...pa∖pier, ...stoff; **de∖ko∖ra∖tiv**; **de-**
ko∖rie∖ren; **De∖ko∖rie∖rung** (auch
Auszeichnung mit Orden u. ä.)
De∖kort fr. [dekor, auch: dekort]
(Zahlungsabzug wegen schlech-
ter Beschaffenheit der Ware oder
wegen Mangels an Maß u. Ge-
wicht; Kassaskonto im Groß-
handel; Preisnachlaß im Export-
geschäft) m; -s, -s u. (bei dt. Aus-
spr.:) -e; **de∖kor∖tie∖ren**

De|ko|rum *lat.* (Anstand, Schicklichkeit) *s*; -s

De|ko|stoff (Kurzform für: Dekorationsstoff)

De|kre|ment *lat.* (Med.: Abnahme [einer Krankheit], Verfall) *s*; -[e]s, -e

de|kre|pit *fr.* (veralt. für: heruntergekommen; abgelebt); De|kre|pi|ta|ti|on [...*zion*] (Verpuffen, Zerknistern [von Kristallen beim Erhitzen]); de|kre|pi|tie|ren

De|kre|scen|do vgl. Decrescendo; De|kres|zenz (Abnahme) *w*; -, -en

De|kret *lat.* (Beschluß; Verordnung; behördliche, richterliche Verfügung) *s*; -[e]s, -e; De|kre|ta|le ([päpstlicher] Entscheid) *s*; -, ...lien [...*i^en*] od. *w*; -, -n (meist *Mehrz.*); de|kre|tie|ren

De|ku|ma|ten|land, De|ku|mat|land *lat.*; *dt.* (Zehntland; vom Limes eingeschlossenes altröm. Kolonialgebiet in Deutschland) *s*; -[e]s

de|ku|pie|ren *fr.* (ausschneiden, aussägen); De|ku|pier|sä|ge (Schweif-, Laubsäge)

De|ku|rio *lat.* [...*i^e*] (bei den Römern urspr. Abteilung von zehn Mann; dann allgemein für Gruppe von Senatoren, Richtern, Rittern) *w*; -, -n; De|ku|rio (Vorsteher einer Zehntschaft; dann auch Mitglied des Gemeinderates in altröm. Städten) *m*; -s u. ...onen, ...onen

de|kus|siert *lat.* (kreuzweise gegenständig [von der Blattstellung bei Pflanzen])

De|ku|vert *fr.* [...*wär*] (Börse: Überschuß der Baissegeschäfte über die Haussegeschäfte) *s*; -s, -s; de|ku|vrie|ren (zu erkennen geben, entlarven)

del. = deleatur; delineavit

Del. = Delaware

De|lat *lat.* (veralt. für jmd., dem ein Eid zugeschoben wird) *m*; -en, -en (↑ R 268); De|la|ti|on [...*zion*] (veralt. für: Anzeige; Übertragung; [Eides]zuschiebung); de|la|to|risch (veralt. für: verleumderisch, angeberisch)

[1]De|la|wa|re [*däl^e wär*] (Staat in den USA; Abk.: Del.); [2]De|la|wa|re (Angehöriger eines nordamerik. Indianerstammes) *m*; -n, -n (↑ R 268)

de|le|gtur *lat.* („man streiche"; Abk.: del.; Druckw.: als Tilgungszeichen ∂); De|lea|tur (Druckw.: Tilgungszeichen ∂) *s*; -s, -; De|le|gtur|zei|chen

De|le|gat *lat.* (Bevollmächtigter) *m*; -en, -en (↑ R 268); Apostolischer De|le|gat; De|le|ga|ti|on [...*zion*]; De|le|ga|ti|ons|lei|ter *m*, ...mit|glied, ...teil|neh|mer; de|le|gie-

ren; De|le|gier|te *m* u. *w*; -n, -n (↑ R 287 ff.); De|le|gie|rung

de|lek|tie|ren *lat.* (geh. für: ergötzen, erfreuen); sich -

de|le|tär *nlat.* (Med.: tödlich, verderblich)

Delft (niederl. Stadt); Delft|ter (↑ R 199); - Fayencen (Töpferwaren)

Del|hi (Hptst. der Indischen Union); vgl. Neu-Delhi

De|lia (w. Vorn.)

De|li|be|ra|ti|on *lat.* [...*zion*] (veralt. für: Berat[schlag]ung, Überlegung); De|li|be|ra|ti|ons|frist (Rechtsspr.: Bedenkzeit); de|li|be|rie|ren (veralt.)

de|li|kat *fr.* (lecker, wohlschmeckend; zart; heikel); De|li|ka|tes|se (Leckerbissen; Feinkost; in der Einz. auch: Zartgefühl) *w*; -, -n; De|li|ka|tes|sen... od. De|li|ka|teß|ge|schäft

De|likt *lat.* (Vergehen; Straftat) *s*; -[e]s, -e

De|li|la (w. Vorn.; bibl. w. Eigenn.)

del|lin., del. = delineavit; de|li|nea|vit *lat.* [...*wit*] (unter Bildern: „hat [es] gezeichnet"; Abk.: del., delin.)

de|lin|quent *lat.* (straffällig, verbrecherisch); De|lin|quent (Übeltäter; Angeklagter) *m*; ↑ R 268

de|li|rie|ren *lat.* (Med.: irre sein, irrereden); De|li|ri|um (Fieber-, Rauschzustand) *s*; -s, ...ien [...*i^en*]; De|li|ri|um tre|mens (Säuferwahnsinn) *s*; - -

de|lisch (von Delos); (↑ R 200:) das delische Problem (von Apollo den Griechen gestellte Aufgabe, seinen würfelförmigen Altar auf Delos zu verdoppeln), aber (↑ R 224): der Delische Bund

de|li|zi|ös *fr.* (köstlich); -este (↑ R 292)

Del|kre|de|re *it.* (Bürgschaft[ssumme]; Wertberichtigung für voraussichtliche Ausfälle) *s*; -s, -

Del|le (ugs. für: [leichte] Vertiefung; Beule) *w*; -, -n

de|lo|gie|ren *fr.* [*delosehir^en*] bes. österr. (jmdn. zum Auszug aus einer Wohnung veranlassen; veralt. für: abmarschieren); De|lo|gie|rung (Zwangsräumung)

De|los (Insel im Ägäischen Meer)

Del|phi (altgr. Orakelstätte)

Del|phin *gr.-lat.* (Zahnwal) *m*; -s, -e; Del|phi|na|ri|um (Anlage zur Pflege, Züchtung und Dressur von Delphinen) *s*; -s, ...ien [...*i^en*]; del|phin|schwim|men (im allg. nur in der Grundform gebr.); er kann nicht -; Del|phin|schwim|men (*s*; -s), ...schwim|mer; Del|phi|nus (lat. Form für Delphin) *m*; -, ...ine; vgl. auch Delphini

del|phisch; (↑ R 200:) ein -es ([nach

Delphi benanntes] doppelsinniges) Orakel, aber (↑ R 224): das Delphische (in Delphi bestehende) Orakel

[1]Del|ta (gr. Buchstabe: *Δ, δ*) *s*; -[s], -s; [2]Del|ta (Schwemmland [an mehrarmigen Flußmündungen]) *s*; -s, -s u. ...ten; del|ta|för|mig; Del|ta|strah|len, *δ*-Strah|len (Höhenstrahlen aus Elektronen mit so hoher Geschwindigkeit, daß sie Zweigspuren erzeugen) *Mehrz.*; ↑ R 149; Del|to|id *gr.* (Viereck aus zwei gleichschenkligen Dreiecken) *s*; -[e]s, -e; Del|to|id|dó|de|ka|eder (Kristallform mit 12 Deltoiden)

de Lu|xe *fr.* [*d^e lüx*] (aufs beste ausgestattet, mit allem Luxus)

dem vgl. der

Dem|ago|ge *gr.* („Volksführer"; Volksverführer, -aufwiegler) *m*; -n, -n (↑ R 268); Dem|ago|gie *w*; -, ...ien; dem|ago|gisch; -ste (↑ R 294)

De|mant [auch: ...*ant*] (dicht. u. mdal. für: Diamant) *m*; -[e]s, -e; de|man|ten (dicht. u. mdal. für: diamanten); De|man|to|id *gr.* (ein Mineral) *m*; -[e]s, -e

De|mar|che *fr.* [*demarsch^e*] (diplomatischer Schritt, mündlich vorgetragener diplomatischer Einspruch) *w*; -, -n

De|mar|ka|ti|on *fr.* [...*zion*] (Abgrenzung); De|mar|ka|ti|ons|li|nie; de|mar|kie|ren; De|mar|kie|rung

de|mas|kie|ren *fr.*; De|mas|kie|rung

De|me|lee (veralt. für: Streit, Handgemenge) *s*; -[s], -s

De|men (*Mehrz.* von: Demos)

dem|ent|ge|gen (dagegen)

De|men|ti *lat.* (offz. Widerruf; Berichtigung) *s*; -s, -s

de|men|tie|ren (widerrufen; berichtigen; für unwahr erklären)

dem|ent|spre|chend

De|menz vgl. Dementia

De|me|rit *fr.* (straffälliger Geistlicher) *m*; -en, -en (↑ R 268)

De|me|ter [österr.: *de...*] (Gött. tin des Ackerbaues)

dem|ge|gen|über (dagegen, anderseits), aber: dem [Manne] gegenüber saß ...; dem|ge|mäß

dem|je|ni|gen

de|mi|li|ta|ri|sie|ren (entmilitarisieren); De|mi|li|ta|ri|sie|rung

De|mi|mon|de *fr.* [*d^e mimongd^e*] („Halbwelt") *w*; -

de|mi|nu|tiv usw. (Nebenform von: diminutiv usw.)

De|mis|si|on *fr.* (Rücktritt eines

Ministers od. einer Regierung); **De|mis|sio|när** (veralt. für: entlassener, verabschiedeter Beamter) *m*; -s, -e; **de|mis|sio|nie|ren** **De|mi|urg** *gr.* (Weltschöpfer, -seele; Gott [bei Platon u. in der Gnosis]) *m*; -en (↑ R 268) u. -s **dem|nach; dem|nächst** **De|mo|bi|li|sa|ti|on** *lat.* [...*zion*]; **de|mo|bi|li|sie|ren; De|mo|bi|li|sie|rung; De|mo|bil|ma|chung** **De|mo|gra|phie** *gr.* (Beschreibung der wirtschafts- u. sozialpolit. Bevölkerungsbewegung) *w*; -, ...ien; **de|mo|gra|phisch** **De|moi|selle** *fr.* [*demoasä̱l*] (veralt. für: Jungfer, Fräulein) *w*; -, -n **De|mo|krat** *gr. m*; -en, -en (↑ R 268); **De|mo|kra|tie** (,,Volksherrschaft'') *w*; -, ...ien; mittelbare, parlamentarische, repräsentative, unmittelbare -; **de|mo|kra|tisch**; -ste (↑ R 294); -e Verfassung, aber (↑ R 224): Demokratische Bauernpartei Deutschlands (DDR; Abk.: DBD); **de|mo|kra|ti|sie|ren; De|mo|kra|ti|sie|rung** **De|mo|krit** (altgr. Philosoph); **De|mo|kri|tos** vgl. Demokrit **de|mo|lie|ren** *fr.;* **De|mo|lie|rung** **de|mo|ne|ti|sie|ren** *fr.* (außer Umlauf setzen [von Münzen]); **De|mo|ne|ti|sie|rung** **De|mon|strant** *lat. m*; -en, -en (↑ R 268); **De|mon|stra|ti|on** [...*zion*]; **De|mon|stra|ti|ons|ap|pa|rat,** ...ma|te|ri|al, ...ob|jekt, ...recht, ...schach|brett, ...zug; **de|mon|stra|tiv; De|mon|stra|tiv** (hinweisendes Fürwort; vgl. Demonstrativpronomen) *s*; -s, -e [...*w͏e*]; **De|mon|stra|tiv|pro|no|men** (Sprachw.: hinweisendes Fürwort, z. B. ,,dieser, diese, dieses''); **De|mon|stra|tor** (Beweis-, Vorführer) *m*; -s, ...oren; **de|mon|strie|ren** (beweisen, vorführen; eine Massenversammlung veranstalten, daran teilnehmen) **De|mon|ta|ge** *fr.* [*demonta̱sche̱*, auch: ...*mong̱*...] (Abbau, Abbruch [insbes. von Industrieanlagen]); **de|mon|tie|ren; De|mon|tie|rung** **De|mo|ra|li|sa|ti|on** *fr.* [...*zion*] (Auflösung von Sitte u. Ordnung; Zuchtlosigkeit); **de|mo|ra|li|sie|ren** (den moralischen Halt nehmen; entmutigen) **de͏ mor|tu|is nil ni|si be|ne** *lat.* (,,von den Toten [soll man] nur gut [sprechen]'') **De|mos** (Gebiet u. Volksgemeinde eines altgr. Stadtstaates; heute in Griechenland Bez. für den kleinsten staatl. Verwaltungsbezirk) *m*; -, Demen; **De|mo|skop** *gr.* (Meinungsforscher) *m*; -en, -en (↑ R 268); **De|mo|sko|pie** (Mei-

nungsumfrage, Meinungsforschung) *w*; -, ...ien; **de|mo|sko|pisch**; -e Untersuchung **De|mo|sthe|nes** (altgr. Redner); **de|mo|sthe|nisch;** aber (↑ R 179): **De|mo|sthe|nisch**; -e Reden **de|mo|tisch** *gr.* (volkstümlich); -e Schrift (altägypt. volkstüml. Schrägschrift); **De|mo|tisch** *s*; -[s]; vgl. Deutsch; **De|mo|ti|sche** *s*; -n; vgl. Deutsche *s* **dem|un|er|ach|tet** [auch: *de̱mun*...], **dem|un|ge|ach|tet** [auch: *de̱m|un*...] (für: dessenungeachtet) **De|mut** *w*; -; **de|mü|tig; de|mü|ti|gen; De|mü|ti|gung; De|muts.ge|bär|de,** ...hal|tung; **de|mut[s]|voll** **dem|zu|fol|ge** (demnach); - ist die Angelegenheit geklärt, aber: das Vertragswerk, dem zufolge die Staaten sich verpflichten ... **den** vgl. der **den** = Denier **De|nar** *lat.* (,,Zehner''; [altröm.] Münze; Abk.: d) *m*; -s, -e **De|na|tu|ra|li|sa|ti|on** *lat.* [...*zion*] (Entlassung aus der bisherigen Staatsangehörigkeit); **de|na|tu|ra|li|sie|ren; de|na|tu|rie|ren** (,,seiner Natur berauben''; ungenießbar machen; vergällen); de-naturierter Spiritus; **De|na|tu|rie|rung** **de|na|zi|fi|zie|ren** (entnazifizieren); **De|na|zi|fi|zie|rung** **Den|drit** *gr.* (Geol.: Gestein mit feiner, verästelter Zeichnung; Med.: verästelter Protoplasmafortsatz einer Nervenzelle) *m*; -en, -en (↑ R 268); **den|dri|tisch** (verzweigt, verästelt); -ste (↑ R 294); **Den|dro|lo|ge** (Erforscher der Bäume und Gehölze) *m*; -n, -n (↑ R 268); **Den|dro|lo|gie** (wissenschaftliche Baumkunde) *w*; -; **Den|dro|me|ter** (Baummeßgerät) *s*; -s, - **de|nen** vgl. der **Den|gel** (Schneide einer Sense, Sichel od. eines Pfluges) *m*; -s, -; **Den|gel.am|boß,** ...ham|mer; **den|geln** (Sense, Sichel od. Pflug durch Hammerschlag schärfen); ich ...[e]le (↑ R 327) **Den|gue|fie|ber** *span.; lat.* [*dänge...*] (eine trop. Infektionskrankheit) *s*; -s **Den Haag** vgl. Haag, Den **De|nier** *fr.* [*denie̱*] (frühere Einheit für die Fadenstärke bei Seide u. Chemiefasern; Abk.: den) *s*; -[s], -; vgl. tex **De|nise** [*deni̱s*] (fr. w. Vorn.) **Denk.an|stoß,** ...art, ...auf|ga|be; **denk|bar;** die - günstigsten Bedingungen; **den|ken;** du dachtest; du dächtest; gedacht; denk[e]!; **Den|ken** *s*; -s; sein ganzes -; **Den|ker;**

den|ke|risch; Den|ker|stirn; denk-faul; Denk.feh|ler, ...**form,** ...hil-fe, ...in|halt, ...leh|re** (für: Logik); ...lei|stung, ...mal** (*Mehrz.* ...mä-ler [seltener: ...male]); **Denk-mal[s]|kun|de** *w*; -; **denk|mal[s]|kund|lich; Denk|mal[s].pfle|ge** (*w*; -), ...schän|dung, ...schutz; **Denk.mo|dell; denk|not|wen|dig; Denk.pause,** ...pro|zeß; **denk-rich|tig** (für: logisch); **Denk.scha-blo|ne,** ...schrift, ...sport; **Denk-sport|auf|ga|be; Denk|spruch; denk|ste!** (ugs. für: das hast du dir so gedacht!); **Denk.stein; Den-kungs|art; Denk.ver|mö|gen** (*s*; -s), ...vor|gang, ...wei|se *w*; **denk-wür|dig; Denk.wür|dig|keit; Denk|zet|tel** **denn;** in gehobener Sprache für: ,,als'', z. B. süßer - Honig; es sei -, daß ...; **denn|noch** [*Trenn.:* ↑ R 236] **De|no|mi|na|ti|on** *lat.* [...*zion*] (Benennung; Anzeige); [*denominé͏l-sch͏en*] (amerik. Bezeichnung für: christliche Glaubensgemeinschaft, Sekte); **De|no|mi|na|tiv** *s*; -s, -e [...*w͏e*] u. **De|no|mi|na|ti|vum** [...*iwum*] (Sprachw.: Ableitung von einem Haupt- oder Eigenschaftswort, z. B. ,,trösten'' von ,,Trost'', ,,bangen'' von ,,bang'') *s*; -s, ...va [...*wa*] **Den|si|me|ter** *lat.; gr.* (,,Dichtemesser'') *s*; -s, - **den|tal** *lat.* (Med.: die Zähne betreffend; Sprachw.: mit Hilfe der Zähne gebildet); **Den|tal** (Sprachw.: Zahnlaut, an den oberen Schneidezähnen gebildeter Laut, z. B. t) *m*; -s, -e; **Den|ta-lis** (veralt. für: Dental) *w*; -, ...les; **Den|tal|laut; den|te|lie|ren** *fr.* [*dan̲t͏el͏ir͏en*] (auszacken [von Spitzen]); **Den|tin** *lat.* (Med.: Zahnbein; Biol.: Hartsubstanz der Haischuppen) *s*; -s; **Den|tist** (früher für: Zahnarzt ohne Hochschulprüfung); ↑ R 268; **Den|ti|ti|on** [...*zion*] (Med.: Zahnen; Zahndurchbruch) **De|nu|da|ti|on** *lat.* [...*zion*] (Geol.: flächenhafte Abtragung der Erdoberfläche durch Wasser, Wind u. a.; Med.: Fehlen bzw. Entfernung einer natürlichen Hülle, z. B. Entblößtsein einer Zahnwurzel vom Zahnfleisch) **De|nun|zi|ant** *lat.* (Angeber aus persönlichen, unmoralischen Beweggründen) *m*; -en, -en (↑ R 268); **De|nun|zi|an|ten|tum** *s*; -s; **De|nun|zi|at** (veralt. für: Verklagter, Beschuldigter) *m*; -en, -en (↑ R 268); **De|nun|zia|ti|on** [...*zion*] (Anzeige eines Denunzianten); **de|nun|zia|to|risch; de|nun|zie|ren**

De|odo|rạnt *engl.* (geruchtilgendes Mittel) *s;* -s, -e u. -s; De|odo|rạnt|spray

Dẹo gra|ti|as! *lat.* [- ...*ziaß*] („Gott sei Dank!")

Dẹo|spray (Kurzform für: Deodorantspray)

De|par|te|ment *fr.* [*depart*(*e*)*mᾱng,* österr.: *departmᾱng,* schweiz.: *de-part*(*e*)*mᾱnt*] (Verwaltungsbezirk in Frankreich; Ministerium beim Bund und in einigen Kantonen der Schweiz; veralt. für: Abteilung, Geschäftsbereich) *s;* -s, -s u. (schweiz.:) -e; De|part|ment [*di-pᾱ'tm*(*e*)*nt*] (engl. Form von: Departement) *s;* -s, -s

De|pen|dance *fr.* [*depangdᾱngß*] (schweiz.:) Dé|pen|dance [*de-pangdᾱngß*] (Nebengebäude [eines Hotels] *w;* -, -n; De|pen|dẹnz *lat.* (Philos.: Abhängigkeit) *w;* -, -en

De|pẹ|sche *fr.* („Eilbotschaft"; Draht-, Funknachricht) *w;* -, -n; De|pe|schen|wech|sel; de|pe|schie|ren

De|phlẹg|ma|tor (Vorrichtung bei der [Spiritus]destillation) *m;* -s, ...oren

De|pi|la|ti|on *lat.* [...*zion*] (Med.: Enthaarung); De|pi|la|to|ri|um (Med.: Enthaarungsmittel) *s;* -s, ...ien [...*i*ᵉ*n*]; de|pi|lie|ren

De|place|ment *fr.* [*deplaßmᾱng*] (Seew.: Wasserverdrängung eines Schiffes) *s;* -s, -s; de|pla|cie|ren [*deplaßir*ᵉ*n*] (veralt. für: verrücken, verdrängen); de|pla|ciert [*deplaßirt*], (eingedeutscht:) de|pla|ziert (fehl am Platz; unangebracht); De|pla|cie|rung (veralt. für: Verrückung, Verdrängung)

De|po|la|ri|sa|ti|on *lat.* [...*zion*] (Aufhebung der Polarisation); de|po|la|ri|sie|ren

De|po|nens *lat.* (Sprachw.: Zeitwort in Leideform mit Bedeutung der Tatform) *s;* -, ...nentia [...*zia*] u. ...nenzien [...*zi*ᵉ*n*]; De|po|nẹnt (Hinterleger); ↑ R 268; De|po|nie *lat.-fr.* (Lagerplatz, zentraler Müllabladeplatz) *w;* -, ...ien; geordnete, wilde -; de|po|nie|ren *lat.;* De|po|nie|rung

De|pọrt *fr.* [auch: *depọr*] (Kursabschlag) *m;* -s, -s u. (bei dt. Ausspr.:) -e

De|por|ta|ti|on *lat.* [...*zion*] (zwangsweise Verschickung; Verbannung); De|por|ta|ti|ons|la|ger; de|por|tie|ren; De|por|tier|te *m u. w;* -n, -n (↑ R 287 ff.); De|por|tie|rung

De|po|si|tar *lat.,* De|po|si|tär *fr.* (Verwahrer von Wertgegenständen, -papieren u. a.) *m;* -s, -e; De|po|si|ten *lat.* (Gelder, die bei einem Kreditinstitut gegen Ver-

zinsung angelegt werden u. nicht auf ein Spar- od. Kontokorrentkonto verbucht werden) *Mehrz.;* De|po|si|ten|bank (*Mehrz.* ...banken), ...kas|se; De|po|si|ti|on [...*zion*] (Hinterlegung; Absetzung eines kath. Geistlichen); De|po|si|to|ri|um (Aufbewahrungsort; Hinterlegungsstelle) *s;* -s, ...ien [...*i*ᵉ*n*]; De|po|si|tum (das Hinterlegte; hinterlegter Betrag) *s;* -s; veral. Depositen

de|pos|se|die|ren *fr.* (veralt. für: enteignen; entrechten; absetzen); De|pos|se|die|rung

De|pọt *fr.* [*depọ*] (Niederlage; Hinterlegtes; Sammelstelle, Lager; Med.: Ablagerung) *s;* -s, -s; De|pọt|fund (Vorgeschichte: Sammelfund), ...schein (Hinterlegungs-, Pfandschein), ...wech|sel (Deckungswechsel)

Dẹpp bes. südd., österr. ugs. (ungeschickter, einfältiger Mensch) *m;* -en, -en (auch: -s, -e); vgl. Tẹpp; dẹp|pert südd., österr. ugs. (einfältig, dumm); vgl. teppert

De|pra|va|ti|on *lat.* [...*wazion*] (veralt. für: Verschlechterung, bes. im Münzwesen; Med.: Verschlechterung eines Krankheitszustandes); de|pra|vie|ren (veralt. für: verschlechtern [von Münzen])

De|pre|ka|ti|on *lat.* [...*zion*] (veralt. für: Abbitte); de|pre|zie|ren

De|prẹs|si|on *lat.* (Niedergeschlagenheit; Senkung; wirtschaftlicher Rückgang; Meteor.: Tief); de|pres|sịv (gedrückt, niedergeschlagen); De|pres|si|vi|tät

de|pre|zie|ren *lat.* (Studentenspr.: Abbitte leisten)

de|pri|mie|ren *fr.* (niederdrücken; entmutigen); de|pri|miert (entmutigt, niedergeschlagen, schwermütig)

De|pri|va|ti|on *lat.* [...*wazion*] (Entsetzung eines kath. Geistlichen von seiner Pfründe)

Dẹ pro|fun|dis *lat.* („Aus der Tiefe [rufe ich, Herr, zu dir]"; Anfangsworte u. Bez. des 130. Psalms nach der Vulgata) *s;* - -

De|pu|tạnt *lat.* (jmd., der auf ein Deputat Anspruch hat) *m;* -en, -en (↑ R 268); De|pu|tạt (regelmäßige Leistungen in Naturalien als Teil des Lohnes) *s;* -[e]s, -e; De|pu|ta|ti|on [...*zion*] (Abordnung); De|pu|tạt|lohn; de|pu|tie|ren (abordnen); De|pu|tier|te *m u. w;* -n, -n (↑ R 287 ff.); De|pu|tier|ten|kam|mer

dẹr (↑ R 135), die (vgl. d.), das (vgl. d.); des u. dessen (vgl. d.), dem, den; *Mehrz.* die, der, deren u. derer (vgl. d.), den u. denen, die

De|ran|ge|ment [*derangseh*ᵉ-

mᾱng] (veralt. für: Störung, Verwirrung; Zerrüttung) *s;* -s, -s; de|ran|gie|ren [*derangsehir*ᵉ*n*] (stören, verwirren); de|ran|giert [...*sehirt*] (verwirrt, zerzaust)

dẹr|ạrt (so); vgl. Art; dẹr|ạr|tig; derartiges (solches; ↑ R 135), aber (↑ R 116): etwas Derartiges (so Beschaffenes)

dẹrb; Dẹrb|heit; dẹrb|kno|chig

¹Dẹr|by [*dᾱ'bi*] (engl. Stadt)

²Dẹr|by [*dᾱrbi*] (nach Lord Derby [*dᾱ'bi*] (Pferderennen) *s;* -[s], -s; Dẹr|by|ren|nen; ↑ R 180

dẹr|ẹinst

de|rẹn; *Wesf.* der Einz. des zurückweisenden *hinweisenden* und des *bezüglichen Fürw.* die, *Wesf.* der *Mehrz.* der zurückweisenden *hinweisenden* und der *bezüglichen Fürw.* der, die, das (vgl. d.); von - liebevollstem Vertreter; von - bester Art; mit - ganzem Zutun; die Stadt u. - zahlreiche Bauten; die Frist, innerhalb - ...; die Schülerin, - Vater man geschrieben hat, ...; meine Freunde u. - Anschauungen; die Freunde, - Wohltaten du empfangen wirst; Ich habe - (z. B. Freunde) nicht viele; vgl. derer; dẹ|rẹnt|hal|ben; dẹ|rẹnt|we|gen; dẹ|rẹnt|wil|len; um - -

de|rẹr; *Wesf.* der *Mehrz.* der vorausweisenden *hinweisenden Fürw.* der, die, das (derer ist richtig, sobald dafür derjenigen stehen kann); die Freunde -, die ...; gedenkt -, die euer gedenken; das Haus - von Arnim; vgl. deren

Dẹrff|lin|ger (Feldherr des Großen Kurfürsten)

dẹr|gẹ|stalt (so)

dẹr|glẹi|chen (Abk.: dgl.); und - [mehr] (Abk. u. dgl. [m.])

De|ri|vạt *lat.* [...*wạt*] (Chemie: „Abkömmling" einer chem. Verbindung; Sprachw.: abgeleitetes Wort, z. B. „kräftig" von „Kraft"; Biol.: abgeleitetes Organ) *s;* -[e]s, -e; De|ri|va|ti|on [...*zion*] (Ableitung); de|ri|va|tịv (Sprachw.: durch Ableitung entstanden); De|ri|va|tịv (Sprachw.: abgeleitetes Wort) *s;* -s, -e [...*w*ᵉ]; de|ri|vie|ren

dẹr|je|ni|ge (↑ R 135); *Wesf.* desjenigen; *Mehrz.* diejenigen

dẹr|lẹi (dergleichen)

Dẹr|ma *(Med.: Haut) s;* -s, -ta; der|mal (Med.: die Haut betreffend, von ihr stammend, an ihr gelegen)

dẹr|mal|ẹinst; dẹr|ma|len (veralt. für: jetzt); dẹr|ma|lig (veralt. für: jetzig)

dẹr|ma|ßen (so)

dẹr|ma|tisch vgl. dermal; Dẹr|ma|to|gẹn *gr.* (pflanzl. Gewebe) *s;* -s;

Der|ma|tol Ⓦ (Wundpuder) s; -s; Der|ma|to|lo|ge (Hautarzt) m; -n, -n (↑ R 268); Der|ma|to|lo|gie (Lehre von den Hautkrankheiten) w; -; Der|ma|to|pla|stik, Dermo|pla|stik (Med.: operativer Ersatz von kranker od. verletzter Haut durch gesunde) w; -, -en; Der|mo|gra|phie w; - u. Der|mogra|phis|mus (Med.: „Hautschrift"; Streifen- od. Striemenbildung auf gereizten Hautstellen) m; -; Der|mo|pla|stik vgl. Dermatoplastik

Der|nier cri [därni-e kri] („letzter Schrei"; letzte Mode) m; - -, -s -s [därni-e kri]

de|ro (veralt. für: deren); in der Anrede: Dero

De|ro|ga|ti|on lat. [...ziọn] (Teilaufhebung [eines Gesetzes]); de|ro|ga|tiv, de|ro|ga|to|risch ([ein Gesetz] zum Teil aufhebend); de|ro|gie|ren ([ein Gesetz] zum Teil aufheben)

de|ro|hal|ben (veralt.); vgl. dero

De|rou|te fr. [derụt] (veralt. für: wilde Flucht; Verfall; Kurs-, Preissturz) w; -, -n

de|ro|we|gen (veralt.); vgl. dero

Der|rick engl. [nach dem engl. Henker Derrick] (Drehkran) m; -s, -s; Der|rick|kran (↑ R 180)

der|sel|be (↑ R 135); Wesf. desselben, Mehrz. dieselben; ein und -; mit einem und demselben; ein[en] und denselben; es war derselbe Hund; der|sel|bi|ge; ↑ R 135 (veralt. für: derselbe)

der|weil, der|wei|le[n]

Der|wisch pers. (Mitglied eines islamischen religiösen Ordens) m; -[e]s, -e; Der|wisch|tanz

der|zeit (augenblicklich, gegenwärtig; veralt. für: früher, damals; Abk.: dz.); der|zei|tig (vgl. derzeit)

des; auch ältere Form für: dessen (vgl. d.); der Wille - (dessen), der mich gesandt hat (bibl.); - (dessen) bin ich sicher; vgl. der

des, Des (Tonbezeichnung) s; -, -; Des (Zeichen für: Des-Dur); in Des

des. = designatus

Des|an|ne|xi|on fr. (Rückgängigmachen einer Annexion; fr. Schlagwort im 1. Weltkrieg in bezug auf Elsaß-Lothringen)

des|ar|mie|ren fr. (veralt. für: entwaffnen; Fechten: dem Gegner die Klinge aus der Hand schlagen)

De|sa|ster fr. („Unstern"; Mißgeschick; Zusammenbruch) s; -s, -

des|avou|ieren fr. [...awui̯e̱n] (nicht anerkennen, in Abrede stellen; im Stich lassen, bloßstellen); Des|avou|ie̱rung

Des|cartes [dekạrt] (fr. Philosoph)

Des|de|mo|na [auch: desdämona] (Frauengestalt bei Shakespeare)

Des-Dur [auch: dạ̈ßdu̱r] (Tonart; Zeichen: Des) s; -; Des-Dur-Tonlei|ter (↑ R 155)

de|sen|si|bi|li|sie|ren lat. (Med.: unempfindlich machen; Fotogr.: Filme weniger lichtempfindlich machen); De|sen|si|bi|li|sie|rung

De|ser|teur fr. [...tö̱r] (Fahnenflüchtiger, Überläufer) m; -s, -e; de|ser|tie|ren; De|ser|ti|on [...ziọn] (Fahnenflucht)

des|falls (veralt. für: für diesen Fall)

desgl. = desgleichen

des|glei|chen (Abk.: desgl.)

des|halb

de|si|de|ra|bel lat. (wünschenswert); ...a|ble Erfolge; De|si|derat s; -[e]s, -e u. De|si|de|ra|tum („Gewünschtes"; ein vermißtes u. zur Anschaffung in Bibliotheken vorgeschlagenes Buch; Lücke) s; -s, ...ta; De|si|de|ra|ten|buch (Wunschbuch)

De|sign engl. [disai̯n] (Plan, Entwurf, Muster, Modell) s; -s, -s; De|si|gna|ti|on lat. [...ziọn] (Bestimmung, Bezeichnung; vorläufige Ernennung); de|si|gna|tus (im voraus ernannt, vorgesehen; Abk.: des.; z. B. Dr. des.); De|si|gner engl. [disai̯ner] (Formgestalter für Gebrauchs- u. Verbrauchsgüter) m; -s, -; de|si|gnie|ren lat. (bestimmen, bezeichnen, für ein Amt vorsehen)

Des|il|lu|si|on fr. (Enttäuschung; Ernüchterung); des|il|lu|sio|nieren; Des|il|lu|sio|nie|rung

Des|in|fek|ti|on [...ziọn], Des|in|fizie̱|rung lat. (Vernichtung von Krankheitserregern; Entkeimung); Des|in|fek|ti|ons|gut, ...lö|sung, ...mit|tel s; Des|in|fi|ziens [...iä̱nß] (Entkeimungsmittel) s; -, ...zienzien [...ziä̱nzi̱e̱n] u. ...zientia [...zia]; des|in|fi|zie|ren; Des|in|fi|zie̱|rung vgl. Desinfektion

Des|in|te|gra|ti|on lat. [...ziọn] (Spaltung, Auflösung eines Ganzen, z. B. [Soziologie:] einer Gemeinschaft, [Psych.:] einer Persönlichkeit); Des|in|te|gra|tor (eine techn. Apparatur) m; -s, ...oren

Des|in|ter|es|se, Des|in|ter|esse|ment fr. [desängterä̱ßma̱ng] (Unbeteiligtheit, Gleichgültigkeit) s; -; des|in|ter|es|siert

de|si|stie̱|ren lat. (veralt. für: von etwas abstehen)

De|skrip|ti|on lat. [...ziọn] (Beschreibung); de|skrip|tiv (beschreibend); -e Grammatik

Des|odo|rans nlat. (geruchtilgen-des Mittel) s; -, ...rạnzien [...i̱e̱n] u. ...rạntia [...zia]; des|odo|rie̱ren, des|odo|ri|sie|ren (geruchlos machen); Des|odo|rie̱|rung, Desodo|ri|sie̱|rung

de|so|la̱t lat. (vereinsamt; trostlos, traurig)

Des|or|dre fr. [desọrdr] (veralt. für: Unordnung, Verwirrung) m; -s, -s

Des|or|ga|ni|sa|ti|on fr. [...ziọn] (Auflösung, Zerrüttung, Unordnung); des|or|ga|ni|sie̱ren

des|ori|en|tiert (nicht unterrichtet)

Des|oxy|da|ti|on gr. [...ziọn] (Entzug von Sauerstoff); vgl. Oxydation; des|oxy|die̱ren vgl. oxydieren

de|spek|tier|lich lat. (verächtlich, geringschätzig)

De|spe|ra̱|do span. („Verzweifelter"; [politischer] Heißsporn; Bandit) m; -s, -s; de|spe|ra̱t lat. (verzweifelt, hoffnungslos); De|spe|ra|ti|on [...ziọn] (selten für: Verzweiflung, Hoffnungslosigkeit) w; -

Des|pọt gr. (Gewaltherr, Willkürherrscher; herrische Person) m; -en, -en (↑ R 268); Des|po|tie̱ w; -, ...ien; des|po|tisch; -ste (↑ R 294); des|po|ti|sie̱ren (gewalttätig behandeln, vorgehen ...); Des|po|tis|mus m; -

Des|sau (Stadt nahe der Mündung der Mulde in die Elbe); Des|sau|er (↑ R 199); der Alte Dessauer (Leopold I. von Anhalt-Dessau; ↑ R 224); des|sau|isch

des|sel|ben; vgl. der-, dasselbe

des|sen (Wesf. der Einz. der [als Vertreter eines Hauptwortes gebrauchten] Fürwörter der, das); der Schüler, dessen Vater tot ist, ...; indessen, währenddessen, -e (vgl. des); des|sent|hal|ben; des|sent|we|gen, des|we|gen; des|sent|wil|len, des|wil|len; um -; des|sen|un|ge|ach|tet [auch: dạ̈ß°nụn...], des|un|ge|ach|tet

Des|sert fr. [dä̱ßä̱r (österr. nur so) od. dä̱ßä̱rt] (Nachtisch) s; -s, -s; Des|sert.be|steck, ...ga̱bel, ...löf|fel, ...mes|ser s, ...tel|ler, ...wein

Des|sin fr. [dä̱ßä̱ng] (Zeichnung; Muster) s; -s, -s; Des|si|na̱|teur [dä̱ßinatö̱r] (Musterzeichner [im Textilgewerbe]) m; -s, -e; des|si|nie̱ren (Muster) zeichnen); Dessi|nie̱|rung

Des|sous fr. [dä̱ßu̱] (Damenunterwäsche) s; - [dä̱ßu̱ od. dä̱ßu̱ß], - [dä̱ßu̱ß] (meist Mehrz.)

De|stil|la̱t lat. (wiederverflüssigter Dampf für feine Destillation) s; -[e]s, -e; De|stil|la̱t|bren|ner (Lehrberuf der Industrie); De|stil|la|teur fr. [...tö̱r] (Branntweinbrenner, -ausschenker) m;

-s, -e; De|stil|la|ti|on *lat.* [...*zion*] (Trennung flüssiger Stoffe durch Verdampfung u. anschließende Wiederverflüssigung; Branntweinbrennerei, -ausschank); De|stil|la|ti|ons|gas; De|stil|le (ugs. für: Branntweinausschank) *w*; -, -n; De|stil|lier|ap|pa|rat; de|stil|lie|ren; destilliertes Wasser (chemisch reines Wasser); De|stil|lier.kol|ben, ...ofen

De|sti|na|tar *lat.*, De|sti|na|tär *fr.* (auf Seefrachtbriefen: Empfänger von Gütern) *m*; -s, -e; De|sti|na|ti|on *lat.* [...*zion*] (Bestimmung, Endzweck)

de|sto; besser, größer, mehr, - weniger, aber (in einem Wort): nichtsdestoweniger

de|stru|ie|ren *lat.* (selten für: zerstören); De|struk|ti|on [...*zion*] (selten für: Zerstörung; Geol.: Abtragung der Erdoberfläche durch Verwitterung); de|struk|tiv (zersetzend, zerstörend)

de|sul|to|risch *lat.* (veralt. für: unbeständig, ohne Ausdauer)

des|un|ge|ach|tet [auch: *däßun*...], des|sen|un|ge|ach|tet; des|we|gen, des|sent|we|gen; des|wil|len vgl. dessentwillen

de|szen|dent, de|szen|die|rend *lat.* (nach unten sinkend, absteigend); -es Wasser, -e Lagerstätten; De|szen|dent (Nachkomme, Ab-, Nachkömmling; Astron.: Gestirn im Untergang; Untergangspunkt); ↑ R 268; De|szen|denz (Abstammung); Nachkommenschaft; Astron.: Untergang eines Gestirns) *w*; -, -en; De|szen|denz|theo|rie (Abstammungslehre) *w*; -; de|szen|die|ren (absteigen, sinken), de|szen|die|rend vgl. deszendent

De|ta|che|ment *fr.* [*detasch*ᵉ*mang,* schweiz.: ...*mänt*] (veralt. für: für besondere Aufgaben abkommandierte Truppenabteilung) *s*; -s, -s u. (schweiz.:) -e; De|ta|cheur [...*schör*] (Fachmann zur Fleckenentfernung [chem. Reinigung] *m*; -s, -e; De|ta|cheu|se [...*schös*ᵉ] (weibl. Detacheur) *w*; -, -n; de|ta|chie|ren [*detaschi*-*r*ᵉ*n*] (von Flecken reinigen; veralt. für: entsenden); detachierte Strafkammer

De|tail *fr.* [*detaj*] (Einzelheit, Einzelteil) *s*; -s, -s; vgl. en détail; De|tail.fra|ge (sich in -n verlieren), ...han|del (veralt. für: Einzel-, Kleinhandel); de|tail|lie|ren [*detajir*ᵉ*n*] (im einzelnen darlegen; veralt.: in kleinen Mengen verkaufen; de|tail|liert (= Angaben; De|tail|list [*detajist*] (veralt. für: Einzelhandelsunternehmer); ↑ R 268; De|tail|ver|kauf (veralt.)

De|tek|tei *lat.* (Detektivbüro); De|tek|tiv *m*; -s, -e [...*w*ᵉ]; dem, den Detektiv (nicht: Detektiven); De|tek|tiv.bü|ro. ...ge|schich|te. ...in|sti|tut, ...ka|me|ra, ...li|te|ra|tur, ...ro|man

De|tek|tor *lat.* (Hochfrequenzgleichrichter) *m*; -s, ...oren; De|tek|tor.emp|fän|ger, ...ge|rät

Dé|tente *fr.* [*detangt*] (Entspannung zwischen Staaten) *w*; -; Dé|ten|te|po|li|tik

De|ten|ti|on *lat.* [...*zion*] (röm. Recht: Besitz einer Sache ohne Rechtsschutz; veralt. für: Haft, Gewahrsam)

De|ter|gen|tia [*ziα*], De|ter|gen|zien [...*i*ᵉ*n*] *lat.* (hautschonende Reinigungsmittel) *Mehrz.*

De|te|rio|ra|ti|on *lat.* [...*zion*], De|te|rio|rie|rung (Rechtsw.: Wertminderung einer Sache); de|te|rio|rie|ren

De|ter|mi|nan|te *lat.* (Hilfsmittel der Algebra zur Lösung eines Gleichungssystems; Biol.: angenommener Faktor der Keimentwicklung) *w*; -, -n; De|ter|mi|na|ti|on [...*zion*] (nähere Begriffsbestimmung); de|ter|mi|na|tiv (bestimmend, begrenzend, festlegend; entschieden, entschlossen); de|ter|mi|nie|ren (bestimmen, begrenzen, entscheiden); De|ter|mi|niert|heit (Bestimmtheit, Abhängigkeit, Festgelegtsein) *w*; -; De|ter|mi|nis|mus (Lehre von der Unfreiheit des menschlichen Willens) *m*; -; De|ter|mi|nist (↑ R 268); de|ter|mi|nis|tisch

de|te|sta|bel *lat.* (veralt. für: verabscheuungswürdig; verwünschenswert); ...a|ble Ansichten; de|te|stie|ren (veralt. für: verabscheuen, verwünschen)

Det|lef [auch: *dätläf*] (m. Vorn.)

Det|mold (Stadt am Teutoburger Wald)

De|to|na|ti|on *lat.* [...*zion*] (Knall, Explosion; Musik: Unreinheit des Tones); De|to|na|tor (Zündmittel) *m*; -s, ...oren; de|to|nie|ren (knallen, explodieren; Musik: unrein singen, spielen)

De|tri|ment *lat.* (veralt. für: Nachteil, Schaden) *s*; -[e]s, -e; De|tri|tus (Med.: kleinste Trümmer von organischen Geweben; Geol.: zerriebenes Gestein; Biol.: Schwebe- u. Sinkstoffe in den Gewässern) *m*; -

De|troit [*ditreut*] (Stadt in den USA)

det|to *it.* (bayr., österr., sonst selten für: dito)

De|tu|mes|zenz *lat.* (Med.: Abschwellung [einer Geschwulst]) *w*; -

Deu|bel vgl. Deiwel

deucht usw. vgl. dünken

Deu|ka|li|on (Gestalt der gr. Sage); Deukalionische Flut

De|us ex ma|chi|na *gr.* [- - *mꬱchi*-*na*] („Gott aus der [Theater]maschine"; unerwarteter Helfer) *m*;
- - -

Deut *niederl.* (veralt. für: kleine Münze) *m*, nur noch in: keinen -, nicht einen - (ugs. für: fast gar nichts) wert sein

deut|bar; Deu|te|lei (abwertend für: kleinliche Auslegung); deu|teln; ich ...[e]le (↑ R 327); deu|ten; Deu|ter

Deu|ter|ago|nist *gr.* (zweiter Schauspieler auf der altgr. Bühne); ↑ R 268

Deu|te|rei

Deu|te|ri|um (um Wasserstoff, Wasserstoffisotop; Zeichen: D) *s*; -s; Deu|te|ron (Atomkern des Deuteriums) *s*; -s, ...onen; Deu|te|ro|no|mi|um (5. Buch Mosis) *s*; -s

...deu|tig (z. B. zweideutig); Deut|ler; deut|lich; auf das, aufs deutlichste (↑ R 134); etwas - machen; Deut|lich|keit; deut|lich|keitshal|ber

deutsch (Abk.: dt.) A. Als Attribut: I. *Kleinschreibung*: das deutsche Volk; der deutsche Fünfkampf; die deutschen Meisterschaften [im Eiskunstlauf]; das deutsche Recht; die deutsche Schweiz; das deutsche Volkstum; die deutsche Volksvertretung; die deutsche Bundesrepublik (kein Titel!); Tag der deutschen Einheit (17. Juni); die deutschen Mundarten; die deutsche Sprache; die deutsche Dogge; der deutsche Schäferhund; die deutsche Buchführung; der deutsche Michel. II. *Großschreibung.* (↑ R 224): die Deutsche Angestellten-Gewerkschaft (Abk.: DAG); die Deutsche Bibliothek (in Frankfurt); die Deutsche Bücherei (in Leipzig); Deutsche Mark (Abk.: DM); Deutscher Krieg (1866) [aber: ein deutscher Krieg (irgendeiner)]; der Deutsch-Französische Krieg (1870/71) [aber: ein deutsch-französischer Krieg (irgendeiner)]; Deutsches Arzneibuch (Abk.: DAB); der Deutsche Bund; der Deutsche Bundestag; Deutsche Bundesbahn (Abk.: DB); Deutsche Bundesbank (Abk.: BBk); Deutsche Bundespost u. Deutsches Bundespatent (Abk.: DBP); Deutsche Demokratische Republik (Abk.: DDR); Deutscher Gewerkschaftsbund (Abk.: DGB); Deutscher Industrie- und Han-

delstag¹ (Abk.: DIHT); Deutsche Industrie-Norm[en] (Zeichen: DIN; vgl. d.); Deutsche Jugendherberge (Abk.: DJH); Deutsche Jugendkraft (ein kath. Verband für Sportpflege; Abk.: DJK); Deutsche Kommunistische Partei (Abk.: DKP); Deutsche Lebens-Rettungs-Gesellschaft (Abk.: DLRG); der Deutsche Orden; Deutsche Presse-Agentur (Abk.: dpa); das Deutsche Reich; Deutsches Rotes Kreuz (Abk.: DRK); DeutscherFußball-Bund² (Abk.: DFB); Deutscher Turnerbund (Abk.: DTB); Deutscher Touring Automobil Club² (Abk.: DTC); Deutscher Sprachatlas (Abk.: DSA); steht das Eigenschaftswort „deutsch" nicht am Anfang des Titels, dann wechselt die Schreibweise: Verein Deutscher Ingenieure; Gesellschaft für deutsche Sprache; Institut für deutsche Sprache (↑ R 224); vgl. Deutsch u. Deutsche *s* – **B.** Als Art**an**ga**be:** deutsch (auf deutsche Art, in deutscher Weise; von deutscher Abstammung; in deutschem Wortlaut); (↑ R 133:) zu deutsch, auf deutsch, auf gut deutsch, in deutsch (in deutschem Text, Wortlaut; vgl. aber: in Deutsch); deutsch fühlen, denken; der Redner hat deutsch (nicht englisch gesprochen (vgl. aber: Deutsch); [auf] deutsch gesagt; ein Fremdwort deutsch aussprechen; sich deutsch (auf deutsch) unterhalten; der Brief ist deutsch (in deutscher Sprache) geschrieben; deutsch mit einem reden (ihm die Wahrheit sagen); Staatsangehörigkeit: deutsch (in Formularen u. ä.); **Deutsch** (die deutsche Sprache, sofern sie die Sprache eines einzelnen oder einer bestimmten Gruppe bezeichnet oder sonstwie näher bestimmt ist; Kenntnis der deutschen Sprache *s*; des -[s], dem -; mein, dein, sein Deutsch ist schlecht; das Plattdeutsch Fritz Reuters; die Aussprache seines Deutsch[s]; das Kanzleideutsch, das Kaufmannsdeutsch, das Schriftdeutsch; er kann, lehrt, lernt, schreibt, spricht, versteht [kein, nicht, gut, schlecht] Deutsch (vgl. aber: deutsch, B); [das ist] gutes Deutsch; das beste Deutsch; er befleißigt sich eines guten Deutsch[s]; er legt Wert auf

gutes Deutsch; er spricht gut[es] Deutsch; er kann kein Wort Deutsch; ein Lehrstuhl für Deutsch; er hat eine Eins in Deutsch (im Fach Deutsch); am Ende des Artikels steht eine Zusammenfassung in Deutsch (in der Sprache Deutsch); der Prospekt erscheint in Deutsch und in Englisch (in den Sprachen Deutsch und Englisch; vgl. aber: in deutsch); in heutigem Deutsch od. im heutigen Deutsch; vgl. auch Deutsche *s* und deutsch, B; **Deutsch|ame|ri|ka|ner** [auch: *...kᵃnᵉr*]; ↑ R 215 (Amerikaner dt. Abstammung); **deutsch|ame|ri|ka|nisch** [auch: *...kᵃnisch*]; ↑ R 215 (die Deutschamerikaner betreffend), z. B. aus dem deutschamerikanischen Schrifttum; aber (↑ R 214): **deutsch-ame|ri|ka|nisch** (zwischen Deutschland und Amerika bestehend), z. B. der deutsch-amerikanische Schiffsverkehr; ¹**Deut|sche** *m* u. *w*; -n, -n (↑ R 287ff.); ich Deutscher; wir Deutschen (auch: wir Deutschen); alle Deutschen; alle guten Deutschen (↑ R 281); ²**Deut|sche** (die deutsche Sprache überhaupt; in Zusammensetzungen zur Bezeichnung der einzelnen Zweige der deutschen Sprache) *s*; des -n, dem -n; das Deutsche (z. B. im Ggs. zum Französischen); das Althochdeutsche, das Mittelhochdeutsche, das Neuhochdeutsche; die Aussprache des Deutschen (z. B. im Ggs. zum Englischen); die Formen des Mittelhochdeutschen; im Deutschen (z. B. im Ggs. zum Italienischen); aus dem Deutschen, ins Deutsche übersetzen; vgl. auch Deutsche; **deutsch_feind|lich**, **...freund|lich; Deutsch|kun|de** *w*; -; **deutschkund|lich**; -er Unterricht; **Deutsch|land; Deutsch|land_funk** (in Köln), **...fra|ge** (die Frage der deutschen Wiedervereinigung; *w*; -), **...lied** (dt. Nationalhymne; *s*; -[e]s), **...po|li|tik**, **...sen|der** (DDR; *m*; -s); **Deutsch|leh|rer**; **Deutsch|mei|ster** (Landmeister des Deutschen Ordens); **Deutschor|dens|rit|ter; Deutsch|rit|ter|or|den** [auch: *deutschritᵉrᵒrdᵉn*] *m*; -s; **Deutsch|schwei|zer** (Schweizer deutscher Muttersprache); **deutsch|schwei|ze|risch** (die deutsche Schweiz betreffend); das deutschschweizerische Schrifttum (↑ R 215), aber (↑ R 214): **deutsch-schwei|ze|risch,** z. B. ein deutsch-schweizerisches Abkommen; vgl. schweizerdeutsch; **deutsch|spra|chig** (in

deutscher Sprache abgefaßt, vorgetragen); -e Bevölkerung; **deutsch|sprach|lich** (die deutsche Sprache betreffend); -er Unterricht; **Deutsch|spre|chen** *s*; -s; **deutsch|stäm|mig; Deutsch|tum** (deutsche Eigenart) *s*; -s; **Deutsch|tü|me|lei** (aufdringliche Betonung des Deutschtums); **Deutsch|tüm|ler; Deutsch|un|ter|richt** *m*; -[e]s

Deu|tung; Deu|tungs|ver|such

Deut|zie [*...iᵉ*; nach dem Holländer van der Deutz] (ein Zierstrauch) *w*; -, -n

Deux-pièces *fr.* [*dö piäß*] (zweiteiliges Damenkleid) *s*; -, -

De|val|va|ti|on *lat.* [*dewalwazion*] (Abwertung einer Währung); **de|val|va|to|risch**, (auch:) **de|val|va|tio|ni|stisch** (abwertend, Devalvation bewirkend); **de|val|vie|ren**

De|va|sta|ti|on *lat.* [*...waßtazion*] (veralt. für: Verwüstung); **de|va|stie|ren**

De|ver|ba|tiv *lat.* [*...wär...*] *s*; -s, -e [*...wᵉ*] u. **De|ver|ba|ti|vum** [*...iwum*] (Sprachw.: von einem Zeitwort abgeleitetes Hauptwort für Eigenschaftswort, z. B. „Eroberung" von „erobern", „hörig" von „hören") *s*; -s, ...va [*...wa*]

de|ve|stie|ren *lat.* [*...wäß...*] (Lehen im Mittelalter, Priesterwürde entziehen); **De|ve|sti|tur** (Entziehung des Lehens od. der Priesterwürde) *w*; -, -en

De|via|ti|on *lat.* [*...wiazion*] (Abweichung, z. B. der Kompaßnadel auf eisernen Schiffen); **de|vi|ieren**

De|vi|se *fr.* [*...wisᵉ*] (Wahlspruch; meist *Mehrz.* für: Zahlungsmittel in ausländ. Währung) *w*; -, -n; **De|vi|sen_aus|gleich, ...be|wirtschaftung, ...bi|lanz, ...kurs, ...markt, ...re|ser|ve, ...sper|re, ...über|schuß, ...ver|kehr**

De|vo|lu|ti|on *lat.* [*dewoluzion*] (veralt. für: Heimfall, Übergang eines Rechtes od. einer Sache); **de|vol|vie|ren** (veralt.)

De|von [*dewon*] (Geol.: eine Formation des Paläozoikums) *s*; -[s]; **de|vo|nisch**

de|vot *lat.* [*dewot*] (gottergeben; unterwürfig); **De|vo|ti|on** [*...zion*] (Gottergebenheit; Unterwürfigkeit; Andacht); **De|vo|tio|na|li|en** [*...zionaliᵉn*] (kath. Kirche: der Andacht dienende Gegenstände) *Mehrz.*

De|vri|ent [*defrint*, auch: *dᵉwriäng*] (Name einer Schauspielerfamilie)

De|wa|na|ga|ri *sanskr.* (ind. Schrift, in der das Sanskrit geschrieben u. gedruckt ist) *w*; -

¹ So die von den Regeln (↑ R 155) abweichende Schreibung.
² So die von den Regeln abweichende Schreibung.

Dex|trin ([Klebe]stärke) *s*; -s, -e **dex|tro|gyr** *lat.*; *gr.* (Chemie: die Ebene polarisierten Lichtes nach rechts drehend; Zeichen: d) **Dex|tro|kar|die** *lat.*; *gr.* (Med.: angeborene rechtsseitige Lagerung des Herzens) *w*; -, ...ien **Dex|tro|pur** ⓦ *lat.* (ein Präparat aus reinem Traubenzucker) *s*; -s; **Dex|tro|se** (Traubenzucker) *w*; - **Dez** mdal. (Kopf) *m*; -es, -e

Dez. = Dezember

De|zem|ber *lat.* (zwölfter Monat im Jahr; Christmond, Julmond, Wintermonat; Abk.: Dez.) *m*; -[s] (↑ R 319), -; **De|zem|ber_abend**, ...tag; **De|zem|vir** [...*wir*] (Mitglied des Dezemvirats) *m*; -n (↑ R 268) u. -s, -n; **De|zem|vi|rat** (altröm. Zehnmännerkollegium) *s*; -[e]s, -e; **De|zen|ni|um** (Jahrzehnt) *s*; -s, ...ien [...*i^e n*]

de|zent *lat.* (anständig; abgetönt; zart; Musik: gedämpft)

de|zen|tral *nlat.* (vom Mittelpunkt entfernt); **De|zen|tra|li|sa|ti|on** [...*zion*], **De|zen|tra|li|sie|rung** (Auseinanderlegung von Verwaltungen usw.; Verlegung des Schwergewichtes in die örtl. od. provinziellen Behörden); **de|zen|tra|li|sie|ren**

De|zenz *lat.* (veralt. für: Anstand, Zurückhaltung) *w*; -

De|zer|nat *lat.* (Geschäftsbereich eines Dezernenten; Sachgebiet) *s*; -[e]s, -e; **De|zer|nent** ([„entscheidender"] Sachbearbeiter [bei Behörden]); ↑ R 268

De|zi... *lat.* (Zehntel...; ein Zehntel einer Einheit, z. B. Dezimeter = 10^{-1} Meter; Zeichen: d); **De|zi|ar** [auch: *dezi*...] ($^1/_{10}$ Ar; Zeichen: da) *s*; -s, -e; 3 - (↑ R 322); **De|zi|bel** [auch: *dezi*...] ($^1/_{10}$ Bel [vgl. d.]; Zeichen: dB) *s*; -s, -

de|zi|die|ren lat. (selten für: entscheiden); **de|zi|diert** (bes. österr. u. schweiz., sonst selten für: entschieden, kurz entschlossen, bestimmt)

De|zi|gramm *lat.*; *gr.* [auch: *dezi*...] ($^1/_{10}$ g; Zeichen: dg); **De|zi|li|ter** [auch: *dezi*...] ($^1/_{10}$ l; Zeichen: dl); **de|zi|mal** *lat.* (auf die Grundzahl 10 bezogen); **De|zi|mal|bruch** (Bruch, dessen Nenner mit einer Potenz von 10 gebildet wird) *m*; **De|zi|ma|le** (die Ziffer der Ziffernfolge, die rechts vom Komma eines Dezimalbruchs steht) *w*; -[n], -n; **de|zi|ma|li|sie|ren** (auf das Dezimalsystem umstellen); **De|zi|ma|li|sie|rung**; **De|zi|mal|klas|si|fi|ka|ti|on** (Abk.: DK), ...maß s, ...rech|nung, ...stel|le, ...sy|stem (*s*; -s), ...waa|ge, ...zahl; **De|zi|ma|ti|on** [...*zion*] („Zehntung"; ehem. Kriegs-

brauch: Hinrichtung jedes zehnten Mannes; veralt. für: Erhebung des Zehnten); **De|zi|me** (Musik: zehnter Ton vom Grundton an) *w*; -, -n; **De|zi|me|ter** *lat.*; *gr.* [auch: *dezi*...] ($^1/_{10}$ m; Zeichen: dm); **de|zi|mie|ren** *lat.* (urspr. jeden zehnten Mann mit dem Tode bestrafen; heute: große Verluste beibringen; stark vermindern); **de|zi|miert**; **De|zi|mie|rung**

de|zi|siv *lat* (entscheidend, bestimmt)

De|zi|ster *lat.*; *gr.* [auch: *dezi*...] ($^1/_{10}$ Ster) *m*; -s, -e u. -s; 5 - (↑ R 322); **De|zi|tonne** *lat.* [auch: *dezi*...] (100 kg; Zeichen: dt)

DFB = Deutscher Fußball-Bund

dg = Dezigramm

Dg = Dekagramm

D. G. = Dei gratia

DGB = Deutscher Gewerkschaftsbund

dgl. = dergleichen

d. Gr. = der Große

d. h. = das heißt

Dhau vgl. Dau

d i = das Ist

Dia (Kurzform für: Diapositiv) *s*; -s, -s

Dia|bas *gr.* (ein Ergußgestein) *m*; -es, -e

Dia|be|tes *gr.* (Harnruhr) *m*; -; - mellitus (Med.: Zuckerharnruhr, Zuckerkrankheit); **Dia|be|ti|ker**; **dia|be|tisch**

Dia|bo|lie, **Dia|bo|lik** *gr.* (teuflisches Verhalten) *w*; -; **dia|bo|lisch** („teuflisch"); -ste (↑ R 294); -es (magisches) Quadrat; **Dia|bo|lo** *it.* (ein Geschicklichkeitsspiel) *s*; -s, -s; **Dia|bo|lus** *gr.* (der Teufel) *m*; -

Dia|dem *gr.* (kostbarer Reif) *s*; -s, -e

Dia|do|che *gr.* („Nachfolger" [Alexanders d. Gr.]) *m*; -n, n (↑ R 268); **Dia|do|chen|zeit**

Dia|ge|ne|se *gr.* (Geol.: Vorgang der nachträglichen Veränderung eines Sediments durch Druck u. Temperatur)

Dia|gno|se *gr.* ([Krankheits]erkennung; Zool., Bot.: Bestimmung) *w*; -, -n; **Dia|gno|se_ver|fah|ren**, ...zen|trum; **Dia|gno|stik** (Fähigkeit und Lehre, [Krankheiten usw.] zu erkennen) *w*; -; **Dia|gno|sti|ker**; **dia|gno|stisch**; **dia|gno|sti|zie|ren**

dia|go|nal *gr.* (schräglaufend); **Dia|go|nal** (schräggestreifter Kleiderstoff in Köperbindung) *m*; -[s], -s; **Dia|go|na|le** (Gerade, die zwei nicht benachbarte Ecken eines Vielecks miteinander verbindet) *w*; -, -n; drei -[n] (↑ R 291); **Dia|go|nal|kraft**

Dia|gramm *gr.* (zeichnerische Darstellung errechneter Werte in einem Koordinatensystem; Stellungsbild beim Schach; Drudenfuß) *s*; -s, -e; **Dia|graph** (Gerät zum Zeichnen von [Schädel]umrissen u. Kurven) *m*; -en, -en (↑ R 268)

Dia|kau|stik *gr.* (die beim Durchgang von parallelem Licht bei einer Linse entstehende Brennfläche) *w*; -, -en; **dia|kau|stisch**

Dia|kon *gr.* [österr.: *dia*...] (kath., anglikan. od. orthodoxer Geistlicher, der um einen Weihegrad unter dem Priester steht; Krankenpfleger od. Pfarrhelfer in der ev. Inneren Mission) *m*; -s u. -en (↑ R 268), -e[n]; vgl. Diakonus; **Dia|ko|nat** (Diakonenamt, -wohnung) *s* (auch: *m*); -[e]s, -e; **Dia|ko|nie** ([berufsmäßige] Sozialtätigkeit [Krankenpflege, Gemeindedienst] in der ev. Kirche) *w*; -; **Dia|ko|nis|se** *w*; -, -n u. **Dia|ko|nis|sin** (ev. Kranken- u. Gemeindeschwester) *w*; -, -nen; **Dia|ko|nis|sen|haus**; **Dia|ko|nus** (veralt. für: zweiter od. dritter Pfarrer einer ev. Gemeinde, Hilfsgeistlicher) *m*; -, ...ko|ne[n]

Dia|kri|se, **Dia|kri|sis** *gr.* (Abgrenzung einer Krankheit gegen andere; entscheidende Krise einer Krankheit) *w*; -, ...isen; **dia|kri|tisch** (unterscheidend); -es Zeichen

Dia|lekt *gr.* (Mundart) *m*; -[e]s, -e; **dia|lek|tal** (mundartlich); -e Besonderheiten; **Dia|lekt_aus|druck**, ...dich|tung, ...fär|bung; **dia|lekt|frei**; **Dia|lekt|geo|gra|phie** *w*; -; **Dia|lek|tik** (Erforschung der Wahrheit durch Aufweis u. Überwindung von Widersprüchen; auch für: Spitzfindigkeit) *w*; -; **Dia|lek|ti|ker** (Vertreter, Meister der Dialektik); **dia|lek|tisch** (mundartlich; die Dialektik betreffend; auch: spitzfindig); -e Methode (von den Sophisten ausgebildete Kunst der Gesprächsführung; das Denken in These, Antithese, Synthese [Hegel]); -er Materialismus ([sowjet.] Lehre von den Grundbegriffen der Dialektik u. des Materialismus; Abk.: DIAMAT, Diamat); -e Theologie (Bez. für eine Richtung der ev. Theologie nach dem 1. Weltkrieg); **Dia|lek|to|lo|gie** (veralt. für: Mundartenkunde) *w*; -; **dia|lek|to|lo|gisch**

Dia|log *gr.* (Zwiegespräch; Wechselrede) *m*; -[e]s, -e; **dia|lo|gisch** (in Dialogform); **Dia|lo|gi|sie|ren** (in Dialogform kleiden); **Dia|log|kunst** *w*; -

Dia|ly|sa|tor *gr.* („Auflöser"; Ge-

rät zur Vornahme der Dialyse) *m*; -s, ...oren; **Dia|ly|se** (chem. Trennungsmethode) *w*; -, -n; **dia|ly|sie|ren; dia|ly|tisch** (auf Dialyse beruhend; auflösend; zerstörend)

[1]**Dia|mant** *fr.* (ein Schriftgrad) *w*; -; [2]**Dia|mant** (Edelstein) *m*; -en, -en (↑ R 268); vgl. auch: Demant; **Dia|mant|boh|rer; dia|man|ten;** (↑ R 224:)-e Hochzeit (60. Jahrestag der Hochzeit); **Dia|mant_feld,** ...**fink** (ein Vogel), ...**glanz,** ...**gra-vie|rung,** ...**hals|band,** ...**leim** (zum Fassen von Schmucksteinen), ...**ring,** ...**schild|krö|te,** ...**schlei-fer,** ...**schliff,** ...**schmuck,** ...**stahl,** ...**staub,** ...**tin|te** (ein Ätzmittel für Glas)

DIAMAT, Diamat (= dialektischer Materialismus; vgl. dialektisch) *m*; -

Dia|me|ter *gr.* (Durchmesser) *m*; -s, -; **dia|me|tral** (entgegengesetzt [wie die Endpunkte eines Durchmessers]; - entgegengesetzt; **dia-me|trisch** (dem Durchmesser entsprechend)

Dia|na (röm. Göttin der Jagd)

Dia|pa|son *gr.* (Kammerton; engl. Orgelregister; Stimmgabel) *m* od. *s*; -s, -s u. ...one

dia|phan *gr.* (durchscheinend); **Dia|pha|nie** (durchscheinendes Bild) *w*; -, ...ien

Dia|pho|ra *gr.* (Rhet.: Betonung des Unterschieds zweier Dinge) *w*; -; **Dia|pho|re|se** (Med.: Schwitzen) *w*; -, -n; **dia|pho|re|tisch** (schweißtreibend)

Dia|phrag|ma *gr.* (Chemie: durchlässige Scheidewand; Med.: Zwerchfell) *s*; -s, ...men

Dia|po|si|tiv *gr.; lat.* (Kopie eines Negativs auf einer durchsichtigen Diapositivplatte; Kurzform: Dia) *s*; -s, -e [...*wᵉ*]; **Dia|pro|jek-tor** (Diaskop)

Di|äre|se, Di|äre|sis *gr.* (Trennung zweier Selbstlaute durch Trema; Zusammenfallen von Wortende mit Versfußende; Begriffszerlegung in der Philos.; Med.: Zerreißung eines Gefäßes mit Blutaustritt) *w*; -, ...resen

Di|ari|um *lat.* (Tagebuch; Kladde) *s*; -s, ...ien [...*iᵉn*]

Di|ar|rhö[1]**, Di|ar|rhöe** *gr.* ("Durchfluß"; Durchfall) *w*; -, ...rrhöen; **di|ar|rhö|isch**

[1] In Übereinstimmung mit der Arbeitsgruppe für medizin. Literaturdokumentation in der Deutschen Gesellschaft für Dokumentation und mit führenden Fachverlagen wurde die Form auf -oe zugunsten der Form auf -ö aufgegeben.

Dia|skop *gr.* (Projektionsapparat für Diapositive) *s*; -s, -e; **Dia|sko-pie** (Durchleuchtung) *w*; -, ...ien

Dia|spo|ra *gr.* ("Zerstreuung"; Gebiete, in denen religiöse Minderheiten leben, auch die religiösen Minderheiten selbst) *w*; -; **Dia|spo|ra|ge|mein|de**

Dia|sto|le *gr.* [*diaßtole,* auch: ...*ßtoʟᵉ*] (Med.: die mit der Systole rhythmisch abwechselnde Erweiterung des Herzens) *w*; -, ...olen

di|ät *gr.* (der richtigen Ernährung entsprechend; mäßig); - kochen, leben; **Di|ät** [richtige] Ernährung; Schonkost) *w*; -; - halten; [eine salzlose]-kochen; jmdn. auf - setzen; **Di|ät|as|si|sten|tin** (svw. Diätistin); **Di|ä|ten** (Tagegelder; Entschädigung) *Mehrz.*; **Diä|te-tik** (Ernährungslehre) *w*; -, -en; **Diä|te|ti|kum** (für eine gesunde Lebensweise geeignetes Nahrungsmittel) *s*; -s, ...ka; **diä|te-tisch** (der Diätetik gemäß)

Dia|thek *gr.* (Diapositivsammlung) *w*; -, -en

dia|ther|man *gr.* (Med., Meteor.: Wärmestrahlen durchlassend); **Dia|ther|mie** (Heilverfahren, bei dem Hochfrequenzströme innere Körperabschnitte durchwärmen) *w*; -

Dia|the|se *gr.* (Krankheitsveranlagung) *w*; -, -n

diä|tisch *gr.* (die Ernährung betreffend); -er Wert (Nährwert); **Diä|ti|stin** (w. Fachkraft, die bei der Aufstellung von Diätplänen mitwirkt) *w*; -, -nen; **Di-ät_koch,** ...**kü|che,** ...**kur**

Dia|to|mee *gr.* (Kieselalge) *w*; -, -n (meist *Mehrz.*)

dia|to|nisch *gr.* (Musik: in Ganz- und Halbtönen der 7stufigen Tonleiter fortschreitend)

Di|ät_plan

Dia|tri|be *gr.* (weitläufige Abhandlung; Streitschrift) *w*; -, -n

Dib|bel|ma|schi|ne *gr.; dt.* (di|beln ("tüpfeln"; in Reihen mit größeren Abständen säen); ich ...[e]le (↑ R 327); vgl. aber: tippeln

Di|bra|chys *gr.* [...*eḫüß*] (ein antiker Versfuß) *m*; -, -

dich; *in Briefen usw.:* Dich (↑ R 121)

Di|cho|to|mie *gr.* [...*cho...*] (Biol.: Zweiteilung; Gabelung) *w*; -, ...ien; **di|cho|tom, di|cho|to|misch**

Di|chro|is|mus *gr.* [...*kro...*] (Zweifarbigkeit von Kristallen bei Lichtdurchgang) *m*; -; **di|chroi-tisch;** -er Spiegel; **di|chro|ma|tisch** (zweifarbig); -e Gläser; **Di|chro-skop** (besondere Lupe zur Prüfung auf Dichroismus) *s*; -s, -e; **di|chro|sko|pisch**

dicht; - auf; I. *Schreibung in Ver-*

bindung mit dem 2. Mittelwort (↑ R 142), z. B. dichtbehaart (vgl. d.), dichtbevölkert (vgl. d.), dichtgedrängt (vgl. d.). II. *Schreibung in Verbindung mit Zeitwörtern* (↑ R 139): **a)** *Getrenntschreibung* in ursprünglicher Bedeutung, z. B. dicht halten; das Faß wird dicht halten; **b)** *Zusammenschreibung,* wenn durch die Verbindung ein neuer Begriff entsteht; vgl. dichthalten; **dicht|be-haart** (↑ R 296:) dichter, am dichtesten behaart; das dichtbehaarte Fell (↑ jedoch R 142), aber: das Fell ist dicht behaart; **dicht|be-völ|kert** (↑ R 296:) dichter, am dichtesten bevölkert; ein dichtbevölkertes Land (↑ jedoch R 142), aber: das Land ist dicht bevölkert; **Dich|te** (Technik auch: Verhältnis der Masse zur Raumeinheit) *w*; -, (selten:) -n; **Dich|te|mes|ser** (für: Densimeter) *m*; [1]**dich|ten** (dicht machen) [2]**dich|ten** (Verse schreiben); **Dich-ten** *s*; -s; (↑ R 120:) das - und Trachten der Menschen; **Dich-ter; Dich|te|rin** *w*; -, -nen; **dich-te-risch;** -ste (↑ R 294); -e Freiheit; **Dich|ter_kom|po|nist** (Dichter u. Komponist in einer Person), ...**kreis,** ...**le|sung; Dich|ter|ling** (Verfasser schlechter Verse); **Dich|ter_schu|le,** ...**spra|che,** ...**tum** (*s*; -s), ...**wort** (*Mehrz.* ...worte)

dicht|ge|drängt; (↑ R 296:) dichter, am dichtesten gedrängt; die dichtgedrängten Zuhörer (↑ jedoch R 142), aber: die Zuhörer sind dicht gedrängt; **dicht|hal|ten;** ↑ R 139 (ugs. für: schweigen); du hältst dicht; dichtgehalten; dichtzuhalten; aber: **dicht hal|ten** (undurchlässig bleiben); **Dicht-heit** *w*; -; **Dich|tig|keit** *w*; -; **Dich-tig|keits|mes|ser** *m*

Dicht|kunst *w*; -

dicht|ma|chen; ↑ R 139 (ugs. für: schließen); er hat seinen Laden dichtgemacht; aber: **dicht ma-chen** (abdichten); er hat das Rohr durch Isolierung dicht gemacht

[1]**Dich|tung** (Gedicht)

[2]**Dich|tung** (Vorrichtung zum Dichtmachen); **Dich|tungs_mit-tel** *s*, ...**ring,** ...**schei|be,** ...**stoff**

Dicht|tungs_art, ...**gat|tung**

dick; durch - und dünn (↑ R 133); **dick|bau|chig; Dick|darm; Dick-darm|ent|zün|dung;** [1]**Dicke** [*Trenn.:* Dik|ke] (Dicksein) *w*; -; (für: Abstand von einer Körperseite zur anderen auch *Mehrz.:*) -n; [2]**Dicke** [*Trenn.:* Dik|ke] *m* u. *w*; -n, -n (↑ R 287ff.)

Dickens [*Trenn.:* Dik|kens] (engl. Schriftsteller)

Di|cken|wachs|tum[1]; Di|cker|chen[1];
dicke|tun[1], dick|tun; ↑ R 139 (ugs.
für: sich wichtig machen); ich tue
mich dick[e]; dick[e]getan;
dick[e]zutun; dick|fel|lig; Dick-
fel|lig|keit w; -; dick|flüs|sig;
Dick|häu|ter; Dickicht[1] s; -s, -e;
Dick|kopf; dick_köp|fig, ...lei|big;
dick|lich; Dick_milch, ...schä|del,
sein (s, -s) Dick|te (Technik oft
für: Dicke) w; -, -n; Dick|tu|er;
Dick|tue|rei; dick|tue|risch; -ste
(↑ R 294); dick|tun vgl. dicketun;
Dickung[1] (Jägerspr. für: Dik-
kicht); dick|wan|dig; Dick_wanst,
...wurz (Runkelrübe)
Di|dak|tik gr. (Unterrichtslehre)
w; -; Di|dak|ti|ker; di|dak|tisch
(unterrichtskundlich; lehrhaft);
-ste (↑ R 294)
di|del|dum!, di|del|dum|dei!
Di|derot [didᵉro] (fr. Schriftsteller
u. Philosoph)
Di|do (sagenhafte Gründerin Kar-
thagos)
Di|dot [dido] (fr. Buchdrucker);
Di|dot|an|ti|qua (↑ R 180)
die (↑ R 135); Wesf. der u. deren
(vgl. d.); Mehrz. vgl. der
Dieb m; -[e]s, -e; Die|be|rei; Die-
bes_ban|de, ...beu|te, ...ge|schich-
te, ...gut, ...ha|ken (²Dietrich);
die|bes|si|cher; Die|bin w; -, -nen;
die|bisch; -ste (↑ R 294); Diebs|ge-
sin|del; Dieb|stahl m; -[e]s, ...stäh-
le; Dieb|stahl|ver|si|che|rung
Di|ege|se gr. (veralt für: weitläufi-
ge Erzählung, Ausführung) w; -,
-n; di|ege|tisch (veralt. für: erzäh-
lend, erörternd)
die|je|ni|ge (↑ R 135); Wesf. derje-
nigen; Mehrz. diejenigen
Die|le w; -, -n
Di|elek|tri|kum gr. (elektr. Nicht-
leiter) s; -s, ...ka; di|elek|trisch;
Di|elek|tri|zi|täts|kon|stan|te
(Wert, mit dem die Isolierfähig-
keit eines Stoffes bezeichnet
wird; Zeichen: ε)
die|len; Die|len_bo|den, ...fen|ster,
...lam|pe
Die|me w; -, -n u. Die|men nordd.
(Heu- od. Getreidehaufen) m;
-s, -
die|nen; Die|ner; Die|ne|rin w; -,
-nen; die|nern; ich ...ere (↑ R 327);
Die|ner_schaft, ...schar; dien|lich;
Dienst m; -[e]s, -e; zu - en stehen;
in - stehen; außer Dienst (Abk.:
a. D.); Dienst|ab|teil
Diens|tag m; -[e]s, -e; ich werde
Sie - aufsuchen; alle -e; eines -s;
des -s, abser (↑ R 129): dienstags:
Tageszeiten (vgl. Abend, II): [am]
Dienstag früh beginnt die Ta-
gung; [am nächsten] Dienstag
abend an dem bestimmten

Dienstag) treffen wir uns; aber:
Dienstag od. dienstags abends
(an jedem wiederkehrenden
Dienstag) spielen wir Skat; ent-
sprechend in Verbindung mit
morgen, morgens, nacht, nachts
usw.; Diens|tag|abend [auch:
dinßtagabᵉnt]; am - hat sie Ge-
sangstunde, am Donners-
tagabend hat sie frei; meine
Dienstagabende sind für die
nächste Zeit alle belegt; vgl.
Dienstag; diens|tä|gig vgl. ...tä-
gig; diens|täg|lich vgl. ...täglich;
diens|tags (↑ R 129); vgl. Dienstag
Dienst_al|ter, ...äl|te|ste, ...antritt,
...an|wei|sung, ...auf|fas|sung,
...aus|weis, ...aus|zeich|nung;
dienst|bar; Dienst|bar|keit;
dienst_be|flis|sen, ...be|reit;
Dienst_be|reit|schaft (w; -), ...bo-
te; dienst_eif|rig, ...fer|tig, ...frei;
Dienst_ge|heim|nis, ...ge|spräch,
...grad; dienst|ha|bend; Dienst|ha-
ben|de m u. w; -n, -n (↑ R 287ff.);
Dienst_lei|stung; Dienst|lei-
stungs_ge|wer|be; dienst|lich;
Dienst|mäd|chen (veralt. für:
Hausgehilfin); ¹Dienst|mann
(veralt. für: Höriger; Mehrz.
...mannen); ²Dienst|mann (Ge-
päckträger; Mehrz. ...männer
[österr. nur so] u. ...leute);
Dienst_per|so|nal, ...pflicht;
dienst|pflich|tig; Dienst|prag|ma-
tik österr. (generelle Norm für
das öffentl.-rechtl. Dienstver-
hältnis in Österreich) w; -; Dienst-
rang; dienst|recht|lich; Dienst-
_rei|se, ...sa|che, ...schluß, ...stel-
le, ...stem|pel, ...straf|ge|walt
(für: Disziplinargewalt); dienst-
_taug|lich, ...tu|end, ...un|fä|hig;
Dienst_un|fä|hig|keit w; -; dienst-
ver|pflich|tet; Dienst_vor|schrift,
...wa|gen, ...weg, ...woh|nung,
...zeit
dies, die|ses (↑ R 135); Wesf. dieses;
diesjährig, diesmal, diesseits;
dies|be|züg|lich (besser: hierauf
bezüglich)
Di|es aca|de|mi|cus lat. [- akademi-
mikuß] (vorlesungsfreier Tag an
der Universität) m; - -; Di|es ater
(„schwarzer Tag", Unglückstag)
m; - -
Die|sel (Kurzform für: Dieselmo-
tor, Wagen mit Dieselmotor) m;
-[s], -
die|sel|be (↑ R 135); Wesf. dersel-
ben; Mehrz. dieselben; ein[e] und
-; die|sel|bi|ge; ↑ R 135 (veralt. für:
dieselbe)
die|sel|elek|trisch; Die|sel_lo|ko-
mo|ti|ve, ...ma|schi|ne, ...mo|tor;
↑ R 180 [nach dem Erfinder]; die-
seln (wie ein Dieselmotor durch
Kompressionswärme ohne
elektr. Zündung weiterlaufen

[vom Ottomotor]); Die|sel_öl,
...trieb|wa|gen (↑ R 180)
die|ser (↑ R 135), diese, dieses
(dies); Wesf. dieses, dieser, die-
ses; Mehrz. diese; - selbe [Augen-
blick]; (Kaufmannsspr.:) Über-
bringer, Schreiber dieses [Wesf.],
dafür besser: ... dieses Briefes;
die|ser|art (österr., sonst veralt.
für: auf diese Weise; so); die|ser-
halb; die|ses vgl. dies, die|ses
Jahres (Abk.: d.J.); die|ses Mo-
nats (Abk.: d. M.); dies|falls
(Amtsdt.); vgl. Fall m
die|sig (nebelig); Die|sig|keit w; -
Di|es irae lat. [- irä] („Tag des
Zornes"; Anfang eines mittel-
alterl. Hymnus auf die Weltge-
richt) s; - -
dies|jäh|rig; dies|mal, aber: dieses
Mal, dieses od. dies eine, letzte
Mal; dies|ma|lig; dies|sei|tig;
Dies|sei|tig|keit w; -; dies|seits;
mit Wesf.: - des Flusses; Dies-
seits s; -; im -; Dies|seits|glau|be
Die|ster|weg (dt. Pädagoge)
Die|ter, Die|ther; ↑ R 191 (m.
Vorn.); Diet|hild, Diet|hil|de (w.
Vorn.); Diet|lind, Diet|lin|de (w.
Vorn.); Diet|mar (m. Vorn.);
¹Diet|rich (m. Vorn.); ²Diet|rich
(Nachschlüssel) m; -s, -e
Dieu le veut! fr. [djölwö] („Gott
will es!"; Kampfruf der Kreuz-
fahrer auf dem ersten Kreuzzug)
die|weil, all die|weil (veralt.);
vgl. weil
Dif|fa|ma|ti|on lat. [...zion] (Ver-
leumdung; Herabsetzung der Eh-
re); dif|fa|ma|to|risch; dif|fa|mie-
ren; Dif|fa|mie|rung
dif|fe|rent lat. (verschieden, un-
gleich); dif|fe|ren|ti|al, dif|fe|ren-
ti|ell [...zi...] (einen Unterschied
begründend od. darstellend); dif-
fe|ren|ti|al (Math.: unendlich
kleine Differenz; Ausgleichsge-
triebe bei Kraftwagen) s; -s, -e;
Dif|fe|ren|ti|al_dia|gno|se (Un-
terscheidung ähnlicher Krank-
heitsbilder), ...geo|me|trie
(Math.), ...ge|trie|be (Differen-
tial), ...quo|ti|ent (Math.), ...rech-
nung (Math.; w; -), ...schal|tung
(Elektrot.), ...ta|rif (Ausnahme-
satz); Dif|fe|ren|tia|ti|on [...zion]
(Math.: Anwendung der Diffe-
rentialrechnung; Geol.: Aufspal-
tung einer Stammschmelze); dif-
fe|ren|ti|ell vgl. differential; Dif-
fe|renz w; -, -en; Dif|fe|renz_be-
trag, ...ge|schäft (Börsentermin-
geschäft); dif|fe|ren|zie|ren (tren-
nen; unterscheiden; Math.: Dif-
ferentialrechnung anwenden);
Dif|fe|ren|ziert|heit (Unter-
schiedlichkeit, Abgestuftsein);
Dif|fe|ren|zie|rung (Sonderung,
Abstufung, Abweichung); dif|fe-

[1] Trenn.: ...ik|k...

rie|ren (verschieden sein; von-
einander abweichen)
dif|fi|zil *fr.* (schwierig, mühsam;
schwer zu behandeln; peinlich,
heikel)
Dif|flu|enz *lat.* (Geol.: Gabelung
eines Gletschers) *w;* -, -en
dif|form *lat.* (mißgestaltet); **Dif-
for|mi|tät** (Mißbildung)
dif|frakt *lat.* (Bot.: zerbrochen);
Dif|frak|ti|on [...*zion*] (Physik:
Strahlenbrechung, Beugung des
Lichtes)
dif|fun|die|ren *lat.* (Zeitwort zu:
Diffusion); **dif|fus** (zerstreut; un-
geordnet); -este (↑ R 292); -es
Licht, -e Reflexion; **Dif|fu|si|on**
(Chemie: gegenseitige Durch-
dringung [von Gasen od. Flüssig-
keiten]; Bergmannsspr.: Wetter-
austausch; Zuckerherstellung:
Auslaugung); **Dif|fu|sor** (Rohr-
leitungsteil, dessen Querschnitt
sich erweitert) *m;* -s, ...oren
Di|gam|ma (Buchstabe im ältesten
gr. Alphabet: *F*) *s;* -[s], -s
di|gen *gr.* (Biol.: durch Verschmel-
zung zweier Zellen gezeugt)
di|ge|rie|ren *lat.* (Chemie: auslau-
gen, -ziehen; Med.: verdauen)
Di|gest *engl.* [*daidsehäßt*] (bes. in
den angels. Ländern übl. Art von
Zeitschriften, die Auszüge aus
Büchern, Zeitschriften u. ä. brin-
gen) *m* od. *s;* -[s], -s; **Di|ge|sten**
lat. („Geordnetes"; Gesetzes-
sammlung des Kaisers Justinian)
Mehrz.
Di|ge|sti|on *lat.* (Med.: Ver-
dauung; Chemie: Auslaugen,
-ziehen); **di|ge|stiv** (Verdauung
bewirkend; Verdauungs...); **Di-
ge|stor** (Dampfkochtopf) *m;* -s,
...oren
di|gi|tal *lat.* (Med.: mit dem Fin-
ger; bei Rechenmaschinen: zif-
fernmäßig); **Di|gi|ta|lis** (Finger-
hut, Arzneipflanze) *w;* -; **Di|gi-
tal|rech|ner** (eine Rechenmaschi-
ne)
Di|glyph *gr.* (Bauw.: zweige-
schlitzte Platte am Gebälk [it. Re-
naissance]) *m;* -s, -e
Di|gni|tar, **Di|gni|tär** *fr.* (Wür-
denträger der kath. Kirche) *m;*
-s, -e; **Di|gni|tät** *lat.* (kath. kirchl.
Würde)
Di|gres|si|on *lat.* (Abschweifung,
Abweichung; Astron.: Winkel
zwischen dem Meridian u. dem
Vertikalkreis, der durch ein pol-
nahes Gestirn geht)
DIHT = Deutscher Industrie-
und Handelstag (vgl. deutsch)
di|hy|brid *gr.* (Biol.: sich in zwei
erblichen Merkmalen unter-
scheidend)
Di|jam|bus *gr.* (Versfuß: Doppel-
jambus) *m;* -, ...ben

Di|ka|ste|ri|um *gr.* (Gerichtshof
bei den alten Griechen) *s;* -s, ...ien
[...*i*ⁿ*n*]
Di|ke (gr. Göttin der Gerechtig-
keit, eine der ²Horen)
di|klin *gr.* (von Blüten: einge-
schlechtig)
Di|ko|ty|le, **Di|ko|ty|le|do|ne** *gr.*
(zweikeimblättrige Pflanze) *w;* -,
-n
Di|ktam vgl. Diptam
dik|tan|do *lat.* (diktierend, beim
Diktieren); **Dik|ta|phon** *lat.; gr.*
(Tonbandgerät zum Diktieren) *s;*
-s, -e; **Dik|tat** *lat. s;* -[e]s, -e; **Dik-
ta|tor** *m;* -s, ...oren; **dik|ta|to-
risch; Dik|ta|tur** *w;* -, -en; **dik|tie-
ren; Dik|tier|ge|rät**, ...ma|schi|ne;
Dik|ti|on [...*zion*] (Schreibart;
Ausdrucksweise); **Dik|tio|när** *fr.*
(Wörterbuch) *s* u. *m;* -s, -e; **Dik-
tum** *lat.* („Gesagtes"; Aus-
spruch) *s;* -s, ...ta
di|la|ta|bel *lat.* (dehnbar); ...a|ble
Buchstaben; **Di|la|ta|bi|les** (in die
Breite gezogene hebr. Buch-
staben) *Mehrz.;* **Di|la|ta|ti|on**
[...*zion*] (Dehnung, Ausdehnung;
Med.: Erweiterung [von
Körperhöhlen])
Di|la|ti|on *lat.* [...*zion*] (Rechtsw.:
Aufschub[frist]); **di|la|to|risch**
(aufschiebend; schleppend; hin-
haltend)
Di|lem|ma *gr.* (Klemme; Wahl
zwischen zwei [unangenehmen]
Dingen, Zwangslage, -entschei-
dung) *s;* -s, -s u. -ta
Di|let|tant *it.* (Nichtfachmann;
Halbwisser [ohne fachmännische
Schulung]; Laie; [Kunst]lieb-
haber) *m;* -en, -en (↑ R 268);
di|let|tan|ten|haft, **di|let|tan|tisch**
(unfachmännisch, laienhaft); **Di-
let|tan|tis|mus** (Oberflächlich-
keit; Spielerei) *m;* -; **di|let|tie|ren**
(selten für: sich als Dilettant betä-
tigen; sich versuchen)
Di|li|gence *fr.* [*dilischengß*] (früher
für: [Eil]postwagen) *w;* -, -n
Dill (eine Gewürzpflanze) *m;* -s,
-e, (österr. auch:) **Dil|le** *w;* -, -n;
Dil|len|kraut (österr.)
Dil|they (dt. Philosoph)
di|lu|vi|al *lat.* [...*wi*...] (zum Dilu-
vium gehörend); **Di|lu|vi|al|bil-
dung; Di|lu|vi|um** (Eiszeitalter) *s;*
-s
dim. = diminuendo
Dime [*daim*] (nordamerik. Münze)
m; -s, -s; 10 - (↑ R 322)
Di|men|si|on *lat.* (Ausdehnung;
[Aus]maß; Bereich); **di|men|sio-
nal** (die Ausdehnung bestim-
mend); **di|men|sio|nie|ren** (selten
für: abmessen)
Di|me|ter *gr.* (antike Verseinheit
aus zwei Füßen) *m;* -s, -
di|mi|nu|en|do *it.* (Musik: in der

Tonstärke abnehmend; Abk.:
dim.); **Di|mi|nu|en|do** *s;* -s, -s u.
...di; **di|mi|nu|ie|ren** *lat.* (verklei-
nern, verringern); **Di|mi|nu|ti|on**
[...*zion*] (Verkleinerung, Verrin-
gerung; Musik: Verkürzung der
Notenwerte; variierende Verzie-
rung); **di|mi|nu|tiv** (Sprachw.:
verkleinernd); **Di|mi|nu|tiv** *s;* -s,
-e [...*w*ᵉ] u. **Di|mi|nu|ti|vum**
[...*wum*] (Sprachw.: Verkleine-
rungswort, z. B. „Öfchen") *s;* -s,
...va [...*wa*]; **Di|mi|nu|tiv|form**
(Sprachw.: Verkleinerungsform)
Di|mis|si|on usw. *lat.* (veralt. für:
Demission usw.; vgl. d.); **di|mit-
tie|ren** (veralt. für: entlassen, ver-
abschieden)
di|morph *gr.* (zweigestaltig, -for-
mig); **Di|mor|phis|mus** *m;* -,
...men
DIN ⓦ [Abk. für: Deutsche Indu-
strie-Norm(en), später gedeutet
als: **Das Ist Norm**] (heute gilt
DIN als Name u. Kennzeichen
für die Gemeinschaftsarbeit des
Deutschen Normenausschusses)
w; -; *Schreibweise:* DIN (mit einer
Nummer zur Bezeichnung einer
Norm [z. B. DIN 16511, DIN
A 4 u. bei Kopplungen [z. B.
DIN-Mitteilungen, DIN-For-
mat, DIN-A 4-Blatt])
Din = (jugoslaw.) Dinar
Di|na (w. Vorn.; bibl. w. Eigenn.)
Di|nar (Münzeinheit von Jugosla-
wien, Tunesien u. a.; iran. Münze
[100 Dinar = 1 Rial]; Abk. jugo-
slaw.: Din, iran.: D) *m;* -s, -e;
6 - (↑ R 322)
di|na|risch (der dinarischen Rasse
angehörend); -e Rasse (nach dem
Hauptausstrahlungsgebiet, dem
Dinarischen Gebirge), aber (↑ R
198): Dinarisches Gebirge (zu-
sammenfassende Bez. des Ge-
birgslandes zwischen der Lai-
bach u. dem Drin)
Di|ner *fr.* [*dine*] (Mittagessen;
[Fest]mahl) *s;* -s, -s
¹**Ding** (Sache) *s;* -[e]s, -e u. (gering-
schätzig) -er; guter -e sein
²**Ding** (germ. Volks-, Gerichts- u.
Heeresversammlung) *s;* -[e]s, -e;
vgl. auch: Thing
Din|gel|chen *s;* -s, - (auch: Dinger-
chen), **Ding|lein**
din|gen (veralt. für: zu Dienstlei-
stungen gegen Entgelt verpflich-
ten; in Dienst nehmen); du ding-
test; gedungen (seltener: ge-
dingt); ding[e]!
Din|ger|chen [*Mehrz.* von: Dingel-
chen]
ding|fest, nur in: jmdn. - machen
Din|gi *Hindi* [*dinggi*] (kleines Bei-
boot) *s;* -s, -s
Ding|lein vgl. Dingelchen
ding|lich (eine Sache betreffend;

gegenständlich); -e Schuld; **Ding|lich|keit** w; -

Din|go austr. [dinggo] (austr. Hund) m; -s, -s

...dings (z. B. neuerdings); **Dings** (ugs. für eine unbekannte od. unbenannte Person od. Sache) m, w, s; -; **Dings|bums** (ugs. für eine unbekannte od. unbenannte Person od. unbenannte Person od. Sache) m, w, s; -; **¹Dings|da** (ugs. für eine unbekannte od. unbenannte Person od. Sache) m, w, s; -; **²Dings|da** (ugs. für einen unbekannten od. unbenannten Ort); **Dings|kir|chen** [auch: ...kirchⁿ] (ugs. für einen unbekannten od. unbenannten Ort); **Ding|wort** (für: Substantiv; Mehrz. ...wörter)

di|nie|ren fr. (zu Mittag essen, speisen); **Di|ning-room** engl. [däiningrum] (engl. Bez. für: Speisezimmer) m; -s, -s

Din|kel (alte, kaum mehr angebaute Weizenart, Spelt) m; -s, -

Din|ner engl. (Hauptmahlzeit in England [abends eingenommen]) s; -s, -[s]; **Din|ner|jacket¹** [...dschäkit] (Herrenjackett für halboffizielle gesellschaftliche Anlässe) s; -s, -s

Di|no|sau|ri|er m. [...iⁿr] u. **Di|no|sau|rus** (ausgestorbenes Riesenkriechtier) m; -, ...rier [...iⁿr]; **Di|no|the|ri|um** (ausgestorbenes Rüsseltier Europas) s; -s, ...ien [...iⁿn]

Di|ode gr. (Zweipolröhre, Gleichrichterröhre) w; -, -n

Dio|ge|nes (altgr. Philosoph)

Dio|kle|ti|an [...klezian] (röm. Kaiser); **dio|kle|tia|nisch**; -e (blutige, grausame) Verfolgung, aber (↑ R 179): **Dio|kle|tia|nisch**

Dio|len Ⓦ (synthet. Faser) s; -[s]

Di|on österr. (Kurzwort für: Direktion, selten auch für· Division) w; -, -nen

Dio|nys, Dio|ny|si|us (m. Vorn.); **Dio|ny|si|en** gr. [...iⁿn] (Dionysosfest) Mehrz.; **dio|ny|sisch**; ↑ R 179 [nach Dionysos, dem gr. Gott des Weines, des Rausches u. der Fruchtbarkeit] (auch: wildbegeistert, tobend; rauschend [von Festen]); **Dio|ny|sos** gr. (gr. Gott des Weines, des Rausches u. der Fruchtbarkeit)

dio|phan|tisch gr.; ↑ R 179 (nach dem altgr. Mathematiker Diophantos); -e Gleichung

Di|op|ter gr. (Zielgerät; veralt. für: Sucher [an fotogr. Apparaten]) s; -s, -; **Di|op|trie** (Maßeinheit für die Brechkraft von Linsen u. Linsensystemen) w; -, ...ien; **Di|op|trik** (veralt. für: Lichtbrechungs-

lehre) w; -; **di|op|trisch** (zur Lichtbrechungslehre gehörend, lichtbrechend)

Di|ora|ma gr. („Durchschaubild"; Art Guckkasten) s; -s, ...men

Di|oris|mus (Begriffsbestimmung) m; -, ...men

Di|orit gr. (Tiefengestein) m; -s, -e

Di|os|ku|ren gr. („Zeussöhne"; Kastor u. Pollux, auch Bez. für unzertrennliche Freunde) Mehrz.

Dio|ti|ma [auch: ...tima] (myth. Priesterin bei Platon; Gestalt bei Hölderlin)

Di|oxyd gr. [auch: ...üt] (Oxyd, das zwei Sauerstoffatome enthält); vgl. Oxid

Di|öze|san gr. (Angehöriger einer Diözese) m; -en, -en (↑ R 268); **Di|öze|se** (Amtsgebiet eines [kath.] Bischofs, auch: ev. Kirchenkreis) w; -, -n; **Di|özie** (Bot.: Zweihäusigkeit) w; -; **di|özisch** (Bot.: zweihäusig); **Di|özis|mus** (Bot.: Zweihäusigkeit) m; -

Diph|the|rie gr. (eine Infektionskrankheit) w; -, ...ien; **Diph|the|rie-schutz|imp|fung, ...se|rum; diph|the|risch**

Di|phthong gr. (Sprachw.: Zwielaut, Doppellaut, z. B. ei, au; Ggs.: Monophthong) m; -s, -e; **di|phthon|gie|ren** (einen Selbstlaut zum Diphthong entwickeln); **Di|phthon|gie|rung; di|phthon|gisch**

Dipl.-Chem. = Diplomchemiker

Di|plex|be|trieb vgl. Duplexbetrieb

Dipl.-Dolm. = Diplomdolmetscher; **Dipl.-Gwl.** = Diplomgewerbelehrer; **Dipl.-Hdl.** = Diplomhandelslehrer; **Dipl.-Holzw.** = Diplomholzwirt; **Dipl.-Ing.** = Diplomingenieur; **Dipl.-Kfm.** = Diplomkaufmann; **Dipl.-Ldw.** = Diplomlandwirt; **Dipl.-Met.** = Diplommeteorologe

Di|plo|do|kus gr. (ausgestorbene Riesenechse) m; -, ...ken

di|plo|id gr. (Biol.: mit doppeltem Chromosomensatz)

Di|plo|kok|kus gr. (Kokkenpaar [Krankheitserreger]) m; -, ...ken

Di|plom gr. (amtl. Schriftstück; Urkunde; [Ehren]zeugnis s; -[e]s, -e; **Di|plo|mand** (jmd., der sich auf die Diplomprüfung vorbereitet) m; -en, -en (↑ R 268); **Di|plo|mar|beit; Di|plo|mat** (beglaubigter Vertreter eines Landes bei Fremdstaaten) m; -en, -en (↑ R 268); **Di|plo|ma|ten|aus|weis, ...kof|fer, ...lauf|bahn, ...paß, ...prü|fung, ...schreib|tisch** (bes. wuchtiger Schreibtisch); **Di|plo|ma|tie** (Kunst des [staatsmänni-

schen] Verhandelns mit fremden Mächten; Staatskunst; Gesamtheit der Diplomaten; kluge Berechnung) w; -; **Di|plo|ma|tik** (Urkundenlehre) w; -; **Di|plo|ma|ti|ker** (Urkundenforscher u. -kenner); **di|plo|ma|tisch** (die Diplomatik betreffend, urkundlich; staatsmännisch; klug berechnend); -ste (↑ R 294); das -e Korps, aber (↑ R 224); das Diplomatische Korps in Rom; **Di|plom-che|mi|ker¹** (Abk.: Dipl.-Chem.), **...dol|met|scher¹** (Abk.: Dipl.-Dolm.), **...ge|wer|be|leh|rer¹** (Abk.: Dipl.-Gwl.), **...han|dels|leh|rer¹** (Abk.: Dipl.-Hdl.), **...holz|wirt¹** (Abk.: Dipl.-Holzw.); **di|plo|mie|ren** (Diplom erteilen); **Di|plom-in|ge|nieur¹** (Abk.: Dipl.-Ing.), **...kauf|mann¹** (Mehrz. ...leute; Abk.: Dipl.-Kfm., österr.: Dkfm.), **...land|wirt¹** (Abk.: Dipl.-Ldw.), **...me|teo|ro|lo|ge¹** (Abk.: Dipl.-Met.), **...phy|si|ker¹** (Abk.: Dipl. Phys.), **...sport|leh|rer¹** (Abk.: Dipl.-Sportl.), **...volks|wirt¹** (Abk.: Dipl.-Volksw.); **Dipl.-Phys.** = Diplomphysiker; **Dipl.-Sportl.** = Diplomsportlehrer; **Dipl.-Volksw** = Diplomvolkswirt

Di|po|die gr. („Doppelfüßigkeit"; zweiteilige Taktgruppe in einem Vers) w; -, ...ien; **di|po|disch** (doppelfüßig); -e Verse

Di|pol gr. (Anordnung von zwei entgegengesetzt gleichen elektrischen Ladungen) m; -s, -e; **Di|pol|an|ten|ne**

Dip|pel (südd. für: Dübel, Zapfen; österr. ugs. für: Beule; vgl. Tippel) m; -s, -; **Dip|pel|baum** österr. (Tragbalken)

dip|pen engl. (Seemannsspr.: die Flagge zum Gruß auf- u. niederholen; mdal. für: eintauchen)

Dip|tam engl. (eine Zierpflanze, brennender Strauch) m; -s

Di|pte|ren gr. (Zweiflügler, zweiflüglige Insekten) Mehrz.; **Di|pte|ros** (Tempel mit doppelter Säulenreihe) m; -, ...roi [...reu]

Di|pty|chon gr. (zusammenklappbare Schreibtafel im Altertum; zweiflügeliges Altarbild im Mittelalter) s; -s, ...chen u. ...cha

dir; in Briefen usw.: **Dir** (↑ R 121); (↑ R 275:) dir alten (selten: alter) Frau; dir jungem (auch: jungen) Menschen; (↑ R 290:) dir Geliebten (weibl.; selten: Geliebter); dir Geliebtem (männl.; neben: Geliebten)

Di|rec|toire fr. [diräktŏar] ([Kunst]stil zur Zeit der Fr. Re-

Trenn.: ...k|k...

¹ Heute oft: Diplom-Chemiker usw.

volution) *s*; -[s]; di|rękt *lat*.; -e
Rede (Sprachw.: wörtliche Re-
de); Di|rękt|flug; Di|rękt|heit; Di-
rek|ti|on [...*zion*] (schweiz. auch:
kantonales Ministerium); Di-
rek|ti|ons|kraft (Physik); di|rek-
ti|ons|los (richtungslos); Di|rekti-
o|ns.se|kre|tä|rin, ...zim|mer;
Di|rek|ti|ve [...*w*ᵉ] (Weisung; Ver-
haltensregel) *w*; -, -n; Di|rękt-
man|dat; Di|rękt|tor *m*; -s, ...ọren;
Di|rek|to|rat *s*; -[e]s, -e; di|rek|to-
ri|al (dem Direktor zustehend,
von ihm herrührend); Di|rek|to-
rin [auch: *diräk*...] *w*; -, -nen; Di-
rek|to|ri|um *s*; -s, ...ien [...*i*ᵉ*n*]; Di-
rek|tor|zim|mer; Di|rek|tri|ce *m*;
[...*triß*ᵉ] (leitende Angestellte
[bes. in der Bekleidungsindu-
strie]) *w*; -, -n; Di|ręk|trix *lat*.
(Richtungslinie in der Mathema-
tik) *w*; -; Di|rękt..sen|dung, ...spiel
(Sportspr.), ...über|tra|gung,
...ver|kauf; Di|rex (Schülerspr.
für: Direktor) *m*; -, -e
Dịr|ham (auch:) Dịr|hem (Münz-
u. Gewichtseinheit, bes. im Irak
u. in Marokko) *m*; -s, -s; 5 - (↑ R
322)
Di|ri|gent *lat*. (↑ R 268); Di|ri|gen-
ten.pult, ...stab; di|ri|gie|ren (lei-
ten; Takt schlagen); Di|ri|gis|mus
(staatl. Lenkung der Wirtschaft)
m; -; di|ri|gi|stisch
Dirk (niederd. Kurzform von:
¹Dietrich)
Dịrn bayr., österr. (mdal.: Magd)
w; -, -en; Dịrndl bayr., österr. (jun-
ges Mädchen; Dirndlkleid;
ostösterr. mdal. auch: [Frucht
der]Kornelkirsche)*s*;-s,-;Dịrndl-
kleid; Dịrndl|strauch ostösterr.
mdal. (Strauch der Kornelkir-
sche); Dịr|ne (Prostituierte; mdal.
für: junges Mädchen) *w*; -, -n
dịs, Dịs (Tonbezeichnung) *s*; -, -;
dịs (Zeichen für: dis-Moll); in dis
Dịs|agio *it*. [...*adscho*] (Abschlag,
um den der Preis od. Kurs hinter
dem Nennwert od. der Parität
eines Wertpapiers od. einer Geld-
sorte zurückbleibt) *s*; -s, -s
Disc|jockey¹ vgl. Diskjockey
Dịs|coun|ter *engl*. [*dißkaunt*ᵉ*r*] (Be-
sitzer eines Discountgeschäftes);
Dịs|count..ge|schäft, ...la|den,
...preis (vgl. ²Preis)
Dịs|co|ve|rer *amerik*. [*dißkaw*ᵉ*r*ᵉ*r*]
(Name amerik. Erdsatelliten) *m*;
-[s], -
Dịs|en|gage|ment *engl*. [*dißin-*
*ge'dsehm*ᵉ*nt*] (milit. Auseinan-
derrücken der Machtblöcke) *s*;
-s
Di|seur *fr*. [*disör*] (Sprecher, Vor-
tragskünstler) *m*; -s, -e; Di|seu|se
[*disös*ᵉ] *w*; -, -n

Dis|har|mo|nie *lat*.; *gr*. (Mißklang;
Uneinigkeit); dis|har|mo|nie|ren;
dis|har|mo|nisch; -ste (↑ R 294)
Dis|junk|ti|on *lat*. [...*zion*] (Tren-
nung; Sonderung); dis|junk|tiv
(trennend); -e Konjunktion (aus-
schließendes Bindewort, z. B.
„oder")
Dis|kant *lat*. (hohe Gegenstimme
zur Hauptstimme; oberste Stim-
me, Sopran) *m*; -s, -e; Dis-
kant.schlüs|sel, ...stim|me
Dịs|ken (*Mehrz*. von: Diskus)
Disk|jockey¹, Disc|jockey¹ *engl*.
[*dißkdsehoke*, engl. Ausspr.: *...ki*]
(jmd., der Schallplatten präsen-
tiert) *m*; -s, -s
Dis|kọnt *it*. (Zinsvergütung bei
noch nicht fälligen Zahlungen)
m; -s, -e; Dis|kọn|ten (inländische
Wechsel) *Mehrz*.; Dis|kont.er-
hö|hung, ...ge|schäft, ...her|ab-
set|zung; dis|kon|tie|ren (eine spä-
ter fällige Forderung unter Ab-
zug von Zinsen ankaufen)
dis|kon|ti|nu|ier|lich *lat*. (aussetz-
end, unterbrochen, zusam-
menhanglos); Dis|kon|ti|nui|tät
(Mangel an Zusammenhang);
Dis|kont.satz (Zinssatz), ...spe-
sen (Wechselspesen; *Mehrz*.)
Dis|kor|dạnz *lat*. (Uneinigkeit;
Geol.: ungleichförmige Lage-
rung zweier Gesteinsverbände)
w; -, -en
Dis|ko|thẹk *gr*. (Schallplatten-
sammlung; Lokal, in dem Schall-
platten gespielt werden) *w*; -, -en;
Dis|ko|the|kar (Verwalter einer
Diskothek [beim Rundfunk]) *m*;
-s, -e
Dis|kre|dit *lat*. (übler Ruf) *m*; -[e]s;
dis|kre|di|tie|ren (in Verruf brin-
gen)
dis|kre|pạnt *lat*. (abweichend;
zwiespältig); Dis|kre|panz (Un-
stimmigkeit, Zwiespältigkeit) *w*;
-, -en
dis|krẹt *lat*. (taktvoll, rücksichts-
voll; unauffällig; vertraulich); -e
Zahlenwerte (Math.); Dis|kre|ti-
on [...*zion*] *w*; -
Dis|kri|mi|nạn|te *lat*. (math. Aus-
druck, der bei Gleichungen zwei-
ten u. höheren Grades den Cha-
rakter der Wurzel angibt) *w*; -,
-n; Dis|kri|mi|na|ti|on [...*zion*]
(seltener für: Diskriminierung);
dis|kri|mi|nie|ren; Dis|kri|mi|nie-
rung (unterschiedliche Behand-
lung; Herabsetzung, Herabwür-
digung)
dis|kur|rie|ren *lat*. (veralt., aber
noch landsch. für: [eifrig] erör-
tern; verhandeln; sich unterhal-
ten); Dis|kụrs ([eifrige] Erörte-
rung; Verhandlung) *m*; -es, -e;

dis|kur|sịv (von einer Vorstellung
zu einer anderen mit logischer
Notwendigkeit fortschreitend)
Dịs|kus *gr*. (Wurfscheibe) *m*; -,
...ken u. -se
Dis|kus|si|ọn *lat*. (Erörterung;
Aussprache; Meinungsaus-
tausch); Dis|kus|si|ons.bei|trag,
...ge|gen|stand, ...grund|la|ge,
...red|ner, ...teil|neh|mer, ...the-
ma
Dịs|kus|wer|fer
dis|ku|ta|bel *lat*. (erwägenswert;
strittig); ...a|ble Fragen; Dis|ku-
tạnt (Diskussionsteilnehmer) *m*;
-en, -en (↑ R 268); dis|ku|tie|r|bar;
dis|ku|tie|ren; [über] etwas -
Dis|lo|ka|ti|on *lat*. [...*zion*] (räum-
liche Verteilung von Truppen;
Geol.: Störung der normalen La-
gerung von Gesteinsverbänden;
Med.: Verschiebung der Bruch-
enden); dis|lo|zie|ren ([Truppen]
räumlich verteilen, verlegen);
Dis|lo|zie|rung
Dis|mem|bra|ti|on *lat*. [...*zion*]
(Zerschlagung; Zerstückelung
[von Gütern, Staaten])
dịs-Moll [auch: *dißmọl*] (Tonart;
Zeichen: dis) *s*; -; dịs-Moll-Ton-
lei|ter (↑ R 155)
Dịs|ney [*dịsni*] (amerik. Trickfilm-
zeichner)
Dis|pa|che *fr*. [*dißpasch*ᵉ] (Scha-
densberechnung u. -verteilung
auf die Beteiligten bei Seescha-
den) *w*; -, -n; Dis|pa|cheur
[*dißpaschör*] (Seeschadenberech-
ner) *m*; -s, -e; dis|pa|chie|ren [*diß-*
*paschir*ᵉ*n*]
dis|pa|rạt *lat*. (ungleichartig; un-
vereinbar, widersprechend); Dis-
pa|ri|tät (Ungleichheit, Verschie-
denheit)
Dis|pat|cher *engl*. [*dißpätsch*ᵉ*r*]
(Betriebs- od. Abteilungsleiter
im Industriebetrieb mit der Auf-
gabe der Bereitstellungs- u. Pro-
duktionsablaufplanung sowie
der laufenden Überwachung u.
Kontrolle) *m*; -s, -; Dịs|pat|cher-
sy|stem
Dis|pẹns *lat*. („Erlaß"; Aufhebung
einer Verpflichtung, Befreiung;
Urlaub; Ausnahme[bewilli-
gung]) *m*; -es, -e u. (österr. u. im
kath. Kirchenrecht nur so:) *w*;
-, -en; Dis|pen|sa|ti|on [...*zion*]
(Befreiung); Dis|pen|sa|to|ri|um *s*; -s,
(Arznei-, Apothekerbuch) *s*; -s,
...ien [...*i*ᵉ*n*]; Dis|pẹns|ehe; dis-
pen|sie|ren (befreien, beurlau-
ben; Arzneien bereiten u. abge-
ben); Dis|pen|sier|recht (Recht,
Arzneien zu bereiten u. abzuge-
ben)
di|sper|gie|ren *lat*. (zerstreuen;
verbreiten); di|spers (feinverteilt;
zerstreut); -e Phase (Physik); Di-

sper|si|on (feinste Verteilung eines Stoffes in einem anderen; Abhängigkeit der Fortpflanzungsgeschwindigkeit der Wellen von der Wellenlänge)

Dis|placed per|son *engl.* [*dißplě'ßt pö'ß*ⁿ*n*] (Bez. für Ausländer, die während des 2. Weltkriegs nach Deutschland [zur Arbeit] gebracht wurden; Abk.: D. P.) *w*; - -, - -s

Dis|play *engl.* [*dißplě'*] (optisch wirksames Ausstellen von Waren, Werbungsmaterial u. ä.; Datenverarbeitung: [Daten]sichtgerät) *s*; -s, -s; Dis|play|er (Dekorations-, Packungsgestalter); Display_gra|phi|ker, ...ma|te|ri|al

Di|spon|de|us *gr.* (Versfuß: Doppelspondeus) *m*; -, ...een

Dis|po|nen|den *lat.* (unverkaufte Bücher im Besitz des Sortimentsbuchhändlers, deren weitere Lagerung beim Sortimentsbuchhändler der Verleger gestattet) *Mehrz.*; Dis|po|nent (kaufmänn. Angestellter, der mit besonderen Vollmachten ausgestattet ist u. einen größeren Unternehmungsbereich leitet); ↑ R 268; Dis|po|nen|tin *w*; -, -nen; dis|po|ni|bel (veralt. für: verfügbar); ...i|ble Gelder; Dis|po|ni|bi|li|tät (veralt. für: Verfügbarkeit) *w*; -; dis|po|nie|ren; dis|po|niert (auch für: aufgelegt; gestimmt zu ...; empfänglich [für Krankheiten]); Dis|po|si|ti|on [...*zion*] (Anordnung, Gliederung; Verfügung; Anlage; Empfänglichkeit [für Krankheiten]); zur - (auf Wartegeld, im einstweiligen Ruhestand; Abk.: z. D.); dis|po|si|ti|ons|fä|hig (BGB: geschäftsfähig); Dis|po|si|ti|ons|fonds, ...gel|der (Verfügungsgelder; *Mehrz.*); dis|po|si|tiv (Rechtsw.: abdingbar; vgl. d.); -es Recht

Dis|pro|por|ti|on [...*zion*], Dis|pro|por|tio|na|li|tät (Mißverhältnis); dis|pro|por|tio|nal, dis|pro|por|tio|niert (unverhältnismäßig; ungleich)

Dis|put *lat.* (Wortwechsel; Streitgespräch) *m*; -[e]s, -e; dis|pu|ta|bel (veralt. für: strittig); ...a|ble Fragen; Dis|pu|tant (Disputierender) *m*; -en, -en (↑ R 268); Dis|pu|ta|ti|on [...*zion*] (gelehrtes Streitgespräch); dis|pu|tie|ren

Dis|qua|li|fi|ka|ti|on [...*zion*], Dis|qua|li|fi|zie|rung *lat.* (Untauglichkeitserklärung; Ausschließung vom sportlichen Wettbewerb); dis|qua|li|fi|zie|ren

Dis|sens *lat.* (Rechtsspr.: Meinungsverschiedenheit) *m*; -es, -e; Dis|sen|ter *engl.* (sich nicht zur anglikan. Kirche Bekennen-

der) *m*; -s, -s (meist *Mehrz.*); dis|sen|tie|ren *lat.* (abweichender Meinung sein)

Dis|ser|tant *lat.* (jmd., der eine Dissertation anfertigt) *m*; -en, -en (↑ R 268); Dis|ser|ta|ti|on [...*zion*] (wissenschaftl. Abhandlung zur Erlangung der Doktorwürde); dis|ser|tie|ren (selten für: eine Dissertation anfertigen)

Dis|si|dent *lat.* (außerhalb einer staatlich anerkannten Religionsgemeinschaft Stehender); ↑ R 268; Dis|si|di|en [...*i*ⁿ*n*] (veralt. für: Streitpunkte) *Mehrz.*; dis|si|die|ren (veralt. für: anders denken; [aus der Kirche] austreten)

Dis|si|mi|la|ti|on *lat.* [...*zion*] (Sprachw.: „Entähnlichung" von Lauten, z. B. Wechsel von t zu k in „Kartoffel" [aus „Tartüffel"]; Naturwiss.: Abbau u. Verbrauch von Körpersubstanz unter Energiegewinnung); dis|si|mi|lie|ren

Dis|si|mu|la|ti|on *lat.* [...*zion*] (Verheimlichung einer Krankheit), dis|si|mu|lie|ren

Dis|si|pa|ti|ons|sphä|re *lat.*; *gr.* (svw. Exosphäre) *w*; -

dis|so|lu|bel *lat.* (löslich, auflösbar, zerlegbar); ...u|ble Mischungen; dis|so|lut (zügellos); Dis|so|lu|ti|on [...*zion*] (Auflösung, Trennung [Med.]; Zügellosigkeit)

dis|so|nant *lat.* (mißtönend), Dis|so|nanz (Mißklang; Unstimmigkeit) *w*; -, -en; dis|so|nie|ren

Dis|so|zia|ti|on *lat.* [...*zion*] (Zerfall, Trennung; Auflösung); dis|so|zi|ie|ren

di|stal *lat.* (weiter von der Körpermitte, bei Blutgefäßen vom Herzen entfernt liegend); Di|stanz *w*; -, -en; vgl. par distance; Di|stanz|ge|schäft (Versendungskauf); di|stan|zie|ren (im Wettkampf überbieten, hinter sich lassen); sich - (von jmdm. od. etwas abrücken); Di|stan|zie|rung; Di|stanz_re|lais, ...ritt (Dauerritt); ...wech|sel (Wechsel mit verschiedenem Ausstellungs- u. Zahlungsort)

Di|stel *w*; -, -n; Di|stel_fal|ter (ein Schmetterling), ...fink (ein Vogel)

Di|sthen *gr.* (ein Mineral) *m*; -s, -e

Di|sti|chon *gr.* [...*chon*] (Verspaar aus Hexameter u. Pentameter) *s*; -s, ...chen

di|stin|gu|iert [*dißtinggírt*] (vornehm); Di|stin|gu|iert|heit; di|stinkt (veralt. für: unterscheiden; verständlich); Di|stink|ti|on [...*zion*] (Auszeichnung; [hoher] Rang; österr. für: Rangabzei-

chen); di|stink|tiv (unterscheidend)

Dis|tor|si|on *lat.* (Optik: Verzerrung, Verzeichnung; Med.: Verstauchung)

dis|tra|hie|ren *lat.* (veralt. für: auseinanderziehen; trennen); Dis|trak|ti|on [...*zion*] (veralt. für: Zerstreuung; Geol.: Zerrung von Teilen der Erdkruste; Med.: Behandlung von Knochenbrüchen mit Streckverband; geburtshilflicher Eingriff)

Dis|tri|bu|ent *lat.* (veralt. für: Verteiler); ↑ R 268; dis|tri|bu|ie|ren (veralt. für: verteilen); Dis|tri|bu|ti|on [...*zion*] (Verteilung; Auflösung; Wirtsch.: Einkommensverteilung, Verteilung von Handelsgütern; Sprachw.: die Umgebung eines sprachlichen Elements; Psych.: Verteilung u. Aufspaltung der Aufmerksamkeit); Dis|tri|bu|ti|ons|for|mel (Spendeformel beim Abendmahl); dis|tri|bu|tiv (verteilend); -e Aufmerksamkeit (Psych.); Dis|tri|bu|tiv|ge|setz (Math.), ...zahl (im Deutschen mit „je" gebildet, z. B. „je acht")

Di|strikt *lat.* (Bezirk, abgeschlossener Bereich) *m*; -[e]s, -e; Di|strikts|vor|ste|her

Dis|zes|si|on *lat.* (veralt. für: Weggang; Abzug; Übertritt zu einer anderen Partei)

Dis|zi|plin *lat.* (Zucht; Ordnung; Fach einer Wissenschaft) *w*; -, -en; (↑ R 145:) Disziplin und maßhalten, aber: maß- u. Disziplin halten; dis|zi|pli|när österr. (disziplinarisch); Dis|zi|pli|nar_ge|setz (Dienststrafordnung), ...ge|walt (Ordnungsgewalt, Dienststrafgewalt); dis|zi|pli|na|risch, dis|zi|pli|nell (die [dienstliche] Zucht, Strafgewalt betreffend; streng); Dis|zi|pli|nar_recht (Dienststrafrecht), ...stra|fe, ...ver|fah|ren (Dienststrafverfahren), ...ver|ge|hen (Vergehen im Dienst); dis|zi|pli|nell vgl. disziplinarisch; dis|zi|pli|nie|ren (zur Ordnung erziehen); dis|zi|pli|niert; Dis|zi|pli|niert|heit; dis|zi|plin_los, ...wid|rig

Dith|mar|schen (Gebiet an der Nordseeküste); Dith|mar|scher (↑ R 199); dith|mar|sisch

Di|thy|ram|be *gr. w*; -, -n u. Di|thy|ram|bus (Weihelied [auf Dionysos]; Loblied, trunkene Dichtung) *m*; -,...ben; di|thy|ram|bisch (begeistert, trunken)

di|to *lat.* („besagt"; dasselbe, ebenso; Abk.: do. od. dto.); vgl. detto; Di|to (Einerlei) *s*; -s, -s

Di|tro|chä|us *gr.* (Versfuß: Doppeltrochäus) *m*; -, ...äen

Dit|chen ostpr. (Groschen)

Dit|te (dän. w. Vorn.)

Dit|to|gra|phie gr. („Doppelschreibung" von Buchstaben[gruppen]) w; -, ...ien

Di|ure|se gr. (Med.: Harnausscheidung) w; -, -n; **Di|ure|ti|kum** (harntreibendes Mittel) s; -s, ...ka; **Di|ure|tin** ⓦ (ein harntreibendes Arzneimittel) s; -s; **di|ure|tisch** (harntreibend); -e Mittel

Di|ur|nal lat. s; -s, -e u. **Di|ur|na|le** („das Tägliche"; Gebetbuch der kath. Geistlichen mit den Tagesgebeten) s; -, ...lia; **Di|ur|num** veralt. österr. (Tagegeld) s; -s, ...nen

Di|va it. [diwa] („die Göttliche"; erste Sängerin, gefeierte Schauspielerin) w; -, -s u. ...ven [...wᵉn]

di|ver|gent lat. [diwär...] (auseinandergehend; in entgegengesetzter Richtung [ver]laufend); **Di|ver|genz** (Auseinandergehen; Meinungsverschiedenheit) w; -, -en; **di|ver|gie|ren; di|ver|gie|rend** (divergent); -ste

di|vers lat. [diwärß] (verschieden; bei attributivem Gebrauch in der Mehrz.: mehrere), -este (↑ R 292); **Di|ver|sant** (im kommunist. Sprachgebrauch: Saboteur) m; -en, -en (↑ R 268); **Di|ver|si|fi|ka|ti|on** [...ziọn] (Abwechslung, Mannigfaltigkeit; Wirtsch.: Ausweitung des Waren- oder Produktionssortiments eines Unternehmens); **di|ver|si|fi|zie|ren; Di|ver|si|on** (veralt. für: Ablenkung; Angriff von der Seite; im kommunist. Sprachgebrauch: Sabotage des Klassenfeindes); **Di|ver|ti|kel** (Med.: Ausbuchtung an Organen) s; -s, -; **Di|ver|ti|men|to** it. (Musik: Tanzeinlage; Potpourri; Zwischenspiel) s; -s, -s u. ...ti; **Di|ver|tis|se|ment** fr. [diwärtis̝ᵉmang] (Divertimento) s; -s, -s

di|vi|de et im|pe|ra! lat. [diwide - -] („Teile und herrsche!")

Di|vi|dend lat. [...wi...] (Bruchrechnung: Zähler) m; -en, -en (↑ R 268); **Di|vi|den|de** (der auf eine Aktie entfallende Gewinn[anteil]) w; -, -n; **Di|vi|den|den|aus|schüt|tung, ...schein** (Gewinnanteilschein); **di|vi|die|ren** (teilen); zehn dividiert durch fünf ist, macht, gibt (nicht: sind, machen, geben) zwei

Di|vi|di|vi indian.-span. [diwidiwi] (Schoten des amerik. Schlehdorns) Mehrz.

Di|vi|na Com|me|dia it. [diwina ko...] (Dantes „Göttliche Komödie") w; - -

Di|vi|na|ti|on lat. [diwinaziọn] (Ahnung; Weissagung, Wahrsagekunst); **di|vi|na|to|risch** (vorah-

nend; seherisch); **Di|vi|ni|tät** (Göttlichkeit; göttliches Wesen) w; -

Di|vis lat. [diwiß] (veralt. für: Teilungszeichen; Druckw.: Bindestrich) s; -es, -e; **Di|vi|si|on** (Math.: Teilung; Heeresabteilung) w; -, -en; **Di|vi|sio|när** fr. bes. schweiz. (Befehlshaber einer Division) m; -s, -e; **Di|vi|si|ons|kom|man|deur, ...la|za|rett, ...stab; Di|vi|sor** (Bruchrechnung: Nenner) m; -s, ...oren; **Di|vi|so|ri|um** (Druckw.: gabelförmige Blattklammer [zum Halten der Vorlage]) s; -s, ...ien [...iᵉn]

Di|vus lat. [diwuß] („der Göttliche"; Titel röm. Kaiser)

Di|wan pers. (niedriges Liegesofa; ehem. türk. Regierung; Gedichtsammlung) m; -s, -e; [Goethes] „Westöstlicher Diwan"

Di|xie (ugs. Kurzform für: Dixieland) m; -s; **Di|xie|land** amerik. [dikßiländ] m; -[s] u. **Di|xie|land-Jazz** (nordamerik. Bez. für eine bestimmte Variante des Jazz)

d. J. = dieses Jahres; der Jüngere

Dja|kar|ta [dschakạrta] (Hptst. u. wichtigster Hafen Indonesiens)

DJH = Deutsche Jugendherberge

Dji|bou|ti [dschibuti] vgl. Dschibuti

DJK = Deutsche Jugendkraft

DK = Dezimalklassifikation

Dkfm. (österr.) = Diplomkaufmann

dkg (österr.) = Dekagramm

dkl, Dl = Dekaliter

dkm, Dm = Dekameter

DKP = Deutsche Kommunistische Partei

dkr = dänische Krone (Münze)

DKW ⓦ (Kraftfahrzeugmarke)

dl = Deziliter

Dl, dkl = Dekaliter

DLG = Deutsche Landwirtschafts-Gesellschaft

DLRG = Deutsche Lebens-Rettungs-Gesellschaft

dm = Dezimeter

Dm, dkm = Dekameter

dm², qdm = Quadratdezimeter

dm³, cdm = Kubikdezimeter

DM = Deutsche Mark

d. M. = dieses Monats

d-Moll [demol, auch: demọl] (Tonart; Zeichen: d) s; -; **d-Moll-Ton|lei|ter** [de...] (↑ R 155)

DNA = Deutscher Normenausschuß

Dnjepr (russ. Strom) m; -[s]

Dnjestr (russ. Strom) m; -[s]

do. = dito

d. O. = der Obige

Do|bel vgl. Tobel

¹Dö|bel (ein Fisch) m; -s, -

²Dö|bel usw. vgl. Dübel usw.

Do|ber|mann [nach dem Züchter] m; -s, ...männer (Hunderasse)

Do|ber|mann|pin|scher

Do|bratsch (Gebirge in Kärnten)

Do|bru|dscha (Gebiet zwischen Donau u. Schwarzem Meer) -

do|cen|do dis|ci|mus lat. [dozạndo diβzi...] („durch Lehren lernen wir")

doch; ja -; nicht -!; o daß - ...

doch|misch gr. [dọch...]; -er Vers (Dochmius); **Dọch|mi|us** (altgr. Versfuß) m; -, ...ien [...iᵉn]

Dọcht m; -[e]s, -e; **Dọcht|hal|ter**

Dock niederl. od. engl. (Anlage zum Ausbessern von Schiffen) s; -s, -s u. (selten:) -e

Docke [Trenn.: Dok|ke] (Garnmaß; zusammengedrehter Garnstrang; landschaftl. für: Puppe) w; -, -n; vgl. aber: Dogge; **¹dok|ken** (Garn, Flachs, Tabak bündeln)

²docken [Trenn.: dok|ken] niederl. od. engl. (ein Schiff ins Dock bringen; ins Dock liegen); **Dọcker** [Trenn.: Dok|ker] (Dockarbeiter) m; -s, -; **Dọck|ha|fen**; vgl. ¹Hafen; **Dọcking** [Trenn.: Dok|king] (Ankoppelung der Mondfähre an das Raumschiff) s; -s, -s; **Dọcking|ma|nö|ver** [Trenn.: Dok|king...]

do|de|ka|disch gr. (12 Einheiten umfassend, duodezimal); **Do|de|ka|eder** (von 12 gleichen, regelmäßigen Fünfecken begrenzter Körper) s; -s, -; **Do|de|ka|nes** (d „Zwölfinseln" im Ägäischen Meer) m; -; **Do|de|ka|pho|nie** (Zwölftonmusik) w; -; **do|de|ka|pho|nisch** (die Dodekaphonie betreffend); **Do|de|ka|pho|nik** (Komponist od. Anhänger der Zwölftonmusik); ↑ R 268

Do|de|rer, Heimito von (österr. Schriftsteller)

Do|do|na (Orakelheiligtum des Zeus); **do|do|nä|isch**

Doe|skin ⓦ engl. [dọßkin] („Rehfell"; Wollgewebe) m; -[s]

Do|ga|res|sa it. (Gemahlin des Dogen) w; -, ...essen

Dog|cart engl. [dọgkạrt, dokạrt] („Hundekarren"; eine Art zweirädriger Einspänner) m; -s, -s

Do|ge it. [dosch̩ᵉ]; it. Aussprache: [dọdsch̩e] („Herzog"; früher: Titel des Staatsoberhauptes in Venedig u. Genua) m; -n, -n; **Do|ge|pa|last**

Dog|ge engl. w; -, -n (eine Hunderasse); vgl. aber: Docke

¹Dog|ger engl. (Geol.: mittlere Juraformation; Brauner Jura) m; -

²Dog|ger niederl. (niederl. Fischerfahrzeug) m; -s, -; **Dog|ger|bank** (Untiefe in der Nordsee) w; -

Dög|ling (Pott-, Entenwal)

Dog|ma gr. (Kirchenlehre; [Glaubens]satz; Lehrmeinung) s; -s, ...men; **Dog|ma|tik** (Glaubenslehre) w; -, -en; **Dog|ma|ti|ker** (Glaubenslehrer; Verfechter einer Lehrmeinung); **dog|ma|tisch** (die [Glaubens]lehre betreffend; lehrhaft; streng [an Lehrsätze] gebunden); -er Gewißheitsgrad; **dog|ma|ti|sie|ren** (zum Dogma erheben); **Dog|ma|tis|mus** (Abhängigkeit von [Glaubens]lehren) m; -; **Dog|men|ge|schich|te**

Doh|le (ein Rabenvogel) w; -, -n; **Doh|len|nest**

Doh|ne (Schlinge zum Vogelfang) w; -, -n; **Doh|nen_stoig, ...stieg** (m; -[e]s, -e)

Do-it-your|self-Be|we|gung engl. [du it ju'ßälf...] (Bewegung der handwerkl. Selbsthilfe); ↑ R 155

Do|ket gr. (Anhänger einer Sekte der ersten christl. Jahrhunderte) m; -en, -en (↑ R 268)

Doki|ma|sie gr. (bei den alten Griechen Prüfung aller Personen, die im Dienste des Staates tätig sein wollten) w; -

lok|tern lat. (ugs. u. scherzh. für: den Arzt spielen); ich ...ere (↑ R 327); **Dok|tor** („Lehrer"; höchster akadem. Grad; auch für: Arzt; Abk.: Dr. [in der Mehrz. Dres., wenn mehrere Personen, nicht mehrere Titel einer Person gemeint sind] u. D. [in: D. theol.]) m; -s, ...oren; Ehrendoktor, - Ehren halber (Abk.: Dr. E. h.; vgl. E. h.), - honoris causa (Abk.: Dr. h. c.); mehrfacher - (Abk.: Dr. mult.); mehrfacher - honoris causa (Abk.: Dr. h. c. mult.); im Brief: Sehr geehrter Herr Doktor!, Sehr geehrter Herr Dr. Schmidt!; - der Arzneikunde (Abk.: Dr. pharm.); - der Bergbauwissenschaften (Abk.: Dr. rer. mont., österr.: Dr. mont.); (österr.:) - der Bodenkultur (Abk.: Dr. nat. techn.); - der Forstwissenschaft (Abk.: Dr. forest.); - der Gartenbauwissenschaften (Abk.: Dr. rer. hort.); habilitierter - [z. B. der Philosophie] (Abk.: Dr. [z. B. phil.] habil.); (österr.:) - der Handelswissenschaften (Abk.: Dr. rer. comm.); - der Ingenieurwissenschaften (Abk. Dr.-Ing.); - der Landwirtschaft (Abk.: Dr. [sc.] agr.); - der mathematischen Wissenschaften (Abk.: Dr. sc. math.); - der Medizin (Abk.: Dr. med.); (österr.:) - der gesamten Medizin (Abk.: Dr. med. univ.); - der Naturwissenschaft (Abk.: Dr. phil. nat. od. Dr. rer. nat. od. Dr. sc. nat.); - der Pädagogik (Abk.: Dr. paed.); - der Philoso-

phie (Abk.: Dr. phil.); - der Rechte (Abk.: Dr. jur.); - beider Rechte (Abk.: Dr. j. u. od. Dr. jur. utr.); - der Sozialwissenschaften (Abk.: Dr. disc. pol.); (österr.:) - der Sozial- und Wirtschaftswissenschaften (Abk.: Dr. rer. soc. oec.); (schweiz.:) - der Staatswirtschaftskunde (Abk.: Dr. rer. camer.); - der Staatswissenschaften (Abk.: Dr. rer. pol. od. Dr. sc. pol. od. Dr. rer. oec. publ.); - der technischen Wissenschaften (Abk.: Dr. rer. techn., Dr. sc[ient]. techn. [österr.: Dr. techn.]); - der Theologie (Abk.: Dr. theol.; Ehrenwürde der ev. Theologie, Abk.: D. od. D. theol.); - der Tierheilkunde (Abk.: Dr. med. vet.); - der Wirtschaftswissenschaft (Abk.: Dr. oec. od. Dr. rer. oec.); - der Zahnheilkunde (Abk.: Dr. med. dent.); **Dok|to|rand** (Student, der sich auf die Doktorprüfung vorbereitet; Abk.: Dd.) m; -en, -en (↑ R 268); **Dok|to|ran|din** w; -, -nen; **Dok|to|ran|din** w; -, -nen; **Dok|to|rat** (Doktorwürde) s; -[e]s, -e; **Dok|tor_di|plom, ...ex|amen, ...fra|ge** (sehr schwierige Frage), ...**grad**, ...**hut** m; **dok|to|rie|ren** (die Doktorwürde erlangen, an der Doktorschrift arbeiten); **Dok|to|rin** [auch: dokt...] (für: Ärztin) w; -, -nen; **Dok|tor_in|ge|nieur** (Abk. Dr.-Ing.), ...**prü|fung**, ...**schrift**, ...**ti|tel**, ...**va|ter**, ...**wür|de**; **Dok|trin** (Lehrsatz; Lehrmeinung) w; -, -en; **dok|tri|när** fr. (an einer Lehrmeinung starr festhaltend; gedanklich einseitig); **Dok|tri|när** m; -s, -e; **Dok|tri|na|ris|mus** lat. (wirklichkeitsfremdes Festhalten an einer Lehrmeinung) m; -

Do|ku|ment lat. (Urkunde; Schriftstück; Beweis) s; -[e]s, -e; **Do|ku|men|ta|list** (↑ R 268), **Do|ku|men|tar** (wissenschaftlicher Mitarbeiter in der Dokumentation) m; -s, -e; **Do|ku|men|tar_auf|nah|me**, ...**film** (Film, der die Wirklichkeit von Mensch u. Landschaft wiedergibt); **do|ku|men|ta|risch** (urkundlich; belegbar); **Do|ku|men|ta|ti|on** [...zion] (Zusammenstellung, Ordnung und Nutzbarmachung von Dokumenten u. Materialien jeder Art, z. B. von Urkunden, Akten, Zeitschriftenaufsätzen, Begriffen, sprachlichen Erscheinungen u. a.); **Do|ku|men|ten|samm|lung**; **do|ku|men|tie|ren** (beurkunden; beweisen)

dol|ce it. [dóltsche] (Musik: sanft, lieblich, weich); **dol|ce far ni|en|te** („süß [ist's], nichts zu tun"); **Dol|ce|far|ni|en|te** (süßes Nichts-

tun) s; -; **Dol|ce vi|ta** [- wi...] („süßes Leben"; Inbegriff des [modernen] ausschweifenden u. übersättigten Müßiggängertums) s od. w; - -

Dolch m; -[e]s, -e; **Dolch_spit|ze, ...stich, ...stoß; Dolch|stoß|le|gen|de** w; -

Dol|de w; -, -n; **Dol|den|blüt|ler; dol|den|för|mig; Dol|den_ge|wächs, ...re|be, ...ris|pe, ...trau|be; dol|dig**

Do|le (bedeckter Abzugsgraben) w; -, -n

Do|le|rit gr. (Abart des Basalts) m; -s, -e

Dolf (m. Vorn.)

Do|li|cho|ze|pha|le gr. [...cho...] (Langkopf) m u. w; -n, -n (↑ R 268); **Do|li|cho|ze|pha|lie** (Langköpfigkeit) w; -

do|lie|ren vgl. dollieren

Do|li|ne slaw. (Geol.: trichterförmige Vertiefung im Karst) w; -, -n

doll nordd. ugs. (unglaublich)

Dol|lar amerik. (Münzeinheit in den USA, in Kanada u. Äthiopien; Zeichen: $) m; -s, -s; 30 - (↑ R 322); **Dol|lar|kurs**

Dol|lart (Nordseebucht an der Emsmündung) m; -s

Dol|lar_wäh|rung, ...zei|chen

Dol|lbord (obere Planke auf dem Bootsbord) m; -[e]s, -e; **Dol|le** (Vorrichtung zum Halten der Riemen (Ruder)) w; -, -n

Dol|lfuß (österr. Politiker)

dol|lie|ren, do|lie|ren fr. ([Leder] abschleifen, abschleifen)

Dol|man türk. (Leibrock der altürk. Tracht; Schnürenjacke der Husaren; kaftanartiges Frauengewand aus den ehemals türk. Gebieten des Balkans) m; -s, -e

Dol|men fr. (tischförmig gebautes urgeschichtliches Steingrab) m; -s, -

Dol|metsch türk.-ung. (österr., sonst weniger gebräuchliche Form von: Dolmetscher; meist übertragen: sich zum Dolmetsch machen) m; -[e]s, -e; **dol|met|schen**; du dolmetschst (dolmetschest); **Dol|met|scher** (Übersetzer; Sprachkundiger) m; -s, -; **Dol|met|sche|rin** w; -, -nen; **Dol|met|scher_in|sti|tut**, ...**schu|le**

Do|lo|mit [nach dem fr. Mineralogen Dolomieu (...miő)] (ein Mineral; Sedimentgestein) m; -s, -e; **Do|lo|mi|ten** (Teil der Südalpen) Mehrz.

Do|lo|res (w. Vorn.)

do|los lat. (BGB: arglistig, mit bösem Vorsatz); -e Täuschung; **Do|lus** (Rechtsw.: List; böse Absicht) m; -; **Do|lus even|tua|lis** [- ewän...] (Rechtsw.: das Inkauf-

nehmen einer [wenn auch unerwünschten] Folge) m; - -

Dom lat. (Bischofs-, Hauptkirche) m; -[e]s, -e; [2]**Dom** gr. (gewölbeartige Decke) m; -[e]s, -e; [3]**Dom** port. (Herr) m; - (in Verbindung mit Namen ohne Geschlechtswort); **Do|ma** gr. (Kristallfläche, die zwei Kristallachsen schneidet) s; -s, ...men; **Do|mä|ne** fr. (Staatsgut, -besitz; besonderes [Arbeits-, Wissens]gebiet) w; -, -n; **Do|mä|nen|amt**; **Do|ma|ni|al|gut**; **Dom_chor** (vgl. [2]Chor), ...**dechant**; **Do|me|stik** (,,Hausgenosse''; Dienstbote) m; -en, -en (meist Mehrz.); ↑ R 268; **Do|me|sti|ka|ti|on** lat. [...zion] (Umzüchtung wilder Tiere zu Haustieren); **Do|me|sti|ke** m; -n, -n vgl. Domestik; **do|me|sti|zie|ren**; **Dom_freiheit** (in Städten mit Domstiften der dem Dom zunächst gelegene Bereich, der im MA. unter der geistl. Gerichtsbarkeit des Domstiftes stand), ...**herr**; **Do|mi|na** (,,Herrin''; Stiftsvorsteherin) w; -, ...nä; **do|mi|nant** (be-, vorherrschend; überlagernd, überdeckend); **Do|mi|nan|te** (Musik: die Quinte vom Grundton aus) w; -, -n; **Do|mi|nanz** (Vererbungslehre: Vorherrschen bestimmter Merkmale) w; -, -en; **do|mi|nie|ren** ([vor]herrschen, beherrschen); **Do|mi|nik**, **Do|mi|ni|kus** [auch: ...min...] (m. Vorn.); [1]**Do|mi|ni|ka|ner** (Angehöriger des vom hl. Dominikus gegr. Ordens) m; -s, -; [2]**Do|mi|ni|ka|ner** (Bewohner der Dominikanischen Republik); **Do|mi|ni|ka|ner_klo|ster**, ...**mönch**, ...**or|den** (m; -s; Abk.: O. P. od. O. Pr.; vgl. d.); **do|mi|ni|ka|nisch**, aber (↑ R 224): Dominikanische Republik; **Do|mi|nion** engl. [domin|j[e]n] (frühere Bez. für einen sich selbst regierenden Teil des Commonwealth) s; -s, -s u. ...ien [...i[e]n]; **Do|mi|ni|um** lat. (Eigentum; bei den Römern: Herrschaftsgebiet) s; -s, -s u. ...ien [...i[e]n]; [1]**Do|mi|no** (Maskenmantel, -kostüm) m; -s, -s; [2]**Do|mi|no** (Spiel) s; -s, -s; **Do|mi|no_spiel**, ...**stein**; **Do|mi|nus vo|bis|cum!** [- wobißkum] (,,der Herr sei mit euch!'' [liturg. Gruß]); **Do|mi|zel|lar** (veralt. für: studierender Kleriker) m; -s, -e; **Do|mi|zil** (Wohnsitz; Zahlungsort [von Wechseln]) s; -s, -e; **do|mi|zi|lie|ren** (ansässig sein, wohnen; [Wechsel] an einem andern Ort als dem Wohnort des Bezogenen zahlbar anweisen); **Do|mi|zil|wech|sel** (Wechsel mit anderem Zahlungsort als dem Wohnort des Bezogenen;

Wechsel, der auf den Wohnort des Bezogenen bei einem Dritten zahlbar gestellt ist); **Dom_ka|pi|tel**, ...**ka|pi|tu|lar** (Domherr); **Dom|pfaff** (ein Vogel) m; -en, -en (↑ R 268)

Domp|teur fr. [...tör] m; -s, -e; **Domp|teur|kunst**; **Domp|teu|se** [...töⁱse] w; -, -n

Dom_ra russ. (altes russ. Volksinstrument in Gestalt einer Laute) w; -, ...ren

[1]**Don** (russ. Strom) m; -[s]

[2]**Don** span. u. it. (,,Herr''; in Spanien höfl. Anrede, w. Form: Doña [vgl. dort], in Italien Titel der Priester u. bestimmter Adelsfamilien, w. Form: Donna [vgl.d.]) m; -[s], -s (in Verbindung mit Namen ohne Geschlechtswort); **Do|ña** [donja] (Frau) w; -, -s (in Verbindung mit Namen ohne Geschlechtswort)

Do|nar (germ. Gott); vgl. Thor

Do|na|tor lat. (veralt. für: Geber, Schenker; Physik, Chemie: Atom od. Molekül, das Elektronen od. Ionen abgibt) m; -s, ...oren

Do|na|tus (m. Vorn.)

Do|nau (ein Strom) w; -; **Do|nau-Dampf|schiff|fahrts|ge|sell|schaft** [Trenn.: ...schiff|fahrts..., ↑ R 236] w; -; ↑ R 152; **Do|nau-Oder-Ka|nal** (↑ R 203) m; -s; **Do|nau-wörth** (Stadt in Bayern)

Don_bass russ. (russ. Kurzw. für: Donez-Steinkohlenbecken; Industriegebiet westl. des Donez) s od. m; -

Don Bos|co vgl. Bosco

Don Car|los [- kar...] (span. Prinz)

Do|nez [russ.: danjäz] (r. Nebenfluß des Don) m; -

Don Gio|van|ni it. [dondsehowáni] (Titelgestalt der gleichnamigen Oper von Mozart)

Don|ja span. (,,Herrin''; scherzh. für: [Dienst]mädchen; Geliebte) w; -, -s; vgl. Doña

Don|jon fr. [dongsehóng] (Bergfried, Hauptturm mittelalterl. Burgen in Frankreich) m; -s, -s

Don Ju|an span. [don chuan, auch: don juan od. dong sehuán] (span. Sagengestalt; Verführer; Frauenheld) m; - -s, - -s

Don|ko|sa|ken (am Don wohnender Stamm der Kosaken); **Don|ko|sa|ken|chor** m; -[e]s (vgl. [2]Chor)

Don|na it. (Herrin) w; -, -s u. Donnen (vor Namen ohne Geschlechtswort); vgl. auch: Madonna

Don|ner m; -s, -; - und Doria! (vgl. Doria). **Don|ner_bal|ken** (ugs. scherzh. für: Latrine), ...**büch|se** (alte Feuerwaffe); **Don|ne|rer** (Donnergott); **Don|ner|keil** (Be-

lemnit); **don|nern**; **Don|ner-schlag**; **Don|ners|tag** m; -[e]s, -e; vgl. Dienstag; **don|ners|tags** (↑ R 129); vgl. Dienstag. **Don|ner|wet-ter**; - [noch einmal]!

[1]**Don Qui|chotte** span. [don kischot, auch: dong -] (Romanheld bei Cervantes); [2]**Don Qui|chotte** (weltfremder Idealist) m; - -s, - -s; **Don|qui|chot|te|rie** (Torheit [aus weltfremdem Idealismus]) w; -, ...jen; **Don Qui|jo|te** [don kiehóte]; vgl. Don Quichotte

Dont|ge|schäft fr.; dt. [dong...] (Börse: Zeitgeschäft)

doof (ugs. für: dumm; einfältig; beschränkt); -er. -ste (↑ R 295); **Doof|heit** w; -

Doorn|kaat ⓦ [dórn...] (ein Branntwein) m; -[e]s, -s

do|pen niederl.-engl. [dórn...] (Sport: durch [verbotene] Anregungsmittel zu Höchstleistungen antreiben); gedopt; **Do|ping** [auch: dó...] s; -s, -s

Dop|pel (zweite Ausfertigung [einer Schrift], Zweitschrift; Tennis Doppelspiel) s; -s, - (schweiz. in der Bedeutung ,,Einsatz beim Schützenfest'': m); **Dop|pel...** (z. B. Doppel-a, Doppelgänger). **Dop|pel_ad|ler**, ...**axel** (doppelter [2]Axel), ...**bett**; **dop|pel|bö|dig** (hintergründig); **Dop|pel_brief**. ...**buch|sta|be**, ...**ci|ce|ro** (ein Schriftgrad), ...**decker** [Trenn. ...dek|ker] (ein Flugzeugtyp scherzh. für: Omnibus mit Oberdeck); **dop|pel|deu|tig**; **Dop|pel_fen|ster**, ...**gän|ger**; **dop|pel-glei|sig**; **Dop|pel|git|ter|röh|re**. **Dop|pel|heit**; **Dop|pel_hoch|zeit**. ...**kinn**, ...**kopf** (Kartenspiel; m; -[e]s), ...**laut** (für: Diphthong), ...**le|ben** (s; -s), ...**mord**; **dop|pel|n|ich** ...[e]le (↑ R 327); Schuhe (südd. mdal. u. österr. für: Schuhe sohlen); **Dop|pel_na|me**, ...**nel-son** (doppelter [2]Nelson), ...**nummer** (doppeltes Heft einer Zeitschrift u. ä.), ...**punkt**; **dop|pel|rei-hig**; **Dop|pel_ritt|ber|ger** (doppelter Rittberger), ...**rol|le**, ...**sal-chow** (doppelter Salchow); **dop|pel|sin|nig**; **dop|pelt**; -e Buchführung; - gemoppelt (ugs. für unnötigerweise zweimal); dop-pelt so groß; aber: doppelt so viel; er ist doppelt so reich wie (seltener: als) ich; (↑ R 116:) um das, ums Doppelte größer; um Doppelte spielen; **Dop|pel-T-E-sen**; ↑ R 155 (von I-förmiger Querschnitt) s; -s, -; **dop|pelt|koh-len|sau|er**; **Dop|pel|tür**; **dop|pel-wir|kend**; **Dop|pel_lung**, **Dop|pr-lung**; **Dop|pel_ver|die|ner**, ...**zen-ner** (100 kg; Zeichen: dz), ...**zim-mer**; **dop|pel|zün|gig**

Dop|pik (doppelte Buchführung) w; -

Dopp|ler südd. mdal., österr. (erneuerte Schuhsohle); vgl. doppeln

Dopp|ler|ef|fekt [nach dem österr. Physiker Chr. Doppler]; ↑ R 180 (ein physikal. Prinzip) m; -[e]s; Dopp|ler|sche Prin|zip (svw. Dopplereffekt) s; ...schen -s

Dopp|lung, Dop|pe|lung

Do|ra (Kurzform von: Dorothea)

Do|ra|de fr. (ein Fisch) w; -, -n; Do|ra|do vgl. Eldorado

Do|rant mlat. (Name verschiedener Pflanzen: Löwenmaul u. a.) m [ə]ə, ə

Dor|chen (Koseform von: Dora)

Dor|do|gne [...dọnjᵉ] (Fluß u. Departement in Frankreich) w; -

Dor|drecht (niederl. Ortsn.)

Do|rer vgl. Dorier

Dorf s; -[e]s, Dörfer; Dorf_an|ger, ...aus|gang, ...bach, ...be|woh|ner; Dörf|chen, Dörf|lein; dörf|fisch; Dörf|ler; dörf|lich; Dörf|lich|keit w; -; Dorf|lin|de; Dorf|schaft (veralt. für: die Einwohner eines Dorfes; das Dorf); Dorf_schen|ke, ...schul|ze, ...stra|ße, ...teich

Do|ria (it. Familienn.): Donner und -! (Fluchwort)

Do|ri|er, Do|rer (Angehöriger eines altgr. Volksstammes) m; -s, -; ¹Do|ris (altgr. Landschaft)

Do|ris (Kurzform von: Dorothea, Dorothee)

do|risch (auf die Dorier bezüglich; aus ¹Doris); -e Tonart

Dor|mi|to|ri|um lat. (Schlafsaal eines Klosters) s; -s, ...ien [...iᵉn]

Dorn m; -[e]s, -en (ugs. auch: Dörner) u. (Technik:) -e; Dorn|busch; Dörn|chen, Dörn|lein; Dor|nen|hecke, Dorn|hecke [Trenn.: ...hek|ke]; Dor|nen|kro|ne; dor|nen|reich; Dor|nen|weg (Leidensweg); Dorn_fort|satz (Med.: nach hinten gerichteter Wirbelfortsatz), ...hecke (vgl. Dornenhecke); Dor|nicht (veralt. für: Dorngestrüpp) s; -s, -e; dor|nig; Dörn|ein, Dörn|chen; Dorn|rös|chen (eine Märchengestalt)

Do|ro|thea, Do|ro|thee [dorote, auch: dorotẹ⁽ᵃ⁾] (w. Vorn.); Do|ro|the|um (Leihhaus in Österr.) s; -s

Dor|pat (Stadt in Estland); vgl. Tartu

Dör|re (für: Darre [Trocken- od. Röstvorrichtung]) w; -, -n; dor|ren (dürr werden); dör|ren (dürr machen); vgl. darren; Dörr|fleisch, ...ge|mü|se, ...obst

Dor|sal lat. (Med.: den Rücken betreffend); Dor|sal|laut (Sprachw.: mit dem Zungenrücken gebildeter Laut)

Dorsch (ein Fisch) m; -[e]s, -e dor|so|ven|tral lat. [...wän...] (Med.: in der Richtung vom Rücken zum Bauch hin)

dort; - drüben; von - aus; dort|her; [auch: dorther, dorther]; von -; dort|hin [auch: dorthin, dorthin]; (↑ R 145:) da- und dorthin; dort|hin|ab [auch: dorthinap, dorthinab]; dort|hin|aus [auch: dorthinauß, dorthinauß]; bis dorthinaus (ugs. für: sehr, maßlos); dor|tig

Dort|mund (Stadt im Ruhrgebiet); Dort|mund-Ems-Ka|nal (↑ R 203) m; -[e]s; Dort|mun|der (↑ R 199) dort|sei|tig (Amtsdt..dortig), dort|seits (Amtsdt.: [von] dort); dort|selbst [auch: dortsälpßt, dortsälpßt]; dort|zu|lan|de (↑ R 141)

Do|ry|pho|ros gr. („Speerträger"; berühmte Statue des gr. Bildhauers Polyklet) m; -

Dos lat. (Rechtsspr.: Mitgift) w; -, Dotes

dos à dos fr. [dosadọ] (Rücken an Rücken)

Dös|chen, Dös|lein; Do|se (kleine Büchse; auch für: Dosis) w; -, -n; Do|sen (auch Mehrz. von: Dosis) dö|sen (ugs. für: wachend träumen; halb schlafen; unaufmerksam vor sich hin starren); du döst (dösest); er or dös|te

Do|sen|bier; do|sen|fer|tig; Do|sen|fleisch, ...milch, ...öff|ner

do|sie|ren fr. (ab-, zumessen); Do|sie|rung

dö|sig (ugs. für: schläfrig; auch für: stumpfsinnig)

Do|si|me|trie gr. (Dosisbemessung von radioaktiven Strahlen) w; -; Do|sis (zugemessene [Arznei]gabe, kleine Menge) w; -, ...sen

Dos|sier fr. [doßie] (Aktenheft, -bündel) m (auch u. schweiz. nur: s); -s, -s; dos|sie|ren (abschrägen; böschen); Dos|sie|rung (flache Böschung)

Dost (eine Gewürzpflanze) m; -[e]s, -e

Do|stal, Nico (österr. Komponist)

Do|sto|jew|ski [doßtojẹ̄ßki] (russ. Dichter)

Do|ta|ti|on lat. [...ziọn] (Ausstattung; Heiratsgut; Schenkung); do|tie|ren; Do|tie|rung

Dot|ter (Eigelb) m u. s; -s, -; Dot|ter|blu|me; dot|ter|gelb; dot|te|rig; Dot|ter|sack (Zool.)

Doua|ne arab.-fr. [duạn°] (fr. Bez. für: Zoll[amt]) w; -, -n; Doua|nier [duạnie] (fr. Bez. für: Zollaufseher) m; -s, -s

dou|beln fr. [dụb°ln] (Film: die Rolle eines Doubles spielen); ich ...[e]le (↑ R 327); Dou|ble [dụb°l] (Film: Ersatzspieler [ähnlichen

Aussehens]) s; -s, -s; Dou|blé [dublẹ] vgl. Dublee; dou|blie|ren [dublir°n] vgl. dublieren

Dou|gla|sie [dugḷạsiᵉ; nach dem schott. Botaniker David Douglas (dạgl⁸β)] w; -, -n u. Dou|glas|tan|ne [dụglaß...]; ↑ R 180 (schnellwachsender Nadelbaum Nordamerikas)

Dou|ro [dọru] (port. Name des Duero) m; -

do ut des lat. („ich gebe, damit du gibst")

Do|ver [dọ⁰wᵉr] (engl. Stadt)

down! engl. [dạun] (Befehl an Hunde: nieder!); down (ugs. für: bedrückt, ermüdet) sein

Dow|ning Street [dạuning ßtrit; nach dem engl. Diplomaten Sir George Downing] (Straße in London; Amtssitz des Premierministers; übertr. für: das Britische Auswärtige Amt) w; - -

Do|xa|le lat. (Gitter zwischen hohem Chor u. Hauptschiff) s; -s, -s

Do|xo|lo|gie gr. („Lobpreis"; gottesdienstliche Lobpreisungsformel) w; -, ...ien

Doy|en fr. [doajäng] ([Rang]ältester u. Wortführer des diplomatischen Korps) m; -s, -s

Do|zent lat. (↑ R 268); Do|zen|ten|schaft; Do|zen|tur w; -, -en; do|zie|ren

D. P. = Displaced person

dpa = Deutsche Presse-Agentur; dpa-Mel|dung (↑ R 150)

Dpf vgl. Pfennig

Dr = Drachme

Dr. = doctor; vgl. Doktor

d. R. = der Reserve (Militär); des Ruhestandes

Dra|che (ein Fabeltier) m; -n, -n (↑ R 268); Drä|chen (Fluggerät; zanksüchtige Person) m; -s, -; Dra|chen|fels (Berg im Siebengebirge) m; -es; Dra|chen_gift, ...saat

Drach|me gr. (Münzeinheit in Griechenland; Abk.: Dr; früheres Apothekergewicht) w; -, -n

Dra|gée (auch:) Dra|gee fr. [...sehẹ] (überzuckerte Frucht; Arzneipille) s; -s, -s; Dra|geur [...sehör] (jmd., der Dragées herstellt) m; -s, -e

Dragg|gen (Seemannsspr.: mehrarmiger Anker ohne Stock) m; -s, -

dra|gie|ren fr. [drasehir°n] (Dragées herstellen)

Dra|go|man arab. (früher: Dolmetscher, Übersetzer im Nahen Osten) m; -s, -e

Dra|gon arab. (eine Gewürzpflanze; vgl. Estragon m od. s; -s

Dra|go|na|de fr. (früher: gewaltsame [durch Dragoner ausgeführ-

te] Maßregel); Dra|go|ner (früher: leichter Reiter; österr. noch für: Rückenspange am Rock u. am Mantel) *m;* -s, -
Dr. agr. = doctor agronomiae; vgl. Doktor
Dra|gun vgl. Dragon
drahn österr. ugs. ([nachts] feiern, sich vergnügen); **Drah|rer** österr. ugs. (Nachtschwärmer) *m;* -s, -
Draht *m;* -[e]s, Drähte; **Draht_an|schrift,** ...ant|wort, ...be|sen, ...bür|ste; **Draht|chen.** Dräht|lein; ¹**drah|ten** (telegrafieren; mit Draht zusammen[flechten); ²**drah|ten** (aus Draht); **Draht_esel** (ugs. scherzh. für: Fahrrad), ...funk (Verbreitung von Rundfunksendungen über Fernsprecher), ...ge|flecht, ...ge|stell, ...gitter, ...glas; **Draht|haar|fox** (Hunderasse); **draht|haa|rig; draht|tig;** ...**dräh|tig** (z. B. dreidrähtig); **Draht_kom|mo|de** (ugs. scherzh. für: Klavier), ...korb; **Draht|lein,** Dräht|chen; **Draht|leh|re** (Werkzeug zur Bestimmung der Drahtdicke); **draht|los;** -e Telegrafie; **Draht_nach|richt,** ...rol|le, ...saite (Stahlsaite), ...sche|re, ...seilbahn, ...ver|hau, ...zan|ge, ...zaun, ...zie|her (auch ugs.: jmd., der wie ein Puppenspieler im verborgenen Vorgänge leitet)
Drai|si|ne [*drai...,* ugs. auch: *drä...*; nach dem Erfinder Drais] (Vorläufer des Fahrrades; Eisenbahnfahrzeug zur Streckenkontrolle) *w;* -, -n
Drake [*dre'k*] (engl. Seefahrer)
Dra|ko vgl. Drakon; **Dra|kon** (altgr. Gesetzgeber); **dra|ko|nisch;** ↑ R 179 (sehr streng); -ste (↑ R 294)
drall (derb, stramm)
Drall ([Geschoß]drehung; Windung der Züge in Feuerwaffen; Drehung bei Garn und Zwirn) *m;* -[e]s, -e
Drall|heit *w;* -
Dra|lon ⓦ (synthet. Faser) *s;* -[s]
Dra|ma *gr.* (Schauspiel; erregendes od. trauriges Geschehen) *s;* -s, ...men; **Dra|ma|tik** (dramatische Dichtkunst; erregende Spannung) *w;* -; **Dra|ma|ti|ker** (dramatischer Dichter, Schauspieldichter); **dra|ma|tisch** (in Dramenform; auf das Drama bezüglich; gesteigert lebhaft; erregend, spannend); -ste (↑ R 294); -e Musik; **dra|ma|ti|sie|ren** (als Schauspiel für die Bühne bearbeiten; etwas lebhafter, erregender darstellen, als es in Wirklichkeit ist); **Dra|ma|ti|sie|rung; Dra|ma|turg** (literarischer Berater einer Bühnenleitung) *m;* -en, -en (↑ R 268); **Dra|ma|tur|gie** (Gestal-

tung, Bearbeitung eines Dramas; Lehre vom Drama) *w;* -, ...ien; **dra|ma|tur|gisch**
dran (ugs. für: daran); - sein (ugs. für: an der Reihe sein); - glauben müssen (ugs. für: vom Schicksal ereilt werden); das Drum und Dran (↑ R 119)
Drän *fr.* (der Entwässerung dienendes unterirdisches Abzugsrohr) *m;* -s, -s u. -e; **Drä|na|ge** [*...aseh^e*] (früher für: Dränung) *w;* -, -n; **drä|nen** (Boden durch Dränung entwässern)
Drang *m;* -[e]s, (selten:) Dränge
dran|ge|ben (ugs. für: darangeben [vgl. d.]); **dran|ge|hen** (ugs. für: darangehen [vgl. d.])
Drän|ge|lei; dran|geln; ich ...[e]le (↑ R 327); **drän|gen; Drän|ge|rei; Drang|pe|ri|o|de** (Sportspr.); **Drang|sal** *w;* -, -e (veralt. *s;* -[e]s, -e); **drang|sa|lie|ren; drang|voll**
dran|hal|ten, sich (ugs. für: daranhalten, sich [vgl. d.])
drä|nie|ren (älter für: dränen)
Drank niederd. (Küchenabfälle, Spülicht, flüssiges Viehfutter) *m;* -[e]s; **Drank_faß,** ...ton|ne
dran|kom|men (ugs. für: an die Reihe kommen); **dran|krie|gen** (ugs. für: hereinlegen, übertölpeln); **dran|ma|chen** vgl. daranmachen
Drän_netz, ...rohr
dran|set|zen (ugs. für: daransetzen [vgl. d.])
Drä|nung (Entwässerung des Bodens durch Dräne)
Dra|pé *fr.* (ein Stoff) *m;* -, -s; **Dra|pe|rie** (Behang; Faltenwurf) *w;* -, ...ien; **dra|pie|ren** ([mit Stoff] behängen; [aus]schmücken; raffen; in Falten legen); **Dra|pie|rung**
drapp[|far|ben] od. ...**fär|big]** österr. (sandfarben)
Drasch landsch. (lärmende Geschäftigkeit, Hast) *m;* -s
Dra|stik *gr.* (Deutlichkeit, Wirksamkeit, Derbheit) *w;* -; **Dra|sti|kum** (starkes Abführmittel) *s;* -s, ...ka; **dra|stisch** (sehr deutlich, wirksam; derb); -ste (↑ R 294)
Drau (r. Nebenfluß der Donau) *w;* -
dräu|en (veralt. für: drohen)
drauf (ugs. für: darauf); - und dran sein (ugs. für: nahe daran sein); **Drauf|ga|be** (Handgeld beim Vertrags-, Kaufabschluß; österr. auch: Zugabe des Künstlers); **Drauf|gän|ger; drauf|gän|ge|risch;** -ste (↑ R 294); **Drauf|gän|ger|tum** *s;* -s; **drauf|ge|ben;** jmdm. eins - (ugs. für: jmdm. einen Schlag versetzen; jmdn. zurechtweisen); **drauf|ge|hen** (ugs. auch für: verbraucht werden, sterben); er geht drauf; ist draufgegangen;

vgl. darauf; **Drauf|geld** (Draufgabe); **drauf|le|gen** (ugs. für: zusätzlich bezahlen); **drauf|los_gehen** (er geht drauflos; drauflosgegangen; draufloszugehen; vgl. darauf), ...re|den, ...rei|ten, ...schie|ßen, ...schimp|fen, ...wirtschaf|ten; **drauf|schla|gen** (ugs. für: auf etwas schlagen; erhöhen, steigern, aufschlagen); **Drauf|sicht** (in der Zeichenlehre) *w;* -; **drauf|zah|len** (drauflegen [vgl. d.])
draus (ugs. für: daraus)
drau|ßen
Dra|wi|da [auch: *drg...*] (Angehöriger einer Völkergruppe in Vorderindien) *m;* -[s], -[s]; **dra|widisch;** -e Sprachen
Draw|ing-room *engl.* [*drå^ingrum*] („Zimmer, in das man sich zurückzieht"; in England Empfangs- und Gesellschaftszimmer) *m;* -s, -s
Dr. disc. pol. = doctor disciplinarum politicarum; vgl. Doktor
Dread|nought *engl.* [*drådnåt*] („Fürchtenichts"; früheres engl. Großkampfschiff) *m;* -s, -s
Drech|se|lei (geschraubte [Schreib]weise); **drech|seln;** ich ...[e]le (↑ R 327); **Drechs|ler; Drechs|ler|ar|beit; Drechs|le|rei**
Dreck (ugs.) *m;* -[e]s; **Dreck_ar|beit** od. Drecks|ar|beit, ...ei|mer ...**fink** (*m;* -en [auch: -s], -en) ...**hau|fen; dreckig** [*Trenn.:* drek|kig]; **Dreck_kerl** od. Drecks|ker|! ...**nest** (ugs. abwertend für Dorf, Kleinstadt), ...**pfo|te** (ugs. abwertend für: schmutzig Hand); **Drecks|ar|beit** od. Dreck ar|beit; **Drecks|sau** (derb; **Drecks|kerl** od. Dreck|kerl; **Dreck|schleu|der** (ugs. abwertend für: freches Mundwerk; **Dreck|spatz**
Dred|sche *engl.* (Schleppnetz) *w* -, -n
Dreesch, Driesch (Brache, unbebautes Land) *m;* -s, -e; **Dreesch_wirt|schaft,** Driesch|wirt|schaft (eine landw. Wirtschaftsform)
Dr. E. h. = Ehrendoktor, Doktor Ehren halber; vgl. E. h.
Dreh (ugs. für: Einfall od. Weg der zu einer Lösung führt) *m;* -[e]s, -s od. -e; **Dreh_ach|se,** ...**ar|beit** (Film; *w;* -, -en; meist Mehrz.), ...**bank** (Mehrz. ...bänke); **dreh|bar; Dreh_bewe|gung,** ...**blei|stift,** ...**brücke** [*Trenn.:* ...brük|ke], ...**buch** (Vorlage für Filmaufnahmen); **Dreh|buch|au tor; Dreh|büh|ne; dre|hen; Dreher; Dre|he|rei; Dreh_rei** (Physik; *s*), ...**or|gel,** ...**pause** (Film), ...**punkt,** ...**schei** ! ...**strom; Dreh|strom|mo|to**

Dreh_stuhl, ...tür; **Dre|hung; Dre-hungs|ver|mö|gen; Dreh_wurm;** ...zahl (für: Tourenzahl); **Dreh-zahl|mes|ser** m
drei, *Wesf.* dreier, *Wemf.* dreien, drei; zu dreien od. zu dritt; herz-liche Grüße von uns dreien; die drei sagen, daß ...; er kann nicht bis drei zählen (ugs. für: er ist sehr dumm); ↑ R 135; (↑ R 276;) dreier mächtiger (selten: mächti-gen) Völker; vgl. acht; **Drei** w; -, -en; eine Drei würfeln; er schrieb in Latein eine Drei; vgl. ¹Acht und Eins; **Drei|ach|ser** (Wagen mit drei Achsen; mit Zif-fer: 3achser; ↑ R 228); **drei|ach-sig; Drei|ach|tel|takt** m; -[e]s; (mit Ziffern: $^3/_8$-Takt; ↑ R 157); im - ; **Drei|an|gel** landsch. (Winkelriß im Stoff) m; -s, -; **drei_ar|mig,** ...bän|dig, ...bei|nig; **Drei|blatt** (Name von Pflanzen); **drei|blät-te|rig,** ...blätt|rig; **Drei|bund** m; -[e]s; **drei|di|men|sio|nal;** -er Film od. (↑ R 155:) Drei-D-Film od (mit Ziffer; ↑ R 157:) 3-D-Film; **Drei|eck; drei|eckig** [*Trenn.:* ...ek|kig; **Drei|eck|schal|tung** (Technik); **Drei|ecks_ge|schich-te,** ...mes|sung, ...netz; **drei|ein-halb, drei|und|ein|halb; Drei|ei-nig|keit** w; -; **Drei|ei|nig|keits|fest** (Sonntag nach Pfingsten); **Drei-er;** vgl. Achter; **Drei|er_kom|bi-na|ti|on** (Sportspr.), ...rei|he (in -n); **drei|er|lei; drei|fach; Drei|fa-che** s; -n; vgl. Achtfache; **Drei|fal-tig|keit** w; -; **Drei|fal|tig|keits|fest** (Sonntag nach Pfingsten); **Drei-far|ben|druck** (*Mehrz.* ...drucke); **drei|far|big; Drei|fel|der|wirt-schaft** w; -; **drei|fenst|rig; Drei|fin-ger|faul|tier** (Ai); **Drei_fuß,** ...ge-stirn; **drei|ge|stri|chen** (Musik); -e Note; **Drei|heit** w; -; **drei|hun|dert;** vgl. hundert; **drei|jäh|rig;** vgl. achtjährig; **Drei|kai|ser_bünd-nis,** ...jahr, ...zu|sam|men|kunft w; - (↑ R 157); **Drei|kant** s oder m; -[e]s, -e (↑ R 228); **Drei|kant|er** (Gesteinsform); **drei|kan|tig; Drei|kant|stahl** (vgl. ¹Stahl u. ↑ R 228); **Drei|kä|se|hoch** m; -s, -[s]; **Drei|klang; Drei|klas|sen|wahl-recht** s; -[e]s; **Drei|kö|ni|ge** (Dreikönigsfest) *Mehrz.*; an, auf, nach, vor, zu -; **Drei|kö|nigs|fest** (6. Jan.); **Drei|län|der|tref|fen; Drei|ling** (alte Münze; altes Weinmaß); **drei|mäh|dig** (drei-schürig); **drei|mal;** (↑ R 145:) zwei- bis dreimal (2- bis 3mal); vgl. achtmal; **drei|ma|lig; Drei-ma|ster** (dreimastiges Schiff; frü-her für: Dreispitz); **drei|ma|stig; Drei|mei|len|zo|ne; Drei|me|ter-brett** (↑ R 157); **Drei|mo|nats|ziel** **rein** (ugs. für: darein); **drein-**

blicken [*Trenn.:* ...blik|ken] (in bestimmter Weise blicken); fin-ster -; **drein|fin|den,** sich (ugs. für: dareinfinden); **Drein|ga|be** landsch. (Zugabe); **drein|mi-schen,** sich (ugs. für: dareinmi-schen, sich); **drein|re|den** (ugs. für: dareinreden); **drein|schla|gen** (ugs. für: in etwas hineinschla-gen)
Drei|paß (gotisches dreibogiges Maßwerk) m; ...passes, ...passe; **Drei|pha|sen|strom; Drei_rad,** ...ru|de|rer (antikes Kriegs-schiff), ...satz, ...schlitz (für: Tri-glyph), ...schneuß (Ornament im got. Maßwerk); **drei|schü|rig;** -e (drei Ernten liefernde) Wiese; **drei_sil|big,** ...spal|tig; **Drei_spän-ner,** ...spitz (früher für: dreieckiger Hut), ...sprung; **drei|ßig** usw. vgl. achtzig usw.; **drei|ßig|jäh|rig;** eine -e Frau, a b e r (↑ R 224:) der Dreißigjährige Krieg; vgl. acht-jährig
dreist; -este (↑ R 292); **Dreist|heit; Drei|stig|keit**
drei_stim|mig, ...stöckig [*Trenn.:* stök|kig]; **Drei|stu|feu|ra|ke|te; Drei|stu|fig|keit; Drei|ta|ge|fie-ber** (subtrop. Infektionskrank-heit); **drei|tau|send;** vgl. tausend; **drei|tei|lig; drei|und|ein|halb, drei|ein|halb; drei|und|zwan|zig;** vgl. acht; **drei|vier|tel** [...fir...]; in - Länge, a b e r (↑ R 118:) in Drei-viertel der Länge; in [einer] drei-viertel Stunde, a b e r: in drei vier-tel Stunden (mit Ziffern: $^3/_4$ Stun-den), in drei Viertelstunden, drei-mal einer Viertelstunde); vgl. acht, viertel, Viertel, Viertelstun-de; **drei|vier|tel|lang** [...fir...]; **Drei|vier|tel|li|ter|fla|sche** (mit Ziffern: $^3/_4$-Liter-Flasche; ↑ R 157); **Drei|vier|tel|mehr|heit** [...fir...]; **Drei|vier|tel|stun|de; Drei|vier|tel|takt** [...fir...] m; -[e]s (mit Ziffern: $^3/_4$-Takt; ↑ R 157); im -; **Drei|zack** m; -[e]s, -e; **drei-zackig** [*Trenn.:* ...zak|kig]; **drei-zehn;** die verhängnisvolle Drei-zehn (↑ R 118); vgl. acht; **Drei-zim|mer|woh|nung** (mit Ziffer: 3-Zimmer-Wohnung; ↑ R 157); **Drei|zü|ger** (mit drei Zügen zu lösende Schachaufgabe)
Drell nordd. (Drillich) m; -s, -e
drem|meln landsch. (bittend drän-gen); ich ...[e]le (↑ R 327)
Drem|pel niederd. m; - [Schleusen-bau:] Schwelle m; -s, -
Dres. = doctores; vgl. Doktor
Dre|sche (ugs. für: Prügel) w; -; **dre|schen;** du drischst (drischest), er drischt; du droschest (droschst), (veralt.: draschest [draschst]); du dröschest (veralt.: dräschest); gedroschen; drisch!;

Drei|scher; Dresch_fle|gel, ...gut (s; -[e]s), ...ma|schi|ne
Dres|den; Dres|den-Alt|stadt; Dres|de|ner, Dres|dner (↑ R 199); **Dres|den-Neu|stadt; Dresd|ner Bank** w; - -
Dreß engl. ([Sport]kleidung) m; - u. Dresses, (selten:) Dresse (österr. w; -, Dressen); **Dres|seur** fr. [...ßör] (Abrichter, Tierleh-rer) m; -s, -e; **dres|sie|ren; Dress-man** anglisierend [dräßmän] (dem Mannequin [vgl. d.] entsprechen-de m. Person, die auf Mode-schauen Herrenkleidung vor-führt) m; -s, ...men; **Dres|sur** fr. w; -, -en; **Dres|sur_akt,** ...num-mer, ...prü|fung, ...rei|ten (s; -s)
Drey|fus|af|fä|re [*draifuß...*] (der gegen den fr. Offizier A. Dreyfus geführte Prozeß u. seine Folgen) w; -
Dr. forest. = doctor scientiae re-rum forestalium; vgl. Doktor
DRGM = Deutsches Reichs-Ge-brauchsmuster
Dr. ... (z. B. phil.) habil. = doctor ... (z. B. philosophiae) habilita-tus; vgl. Doktor
Dr. h. c. = doctor honoris causa; vgl. Doktor; **Dr. h. c. mult.** = doctor honoris causa multiplex; vgl. Doktor
drib|beln engl. (Sport: den Ball durch kurze Stöße vortreiben); ich ...[e]le (↑ R 327); **Drib|b|ling** (das Laufen mit dem Ball [am Fuß]) s; -s, -s
Driesch vgl. Dreesch; **Driesch-wirt|schaft** vgl. Dreeschwirt-schaft
Drift (Seemannsspr.: vom Wind bewirkte Bewegung an der Mee-resoberfläche; Seemannsspr. auch: svw. Abtrift; vgl. Trift) w; -, -en; **drif|ten** (Seemannsspr.: treiben); **drif|tig** (Seemannsspr.: treibend)
Drilch schweiz. (Drillich) m; -[e]s, -e
¹Drill (Nebenform von: Drell) m; -[e]s, -e
²Drill (Militär: Einübung, Schin-derei) m; -[e]s; **Drill|boh|rer; dril-len** („drehen"; Militär: einüben, schinden; mit dem Drillbohrer bohren; Landw.: in Reihen säen)
Dril|lich (ein festes Gewebe) m; -s, -e; **Dril|lich_an|zug,** ...ho|se, ...zeug (s; -[e]s); **Dril|ling** (auch: Jagdgewehr mit drei Läufen)
Drill|ma|schi|ne (Maschine, die in Reihen sät)
drin (ugs. für: darin)
Dr.-Ing. = Doktoringenieur, Doktor der Ingenieurwissen-schaften; vgl. Doktor
drin|gen; du drang[e]st; du drän-gest; gedrungen; dring[e]!; **drin-**

gend; auf das, aufs -ste (↑ R 134); dring|lich; Dring|lich|keit w; -; Dring|lich|keits|an|fra|ge

Drink engl. (alkohol. [Misch]getränk) m; -[s], -s

drin|nen (ugs. für: darinnen); drin|sit|zen (ugs. für: in der Patsche sitzen); er hat ganz schön dringesessen; vgl. darin; drin|stecken [Trenn.: ...stek|ken] (ugs. für: viel Arbeit, Schwierigkeiten haben); er hat bis über die Ohren dringesteckt; vgl. darin

Dri|schel bayr. u. österr. ([Schlagkolben am] Dreschflegel) m; -s, - od. w; -, -n

dritt vgl. drei; drit|te; I. Kleinschreibung: a) (↑ R 135:) von dreien der dritte; der eine ..., der andere ..., der dritte ...; jeder dritte; der dritte Stand (Bürgerstand); die dritte Welt (die Entwicklungsländer); b) (↑ R 135:) zum dritten (drittens). II. Großschreibung (↑ R 118): er ist der Dritte im Bunde; ein Dritter (ein Unbeteiligter), z. B. einem Dritten gegenüber; es bleibt noch ein Drittes zu erwähnen; (↑ R 224:) Friedrich der Dritte; vgl. achte; Dritt|teil [Trenn.: ↑ R 236] s; drit|tel; vgl. achtel; Drit|tel s (schweiz. meist: m); -s, -; vgl. Achtel; drit|teln (in drei Teile teilen); ich ...[e]le (↑ R 327); Drit|ten|ab|schla|gen (ein Laufspiel) s; -s; drit|tens; drit|thöchst; Dritt|in|ter|es|se; drit|tletzt, aber (↑ R 118): der Drittletzte (in der Leistung); Dritt|scha|den, ...schuld|ner

Drive engl. [draiw] (Treibschlag beim Golfspiel u. Tennis; Tennis: treibender Rhythmus, erzielt durch verfrühten Toneinsatz) m; -s, -s; Drive-in-Film|thea|ter (amerik. Bez. für: Autokino); Drive-in-Re|stau|rant (Schnellgaststätte für Autofahrer mit Bedienung am Fahrzeug); Dri|ver [draiwᵉr] (Golfschläger für Abschlag u. Treibschlag) m; -s, -

Dr. j. u., Dr. jur. utr. = doctor juris utriusque; vgl. Doktor

Dr. jur. = doctor juris; vgl. Doktor

DRK = Deutsches Rotes Kreuz

Dr. med. = doctor medicinae; vgl. Doktor

Dr. med. dent. = doctor medicinae dentariae; vgl. Doktor

Dr. med. univ. (in Österr.) = doctor medicinae universae; vgl. Doktor

Dr. med. vet. = doctor medicinae veterinariae; vgl. Doktor

Dr. mont. (in Österr.) = doctor rerum montanarum; vgl. Doktor

Dr. mult. = doctor multiplex; vgl. Doktor

Dr. nat. techn. = doctor rerum naturalium technicarum; vgl. Doktor

drob, dar|ob; dro|ben (da oben)

Dr. oec. = doctor oeconomiae; vgl. Doktor

Dr. oec. publ. = doctor oeconomiae publicae; vgl. Doktor

Dro|ge fr. (bes. medizin. verwendeter tier. od pflanzl. [Roh]stoff) w; -, -n; dro|gen|ab|hän|gig; Dro|gen|ge|schäft; Dro|ge|rie w; -, ...ien; Dro|gist (↑ R 268)

Droh|brief; dro|hen

Drohn (fachspr. für: Drohne) m; -en; -en (↑ R 268) u. Droh|ne (Bienenmännchen; übertr. für: Nichtstuer) w; -, -n; Droh|nen|da|sein

dröh|nen

Dro|hung; Droh|wort (Mehrz. ...worte)

drol|lig; Drol|lig|keit

Dro|me|dar gr. [auch: dro...] („Renner"; einhöckeriges Kamel) s; -s, -e

Dront|te (ausgestorbener Taubenvogel) w; -, -n

Dront|heim (norw. Stadt); vgl. auch: Trondheim

Drops engl. (Fruchtbonbon) m (auch: s); -, - (meist Mehrz.)

Dröschel|ka russ. w; -, -n; Droschken_gaul, ...kut|scher

drö|seln landsch. ugs. ([Faden] drehen); ich ...[e]le (↑ R 327)

¹Dros|sel (Singvogelart) w; -, -n

²Dros|sel (Jägerspr.: Luftröhre des Wildes; auch für: Drosselspule) w; -, -n; Dros|sel|bart; König - (eine Märchengestalt); Dros|sel|klap|pe (Technik); dros|seln; ich drossele u. droßle (↑ R 327); Dros|sel|spu|le (Elektrotechnik); Dros|se|lung, Droß|lung

Drost (früher niederd. für: Verwalter einer Drostei) m; -es, -e; Dro|ste-Hüls|hoff (dt. Dichterin); Dro|stei (früher niederd. für: Verwaltungsbezirk)

Dr. paed. = doctor paedagogiae; vgl. Doktor

Dr. pharm. = doctor pharmaciae; vgl. Doktor

Dr. phil. = doctor philosophiae; vgl. Doktor

Dr. phil. nat. = doctor philosophiae naturalis; vgl. Doktor

Dr. rer. camer. = doctor rerum cameralium; vgl. Doktor

Dr. rer. comm. (in Österr.) = doctor rerum commercialium; vgl. Doktor

Dr. rer. hort. = doctor rerum hortensium; vgl. Doktor

Dr. rer. mont. = doctor rerum montanarum; vgl. Doktor

Dr. rer. nat. = doctor rerum naturalium; vgl. Doktor

Dr. rer. oec. = doctor rerum oeconomicarum; vgl. Doktor

Dr. rer. pol. = doctor rerum politicarum; vgl. Doktor

Dr. rer. soc. oec. (in Österr.) = doctor rerum socialium oeconomicarumque; vgl. Doktor

Dr. rer. techn. = doctor rerum technicarum; vgl. Doktor

Dr. sc. agr. = doctor scientiarum agrarium; vgl. Doktor

Dr. sc. math. = doctur scientiarum mathematicarum; vgl. Doktor

Dr. sc. nat. = doctor scientiarum naturalium od. doctor scientiae naturalis; vgl. Doktor

Dr. sc. pol. = doctor scientiarum politicarum od. doctor scientiae politicae; vgl. Doktor

Dr. sc[ient]. techn. = doctor scientiarum technicarum; vgl. Doktor

Dr. techn. (in Österreich) = doctor rerum technicarum; vgl. Doktor

Dr. theol. = doctor theologiae; vgl. Doktor

drü|ben (auf der anderen Seite); drü|ber (ugs. für: darüber)

Druck m; -[e]s, (techn.:) Drücke, (Druckw.:) Drucke u. (Textilw. für bedruckte Stoffe:) -s; Druck_ab|fall (m; -[e]s), ...an|stieg (m; -[e]s), ...aus|gleich (m; -[e]s), ...bo|gen (m; -s, -), ...buch|sta|be; Drücke|ber|ger¹; druck_emp|find|lich; drucken¹; drücken¹; drückend¹; drückendheißes Wetter (↑ R 143), aber: das Wetter ist drückend heiß; Drucker¹; Drücker¹; Drucke|rei¹; Drücke|rei¹; Druck_emp|find_laub|nis; Drucker schwär|ze¹; Drucker|spra|che¹; ¹Druck|er|zeug|nis, aber ²Drucker|zeug|nis¹ (↑ R 147); Druck_fah|ne, ...feh|ler; druck fer|tig; Druck_kes|sel, ...knopf ...koch|topf, ...le|gung (w; -); Druck|luft|brem|se; druck|luft ge|steu|ert; Druck_mit|tel s ...mu|ster, ...pa|pier, ...plat|te ...punkt; druck|reif; Druck_sa che, ...schrift, ...schwan|kung ...sei|te; druck|sen (ugs. für: nich recht mit der Sprache heraus kommen); du druckst (druck sest); Druck|se|lei; Druck_sor|t (österr. für: Formular), ...spal|te ...stel|le, ...stock (Mehrz. ...stök ke), ...ta|ste, ...ver|än|de|rung ...ver|fah|ren, ...we|sen, ...zy|lin der

Dru|de (Nachtgeist; Zauberin Hexe) w; -, -n; Dru|den|fuß (Ze chen gegen Zauberei; Penta gramm)

Drug|store engl.-amerik. [dr_

¹ Trenn.: ...k|k...

stạ̈'] (in den USA urspr. Droge-
rie, jetzt Verkaufsgeschäft für al-
le gängigen Bedarfsartikel mit
Imbißecke) *m*; -s, -s
Dry|gu|lin|druck [nach dem Fami-
lienn. Drugulin] (*Mehrz. ...druk-
ke); ↑ R 180
Druị|de (kelt. Priester) *m*; -n, -n
(↑ R 268)
drụm (ugs. für: darum)
Drum *engl.* [drạm] (engl. Bez. für:
Trommel) *w*; -, -s; vgl. Drums
Drụm|lin *engl.* [selten: drạmlin] (el-
liptisch geformter Hügel der
Grundmoräne) *m*; -s, -s
Drum|mer *engl.* [drạmᵉr] (Jazz:
Musiker, der die Drum [vgl. d.]
schlägt) *m*; -s, -; Drums [drạms]
(Bez. für das Schlagzeug) *Mehrz.*
Drum und Dran *s*; - - -
drun|ten (da unten); drụn|ter (ugs.
für: darunter); es geht drunter
und drüber; Drụn|ter und Drüber
s; - - -
Drụsch (Dreschen; Dreschertrag)
m; -[e]s, -e
Drüs|chen, Drüs|lein (kleine Drü-
se)
Druịsch|ge|mein|schaft (DDR)
Dru|schị|na *russ.* (Gefolgschaft
altruss. Fürsten) *w*; -
Dru|se ([Höhlung im] Gestein mit
Kristallen; nur *Einz.* für: eine
Pferdekrankheit) *w*; -, -n
Dru|se (Mitglied einer kleinasia-
tisch-syrischen Sekte des Islams)
m; -n, -n (↑ R 268)
Drü|se *w*; -, -n
Drụ|sen (veralt. u. mdal. für:
Weinhefe, Bodensatz) *Mehrz.*
Drü|sen_funk|tion, ...schwel|lung
drụ|sig [zu: ¹Druse]
drü|sig (voll Drüsen); Drüs|lein,
Drüs|chen
ry *engl.* [drại] („trocken"; herb
[von alkohol. Getränken])
Drya|de (gr. weibliche Baumgott-
heit, Waldnymphe) *w*; -, -n (meist
Mehrz.)
DSA = Deutscher Sprachatlas
Dsche|bel *arab.* (In arab. erdkundl.
Namen: Gebirge, Berg) *m*; -[s]
Dschi|bu|ti (Hptst. von Fr.-Soma-
liland)
D-Schicht; ↑ R 149 (eine stark ioni-
sierte Luftschicht in der hohen
Atmosphäre) *w*; -
Dschig|ge|tai *mong.* (wilder Halb-
esel in Asien) *m*; -s, -s
Dschin|gis-Khan (mongol. Erobe-
rer)
Dschiu-Dschịt|su (eindeutschende
Schreibung von: Jiu-Jitsu)
Dschun|gel *Hindi* (undurchdring-
liche tropische Sumpfwälder) *m*
selten: *s*); -s, -; (selten auch:) *w*;
-, -n; Dschun|gel_krieg, ...pfad
Dschun|ke *malai.* (chin. Segel-
schiff) *w*; -, -n

DSG = Deutsche Schlafwagen-
und Speisewagen-Gesellschaft
mbH; vgl. Mitropa
Dsun|ga|rei (zentralasiat. Land-
schaft) *w*; -; dsun|ga|risch
dt = Dezitonne
dt. = deutsch
DTB = Deutscher Turnerbund
DTC = Deutscher Touring Auto-
mobil Club
dto. = dito
Dtzd. = Dutzend
du (in Briefen usw.: Du; ↑ R 121);
jmdn. du nennen; du zueinander
sagen; mit einem auf du und du
stehen; Du *s*; -[s], -[s]; (↑ R 117:)
das traute Du; jmdm. das Du an-
bieten; jmdn. mit Du anreden
Du|al *lat.* (Sprachw.: Zweizahl) *m*;
-s, -e
¹Dua|la (Hafenstadt in Kamerun)
²Dua|la (Angehöriger eines Ban-
tustammes) *m*; -[s], -[s]; ³Dua|la
(Sprache) *s*; -
Dua|lis *lat. m*; -, ...le; vgl. Dual;
Dua|lis|mus (Zweiheit, Gegen-
sätzlichkeit) *m*; -; Dua|list (↑ R
268); dua|li|stisch; -e Weltan-
schauung; Dua|li|tät (Zweiheit;
Doppelheit; Vertauschbarkeit)
w; -; Du|al|sy|stem *s*; -s
Dü|bel (kleiner Holzkeil, Zapfen)
m; -s, -; dü|beln; ich ...[e]le (↑ R
327)
du|bi|os *lat.*, (seltener:) du|bi|ös *fr.*
(zweifelhaft; unsicher); -este (↑ R
292); Du|bio|sen (Wirtsch.: unsi-
chere Forderungen) *Mehrz.*; du-
bi|ta|tiv (zweifelhaft, Zweifel aus-
drückend)
Du|blee *fr.* [...*blẹ*] (Metall mit
[Edelmetall]überzug; Stoß beim
Billardspiel) *s*; -s, -s; Du|blee-
gold; Du|blẹt|te *w*; -, -n; du|blie-
ren (verdoppeln [Garn]; mit Du-
blee versehen) [Du|blier|ma|schi-
ne
Dub|lin [dạblin] (Hptst. der Repu-
blik Irland)
Du|blo|ne *lat.* (frühere span. Gold-
münze) *w*; -, -n; Du|blü|re *fr.* (Un-
terfutter; Aufschlag an Unifor-
men; verzierte Innenseite des
Buchdeckels) *w*; -, -n
Du|brov|nik [dụbrăwnịk] (Hafen-
stadt in Jugoslawien)
¹Du|chesse *fr.* [düschäß] (Herzo-
gin) *w*; -, -n [...*ß'n*]; ²Du|chesse
(ein Seidengewebe) *w*; -
Du|cho|bor|ze [ducho...] (Anhän-
ger einer im 18. Jh. entstandenen
russ. Sekte) *m*; ..n, -n (↑ R 268)
Ducht (Seemannsspr.: Sitzbank
im Boot) *w*; -, -en
Duck|dal|be (in den Hafengrund
gerammte Pfahlgruppe zum
Festmachen von Schiffen) *w*; -n,
-n (meist *Mehrz.*); Dück|dal|be
(Nebenform von: Duckdalbe)

dụcken [*Trenn.*: duk|ken]; sich -;
Dụcker [*Trenn.*: Duk|ker]
(Schopfantilope); Dụck|mäu|ser
(ugs. für: verängstigter, feiger,
heuchlerischer Mensch); dụck-
mäu|se|risch; -ste (↑ R 294)
du|del|dum|dẹi!; Du|de|lei; Du|de-
ler, Dụd|ler; du|deln; ich ...[e]le
(↑ R 327); Du|del|sack *türk.* (ein
Blasinstrument); Du|del|sack-
pfei|fer, Dụd|ler, Dụ|de|ler
Du|ẹll *fr.* (Zweikampf) *s*; -s, -e;
Du|el|lant *m*; -en, -en (↑ R 268);
du|el|lie|ren, sich
Du|en|ja [Eindeutschung von
span. dueña (= Herrin)] (veralt.
für: Hüterin; Anstandsdame, Er-
zieherin) *w*; -, -s
Due|ro *span.* (Fluß der Pyrenäen-
halbinsel) *m*; -; vgl. auch: Douro
Du|ẹtt *it.* (Musikstück für zwei
Gesangsstimmen; Zwiegesang) *s*;
-[e]s, -e
duff *nordd.* (matt); -es Gold
Düf|fel [nach einem belg. Ort] (ein
weiches Gewebe) *m*; -s, -
Duf|fle|coat *engl.* [dáᶠlkoᵘrt] (drei-
viertellanger Sportmantel) *m*; -s,
-s
Du|four [düfụr] (schweiz. Gene-
ral); Du|four|kar|te (topograph.
Landkarte der Schweiz); ↑ R 180
Duft *m*; -[e]s, Düfte; Düft|chen,
Düft|lein
duf|te *jidd.* (ugs., bes. berl. für: gut,
fein)
duf|ten; duf|tig; Düft|lein, Düft-
chen; Duft|no|te; duft|reich; Duft-
stoff, ...was|ser (*Mehrz. ...wäs-
ser*)
Du|gong *malai.* (Seekuh der austr.
Gewässer u. des Roten Meeres)
m; -s, -e u. -s
Duis|burg [düß...] (Stadt an der
Mündung der Ruhr in den
Rhein)
du jour *fr.* [düsehur] („vom Ta-
ge"); - - sein (früher für: Tages-
dienst haben)
Du|ka|ten *it.* (frühere Goldmünze)
Dü|ker (Rohrleitung unter einem
Deich, durch ein Flußbett usw.;
mdal. für: Tauchente) *m*; -s, -
duk|til *lat.* (dehn-, verformbar);
Duk|ti|li|tät *w*; -; Dụk|tus
(Schriftzug, -art) *m*; -
dul|den; Dụl|der; Dụl|der|mie|ne;
duld|sam; Dụld|sam|keit *w*; -; Dụl|-
dung
Dụlt *bayr.* (Messe, Jahrmarkt) *w*;
-, -en
¹Dul|zị|nea *span.* (Geliebte des
Don Quichotte); ²Dul|zị|nea (ab-
wertend für: Geliebte, Freundin)
w; -, ...een u. -s
Dụ|ma *russ.* (Rat der fürstl. Ge-
folgsleute im alten Rußland;
russ. Stadtverordnetenversamm-

lung [seit 1870]; russ. Parlament [1906–1917]) w; -, -s

Du|mas d. Ä. [dümạ], Du|mas d. J. (Dumas der Ältere u. der Jüngere: fr. Schriftsteller)

Dum|dum [nach dem gleichnamigen ind. Herstellungsort] (Infanteriegeschoß mit sprenggeschoßartiger Wirkung) s; -[s], -[s]; Dum|dum|ge|schoß

dumm; dümmer, dümmste; -er August (Clown); Dumm|bar|tel (ugs. für: dummer Mensch) m; -s, -; dumm|dreist; Dum|me|jun|gen|streich m; Wesf. des Dumme[n]jungenstreich[e]s, Mehrz. die Dumme[n]jungenstreiche; ein Dumme[r]jungenstreich; Dum|men|fang m; -[e]s; auf - ausgehen; Dum|mer|jan, Dumm|ri|an (ugs. für: dummer Kerl) m; -s, -e; Dum|mer|ling; dum|mer|wei|se; Dumm|heit; Dumm|mi|an landsch. u. österr. (Dummerjan); Dumm|kopf; dümm|lich; Dümm|ling; Dumm|ri|an vgl. Dummerjan; dumm|stolz

Dum|my engl. [dạmi] (Attrappe; lebensgroße Puppe für Unfalltests u. a.)

düm|peln (Seemannsspr.: leicht schlingern)

Dum|per engl. [dạmpᵉr] (Kippwagen, -karren) m; -s, -

dumpf; Dumpf|heit w; -; dump|fig; Dump|fig|keit w; -

Dum|ping engl. [dạmping] (Unterbieten der Preise im Ausland) s; -s

dun niederd. (betrunken)

Dü|na (Westliche Dwina; vgl. Dwina) w; -

Du|nant, Henri, später Henry [dünạng, schweiz.: dünạng] (schweiz. Philanthrop, Begründer des Roten Kreuzes)

Dun|cker [zur Trenn. ↑ R 189] (dt. Buchhändler)

Du|ne niederd. (Daune) w; -, -n

Dü|ne w; -, -n; Dü|nen|bil|dung, ...gras, ...sand

Dung m; -[e]s; Dung|ab|la|ge; Dün|ge|mit|tel s; dün|gen; Dün|ger m; -s, -; Dün|ger|wirt|schaft w; -; Dung|gru|be; Dün|gung

dun|kel; dunkler, -ste; (↑ R 133:) seine Spuren verloren sich im dunkeln (im ungewissen); im dunkeln (im ungewissen) lassen, aber (↑ R 116): im Dunkeln ist gut munkeln; im dunkeln tappen (nicht Bescheid wissen), aber: im Dunkeln (in der Finsternis) tappte er nach Hause; ein Sprung ins Dunkle; dunkel färben usw.; vgl. blau, III u. IV; dunkelblau usw.; Dun|kel s; -s

Dün|kel m; -s

Dun|kel|ar|rest; dun|kel|äu|gig,

...blau, ...blond, ...braun|rot (vgl. dunkel), ...haa|rig

dün|kel|haft

dun|kel|häu|tig; Dun|kel|heit; Dun|kel.kam|mer, ...mann (Mehrz. ...männer); dun|kel ist dunkelt; dun|kel|rot; Dun|kel|zif|fer (nicht bekannte Anzahl)

dün|ken; mich od. mir dünkt (auch: deucht), dünkte (auch: deuchte), hat gedünkt (auch: gedeucht)

Dün|kir|chen, (fr.:) Dun|kerque [dön̈kạrk] (fr. Hafenstadt an der Nordsee)

dünn; I. Kleinschreibung (↑ R 133): durch dick und -. II. Schreibung in Verbindung mit dem 2. Mittelwort (↑ R 142), z. B. dünnbevölkert (vgl. d.). III. Schreibung in Verbindung mit Zeitwörtern (↑ R 139): a) Getrenntschreibung in ursprünglicher Bedeutung, z. B. dünn machen; sie hat den Teig dünn gemacht; b) Zusammenschreibung, wenn durch die Verbindung ein neuer Begriff entsteht; vgl. dünnmachen; dünn|be|völ|kert; (↑ R 296:) dünner, am dünnsten bevölkert; das dünnbevölkerte Land (↑ R 142), aber: das Land ist dünn bevölkert; Dünn.bier, ...darm; Dünn|darm|ent|zün|dung; Dünn|druck (Mehrz. ...drucke); Dünn|druck.aus|ga|be, ...pa|pier

dün|ne|mals ländsch. (damals)

dünn|flüs|sig; Dün|ne w; -; dünn|häu|tig (auch übertr. für: empfindlich, sensibel); Dünn|heit w; -; dünn|ma|chen, sich; ↑ R 139 (ugs. für: weglaufen); er hat sich dünngemacht; aber: dünn ma|chen, sich (wenig Platz einnehmen); Dünn.pfiff (ugs. für: Durchfall), ...schiß (derb für: Durchfall), ...schliff, ...schnitt; Dünn|nung (Jägerspr.: Flanke des Wildes); dünn|wan|dig

Dun|sel mdal. (Dummkopf, Tolpatsch) m; -s, -

Duns Sco|tus [- βkọtuß] (scholastischer Philosoph u. Theologe)

Dunst m; -es, Dünste; dun|sten (Dunst verbreiten); dün|sten (dunsten; in Dampf gar machen); Dunst|glocke [Trenn.: ...glok|ke]; dun|stig; Dunst|kreis; Dunst|obst (österr. nur so), Dünst|obst; Dunst.schicht, ...schlei|er, ...wol|ke

Dü|nung (Seegang nach dem Sturm)

Duo it. (Musikstück für zwei Instrumente; auch die zwei Ausführenden) s; -s, -s

Duo|de|num lat. (Med.: Zwölffingerdarm) s; -s, ...na

Duo|dez lat. (Zwölftelbogengröße

[Buchformat]; Zeichen: 12°; in Zus. bildl.: Begriff des Kleinen, Lächerlichen) s; -es; Duo|dez|für|sten|tum; duo|de|zi|mal (zwölfteilig); Duo|de|zi|mal|sy|stem s; -s; Duo|de|zi|me (der zwölfte Ton der diaton. Tonleiter; Intervall von 12 diaton. Tonstufen) w; -, -n

dü|pie|ren fr. (täuschen, foppen; unsicher machen); Dü|pie|rung

Du|pla (Mehrz. von: Duplum); Du|plet fr. [duplẹ, duplạ] (Lupe aus zwei Linsen) s; -s, -s; Du|plex|be|trieb, (auch:) Dj|plex|be|trieb (Doppelbetrieb); du|plie|ren (verdoppeln); Du|plie|rung; Du|plik (veralt. für: Gegenantwort auf eine Replik) w; -, -en; Du|pli|kạt lat. s; -[e]s, -e; Du|pli|ka|ti|on [...ziọn] (Verdopplung); Du|pli|ka|tor (Multiplikator; Vorrichtung der Elektrotechnik) m; -s, ...ọren; Du|pli|ka|tur (Verdopplung, Doppelbildung, Doppelage) w; -, -en; du|pli|zie|ren (verdoppeln); Du|pli|zi|tät (Doppelheit; doppeltes Vorkommen, Auftreten; Zweideutigkeit) w; -, -en; Du|plum (Duplikat) s; -s, ...pla

Dups poln. bes. schles. (Gesäß) m; -es, -e

Dur lat. („harte" Tonart) s; -, -; A-Dur, A-Dur-Tonleiter (↑ R 155); vgl. ¹Moll

du|ra|bel lat. (dauerhaft; bleibend); ...a|ble Ausführung

Dur|ak|kord

Dur|alu|min ⓦ Aluminiumlegierung) s; -s

du|ra|tiv lat. (Sprachw.: verlaufend, dauernd)

durch; mit Wenf.: - ihn; durch une durch; die ganze Nacht [hin] durch; durch... in Verbindung mi Zeitwörtern: a) unfeste Zusam mensetzungen (↑ R 304), z. B durcharbeiten (vgl. d.), durch gearbeitet; b) feste Zusammense zungen (↑ R 304), z. B. durchạ beiten (vgl. d.), durcharbeitet

durch|ackern [Trenn.: ...ak|kerr (ugs. für: sorgsam durcharbei ten); er hat die ganze Buch durch geackert

durch|ar|bei|ten (sorgsam bearbe ten; [den Körper] stählen pausenlos arbeiten); der Teig i tüchtig durchgearbeitet; er ha die ganze Nacht durchgearbeite durch|ar|bei|ten (selten, meist i 2. Partizip); eine durcharbeite Nacht; Durch|ar|bei|tung

durch|at|men; er hat tief durch geatmet

durch|aus [auch: durchauß durch...]

durch|backen [Trenn.: ...bak|ker

[gut] durchgebackenes Brot; **durch|bak|ken** [*Trenn.:* ...bak|ken]; mit Rosinen -es Brot **durch|bei|ßen** (beißend trennen); er hat den Faden durchgebissen; sich -; **durch|bei|ßen** (beißend durchdringen); der Hund hat ihm die Kehle durchbissen

durch|be|ra|ten; es ist durchberaten

durch|bet|teln; er hat sich durchgebettelt [und nichts gearbeitet]; **durch|bet|teln**; er hat das Land durchbettelt

durch|bie|gen; das Regal hat sich durchgebogen

durch|bil|den (vollständig ausbilden); sein Körper ist gut durchgebildet; **Durch|bil|dung**

durch|bla|sen; er hat die Kugel [durch das Rohr] durchgeblasen; **durch|bla|sen**; vom Wind -

durch|blät|tern, durch|blät|tern; er hat das Buch durchgeblättert od. durchblättert

durch|bleu|en (ugs. für: durchprügeln); er hat ihn durchgebleut

Durch|blick; durch|blicken [*Trenn.:* ...blik|ken] (hindurchblicken); er hat [durch das Fernrohr] durchgeblickt; - lassen (=deuten); er hat durchblicken lassen (↑ R 305), daß er damit nicht zufrieden sei

durch|blit|zen; ein Gedanke hat ihn durchblitzt

durch|blu|tet; frisch -e Haut; **Durch|blu|tung; Durch|blu|tungs|stö|rung**

durch|boh|ren; er hat ein Loch durchgebohrt; der Wurm hat sich durchgebohrt; **durch|boh|ren**; eine Kugel hat die Tür durchbohrt; von Blicken durchbohrt; **Durch|boh|rung**

durch|bo|xen (ugs. für: durchsetzen); er hat das Projekt durchgeboxt; sich -

durch|braten; das Fleisch war gut durchgebraten

durch|brau|sen; der Zug ist durchgebraust; **durch|brau|sen**; vom Sturm durchbraust

durch|bre|chen; er ist [durch den schadhaften Boden] durchgebrochen; er hat den Stock durchgebrochen; **durch|bre|chen**; er hat die Schranken, die Schallmauer durchbrochen; durchbrochene Arbeit (Stickerei, Goldarbeit); **Durch|bre|chung**

durch|bren|nen (auch ugs. für: sich heimlich davonmachen); der Faden ist durchgebrannt; der Kassierer ist mit einer großen Summe durchgebrannt; **Durch|bren|ner** (ugs. für: Ausreißer)

durch|brin|gen; die Schmuggler haben ihre Waren glücklich durchgebracht; es war schwer, sich ehrlich durchzubringen; er hat die ganze Erbschaft durchgebracht (vergeudet, verschwendet)

Durch|bruch *m;* -[e]s, ...brüche

durch|den|ken; ich habe die Sache noch einmal durchgedacht; **durch|den|ken**; ein fein durchdachter Plan

durch|dis|ku|tie|ren; die Frage ist noch nicht durchdiskutiert

durch|drän|gen; sich -; er hat sich durchgedrängt

durch|dre|hen; das Fleisch [durch den Wolf] -; ich bin völlig durchgedreht (ugs. für: verwirrt)

durch|drin|gen; er ist mit seiner Ansicht durchgedrungen; **durch|drin|gen**; er hat das Urwaldgebiet durchdrungen; er war von der Idee ganz durchdrungen (erfüllt); **Durch|drin|gung** *w;* -; geistige -; **durch|dröh|nen**; der Schrei hat das Haus durchdröhnt

durch|drucken [*Trenn.:* ...drukken] (bis zu Ende drucken, ausdrucken); er hat in der Nacht durchgedruckt

durch|drücken [*Trenn.:* ...drükken]; er hat das Obst durchgedrückt; er hat die Änderung doch noch durchgedrückt (ugs. für: durchgesetzt)

durch|drun|gen; von etwas - (erfüllt); vgl. durchdringen

durch|ei|len; er ist schnell durchgeeilt; **durch|ei|len**; er hat den Hof durcheilt

durch|ein|an|der; *Schreibung in Verbindung mit Zeitwörtern* (↑ R 139): durcheinander (verwirrt, konfus) sein, alles durcheinander essen und trinken, aber: durcheinanderbringen (in Unordnung bringen), durcheinanderlaufen, durcheinanderreden (alle reden zugleich), durcheinanderwerfen usw.; vgl. aneinander; **Durch|ein|an|der** [auch: ...durch...] *s;* -s; **Durch|ein|an|der|lauf** *s;* -s

durch|es|sen, sich; er hat sich überall durchgegessen

durch|ex|er|zie|ren (ugs.); wir haben die Grammatik durchexerziert

durch|fah|ren; ich bin die ganze Nacht durchgefahren; **durch|fah|ren**; er hat das ganze Land -; **Durch|fahrt;** - verboten!; **Durch|fahrts|recht, ...stra|ße**

Durch|fall *m;* **durch|fal|len**; das Mehl ist [durch das Sieb] durchgefallen; er ist durchgefallen (ugs.: hat die Prüfung nicht bestanden); **durch|fal|len**; der Stein hat den Raum -

durch|fau|len; das Brett ist durchgefault

durch|fech|ten; er hat den Kampf durchgefochten; er hat sich durchgefochten (ugs. für: durchgebettelt)

durch|fe|gen (sauber machen); sie hat tüchtig durchgefegt; **durch|fe|gen**; der Sturm hat die Wälder durchfegt

durch|fei|ern; sie haben bis zum Morgen durchgefeiert; **durch|fei|ern**, eine durchfeierte Nacht

durch|fei|len; er hat das Gitter durchgefeilt

durch|feuch|ten; vom Regen durchfeuchtet

durch|fin|den; sich -; ich habe mich gut durchgefunden

durch|flech|ten; er hat das Band [durch den Kranz] durchgeflochten; **durch|flech|ten**; mit Blumen durchflochten

durch|flie|gen; der Stein ist [durch die Fensterscheibe] durchgeflogen; er ist [bei der Prüfung] durchgeflogen (ugs.: hat die Prüfung nicht bestanden); **durch|flie|gen**; das Flugzeug hat die Wolken durchflogen; ich habe das Buch nur durchflogen (rasch gelesen)

durch|flie|ßen; das Wasser ist durchgeflossen; **durch|flie|ßen**; ein von Wasserläufen durchflossenes Waldgebiet

Durch|flug

durch|flu|ten; das Wasser ist beim Deichbruch durchgeflutet; ein Schiff ist durch den Kanal durchgeflutet worden; **durch|flu|ten**; das Zimmer ist von Licht durchflutet

durch|for|men (vollständig formen); die Statue ist durchgeformt; **Durch|for|mung**

durch|for|schen (forschend durchsuchen); er hat alles durchforscht; **Durch|for|schung**

durch|for|sten (den Wald ausholzen); durchforstet; **Durch|for|stung**

durch|fres|sen; der Wurm hat sich durchgefressen; er hat sich wieder bei andern durchgefressen (derb: durchgegessen); **durch|fres|sen**; vom Lauge -

durch|frie|ren; der See ist durchgefroren; die Kinder waren völlig durchgefroren; **durch|frie|ren**; ich bin ganz durchfroren

Durch|fuhr *w;* -, -en; **durch|führ|bar; Durch|füh|ren**; er hat die ihm gestellte Aufgabe durchgeführt; **Durch|fuh|r|er|laub|nis; Durch|füh|rung; Durch|fuh|rungs|be|stim|mung, ...ver|ord|nung; Durch|fuhr|ver|bot**

durch|fur|chen; ein durchfurchtes Gesicht

durch|füt|tern; wir haben das Vieh durchgefüttert

Durch|gang; Durch|gän|ger; durch|gän|gig; Durch|gangs-_bahn|hof, ...la|ger, ...sta|dium, ...sta|ti|on, ...stra|ße, ...ver|kehr, ...zug (Abk.: D-Zug)
durch|ge|dreht (ugs. für: verwirrt); er ist völlig durchgedreht; vgl. durchdrehen
durch|ge|hen; ich bin [durch alle Räume] durchgegangen; das Pferd ist durchgegangen; wir sind den Plan Punkt für Punkt durchgegangen; durch|ge|hen; ich habe den Wald durchgangen; durch|ge|hend; -e Breite; das Geschäft ist - geöffnet; durch|ge|hends (österr., sonst ugs.); das Geschäft ist - geöffnet
durch|gei|stigt
durch|ge|stal|ten; das Motiv ist künstlerisch durchgestaltet
durch|glie|dern, durch|glie|dern (unterteilen); ein gut durchgegliedertes, durchgliedertes Buch; Durch|glie|de|rung [auch: ...gli...]
durch|glü|hen; das Eisen wird durchgeglüht; durch|glü|hen; durchglüht von Begeisterung
durch|grei|fen (Ordnung schaffen); er hat energisch durchgegriffen
durch|hal|ten (bis zum Ende aushalten); er hat bis zum Äußersten durchgehalten; Durch|hal|te.pa|ro|le, ...ver|mö|gen (s; -s)
durch|hau|en; er hieb den Ast mit der Axt durch, hat ihn durchgehauen; er haute den Jungen durch, hat ihn durchgehauen; durch|hau|en; er hat den Knoten mit einem Schlag durchhauen; durchhauener Wald
Durch|haus österr. (Haus mit einem Durchgang, der zwei Straßen verbindet)
durch|he|cheln; der Flachs wird durchgehechelt; die lieben Verwandten wurden durchgehechelt (ugs. für: es wurde unfreundlich über sie geredet)
durch|hei|zen; das Haus ist gut durchgeheizt
durch|hel|fen; er hat ihr durchgeholfen
Durch|hieb (Schneise, ausgehauener Waldstreifen)
durch|hun|gern, sich; ich habe mich mit meiner Familie durchgehungert
durch|ir|ren; er hat die Straßen durchirrt
durch|ixen (ugs.: auf der Schreibmaschine mit dem Buchstaben x ungültig machen); in dem Text waren einige Wörter durchgeixt
durch|ja|gen; das Auto ist hier durchgejagt; durch|ja|gen; der Wagen durchjagte die Stadt
durch|käm|men; das Haar wurde durchgekämmt; die Soldaten haben den Wald durchgekämmt oder durchkämmt; Durch|käm|mung [auch: ...käm...]
durch|kämp|fen; er hat den Kampf durchgekämpft; durch|kämp|fen; manche durchkämpfte Stunde
durch|klet|tern; er ist unterm Zaun durchgeklettert; durch|klet|tern; der Bergsteiger hat den Kamin durchklettert
durch|klin|gen; das Instrument hat zu laut durchgeklungen; durch|klin|gen; die Musik hat das ganze Haus durchklungen
durch|knöp|fen; das Kleid ist durchgeknöpft
durch|kom|men (eine Prüfung bestehen; sich retten); er ist noch einmal durchgekommen
durch|kom|po|nie|ren (einem Gedicht eine von Strophe zu Strophe wechselnde Vertonung geben); Schubert hat viele Lieder durchkomponiert
durch|kön|nen (ugs. für: hindurchgelangen, vorbeikommen können); wir haben wegen der Absperrungen nicht durchgekonnt
durch|kon|stru|ieren; der Motor war gut durchkonstruiert
durch|ko|sten; er hat alle Weine durchgekostet
durch|kreu|zen (kreuzweise durchstreichen); er hat den Brief durchgekreuzt; durch|kreu|zen; man hat seinen Plan durchkreuzt; Durch|kreu|zung
durch|krie|chen; er ist unter dem Zaun durchgekrochen; durchkrie|chen; Angst durchkriecht sie (steigt in ihr hoch)
durch|la|den; eine Schußwaffe -
durch|län|gen (Bergmannsspr.: Strecken anlegen); durchgelängt
Durch|laß m; ...lasses, ...lässe; durch|las|sen; er hat ihn noch durchgelassen; durch|läs|sig; Durch|läs|sig|keit w; -
Durch|laucht w; -, -en; vgl. euer, ihr u. sein; durch|lauch|tig; durch|lauch|tigst; in der Anrede u. als Ehrentitel: Durchlauchtigst
Durch|lauf; durch|lau|fen; er ist die ganze Nacht durchgelaufen; das Wasser ist durchgelaufen; durch|lau|fen; ich habe den Wald -; das Projekt hat viele Stadien -; es durchläuft mich eiskalt; Durch|lauf|er|hit|zer, Durch|lauf-Was|ser|er|hit|zer; ↑R 152 (ein Gas- od. Elektrogerät)
durch|le|ben; froh durchlebte Tage
durch|lei|den; sie hat viel durchlitten
durch|le|sen; ich habe den Brief durchgelesen
durch|leuch|ten; das Licht hat [durch das Fenster] durchge-leuchtet; durch|leuch|ten (mit Licht, auch mit Röntgenstrahlen durchdringen); er hat den Raum durchleuchtet; die Brust des Kranken wurde durchleuchtet; Durch|leuch|tung
durch|lie|gen (sich wundliegen); der Kranke hat sich durchgelegen
durch|lö|chen; er hat das Papier durchlöcht; durch|lö|chern; das Brett war von Kugeln durchlöchert
durch|lüf|ten (gründlich lüften); er hat gut durchgelüftet; durch|lüf|ten (von der Luft durchziehen lassen); das Zimmer wurde durchlüftet; Durch|lüf|ter; Durch|lüf|tung
durch|ma|chen; die Familie hat viel durchgemacht
Durch|marsch m; durch|mar|schie|ren; die Truppe ist durchmarschiert
durch|mes|sen (die Länge, Weite usw. messen); er hat alle Räume durchgemessen; durch|mes|sen; er hat die ganze Welt -; Durch|mes|ser (Zeichen: d [nur kursiv] od. ø) m
durch|mo|geln, sich (ugs.); du hast dich mal wieder durchgemogelt
durch|müs|sen (ugs. für: hindurchgelangen, vorbeikommen müssen); wir haben hier durchgemußt
durch|mu|stern, durch|my|stern; er hat die Waren durchgemustert od. durchmystert; Durch|mu|ste|rung [auch: ...muß...]
durch|na|gen, durch|na|gen; die Maus hat den Strick durchgenagt od. durchnagt
Durch|nah|me w; -
durch|näs|sen; er war völlig durchnäßt
durch|neh|men; der Lehrer hat den schwierigen Stoff nochmal durchgenommen
durch|nu|me|rie|ren; Durch|nu|me|rie|rung
durch|or|ga|ni|sie|ren; es war alles gut durchorganisiert
durch|ör|tern (Bergmannsspr.: Strecken anlegen, durchfahren); durchörtert
durch|pau|sen; er hat die Zeichnung durchgepaust
durch|peit|schen; man hat ihn grausam durchgepeitscht; der Gesetzentwurf wurde im Parlament durchgepeitscht (eilig durchgebracht)
durch|prü|fen; er hat alles noch einmal durchgeprüft
durch|prü|geln; man hat ihn tüchtig durchgeprügelt
durch|pul|sen; von Begeisterung durchpulst

durch|que|ren; er hat das Land durchquert; Durch|que|rung

durch|ra|sen; der Zug ist durchgerast; durch|ra|sen; eine von Kraftwagen durchraste Straße

durch|ras|seln (ugs. für: eine Prüfung nicht bestehen); er ist durchgerasselt

durch|rech|nen; er hat die Aufgabe noch einmal durchgerechnet

durch|reg|nen; es hat durchgeregnet; durch|reg|nen; ich bin ganz durchregnet (meist: durchgeregnet)

Durch|rei|che (Öffnung zum Durchreichen von Speisen) w; -, -n; durch|rei|chen; er hat es ihm durchgereicht

Durch|rei|se; durch|rei|sen; ich bin oft durchgereist; durch|rei|sen; er hat das Land durchreist; Durch|rei|sen|de

urch|rei|ßen; er hat den Brief durchgerissen

urch|rei|ten; er ist nur durchgeritten; durch|rei|ten; das durchrittene Land

urch|rie|seln; der Sand ist durchgerieselt; durch|rie|seln; von Wonne durchrieselt

urch|rin|gen; er hat sich zu dieser Überzeugung durchgerungen

urch|ro|sten; das Rohr ist ganz durchgerostet

urchs; † R 240 (durch das); durchs Haus

urch|sa|ge w; -, -n; durch|sa|gen

urch|satz (fachspr. für: der in einer bestimmten Zeit durch Hochöfen u. ä. geleitete Stoff)

urch|schau|bar; durch|schau|en; er hat [durch das Fernrohr] durchgeschaut; durch|schau|en; ch habe ihn durchschaut

urch|schei|nen; die Sonne hat durchgeschienen; durch|schei|nen; vom Tageslicht durchschienen; rch|schei|nend

rch|scheu|ern; der Ärmel ist urchgescheuert

rch|schie|ßen; er hat [durch die Wand] durchgeschossen; durch|schie|ßen; er hat die Wand durchschossen; ein [mit Schreibpapier] durchschossenes Buch

rch|schim|mern; die Sterne haben durchgeschimmert; durch|schim|mern; von Licht durchschimmert

rch|schla|fen; er hat durchgeschlafen (ohne Unterbrechung); urch|schla|fen; durchschlafene Nächte

urch|schlag (Bergmannsspr.: Treffpunkt zweier Grubenbaue, die aufeinander zulaufen); urch|schla|gen; sie hat die Suppe [durch das Sieb] durchgeschlagen; durch|schla|gen; die Kugel

hat den Panzer durchschlagen; durch|schla|gend; durch|schlä|gig; Durch|schlag|pa|pier; Durch|schlags|kraft w; -

durch|schlän|geln, sich; ich habe mich überall durchgeschlängelt

durch|schlei|chen; er hat sich durchgeschlichen; durch|schlei|chen; er hat das Haus durchschlichen

durch|schleu|sen; das Schiff wurde durchgeschleust

Durch|schlupf; durch|schlüp|fen; er ist durchgeschlüpft

durch|schmug|geln; er hat den Brief durchgeschmuggelt

durch|schnei|den; er hat das Tuch durchgeschnitten; durch|schnei|den; von Kanälen durchschnittenes Land; Durch|schnitt; im -; durch|schnitt|lich; Durch|schnitts_al|ter, ...bil|dung (w; -), ...ge|schwin|dig|keit, ...lei|stung, ...mensch, ...preis (vgl. [2]Preis), ...schü|ler, ...wert

durch|schnüf|feln, durch|schnüf|feln (ugs. für: untersuchen); er hat alle Winkel durchgeschnüffelt od. durchschnüffelt

durch|schoß|sen; [mit Schreibpapier] -es Buch; (Druckw.:) -er Satz

durch|schrei|ben; er hat diese Rechnung durchgeschrieben; Durch|schrei|be_block (Mehrz. ...blocks), ...ver|fah|ren

durch|schrei|ten; er ist [durch den Saal] durchgeschritten; durch|schrei|ten; sie durchschritten den Fluß

Durch|schrift

Durch|schuß (Druckw.: Zeilenzwischenraum; der dem Zwischenraum entsprechende Metallstreifen im Satz); vgl. Reglette

durch|schwär|men; durchschwärmte Nächte

durch|schwei|fen; er hat den Wald durchschweift

durch|schwim|men; er ist unter dem Seil durchgeschwommen; durch|schwim|men; er hat den Fluß durchschwommen

durch|schwit|zen; er hat das Hemd durchgeschwitzt

durch|se|geln; das Schiff ist [durch den Kanal] durchgesegelt; durch|se|geln; er hat das Meer durchsegelt

durch|se|hen; er hat die Akten durchgesehen

durch|set|zen (erreichen); ich habe es durchgesetzt; durch|set|zen; das Gestein ist mit Erzen durchsetzt

durch|seu|chen; das Gebiet wurde durchseucht

Durch|sicht w; -; durch|sich|tig; Durch|sich|tig|keit w; -

durch|sickern [Trenn.: ...sik|kern]; die Nachricht ist durchgesickert

durch|sie|ben; sie hat das Mehl durchgesiebt; durch|sie|ben; die Tür war von Kugeln durchsiebt

durch|sit|zen; er hat die Hose durchgesessen

durch|spre|chen; er hat das Gedicht durchgesprochen

durch|sprin|gen; er ist [durch das Feld] durchgesprungen; durchsprin|gen; er hat das Feld durchsprungen

durch|star|ten; der Pilot hat die Maschine durchgestartet

durch|ste|chen; ich habe [durch das Tuch] durchgestochen; durch|ste|chen; der Damm wird durchstochen; Durch|ste|che|rei (Täuschung, Betrug)

durch|ste|hen; sie hat viel durchgestanden; er hat den Schisprung durchgestanden

durch|stei|gen; er ist [durch das Fenster] durchgestiegen; da steig' ich nicht mehr durch (ugs. für: das verstehe ich nicht); durch|stei|gen; er hat die Gebirgswand durchstiegen

Durch|stich

durch|stö|bern; er hat die Papiere durchstöbert

Durch|stoß; durch|sto|ßen; er hat [durch das Eis] durchgestoßen; durch|sto|ßen; er hat das Eis durchstoßen

durch|strei|chen; das Wort ist durchgestrichen; durch|strei|chen; er hat das Land durchstrichen

durch|strei|fen; das Band wird durch eine Öffnung durchgestreift; durch|strei|fen; er hat das Land durchstreift

durch|strö|men; große Scharen sind durchgeströmt; durch|strö|men; das Land wird durchströmt von ...

durch|su|chen; sie hat den Schrank durchgesucht; durch|su|chen; durchsuchte Koffer; Durch|su|chung

durch|tan|zen; er hat die Nacht durchgetanzt; durch|tan|zen; durchtanzte Nächte

durch|to|ben; durchtobte Nächte

durch|trai|nie|ren; mein Körper ist durchtrainiert

durch|trän|ken; das Papier ist mit Öl durchtränkt

durch|trei|ben; ein durchgetriebener Nagel; durch|trei|ben (gerissen); ein durchtriebener Bursche; Durch|trie|ben|heit w; -

durch|tren|nen, durch|tren|nen; er hat das Kabel durchgetrennt od. durchtrennt

durch|tre|ten; er hat den Gashebel ganz durchgetreten

durch|wa|chen; sie hat bis zum Morgen durchgewacht; **durch-wa|chen**; ich habe die Nacht durchwacht

durch|wach|sen; der Baum ist durchgewachsen; **durch|wạch-sen**; [mit Fett] -es Fleisch

durch|wa|gen, sich; ich habe mich durchgewagt

durch|wal|ken; das Tuch wurde durchgewalkt; er wurde durchge-walkt (ugs. für: verprügelt)

durch|wan|dern; er ist ohne Auf-enthalt durchgewandert; **durch-wạn|dern**; er hat das ganze Land durchwandert

durch|wär|men, **durch|wär|men**; der Tee hat uns durchgewärmt od. durchwärmt

durch|wa|schen; sie hat die Strümpfe durchgewaschen

durch|wa|ten; ich bin durchgewa-tet; **durch|wa|ten**; ich habe den Bach durchwatet

durch|we|ben; der Stoff ist durch-gewebt; **durch|we|ben**; mit Gold-fäden durchwebt; mit poetischen Gedanken durchwoben

durch|weg [auch: durchwäk]; durch|wegs [auch: durchwekß] (österr. nur so, sonst ugs. neben: durchweg)

durch|wei|chen, **durch|wei|chen**; ich bin vom Regen ganz durchge-weicht, durchweicht worden; vgl. [1]weichen

durch|win|den, sich; ich habe mich durch diese Schwierigkeiten durchgewunden; **durch|win|den**; ein von einem Bach durchwunde-nes Tal

durch|win|tern; gut durchwinterte Pflanzen; **Durch|win|te|rung**

durch|wir|ken; durchgewirkter Teig; **durch|wir|ken**; durchwirkt mit Seidenfäden

durch|wit|schen; er ist mir durch-gewitscht (ugs. für: durchge-schlüpft)

durch|wol|len (ugs. für: hindurch-gelangen wollen); an dieser Stelle haben sie durchgewollt

durch|wüh|len; die Maus hat sich durchgewühlt; **durch|wüh|len**; die Diebe haben alles durchwühlt od. durchgewühlt

durch|zäh|len; er hat durchgezählt; **Durch|zäh|lung**

durch|ze|chen; er hat die Nacht durchgezecht; **durch|ze|chen**; durchzechte Nächte

durch|zeich|nen; er hat die Nacht durchgezeichnet; er hat die Skiz-ze durchgezeichnet

durch|zie|hen; ich habe den Faden durchgezogen; **durch|zie|hen**; wir haben das Land durchzogen; **Durch|zie|her** (Studentenspr.: bes. Fechthieb, auch: Narbe)

durch|zịt|tern; Schrecken haben ihn durchzittert

durch|zụcken [Trenn.: ...zuk|ken]; grelle Blitze haben die Finsternis durchzuckt

Durch|zug; Durch|zug|ler; Durch-zugs|ar|beit (Weberei: eine Art Spitze)

durch|zwän|gen; ich habe mich durchgezwängt

Dur|drei|klang

Dü|rer (dt. Maler)

dür|fen; du darfst, er darf; du durf-test; du dürftest; gedurft; du hast [es] nicht gedurft, aber (↑ R 305): das hättest du nicht tun -

dürf|tig; Dürf|tig|keit w; -

dürr

Dur|ra arab. (Getreidepflanze; Sorgho) w; -

Dür|re w; -, -n

Dür|ren|matt (schweiz. Dramati-ker u. Erzähler)

Dürr|erz|e (Silbererze mit starken Erdbeimengungen; Mehrz.), ...fut|ter (vgl. [1]Futter), ...kräut|ler (österr. für: Heilkräuterverkäu-fer), ...wurz (ein Unkraut)

Durst m; -[e]s; dur|sten (vereinzelt für: dürsten); **dür|sten** (geh.); mich dürstet, ich dürste; **dur|stig; durst|lö|schend**, aber (↑ R 142): den Durst löschend; **Durst-strecke** [Trenn.: ...strek|ke] (meist übertr.: Zeit der Entbehrung)

Dur...ton|art, ...ton|lei|ter

Dusch|bad [auch: du...]; **Du|sche** fr. [auch: du...] w; -, -n; **Dusch|ecke** [Trenn.: ...ek|ke; auch: du...]; du-schen [auch: du...]; du duschst (duschest); **Dusch.ka|bi|ne**, ...raum

Dü|se w; -, -n

Du|sel (ugs. für: unverdientes Glück; auch für: Schwindel, Rausch) m; -s; Du|se|lei; du|se|lig, dus|lig; du|seln (träumen); ich ...[e]le (↑ R 327)

Dü|sen_ag|gre|gat, ...an|trieb, ...flug|zeug, ...jä|ger, ...ma|schi-ne, ...trieb|werk

dus|lig, du|se|lig

Dus|sel (ugs. für: Dummkopf) m; -s, -

Düs|sel|dorf (Stadt am Rhein); **Düs|sel|dor|fer** (↑ R 199)

Dus|se|lei; dus|se|lig, duß|lig; Dus-se|lig|keit; Duß|lig|keit

Dust niederd. (Dunst, Staub) m; -[e]s

dü|ster landsch. (düster); **dü|ster**; düst[e]rer, -ste; **Dü|ster** s; -s; **Dü-ster|heit**, **Dü|ster|keit** w; -; **dü-stern** (dicht.); es düstert; **Dü|ster-nis** w; -, -se

Dutch|man engl. [dạtschmɐn] (Nie-derländer; Schimpfwort engli-scher Matrosen für deutsche See-leute) m; -s, ...men

Dutt landsch. (Haarknoten; klei-ner Mensch) m; -[e]s, -s od. -e[

Dut|te landsch. (Zitze) m; -, -n

Du|ty-free-Shop engl. [djuti fri schɔp] (Laden, in dem zollfreie Waren verkauft werden)

Dut|zend fr. (Abk.: Dtzd.) s; -s, -e; 6 - (↑ R 322); das Heulen Dut-zender von Sirenen; **dut|zen|de-mal; dut|zend|fach; dut|zend|mal**; ein, ein halbes, einige, viele - aber: viele Dutzend Male; **Dut-zend.mensch** m, ...wa|re (w; -); **dut|zend|wei|se**

Du|um|vir lat. [...wir] (altröm. Beamtentitel) m; -n, -n (auch ...iri; meist Mehrz.); **Du|um|vi|rat** (Amt der Duumvirn) s; -[e]s, -e

Duve|tine fr. [düftịn] (ein samtarti-ges Gewebe) m; -s, -s

Du|wock niederd. (Schachtel-halm) m; -s, -e

Dụz|bru|der; du|zen; du duzt (du zest); **Dụz|freund; Dụz|fuß**, nu noch in: auf [dem] - stehen

Dvo|řák [dwọrsehgk] (tschech Komponist)

dwars (Seemannsspr.: quer)

Dwars.li|nie (in - [Seemannsspr nebeneinander] fahren), ...see

Dweil (Seemannsspr.: schrubbe ähnlicher Aufwischer) m; -s, -

Dwi|na (russ. Strom, Nördlich Dwina; russ.-lett. Strom, Dün od. Westliche Dwina) w; -

Dy = chem. Zeichen für: Dyspro sium

dya|disch gr. (zweiteilig, dem dy dischen Zahlensystem zuge hörend); **Dy|as** (,,Zweiheit'' Geol. veralt. für: Perm) w; -

Dyck, van [wan od. fan daịk] (fl mischer Maler)

dyn gr. (Zeichen für die Einhe der Kraft im CGS-System); **D na|mik** (Lehre von den Kräfte Schwung, Triebkraft) w; -; **dy| misch** (die ,,Kraft'' betreffen voll innerer Kraft; kraft spannt; triebkräftig; Kraft...); Belastung; -e Rente; **dy|na|mi|s ren**; **Dy|na|mi|sie|rung**; **Dy| mịs|mus** (Weltanschauung, die Wirklichkeit auf Kräfte u. ih ren Wirkungen zurückführt) -; **Dy|na|mịt** (Sprengstoff) s; **Dy|na|mịt|pa|tro|ne; Dy|na|m** [oft: dünamo] (Kurzform für: D namomaschine) m; -s, -s; **Dy|r mo|ma|schi|ne** (Stromerzeuge **Dy|na|mo|me|ter** (Vorrichtu zum Messen von Kräften u. v mechan. Arbeit) s; -s, -; **Dy|na** (Herrscher; [kleiner] Fürst) -en, -en (↑ R 268); **Dy|na|s** (Herrschergeschlecht, -haus) -, ...ien; **dy|na|stisch**

dys... (gr. Vorsilbe: übel, schlec miß...)

Dys|en|te|rie *gr.* (Med.: Ruhr [Darmkrankheit]) *w*; -, ...jen; **dys-en|te|risch** (ruhrartig)

Dys|kra|sie *gr.* (Med.: fehlerhafte Zusammensetzung der Körpersäfte, bes. des Blutes) *w*; -, ...jen

Dys|me|nor|rhö[1], **Dys|me|nor|rhöe** *gr.* (Med.: Menstruationsschmerzen) *w*; -, ...rrhöen

Dys|pep|sie *gr.* (Med.: Verdauungsstörung, -schwäche) *w*; -, ...jen; **dys|pep|tisch** (schwer verdaulich; scher verdauend)

Dys|pnoe *gr.* [...ọ-e] (Med.: Atembeschwerden) *w*, -

Dys|pro|si|um *gr.* (chem. Grundstoff, Metall; Zeichen: Dy) *s*; -s

Dys|te|leo|lo|gie *gr.* (philosoph. Lehre von der Zweckwidrigkeit in der Natur) *w*; -

Dys|to|nie *gr.* (Med.: Störung des normalen Spannungszustandes der Muskeln u. Gefäße) *w*; -, ...jen; vegetative -

dys|troph *gr.* (Med.: die Ernährung störend); **Dys|tro|phie** (Med.: Ernährungsstörung) *w*; -, ...jen

Dys|urie *gr.* (Med.: Harnbeschwerden) *w*; -, ...jen

dz = Doppelzentner

dz. = derzeit

D-Zug [dẹ...] („Durchgangszug"; Schnellzug); **D-Zug-ar|tig** (↑ R 155); **D-Zug-Wa|gen** (↑ R 155)

E

E (Buchstabe); das E; des E, die E, aber: das e in Berg (↑ R 123); der Buchstabe E, e

e, E (Tonbezeichnung) *s*; -, -; **e** (Zeichen für: e-Moll); in e; **E** (Zeichen für: E-Dur); in E

ε = Zeichen für: Dielektrizitätskonstante

E = (internationale Wetterkunde:) East *engl.* [iißt] od. Est *fr.* [äßt] (Ost)

E = Eilzug

E, ε = Epsilon

H, η = Eta

Earl *engl.* [ö͞rl] (engl. Graf) *m*; -s, -s

Eau de Co|lo|gne *fr.* [ọ dᵉ kolọnj͟ᵉ] (Kölnischwasser) *s* (seltener: *w*); - - -; **Eau de vie** [- - wī] (Weinbrand) *s* od. *w*; - - -

Eb|ba (w. Vorn.)

Eb|be *w*; -, -n; **eb|ben**

Eb|bo (m. Vorn.)

ebd. = ebenda

eben; -es (flaches) Land; -e Fläche;

- sein; - (soeben) genannt; das ist nun - (einmal) so; **Eben|bild**; **eben|bür|tig**; **Eben|bür|tig|keit** *w*; -; **eben|da** [auch: *eb͟ᵉndá*] (Abk.: ebd.); **eben|da|her** [auch: *eb͟ᵉndá-her*]; **eben|da|hin** [auch: *eb͟ᵉndá-hin*]; **eben|dann** [auch: *eb͟ᵉndán*]; **eben|dar|um** [auch: *eb͟ᵉndárum*]; **eben|da|selbst** [auch: *eb͟ᵉndásélbst*]; **eben|der** [auch: *eb͟ᵉndér*]; **eben|der|sel|be** [auch: *eb͟ᵉndérsálb͟ᵉ*]; **eben|des|halb** [auch: *eb͟ᵉndä́ßhalp*]; **eben|des|we|gen** [auch: *eb͟ᵉndä́ßwég͟ᵉn*]; **eben|die|ser** [auch: *eb͟ᵉndís͟ᵉr*]; **eben-dort** [auch: *eb͟ᵉndór͟t*]; **eben|dort|selbst**; **Ebe|ne** *w*; -, -n; **eben|er|dig**; **eben|falls**; vgl. Fall *m*; **Eben|heit** (ebener Zustand) *w*; -

Eben|holz *ägypt.*; *dt.*

eben|je|ner [auch: *eb͟ᵉnjén͟ᵉr*]; **Eben-maß** *s*; **eben|mä|ßig**; **Eben|mä|ßig|keit**

eben|so; - wie. I. (↑ R 139:) Bei folgendem Umstandswort u. den ungebeugten Formen der unbestimmten Zahlwörter viel u. wenig *Zusammenschreibung*: ebensooft, ebensoviel. II. Bei folgendem ungebeugtem Eigenschaftswort *Zusammenschreibung*, wenn der Ton nur auf ebenso liegt, *Getrenntschreibung*, wenn beide Wörter betont werden: er hätte ebensogut zu Hause bleiben können, aber: er spielt ebenso gut Klavier wie ich. III. Bei folgendem gebeugtem Eigenschaftswort od. bei den gebeugten Formen der unbestimmten Zahlwörter viel u. wenig *immer Getrenntschreibung* (der Ton liegt auf beiden Wörtern): ebenso gute Leute, ebenso viele Freunde; **eben|so|gut** (ebensowohl); du kannst das ebensogut machen, aber: das ist ebenso gut wie ..., ebenso (gleich) gute Leute; vgl. **eben|so-häu|fig**; er hat es ebensohäufig getan, aber: eine ebenso häufige Wiederholung; vgl. ebenso; **eben-so|lang**, **eben|so|lan|ge** (gleich lange dauernd); das dauert ebensolang[e], aber: er hat ebenso lange Beine wie ich; vgl. ebenso; **eben|solch**; **eben|sol|cher** [auch: *eb͟ᵉnsólch͟ᵉr*]; **eben|so|oft**; **eben|so-sehr**; **eben|so|viel**; ebensoviel sonnige Tage, aber: ebenso viele sonnige Tage; vgl. ebenso; **eben|so|weit**, aber: eine ebenso weite Entfernung; vgl. ebenso; **eben|so-we|nig**; ebensowenig reife Birnen, aber: ebenso wenige reife Birnen; vgl. ebenso; **eben|so|wohl**

Eber (männl. Schwein) *m*; -s, -

Eber|esche (ein Laubbaum)

Eber|hard (m. Vorn.)

eb|nen

Eb|ner-Eschen|bach, Marie von (österr. Dichterin)

Eb|nung

Ebo|nit *ägypt.* (Hartgummi aus Naturkautschuk) *s*; -s

Ebro (Fluß in Spanien) *m*; -[s]

e. c. = exempli causa

Ec|ce *lat.* [ä́kze] („siehe da!"; früher für: Totengedächtnisfeier [eines Gymnasiums]) *s*; -, -; **Ec|ce-Ho|mo** [volkstüml.: - *homo*] („Sehet, welch ein Mensch!"; Darstellung des dornengekrönten Christus) *s*; -[s], -[s]

Echarpe *fr.* [escharp] (veraltend, noch fachspr. für: Schärpe; Schal; bes. schweiz.: gemusterter Umschlagtuch) *w*; , -n

echauf|fie|ren, sich *fr.* [escho*fīr* ͟ᵉn] (veralt. für: sich erhitzen; sich aufregen); **echauf|fiert**

Echec *pers.* [eschä́k] (fr. Bez. für: Schach; übertr.: Niederlage) *m*; -s, -s

Eche|ve|ria [ätschewẹria; nach dem mexikan. Pflanzenzeichner Echeverría (Dickblattgewächs, beliebt als Zimmerpflanze) *w*; -, ...ien [...i͟ᵉn]

Echi|nit *gr.* (versteinerter Seeigel) *m*; -s u. -en (↑ R 268), -e[n]; **Echi-no|der|me** (Stachelhäuter) *m*; -n, -n (meist *Mehrz.*); ↑ R 268; **Echi-no|kok|kus** (Blasenwurm [ein Hundebandwurm] od. dessen Finne) *m*; -, ...kken; **Echi|nus** (ein Seeigel; ein Säulenwulst) *m*; -, -

[1]**Echo** (Nymphe des gr. Mythos), [2]**Echo** *gr.* (Widerhall) *s*; -s, -s; **echo|en** [...ọᵉn]; es echot; geechot; **Echo|lot**; **Echo|lo|tung**

Ęch|se (ein Kriechtier) *w*; -, -n

echt; eine echtdeutsche Eigentümlichkeit; ein echtdeutener, echtsilberner Ring (↑ jedoch R 143), aber: eine echt deutsche Eigentümlichkeit, sein Verhalten ist echt deutsch; der Ring ist echt golden, echt silbern; (vgl. S. 45, Merke, 2:) echtblau; ein echtblauer Farbstoff, der Farbstoff ist echtblau; **echt|blau**; vgl. echt; **echt|deutsch**; vgl. echt

Ęch|ter|nach (Stadt in Luxemburg; **Ęch|ter|na|cher** (↑ R 199); - Springprozession

echt|gol|den; vgl. echt; **Echt|haar**; **Echt|haar|pe|rücke** [*Trenn.:* ...rük|ke]; **Echt|heit** *w*; -; **Echt-heits|prü|fung**; **Echt|sil|ber**; aus -; **echt|sil|bern**; vgl. echt

Eck (bes. südd. u. österr. (Ecke; sonst fast nur noch in geogr. Namen u. in: Dreieck usw.) *s*; -[e]s, -e (österr.: -en, für Dreieck usw.: -e); das Deutsche - (in Koblenz)

Eckart [*Trenn.:* Ek|kart], **Eck-hart**, **Ecke|hart** (dt. Mystiker, gen. Meister -); vgl. Eckhard

[1] Vgl. die Anmerkung zu „Diarrhö, Diarrhöe".

Eck.ball (Sportspr.), ...bank (Mehrz. ...bänke)

Eck|bert, Eg|bert (m. Vorn.); Eck-brecht, Eg|brecht (m. Vorn.)

Eck|brett; Eck|chen, Eck|lein; Ecke¹ w; -, -n; vgl. Eck

Ecke|hard¹ vgl. Eckhard; Ecke-hart¹ vgl. Eckart

ecken¹ (veralt. für: mit Ecken versehen); Ecken|band¹ vgl. Eggenband; ecken|los¹; Ecken|ste|her¹

Ecker¹ (Eichen-, Buchenfrucht; heute fast nur noch in: Buchek-ker) w; -, -n; Eckern¹ (Farbe im dt. Kartenspiel) Mehrz.

Eckern|för|de¹ (Hafenstadt an der Eckernförder Bucht)

Eck|fah|ne, ...fen|ster

Eck|hard (m. Vorn.), bei Goethe: Eckart, bei Scheffel: Ek|ke|hard; Eck|hart vgl. Eckart

Eck|haus; eckig¹; Eckig|keit¹; Eck-lein, Eck|chen; Eck|lohn

Eck|mann|schrift; ↑ R 180 (eine Druckschrift) w; -

Eck.pfei|ler, ...schrank, ...stein, ...stoß (Sportspr.), ...zahn, ...zins

Eclair fr. [eklär] (ein Gebäck) s; -s, -s

Eco|no|mi|ser vgl. Ekonomiser

Ecua|dor (südamerik. Staat); Ecua|do|ria|ner (↑ R 199); ecua-do|ria|nisch

ed. = edidit lat. („herausgegeben hat es ..."); Ed. = Edition

Edam (niederl. Stadt); Eda|mer (↑ R 199); - Käse; Eda|mer (ein Käse) m; -s, -

Eda|phon gr. (Biol.: Lebensge-meinschaft der in und auf dem Erdboden lebenden Pflanzen u. Tiere) s; -s

edd. = ediderunt lat. („herausge-geben haben es ...")

Ed|da altnord. (Sammlung alt-nord. Dichtungen; w. Vorn.) w; -, (für: Dichtung auch Mehrz.:) Edden; ed|disch; -e Lieder

Ede|ka = Einkaufsgenossen-schaft deutscher Kolonialwaren-händler

edel; edler, -ste; vgl. Edle; Edel-bert (m. Vorn.); Edel|fäu|le (fach-spr. für: Überreife von Weintrau-ben); Edel|gard (w. Vorn.); Edel-gas; Edel|ling (germ. Adliger); Edel.ka|sta|nie, ...kitsch (iron.), ...ko|ral|le, ...mann (Mehrz. ...leute); edel|män|nisch; Edel-.me|tall, ...mut; edel|mü|tig; Edel-.obst, ...rost (für: Patina), ...stahl, ...stein, ...tan|ne; Edel|traud, Edel|trud (w. Vorn.); Edel|weiß (eine Gebirgspflanze) s; -[es], -e

Eden hebr. (Paradies im A. T.) s; -s

Eden|ta|te lat. (zahnarmes Säuge-

tier) m; -n, -n (meist Mehrz.); ↑ R 268

Eder (Nebenfluß der Fulda) w; -

Ed|gar (m. Vorn.)

edie|ren lat.; Bücher - (herausge-ben, veröffentlichen); ediert

Edikt lat. (amtl. Erlaß von Kaisern u. Königen) s; -[e]s, -e

Edin|burg (dt. Form von: Edin-burgh); Edinburgh [ädinbᵉrᵉ] (Hptst. Schottlands)

Edir|ne (türk. Name von: Adria-nopel)

Edi|son [engl. Ausspr.: ädißn] (amerik. Erfinder)

Edith, Edi|tha (w. Vorn.)

Edi|ti·on lat. [...zion] (Ausgabe; Abk.: Ed.); Edi|tor [auch: edi...] (Herausgeber) m; -s, ...oren; edi-to|risch

Ed|le m u. w; -n, -n (↑ R 287 ff.); -r von ... (Adelstitel)

Ed|mar (m. Vorn.)

Ed|mund (m. Vorn.)

Edom (Land östl. u. südöstl. des Toten Meeres); Edo|mi|ter

Ed|schmid [auch: ät...] (dt. Schrift-steller)

Edu|ard, Ed|ward (m. Vorn.)

Edu|ka|ti·on lat. [...zion] (veralt. für: Erziehung) w; -; Edukt (aus Rohstoffen abgeschiedener Stoff [z. B. Öl, Zucker]) s; -[e]s, -e

E-Dur [auch: edur] (Tonart; Zei-chen: E) s; -; E-Dur-Ton|lei|ter (↑ R 155)

EDV = elektronische Datenver-arbeitung

Ed|ward vgl. Eduard; Ed|win (m. Vorn.)

Efen|di türk. (ein türk. Anredeti-tel) m; -s, -s

Efeu m; -s; Efeu|ran|ke

Eff|eff [auch: äfäf u. äfäf] (ugs.); etwas aus dem - (gründlich) ver-stehen

Ef|fekt lat. (Wirkung, Erfolg; Er-gebnis) m; -[e]s, -e; Ef|fek|ten (Wertpapiere) Mehrz.; Ef|fek-ten|band (Mehrz. ...banken), ...be|stand, ...bör|se, ...gi|ro|ver-kehr, ...han|del, ...ver|wah|rung; Ef|fekt ha|sche|rei; ef|fek|tiv (tat-sächlich; wirksam; greifbar); -e Leistung (Nutzleistung); Ef|fek-tiv (Sprachw.: Zeitw. des Ver-wandelns, z. B. „knechten" = „zum Knecht machen") s; -s, -e [...wᵉ]; Ef|fek|tiv|be|stand (Ist-Bestand); Ef|fek|ti|vi|tät (Wir-kungskraft); Ef|fek|tiv|lohn; ef-fek|tu|ie|ren fr. (Wirtsch.: einen Auftrag ausführen; eine Zahlung leisten); ef|fekt|voll (wirkungs-voll)

ef|fe|mi|niert (verweiblicht)

Ef|fet fr. [äfe od. äfä] (der Drall einer [Billard]kugel, eines Balles) m (selten: s); -s, -s; Ef|fi|cien|cy¹

engl. [ᶠfisch ᵉnßi] (Wirtsch.: Wirt-schaftlichkeit, bestmöglicher Wirkungsgrad) w; -; Ef|fi|zi|enz (Wirksamkeit; Wirkungsgrad) w; -, -en

ef|fi|lie|ren fr. (die Haare zum Schneiden ausdünnen); Ef|fi|lier-sche|re

Ef|flo|res|zenz lat. (Med.: Haut-blüte [z. B. Pusteln, Bläschen]; Geol.: Überzug aus Salzen auf Gesteinen) w; -, -en; ef|flo|res|zie-ren

Ef|fu|si·on lat. (Ausfließen von Lava); ef|fu|siv (durch Erguß ge-bildet); Ef|fu|siv|ge|stein (Erguß-gestein)

EFTA = European Free Trade Association [ju ᵉrᵉpi ᵉn fri tre ᵗt ᵉßo ᵘßie sch ᵉn] (Europäische Frei-handelszone)

EG = Europäische Gemeinschaft

¹egal (ugs. für: gleichgültig); das ist mir -; ²egal landsch. (immer [wieder, noch]); er hat - etwas an mir auszusetzen; ega|li|sie|ren (gleichmachen, ausgleichen); Ega|li|sie|rung; ega|li|tär (auf Gleichheit gerichtet); Ega|li|tät (veralt. für: Gleichheit) w; -; Éga-li|té (vgl. Liberté)

Egart bayr. u. österr. (Grasland) w; -; Egar|ten|wirt|schaft, Egart-wirt|schaft (Feldgraswirtschaft) w; -

Eg|bert vgl. Eckbert; Eg|brecht vgl. Eckbrecht

Egel (ein Wurm) m; -s, -; Egel-schnecke [Trenn.: ...schnek|ke]

Eger (Stadt in der Tschechoslowa-kei); vgl. Cheb; Eger|land s; -[e]s; Eger|län|der (↑ R 199)

Egge|ria (röm. Nymphe)

Eger|ling (dt. Name für: Champi-gnon)

¹Eg|ge (Gewebekante, -leiste) w; -, -n; ²Eg|ge (ein Ackergerät) w; -, -n; eg|gen; das Feld wird geeggt; Eg|gen|band, Ecken|band [Trenn.: Ek|ken...] (festes Band, das Nähte vor dem Verziehen schützen soll; Mehrz. ...bänder)

Egg|head engl.-amerik. [äghäd] („Eierkopf"; in den USA spött. od. verächtl. Bez. für: Intellek-tueller) m; -[s], -s

Egil [auch: äg...] (nord. Sagenge-stalt)

Egi|nald¹ (m. Vorn.); Egin|hard¹, Ein|hard (m. Vorn.)

Egk (dt. Komponist)

EGmbH = Eingetragene Genos-senschaft mit beschränkter Haft-pflicht; (auch: eGmbH); vgl. ein-getragen)

Eg|mont (Titelgestalt der gleich-namigen Tragödie von Goethe)

¹ Trenn.: ...k|k... ¹ Auch: äg...

EGmuH = Eingetragene Genossenschaft mit unbeschränkter Haftpflicht (auch: eGmuH; vgl. eingetragen)

ego [auch: ego] *lat.* (ich); vgl. Alter -; Ego|is|mus (Selbstsucht; Ggs.: Altruismus) *m*; -, ...men; Ego|ist (↑R 268); egoi|stisch; -ste (↑R 294)

Egolf (m. Vorn.)

Egon (m. Vorn.)

Ego|tis|mus *lat.* (Neigung, sich selbst in den Vordergrund zu stellen) *m*; -; Ego|tist (↑R 268); Ego|zen|trik (Ichbezogenheit) *w*; -; Ego|zen|tri|ker (ichbezogener Mensch); ego|zen|trisch

egre|nie|ren *fr.* (Baumwollfasern von den Samen trennen); Egre|nier|ma|schi|ne

Egyp|ti|enne *fr.* [*eschipßiän*] (eine Antiquaschriftart) *w*; -

¹eh südd., österr. (ohnehin, sowieso)

²eh!

eh'! vgl. ehe

e. h. = ehrenhalber; (österr·) eigenhändig

E. h. = Ehren halber¹, in: Dr.-Ing. E. h.

ehe; ehedem: - denn; ehe (eh') ich das nicht weiß, ...; (↑R 241:) seit eh und je; vgl. eher u. eheste

Ehe *w*; -, -n; ehe|ähn|lich; Ehe|an|bah|nungs|in|sti|tut

ehe|bal|dig österr. (möglichst bald)

Ehe|be|ra|tung, ...be|ra|tungs|stel|le, ...bett; ehe|bre|chen; ich breche die Ehe; ich habe die Ehe gebrochen; die Ehe zu brechen; Ehe|bre|cher, ...bre|che|rin (*w*; -, -nen); ehe|bre|che|risch; Ehe|bruch *m*

ehe|dem (vormals)

Ehe|fä|hig|keit, ...frau, ...füh|rung, ...gat|te, ...ge|spons (scherzh.)

ehe|ge|stern (veraltend· vor längerer Zeit); gestern und -

Ehe|glück, ...gü|ter|recht, ...ha|fen (scherzh.), ...hälf|te (scherzh.); ehe|herr|lich; -e Gewalt; Ehe|hin|der|nis, ...krach, ...kri|se, ...leu|te (*Mehrz.*); ehe|lich; -es Güterrecht; ehe|li|chen; Ehe|lich|keit (Abstammung aus rechtsgültiger Ehe) *w*; -; Ehe|lich|keits|er|klä|rung (BGB); ehe|los; Ehe|lo|sig|keit *w*; -

ehe|ma|lig; ehe|mals

ehe|mann (*Mehrz.* ...männer;)

ehe|männ|lich; -e Gewalt; Ehe|paar, ...part|ner

eher; je eher (früher), je lieber; je eher (früher), desto besser; eher

Getrenntschreibung nur in diesem Titel, sonst: ehrenhalber, vgl.

([viel]mehr) klein [als groß]; er wird es um so eher (lieber) tun, als ...

Ehe|recht, ...ring

ehern; -es (unveränderliches) Gesetz; -es Lohngesetz (Sozialwissenschaft), aber (↑R 224): die Eherne Schlange (bibl.)

Ehe|ro|man, ...schei|dung, ...schlie|ßung, ...stand (*m*; -[e]s)

ehe|ste; -ns; (↑R 134:) des -n, am -n, mit -m

Ehe|streit, ...tra|gö|die, ...ver|bot, ...ver|mitt|lung, ...ver|spre|chen, ...ver|trag, ...weib (scherzh.); ehe|wid|rig; -es Verhalten

...ehig (z. B. einehig)

Ehr|ab|schnei|der; ehr|bar; Ehr|bar|keit *w*; -; ehr|be|gie|rig; Ehr|be|gier|de; ehr|er|bie|tig; Eh|re *w*; -, -n; in, mit -n; vgl. E. h.; eh|ren; Eh|ren|amt; eh|ren|amt|lich; Eh|ren.be|zei|gung (nicht: ...bezeugung), ...bür|ger, ...dienst, ...dok|tor (Abk.: Dr. h. c. u. Dr. E. h.), ...ein|tritt (bei Intervention [bei einem Wechsel]), ...er|klä|rung, ...fä|hig|keit (*w*; -); Eh|ren|fried (m. Vorn.); Eh|ren.ga|be, ...gar|de, ...gast (*Mehrz.*...gäste), ...ge|richt, ...ge|schenk; eh|ren|haft; Eh|ren|haf|tig|keit *w*; -; eh|ren|hal|ber (vgl. aber E. h.); Eh|ren.kar|te, ...ko|dex, ...kom|pa|nie, ...le|gi|on (Fr. Orden; *w*;-), ...mal (*Mehrz.* ...ma|le u. ...mäler), ...mann (*Mehrz.* ...männer), ...mit|glied, ...na|del, ...na|me, ...pen|si|on, ...pflicht, ...platz, ...preis (Gewinn; vgl. ²Preis), ...preis (Name verschiedener Pflanzen; *s* od. *m*; -es, -), ...pro|mo|ti|on, ...rat, ...rech|te (*Mehrz.*); die bürgerlichen -; eh|ren|reich; Eh|ren|ret|tung; eh|ren|rüh|rig; Eh|ren|run|de; Eh|ren|sa|che; das ist für mich eine -; Ehrensache! (ugs· für· selbstverständlich!); Eh|ren.sa|lut, ...sal|ve; eh|ren|schän|de|risch; Eh|ren.schuld, ...sold, ...spa|lier, ...stand|punkt, ...stra|fe, ...tag, ...tanz, ...ti|tel, ...tor *s*; Eh|ren|traud, Eh|ren|trud (w. Vorn.); Eh|ren.tri|bü|ne, ...ur|kun|de; eh|ren|voll, ...wert; Eh|ren|wort (*Mehrz.*...worte), ...zei|chen; ehr|er|bie|tig; Ehr|er|bie|tig|keit *w*; -; Ehr|furcht *w*; -, (selten) -en; ehr|fürch|tig; ehr|furchts.los, ...voll; Ehr|ge|fühl (*s*; -[e]s), ...geiz; ehr|gei|zig; Ehr|geiz|ling; ehr|lich; ein -er Makler (unparteiischer Vermittler) sein; ehr|li|cher|wei|se; Ehr|lich|keit *w*; -; ehr|lie|bend; ehr|los; -este (↑R 292); Ehr|lo|sig|keit; ehr|pus|se|lig, ehr|puß|lig (mit einem kleinlichen, spießigen Ehr-

begriff); Ehr|pus|se|lig|keit, Ehr|puß|lig|keit; ehr|sam; Ehr|sam|keit *w*; -; Ehr|sucht *w*; -; ehr|süch|tig; Eh|rung; ehr|ver|ges|sen; Ehr|ver|lust *m*; -[e]s; Ehr|wür|den (kath. Kirche [veraltend]: Anrede für Brüder u. Schwestern in geistl. Orden u. Kongregationen); ehr|wür|dig; Ehr|wür|dig|keit *w*; -

ei!; ei, ei!; ei machen

Ei *s*; -[e]s, -er

...ei (z. B. Bäckerei *w*; -, -en)

eia!, eia|po|peia!, heia|po|peia!

Ei|be (ein Nadelbaum) *w*; -, -n; ei|ben (aus Eibenholz)

Ei|bisch (eine Heilpflanze) *m*; -[e]s, o; Ei|bisch|tee *m*; e

Eib|see *m*; -s

Eich (dt. Lyriker u. Hörspielautor)

Eich|amt

Ei|che *w*; -, -n

Eich|baum, Ei|chen|baum; ¹Ei|che (ein Baum) *w*; -, -n

²Ei|che (Eichung; Maischemaß) *w*; -, -n

Ei|chel *w*; -, -n; Ei|chel|hä|her (ein Vogel); Ei|chel|mast *w*; Ei|cheln (Farbe im dt. Kartenspiel) *Mehrz.*, ei|chen (aus Eichenholz)

²ei|chen (das gesetzl. Maß geben; prüfen)

Ei|chen (kleines Ei) *s*; -s, - u. Eierchen

Ei|chen|baum, Eich|baum

Ei|chen|dorff (dt. Dichter)

Ei|chen.hain, ...holz, ...klotz, ...kranz, ...laub, ...schäl|wald, ...stock (*Mehrz.* ...stöcke), ...tisch, ...wick|ler (ein Schmetterling)

Ei|cher (Eichmeister); Eich|ge|wicht

Eich.hörn|chen, ...kätz|chen od. ...kat|ze (ein Nagetier)

Eich.maß *s*, ...mei|ster (Beamter beim Eichamt), ...me|ter

Eichs|feld (Landschaft) *s*; -[e]s

Eich|stätt (Stadt in der Fränkischen Alb)

Eich.stem|pel, ...strich; Ei|chung

Eld *m*; -[e]s, -e; an -es Statt

Ei|dam (veralt. für: Schwiegersohn) *m*; -[e]s, -e

Eid.bruch *m*; eid|brü|chig

Ei|dechs|chen, Ei|dechs|lein; Ei|dech|se *w*; -, -n; Ei|dech|sen|le|der

Ei|der (ein Fluß) *w*; -

Ei|der.dau|ne *isländ.*; *dt.*; Ei|der.en|te, ...gans

Ei|der|stedt (Halbinsel an der Nordseeküste); Ei|der|sted|ter (↑R 199)

Eides|for|mel; Ei|des|hel|fer, Eid|hel|fer; Ei|des|lei|stung; ei|des|statt|lich (an Eides Statt); -e Versicherung

Ei|de|tik *gr.* (Psych.: Fähigkeit, früher Geschehenes od. Vorge-

stelltes anschaulich zu vergegen-
wärtigen) w; -; Ei|de|ti|ker; ei|de-
tisch

Eid|ge|nos|se; Eid|ge|nos|sen-
schaft w; -; Schweizerische Eidge-
nossenschaft (amtl. Name der
Schweiz); eid|ge|nös|sisch, a b e r
(↑ R 224): Eidgenössische Tech-
nische Hochschule (in Zürich;
Abk.: ETH); Eid|hel|fer, Ei|des-
hel|fer); eid|lich

Ei|dot|ter (das Gelbe in Ei); Ei|er-
bri|kett; Ei|er|chen (Mehrz. von:
Eichen); ei|er|gelb; Eiklar vgl.
Eier|klar vgl. Eiklar; Ei|er_kopf
(für: Egghead), ...korb, ...ku-
chen, ...li|kör; ei|ern (ugs.); das
Rad eiert; Ei|er_scha|le, ...schek-
ke (landsch.: eine Kuchensorte),
...schwamm (landsch. für: Pfiffer-
ling), ...speis od. ...spei|se (österr.
für: Rührei), ...spei|se (Gericht,
für das bes. Eier verwendet wer-
den), ...stich (Suppeneinlage aus
Ei), ...stock (Mehrz. ...stöcke),
...tanz, ...tätsch (schweiz. mdal.:
Eierpfannkuchen; m; -[e]s, -e),
...uhr

Ei|fel (Teil des westl. Rhein. Schie-
fergebirges) w; -; Ei|fe|ler, Eif|ler
(↑ R 199)

Ei|fer m; -s; Ei|fe|rer; ei|fern; ich
...ere (↑ R 327); Ei|fer|sucht w; -;
Ei|fer|süch|te|lei; ei|fer|süch|tig;
Ei|fer|suchts|sze|ne

Eif|fel|turm; ↑ R 180 (in Paris) m;
-[e]s

Eif|ler vgl. Eifeler

ei|för|mig

eif|rig; Eif|rig|keit w; -

Ei|gelb (Dotter) s; -s, -e; 3 - (↑ R
322)

ei|gen; eig[e]ne; zu - geben, ma-
chen; mein - Kind, mein eig[e]ner
Sohn; es ist, ich nenne es mein
-; das ist ihm -; aus eig[e]nem
bezahlen; eigene Aktien
(Wirtsch.); vgl. volkseigen; Ei-
gen (Besitz) s; -s; Ei|gen|art; ei-
gen|ar|tig; Ei|gen_ar|tig|keit, w; -;
...bau (m; -s), ...be|darf, ...be-
richt, ...be|sitz (BGB), ...be|sit|zer
(BGB), ...be|we|gung; Ei|gen_bro-
te|lei; Ei|gen|bröt|le|rei; ei|gen-
bröt|le|risch; -ste (↑ R 294); Ei-
gen_dün|kel; Ei|ge|ne, Eig|ne (Ei-
gentum; Eigenart) s; -n; -es und
Fremdes; Ei|gen_fi|nan|zie|rung,
...ge|schwin|dig|keit; angezeigte
-; ei|gen|ge|setz|lich; Ei|gen_ge-
setz|lich|keit, ...ge|wicht; ei|gen-
hän|dig (Abk. österr.: e. h.); -es
Delikt (Rechtsspr.); Ei|gen|hän-
dig|keit w; -; Ei|gen_heim, ...hei-
mer, ...heit, ...hil|fe, ...in|itia|ti|ve,
...ka|pi|tal, ...kir|che, ...le|ben,
...lei|stung, ...lie|be, ...lob; ei|gen-
mäch|tig; ei|gen|mäch|tig|er|wei-

se; Ei|gen_mäch|tig|keit, ...mar-
ke, ...mit|tel (s; meist Mehrz.),
...na|me, ...nutz (m; -es); ei|gen-
nüt|zig; Ei|gen_nüt|zig|keit (w; -),
...per|sön|lich|keit, ...pro|duk|ti-
on; ei|gens (geh.); Ei|gen|schaft;
Ei|gen|schafts|wort (für: Adjek-
tiv; Mehrz. ...wörter); ei|gen-
schafts|wört|lich; Ei|gen_schwin-
gung, ...sinn (m; -[e]s); ei|gen|sin-
nig; Ei|gen|sin|nig|keit; ei|gen-
staat|lich; Ei|gen|staat|lich|keit
w; -; ei|gen|stän|dig; Ei|gen_stän-
dig|keit (w; -), ...süch|tig (w; -); ei-
gen|süch|tig; ei|gent|lich (Abk.:
eigtl.); Ei|gent|lich|keit; Ei|gen-
tor (Sportspr.; s)

Ei|gen|tum s; -s; Ei|gen|tü|mer; ei-
gen|tüm|lich; Ei|gen|tüm|lich-
keit; Ei|gen|tums_bil|dung, ...de-
likt, ...recht, ...streu|ung, ...ver-
ge|hen, ...woh|nung

ei|gen|ver|ant|wort|lich; Ei|gen-
_ver|brauch, ...ver|si|che|rung,
...wär|me, ...wech|sel (für: Sola-
wechsel), ...wert (m; -[e]s); ei|gen-
wer|tig; ei|gen|wil|le; ei|gen|wil-
lig; Ei|gen|wil|lig|keit; eig|nen; et-
was eignet ihm (ist ihm eigen);
sich - (passen); Eig|ne vgl. Eigene.
eig|ner, ei|ge|ner vgl. eigen; Eig|ner
([Schiffs]eigentümer); Eig-
nung (Befähigung); Eig|nungs-
_prüfung, ...test

eigtl. = eigentlich

...ei|ig (z. B. eineiig)

Ei|klar, Ei|er|klar österr. (Eiweiß)
s; -s, -

Eil|an|ge|bot

Eil|bert (m. Vorn.)

Eil_bo|te, ...brief; Ei|le w; -

Ei|lei|ter m

ei|len; eile mit Weile!; ei|lends; eil-
fer|tig; Eil|fer|tig|keit; Eil|gut;
Eil|gü|ter|zug

Eil|hard (m. Vorn.)

ei|lig; (↑ R 116:) etwas Eiliges
(Wichtiges) besorgen; nichts Eili-
geres (Wichtigeres) zu tun haben,
als ...; Eil_marsch, ...schritt,
...tem|po, ...trieb|wa|gen, ...zug
(Zeichen: E)

Ei|mer m; -s, -; ei|mer|wei|se

¹ein; I. Unbestimmtes Ge-
schlechtsw. (nicht betont; als Bei-
fügung zu einem Hauptw.
[Fürw.]): es war ein Mann, nicht
eine Frau; es war ein Kind und
kein Erwachsener; eines Mannes,
Kindes; ein anderer, jeder; eines
jeden [Mannes] Hilfe ist wichtig.
II. Unbestimmtes Fürw. 1. (allein-
stehend): wenn einer (jemand)
etwas nicht versteht, dann soll
er darüber nicht reden; das kann
einer (man) doch völlig verrückt
werden; wenn einer, (ugs.:) eins

(jemand) das hört!; nach den
Aussagen eines (jemandes), der
dabei war ...; ein[e]s (etwas) fehlt
ihm: Geduld; das tut einem (mir)
wirklich leid; sie sollen einen in
Ruhe lassen; einer (irgendeiner)
dieser Burschen; einer von uns,
unsereiner; ein[e]s (irgendein[e]s)
von uns Kindern; (ugs.:) einen
(einen Schnaps) heben; eins (ein
Lied) singen; gib ihm eins (eine
Schlag); jmdm. eins auswischen.
2. (in [hinweisender] Gegenüber-
stellung): ein[er] und der and[e]-
re; eins kommt nach dem and[e]-
ren, andern; vom einen, von ei-
nem (von diesem) zum and[e]ren,
andern (zu jenem); die einen (die-
se) [Zuschauer] klatschten, die
and[e]ren, andern (jene) [Zu-
schauer] pfiffen; eins (dieses) geht
ins and[e]re (in jenes) über. III.
Zahlw. (betont; als Beifügung
oder alleinstehend): es war ein
Mann, eine Frau, ein Kind [es
waren nicht zwei]; wenn [nur] ei-
ner das erfährt, dann ist der Plan
zunichte; einer für alle und alle
für einen; der eine, a b e r (↑ R
118): der Eine (Bez. für: Gott);
ein[e]s der beiden Pferde, nicht
beide; einer, eine, ein[e]s von uns,
nicht zwei; eins von beiden; zwei
Augen sehen mehr als ein[e]s; mit
einem Schlag; in einem fort; unter
einem (österr.: zugleich); zwei
Pfund Wurst in einem [Stück];
in ein[er] und einem halben Jahr;
in ein[er] und derselben Straße;
ein und dieselbe Sache; es läuft
alles auf eins (ein u. dasselbe) hin-
aus; sie stehen alle wie ein Mann
ein Herz und eine Seele; sein ein
und [sein] alles; einundzwanzig
einmal; einhalbmal; ein für alle-
mal; ein oder mehrmals (vgl
Mal, II); es ist zwei Tage; eins

²ein; Umstandsw.: nicht ein noch
aus wissen (ratlos sein); wer be
dir ein und aus geht (verkehrt)
a b e r in Zus.; ↑ R 145): ein- un
aussteigen (einsteigen und aus
steigen); ein... (in Zus. m
Zeitwörtern, z. B. einbürgern, d
bürgerst ein, eingebürgert, einzu
bürgern; zum 2. Mittelw. ↑ R 304

Ein|achs|an|hän|ger; ein|ach|sig

Ein|ak|ter (Bühnenstück aus nu
einem Akt); ein|ak|tig

ein|an|der; vgl. an-, auf-, aus
beieinander usw.

ein|ant|wor|ten österr. (Amtsspr
für: übergeben); Ein|ant|wor
tung (österr.)

Ei|nar (m. Vorn.)

ein|ar|bei|ten; Ein|ar|bei|tung

ein|ar|mig

ein|äschern; ich äschere ein (↑

327); ein|geäschert (Zeichen: Ö);
Ein|äsche|rung; Ein|äsche|rungs-
hal|le (für: Krematorium)
ein|at|men
ein|ät|zen
ein|äu|gig
Ein|back (ein Gebäck) m; -[e]s, -e
u. ...bäcke u. (ugs.:) -s
Ein|bahn|stra|ße
ein|bal|lie|ren (in Ballen verpak-
ken); Ein|bal|lie|rung
ein|bal|lig, ein|bäl|lig; - (über den-
selben [geraden] Leisten) gear-
beitete Schuhe
ein|bal|sa|mie|ren; Ein|bal|sa|mie-
rung
Ein|band (Bucheinband) m; -[e]s,
...bände; Ein|band|decke [Trenn.:
...dek|ke]; ein|bän|dig
ein|ba|sisch (Chemie); -e Säure
Ein|bau m; -[e]s, (für: eingebauter
Teil auch Mehrz.:) -ten; ein|bau-
en
Ein|baum (Boot aus einem aus-
gehöhlten Baumstamm)
Ein|bau|leuch|te, ...mö|bel; ein-
bau|reif; Ein|bau_schrank, ...teil s
Ein|bee|re (eine Giftpflanze)
ein|be|grif|fen, in|be|grif|fen
(österr. nur so); in dem od. den
Preis [mit] einbegriffen; alle wa-
ren beteiligt, er einbegriffen; er
erinnerte sich aller Beteiligten,
ihn einbegriffen; der Tadel galt
allen, ihn einbegriffen; er zahlte
die Zeche, den Wein einbegriffen
ein|be|hal|ten
ein|bei|nig
ein|be|ken|nen österr. (eingeste-
hen); Ein|be|kennt|nis
ein|be|rech|nen
ein|be|ru|fen; Ein|be|ru|fe|ne m u.
w; -n, -n (↑ R 287ff.); Ein|be|ru-
fung; Ein|be|ru|fungs|be|fehl
ein|be|schlie|ßen
ein|be|schrie|ben (Math.); -er
Kreis (Inkreis)
ein|be|stel|len (Amtsdt.: [zur Un-
tersuchung] an einen bestimmten
Ort bestellen)
ein|be|to|nie|ren
ein|bet|ten; vgl. eingebettet; Ein-
bet|tung
ein|beu|len
ein|be|zie|hen; Ein|be|zie|hung; un-
ter - von ...
ein|bie|gen; Ein|bie|gung
ein|bild|bar; ein|bil|den, sich; Ein-
bil|dung; Ein|bil|dungs|kraft w; -
ein|bim|sen (ugs. für: durch ange-
strengtes Lernen einprägen)
ein|bin|den
ein|bla|sen; Ein|blä|ser (Schü-
lerspr. auch: Vorsager)
Ein|blatt; Ein|blatt|druck (Mehrz.
...drucke)
ein|bläu|en (blau machen); vgl.
aber: einbleuen

ein|blen|den; sich -; Ein|blen|dung
ein|bleu|en (ugs. für: mit Nach-
druck einprägen, einschärfen);
vgl. aber: einbläuen
Ein|blick
ein|boh|ren; sich -
ein|bre|chen; in ein[em] Haus -;
Ein|bre|cher
Ein|brenn (österr.) w; -, -en u. Ein-
bren|ne bes. südd. u. österr.
(Mehlschwitze) w; -, -n; ein|bren-
nen; Ein|brenn|sup|pe (österr.)
ein|brin|gen; ein|bring|lich; Ein-
brin|gung
ein|brocken [Trenn.: ...brok|ken];
sich, jmdm. etwas - (ugs. für:
Unannehmlichkeiten bereiten)
Ein|bruch m; -[e]s, ...brüche; Ein-
bruch[s]|dieb|stahl; ein|bruch[s]-
si|cher; Ein|bruch|stel|le; Ein-
bruch[s]|werk|zeug
ein|buch|ten (ugs. auch für: ins Ge-
fängnis sperren); Ein|buch|tung
ein|bud|deln (ugs.)
Ein|bund schweiz. (Patenge-
schenk) m; -[e]s, ...bünde; vgl.
Eingebinde
ein|bun|kern (ugs. auch für: ins Ge-
fängnis sperren)
ein|bür|gern; ich bürgere ein (↑ R
327); sich -; Ein|bür|ge|rung
Ein|bu|ße; ein|bü|ßen
ein|cre|men
ein|däm|men; Ein|däm|mung
ein|damp|fen; Ein|damp|fung
ein|decken [Trenn.: ...dek|ken];
sich -; Ein|decker [Trenn.: ...dek-
ker] (Flugzeugtyp)
ein|dei|chen; Ein|dei|chung
ein|del|len (ugs.: eine Delle in et-
was machen)
ein|deu|tig; Ein|deu|tig|keit
ein|deut|schen; ich deutsche ein; du
deutschst (deutschest) ein; Ein-
deut|schung
ein|dicken [Trenn.: ...dik|ken]
ein|di|men|sio|nal
ein|docken [Trenn.: ...dok|ken]
(ins Dock transportieren)
ein|do|sen (in Dosen einkochen;
du dost (dosest) ein; sie do|ste
ein
ein|dö|sen (ugs. für: in Halbschlaf
fallen; einschlafen)
ein|drän|gen, sich
ein|dre|hen; sich die Haare -
ein|dre|schen; er hat auf das Pferd
eingedroschen
ein|dril|len (ugs. für: einüben)
ein|drin|gen; ein|dring|lich; auf
das, aufs -ste (↑ R 134); Ein|dring-
lich|keit w; -; Ein|dring|ling; Ein-
drin|gung
Ein|druck m; -[e]s, ...drücke; ein-
drucken [Trenn.: ...druk|ken];
ein|drücken [Trenn.: ...drük|ken];
ein|drück|lich (schweiz., sonst
veralt. für: eindrucksvoll); ein-
drucks|voll

ein|dü|beln (mit einem Dübel befe-
stigen)
ein|du|seln (ugs.: in Halbschlaf
fallen)
ei|ne; I. Unbestimmtes Ge-
schlechtsw.: vgl. [1]ein, I. II. Unbe-
stimmtes Fürw.: vgl. [1]ein, II. III.
Zahlw.: vgl. [1]ein, III.
ein|eb|nen; Ein|eb|nung
Ein|ehe (für: Monogamie); ein-
ehig (für: monogam)
ein|ei|ig
ein|ein|deu|tig (Math.: umkehrbar
eindeutig)
ein|ein|halb, ein|und|ein|halb; -
Tag[e], ein- und ein halber
Tag; ein[und]einhalbmal soviel
Ei|nem, von (österr. Komponist)
ei|nen (geh. für: einigen)
ei|nen|gen; Ein|en|gung
ei|ner; I. Unbestimmtes Fürw.: vgl.
[1]ein, I. II. Zahlw.: vgl. [1]ein, III.;
[1]Ei|ner, Ein|ser; [2]Ei|ner (Sport-
boot für einen Mann); Einer|ka-
jak; ei|ner|lei; Ei|ner|lei s; -s; ei-
ner|seits; einerseits - ander[er]-
seits, andrerseits; ei|nes; I. Unbe-
stimmtes Geschlechtsw. (Wesf.):
vgl. [1]ein, I. II. Unbestimmtes
Fürw.: vgl. [1]ein, II. III. Zahlw.:
vgl. [1]ein, III.; ei|nes|teils; eines-
teils - ander[e]nteils
ein|ern|ten
ein|ex|er|zie|ren
ein|fach; -e Blüten (Bot.); -er
Bruch; -e Buchführung; -e Fahrt;
-e Mann; - wirkend; -es Wort
(für: Simplex); (↑ R 116:) [sich]
etwas Einfaches [wünschen]; Ein-
fa|che s; -n (↑ R 287ff.); das - einer
Zahl; ein|fä|chern; Ein|fach|heit
w; -; der - halber
ein|fä|deln; Ein|fä|de|lung, Ein-
fäd|lung
ein|fah|ren; Ein|fahr|si|gnal (fach-
spr.); Ein|fahrt; Ein|fahr[s]_er-
laub|nis, ...ge|lei|se od. ...gleis,
...si|gnal, ...wei|che (vgl. [1]Wei-
che)
Ein|fall m; ein|fal|len; Ein|fallicht
[Trenn.: ...fall|licht, ↑ R 236] s;
-[e]s, -er; ein|falls|los; Ein|falls|lo-
sig|keit w; -; ein|fall[s]|reich; Ein-
fall[s]|win|kel
Ein|falt w; -; ein|fäl|tig; Ein|falts-
pin|sel (abschätzig)
ein|fal|zen; Ein|fal|zung
Ein|fa|mi|li|en|haus
ein|fan|gen
ein|fär|ben; ein|far|big, (österr.:)
ein|fär|big
ein|fa|schen österr. (verbinden);
vgl. Fasche
ein|fas|sen; Ein|fas|sung
ein|fen|zen dt.; engl. (einfriedigen,
einzäunen); du fenzt (fenzest) ein
ein|fet|ten; Ein|fet|tung
ein|fil|trie|ren
ein|fin|den, sich

ein|flech|ten; Ein|flech|tung
ein|flicken [*Trenn.*: ...flik|ken]
ein|flie|gen
ein|flie|ßen
ein|flö|ßen; Ein|flö|ßung
Ein|flug; ein|flü|ge|lig, ein|flüg|lig;
Ein|flug|schnei|se (Flugw.)
Ein|fluß; Ein|fluß|be|reich m,
...nah|me (Amtsdt.; w; -, selten:
-n); ein|fluß|reich
ein|flü|stern; Ein|flü|ste|rung
ein|for|dern
ein|för|mig; Ein|för|mig|keit
ein|fres|sen, sich; der Rost hatte
sich tief eingefressen
ein|frie|den, ein|frie|di|gen (einhe-
gen); Ein|frie|di|gung, Ein|frie-
dung
ein|frie|ren; Ein|frie|rung
ein|fro|sten; Ein|fro|stung
ein|fü|gen; sich -; Ein|fü|gung
ein|füh|len, sich; Ein|füh|lung; Ein-
füh|lungs|ga|be (w; -), ...kraft (w;
-), ...ver|mö|gen (s; -s)
Ein|fuhr w; -, -en; ein|fuhr|be-
schrän|kung; ein|füh|ren; Ein-
fuhr_ha|fen (vgl. ¹Hafen), ...kon-
tin|gent, ...sper|re; Ein|füh|rung;
Ein|füh|rungs_kurs, ...preis (vgl.
²Preis), ...vor|trag; Ein|fuhr_ver-
bot, ...zoll
ein|fül|len; Ein|füll|öff|nung
ein|füt|tern (einhüllen; einpro-
grammieren)
Ein|ga|be
Ein|gang; im Eingang[e]; Ein- und
Ausgang (↑ R 145); ein|gän|gig;
ein|gangs (Papierdt.; ↑ R 129 u.
130); mit *Wesf.*: - des Briefes; Ein-
gangs_hal|le, ...stro|phe, ...tor s
ein|ge|äschert (Zeichen: ⊙)
ein|ge|ben
ein|ge|bet|tet; - in die od. in der
Landschaft
ein|ge|bil|det; - sein
Ein|ge|bin|de (veralt. für: Patengе-
schenk)
ein|ge|bo|ren; der eingebor[e]ne
Sohn [Gottes]; Ein|ge|bo|re|ne,
Ein|ge|bor|ne m u. w; -n, -n (↑ R
287ff.); Ein|ge|bo|re|nen|spra|che
ein|ge|bracht; -es Gut (Rechts-
spr.); Ein|ge|brach|te (veralt. für:
Heiratsgut) s; -n (↑ R 287ff.)
Ein|ge|bung
ein|ge|denk; mit *Wesf.*: - des Ver-
dienstes
ein|ge|fal|len; mit -em Gesicht
ein|ge|fleischt; ein -er Junggeselle
ein|ge|frie|ren
ein|ge|fuchst (ugs. für: eingearbei-
tet)
ein|ge|hen; ein|ge|hend; auf das,
aufs -ste (↑ R 134)
ein|ge|keilt; in eine[r] Menge -
ein|ge|lei|sig, ein|glei|sig
ein|ge|lernt
Ein|ge|mach|te s; -n (↑ R 287ff.)
ein|ge|mein|den; Ein|ge|mein|dung

ein|ge|nom|men (begeistert); er ist
von dem Plan sehr -; Ein|ge|nom-
men|heit w; -
ein|ge|rech|net; den Überschuß -
Ein|ge|rich|te (innere Bauart beim
Türschloß) s; -s, -
ein|ge|sandt; Ein|ge|sandt (veralt.
für: Leserzuschrift) s; -s, -s
ein|ge|schlech|tig (für: diklin)
ein|ge|schlos|sen; - im, (auch:) in
den Preis
ein|ge|schos|sig
ein|ge|schwo|ren; er ist auf diese
Musik -
ein|ge|ses|sen (einheimisch)
Ein|ge|sot|te|ne österr. (einge-
machte Früchte) s; -n (↑ R 287ff.)
ein|ge|spielt; sie sind aufeinander -
ein|ge|sprengt; -es Gold
ein|ge|stan|de|ner|ma|ßen, ein|ge-
stand|ner|ma|ßen; Ein|ge|ständ-
nis; ein|ge|ste|hen
ein|ge|stri|chen (Musik)
ein|ge|tra|gen, aber (↑ R 224): Ein-
getragene¹ Genossenschaft mit
beschränkter Haftpflicht (Abk.:
EGmbH), Eingetragene¹ Genos-
senschaft mit unbeschränkter
Haftung (Abk.: EGmuH), Ein-
getragener¹ Verein (Abk.: E. V.)
Ein|ge|tropf|te österr. (Tropfteig)
s; -n (↑ R 287ff.)
Ein|ge|wei|de s; -s, - (meist
Mehrz.); Ein|ge|wei|de|bruch
Ein|ge|weih|te m u. w; -n, -n (↑ R
287ff.)
ein|ge|wöh|nen; sich -; Ein|ge|wöh-
nung
ein|ge|zo|gen; - (zurückgezogen)
leben; Ein|ge|zo|gen|heit w; -
ein|gie|ßen; Ein|gie|ßung
ein|gip|sen; ein Bein -; einen Ha-
ken -
ein|git|tern; Ein|git|ter|röh|re (für:
Triode)
Ein|glas (für: Monokel; *Mehrz.*
...gläser); ein|gla|sen
ein|glei|sen (wieder auf das Gleis
bringen); du gleist (gleisest) ein;
er gleiste ein; ein|glei|sig, ein|ge-
lei|sig
ein|glie|dern; sich -; Ein|glie|de-
rung
ein|gra|ben; Ein|gra|bung
ein|gra|vie|ren [...*wir^en*]
ein|grei|fen
ein|gren|zen; Ein|gren|zung
Ein|griff; Ein|griffs|mög|lich|keit
ein|grü|nen; Ein|grü|nung
ein|grup|pie|ren; Ein|grup|pie|rung
Ein|guß (Technik)
ein|hacken [*Trenn.*: ...hak|ken];
der Raubvogel hackte auf die
Beute ein

¹ Aber auch häufig: eingetrage-
ne Genossenschaft... (eGmbH,
eGmuH), eingetragener Verein
(e. V.).

ein|ha|ken; den Riemen -; sich bei
jmdm. -; er hakte hier ein (unter-
brach das Gespräch)
ein|halb|mal; - so teuer
Ein|halt m; -[e]s - gebieten, tun;
ein|hal|ten; Ein|hal|tung
ein|häm|mern
ein|han|deln
ein|hän|dig; ein|hän|di|gen; Ein-
hän|di|gung
ein|hän|gen; vgl. ²hängen; Ein|hän-
ge|öse (Technik)
Ein|hard vgl. Eginhard
ein|har|ken nordd. ([Samen, Dün-
ger] mit der Harke unter das Erd-
reich mischen)
ein|hau|chen; Ein|hau|chung
ein|hau|en; er hieb auf die Fliehen-
den ein; er haute tüchtig ein (ugs.
für: aß tüchtig)
ein|häu|sig (Bot.: monözisch)
ein|he|ben; einen Betrag- (landsch.
für: einziehen); Ein|he|bung
ein|hef|ten
ein|he|gen; Ein|he|gung
ein|hei|len; Ein|hei|lungs|stö|rung
(Med.)
ein|hei|misch; Ein|hei|mi|sche m u.
w; -n, -n (↑ R 287ff.)
ein|heim|sen; du heimst (heimsest)
ein
Ein|hei|rat; ein|hei|ra|ten
Ein|heit; Tag der deutschen - (17.
Juni); ein|heit|lich; -e Wirt-
schaftswissenschaft; Ein|heit-
lich|keit w; -; Ein|heits_front,
...ge|werk|schaft, ...kurz|schrift,
...li|ste, ...par|tei, ...preis (vgl.
²Preis), ...staat, ...wert
ein|hei|zen
ein|hel|fen (vorsagen); jmdm. -
ein|hel|lig; Ein|hel|lig|keit w; -
ein|hen|ke|lig, ein|henk|lig; ein-
hen|keln; ich henk[e]le ein (↑ R
327)
ein|her...; ein|her_fah|ren, ...ge-
hen; (zum 2. Mittelw. ↑ R 304:)
er ist einhergefahren, einherge-
gangen
Ein|he|ri|er [...*i^er*] (nord. Mythol.:
der gefallene Kämpfer in Wal-
hall) m; -s, -
ein|her|schrei|ten (geh.)
ein|hie|ven [...*hif*...]; die Ankerket-
te - (Seemannsspr.: einziehen)
ein|höcke|rig [*Trenn.*: ...hök-
kerig], ein|höck|rig
ein|ho|len; Ein|hol_netz, ...ta|sche;
Ein|ho|lung
Ein|horn (ein Fabeltier; *Mehrz.*
...hörner)
ein|hu|fer; ein|hu|fig
ein|hül|len; Ein|hül|lung
ein|hun|dert; vgl. hundert
ein|hü|ten nordd. (sich in jmds
Abwesenheit um die Wohnung
kümmern)
ei|nig; *Schreibung in Verbindung
mit Zeitwörtern* (↑ R 139); [sich

einig sein, werden; vgl. aber: einiggehen; ei|ni|ge; einige (mehrere) Häuser weiter; einige Stunden später; einige tausend Schüler; -s, was; einige (etwas; oft auch: [sehr] viel) Mühe hat dies bereitet; einiges Geld konnte ich verdienen; dieser Schüler wußte einiges (↑ R 135); (↑ R 280:) einiger politischer Sinn; einiges milde Nachsehen; bei einigem guten Willen; (↑ R 286.) einige gute Menschen; die Taten einiger guter (seltener: guten) Menschen; (↑ R 290:) mit einigem Neuen

ein|igeln, sich; ich igelle mich ein (↑ R 327); Ein|ige|lung

ei|ni|ge|mal [auch: ainigᵉmạl], aber: ei|nige Ma|le; ei|ni|gen; sich -; Ei|ni|ger; ei|ni|ger|ma|ßen; ei|ni|ges vgl. einige; ei|nig|ge|hen; ↑ R 139 (Kaufmannsspr.: übereinstimmen, dafür besser: einig sein); Ei|nig|keit w; -; Ei|ni|gung; Ei|ni|gungs_be|stre|bung (meist Mehrz.), ...werk

ein|imp|fen; Ein|imp|fung

ein|ja|gen; jmdm. einen Schrecken -

ein|jäh|rig; Ein|jäh|ri|ge m od w od. s; -n, -n (↑ R 287ff.); Ein|jäh|rig-Frei|wil|li|ge (im ehem. deutschen Heer) m; -n, -n (↑ R 287ff.)

ein|jo|chen

ein|ka|cheln (ugs.: sehr stark heizen)

ein|kal|ku|lie|ren (einplanen)

Ein|kam|mer|sy|stem s; -s

ein|kap|seln; ich kaps[e]le ein (↑ R 327); Ein|kap|se|lung, Ein|kaps|lung

ein|ka|rä|tig

ein|kas|sie|ren; Ein|kas|sie|rung

Ein|kauf; ein|kau|fen; Ein|käu|fer; Ein|kaufs_bum|mel, ...ge|nos|sen|schaft, ...netz, ...preis (vgl. ²Preis), ...quel|le, ...ta|sche, ...zen|trum

Ein|kehr w; -, -en; ein|keh|ren

ein|keim|blät|te|rig, ein|keim|blätt|rig (Bot.); -e Pflanzen (Pflanzen mit nur einem Keimblatt)

ein|kel|lern; ich kellere ein (↑ R 327); Ein|kel|le|rung; Ein|kel|le|rungs_kar|tof|feln Mehrz.

ein|ker|ben; Ein|ker|bung

ein|ker|kern; ich kerkere ein (↑ R 327); Ein|ker|ke|rung

ein|kes|seln; ich kessele ein (↑ R 327)

ein|kla|gen; einen Rechnungsbetrag -

ein|klam|mern; Ein|klam|me|rung

Ein|klang; mit etwas im od. in - stehen

ein|klas|sig; eine -e Schule

ein|kle|ben

ein|klei|den; Ein|klei|dung

ein|klem|men; Ein|klem|mung

ein|klin|ken

ein|knicken [Trenn.: ...knik|ken]; Ein|knickung [Trenn.: ...knik|kung]

ein|knöp|fen; Ein|knöpf|fut|ter (vgl. ²Futter)

ein|ko|chen; Ein|koch|topf

ein|kom|men; um etwas (Amtsdt.); Ein|kom|men s; -s, -; Ein|kom|mens|gren|ze; ein|kom|mens_los, ...schwach; Ein|kom|mens|steu|er, Ein|kom|men|steu|er w (↑ R 334); ein|kom|men|steu|er|pflich|tig; Ein|kom|mens_ver|hält|nis|se (Mehrz.), ...ver|tei|lung, ...zu|wachs

ein|köp|fen (Fußball: durch einen Kopfball ein Tor erzielen)

Ein|korn (eine Weizenart) s; -[e]s

ein|kra|chen (ugs.)

ein|krei|sen; Ein|krei|ser (auch: Rundfunkgerät); Ein|krei|sung; Ein|krei|sungs_po|li|tik

ein|kre|men vgl. eincremen

ein|krie|gen (ugs.)

ein|küh|len (durch Kühlanlage haltbar machen); Ein|küh|lung

ein|künf|te Mehrz.

ein|kup|peln; den Motor -

Ein|lad (schweiz. neben: Ein-, Verladung) m; -s; ¹ein|la|den; Waren -; vgl. ¹laden; ²ein|la|den; zum Essen -; vgl. ²laden; ein|la|dend; Ein|la|dung; Ein|la|dungs_kar|te, ...schrei|ben

Ein|la|ge

ein|la|gern; Ein|la|ge|rung

ein|lan|gen österr. (eintreffen)

Ein|laß m; ...lasses, ...lässe; ein|las|sen (südd. u. österr. auch für: mit Wachs einreiben; eindringen auf etwas -); Ein|laß_kar|te; ein|läß|lich schweiz. (gründlich); des -sten (↑ R 134); Ein|läß|lich|keit schweiz. w; -; Ein|las|sung (Rechtsspr.)

Ein|lauf; ein|lau|fen

ein|läu|ten; den Sonntag -

ein|le|ben, sich

Ein|le|ge_ar|beit; ein|le|gen; Ein|le|ger; Ein|le|ge|rin w; -, -nen; Ein|le|ge_soh|le; Ein|le|gung

ein|lei|ten; Ein|lei|tung; Einlei|tungs_ka|pi|tel

ein|len|ken; Ein|len|kung

ein|ler|nen

ein|le|sen, sich

ein|leuch|ten; dieser Grund leuchtet mir ein; ein|leuch|tend; -ste

Ein|lie|fe|rer; ein|lie|fern; Ein|lie|fe|rung; Ein|lie|fe|rungs_schein, ...ter|min

ein|lie|gend od. (österr. nur so:) in|lie|gend (Kaufmannsspr.); - (anbei, hiermit) der Bericht;

Ein|lie|ger (Mieter [bei einem Bauern]); Ein|lie|ger|woh|nung

ein|li|nig

ein|lo|chen (ugs. für: ins Gefängnis sperren)

ein|lo|gie|ren [...sehirᵉn]

ein|lös|bar; ein|lö|sen; Ein|lö|se|sum|me; Ein|lö|sung; Ein|lö|sungs_sum|me

ein|lul|len (ugs.)

Ein|mach österr. (Mehlschwitze) w; -; ein|ma|chen; Ein|mach_glas (Mehrz. ...gläser)

ein|mäh|dig (einschürig)

ein|mah|nen; Ein|mah|nung

ein|mal; auf -; noch -; nicht -; nun -; (↑ R 145:) ein- bis zweimal (mit Ziffern: 1- bis 2mal); vgl. mal; Ein|mal|eins s, -, das große -, das kleine - (↑ R 224); ein|ma|lig; Ein|ma|lig|keit

Ein|mann_be|trieb, ...ge|sell|schaft (Wirtsch.: Kapitalgesellschaft, deren Anteile in einer Hand sind); ein|män|nig (Bot.: einen Staubfaden habend)

Ein|mark|stück (mit Ziffer: 1-Mark-Stück; ↑ R 157)

Ein|marsch m; ein|mar|schie|ren

ein|mas|sie|ren

Ein|ma|ster; ein|ma|stig

ein|mau|ern; Ein|maue|rung

ein|mei|ßeln

ein|men|gen, sich

Ein|me|ter|brett (mit Ziffer: 1-Me-ter-Brett; ↑ R 157)

¹ein|mie|ten; sich -; vgl. ¹mieten

²ein|mie|ten; Feldfrüchte -; vgl. ⁴mieten

ein|mi|schen; sich; Ein|mi|schung

ein|mo|na|tig; ein -er (einen Monat dauernder) Lehrgang

ein|mon|tie|ren

ein|mot|ten

ein|mum|meln (ugs. für: warm einhüllen); ein|mum|men (ugs.); sich -

ein|mün|den; Ein|mün|dung

ein|mü|tig; Ein|mü|tig|keit w; -

ein|nach|ten (schweiz. neben: nachten = Nacht werden)

ein|nä|hen

Ein|nah|me w; -, -n; Ein|nah|me_buch, ...quel|le, ...soll; Ein|nahms_quel|le (österr.)

ein|ne|beln; ich neb[e]le ein (↑ R 327); Ein|ne|be|lung, Ein|neb|lung

ein|neh|men; ein|neh|mend; -ste; Ein|neh|mer; Ein|neh|me|rin w; -, -nen

ein|nicken [Trenn.: ...nik|ken] ([für kurze Zeit] einschlafen)

ein|ni|sten, sich

Ein|öde; Ein|öd|hof

ein|ölen; sich -

ein|ord|nen; sich -; Ein|ord|nung; Ein|ord|nungs_schwie|rig|kei|ten (Mehrz.)

ein|packen [Trenn.: ...pak|ken];

Ein|packung [*Trenn.:* ...pak-kung]

ein|par|ken

Ein|par|tei[|en]_re|gie|rung, ...sy-stem

ein|pas|sen; Ein|pas|sung

ein|pau|ken (ugs.); Ein|pau|ker

ein|peit|schen; Ein|peit|scher

ein|pen|deln, sich; Ein|pend|ler (Person, die an einem Ort arbei-tet, aber nicht dort wohnt)

ein|pen|nen ugs. (einschlafen)

ein|pfar|ren; Ein|pfar|rung

Ein|pfen|nig|stück (vgl. Einmark-stück)

ein|pfer|chen; Ein|pfer|chung

ein|pflan|zen; Ein|pflan|zung

Ein|pha|sen|strom; Ein|pha|sen-Wech|sel|strom|sy|stem (↑ R 152); ein|pha|sig

ein|pin|seln; Ein|pin|se|lung, Ein-pins|lung

ein|pla|nen; Ein|pla|nung

ein|pö|keln

ein|pol|dern; Ein|pol|de|rung (Ein-deichung)

ein|po|lig

ein|prä|gen; ein|präg|sam; Ein-präg|sam|keit; Ein|prä|gung

ein|pro|gram|mie|ren

ein|pres|sen

ein|pu|dern; sich -

ein|pup|pen, sich (Biol.)

ein|quar|tie|ren; Ein|quar|tie|rung

ein|rah|men; ein Bild -

ein|ram|men; Pfähle -

ein|ran|gie|ren; Ein|ran|gie|rung

ein|ra|sten

ein|räu|men; jmdm. etwas -; Ein-räu|mung; Ein|räu|mungs|satz (für: Konzessivsatz)

Ein|raum|woh|nung

ein|rech|nen; vgl. eingerechnet

Ein|re|de (Rechtsspr. für: Ein-wand, Einspruch); ein|re|den

ein|reg|nen; es hat sich eingeregnet

ein|re|gu|lie|ren

ein|rei|ben; Ein|rei|bung

ein|rei|chen; Ein|rei|chung

ein|rei|hen; Ein|rei|her; ein|rei|hig; Ein|rei|hung

Ein|rei|se; Ein|rei|se|er|laub|nis; Ein|rei|se|ge|neh|mi|gung; ein-rei|sen; - in; Ein|rei|se|vi|sum

ein|rei|ßen; Ein|reiß|ha|ken; Ein-rei|ßung

ein|ren|ken; Ein|ren|kung

ein|re|xen österr. (einwecken); du rext ein

ein|rich|ten; sich -; Ein|rich|ter; Ein|rich|tung; Ein|rich|tungs_ge-gen|stand, ...haus, ...stück

Ein|riß

ein|rit|zen; Ein|rit|zung

ein|rol|len

ein|ro|sten

ein|rücken [*Trenn.:* ...rük|ken]; Ein|rückung [*Trenn.:* ...rük|kung]

ein|rü|sten; ein Haus - (mit einem Gerüst versehen)

eins; I. *Zahlw.* (Zahl 1): eins u. zwei macht, ist (nicht: machen, sind) drei; er war eins, zwei, drei damit fertig; es ist, schlägt eins (ein Uhr); ein Viertel auf, vor eins; halb eins; gegen eins; das ist eins a [Ia] (ugs. für: ausgezeich-net); Nummer, Abschnitt, Punkt eins; ein[e]s vgl. ¹ein, III. II. Kennzeichnung eines Einsseins, einer Einheit: eins (einig) sein, werden; in eins setzen (gleichset-zen); es ist mir alles eins (gleich-gültig). III. *Unbestimmtes Fürw.:* ein[e]s vgl. ¹ein, II.; Eins *w;* -, -en; er hat die Prüfung mit der Note „Eins" bestanden; er wür-felt drei Einsen; er hat in Latein eine Eins geschrieben; vgl. ¹Acht

Ein|saat

ein|sacken [*Trenn.:* ...sak|ken]

ein|sä|en

ein|sa|gen landsch. (vorsagen); Ein|sa|ger

ein|sal|zen; Ein|sal|zung

ein|sam; Ein|sam|keit *w;* -, (selten:) -en; Ein|sam|keits|ge|fühl

ein|sam|meln; Ein|sam|me|lung, Ein|samm|lung

ein|sar|gen; Ein|sar|gung

ein|sat|teln; Ein|sat|te|lung, Ein-satt|lung

Ein|satz *m;* -[e]s, Einsätze; Ein-satz|be|fehl; ein|satz|be|reit; Ein-satz|be|reit|schaft; ein|satz|fä-hig, ...freu|dig; Ein|satz_grup|pe, ...kom|man|do, ...mög|lich|keit, ...wa|gen (Verkehrswesen: nach Bedarf einzusetzender [Straßen-bahn]wagen)

ein|säu|ern; Ein|säue|rung

ein|sau|gen; Ein|sau|gung

ein|säu|men

ein|schach|teln; Ein|schach|te-lung, Ein|schacht|lung

ein|scha|len (Bauw.: verschalen); Ein|scha|ler (Bauberuf)

ein|schal|ten; sich -; Ein|schalt|he-bel; Ein|schal|tung

ein|schär|fen

ein|schar|ren

ein|schät|zen; sich -; Ein|schät-zung

ein|schäu|men; sich -

ein|schen|ken; Wein -

ein|sche|ren (Verkehrswesen: sich in den Verband, in die Kolonne einreihen; Seemannsspr.: ein Tau durch einen sog. Block ziehen); scherte ein; eingeschert

Ein|schicht südd., österr. (Öde, Einsamkeit) *w;* -; ein|schich|tig südd., österr. (abseits gelegen, einsam)

ein|schicken [*Trenn.:* ...schik|ken]

ein|schie|ben; Ein|schieb|sel *s;* -s, -; Ein|schie|bung

ein|schie|nen|bahn

ein|schie|ßen; sich -

ein|schiff|en; sich -; Ein|schif|fung

einschl. = einschließlich

ein|schla|fen

ein|schlä|fe|rig, ein|schläf|rig, (neuere Form:) ein|schlä|fig (ei-nen Schläfer fassend); -es Bett

ein|schlä|fern; ich schläfere ein (↑ R 327); ein|schlä|fernd; Ein-schlä|fe|rung

ein|schlä|fig; ein|schläf|rig vgl. ein-schläferig

ein|schlag; ein|schla|gen; ein-schlä|gig (zu etwas gehörend); Ein|schlag|pa|pier; Ein|schla-gung

ein|schläm|men (Landw.); Sträu-cher - (stark bewässern)

ein|schlep|pen

ein|schlei|chen, sich

ein|schlei|sen; Ein|schleu|sung

ein|schlie|ßen; ein|schließ|lich (Abk.: einschl.); *Verhältnisw.* mit *Wesf.:* - des Kaufpreises; ein alleinstehendes, stark gebeugtes Hauptw. steht in der *Einz.* unge-beugt: - Porto; *Wemf.,* wenn bei Mehrzahlformen der Wesf. nicht erkennbar ist: - Getränken; Ein-schlie|ßung

ein|schlum|mern

Ein|schlupf

Ein|schluß

ein|schmei|cheln, sich; Ein|schmei-che|lung, Ein|schmeich|lung; Ein-schmeich|ler

ein|schmel|zen; Ein|schmel|zung; Ein|schmel|zungs|pro|zeß

ein|schmie|ren; sich -

ein|schmug|geln

ein|schnap|pen

ein|schnei|den; ein|schnei|dend; -ste

ein|schnei|en

ein|schnitt

ein|schnü|ren; Ein|schnü|rung

ein|schrän|ken; sich -; Ein|schrän-kung

ein|schrau|ben

Ein|schreib|brief; Ein|schrei|be-brief; ein|schrei|ben; ¹Ein|schrei-ben! (Vermerk auf eingeschriebe-nen Postsendungen); ²Ein|schrei-ben (eingeschriebene Postsen-dung) *s;* -s, -; Ein|schrei|be|sen-dung, Ein|schreib|sen|dung; Ein-schrei|bung

ein|schrei|ten

ein|schrump|fen; Ein|schrump-fung

Ein|schub *m;* -[e]s, Einschübe; Ein-schub|decke [*Trenn.:* ...dek|ke]

ein|schüch|tern; ich schüchtere ein (↑ R 327); Ein|schüch|te|rung; Ein|schüch|te|rungs|ver|such

ein|schu|len; Ein|schu|lung

ein|schü|rig; -e (eine Ernte liefern-de) Wiese

Ein|schuß; Ein|schuß|stel|le

ein|schwär|zen (auch für: einschmuggeln)

ein|schwen|ken (einen Richtungsod. Gesinnungswechsel vollziehen)

ein|schwim|men (Technik)

ein|schwin|gen

ein|schwö|ren; er ist auf diese Mittel eingeschworen

ein|oog|non; Ein|seg|nung

ein|se|hen; Ein|se|hen s; -s; ein - haben

ein|sei|fen

ein|sei|tig; -es Rechtsgeschäft; Ein|sei|tig|keit

ein|sen|den; Ein|sen|der; Ein|sendung

ein|sen|ken; sich -; Ein|senk|pfanne

Ein|ser vgl. Einer

ein|set|zen; Ein|set|zung

Ein|sicht w; -, -en; in etwas - nehmen; ein|sich|tig; Ein|sich|tigkeit; Ein|sicht|nah|me w; -, -n; einsichts_los, ...voll

ein|sickern [Trenn.: ...sik|kern]

Ein|sie|de|glas südd., österr. (Einmachglas; Mehrz. ...gläser)

Ein|sie|de|lei; Ein|sie|deln (schweiz. Abtei u. Wallfahrtsort)

ein|sie|den südd., österr. (einkochen, einmachen)

Ein|sied|ler; ein|sied|le|risch; -ste (↑ R 294); Ein|sied|ler|krebs

Ein|sil|ber vgl. Einsilbler; ein|silbig; Ein|sil|big|keit w; -; Ein|silbler, Ein|sil|ber (einsilbiges Wort)

ein|si|lie|ren (Landw.: in einem Silo einlagern)

ein|sin|gen; die Kinder singen den Sommer ein

ein|sin|ken; Ein|sink|tie|fe

ein|sit|zen (im Gefängnis sitzen); Ein|sit|zer; ein|sit|zig

eins|mals mdal. (auf einmal)

ein|soh|lig

ein|söm|me|rig

ein|sor|tie|ren

ein|span|nen

Ein|spän|ner; ein|spän|nig

ein|spa|ren; Ein|spar|mög|lichkeit; Ein|spa|rung

ein|spei|cheln; Ein|spei|che|lung

ein|sper|ren (ugs.)

ein|spie|len; Ein|spiel|er|geb|nis; Ein|spie|lung

ein|spin|nen; sich -

Ein|spra|che (Beschwerde; österr., schweiz. auch für: Einspruch); ein|spra|chig

ein|spre|chen; er hat auf sie eingesprochen

ein|spren|gen; Ein|spreng|sel

ein|sprin|gen

Ein|spritz|dü|se; ein|sprit|zen; Ein|spritz|mo|tor; Ein|sprit|zung

Ein|spruch; - erheben; Ein|spruchsrecht

ein|spu|rig

Eins|sein

einst; Einst s; -; das - und [das] Jetzt (↑ R 119)

ein|stamp|fen; Ein|stamp|fung

Ein|stand m; -[e]s, Einstände

ein|stan|zen

ein|stau|ben österr. ([ein]pudern)

ein|ste|chen

Ein|steck|bo|gen (Druckw.); einstecken [Trenn.: ...stek|ken]; vgl. ²stecken; Ein|steck|kamm

ein|ste|hen (bürgen)

ein|stei|gen

Ein|stein (dt.-amerik. Physiker); Ein|stei|ni|um [nach Einstein] (chem. Grundstoff; Zeichen: Es) ɒ₁ ɒ; Ein|stein|sche Glei|chung (↑ R 179)

ein|stell|bar; ein|stel|len (schweiz. auch: [jmdn. von einem Amt, von seinen Rechten] suspendieren); sich -; Ein|stell|platz; Ein|stellung; Ein|stel|lungs|un|ter|suchung

ein|stens (veralt. für: einst)

Ein|stich; Ein|stich|stel|le

Ein|stieg m; -[e]s, -e

ein|stig

ein|stim|men, sich -; ein|stim|mig; Ein|stim|mig|keit w; -; Ein|stimmung

ein|stip|pen landsch.; das Brot - (eintauchen)

einst|ma|lig; einst|mals

ein|stöckig [Trenn.: ...stök|kig]

ein|sto|ßen

ein|strah|len; Ein|strah|lung (Meteor.: Bestrahlung durch die Sonne)

ein|strei|chen; er strich das Geld ein

Ein|streu (Landw.); ein|streu|en

ein|strö|men

ein|stu|die|ren; Ein|stu|die|rung

ein|stu|fen; Ein|stu|fig

ein|stül|pen; sich -

ein|stür|men; alles stürmt auf ihn ein

Ein|sturz; ein|stür|zen; Einsturz_be|ben, ...ge|fahr

einst|wei|len; einst|wei|lig; -e Verfügung

Eins|wer|den s; -s; Eins|wer|dung

Ein|tags_flie|ge, ...flie|ge

ein|tan|zen; Ein|tän|zer (in Tanzlokalen angestellter Tanzpartner); Ein|tän|ze|rin w; -, -nen

ein|tä|to|wie|ren

ein|tau|chen; Ein|tau|chung

ein|tau|schen

ein|tau|send; vgl. tausend

ein|ta|xie|ren

ein|tei|gen

ein|tei|len; ein|tei|lig; Ein|tei|lung; Ein|tei|lungs|prin|zip

Ein|tel (Math.: Ganzes) s (schweiz. meist: m); -s, -

ein|tö|nig; Ein|tö|nig|keit

Ein|topf (ugs. für: Eintopfessen, -gericht); Ein|topf_es|sen, ...gericht

Ein|tracht w; -; ein|träch|tig; einträch|tig|lich (veralt.)

Ein|trag m; -[e]s, ...träge; ein|tragen; vgl. eingetragen; ein|träglich; Ein|träg|lich|keit w; -; Eintra|gung

ein|trän|ken (ugs.); jmdm. etwas -

ein|trän|ken (ugs.)

ein|träu|feln; Ein|träu|fe|lung, Einträuf|lung

ein|tref|fen

ein|treib|bar; ein|trei|ben; Ein|treiber; Ein|trei|bung

ein|tre|ten; in ein Zimmer, eine Verhandlung -; auf etwas - (schweiz. für: auf etwas eingehen, mit der Beratung von etwas beginnen); ein|tre|ten|den|falls (Amtsdt.); vgl. Fall m; Ein|tretens|de|bat|te schweiz. (allg. Aussprache über eine Vorlage im Parlament)

ein|trich|tern (ugs.); Ein|trich|terung

Ein|tritt; Ein|tritts_geld, ...kar|te

ein|trock|nen

ein|tröp|feln; Ein|tröp|fe|lung, Eintröpf|lung

ein|trü|ben; sich -; Ein|trü|bung

ein|tru|deln (ugs. für: langsam eintreffen)

ein|tun|ken landsch.; das Brot - (eintauchen)

ein|tü|ten (Ware od. Geld in Tüten verteilen)

ein|üben; sich -; Ein|über (für: Korrepetitor); Ein|übung

ein und der|sel|be; vgl. derselbe

ein|[und|]ein|halb; ein[und]einhalbmal soviel; ein|und|zwan|zig

Ei|nung (veralt. für: Einigung)

ein|ver|lei|ben; sich -; er verleibt ein u. er einverleibt; einverleibt, einzuverleiben; Ein|ver|lei|bung

Ein|ver|nah|me österr., schweiz. (Verhör) w; -, -n; ein|ver|neh|men [zu: Einvernahme]; Ein|ver|nehmen s; -s; mit jmdm. in gutem - stehen; sich ins - setzen; ein|vernehm|lich

ein|ver|stan|den; ein|ver|ständ|lich; Ein|ver|ständ|nis; Ein|verständ|nis|er|klä|rung

Ein|waa|ge (in Dosen eingewogene Menge; Gewichtsverlust beim Wiegen) w; -

¹ein|wach|sen; ein eingewachsener Nagel

²ein|wach|sen (mit Wachs einreiben)

Ein|wand m; -[e]s, ...wände

Ein|wan|de|rer; ein|wan|dern; Einwan|de|rung; Ein|wan|de|rungs|behör|de

ein|wand|frei (nicht: einwandsfrei)

ein|wärts; ein|wärts|ge|bo|gen; ein-

wärts|ge|hen (mit einwärts ge-
richteten Füßen gehen)
ein|wech|seln; Ein|wech|se|lung,
Ein|wechs|lung
ein|wecken [Trenn.: ...wek|ken]
([in Weckgläsern] einmachen);
Ein|weck|glas (Mehrz. ...gläser)
Ein|weg.fla|sche (Flasche zum
Wegwerfen), ...glas, ...hahn (Che-
mie)
ein|wei|chen; vgl. ¹weichen; Ein-
wei|chung
ein|wei|hen; Ein|wei|hung
ein|wei|sen (in ein Amt); Ein|wei-
ser (Verkehrsw.); Ein|wei|sung
ein|wen|den; ich wandte od. wen-
dete ein, habe eingewandt od.
eingewendet; Ein|wen|dung
ein|wer|fen
ein|wer|tig (Chemie); Ein|wer|tig-
keit
ein|wickeln [Trenn.: ...wik|keln];
Ein|wickel|pa|pier [Trenn.:
...wik|kel...]; Ein|wicke|lung
[Trenn.: ...wik|ke...], Ein|wick-
lung
ein|wie|gen
ein|wil|li|gen; Ein|wil|li|gung
ein|win|keln; die Arme -
ein|win|ken (Verkehrswesen)
ein|win|tern; ich wintere ein († R
327)
ein|wir|ken; Ein|wir|kung; Ein|wir-
kungs|mög|lich|keit
ein|woh|nen; Ein|woh|ner; Ein-
woh|ner|mel|de|amt; Ein|woh-
ner.schaft, ...ver|zeich|nis, ...zahl
ein|wüh|len; sich -
Ein|wurf
ein|wur|zeln; Ein|wur|ze|lung, Ein-
wurz|lung
Ein|zahl (für: Singular) w; -, (sel-
ten:) -en
ein|zah|len; Ein|zah|lung; Ein-
zahl|lungs.schal|ter, ...schein
(schweiz. für: Zahlkarte)
ein|zäu|nen; Ein|zäu|nung
ein|ze|hig
ein|zeich|nen; Ein|zeich|nung
ein|zei|lig
Ein|zel (Sportspr.: Einzelspiel) s;
-s, -; Ein|zel.ab|teil, ...ak|ti|on,
...be|ob|ach|tung, ...box, ...dar-
stel|lung, ...ding (Mehrz. ...din-
ge), ...er|schei|nung, ...fall m,
...gän|ger, ...haft w, ...han|del,
...han|dels|ge|schäft, ...händ|ler,
...heit, ...kämp|fer
Ein|zel|ler (einzelliges Lebewe-
sen); ein|zel|lig
Ein|zel|mit|glied|schaft
ein|zeln; I. Kleinschreibung († R
135): der, die, das einzelne; ein-
zelnes; er als einzelner; einzelnes
hat mir gefallen; einzelne sagen
...; jeder einzelne; bis ins einzelne;
ins einzelne gehende Richtlinien;
ein einzelner; alles einzelne; im
einzelnen; zu sehr ins einzelne ge-

hen. II. Großschreibung († R 116):
vom Einzelnen (von der Einzel-
form, der Einzelheit) ins Ganze
gehen; vom Einzelnen zum All-
gemeinen; ein|zeln|ste|hend; ein
-er Baum; Ein|zel|ste|hen|de m u.
w; -n, -n († R 287ff.); Ein|zel.per-
son, ...rich|ter, ...staat, ...stück,
...teil s, ...we|sen, ...zel|le, ...zim-
mer
ein|ze|men|tie|ren
ein|zie|hen; Ein|zieh|schacht
(Bergmannspr.: Schacht, durch
den frische Luft einzieht); Ein-
zie|hung
ein|zig; I. Kleinschreibung († R
135): der, die, das einzige; das
einzige (nicht: einzigste) wäre, zu
...; ein einziger; kein einziger; et-
was einziges; einzig schön; er ist
einzig in seiner Art; er als einzi-
ger; einzig und allein. II. Groß-
schreibung († R 116): Karl ist un-
ser Einziger. III. Getrenntschrei-
bung: ein - dastehendes Erlebnis;
ein|zig|ar|tig [auch: einzichar-
tich]; († R 134:) das -e ist, daß
...; Ein|zig|ar|tig|keit; Ein|zig-
keit
Ein|zim|mer|woh|nung
Ein|zug; Ein|zü|ger (in einem Zug
zu lösende Schachaufgabe;
schweiz.: Kassierer o. ä.); Ein-
zugs.be|reich, ...ge|biet
ein|zwän|gen; Ein|zwän|gung
Éire [ir.: q-iri, íri; engl.: äᵉrⁱ] (ir.
Name vor: Irland)
Ei|re|ne (gr. Göttin des Friedens,
eine der ²Horen); Ei|rund
Eis s; -es; [drei] - essen
eis, Eis (Tonbezeichnung) s; -, -
Eis|sack (l. Nebenfluß der Etsch)
m; -s
Eis.bahn, ...bär
Eis.berg, ...bein (eine Speise)
Eis|beu|tel; Eis|blink (Wider-
schein des Polareises am Hori-
zont) m; -[e]s, -e; Eis.block
(Mehrz. ...blöcke), ...blu|me,
...bom|be, ...bre|cher
Ei|schnee
Eis.creme od. ...krem, ...decke
[Trenn.: ...dek|ke], ...die|le,
...drink; ein -en (Eis gewinnen;
etw. einfrieren); du eist (eisest)
geeiste Früchte
Ei|sen (chem. Grundstoff, Metall;
Zeichen: Fe) s; -s, -; vgl. Ferrum
Ei|sen|ach (Stadt am Thüringer
Wald); Ei|sen|acher († R 199)
Ei|sen.bahn; Ei|sen|bah|ner; Ei-
sen|bahn|fahr|plan († R 152); Ei-
sen|bahn.wa|gen, ...wagen
Ei|sen|bart[h] (dt. Wanderarzt);
ein Doktor - (übertr. für: derbe
Kuren anwendender Arzt)
Ei|sen|bau (Mehrz. ...bauten); ei-
sen|be|schla|gen; Ei|sen.be|ton,

...blech, ...block (Mehrz.: ...blök-
ke), ...blü|te (ein Mineral), ...fres-
ser; ei|sen|hal|tig; ei|sen|hart
Ei|sen|ho|wer [...hauᵉr] (Präsident
der USA)
Ei|sen|hut (eine Heil- u. Zierpflan-
ze) m; Ei|sen.hüt|ten|we|sen (s;
-s), ...in|du|strie, ...lup|pe, ...rahm
(ein Mineral; m; -[e]s, -e); ei-
sen.schaf|fend (-e Industrie),
...schüs|sig (eisenhaltig); Ei|sen-
stadt (Hptst. des Burgenlandes
in Österreich); Ei|sen|stan|ge; ei-
sen|ver|ar|bei|tend; die -e Indu-
strie (vgl. S. 45, Merke, 2), aber
(vgl. S. 45, Merke, 1): viel Eisen
verarbeitend; Ei|sen|zeit w; -; ei-
sern; -e Disziplin; mit -er Faust;
-er Wille; die -e Ration; die -e
Lunge; die -e Hochzeit; der -e
Bestand; der -e Schaffner; ein -er
Schutzmann; mit -em Besen aus-
kehren (ugs.); der -e Vorhang
(feuersicherer Abschluß der Büh-
ne gegen den Zuschauerraum),
aber († R 224): der Eiserne Vor-
hang (weltanschauliche Grenze
zwischen Ost u. West); die Eiser-
ne Krone (der lombard. Königs-
krone); das Eiserne Kreuz (ein
Orden); († R 198:) das Eiserne
Tor (Durchbruchstal der Donau)
Ei|ses.käl|te; Eis|flä|che; eis|frei;
dieser Hafen ist -; Eis|gang; Eis-
hei|li|gen (Maifröste) Mehrz.;
Eis|hockey [Trenn.: ...hok|key];
Eis|hockey|län|der|spiel [Trenn.:
...hok|key...] († R 152); ei|sig;
Schreibung in Verbindung mit ei-
nem Eigenschaftswort: die eisig-
kalten Tage († R 143), aber: die
Tage sind eisig kalt; eis|kalt;
Eis.ka|sten (bes. südd., österr.
für: Kühlschrank), ...krem od.
...creme, ...kunst|lauf, ...lauf; eis-
lau|fen († R 140); ich laufe eis († R
132); bin eisgelaufen; eiszulau-
fen; († R 145:) eis- u. Schi laufen,
aber: Schi u. eislaufen
Eis|le|ben (Stadt im östl. Harzvor-
land); Eis|le|ber († R 199)
Eis.män|ner bayr., österr. (Eishei-
lige; Mehrz.), ...meer, ...mo|nat
od. ...mond (alte Bez. für: Ja-
nuar), ...pickel [Trenn.: ...pik-
kel], ...re|vue [...wü]
Eiß m; -es, -e u. Ei|ße südd. u.
schweiz. mdal. (Blutgeschwür;
Eiterbeule) w; -, -n
Eis.schie|ßen (s; -s), ...schnellauf
[Trenn.: ...schnell|lauf, † R 236],
...scholl|le, ...schrank, ...see (s;
-s), ...sproß od. ...spros|se (Jä-
gerspr.), ...sta|di|on, ...stau,
...stock.schie|ßen (eine Sportart),
...stoß (landsch. für: aufgestautes
Eis in Flüssen), ...tanz, ...vo|gel,
...zap|fen, ...zeit; eis|zeit|lich
ei|tel; ein eitler Mensch; Ei|tel|keit

Ei|ter m; -s; Ei|ter.beu|le, ...er|re-
ger, ...herd; ei|te|rig, eit|rig; ei-
tern; Ei|te|rung
Ei|weiß s; -es, -e; 2 - († R 322);
Ei|weiß.be|darf, ...ge|halt, ...kör-
per, ...man|gel m, ...prä|pa|rat,
...stoff; Ei|zel|le
Eja|ku|la|ti|on lat. [...zion] (Med.:
Ausspritzung; Samenerguß); eja-
ku|lie|ren; Ejek|ti|on [...zion]
(Geol.. Ausschleudern von Mag-
ma; veralt. für: [Hin]auswerfen;
Vertreiben [aus dem Besitz]);
Ejek|tor (Auswerfer bei Jagdge-
wehren; absaugende Strahlpum-
-pe) m; -s, ...oren; eji|zie|ren
(Geol.: ausschleudern; veralt.
für: [hin]auswerfen; vertreiben)
Ekart fr. [ekar] (im Börsenge-
schäft der Abstand zwischen Ba-
sis- u. Prämienkurs) m; -s, -s;
Ekar|té [...te] (ein Kartenspiel;
zur Seite gespreiztes Bein beim
Kunsttanz) s; -s, -s
EKD = Evangelische Kirche in
Deutschland
ekel; ekle (veralt. für: ekelhafte)
Angelegenheit; ¹Ekel m; -s; ²Ekel
(ugs. für: widerlicher Mensch) s;
-s, -; ekel|er|re|gend, aber († R
142): heftigen Ekel erregend;
ekel|haft; ek[e]l|lig; ekeln; es ekelt
mich od. mir; sich -; ich ek[e]lle
mich († R 327)
Ekel|na|me (Bei-, Spitz-, Über-
name)
EKG, Ekg = Elektrokardio-
gramm
Ek|ke|hard (Scheffelsche Schrei-
bung von: Eckehard)
Ek|kle|sia gr.-lat. (Kirche) w; :
Ek|kle|siã|sti|kus (in der Vulgata:
Titel des Buches Jesus Sirach) m;
-; Ek|kle|sio|lo|gie (Lehre von
der Kirche) w; -
Ek|lamp|sie gr.(einebestimmteArt
von Krampfanfällen) w; -, ...ien
Eklat fr. [ekla] (aufsehenerregen-
des Ereignis) m; -s, -s; ekla|tant
(aufsehenerregend; offenkundig)
Ek|lek|ti|ker gr. (jmd., der aus ver-
schiedenen philos. Systemen das
ihm Passende „auswählt"); ek-
lek|tisch; Ek|lek|ti|zis|mus m; -;
ek|lek|ti|zi|stisch
k|lig, eke|lig
Ek|lip|se gr.(Sonnen- u. Mondfin-
sternis) w; -,-n; Ek|lip|tik (schein-
bare Sonnenbahn; Erdbahn) w;
-, -en; ek|lip|tisch
Ek|lo|ge gr. (altröm. Hirtenlied)
w; -, -n
ko|no|mi|ser engl. [ikon°mais°r]
(Vorwärmer bei Dampfkesselan-
lagen) m; -s, -
kos|sai|se fr. [ekoßäs°] (ein Tanz)
w; -, -n
k|pho|rie gr. (Med.: Vorgang der
Erinnerung) w; -, ...ien

Ekra|sit fr. (ein Sprengstoff) s; -s
Ekrü|sei|de fr. (Rohseide)
Ek|sta|se gr. ([religiöse] Verzük-
kung; höchste Begeisterung) w;
-, -n; Ek|sta|ti|ker; ek|sta|tisch;
-ste († R 294)
Ek|ta|se, Ek|ta|sis gr. (antike
Verslehre: Dehnung eines Selbst-
lautes) w; -, Ektasen; Ek|ta|sie
(Med.: Erweiterung) w; -, ...ien;
Ek|ta|sis vgl. Ektase
ek|to... gr. (außen...); Ek|to... (Au-
ßen...)
Ek|to|derm gr. (Zool.: äußeres
Keimblatt des Embryos) s; -s, -e;
Ek|to|derm|zel|le
Ek|to|mie gr. (Med.: operative
Entfernung) w; -, ...ien
Ek|to|pa|ra|sit (Med.: Schmarot-
zer der äußeren Haut)
Ekua|dor usw. vgl. Ecuador usw.
Ek|zem gr. (Med.: eine Entzün-
dung der Haut) s; -s, -e
Ela|bo|rat lat. (schlechte schriftl.
Ausarbeitung; Machwerk) s;
-[e]s, -e
Ela|id|in|säu|re (Chemie: ungesät-
tigte Fettsäure)
Flan fr. [fr. Ausspr.: elang]
(Schwung; Begeisterung) m; -s
Ela|ste (Kunststoffe von gum-
miartiger Elastizität) Mehrz.;
Ela|stik (ein elastisches Gewebe)
s; -s, -s od. w; -, -en; ela|stisch
(einer Krafteinwirkung nachge-
bend, aber wieder in die Aus-
gangsform zurückstrebend;
übertr. für: federnd u. zugleich
kraftvoll gespannt); -ste († R
294); Ela|sti|zi|tät (Federkraft;
Spannkraft) w; -; Ela|sti|zi-
täts.gren|ze, ...mo|dul (Meß-
größe der Elastizität), ...ver|lust
Ela|tiv lat. (Sprachw.: absoluter
Superlativ [ohne Vergleich], z. B.
„modernste [= sehr moderne]
Maschinen") m; -s, -e [...wᵉ]
Ell|ba (it. Mittelmeerinsel)
elb|ab|wärts; elb|auf|wärts; El|be
(ein Strom) w; -; El|be-Lü|beck-
Ka|nal († R 203) m; -s
El|ber|feld [auch: äl...] (Stadtteil
von Wuppertal)
Elb-Flo|renz; † R 212 (Bez. für
Dresden); Elb.kahn, ...mün|dung
(w; -)
El|brus (höchste Erhebung des
Kaukasus) m; -
Elb|sand|stein|ge|bir|ge († R 201) s;
-s; Elb.strand (m; -[e]s), ...strom
(m; -[e]s)
el|burs (iran. Gebirge) m; -
Elch (Hirschart) m; -[e]s, -e; Elch-
jagd
El|do|ra|do, Do|ra|do span. (sa-
genhaftes Goldland in Südameri-
ka; übertr. für: Paradies) s; -s, -s
Elea|te (Vertreter einer altgr. Phi-
losophenschule) m; -n, -n (meist

Mehrz.); † R 268; elea|tisch; -e
Schule
Ele|fant gr. m; -en, -en († R 268);
Ele|fan|ten|rüs|sel; Ele|fan|tia|sis
(eine Krankheit) w; -, ...iasen
ele|gant fr.; Ele|gant [elegang]
(Stutzer) m; -s, -s; Ele|ganz w; -
Ele|gie gr. (eine Gedichtform;
Klagelied, wehmütiges Lied) w;
-, ...ien; Ele|gi|en|dich|ter; Ele|gi-
ker (Flegiendichter); ele|gisch;
-ste († R 294); Eleg|jam|bus (ein
altgr. Versmaß)
Elei|son gr. („Erbarme dich!" im
gottesdienstl. Gesang) s; -s, -s
elek|tiv lat. (auswählend); vgl. se-
lektiv; Elek|to|rat (Kurfürsten-
tum, Kurwürde) s; -[e]s, -e
Elek|tra (gr. Sagengestalt)
Elek|tri|fi|ka|ti|on gr. [...zion]
(schweiz. neben: Elektrifizie-
rung); elek|tri|fi|zie|ren (auf
elektr. Betrieb umstellen); Elek-
tri|fi|zie|rung; Elek|trik (Gesamt-
heit einer elektrischen Anlage;
ugs. für: Elektrizitätslehre) w; -;
Elek|tri|ker; elek|trisch; -es
Haushaltsgerät; -e Eisenbahn; -e
Lokomotive (Abk.: E-Lok); -e
Heizung; -er Strom; -er Zaun; -er
Stuhl; -es Feld; -es Klavier; Elek-
tri|sche (ugs. für: elektr. Straßen-
bahn) w; -n, -n; vier -[n] († R 291);
elek|tri|sie|ren; Elek|tri|sier|ma-
schi|ne; Elek|tri|zi|tät w; -; Elek-
tri|zi|täts|werk; Elek|tro|che|mie;
elek|tro|che|misch; -e Span-
nungsreihe; Elek|tro|de (den
Stromübergang vermittelnder
Leiter) w; -, -n; Elek|tro|dy|na-
mik; elek|tro|dy|na|misch; Elek-
tro|en|ze|pha|lo|gramm (Auf-
zeichnung der Hirnströme);
Elek|tro|ge|rät; Elek|tro|gra|phie
(galvanische Hochätzung) w; -;
Elek|tro.herd, ...in|du|strie, ...in-
ge|nieur, ...in|stal|la|teur; Elek-
tro.kar|dio|gramm (Abk.: EKG,
Ekg); Elek|tro.kar|re[n], ...lun-
ge; Elek|tro|ly|se (elektr. Zerset-
zung chem. Verbindungen; w; -,
-n), ...ly|seur [...lüsör] (Vorrich-
tung zur Ausführung der Elek-
trolyse; m; -s, -e), ...lyt (durch
Strom zersetzbarer Stoff; m; -en
[selten: -s], -e [selten: -en]; † R
268); elek|tro|ly|tisch; -e Disso-
ziation; Elek|tro|ma|gnet; elek-
tro|ma|gne|tisch; -es Feld; -e
Wellen; Elek|tro.me|cha|ni|ker,
...mei|ster; Elek|tro|me|ter s; -s,
-; Elek|tro.mon|teur, ...mo|tor
¹Elek|tron [auch: eläk... od. ...tron]
(negativ geladenes Elementar-
teilchen) s; -s, ...onen; ²Elek|tron
℗ (eine Magnesiumlegierung) s;
-s; Elek|tro|nen.blitz, ...dich|te,
...[ge]hirn, ...mi|kro|skop, ...rech-
ner, ...röh|re, ...schleu|der (Beta-

tron), ...stoß (Stoß eines Elektrons auf Atome), ...theo|rie (Lehre vom Elektron); Elek|tro|nik (Lehre von den Elektronengeräten) w; -; elek|tro|nisch; -e Musik; -e Datenverarbeitung (Abk.: EDV); Elek|tron|volt (Energieeinheit der Kernphysik; Zeichen: eV)

Elek|tro|ofen; Elek|tro_pho|re|se (Transport elektr. geladener Teilchen durch elektr. Strom; w; -), ...phy|sik; Elek|tro|ra|sie|rer; Elek|tro|sta|tik; elek|tro|sta|tisch; -er Lautsprecher; Elek|tro_tech|nik (w; -), ...tech|ni|ker; elek|tro|tech|nisch; Elek|tro|the|ra|pie; Elek|tro|to|mie (Operation mit elektr. Schneidschlinge; w; -, ...ien)

Ele|ment lat. (Urstoff; Grundbestandteil; chem. Grundstoff; Naturgewalt; ein elektr. Gerät; Bez. für: [minderwertige] Person, meist Mehrz.) s; -[e]s, -e; er ist, fühlt sich in seinem -; ele|men|tar (grundlegend; naturhaft; einfach; Natur..., Ur..., Grund..., Anfangs...); -e Begriffe; -e Gewalt; Ele|men|tar_ge|walt (Naturgewalt), ...schu|le (Anfänger-, Volksschule), ...teil|chen (Atom[kern]baustein); Ele|men|te Mehrz.; - (Grundbegriffe) einer Wissenschaft

Ele|mi arab. (trop. Harz) s; -s; Ele|mi|öl s; -[e]s

Elen lit. (Elch) s (seltener: m); -s, -

elend; Elend s; -[e]s; elen|dig¹; elen|dig|lich¹; Elends_ge|stalt, ...quar|tier, ...vier|tel

Elen|tier (Elen, Elch)

Eleo|no|re (w. Vorn.)

Ele|phan|tia|sis vgl. Elefantiasis
Ele|phan|ti|ne (eine Nilinsel)

Eleu|si|ni|en [...iᵉn; nach Eleusis] (Fest mit Prozession zu Ehren der gr. Ackerbaugöttin Demeter Mehrz.; eleu|si|nisch, aber (↑ R 224): die Eleusinischen Mysterien ([mit den Eleusinien verbundener] Geheimkult im alten Athen); Eleu|sis (altgr. Ort)

Ele|va|ti|on lat. [...wazion] (,,Erhebung''; Emporheben der Hostie u. des Kelches beim kath. Meßopfer; Astron.: Höhe eines Gestirns über dem Horizont); Ele|va|ti|ons|win|kel (Erhöhungswinkel); Ele|va|tor (Förder-, Hebewerk) m; -s, ...oren; Ele|ve fr. [...wᵉ] (Land- und Forstwirt während der prakt. Ausbildungszeit) m; -n, -n (↑ R 268); Ele|vin w; -, -nen

elf; wir sind zu elfen od. zu elft; vgl. acht

¹ Auch elän...

¹Elf (ein Naturgeist) m; -en, -en (↑ R 268) u. El|fe w; -, -n
²Elf (alte schwed. Schreibung für älv = Fluß) m; -[e]s, -e
³Elf (Zahl; Mannschaftsbez. beim Sport) w; -, -en; vgl. ¹Acht
El|fe vgl. ¹Elf
Elf|eck; elf|eckig [Trenn.: ...ek|kig]; elf|ein|halb, elf|und|ein|halb
El|fen|bein s; -[e]s, (selten:) -e; el|fen|bei|nern (aus Elfenbein); el|fen|bein|far|ben; el|fen|bei|nisch (von ²Elfenbeinküste); ¹El|fen|bein|kü|ste (Küstenstreifen in Westafrika) w; -; ²El|fen|bein|kü|ste (Staat in Westafrika); El|fen|bein|turm
el|fen|haft
El|fer (ugs. für: Elfmeter); vgl. Achter; el|fer|lei; El|fer|rat; elf|fach; Elf|fa|che s; -n; vgl. Achtfache
El|fi (Kurzform von: Elfriede); el|fisch [zu: ¹Elf]
elf|mal; vgl. achtmal; elf|ma|lig; Elf|me|ter (Strafstoß vom Elfmeterpunkt beim Fußball) m; -s, -; Elf|me|ter_mar|ke, ...punkt, ...schuß (↑ R 228)
El|frie|de (w. Vorn.)
elft; vgl. elf; elf|tau|send; vgl. tausend; elf|te; der Elfte im Elften (karnevalist. Bezeichnung für den 11. November); vgl. achte; elf|tel; vgl. achtel; Elf|tel s (schweiz. meist: m); -s,-; vgl. Achtel; elf|tens; elf [und]|ein|halb
Eli|as, (ökum.:) Eli|ja (Prophet im A. T.)
eli|die|ren lat. (eine Elision [vgl. d.] vornehmen); Eli|die|rung
Eli|gi|us (Heiliger)
Eli|ja vgl. Elias
Eli|mi|na|ti|on lat. [...zion] (Beseitigung, Ausscheidung); eli|mi|nie|ren; Eli|mi|nie|rung
Eliot [eljᵉt] (amerik.-engl. Schriftsteller)
Eli|sa vgl. Elise; ¹Eli|sa|beth (w. Vorn.); ²Eli|sa|beth, (ökum.:) Eli|sa|bet (bibl. w. Eigenn.); eli|sa|be|tha|nisch, aber (↑ R 179): Elisa|be|tha|nisch; das -e England
Eli|se, Eli|sa (w. Vorn.)
Eli|si|on lat. (Sprachw.: Auslassung eines unbetonten Selbstlautes, z. B. des ,,e'' in ,,Wand[e]rung, Freud[e] und Leid'')
eli|tär (einer Elite angehörend, auserlesen); Eli|te fr. [österr.: ...lit] (Auslese der Besten) w; -, -n; Eli|te|trup|pe
Eli|xier gr. (Heil-, Zaubertrank) s; -s, -e
El|ke (w. Vorn.)
El|la (w. Vorn.)
Ell|bo|gen, El|len|bo|gen m; -s, ...bogen; Ell|bo|gen|frei|heit, El|len|bo|gen|frei|heit w; -

El|le w; -, -n; drei -n Tuch (↑ R 322)
El|len (w. Vorn.)
El|len|bo|gen vgl. Ellbogen; El|len|bo|gen|frei|heit vgl. Ellbogenfreiheit; el|len|lang
El|ler niederd. (Erle) w; -, -n
El|li, El|ly (w. Vorn.)
El|lip|se gr. (Sprachw.: Ersparung von Redeteilen, z. B. ,,[ich] danke schön''; Math.: Kegelschnitt) w; -, -n; el|lip|sen|för|mig; El|lip|so|id (ein durch Umdrehung einer Ellipse entstandener Körper) s; -[e]s, -e; el|lip|tisch (in der Form einer Ellipse; Sprachw.: unvollständig); -e Geometrie; El|lip|ti|zi|tät (Astron.: Abplattung) w; -
Ell|wan|gen (Jagst) (Stadt am Oberlauf der Jagst); Ell|wan|ger (↑ R 199)
El|ly vgl. Elli
Elm (Höhenzug südöstl. von Braunschweig) m; -s
El|mar, El|mo (m. Vorn.)
Elms|feu|er (elektrische Lichterscheinung); vgl. auch: Sankt
Elo|ge gr. [eloscheᵉ] (Lob, Schmeichelei) w; -, -n
E-Lok (= elektrische Lokomotive) w; -, -s (↑ R 154)
Elon|ga|ti|on lat. [...zion] (Ausschlag des Pendels; Astron.: Winkel zwischen Sonne u. Planeten) elo|quent lat. (beredt); Elo|quenz w; -
Elo|xal ® (Schutzschicht aus Aluminiumoxyd) s; -s; elo|xie|ren
El|rit|ze od. Pfrill|le (ein Fisch) w; -, -n
El|sa, Els|beth, El|se (Kurzformen von: Elisabeth)
El Sal|va|dor [- ...wa...] (mittelamerik. Staat); Salvadorianer; salvadorianisch
El|saß s; - u. ...sasses; El|sässer (↑ R 199), El|säs|sisch; El|saß-Loth|rin|gen; el|saß-loth|rin|gisch
Els|beth, El|se vgl. Elsa; Els|chen
El|se|lein, Els|lein (Koseformen von: Elsa usw.)
¹El|ster (Flußname) w; -; die Schwarze -, die Weiße - (↑ R 198)
²El|ster (ein Vogel) w; -, -n; El|stern|nest
El|ter (naturwissenschaftl. u. statist. für: ein Elternteil) s u. m; -s, -n; el|ter|lich; -e Gewalt; El|tern (Mehrz.); El|tern_abend ...bei|rat, ...haus, ...lie|be; el|tern|los; El|tern_recht, ...schaft (w; -) ...se|mi|nar, ...teil m
Elt|ville am Rhein [älwil̮ᵉ od. ält wil̮ᵉ] (Stadt im Rheingau)
El|vi|ra [älwira] (w. Vorn.)
ely|sä|isch, ely|sisch gr. (wonnevoll, paradiesisch); -e Gefilde aber (↑ R 224): ,,Elysäische Feen

der'' (vgl. Champs-Élysées); Ely|see fr. (Palast in Paris) s; -s; ely|sisch vgl. ely|säisch; Ely|si|um gr. (Aufenthaltsort der Seligen in der gr. Sage) s; -s

Ely|tron gr. (Deckflügel [der Insekten]) s; -s, ...ytren (meist Mehrz.)

El|ze|vir [åls^e wir] [nach der niederl Buchdruckerfamilie Elzevi(e)r] (eine Antiquadruckschrift) w; -; El|ze|vir|aus|ga|be (↑ R 180); El|ze|vi|ria|na (Elzevirdrucke) Mehrz.

em. = emeritiert, emeritus (vgl. Emerit)

Em – Emanation; veralt. Bez für Radon

Email [auch: emãj] s; -s, -s u. Email|le fr. [emãlj^e, emaj, emãj] (Schmelz[überzug]) w; -, -n; Email|far|be; Email|leur [emaljör, emajör] (Schmelzarbeiter) m; -s, -e; email|lie|ren [emaljir^e n, emajir^e n]; Email|lier|werk; Email|ma|le|rei

Eman lat. (Maßeinheit für den radioaktiven Gehalt bes. im Quellwasser) s; -s, -; Ema|na|ti|on [...zion] („Ausfluß''; Ausstrahlung; veralt. Bez. für: Radon); ema|nie|ren

Ema|nu|el, Im|ma|nu|el (m. Vorn.); Ema|nue|la (w. Vorn.)

Eman|zi|pa|ti|on lat. [...zion] („Freilassung''; Verselbständigung; Gleichstellung); Eman|zi|pa|ti|ons_be|we|gung, ...streben; eman|zi|pa|to|risch; eman|zi|pie|ren, sich -; eman|zi|piert (frei, ungebunden; betont vorurteilsfrei); Eman|zi|pie|rung w; -

Em|bal|la|ge fr. [angbalaseh^e] (Verpackung, Umhüllung [einer Ware]); em|bal|lie|ren

Em|bar|go span. (Zurückhalten od. Beschlagnahme [von Schiffen] im Hafen; Ausfuhrverbot) s; -s, -s

Em|blem fr. [fr. Aussprache: angblëm] (Kennzeichen, Hoheitszeichen; Sinnbild) s; -s, -e; em|ble|ma|tisch (sinnbildlich)

Em|bo|lie gr. (Med.: Verstopfung von Blutgefäßen durch einen Fremdkörper [Embolus]) w; -, ...jen; Em|bo|lus m; -, ...li

Em|bon|point fr. [angbongpoäng] (Wohlbeleibtheit) s od. m; -s

Em|bryo gr. (noch nicht geborenes Lebewesen) m (österr. auch: s); -s, -s u. ...onen; Em|bryo|lo|gie (Lehre von der Entwicklung des Embryos) w; -; em|bryo|nal, em|bryo|nisch (im Anfangsstadium der Entwicklung)

Emd s; -[e]s u. Em|det schweiz. (Öhmd) m; -s; em|den

Em|den (Hafenstadt an der Ems-

mündung); Em|der, (auch:) Em|de|ner (↑ R 199)

Em|det vgl. Emd

Emen|da|ti|on lat. [...zion] (veralt. für: Verbesserung, Berichtigung); emen|die|ren (veralt.)

Eme|ren|tia [...zia], Eme|renz (w. Vorn.)

Eme|rit lat. m; -en, -en (↑ R 268) u. Eme|ri|tus (Person im Ruhestand, bes. von Universitätsprofessoren; vgl. em.) m; -, ...ti; eme|ri|tie|ren (in den Ruhestand versetzen); eme|ri|tiert (Abk.: em.); -er Professor; Eme|ri|tie|rung; Eme|ri|tus vgl. Emerit

Eme|ti|kum gr. (Brechmittel) s; -s, ...ka; eme|tisch (Brechen erregend)

Emi|grant lat. (Auswanderer [bes. aus polit. od. religiösen Gründen]) m; -en, -en (↑ R 268); Emi|gran|ten|schick|sal; Emi|gran|tin w; -, -nen; Emi|gra|ti|on [...zion]; emi|grie|ren

Emil (m. Vorn.); Emi|lia, Emi|lie [...i^e] (w. Vorn.)

emi|nent lat. (hervorragend; außerordentlich); Emi|nenz (frühere Anrede für Kardinäle) w; -, -en; vgl. auch: euer; vgl. grau

Emir [auch: ...ir] arab. (arab. [Fürsten]titel) m; -s, -e; Emi|rat (Fürstentum) s; -[e]s, -e

Emis|sär fr. (Abgesandter mit geheimem Auftrag) m; -s, -e; Emis|si|on lat. (Physik: Ausstrahlung; Technik: Abblasen von Gasen, Ruß u. ä. industriellen Abfallstoffen in die Luft; Wirtsch.: Ausgabe [von Wertpapieren]; Med.: Entleerung); Emis|si|ons_stopp (Wirtsch.); Emit|tent (Ausgeber von Wertpapieren); ↑ R 268; emit|tie|ren; Wertpapiere - (ausgeben); Elektronen -

Em|ma (w. Vorn.)

Em|ma|us [...a-uß] (bibl. Ort)

Emm|chen (ugs. scherzh. für: Mark); das kostet tausend -

Em|me (Nebenfluß der Aare); Kleine - (Nebenfluß der Reuß)

Em|men|tal (schweiz. Landschaft) s; -[e]s; ^1 Em|men|ta|ler (↑ R 199); - Käse; ^2 Em|men|ta|ler (Käse) m; -s, -

Em|mer südd. (eine Weizenart) m; -s

Em|me|rich (m. Vorn.); Em|mi (Koseform von: Emma); Em|mo (m. Vorn.)

e-Moll [auch: emoll] (Tonart; Zeichen: e) s; -; e-Moll-Ton|lei|ter (↑ R 155)

Emo|ti|on lat. [...zion] (Gemütsbewegung); emo|tio|nal, emo|tio|nell (gefühlsmäßig); emo|tio|na|li|sie|ren, Emo|tio|na|li|tät; emo|tio|nell vgl. emotional

EMPA, Empa = Eidgenössische Materialprüfungsanstalt

Em|pa|thie (Fähigkeit, sich in andere hineinzuversetzen) w; -

Em|pe|do|kles (altgr. Philosoph)

Emp|fang m; -[e]s, ...fänge; emp|fan|gen; du empfängst; du empfingst; du empfingest; empfangen; empfang[e]!; Emp|fän|ger; Emp|fän|ge|rin w; -, -nen; emp|fäng|lich; Emp|fäng|lich|keit w; -; Emp|fang|nah|me w; -; Emp|fäng|nis w; -, -se; emp|fäng|nis|ver|hü|tend; -e Mittel, aber (↑ R 142); einige die Empfängnis verhütende Mittel; Emp|fäng|nis_ver|hü|tung, ...zeit; Emp|fangs_an|ten|ne; emp|fangs_be|reit (Ugt., Emp|fangs_chef, ...da|me, ...ge|rät, ...saal, ...schein, ...sta|ti|on, ...stö|rung, ...zim|mer

emp|feh|len; du empfiehlst; du empfahlst; du empföhlest (auch: empfählest); empfohlen; empfiehl!; sich -; emp|feh|lens|wert; Emp|feh|lung; Emp|feh|lungs|schrei|ben

emp|fin|den; Emp|fin|de|lei (übergroßes Empfinden); emp|fin|den; du empfandst (empfandest); du empfändest; empfunden; empfind[e]!; Emp|fin|den s; -s; emp|find|lich; Emp|find|lich|keit; emp|find|sam; -e Dichtung; Emp|find|sam|keit; Emp|fin|dung; emp|fin|dungs_los; Emp|fin|dungs|lo|sig|keit w; -; Emp|fin|dungs|wort (für: Interjektion; Mehrz. ...wörter)

Em|pha|se gr. (Nachdruck [im Reden]) w; -, -n; em|pha|tisch (mit Nachdruck, stark)

Em|phy|sem gr. (Med.: Luftansammlung im Gewebe) s; -s, -e

^1 Em|pire fr. [angpir] (Kunststil der Zeit Napoleons I.) s; -s (fachspr. auch: -); ^2 Em|pi|re engl. [ämpai^e r] (britisches Weltreich) s; -[s]

Em|pi|rem (Erfahrungstatsache) s; -s, -e

Em|pi|re|stil [angpir...] (^1 Empire) m; -[e]s

Em|pi|rie gr. (Erfahrung, Erfahrungswissen[schaft]) w; -; Em|pi|ri|ker (Erfahrungsmensch); Em|pi|rio|kri|ti|zis|mus (eine bestimmte Richtung der Philosophie, die sich allein auf die kritische Erfahrung beruft); em|pi|risch; Em|pi|ris|mus (Lehre, die allein die Erfahrung als Erkenntnisquelle gelten läßt) m; -; Em|pi|rist m; -en, -en (↑ R 268); em|pi|ri|stisch; -ste (↑ R 294)

em|por; em|por... (in Zus. mit Zeitwörtern, z. B. emporkommen, du kamst empor, emporgekommen, emporzukommen; zum 2. Mittelw. ↑ R 304); Em|po|re (erhöhter Sitzraum [in Kir-

chen]) w; -, -n; em|pö|ren; sich -; Em|pö|ren|kir|che; Em|pö|rer; em|pö|re|risch; -ste († R 294); Em|por|füh|rung

Em|po|ri|um gr. (veralt. für: Stapel-, Haupthandelsplatz) s; -s, ...ien [...*i*^en]

em|por|kom|men; Em|por|kömmling; em|por|stre|ben; Em|porung; Em|pö|rungs|schrei

Em|pres|se|ment fr. [*angpräß*^e-*mang*] (veralt. für: Eifer; Bereitwilligkeit) s; -s

em|py|re|isch gr. (lichtstrahlend; himmlisch); Em|py|re|um (Lichtgebiet; Himmel in der antiken u. scholast. Philosophie) s; -s

Ems (Fluß in Nordwestdeutschland) w; -

¹Em|scher (r. Nebenfluß des Niederrheins) w; -; ²Em|scher [nach ¹Emscher] (eine geolog. Stufe); s; -s

Em|ser [nach Bad Ems] († R 199); Emser Depesche; Emser Salz

em|sig; Em|sig|keit w; -

Ems-Ja|de-Ka|nal († R 203) m; -s

Emu port. (ein straußenähnl. Laufvogel) m; -s, -s

emul|gie|ren lat. (eine Emulsion bilden); Emul|sin (Ferment in bitteren Mandeln) s; -s; Emul|si|on (feinste Verteilung eines unlösl. nichtkristallinen Stoffes in einer Flüssigkeit); lichtempfindl. Schicht auf fotogr. Platten, Filmen u. ä.)

Ena|ki|ter, Enaks|kin|der, Enakssöh|ne (riesengestaltiges vorisraelit. Volk in Palästina) Mehrz.

En|al|la|ge gr. [*enalage*] (Setzung eines Eigenschaftswortes zu einem anderen Hauptwort, als zu dem es logisch gehört, z. B. „mit einem blauen Lächeln seiner Augen" statt: „mit einem Lächeln seiner blauen Augen") w; -

En|an|them (Med.: Schleimhautausschlag) s; -s, -e

en|an|tio|trop gr. (zur Enantiotropie fähig); En|an|tio|tro|pie (Chemie: wechselseitige Überführbarkeit eines Stoffes von einer Zustandsform in eine andere) w; -

en avant! fr. [*angnawang*] (vorwärts!)

en bloc fr. [*angblok*] (im ganzen); En-bloc-Ab|stim|mung († R 155)

en ca|naille fr. [*angkanaj*] (verächtlich, wegwerfend); - - behandeln

en car|rière fr. [*angkariär*] („im Laufe"; in vollem Laufe)

en|chan|tiert fr. [*angschangt...*] (veralt. für: bezaubert, entzückt)

End_ab|rech|nung, ...bahn|hof, ...be|scheid; End|chen, End|lein; En|de s; -s, -n; am -; am - sein;

zu - sein, bringen, führen, gehen, kommen; das dicke - kommt nach (ugs.); - Januar († R 319); letzten Endes (besser: im Grunde; schließlich); End|ef|fekt; im - End|del bayr., österr. (Stoffrand) s; -s, -; en|deln bayr., österr. (Stoffränder einfassen); ich end[e]le († R 327)

En|de|mie gr. (Krankheit, die in einem bestimmten Gebiet ständig auftritt, z. B. Malaria) w; -, ...ien; en|de|misch; En|de|mis|mus (begrenztes Vorkommen von Tieren u. Pflanzen in einem bestimmten Bezirk) m; -

en|den; nicht enden wollender Beifall; ...en|der (z. B. Achtender); End_er|folg, ...er|geb|nis, ...erzeug|nis

en dé|tail fr. [*angdetaj*] (im kleinen; einzeln; im Einzelverkauf; Ggs.: en gros); vgl. Detail; En|dé|tail|ge|schäft

End|ge|schwin|dig|keit; end|gil|tig vgl. giltig; end|gül|tig; End|gül|tig|keit; en|di|gen (älter für: enden); En|di|gung (veralt.)

En|di|vie ägypt. [...*wi*^e] (eine Salatpflanze) w; -, -n; En|di|vi|en|sa|lat

End_kampf, ...kon|so|nant, ...lauf; End|lein, End|chen; end|lich; end|lich|keit w; -, (selten:) -en; end|los; -es Band; bis ins Endlose († R 116); End_los|bahn, ...band, ...for|mu|lar (Druckw.); End|lo|sig|keit w; -, (selten:) -en

en|do... gr. (innen...); En|do... (innen...)

En|do|der|mis gr. (Bot.: innerste Zellschicht der Pflanzenrinde) w; -, ...men

En|do|ga|mie gr. (Heirat innerhalb von Stamm, Kaste usw.) w; -, ...ien

en|do|gen gr. (Bot.: im Innern entstehend; Med.: von innen kommend); -e Psychosen

En|do|kard (Med.: Herzinnenhaut) s; -[e]s, -e; En|do|kar|di|tis (Entzündung der Herzinnenhaut) w; -, ...it|den

En|do|karp (Bot.: innerer Teil der Fruchtwand) s; -[e]s, -e

en|do|krin (Med.: mit innerer Sekretion); -e Drüsen; En|do|kri|no|lo|gie (Lehre von der inneren Sekretion) w; -

En|do|skop gr. (Med.: Instrument zur Untersuchung von Körperhöhlen) s; -s, -e; En|do|sko|pie (Untersuchung mit dem Endoskop) w; -, ...ien

En|do|sperm gr. (Nährgewebe im Pflanzensamen) s; -s

En|do|thel gr. s; -s, -e u. En|do|the|li|um (Zellschicht, die Blut- u. Lymphgefäße auskleidet) s; -s, ...ien [...*i*^en]

en|do|therm gr. (Chemie: Wärme bindend, aufnehmend)

End_pha|se, ...punkt, ...reim, ...run|de; End|run|den|spiel; End_sil|be, ...spiel, ...spurt, ...sta|di|um, ...sta|ti|on, ...stück; En|dung; en|dungs|los (Grammatik); End_ur|sa|che, ...ver|brau|cher, ...vier|zi|ger, ...vo|kal, ...zeit; end-zeit|lich; End_ziel, ...zu|stand, ...zweck

Ener|ge|tik gr. (Lehre von der Energie; Philos.: Auffassung von der Energie als Grundkraft aller Dinge) w; -; ener|ge|tisch; -er Imperativ; Ener|gie (Tatkraft; Physik: Fähigkeit, Arbeit zu leisten) w; -, ...ien; ener|gie|arm; Ener-gie_be|darf, ...haus|halt; ener|gie-los; Ener|gie|lo|sig|keit w; -; Ener|gie_po|li|tik, ...pro|gramm, ...quel|le; ener|gie|reich; Ener|gie_trä|ger, ...ver|brauch, ...ver|sor|gung, ...wirt|schaft, ...zu|fuhr; ener|gisch; -ste († R 294)

ener|vie|ren lat. [...*wir*^en] (entnerven, entkräften)

Enes|cu [*eneßku*], (fr.:) Enes|co [*enäßko*] (rumän. Komponist u. Geigenvirtuose)

en face fr. [*angfaß*, auch: ...*faß*] (von vorn; gegenüber)

en fa|mille fr. [*angfamij*] („in der Familie"; in engem Kreise)

En|fant ter|ri|ble fr. [*angfang täribl*] (jmd., der gegen die geltenden [gesellschaftlichen] Regeln verstößt und dadurch seine Umgebung ohne Absicht oft schokkiert) s; - -, -s -s [*angfang täribl*]

eng; I. Kleinschreibung: einen engen Horizont haben; († R 134:) auf das, aufs engste. II. Schreibung in Verbindung mit dem 2. Mittelwort († R 142), z. B. engbefreundet, engbegrenzt (vgl. d.)

En|ga|din [auch: ...*din*] (Talschaft des Inns in der Schweiz) s; -s

En|ga|ge|ment fr. [*anggaseh*^e*mang*, österr.: ...*gasehmang*] (Verpflichtung, Bindung; [An]stellung, bes. eines Künstlers) s; -s, -s; en|ga-gie|ren [*anggasehir*^en] (verpflichten, binden); sich - (sich einsetzen); en|ga|giert; -e Literatur; En|ga|giert|heit w; -

eng|an|lie|gend; eng|an|schlie-ßend; eng|be|druckt; vgl. eng II; eng|be|freun|det; († R 296:) enger, am engsten befreundet; die eng-befreundeten Männer († jedoch R 142), a ber: die Männer sind eng befreundet; eng|be|grenzt; († R 296:) enger, am engsten begrenzt; seine engbegrenzte Anschauung († jedoch R 142), a ber: seine Anschauung ist eng begrenzt; eng|be|schrie|ben; vgl. eng II; eng|brü|stig; En|ge w; -, -n

249 enteisen

En|gel m; -s, -
En|gel|berg (schweiz. Abtei u.
Kurort südl. des Vierwaldstätter
Sees)
En|gel|bert, En|gel|brecht (m.
Vorn.); En|gel|ber|ta (w. Vorn.)
En|gel|chen, En|ge|lein, Eng|lein;
en|gel|gleich, en|gels|gleich; en-
gel|haft; En|gel|haf|tig|keit w; -
En|gel|hard (m, Vorn.)
En|gel|ma|cher (ugs. verhüllend:
Kurpfuscher, der illegale Abtrei-
bungen vornimmt); En|gel|ma-
che|rin w; -, -nen; en|gel|rein; eine
-e Stimme
En|gels (Sozialist, Mitbegründer
des Marxismus)
En|gels|burg (in Rom) w; -; en|gel-
schön; En|gels|ge|duld; en|gel(s)-
gleich; En|gels|haar; En|gel(s)-
.kopf, ...stim|me; En|gel|süß
(Farnart) s; -es; En|gels|zun|gen
Mehrz.; mit [Menschen- und mit]
Engelszungen (so eindringlich
wie möglich) reden; En|gel|wurz
(eine Heilpflanze); vgl. ²Angelika
en|gen (selten für: einengen)
Eng|er|ling (Maikäferlarve)
eng|her|zig; Eng|her|zig|keit w; -;
En|gig|keit w; -
Eng|land; Eng|län|der (auch Bez.
für ein zangenartiges Werkzeug)
Eng|lein, En|ge|lein, Eng|lein
eng|lisch; (↑ R 200:) die -e Krank-
heit, die -e Dogge, -es Pflaster,
-er Trab, -er Garten, -e Broschur
(ein Bucheinband), aber (↑ R
224):das Englische Fräulein (vgl.
d.), der Englische Garten in
München; vgl. deutsch; Eng|lisch
(eine Sprache) s; -[s]; vgl.
Deutsch; Eng|li|sche s; -n; vgl.
Deutsche s; Eng|li|sche Fräu|lein
(Angehörige eines Frauenor-
dens) s; -n -s, -n -
Eng|li|sche Gruß [zu: Engel] (ein
Gebet) m; -n -es
Eng|lisch.horn (ein Holzblasin-
strument; Mehrz. ...hörner), ...le-
der (ein Baumwollgewebe),
...pfla|ster (ein Heftpflaster);
Eng|lish spo|ken engl. [ingglisch
βpo°k°n] (hier wird) „Englisch
gesprochen“); Eng|lish-Waltz
[ingglisch ºálz] (langsamer Wal-
zer) m; -, -; eng|li|sie|ren ([Pfer-
den] die niederziehenden
Schweifmuskeln durchschnei-
den, damit sie den Schwanz hoch
tragen; anglisieren [vgl. d.])
eng|ma|schig
En|go|be fr. [anggob°] (keram.
Überzugsmasse) w; -, -n; en|go-
bie|ren
Eng|paß
En|gramm gr. (Med.: bleibende
Spur geist. Eindrücke, Erinne-
rungsbild) s; -s, -e
en gros fr. [anggro] (im großen;

Ggs.: en détail); En|gros.ge-
schäft, ...han|del (Großhandel);
En|gros|sist (österr. neben: Gros-
sist)
eng|stir|nig; Eng|stir|nig|keit w; -;
eng.um|grenzt, ...ver|bün|det,
...ver|wandt; vgl. eng II
en|har|mo|nisch gr. (von Tönen:
dem Klang nach gleich, in der
Bez. verschieden, z. B. cis = des);
-e Verwechslung
En|jam|be|ment fr. [angschangb°-
mang, österr.: ...sehangbmang]
(Poetik: Übergreifen eines Satzes
auf den nächsten Vers) s; -s, -s
en|kau|stie|ren gr. (bild. Kunst:
Farben, mit flüssigem Wachs
verschmolzen, auftragen); En-
kau|stik w; -; en|kau|stisch
¹En|kel landsch. (Fußknöchel) m;
-s, -
²En|kel (Kindeskind) m; -s, -; En-
ke|lin w; -, -nen; En|kel.kind,
...sohn, ...toch|ter
En|kla|ve lat. [...w°] (ein fremd-
staatl. Gebiet im eigenen Staats-
gebiet) w; -, -n; vgl. Exklave
En|kli|se, En|kli|sis gr. (Sprachw.:
Anlehnung eines unbetonten
Wortes an das vorausgehende be-
tonte; Ggs.: Proklise) w; -, ...isen;
En|kli|ti|kon (unbetontes Wort,
das sich an das vorhergehende
betonte anlehnt, z. B. [ugs.]
„kommste“ für: „kommst du“)
s; -s, ...ka; en|kli|tisch
En|ko|mi|ast gr. (Lobredner) m;
-en, -en (↑ R 268); En|ko|mia|stik
(Lobpreisung; Lobrednerei) w; -;
En|ko|mi|on, En|ko|mi|um s;
(Lobrede, -schrift) s; -s, ...ien
[...i°n]
en masse fr. [angmaß] (ugs. für:
„in Masse“; gehäuft)
en mi|nia|ture fr. [angminiatür] (in
kleinem Maßstabe, im kleinen)
en|net schweiz. mdal. (jenseits),
mit Wemf.; ennetbirgisch (jen-
seits der Alpen gelegen); en-
netrheinisch (jenseits des Rheins
gelegen, d. h. [bundes]deutsch)
En|no (m. Vorn.)
¹Enns r. (Nebenfluß der Donau)
w; -; ²Enns (Stadt in Oberöster-
reich); Enns|tal (Tal in der Steier-
mark); Enns|ta|ler Al|pen
en|nu|yie|ren [angnüjir°n] (veralt.
für: langweilen)
enorm fr. (außerordentlich; unge-
heuer); Enor|mi|tät
en pas|sant fr. [angpaßang] (im
Vorübergehen; beiläufig)
en pleine car|riè|re fr. [angplän-
kariär] (in gestrecktem Galopp)
en pro|fil fr. [angprofil] (im Profil,
von der Seite)
En|quete fr. [angkät] (Untersu-
chung, Erhebung; österr. auch:
Arbeitstagung w; -, -n

en|ra|giert fr. [angraschirt] (veralt.
für: leidenschaftl. eingenommen)
en|rol|lie|ren fr. [angrolir°n]; Trup-
pen - (früher für: anwerben)
en route fr. [angrut] (unterwegs)
En|sem|ble fr. [angßangb°l] (ein
zusammengehörendes Ganzes;
eine Gruppe von Künstlern)
s; -s, -s; En|sem|ble|spiel s; -[e]s
En|si|la|ge, Si|la|ge fr. [angßila-
seh°] (Gärfutter[bereitung]) w; -
en suite fr. [angßwit] (im folgen-
den, demzufolge; [ohne Unter-
brechung] hintereinander)
ent... (Vorsilbe von Zeitwörtern, z.
B. entfuhren, du entführst, ent-
führt, zu entführen; zum 2. Mit-
telw. ↑ R 304)
...ent (z. B. Referent m; -en, -en;
↑ R 268)
ent|am|ten; Ent|am|tung
ent|ar|ten; ent|ar|tet; -ste; (natio-
nalsoz.:) -e Kunst; Ent|ar|tung;
Ent|ar|tungs|er|schei|nung
ent|aschen; Ent|aschung
En|ta|se, En|ta|sis gr. (Architek-
tur: Schwellung des Säulenschaf-
tes) w; -, ...asen
ent|asten, ent|ästen (Äste entfer-
nen)
ent|äu|ßern, sich; ich entäußere
mich allen Besitzes; Ent|äu|ße-
rung w; -
Ent|bal|lung; - von Industriegebie-
ten
ent|beh|ren; ein Buch -; des Trostes
- (geh.); ent|behr|lich; Ent|behr-
lich|keit w; -; Ent|beh|rung; ent-
beh|rungs|reich
ent|bie|ten; Grüße -
ent|bin|den; Ent|bin|dung; Ent|bin-
dungs.heim, ...sta|ti|on
ent|blät|tern; sich -; Ent|blät|te-
rung
ent|blö|en; entbleites Benzin
ent|blö|den, nur in: sich nicht
entblöden (sich nicht scheuen)
ent|blö|ßen; du entblößt (entblö-
ßest); sich -; Ent|blö|ßung
ent|bren|nen
ent|bü|ro|kra|ti|sie|ren; Ent|bü|ro-
kra|ti|sie|rung
ent|decken; Ent|decker¹; Ent-
decker|freu|de¹; ent|decke|risch;
Ent|deckung¹; Ent|deckungs¹-
.fahrt, ...rei|se
ent|dun|keln; ich ...[e]le (↑ R 327)
En|te w; -, -n (↑ R 224:) kalte -
(ein Getränk)
ent|eh|ren; ent|eh|rend; Ent|eh-
rung
ent|eig|nen; Ent|eig|nung
ent|ei|len
ent|ei|sen (von Eis befreien); du
enteist (enteisest); er entei|ste;
enteist

¹ Trenn.: ...dek|k...

ent|ei|se|nen (von Eisen befreien); du enteisenst; enteisent; Ent|ei|se|nung

Ent|ei|sung (Befreiung von Eis)

En|te|le|chie gr. (Gestaltungskraft zur Entwicklung u. Vollendung der Anlagen) w; -, ...ien; en|te|le|chisch

En|ten.bra|ten, ...ei, ...kü|ken (vgl. [1]Küken), ...schna|bel

En|tente fr. [angtangt] (Staatenbündnis) w; -, -n; (↑ R 224:) die Große -, die Kleine -; En|tente cor|di|ale [- kordiạl] (Bez. für das fr.-engl. Bündnis nach 1904) w; - -

En|ter niederd. (einjähr. Fohlen, Kalb) s; -s, -

ent|er|ben; Ent|er|bung

En|ter.brücke [Trenn.: ...brük|ke], ...ha|ken

En|te|rich (männl. Ente) m; -s, -e

En|te|ri|tis gr. (Med.: Darmentzündung, -katarrh) w; -, ...itiden

en|tern niederl. (auf etwas klettern); ein Schiff - (mit Enterhaken festhalten und erobern); ich ...ere (↑ R 327)

En|te|ro|kly|se gr. (Med.: Darmspülung) w; -, -n; En|te|ro|sto|mie (Med.: Anlegung eines künstl. Afters) w; -, ...ien

En|ter|tai|ner engl. [ạ̈nterteị'n'r] (Unterhalter) m; -s, -

En|te|rung

ent|fa|chen; Ent|fa|chung

ent|fah|ren; ein Fluch entfuhr ihm

ent|fal|len

ent|falt|bar; ent|fal|ten; sich -; Ent|fal|tung

ent|fär|ben; Ent|fär|ber (Entfärbungsmittel)

ent|fer|nen; sich -; ent|fernt; weit [davon] -, das zu tun; nicht im -esten (↑ R 134); Ent|fer|nung; in einer - von 4 Meter[n] (↑ R 322); Ent|fer|nungs|mes|ser m

ent|fes|seln; Ent|fes|se|lung, Ent|feß|lung

ent|fe|sti|gen; Metalle - (weich[er] machen); Ent|fe|sti|gung

ent|fet|ten; Ent|fet|tung; Ent|fet|tungs|kur

ent|feuch|ten; Ent|feuch|ter (Gerät, das der Luft in einem Raum Feuchtigkeit entzieht); Ent|feuch|tung

ent|flamm|bar; leicht -es Material; ent|flam|men; ent|flammt; Ent|flam|mung

ent|flech|ten; er entflicht (auch entflechtet); er entflocht (auch: entflechtete); entflochten; Ent|flech|tung

ent|flie|gen

ent|flie|hen

ent|frem|den; sich -; Ent|frem|dung

ent|fro|sten; Ent|fro|ster; Ent|fro|stung

ent|füh|ren; Ent|füh|rer; Ent|füh|rung

ent|ga|sen; du entgast (entgasest); er entga|ste; Ent|ga|sung

ent|ge|gen; meinem Vorschlag - od. - meinem Vorschlag; ent|ge|gen... (in Zus. mit Zeitwörtern, z. B. entgegenkommen, du kommst entgegen, entgegengekommen, entgegenzukommen; zum 2. Mittelw. ↑ R 304); ent|ge|gen|brin|gen; jmdm. Vertrauen -; ent|ge|gen.fah|ren, ...ge|hen; ent|ge|gen|ge|setzt; aber: das Entgegengesetzte (↑ R 116); er ging in die -e Richtung; die Verhandlungen entwickelten sich -; ent|ge|gen|ge|setzt|ten|falls; vgl. Fall m; ent|ge|gen.hal|ten, ...kom|men; Ent|ge|gen|kom|men s; -s; ent|ge|gen|kom|mend; ent|ge|gen|kom|men|der|wei|se; aber: in entgegenkommender Weise; ent|ge|gen.lau|fen, ...neh|men, ...se|hen, ...set|zen; ent|ge|gen|set|zend (Gramm.: adversativ); ent|ge|gen.ste|hen, ...stem|men, sich, ...tre|ten; ent|geg|nen; Ent|geg|nung

ent|ge|hen; ich lasse mir nichts - ent|gei|stert (sprachlos; verstört)

Ent|gelt s (veralt.: m); -[e]s, -e; entgegen, ohne -; ent|gel|ten; er läßt mich meine Nachlässigkeit nicht -; ent|gelt|lich (gegen Bezahlung)

ent|gif|ten; Ent|gif|tung

ent|glei|sen; du entgleist (entgleisest); er entglei|ste; Ent|glei|sung

ent|glei|ten

ent|göt|tern; ich ...ere (↑ R 327); Ent|göt|te|rung; Ent|göt|tung

ent|gra|ten; entgratetes Eisen

ent|grä|ten; entgräteter Fisch

ent|gren|zen; Ent|gren|zung

ent|haa|ren; Ent|haa|rung; Ent|haa|rungs|mit|tel s

ent|haf|ten (aus der Haft entlassen)

ent|hal|ten; sich -; ich enthielt mich der Stimme; ent|halt|sam; Ent|halt|sam|keit w; -; Ent|hal|tung

ent|här|ten; Ent|här|tung

ent|haup|ten; Ent|haup|tung

ent|häu|ten; Ent|häu|tung

ent|he|ben; jmdn. seines Amtes -; Ent|he|bung

ent|hei|li|gen; Ent|hei|li|gung

ent|hem|men; Ent|hemmt|heit; Ent|hem|mung

ent|hül|len; sich -; Ent|hül|lung

ent|hül|sen

ent|hu|ma|ni|sie|ren; Ent|hu|ma|ni|sie|rung

en|thu|si|as|mie|ren fr. (begeistern); En|thu|si|as|mus gr. (Begeisterung; Leidenschaftlichkeit) m; -; En|thu|si|ast m; -en, -en (↑ R 268); en|thu|si|a|stisch; -ste (↑ R 294)

ent|ideo|lo|gi|sie|ren; Ent|ideo|lo|gi|sie|rung

En|ti|tät lat. (Philos.: Dasein im Unterschied zum Wesen eines Dinges)

ent|jung|fern (für: deflorieren); Ent|jung|fe|rung

entkal|ken

ent|kei|men; Ent|kei|mung

ent|ker|nen; Ent|ker|ner (Werkzeug); Ent|ker|nung

ent|klei|den; sich -; Ent|klei|dung

ent|kno|ten

ent|kom|men; Ent|kom|men s; -s

ent|kor|ken

ent|kräf|ten; Ent|kräf|tung

ent|kramp|fen; Ent|kramp|fung

ent|krau|ten; den Boden -; Ent|krau|tung

ent|la|den; vgl. [1]laden; sich -; Ent|la|dung

ent|lang; bei Nachstellung mit Wenf.: den Wald - (selten Wemf.: dem Wald -); bei Voranstellung Wemf.: - dem Fluß (selten Wesf.: - des Flusses; veralt. Wenf.: - den Fluß); am Ufer -; am, das Ufer entlang laufen (nicht fahren); aber: am, das Ufer entlanglaufen (nicht am Berg, den Berg); vgl. längs; ent|lang... (in Zus. mit Zeitwörtern, z. B. entlanglaufen, du läufst entlang, entlanggelaufen, entlangzulaufen; zum 2. Mittelw. ↑ R 304); ent|lang|lau|fen vgl. entlang u. entlang...

ent|lar|ven; sich -; Ent|lar|vung

Ent|laß...südd. (in Zusammensetzungen für: Entlassungs..., z. B. Entlaßfeier); ent|las|sen; Ent|las|sung; Ent|las|sungs.fei|er, ...klas|se, ...schein, ...schü|ler

ent|la|sten; Ent|la|stung; Ent|la|stungs.an|griff, ...ma|te|ri|al, ...schlag, ...zeu|ge, ...zug

ent|lau|ben; ent|laubt; Ent|lau|bung

ent|lau|fen

ent|lau|sen; Ent|lau|sung; Ent|lau|sungs|schein

Ent|le|buch (schweiz. Landschaft) s; -s

ent|le|di|gen; sich der Aufgabe -; Ent|le|di|gung

ent|lee|ren; Ent|lee|rung

ent|le|gen; -ste; Ent|le|gen|heit w; -; ent|leh|nen; Ent|leh|nung

ent|lei|ben (töten); sich -

ent|lei|hen; Ent|lei|her; Ent|lei|hung

Ent|lein, Ent|chen (kleine Ente)

ent|lo|ben, sich; Ent|lo|bung

ent|locken [Trenn.: ...lok|ken]

ent|loh|nen, (schweiz.:) ent|löh|nen; Ent|loh|nung, (schweiz.:) Ent|löh|nung

ent|lüf|ten; Ent|lüf|ter (für: Exhaustor); Ent|lüf|tung; Ent|lüf|tungs|an|la|ge

ent|mach|ten; Ent|mach|tung
ent|man|nen; Ent|man|nung
ent|men|schen; ent|mensch|li|chen;
ent|menscht
ent|mi|li|ta|ri|sie|ren; entmilitari-
sierte Zone; Ent|mi|li|ta|ri|sie|
rung
ent|mi|sten; Ent|mi|stung; Ent|mi-
stungs|an|la|ge
ent|mün|di|gen; Ent|mün|di|gung
ent|my|ti|gen; Ent|my|ti|gung
ent|my|thi|sie|ren; Ent|my|thi|sie-
rung; ent|my|tho|lo|gi|sie|ren;
Ent|my|tho|lo|gi|sie|rung
ent|nah|me w; -, -n
ent|na|tio|na|li|sie|ren; Ent|na|tio-
na|li|sie|rung
ent|na|zi|fi|zie|ren; Ent|na|zi|fi|
zie|rung
ent|neh|men; [aus] den Worten -
ent|ner|ven [...fᵉn]; ent|nervt; Ent|
ner|vung
En|to|derm gr. (inneres Keimblatt
des Embryos) s; -s, -e
En|to|mo|lo|ge gr. (Insektenfor-
scher m; -n, -n († R 268); En|to-
mo|lo|gie w; -; en|to|mo|lo|gisch
En|to|pa|ra|sit gr. (im Innern an-
derer Tiere und Pflanzen leben-
der Schmarotzer)
ent|op|tisch gr. (Med.: im Innern
des Auges gelegen)
ent|oti|sch gr. (Med.: im Innern des
Ohres entstehend)
En|to|zo|on gr. (Med.: tier. Schma-
rotzer im Körperinnern) s; -s,
...zoen u. ...zoa
Ent|per|sön|li|chung
ent|pflich|ten (der Amtspflicht
entbinden); Ent|pflich|tung
ent|po|li|ti|sie|ren; Ent|po|li|ti|sie-
rung
ent|pul|pen ([Rübenzuckersaft]
entfasern)
ent|pup|pen, sich; Ent|pup|pung
ent|quel|len (geh.)
ent|rah|men; Ent|rah|mer (Milch-
schleuder); Ent|rah|mung
ent|ra|ten (veralt. für: entbehren);
eines Dinges [nicht] - können
ent|rät|seln; Ent|rät|se|lung, Ent-
räts|lung
En|treakt fr. [angtrakt] (Zwischen-
akt, Zwischenspiel, Zwischen-
musik) m; -[e]s, -e
ent|rech|ten; Ent|rech|tung
En|tre|cote fr. [angtrᵉkot] (Rip-
penstück beim Rind) s; -[s], -s
En|tree fr. [angtre] (Eintritt[sgeld],
Eingang; Vorspeise; Eröffnungs-
musik [bei Balletten]) s; -s, -s;
Entree|tür
ent|rei|ßen
En|tre|lacs fr. [angtrᵉla] (Bauw.:
geflechtartige Verzierung) s; -, -
(meist Mehrz.)
en|tre nous fr. [angtrᵉnu] (selten
für: „unter uns"; ungezwungen,
vertraulich)

En|tre|pot fr. [angtrᵉpo] (Zollnie-
derlage) s; -, -s
ent|rich|ten; Ent|rich|tung
ent|rin|den; Baumstämme -
ent|rin|gen, sich (geh.); ein Seufzer
entrang sich ihm
ent|rin|nen; Ent|rin|nen s; -s
ent|risch bayr. österr. mdal. (un-
heimlich, nicht geheuer)
ent|rol|len; sich -
En|tro|ple gr. (eine physikal.
Größe) w; -, ...ien
ent|ro|sten; Ent|ro|ster (Mittel ge-
gen Rost); Ent|ro|stung
ent|rücken [Trenn.: ...rük|ken];
Ent|rückt|heit; Ent|rückung
[Trenn.: ...rük|kung]
ent|rüm|peln; ich ...[e]le († R 327);
Ent|rüm|pe|lung, Ent|rümp|lung
ent|rü|sten; sich -; ent|rü|stet; Ent-
rü|stung
ent|saf|ten; Ent|saf|ter
ent|sa|gen; dem Vorhaben -; Ent-
sa|gung; ent|sa|gungs|voll
ent|sal|zen; entsalzt; Ent|sal|zung
ent|säu|ern; Ent|säue|rung
Ent|satz m; -es
ent|schä|di|gen; Ent|schä|di|gung;
Ent|schä|di|gungs|sum|me
ent|schär|fen; eine Mine -; Ent-
schär|fung
Ent|scheid m; -[e]s, -e; ent|schei-
den; sich - für etwas; ent|schei-
dend; -ste; Ent|schei|dung; Ent-
schei|dungs_be|fug|nis, ...frei-
heit, ...ge|walt, ...recht,
...schlacht; ent|schei|dungs-
schwer; Ent|schei|dungs|spiel;
ent|schie|den; auf das, aufs -ste
(† R 134); Ent|schie|den|heit w; -
ent|schlacken [Trenn.: ...schlak-
ken]; Ent|schlackung [Trenn.:
...schlak|kung]
ent|schla|fen (sterben)
ent|schla|gen, sich (veralt.); sich al-
ler Sorgen -
ent|schlam|men; Ent|schlam|mung
ent|schlei|ern; ich ...ere († R 327);
Ent|schleie|rung
ent|schlie|ßen, sich; Ent|schlie-
ßung; ent|schlos|sen; Ent|schlos-
sen|heit w; -
ent|schlüp|fen
Ent|schluß
ent|schlüs|seln; Ent|schlüs|se|lung,
Ent|schlüß|lung
ent|schluß|fä|hig; Ent|schluß|fä-
hig|keit (w; -), ...frei|heit (w; -),
...kraft (w; -); ent|schluß|los; Ent-
schluß|lo|sig|keit w; -
ent|schrot|ten; Ent|schrot|tung
ent|schuld|bar; Ent|schuld|bar|keit
w; -; ent|schul|den (Schulden ab-
tragen); ent|schul|di|gen; sich we-
gen etwas -; ent|schul|di|gung;
Ent|schul|di|gungs_brief, ...grund,
...schrei|ben; Ent|schul|dung
ent|schup|pen
ent|schwe|feln

ent|schwe|feln; Ent|schwe|fe|lung,
Ent|schwef|lung
ent|schwei|ßen; Wolle - (von
Schweiß und Fett reinigen)
ent|schwin|den
ent|seelt (geh. für: tot)
ent|sen|den; Ent|sen|dung
ent|set|zen; sich -; Ent|set|zen s; -s;
ent|set|zen|er|re|gend; ein -er An-
blick, aber († R 142): großes Ent-
setzen erregend: Ent|set|zens-
schrei; ent|setz|lich; Ent|setz|lich-
keit; ent|setzt
ent|seu|chen (fachspr. für: desinfi-
zieren); Ent|seu|chung
ent|si|chern
ent|sie|geln; Ent|sie|ge|lung, Ent-
sieg|lung
ent|sin|nen, sich; ich habe mich
deiner entsonnen; ent|sinn|li-
chen; Ent|sinn|li|chung
ent|sitt|li|chen; Ent|sitt|li|chung
ent|sor|gen; Ent|sor|gung (Beseiti-
gung von Müll)
ent|span|nen; sich -; ent|spannt; -es
Wasser; Ent|span|nung; Ent-
span|nungs_po|li|tik, ...übung
ent|spin|nen, sich
ent|spre|chen; ent|spre|chend; († R
28:) - seinem Vorschlag od. sei-
nem Vorschlag -; († R 116:) Ent-
sprechendes, das Entsprechende
gilt für ...; Ent|spre|chung
ent|sprie|ßen
ent|sprin|gen
Ent|sta|li|ni|sie|rung w; -
ent|stam|men
ent|stau|ben; Ent|stau|ber; Ent-
stau|bung
ent|ste|hen; Ent|ste|hung; Ent|ste-
hungs_ge|schich|te, ...ort, ...ur|sa-
che, ...zeit
ent|stei|gen (geh.); er entstieg dem
Zug
ent|stei|nen; Kirschen -
ent|stel|len; ent|stellt; Ent|stel|lung
ent|stem|peln; die Nummernschil-
der wurden entstempelt
ent|stoff|li|chen
ent|stö|ren; Ent|stö|rung; Ent|stö-
rungs_dienst, ...stel|le
ent|strö|men
ent|süh|nen; Ent|süh|nung
ent|sump|fen; Ent|sump|fung
ent|tar|nen; Ent|tar|nung
ent|täu|schen; Ent|täu|schung; ent-
täu|schungs|reich
ent|tee|ren; Ent|tee|rung
ent|thro|nen; Ent|thro|nung
ent|trüm|mern; Ent|trüm|me|rung
ent|völ|kern; ich ...ere († R 327);
Ent|völ|ke|rung
entw. = entweder
ent|wach|sen
ent|waff|nen; Ent|waff|nung
ent|war|nen; Ent|war|nung
ent|wäs|sern; Ent|wäs|se|rung,
Ent|wäß|rung; Ent|wäs|se|rungs-
gra|ben

ent|we|der [auch: ä̱nt...] (Abk.: entw.); entweder – oder; E̱nt|we|der-O̱der (↑ R 119) s; -, -
ent|wei|chen; vgl. ²weichen; Ent|wei|chung
ent|wei|hen; Ent|wei|hung
ent|wen|den; ich entwendete, habe entwendet; Ent|wen|dung
ent|wer|fen; Pläne -
ent|wer|ten; sich -; Ent|wer|tung
ent|we|sen; ein Gebäude - (fachspr. für: von Ungeziefer reinigen); Ent|we|sung
ent|wickeln [Trenn.: ...wik|keln]; sich -; Ent|wicke|lung [Trenn.: ...wik|ke...]; Ent|wick|ler; Ent|wick|lung; Ent|wick|lungs_dienst, ...ge|schich|te; ent|wick|lungs.ge|schicht|lich; Ent|wick|lungs_ge|setz, ...grad; ent|wick|lungs|hem|mend; Ent|wick|lungs_hil|fe, ...jah|re (Mehrz.), ...land, (Mehrz. ...länder; meist Mehrz.), ...pro|zeß, ...ro|man, ...stö|rung, ...stu|fe, ...zeit, ...zu|stand
ent|wid|men (Amtsspr.: einzelnen; einer bestimmten Benutzung entziehen); einen Weg -; Ent|wid|mung
ent|win|den; vgl. ¹winden
ent|wirr|bar; ent|wir|ren; sich -; Ent|wir|rung
ent|wi|schen (ugs. für: entkommen)
ent|wöh|nen; Ent|wöh|nung
ent|wöl|ken, sich; Ent|wöl|kung
Ent|wurf; Ent|wurfs_ge|schwin|dig|keit (Richtwert im Straßenbau), ...zeich|nung
ent|wur|men
ent|wur|zeln; ich ...[e]le (↑ R 327); Ent|wur|ze|lung, Ent|wurz|lung
ent|zau|bern; Ent|zau|be|rung
ent|zer|ren; Ent|zer|rer (Technik); Ent|zer|rung
ent|zie|hen; sich -; Ent|zie|hung; Ent|zie|hungs_an|stalt, ...kur
ent|zif|fer|bar; Ent|zif|fe|rer; ent|zif|fern; ich ...ere (↑ R 327); Ent|zif|fe|rung
ent|zücken¹; Ent|zücken¹ s; -s; ent|zückend¹; -ste; am -sten; Ent|zückung¹
Ent|zug m; -[e]s
ent|zünd|bar; ent|zün|den; sich - ent|zün|dern (für: dekapieren); ich ...ere (↑ R 327)
ent|zünd|lich; leichtentzündlich (vgl. d.); Ent|zünd|lich|keit w; -; Ent|zün|dung; ent|zün|dungs_hem|mend; Ent|zün|dungs|herd
ent|zwei; - sein; ent|zwei... (in Zus. mit Zeitwörtern, z. B. entzweibrechen, du brichst entzwei, entzweigebrochen, entzweizubrechen; zum 2. Mittelw. ↑ R 304);

¹ Trenn.: ...zük|k...

ent|zwei|bre|chen; vgl. entzwei...;
ent|zwei|en; sich -; ent|zwei|fah|ren; ent|zwei|ge|hen; ent|zwei|schnei|den; Ent|zwei|ung
En|ve|lop|pe fr. [a̱ŋgwᵉlǫpᵉ] (veralt. für: Hülle, Decke, [Brief]umschlag; Math.: einhüllende Kurve) w; -, -n
En|vi|ron|ment amerik. [inwa̱i⁽ᵉ⁾-rᵉnmᵉnt] (Kunstrichtung, die ganze Räume zu formen versucht; Umgebungsgestaltung) s; -s, -s; En|vi|ron|to|lo|gie (Umweltforschung) w; -
en vogue fr. [a̱ŋgwǫg] (beliebt; modisch; im Schwange)
En|voyé fr. [a̱ŋgwoaje] (fr. Bez. für: Gesandter) m; -s, -s
Enz (l. Nebenfluß des Neckars) w; -
En|ze|pha|li|tis gr. (Med.: Gehirnhautentzündung) w; -, ...it|den
En|zi|an (eine Alpenpflanze; ein alkohol. Getränk) m; -s, -e; en|zi|an|blau
En|zio (m. Vorn.)
En|zy|kli|ka gr. [auch: änzü...] (päpstl. Rundschreiben) w; -, ...ken; en|zy|klisch (auch: änzü...] (einen Kreis durchlaufend) En|zy|klo|pä|die gr. (ein Nachschlagewerk) w; -, ...ien; en|zy|klo|pä|disch (umfassend); En|zy|klo|pä|dist (Mitarbeiter an der berühmten fr. „Enzyklopädie"); ↑ R 268
En|zym gr. (Ferment) s; -s, -e; En|zy|mo|lo|gie (Lehre von den Enzymen) w; -
eo ip|so lat. (von selbst; selbstverständlich)
Eo|li|enne fr. [eoliä̱n] ([Halb]seidengewebe in Taftbindung) w; -
Eo|lith gr. (vermeintl. vorgeschichtl. Werkzeug) m; -s u. -en (↑ R 268), -e[n]; Eos (gr. Göttin der Morgenröte); Eo|sin (ein roter Farbstoff) s; -s; eo|si|nie|ren (mit Eosin färben)
eo|zän gr. (das Eozän betreffend); Eo|zän (zweitälteste Stufe des Tertiärs) s; -s; Eo|zän|for|ma|ti|on; Eo|zoi|kum (svw. Algonkium) s; -s; eo|zo|isch
ep... vgl. epi...
ep|ago|gisch gr. (Philos.: zum Allgemeinen führend); -er Beweis
Ep|ak|te gr. (Zahl, die angibt, wie viele Tage vom letzten Neumond bis zu einem bestimmten Tag vergangen sind) w; -, -n
Epau|lett fr. [epolä̱t] s; -s, -s (seltener für: Epau|let|te [epolä̱tᵉ] (Schulterstück auf Uniformen) w; -, -n
Epen (Mehrz. von: Epos)
Ep|en|the|se, Ep|en|the|sis gr. (Sprachw.: Einschaltung von Lauten zur Ausspracheerleich-

terung], z. B. „t" in „namentlich") w; -, ...the̱sen; ep|en|the̱|tisch
Ep|ex|ege|se gr. (Rhet.: hinzugefügte Erklärung, z. B. drunten „im Unterland") w; -, -n; ep|ex|ege̱|tisch
eph...vgl. epi...
Ephe̱|be gr. (in Griechenland Bez. für den mannbaren Jüngling [18.–20. Lebensjahr]) m; -n, -n (↑ R 268); ephe̱|bisch
Ephe̱|li|den gr. (Med.: Sommersprossen) Mehrz.
eph|emer gr. (nur einen Tag dauernd; vorübergehend); -e Blüten, Pflanzen, Siedlungen; Eph|eme|ri̱|de (Zool.: Eintagsfliege; Buchw. veralt. für: Tageblatt; Tagebuch; Astron.: Ge|stirn[berechnungs]tafel) w; -, -n
Ephe̱|ser¹ (↑ R 199); Ephe̱|ser|brief¹ (↑ R 205); ephe̱|sisch; Ephe̱|sos¹ vgl. Ephesus; Ephe̱|sus¹ (altgr. Stadt in Kleinasien)
Ephi̱|al|tes (altgr. Verräter)
Ephor (einer der fünf jährl. gewählten höchsten Beamten in Sparta) m; -en, -en (↑ R 268); Epho|rat (Amt eines Ephoren od. Ephorus) s; -[e]s, -e; Epho̱|ren|amt; Epho̱|rie (kirchl.] Aufsichtsbezirk) w; -, ...ien; Epho̱|rus [auch: e̱f...] (Dekan in der reformierten Kirche; Leiter eines ev. Predigerseminars) m; -, Ephoren
Ephra̱|im [auch: ä̱fra-im] (m. Vorn.)
epi..., vor Selbstlauten und h: ep... (gr. Vorsilbe; darauf [örtl. u. zeitl.], daneben, bei, darüber)
Epi|de|mie gr. (Seuche, Massenerkrankung) w; -, ...ien; Epi|de|mio|lo̱|ge (↑ R 268); Epi|de|mio|lo|gie (Seuchenlehre) w; -; epi|de|mio|lo̱|gisch; epi|de|misch
Epi|der|mis gr. (Med.: Oberhaut) w; -, ...men
Epi|dia|skop gr. (Bildwerfer, der als Diaskop und als Episkop verwendet werden kann) s; -s, -e
Epi|ge|ne̱|se gr. (Entwicklung durch Neubildung; Geol.: Beibehaltung des ursprüngl. Verlaufs von Flußtälern trotz Umweltsänderung) w; -; epi|ge|ne̱|tisch
Epi|go̱|ne gr. (schwächerer Nachkomme; Nachahmer ohne Schöpferkraft) m; -n, -n (↑ R 268); epi|go|nen|haft; epi|go|nen|tum s; -s
Epi|gramm gr. (Sinn-, Spottgedicht) s; -s, -e; Epi|gram|ma|ti|ker (Verfasser von Epigrammen); epi|gram|ma|tisch (kurz, treffend); Epi|graph (antike Inschrift) s; -s, -e; Epi|gra̱|phik (In-

¹ Auch: e̱f...

schriftenkunde) *w*; -; Epi|gra|phi|ker (Inschriftenforscher)

Epik *gr.* (erzählende Dichtkunst) *w*; -

Epi|karp *gr.* *s*; -s, -e u. (älter:) Epi|kar|pi|um (Bot.: äußerste Schicht der Pflanzenfrucht) *s*; -s, ...ien [...*i^en*]

Epi|ker [zu: Epik]

Epi|kle|se *gr.* (Anrufung des Heiligen Geistes in der Orthodoxen Kirche) *w*; -, -n

Epi|kri|se *gr.* (abschließende wissenschaftl. Beurteilung einer Krankheit) *w*; -, -n

Epi|kur (gr. Philosoph); Epi|ku|re|er (Anhänger der Lehre Epikurs; seit der röm. Zeit für: Genußmensch); epi|ku|re|isch, epi|ku|risch (nach Epikurs Art; auch für: dem Genuß ergeben), aber (↑ R 179): Epi|ku|re|isch, Epi|ku|risch; -e Schriften; Epi|ku|ros vgl. Epikur

Epi|la|ti|on *lat.* [...*zion*] (Med.: Enthaarung)

Epi|lep|sie *gr.* (Fallsucht, meist mit Krämpfen) *w*; -, ...ien; Epi|lep|ti|ker; epi|lep|tisch

epi|lie|ren *lat.* (Med.: enthaaren)

Epi|log *gr.* (Nachwort; Nachspiel, Ausklang) *m*; -s, -e

Epin|glé *fr.* [*epänggle*] (Kleider- u. Möbelstoff mit ungleich starken Querrippen) *m*; -[s], -s

Epi|ni|ki|on *gr.* (altgr. Siegeslied) *s*; -s, ...ien [...*i^en*]

Epi|pha|ni|as od. Epi|pha|ni|enfest [...*i^en*...] (Fest der ..Erscheinung" [des Herrn]; Dreikönigsfest); Epi|pha|nie *gr.* (,,Erscheinung" [des Herrn]) *w*; -; Epi|phg|nien|fest vgl. Epiphanias

Epi|pho|ra *gr.* [auch: *epi*...] (Med.: Tränenfluß; Rhet., Stilk.: Wiederholung von Wörtern am Ende aufeinanderfolgender Sätze oder Satzteile) *w*; -, ...rä

Epi|phyl|lum *gr.* (ein Blätterkaktus aus Brasilien) *s*; -s, ...llen

Epi|phy|se *gr.* (Zirbeldrüse; Endstück der Röhrenknochen) *w*; -, -n; Epi|phyt (Pflanze, die [bei selbständiger Ernährung] auf anderen Pflanzen wächst) *m*; -en, -en (↑ R 268)

Epi|rot (Bewohner von Epirus) *m*; -en, -en (↑ R 268); epi|ro|tisch; Epi|rus (westgr. Landschaft)

episch (erzählend; das Epos betreffend); -es Theater

Epi|skop *gr.* (Bildwerfer für nicht durchsichtige Bilder [z. B. aus Büchern]) *s*; -s, -e

epi|sko|pal, epi|sko|pisch (bischöflich); Epi|sko|pa|lis|mus (Auffassung, nach der das Konzil der Bischöfe über dem Papst steht) *m*; -; Epi|sko|pa|list (An-

hänger des Episkopalismus); ↑ R 268; Epi|sko|pat|kir|che; Epi|sko|pat (Gesamtheit der Bischöfe; Bischofswürde) *s*; (Theol.: *m*); -[e]s, -e; epi|sko|pisch vgl. episkopal; Epi|sko|pus (lat. Bez. für: Bischof) *m*; -, ...pi

Epi|so|de *gr.* (vorübergehendes, nebensächl. Ereignis; Zwischenstück) *w*; -, -n; epi|so|den|haft; epi|so|disch

Epi|stel *gr.* (Apostelbrief im N. T.; vorgeschriebene gottesdienstl. Lesung; ugs. für: Brief, Strafpredigt) *w*; -, -n

Epi|styl *gr.* (svw. Architrav) *s*; -s, -e

Epi|taph *gr.* *s*; -s, -e u. Epi|ta|phium (Grabschrift; Grabmal mit Inschrift) *s*; -s, ...ien [*i^en*]

Epi|tha|la|mi|on, Epi|tha|la|mi|um *gr.* (antikes] Hochzeitslied) *s*; -s, ...ien [...*i^en*]

Epi|thel *gr.* *s*; -s, -e u. Epi|the|li|um (oberste Zellschicht der Haut) *s*; -s, ...ien [...*i^en*]

Epi|the|ton *gr.* (Sprachw.: Beiwort) *s*; -s, ...ta; Epi|the|ton or|nans *gr.*; *lat.* (,,schmückendes" [formelhaftes] Beiwort, z. B. ,,grüne Wiese") *s*; - -, ...ta ...antia

Epi|to|ma|tor *gr.* (Verfasser einer Epitome) *m*; -s, ...oren; Epi|to|me [*epitome*] (Auszug aus einem Schriftwerk) *w*; -, ...omen

Epi|trit *gr.* (altgr. Versfuß) *m*; -en, -en (↑ R 268)

Epi|zen|trum *gr.* (senkrecht über dem Erdbebenherd liegender Erdoberflächenpunkt)

Epi|zo|on *gr.* (Schmarotzer, der auf Tieren lebt) *s*; -s, ...zoen u. ...zoa

Epi|zy|kel *gr.* *m*; -s, - u. Epi|zy|klo|de (Math.: Kurve, die ein Punkt eines an einem anderen Kreis ablaufenden Kreises beschreibt) *w*; -, -n

epo|chal *gr.* (für einen [großen] Zeitabschnitt geltend; [hoch]bedeutend); Epo|che (Beginn eines Zeitraums; Zeitabschnitt) *w*; -, -n; epo|che|ma|chend; eine -e Erfindung

Ep|ode *gr.* (eine Gedichtform) *w*; -, -n

Epo|pöe *gr.* [auch: ...*pö*] (veralt. für: Epos) *w*; -, -n; Epos (erzählende Versdichtung; Heldengedicht) *s*; -, Epen

Ep|pich (Name für mehrere Pflanzen, auch für: Efeu) *m*; -s, -e

Eprou|vette *fr.* [*epruwät*] österr. (Probierröhrchen [z. B. für chem. Versuche) *w*; -, -n

Ep|si|lon (gr. Buchstabe [kurzes e]: *E*, *ε*) *s*; -[s], -s

Equi|li|brist usw. vgl. Äquilibrist usw.

Equi|pa|ge *fr.* [*ek(w)ipgseh^e*] (früher für: Luxuswagen; Schiffsmannschaft; Ausrüstung eines Offiziers); Equipe [*ekip*, schweiz.: *ekip^e*] ([Reiter]mannschaft; Gruppe; Begleitung) *w*; -, -n; equi|pie|ren (veralt. für: ausrüsten); Equi|pie|rung

er; - kommt; ¹Er; ↑ R 122 (veralt. Anrede an eine Person männl. Geschlechts.) höre Er!, jmdn. Er nennen; (↑ R 117:) das veraltete Er; ²Er (ugs. für: Mensch oder Tier männl. Geschlechts) *m*; -, -s; es ist ein Er; ein Er und eine Sie saßen dort

³Er = chem. Zeichen für: Erbium

er... (*Vorsilbe von Zeitwörtern*, z. B. erahnen, du erahnst, erahnt, zu erahnen; zum 2. Mittelw. ↑ R 304)

...er (z. B. Lehrer *m*; -s, -)

er|ach|ten; jmdn. od. etwas als oder für etwas -; Er|ach|ten *s*; -s; meinem - nach, meines -s (Abk.: m. E.); (falsch:) meines Erachtens nach

er|ah|nen

er|ar|bei|ten; sich etwas -; Er|ar|bei|tung

eras|misch (in der Weise des Erasmus von Rotterdam), aber (↑ R 179): Eras|misch; Eras|mus (m. Vorn.); Eras|mus von Rot|ter|dam (niederländ. Theologe; Humanist u. Gegner Luthers)

Era|to [auch: *er*...] (Muse der Lyrik, bes. der Liebesdichtung)

Era|to|sthe|nes (altgr. Gelehrter)

er|äu|gen (meist scherzh.)

Erb.adel, an|la|ge, ...än|de|rung, ...an|spruch

er|bar|men; sich -; du erbarmst dich seiner, (seltener:) über ihn; er erbarmt mich, (österr. auch:) mir (tut mir leid); Er|bar|men *s*; -s; (↑ R 120:) zum -; er|bar|mens|wert; Er|bar|mer; er|bärm|lich; Er|bärm|lich|keit; Er|bar|mung; er|bar|mungs|los; -este (↑ R 292); Er|bar|mungs|lo|sig|keit *w*; -; er|bar|mungs.voll, ...wür|dig

er|bau|en; sich -; Er|bau|er; er|bau|lich; Er|bau|lich|keit; Er|bau|ung

Erb.bau|recht, ...be|gräb|nis; erb|be|rech|tigt, Erb.bild (für: Genotyp), ...bio|lo|gie; erb|bio|lo|gisch; ¹Er|be *m*; -n, -n (↑ R 268); der gesetzliche -; ²Er|be *s*; -s; das kulturelle -

er|be|ben

erb|ei|gen (ererbt); erb|ein|ge|ses|sen; er|ben|ge|mein|schaft

¹erbe|ten (durch Beten erlangen); erbetete, erbetet

²er|be|ten; ein -er Gast

er|bet|teln

er|beu|ten; Er|beu|tung

erb|fä|hig; Erb.fak|tor, ...fall

(Rechtsspr.: Todesfall, der jmdn. zum Erben macht; *m*), ...feind, ...fol|ge (*w*; -); Erb|fol|ge|krieg; Erb_fol|ger, ...gang, ...groß|her-zog, ...gut

er|bie|ten, sich; Er|bie|ten *s*; -s

Er|bin *w*; -, -nen

er|bit|ten

er|bit|tern; es erbittert mich; Er-bit|te|rung

Er|bi|um (chem. Grundstoff, Metall; Zeichen: Er) *s*; -s

Erb|krank|heit

er|blas|sen (bleich werden)

Erb|las|sen|schaft; Erb|las|ser (der eine Erbschaft Hinterlassende); Erb|las|se|rin *w*; -, -nen; erb|las-se|risch; Erb|las|sung; Erb|le|hen

er|blei|chen (bleich werden); du erbleichtest; erbleicht u. (veralt., im Sinne von „gestorben" nur:) erblichen; vgl. [2]bleichen

erb|lich; Erb|lich|keit *w*; -

er|blicken [*Trenn.*: ...blik|ken]

er|blin|den; Er|blin|dung

erb|los

er|blü|hen

Erb|mas|se; erb|mä|ßig

er|bo|sen (erzürnen); du erbost (erbosest); er erbo|ste; sein Verhalten erbost mich; sich -; ich habe mich erbost

er|bö|tig (bereit); er ist - zu diesem Dienst; er ist -, diesen Dienst zu leisten; Er|bö|tig|keit *w*; -

Erb_pacht, ...pächter, ...pfle|ge (für: Eugenik; *w*; -), ...prinz

er|bre|chen; sich -; Er|bre|chen *s*; -s

Erb|recht

er|brin|gen; den Nachweis -

er|brü|ten (fachspr. für: ausbrüten)

Erbs|brei, Erb|sen|brei

Erb|schaft; Erb|schafts|steu|er, Erb|schaft|steu|er *w* (↑ R 334); Erb_schein, ...schleicher

Erb|se *w*; -, -n; Erb|sen|bein (Knochen der Handwurzel); Erb|sen-brei, Erbs|brei; erb|sen|groß; Erb-sen|stroh, Erbs|stroh; Erb|sen-sup|pe

Erb_stück, ...sün|de

Erbs|wurst

Erb|teil *s* (BGB: *m*); Erb|tei|lung; erb|tüm|lich; erb- und eigentümlich (↑ R 145); Erb_ver|trag, ...verzicht; Erb|ver|zichts|ver|trag; Erb|we|sen *s*; -s

Erd|ach|se *w*; -

er|dacht; eine -e Geschichte

Erd_apfel (landsch. für: Kartoffel), ...ar|bei|ter, ...at|mo|sphä|re

er|dau|ern schweiz. (gründlich prüfen); Er|daue|rung

Erd_ball (*m*; -[e]s), ...be|ben; Erd-be|ben_herd, ...mes|ser *m*, ...warte, ...wel|le; Erd|beer|bow|le; Erd-bee|re; erd|beer_far|ben, ...far-

big; Erd_be|schleu|ni|gung (Physik: Fallbeschleunigung), ...be-schrei|bung, ...be|stat|tung, ...be-völ|ke|rung, ...be|we|gung, ...bir-ne (landsch. für: Kartoffel), ...bo-den, ...boh|rer; erd|braun; Er|de *w*; -, (selten:) -n; er|den (Elektrotechnik: Verbindung zwischen einem elektr. Gerät und der Erde herstellen); Er|den_bür|ger, ...glück

er|denk|bar; er|den|ken; er|denk-lich

Er|den|le|ben; Er|den|rund *s*; -[e]s; Erd|fall (trichterförmige Senkung von Erdschichten) *m*; erd-_far|ben od. ...far|big, ...fern; ein -er Planet; Erd|fer|ne *w*; -

Erdg. = Erdgeschichte; Erdge-schnoß

Erd_gas; erd|gas|höf|fig (reiches Erdgasvorkommen verspre-chend); Erd|ge|bo|re|ne, Erd|ge-bor|ne *m* u. *w*; -n, -n (↑ R 287ff.); erd|ge|bun|den; Erd_geist (*Mehrz.* ...geister), ...ge|schich|te (*w*; -; Abk.: Erdg.), ...ge|schoß (Abk.: Erdg.); erd|haft; Erd|hörn-chen (ein Nagetier)

er|dich|ten (scherzh.: [als Ausrede] erfinden); sich ausdenken)

er|dig; Erd_kreis (*m*; -es), ...kru-ste, ...ku|gel, ...kun|de (*w*; -), ...kund|ler; erd|kund|lich; Erd-ma|gne|tis|mus; erd|ma|gne|tisch; -e Wellen

Erd|mann (m. Vorn.)

Erd|männ|chen (Zwerg)

Erd|mu|te (w. Vorn.)

erd|nah; ein -er Planet; Erd_nä|he, ...nuß, ...ober|flä|che, ...öl

er|dol|chen; Erd|ol|chung

erd|öl|höf|fig (reiches Erdölvor-kommen versprechend); Erd_öl-pro|duk|ti|on; Erd_pech, ...rauch (eine Pflanze), ...raum, ...reich (*s*; -[e]s)

er|drei|sten, sich

Erd|rin|de *w*; -

er|dröh|nen

er|dros|seln; Er|dros|se|lung, Er-droß|lung

er|drücken[1]; er|drückend[1]; -ste; Er-drückung[1]

Er|drusch (Ertrag des Dreschens) *m*; -[e]s, -e

Erd_rutsch, ...sa|tel|lit, ...schicht, ...schlipf (schweiz. neben: Erd-rutsch), ...schluß (Elektrotech-nik), ...schol|le, ...sicht, ...spal|te, ...stoß, ...strö|me (für: vagabun-dierende [durch den Erdboden fließende] elektr. Ströme; *Mehrz.*), ...teil *m*, ...tra|bant

Erd|dul|den

Erd_um|krei|sung, ...um|run|dung; erd|um|span|nend; Er|dung (Er-

den); Erd_ver|mes|sung, ...wachs (für: Ozokerit), ...wall, ...wen|dig-keit (für: Geotropismus), ...zeit-al|ter

Ere|bos vgl. Erebus; Ere|bus *gr.* [auch: *er*...] (Unterwelt der gr. Sage) *m*; -

Ere|chthei|on (Tempel des Ere-chtheus in Athen) *s*; -s; Ere|chthe-um vgl. Erechtheion; Ere|chtheus [...*teuß*] (gr. Sagengestalt)

er|ei|fern, sich; Er|ei|fe|rung

er|eig|nen, sich; Er|eig|nis *s*; -ses, -se; ein freudiges -; ein großes -; er|eig|nis_los, ...reich

er|ei|len; das Schicksal ereilte ihn

erek|til *lat.* (Med.: aufrichtbar, schwellfähig); Erek|ti|on [...*zion*] (Aufrichtung; Anschwellung)

Ere|mit *gr.* (Einsiedler; Klausner) *m*; -en, -en (↑ R 268); [1]Ere|mi|ta-ge *fr.* [...*tasch*[e]] (abseits gelegene Grotte od. Nachahmung einer Einsiedelei in Parkanlagen des 18. Jh.s)

[2]Ere|mi|ta|ge, Er|mi|ta|ge [...*tg-seh*[e]] (Kunstsammlung in Lenin-grad) *w*; -

Eren, Ern südd. (Hausflur, -gang) *m*; -, -

er|erben

Ere|this|mus *gr.* (Med.: krankhaft gesteigerte Gereiztheit) *m*; -

er|fahr|bar; [1]er|fah|ren; etwas Wichtiges -; [2]er|fah|ren; -er Mann; Er|fah|re|ne *m* u. *w*; -n, -n (↑ R 287ff.); Er|fah|ren|heit *w*; -; Er|fah|rung; Er|fah|rungs_aus tausch, ...be|richt, ...ge|halt; er-fah|rungs_ge|mäß, ...mä|ßig; Er-fah|rungs_schatz, ...wert, ...wis sen|schaft (für: Empirie; *w*; -)

er|faß|bar; er|fas|sen; erfaßt; Er-fas|sung

er|fin|den; Er|fin|der; Er|fin|der-geist; er|fin|de|risch; -ste (↑ R 294); er|find|lich; Er|fin|dung; Er-fin|dungs_ga|be, ...kraft (*w*; -); Er-fin|dungs_reich

er|fle|hen; erflehte Hilfe

er|flie|gen; Rekorde -

er|folg *m*; -[e]s, -e; er|fol|gen; er-folg_ge|krönt; Er|folg_ha|sche|re *w*; -; er|folg_los; -este (↑ R 292); Er|folg_lo|sig|keit *w*; -; er|folgs_reich; Er|folgs_aus|sicht (meist *Mehrz.*), ...au|tor, ...buch, ...der|ken, ...nach|weis, ...quo|te, ...prä|mie, ...rech|nung (Wirtsch.), ...se|rie; er|folgs_si|cher; Er|folgs_stück, ...zif|fer; er|folg|ver|spre chend; -ste; ein -er Anfang, ab e (↑ R 142): keinen großen Erfol versprechend

er|for|der|lich; er|for|der|li|chen falls; vgl. Fall *m*; er|for|dern; Er-for|der|nis *s*; -ses, -se

er|forsch|bar; er|for|schen; Er|fo scher; Er|for|schung

[1] *Trenn.*: ...drük|k...

er|fra|gen; Er|fra|gung
er|fre|chen, sich
er|freu|en; sich -; er|freu|lich; manches Erfreuliche (↑ R 116); er|freu|li|cher|wei|se
er|frie|ren; Er|frie|rung; Er|frie|rungs|tod
er|fri|schen; er|fri|schend; -ste; Er|fri|schung; Er|fri|schungs.raum, ...stand
er|füh|len
er|füll|bar; -e Wünsche; er|fül|len; sich -; Er|füllt|heit w; -; Er|fül|lung; Er|füll|lungs.ort (m; -[e]s, -e), ...soll (DDR); vgl. ²Soll
Er|furt (Stadt a. d. Gera); Er|fur|ter (↑ R 199); der - Dom
erg = Erg; Erg gr. (physikal. Energieeinheit; Zeichen: erg) s; -s, - erg. = ergänze!
er|gän|zen; du ergänzt (ergänzest); ergänze! (Abk.: erg.); sich -; Er|gän|zung; Er|gän|zungs.ab|ga|be (Zuschlag zur Einkommensteuer), ...band m (Abk.: Erg.-Bd.), ...bin|de|strich, ...satz (Objektsatz)
er|gat|tern (ugs. für: sich durch eifriges, geschicktes Bemühen verschaffen); ich ...ere (↑ R 327)
er|gau|nern (ugs. für: sich durch Betrug verschaffen)
Erg.-Bd. = Ergänzungsband
¹er|ge|ben; die Zählung hat ergeben, daß ...; sich ins Unvermeidliche -; ²er|ge|ben; -er Diener; Er|ge|ben|heit w; -; Er|ge|ben|heits|adres|se; er|ge|benst; Er|geb|nis s; -ses, -se; er|geb|nis|los; Er|geb|nis|lo|sig|keit w; -; er|geb|nis|reich; Er|ge|bung; er|ge|bungs|voll
er|ge|hen; wie ist es dir ergangen?; sich -; er hat es über sich - lassen; Er|ge|hen (Befinden) s; -s
er|gie|big; Er|gie|big|keit w; -
er|gie|ßen; sich -; Er|gie|ßung
er|glän|zen
er|glim|men
er|glü|hen
er|go lat. (folglich, also)
Er|go|graph, Er|go|stat gr. (Med.: Gerät zur Messung der Muskelarbeit) m; -en, -en (↑ R 268)
Er|go|ste|rin (Vorstufe des Vitamins D₂) s; -s
er|göt|zen; du ergötzt (ergötzest); sich -; Er|göt|zen s; -s; er|götz|lich; Er|göt|zung
er|grau|en; ergraut
er|grei|fen; er|grei|fend; -ste; Er|grei|fung; er|grif|fen; er war sehr -; Er|grif|fen|heit w; -; Er|grif|fen|sein s; -s
er|grim|men
er|gründ|bar; er|grün|den; Er|grün|dung
Er|guß; Er|guß|ge|stein (für: Effusivgestein)

er|ha|ben; -e (erhöhte) Stellen eines Holzstocks; über allen Zweifel -; Er|ha|ben|heit
Er|halt (Empfang; Erhaltung, Bewahrung) m; -[e]s; er|hal|ten; -; bleiben; etwas frisch -; sich gesund -; Er|hal|ter (Ernährer); er|hält|lich; Er|hal|tung; Er|hal|tungs.trieb, ...zu|stand; er|hal|tungs|wür|dig
er|han|deln
er|hän|gen; sich -; vgl. ²hängen; Er|häng|te m u. w; -n, -n (↑ R 287 ff.)
Er|hard (m. Vorn.)
er|här|ten; Er|här|tung
er|ha|schen
er|he|ben, sich -; er|he|bond (feierlich); -ste; er|heb|lich; Er|he|bung
er|hei|ra|ten (durch Heirat erlangen)
er|hei|schen (veraltend für: erfordern)
er|hei|tern; ich ...ere (↑ R 327); Er|hei|te|rung
¹er|hel|len; das Zimmer - (beleuchten); sich - (hell werden); ²er|hel|len; daraus erhellt (wird klar), daß ...; Er|hel|lung
er|hit|zen; du erhitzt (erhitzest); sich -; Er|hit|zer; Er|hit|zung
er|ho|ben; Er|ho|ben|sein s; -s
er|hof|fen
er|hö|hen; Er|hö|hung; Er|hö|hungs|zei|chen (Musik: ♯ [Kreuz])
er|ho|len, sich; er|hol|sam; Er|ho|lung; Er|ho|lungs.auf|ent|halt; er|ho|lungs|be|dürf|tig; Er|ho|lungs.ge|biet, ...heim, ...kur, ...pau|se, ...rei|se, ...stät|te; er|ho|lungs|su|chend, aber (↑ R 142): der die Erholung suchende Gast; Er|ho|lungs.ur|laub, ...zeit, ...zen|trum
er|hö|ren; Er|hö|rung
Erich (m. Vorn.)
Eri|da|nos vgl. ¹Fridanus; ¹Eri|da|nus [auch: erid...] (Fluß der gr. Sage) m; -; ²Eri|da|nus [auch: erid...] (ein Sternbild) m; -
eri|gi|bel lat. (svw. erektil); eri|gie|ren (sich aufrichten)
¹Eri|ka [zu: Erich] (w. Vorn.)
²Eri|ka gr. (eine Farbe) s; -s; ³Eri|ka (Heidekraut) w; -, ...ken
Erin (kelt. Name von Irland); vgl. Éire
er|in|ner|lich; er|in|nern; ich ...ere (↑ R 327); jemanden an etwas -; sich -; ich erinnere mich an das Ereignis od. (geh.:) des Ereignisses; Er|in|ne|rung; er|in|ne|rungs|bild; er|in|ne|rungs|los; Er|in|ne|rungs.lücke [Trenn.: ...lük|ke], ...mal (vgl. ²Mal); Er|in|ne|rungs|schwer; Er|in|ne|rungs.stück, ...ver|mö|gen (s; -s), ...zei|chen

Erin|nye [...üᵉ], Erin|nys (gr. Rachegöttin) w; -, ...yen (meist Mehrz.)
Eris [auch: eriß] (gr. Göttin der Zwietracht); Eri|stik gr. (Kunst des Redestreits) w; -
Eri|trea (äthiop. Provinz am Roten Meer); eri|tre|isch
er|ja|gen
er|kal|ten; erkaltet; er|käl|ten, sich; erkältet, Er|kal|tung; Er|käl|tung; Er|käl|tungs.ge|fahr, ...krank|heit
er|kämp|fen
Er|kannt|nis (schweiz. neben: ²Erkenntnis)
er|kau|fen
er|kecken [Trenn.: ...kek|ken], sich (sich erkühnen)
er|kenn|bar; Er|kenn|bar|keit w; -; er|ken|nen; etwas - (deutlich erfassen); auf eine Freiheitsstrafe - (Rechtsspr.); sich zu erkennen geben; er|kennt|lich; sich - zeigen; Er|kennt|lich|keit; ¹Er|kennt|nis (Einsicht) w; -, -se; ²Er|kennt|nis (richterl. Urteil) s; -ses, -se; Er|kennt|nis.fä|hig|keit, ...ge|halt m, ...kri|tik, ...mit|tel s; er|kennt|nis|theo|re|tisch; Er|kennt|nis.theo|rie; Er|ken|nung; Er|ken|nungs.dienst, ...mar|ke, ...zei|chen
Er|ker m; -s, -; Er|ker|fen|ster
er|kie|sen (geh. für: erwählen); du erkiest (erkiesest); er erkiest; ich erkor, du erkorst (selten: ich erkieste, du erkiestest); du erkörest; erkoren (selten: erkiest); erkie|s[e]!
er|klär|bar; Er|klär|bar|keit w; -; er|klä|ren; sich -; Er|klä|rer; er|klär|lich; er|klär|li|cher|wei|se; er|klär|ter|wei|se; Er|klä|rung
er|kleck|lich (beträchtlich)
er|klet|tern
er|klim|men; Er|klim|mung
er|klin|gen
er|klü|geln
er|ko|ren vgl. erkiesen
er|kran|ken; Er|kran|kung; Er|kran|kungs|fall; vgl. Fall m; -[e]
er|küh|nen, sich
er|kun|den; Er|kun|di|gen, sich; Er|kun|di|gung; Er|kun|dung; Er|kun|dungs|fahrt
er|kün|steln; er|kün|stelt; Er|kün|ste|lung
er|kü|ren
er|la|ben (geh.); sich -
Er|lag österr. (Hinterlegung) m; -s; Er|lag|schein österr. (Zahlkarte)
er|lah|men; Er|lah|mung
er|lan|gen
Er|lan|gen (Stadt a. d. Regnitz); Er|lan|ger (↑ R 199)
Er|lan|gung (Papierdt.)
Er|laß m; Erlasses, Erlasse

(österr.: Erlasse); er|las|sen; Er|las|sung

er|lau|ben; sich -; Er|laub|nis w; -; Er|laub|nis|schein

er|laucht; Er|laucht (ein Adelstitel) w; -, -en; vgl. euer, ihr u. sein

er|lau|fen (durch Laufen erreichen); den Ball -

er|lau|schen

er|läu|tern; Er|läu|te|rung; er|läu|te|rungs|wei|se

Er|le (ein Laubbaum) w; -, -n

er|le|ben; Er|le|ben s; -s; Er|le|bens|fall m; -[e]s; im -; Er|leb|nis s; -ses, -se; Er|leb|nis.auf|satz, ...be- richt, ...fä|hig|keit (w; -), ...hun- ger; er|leb|nis|reich; er|leb|nis|ro- man; er|leb|nis|stark; er|lebt; -e Rede

er|le|di|gen; er|le|digt; Er|le|di- gung

er|le|gen (österr. u. schweiz. auch: einen Betrag zahlen); Er|le|gung

er|leich|tern; sich -; er|leich|tert; Er|leich|te|rung

er|lei|den

er|len (aus Erlenholz); Er|len- ₋busch, ...holz

er|lern|bar; Er|lern|bar|keit w; -; er|ler|nen; Er|ler|nung

¹er|le|sen; er hat sein Wissen erle- sen; ²er|le|sen; ein -es (ausgesuch- tes) Gericht; Er|le|sen|heit w; -

er|leuch|ten; Er|leuch|tung

er|lie|gen; († R 120:) zum Erliegen kommen

er|li|sten; Er|li|stung

Erl|kö|nig („Elfenkönig", Sagen- gestalt [nur Einz.]; ugs. für: ge- tarnter Versuchswagen)

er|lo|gen; vgl. erlügen; Er|lo|gen- heit w; -

Er|lös m; -es, -e

er|lö|schen; vgl. ²löschen; Er|lö- schen s; -s

er|lo|sen; erlost

er|lö|sen; erlöst; Er|lö|ser; Er|lö- ser|bild; er|lö|ser|haft; Er|lö|sung

er|lü|gen; erlogen

er|mäch|ti|gen; Er|mäch|ti|gung

er|mah|nen; Er|mah|nung

er|man|geln (veralt.); Er|man|ge- lung, Er|mang|lung w; -; in - eines Besser[e]n

er|man|nen, sich; Er|man|nung w; - er|mä|ßi|gen; Er|mä|ßi|gung

er|mat|ten; Er|mat|tung

er|meß|bar; er|mes|sen; Er|mes|sen s; -s; nach meinem -; Er|mes- sens.fra|ge, ...frei|heit, ...miß- brauch

Er|mi|ta|ge vgl. Eremitage

er|mit|teln; ich ...[e]le († R 327); Er- mit|te|lung, Er|mitt|lung; Er|mitt- lungs.ar|beit, ...be|am|te, ...rich- ter, ...ver|fah|ren

Erm|land (Gebiet des ehemal. Bis- tums Ermland in Ostpreußen) s; -[e]s

er|mög|li|chen; Er|mög|li|chung

er|mor|den; Er|mor|dung

er|müd|bar; Er|müd|bar|keit w; -; er|mü|den; Er|mü|dung; Er|mü- dungs.er|schei|nung, ...zustand

er|mun|tern; ich ...ere († R 327); Er|mun|te|rung

er|mu|ti|gen; Er|mu|ti|gung

Ern vgl. Eren

Er|na (w. Vorn.)

er|näh|ren; Er|näh|rer; Er|näh|re- rin w; -, -nen; Er|näh|rung; Er- näh|rungs.ba|sis, ...bei|hil|fe, ...for|schung, ...la|ge, ...phy|sio- lo|gie; er|näh|rungs|phy|sio|lo- gisch; Er|näh|rungs|stö|rung

er|nen|nen; Er|nen|nung; Er|nen- nungs.schrei|ben, ...ur|kun|de

Er|ne|sta, Er|ne|sti|ne (w. Vorn.)

Er|ne|sti|ni|sche Li|nie (herzogl. Linie der Wettiner) w; -n -

er|neu|en; Er|neu|er; Er|neu[e]|rer; Er|neue|rin w; -, -nen; er|neu|ern; sich -; Er|neue|rung; er|neut (wiederholt, abermals); Er|neu- ung

er|nied|ri|gen; sich -; er|nied|ri- gend; -ste; Er|nied|ri|gung; Er- nied|ri|gungs|zei|chen (Musik: ♭)

ernst; -er, -este († R 292); I. Schrei- bung in Verbindung mit dem 2. Mittelwort († R 142), z. B. ernst- genommen, ernstgemeint (vgl. d.). II. In Verbindung mit Zeitwörtern immer getrennt, z. B. ernst sein, werden, nehmen; die Lage wird -; es wurde - u. gar nicht lustig; eine Sache [für] - nehmen; ¹Ernst m; -es; im -; - machen; Scherz für - nehmen; es ist mir [vollkommener]- damit; es wurde - [aus dem Spiel]; allen (veralt.: alles) -es; ²Ernst (m. Vorn.); Ernst|fall m; ernst|ge- meint († R 296:) ernster, am ern- stesten gemeint; die ernstgemein- te Anfrage († R 142), aber: die Anfrage ist ernst gemeint; ernst- ge|nom|men; vgl. ernstgemeint; ernst|haft; Ernst|haf|tig|keit w; -; ernst|lich

Ern|te w; -, -n; Ern|te.aus|fäl|le (Einbußen bei der Ernte; Mehrz.),...bri|ga|de(DDR); Ern- te.dank|fest [auch: ärn...]; Ern- te.ein|satz (DDR), ...er|geb|nis, ...fest (Erntedankfest), ...kam- pa|gne (DDR), ...ma|schi|ne, ...mo|nat od. ...mond (für: Au- gust); ern|ten; Ern|te|ver|si|che- rung; Ern|ting (August) m; -s, -e er|nüch|tern; ich ...ere († R 327); Er|nüch|te|rung

Er|obe|rer; Er|obe|rin w; -; -nen; er|obern; ich ...ere († R 327); Er- obe|rung; er|obe|rungs.ab|sicht, ...drang, ...krieg, ...lust; er|obe- rungs|lu|stig; er|obe|rungs|sucht; er|obe|rungs|süch|tig

ero|die|ren lat. (Geol.: auswaschen [von fließendem Wasser])

er|öff|nen; sich -; Er|öff|nung; Er- öff|nungs.be|schluß (BGB), ...bi- lanz, ...re|de, ...vor|stel|lung

eros gr. (Med.: geschlechtliche Erregung auslösend); -e Zone

Ero|i|ca, (auch:) Ero|i|ka gr. (kurz für: Sinfonia eroica, Titel der 3. Sinfonie Es-Dur von Beethoven) w; -

er|ör|tern; Er|ör|te|rung

¹Eros [auch: eroß] (gr. Gott der Liebe); vgl. Eroten; ²Eros gr. [auch: eroß] ([geschlechtl.] Liebe; Philos.: durch Liebe geweckter schöpferischer Urtrieb) m; -; phi- losophischer -; ³Eros [auch: eroß] (ein Planet) m; -; Eros-Center [auch: eroß...] (verhüllend für: Bordell)

Ero|si|on lat. (Geol.: Erdabtra- gung durch Wasser, auch durch Eis, Wind)

Ero|ten gr. (allegor. Darstellung geflügelter Liebesgötter, meist in Kindergestalt) Mehrz.; vgl. ¹Eros; Ero|ti|cal engl. [erotikᵉl] (Bühnenstück od. Film mit eroti- schem Inhalt) s; -s, -s; Ero|tik (den geistig-seel. Bereich ein- beziehende sinnliche Liebe) w; -; Ero|ti|ker (Verfasser von Liebes- liedern u. erot. Schriften; jmd., der das Erotische betont); Ero|ti- kon (erotisches Buch) s; -s, ...ka od. ...ken; ero|tisch; -ste († R 294); ero|ti|sie|ren; Ero|ti|sie|rung; Ero|tis|mus, Ero|ti|zis|mus (Überbetonung des Erotischen) m; -; Ero|to|ma|nie (Liebeswahn- sinn) w; -

ERP = European Recovery Pro- gram engl. [juːᵉrᵉpiːⁿ rikᵃwᵉrⁱ prᵒᵘgräm] (Marshallplan)

Er|pel (Enterich) m; -s, -

er|picht; auf eine Sache - (begierig) sein

er|pres|sen; Er|pres|ser; er|pres|se- risch; -ste († R 294); Er|pres|sung

er|pro|ben; er|probt; er|probter- wei|se; Er|pro|bung; er|pro|bungs- hal|ber

er|quicken [Trenn.: ...quik|ken], er|quick|lich; Er|quickung [Trenn.: ...quik|kung]

Er|ra|ta (Mehrz. von: Erratum)

er|ra|ten

er|rat|bar; er|ra|ten

er|ra|tisch lat. (verirrt, zerstreut); -er Block (Findling[sblock]); Er- ra|tum (Versehen, Druckfehler) s; -s, ...ta

er|rech|nen

er|reg|bar; Er|reg|bar|keit w; -; er- re|gen; Er|re|ger; Er|regt|heit w; -; Er|re|gung; Er|re|gungs|zu- stand

er|reich|bar; Er|reich|bar|keit w; -; er|rei|chen; Er|rei|chung

er|ret|ten; - von (selten: vor); Er-
ret|ter; Er|ret|tung
er|rich|ten; Er|rich|tung
er|rin|gen; Er|rin|gung
er|rö|ten; Er|rö|ten s; -s
Er|run|gen|schaft; Er|run|gen-
schafts|ge|mein|schaft (BGB)
Er|satz m; -es; Er|satz..be|frie|di-
gung (Psych.), ...deh|nung
(Sprachw.), ...dienst; er|satz-
dienst|pflich|tig; Er|satz|dienst-
pflich|ti|ge m; -n, -n (↑ R 268);
Er|satz..hand|lung (Psych.), ...in-
fi|ni|tiv (Sprachw.: Infinitiv an
Stelle eines 2. Mittelwortes nach
einem reinen Infinitiv, z. B. er
hat ihn kommen „hören" statt:
„gehört"; ↑ R 305), ...kas|se,
...mann (Mehrz. ...männer u.
...leute); er|satz|pflich|tig; Er-
satz|teil s (seltener: m); Er|satz-
teil|la|ger; er|satz|wei|se
er|sau|fen (ugs. für: ertrinken); er-
soffen; er|säu|fen (ertränken); er-
säuft
er|schaf|fen; vgl. ²schaffen; Er-
schaf|fer (meist für: Gott); Er-
schaf|fung
er|schal|len; es erscholl od. er-
schallte; es erschölle od. erschall-
te; erschollen od. erschallt; er-
schall[e]!
er|schau|dern
er|schau|en
er|schau|ern
er|schei|nen; Er|schei|nung; Er-
schei|nungs..bild, ...form
er|schie|ßen; Er|schie|ßung
er|schim|mern
er|schlaf|fen; er|schlafft; Er|schlaf-
fung
er|schla|gen
er|schlei|chen (durch List errin-
gen); Er|schlei|chung
er|schließ|bar; er|schlie|ßen; sich -;
Er|schlie|ßung
er|schmel|zen
er|schöpf|bar; er|schöp|fen; sich -;
er|schöpft; Er|schöp|fung; Er-
schöp|fungs..tod, ...zu|stand
er|schrecken¹; ich bin darüber er-
schrocken; vgl. ¹schrecken; ²er-
schrecken¹; sein Aussehen hat
mich erschreckt; vgl. ²schrecken;
er|schrecken¹, sich (ugs.); ich
habe mich erschreckt, erschrok-
ken; er|schreckend¹; -ste; er-
schreck|lich (veralt. für: erschrek-
kend); Er|schrocken|heit¹ w; -; er-
schröck|lich (scherzh. für: er-
schrecklich)
er|schüt|tern; er|schüt|ternd; -ste;
er|schüt|te|rung
er|schwe|ren; Er|schwer|nis w; -,
-e; Er|schwer|nis|zu|la|ge (Lohn-
zuschlag bei bes. schwerer od.
schichtarbeit); Er|schwe|rung

Trenn.: ...k|k...

er|schwin|deln
er|schwing|bar (seltener für: er-
schwinglich); er|schwin|gen; er-
schwing|lich; Er|schwing|lich|keit
w; -
er|se|hen
er|seh|nen
er|setz|bar; Er|setz|bar|keit w; -;
er|set|zen; Er|set|zung
er|sicht|lich
er|sin|nen; er|sinn|lich
er|sit|zen; ersessene Rechte; Er|sit-
zung (Rechtsw.: Eigentumser-
werb durch langjährigen Besitz)
er|sor|gen schweiz. (mit Sorge er-
warten)
er|spä|hen
er|spa|ren; Er|spar|nis w; -, -se
(österr. auch: s; -ses, -se); Er|spa-
rung
er|sprieß|lich; Er|sprieß|lich|keit
erst; - recht; - mal (ugs. für: erst
einmal)
er|star|ken; Er|star|kung
er|star|ren; Er|star|rung
er|stat|ten; Er|stat|tung
erst|auf|füh|ren (nur in der Grund-
form u. im 2. Mittelw. gebr.);
erstaufgeführt; Erst|auf|füh|rung
er|stau|nen; Er|stau|nen s; -s; er-
stau|nens|wert; er|staun|lich
Erst..aus|ga|be, ...be|sitz; erst|be-
ste; erstere (vgl. d.); Erst|be..stei|gung,
...druck (Mehrz. ...drucke)
er|ste; erstere (vgl. d.); erstens. I.
Kleinschreibung: (↑ R 135:) der,
die, das erste (der Reihe nach);
als erster, erstes; der erste – der
letzte (zurückweisend für: jener
– dieser); er war der erste, der
das erwähnte (er hat das zuerst
erwähnt); das erste, was ich höre
(das höre ich jetzt zuerst); der
erstbeste; der erste beste; die er-
sten beiden (das erste und das
zweite Glied, das erste Paar ei-
ner Gruppe), die ersten drei
usw., aber: die beiden ersten
(von zwei Gruppen das jeweils
erste Glied); die drei ersten usw.;
der erste (häufig bereits als Na-
me: Erste) Weltkrieg, der erste
(1.) April (Datum); erstes Mittel-
wort, Partizip (vgl. d.); der erste
Rang; erste Geige spielen; erster
Geiger; die erste heilige Kommu-
nion; der erste Spatenstich; der
erste Stock eines Hauses; das er-
ste Programm; das erste Mal,
aber: das erstemal; am ersten
(zuerst), fürs erste, zum ersten;
beim, zum ersten Mal[e], aber:
beim, zum erstenmal. II. Groß-
schreibung: a) (↑ R 224:) Otto der
Erste (Abk.: Otto I.); der Erste
Staatsanwalt; der Erste Vorsit-
zende (als Dienstbez.); der Erste
Schlesische Krieg; der Erste Mai
(Feiertag); die Erste Hilfe (bei

Unglücksfällen); b) (↑ R 118:) der
Erste des Monats, am Ersten des
Monats; vom nächsten Ersten
an; das Erste und [das] Letzte
(Anfang und Ende); der, die Erste
(dem Range, der Tüchtigkeit
nach [nicht der Reihe nach]),
z. B. die Ersten unter Gleichen;
die Ersten werden die Letzten
sein
er|ste|chen
er|ste|hen; Er|ste|her
Er|ste-Hil|fe-Aus|rü|stung (↑ R
155)
Er|ste|hung
er|steig|bar; er|steig|bar|keit w; -;
er|stei|gen; Er|stei|ger
er|stei|gern; Er|stei|ge|rung
er|stei|gung
er|stel|len (Modewort für: errich-
ten; aufstellen); Er|stel|lung
er|ste|mal; das -; vgl. erste u. Mal;
er|stens; er|ster; als -
er|ster|ben; mit -der Stimme
er|ste|re, der (der erste [von zwei-
en]); -r; das -; -s (auch alleinste-
hend klein geschrieben) ; Er-
ste[r]-Klas|se-Ab|teil (↑ R 155);
erst|er|wähnt, aber (↑ R 116)· der
Ersterwähnte; Erst|ge|bä|ren|de
(Med.) w; -n, -n (↑ R 287ff.); erst-
ge|bo|ren; Erst|ge|bo|re|ne, Erst-
ge|bor|ne m, w, s; -n, -n (↑ R
287ff.); Erst|ge|burt; Erst|ge-
burts|recht; erst|ge|nannt, aber
(↑ R 116): der Erstgenannte
er|sticken¹; Er|stickung¹; Er-
stickungs¹..an|fall, ...ge|fahr,
...tod
Erst|kläs|ser mitteld. (Erstkläß-
ler); erst|klas|sig; Erst|klas|sig-
keit w; -; Erst|kläß|ler (landsch.,
bes. österr.) u. Erst|kläß|ler
schweiz. u. südd. (Schüler der er-
sten Klasse); Erst|kläß|wa|gen
schweiz. (Wagen erster Klasse);
Erst..kom|mu|ni|kant, ...kom|mu-
ni|on; erst|lich; Erst|ling; Erst-
lings..druck (Mehrz. ...drucke),
...film, ...stück, ...wä|sche,
...werk; erst|ma|lig; Erst|ma|lig-
keit w; -; erst|mals; Erst|pla|cier-
te, (eingedeutscht auch:) Erst-
pla|zier|te m u. w; -n, -n (↑ R
287ff.)
er|stra|ben
erst|ran|gig; Erst|ran|gig|keit w; -
er|stre|ben; er|stre|bens|wert
er|strecken [Trenn.: ...strek|ken],
sich; Er|streckung [Trenn.:
...strek|kung]
erst|stel|lig; -e Hypothek; Erst-
stim|me; Erst|tags..brief, ...stem-
pel
er|stun|ken (derb für: erdichtet);
- und erlogen
er|stür|men; Er|stür|mung

¹ Trenn.: ...stik|k...

erst|ver|öf|fent|li|chen (nur in der Grundform u. im 2. Mittelw. gebr.); Erst_ver|öf|fent|li|chung; ...ver|sor|gung (Erste Hilfe), ...ver|stor|be|ne (*m* u. *w*; -n, -n; ↑ R 287ff.), ...zu|las|sung
er|su|chen; Er|su|chen *s*; -s, -; auf -
er|tap|pen; sich -; Er|tap|pung
er|tei|len; Er|tei|lung
er|tö|nen
er|tö|ten; Begierden -
Er|trag *m*; -[e]s, ...träge; er|trag|bar; er|tra|gen; er|trag|fä|hig; Er|trag|fä|hig|keit *w*; -; er|träg|lich; Er|träg|lich|keit *w*; -; er|trag|los; Er|träg|nis (seltener für: Ertrag *s*; -ses, -se; er|träg|nis|reich (seltener für: ertragreich); er|trag|reich; Er|trags_aus|sich|ten (*Mehrz.*), ...la|ge, ...min|de|rung; er|trags|sicher; Er|trag[s]_stei|ge|rung, ...steu|er
er|trän|ken; ertränkt; Er|trän|kung
er|träu|men; ich erträume mir etwas
er|trin|ken; ertrunken; Er|trin|ken *s*; -s; Er|trin|ken|de *m* u. *w*; -n, -n (↑ R 287ff.)
er|trot|zen
er|trun|ken vgl. ertrinken; Er|trun|kene *m* u. *w*; -n, -n (↑ R 287ff.)
er|tüch|ti|gen; Er|tüch|ti|gung *w*; -
er|üb|ri|gen; er hat viel erübrigt (gespart) (Papierdt.:) es erübrigt sich noch (bleibt noch übrig)[,] zu erwähnen ..., es erübrigt sich (ist überflüssig)[,] zu erwähnen ...; Er|üb|ri|gung
eru|ie|ren *lat.* (herausbringen; ermitteln); Eru|ie|rung
erup|tie|ren; Erup|ti|on *lat.* [...*ziọn*] ([vulkan.] Ausbruch); erup|tiv; Erup|tiv|ge|stein
Er|ve [*ärwᵉ*] (eine Hülsenfrucht) *w*; -, -n
er|wa|chen; Er|wa|chen *s*; -s
¹er|wach|sen; ein erwachsener Mensch; ²er|wach|sen; mir sind Bedenken erwachsen; Er|wach|se|ne *m* u. *w*; -n, -n (↑ R 287ff.); Er|wach|se|nen_bil|dung (*w*; -), ...tau|fe
er|wä|gen; du erwägst; du erwogst; du erwögest; erwogen; erwäg[e]!; er|wä|gens|wert; Er|wä|gung; in - ziehen
er|wäh|len; Er|wäh|lung
er|wäh|nen; er|wäh|nens|wert; er|wäh|nter|ma|ßen; Er|wäh|nung
er|wah|ren schweiz. (als wahr erweisen; das Ergebnis einer Abstimmung od. Wahl amtl. bestätigen); Er|wah|rung
er|wan|dern; Er|wan|de|rung
er|wär|men (warm machen); ich habe, bin erwärmt; sich - (begeistern) für; Er|wär|mung

er|war|ten; Er|war|ten *s*; -s; wider -; Er|war|tung; er|war|tungs_ge|mäß, ...voll
er|wecken [*Trenn.*: ...wek|ken]; Er|weckung [*Trenn.*: ...wek|kung]
er|weh|ren, sich; ich konnte mich seiner kaum -
er|weich|bar; er|wei|chen; vgl. ¹weichen; Er|wei|chung
er|weis *m*; -es, -e; er|wei|sen; sich -; er|weis|lich; Er|wei|sung
er|wei|tern; Er|wei|te|rung; Er|wei|te|rungs|bau (*Mehrz.* ...bauten)
Er|werb *m*; -[e]s, -e; er|wer|ben; Er|wer|ber; er|werbs|fä|hig; Er|werbs|fä|hig|keit *w*; -; er|werbs|ge|min|dert; er|werbs|los; Er|werbs|lo|se *m* u. *w*; -n, -n (↑ R 287ff.); Er|werbs|lo|sen|für|sor|ge; Er|werbs|lo|sig|keit *w*; -; Er|werbs|min|de|rung, ...mög|lich|keit, ...quel|le, ...stre|ben; er|werbs|tä|tig; Er|werbs|tä|ti|ge *m* u. *w*; -n, -n (↑ R 287ff.); er|werbs|un|fä|hig; Er|wer|bung
er|wi|dern; ich ...ere (↑ R 327); Er|wi|de|rung
er|wie|sen; er|wie|se|ner|ma|ßen
Er|win (m. Vorn.)
er|wir|ken; Er|wir|kung
er|wirt|schaf|ten; Gewinn -
er|wi|schen (ugs.); man hat ihn erwischt
er|wor|ben; -e Rechte
er|wünscht; das -este, am erwünschtesten wäre es, wenn ... (↑ R 134)
er|wür|gen; Er|wür|gung
ery|man|thisch, aber (↑ R 224): der Erymanthische Eber; Ery|man|thos vgl. Erymanthus; Ery|man|thus (Gebirge im Peloponnes) *m*; -
Ery|si|pel *gr.* *s*; -s u. Ery|si|pe|las [auch: ...*sịp*...] (Med.: Wundrose [Hautentzündung] *s*; -; Ery|them (Med.: Hautrötung) *s*; -s
Ery|thräa usw. vgl. Eritrea usw.; Ery|thräi|sche Meer (altgr. Name für das Arabische Meer) *s*; -n (-es)
¹Ery|thrin *gr.* (ein Farbstoff) *s*; -s; ²Ery|thrin (ein Mineral) *m*; -s; Ery|thro|zyt (Med.: rotes Blutkörperchen) *m*; -en, -en (meist *Mehrz.*); ↑ R 268
Erz *s*; -es, -e
erz... *u.* (verstärkende Vorsilbe, z. B. erzböse); Erz... (in Titeln, z. B. Erzbischof, u. in Scheltnamen, z. B. Erzschelm)
Erz|ader
er|zäh|len; erzählende Dichtung; er|zäh|lens|wert; Er|zäh|ler; er|zäh|le|risch; Er|zähl|kunst; Er|zäh|lung
Erz|bau *m*; -[e]s; Erz|berg|bau *m*; -[e]s
Erz|bi|schof; erz|bi|schöf|lich
erz_bö|se, ...dumm

er|zei|gen; sich dankbar -; Er|zei|gung
er|zen (aus Erz)
Erz|en|gel
er|zeu|gen; Er|zeu|ger; Er|zeu|ger_land, ...preis (vgl. ²Preis); Er|zeug|nis *s*; -ses, -se; Er|zeu|gung; Er|zeu|gungs_ko|sten, ...plan
erz|faul; Erz_feind, ...gau|ner
Erz|ge|bir|ge *s*; -s; Erz|ge|win|nung; erz|hal|tig
Erz|ha|lun|ke; Erz|her|zog; Erz|her|zo|gin; Erz|her|zog-Thron|fol|ger (↑ R 152); Erz|her|zog|tum
erz|höf|fig (reiches Erzvorkommen versprechend)
er|zieh|bar; er|zie|hen; Er|zie|her; Er|zie|her|ga|be; Er|zie|he|rin *w*; -, -nen; er|zie|he|risch; Er|zie|her|schaft *w*; -; er|zieh|lich; Er|zie|hung *w*; -; Er|zie|hungs_bei|hil|fe, ...be|ra|tung, ...be|rech|tig|te (*m* u. *w*; -n, -n (↑ R 287ff.), ...heim ...sy|stem, ...we|sen
er|zie|len; Er|zie|lung
er|zit|tern
erz|kon|ser|va|tiv; Erz_lüg|ner, Erz|lump; Erz|prie|ster
Erz|schei|den *s*; -s; Erz|schei|der; Erz_schelm, ...spitz|bu|be, ...übel
er|zür|nen; Er|zür|nung
Erz|va|ter
er|zwin|gen; Er|zwin|gung; E... zwün|ge|ne *s*; -n (↑ R 287ff.); e... was -s; er|zwun|ge|ner|ma|ßen
¹es; es sei denn, daß (↑ R 61); (↑ R 238:) er ist's, er war's, er sprach's 's ist nicht anders, 's war einmal; (↑ R 117:) das unbestimmte E
²es; alter *Wesf.* von „es", nu noch in Wendungen wie: ich bi es zufrieden; ich habe oder ic bin es satt
³es, Es (Tonbezeichnung) *s*; -,
⁴es (Zeichen für: es-Moll); in e
¹Es (Zeichen für: Es-Dur); in F
²Es = Einsteinium
Esau (bibl. m. Eigenn.)
Esc = Escudo
Es|cha|to|lo|gie *gr.* [...*cha*...] (Le re von den Letzten Dingen, d. vom Endschicksal des einzelne Menschen u. der Welt) *w*; -; e cha|to|lo|gisch
Esche (ein Laubbaum) *w*; -, -eschen (aus Eschenholz); Esche holz
E-Schicht; ↑ R 149 (Schicht der I nosphäre) *w*; -
Es|co|ri|al [...*ko*...] (span. Klost u. Schloß) *m*; -[s]
Es|cu|do *port.* [...*kụdo*] (port. chilen. Währungseinheit; Ab Esc., in Chile: chil Esc) *m*; --[s]
Es-Dur [auch: *ä*ß*dụr*] (Tonart; Z chen: Es) *s*; -; Es-Dur-Ton|lei (↑ R 155)
Esel *m*; -s, -; Esel|chen; Ese|lei; E

lein; esel|haft; Ese|lin w; -, -nen;
Esels.brücke [Trenn.: ...brük|ke],
...ohr

es|ka|la|die|ren fr. (früher für: eine
Festung mit Sturmleitern erstür-
men; eine Eskaladierwand über-
winden); Es|ka|la|dier|wand
(Hinderniswand); Es|ka|la|ti|on
fr.-engl. [...zion] (stufenweise
Steigerung, bes. im Einsatz polit.
u. militär. Mittel), es|ka|lie|ren
(stufenweise steigern); Es|ka|lie-
rung

Es|ka|mo|ta|ge fr. [...tasch] (Ta-
schenspielerei); Es|ka|mo|teur
[...tör] (Taschenspieler, Zauber-
künstler) m; -s, -e; es|ka|mo|tie-
ren (wegzaubern)

Es|ka|pa|de fr. (Reitsport: Seiten-
sprung; mutwilliger Streich)

¹Es|ki|mo (Angehöriger eines
arkt. Volkes) m; -[s], -[s]; ²Es|ki-
mo indian. (ein Wollstoff) m; -s,
-s; es|ki|mo|isch

Es|ko|ri|al vgl. Escorial

Es|kor|te fr. (Geleit, Bedeckung;
Gefolge) w; -, -n; es|kor|tie|ren;
Es|kor|tie|rung

Es|ku|do vgl. Escudo

Es|me|ral|da span. (span. Tanz)
w; -; ²Es|me|ral|da (w. Vorn.)

s-Moll [auch: äßmoll] (Tonart;
Zeichen: es) s; -; es-Moll-Ton|lei-
ter († R 155)

Eso|te|rik gr. (Geheimlehre) w; -,
-en; Eso|te|ri|ker (in die Geheim-
lehre Eingeweihter; innerlicher
Mensch); eso|te|risch

Es|pa|gnole .fr. [äßpanjol⁽ᵉ⁾] (ein
span. Tanz) w; -, -n; Es|pa|gno-
let|te|ver|schluß [...lät⁽ᵉ⁾...] (Dreh-
stangenverschluß für Fenster)

Es|par|set|te fr. (eine Futterpflan-
ze) w; -, -n

Es|par|to span. (ein Gras) m; -s;
vgl. Alfa, Halfa; Es|par|to|gras

Es|pe (Zitterpappel) w; -, -n; es|pen
(aus Espenholz); Es|pen|laub

Es|pe|ran|tist (Kenner u. Verfech-
ter des Esperanto); († R 268); Es-
pe|ran|to [nach dem Pseudonym
„Dr. Esperanto" des poln. Erfin-
ders L. Zamenhof] (eine künstl.
Weltsprache) s; -[s]

Es|pla|na|de fr. (freier Platz)

es|pres|si|vo it. [...wo] (Musik: aus-
drucksvoll); Es|pres|so (it. Bez.
für das in der Maschine bereitete,
starke Kaffeegetränk) m; -[s], -s
od. ...ssi u. (für: kleines Café)
s; -[s], -[s]; Es|pres|so|bar w

Es|prit fr. [...pri] (Geist, Witz)
m; -s

Esq. = Esquire

Es|qui|lin (Hügel in Rom) m; -s

Es|qui|re engl. [ißkwai⁽ᵉ⁾r] (engl.
Höflichkeitstitel, Abk.: Esq.) m;
-s, -s

Es|ra (bibl. m. Vorn.)

Es|say engl. [äßä⁴, auch: äßḗ¹, äßḙ
u. äßḙ] (kürzere Abhandlung) m
od. s; -s, -s; Es|say|ist (Verfasser
von Essays); † R 268; es|say-
stisch

eß|bar; Eß|ba|re s; -n (↑ R 287ff.);
etwas -s; Eß|bar|keit w; -; Eß|be-
steck

Es|se bes. ostmitteld. (Schorn-
stein) w; -, -n

es sei denn, daß († R 61)

es|sen; du ißt (issest); du aßest;
du äßest; gegessen; iß!; zu Mittag
-; selber - macht fett; ¹Es|sen s;
-s, -

²Es|sen (Stadt im Ruhrgebiet)

Es|sen.aus|ga|be, ...emp|fang

Es|se|ner († R 199); es|sensch.
(auch: es|sen|disch

Es|sen.ho|ler, ...kar|te

Es|sen|keh|rer bes. ostmitteld.
(Schornsteinfeger)

Es|sen|mar|ke; Es|sens|zeit

es|sen|ti|al lat. [...zial], es|sen|ti|ell
fr. [...ziäl] (Philos.: wesentlich);
Es|senz (Wesen; Hauptbegriff;
Geist) w; -, (für: Auszug, Extrakt
auch Mehrz.:) -en

Es|ser; Es|se|rei; Eß.ge|schirr,
...gier

Es|sig m; -s, -e; Eß|sig.es|senz,
...gur|ke, ...mut|ter (die sich im
Essigfaß bildende Bakterienkul-
tur; w; -); es|sig|sau|er; essigsaure
Tonerde; Es|sig|säu|re

Eß|koh|le (Steinkohlenart)

Eß.künst|ler (einfallsreicher
Koch), ...kul|tur, ...löf|fel; eß|löf-
fel|wei|se; Eß|lust w; -; eß|lu|stig

Es|so Ⓦ (ein Kraftstoff) s; -s

Eß.tisch, ...un|lust, ...wa|ren
(Mehrz.), ...zim|mer

Esta|blish|ment [äßtäblischm⁽ᵉⁿ⁾t]
(Schicht der Einflußreichen u.
bürgerlich Etablierten) s; -s, -s

Esta|min vgl. Etamin

Estam|pe fr. [äßtangp⁽ᵉ⁾] (von ei-
ner Platte gedruckte Abbildung)
w; -, -n

Estan|zia span. (südamerik. Land-
gut [mit Viehwirtschaft]) w; -, -s

¹Este (Estländer) m; -n, -n († R 268)

¹Ester (eine chem. Verbindung) m;
-s, -

²Ester vgl. ¹Esther

Ester.há|zy [äßt⁽ᵉ⁾rhasi] m; -, -s
(österr.-ung. Adelsgeschlecht)

¹Esther, (ökum.:) Ester (bibl. w.
Eigenn.); ²Esther (w. Vorn.)

Est|land¹; ¹Est|län|der¹; est|län-
disch¹, est|nisch¹; -e Sprache; vgl.
deutsch; Est|nisch¹ (Sprache) s;
-[s]; vgl. Deutsch; Est|ni|sche¹ s;
-n; vgl. Deutsche s

Esto|mi|hi lat. [auch: ...mihi] („Sei
mir [in starker Fels]!"; Bez. des
Sonntags vor Aschermittwoch)

¹ Auch: äßt...

Estra|de fr. (erhöhter Teil des Fuß-
bodens [vor einem Fenster usw.];
DDR: volkstüml. künstler. Ver-
anstaltung mit verschieden-
artigsten Nummern [aus Musik,
Artistik u. ä.]); Estra|den|kon-
zert (DDR)

Estra|gon arab. (eine Gewürz-
pflanze) m; -s

¹Estre|ma|du|ra (hist. Provinz in
Spanien, port. Landschaft);
²Estre|ma|du|ra w; - u. Estre|ma-
du|ra|garn (ein Garn); † R 201

Est|rich (fugenloser Fußboden;
schweiz. für: Dachboden, -raum)
m; -s, -e

Es|zett (Buchstabe: „ß") s; -, -

et lat. (und; Zeichen [in Firmenna-
men]: &); vgl. Et-Zeichen

Eta (gr. Buchstabe [langes e]: H,
η) s; -[s], -s

eta|blie|ren fr. (festsetzen; begrün-
den); sich - (sich selbständig ma-
chen; sich niederlassen; am Er-
reichten festhalten); Eta|blier|te
(jmd., der es zu etwas gebracht
hat; Mitglied der Gesellschaft) m
u. w; -n, -n († R 287ff.); Eta|blie-
rung; Eta|blis|se|ment [...ß⁵mang,
schweiz.: ...mänt] (Einrichtung;
Betrieb, Anlage, Fabrik; [vor-
nehme] Gaststätte; auch für: Bor-
dell) s; -s, -s u. (schweiz.:) -e

Eta|ge fr. [etasch⁴, österr.: etasch]
(Stock[werk], [Ober]geschoß);
eta|gen|för|mig; Eta|gen.bett,
...hei|zung, ...woh|nung; Eta|ge|re
[etaschär⁴] (veralt. für: Bücher-
brett; Stufengestell; Glas-
schrank) w; -, -n

Eta|lon [etalong] (Normalmaß-
stab) m; -s, -s

Eta|min fr. s (auch, bes. österr.:)
m); -s od. Eta|mi|ne (ein Gewebe)
w; -

Etap|pe fr. ([Teil]strecke, Ab-
schnitt; Stufe; Militär: Versor-
gungsgebiet hinter der Front) w;
-, -n; Etap|pen.ge|biet, ...ha|se
(Soldatenspr.), ...hengst (Solda-
tenspr.); etap|pen|wei|se

Etat fr. [eta] ([Staats]haushalt[s-
plan]; Geldmittel) m; -s, -s; Etat-
auf|stel|lung; eta|ti|sie|ren (in den
Etat aufnehmen); Etat.jahr, ...la-
ge; etat|mä|ßig (dem Etat gemäß;
fest angestellt; zum Bestand ge-
hörend); Etat.pe|ri|ode, ...po-
sten, ...re|de

Eta|zis|mus gr. (Aussprache des
gr. Eta [η] wie langes e) m; -

etc. = et cetera; dafür im deut-
schen Satz besser (vgl. S. 84,
5, c): usw.

et ce|te|ra lat. [ät ze...] (und so
weiter; Abk.: etc.); dafür im deut-
schen Satz besser (vgl. S. 84, 5,
c); und so weiter (Abk.: usw.);
etc. pp. vgl. pp.

ete|pe|te|te (ugs. für: geziert, zimperlich; übertrieben feinfühlig)

Eter|nịt ⓦ lat. (Asbestzement) s od. m; -s

Ete|si|en gr. [...i^en] (passatartige Winde im Mittelmeer) Mehrz.; Ete|si|en|kli|ma (winterfeuchtes, sommertrockenes Mittelmeerklima)

ETH = Eidgenössische Technische Hochschule; ETHL (in Lausanne), ETHZ (in Zürich)

Ethik gr. (Philosophie u. Wissenschaft von der Sittlichkeit; Sittenlehre) w; -, (selten:) -en; Ethi|ker (Vertreter der Ethik); ẹthisch (sittlich)

eth|nisch gr. (ein bestimmtes Volkstum betreffend); Eth|no|graph (Erforscher der Völkerkunde) m; -en, -en (↑ R 268); Eth|no|gra|phie ([beschreibende] Völkerkunde) w; -, ...ien; eth|no|grạphisch; Eth|no|lo|ge (Völkerkundler) m; -n, -n (↑ R 268); Eth|no|lo|gie (Völkerkunde) w; -, ...ien; eth|no|lo|gisch

Etho|lo|gie gr. (auf das Studium der Lebensgewohnheiten gegründete Lehre vom Verhalten der Tiere) w; -; Ethos (das Ganze der moral. Gesinnung) s; -

¹Eti|enne [etịạn] (fr. Buchdruckerfamilie); ²Eti|enne (eine Schriftart) w; -

Eti|kẹtt fr. s; -[e]s, -e (auch: -s) u. (schweiz., österr. sonst veraltet:) ¹Eti|ket|te (Zettel mit [Preis]aufschrift, Schild[chen]; Auszeichnung [von Waren]) w; -, -n; ²Eti|ket|te ([Hof]sitte, Förmlichkeit; feiner Brauch) w; -, -n; eti|ket|tie|ren (mit Etikett versehen); Eti|ket|tie|rung

Etio|le|ment fr. [etiol^emạng] (Vergeilung von Pflanzen) s; -s; etio|lie|ren (vergeilen)

ẹt|li|che; etliche (einige, mehrere) Tage, Stunden usw. sind vergangen; ich weiß etliches (manches) darüber zu erzählen; (↑ R 280:) etliches milde Nachsehen, mit etlichem kalten Wasser; (↑ R 286:) etliche gute Menschen; die Taten etlicher guter (selten: guten) Menschen; ẹt|li|che|mal, aber: etliche Male

Ẹt|mal (Seemannsspr.: Zeit von Mittag bis Mittag; innerhalb dieses Zeitraums zurückgelegte Strecke) s; -[e]s, -e

Eton [it^en] (engl. Schulstadt)

Etru|ri|en [...i^en] (altital. Landschaft); Etrụs|ker (Einwohner Etruriens); etrụs|kisch

Ẹtsch (Zufluß der Adria) w; -; vgl. Adige; Ẹtsch|tal

Ẹt|ter südd. (bebautes Ortsgebiet) m od. s; -s, -

Etü|de fr. (Musik: Übungsstück) w; -, -n

Etui fr. [ätwị] (Behälter, [Schutz]hülle; ärztl. Besteck) s; -s, -s; Etui|kleid (modisches, sehr eng geschnittenes Kleid)

ẹt|wa; in - (annähernd, ungefähr); vgl. in etwas; ẹt|wa|ig; etwaige weitere Kosten; ẹt|was; (↑ R 116:) etwas Auffälliges, Dementsprechendes, Derartiges, Passendes usw., aber (↑ R 135): etwas anderes, weniges, einziges; das ist doch etwas; in etwas (veralt. für: einigermaßen, ein wenig); vgl. in etwa; vgl. auch: was; Ẹt|was s; -, -; ein gewisses -; ẹt|wel|che (veralt. für: einige) Mehrz.

Ety|mo|lo|ge gr. m; -n, -n (↑ R 268); Ety|mo|lo|gie (Sprachw.: Ursprung u. Geschichte der Wörter; Forschungsrichtung, die sich damit befaßt) w; -, ...ien; ety|mo|lo|gisch; ety|mo|lo|gi|sie|ren (nach Herkunft u. Wortgeschichte untersuchen); Ety|mon [auch: ẹt...] (Wurzel-, Stammwort) s; -s, ...ma

Ẹt-Zei|chen (Und-Zeichen [in Firmennamen]: &) s; -s, -

Ẹt|zel (in der dt. Sage Name des Hunnenkönigs Attila [vgl. d.])

Eu = chem. Zeichen für: Europium

eu... gr. (wohl..., gut...); Eu... (Wohl..., Gut)

Eu|bio|tik gr. (Lehre vom gesunden körperl. u. geistigen Leben) w; -

Eu|böa (gr. Insel); eubö|isch

Eu|ca|in ⓦ [euk...] (Med.: örtl. betäubendes Mittel) s; -s

euch; in Briefen (↑ R 121f.): Euch; vgl. dein

Eu|cha|ri|stie gr. [...cha...] (kath. Kirche: Abendmahl, Altarsakrament) w; -, ...ien; eu|cha|ri|stisch; -e Taube (ein liturg. Gefäß), aber (↑ R 224): der Eucharistische Kongreß

Eu|dä|mo|nie gr. (Philos.: Glückseligkeit) w; -; Eu|dä|mo|nịs|mus (Glückseligkeitslehre) m; -; eu|dä|mo|nị|stisch

¹eu|er, eu[e]|re, eu|er (in Briefen: Euer usw.) Werf. (euer Tisch usw.; euer von allen unterschriebener Brief; ↑ R 272); vgl. eu[e]re. In Titeln: Werf., Wenf.: Euer, Eure (Abk. für beide: Ew.) Hochwürden usw.; Wesf., Wemf.: Euer, Eurer (Abk. für beide: Ew.) Hochwürden usw.; ²eu|er (in Briefen: Euer usw.) Wesf. (von ihr); euer (nicht: eurer) sind drei, sind wenige; ich gedenke, ich erinnere mich euer (nicht: eurer); eu[e]|re, eu|ri|ge; eu[e]rem, euerm Schrank[e], Bett[e]; in Briefen (↑ R 121): Eu[e]re, Eurige; der,

die, das eu[e]re od. eurige; unser Bauplatz ist dicht bei dem eur[ig]en; Großschreibung (↑ R 117): die Euern, Euren od. Eurigen (eure Angehörigen); das Eu[e]re od. Eurige (eure Habe, das euch Zukommende); ihr müßt das Eu[e]re od. Eurige tun; eu|er|seits, eu|rer|seits, in Briefen (↑ R 121): Euerseits usw.; eu|ers|glei|chen, eu|res|glei|chen; eu|ert|hal|ben, eu|ret|hal|ben; eu|ert|we|gen, eu|ret|we|gen; eu|ert|wil|len, eu|ret|wil|len; um -

Eu|gen [auch: eugẹn] (m. Vorn.); Eu|ge|nie [...i^e] (w. Vorn.)

Eu|ge|nik gr. (Erbpflege, Förderung des Erbgutes) w; -; Eu|ge|ni|ker; eu|ge|nisch

Eu|ka|lyp|tus gr. (ein Baum) m; -, ...ten u. -

Eu|klid (altgr. Mathematiker); eu|kli|disch; die euklidische Geometrie, aber (↑ R 179): Eu|kli|disch; der Euklidische Lehrsatz

Eu|ko|dạl ⓦ (Schmerzlinderungs-, Betäubungsmittel) s; -s

Eu|la|lia, Eu|la|lie [...i^e] (w. Vorn.)

Eu|lan ⓦ (Mittel gegen Mottenfraß) s; -s; eu|la|ni|sie|ren

Eu|le (nordd. auch: [Decken]besen) w; -, -n; eu|len|äu|gig; Eu|len|flucht nordd. (Abenddämmerung) w; -; Eu|len|flug; eu|len|haft; ein -es Aussehen

Eu|len|spie|gel (Titelgestalt eines dt. Volksbuches); Eu|len|spie|ge|lei

Eu|me|ni|de (die „Wohlwollende"; verhüllender Name für die gr. Rachegöttin Erinnye) w; -, -n (meist Mehrz.)

Eu|no|mia [auch: ...mịa] (gr. Göttin der Gesetzmäßigkeit, eine der ²Horen)

Eu|nuch gr. (entmannter Haremswächter) m; -en, -en (↑ R 268); Eu|nu|che m; -n, -n; vgl. Eunuch; eu|nu|chen|haft

Eu|phe|mia (w. Vorn.)

Eu|phe|mịs|mus gr. (beschönigendes, verhüllendes Wort, Hüllwort, z. B. „einschlafen" für „sterben") m; -, ...men; eu|phe|mị|stisch; -ste (↑ R 294)

Eu|pho|nie gr. (Wohlklang, -laut Ggs.: Kakophonie) w; -, ...ien eu|pho|nisch (wohlklingend; von Lauten: des Wohllauts wegen eingeschoben, z. B. „t" in „a genr lich"); -ste (↑ R 294)

Eu|phor|bia, Eu|phor|bie gr. [...i (eine Pflanze) w; -, ...ien

Eu|pho|rie gr. (subjektives Wohbefinden [von Schwerkranke od. Menschen unter dem Einflu von Drogen]) w; -; eu|pho|risc -ste (↑ R 294); eu|pho|ri|sie|ren (eine Glücksstimmung verse

zen); euphorisierende Rauschgifte

Eu|phrat (Strom in Vorderasien) *m*; -[s]

Eu|phro|sy|ne („die Frohsinnige"; eine der drei Chariten)

Eu|phu|is|mus *engl.* (Schwulststil der engl. Barockzeit) *m*; -; **eu|phu|is|tisch**

Eu|pnoe *gr.* [...*ǫ-e*] (Med.: ruhiges Atmen) *w*, -

Eu|ra|si|en [...*ien*] (Festland von Europa u. Asien); **Eu|ra|si|er** [...*ier*] (Bewohner Eurasiens; Mischling, dessen einer Elternteil Europäer, der andere Asiate ist) *m*; -s, -; **eu|ra|sisch; Eu|ra|tom** (Kurzw. für: Europäische Gemeinschaft für Atomenergie) *w*; -

eu|re, eue|re, eu|ri|ge, in *Briefen* (↑ R 121): Eure, Eurige, vgl. eu[e]re; **Eu|rer** (Abk.: Ew.); vgl. ¹euer *Werf.*; **eu|[r]er|seits,** in *Briefen* (↑ R 121): Eu[r]erseits usw.; **eu|res|glei|chen,** eu|ers|glei|chen; **eu|ret|hal|ben,** eu|ert|hal|ben; **eu|ret|we|gen,** eu|ert|we|gen; **eu|ret|wil|len,** eu|ert|wil|len; um -

Eu|rhyth|mie *gr.* (Ebenmaß, Gleichmaß von Bewegungen; Med.: Regelmäßigkeit des Pulses) *w*; -

eu|ri|ge vgl. eu[e]re

eu|ri|pi|de|isch, aber (↑ R 179): **Eu|ri|pi|de|isch; Eu|ri|pi|des** (altgr. Tragiker)

Eu|ro|cheque, (internationale Schreibung auf den Formularen:) **eu|ro|cheque** [...*schäk*] (offizieller, bei den Banken fast aller europ. Länder einzulösender Scheck) *m*; -s, -s; **Eu|ro|cheque-Kar|te**

Eu|ro|pa *gr.* („Abendland"; auch: gr. weibl. Sagengestalt); **Eu|ro|pa|cup** [...*kap*] vgl. Europapokal; **Eu|ro|pä|er** *m*; -s, -; **eu|ro|pä|id** (Anthropol.: den Europäern ähnlich); **Eu|ro|pä|jde** *m* u. *w*; -n, -n (↑ R 268); **eu|ro|pä|isch** (↑ R 200:) das -e Gleichgewicht, eine -e Gemeinschaft, aber (↑ R 224:) Europäische Gemeinschaft für Atomenergie (Kurzw.: Euratom), Europäische Gemeinschaft für Kohle und Stahl (Montanunion), Europäische Wirtschaftsgemeinschaft (Abk.: EWG), Europäische Zahlungsunion (Abk.: EZU); **eu|ro|pä|si|e|ren; Eu|ro|pä|si|e|rung; Eu|ro|pa|.meister,** ...**po|kal** (internationale Sporttrophäe, bes. im Fußball), ...**rat** *m*; -[e]s), ...**uni|on** (*w*; -); **eu|ro|pid** (zum europäisch-südeurasischen Rassenkreis gehörend); **Eu|ro|pi|de** (Angehörige[r] des europiden Rassenkrei-

ses) *m* u. *w*; -n, -n (↑ R 268); **Eu|ro|pi|um** (chem. Grundstoff, Metall; Zeichen: Eu) *s*; -s; **Eu|ro|vi|si|on** [Kurzw. aus europäisch u. Television] (europ. Organisation zur Kettenübertragung von Fernsehsendungen) *w*; -

Eu|ry|an|the (Titelgestalt einer Oper von C. M. v. Weber)

Eu|ry|di|ke [auch: ...*dịk*ᵉ] (Gattin des Orpheus)

eu|ry|top *gr.* (weit verbreitet [von Tieren u. Pflanzen])

Eu|se|bi|us (m. Eigenn.); - von Cäsarea (gr. Kirchenschriftsteller)

Eu|stach, Eu|sta|chi|us (m. Vorn.) **Eu|sta|chi|sche Röh|re, Eu|sta|chi|sche Tu|be** [nach dem it. Arzt Eustachio (...*ąkio*)]; ↑ R 179 (Med., Biol.: Ohrtrompete) *w*; -n -, -n -n

Eu|ter *s*; -s, -

Eu|ter|pe (gr. Muse der lyr. Poesie u. des lyr. Gesangs)

Eu|tha|na|sie *gr.* (Med.: Sterbeerleichterung durch Narkotika) *w*; -

Eu|tin (Stadt im Ostholsteinischen Hügelland)

eu|troph *gr.* (nährstoffreich); -e Pflanzen (an nährstoffreichen Boden gebundene Pflanzen); **Eu|tro|phie** (guter Ernährungszustand) *w*; -; **Eu|tro|phie|rung** (Wuchern nutzloser Pflanzenarten in stehenden Gewässern [durch Zufuhr von Abwässern])

eV = Elektronvolt

E. V. = Eingetragener Verein; (auch: e. V.; vgl. eingetragen)

ev. = evangelisch

Ev. = Evangelium

Eva [*ẹfa*, auch: *ẹwa*] (w. Vorn.)

eva|ku|ie|ren *lat.* [*ẹwa*...] (veralt. für: [aus]leeren; Technik: ein Vakuum herstellen; [in Gebiet von Bewohnern] räumen; [Bewohner aus einem Gebiet] aussiedeln); **Eva|ku|ier|te** *m* u. *w*; -n, -n (↑ R 287ff.); **Eva|ku|ie|rung**

Evan|ge|li|ar *gr.* *s*; -s, -e u. -ien [...*iᵉn*] u. **Evan|ge|li|a|ri|um** [*ẹw*..., auch: *ẹf*...] (Evangelienbuch) *s*; -s, ...ien [...*iᵉn*]; **Evan|ge|li|en|buch; Evan|ge|li|sa|ti|on** [...*ziǫn*] (Verkündigung des Evangeliums außerhalb des Gottesdienstes); **evan|ge|lisch** (das Evangelium betreffend; auf dem Evangelium fußend; protestantisch; Abk.: ev.); die evangelische Kirche, aber (↑ R 224:) die Evangelische Kirche in Deutschland (Abk.: EKD); der Evangelische Bund; **evan|ge|lisch-lu|the|risch** [veralt. od. zur Kennzeichnung einer stark orthodoxen Auffassung noch: - *luterisch*] (Abk.: ev.-luth.); **evan|ge|lisch-re|for|miert** (Abk.: ev.-ref.); **Evan|ge|list**

(Verfasser der 4 Evangelien; Titel in der ev. Freikirche; Wanderprediger); ↑ R 268; **Evan|ge|li|um** („gute Botschaft", die Frohbotschaft von Jesus Christus) *s*; -s, (für: die vier ersten Bücher im N. T. auch *Mehrz.*:) ...ien [...*iᵉn*]

Eva|po|ra|ti|on *lat.* [*ẹwaporazion*] (Verdampfung, Verdunstung); **Eva|po|rg|tor** (Gerät zur Süßwassergewinnung, vorwiegend aus Meerwasser) *m*; -s, ...ọren; **eva|po|rie|ren** (eindampfen, bes. von Milch)

Eva|si|on *lat.* [*ẹwa*...] (Flucht; veralt. für: [Aus]flucht)

Evas.ko|stüm, ...**toch|ter** [*ẹfa*..., auch: *ẹwa*...]; **Ev|chen** (Koseform von: Eva); **Eve|li|ne** [*ẹwe*...] (w. Vorn.)

even|tu|al *lat.* [*ẹwän*...] (seltener für: eventuell); **Even|tu|al.an|trag** (Rechtsspr.: Neben-, Hilfsantrag), ...**fall** *m* (im -[e]), ...**haus|halt; Even|tua|li|tät** (Möglichkeit, mögl. Fall); **even|tua|li|ter** (veralt. für: eventuell); **even|tu|ell** *fr.* (möglicherweise eintretend; gegebenenfalls, unter Umständen; Abk.: evtl.)

Eve|rest vgl. Mount Everest

Ever|glaze ⓦ *engl.* [*ẹw*ᵉ*rglẹ's*] (krumpf- und knitterfreies [Baumwoll]gewebe mit Kleinmusterung) *s*; -, -; **Ever|green** [*ẹw*ᵉ*rgrịn*] (Schlager usw., der lange Zeit hindurch beliebt ist) *s* (auch: *m*); -s, -s

Ever|te|brat, In|ver|te|brat *lat.* [*ẹwär*...] (wirbelloses Tier) *m*; -en, -en (meist *Mehrz.*); ↑ R 268

evi|dent *lat.* [*ẹwi*...] (offenbar; überzeugend, einleuchtend); **Evi|denz** (Augenschein, Deutlichkeit, völlige Klarheit) *w*; -; in - halten (österr. Amtsspr.: auf dem laufenden halten, registrieren); **Evi|denz|bü|ro** österr. (Büro, in dem bestimmte Personen, Daten o. ä. registriert werden)

Evi|pan ⓦ [*ẹwi*...] (ein Betäubungsmittel) *s*; -s

ev.-luth. = evangelisch-lutherisch

Evo|ka|ti|on *lat.* [*ẹwokazion*] (veralt. für: Vorladung eines Beklagten vor ein fremdes od. höheres Gericht; Erweckung von Vorstellungen od. Erlebnissen bei Betrachtung eines Kunstwerkes); **evo|ka|tiv**

Evo|lu|ti|on *lat.* [*ẹwolution*] (fortschreitende Entwicklung; Biol.: stammesgeschichtl. Entwicklung der Lebewesen von niederen zu höheren Formen); **evo|lu|tio|när** (sich stetig weiterentwickelnd [im Ggs. zu: revolutionär]); **Evo|lu|tio|nis|mus** (naturphilos. Rich-

tung des 19. Jh.s) *m*; -; Evo|lu|ti|ons|theo|rie; Evol|ven|te [*ewolw*...] (math. Linie) *w*; -, -n

Evo|ny|mus *gr.* [*ewǫn*...] (ein Zierstrauch, Spindelbaum) *m*; -

evo|zie|ren *lat.* [*ewo*...] (Zeitw. zu: Evokation)

ev.-ref. = evangelisch-reformiert

evtl. = eventuell

ev|vi|va *it.* [*ewịwa*] (it. Hochruf: „er lebe hoch!'')

Ew. vgl. euer

Ew. M. = Euer od. Eure Majestät

Ewald (m. Vorn.)

¹Ewe [*ewe*] (Angehöriger eines Sudannegerstammes) *m*; -, -; ²Ewe (eine Sprache) *s*; -; vgl. Deutsch

Ewen|ke (Angehöriger eines sibir. Volksstammes; Tunguse) *m*; -n, -n (↑ R 268)

Ewer (anderthalbmastiges Küsten- u. Fischerfahrzeug) *m*; -s, -

EWG = Europäische Wirtschaftsgemeinschaft

ewig; ein -es Einerlei; das -e Leben; der -e Frieden; -er Schnee; die -e Seligkeit; das -e Licht leuchte ihnen, aber (↑ R 224): die Ewige Lampe u. das Ewige Licht [in kath. Kirchen]; die Ewige Stadt (Rom); der Ewige Jude (Ahasver); Ewig|ge|stri|ge *m* u. *w*; -n, -n (↑ R 287ff.); Ewig|keit; Ewig|keits|sonn|tag (Totensonntag, letzter Sonntag des Kirchenjahres); ewig|lich (veralt. für: ewig); Ewig|weib|li|che *s*; -n (↑ R 287ff.)

ex *lat.* (aus; verhüllend für: tot); - trinken (Studentenspr.)

Ex... (ehemalig, z. B. Exminister)

ex|akt *lat.* (genau; sorgfältig; pünktlich); -e Wissenschaften (Naturwissenschaften u. Mathematik); Ex|akt|heit

Ex|al|ta|ti|on *lat.* [...*zịọn*] (Überspanntheit; leidenschaftl. Erregung); ex|al|tiert; Ex|al|tiert|heit

Ex|amen *lat.* ([Abschluß]prüfung) *s*; -s, - od. (seltener:) ...mina; Ex|amens_angst, ...ar|beit, ...kan|di|dat, ...not; Ex|ami|nand (Prüfling) *m*; -en, -en (↑ R 268); Ex|ami|na|tor (Prüfer) *m*; -s, ...ǫren; ex|ami|nie|ren (prüfen)

Ex|an|them *gr.* (Med.: [entzündl.] Hautausschlag) *s*; -s, -e

Ex|arch *gr.* (byzant. weltl. od. geistl. Statthalter) *m*; -en, -en (↑ R 268); Ex|ar|chat *s* (auch: *m*); -[e]s, -e

Ex|ar|ti|ku|la|ti|on *lat.* [...*zịọn*] (Med.: Abtrennung eines Gliedes im Gelenk)

Ex|au|di *lat.* („erhöre!''; Bez. des 6. Sonntags nach Ostern)

exc., excud. = excudit

ex ca|the|dra *lat.* [- *kạ*...] („vom

[Päpstl.] Stuhl''; aus päpstl. Vollmacht; unfehlbar [auch bildl.])

Ex|change *engl.* [*ikßtsche'ndseh*] (Tausch, Kurs [im Börsengeschäft]; Devise; Börse) *w*; -, -n

ex|cu|dit *lat.* [*äkßk*...] („hat es gebildet, verlegt od. gedruckt''; Vermerk hinter dem Namen des Verlegers [Druckers] bei Kupferstichen; Abk.: exc. u. excud.)

Ex|edra *gr.* (Bauw.: [halbrunde] Nische) *w*; -, Exedren

Ex|ege|se *gr.* ([Bibel]erklärung; Wissenschaft von der Bibelauslegung) *w*; -, -n; Ex|eget (gelehrter [Bibel]erklärer) *m*; -en, -en (↑ R 268; Ex|ege|tik (veralt. für: Wissenschaft der Bibelauslegung) *w*; -; ex|ege|tisch

exe|ku|tie|ren *lat.* (vollstrecken); exekutiert (österr. für: gepfändet) werden; Exe|ku|ti|on [...*zịọn*] (Vollstreckung [eines Urteils]; Hinrichtung; österr. auch für: Pfändung); exe|ku|tiv (ausführend); Exe|ku|ti|ve [...*w*ᵉ] *w*; - u. Exe|ku|tiv|ge|walt (vollziehende Gewalt [im Staat]) *w*; -; Exe|ku|tor (Vollstrecker) *m*; -s, ...ǫren; exe|ku|to|risch

Ex|em|pel *lat.* ([warnendes] Beispiel; Aufgabe) *s*; -s, -; Ex|em|plar [(einzelnes) Stück; Abk.: Expl.) *s*; -s, -e; ex|em|pla|risch (musterhaft; warnend, abschreckend); -ste (↑ R 294); -es Lernen; ex|em|pli cau|sa [- *kạu*...] (beispielshalber; Abk.: e. c.); Ex|em|pli|fi|ka|ti|on [...*zịọn*] (Erläuterung durch Beispiele); ex|em|pli|fi|zie|ren

ex|empt *lat.*'(Rechtsw.: befreit); Ex|em|ti|on [...*zịọn*] (Befreiung von einem Gesetz od. Recht)

Exe|qua|tur *lat.* („er vollziehe!''; Zulassung eines ausländ. Konsuls) *s*; -s, ...uren; Exe|qui|en [...*i*ᵉ*n*] (kath. Begräbnis[feier], Totenmesse) *Mehrz.*

ex|er|zie|ren *lat.* (meist von Truppen: üben); Ex|er|zier|platz; Ex|er|zi|ti|en [...*zi*ᵉ*n*] (geistl. Übungen) *Mehrz.*; Ex|er|zi|ti|um (Übung[sstück]; Hausarbeit) *s*; -s, ...ien [...*i*ᵉ*n*]

Ex|ha|la|ti|on *lat.* [...*zịọn*] (Med.: Ausatmung; Geol.: Ausströmen vulkan. Gase u. Dämpfe)

Ex|hau|stor *lat.* (Absauger, Entlüfter) *m*; -s, ...ǫren

ex|hi|bie|ren *lat.* (vorzeigen); Ex|hi|bi|ti|on [...*zịọn*] (Med.: Zurschaustellung); Ex|hi|bi|tio|nis|mus (Med.: krankhafte Neigung zur öffentl. Entblößung der Geschlechtsteile) *m*; -; Ex|hi|bi|tio|nist (↑ R 268)

ex|hu|mie|ren *lat.* ([einen Leichnam] wieder ausgraben); Ex|hu|mie|rung

Exil *lat.* (Verbannung[sort]) *s*; -s, -e; exi|liert (ins Exil geschickt); Exil|re|gie|rung

ex|imie|ren *lat.* (Rechtsspr.: von einer Verbindlichkeit, bes. von der Gerichtsbarkeit eines anderen Staates, befreien)

exi|stent *lat.* (wirklich, vorhanden); exi|sten|ti|al [das [menschl.] Dasein hinsichtl. seines Seinscharakters betreffend); Exi|sten|tia|lis|mus *m*; - u. Existen|ti|al|phi|lo|so|phie (zusammenfassende Bez. für eine Hauptrichtung der Gegenwartsphilosophie) *w*; -; Exi|sten|tia|list (↑ R 268); exi|sten|tia|li|stisch; Exi|sten|ti|al|phi|lo|so|phie vgl. Existentialismus; exi|sten|ti|ell *fr.* (auf das unmittelbare u. wesenhafte Dasein bezogen; daseinsmäßig); Exi|stenz (Dasein; Auskommen; Unterhalt; abschätzig für: Mensch) *w*; -, (für Mensch *Mehrz.*:) -en; exi|stenz|be|dro|hend, aber (↑ R 142): seine Existenz bedrohend; Exi|stenz|be|rech|ti|gung; exi|stenz|fä|hig; Exi|stenz|grund|lage; Exi|sten|zi|al... usw. vgl. Existential... usw.; Exi|stenz_kampf, ...mi|ni|mum, ...phi|lo|so|phie (Existentialismus); exi|stie|ren (vorhanden sein, bestehen, auskommen)

Exi|tus *lat.* (Med.: Tod) *m*; -

Ex|kai|ser; Ex|kai|se|rin

Ex|kar|di|na|ti|on *lat.* [...*zịọn*] (Entlassung eines kath. Geistlichen aus seiner Diözese)

Ex|ka|va|ti|on *lat.* [...*wazịọn*] (Ausschachtung, Aushöhlung; Zahnmed.: Ausbohrung); ex|ka|vie|ren

exkl. = exklusive

Ex|kla|ma|ti|on *lat.* [...*zịọn*] (veralt. für: Ausruf)

Ex|kla|ve [...*w*ᵉ] (ein eigenstaatl. Gebiet in fremdem Staatsgebiet) *w*; -, -n; vgl. Enklave

ex|klu|die|ren *lat.* (veralt. für: ausschließen); Ex|klu|si|on (veralt. für: Ausschließung); ex|klu|siv (nur einem bestimmten Personenkreis zugänglich; sich [gesellschaftl.] absondernd; unnahbar); ex|klu|si|ve [...*w*ᵉ] (mit Ausschluß von ..., ausschließlich; Abk. exkl.); *Verhältnisw.* mit *Wesf.*: - aller Versandkosten; ein alleinstehendes, stark gebeugtes Hauptw. steht in der *Einz.* ungebeugt - Porto; *Wemf.*, wenn der Wesf. nicht erkennbar ist: - Getränken; Ex|klu|siv|in|ter|view; Ex|klu|si|vi|tät (Ausschließlichkeit, [gesellschaftl.] Abgeschlossenheit) *w*; -

Ex|kom|mu|ni|ka|ti|on *lat.* [...*zịọn*

(Kirchenbann; Ausschluß aus der Kirchengemeinschaft); ex|kom|mu|ni|zie|ren
Ex|kö|nig; Ex|kö|ni|gin
Ex|kre|ment lat. (Ausscheidung) s; -[e]s, -e
Ex|kret lat. (Med.: für den Körper wertloses Stoffwechselprodukt) s; -[e]s, -e; Ex|kre|ti|on [...zion] (Med.: Ausscheidung von Exkreten)
Ex|kul|pa|ti|on lat. [...zion] (Rechtsspr.: Rechtfertigung, Entschuldigung); ex|kul|pie|ren; sich -
Ex|kurs lat. (Abschweifung; einer Abhandlung beigefügte kürzere Ausarbeitung; Anhang) m; -es, -e; Ex|kur|si|on (wissenschaftl. Ausflug, Lehrfahrt; Streifzug)
Ex|li|bris lat. („aus den Büchern"; [kunstvoll ausgeführtes] Bücherzeichen mit dem Namen[zeichen] des Bucheigentümers) s; -, -
Ex|ma|tri|kel lat. [auch: ...ik^e l] (Bescheinigung über das Verlassen einer Hochschule); Ex|ma|tri|ku|la|ti|on [...zion] (Streichung aus der Matrikel einer Hochschule); ex|ma|tri|ku|lie|ren
Ex|mi|ni|ster; Ex|mi|ni|ste|rin
Ex|mis|si|on lat. (veralt. für: gerichtl. Ausweisung aus einer Wohnung); ex|mit|tie|ren; Ex|mit|tie|rung
Exo|bio|lo|gie gr. (Weltraumwissenschaft, die nach lebenden Organismen außerhalb der irdischen Bereichs fragt)
Ex|odus gr. („Auszug"; 2. Buch Mosis) m; -
ex of|fi|cio lat. [- ...zio] Rechtsspr.: von Amts wegen)
Exo|ga|mie gr. (Heirat außerhalb von Stamm, Kaste usw.) w; -
exo|gen gr. (Bot.: außen entstehend; Med.: in den Körper eingeführt)
Exo|karp gr. (Bot.: äußere Schicht der Fruchtwand) s; -[e]s, -e
ex|or|bi|tant lat. (übertrieben; gewaltig)
Ex|or|di|um lat. (Rhet.: [kunstgerechte] Einleitung) s; -s, ...ia
ex ori|en|te lux lat. („aus dem Osten [kommt das] Licht"; zunächst auf die Sonne bezogen, dann übertr. auf Christentum u. Kultur)
ex|or|z[i]s|ie|ren gr. (böse Geister durch Beschwörung austreiben); Ex|or|zis|mus (Beschwörung böser Geister) m; -, ...men; Ex|or|zist (Geisterbeschwörer; dritter Grad der kath. niederen Weihen); ↑ R 268
Exo|sphä|re gr. (oberste Schicht der Atmosphäre) w; -

Ex|osto|se gr. (Med.: eine Knochengeschwulst) w; -, -n
Exot gr. (Mann aus einem fernen Land; auch für: Tiere, Pflanzen, Wertpapiere) m; -en, -en (↑ R 268); Exo|ta|ri|um (Anlage für exotische Tiere) s; -s, ...ien [...i^e n]; exo|te|risch (für Außenstehende bestimmt, allgemein verständlich)
exo|therm gr. (Chemie: Wärme abgebend)
Exo|tik gr. (Anziehungskraft, die vom Fremdländischen ausgeht) w; -; Exo|tin (Frau aus einem fernen Land) w; -, -nen; exo|tisch (fremdländisch, überseeisch, fremdartig); -e Musik
Ex|pan|der engl. (ein Sportgerät: Muskelstrecker) m; -s, -; ex|pan|die|ren lat. ([sich] ausdehnen); ex|pan|si|bel fr. (ausdehnbar); ...i|ble Stoffe; Ex|pan|si|on lat. (Ausdehnung; Ausbreitung [eines Staates]); ex|pan|sio|ni|stisch; Ex|pan|si|ons|ge|lü|ste, ...ge|schwin|dig|keit, ...kraft; ex|pan|siv ([sich] ausdehnend); Ex|pan|siv|kraft w
ex|pa|tri|ie|ren lat. (ausbürgern)
Ex|pe|di|ent lat. (Abfertigungsbeauftragter in der Versandabteilung einer Firma); ↑ R 268; ex|pe|die|ren (abfertigen; absenden; befördern); Ex|pe|dit österr. (Versandabteilung) s; -[e]s, -e; Ex|pe|di|ti|on [...zion] (Forschungsreise; Versand- od. Abfertigungsabteilung); Ex|pe|di|ti|ons|lei|ter m; Ex|pe|di|tor (seltener, bes österr. für: Expedient) m; -s, ...oren
Ex|pek|to|ran|ti|um lat. [...zium] (Med.: schleimlösendes [Husten]mittel) s; -s, ...tia; Ex|pek|to|ra|ti|on [...zion] (veralt. für: Aussprache, Erklärung [von Gefühlen]; Med.: Auswurf); ex|pek|to|rie|ren (veralt.: Gefühle aussprechen; Med.: Schleim aushusten)
Ex|pen|sen lat. ([Gerichts]kosten) Mehrz.; ex|pen|siv (kostspielig)
Ex|pe|ri|ment lat. s; -[e]s, -e; Ex|pe|ri|men|tal... (auf Experimente beruhend, z. B. Experimentalphysik); Ex|pe|ri|men|ta|tor m; -s, ...oren; ex|pe|ri|men|tell (auf Experimente beruhend); -e Psychologie; ex|pe|ri|men|tie|ren; Ex|per|te (Sachverständiger, Gutachter) m; -n, -n (↑ R 268); Ex|per|ti|se fr. (Untersuchung durch Sachverständige; Gutachten) w; -, -n
Expl. = Exemplar
Ex|plan|ta|ti|on lat. [...zion] (Züchtung von Einzelzellen od. Geweben auf einem künstl. Nährboden)

Ex|pli|ka|ti|on lat. [...zion] (veralt. für: Erklärung, Erläuterung); ex|pli|zie|ren; ex|pli|zit (erklärt, ausführlich dargestellt; Ggs.: implizit); -e Funktion (Math.); ex|pli|zi|te (ausdrücklich, deutlich); etwas - sagen
ex|plo|die|r|bar; ex|plo|die|ren lat.
Ex|ploi|ta|ti|on fr. [...ploatazion] (Ausbeutung; Nutzbarmachung); ex|ploi|tie|ren
Ex|plo|rand lat. (Med.: zu Untersuchender); Ex|plo|ra|ti|on [...zion] (Med.: Untersuchung u. Befragung eines Kranken); Ex|plo|rer engl. [iks'plər^e r] („Erforscher"; Bez. für die ersten amerik. Erdsatelliten) m; -s, -; ex|plo|rie|ren lat.
ex|plo|si|bel fr. (explosionsfähig, -gefährlich); ...i|ble Stoffe; Ex|plo|si|on lat.; Ex|plo|si|ons_ge|fahr, ...herd, ...ka|ta|stro|phe, ...kra|ter (Geol.), ...mo|tor; ex|plo|si|ons|si|cher; ex|plo|siv (leicht explodierend, explosionsartig); Ex|plo|siv m; -s, -e [...w^e] (meist Mehrz.) u. Ex|plo|siv|laut m; -[e]s, -e (Sprachw.: Verschlußlaut, z. B. b, k); Ex|plo|siv_ge|schoß, ...kör|per, ...laut (vgl. Explosiv), ...stoff
Ex|po|nat lat. (Ausstellungs-, Museumsstück) s; -[e]s, -e; Ex|po|nent (Hochzahl, bes. in der Wurzel-u. Potenzrechnung; Vertreter [einer Ansicht]; ↑ R 268; Ex|po|nen|tl|al_funk|ti|on [...zigl...] (Math.), ...gleichung (Math.), ...größe, ...röh|re (Technik); ex|po|nie|ren (hervorheben, [einer Gefahr] aussetzen; veralt. für: belichten [Fotogr.]); sich -; ex|po|niert (hervorgehoben; gefährdet; [Angriffen] ausgesetzt; Fotogr.: belichtet)
Ex|port engl. (Ausfuhr) m; -[e]s, -e; (↑ R 145:) Ex- u. Import; Ex|port_an|teil, ...ar|ti|kel; Ex|por|ten (Ausfuhrwaren) Mehrz.; Ex|por|t|er|lös; Ex|por|teur fr. [...tör] (Ausfuhrhändler od. -firma) m; -s, -e; Ex|port_för|de|rung, ...ge|schäft; ex|por|tie|ren; ex|port|in|ten|siv; -e Industriezweige; Ex|port_kauf|mann, ...quo|te
Ex|po|sé fr. (Denkschrift, Bericht, Darlegung; Zusammenfassung; Plan, Skizze [für ein Drehbuch]) s; -s, -s; Ex|po|si|ti|on [...zion] (einführender Teil des Dramas; selten für: Ausstellung, Schau; veralt. für: Darlegung; veralt. für: Belichtung [Fotogr.]); Ex|po|si|ti|ons|zeit (Fotogr.); Ex|po|si|tur (abgegrenzter selbständiger Seelsorgebezirk einer Pfarrei; österr. für: auswärtige Geschäftsfiliale, auswärtiger Teil einer höheren Schule) w; -, -en; Ex|po|si|tus

(ein leitender Geistlicher) *m*; -,
...ti

ex|preß *lat.* (veralt., noch ugs. für:
eilig, Eil...; mdal. für: eigens, aus-
drücklich, zum Trotz); Ex|preß
(österr., sonst veralt. für: Ex-
preßzug) *m*; ...presses, Expreßzü-
ge; Orientexpreß; Ex|preß.bo|te
(veralt. für: Eilbote), ...gut; Ex-
pres|si|on (Ausdruck); Ex|pres-
sio|nis|mus (Kunstrichtung im
frühen 20 Jh., Ausdruckskunst)
m; -, (für: Erzeugnis [nach Art]
des Expressionismus auch
Mehrz.:) ...men; Ex|pres|sio|nist
(↑ R 268); ex|pres|sio|ni|stisch;
-ste (↑ R 294); ex|pres|sis verbis
[- *wär*...] (ausdrücklich; mit aus-
drücklichen Worten); ex|pres|siv
(ausdrucksvoll); Ex|pres|si|vi|tät
[...*wi*...] (Fülle des Ausdrucks,
Ausdrucksfähigkeit; Biol.: Aus-
prägungsgrad einer Erbanlage)
w; -; Ex|preß.rei|ni|gung, ...zug
(veralt. für: Schnellzug; vgl. Ex-
preß)

Ex|pro|pria|ti|on *lat.* [...*zion*] (Ent-
eignung [marxist. Begriff]); ex-
pro|pri|ieren

Ex|pul|si|on *lat.* (Med.: Austrei-
bung, Abführung); ex|pul|siv

ex|qui|sit *lat.* (ausgesucht, erlesen)

Ex|sik|ka|ti|on *lat.* [...*zion*] (Che-
mie: Austrocknung); ex|sik|ka-
tiv; Ex|sik|ka|tor (Gerät zum
Austrocknen od. zum trockenen
Aufbewahren von Chemikalien)
m; -s, ...oren

Ex|spek|tant *lat.* (Anwärter) *m*;
-en, -en (↑ R 268); Ex|spek|tanz
(Anwartschaft auf noch besetzte
Stellen im Staat od. in der Kirche)
w; -, -en; ex|spek|ta|tiv (Anwart-
schaft gewährend; abwartend
[bei Krankenbehandlung])

Ex|spi|ra|ti|on *lat.* [...*zion*] (Med.:
Ausatmung); ex|spi|ra|to|risch
(auf Exspiration beruhend); -e
Artikulation (unter Ausatmen
zustandekommende Lautbil-
dung); -er Akzent (Druckak-
zent); ex|spi|rie|ren

Ex|stir|pa|ti|on *lat.* [...*zion*] (Med.:
völlige Entfernung [eines Or-
gans]); ex|stir|pie|ren

Ex|su|dat *lat.* (Med.: Ausschwit-
zung; Biol.: Absonderung) *s*;
-[e]s, -e; Ex|su|da|ti|on [...*zion*]
(Ausschwitzen, Absondern eines
Exsudates)

Ex|tem|po|ra|le *lat.* (unvorbereitet
anzufertigende [Klassen]arbeit)
s; -s, ...lien [...*i*e*n*]; ex tem|po|re
(aus dem Stegreif); Ex|tem|po|re
(Zusatz, Einlage; Stegreifspiel) *s*;
-s, -[s]; ex|tem|po|rie|ren (aus dem
Stegreif reden, schreiben usw.;
einflechten, zusetzen)

Ex|ten|ded *engl.* [*ikßtändid*]

(Schriftgattung) *w*; -; Ex|ten|si|on
lat. (Ausdehnung, Streckung);
Ex|ten|si|tät (Ausdehnung; Um-
fang) *w*; -; ex|ten|siv (der Ausdeh-
nung nach; räumlich; nach außen
wirkend); -e Wirtschaft (Form
der Bodennutzung mit geringem
Einsatz von Arbeitskraft u. Ka-
pital); Ex|ten|sor (Med.: Streck-
muskel) *m*; -s, ...oren

Ex|te|ri|eur *fr.* (Äußeres;
Außenseite; Erscheinung) *s*; -s, -e

ex|tern *lat.* (draußen befindlich;
auswärtig, fremd); Ex|ter|nat
(Lehranstalt, deren Schüler au-
ßerhalb der Schule wohnen) *s*;
-[e]s, -e; Ex|ter|ne (Schüler od.
Schülerin, die nicht im Internat
wohnt od. die die Abschlußprü-
fung an einer Schule ablegt, ohne
diese zuvor besucht zu haben) *m*
u. *w*; -n, -n (↑ R 287 ff.); Exter|nist
(Facharzt für äußere Krankhei-
ten; österr. für: Externer, nicht
fest verpflichteter Schauspieler);
↑ R 268

Ex|tern|stei|ne (Felsgruppe im
Teutoburger Wald) *Mehrz.*

ex|ter|ri|to|ri|al *lat.* (den Landes-
gesetzen nicht unterworfen); Ex-
ter|ri|to|ria|li|tät (Befreiung der
Gesandten usw. von der Ge-
richtsbarkeit des Aufenthalts-
staates, ihre Unverletzlichkeit,
Unantastbarkeit) *w*; -

Ex|tink|ti|on *lat.* [...*zion*] (Physik:
Schwächung einer Strahlung)

ex|tra *lat.* (nebenbei, außerdem,
besonders, eigens); (ugs.:) etwas
Extraes (↑ R 116); Ex|tra ([nicht
serienmäßig mitgeliefertes] Zu-
behör[teil] *s*; -s, -s; Ex|tra.aus-
ga|be, ...blatt (Sonderblatt),
...chor (zusätzlicher, nur in be-
stimmten Opern eingesetzter
Theaterchor); ex|tra|fein

ex|tra|ga|lak|tisch *lat.-gr.*
(Astron.: außerhalb des Milch-
straßensystems gelegen); vgl. Ga-
laxie

Ex|tra|hent *lat.* (Rechtsspr. veralt.
für: jmd., auf dessen Antrag eine
gerichtl. Verfügung erlassen
wird); ↑ R 268; ex|tra|hie|ren (ei-
nen Auszug machen; [einen
Zahn] ausziehen; auslaugen; ver-
alt. für: [eine Vollstreckungs-
maßregel] erwirken); Ex|trakt
(Auszug aus Büchern, Stoffen]);
Hauptinhalt; Kern) *m* (natur-
wiss. auch: *s*); -[e]s, -e; Ex|trak|ti-
on [...*zion*] (Auszug; Auslaugung;
Herausziehen, z. B. eines Zah-
nes); ex|trak|tiv *fr.* (ausziehend;
auslaugend); Ex|trak|tiv|stof|fe
Mehrz.

Ex|tra|ne|er [...*e*er*] *m*; -s, - u. Ex-
tra|ne|us *lat.* [...*e-uß*] (Externer)
m; -, ...neer [...*e*r*]

ex|tra|or|di|när *fr.* (außergewöhn-
lich, außerordentlich); Ex|tra|or-
di|na|ri|um *lat.* (außerordentl.
Haushaltsplan od. Etat) *s*; -s,
...ien [...*i*e*n*]; Ex|tra|or|di|na|ri|us
(außerordentl. Professor) *m*; -,
...ien [...*i*e*n*]

ex|tra|po|lie|ren *lat.* (Math., Stati-
stik: aus den bisherigen Werten
einer Funktion auf weitere schlie-
ßen)

Ex|tra|post (früher für: Postwa-
gen, den man eigens für sich
nahm, Sonderpost)

ex|tra|va|gant *fr.* [...*wa*..., auch:
äk...] (verstiegen, überspannt);
Ex|tra|va|ganz [auch: *äk*...] *w*; -,
-en

ex|tra|ver|tiert, ex|tro|ver|tiert *lat.*
(nach außen gerichtet); ein -er
Mensch

Ex|tra.wurst (ugs.), ...zug (Son-
derzug)

ex|trem *lat.* („äußerst"; übertrie-
ben); Ex|trem (höchster Grad,
äußerster Standpunkt; Übertrei-
bung) *s*; -s, -e; Ex|trem|fall *m*;
im -[e]; Ex|tre|mis|mus (überstei-
gert radikale Haltung) *m*; -,
...men; Ex|tre|mist (↑ R 268); ex-
tre|mi|stisch; Ex|tre|mi|tät (äu-
ßerstes Ende) *w*; -, -en; Ex|tre|mi-
tä|ten (Gliedmaßen) *Mehrz.*

ex|tro|ver|tiert vgl. extravertiert

Ex|tru|der *engl.* (Technik: Ma-
schine zum Ausformen thermo-
plast. Kunststoffe; Schnecken-
presse) *m*; -s, -

Ex|ul|ze|ra|ti|on *lat.* [...*zion*]
(Med.: Geschwürbildung); ex|ul-
ze|rie|ren

ex usu *lat.* („aus der Erfahrung";
durch Übung)

Ex|uvie *lat.* [...*wi*e*] (abgestreifte
tierische Körperhülle [z. B.
Schlangenhaut]) *w*; -, -n; Ex|uvi-
en [...*wi*e*n*] (Siegesbeute) *Mehrz.*

ex vo|to *lat.* [- *woto*] („auf Grund
eines Gelübdes" [Inschrift auf
Votivgaben]); Ex|vo|to (Weihe-
schenk, Votivbild) *s*; -s, -s u.
...ten

Ex|welt|mei|ster (Sport)

Exz. = Exzellenz

ex|zel|lent *lat.* (hervorragend);
Ex|zel|lenz (ein Titel; Abk.: Exz.)
w; -, -en; vgl. euer; ex|zel|lie|ren
(selten für: hervorragen; glänzen)

Ex|zen|ter *gr.-nlat.* *m*; -s, - u. Ex-
zen|ter|schei|be (exzentrisch angebrach-
te Steuerungsscheibe); Ex|zen-
trik ([mit Groteske verbundene]
Artistik) *w*; -; Ex|zen|tri|ker; ex-
zen|trisch (außerhalb des Mittel-
punktes liegend; überspannt,
verschroben); -ste (↑ R 294); Ex-
zen|tri|zi|tät (Abweichen, Ab-
stand vom Mittelpunkt; Über-
spanntheit)

Ex|zep|ti|on *lat.* [...*zion*] (veralt. für: Ausnahme; Einwendung); ex|zep|tio|nell *fr.* (ausnahmsweise eintretend, außergewöhnlich); ex|zep|tiv (veralt. für: ausschließend)

ex|zer|pie|ren *lat.* (ein Exzerpt machen); Ex|zerpt (schriftl. Auszug aus einem Werk) *s*; -[e]s, -e

Ex|zeß *lat.* (Ausschreitung; Ausschweifung) *m*; Exzesses, Exzesse; ex|zes|siv (das Maß überschreitend; ausschweifend)

ex|zi|die|ren *lat.* (Med.: herausschneiden); Ex|zi|si|on (Med.: Ausschneidung, z. B. einer Geschwulst)

Eyck, van [*fan* od. *wan aik*] (niederl. Maler)

Ey|rir *islånd.* [*ai*...] (is¹länd. Währungseinheit; 100 Aurar = 1 Krone) *m* od. *s*; -s. Aurar

Eze|chi|el [...*iäl*] (bibl. Prophet; bei Luther: Hesekiel)

EZU = Europäische Zahlungsunion

Ez|zes *jidd.* österr. ugs. (Tips, Ratschläge) *Mehrz.*

F

F (Buchstabe): das F, des F, die F, aber: das f in Haft (↑ R 123); der Buchstabe F, f

f = Femto...; forte

f, F (Tonbezeichnung) *s*; -, -; f (Zeichen für: f-Moll); in f; F (Zeichen für: F-Dur); in F

F = Fahrenheit; Farad; Fernschnellzug; vgl. Franc

F = chem. Zeichen für: Fluor

f. = folgende [Seite]; für

Fa. = Firma

Faa|ker See (See in Kärnten) *m*; - -s

Fa|bel *fr.* (erdichtete [lehrhafte] Erzählung; Grundhandlung einer Dichtung) *w*; -, -n; Fa|bel|buch, ...dich|ter; Fa|be|lei; fa|bel|haft; fa|beln; ich ...[e]le (↑ R 327); Fa|bel|tier, ...we|sen

Fa|bia (w. Vorn.); Fa|bi|an (m. Vorn.); Fa|bi|er [...*i°r*] (Angehöriger eines altröm. Geschlechtes) *m*; -s, -; Fa|bio|la (w. Vorn.); Fa|bi|us (Name altröm. Staatsmänner)

Fa|brik *fr. w*; -, -en; Fa|brik|an|la|ge¹; Fa|bri|kant *m*; -en, -en (↑ R 268); Fa|brik¹|ar|beit (w; -), ...ar|bei|ter (österr.: Fabriksarbeiter); Fa|bri|kat *lat. s*; -[e]s, -e; Fa|bri|ka|ti|on [...*zion*]; Fa|bri|ka|ti|ons|feh|ler, ...ge|heim|nis, ...me|tho-

Auch: ...*ik*.

de, ...pro|zeß; Fa|brik¹|be|sit|zer, ...ge|bäu|de, ...ge|län|de, ...hal|le, ...mar|ke; fa|brik¹|mä|ßig, ...neu; Fa|briks... (österr. für: Fabrik..., z. B. Fabrikarbeiter, Fabriksbesitzer, fabriksneu); Fa|brik¹|schorn|stein, ...si|re|ne; fa|bri|zie|ren

Fa|bu|lant *lat.* (Erzähler von phantastisch ausgeschmückten Erzählungen; Lügner, Schwätzer) *m*; -en, -en (↑ R 268); fa|bu|lie|ren

Fa|cet|te *fr.* [*faßät*°] (eckig geschliffene Fläche von Edelsteinen u. Glaswaren) *w*; -, -n; Fa|cet|ten|au|ge (Netzauge), ...glas (Mehrz. ...gläser), ...schliff; fa|cet|tie|ren (mit Facetten versehen)

Fach *s*; -[e]s, Fächer ...fach (z. B. vierfach [mit Ziffer: 4fach]; aber: n-fach) Fach|ar|bei|ter; Fach|ar|bei|ter|brief; Fach|arzt; fach|ärzt|lich; Fach|aus|druck, ...be|griff, ...bereich, ...be|zeich|nung, ...bi|blio|thek, ...buch; ...fa|che (z. B. Vierfache [mit Ziffer: 4fache, ↑S. 87, g] *s*; -n)

fä|cheln; ich ...[e]le (↑ R 327); fa|chen (seltener für: anfachen); Fä|cher *m*; -s, -; fä|cher|för|mig; fä|che|rig; fä|chern; ich ...ere (↑ R 327); Fä|cher|pal|me; Fä|che|rung

Fach|ge|biet; fach|ge|mäß, ...ge|recht; Fach|ge|schäft, ...han|del (vgl. ¹Handel), ...idi|ot (abwertend für: jmd., der nur ein Fachgebiet kennt), ...ken|ner, ...kraft *w*, ...kreis (in -en); fach|kun|dig; Fach|leh|rer, ...leh|re|rin, ...leu|te (Mehrz.); fach|lich; Fach|li|te|ra|tur, ...mann (Mehrz. ...männer u. ...leute); fach|män|nisch; -ste (↑ R 294); fach|mä|ßig; Fach|pres|se, ...re|fe|rent, ...rich|tung, ...schaft, ...schu|le; Fach|sim|pe|lei (ugs.); fach|sim|peln (ugs.: [zur Unzeit] Fachgespräche führen); ich ...[e]le (↑ R 327); gefachsimpelt; zu-; Fach|spra|che, ...werk; Fach|werk|haus; Fach|wis|sen|schaft, ...wort (Mehrz. ...wörter), ...zeit|schrift

Fa|cia|lis vgl. Fazialis

Fackel² *lat. w*; -, -n; Fackel|licht² (Mehrz. ...lichter); fackeln²; ich ...[e]le (↑ R 327); wir wollen nicht lange - (ugs. für: zögern); es wird nicht lange gefackelt; Fackel|zug²

Fac|to|ring *engl.* [*fäkt°ring*] (bestimmte Methode der Absatzfinanzierung und Kreditrisikoabsicherung) *s*; -s

Fa|cul|tas do|cen|di *lat.* [*fakų... dozǻndi*] (Lehrbefähigung) *w*; - -

¹ Auch: ...*ik*.
² Trenn.: ...ak|ke...

fad, fa|de *fr.*

Fäd|chen, Fäd|lein; fä|deln (einfädeln); ich ...[e]le (↑ R 327); Fa|den *m*; -s, Fäden (Seemannsspr.:) 4 - tief (↑ R 322); fa|den|dünn; Fa|den|en|de, ...kreuz, ...lauf (Weberei), ...nu|del, ...pilz; fa|den|schei|nig; Fa|den|schlag (schweiz. für: lockere [Heft]naht; Heftfaden; übertr. für: Vorbereitung; *m*; -[e]s), ...wurm, ...zäh|ler (Weberei)

Fad|heit
fä|dig (aus feinen Fäden bestehend)

Fa|ding *engl.* [*fe'ding*] (Schwund, An- und Abschwellen der Empfangslautstärke im Rundfunkgerät; Nachlassen der Bremswirkung infolge Erhitzung der Bremsen) *s*; -s

fa|di|sie|ren österr. (langweilen); sich -

Fäd|lein, Fäd|chen; Fäd|le|rin schweiz. (Einfädlerin) *w*; -, -nen

Fae|ces [*fäzäß*] vgl. Fäzes

Faf|ner, Faf|nir (nord. Sagengestalt)

Fa|gott (ein Holzblasinstrument) *s*; -[e]s, -e; Fa|gott|blä|ser; Fa|got|tist (Fagottbläser; ↑ R 268

Fäh|e (Jägerspr.: Hündin, Füchsin, Wölfin u. a.) *w*; -, -n

fa|hen (veralt. u. dicht. für: fangen); nur in den Grundform gebräuchlich

fä|hig; mit *Wesf.* (eines Betruges -) od. mit „zu" (zu allem -); Fä|hig|keit

fahl; fahlgelb usw.; Fahl|erz; Fahl|heit (fahles Aussehen) *w*; -; Fahl|le|der (Kalbsoberleder) *s*; -s

Fähn|chen, Fähn|lein
fah|nden; Fahn|dung; Fahn|dungs|buch, ...li|ste

Fah|ne *w*; -, -n; Fah|nen|ab|zug, ...eid, ...flucht (*w*; -; vgl. ²Flucht); fah|nen|flüch|tig; Fah|nen|jun|ker, ...mast *m*, ...stan|ge, ...wei|he; Fähn|lein, Fähn|chen; Fähn|rich *m*; -s, -e

Fahr|ab|tei|lung, ...aus|weis (Fahrkarte, -schein); schweiz. auch für: Führerschein), ...bahn; fahr|bar; Fahr|be|reit; Fahr|be|reit|schaft; Fahr|damm (landsch.)

Fähr|de (dicht. für: Gefahr) *w*; -, -n

Fahr|dienst *m*; -[e]s; Fahr|dienst|lei|ter *m*, ...lei|te|rin

Fäh|re *w*; -, -n

fah|ren; du fährst, er fährt; du fuhrst (fuhrest); du führest; er fuhr; gefahren; fahr[e]!; erster, zweiter [Klasse] -; (↑ R 140:) ich fahre Auto, ich fahre Rad; vgl. spazierenfahren, fahrenlassen; (↑ R 145:) Auto u. radfahren, aber: rad-

u. Auto fahren; **fah|rend**; -e Habe
(Fahrnis), -e Leute; **Fah|ren|de**
(umherziehender Spielmann,
Gaukler) *m*; -n, -n (↑ R 287ff.)
Fah|ren|heit [nach dem dt. Physi-
ker Fahrenheit] (Einheit der Gra-
de beim 180teiligen Thermome-
ter; Zeichen: F); 5° F (↑ S. 86,
9, f)
fah|ren|las|sen; ↑ R 139 (ugs. für:
aufgeben); er hat sein Vorhaben
fahrenlassen (↑ R 305); aber: **fah-
ren las|sen** (die Erlaubnis zum
Fahren geben); **Fah|rens|mann**
landsch. (Schiffer; *Mehrz.* ...leute
u. ...männer); **Fah|rer; Fah|re|rei**
w; -; **Fah|rer_flucht** (*w*; -), ...**haus**;
Fah|re|rin *w*; -, -nen; **Fah|rer|sitz**;
Fahr|gast (*Mehrz.* ...gäste); **Fahr-
gast|schiff**, **Fahr_geld**, ...**ge|le-
gen|heit**, ...**ge|schwin|dig|keit**,
...**ge|stell**, ...**ha|be** (schweiz. für:
Fahrnis; *w*; -, -n), ...**hau|er** (Berg-
mannsspr.); **fah|rig** (zerstreut);
Fah|rig|keit *w*; -; **Fahr|kar|te;
Fahr|kar|ten|aus|ga|be; Fahr-
kom|fort; Fahr|ko|sten, Fahrt-
ko|sten** *Mehrz.*; **fahr|läs|sig**; -e
Tötung; **Fahr|läs|sig|keit; Fahr-
leh|rer**
Fähr|mann (*Mehrz.* ...männer u.
...leute)
Fahr|nis (Rechtsspr.: fahrende
Habe, bewegliches Vermögen) *w*;
-, -se od. *s*; -ses, -se
Fähr|nis (dicht. für: Gefahr) *w*; -,
-se
Fahr|nis|ge|mein|schaft (Rechts-
spr.) *w*; -
Fahr|plan (vgl. ²Plan); **fahr|plan-
mä|ßig; Fahr_preis** (vgl. ²Preis),
...**prü|fung**, ...**rad**, ...**rin|ne**,
...**schein; Fahr|schein|heft**
Fähr|schiff
Fahr_schu|le, ...**schü|ler**, ...**si|cher-
heit** (*w*; -), ...**spur**, ...**stei|ger** (Berg-
mannsspr.), ...**stil**, ...**stra|ße**,
...**stuhl**, ...**stun|de; Fahrt** *w*; -, -en;
- ins Blaue; **Fahrt|dau|er**
Fähr|te (Spur) *w*; -, -n
fahr|tech|nisch
Fahr|ten_buch, ...**mes|ser** *s*,
...**schrei|ber**, (amtlich:) Fahrt-
schreiber
Fähr|ten|su|cher
**Fahr|test; Fahrt|ko|sten, Fahr_ko-
sten** *Mehrz.*; **Fahrt_rich|tung**,
...**schrei|ber** (amtlich für: Fahr-
tenschreiber); **Fahr|tüch|tig|keit;
Fahrt_un|ter|bre|chung**, ...**wind**
(beim Auto u. ä.); **Fahr_ver|hal-
ten**, ...**was|ser** (*s*; -s), ...**weg**, ...**wei-
se** *w*, ...**werk**, ...**wind** (guter Segel-
wind), ...**zeit**, ...**zeug; Fahr|zeug-
_bau** (*m*; -[e]s), ...**hal|ter**, ...**len-
ker**, ...**park**, ...**rah|men**
Fai|ble [*fäb^el*] (Schwäche; Nei-
gung, Vorliebe) *s*; -[s], -s; ein -
für etwas haben

fair *engl.* [*fär*] (einwandfrei; an-
ständig; ehrlich); das war ein -es
Spiel; **Fair|neß** [*fär*...] *w*; -; **Fair
play** [*fär ple^i*] (ehrenhaftes, an-
ständiges Spiel od. Verhalten [im
Sport]) *s*; - -
Fait ac|com|pli *fr.* [*fätakongpli]*
(vollendete Tatsache) *s*; - -, -s -s
[*fäsakongpli]*
fä|kal *lat.* (Med.: kotig); **Fä|kal-
dün|ger; Fä|ka|li|en** [...*i^en*] (Med.:
Kot) *Mehrz.*
Fa|kir [österr.: ...*kir*] *arab.* ([ind.]
Büßer, Asket; Zauberkünstler)
m; -s, -e
Fak|si|mi|le *lat.* („mache ähn-
lich!"; getreue Nachbildung ei-
ner Vorlage, z. B. einer alten
Handschrift) *s*; -s, -s; **Fak|si|mi-
le_aus|ga|be**, ...**druck** (*Mehrz.*
...drucke); **fak|si|mi|lie|ren**
Fakt (svw. Faktum) *s* (auch: *m*);
-[e]s, -en (meist *Mehrz.*); **Fak|ta**
(*Mehrz.* von: Faktum); **Fak|ten-
wis|sen**
Fak|ti|on *lat.* [...*zion*] (polit. [bes.
aktive od. radikale] Partei); **fak-
ti|ös** *fr.* (vom Parteigeist beseelt;
aufrührerisch); -este (↑ R 292)
fak|tisch *lat.* (tatsächlich); -es Ver-
tragsverhältnis (Rechtsspr.); **fak-
ti|tiv** (bewirkend); **Fak|ti|tiv**
[auch: *fak*...] (Sprachw.: bewir-
kendes Zeitwort, z. B. „schärfen"
= „scharf machen") *s*; -s, -e
[...*w^e*]; **Fak|ti|zi|tät** (Tatsächlich-
keit, Gegebenheit, Wirklichkeit);
Fak|tor („Macher"; Werkmei-
ster [einer Buchdruckerei]; Ver-
vielfältigungszahl; Umstand,
Grund) *m*; -s, ...**oren; Fak|to|rei**
(Handelsniederlassung, bes. in
Kolonien); **Fak|to|tum** („tu al-
les!"; jmd., der alles besorgt;
Mädchen für alles) *s*; -s, -s u.
...ten; **Fak|tum** [nachweisbare]
Tatsache; Ereignis) *s*; -s, ...ta u.
...ten; vgl. Fakt
Fak|tur *it.* ([Waren]rechnung) *w*;
-, -en; **Fak|tu|ra** (österr., sonst
veralt. für: Faktur) *w*; -, ...ren;
Fak|tu|ren|buch, **fak|tu|rie|ren**
([Waren] berechnen, Fakturen
ausschreiben); **Fak|tu|rier|ma-
schine; Fak|tu|rist** (↑ R 268); **Fak-
tu|ri|stin** *w*; -, -nen
Fa|kul|tas *lat.* ([Lehr]befähigung)
w; -...täten; vgl. Facultas docen-
di; **Fa|kul|tät** (Hochschule: Wis-
senschaftsgruppe; Gemeinschaft
der Lehrer u. Schüler einer Wis-
senschaftsgruppe; veralt. für:
Lehrbefähigung; math. Aus-
druck); **fa|kul|ta|tiv** (freigestellt,
wahlfrei); -e Fächer
falb; Falb (e) (gelbliches Pferd) *m*;
-n, -n (↑ R 291)
Fäl|bel *fr.* (gekrauster od. gefältel-
ter Kleidbesatz) *w*; -, -n; **fäl|beln**

(mit Falbeln versehen); ich ...[e]le
(↑ R 327)
Fal|ler|ner (Wein) *m*; -s, -; - Wein
fä|lisch (in Anlehnung an West-
[..falen"]) (der fälischen Rasse
angehörend); die -e Rasse
Falk (m. Vorn.); **Fal|ke** *m*; -n, -n
(↑ R 268); **Fal|ken_au|ge**, ...**bei|ze;
Fal|ke|nier** (Falkner, Falkenbab-
richter) *m*; -s, -e; **Fal|ken|jagd**
Fal|ken|see; Fal|ken|seer [...*e^er*]
(↑ R 166, 199 u. 205); Falkenseer
Forst
Falk|land_in|seln (östl. der Süd-
spitze Südamerikas) *Mehrz.*
Falk|ner (veralt. für: Falkenier; **Falk|ne-
rei** (Jagd mit Falken); **Fal|ko** (m.
Vorn.)
¹Fall (auch für: Kasus) *m*; -[e]s,
Fälle; (↑ R 61 u. R 63:) für den
-, daß ...; gesetzt den -, daß ...;
im Fall[e](,) daß ...; von - zu -;
zu Fall bringen; erster (1.) Fall;
Klein- u. Zusammenschreibung
(↑ R 129): besten-, schlimmsten-,
nötigen-, eintretendenfalls; al-
len-, ander[e]n-, äußersten-,
gegebenen-, gesetzten-, jeden-,
keinesfalls u. ä.; **²Fall** (See-
mannsspr.: ein Tau) *s*; -[e]s, -en
Fal|la|da (dt. Schriftsteller)
Fäll_bad (bei der Chemiefaserher-
stellung); **Fall_beil**, ...**be|schleu-
ni|gung** (Physik; Zeichen: g),
...**brücke** [*Trenn.*: ...brük|ke]; **Fal-
le** *w*; -, -n; **fal|len;** du fällst, er
fällt; du fielst; du fielest; gefallen
(vgl. d.); fall[e]!; **fäl|len;** du fällst,
er fällt, du fälltest; du fälltest;
gefällt, fäll[e]!; **fal|len|las|sen;**
(↑ R 139:) er hat seine Absicht
fallenlassen (aufgegeben); er hat
entsprechende Bemerkungen fal-
lenlassen, (seltener:) fallengelas-
sen (geäußert); ↑ R 305; aber: **fal-
len las|sen;** ich habe den Teller
fallen lassen; die Maske fallen
lassen (sein wahres Gesicht zei-
gen); **Fal|len|stel|ler**
Fal|lers|le|ben (Stadt am Mittel-
landkanal); **Fal|lers|le|ber** (↑ R
199)
Fall|gru|be (Jägerspr.)
fal|lie|ren *it.* (zahlungsunfähig
werden)
fäl|lig; -er-, -gewordener Wechsel
Fäl|lig|keit; Fäl|lig|keits|tag
Fäll_mit|tel (Chemie: Mittel zum
Ausfällen eines Stoffes) *s*; **Fall_
obst**
Fall_lot vgl. Falott
Fall|out *engl.* [*fâlaut*] (radioaktive
Niederschlag [nach Kernwaffen-
explosionen]) *m*; -s, -s
Fall|reep (äußere Schiffstreppe);
Fall_rück|zie|her (Fußball); **falls;**
komme doch [,] falls möglich /
schon um 17 Uhr (↑ R 49); **Fall_
schirm; Fall|schirm_jä|ger**, ...**se-**

de, ...sprin|ger, ...trup|pe; Fall‿strick, ...sucht (Epilepsie; w; -); fall|süch|tig; Fall|tür; Fäl|lung; fall|wei|se österr. (gegebenenfalls, von Fall zu Fall); Fall|wind Fa|lott, Fal|lot fr. österr. (Gauner) m; -en, -en (↑ R 268)

Fal|sa (Mehrz. von: Falsum)

falsch; -este (↑ R 292); - sein; - und richtig nicht unterscheiden können; -e Zähne; unter -er Flagge segeln; an die -e Adresse geraten; -er Hase (eine Speise), aber (↑ R 224): der Falsche Demetrius.

Schreibung in Verbindung mit Zeitwörtern (↑ R 139): a) Getrenntschreibung in ursprünglicher Bedeutung, z. B. falsch (unrichtig) spielen; er hat immer falsch (unrichtig) gespielt; b) Zusammenschreibung, wenn durch die Verbindung ein neuer Begriff entsteht; vgl. falschspielen (betrügerisch spielen); Falsch m, nur noch in: es ist kein - an ihm; ohne -; fäl|schen; du fälschst (fälschest); Fäl|scher; Falsch|geld; Falsch|heit; fälsch|lich; fälsch|li|cher|wei|se; Falsch.mel|dung, ...mün|zer; Falsch|mün|ze|rei; falsch|spie|len; ↑ R 139 (betrügerisch spielen); er spielt falsch; falschgespielt; falschzuspielen; aber: falsch spie|len (unrichtig spielen); Falsch|spie|ler; Fäl|schung

Fal|sett it. (Fistelstimme) s; -[e]s, -e; fal|set|tie|ren; Fal|set|tist (↑ R 268); Fal|sett|stim|me

Fal|si|fi|kat lat. (,,Gefälschtes''; selten für: Fälschung) s; -[e]s, -e; Fal|si|fi|ka|ti|on [...zion] (veralt. für: Fälschung); fal|si|fi|zie|ren

Fal|staff (Gestalt bei Shakespeare [nur Einz., ohne Geschlechtsw.]; dicker Prahlhans, Schlemmer) m; -s, -s

Fal|ster (dän. Insel)

Fal|sum lat. (veralt. für: Falsches, Fälschung) s; -s, ...sa

Falt‿ar|beit, ...blatt, ...boot; Fält|chen, Fält|lein; Fal|te w; -, -n; fäl|teln; ich ...[e]le (↑ R 327); fal|ten; gefaltet; fal|ten|ge|bir|ge (Geol.); fal|ten|los; fal|ten|reich; Fal|ten.rock, ...wurf

Fal|ter m; -s, -

fal|tig (Falten habend)

...fäl|tig (z. B. vielfältig)

Falt|kar|te; Fält|lein, Fält|chen; Falt|schach|tel; Fal|tung

Falz m; -es, -e; Falz|bein; fal|zen; du falzt (falzest); Fal|zer; Fal|ze|rin w; -, -nen; fal|zig; Fal|zung; Falz|zie|gel

Fa|ma lat. (Ruf; Gerücht) w; -

fa|mi|li|är lat. (die Familie betreffend; vertraut, eng verbunden); Fa|mi|lia|ri|tät; Fa|mi|lie [...iᵉ] w;

-, -n; Fa|mi|li|en‿ähn|lich|keit, ...an|ge|le|gen|heit, ...an|schluß, ...be|sitz, ...bild, ...fei|er, ...forschung, ...grab, ...gruft, ...kreis, ...kun|de (w; -), ...la|sten|ausgleich, ...mi|ni|ster, ...mit|glied, ...na|me, ...ober|haupt, ...planung, ...sinn, ...stand (m; -[e]s), ...tag, ...va|ter, ...ver|hält|nis|se (Mehrz.), ...vor|stand, ...wap|pen, zu|sam|men|füh|rung

fa|mos lat. (ugs. für: ausgezeichnet, prächtig, großartig); -este (↑ R 292)

Fa|mu|la|tur lat. (von Medizinstudenten abzuleistender Hilfsdienst im Krankenhaus) w; -, -en; fa|mu|lie|ren, Fa|mu|lus [,,Diener''; Gehilfe] m; -, -se u. ...li

Fan engl. [fän] (überschwenglich Begeisterter) m; -s, -s

Fa|nal gr. ([Feuer]zeichen, Brandfackel) s; -s, -e

Fa|na|ti|ker lat. (Eiferer; [Glaubens]schwärmer); fa|na|tisch (sich unbedingt, rücksichtslos einsetzend); -ste (↑ R 294); fa|na|ti|sie|ren (fanatisch machen; aufhetzen); Fa|na|tis|mus m; -

Fan|dan|go [...danggo] (ein span. Tanz) m; -s, -s

Fan|fa|re fr. (Trompetengeschmetter; Blasinstrument) w; -, -n; Fan|fa|ren|blä|ser, ...stoß, ...zug

Fang m; -[e]s, Fänge; Fang‿arm, ...ball, ...ei|sen; fan|gen; du fängst, er fängt; du fingst; du fingest; gefangen; fang[e]!; vgl. fahen; Fan|gen landsch. (Haschen, Nachlaufen) s; -s; - spielen; Fän|ger; Fang.fra|ge, ...ge|rät, ...grube

Fan|gio [fandseho] (argentin. Autorennfahrer)

fän|gisch (Jägerspr.: fangbereit [Falle]); Fang.korb, ...lei|ne, ...mes|ser s, ...netz

Fan|go it. (heilkräftiger ,,Schlamm'') m; -s; Fan|gopackung [Trenn.: ...k|k...]

Fang.schnur (Uniformteil; Mehrz. ...schnüre), ...schuß, ...spiel, ...stoß, ...vor|rich|tung

Fan|ni, (auch:) Fan|ny (Kurzform von: Franziska)

Fant (veralt. abschätzig für: unreifer junger Mensch) m; -[e]s, -e

Fan|ta|sia gr. (nordafrik. Reiterkampfspiel) w; -, -s; Fan|ta|sie (Musikstück; gelegentl. auch eindeutschend für: Phantasie) w; -, ...ien

Fa|rad [nach dem engl. Physiker Faraday (fär'di)] (Maßeinheit der elektr. Kapazität; Zeichen: F) s; -[s], -; 3 - (↑ R 322); Fara|di|sa|ti|on [...zion] (med. Anwendung faradischer Ströme); Fa|ra-

disch; -e Ströme (Induktionsströme)

Farb‿ab|stim|mung, ...auf|nah|me, ...band (s; Mehrz. ...bänder), ...be|zeich|nung od. Far|ben|be|zeich|nung, ...brü|he; Farb|druck, Far|ben|druck (Mehrz. ...drukke); Far|be w; -, -n; eine blaue -; die - Blau; farb|echt; Farb|effekt; Fär|be|mit|tel s; ...far|ben, ...far|big (z. B. cremefarben, cremefarbig; orange[n]farben, orange[n]farbig; beigefarben, beigefarbig; fleischfarben, fleischfarbig); fär|ben; Far|ben|be|zeich|nung, Farb|be|zeich|nung; far|ben|blind; Far|ben.blind|heit (w; -), ...druck od. Farb|druck (Mehrz. ...drucke); far|ben.freu|dig, ...froh; Far|ben|ka|sten, Farb|ka|sten; Far|ben.leh|re, ...pracht (w; -); far|ben|präch|tig; Far|ben.pro|be, Farb|pro|be; Far|ben.sinn (m; -[e]s), ...sym|bo|lik; Fär|ber; Fär|ber|baum (Pflanze); vgl. Sumach; Fär|be|rei; Fär|ber.waid (Pflanze); Farb.fern|se|hen, ...fern|seh|ge|rät, ...fern|seh-film, ...fern|seh|ka|me|ra, ...fern|seh|über|tra|gung, ...film, ...fil|ter, ...ge|bung (für: Kolorit; w; -), ...holz, far|big (österr. auch:) far|big; farbig ausgeführt, aber (↑ R 116): in Farbig ausgeführt; ...far|big, (österr.:) ...fär|big, z. B. einfarbig, (österr.:) einfärbig; vgl. ...farben; Far|bi|ge (Angehöriger der nichtweißen Rasse) m u. w; -n, -n (↑ R 287ff.); Far|big|keit w; -; Farb|ka|sten; Far|ben|ka|sten, ...kom|bi|na|ti|on, ...kom|po|nen|te, ...kör|per (für: Pigment); farb|lich; farb|los; -este (↑ R 292); Farb|lo|sig|keit w; -; Farb.mi|ne, ...nu|an|ce, ...pro|be od. Far|ben-pro|be, ...stift, ...stoff, ...ton (Mehrz. ...töne); farb|ton|rich|tig (für: isochromatisch); Fär|bung; Farb|wal|ze

Far|ce fr. [farß'], österr.: farß] (,,Füllsel''; Posse) w; -, -n; Far|ceur [farßör] (veralt. für: Possenreißer) m; -s, -e; far|cie|ren [farßi-r'n] (Gastr.: füllen)

Fa|rin lat. (unreiner, gelblicher Zucker) m; -s

Fä|rin|ger, Fä|rö|er [auch: fä...] (Bewohner der Färöer) m; -s, -

Farm engl. w; -, -en; Far|mer m; -s, -; Far|mers|frau

Farn (eine Sporenpflanze) m; -[e]s, -e

Far|ne|se (Angehöriger eines it. Fürstengeschlechtes) m; -, -; far|ne|sisch, aber (↑ 179): der Farnesische Herkules, der Farnesische Stier

Farn.kraut, ...pflan|ze, ...we|del

Fa|ro *it.* (svw. Pharus) *m*; -s, -s

Fä|rö|er [auch: *fä*...] (,,Schafin-
seln"; dän. Inselgruppe) *Mehrz.*;
vgl. Färinger; fä|rö|isch [auch:
fä...]

Far|re landsch. (junger Stier) *m*;
-n, -n (↑ R 268); Fär|se (Kuh, die
noch nicht gekalbt hat) *w*; -, -n;
vgl. aber: Ferse

Fa|san [nach Phasis (Fluß u. Stadt
am Schwarzen Meer)] *m*; -[e]s,
-e[n]; Fa|sa|nen|ge|he|ge, ...zucht;
Fa|sa|ne|rie (Fasanengehege) *w*;
-, ...ien

Fa|sche *it.* österr. (Binde) *w*; -, -n;
fa|schen österr. (mit einer Fasche
umwickeln)

Fäs|chen, Fä|ser|chen, Fä|ser|lein,
Fäs|lein

fa|schie|ren *fr.* österr. (Fleisch
durch den Fleischwolf drehen);
faschierte Laibchen (Buletten,
Frikadellen); Fa|schier|ma|schi-
ne österr. seltener neben:
Fleischmaschine); Fa|schier|te
österr. (Hackfleisch) *s*; -n (↑ R
287ff.)

Fa|schi|ne *fr.* (Reisiggeflecht [für
Befestigungsbauten]) *w*; -, -n; Fa-
schi|nen|mes|ser (eine Art Seiten-
gewehr; *s*), ...wall

Fa|sching *m*; -s, -e u. -s; Fa|schings-
ball, ...diens|tag, ...ko|stüm,
...krap|fen (österr.), ...scherz,
...zeit, ...zug

Fa|schis|mus *it.* (antidemokrati-
sche, nationalistische Staatsauf-
fassung) *m*; -; Fa|schist (↑ R 268);
fa|schi|stisch (zum Faschismus
gehörend); fa|schi|sto|id (dem
Faschismus ähnlich)

Fa|se (Abschrägung einer Kante
[an Holz u. Stein], Kante) *w*; -,
-n

Fa|sel (junges Zuchttier; Wurf,
Brut) *m*; -s, -; Fa|sel|eber

Fa|se|lei; Fa|se|ler, Fas|ler; Fa|sel-
hans *m*; -[es], -e u. ...hänse; fa|se-
lig; fa|seln (törichtes Zeug reden);
ich ...[e]le (↑ R 327)

fa|sen (abkanten); du fast (fasest);
er fa|ste

Fa|ser *w*; -, -n; Fä|ser|chen, Fä|ser-
lein, Fäs|lein, Fäs|chen; fa|se|rig,
fas|rig; fa|sern; ich ...ere (↑ R 327);
fa|ser|nackt; Fa|ser|pflan|ze; fa-
ser|scho|nend; Fa|se|rung

Fa|shion *engl.* [*fäsch^e^n*] (Mode;
feine Sitte) *w*; -; fa|shio|na|bel,
(heute meist:) fa|shio|na|ble [*fä-
sch^e^n^e^b^e^l*] (modisch, fein); ...a|ble
Kleidung

Fäs|lein vgl. Fäserchen

Fas|ler, Fa|se|ler

fas|rig, fa|se|rig

Fas|nacht landsch. (Fastnacht)

Faß *s*; Fasses, Fässer; zwei - Bier
(↑ R 321 u. 322)

Fas|sa|de *fr.* (Vorder-, Schau-,

Stirnseite; Ansicht; Fas|sa|den-
klet|te|rer, ...rei|ni|gung

faß|bar; Faß|bar|keit *w*; -

Faß.bier, ...bin|der (südd. u.
österr. für: Böttcher); Fäß|chen,
Fäß|lein; Faß|dau|be

fas|sen; du faßt (fassest), er faßt;
du faßtest; gefaßt; fasse! u. faß!

fäs|ser|wei|se (in Fässern)

Fas|si|on *lat.* (veralt. für: [Steuer]-
bekenntnis; Angabe)

Fäß|lein, Fäß|chen

faß|lich; Faß|lich|keit *w*; -

¹Fas|son *fr.* [*faßong*, schweiz. u.
österr. meist: *faßòn*] (Form; Mu-
ster; Art; Zuschnitt) *w*; -, -s
(schweiz., österr.: -en); ²Fas|son
(Revers) *s*; -s, -s; fas|so|nie|ren [*fa-
ßonir^e^n*]; Fas|son|schnitt (bes. Art
des Haarschnitts)

Faß.reif (vgl. ²Reif), ...rei|fen,
...spund

Fas|sung; Fas|sungs|kraft *w*; -; fas-
sungs|los; -este (↑ R 292); Fas-
sungs.lo|sig|keit (*w*; -), ...ver|mö-
gen

Faß|wein; faß|wei|se (Faß für Faß)

fast (beinahe)

Fa|sta|ge vgl. Fustage

Fast.back *engl.* [*faßtbäk*] (Fließ-
heck) *s*; -s, -s

Fa|ste (veralt. für: Fasten, Fasten-
zeit) *w*; -

Fast|ebe|ne (Geogr.: nicht ganz
ebene Fläche, Rumpffläche); vgl.
Peneplain

Fa|stel|abend rheinisch (Fast-
nacht); fa|sten; ¹Fa|sten *s*; -s; ²Fa-
sten (Fasttage) *Mehrz.*; ³Fa-
sten.kur, ...spei|se, ...zeit; Fast-
nacht *w*; -; Fast|nacht[s].brauch,
...diens|tag, ...ko|stüm, ...spiel,
...trei|ben (*s*; -s), ...um|zug, ...zeit;
Fast|tag

Fas|zes *lat.* (Bündel aus Stäben
[Ruten] u. einem Beil, Abzeichen
der altröm. Liktoren) *Mehrz.*;
fas|zi|al (bündelweise); Fas|zia-
ti|on [...*zion*] (das Einwickeln in
Binden [Med.]; Verbänderung
[von Pflanzenwurzeln]); Fas|zie
[...*i^e^*] (Med.: sehnenartige Mus-
kelhaut; Bindenverband) *w*; -, -n;
Fas|zi|kel ([Akten]bündel, Heft,
Lieferung) *m*; -s, -

Fas|zi|na|ti|on *lat.* [...*zion*] (Bezau-
berung, Verblendung; fas|zi|nie-
ren

Fa|ta (*Mehrz.* von: Fatum); fa|tal
lat. (verhängnisvoll; unange-
nehm; peinlich); fa|ta|ler|wei|se;
Fa|ta|lis|mus (Glaube an Vorher-
bestimmung; Schicksalsglaube)
m; -; Fa|ta|list (↑ R 268); fa|ta|li-
stisch; -ste (↑ R 294); Fa|ta|li|tät
(Verhängnis, Mißgeschick)

Fa|ta Mor|ga|na *it.* (eine durch
Luftspiegelung verursachte Täu-
schung) *w*; - , - ...nen u. - -s

fa|tie|ren *lat.* (veralt. für: beken-
nen; österr. für: seine Steuerer-
klärung abgeben); Fa|tie|rung

fa|ti|gant *fr.* (veralt. für: ermü-
dend; lästig)

Fa|ti|ma (arab. w. Vorn.)

Fa|tum *lat.* (Schicksal) *s*; -s, ...ta

Fatz|ke (ugs. für: Geck, eitler
Mensch, Hohlkopf) *m*; -n (↑ R
268) u. -s, -n u. -s

fau|chen

faul; -e Ausreden; -er (ugs. für:
deckungsloser) Wechsel; -er Zau-
ber; auf der -en Haut liegen
(ugs.); Faul.baum (Heilpflanze),
...brut (Bienenkrankheit); Fäu|le
w; -; fau|len; fau|len|zen; du fau-
lenzt (faulenzest); Faul|len|zer;
Faul|len|ze|rei; Faul|heit *w*; -; fau-
lig; Fäul|nis *w*; -; Fäul|nis|er|re-
ger; Faul.pelz, ...schlamm (Bo-
denschlamm in flachen Meeres-
gebieten u. stehenden Gewäs-
sern), ...tier

Faun (von ,,Faunus"; lüsterner
Mensch) *m*; -[e]s, -e; Fau|na (Tier-
welt [eines Gebietes]) *w*; -, ...nen;
fau|nisch (lüstern wie ein Faun);
Fau|nus (röm. Fruchtbarkeits-,
Feld- und Waldgott) *m*; -

Faure [*fòr*] (fr. Politiker)

Fau|ré [*fore*] (fr. Komponist)

¹Faust *w*; -, Fäuste

²Faust (Gestalt der dt. Dichtung)

Faust|ball; Fäust|chen, Fäustlein;
faust|dick; er hat es - hinter den
Ohren; Fäu|stel (Hammer, Schlä-
gel der Bergleute) *m*; -s, -; fau-
sten; faust|groß; Faust|hand-
schuh

fau|stisch; ↑ R 179 (nach Art u.
Wesen des ²Faust)

Faust.kampf, ...keil; Fäust|lein,
Fäust|chen; Fäust|ling (Faust-
handschuh, Bergmannsspr.:
faustgroßer Stein); Faust.pfand,
...recht (gewaltsame Selbsthil-
fe), ...re|gel, ...sä|ge (große Hand-
säge), ...schlag

faute de mieux *fr.* [*fòtd^e^mjö*] (in
Ermangelung eines Besseren; im
Notfall)

Fau|teuil *fr.* [*fotöj*] (Lehnsessel) *m*;
-s, -s

Faut|fracht *fr.*; *dt.* (im Fracht-
geschäft Bez. für den abmachungs-
widrig nicht ausgenutzter
[Schiffs]frachtraum u. für die
Summe, die ein solcher
Rücktritt vom Frachtvertrag zu
zahlen ist)

Faux|pas *fr.* [*fopa*] (,,Fehltritt";
Taktlosigkeit; gesellschaftliche
Verstoß) *m*; - [...*pa(ß)*], - [...*paß*]

fa|vo|ra|bel *fr.* [*faw*...] (veralt. für:
günstig, geneigt; vorteilhaft)
...a|ble Werte; fa|vo|ri|sie|ren (den
günstigen; als voraussichtlicher
Sieger [im Sportkampf] nennen)

Fa|vo|rit (Günstling; Liebling; erwarteter Sieger [im Sportkampf]) m; -en, -en (↑ R 268); Favo|ri|tin (Geliebte [eines Herrschers]; erwartete Siegerin [im Sportkampf]) w; -, -nen

¹Fa|vus lat. [fawuß] (Med.: Hautkrankheit) m; -; ²Fa|vus (Wachsscheibe im Bienenstock) m; -, ...ven u. ...vi

Fa|xe (Vorgetäuschtes; dummer Spaß) w; -, -n (meist Mehrz.); Fa|xen|ma|cher (Gesichterschneider; Spaßmacher)

Fa|yence fr. [fajangß] (feinere Töpferware) w; -, -n [...ß°n]; Fa|yence|krug, ...ofen, ...tel|ler

Fä|zes lat. (Med.: Stuhlleerung; Kot) Mehrz.

Fa|ze|ti|en lat. [...i°n] (Witzreden, Schwänke) Mehrz.

fa|zi|al lat. (Med.: das Gesicht betreffend; Gesichts...); Fa|zia|lis (Med.: Gesichtsnerv) m; -; Fa|zies [...iäß] (Geol.) w; -, -; Fa|zi|li|tät lat. (veralt. für: Leichtigkeit, Gewandtheit); Fa|zit (,,es macht''; [Schluß]summe, Ergebnis; Schlußfolgerung) s; -s, -e u. -s

FBI [äf|bi|ai] — Federal Bureau of Investigation [fäd°r°l bju°ro° °w inwäßtigé°sch°n] (Bundeskriminalpolizei der USA)

FDGB = Freier Deutscher Gewerkschaftsbund (DDR)

FDJ = Freie Deutsche Jugend (DDR); FDJler (DDR); FDJlerin (DDR) w; -, -nen

FDP. (parteiamtliche Schreibung);F.D.P. = Freie Demokratische Partei (Deutschlands)

F-Dur [äfdur, auch: äfdur] (Tonart; Zeichen: F) s; -; F-Dur-Ton|lei|ter [äf...] (↑ R 155)

FD-Zug = Ferndurchgangszug

Fe = Ferrum (chem. Zeichen für: Eisen)

Fea|ture engl. [fitsch°r] (aktuell aufgemachter Dokumentarbericht, bes. für Funk od. Fernsehen) s; -s, -s (auch: w; -, -s)

Fe|ber österr. (Februar) m; -s, -
Febr. = Februar

fe|bril lat. (Med.: fieberhaft)

Fe|bru|ar lat. (der zweite Monat des Jahres, Hornung, Abk.: Febr.) m; -[s] (↑ R 319), -e

fec. = fecit

Fech|ser (Hopfensteckling)

Fecht|bru|der (Bettler); fech|ten; du fichtst, er ficht; du fochtest; du föchtest; gefochten; ficht!; Fech|ter; Fecht|hand|schuh, ...hieb, ...kampf, ...mas|ke, ...sport

fe|cit lat. [fezit] (,,hat [es] gemacht''; Abk.: fec.); ipse - (vgl. d.)

Fe|der w; -, -n; Fe|der_ball, ...bein (im Flug- u. Fahrzeugbau), ...bett, ...busch, ...fuch|ser (Pedant); fe|der|füh|rend; Fe|der_gewicht (Körpergewichtsklasse in der Schwerathletik), ...hal|ter; fe|de|rig, fed|rig; Fe|der|kleid; fe|der|leicht;Fe|der|le|sen s; -s; nicht viel -s machen; Fe|der|ling (ein Insekt); Fe|der|mes|ser s (feines Messer); fe|dern; ich ...ere (↑ R 327), Fe|der_schmuck, ...spiel (Jagerspr.: zwei Taubenflügel zum Zurücklocken des Beizvogels), ...stiel (österr. für: Federhalter), ...strich; Fe|de|rung; Fe|der_vieh, ...waa|ge; fe|der|weiß; Fe|der_weiß (feines Pulver, Schneiderkreide); Fe|der|wei|ße (gärender Weinmost) m; -n, -n (↑ R 287 ff.); Fe|der_wild, ...wol|ke, ...zan|ge (für: Pinzette), ...zeich|nung

Fe|dor, Feo|dor (m. Vorn.)

fed|rig, fe|de|rig; Fed|rig|keit

Fee fr. (Weissagerin; eine w. Märchengestalt) w; -, Feen; fe|en|haft; Fe|en_mär|chen, ...rei|gen, ...schloß

Feet [fit] (Mehrz. von: Foot)

Fe|ge (Werkzeug zum Getreidereinigen) w; -, -n; Fe|ge|feu|er, Feg|feu|er; Fegenest schweiz. mdal. (unruhiger Geist [bes. von Kindern]); feg|nesten (schweiz. mdal.); gefegnestet; zu -; Feg|sel landsch. (Kehricht) s; -s

Feh (russ. Eichhörnchen; Pelzwerk) s; -[e]s, -e

Feh|de w; -, -n; Feh|de|hand|schuh

fehl; - am Ort, Platz; Fehl m, nur noch in: ohne -; Fehl|an|zei|ge; fehl|bar schweiz. (einer Übertretung] schuldig); fehl|be|set|zen; er besetzt[e] fehl; fehlbesetzt; fehlzubesetzen; Fehl_be|set|zung, ...be|trag, ...bit|te, ...deu|tung, ...dia|gno|se, ...dis|po|si|ti|on, ...ein|schät|zung; feh|len; Fehl_ent|schei|dung, ...ent|wick|lung, Feh|ler; feh|ler|frei; feh|ler|haft; Feh|ler|haf|tig|keit w; -; feh|ler|los; Feh|ler_quel|le, ...zahl; Fehl_far|be, ...ge|burt; fehl_ge|hen, ...grei|fen; vgl. fehlgehen; Fehl_griff, ...in|ter|pre|ta|ti|on; fehl|in|ter|pre|tie|ren; vgl. fehlbesetzen; Fehl_kon|struk|ti|on, ...lei|stung, Fehl_lei|ten; vgl. fehlbesetzen; Fehl_lei|tung, ...mel|dung, ...paß (Sportspr.); fehl_schie|ßen; vgl. fehlbesetzen; Fehl_schlag m; -[e]s, ...schläge; fehl_schla|gen; vgl. fehlbesetzen; Fehl_schluß, ...schuß, ...sich|tig|keit (Med.; w; -), ...start (Sportspr.); fehl|tre|ten; vgl. fehlbesetzen; Fehl_tritt, ...ur|teil, ...ver|hal|ten, ...zün|dung

Feh|marn (eine Ostseeinsel); Feh|marn|belt m; -[e]s

Fehn|kul|tur niederl.; lat. (bes. Art Moorkultur) w; -; vgl. Fenn

Fehr|bel|lin (Stadt im Bezirk Potsdam)

Feh|werk (Pelzwerk) s; -[e]s

fei|en ([durch vermeintliche Zaubermittel] schützen); gefeit (sicher, geschützt)

Fei|er w; -, -n; Fei|er|abend; fei|er_abend|lich, Fele|rel w, -; Fei|er|kleid; fei|er|lich; Fei|er_lich|keit ...ere (↑ R 327); Fei|er_schicht ...stun|de; Fei|er|tag; des Feiertags, aber (↑ R 129): feiertags, sonn- u. feiertags; ↑ R 145); fei|er_täg|lich; fei|er|tags; vgl. Feiertag; Fei|er|tags|stim|mung

feig, fei|ge

Fei|ge w; -, -n; Fei|gen_baum, ...blatt

Feig|heit; feig_her|zig; Feig|her|zig|keit; Feig|ling

Feig|war|ze (Hautwucherung)

feil; feil|bie|ten (↑ R 139); er bietet feil; feilgeboten; feilzubieten; Feil|bie|tung

Fei|le w; -, -n; fei|len; Fei|len_hau|er feil|hal|ten; vgl. feilbieten

Feil|licht (Feilstaub) s; -s

feil|schen; du feilschst (feilschest) Feil_span, ...staub

Feim m; -[e]s, -e u. Fei|me w; -, -n u. Fei|men landsch. (geschichteter Getreidehaufen) m; -s

fein; sehr - (Zeichen: ff); eine - Nase haben; -e Sitten; Schreibung in Verbindung mit dem 2. Mittelwort: feingemahlenes Mehl (↑ jedoch R 142), aber: das Mehl ist fein gemahlen; Fein_ar|beit, ...bäcke|rei [Trenn.: ...bäk|ke...], ...blech

feind; (↑ R 132:) jmdm. - bleiben, sein, werden; Feind m; -[e]s, -e; jemandes - bleiben, sein, werden; Feind_be|rüh|rung; Feind_hand w; -; Fein_des|land s; -[e]s; feind|lich; Feind_lich|keit; Feind_mäch|te (Mehrz.), ...schaft; feind_schaft|lich; feind_se|lig; Feind_se|lig|keit

Fei|ne (Feinheit) w; -; fei|nen (Hüttenw.: Metall veredeln); fein_füh|lend; -ste; fein|füh|lig; Fein_füh|lig|keit w; -; fein_ge|ädert; vgl. fein; Fein_ge|fühl (s; -[e]s), ...gehalt m; fein_ge|mah|len, ...ge|schnit|ten, ...ge|schwun|gen, ...ge|streift; vgl. fein; Fein_gie|wicht; fein_glie|de|rig, ...gold, ...heit, ...ke|ra|mik; fein_ke|ra|misch, ...kör|nig; Fein_kör|nig|keit (w; -), ...kost, ...me|cha|ni|ker, ...mes|sung; fein_ner|vig, ...po|rig, ...san|dig; fein|schlei|fen (↑ R 139); ich

schleife fein; feingeschliffen;
feinzuschleifen; Fein..schmecker
[Trenn.: ...schmek|ker], ...schnitt,
...sil|ber; fein|sin|nig; Fein|sin-
nig|keit; Feins|lieb|chen; Feinst-
waa|ge; fein|ver|mah|len; vgl.
fein; Fein|wasch|mit|tel
feiß alemann. (fett, reich, feist);
feist; -este (↑ R 292); Feist (Jä-
gerspr.: Fett) s; -[e]s; Fei|ste,
Feist|heit, Fei|stig|keit w; -
Fei|tel südd., österr. ugs. (einfa-
ches Taschenmesser) m; -s, -
fei|xen (ugs. für: grinsend lachen);
du feixt (feixest)
Fel|bel it. (ein Gewebe) m; -s, -
Fel|ber südd. mdal. (Weiden-
baum) m; -s, -; Fel|ber|baum (svw.
Felber)
Fel|chen (ein Fisch) m; -s, -
Feld s; -[e]s, -er; elektrisches -; feld-
ein u. feldaus; querfeldein; ins -
(in den Krieg) ziehen; (↑ R 145:)
Feld- u. Gartenfrüchte; Feld..ar-
beit, ...artil|le|rie, ...be|rei|ni-
gung, ...bett, ...blu|me, ...dienst;
feld|ein; Feld..fla|sche, ...flüch|ter
(Taube), ...flur w, ...frucht, ...got-
tes|dienst; feld|grau; Feld..heer,
...herr, ...huhn, ...hü|ter; ...fel|dig
(z. B. vierfeldig); Feld..jä|ger (mi-
lit. Truppe), ...kü|che, ...la|ger,
...mark (¹Flur; w), ...mar|schall,
...maß s, ...maus, ...mes|ser m,
...post, ...sa|lat, ...scher (m; -s, -e;
veralt. für: Wundarzt; DDR: mi-
litärischer Arzthelfer), ...spat (ein
Mineral), ...stär|ke (Physik),
...ste|cher (Fernglas), ...theo|rie
(Sprachw.), ...über|le|gen|heit
(Sport), ...we|bel (m; -s, -), ...weg,
...wei|bel (schweiz. für: Feldwe-
bel), ...zug
Felg|auf|schwung (Reckübung);
Fel|ge (Radkranz; Reckübung)
w; -, -n; fel|gen ([Rad] mit Felgen
versehen); Fel|gen|brem|se; Felg-
um|schwung (Reckübung)
Fe|lix (w. Vorn.); Fe|li|zia (w.
Vorn.); Fe|li|zi|tas (w. Vorn.)
Fell s; -[e]s, -e; ein dickes - haben
(ugs.)
Fel|la|che arab. (Bauer im Vorde-
ren Orient) m; -n, -n (↑ R 268);
Fel|la|chin w; -, -nen
Fel|la|tio lat. [...zio] (Herbeifüh-
ren der Ejakulation mit Lippen u.
Zunge) w; -
Fell|ei|sen (veralt. für: Ranzen,
Reisesack) s; -s, -
Fell|müt|ze
Fel|low engl. [fälou] ("Bursche";
Mitglied einer engl. gelehrten
Körperschaft; Graduierter einer
Universität) m; -s, -s
Fe|lo|nie fr. (Untreue, Verrat [ge-
gen den, an dem Lehnsherrn]) w;
-, ...ien
Fels ([hartes] Gestein) m; -en, -en

(↑ R 268); Fels|block (Mehrz.
...blöcke); Fel|sen (vegetations-
lose Stelle, schroffe Gesteinsbil-
dung) m; -s, -; fel|sen|fest; Fel-
sen..nest, ...riff; Fel|sen|schlucht,
Fels|schlucht; Fel|sen|spit|ze,
Fels|spit|ze; Fel|sen|stück, Fels-
stück; Fel|sen|vor|sprung, Fels-
vor|sprung; Fel|sen|wand, Fels-
wand; fel|sig; Fel|sit (Gestein) m;
-s, -e; Fels|zeich|nung
Fe|luk|ke arab. (Küstenfahrzeug
des Mittelmeers) w; -, -n
Fe|me (heimliches Gericht, Frei-
gericht) w; -, -n
Fe|mel, Fim|mel (männl. Hanf-
pflanze) m; -s; Fe|mel|be|trieb
(Art des Forstbetriebes)
Fe|me|mord; Fem|ge|richt
fe|mi|ni|ren lat. (durch Eingriff
in den Hormonhaushalt verweib-
lichen); fe|mi|nin (weibisch;
Sprachw.: weiblich); Fe|mi|ni-
num [auch: fg...] (Sprachw.: weib-
liches Hauptwort, z. B. "die Er-
de") s; -s, ...na; fe|mi|nis|mus
(Verweiblichung bei Männern;
Überbetonung des Weiblichen)
m; -, ...men; fe|mi|ni|stisch
Fem|to... skand. (ein Billiardstel
einer Einheit, z. B. Femtofarad
= 10⁻¹⁵ Farad; Zeichen: f)
Fench, Fen|nich lat. (Hirseart) m;
-[e]s, -e; Fen|chel (eine Heilpflan-
ze) m; -s; Fen|chel|tee
Fen|dant fr. [fangdang, schweiz.:
fangdang] (Weißwein aus dem
Kanton Wallis) m; -s
Fen|der engl. (kissenartiges Stoß-
schutzstück [an Schiffen]) m; -s, -
Fenn niederd. (Sumpf-, Moor-
land) s; -[e]s, -e; vgl. aber: Venn
Fen|nich vgl. Fench
Fen|no|sar|ma|tia lat. [...zia] (eu-
ropäischer Urkontinent); fen|no-
sar|ma|tisch; Fen|no|skan|dia (ein
Teil von Fennosarmatia); fen|no-
skan|disch
Fen|rir, Fen|ris|wolf (Unhold der
nord. Mythol.) m
Fen|ster s; -s, -; Fen|ster..bank
(Mehrz. ...bänke), ...brett, ...flü-
gel, ...glas (Mehrz. ...gläser),
...kreuz, ...la|den (Mehrz. ...lä-
den, selten: ...laden), ...lai|bung,
...le|der; fen|sterln südd., österr.
(die Geliebte nachts [am od.
durchs Fenster] besuchen); ich
fensterle, du fensterlst, er fen-
sterlt, hat gefensterlt; fen|ster|los;
Fen|ster..lu|ke, ...ni|sche, ...platz,
...put|zer, ...rah|men, ...ro|se
(rundes Kirchenfenster), ...schei-
be, ...schnal|le (österr.: Fenster-
griff), ...sims, ...stock (Mehrz.
...stöcke); ...fenst|rig (z. B. zwei-
fenstrig)
Fenz engl. (Einfried[ig]ung in
Nordamerika) w; -, -en

Feo|dor vgl. Fedor; Feo|do|ra (w.
Vorn.)
Fe|ra|li|en lat. [...iⁿn] (altröm. jähr-
liches Totenfest) Mehrz.
Fer|di|nand (m. Vorn.); Fer|di-
nan|de (w. Vorn.); Ferdl (bayr.
Kurzform von: Ferdinand)
Fe|renc [...ränz] (ung. m. Vorn.)
Fer|ge (dicht. für: Fährmann) m;
-n, -n (↑ R 268)
ferg|en schweiz. (abfertigen, fort-
schaffen); Ferg|ger schweiz.
(Spediteur, Geschäftsvermittler)
Fe|ri|al... lat. (österr. neben: Feri-
en..., z. B. Ferialarbeit, Ferial-
praxis, Ferialtag); Fe|ri|en [...iⁿn]
lat. (zusammenhängende Frei-
zeiten im Schulleben; Urlaub)
Mehrz.; die großen Ferien; Fe|ri-
en..ar|beit, ...häus|chen, ...heim,
...kind, ...kurs, ...la|ger, ...ort (m;
-[e]s, -e), ...pa|ra|dies, ...park,
...rei|se, ...son|der|zug, ...tag,
...zeit
Fer|kel s; -s, -; Fer|ke|lei; fer|keln;
Fer|kel|zucht
ferm vgl. firm
Fer|man pers. (in islam. Ländern
Erlaß des Landesherrn) m; -s, -e
Fer|ma|te it. (Musik: Haltezei-
chen; Zeichen: ⌢) w; -, -n
Fer|me fr. [färm] (Pachthof, Gut
in Frankreich) w; -, -n
Fer|ment lat. (den Stoffwechsel
fördernde organ. Verbindung) s;
-s, -e; Fer|men|ta|ti|on [...zion]
(Gärung); fer|men|ta|tiv (durch
Ferment hervorgerufen); Fer-
ment|bil|dung; fer|men|tie|ren
(durch Fermentation veredeln);
Fer|ment..man|gel, ...pro|duk|ti-
on
Fer|mi|um [nach dem ital. Physiker
Fermi] (chem. Grundstoff, ein
Transuran; Zeichen: Fm) s; -s
fern; fern den Heimathaus; vgl.
ferne. I. Kleinschreibung (↑ R
134): von nah und fern; von fern,
von fern her, vgl. aber: fernhin.
II. Großschreibung: a) (↑ R 224:)
der Ferne Orient, der Ferne
Osten (svw. Ostasien); b) (↑ R
116:) das Ferne suchen; fern|ab
(geh.); Fern|amt, ...auf|nah|me, ...bahn,
...be|ben; fern|blei|ben (↑ R 139);
er bleibt fern; ferngeblieben;
fernzubleiben; Fern|durch|gangs-
zug (Abk.: FD-Zug); fer|ne (geh.
u. dichter.); von - [her]; Fer|ne
w; -, -n; fer|ner; des -[e]n darlegen
(↑ R 134)
Fer|ner, Fir|ner bayr. u. österr.
(alter Schnee; Gletscher) m; -s, -
fer|ner|hin [auch: färnᵉrhin]; fer-
ners (ugs. für: ferner); Fern|fah-
rer; Fern..fo|to|gra|fie, ...gas;
Fern|gas..netz, ...ver|sor|gung (w,

-); fern_ge|lenkt, ...ge|schult;
Fern|ge|spräch; Fern|ge|steu|ert;
Fern|glas (Mehrz. ...gläser); fern-
hal|ten; vgl. fernbleiben; Fern-
hei|zung; fern|her (aus der Ferne),
aber: von fern her; fern|hin;
Fern_kurs, ...kur|sus, ...la|ster
(ugs. für: Fernlastzug; m), ...last-
fah|rer, ...last|zug, ...lei|tung;
fern|len|ken; vgl. fernbleiben;
Fern_lon|kung, licht; fern|lie-
gen; vgl. fernbleiben; fern|lie-
gend; Fern|mel|de_amt, ...dienst,
...tech|nik; Fern|mel|dung; fern-
münd|lich (für: telefonisch); Fern-
ost; in -; fern|öst|lich; Fern-
_pend|ler, ...rohr, ...ruf, ...schnell-
zug (Zeichen: F), ...schnel|ben,
...schrei|ber; Fern|schreib|netz;
fern|schrift|lich; Fern|seh_an|sa-
ger, ...an|sa|ge|rin (w; -, -nen),
...an|ten|ne, ...ap|pa|rat, ...bild,
...emp|fang, ...emp|fän|ger; fern-
se|hen; vgl. fernbleiben; Fern-
se|hen s; -s; Fern|se|her (Fernseh-
gerät; Fernsehteilnehmer); Fern-
seh_film, ...ge|rät, ...ge|spräch,
...in|ter|view, ...ka|me|ra, ...ka-
nal, ...kom|men|ta|tor, ...leuch|te,
...pro|gramm, re|por|ta|ge,
...re|por|ter, ...röh|re, ...schirm,
...sen|der, ...sen|dung, ...spiel,
...studio, ...teil|neh|mer, ...tru|he,
...über|tra|gung, ...zu|schau|er;
fern|sich|tig; Fern|sich|tig|keit w;
-; Fern|sprech_amt, ...an|schluß,
...ap|pa|rat; Fern|spre|cher; Fern-
sprech_ge|bühr, ...ge|heim|nis (s;
-ses), ...teil|neh|mer, ...ver|zeich-
nis, ...zel|le; Fern|spruch; fern-
_ste|hen, ...steu|ern; vgl. fern-
bleiben; Fern_steue|rung, ...stra-
ße, ...stu|di|um, ...sucht (w; -);
fern|trau|en; vgl. fernbleiben;
Fern|trau|ung; Fern_un|ter|richt,
...ver|kehr, ...ver|kehrs|stra|ße,
...weh (s; -s), ...ziel
Fer|ra|ra (it. Stadt)
Fer|ri|salz lat.; dt. (dreiwertiges
Eisensalz); Fer|rit (reine Eisen-
kristalle) m; -s, -e
Fer|ro (kleinste Kanarische Insel)
Fer|ro|salz lat.; dt. (zweiwertiges
Eisensalz); Fer|rum lat. (Eisen,
chem. Grundstoff; Zeichen: Fe) s;
-s
Fer|se (Hacken) w; -, -n; vgl. aber:
Färse; Fer|sen|geld, in: - geben
(ugs. für: fliehen)
fer|tig; - sein, werden. Schreibung
in Verbindung mit Zeitwörtern
(↑ R 139): fer|tig (im endgültigen
Zustand) brin|gen; es wird den
Kuchen fertig [nach Hause] brin-
gen; aber: fer|tig|brin|gen (voll-
bringen); ich bringe es fertig,
habe es fertiggebracht, habe es
fertigzubringen; Fer|tig_bau
(Mehrz. ...bauten), ...bau|wei|se;

fer|tig|be|kom|men; vgl. fertig;
fer|ti|gen; Fer|tig_er|zeug|nis,
...haus; Fer|tig|keit; Fer|tig|klei-
dung (für: Konfektion); fer|tig-
_ko|chen, ...ma|chen (ugs. auch
für: körperlich oder moralisch er-
ledigen), ...stel|len; Fer|tig_stel-
lung, ...teil s; Fer|ti|gung; Fer|ti-
gungs_bri|ga|de (DDR), ...ko-
sten (Mehrz.), ...me|tho|de, ...pro-
gramm, ...pro|zeß, ...ver|fah|ren;
Fer|tig|wa|re
fer|til lat. (Biol., Med.: fruchtbar);
Fer|ti|li|tät (Biol., Med.: Frucht-
barkeit) w; -
fes, ¹Fes (Tonbezeichnung) s; -
²Fes türk. (rote Kopfbedeckung)
m; -[es], [e]
³Fes [fäß] (Stadt in Marokko)
fesch engl. [fäsch] (ugs. für: schick,
flott, schneidig); -este (↑ R 292);
Fe|schak österr. ugs. (fescher
Kerl) m; -s, -s
Fes|sel w; -, -n
Fes|sel_bal|lon; fes|sel|frei
Fes|sel|ge|lenk
fes|sel|los; Fes|sel|lo|sig|keit; fes-
seln; ich fessele u. feßle (↑ R 327);
fes|selnd; -ste; Fes|se|lung, Feß-
lung
fest; -este (↑ R 292); -er Grundsatz;
-c Kosten; -er Wohnsitz; -er Kör-
per. I. Schreibung in Verbindung
mit dem 2. Mittelwort: die festge-
schnürte Schlinge (↑ jedoch R
142), aber: die Schlinge ist fest
geschnürt. II. Schreibung in Ver-
bindung mit Zeitwörtern (↑ R
139), z. B. fest backen; sie wird
den Kuchen fest backen; aber:
festbacken (ankleben); vgl. d.
Fest s; -[e]s, -e; Fest_akt
fest|an|ge|stellt; ein festangestell-
ter Beamter (↑ jedoch R 142),
aber: der Beamte ist fest ange-
stellt; Fest|an|ge|stell|te m u. w;
-n, -n (↑ R 278ff.)
Fest_an|spra|che, ...auf|füh|rung
fest|backen [Trenn.: ...bak|ken];
↑ R 139 (ankleben); der Stein
backt fest, backte fest, hat festge-
backt, festzubacken; aber: fest
backen [Trenn.: - bak|ken]; sie
wird den Kuchen fest backen
Fest|ban|kett
fest|bei|ßen, sich; ↑ R 139 (sich in-
tensiv u. ausdauernd mit etwas
beschäftigen); er beißt sich fest,
hat sich festgebissen, sich festzu-
beißen; er hat sich an dem Pro-
blem festgebissen, aber: fest bei-
ßen; der Hund hat ihn fest gebis-
sen
Fest_bei|trag, ...be|leuch|tung
fest|be|sol|det; vgl. festangestellt;
Fest_be|sol|de|te m u. w; -n, -n
(↑ R 287ff.); fest|bin|den (↑ R 139);
ich binde fest, festgebunden, fest-
zubinden; die Kuh ist festgebun-

den; aber: fest binden; du sollst
das Band [ganz] fest binden; fest-
blei|ben; ↑ R 139 (nicht nachge-
ben); ich bleibe fest, festgeblie-
ben, festzubleiben; er ist in sei-
nem Entschluß festgeblieben;
aber: fest blei|ben; ich hoffe, daß
der Pudding fest bleibt
Fe|ste (Festung; Himmel) w; -, -n;
vgl. auch: Veste
fe|sten (schweiz., sonst selten für:
ein Fest feiern), Fe|stes|freu|de,
Fest_freu|de; Fest|es|sen; Fe|stes-
stim|mung, Fest|stim|mung
fest|fah|ren; sich -; fest|ge|fügt; vgl.
fest; fest|ge|schnürt; vgl. fest
Fest_ge|wand, ...got|tes|dienst
fest|hal|ken, sich -; fest|hal|ten; sich
-; fest|hef|ten; vgl. festbacken; fe-
sti|gen; Fe|stig|keit w; -; Fe|stig-
keits|leh|re w; -; Fe|sti|gung w; -
Fe|sti|val engl. [fäßtiwᵉl] u. fäßti-
wal] (Musikfest, Festspiel) s; -s,
-s; Fe|sti|vi|tät lat. [...wi...] (ver-
alt., aber noch scherzh. für: Fest-
lichkeit)
fest|klam|mern, sich -; fest|kle|ben;
vgl. festbacken
Fest_land (Mehrz. ...länder); fest-
län|disch; Fest|land[s]_block
(Mehrz. ...blöcke), ...sockel
[Trenn.: ...sok|kel]
fest|le|gen (auch für: anordnen);
er hat die Hausordnung festge-
legt; sich - (sich binden); er hat
sich mit dieser Äußerung festge-
legt; vgl. festbacken; Fest|le|gung
fest|lich; Fest|lich|keit
fest|lie|gen; auf einer Sandbank -;
vgl. festbacken
fest|ma|che|bo|je; fest|ma|chen
(auch für: vereinbaren); ich habe
nichts mit ihm festgemacht; vgl.
festbacken
Fest|mahl
Fest|me|ter (1 cbm fester Holz-
masse, im Gegensatz zu Raum-
meter; Abk.: fm)
fest|na|geln (ugs. auch für: jmdn.
auf etwas festlegen); ich nag[e]le
fest (↑ R 327); ich habe ihn fest-
genagelt; vgl. festbacken; fest|nä-
hen; vgl. festbacken
Fest_nah|me w; -, -n; fest|neh|men
(verhaften); vgl. festbacken
Fest_of|fer|te (Kaufmannsspr.: fe-
stes Angebot)
Fe|ston fr. [fäßtong] (Blumenge-
winde, meist als Ornament; Stik-
kerei) s; -s, -s; fe|sto|nie|ren (mit
Festons versehen; Stoffkanten
mit Knopflochstich ausarbei-
ten); Fe|ston|stich
Fest_ord|ner, ...pla|ket|te, ...platz
Fest|preis; vgl. ²Preis
Fest_pro|gramm, ...re|de, ...red|ner
fest|ren|nen, sich; vgl. festbacken;
sich; fest|sau|gen; sich -; fest-
schnal|len; fest|schrei|ben (durch

einen Vertrag o. ä. vorläufig festlegen); Fęst|schrei|bung

Fęst|schrift

fęst|set|zen (auch für: gefangenehmen); er wurde nach dieser Straftat festgesetzt; vgl. festbacken; Fęst|set|zung

fęst|sit|zen (ugs. auch für: nicht mehr weiter können); wir sitzen mit unserem Plan fest; vgl. festbacken

Fęst|spiel; Fęst|spiel_haus, ...stadt

fęst|ste|hen (auch für: sicher, gewiß sein); fest steht, daß ... (↑ R 144); es hat festgestanden, daß ...; vgl. festbacken; fęst|ste|hend (sicher, gewiß); (↑ R 296:) fester stehend, am festesten stehend; Fęst|stell|brem|se; fęst|stel|len (auch für: Gewißheit verschaffen); er hat es eindeutig festgestellt; vgl. festbacken; Fęst|stel|lung

fęst|stie|ge österr. (Prunktreppe)

Fęst|stim|mung, Fe|stes|stim|mung; Fęst|tag; des Festtags, aber: (↑ R 129): festtags, sonnund festtags; fęst|täg|lich; Festtags_klei|dung, ...stim|mung

fęst|tre|ten; vgl. festbacken

Fęst|um|zug

Fe|stung; Fe|stungs_gra|ben, ...wall

Fęst_ver|an|stal|tung, ...ver|samm|lung

fęst|ver|zins|lich; -e Wertpapiere

Fęst_vor|stel|lung, ...vor|trag, ...wie|se, ...wo|che, ...zelt

fęst|zie|hen; vgl. festbacken

Fęst|zug

fe|tal, fö|tal lat. (zum Fetus gehörend, auf ihn bezüglich)

Fe|te fr. [auch: fät*] (verält., noch scherzh. für: Fest) w; -, -n; fe|tie|ren (verält. für: durch ein Fest [eine Fete] ehren)

Fe|tisch fr. (magischer Gegenstand; ein zum Gott erklärter Gegenstand) m; -[e]s, -e; fe|ti|schi|sie|ren (zum Fetisch erheben); Fe|ti|schis|mus (Fetischverehrung; krankhaftes Übertragen des Geschlechtstriebes auf Gegenstände) m; -; Fe|ti|schist (↑ R 268); fe|ti|schi|stisch

fętt; -este (↑ R 292); -er Boden. *Schreibung in Verbindung mit dem 2. Mittelwort:* fettgedruckt (vgl. d.); Fętt s; -[e]s, -e; Fętt|an|satz; fętt|arm; Fętt_au|ge, ...be|darf, ...bauch, ...cre|me, ...de|pot (Med.); Fęt|te (Fettheit) w; -; fęt|ten; fętt|fein (Druckw.); Fętt fleck od. ...flecken [*Trenn.:* ...flek|ken]; fętt|frei; fętt|ge|druckt (↑ R 296:) fetter, am fettesten gedruckt; die fettgedruckten Buchstaben (↑ jedoch R 142), aber: die Hauptstellen sind fętt gedruckt; Fętt-

...ge|halt m, ...ge|we|be; fętt|hal|tig; Fętt|heit w; -; Fętt|hen|ne (Zierpflanze, Heilkraut); fęt|tig; Fęt|tig|keit w; -, (fettige Nahrungsmittel:) -en; Fętt|koh|le (Steinkohlenart); Fętt|le|be (ugs. für: reichhaltige, üppige Mahlzeit; Wohlleben) w; -; - machen (üppig leben); fętt|lei|big; Fętt|lei|big|keit w; -; Fętt|näpf|chen; nur noch in: bei jmdm. ins - treten (jmds. Unwillen erregen); Fętt_pol|ster, ...schicht, ...sucht (w; -); fętt|trie|fend (↑ R 237); Fętt|trop|fen (↑ R 237); Fęttu|sche [*Trenn.:* Fett|tu..., ↑ R 236]

Fę|tus lat. (Leibesfrucht von dritten Monat an) m; - u. -ses, -se u. ...ten

Fętz|chen; fęt|zeln (in Fetzen zerreißen); ich ...[e]le (↑ R 327); fęt|zen; du fetzt (fetzest); Fęt|zen m; -s, -; Fętz|lein

feucht; -este (↑ R 292); - werden; Feuch|te w; -, -n; feuch|ten; feucht_fröh|lich (fröhlich beim Zechen; ↑ R 158), ...heiß (↑ R 158); Feuch|tig|keit w; -; Feuch|tig|keits_ge|halt m, ...grad, ...mes|ser m

Feucht|wan|ger, Lion (dt. Schriftsteller)

feucht|warm (↑ R 158)

feu|dal germ.-mlat. (das Lehnswesen betreffend; Lehns...; vornehm, großartig; reaktionär); Feu|dal_ge|sell|schaft, ...herr|schaft; Feu|da|lis|mus (auf dem Lehnswesen beruhende, den Adel privilegierende [ma.] Gesellschafts- u. Wirtschaftsordnung) m; -; feu|da|li|stisch; Feu|da|li|tät (Lehnsverhältnis im MA.; Vornehmheit) w; -; Feu|dal_staat, ...sy|stem, ...we|sen (s; -s)

Feu|del niederd. (Scheuerlappen) m; -s, -

Feu|er s; -s, -; offenes -; Feu|er_alarm, ...an|zün|der; feu|er|be|stän|dig; Feu|er_be|stat|tung, ...boh|ne, ...ei|fer; feu|er|fest; Feu|er_fe|stig|keit (w; -), ...fres|ser, ...ge|fahr; feu|er|ge|fähr|lich; Feu|er_ge|fähr|lich|keit (w; -), ...ha|ken, ...hal|le (österr. neben: Krematorium), ...herd, ...holz (s; -es); feu|er|jo!, feu|rio! (Feuerruf); Feu|er_land (Südspitze von Südamerika); Feu|er|län|der m; Feu|er_lei|ter w, ...li|lie, ...loch, ...lö|scher; Feu|er_lösch|ge|rät, ...zug; Feu|er_mau|er, ...mel|der; feu|ern; 'ich ...ere (↑ R 327); Feu|er_pro|be; feu|er|rot; Feu|er|sa|la|man|der; Feu|ers|brunst; Feu|er_scha|den, ...schein, ...schutz; Feu|er|s_ge|fahr; feu|er|si|cher; Feu|ers|not; feu|er|spei|end; Feu-

er_stät|te, ...stein, ...stel|le, ...stuhl (ugs. für: Motorrad), ...tau|fe, ...tod, ...über|fall; Feue|rung; Feue|rungs_an|la|ge; Feu|er_ver|si|che|rung; feu|er|ver|zinkt; Feu|er_waf|fe, ...was|ser (Branntwein; s; -s), ...wehr; Feu|er_wehr|au|to, ...mann (Mehrz. ...männer u. ...leute), ...sprit|ze, ...übung; Feu|er|werk; feu|er|wer|ken; ich feuerwerke; gefeuerwerkt; zu -: Feu|er|wer|ker; Feu|er|werks|kör|per; Feu|er|zan|ge; Feu|er|zan|gen|bow|le; Feu|er_zei|chen, ...zeug

Feuil|la|ge fr. [föjaseh*] (geschnitztes, gemaltes usw. Laubwerk); Feuil|le|ton [föj*tong, auch: föj*tong] (Zeitungsw.: literarischer Unterhaltungsteil; im Plauderton geschriebener Aufsatz) s; -s, -s; Feuil|le|to|nist (↑ R 268); feuil|le|to|ni|stisch; Feuil|le|ton|stil m; -[e]s

feu|rig; -e Kohlen auf jmds. Haupt sammeln (ihn beschämen); feu|rio!, feu|er|jo! (Feuerruf [verält.])

Fe|wa ⓦ (Kurzw. für: Feinwaschmittel) s; -s

Fęx (Narr; in etwas Vernarrter) m; -es (seltener: -en; ↑ R 268), -e (seltener: -en)

¹Fez [fäß] vgl. ²Fes

²Fez fr. (ugs. für: Spaß, Vergnügen) m; -es

ff = sehr fein

ff = fortissimo; vgl. Effeff

ff. = folgende [Seiten]

FF vgl. Franc

FHD = Frauenhilfsdienst[leistende] (in der Schweiz)

Fia|ker fr. österr. (leichte Lohnkutsche, Lohnkutscher) m; -s, -

Fia|le it. (gotisches Spitztürmchen) w; -, -n

Fi|as|ko it. (Mißerfolg; Zusammenbruch) s; -s, -s

fi|at! lat. („es geschehe!")

Fi|at, FIAT ⓦ = Fabbrica Italiana Automobili Torino (Italienische Automobilfabrik Turin)

¹Fi|bel gr. (erstes Lesebuch, Abc-Buch; Elementarlehrbuch) w; -, -n

²Fi|bel lat. (Spange; Gewandklammer in frühgeschichtl. Zeit) w; -, -n

Fi|ber lat. (Faser) w; -, -n; Fi|bril|le (Einzelfaser des Muskel- u. Nervengewebes) w; -, -n; Fi|brin (Faserstoff des Blutes) s; -s; Fi|bro|in (ein Eiweißkörper, Kernfaden der Seide) s; -s; Fi|brom (Bindegewebsgeschwulst) s; -s, -e; fi|brös (aus Bindegewebe bestehend); -e Geschwulst

Fi|bu|la lat. (Wadenbein; Spange) w; -, Fibuln u. (für: Wadenbein:) Fibulä

¹Fich|te (dt. Philosoph)
²Fich|te (Nadelbaum) w; -, -n; Fich|tel|ge|bir|ge s; -s; fich|ten (aus Fichtenholz); Fich|ten-.hain, ...holz, ...na|del; Fich|ten-na|del|bad; Fich|ten_spar|gel (eine Waldpflanze), ...stamm, ...wald, ...zweig

Fi|chu fr. [fischü] (Schultertuch) s; -s, -s

fjcken [Trenn.: fik|ken] (derb für: Geschlechtsverkehr ausüben); fjcke|rig [Trenn.: fik|ke...]; Fjck-fack landsch. (Ausflucht, Vorwand) m; -[e]s, -e; fjck|facken [Trenn.: ...fak|ken] landsch. (Ausflüchte suchen); Fjck|facker [Trenn.: ...tak|kér] landsch. (unzuverlässiger Mensch); Fjck-facke|rei [Trenn.: ...fak|ke...]; Fjck|müh|le landsch. (Zwickmühle)

Fi|dei|kom|miß lat. [...de-i..., auch: fide-i...] (früher: unveräußerliches u. unteilbares Erbgut, Stammgut) s; ...misses, ...misse

fl|del lat. („treu"; ugs. für: lustig, heiter)

Fj|del (Streichinstrument des 8. bis 14. Jh.s, heute erneuert als Instrument der Volksmusik) w; -, -n; vgl. Fiedel

Fi|del Ca|stro vgl. Castro Ruz

Fj|di|bus (gefalteter Papierstreifen als [Pfeifen]anzünder) m; - u. -ses, - u. -se

Fj|dschi (aus vielen kleineren Inseln bestehender Staat im Südpazifik); Fj|dschia|ner; fi|dschia-nisch; Fj|dschi|in|seln Mehrz.

Fi|duz (ugs. für: Vertrauen) s; -es

Fj|ber [Trenn.: fie|ber] vgl. Fieber

Fie|ber m; -s, (selten:) -; Fie|ber-an|fall; fie|ber|frei; Fie|ber|frost; fieber|haft; Fie|ber|hit|ze; fie|ber-rig, fieb|rig; fie|ber|krank; Fieber_kur|ve, ...mes|ser m; fie|bern; ich ...ere (↑ R 327); Fie|ber-phanta|sie (meist Mehrz.), ...ta|bel|le, ...ther|mo|me|ter, ...traum; fieb-rig, fie|be|rig

Fie|del (ugs. für: Geige) w; -, -n; vgl. Fidel; fie|deln; ich ...[e]le (↑ R 327)

Fie|der (veralt. für: kleine Feder) w; -, -n; Fie|der|blatt; fie|de|rig; fie|der|tei|lig; Fie|de|rung

Fied|ler

fie|pen (Jägerspr. von Rehkitz u. Rehgeiß, auch allg.: einen schwachen, hohen Ton geben)

Fie|rant it. [fi⁰...] österr. (Markthändler) m; -en, -en (↑ R 268)

fie|ren (Seemannsspr. für: [Tau] ablaufen lassen, herablassen)

fies (ugs. für: ekelhaft, widerwärtig); fieses Gefühl

Fies|co, bei Schiller: Fies|ko (genuesischer Verschwörer)

FIFA, Fj|fa (Kurzw. für: Fédéra-tion Internationale de Football Association) fr. [federaßjong ängstärnaßjonal d° futbol aßoßjaßjong; Internationaler Fußballverband]) w; -

fiff|ty-fif|ty engl. [fifti fifti] („fünfzig-fünfzig"; ugs. für: halbpart)

Fj|ga|ro (Lustspiel- u. Opernfigur; auch scherzh. für: Friseur) m; -s, -s

Fight engl. [fait] (Boxen: [drauf]gängerisch geführter Nahkampf) m; -s, -s; figh|ten [fait⁰n] (Boxen: hart u. draufgängerisch kämpfen); Figh|ter [fait⁰r] (Boxen: Kämpfer) m; -s, -

Figl, Leopold (österr. Politiker)

Fj|gur w; -, -en, Fj|gu|ra, lat. wie - zeigt (wie klar vor Augen liegt); fi|gu|ral (mit Figuren versehen); Fj|gu|ral|mu|sik; Fj|gu|rant (Theater: Chortänzer; stumme Person) m; -en, -en (↑ R 268); Fi|gu|ran|tin w; -, -nen; Fj|gu|ra|ti|on [...zion], Fj|gu|rie|rung (Musik: Ausschmückung einer Figur od. Melodie); fi|gu|ra|tiv (Figuren darstellend); Fj|gür|chen, Fi|gür-lein; fi|gu|rie|ren (erscheinen als ..., auftreten als ...; darstellen; mustern; Musik: eine Figur od. Melodie ausschmücken); Fi|gu-riert (gemustert; Musik: ausgeschmückt) -es Gewebe; Fi|gu-rie|rung vgl. Figuration; ...fi|gu-rig (z. B. kleinfigurig); Fj|gu|ri|ne fr. (Figürchen; Nebenfigur in Landschaftsgemälden; Kostümzeichnung [für Bühne od. Model) w; -, -n; Fi|gür|lein, Fi|gür|chen; fi|gür|lich

Fik|ti|on lat. [...zion] (Erdichtung; Annahme; Unterstellung; fik|tiv (erdichtet; angenommen, nur gedacht)

Fi|la|ment lat. (bot.: Staubfaden der Blüte) s; -[e]s, -e; Fi|lan|da it. (Seidenspinnerei) w; -, ...den; Filet fr. [file] (Netzstoff; Lenden-, Rückenstück; Abnehmerwalze an der ²Krempel) s; -s, -s; Filet_ar|beit, ...bra|ten, ...handschuh; fi|le|tie|ren (Filetstücke schneiden); Fi|le|tie|rer (jmd. der Filetstücke schneidet); Fi|le-tier|ma|schi|ne; Fi|let_na|del, ...spit|ze, ...steak

Fj|lia ho|spi|ta|lis lat. (Studentenspr.: Tochter der Wirtsleute) w; - -, ...ae [...ä] ...les; Fi|lia|le (Zweiggeschäft, -stelle) w; -, -n; Fj|lia|list (Filialleiter) (↑ R 268); Fi|li|al_kir|che (Tochterkirche), ...lei|ter m; Fi|lia|ti|on [...zion] (Einrichtung einer Filialkirche; rechtliche Abstammung; Gliederung des Staatshaushaltsplanes) Fj|li|bert (m. Vorn.); Fi|li|ber|ta (w. Vorn.)

Fi|li|bu|ster vgl. Flibustier

fi|lie|ren fr. (Netzwerk knüpfen; Filetstücke schneiden; Karten beim Spiel unterschlagen); fi|liert (netzartig); Fi|li|gran it. (eine aus feinem Draht geflochtene Zierarbeit) s; -s, -e; Fi|li|gran_ar|beit, ...schmuck

Fi|li|pi|no span. (Angehöriger der zivilisierten eingeborenen Bevölkerung der Philippinen) m; -s, -s

Fj|li|us lat. (scherzh. für: Sohn) m; -, ...lii [...li-i] u. ...usse

Fil|lér [filer, auch: fil⁰r] (ung. Währungseinheit; 100 Fillér = 1 Forint) m; -[s], -

Film engl. ; -[e]s, -e; Film_ar|chiv, ...ate|lier, ...au|tor, ...ball, ...branche, ...di|va; fil|men; Film_en|thu-si|ast, ...fan, ...fe|sti|val, ...festspie|le (Mehrz.), ...genre, ...gesell|schaft; fil|misch; Film_ka|me-ra, ...kar|rie|re, ...kom|po|nist, ...ko|pie, ...mu|si|cal; Fil|mo|thek gr. (Sammlung von Filmen u. die dafür bestimmten Räume; Filmarchiv) w; -, -en; Film_pro|du-zent, ...pro|jekt, ...re|gie, ...schaf-fen (s; -s), ...schaf|fen|de (m u. w.: -n, -n; ↑ R 287ff.), ...schau-spie|ler, ...selbst|kon|trol|le, ...stadt, ...star (Mehrz. ...stars), ...sto|ry, ...stu|dio, ...ver|leih, ...vor|füh|rer, ...zeit|schrift

Fi|lou fr. [filu] (scherzh. für: Betrüger; Spitzbube; Schlaukopf) m; -s, -s

Fils arab. (irak. u. jordan. Währungseinheit; 1 Fils = 0,001 Dinar) m; -, -; 4 - (↑ R 322)

Fjl|ter mlat. m od. (Technik meist:) s; -s, -; fjl|tern; ich ...ere (↑ R 327); Fjl|ter|pa|pier, Fil|trier|pa|pier; Fjl|te|rung; Fjl|ter|zi|ga|ret|te; Fil|trat (Durchfiltriertes) s; -[e]s, -e; Fil|tra|tion [...zion] (Filterung); fil|trie|ren; Fil|trier|pa-pier, Fjl|ter|pa|pier

Fi|lü|re fr. (veralt. für: Gewebe, Gespinst) w; -, -n

Fjlz (ugs. auch: Geizhals; österr. auch: unausgeschmolzenes Fett) m; -es, -e; Fjlz|decke [Trenn.: ...dek|ke]; fjl|zen (ugs. auch für: nach [verbotenen] Gegenständen durchsuchen; du filzt (filzest); Fjlz_hut m; fjl|zig; Fjlz_laus, ...pan|tof|fel, ...stie|fel

¹Fim|mel (Hanf); vgl. Femel
²Fim|mel m (ugs. für: übertriebenes Interesse, z. B. Musikfimmel) m; -s, -

¹FINA ⓦ (ein Kraftstoff)
²FINA, ¹Fj|na (Kurzw. für: Fédération Internationale de Natation Amateur fr. [federaßjong ängstärnaßjonal d° nataßjong ama-tör; Internationaler Schwimmverband) w; -

²Fi|na (Kurzform von: Josefine)
fi|nal *lat.* (den Schluß bildend;
zweckbezeichnend); Fi|nal *fr.*
schweiz. (Sport: svw. Finale) *m;*
-s, -s; Fi|nal|ab|schluß (Wirtsch.:
Endabschluß); Fi|na|le *fr.*
(Schlußteil; Musik: Schlußstück,
-satz; Sport: Endrunde, End-
spiel) *s;* -s, - (auch: -s); Fi|na|list
(Endrundenteilnehmer); ↑ R 268;
Fi|nal|satz (Sprachw.: Um-
standssatz der Absicht, Zweck-
satz)

Fi|nan|cier [*finãßje*]; vgl. Finan-
zier; Fi|nanz *fr.* (Geldwesen: Ge-
samtheit der Geld- und Bank-
fachleute) *w;* -, -en; Fi|nanz_amt,
...aus|gleich, ...be|am|te, ...buch-
hal|tung; Fi|nan|zen (Geldwesen:
Staatsvermögen; Vermögensla-
ge) *Mehrz.;* Fi|nan|zer österr. ugs.
(Zollbeamter); Fi|nanz_ex|per|te,
...ge|ba|rung, ...ho|heit (*w;* -); fi-
nan|zi|ell; Fi|nan|zier [*finãzje*]
(Finanz-, Geldmann) *m;* -s, -e;
fi|nan|zie|ren; Fi|nan|zie|rung; fi-
nanz|kräf|tig; Fi|nanz_kri|se,
...la|ge, ...mann (*Mehrz.* ...leute),
...mi|ni|ster, ...plan (vgl. ²Plan);
fi|nanz_po|li|tisch, ...schwach,
...stark; Fi|nanz_ver|wal|tung,
...we|sen (*s;* -s)
fi|nas|sie|ren *fr.* (Finessen anwen-
den)

Fin|del_haus, ...kind; fin|den; du
findest (findst); du fandst (fan-
dest); du fändest; gefunden; fin-
d[e]!; ein gefundenes Fressen für
jmdn. sein (ugs. für: jmdm. sehr
gelegen kommen); Fin|der; Fin-
der|lohn

Fin de siècle *fr.* [*fãgdßjäkl*]
(„Jahrhundertende"; bildl. für:
Verfallserscheinungen in der Ge-
sellschaft, Kunst u. Literatur)
s; - - -

fin|dig; -er Kopf; eine Sache - ma-
chen (Bergmannsspr.: entdek-
ken); Fin|dig|keit *w;* -, (selten:)
-en; Find|ling; Find|lings|block
(*Mehrz.* ...blöcke)

Fi|nes|se *fr.* (Feinheit; Kniff) *w;*
-, -n

Fin|gals|höh|le [*fingalß*...] (auf ei-
ner der Hebriden) *w;* -

Fin|ger *m;* -s, -; der kleine - (ugs.):
jmdn. um den kleinen Finger
wickeln; etwas mit spitzen Fin-
gern vorsichtig anfassen; lange,
krumme Finger machen (ugs.
für: stehlen); Fin|ger|ab|druck
(*Mehrz.* ...drücke); fin|ger|breit;
ein -er Spalt; a b e r: der Spalt ist
drei Finger breit; keinen Finger
breit (vgl. Fingerbreit); Fin|ger-
breit *m;* -, -; einen, ein paar Fin-
gerbreit größer; keinen Finger-
breit Landes hergeben; fin|ger-
dick; vgl. fingerbreit; Fin|ger_fer-

tig|keit, ...glied, ...hand|schuh,
...hut *m;* ...fin|ge|rig, ...fing|rig (z.
B. dickfing[e]rig); Fin|ger|kup|pe
(Fingerspitze); fin|ger|lang; alle -
(ugs. für: jeden Augenblick); vgl.
fingerbreit; Fin|ger|ling; fin|gern;
ich ...ere (↑ R 327); Fin|ger_na|gel,
...ring, ...satz (Musik: Fingerver-
teilung beim Spielen eines Instru-
ments), ...spiel, ...spit|ze, ...spit-
zen|ge|fühl (*s;* -[e]s), ...übung,
...zeig (*m;* -[e]s, -e)

fin|gie|ren *lat.* (erdichten; vortäu-
schen; unterstellen)
...fing|rig vgl. ...fingerig

Fi|ni (österr. Kurzform von: Jose-
fine)

Fi|nis *lat.* („Ende"; veralteter
Schlußvermerk in Druckwer-
ken); Fi|nish *engl.* [*finisch*] (letzter
Schliff; Vollendung; Sport: En-
de, Endkampf) *s;* -s, -s

Fi|nis|ter|re (nordwestspan. Kap)
fi|nit *lat.* (Sprachw.: bestimmt); -e
Form (Personalform, Form des
Zeitworts, die im Ggs. zur infini-
ten Form [vgl. infinit] nach Per-
son u. Zahl bestimmt ist, z. B.
[er] „erwacht" [3. Pers. Einzahl])

Fink (ein Vogel) *m;* -en -en (↑ R
268)

Fin|ken schweiz. mdal. (warmer
Hausschuh) *m;* -s, -

Fin|ken|schlag *m;* -[e]s

Fin|ken|wer|der (Elbinsel)

Fink|ler (Vogelfänger) *m;* -s, -

Fink|land (schwed. Schreibung für:
Finnland); vgl. auch: Suomi

Finn-Din|gi *schwed.;* *Hindi*
[...*dinggi*] (kleines Einmann-
Sportsegelboot) *s;* -s, -s

¹Fin|ne (Jugendform der Bandwürmer;
Hautkrankheit) *w;* -, -n;
²Fin|ne (Rückenflosse von Hai u.
Wal; zugespitzte Seite der Hand-
hammers) *w;* -, -n

³Fin|ne (Höhenzug in Thüringen)
w; -

⁴Fin|ne (Angehöriger eines nordeu-
ropäischen Volkes) *m;* -n, -n (↑ R
268)

fin|nig (mit ¹Finnen behaftet;
durchseucht)

Fin|nin *w;* -, -nen; fin|nisch, a b e r
(↑ R 198): der Finnische Meerbu-
sen; vgl. deutsch; Fin|nisch (Spra-
che) *s;* -[s]; vgl. Deutsch; Fin|ni-
sche *s;* -n; vgl. Deutsche s; fin-
nisch-ug|risch; finnisch-ugrische
Sprachen, Völker; Finn|land; vgl.
auch: Finland; Finn|län|der (↑ R
199); finn|län|disch; ¹Finn|mark
(finn. Münzeinheit; Abk.: Fmk)
w; -, -; ²Finn|mark (norw. Verwal-
tungsbezirk)

Finn|wal

Fi|now_ka|nal [*fino*...] *m;* -s; ↑ R 201

fin|ster; finst[e]rre, -ste; ein -er
Blick (ugs.:) eine - Kneipe; das

-e Mittelalter; (↑ R 133:) im fin-
stern tappen (ungewiß sein),
a b e r (↑ R 116): wir tappten lange
im Finstern (in der Dunkelheit);
Fin|ster|keit *w;* -; Fin|ster|ling;
fin|stern (veralt. für: dunkel wer-
den); es finstert; Fin|ster|nis *w;*
-, -se

Fin|te *it.* (Scheinhieb; Vorwand,
Ausflucht) *w;* -, -n; fin|ten|reich
fin|ze|lig, finz|lig (ugs. für: über-
zart, überfein; die Augen [über]-
anstrengend)

Fio|ret|ten *it.* („Blümchen"; Mu-
sik: Gesangsverzierung) *Mehrz.;*
Fio|ri|tu|ren (Fioretten) *Mehrz.*

Fips (Schneller mit Daumen u.
Mittelfinger; auch für: Nasenstü-
ber) *m;* -es, -e; Meister - (Spottna-
me für: Schneider); fip|sig (un-
bedeutend, klein)

Fi|ren|ze (it. Form von: Florenz)

Fir|le|fanz (vgl. für: Flitterkram;
Torheit; Possen) *m;* -es, -e; Fir|le-
fan|ze|rei

firm *lat.* (fest, sicher, [in einem
Fachgebiet] beschlagen); österr.
ugs. auch: ferm

Fir|ma *it.* (Abk.: Fa.) *w;* -, ...men

Fir|ma|ment *lat. s;* -[e]s, -e

fir|men *lat.* (die Firmung erteilen)

Fir|men|buch; Fir|men_in|ha|ber,
...re|gi|ster, ...schild *s;* ...ver-
zeich|nis, ...wert, ...zei|chen; fir-
mie|ren ([den Geschäfts-, Han-
delsnamen] unterzeichnen; einen
Geschäfts-, Handelsnamen füh-
ren)

Firm|ling *lat.* (der zu Firmende);
Firm_pa|te, ...pa|tin; Fir|mung
(kath. Sakrament)

Firn („vorjähriger" Schnee, Alt-
schnee) *m;* -[e]s, -e; Fir|ne (Reife
des Weines) *w;* -, -n; Firn_wein (vor-
jähriger Wein); fir|nig

Fir|nis *fr.* (trocknender Schutzan-
strich) *m;* -ses, -se; fir|nis|sen (du
firnißt (firnissest))

Firn|schnee

First *m;* -[e]s, -e; First|zie|gel

fis, Fis (Tonbezeichnung) *s;* -, -;
fis (Zeichen für: fis-Moll); in fis;
Fis (Zeichen für: Fis-Dur); in Fis

FIS, Fis (Kurzw. für: Fédération
Internationale de Ski *fr.* [*federa-
ßjõg ägtärnaßjonal d²ßki*; Inter-
nationaler Schiverband]) *w;* -;
FIS-Rennen

Fisch *m;* -[e]s, -e; faule -e (ugs.
für: Ausreden); kleine -e (ugs. für:
Kleinigkeiten); frische Fische;
Fisch_ad|ler; fisch|arm; fisch|äu-
gig; Fisch_bein (*s;* -[e]s), ...be-
stand, ...be|steck, ...bla|se; Fisch-
bla|sen|stil (Bauw.) *m;* -[e]s;
Fisch|blut; Fisch|bra|te|rei, Fisch-
brat|kü|che (Gaststätte für Fisch-
gerichte); Fisch_bröt|chen

...brut; fi|schen; du fischst (fischest); Fi|schenz schweiz. (Fischpacht) w; -, -en; Fi|scher; Fi|scher|boot

Fi|scher-Dies|kau (dt. Sänger) Fi|scher|dorf; Fi|sche|rei; Fi|sche|rei|ha|fen

Fi|scher von Er|lach (österr. Barockbaumeister)

Fisch..ge|richt, ...grä|te, ...grä|ten|mu|ster; fi|schig; Fisch..grün|de (Mehrz.), ...kal|ter (bayr., österr., schweiz. für: Fischbehälter), ...kon|ser|ve, ...kut|ter, ...laich, ...leim, ...mehl, ...mes|ser s, ...ot|ter m, ...rei|her, ...reu|se, ...ro|gen

Fis-Dur [auch: fiβdur] (Tonart; Zeichen: Fis) s; -; Fis-Dur-Ton|lei|ter (↑ R 155)

Fi|sett|holz (ung. Gelbholz) s; -es

Fi|si|ma|ten|ten (ugs. für: leere Ausflüchte) Mehrz.

Fis|kal lat. (veralt. für: Vertreter der Staatskasse) m; -s, -e; fis|ka|lisch (dem Fiskus gehörend; staatlich; staatseigen); Fis|kus (Staat[sbehörde]) m; -, (selten:) ...ken u. -se

fis-Moll [auch: fiβmol] (Tonart; Zeichen: fis) s; -; fis-Moll-Ton|lei|ter (↑ R 155)

Fi|so|le it. österr. (grüne Gartenbohne) w; -, -n

fis|sil lat. (spaltbar); Fis|si|li|tät w; -; Fis|sur (Med.: Spalte, [Knochen]riß) w; -, -en

Fi|stel lat. (Med.: anormaler röhrenförmiger Kanal, der ein Organ mit der Körperoberfläche od. einem anderen Organ verbindet) w; -, -n; fi|steln (mit Kopfstimme sprechen); ich ...[e]le (↑ R 327); Fi|stel|stim|me

fit engl.-amerik. (tauglich; Sport: in Form, [höchst]leistungsfähig); sich - halten

Fi|tis (ein Singvogel) m; - u. -ses, -se

Fit|ness, (eingedeutscht auch:) Fit|neß engl.-amerik. (gute, zur rechten Zeit erlangte körperl. Gesamtverfassung, Bestform) w; -; Fit|ness... od. Fit|neß|test

Fit|sche landsch. (Tür-, Fensterangel, Scharnier) w; -, -n

Fit|tich (meist dicht. für: Flügel) m; -[e]s, -e

Fit|ting engl. (Formstück zur Installation von Rohrleitungen) s; -s, -s (meist Mehrz.)

Fitz|boh|ne (Veitsbohne, Gemüsepflanze)

Fitz|chen („Fädchen"; Kleinigkeit); Fit|ze (Faden zum Zusammenbinden des Garns; Garngebinde; verwirrte Fäden) w; -, -n; fit|zen (in Fitzen ordnen; in Falten legen; ugs. für: [mit einer Ru-

te] schlagen; auch für: übereilt, unsicher, nervös arbeiten); du fitzt (fitzest)

Fiu|ma|ra, Fiu|ma|re it. (Karstfluß, der nur in regenreicher Zeit Wasser führt) w; -, ...re[n]; Fiu|me (it. Name von: Rijeka)

Five o'clock engl. [faiwᵉklok] (Five o'clock tea) m; - -, - -s; Five o'clock tea [- - ti] (Fünfuhrtee) m; - - -, - - -s

fix lat. („fest"; sicher; ugs. für: gewandt); -este; -e Idee (Zwangsvorstellung; törichte Einbildung); -er Preis (fester Preis); -es Gehalt; -e Kosten; und fertig; Fi|xa|teur fr. [...tör] (Zerstäuber zum Haltbarmachen von Zeichnungen) m; -s, -e; Fi|xa|tiv lat. (Fixiermittel) s; -s, -e [...wᵉ]; fix-be|sol|det (schweiz. veralt. neben: festbesoldet); fi|xen engl. (Börsenkurse hochtreiben; Leerverkäufe von Wertpapieren tätigen; ugs. für: sich Drogen einspritzen); du fixt (fixest); Fi|xer (Leerverkäufer; Börsenspekulant; ugs. für: jmd., der sich Drogen einspritzt); fix|fer|tig schweiz. (fix und fertig); Fi|xier|bad; fi|xie|ren; Fi|xier|mit|tel s; Fi|xie|rung; Fi|xig|keit (ugs. für: Gewandtheit); Fix..ko|sten (fixe Kosten), ...punkt (Festpunkt), ...stern (scheinbar unbeweglicher Stern; vgl. ²Stern); Fi|xum („Festes"; festes Einkommen) s; -s, ...xa

Fjäll schwed., Fjeld (veralt. Schreibung für:) Fjell norw. (öde Hochfläche; großes Firnfeld in Skandinavien) m; -[e]s, -s

Fjord skand. (schmale Meeresbucht mit Steilküsten) m; -[e]s, -e

FKK = Freikörperkultur

fl., Fl. = Florin (Gulden)

Fla. = Florida

flach; -er, -ste; ein -es Dach; ein -es Wasser; auf dem -en Land[e] (außerhalb der Stadt) wohnen; Flach (Seemannsspr.: Untiefe) s; -[e]s, -e; ...flach (z. B. Achtflach s; -[e]s, -e); Flach..bau (Mehrz. ...bauten), ...dach, ...druck (Mehrz. ...drucke) Flä|che w; -, -n; Flä|chen..aus|deh|nung, ...er|trag; flä|chen|haft; Flä|chen|in|halt; Flä|chen|träg|heits|mo|ment (Physik); flach|fal|len (ugs. für: sich erübrigen); Flach|feu|er|ge|schütz; Flach|heit; flä|chig; Flach..kü|ste, ...land (Mehrz. ...länder), ...län|der m; ...fläch|ner (z. B. Achtflächner)

Flachs (Faserpflanze) m; -es; flachs|blond; Flachs..bre|che, ...dar|re; Flach|se bayr., österr. (Flechse) flach|sen (ugs. für: nekken, spotten, scherzen); du

flachst (flachsest); fläch|sen, fläch|sern (aus Flachs); Flachs-haar

Flach|zan|ge

flacken[1] mdal. (flackern); Flacker-feu|er[1]; flacke|rig[1], flack|rig; flackern[1]

fla|den (flacher Kuchen; breiige Masse; Kot) m; -s, -

Fla|der (Maser, Holzader; bogenförmiger Jahresring des Sehnenschnitts beim Baumstamm) w; , -n; Fla|der|holz; fla|de|rig, flad|rig

fla|dern österr. ugs. (stehlen)

Fla|de|rung (Übereinanderreihung bogenförmiger Jahresringe im Sehnenschnitt beim Baumstamm) w; -; flad|rig, fla|de|rig

Fla|gel|lan|ten lat. (Geißler) Mehrz.; Fla|gel|lan|ten|tum s; -s; Fla|gel|la|te (Geißeltierchen) w; -, -n (meist Mehrz.)

Fla|geo|lett fr. [flaseho...] (kleinster Typ der Schnabelflöte; flötenähnlicher Ton bei Streichinstrumenten u. Harfen; Flötenregister der Orgel) s; -s, -e u. -s; Fla|geo|let|ton [Trenn.: Fla|geo-lett|ton, ↑ R 263]

Flag|ge w; -, -n; flag|gen; Flag|gen..gruß, ...mast (vgl. ¹Mast); Flagg|schiff

fla|grant lat. (brennend; schreiend; offenkundig); vgl. in flagranti

Flair fr. [flär] (Fluidum, Atmosphäre, gewisses Etwas; selten für: Spürsinn) s; -s

Flak (Kurzw. für: Flugzeugabwehrkanone; Flugabwehrartillerie) w; -, - (auch: -s); die leichten und schweren - (auch: -s); Flak... (in Zusammensetzungen für: Flugabwehr...); Flak|bat|te|rie

Fla|ke niederd. ([Holz]geflecht; Netz) w; -, -n

Fla|kon fr. [flakong] ([Riech]fläschchen) s od. m; -s, -s

Flam|berg (zweihändiges [meist flammenförmiges] Schwert der Landsknechte) m; -[e]s, -e

flam|bie|ren (veralt. für: absengen; Speisen mit Alkohol übergießen u. brennend auftragen)

Fla|me (Angehöriger der Bevölkerung im Westen u. Norden Belgiens u. in den angrenzenden Teilen Frankreichs u. der Niederlande) m; -n, -n (↑ R 268)

Fla|men|co span. [...ko] (andalus. [Tanz]lied; Tanz) m; -[s], -s

Flä|min (Landrücken in der Mark Brandenburg) m; -s

Fla|min|go span. [...minggo] (Wasserwatvogel) m; -s, -s

[1]Trenn.: ...ak|ke...

flä|misch; vgl. deutsch; Flä|misch (Sprache) s; -[s]; vgl. Deutsch; Flä|mi|sche s; -n; vgl. Deutsche s; Flam|län|der vgl. Flame

Flämm|chen, Flämm|lein; Flam|me w; -, -n; Flamm|ei|sen (ein Tischlerwerkzeug); flam|men; fläm|men (Technik: absengen); Flam|men_bo|gen, ...meer, ...tod, ...wer|fer

Flam|me|ri engl. (kalte Süßspeise) m; -[s], -s

Flamm|garn; flam|mig; Flamm|koh|le (jüngere, mit langer Flamme brennende Steinkohle); Flämm|lein, Flämm|chen; Flamm|punkt (Entflammungstemperatur bei Brennstoffen)

Flan|dern (Gebiet zwischen der Schelde u. der Nordsee); flan|drisch; -e Küste

Fla|nell fr. (ein Gewebe) m; -s, -e; Fla|nell|an|zug; fla|nel|len (aus, wie Flanell)

Fla|neur fr. [flanö̱r] (müßig Umherschlendernder) m; -s, -e; fla|nie|ren

Flan|ke fr. w; -, -n; flan|ken; Flan|ken|an|griff; flan|kie|ren

Flansch (Verbindungsansatz an Rohren, Maschinenteilen usw.) m; -[e]s, -e; flan|schen (etwas mit einem Flansch versehen); Flansch|ver|bin|dung

Flap|pe mitteld. u. niederd. (herabhängende Lippe, schiefer Mund) w; -, -n

Flap|per engl. [fläp^er] (junges Mädchen von übertrieben selbständigem, jungenhaftem Auftreten) m; -s, -

Flaps (ugs. für: Flegel) m; -es, -e; flap|sig (ugs.)

Fläsch|chen, Fläsch|lein; Flä|sche w; -, -n; Flä|schen_bier, ...bür|ste; flä|schen|grün; Fla|schen|hals, ...öff|ner, ...post, ...zug; Flasch|ner südd. (Klempner, Spengler)

Fla|ser (Ader im Gestein; selten für: Flader); flase|rig, flas|rig

Flat|sche [auch: flą...] w; -, -n u. Flat|schen [auch: flą...] mitteld. (Guß; Fetzen, Haufen, Stück) m; -s, -

Flat|ter_ech|se, ...geist (Mehrz. ...geister); flat|ter|haft; Flat|ter|haf|tig|keit; flat|te|rig, flat|rig; Flat|ter_mar|ke (Druckw.), ...mi|ne; flat|tern; ich ...ere (↑R 327); Flat|ter|satz (Druckw.)

flat|tie|ren fr. (gut zureden, schmeicheln)

flatt|rig, flat|te|rig

Fla|tu|lenz lat. (Med.: Darmaufblähung) w; -

flau (ugs. für: schlecht, übel); -er, -[e]ste (↑R 293); Flau|heit

Flau|bert [flobä̱r] (fr. Romanschriftsteller)

¹Flaum, Flom m; -[e]s u. Flo|men nordd. (Bauch- u. Nierenfett [des Schweines usw.]) m; -s

²Flaum (weiche Bauchfedern; erster Bartwuchs) m; -[e]s

Flau|ma|cher (ugs. für: Miesmacher)

Flau|mer schweiz. (Mop) m; -s, -

Flaum|fe|der; flau|mig; flaum|weich; vgl. auch: pflaum[en]|weich

Flaus m; -es, -e u. Flausch (weiches Wollgewebe) m; -[e]s, -e; flauschig; Flau|se (ugs. für: Ausflucht; törichter Einfall) w; -, -n (meist Mehrz.); Flau|sen|ma|cher (ugs.); Flaus|rock, Flausch|rock

Flau|te (Windstille; übertr.: Unbelebtheit [z. B. im Geschäftsleben]) w; -, -n

Fla|via (w. Vorn.); Fla|vi|er [...wi^er] (Angehöriger eines röm. Kaisergeschlechtes) m; -s, -; Fla|vio (m. Vorn.); fla|visch

Fläz (ugs. für: plumper, roher Mensch, Lümmel) m; -es, -e; flä|zen, sich (sich hinlümmeln); du fläzt (fläzest) dich; flä|zig

Fleb|be (Gaunerspr.: Wanderschein, Ausweispapier) w; -, -n

Flech|se (Sehne) w; -, -n; flech|sig

Flech|te (Pflanze; Hautausschlag; Zopf) w; -, -n; flech|ten; du flichtst, er flicht; du flochtest; du flöchtest; geflochten; flicht!; Flech|ter; Flecht|werk

Fleck m; -[e]s, -e u. Flecken¹ m; -s, -; der blinde Fleck (im Auge); blaue Flecke; Fleck|chen, Fleck|lein; Flecke¹ landsch. (Kaldaunen) Mehrz.; flecken¹ (Flecke[n] machen); auch ugs. für: vorankommen, z. B. es fleckt); Flecken¹ (größeres Dorf) m; -s, -e; flecken|los¹; Flecken|lo|sig|keit¹ w; -; Flecken|was|ser¹; Flecker|l¹ österr. (Speise aus quadratisch geschnittenem Nudelteig) s; -s, -n; Flecker|l¹_sup|pe (österr.: Suppe mit Flecker|ln als Einlage), ...tep|pich (südd. u. österr.: Teppich aus Stoffstreifen); Fleck|fieber s; -s; fleckig¹; Fleckig|keit¹ w; -; Fleck|lein, Fleck|chen; Fleck|ty|phus

Fled|de|rer; fled|dern (Gaunerspr.: [Leichen] ausplündern); ich ...ere (↑R 327)

Fle|der_maus, ...wisch

Fleet niederd. (Graben, Kanal, fließendes Wässerchen) s; -[e]s, -e

Fle|gel m; -s, -; Fle|ge|lei; fle|gel|haft; Fle|gel|haf|tig|keit; fle|gelig; Fle|gel|jah|re Mehrz.; fle|geln, sich; ich ...[e]le mich (↑R 327)

fle|hen; fle|hent|lich

Flei|er usw. vgl. Flyer usw.

Fleisch s; -[e]s; Fleisch_bank (österr. auch für: Fleischerei; Mehrz. ...bänke), ...be|schau (w; -), ...be|schau|er, ...brü|he; Flei|scher; Flei|sche|rei; Flei|scher_in|nung, ...mei|ster; ¹flei|schern; ich ...ere (↑R 327); ²flei|schern (aus Fleisch); Flei|sches|lust; Fleisch|ex|trakt; fleisch|far|ben, fleisch|far|big; fleisch|fres|send; (vgl. S. 45, Merke, 2:) -e Pflanzen; Fleisch|ge|richt; fleisch|ge|wor|den; Fleisch_hacker¹ (ostösterr. ugs.), ...hau|er (österr. für: Fleischer); Fleisch|haue|rei (österr. für: Fleischerei); flei|schig; Flei|schig|keit w; -; Fleisch_klöß|chen, ...kon|ser|ve, ...laib|chen (österr. für: Frikadelle); fleisch|lich; -e Lüste; Fleisch|lich|keit w; -; fleisch|los; Fleisch_ma|schi|ne (österr. für: Fleischwolf), ...sa|lat, ...ver|gif|tung, ...vo|gel (schweiz. für: Roulade), ...wer|dung (Menschwerdung, Verkörperung), ...wolf m, ...wun|de, ...wurst

Fleiß m; -es; Fleiß|ar|beit; flei|ßig, aber (↑R 224): das Fleißige Lieschen (eine Blume)

Flei|ver|kehr (Flug-Eisenbahn-Güterverkehr) m; -[e]s

flek|tier|bar lat. (Sprachw.: beugbar); flek|tie|ren (Sprachw.: ein Wort beugen, d. h. deklinieren oder konjugieren); vgl. auch: Flexion

Fle|ming (dt. Dichter)

flen|nen (ugs. für: weinen); Flenne|rei

flet|schen (die Zähne zeigen); du fletschst (fletschest)

Flett (Wohn- u. Herdraum im niedersächs. Bauernhaus) s; -[e]s, -e

Flett|ner (dt. Maschinenbauer); Flett|ner_ro|tor (Drehmast), ...ru|der (Hilfsruder); ↑R 180

Fletz [auch: flą̈ts] südd. (Hausflur) s od. m; -es, -e

fleucht (veralt. für: flieht); vgl. fliehen

fleugt (veralt. für: fliegt); vgl. fliegen; was da fleugt und kreucht

Fleu|rop [auch: flọ̈rop] (internationale Blumengeschenkvermittlung) w; -

fleußt (veralt. für: fließt); vgl. fließen

fle|xi|bel lat. (biegbar, biegsam, geschmeidig; veränderlich; Sprachw.: beugbar); ...i|ble Wörter; Fle|xi|bi|li|tät (Biegsamkeit)

¹ Trenn.: ...ek|k...

¹ Trenn.: ...k|k...

w; -; Fle|xi|on (Beugung, Abknik-kung; Sprachw.: Beugung, d. h. Deklination od. Konjugation); Fle|xi|ons|en|dung; fle|xi|ons_fä-hig, ...los; fle|xi|visch [...wisch] (Sprachw.: die Beugung betref-fend); Fle|xur (Geol.: Verbie-gung) w; -, -en

Fli|bu|stier niederl. [...i^er] (Frei-beuter, Seeräuber des 17. Jh.s)

Flic fr. [flik] (fr. ugs. für: Polizist) m; -s, -s

Flick|ar|beit; flicken[1]; Flicken[1] m; -s, -; Flicker[1]; Flicke|rei[1]; Flicke-rin[1] w; -, -nen

Flick|flack fr. (meist in schneller Folge geturnter Handstandüber-schlag) m; -s, -s

Flick_schnei|der, ...schu|ster, ...werk (s; -[e]s)

Flie|boot niederl. (kleines Fischer-boot; auch für: Beiboot)

Flie|der (Zierstrauch; landsch. für: schwarzer Holunder) m; -s, -; Flie|der_bee|re, ...blü|te; flie-der_far|ben od. ...far|big; Flie|der|tee m; -s

Flie|ge w; -, -n; flie|gen; er fliegt (vgl. fleugt); du flogst (flogest); du flögest; geflogen; flieg[e]!; flie-gende Blätter, fliegende Hitze, fliegende Brücke (Fähre), flie-gender Drache, fliegende Unter-tasse, in fliegender Eile, fliegende Brigade (DDR: Brigade, die ständig und schnell überall einge-setzt werden kann), aber (↑ R 224): Fliegende Blätter (früheres Witzblatt), der Fliegende Hol-länder (Oper); Flie|gen_fän|ger, ...fen|ster, ...ge|wicht (Körperge-wichtsklasse in der Schwerathle-tik), ...klap|pe, ...kopf (Druk-kerspr.), ...pilz, ...schnäp|per (Singvogel); Flie|ger; Flie|ger_ab-wehr, ...alarm; Flie|ge|rei w; -; Flie|ger|horst; flie|ge|risch; Flie-ger|spra|che

Flieh|burg (hist.); flie|hen; er flieht (vgl. fleucht); du flohst (flohest); du flöhest; geflohen; flieh[e]!; Flieh|kraft (für: Zentrifugal-kraft)

Flie|se (Wand- od. Bodenplatte) w; -, -n; flie|sen (mit Fliesen verse-hen); du fliest (fliesest); er flieste; Flie|sen|le|ger

Fließ (veralt. für: Bach) s; -es, -e; Fließ_ar|beit (Arbeit am laufen-den Band), ...band (s; Mehrz. ...bänder), ...ei (Vogelei ohne Kalkschale); flie|ßen; du fließt (fließest), er fließt (vgl. fleußt); ich floß, du flossest; du flössest; geflossen; fließ[e]!; Fließ_heck (vgl. [1]Heck), ...laut (für: Liqui-

da), ...pa|pier, ...was|ser (österr. für: Wasserleitungsanschluß; s; -s); Zimmer mit - zu vermieten

Flim|mer m; -s, -; Flim|mer_epi-thel, ...ki|ste (ugs. für: Fernsehge-rät); flim|mern; ich ...ere (↑ R 327)

flink; Flink|heit w; -

Flin|serl österr. ugs. (Flitter; klei-nes Gedicht) s; -s, -n

Flint engl. niederd. (Feuerstein) m; -[e]s, -e; Flin|te (Schrotgewehr) w; -, -n; Flin|ten_ku|gel, ...schuß; Flint|glas (Mehrz. ...gläser)

Flinz (ein Mineral) m; -es, -e

Flip engl. (ein alkohol. Mischge-tränk mit Ei) m; -s, -s

flir|ren (flimmern)

Flirt engl. [auch, österr. nur: flö'r] (Liebelei; harmloses, kokettes Spiel mit der Liebe) m; -[e]s, -s; flir|ten [auch, österr. nur: flö't^en]

Flit|scherl österr. ugs. (Flittchen) s; -s, -n; Flit|chen (ugs. für: leich-tes Mädchen, Dirne)

Flit|ter m; -s, -; Flit|ter_glanz, ...gold; flit|tern (glänzen); Flit-ter_staat (m; -[e]s), ...werk, ...wo-chen (Mehrz.)

Flitz (veralt. für: Pfeil) m; -es, -e; Flitz|bo|gen (ugs.); flit|zen (ugs. für: [wie ein Pfeil] sausen, eilen); du flitzt (flitzest); du flitztest; Flit|zer (ugs. für: kleines, schnel-les Auto)

floa|ten engl. [flo^uten] (den Wech-selkurs freigeben); Floa|ting s; -s

Flo|bert|ge|wehr [auch: flobär...; nach dem fr. Waffenschmied]

F-Loch (an der Geige) s; -[e]s, F-Löcher

Flocke[1] w; -, -n; flocken[1]; flocken-för|mig[1]; flocken|wei|se[1]; flok-kig; Flock|sei|de w; -

Flö|del (schmaler Doppelstreifen am Rand von Decke u. Boden bei Streichinstrumenten) m; -s, -

Floh m; -[e]s, Flöhe; flö|hen; Floh-markt (Trödelmarkt), ...zir|kus

Flom, Flo|men vgl. [1]Flaum

[1]Flor lat. (Blüte, Blumenfülle; Wohlstand, Gedeihen) m; -s, -e; [2]Flor niederl. (dünnes Gewebe; samtartige Oberfläche eines Ge-webes) m; -s, -e u. (selten:) Flöre; [1]Flo|ra lat. (Pflanzenwelt [eines Gebietes]) w; -, Floren; [2]Flo|ra (altröm. Göttin; w. Vorn.); Flor-band s (Mehrz. ...bänder); Flo|re-al ("Blütenmonat" der Fr. Revo-lution: 20. April bis 19. Mai) m; -[s], -s; Flo|ren|tin (m. Vorn.); Flo-ren|ti|ne w. Vorn.)

Flo|ren|ti|ner (↑ R 199); - Hut; flo-ren|ti|nisch; Florenz (it. Stadt)

Flo|res|zenz lat. (Bot.: Gesamtheit der Blüten einer Pflanze, Blüten-stand; Blütezeit) w; -, (selten:) -en

Flo|rett fr. s; -[e]s, -e; Flo|rett_fech-ten (s; -s), ...sei|de (Abfallseide; w; -)

Flo|ri|an (m. Vorn.)

Flo|ri|da (Halbinsel u. Staat in den USA; Abk.: Fla.)

flo|rie|ren lat. (blühen, [geschäft-lich] vorankommen; gedeihen); Flo|ri|le|gi|um (andere Bez. für Anthologie; Sammlung von schmückenden Redewendun-gen, rhetorischen Figuren u. Sen-tenzen zur wahlweisen Wieder-verwendung) s; -s, ...ien [...i^en]; Flo|rin (Gulden in den Nieder-landen; Silbermünze in England; Abk.: fl. u. Fl.) m; -s, -e u. -s; Flo|rist (Erforscher einer Flora; Blumenbinder); ↑ R 268; Flo|ri-stin w; -, -nen; flo|ri|stisch; Flos-kel ("Blümchen"; [inhaltsarme] Redensart) w; -, -n; flos|kel|haft

Floß (Wasserfahrzeug) s; -es, Flöße; flöß|bar; Flos|se w; -, -n; flö|ßen; du flößt (flößest); Flos-sen|fü|ßer; Flöß|ßer; ...flos|ser (z. B. Bauchflosser); Flö|ße|rei; Floß_fahrt, ...gas|se; ...flos|sig (z. B. breitflossig); Floß|platz

Flo|ta|ti|on engl. [...ziọn] (Technik: Verfahren der Aufbereitung von Erzen)

Flö|te w; -, -n; (↑ R 140:) - spielen, aber (↑ R 120): beim Flötespie-len; flö|ten; Flö|ten|blä|ser

flö|ten|ge|hen (ugs. für: verloren-gehen)

Flö|ten_spiel (s; -[e]s), ...ton (Mehrz. ...töne)

flo|tie|ren engl. (Erze durch Flota-tion aufbereiten)

Flö|tist (Flötenspieler); ↑ R 268

flott (ungebunden, leicht; flink). I. Schreibung in Verbindung mit dem 2. Mittelwort: ein flottgehen-des Geschäft (↑ jedoch R 142), aber: das Buch ist flott geschrie-ben. II. Schreibung in Verbindung mit Zeitwörtern, z. B. flottma-chen (↑ R 139); Flott niederd. (Milchrahm) s; -[e]s, -e; Flot|te w; -, -n; Flot|ten_ab|kom|men, ...ba-sis, ...stütz|punkt; flot|tie|ren (schwimmen; schweben; schwan-ken); -de (schwebende, nicht fun-dierte Schuld); Flot|til|le span. [auch: flotilje^] (Verband kleiner Kriegsschiffe) w; -, -n; flott_ma-chen (↑ R 139); er hat das Schiff flottgemacht; aber: flott (flink) ma|chen; flott|weg (ugs. für: in einem weg)

Flotz|maul (der stets feuchte Na-senteil bei Rindern u. a.)

Flöz (abbaubare Nutzschicht, vor allem Kohle) s; -es, -e; Flöz|ge-bir|ge

Flu|at (Kurzw. für: Fluorsilikat) s; -[e]s, -e

[1] Trenn.: ...ik|ke...

[1] Trenn.: ...ok|k...

Fluch *m;* -[e]s, Flüche; **fluch|be|la-den; fly|chen; Flu|cher**

¹Flucht [zu: fliegen] (Fluchtlinie, Richtung, Gerade) *w;* -, -en

²Flucht [zu: fliehen] *w;* -, -en; **flucht|ar|tig**

fluch|ten (Technik: in eine gerade Linie bringen)

flüch|ten, (schweiz. auch:) sich -; **Flücht|ter** (Haus-, Feldtaube); **Flucht|ge|schwin|dig|keit** (Geschwindigkeit, die nötig ist, um das Gravitationsfeld eines Planeten zu überwinden); **Flucht|hel-fer**

fluch|tig (für: perspektivisch)

flüch|tig; Flüch|tig|keit; Flüch|tig-keits|feh|ler; Flücht|ling; Flücht-lings|la|ger

Flücht|li|nie

flucht|ver|däch|tig; Flucht_ver-such, ...weg

fluch|wür|dig

Flüe [*flü'*], Nik[o]laus von der (schweiz. Heiliger)

Flug *m;* -[e]s, Flüge; inm -e; **Flug_ab-wehr, ...asche, ...bahn; flug|be-reit; Flug_blatt, ...boot, ...dra-chen** (Fluggerät), **...ei|dech|se** (für: Pterosaurier); **Flü|gel** *m;* -s, -; **Flü|gel_ad|ju|tant, ...al|tar; ...flü|ge|lig, ...flüg|lig** (z. B. ein-flü[e]lig); **Flü|gel|kleid** (um 1900); **flü|gel|lahm; Flü|gel|mann** (*Mehrz.* ...männer u. ...leute); **flü-geln** (Jägerspr. auch: Flügelkno-chen zerschießen); in ...[e]le (↑ R 327); geflügelt (vgl. d.); **Flü|gel-schlag; flü|gel|schla|gend; Flü|gel|tür; Flug_funk, ...gast** (*Mehrz.* ...gäste); **Flug_ge|sell-schaft, ...ha|fen** (vgl. ²Hafen), **...kör|per, ...leh|rer; ...flüg|lig** vgl. ...flügelig; **Flug_loch, ...plan** (vgl. ²Plan), **...platz, ...post, ...rei|se; flugs** (schnell, sogleich); ↑ R 129; **Flug_sand, ...schiff, ...schrift, ...steig, ...stun|de, ...stütz|punkt, ...taug|lich|keit, ...tech|nik, ...tou-ri|stik, ...ver|kehr, ...we|sen** (*s;* -s), **...zet|tel** (österr. für: Flugblatt), **...zeug** (*s;* -[e]s, -e); **Flug|zeug|ab-wehr; Flug|zeug|ab|wehr|ka|no-ne** (Kurzw.: Flak); **Flug|zeug_bau** (*m;* -[e]s), **...ent|füh|rung, ...füh-rer, ...hal|le, ...mut|ter|schiff, ...trä|ger**

Fluh schweiz. (Fels[wand]) *w;* -, Flühe; **Flüh|vo|gel** (Alpenvogel)

Flui|dum lat. (von einer Person od. Sache ausströmende Wirkung) *s;* -s, ...da; **Fluk|tua|ti|on** [...*zión*] (Schwanken, Schwankung); **fluk|tu|ie|ren**

Flun|der (ein Fisch) *w;* -, -n

Flun|ke|rei (kleine Lüge, Auf-schneiderei); **Flun|ke|rer; flun-kern;** ich ...ere (↑ R 327)

Flunsch niederd. u. mitteld. ([ver-drießlich od. zum Weinen] verzo-gener Mund) *m;* -[e]s, -e

Flu|or lat.· (chem. Grundstoff; Nichtmetall; Zeichen: F) *s;* -s; **Fluo|res|zenz** (Aufleuchten unter Strahleneinwirkung) *w;* -; **fluo-res|zie|ren;** fluoreszierender Stoff (Leuchtstoff); **Fluo|ro|phor** (Fluoreszenzträger) *m;* -s, -e; **Flu-or|si|li|kat** (Mittel zur Härtung von Baustoffen); vgl. Fluat

¹Flur (nutzbare Landfläche; Feld-flur) *w;* -, -en; **²Flur** (Hausflur) *m;* -[e]s, -e; **Flur_be|rei|ni|gung, ...buch** (für: Kataster), **...gar|de-ro|be, ...hü|ter, ...na|me, ...scha-den, ...schütz** *m,* **...um|gang** (Bitt-gang)

flu|schen nordd. mdal. (flutschen)

Flu|se landsch. (Fadenrest, Fa-denende) *w;* -, -n

Fluß *m;* Flusses, Flüsse; **fluß|ab-[wärts]; Fluß|arm; fluß|auf-[wärts]; Fluß|bett** (*Mehrz.* ...bet-ten [seltener: ...bette]); **Flüß|chen, Flüß|lein; fluß|sig,** -e (verfügbare) Gelder; -e Luft; -e Kristalle. *Schreibung in Verbindung mit Zeitwörtern,* z. B. flüssigmachen (↑ R 139); **Flüs|sig|gas; Flüs|sig-keit; Flüs|sig|keits_brem|se** (hy-draulische Bremse), **...maß** *s,* **...men|ge, ...pres|se** (hydraulische Presse); **flüs|sig|ma|chen** (↑ R 139); ich habe das Kapital flüssig-gemacht; *aber:* **flüs|sig ma|chen** (schmelzen); er wird das Eisen flüssig machen; **Fluß|lauf; Flüß-lein, Flüß|chen; Fluß|pferd, ...re-gu|lie|rung, ...sand, ...schiffahrt** [*Trenn.:* ...schiff|fahrt, ↑ R 236], **...spat** (ein Mineral; vgl. ¹Spat), **...stahl** (vgl. ¹Stahl), **...ufer**

Flü|ste|rer; flü|stern; ich ...ere (↑ R 327); **Flü|ster_pro|pa|gan|da, ...stim|me, ...ton** (*m;* -[e]s), **...tü|te** (scherzh. für: Sprachrohr)

Flut *w;* -, -en; **flu|ten; Flut_hö|he, ...ka|ta|stro|phe, ...licht**

flut|schen (ugs. für: gut voran-kommen, -gehen); es flutscht

Flut_wel|le, ...zeit

flu|vi|al lat. [...*wi*...] (Geol.: von fließendem Wasser abgetragen od. abgesetzt)

Fly|er engl. [*flai'r*] (Vorspinn-, Flügelspinnmaschine; Arbeiter an einer solchen Maschine) *m;* -s, -; **Flye|rin** *w;* -, -nen; **Fly|er-mei|ster; Fly|ing Dutch|man** engl. [*flaiing datschm'n*] (Zweimann-Sportsegelboot) *m;* - -, - ...men; **Fly-over** engl. [*flaio"w'r*] (Straßen-überführung [in Form einer Stahlbrücke]) *m;* -s, -s

Flysch schweiz. [*fli*...] (ein Gestein) *s* (österr.: *m*); -[e]s

fm = Festmeter

Fm = Fermium

FMH = Foederatio Medicorum Helveticorum (Vereinigung schweiz. [Fach]ärzte)

Fmk = Finnmark; vgl. Markka

f-Moll [*äfmol,* auch: *äfmol*] (Ton-art; Zeichen: f) *s;* -; **f-Moll-lei|ter** (↑ R 155)

fob = free on board engl. [*fri on bo'd*] (frei an Bord); - Hamburg, - deutschen Ausfuhrhafen

Foch [*fosch*] (fr. Marschall)

Fock (Stagsegel vor dem Mast; un-terstes Rahsegel des Vormastes) *w;* -, -en; **Fock_mast** *m,* **...ra|he, ...se|gel**

fö|de|ral (föderativ); **Fö|de|ra|lis-mus** lat.-fr. (Streben nach) Selb-ständigkeit der Länder innerhalb eines Staatsganzen) *m;* -; **Fö|de-ra|list** (↑ R 268); **fö|de|ra|li|stisch; Fö|de|ra|ti|on** [...*zion*] (loser [Staaten]bund); **fö|de|ra|tiv** (bun-desmäßig); **Fö|de|ra|tiv|staat** (*Mehrz.* ...staaten); **fö|de|rie|ren** (verbünden)

Fog engl. (engl. Bez. für: dichter Nebel) *m;* -s

Fo|gosch ung. (Zander [Fischart]) *m;* -[e]s, -e

foh|len (ein Fohlen zur Welt brin-gen); **Foh|len, Fül|len** *s;* -s, -; **Föhn** (warmer, trockener Fall-wind) *m;* -[e]s, -e; vgl. aber: För (Heißluftdusche); **föh|nen** (föh-nig werden); **föh|nig; Föhn-_krank|heit, ...wind**

Föhr (eine nordfries. Insel)

Föh|re (Kiefer) *w;* -, -n; **föh|rer** (aus Föhrenholz); **Föh|ren|wald**

fo|kal lat. (den Fokus betreffend, Brenn...); **Fo|kal|in|fek|ti|on** (Med.: von einem Ausgangsherd im Körper dauernd unterhaltene Infektion); **Fo|kus** (Brennpunkt; Krankheitsherd) *m;* -, - u. -se; **fo|kus|sie|ren** (optische Linsen ausrichten)

fol., Fol. = Folio; Folioblatt

Fol|ge *w;* -, -n; Folge leisten; zur Folge haben; für die Folge, in der Folge; demzufolge (vgl. d.); infolge; zufolge; infolgedessen, **Fol|ge|er|schei|nung; fol|gen;** er ist mir gefolgt (nachgekommen); er hat mir gefolgt (Gehorsam ge-leistet); **fol|gend;** folgende [Seite] (Abk.: f.); folgende [Seiten] (Abk.: ff.); folgendes, was...; (↑ R 277:) folgendes schauderhafte Geschehnis; (↑ R 284:) folgende lange (seltener: langen) Ausfüh-rungen. **I.** *Kleinschreibung:* **a)** (↑ R 135:) der -e (der Reihe nach); -es (dieses); das -e (dieses); aus -em (diesem); durch -es (dieses); mit -em (diesem); von -em (die-sem); alle -en (anderen); **b)** (↑ R 134:) im -en, in -em (weiter un-ten). **II.** *Großschreibung* (↑ R 116:)

der Folgende (der einem andern Nachfolgende); das Folgende (das später Erwähnte, Geschehende, die folgenden Ausführungen); durch das Folgende; aus, in, mit, nach, von dem Folgenden (den folgenden Ausführungen); fol|gen|der|ge|stalt, ...ma|ßen, ...wei|se; fol|gen_reich, ...schwer; Fol|gen|schwe|re w; -; fol|ge|recht; fol|ge|rich|tig; Fol|ge|rich|tig|keit; fol|gern; ich ...ere (↑ R 327); fol|gernd; Fol|ge|rung; fol|ge|wid|rig; Fol|ge_wid|rig|keit, ...zeit; folg|lich; fol|g|sam; Folg|sam|keit w; -

Fo|lia (Mehrz. von: Folium); Fo|li|ant lat. (Buch in Folio) m; -en, -en (↑ R 268); Fo|lie [...iᵉ] (dünnes [Metall]blatt; Prägeblatt; Hintergrund) w; -, -n

Fo|lies-Ber|gère fr. [folibärsehär] (Varieté u. Tanzkabarett in Paris) Mehrz.

fo|li|ie|ren lat. ([Bogenseiten] beziffern; mit einer Folie unterlegen); Fo|lio (Halbbogengröße [Buchformat; Abk.: fol., Fol. od. 2⁰]; Blatt im Geschäftsbuch; Seite) s; -s, Folien [...iᵉn] u. -s; in -; Fo|lio_band m, ...blatt (Abk.: Fol.), ...for|mat; Fo|li|um (Pflanzenblatt) s; -s, Folia u. Folien [...iᵉn]

Fol|ke|ting (dän. Ausspr.: folgᵉ-teng] (bis 1953 zweite Kammer des dän. Reichstags, seitdem Bez. für das dän. Parlament) s; -s

Folk|lore engl. [folklor, auch: folklor^ᵉ] (Volksüberlieferungen; Volkskunde) w; -; Folk|lo|rist (↑ R 268); Folk|lo|ri|stik (selten für: Wissenschaft von der Folklore) w; -; folk|lo|ri|stisch; Folk|song (volkstümliches Lied, volksliedhafter [Protest]song); Folk|wang (nord. Mythol.: Palast der Freyja)

Fol|li|kel lat. (Med.: Säckchen; Drüsenbläschen; Zellhülle des gereiften Eies der Eierstocks) m; -s, -; fol|li|ku|lar, fol|li|ku|lär (auf den Follikel bezüglich)

Fol|ter w; -, -n; Fol|ter|bank (Mehrz. ...bänke); Fol|te|rer; Fol|ter_in|stru|ment, ...kam|mer; fol|tern; ich ...ere (↑ R 327); Fol|te|rung; Fol|ter|werk|zeug

Fo|ment lat. (Med.: warmer Umschlag) s; -s, -e

Fön ⓦ (elektr. Heißluftdusche) m; -[e]s, -e; vgl. aber: Föhn (Fallwind)

Fond fr. [fọng] (Hintergrund eines Gemäldes od. einer Bühne; Rücksitz im Wagen) m; -s, -s

Fon|dant fr. [fọngdang] (Zuckerwerk) m (österr.: s); -s, -s

Fonds fr. [fọng] (Geldmittel, -vorrat, Bestand) m; - [fọng(ß)], -

[fọngß] (auch für: Anleihen); vgl. à fonds perdu

Fon|due fr. [fọngdü, schweiz.: fọngdü] ([west]schweiz. Käsegericht) w; -, -s od. s; -s, -s

fö|nen (mit dem Fön behandeln)

Fons (Kurzform von: Alfons)

Fon|tai|ne|bleau [fọngtänblọ] (Stadt u. Schloß in Frankreich)

Fon|ta|ne (dt. Dichter)

Fon|tä|ne fr. ([Spring]brunnen) w; -, -n; Fon|ta|nel|le (Knochenlücke am kindlichen Schädel) w; -, -n

Fon|tan|ge fr. [fọngtangseh'] (Frauenkopfputz des 17. Jh.s) w; -, -n

Foot engl. [fut] (engl. Längenmaß, Abk.: ft; Zeichen: ′) m; -, Feet [fit]

fop|pen; Fop|per; Fop|pe|rei

Fo|ra|mi|ni|fe|re lat. (einzelliges Wassertier mit Kalkschale) w; -, -n

Force fr. [forß] (veralt. für: Stärke; Zwang; Gewalt) w; -, -n [...ß^ᵉn], vgl. par force; Force de frappe [forßd^ᵉfrap] (Abschreckungsstreitmacht, Bez. für die Gesamtheit der fr. atomgerüsteten milit. Einheiten) w; - - -; Force ma|jeure [forß maschör] (höhere Gewalt) w; - -; for|cie|ren [forßir^ᵉn] (mit Gewalt beschleunigen, vorantreiben; steigern); for|ciert (auch: gezwungen, unnatürlich)

Ford, Henry (amerik. Industrieller)

För|de niederd. (schmale, lange Meeresbucht) w; -, -n

För|der_band (s; Mehrz. ...bänder), ...be|trieb m; -[e]s); För|de|rer; För|de|rin w; -, -nen; För|der_koh|le, ...korb, ...kurs; för|der|lich; För|der|ma|schi|ne

for|dern; ich ...ere (↑ R 327)

för|dern; ich ...ere (↑ R 327); För|der_nis s; -ses, -se; för|der|sam (veralt.); För|der_schacht, ...seil, ...soh|le, ...turm

För|de|rung

För|de|rung; För|de|rungs_maß|nah|me; För|der|werk

Fö|re skand. (Schisport: Eignung des Schnees zum Fahren, Geführigkeit) w; -

Fore_checking engl. [fọ'tschäking; Trenn.: ...chek|king] (Eishockey: das Stören und Angreifen des Gegners im gegnerischen Verteidigungsdrittel) s; -s, -s

Fore|hand [fọ'hänt] (Sportspr.: Vorhandschlag) w; -, -s (auch: m; -[s], -s)

Fo|reign Of|fice [forin ọfiß] (Brit. Auswärtiges Amt) s; - -

Fo|rel|le (ein Fisch) w; -, -n; Fo|rel|len|zucht

fo|ren|sisch lat. (gerichtlich)

Fo|rint ung. (ung. Münzeinheit; Abk. für Einz. u. Mehrz.: Ft) m; -[s], -s (österr. -e); 10 -

För|ke nordd. (Heu-, Mistgabel) w; -, -n; för|keln (Jägerspr.: mit dem Geweih, Gehörn verletzen)

Fo|rle südd. (Föhre, Kiefer) w; -, -n; Forl|eu|le (Schmetterling)

Form w; -, -en; in - sein; in - von; vgl. pro forma; for|mal (auf die Form bezüglich; förmlich; unlebendig, äußerlich)

Form|al|de|hyd [auch: ...hüt] (ein Gas) m; -s

For|ma|li|en [...iᵉn] (Förmlichkeiten; Äußerlichkeiten) Mehrz.

For|ma|lin ⓦ, For|mol ⓦ (Konservierungs_, Desinfektionsmittel) s; -s

for|ma|li|sie|ren fr. (in [strenge] Form bringen; sich an gegebene Formen halten); For|ma|lis|mus lat. (übertriebene Berücksichtigung von Äußerlichkeiten; Überbetonung des rein Formalen) m; -, ...men; For|ma|list (↑ R 268); for|ma|li|stisch; For|ma|li|tät; for|ma|li|ter (förmlich, in aller Form); for|mal_ju|ri|stisch, ...recht|lich; Form_an|stieg (Sportspr.), ...ar|beit; For|mat s; -[e]s, -e; For|mat|bo|gen; For|ma|ti|on [...ziọn]; for|ma|tiv (auf die Gestaltung bezüglich, gestaltend); form|bar; Form|bar|keit w; -; form_be|stän|dig; Form_blatt, ...ei|sen; For|mel w; -, -n; For|mel-I-Wa|gen [- ainß -]; ↑ R 157 (ein Rennwagen); for|mel|haft; For|mel|haf|tig|keit w; -; For|mel_kram m; -[e]s; for|mell fr. (förmlich, die Formen [peinlich] beobachtend; äußerlich; zum Schein vorgenommen); For|mel|we|sen s; -s, -; for|men; For|men_kram (m; -[e]s), ...leh|re (Teil der Sprachlehre u. der Musiklehre); for|men|reich; For|men|reich|tum m; -s; for|men_schnei|der, Form_schnei|der; For|men|schön|heit, Form|schön|heit w; -; For|men_sinn m; -[e]s; For|mer; For|me|rei; Form_feh|ler, ...frä|ser, ...ge|bung, ...ge|stal|tung; form_ge_wandt; Form_ge|wandt_heit w; -; form|haft

for|mi|da|bel fr. (veralt. für: furchtbar; auch fam.: großartig); ...a|ble Erscheinung

for|mie|ren fr.; For|mie|rung; ...för|mig (z. B. nadelförmig); For|mkri|se (Sportspr.); förm|lich; Förm|lich|keit; form|los; Form|lo|sig|keit; Form|obst (Spalierobst[bäume])

For|mol vgl. Formalin

Form_sa|che, Form_schnei|der, For|men_schnei|der, form_schön; Form|schön|heit, För|men-

schön|heit; Form_stren|ge, ...tief (Sportspr.); form|treu; For|mu|lar *lat.* s; -s, -e; For|mu|lar|block (*Mehrz.* ...blocks); for|mu|lie|ren; For|mu|lie|rung; For|mung; form|voll|en|det

For|nix *lat.* (Med.: Gewölbe, Bogen) *m*; -, ...nices [...*zä*ß]

forsch *lat.* (schneidig, kühn, selbstbewußt); -este († R 292); For|sche (ugs. für: Nachdruck) *w*; - för|scheln schweiz. (vorsichtig forschen, aushorchen); ich ...[e]le († R 327); for|schen; du forschst (forschest); For|scher; For|schergeist (*m*; -[e]s); for|sche|risch; For|schung; For|schungs_auf|trag, ...ge|mein|schaft, ...in|sti|tut, ...la|bo|ra|to|ri|um, ...me|tho|de, ...or|ga|ni|sa|ti|on, ...rat (*Mehrz.* ...räte), ...rei|sen|de, ...schiff, ...sta|ti|on, ...zen|trum, ...zweig

Forst *m*; -[e]s, -e[n]; Forst|amt; Förster; För|ste|rei; Forst_fre|vel, ...haus; forst|lich; Forst_mann (*Mehrz.* ...männer u. ...leute), ...mei|ster, ...rat (*Mehrz.* ...räte), ...re|vier, ...scha|den, ...schu|le, ...ver|wal|tung, ...wirt|schaft, ...wis|sen|schaft (*w*; -)

For|sy|thie [*forsüzi*; auch: ...*ti*ᵉ; österr.: *forsizi*ᵉ] (ein Zierstrauch) *w*; -, -n

fort; - sein; - mit ihm!; und so - (Abk.: usf.); in einem -; weiter -; immerfort

fort... (*in Zus. mit Zeitwörtern, z. B.* fortbestehen, du bestehst fort, fortbestanden, fortzubestehen; zum 2. Mittelw. † R 304)

Fort *fr.* [*for*] (Festungswerk)*s*; -s, -s

fort|ab; fort|an

Fort|be|stand *m*; -[e]s; fort|be|stehen

fort|be|we|gen; sich -; vgl. ¹bewegen; Fort|be|we|gung

fort|bil|den; sich -; Fort|bil|dung; Fort|bil|dungs_schu|le österr. veralt. u. schweiz. (Berufsschule)

fort|blei|ben

fort|brin|gen

Fort|dau|er; fort|dau|ern; fort|dauernd

for|te *it.* (Musik: stark, laut; Abk.: f); Forte *s*; -s, -s u. ...ti

fort|ent|wickeln [*Trenn.:* ...wik-keln]; sich -; Fort|ent|wicke|lung [*Trenn.:* ...wik|ke...], Fort|ent|wick|lung

For|te|pia|no *it.* (alte Bez. für: Pianoforte) *s*; -s, -s u. ...ni

fort|er|ben; sich

fort|fah|ren

Fort|fall *m*; -[e]s; in - kommen (Papierdt.); fort|fal|len

fort|flie|gen

fort|füh|ren; Fort|füh|rung

Fort|gang *m*; -[e]s; fort|ge|hen

fort|ge|schrit|ten; Fort|ge|schritte|ne *m* u. *w*; -n, -n († R 287ff.)

fort|ge|setzt

fort|hin

For|ti|fi|ka|ti|on *lat.* [...*ziọn*] (früher für: Befestigung, Befestigungswerk, -kunst); for|ti|fi|ka|to|risch; for|ti|fi|zie|ren

For|tis *lat.* (Sprachw.: starker Mitlaut, mit großer Intensität gesprochener Mitlaut, z. B. p, t, k; Ggs.: Lenis [vgl. d.]) *w*; -, ...tes; for|tis|si|mo *it.* (Musik: sehr stark, sehr laut; Abk.: ff); For|tis|si|mo *s*; -s, -s u. ...mi

fort|ja|gen

fort|kom|men; Fort|kom|men *s*; -s

fort|kön|nen

fort|lau|fen; fort|lau|fend; - numeriert

fort|le|ben

fort|müs|sen

fort|pflan|zen; Fort|pflan|zung; Fort|pflan|zungs_ge|schwin|dig|keit, ...or|gan

fort|rei|ßen; jmdn. mit sich -

fort|ren|nen

Fort|satz *m*; -es, Fortsätze

fort|schaf|fen; vgl. ¹schaffen

fort|sche|ren; sich

fort|schicken [*Trenn.:* ...schik|ken]

fort|schrei|ben (eine Statistik fortlaufend ergänzen; Wirtsch.: den Grundstückseinheitswert durch Bescheid neu feststellen); Fort|schrei|bung

fort|schrei|ten; fort|schrei|tend; Fort|schritt; Fort|schritt|ler; fort|schritt|lich; Fort|schritt|lich|keit *w*; -; fort|schritts|gläu|big

fort|set|zen; Fort|set|zung

fort|steh|len; sich

fort|stre|ben

For|tu|na (röm. Glücksgöttin); For|tu|nat, For|tu|na|tus (m. Vorn.); For|tü|ne *fr.* (Glück, Erfolg) *w*; -; keine - haben

fort|wäh|rend

fort|wer|fen

fort|wol|len

fort|wur|steln (ugs. für: im alten Schlendrian fortfahren); ich wurst[e]le fort († R 327)

fort|zie|hen

Fo|rum *lat.* (altröm. Marktplatz; Gericht, Gerichtshof; Öffentlichkeit; öffentliche Diskussion) *s*; -s, ...ren, ...ra u. -s; Fo|rums_dis|kus|si|on, ...ge|spräch

for|za|to vgl. sforzato

Fos|bu|ry-Flop [*foßb*ᵉ*riflop*; nach dem amerik. Leichtathleten] (ein Sprungstil beim Hochsprung) *m*; -s, (für den einzelnen Sprung *Mehrz.*:) -s † R 180

Fo|se mdal. (Dirne) *w*; -, -n

Fo|ße *fr.* (leere Karte; Fehlfarbe) *w*; -, -n

fos|sil *lat.* (versteinert; vorweltlich); Fos|sil (versteinerter Rest von Tieren od. Pflanzen) *s*; -s -ien [...*i*ᵉ*n*] (meist *Mehrz.*)

fö|tal vgl. fetal

¹Fo|to¹ (kurz für: Fotografie, Lichtbild) *s*; -s, -s (schweiz.: *w* -, -s); ²Fo|to (ugs. kurz für: Fotoapparat) *m*; -s, -s; Fo|to_al|bum ...ama|teur, ...ap|pa|rat, ...ar|ti|kel, ...ate|lier; Fo|to|che|mi|gra|fie usw. vgl. Photochemigraphie usw.; fo|to|gen (zum Fotografieren od. Filmen geeignet, bildwirksam); Fo|to|ge|ni|tät (Bildwirksamkeit) *w*; -; Fo|to|graf *m* -en, -en († R 268); Fo|to|gra|fie *w*; -, ...ien; Fo|to|gra|fie|al|bum fo|to|gra|fie|ren; fo|to|gra|fisch -e Kamera; -er Effekt; -es Objektiv; Fo|to|in|du|strie; Fo|to|ko|pie (Lichtbildabzug von Schriften, Dokumenten u. a.); Fo|to|ko|pier|au|to|mat; fo|to|ko|pie|ren; Fo|to|li|tho|gra|fie vgl. Photolithographie; Fo|to|mo|dell (jmd., der für Fotoaufnahmen Modell steht) ...mon|ta|ge (Zusammenstellung verschiedene Bildausschnitte zu einem Gesamtbild), ...re|por|ter, ...zeit|schrift, ...zin|ko|gra|fie (Herstellung von Strichätzungen mit Hilfe der Fotografie; *w*; -)

Fö|tus vgl. Fetus

Fot|ze (derb für: weibl. Scham bayr. u. österr. ugs. für: Ohrfeige Maul) *w*; -, -n

Föt|zel schweiz. (Lump, Taugenichts) *m*; -s, -

fot|zen bayr. u. österr. ugs. (ohrfeigen); Fotz|ho|bel bayr. u. österr ugs. (Mundharmonika)

Fou|cault [*fukọ*] (fr. Physiker) Fou|cault|sche Pen|del|ver|such *m*; -n -[e]s

Fou|ché [*fusche*] (fr. Staatsmann foul *engl.* [*faul*] (Sport: regelwidrig); Foul (Regelverstoß) *s*; -s, -

Fou|lard *fr.* [*fular*, schweiz.: *fular* (leichtes [Kunst]seidengewebe schweiz.: Halstuch aus [Kunst]seide) *m* (schweiz.) *s*; -s, -s; Fou|lar|dine [*fulardịn*] (ein Baumwoll gewebe) *w*; -; Fou|lé [*fule*] (ein Gewebe) *m*; -[s], -s

fou|len *engl.* [*faul*ᵉ*n*] (Sport: sich regelwidrig verhalten); Foul|spie|ᵉ [*faul*...] (regelwidriges Spielen) *s* -[e]s

Fou|qué [*fuke*] (dt. Dichter)

Four|gon *fr.* [*furgọ*ᵑ*ǥ*, schweiz. *furgọ*ᵑ*ǥ*] (veralt. für: Packwagen Vorratswagen; schweiz.: Militär-, Postlastauto) *m*; -s, -s

Fou|rier *fr.* [*furịr*] österr. u

¹ Vgl. die nicht eindeutschend ge schriebenen Stichwörter photo... Photo... auf S. 526 f.

schweiz. (milit.: ein Unteroffiziersgrad; schweiz. auch: Rechnungsführer) *m*; -s, -e; vgl. Furier.

Fox (Kurzform für: Foxterrier, Foxtrott) *m*; -[es], -e; **Fox|ter|ri|er** *engl.* [...*iᵉr*] (Hunderasse); **Fox|trott** *engl.-amerik.* („Fuchsschritt"; ein Tanz) *m*; -[e]s, -e u. -s

Foy|er *fr.* [*foaję*] (Vor-, Wandelhalle, Wandelgang [im Theater]) *s*; -s, -s

FPÖ = Freiheitliche Partei Österreichs

Fr = Franc

Fr = chem. Zeichen für: Francium

fr. = frei

Fr. = Frau; vgl. ²Franken

Fra *it.* (Ordens„bruder"; meist vor konsonantisch beginnenden Namen, z. B. Fra Tommaso); vgl. Frate

Fracht *w*; -, -en; **Fracht|brief**, ...**damp|fer**; **Frach|ten|aus|schuß** *m*; ...schusses; **Frach|ter** (Frachtschiff); **fracht|frei**; **Fracht|gut**, ...**raum**, ...**schiff**, ...**stück**, ...**verkehr**

Frack *engl. m*; -[e]s, Fräcke u. -s; **Frack_hemd**, ...**man|tel**, ...**we|ste**

Fra Dia|vo|lo [- *dịawolo*] („Bruder Teufel"; neapolitan. Räuberhauptmann)

fra|ge *w*; -, -n; († R 141:) in - kommen, stehen; **Fra|ge_bo|gen**, ...**für|wort** (für: Interrogativpronomen); **frä|geln** schweiz. mdal. (vorsichtig, listig fragen); ich ...[e]le († R 327); **fra|gen**; du fragst (landsch.: frägst); er fragt (landsch.: frägt); du fragtest (landsch.: frugst); gefragt; frag[e]!; **Fra|gen|kom|plex**; **Frager**; **Fra|ge|rei**; **Fra|ge_satz** (für: Interrogativsatz), ...**stel|lung**, ...**stun|de** (im Parlament); **Frage-und-Ant|wort-Spiel** († R 155); **Fra|ge_wort** (*Mehrz.* ...wörter), ...**zei|chen**

fra|gil *lat.* (zerbrechlich; zart); **Fra|gi|li|tät** *w*; -

-ag|lich; **Frag|lich|keit**; **frag|los** (sicher, bestimmt); **Frag|lo|sigkeit** *w*; -

Frag|ment *lat. s*; -[e]s, -e; **frag|menta|risch**; -ste († R 294)

Frag|ner bayr. u. österr. veralt. (Krämer, Kleinhändler) *m*; -s, -

frag|wür|dig; **Frag|wür|dig|keit**

fraise[e] *fr.* [*fräs*] (erdbeerfarben); mit einem fraise[e] Band

frai|sen südd., österr. (Krämpfe bei kleinen Kindern) *Mehrz.*

Frak|ti|on *fr.* [...*zion*]; **frak|tio|nell**; **Frak|tio|nie|rer|ap|pa|rat**; **frak|tionie|ren** (Gemische aus Flüssigkeiten mit verschiedenen Siedezeiten durch Verdampfung iso-

lieren); **fraktionierte Destillation**; **Frak|ti|ons_aus|schuß**, ...**dis|zi|plin** (*w*; -), ...**füh|rer**, ...**mit|glied**, ...**stär|ke**, ...**versamm|lung**, ...**vor|sit|zen|de**, ...**vor|stand**, ...**zwang**; **Frak|tur** *lat.* (Knochenbruch; dt. Schrift, Bruchschrift) *w*; -, -en; **Frak|turschrift**

Fram|bö|sie *fr.* (trop. Hautkrankheit) *w*; -, ...ien

Frame *engl.* [*frēᵉm*] (Rahmen, Träger in Eisenbahnfahrzeugen) *m*; -n, -n († R 268)

Franc *fr.* [*frąng*] (Währungseinheit; Abk.: fr, *Mehrz.* frs) *m*; -s [*frąng*]; 100 -; fr. Franc (Abk.: F, FF), belg. Franc (Abk.: bfr, *Mehrz.* bfrs); Luxemburger Franc (Abk.: lfr, *Mehrz.* lfrs); vgl. ²Frank und ²Franken

Fran|çai|se *fr.* [*frąngßäsᵉ*] (ein Tanz) *w*; -, -n

Fran|çaix [*frąngßä*] (fr. Komponist)

France, Anatole [*frąngß*] (fr. Schriftsteller); France' Werke († R 310)

Fran|ces|ca [*frantscheßka*] (it. w. Vorn.); **Fran|ces|co** [*frantscheßko*] (it. m. Vorn.)

Fran|chi|se *fr.* [*frąngschịsᵉ*] (Freisein von Abgaben, bes. beim Zoll u. im Versicherungsgeschäft; bestimmte Vertriebsform im Einzelhandel; veralt. für: Freiheit, Freimütigkeit) *w*; -, -n

Fran|ci|um [...*zium*] (chem. Grundstoff, Metall; Zeichen: Fr) *s*; -s

Fran|cke [zur *Trenn.*: † R 189] (dt. Theologe u. Pädagoge); **Francke|sche Stif|tun|gen** *Mehrz.*

Fran|co, Francisco [...*ko*] (span. Staatschef)

frank *mlat.-fr.* (frei, offen); - und frei

¹Frank (m. Vorn.)

²Frank (eindeutschende Schreibung für: Franc) *m*; -en, -en u. (bei Wertangaben auch:) -; vgl. Franc u. ²Franken

Fran|ka (w. Vorn.)

Fran|ka|tur *it.* (Bezahlung der Transportkosten vor Beginn der Beförderung) *w*; -, -en

Fran|ke (Angehöriger eines germanischen Volksstammes) *m*; -n, -n († R 268); **¹Fran|ken** (Land); **²Fran|ken** (schweiz. Währungseinheit; Abk.: fr, sFr.; im dt. Bankwesen: sfr, *Mehrz.* sfrs) *m*; -s, -; vgl. Franc u. ²Frank

Fran|ken|wald (ein Gebirge) *m*; -[e]s

Frank|furt am Main (Ortsn.); **¹Frank|fur|ter** († R 199); **²Frankfur|ter** (Frankfurter Würstchen) *w*; -, -; **Frank|fur|ter Schwarz**

(Farbe) *s*; - -; **frank|fur|tisch**; **Frank|furt** (Oder) (Ortsn.)

fran|kie|ren *it.*; **Fran|kier|ma|schine**

Frän|kin *w*; -, -nen; **frän|kisch**, aber († R 198): die Fränkische Schweiz

Frank|lin [*fränklin*] (nordamerik. Staatsmann u. Schriftsteller)

fran|ko *it.* (frei [die Transportkosten werden vom Absender bezahlt]); - nach allen Stationen; - Basel; - dort; - hier; - verzollt amerikanische Häfen

Fran|ko|bert (m. Vorn.)

Fran|ko|ka|na|dier [...*iᵉr*] (französisch sprechender Bewohner Kanadas); **fran|ko|ka|na|disch** (die fr. sprechenden Kanadier betreffend); † R 215

fran|ko|phil *germ.; gr.* (franzosenfreundlich); **fran|ko|phon** (französischsprachig); **Fran|ko|phonie** (Französischsprachigkeit) *w*; -

Frank|reich

Frank|ti|reur *fr.* [*frangtirör*] (früher für: Freischärler) *m*; -s, -e

Fräns|chen, **Fräns|lein** (kleine Franse); **Fran|se** *w*; -, -n; **fran|sen**; du franst (fransest); gefranst; **fran|sig**

Franz (m. Vorn.)

Franz_band (Ledereinband nach „französischer" Art; *m*), ...**brannt|wein**, ...**brot**, ...**bröt|chen**

Fränz|chen (Koseform von: Franz, Franziska); **Frän|ze** (Koseform von: Franziska); **Fran|ziska** (w. Vorn.); **Fran|zis|ka|ner** (Angehöriger des Mönchsordens der Franziskaner) *m*; -s, -; **Franzis|ka|ne|rin** (Angehörige des Ordens der Franziskanerinnen) *w*; -, -nen; **Fran|zis|ka|ner|or|den** (Abk.: OFM) *m*; -s; **Fran|zis|kus** (m. Vorn.)

Franz-Jo|seph-Land; † R 211 (eine Inselgruppe) *s*; -[e]s

Franz|mann (*Mehrz.* ...männer)

Fran|zo|se *m*; -n, -n († R 268); **fran|zo|sen|freund|lich**; **fran|zösie|ren** (zum Franzosen machen); nach fr. Art gestalten) **Fran|zösin** *w*; -, -nen; **fran|zö|sisch**; -er Kegel (Druckw.); -e Broschur; die französische Schweiz (der fr. Teil der Schweiz), aber († R 224): die Französische Republik; die Französische Revolution (1789–1794); vgl. deutsch; **Fran|zö|sisch** (Sprache) *s*; -[s]; vgl. Deutsch; **Fran|zö|si|sche** *s*; -n; vgl. Deutsche *s*; **fran|zö|si|sie|ren** vgl. französieren

frap|pant *fr.* (auffallend, überraschend; befremdend); **Frap|pé** [...*pe*] (Stoff mit eingeprägtem Muster) *m*; -s, -s; **frap|pie|ren**

Fräsdorn 282

(überraschen, befremden; Wein
u. Sekt in Eis kühlen)
Fräs|dorn (Mehrz. ...dorne); Frä-
se w; -, -n; fräsen; du fräst (frä-
sest), er fräste; Fräser (Mann
an der Fräse; Teil an der Fräsma-
schine); Fräs|ma|schi|ne
Fraß m; -es, -e
Fra|te it. (Ordens„bruder"; meist
vor vokalisch beginnenden Na-
men, z. B. Frate Elia, Frat' Anto-
nio); vgl. Fra; Fra|ter lat. ([Or-
dens]bruder) m; -s, Fra|tres; fra-
ter|ni|sie|ren fr. (sich verbrüdern;
vertraut werden); Fra|ter|ni|tät
lat. (Brüderlichkeit; Verbrüde-
rung; kirchl. Bruderschaft); Fra-
ter|ni|té vgl. Liberté; Fra|tres
(Mehrz. von: Frater)
Fratz it. (ungezogenes Kind;
schelmisches Mädchen) m; -es
(österr.: -en), -e u. (österr. nur:)
-en; Frätz|chen, Frätz|lein; Frat-
ze (verzerrtes Gesicht) w; -, -n;
Frat|zen|ge|sicht; frat|zen|haft
Frau (Abk.: Fr.) w; -, -en; Frau-
chen
frau|du|lös fr. (veralt. für: betrüge-
risch); -este (↑ R 292)
Frau|en.arzt, ...be|ruf, ...be|we-
gung (w; -), ...eis (ein Mineral),
...eman|zi|pa|ti|on
Frau|en|feld (Hptst. des Thur-
gaus)
Frau|en.fra|ge (w; -), ...haar (Na-
me verschiedener Pflanzen; s;
-[e]s); frau|en|haft; Frau|en.held,
...heil|kun|de (für: Gynäkologie),
...ken|ner, ...klo|ster, ...krank-
heit, ...lei|den, ...recht|le|rin (w;
-, -nen); frau|en|recht|le|risch;
Frau|en|schuh (Name verschiede-
ner Pflanzen) m; -[e]s; Frau|ens-
.leu|te, ...per|son; Frau|en.tum (s;
-s), ...über|schuß, ...wahl|recht,
...zim|mer; Frau|ke (w. Vorn.);
Fräu|lein (Abk.: Frl.) s; -s, - (ugs.
auch: -s); - Müllers Adresse; die
Adresse - Müllers, des - Müller,
Ihres-Tochter; Ihr, (veralt.:) Ihrer
- Braut, Tochter; frau|lich; Frau-
lich|keit w; -
Fraun|ho|fer|sche Li|nien [nach
dem dt. Physiker Fraunhofer]
(Linien im Sonnenspektrum)
Mehrz.
frdl. = freundlich
frech; Frech.dachs, ...heit; Frech-
ling
Fred [fret, frät] (Kurzform zu: Al-
fred, Manfred)
Free|hol|der engl. [friho"ldᵉr] (frü-
her: lehnsfreier Grundeigentü-
mer in England) m; -s, -s
Free|sie [frēsiᵉ; nach dem Kieler
Arzt Freese] (eine Zierpflanze) w;
-, -n
Free|town [frītaun] (Hptst. von
Sierra Leone)

Fre|gat|te fr. (früher für: schnellse-
gelndes, vollgetakeltes Kriegs-
schiff; Geleitschiff) w; -, -n; Fre-
gat|ten|ka|pi|tän; Fre|gatt|vo|gel
frei (Abk.: fr.); -er, -[e]ste (↑ R 293).
I. Kleinschreibung: - deutschen
Ausfuhrhafen, - deutsche Grenze
liefern; das Signal steht auf frei
(↑ R 136); der -e Fall; der -e Mann;
der -e Wille; der -e Raum; -e Aus-
sicht; -e Beweisführung; -e Ent-
faltung; -e Fahrt; -e Liebe; -e
Marktwirtschaft; -e Station; -e
Ansichten; -e Berufe; -e Rhyth-
men; -e Rücklagen; -e Wahlen;
-er Eintritt; -er Journalist; -er
Mitarbeiter; -er Schriftsteller;
aus -em Antrieb; das -e Spiel der
Kräfte; in -er Wildbahn; -es Ge-
leit zusichern; dort herrscht ein
-er Ton; jmdm. -e Hand, -es Spiel
lassen; jmdn. auf -en Fuß setzen.
II. Großschreibung: a) (↑ R 116:)
das Freie, im Freien, ins Freie;
b) (↑ R 224:) Sender Freies Berlin
(Abk.: SFB); Freie Demokrati-
sche Partei (Abk.: FDP u. par-
teiamtlich: F. D. P.); Freie Deut-
sche Jugend (DDR; Abk.: FDJ);
die Sieben Freien Künste (im
Mittelalter); Freier Architekt (im
Titel, sonst: [er ist ein] freier Ar-
chitekt); Freie und Hansestadt
Hamburg; Freie Hansestadt Bre-
men, aber: Frankfurt war lange
Zeit eine freie Reichsstadt (vgl.
I). III. In Verbindung mit Zeitwör-
tern (↑ R 139): a) Getrenntschrei-
bung, wenn „frei" in der Bedeu-
tung „nicht abhängig", „nicht
gestützt" usw. als selbständiges
Satzglied steht, z. B. frei sein,
werden, bleiben, halten; b) Zu-
sammenschreibung, wenn „frei"
bloßes Vorwort des Zeitworts
ist, z. B. freihalten (vgl. d.; ich
halte frei; freigehalten; freizuhal-
ten)
Freia vgl. Freyja
Frei.bad, ...bank (Mehrz. ...bän-
ke); frei|be|kom|men; eine Stun-
de, die Arme freibekommen;
aber: frei (unentgeltlich) be-
kom|men; vgl. frei, III
Frei|berg (Stadt im Erzgebirge)
frei|be|ruf|lich; Frei|be|trag; Frei-
beu|ter (Seeräuber); Frei|beu|te-
rei; frei|beu|te|risch; Frei|bier s;
-[e]s; frei blei|ben; vgl. frei, III;
frei|blei|bend (Kaufmannsspr.
beim Angebot: ohne Verbind-
lichkeit, ohne Verpflichtung);
(vgl. S. 45, Merke, 2:) das -e An-
gebot, das Angebot ist -; Frei-
.bord (Höhe des Schiffskörpers
über der Wasserspiegellinie; m),
...brief
Frei|burg im Breis|gau (Stadt in
Baden-Württemberg); Frei|burg

im Üecht|land [- - üächt...] od
Ücht|land (Stadt in der Schweiz)
Frei|den|ker; frei|den|ke|risch; -ste
(↑ R 294)
Freie (früher für: jmd., der Rechts-
fähigkeit u. polit. Rechte besitzt)
m; -n, -n (↑ R 287ff.)
frei|en; Freier; Frei|ers|fü|ße
Mehrz., nur in: auf -n gehen;
Frei|ers|mann (Mehrz. ...leute)
Frei.ex|em|plar, ...frau, ...frä
lein; frei|ge|ben; vgl. frei, III; frei
ge|big; Frei|ge|big|keit; Frei.ge
he|ge, ...geist (Mehrz. ...geister)
Frei|gei|ste|rei; frei|gei|stig; Frei
ge|las|se|ne m u. w; -n, -n (↑ R
287ff.); Frei.ge|richt, ...graf
...gut, ...ha|fen (vgl. ²Hafen); frei
hal|ten; ich werde dich - (für dich
bezahlen); ich werde den Stuhl
- (belegen); die Ausfahrt - (nich
verstellen); aber: frei hal|ten; ic
kann das Gewicht frei halten (oh
ne Stütze); vgl. frei, III; Frei
hand|bü|che|rei (in der man de
Lesestoff aus den Regalen ent
nehmen kann); Frei|han|del m; -s
Frei|han|dels|zo|ne; frei|hän|dig
Frei|hän|dig|keit w; -; Frei|hand
zeich|nen s; -s; Frei|heit; frei|hei
lich; Frei|heits.be|griff, ...be|rau
bung, ...drang, ...ent|zug; fre
heits|feind|lich; Frei|heits|krie
freiheits|lie|bend; Frei|heits.sta
tue, ...stra|fe; frei|her|aus; etwa
freiheraus sagen, etwa: ihr hat
frei (ohne Hemmung) herausga
gen; Frei|herr (Abk.: Frhr.); Fre
herrn|stand m; -[e]s; Frei|in (Fre
fräulein) w; -, -nen; Frei|kar|te
frei|kau|fen (durch ein Lösegel
befreien); frei|kom|men (loskom
men); vgl. frei, III; Frei|kör|pe
kul|tur (Abk.: FKK); Frei.korp
...la|de|bahn|hof, ...land (s; -[e]s
Frei|land|ge|mü|se; frei|las|se
(einen Gefangenen), aber: fr
las|sen (einen Platz u. a.); vg
frei, III; Frei.las|sung, ...lau
frei|lau|fen, sich (beim Fußball
spiel), aber: frei lau|fen (oh
Hilfeleistung, ohne Stock); vg
frei, III; frei|le|bend; frei|le|ge
(entblößen; deckende Schich
entfernen), aber: frei le|ge
([Leitung] ohne besonderer
Schutz legen); vgl. frei, III; Fre
.le|gung, ...lei|tung
frei|lich
Frei|licht.büh|ne, ...ma|le|re
...mu|se|um
Frei|lig|rath (dt. Dichter)
Frei|luft|schu|le; frei|ma|ch
(Postw.); ein paar Tage - (Urla
machen); sich - (Zeit nehmen
aber: frei ma|chen (Plätze, Stü
le); vgl. frei, III; Frei|ma|chu
(Postw.); Frei|mar|ke; Frei|ma
rer; Frei|mau|re|rei w; -; frei|ma

re|risch; Frei|mau|rer|lo|ge; Frei-
mund (m. Vorn.); Frei|mut; frei-
mü|tig; Frei|mü|tig|keit; Frei_pla-
stik, ...platz; frei|re|li|gi|ös; Frei-
saß, Frei|sas|se; frei|schaf|fend;
(vgl. S. 45, Merke, 2:) der frei-
schaffende Künstler; Frei_schar,
...schär|ler; frei|schwim|men, sich
(die Schwimmprüfung ablegen),
aber: frei schwim|men (ohne
Hilfeleistung, ohne Schwimm-
gürtel); vgl. frei, III; Frei|schwim-
mer; frei sein; vgl. frei, III; Frei-
sinn m; -[e]s; frei|sin|nig; frei|spre-
chen (von Schuld), aber: frei
spre|chen (ohne schriftliche Un-
terlage); vgl. frei, III; Frei_spre-
chung, ...spruch, ...staat (Mehrz.
...staaten), ...statt od. ...stätte;
frei|ste|hen; das soll dir - (gestat-
tet sein); ein freistehendes (leeres)
Haus, aber: frei (ohne Stütze)
ste|hen; frei stehendes Gerüst,
Haus (für sich stehend); vgl. frei,
III; frei|stel|len (erlauben);
jmdm. etwas -, aber: frei (ohne
Stütze) stel|len; vgl. frei, III; Frei-
stem|pel (Postw.); Frei|stil-
schwim|men s; -s; Frei|stoß (beim
Fußball); [in]direkter -; Frei-
_stück, ...stun|de
"rei|tag m; -[e]s, -e; (↑ R 224.) der
Stille Freitag (Karfreitag); vgl.
Dienstag; frei|tags (↑ R 129); vgl.
Dienstag
"rei|te (Brautwerbung) w; -, meist
in: auf die - gehen
"rei_tisch, ...tod (Selbstmord);
frei|tra|gend; eine -e Brücke; Frei-
_trep|pe, ...übung; frei wer|den;
vgl. frei, III, das Freiwerden (↑ R
120); Frei|wild; frei|wil|lig; die -e
Feuerwehr, aber (↑ R 224): die
Freiwillige Feuerwehr Nassau;
Frei|wil|li|ge m u. w; -n, -n (↑ R
287ff.); Frei_wil|lig|keit (w; -),
...zei|chen, ...zeit; Frei|zeit_ge-
stal|tung, ...hemd, ...ko|stüm; frei-
zü|gig; Frei|zü|gig|keit w; -
-emd; frem[d]|ar|tig; Fremd|ar|tig-
keit; ¹Frem|de m u. w; -n, -n (↑ R
287ff.); ²Frem|de (Ausland) w; -;
in der -; frem|deln (landsch.); ich
..[e]le (↑ R 327) u. in. frem|den
schweiz. (vor Fremden scheu,
ängstlich sein); Frem|den_bett,
...buch, ...füh|rer, ...heim, ...le|gi-
on, ...ver|kehr, ...zim|mer; fremd-
gehen (ugs. für: untreu sein);
¹remd_gut, ...heit (Fremdsein),
..herr_schaft, ...kör|per; fremd-
än|disch; Fremd|ling; Fremd-
pra|che (eine fremde Sprache),
remde Sprache sprechend); -er
in einer Fremdsprache gehalte-
er) Unterricht; -er Druck;
remd|sprach|lich (auf eine frem-
le Sprache bezüglich); -er (über
ine Fremdsprache gehaltener)

Unterricht; Fremd|stäm|me
Mehrz.; fremd|stäm|mig; Fremd-
stäm|mi|ge m u. w; -n, -n (↑ R
287ff.); Fremd|stäm|mig|keit w;
-; Fremd|wort (Mehrz. ...wörter);
Fremd|wör|ter|buch; fremd|wort-
frei
fre|ne|tisch fr. (rasend); -er Beifall;
vgl. aber: phrenetisch
fre|quent lat. (veralt. für: zahl-
reich; Med.: beschleunigt [vom
Puls]); Fre|quen|tant (veralt. für:
regelmäßiger Besucher) m; -en,
-en (↑ R 268); Fre|quen|ta|ti|on
[...zion] w; -; fre|quen|tie|ren (häu-
fig besuchen; ein- u. ausgehen;
verkehren); Fre|quenz (Besuch,
Besucherzahl, Verkehrsdichte;
Schwingungs-, Periodenzahl) w;
-, -en; Fre|quenz_li|ste (veralt. für:
Anwesenheitsliste), ...mes|ser
(zur Zählung der Wechselstrom-
perioden; m)
Fres|ke fr. w; -, -n u. Fres|ko it.
(„frisch"; Wandmalerei auf
feuchtem Kalkputz) s; -s, ...ken;
vgl. a fresco; Fres|ko|ma|le|rei
Fres|sa|li|en [...i^en] (scherzh. für:
Eßwaren) Mehrz.; Fres|se (derb
für: Mund, Maul) w; -, -n; fres-
sen; du frißt (frissest), er frißt;
du fraßest; du fräßest; gefressen;
friß!; Fres|sen s; -s; Fres|ser; Fres-
se_rei; Freß_gier, ...korb (ugs.),
...pa|ket (ugs.), ...sack (ugs.),
...werk|zeu|ge (Zool.; Mehrz.)
Frett|chen niederl. (Iltisart) s; -s, -
fret|ten, sich österr. (sich abmü-
hen, sich kümmerlich durchbrin-
gen)
fret|tie|ren niederl. (Jägerspr.: mit
dem Frettchen jagen)
Freud (österr. Psychiater u. Neu-
rologe)
Freu|de w; -, -n; [in] Freud und
Leid (↑ R 241); Freu|den_be|cher,
...bot|schaft, ...fest, ...feu|er, ...ge-
heul, ...haus; freu|de[n]|los, freud-
los; Freu|de[n]|lo|sig|keit, Freud-
lo|sig|keit w; -; Freu|den|mäd-
chen (gch. verhüllend für: Dirne);
freu|den|reich; Freu|den_ruf,
...sprung, ...tag, ...tanz, ...tau|mel,
...trä|ne; freu|de|strah|lend, aber
(↑ R 142): vor Freude strahlend;
freu|de|trun|ken
Freu|dig|ner (Schüler, Anhänger
Freuds)
freu|dig; ein -es Ereignis; Freu|dig-
keit w; -; freud|los, freu|de[n]|los;
Freud|lo|sig|keit, Freu|de[n]|lo-
sig|keit w; - freu|en sich; -
freund; (↑ R 132:) jmdm. - (freund-
lich gesinnt) sein, bleiben, wer-
den; Freund m; -[e]s, -e; jemandes
- bleiben, sein, werden; gut - sein;
Freund|chen (meist [scherzh.]
drohend als Anrede); Freun|des-
_kreis, ...treue; Freun|din w; -, -

-nen; freund|lich (Abk.: frdl.);
freund|li|cher|wei|se; Freund|lich-
keit; freund|nach|bar|lich;
Freund|schaft; freund|schaft|lich;
Freund|schafts_ban|de (Mehrz.),
...be|weis, ...dienst, ...spiel
(Sport), ...ver|trag
fre|vel; frevler Mut; Fre|vel m; -s,
-; Fre|vel|haft; Fre|vel|haf|tig|keit
w; -; Fre|vel|mut; fre|veln; ich
..[e]le (↑ R 327); Fre|vel|tat; fre-
vent|lich; Frev|ler; Frev|le|rin w;
-, -nen; frev|le|risch; -ste (↑ R 294)
Frey, Freyr (nord. Mythol.: Gott
der Fruchtbarkeit u. des Frie-
dens)
Frey|burg/Un|strut (Stadt an der
unteren Unstrut)
Frey|ja (nord. Mythol.: Lie-
besgöttin)
Frey|tag (dt. Dichter)
Frhr. = Freiherr
Fri|aul (it. Landschaft)
Fricsay, Ferenc [fritschai] (ung.
Dirigent)
Fri|de|ri|cus [...kuß] (lat. Form für:
Friedrich); - Rex (König Fried-
rich [der Große]); fri|de|ri|zia-
nisch
Fri|do|lin (m. Vorn.)
Frie|da (w. Vorn.); Fried|bert,
Frie|de|bert (m. Vorn.)
Frie|de (älter, geh. für: Frieden)
m; -ns, -n; [in] Fried und Freud
(↑ R 241)
Frie|del (Koseform für: Fried-
rich, Gottfried, Elfriede u. a.)
Frie|dell, Egon (österr. Schriftstel-
ler)
Frie|de|mann, Fried|mann (m.
Vorn.)
frie|den (selten für: einfrieden, be-
frieden); gefriedet; Frie|den (äl-
ter, geh. auch: Friede) m; -s, -;
Frie|dens_be|din|gung, ...bruch
m, ...fahrt (DDR), ...for|schung,
...freund (DDR), ...kon|fe|renz,
...kurs, ...la|ger (DDR), ...lie|he,
...no|bel|preis, ...pfei|fe, ...po|li-
tik, ...rich|ter, ...schluß; Frie-
den[s]_stif|ter, ...stö|rer; Frie-
dens_tau|be, ...ver|hand|lun|gen
(Mehrz.), ...ver|trag, ...wacht
(DDR), ...zei|chen, ...zeit
Frie|der (m. Vorn.); Frie|de|ri|ke
(w. Vorn.)
fried|fer|tig; Fried|fer|tig|keit
Fried|helm (m. Vorn.)
Fried|hof; Fried|hofs_ka|pel|le,
...we|sen (s; -s)
Fried|län|der (Bez. Wallensteins
nach dem Herzogtum Friedland;
einer aus Wallensteins Mann-
schaft); fried|län|disch
fried|lich; Fried|lich|keit w; -; fried-
_lie|bend, ...los; Fried|lo|sig|keit
w; -
Fried|mann, Frie|de|mann (m.
Vorn.)

Frie|do|lin vgl. Fridolin; Fried|rich (m. Vorn.); Friedrich der Große (↑ R 224)

Fried|rich|ro|da (Stadt am Nordrand des Thüringer Waldes)

Fried|richs|dor (alte Goldmünze) m; -s, -e; 10 - (↑ R 322)

Fried|richs|ha|fen (Stadt am Bodensee)

fried|sam (veralt.); Fried|sam|keit (veralt.) w; -; fried|se|lig (veralt.)

frie|ren; du frierst; du frorst; du frörest; gefroren; frier[e]!; ich friere an den Füßen; mich friert an den Füßen (nicht: an die Füße); mir od. mich frieren die Füße

Fries fr. (Gesimsstreifen, Verzierung; ein Gewebe) m; -es, -e

Frie|se (Angehöriger eines germ. Stammes an der Nordseeküste) m; -n, -n (↑ R 268)

Frie|sel (Hautbläschen, Pustel) m od. s; -s, -n (meist Mehrz.); Frie|sel|fie|ber; Frie|seln (Hautausschlag) Mehrz.

Frie|sin w; -, -nen; frie|sisch; Friesland; Fries|län|der m; fries|ländisch

Frigg (nord. Mythol.: Wodans Gattin); vgl. Frija

fri|gid, fri|gi|de lat. ([gefühls]kalt, kühl; geschlechtlich nicht hingabefähig; Fri|gi|daire ⓦ fr. [frisehidär, auch: frigi..., ugs. u. österr.: fridsehi...] (eine Kühlschrankmarke) m; -s, -[s]; Fri|gi|da|ri|um lat. (Abkühlungsraum [in altröm. Bädern]) s; -s, ...ien [...i°n]; fri|gi|de vgl. frigid; Fri|gi|di|tät (Med.: geschlechtl. Empfindungslosigkeit [von Frauen]) w; -

Fri|ja (altd. Name für: Frigg)

Fri|ka|dell|le it. w; -, -n; Fri|kandeau fr. [...kandọ] (Teil der [Kalbs]keule) s; -s, -s; Fri|kan|del|le (Schnitte aus gedämpftem Fleisch) w; -, -n; Fri|kas|see s; -s, -s; fri|kas|sie|ren

fri|ka|tiv lat. (auf Reibung beruhend); Fri|ka|tiv m; -s, -e [...w°] (meist Mehrz.) u. Fri|ka|tiv|laut (Sprachw.: Reibelaut, z. B. f, sch); Frik|ti:on [...zion] (Reibung); frik|ti|ons|los

Fri|maire [frimär] („Reifmonat" der Fr. Revolution: 21. Nov. bis 20. Dez.) m; -[s], -s

Frisch (schweiz. Erzähler u. Dramatiker)

frisch; -este (↑ R 292); etwas - halten; sich - machen; auf -er Tat ertappen; frisch-fröhlich (↑ R 158). In Verbindung mit dem 2. Mittelwort immer getrennt (↑ R 142); die frisch getünchte Wand; der frisch gebackene Kuchen; vgl. jedoch: frischbacken; frischauf!; frischweg; (↑ R 134:) von frischem, aufs frische; (↑ R 198:) die Frische Nehrung, das Frische Haff; frisch|auf!; frisch|backen [Trenn.: ...bak|ken]; ein frischbackenes Brot; Frisch|blut (erst vor kurzer Zeit entnommenes Blut); Fri|sche w; -; fri|schen (veralt. für: erfrischen, erneuern; Hüttenw.: Metall herstellen, reinigen; von der Wildsau: Junge werfen); du frischst (frischest); du frisch-fröh|lich; vgl. frisch; Frisch|ge|mü|se; Frisch|hal|te-packung [Trenn.: ...pak|kung]; Frisch|kost; Frisch|ling (Junges vom Wildschwein); Frisch..milch, ...was|ser (Süßwasser auf Schiffen [für Dampfkessel]) s; -s; frisch|weg; Frisch|zel|le; Frisch|zel|len..be|hand|lung, ...the|ra|pie

Fris|co (amerik. Abkürzung für: San Francisco)

Fri|seur germ.-fr. [...sör] m; -s, -e; vgl. auch: Frisör; Fri|seu|se w; -, -nen; Fri|seur|sa|lon; Fri|seu|se [...sös°] w; -, -n; Fri|sie|ren (ugs. auch: herrichten, putzen); Fri|sier.kom|mo|de, ...sa|lon, ...toi|let|te

Fris|ko (eindeutschend für: Frisco)

Fri|sör usw. (eindeutschend für: Friseur usw.)

Frist w; -, -en; fri|sten; frist.gemäß, ...los; -e Entlassung; Frist|wech|sel (Kaufmannsspr.: Datowechsel)

Fri|sur w; -, -en

Fri|teu|se fr. [...tös°] (elektr. Gerät zum Fritieren) w; -, -n

Frit|flie|ge (gefährlicher Getreideschädling)

Frit|hjof (norweg. Held); Frit|hjof[s]|sa|ge w; -

fri|tie|ren fr.; Fleisch, Kartoffeln - (in schwimmendem Fett braun braten); Frit|ta|te it. (Eierkuchen) w; -, -n; Frit|te fr. („Gebak|kenes"; Schmelzgemenge) w; -, -n; frit|ten (eine Fritte machen; [von Steinen:] sich durch Hitze verändern; ugs. auch für: fritieren); Frit|tü|re fr. (heißes Ausbackfett; die darin gebackene Speise) w; -, -n

Fritz (Kurzform von: Friedrich); ...frit|ze (ugs. abschätzig, z. B. Filmfritze, Versicherungsfritze, Zeitungsfritze u. a.; m; -n, -n)

fri|vol fr. [...wọl] (leichtfertig; schlüpfrig); Fri|vo|li|tät w; -, -en; Fri|vo|li|tä|ten|ar|beit (mit Schiffchen hergestellte Handarbeit)

Frl. = Fräulein

Frö|bel (dt. Pädagoge)

froh; -er, -[e]ste (↑ R 293); -en Sinnes (↑ R 275); -es Ereignis, aber (↑ R 224): die Frohe Botschaf (Evangelium); Froh|bot|schaf (für: Evangelium) w; -; Fro|hei [Trenn.:↑R 163](veralt.) w; -; froh|ge|launt; froh|ge|mut; fröh|lich, Fröh|lich|keit w; -; froh|locken [Trenn.: ...lok|ken]; frohlock (↑ R 304); Froh|lockung [Trenn.: ...lok|kung]; Froh|mut; froh|mü|tig; Froh|sinn m; -[e]s; froh|sin|ni; Fro|mage de Brie fr. [fromaseh d -] (Briekäse) m; - - -

fromm; (↑ R 295:) frommer od frömmer, frommste od. frömmste; From|me (veralt. für: Ertrag Nutzen) m; -n, noch gebräuchlich in: zu Nutz und -n; Fröm|me|le fröm|meln (sich fromm zeigen) ich ...[e]le (↑ R 327); from|men (nutzen); es frommt ihm nicht Fromm|heit w; -; fromm|her|zig Fröm|mig|keit w; -; Fömm|ler Frömm|le|rei; Frömm|le|rin w; - -nen; fromm|le|risch

[1]Fron (hist. für: Gerichtsbote Amtsbote) m; -[e]s u. -en (↑ R 268), -e[n]; [2]Fron (dem [Lehns. herrn zu leistende Arbeit; Her rendienst) w; -, -en; Fron|ar|bei (schweiz. auch: unbezahlte Ar beit für Gemeinde, Genossen schaft, Verein); [1]Fron|de (veralt für: [2]Fron) w; -, -n

[2]Fron|de fr. [frọnsd°] (regierungs feindliche Partei; Auflehnung) w -, -n

fron|den (veralt. für: fronen)

Fron|deur fr. [frongdör] (Anhänge der [2]Fronde) m; -s, -e

Fron|dienst (Dienst für de [Lehns]herrn)

fron|die|ren fr. [frongdịr°n] (W derspruch erheben; gegen die R gierung arbeiten)

fro|nen (Frondienste leisten); fronen ([einer Leidenschaft] huld gen); Frö|ner (Arbeiter im Frondienst); Fron|leich|nam („de Herrn Leib"; kath. Fest) m; -[e] Fron|leich|nams.fest, ...pro|ze si|on

Front fr. w; -, -en; - machen (sic widersetzen); Front|ab|schnit fron|tal; Front|an|griff; Fron .an|trieb, ...bo|gen (Bauw. ...brei|te; Fron|ti|spiz (Vordergibel; Titelblatt [mit Titelbild]) -es, -e; Front..kämp|fer, ...sol|da ...wand (Stirnwand), ...wech|se (Meinungswechsel)

Fron|vogt

Frosch m; -[e]s, Frösche; Frosch biß (Sumpf- u. Wasserpflanze Frösch|chen, Frösch|lein; Frosch .go|scherl (österr. ugs. fü Löwenmaul; geraffte Borte a Trachtenkleidern; s; -s, -n), ...kö nig (eine Märchengestal ...laich; Frösch|lein, Frösch|che

Frosch_mann (*Mehrz.* ...männer), ...per|spek|ti|ve, ...schen|kel

Frost *m*; -[e]s, Fröste; frost|an|fällig; Frost_auf|bruch, ...beu|le; fröste|lig, fröst|lig, frö|steln; ich ...[e]le (↑ R 327); mich fröstelt; fro|sten; Fro|ster (Tiefkühlteil einer Kühlvorrichtung) *m*; -s, -; Frost|ge|fahr; fro|stig; Fro|stigkeit; Fröst|ler; fröst|lig, frö|stelig; Fröst|ling; Frost_scha|den, ...schutz, ...span|ner (ein Schmetterling)

Frot|tee *fr.* (Gewebe mit noppiger Oberfläche) *s od. m*; -[s], -s; Frottee_kleid, ...tuch (vgl. Frottiertuch); Frot|teur [...*tör*] (verolt. für: Reiber, Bohner) *m*; -s, -e; frot|tie|ren; Frot|tier|tuch *m* (*Mehrz.* ...tücher)

Frot|zeln (ugs. für: necken, aufziehen); ich ...[e]le (↑ R 327)

Frucht *w*; -, Früchte; frucht|bar; Frucht|bar|keit *w*; -; Frucht|barma|chung; Frucht|bo|den; fruchtbrin|gend; Frücht|chen, Früchtlein; Früch|te|brot, (österr.:) Früch|ten|brot *s*; -[e]s; fruch|ten; es fruchtet (nutzt) nichts; Früchten|brot (österr. für: Früchtebrot); früch|te|reich, frucht|reich; Frucht_fol|ge (Anbaufolge der einzelnen Feldfrüchte), ...geschmack; fruch|tig (z. B. vom Wein); ...fruch|tig (z. B. einfruchtig); Frucht|kno|ten; Frücht|lein, Frücht|chen; frucht|los; Fruchtlo|sig|keit *w*; -; Frucht|pres|se; frucht|reich, früch|te|reich; Frucht_saft, ...staub, ...was|ser (*s*, -s), ...wech|sel, ...zucker [*Trenn.:* ...zuk|ker]

Fruc|to|se *lat.* (Fruchtzucker) *w*; - ru|gal *lat.* (mäßig; einfach; heute ugs. vielfach für: üppig, schlemmerhaft); Fru|ga|li|tät *w*; - ...üh (früh[e]stens; «er Winter; eine -e Sorte Äpfel; (↑ R 134:) zum, mit dem, am früh[e]sten; frühmorgens; morgens früh; von [morgens] früh bis [abends] spät; morgen früh; Dienstag früh; frühestmöglich (vgl. d.); allzufrüh; früh|auf; von -; Früh_aufste|her, ...beet, ...druck (*Mehrz.* ...drucke) Frü|he *w*; -; in der -; in aller -; bis in die Früh; Früh_dia|gno|se (Med.), ...ehe; frü|her; früh|hest|mög|lich; zum -en Termin; Früh|ge|burt; früh|go|tisch; Früh|in|va|li|di|tät; Früh|jahr; früh|jahrs; Früh|jahrs_an|fang, ...be|stel|lung, ...mü|dig|keit; Früh|jahrs-Tag und|nacht|gleiche *w*; -, -n; Früh|ling *m*; -s, -e; früh|lings (zuweilen für: frühjahrs); Früh|lings_an|fang, ...fest; früh|ling[s]|haft; Früh|lings_monat od. ...mond (März), ...tag,

...zeit; Früh|met|te; früh|morgens; früh|neu|hoch|deutsch; vgl. deutsch; Früh|neu|hoch|deutsch (Sprache) *s*; -[e]s; vgl. Deutsch; Früh|neu|hoch|deut|sche *s*; -n; vgl. Deutsche *s*; früh|reif; Früh_reif (gefrorener Tau), ...rei|fe (*w*; -), ...schop|pen, ...sport, ...sta|di|um, ...start, ...stück; früh|stücken [*Trenn.:* ...stük|ken]; gefrühstückt; Früh|stücks_brot, ...pause; früh|zei|tig

Fruk|ti|dor [*frük*...] (,,Fruchtmonat‘‘ der Fr. Revolution: 18. Aug. bis 16. Sept.) *m*; -[s], -s; Fruk|ti|fika|ti|on *lat.* [...*zion*] (Bot.: Fruchtbildung; verolt. für: Nutzbarmachung, Verwertung); frukti|fi|zie|ren; Fruk|to|se vgl. Fructose

Fru|stra|ti|on *lat.* [...*zion*] (Psych.: Erlebnis der Enttäuschung u. Zurücksetzung durch erzwungenen Verzicht od. Versagung von Befriedigung); fru|stra|torisch (veralt. für: auf Täuschung berechnet); fru|strie|ren (enttäuschen; veralt. für: vereiteln, täuschen); Fru|strie|rung

Frut|ti *it.* (Früchte) *Mehrz.*

F-Schlüs|sel (Musik)

ft = Foot

Ft = Forint

Fuchs *m*; -es, Füchse; Fuchs|bau (*Mehrz.* ...baue); Füchs|chen, Füchs|lein; fuch|sen; sich - (ugs. für: sich ärgern); du fuchst (fuchsest) dich; das fuchst (ärgert) ihn; Fuchs|hatz

Fuch|sie [...*iᵉ*; nach dem Botaniker Leonhard Fuchs] (eine Zierpflanze) *w*; -, -n

fuch|sig (fuchsrot; fuchswild)

Fuch|sin (roter Farbstoff) *s*; -s

Füchs|in *w*; -, -nen; Fuchs|jagd; Füchs|lein, Füchs|chen; Fuchs_loch, ...pelz; fuchs|rot; Fuchsschwanz; fuchs|schwän|zeln (veralt. für: nach dem Munde reden); ich ...[e]le (↑ R 327) od. fuchsschwän|zen; du fuchsschwänzt (fuchsschwänzest); Fuchsschwän|zer (veralt.); fuchs|[teufels]|wild

Fuch|tel [(Schlag mit der) Klinge; Stock; strenge Zucht; österr. ugs.: herrschsüchtige, zänkische Frau) *w*; -, -n; fuch|teln; ich ...[e]le (↑ R 327); fuch|tig (ugs. für: zornig, aufgebracht)

fud. = fudit

Fu|der (Wagenladung, Fuhre; Hohlmaß für Wein) *s*; -s, -; fu|derwei|se

fu|dit *lat.* (auf künstlerischen Gußwerken: ,,hat [es] gegossen‘‘; Abk.: fud.)

Fu|dschi|ja|ma [...*dschi*...] (jap. Vulkan) *m*; -s

Fuff|zehn (landsch.), in: [‘ne] - machen (Pause machen); Fuff|ziger landsch. (Fünfzigpfennigstück) *m*; -s, -; ein falscher - (unaufrichtiger, hinterlistiger Mensch)

Fug *m*, nur noch in: mit - und Recht

fu|ga to *it.* (Musik: fugenartig); Fu|ga|to *s*; -s, -s u. ...ti

¹Fu|ge (Furche, Nute) *w*; -, -n

²Fu|ge *lat.-it.* (mehrstimmiges Tonstück mit bestimmtem Aufbau) *w*; -, -n

fu|gen (¹Fugen ziehen); fü|gen; sich -

Fu|gen|form

fu|gen|los

Fu|gen-s (↑ R 149) *s*; -, -

Fu|gen|stil (Musik) *m*; -[e]s

Fu|gen|zei|chen (Sprachw.: die Fuge einer Zusammensetzung kennzeichnender Laut od. kennzeichnende Silbe, z. B. -esin: ,,Liebesdienst‘‘)

Fug|ger (Augsburger Kaufmannsgeschlecht im 15. u. 16. Jh.); Fugge|rei (Handelsgesellschaft der Fugger; Stadtteil in Augsburg) *w*; -

fu|gie|ren (ein Thema nach Fugenart durchführen)

füg|lich; füg|sam; Füg|sam|keit *w*; -; Fü|gung; Fü|gung

fühl|bar; Fühl|bar|keit *w*; -; füh|len; er hat den Schmerz gefühlt, aber (↑ R 305): er hat das Fieber kommen fühlen (od. gefühlt); Füh|ler; Fühl|horn (*Mehrz.* ...hörner); fühl|los; Fühl|lo|sig|keit *w*; -; Füh|lung; Fühl|lung|nah|me *w*; - Fuhr|re *w*; -, -n

Füh|re (Bergsteigen: Route) *w*; -, -n; füh|ren; Buch -; Füh|rer; Führer|haus; Füh|re|rin *w*; -, -nen; führer|los; Füh|rer_schein, ...stand; füh|rig usw. vgl. geführig usw.

Fuhr_lohn, ...mann (*Mehrz.* ...männer u. ...leute), ...park

Füh|rung; Füh|rungs_an|spruch, ...schie|ne (Technik), ...spit|ze, ...stab, ...tor (Sportspr.), ...zeugnis

Fuhr_un|ter|neh|mer, ...werk; fuhrwer|ken; ich fuhrwerke; gefuhrwerkt; zu fuhrwerken; Fuhrwerks|len|ker

Fu|ji|ya|ma [*fudschija*...] (engl. Schreibung von: Fudschijama)

Ful|be (westafrik. Volk) *Mehrz.*

¹Ful|da (Quellfluß der Weser) *w*; -; ²Ful|da (Stadt a. d. Fulda); Fulda|er (↑ R 199); ful|disch

Ful|gu|rit *lat.* (Blitzröhre; Sprengstoff; [*Einz.:*] ⌾ Asbestzementbaustoff) *m*; -s, -e

full dress *engl.* (großer Gesellschaftsanzug, Staatskleid) *m*; - -

Fül|le *w*; -; fül|len

Fül|len vgl. Fohlen

Fül|ler; Füll_fe|der, ...[fe|der]|hal|ter, ...horn (Mehrz. ...hörner); fül|lig; Füll_mas|se, ...ofen, ...ort (Bergmannsspr.; Mehrz. ...örter); Füll|sel s; -s, -; Füll|lung; Füll|wort (Mehrz. ...wörter)

ful|mi|nant lat. (glänzend, prächtig, ausgezeichnet); Ful|mi|nanz

Fulp|mes (österr. Ort)

Fu|ma|ro|le it. (vulkan. Gasaushauchung) w; -, -n; Fu|mé fr. [füme] (Rauch- od. Rußabdruck beim Stempelschneiden; Probeabdruck eines Holzschnittes mit Hilfe feiner Rußfarbe) m; -[s], -s

Fum|mel (landsch. abschätzig für: Kleid; Fähnchen) m; -s, -; fum|meln (ugs. für: sich [unsachgemäß] an etwas zu schaffen machen; reibend putzen); ich ...[e]le (↑ R 327)

Fund m; -[e]s, -e

Fun|da|ment lat. s; -[e]s, -e; fun|da|men|tal (grundlegend; schwerwiegend); Fun|da|men|tal_be|griff (Grundbegriff), ...satz; fun|da|men|tie|ren (den Grund legen; gründen); Fun|da|ment|wan|ne (Bauw.); Fun|da|ti|on [...zion] (fromme Stiftung; schweiz. für: Fundament[ierung])

Fund_amt (österr.), ...bü|ro, ...grube

fun|die|ren lat. ([be]gründen; mit [den nötigen] Mitteln versehen); fun|diert ([fest] begründet; Kaufmannsspr.: durch Grundbesitz gedeckt, sicher[gestellt])

fün|dig (Bergmannsspr.: ergiebig, reich); -er Erzgang; - werden ([Mutung] ausfindig machen, erhalten)

Fund_stät|te, ...stel|le

Fun|dus lat. (Grund u. Boden, Grundstück; Grundlage; Bestand) m; -, -

Fü|nen (dän. Insel)

Fu|ne|ra|li|en lat. [...iⁿn] (veralt. für: [feierliches Gepränge bei einem] Leichenbegängnis) Mehrz.

fünf; die - Sinne; wir sind heute zu fünfen od. zu fünft; fünf gerade sein lassen (ugs. für: etwas nicht so genau nehmen); vgl. acht; Fünf (Zahl) w; -, -en; eine - würfeln, schreiben; vgl. ¹Acht u. Eins; Fünf|eck; fünf|eckig [Trenn.: ...ek|kig]; fünf|ein|halb, fünf|und|ein|halb; Fün|fer; vgl. Achter; fün|fer|lei; fünf|fer|reihe; in -n; fünf|fach; Fünf|fa|che s; -n; vgl. Achtfache; Fünf|flach s; -[e]s, -e, Fünf|fläch|ner (Pentaeder); Fünf|fran|ken|stück, Fünf|frank|stück; fünf|hun|dert (als röm. Zahlzeichen: D); vgl. hundert; Fünf|jah|res|plan (mit Ziffer: 5-

Jahr[es]-Plan; ↑ R 157), (selten:) Fünf|jah|re|plan, Fünf|jahr|plan; Fünf|kampf; Fünf|li|ber schweiz. mdal. (Fünffrankenstück) m; -s, -; Fünf|ling; fünf|mal; vgl. achtmal; fünf|ma|lig; Fünf|mark|stück (mit Ziffer: 5-Mark-Stück; ↑ R 157); fünf|mark|stück|groß; Fünf|paß (gotisches Maßwerk) m; ...passes, ...passe; Fünf|pfennig|stück; Fünf|pol|röh|re; Fünf|pro|zent|klau|sel (mit Ziffer: 5-Prozent-Klausel, ↑ R 157; mit Zeichen: 5%-Klausel, vgl. Prozent u. ...prozentig) w; -; Fünf|ru|de|rer (für: Pentere); fünf|stel|lig; Fünf|strom|land (Pandschab) s; -[e]s; fünft vgl. fünf; Fünf|ta|ge_fie|ber (Infektionskrankheit; s; -s), ...wo|che; fünf|tau|send; vgl. tausend; fünf|te; die - Kolonne; vgl. achte; fünf|tel; vgl. achtel; Fünf|tel s (schweiz. meist: m); -s, -; vgl. Achtel; fünf|tens; Fünf|ton|ner (mit Ziffer: 5tonner; ↑ R 228); Fünf|uhr|tee; fünf|und|ein|halb, fünf|ein|halb; fünf|und|sech|zig|jäh|rig; vgl. achtjährig; fünf|und|zwan|zig; vgl. acht; fünf|zehn; vgl. acht u. Fuffzehn; fünf|zig (als röm. Zahlzeichen: L) usw.; vgl. achtzig usw.; Fünf|zi|ger (ugs. für: Fünfzigpfennigstück) m; -s, -; vgl. Fuffziger; fünf|zig|jäh|rig; vgl. achtjährig; Fünf|zig|mark|schein (mit Ziffer: 50-Mark-Schein; ↑ R 157); Fünf|zim|mer|woh|nung (mit Ziffer: 5-Zimmer-Wohnung; ↑ R 157)

fun|gi|bel lat. (Rechtsspr.: vertretbar); ...i|ble Sache; fun|gie|ren (ein Amt verrichten, verwalten; tätig, wirksam sein)

Fun|gus lat. (Pilz; Geschwulst) m; -, ...gi

Funk (Rundfunk[wesen], drahtlose Telegrafie) m; -s; Funk_ama|teur, ...aus|stel|lung, ...bild; Funk_chen, Funk|lein; Funk|dienst; Fun|ke, (auch u. übertr. häufiger:) Funken m; ...kens, ...ken; fun|keln; ich ...[e]le (↑ R 327); fun|kel|na|gel|neu (ugs.); fun|ken (durch Funk übermitteln); ugs. auch für: funktionieren); Fun|ken vgl. Funke; Fun|ken_flug, ...sprü|hen (s; -s); fun|ken|sprü|hend; ein -er Schornstein, aber (↑ R 142): rote Funken sprühend; Fun|ker; Funk_ge|rät, ...haus

Fun|kie[...iⁿ; nach dem dt. Apotheker Funck] (Zierpflanze) w; -, -n

fun|kisch; Funk|kol|leg; Funk|lein, Fünk|chen; Funk_lot|te|rie, ...maat, ...meß|ge|rät, ...or|tung, ...pei|lung, ...spruch, ...sta|ti|on, ...stel|le, ...still|le, ...stö|rung, ...strei|fe, ...strei|fen|wa|gen, ...ta|xi, ...tech|nik

Funk|ti|on lat. [...zion] (Verrichtung; Geltung); in, außer - (im, außer Dienst, Betrieb); funk|tio|nal (funktionell); -e Grammatik; Funk|tio|na|lis|mus (Architektur, Philos.) m; -; Funk|tio|na|list (↑ R 268); Funk|tio|när fr. m; -s, -e; funk|tio|nell (auf die Funktion bezüglich; wirksam); -e Erkrankung; funk|tio|nie|ren; funk|ti|ons|fä|hig; Funk|ti|ons_stö|rung, ...theo|rie; funk|ti|ons|tüch|tig; Funk|ti|ons|verb (Sprachw.: ein Zeitwort, das in Verbindung mit einem Hauptwort einen Vollzug anzeigt, ohne dabei einen eigenen Inhalt auszudrücken, z. B. „[zur Durchführung] bringen")

Funk_turm, ...ver|bin|dung, ...wesen (s; -s)

Fun|sel, Fun|zel (ugs. für: schlecht brennende Lampe) w; -, -n

für (Abk.: f.); mit Wenf.; ein für allemal; fürs erste (vgl. fürs); für und wider, aber (↑ R 119): das Für und [das] Wider

Fu|ra|ge fr. [...aseh°] (Militär: Lebensmittel; Mundvorrat; Futter) w; -; fu|ra|gie|ren [...asehir°n] (Militär: Lebensmittel, Futter empfangen, holen)

für|baß (veralt. für: weiter); - schreiten

Für|bit|te; für|bit|ten, nur in der Grundform gebräuchlich; fürzu bitten; Für|bit|ten s; -s; Für|bit|ter; Für|bit|te|rin w; -, -nen

Fur|che w; -, -n; fur|chen; fur|chig; Furcht w; -; furcht|bar; Furcht|bar|keit w; -

Fürch|te|gott (m. Vorn.)

fürch|ten|flö|ßend; ein -es Äußere[s], aber (↑ R 142): große Furcht einflößend; fürch|ten|reich; fürch|ter|lich; fürch|ter|re|gend vgl. furchteinflößend; furcht_los (-este (↑ R 292); Furcht|lo|sig|keit w; -), furcht|sam; Furcht|sam|keit w; -

Fur|chung

für|der (veralt. für: weiter, ferner); für|der|hin (veralt. für: in Zukunft)

für|ein|an|der; Schreibung in Verbindung mit Zeitwörtern: füreinander (für sich gegenseitig) einstehen, leben usw.

Fu|rie lat. [...iⁿ] (röm. Rachegöttin; wütendes Weib; nur Einz. Wut) w; -, -n

Fu|rier fr. (Militär: der für Unterkunft u. Verpflegung sorgende Unteroffizier) m; -s, -e

fu|ri|os lat. (wütend, hitzig); -e -este (↑ R 292); fu|rio|so it. (Musik: leidenschaftlich); Fu|rio|so (leidenschaftl. Tonstück) s; -s, -s u. ...si

Fur|ka (schweiz. Alpenpaß) w; -

287 G

für|lieb (älter für: vorlieb); **für|lieb|neh|men** (älter für: vorliebnehmen); ich nehme fürlieb; fürliebgenommen; fürliebzunehmen

Fur|nier *fr.* (dünnes Deckblatt aus Holz od. Kunststoff) *s*; -s, -e; **fur|nie|ren**; **Fur|nier|holz**; **Fur|nie|rung**

Fu|ror *lat.* (Wut) *m*; -s; **Fu|ro|re** *it.* („rasender" Beifall; Leidenschaft[lichkeit]) *w*; - od. -s; - machen (ugs. für: Aufsehen erregen; Beifall erringen); **Fu|ror teu|to|ni|cus** *lat.* [- ...*kuß*] („teutonisches [= deutsches] Ungestüm") *m*; - -

fürs (↑ R 240 (für das); - erste (↑ R 135)

Für|sor|ge (früher auch für: Sozialhilfe) *w*; -; **Für|sor|ge...amt,** ...**er|zie|hung**; **Für|sor|ger** (Beamter im Dienst der Fürsorge); **Für|sor|ge|rin** *w*; -, -nen; **für|sor|ge|risch** (zum Fürsorgewesen gehörend); **Für|sor|ge|un|ter|stüt|zung**; **für|sorg|lich** (pfleglich, liebevoll); **Für|sorg|lich|keit** *w*; -

Für|spra|che; Für|sprech (veralt. für: Fürsprecher, Wortführer; schweiz. für: Rechtsanwalt, -beistand) *m*; -s, -e; **Für|spre|cher**

Fürst *m*; -en, -en (↑ R 268); **Fürst_abt,** ...**bi|schof; für|sten,** meist nur noch: gefürstet; **Fürsten.ge|schlecht, ...haus, ...hof, ...sitz, ...tum; Fürst|erz|bi|schof; Für|stin** *w*; -, -nen; **Für|stin|mut|ter;** (getrennt, in Titeln ↑R 224); **Fürstlich; Fürst|lich|keit**

Furt *w*; -, -en

Fürth (Nachbarstadt von Nürnberg)

Furt|wäng|ler (dt. Dirigent)

Fu|run|kel *lat. m* (auch: *s*); -s, -; **Fu|run|ku|lo|se** *w*; -, -n

für|wahr (veralt.)

Für|witz (älter für: Vorwitz) *m*; -es; **für|wit|zig** (älter für: vorwitzig)

Für|wort (für: Pronomen; *Mehrz.* ...**wörter**); **für|wört|lich**

Furz (derb für: abgehende Blähung) *m*; -es, Fürze; **fur|zen**

Fu|sche|lei *mdal.* (rasch hin u. her bewegen; täuschen; pfuschen); ich ...[e]le (↑ R 327); **fu|scheln** (svw. fuscheln); du fuschst (fuschest); **fu|schern** (svw. fuscheln); ich ...ere (↑ R 327)

Fu|sel (ugs. für: schlechter Branntwein) *m*; -s, -

fu|seln *mdal.* (übereilt u. schlecht arbeiten); ich ...[e]le (↑ R 327)

Fü|si|lier *fr.* (schweiz., sonst veralt. für: Infanterist) *m*; -s, -e; **fü|si|lie|ren** (standrechtlich erschießen); **Fü|sil|la|de** [...*sijad*] (massenweise, reihenweise standrechtl. Erschießung)

Fu|si|on *lat.* (Verschmelzung, Zusammenschluß [großer Unternehmen]); **fu|sio|nie|ren**; **Fu|si|ons|ver|hand|lung**

Fuß *m*; -es, Füße u. (bei Berechnungen:) - drei - lang (↑ R 322); nach - rechnen; zu - gehen; zu Füßen fallen; - fassen; einen -breit, aber: keinen Fußbreit (vgl. d.) weichen; der Weg ist kaum fußbreit; der Schnee ist fußhoch, fußtief; **Fuß.ab|strei|fer, ...an|gel, ...bad; Fuß|ball;** - spielen (↑ R 140), aber: das Fußballspielen (↑ R 120); **Fuß|ball|bun|des|trai|ner** (↑ R 152); **Fuß|bal|ler; Fuß|ball.fan, ...mann|schaft, ...mei|ster|schaft, ...spiel; Fuß|ball|spie|len s, -s, aber (↑ R 140): Fußball spielen; Fuß|ball.spie|ler, ...to|to, ...welt|mei|ster|schaft** (↑ R 152); **Fuß.bank** (*Mehrz.* ...**bänke**), ...**bo|den** (*Mehrz.* ...**böden**); **Fuß|bo|den|le|ger; fuß|breit** (vgl. Fuß) **Fuß|breit** (Maß) *m*; -, -; keinen - weichen; keinen -Landes hergeben; vgl. Fuß; **Füß|chen, Füß|lein**

Fus|sel (mdal. u. ugs. für: Fädchen [in der Schreibfeder, am Kleidstücke usw.]) *w*; -, -n (auch: *m*; -s, -[n]); **fus|se|lig, fußlig; fus|seln;** der Stoff fusselt

fü|ßeln (mit den Füßen unter dem Tisch Berührung suchen; veralt. für: kleine Schritte machen, trippeln; österr. auch: ein Bein stellen); ich ...[e]le (↑ R 327); **fu|ßen;** du fußt (fußest); auf einem Vertrag -

Füs|sen (Stadt am Lech)

Fuß|en|de

Fus|sen|eg|ger, Gertrud (österr. Dichterin)

...fü|ßer (z. B. Bauchfüßer), ...**füßler** (z. B. Tausendfüßler); **Fuß|fall** *m*; **fuß|fäl|lig,** ...**frei** (die Füße frei lassend); **Fuß|gän|ger; Fuß|gänger.über|weg, ...zo|ne; Fuß|ge|her** (österr. neben: Fußgänger); **fuß|ge|recht;** -es Schuhwerk; **fuß|hoch;** das Wasser steht -; ...**fü|ßig** (z. B. vierfüßig); **fuß|kalt;** ein -es Zimmer; **fuß|lang;** die Blindschleiche war -; **Fuß|lap|pen; fuß|lei|dend; Füß|lein, Füß|chen;** ...**füß|ler** vgl. ...füßer

fuß|lig, fus|se|lig

Füß|ling (Teil des Strumpfes); **Fuß.marsch** *m*, ...**no|te,** ...**pfad,** ...**pfle|ge,** ...**ra|ste** (*w*; -, -n) od. ...**ra|ster** (*m*; -s, -), ...**sack,** ...**sohle,** ...**sol|dat,** ...**spur; Fuß|[s]tap|fe** *w*; -, -n u. **Fuß|[s]tap|fen** *m*; -s, -; **fuß|tief;** ein -es Loch; **Fuß.wan|de|rung,** ...**wa|schung,** ...**weg; fuß|wund**

Fu|sta|ge *fr.* [...*aseh*] (Leergut; Preis für Leergut)

Fu|sta|nel|la *it.* (kurzer Männer-

rock der Albaner und Griechen) *w*; -, ...llen

Fu|sti *it.* ([Vergütung für] Unreinheiten einer Ware) *Mehrz.*

Fu|stik|holz *arab.*; dt. (tropische Holzart)

Fu|thark [*futhark*] (Runenalphabet) *s*; -s, -e

futsch, (österr.:) **pfutsch** (ugs. für: weg, verloren)

¹**Fut|ter** (Nahrung [der Tiere]) *s*; -s

²**Fut|ter** (innere Stoffschicht der Oberbekleidung) *s*; -s, -

Fut|te|ra|ge [...*aseh*] (ugs. für: Essen) *w*; -

Fut|te|ral *germ.-mlat.* ([Schutz]hülle, Überzug; Behälter) *s*; -s, -e; **Fut|ter|mau|er** (Stützmauer)

Fut|ter|mit|tel *s*; **fut|tern** (scherzh. für: essen); ich ...ere (↑ R 327); ¹**füt|tern** (Tiere); ich ...ere (↑ R 327)

²**füt|tern** (Futterstoff einlegen); ich ...ere (↑ R 327)

Fut|ter.neid, ...**platz,** ...**rau|fe,** ...**rü|be,** ...**schnei|de|ma|schi|ne** od. ...**schneid|ma|schi|ne**

Fut|ter|stoff

Fut|ter|trog, Füt|te|rung; Füt|te|rungs|ver|fah|ren

Fu|tur *lat.* (Sprachw.: Zukunftsform, Zukunft) *s*; -s, -e; **fu|tu|risch** (das Futur betreffend, im Futur auftretend) *s*; -s, -; **Fu|tu|ris|mus** (Kunstrichtung des 20. Jh.s) *m*; -; **Fu|tu|rist** (Anhänger des Futurismus); ↑ R 268; **fu|tu|ri|stisch;** **Fu|tu|ro|lo|ge** (Zukunftsforscher) *m*; -n, -n (↑ R 268); **Fu|tu|ro|lo|gie** (Zukunftsforschung) *w*; -; **fu|tu|ro|lo|gisch; Fu|tu|rum** (älter für: Futur) *s*; -s, ...ra; **Fu|tu|rum ex|ak|tum** (Sprachw.: vollendete Zukunft, Vorzukunft) *s*; - -, ...ra ...ta

Fu|zel österr. (Fussel); **fu|zeln** österr. ugs. (sehr klein schreiben); ich ...[e]le (↑ R 327)

G

G (Buchstabe); das G; des G, die G, aber: das g in Lage (↑ R 123); der Buchstabe G, g

g = Gramm; (in Österreich auch:) Groschen

g = Zeichen für: Fallbeschleunigung

ᵍ = Zeichen für: Gon

g, G (Tonbezeichnung) *s*; -, -; **g** (Zeichen für: g-Moll); in g; **G** (Zeichen für: G-Dur); in G

G (auf dt. Kurszetteln) = Geld (d. h., das betr. Wertpapier war zum angegebenen Preis gesucht)

G 288

G = Gauß; Giga...; Gourde
γ = veralt. für: µg
Γ, γ = Gamma
Ga = chem. Zeichen für: Gallium
Ga. = Georgia
Gäa (gr. Göttin der Erde)
Ga|bar|dine *fr.* [gabardin, auch: gabardin] (ein Gewebe) *m*; -s (auch: *w*; -)
Gab|bro *it.* (ein Tiefengestein) *m*; -s
Ga|be *w*; -, -n; gä|be vgl. gang
Ga|bel *w*; -, -n; Ga|bel.bis|sen, ...bock (Jägerspr.); Gä|bel|chen, Gäb|lein; Ga|bel.deich|sel, ...früh|stück, ...hirsch (Jägerspr.); ga|be|lig, gab|lig; ga|be|lig; ga|beln; ich ...[e]le (↑ R 327)
Ga|bels|ber|ger (Familienn.); -sche Stenographie
Ga|bel|stap|ler; Ga|be|lung, Gab|lung; Ga|bel|wei|he (ein Vogel)
Ga|ben|tisch
Ga|bi (Koseform von: Gabriele)
Gäb|lein, Gä|bel|chen; Gab|ler (Gabelbock, -hirsch); gab|lig, ga|be|lig; Gab|lung, Ga|be|lung
Ga|bun usw. vgl. Gabun usw.
Ga|bri|el [...iäl] (ein Erzengel; m. Vorn.); Ga|brie|le (w. Vorn.)
Ga|bun (Staat in Afrika); Ga|bu|ner; ga|bu|nisch
Gacke|lei¹; gackeln¹; ich ...[e]le (↑ R 327); gackern¹; ich ...ere (↑ R 327); gack|sen; du gackst (gacksest); gicksen und gacksen
Gad (bibl. m. Eigenn.)
Ga|den (veralt., noch mdal. für: Nebengebäude, Stall, Hütte; Nebenzimmer, Vorrats-, Schlafkammer) *m*; -s, -
Ga|do|li|ni|um [nach dem finn. Chemiker Gadolin] (chem. Grundstoff; Zeichen: Gd) *s*; -s
Gaf|fel („Gabel"; Segelstange zum Halten des Gaffelsegels) *w*; -, -n; Gaf|fel.scho|ner, ...se|gel
gaf|fen; Gaf|fer; Gaf|fe|rei
Gag *engl.-amerik.* [gäg] (Film: bildwirksamer, witziger Einfall) *m*; -s, -s
Ga|ga|rin (russ. Kosmonaut)
Ga|gat (gr. (Pechkohle, Jett) *m*; -[e]s, -e; Ga|gat|koh|le
Ga|ge *germ.-fr.* [gaseh°] (Bezahlung, Gehalt [von Künstlern]) *w*; -, -n
gäh|nen; Gäh|ne|rei
Gail|lard *fr.* [gajar] (fr. ugs. Bez. für: Bruder Lustig) *m*; -s, -s; Gail|lar|de [...ard°] (ein Tanz) *w*; -, -n
Gains|bo|rough [ge^insb^er°] (engl. Maler)
Gai|ser (dt. Schriftsteller)
Ga|jus (altröm. m. Vorn.; Abk.: C. [nach der alten Schreibung Cajus])

Ga|la *span.* [auch: ggla] (Kleiderpracht; Festkleid) *w*; -; Ga|la-.abend [auch: gg...], ...an|zug, ...di|ner, ...emp|fang, ...vor|stel|lung (im Theater)
ga|lak|tisch *gr.* (zur Galaxis gehörend, sie betreffend); Ga|lak|tor|rhö¹, Ga|lak|tor|rhöe (Milchfluß nach dem Stillen) *w*; -, ...rrhöen; Ga|lak|to|se (einfacher Zucker) *w*; -, -n; Ga|la|lith Ⓦ („Milchstein"; Kunsthorn) *s*; -s
ga|la|mä|ßig [auch: gg...]
Ga|lan *span.* (vornehm auftretender) Liebhaber) *m*; -s, -e; ga|lant *fr.* (höflich, ritterlich; rücksichtsvoll; aufmerksam); -e Dichtung (eine literar. Strömung in Europa um 1700); -er Stil (eine Kompositionsweise des 18. Jh.s in Deutschland); Ga|lan|te|rie (Höflichkeit [gegenüber Frauen]) *w*; -, ...ien; Ga|lan|te|rie|wa|ren (veralt. für: Schmuck-, Kurzwaren) *Mehrz.*; Ga|lant|homme [galantom] (Ehrenmann) *m*; -s, -s; Ga|lant|uo|mo *it.* (Ehrenmann) *m*; -s, ...mini
Ga|la|pa|gos|in|seln (zu Südamerika gehörend) *Mehrz.*
Ga|la|tea (gr. Meernymphe)
Ga|la|ter (gr. Name der Kelten in Kleinasien) *Mehrz.*; Ga|la|ter|brief *m*; -[e]s; ↑ R 205
Ga|la|uni|form [auch: gg...]
Ga|la|xis, (auch:) Ga|la|xie gr. (Milchstraße) *w*; -, (für: Sternsystem allgem. *Mehrz.*:) ...xien
Gal|ba (röm. Kaiser)
Gal|ban, Gal|ba|num *lat.* (Galbansaft, Heilmittel) *s*; -s
Gä|le (irisch-schottischer Kelte) *m*; -n, -n (↑ R 268)
Ga|le|as|se *it.* (größere Galeere; kleines Fahrzeug mit Kiel, plattem Heck, Großmast u. kleinem Besanmast) *w*; -, -n; Ga|lee|ren|skla|ve, ...sträf|ling
Ga|len, Ga|le|nus (altgr. Arzt); ga|le|nisch, aber (↑ R 179): Ga|le|nisch
Ga|leo|ne, Ga|lio|ne *niederl.* (mittelalterl. Segel[kriegs]schiff) *w*; -, -n; Ga|leo|te, Ga|lio|te *w*; -, -n u. Gal|jot (der Galeasse ähnliches kleineres Küstenfahrzeug) *w*; -, -en
Ga|le|ot|to (it. m. Eigenn.)
Ga|le|rie *it.* *w*; -, ...ien; Ga|le|rist (Galeriebesitzer, -leiter); ↑ R 268; Ga|le|ri|stin *w*; -, -nen
Gal|gant|wur|zel *arab.*; dt. (heilkräftige Wurzel)
Gal|gen *m*; -s, -; Gal|gen.frist,

...hu|mor (*m*; -s; vgl. ¹Humor), ...strick, ...vo|gel
Ga|li|ci|en [...zi^en] (hist. Provinz in Spanien); vgl. aber: Galizien; Ga|li|ci|er [...i^r]; ga|li|cisch
Ga|li|läa (Gebirgsland westl. des Jordans); Ga|li|lä|er; ga|li|lä|isch, aber (↑ R 198): das Galiläische Meer (See Genezareth)
Ga|li|lei (it. Physiker)
Ga|li|ma|thi|as *fr.* (sinnloses, verworrenes Gerede) *m* u. *s*; -
Ga|li|on *niederl.* (Vorbau am Bug älterer Schiffe) *s*; -s, -s; Ga|li|ons|fi|gur; Ga|li|o|te vgl. Galeote
Ga|li|pot *fr.* [...po] (Fichtenharz) *m*; -s
gä|lisch; -e Sprache (Zweig des Keltischen); vgl. deutsch; Gä|lisch (Sprache) *s*; -[s]; vgl. Deutsch; Gä|li|sche *s*; -n; vgl. Deutsche *s*
Ga|li|zi|en [...i^en] (hist. für: Gebiet nördl. der Karpaten); vgl. aber: Galicien; Ga|li|zi|er [...i^r]; ga|li|zisch
Gal|jaß *w*; -, ...jassen; vgl. Galeasse; Gal|jon vgl. Galion; Gal|jot vgl. Galeote
Gall|ap|fel
Gal|le *w*; -, -n; gal|le[n]|bit|ter; Gal|len.bla|se, ...gang *m*, ...ko|lik, ...lei|den, ...stein, ...tee; gal|len|trei|bend
Gal|lert *lat.* [auch: ...lärt] *s*; -[e]s, -e u. (österr. nur:) Gal|ler|te [auch: gal^ert^e] (elastisch-steife Masse aus eingedicktem pflanzl. u. tier. Säften) *w*; -, -n; gal|lert.ar|tig [auch, österr. nur: ...lärt...]; gal|ler|tig [auch: gal^ert^e]; gall|ler|tig [auch: ga...]; Gal|lert|mas|se [auch, österr. nur: ...lärt...]
Gal|li|en [...i^en] (röm. Name Frankreichs); Gal|li|er [...i^r]
gal|lig (Galle enthaltend; verbittert)
gal|li|ka|nisch; -e [kath.] Kirche (in Frankreich vor 1789); gal|lisch (aus, von Gallien; Gallien, die Gallier betreffend); Gal|li|um (chem. Grundstoff, Metall; Zeichen: Ga) *s*; -s; Gal|li|zis|mus (Spracheigentümlichkeit in einer nichtfr. Sprache) *m*; -, ...men; Gal|lo|ma|ne *m*; -n, -n (↑ R 268); Gal|lo|ma|nie (übertriebene Vorliebe für fr. Wesen) *w*; -
Gal|lo|ne *engl.* (engl.-amerik. Hohlmaß) *w*; -, -n
gal|lo|ro|ma|nisch (den roman. Sprachen auf gallischem Boden angehörend, von ihnen abstammend)
gall|süch|tig (veralt.)
Gal|lup-In|sti|tut [auch: gäl^p...]

¹ *Trenn.*: ...ak|ke...

¹ Vgl. die Anmerkung zu „Diarrhö, Diarrhöe".

nach dem Begründer] (amerik. Anstalt zur Erforschung der öffentl. Meinung) s; -[e]s; ↑ R 180
Gạl|lus (m. Eigenn.)
Gạl|lus_säu|re lat.; dt. (w; -), ...tinte (w; -); **Gạll|wes|pe**
Gal|mei [auch: gạ...] (Zinkerz) m; -s, -e
Ga|lon fr. [galọng] m; -s, -s u. **Ga|lone** it. (Borte, Tresse) w; -, -n; **ga|lonie|ren** (mit Borten, Tressen usw. besetzen); **ga|lo|niert** (auch: betreßt)
Ga|lopp it. m; -s, -s u. -e; **ga|lop|pieren**; galoppierende Schwindsucht (volkstüml. Bez. für die in kurzer Zeit tödl. verlaufende Form der Lungentuberkulose); **Ga|lopp|ren|nen**
Ga|lo|sche fr. (Überschuh) w; -, -n
Gals|wor|thy [gǎlswö'dhi] (engl. Schriftsteller)
galt bayr., österr., schweiz. (von Kühen: nicht tragend, unfruchtbar) vgl. ¹gelt; **Galt|vieh** bayr., österr., schweiz. (Jungvieh; Kühe, die keine Milch geben)
Gal|va|ni [galwạni] (it. Naturforscher); **Gal|va|n|sa|ti|on** nlat. [...ziọn] (therapeut. Anwendung des elektr. Gleichstromes) w; -; **Gal|va|ni|seur** [...sör] (Facharbeiter für Galvanotechnik) m; -s, -e; **gal|va|nisch; **-er Strom; -es Element; -e Verbindung; **gal|va|nisie|ren** (durch Elektrolyse mit Metall überziehen); **Gal|va|nismus** (Lehre vom galvanischen Strom) m; -; **Gal|va|no** it. (galvanische Abformung eines Druckstockes) s; -s, -s; **Gal|vano_kau|stik** it.; gr. (Anwendung des Galvanokauters), ...**kau|ter** (auf galvanischem Wege glühend gemachtes Instrument zur Vornahme von Operationen), ...**meter** (Strommesser; s; -s, -), ...**plastik** (Verfahren, Gegenstände galvanisch mit Metall zu überziehen, bes. die Herstellung von Galvanos), ...**plạ|stik|ker** (ein Beruf in der Industrie); **gal|va|noplạ|stisch; **Gal|va|no_skop** (elektr. Meßgerät; s; -s, -e), ..**tech|nik** (Technik des Galvanisierens; w; -), ...**ty|pe** (früher für: Galvanoplastik; w; -)
a|mạn|der gr. (eine Pflanze) m; s, -
a|mạ|sche arab. w; -, -n; **Ga|mạschen|dienst** (kleinlicher, pedanischer [Kasernen]drill)
am|be it. (Viola da gamba) w; -, -n
ạm|bia (Staat in Afrika); **Gạmi|er; gạm|bisch**
am|bịst it. (Gambenspieler); ↑ R 68

Gam|bịt span. (eine Schachspielereröffnung) s; -s, -s
Gam|bri|nus [sagenhafter] König, angeblicher Erfinder des Bieres)
Ga|mẹl|le fr. schweiz. (Koch- u. Eßgeschirr der Soldaten) w; -, -n
Ga|mẹt gr. (Fortpflanzungszelle) m; -en, -en (↑ R 268); **Ga|me|tophyt** (Pflanzengeneration, die sich geschlechtlich fortpflanzt) m; -en, -en (↑ R 268)
Ga|min fr. [gamẽng] (fr. Bez. für: [Gassen]junge) m; -s, -s
Gạm|ma (gr. Buchstabe; Γ, γ) s; -[s], -s; vgl. γ; **Gạm|ma|strah|len**, γ-Strah|len; ↑ R 149 (radioaktive Strahlen, kurzwellige Röntgenstrahlen) Mehrz.
gam|me|lig, **gạmm|lig** (ugs. für: verkommen; verdorben, faulig); **gạm|meln** (ugs.); ich ...[e]le (↑ R 327); **Gạmm|ler; Gạmm|le|rin** w; -, -nen; **Gạmm|ler|tum** s; -s
Gams (insbesondere Jägerspr. u. landsch. für: Gemse) m od. w, (Jägerspr. u. landsch.:) s; -, -en; **Gạms|bart**
Ga|nau|ser österr. mdal. (Gänserich)
Gạnd tirol. u. schweiz. (Schuttfeld, Geröllhalde) w; -, -en od. s; -s, Gänder
Gạn|dhi, Mahạtma (ind. Staatsmann)
Gạ|neff vgl. Ganove
Gạn|er|be (veralt. für: Miterbe) m; **Gạn|erb|schaft** w; -
gang; - und gäbe (landsch., bes. schweiz. auch: gäng u. gäbe); ¹**Gạng** m; -[e]s, Gänge; im -[e] sein; in - bringen, halten, setzen, aber: das Inganghalten, Ingangsetzen (↑ R 120)
²**Gang** engl.-amerik. [gäng] (Horde, Rotte, organisierte Verbrecherbande) w; -, -s
gäng landsch. (svw. gang); **Gạngart; gạng|bar; Gạng|bar|keit** w; -; **Gän|gel|band** s; -[e]s; **Gän|ge|lei; gän|geln;** ich ...[e]le (↑ R 327)
Gạn|ges [gạnggäß] (Fluß in Vorderindien) m; -
gän|gig; -es Pferd; -e Ware; (Jägerspr.:) -er Hund; **Gän|gig|keit** w; -
Gạn|gli|en|zel|le [...iᵉn...] (Nervenzelle); **Gạn|gli|on** gr. (Med.: Nervenknoten; Überbein) s; -s, ...ien [...iᵉn]
Gạn|grän gr. [ganggrän] w; -, -en (auch: s; -s, -e) u. (selten:) **Gangrä|ne** (Med.: Brand der Gewebe, Knochen) w; -, -n; **gan|gränös** (brandig)
Gạng|schal|tung
Gạng|spill niederl. (Ankerwinde)
Gạng|ster engl.-amerik. [gängßt'r] (Schwerverbrecher) m; -s, -; **Gạng|ster_boß, ...me|tho|de**

Gạng|way engl. [gängwe¹] (Laufgang zum Besteigen eines Schiffes od. Flugzeuges) w; -, -s
Ga|no|ve jidd. [...wᵉ] m; -n, -n (↑ R 268) u. **Gạ|neff** (Gaunerspr.: Gauner, Spitzbube, Dieb) m; -[s], -e; **Ga|no|ven_eh|re**, ...**spra|che**
Gans w; -, Gänse; **Gạns|bra|ten** südd., österr. (Gänsebraten)
Gäns|chen, **Gäns|lein; Gänse_blüm|chen** (Maßliebchen), ...**bra|ten**, ...**brust**, ...**fe|der**, ...**fett** (s; -[e]s), ...**füß|chen** (ugs. für: Anführungsstrich; ↑ R 94 ff.), ...**haut**, ...**klein** (s; -s), ...**le|ber**, ...**marsch** (m; -es); **Gạn|ser** südd., österr. (Gänserich); **Gän|se|rich** m; -s, -e; **Gän|se_schmalz**, **...wein** (scherzh. für: Wasser; m; -[e]s); **Gạns|jung** südd. (Gänseklein) s; -s; **Gạns|leber** österr. (Gänseleber); **Gänslein**, Gäns|chen; **Gạnsl|jun|ge** österr. (Gänseklein) s; -n (↑ R 287 ff.)
Gạnt schweiz. (öffentl. Versteigerung; Konkurs) w; -, -en
Gạn|ter niederd. (Gänserich)
Gạn|ny|med [auch: gạn...], **Gạ|nyme|des** (Mundschenk des Zeus)
ganz; [in] ganz Europa; ganze Zahlen (Math.); ganz und gar; ganz ergeben (nicht: ganz ergebenst); die ganzen Leute (mdal. u. ugs. für: alle Leute); etwas wieder ganz machen. **I.** *Kleinschreibung:* im ganzen [gesehen] (↑ R 134); im großen [und] ganzen (↑ R 133). **II.** *Großschreibung* (↑ R 116): das Ganze; aufs Ganze gehen; als Ganzes gesehen; fürs Ganze; ums Ganze; das große Ganze; ein großes Ganze od. Ganzes; ein Ganzer; ein Ganzes; als Ganzes. **III.** *Zusammenschreibung mit einem folgenden Eigenschaftswort:* Zusammen schreibt man g. mit einem folgenden Eigenschaftswort, wenn beide das Hauptwort, auf das sie sich beziehen, klassifizieren (vgl. S. 45, Merke, 2): ganzleinen, ganzwollen, ganzledern; **Gạn|ze** (Geschlossenheit, Gesamtheit) w; -; zur - (bes. österr. für: ganz, vollständig); **gạnz|gar;** -e Häute (↑ jedoch R 143), aber: das Fleisch ist noch nicht ganz gar; **Gạnz|heit** (gesamtes Wesen) w; -; **ganz|heit|lich; Gạnz_heits_me|tho|de**, ...**theo|rie**; **ganz|jäh|rig** (während des ganzen Jahres); **Gạnz|le|der|band** m; **gạnz|le|dern** (aus reinem Leder; vgl. ganz, III); **ganz|lei|nen** (aus reinem Leinen; vgl. ganz, III); **Gạnz|lei|nen** s; -; **Gạnz|lei|nenband** m; **gänz|lich; ganz|sei|den** (aus reiner Seide; vgl. ganz, III); **Gạnz_stahl|wa|gen; ganz|tä|gig** (während des ganzen Tages);

Ganz|tags|schu|le; Ganz|ton (Mehrz. ...töne); ganz|wol|len (aus reiner Wolle); vgl. ganz, III)

¹gar (fertig, bereit, vollständig, fertiggekocht; südd., österr. ugs.: zu Ende); das Fleisch ist noch nicht ganz gar, erst halb gar; vgl. ganzgar, halbgar; gar kochen (vgl. gargekocht); ²gar (ganz, sehr, sogar; stets getrennt geschrieben); ganz und gar, gar kein, gar nicht, gar nichts; gar sehr, gar wohl; du sollst das nicht gar so ernst nehmen

Ga|ra|ge fr. [garaseʰ] w; -, -n; ga|ra|gie|ren (österr. u. schweiz. neben: [Wagen] einstellen)

Ga|ra|mond [nach dem fr. Stempelschneider Garamond; ...moṇs] (eine Antiquadruckschrift) w; -; vgl. Garmond

Ga|rant fr. m; -en, -en (↑ R 268); Ga|ran|tie w; -, ...ien; ga|ran|tie|ren; Ga|ran|tie_an|spruch, ...schein

Gar|aus m, nur in: jmdm. den -machen

Gar|be w; -, -n; Gar|ben|bin|de|ma|schi|ne; Gar|ben|bund s

Gar|bo, Greta (schwed. Filmschauspielerin)

Gär|bot|tich

Gärb|stahl m; -[e]s

Gar|çon fr. [garßoṇs] (junger Mann; Kellner; Junggeselle) m; -s, -s; Gar|çon|ne [garßoṇ°] (Junggesellin) w; -, -n; Gar|çon|niè|re [garßoniär°] österr. (Einzimmerwohnung) w; -, -n

Gar|da|see (in Oberitalien) m; -s

Gar|de fr. w; -, -n; Gar|de|du|korps [gard°dükọr] (Leibgarde) s; -; Gar|de_of|fi|zier, ...re|gi|ment

Gar|de|ro|be w; -, -n; Gar|de|ro|ben_frau, ...mar|ke, ...schrank, ...stän|der; Gar|de|ro|bier [...bie] (Kleiderverwahrer; Theater: Gewandmeister) m; -s, -s; Gar|de|ro|bie|re [...biär°] (Garderobenfrau) w; -, -n

gar|dez! fr. [garde] (bei privaten Schachpartien manchmal verwendeter, höflicher Hinweis: „schützen Sie" [die Dame]!)

Gar|di|ne niederl. w; -, -n; Gar|di|nen_pre|digt (ugs.), ...schnur, ...stan|ge

Gar|dist fr. (Soldat der Garde); ↑ R 268

Ga|re (günstigster, lockerer Zustand des Kulturbodens) w; -

ga|ren (gar kochen)

gä|ren; es gor (auch, bes. in übertr. Bedeutung: gärte); es göre (auch: gärte); gegoren (auch: gegärt); gär[e]!

gar|ge|kocht; -es Fleisch (↑ jedoch R 142), aber: das Fleisch ist gar gekocht

Ga|ri|bal|di (it. Freiheitskämpfer)

gar kein

Gar_koch m, ...kü|che

Gar|mond fr. [garmọṇs] südd. u. österr. (Korpus [Schriftgrad]) w; -; vgl. Garamond

Garn s; -[e]s, -e

Gar|ne|le (ein Krebstier) w; -, -n

gar|ni vgl. Hotel garni

gar nicht; gar nichts

gar|nie|ren fr. (einfassen; mit Zubehör versehen; schmücken); Gar|nie|rung; Garni|son w; -, -en; gar|ni|so|nie|ren (in der Garnison [als Besatzung] liegen); Gar|ni|son_kir|che, ...pfar|rer; Gar|ni|tur w; -, -en

Garn|knäu|el

Ga|ronne [garọn] (fr. Fluß) w; -

Ga|rot|te usw. vgl. Garrotte usw.; Gar|rot|te span. (Würgschraube od. Halseisen zum Hinrichten [Erdrosseln]) w; -, -n; gar|rot|tie|ren

gar|stig; Gar|stig|keit

Gär|stoff

Gärt|chen, Gärt|lein; gär|teln südd. (Gartenarbeit aus Liebhaberei verrichten); ich ...[e]le (↑ R 327); Gar|ten m; -s, Gärten; Gar|ten_ar|beit, ...bank (Mehrz. ...bänke), ...bau (w; -[e]s); Gar|ten|bau_aus|stel|lung; Gar|ten_beet, ...fest, ...frucht (Garten- u. Feldfrüchte; ↑ R 145), ...ge|rät, ...haus, ...lau|be, ...lo|kal, ...par|ty, ...stadt, ...tür, ...weg, ...zaun; Gärt|lein, Gärt|chen; Gärt|ner; Gärt|ne|rei; Gärt|ne|rin w; -, -nen; gärt|ne|risch; gärt|nern; ich ...ere (↑ R 327); Gärt|ner[s]|frau

Gä|rung; Gä|rungs|pro|zeß

Gär|zeit

Gas s; -es, -e; - geben; Gas|ba|de_ofen

Ga|sel arab. s; -s, -e u. Ga|se|le [oriental.] Gedichtform) w; -, -n

ga|sen; es gast; es ga|ste; Gas|fern_ver|sor|gung w; -; Gas|feu|er|zeug; gas|för|mig; Gas_hahn, ...herd, ...hül|le; ga|sie|ren (Garne sengen, glattbrennen); ga|sig; Gas|ko|cher

Gas|ko|gner [gaßkọṇ]r; nach der hist. Provinz Gascogne (veralt. für: Prahler, Aufschneider); Gas|ko|na|de (veralt. für: Prahlerei)

Gas|mas|ke; Ga|sol (Flüssiggas) s; -s; Gas_öl, ...pe|dal (ein Kraftstoff) s; -s; Ga|so|me|ter gr. (Gasbehälter) m; -s, -; Gas_pe|dal, ...pi|sto|le

gaß|aus, gaß|ein; Gäß|chen, Gäßlein

Gas|schlauch; Gas_[schmelz]schwei|ßung (autogene Schweißung)

Gas|se (enge, schmale Straße; österr. auch für: Straße) w; -, -n;

Schreibung in Straßennamen: ↑ R 219ff.; Gas|sen_bu|be, ...ge|sang (Druckw.: Arbeitskollege in einer Gasse [Raum zwischen den Regalen im Setzersaal]), ...hau|er, ...jun|ge, ...lied; gas|sen|sei|tig österr. (nach der Straße zu gelegen); Gas|si, in: Gassi gehen (ugs. für: mit dem Hund auf die Straße [Gasse] gehen); Gäß|lein, Gäßchen

Gast m; -es, Gäste u. (Seemannsspr. für bestimmte Matrosen:) -en; zu -[e] bitten: als - (Abk.: a. G.); Gast_ar|bei|ter, ...bett; Gä|ste_buch, Gast|ste|rei (veralt. für: üppiges Gastmahl; Schlemmerei); gast|frei; Gast_frei|heit (w; -), ...freund; gast|freund|lich; Gast_freund|lich|keit (w; -), ...freund|schaft, ...ge|ber, ...ge|schenk, ...haus, ...hof, ...hö|rer; ga|stie|ren (Theater: Gastrolle geben; bildl.: nur vorübergehend anwesend sein); gast|lich; Gast_lich|keit; Gast|mahl (Mehrz. ...mähler u. -e), ...pflan|ze (Schmarotzer)

Ga|sträa gr. (angenommenes Urdarmtier) w; -, ...äen; ga|stral (zum Magen gehörend, den Magen betreffend); Ga|stral|gie (Med.: Magenkrampf) w; -, ...ien; ga|strisch (zum Magen gehörend; vom Magen ausgehend); -es Fieber; Ga|stri|tis (Med.: Magenschleimhautentzündung) w; -, ...itiden

Gast|rol|le

Ga|stro|nom gr. (Gastwirt; Freund feiner Kochkunst) n -en, -en (↑ R 268); Ga|stro|no|mie (feine Kochkunst) w; -; ga|stro|no|misch; -ste (↑ R 294); Ga|stro|po|de (Bez. der Schnecke) m; -n (meist Mehrz.); ↑ R 268; Ga|stro|sto|mie (Med.: Anlegung einer Magenfistel) w; -, ...ien; Ga|stro|to|mie (Med.: Magenschnitt) w; -, ...ien; Ga|stru|la (Zool.: Entwicklungsstadium vielzelliger Tiere) w; -

Gast_spiel, ...stät|te; Gast|stät|ten_ge|wer|be, Gast_stu|be, ...ti|sch (Schmarotzer), ...wirt, ...wirt|schaft, ...wort (für: fremdes Wort; Mehrz. ...wörter), ...zim|mer

Gas_ver|gif|tung, ...werk, ...zäh|ler

Ga|te[ho|se] ung. ostösterr. ugs. (Unterhose) w; -, -n

Gat[t] niederd. (enger Durchgang; Loch) s; -[e]s, -en u. -s

Gat|te m; -n, -n (↑ R 268); gat|te sich; Gat|ten_lie|be, ...wahl

Gat|ter (Gitter, [Holz]zaun) s; -, -; Gat|ter|sä|ge

gat|tie|ren (verschiedene Eisensorten u. Zusätze für das Gießen von Gußeisen zusammenstellen

Gat|tin w; -, -nen; Gat|tung; Gat|tungs|na|me (auch für: Appellativ)

Gau m (landsch.: s); -[e]s, -e; Gäu mdal. (Gau) s; -[e]s, -e; das Obere -; das Allgäu

Gau|be, Gau|pe mdal. u. bautechn. (Dachfenster) w; -, -en

Gauch („Kuckuck"; veralt. für: Narr) m; -[e]s, o u. Gäuche; Gauch|heil (Zierpflanze u. Akkerunkraut) m; -[e]s, -e

Gau|cho indian.-span. [gautscho] (südamerik. Viehhirt) m; -[s], -s

Gau|dea|mus lat. („Freuen wir uns!" [Anfang eines Studentenliedes]) s; -

Gau|di (ugs. für: Gaudium) s; -s (südd.-auch, österr. nur: w; -)

Gau|dieb nordd. veralt. (Gauner)

Gau|di|um lat. (Freude; Ausgelassenheit; Spaß) s; -s

gau|frie|ren fr. [gofrir̄ⁿ] (mit dem Gaufrierkalander prägen); Gaufrier|ka|lan|der (Kalander zur Narbung od. Musterung von Papier u. Geweben)

Gau|graf

Gau|guin [gogäng] (fr. Maler)

Gau|ke|lei; gau|kel|haft; gau|keln; ich ...[e]le (↑ R 327); Gauk|kel₋spiel, ...werk (s; -[e]s); Gaukler; Gauk|le|rei; gauk|ler|haft; Gauk|le|rin w; -, -nen; gauk|le|risch; -ste (↑ R 294); Gauk|ler|trup|pe

Gaul m; -[e]s, Gäule; Gäul|chen

Gaulle, de [gol] (fr. General u. Staatsmann); vgl. de-Gaullefreundlich; Gaul|list [golißt] (Anhänger von de Gaulle); ↑ R 264

Gault engl. [gâlt] (Geol.: zweitälteste Stufe der Kreide) m; -[e]s

Gau|men m; -s, -; Gau|men₋kit|zel (ugs.), ...laut (für: Palatal, Velar), ...se|gel, ...zäpf|chen; gau|mig; -sprechen

Gau|men m; -s, -; Gau|ner|ban|de; Gau|ne|rei; gau|ner|haft; gau|nerisch; -ste (↑ R 294); gau|nern; ich ...ere (↑ R 327); Gau|ner|spra|che

Gau|pe vgl. Gaube

Gau|ri|san|kar [...sangkar] (ein Gipfel des Himalaja) m; -[s]

Gauß (dt. Mathematiker); ²Gauß (Maßeinheit des Magnetismus; Zeichen: G) s; -, -

Gautsch|brief; Gaut|sche südd. (Schaukel) w; -, -n; gaut|schen (Papier zum Pressen ins Gautschbrett legen; auch: Lehrlinge nach altem Buchdruckerbrauch unter die Gehilfen aufnehmen; mdal. für: schaukeln); du gautschst (gautschest); Gautscher; Gautsch|fest

au|wei|se

Ga|vot|te fr. [gawọtʰ] (ein Tanz) w; -, -n

Ga|wein (Gestalt der Artussage)

Ga|ze pers. [gas⁰] (durchsichtiges Gewebe; Verbandmull) w; -, -n

Ga|zel|le arab.-it. (Antilopenart) w; -, -n; Ga|zel|len|fluß (l. Nilzufluß) m; ...flusses

Ga|zet|te fr. [auch: gasắtʰ] (veralt., noch abschätzig für: Zeitung) w; -, -n

Gd = chem. Zeichen für: Gadolinium

G-Dur [gedur, auch: gedur] (Tonart; Zeichen: G) s; -; G-Dur-Ton|lei|ter [ge...] (↑ R 155)

Ge = chem. Zeichen für: Germanium

ge... (Vorsilbe von Zeitwörtern, z. B. gehorchen, du gehorchst, gehorcht, zu gehorchen; zum 2. Mittelw. ↑ R 304)

Ge|äch|te m u. w; -n, -n (↑ R 287 ff.)

Ge|äch|ze (Stöhnen) s; -s

Ge|äder s; -s; ge|ädert; das Blatt ist schön

Ge|äf|ter (Jägerspr.: die beiden hinteren Zehen beim Schalenwild u. a.) s; -s, -

Ge|al|be|re s; -s

ge|ar|tet; das Kind ist gut -

Ge|äse (Jägerspr.: Äsung, auch für: Maul bei Hirsch und Reh)

Ge|äst (Astwerk) s; -[e]s

¹geb. (Zeichen: *) = geboren[e]

²geb. = gebunden (vgl. d.)

Ge|bäck s; -[e]s, -e; Ge|backe|ne [Trenn.: ...bak|ke...] s; -n (↑ R 287 ff.); Ge|bäck|scha|le (vgl. ¹Schale)

Ge|bal|ge (Prügelei) s; -s

Ge|balk s; -[e]s u. Ge|bäl|ke s; -s

Ge|bän|de (Bandwerk, mittelalterl. Kopftracht) s; -s

Ge|bär|de w; -, -n; ge|bär|den, sich; Ge|bär|den|spiel (s; -[e]s), ...spra|che; ge|ba|ren, sich (sich verhalten, sich benehmen); Ge|ba|ren s; -s

ge|bä|ren; du gebärst, sie gebärt (in gehobener Sprache: gebierst, gebiert); du gebarst; du gebärest; geboren (vgl. d.); gebär[e]! (in gehobener Sprache: gebier!); Ge|bä|re|rin w; -, -nen; Ge|bär|kli|nik (österr. für: Entbindungsabteilung, -heim), ...mut|ter (w; -, [selten:] ...mütter); Ge|bär|mut|ter|spie|gel

Ge|ba|rung (Gebaren; österr. für: Buchführung, Geschäftsführung)

ge|bauch|pin|selt (ugs. für: geehrt, geschmeichelt); ge|baucht (bauchig)

Ge|bäu|de s; -s, -; Ge|bäu|de₋kom|plex, ...teil m

ge|be|freu|dig

Ge|bein s; -[e]s, -e

Ge|bel|fer (Belfern, Bellen) s; -s;
Ge|bell s; -[e]s u. Ge|bel|le s; -s

ge|ben; du gibst, er gibt; du gabst; du gäbest; gegeben (vgl. d.); gib!; (↑ R 120:) Geben (auch: geben) ist seliger denn Nehmen (auch: nehmen)

Ge|ben|de vgl. Gebände

Ge|be|ne|dei|te [zu: benedeien] (Gottesmutter) w; -n

Ge|ber; Ge|ber|lau|ne; in -; Ge|ber|spra|che (Sprachw.)

Ge|bet s; -[e]s, -e; Ge|bet|buch; Ge|bets₋man|tel, ...müh|le, ...tep|pich

Ge|bet|tel s; -s

ge|beut (dicht. für: gebietet); die Stunde -, daß ...

Geb|hard (m. Vorn.)

Ge|biet s; -[e]s, -e; ge|bie|ten; gebo|ten; ge|bie|tend; Ge|bie|ter; Ge|bie|te|rin w; -, -nen; ge|bie|te|risch; -ste (↑ R 294); ge|biet|lich; Ge|biets₋an|spruch, ...er|wei|te|rung, ...ho|heit, ...kran|ken|kas|se (österr.), ...teil m; ge|biets|wei|se

Ge|bild|brot (Gebäck besonderer Gestalt zu bestimmten Festtagen); Ge|bil|de s; -s, -; ge|bil|det; Ge|bil|de|te m u. w; -n, -n (↑ R 287 ff.)

Ge|bim|mel s; -s

Ge|bin|de s; -s, -

Ge|bir|ge s; -s, -; ge|bir|gig; Ge|bir|gig|keit w; -; Ge|birg|ler; Ge|birgs₋bach, ...land|schaft, ...mas|siv, ...stock (Mehrz. ...stöcke), ...zug

Ge|biß s; Gebisses, Gebisse

Ge|blaf|fe s; -s

Ge|bla|se (Blasen) s; -s; Ge|blä|se (Vorrichtung zum Verdichten u. Bewegen von Gasen) s; -s, -

Ge|blö|del (ugs.) s; -s

Ge|blök s; -[e]s u. Ge|blö|ke s; -s

ge|blümt (österr.:) ge|blumt (mit Blumen gemustert); (bildl.:) -er Stil

Ge|blüt s; -[e]s

ge|bogt (mit Bogen versehen); ein -er Kragen

ge|bo|ren (Abk.: geb.; Zeichen: *); sie ist eine geborene ... [folgt der Name]; Frau Müller geb. Schulz od. Frau Müller, geb. Schulz (↑ R 23); Ge|bo|ren|zei|chen

ge|bor|gen; hier fühle ich mich -; Ge|bor|gen|heit w; -

Ge|bot s; -[e]s, -e; zu -[e] stehen; die Zehn -e (↑ R 224); Ge|bots|schild (Verkehrswesen; Mehrz. ...schilder)

Gebr. = Gebrüder

Ge|bräch s; -[e]s, -e u. Ge|brä|che (Bergmannsspr.: Gestein, das leicht in Stücke zerfällt; Jägerspr.: der vom Schwarzwild mit dem Rüssel aufgewühlte Boden) s; -s, -

Ge|brä|me landsch. (Verbrämung) s; -s, -
ge|brannt; -er Kalk
Ge|bra|te|ne s; -n († R 287ff.)
Ge|bräu s; -[e]s, -e
Ge|brauch m; -[e]s, (für Sitte, Verfahrensweise auch Mehrz.:) Gebräuche; ge|brau|chen (benutzen; fälschlich für: brauchen, nötig haben); ge|bräuch|lich; Gebräuch|lich|keit w; -; Ge|brauchs-an|wei|sung; ge|brauchs|fer|tig; Ge|brauchs_ge|gen|stand, ...graphik (vgl. Anm. S. 310), ...gut, ...mu|sik; Ge|braucht|wa|gen; Gebraucht|wa|gen|markt
Ge|braus s; Ge|brau|se s; ...ses
Ge|brech s; -[e]s -e u. Ge|bre|che (Bergmannsspr.: Gebräch; Jägerspr.: Rüssel des Schwarzwildes) s; -s, -; ge|bre|chen (selten für: fehlen, mangeln); es gebricht mir an [einer Sache]; Ge|bre|chen (Fehler) s; -s, -; ge|brech|lich; Gebrech|lich|keit w; -
Ge|bre|sten (schweiz., sonst veralt. für: Krankheit, Leiden) s; -s, - ge|bro|chen; -e Farben; -e Schriften; -e Zahlen
Ge|bröckel [Trenn.: ...brök|kel] s; -s
Ge|bro|del s; -s
Ge|brü|der (Abk.: Gebr.) Mehrz.
Ge|brüll s; -[e]s
Ge|brumm s; -[e]s u. Ge|brum|me s; -s; Ge|brum|mel s; -s
ge|buch|tet; ein tief -er Resonanzkörper
Ge|bück (früher für: geflochtene Hecke zum Schutze von Anlagen oder Siedlungen; heute noch als Flurname) s; -[e]s, -e
Ge|bühr w; -, -en; nach, über -; ge|büh|ren; etwas gebührt ihm (kommt ihm zu); es gebührt sich nicht, dies zu tun; ge|büh|rend; er erhielt die -e (entsprechende) Antwort; ge|büh|ren|der_ma|ßen, ...wei|se; ge|büh|ren|frei; Ge|büh-ren_frei|heit (w; -), ...ord|nung; ge|büh|ren|pflich|tig; ge|büh|rlich (veralt.); Ge|bühr|nis (Papierdt.: Gebühr, Abgabe) w; -, -se
Ge|bums, Ge|bum|se s; ...ses
Ge|bund s; 4 - Seide, Stroh († R 321 u. 322); ge|bun|den (Abk. [bei Büchern]: geb.); -e Aktien; -es System (roman. Baukunst); -e Rede (Verse); Ge|bun|den|heit w; -
Ge|burt w; -, -en; Ge|bur|ten_be-schrän|kung, ...kon|trol|le, ...re-ge|lung od. ...reg|lung, ...rück-gang, ...über|schuß; ge|bür|tig; Ge|burts_adel, ...an|zei|ge, ...da-tum, ...feh|ler, ...haus, ...hel|fer, ...hil|fe (w; -), ...ort (m; -[e]s, -e), ...schein, ...tag; Ge|burts|tags_fei-er, ...kind; Ge|burts|ur|kunde
Ge|büsch s; -[e]s, -e

Geck m; -en -en († R 268); Gecken-art[1] w; -; gecken|haft[1]; Gecken-haf|tig|keit[1]; gecken|mä|ßig[1]
Gecko [Trenn.: Gek|ko] malai. (eine trop. Eidechse) m; -s, -s u. ...onen
ge|dacht [von: denken, gedenken]; ich habe nicht daran -; ich habe seiner -; Ge|dach|te s; -n († R 287ff.); ge|dächt|nis s; -ses, -se; Ge|dächt|nis_fei|er, ...schwund, ...stö|rung, ...stütze
ge|dackt (Orgelbau: gedeckt); -e Pfeife
Ge|dan|ke, (selten:) Ge|dan|ken m; ...kens, ...ken; Ge|dan|ken_ar-beit, ...aus|tausch, ...blitz, ...frei-heit (w; -), ...gang m, ...gut (s; -[e]s), ...le|sen (s; -s); Ge|dan|ken-los; -este († R 292); Ge|dan|ken|lo-sig|keit; ge|dan|ken|reich; Ge-dan|ken_split|ter, ...sprung, ...strich, ...über|tra|gung, ...ver-bin|dung; Ge|dan|ken|ver|lo|ren; ge|dan|ken|voll; ge|dank|lich
Ge|därm s; -[e]s, -e u. Ge|där|me s; -s, -
Ge|deck s; -[e]s, -e
Ge|deih m, nur in: auf - und Verderb u. (selten:) auf - und Ungedeih; ge|dei|hen; du gediehst; du gediehest; gediehen; gedieh[e]!; Ge|dei|hen s; -s; ge-deih|lich; Ge|deih|lich|keit w; -
Ge|den|ke|mein (Waldblume) s; -s, -; ge|den|ken; mit Wesf.: gedenket unser!; Ge|den|ken s; -s; Ge|denk_mi|nu|te, ...stät|te, ...stun|de, ...tag
ge|deucht vgl. dünken
Ge|dicht s; -[e]s, -e; Ge|dicht-samm|lung
ge|die|gen; -es (reines) Gold; ein -er (zuverlässiger, lauterer) Charakter; -e Kenntnisse; du bist aber -! (ugs. für: wunderlich); Ge-die|gen|heit w; -
ge|dient; -er Soldat
Ge|din|ge (Akkordlohn im Bergbau) s; -s, -; Ge|din|ge_ab|schluß, ...ar|bei|ter
Ge|don|ner s; -s
Ge|döns landsch. (Aufheben, Getue) s; -es; viel - um etwas machen
Ge|drän|ge s; -s; Ge|drän|gel (ugs.) s; -s; ge|drängt; -e Übersicht; Ge-drängt|heit w; -
Ge|dröhn s; -[e]s u. Ge|dröh|ne s; -s
ge|drückt; seine Stimmung ist -
Ge|druck|te s; -n († R 287ff.)
Ge|drückt|heit w; -
ge|drun|gen; eine -e (untersetzte) Gestalt; Ge|drun|gen|heit w; -
Ge|du|del s; -s
Ge|duld w; -; ge|dul|den, sich; ge-dul|dig; Ge|dulds_ar|beit, ...fa|den

(nur in: jmdm. reißt der Geduldsfaden), ...pro|be; Ge|duld[s]|spiel
ge|dun|sen; der Kranke hatte ein -es Gesicht; Ge|dun|sen|heit w; -
Ge|ehr|te (veralt. für: Schreiben) s; -n († R 287ff.); Ihr -s
ge|eig|net; -ste; man muß die -en Mittel anwenden; ge|eig|ne|ten-orts; Ge|eig|net|heit w; -
Geest (hochgelegenes, trockenes u. meist unfruchtbares Land im Küstengebiet) w; -, -en; Geest-land s; -[e]s
gef. (Zeichen: ✕ = gefallen)
Ge|fach (Fach, Lade) s; -[e]s, Gefächer
Ge|fahr w; -, -en; - laufen; ge|fahr-brin|gend; ge|fähr|den; ge|fahr-dro|hend; Ge|fähr|dung w; -
Ge|fah|re (häufiges [unvorsichtiges, schlechtes] Fahren) s; -s
Ge|fah|ren_ge|mein|schaft, ...herd, ...mo|ment s, ...quel|le, ...zo|ne, ...zu|la|ge; ge|fähr|lich; -e Körperverletzung (Rechtsspr.); Ge-fähr|lich|keit; ge|fahr|los; -este († R 292); Ge|fahr|lo|sig|keit w; -
Ge|fährt (Wagen) s; -[e]s, -e; Ge-fähr|te (Begleiter) m; -n, -n († R 268); Ge|fähr|tin w; -, -nen
ge|fahr|voll
Ge|fäl|le s; -s, -; Ge|fäl|le|mes|ser m; [1]ge|fal|len; es hat mir -; sich etwas - lassen; [2]ge|fal|len; er ist - (Abk.: gef.; Zeichen: ✕); [1]Ge-fal|len m; -s, -; jmdm. einen Gefallen tun; jmdm. etwas zu Gefallen tun; [2]Ge|fal|len s; -s; [kein] - an etwas finden; Ge|fal|le|ne m u. w; -n, -n († R 287ff.); Ge|fal|le-nen_ge|denk|fei|er; ge|fäl|lig (Abk.: gefl.); Ge|fäl|lig|keit; Ge-fäl|lig|keits_wech|sel (Geldw.) ge|fäl|ligst (Abk.: gefl.); Ge|fall-sucht w; -; ge|fall|süch|tig
Ge|fäl|tel (Faltenwerk; Besatz) s; -s
ge|fan|gen; Ge|fan|ge|ne m u. w; -n, -n († R 287ff.); Ge|fan|ge|nen_be|frei|ung, ...haus (österr. auch neben: Gefängnis), ...la|ger, ...wär|ter; ge|fan|gen|hal|ten († R 139); du hältst gefangen; gefangengehalten; gefangenzuhalten; Ge|fan|gen|haus (österr. amtl. Form für: Gefangenenhaus); Ge-fan|gen|nah|me w; -; ge|fan|gen-neh|men; vgl. gefangenhalten; Ge|fan|gen|neh|mung; Ge|fan-gen|schaft w; -; ge|fan|gen|set|zen; vgl. gefangenhalten; Ge|fäng|nis s; -ses, -se; Ge|fäng|nis_auf|se|he-...stra|fe, ...zel|le
ge|färbt; dunkelgefärbt usw.; v blau, IV
Ge|fa|sel s; -s
Ge|fa|ser s; -s
Ge|fäß s; -es, -e; Ge|fäß_chir|ur|gi ...er|wei|te|rung

[1] Trenn.: ...ek|ken...

ge|faßt; auf alles - sein; Ge|faßt|heit w; -

Ge|fecht s; -[e]s, -e; ge|fechts|be|reit; Ge|fechts..be|reit|schaft (w; -), ...pau|se, ...stand

Ge|fe|ge (Jägerspr.: vom Geweih abgefegter Bast) s; -s

ge|feit (sicher, geschützt); er ist gegen böse Einflüsse -

Ge|fer|tig|te (Kaufmannsspr. veralt.: Unterzeichnete[r]) m u. w; -n, -n (↑ R 287 ff.)

Ge|fie|del s; -s

Ge|fie|der s; -s, -; ge|fie|dert; -e (mit Federn versehene) Pfeile

Ge|fil|de (dicht. für: Felder) s; -s, -

ge|fin|kelt österr. (schlau, durchtrieben)

Gefi|on [auch: gef...] (nord. Göttin)

ge|fir|nißt; das Brett ist -

gefl. = gefällig, gefälligst

Ge|flacker [Trenn.: ...flak|ker] s; -s

ge|flammt; -e Muster

Ge|flat|ter s; -s

Ge|flecht s; -[e]s, -e

ge|fleckt; rotgefleckt usw.; vgl. blau, IV; rot und weiß -

Ge|flen|ne (ugs. für: andauerndes Weinen) s; -s

Ge|flim|mer s; -s

Ge|flis|sen|heit w; -; ge|flis|sent|lich

Ge|flu|che s; -s

Ge|flu|der (Bergmannsspr. für: Gerinne) s; -s, -

Ge|flü|gel s; -s; Ge|flü|gel..farm, ...sa|lat; ge|flü|gelt; -es Wort (oft angeführter Ausspruch u. Ausdruck; Mehrz.: -e Worte)

Ge|flun|ker s; -s

Ge|flü|ster s; -s

Ge|fol|ge s; -s, (selten) -; im - von ...; Ge|folg|schaft; Ge|folgs|mann (Mehrz. ...männer u. ...leute)

Ge|fra|ge s; -s; dein dummes - ; ge|fra|ßig; der Kerl ist dumm und - ; Ge|frä|ßig|keit w; -

Ge|frei|te m; -n, -n (↑ R 287 ff.)

Ge|frett, Gfrett südd., österr. ugs. (Ärger, Plage) s; -s

ge|freut schweiz. mdal. (erfreulich)

ge|frie|ren; Ge|frier..fleisch, ...gemü|se; ge|frier|ge|trock|net; Gefrier..ket|te (w; -), ...punkt, ...schutz|mit|tel, ...trock|nung, ...tru|he, ...ver|fah|ren, ...wa|re

Ge|frieß, Gfrieß südd., österr. ugs. abwertend (Gesicht) s; -es, -er

ge|frit|tet (zusammengeschmolzen); eine pulverförmige Mischung wurde - (d. h. bis zum Zusammenschmelzen der äußeren Teilchen erhitzt)

Ge|fro|re|ne, Ge|fror|ne südd., österr. ([Speise]eis) s; -n (↑ R 287 ff.)

ge|fü|ge (veralt. für: gefügig); er ist -; Ge|fü|ge s; -s, -; ge|fü|gig; Ge|fü|gig|keit w; -

Ge|fühl s; -[e]s, -e; ge|fühl|lig (abschätzig für: gefühlvoll); Ge|füh|lig|keit w; -; ge|fühl..er|füllt, ...los (-este; ↑ R 292); Ge|fühl|lo|sig|keit; ge|fühls..arm, ...be|tont; Ge|fühls|du|se|lei; ge|fühls|mä|ßig; Ge|fühls..mensch, ...re|gung, ...wert; ge|fühl|voll

ge|füh|rig (vom Schnee: für das Schilaufen günstig); Ge|füh|rig|keit (für: Före) w; -

Ge|fun|kel s; -s

ge|furcht; der Stengel der Pflanze ist -

ge|für|stet; -e Abtei

Ge|gacker [Trenn.: ...gak|ker] s; -s

ge|ge|ben; es ist das -e (↑ R 134), aber (↑ R 116): er nahm das Gegebene gern; ge|ge|be|nen|falls (Abk.: ggf.); vgl. Fall m; Ge|ge|ben|heit

ge|gen; Verhältnisw. mit Wenf.: er rannte - das Tor; Umstandsw. (ohne Einfluß auf die Beugung): - 20 Leute standen - der Straße; gegeneinander; gegenüber; ge|gen; Ge|gen..ab|sicht, ...an|griff, ...an|trag, ...be|such, ...be|weis, ...bu|chung

ge|gend w; -, -en

Ge|gen..dienst, ...druck m; -[e]s

ge|gen|ein|an|der; Schreibung in Verbindung mit Zeitwörtern (↑ R 139): damit sie gegeneinander (einer gegen den anderen) kämpfen, aber: die Bretter gegeneinanderstellen; vgl. aneinander; ge|gen|ein|an|der|ste|hen (sich feindlich gegenüberstehen); sie [die Gegner] haben gegeneinandergestanden; ge|gen|ein|an|der|stell|len; vgl. gegeneinander

Ge|gen..fahr|bahn, ...for|de|rung, ...fra|ge, ...füß|ler (für: Antipode), ...ge|ra|de (Sportspr.), ...gewicht, ...gift s; ...kai|ser, ...kurs; ge|gen|läu|fig; Ge|gen|lei|stung; ge|gen|le|sen (als zweiter zur Kontrolle lesen); vgl. gegenzeichnen; Ge|gen|licht|auf|nah|me (Fotogr.); Ge|gen|lie|be, ...maß|nah|me, ...mit|tel s, ...papst, ...par|tei, ...pol, ...pro|be, ...re|de, ...re|for|ma|ti|on; Ge|gen|satz; ge|gen|sätz|lich; Ge|gen|sätz|lich|keit; Ge|gen|satz|wort, Ge|gen|wort (für: Antonym; Mehrz. ...wörter); Ge|gen|schlag; ge|gen|sei|tig; Ge|gen|sei|tig|keit w; -; Ge|gen..spiel, ...spie|ler

Ge|gen|stand; ge|gen|stän|dig (Bot.: gegenüberstehend); -e Beblätterung; ge|gen|ständ|lich (sachlich, anschaulich, klar); -es Hauptwort (für: Konkretum); Ge|gen|ständ|lich|keit w; -; ge-

ge|gen|stands|los (keiner Berücksichtigung wert); Ge|gen|stands|lo|sig|keit w; -

Ge|gen|stim|me; ge|gen|stim|mig; Ge|gen..stoß, ...strom; ge|gen|stro|mig, ge|gen|strö|mig; Ge|gen..strö|mung, ...stück

Ge|gen|teil s; -[e]s, -e; im - ; ins - umschlagen; ge|gen|tei|lig

ge|gen|über; mit Wemf.: die Schule steht - der Kirche, (auch:) der Kirche-; bei Ortsnamen auch mit „von": gegenüber von Blankenese. Schreibung im Verbindung mit Zeitwörtern (↑ R 139): I. Getrenntschreibung, wenn q. im Sinne von „dort drüben, auf der anderen Seite" gebraucht wird: gegenüber stehen zwei Häuser. II. Zusammenschreibung, wenn durch die Verbindung ein neuer Begriff entsteht; vgl. gegenüberliegen, gegenüberstehen; Ge|gen|über s; -s, -; ge|gen|über|lie|gen (↑ R 139); die feindlichen Truppen haben sich gegenüberliegen; aber: gegenüber liegen; gegenüber (dort) liegen zwei Burgen; ge|gen|über|ste|hen (↑ R 139); sie haben sich feindlich gegenübergestanden; aber: ge|gen|über stehen; gegenüber (dort) stehen zwei Häuser; ge|gen|über..stel|len, ...tre|ten

Ge|gen..ufer, ...ver|kehr, ...vor|schlag

Ge|gen|wart w; -; ge|gen|wär|tig [auch: ...wär...]; (↑ R 116:) die hier Gegenwärtigen; (Papierdt.:) mit Gegenwärtigen beehre ich mich ...; ge|gen|warts|be|zo|gen; Ge|gen|warts|form; ge|gen|warts..fremd, ...nah od. ...na|he; Ge|gen|warts|spra|che

Ge|gen..wehr w; -, ...wert, ...wind, ...wir|kung, ...woh|ner (für: Antipode); Ge|gen|wort vgl. Gegensatzwort

ge|gen|zeich|nen (seine Gegenunterschrift geben, mit seiner Gegenunterschrift versehen); ich zeichne gegen; gegengezeichnet; gegenzuzeichnen; Ge|gen|zeich|ner, ...zeich|nung

Ge|gen..zeu|ge, ...zug

Ge|gir|re s; -s

Ge|git|zer s; -s

Geg|ner; geg|ne|risch; Geg|ner|schaft w; -

ge|go|ren; der Saft ist -

gegr. = gegründet

Ge|grö|le (ugs. für: Geschrei) s; -s

ge|grün|det (Abk.: gegr.); der Verein wurde -

Ge|grun|ze s; -s

geh. = geheftet

Ge|ha|be (Ziererei; eigenwilliges Benehmen) s; -s; ge|ha|ben, sich;

nur in der Gegenw.; du gehabst
dich; er gehabt sich; gehab[e] dich
wohl!; Ge|ha|ben s; -s
Ge|hack|te (Hackfleisch) s; -n (↑ R
287ff.)
Ge|hal|der s; -s
¹Ge|halt (Besoldung) s; -[e]s, Ge-
hälter; ²Ge|halt (Inhalt; Wert) m;
-[e]s, -e; ge|halt|arm; ge|hal|ten;
- (verpflichtet) sein; ge|halt|los;
-este (↑ R 292); Ge|halt|lo|sig|keit
w; -; ge|halt|reich; Ge|halts_aus-
zah|lung, ...emp|fän|ger, ...er|höh-
hung, ...nach|zah|lung, ...stu|fe,
...vor|rückung [Trenn.: ...rük|k...]
(österr.: Gehaltserhöhung der
Beamten), ...zah|lung; ge|halt-
voll
Ge|häm|mer s; -s
ge|han|di|kapt engl. [...händikäpt]
(behindert, gehemmt, benachtei-
ligt)
Ge|hän|ge s; -s, -
Ge|hängte m u. w; -n, -n (↑ R
287ff.); vgl. auch: Gehenkte
ge|har|nischt; ein -er Reiter; ein
-er (scharfer) Protest
ge|häs|sig; Ge|häs|sig|keit
Ge|häu|se s; -s, -
Geh|bahn; geh|bar; geh|be|hin|dert
Ge|heck s; -[e]s, -e
ge|hef|tet (Abk.: geh.); die Akten
sind -; er hat sich an seine Sohlen
- (weicht nicht von ihm)
Ge|he|ge s; -s, -
ge|hei|ligt; der Zweck hat die Mit-
tel -
ge|heim; insgeheim. I. Kleinschrei-
bung: geheimer Vorbehalt; (↑ R
134:) im -en. II. Großschreibung
in Titeln (↑ R 224): [Wirklicher]
Geheimer Rat, Geheimer Regie-
rungsrat, Geheime Staatspolizei
(polit. Polizei im nationalsoz.
Reich; Abk.: Gestapo), Gehei-
mes Staatsarchiv. III. Schreibung
in Verbindung mit Zeitwörtern
(↑ R 139): a) Getrenntschreibung,
wenn beide Wörter ihre Selbstän-
digkeit bewahren: etwas geheim
erledigen; etwas muß geheim
bleiben; b) Zusammenschreibung,
wenn beide Wörter als Einheit
empfunden werden, z. B. geheim-
halten, geheimtun; Ge|heim_ab-
kom|men, ...agent, ...bund m; Ge-
heim|bün|de|lei; Ge|heim_bünd-
ler, ...dienst, ...do|ku|ment,
...fach; ge|heim|hal|ten (↑ R 139);
du hältst geheim; geheimgehal-
ten; geheimzuhalten; Ge|heim-
hal|tung; Ge|heim|nis s; -ses, -se;
ge|heim|nis |krä|mer; Ge|heim|nis-
krä|mer; Ge|heim|nis|krä|me|rei;
ge|heim|nis|tue|rei w; -; ge|heim-
_tue|risch, ...voll; Ge|heim_po|li-
zei, ...rat (Mehrz. ...räte; vgl. ge-
heim);

[Trenn.: ...ek|ken] (Mehrz.), ...ti-
tel; Ge|heim_re|zept, ...schrift,
...sen|der, ...tu|er; Ge|heim|tue|rei
w; -; ge|heim|tue|risch; ge|heim-
tun; vgl. geheimhalten
Ge|heiß s; -es; auf - des ...; auf
sein -
ge|hemmt; Ge|hemmt|heit w; -
ge|hen; du gehst; du gingst, er ging;
du gingest; gegangen; geh[e]!;
geht's! (südd., österr.: Ausdruck
der Ablehnung, des Unwillens);
vor sich -; baden gehen, schlafen
gehen, vgl. aber: gehenlassen u.
gutgehen; Ge|hen (Sportart) s; -s;
(↑ R 157:) 20-km-Gehen
Ge|henk (selten für: Gehänge) s;
-[e]s, -e
ge|hen|kelt (mit Henkeln verse-
hen)
Ge|henk|te (die durch den Henker
hingerichtete Person) m u. w; -n,
-n (↑ R 287ff.); vgl. auch: Ge-
hängte
ge|hen|las|sen; ↑ R 139 (in Ruhe
lassen); er hat ihn gehenlassen
(↑ R 305); sich - (sich vernachläs-
sigen, zwanglos verhalten); er hat
sich gehenlassen, (seltener:) ge-
hengelassen (↑ R 305); aber: ge-
hen las|sen; du sollst ihn nach
Hause gehen lassen; den Teig ge-
hen lassen
Ge|hen|na hebr. (spätjüd.-neutest.
Bez. der Hölle) w; -
Ge|her
Ge|het|ze s; -s
ge|heu|er; das kommt mir nicht
- vor
Ge|heul s; -[e]s
Ge|hil|fe m; -n, -n (↑ R 268); Ge-
hil|fen|brief; Ge|hil|fen|schaft
schweiz. (Rechtsspr.: Beihilfe)
Ge|hil|fin w; -, -nen
Ge|hirn s; -[e]s, -e; Ge|hirn_akro-
ba|tik (scherzh.), ...chir|ur|gie,
...er|schüt|te|rung, ...er|wei|chung
(für: Paralyse), ...haut, ...scha|le,
...schlag, ...trust (für: Brain-
Trust), ...wä|sche (Zerstörung
der Wertbegriffe eines Menschen
und gesteuerte geistige Neu-
orientierung durch psych. Druck
u. Suggestion [sowie Medika-
mente])
gehl mdal. (gelb); Gehl|chen mdal.
(Pfifferling, Gelbling)
ge|ho|ben; durch diese Taten wur-
de sein Ansehen sehr -
Ge|höft s; -[e]s, -e
Ge|höh|ne s; -s
Ge|hölz s; -es, -e; Ge|hol|ze (Sport:
rücksichtsloses u. stümperhaftes
Spielen) s; -s
Ge|hör s; -[e]s - finden, schenken;
Ge|hör|bil|dung (Musik); ge|hor-
chen; du mußt ihm -; der Not
gehorchend; ge|hö|ren; das Haus
gehört mir; die mir gehörenden

Häuser; ich gehöre zur Familie;
(südd., österr. auch:) ihm gehört
(gebührt) eine Strafe; Ge|hör-
_feh|ler, ...gang m; ge|hö|rig; er
hat -en Respekt; (Papierdt.:) -en
Ortes; ge|hör|los; Ge|hör|lo|se m
u. w; -n, -n (↑ R 287ff.); Ge|hör|lo-
sen|schu|le; Ge|hör|lo|sig|keit w; -
Ge|hörn s; -[e]s, -e; ge|hörnt; -es
Wild
ge|hor|sam; Ge|hor|sam m; -s; Ge-
hor|sam|keit w; -; Ge|hor-
sams_pflicht, ...ver|wei|ge|rung
Ge|hör|sinn m; -[e]s
Geh|pelz
¹Geh|re w; -, -n; vgl. Gehrung;
²Geh|re w; -, -n u. Geh|ren mdal.
(Zwickel, Einsatz, Schoß; zwik-
kelförmiges Ackerbeet; Keil) m;
-s, -; geh|ren (schräg abschnei-
den); Geh|ren|zie|gel
Geh|rock
Geh|rung, (in der Technik auch:)
Geh|re (Abschrägung am Zu-
sammenstoß); Geh|rungs|sä|ge
Geh|steig
Ge|hu|del s; -s
Ge|hu|pe s; -s
Geh_ver|band, ...weg, ...werk
Gei (Tau zum Geien) w; -, -en;
gei|en ([Segel] zusammenschnü-
ren)
Gei|er m; -s, -
Gei|fer m; -s; Gei|fe|rer; gei|fe|rig,
geif|rig; gei|fern; ich ...ere (↑ R
327)
Gei|ge w; -, -n; gei|gen; Gei-
gen_bau|er (m; -s, -), ...bo|gen,
...sai|te, ...spie|ler; Gei|ger (Gei-
genspieler)
Gei|ger|zäh|ler [nach dem dt. Phy-
siker Hans Geiger]; ↑ R 180 (Ge-
rät zum Nachweis radioaktiver
Strahlen)
geil; ¹Gei|le (Geilheit) w; -; ²Gei|le
(Jägerspr.: Hode) w; -, -n; gei|len;
Geil|heit w; -
Gei|sa (Mehrz. von: Geison)
Gei|sel w; -, -n; (selten:) m; -s, -;
-n stellen; vgl. aber: Geißel; Gei-
sel|nah|me w; -, -n
Gei|ser (eindeutschende Schrei-
bung für: Geysir) m; -s, -
Gei|se|rich (König der Wandalen)
Gei|sha jap. [gescha] (jap. Gesell-
schafterin, Tänzerin, Sängerin in
Teehäusern) w; -, -s
Gei|son gr. (Kranzgesims des anti-
ken Tempels) s; -s, -s u. ..sa
Geiß südd., österr., schweiz. (Zie-
ge) w; -, -en; Geiß_bart (eine Wie-
senpflanze; m; -[e]s), ...blatt (ein
Klettergewächs; s; -[e]s), ...bock
Gei|ßel (Peitsche; Treibstecken) w;
-, -n; vgl. aber: Geisel; gei|ßeln;
ich ...[e]le (↑ R 327); Gei|ßel|tier-
chen (ein Einzeller); Gei|ße|lung
Geiß|lung
Geiß|fuß (ein Wiesenkraut [nur

Einz.]; Werkzeug; zahnärztl. Instrument) m; -es, ...füße; Geiß|hirt; Geiß|lein (junge Geiß)
Geiß|ler [zu: geißeln]
Geiß|ler|sche Röh|re [nach dem Mechaniker Geißler] (elektr. Entladungsröhre) w; -n -, -n -n
Geiß|lung, Gei|ße|lung
Geist m; -[e]s, (für: Gespenst, kluger Mensch *Mehrz.*:) -er u. (für: Weingeist usw. *Mehrz.*:) -e; geist|bil|dend, aber (↑ R 142): den Geist bildend; Gei|ster.bahn ...be|schwö|rung, ...er|schei|nung; gei|ster|haft; Gei|ster|hand; wie von -; gei|stern; es geistert; Gei|ster..|her, ...notun|de; gei|stes|ab|we|send; Gei|stes.ab|we|sen|heit, ...ar|bei|ter, ...blitz, ...ga|ben (*Mehrz.*), ...ge|gen|wart; gei|stes|ge|gen|wär|tig; Gei|stes|ge|schich|te; gei|stes.ge|stört, ...krank; Gei|stes|kran|ke m u. w; -n, -n (↑ R 287ff.); Gei|stes.krank|heit, ...stö|rung, ...wis|sen|schaf|ten (*Mehrz.*); Gei|stes|wis|sen|schaft|lich; Gei|stes|zu|stand; geist|feind|lich; gei|stig; -e Getränke; -e Nahrung; -es Eigentum; Gei|stig|keit w; -; gei|stig.see|lisch (↑ R 158); geist|lich; -er Beistand; -e Dichtung, aber (↑ R 224): Geistlicher Rat (kath.); Geist|li|che m; -n, -n (↑ R 287ff.); Geist|lich|keit w; -; geist.los (-este [↑ R 292]), ...reich, ...tö|tend (aber [↑ R 142]: den Geist tötend), ...voll
Gei|tau (Tau zum Geien) s
Geiz m; -es; gei|zen; du geizt (geizest); Geiz|hals; gei|zig; Geiz|kra|gen
Ge|jam|mer s; -s
Ge|jauch|ze s; s
Ge|jo|del s; -s
Ge|joh|le s; -s
Ge|kei|fe s; -s
Ge|ki|cher s; -s
Ge|kläff s; -[e]s u. Ge|kläf|fe s; -s
Ge|klap|per s; -s
Ge|klat|sche s; -s
Ge|klim|per s; -s
Ge|klin|gel s; -s
Ge|klirr s; -[e]s u. Ge|klir|re s; -s
Ge|klop|fe s; -s
Ge|klüft s; -[e]s, -e u. Ge|klüf|te s; -s, -
Ge|knat|ter s; -s
ge|knickt
Ge|knir|sche s; -s
Ge|kni|ster s; -s
ge|konnt; sein Spiel war, wirkte sehr -; Ge|konnt|heit w; -
ge|kö|pert (köperbindig gewebt)
ge|körnt; das Werkstück wurde -
ge|kräch|ze s; -s
Ge|kra|kel s; -s
Ge|krätz (Metallabfall) s; -es; Ge|krat|ze s; -s

Ge|kräu|sel s; -s
Ge|kreisch s; -[e]s u. Ge|krei|sche s; -s
Ge|kreu|zig|te m; -n, -n (↑ R 287ff.)
ge|kröpft (hakenförmig gebogen); eine -e Welle
Ge|krö|se s; -s, -
ge|kün|stelt; ein -es Benehmen
Gel (gallertartig ausgeflockter Niederschlag aus kolloider Lösung) s; -s, -e
Ge|läch|ter s; -s, -
ge|lack|mei|ert (ugs. für: angeführt); Ge|lack|mei|er|te m u. w; -n, -n (↑ R 287ff.)
ge|lackt vgl. lacken
ge|la|den (ugs. für: wütend, zornig)
Ge|la|ge s; -s, -; Ge|lä|ger (Gärniederschlag) s; -s, -
ge|lähmt; Ge|lähm|te m u. w; -n, -n (↑ R 287ff.)
ge|lahrt (veralt. für: gelehrt); ein -er Mann
Ge|län|de s; -s, -; Ge|län|de.fahrt, ...fahr|zeug; ge|län|de|gän|gig; Ge|län|de|lauf
Ge|län|der s; -s, -
Ge|län|de.sport (m; -[e]s), ...übung, ...wa|gen
ge|lan|gen; der Brief gelangte nicht in meine Hände; an jmdn. - (schweiz. für: an jmdn. herantreten, sich an jmdn. wenden)
ge|lappt; -e Blätter (Bot.)
Ge|lär|me s; -s
Ge|laß (veralt. für: Raum) s; Gelasses, Gelasse
ge|las|sen; er steht der Gefahr - gegenüber; Ge|las|sen|heit w; -
Ge|la|ti|ne *fr.* [*sehe...*] ([Knochen]leim, Gallert) w; -; Ge|la|ti|ne.kap|sel; ge|la|ti|nie|ren (zu Gelatine erstarren; in Gelatine verwandeln); ge|la|ti|nös (gelatineartig); -e Masse
Ge|läuf (Jägerspr.: Spuren u. Wechsel des Federwildes; Sport: Boden einer Pferderennbahn) s; -[e]s, -e; Ge|lau|fe s; -s u. Ge|läu|fig; die Redensart ist -; Ge|läu|fig|keit w; -
ge|launt; gutgelaunt; der gutgelaunte Vater (↑ jedoch R 142), aber: der Vater ist gut gelaunt
Ge|läu|te s; -s, -e u. Ge|läu|te s; -s, -
gelb; gelbe Rüben (südd. für: Mohrrüben), das gelbe Fieber, die gelbe Gefahr, gelbe Rasse, gelbes Blinklicht, das gelbe Trikot (des Spitzenreiters im Radsport), aber (↑ R 198): der Gelbe Fluß; vgl. blau, IV, V; Gelb (gelbe Farbe) s; -s, - (ugs: -s); bei Gelb ist die Kreuzung zu räumen; die Ampel zeigt auf Gelb; vgl. Blau; gelb|braun usw.; vgl. blau, V u.

↑ R 158; Gel|be s; -n; Gelb.fie|ber, ...fil|ter, ...gie|ßer (Messinggießer); gelb|lich; gelblichgrün usw. (↑ R 158); Gelb|licht s; -[e]s; Gelb|ling (ein Pilz); Gelb.schna|bel (seltener für: Grünschnabel), ...stern (eine Zwiebelpflanze; vgl. ²Stern), ...sucht (w; -); gelb|süch|tig; Gelb|vei|ge|lein südd. volkstümlich (Levkoje)
Geld (Abk. auf dt. Kurszetteln: G [vgl. d.]) s; -[e]s, -er; (↑ R 145.) Geld- und andere Sorgen; Geld.an|la|ge, ...beu|tel, ...bör|se, ...brief|trä|ger, ...büch|se (ugs.)
Gel|dern (Stadt im Niederrhein. Tiefland); Gel|der|ner (↑ R 199)
Gel|des|wert m; -[e]s; Geld.ge|ber, ...gier; geld|gie|rig; geld|lich, aber: unentgeltlich; Geld|mit|tel (*Mehrz.*)
geld|risch [zu: Geldern]
Geld.schein, ...schrank, ...sor|gen (*Mehrz.*), ...sor|te, ...stra|fe, ...stück, ...sum|me, ...ver|le|gen|heit, ...wech|sel, ...wert (m; -[e]s), we|sen (s; -s), ...wirt|schaft
ge|leckt; das Zimmer sieht aus wie - (ugs. für: sehr sauber); Ge|leckt|helt w; -
Ge|lee *fr.* [*sehele*] s od. m; -s, s
Ge|le|ge s; -s
ge|le|gen; das kommt mir sehr - (zur rechten Zeit); ich werde zu -er Zeit wiederkommen; Ge|le|gen|heit; Ge|le|gen|heits.ar|beit, ...ar|bei|ter, ...ge|dicht, ...kauf; ge|le|gent|lich; mit *Wesf.*: - seines Besuches, dafür besser: bei seinem Besuch
ge|leh|rig; Ge|leh|rig|keit w; -; ge|lehr|sam; Ge|lehr|sam|keit w; -; ge|lehrt; ein -er Mann; das Buch ist mir zu -; Ge|lehr|te m u. w; -n, -n (↑ R 287ff.); Ge|lehr|ten|stand m; -[e]s; Ge|lehrt|heit w; -
Ge|lei|er s; -s
Ge|leis vgl. Gleis; ...ge|lei|sig, ...glei|sig (z. B. eingleisig)
Ge|leit s; -[e]s, -e u. (veralt.:) Ge|lei|te; Ge|lei|ter; Ge|leit|schutz; Ge|leits.herr, ...mann (*Mehrz.* ...männer u. ...leute); Ge|leit.wort (*Mehrz.* ...worte), ...zug
ge|lenk (älter für: gelenkig); Ge|lenk s; -[e]s, -e; Ge|lenk.band (s; *Mehrz.* ...bänder), ...ent|zün|dung (österr.: Gelenksentzündung), ...fahr|zeug; ge|len|kig; Ge|len|kig|keit w; -; Ge|lenk.kap|sel, ...knor|pel, ...rheu|ma|tis|mus; Ge|lenks|ent|zün|dung österr. (Gelenkentzündung); Ge|lenk|wel|le (für: Kardanwelle)
ge|lernt; ein -er Maurer
Ge|leucht s; -[e]s u. Ge|leuch|te (Bergmannsspr.: Licht, Beleuchtung unter Tage) s; -s

Ge|lich|ter s; -s
Ge|lieb|te m u. w; -n, -n (↑ R 287ff.)
ge|lie|fert (ugs. für: verloren, rui-
niert)
ge|lie|ren fr. [sehelir°n] (zu Gelee
werden)
ge|lind, ge|lin|de; ein gelinder (mil-
der) Regen; ein gelinder Schauer
ging ihm über den Rücken
ge|lin|gen; es gelang; es gelänge;
gelungen; geling[e]!; Ge|lin|gen s;
-s
Ge|lis|pel s; -s
¹gell (helltönend)
²gell?, gel|le? mitteld. (svw. gelt?)
gel|len; es gellt; es gellte; gegellt
Geln|hau|sen (Stadt a. d. Kinzig)
ge|lo|ben; jmdm. etwas - (verspre-
chen); ich habe mir gelobt (ernst-
haft vorgenommen); (↑ R 224:)
das Gelobte Land (bibl.); Ge|löb-
nis s; -ses, -se
Ge|lock s; -[e]s u. Ge|locke [Trenn.:
...lok|ke] s; -s; ge|lockt; sein Haar
ist -
ge|löscht; -er Kalk
ge|löst; Ge|löst|heit w; -
Gel|se österr. (Stechmücke) w; -,
-n
Gel|sen|kir|chen (Stadt im Ruhr-
gebiet)
¹gelt mitteld. (bes. von Kühen:
nichttragend, unfruchtbar); vgl.
galt
²gelt? [„es gelte!"] bes. südd. u.
österr. (nicht wahr?); vgl. auch:
gell?
gel|ten; du giltst, er gilt; du galtst
(galtest); du gältest (auch: göl-
test); gegolten (selten:) gilt!; - las-
sen; geltend machen; Gel|tend-
ma|chung; Gel|tung; Gel|tungs-
_be|dürf|nis (s; -ses), ...be|reich m,
...sucht (w; -), ...trieb (m; -[e]s)
Ge|lüb|de s; -s, -
Ge|lum|pe s; -s
Ge|lün|ge (Jägerspr.: Herz, Lunge,
Leber u. Milz des Wildes; ¹Ge-
räusch) s; -s
ge|lun|gen; gutgelungen; eine gut-
gelungene Aufführung (↑ jedoch
R 142) a b e r: die Aufführung ist
gut gelungen
Ge|lüst s; -[e]s, -e u. Ge|lü|ste s;
-s, - u. (selten:) Ge|lü|sten s; -s;
ge|lü|sten; es gelüstet mich; ge|lü-
stig landsch. (begierig)
Gel|ze südd. u. rhein. (verschnitte-
nes Schwein) w; -, -n; gel|zen ([ein
Schwein] verschneiden); du gelzt
(gelzest)
GEMA = Gesellschaft für musi-
kal. Aufführungs- u. mechan.
Vervielfältigungsrechte
ge|mach; Ge|mach s; -[e]s, ...mä-
cher u. (dicht.:) -e; ge|mäch|lich
[auch: g°mäch...]; Ge|mäch|lich-
keit [auch: g°mäch...] w; -

Ge|mächt s; -[e]s, -e u. Ge|mäch|te
(veralt. für: männliche Ge-
schlechtsteile) s; -s, -
¹Ge|mahl m; -[e]s, -e; ²Ge|mahl
(dicht. für: Gemahlin) s; -[e]s, -e;
Ge|mah|lin w; -, -nen
ge|mah|nen; das gemahnt mich
an ...
Ge|mäl|de s; -s, -; Ge|mäl|de_aus-
stel|lung, ...ga|le|rie, ...samm-
lung
Ge|mar|kung
ge|ma|sert; -es Holz
ge|mäß; dem Befehl - (seltener: -
dem Befehl; nicht: - des Befehles);
ge|mäß (veralt. für: Gefäß zum
Messen) s; -es, -e; ...ge|mäß (z.
B. zeitgemäß); Ge|mäß|heit w; -
(Papierdt.:) in - des Befehles, da-
für besser: dem Befehl gemäß;
ge|mä|ßigt; -e Zone (Meteor.)
Ge|mäu|er s; -s, -
Ge|mecker [Trenn.: ...mek|ker] s;
-s u. Ge|mecke|re [Trenn.: ...mek-
ke...] s; -s u. Ge|meck|re s; -s
ge|mein; insgemein; das gemeine
Recht; gemeiner Wert, a b e r (↑ R
116): das Gemeine; Ge|mein|be-
sitz; Ge|mein|de w; -, -n; Ge|mein-
de_am|mann (schweiz. für: Ge-
meindevorsteher; Schuldbetrei-
bungs- u. Vollstreckungsbeam-
ter), ...be|am|te, ...ge|mein|de|ei-
gen, ...haus, ...kir|chen|rat, ...ord-
nung, ...rat (Mehrz. ...räte),
...schwe|ster, ...steu|er w; Ge-
mein|de|um|la|ge (↑ R 148); ge-
mein|deutsch; Ge|mein|de_ver-
tre|tung, ...ver|wal|tung, ...vor-
ste|her, ...wahl|recht, ...zen|trum;
ge|meind|lich; Ge|mei|ne
(Druckw.: Kleinbuchstabe; frü-
her für: Soldat des untersten
Ranges) m; -n, -n (↑ R 287ff.);
Ge|mein|ei|gen|tum; ge|mein_faß-
lich, ...frei (hist.), ...ge|fähr|lich;
Ge|mein_geist (m; -[e]s), ...gut (s;
-[e]s); Ge|mein|heit; ge|mein|hin;
ge|mei|nig|lich (veralt.); Ge|mein-
nutz; ge|mein|nüt|zig; Ge|mein-
_platz, ...recht (hist.); ge|mein-
sam; gemeinsamer Unterricht,
a b e r (↑ R 224): der Gemeinsame
Markt (Ziel der Europäischen
Wirtschaftsgemeinschaft); Ge-
mein|sam|keit; Ge|mein|schaft;
ge|mein|schaft|lich; Ge|mein-
schafts_an|ten|ne, ...ar|beit, ...er-
zie|hung (w; -), ...ge|fühl (s; -[e]s),
...geist (m; -[e]s), ...haus, ...kun|de
(ein Schulfach; w; -), ...schu|le,
...ver|pfle|gung (w; -); Ge|mein-
_sinn (m; -[e]s), ...spra|che
ge|meint; gutgemeint; ein gut-
gemeinter Vorschlag (↑ jedoch R
142), a b e r: der Vorschlag ist gut
gemeint
ge|mein|ver|ständ|lich; Ge|mein-

_werk (schweiz. für: unbezahlte
Arbeit für die Gemeinde, eine
Genossenschaft u. ä.), ...we|sen,
...wirt|schaft, ...wohl
Ge|men|ge s; -s, -; Ge|meng|sel s;
-s, -
ge|mes|sen; in -er Haltung; Ge-
mes|sen|heit w; -
Ge|met|zel s; -s, -
Ge|mi|na|ti|on lat. [...zion]
(Sprachw.: Konsonantenver-
doppelung); ge|mi|nie|ren; Ge-
mi|ni|pro|gramm lat.; gr. (Pro-
gramm des Zwei-Mann-Raum-
fluges in den USA)
Ge|misch s; -[e]s, -e; ge|mischt; aus
Sand u. Zement - ; -e Gefühle;
-es Doppel (Sportspr.); -er Aus-
schuß (Grundgesetz); -er Chor;
-er Satz (Druckw.); Ge|mischt-
bau|wei|se w; -; ge|mischt|spra-
chig; Ge|mischt|wa|ren|hand-
lung; ge|mischt|wirt|schaft|lich
Gem|ma lat. (ein Stern) w; -; Gem-
me (geschnittener Edelstein;
Brutkörper niederer Pflanzen) w;
-, -n
Gems_bart, ...bock; Gem|se w; -,
-n; vgl. auch: Gams; Gem|sen|jä-
ger, Gems|jä|ger; gems|far|ben
(für: chamois)
Ge|mun|kel s; -s
Ge|mur|mel s; -s
Ge|mur|re s; -s
Ge|mü|se (krautige Nutzpflanzen;
Gericht daraus) s; -s, -; Mohrrü-
ben sind ein nahrhaftes Gemüse;
Mohrrüben u. Bohnen sind nahr-
hafte Gemüse; frühes Gemüse;
Ge|mü|se_bau m; -[e]s; Ge|mü|se-
bau|be|trieb; Ge|mü|se_beet,
...gar|ten, ...händ|ler, ...saft,
...sup|pe
ge|mü|ßigt; sich - sehen (veralt. für:
sich bemüßigt sehen)
Ge|müt s; -[e]s, -er; zu Gemüte füh-
ren; ge|müt|lich; Ge|müt|lich|keit
w; -; ge|müt|los; -este (↑ R 292);
Ge|müt|lo|sig|keit w; -; ge|müts-
arm; ge|müts_art, ...be|we|gung;
ge|müts|krank; Ge|müts_kran|ke,
...krank|heit, ...la|ge, ...lei|den,
...mensch, ...ru|he, ...stim|mung,
...ver|fas|sung, ...zu|stand; ge-
müt|voll
gen (bibl. u. dicht. für: gegen [vgl.
d.]); - Himmel
Gen gr. (Erbfaktor) s; -s, -e (meist
Mehrz.)
gen. = genannt
Gen. = Genitiv; Genossenschaft
ge|nannt (Abk.: gen.)
ge|nant fr. [sehe...] (veralt. für: be-
lästigend; unangenehm; pein-
lich)
ge|narbt; -es Leder
ge|nä|schig (naschhaft)
ge|nau; auf, aufs -[e]ste (↑ R
134; genau[e]stens; nichts Ge-

naues (↑ R 116); etwas - nehmen; ge|nau|ge|nom|men (↑ R 139), aber: er hat es genau genommen; Ge|nau|ig|keit; Ge|nau|ig|keits|gren|ze; ge|nau|so usw. vgl. ebenso usw.

Gen|darm fr. [*sehan...*, auch: *sehang...*] m; -en, -en (↑ R 268); Gen|dar|me|rie w; -, ...ien

Ge|ne (*Mehrz.* von: Gen), Ge|nea|lo|ge gr. m; -n, -n (↑ R 268); Ge|nea|lo|gie (Geschlechter-, Familienkunde; Stammbaum[forschung]) w; -, ...ien; ge|nea|lo|gisch

ge|nehm· ge|neh|mi|gen; Ge|neh|mi|gung

ge|neigt; er ist -, die Stelle anzunehmen; der -e Leser; das Gelände ist leicht -; Ge|neigt|heit w; -

Ge|ne|ra (*Mehrz.* von: Genus)

Ge|ne|ral *lat.* m; -s, -e u. ...räle; Ge|ne|ral ab|so|lu|ti|on, ...ad|mi|ral, ...agent (Hauptvertreter), ...an|griff, ...arzt, ...Ge|ne|ral|lat (Generalswürde) s; -[e]s, -e; Ge|ne|ral baß (Musik), ...beich|te, ...di|rek|tor, ...dis|pens; Ge|ne|ra|le (allg. Gültiges; allg. Angelegenheiten) s; -s, ...lien [...*iᵉn*] (auch: ...lia); Ge|ne|ral feld|marschall; Ge|ne|ral gou|ver|ne|ment, ...gou|ver|neur, ...in|ten|dant; Ge|ne|ra|li|sa|ti|on [...*zion*] (Verallgemeinerung); ge|ne|ra|li|sie|ren; Ge|ne|ra|lis|si|mus it. (Oberbefehlshaber) m; -, ...mi u. ...musse; Ge|ne|ra|li|tät fr.; ge|ne|ra|li|ter lat. (im allgemeinen; allgemein betrachtet); Ge|ne|ral _ka|pi|tel (eines kath. Ordens), ...klau|sel (Rechtsspr.), ...kom|man|do, ...kon|su|lat, ...leut|nant, ...ma|jor, ...mu|sik|di|rek|tor, ...nen|ner, ...oberst, ...pau|se (Musik), ...pro|be, ...re|fe|rent; Ge|ne|rals|rang; Ge|ne|ral|staa|ten (früher: das niederländische Parlament) *Mehrz.*; Ge|ne|ral staats|an|walt; Ge|ne|ral|stab; der Große - (↑ R 224); Ge|ne|ral stäb|ler; Ge|ne|ral|stabs|kar|te; Ge|ne|ral|streik; Ge|ne|rals|uni|form; ge|ne|ral|über|hol|en (nur in der Grundform u. als 2. Mittelwort gebräuchlich); ich lasse den Wagen -; der Wagen wurde generalüberholt; Ge|ne|ral über|ho|lung, ...ver|samm|lung, ...ver|tre|ter, ...vi|kar (Vertreter des kath. Bischofs, bes. in der Verwaltung); Ge|ne|ra|ti|on lat. [...*zion*]; Ge|ne|ra|ti|ons.kon|flikt, ...wech|sel; ge|ne|ra|tiv (geschlechtlich, die Geschlechtl. Fortpflanzung betref[fend; erzeugend; hervorbringend); -e Zelle; -e Grammatik; Ge|ne|ra|tor (Erzeuger für Energie u. Energieträger [Gas]) m; -s,

...oren; ge|ne|rell fr.; ge|ne|risch lat. (das Geschlecht od. die Gattung betreffend, Gattungs...)

ge|ne|rös fr. [*ge...*, seltener: *sehe...*] (groß-, edelmütig; freigebig); -este (↑ R 292); Ge|ne|ro|si|tät

Ge|ne|se gr. (Entstehung, Entwicklung) w; -, -n; vgl. auch: Genesis

ge|ne|sen; du genost (genosest), er genest; du genasest, er genas; du genäsest; genesen; genese!; ge|ne|sen de m u. w; -n, -n (↑ R 287ff.)

Ge|ne|sis [auch: *gen...*] gr. (Werden, Entstehung, Ursprung; [1. Buch Mosis mit der] Schöpfungsgeschichte) w; -; vgl. auch: Gene-se

Ge|ne|sung; Ge|ne|sungs.heim, ...pro|zeß, ...ur|laub

Ge|ne|tik gr. (Vererbungslehre) w; -; ge|ne|tisch (entwicklungsgeschichtlich; erblich bedingt; die Vererbung betreffend)

Ge|ne|tiv [auch: *ge...* od. *genetif*] vgl. Genitiv

Ge|nève [*seh'näw*] (fr. Form von: Genf)

Ge|ne|ver fr. [*sehenew'r*od. *geng...*] (Wacholderbranntwein) m; -s, -

Ge|ne|za|reth; vgl. See Genezareth

Genf (Kanton u. Stadt in der Schweiz); vgl. Genève; Gen|fer (↑ R 199); - See. - Konvention; gen|fe|risch; Gen|fer See (See zwischen den Westalpen u. dem Jura) m; - -s

ge|ni|al lat.; ge|nia|lisch (nach Art eines Genies); Ge|nia|li|tät w; -

Ge|nick s; -[e]s, -e; Ge|nick.fang (Jägerspr.; m; -[e]s), ...fän|ger (Wildmesser), ...schuß, ...star|re

Ge|nie fr. [*sehe...*] (höchste schöpferische Geisteskraft; höchstbegabter, schöpferischer Mensch; *Einz.* schweiz. für: militar. Ingenieurwesen) s; -s, -s; Ge|nien (*Mehrz.* von: Genius); Ge|nie|of|fi|zier (schweiz.)

ge|nie|ren fr. [*sehe...*]; sich -; Ge|nie|rer österr. ugs. (Schüchternheit) m; -s; ge|nier|lich (ugs. für: lästig, störend; schüchtern, genant)

ge|nieß|bar; Ge|nieß|bar|keit w; -; ge|nie|ßen; du genießt (genießest); ich genoß, du genossest, er genoß; du genössest; genossen; genieß[e]!; Ge|nie|ßer; ge|nie|ße|risch; -ste (↑ R 294)

Ge|nie|trup|pen (schweiz.) *Mehrz.*

ge|ni|tal lat. (die Genitalien betreffend); Ge|ni|ta|li|en [...*iᵉn*] (Med.: Geschlechtsorgane) *Mehrz.*; Ge|ni|tal|tu|ber|ku|lo|se

Ge|ni|tiv, (auch:) Ge|ne|tiv lat. [auch: *ge...*, od.: *genitif*] (Sprachw.; Wesfall, 2. Fall; Abk.: Gen.) m; -s, -e [...*wᵉ*]; Ge|ni|tiv|ob-

jekt; Ge|ni|us (schöpferische Kraft eines Menschen) m; -, (für: Schutzgeist im röm. Altertum auch *Mehrz.*:) ...ien [...*iᵉn*]; - loci [- *lozi*] (Schutzgeist eines Ortes)

Gen|ne|sa|ret vgl. See Genezareth

Ge|nom gr. (der einfache Chromosomensatz einer Zelle) s; -s, -e

Ge|nör|gel s; -s

Ge|nos|se m; -n, -n (↑ R 268); Ge-nos|sen|schaft (Abk.: Gen.); vgl. EGmbH, EGmuH; Ge|nos|sen|schaf|ter, Ge|nos|sen|schaft|ler; ge|nos|sen|schaft|lich; Ge|nos|sen|schafts.bank (*Mehrz.* ...banken), ...bau|er (DDR; m); Ge|nos|slin w; -, -nen, Ge|noß|sa|mo schweiz. (Alp-, Allmendgenossenschaft, -korporation) w; -, -n

ge|no|ty|pisch gr. (erbmäßig); Ge-no|typ, Ge|no|ty|pus (Gesamtheit der Erbfaktoren)

Ge|no|va [*dsehänowa*] (it. Form von: Genua)

Ge|no|ve|va [...*sefa*] (w. Vorn.)

Ge|no|zid gr.; lat. (Mord an nationalen, rassischen od. religiösen Gruppen) s; -[e]s, -e u. ...ien [...*iᵉn*]

Genre fr. [*sehangr*] (Art, Gattung; Wesen) s; -s, -s; Genre|bild (Bild aus dem täglichen Leben); genre-haft (alltäglich, volksmäßig); Genre|ma|le|rei

¹Gent (Stadt in Belgien)

²Gent engl. [*dsehänt*] (iron. Kurzform von: Gentleman; Stutzer, feiner Mann) m; -s, -s

gen|til fr. [*sehäntil*] od. *sehangtil*] (veralt. für: fein, nett); Gen|til-homme [*sehangtiljom*] (veralt. für: Edelmann; Mann vornehmer Gesinnung) m; -s, -s; Gentle|man engl. [*dsehäntlmᵉn*] (Mann von Lebensart u. Charakter, von guter Familie u. guter Erziehung) m; -s, ...men; gentle|man|like [...*laik*] (nach Art eines Gentlemans; vornehm; höchst anständig; Gentle|man's ge|bot; Gentle-men's Agree|ment [*dsehäntlmᵉns ᵉgrimᵉnt*] (diplomat. Übereinkunft ohne formalen Vertrag; Abkommen auf Treu u. Glauben) s; - -, - -s; Gen|try [*dsehäntri*] (der engl. niedere Adel u. die ihm sozial Nahestehenden) w; -

Ge|nua (it. Stadt); vgl. Genova; Ge|nue|se m; -n, -n, -n (↑ R 268); Ge-nue|ser (↑ R 199); ge|nue|sisch

ge|nug; - u. übergenug; (↑ R 116:) - Gutes, Gutes -; - des Guten; von etwas - haben; vgl. genugtun; Ge|nü|ge w; -; - tun, leisten; zur -; ge|nü|gen; dies genügt für unsere Zwecke; ge|nü|gend; vgl. ausreichend; ge|nug|sam; es ist - bekannt (es ist genügend bekannt); ge|nüg|sam (anspruchslos); Ge-nüg|sam|keit w; -; ge|nug|tun (↑ R

139); jmdm. - (Genugtuung gewähren); er hat mir genuggetan; sich (Dativ) nicht - können (nicht mit etwas aufhören); aber: ge|nug tun (genügend arbeiten); ich habe jetzt genug getan; Ge|nug|tu|ung

ge|nu|in *lat.* (angeboren, echt); Ge|nus (Gattung, Art; Sprachw.: grammatisches Geschlecht) s; -, Genera; vgl. in genere

Ge|nuß *m*; Genusses, Genüsse; ge|nuß|freu|dig; Ge|nuß|gift; ge|nüß|lich; Ge|nüß|ling (Genußmensch); Ge|nuß|mit|tel s; ge|nuß|reich; Ge|nuß|sucht w; -; ge|nuß_süch|tig, ...voll

Ge|nus ver|bi *lat.* [- *wär...*] (Sprachw.: Verhaltensrichtung des Zeitwortes: Aktiv u. Passiv) s; - -, Genera -

Geo|bo|ta|nik *gr.* (Wissenschaft von der geograph. Verbreitung der Pflanzen); geo|bo|ta|nisch; Geo|che|mie (Wissenschaft von der chemischen Zusammensetzung der Erde); geo|che|misch; Geo|dä|sie (Erdvermessung) w; -; Geo|dät (Landvermesser) *m*; -en, -en (↑ R 268); geo|dä|tisch; Geo|ge|nie, Geo|go|nie (Lehre von der Entstehung der Erde) w; -; Geo|gno|sie (veralt. für: Geologie) w; -; Geo|gnost (veralt. für: Geologe) *m*; -en, -en (↑ R 268); geo|gno|stisch; Geo|go|nie vgl. Geogenie; Geo|graph *m*; -en, -en (↑ R 268); Geo|gra|phie w; -; geo|gra|phisch ge|öhrt (mit einem Öhr versehen) Geo|id *gr.* (tatsächl. Form der Erde) s; -[e]s; Geo|lo|ge *m*; -n, -n (↑ R 268); Geo|lo|gie (Lehre von Entstehung u. Bau der Erde) w; -; geo|lo|gisch; -e Zeitmessung; Geo|man|tie (Kunst, aus Linien u. Figuren im Sand wahrzusagen) w; -; Geo|me|ter (Landvermesser) *m*; -s, -; Geo|me|trie (ein Zweig der Mathematik) w; -, ...ien; geo|me|trisch; -er Ort; -es Mittel; Geo|mor|pho|lo|gie (Lehre von der äußeren Gestalt der Erde u. deren Veränderungen) w; -; Geo|phy|sik (Lehre von den physikal. Eigenschaften des Erdkörpers); geo|phy|si|ka|lisch; -e Untersuchungen, aber (↑ R 224): das Geophysikalische Jahr; Geo_pla|stik (räuml. Darstellung von Teilen der Erdoberfläche; w; -), ...po|li|tik (Lehre von der Wirksamkeit geograph. Faktoren auf polit. Vorgänge u. Kräfte; w; -); geo|po|li|tisch ge|ord|net; in -en Verhältnissen leben; eine gutgeordnete Bibliothek (↑ jedoch R 142), aber: die Bibliothek ist gut geordnet; Ge|ord|net|heit w; -

Ge|org [auch: *ge...*] (m. Vorn.); ¹Ge|or|ge (Familienname); ²George *engl.* [*dschådsch*] (m. Vorn.); George[s] *fr.* [*schorsch*] (m. Vorn.); ¹Geor|gette [*schorschät*] (w. Vorn.); ²Geor|gette (svw. Crêpe Georgette) w; - (auch: *m*; -s); Geor|gia [*dschådschi*e] (Staat in den USA; Abk.: Ga.); Ge|or|gi|en [...*i*²*n*] (hist.: Land am Südhang des Kaukasus); Ge|or|gi|er [...*i*²*r*]; Ge|or|gi|ka (Gedicht Vergils über den Landbau) *Mehrz.*; ¹Ge|or|gi|ne [nach dem Petersburger Botaniker Georgi] (Seerosendahlie) w; -, -n; ²Ge|or|gi|ne (w. Vorn.); ge|or|gisch (aus Georgien); -e Sprache; Ge|or|gisch (Sprache) s; -[s]; vgl. Deutsch; Ge|or|gi|sche s; -n; vgl. Deutsche s

Geo|sta|tik *gr.* (Erdgleichgewichtslehre); Geo|tek|to|nik (Lehre von Entwicklung u. Aufbau der gesamten Erdkruste); geo|tek|to|nisch; geo|ther|misch (die [Zunahme der] Erdwärme betreffend); -e Tiefenstufe; geo|trop, geo|tro|pisch; Geo|tro|pis|mus (Erdwendigkeit; Vermögen der Pflanzen, sich in Richtung der Schwerkraft zu orientieren); geo|zen|trisch (auf die Erde als Mittelpunkt bezogen; auf den Erdmittelpunkt bezogen); geo|zy|klisch [auch: ...*zü...*] (den Umlauf der Erde betreffend)

Ge|päck s; -[e]s; Ge|päck_ab|fer|ti|gung, ...an|nah|me; (↑ R 145:) Ge|päck|an|nah|me und -aus|ga|be; Ge|päck_auf|be|wah|rung (österr.: Gepäcksaufbewahrung), ...auf|be|wah|rungs|schein, ...netz (österr.: Gepäcksnetz), ...schal|ter, ...schein, ...stück (österr.: Gepäcksstück), ...trä|ger (österr.: Gepäcksträger), ...wa|gen

Ge|pard *fr.* (ein Raubtier) *m*; -s, -e

ge|perlt (mit Perlen versehen); -e Arm- und Beinringe

Ge|pfei|fe s; -s

ge|pflegt; ein -es Äußere[s]; gutgepflegt; ein gutgepflegter Mann (↑ jedoch R 142), aber: der Mann ist gut gepflegt; Ge|pflegt|heit w; -; Ge|pflo|gen|heit (Gewohnheit)

Ge|pi|de (Angehöriger eines ostgerm. Volkes) *m*; -n, -n (↑ R 268)

Ge|pie|pe s; -s; Ge|piep|se s; -s

Ge|plän|kel s; -s, -

Ge|plap|per s; -s

Ge|plärr s; -[e]s u. Ge|plär|re s; -s

Ge|plät|scher s; -s

Ge|plau|der s; -s

Ge|po|che s; -s

Ge|pol|ter s; -s

Ge|prä|ge s; -s

Ge|prah|le s; -s

Ge|prän|ge s; -s

Ge|pras|sel s; -s

ge|punk|tet; -er Stoff

Ge|qua|ke s; -s; Ge|quä|ke s; -s

Ge|quas|sel s; -s

Ge|quat|sche s; -s

Ge|quen|gel s; -[e]s u. Ge|quen|gel|le, Ge|queng|le s; -s

Ge|quie|ke s; -s

Ge|quiet|sche s; -s

Ger (Wurfspieß) *m*; -[e]s, -e

ge|rad¹... (z. B. geradlinig); Ge|rad¹... (z. B. Geradflügler)

ge|ra|de¹; eine - Funktion; eine - Zahl; fünf - sein lassen; - darum; der Weg ist - (ändert die Richtung nicht); er wohnt mir - (direkt) gegenüber; etwas - (offen, ehrlich) heraussagen (vgl. geradeheraus); er hat ihn - (genau) in das Auge getroffen; er hat es - (soeben) getan. *Schreibung in Verbindung mit Zeitwörtern* (↑ R 139). I. *Zusammenschreibung,* z. B. geradelegen, geradesitzen, geradeslehen. II. *Getrenntschreibung:* a) wenn die Zeitwörter selbst schon Zusammensetzungen sind, z. B. das Buch gerade (nicht schief) hinlegen; b) wenn „gerade" bedeutet „soeben", z. B. da er gerade sitzt (sich soeben hingesetzt hat); Ge|ra|de¹ (gerade Linie) w; -n, -n; vier -[n] (↑ R 291); ge|ra|de|aus¹; - gehen; er geht - (in unveränderter Richtung); aber: er geht gerade (soeben) aus (zum Stammtisch); Ge|ra|de|aus|emp|fän|ger¹ (ein bes. Rundfunkgerät); ge|ra|de|bie|gen¹; ↑ R 139 (in gerade Form bringen; auch für: einrenken); ge|ra|de|hal|ten¹ sich; ↑ R 139 (sich ungebeugt halten), aber: ge|ra|de¹ hal|ten (so eben ...); ge|ra|de|her|aus¹; etwa - sagen, aber: er kam gerade (soeben) [aus dem Hause] heraus ge|ra|de|hin¹; er ging - (in unveränderter Richtung), aber: er ging gerade (soeben) hin (nach einem bestimmten Ort); ge|ra|de|le|gen¹; ↑ R 139 (zurechtlegen; ordnen), aber: ge|ra|de¹ le|gen (soeben ...); ge|ra|de|ma|chen¹ ↑ R 139 (in gerade Lage bringen); aber: ge|ra|de¹ ma|chen (soeben ...); ge|ra|de[n]|wegs¹; ge|ra|de|rich|ten¹; ↑ R 139 (in gerade Lage bringen), aber: ge|ra|de¹ rich|ten (soeben ...); ge|ra|de|sit|zen¹; ↑ R 139 (aufrecht sitzen), aber: ge|ra|de¹ sit|zen (sich soeben hingesetzt haben); ge|ra|de|so¹; vgl. ebenso; ge|ra|de|ste|hen¹; ↑ R 139 (aufrecht stehen; die Konsequen-

¹ In der Umgangssprache wendet man häufig die verkürzte Form „grad...", „Grad..." an.

zen auf sich nehmen), aber: ge|ra|de[1] ste|hen (soeben ...); ge|ra|de|stel|len[1]; ↑ R 139 (ordnen), aber: ge|ra|de[1] stel|len (soeben ...); ge|ra|des|wegs[1] (schweiz., sonst selten für: gerade[n]wegs); Ge|ra|de[1] und Un|ge|ra|de[1] (Spiel) *Mehrz.*; ge|ra|de|wegs[1], ge|ra|den|wegs[1]; ge|ra|de|zu[1]; - gehen; - sein; Ge|rad|flüg|ler[1] (Libelle u. dgl.); Ge|rad|heit[1] *w*; - ge|rad|läu|fig[1]; ge|rad|li|nig[1]; ge|rad|sin|nig[1]

Ge|raf|fel, Graf|fel österr. ugs. (Gerümpel) *s*; -s

Ge|rald, Ge|rold (m. Vorn.); Ge|ral|de, Ge|ral|di|ne (w. Vorn.)

ge|ram|melt (ugs.); der Saal war - voll (übervoll)

Ge|ran|gel *s*; -s

Ge|ra|nie *gr.* [...ie] *w*; -, -n u. Ge|ra|ni|um (Storchschnabel; Zierstaude) *s*; -s, ...ien [...ien]

Ge|ran|ke (Rankenwerk) *s*; -s

Ge|ra|schel *s*; -s

Ge|ras|sel *s*; -s

Ge|rät *s*; -[e]s, -e; ge|ra|ten; es gerät [mir]; geriet; geraten; ich gerate außer mich (auch: mir) vor Freude; (↑ R 134:) es ist das geratenste (am besten); Ge|rä|te|schup|pen; Ge|rä|te|tur|nen, Ge|rät|tur|nen *s*; -s; Ge|rä|te|wart, Ge|ra|te|wohl [auch: geratewol] *s*; aufs - (auf gut Glück); Ge|rät|schaf|ten *Mehrz.*

Ge|ra|ter *s*; -s

Ge|rät|tur|nen vgl. Geräteturnen

Ge|räu|cher|te *s*; -n (↑ R 287ff.)

Ge|rau|fe *s*; -s

ge|raum; -e (längere) Zeit; Ge|räum|de (abgeholztes Waldstück) *s*; -s, -n; ge|räu|mig; Ge|räu|mig|keit *w*; -

Ge|rau|ne *s*; -s

Ge|räu|sch (Gelünge) *s*; -[e]s

Ge|räusch *s*; -[e]s, -e; ge|räusch|arm; Ge|räusch|dämp|fung; Ge|rau|sche *s*; -s; ge|räusch|emp|find|lich; Ge|räusch|ku|lis|se; ge|räusch|los; Ge|räusch|lo|sig|keit *w*; -; ge|räusch|voll

Ge|räus|per *s*; -s

...ger|ben (,,gar" machen); Ger|ber; Ger|be|rei; Ger|ber|lo|he

Ger|be|ra [nach dem dt. Arzt u. Naturforscher T. Gerber] (eine Schnittblume) *w*; -, -s

...Ger|bert (m. Vorn.)

...Ger|borg vgl. Gerburg

...Ger|b|säu|re, ...stoff; Ger|bung

Ger|burg, Ger|borg (w. Vorn.)

...Gerd (Kurzform von: Gerhard); Ger|da (auch Kurzform verschiedener w. Vorn.)

...Ge|re|bel|te österr. (Wein aus einzeln abgenommenen Beeren) *m*; -n, -n (↑ R 287ff.); vgl. rebeln

...re|recht; jmdm. - werden; Ge|rech-te *m* u. *w*; -n, -n (↑ R 287ff.); Ge|rech|tig|keit *w*; -; Ge|rech|tig|keits_lie|be, ...sinn; Ge|recht|sa|me (veralt. für: [Vor]recht) *w*; -, -n

Ge|re|de *s*; -s

ge|rei|chen; es gereicht mir zur Ehre

ge|rei|me *s*; -s

ge|reizt; in -er Stimmung; Ge|roiat|hoit *w*;

ge|reu|en; es gereut mich

Ger|fal|ke (Jagdfalke); vgl. Gierfalke

Ger|hard (m. Vorn.); Ger|har|de, Ger|har|di|ne (w. Vorn.)

Ger|hardt, Paul (dt. Dichter)

Ger|hild, Ger|hil|de (w. Vorn.)

Ge|richt *s*; -[e]s, -e; ge|richt|lich; -e Chemie; -e Medizin; -e Psychologie; Ge|richts|bar|keit; Ge|richts_be|schluß, ...hof, ...ko|sten (*Mehrz.*), ...me|di|zin, ...me|di|zi|ner; ge|richts|no|to|risch (Rechtsspr.: vom Gericht zur Kenntnis genommen, gerichtskundig); Ge|richts_prä|si|dent, ...saal, ...schrei|ber, ...spra|che, ...stand, ...ter|min, ...ver|fah|ren, ...ver|hand|lung, ...voll|zie|her

ge|rie|ben (auch ugs. für: schlau); ein -er Bursche; Ge|rie|ben|heit *w*; -

ge|rie|hen (mdal. u. fachspr. für: gerciht); vgl. reihen

ge|rie|ren, sich *lat.* (veralt. für: sich benehmen; sich ausgeben als ...)

Ge|rie|sel *s*; -s

ge|ring; **I.** *Kleinschreibung:* **a)** (↑ R 135:) ein geringes (wenig) tun; um ein geringes (wenig) erhöhen; **b)** (↑ R 134:) am geringsten; nicht im geringsten (gar nicht); es entgeht ihm nicht das geringste (gar nichts). **II.** *Großschreibung:* **a)** (↑ R 116:) auch der Geringste hat Anspruch auf ...; kein Geringerer als ...; Vornehme u. Geringe; er beachtet auch das Geringste (Unbedeutendste); es entgeht ihm nicht das Geringste; er ist auch im Geringsten treu; [sich] auf ein Geringes beschränken; der Kampf ging nicht um ein Geringes (etwas Unbedeutendes); das Geringste, was er tun kann, ist ...; **b)** (↑ R 116:) es ist nichts Geringes, nichts Geringeres als ... **III.** *In Verbindung mit Zeitwörtern,* z. B. ge|ring|ach|ten (↑ R 139:); ich achte gering; geringgeachtet; geringzuachten; Ge|ring|ach|tung *w*; -; ge|ring|fü|gig; Ge|ring|fü|gig|keit; ge|ring|hal|tig; ge|ring|schät|zen; ↑ R 139 (verachten); vgl. geringachten; aber: ge|ring schät|zen (niedrig veranschlagen); es kostet, gering geschätzt, drei Mark; gering geschätzt; Ge|ring|schät|zung *w*; -; ge|ring|sten|falls; vgl. Fall *m*;

ge|rinn|bar; ge|rinn|bar|keit *w*; -; Ge|rin|ne *s*; -s, -; ge|rin|nen; Ge|rinn|sel *s*; -s, -; Ge|rin|nung *w*; -

Ge|rip|pe *s*; -s, -; ge|rippt

ge|ris|sen; er ist ein -er Bursche; Ge|ris|sen|heit *w*; -

Ger|lin|de (w. Vorn.)

Germ bayr., österr. (Hefe) *m*; -[e]s od. (österr.:) *w*; -

Ger|ma|ne *m*; -n, -n (↑ R 268); Ger|ma|nen|tum *s*; -[s]; Ger|ma|nia (Frauengestalt als Sinnbild Deutschlands) *w*; -; Ger|ma|nin Ⓦ [...ien] (Deutschland zur Römerzeit); Ger|ma|nin *w*; -, -nen; Ger|ma|nin Ⓦ (Mittel gegen die Schlafkrankheit) *s*; -s; ger|ma|nisch; -e Kunst, aber (↑ R 224): Germanisches National-Museum (Nürnberg); ger|ma|ni|sie|ren (eindeutschen); Ger|ma|nis|mus (deutsche Spracheigentümlichkeit in einer nichtdeutschen Sprache) *m*; -, ...men; Ger|ma|nist (Wissenschaftler auf dem Gebiet der Germanistik) *m*; -en, -en (↑ R 268); Ger|ma|ni|stik (deutsche [auch: germanische] Sprach- u. Literaturwissenschaft; Deutschkunde) *w*; -; ger|ma|ni|stisch; Ger|ma|ni|um (chem. Grundstoff; Metall; Zeichen: Ge) *s*; -s

Ger|mar (m. Vorn.)

Ger|mer südd. (Name verschiedener Pflanzen) *m*; -s, -

Ger|mi|nal *fr.* [sehär...] (,,Keimmonat" der Fr. Revolution: 21. März bis 19. April) *m*; -[s], -s; Ger|mi|na|lie *lat.* [...ie] (Keim- od. Geschlechtsdrüse) *w*; -, -n (meist *Mehrz.*); Ger|mi|na|ti|on [...zion] (Keimungsperiode der Pflanzen) *w*; -

gern, ger|ne; lieber, am liebsten; jmdn. - haben; möchte; etwas - tun; gar zu gern; allzugern; ein gerngesehener Gast (↑ jedoch R 142), aber: er ist gern gesehen; Ger|ne|groß *m*; -, -e; Ger|ne|klug *m*; -, -e

Ger|not (m. Vorn.); Ge|ro (m. Vorn.)

Ge|rö|chel *s*; -s

ge|ro|chen; vgl. riechen u. rächen

Ge|rold vgl. Gerald; Ge|rolf (m. Vorn.)

Ge|röll *s*; -[e]s, -e u. Ge|röl|le *s*; -s, -; Ge|röll_hal|de, ...mas|se, ...schicht, ...schutt

Ge|ront *gr.* (Mitglied der Gerusia) *m*; -en, -en (↑ R 268); Ge|ron|to|lo|gie (Alternsforschung) *w*; -

Ge|rö|ste|te südd., österr. (Bratkartoffeln) *Mehrz.*

Ger|shwin [gǒ'schwin] (amerikanischer Komponist)

Ger|ste w; -, (fachspr.:) -n; Ger|stel österr. (Graupe) s; -s, -[n]; Ger|stel|sup|pe österr. (Graupensuppe); Ger|sten_bier, ...brot, ...korn (auch: Vereiterung einer Drüse am Augenlid; s; Mehrz. ...körner), ...saft (scherzh. für: Bier; m; -[e]s), ...schrot, ...sup|pe

Ger|ta (w. Vorn.); Ger|te w; -, -n; ger|ten|schlank; ger|tig

Ger|traud, Ger|trau|de, Ger|trud, Ger|tru|de (w. Vorn.); Ger|traut (alte Schreibung von: Gertraud)

Ge|ruch m; -[e]s, Gerüche; ge|ruch|los; Ge|ruch|lo|sig|keit w; -; ge|ruch[s]|frei; Ge|ruchs_or|gan, ...sinn (m; -[e]s), ...ver|mö|gen

Ge|rücht s; -[e]s, -e; Ge|rüch|te|ma|cher

ge|ruch|til|gend, aber (↑ R 142): den Geruch tilgend

ge|rücht|wei|se

Ge|ru|fe s; -s

ge|ru|hen (sich geneigt zeigen, sich bereit finden); ge|ru|hig; ge|ruh|sam; Ge|ruh|sam|keit w; -

Ge|rum|pel (Rumpeln) s; -s

Ge|rüm|pel (Abfall, Wertloses) s; -s

Ge|run|di|um lat. (Sprachw.: gebeugte Grundform des lat. Zeitwortes) s; -s, ...ien [...iᵉn]; Ge|run|div (Sprachw.: Mittelwort der Leideform der Zukunft, z. B. der „zu billigende" Schritt) s; -s, -e [...wᵉ]

Ge|ru|sia, Ge|ru|sie gr. (Rat der Alten [in Sparta]) w; -

Ge|rüst s; -[e]s, -e; Ge|rü|ster österr. (Gerüstarbeiter)

Ge|rüt|tel s; -s; ge|rüt|telt; ein -Maß; - voll

Ger|vais ⓦ [schärwä; nach dem fr. Hersteller Gervais] (ein Rahmkäse) m; - [...wä(ß)], - [...wäß]

Ger|va|si|us [...wa...] (ein Heiliger)

Ger|wig (m. Vorn.); Ger|win (m. Vorn.)

ges, Ges (Tonbezeichnung) s; -, -; Ges (Zeichen für: Ges-Dur); in Ges

Ge|sa, Ge|se (w. Vorn.)

Ge|sä|ge s; -s

Ge|salb|te m u. w; -n, -n (↑ R 287 ff.)

ge|sal|zen vgl. salzen; Ge|sal|ze|ne s; -n (↑ R 287 ff.)

ge|sam|melt; ge|samt; im -en (zusammengenommen); Ge|samt s; -s; im -; Ge|samt_an|sicht, ...aus|ga|be; ge|samt|deutsch; -e Fragen; Ge|samt|deutsch|land (↑ R 206); Ge|samt|ein|druck; ge|samt|haft schweiz. u. westösterr. ([ins]gesamt); Ge|samt_heit (w; -), ...hoch|schu|le, ...klas|se|ment,

...kom|plex, ...scha|den, ...schuld|ner (für: Solidarschuldner), ...schu|le, ...sum|me, ...um|satz, ...ver|band, ...wer|tung

Ge|sand|te m; -n, -n (↑ R 287 ff.); Ge|sand|ten|po|sten; Ge|sand|tin w; - -nen; ge|sandt|schaft; ge|sandt|schaft|lich; Ge|sandt-schafts_ge|bäu|de, ...rat (Mehrz. ...räte)

Ge|sang m; -[e]s, Gesänge; ge|sang|ar|tig; Ge|sang_buch (österr. Gesangsbuch), ...leh|rer; ge|sang|lich; Ge|sang|schu|le; Ge|sangs_kunst; Ge|sang_stück, ...stun|de, ...un|ter|richt, ...ver|ein (österr.:Gesangsverein)

Ge|säß s; -es, -e; Ge|säß_kno|chen, ...ta|sche

Ge|sätz (fachspr. für: Strophe im Meistergesang) s; -es, -e; Ge|sätz|lein südd. (Abschnitt, Strophe)

Ge|säu|ge (Jägerspr.: Milchdrüsen des Haarwildes u. des Hundes) s; -s

Ge|sau|se s; -s; Ge|säu|se (Alpental) s; -s; Ge|säu|sel s; -s

gesch. (Zeichen; ∞) = geschieden (Eherecht)

Ge|schä|dig|te m u. w; -n, -n (↑ R 287 ff.)

Ge|schäft s; -[e]s, -e; -e halber, (auch:) geschäftehalber; Ge|schäf|te|ma|cher; Ge|schäf|te-ma|che|rei; ge|schäf|tig; Ge|schäf|tig|keit w; -; Ge|schäft|l|hu|ber, Gschäftl|hu|ber mdal. (übertrieben geschäftiger, wichtigtuerischer Mensch) m; -s, -; ge|schäft|lich; Ge|schäfts_ab|schluß, ...auf|sicht, ...be|reich m, ...be|richt, ...brief, ...er|öff|nung, ...frau; ge|schäfts|fä|hig; Ge|schäfts_freund, ...füh|rer, ...ge|ba|ren, ...geist (m; -[e]s), ...in|ha|ber, ...jahr; ge|schäfts|kun|dig; Ge|schäfts_la|ge, ...lei|tung, ...mann, (Mehrz. ...leute u. männer); ge|schäfts|mä|ßig; Ge|schäfts_ord|nung, ...part|ner, ...rei|se, ...schluß, ...sinn (m; -[e]s), ...sitz, ...stel|le, ...stra|ße, ...stun|de, ...trä|ger; ge|schäfts_tüch|tig, ...un|fä|hig

Ge|schä|ker s; -s

ge|scha|mig, gscha|mig, ge|schä|mig, gschä|mig österr. u. bayr. (schamhaft)

Ge|schar|re s; -s

Ge|schau|kel s; -s

ge|scheckt; ein -es Pferd

ge|sche|hen; es geschieht; es geschah; es geschähe; geschehen; Ge|sche|hen s; -s, -; Ge|scheh|nis s; -ses, -se

Ge|schei|de (Magen u. Gedärme der Jagdtiere) s; -s, -

Ge|schein (Blütenstand der Weinrebe) s; -[e]s, -e

ge|scheit; -este (↑ R 292); Ge|scheit|heit w; -, (selten:) -en

Ge|schenk s; -[e]s, -e; Ge|schenk_ar|ti|kel, ...packung [Trenn.: ...pak|kung]; ge|schenk|wei|se

ge|schert, gschert bayr., österr. ugs. (ungeschlacht, grob, dumm); Ge|scher|te, Gscher|te bayr., österr. ugs. (Tölpel, Landbewohner) m; -n, -n (↑ R 287 ff.)

Ge|schich|te w; -, -n; Ge|schich|ten_buch (Buch mit Geschichten [Erzählungen]); ge|schicht|lich; Ge|schichts_auf|fas|sung, ...buch (Buch mit Geschichtsdarstellungen), ...for|scher, ...klit|te|rung, ...schrei|ber, ...schrei|bung (w; -), ...un|ter|richt, ...werk, ...wis|sen|schaft, ...wis|sen|schaft|ler

Ge|schick s; -[e]s, (für: Schicksal auch Mehrz.:) -e; Ge|schick|lich|keit; ge|schickt; ein -er Arzt; Ge|schickt|heit w; -

Ge|schie|be s; -s, -; Ge|schie|be-lehm

ge|schie|den (Eherecht; Abk. gesch.; Zeichen: ∞)

Ge|schie|ße s; -s

Ge|schimp|fe s; -s

Ge|schirr s; -[e]s, -e; Ge|schirr_ma|cher, ...spül|ma|schi|ne; Ge|schirrei|ni|gen [Trenn.: ...schirr r..., ↑ R 236] s; -s; Ge|schirr|tuch (Mehrz. ...tücher)

ge|schla|gen; eine -e Stunde

ge|schlämmt; -e Kreide

Ge|schlecht s; -[e]s, -er; Ge|schlech|ter_buch, ...fol|ge, ...kun|de (w; - ...ge|schlech|tig (z. B. getrenntge schlechtig); ge|schlecht|lich; - Fortpflanzung; Ge|schlecht|lich keit w; -; Ge|schlechts_akt, ...be stim|mung; ge|schlechts|krank Ge|schlechts_krank|heit, ...le ben; ge|schlecht[s]|los; Ge schlechts_merk|mal, ...na|me ...or|gan, ...rei|fe, ...teil (s, [auch m; meist Mehrz.), ...trieb (n -[e]s), ...ver|kehr (m; -[e]s), ...wo (Mehrz. ...wörter)

Ge|schleck s; -[e]s u. Ge|schleck [Trenn.: ...schlek|ke] s; -s

Ge|schleif s; -[e]s u. Ge|schlei| s; -s

Ge|schlep|pe s; -s

ge|schlif|fen; Ge|schlif|fen|heit -, (selten:) -en

Ge|schlin|ge (Herz, Lunge, Leb bei Schlachttieren) s; -s, -

Ge|schlos|sen; -e Gesellschaft; G schlos|sen|heit w; -

Ge|schluch|ze s; -s

Ge|schmack m; -[e]s, Geschmäc u. (scherzh.:) Geschmäcker; ge schmack|bil|dend, aber (↑ R 142 den Geschmack bildend; ge schmackig [Trenn.: ...ak|k österr. (wohlschmeckend;

auch: kitschig); ge|schmäck|le|risch; ge|schmack|lich; ge|schmack|los; -este (↑ R 292); Ge|schmack|lo|sig|keit; ge|schmacks|bil|dend; Ge|schmacks_emp|fin|dung, ...rich|tung; Ge|schmack[s]_sa|che, ...sinn (m; -[e]s); Ge|schmacks|ver|ir|rung; ge|schmack|voll

Ge|schmat|ze s; -s

Ge|schmau|se s; -s

Ge|schmei|chel s; -s

Ge|schmei|de s; -s, -; ge|schmei|dig; Ge|schmei|dig|keit w; -

Ge|schmeiß (Kot von Raubvögeln; ekle Brut von Gewürm usw. [auch übertr. ugs. von Personen]) s; -es

Ge|schmet|ter s; -s

Ge|schmier s; -[e]s u. Ge|schmie|re s; -s

Ge|schmor|te s; -n (↑ R 287 ff.)

Ge|schmun|zel s; -s

Ge|schmus, Ge|schmu|se s; ...ses

Ge|schnä|bel s; -s

Ge|schnat|ter s; -s

ge|schnie|gelt; - und gebügelt

Ge|schnör|kel s; -s

Ge|schnüf|fel s; -s

Ge|schöpf s; -[e]s, -e

Ge|schoß s; Geschosses, Geschosse; Ge|schoß_bahn, ...ha|gel; ...ge|schos|sig (z. B. dreigeschossig, mit Ziffer: 3geschossig; ↑ R 229)

ge|schraubt; Ge|schraubt|heit w; -

Ge|schrei s; -s

Ge|schrei|be s; -s; Ge|schreib|sel s; -s

Ge|schreie s; -s

Ge|schütz s; -es, -e; Ge|schütz_be|die|nung, ...bet|tung, ...feu|er, ...rohr

Ge|schwa|der (Verband von Kriegsschiffen od. Flugzeugen) s; -s, -

Ge|schwa|fel s; -s

...ge|schwänzt (z. B. langgeschwänzt)

Ge|schwätz s; -es; Ge|schwat|ze, Ge|schwät|ze s; -s; ge|schwät|zig; Ge|schwät|zig|keit w; -

ge|schweift; -e Tischbeine

ge|schwei|ge [denn] (noch viel weniger); geschweige[,] daß u. geschweige denn, daß (↑ R 63)

ge|schwind; Ge|schwin|dig|keit; Ge|schwin|dig|keits_be|gren|zung, ...be|schrän|kung, ...mes|ser m, ...über|schrei|tung; Ge|schwind|schritt m, nur in: im -

Ge|schwirr s; -s

Ge|schwi|ster (bes. naturwissenschaftlich u. statistisch für: eines der Geschwister [Bruder od. Schwester]) s; -s, (im allg. Sprachgebrauch nur Mehrz.:) -; Ge|schwi|ster|kind (veralt., aber noch landsch. für: Neffe, Nichte); ge|schwi|ster|lich

ge|schwol|len; ein -er Stil; vgl. ¹schwellen

ge|schwo|ren; ein -er Feind des Alkohols; Ge|schwo|re|ne, (österr. amtl. auch:) Ge|schwor|ne m u. w; -n, -n (↑ R 287 f.); Ge|schwo|re|nen|li|ste

Ge|schwulst w; -, Geschwülste

ge|schwun|gen; eine -e Linie

Ge|schwür s; -[e]s, -e; Ge|schwür_bil|dung; ge|schwü|rig

Ges-Dur [auch: gásĎdur] (Tonart; Zeichen: Ges) s; -; Ges-Dur-Ton|lei|ter (↑ R 155)

Ge|se, Ge|sa (w. Vorn.)

ge|seg|net; gesegnete Mahlzeit!

Ge|sei|re jidd. (unnützes Gerede) s; s

Ge|selch|te bayr., österr. (geräuchertes Fleisch) s; -n (↑ R 287 ff.)

Ge|sell (veralt.) m; -en, -en (↑ R 268); ein fahrender -; Ge|sel|le m; -n, -n (↑ R 268); ge|sel|len; sich -; Ge|sel|len_brief, ...stück; ge|sel|lig; Ge|sel|lig|keit w; -; Ge|sell|schaft; - mit beschränkter Haftung (Abk.: GmbH); Ge|sell|schaf|ter; Ge|sell|schaf|te|rin w; -, -nen; ge|sell|schaft|lich; Ge|sell|schafts|an|zug, ...da|me; ge|sell|schafts|fä|hig; Ge|sell|schafts_form, ...in|seln (in der Südsee; Mehrz.), ...kri|tik (w; -), ...leh|re, ...ord|nung, ...rei|se, ...schicht, ...spiel, ...sy|stem, ...tanz, ...wis|sen|schaf|ten (für: Sozialwissenschaften; Mehrz.)

Ge|senk (Schmiedeform; Bergmannsspr.: Blindschacht, der von oben nach unten niedergebracht worden ist) s; -[e]s, -e; Ge|sen|ke (selten für: Bodensenkung) s; -s, -

Ge|setz s; -es, -e; Ge|setz_aus|le|gung, ...blatt (Abk.: GBl.), ...buch, ...ent|wurf; Ge|set|zes_kraft w; -; Ge|set|zes|kun|de, Ge|setz|kun|de; Ge|set|zes|samm|lung, Ge|setz|samm|lung; Ge|set|zes_spra|che, ...vor|la|ge; ge|setz|ge|bend; -e Gewalt; Ge|setz_ge|ber; ge|setz|ge|be|risch; Ge|setz_ge|bung; Ge|set|zes|kun|de, Ge|setz_zes|kun|de; ge|setz|lich; -e Erbfolge; -er Richter; -e Zinsen; Ge|setz|lich|keit; ge|setz|los; Ge|setz_lo|sig|keit; ge|setz|mä|ßig; Ge|setz|mä|ßig|keit; Ge|setz_samm|lung, Ge|set|zes|samm|lung; ge|setzt; ...,[daß]...; - den Fall, [daß] ... (↑ R 61); Ge|setz|ten|falls; vgl. Fall m; Ge|setzt|heit w; -

ge|setz_wid|rig

Ge|seuf|ze s; -s

ges. gesch. = gesetzlich geschützt

Ge|sicht s; -[e]s, -er u. (für: Erscheinung Mehrz.:) -e; sein - wahren; Ge|sichts_aus|druck,

...creme, ...far|be, ...feld, ...kreis, ...mas|sa|ge, ...punkt, ...sinn (m; -[e]s), ...was|ser, ...win|kel, ...zug (meist Mehrz.)

Ge|sims s; -es, -e

Ge|sin|de s; -s, -; Ge|sin|del s; -s; Ge|sin|de_ord|nung, ...stu|be

Ge|sin|ge s; -s

ge|sinnt (von einer bestimmten Gesinnung); ein gutgesinnter, gleichgesinnter, übelgesinnter, deutschgesinnter, andersgesinnter, gütiggesinnter Mensch usw. (↑ jedoch R 142), aber: er ist gut gesinnt usw.; vgl. aber: gesonnen; Ge|sin|nung; Ge|sin|nungs_ge|nos|se; ge|sin|nungs|los; -este (↑ R 292); Ge|sin|nungs_lo|sig|keit w; -; Ge|sin|nungs|lump (ugs.); ge|sin|nungs_mä|ßig, ...tüch|tig; Ge|sin|nungs|wan|del

ge|sit|tet; Ge|sit|tung w; -

Ge|socks (derb für: Gesindel) s; -

Ge|söff (derb für: schlechtes Getränk) s; -[e]s, -e

ge|son|dert; - verpacken

ge|son|nen (willens); - sein, etwas zu tun; vgl. aber: gesinnt

ge|sot|ten; Ge|sot|te|ne s; -n (↑ R 287 f.)

ge|spal|ten, vgl. spalten

¹Ge|span (veralt., noch mdal. u. in der Druckerspr. für: Mitarbeiter, Helfer; Genosse) m; -[e]s u. -en (↑ R 268), -e[n]

²Ge|span ung. (früher: ung. Verwaltungsbeamter) m; -[e]s, -e

Ge|spän|ge (Spangenwerk) s; -s

Ge|spann (Zugtiere) s; -[e]s, -e

ge|spannt; Ge|spannt|heit w; -

Ge|span|schaft ung. (Amt od. Amtsbereich eines ²Gespans)

Ge|spär|re (Bauw.: ein Paar sich gegenüberliegender Dachsparren) s; -s

ge|spa|ßig, gspa|ßig bayr. u. österr. (spaßig, lustig)

Ge|spenst s; -[e]s, -er; Ge|spen|ster_chen Mehrz.; Ge|spen|ster_furcht, ...glau|be[n]; ge|spen|ster|haft; ge|spen|stern; ich ...ere (↑ R 327); ge|spen|stig, ge|spen|stisch; -ste (↑ R 294)

ge|sper|bert (in der Art des Sperbers); -es Gefieder

Ge|sper|re (Jägerspr.: Geheck [vom Auer-, Birk-, Haselwild, Fasan]; Technik: Hemmvorrichtung) s; -s, -

¹Ge|spie|le (andauerndes Spielen) s; -s; ²Ge|spie|le (Spielgenosse der Jugend) m; -n, -n (↑ R 268); Ge|spie|lin w; -, -nen

Ge|spinst s; -[e]s, -e; Ge|spinst_pflan|ze

¹Ge|spons (nur noch scherzh. für: Bräutigam; Gatte) m; -es, -e; ²Ge|spons (nur noch scherzh. für: Braut; Gattin) s; -es, -e

Ge|spött s; -[e]s; zum -[e] sein, werden; Ge|spött|tel s; -s

Ge|spräch s; -[e]s, -e; Gespräch am runden Tisch; ge|sprä|chig; Ge|sprä|chig|keit w; -; Ge|sprächs_form, ...part|ner, ...stoff, ...the|ma; ge|sprächs|wei|se

ge|spreizt; -e Flügel; -e (gezierte) Reden; Ge|spreizt|heit

Ge|spren|ge (häufiges Sprengen; Aufbau über spätgot. Altären; Bergmannsspr.: steil aufsteigendes Gebirge; Dachstuhl od. Wand mit Sprengwerk) s; -s, -; ge|spren|kelt; das Fell dieses Tieres ist -

Ge|spritz|te bes. bayr. u. österr. (Wein mit Sodawasser) m; -n, -n (↑ R 287 ff.)

Ge|spru|del s; -s

Ge|spür s; -s

Geß|ner, Salomon (schweiz. Dichter u. Maler)

Gest niederd. (Hefe) m; -[e]s od. w; -

gest. (Zeichen: †) = gestorben

Ge|sta|de s; -s, -

Ge|stalt w; -, -en; dergestalt (so); gleichergestalt; solchergestalt; ...ge|stalt (von Natur aus, z. B. miß-, un-, wohlgestalt); ge|stalt|bar; ge|stal|ten; ge|stal|ten_reich, ...voll; Ge|stal|ter; Ge|stal|te|rin w; -, -nen; ge|stal|te|risch; -ste (↑ R 294); ...ge|stal|tet (von Menschenhand, z. B. gut-, schlecht-, wohlgestaltet); ein schöngestaltetes Werk (↑ jedoch R 142), aber: das Werk ist schön gestaltet; ge|stalt|haft; ...ge|stal|tig (z. B. vielgestaltig); ge|stalt|los; Ge|stal|tung; Ge|stal|tungs_kraft, ...ver|mö|gen (s; -s)

Ge|stam|mel s; -s

Ge|stamp|fe s; -s

Ge|stän|de (Jägerspr.: Füße, bes. der Beizvögel; Horst) s; -s, -; ge|stan|den; ein -er (südd. ugs. für: gesetzter) Mann

ge|stän|dig; Ge|ständ|nis s; -ses, -se

Ge|stän|ge s; -s, -

Ge|stank m; -[e]s

Ge|sta|po = Geheime Staatspolizei

ge|stat|ten

Ge|ste lat. [auch: ge...] (Gebärde) w; -, -n

Ge|steck bayr., österr. (Hutschmuck [aus Federn od. Gamsbart]) s; -[e]s, -e

ge|ste|hen; gestanden; Ge|stehungs|ko|sten Mehrz.

Ge|stein s; -[e]s, -e; Ge|steins_art, ...block (Mehrz. ...blöcke), ...bohr|ma|schi|ne, ...kun|de (w; -), ...pro|be, ...schicht

Ge|stell s; -[e]s, -e; Ge|stell|lung; Ge|stel|lungs|be|fehl

ge|stern; (↑ R 129:) - abend, morgen, nachmittag, nacht; bis -; die Mode von -; zwischen - und morgen, (auch hauptwörtlich [↑ R 119]:) zwischen [dem] Gestern und [dem] Morgen liegt das Heute; vorgestern; ehegestern; Ge|stern (die Vergangenheit) s; -

Ge|sti|chel s; -s

ge|stie|felt; - u. gespornt (bereit, fertig) sein; aber (↑ R 224): der Gestiefelte Kater (eine Märchengestalt)

ge|stielt; ein -er Besen

Ge|stik lat. [auch: ge...] (Gesamtheit der Gesten als Ausdruck des Seelischen) w; -; Ge|sti|ku|la|ti|on [...zion] (Gebärde, Gebärdensprache); ge|sti|ku|lie|ren

Ge|sti|on lat. (veralt. für: Führung, Verwaltung); Gesti|ons|be|richt österr. Amtsspr. (Geschäftsbericht)

Ge|stirn s; -[e]s, -e; ge|stirnt; der -e Himmel

ge|stisch [auch: ge...]

Ge|stö|ber s; -s, -

ge|stockt; -e Milch (südd. u. österr. für: Dickmilch)

Ge|stöhn s; -[e]s u. Ge|stöh|ne s; -s

Ge|stol|per s; -s

Ge|stör (Teil eines Floßes) s; -[e]s, -e

ge|stor|ben (Abk.: gest.; Zeichen: †)

Ge|stot|ter s; -s

Ge|stram|pel s; -s

Ge|sträuch s; -[e]s, -e

ge|streckt; -er Galopp

ge|streift; schwarz gestreift, schwarzgestreift (vgl. blau, IV); ein weiß und rot gestreiftes Kleid, das Kleid ist weiß u. rot gestreift

Ge|strei|te s; -s

ge|streng, aber (↑ R 224): die Gestrengen Herren (die Eisheiligen)

Ge|streu s; -[e]s

Ge|strick (gestrickte Ware) s; -[e]s, -e

gest|rig; mein gestriger Brief (nicht gut ist: mein Gestriges, unterm Gestrigen [Kaufmannsspr.])

Ge|ström (Strömung) s; -[e]s; ge|strömt (gefleckt, streifig ohne scharfe Abgrenzung); eine -e Dogge

Ge|strüpp s; -[e]s, -e

Ge|stü|be (Hüttenw.: Gemisch von Koksrückstand u. Lehm) s; -s

Ge|stü|ber (Jägerspr.: Losung des Federwildes) s; -s

Ge|stühl s; -[e]s, -e u. Ge|stüh|le s; -s, -

Ge|stüm|per s; -s

Ge|stürm schweiz. mdal. (aufgeregtes Gerede, Getue) s; -s

Ge|stüt s; -[e]s, -e; Ge|stüt_hengst, ...pferd; Ge|stüts_brand (Brandzeichen für Pferde eines Gestütes)

Ge|such s; -[e]s, -e; Ge|such|stel|ler (Amtsdt.)

ge|sucht; eine -e Ausdrucksweise; Ge|sucht|heit w; -

Ge|su|del s; -s

Ge|summ s; -[e]s u. Ge|sum|me s; -s

Ge|sums s; -es

ge|sund; (↑ R 295:) gesünder (weniger üblich: gesunder), gesündeste (weniger üblich: gesundeste); gesund sein, werden; jmdn. gesund schreiben; vgl. aber: gesundmachen, sich; ge|sund|be|ten (↑ R 139); jmdn. -; ich bete gesund; gesundgebetet; um gesundzubeten; Ge|sund_be|ten (s; -s), ...brun|nen (Heilquelle); ge|sun|den; Ge|sund|heit w; -; ge|sund|heit|lich; Ge|sund|heits_amt, ...apo|stel (scherzh.); ge|sund|heits|hal|ber; Ge|sund|heits|pfle|ge w; -; ge|sund|heits_schä|di|gend, ...schäd|lich; Ge|sund|heits_we|sen (s; -s), ...zeug|nis, ...zu|stand (m; -[e]s); ge|sund|ma|chen (↑ R 139), sich (ugs. für: sich bereichern); ich mache mich gesund; gesundgemacht; um sich gesundzumachen; aber: gesund ma|chen; einen Kranken - -; ge|sund_schrump|fen (↑ R 139), sich (ugs. für: durch Verkleinerung [eines Betriebes] die rentable Größe erreichen); ge|sund|sto|ßen (↑ R 139), sich (ugs.); Ge|sun|dung w; -

get. (Zeichen: ∿) = getauft

Ge|tä|fel (Tafelwerk, Täfelung) s; -s; ge|tä|felt; Ge|tä|fer schweiz. (Getäfel) s; -s; ge|tä|fert schweiz. (getäfelt)

Ge|tän|del s; -s

ge|tauft (Abk.: get.; Zeichen: ∿)

Ge|tau|mel s; -s

ge|teilt vgl. teilen

Geth|se|ma|ne, Geth|se|ma|ni, (ökum.:) Get|se|ma|ni (Garten am Ölberg bei Jerusalem)

Ge|tier s; -[e]s

ge|ti|gert (geflammt)

Ge|tön s; -s

Ge|tös, Ge|tö|se s; ...ses; Ge|to|se s; -s

ge|tra|gen; eine -e Redeweise; Ge|tra|gen|heit w; -

Ge|tram|pel s; -s

Ge|tränk s; -[e]s, -e; Ge|trän|ke_au|to|mat, ...kar|te, ...steu|er w

Ge|trap|pel s; -s

Ge|tratsch s; -[e]s u. Ge|trat|sche s; -s

ge|trau|en, sich; ich getraue mich (seltener: mir), das zu tun; aber nur: ich getraue mir den Schritt nicht; ich getraue mich nicht hineinzugehen

Ge|trei|de s; -s, -; ge|trei|de_arm

Ge|trei|de_an|bau, ...aus|fuhr, ...ein|fuhr, ...ern|te (↑ R 148), ...feld, ...frach|ter, ...han|del, ...spei|cher

ge|trennt; - schreiben, - lebend, - vorkommend u. a., aber: getrenntgeschlechtig (Biol.); Ge|trennt|schrei|bung

ge|treu; -er, -[e]ste; - seinem Vorsatz; Ge|treue m u. w, -n, -n (↑ R 287 ff.); ge|treu|lich

Ge|trie|be s; -s, -; ge|trie|ben; -e Arbeit; Ge|trie|be|über|set|zung

Ge|tril|ler s; -s

Ge|trip|pel s; -s

Co|trom|mel s; -s

ge|trost; ge|trö|sten (geh.); sich -

Get|se|ma|ni vgl. Gethsemane

Get|to it. (früher für: ein von Juden bewohntes, abgesondertes Stadtviertel) s; -s, -s

Ge|tue s; -s

Ge|tüm|mel s; -s, -

ge|tüp|felt, ge|tupft; ein -er Stoff

ge|tu|schel s; -s

ge|übt; ein -er Reiter; Ge|übt|heit w; -

Geu|se niederl. („Bettler"; Angehöriger des ehem. Bundes niederländ. Freiheitskämpfer gegen Spanien) m; -n, -n (meist Mehrz.); ↑ R 268

Ge|vat|ter m; -s u. (älter:) -n (↑ R 268), -n; Ge|vat|te|rin w; -, -nen; Ge|vat|ter|schaft; Ge|vat|ters|mann (Mehrz. ...leute)

ge|viert (veralt. für: viereckig, quadratisch; vierteilig); Ge|viert (Rechteck, bes. Quadrat) s; -[e]s, -e; ins Geviert; ge|vier|teilt; Ge|viert|schein (Astron.)

Ge|wächs s; -es, -e; ge|wach|sen; jmdm., einer Sache - sein; -er Boden; Ge|wächs|haus

ge|wackelt (mit Wachs geglättet)

Ge|wackel [Trenn.: ...wak|kel] s; -s u. Ge|wacke|le [Trenn.: ...wak-ke...], Ge|wack|le s; ...les

Ge|waff (Jägerspr.: Hauer) s; -[e]s; Ge|waf|fen (gelegentl. dicht. für: Gesamtheit der Waffen) s; -s

ge|wagt; Ge|wagt|heit

ge|wählt; er drückt sich - aus

ge|wahr; eine[r] Sache - werden; es (vgl. „²es" [alter Wesf.]) u. dessen - werden

Ge|währ (Bürgschaft, Sicherheit) w; -

ge|wah|ren (bemerken, erkennen); er gewahrte den Freund

ge|wäh|ren (bewilligen); Ge|währfrist; ge|währ|lei|sten (↑ R 140); ich gewährleiste, aber: ich leiste [dafür] Gewähr; gewährleistet; zu - Ge|währ|lei|stung

¹Ge|wahr|sam (Haft, Obhut) m; -s, -e; ²Ge|wahr|sam (Gefängnis) s; -s, -e

Ge|währ|schaft (veralt. für: Haftung für eine Zusicherung beim Kauf) w; -; Ge|währs|mann (Mehrz. ...männer u. ...leute); Ge|wäh|rung

ge|walmt [zu: ²Walm]; ein -es Dach

Ge|walt w; -, -en; Ge|walt_akt, ...an|wen|dung, ...ha|ber, ...herrschaft; ge|wal|tig; ge|wäl|ti|gen (Bergmannsspr.: wieder zugänglich machen); Ge|wal|tig|keit w; -; ge|walt|los; Ge|walt|lo|sig|keit w; -; Ge|walt_marsch, ...maß|nahme, ...mensch; ge|walt|sam; Ge|walt|sam|keit; Ge|walt_streich, ...tat; ge|walt|tä|tig; Ge|walt|tä|tig|keit; Ge|walt_ver|bre|chen, ...ver|zicht, Ge|walt|vor|zichts-ab|kom|men

Ge|wand s; -[e]s, ...wänder u. (dicht.:) -e; Ge|wän|de (seitl. Umgrenzung der Fenster und Türen) s; -s, -; Ge|wand|haus (früher für: Lagerhaus der Tuchhändler)

ge|wandt; ein -er Mann; vgl. wenden; Ge|wandt|heit w; -

Ge|wan|dung

Ge|wann s; -[e]s, -e u. Ge|wan|ne (viereckiges Flurstück, Ackerstreifen) s; -s, -

ge|wär|tig; eines Zwischenfalls -; ich bin es (vgl. „²es" [alter Wesf.]) -; ge|wär|ti|gen; zu - haben

Ge|wäsch (ugs. für: [nutzloses] Geschwätz) s; -[e]s

Ge|wäs|ser s; -s, -; ge|was|sert; das Flugzeug hat -; ge|wäs|sert; die Hausfrau hat die Heringe -

Ge|we|be s; -s, -; Ge|we|be|brei|te; Ge|webs_leh|re (w; -), ...transplan|ta|ti|on, ...ver|än|de|rung

ge|weckt; ein -er (kluger) Junge; Ge|weckt|heit w; -

Ge|wehr s; -[e]s, -e; Ge|wehr|lauf

Ge|weih s; -[e]s, -e; ge|weiht (Jägerspr.: Geweih tragend)

Ge|wen|de landsch. (Feldstück; Ackergrenze) s; -s, -

Ge|wer|be s; -s, -; Ge|wer|be_aufsicht, ...be|trieb, ...fleiß, ...freiheit, ...in|spek|tor, ...ord|nung (Abk.: GewO), ...schein, ...steuer w; ge|wer|be|trei|bend, aber (↑ R 142): ein eigenartiges Gewerbe treibend; Ge|wer|be|trei|ben|de m u. w; -n, -n (↑ R 287ff.); ge|werblich; -er Rechtsschutz; ge|werbsmä|ßig; Ge|werbs|zweig

Ge|werk (veralt. für: Gewerbe, Handwerk; Innung, Zunft) s; -[e]s, -e; Ge|wer|ke (Mitglied einer bergrechtlichen Gewerkschaft) m; -n, -n (↑ R 268); Ge|werken|tag (Versammlung der bergrechtl. Gewerkschaft); Ge|werkschaft; Ge|werk|schaf|ter, Ge|werk|schaft|ler; ge|werk|schaftlich; Ge|werk|schafts_bund m, ...funk|tio|när, ...mit|glied, ...versamm|lung

Ge|we|se niederd. (Anwesen) s; -s, -

¹Ge|wicht (Jägerspr.: Rehgehörn) s; -[e]s, -er

²Ge|wicht s; -[e]s, -e; ge|wich|ten (Statistik: einen Durchschnittswert unter Berücksichtigung der Häufigkeit des Auftretens vorhandener Einzelwerte bilden); Ge|wicht|he|ber (Schwerathlet), ge|wich|tig; Ge|wich|tigkeit w; -; Ge|wichts_an|ga|be, ...be|stim|mung, ...klas|se, ...verla|ge|rung, ...ver|lust; Ge|wichtung (zu: gewichten)

ge|wieft (ugs. für: schlau, gerissen); -este

ge|wiegt (ugs. für: schlau, durchtrieben); -este

Ge|wie|her s; -s

ge|willt (gesonnen)

Ge|wim|mel s; -s

Ge|wim|mer s; -s

Ge|win|de s; -s, -; Ge|win|de_boh|rer, ...schnei|der

Ge|winn m; -[e]s, -e; Ge|winn_anteil, ...be|tei|li|gung; ge|winn|brin|gend, aber (↑ R 142): einen großen Gewinn bringend; ge|winnen; du gewannst (gewannest); du gewönnest (auch: gewännest); gewonnen; gewinn[e]!; ge|winnend; -ste; Ge|win|ner; ge|winnreich; Ge|winn_span|ne, ...streben (s; -s), ...sucht (w; -); ge|winnsüch|tig; Ge|win|num|mer [Trenn.: ...winn|num...,↑ R 236]; Ge|winnund-Ver|lust-Rech|nung[1] (↑ R 155); Ge|win|nung

Ge|win|sel s; -s

Ge|winst (veralt. für: Gewinn) m; -[e]s, -e

Ge|wirk s; -[e]s, -e u. Ge|wir|ke (Maschenware) s; -s, -; Ge|wirkst, Gwirkst österr. ugs. (verzwickte Angelegenheit, mühsame Arbeit) s; -s; ge|wirkt; -er Stoff

Ge|wis|per s; -s, -[e]s, -e

ge|wiß; gewisser, gewisseste (↑ R 116:) etwas, nichts Gewisses; (↑ R 117:) ein gewisses Etwas; ein gewisser Jemand, aber (↑ R 135): ge|wisser anderer

Ge|wis|sen s; -s, -; ge|wis|sen|haft; Ge|wis|sen|haf|tig|keit w; -; ge|wis|sen|lo|sig|keit w; -; Ge|wis|sens|biß (meist Mehrz.); Ge|wis|sens_ent|schei|dung, ...er|forschung, ...fra|ge, ...frei|heit (w; -); ge|wis|sens|hal|ber; Ge|wis|sens_kon|flikt; ge|wis|ser|ma|ßen; Ge|wiß|heit; ge|wiß|lich

Ge|wit|ter s; -s, -; ge|wit|te|rig, ge-

[1] Fachspr. oft in der von der Regel abweichenden Schreibung: Gewinn- und Verlustrechnung.

wit|rig; ge|wit|tern; es gewittert; Ge|wit|ter|re|gen; ge|wit|ter-schwül; Ge|wit|ter.stim|mung (w; -), ...wol|ke; ge|witt|rig, ge-wit|te|rig

Ge|wit|zel s; -s

ge|wit|zigt (durch Schaden klug geworden); ge|witzt (schlau); Ge-witzt|heit w; -

GewO = Gewerbeordnung

Ge|wo|ge s; -s

ge|wo|gen (zugetan); er ist mir -; Ge|wo|gen|heit w; -

ge|wöh|nen; sich an eine Sache -; Ge|wohn|heit; ge|wohn|heits|mä-ßig; Ge|wohn|heits.mensch (m; -en, [selten:] -en), ...recht, ...ver-bre|cher; ge|wöhn|lich; für - (meist); Ge|wöhn|lich|keit w; -; ge|wohnt (durch [zufällige] Ge-wohnheit mit etwas vertraut); ich bin es -, bin schwere Arbeit -; die -e Arbeit; mit der -en Gründ-lichkeit; jung -, alt getan; ge-wöhnt (durch [bewußte] Gewöh-nung mit etwas vertraut); ich habe mich an diese Arbeit -; Ge-wöh|nung

Ge|wöl|be s; -s, -; Ge|wöl|be.bo-gen, ...pfei|ler

Ge|wölk s; -[e]s

Ge|wöl|le (von Raubvögeln her-ausgewürgter Klumpen unver-daulicher Nahrungsreste) s; -s, -

Ge|wühl s; -[e]s

ge|wür|felt; -e Stoffe

Ge|würm s; -[e]s, -e

Ge|würz s; -es, -e; ge|wür|zig; Ge-würz.gur|ke, ...in|seln (indones. Inselgruppe), ...mi|schung, ...nel-ke

Gey|sir isländ. [gai...] (in bestimm-ten Zeitabständen springende heiße Quelle) m; -s, -e; vgl. Geiser

gez. = gezeichnet

ge|zackt; der Felsgipfel ist -

Ge|zä|he (Werkzeug von Berg- und Hüttenmann) s; -s, -

ge|zahnt, ge|zähnt; -es Blatt

Ge|zänk s; -[e]s; Ge|zan|ke s; -s

Ge|zap|pel s; -s

ge|zeich|net (Abk.: gez.)

Ge|zei|ten (Wechsel von Ebbe u. Flut) Mehrz.; Ge|zei|ten.kraft-werk, ...ta|fel, ...wech|sel

Ge|zer|re s; -s

Ge|ze|ter s; -s

ge|zielt; -e Werbung; - fragen

ge|zie|men, sich; es geziemt sich für ihn; ge|zie|mend; -ste

Ge|zie|re s; -s; ge|ziert; Ge|ziert-heit

Ge|zirp s; -[e]s u. Ge|zir|pe s; -s

Ge|zisch, Ge|zi|sche s; ...sch[e]s; Ge|zi|schel s; -s

Ge|züch (verächtl. für: Kreatur, Gesindel) s; -[e]s, -e

Ge|zün|gel s; -s

Ge|zweig s; -[e]s

ge|zwirnt; vgl. zwirnen

Ge|zwit|scher s; -s

ge|zwun|gen|er|ma|ßen; ge|zwun-ge|ner|wei|se; Ge|zwun|gen|heit w; -, (selten:) -en

Gfrast bayr., österr. ugs. (Fussel; Nichtsnutz, Flegel) s; -s, -er

Gfrett vgl. Gefrett

Gfrieß vgl. Gefrieß

GG = Grundgesetz

ggf. = gegebenenfalls

g.g.T., ggT = größter gemeinsa-mer Teiler

Gha|na (Staat in Afrika); Gha|na-er; gha|na|isch

Gha|sel, Gha|se|le vgl. Gasel, Ga-sele

Ghet|to vgl. Getto

Ghi|bel|li|ne vgl. Gibelline

Ghost|wri|ter engl. [go"ßtrait°r] (Autor, der für eine andere Per-son schreibt und nicht als Verfas-ser genannt wird) m; -s, -

G.I., GI amerik. [dsehi ai; Abk. von: Government Issue (gaw°rn-m°nt ischu) = Regierungs-ausgabe (urspr. für die Ausrü-stung der Truppe]) (aus der ame-rik. Soldatensprache übernom-mene ugs. Bezeichnung für den amerik. Soldaten) m; -[s], -[s]

Gi|aur pers. (Ungläubiger; Bez. des Nichtmohammedaners im Is-lam) m; -s, -s

Gib|bon fr. (ein Affe) m; -s, -s

Gi|bel|li|ne, Ghi|bel|li|ne it. (it. Anhänger der Hohenstaufen) m; -n, -n (↑ R 268)

Gi|bral|tar arab. [österr. gib...] („Berg des Tarik"; Halbinsel an der Südspitze Spaniens)

¹Gicht (Hüttenw.: oberster Teil des Hochofens) w; -, -

²Gicht (Stoffwechselkrankheit) w; -; Gicht.an|fall, ...bee|re (landsch. für: schwarze Johan-nisbeere); gicht|brü|chig; gich|tig (veralt. für: gichtisch); gich|tisch; -ste (↑ R 294); Gicht|kno|ten; gicht|krank

Gickel [Trenn.: Gik|kel] mitteld. (Hahn) m; -s, -

gicks (ugs.); weder - noch gacks sagen; gick|sen, kick|sen landsch. (einen [leichten] Schrei aussto-ßen, stechen, stoßen [um einen leichten Schrei hervorzurufen]); du gickst (gicksest); gicksen und gacksen; vgl. giksen

Gide [sehid, auch: sehid] (fr. Schriftsteller)

Gi|de|on (m. Vorn.; bibl. m. Ei-genn.)

¹Gie|bel (ein Fisch) m; -s, -

²Gie|bel (lotrechter Dachab-schluß) m; -s, -; gie|be|lig, gieb|lig; Gie|bel.dach, ...fen|ster, ...wand

Giek|baum (Seemannsspr.: Rund-holz für Gaffelsegel)

Gie|men (krankhaftes Luftröh-rengeräusch [bei Pferden]) s; -s

Gien engl. (Seemannsspr.: schwe-res Takel) s; -s, -e; Gien|block (Mehrz. ...blöcke)

Gien|gen an der Brenz [ging°n ---] (Stadt in Baden-Württemberg)

Gie|per nordd. ugs. (Gier, Appe-tit) m; -s; einen - auf etwas haben; gie|pern; nach etwas -; giep|rig

Gier w; -; ¹gie|ren (gierig sein)

²gie|ren (seitliches Abweichen des Schiffes od. Flugzeuges); Gier-fäh|re (Seilfähre)

Gier|fal|ke vgl. Gerfalke

gie|rig; Gie|rig|keit w; -

Giersch landsch. (Geißfuß, Un-kraut) m; -[e]s

Gieß|bach; gie|ßen; du gießt (gie-ßest); ich goß, du gossest; du gös-sest; gegossen; gieß[e]!

Gie|ßen (Stadt a. d. Lahn); Gie|ße-ner (↑ R 199)

Gie|ßer; Gie|ße|rei; Gieß.form, ...harz s, ...kan|ne; Gieß|kan|nen-prin|zip s; -s; etwas nach dem - (unterschiedslos, willkürlich) verteilen

¹Gift s; -[e]s, -e; ²Gift (veralt. für: „Gabe"; vgl. Mitgift) w; -; ³Gift landsch. (Ärger, Zorn) m; -[e]s; einen - auf jmdn. haben; gif|ten (ugs. für: ärgern); es gift et mich; gift|fest; gift|gas; gift|grün; gif-tig; Gif|tig|keit w; -; Gift.mi-scher, ...mi|sche|rin (w; -, -nen), ...mord, ...nu|del (scherzh. für: [schlechte] Zigarre u. Zigarette; zänkischer Mensch), ...pflan|ze, ...schlan|ge, ...schrank, ...stoff, ...zahn

Gig engl. (leichter Einspänner; Sportruderboot; leichtes Bei-boot) s; -s, -s

Gi|ga... gr. (das Milliardenfache einer Einheit, z. B. Gigameter = 10^9 Meter; Zeichen: G)

Gi|gant gr. (Riese) m; -en, -en (↑ R 268); gi|gan|tisch; -ste (↑ R 294); Gi|gan|tis|mus (Med.: krankhaf-ter Riesenwuchs; übersteigerte Größensucht) m; -; Gi|gan|to|ma-chie (Kampf der Giganten gegen Zeus) w; -

Gi|gerl bes. österr. (Modegeck) m (auch: s); -s, -n; gi|gerl|haft

Gi|go|lo fr. [sehi..., auch: sehi...] (Eintänzer; ugs. für: Hausfreund, ausgehaltener Mann) m; -s, -s

Gigue fr. [sehig] (ein Tanz; Teil der Suite) w; -, -n [...g°n]

gik|sen mdal. (stechen, stoßen); du gikst (giksest); vgl. gicksen

gil|ben (dicht. für: gelb werden)

Gil|bert (m. Vorn.); Gil|ber|ta (w. Vorn.)

Gilb|hard, Gilb|hart (Oktober) m; -s, -e

Gil|de w; -, -n; **Gil|de_haus**, ...**meister**; **Gil|den_hal|le**, ...**schaft**
Gil|do (m. Vorn.)
Gi|let fr. [*sehile̜*] (österr. u. schweiz. neben: Weste) s; -s, -s
Gil|ga|mesch (myth. König)
Gil|ka ⓦ (Kümmellikör) m; -s, -s
Gil|lette ⓦ [*sehilä̜t*; nach dem amerik. Erfinder] (eine Rasierklinge̜) w; -, -s
Gil|ling w; -, -s u. **Gil|lung** (Seemannsspr.: einwärts gebogene Seite des Rahsegels; nach innen gewölbter Teil des Hinterschiffs) w; -, -en
gil|tig (veralt., aber noch mdal. für u. österr. neben̜ gültig)
Gim|pe (leicht gedrehte Schnur, Ansatzborte) w; -, -n
Gim|pel (Singvogel; einfältiger Mensch) m; -s, -; **Gim|pel|fang**; auf - ausgehen
Gin engl. [*dschin*] (engl. Wacholderbranntwein) m; -s, -s
Gin|gan malai. u. **Ging|ham** engl. [*ging̜ᵉm*] (ein Baumwollstoff) m; -s, -s
Ginkʼgo (so in der Fachsprache übliche Schreibweise) Jap. [*gink̜ko*], (richtiger:) **Ginkʼjo** [*gink̜kjo*] (in Japan u. China heimischer Zierbaum) m; -s, -s
Gin|seng chin. [auch: *sehin...*] (ostasiat. Pflanze mit heilkräftiger Wurzel) m; -s, -s
Gin|ster (ein Strauch) m; -s, -; **Gin|ster|blü|te**
Ginz|key (österr. Dichter)
Giot|to [*dsehotto*] (it. Maler)
Gio|van|ni [*dsehow...*] (it. Form für: Johannes)
Gip|fel (schweiz. auch für: Hörnchen, Kipfel) m; -s, -; **gip|fe|lig**, **gipf|lig**; **Gip|fel_kon|fe|renz**, ...**kreuz** (Kreuz auf dem Berggipfel); **gip|feln**; **Gip|fel_punkt**, ...**tref|fen**; **gipf|lig**, **gip|fe|lig**
Gips semit. m; -es, -e; **Gips_abdruck** (Mehrz. ...abdrücke), ...**bü|ste**; **gip|sen**; du gipst (gipsest); **Gip|ser**; **gip|sern** (aus Gips; gipsartig); **Gips|ver|band**
Gi|pü|re fr. (Geflecht aus Gimpen) w; -, -n
Gi|raf|fe arab. [südd., österr.: *sehi...*] (ein Steppenhuftier) w; -, -n
Gi|ran|do|la it. [*dsehi...*] u. **Gi|rando|le** fr. [*sehi...*] (Feuergarbe beim Feuerwerk; Armleuchter) w; -, ...**olen**; **Gi|rant** it. [*sehi...*] (wer ein Orderpapier durch Indossament überträgt; Begeber) m; -en, -en (↑ R 268); **Gi|rat** m; -en, -en (↑ R 268) u. **Gi|ra|tar** (Person, der bei der Übertragung eines Orderpapiers ein Indossament erteilt wurde) m; -s, -e; **gi|rie̜|ren** ([einen Wechsel] übertragen)

Gi|rau|doux [*sehirodu̜*] (fr. Schriftsteller); Giraudoux' [...*du̜ß*] Werke (↑ R 310)
Girl engl. [*gö̜ʼl*] (Mädchen; weibl. Mitglied einer Tanztruppe) s; -s, -s
Gir|lan|de fr. ([bandförmiges Laub- od. Blumen]gewinde) w; -, -n
Gir|litz (ein Singvogel) m; -es, -e
Gi|ro it. [*sehiro*] (,,Kreis''; Überweisung im bargeldlosen Zahlungsverkehr; Übertragungsvermerk eines Orderpapiers) s; -s, -s (österr. auch: Giri); **Gi|ro_bank** (Mehrz. ...banken), ...**kas|se**, ...**kon|to**
Gi|ronde [*sehirong̜d*] (Mündungstrichter der Garonne; fr. Departement) w; -; **Gi|ron|dist** (gemäßigter Republikaner der Fr. Revolution) meist Mehrz. (↑ R 268)
Gi|ro|ver|kehr [*sehiro...*] (bargeldloser Zahlungsverkehr)
gir|ren; die Taube girrt
gis, Gis (Tonbezeichnung) s; -, -; **gis** (Zeichen für: gis-Moll); in gis
Gis|bert (m. Vorn.); **Gis|ber|ta** (w. Vorn.)
gi|schen (hebr. für: [auf]schäumen, sprühen); du gischst (gischest); **Gischt** (Schaum; Sprühwasser, aufschäumende See) m; -[e]s, (selten:) -e (auch: w; -, [selten:] -en); **gischt|sprü|hend**, a b e r (↑ R 142): weiße Gischt sprühend
Gi|se|la [österr.: ...*se̜...*] (w. Vorn.); **Gi|sel|bert** (m. Vorn.); **Gi|sel|ber|ta** (w. Vorn.); **Gi|sel|her** (m. Vorn.); **Gi|sel|mar** (m. Vorn.)
gis-Moll [auch: *gißmo̜l*] (Tonart; Zeichen: gis) s; -; **gis-Moll-Tonlei|ter** (↑ R 155)
Gi|ß niederd. (Mutmaßung, Schätzung [durch Schiffer u. Flieger]) m; Gisses, Gisse; **gis|sen**; du gißt (gissest); du gißtest; gegißt; **Gis|sung**
Gi|tar|re span. (ein Saiteninstrument) w; -, -n; **Gi|tar|ren_spie|ler**, ...**ton** (Mehrz. ...töne); **Gi|tar|rist** (↑ R 268)
Gi|ta, Git|te (w. Vorn.)
Git|ter s; -s, -; **Git|ter_bett|chen**, ...**brücke** [Trenn.: brük|ke], ...**fen|ster**; **git|tern**; ich ...ere (↑ R 327); **Git|ter_stab**, ...**tor**
Glace fr. [*glaß*; schweiz.: *glaß̜ᵉ*] (glänzender Überzug [Zuckerguß]; Gelee aus Fleischsaft; schweiz.: Speiseeis, Gefrorenes) w; -, -s [*glaß̜*], (schweiz.:) -n; **Glacé** [*glaß̜e*] (glänzendes Gewebe) m; -[s], -s; **Gla|cé_hand|schuh**, ...**le|der**; **gla|cie̜|ren** [*glaß̜iʼᵉn*] (veralt. für: gefrieren machen; auch für: glasieren); **Gla|cis** [*gla-ß̜*] (Erdaufschüttung vor einem Festungsgraben, die keinen toten

Winkel entstehen läßt) s; - [*gla-ß̜i(ß)*], - [*glaß̜iß*]
Gla|dia|tor lat. (altröm. Schaufechter) m; -s, ...**oren**; **Gla|dio|le** (Schwertliliengewächs) w; -, -n
gla|go|li|tisch slaw.; -es Alphabet (kirchenslaw. Alphabet); **Gla|go|li|za** (die glagolitische Schrift) w; -
Gla|mour|girl engl. [*glämᵉrgö̜ʼl*] (bes. aufgemachtes Mädchen; Reklame-, Filmschönheit)
Glan|del lat. (veralt. für: Drüse) w; -, -n
Glanz m; -es; **Glanz|bür|ste**; **glän|zen**; du glänzt (glänzest); **glän|zend**; -ste; glänzendschwarze Haare (↑ jedoch R 143), a b e r : seine Augen waren glänzend schwarz; **glanz|er|hellt**; **Glanz_koh|le**, ...**lei|stung**, ...**le|der**; **glanz|los**; **Glanz_num|mer**, ...**punkt** (Höhepunkt), ...**stoff**; **glanz|voll**
Glar|ner; ↑ R 199 (von Glarus); **Glar|ner Al|pen** Mehrz.; **glar|ne-risch**; **Gla|rus** (Kanton und Stadt in der Schweiz)
¹**Glas** s; -es, Gläser; zwei - Bier (↑ R 321 u. 322); ein - voll; blasen; ²**Glas** (Seemannsspr.: halbe Stunde) s; -es, -en; **glas|ar|tig**; **Glas_au|ge**, ...**blä|ser**; **Gläs|chen**, Gläs|lein; **Gla|ser**; **Gla|se|rei**; **Glä|ser|klang**; **Gla|ser|mei|ster**; **glä|sern** (aus Glas, glasartig); **Glas_fa|ser**; **glas|hart**; **Glas_haus**, ...**hüt|te**; **gla|sie̜|ren** (mit Glasur versehen); **gla|sig**; **glas|klar**; **Glas|kopf** (Eisenerzart; m; -[e]s); **Gläs|lein**, Gläs|chen; **Glas_ma|ler**, ...**per|le**, ...**röh|re**, ...**schei|be**, ...**split|ter**, ...**sturz** (bes. österr. für: Glasglocke)
Glast (südd., schweiz. u. dicht. für: Glanz) m; -[e]s; **gla|stig**
Glas|tür; **Gla|sur** (glasiger Überzug, Schmelz; Zuckerguß) w; -, -en; **Glas|ve|ran|da**; **glas|wei|se**; **Glas|wol|le**
glatt; (↑ R 295:) -er (auch: glätter), -este (auch: glätteste); **Glät|te** w; -, -n; **Glatt|eis**; **glät|ten** (landsch. auch für: bügeln); **glat|ter|dings**; **Glät|te|rin** schweiz. (Büglerin) w; -, -nen; **glatt|ge|hen** (ugs.: ohne Hindernis vonstatten gehen); es hoffe, daß alles glattgeht; vgl. glatthobeln-, **glatt|ho|beln** (↑ R 139); ich hob[e]le glatt (↑ R 327); glattgehobelt, glattzuhobeln; **glatt_käm|men**, ...**le|gen**, ...**ma-chen** (ausgleichen; ugs. für: bezahlen), ...**schlei|fen**; vgl. glatthobeln; **Glätt|stahl** landsch. (Bügeleisen); **glatt|stel|len** (Kaufmannsspr.: ausgleichen); vgl. glatthobeln; **Glätt|stel|lung**; **glatt|strei|chen**; vgl. glatthobeln;

Glät|tung; glatt|weg; glatt|zie-
hen; vgl. glatthobeln; glatt|zün-
gig; glatt|zün|gig|keit w; -
Glät|ze w; -, -n; glat|zig; Glatz-
kopf; glatz|köp|fig
Glau|be m; -ns, (selten:) -n; glau-
ben; er wollte mich - machen, daß
...; Glau|ben (seltener für: Glau-
be) m; -s, (selten:) -; Glau|bens_ar-
ti|kel, ...be|kennt|nis, ...ei|fer,
...ge|mein|schaft, ...sa|che, ...satz;
glau|bens_stark, ...voll
Glau|ber|salz (Natriumsulfat) s;
-es
glaub|haft; Glaub|haf|tig|keit w; -;
gläu|big; Gläu|bi|ge m u. w; -n,
-n (↑ R 287ff.); Gläu|bi|ger (jmd.,
der berechtigt ist, von einem
Schuldner eine Leistung zu for-
dern) m; -s, -; Gläu|bi|ger_an-
spruch, ...ver|samm|lung; Gläu-
big|keit w; -; glaub|lich; kaum -;
glaub|wür|dig; Glaub|wür|dig-
keit w; -
Glau|ko|chro|it gr. [...kro...] (ein
Mineral) m; -s, -e; Glau|ko|dot
(ein Mineral) s; -[e]s, -e; Glau-
kom (grüner Star [Augenkrank-
heit]) s; -s, -e; Glau|ko|nit (ein
Mineral) m; -s, -e; Glau|ko|phan
(ein Mineral) m; -s, -e
gla|zi|al lat. (Eis, Gletscher betref-
fend; zur Eiszeit gehörend, eis-
zeitlich; Eis[zeit]...); Gla|zi-
al_fau|na, ...flo|ra, ...kos|mo|go-
nie (Welteislehre; w; -), ...zeit
(Vereisungszeit); Gla|zio|lo|ge
lat.; gr. (Kenner u. Erforscher der
Eis- u. Gletscherbildungen) m;
-n, -n (↑ R 268)
Glei|bo|den russ.; dt. (Geol.: Stau-
nässeboden)
gleich; die Sonne ging gleich einem
roten Ball unter. I. Kleinschrei-
bung: a) (↑ R 135:) der, die, das
gleiche; das gleiche (dasselbe)
tun; das gleiche gilt ...; es kommt
aufs gleiche hinaus; b) (↑ R 133:)
ins gleiche (in die Richte) brin-
gen; gleich und gleich gesellt sich
gern. II. Großschreibung (↑ R
116): Gleiches mit Gleichem ver-
gelten; es kann uns Gleiches be-
gegnen; Gleiches vom Gleichem
bleibt Gleiches; ein Gleiches tun;
Gleicher unter Gleichen. III. Ge-
trenntschreibung: gleich sein,
werden; gleich alt, groß, gut,
lang, schnell, verteilt, wahr-
scheinlich, weit u. a.: zwei gleich
große Kinder; die Kinder waren
gleich groß. IV. In Verbindung
mit Zeitwörtern (↑ R 139): 1. Ge-
trenntschreibung, wenn „gleich"
bedeutet: a) „nicht verschieden",
„in gleicher Weise". z. B. gleich
denken, gleich klingen, gleich
lauten, die Wörter werden gleich
geschrieben; b) „sogleich", „so-

fort", z. B. er soll gleich kom-
men. 2. Zusammenschreibung in
übertragenem Sinne (↑ R 139),
z. B. gleichkommen (vgl. d.); ich
komme gleich, gleichgekommen,
gleichzukommen; gleich|al|te-
rig, gleich|alt|rig; gleich|ar|tig;
Gleichartiges (↑ R 116); Gleich-
ar|tig|keit; gleich|auf; - liegen;
gleich_be|deu|tend, ...be|rech|tigt;
Gleich|be|rech|ti|gung w; -;
gleich|blei|ben (↑ R 139), sich
(unverändert bleiben); ich bleibe
mir gleich; gleichgeblieben,
gleichzubleiben; gleichbleibend
(unveränderlich), aber: gleich
blei|ben (sofort, ohne Umstände
bleiben); er ist gleich geblieben,
als wir ihn um diese Gefälligkeit
baten; vgl. gleich, IV, 1, b); gleich-
den|kend; vgl. aber gleich, IV, 1,
a; Glei|che w; -; etwas in die -
bringen; vgl. aber: gleich, I, b;
glei|chen (gleich sein; gleichma-
chen); du glichst (glichest); ge-
glichen; gleich[e]!; Glei|chen|fei-
er österr. (Richtfest); glei|chen-
tags schweiz. (am selben Tage);
glei|cher|ge|stalt; glei|cher|ma-
ßen; glei|cher|wei|se; gleich|falls;
vgl. Fall m; gleich_far|big, ...för-
mig; Gleich|för|mig|keit w; -;
gleich_ge|ar|tet, ...ge|la|gert,
...ge|schlecht|lich, ...ge|sinnt (↑ R
142), ...ge|stimmt (↑ R 142);
gleich_ge|wicht s; -[e]s, -e; gleich-
ge|wich|tig; Gleich|ge|wichts_la-
ge, ...or|gan, ...sinn, ...stö|rung;
gleich|gül|tig vgl. giltig; gleich-
gül|tig; Gleich|gül|tig|keit;
Gleich|heit; Gleich|heits_grund-
satz, ...prin|zip, ...zei|chen;
Gleich|klang; gleich|kom|men;
↑ R 139 (entsprechen); das war
einer Kampfansage gleichge-
kommen, aber: gleich kom|men
(sofort kommen); vgl. gleich, IV,
1, b); Gleich|lauf (Technik) m;
-[e]s; gleich|lau|fend; gleich|läu-
fig (Technik); Gleich|läu|fig|keit
w; -; gleich|lau|tend; vgl. aber
gleich, IV, 1, a; gleich|ma|chen;
↑ R 139 (angleichen); dem Erdbo-
den -, aber: gleich ma|chen (so-
fort machen); das wollen wir
gleich machen; vgl. gleich, IV,
1, b); Gleich|ma|cher; Gleich|ma-
che|rei; gleich|ma|che|risch;
Gleich|maß s; gleich|mä|ßig;
Gleich|mä|ßig|keit; Gleich|mut
m; -[e]s u. (selten:) w; -; gleich|mü-
tig; Gleich|mü|tig|keit w; -; gleich-
na|mig; Gleich|na|mig|keit w; -;
Gleich|nis s; -ses, -se; gleich|nis-
_haft, ...wei|se; gleich|ran|gig;
Gleich|rich|ter (Elektrotechnik);
gleich|sam; gleich|schal|ten; ↑ R
139 (einheitlich durchführen),
aber: gleich schal|ten (für: so-

fort schalten [beim Auto]); vgl.
gleich, IV, 1, b); Gleich|schal-
tung; gleich|schen|ke|lig, gleich-
schenk|lig; Gleich|schritt; gleich-
se|hen; ↑ R 139 (ähnlich sehen),
aber: gleich se|hen (sofort se-
hen); wie wir gleich sehen wer-
den; vgl. gleich, IV, 1, b); gleich
sein; gleich se|hen sei|tig; Gleich|sei|tig-
keit w; -; gleich|set|zen; ↑ R 139;
etwas mit einer Sache -, aber:
gleich set|zen (sofort setzen); vgl.
gleich, IV, 1, b); Gleich|set|zung;
Gleich|set|zungs_ak|ku|sa|tiv
(Sprachw.: Gleichsetzungsglied
neben einem Akkusativobjekt, z.
B. er nennt mich „einen Lüg-
ner"), ...no|mi|na|tiv (Sprachw.:
Ergänzung im Nominativ, z. B.
er ist „ein Lügner"), ...satz;
Gleich|stand m; -[e]s; gleich|ste-
hen; ↑ R 139 (gleich sein), aber:
gleich ste|hen (sofort, ohne wei-
teres stehen); vgl. gleich, IV, 1, b);
Gleich|ste|hen|de m u. w; -n, -n
(↑ R 287ff.); gleich|stel|len; ↑ R
139 (gleichmachen), aber: gleich
stel|len (sofort stellen); er mußte
sich gleich stellen; vgl. gleich, IV,
1, b); Gleich|stel|lung; gleich|stim-
mig; Gleich|strom; Gleich|strom-
ma|schi|ne; gleich|tun; ↑ R 139 (er-
reichen); es jmdm. -, aber: gleich
tun (sofort tun); vgl. gleich, IV,
1, b); Glei|chung; gleich|viel;
gleichviel[,] ob/wenn/wo (↑ R 63);
-[,] ob du kommst, aber: wir
haben gleich viel; gleich wer|den;
gleich wer|tig; Gleich|wer|tig|keit
w; -; gleich|wie; gleich|win|ke|lig,
gleich|wink|lig; gleich|wohl;
aber: wir befinden uns alle gleich
(in gleicher Weise) wohl; gleich-
zei|tig; Gleich|zei|tig|keit; gleich-
zie|hen; ↑ R 139 (Technik; ugs.
auch für: in gleicher Weise han-
deln), aber: wir müssen [den
Wagen] gleich ziehen (sofort zie-
hen); vgl. gleich, IV, 1, b
Gleis (Bundesbahn nur so) s; -es,
-e u. Ge|lei|se s; -s, -; Gleis_an-
schluß, ...bau (m; -[e]s), ...bet|tung
(Untergrund einer Gleisanlage)
...drei|eck; ...glei|sig, ...ge|lei|sig
(z. B. zwei[e]leisig)
Gleis|ner (Heuchler); Gleis|ne|rei
w; -; gleis|ne|risch; -ste (↑ R 294)
Gleiß (dicht. für: Gleißendes) m;
-es; Glei|ße (Giftpflanze, Hunds-
petersilie) w; -, -n; gleißen (glän-
zen, glitzern); du gleißt (gleißest)
ich gleiße, du gleißest; gegleißt
gleiß[e]!
Gleit_bahn, ...boot; glei|ten; du
glittst (glittest, veralt.: gleitetest)
gegleiten (veralt.: gegleitet); gli
t[e]!; gleitende Arbeitszeit, Lohn
skala; Glei|ter (Flugw.); Gleit
_flä|che, ...flug, ...klau|sel

...schie|ne, ...schutz; gleit|si|cher
Glen|check engl. [glän'tschäk] (ein
Gewebe) m; -[s], -s
Glet|scher m; -s, -; glet|scher|ar|tig;
Glet|scher_bach, ...brand (m;
-[e]s), ...eis, ...feld, ...milch (mil-
chig-trübes Schmelzwasser eines
Gletschers), ...müh|le (röhrenför-
mige Stelle in Gletscherspalten),
...schliff, ...spal|te, ...tor (Aus-
trittsstelle des Gletscherbaches),
...zun|ge
Gle|ve fr. [gläf^e] (mittelalterl.
Waffe) w; -, -n
Glied s; -[e]s, -er; Glie|der|fü|ßer;
...glie|de|rig, ...glied|rig (z. B.
zweiglied[e]rig, mit Ziffer: 2-glie-
d[e]rig)i glie|dor|lahm, glie|dern;
ich ...ere (↑ R 327); Glie|der_pup-
pe, ...rei|ßen, ...sucht (mdal. ne-
ben: Rheuma), ...tier; Glie|de-
rung; Glied|ma|ße w; -, -n (meist
Mehrz.); ...glied|rig vgl. ...gliede-
rig; Glied_satz (Sprachw.),
...staat (Mehrz. ...staaten); glied-
wei|se
glim|men; es glomm (auch: glimm-
te); es glömme (auch: glimmte);
geglommen (auch: geglimmt);
glimm[e]!; Glim|mer (ein Mine-
ral) m; -s, -; glim|me|rig; glim-
mern; Glim|mer|schie|fer;
Glimm_lam|pe, ...sten|gel
(scherzh. für: Zigarre und Ziga-
rette)
glimpf|lich; er behandelte ihn -;
Glimpf|lich|keit w; -
Glis|sa|de fr. (Gleitschritt beim
Tanzen); glis|san|do it. (Musik:
gleitend); Glis|san|do s; -s, -s u.
...di
Glitsch|bahn; Glit|sche mdal.
(Schlitterbahn) w; -, -n; glit|schen
(ugs. für: gleiten; schlittern); du
glitschst (glitschest); glit|sche|rig,
glit|schig, glitsch|rig
Glit|zer m; -s, -; glit|ze|rig, glitz-
rig; glit|zern; ich ...ere (↑ R 327)
glo|bal lat. (auf die gesamte Erd-
oberfläche bezüglich; Erd...; ge-
samt; ungefähr); Glo|bal_sum-
me, ...ver|ein|ba|rung, ...zahl;
Glo|be|trot|ter engl. [glob^e tr...,
auch: globtr...] (Weltenbumm-
ler) m; -s, -
Glo|bin lat. (Eiweißbestandteil der
Hämoglobins) s; -s; Glo|bu|lin
(Eiweißkörper) s; -s, -e
Glo|bus lat. („Kugel"; Nachbil-
dung der Erde od. der Himmels-
kugel) m; - u. ...busses, ...ben u.
(bereits häufiger) ...busse
Glöck|chen, Glöck|lein; Glocke[1] w;
-, -n; Glocken|blu|me[1]; glocken-
för|mig[1]; Glocken[1]_ge|läut, ...ge-
läu|te, ...gie|ßer, ...gie|ße|rei,
...guß; glocken|hell[1]; Glocken[1]-

...klang, ...rock, ...schlag, ...spiel,
...stu|be, ...stuhl, ...ton, ...turm,
...zei|chen; glockig[1]; Glöck|ner
Glogg|nitz (österr. Stadt)
[1]Glo|ria lat. (Ruhm, Ehre); nur
noch in: mit Glanz und - (iron.);
[2]Glo|ria (Lobgesang in der kath.
Messe) s; -s; Glo|rie [...i^e] (Ruhm,
Glanz; Heiligenschein) w; -, -n;
Glo|ri|en|schein; Glo|ri|fi|ka|ti-
on [...zion] (Verherrlichung); glo-
ri|fi|zie|ren; Glo|ri|fi|zie|rung;
Glo|rio|le (Heiligenschein) w; -,
-n; glo|ri|os (ruhmvoll); -este (↑ R
292); glor|reich
glo|sen mdal. (glühen, glimmen);
es glo|ste
Clos|sgr gr (Sammlung von Glos-
sen; Wörterverzeichnis [mit Er-
klärungen]) s; -s, -e; Glos|sa|tor
(Verfasser von Glossen) m; -s,
...oren; Glos|se [fachspr. auch:
gloß^e] („Zunge"; Erläuterung zu
einem erklärungsbedürftigen
Ausdruck innerhalb eines Tex-
tes, und zwar als Interlinear-,
Kontext- od. Marginalglosse
[vgl. d.]; spöttische [Rand]bemer-
kung, auch als polemische feuil-
letonistische Kurzform) w; -, -n;
glos|sie|ren; Glos|so|la|lie gr.
(bibl.: „Zungenreden") w; -
glo|sten (Nebenform von: glosen)
Glot|tal gr. (Sprachw.: Stimmrit-
zenlaut, Kehlkopflaut) m; -s, -e;
Glot|tis (Stimmapparat, Stimm-
ritze) w; -, Glottides [...äß]
Glotz|au|ge (ugs.); glotz|äu|gig
(ugs.); glot|zen (ugs.); du glotzt
(glotzest)
Glo|xi|nie [...i^e; nach dem Arzt
Gloxin] (eine Zimmerpflanze) w;
-, -n
gluck!; gluck, gluck!
Glück s; -[e]s; jmdm. - wünschen;
Glück ab! (Fliegergruß); Glück-
ab s; -; Glück auf! (Bergmanns-
gruß); Glück|auf s; -s; er rief ihm
ein Glückauf zu; glück|brin|gend,
aber (↑ R 142): ein dem Nächsten
Glück bringendes Verhalten
Glücke[1] w; -, -n; glucken[1]
glücken
gluckern[1]; ich ...ere (↑ R 327)
glück|haft
Gluck|hen|ne
glück|lich; glück|li|cher|wei|se;
Glück|sa|che (seltener für:
Glückssache; vgl. d.); Glücks|bu-
de; glück|se|lig; Glück|se|lig|keit
w; -, (selten:) -en
gluck|sen; du gluckst (glucksest)
Glücks_fall m, ...ge|fühl, ...kind,
...pfen|nig, ...pilz, ...rad, ...rit|ter,
...sa|che (w; -), ...spiel, ...stern (m;
-s), ...sträh|ne (w; -), ...tag; glück-
strah|lend, aber (↑ R 142): vor

Glück strahlend; Glücks_um-
stand, ...zahl; glück|ver|hei|ßend,
aber (↑ R 142): ein großes Glück
verheißend; Glück|wunsch;
Glück|wunsch|te|le|gramm;
Glück zu!; Glück|zu s; -
Glu|co|se [...ko...] (Chemie: Trau-
benzucker) w; -
Glüh|bir|ne; glü|hen; ein glühend-
heißes Eisen (↑ jedoch R 143),
aber: das Eisen ist glühend heiß;
glüh|heiß, Glüh_hit|ze, ...lam|pe,
...licht (s; -[e]s), ...strumpf, ...wein,
...würm|chen
Glüm|pert vgl. Klumpert
Glum|se landsch. (Quark) w; -
Glupsch|au|gen gr (nordd.) Mehrz.;
glup|schen nordd. (starr blicken)
Glut w; -, -en; glut|äu|gig
Glu|ten lat. (Kleber) s; -s
Glut|hit|ze
Glu|tin lat. (Eiweißstoff) s; -s
Gly|ce|rin vgl. Glyzerin; Glyk-
ämie gr. (Zuckergehalt des Blu-
tes) w; -; Gly|ko|gen (tierische
Stärke) s; -s; Gly|ko|se (ältere
Form für: Glucose); Gly|ko|si|de
(Pflanzenstoffe, die in Zucker u.
andere Stoffe spaltbar sind)
Mehrz.; Gly|kos|urie (Zucker-
ausscheidung im Harn) w; -, ...ien
Glyp|te (geschnittener Stein;
Skulptur) w; -, -n; Glyp|tik (Stein-
schneidekunst) w; -; Glyp|to|thek
(Sammlung von geschnittenen
Steinen od. [antiken] Skulpturen)
w; -, -en
Gly|san|tin ® (Gefrierschutzmit-
tel für Kraftfahrzeuge) s; -s
Gly|ze|rin, auch (chem. fachspr.: Glyce-
rin [...ze...]) gr. (dreiwertiger
Alkohol) s; -s; Gly|ze|rin|sei|fe;
Gly|zi|nie [...i^e] (ein Kletter-
strauch) w; -, -n
G-man amerik. [dschiemän; Kurzw.
aus government man = Regie-
rungsmann] (Sonderagent des
FBI) m; -[s], G-men
GmbH = Gesellschaft mit be-
schränkter Haftung; GmbH-Ge-
setz s; -es, -e
g-Moll [gemol, auch: gemoll]
(Tonart; Zeichen: g) s; -; g-Moll-
Ton|lei|ter [ge...] (↑ R 155)
Gmünd (österr. Stadt)
Gmun|den (österr. Stadt)
Gna|de w; -, -n; zu -n annehmen,
kommen; von Gottes Gnaden
(veralt.:) Euer Gnaden (vgl. euer
Werf.); gna|den (veralt. für: gnä-
dig sein), heute nur noch in der
Möglichkeitsform der Gegen-
wart: gnade dir [Gott]!; Gna-
den_akt, ...be|zei|gung (nicht:
...bezeugung), ...brot (s; -[e]s),
...er|laß, ...frist, ...ge|such, ...lohn;
gna|den_los, ...reich, ...voll; Gna|den-
stoß; gna|den|voll; Gna|den|weg;
gnä|dig

[1] Trenn.: ...k|k...

Gna|gi schweiz. (gepökelte Teile von Kopf, Gliedmaßen und Schwanz des Schweines) s; -s

Gneis (ein Gestein) m; -es, -e

gnei|ßen österr. mdal. (bemerken)

Gnit|te, Gnit|ze niederd. (kleine Mücke) w; -, -n

Gnom (Kobold; Zwerg) m; -en, -en (↑ R 268)

Gno|me gr. (lehrhafter [Sinn-, Denk]spruch) w; -, -n

gno|men|haft (in der Art eines Gnomen)

Gno|mi|ker gr. (Verfasser von [Sinn-, Denk]sprüchen); **gno|misch**; -er Dichter (Spruchdichter); **Gno|mon** (,,Anzeiger''; antikes astronom. Instrument [Sonnenuhr]) m; -s, ...mone; **Gno|sis** ([Gottes]erkenntnis; in der Schau Gottes erfahrene Welt des Übersinnlichen) w; -; **Gno|stik** (Lehre der Gnosis) w; -; **Gno|sti|ker** (Vertreter der Gnosis); **gno|stisch**; **Gno|sti|zis|mus** m; -

Gnu hottentott. (ein Steppenhuftier) s; -s, -s

Go (jap. Brettspiel) s; -

Goa (ehem. portug. Besitzung an der Westküste Vorderindiens)

Goal engl. (veralt., aber noch österr. u. schweiz. für: Tor [beim Fußball]) s; -s, -s; **Goal|get|ter** (Torschütze), ...**mann** (Torhüter)

Go|be|lin fr. [...läng] (Wandteppich mit eingewirkten Bildern) m; -s, -s

Go|bi mong. (,,Wüste''; Wüste in Innerasien) w; -

Gockel [Trenn.: Gok|kel] bes. südd. (Hahn) m; -s, -; vgl. auch: Gickel; **Gockel|hahn** [Trenn.: Gok|kel...]

Go|de (Nebenform von: Gote [Pate])

Go|del, Go|den, Godl südd. u. österr. mdal. (Patin) w; -, -n

Go|der österr. ugs. (Doppelkinn) m; -s, - u. **Go|derl** s; -s, -n

Godt|háb [gódháb] (Hauptansiedlung Grönlands)

Goe|de|ke [gö...] (dt. Literarhistoriker)

Goes [gööß] (dt. Schriftsteller)

Goe|the [gö...] (dt. Dichter); **Goethea|num** (von der Allgemeinen Anthroposoph. Gesellschaft in Dornach bei Basel für Tagungen u. Aufführungen errichteter Bau) s; -s; **Goe|the-Band** (↑ R 180) m; -[e]s, -Bände; **goe|the|freund|lich** (↑ R 187); **Goe|the|haus** s; -es (↑ R 180); **goe|thesch, goe|thisch** (nach Art Goethes); nach Goethe benannt); ihm gelangen Verse von goethescher od. goethischer Klarheit (nach Goethes Art), aber (↑ R 179): Goe|thesch, Goe|thisch (von Goethe herrührend);

Goethesche od. **Goethische** Dramen (Dramen von Goethe); **Goethe-und-Schil|ler-Denk|mal** (↑ R 182)

Gof schweiz. mdal. ([kleines] Kind; ungezogenes Mädchen) m od. s; -s, -en

Gog (König von Magog im A. T.); - und Magog (barbarische Völker im N. T.)

Gogh, van [fan od. wan góch] (niederl. Maler)

Go-go-Girl amerik. [gogogö'l] (Vortänzerin in Tanzlokalen) s; -s, -s

Goi hebr. (jüd. Bez. des Nichtjuden) m; -[s], Gojim [auch: gojjim]

Go-in engl. [go" in] (unbefugtes [gewaltsames] Eindringen demonstrierender Gruppen, meist um eine Diskussion zu erzwingen) s; -s, -s

Goi|se|rer [nach dem Ort Goisern] österr. (schwerer, genagelter Bergschuh) m; -s, -

Go-Kart engl. [go"...] (niedriger, unverkleideter kleiner Sportrennwagen) m; -[s], -s

go|keln (mitteld. für: unvorsichtig mit Feuer umgehen); ich ...[e]le (↑ R 327)

Go|lat|sche vgl. Kolatsche

Gold (chem. Grundstoff, Edelmetall; Zeichen: Au) s; -[e]s; vgl. Aurum; **gold|ähn|lich, Gold_am|mer** (ein Singvogel), ...**am|sel**, ...**bar|ren**, ...**barsch**; **gold|blond**; **Gold_bro|kat**, ...**bron|ze**; **gol|den**; I. Kleinschreibung (↑ R 224): goldene Hochzeit, die goldenen zwanziger Jahre, die goldenen Zwanziger, goldene Medaille, goldene Worte, den goldenen Mittelweg einschlagen; goldenes Tor (Sportspr.: den Sieg entscheidendes Tor). II. Großschreibung: a) (↑ R 198:) die Goldene Aue; b) (↑ R 224:) der Goldene Schnitt (Math.), der Goldene Sonntag, die Goldene Bulle, die Goldene Rose, die Goldene Stadt (Prag), das Goldene Kalb (bibl.), das Goldene Vlies (vgl. Vlies), das Goldene Zeitalter (vgl. saturnisch; **Gol|den De|li|cious** engl. [go"ld'n dilísch'ß] (eine Apfelsorte) m; - -, - -; **gold_far|ben, ...far|big; Gold_fa|san, ...fisch; gold|gelb; Gold_grä|ber, ...gru|be; gold_haa|rig, ...hal|tig, (österr.:) ...häl|tig; Gold_ham|ster, ...hortung; gol|dig; Gold_klum|pen, ...kü|ste** (in Westafrika; w; -), ...**lack** (eine Blume), ...**le|gierung**, ...**lei|ste**, ...**ma|cher**, ...**medail|le**, ...**mi|ne**, ...**mün|ze**, ...**pa|pier**, ...**par|mä|ne** (eine Apfelsorte; w; -, -n), ...**re|gen** (ein Strauch, Baum), ...**re|ser|ve; gold|rich|tig**

(ugs.); **Gold_schmied**, ...**schnitt**, ...**waa|ge**, ...**wäh|rung**, ...**wert** (m; -[e]s), ...**zahn**

Go|lem hebr. (durch Zauber zum Leben erweckte menschl. Tonfigur der jüd. Sage) m; -s

[1]**Golf** gr. (größerer Meeresbucht) m; -[e]s, -e

[2]**Golf** schott.-engl. (ein Rasenspiel) s; -s; - spielen (↑ R 140); **Golf|fer** (Golfspieler) m; -s, -; **Golf_platz**, ...**schlä|ger**, ...**spiel**, ...**tur|nier**

Golf|strom m; -[e]s

Gol|ga|tha, (eigentlich:) **Gol|gotha**, (ökum.:) **Gol|go|ta** hebr. (,,Schädelstätte''; Hügel vor den alten Jerusalem)

[1]**Go|li|ath**, (ökum.:) **Go|li|at** (Riese im A. T.); [2]**Go|li|ath** (riesiger Mensch) m; -s, -s

Gol|lancz [g'länz] (engl. Verleger u. Schriftsteller)

Göl|ler schweiz. (Halspartie am Hemd u. Frauenkleid) s; -s, -

Go|lo (m. Vorn.)

Go|mor|rha, (ökum.:) **Go|mor|ra** vgl. Sodom

Gon gr. (in der Erdvermessung, Geodäsie, verwendete Einheit für [ebene] Winkel [1[g] = 100. Teil eines rechten Winkels], auch Neugrad genannt [vgl. Grad]; Zeichen: [g]) s; -s, -e; 5 - (↑ R 322)

Go|na|den gr. (Med., Biol.: Keimdrüsen) Mehrz.

Gon|agra gr. (Gicht im Kniegelenk) s; -s

Gon|del it. (schmales Ruderboot; Korb am Luftballon od. Kabine am Luftschiff) w; -, -n; **gon|deln** (ugs. für: [gemächlich] fahren); ich ...[e]le (↑ R 327); **Gon|do|lie|re** (Gondelführer) m; -, ...ri

Gond|wa|na|land [nach der ind. Landschaft] (Kontinent der Südhalbkugel im Präkambrium)

Gon|fa|lo|nie|re it. (in Italien bis 1859 gebräuchliche Bez. für das Stadtoberhaupt) m; -s, ...ri

Gong malai. m (selten: s); -s, -s; **gon|gen**; es gongt; **Gong|schlag**

Go|nio|me|ter gr. (Winkelmesser) s; -s; **Go|nio|me|trie** (Winkelmessung) w; -

gön|nen; Gön|ner; gön|ner|haft; Gön|ner|haf|tig|keit w; -; **gön|ne|risch** (selten für: gönnerhaft); **Gön|ner|mie|ne; Gön|ner|schaft** w; -

Go|no|kok|kus gr. (eine Bakterienart) m; -, ...kken; **Go|nor|rhö**[1], **Go|nor|rhöe** (Tripper) w; -, ...rrhöen; **go|nor|rho|isch**

good bye! engl. [gud bai] (,,leb[t] wohl!'')

Good|will engl. [gudwil] (Ansehen,

Wert; Wohlwollen, freundliche Gesinnung; Firmen-, Geschäftswert) *m*; -s; **Good|will|rei|se** **Gö|pel** (Antriebsvorrichtung) *m*; -s, -; **Gö|pel|werk** **Gör** *s*; -[e]s, -en u. **Gö|re** niederd. ([kleines] Kind; ungezogenes Mädchen) *w*; -, -n **Gor|ding** (Seemannsspr.: Tau zum Zusammenholen der Segel) *w*; -, -s **gor|disch**; ein [beliebiger] gordischer [unauflösbarer] Knoten, aber (↑ R 179): der [berühmte] Gordische Knoten **Gor|don** [*gắrdⁿn*] (schott. m. Vorn.) **Gö|re** vgl. Gör **Gor|go** (weibl. Ungeheuer der gr. Sage) *w*; -, ...onen; **Gor|go|nen|haupt** **Gor|gon|zo|la** [nach der gleichnamigen it. Gemeinde] (ein Käse) *m*; -s, -s **Go|ril|la** afrik. (größter Menschenaffe; ugs. für: Leibwächter hoher Persönlichkeiten) *m*; -s, -s **Go|ri|zia** (it. Form von: Görz) **Gor|ki** (russ. Schriftsteller; russ. Stadt) **Gör|res** (dt. Publizist) **Görz** (it. Stadt); vgl. Gorizia **Gösch** niederl. (kleine rechteckige National- od. Kriegsflagge auf dem Vorsteven; andersfarbiges Obereck am Flaggenstock) *w*; -, -en **Go|sche** (österr. u. schweiz. mdal. nur so), **Gu|sche** südd. u. mitteld. (Mund, Maul) *w*; -, -n **Go|se** mitteld. (obergäriges Bier) *w*; -, -n **Go|sen** (Landschaft im alten Unterägypten) **Gos|lar** (Stadt am Nordrand des Harzes) **Gos|pel** *s*; -s, -s u. **Gos|pel|song** (religiöses Negerlied) **Gos|po|dar** vgl. Hospodar **Gos|se** *w*; -, -n **Gös|sel** niederd. (Gänschen) *s*; -s, -[n] **¹Go|te** landsch. (Pate) *m*; -n, -n (↑ R 268); **²Go|te** landsch. (Patin) *w*; -, -n; vgl. auch: Gotte u. Gode **³Go|te** (Angehöriger eines germ. Volkes) *m*; -n, -n (↑ R 268) **Gö|te|borg** (Hafenstadt an der Südwestküste Schwedens) **¹Go|tha** (Stadt im Thüringer Becken); **²Go|tha** (Adelskalender) *m*; -; **Go|tha|er** (↑ R 199); **go|tha|isch**, aber (↑ R 224): Gothaischer Hofkalender **Go|tik** fr. (Kunststil vom 12. bis 15. Jh.; Zeit des got. Stils) *w*; -; **go|tisch** (den Goten gemäß; im Stil der Gotik, die Gotik betreffend); **¹Go|tisch** [zu: Gotik] (eine

Schriftgattung) *w*; -; **²Go|tisch** [zu: ³Gote] (Sprache) *s*; -[s]; vgl. Deutsch; **Go|ti|sche** *s*; -n; vgl. Deutsche *s*; **Got|land** (schwed. Ostseeinsel) **Gott** *m*; -es (selten in festen Wendungen: -s; z. B. -s Wunder!), *Mehrz*.: Götter; um - es willen; in -es Namen; - sei Dank!; - befohlen!; weiß -!; Gott[,] der Herr[,] hat ... ; (↑ R 245 und 246:) grüß [dich] Gott!; - grüß' das Handwerk!; **gott|ähn|lich**; **Gott|ähn|lich|keit** *w*; -; **gott|be|gna|det**; **Gott|bert** (m. Vorn.); **Gott|ber|ta** (w. Vorn.); **gott|be|wahr|re!**, aber: Gott bewahre uns davor!; **Göt|te** schweiz. mdal. (Patin) *w*; -, -n; **Göt|ter|bild**, ...bo|te, ...dämme|rung; **gott|er|ge|ben**; **göt|ter|gleich**; **Göt|ter|spei|se** (auch: Süßspeise), ...trank; **Got|tes|acker** [*Trenn*.: ...ak|ker], ...anbe|te|rin (Heuschreckenart), ...be|wels, ...dienst, ...furcht; **got|tes|fürch|tig**; **Got|tes.ga|be**, ...gericht; **Got|tes|gna|de**; es ist eine -, aber in Titeln: von Gottes Gnaden König ...; **Got|tes.haus**, ...kind|schaft (*w*; -); **got|tes|lä|ster|lich**; **Got|tes.lä|ste|rung**, ...leug|ner, ...lohn (*m*; -[e]s), ...sohn (*m*; -[e]s), ...ur|teil; **Gott|fried** (m. Vorn.); **gott.ge|fäl|lig**, ...gläu|big, ...haft; **¹Gott|hard** (m. Vorn.); **²Gott|hard** (kurz für: Sankt Gotthard) *m*; -s; **Gott|hard|bahn** *w*; -; **Gott|heit**; **¹Gott|helf** (m. Vorn.) **²Gott|helf**, Jeremias [Albert Bitzius] (schweiz. Schriftsteller) **Gott|hold** (m. Vorn.); **Göt|ti** schweiz. mdal. (Pate) *m*; -s, -; **Göt|tin** *w*; -, -nen **Göt|tin|gen** (Stadt a. d. Leine); **Göt|tin|ger** (↑ R 199) Göttinger Hain, Manifest, Sieben; Göttinger Wald **gött|lich**; die -e Gnade, aber (↑ R 224): die Göttliche Komödie (von Dante); **Gött|lich|keit** *w*; -; **Gott|lieb** (m. Vorn.); **gott|lob!**, aber: Gott [sei] Lob und Dank!; **Gott|lob** (m. Vorn.); **gott|los**, -este (↑ R 292); **Gott|lo|se** *m* u. *w*; -n, -n (↑ R 287ff.); **Gott|lo|sen|be|we|gung**; **Gott|lo|sig|keit**; **Gott|mensch** (Christus) *m*; -en; **Gott|ram** (m. Vorn.); **Gott|schalk** (m. Vorn.) **Gott|sched** (dt. Gelehrter u. Schriftsteller) **Gott|schee** (ehemals dt. Sprachinsel in Jugoslawien) *w*; - **Gott|sei|bei|uns** [auch: ...*sai*...] (verhüll. für: Teufel) *m*; -; **gott|se|lig**; **Gott|se|lig|keit** *w*; -; **gotts.er|bärm|lich**, ...jäm|mer|lich; **Gott|su|cher**; **Gott|va|ter** *m*; -s (meist

ohne Geschlechtsw.); **gott|ver|las|sen**; **Gott|ver|trau|en**; **gott|voll**; **Gott|wald** (m. Vorn.); **Gott|we|sen** (Gott) *s*; -s; **Götz** (m. Vorn.); **Göt|ze** (Abgott) *m*; -n, -n (↑ R 268); **Göt|zen.al|tar**, ...bild, ...die|ner, ...dienst **Gou|ache** vgl. Guasch **Gou|da** [*ehauda*] (niederl. Stadt bei Rotterdam); **Gou|da|kä|se** [*ehauda*... u. *gauda*...] **Gou|dron** arab.-fr. [*guh̆yns*] (wasserdichter Anstrich) *m* (auch: *s*); -s **Gourde** fr. [*gurd*] (Münzeinheit in Haiti; Abk.: G; 1 Gourde = 100 Centimes) *m*; -, - **Gour|mand** fr. [*gurmang*] (Vielfraß; Schlemmer; Feinschmecker) *m*; -s, -s; **Gour|man|di|se** [*gurmangdis*] (Feinschmeckerei) *w*; -, -n; **Gour|met** [*gurmä*] (Feinschmecker) *m*; -s, -s **gou|tie|ren** fr. [*gutirⁿn*] (Geschmack an etwas finden; gutheißen) **Gou|ver|nan|te** fr. [*guw*...] (veralt. für: Erzieherin) *w*; -, -n; **gou|ver|nan|ten|haft**; **Gou|ver|ne|ment** [...*mang*] (Regierung; Verwaltung, Verwaltungsbezirk) *s*; -s, -s; **gou|ver|ne|men|tal** [...*mangtạl*] (veralt. für: regierungsfreundlich; Regierungs...); **Gou|ver|neur** [...*nör*] (Statthalter) *m*; -s, -e **Go|ya** [*goja*] (span. Maler) **Gr.** = Greenwich **Gr.-2°** = Großfolio **Gr.-8°** = Großoktav **Gr.-4°** = Großquart **Grab** *s*; -[e]s, Gräber; zu -e tragen **Grab|be** (dt. Dichter) **Grab|be|lei**; **grab|beln** nordd. (herumtasten); ich ...[e]le (↑ R 327); vgl. aber: krabbeln **Gräb|chen**, **Gräb|lein** (kleines Grab; niedriger Graben); **Grab|be|land**, **Grab|land** (kleingärtnerisch genütztes Brachland) *s*; -[e]s; **grä|ben**; du gräbst; du grubst (gruebst) du grübest; gegraben; grab[e]!; **Gra|ben** *m*; -s, Gräben; *Schreibung in Straßennamen*: ↑ R 219ff.; **Grä|ber**; **Grä|ber|feld**; **Grab|bes.käl|te**, ...ru|he, ...stil|le, ...stim|me; **Grab.ge|sang**, ...ge|wöl|be, ...hü|gel, ...land (vgl. Grabeland), ...le|gung; **Gräb|lein** vgl. Gräbchen; **Grab.mal** (*Mehrz*. ...mäler, gehoben: ...male), ...re|de, ...scheit (landsch. für: Spaten), ...stät|te, ...stein, ...stel|le (vgl. Stele), ...sti|chel (ein Werkzeug); **Grab.bung** **Grac|che** [*grächˀ*] (Angehöriger eines altröm. Geschlechtes) *m*; -n (↑ R 268), -n (meist *Mehrz*.) **Grace** [*grēß*] (engl. w. Vorn.) **Gracht** niederl. (Wassergraben,

Kanal[straße] in Holland) w; -, -en; *Schreibung in Straßennamen:* ↑ R 219 ff.

grad. = graduiert; vgl. graduieren

grad..., **Grad...** (ugs. für: gerad..., Gerad...)

Grad *lat.* (Temperatureinheit; Einheit [für [ebene] Winkel [1 ° = 90. Teil eines rechten Winkels], auch: Altgrad genannt [vgl. Gon]; Zeichen: °) *m*; -[e]s, -e; 3 - C (↑ R 322) oder 3°C (↑ S. 86, f); aber auch: der 30. - (nicht: 30. °); es ist heute um einige - wärmer; ein Winkel von 30°(↑ S. 86, f); **Gra|da|ti|on** [...*zion*] (Steigerung, stufenweise Erhöhung; Abstufung; **Grad|bo|gen**

gra|de (ugs. für: gerade)

Grad|ein|tei|lung; **Gra|del**, **Gradl** südd., österr. (ein Gewebe) *m*; -s, -; **Gra|di|ent** *lat.* (Math.: Steigungsmaß einer Funktion in verschiedenen Richtungen; Meteor.: Gefälle auf einer bestimmten Strecke); ↑ R 268; **Gra|di|en|te** (von Gradienten gebildete Neigungslinie) *w*; -, -n; **gra|die|ren** (Salzsole konzentrieren; verstärken); **Gra|dier|haus** (Salzgewinnungsanlage); **Gra|die|rung** (Verstärkung; Verdunstung); **Gra|dier|werk** (Rieselwerk zur Salzegewinnung); ...**gra|dig**, (österr.:) ...**grä|dig** (z. B. dreigradig, mit Ziffer: 3gradig; ↑ R 229)

Gra|ditz (Ort südöstl. von Torgau); **Gra|dit|zer** (↑ R 199); - Gestüt

Gradl vgl. Gradel

grad|mä|ßig; **Grad_mes|ser** *m*, ...**netz**; **gra|du|al** *lat.* (den Rang betreffend); **Gra|dua|le** (kurzer Psalmengesang nach der Epistel in der kath. Messe; das die Choralmeßgesänge enthaltende Buch) *s*; -s, ...lien [...*i*ᵉ*n*]; **gra|du|ell** *fr.* (grad-, stufenweise, allmählich); **gra|du|ieren** (Technik: mit genauer Einteilung versehen; einen [akadem.] Grad erteilen); graduierter Ingenieur, Abk.: Ing. (grad.); **Gra|du|ier|te** (jmd., der einen akademischen Grad besitzt) *m* u. *w*; -n, -n (↑ R 287 ff.); **Gra|du|ie|rung**; **Grad|un|ter|schied**; **grad|wei|se**

Grae|cum *gr.* [*gräk*...] (Prüfung im Griechischen) *s*; -s

Graf *m*; -en, -en (↑ R 268); **Gra|fen.kro|ne**, ...**ti|tel**

Graf|fel vgl. Geraffel

Gra|fik usw. (eindeutschende Schreibung von: Graphik usw.)

Grä|fin *w*; -, -nen; **Grä|fin|wit|we**; **gräf|lich**, im Titel (↑ R 224): Gräflich; **Graf|schaft**

Gra|ham|brot [nach dem amerik. Arzt] (↑ R 180)

Grain *engl.* [*grẹⁱn*] (älteres kleines Gewicht) *m*; -s, -s; 5 - (↑ R 322)

gra|jisch, aber (↑ R 198): die Grajischen Alpen

grä|ko-la|tei|nisch; ↑ R 214 (griechisch-lateinisch); **Grä|ko|ma|nie** *gr.* (Vorliebe für altgr. Kultur; Sucht, die alten Griechen nachzuahmen) *w*; -; **Grä|kum** vgl. Graecum

Gral *fr.* (Heldensage: wunderwirkende Schale) *m*; -s; der Heilige - (↑ R 224); **Grals.burg**, ...**hü|ter**, ...**rit|ter**, ...**sa|ge**

gram; jmdm. - sein (↑ R 132); **Gram** *m*; -[e]s; **grä|meln** bes. mitteld., niederd. (mißmutig sein) ich ...[e]le (↑ R 327); **grä|men**, sich; **gram|er|füllt**; vgl. gramgebeugt

Gram-Fär|bung [nach dem dän. Arzt H. C. J. Gram]; ↑ R 180 (eine bestimmte Bakterienfärbung); **gram.negativ**, ...**positiv**

gram|ge|beugt, aber (↑ R 142): von Gram gebeugt; **gräm|lich**

Gramm *gr.* (Zeichen: g) *s*; -s, -e; 2 - (↑ R 322); **Gramm|ma|tik** (seltener für: grammatisch); **Gramm|ma|ti|ker**; **gramm|ma|tisch**; -es Geschlecht (Genus); -er Reim

Gram|mel bayr., österr. (Griebe) *w*; -, -n

Gramm|ka|lo|rie vgl. Kalorie; **Grammol|le|kül**, **Grammol** [*Trenn.:* Gramm|mo...; ↑ R 236] *gr.*; *lat.* u. Mol *lat.* (so viele Gramm einer chemischen Verbindung, wie deren Molekulargewicht angibt) *s*; -s, -e; **Grammo|phon** ⓦ *gr.* (Schallplattenapparat) *s*; -s, -e

gram.ne|ga|tiv, ...**po|si|tiv** (↑ R 187); vgl. Gram-Färbung

gram|voll

Gran *lat.*, (auch:) **Grän** *fr.* (altes Apotheker- und Edelmetallgewicht) *s*; -[e]s, -e; 3 - (↑ R 322)

Gra|na|da (Hptst. der gleichnamigen span. Provinz)

Gra|na|dil|le vgl. Grenadille

¹**Gra|nat** (ein Halbedelstein) *m*; -[e]s, -e (österr.: *m*; -en, -en; ↑ R 268)

²**Gra|nat** *niederl.* (kleiner Krebstier, Garnelenart) *m*; -[e]s, -e

Gra|nat.ap|fel *lat.*; *dt.* (Frucht des Granatbaumes), ...**baum** (immergrüner Baum des Orients); **Gra|na|te** *it.* *w*; -, -n; **Gra|nat.split|ter**, ...**trich|ter**, ...**wer|fer**

Gran Cha|co [- *tschạko*] (südamerik. Landschaft) *m*; - -s

¹**Grand** *niederl.* (Kies) *m*; -[e]s

²**Grand** bayr., österr. ([Wasser]behälter) *m*; -[e]s, -e

³**Grand** *fr.* [*grang*; nds. auch *grang*] ("Großspiel" beim Skat) *m*; -s, -s; **Gran|de** *span.* (früher: Mit-

glied des Hof-, Hochadels in Spanien) *m*; -n, -n (↑ R 268)

Gran|del, **Grä|ne**, (österr.:) Grane (oberer Eckzahn des Rotwildes) *w*; -, -n

Gran|deur *fr.* [*grangdör*] (Großartigkeit, Größe) *w*; -; **Gran|dez|za** *span.* (urspr. Würde eines Granden; dann: Hoheit; feierliches u. dabei anmutiges Benehmen) *w*; -; **Grand|ho|tel** [*grang*...]; gran diós *it.* (großartig, überwältigend); -este (↑ R 292); **Grand Old Man** *engl.* [*gränd ọ̈ⁿld män*] ("der große [bedeutende] alte Mann") *m*; - - -, - - Men; **Grand ou|vert** *fr.* [*grang uwär*] ("offenes Großspiel" [beim Skat]) *m*; - -, -s -s [*grang uwär*]; **Grand Prix** [*grang prị*] (fr. Bez. für: "großer Preis") *m*; - -; **Grand|sei|gneur** *fr.* [*grangßänjör*] ("vornehmer Herr") *m*; -s, -s u. -e

Gra|ne, **Grä|ne** vgl. Grandel

gra|nie|ren *lat.* (körnig machen); **Gra|nit** *it.* (ein Gestein) *m*; -s, -e; **gra|nit|ar|tig**; **Gra|nit|block** (*Mehrz.* ...blöcke); **gra|ni|ten** (aus Granit); **Gra|nit|qua|der**

Gran|ne (Ährenborste) *w*; -, -n; **gran|nig**

Gran|ny Smith *engl.* [*gräni ßmịth*] (eine Apfelsorte) *m*; - -, - -

Grans *m*; -es, Gränse u. **Gan|sen** vorwiegend aleman. (Schiffsschnabel) *m*; -s, -

Grant bayr., österr. (Übellaunigkeit; Unwille) *m*; -[e]s; **gran|tig**; ein -er (mürrischer) Mann; **Gran|tig|keit**

Gra|nu|lat *lat.* (Substanz in Körnchenform) *s*; -[e]s, -e; **Gra|nu|la|ti|on** [...*zion*] (Bildung von Fleischwärzchen bei Heilung von Wunden; [körnerartige] Oberflächenansicht der Sonne; Auflösen von Gold- od. Silberkörnchen); **gra|nu|lie|ren** (Wärzchen bilden; Körner auflösen; Technik: [ver-, zer]körnen, zerstoßen, zerreiben); **Gra|nu|lit** (ein Gestein) *m*; -s, -e; **Gra|nu|lom** (Med.: Granulationsgeschwulst [bes. an der Zahnwurzelspitze]) *s*; -s, -e; **gra|nu|lös** (körnig); -este (↑ R 292); **Gra|nu|lo|se** (eine Augenkrankheit, Trachom) *w*; -

Grape|fruit *engl.* [*grẹⁱpfrut*, engl. Ausspr.: *grẹⁱpfru't*] (eine Art Pampelmuse) *w*; -, -s

Graph *gr.* (Math.) *m*; -en, -en (↑ R 268); ...**gra|phie** (...[be]schreibung, z. B. Geographie); **Gra|phik**¹ *gr.* ("Schreibkunst"; Sam-

¹ Häufig in eindeutschender Schreibung: Grafik, Grafiker, grafisch (↑ R 170).

melbezeichnung für Holzschnitt, Kupferstich, Lithographie u. Handzeichnung) w; -, (für: Einzelblatt auch *Mehrz.*:) -en; **Gra**|**phi**|**ker**[1]; **gra**|**phisch**[1]; -e Darstellung (Schaubild); -es Gewerbe; -es Rechnen; **Gra**|**phit** (ein Mineral) *m*; -s, -e; **gra**|**phit**|**grau**; **Gra**|**pho**|**lo**|**ge** *m*; -n, -n († R 268); **Gra**|**pho**|**lo**|**gie** (Lehre von der Deutung der Handschrift als Ausdruck des Charakters) *w*; -; **gra**|**pho**|**lo**|**gisch**; **Gra**|**pho**|**sta**|**tik** (zeichnerische Methode zur Lösung von Aufgaben der Statik) **grap**|**schen** (ugs. für: schnell nach etwas greifen, österr. ugs.: nach len); du grapschst (grapschest) u. **grap**|**sen**; du grapst (grapsest) **Grap**|**to**|**lith** *gr.* (ausgestorbenes Tier aus dem Silur) *m*; -s, -en (meist *Mehrz.*)

Gras *s*; -es, Gräser; **Gras**|**af**|**fe** (Schimpfwort für: unreifer Mensch; früher auch: junger Mensch); **gras**|**ar**|**tig**; **gras**|**be**|**wach**|**sen**, aber († R 142): mit Gras bewachsen; **Gräs**|**chen** *s*; -s, - u. Gräserchen od. **Gräs**|**lein**; **Gras**|**decke** [*Trenn.*: ...dek|ke]; **gra**|**sen**; du grast (grasest); er graste; **Gra**|**ser** (Jägerspr. für: Zunge von Rot- u. Damwild); **Grä**|**ser**|**chen** (*Mehrz.* von: Gräschen); **Gras**|**flä**|**che**, ...**fleck**, ...**füt**|**te**|**rung**, ...**gar**|**ten**; **gras**|**grün**; **Gras**|**halm**, ...**hüp**|**fer**; **gras**|**ig**; **Gras**|**land** (Steppe), ...**li**|**lie**, ...**mücke** [*Trenn.*: ...mük|ke] (Singvogel; *w*; -, -n), ...**nar**|**be**

Graß (aus graphischen Gründen mit Zustimmung des Autors auch: Grass), Günter (dt. Schriftsteller); Graß' Roman († R 310) **gras**|**sie**|**ren** *lat.* (sich ausbreiten; wüten [von Seuchen]) **gräß**|**lich**; **Gräß**|**lich**|**keit Gras**|**step**|**pe**, ...**strei**|**fen Grat** (Kante; Bergkamm[linie]; Schneide) *m*; -[e]s, -e; **Grä**|**te** (Fischknochen) *w*; -, -n; **grä**|**ten**|**los Gra**|**ti**|**an**, **Gra**|**tia**|**nus** [...zian(uß)] (röm. Kaiser; m. Vorn.); **Gra**|**ti**|**as** [...ziaß] (Dank[gebet]) *s*; -, -; **Gra**|**ti**|**fi**|**ka**|**ti**|**on** [...zion] ([freiwillige] Vergütung, Entschädigung, [Sonder]zuwendung, Ehrengabe) **grä**|**tig** (viele Gräten enthaltend; ugs. für: reizbar, gereizt; aufbrausend) **Grä**|**ting** *engl.* (rostartiges Gitterwerk [auf Schiffen]) *w*; -, -e od. -s **gra**|**ti**|**nie**|**ren** *fr.* (mit einer Kruste überbacken)

[1]Vgl. Anm. S. 310.

gra|**tis** *lat.*; - und franko; **Gra**|**tis**|**ak**|**tie**, ...**an**|**teil**, ...**bei**|**la**|**ge**, ...**pro**|**be**, ...**vor**|**stel**|**lung Grat**|**lei**|**ste** (in der Schreinerei) **grätsch**|**bei**|**nig**; **Grät**|**sche** (eine Turnübung) *w*; -, -n; **grät**|**schen** ([die Beine] seitwärts spreizen); du grätschst (grätschest); **Grätsch**|**stel**|**lung Gra**|**tu**|**lant** *lat. m*; -en, -en († R 268); **Gra**|**tu**|**la**|**ti**|**on** [...zion]; **Gra**|**tu**|**la**|**ti**|**ons**|**cour** *lat.; fr.* [...kur] *w*; -, -en; **gra**|**tu**|**lie**|**ren Grat**|**wan**|**de**|**rung Grät**|**zel** österr., ugs. abschätzig (Teil eines Wohnviertels, einer Straße) *s*; -s, -n

grau; **I.** *Kleinschreibung:* - werden; - in - malen; († R 224:) der -e Alltag, eine -e Eminenz (Bez. für eine nach außen kaum in Erscheinung tretende, aber einflußreiche [polit.] Persönlichkeit; vgl. aber: die Graue Eminenz), in -er Vorzeit, sich -e Haare wachsen lassen (ugs.: sich Sorgen machen), -er Markt, -er Papagei, -e Salbe, -er Star. **II.** *Großschreibung.* **a)** († R 224:) die Grauen Schwestern (kath. Kongregation), die Graue Eminenz (F. v. Holstein; vgl. aber: eine graue Eminenz); **b)** († R 198:) Graue Hörner (schweiz. Berggruppe); vgl. blau, III–V; vgl. graumeliert; **Grau** (graue Farbe) *s*; -s, - (ugs.: -s); vgl. Blau; **grau**|**äu**|**gig**; **Grau**|**bart**; **grau**|**bär**|**tig**, ...**blau** († R 158); **Grau**|**brot Grau**|**bün**|**den** (schweiz. Kanton) vgl. Bünden; **Grau**|**bünd**|**ner** († R 199); vgl. Bündner; **grau**|**bünd**|**ne**|**risch**; vgl. bündnerisch **Grau**|**chen** (Eselchen) [1]**grau**|**en** (Furcht haben); mir (seltener: mich) graut [es] vor dir [2]**grau**|**en** (allmählich hell, dunkel werden; dämmern); der Morgen graut **Grau**|**en** (Schauder, Furcht) *s*; -s; es überkommt mich ein -; grau|en|er|re|gend, aber († R 142): heftiges Grauen erregend; -ste; **grau**|**en**|**haft**; **grau**|**en**|**voll Grau**|**gans**; **grau**|**haa**|**rig**; **Grau**|**kopf grau**|**en** (sich fürchten); es grault mir; (ugs.:) ich graule mich; vgl. aber: kraulen **gräu**|**lich**, (auch:) **grau**|**lich** [zu: grau]; **grau**|**me**|**liert**; das -e Haar († jedoch R 142), aber: das Haar war grau meliert **Gräup**|**chen**; **Grau**|**pe** ([Getreide]korn) *w*; -, -n (meist *Mehrzahl*); **Grau**|**pel** (Hagelkorn) *w*; -, -n (meist *Mehrz.*); **grau**|**peln**; es graupelt; **Grau**|**pel**|**schau**|**er**, ...**wet**|**ter**; **Grau**|**pen**|**sup**|**pe**

graus (veralt. für: schrecklich, grauenerregend); -es Morden; **Graus** (Schrecken) *m*; -es; o -! **grau**|**sam**; **Grau**|**sam**|**keit**; **grau**|**sen** (sich fürchten); mir (mich) grauste; „Dem Vater grauset's, er reitet geschwind"; sich -; **Grau**|**sen** *s*; -s; „Hier wendet sich der Gast mit Grausen"; **grau**|**sig** (grauenerregend, gräßlich); **graus**|**lich** bes. österr. (unangenehm, häßlich)

Grau|**specht**, ...**spieß**|**glanz** (ein Mineral), ...**tier** (Esel), ...**wacke** [*Trenn.*: ...wak|ke] (Sandstein), ...**werk** (Pelzwerk, bes. aus dem grauen Winterpelz russ. Eichhörnchen, Feh; *s*; -[e]s) **Gra**|**va**|**men** *lat.* [...wa...] (Beschwerde) *s*; -s, ...mina (meist *Mehrz.*) **gra**|**ve** *it.* [...we] (Musik: schwer, wuchtig) **Gra**|**ven**|**ha**|**ge** vgl. 's-Gravenhage **Gra**|**ven**|**stei**|**ner** [*graw*...] (eine Apfelsorte); † R 199 **Gra**|**veur** *fr.* [...wör] (Metall-, Steinschneider, Stecher) *m*; -s, -e; **Gra**|**veur**|**ar**|**beit** [...wör...], Gravier|ar|beit [...wir...]; **Gra**|**veu**|**rin** [...wörin] *w*; -, -nen **gra**|**vid** *lat.* [...wit] (Med. für: schwanger); **Gra**|**vi**|**di**|**tät** (Med.: Schwangerschaft) **Gra**|**vier**|**an**|**stalt** [...wir...]; **Gra**|**vier**|**ar**|**beit** vgl. Graveurarbeit; [1]**gra**|**vie**|**ren** [...wir^e n] (in Metall, Stein) [ein]schneiden) [2]**gra**|**vie**|**ren** *lat.* [...wir^e n] (veralt. für: beschweren, belasten); **gra**|**vie**|**rend** (erschwerend; belastend); -e Umstände; **Gra**|**vie**|**rung**; **Gra**|**vi**|**me**|**ter** *lat.; gr.* (Instrument zur Messung der Schwereunterschiede der Erde) *s*; -s, -; **gra**|**vi**|**me**|**trisch**; **Gra**|**vis** *lat.* (ein Betonungszeichen: `, z. B. è) *m*; -, -; **Gra**|**vi**|**tät** (veralt. für: [steife] Würde) *w*; -; **Gra**|**vi**|**ta**|**ti**|**on** [...zion] Schwerkraft, Anziehungskraft) *w*; -; **Gra**|**vi**|**ta**|**ti**|**ons**|**feld**, ...**ge**|**setz**; **gra**|**vi**|**tä**|**tisch** (würdevoll); -ste († R 294); er ging - einher; **gra**|**vi**|**tie**|**ren** (infolge der Schwerkraft) zu etwas hinstreben) **Gra**|**vur** *fr.* [...wur] (Darstellung, Zeichnung auf Metall, Stein) *w*; -, -en; **Gra**|**vü**|**re** ([Kupfer-, Stahl]stich) *w*; -, -n **Graz** (Hptst. der Steiermark); **Gra**|**zer** († R 199) **Gra**|**zie** [...i^e] (Anmut) *w*; -, (für: eine der 3 röm. Göttinnen der Anmut und scherzh. für: anmutige, hübsche junge Dame auch *Mehrz.*:) -n (meist *Mehrz.*) **gra**|**zil** *lat.* (schlank, geschmeidig, schmächtig); **Gra**|**zi**|**li**|**tät** *w*; -

gra|zi|ös *fr.* (anmutig); -este (↑ R 292); gra|zio|so *it.* (Musik: anmutig); gra|zio|so *s;* -s, -s u. ...si
grä|zi|sie|ren *gr.* (nach gr. Muster formen; die alten Griechen nachahmen); Grä|zis|mus (altgr. Spracheigentümlichkeit) *m;* -, ...men; Grä|zist (Kenner, Erforscher des Griechischen); ↑ R 268; Grä|zi|stik (Erforschung des Griechischen) *w;* -; Grä|zi|tät (Wesen der altgr. Sprache u. Sitte) *w;* -
Green|horn *engl.* [*grịn*...] (engl. Bez. für: Grünschnabel, Neuling) *s;* -s, -s
Green|wich [*grịnidsch*] (Stadtteil Londons; Abk.: Gr.); Green|wicher (↑ R 199); - Zeit (westeuropäische Zeit)
Grège *fr.* [*gräsch*] (Naturseidenfaden) *w;* -; Grège|sei|de
Gre|gor, Gre|go|ri|us (m. Vorn.); Gre|go|ria|nisch; ↑ R 179 (von Gregorius herrührend); der -e Kalender
Greif (Fabeltier [Vogel]; auch: Tagraubvogel) *m;* -[e]s u. -en (↑ R 268), -e[n]
greif|bar; grei|fen; du griffst (griffest); du griffest; gegriffen; greif[e]!; um sich -; ↑ R 120:) zum Greifen nahe; Grei|fer
Greifs|wald (Stadt in Vorpommern); Greifs|wal|der (↑ R 199)
Greif.vo|gel (Raubvogel), ...zan|ge
grei|nen (ugs. für: weinen; veralt. für: zanken); Grei|ner (veralt. für: Zänker)
greis ([alters]grau; sehr alt); -este (↑ R 292); Greis *m;* -es, -e; Grei|sen|al|ter; grei|sen|haft; Grei|sen|haf|tig|keit *w;* -; Grei|sen|stim|me; Grei|sin *w;* -, -nen
Greiß|ler ostösterr. (Krämer); Greiß|le|rei
grell; grellrot usw.; grell|be|leuch|tet; die grellbeleuchtete Bühne, aber (↑ R 142): die zu grell beleuchtete Bühne; Grel|le *w;* -
Gre|mi|um *lat.* („Schoß"; Gemeinschaft, Körperschaft) *s;* -s, ...ien [...*i*ⁿ*n*]
Gre|na|dier *fr.* („Handgranatenwerfer"; Infanterist) *m;* -s, -e
Gre|na|dil|le *fr.,* Gra|na|dil|le *span.* (Frucht verschiedener Arten von Passionsblumen) *w;* -, -n
Gre|na|di|ne („aus Granada"; ein Gewebe) *w;* -
Grenz.bahn|hof, ...baum, ...be|am|te, ...deut|sche; Gren|ze *w;* -, -n; gren|zen; du grenzt (grenzest); gren|zen|los; bis ins Grenzenlose (bis in die Unendlichkeit; ↑ R 116); Gren|zen|lo|sig|keit; Gren|zer (ugs für: Grenzjäger, -bewohner); Grenz.fall *m,* ...fluß, ...gän-

ger, ...ge|biet, ...land, ...li|nie, ...ort (*m;* -[e]s, -e), rain, ...schutz, ...si|tua|ti|on, ...stein, ...über|gang, ...über|tritt, ...ver|kehr, ...ver|let|zung, ...wert (für: Limes [Math.]), ...wall, ...zwi|schen|fall
Gret|chen (Koseform von: Margarete, Grete); Gret|chen|fra|ge; Gre|te (w. Vorn., Kurzform von: Margarete); Gre|tel (Koseform von: Margarete, Grete)
Greu|el *m;* -s, -; Greu|el.mär|chen, ...tat; greu|lich
Gre|ven|broich [*grewᵉnbroeh*] (Stadt an der unteren Erft)
Grey|erz (schweiz. Ortsn.); -er Käse; vgl. Gruyères
Grie|be (ausgebratener Speckwürfel) *w;* -, -n; Grie|ben.fett (*s;* -[e]s), ...wurst
Griebs (landsch. für: Kerngehäuse des Obstes; mitteld. für: Gurgel) *m;* -es, -e; vgl. aber: Grips
Grie|che *m;* -n, -n (↑ R 268); Grie|chen|land; Grie|chin *w;* -, -nen; grie|chisch; vgl. deutsch; Grie|chisch (Sprache) *s;* -[s]; vgl. Deutsche *s;* grie|chi|sch-ka|tho|lisch (Abk.: gr.-kath.); grie|chisch-ori|en|ta|lisch; grie|chisch-or|tho|dox; grie|chisch-uniert
Grie|fe mitteld. (Griebe) *w;* -, -n
Grieg, Edvard (norw. Komponist)
grie|meln westmitteld. (schadenfroh in sich hineinlachen); ich ...[e]le (↑ R 327)
Grien schweiz. mdal. (Kies) *s;* -s
grie|nen (ugs. für: spöttisch lächeln, grinsen)
grie|seln westniederd. (erschauern [vor Kälte, Ekel usw.]); mich grieselt; vgl. aber: grießeln
Gries.gram *m;* -[e]s, -e, gries|grä|mig, (seltener:) gries|grä|misch, gries|gräm|lich
Grieß *m;* -es, -e; Grieß|brei; grie|ßeln (körnig werden; auch: rieseln); es grießelt; vgl. aber: grieseln; grie|ßig; -es Mehl; Grie|ßig (Bienenkot) *s;* -[e]s; Grieß.kloß, ...koch (bayr., österr.: Grießbrei; vgl. ²Koch), ...mehl, ...schmar|ren (österr.: Eierkuchen aus geröstetem Grieß), ...sup|pe
Grieve [*grịw*], James (engl. Apfelzüchter)
Griff *m;* -[e]s, -e; Griff|be|reit; Griff|brett
Grif|fel *m;* -s, -; ...grif|fe|lig, ...griff|lig (z. B. vielgrifff[e]lig)
griffest [*Trenn.:* griff|fest, ↑ R 236]; grif|fig
...grif|fig vgl. ...griffelig
griff|los
Grif|fon *fr.* [...*fọng*] (ein Vorstehhund) *m;* -s, -s
Grill *engl.* (Bratrost) *m;* -s, -s; Gril|la|de *fr.* [*grịjad*ᵉ] (gegrilltes Fleischstück)

¹Gril|le (Laune) *w;* -, -n; ²Gril|le (ein Insekt) *w;* -, -n
grill|len *engl.* (auf dem Grill braten)
Grill|len|fän|ger [zu: ¹Grille]; grill|len|fän|ge|risch; gril|len|haft; Grill|len|haf|tig|keit
Grill.ge|rät, ...ge|richt; gril|lie|ren *fr.* [auch: *grijir*ᵉ*n*] (grillen)
grill|lig [zu: ¹Grille]; Grill|lig|keit
Grill|par|zer (österr. Dichter)
Grill|room *engl.* [*grịlrum*] (Rostbratküche, -stube) *m;* -s, -s
Gri|mas|se *fr.* (Fratze) *w;* -, -n; gri|mas|sie|ren
Grim|bart (der Dachs in der Tierfabel) *m;* -s
grimm (veralt. für: zornig); ¹Grimm *m;* -[e]s
²Grimm, Jacob u. Wilhelm (dt. Sprachwissenschaftler); die Brüder Grimm
Grimm|darm (Dickdarmteil)
Grimm|els|hau|sen (dt. Schriftsteller im 17. Jh.)
grim|men (veralt. für: ärgern); Grim|men ([Bauch]weh) *s;* -s; grim|mig; Grim|mig|keit *w;* -
Grimmsch; ↑ R 179 (von Grimm herrührend); das -e Wörterbuch; die -en Märchen
Grind (Schorf; Jägerspr.: Kopf bei allen Hirscharten u. beim Gamswild) *m;* -[e]s, -e; grin|dig; Grind|wal
Grin|sel österr. (Kimme am Gewehrlauf) *s;* -s, -[n]
grin|sen; du grinst (grinsest)
Grin|zing (Stadtteil von Wien)
grip|pal vgl. grippös; Grip|pe *fr.* (eine Infektionskrankheit) *w;* -, -n; Grip|pe.an|fall, ...epi|de|mie (↑ R 148), ...vi|rus, ...wel|le; grip|pös, grip|pal (Med.: grippeartig)
Grips (ugs. für: Verstand, Auffassungsgabe) *m;* -es, -e; vgl. aber: Griebs
Gri|saille *fr.* [*grisaj*] (Malerei grau in grau; schwarzweißer Seidenstoff) *w;* -, (für: in dieser Weise hergestelltes Kunstwerk auch *Mehrz.:*) -n [...*sajen*]
Gri|sel|dis (w. Eigenn.)
Gri|set|te *fr.* (veralt. für: junges leichtfertiges Mädchen) *w;* -, -n
Gris|ly|bär *engl.;* *dt.* („Graubär")
Grit *engl.* (Mühlensandstein) *m;* -s, -e
gr.-kath. = griechisch-katholisch
grob; gröber, gröbste; grob fahrlässig; (↑ R 133:) aus dem groben, dem gröbsten arbeiten, aber (↑ R 116:) aus dem Gröbsten heraus sein; Grob|blech; grob|fa|se|rig; Grob|heit; Gro|bi|an (grober Mensch) *m;* -[e]s, -e; grob.kno|chig, ...kör|nig; gröb|lich (ziemlich grob; stark; sehr); grob.ma|schig, ...schläch|tig (von grober Art); grob.schmied, ...schnitt

Gro|den niederd. ([mit Gras bewachsenes] angeschwemmtes Vorland von Deichen) *m*; -s, -

Grog [nach dem Spitznamen des engl. Admirals Vernon: „Old Grog"] (heißes Getränk aus Rum [Arrak od. Weinbrand], Zucker u. Wasser) *m*; -s, -s; grog|gy [...*gi*; eigentl. „vom Grog betrunken"] (Boxsport: schwer angeschlagen; auch allg. für: zerschlagen, erschöpft)

Groitzsch [*greutsch*] (Stadt südl. von Leipzig)

grö|len (ugs. für: schreien, lärmen); Gro|le|rei

Groll *m*; -[e]s; grol|len

Gru|my|ko (sowjet. Politiker)

Gro|nin|gen (niederl. Stadt)

Grön|land; Grön|län|der; ↑ R 199; Grön|land|fah|rer; grön|län|disch; Grön|land|wal

Groom *engl.* [*grum*] (engl. Bez. für: Reitknecht; junger Diener, Page) *m*; -s, -s

Grup|pe (ein Fisch) *w*; -, -n

¹Gros *fr.* [*gro*] (Hauptmasse [des Heeres]) *s*; - [*gro(β)*], - [*gro(β)*]; vgl. en gros; ²Gros *niederl.* [*groß*] (12 Dutzend) *s*; Grosses, Grosse; 2 Gros Schreibfedern (↑ R 321 f.); Gro|schen *tschech.* Münze; Abk.: g [100 Groschen = 1 Schilling]; ugs. für: die Zehnpfennigstück) *m*; -s, -; Gro|schen|blatt (abschätzig für: Zeitung), ...heft

groß; größer, größte; (↑ R 129:) großenteils, größer[e]nteils, größtenteils. I. *Kleinschreibung*: a) (↑ R 134:) am größten (sehr groß); b) (↑ R 135:) um ein großes (viel) verteuert; c) (↑ R 133:) im großen [und] ganzen; im großen und im kleinen betreiben, verkaufen, vertreiben; groß und klein (jedermann); d) (↑ R 224:) die großen Ferien; auf große Fahrt gehen; der große Teich (ugs. für: Atlant. Ozean); die große Anfrage; das große Einmaleins; das große Latinum; die große Pause (im Konzertsaal); die große (vornehme) Welt; auf großem Fuß (ugs. für: verschwenderisch) leben; etwas an die große Glocke hängen (ugs. für: überall erzählen); einen großen Bahnhof (ugs. für: feierlichen Empfang) bekommen. II. *Großschreibung*: a) (↑ R 116:) Große und Kleine, die Großen und die Kleinen; vom Kleinen auf das Große schließen; ein Zug ins Große; im Großen wie im Kleinen treu sein; b) (↑ R 116:) etwas, nichts, viel, wenig Großes; c) (↑ R 224:) Otto der Große (Abk.: d. Gr.), *Wesf.*: Ottos des Großen; der Große Schweiger (Moltke); der Große

Wagen; der Große Bär; das Große Los; der Große Rat (schweiz.: Kantonsparlament); d) (↑ R 198:) Großer Belt; Großer Knollen; Großer Ozean; die Große Strafkammer. III. *Schreibung in Verbindung mit dem 2. Mittelwort*: ein großangelegter Plan (↑ jedoch R 142), a b e r: der Plan ist groß angelegt. IV. *Schreibung in Verbindung mit Zeitwörtern* (↑ R 139:) a) *Getrenntschreibung* in ursprünglicher Bedeutung, z. B. groß sein, werden, schreiben; b) *Zusammenschreibung*, wenn durch die Verbindung ein neuer Begriff entsteht; vgl. großmachen, großschreiben, großtun, großziehen. V. *Über die Schreibung in erdkundlichen Namen* ↑ R 206, *in Straßennamen* ↑ R 221 u. 222; Groß.ad|mi|ral, ...ak|tio|när; groß|ar|tig; Groß|ar|tig|keit *w*; -; Groß.auf|nah|me, ...bau|stel|le; Groß-Ber|lin [auch: *groß*...] (↑ R 206); Groß|ber|li|ner [auch: *groß*...] (↑ R 199); Groß|be|trieb; Groß|bri|tan|ni|en [...*i̯ən*]; groß|bri|tan|nisch; Groß|buch|sta|be; groß|den|kend; der -e Mann; Grö|ße *w*; -, -n; Groß.ein|kauf, ...ein|satz, ...el|tern (*Mehrz.*), ...en|kel; Grö|ßen|ord|nung; gro|ßen|teils; Grö|ßen.un|ter|schied, ...ver|hält|nis, ...wahn; grö|ßen|wahn|sin|nig; grö|ßer; vgl. groß; grö|ße|ren|teils, grö|ßern|teils; Groß|feu|er; groß|fi|gu|rig; Groß.flug|boot, ...fol|lio (Abk.: Gr.-2°; *s*; -s), ...for|mat, ...fürst, ...für|stin; Groß|für|stin-Mut|ter *w*; -; Groß.ga|ra|ge, ...ge|mein|de; groß|ge|mu|stert; groß|ge|wach|sen; Groß|glock|ner [auch: ...*glok*...] (ein Berg) *m*; -s; Groß|glock|ner|mas|siv (↑ R 201); Groß.grund|be|sitz, ...han|del, han|dels|preis (vgl. ²Preis), ...händ|ler; groß|her|zig; Groß.her|zig|keit (*w*; -), ...her|zog; groß|her|zog|lich, im Titel (↑ R 224): Großherzoglich; Groß.hirn, ...hun|dert (altes Zählmaß; 120 Stück), ...in|du|stri|el|le

Gros|sist *fr.* (Großhändler); ↑ R 268

groß|jäh|rig (volljährig); Groß|jäh|rig|keit *w*; -; groß.ka|li|be|rig od. ...ka|li|brig; Groß|kampf|schiff *s*; -[e]s, -e; groß|ka|riert; Groß|kauf|mann (*Mehrz.* ...kaufleute); Großkind, schweiz. (Enkelkind); Groß|kop|fe|te, (bes. bayr., österr.:) Groß|kop|fer|te (ugs. abschätzig für: einflußreiche Persönlichkeit) *m*; -n, -n (↑ R 287 ff.); groß|köp|fig; groß|kot|zig (ugs.); groß|ma|chen (sich; -) (↑ R 139 (ugs. für: sich rühmen, prahlen); er hat

sich großgemacht; Groß|macht; groß|mäch|tig; Groß|macht|po|li|tik; Groß|manns|sucht *w*; -; groß-manns|süch|tig; groß|ma|schig; groß|maß|stäb|lich, (gelegentlich auch:) groß|maß|stä|big; Groß|maul; groß|mäu|lig; Groß|mäu|lig|keit, ...mei|ster, ...mo|gul, ...mut (*w*;-); groß|mü|tig; Groß|mü|tig|keit *w*; -; Groß|mut|ter (*Mehrz.* ...mütter); Groß|ok|tav (Abk.: Gr.-8°) *s*; -s; Groß|quart (Abk.: Gr.-4°) *s*; -[e]s; Groß|rat (Mitglied schweiz. Kantonsparlamente; *Mehrz.* ...räte); groß-räu|mig; Groß|raum|wa|gen (bei der Straßenbahn); Groß|rei|ne|ma|chen *s*; -s; Groß|satz (für: Periode); Groß|schiffahrts|weg [*Trenn.*: ...schiff|fahrts..., vgl. ↑ R 236]; groß|schnau|zig, groß-schnäu|zig; groß|schrei|ben; ↑ R 139 (ugs. für: hochhalten, besonders schätzen); Toleranz wird bei ihm großgeschrieben; a b e r: groß schrei|ben (mit großem Anfangsbuchstaben schreiben); das Wort wird groß geschrieben; Groß|schrei|bung; Groß|sie|gel|be|wah|rer; groß|spre|che|risch; -ste (↑ R 294); groß|spu|rig; Groß-spu|rig|keit *w*; -; Groß.stadt, ...städ|ter, groß|städ|tisch; Groß-stadt.mensch, ...ver|kehr; Groß-stein|grab|er|leu|te (Megalithiker der jüngeren Steinzeit) *Mehrz.*; Groß|tat; groß|tä|tig; vgl. groß; Groß|teil od. groß|ten|teils; Größt|maß *s*; größt|mög|lich, dafür besser: möglichst groß; falsch: größtmöglichst (↑ R 299); Groß|tue|rei; groß|tue|risch; -ste (↑ R 294); groß|tun; ↑ R 139 (prahlen); er soll nicht so großtun; Groß.va|ter, ...ver|an|stal|tung, ...vieh, ...warn|an|la|ge, ...we|sir, ...wetter|la|ge, ...wild, ...wür|den|trä|ger; groß|zie|hen; ↑ R 139 (Lebewesen aufziehen); er hat dieses Pferd großgezogen; groß|zü|gig; Groß|zü|gig|keit *w*; -

¹Grosz [*gra̱ß*] (dt.-amerik. Graphiker u. Maler)

²Grosz *dt.-poln.* [*grosch*] (poln. Währungseinheit [100 Groszy = 1 Zloty]) *m*; -, -y

gro|tesk *fr.* (wunderlich, grillenhaft; überspannt, verzerrt); Gro-tesk (eine Schriftgattung) *w*; -; Gro|tes|ke (phantastisch geformte Tier- u. Pflanzenverzierung der Antike u. der Renaissance; phantastische Erzählung; ins Verzerrte gesteigerter Ausdruckstanz) *w*; -, -n; gro|tes|ker|wei|se; Gro|tesk-tanz

Grot|te *it.* ([künstl.] Höhle) *w*; -, -n; Grot|ten|bau (*Mehrz.* ...bauten)

Grot|zen mdal. (Griebs, Kerngehäuse) m; -s, -

Grou|pie engl. [*grupi*] (weiblicher Fan, der immer wieder versucht, in möglichst engen Kontakt mit der von ihm bewunderten Person zu kommen) s; -s, -s

grub|ben engl.; **Grub|ber** engl. (landw. Gerät) m; -s, -; **grub|bern** (mit dem Grubber pflügen); ich ...ere (↑ R 327)

Grüb|chen, Grüb|lein; **Gru|be** w; -, -n

Grü|be|lei; grü|beln; ich ...[e]le (↑ R 327)

Gru|ben_ar|bei|ter, ...**aus|bau**, ...**bau** (*Mehrz.* ...baue), ...**brand**, ...**gas**, ...**lam|pe**, ...**un|glück; Grüb|lein**, Grüb|chen

Grüb|ler; Grüb|le|rin w; -, -nen; **grüb|le|risch**; -ste (↑ R 294)

Gru|de (Braunkohlenkoks; Grudeherd, -ofen) w; -, -n

Gruft w; -, Grüfte

Gru|ga (Kurzw. für: Große Ruhrländische Gartenbau-Ausstellung)

grum|meln landsch. (leise donnern, rollen; auch: lärmen; murren); ich ...[e]le (↑ R 327)

Grum|met (österr. nur so) s; -s u.

Grumt (zweites Heu) s; -[e]s

grün; I. *Kleinschreibung:* a) (↑ R 133:) er ist mir nicht grün (ugs. für: gewogen); **b)** (↑ R 224:) am grünen Tisch; die grüne Star; die grüne Grenze; die grüne Minna (ugs. für: Polizeiauto); die grüne Welle (durchlaufendes Grün bei Signalanlagen); die grüne Hochzeit; die grüne Versicherungskarte; die grüne Hölle (trop. Urwald); die grüne Lunge (Grünflächen der Großstadt); eine grüne Witwe (im Grünen in der Umgebung von Großstädten wohnende Frau, deren Mann tagsüber beruflich abwesend ist); ein grüner (ugs. für: unerfahrener) Junge; ach du grüne Neune (ugs.: Ausruf des Erstaunens). **II. *Großschreibung:* a)** (↑ R 133:) das ist dasselbe in Grün (ugs. für: [fast] ganz dasselbe); **b)** (↑ R 224:) der Grüne Donnerstag; die Grüne Insel (Irland); die Grüne Woche; das Grüne Gewölbe (Kunstsammlung in Dresden); das Grüne Herz Deutschlands (Thüringen); der Grüne Plan (staatl. Plan zur Unterstützung der Landwirtschaft); vgl. blau, III-V; **Grün** (grüne Farbe) s; -s, - (ugs.: -s); das erste -; bei Grün darf man die Straße überqueren; die Ampel zeigt, steht auf Grün; vgl. Blau; **Grün_al|ge**, ...**an|la|ge** (meist *Mehrz.*); **grün|blau** (↑ R 158)

Grund m; -[e]s, Gründe; im Grunde; von Grund auf; von Grund aus; auf Grund¹ [dessen, von]; auf Grund laufen; in [den] Grund bohren; im Grunde genommen; a b e r (↑ R 141): zugrunde gehen, legen, liegen, richten; der Grund und Boden (vgl. d.); **grund|an|stän|dig; Grund_an|strich**, ...**aus|bil|dung**, ...**be|deu|tung**, ...**be|din|gung**, ...**be|griff**, ...**be|sitz**, ...**buch; Grund_buch|amt; grund|ehr|lich; Grund_ei|gen|tum**, ...**ei|gen|tü|mer**, ...**eis; Grün|del, Grün|del** (ein Fisch) w; -, -n (auch: m; -s, -); **grün|deln** (von Enten: Nahrung unter Wasser suchen); **grün|den**; gegründet (Abk.: gegr.); sich auf eine Ansicht gründen; **Grün|der; Grün|der|jah|re** *Mehrz.*; **Grund|er|werb; Grund_er|werbs|steu|er, Grund_er|werb|steu|er** w; (↑ R 334); **grund|falsch; Grund_far|be**, ...**feh|ler**, ...**fe|sten** (*Mehrz.*, nur in: etwas in den -n erschüttern), ...**ge|setz** (für: Statut); Grundgesetz für die Bundesrepublik Deutschland vom 23. Mai 1949 (Abk.: GG); **Grund|hol|de** (ehem. an Grund u. Boden gebundener Höriger) m; -n, -n (↑ R 287ff.); **grun|die|ren** (Grundfarbe auftragen); ...**grün|dig** (z.B. tiefgründig); **Grund_la|ge; Grund_la|gen|for|schung; grund|le|gend; a b e r** (↑ R 142): den Grund legend; **gründ|lich; Gründ|lich|keit** w; -; **Gründ|ling** (ein Fisch); **Grund|li|nie; grund|los; Grund_lo|sig|keit** w; -; **Grund_mau|er** (meist *Mehrz.*), ...**nah|rungs|mit|tel**

Grün|don|ners|tag

Grund_ord|nung, ...**prin|zip**, ...**recht**, ...**regel**, ...**ren|te**, ...**riß**, ...**satz; Grund_satz_ent|schei|dung**, ...**er|klä|rung; grund|sätz|lich;** (↑ R 134:) im -en (grundsätzlich), a b e r (↑ R 116:) es bewegt sich stets nur im Grundsätzlichen; **Grund_schuld**, ...**schu|le; grund|stän|dig** (bodenständig; Bot.: an der Basis stehend); -e Blätter; **Grund|stein; Grund_stein_le|gung; Grund_stel|lung**, ...**stock** (*Mehrz.* ...stöcke), ...**stoff**, ...**strecke** [*Trenn.*: ...strek|ke] (Bergw.), ...**stück; Grund_stücks_ei|gen|tü|mer**, ...**scha|den; Grund_stu|fe** (für: ²Positiv), ...**ten|denz**, ...**ton** (*Mehrz.* ...töne), ...**übel**, ...**um|satz** (Kalorienbedarf des ruhenden, nüchternen Menschen in einem Tag); **Grund und Bo|den** m; - - -s; ein Teil meines - - -s; **Grün|dung; Grün|dungs_fei|er**, ...**ka|pi|tal**, ...**ver|samm|lung**

¹ Häufig auch schon: aufgrund.

Grün|dün|gung

grund|ver|schie|den; Grund_was|ser (*Mehrz.* ...wasser); **Grund_was|ser_ab|sen|kung** (künstl. Tieferlegen des Grundwasserspiegels), ...**spie|gel; Grund_wert**, ...**wort** (Sprachw.: durch das Bestimmungswort [vgl. d.] näher bestimmter zweiter Bestandteil einer Zusammensetzung, z. B. „Wagen" in „Speisewagen"; *Mehrz.* ...wörter), ...**zahl** (für: Kardinalzahl), ...**zins**, ...**zug**

¹**Grü|ne** s; im -n lustwandeln; ins - gehen; Fahrt ins -; ²**Grü|ne** (veralt., noch dicht. für: grüne Farbe, Grünsein) w; -; **grün|en** (grün werden); **Grün_flä|che**, ...**fut|ter** (vgl. ¹Futter); **grün|gelb** (↑ R 158); **Grün_gür|tel**, ...**horn** (ugs. für: Neuling; *Mehrz.* ...hörner), ...**kern** (Suppeneinlage), ...**kohl** (w; -[e]s); **Grün_kram_la|den; Grün|land; grün|lich;** grünlichgelb (↑ R 158); **Grün|licht** s; -[e]s; **Grün|ling** (ugs. für: unerfahrener, unreifer Mensch); **Grün|rock** (scherzh. für: Förster, Jäger); **Grün|rot|blind|heit** (↑ R 158) w; -; **Grün|schna|bel** (ugs. für: unerfahrener, unreifer, vorlauter Mensch), ...**span** („spanisches Grün"; Kupferverbindung; m; -[e]s), ...**specht**, ...**strei|fen**

grun|zen; du grunzt (grunzest)

Grün|zeug

Grupp fr. (aus Geldrollen bestehendes, zur Versendung bestimmtes Paket) m; -s, -s; **Grüpp|chen**, Grüpp|lein; ¹**Grup|pe** w; -, -n

²**Grup|pe, Grüp|pe** niederd. ([Wasser]graben, Rinne; Abzugsgraben) w; -, -n; **grüp|peln** (eine ²Gruppe ausheben); ich ...[e]le (↑ R 327); **grup|pen** (svw. grüppeln)

Grup|pen_auf|nah|me, ...**bild**, ...**füh|rer**, ...**pra|xis**, ...**psy|cho|lo|gie**, ...**sex**, ...**the|ra|pie; grup|pen|wei|se; Grup|pen|ziel; grup|pie|ren; Grup|pie|rung; Grüpp|leim; Grüpp|chen**

Grus („Grieß"; verwittertes Gestein; zerbröckelte Kohle, Kohlenstaub) m; -es, -e; vgl. a b e r Gruß

gru|se|lig, grus|lig (Furcht erregend); **Gru|sel|mär|chen; gru|seln**; ich ...[e]le mich (↑ R 327); mir od. mich gruselt's; **Gru|si|ca** [*grusik'l*]; anglisierende Neubildung nach dem Vorbild von „Musical"] (scherzh. für: musikalisches Schauermärchen, nach Art eines Musicals aufgemachter Gruselfilm) s; -s, -s

grus|sig [zu: Grus]

315 Gupf

Gru|si|ni|er [...*i^e*r] (Einwohner der Grusinischen SSR); gru|si|nisch; Gru|si|nisch (Sprache) *s*; -[s]; vgl. Deutsch; Gru|si|ni|sche *s*; -n; vgl. Deutsche *s*; Gru|si|ni|sche SSR (Unionsrepublik der UdSSR) Grus|koh|le (Kohlenklein) *w*; - grus|lig vgl. gruselig Gruß *m*; -es, Grüße; vgl. aber: Grus; Gruß|adres|se; grü|ßen; du grüßt (grüßest); grüß [dich] Gott! grüß Gott sagen; Gruß.form, ...for|mel; gruß|los Grütz|beu|tel (Balggeschwulst [bes. unter der Kopfhaut]); Grüt|ze *w*; -, -n Gru|y|ères [*grüjär*] (fr [offiz.] Form von: Greyerz) Grzi|mek [*gschimäk*] (dt. Zoodirektor u. Tierarzt) G-Sai|te [*gg*...] (Musik); G-Schlüs|sel [*gg*...] Gschaftl|hu|ber vgl. Geschaftl... gscha|mig, gschä|mig vgl. geschamig, geschämig gschert vgl. geschert Gschnas|fest (Maskenball der Wiener Künstler) *s*; -es gschupft ostr., schweiz. ugs. (überspannt, affektiert; geschniegelt) gspa|ßig vgl. gespaßig Gstaad (schweiz. Kurort) Gstan|zel, Gstanzl bayr. u. österr. (Schnaderhüpfl) *s*; -s, -n Gstät|ten ostösterr. ugs. (verwahrloster Hang, Wiese) *w*; -, - Gua|jak.harz indian.; dt. (*s*; -es), ...holz; Gua|ja|kol (Antiseptikum) *s*; -s Gua|na|ko indian. (südamerik. Lama) *s* (älter: *m*); -s, -s Gua|no indian. (Vogeldünger) *m*; -s; Gua|no|in|seln (an der Westküste Südamerikas) *Mehrz.* Gua|ra|ni, (offz. Schreibung:) Gua|ra|ní (Währungseinheit in Paraguay) *m*; -, - Gu|ar|di|an mlat. [österr.: *guar*...] („Wächter"; Oberer [bei Franziskanern u. Kapuzinern]) *m*; -s, -e Gu|asch fr. *w*; -, -en, (fachspr. meist:) Gou|ache [*gugsch*] (Art Deckfarbenmalerei) *w*; -, (für: in dieser Weise hergestelltes Kunstwerk auch *Mehrz.*:) -n; Gu|asch|ma|le|rei Gua|te|ma|la (Staat und Stadt in Mittelamerika); Gua|te|mal|te|ke (Bewohner von Guatemala) *m*; -n, -n (↑ R 268); gua|te|mal|te|kisch Gua|ya|na, (amtlich:) Gu|ya|na [...*jgna*] (Staat in Südamerika); Gua|ya|ner, (amtlich:) Gu|ya|ner; gua|ya|nisch, (amtlich:) gu|ya|nisch Gu|ber|ni|um (veralt. für: Gouvernement) *s*; -s, ...ien [...*i^e*n]

gucken[1]; vgl. auch: kucken; Guk|ker[1] Guckerschecken[1] [Trenn.: ...ek|ken] österr. ugs. (Sommersprossen) *Mehrz.* Guck|fen|ster; Gucki[1] (im Skatspiel; Gerät zum Betrachten von Diapositiven) *m*; -s, -s; Guck|in|die|luft; Hans -; Guck|ka|sten; Guck|ka|sten|büh|ne; Guck|loch Gud|run (w. Vorn.) Gu|du|la (w. Vorn.) Guel|fe it. [*guäl*..., auch: *gäl*...] (mittelalterl. Anhänger der päpstl. Politik, Gegner der Gibelinen) *m*; -n, -n (↑ R 268) Guo|ricke [Trenn ... rik|ke; *gg*] (dt. Physiker); -sche Halbkugel, -sche Leere (Physik) Gue|ril|la span. [*geril(j)a*] (Kleinkrieg) *w*; -, -s u. (Angehöriger einer bewaffneten Bande, die einen Kleinkrieg führt) *m*; -[s], -s (meist *Mehrz.*); Gue|ril|la|krieg; Gue|ril|le|ro [*geriljero*] (Untergrundkämpfer in Südamerika *m*; -s, -s Gué|rin [*geräng*] (fr. Tierarzt); vgl. BCG-Schutzimpfung Gue|va|ra [*gewara*] (kuban. Arzt u. Politiker); vgl. Che Gu|gel|hopf schweiz. (svw. Gugelhupf); Gu|gel|hupf südd., österr. u. seltener schweiz. (eine Art Napfkuchen) *m*; -[e]s, -e Güg|gel schweiz. mdal. (Gockel) *m*; -s, -; Güg|ge|li schweiz. (Backhähnchen) *s*; -s, - Gui|do [*gido*, österr. meist: *guido*] (m. Vorn.) Guil|loche fr. [*gi(l)josch*] (verschlungene Linienzeichnung; Werkzeug zum Anbringen solcher Linien) *w*; -, -n; Guil|lo|cheur [...*schör*] (Linienstecher) *m*; -s, -e; guil|lo|chie|ren (Guillochen stechen) Guil|lo|ti|ne [*giljo*..., auch *gijotin^e*]; nach dem fr. Arzt Guillotin] (Fallbeil) *w*; -, -n; guil|lo|ti|nie|ren [1]Gui|nea [*gi*...] (Staat in Westafrika); [2]Gui|nea engl. [*gini*] *w*; -, -s u. Gui|nee fr. [*gi*...] (ehem. engl. Münze) *w*; -, -en; Gui|ne|ger (Einwohner von [1]Guinea); gui|ne|isch ([1]Guinea betreffend) Gu|lasch ung. *s* (auch: *m*, österr. nur: *m*); -[e]s, -e (österr. nur so) u. -s; Gu|lasch..ka|no|ne (scherzh. für: Feldküche), ...sup|pe Gul|brans|sen, Trygve (norweg. Schriftsteller) Gul|brans|son, Olav (norweg. Zeichner u. Karikaturist) Gul|den (niederl. Münzeinheit; Abk.: hfl) *m*; -s, -; gül|den (dicht. für: golden); Gul|disch (Berg-

mannsspr.: goldhaltig); Gül|disch|sil|ber (Bergmannsspr.: goldhaltiges Silber) Gül|le („Pfütze"; südwestd. u. schweiz. neben: Jauche [zum Düngen]) *w*; -; gül|len; Gül|len|faß Gul|ly engl. [*guli*, auch engl. Ausspr.: *gali*] landsch. (Schlammfang; Senkloch) *m* (auch: *s*); -s, -s Gült, Gül|te (südd. für: Grundstücksertrag; Abgabe, Zins; Grundschuld; schweiz. veralt. für: Grundschuldverschreibung) *w*; -, ...ten; Gült.brief, ...buch; gül|tig; vgl. giltig; Gül|tig|keit *w*; -; Gül|tig|keits|dau|er Gul|vas [*gulvasch*] (österr. neben: Gulasch) Gum|mi *ägypt. s* (auch, österr. nur: *m*); -s, -[s], (Radiergummi:) *m*; -s, -s; Gum|mi|ara|bi|kum *nlat.* (Klebstoff) *s*; -s; gum|mi|ar|tig; Gum|mi.ball, ...band (*s*; *Mehrz.* ..bänder), ...baum, ...be|griff (ugs.), ...druck (*Mehrz.* ..drukke); Gum|mi|ela|sti|kum (Kautschuk) *s*; -s; gum|mie|ren (mit Gummi[arabikum] bestreichen); Gum|mi|gutt *ägypt.*; *malai.* (giftiges Harz, Farbe) *s*; -s; Gum|mi.knüp|pel, ...lö|sung (ein Klebstoff), ...man|tel, ...pa|ra|graph (ugs.), ...rei|fen, ...ring, ...schlauch, ...schuh, ...soh|le, ...stie|fel, ...tier, ...un|ter|la|ge, ...zel|le; Gum|mo|se (Bot.: krankhafter Harzfluß) *w*; -, -n Gum|pe (Bergmannsspr.: Schlammkasten; südd., schweiz. mdal. für: Wasseransammlung, Wasserloch, tiefe Stelle in Wasserläufen und Seen) *w*; -, -n Gun|del|re|be *w*. - u. Gun|der|mann (eine Heilpflanze) *m*; -[e]s Gun|du|la (w. Vorn.) Gun|kel oberbayr. (kesselförmige Bodensenkung) *w*; -, -n Gun|nar (m. Vorn.) Gun|nars|son (isländ. Schriftsteller) Gun|sel (eine Heilpflanze) *m*; -s, - Gunst *w*; -; nach Gunst; in Gunst stehen; zu seinen Gunsten, zu seines Freundes Gunsten, aber (↑ R 141): zugunsten, zuungunsten der Armen; Gunst.be|zei|gung, ...ge|werb|le|rin (scherzh. für: Prostituierte; *w*; -, -nen); gün|stig; gün|sti|gen|falls; vgl. Fall *m*; Gün|stig|keit *w*; -; Günst|ling; Günst|lings|wirt|schaft *w*; - Gün|ter, (auch:) Gün|ther; ↑ R 191 (m. Vorn.); Gun|ther (dt. Sagengestalt); Gunt|hild, Gunt|hild|de (w. Vorn.) Gupf südd., österr. u. schweiz. mdal. (Gipfel, Spitze; stumpfer Teil des Eies) *m*; -[e]s, Güpfe u. (österr.:) -e

[1] *Trenn.*:...uk|k...

Gup|py [nach dem engl.-westind. Naturforscher Guppy] (ein Aquarienfisch) *m*; -s, -s

Gur (Bergmannsspr.: breiige, erdige Flüssigkeit) *w*; -

Gur|gel *w*; -, -n; Gur|gel..ab|schnei|der, ...ader (veralt. für: Schlagader); gur|geln; ich ...[e]le (↑R 327); Gur|gel|was|ser (*Mehrz.* ...wässer)

Gürk|chen, Gürk|lein; Gur|ke *w*; -, -n; Gur|ken|sa|lat

Gur|kha *angloind.* (Angehöriger eines Volkes in Nepal) *m*; -[s], -[s]

Gürk|lein, Gürk|chen

gur|ren; die Taube gurrt

Gurt *m*; -[e]s, -e u. (landsch. fachspr.:) Gür|te *w*; -, -n; Gurt|bogen (Bauw.); Gür|tel *m*; -s, -; Gürtel..li|nie, ...rei|fen, ...ro|se (eine Krankheit), ...tier; gür|ten; Gurtge|sims (Bauw.); Gürt|ler (Messingschlosser)

Gu|sche vgl. Gosche

Guß *m*; Gusses, Güsse; Guß|ei|sen; guß|ei|sern; Guß.form, ...re|gen, ...stahl (vgl. ¹Stahl)

güst bes. niederd. (unbefruchtet, unfruchtbar, nicht milchgebend [von Tieren])

Gu|stav (m. Vorn.); Gu|stav A̲dolf (Schwedenkönig); Gustav-A̲dolf-Werk (↑R 182) *s*; -[e]s

Gu|ste (Koseform von: Auguste); Gu|stel, Gu|sti (Koseformen von: August u. Auguste)

gu|stie|ren *it.* (ugs. für: goutieren; österr. ugs. für: kosten, prüfen)

Gu|stin Ⓦ (reiner Maisstärkepuder) *s*; -s

gu|sti|ös *it.* österr. ugs. (appetitlich); -este (↑R 294); Gu|sto (veralt. für: Geschmack, Geschmacksrichtung; Neigung) *m*; -s, -s, gelegentl. noch üblich in: das ist nach seinem -; Gu|stostückerl [*Trenn.:* ...ük|k...] österr. ugs. (besonders gutes Stück) *s*; -s, -n

gut; besser (vgl. d.), beste (vgl. d.); vgl. ausreichend; guten Abend, Morgen, gute Nacht sagen; einen guten Morgen wünschen; ein gut Teil; guten Mutes (↑R 275); gute Sitten; gut und gern; so gut wie; so weit, so gut; es gut sein lassen; vgl. auch: Gut. I. *Kleinschreibung:* a) (↑R 135:) um ein gutes (viel); b) (↑R 133:) im guten sagen; ins gute [Heft] schreiben; von gutem sein. II. *Großschreibung:* a) (↑R 116:) im Guter; Gutes und Böses; jenseits von Gut und Böse; sein Gutes haben; des Guten zuviel tun; vom Guten das Beste; zum Guten lenken, wenden; b) (↑R 116:) etwas, nichts, viel, wenig Gutes; alles Gute; c)

(↑R 224:) der Gute Hirt[e] (Christus); das Kap der Guten Hoffnung. III. *In Verbindung mit Zeitwörtern* (↑R 139): a) *Getrenntschreibung,* wenn „gut" in ursprünglichem Sinne gebraucht wird, z. B. er will gut sein; er wird es gut haben; er wird mit ihm gut aus|kommen; er will gut leben; b) *Zusammenschreibung* in übertragenem Sinne; vgl. gutbringen, gutgehen, guthaben, gutheißen, gutmachen, gutsagen, gutschreiben, gutsprechen, guttun. IV. *In Verbindung mit dem* 2. *Mittelwort:* der gutgelaunte Besucher (↑ jedoch R 142), aber: die Besucher waren alle gut gelaunt; Gut *s*; -[e]s, Güter: - und Blut; (↑R 132:) zugute halten, kommen, tun; Gut|ach|ten *s*; -s, -; Gut|ach|ter; gut|ach|tlich; gutar|tig; Gut|ar|tig|keit *w*; -; gut|aus|se|hend; ein -er Mann; gut|be|zahlt; vgl. gut, IV; gut|brin|gen; ↑R 139 (Kaufmannsspr.: gutschreiben); er hat mir diese Summe gutgebracht; aber: gut bringen; du kannst beruhigt sein, es wird es dir gut (in einwandfreiem Zustand) bringen; gut|bür|gerlich; ¹Güt|chen (kleine Guttat; Zubuße) *s*; -s; (ugs.:) sich ein - tun; ²Güt|chen (kleines Besitztum, kleines Gut); Gut|dün|ken *s*; -s; nach [seinem] -; Gü|te *w*; -; in -; Gü|te|klas|se (einer Ware); Gu|te|nacht.gruß, ...kuß, ...lied

Gu|ten|berg (Erfinder der Buchdruckerkunst); Gu|ten|berg|gotisch (Schriftgattung) *w*; - (↑R 180)

Gu|ten|mor|gen|gruß; Gü|ter.abfer|ti|gung, ...aus|tausch, ...bahnhof, ...ge|mein|schaft, ...nah|verkehr, ...tren|nung, ...ver|kehr, ...wa|gen, ...zug; Gü|te.ver|fah|ren, ...zei|chen; Gut|frie|den schweiz. (Gutdünken) *s*; -s; Gut Freund! (Antwort auf den Ruf: Wer da?); gut|ge|hen; ↑R 139 (sich in einem angenehmen Zustand befinden; ein gutes Ende nehmen); es ist ihm in seinem ganzen Leben gutgegangen; das ist zum Glück noch einmal gutgegangen; aber: gut ge|hen; ich kann in diesen Schuhen gut gehen; die Bücher werden gut gehen (gut abgesetzt werden); gut|gehend; ein -es Geschäft; gut.gelaunt, ...ge|meint, ...ge|ord|net, ...ge|pflegt, ...ge|sinnt; vgl. gut, IV; Gut|ge|sinn|te *m* u. *w*; -n, -n (↑R 287ff.); gut|gläu|big; Gut|gläu|big|keit *w*; -; gut|ha|ben; ↑R 139 (Kaufmannsspr.: zu fordern haben); du hast bei mir noch 10

DM gut; den Betrag hat er noch gutgehabt; aber: gut ha|ben; er hat es zu Hause gut gehabt; Gut|ha|ben *s*; -s, -; Gut Heil! (alter Turnergruß); gut|hei|ßen; ↑R 139 (billigen); er hat den Plan gutgeheißen; Gut|heit *w*; -; gut|her|zig; Gut|her|zig|keit *w*; -; Gut Holz! (Keglergruß); gü|tig; Gut|leuthaus (früher für: Heim der Leprakranken; heute vereinzelt südd. für: Armenhaus); güt|lich; etwas - regeln; sich - tun; gut|machen; ↑R 139 (auf gütlichem Wege erledigen, in Ordnung bringen; erwerben, Vorteil erringen); er hat etwas gutgemacht; aber: gut ma|chen (gut ausführen); er hat seine Sache gut gemacht; gut|mü|tig; Gut|mü|tig|keit *w*; -, (selten:) -en; gut|nachbar|lich; Gut|punkt (Sportspr.); gut|sa|gen; ↑R 139 (bürgen); ich habe für ihn gutgesagt; aber: gut sa|gen (treffend, schön sagen); das hast du gut gesagt; Guts|be|sit|zer; Gut|schein; gut|schrei|ben; ↑R 139 (anrechnen); er versprach, den Betrag gutzuschreiben; aber: gut schrei|ben (schön richtig schreiben); er bemühte sich, gut zu schreiben; Gut|schrift (Eintragung einer Summe als Guthaben); gut sein (freundlich gesinnt sein); jmdm. - -; es lassen; Gut|sel landsch. (Bonbon) *s*; -s, -; Guts.herr, ...herr|schaft, ...hof; gut|si|tu|iert (in guten Verhältnissen lebend wohlhabend); gut|sit|zend; ein -er Anzug

Guts/Muths (Mitbegründer der dt. Turnens)

gut|spre|chen; ↑R 139 (veralt. noch mdal. für: bürgen, gutsagen); er hat für mich gutgesprochen; aber: gut spre|chen (schön richtig sprechen); das Kind kann schon gut sprechen; Guts|verwal|ter

Gut|ta|per|cha *malai.* (kautschukartiger, aus dem Milchsaft bestimmter Bäume gewonnener Stoff) *w*; - od. *s*; -[s]

Gut|tat (veralt. für: Wohltat); gut|tä|tig (veralt. für: wohltätig, mildtätig)

Gut|temp|ler; Gut|temp|ler|or|den (den Alkoholgenuß bekämpfender Bund) *m*; -s

gut|tun; ↑R 139 (wohltun); die Wärme hat dem Kranken gutgetan; aber: gut tun; etwas gut tun (richtig tun)

gut|tu|ral *lat.* (die Kehle betreffend; Kehl..., kehlig); Gut|tu|ral *m*; -s, -e u. Gut|tu|ral|laut (Sprachw.: Gaumen-, Kehllaut zusammenfassende Bez. für

Labiovelar, Palatal u. Velar [vgl. d.])

gut|un|ter|rich|tet; vgl. gut, IV; gut wer|den; das wird schon - -; Gut|wet|ter|zei|chen; gut|wil|lig; Gut|wil|lig|keit w; -

Guy [fr. Ausspr.: gi; engl. Ausspr.: gai] (fr. u. engl. m. Vorn.)

Gu|ya|na usw. vgl. Guayana usw.

Gwirkst vgl. Gewirkst

Gym|na|si|al.bil|dung (w; -), ...leh|rer, ...pro|fes|sor (Lehrer an einer höheren Schule); Gym|na|si|ast gr. (Schüler eines Gymnasiums) m; -en, -en (↑ R 268); Gym|na|si|um (im Altertum: Schule, Raum für Leibesübungen; Versammlungsraum für Philosophen; in Deutschland, Österreich u. der Schweiz: Form der höheren Schule) s; -s, ...ien [...iᵉn]; Gym|na|stik w; -; Gym|na|sti|ker; Gym|na|stik|un|ter|richt; Gym|na|stin (Lehrerin der Heilgymnastik) w; -, -nen; gym|na|stisch; Gym|no|sper|men (nacktsamige Pflanzen) Mehrz.

Gy|nä|kei|on gr. (Frauengemach des altgr. Hauses) s; -s, ...keien; vgl. Gynäzeum; Gy|nä|ko|lo|ge (Frauenarzt) m; -n, -n (↑ R 268); Gy|nä|ko|lo|gie (Frauenheilkunde) w; -; gy|nä|ko|lo|gisch; Gyn|an|drie (Verwachsung der männl. u. weibl. Blütenorgane; Scheinzwittrigkeit bei Tieren durch Auftreten von Merkmalen des anderen Geschlechtes) w; -; Gy|nä|ze|um (svw. Gynäkeion; Bot.: Gesamtheit der weibl. Blütenorgane einer Pflanze) s; -s, ...een

Gy|ro|skop gr. (Meßgerät zum Nachweis der Achsendrehung der Erde) s; -s, -e

H

H (Buchstabe); das H; des H, die H, aber: das h in Bahn (↑ R 123); der Buchstabe H, h

= Zeichen für das Plancksche Wirkungsquantum

= Hekto...; (Astron.: ʰ, z. B. 8ʰ) = hora (Stunde); auch als Zeitbestimmung, z. B. 8ʰ = 8 Uhr

, H (Tonbezeichnung) s; -, -; h (Zeichen für: h-Moll); in h; H (Zeichen für: H-Dur); in H

= ²Henry; Hydrogenium (chem. Zeichen für: Wasserstoff)

a!; haha!

a = Hektar, Hektare

a = chem. Zeichen für: Hahnium

a. = hujus anni u. hoc anno, dafür besser: dieses Jahres (d. J.)

. in diesem Jahre

Haag, Den (Residenzstadt der Niederlande); (dt. auch:) Haag, der; im Haag; in Den Haag (auch: in Haag); vgl. 's-Gravenhage; Haa|ger (↑ R 199); Haager Konventionen

¹Haar w; -, (auch:) Haar|strang (Höhenzug in Westfalen) m; -[e]s

²Haar s; -[e]s, -e; vgl. aber: Härchen; Haar.an|satz, ...aus|fall; Haar|breit s; -; nicht ein -

Haard (Waldhöhen im Münsterland) w; -; vgl. aber: Haardt u. Hardt

Haardt (östl. Teil des Pfälzer Waldes) w; -; vgl. aber: Haard u. Hardt

haa|ren; sich -; der Hund hat sich gehaart; Haa|res|brei|te w; -; um -, aber: um eines Haares Breite; Haar.far|be, ...farn; haar|fein; Haar|garn|tep|pich; haar|ge|nau; haa|rig; Haar.klam|mer, ...kleid; haar|klein; Haar|kranz

Haar|lem (niederl. Stadt); Haar|le|mer (↑ R 199)

Haar|ling (ein lausartiges Insekt)

Haar|na|del; Haar|na|del|kur|ve; Haar.pfle|ge, ...riß, ...röhr|chen; haar|scharf; Haar.schnei|der, ...schnitt, ...schopf, ...spal|ter; Haar|spal|te|rei; Haar|spray

Haar|strang vgl. ¹Haar

haar|sträu|bend; -ste; Haar.teil s, ...was|ser (Mehrz. ...wässer). ...wild (alle Säugetiere, die gejagt werden), ...wuchs; Haar|wuchs|mit|tel s

Ha|ba|kuk (bibl. Prophet)

Habana [abana], La (span. Form von: Havanna)

Hab|dank [auch: hapdank] vgl. Habedank

Ha|be w; -, vgl. Hab und Gut

Ha|be|as|kor|pus|ak|te lat. (engl. Staatsgrundgesetz von 1679 zum Schutz der persönlichen Freiheit) w; -

Ha|be|dank [auch: habᵉdank] (dicht. für: Dank) m; -[s]; aber: habe Dank!; ha|ben; du hast, er hat; du hattest; du hättest; gehabt; hab[e]!; Gott hab' ihn selig!; habt acht! österr. Kommando für „stillgestanden!"); ich habe auf dem Tische Blumen stehen (nicht: ... zu stehen); Ha|ben s; -s, -; [das] Soll und [das] -; Ha|be|nichts m; - u. -es, -e; Ha|ben.sei|te (für: ²Kredit), ...zin|sen (Mehrz.)

Ha|ber (südd., österr. u. schweiz. neben: Hafer) m; -s

Ha|be|rer österr. salopp (Verehrer; Kumpan) m; -s, -

Ha|ber|feld|trei|ben (früher: volkstüml. Rügegericht in Bayern u. Tirol) s; -s, -

Ha|ber|geiß (eine Spukgestalt)

ha|bern österr. salopp (essen)

Hab|gier w; -; hab|gie|rig; hab|haft; des Diebes - werden (ihn verhaften)

Ha|bicht m; -s, -e; Ha|bichts|na|se

ha|bil lat. (geschickt, fähig; handlich; passend); ha|bil. vgl. Dr. habil.; Ha|bi|li|tand (jmd., der zur Habilitation zugelassen wird) m; -en, -en (↑ R 268); Ha|bi|li|ta|ti|on [...zion] (Erwerb der Lehrberechtigung an Hochschulen); Ha|bi|li|ta|ti|ons|schrift; ha|bi|li|tie|ren, sich (die Lehrberechtigung an Hochschulen erwerben)

¹Ha|bit fr. [österr. meist: ha...] ([Amts]kleidung, [Ordens]tracht; wunderlicher Aufzug) s (auch: m); -s, -e; ²Ha|bit engl. [hä-bit] (Psych.: Gewohnheit, Verhaltensart; auch: Lernschritt) s (auch: m); -s, -s; Ha|bi|tat lat. (Wohnplatz, Wohngebiet [einer Tierart]) s; -s, -e; Ha|bi|tué fr. [(h)abitüé] (österr., sonst veralt. für: ständiger Besucher, Stammgast) m; -s, -s; ha|bi|tu|ell (gewohnheitsmäßig; ständig); -e Krankheit; Ha|bi|tus lat. (Erscheinungsbild [von Menschen, Pflanzen u. Kristallen]; Anlage; Haltung; Körperbau) m; -

hab|lich schweiz. (wohlhabend)

Habs|burg (Ort u. Burg im Kanton Aargau) w; -; Habs|bur|ger (Angehöriger eines dt. Fürstengeschlechtes) m; -s, -; Habs|bur|ger|mon|ar|chie (↑ R 205) w; -; habs|bur|gisch

Hab|schaft (Habe); Hab|se|lig|keit (Besitztum) w; -, -en (meist Mehrz.); Hab|sucht w; -; hab|süch|tig; Hab und Gut (↑ R 241) s; - - -[e]s

hach!

Ha|che [(h)asche] vgl. Haschee

Hä|chel franz. (Küchenhobel) s; -s, - u. w; -, -n; hä|cheln österr. (Gemüse mit einem Hachel hobeln); ich ...[e]le (↑ R 327)

Hach|se, (südd.:) Ha|xe (unteres Bein von Kalb od. Schwein) w; -, -n; vgl. ²Hesse

Hack.bank (Mehrz. ...bänke), ...bau (m; -[e]s), ...beil, ...block (Mehrz. ...blöcke), ...bra|ten, ...brett (Hackbank für Fleischer; Saiteninstrument)

¹Hacke¹ w; -, -n u. Hacken¹ (Ferse) m; -s, -

²Hacke¹ (ein Werkzeug) w; -, -n; hacken¹ (hauen); gehacktes Fleisch

Hacken¹ vgl. ¹Hacke; Hacken|trick¹ (Fußball: Fersenstoß [zur Täuschung des Gegners])

Hacke|pe|ter¹ nordd. (ein Gericht

¹ Trenn.: ...k|k...

aus Gehacktem) *m*; -s, -; Hạcker[1];
Hạcker|ling[1] (Häcksel) *m*; -s;
Hạck̲fleisch, ...frucht, ...klotz,
...mes|ser *s*; Hạck|sel (Schnitt-
stroh) *s* od. *m*; -s; Häck|se|ler,
Häcks|ler (Häckselmaschine);
Hạck|stock österr. (Hackklotz)
[1]Hạ|der (südd., österr. für: Lum-
pen; ostmitteld. für: Scheuer-
tuch) *m*; -s, -n u. (für Scheuertü-
cher:) -
[2]Hạ|der (Zank, Streit) *m*; -s; in -
leben; Hạ|de|rer, Hạd|rer
Hạ|der|lump südd., österr. (lieder-
licher Mensch, Taugenichts)
hạ|dern; ich ...ere (↑ R 327)
hạ|dern|hal|tig; -es Papier
[1]Hạ|des (gr. Gott der Unterwelt);
[2]Hạ|des (Unterwelt) *m*; -
Hạd|rer vgl. Haderer
Ha|dri|an [auch, österr. nur: *ha...*]
(röm. Kaiser; Papstname); vgl.
Adrian
Hạ|dschi *arab.* (Mekkapilger;
auch: christl. Jerusalempilger im
Orient) *m*; -s, -s
Hạ|du|brand (germ. Sagengestalt)
Hạd|wig (ältere Form von: Hed-
wig)
Haeckel [*Trenn.:* Haek|kel; *hä...*]
(dt. Naturforscher)
[1]Hạ|fen südd., schweiz., österr.
(Topf) *m*; -s, Häfen; [2]Hạ|fen
(Lande-, Ruheplatz) *m*; -s, Hä-
fen; Hä|fen österr. ([1]Hafen; ugs.:
Gefängnis) *m*; -s, -; Hạ|fen amt,
...ar|bei|ter, ...ein|fahrt, ...knei-
pe, ...rund|fahrt, ...schen|ke,
...stadt
Hạ|fer *m*; -s, (fachspr.:) -; vgl.
auch: Haber; Hạ|fer|brei, ...flok-
ken [*Trenn.:* ...flok|ken
(*Mehrz.*), ...grüt|ze
Hạ|ferl, Hä|ferl österr. ugs. (Tas-
se) *s*; -s, -n; Hạ|ferl|schuh (ein
Sporthalbschuh)
Hạ|fer̲mark *s*, ...schleim
Haff (durch Nehrungen vom
Meere abgetrennte Küsten-
bucht) *s*; -[e]s od. -e; (↑ R 224:)
das Frische -, das Kurische -;
Haffi|scher [*Trenn.:* Haff|fi..., ↑ R
236]
Hạ|fis (pers. Dichter)
Hạf|lin|ger (Pferd einer bestimm-
ten Rasse); Hạf|lin|ger|ge|stüt
Hạf|ner, Häf|ner landsch. (Töp-
fer, [Kachel]ofensetzer) *m*; -s, -;
Hạf|ne|rei
Hạf|ni|um (chem. Grundstoff,
Metall; Zeichen: Hf) *s*; -s
...haft (z. B. krankhaft)
[1]Hạft (Gewahrsam) *w*; -; [2]Hạft
(nur noch selten für: Haken;
Spange) *m*; -[e]s, -e[n]; Hạft an-
stalt, ...aus|set|zung; hạft|bar;
Hạft|bar|ma|chung; Hạft̲be|fehl,

...dau|er; Hạf|tel südd., österr.
(Häkchen und Öse) *m* od. *s*
(österr. nur so); -s, -; häf|teln; ich
...[e]le (↑ R 327); hạf|ten-
blei|ben; (↑ R 139:) ich bleibe haf-
ten; haftengeblieben; haftenzu-
bleiben; seine Undankbarkeit
wird mir ewig im Gedächtnis
haftenbleiben; Hạft̲ent|las|sung,
...ent|schä|di|gung; hạft|fä|hig;
Hạft̲frist, ...glä|ser (*Mehrz.*);
Häf|ling; Hạft|pflicht; vgl.
EGmbH, EGmuH, GmbH; hạft-
pflich|tig; Hạft|pflicht|ver|si|che-
rung; Hạft̲prü|fungs|ter|min,
...rei|bung (Physik), ...rich|ter,
...scha|len (*Mehrz.*), ...stra|fe;
Hạf|tung; vgl. EGmbH,
EGmuH, GmbH; Hạft̲un|ter-
bre|chung, ...ze|her (eine Eidech-
senart)
Hạg (schweiz. für: Hecke, Zaun;
veralt. dicht. für Hecke; umfrie-
deter Bezirk; Waldgrundstück)
m; -[e]s, -e u. (schweiz.:) Häge
Ha|ga|nah *hebr.* (Vorläufer der is-
rael. Nationalarmee) *w*; -
Hạ|gar (bibl. w. Eigenn.)
Hạ|ge|bu|che (svw. Hainbuche);
hạ|ge|bu|chen, hạ|ge|bü|chen
(vereinzelt für: hanebüchen); Hạ-
ge̲but|te (*w*; -, -n), ...dorn (*Mehrz.*
...dorne)
Hạ|gel *m*; -s; hạ|gel|dicht; Hạ|gel-
korn *s* (*Mehrz.* ...körner); hạ|geln;
es hagelt; Hạ|gel̲schlag, ...schlo-
ße
Hạ|gel|stan|ge (dt. Dichter)
Hạ|gel|wet|ter
Hạ|gen (m. Vorn.); - von Tronje
(Gestalt der Nibelungensage)
hạ|ger; -er, -ste; Hạ|ger|keit *w*; -
Hạ|ge|stolz ([alter] Junggeselle) *m*;
-es, -e
Hạg|gai (bibl. Prophet)
Hạ|gia So|phia *gr.* (Kirche in
Istanbul; heute Museum) *w*; - -;
Hạ|gio|graph (Verfasser von Hei-
ligenleben) *m*; -en, -en (↑ R 268);
Hạ|gio|gra|phen (dritter Teil der
Bücher des A. T.) *Mehrz.*; Ha-
gio|gra|phie (Erforschung u. Be-
schreibung von Heiligenleben) *w*;
-, ...ien; Hạ|gio|la|trie (Vereh-
rung der Heiligen) *w*; -, ...ien
ha|ha!, ha|ha|ha!
Hä|her (ein Rabenvogel) *m*; -s, -
Hạhn *m*; -[e]s, Hähne (in der Tech-
nik auch: -en); Hähn|chen, Hähn-
lein; Hạhn̲nen bal ken (oberster
Querbalken im Dachstuhl), ...fe-
der, ...fuß (auch [nur *Einz.*]: Wie-
senblume), ...kamm (auch: Zier-
pflanze; Pilz), ...kampf, ...ruf,
...schrei. ...tritt (Keimscheibe im
Hühnerei; ein Stoffmuster; auch:
Zuckfuß; *m*; -[e]s); Hạh|ne|pot
(Seemannsspr.: Gabelung eines
Taues) *w*; -, -en

Hạh|ni|um [nach dem Physiker Ot-
to Hahn] (vorgeschlagener Name
für das neue chem. Element 105;
Zeichen: Ha) *s*; -s
Hähn|lein, Hähn|chen; Hạhn|rei
(betrogener Ehemann) *m*; -[e]s,
-e; Hạhn|rei|schaft *w*; -
Hai *niederl.* (ein Raubfisch) *m*;
-[e]s, -e
Hai|fa (Hafenstadt in Israel)
Hai|fisch; Hai|fisch|fi|let
Hai|le Se|las|sie [- ...*laßi*] (Kaiser
von Äthiopien)
Hai|mons|kin|der (Helden des ka-
roling. Sagenkreises) *Mehrz.*
Hain (dicht. für: Wald, Lustwäld-
chen) *m*; -[e]s, -e; Hain̲bu|che (ein
Baum), ...bund (ein Dichterbund;
m; -[e]s)
Hain|lei|te (Höhenzug in Thürin-
gen) *w*; -
Hai|ti (westind. Insel; Republik)
Hai|tia|ner [*ha-i...*], (auch:) Hai-
ti|er [...*ier*]; hai|tia|nisch, (auch:)
hai|tisch
Häk|chen, Häk|lein (kleiner Ha-
ken); Hä|kel|ar|beit; Hä|ke|lei
Hä|kel|garn; hä|keln; ich ...[e]le
(↑ R 327); Hä|kel|na|del; hạ|ken
Hạ|ken *m*; -s, -; Hạ|ken|büch|se
(eine frühere Handfeuerwaffe)
hạ|ken|för|mig; Hạ|ken|kreuz
...na|se; hạ|kig
Hạ|kim *arab.* (Gelehrter, Philo
soph, Arzt [im Orient]) *m*; -s, -
Häk|lein vgl. Häkchen
Ha|la|li *fr.* (Jagdruf) *s*; -s, -[s];
blasen (Weidw.)
halb; das Haus liegt halb rechts
es ist, es schlägt halb eins; all-
(besser: jede) halbe Stunde; all-
halbe[n] Stunden; eine viertel un
eine halbe Stunde; eine halbe un
eine dreiviertel Stunde; [um] vol
und halb jeder Stunde; der Zeige
steht auf halb; ein halb Dutzen
ein halbes Brot; ein halbes du[t]
zendmal, ein halbes hundertma
drei[und]einhalb Prozent, aber
drei und ein halbes Prozent; an
derthalb; (↑ R 118:) ein Halbe
(Glas), einen Halben (Scho
pen), eine Halbe (halbe Ma
[bayr.]); (↑ R 116:) das ist nich
Halbes und nichts Ganzes; d
halboffene Tür (↑ jedoch R 143
aber: die Tür steht halb offen
vgl. halbfett, halbgar, halbrun-
halbtot, halbvoll; Hạlb|af|fe
hạlb|amt|lich; eine -e Nachrich
aber (↑ R 143): etwas geschieh
hạlb amtlich, hạlb privat; hạlb
bat|zig schweiz. (ungenügen
nicht zu Ende geführt, halbhe
zig); Hạlb̲bil|dung, ...blut; Hạl
blü|ti|ge (Mischling) *m*; -s, -
-n (↑ R 287ff.); hạlb|bür|tig (von
einen Elternteil gemeinsa
habend); hạlb|dun|kel; Hạlb|dun-

[1] *Trenn.:* ...k|k...

kel; **Hal|be** *m, w, s;* -n, -n (↑ R 287f.); **hal|be-hal|be;** [mit jemandem] - machen (ugs. für: teilen); **Halb|edel|stein;** ...hal|ben (z. B. meinethalben); **hal|ber;** mit *Wesf.:* der Ehre -; dringender Geschäfte -; gewisser Umstände -; des [guten] Beispiels -; **...hal|ber** (z. B. beispielshalber, umständehalber); **halb|er|wach|sen;** eine -e Tochter, aber (↑ R 143): sie ist [erst] halb erwachsen; **Halb|fabri|kat; halb|fett;** -e Buchstaben (Druckw.) (↑ jedoch R 143), aber: das Schwein ist erst halb fett; **Halb|fi|na|le** (Sport); **Halbfranz** *s;* -; in - [binden]; **Halbfranz|band** (Halbfranzband) *m,* **halb|gar;** -e Häute (↑ jedoch R 143), aber: das Essen ist halb gar; **Halb.gott,...heit; hal|bie|ren; Hal|bie|rung; Halb..in|sel, ...jahr; Halb|jah|res|kurs, Halb|jahrskurs; halb|jäh|rig** (ein halbes Jahr alt, ein halbes Jahr dauernd); -e Übungszeit; **halb|jähr|lich** (jedes Halbjahr wiederkehrend; alle halben Jahre); -e Zusammenkunft; **Halb|jahrs|kurs, Halb|jahres|kurs; Halb..kan|ton** (in der Schweiz), **...kreis, ...ku|gel; halblaut; Halb|le|der** (Bucheinband); **halb|lei|nen;** ein halbleinenes Tuch, aber (↑ R 143): ein halb leinenes, halb wollenes Tuch; **Halb|lei|nen; Halb|lei|nen|band** *m;* **Halb|lei|ter** (Physik: Stoff, der bei Zimmertemperatur elektrisch leitet u. bei tieferen Temperaturen isoliert) *m;* **Halb|lin|ke** (beim Sport) *m;* -n, -n (↑ R 287f.); **halb|links;** er spielt halblinks (augenblickliche Position eines Spielers), aber: du mußt dich halb links halten; **Halb|links** (Halblinke) *m;* -, -; er spielt - (als Halblinker); **halb|mast** (als Zeichen der Trauer); [Flagge] - hissen; auf - stehen; **Halb|mes|ser** *m;* **halb|me|ter|dick; Halb|mond; halb|mondför|mig; halb|of|fen;** die halboffene Tür (↑ jedoch R 143), aber: die Tür steht halb offen; **halb|part** (zu gleichen Teilen); - machen (teilen); **Halb|pen|si|on** (Wohnung mit Frühstück u. einer warmen Mahlzeit) *w;* -; **Halb|rech|te** (beim Sport) *m;* -n, -n (↑ R 287ff.); **halb|rechts;** er spielt halbrechts (augenblickliche Position eines Spielers), aber: du mußt dich halb rechts halten; **Halb|rechts** (Halbrechte) *m;* -, -; er spielt - (als Halbrechter); **halb|rund;** ein halbrunder Bogen (↑ jedoch R 143), aber: der Bogen ist halb rund; **Halb|rund; Halb|schat|ten; halb|schläch|tig** (veralt. für: nicht eindeutig einem Schlag [Ge-

schlecht] angehörend; schwankend); **Halb.schlaf** (vgl. ²Schlaf), **...schuh; halb|schü|rig** (Wolle: von halbjährlich geschorenen Schafen; übertr.: minderwertig); **Halb.schwer|ge|wicht** (Körpergewichtsklasse in der Schwerathletik), **...schwe|ster,...sei|de; halbsei|den;** ein halbseidenes Tuch, aber (↑ R 143): ein halb seidenes, halb wollenes Tuch; **halb|sei|tig; halb|staat|lich;** ein -er Betrieb, aber (↑ R 143): der Betrieb ist halb staatlich, halb städtisch; **Halb|star|ke** *m;* -n, -n (↑ R 287ff.); **Halb|stie|fel; halb|stock** (halbmast); **halb|stün|dig** (eine halbe Stunde dauernd), **halb|stünd|lich** (jede halbe Stunde); **Halbtags.ar|beit, ...schu|le; Halb|teil** (selten für: Hälfte; *s;* auch: *m*), **...ton** (Mehrz. ...töne); **halb|tot;** das halbtote Tier (↑ jedoch R 143), aber: das Tier ist halb tot; er wurde halb totgeschlagen, hat sich halbtotgelacht; **Halb|to|ta|le** (Film); **halb|voll;** ein halbvolles Glas (↑ jedoch R 143), aber: das Glas ist nur halb voll; **halb|wach;** in halbwachem Zustand (↑ jedoch R 143), aber: er war erst halb wach; **Halb.wahr|heit, ...wai|se; halb|wegs; Halb|welt** *w;* -; **Halb|werts|zeit** (Zeit, nach der eine physikal. Größe des Teilchens ihres Anfangswertes erreicht hat; Zeit, nach der die Hälfte einer Anzahl radioaktiver Atome zerfallen ist); **Halb|wis|sen; Halb|wis|se|rei** *w;* -; **Halb|wol|le; halb|wol|len;** ein halbwollenes Tuch, aber (↑ R 143): ein halb wollenes, halb baumwollenes Tuch; **halb|wüch|sig; Halb|wüch|si|ge** *m;* -n, -n (↑ R 287ff.); **Halb.zeit, ...zeug** (Halbfabrikat)

Hal|de *w;* -, -n

Ha|lér [*hálärsch*] (tschechoslowak. Münze; 100 Haléřů = 1 Krone) *m;* -, ...řů

Hal.fa usw. vgl. Alfa usw.

Hälf|te *w;* -, -n; bessere -(scherzh. für: Ehefrau, -mann); **hälf|ten**

¹Half|ter (Zaum ohne Gebiß) *m* od. *s;* -s, - (veralt.: *w;* -, -n)

²Half|ter (Pistolenbehälter, -tasche [am Sattel]) *w;* -, -n, auch: *s;* -s, -

half|tern (das ¹Halfter anlegen); ich ...ere (↑ R 327); **Half|ter|rie|men**

hälf|tig; Hälf|tung

Ha|li (Hornklang) *s;* -s, -[s]

Hal|kyo|ne [auch: *halkŭo...*] usw. vgl. Alkyone usw.

¹Hall *m;* -[e]s, -e

²Hall (Name mehrerer Orte); vgl. Haller

Hal|le *w;* -, -n

hal|le|lu|ja! hebr. („lobet den Herrn!"); **Hal|le|lu|ja** (liturg. Freudengesang) *s;* -s, -s; das - singen

hal|len (schallen)

Hal|len.bad, ...hand|ball, ...kirche, ...schwimm|bad

Hal|len|ser (Einwohner von Halle [Saale]); ↑ R 199

Hal|ler (Einwohner von ²Hall u. von Halle [Westf.]); ↑ R 199

Hal|lert|au, (auch:) **Hol|led|au** (Landschaft in Bayern) *w;* -

Hal|le (Saa|le) (Stadt an der mittleren Saale); vgl. Hallenser; **hallesch** vgl. hallisch

Hal|le (Westf.) (Stadt am Südrand des Teutoburger Waldes); vgl. Haller

Hal|ley|sche Ko|met [*hálesch^e* -; nach dem engl. Astronomen Halley (*háli*)] *m;* -n, -en

Hal|lig (kleine nordfries. Insel im Wattenmeer) *w;* -, -en; **Hal|li|gen** (nordfries. Inselgruppe im Wattenmeer) *Mehrz.;* **Hal|lig|leu|te** *Mehrz.*

Hal|li|masch (ein Pilz) *m;* -[e]s, -e

hal|lisch (auf Halle [Saale] bezüglich; aus, von Halle [Saale]), aber (↑ R 224): das Hallische Waisenhaus

häl|lisch vgl. schwäbisch-hällisch

Hall|jahr (im A. T.: Feier-, Jubeljahr)

hal|lo! [auch: *halo*]; - rufen; **Hal|lo** [auch: *halo*] *s;* -s, -s; mit großem -; **Hal|lo|dri** bayr. u. österr. (ausgelassener, auch leichtsinniger Mensch) *m;* -s, -[s]

Hal|lo|re (hist. Bez. für: Salinenarbeiter in Halle [Saale]) *m;* -n, -n (↑ R 268)

Hall|statt (Ort in Oberösterreich); **Hall|stät|ter See** *m;* - -s; **Hallstatt|zeit** (ältere Eisenzeit) *w;* -

Hal|lu|zi|na|ti|on lat. [...zion] (Sinnestäuschung); **hal|lu|zi|na|tiv; hal|lu|zi|nie|ren; hal|lu|zi|no|gen** (Med.: Medikament, das Halluzinationserscheinungen hervorruft; oft Rauschmittel)

Halm *m;* -[e]s, -e

Hal|ma gr. („Sprung"); ein Brettspiel) *s;* -s

Hälm|chen, Hälm|lein; Halm|frucht; ...hal|mig (z. B. vielhalmig)

Ha|lo gr. (Hof um eine Lichtquelle; Med.: Ring um die Augen; Warzenhof) *m;* -[s], -s od. ...onen

ha|lo... gr. (Salz...); **Ha|lo...** (Salz...); **ha|lo|gen** (salzbildend); **Ha|lo|gen** (salzbildende chem. Grundstoff) *s;* -s, -e; **ha|lo|ge|nie|ren** (Salz bilden); **Ha|lo|ge|nid, Ha|lo|id** (Metallsalz des Halogens) *s;* -[e]s; **Ha|lo|ge|nid|salz** od. **Ha|lo|id|salz; Ha|lo|gen.lam|pe,**

...schein|wer|fer; Ha|lo|phyt (Salzpflanze) m; -en, -en (↑ R 268) Hals m; -es, Hälse; - über Kopf; Hals- und Beinbruch; Hals|ab|schnei|der; hals|ab|schnei|de|risch; Hals_aus|schnitt, ...band (s; Mehrz. ...bänder), ...ber|ge (Teil der Rüstung; w; -, -n); hals|bre|che|risch; -ste (↑ R 294); Häls|chen, Häls|lein; hal|sen (nur noch selten für: umarmen; Seemannsspr.: ein Segelschiff auf die andere Windseite bringen); du halst (halsest); hals|fern; ein -er Kragen; Hals|ge|richt (im späten MA. Gericht für schwere Verbrechen); ...hal|sig (z. B. langhalsig); Hals_ket|te, ...kra|gen, ...krau|se; Häls|lein, Häls|chen; hals|nah; vgl. halsfern; Hals-Na|sen-Oh-ren-Arzt (Abk.: HNO-Arzt); Hals|schlag|ader; hals|star|rig; Hals|star|rig|keit; Hals|tuch (Mehrz. ...tü|cher); Hals über Kopf; Hals- und Bein|bruch! (ugs.); Hal|sung (Jägerspr.: Hundehalsband); Hals|wir|bel

¹halt landsch. (eben, wohl, ja, schon)

²halt!; halt! Wer da?; vgl. Werda; Halt m; -[e]s, -e; keinen - haben; - gebieten; haltmachen (vgl. d.); halt|bar; Halt|bar|keit w; -; Halte.bucht, ...gurt, ...li|nie; halt|machen (landsch., bes. österr. auch für: [Kühe] hüten); du hältst, er hält; du hieltst (hieltest); du hieltest; gehalten; halt[e]!; an sich -; ich hielt an mich; Hal|te|punkt; Hal|ter (landsch., bes. österr. auch für: Viehhirt)

Hal|te|re gr. (Zool.: verkümmerter Hinterflügel der Zweiflügler) w; -, -n (meist Mehrz.)

Hal|te|rin w; -, -nen

hal|tern (festmachen, festklemmen); ich ...ere (↑ R 327); Hal|te|rung (Haltevorrichtung)

Halt|te.stel|le, ...tau, ...ver|bot (amtl.: Haltverbot), ...zei|chen; hal|tig (Bergmannsspr.: Erz führend); ...hal|tig, (österr.:) ...häl|tig (z. B. mehlhaltig); halt|los; -este (↑ R 292); Halt|lo|sig|keit w; -; halt|ma|chen (↑ R 140); ich mache halt (↑ R 132); haltgemacht; haltzumachen; Halt|ma|chen s; -s; Hal|tung; Hal|tungs_feh|ler, ...no|te (Sport); Halt|ver|bot vgl. Halteverbot

Ha|lun|ke tschech. (Schuft, Spitzbube) m; -n, -n (↑ R 268); Ha|lun|ken|streich

Ham (bibl. m. Eigenn.)

Ha|ma|me|lis gr. (ein Zierstrauch, Heilpflanze) w; -

Hä|ma|tin gr. (eisenhaltiger Bestandteil des roten Blutfarbstoffes) s; -s; Hä|ma|ti|non (rote Glasmasse [im Altertum sehr beliebt]) s; -s; Hä|ma|tit (wichtiges Eisenerz) m; -s, -e; Hä|ma|to|lo|gie (Lehre vom Blut u. seinen Krankheiten) w; -; Hä|ma|tom (Blutgeschwulst, Bluterguß) s; -s, -e; Hä|ma|to|xy|lin (Pflanzenfarbstoff) s; -s; Hä|ma|to|zo|on (Blutschmarotzer) s; ...zoen (meist Mehrz.); Hä|mat|urie (Blutharnen) w; -, ...ien

Ham|burg (Land u. Hafenstadt an der unteren Elbe); Ham|burg-Ame|ri|ka Li|nie (so die von den Richtlinien [↑ R 203] abweichende Schreibung der Gesellschaft) w; - -; Ham|burg-Ame|ri|ka|ni-sche Packet|fahrt-Ac|tien-Ge-sell|schaft [Trenn.: - Pak|ket...; so die Firmenschreibung] (Kurzw.: Hapag) w; -n -; Ham|bur|ger (↑ R 199); ham|bur|ger|ge (hamburgisch sprechen); ich ...ere (↑ R 327); ham|bur|gisch

Ha|meln (Stadt an der Weser); Ha|mel|ner, (auch:) Ha|me|ler (↑ R 199); ha|melnsch

Ha|men (ein Fangnetz) m; -s, -

Ha|mil|kar (Name mehrerer karthagischer Heerführer)

Hä|min gr. (Salz des Hämatins; vgl. d.) s; -s, -e

hä|misch; -ste (↑ R 294)

Ha|mit [zu: Ham] (Angehöriger einer Völkergruppe in Afrika) m; -en, -en (↑ R 268); ha|mi|tisch; -e Sprachen

Ham|let (sagenhafter Dänenprinz)

Hamm (Stadt an der Lippe)

Ham|mel m; -s, - u. Hämmel; Ham|mel|bein; jmdm. die -e langziehen (ugs. für: jmdn. heftig tadeln; drillen); Ham|mel.bra|ten, ...her-de, ...keu|le, ...sprung (parlamentar. Abstimmungsform)

Ham|mer (ein Werkzeug) m; -s, Hämmer; Häm|mer|chen, ¹Häm|mer|lein; ²Häm|mer|lein u. Häm|mer|ling (veralt. für: böser Geist, Teufel); Meister - (Teufel; Henker, Scharfrichter); häm|mern; ich ...ere (↑ R 327); Ham|mer|.schmied, ...wer|fen (s; -s)

Ham|mond or|gel; ↑ R 180 [hä-m'̍nd...]; nach dem amerik. Erfinder Hammond] (elektroakustische Orgel)

Ham|mu|ra|bi (babylon. König)

Hä|mo|glo|bin gr.; lat. (roter Blutfarbstoff; Zeichen: Hb) s; -s; Hä|mo|phi|lie gr. (Med.: Bluterkrankheit) w; -, ...ien; Hä|mor|rha|gie (Med.: Blutung) w; -, ...ien; Hä|mor|rhoi|dal|lei|den [...o-i...]; Hä|mor|rhoi|de gr. (aus krankhaft erweitertem Mastdarmvenen gebildeter Knoten) w; -, -n (meist Mehrz.)

Ham|pel|mann (Mehrz. ...männer); ham|peln (zappeln); ich ...[e]le (↑ R 327)

Ham|ster (ein Nagetier) m; -s, -; Ham|ste|rer (Mensch, der [gesetzwidrig] Vorräte aufhäuft); Ham|ster|kauf; ham|stern; ich ...ere (↑ R 327)

Ham|sun (norw. Dichter)

Ha|na|ni|as vgl. Ananias

Hand w; -, Hände; Hand anlegen; letzter, linker, rechter Hand; freie Hand haben; von langer Hand [her] (lange) vorbereitet; an Hand (jetzt häufig: anhand) des Buches, an Hand von Unterlagen; etwas an, bei, unter der Hand haben; an etwas Hand anlegen; jmdm. an die Hand gehen; Hand in Hand arbeiten, die Hand in Hand Arbeitenden, aber (↑ R 156): das Hand-in-Hand-Arbeiten; von Hand zu Hand; das ist nicht von der Hand zu weisen (ist möglich); zur Hand sein; zu Händen (vgl. d.). I. Zusammenschreibung: allerhand, zuhanden (vgl. d.), abhanden (vgl. d.), kurzerhand (vgl. d.), unterderhand (vgl. d.), überhand, vorderhand (vgl. d.), vorhanden (vgl. d.), handhaben (vgl. d.), überhandnehmen (vgl. d.). II. Maßangaben: das Brett ist eine Hand breit, aber (als Maßeinheit) eine Handbreit (vgl. d.) Tuch ansetzen, der Enzel ist kaum handbreit; zwei Hände od. Hand breit, groß, lang (↑ R 322); er hat die eine Hand voll Kirschen, aber (als Mengenangabe): eine Handvoll Kirschen essen (↑ R 139); Hand|än|de|rung schweiz. (Wechsel im Grundbesitz); Hand|ar|beit; hand|ar|bei|ten; gehandarbeitet; vgl. aber: handgearbeitet; Hand|ar|bei|ter; Hand|ball; - spielen (↑ R 140), aber: das Handballspielen (↑ R 120); Hand.ball|len, ...bal|ler (Handballspieler), ...be|sen, ...be|we|gung; hand|breit; ein handbreiter Saum, aber: der Streifen ist eine Hand breit; Hand|breit w; -, -; (↑ R 139:) eine, zwei, keine Handbreit, aber: ein zwei Hand breiter Streifen; Hand|brem|se; Händ|chen, Hand|lein; Hän|de-.druck (Mehrz. ...drücke), ...klat-schen (s; -s)

¹Han|del (Kaufgeschäft) m; -s; - treiben; -s wegen; ²Han|del (Streit) m; -s, Händel (meist Mehrz. in Fügungen wie:) Händel suchen, Händel haben, sich in Händel einlassen

Hän|del (dt. Komponist)

Han|del-Maz|zet|ti (österr. Schriftstellerin)

han|deln; ich ...[e]le († R 327); es handelt sich um ...; Han|deln s; -s; Han|dels_ab|kom|men, ...aka|de|mie (österr. für: höhere Handelsschule), ...be|zie|hun|gen (Mehrz.), ...bi|lanz, ...brauch; han|dels_ei|nig od. ...eins; Han|dels_fir|ma, ...ge|richt, ...ge|sell|schaft, ...ge|setz|buch (Abk.: HGB), ...ha|fen (vgl. ¹Hafen), ...kam|mer, ...krieg, ...mann (Mehrz. ...leute, selten: ...männer), ...ma|ri|ne, ...or|ga|ni|sa|ti|on (DDR; Abk.: HO [vgl. d.]; w; -), ...platz, ...po|li|tik, ...recht, ...re|gi|ster, ...rei|sen|de, ...schiff, ...schu|le, ...span|ne, ...stand (m; -[e]s); han|dels_üb|lich, Han|del_sucht w; -; hän|del|süch|tig; Han|dels_ver|trag, ...ver|tre|ter, ...vo|lu|men; han|del|trei|bend, aber († R 142): ausgedehnten Handel treibend

Hän|de|rin|gen s; -s; hän|de|rin|gend, aber († R 142): die Hände ringend; Hän|de|wa|schen s; -s; Hand|fer|tig|keit; hand|fest; Hand|fe|ste (veralt. für: Urkunde); Hand_feu|er|waf|fe, ...flä|che; hand|ge|ar|bei|tet; ein -es Möbelstück; vgl. aber: handarbeiten; Hand|ge|brauch; hand|ge|bun|den; Hand_geld, ...ge|lenk; hand|ge|mein; - werden; Hand_ge|men|ge, ...ge|päck; hand_ge|schrie|ben, ...ge|strickt, ...ge|webt; Hand|gra|na|te; hand|greif|lich; - sein, werden; Hand|greif|lich|keit; hand|griff; hand|groß; ein -er Flecken, aber: eine zwei Hand große Platte; hand|hab|bar; Hand|hab|bar|keit w; -; Hand|ha|be w; -, -n; hand|ha|ben; du handhabst; du handhabtest; gehandhabt; er hat die Bestimmungen unparteiisch gehandhabt; zu -; das ist schwer zu handhaben; Hand|ha|bung; ...hän|dig (z. B. zweihändig); Hand|har|mo|ni|ka

¹an|di|kap engl. [hǟndikäp] (Benachteiligung, Behinderung; Sport: [Wettkampf mit] Ausgleichsvorgabe) s; -s, -s; han|di|ka|pen [...käpᵉn]; gehandikapt

¹and-in-Hand-Ar|bei|ten († R 156) s; -s; Hand-in-Hand-Ge|hen († R 156) s; -s; hän|disch österr. (manuell); Hand|kan|ten|schlag; ¹and|kehr|um schweiz. (svw. im Handkehrum); Hand|kehr|um veralt.), nur in: im - (schnell, unversehens); Hand_kä|se, ...kof|er, ...korb, ...kuß; hand|lang; ein er Schnitt, aber: der Schnitt war zwei Hand lang; Hand|lan|ger; ¹and|lan|ger|dienst (meist Mehrz.); hand|lan|gern; ich ...ere († R 327); Hand|lauf (an Treppengeländern)

Hand|ke (österr. Schriftsteller)
Händ|lein, Händ|chen
Händ|ler; Händ|ler|spra|che (eine Geheimsprache)
Hand|le|se|kunst w; -; Hand|le|se|rin; hand|lich; Hand|lich|keit w; -
Hand_lung, Hand_lungs_ab|lauf, ...be|voll|mäch|tig|te m u. w; hand|lungs_fä|hig (schweiz. Rechtsspr. auch für: geschäftsfähig); Hand|lungs_frei|heit, ...ge|hil|fe, ...rei|sen|de, ...wei|se w
Hand|ma|le|rei; Hand|mehr schweiz. (durch Handaufheben festgestellte Mehrheit) s; -s; Hand|or|gel schweiz. (Handharmonika); hand|or|gel|spie|len (schweiz.), Hand_pferd, ...pres|se, ...rei|chung, ...rücken [Trenn.: ...rük|ken]; hand|sam (österr., sonst veralt. für: handlich); Hand|schei|den (Hüttenw.: Teil der Aufbereitung der Erze) s; -s; Hand_schel|le (Fessel; vgl. ¹Schelle; meist Mehrz.), ...schlag, ...schrei|ben, ...schrift (in der Bedeutung „altes Schriftstück" Abk.: Hs., Mehrz. Hss.); Hand_schrif|ten_deu|ter, ...deu|tung, ...druck (Mehrz. ...drucke), ...kun|de (w; -), ...kun|di|ge, hand|schrift|lich, Hand_schuh; ein Paar -e; Hand_set|zer; hand|si|gniert, aber: von Hand signiert; Hand_spie|gel, ...stein (nordd. für: Ausguß), ...streich, ...ta|sche, ...tel|ler, ...tuch (Mehrz. ...tücher); Hand|um|dre|hen s; -s; im - (im Augenblick); Hand|voll w; -, -; († R 139:) eine, zwei, etliche, einige, ein paar -, aber: die Hand voll Geld; Hand_werk, ...wer|ker; Hand|wer|ker|stand m; -[e]s; Hand|werk|lich; Hand|werks_be|trieb, ...bur|sche, ...kam|mer, ...mann (veralt. für: Handwerker; Mehrz. ...leute), ...zeug; Hand_zei|chen, ...zeich|nung, ...zet|tel

Hands engl. [händs] österr. u. schweiz. (Fußball: Handspiel) s; -, -
ha|ne|bü|chen (ugs. für: derb, grob, unerhört); vgl. hagebüchen
Hanf (eine Faserpflanze) m; -[e]s; han|fen, hän|fen (aus Hanf); Hanf|garn; Hänf|ling (eine Finkenart); Hanf|sa|me[n]
Hang m; -[e]s, Hänge; hang|ab|wärts
Hän|gar germ.-fr. [auch: ...gãr] (Flugzeughalle) m; -s, -s
Hän|ge_backen [Trenn.: ...bak|ken] (Mehrz.), ...bank (Mehrz. ...bänke), ...bauch; Hän|ge_bauch|schwein; Hän|ge_bo|den, ...brücke [Trenn.: ...brük|ke], ...lam|pe; han|geln (Turnen); ich ...[e]le († R 327); Hän|gel|tau

(Klettertau) s; Hän|ge|mat|te; han|gen (älter, mdal. u. schweiz. für: ¹hängen); mit Hangen und Bangen; ¹hän|gen; du hängst; du hingst (hingest); du hingest; gehangen; häng[e]! die Kleider hingen an der Wand; der Rock hing an der Wand, hat dort gehangen; († R 120:) mit Hängen und Würgen (ugs. für: mit Müh und Not); hängende Gärten (terrassenförmig angelegte Gärten im Altertum), aber († R 224): die Hängenden Gärten der Semiramis; ²hän|gen; du hängst; du hängtest; gehängt; häng[e]!; ich hängte den Rock an die Wand, habe ihn an die Wand gehängt, hän|gen|blei|ben († R 139), ich bleibe hängen; hängengeblieben; hängenzubleiben; er ist an einem Nagel hängengeblieben; von dem Gelernten ist wenig hängengeblieben; aber: das Bild soll hängen bleiben (nicht abgehängt werden); Hän|gen|de (Bergmannsspr.: Gesteinsschichten über einer Lagerstätte) s; -n († R 287 ff.); hän|gen|las|sen; († R 139 vergessen) er hat seinen Hut hängenlassen, (seltener.) hängengelassen († R 305), aber: hän|gen las|sen; kann ich meinen Hut hier hängen lassen?; er hat den Verräter hängen lassen; Hän|ge|par|tie (Schach: abgebrochene Partie, die noch fortgeführt werden muß); Hän|ger (eine Mantelform; auch für: [Fahrzeug]anhänger); Hän|gerl österr. mdal. (Lätzchen; Wischtuch [der Kellner]) s; -s, -[n]; Hän|ge_schloß, ...hän|ge|lig schweiz. (schwebend, unerledigt); Hang|tä|ter
Han|na, Han|ne (Kurzformen von: Johanna)
Han|na|ke (Angehöriger eines tschech. Volksstammes) m; -n, -n († R 268)
Hann|chen (Koseform von: Hanna, Hanne); Han|ne|lo|re (w. Vorn.); Han|ne|mann (Koseform von: Hans, Johannes); Han|nes (Kurzform von: Johannes)
Han|ni|bal (karthag. Feldherr)
Hann. Mün|den [hanofᵉrschmün-dᵉn] (post- u. bahnamtl. Schreibung von: Münden)
Han|no (m. Vorn.)
Han|no|ver [...fᵉr] (Stadt a. d. Leine); Han|no|ve|ra|ner [...wᵉ... od. ...fᵉ...]; han|no|ve|risch, han|nö|ve|risch, han|nö|ver|sch, han|nö|versch [...fᵉ...], aber († R 116): im Hannöverschen
Ha|noi [hanoi] (Hptst. von Nordvietnam)
Ha|no|mag Ⓦ (ehem. Kraftfahrzeugmarke)

Hans (Kurzform von: Johann, Johannes; Hans' Mütze (↑ R 310); - im Glück; - Liederlich; - Taps; vgl. Hansdampf, Hansnarr, Hanswurst; (↑ R 224:) der blanke - (Nordsee bei Sturm)

Han|sa vgl. Hanse usw.

Han|sa|plast Ⓦ (ein Verbandpflaster) s; -[e]s

Häns|chen (Koseform von: Hans); Hans|dampf [auch: hanß...] m; -[e]s, -e; - in allen Gassen; vgl. Hans

Han|se (mittelalterl. niederd. Kaufmanns- u. Städtebund) w; -; Han|se|at (Mitglied der Hanse; Hansestädter) m; -en, -en (↑ R 268); Han|sea|ten|geist m; -[e]s; han|sea|tisch; vgl. hansisch; Han-se_bund (m; -[e]s), ...kog|ge

Han|sel, Hän|sel, Hansl (Koseformen von: Hans)

Han|sel|bank vgl. Heinzelbank

Hän|se|lei; hän|seln (necken); ich ...[e]le (↑ R 327)

Han|se|stadt; han|se|städ|tisch

Han|si (Koseform von: Hans, Johanna)

han|sisch (hansestädtisch), aber (↑ R 224): die Hansische Universität (in Hamburg)

Hans|joa|chim; Hansl, Han|sel (vgl. d.); Hans|narr [auch: hanß...]; Hans Taps; vgl. Taps; Hans|wurst [auch: hanß...] m; -[e]s, -e (scherzh. auch: ...würste); Hans|wur|ste|rei; Hans|wur|stia-de

Han|tel (Handturngerät) w; -, -n; han|teln; ich ...[e]le (↑ R 327)

han|tie|ren niederl. (handhaben; umgehen mit ...); Han|tie|rung

han|tig bayr., österr. (bitter, scharf; heftig, unwillig)

Ha|pag (Kurzw. für: Hamburg-Amerikanische Packetfahrt-Actien-Gesellschaft) w; -

ha|pe|rig, hap|rig niederl. (stokkend); ha|pern; es hapert (geht nicht vonstatten; fehlt [an])

ha|plo|id gr. (Biol. [von Zellen]: mit einfachem Chromosomensatz)

Häpp|chen, Häpp|lein; hap|pen nordd. (einen Biß machen, zubeißen); Hap|pen m; -s, -

Hap|pe|ning engl. [häp°ning] (Bez. für eine bestimmte Art der Kunstveranstaltung) s; -s, -s; Hap|pe|nist (↑ R 268)

hap|pig bes. nordd. (gierig; ungewöhnlich stark); Häpp|lein, Häpp|chen

Hap|py-End, (auch:) Happy|end engl. [häpi änd] („glückliches Ende", guter Ausgang) s; -[s], -s

hap|rig vgl. haperig

har! (Ruf an die Pferde: links!)

Ha|ra|ki|ri jap. (heute offz. nicht mehr übl. Art des rituellen Selbstmordes durch Bauchaufschneiden in Japan) s; -[s], -s

Ha|rald (m. Vorn.)

Ha|raß fr. (Lattenkiste [zum Verpacken von Glas od. Porzellan]) m; ...rasses, ...rasse

Här|chen, Här|lein [zu: Haar]

Har|de (früher in Schleswig-Holstein: Verwaltungsbezirk von mehreren Dörfern od. Höfen) w; -, -n; Har|des|vogt (Amtsvorsteher einer Harde)

Hardt (Teil der Schwäb. Alb) w; -; vgl. aber: Haard u. Haardt

Hard|top engl. (abnehmbares, nicht faltbares Verdeck von Kraftwagen, bes. Sportwagen; auch der Wagen selbst) s od. m; -s, -s; Hard|ware [ha͞ᵈd°ä͞ᵈ] (Datenverarbeitung: die apparativen [„harten"] Bestandteile der Anlage; Ggs.: Software) w; -, -s

Ha|rem arab. („Unzugängliches"; von Frauen bewohnter Teil des islam. Hauses; auch die Frauen darin) m; -s, -s

hä|ren (aus Haar); -es Gewand

Hä|re|sie gr. (Ketzerei) w; -, ...ien; Hä|re|ti|ker (Ketzer); hä|re|tisch

Har|fe w; -, -n; har|fen; har|fe|nist (Harfenspieler) ↑ R 268; Har|fe-ni|stin w; -, -nen; Har|fen_klang, ...spiel (s; -[e]s); Harf|ner (veralt. für: Harfenspieler)

Har|ke nordd. (Rechen) w; -, -n; har|ken (rechen)

Här|lein vgl. Härchen

Har|le|kin fr. [härlekin] (Hanswurst; Narrengestalt) m; -s, -e; Har|le|ki|na|de (Hanswursterei); har|le|ki|nisch

Harm m; -[e]s; här|men, sich; harm|los; -este (↑ R 292); Harm|lo|sig|keit

Har|mo|di|os vgl. Harmodius; Har|mo|di|us (athen. Tyrannenmörder, Freund Aristogitons)

Har|mo|nie gr. w; -, ...ien; Har|mo|nie|leh|re; har|mo|nie|ren; har|mo|nik (die für die jeweilige Epoche kennzeichnende Interpretation u. Ausgestaltung der Harmonie) ẇ; -; Har|mo|ni|ka (ein Musikinstrument) w; -, -s u. ...ken; har|mo|nisch; -ste (↑ R 294); -e Funktion (Math.); har|mo|ni|sie|ren (in Einklang bringen, stehen); Har|mo|ni|sie|rung; Har|mo|ni|um (Tasteninstrument) s; -s, ...ien [...iᵉn] od. -s

Harn m; -[e]s, -e; Harn|bla|se; har|nen

Har|nisch ([Brust]panzer) m; -[e]s, -e; jmdn. in - (in Wut) bringen

Harn_lei|ter ...röh|re, ...ruhr (für: Diabetes), ...säu|re, ...stoff; harn|trei|bend

Har|pu|ne niederl. (Wurfspeer [für den Walfang]) w; -, -n; Har|pu|nen_ka|no|ne, ...wer|fer; har|pu|nier m; -s, -e u. Har|pu|nie|rer (Harpunenwerfer); har|pu|nie|ren

Har|py|ie [...püi°] (Sturmdämon in Gestalt eines vogelartigen Mädchens in der gr. Sage; ein Raubvogel) w; -, -n

har|ren

Har|ri (dt. Schreibung von: Harry); Har|ro (m. Vorn.); Har|ry [häri] (Koseform von: Henry)

harsch; -este (↑ R 292); Harsch (hartgefrorener Schnee) m; -[e]s, har|schen (hart, krustig werden) der Schnee harscht; har|schig

Harst (Vorhut eines altschweiz Heeres; Schar) m; -[e]s, -e

hart; härter, härteste; hart au hart; -e Währung. Schreibung in Verbindung mit dem 2. Mittel wort: das hartgewordene Bro (↑ jedoch R 142); aber: das Bro ist hart geworden; hartgebrann ter Stein (↑ jedoch R 142), abe der Stein ist hart gebrannt; Hart brand|zie|gel; Här|te w; -, -n; Här te_aus|gleich, ...fall m, ...grad graph; Här|ter; Här|te_rei; hart ge|brannt; vgl. hart; hart|ge kocht; vgl. hart; Hart|geld s; -[e]s hart|ge|sot|ten; -er Sünder; Hart gum|mi m; hart|her|zig; Hart|her zig|keit w; -, (selten:) -en; Hart _heu (eine Pflanze), ...holz hart|hö|rig; Hart|hö|rig|keit w; - Hart|kä|se; hart|köp|fig; Hart köp|fig|keit w; -; hart|lei|big Hart|lei|big|keit w; -; Hart|lin (Erhebung, die aus abgetra genem Gestein aufragt; Zwi schenprodukt beim Ver hütten eisenhaltiger Zinn erze)

Hart|mann (m. Vorn.)

hart|mäu|lig; Hart|mäu|lig|keit w -; Hart_me|tall, ...platz (Tennis Ggs.: Rasenplatz)

Hart|mut (m. Vorn.)

hart|näckig [Trenn.: ...näk|kig Hart|näckig|keit [Trenn.: ...näk kig...] w; -

Hart|rie|gel (ein Strauch) m; - -; hart|rin|dig

Hart|schier it. („Bogenschütze" Leibwächter [der bayr. Könige m; -s, -e

Hart|spi|ri|tus (ein Brennstoff Har|tung (Januar) m; -s, -e; Hä tung

Hart|wig (m. Vorn.)

Ha|ru|spex lat. (aus den Eingewe den von Opfertieren Wahrsage der) m; -, -e u. ...spizes; Ha|ru|s zi|um (Wahrsagung aus den Ein geweiden) s; -s, ...ien [...iᵉn od.

Har|vard|uni|ver|si|tät [...wᵉrd...; nach dem Mitbegründer J. Harvard] (in Cambridge [Mass.]) w; - (↑ R 180)

¹Harz (Stoffwechselprodukt verschiedener Pflanzen) s; -es, -e

²Harz (ein Gebirge) m; -es

har|zen (Harz ausscheiden; schweiz. auch für: schwer, schleppend vonstatten gehen)

¹Har|zer [zu: ²Harz] († R 199); - Käse; - Roller (Kanarienvogel);

²Har|zer (eine Käseart) m; -s, -

har|zig (schweiz. auch für: schwierig); Harz|säu|re

Ha|sard fr. (Kurzform für: Hasardspiel) s; -s; Ha|sar|deur [...ø̈r] (Glücksspieler) m; -s, -e; Ha|sar|deu|se [...ȫsᵉ] w; -, -n; ha|sar|die|ren (auch für: wagen); Ha|sard|spiel (Glücksspiel)

Hasch (ugs. für: Haschisch) s; -s

Ha|schee fr. (Gericht aus feinem Hackfleisch) s; -s, -s

ha|schen (fangen); du haschst (haschest); sich -

ha|schen (ugs. für: Haschisch rauchen); du haschst

ha|schen s; -s; - spielen

Häs|chen, Häs|lein

Ha|scher österr. ugs. (armer, bedauernswerter Mensch)

Ha|scher (ugs. für: Haschischraucher)

Hä|scher (veralt. für: Büttel; Gerichtsdiener)

Ha|scherl bayr. u. österr. ugs. (bedauernswertes Kind, bedauernswerter Mensch) s, -s, -n

a|schie|ren (Haschee machen) s; -

Ha|schisch arab. (ein Rauschgift) s; -

Ha|se m; -n, -n († R 268); († R 224:) falscher Hase (Hackbraten)

Ha|sel (ein Fisch) m; -s, -

Ha|sel (ein Strauch) w; -, -n; Ha|sel.busch, ...huhn, ...maus, ...nuß; Ha|sel|nuß|strauch; Ha|sel.stau|de, ...wurz (eine Pflanze; w; -)

Ha|sen.bra|ten, ...fell, ...fuß; ha|sen|fü|ßig; Ha|sen|herz; ha|sen.er|zig; Ha|sen.jun|ge (österr. für: Hasenklein; s; -n), ...klein [Gericht aus] Innereien, Kopf u. Vorderläufen des Hasen; s); Ha|sen|pa|nier s, nur in: das - ergreifen (ugs. für: fliehen); ha|sen.pfef|fer (Hasenklein); ha|sen.rein; Ha|sen|schar|te; Hä|sin w; -, -nen; Häs|lein, Häs|chen; Has|lin|ger österr. (ein Stock aus Haselholz)

Has|pe (Tür- od. Fensterhaken) w; -, -n; Has|pel (Garnwinde; Gerbereibottich; Seilwinde) w; -; n (seltener: m; -s, -); has|peln; ich ...[e]le († R 327); Has|pen (Nebenform von: Haspe) m; -s, -

(hassest); gehaßt; hasse! u. haß!; has|sens|wert; Has|ser; haß|er|füllt, aber († R 142): von Haß erfüllt; häs|sig schweiz. mdal. (mürrisch, verdrießlich); häßlich; Häß|lich|keit; Haß|lie|be Hast w; -; ha|sten; ha|stig; Ha|stig|keit w; -

hät|scheln; ich ...[e]le († R 327) hat|schen bayr., österr. ugs. (lässig, schlendernd gehen, auch: hinken); du hatschst; Hatsch (langer Marsch); ausgetretene Schuhe m; -s, -

hat|schi![!], hat|zi! [auch: hat...] (das Niesen nachahmend)

Hat-Trick engl., (auch) Hat|trick [hät-trik] (dreimaliger Torerfolg hintereinander durch denselben Spieler [Fußball]; auch allg. für: dreifacher Erfolg) m; -s, -s

Hatz (bayr. für: Hetze; Jägerspr.: Hetzjagd mit Hunden) w; -, -en

hat|zi! vgl. hatschi!

Hatz|rü|de

Hau (veralt., noch mdal. auch für: Hieb) m; -[e]s, -e; vgl. ²Haue

Hau|bank (Schieferdeckergerät; Mehrz. ...bänke); Hau|bar|keits|al|ter (Forstw.)

Häu|ble, Häub|lein; Hau|be w; -, -n; Hau|ben.ler|che, ...tau|cher

Hau|bit|ze tschech. (Flach- u. Steilfeuergeschütz) w; -, -n

Hauch m; -[e]s, (selten:) -e; hauchdünn; hau|chen; hauch.fein, ...haft; Hauch|laut; hauch|zart

Hau|de|gen (alter, erprobter Krieger)

¹Haue südd., österr. (Hacke) w; -, -n; ²Hau|e (ugs. für: Hiebe) w; - - (eigtl. Mehrz. zu: Hau); - kriegen; hau|en; du haust; du hautest (für: „mit dem Säbel, Schwert schlagen, im Kampfe verwunden" u. gehoben: hiebest); gehauen (landsch.: gehaut); hau[e]!; sich -; er hat Holz gehauen; er hat ihm (auch: ihn) ins Gesicht gehauen; gehauen und gestochen; Hau|er (Bergmann mit abgeschlossener Ausbildung; österr. svw. Weinhauer, Winzer; Jägerspr.: Eckzahn des Keilers; s); Häu|er österr. (Hauer [Bergmann])

Häuf|chen, Häuf|lein; Hau|fe (seltener für: Haufen) m; -ns, -n; häu|feln; ich ...[e]le († R 327); Hau|fen m; -s, -; zuhauf; häu|fen; sich -; Hau|fen|dorf; hau|fen|wei|se; Hau|fen|wol|ke

Hauff (dt. Dichter)

häu|fig; Häu|fig|keit w; -, (selten:) -en; Häuf|lein, Häufl|chen; Häu|fung; Hauf|werk, Hau|werk (Bergmannsspr.: durch Hauen erhaltenes Roherzeugnis) s; -[e]s

Hau.he|chel (Heilkraut; w; -, -n), ...klotz, ...land (Siedlungsart [Dorfart]; Mehrz. ...landereien)

Häu|nel österr. (kleine ¹Haue) s; -s, -n

Haupt s; -[e]s, Häupter; zu Häupten; drei - (Stück) Rinder († R 322); haupt|amt|lich; Haupt.au|gen|merk, ...bahn|hof (Abk.: Hbf.), ...be|ruf; haupt|be|ruf|lich; Haupt.buch, ...dar|stel|lor; Häuptel südd., österr. (Kopf einer Gemüsepflanze, z. B. von Salat) s; -s, -[n]; Häup|tel|sa|lat österr. (Kopfsalat); Haupt|es|län|ge; um -; Haupt.fach, ...film, ...ge|bäu|de, „ge|winn, ...haar, ...ha|fen (vgl. ²Hafen); Häupt|ling; haupt|lings; ¹Haupt|mann (Mehrz. ...leute)

²Haupt|mann, Gerhart (dt. Dichter)

Haupt.per|son, ...por|tal, ...post, .pro|be, ...quar|tier, ...rol|le, ...sa|che; haupt|säch|lich; Haupt.sai|son, ...satz, ...schlag|ader, ...schu|le, ...schwie|rig|keit, ...stadt (Abk.: Hptst.); haupt|städ|tisch; Haupt.stra|ße, ...teil m, ...the|ma, ...tref|fer; Haupt- und Staats|ak|ti|on († R 145); Haupt.ver|hand|lung, ...ver|kehrs|stra|ße, ...ver|le|sen (schweiz. Milit.: abendlicher Appell; s; -s, -), ...ver|samm|lung, ...wert, ...wort (für: Substantiv; Mehrz. ...wörter); Haupt|wör|te|rei (abwertend für: Nominalstil); haupt|wört|lich; Haupt.zeu|ge, ...ziel

hau ruck!, ho ruck!; Hau|ruck s; -s; mit einem kräftigen -

Haus s; -es, Häuser; außer [dem] Hause; außer Haus; zu, nach Hause (auch: Haus); von Hause; von Haus aus; von Haus zu Haus; von zu Haus[e] (ugs.); im Hause (auch: Haus; Abk.: i. H.), vgl. Zuhause

Hau|sa vgl. Haussa

Haus.an|ge|stell|te w, ...an|zug, ...apo|the|ke, ...arzt, ...auf|ga|be; Haus.bau (Mehrz. ...bauten), ...be|sit|zer, ...be|sor|ger (österr. neben: Hausmeister), ...be|woh|ner; Haus|brand.koh|le, ...ver|sor|gung; Häus|chen (s; -s, - u. Häuserchen); Häu|sel, Häusl (s; -s, -), Häus|lein, Häusl.da|me; Haus.durch|su|chung österr. (Haussuchung); hau|sen (schweiz. mdal. u. westd. auch für: sparen); du haust (hausest); er haust

Hau|sen (ein Fisch) m; -s, -; Hau|sen|bla|se (Fischleim) w; -

Hau|ser bayr., westösterr. (Haushälter, Wirtschaftsführer); Häu-

ser‿block (*Mehrz.* ...blocks), ...front; Hau|se|rin, Häu|se|rin bayr., westösterr. (Haushälterin) *w*; -, -nen; Häu|ser‿meer, ...rei|he; Haus‿flur *m*, ...frau; Haus|frau|en|bri|ga|de (DDR); haus|frau|lich; Haus‿freund, ...frie|dens|bruch, ...ge|hil|fin; haus|ge|macht; -e Nudeln; Haus‿ge|mein|schaft, ...ge|nos|se, ...halt (*m*; -[e]s, -e); haus|hal|ten (↑R 140); er hält haus (↑R 132); hausgehalten; hauszuhalten; Haus|hal|ter od. ...häl|ter; Haus|häl|te|rin *w*; -, -nen; haus|häl|te|risch; -ste (↑R 294); Haus|halt[s]‿aus|gleich, ...aus|schuß, ...de|bat|te, ...de|fi|zit, ...fehl|be|trag, ...fra|ge, ...füh|rung, ...geld, ...ge|rät, ...ge|setz, ...jahr, ...kas|se, ...mit|tel (*Mehrz.*), ...ord|nung, ...plan, ...pla|nung, ...po|li|tik, ...po|sten, ...sum|me; Haus|hal|tung; Haus|hal|tungs‿schu|le, ...vor|stand; Haus|halt‿wa|ren *Mehrz.*; Haus|herr; haus|hoch; haushohe Wellen; Haus|hof|mei|ster; haus|sie|ren (von Haus zu Haus Handel treiben); Hau|sie|rer; ...häu|sig (z. B. einhäusig); Haus|ju|rist; Häusl vgl. Häusel; Häus|lein vgl. Häuschen; Häus|ler (Tagelöhner mit kleinem Grundbesitz); Haus|leu|te (Hausmann u. dessen Frau) *Mehrz.*; vgl. Hausmann; häus|lich; Häus|lich|keit *w*; -; Haus|ma|cher‿art (*w*; -; nach -), ...wurst; Haus‿macht, ...mann (*Mehrz.* ...männer); vgl. Hausleute Haus|man|nit (ein Mineral) *m*; -s Haus|manns|kost; Haus‿mar|ke, ...mei|er (Vorsteher der merowing. Hofhaltung), ...mei|ster (schweiz. ugs. für: Hauseigentümer, Hausverwalter), ...mu|sik, ...num|mer, ...ord|nung, ...pfle|ge|rin, ...putz, ...rat (*m*; -[e]s) Haus|sa, (auch:) Hau|sa (Angehöriger eines afrik. Negermischvolkes) *m*; -[s], -[s] Haus|samm|lung; ¹haus|schlach|ten (nur in der Grundform u. im 2. Mittelw. gebr.); hausgeschlachtet; ²haus|schlach|ten; -e Wurst; Haus‿schlach|tung, ...schlüs|sel, ...schuh Hausse *fr.* [*hoß*] ([starkes] Steigen der Börsenkurse; allg. Aufschwung der Wirtschaft) *w*; -, -n; Haus|sier [*hoßie̯*] (auf die Hausse Spekulierender) *m*; -s, -s Haus‿stand (*m*; -[e]s), ...su|chung od. (österr.:) Haus|durch|su|chung, ...tier, ...tür, ...ur|ne (vorgeschichtl. Tongefäß), ...ver|wal|ter, ...wart, ...war|tin (schweiz.), ...we|sen (*s*; -s), ...wirt, ...wirt|schaft, ...wurz (eine Pflanze; *w*; -), ...zins (südd. für: Miete;

Mehrz.: ...zinse); Haus[-zu]-Haus-Ver|kehr (bahnamtl.: Beförderung mit Containern); ↑R 155 Haut *w*; -, Häute; (↑R 156:) zum Aus-der-Haut-Fahren; Haut‿arzt, ...aus|schlag, ...bank (*Mehrz.* ...banken); Häut|chen; Häut|lein; Haut|cre|me Haute Cou|ture *fr.* [(*h*)ọt kutụ̈r] (das die europ. [Kleider]mode schaffende Kunsthandwerk, bes. in Paris) *w*; - -; Haute-Couture-Modell (↑R 155); Haute|fi|nance [ọtfinã̱ŋßß] (Hochfinanz) *w*; -; Haute|lisse [(*h*)ọtlị̈ß] (Webart mit senkrechter Kette) *w*; -, -n [...lị̈-ß‿n]; Haute|lisse|stuhl häu|ten; sich -; haut|eng; -es Kleid Haute|vo|lee *fr.* [(*h*)ọtwolẹ̱] (vornehmste Gesellschaft) *w*; - Haut‿far|be, ...fet|zen, ...flüg|ler; haut|freund|lich; ein -er Stoff Haut|gout *fr.* [*ogụ̈*] (scharfer Wildgeschmack; übertr. für: Anrüchigkeit) *m*; -s häu|tig; Haut‿jucken [*Trenn.*: ...juk|ken], ...kli|nik, ...krank|heit, ...krebs; Häut|lein, Häutchen; haut|nah; Haut|pfle|ge Haut|re|li|ef *fr.* [(*h*)ọreliạ̈f] (Hochrelief); Haut-Sau|ternes [*oßotạ̈rn*] (ein südwestfr. Weißwein) *m*; - haut‿scho|nend, ...sym|pa|thisch; Haut|trans|plan|ta|ti|on; Häu|tung Hau|werk vgl. Haufwerk Ha|va|na (engl. Schreibung von: Havanna); ¹Ha|van|na [*hawạna*] (Hptst. Kubas); span. Habana; ²Ha|van|na (Havannazigarre) *w*; -, -s; Ha|van|na|zi|gar|re (↑R 201) Ha|va|rie *arab.* [*hawa*...] (Seeschaden, den Schiff od. Ladung erleidet; bei Flugzeugen: Bruch, Unfall, österr. auch bei Kraftfahrzeugen) *w*; -, ...ien; ha|va|riert ([see]beschädigt [österr. auch bei Kraftfahrzeugen]; verdorben); Ha|va|rist (havariertes Schiff; Eigentümer eines havarierten Schiffes) *m*; -en, -en (↑R 268) Ha|vel [*haf‿l*] (r. Nebenfluß der Elbe) *w*; -; Ha|vel|land (vgl. ↑R 201) *s*; -[e]s; ha|vel|län|disch Ha|ve|lock [*haw‿lok*] (ärmelloser Herrenmantel mit Schulterkragen) *m*; -s, -s Ha|ve|rei [*haf*...] (älter für: Havarie) *w*; -, -en Ha|waii (Hauptinsel der Hawaii-Inseln im Pazif. Ozean; Staat der USA [vgl. Hawaii-Inseln]); Ha|waii‿gi|tar|re; Ha|waii-In|sel; ↑R 148 (eine der Hawaii-Inseln) *w*; -, -n; die Hawaii-Inseln (Inselgruppe im Pazif. Ozean, die den Staat Hawaii [vgl. d.] bildet) *Mehrz.*; ha|wai|isch

Ha|xe (südd. Schreibung von: Hachse) *w*; -, -n Haydn (österr. Komponist); haydnsch, aber (↑R 179): Haydnsch; -e Symphonie Ha|zi|en|da span. (Landgut, südamerik. Farm) *w*; -, -s (auch: ...den) Hb = Hämoglobin HB = Brinellhärte H.B. = Helvetisches Bekenntnis Hbf. = Hauptbahnhof H-Bom|be; ↑R 150 [*ha̱*...; nach dem chem. Zeichen H = Wasserstoff] (Wasserstoffbombe) h. c. = honoris causa HD = Hilfsdienst[pflichtiger] (in der Schweiz) H-Dur [*ha̱dur*], auch: *ha̱dur* (Tonart; Zeichen: H) *s*; -; H-Dur-Ton|lei|ter [*ha̱*...] (↑R 155) he!; heda! He = chem. Zeichen für: Helium Head|line *engl.* [*hạ̈dlain*] (engl. Bez. für: Schlagzeile) *w*; -, -s Hea|ring *engl.* [*hịring*] (engl. Bez. für: Verhör; öffentliche, parlamentarius Anhörung) *s*; -[s], - Hea|vi|side [*hạ̈wißaid*] (engl. Phy siker); Hea|vi|side|schicht; ↑R 180 (svw. Kennelly-Heaviside-Schicht) *w*; - Heb|am|me *w*; -, -n Heb|bel (dt. Dichter) He|be (gr. Göttin der Jugend Mundschenkin der Götter) He|be‿baum, ...fi|gur (Sport) ¹He|bel (dt. [Mundart]dichter) ²He|bel *m*; -s, -; He|bel‿arm ...griff; he|beln; he|ben; du hob (hobest, veralt.: hub[e]st; d höbest (veralt.: hübest); gehc ben; heb[e]!; sich - He|be|prahm; He|ber; He|be‿schmaus (Richtfest), ...werk He|brä|er (nicht offz. Bez. für: An gehörige des Volkes Israel); He brä|er|brief *m*; -[e]s; ↑R 205; he brä|isch; -e Schrift; vgl. deutsch He|brä|isch (Sprache) *s*; -[s]; vg Deutsch; He|brä|sche *s*; -n; vg Deutsche *s*; He|bra|ist (Forsche u. Kenner des Hebräischen); ↑ 268; He|bra|istik (wissenschaft Erforschung der hebräische Sprache u. Literatur) *w*; - He|bri|den (schott. Inselgruppe *Mehrz.*; die Neuen- (Inselgrupp im Pazifischen Ozean); Äußer u. Innere - He|bung He|chel *w*; -, -n; He|che|lei; h cheln; ich ...[e]le (↑R 327); He chel|re|de Hech|se (Nebenform von: Hac se) Hecht *m*; -[e]s, -e; hecht|blau; hech ten (ugs. für: einen Hechtsprur machen); hecht|grau; Hech

...rol|le (eine Bodenturnübung), ...sprung

He|ck (Schiffshinterteil) s; -[e]s, -e od. -s; [2]Heck niederd. (Gattertür, Koppel) s; -[e]s, -e; Heck|an|trieb; [1]Hecke[1] (Umzäunung aus Sträuchern) w; -, -n

Hecke[1] (Nistplatz; Brutzeit; Brut) w; -, -n; hecken[1] (von Vögeln und kleineren Säugetieren: Junge zur Welt bringen)

Hecken[1]|ro|se, ...schüt|ze; Heckflos|se (schmückendes Teil an der Karosserie mancher Autos; meist Mehrz.); heck|la|stig; Heck|la|ter|ne

Heck|meck (ugs.; Geschwätz, Unsinn; unnötige Umstände) m; -s

Heck|mo|tor

Heck|pfen|nig [zu: hecken]

He|cu|ba vgl. Hekuba

e|da!

He|de (Kurzform von: Hedwig)

He|de niederd. (Werg) w; -, -n; he|den niederd. (aus [2]Hede gemacht)

He|de|rich (ein Unkraut) m; -s, -e

He|din, Sven (schwed. Asienforscher)

He|do|ni|ker, He|do|nist gr. (Anhänger des Hedonismus); ↑ R 268; He|do|nis|mus (ethische Lehre der gr. Philosophie, nach der Glück u. Ziel der Menschen im Gefühl der Lust besteht) m; -

e|dschas (seit 1922 mit Nedschd zu Saudi-Arabien verbunden);

He|dschas|bahn w; -

e|dschra arab. („Loslösung"; Übersiedlung Mohammeds von Mekka nach Medina; Beginn der islam. Zeitrechnung) w; -

ed|wig (w. Vorn.)

...eer s; -[e]s, -e; Heer|bann; Heeres|be|richt, ...lei|tung, ...macht; Hee|res|zug, Heer|zug; Heer|führer, ...la|ger (Mehrz. ...lager), ...schar, ...schau, ...stra|ße, ...we|sen; Heer|zug, Hee|res|zug

...e|fe w; -, -n; He|fe|...(veralt., aber noch landsch.: Hefen)ku|chen, ...stück|chen (Kleingebäck), ...teig; he|fig

[...e]f|ner|ker|ze; ↑ R 180 [nach dem [...]t. Elektrotechniker] (frühere Lichtstärkeeinheit; Zeichen: HK)

[...e]ft s; -[e]s, -e; Hef|tel landsch. (Häkchen, Spange) s; -s, -; heff|ln; ich ...[e]le (↑ R 327); heff|ten; ge|heftet (Abk.: geh.); die Akten wurden geheftet; Hef|ter (Mappe zum Abheften); Heft|fa|den [...]tig; Hef|tig|keit

...ft|klam|mer, ...la|de (Gerät in der Buchbinderei), ...pfla|ster, ...zwecke[1]

...renn.: ...k|k...

He|gau (Landschaft am Bodensee) m; -[e]s

He|ge (alle Maßnahmen zur Pflege u. zum Schutz des Wildes) w; -

He|gel (dt. Philosoph); He|ge|lia|ner (Anhänger Hegels); he|ge|lia|nisch, he|gelsch, aber (↑ R 179): He|ge|lia|nisch, He|gelsch

He|ge|mei|ster (Forstbeamter)

he|ge|mo|ni|al (den Herrschaftsbereich seines Staates) betreffend); He|ge|mo|ni|al... gr. (Vorherrschafts...); He|ge|mo|nie („Führerschaft"; [staatliche] Vorherrschaft) w; -, ...ien; he|ge|mo|nisch

he|gen; He|ger; He|ge|ring (kleinster jagdlicher Bezirk); He|ge|ring|lei|ter m; He|ge|zeit

Hehl s (auch: m); kein (auch: keinen) - daraus machen; heh|len; Heh|ler; Heh|le|rei; Heh|le|rin w; -, -nen

hehr (erhaben; heilig)

hei!; Heia (Kinderspr. für: Bett) w; -, -[s]; Heia|bett; heia|po|peia!, heio|po|peia!, eia|po|peia!; hei|da! [auch: haida]

[1]Hei|de (Nichtchrist; Nichtjude; der Ungetaufte. auch: Religionslose; jmd., der nicht an einen Gott glaubt) m; -n, -n (↑ R 268)

[2]Hei|de (sandiges, unbebautes Land; Heidekraut) w; -, -n

Hei|deg|ger (dt. Philosoph)

Hei|de.korn (s; -[e]s), ...kraut (s; -[e]s),...land (s; -[e]s); Hei|del|bee|re; Hei|del|beer|kraut s; -[e]s

Hei|del|berg (Stadt am unteren Neckar)

Hei|de|ler|che

Hei|den ostösterr. (Buchweizen) m; -s

Hei|den... (ugs. für: groß, sehr viel, z. B. Heidenangst, Heidenarbeit, Heidengeld, Heidenlärm); Hei|den|chri|sten|tum s; -s; hei|den|mä|ßig (ugs. für: sehr, groß)

Hei|de[n].rös|chen od. ...rös|lein

Hei|den.tum (s; -s), ...volk

Hei|de|ro|se

hei|di! [auch: haidi] niederd. (lustig!; schnell!); - gehen (ugs. für: verlorengehen)

Hei|di (Kurzform von: Adelheid u. Heidrun)

Hei|din w; -, -nen

Hei|d|jer (Bewohner der [Lüneburger] Heide)

heid|nisch

Heid|schnucke [Trenn.: ...schnuk-ke] (Schaf einer bestimmten Rasse)

Hei|duck ung. (ung. [Grenz]soldat; ung. Gerichtsdiener) m; -en, -en (↑ R 268)

hei|kel (südd. u. österr. auch für: wählerisch [beim Essen]); eine heikle Sache; sei nicht so -!

heil; Heil s; -[e]s; Berg -!; Schi -!; Heil|land m; -[e]s, -e; Heil|an|stalt; heil|bar; Heil|bar|keit w; -; heil-brin|gend, aber (↑ R 142): großes Heil bringend

Heil|bronn (Stadt am Neckar)

Heil|butt (ein Fisch); hei|len; Heil|er|de; heil|froh; Heil..ge-hil|fe, ...gym|nast, ...gym|na|stik, ...gym|na|stin (w; -, -nen); hei|lig (Abk.: hl., für die Mehrz.: hll.). I. Kleinschreibung: in heiligem Zorn; heilige Einfalt! (Ausruf der Verwunderung); der heilige Paulus. die heilige Theresia usw.; (↑ R 224:) das heilige Abendmahl, die erste heilige Kommunion, die heilige Taufe usw.; das heilige Pfingstfest usw. II. Großschreibung (↑ R 224): der Heilige Abend; die Heilige Allianz; der Heilige Christ; die Heilige Dreifaltigkeit; die Heilige Familie; der Heilige Geist; das Heilige Grab; der Heilige Gral; die Heilige Jungfrau; die Heiligen Drei Könige; der Heilige Krieg; das Heilige Land; die Heilige Nacht; der Heilige Rock; das Heilige Römische Reich Deutscher Nation; die Heilige Schrift; die Heilige Stadt (Jerusalem); der Heilige Stuhl; der Heilige Vater (der Papst). III. In Verbindung mit Zeitwörtern, z. B. heilighalten; heiligsprechen (↑ R 139); Heil|ig-abend; Hei|li|ge m u. w; -n, -n (↑ R 287 ff.); Hei|li|ge|drei|kö|nigs|tag Heilige[n]dreikönigstag[e]s, Heilige[n]dreikönigstage; ein Heilige[r]dreikönigstag; hei|li|gen; Hei|li|gen.bild, ...figur, ...schein; Hei|lig|geist|kir|che; hei|lig|hal|ten; ↑ R 139 (feiern); ich halte heilig; heiligehalten; heiligzuhalten; Hei|lig|keit w; -; Seine -; ↑ R 224 (der Papst); hei|lig|spre|chen; ↑ R 139 (zum od. zur Heiligen erklären); vgl. heilighalten; Hei|lig|spre-chung; Hei|lig|tum; Hei|li|gung; heil.kli|ma|tisch, ...kräf|tig; Heil|kun|de w; -, -n; heil|kun|dig; Heil|kun|di|ge m u. w; -n, -n (↑ R 287 ff.); heil|los; -este (↑ R 292); Heil|mit|tel s; heil|päd|ago|gisch; Heil.pflan|ze, ...prak|ti|ker, ...quel|le, ...ruf; heil|sam; Heil-sam|keit w; -; Heils.ar|mee (w; -), ...bot|schaft; Heil|se|rum; Heils-ge|schich|te w; -; heils|ge|wiß; Heil|stät|te; Hei|lung; Hei|lungs-pro|zeß; Heil|ver|fah|ren

heim...; vgl. heimbegeben, sich; vgl. heimbegleiten usw.

Heim s; -[e]s, -e; Heim.abend, ...ar-beit; Hei|mat w; -, (selten:) -en; hei|mat|be|rech|tigt; Hei|mat..er-de (w; -), ...fest, ...film; hei|mat|ge-

nös|sig (schweiz. neben; heimat-
berechtigt); Hei|mat.ha|fen (vgl.
[2]Hafen), ...kun|de (w; -); hei|mat-
kund|lich; Hei|mat.kunst, ...land
(Mehrz. ...länder); hei|mat|lich;
hei|mat|los; Hei|mat|lo|se m u. w;
-n, -n (↑ R 287 ff.); Hei|mat|lo|sig-
keit w; -; Hei|mat.ort (m; -[e]s,
...orte), ...recht; Hei|mat.staat
(Mehrz. ...staaten), ...stadt,
...ver|trie|be|ne; heim|be|ge|ben,
sich; er hat sich heimbegeben;
heim|be|glei|ten; er hat sie heim-
begleitet; heim|brin|gen; er hat sie
heimgebracht; Heim|bür|ge (ver-
alt. für: Dorfrichter, Schöffe);
Heim|bür|gin mitteld. (Toten-
frau); Heim|chen (eine Grille);
Heim|dal[l] (nord. Mythol.:
Wächter der Götter u. ihres Sit-
zes); hei|me|lig (anheimelnd);
Hei|men, Hei|met schweiz.
(Bauerngut) s; -s, -; vgl. Heimwe-
sen; heim|fah|ren; er ist heimge-
fahren; Heim.fahrt, ...fall (Rück-
fall [eines Gutes] an den Besitzer;
m; -[e]s); heim|fäl|lig; heim|füh-
ren; er hat ihn heimgeführt;
Heim.gang (m; -[e]s), ...gar|ten;
heim|ge|gan|gen; Heim|ge|gan-
ge|ne, Heim|ge|gang|ne m u. w;
-n, -n (↑ R 287 ff.); heim|ge|hen;
er ist heimgegangen; heim|ho|len;
er wurde heimgeholt; hei|misch;
Heim|kehr w; -; heim|keh|ren; er
ist heimgekehrt; Heim.keh|rer,
...kunft (w; -), ...lei|ter m; heim-
leuch|ten; dem haben sie heim-
geleuchtet (ugs.: ihn derb abge-
fertigt); heim|lich; vgl. heimlich-
tun; heim|lich|feiß schweiz. mdal.
(einen Besitz, ein Können ver-
heimlichend); Heim|lich.keit,
...tu|er; Heim|lich|tue|rei; heim-
lich|tun; (↑ R 139 (geheimnisvoll
tun); er hat sehr heimlichgetan;
aber: heim|lich tun; er hat es
heimlich getan; heim|los; Heim-
lo|sig|keit w; -; Heim|rei|se; heim-
rei|sen; er ist heimgereist; Heim-
.sau|na ⓦ, ...stät|te; heim|su-
chen; er wurde von Unglück u.
Krankheit schwer heimgesucht;
Heim.su|chung, ...trai|ner (für:
Hometrainer), ...tücke[1]; Heim-
tücker[1]; heim|tückisch[1]; -ste (↑ R
294); Heim|volks|hoch|schu|le;
heim|wärts; Heim.weg (m; -[e]s),
...weh (s; -s); heim|weh|krank;
Heim.wer|ker (jmd., der hand-
werkliche Arbeiten zu Hause
selbst macht; Bastler), ...we|sen
(schweiz. für: Anwesen); heim-
zah|len; jmdm. etwas -; heim|zu
(ugs. für: heimwärts)

Hein (Kurzform von: Heinrich);
Freund - (der Tod)

[1] Trenn.: ...tük|ke...

Hei|ne (dt. Dichter)
Hei|ne|mann (dritter dt. Bun-
despräsident)
hei|nesch vgl. heinisch; Hei|nesch
vgl. Heinisch
[1]Hei|ni (Koseform von: Heinrich);
[2]Hei|ni (ugs. für: einfältiger
Mensch) m; -s, -s; ein doofer -
hei|nisch; dies ist heinische Ironie
(nach Art von Heine), aber (↑ R
179): Hei|nisch; die Heinischen
„Reisebilder" (ein Werk von
Heine)
Hein|rich (m. Vorn.); [1]Heinz
(Kurzform von: Heinrich);
[2]Heinz m; -en, -en (↑ R 268) u.
[1]Hein|ze südd. (Heureuter; Stie-
felknecht) m; -n, -n (↑ R 268);
[2]Hein|ze schweiz. (Heureuter) w;
-, -n; Hein|zel|bank österr.
(Werkbank; Mehrz. ...bänke);
Hein|zel|männ|chen [nach Heinz,
Kurzform von Heinrich] (hilfrei-
cher Hausgeist)
heio|po|pejo!, heia|po|peia!, eia-
po|peia!
Hei|rat w; -, -en; hei|ra|ten; Hei-
rats.an|trag, ...an|zei|ge, ...er-
laub|nis; hei|rats|fä|hig, ...lu|stig;
Hei|rats.schwind|ler, ...ver|mitt-
ler
hei|sa!, hei|ßa!
hei|schen (geh.,dicht. für: fordern,
verlangen); du heischst (hei-
schest)
hei|ser; -er, -ste; Hei|ser|keit w; -,
(selten:) -en
heiß; -er, -este; am -esten (↑ R 134);
das Wasser heiß machen; jmdm.
die Hölle heiß machen (ugs.:
jmdm. Angst machen); was ich
nicht weiß, macht mich nicht
heiß; (↑ R 224:) ein heißes Eisen
(ugs. für: eine schwierige Angele-
genheit); ein heißes (inbrünsti-
ges) Gebet; heiße Hände; heiße
Quellen; ein heißer (sehnlicher)
Wunsch; heißes Blut haben (ugs.
für: leidenschaftlich sein); heißer
Draht ([telefon.] Direktverbin-
dung für schnelle Entscheidun-
gen); heiße Höschen (für: Hot
pants); heißer Ofen (ugs. für: sehr
schneller Sportwagen, schweres
Motorrad). Schreibung in Ver-
bindung mit dem 2. Mittelwort
(↑ R 142); vgl. heißersehnt, heiß-
geliebt, heißumkämpft, heißum-
stritten
hei|ßa!, hei|sa!; hei|ßas|sa!
Heiß|be|hand|lung; heiß|blü|tig
[2]hei|ßen (befehlen); nennen; einen
Namen tragen); du heißt (hei-
ßest); ich hieß, du hießest; gehei-
ßen; heiß[e]!; er hat mich's gehei-
ßen, aber (↑ R 305): wer hat dich
das tun heißen?; er hat mich kom-
men heißen (seltener: geheißen);
das heißt (Abk.: d. h.)

[2]hei|ßen (hissen); du heißt (hei-
ßest); du heißtest; geheißt; hei-
ß[e]!
heiß|er|sehnt; seine heißersehnte
Ankunft (↑ jedoch R 142), aber:
seine Ankunft wurde heiß er-
sehnt; heiß|ge|liebt; ein heißge-
liebtes Mädchen (↑ jedoch R 142)
aber: er hat sein Vaterland heiß
geliebt; Heiß|hun|ger m; -s; heiß
hung|rig; heiß|lau|fen; der Moto
hat sich heißgelaufen; der Moto
ist heißgelaufen; Heiß|luft|hei
zung; Heiß|man|gel w; Heiß|spor
(Mehrz. ...sporne); heiß|spor|nig
heiß|um|kämpft; ein heißum
kämpfter Sieg (↑ jedoch R 142)
aber: der Sieg war heiß um
kämpft; heiß|um|strit|ten; das is
eine heißumstrittene Frage (↑ je
doch R 142), aber: die Frag
war lange Zeit heiß umstritten
Heiß|was|ser|spei|cher
Hei|ster (junger Laubbaum au
Baumschulen) m; -s, -
...heit (z. B. Keckheit w; -, -er
hei|ter; heit[e]rer, -ste; Hei|ter|ke
w; -; Hei|ter|keits|er|folg
Heiz|an|la|ge; heiz|bar; Hei
decke [Trenn.: ...dek|ke]; hei|ze
du heizt (heizest); Hei|zer; Hei
.gas, ...kis|sen, ...kör|per, ...m
te|ri|al, ...öl, ...plat|te, ...roh
...son|ne, ...stoff; Hei|zung; H
zungs.an|la|ge, ...rohr
He|ka|te (gr. Nacht- u. Unte
weltsgöttin)
He|ka|tom|be gr. ([großes] Opf
[von ..,100" Stieren]) w; -, -n
He|kla [dt. Aussspr.: hekla, islän
Aussspr.: hähkla] (Vulkan auf
land) w; -
hekt..., hekto- gr. (100); Hekt
gr.; lat. [auch: häk...](100 a; Z
chen: ha) s (auch: m); -s, -e;
- gutes Land od. guten Land
(↑ R 321 u. 322); Hekt|a
schweiz. (Hektar; Zeichen: ha)
-, -n; Hekt|ar|er|trag (me
Mehrz.)
Hek|tik gr. (Med.: chron. Fiet
u. Kräfteverfall, insbes.
Schwindsucht; fieberhafte A
regung, nervöses Getriebe) w
hek|tisch (fieberhaft, aufgere
sprunghaft); -e Röte; -es Fiet
hek|to- vgl. hekt...; Hek|to... (c
Hundertfache einer Einheit, z.
Hektoliter = 10^2 Liter; Zeich
h); Hek|to|gramm gr. (100 g; Z
chen: hg); Hek|to|graph (Verv
fältigungsgerät; m; -en, -en (↑
268); Hek|to|gra|phie (Vervielf
tigung) w; -, ...ien; hek|to|g
phie|ren; Hek|to|li|ter [au
häk...] (100 l; Zeichen: hl); H
to|me|ter (100 m; Zeichen: h
Hek|tor (Held der gr. Sage)
Hek|to.ster gr. [auch: häk...] l

Ster; Zeichen: hs), ...watt (100 Watt)

He|ku|ba (w. gr. Sagengestalt)

Hel (nord. Göttin des Todes; auch: Welt der Toten; Unterwelt)

he|lau! (Fastnachtsruf)

Held m; -en, -en (↑ R 268); Hel|den.dar|stel|ler, ...epos; hel|den|haft; Hel|den|mut; hel|den|mü|tig; Hel|den.tat, ...te|nor, ...tod, ...tum (s; -s)

Hel|der niederd. (uneingedeichtes Marschland) m od. s; -s, -

Hel|din w; -, -nen; hel|disch

He|le|na (gr. mytholog. Gestalt; w. Figenn.); He|le|ne (w. Vorn.)

Hel|fe (Schnur am Webstuhl) w, -, -n

hel|fen; du hilfst; du halfst (halfest); du hülfest (selten: hälfest); geholfen; hilf!; sie hat ihr beim Nähen geholfen, aber (↑ R 305): sie hat ihr nähen helfen (od.: geholfen); sich zu - wissen; das hilft mir nicht; Hel|fer; Hel|fers|hel|fer

Helf|gott (m. Vorn.)

Hel|ga (w. Vorn); ¹Hel|ge (nord. m. Vorn.)

²Hel|ge w; -, -n u. ¹Hel|gen [aus: Helligen] (Nebenformen von: Helling) m; -s, -

Hel|gen schweiz. (verächtl. für: Bild) m; -s, -

hel|go|land; Hel|go|län|der (↑ R 199); hel|go|län|disch

He|li|and (,,Heiland''; altsächs. Evangeliendichtung) m; -s

he|li|an|thus gr. (Sonnenblume) m; -, ...then; He|li|ar ® (ein [fotograf.] Objektiv) s; -s, -e

He|li|kon gr. (ein Blasinstrument) s; -s, -s

¹He|li|kon (Gebirge in Böotien; Musensitz) m; -[s]

He|li|ko|pter gr. (Hubschrauber) m; -s, -

He|lio... gr. (Sonnen...); He|lio|dor (ein Edelstein) m; -s, -e; He|lio|graph (Heliostat; Signalgerät) m; -en, -en (↑ R 268); He|lio|gra|phie (ein Tiefdruckverfahren; Zeichengeben mit dem Heliographen) w; -; he|lio|gra|phisch; He|lio|gra|vü|re (ein Tiefdruckverfahren) w; -, (für: Ergebnis dieses Verfahrens auch Mehrz.:) -n; He|li|os (gr. Sonnengott); He|lio|skop (Gerät mit Lichtschwächung zur direkten Sonnenbeobachtung) s; -s, -e; He|lio|stat (Spiegelvorrichtung, die den Sonnenstrahlen eine gleichbleibende Richtung gibt) m; -en, -en ↑ R 268); He|lio|the|ra|pie (Med.; Behandlung mit Sonnenlicht) w; ; ¹He|lio|trop (eine Zierpflanze; eine Farbe; Spiegelvorrichtung in der Geodäsie) s; -s, -e; ²He|lio-

trop (ein Edelstein) m; -s, -e; he|lio|tro|pisch (lichtwendig); he|lio|zen|trisch (auf die Sonne als Mittelpunkt bezüglich); -es Weltsystem; He|lio|zo|on (Sonnentierchen) s; -s, ...zoen (meist Mehrz.); He|li|um (chem. Grundstoff, Edelgas; Zeichen: He) s; -s

hell; hellblau usw. Schreibung in Verbindung mit Mittelwörtern (↑ R 142): vgl. helleuchtend, hellodernd, hellstrahlend

Hel|las (Griechenland)

hell|auf; - lachen (laut u. fröhlich lachen); aber: hell auflachen (plötzlich zu lachen anfangen); - begeistert; hell|äu|gig; hell|blau; - färben; hell|blond; hell|dun|kel; Hell|dun|kel; hel|le landsch. (aufgeweckt, gewitzt); Mensch, sei -!; ¹Hel|le (Helligkeit) w; -; ²Hel|le s; -n, (ugs. für: ein Glas helles Bier Mehrz.:) -n; 3 Helle

Hel|le|bar|de [schweiz.: häl⁴...] (Hieb- u. Stoßwaffe im MA.; Paradewaffe der Schweizergarde im Vatikan) w; -, -n; Hel|le|bar|dier (mit einer Hellebarde Bewaffneter) m; -s, -e

Hel|le|bo|rus gr. (Gattung der Hahnenfußgewächse [mit Nieswurz und Christrose]) m; -, ...ri

Hel|le|gat[t] ([Vorrats-, Geräte]raum auf Schiffen)

hel|len, sich (dicht. für: sich erhellen)

Hel|le|ne (Grieche) m; -n, -n; (↑ R 268; Hel|le|nen|tum s; -s; Hel|le|nin w; -, -nen; hel|le|nisch; hel|le|ni|sie|ren (nach gr. Vorbild gestalten, einrichten); Hel|le|nis|mus (nachklass. gr. Kultur) m; -; Hel|le|nist (Gelehrter des nachklass. Griechentums; Forscher u. Kenner des Hellenismus; ↑ R 268; Hel|le|ni|stik (wissenschaftl. Erforschung der hellenist. Sprache u. Literatur) w; -; hel|le|ni|stisch

Hel|ler (ehem. Münze) m; -s, -; auf - u. Pfennig; ich gebe keinen - dafür

Hel|les|pont gr. (antike Bez. für: Dardanellen) m; -[e]s

hell|euch|tend [Trenn.: hell|leuch..., ↑ R 236]; dieser hell|euchtende Stern, aber (↑ R 143, Merke): dieser auffallend hell leuchtende Stern

Hell|gat[t] vgl. Hellegat[t]

hell|haa|rig, ...hö|rig (feinhörig; heute auch für: schalldurchlässig); hell|licht [Trenn.: hell|licht, ↑ R 236]; es ist -er Tag

Hel|ling (Mehrz. von: Helling)

Hell|lig|keit w; -; hell|li|la [Trenn.: hell|li..., ↑ R 236]; in einem hell|lila Kleid

Hell|ling niederd. (schräger

Schiffsbauplatz; Unterlage, auf der Schiffe gebaut werden) w; -, -en u. Helligen; (auch:) m; -s, -e; vgl. Helge[n]

hell|o|dernd [Trenn.: hell|lo..., ↑ R 236]; die hellodernde Flamme, aber (↑ R 143, Merke): die sehr hell lodernde Flamme, hell|se|hen (nur in der Grundform gebräuchlich); Hell.se|hen (s; -s), ...se|hor; Hell|se|he|rei; Hell|se|he|rin; hell.se|he|risch, ...sich|tig; Hell|sich|tig|keit w; -; hell|strah|lend; das hellstrahlende Gesicht des Kindes, aber (↑ R 143, Merke): das sehr hell strahlende Gesicht des Kindes; hell|wach

Hell|weg (Landstrich in Westfalen) m; -[e]s

¹Helm (Kopfschutz; Turmdach) m; -[e]s, -e

²Helm (Stiel von Schlagwerkzeugen) m; -[e]s, -e

Hel|ma (w. Vorn.)

Helm|busch

Helm|holtz (dt. Physiker)

Helm|mi|ne (w. Vorn.)

Helm|min|the gr. (Med.: Eingeweidewurm) w; -, -n (meist Mehrz.); Helm|min|thja|sis (Med.: Wurmkrankheit) w; -; Helm|min|tho|lo|gie (Med.: Lehre von den Eingeweidewürmern) w; -

Helm|mold (m. Vorn.)

Helm|stedt (Stadt östl. von Braunschweig); Helm|sted|ter (↑ R 199)

Helm|traud, Helm|trud (w. Vorn.); Helm|traut (veralt. Schreibung von: Helmtraud); Helm|mut (m. Vorn.); Helm|ward (m. Vorn.)

He|loi|se (fr. w. Eigenn.)

He|lot gr. [spartan.] Staatssklave m; -en, -en (↑ R 268); He|lo|ten|tum s; -s

Hel|sing|fors (schwed. für: Helsinki); Hel|sin|ki (Hptst. Finnlands)

Hel|ve|ti|en [...wezi⁴n] (Schweiz); Hel|ve|ti|er [...i⁴r] (Angehöriger eines kelt. Volksstammes); hel|ve|tisch, aber (↑ R 224): die Helvetische Republik; das Helvetische Bekenntnis (Abk.: H. B.)

hem!, hm!; hem, hem!; hm, hm!

Hemd m; -[e]s, -en; Hemd|blu|se; Hem|den|knopf, Hemd|knopf; Hem|den|matz (ugs. für: Kind im Hemd); Hemd|ho|se; Hemd|knopf, Hem|den|knopf; Hemds|är|mel (meist Mehrz.); hemds|är|me|lig

He|ming|way [...⁴e¹] (amerik. Schriftsteller)

he|mi... gr. (halb...); He|mi|... (Halb...); He|mi|ple|gie (Med.: halbseitige Lähmung) w; -, ...ien; He|mi|pte|ren (Zool.: systematische Bezeichnung für Halbflügler [darunter die Wanze]) Mehrz.; He|mi|sphä|re (Erd]halbkugel);

he|mi|sphä|risch; He|mi|sti|chi|on gr., He|mi|sti|chi|um (Halbvers in der altgr. Metrik) s; -s, ...ien [...i^rn]; he|mi|zy|klisch [auch: ...zü...] (halbkreisförmig)
hem|men; Hemm|nis s; -ses, -se; Hemm.schuh, ...stoff (Chemie: Stoff, der das Zellenwachstum od. chem. Reaktionen hemmt); Hemm|mung; hem|mungs|los; -este (↑ R 292); Hemm|mungs|lo|sig|keit; Hemm|wir|kung
Hem|ster|huis, Frans [hämßt^r-höiß] (niederl. Philosoph)
Hen|de|ka|gon gr. (Elfeck) s; -s, -e; Hen|de|ka|syl|la|bus (elfsilbiger Vers) m; -, ...syllaben u. ...syllabi
Hen|dia|dy|oin gr. [...dieun] s; -s, (seltener:) Hen|dia|dys (Bez. eines Begriffs durch zwei nebengeordnete, z. B. „bitten und flehen") s; -
Hendl österr. ([junges] Huhn; Back-, Brathuhn) s; -s, -n
Hengst m; -es, -e
Hen|kel m; -s, -; ...hen|ke|lig, ...henk|lig (z. B. zweihenk[e]lig); Hen|kel|krug
Hen|kell ⓦ (ein Sekt)
hen|ken; Hen|ker; Hen|kers.beil, ...frist, ...knecht, ...mahl[zeit] (letztes Mahl, letzte Mahlzeit)
...henk|lig vgl. ...henkelig
Hen|na arab. (ein Färbemittel, das im Orient kosmetischen Zwecken dient) w; -; Hen|na|strauch
Hen|ne w; -, -n
Hen|ne|gat[t] niederd. (Durchlaß [durch die Schiffswand] für das Ruder)
Hen|ne|gau (belg. Prov.) m; -[e]s
Hen|ni (Kurzform von: Henriette)
¹Hen|ni|n[n]g (m. Vorn.)
²Hen|ning (der Hahn in der Tierfabel)
Hen|ny [häni] (engl. Kurzform von: Henriette)
He|no|the|is|mus gr. (Absolutsetzung einer Gottheit ohne Leugnung anderer od. Verbot ihrer Verehrung)
Hen|ri [angri] (fr. Form von: Heinrich); Hen|ri|et|te (w. Vorn.)
Hen|ri|qua|tre fr. [(h)angrikatr] (Spitzbart [wie ihn Heinrich IV. von Frankreich trug]) m; -s [...katr], -s [...katr]
¹Hen|ry [hänri] (engl. Form von: Heinrich)
²Hen|ry [hänri; nach dem nordamerik. Physiker] (Einheit der Selbstinduktion; Zeichen: H) s; -, -
He|pa|ti|ka gr. (Leberblümchen) w; -, ...ken; he|pa|tisch (zur Leber gehörend); He|pa|ti|tis (Med.: Leberentzündung) w; -, ...it|den
He|phai|stos vgl. Hephäst, Hephä-

stus; He|phäst, He|phä|stus (gr. Gott des Feuers u. der Schmiedekunst)
Hep|ta|chord gr. [...kort] (Musik: große Septime) m od. s; -[e]s, -e; Hep|ta|gon (Siebeneck) s; -s, -e; Hept|ame|ron (Novellensammlung, an „sieben Tagen" erzählt, von Margarete von Navarra) s; -s; Hep|ta|me|ter (siebenfüßiger Vers) m; -s, -; Hep|tan (Kohlenwasserstoff mit sieben Kohlenstoffatomen, Bestandteil von Erdöl, Benzin usw.) s; -s; Hep|ta|teuch (die ersten sieben bibl. Bücher) m; -s; Hept|ode (Elektronenröhre mit sieben Elektroden) w; -, -n
¹her (Bewegung auf den Sprechenden zu; her zu mir!; her damit!; hin und her!; vgl. hin
²her... (in Zus. mit Zeitwörtern, z. B. herbringen, du bringst her, hergebracht, herzubringen; zum 2. Mittelw. ↑ R 304)
He|ra, He|re (Gemahlin des Zeus)
her|ab; her|ab... (z. B. herablassen; ↑ R 304; er hat sich herabgelassen); her|ab|hän|gen; die Deckenverkleidung hing herab; vgl. ¹hängen; her|ab|las|sen; sich -; Her|ab|las|sung; her|ab|schaf|fen; vgl. ¹schaffen; her|ab|se|hen; auf jemanden -; her|ab|set|zen; Her|ab|set|zung; her|ab|wür|di|gen; Her|ab|wür|di|gung
He|ra|kles (Halbgott u. Held der gr.-röm. Sage); vgl. Herkules; He|ra|kli|de (Nachkomme des Herakles) m; -n, -n (↑ R 268); He|ra|klit [auch: ...it] (altgr. Philosoph); He|ra|kliṯh [auch: ...it] ⓦ (Leichtbauplatten)
He|ral|dik fr. (Wappenkunde) w; -; He|ral|di|ker (Wappenkundiger, -forscher); he|ral|disch; -e Farben
her|an; her|an... (ugs.:) ran (↑ R 238); her|an... (z. B. heranbringen; ↑ R 304: er hat es mir herangebracht); her|an|ar|bei|ten, sich; her|an|bil|den; her|an|brin|gen; vgl. heran...; her|an|fah|ren; er ist zu nahe herangefahren; her|an|kom|men; her|an|ma|chen, sich (ugs. für: sich [mit einer bestimmten Absicht] nähern; beginnen); her|an|rei|fen (allmählich reif werden); her|an|rücken (Trenn.: ...rük|ken); her|an|schaf|fen; vgl. ¹schaffen; her|an|ta|sten, sich; her|an|tre|ten; her|an|wach|sen; Her|an|wach|sen|de m u. w; -n, -n (↑ R 287 ff.); her|an|wa|gen, sich; her|an|zie|hen
her|auf, (ugs.:) rauf (↑ R 238); her|auf... (z. B. heraufziehen; ↑ R 304: er hat den Eimer heraufgezogen); her|auf|be|schwö|ren; her|auf-

brin|gen; her|auf|däm|mern; her|auf|zie|hen; vgl. herauf...
her|aus, (ugs.:) raus (↑ R 238); her|aus... (z. B. herausstellen; ↑ R 304: er hat die Schuhe herausgestellt); her|aus|ar|bei|ten; her|aus|ar|bei|tung; her|aus|be|kom|men; her|aus|bil|den, sich; Her|aus|bil|dung; her|aus|fin|den; Her|aus|for|de|rer; her|aus|for|dern; ich fordere heraus (↑ R 327); her|aus|for|dernd; Her|aus|for|de|rung; Her|aus|ga|be w; -; her|aus|ge|ben; ich gebe heraus; vgl. heraus gegeben; Her|aus|ge|ber (Abk.: Hg. u. Hrsg.); her|aus|ge|ge|ben (Abk.: hg. u. hrsg.); - von; her|aus|ge|hen; du mußt mehr aus di - (dich freier, weniger befangen äußern); her|aus|ha|ben (ugs. etw. gelöst haben); er hat die Aufgabe heraus; her|aus|hal|ten; sich -; ¹her|aus|hän|gen; die Fahne hing zum Fenster heraus; vgl. ¹hängen; ²her|aus|hän|gen; er hängte die Fahne heraus; vgl. ²hängen; her|aus|he|ben; sich -; her|aus|ho|len; her|aus|kom|men; es wird nichts dabei herauskommen; her|aus|kri|stal|li|sie|ren; sich -; her|aus|neh|men; sich etwa -; her|aus|plat|zen; her|aus|rücken [Trenn.: ...rük|ken]; mit der Sprache (ugs.); her|aus|schaf|fen; vg ¹schaffen; her|aus|schau|en österr. (herauskommen [vgl. d.] her|au|ßen bayr., österr. (hier au ßen)
her|aus|stel|len; vgl. heraus...; e hat sich herausgestellt, daß... her|aus|wach|sen; sie ist aus der Kleid herausgewachsen (größe geworden, dem Kleid entwach sen); aber: seine Sicherheit is aus den Erfahrungen heraus ge wachsen (ist dadurch größer ge worden); her|aus|zie|hen
herb
Her|ba|ri|um lat. (Sammlung ge trockneter Pflanzen) s; -s, ...ie [...i^en]
Her|bart (dt. Philosoph)
Her|be (geh. für: Herbheit) w; her|bei; her|bei... (z. B. herbeieile ↑ R 304: er ist herbeigeeilt); he bei|füh|ren; bei Gelegenheit, sic her|bei|locken [Trenn.: ...lok ken]; her|bei|ru|fen; herbeirufe und -winken (↑ R 145); her|be schaf|fen; vgl. ¹schaffen; her|be schlep|pen; her|bei|strö|men; her bei|wün|schen; her|bei|zi|tie|re (ugs.)
her|be|mü|hen; sich -; er hat sic herbemüht
Her|ber|ge w; -, -n; her|ber|gen; de herbergtest; geherbergt; He bergs|va|ter

Her|bert (m. Vorn.)
Herb|heit w; -
her|bit|ten; er hat ihn hergebeten
Her|bi|vo|re lat. [...*wor*^e] (pflan-
zenfressendes Tier) m; -n; -n (↑ R
268); Her|bi|zid (pflanzentöten-
des Mittel) s; -[e]s, -e
Herb|ling (ein Pilz)
her|brin|gen
Herbst m; -[e]s, -e; Herbst|an-
fang, (dicht.:) Herb|stes|an|fang;
Herbst|blu|me; herb|steln (österr.
nur so), herb|sten (auch für: Trau-
ben ernten); es herbstelt, herb-
stet; Herbst|fe|ri|en Mehrz.;
herbst|lich; herbst|lich|gelb;
Herbst|ling (ein Pilz), Herbst..mo-
nat od. ...mond (alte Bez. für: Sep-
tember), ...ne|bel, ...son|ne,
...sturm, ...tag; Herbst-Tag|und-
nacht|glei|che w; -, -n; ↑ R 152;
Herbst|zeit|lo|se w; -, -en
herb|süß
Her|cu|la|ne|um, Her|cu|la|num
(röm. Ruinenstadt am Vesuv);
her|cu|la|nisch
Jerd m; -[e]s, -e
Jerd|buch (Zuchtstammbuch);
Her|de w; -, -n; Her|den..mensch,
...tier, ...trieb (m; -[e]s); her|den-
wei|se
Jer|der (dt. Philosoph u. Dich-
ter); her|de|risch, her|dersch; das
ist eine herder[i]sche Betrach-
tungsweise (nach Art Herders),
aber (↑ R 179): Her|de|risch,
Her|dersch; die Herder[i]schen
„Ideen zur Philosophie der Ge-
schichte der Menschheit" (Werk
von Herder)
Jerd..feu|er, ...plat|te
Je|re w; -. Hera
e|re|di|tär lat. (die Erbschaft be-
treffend; erblich); He|re|di|tät
(veralt. für: Erbschaft, Erbfolge)
w; -
er|ein, (ugs.:) rein (↑ R 238);
„Herein!" rufen; her|ein... (z. B.
hereinbrechen; ↑ R 304: der
Abend ist hereingebrochen); her-
ein|be|kom|men; her|ein|bre-
chen; her|ein|brin|gen; her|ein-
fah|ren; her|ein|fal|len; Her|ein-
ge|schmeck|te, Rein|ge|schmeck-
te (ugs. für: Ortsfremde[r], Zuge-
zogene[r] m.u. w; -n, -n (↑R 287ff.);
her|ein|kom|men; her|ein|las|sen;
her|ein|le|gen; her|ein|plat|zen,
her|ein|schaf|fen; vgl. schaffen;
her|ein|schlei|chen; sich -; her|ein-
schmecken [Trenn.: ...schmek-
ken]; her|ein|schnei|en (ugs. für:
unvermutet hereinkommen);
her|ein|spa|zie|ren; her|ein|strö-
nen; her|ein|stür|zen
Je|re|ro (Angehöriger eines Ban-
tunegerstammes) m; -[s], -[s]
er|fah|ren; Her|fahrt; vgl. Hin-
und Herfahrt (↑ R 145)

her|fal|len; über jmdn. -
her|füh|ren
Her|ga|be
Her|gang
her|ge|ben; sich -
her|ge|brach|ter|ma|ßen
her|ge|hen; hinter jmdm. -; hoch -
her|ge|hö|ren
her|ge|lau|fen; Her|ge|lau|fe|ne m
u. w; -n, -n (↑ R 287ff.)
her|ha|ben (ugs.); woer's wohl her-
hat?
her|hal|ten (büßen), er mußte da-
für -
her|hö|ren; alle mal -!
her|ho|len; das ist weit hergeholt
(ist kein naheliegender Gedan-
ke); aber: diesen guten Wein ha-
ben wir von weither geholt
He|ri|bert (m. Vorn.)
He|ring (ein Fisch; Zeltpflock) m;
-s, -e; He|rings..fang, ...fi|let,
...milch, ...ro|gen, ...sa|lat, ...ton-
ne
her|in|nen bayr. u. österr. ([hier]
drinnen)
He|ris|au (Stadt südwestl. von St.
Gallen)
her|kom|men; du sollst hinter mir
herkommen; ...so daß ich hinter
ihm herkam; aber: von der Tür
her kam er; Her|kom|men; her-
kömm|lich
¹Her|ku|les (lat. Form von: Hera-
kles); ²Her|ku|les (ein Sternbild)
m; -; ³Her|ku|les (Mensch von
großer Körperkraft) m; -, -se;
Her|ku|les|ar|beit; her|ku|lisch
(riesenstark; schwer zu vollbrin-
gen); -ste (↑ R 294)
Her|kunft w; -, (selten:) ...künfte;
Her|kunfts..an|ga|be, ...ort, ...zei-
chen
her|lau|fen; hinter jmdm. -
her|lei|hen österr. (verleihen)
her|lei|ten; sich -
Her|lin|de (w. Vorn.)
Her|ling (veralt. für: noch „har-
te", unreife Weintraube)
Her|lit|ze [auch: ...*lit*...] (Kornel-
kirsche, Ziergehölz) w; -, -n
her|ma|chen; sich über eine Sa-
che -
Her|man|dad span. [auch: *ärman-
da(dh)*] („Bruderschaft"; urspr.
polit. Bündnis gegen Räubereien
des span. Adels, später eine Art
Polizei) w; -; die heilige - (früher
verächtl., auch scherzh. für: Poli-
zei)
Her|mann (m. Vorn.); Her-
manns..denk|mal (s; -[e]s),
...schlacht
Her|mann|stadt (Stadt in Sieben-
bürgen); vgl. Sibiu
Herm|aphro|dit gr. (Zwitter) m; -
en, -en (↑ R 268); herm|aphro|di-
tisch; Herm|aphro|dis|mus,
Herm|aphro|di|tis|mus (Zwittrig-

keit) m; -; Her|me (Büstenpfeiler,
-säule) w; -, -n
¹Her|me|lin dt. [mit undeutscher
Betonung] (großes Wiesel) s; -s,
-e; ²Her|me|lin (ein Pelz) m; -s,
-e
Her|me|neu|tik gr. (Auslegekunst,
Deutung) w; -; her|me|neu|tisch
Her|mes (gr. Götterbote, Gott des
Handels, Totenführer)
hor|mo|tisch gr (flnft- u. wasser]-
dicht)
Her|mi|ne (w. Vorn.)
Her|mi|no|nen (germ. Stammes-
gruppe) Mehrz.; her|mi|no|nisch
Her|mi|ta|ge fr. [(*h*)*ärmitasche*^e]
(ein fr. Wein) m; -
Her|mun|du|re (Angehöriger eines
germ. Volksstammes) m; -n, -n
(↑ R 268)
her|nach landsch. (nachher)
her|neh|men (ugs.)
Her|nie lat. [...*i*^e] (Eingeweide-
bruch; Pflanzenkrankheit) w;
-, -n
her|nie|der; her|nie|der... (z. B. her-
niedergehen; ↑ R 304: der Regen
ist herniedergegangen)
Her|nio|to|mie lat.; gr. (Med.:
Bruchoperation) w; -, ...ien
He|ro (w. Eigenn.); vgl. Hero-und-
Leander-Sage
He|roa (Mehrz. von: Heroon)
her|oben bayr., österr. (hier oben)
He|ro|des (jüd. Königsname); He-
ro|di|as (w. Eigenn.)
He|ro|dot [auch: ...*dot*, österr.:
her...] (gr. Geschichtsschreiber)
He|ro|e (gr. Heros) m; -n, -n (↑ R
268); he|ro|en|haft; He|ro|en|kult,
He|ro|en|kul|tus (Heldenvereh-
rung); ¹He|ro|in (ein Rauschgift)
s; -s; ²He|ro|in (Heldin; auch für:
Heroine) w; -, -nen; He|ro|i|ne
(Heldendarstellerin) w; -, -n; he-
ro|isch (heldenmütig, heldisch;
erhaben); -ste (↑ R 294); he|roi-
sie|ren [...*o-i*...] (zum Helden er-
heben; verherrlichen); He|ro|is-
mus m; -
He|rold (Verkündiger, Ausrufer
[im MA.]) m; -[e]s, -e; He-
rolds..amt (Wappenamt), ...stab
He|ron (gr. Mathematiker); He-
rons|ball (vgl. ¹Ball!); ↑ R 180
He|ro|on (gr. Heroentempel) s;
Heroa; He|ros (Held; Halbgott
[bes. im alten Griechenland]) m;
-, ...oen
He|ro|strat [nach dem Griechen
Herostratos, der den Artemis-
tempel zu Ephesus anzündete,
um berühmt zu werden] (Verbre-
cher aus Ruhmsucht) m; -en, -en
(↑ R 268); He|ro|stra|ten|tum s; -s;
he|ro|stra|tisch (ruhmsüchtig)
He|ro-und-Le|an|der-Sa|ge (↑ R
155) w; -
Her|pes gr. (Bläschenausschlag)

m; -; Her|pe|to|lo|gie (Kriechtierkunde) *w*; -

Herr (Abk.: Hr., *Wemf.* u. *Wenfall:* Hrn.) *m*; -n (selten: -en), -en; mein -!; meine -en!; seines Unmutes - werden; der Besuch eines Ihrer Herren; Ihres Herrn Vaters; aus aller Herren Länder[n]; Herrn Ersten Staatsanwalt Müller (vgl. erste II, a); Herrn Präsident[en] Meyer; Herr|chen, Herrlein

Her|rei|se; vgl. Hin- und Herreise (↑ R 145)

Her|ren_abend, ...aus|stat|ter, ...be|klei|dung

Her|ren|chiem|see [...*kim*...] (Ort u. Schloß auf der Herreninsel im Chiemsee)

Her|ren_dop|pel (Sportspr.), ...ein|zel (Sportspr.), ...fah|rer; her|ren|los; Her|ren_par|tie, ...rei|ter, ...schnei|der, ...sitz (*m*; -es), ...tum (*s*; -s), ...zim|mer; Herr|gott *m*; -s; Herr|gotts_frü|he *w*; -; in aller -; Herr|gotts_schnit|zer, ...win|kel

her|rich|ten; etwas - lassen; Her|rich|tung

Her|rin *w*; -, -nen; her|risch; -ste (↑ R 294); herr|je! (aus: Herr Jesus!), herr|je|mi|ne!; vgl. auch: jemine; Herr|lein, Herr|chen; herr|lich; Herr|lich|keit

Herrn|hut (Stadt im Lausitzer Bergland); Herrn|hu|ter (↑ R 199); - Brüdergemeine; herrn|hu|tisch

Herr|schaft; herr|schaft|lich; Herr|schafts_an|spruch, ...form, ...ord|nung; Herrsch|be|gier|[de]; herrsch|be|gie|rig; herr|schen; du herrschst (herrschest); herr|schend; Herr|scher; Herr|scher_ge|schlecht, ...haus; Herr|sche|rin *w*; -, -nen; Herrsch|sucht *w*; -; herrsch|süch|tig

her|rüh|ren

her|schau|en (ugs.); da schau her! (bayr., österr. für: sieh mal an!)

Her|schel (engl. Astronom dt. Herkunft); -sches Teleskop

her|stel|len; Her|stel|ler; Her|stel|ler_be|trieb, ...fir|ma; Her|stellung; Her|stel|lungs|ko|sten *Mehrz.*

Her|ta, Her|tha; ↑ R 191 (w. Vorn.)

Hertz [nach dem Physiker Hertz] (Maßeinheit der Frequenz; Zeichen: Hz) *s*; -; 440 -

her|üben bayr., österr. (hier auf dieser Seite; diesseits)

her|über, (ugs.:) rü|ber (↑ R 238); her|über... (z. B. herüberkommen; ↑ R 304: herübergekommen)

her|um, (ugs.:) rum (↑ R 238); um den Tisch -; her|um... (z. B. herumlaufen; ↑ R 304: ist herumgelaufen); her|um|är|gern, sich;

her|um|drücken [*Trenn.*: ...drük|ken], sich (ugs.); her|um|füh|ren; her|um|kom|men; nicht darum -; her|um|krie|gen (ugs. für: umstimmen); wir werden ihn schon -; her|um|lau|fen; her|um|lun|gern (ugs.); ich lungere herum (↑ R 327); her|um|schla|gen, sich; her|um|sit|zen; her|um|stie|ren österr. (herumstöbern); her|um|stö|bern; her|um|trei|ben, sich; Her|um|trei|ben; her|um|wer|fen; das Steuer -

her|un|ten bayr., österr. (hier unten)

her|un|ter, (ugs.:) run|ter (↑ R 238); her|un|ter... (z. B. herunterkommen; ↑ R 304: er ist sofort heruntergekommen); her|un|ter|ge|kom|men (armselig; verkommen); ein -er Mann; her|un|ter|hän|gen; der Vorhang hing herunter; vgl. ¹hängen; her|un|ter|krem|peln; die Ärmel -; her|un|ter|las|sen; her|un|ter|ma|chen (ugs.: abwerten, schlechtmachen; ausschelten); her|un|ter|rei|ßen; her|un|ter|sein (ugs. für: abgearbeitet, elend sein); her|un|ter|spie|len (ugs.: nicht so wichtig nehmen); her|un|ter|zie|hen

her|vor; her|vor... (z. B. hervorholen; ↑ R 304: er hat es hervorgeholt); her|vor|bre|chen; her|vor|brin|gen; her|vor|he|ben; her|vor|ho|len; her|vor|ra|gen; her|vor|ra|gend; -ste; her|vor|ru|fen; her|vor|ste|chen; her|vor|tre|ten; her|vor|tun, sich; her|vor|zie|hen

Her|ward, Her|wart (m. Vorn.)

her|wärts

Her|weg; vgl. Hin- und Herweg (↑ R 145)

Her|wegh (dt. Dichter)

Her|wig (m. Vorn.); Her|wi|ga (w. Vorn.); Her|win (m. Vorn.)

Herz *s*; -ens, *Wemf.* u. *Mehrz.* -en; von -en kommen; zu -en gehen, nehmen; mit Herz und Hand (formelhaft ungebeugt; ↑ R 268, 2); vgl. Herze; herz|al|ler|liebst; Herz_al|ler|lieb|ste, ...an|fall, ...ano|ma|lie; Herz|as; herz|be|klem|mend; der Anblick war -, aber (↑ R 142): das Herz beklemmend; Herz_beu|tel, ...bin|kerl (österr. ugs.: Lieblingskind; *s*; -s, -n), ...blätt|chen, ...blut; herz|brechend; eine -e Geschichte; Herz_bru|der, Her|zens|bru|der; Herz|chen, Herz|lein; Herz_chir|ur|gie (operative Behandlung von Herzleiden); Her|ze (dicht. für: Herz; ugs. für: Geliebte, Mädchen [bes. in der Anrede]) *s*; -ns, -n

Her|ze|go|wi|na [auch: ...gowina] (Gebiet in Jugoslawien)

Her|ze|leid (veralt.); her|zen; du herzt (herzest); Her|zens_angst; Her|zens_be|dürf|nis, ...bre|cher, Her|zens_bru|der, Herz|bru|der; Her|zens_er|gie|ßung (veralt. aber noch scherzh.), ...freund (veralt.); her|zens|gut; Her|zens_gü|te, ...lust (nach -), ...sa|che, ...wunsch; herz_er|freu|end ...er|grei|fend, ...er|quickend [*Trenn.*: ...quik|kend]; -ste; der Anblick war -, aber (↑ R 142) das Herz erfreuend, ergreifend, erquickend; Herz|feh|ler, ...flim|mern (Med.); herz_för|mig, ...haft; Herz|haf|tig|keit *w*; -

her|zie|hen; du sollst hinter mir ...; so daß ich den Sack hinter mir herzog; er ist über ihn hergezogen (ugs.: hat schlecht von ihm gesprochen); aber: vor der Tür her zog es

herz|zig; Herz_in|farkt; herz_in|nig; herz_in|nig|lich; Herz_in|suf|fi|zi|enz, ...kam|mer, ...ka|the|ter, ...kir|sche, ...klap|pen|feh|ler, ...klop|fen (*s*; -s); herz|krank; Herz_kranz|ge|fäß; Herz|lein; Herz|chen; herz|lich; aufs, au das -ste (↑ R 134); Herz|lich|keit; herz|los; -este (↑ R 292); Herz|lo|sig|keit; Herz-Lun|gen-Ma|schi|ne (↑ R 155)

Herz|ma|nov|sky-Or|lan|do (österr. Schriftsteller)

Herz_mas|sa|ge, ...mit|tel *s*, ...muskel, ...mus|kel|schwä|che; herz_nah

Her|zog *m*; -[e]s, ...zöge (auch: -e Her|zo|gen|busch (niederl. Stad im Titel (↑ R 224): Herzoglich Her|zo|gin|mut|ter (*Mehr...*mütter); her|zogs|wür|de *w*; Her|zog|tum

Herz_pa|ti|ent, ...schlag, ...schrit ma|cher, ...schwä|che; herz|stärkend, aber (↑ R 142): das Herz stärkend; Herz_still|stan ...stück, ...ton (meist *Mehr...*töne), ...trans|plan|ta|ti|on

her|zu; her|zu... (z. B. herzukommen; ↑ R 304: er ist herzugekommen)

Herz_ver|pflan|zung

her|zy|nisch (Geol.: das Bruchs stem [des dt. Mittelgebirges] b treffend, aber (↑ R 224): Herz nischer Wald (alter Name des d Mittelgebirges)

herz|zer|rei|ßend; -ste; der Anblic war -, aber (↑ R 142): das Her zerreißend

He|se|ki|el [...*kiäl*] (bibl. Prophet); vgl. Ezechiel

He|si|od [auch: ...*ot*] (altgr. Dichter)

Hes|pe|ri|de (Tochter des Atla *w*; -, -n (meist *Mehrz.*); Hes|per

den|äp|fel *Mehrz.*; Hes|pe|ri|en [...*i*ⁿ*n*] (im Altertum Bez. für: Land gegen Abend [Italien, Westeuropa]); Hes|pe|ros vgl. Hesperus; Hes|pe|rus (Abendstern in der gr. Mythol.) *m*; -
¹Hes|se (dt. Dichter)
²Hes|se landsch. (unteres Bein von Rind od. Pferd) *w*; -, -n; vgl. Hachse
³Hes|se (Angehöriger eines dt. Volksstammes) *m*; -n, -n (↑R 268); Hes|sen (Land); Hes|sen-Darm|stadt, Hes|sen|land *s*; -[e]s; Hes|sen-Nas|sau; Hes|sin *w*; -, -nen, hes|sisch, aber (↑R 224): das Hessische Bergland
Hes|tia (gr. Göttin des Herdes)
He|tä|re gr. („Gefährtin"; [hochgebildete] Freundin, Geliebte bedeutender Männer im alten Griechenland) *w*; -, -n; He|tä|rie (altgr. polit. Verbindung) *w*; -, ...ien
he|te|ro... *gr.* (anders..., fremd...); He|te|ro... (Anders..., Fremd...); he|te|ro|dox (anders-, irrgläubig); He|te|ro|do|xie (Irrlehre) *w*; -, ...ien; he|te|ro|gen (andersgeartet, ungleichartig, fremdstoffig); He|te|ro|ge|ni|tät *w*; -; he|te|ro|morph (anders-, verschiedengestaltig); He|te|ro|phyl|lie (Bot.: Verschiedengestaltigkeit der Blätter bei einer Pflanze) *w*; -; He|te|ro|se|xua|li|tät (normales, auf das andere Geschlecht gerichtetes Empfinden im Ggs. zur Homosexualität); he|te|ro|se|xu|ell; he|te|ro|troph (Biol.: von Organismen: auf organische Nahrung angewiesen); he|ter|özisch (svw. diözisch); he|te|ro|zy|got (ungleicherbig); he|te|ro|zy|klisch [auch: ...zü...] (Bot. von Blüten: verschiedenquirlig; Chemie: im Kohlenstoffring auch andere Atome enthaltend)
He|thi|ter, (ökum.:) He|ti|ter (Angehöriger eines indogerman. Kulturvolkes in Kleinasien) *m*; -s, -; he|thi|tisch, (ökum.:) he|ti|tisch
Het|man (Oberhaupt der Kosaken; in Polen [bis 1792] vom König eingesetzter Oberbefehlshaber) *m*; -s, -e (auch: -s)
Het|sche|petsch *w*; -, - u. Het|scherl österr. mdal. (Hagebutte) *s*; -s, -n
Het|ti|ter vgl. Hethiter
Hetz österr. ugs. (Spaß), aus - (zum Spaß); Het|ze *w*; -, -n; het|zen; du hetzt (hetzest); Het|zer; Het|ze|rei; hetz|risch; -ste (↑R 294); hetz|hal|ber österr. ugs. (zum Spaß); Hetz|jagd, ...re|de Heu *s*; -[e]s; Heu_bo|den, ...büh|ne (schweiz.: Heuboden), ...bün|del

Heu|che|lei; heu|cheln; ich ...[e]le (↑R 327); Heuch|ler; heuch|le|risch; -ste (↑R 294); Heuch|ler|mie|ne
Heu|die|le (schweiz. neben: Heubühne); heu|en landsch. (Heu machen)
heu|er südd., österr., schweiz. (in diesem Jahre)
¹Heu|er (Heumacher)
²Heu|er (Löhnung, bes. der Schiffsmannschaft; Anmusterungsvertrag) *w*; -, -n; Heu|er.baas, ...bü|ro; heu|ern ([Schiffsleute] dingen); heu|ern (↑R 327)
Heu|ern|te, Heu|ort vgl. ¹Heuet; ¹Heu|et (für: Heumonat) *m*; -s, -e; ²Heu|et südd. u. schweiz. (Heuernte) *m*; -s od. *w*; -; Heu_feim od. ...fei|me od. ...fei|men, ...fie|ber (*s*; -s), ...ga|bel
Heul|bo|je; heu|len; (ugs.:) das heulende Elend bekommen; Heu|ler; Heul_krampf, ...su|se (Schimpfwort), ...ton
Heu_mahd, ...mo|nat od. ...mond (alte Bez. für: Juli), ...ochs od. ...och|se (Schimpfwort), ...pferd (Heuschrecke), ...rei|ter (österr.) od. ...reu|ter (südd. für: Holzgestell zum Heu- u. Kleetrocknen); heu|re|ka! *gr.* („ich hab's [gefunden]!")
heu|rig südd., österr. (diesjährig); Heu|ri|ge bes. österr. (junger Wein im ersten Jahr; Lokal für den Ausschank jungen Weins, Straußwirtschaft; *Mehrz.*: Frühkartoffeln) *m*; -n, -n (↑R 287ff.); Heu|ri|gen|abend
Heu|ri|stik *gr.* (Lehre von den Methoden zur Auffindung neuer wissenschaftl. Erkenntnisse) *w*; -; heu|ri|stisch (erfinderisch; das Auffinden bezweckend); -es Prinzip
Heu_schnup|fen, ...scho|ber, ...schreck (dicht. u. österr. neben: Heuschrecke; *m*; -[e]s, -e), ...schrecke [*Trenn.*: ...schrek|kel (ein Insekt; *w*; -, -n)
Heuss (erster dt. Bundespräsident); (↑R 249:) Heusssche Schriften
Heu_sta|del, ...stock (schweiz., österr. für: Heuvorrat [auf dem Heuboden]; *Mehrz.* ...stöcke)
heu|te (ugs. auch: heut) (↑R 129:) - abend, früh, mittag, morgen, nachmittag, nacht; die Frau von -; bis -; hier und -; Heu|te (die Gegenwart) *s*; -; das - und das Morgen, heu|tig; (↑R 116:) am Heutigen; nicht gut ist kaufmänn.: mein Heutiges (Schreiben vom gleichen Tag); heu|ti|gen|tags (↑R 129); heut|zu|ta|ge (↑R 129)

He|xa|chord *gr.* [...kort] (Aufeinanderfolge von sechs Tönen der diaton. Tonleiter) *m* od. *s*; -[e]s, -e; He|xa|eder (Sechsflächner, Würfel) *s*; -s, -; he|xa|edrisch; He|xa|eme|ron (Schöpfungswoche außer dem Sabbat) *s*; -s; He|xa|gon (Sechseck) *s*; -s, -e; he|xa|go|nal; He|xa|gramm (Figur aus zwei gekreuzten gleichseitigen Dreiecken; Sechsstern) *s*; -s, -e; He|xa|me|ter (sechsfüßiger Vers) *m*; -s, -; he|xa|me|trisch; He|xa|teuch (die ersten sechs bibl. Bücher) *m*; -s
He|xe *w*; -, -n, he|xen; du hext (hexest); He|xen|jagd, ...kes|sel, ...kü|che, ...mei|ster, ...sab|bat, ...schuß, ...tanz, ...ver|bren|nung, ...wahn; He|xer; He|xe|rei
Hex|ode *gr.* (Elektronenröhre mit sechs Elektroden) *w*; -, -n
Heym, Georg (dt. Lyriker)
Hf = chem. Zeichen für: Hafnium
hfl = holländ. Gulden
hg = Hektogramm
Hg = Hydrargyrum (chem. Zeichen für: Quecksilber)
hg., hrsg. = herausgegeben
Hg., Hrsg. = Herausgeber
HGB = Handelsgesetzbuch
hi!; hihi!
Hi|as[l] (österr. Kurzform von: Matthias)
Hi|at *lat.* *m*; -s, -e (svw. Hiatus); Hia|tus (Zusammentreffen zweier Selbstlaute im Auslaut des einen u. im Anlaut des folgenden Wortes oder Wortteiles, z. B. „sagte er" od. „Kooperation"; Geol.: zeitl. Lücke bei der Ablagerung von Gesteinen; Med.: Öffnung, Spalt) *m*; -, -
Hi|ber|na|kel *lat.* (Überwinterungsknospe von Wasserpflanzen) *s*; -s, -n (meist *Mehrz.*); hi|ber|nal (veralt. für: winterlich); Hi|ber|na|ti|on [...zion] (Med.: künstl. „Winterschlaf" als Narkoseergänzung, Heilschlaf) *w*; -
Hi|ber|ni|en *lat.* [...*i*ⁿ*n*] (lat. Name von: Irland)
Hi|bis|kus *gr.* (Eibisch) *m*; -, ...ken
Hick|hack (ugs. Streiterei; törichtes, zermürbendes Hinundhergerede) *m* u. *s*; -s, -s
Hick|ory [*Trenn.*: Hik|ko...] *indian.-engl.* (Holz eines nordamerik. Walnußbaumgewächses) *s*; -s; Hick|ory|holz [*Trenn.*: Hik|ko...] *s*; -es
Hi|dal|go *span.* (früher Mitglied des niederen iberischen Adels; mexik. Goldmünze) *m*; -s, -s
Hid|den|see (eine Ostseeinsel); Hid|den|seer [...se*e*r] (↑R 199 u. R 205)
hi|dro|tisch *gr.* (Med.: schweißtreibend)

hie

332

hie (südd. u. österr., sonst veralt. für: hier); hie und da

Hieb *m*; -[e]s, -e

hie|bei [auch: *hibái̯, hi̯bái̯*] vgl. hierbei

hieb|fest; hieb- und stichfest (↑ R 145); Hiebs|art (Forstw.)

hie|durch [auch: *hidu̯rch, hi̯durch*] vgl. hierdurch

Hie|fe mdal. (Hagebutte); Hie|fen|mark *s*

hie|für [auch: *hifǘr, hi̯fǘr*]; hie|gegen [auch: *higége̦n, hi̯gége̦n*]; hie|her [auch: *hihe̦r, hi̯her*] [auch: *hi̯mít, hi̯mít*]; hie|nach [auch: *hinách, hi̯nach*]; hie|ne|ben [auch: *hine̦b'n, hi̯ne̦b'n*] vgl. hierfür usw.

hie|nie|den [auch: *hini̯d'n, hi̯ni̯d'n*] (geh.: auf d[ies]er Erde)

hier[1]: - und da; von - aus; - oben, unten usw. Für die *Schreibung in Verbindung mit Zeitwörtern* gelten dieselben Gesichtspunkte wie für „da" (vgl. d.); hier|amts [auch: *hira̦mz, hi̯ramz*] (österr. Amtsdt.); hier|an [auch: *hira̦n, hi̯ran*]

Hier|ar|chie *gr.* [*hi-er-...*] (Rangordnung [der geistl. Gewalten]) *w*; -, ...ien; hier|ar|chisch; hie|ra|tisch (priesterlich); -e Schrift (altägypt. Priesterschrift)

hier|auf [auch: *hira̯uf, hi̯rauf*]; hier|auf|hin [auch: *hirau̯fhin, hi̯raufhin*]; hier|aus [auch: *hiráu̯s, hi̯raus*]; hier|be|hal|ten (zurückbehalten, nicht weglassen); vgl. hier; hier|bei[1] [auch: *hirbái̯, hi̯rbái̯*]; hier|blei|ben; ↑ R 139 (nicht weggehen), aber: hier blei|ben; du sollst hier [an der bezeichneten Stelle] bleiben; vgl. hier; hier|durch[1] [auch: *hirdu̯rch, hi̯rdurch*]; hier|ein [auch: *hira̯in, hi̯rain*]; hier|für[1] [auch: *hirfǘr, hi̯rfür*]; hier|ge|gen[1] [auch: *hirgége̦n, hi̯rgége̦n*]; hier|her[1] [auch: *hirhe̦r, hi̯rher*] (zu dem Redenden hin); komm - (zu mir); hier|her... (z. B. hierherkommen; ↑ R 304: er ist hierhergekommen); hier|her|auf [auch: *hirhärau̯f, hi̯rhärauf*]; hier|her|ge|hö|rend, hier|her|ge|hö|rig; hier|her|kom|men; vgl. hierher...; hier|her|um [auch: *hirhäru̯m, hi̯rhärum*]; hier|her|wärts [auch: *hirherwä̯rz, hi̯rherwärz*]; hier|hin [auch: *hirhi̯n, hi̯rhin*] (nach diesem Orte hin); bald -, bald dorthin; hier|hin... (z. B. hierhinlaufen; ↑ R 304: er ist hierhingelaufen); hier|hin|ter [auch:

hirhi̯nt'r, hi̯rhint'r]; hier|in [auch: *hiri̯n, hi̯rin*]; hier|in|nen [auch: *hiri̯n'n, hi̯rin'n*]; hier|lands [auch: *hirla̯nz, hi̯rlanz*]; hier|las|sen; er hat das Buch hiergelassen; aber: hier las|sen; er soll das Buch hier (nicht dort) lassen; hier|mit[1] [auch: *hirmi̯t, hi̯rmit*]; hier|nach[1] [auch: *hirnge̦h, hi̯rnaeh*]; hier|nächst[1] [auch: *hirnächßt, hi̯rnächßt*] (veralt.); hier|ne|ben[1] [auch: *hirne̦b'n, hi̯rne̦b'n*]

[1]Hie|ro|dy|le *gr.* [*hi-er-...*] (Tempelsklave des gr. Altertums) *m*; -n, -n (↑ R 268); [2]Hie|ro|dy|le (Tempelsklavin) *w*; -, -n; Hie|ro|gly|phe (Bilderschriftzeichen; übertr. für: rätselhaftes Schriftzeichen) *w*; -, -n; hie|ro|gly|phisch (in Bilderschrift; dunkel, rätselhaft); Hie|ro|mant (aus Opfern Weissagender) *m*; -en, -en (↑ R 268); Hie|ro|man|tie *w*; -; Hie|ro|ny|mus [auch: *hiero̦...*] (Heiliger; m. Vorn.)

hier|orts [auch: *hiro̦rz, hi̯rorz*] (Amtsdt.); hier|sein (zugegen sein), aber: hier sein (an dieser Stelle sein); Hier|sein *s*; -s; hier|selbst[1] [auch: *hirsä̯lpßt, hi̯rsälpßt*]; hier|über [auch: *hirü̯b'r, hi̯rüb'r*]; hier|um [auch: *hiru̯m, hi̯rum*]; hie[r] und da; vgl. hier; hier|un|ter [auch: *hiru̯nt'r, hi̯runt'r*]; hier|von[1] [auch: *hirfo̯n, hi̯rfon*]; hier|vor[1] [auch: *hirfo̯r, hi̯rfor*]; hier|wi|der[1] [auch: *hirwi̯d'r, hi̯rwid'r*]; hier|zu[1] [auch: *hirzu̯, hi̯rzu*]; hier|zu|lan|de[1] [auch *hir...*] (↑ R 141); hier|zwi|schen[1] [auch: *hirzwi̯sch'n, hi̯rzwisch'n*] vgl. hiervon usw.

Hie|sel, Hiesl (südd. Kurzform von: Matthias)

hie|selbst [auch: *hisä̯lpßt, hi̯sälpßt*] vgl. hierselbst

hie|sig; -en Ort[e]s; Hie|si|ge *m* u. *w*; -n, -n (↑ R 287 ff.)

hie|ven [*...f'n*] (Seemannsspr.: eine Last auf- od. einziehen, hochstemmen)

hie|von [auch: *hifo̯n, hi̯fon*]; hie|vor [auch: *hifo̯r, hi̯for*]; hie|wi|der [auch: *hiwi̯d'r, hi̯wid'r*]; hie|zu [auch: *hizu̯, hi̯zu*]; hie|zu|lan|de [auch: *hi̯...*]; hie|zwi|schen [auch: *hizwi̯sch'n, hi̯zwisch'n*] vgl. hiervon usw.

Hi-Fi = High-Fidelity

Hift|horn (Jagdhorn; *Mehrz.* ...hörner)

high *engl.* [*hai̯*] (in gehobener Stimmung nach dem Genuß von Rauschgift); High-Church [*hai̯tschö̯'tsch*] (Hochkirche[1]) *w*; -; High-Fi|de|li|ty [*hai̯faidä̯liti*] (Gütebez. für hohe Wiedergabetreue bei Schallplatten u. elek-

troakustischen Geräten; Abk.: HiFi); High|life [*hai̯lai̯f*] üppige, vornehme Lebensweise [der Reichen]) *s*; -s; High-So|cie|ty *engl.-amerik.* [*hai̯βḃai̯'ti*] (die gute Gesellschaft, die große Welt) *w*; -; Hi|jacker [*Trenn.*: ...jak|ker; *hai̯dsehä̯k'r*] (Entführer eines Fahrzeugs; Luftpirat) *m*; -s, -

Hil|da (w. Vorn.); Hild|burg vgl. Hildeburg; Hild|chen, Hil|de (w. Vorn.); Hil|de|brand (m. Eigenn.); Hil|de|brands|lied *s*; -[e]s; Hil|de|burg, Hild|burg (w. Vorn.); Hil|de|fons, Il|de|fons (m. Vorn.); Hil|de|gard (w. Vorn.); Hil|de|gund, Hil|de|gun|de (w. Vorn.)

Hil|fe *w*; -, -n (↑ R 224:) die Erste Hilfe (bei Verletzungen usw.); - leisten, suchen; zu - kommen, eilen; der Mechaniker, mit Hilfe dessen od. mit dessen Hilfe er sein Auto reparierte; hil|fe|bringend, aber (↑ R 142): wertvolle Hilfe bringend; hil|fe|fle|hend, aber (↑ R 142): um Hilfe flehend; Hil|fe...lei|stung, ...ruf; hil|fe|ru|fend, aber (↑ R 142): nach Hilfe rufend; hil|fe|stel|lung; hil|fe|su|chend, aber (↑ R 142): ständige Hilfe suchend; hilf|los; -este (↑ R 292); Hilf|lo|sig|keit *w*; -; hilf|reich; Hilfs..ak|ti|on, ...ar|beit; hilfs..be|dürf|tig, ...be|reit; Hilfs..be|reit|schaft (*w*; -), ...kraft *w*, ...leh|rer, ...mit|tel *s*, ...mo|tor, ...pre|di|ger, ...quel|le, ...schiff. ...schu|le; hilfs|wil|lig; Hilfs..wis|sen|schaft, ...zeit|wort

Hi|li (*Mehrz.* von: Hilus)

Hil|le|bil|le niederd. (hölzernes Signalgerät) *w*; -, -n

Hil|ma vgl. Helma; Hil|mar (m. Vorn.)

Hil|traud, Hil|trud (w. Vorn.)

Hi|lus *lat.* (Med.: Eintritts- od. Austrittsstelle der Gefäße, Nerven usw. an einem Organ) *m*; -, Hili

Hi|ma|la|ja [auch: *himala̯ja*] (Gebirge in Asien) *m*; -[s]

Him|bee|re; him|beer|far|ben, him|beer|far|big; Him|beer|geist (ein Trinkbranntwein; *m*; -[e]s), ...hecke [*Trenn.*: ...hek|ke] (vgl. [1]Hecke), ...saft (*m*; -[e]s)

Him|mel *m*; -s, -; um [des] -s willen; es ist mir -; him|mel|auf; Him|mel|bett; him|mel|blau; Him|mel|don|ner|wet|ter!; Him|mel|fahrt; Him|mel|fahrts..kom|man|do (Auftrag [im Krieg], der mit großer Wahrscheinlichkeit das Leben kostet; auch: die Ausführenden eines solchen Auftrags), ...na|se (ugs.) ...tag; him|mel|hoch; him|mel

[1] Die Formen ohne „r" gelten in Norddeutschland als veraltend, in Süddeutschland, Österr. u. der Schweiz sind sie noch in lebendigem Gebrauch.

[1] Vgl. Sp. 1, Anm. 1.

ich ...[e]le (↑ R 327); H**i**m|mel|reich; H**i**m|mels_ach|se (w; -), ...bahn, ...bo|gen, ...braut; h**i**m|mel|schrei|end, aber (↑ R 142): zum H**i**mmel schr**ei**end; -ste; H**i**m|mels_f**e**|ste (dicht.; w; -), ...ge|gend, ...kör|per, ...kraft (w; -), ..ku|gel (w; -), ...leit|er (w; -), ...rich|tung, ...saal (dicht.); H**i**m|mel[s]|schlüs|sel (Schlüsselblume) m (auch: s); H**i**m|mel[s]|strich; H**i**m|mel[s]|stür|mer; H**i**m|mels_tür (w; -), ...zelt (dicht.; s; -[e]s); h**i**m|mel|wärts; h**i**m|mel|weit; h**i**mm|lisch; -ste (↑ R 294)

h**i**n (Bewegung vom Sprechenden weg); bis zur Mauer hin; über die ganze Welt hin verstreut; vor sich hin brummen usw.; hin und her schaukeln; hin und her laufen (ohne bestimmtes Ziel), aber (↑ R 145): hin- und herlaufen (hin- und wieder zurücklaufen); hin und wieder (zuweilen); vgl. hinsein

h**i**n... (in Zus. mit Zeitwörtern, z. B. hingehen, du gehst hin, hingegangen, hinzugehen; zum 2. Mittelw. ↑ R 304)

h**i**n|ab; etwas weiter -; h**i**n|ab... (z. B. hinabfahren; ↑ R 304: er ist hinabgefahren); h**i**n|ab_f**a**h|ren, ...ge|hen, ...stei|gen, ...stür|zen (sich -), ...tau|chen

h**i**n|an; etwas weiter -; h**i**n|an... (z. B. hinangehen; ↑ R 304: er ist hinangegangen)

h**i**n|ar|bei|ten; auf eine Sache -, aber: auf seine Mahnungen h**i**n arbeiten

h**i**n|auf, (ugs.:) 'nauf (↑ R 238); den Rhein -; h**i**n|auf... (z. B. hinaufsteigen; ↑ R 304: er ist hinaufgestiegen); h**i**n|auf_blicken [Trenn.: ...blik|ken], ...ge|hen, ...klet|tern, ...rei|chen, ...schrau|ben (sich -), ...stei|gen, ...zie|hen (sich -)

h**i**n|aus; (ugs.:) 'naus (↑ R 238); auf das Meer -; darüber hinaus sein; h**i**n|aus... (z. B. hinausgehen; ↑ R 304: er ist hinausgegangen); h**i**n|aus_beu|gen, sich, ...drängen, ...ekeln (ugs.), ...fah|ren, ...ge|hen (alles darüber Hinausgehende), ...grei|fen (darüber -), ...ka|ta|pul|tie|ren (hinausschleudern), ...kom|men, ...kom|pli|men|tie|ren, ...las|sen, ...lau|fen (aufs gleiche -), ...schaf|fen (vgl. ¹schaffen), ...schie|ben, ...schmei|ßen (ugs.), ...sprin|gen, ...trei|ben, ...wa|gen, sich, ...wer|fen, ...wol|len (zu hoch -), ...zö|gern

h**i**n|be|ge|ben, sich

h**i**n|blick; in od. im - auf

h**i**n|brin|gen; er hat es ihm hingebracht

H**i**n|de vgl. Hindin

H**i**n|de|mith (dt. Komponist)

h**i**n|der|lich; h**i**n|dern; ich ...ere (↑ R 327); H**i**n|der|nis s; -ses, -se; H**i**n|der|nis_lauf, ...ren|nen; H**i**n|de|rung; H**i**n|de|rungs|grund

h**i**n|deu|ten; alles scheint darauf hinzudeuten, daß ...

H**i**n|di (Amtsspr. in Indien) s; -

H**i**n|din w; -, -nen, (auch:) Hin|de (veralt. für: Hirschkuh) w; -, -n

Hin|do|stan [auch: h**i**n...] vgl. Hindustan. H**i**n|du (Anhänger des Hinduismus) m; -[s], -[s]; H**i**n|du|is|mus (indische Religion) m; -; h**i**n|du|istisch; H**i**n|du|kusch (zentralasiat. Hochgebirge) m; -[s]

h**i**n|durch; durch alles -; h**i**n|durch... (z. B. hindurchgehen; ↑ R 304: er ist hindurchgegangen)

H**i**n|du|stan [auch: h**i**n...] (früherer Name für Nordindien; heute für das Gangesgebiet; auch: Bezeichnung für Indien; H**i**n|du|sta|ni (Form des Westhindi, Hauptverkehrssprache in Indien) s; -[s]; h**i**n|du|sta|nisch

h**i**n|ein, (ugs.:) 'nein (↑ R 238); bis in das Herz -; h**i**n|ein... (z. B. hineingehen; ↑ R 304: er ist hineingegangen); h**i**n|ein_f**a**l|len, ...flüch|ten (sich -), ...ge|heim|nis|sen (du geheimnißt [geheimnissest] hinein), ...ge|hen, ...ge|ra|ten (in etwas -), ...grei|fen, ...pas|sen, ...re|den, ...ren|nen (in sein Unglück -), ...schaf|fen (vgl. ¹schaffen), ...schau|en, ...schlit|tern (ugs.), ...schüt|ten, ...stei|gern, sich, ...stel|len, ...stop|fen, ...tap|pen (ugs.), ...tre|ten, ...ver|set|zen (sich -)

h**i**n|fah|ren; H**i**n|fahrt; Hin- und Herfahrt (vgl. d.)

h**i**n|fal|len; h**i**n|fäl|lig; H**i**n|fäl|lig|keit w; -

h**i**n|fin|den; sich -

h**i**n|fort (veralt. für: in Zukunft)

h**i**n|füh|ren

H**i**n|ga|be w; -; h**i**n|ga|be|fä|hig

H**i**n|gang

h**i**n|ge|ben (↑ R 139); sich -; er hat sein Geld hingegeben; aber: auf sein Verlangen hin geben; h**i**n|ge|bend; -ste; H**i**n|ge|bung; h**i**n|ge|bungs|voll

h**i**n|ge|gen

h**i**n|ge|gos|sen (ugs.); sie lag wie - auf dem Sofa

h**i**n|ge|hen

h**i**n|ge|hö|ren

h**i**n|ge|ris|sen (ugs. für: begeistert); er war von dieser Aufführung hingerissen; H**i**n|ge|ris|sen|heit w; -

h**i**n|ge|zo|gen; sich - fühlen

h**i**n|gucken [Trenn.: ...guk|ken]

h**i**n|hän|gen; vgl. ²hängen

h**i**n|hal|ten; er hat das Buch hingehalten; mit der Rückgabe des Buches hat er sie lange hingehalten

hinhaltend antworten; H**i**n|hal|tung

h**i**n|hau|en (ugs.); das haute hin (ugs. für: das traf zu, das war in Ordnung); ich haute mich hin (ugs. für: legte mich schlafen); er haut hin (österr. für: beeilt sich sehr bei der Arbeit)

h**i**n|hocken [Trenn.: ...hok|ken]; sich -

h**i**n|hor|chen

H**i**n|ke_bein, ...fuß

h**i**n|kel mdal. (Huhn) s; -s, -

h**i**n|ken; gehinkt

h**i**n|knien; sich -

h**i**n|krie|gen (ugs.); wir werden das schon -

H**i**n|kunft w; - (bes. österr.:) in - (in Zukunft)

h**i**n|läng|lich

h**i**n|le|gen; sich -

h**i**n|nah|me w; -; h**i**n|neh|men

h**i**n|nei|gen; sich -; H**i**n|nei|gung

h**i**n|nen (veralt.), noch in: von - gehen

h**i**n|rei|chen; h**i**n|rei|chend; -e Bedingung (Math.)

H**i**n|rei|se; Hin- und Herreise (vgl. d.); h**i**n|rei|sen

h**i**n|rei|ßen; sich - lassen; h**i**n|rei|ßend; -ste

H**i**n|rich niederd. (Heinrich)

h**i**n|rich|ten; H**i**n|rich|tung

h**i**n|sa|gen; das war nur so hingesagt

h**i**n|schau|en

h**i**n|schicken [Trenn.: ...ik|ken]

h**i**n|schie|ben

H**i**n|schied schweiz. (Ableben) m; -[e]s

h**i**n|schla|gen; er ist lang hingeschlagen

h**i**n|schlep|pen; sich -

h**i**n|schmei|ßen (ugs. für: hinwerfen); sich -

h**i**n|se|hen

h**i**n|sein (ugs.: völlig kaputt sein; tot sein; hingerissen sein); alles ist hin; das Auto wird hinsein; weil er vor Begeisterung ganz hin ist, war

h**i**n|set|zen; sich

H**i**n|sicht w; -; in - auf; h**i**n|sicht|lich; mit Wesf.: - seines Briefes

h**i**n|sie|chen

h**i**n|sin|ken

H**i**n|spiel (Sportspr.; Ggs.: Rückspiel)

h**i**n|stel|len; sich -

h**i**n|strecken [Trenn.: ...ek|ken]

h**i**n|streu|en

h**i**n|strö|men

h**i**n|stür|zen

hint|an... (z. B. hintansetzen; ↑ R 304: er hat seine Wünsche hintangesetzt); hint|an|hal|ten; H**i**nt|an|hal|tung; hint|an|set|zen; H**i**nt|an|set|zung; hint|an|stel|len; H**i**nt|an|stel|lung; unter - aller Wün-

sche; hin|ten; hin|ten|an; hin|ten-
an|set|zen; hin|ten|drauf (ugs.);
hin|ten|her|um; hin|ten|hin; hin-
ten|nach; hin|ten|rum (ugs. für:
hintenherum); hin|ten|über; hin-
ten|über... (z. B. hintenüberfal-
len; ↑ R 304: er ist hintenüberge-
fallen); hin|ten|über⌣käm|men,
...stür|zen
hin|ter; mit Wemf. u. Wenf.: hinter
dem Zaun stehen, aber: hinter
den Zaun stellen; hin|ter... in Ver-
bindung mit Zeitwörtern: a) unfe-
ste Zusammensetzungen (↑ R
304), z. B. hinterbringen (vgl. d.),
hintergebracht; b) feste Zusam-
mensetzungen (↑ R 304), z. B. hin-
terbringen (vgl. d.), hinterbracht
Hin|ter⌣ach|se, ...an|sicht, ...aus-
gang, ...backe [Trenn.: ...bak|ke],
...bänk|ler (wenig einflußreicher
Parlamentarier [der auf einer der
hinteren Bänke sitzt], ...bein
hin|ter|blei|ben; die hinterbliebe-
nen Kinder; Hin|ter|blie|be|ne m
u. w; -n, -n (↑ R 287ff.); Hin|ter-
blie|be|nen|ren|te
hin|ter|brin|gen (ugs. für: nach hin-
ten bringen); er hat das Essen
kaum hintergebracht; hin|ter-
brin|gen (heimlich melden, verra-
ten); er hat die Nachricht hinter-
bracht; Hin|ter|brin|gung
hin|ter|drein; er war -; hin|ter-
drein... (z. B. hinterdreinlaufen;
↑ R 304: er ist hinterdreinge-
laufen)
hin|te|re; hinterst (vgl. d.); Hin|te-
re (ugs. für: Gesäß) m; ...ter[e]n,
...ter[e]n; vgl. auch: Hintern und
Hinterste
hin|ter|ein|an|der; Schreibung in
Verbindung mit Zeitwörtern (↑ R
139): die Briefe hintereinander
(sofort) schreiben, aber: die Na-
men in der Liste hintereinander-
schreiben, vgl. aneinander; hin-
ter|ein|an|der|schal|ten; Hin|ter-
ein|an|der|schal|tung
Hin|ter|ein|gang
hin|ter|es|sen (ugs. für: mit Mühe,
auch: unwillig essen); er hat das
Gemüse hintergegessen
hin|ter|fot|zig (ugs. für: hinterli-
stig, heimtückisch); Hin|ter|fot-
zig|keit
hin|ter|fra|gen (nach den Hinter-
gründen von etw. fragen); et-
was -
Hin|ter|front
Hin|ter|fuß
Hin|ter⌣gau|men|laut (für: Velar),
...ge|bäu|de, ...ge|dan|ke
hin|ter|ge|hen (ugs. für: nach hin-
ten gehen); hintergegangen; hin-
ter|ge|hen (täuschen, betrügen);
hintergangen; Hin|ter|ge|hung
hin|ter|gie|ßen (ugs. für: hinunter-
gießen); hintergegossen; hin|ter-

gie|ßen (Druckw.: durch weiteren
Guß verstärken); hintergossen
Hin|ter|grund; hin|ter|grün|dig;
Hin|ter|grün|dig|keit
hin|ter|ha|ken (ugs. für: nachfas-
sen; eine Sache vorantreiben od.
ihr auf den Grund gehen); da
muß ich schleunigst -
Hin|ter|halt m; -[e]s, -e; hin|ter|häl-
tig; Hin|ter|häl|tig|keit
Hin|ter|hand w; -
Hin|ter|haupt; Hin|ter|haupt[s]|-
bein
Hin|ter|haus
hin|ter|her [auch: hin...]; hinterher
(danach) polieren, aber: hinter-
herlaufen (nachlaufen); er ist hin-
terhergelaufen
Hin|ter|hof
Hin|ter|in|di|en (südöstl. Halbin-
sel Asiens; ↑ R 206)
Hin|ter|kopf
Hin|ter|la|der (eine Feuerwaffe)
Hin|ter|la|ge schweiz. (Hinterle-
gung, Faustpfand)
Hin|ter|land w; -[e]s
hin|ter|las|sen (zurücklassen; ver-
erben); er hat etwas -; Hin|ter|las-
se|ne schweiz. (Hinterbliebene) m
u. w; -n, -n (↑ R 287ff.); Hin|ter-
las|sen|schaft; Hin|ter|las|sung
unter - von ...
hin|ter|le|gen (als Pfand usw.); er
hat die Aktien hinterlegt; Hin|-
ter|le|ger; Hin|ter|le|gung
Hin|ter|list; hin|ter|li|stig; Hin|ter-
li|stig|keit
hin|term; ↑ R 240 (ugs. für: hinter
dem)
Hin|ter|mann (Mehrz. ...männer);
Hin|ter|mann|schaft
Hin|ter|maue|rung
hin|tern; ↑ R 240 (ugs. für: hinter
den)
Hin|tern (für: Hintere) m; -s, -
Hin|ter|rad
hin|ter|rücks
hin|ters; ↑ R 240 (ugs. für: hinter
das)
Hin|ter|saß od. ...sas|se (veralt.
für: jmd., der nur Haus, Garten
u. einzelne Felder, aber kein
Bauerngut besitzt) m; ...sassen,
...sassen; Hin|ter|säß (schweiz.
früher für: Einwohner ohne Bür-
gerrecht) m; ...sässen, ...sässen
hin|ter|schlin|gen (ugs. für: mit
Mühe, unwillig, rasch essen); er
hat die Speise hintergeschlungen
hin|ter|schlucken [Trenn.:
...schluk|ken] (ugs. für: hinunter-
schlucken); er hat das Brot hin-
tergeschluckt
Hin|ter|sinn (geheime Nebenbe-
deutung) m; -[e]s; hin|ter|sin|nen,
sich südd. u. schweiz. (grübeln,
schwermütig werden); du hast
dich hintersonnen; hin|ter|sin-
nig; -er Humor

hin|terst; zuhinterst; der hinterste
Mann, aber (↑ R 116): die Hin-
tersten sind kaum noch zu sehen;
Hin|ter|ste (ugs. für: Gesäß) m;
-n, -n
Hin|ter⌣ste|ven, ...teil (Gesäß s;
hinterer Teil m), ...tref|fen (ins
- kommen)
hin|ter|trei|ben (vereiteln); er hat
den Plan hintertrieben; Hin|ter-
trei|bung
Hin|ter|trep|pe; Hin|ter|trep|pen-
ro|man
Hin|ter|tür
Hin|ter|wäld|ler; Hin|ter|wäld|le-
risch
hin|ter|wärts (veralt. für: zurück,
[nach] hinten)
hin|ter|zie|hen (unterschlagen); er
hat die Steuer hinterzogen; Hin-
ter|zie|hung
hin|tra|gen
hin|trei|ben
hin|tre|ten; vor jmdn. -; Hin|tritt
[eigentlich: das Hintreten (vor
den Richterstuhl Gottes)] (veralt.
für: Tod, Heimgang) m; -[e]s
hin|über, (ugs.:) 'nü|ber (↑ R 238);
hinüber sein (ugs. für: ver-
braucht, verdorben, gestorben
sein); hin|über... (z. B. hinüberge-
hen; ↑ R 304: er ist hinübergegan-
gen); hin|über⌣brin|gen, ...ge|hen,
...schaf|fen (vgl. ¹schaffen),
...schau|en, ...schicken [Trenn.:
...ik|ken], ...schwim|men, ...spie-
len [ein ins Grünliche hinüber-
spielendes Blau], ...wech|seln,
...wer|fen, ...win|ken, ...zie|hen
Hin und Her s; - - -; nach längerem
- - -; ein ewiges - - -; Hin|und|her-
fah|ren s; -s; aber (↑ R 145): [das]
Hin- und [das] Herfahren; Hin-
und Her|fahrt (↑ R 145) Hin|und-
her|ge|re|de; Hin- und Her|rei|se
(↑ R 145) Hin- und Her|weg (↑ R
145)
hin|un|ter, (ugs.:) 'nun|ter (↑ R
238); hin|un|ter... (z. B. hinunter-
gehen; ↑ R 304: er ist hinunter-
gegangen); hin|un|ter⌣be|för-
dern, ...blicken, ...brin|gen [Trenn.: ...blik-
ken], ...brin|gen, ...ei|len, ...flie-
ßen, ...ge|hen, ...kip|pen, ...rei-
chen, ...rei|ßen, ...rol|len
...schlucken [Trenn.: ...schluk-
ken], ...stür|zen, ...ta|sten, ...wür-
fen
hin|wärts
hin|weg; hin|weg... (z. B. hinwegge-
hen; ↑ R 304: er ist hinweggegan-
gen)
Hin|weg; Hin- und Herweg (↑ R
145)
hin|weg⌣brau|sen, ...brin|gen, ...fe-
gen, ...ge|hen, ...glei|ten, ...hel|fen
(er half ihm darüber hinweg)
...kom|men, ...raf|fen, ...rol|len
...set|zen (sich darüber -), ...stei-

gen, ...täu|schen, ...trö|sten, ...zie-
hen
Hin|weis *m*; -es, -e; hin|wei|sen;
-des Fürwort (für: Demonstra-
tivpronomen); Hin|wei|sung
hin|wen|den; sich -; Hin|wen|dung
hin|wer|fen; sich -
hin|wie|der, hin|wie|der|um
Hinz (Kurzform von: Heinrich);
und Kunz (jedermann)
hin|zeich|nen
hin|zie|hen (verzögern); die Erledi-
gung dieses Vorganges hat sich
lange hingezogen
hin|zie|len; auf Erfolg -
hin|zu; hin|zu... (z. B. hinzukom-
men; ↑ R 304. es ist hinzugekom-
men, aber [↑ R 144]: hinzu
kommt, daß ...); hin|zu|fü|gen;
Hin|zu|fü|gung; hin|zu|ge|sel|len
(sich -); ...kau|fen, ...kom|men,
...rech|nen, ...sprin|gen, ...tre|ten;
Hin|zu|tun *s*; -s
Hi|ob, Job, (ökum.:) Ijob (bibl.
m. Eigenn.); Hi||obs|bot|schaft,
...post (Unglücksbotschaft)
hipp..., hip|po... *gr.* (pferd...);
Hipp..., Hip|po... (Pferd...);
Hipp|arch (Befehlshaber der Rei-
terei bei den alten Griechen) *m*;
-en, -en (↑ R 268); Hipp|uri|on
(Biol.: fossiler Vorläufer des
Pferdes) *s*; -s, ...ien [...i^e n]
¹Hip|pe (sichelförmiges Messer)
w; -, -n
²Hip|pe südd. (eine Art Fladen-
kuchen) *w*; -, -n
³Hip|pe mitteld. (Ziege) *w*; -, -n
hipp, hipp, hurra!; hipp, hipp, hurra
rufen; er rief: „Hipp, hipp, hur-
ra!"; Hipp|hipp|hurra! (Hochruf
[beim Rudersport]) *s*; -s, -s; er
rief ein kräftiges -
Hipp|ia|trik *gr.* (Pferdeheilkunde)
w; -
Hip|pie *amerik.* [*hipi*] (Jugend-
licher, der sich zu einer antibür-
gerlichen, pazifistischen Lebens-
form bekennt; Anhänger einer
urspr. von Amerika u. England
ausgehenden Bewegung; „Blu-
menkind") *m*; -s, -s
hip|po... vgl. hipp...; Hip|po... vgl.
Hipp...; Hip|po|drom (Reitbahn)
m od. *s*; -s, -e; Hip|po|gryph (Flü-
gelroß) *m*; -s u. -en, -e[n] (↑ R
268); Hip|po|kra|tes [auch: *hi-
pọ...*] (altgr. Arzt); Hip|po|kra|ti-
ker (Anhänger des Hippokrates);
hip|po|kra|tisch; -er Eid (mora-
lisch-ethische Grundlage des
Arzttums; früher: Schwur auf die
Satzung der Ärzteschaft); -es Ge-
sicht (Med.: Gesichtsausdruck
des Sterbenden; aber (↑ R 179):
Hip|po|kra|tisch; Hip|po|kre|ne
(„Roßquelle"; Musenquelle;
Dichterheimat) *w*; -; Hip|po|lo-
gie ([wissenschaftl.] Pferdekun-

de) *w*; -; hip|po|lo|gisch (Pfer-
de...); Hip|po|lyt (m. Eigenn.);
Hip|po|ly|tos [auch: *hipọ...*], Hip-
po|ly|tus [auch: *hipọ...*] vgl. Hip-
polyt; Hip|po|po|ta|mus [auch: *hi-
popọ...*] (Flußpferd) *m*; -, -; Hip-
pu|rit (fossile Muschel) *m*; -en,
-en (↑ R 268); Hip|pur|säu|re (or-
gan.-chem. Verbindung) *w*; -
Hip|pus *gr.* (Med.: Blinzeln; Zit-
tern der Regenbogenhaut) *m*; -
Hi|ra|ga|na (jap. Silbenschrift) *s*;
-[s] od. *w*; -
Hirn *s*; -[e]s, -e; Hirn|er|schüt|te-
rung (schweiz. neben: Gehirner-
schütterung); Hirn|ge|spinst;
Hirn|haut|ent|zün|dung; Hirn-
holz (quer zur Faser geschnitte-
nes Holz mit Jahresringen); hirn-
los; hirn|ris|sig österr. ugs. (über-
spannt, verrückt); Hirn|scha|le;
Hirn|strom|bild (Med.); hirn|ver-
brannt (ugs.); eine -e (unsinnige,
verrückte) Idee; hirn|ver|letzt
Hi|ro|schi|ma [auch: *hirọ...*],
(postamtl.:) Hiroshima (Stadt in
Japan, auf die am 6. 8. 1945 die
erste Atombombe abgeworfen
wurde)
Hirsch *m*; -[e]s, -e; Hirsch_art,
...fän|ger; hirsch|ge|recht (mit der
Hirschjagd vertraut); Hirsch_ge-
weih, ...horn *s*; -[e]s, ...kä|fer,
...kalb, ...kuh; hirsch|le|dern
Hir|se *w*; -, (fachspr.:) -n; Hir-
se_brei, ...korn (*Mehrz.*: ...körner)
Hirt *m*; -en, -en (↑ R 268); Hir|te
(veralt. u. dicht. für: Hirt) *m*; -n,
-n; hir|ten schweiz. mdal. (Hirt
sein, die Herde hüten, Vieh be-
sorgen); Hir|ten_amt, ...brief
(bischöfl. Rundschreiben), ...flö-
te, ...ge|dicht, ...stab, ...tä|schel
(ein Heilkraut; *s*; -s), ...tum (*s*;
-s), ...volk; Hir|tin *w*; -, -nen
his, His (Tonbezeichnung) *s*; -, -
His|kia, His|ki|as, (ökum.:) Hiski-
ja (jüd. König)
Hi|spa|ni|en [...*i^e n*] (alter Name
der Pyrenäenhalbinsel); hi|spa-
nisch; hi|spa|ni|sie|ren (spanisch
machen)
his|sen (Flagge, Segel) hochzie-
hen); du hißt (hissest); du hißtest;
gehißt; hisse! vgl. auch:
heißen (hissen)
Hist|amin (ein Gewebehormon)
-s; Hi|sto|lo|ge *gr.* (Forscher u.
Lehrer der Histologie) *m*; -n, -n
(↑ R 268); Hi|sto|lo|gie (Lehre
von den Geweben des Körpers)
w; -; hi|sto|lo|gisch
Hi|stör|chen *gr.* (Geschichtchen);
Hi|sto|rie [...*i^e*] (*[Welt]geschich-
te; früher auch: Erzählung, Be-
richt, Kunde) *w*; -, -n; Hi|sto|ri-
en|ma|le|rei; Hi|sto|rik (Ge-
schichtsforschung) *w*; -; Hi|sto|ri-
ker (Geschichtsforscher); Hi|sto-

rio|graph (Geschichtsschreiber)
m; -en, -en (↑ R 268); hi|sto|risch;
-e Geologie; -e Grammatik; -er
Materialismus; -es Präsens; hi|
sto|ri|sie|ren (das Geschichtliche
betonen, anstreben); Hi|sto|ris-
mus (Überbetonung des Ge-
schichtlichen) *m*; -; ...men; hi|sto-
ri|stisch (in der Art des Historis-
mus)
Hi|strio|ne *lat.* (altröm. Schau-
spieler) *m*; -n, -n (↑ R 268)
Hit *engl.* (ugs. für: erfolgreiches
Musikstück, Spitzenschlager) *m*;
-[s], -s; Hit_li|ste, ...pa|ra|de
Hit|sche, Hüt|sche, Hüt|sche ost-
mitteld. (Fußbank; kleiner
Schlitten) *w*; -, -n
Hit|ze *w*; -; hit|ze_ab|wei|send,
...be|stän|dig; Hit|ze|fe|ri|en
Mehrz.; hit|ze|frei; Hit|ze_schild
(*m*), ...wel|le; hit|zig; Hitz|kopf;
hitz|köp|fig; Hitz_pocke [*Trenn.*:
...pok|ke], ...schlag
Hjal|mar (m. Vorn.)
HK = Hefnerkerze
hl = Hektoliter
hl. = heilig; hll. = heilige *Mehrz.*
hm = Hektometer
h. m. = hujus mensis, dafür besser:
d. M.
hm!, hem!; hm, hm!, hem, hem!
h-Moll [*hamọl*, auch: *hạmọl*] (Ton-
art; Zeichen: h) *s*; -; h-Moll-Ton-
lei|ter [*hạ...*] (↑ R 155) *w*; -, -n
ho!; hoho!; ho ruck!
Ho = chem. Zeichen für: Hol-
mium
HO = Handelsorganisation
(DDR); HO-Geschäft (↑ R 150)
Ho|ang|ho [auch: *hoanghọ*] vgl.
Hwangho
Hob|bes [*engl.* Ausspr.: *họbs*]
(engl. Philosoph)
Hob|bock [wohl nach dem engl.
Familiennamen Hubbuck] (ein
viereckiges Versandgefäß) *m*; -s, -s
Hob|by *engl.* (Steckenpferd; Lieb-
haberei) *s*; -s, -s; Hob|by|ist
Ho|bel *m*; -s, -; Ho|bel|bank
(*Mehrz.* ...bänke); ho|beln; ich
...[e]le (↑ R 327); Ho|bel|span;
Hob|ler
hoc an|no *lat.* (in diesem Jahr;
Abk.: h. a.); dafür besser als die dt.
Ausdruck
hoch; höher (vgl. d.), höchst (vgl.
d.); vgl. hohe; hoch oben. I. *Klein-
und Großschreibung* vgl. hohe,
höher, höchst. II. *In Verbindung
mit Zeitwörtern* (↑ R 139): 1. *Ge-
trenntschreibung*, wenn „hoch"
in ursprünglichem Sinne ge-
braucht wird, z. B. hoch sitzen;
hoch fliegen (vgl. aber: hochflie-
gen); den Zaun hoch (nicht:
niedrig) machen; den Ertrag
hoch (nicht niedrig) schätzen
(vgl. aber: hochschätzen). 2. *Zu-*

sammenschreibung: **a)** wenn „hoch" bedeutet „in die Höhe", z. B. hochhalten, hochheben; **b)** wenn „hoch" in übertragenem Sinne gebraucht wird, z. B. hochhalten (schätzen), hochschätzen. **III.** *In Verbindung mit dem 2. Mittelwort* Getrennt- oder Zusammenschreibung: ein hochbegabter Mann (↑ jedoch R 142), a b e r: der Mann ist hoch begabt; vgl. hochgeehrt, hochverehrt

Hoch (Hochruf; Meteor.: Gebiet hohen Luftdrucks) *s*; -s, -s

hoch|ach|ten; er wurde hochgeachtet; vgl. hoch, II, 2, b: **hoch|ach|tend; Hoch|ach|tung; hoch|ach|tungs|voll; Hoch|adel;** hoch|ak|tu|ell; Hoch.al|tar, ...amt; hoch|an|stän|dig; Hoch|an|ten|ne; hoch|ar|bei|ten, sich -

Hoch.bahn, ...bau (*Mehrz.* ...bauten); **hoch|be|gabt;** (↑ R 296:) höherbegabt, höchstbegabt; der hochbegabte Mann (↑ jedoch R 142), a b e r: der Mann ist hoch begabt; **hoch|bei|nig; hoch|bekom|men; hoch|be|steu|ert;** (↑ R 296:) höherbesteuert, höchstbesteuert; ein hochbesteuertes Unternehmen (↑ jedoch R 142), a b e r: das Unternehmen ist hoch besteuert; **hoch|be|tagt** (vgl. S. 45, Merke, 2); er ist -; **Hoch|betrieb** *m*; -[e]s; **hoch|be|zahlt;** eine -e Stellung (↑ jedoch R 142), a b e r: der Posten wird hoch bezahlt; **hoch|bin|den; hoch|blü|te** *w*; -; **hoch|brin|gen;** er hat den Korb hochgebracht; vgl. hoch, II, 2, a; **Hoch|burg; hoch|bu|sig**

hoch|deutsch; auf -; vgl. deutsch; **Hoch|deutsch** (Sprache) *s*; -[s]; vgl. Deutsch; **Hoch|deut|sche** *s*; -n; im -n; vgl. Deutsche s; **hoch|do|tiert;** vgl. hoch|be|zahlt; **hoch|dre|hen;** den Motor - (auf hohe Drehzahlen bringen); **Hochdruck** *m*; -[e]s, (für: Erzeugnis im Hochdruckverfahren auch *Mehrz.*:) ...drucke; mit - arbeiten; **Hoch|druck.ge|biet,** ...ver|fah|ren **Hoch|ebe|ne; hoch|emp|find|lich;** ein -er Film; **hoch|er|freut;** der hocherfreute Vater (↑ jedoch R 142), a b e r: der Vater war hoch erfreut; **hoch|ex|plo|siv**

hoch|fah|ren; er ist aus dem Schlaf hochgefahren; vgl. hoch, II, 2, a; **hoch|fah|rend;** -er, -ste (↑ R 297); ein -er Plan; **hoch|fein; Hoch|fi|nanz** *w*; -; **hoch|flie|gen** (in die Höhe fliegen, auffliegen); die Tauben sind plötzlich hochgeflogen; a b e r: die hoch flie|gen; die Flugzeuge sind hoch (in großer Höhe) geflogen; vgl. hoch, II, 1 u. 2; **hoch|flie|gend;** -ste (↑ R 297); eine -e Idee; **Hoch|form** (Sport-

spr.); in - sein; **Hoch|fre|quenz; Hoch|fre|quenz|strom**

hoch|ge|bie|tend, in der Anrede (veralt.): Hochgebietend; **hoch|ge|bil|det;** ein hochgebildeter Mann (↑ jedoch R 142), a b e r: der Mann ist hoch gebildet; **Hoch|ge|bir|ge; hoch|ge|bo|ren,** als Titel: Hochgeboren; in der Anrede: Eure, Euer Hochgeboren; **hoch|ge|ehrt;** (↑ R 142:) hochgeehrter Herr!, a b e r: der von mir hoch geehrte Herr; der Herr wird von mir hoch geehrt; **Hoch|gefühl; hoch|ge|hen** (ugs. auch für; aufbrausen); **hoch|ge|lehrt;** ein -er Mann; **hoch|ge|mut;** ein -er Mensch; **Hoch.ge|nuß,** ...ge|richt (hist.); **hoch.ge|schlos|sen,** ...gespannt; **hoch|ge|steckt;** -e Ziele; **hoch|ge|stellt;** (↑ R 296:) höhergestellt, höchstgestellt; ein hochgestellter Mann (↑ jedoch R 142), a b e r: der Mann ist hoch gestellt; **hoch|ge|sto|chen** (ugs.); er ist - (eingebildet); **hoch.ge|wach|sen,** ...ge|züch|tet

Hoch|glanz; hoch|glän|zend; -e Seide; **hoch|glanz|po|liert; hoch|gra|dig**

hoch|hackig [*Trenn.:* ...hak|kig]; -e Schuhe; **hoch|hal|ten;** er hat das Kind hochgehalten; er hat die Ehre hochgehalten; a b e r: hoch halten; die Preise [künstlich] hoch halten; vgl. hoch, II, 2, a u. b; **Hoch|haus; hoch|he|ben;** er hat den Sack hochgehoben; vgl. hoch, II, 2, a; **Hoch|hei|mer** (ein Wein); **Hoch|herr|schaft|lich; hoch|her|zig; Hoch|her|zig|keit**

Ho Chi Minh [*hotschimín*] (nordvietnames. Politiker); **Ho-Chi-Minh-Pfad** (↑ R 182) *m*; -[e]s

hoch.in|tel|li|gent, ...in|ter|es|sant **hoch|ja|gen** (aufjagen, in die Höhe jagen); er hat den Motor hochgejagt; **hoch|ju|beln** (ugs.: etwas durch übertriebenes Lob allgemein bekannt machen)

hoch|kant; - stellen; **hoch|kan|tig; hoch|ka|rä|tig; Hoch|kir|che; hoch|klet|tern** (ugs. für: in die Höhe klettern, hinaufklettern); **hoch|kom|men** (ugs.); **Hoch|konjunk|tur; hoch|krem|peln;** die Ärmel -; **Hoch|kul|tur**

Hoch|land (*Mehrz.* ...länder, auch: ...lande); **Hoch|län|der** (auch: Schotte) *m*; **hoch|län|disch** (auch: schottisch); **Hoch|lau|tung** (Sprachw.: die für die Aussprache der Hochsprache zu fordernde Norm); **hoch|le|ben;** er hat ihn hochleben lassen; vgl. hoch, II, 2, b; **hoch|le|gen;** du mußt das Bein -; **Hoch|lei|stung; Hoch|leistungs.mo|tor,** ...sport, ...training; **höch|lich;** -st; **hoch|löb|lich**

Hoch|mei|ster; **hoch|mo|dern; hoch|mo|disch; hoch|mö|gend,** als Titel: Hochmögend; **hoch|mo|le|ku|lar** (aus vielen Atomen bestehend); **Hoch.moor,** ...mut; **hochmü|tig; Hoch|mü|tig|keit** *w*; - **hoch|nä|sig** (ugs. für: hochmütig); **Hoch|nä|sig|keit** *w*; -; **hoch|nehmen** (ugs. für: übervorteilen; hänseln, necken; Gaunerspr.: verhaften); er hat ihn tüchtig hochgenommen; vgl. hoch, II, 2, b; **hoch|not|pein|lich** [auch: *hochnot-pain...*] (hist.); -es Gericht

Hoch|ofen

hoch|päp|peln (ugs.); **Hoch|parterre; hoch|prei|sen;** er hat Gott hochgepriesen; vgl. hoch, II, 2, b; **hoch|pro|zen|tig**

hoch|qua|li|fi|ziert

hoch|rä|drig; ein -er Wagen; **hochrap|peln,** sich (ugs.); **hoch|rechnen** (aus repräsentativen Teilergebnissen [mit dem Computer] das Gesamtergebnis vorausberechnen); **Hoch.rech|nung,** ...re|li|ef; **hoch|rot; Hoch|ruf**

Hoch|sai|son; hoch|schät|zen (sehr schätzen, verehren); er hat ihn hochgeschätzt; a b e r: **hoch schät|zen;** die Kosten hoch schätzen; vgl. hoch, II, 1 u. 2; **Hoch|schät|zung** (*w*; -); **hoch|schla|gen;** den Kragen -; **hoch|schrecken** [*Trenn.:* ...schrek|ken]; vgl. 'schrecken; **Hoch.schu|le,** ...schü|ler; **Hoch|schul.leh|rer,** ...re|form; **hoch|schul|tern; Hoch|see|fi|sche|rei; hoch|se|lig** (veralt.), ...sin|nig; **Hoch.sitz** (Weidw.), ...som|mer, ...span|nung; **Hoch|span|nungslei|tung; hoch|spie|len;** er hat die Angelegenheit hochgespielt; a b e r: hoch (mit hohem Einsatz) spie|len; vgl. hoch, II, 1 u. 2; **Hoch|spra|che; hoch|sprach|lich; hoch|sprin|gen;** vom Stuhl in die Höhe springen); der Hund ist an ihm hochgesprungen; a b e r: **hoch sprin|gen;** Flöhe können hoch springen; vgl. hoch, II, 1 u. 2; a; **Hoch|sprung**

höchst; höchstens; am höchsten. **I.** *Kleinschreibung* (↑ R 134): auf das od. aufs höchste (↑ R 116): seinen Sinn ist auf das od. aufs Höchste gerichtet; nach dem Höchsten streben

Hoch|sta|pe|lei; **hoch|sta|peln** (Ggs.: tiefstapeln); ich stap[e]le hoch (↑ R 327); ich habe hochgestapelt; um hochzustapeln; **Hoch|stap|ler**

Höchst|bie|ten|de *m* u. *w*; -n, -n (↑ R 287ff.); **höchst|der|sel|be** (veralt.); höchstdieselben-

höchstdero; mit Bezug auf die angeredete Person, aber auch sonst oft: Höchstderselbe usw.
hoch|ste|hend; höherstehend, höchststehend († R 296)
höchst|ei|gen; in höchsteigener Person
hoch|stel|len; er hat den Stuhl hochgestellt; vgl. hoch, II, 2, a
höch|stens; Höchst_fall (im -[e]), ...form, ge|schwin|dig|keit, ...gren|ze; Hoch|stim|mung; Höchst_lei|stung, ...maß s; höchst|mög|lich; die -e (falsch: höchstmöglichste) Leistung; höchst|per|sön|lich; er ist höchstpersönlich (selbst, in eigener Person) gekommen, aber: das ist eine höchst (im höchsten Grade, rein) persönliche Ansicht; Höchst|preis; vgl. [2]Preis; Hoch|stra|ße; höchst|rich|ter|lich; Höchst_stand, ...stra|fe, ...stu|fe (für: Superlativ); höchst|wahr|schein|lich; er hat es höchstwahrscheinlich getan, aber: es ist höchst (im höchsten Grade) wahrscheinlich, daß...; Höchst_wert, ...zahl; höchst|zu|läs|sig
Hoch_tal, ...ton (Mehrz. ...töne); hoch|tö|nend; -er, -ste († R 297); hoch|to|nig (den Hochton habend; Hochton...); Hoch|tour [...tur]; hoch|tou|rig; Hoch|tourist; hoch|tra|bend; -er, -ste († R 297); -e Gedanken († R 142); hoch|trei|ben; die Preise -
hoch|ver|ehrt; höchstverehrt, in der Anrede auch: hochverehrtest († R 297); († R 142:) hochverehrter Herr, aber: ein von mir hoch verehrter Herr; der Herr wird von mir hoch verehrt; Hoch_ver|rat, ...ver|rä|ter; hoch|ver|rä|te|risch
Hoch_wald, ...was|ser (Mehrz. ...wasser); hoch|wer|fen; hoch|wer|tig; -es Metall; Hoch|wild; hoch|will|kom|men; der hochwillkommene Gast, aber († R 142): es ist ihm hoch (sehr) willkommen; hoch|win|den, sich; hoch|wir|beln; hoch|wirk|sam; eine -e Medizin; hoch|wohl|ge|bo|ren, als Titel (veralt.): Hochwohlgeboren; in der Anrede (veralt.): Eure, Euer Hochwohlgeboren; hoch|wöl|ben; sich -; Hoch|wür|den (Anrede für kath. Geistliche); Eure, Euer (Abk.: Ew.) -; hoch|wür|dig (veralt.); der -e Herr Pfarrer; hoch|wür|digst (Anrede für höhere kath. Geistliche); aber († R 224): das Hochwürdigste Gut (kath. Kirche: heiligstes Altarsakrament); Hoch|zahl (für: Exponent)
[1]Hoch|zeit (Feier der Eheschließung); silberne, goldene -; [2]Hoch|zeit (Fest, Glanz, Hochstand);

Hoch|zei|ter; Hoch|zei|te|rin w; -, -nen; hoch|zeit|lich; Hoch|zeits_bit|ter, ...fei|er, ...ge|schenk, ...rei|se, ...schmaus, ...tag; hoch|zie|hen; Hoch|ziel
Hock, Höck schweiz. mdal. (geselliges Beisammensein) m; -s, Hökke; [1]Hocke[1] (auf dem Feld zusammengesetzte Garben; Hukke) w; -, -n; [2]Hocke[1] (eine Turnübung) w; -, -n; hocken[1]; sich -; Hocker[1] (Schemel; Mensch in hockender Stellung)
Höcker[1] (Buckel) m; -s, -
Hocker|grab[1]
hocke|rig[1]
Hockey[1] engl. [hoki] (eine Sportart) s, -s, Hockey_schlä|ger[1], ...spie|ler
Hock|stel|lung
Ho|de m; -n, -n († R 268) od. w; -, -n u. Ho|den (Samendrüse) m; -s, -; Ho|den_bruch (m; -[e]s, ...brüche), ...sack
Hod|ler (schweiz. Maler)
Ho|do|me|ter gr. (Wegemesser, Schrittzähler) s; -s, -
Hödr, Hö|dur (nord. Mythol.: der blinde Gott)
Ho|dscha pers. ([geistl.] Lehrer) m; -[s], -s
Hö|dur vgl. Hödr
Hoek van Hol|land [huk fan -] (niederl. Ortsn.)
Hof m; -[e]s, Höfe; vgl. hofhalten; Hof|an|la|ge; Höf|chen, Höf|lein; Hof|da|me; hö|feln schweiz. (jmdm. schöntun, schmeicheln); ich ...[e]le († R 327); Hö|fe|recht; hof|fä|hig; Hof|fä|hig|keit w; -
Hof|fart (Hochmut) w; -; hof|fär|tig; Hof|fär|tig|keit
hof|fen; hof|fent|lich
Hof|fest
...höf|fig (reiches Vorkommen versprechend, z. B. erdölhöffig)
höff|lich (Bergmannsspr.: reiche Ausbeute verheißend)
Hoff|mann, E. T. A. (dt. Dichter)
Hoff|manns|trop|fen [nach dem Arzt F. Hoffmann]; † R 180 (ein Arzneimittel) Mehrz.
Hoff|mann von Fal|lers|le|ben (dt. Dichter)
Hoff|nung; Hoff|nungs|lauf (Sport: zusätzlicher Zwischenlauf, dessen Sieger noch am Endlauf teilnehmen darf); hoff|nungs|los; -este († R 292); Hoff|nungs|lo|sig|keit w; -; Hoff|nungs_schim|mer, ...strahl; hoff|nungs|voll
Hof|ga|stein, Bad (österr. Ortsn.)
Hof|halt m; -[e]s, -e; hof|hal|ten († R 140); ich halte hof; hofhalten; hofzuhalten; aber († R 132): [einen] großen Hof halten; Hof|hal|tung

[1] Trenn.: ...k|k...

ho|fie|ren (den Hof machen); jmdn. -
hö|fisch; -ste († R 294); Hof|knicks; Höf|lein, Höf|chen
höf|lich; Höf|lich|keit; Höf|lich|keits_be|such, ...be|zei|gung (nicht: ...bezeugung), ...flos|kel; höf|lich|keits|hal|ber
Höf|ling; Hof|mann (Mehrz. ...leute); hof|män|nisch; -ste († R 294) Hof|manns|thal (österr. Dichter)
Hof|mei|ster; hof|mei|ster|lich; hof|mei|stern; ich ...ere († R 327); gehofmeistert; zu -; Hof_narr, ...rat (Mehrz. ...räte); Hof|rei|te südd. (Gut[shof]) w; -, -n; Höf|lings schran|ze (verächtlich für: Höfling, höherer Hofbediener) m; -n, -n († R 268) od. w; -, -n; Hof|staat (Mehrz. selten: ...staaten) m; -[e]s, ...staaten
Hof|statt schweiz. (Haus mit Hof; Hauswiese) w; -, -en
Höft niederd. (Haupt; Landspitze; Buhne) s; -[e]s, -e
Hof|tor s, ...trau|er, tür
HO-Ge|schäft (DDR); vgl. HO
ho|he; I. Kleinschreibung († R 224): der hohe Berg; der hohe Chor; die hohe Jagd; das hohe C; auf hoher See. II. Großschreibung: a) († R 198:) die Hohe Tatra; die Hohen Tauern; b) († R 224:) die Hohe Schule (beim Reiten); das Hohe Haus (Parlament); die Hohe Behörde (Exekutivorgan der Montanunion); die Hohe Pforte (frühere türkische Regierung); die Hohe Messe (in h-Moll (von J. S. Bach); Hö|he w; -, -n
Ho|heit [Trenn.: † R 163]; vgl. euer, Ew., ihr u. sein; ho|heit|lich; Ho|heits_akt, ...ge|biet, ...ge|walt, ...ge|wäs|ser (Mehrz.), ...recht, ...trä|ger (ho|heits|voll; Ho|heits|zei|chen (sinnbildliches Zeichen der Staatsgewalt)
Ho|he|lied s; Hohenlied[e]s; im Hohenlied[e]; in Salomo[n]s Hohemlied[e]; ein Hoheslied der Kameradschaft
hö|hen (Malerei: bestimmte Stellen hervortreten lassen); weiß gehöht
Hö|hen_an|ga|be, ...flug
Ho|hen|fried|ber|ger m; -s; -Marsch
Hö|hen_krank|heit, ...kur|ort, ...la|ge, ...li|nie, ...luft (w; -), ...mar|ke, ...mes|ser m, ...punkt, ...rücken [Trenn.: ...rük|ken], ...ru|der (Flugw.), ...son|ne (als ⓦ: Ultraviolettlampe)
Ho|hen|stau|fe (Angehöriger eines dt. Fürstengeschlechts) m; -n, -n († R 268); [1]Ho|hen|stau|fen (Ort am gleichnamigen Berg); [2]Ho|hen|stau|fen (Berg vor der Schwäb. Alb) m; -s; ho|hen|stau|fisch

Hö|hen_steu|er s, ...strah|lung (kosmische Strahlung)

Ho|hen|twiel (Bergkegel bei Singen) m; -s

Ho|hen|zol|ler (Angehöriger eines Fürstengeschlechts) m; -n, -n (↑ R 268); ho|hen|zol|le|risch; Ho|hen|zol|lern (Berg vor der Schwäb. Alb) m; -s; Ho|hen|zol|lern-Sigma|rin|gen

Hö|hen|zug

Ho|he|prie|ster m; Hohenpriesters, Hohenpriester; ein Hoherpriester, zwei Hohepriester; Ho|he|prie|ster|amt s; -[e]s (auch: Hohenpriesteramtes), ...ämter; hohe|prie|ster|lich; die Aufgabe des -en Amtes

Hö|he|punkt

hö|her; -e Gewalt; -[e]n Ort[e]s; die höhere Laufbahn; höheres Lehramt; höhere Schule (Oberschule, Gymnasium usw.), aber (↑ R 224): Höhere Handelsschule in Stuttgart; höher achten usw.; Hö|her|ent|wick|lung; hö|he|rer|seits; hö|her|ge|stellt vgl. hochgestellt; hö|her|ran|gig; hö|her|schrau|ben ([allmählich] erhöhen); die Preise -; hö|her|stu|fen (auf eine höhere Stufe bringen); den Beamten -; Hö|her|stu|fung

Ho|he Schu|le; ↑ R 224 (Reitkunst); übertr. für: Kunstfertigkeit, Gewandtheit) w; -n -; die - - reiten; die - - des Lebens

hohl; hohl|äu|gig; Höh|le w; -, -n; Hohl|ei|sen (ein Werkzeug); höh|len; Höh|len|bär, ...be|woh|ner, ...brü|ter, ...for|schung, ...ma|le|rei, ...mensch; Hohl|heit, ...keh|le, ...kopf, ...ku|gel, ...maß s, ...na|del, ...naht, ...raum, ...saum, ...spie|gel; Höh|lung; Hohl|ve|ne; hohl|wan|gig; Hohl|weg, ...zie|gel

Hohn m; -[e]s; höh|nen; Hohn|ge|läch|ter; höh|nisch; -ste (↑ R 294); hohn|lä|cheln (↑ R 140); meist nur in der Grundform gebräuchlich; hohn|la|chen (↑ R 140); jmdm. -; er hohnlachte od. lachte hohn; hohngelacht; hohnzulachen; hohn|spre|chen (↑ R 140); jmdm. -; das spricht allem Rechte hohn; er sprach mir hohn, hat mir hohngesprochen; hohnzusprechen

ho|ho!

hoi! [heu]

hö|ken (seltener für: hökern); Hö|ker (Kleinhändler); Hö|ke|rei; Hö|ke|rin w; -, -nen; hö|kern; ich ...ere (↑ R 327); Hö|ker|weib

Ho|kus|po|kus engl. (Zauberformel der Taschenspieler, Gaukelei; Blendwerk) m; -

Hol|bein (dt. Maler); hol|beinsch, aber (↑ R 179): Hol|beinsch; -sche Madonna

hold; -este (↑ R 292)

Hol|da, Hol|le (Gestalt der dt. Mythologie); Frau Holle; [2]Hol|da, Hul|da (w. Vorn.)

Hol|der u. (österr. nur so:) Hol|ler mdal. (Holunder) m; -s, -; Hol|der|baum, Hol|ler|baum

Höl|der|lin (dt. Dichter)

Hol|ding|ge|sell|schaft engl.; dt. (Effektenhaltegesellschaft)

hol|drio! [auch: ...drio] (Freudenruf); [1]Hol|drio [auch: ...drio] s; -s; [2]Hol|drio (leichtsinniger, leichtlebiger Mensch) m; -[s], -[s]

hold|se|lig; Hold|se|lig|keit w; -

ho|len (abholen); etwas - lassen

Ho|lis|mus gr. (eine Ganzheitslehre) m; -

Holk vgl. Hulk

hol|la!

Holl|a|brunn (österr. Stadt)

Hol|land; [1]Hol|län|der (↑ R 199); -Käse; [2]Hol|län|der (Kinderfahrzeug; Holländermühle, vgl. d.); der Fliegende - (Oper; vgl. fliegen); [3]Hol|län|der (Käse) m; -s, -; Hol|län|de|rei (Milchwirtschaft); Hol|län|de|rin w; -, -nen; Hol|län|der|müh|le (Zerkleinerungsmaschine für Papier); hol|län|dern (auch: auf besondere Art Schlittschuh laufen); ich ...ere (↑ R 327); hol|län|disch; -er Gulden (Abk.: hfl); Hol|län|disch (Sprache; vgl. Niederländisch) s; -[s]; vgl. Deutsch; Hol|län|di|sche s; -n; vgl. Deutsche s

[1]Hol|le (Federhaube [bei Vögeln]) w; -, -n

[2]Hol|le vgl. [1]Holda

Höl|le w; -, (selten:) -n

Hol|led|au [auch: hol...] vgl. Hallertau

Höl|len... (ugs. für: groß, sehr viel, z. B. Höllenangst); Höl|len|angst, ...brut, ...fahrt, ...hund, ...lärm, ...ma|schi|ne, ...spek|ta|kel, ...stein (ein Ätzmittel; m; -[e]s

Hol|ler usw. vgl. Holder usw.

Höl|ler, Karl (dt. Komponist)

hol|le|ri|thie|ren (auf Lochkarten bringen); Hol|le|rith|ma|schi|ne [auch: hol...]; nach dem deutschamerik. Erfinder]; ↑ R 180 (Lochkartenbuchungsmaschine)

höl|lisch; -ste (↑ R 294)

Hol|ly|wood [holi"ud] (nordamerik. Filmstadt); Hol|ly|wood-schau|kel (breite, frei aufgehängte Sitzbank); ↑ R 201

[1]Holm (Griffstange des Barrens, Längsstange der Leiter) m; -[e]s, -e

[2]Holm niederd. (kleine Insel) m; -[e]s, -e; Holm|gang (altnord. Zweikampf, der aufeinem [2]Holm ausgetragen wurde) m

Hol|mi|um (chem. Grundstoff, Metall; Zeichen: Ho) s; -s

Ho|lo|fer|nes (assyr. Feldherr)

Ho|lo|gramm gr. (Speicherbild) s; -s, -e; Ho|lo|gra|phie (besondere Technik zur Bildspeicherung u. -wiedergabe in dreidimensionaler Struktur; Laserfotografie); ho|lo|gra|phisch (Bibliotheksw., Rechtsw.: [ganz] eigenhändig geschrieben); ho|lo|kri|stal|lin (von Gesteinen: ganz kristallin); Ho|lo|pha|ne|glas Ⓦ engl. (Riffelglas; Mehrz.: ...gläser); Ho|lo|zän s; -s (vgl. Alluvium)

hol|pe|rig; Hol|pe|rig|keit; hol|pern; ich ...ere (↑ R 327); hol|prig; Holp|rig|keit

Hol|ste (altertüml. für: Holsteiner) m; -n, -n (↑ R 268); Hol|stein (Teil des Landes Schleswig-Holstein); Hol|stei|ner (auch für eine Pferderasse); ↑ R 199; Hol|stei|ne|rin w; -, -nen; hol|stei|nisch; -e Butter, aber (↑ R 224): die Holsteinische Schweiz

hol|ter|die|pol|ter!

hol|über! (Ruf an den Fährmann)

Ho|lun|der (ein Strauch; auch kurz und ohne Mehrz. für: Holunderbeeren) m; -s, -; Ho|lun|der|bee|re; vgl. auch: Holder u. Holler

Holz s; -es, Hölzer; (Kegeln:) er siegte mit 643 - (↑ R 322); Holz-ap|fel, ...art, ...bein, ...block (Mehrz. ...blöcke), ...bock, ...boden; Hölz|chen, Hölz|lein; Holz|ein|schlag (Forstw.); höl|zeln südostösterr. ugs. (lispeln); hol|zen du holzt (holzest); Hol|zer (Holzknecht; Sport: roher Spieler [im Fußball]); Hol|ze|rei (ugs für: Prügelei; Sport: regelwidriges, rohes Spiel); höl|zern (aus Holz); Holz-es|sig (m; -s), ...fäl|ler, ...geist (Methylalkohol; m -[e]s), ...ge|rüst, ...hacker [Trenn. ...hak|ker] (österr. veralt. für Holzfäller), ...haus; hol|zig; Holz-klotz, ...knecht (österr. für Holzfäller), ...koh|le; Hölz|lein Hölz|chen; Holz-pflock, ...scheit ...schliff; holz|schliff|frei (↑ R 337); Holz-schnei|der, ...schnitt ...schnit|zer, ...schuh, ...span ...sta|pel, ...stoß, ...trep|pe; Holzzung; holz|ver|ar|bei|tend; die -Industrie (vgl. S. 45, Merke, 2) aber (vgl. S. 45, Merke, 1): vie Holz verarbeitend; holz|ver|klei det; Holz_weg, ...wol|le (w; -) ...wurm

Hom|burg (steifer Herrenhut) m -s, -s

Ho|mer (altgr. Dichter); Ho|me|ri de gr. (Nachfolger Homers) m -n, -n (↑ R 268); ho|me|risch; -e Gelächter, aber (↑ R 179): Ho me|risch; -e Gedichte; Ho|me|ro vgl. Homer

Home|rule engl. [hő"mrul

(„Selbstregierung", Schlagwort der ir. Unabhängigkeitsbewegung) w; -; **Home|spun** [*hó͞ʷmßpạn*] (grobes Wollgewebe) s; -s, -s; **Home|trai|ner** (Sportgerät für häusliches Training)

Ho|mi|let gr. (Kenner der Homiletik) m; -en, -en (↑ R 268); **Ho|mile|tik** (Geschichte u. Theorie der Predigt) w; -; **ho|mi|le|tisch**; **Homi|lie** (erbaul. Bibelauslegung; Predigt über einen Bibelabschnitt) w; -, ...ien

Ho|mi|ni|den lat. (Biol.: Familie der Menschenartigen) Mehrz.

Ho|mo (ugs. für: Homosexueller) m; -s, -s; **ho|mo...** gr. (gleich...); **Ho|mo...** (Gleich...); **ho|mo|dọnt** (Zool.: mit gleichartigen Zähnen); **ho|mo|gen** (gleichartig, gleichgeartet; gleichstoffig); -es Feld; **ho|mo|ge|ni|sie|ren** (innig vermischen); **Ho|mo|ge|ni|sierung**; **Ho|mo|ge|ni|tät** (Gleichartigkeit) w; -; **ho|mo|log** (gleichliegend, gleichlautend, übereinstimmend, entsprechend); **homo|lo|gie|ren** (einen Serienwagen in die internationale Zulassungsliste zur Klasseneinteilung für Rennwettbewerbe aufnehmen); **hom|onym** (gleichlautend; mehrdeutig; doppelsinnig); **Hom|onym** (Sprachw.: Wort, das mit einem anderen gleich lautet, z. B. „Heide" = Nichtchrist u. „Heide" = unbebautes Land) s; -s, -e; **hom|ony|misch** (älter für: homonym)

ho|möo... gr. (ähnlich...); **Ho|möo...** (Ähnlich...); **Ho|möo|path** (homöopath. Arzt, Anhänger der Homöopathie) m; -en, -en (↑ R 268); **Ho|möo|pa|thie** (ein Heilverfahren) w; -; **ho|möo|pa|thisch**

ho|mo|phil gr. (svw. homosexuell); **Ho|mo|phi|lie** (svw. Homosexualität) w; -; **ho|mo|phon; Ho|mo|pho|nie** (Kompositionsstil mit nur einer führenden Melodiestimme) w; -; **ho|mo|pho|nisch** (älter für: homophon)

Ho|mo sa|pi|ens lat. [- ...pi-änß] (wissenschaftl. Bez. für den vernunftbegabten Menschen) m; - -

Ho|mo|se|xua|li|tät gr.; ... lat. (gleichgeschlechtliche Liebe [bes. des Mannes]); **ho|mo|se|xu|ell; ho|mo|zy|got** (Biol.: reinerbig); **Ho|mo|zy|go|tie** (Erbgleichheit) w; -

Ho|mun|ku|lus lat. (‚Menschlein"; in Goethes Faust: ein künstlich erzeugter Mensch) m; -, ...lusse od. ...li

Ho|nan (chines. Prov.); **Ho|nansei|de**

Hon|du|ra|ner (Bewohner von Honduras); **hon|du|ra|nisch; Hon|du|ras** (mittelamerik. Staat)

Ho|neg|ger, Arthur [fr. Ausspr.: *onägär*] (fr.-schweiz. Komponist)

ho|nen engl. (ziehschleifen)

ho|nett fr. (ehrenhaft; anständig)

Hong|kong (Hafenstadt an der südchines. Küste)

Ho|nig m; -s, (für: Honigsorten Mehrz.:) -e; **Ho|nig|bie|ne; ho|nig_far|ben, ...gelb; Ho|nig_glas, ...ku|chen, ...mond** (Flitterwochen), ...**seim; ho|nig|süß; Ho|nig_tau** m, ...**wa|be, ...wein**

Hon|neurs fr. [(*h*)*onörß*] ([milit. Ehrenerweisungen) Mehrz.: die - machen (die Gäste willkommen heißen)

ho|no|lu|lu (Hptst. von Hawaii)

ho|no|ra|bel lat. (veralt. für: ehrbar; ehrenvoll); ...able Bedingungen; **Ho|no|rar** („Ehrensold"; Vergütung [für Arbeitsleistung in freien Berufen]) s; -s, -e; **Ho|no|rar_pro|fes|sor; Ho|no|ra|tio|ren** [...*zi*...] (Standespersonen, bes. in kleineren Orten) Mehrz.; **ho|no|rie|ren** (bezahlen; vergüten); **Ho|no|rie|rung; ho|no|rig** (Studentenspr.: ehrenhaft; freigebig); **ho|no|ris cau|sa** [- *kau*...] (ehrenhalber; Abk.: h. c.)

Ho|no|ri|us (röm. Kaiser)

Hoorn [*horn*]; Kap - (Südspitze Amerikas [auf der Insel Hoorn])

hop|fen (Bier mit Hopfen versehen); **Hopf|fen** (eine Kletterpflanze; Bierzusatz) m; -s, -; **Hop|fen|stan|ge**

Ho|plit gr. (altgr. Schwerbewaffneter) m; -en, -en (↑ R 268)

hopp!; hopp, hopp!; **Hopp** m; -s, -e; **hop|peln**, ich ...[e]le (↑ R 327); **Hopf|pel|pop|pel** (Mischgericht; heißer Punsch) s; -s, -; **Hopp|hei** landsch. (Rummel, Lärm; auch: Familienanhang) m (auch: s); -; es gab großen -; **hopp|hopp!; hoppla!; hops** - (ugs. für: verloren) sein, gehen; **Hops** m; -es, -e; **hops!, hop|sa!, hop|sa|la!, hop|sa|sa!; hop|sen; du hopst (hopsest); Hopser; Hop|se|rei**

ho|ra lat. („Stunde"; nur als Zeichen [h, auch: *h*] in Abkürzungen von Maßeinheiten, z. B. kWh [= Kilowattstunde] als Zeitangabe, z. B. 6[h] [= 6 Uhr]); **Ho|ra, Ho|re** (Stundengebet der kath. Geistlichen) w; -, Horen (meist Mehrz.); die Horen beten

Hör|ap|pa|rat

Ho|ra|ti|us [...*ziuß*], **Ho|raz** (röm. Dichter); **ho|ra|zisch**, aber (↑ R 179); **Ho|ra|zisch**

hör|bar; Hör_be|reich m, ...**be|richt, ...bild, ...bril|le; horch!; hör-**

chen; **Hor|cher; Horch_ge|rät, ...po|sten; horch|sam** (veralt. für: aufmerksam)

[1]**Hür|de** (Flechtwerk; Lattengestell; Rost, Sieb zum Dörren [von Obst, Gemüse usw.]; veralt. für: Pferch) w; -, -n; vgl. Hurde, Hürde

[2]**Hür|de** tatar. ([ungezügelte, wilde Kriegs]schar) w; -, -n; **hor|den|wei|se**

Ho|re vgl. Hora; [1]**Ho|ren** (eingedeutschte Mehrz. von: Hora)

[2]**Ho|ren** (in der gr. Mythol. Töchter des Zeus u. der Themis: Dike, Eunomia, Eirene [vgl. d.]; auch [4] Göttinnen der Jahreszeiten) Mehrz.

hö|ren; er hat von dem Unglück heute gehört (↑ R 305): sie hat die Glocken läuten hören (od. gehört); von sich - lassen; **Hö|ren_sa|gen** s, nur in: er weiß es vom -; **hö|rens|wert; Hö|rer; Hö|re|rin** w; -, -nen; **Hö|rer_kreis, ...schaft** (w; -); **Hör_feh|ler, ...fol|ge, ...funk** (für: Rundfunk im Ggs. zum Fernsehen), ...**ge|rät; hör|ge|schä|digt**

hö|rig; Hö|ri|ge m u. w; -n, -n (↑ R 287ff.); **Hö|rig|keit** w;

Ho|ri|zont gr. (scheinbare Begrenzungslinie zwischen Himmel u. Erde; Seew.: Kimmung; Sichtgrenze; Gesichtskreis [auch in übertr. Sinne]; Geol.: Zeitabschnitt, der eine abgegrenzte Schicht umfaßt) m; -[e]s, -e; **ho|ri|zon|tal** (waagerecht); **Ho|ri|zon|ta|le** w; -, -n; drei -[n] (↑ R 291); **Ho|ri|zon|tal|pen|del**

Hor|mon gr. (Drüsenstoff; körpereigener Wirkstoff) s; -s, -e; **hor|mo|nal, hor|mo|nell; Hor|mon_be|hand|lung, ...for|schung, ...haus|halt, ...prä|pa|rat, ...spie|gel** (Med.)

Hör|mu|schel (am Telefon)

Horn s; -[e]s, Hörner u. (Hornarten:) -e; **Horn|ber|ger Schie|ßen** s; - -s; **Horn_blen|de** (ein Mineral), ...**bril|le; Hörn|chen, Hörn|lein; Hörn|dl|bau|er** österr. (Bauer, der vorwiegend Viehzucht betreibt); **hor|nen** (älter für: hörnern); **hör|nen** (mit Hörnern versehen; das Gehörn abwerfen); **hör|nern** (aus Horn); **Hör|ner_schall, ...schlit|ten; Horn|haut; hor|nig**

Hor|nis|grin|de [auch: *hor*...] (höchster Berg des nördl. Schwarzwaldes)

Hor|nis|se [auch: *hor*...] (eine Wespenart) w; -, -n; **Hor|nis|sen|nest** [auch: *hor*...]

Hor|nist (Hornbläser); ↑ R 268; **Hörn|klee; Hörn|lein**, Hörnchen; **Horn_ochs** od. ...**och|se, ...si|gnal, ...stoß, ...tier**

Hor|nung (alte dt. Bezeichnung für: Februar) *m*; -s, -e
Hor|nuß [*hórnuß*] schweiz. (Schlagscheibe) *m*; -es, -e; hornußen schweiz. (ein ländliches schlagballähnliches Spiel spielen)
Horn|vieh
Hör|or|gan
Ho|ros (Sohn der Isis)
Ho|ro|skop *gr. s*; -s, -e
hor|rend *lat.* (schauderhaft; schrecklich; übermäßig); -e Preise; hor|ri|bel (grauenerregend; furchtbar); ...i|ble Zustände; horri|bi|le dic|tu (schrecklich zu sagen)
hor|ri|do! (Jagdruf); Hor|ri|do *s*; -s, -s
Hör|rohr
Hor|ror *lat.* (Schauder, Abscheu) *m*; -s; Hor|ror|film; Hor|ror vacui [- *waku-i*] (Scheu vor der Leere) *m*; - -
Hör|saal
Hors|d'œu|vre *fr.* [*ordówr*⁽ᵉ⁾, auch: *or*...] (Nebenwerk; appetitanregende Vorspeise, auch Nebenspeise) *s*; -s, -s [*ordówr*⁽ᵉ⁾]
Hör|sel (r. Nebenfluß der Werra) *w*; -; Hör|sel|ber|ge (Höhen im nördl. Vorland der Thüringer Waldes) *Mehrz.*
Hör|spiel
¹Horst (Raubvogelnest; Strauchwerk) *m*; -[e]s, -e
²Horst (m. Vorn.)
hor|sten (von Raubvögeln: nisten)
Horst|mar (m. Vorn.)
Hort *m*; -[e]s, -e
hört!; hört, hört!
hor|ten ([Geld usw.] aufhäufen)
Hor|ten|sia (w. Vorn.); Hor|ten|sie [...*iᵉ*] (ein Zierstrauch) *w*; -, -n; Hor|ten|si|us (m. Vorn.)
hört, hört!; Hört|hört|ruf
Hort|ne|rin (Kindergärtnerin) *w*; -, -nen; Hor|tung [zu: horten]
ho ruck!, hau ruck!
Ho|rus vgl. Horos
Hor|váth, Ödön von (österr. Schriftsteller)
Hör|wei|te; in -
ho|san|na usw. vgl. hosianna
Hös|chen, Hös|lein; heiße Höschen (Hot pants); Ho|se *w*; -, -n
Ho|sea (bibl. Prophet)
Ho|sen.an|zug, ...band *s* (*Mehrz.* ...bänder); Ho|sen|band|or|den; Ho|sen.bo|den, ...bund (*m*; -[e]s, ...bünde), ...lupf (schweiz. mdal.: eine Art Ringkampf; vgl. Schwingen), ...matz, ...naht, ...rol|le (von einer Frau gespielte Männerrolle), ...schei|ßer (derb für: ängstlicher Mensch), ...tasche, ...trä|ger (meist *Mehrz.*)
ho|si|an|na! (ökum.:) ho|san|na! *hebr.* (,,hilf doch!‘‘; Gebets- u.

Freudenruf); Ho|si|an|na, (ökum.:) Ho|san|na *s*; -s, -s
Hös|lein, Hös|chen
Hos|pi|tal *lat.* (früher für: Kranken-, Armenhaus, Altersheim) *s*; -s, -e u. ...täler; hos|pi|ta|li|sieren; Hos|pi|ta|lis|mus (Med.: seel. u. körperl. Schäden, bes. bei Kindern, durch längere Krankenhaus- od. Heimunterbringung); Hos|pi|tant (Gast[hörer an Hochschulen]; Parlamentarier, der sich einer Fraktion anschließt, ohne [vorläufig] Mitglied der betr. Partei zu sein); *m*; -en, -en (↑R 268); hos|pi|tie|ren (als Gast [in Schulen] zuhören); Hos|piz (Beherbergungsbetrieb [mit christl. Hausordnung]) *s*; -es, -e
Hos|po|dar, Gos|po|dar (ehem. slaw. Fürstentitel in der Moldau u. Walachei) *m*; -s u. -en (↑R 268), -e[n]
Ho|stess, (eingedeutscht auch:) Ho|steß *engl.* [*hoßtäß* u. *hoßtäß*] (Bardame [in den USA]; Begleiterin, Betreuerin, Führerin [auf einer Ausstellung]; Auskunftsdame) *w*; -, ...tessen
Ho|stie *lat.* [...*iᵉ*] (,,Opfer[tier]‘‘; Abendmahlsbrot) *w*; -, -n
Hot amerik. (Kurzform von: Hot Jazz) *m*; -s, -s
Hot dog *amerik.* (heißes Würstchen in einem aufgeschnittenen Brötchen) *s*; - -s, - -s
Ho|tel *fr. s*; -s, -s; Ho|tel.be|sit|zer, ...be|trieb; Ho|tel gar|ni [*hotál garní*] (Hotel, das neben der Übernachtung nur Frühstück gewährt) *s*; - -, -s -s [*hotál garní*]; Ho|te|lier [...*lié*] (Hotelbesitzer) *m*; -s, -s; Ho|tel|le|rie (Gast-, Hotelgewerbe) *w*; -; Ho|tel|zim|mer
Hot Jazz *amerik.* [*hot dschäs*] (scharf akzentuierter, oft synkopischer Jazzstil) *m*; - -
Hot pants *amerik.* [*hot pänz*] (,,heiße Höschen‘‘; modische, kurze u. enge Damenhosen) *Mehrz.*
hott! (Zuruf an Zugtiere: rechts!); - und har!; - und hüst!; - und hü!
Hot|te südwestd. (Butte, Tragkorb) *w*; -, -n; vgl. Hutte
hot|te|hü! (Kinderspr.: voran!); Hot|te|hü (Kinderspr. für: Pferd) *s*; -s, -s
hott nen *amerik.* [zu: Hot]
Hot|ten|tot|te (Angehöriger eines Mischvolkes in Südwestafrika) *m*; -n, -n (↑R 268); hot|ten|tottisch
Hot|ter ostösterr. (Gemeindegrenze) *m*; -s, -
hot|to!; Hot|to (Kinderspr. für: Pferd) *s*; -s, -s

h. p., (früher:) **HP** = horse-power *engl.* [*hó'ßpau*ᵉr] (,,Pferdestärke‘‘; mechan. Leistungseinheit = 745,7 Watt, nicht gleichzusetzen mit PS = 736 Watt; vgl. PS
Hptst. = Hauptstadt
Hr. = Herr
Hra|ban (dt. Gelehrter des MA.); Hra|ba|nus Mau|rus (lat. Name für: Hraban)
Hra|dschin [auch: ...*tschin*] (Stadtteil von Prag mit Burg) *m*; -s
Hrd|lič|ka [*hrídlitschka*] (österr. Bildhauer u. Graphiker)
Hrn. = Herrn Wem- u. *Wenf.*; vgl. Herr
Hros|wi|tha vgl. Roswith
hrsg., hg. = herausgegeben; **Hrsg.**, Hg. = Herausgeber
hs = Hektoster
Hs. = Handschrift; **Hss.** = Handschriften
HTL = Höhere technische Lehranstalt (Technikum, Ingenieurschule in der Schweiz u. in Österreich)
hü!; hu|hu!
hü! (Zuruf an Zugtiere: links!; auch: vorwärts! od. halt!); vgl. hott
Hub (Weglänge eines Kolbens usw.) *m*; -[e]s, Hübe; Hub|brücke [*Trenn.*: ...brük|ke] (Brücke, deren Verkehrsbahn gehoben werden kann)
Hu|be südd., österr. (Hufe) *w*; -, -n
Hu|bel, Hü|bel (veralt., aber noch mdal. für: kleine Erhöhung, Hügel) *m*; -s, -
hü|ben; - und drüben
Hu|ber, Hüb|ner südd., österr. (Hufner, Hüfner) *m*; -s, -
Hu|bert, Hu|ber|tus (m. Vorn.)
Hu|ber|tus|burg (Schloß in Sachsen) *w*; -; der Friede von - Huber|tus.jagd (festl. Treibjagd, die ursprüngl. am Hubertustag stattfand), ...man|tel (österr. für: grüner Lodenmantel), ...tag (3. November)
Hub|hö|he
Hüb|ner vgl. Huber
Hub|raum; Hub|raum|steu|er *w*
hübsch; -este (↑R 292); Hübschheit *w*; -
Hub|schrau|ber (Flugzeugtyp: Senkrechtstarter); Hub|vo|lumen (Hubraum)
huch!
Huch, Ricarda (dt. Schriftstellerin)
Hu|chen (ein Raubfisch) *m*; -s, -
Hucke[1] niederd., ostmitteld. (auf dem Rücken getragene Last) *w*; -, -n; jmdm. die - voll lügen (ugs.); Hucke|bein[1] *m*; -[e]s, -e; Hans -

[1] *Trenn.*: ...k|k...

("der Unglücksrabe"); **hucken**[1]; **hucke**|**pack**[1]; - tragen; **Hucke**|**pack**|**ver**|**kehr**[1] (Eisenbahnw.: Transport von Straßenfahrzeugen auf Waggons)

Hu|**de** mitteld. u. niederd. mdal. (Weideplatz, Viehweide) w; -, -n

Hu|**del** (veralt., noch mdal. für: Lappen, Lumpen; Lump) m; -s, -[n]; **Hu**|**de**|**lei**; **Hu**|**de**|**ler**, **Hud**ler; **hu**|**de**|**lig**, **hud**|**lig**, **hu**|**de**|**lich** (nachlässig sein od. handeln); ich ...[e]le (↑ R 327)

hu|**dern** (fachspr. von Vögeln: die Jungen unter die Flügel nehmen); sich - (im Sand baden)

Hud|**ler**, **Hu**|**de**|**ler**; **hud**|**lig**, **hu**|**de**|**lig**

Hud|**son**|**bai** [*hadß"nbai*] (nordamerik. Binnenmeer) w; -

huf!, (auch:) **hüf**! (Zuruf an Zugtiere: zurück!)

Huf m; -[e]s, -e; **Huf**|**be**|**schlag**

Hu|**fe** (ehem. Durchschnittsmaß bäuerlichen Grundbesitzes) w; -, -n; vgl. Hube

Huf|**ei**|**sen**

Hu|**fe**|**land** (dt. Arzt)

hu|**fen** [zu: huf] (veralt , noch mdal. für: zurückweichen)

Huf..**lat**|**tich** (Unkraut u. Heilpflanze), ...**na**|**gel**

Huf|**ner**, **Hüf**|**ner** (früher für: Besitzer einer Hufe); vgl. Huber, Hübner

Huf..**schlag**, ...**schmied**

Hüf|**te** w; -, -n; **Hüft**..**ge**|**lenk**, ...**gür**|**tel**, ...**hal**|**ter**, ...**horn** (verderbt aus: Hifthorn, *Mehrz*. ...hörner)

Huf|**tier**

Hüft..**kno**|**chen**, ...**lei**|**den**; **hüft**schmal; **Hüft**|**weh**

Hü|**gel** m; -s, -; **hü**|**gel**..**ab**, ...**an**, ...**auf**; **hü**|**ge**|**lig**, **hüg**|**lig**; **Hü**|**gel**..**ket**|**te**, ...**land** (*Mehrz*. ...länder)

Hu|**ge**|**not**|**te** fr. (fr. Reformierter) m; -n, -n (↑ R 268); **hu**|**ge**|**not**|**tisch**

Hughes [*hjus*] (nach dem engl. Physiker Hughes benanntes telegrafisches Gerät) m; -; **Hughes**|**te**|**le**|**graf** (↑ R 180)

Hu|**gin** ("der Denker"; nord. Mythol.: einer der beiden Raben Odins); vgl. Munin

hüg|**lig**, **hü**|**ge**|**lig**

[1]**Hu**|**go** (m. Vorn.)

[2]**Hu**|**go** [*ügó*], Victor (fr. Dichter)

Huhn s; -[e]s, Hühner; **Hühn**|**chen**, **Hühn**|**lein**; **Hüh**|**ner**..**au**|**ge**, ...**brü**he, ...**brust**, ...**ei**, ...**fri**|**kas**|**see**, ...**ha**|**bicht**, ...**hund**, ...**lei**|**ter** w, ...**stei**|**ge** od. ...**stie**|**ge**

hu|**hu**!

hui!, aber (↑ R 119): im Hui, in einem Hui

Hui|**zin**|**ga**, Johan [*hói̯singehą*] (niederl. Geschichtsforscher)

hu|**jus** **an**|**ni** *lat.* (dieses Jahres, in diesem Jahr; Abk.: h. a.); dafür besser der dt. Ausdruck

hu|**jus** **men**|**sis** *lat.* (dieses Monats, in diesem Monat; Abk.: h. m.); dafür besser der dt. Ausdruck

Hu|**ka** *arab.* (ind. Wasserpfeife) w; -, -s

Huk|**boot** *niederl.* u. **Hu**|**ker** (größeres Fischerfahrzeug) m; -s, -

Hu|**la** *hawaiisch* (Eingeborenentanz auf Hawaii) w; -, -s od. m; -s, -s; **Hu**|**la**-**Mäd**|**chen**

Huld w; -

Hul|**da** vgl. Holda

hul|**di**|**gen**; **Hul**|**di**|**gung**; **Hul**|**din** (veralt. für: anmutiges weibl. Wesen) w; -, -nen; **huld**..**reich**, ...**voll**

Hulk, **Holk** *engl.* (ausgedientes, für Kasernen- u. Magazinzwecke verwendetes Schiff) w; -, -e[n] od. m; -[e]s, -e[n]

Hüll|**blatt**; **Hül**|**le** w; -, -n; **hül**|**len**; sich in etwas - **hül**|**len**|**los**; **Hüll**wort (für: Euphemismus; *Mehrz*. ...wörter)

Hul|**ly**-**Gul**|**ly** *engl.* [*hąligąlí*] (ein Modetanz) m; -s

Hüls|**chen**, Hüls|**lein**; [1]**Hül**|**se** (Kapsel[frucht]) w; -, -n; [2]**Hül**|**se** landsch. (Stechpalme) w; -, -n

hül|**sen**; du hülst (hülsest); **Hül**|**sen**|**frucht**; **Hül**|**sen**|**frücht**|**ler**; **hül**|**sig**; **Hüls**|**lein**, **Hüls**|**chen**

Hult|**schin** [auch: *hult*...] (Ort in der Tschechoslowakei); **Hult**schi|**ner** [auch: *hult*...] (↑ R 199); - Ländchen

hum! (ältere Form von: hm); hum, **hum**!

hu|**man** *lat.* (menschlich; menschenfreundlich; mild, gesittet, zugänglich); **hu**|**ma**|**ni**|**sie**|**ren** (gesittet, menschlich machen; zivilisieren); **Hu**|**ma**|**nis**|**mus** (Bildungsideal der gr.-röm. Antike; Humanität; geistige Strömung zur Zeit der Renaissance, als Neuhumanismus im 18. Jh.) m; -; **Hu**|**ma**|**nist** (Vertreter des Humanismus; Kenner der alten Sprachen); ↑ R 268; **hu**|**ma**|**ni**stisch; -es Gymnasium; **hu**|**ma**|**ni**tär (menschenfreundlich; wohltätig); **Hu**|**ma**|**ni**|**tät** (edle "Menschlichkeit"; hohe Gesittung; humane Gesinnung) w; -; **Hu**|**ma**|**ni**|**täts**..**den**|**ken**, ...**du**|**se**|**lei** (abschätzig), ...**ide**|**al**

Hum|**bert** (m. Vorn.)

Hum|**boldt** (Familienn.); **hum**|**boldt**|**tisch**, **hum**|**boldtsch**, aber (↑ R 179): **Hum**|**boldt**|**tisch**, **Hum**boldtsch; **Hum**|**boldt**-**Uni**|**ver**|**si**|**tät** (Universität in Ost-Berlin) w; -

Hum|**bug** *engl.* (Aufschneiderei, Schwindel; Unsinn) m; -s

Hume [*hjum*] (engl. Philosoph)

Hu|**me**|**ra**|**le** *lat.* (liturg. Schultertuch des kath. Priesters) s; -s, ...li-en [...*i"n*] u. ...lia

hu|**mid**, **hu**|**mi**|**de** *lat.* (feucht, naß); **Hu**|**mi**|**di**|**tät** (Feuchtigkeit) w; -

Hu|**mi**|**fi**|**ka**|**ti**|**on** *lat.* [...*zion*] (Vermoderung; Humusbildung) w; -; **hu**|**mi**|**fi**|**zie**|**ren**; **Hu**|**mi**|**fi**|**zie**|**rung** (svw. Humifikation)

Hum|**mel** (eine Bienenart) w; - , -n

Hum|**mer** (ein Krebs) m; -s, -;

Hum|**mer**|**sa**|**lat**

[1]**Hu**|**mor** *engl.* ([gute] Laune) m; -s, (selten:) -e; [2]**Hu**|**mor** *lat.* (Med.: Feuchtigkeit, Körperflüssigkeit) m; -s, ...ores; **hu**|**mo**|**ral** (Med.: die Körperflüssigkeiten betreffend); **Hu**|**mo**|**ral**|**pa**|**tho**|**lo**|**gie** (antike Lehre von den Körpersäften als Ausgangspunkt der Krankheiten) w; -; **Hu**|**mo**|**res**|**ke** [zu [1]Humor] (kleine humoristische Erzählung; Musikstück von komischem Charakter) w; -, -n; **hu**|**mo**|**rig** (launig, mit Humor); **hu**|**mo**|**ri**|**sie**|**ren**; **Hu**|**mo**|**rist** (jmd., der mit Humor schreibt, spricht, vorträgt usw.; auch: humorvoller Mensch); ↑ R 268; **hu**|**mo**|**ri**|**stisch**; -ste (↑ R 294); **hu**|**mor**|**los**; **Hu**|**mor**|**lo**|**sig**keit; **hu**|**mor**|**voll**

hu|**mos** *lat.* (reich an Humus); -er Boden

Hüm|**pel** nordd. (Haufen, Gruppe) m; -s, -

Hum|**pe**|**lei**; **hum**|**pe**|**lig**, **hump**|**lig**; **hum**|**peln**; ich ...[e]le (↑ R 327)

Hum|**pen** m; -s, -

Hum|**per**|**dinck** (dt. Komponist)

hump|**lig**, **hum**|**pe**|**lig**

Hu|**mus** *lat.* (fruchtbarer Bodenbestandteil, organ. Substanz im Boden) m; -; **Hu**|**mus**..**bo**|**den**, ...**er**|**de**; **hu**|**mus**|**reich**

Hund (Bergmannsspr. auch: Förderwagen) m; -[e]s, -e; (↑ R 224:) der Große -, der Kleine - (Sternbilder); **Hünd**|**chen**, **Hünd**|**lein**; **Hun**|**de**..**art**, ...**biß**; **hun**|**de**|**elend** (ugs. für: sehr elend); **Hun**|**de**|**hüt**te; **hun**|**de**|**kalt** (ugs. für: sehr kalt); **Hun**|**de**|**käl**|**te** (ugs.), ...**ku**chen; **hun**|**de**|**mü**|**de**, **hunds**|**mü**|**de** (ugs. für: sehr müde)

hun|**dert** (als römisches Zahlzeichen: C). I. *Kleinschreibung* als einfaches, ungebeugtes Zahlwort (↑ R 135): [vier] von hundert; hundert Menschen; bis hundert zählen; Tempo hundert (für: hundert Stundenkilometer); aberhundert (viele hundert) Sterne; an die hundert Menschen; der fünfte Teil von hundert; vgl. III, b. II. *Großschreibung* Maßeinheit (↑ R 118): das Hundert (vgl. d.); ein halbes Hundert; ein paar

Trenn.: ...k|k...

Hundert; das zweite Hundert; einige, viele Hunderte; Aberhunderte kleiner Vögel; vier vom Hundert (vgl. Hundert); einige Hundert Büroklammern (Packungen von je hundert Stück); [ganze] Hunderte von Menschen; Hunderte von [berufstätigen] Jugendlichen, (auch:) Hunderte [berufstätige] Jugendliche od. Hunderte berufstätiger Jugendlicher; Hunderte armer Menschen; viele Hundert[e] (z. B. Menschen); viele Hunderte von Menschen; Hunderte und aber (abermals) Hunderte, (österr.:) Hunderte und Aberhunderte; zu Hunderten u. Tausenden; es geht in die Hunderte; der Protest einiger, vieler Hunderte; der Einsatz Hunderter Pioniere; der Beifall Hunderter von Zuschauern. **III.** *Zusammen- u. Getrenntschreibung:* **a)** *Zusammenschreibung* mit bestimmten Zahlwörtern: einhundert, zweihundert [Mann, Menschen]; hundert[und]eins, hundert[und]siebzig; hundert[und]ein Salutschuß, mit hundertundeinem Salutschuß od. mit hundert[und]ein Salutschüssen; hundertunderster Tag; **b)** *Getrenntschreibung* nach unbestimmten Zahlwörtern: viel[e], einige, mehrere, ein paar hundert Bäume, Menschen u. a.; hundert und aber (abermals) hundert; ¹**Hun|dert** *s;* -s, -e; [vier] vom Hundert (Abk.: v. H., p. c.; Zeichen: %); vgl. hundert, II; ²**Hun|dert** (Zahl) *w;* -, -en; vgl. ¹Acht; **hun|dert|ein[s]**, hundert|und|ein[s]; vgl. hundert, III, a; **Hun|der|ter** *m;* -s, -; vgl. Achter; **hun|der|ter|lei;** auf - Weise; **hun|dert|fach; Hun|dert|fa|che** *s;* -n; vgl. Achtfache; **hun|dert|fäl|tig; Hun|dert|jahr|fei|er** *m.* (m. Ziffern: 100-Jahr-Feier; ↑R 157); **hun|dert|jäh|rig,** aber (↑R 224): der Hundertjährige Kalender; vgl. achtjährig; **Hun|dert|ki|lo|me|ter|tem|po;** im -; **hun|dert|mal;** einhundertmal; vielhundertmal, viele hundertmal, viel[e] hundert Male; ein halbes hundertmal; vgl. achtmal; **hun|dert|ma|lig; Hun|dert|mark|schein** (mit Ziffern: 100-Mark-Schein; ↑R 157), ...**me|ter|lauf; hun|dert|pro|zen|tig; Hun|dert|satz,** Vomhundertsatz (Prozentsatz) **hun|dert|schaft; hun|dert|ste;** das hundertste Tausend, aber (↑R 118): das weiß der Hundertste nicht, vom Hundertsten ins Tausendste kommen; vgl. achte; **hun|dert|stel;** vgl. achtel; **Hun|dert|stel** *s* (schweiz. meist: *m*); -s, -; vgl. Ach-

tel; **Hun|dert|stel|se|kun|de; hun|dert|stens; hundert|tau|send;** vgl. tausend; **Hun|dert|tau|send|mann|heer;** ↑R 157 (Reichsheer in der Weimarer Republik) *s;* -[e]s; **hun|dert|[und]|ein[s];** vgl. hundert, III, a
Hun|de.sa|lon, ...**schnau|ze,** ...**sper|re,** ...**steu|er** *w,* ...**wa|che** (Seemannsspr.: Nachtwache), ...**wet|ter** (ugs. für: sehr schlechtes Wetter; *s;* -s), ...**zucht** (↑R 294); **Hünd|chen** *w;* -, -nen; **hün|disch;** -ste (↑R 294); **Hünd|lein,** Hünd|chen
Hun|dred|weight *engl.* [ḥạ̈ndrᵉdwệ't] (engl. Handelsgewicht; Abk.: cwt. [eigtl.: centweight]) *s;* -, -s
Hunds|fott (Schurke) *m;* -[e]s, -e u. ...fötter; **Hunds|föt|te|rei; hunds|föt|tisch;** -ste (↑R 294); **hunds.ge|mein,** ...**mä|ßig,** ...**mi|se|ra|bel,** ...**mü|de** (vgl. hundemüde); **Hunds.ro|se** (Heckenrose), ...**ta|ge** (vom 24. Juli bis zum 23. August; *Mehrz.*), ...**veil|chen** (duftloses Veilchen), ...**wut** (veralt. für: Tollwut); **hunds|wü|tig**
Hü|ne *m;* -n, -n (↑R 286); **Hü|nen.ge|stalt,** ...**grab; hü|nen|haft**
Hun|ger *m;* -s; - sterben, vor - sterben; **Hun|ger.blocka|de** [*Trenn.:* ...blok|ka...], ...**blüm|chen** (Gattung der Kreuzblütler), ...**da|sein,** ...**kur,** ...**lei|der** (ugs. für: armer Schlucker), ...**lohn; hun|gern;** ich ...ere (↑R 327); **Hun|ger|ödem; Hun|gers|not; Hun|ger.streik,** ...**tuch** (Fastentuch; *Mehrz.* ...tücher), ...**turm; hung|rig**
Hun|ne (Angehöriger eines mongol. Nomadenvolkes) *m;* -n, -n (↑R 268); **Hun|nen.kö|nig,** ...**zug; hun|nisch**
Hun|nold (m. Vorn.)
Huns|rück (Teil des westl. Rhein. Schiefergebirges) *m;* -s; **Huns|rücker** [*Trenn.:* ...rük|ker] (↑R 199)
Hunt (Nebenform von: Hund [Förderwagen]) *m;* -[e]s, -e
Hun|ter *engl.* [ḥạn...] (Jagdpferd, -hund) *m;* -s, -
hun|zen (veralt., noch mdal. für: wie einen Hund behandeln; plagen; beschimpfen); du hunzt (hunzest)
Hu|pe (Signalhorn) *w;* -, -n; **hu|pen; Hu|pe|rei**
Hupf (veralt., noch mdal. für: Sprung) *m;* -[e]s, -e; **hupf|en** (südd., österr., sonst veralt.) od. **hüp|fen;** das ist gehupft od. gehüpft wie gesprungen (ugs. für: das ist völlig gleich); **hüp|fen; Hüp|fer** (südd., österr.), **Hüp|fer** (kleiner Sprung); **Hüp|fer|ling** (eine Krebsart)

Hup.kon|zert (scherzh. für: wildes Hupen), ...**ton** (*Mehrz.* ...töne)
Hür|chen [zu: Hure]
Hur|de (Flechtwerk; südwestd. u. schweiz. für: Obstbehälter, -ständer, Kartoffelkiste) *w;* -, -n; **Hür|de** ([mit] Flechtwerk [eingeschlossener Raum]; Hindernis beim Hürdenlauf) *w;* -, -n; vgl. ¹Horde; **Hür|den|lauf**
Hu|re *w;* -, -n; **hu|ren; Hu|ren.bock** (Schimpfwort), ...**kind** (Druckersprache: [einen Absatz zerreißende] Einzelzeile am Anfang einer neuen Seite od. Spalte), ...**sohn** (Schimpfwort), ...**wei|bel** (hist.); **Hu|re|rei**
Hu|ri *arab.* (schönes Mädchen im Paradies des Islams) *w;* -, -s
hür|nen (veralt. für: hörnern, mit Hornhaut versehen)
Hu|ro|ne (Angehöriger eines nordamerik. Indianerstammes) *m;* -n, -n (↑R 268); **Hu|ro|nisch**
hur|ra! [auch: hụ...]; hurra schreien; **Hur|ra** [auch: hụ...] *s;* -s, -s; viele -s; **Hur|ra.pa|trio|tis|mus,** ...**ruf** [auch: hụ...]
Hur|ri|kan *indian.* [engl. Ausspr.: hạrikᵉn] (Wirbelsturm in Mittelamerika) *m;* -s, -e u. (bei engl. Ausspr.:) -s
hur|tig; Hur|tig|keit *w;* -
Hus (tschech. Reformator); vgl. Huß
Hu|sar *ung.* (früher: Angehöriger einer leichten Reitertruppe in ungarischer Nationaltracht) *m;* -en, -en (↑R 268); **Hu|sa|ren.oberst,** ...**ritt,** ...**stück|chen**
husch!; husch, husch!; **Husch** *m;* -es, -e; auf den -, im - (rasch); **Hu|sche** ostmitteld. (Regenschauer) *w;* -, -n; **hu|sche|lig,** huschig (ugs. für: oberflächlich, eilfertig); **Hu|sche|lig|keit,** Husch|lig|keit; **hu|scheln** landsch. (ungenau arbeiten); ich ...[e]le (↑R 327); sich - (landsch. für: sich in einen Mantel usw wickeln); **hu|schen;** du huschs (huschest); **hu|schig, husch|lig;** vgl. huschelig; **Husch|lig|keit; Husch|lig|keit**
Hus|ky *engl.* [ḥạskī] (Eskimohund) *m;* -s, -ies
Huß (Nebenform von: Hus)
hus|sa!; hus|sa|sa!; hus|sen österr. ugs. (aufwiegeln, hetzen)
Hus|sit (Anhänger von J. Hus) *m* -en, -en (↑R 268); **Hus|si|ten|krieg**
hüst vgl. hott
hü|steln; ich ...[e]le (↑R 327); **hü|sten;** Hu|sten *m;* -s, (selten:) -; **Hu|sten.an|fall,** ...**bon|bon,** ...**mit|tel** *s,* ...**reiz**
Hu|sum (Stadt an der Nordsee); **Hu|su|mer** (↑R 199)

¹Hut (Kopfbedeckung) *m;* -[e]s,
Hüte; ²Hut (Schutz, Aufsicht) *w;*
-; auf der - sein; Hut..ab|tei|lung,
...band *s (Mehrz.* ...bänder); Hüt-
chen, Hüt|lein; Hü|te|jun|ge *m;*
hü|ten; sich -; Hü|ter; Hut..ge-
rech|tig|keit (veralt.: Recht, sein
Vieh an einer bestimmten Stelle
hüten zu lassen), ...kof|fer,
...krem|pe; Hüt|lein, Hüt|chen;
hut|los; Hut..ma|che|rin *(w,* -,
-nen), ...schach|tel

¹Hut|sche, Hüt|sche vgl. Hitsche;
²Hut|sche bayr., österr. (Schau-
kel) *w;* -, -n; hut|schen bayr.,
österr. (schaukeln); du hutschst
(hutschest)
Hut|schnur; das geht über die -
(ugs. für: das geht zu weit)
Hutsch|pferd österr. (Schaukel-
pferd)
Hütt|chen, Hütt|lein
Hüt|te schweiz. mdal. (Rücken-
tragkorb) *w;* -, -n; vgl. Hotte
Hüt|te *w;* -, -n
Hüt|ten (dt. Humanist)
Hüt|ten..ar|bei|ter, ...be|trieb, ...in-
du|strie, ...kom|bi|nat (DDR),
...kun|dc *(w;*), ...werk, ...we|sen
(s; -s); Hütt|lein, Hüt|chen; Hütt-
ner (veralt. für: Inhaber einer
Hütte; kleiner Landwirt; Hütt-
rach westösterr. mdal. (Arsen) *s;*
-s
Hu|tung (dürftige Weide [für
Schafe od. Ziegen]); Hü|tung (Be-
wachung); Hut|wei|de (Gemein-
deweide, auf die das Vieh täglich
getrieben wird)
Hut|zel landsch. (Tannenzapfen;
Dörrobstschnitzel; auch: alte
Frau) *w;* -, -n; Hut|zel|brot (mit
Hutzeln [Dörrobstschnitzeln] ge-
backenes Brot; südd. Festge-
bäck); hut|ze|lig, hutz|lig (dürr,
welk; alt); Hut|zel|männ|chen
(Heinzelmännchen); hut|zeln
landsch. (dörren; schrumpfen);
ich ...[e]le († R 327)
Hut|zucker [*Trenn.:* ...zuk|ker]
Hux|ley [*hąkßli*], Aldous (engl.
Schriftsteller)
Huy [*hü*], *m,* -s, (auch:) Huy|wald
(Höhenzug nördl. des Harzes) *m;*
-[e]s
Huy|gens [*heug^enß*] (niederl. Phy-
siker u. Mathematiker); das
-sche Prinzip († R 249)
Hu|zu|le (Angehöriger eines
ukrain. Volksstammes) *m;* -n, -n
(† R 268)
Hwang|ho *chin.* („gelber Fluß";
Strom in China) *m;* -[s]
Hya|den *gr.* („Regensterne";
Töchter des Atlas) *Mehrz.*
hya|lin *gr.* (Med.: durchsichtig wie
Glas, glasartig; Geol.: glasig er-
starrt); Hya|lit (Geol.: Glasopal)
m; -s, -e; Hya|lo|gra|phie (Glas-

radierung) *w;* -; Hya|lo|phan (ein
Mineral) *m;* -s, -e
Hyä|ne *gr.* (ein Raubtier) *w;* -, -n
¹Hya|zinth *gr.* (ein Edelstein) *m;*
-[e]s, -e; ²Hya|zinth (Liebling
Apollos); ³Hya|zinth (schöner
Jüngling) *m;* -s, -e; Hya|zin|the
(eine Zwiebelpflanze) *w;* -, -n
¹hy|brid *gr.* (Hybris zeigend)
²hy|brid *lat.* (von zweierlei Her-
kunft, zwitterhaft), -e Bildung
(Sprachw.: Zwitterbildung; zu-
sammengesetztes Wort, dessen
Teile versch. Sprachen an-
gehören); Hy|bri|de (Bastard,
aus Kreuzungen hervorgegange-
nes pflanzl. od. tier. Individuum)
w; -, -n (auch: *m;* -n, -n; † R 268);
Hy|bri|den|züch|ter
Hy|bris *gr.* (frevelhafter Übermut)
w; -
hyd... *gr.* (wasser...); Hyd... (Was-
ser...); hy|da|to|gen *gr.* (Geol.:
[von Schichtgesteinen] durch
Wasser zusammengeführt)
Hyde|park [*hạid...*] (Park in Lon-
don) *m;* -[e]s
¹Hy|dra *gr.* (sagenhafte Seeschlan-
ge) *w;* -; ²Hy|dra (ein Süßwasser-
polyp) *w;* -, ...dren
Hy|drä|mie *gr.* (Med.: erhöhter
Wassergehalt des Blutes) *w;* -,
...ien; Hy|drant (Anschluß an die
Wasserleitung, Zapfstelle) *m;*
-en, -en († R 268); Hy|drar|gy|rum
(Quecksilber, chem. Grundstoff;
Zeichen: Hg) *s;* -s; Hy|drat (Ver-
bindung chem. Stoffe mit Was-
ser) *s;* -[e]s, -e; Hy|dra|[ta]|ti|on
[...*zion*] (Bildung von Hydraten);
hy|dra|ti|sie|ren (Hydrate bil-
den); Hy|drau|lik (Lehre von der
Bewegung der Flüssigkeiten) *w;*
-; hy|drau|lisch (mit Flüssigkeits-
druck arbeitend, mit Wasseran-
trieb); -e Bremse; -e Presse; -er
Mörtel (Wassermörtel); Hy|dra-
zin (chem. Verbindung von Stick-
stoff mit Wasserstoff; Bestand-
teil im Raketentreibstoff) *s;* -s;
Hy|drier|ben|zin; hy|drie|ren
(Chemie: Wasserstoff anlagern);
Hy|drie|rung; Hy|drier..ver|fah-
ren, ...werk
Hy|dro|bio|lo|gie *gr.* (Lehre von
den im Wasser lebenden Organis-
men)
Hy|dro|chi|non Ⓦ *gr.;* indian. (fo-
togr. Entwickler) *s;* -s
Hy|dro|dy|na|mik *gr.* (Strömungs-
lehre); hy|dro|dy|na|misch
Hy|dro|gen, Hy|dro|ge|ni|um *gr.*
(Wasserstoff; chem. Grundstoff;
Zeichen: H) *s;* -s; Hy|dro|gra|phie
(Gewässerkunde) *w;* -; hy|dro-
gra|phisch
Hy|dro|kul|tur *gr.* (Wasserkultur;
Pflanzenzucht in Nährlösungen
ohne Erde) *w;* -

Hy|dro|lo|gie *gr.* (Lehre vom Was-
ser) *w;* -; hy|dro|lo|gisch; Hy|dro-
ly|se (Spaltung chem. Verbin-
dungen durch Wasser) *w;* -, -n;
hy|dro|ly|tisch
Hy|dro|me|cha|nik *gr.* (Mechanik
der Flüssigkeiten); Hy|dro|me-
du|se (Qualle); Hy|dro|me|ter
(Gerät zur Messung der Ge-
schwindigkeit fließenden Was-
sers) *s;* -s, -; hy|dro|me|trisch
Hy|dro|pa|thie (Wasserheilkun-
diger) *m;* -en, -en († R 268); Hy|dro-
dro|pa|thie (svw. Hydrotherapie)
w; -; hy|dro|pa|thisch; Hy|droph-
thal|mus (Med.: Augenwasser-
sucht) *m;* -; hy|dro|pisch (Med.:
wassersüchtig); hy|dro|pneu|ma-
tisch (durch Wasser u. Luft [ge-
trieben usw.]); Hy|dro|po|nik
(svw. Hydrokultur) *w;* -; Hy-
drops *m;* - u. Hy|drop|sie (Med.:
Wassersucht) *w;* -
Hy|dro|sphä|re (Wasserhülle der
Erde) *w;* -; Hy|dro|sta|tik (Phy-
sik: Lehre von den Gleichge-
wichtszuständen bei Flüssigkei-
ten); hy|dro|sta|tisch; -e Waage
(zum Bestimmen des Auftriebs)
Hy|dro|tech|nik *gr.* (Wasserbau-
[kunst]) *w;* -; hy|dro|the|ra|peu-
tisch; Hy|dro|the|ra|pie (Med.:
Wasserheilkunde) *w;* -
Hy|dro|xyd *gr.* (chem. Verbin-
dung) *s;* -[e]s, -e; vgl. Oxid; Hy-
dro|xyl|grup|pe *gr.; dt.* (Wasser-
stoff-Sauerstoff-Gruppe)
Hy|dro|ze|le *gr.* (Med.: „Wasser-
bruch") *w;* -, -n; Hy|dro|ze|pha-
lus (Wasserkopf) *m;* -, ...alen; Hy-
dro|zo|en (Klasse der Hohltiere)
Mehrz.
Hye|to|gra|phie *gr.* [*hü-eto...*] (Meteor.: Messung der Menge und
Verteilung von Niederschlägen)
w; -; Hye|to|me|ter (Regenmes-
ser) *s;* -s, -
Hy|gi|ela (gr. Göttin der Gesund-
heit); Hy|gie|ne *gr.* (Gesundheits-
lehre, -fürsorge, -pflege) *w;* -; hy-
gie|nisch; -ste († R 294)
Hy|gro|me|ter *gr.* (Luftfeuchtig-
keitsmesser) *s;* -s, -; Hy|gro|phyt
(Bot.: Landpflanze mit hohem
Wasserverbrauch) *m;* -en, -en
(† R 268); Hy|gro|skop (Meteor.:
Luftfeuchtigkeitsanzeiger) *s;* -s,
-e; hy|gro|sko|pisch (Feuchtigkeit
an sich ziehend)
Hyk|sos (asiat. Eroberervolk im
alten Ägypten) *Mehrz.*
Hy|lo|zo|is|mus *gr.* (altgr. Lehre
vom belebten Urstoff) *m;* -
¹Hy|men, Hy|me|nai|os u. Hy|me-
nä|us (gr. Hochzeitsgott); ²Hy-
men *gr.* (antiker Hochzeitsge-
sang) *m;* -s, -e; ³Hy|men (Med.:
Jungfernhäutchen) *s* (auch: *m*);
-s, -; Hy|me|nai|os [auch: *hüme*-

naios, hüme...], Hy|me|nä|us vgl.
¹Hymen; Hy|me|ni|um (Bot.:
Fruchtschicht der Ständerpilze)
s; -s, ...ien [...iⁿn]; Hy|me|no|my-
ze|ten (Bot.: Ständerpilze)
Mehrz.; Hy|me|no|pte|ren (Haut-
flügler) *Mehrz.*
Hym|ne *gr.* w; -, -n u. Hym|nus
(Festgesang; christl. Lobgesang;
Weihelied) m; -, ...nen; Hym|nik
(Kunstform der Hymne); hym-
nisch; Hym|no|lo|gie (Hymnen-
kunde) w; -; hym|no|lo|gisch
Hy|os|cya|min *gr.* [...ßzü...] (chem.
fachspr. für:) Hy|os|zya|min (Al-
kaloid, Heilmittel) s; -s
hyp... vgl. hypo...; Hyp... vgl. Hy-
po...; Hyp|äs|the|sie *gr.* (Med.:
verminderte Empfindlichkeit) w;
-, ...ien
hy|per... *gr.* (über...); Hyper...
(Über...); Hy|per|al|ge|sie (Med.:
gesteigertes Schmerzempfinden)
w; -; hy|per|al|ge|tisch (schmerz-
überempfindlich); Hy|per|ämie
(Med.: Blutüberfüllung in einem
Körperteil) w; -; Hy|per|äs|the|sie
(Med.: Überempfindlichkeit) w;
-, ...ien; hy|per|äs|the|tisch
Hy|per|bel *gr.* (Übertreibung des
Ausdrucks; Math.: Kegelschnitt)
w; -, -n; hy|per|bo|lisch (hyperbel-
artig; im Ausdruck übertrei-
bend); -ste (↑ R 294); -e Funktion
(Math.); Hy|per|bo|lo|id (Math.:
Körper, der durch Drehung einer
Hyperbel um ihre Achse ent-
steht) s; -[e]s, -e
Hy|per|bo|re|er (Angehöriger ei-
nes sagenhaften Volkes des ho-
hen Nordens); hy|per|bo|re|isch
(veralt. für: im hohen Norden ge-
legen, wohnend)
Hy|per|dak|ty|lie *gr.* (Med.: Bil-
dung von mehr als je fünf Fin-
gern od. Zehen) w; -
Hy|per|eme|sis *gr.* [auch: ...ẹm...]
(Med.: übermäßiges Erbrechen)
w; -
hy|per|go|lisch *gr.*; *lat.*; -er Treib-
stoff (Raketentreibstoff, der bei
Berührung mit einem Sauerstoff-
träger sofort zündet)
Hy|pe|ri|on [auch: *hyperiọn*] (Ti-
tan, Vater des Helios)
hy|per|ka|ta|lek|tisch *gr.* (Versleh-
re: mit überzähliger Silbe verse-
hen); hy|per|kor|rekt (überkor-
rekt); hy|per|kri|tisch (über-
streng, tadelsüchtig)
Hy|per|me|ter *gr.* m; -s, - u. Hy-
per|me|tron (Vers, der um eine
Silbe zu lang ist u. mit der
Anfangssilbe des folgenden Ver-
ses durch Elision verbunden
wird) s; -s, ...tra; hy|per|me|trisch;
Hy|per|me|tro|pie (Med.: Weit-,
Übersichtigkeit) w; -; hy|per|me-
tro|pisch

hy|per|mo|dern (übermodern,
übertrieben neuzeitlich)
Hy|pe|ron (Kernphysik: über-
schweres Elementarteilchen) s;
-s, ...onen
Hy|per|pla|sie *gr.* (Med., Biol.: ab-
norme Vermehrung von Zellen)
w; -, ...ien; hy|per|pla|stisch
hy|per|sen|si|bel; hy|per|so|nisch
(im hohen Überschallbereich
[fliegend]); -e Geschwindigkeit
(Überschallgeschwindigkeit)
Hy|per|to|nie *gr.* (Med.: gesteiger-
ter Blutdruck; gesteigerte Mus-
kelspannung; vermehrte Span-
nung im Augapfel) w; -, ...ien;
Hy|per|tri|cho|se *gr.* (Med.: über-
mäßig starke Behaarung) w; -;
hy|per|troph (überspannt, über-
zogen; Med.: durch Zellenwachs-
tum vergrößert); Hy|per|tro|phie
gr. (übermäßige Vergrößerung
von Geweben u. Organen; Über-
ernährung) w; -
Hy|phe *gr.* (Bot.: Pilzfaden) w; -,
-n
Hyph|en *gr.* (Bindestrich) s; -[s],
-[e]
Hyp|no|pä|die („Schlaflernen";
Methode des mechanischen Ler-
nens nach im Halbschlaf ab-
gehörten Tonbändern) w; -;
hyp|no|pä|disch; Hyp|nos (gr.
Gott des Schlafes) Hyp|no|se *gr.*
(schlafähnl. Bewußtseinszu-
stand, Zwangsschlaf) w; -, -n;
Hyp|no|tik (Lehre von der Hyp-
nose) w; -; Hyp|no|ti|kum (Schlaf-
mittel) s; -s, ...ka; hyp|no|tisch;
Hyp|no|ti|seur *fr.* [...sör] (die
Hypnose Bewirkender) m; -s, -e;
hyp|no|ti|sie|ren (in Hypnose ver-
setzen; beeinflussen; wi-
derstandslos machen); Hyp|no-
tis|mus *gr.* (Lehre von der Hyp-
nose; Beeinflussung) m; -
hy|po... *gr.*, (vor Selbstlauten:)
hyp... (unter...); Hy|po..., (vor
Selbstlauten:) Hyp... (Unter...)
Hy|po|chon|der *gr.* [...eh...]
(Schwermütiger; eingebildeter
Kranker) m; -s, -; Hy|po|chon-
drie (Einbildung, krank zu sein;
Trübsinn, Schwermut) w; -; hy-
po|chon|drisch; -ste (↑ R 294)
Hy|po|ga|stri|um *gr.* (Med.: Un-
terleib) s; -s, ...ien [...iⁿn]
hy|po|gyn, hy|po|gy|nisch *gr.* (Bot.:
von Blüten: mit oberständigem
Fruchtknoten)
hy|po|kau|stisch *gr.*; Hy|po|kau-
stum (antike Heizanlage unter ei-
nem Raum) s; -s, ...sten; Hy|po-
ko|tyl (Bot.: Keimstengel der Sa-
menpflanzen) s; -s, -e; Hy|po|kri-
sie (Heuchelei) w; -; Hy|po|krit
(Heuchler) m; -en, -en (↑ R 268);
hy|po|kri|tisch; -ste (↑ R 294)
Hy|po|phy|se *gr.* (Bot.: Keiman-

schluß; Med.: Hirnanhang) w;
-, -n
Hy|po|spa|die *gr.* (Med.: Spalte,
Mißbildung an der unteren
Harnröhre) w; -, ...ien; Hy|po|sta-
se (Grund-, Unterlage, Substanz;
Verdinglichung von Begriffen;
Med.: Senkungsblutfülle) w; -, -n;
hy|po|sta|sie|ren (zu einem We-
sen verselbständigen, gegen-
ständlich machen, verding-
lichen); hy|po|sta|tisch (verge-
genständlichend, gegenständ-
lich); Hy|po|sty|lon s; -s, ...la u.
Hy|po|sty|los (gedeckter Säulen-
gang; Säulenhalle; Tempel mit
Säulengang) m; -, ...loi [...leu]
hy|po|tak|tisch *gr.* (Sprachw.:
unterordnend); Hy|po|ta|xe, (äl-
ter:) Hy|po|ta|xis (Sprachw.:
Unterordnung) w; -, ...xen; Hy-
po|te|nu|se (Math.: im rechtwink-
ligen Dreieck Seite gegenüber
dem rechten Winkel) w; -, -n; Hy-
po|thek (im Grundbuch eingetra-
genes Pfandrecht an einem
Grundstück; übertr. für: ständi-
ge Belastung) w; -, -en; Hy|po|the-
kar (Hypothekengläubiger) m;
-s, -e; hy|po|the|ka|risch; Hy|po-
the|ken.bank (*Mehrz.* ...banken),
...[pfand]brief; Hy|po|ther|mie
(Med.: unternormale Körper-
wärme) w; -; Hy|po|the|se ([unbe-
wiesene] wissenschaftl. Annah-
me); hy|po|the|tisch (angenom-
men; zweifelhaft); Hy|po|to|nie
(Med.: Verminderung des Blut-
drucks; herabgesetzte Mus-
kelspannung) w; -, ...ien; Hy|po-
tra|che|li|on (Architektur: Säu-
lenhals unter dem Kapitell) s; -s,
...ien [...iⁿn]; Hy|po|tri|cho|se (Med.:
spärlicher Haarwuchs) w; -; Hy-
po|tro|phie (Med.: Unterernäh-
rung, Unterentwicklung) w; -,
...ien
Hy|po|zen|trum (unter der Erd-
oberfläche liegender Erdbeben-
herd); Hy|po|zy|klo|ide (eine
geometr. Kurve) w; -, -n
Hyp|so|me|ter *gr.* (Höhenmesser)
s; -s, -; Hyp|so|me|trie (Höhen-
messung) w; -; hyp|so|me|trisch
Hyr|ka|ni|en [...iⁿn] *gr.* (im Alter-
tum Bez. für die südöstl. Küste
des Kaspischen Meeres); hyr|ka-
nisch, aber (↑ R 198): das
Hyrkanische Meer (alter Name
für das Kaspische Meer)
Hy|ster|al|gie *gr.* (Med.: Gebär-
mutterschmerz) w; -, ...ien; Hy-
ste|re|se, Hy|ste|re|sis (Physik:
Fortdauer einer Wirkung nach
Aufhören der Ursache) w; -; Hy-
ste|rie (abnorme seel. Verhal-
tensweise) w; -, ...ien; Hy|ste|ri-
ker; hy|ste|risch; -ste (↑ R 294)

Hy|ste|ron-Pro|te|ron (Redefigur, bei der das „Spätere" „zuerst" steht) s; -s, Hystera-Protera; **Hy|ste|ro|sko|pie** (Med.: Untersuchung der Gebärmutterhöhle) w; -; **Hy|ste|ro|to|mie** (Med.: Gebärmutterschnitt) w; -

Hz = Hertz

I

I (Buchstabe); das I; des I, die I, aber: das i in Bild; der Buchstabe I, i; der Punkt auf dem i (↑ R 123); I-Punkt (↑ R 149)

i (Math.: Zeichen für die imaginäre Einheit)

i!; (ugs.:) i bewahre!; i wo!; (landsch.:) i gitt [i gitt]!

I (röm. Zahlzeichen) = 1

I, i = Iota

i. = in, im (bei Ortsnamen, z. B. Immenstadt i. Allgäu); vgl. i. d.

Ia = (ugs. für: prima); das ist Ia od. eins a

Ia = Iowa

i. A.[1] = im Auftrag[e]

iah; ia|hen; der Esel iaht, hat iaht

i. allg. = im allgemeinen

Iam|be usw. vgl. Jambe usw.

...iana vgl. ...ana

Ia|son vgl. Jason

ia|tro|che|mie (mittelalterl. heilkundl. Richtung)

ib., ib. = ibidem

Ibe|rer (Angehöriger der vorindogerm. Bevölkerung der Iber. Halbinsel); **ibe|risch** (spanisch). aber (↑ R 198): die Iberische Halbinsel; **Ibe|ro|ame|ri|ka** (Lateinamerika); **ibe|ro|ame|ri|ka|nisch**; ↑ R 215 (lateinamerikanisch), aber (↑ R 214): **ibe|ro-ame|ri|ka|nisch** (zwischen Spanien, Portugal u. Lateinamerika bestehend)

ibi|dem lat. [auch: *ibi*...] (ebenda; Abk.: ib., ibd.)

Ibis ägypt. (ein Storchvogel) m; Ibisses, Ibisse

IBM Deutsch|land = Internationale Büro-Maschinen GmbH Deutschland (in Sindelfingen; Tochtergesellschaft des amerikanischen Konzerns IBM = International Business Machines [*int⁴rnäsch⁴n⁴l bisniß m⁴schins*]

[1] Diese Abkürzung wird so geschrieben, wenn sie die Bezeichnung einer Behörde, Firma u. dgl. folgt. Sie wird im ersten Bestandteil groß geschrieben (I. A.), wenn sie nach einem abgeschlossenen Text oder allein vor einer Unterschrift steht.

Corp., New York); **IBM-Schreib|kopf|ma|schi|ne** (↑ R 150)

Ibn arab. (Sohn; Teil von arab. Personennamen)

Ibra|him [auch: *ibrahim*] (arab. Form von: Abraham)

Ib|sen (norw. Dichter)

Iby|kos vgl. Ibykus; **Iby|kus** (altgr. Dichter)

IC = Intercity-Zug

ich; Ich s; -[s], -[s]; das liebe -; mein anderes -; **ich|be|zo|gen**; **Ich|form** w; -; Erzählung in der -; **Ich|ge|fühl**; **Ich|heit** w; -; **Ich-Laut** (↑ R 151) m; -[e]s, -e

Ich|neu|mon gr. (eine Schleichkatze) m od. s; -s, -e u. -s; **Ich|neu|mo|ni|den** (wissenschaftl. Bez. für die Schlupfwespen) Mehrz.

Ich-Ro|man (Roman in der Ichform; ↑ R 151) m; -s, -e; **Ich|sucht** w; -; **ich|süch|tig**

Ich|thy|o|dont gr. (versteinerter Fischzahn) m; -en, -en (↑ R 268); **Ich|thy|ol** ⓦ gr.; lat. (ein Hautreizmittel) s; -s; **Ich|thyo|lith** gr. (versteinerter Fisch[rest]) m; -s u. -en, -e[n] (↑ R 268); **Ich|thyo|lo|ge** (Fischkundler) m; -n, -n (↑ R 268); **Ich|thyo|lo|gie** (Fischkunde) w; -; **Ich|thyo|lo|gisch**; **Ich|thyo|se** (Med.: eine Hautkrankheit) w; -, ...osen; **Ich|thyo|toxin** (im Blutserum des Aales enthaltenes Gift)

id. = idem, idem

Id. = Idaho

i. d. = in der (bei Ortsnamen, z. B. Neumarkt i. d. Opf. [in der Oberpfalz])

¹Ida (Gebirge in Kleinasien, auch auf Kreta) m; -

²Ida (w. Vorn.); **Ida|feld** (isländ. Mythol.: Wohnort der Asen) s; -[c]s

Ida|ho [*áid⁴ho⁴*] (Staat in den USA; Abk.: Id.)

idä|isch (zu ¹Ida)

ide|al gr. (nur in der Vorstellung existierend; der Idee entsprechend; musterhaft, vollkommen); **Ide|al** (dem Geiste vorschwebendes Muster der Vollkommenheit; Vor-, Wunschbild) s; -s, -e; **Ide|al|bild**, ...fall m, ...figur, ...ge|stalt; **idea|li|sie|ren** (der Idee od. dem Ideal annähern; verklären) (Wissenschaft von den Ideen; Überordnung der Gedanken-, Vorstellungswelt über die wirkliche [nur Einz.]; Streben nach Verwirklichung von Idealen) m; -, ...men; **Idea|list** (↑ R 268); **idea|li|stisch**, -ste (↑ R 294); **Idea|li|tät** (das Sein als Idee od.

Vorstellung) w; -; **Ide|al.kon|kurrenz** (Rechtsw.), ...lö|sung, ...staat, ...ty|pus, ...vor|stel|lung, ...wert (Kunstwert), ...zu|stand; **Idee** ([Ur]begriff, Urbild; [Leit-, Grund]gedanke; Einfall, Plan) w; -, Ideen; eine - (ugs. auch für: eine Kleinigkeit); **ideell** (nur gedacht, geistig); **ide|en|arm; Ide|en.ar|mut**, ...as|so|zia|ti|on (Gedankenverbindung Vorstellungsverknüpfung), ...dra|ma, ...flucht (krankhafte Beschleunigung und Zusammenhanglosigkeit des Gedankenablaufes; vgl. ²Flucht), ...fül|le, ...ge|halt m, ...gut; ide|en|los; Ide|en|lo|sig|keit w, -, klei|en|reich, Ide|en.reich|tum (m; -s), ...welt

¹idem lat. (derselbe; Abk.: id.); **²idem** (dasselbe; Abk.: id.)

Iden, Idus [*ídⁿß*] lat. (13. od. 15. Monatstag des altröm. Kalenders) Mehrz.; die Iden des März (15. März)

Iden|ti|fi|ka|ti|on lat. [...zión], **Iden|ti|fi|zie|rung** (Gleichsetzung, Feststellung der Identität); **iden|ti|fi|zie|ren** (einander gleichsetzen; [die Persönlichkeit] feststellen; etwas genau wiedererkennen); sich -; **Iden|ti|fi|zie|rung** vgl. Identifikation; **iden|tisch** (ein und) derselbe; übereinstimmend; völlig gleich); **Iden|ti|tät** (Wesenseinheit; völlige Gleichheit) w; -; **Iden|ti|täts|nach|weis** (Zollw.)

Ideo|gramm gr. (Begriffszeichen); **Ideo|gra|phie** (Begriffsschrift) w; -; **ideo|gra|phisch**; -e Schrift; **Ideo|lo|ge** (Lehrer od. Anhänger einer Ideologie) m; -n, -n (↑ R 268); **Ideo|lo|gie** (polit. Grundvorstellung; Weltanschauung; oft abwertend) w; -, ...ien; **ideo|lo|gisch**; **ideo|lo|gi|sie|ren** (ideologisch durchdringen, interpretieren); **Ideo|lo|gi|sie|rung**; **ideo|mo|to|risch** gr.; lat. (Psych.: unbewußt ausgeführt)

id est lat. (veralt. für: das ist, das heißt; Abk.: i. e.)

idg. = indogermanisch

idio... gr. (eigen..., sonder...); **Idio...** (Eigen..., Sonder...); **Idio|blast** (kleinster Teil des Idioplasmas) m; -en, -en (meist Mehrz.); ↑ R 268

Idio|la|trie (Selbstvergötterung) w; -

Idio|lekt gr. (Sprachw.: individueller Sprachgebrauch) m; -[e]s, -e

Idi|om gr. ([Standes]sprache; Mundart; idiomatische Wendung) s; -s, -e; **Idio|ma|tik** (Lehre von den Idiomen) w; -; **idio|matisch**

idio|morph *gr.* (von Mineralien: von eigenen echten Kristallflächen begrenzt)

Idio|plas|ma *gr.* (Biol.: Keimplasma, das Träger des Erbgutes sein soll) *s;* -s

Idio|syn|kra|sie *gr.* (Med.: Überempfindlichkeit gegen bestimmte Stoffe u. Reize) *w;* -, ...ien; idio|syn|kra|tisch (Med.: überempfindlich; von Abneigung erfüllt)

Idi|ot *gr. m;* -en, -en (↑ R 268); idio|ten|haft; Idio|ten|hü|gel (ugs. scherzh.: Hügel, an dem Anfänger im Schifahren üben); idio|ten|si|cher (ugs.: so, daß niemand etwas falsch machen kann); Idio|tie *w;* -, ...jen

Idio|ti|kon *gr.* (veralt. für: Mundartwörterbuch) *s;* -s, ...ken (auch: ...ka)

Idio|tin *gr. w;* -, -nen; idio|tisch; -ste (↑ R 294)

Idio|tis|mus *gr.* (Äußerung der Idiotie; Sprachw. veralt.: kennzeichnende Eigenheit eines Idioms) *m;* -, ...men

Idio|va|ria|ti|on *gr.; lat.* (erbliche Veränderung eines Gens, Mutation)

Idle|wild *engl.* [*aidlwaild*] (Hauptflughafen von New York; heute: John F. Kennedy International Airport)

Ido|kras *gr.* (ein Mineral) *m;* -, -e

Idol *gr.* (Götzenbild; Abgott; Publikumsliebling, Schwarm) *s;* -s, -e; Ido|lo|la|trie, (häufig verkürzt:) Ido|la|trie ("Bilderdienst"; Abgötterei; Götzendienst) *w;* -, ...jen

Idria|lit (ein Mineral) *m;* -s, -e

Idu|mäa (Edom)

Idun (nord. Göttin der ewigen Jugend); Idu|na (latinis. Form für: Idun)

i. Durchschn. = im Durchschnitt

Idus vgl. Iden

Idyll (Bereich, Zustand eines friedl. und einfachen, meist ländl. Lebens) *s;* -s, -e; Idyl|le (Schilderung eines Idylls in Literatur u. bildender Kunst; auch svw. Idyll) *w;* -, -n; Idyl|lik (idyllischer Zustand, idyllisches Wesen) *w;* -; idyl|lisch (das Idyll, die Idylle betreffend; ländlich; friedlich; einfach); -ste (↑ R 294)

i. e. = id est

i.-e. = indoeuropäisch

I. E., IE: Internationale Einheit

i. f. = ipse fecit

If|(f)er|ten vgl. Yverdon

i-för|mig (in Form eines lat. I); ↑ R 149

IG = Industriegewerkschaft

Igel *m;* -s, -; Igel|fisch

Ige|lit Ⓦ (ein Kunststoff) *s;* -s, -e

Igel-kak|tus, ...kopf

IG-Far|ben (Kurzw. für den ehemaligen Konzern I. G. Farbenindustrie A. G. [= Interessengemeinschaft der deutschen Farbenindustrie])

i gitt! vgl. i!

Iglu eskim. (runde Schneehütte der Eskimos) *m* od. *s;* -s, -s

Igna|ti|us [...*ziuß*] (Name von Heiligen); Ignatius von Loyola (Gründer der Gesellschaft Jesu)

Ignaz [auch: *ignaz*] (m. Vorn.)

Igno|rant *lat.* ("Nichtwisser"; Dummkopf) *m;* -en, -en (↑ R 268); Igno|ran|ten|tum *s;* -s; Igno|ranz (Unwissenheit, Dummheit) *w;* -; igno|rie|ren (nicht wissen [wollen], absichtlich übersehen, nicht beachten)

Igor (russ. m. Vorn.)

Igu|an|odon *indian.; gr.* (Biol.: pflanzenfressender Dinosaurier) *s;* -s od. ...odonten

i. H. = im Haus[e]

Ihe|ring [*ig...*] (dt. Rechtslehrer)

IHK = Industrie- u. Handels-Kammer (vgl. d.)

Ih|le (Hering, der abgelaicht hat; Hohlhering) *m;* -n, -n (↑ R 268)

ihm; ihn; ihnen[1]

ihr[1], ih|re, ihr; ihres, ihrem, ihren, ihrer; Ihre Majestät (Abk.: I. M.); vgl. dein; (↑ R 275:) ihr lieben Kinder; (↑ R 290:) ihr Hübschen; ih|re[1], ih|ri|ge[1]; vgl. deine, deinige; ih|rer|seits[1]; ih|res|glei|chen[1]; ih|res|teils[1]; ih|ret|hal|ben[1]; ih|ret|we|gen[1]; ih|ret|wil|len[1]; um -; ih|ri|ge[1], ihre[1]; vgl. deine, deinige; Ih|ro (veralt. für: Ihre); - Gnaden; ihr|zen (gus. für: mit „Ihr" anreden); du ihrzt (ihrzest)

IHS = *IH(ΣΟΥ)Σ* = Jesus (volkstümlich als Jesus, Heiland, Seligmacher gedeutet)

I. H. S. = in hoc salus; in hoc signo

i. J. = im Jahre

Ijob vgl. Hiob

IJs|sel, (eingedeutscht auch:) Is|sel [*e'ßel*] (Flußarm im Rheindelta) *w;* -; IJs|sel|meer, (eingedeutscht auch:) Is|sel|meer (an der ehem. Nordseebucht der Zuidersee durch Abschlußdeich gebildeter See) *s;* -[e]s

ika|risch [zu: Ikarus], aber (↑ R 198:) das Ikarische Meer; Ika|ros vgl. Ikarus; Ika|rus (Gestalt der gr. Sage)

Ike|ba|na *jap.* (Kunst des Blumensteckens) *s;* -[s]

Ikon *gr.* (seltener für: Ikone) *s;* -s, -e; Iko|ne (Kultbild der Ostkirche) *w;* -, -n; Iko|nen|ma|le|rei;

Iko|no|du|lie (Bilderverehrung) *w;* -; Iko|no|graph (Vertreter der Ikonographie) *m;* -en, -en (↑ R 268); Iko|no|gra|phie (wiss. Bestimmung, Beschreibung, Erklärung von Ikonen) *w;* -; Iko|no|klas|mus (Bildersturm) *m;* -...men; Iko|no|klast (Bilderstürmer) *m;* -en, -en (↑ R 268); Iko|no|la|trie (svw. Ikonodulie) *w;* -; Iko|no|lo|gie (svw. Ikonographie) *w;* -; Iko|no|skop (speichernde Fernsehaufnahmeröhre) *s;* -s, -e; Iko|no|stas *m;* -, -e u. Iko|no|sta|se (dreitürige Bilderwand zwischen Gemeinde- und Altarraum in der Orthodoxen Kirche) *w;* -, -n

Iko|sa|eder (Math.: Zwanzigflächner) *s;* -s, -; Iko|si|te|tra|eder (Vierundzwanzigflächner)

ikr = isländische Krone

IKRK = Internationales Komitee vom Roten Kreuz (in Genf)

IKS = Interkantonale Kontrollstelle für Arzneimittelprüfungen (in der Schweiz)

ik|te|risch (Med.: gelbsüchtig); Ik|te|rus (Gelbsucht) *m;* -

Ik|tus *lat.* (Betonung der Hebung im Vers; Med.: unerwartet auftretendes, schweres Krankheitsbild) *m;* -, - u. Ikten

Ilang-Ilang-Öl *tagal.* vgl. Ylang-Ylang-Öl

Il|de|fons, Hil|de|fons (m. Vorn.)

Iler (Schabeisen der Kammmacher) *m;* -s, -

Ile|us *gr.* [*ile-uß*] (Med.: Darmverschluß) *m;* -, Ileen [...*e'n*]

Ilex *lat.* (Stechpalme) *w;* -

Ili|as, (auch:) Ilia|de gr [(Homers) Heldengedicht über den Krieg gegen Ilion) *w;* -; Ili|on (gr. Name von: Troja); Ili|um (latinis. Form von: Ilion)

Il|ka (Kurzform von: Ilona)

Ill (r. Nebenfluß des Rheins; l. Nebenfluß des Rheins)

ill. = illustriert

Ill. = Illinois

Il|la|tum *lat.* (veralt. für: von der Frau in die Ehe eingebrachtes Vermögen) *s;* -s, ...ta u. ...ten (meist *Mehrz.*)

il|le|gal *lat.* [auch: ...*gl*] (ungesetzlich; unrechtmäßig); Il|le|ga|li|tät [auch: *il...*]; il|le|gi|tim [auch: ...*im*] (ungesetzlich; unecht; unehelich); Il|le|gi|ti|mi|tät [auch: *il...*] *w;* -

Il|ler (r. Nebenfluß der Donau) *w;* -

il|lern *landsch.* (spähen); ich ...ere (↑ R 327)

il|li|be|ral *lat.* [auch: ...*gl*] (selten für: engherzig); Il|li|be|ra|li|tät [auch: *il...*]

Il|li|nois [...*neu*(s)] (Staat in den USA; Abk.: Ill.)

[1] Als Anrede stets groß geschrieben (↑ R 121 f.).

il|li|quid *lat.* [auch: ...*it*] (zahlungsunfähig); Il|li|qui|di|tät [auch: *il*...] (Zahlungsunfähigkeit, Mangel an flüssigen Geldmitteln) *w;* -

Il|li|te|rat *lat.* [auch: ...*at*] (selten für: Ungelehrter, Ungebildeter) *m;* -en, -en (↑ R 268)

il|loy|al *fr.* [*iloajal*, auch: ...*al*] (unehrlich; gesetzwidrig; übelgesinnt), Il|loy|a|li|tät [auch: *il*...]

Il|lu|mi|nat *m.* (Angehöriger verschiedener früherer Geheimverbindungen, bes. des Illuminatenordens) *m;* -en, -en (↑ R 268); Il|lu|mi|na|ten|or|den (aufklärerisch-freimaurerische geheime Gesellschaft des 18. Jh.s); Il|lu|mi|na|ti|on [...*zion*] (Festbeleuchtung; Ausmalung); Il|lu|mi|na|tor (mittelalterl. Ausmaler von Büchern u. Hersteller von Buchmalereien) *m;* -s, ...oren; il|lu|mi|nie|ren (festlich erleuchten; bunt ausmalen); Il|lu|mi|nie|rung (Festbeleuchtung)

Il|lu|si|on *lat.* (auf Wünschen beruhende Einbildung, Wahn, Sinnestäuschung); il|lu|sio|när (Scheinwirkungen erzeugend); Il|lu|sio|nis|mus (Lehre, daß die Außenwelt nur Illusion sei) *m;* -; Il|lu|sio|nist (Schwärmer, Träumer; Zauberkünstler) ↑ R 268; il|lu|si|ons|los; il|lu|so|risch (nur in der Illusion bestehend; eingebildet, trügerisch); -ste (↑ R 294)

il|lu|ster *lat.* (glänzend, vornehm); ...u|stre Gesellschaft; Il|lu|stra|ti|on [...*zion*] (Erläuterung, Bildbeigabe, Bebilderung); il|lu|stra|tiv (erläuternd, anschaulich); Il|lu|stra|tor (Erläuterer [durch Bilder]; Künstler, der ein Buch mit Bildern schmückt) *m;* -s, ...oren; il|lu|strie|ren ([durch Bilder] erläutern; [ein Buch] mit Bildern schmücken; bebildern); il|lu|striert (Abk.: ill.); Il|lu|strier|te *w;* -n, -n; zwei - (auch: -n); ↑ R 291; Il|lu|strie|rung (Vorgang des Illustrierens)

Il|ly|ri|en [...*i^en*] (das heutige Dalmatien u. Albanien); Il|ly|rer, Il|ly|ri|er [...*i^r*] (Angehöriger idg. Stämme in Illyrien); il|ly|risch

Ilm (l. Nebenfluß der Saale; r. Nebenfluß der Donau) *w;* -; Ilm-Athen; ↑ R 212 (für: Weimar); ¹Il|men|au (Stadt am Nordostfuß des Thüringer Waldes); ²Il|men|au (l. Nebenfluß der unteren Elbe) *w;* -

Il|me|nit (ein Mineral) *m;* -s, -e
Ilo|na (w. Vorn.)
Il|se (w. Vorn.)

Il|tis (ein Raubtier; Pelz) *m;* Iltisses, Iltisse

im (in dem; Abk.: i. [bei Ortsnamen, z. B. Königshofen i. Grabfeld]); - Auftrag[e] (Abk.: i. A.¹ od. I. A.¹); - Grunde [genommen]; - Haus[e] (Abk.: i. H.).

Kleinschreibung folgender Wörter in Verbindung mit „im" (↑ R 133 u. R 134): - allgemeinen (Abk.: i. allg.), - besonderen, - einzelnen, - ganzen, - großen [und] ganzen, [nicht] geringsten, [nicht] - mindesten usw.; - argen liegen; - klaren, - reinen sein

I. M. = Ihre Majestät

Image *engl.* [*imidsch*] (vorgefaßtes, festumrissenes Vorstellungsbild von einer Einzelperson od. einer Gruppe; Persönlichkeits-, Charakterbild) *s;* -[s], -s ...*dschis*);

ima|gi|na|bel *lat.* (vorstellbar, erdenklich); ...a|ble Vorgänge; ima|gi|när (nur in der Vorstellung bestehend; scheinbar); -e Zahl (Math.; Zeichen: i); Ima|gi|na|ti|on [...*zion*] (dicht.) Einbildung[skraft]); ima|gi|nie|ren ([sich] vorstellen, einbilden); Ima|go (Biol.: fertig ausgebildetes, geschlechtsreifes Insekt) *w;* -, ...gines

im all|ge|mei|nen (Abk.: i. allg.; ↑ R 134)

Imam *arab.* (Vorbeter in der Moschee; Titel für Gelehrte des Islams; Prophet u. religiöses Oberhaupt der Schiiten; Titel der Herrscher des Jemens) *m;* -s, -s u. -e

Iman *arab.* (im Islam: Glaube) *s;* -s

im Auf|trag, im Auf|tra|ge (Abk.: i. A.¹ od. I. A.¹)

im Be|griff, im Be|griff|fe; - sein

im be|son|de|ren (↑ R 134)

im|be|zil, im|be|zill *lat.* (Med.: mittelgradig schwachsinnig); Im|be|zil|li|tät (Med.) *w;* -

Im|bi|bi|ti|on *lat.* [...*zion*] (Quellung von Pflanzenteilen; Geol.: Durchtränken des Nebengesteins mit Gasen od. wäßrigen Lösungen beim Erstarren einer magmatischen Schmelze)

Im|biß *m;* Imbisses, Imbisse; Im|biß|hal|le, ...stand, ...stu|be

im Durch|schnitt (Abk.: i. Durchschn.)

im Fall od. Fal|le[,] daß (↑ R 63)

im Grun|de; - genommen

Imi|ta|ti|on *lat.* [...*zion*] ([minderwertige] Nachahmung); Imi|ta|tor (Nachahmer) *m;* -s, ...oren; imi|tie|ren; imi|tiert (nachgeahmt, künstlich, unecht)

im Jah|re (Abk.: i. J.)

Im|ker (Bienenzüchter) *m;* -s, -; Im|ke|rei (Bienenzucht; Bienenzücherei); im|kern; ich ...ere (↑ R 327)

Im|ma (w. Vorn.)

im|ma|nent *lat.* (innewohnend, in etwas enthalten); Im|ma|nenz (Innewohnen, Anhaften) *w;* -

Im|ma|nu|el vgl. Emanuel

im|ma|te|ri|ell *fr.* [auch: *im*...] (unkörperlich; unstofflich; geistig)

Im|ma|tri|ku|la|ti|on *lat.* [...*zion*] (Einschreibung in die Liste der Studierenden Aufnahme an einer Hochschule; schweiz. auch: amtliche Zulassung eines Kraftfahrzeugs; im|ma|tri|ku|lie|ren

Im|me (landsch., dicht. für: Biene) *w;* -, -n

im|me|di|at *lat.* (unmittelbar [dem Staatsoberhaupt unterstehend, vortragend usw.]); Im|me|di|at|ge|such (unmittelbar an die höchste Behörde gerichtetes Gesuch); im|me|dia|ti|sie|ren (veralt. für: reichsunmittelbar machen)

im|mens *lat.* (unermeßlich [groß]); -er Reichtum; Im|men|si|tät (veralt. für: Unermeßlichkeit) *w;* -

Im|men|stock (Mehrz. ...stöcke)

Im|men|su|ra|bel (unmeßbar); Im|men|su|ra|bi|li|tät

im|mer; - wieder; - mehr; noch -; für -; im|mer|dar; im|mer|fort; im|mer|gern; -e Blätter, aber: im|mer grün bleiben; Im|mer|grün (eine Pflanze) *s;* -s, -e; im|mer|hin

Im|mer|si|on *lat.* (Ein-, Untertauchen; Überflutung; Med.: Dauerbad; Astron.: Eintritt eines Himmelskörpers in den Schatten eines anderen)

im|mer|wäh|rend; -er Kalender; im|mer|zu (fortwährend)

Im|mi|grant (Einwanderer) *m;* -en, -en (↑ R 268); Im|mi|gra|ti|on [...*zion*]; im|mi|grie|ren

im|mi|nent *lat.* (Med.: bevorstehend, drohend [z. B. von Fehlgeburten])

Im|mis|si|on *lat.* (Rechtsw.: Einwirkung auf ein Grundstück von einem Nachbargrundstück aus)

im|mo|bil *lat.* [auch: ...*il*] (unbeweglich; Militär: nicht für den Krieg bestimmt od. ausgerüstet); Im|mo|bi|li|ar|kre|dit *lat.; it.* (durch Grundbesitz gesicherter Kredit), ...ver|si|che|rung (Versicherung von Gebäuden gegen Feuerschäden); Im|mo|bi|li|en *lat.* [...*i^en*] (Grundstücke, Grundbesitz) *Mehrz.;* Im|mo|bi|li|en|händ|ler; Im|mo|bi|lis|mus *m;* -, Im|mo|bi|li|tät (Unbeweglichkeit) *w;* -

Im|mo|ra|lis|mus *lat.* ([überlieferte] moral. Grundsätze ablehnende Weltanschauung) *m;* -; Im|mo|ra|li|tät [auch: *im*...] (Gleichgültigkeit gegenüber moral. Grundsätzen) *w;* -

¹ Vgl. S. 345, Sp. 1, Anm. 1.

Im|mor|ta|li|tät *lat.* [auch: *im...*] (Unsterblichkeit) *w*; -; Im|mor|tel|le *fr.* (Sommerblume mit strohtrockenen, gefüllten Blüten) *w*; -, -n

im|mun *lat.* (unempfänglich [für Krankheit], gefeit; unter Rechtsschutz stehend; unempfindlich); im|mu|ni|sie|ren (unempfänglich machen [für Krankheit], feien); Im|mu|ni|sie|rung; Im|mu|ni|tät (Unempfindlichkeit gegenüber Krankheitserregern; Persönlichkeitsschutz der Abgeordneten in der Öffentlichkeit) *w*; -; Im|mu|ni|täts|for|schung

im nach|hin|ein bes. österr. (nachträglich, hinterher)

Imp bayr., österr. mdal. (Biene) *m*; -s, -; vgl. Imme

imp. = imprimatur

Imp. = Imperator

Im|pa|sto *it.* (dickes Auftragen von Farben) *s*; -s, -s u. ...sti

Im|pe|danz *lat.* (elektr. Scheinwiderstand) *w*; -, -en

im|pe|ra|tiv *lat.* (befehlend, zwingend); -es Mandat (Mandat, das den Abgeordneten an den Auftrag seiner Wähler bindet); Im|pe|ra|tiv [auch: ...*tif*] (Sprachw.: Befehlsform, z. B. „lauf!, lauft!“; Pflichtgebot) *m*; -s, -e [...*wᵉ*]; im|pe|ra|ti|visch [...*wisch*, auch: *im...*] (befehlend; Befehls...); Im|pe|ra|tor (im alten Römerreich: Oberfeldherr; später für: Kaiser; Abk.: Imp.) *m*; -s, ...oren; im|pe|ra|to|risch; Im|pe|ra|tor Rex (Kaiser [und] König; Abk.: I. R.)

Im|per|fekt *lat.* [auch: ...*fäkt*] („unvollendet“; Sprachw.: erste Vergangenheit) *s*; -s, -e

im|pe|ri|al *lat.* (das Imperium betreffend; kaiserlich); Im|pe|ria|lis|mus (Ausdehnungs-, Machterweiterungsdrang der Großmächte) *m*; -; Im|pe|ria|list (↑ R 268); im|pe|ria|li|stisch; -ste (↑ R 294); Im|pe|ri|um (Oberbefehl im alten Rom; röm.] Kaiserreich; Weltreich) *s*; -s, ...ien [...*iᵉn*]

im|per|mea|bel *lat.* [auch: *im...*] (undurchlässig); ...a|ble Schicht

Im|per|so|na|le *lat.* (Sprachw.: unpersönliches Zeitwort, ein Zeitwort, das mit unpersönlichem „es“ konstruiert wird, z. B. „es schneit“) *s*; -s, ...lien [...*iᵉn*] u. (älter:) ...lia

im|per|ti|nent *lat.* (ungehörig, frech, unausstehlich); Im|per|ti|nenz *w*; -, -en

im|per|zep|ti|bel *lat.* [auch: *im...*] (nicht wahrnehmbar; unbemerkbar); ...i|ble Geräusche

Im|pe|ti|go *lat.* (eine Hautkrankheit) *w*; -

im|pe|tuo|so *it.* (Musik: stür-

misch); Im|pe|tuo|so *s*; -s, -s u. ...si; Im|pe|tus *lat.* (Ungestüm, Antrieb, Drang) *m*; -

Impf.-ak|ti|on, ...arzt; imp|fen; Impf|ling; Impf.-pflicht, ...pi|sto|le, ...schein, ...stoff; Imp|fung; Impf|zwang *m*; -[e]s

Im|plan|ta|ti|on *lat.* [...*zion*] (Med.: Einpflanzung; Einheilen von operativ übertragenen Gewebeteilen); im|plan|tie|ren

Im|pli|ka|ti|on [...*zion*] (Subst. zu: implizieren); im|pli|zie|ren *lat.* (mit hineinziehen, mit einbegreifen); im|pli|zit (inbegriffen, eingeschlossen, mitgemeint; Ggs.: explizit); im|pli|zi|te (mit inbegriffen, einschließlich); etwas - (zugleich mit) sagen

im|plo|die|ren *lat.* (von [luftleeren] Gefäßen: durch äußeren Überdruck eingedrückt werden); Im|plo|si|on

im|pon|de|ra|bel *lat.* (veralt. für: unwägbar); ...a|ble Stoffe; Im|pon|de|ra|bi|li|en [...*iᵉn*] (Unwägbarkeiten, Gefühls- u. Stimmungswerte) *Mehrz.*; Im|pon|de|ra|bi|li|tät (Unwägbarkeit) *w*; -

im|po|nie|ren *lat.* (Achtung einflößen, [großen] Eindruck machen); im|po|nier|ge|ha|be[n] (Zool.: bei männl. Tieren vor der Paarung)

Im|port *engl.* (Einfuhr) *m*; -[e]s, -e; Im- u. Export (↑ R 145); Im|port|be|schrän|kung; Im|por|te (eingeführte Ware, bes. Zigarre) *w*; -, -n (meist *Mehrz.*); Im|por|teur *fr.* [...*tör*] ([Waren]einführer im Großhandel) *m*; -s, -e; Im|port.-ge|schäft, ...han|del (vgl. ¹Handel); im|por|tie|ren

im|por|tun *lat.* (selten für: ungeeignet; ungelegen)

im|po|sant *fr.* (eindrucksvoll; großartig)

im|po|tent *lat.* [auch: ...*tänt*] ([geschlechtlich] unvermögend); Im|po|tenz [auch: ...*tänz*] *w*; -, -en

impr. = imprimatur

Im|prä|gna|ti|on *lat.* [...*zion*] (Geol.: feine Verteilung von Erdöl od. Erz auf Spalten od. in Poren eines Gesteins; Med.: Eindringen des Spermiums in das reife Ei, Befruchtung); im|prä|gnie|ren (feste Stoffe mit Flüssigkeiten zum Schutz vor Wasser, Zerfall u. a. durchtränken; Im|prä|gnie|rung

im|prak|ti|ka|bel *lat.*; *gr.* [auch: *im...*] (unausführbar, unanwendbar); ...i|ble Anordnung

Im|pre|sa|rio *it.* ([Theater-, Konzert]unternehmer) *m*; -s, -s u. ...ri; Im|pres|sen (*Mehrz.* von: Impressum); Im|pres|si|on *lat.* (Ein-

druck; Empfindung; Sinneswahrnehmung; im|pres|sio|na|bel (für Eindrücke empfänglich; erregbar, reizbar); ...a|ble Naturen; Im|pres|sio|nis|mus (Kunst-u. Literaturstil der 2. Hälfte des 19. Jh.s) *m*; -; Im|pres|sio|nist (↑ R 268); im|pres|sio|ni|stisch; -ste (↑ R 294); Im|pres|sum (Erscheinungsvermerk; Angabe über Verleger, Drucker usw. in Druckschriften) *s*; -s, ...ssen; im|pri|ma|tur („es werde gedruckt“; Abk.: impr. u. imp.); Im|pri|ma|tur (Druckerlaubnis) *s*; -s; im|pri|mie|ren (das Imprimatur erteilen)

Im|promp|tu *fr.* [*ängprongtü*] (Phantasiekomposition aus dem Stegreif) *s*; -s, -s

Im|pro|vi|sa|ti|on *it.* [...*wisazion*] (Stegreifdichtung, -rede usw.; unvorbereitetes Handeln; Schnell...); Im|pro|vi|sa|ti|ons|ta|lent; Im|pro|vi|sa|tor (Stegreifdichter usw.) *m*; -s, ...oren; im|pro|vi|sie|ren (etwas aus dem Stegreif tun)

Im|puls *lat.* (Antrieb; Anregung; [An]stoß; Anreiz) *m*; -es, -e; im|pul|siv (von plötzl. Einfällen abhängig; lebhaft, rasch [handelnd]); Im|pul|si|vi|tät [...*wi...*] *w*; -

im Ru|he|stand, im Ru|he|stan|de (Abk.: i. R.)

Imst (österr. Stadt)

im|stan|de; - sein; vgl. Stand u. R 141

im üb|ri|gen (↑ R 134)

im vor|aus [auch: -*forauß*] (↑ R 134)

im vor|hin|ein bes. österr. (im voraus)

¹in (Abk.: i. [bei Ortsnamen, z. B. Weißenburg i. Bay.]); mit *Wemf.* u. *Wenf.*: ich gehe in dem (im) Garten auf u. ab. a b e r: ich gehe in den Garten; im (in dem); ins (in das); vgl. ins

²in *engl.* (innen, darin); - sein (dazugehören; zeitgemäß, modern sein)

in. = Inch

In = chem. Zeichen für: Indium

in ab|sen|tia *lat.* [...*zia*] (in Abwesenheit [des Angeklagten])

in ab|strac|to *lat.* (im allgemeinen betrachtet; ohne Berücksichtigung der besonderen Lage); vgl. abstrakt

in|ad|äquat *lat.* [auch: ...*at*] (nicht passend; nicht entsprechend); In|ad|äquat|heit *w*; -

in aeter|num *lat.* [- ä...] (auf ewig)

in|ak|ku|rat *lat.* [auch: ...*at*] (ungenau)

in|ak|tiv *lat.* [auch: ...*if*] (untätig; außer Dienst; beurlaubt; verabschiedet; Studentenspr.: zur Verbindung in freierem Verhältnis

stehend); in|ak|ti|vie|ren [...wir^en]
(in den Ruhestand usw. versetzen); In|ak|ti|vi|tät [auch: in...]
(Untätigkeit usw.) w; -
in|ak|zep|ta|bel lat. [auch: ...ab^l]
(unannehmbar); ...a|ble Bedingung
inan lat. (nichtig, leer, eitel)
In|an|griff|nah|me w; -
In|an|spruch|nah|me w; -
Ju|ai|ti|ku|liert lat. [auch: ...irt]
(ohne Gliederung, undeutlich
[ausgesprochen])
In|au|gen|schein|nah|me w; -
In|au|gu|ral|dis|ser|ta|ti|on lat.
[...zion] (wissenschaftl. Arbeit
zur Erlangung der Doktorwürde); In|au|gu|ra|ti|on [...zion]
([feierl.] Einsetzung [in ein akadem. Amt od. in eine akadem.
Würde]); in|au|gu|rie|ren (einsetzen; beginnen, einleiten)
in bar
In|be|griff (Gesamtheit; die unter
einen Begriff gefaßten Einzelheiten; Höchstes) m; -[e]s; in|be|griffen vgl. einbegriffen
In|be|sitz|nah|me w; -, -n
in be|treff vgl. Betreff
In|be|trieb_nah|me (w; -, -n). ...setzung
in be|zug; vgl. Bezug u. R 141
In|bild (für: Ideal)
In|brunst w; -; in|brün|stig
Inc. = incorporated engl.-amerik.
[inkọ^'p^e^re^'tid] (amerik. Bez. für:
eingetragen [von Vereinen])
Inch engl. [intsch] (angelsächs.
Längenmaß, Abk.: in.; Zeichen:
'') m; -, -es [...schis]; 4 -[es] (↑ R
322)
In|choa|tiv lat. [inkoatif, auch:
...tif] (Sprachw.: Zeitw., das den
Beginn eines Geschehens ausdrückt, z. B. „erwachen") s; -s,
-e [...w^e]
in|ci|pit lat. [...zi...] („es beginnt"
[am Anfang von Handschriften
u. Frühdrucken])
incl. vgl. inkl.
in con|cre|to lat. [- kon...] (in
Wirklichkeit; tatsächlich); vgl.
konkret
in con|tu|ma|ci|am lat. [- kontumaziam]; --verurteilen (gegen jmdn.
wegen Nichterscheinens vor Gericht ein Versäumnisurteil fällen)
in cor|po|re lat. [- kọ...] (Rechtsw.:
in Gesamtheit)
I.N.D. = in nomine Dei; in nomine Domini
Ind. = Indiana; Indikativ
Ind|an|thren Ⓦ (licht- u. waschechter Farbstoff) s; -s, -e; ind|an-
thren_far|ben, ...far|big; Ind|an-
thren|farb|stoff
In|de|fi|nit|pro|no|men lat.
(Sprachw.: unbestimmtes Fürwort, z. B. „jemand")

in|de|kli|na|bel lat. [auch: in...]
(Sprachw.: nicht beugbar); ...a-
bles Wort
in|de|li|kat fr. [auch: ...at] (unzart;
unfein)
in|dem; er diktierte den Brief, indem (während) er im Zimmer
umherging; aber: er diktierte
den Brief, in dem (in welchem) ...
in|dem|ni|sie|ren lat. (veralt. für:
entschädigen, vergüten; Indemnität erteilen); In|dem|ni|tät
(nachträgliche Billigung eines zuvor vom Parlament [als verfassungswidrig] abgelehnten Regierungsaktes; Straflosigkeit für
Abgeordnete) w; -
In-den-April-Schicken [Trenn.:
...Schik|ken] (↑ R 156) s; -s
In-den-Tag-hin|ein-Le|ben (↑ R
156) s; -s
In|dent|ge|schäft engl.; dt. (besondere Art des Exportgeschäftes)
In-den-Wind-Schla|gen (↑ R 156) s;
-s
In|de|pen|dence Day engl.-amerik.
[indipäns de^'] (nordamerik.
Unabhängigkeitstag [4. Juli]); In-
de|pen|den|ten engl. (Anhänger
einer engl. puritan. Richtung des
17. Jh.s) Mehrz.; In|de|pen|denz
lat. (veralt. für: Unabhängigkeit)
w; -
In|der (Bewohner Indiens) m; -s. -
in der An|nah|me, Er|war|tung,
Hoff|nung, daß (↑ R 61)
in|des, in|des|sen
in|de|ter|mi|na|bel lat. [auch: in...]
(unbestimmbar); ...a|bler Begriff; In|de|ter|mi|na|ti|on [...zion,
auch: in...] (Unbestimmtheit;
veralt. für: Unentschlossenheit)
w; -; in|de|ter|mi|niert (unbestimmt, nicht festgelegt, nicht abgegrenzt, frei); In|de|ter|mi|nis-
mus (Lehre von der Willensfreiheit) m; -
In|dex lat. (alphabet. Namen-,
Sachverzeichnis; Liste verbotener Bücher; statistische Meßziffer) m; -[es], -e u. ...dizes [...zäß];
das Buch steht auf dem -; In|dex-
_wäh|rung (Wirtsch.), ...zif|fer
in|de|zent lat. (unschicklich); In-
de|zenz (veralt. für: Unschicklichkeit) w; -, -en
In|di|an bes. österr. (Truthahn) m;
-s, -e
In|dia|na (Staat in den USA; Abk.:
Ind.); In|dia|ner (Angehöriger
der Urbevölkerung Amerikas
[außer den Eskimos]) m; -s, -; vgl.
auch: Indio; In|dia|ner_buch,
...ge|schich|te, ...krap|fen (österr.
für: Mohrenkopf), ...re|ser|va|ti-
on, ...stamm; in|dia|nisch; In|dia-
nist (selten für: Erforscher der Indianersprachen und -kulturen)
↑ R 268; In|dia|ni|stik w; -

In-die-Hän|de-Klat|schen (↑ R 156)
s; -s
In|di|en [...i^e^n] (Vorder- u. Hinterindien; im engeren Sinne: Republik Indien); vgl. auch: Bharat
In|dienst|stel|lung
in|dif|fe|rent lat. [auch: ...änt] (unbestimmt, gleichgültig, teilnahmslos; wirkungslos); In|dif-
fe|ren|tis|mus (Gleichgültigkeit
[gegenüber bestimmten Dingen,
Meinungen, Lehren]) m; -; In|dif-
fe|renz [auch: ...änz] (Unbestimmtheit, Gleichgültigkeit;
Wirkungslosigkeit) w; -, -en
in|di|gen lat. (veralt. für: eingeboren, einheimisch); In|di|ge|nat
(veralt. für: Staatsangehörigkeit,
Bürger-, Heimatrecht) s; -[e]s, -e
In|di|ge|sti|on lat. [auch: in...]
(Med.: Verdauungsstörung)
In|di|gna|ti|on lat. [...zion] (veralt.
für: Unwille, Entrüstung) w; -;
in|di|gnie|ren (veralt. für: Unwillen, Entrüstung erregen); in|di-
gniert (peinlich berührt, unwillig,
entrüstet); In|di|gni|tät
(Rechtsw.: Erbunwürdigkeit;
veralt. für: Unwürdigkeit) w; -
In|di|go span. (ein blauer Farbstoff) m od. s; -s, (für Indigoarten
Mehrz.:) -s; in|di|go|blau; In|di-
go|blau; In|di|go|lith (ein Mineral) m; -s u. -en, -e[n] (↑ R 268;
In|di|go|tin nlat. (Indigo) s; -s
In|di|ka|ti|on lat. [...zion] (Merkmal; Med.: Heilanzeige); In|di-
ka|tiv [auch: ...tif] (Sprachw.:
Wirklichkeitsform; Abk.: Ind.)
m; -s, -e [...w^e]; in|di|ka|ti|visch
[auch: ...iwisch] (die Wirklichkeitsform betreffend); In|di|ka-
tor (Gerät zum Aufzeichnen des
theoret. Arbeitsverbrauches einer Maschine; Stoff, der durch
Farbwechsel das Ende einer
chem. Reaktion anzeigt; Merkmal, das etwas anzeigt) m; -s,
...oren; In|di|ka|tor|dia|gramm
(Leistungsbild [einer Maschine]);
In|di|ka|trix (math. Hilfsmittel)
w; -
In|dio span. (süd- u. mittelamerik.
Indianer) m; -s, -s
in|di|rekt lat. [auch: ...äkt] (mittelbar; auf Umwegen; abhängig;
nicht geradezu); -e Wahl; -e Rede
(Sprachw.: abhängige Rede); -er
Fragesatz (abhängiger Fragesatz); In|di|rekt|heit
in|disch; -e Musik, aber (↑ R 198):
der Indische Ozean; In|disch|rot
(Anstrichfarbe)
in|dis|kret fr. [auch: ...kret] (nicht
verschwiegen; taktlos; zudringlich); In|dis|kre|ti|on [...zion,
auch: in...] (Vertrauensbruch;
Taktlosigkeit)

in|dis|ku|ta|bel *fr.* [auch: ...*ɡbᵉl*] (nicht der Erörterung wert); ...a|ble Forderung
in|dis|po|ni|bel *lat.* [auch: ...*ib𝘦l*] (nicht verfügbar; festgelegt); ...i|ble Menge; in|dis|po|niert [auch: ...*irt*] (unpäßlich; nicht zu etwas aufgelegt); In|dis|po|si|ti|on [auch: ...*ziọn*] (Unpäßlichkeit)
in|dis|pu|ta|bel *lat.* [auch: ...*ɡbᵉl*] (veralt. für: unbestreitbar); ...a|ble Sache
In|dis|zi|plin *lat.* [auch: ...*in*] (selten für: Mangel an Ordnung, Zucht) *w;* -; in|dis|zi|pli|niert [auch: ...*irt*]
In|di|um (chem. Grundstoff, Metall; Zeichen: In) *s;* -s
in|di|vi|dua|li|sie|ren *fr.* [...*wi...*] (die Individualität bestimmen; das Besondere, Eigentümliche hervorheben); In|di|vi|dua|li|sie|rung; In|di|vi|dua|lis|mus *lat.* ([betonte] Zurückhaltung eines Menschen gegenüber der Gemeinschaft) *m;* -; In|di|vi|dua|list († R 268); in|di|vi|dua|li|stisch (nur das Individuum berücksichtigend; das Besondere, Eigentümliche betonend); -ste († R 294); In|di|vi|dua|li|tät *fr.* (Einzigartigkeit der Persönlichkeit; Eigenart) *w;* -, (für Persönlichkeiten *Mehrz.:*) -en; In|di|vi|du|al|psy|cho|lo|gie, ...recht (Persönlichkeitsrecht), ...sphä|re; In|di|vi|dua|ti|on *lat.* [...*ziọn*] (Entwicklung der Einzelseele, Vereinzelung); in|di|vi|du|ẹll *fr.* (dem Individuum eigentümlich; vereinzelt; besonders geartet); In|di|vi|du|um *lat.* [...*u-um*] (Einzelwesen, einzelne Person; verächtl. für: Kerl, Lump) *s;* -s, ...duen [...*u𝘦n*]
In|diz *lat.* (Anzeichen; Verdacht erregender Umstand) *s;* -es, -ien [...*i𝘦n*] (meist *Mehrz.*); In|di|zes (*Mehrz.* von: Index); In|di|zi|en [...*i𝘦n*] (*Mehrz.* von: Indiz); In|di|zi|en|be|weis (auf zwingenden mittelbaren Anzeichen und Umständen beruhender Beweis), ...ket|te, ...pro|zeß; in|di|zie|ren (auf den Index setzen; mit einem Index versehen; anzeigen; Med.: als angezeigt erscheinen lassen); in|di|ziert (angezeigt, ratsam; Med.: ein bestimmtes Heilverfahren nahelegend); In|di|zie|rung
In|do.chi|na (ehem. fr. Gebiet in Hinterindien), ...eu|ro|pä|er; in|do|eu|ro|pä|isch (Abk.: i.-e.); In|do|ger|ma|ne; in|do|ger|ma|nisch (Abk.: idg.); In|do|ger|ma|nist († R 268); In|do|ger|ma|ni|stik; in|do|ger|ma|ni|stisch
In|dok|tri|na|ti|on [...*ziọn*] ([ideologische] Durchdringung, Beeinflussung); in|dok|tri|nie|ren ([ideologisch] durchdringen, beeinflussen); In|dok|tri|nie|rung
In|dol (chem. Verbindung) *s;* -s
in|do|lent *lat.* [auch: ...*änt*] (unempfindlich; gleichgültig; träge); In|do|lenz [auch: ...*änz*] *w;* -, -en
In|do|lo|ge *gr.* (Erforscher der Sprachen u. Kulturen Indiens) *m;* -n, -n († R 268); In|do|lo|gie *w;* -; In|do|ne|si|en [...*i𝘦n*] (Inselstaat in Südostasien); In|do|ne|si|er [...*i𝘦r*]; in|do|ne|sisch
in|do|pa|zi|fisch (um den Indischen u. Pazifischen Ozean gelegen); der -e Raum
In|dos|sa|ment *it.* (Wechselübertragungsvermerk) *s;* -s, -e; In|dos|sant (Wechselüberschreiber) *m;* -en, -en († R 268); In|dos|sat *m;* -en, -en († R 268) u. In|dos|sa|tar (durch Indossament ausgewiesener Wechselgläubiger) *m;* -s, -e; in|dos|sie|ren (einen Wechsel durch Indossament übertragen); In|dos|sie|rung; In|dos|so (Übertragungsvermerk eines Wechsels) *s;* -s, -s u. ...dossi
In|dra (ind. Hauptgott der wedischen Zeit)
in du|bio *lat.* (im Zweifelsfalle); in du|bio pro reo ("im Zweifel für den Angeklagten"; ein alter Rechtsgrundsatz); In-dubio-pro-reo-Grundsatz († R 155)
In|duk|tanz *lat.* (Technik: rein induktiver Widerstand) *w;* -; In|duk|ti|on [...*ziọn*] (Herleitung von allgemeinen Regeln aus Einzelfällen; Technik: Erregung elektr. Ströme u. Spannungen durch bewegte Magnetfelder); In|duk|ti|ons.ap|pa|rat (svw. Induktor), ...be|weis (Logik), ...krank|heit (Med.), ...ofen (Technik), ...strom (durch Induktion erzeugter Strom); in|duk|tiv [auch: *in...*] (auf Induktion beruhend); In|duk|ti|vi|tät [...*wi...*] (Maßbez. für Selbstinduktion) *w;* -; In|duk|tor (Transformator zur Erzeugung hoher Spannung) *m;* -s, ...oren
in dul|ci ju|bi|lo *lat.* [- *dulzi* -] ("in süßem Jubel"; übertr. für: herrlich u. in Freuden)
in|dul|gent *lat.* (nachsichtig); In|dul|genz (Nachsicht; Straferlaß; Ablaß der zeitl. Sündenstrafen) *w;* -, -en
In|dult *lat.* (Nachsicht; Vergünstigung; Befreiung) *m* od. *s;* -[e]s, -e
In|du|ra|ti|on *lat.* [...*ziọn*] (Med.: Gewebe- od. Organverhärtung)
In|dus (Strom in Vorderindien) *m;* -
In|du|si (Kurzw. aus: induktive Zugsicherung; Zugsicherungseinrichtung) *w;* -

In|du|si|en|kalk *lat.; dt.* [...*i𝘦n...*] (Geol.); In|du|si|um *lat.* (Bot.: häutiger Auswuchs der Blattunterseite von Farnen) *s;* -s, ...ien [...*i𝘦n*]
in|du|stria|li|sie|ren *fr.* (Industrie auf- od. ausbauen); In|du|stria|li|sie|rung; In|du|stria|lis|mus (Prägung einer Volkswirtschaft durch die Industrie) *m;* -; In|du|strie *w;* -, ...ien; In|du|strie.an|la|ge, ...aus|stel|lung, ...be|trieb, ...er|zeug|nis († R 148), ...ge|biet, ...ge|werk|schaft (Abk.: IG), ...in|sti|tut, ...ka|pi|tän, ...kauf|mann, ...la|den (DDR), ...kom|bi|nat (DDR), ...land, ...land|schaft; in|du|stri|ẹll (die Industrie betreffend); die erste, zweite -e Revolution; In|du|stri|ẹl|le (Inhaber eines Industriebetriebes) *m;* -n, -n († R 287 ff.); In|du|strie.ma|gnat, ...ofen, ...pro|dukt, ...staat, ...stadt; In|du|strie- u. Han|dels|kam|mer (so die von den Richtlinien der Rechtschreibung [† R 155] abweichende übliche Schreibung; Abk.: IHK); In|du|strie.un|ter|neh|men, ...zweig
in|du|zie|ren *lat.* (Zeitwort zu: Induktion); induziertes Irresein (Med.)
in|ef|fek|tiv *lat.* [auch: ...*if*] (veralt. für: unwirksam)
in ef|fi|gie *lat.* [- ...*i-e*] ("im Bilde"; bildlich)
in|egal *fr.* [auch: ...*ɡl*] (selten für: ungleich)
in|ein|an|der; *Schreibung in Verbindung mit Zeitwörtern* († R 139): ineinander (in sich gegenseitig) aufgehen, die Fäden haben sich ineinander (sich gegenseitig) verschlungen, aber: die Linien sollen ineinanderfließen, die Teile ineinanderfügen, die Räder werden ineinandergreifen; vgl. aneinander; In|ein|an|der|grei|fen *s;* -s
in eins; in eins setzen (gleichsetzen); In|eins|set|zung
in|ert *lat.* (veralt. für: untätig, träge; unbeteiligt)
Ines (w. Vorn.)
in|es|sen|ti|ell *lat.* [auch: ...*ziẹl*] (nicht wesensgemäß, unwesentlich)
in|ex|akt *lat.* [auch: ...*ạkt*] (ungenau)
In|exi|stenz *lat.* [auch: ...*änz*] (Philos.: das Dasein, Enthaltensein in etwas) *w;* -
in|ex|plo|si|bel *lat.* [auch: ...*sib𝘦l*] (selten für: nicht explodierend) ...i|bles Gemisch
in ex|ten|so *lat.* (ausführlich vollständig)
in ex|tre|mis *lat.* (Med.: in der letzten Zügen [liegend])

in|fal|li|bel *lat.* (unfehlbar); ...i|bler Papst; In|fal|li|bi|li|tät (päpstliche Unfehlbarkeit) w; - in|fam *lat.* (ehrlos; niederträchtig, schändlich); In|fa|mie w; -, ...ien In|fant *span.* („Kind"; ehem. Titel span. u. port. Prinzen) m; -en, -en (↑ R 268); In|fan|te|rie *fr.* (Fußtruppe) w; -, ...ien; In|fan|te|rie|re|gi|ment (Abk.: IR.); In|fan|te|rist (Fußsoldat); ↑ R 268; in|fan|te|ri|stisch; in|fan|til *lat.* (kindlich; unentwickelt, unreif); In|fan|ti|lis|mus (Stehenbleiben auf kindlicher Entwicklungsstufe) m; ; In|fan|ti|list (↑ R 268); In|fan|ti|li|tät; In|fan|tin *span.* (ehem. Titel span. u. port. Prinzessinnen) w; -, -nen In|farkt *lat.* (Med.: Absterben eines Gewebeteils infolge Verschlusses von Arterien) m; -[e]s, -e In|fekt m; -[e]s, -e u. In|fek|ti|on *lat.* [...zion] (Ansteckung durch Krankheitserreger); In|fek|ti|ons..ge|fahr, ...herd, ...krank|heit; in|fek|ti|ös (ansteckend); -este In|fel vgl. Inful in|fe|ri|or *lat.* (untergeordnet; minderwertig); In|fe|rio|ri|tät (untergeordnete Stellung; Minderwertigkeit) w; - in|fer|nal (seltener für: infernalisch); in|fer|na|lisch *lat.* (höllisch; teuflisch); -ste (↑ R 294); In|fer|no *it.* („Hölle"; auch Name des ersten Teiles von Dantes „Göttlicher Komödie") s; -s in|fer|til *lat.* [auch: *in*...] (Med.: unfruchtbar) In|fil|tra|ti|on *lat.* [...zion] (Eindringen von Flüssigkeiten; Eindringen fremdartiger, bes. krankheitserregender Substanzen in Zellen u. Gewebe; [ideologische] Unterwanderung); In|fil|tra|ti|ons..an|äs|the|sie (Med.: Betäubung durch Einspritzungen), ...ver|such; in|fil|trie|ren (eindringen; durchtränken); In|fil|trie|rung w; - in|fi|nit *lat.* [auch: ...nit] (Sprachw.: unbestimmt); -e Form (Form des Zeitworts, die im Ggs. zur finiten Form [vgl. finit] nicht nach Person u. Zahl bestimmt ist, z. B. „erwachen" [vgl. Infinitiv], „erwachend" u. „erwacht" [vgl. Partizip]); in|fi|ni|te|si|mal (Math.: zum Grenzwert hin unendlich klein werdend); In|fi|ni|te|si|mal|rech|nung (Math.); In|fi|ni|tiv [auch: ...tif] (Sprachw.: Grundform [des Zeitwortes], z. B. „erwachen") m; -s, -e [...w⁴]; In|fi|ni|tiv|kon|junk|ti|on; In|fi|ni|tiv|satz (Grundformsatz)

In|fix *lat.* (in den Wortstamm eingefügtes Sprachelement) s; -es, -e in|fi|zie|ren *lat.* (anstecken; mit Krankheitserregern verunreinigen); In|fi|zie|rung in fla|gran|ti *lat.* (auf frischer Tat); - - ertappen; vgl. auch: flagrant in|flam|ma|bel *lat.* (entzündbar); ...a|ble Stoffe In|fla|ti|on *lat.* [...zion] (übermäßige Ausgabe von Zahlungsmitteln; Geldentwertung; übertr. auch: Überangebot); in|fla|tio|när, in|fla|tio|ni|stisch, in|fla|to|risch (die Inflation betreffend; Inflation bewirkend) in|fle|xi|bel *lat.* [auch: ...ib⁰l] (selten für: unbiegsam; unveränderlich; Sprachw.: nicht beugbar); ...i|ble Dinge; In|fle|xi|bi|le (unbeugbares Wort) s; -, ...bilia; In|fle|xi|bi|li|tät (selten für: Unbeugbarkeit) w; - In|flo|res|zenz *lat.* (Bot.: Blütenstand) w; -, -en In|flu|enz *lat.* (Beeinflussung eines elektr. ungeladenen Körpers durch die Annäherung eines geladenen) w; -, -en; In|flu|en|za *it.* (veralt. für: Grippe) w; -; In|flu|enz..elek|tri|zi|tät, ...ma|schi|ne (zur Erzeugung hoher elektr. Spannung) in|fol|ge (↑ R 141); mit *Wesf.* od. mit „von"; - des schlechten Wetters; - übermäßigen Alkoholgenusses; - von Krieg; in|fol|ge|des|sen In|for|mand *lat.* (eine Person, die informiert wird) m; -en, -en (↑ R 268); In|for|mant (eine Person, die informiert) m; -en, -en (↑ R 268); In|for|ma|tik (Wissenschaft von der Informationsverarbeitung, insbes. von den elektronischen Datenverarbeitungsanlagen) w; -; In|for|ma|ti|ker; In|for|ma|ti|on [...zion] (Belehrung; Auskunft; Nachricht); in|for|ma|ti|ons..aus|tausch, ...be|dürf|nis, ...bü|ro, ...ma|te|ri|al, ...quel|le, ...theo|rie (w; -), ...ver|ar|bei|tung; in|for|ma|tiv (belehrend; Auskunft gebend; aufschlußreich); In|for|ma|tor (der Unterrichtende, Mitteilende) m; -s, ...oren; in|for|ma|to|risch (der vorläufigen Unterrichtung dienend, einen Überblick verschaffend); in|for|mell [auch: ...mäl] (aufklärend, belehrend, mitteilend); -e Kunst (eine Richtung der modernen Malerei); in|for|mie|ren (belehren; Auskunft geben; benachrichtigen); sich - (sich unterrichten, Auskünfte, Erkundigungen einziehen); In|for|miert|heit w; -; In|for|mie|rung

in Fra|ge: - - kommen, stehen in|fra|rot, (auch:) ul|tra|rot (zum Bereich des Infrarots gehörend); In|fra|rot, (auch:) Ul|tra|rot (unsichtbare Wärmestrahlen, die im Spektrum zwischen dem roten Licht u. den kürzesten Radiowellen liegen); In|fra|rot..hei|zung, ...strah|ler (ein Elektrogerät); In|fra|schall (Schallwellengebiet unter 20 Hertz); In|fra|struk|tur (wirtschaftlich-organisatorischer Unterbau einer hochentwickelten Wirtschaft; Sammelbezeichnung für milit. Anlagen [Kasernen, Flugplätze usw.]); in|fra|struk|tu|rell In|ful *lat.* (altröm. weiße Stirnbinde; Bez. der Mitra u. der herabhängenden Bänder) w; -, -n; in|fu|liert (zum Tragen der Infut berechtigt) In|fus *lat.* (Infusum) s; -es, -e; In|fu|si|on (Eingießung; Med.: Einfließenlassen); In|fu|si|ons|tier|chen u. In|fu|so|ri|um (Aufgußtierchen) s; -s, ...ien [...i⁰n] (meist *Mehrz.*); In|fu|sum (Aufguß) s; -s, ...sa

Ing. = Ingenieur In|gang..hal|tung (w; -), ...set|zung (w; -) Ing|bert (m. Vorn.); In|ge (Kurzform für: Ingeborg); In|ge|borg (w. Vorn.); In|ge|lo|re (w. Vorn.); ↑ R 194 in ge|ne|re *lat.* [auch: - ge...] (im allgemeinen); in|ge|ne|riert (Med.: angeboren) In|ge|nieur *fr.* [*inseheniör*] (Abk.: Ing.) m; -s, -e; vgl. Ing. (grad.); In|ge|nieur..aka|de|mie, ...bau (*Mehrz.* ...bauten), ...be|ruf, ...bü|ro; In|ge|nieu|rin w; -, -nen; In|ge|nieur|schu|le (früher für: Ingenieurakademie); in|ge|ni|ös [...gen...] (sinnreich; erfinderisch; scharfsinnig); -este (↑ R 292); In|ge|nio|si|tät (Erfindungsgabe, Scharfsinn) w; -; In|ge|ni|um *lat.* (natürl. Begabung, schöpferische Geistesanlage, Erfindungskraft, Genie) s; -s, ...ien [...i⁰n] In|ger|man|land (hist. Landschaft am Finnischen Meerbusen) s; -[e]s In|ge|sin|de (veralt. für: die zum Hauswesen gehörende Dienerschaft) s; -s In|ge|sti|on *lat.* (Med.: Nahrungsaufnahme) w; - in|ge|züch|tet [zu: Inzucht] Ing. (grad.) = graduierter Ingenieur (Absolvent einer Ingenieurakademie mit staatl. Prüfung) in glo|bo *lat.* (selten für: insgesamt) In|go [*inggo*], In|go|mar (m. Vorn.)

In|got *engl.* (Metallblock, -barren) *m*; -s, -s

In|grain.far|be *engl.*; *dt.* [*inggre'n...*], ...pa|pier (Zeichenpapier von rauher Oberfläche mit farbigen od. schwarzen Wollfasern)

In|gre|di|ens *lat.* [...*diänß*] *s*; -, ...i̯enzien [...*i*ⁿ] (meist *Mehrz.*) u. In|gre|di|enz (Zutat; Bestandteil) *w*; -, -en (meist *Mehrz.*); In|greß (veralt. für: Eingang, Zutritt) *m*; Ingresses, Ingresse; Ingres|si|on (Geogr.: kleinräumige Meeresüberflutung des Festlandes)

Ing|rid [*inggrit*] (w. Vorn.)

In|grimm *m*; -[e]s; in|grim|mig

in gros|so *it.* (veralt. für: en gros, im großen)

Ing|wä|o̯|nen (Kultgemeinschaft westgerm. Stämme) *Mehrz.*; ing|wä|o̯|nisch

Ing|wer *sanskr.* (eine Gewürzpflanze) *m*; -s, (für Schnaps *Mehrz.*:) -; Ing|wer.bier, ...öl

In|ha|ber; In|ha|be|rin *w*; -, -nen; In|ha|ber|pa|pier

in|haf|tie|ren (in Haft nehmen); In|haf|tie|rung; In|haft|nah|me *w*; -, -n

In|ha|la|ti|on *lat.* [...*zion*] (Einatmung von Heilmitteln); In|ha|la|ti̯ons|ap|pa|rat; In|ha|la|to|ri|um (Raum zum Inhalieren) *s*; -s, ...ien [...*i*ⁿ]; in|ha|lie|ren ([zerstäubte] Heilmittel einatmen; ugs. für: [beim Zigarettenrauchen] den Rauch [in die Lunge] einziehen)

In|halt; in|halt|lich; In|halts|an|ga|be; in|halt[s].arm, ...los, ...reich, ...schwer; In|halts.über|sicht, ...ver|zeich|nis; in|halt[s]|voll

in|hä|rent *lat.* (anhaftend; innewohnend); In|hä|renz (Innewohnen) *w*; -; in|hä|rie|ren (an etwas hängen, anhaften)

in|hi|bie|ren *lat.* (veralt. für: Einhalt tun; verbieten, verhindern); In|hi|bi|ti|on [...*zion*] (veralt. für: Einhalt; Verbot)

in hoc sa̱|lus *lat.* [- ho̱k -] („in diesem [ist] Heil"; Abk.: I. H. S.)

in hoc si̱|gno *lat.* [- ho̱k -] („in diesem Zeichen"; Abk.: I. H. S.)

in|ho|mo|gen *lat.*; *gr.* [auch: ...*gen*] (ungleichstoffig, ungleich geartet); In|ho|mo|ge|ni|tät [auch: i̱n...] *w*; -

in ho|no̱|rem *lat.* (zu Ehren)

in|hu|man *lat.* [auch: ...*an*] (unmenschlich; rücksichtslos); In|hu|ma|ni|tät [auch: i̱n...]

in in|fi̱|ni|tum vgl. ad infinitum

in in|te|grum *lat.*; - - restituieren (in den vorigen [Rechts]stand wiedereinsetzen, den früheren Rechtszustand wiederherstellen)

In|iti̱|al *lat. s*; -s, -e u. (häufiger:) In|itia|le (österr. nur so) [*inizial*⁽ᵉ⁾] (großer [meist durch Verzierung u. Farbe ausgezeichneter] Anfangsbuchstabe) *w*; -, -n; In|iti̱|al.buch|sta|be, ...sprengstoff (explosiver Zündstoff für Sprengstoffüllung), ...wort (Sprachw.), ...zel|len (Bot.; *Mehrz.*), ...zün|dung (Explosion mit Initialsprengstoff); In|iti|and (Einzuweihender; Anwärter auf eine Initiation) *m*; -en, -en (↑ R 268); In|iti|ant (jemand, der die Initiative ergreift) *m*; -en, -en (↑ R 268); In|iti|an|tin *w*; -, -nen; In|itia|ti|on [...*zion*] (Aufnahme, Einführung, Einweihung); in|itia|tiv (die Initiative ergreifend; rührig); - werden; In|itia|ti̱v|an|trag (die parlamentarische Diskussion eines Problems einleitender Antrag); In|itia|ti̱ve *fr.* [...*w*ᵉ] (erste tätige Anregung zu einer Handlung; auch das Recht dazu; Entschlußkraft, Unternehmungsgeist; schweiz. auch für: Volksbegehren [auch *Mehrz.*: -n]) *w*; -; die - ergreifen; In|itia|ti̱v|recht (Recht, Gesetzentwürfe einzubringen); In|itia|tor *lat.* (Urheber; Anreger; Anstifter) *m*; -s, ...oren; In|itia|to̱|rin *w*; -, -nen; In|iti̱|en [...*i*ⁿ] (Anfänge; Anfangsgründe) *Mehrz.*; in|iti|ieren (den Anstoß geben; [in ein Amt] einführen; einweihen)

In|jek|ti̱|on *lat.* [...*zion*] (Med.: Einspritzung; Geol.: Eindringen von Magma in Spalten des Nebengesteins; Bauw.: Bodenverfestigung durch das Einspritzen von Zement); In|jek|ti̱ons|sprit|ze; In|jek|tor (Preßluftzubringer in Saugpumpen; Einspritzpumpe als Speisewasserzubringer für Dampfkessel) *m*; -s, ...oren; inji|zie|ren (einspritzen)

In|ju̱|rie *lat.* [...*i*ᵉ] (Unrecht, Beleidigung) *w*; -, -n; in|ju|ri|ieren (veralt. für: beleidigen)

In|ka (Angehöriger der ehem. indian. Herrscher- u. Adelsschicht in Peru) *m*; -[s], -[s]; In|ka.bein od. ...kno|chen (ein Schädelknochen); in|ka|isch

In|kar|di|na|ti̱|on *lat.* [...*zion*] (Zuteilung eines kath. Geistlichen an eine bestimmte Diözese; Aufnahme in eine andere Diözese nach erfolgter Exkardination)

in|kar|nat *lat.* (fleischfarben, fleischrot); In|kar|nat (Fleischton [auf Gemälden]) *s*; -[e]s; In|kar|na|ti̱|on [...*zion*] („Fleischwerdung" [Christi]; Verkörperung) *w*; -, (für Verkörperung *Mehrz.*:) -en; In|kar|nat|rot *s*; -[e]s; in|kar|nie|ren (verkörpern);

sich -; in|kar|niert (fleischgeworden)

In|kas|sant *it.* österr. (jmd., der Geld kassiert) *m*; -en, -en (↑ R 268); In|kas|san|tin *w*; -, -nen; In|kas|so (Einziehung von Geldforderungen) *s*; -s, -s (auch u. österr. nur: ...kassi); In|kas|so.bü|ro, ...voll|macht

In|kauf|nah|me *w*; -

inkl. = inklusive

In|kli|na|ti̱|on *lat.* [...*zion*] (Physik: Neigung einer frei aufgehängten Magnetnadel zur Waagrechten; Math.: Neigung zweier Ebenen od. einer Linie u. einer Ebene gegeneinander; veralt. für: Zuneigung); in|kli|nie|ren (veralt. für: Neigung, Vorliebe für etwas haben)

in|klu|si̱|ve *lat.* [...*w*ᵉ] (einschließlich, inbegriffen; Abk.: inkl.); *Verhältnisw.* mit *Wesf.*: - des Verpackungsmaterials; tritt ein alleinstehendes, stark gebeugtes Hauptw. steht in der *Einz.* ungebeugt: - Porto; mit *Wemf.*, wenn der *Wesf.* nicht erkennbar ist: - Getränken

in|ko̱|gni|to *it.* („unerkannt"; unter fremdem Namen); - reisen; In|ko̱|gni|to *s*; -s, -s

in|ko|hä|rent *lat.* (unzusammenhängend); In|ko|hä|renz *w*; -, -en

In|koh|lung (Geol.: Umwandlung von Pflanzen in Kohle unter Luftabschluß)

in|kom|men|su|ra|bel *lat.* (nicht meßbar; nicht vergleichbar); ...a|ble Größen (Math.)

in|kom|mo|die|ren *lat.* (veralt. für belästigen; bemühen); sich - (sich Mühe machen)

in|kom|pa|ra|bel *lat.* (veralt. für unvergleichbar; nicht steigerungsfähig; ...a|ble Verhältnisse

in|kom|pa|ti|bel *lat.* (unverträglich; unvereinbar); ...i|ble Vorschläge; In|kom|pa|ti|bi|li|tät

in|kom|pe|tent *lat.* [auch: ...*än*] (nicht zuständig, nicht befugt) In|kom|pe|tenz [auch: ...*änz*] *w*; -, -en

in|kom|plett *fr.* [auch: ...*ät*] (unvollständig)

in|kom|pres|si̱|bel *lat.* (Physik nicht zusammenpreßbar); ...i|ble Körper; In|kom|pres|si|bi|li|tät *w*; -

in|kon|gru|ent *lat.* [auch ...*än*] (Math.: nicht übereinstimmend; sich nicht deckend); In|kon|gru̱|enz [auch: ...*änz*] *w*; -, -en

in|kon|se|quent *lat.* [auch: ...*än*] (folgewidrig; widersprüchlich wankelmütig; unbeständig); In|kon|se|quenz [auch: ...*änz*] *w*; -en

in|kon|si̱|stent *lat.* [auch: ...*än*]

(unbeständig; unhaltbar); In|kon|si|stenz [auch: ...ä̲nz] w; -, - in|kon|stant lat. [auch: ...a̲nt] (nicht feststehend; unbeständig) In|kon|ti|nenz lat. [auch: ...ä̲nz] (Med.: Unvermögen. [Harn, Stuhl] zurückzuhalten) w; -, -en in|kon|ver|ti|bel lat. (veralt. für: unbekehrbar, unwandelbar; Wirtsch.: nicht austauschbar [von Währungen]); ...i|ble Währungen

in|kor|po|ral lat. (Med.: im Körper [befindlich]); In|kor|po|ra|ti|on [...zi̲o̲n] (Einverleibung; Aufnahme; Angliederung); in|kor|po|rie̲ren, In|kor|po|rie̲rung

in|kor|rekt lat. [auch: ...ä̲kt] (unrichtig; fehlerhaft [im Benehmen]; unzulässig; In|kor|rekt|heit [auch: ...ä̲kt...]

in Kraft; vgl. Kraft; In|kraft|set|zung; In|kraft|tre|ten (eines Gesetzes) s; -s; ↑ R 120 u ↑ R 156 u. Kraft w

In|kreis (einer Figur einbeschriebener Kreis)

In|kre|ment lat. (veralt. für: Zuwachs; Math.: Zunahme einer Größe) s; -[e]s, -e

In|kret (von den Blutdrüsen in den Körper abgegebener Stoff, Hormon) s; -[e]s, -e; In|kre|ti|on [...zi̲o̲n] (innere Sekretion) w; -; in|kre|to̲risch (Med.: auf die innere Sekretion bezüglich, ihr dienend)

in|kri|mi|nie̲ren lat. (beschuldigen; unter Anklage stellen)

In|kru|sta|ti|on lat. [...zi̲o̲n] (farbige Verzierung von Flächen durch Einlagen; bes. Geol.: Krustenbildung durch chem. Ausscheidung); in|kru|stie̲ren

In|ku|ba|ti|on lat. [...zi̲o̲n] (Tempelschlaf in der Antike; Zool.: Bebrütung von Vogeleiern; Med.: das Sichfestsetzen von Krankheitserregern im Körper); In|ku|ba|ti|ons|zeit (Zeit der Infektion bis zum Ausbruch einer Krankheit); In|ku|ba|tor (Brutkasten [für Frühgeburten] m; -s, ...o̲ren; In|ku|bus (Alpdruck; Buhlteufel des mittelalterl. Hexenglaubens) m; -, Inku̲ben; vgl. Sukkubus

in|ku|lant lat. [auch: ...a̲nt] (geschäftlich] ungefällig); In|ku|lanz [auch: ...a̲nz] w; -, -en

In|kul|pant lat. (veralt. für: Ankläger) m; -en, -en (↑ R 268); In|kul|pat (veralt. für: Angeschuldigter) m; -en, -en (↑ R 268)

In|ku|na|bel lat. (Wiegen-, Frühdruck, Druck aus der Zeit vor 1500) w; -, -n (meist Mehrz.)

in|ku|ra|bel lat. [auch: in...] (Med.: unheilbar); ...a|ble Krankheit

In|kur|va|ti|on lat. [...wazi̲o̲n] (veralt. für: Krümmung; Einbiegung)

In|laid engl. [i̲nlait] schweiz. (durchgemustertes Linoleum) m; -s, -e

In|land s; -[e]s; In|land|eis; In|län|der m; In|län|de|rin w; -, -nen; in|län|disch; In|lands.markt. ...nach|fra|ge. ...preis. ...rei|se

In|laut; in|lau|tend

In|lett (Baumwollstoff [für Federbetten u -kissen]) s; -[e]s. -e

in|lie|gend vgl. einliegend; In|lie|gen|de s; -n (↑ R 287 ff.)

in maio̲|rem Dei glo̲|ri̲|am vgl. ad...

in me̲|di|as re̲s lat. (...mitten in die Dinge hinein"; [unmittelbar] zur Sache)

in me|mo̲|ri̲|am lat. (...zum Gedächtnis". zum Andenken)

im|mit|ten (geh.) ↑ R 141; Verhältnisw. mit Wesf.: - des Sees

Inn (r. Nebenfluß der Donau) m; -[s]

in na̲|tu̲|ra lat. (...in Natur"; leibhaftig)

in|ne; mitteninne (vgl. d.); in|ne|ha|ben; seit er dieses Amt innehat; er hat dieses Amt innegehabt; in|ne|hal|ten; er hat den rechten Weg innegehalten

in|nen; von, nach -; - und außen; In|nen.an|ten|ne. ...ar|bei|ten (Mehrz.). ...ar|chi|tekt. ...ar|chi|tek|tur. ...auf|nah|me. ...aus|statt|tung. ...dienst. ...ein|rich|tung. ...flä|che. ...hof. ...kur|ve. ...le|ben. ...mi|ni|ster. ...mi|ni|ste|ri|um. ...po|li|tik; in|nen|po|li|tisch. in|ner|po|li|tisch; In|nen.raum. ...sei|te. ...stadt. ...ta|sche. ...tem|pe|ra|tur. ...welt

In|ner.asi|en [...i̲*n]; in|ner.be|trieb|lich. ...deutsch. ...dienst|lich; in|ne|re; innerste; zuinnerst; die -e Medizin; e Angelegenheiten eines Staates; -e Führung (Bez. für geistige Rüstung u. zeitgemäße Menschenführung in der dt. Bundeswehr), aber (↑ R 224): die Innere Mission; (↑ R 198:) die Innere Mongolei; In|ne|re s; ...r[e]n; das Ministerium des Innern; im Inner[e]n (↑ R 287 ff.); In|ne|rei (eßbares Tiereingeweide) w; -, -en (meist Mehrz.); In|ner|halb; Verhältnisw. mit Wesf.: - eines Jahres, zweier Jahre; mit Wemf., wenn der Wesf. nicht erkennbar ist: - vier Jahren, vier Tagen; in|ner|lich; In|ner|lich|keit w; -; in|ner|orts bes. schweiz. (innerhalb des Ortes); in|ner|par|tei|lich. in|ner|po|li|tisch, in|nen|po|li|tisch; in|ner_se|kre|to̲risch. ...staat|lich; In|ner|stadt (schweiz. häufiger als: Innenstadt); In|ner|ste s;

-n (↑ R 287 ff.); im -n; bis ins -; in|nert schweiz. u. westösterr. (innerhalb, binnen); - eines Jahres od. - einem Jahre; - drei Tagen

In|ner|va|ti̲on lat. [...wazi̲o̲n] (Med.: Versorgung der Körperteile mit Nerven; Reizübertragung durch Nerven) w; -; in|ner|vie̲ren (mit Nerven od. Nervenreizen versehen; selten auch übertr. für: anregen)

in|ne|se̲in; er ist dieses Erlebnisses innegewesen, aber: ehe er dessen inne ist, inne war; in|ne|wer|den; er ist sich seines schlechten Verhaltens innegeworden, aber: ehe er dessen inne wurde; in|ne|woh|nen; auch diesen alten Methoden hat Gutes innegewohnt; In|ne|woh|nen s; -s

in|nig; In|nig|keit w; -; in|nig|lich; in|nigst

in no̲|mi|ne lat. (...im Namen"; im Auftrage);-- Dei (...in Gottes Namen"; Abk.: I. N. D.); -- Domini (...im Namen des Herrn"; Abk.: I. N. D.)

In|no|va|ti̲on lat. [...zi̲o̲n, auch engl.: inowe̲'sch*n] (Erneuerung, Neuerung. Erfindung, Entdeckung; neue, fortschrittliche Lösung eines [technischen] Problems bei Produkten od. Verfahren) w; -, -en u. (bei engl. Aussprache:) -s; In|no|va|ti̲ons|sproß lat.; dt. [...wazi̲o̲nß...] (Erneuerungssproß der mehrjährigen Pflanzen)

In|no̲|zenz (m. Vorn.)

Inns|bruck (Hptst. Tirols)

in nu̲|ce lat. [- nu̲ze] (...in der Nuß"; im Kern; in Kürze, kurz und bündig)

In|nung; In|nungs_mei|ster. ...ver|samm|lung

Inn|vier|tel s; -s; ↑ R 201

in|of|fen|siv lat. [auch: ...i̲f] (nicht offensiv)

in|of|fi|zi|ell fr. [auch: ...ä̲l] (nichtamtlich; außerdienstlich; auch: vertraulich; in|of|fi|zi|ös [auch: ...ö̲ß] (nicht offiziös)

in|ope|ra̲|bel fr. [auch: ...ab*l] (nicht operierbar); ...a|ble Verletzung

in|op|por|tun lat. [auch: ...u̲n] (ungelegen, unangebracht); In|op|por|tu|ni|tät [auch: in...]

in op|ti|ma for|ma lat. (selten für: ...in bester Form"; einwandfrei)

Ino|sit gr. (Med.: Muskelzucker) m; -s; Inos|urie (Med.: Auftreten von Inosit im Harn) w; -

in par|ti|bus in|fi|de̲|li|um lat. (...im Gebiet der Ungläubigen"; Abk.: i. p. i.)

in per|pe̲|tu|um lat. [- ...u-um] (auf immer)

in per|so̲|na lat. (persönlich)

in pet|to *it.*; etwas - - (ugs. für: im Sinne, bereit) haben
In|pflicht|nah|me *w*; -, -n
in ple|no *lat.* (in voller Versammlung, vollzählig)
in pon|ti|fi|ca|li|bus *lat.* [- ...*kg*...] (scherzh. für: im Festgewand; [höchst] feierlich)
in pra|xi *lat.; gr.* (in der Ausübung; im wirklichen Leben; tatsächlich)
in punc|to *lat.* (hinsichtlich); - - puncti („im Punkte des Punktes"; hinsichtlich der Keuschheit)
Input *engl.* (Wirtsch.: von außen bezogene u. im Betrieb eingesetzte Produktionsmittel; EDV: in eine Datenverarbeitungsanlage eingegebene Daten) *s*; -s, -s
In|qui|lin *lat.* (veralt. für: Insasse; Biol.: Einmieter, Schmarotzer) *m*; -en, -en (meist *Mehrz.*); ↑ R 268
In|qui|rent *lat.* (veralt. für: Untersuchungsführer); ↑ R 268; in|qui|rie|ren (untersuchen, verhören); In|qui|sit (veralt. für: Angeklagter) *m*; -en, -en (↑ R 268); In|qui|si|ten|spi|tal österr. (Gefangenenkrankenhaus); In|qui|si|ti|on [...*zion*] (frühere.s kath. Ketzergericht; [strenge] Untersuchung); In|qui|si|ti|ons_ge|richt, ...me|tho|de, ...pro|zeß; In|qui|si|tor (Ketzerrichter; [strenger] Untersuchungsrichter) *m*; -s, ...oren; in|qui|si|to|risch
I. N. R. I. = Jesus Nazarenus Rex Judaeorum
ins; ↑ R 240 (in das), aber (↑ R 238): in 's (in des) Teufels Küche; eins - andre gerechnet
in sal|do *it.* (veralt. für: im Rest, im Rückstand); - - (schuldig) bleiben
in sal|vo *lat.* [- ...*wo*] (veralt. für: in Sicherheit)
In|sas|se *m*; -n, -n (↑ R 268); In|sas|sen|ver|si|che|rung; In|sas|sin *w*; -, -nen
ins|be|son|de|re, ins|be|sond|re (↑ R 19); insbesond[e]re[,] wenn (↑ R 63)
insch|al|lah *arab.* („so Allah will")
In|schrift; In|schrif|ten_kun|de (*w*; -), ...samm|lung; in|schrift|lich
In|sekt (Kerbtier) *s*; -[e]s, -en; In|sek|ta|ri|um (Anlage für Insektenaufzucht) *s*; -s, ...ien [...*i⁸n*]; In|sek|ten_be|kämp|fung, ...fraß; in|sek|ten|fres|send; Pflanzen; In|sek|ten_fres|ser, ...haus (Anlage zur Aufzucht u. zum Studium der Insekten; Insektarium), ...pla|ge, ...pul|ver, ...stich, ...ver|til|gungs|mit|tel *s*; In|sek|ti|vo|ren; [...*wo*...] (Insektenfresser; insektenfressende

Pflanzen) *Mehrz.*; In|sek|ti|zid (insektentötendes Mittel) *s*; -s, -e; In|sek|to|lo|ge *lat.; gr.* (selten für: Entomologe) *m*; -n, -n (↑ R 268)
In|sel *lat.* *w*; -, -n; In|sel_berg (Geogr.), ...be|woh|ner, ...grup|pe; in|sel|haft; In|sel_la|ge (*w*; -), ...land (*Mehrz.* ...länder)
In|sels|berg (im Thüringer Wald) *m*; -[e]s
in|sen|si|bel *lat.* [auch: *in*...] (unempfindlich; gefühllos); In|sen|si|bi|li|tät [auch: *in*...] *w*; -
In|se|pa|ra|bles *fr.* [*ãsßeparabl*] (eine Papageienart) *Mehrz.*
In|se|rat *lat.* (Anzeige [in Zeitungen usw.]) *s*; -[e]s, -e; In|se|ra|ten_teil *m*; In|se|rent (Aufgeber eines Inserates); ↑ R 268; in|se|rie|ren (ein Inserat aufgeben, „einrücken" [lassen]); In|ser|ti|on [...*zion*] (Aufgeben einer Anzeige; auch: Ansatz, Befestigung [z. B. von Muskeln an Knochen]); In|ser|ti|ons_preis
ins|ge|heim [österr.: *ins*...]; ins|ge|mein [österr.: *ins*...] (veralt.); ins|ge|samt [österr.: *ins*...]
In|si|der *engl.* [*inßaid⁸r*] (jmd., der interne Kenntnisse von etwas besitzt, Eingeweihter) *m*; -s, -; In|si|de-Sto|ry [*inßaid*...] (Geschichte, die auf Grund interner Kenntnis von etwas geschrieben wurde)
In|si|di|en *lat.* [...*i⁸n*] (veralt. für: Nachstellungen) *Mehrz.*
In|sie|gel (veralt. für: Siegelbild; Jägerspr.: altes Fährtenzeichen)
In|si|gni|en *lat.* [...*i⁸n*] (Kennzeichen staatl. od. ständischer Macht u. Würde) *Mehrz.*; in|si|gni|fi|kant [auch: ...*kant*] (unbedeutend, unwichtig)
in|si|stie|ren *lat.* (selten für: auf etwas bestehen, dringen)
in si|tu *lat.* (Med. für: „in der [natürlichen, richtigen] Lage")
in|skri|bie|ren *lat.* (in eine Liste aufnehmen; bes. österr. für: sich für das laufende Semester als Hörer an einer Universität anmelden); In|skrip|ti|on [...*zion*]
ins|künf|tig (schweiz., sonst veralt. für: zukünftig, für die Zukunft, fortan)
in|so|fern [auch: *insofärn*, österr.: *in*...]; insofern hast du recht, aber: insofern du nichts dagegen hast; insofern[,] als (↑ R 63)
In|so|la|ti|on *lat.* [...*zion*] (Meteor.: Sonnenbestrahlung; Med.: Sonnenstich)
in|so|lent [auch: *insolänt*] *lat.* (anmaßend, unverschämt); In|so|lenz [auch: *insolänz*] *w*; -, -en
in|sol|vent *lat.* [auch: *insolwänt*] (zahlungsunfähig); In|sol|venz [auch: *insolwänz*] *w*; -, -en
in|son|der|heit (geh. für: beson-

ders, im besonderen); insonderheit[,] wenn (↑ R 63)
in|so|weit [auch: *insoweit*]; insoweit hast du recht, aber: insoweit es möglich ist; insoweit[,] als (↑ R 63)
in spe *lat.* [- *ßpe*] („in der Hoffnung"; zukünftig)
In|spek|teur *fr.* [...*tör*] (Leiter einer Inspektion; Dienststellung der ranghöchsten Offiziere der Bundeswehr) *m*; -s, -e; In|spek|ti|on *lat.* [...*zion*] (Prüfung, Kontrolle, Besichtigung, Aufsicht; Behördenstelle, der die Aufsicht obliegt; Aufsichts-, Prüfstelle); In|spek|ti|ons_fahrt, ...gang *m*, ...rei|se; In|spek|tor (Aufseher, Vorsteher, Verwalter; Verwaltungsbeamter) *m*; -s, ...oren; In|spek|to|rin *w*; -, -nen
In|spi|ra|ti|on *lat.* [...*zion*] (Eingebung; Erleuchtung; Beeinflussung; Theol.: Eingebung des Heiligen Geistes bei Abfassung der Heiligen Schrift); In|spi|ra|tor (Anreger; selten für: Eingeber, Einflüsterer) *m*; -s, ...oren; in|spi|rie|ren
In|spi|zi|ent *lat.* (Theater: Bühnen-, Spielwart); ↑ R 268; in|spi|zie|ren (be[auf]sichtigen); in|spi|zie|rung
in|sta|bil [auch: ...*bil*] (unbeständig); In|sta|bi|li|tät (Unbeständigkeit) *w*; -, (selten:) -en
In|stal|la|teur *fr.* [...*tör*] (Einrichter u. Prüfer von techn. Anlagen [Heizung, Wasser, Gas]) *m*; -s, -e; In|stal|la|ti|on [...*zion*] (Einrichtung, Einbau, Anlage, Anschluß [von techn. Anlagen]; Einweisung in ein [geistl.] Amt); in|stal|lie|ren
in|stand hal|ten (↑ R 141); aber: das Instandhalten; instand zu halten; ↑ R 120 u. Stand; In|stand_hal|tung; In|stand|hal|tungs|ko|sten *Mehrz.*
in|stän|dig (eindringlich; flehentlich); - bitten; In|stän|dig|keit *w*; -
in|stand set|zen (↑ R 141); aber: das Instandsetzen; instand zu setzen; ↑ R 120 u. Stand; In|stand_set|zung; in|stand stel|len (schweiz. neben: instand setzen) In|stand_stel|lung (schweiz. neben: Instandsetzung)
In|stant... *engl.* [*inßt⁸rnt*...] (in Zusammensetzungen = sofort, ohne Vorbereitung zur Verfügung z. B. Instantgetränk, Instantkaffee, Instantsex)
In|stanz *lat.* (zuständige Stelle be Behörden od. Gerichten; Dienstweg) *w*; -, -en; in|stan|zen|mä|ßig; in|stanz|mä|ßig; In|stan|zen_weg (Dienstweg), ...zug

in sta|tu nas|cen|di *lat.* [- - *naß-zändi*] (,,im Zustand des Entstehens")

in sta|tu quo *lat.* (im gegenwärtigen Zustand); in sta|tu quo an|te (im früheren Zustand)

In|ste *niederd.* (,,Insasse"; früher für: Gutstagelöhner) *m*; -n, -n (↑ R 268)

In|ster (Quellfluß des Pregels) *w*; -

In|still|la|ti|on *lat.* [...*zion*] (Med.: Einträufelung); in|still|lie|ren

In|stinkt *lat.* (angeborene Verhaltensweise u. Reaktionsbereitschaft der Triebsphäre; auch für: sicheres Gefühl) *m*; -[e]s, -e; in-stinkt|haft; In|stinkt|hand|lung; in|stink|tiv (trieb-, gefühlsmäßig, unwillkürlich); in|stinkt|los; In-stinkt|lo|sig|keit; in|stinkt.mä-ßig, ...si|cher

In|sti|tu|ieren *lat* (einrichten; veralt. für: unterweisen); In|sti|tut (Unternehmen; Bildungs-, Forschungsanstalt) *s*; -[e]s, -e; In|sti-tu|ti|on [...*zion*] (Einrichtung; Stiftung, gesellschaftlich anerkannte Form einer Gruppe); in|sti|tu|tio|na|li|sie|ren (in eine feste, auch starre Institution verwandeln); In|sti|tu|tio|na|li-sie|rung; in|sti|tu|tio|nell (die Institution betreffend); In|sti-tuts.bi|blio|thek, ...bü|che|rei, ...di|rek|tor, ...lei|ter *m*, ...ver-samm|lung

Inst|mann [zu: Inste] *niederd.* (früher für: Gutstagelöhner; *Mehrz.* ...leute)

in|stru|ieren *lat.* (unterweisen; anleiten); In|struk|teur *fr.* [...*tör*] (Unterrichtender; Anleiter) *m*; -s, -e; In|struk|ti|on *lat.* [...*zion*] (Anleitung, Vorschrift, Richtschnur; Dienstanweisung); in|struk|tiv (lehrreich); In|struk|tor (veralt. für: Lehrer; Erzieher; österr. für: Instrukteur) *m*; -s, ...oren

In|stru|ment *lat.* -s, -[e]s, -e; in|stru-men|tal (Musikinstrumente verwendend); In|stru|men|tal.be-glei|tung, ...flug (Flugw.), ...mu-sik, ...satz Sprachw.: Umstandssatz des Mittels od. Werkzeugs); In|stru|men|ta|ri|um (Instrumentensammlung; Gesamtzahl der zur Verfügung stehenden Instrumente) *s*; -s, ...ien [...*i*ⁿ*n*]; In|stru|men|ta|ti|on [...*zion*] (Instrumentierung); in|stru|men-tell (mit Instrumenten); In|stru-men|ten.bau (*m*; -[e]s), ...brett; in-stru|men|tie|ren (ein Musikstück für Orchesterinstrumente einrichten; mit [techn.] Instrumenten ausstatten); In|stru|men|tie-rung

In|sub|or|di|na|ti|on *lat.* [...*zion*,

auch: *in*...] (mangelnde Unterordnung; Ungehorsam im Dienst)

in|suf|fi|zi|ent *lat.* [auch: ...*ziänt*] (unzulänglich); In|suf|fi|zi|enz [auch: ...*änz*] (Unzulänglichkeit [auch in der Bezahlung von Schulden]; Med.: mangelhafte Funktion eines Organs) *w*; -, -en

In|su|la|ner *lat.* (Inselbewohner); in|su|lar (eine Insel od. Inseln betreffend, inselartig; Insel...); In-su|lin (Hormon der Bauchspeicheldrüse; ⓦ ein Heilmittel für Zuckerkranke) *s*; -s; In|su|lin|de *niederl.* (veralt. Bez. für die ehem. niederl. Besitzungen in Südostasien); (auch mit Artikel: *w*; -); In|su|lin.man|gel, ...prä|pa|rat, ...schock, ...stoß

In|sult *lat.* ([schwere] Beleidigung, Beschimpfung; Belästigung; Med.: Anfall) *m*; -[e]s, -e; In|sul-ta|ti|on [...*zion*] (svw. Insult); in-sul|tie|ren

in sum|ma *lat.* (im ganzen, insgesamt)

In|sur|gent *lat.* (Aufständischer); ↑ R 268; in|sur|gie|ren (zum Aufstand reizen; [in Masse] aufstehen); In|sur|rek|ti|on [...*zion*] (Aufstand)

in|sze|na|to|risch *lat.; gr.* (die Inszenierung betreffend); in|sze-nie|ren (in ,,Szene", ins Werk setzen; einrichten; eine Bühnenaufführung vorbereiten); In|sze|nie-rung

In|ta|glio *it.* [*intaljo*] (Gemme mit eingeschnittenen Figuren) *s*; -s, ...ien [*intalj*ⁿ*n*]

in|takt *lat.* (unversehrt, unberührt); In|takt|heit *w*; -; In|takt-seln *u*, -s

In|tar|sia, In|tar|sie *it.* (eingelegte Arbeit) *w*; -, ...ien [...*i*ⁿ*n*] (meist *Mehrz.*); In|tar|si|en|ma|le|rei

in|te|ger *lat.* (unbescholten; unversehrt; veralt. für: neu); ein integrer Charakter; vgl. in integrum; in|te|gral (ein Ganzes ausmachend; vollständig; für sich bestehend); In|te|gral (Math.; Zeichen: ∫) *s*; -s, -e; In|te|gral.glei-chung, ...rech|nung; In|te|gra|ti-on [...*zion*] (Vervollständigung; Zusammenschluß; Vereinigung; Summierung); in|te|grier|bar; in-te|grie|ren (ergänzen; zusammenschließen [in ein übergeordnetes Ganzes]; das Integral berechnen); in|te|grie|rend (unerläßlich, notwendig, wesentlich); ein -er Bestandteil; In|te|grie-rung; In|te|gri|tät (Unversehrtheit, Unbescholtenheit) *w*; -

In|te|gu|ment *lat.* (Hautschichten von Tier u. Mensch; Bot.: Hülle um die Samenanlage) *s*; -s, -e

In|tel|lekt *lat.* (Verstand; Erkenntnis-, Denkvermögen) *m*; -[e]s; In-tel|lek|tua|lis|mus (philos. Lehre, die dem Intellekt den Vorrang gibt; einseitig verstandesmäßiges Denken) *m*; -; in|tel|lek|tu|ell *fr.* (den Intellekt betreffend; [einseitig] verstandesmäßig; geistig); In-tel|lek|tu|el|le ([einseitiger] Verstandesmensch; geistig Geschulte[r]) *m* u. *w*; -n, -n (↑ R 287 f.); in|tel|li|gent *lat.* (verständig, klug, begabt); In|tel|li|genz (besondere geistige Fähigkeit, Klugheit; in der Einz. auch: Schicht der wissenschaftl. Gebildeten) *w*; -, -en; In|tel|li|genz.be|stie (abschätzig: Person, die ihre Intelligenz in unangenehmer Weise nach außen hin zeigt), ...grad; In-tel|li|genz|ler *lat.-russ.* (russ. Bez. für die Gebildeten) *w*; -; In-tel|li|genz|ler *lat.* (oft abschätzig für: Angehöriger der Intelligenz) *m*; -s, -; In|tel|li|genz.lei|stung, ...prü|fung (Eignungsprüfung), ...quo|ti|ent (Zahlenwert aus dem Verhältnis der dem jeweiligen Alter angemessenen Intelligenz zum Lebensalter, Abk.: IQ), ...test; in|tel|li|gi|bel (nur durch den Intellekt erkennbar; nur geistig faßbar); ...i|ble Welt (die nur geistig wahrnehmbare Ideenwelt)

In|ten|dant *fr.* (Leiter eines Theaters, eines Rundfunk- od. Fernsehsenders) *m*; -en, -en (↑ R 268); In|ten|dan|tur (veralt. für: Amt eines Intendanten; Verwaltungsbehörde eines Heeres) *w*; -, -en; In|ten|danz (Amt, Büro eines Intendanten) *w*; -, -en; in|ten|die|ren *lat.* (beabsichtigen, anstreben, planen)

In|ten|si|me|ter *lat.; gr.* (Meßgerät, bes. für Röntgenstrahlen) *s*; -s, -; In|ten|si|on *lat.* (Anspannung; Eifer); In|ten|si|tät (Stärke, Kraft; Wirksamkeit) *w*; -, (selten) -en; in|ten|siv (eindringlich; kräftig; gründlich; durchdringend); -e Bewirtschaftung (Landw.: Form der Bodennutzung mit großem Einsatz von Arbeitskraft u. Kapital); In|ten-siv.an|bau, ...hal|tung; in|ten|si-vie|ren [...*wir*ⁿ*n*] (verstärken, steigern); In|ten|si|vie|rung; in|ten-siv.pfle|ge, ...sta|ti|on; In|ten|si-vum [...*wum*] (Sprachw.: Zeitw., das den größeren od. geringeren Grad, die Intensität eines Geschehens kennzeichnet, z. B. ,,schnitzen" = kräftig schneiden) *s*; -s, ...va [...*wa*]

In|ten|ti|on *lat.* [...*zion*] (Absicht; Plan; Vorhaben); in|ten|tio|nal (zweckbestimmt; zielgerichtet)

In|ter|ak|ti|on *lat.-engl.* [...*zion*] Psych., Soziologie: Wechselbeziehung zwischen aufeinander ansprechenden Partnern)

in|ter|al|li|iert [auch: ...*iirt*] (von mehreren Alliierten gemeinsam getroffen; aus Verbündeten bestehend)

In|ter|ci|ty-Zug [...*ßiti*...] (schneller, zwischen bestimmten Großstädten eingesetzter Eisenbahnzug; Abk.: IC)

in|ter|de|pen|dent *lat.* (gegenseitig abhängend [vor allem von Preisen]); In|ter|de|pen|denz (gegenseitige Abhängigkeit [sämtl. Preise]; auch: Abhängigkeit der Politik eines Landes von anderen Ländern)

In|ter|dikt *lat.* (Verbot aller kirchl. Amtshandlungen als Strafe für einen Bezirk od. Ort) *s*; -[e]s, -e; In|ter|dik|ti|on [...*zion*] (veralt. für: Untersagung; Entmündigung)

in|ter|dis|zi|pli|när *lat.* (zwischen Disziplinen bestehend, mehrere Disziplinen betreffend)

in|ter|di|zie|ren (Zeitw. zu: Interdiktion)

in|ter|es|sant *fr.*; in|ter|es|san|ter|wei|se; In|ter|es|sant|heit *w*; -; In|ter|es|se *lat. s*; -s, -n; - an, für etwas haben; vgl. Interessen; in|ter|es|se|hal|ber; in|ter|es|se|los, -este (↑ R 292); In|ter|es|se|lo|sig|keit *w*; -; In|ter|es|sen (veralt. für: Zinsen) *Mehrz.*; In|ter|es|sen|be|reich, ...ge|biet, ...ge|gen|satz, ...ge|mein|schaft (Zweckverband), ...grup|pe, ...sphä|re (Einflußgebiet); In|ter|es|sent (↑ R 268); In|ter|es|sen|ten|kreis; In|ter|es|sen|ver|band, ...ver|tre|tung; in|ter|es|se|wah|rend, aber (↑ R 142): sein Interesse wahrend; in|ter|es|sie|ren (Teilnahme erwecken); jmdn. an, für etwas -; sich - (Anteil nehmen, Sinn haben) für ...; in|ter|es|siert (Anteil nehmend; beteiligt; veralt. für: eigennützig); In|ter|es|siert|heit *w*; -

In|ter|fe|renz *lat.* (Physik: Überlagerung von Wellen; Sprachw.: Abweichung von der Norm durch den Einfluß anderer sprachlicher Elemente) *w*; -, -en; In|ter|fe|ro|me|ter *lat.*; *gr.* (physikal. Meßgerät) *s*; -s, -

in|ter|frak|tio|nell *lat.* (zwischen Fraktionen bestehend, ihnen gemeinsam)

in|ter|gla|zi|al *lat.* (Geol.: zwischeneiszeitlich); In|ter|gla|zi|al|zeit *w*; -

In|te|rieur *fr.* [*ängteriör*] (Inneres; Ausstattung eines Innenraumes; einen Innenraum darstellendes Bild) *s*; -s, -s u. -e

In|te|rim *lat.* (Zwischenzeit, -zustand; vorläufige Regelung) *s*; -s, -s; in|te|ri|mi|stisch (vorläufig, einstweilig); In|te|rims|kon|to, ...lö|sung, ...re|ge|lung od. ...reg|lung, ...schein (Zwischenschein)

In|ter|jek|ti|on *lat.* [...*zion*] (Sprachw.: Ausrufe-, Empfindungswort, z. B. „au", „bäh")

in|ter|ka|lar *lat.* (von Schaltjahren: eingeschaltet); In|ter|ka|la|ri|en [...*i*ᵉ*n*] (Einkünfte einer unbesetzten kath. Kirchenpfründe) *Mehrz.*

in|ter|kan|to|nal schweiz. (zwischen den Kantonen bestehend; allgemein)

In|ter|ko|lum|nie *lat.* [...*i*ᵉ] *w*; -, -n u. In|ter|ko|lum|ni|um (Säulenabstand bei einem antiken Tempel) *s*; -s, ...ien [...*i*ᵉ*n*]

in|ter|kom|mu|nal *lat.* (zwischen Gemeinden bestehend [von Abkommen usw.])

in|ter|kon|fes|sio|nell *lat.* (das Verhältnis verschiedener Konfessionen zueinander betreffend)

in|ter|kon|ti|nen|tal *lat.* (Erdteile verbindend); In|ter|kon|ti|nen|tal|ra|ke|te

in|ter|ko|stal *lat.* (Med.: zwischen den Rippen)

in|ter|kur|rent *lat.* (hinzukommend); -e Krankheit

In|ter|la|ken (schweiz. Kurort)

in|ter|li|ne|ar *lat.* (zwischen die Zeilen des fremdsprachigen Urtextes geschrieben); In|ter|li|ne|ar|glos|se (Glosse, die zwischen die Zeilen geschrieben ist; vgl. Glosse), ...über|set|zung, ...ver|si|on

In|ter|lock_wa|re *engl.*; *dt.* (feinmaschige Rundstrickware für Herren- u. Damenwäsche), ...wä|sche

In|ter|lu|di|um *lat.* (Zwischenspiel) *s*; -s, ...ien [...*i*ᵉ*n*]

In|ter|lu|ni|um *lat.* (Zeit des Neumondes) *s*; -s, ...ien [...*i*ᵉ*n*]

In|ter|ma|xil|lar|kno|chen *lat.*; *dt.* (Zwischenkiefer[knochen])

in|ter|me|di|är *lat.* (bes. Med.: dazwischen befindlich; ein Zwischenglied bildend)

In|ter|mez|zo *it.* (Zwischenspiel, -fall) *s*; -s, -s u. ...zzi

in|ter|mi|ni|ste|ri|ell (zwischen Ministerien bestehend, mehrere Ministerien betreffend)

in|ter|mit|tie|rend (zeitweilig aussetzend); -es Fieber

In|ter|mun|di|en [...*i*ᵉ*n*] (die von Epikur zwischen den unendlich vielen Welten angenommenen Zwischenräume) *Mehrz.*

in|tern *lat.* ([Med.:] innerlich; nur die inneren, eigenen Verhältnisse angehend; vertraulich; [von

Schülern]: im Internat wohnend); In|ter|na (*Mehrz.* von: Internum); In|ter|nat (pädagogische Anstalt mit Wohnung u. Verpflegung) *s*; -[e]s, -e

in|ter|na|tio|nal *lat.* [...*nazional*] (zwischenstaatlich, nicht national begrenzt); -es Recht; -e Vereinbarung, aber (↑ R 224): Internationales Olympisches Komitee (Abk.: IOK); Internationales Rotes Kreuz (Abk.: IRK); Internationale Einheit (Abk.: I. E. od. IE); Internationale *w*; -, -n: in|ter|na|tio|na|li|sie|ren (international gestalten); In|ter|na|tio|na|li|sie|rung *w*; -; In|ter|na|tio|na|lis|mus (Streben nach überstaatl. Organisation oder Gemeinschaft; international gebräuchliches Wort) *m*; -, (für Wörter:) ...men

In|ter|ne *lat.* (Schüler[in] eines Internats) *m* u. *w*; -n, -n (↑ R 287 ff.); in|ter|nie|ren (in staatl. Gewahrsam, in Haft nehmen; Kranke isolieren); In|ter|nier|te *m* u. *w*; -n, -n (↑ R 287 ff.); In|ter|nie|rung; In|ter|nie|rungs|la|ger; In|ter|nist (Facharzt für innere Krankheiten); ↑ R 268

In|ter|no|di|um *lat.* (Bot.: Sproßabschnitt zwischen zwei Blattknoten) *s*; -s, ...ien [...*i*ᵉ*n*]

In|ter|num *lat.* (selten für: nur die inneren, eigenen Verhältnisse angehende Angelegenheit; vorbehaltenes, eigenes Gebiet) *s*; -s, ...na

In|ter|nun|ti|us *lat.* [...*ziuß*] (päpstl. Gesandter in kleineren Staaten)

in|ter|oze|a|nisch *lat.*; *gr.* (Weltmeere verbindend)

in|ter|par|la|men|ta|risch *lat.*; *gr.* (die Parlamente der einzelnen Staaten umfassend)

In|ter|pel|lant *lat.* (Anfragender) *m*; -en, -en (↑ R 268); In|ter|pel|la|ti|on [...*zion*] ([parlamentar.] Anfrage; früher für: Einspruch); in|ter|pel|lie|ren

in|ter|pla|ne|tar, in|ter|pla|ne|ta|risch (zwischen den Planeten befindlich); -e Materie; -er Raum

In|ter|pol (Kurzw. für: Internationale Kriminalpolizeiliche Organisation; Zentralstelle zur internationalen Koordination der Ermittlungsarbeit in der Verbrechensbekämpfung) *w*; -

in|ter|po|la|ti|on *lat.* [...*zion*] (nachträgl. Einschaltung; Änderung; Math.: Bestimmung von Zwischenwerten); in|ter|po|lie|ren

In|ter|pret *lat.* (Ausleger, Erklärer, Deuter) *m*; -en, -en (↑ R 268); In|ter|pre|ta|ti|on [...*zion*]; in|ter|pre|tie|ren

in|ter|pun|gie|ren *lat.* (seltener für: interpunktieren); in|ter|punk|tie|ren (Satzzeichen setzen); In|ter|punk|ti|on [...*zion*] (Zeichensetzung); In|ter|punk|ti|ons.re|gel, ...zei|chen (Satzzeichen)

In|ter|re|gnum [auch: ...*regn*...] *lat.* (Zwischenregierung; kaiserlose Zeit [1254–1273]) *s*; -s, ...gnen u. ...gna

in|ter|ro|ga|tiv *lat.* (fragend); In|ter|ro|ga|tiv (Sprachw.: Fragefürwort, Fragewort, z. B. „wer?", „welcher?") *s*; -s, -e [...*w*^e]; In|ter|ro|ga|tiv.ad|verb (Frageumstandswort), pro|no|men (Fragefürwort), ...satz (Fragesatz)

In|ter|sep|tum *lat.* (veralt. für: Septum) *s*; -s, ...ta

in|ter|sex *lat.* (Biol.: Organismus mit Intersexualität) *s*; -es, -e; In|ter|se|xua|li|tät (das Auftreten männl. Geschlechtsmerkmale bei einem weibl. Organismus u. umgekehrt) *w*; -; in|ter|se|xu|ell (zwischengeschlechtlich)

in|ter|stel|lar (zwischen den Sternen befindlich); -e Materie

in|ter|sti|ti|ell *lat.* [...*ziäl*] (Med., Biol.: dazwischenliegend); In|ter|sti|ti|um [...*zium*] (Biol.: Zwischenraum [zwischen Organen]; *Mehrz.:* vorgeschriebene Zwischenzeit zwischen dem Empfang zweier geistl. Weihen) *s*; -s, ...ien [...*i*^e*n*]

in|ter|ter|ri|to|ri|al *lat.* (zwischenstaatlich)

in|ter|tri|go *lat.* (Med.: Wundsein, Hautwolf) *w*; -, ...trigines [...*näß*]

in|ter|type^W *engl.* [...*taip*] (Zeilenguß-Setzmaschine) *w*; -, -s; In|ter|type-Fo|to|set|ter [...*Bät*...] (eine Lichtsatzmaschine) *m*; -s, -

in|ter|ur|ban *lat.* österr., sonst veralt. für: Fern...); -es Telefongespräch

in|ter|usu|ri|um *lat.* (BGB: Zwischenzinsen) *s*; -s, ...ien [...*i*^e*n*]

in|ter|vall *lat.* [...*wal*] (Zeitabstand, Zeitspanne, Zwischenraum; Frist; Abstand [zwischen zwei Tönen]) *s*; -s, -e

in|ter|ve|ni|ent *lat.* [...*we*...] (jmd., der sich in [Rechts]streitigkeiten [als Mittelsmann] einmischt); ↑ R 268; in|ter|ve|nie|ren (dazwischentreten; vermitteln; sich einmischen); In|ter|vent *lat.* (kommunist. Bez. für: kriegerischer Intervenient) *m*; -en, -en (↑ R 268); In|ter|ven|ti|on *lat.* [...*zion*] (Vermittlung; staatl. Einmischung in die Angelegenheiten eines fremden Staates; Eintritt in eine Wechselverbindlichkeit)

in|ter|view *engl.* [...*wju*, auch: *in*...] (Unterredung [von Reportern] mit [führenden] Persönlichkeiten über Tagesfragen usw.; Befragung) *s*; -s, -s; in|ter|view|en [...*wju*...]; interviewt; In|ter|viewer [...*wju*...]

In|ter|vi|si|on [Kurzw. aus international und Television] (osteurop. Organisation zur Kettenübertragung von Fernsehsendungen)

in|ter|ze|die|ren *lat.* (dazwischentreten; vermitteln; sich verbürgen)

in|ter|zel|lu|lar, in|ter|zel|lu|lär *lat.* (Med., Biol.: zwischenzellig); In|ter|zel|lu|lar|raum (Zwischenzellraum)

In|ter|zes|si|on *lat.* (Schuldübernahme durch Rechtsgeschäft; veralt. für: Intervention)

in|ter|zo|nal *lat.*; *gr.* (zwischen den Zonen); In|ter|zo|nen.han|del, ...ver|kehr, ...zug

in|te|sta|bel *lat.* (unfähig, ein Testament zu machen od. als Zeuge aufzutreten); ...a|ble Leute; In|te|stat|er|be (natürlicher, gesetzl. Erbe) *m*

in|te|sti|nal *lat.* (Med.: zum Darmkanal gehörend)

In|thro|ni|sa|ti|on [...*zion*] *lat.*; *gr.* (Thronerhebung, feierliche Einsetzung); in|thro|ni|sie|ren; In|thro|ni|sie|rung

in|tim *lat.* (vertraut; innig; gemütlich; das Geschlechtsleben betreffend); In|ti|ma (Med.: innerste Haut der Gefäße) *w*; -; In|ti|ma|ti|on [...*zion*] (früher für: gerichtl. Ankündigung [bes. des Todesurteils]; amtl. Zustellung); In|tim.be|reich, ...hy|gie|ne; In|ti|mi (*Mehrz.* von: Intimus); In|ti|mi|tät [zu: intim]; In|tim|sphä|re (vertraut-persönlicher Bereich); In|ti|mus (vertrauter Freund) *m*; -, ...mi

in|to|le|rant *lat.* [auch: ...*ant*] (unduldsam); In|to|le|ranz [auch: ...*anz*] *w*; -, -en

In|to|na|ti|on [...*zion*] (Musik: An-, Abstimmen; Sprachw.: Veränderung des Tones nach Höhe u. Stärke beim Sprechen von Silben oder ganzen Sätzen, Tongebung); in|to|nie|ren (anstimmen)

in toto *lat.* (im ganzen)

In|tou|rist [...*tu*...] (staatl. sowjet. Reisebüro mit Vertretungen im Ausland)

In|to|xi|ka|ti|on *lat.*; *gr.* [...*zion*] (Vergiftung)

In|tra|de *it.* (Musik: festl. Eröffnungsstück der Suite) *w*; -, -n

in|tra|kar|di|al *lat.*; *gr.* (Med.: innerhalb des Herzens)

in|tra|ku|tan *lat.* (Med.: im Innern, ins Innere der Haut)

in|tra|mo|le|ku|lar *lat.* (Chemie: sich innerhalb der Moleküle vollziehend)

in|tra|mu|ros *lat.* („innerhalb der Mauern"; nichtöffentlich)

in|tra|mus|ku|lär *lat.* (Med.: im Innern, ins Innere des Muskels, der Muskeln)

in|tran|si|gent *lat.* (unversöhnlich); In|tran|si|gent (starrer Parteimann; *Mehrz.* auch für: extreme polit. Partei[en]); ↑ R 268; In|tran|si|genz *w*; -

in|tran|si|tiv *lat.* [auch: ...*if*] (Sprachw.: nicht zum persönlichen Passiv fähig; nichtzielend); -es Zeitwort; In|tran|si|tiv [auch: ...*if*] (Sprachw.: nichtzielendes Zeitwort, z. B. „blühen") *s*; -s, -e [...*w*^e]

in|tra|oku|lar *lat.* (Med.: im Augeninnern liegend)

in|tra|ve|nös *lat.* [...*we*...] (Med.: im Innern, ins Innere der Vene); -e Einspritzung, Injektion

in|tra|zel|lu|lar, in|tra|zel|lu|lär *lat.* (innerhalb der Zelle liegend)

in|tri|gant *fr.* (ränkevoll, -süchtig); In|tri|gant *m*; -en, -en (↑ R 268); In|tri|gan|tin *w*; -, -nen; In|tri|ge (Ränke[spiel]) *w*; -, -n; In|tri|gen.spiel, ...wirtschaft; in|tri|gie|ren

In|tro|duk|ti|on *lat.* [...*zion*] (Musik: Einleitung, Vorspiel); in|tro|du|zie|ren (einführen)

In|tro|itus (Eingangsgesang der kath. Messe; Eingangsworte od. Eingangslied im ev. Gottesdienst) *m*; -, -

in|trors *lat.* (nach innen gewendet); -e Staubbeutel

In|tro|spek|ti|on *lat.* [...*zion*] (Selbstbeobachtung)

In|tro|ver|si|on *lat.* [...*wär*...] (Konzentration des Interesses auf innerseelische Vorgänge); in|tro|ver|tiert (nach innen gewandt)

In|tru|si|on *lat.* (Geol.: Eindringen von Gesteinsschmelze in die Erdkruste); In|tru|siv.ge|stein

In|tu|ba|ti|on *lat.* [...*zion*] (Med.: Einführen einer Röhre; Einblasen von Heilmitteln)

In|tui|ti|on *lat.* [...*zion*] (unmittelbare ganzheitl. Sinneswahrnehmung; unmittelbare, ohne Reflexion entstandene Erkenntnis des Wesens eines Gegenstandes); in|tui|tiv

In|tu|mes|zenz, In|tur|ges|zenz *lat.* (Med.: Anschwellung) *w*; -, -en

in|tus *lat.* (inwendig, innen); etwas -haben (ugs. für: etwas im Magen haben od. etwas begriffen haben); In|tus|sus|zep|ti|on [...*zion*] (Bot.: Einlagerung neuer Teilchen zwischen bereits vorhandene; Med.: Darmeinstülpung)

Inu|it *eskim.* („Menschen"; Selbstbez. der Eskimos) *Mehrz.*

Inu|la *gr.* (Gattung der Korbblüt-

ler mit zahlreichen Arten von Gewürz- u. Heilkräutern) w; -; In|u|lin (hochpolymerisierter Fruchtzucker) s; -s

In|un|da|ti|on lat. [...zion] (Geogr.: völlige Überflutung des Landes bei Transgression des Meeres); In|un|da|ti|ons|ge|biet (in Wien: Überschwemmungsgebiet der Donau)

In|unk|ti|on lat. [...zion] (Med.: Einreibung)

in usum Del|phi|ni lat. (svw. ad usum Delphini)

In|va|gi|na|ti|on lat. [inwaginazion] (Med.: Darmeinstülpung)

In|va|li|da|ti|on fr. [inwalidazion] (veralt. für: Ungültigsprechung); in|va|lid (österr. nur so), in|va|li|de ([durch Verwundung od. Unfall] dienst-, arbeitsunfähig); In|va|li|de (Dienst-, Arbeitsunfähiger) m; -n, -n (↑ R 291); In|va|li|den|ren|te, ...ver|si|che|rung (w; -); in|va|li|die|ren (veralt. für: ungültigmachen; entkräften); in|va|li|di|sie|ren (jmdn. zum Invaliden erklären; jmdm. eine Alters- od. Arbeitsunfähigkeitsrente gewähren); In|va|li|di|sie|rung; In|va|li|di|tät (Erwerbs-, Dienst-, Arbeitsunfähigkeit) w; -

in|va|ri|a|bel lat. [auch: inwa...] (unveränderlich); ...a|ble Größen; In|va|ri|an|te (Math.: unveränderliche Größe) w; -, -n; In|va|ri|an|ten|theo|rie (Math.)

In|va|si|on fr. [...wa...] ([feindlicher] Einfall); In|va|sor lat. (Eroberer; eindringender Feind) m; -s, ...oren (meist Mehrz.)

In|vek|ti|ve [...wäktiwᵉ] (Schmährede) w; -, -n

In|ven|tar lat. [...wän...] (Einrichtungsgegenstände eines Unternehmens; Vermögensverzeichnis; Nachlaßverzeichnis) s; -s, -e; In|ven|tar|er|be m; In|ven|ta|ri|sa|ti|on [...zion] (Bestandsaufnahme); in|ven|ta|ri|sie|ren (Bestand aufnehmen); In|ven|ta|ri|sie|rung; In|ven|tar|recht, ...ver|zeich|nis; in|ven|tie|ren (veralt. für: erfinden; Bestand aufnehmen); In|ven|ti|on [...zion] (veralt. für: Erfindung); In|ven|tur (Wirtsch.: Bestandsaufnahme des Vermögens eines Unternehmens) w; -, -en; In|ven|tur_prü|fung, ...ver|kauf (verbilligter Verkauf nach einer Inventur)

in ver|ba ma|gi|stri lat. [-wärba-] (auf des Meisters Worte [schwören])

in|vers lat. [inwärß] (umgekehrt); -e Funktionen (Math.); In|ver|si|on (Sprachw.: Umkehrung, bes. der regelmäßigen Wortfolge; Meteor.: Temperaturumkehr an

einer Sperrschicht, an der die normalerweise mit der Höhe abnehmende Temperatur sprunghaft zunimmt)

In|ver|te|brat vgl. Evertebrat

in|ver|tie|ren lat. [...wär...] (umkehren); in|ver|tiert (umgekehrt; zum eigenen Geschlecht hin empfindend)

In|ver|tin lat. [...wär...] (ein Ferment) s; -s

in Ver|tre|tung (Abk.: i. V. od. I. V.; Klein- od. Großschreibung entsprechend „i. A."[1])

In|vert|zucker [Trenn.: ...zuk|ker] lat.; dt. [...wärt...] (Gemisch von Trauben- u. Fruchtzucker)

In|ver|wahr|nah|me w; -, -n

in|ve|stie|ren lat. [...wä...] (in ein Amt einweisen; [Kapital] anlegen); In|ve|stie|rung

In|ve|sti|ga|ti|on lat. [inwäßtigazion] (veralt. für: gerichtl. Nachforschung); in|ve|sti|gie|ren (veralt.)

In|ve|sti|ti|on lat. [inwäßtizion] (langfristige [Kapital]anlage); In|ve|sti|ti|ons|gü|ter (Güter, die zur Produktionsausrüstung gehören) Mehrz.; In|ve|sti|ti|ons|hil|fe; In|ve|sti|ti|ur (Einweisung in ein niederes geistl. Amt; im MA. feierl. Belehnung mit dem Bischofsamt durch den König; in Frankreich Bestätigung des Ministerpräsidenten durch die Nationalversammlung) w; -, -en; In|ve|sti|ti|ur|lohn (als Spareinlage zwangsgebundener Teil des Arbeitnehmerlohnes); In|vest|ment engl. [inwäßt...] (engl. Bez. für: Investition); In|vest|ment_fonds (Effektenbestand einer Kapitalanlagegesellschaft), ...ge|sell|schaft (Kapitalverwaltungsgesellschaft), ...pa|pier od. ...zer|ti|fi|kat; In|ve|stor lat. (Kapitalanleger) m; -s, ...oren

in vi|no ve|ri|tas lat. [- wino we...] (,,im Wein [ist] Wahrheit")

In|vo|ka|ti|on lat. [...wokazion] (Anrufung [Gottes]); In|vo|ka|vit [...wokawit] (,,Er hat angerufen"; erster Fastensonntag)

in Voll|macht (Abk.: i. V. od. I. V.; Klein- od. Großschreibung vgl. ,,i. A."[1])

In|vo|lu|ti|on lat. [...woluzion] (Med.: Rückbildung; geometrischer Begriff); in|vol|vie|ren [...wolwi...] (in sich schließen)

in|wärts

in|wen|dig; in- u. auswendig

in|wie|fern

in|wie|weit

In|woh|ner (veralt. für: Bewohner; österr. auch für: Mieter)

[1] Vgl. S. 345, Spalte 1, Anm. 1.

In|zah|lung|nah|me w; -, -n

In|zest lat. (Blutschande) m; -[e]s, -e; In|zest|hem|mung; in|ze|stu|ös (blutschänderisch)

In|zi|si|on lat. (Med.: Einschnitt); In|zi|siv m; -s, -en [...wᵉn] od. In|zi|siv|zahn (Schneidezahn); In|zi|sur ([künstl.] Einschnitt, Einkerbung) w; -, -en

In|zucht w; -; In|zucht_schä|di|gung, ...test

in|zwi|schen

Io. = Iowa

IOK = Internationales Olympisches Komitee

Io|ka|ste (Mutter u. Gattin des Ödipus)

Io|lan|the (w. Vorn.)

Ion gr. (elektr. geladenes atomares od. molekulares Teilchen) s; -s

...ion (z. B. Reduktion w; -, -en)

Io|nen_an|trieb, ...strah|len (Mehrz.)

Io|nes|co [jonäsko] (fr. Dramatiker rumänischer Abstammung)

Io|ni|en [...iᵉn; auch: jo...] (Küstenlandschaft Kleinasiens); Io|ni|er [...iᵉr; auch: jo...]

Io|ni|sa|ti|on gr. [...zion] (Versetzung neutraler materieller Teilchen in elektr. geladenen Zustand)

io|nisch [auch: jo...]; -er Vers, Stil aber (↑ R 198): die Ionischen Inseln

io|ni|sie|ren gr. (Ionisation bewirken); Io|ni|sie|rung

Io|no|sphä|re gr. (oberste Schicht der Atmosphäre) w; -

Io|ta usw. vgl. Jota usw.

Io|wa [ai̯ᵉwᵉ] (Staat in den USA; Abk.: Ia. od. Io.)

Ipe|ka|ku|an|ha indian. [...anja (Brechwurzel, Heilpflanze) w; -

Iphi|ge|nie [...iᵉ] (Tochter Agamemnons)

i. p. i. = in partibus infidelium

ip|se fe|cit lat. [- fezit] (,,er hat [es] selbst gemacht", Abk.: i. f.)

ip|sis|si|ma ver|ba [- wärba] (völlig, nur die eigenen Worte); ip|so fac|to [- fakto] (,,durch die Tat selbst"; eigenmächtig); ip|su|re (,,durch das Recht selbst" ohne weiteres)

I-Punkt (↑ R 149) m; -[e]s, -e

IQ = Intelligenzquotient

Ir = chem. Zeichen für: Iridium

IR. = Infanterieregiment

i. R. = im Ruhestand[e]

IR. = Imperator Rex

Ira|de arab. (,,Wille"; früher: ein Erlaß des Sultans) m od. s; -s, -s

Irak [auch: irak] (auch mit Geschlechtsw.: m; -s; vorderasia Staat); Ira|ker; ira|kisch

Iran (auch mit Geschlechtsw.: m -s; asiat. Staat); vgl. Persien; Ira

ner; ira|nisch; Ira|nist (Kenner u. Erforscher des Irans); ↑ R 268; Ira|ni|stik (Irankunde) w; - Ir|bis mong. (Schneeleopard) m; -ses, -se

ir|den (aus „Erde"); -e Ware; Ir|den.ge|schirr, ...wa|re; ir|disch; -ste (↑ R 294)

Ire (Irländer) m; -n, -n (↑ R 268); Ire|land [ai²rl²nd] (engl. für. Ir land)

Ire|nä|us (gr. Kirchenvater)

Ire|ne (w. Vorn.); Ire|nik (Friedenslehre; Friedensstreben, Aussöhnung [bei kirchl. Streitigkeiten]) w; ↑ irg|nisch

ir|gend; wenn du irgend kannst, so ...; wenn irgend möglich; irgend so ein Bettler. I. Zusammenschreibung: irgendein; irgendeinmal; irgendwann; irgendwas (ugs. für: irgend etwas); irgendwelch; irgendwer; irgendwie; irgendwo anders, irgendwo sonst, sonst irgendwo; irgendwoher, irgendwohin; irgendworan. II. Getrenntschreibung, da „jemand" u. „etwas" größere Selbständigkeit bewahren: irgend jemand, irgend etwas

Irid|ek|to|mie gr. (Med.: Ausschneiden der Regenbogenhaut) w; -, ...ien; Iri|di|um (chem. Grundstoff, Metall; Zeichen: Ir) s; -s; Iri|do|lo|ge (Augendiagnostiker) m; -n, -n (↑ R 268); Iri|do|lo|gie w; -

-rin (Irländerin) w; -, -nen

Iris (gr. Götterbotin); ²Iris gr. (Regenbogen; Regenbogenhaut im Auge; Schwertlilie) w; -, -; Iris|blen|de (Optik: verstellbare Blende für gleichen Strahlengang)

-risch; (↑ R 200:) das -e Bad, aber (↑ R 198): die Irische See; Irish-Stew engl. [airish βtjy] (Weißkraut mit Hammelfleisch u. a.) s; -[s]

-ri|sie|ren gr. (in Regenbogenfarben schillern); Iri|tis (Entzündung der Regenbogenhaut) w; -, ...itjden

RK = Internationales Rotes Kreuz

r|kutsk (Gebiet und Stadt in Sibirien)

-r|land (nordwesteurop. Insel); Ir|län|der; Ir|län|de|rin w; -, -nen; ir|län|disch, aber (↑ R 198): Irländisches Moos (Karrageen)

-r|ma (w. Vorn.); Irm|gard (w. Vorn.)

-r|min|säu|le, Ir|min|sul (germ. Heiligtum) w; -

-rm|traud (w. Vorn.)

ro|ke|se (Angehöriger eines nordamerik. Indianerstammes) m; -n, -n (↑ R 268)

ro|nie gr. ([versteckter, feiner]

Spott, Spöttelei) w; -, ...jen; Iro|ni|ker; iro|nisch; -ste (↑ R 294); iro|ni|sie|ren

irr, ir|re (vgl. d.)

Ir|ra|dia|ti|on lat. [...zion] (Ausstrahlung [von Schmerzen, Gefühlen, Affekten]; Überbelichtung fotografischer Platten)

ir|ra|tio|nal lat. [auch: irazional] (verstandesmäßig nicht faßbar; vernunftwidrig; unberechenbar); -e Zahl; Ir|ra|tio|na|lis|mus (Ausschaltung der Vernunft) m; -; Ir|ra|tio|nal|zahl (Math.)

ir|re, irr; irr[e] sein, werden; vgl. aber: irreführen, irregehen, irreleiten, irremachen, irrereden; ¹Ir|re w; -; in die - gehen; ²Ir|re m u. w; -n, -n (↑ R 287ff.)

ir|re|al lat. [auch: ...al] (unwirklich); Ir|re|al [auch: ...al] (Zeitwortform der Unwirklichkeit) m; -s, -e; Ir|rea|li|tät [auch: ir...] (Unwirklichkeit)

Ir|re|den|ta it. („unerlöstes" Italien; urspr. nur it., übertr.: jede polit. Bewegung, die den staatl. Anschluß abgetrennter Gebiete an das Mutterland erstrebt) w; -, ...ten; Ir|re|den|tis|mus (Geisteshaltung der Irredenta; polit. Bewegung) m; -; Ir|re|den|tist (↑ R 268); ir|re|den|ti|stisch

ir|re|füh|ren; seine Darstellungsweise hat mich irregeführt; eine irreführende Auskunft; Ir|re|füh|rung; ir|re|ge|hen; er ist irregegangen, obwohl ich ...

ir|re|gu|lär lat. [auch: ...är] (unregelmäßig, ungesetzmäßig); -e Truppen (die nicht zum eigentl. Heer gehören); Ir|re|gu|lä|re (nicht zum eigentl. Heer Gehörender) m; -n, -n (↑ R 287ff.); Ir|re|gu|la|ri|tät [auch: ir...] (Unregelmäßigkeiten)

ir|re|lei|ten; der Dieb hat die Polizei irregeleitet; ein irregeleitetes Kind

ir|re|le|vant lat. [auch: ...want] (unerheblich, belanglos); Ir|re|le|vanz [auch: ...anz] w; -, -en

ir|re|li|gi|ös lat. [auch: ...öß] (religionslos); ein -er Mann; Ir|re|li|gio|si|tät [auch: ir...]

ir|re|ma|chen; er hat mich irregemacht; ir|ren; sich -; (↑ R 120:) Irren (auch: irren) ist menschlich; Ir|ren.an|stalt, ...arzt, ...haus

ir|re|pa|ra|bel lat. [auch: ...ab²l] (unersetzlich, nicht wiederherstellbar); ...a|bler Verlust

ir|re|po|ni|bel lat. [auch: ...ib²l] (Med.: nicht einrenkbar); ...i|ble Gelenkköpfe

ir|re|re|den; er hat irgeredet; ir|re sein, irr sein; Ir|re|sein, Irr|sein s; -s (↑ R 120)

ir|re|spi|ra|bel lat. [auch: ...ab²l]

(zum Einatmen untauglich); ...a|ble Luft

ir|re|ver|si|bel lat. [auch: ...wärsib²l] (nicht umkehrbar); ...i|ble Vorgänge

ir|re wer|den, irr wer|den; Ir|re|wer|den, Irr|wer|den s; -s (↑R 120); Irr.fahrt, ...gang, m, ...garten, ...glaube(n); irr|gläu|big; ir|rig; ir|ri|ger|wei|se

Ir|ri|ga|ti|on lat. [...zion] (med. Abod. Ausspülung); Ir|ri|ga|tor (med. Spülapparat) m; -s, ...oren

ir|ri|ta|bel lat. [auch: ...a|bler Mensch; Ir|ri|ta|bi|li|tät w; -; Ir|ri|ta|ti|on [...zion] (Reiz, Erregung); ir|ri|tie|ren ([auf]reizen, erregen, beirren, stören, unsicher machen)

Irr.läu|fer (falsch beförderter Gegenstand), ...leh|re, ...licht (Mehrz. ...lichter); irr|lich|te|lie|ren (in Goethes Faust: wie ein Irrlicht hin u. her fahren); irr|lich|tern; es irrlichtert; gerirrlichtert; Irr|nis (veralt.) w; -, -se; Irr|sal (dicht.) s; -[e]s, -e; irr sein, ir|re sein; Ir|re|sein, Irr|sein m; -[e]s; irr|sin|nig; Irr|sin|nig|keit w; -; Irr|tum m; -s, ...tümer; irr|tüm|lich; Irr|tüm|li|cher|wei|se; Irr|tums|quel|le; Ir|rung (veralt. für: Irrtum); Irr|weg; ir wer|den, ir|re werden; Irr|wer|den vgl. Irrewerden; Irr|wisch (Irrlicht; sehr lebhafter Mensch); irr|wit|zig

Ir|tysch (linker Nebenfluß des Ob)

Ir|vin|gia|ner [...winggia̯²r] (Anhänger des engl. Predigers E. Irving); Ir|vin|gia|nis|mus m; -

Isa (mohammedan. Name für: Jesus)

Isaak [isa-ak (bei dieser Ausspr. Trennung: Isa|ak), auch: isak od. isąk] (bibl. m. Vorn.)

Isa|bel|la, ¹Isa|bel|le (w. Vorn.); ²Isa|bel|le (falbes Pferd) w; -, -n; isa|bell|far|ben, isa|bell|far|big (graugelb)

Is|ago|ge gr. (in der Antike: Einleitung [in eine Wissenschaft]) w; -, -n; Is|ago|gik (Einleitungskunst, -wissenschaft) w; -

Isai|as (Schreibung der Vulgata für: Jesaja)

Is|ane|mo|ne gr. (Meteor.: Verbindungslinie von Punkten gleicher Windstärke) w; -, -n

Is|ano|ma|le w; (Meteor.: Linie gleicher Abweichung von Normalwerten) w; -, -n

Isar (r. Nebenfluß der Donau) w; -; Isar-Athen; ↑ R 212 (scherzh. für: München)

Isa|tin s; (eine Indigoverbindung) w; -s; Isa|tis [auch: is...] (Waid, Gattung der Kreuzblütler) w; -

Isau|ri|en (antike Landschaft in Kleinasien)

Isch|ämie gr. [iß-ch...] (Med.: Blutverhaltung, -leere) w; -, ...ien

Is|cha|ri|ot hebr. [isch...]; vgl. Judas

Is|chia [ißkia] (it. Insel)

is|chia|disch gr. [iß-chia...[1]] (den Ischias betreffend); Is|chi|al|gie [iß-chial...[1]] w; - u. Is|chi|as [iß-chiaß[1]] (Hüftweh) m (auch: s, seltener, fachspr. auch: w); -; Is|chi|as|nerv

Ischl, Bad (österr. Badeort)

Isch|tar vgl. Istar

Isch|urie gr. [iß-ch...] (Med.: Harnverhaltung) w; -, ...ien

[1]Ise|grim (der Wolf in der Tierfabel); [2]Ise|grim (mürrischer Mensch) m; -s, -e

Isel (Berg in Tirol) m; -[s]

Iser (r. Nebenfluß der Elbe) w; -; Iser|ge|bir|ge s; -s

Iser|lohn (Stadt im Sauerland)

Isi|dor (m. Vorn.)

Isis (altägypt. Göttin)

Is|ka|ri|ot vgl. Judas

Is|ken|de|run (türk. Hafenstadt)

Is|lam arab. [auch: ...lạm] (Lehre Mohammeds) m; -s; is|la|misch (mohammedanisch); Is|la|mismus (Islam) m; -; Is|la|mịt m; -en, -en (↑ R 268); is|la|mi|tisch

Is|land; Is|län|der m; is|län|disch; -e Sprache, aber (↑ R 224): Isländisch[es] Moos (eine Heilpflanze); Is|län|disch (Sprache) s; -[s]; vgl. Deutsch; Is|län|di|sche s; -n; vgl. Deutsche s

Is|ma|el [...aäl] (bibl. m. Vorn.); Is|mae|lịt (Angehöriger einer mohammedan. Sekte) m; -en, -en (↑ R 268)

Is|me|ne (Tochter des Ödipus)

Is|mus gr. (abwertende Bez. für eine bloße Theorie) m; -, ...men

ISO = International Organization for Standardization [int^er-näsch^en^el o^rg^enaise'sch^en fo^r ßtänd^edaise'sch^en] (internationale Normierungsorganisation) w; -

iso... gr. (gleich...); Iso... (Gleich...); Iso|ba|re (Meteor.: Verbindungslinie zwischen Orten gleichen Luftdrucks) w; -, -n; Iso|bu|tan (gesättigter Kohlenwasserstoff) s; -s

Iso|chas|me gr. [...chaß...] (Meteor.: Verbindungslinie zwischen Orten gleicher Polarlichthäufigkeit) w; -, -n; Iso|chi|me|ne [...chi...] (Meteor.: Verbindungslinie zwischen Orten gleicher mittlerer Wintertemperatur) w; -, -n; Iso|chio|ne [...chi...] (Meteor.:

[1] Oft auch: ischiad..., ischial..., ischiaß.

Verbindungslinie zwischen Orten gleichen Schneefalls) w; -, -n; Iso|chro|ma|sie [...kro...] (gleiche Farbempfindlichkeit von fotogr. Material); iso|chro|ma|tisch (gleichfarbig, farbtonrichtig); iso|chron [...krọn] (Physik: gleich lange dauernd); Iso|chro|ne (Linie gleichzeitigen Auftretens [Erdbebenwelle u. a.]) w; -, -n; Iso|chro|nis|mus (gleichzeitiges Ablaufen von Uhren) m; -

Iso|dy|na|me gr. (Verbindungslinie zwischen Orten mit gleicher magnet. Stärke) w; -, -n; Iso|dy|ne (Physik: Linie, die Punkte gleicher Kraft verbindet) w; -, -n

Iso|ga|mie gr. (Biol.: Fortpflanzung durch gleichgestaltete Geschlechtszellen) w; -, ...ien

Iso|geo|ther|me gr. (Meteor.: Verbindungslinie zwischen Orten gleicher Erdbodentemperatur) w; -, -n; Iso|glos|se (Linie auf Sprachkarten, die Gebiete gleichen Wortgebrauchs begrenzt) w; -, -n; Iso|gon (regelmäßiges Vieleck) s; -s, -e; iso|go|nal (winkelgetreu; gleichwinklig); Iso|gone (Meteor.: Verbindungslinie zwischen Orten gleicher magnet. Abweichung od. gleichen Windes) w; -, -n

Iso|hy|e|te gr. (Meteor.: Verbindungslinie zwischen Orten mit gleicher Niederschlagsmenge) w; -, -n; Iso|hyp|se (Geogr.: Verbindungslinie zwischen Orten mit gleicher Höhe ü. d. M.) w; -, -n

Iso|ke|pha|lie gr. (gleiche Kopfhöhe aller Gestalten eines Gemäldes od. Reliefs) w; -

Iso|kli|ne gr. (Geogr.: Verbindungslinie zwischen Orten mit gleicher Neigung der Magnetnadel); Iso|kry|me (Meteor.: Verbindungslinie zwischen Orten mit gleicher Eisbildung auf Gewässern) w; -, -n

Iso|la|ti|on [...ziọn], Iso|lie|rung fr. ([politische u. a.] Absonderung; Abkapselung; Getrennthaltung; [Ab]dämmung, Sperrung); w; -; Iso|la|tio|nis|mus lat. (polit. Tendenz, sich vom Ausland abzuschließen) m; -; Iso|la|tio|nist (↑ R 268); iso|la|tio|ni|stisch; Iso|la|tor (Stoff, der Energieströme schlecht od. gar nicht leitet; Nichtleiter) m; -s, ...oren

Isọl|de (mittelalterl. Sagengestalt; w. Vorn.)

Iso|lier|band s (Mehrz. ...bänder); iso|lie|ren fr. (absondern, abkapseln; getrennt halten; abschließen, [ab]dichten, [ab]dämmen, sperren; einen Isolator anbringen); Iso|lie|rer; Iso|lier-fla|sche, ...ma|te|ri|al, ...schicht, ...sta|ti-

on; iso|liert (auch für: vereinsamt); Iso|liert|heit w; -; Iso|lie|rung vgl. Isolation

Iso|li|ni|en (Sammelbez. für alle Linien auf geogr., meteor. u. sonstigen Karten, die Punkte gleicher Wertung od. Erscheinung verbinden) Mehrz.

Iso|mer gr. (Isomerie aufweisend); Iso|mer s; -s, -e u. Iso|me|re (eine chem. Verbindung) s; -n, -n (meist Mehrz.); Iso|me|rie (Gleichzähligkeit in bezug auf die Zahl der Glieder in den verschiedenen Blütenkreisen; unterschiedliches Verhalten chem. Verbindungen trotz der gleichen Anzahl gleichartiger Atome) w; -; Iso|me|trie (Längengleichheit Längentreue, bes. bei Landkarten) w; -; iso|me|trisch; Iso|trop (Med.: gleichsichtig [auf beiden Augen]); iso|morph (gleichförmig, von gleicher Gestalt, bes. bei Kristallen); Iso|mor|phie w; -; Iso|mor|phis|mus (Eigenschaft gewisser chem. Stoffe, gemeinsam dieselben Kristalle zu bilden) m; -

Iso|ne|phe gr. (Meteor.: Verbindungslinie zwischen Orten mi gleich starker Bewölkung) w; --n

Isọn|zo (Zufluß des Golfs vor Triest) m; -[s]

iso|pe|ri|me|trisch gr. (von gleichem Ausmaß [von Längen, Flächen u. Körpern]); Iso|po|de (Assel) m; -n, -n (meist Mehrz.); ↑ R 268

Iso|pren (flüssiger, ungesättigter Kohlenwasserstoff) s; -s

Isor|rha|chie gr. [...ehi^e] (Verbindungslinie zwischen Orten mi gleichzeitigem Fluteintritt) w; -, -n

Iso|sei|ste gr. (Verbindungslini zwischen Orten mit gleicher Erdbebenstärke) w; -, -n

Iso|sta|sie gr. (Gleichgewichtszustand der Krustenschollen der Erde) w; -

Iso|ta|lan|to|se gr. (Meteor.: Verbindungslinie zwischen Orten mit gleicher jährl. Temperaturschwankung) w; -, -n; Iso|the|re (Meteor.: Verbindungslinie zwischen Orten mit gleich starker Sommernebestrahlung) w; -, -n; Iso|ther|me (Meteor.: Verbindungslinie zwischen Orten mit gleicher Temperatur) w; -, -n

Iso|ton (Atomkerne mit gleicher Anzahl Neutronen) s; -s, -e (meist Mehrz.); iso|to|nisch (von gleichem osmot. Druck); Iso|top s; -s, -e (Atome eines chem. Elementes mit gleicher Ordnungszahl und gleichen chem. Eigen-

schaften, aber mit verschiedener Masse); Iso|to|pen.dia|gno|stik, ...tren|nung, ...the|ra|pie; Iso|tron (Gerät zur Isotopentrennung) s; -s, ...tro̱ne (auch: -s); iso|trop (Physik: nach allen Richtungen hin gleiche Eigenschaften aufweisend)

Is|ra|el [...aäl] (Volk der Juden im A. T.; Staat in Vorderasien); das Volk -; die Kinder -[s]; Is|rae̱|li (Angehöriger des Staates Israel) m; -[s], -[s]; is|rae|lisch (zum Staat Israel gehörend); Is|rae|lit (Angehöriger eines der semit. Stämme in Palästina) m; -en, -en (↑ R 268); is|rae|li|tisch

..ist (z. B. Romanist m; -en, -en; ↑ R 268)

Istan|bul [auch: ...buɫ] (heutiger Name von: Konstantinopel)

Istar, Isch|tar (babylon. Göttin)

Ist-Auf|kom|men (der tatsächliche [Steuer]ertrag) s; -s, - (↑ R 151); Ist-Be|stand m; -[e]s, ...stände (↑ R 151)

isth|misch gr., aber (↑ R 224): Isthmische Spiele; Isth|mus (Landenge, bes. die von Korinth) m; -, ...men

istri|en [...i°n] (Halbinsel im Adriatischen Meer)

Ist-Stärke w; -, -n (↑ R 151)

Ist|wä|o|nen (Kultgemeinschaft westgerm. Stämme) Mehrz.; istwä|o|nisch

Is|we|sti|ja russ. („Nachrichten"; eine Moskauer Abendzeitung) w; -

it. = item

i. T. = in [der] Trockenmasse

Ita|la lat. (älteste lat. Bibelübersetzung) w; -; Ita|ler (Angehöriger der alten Bewohner von Italia) -; Ita|lia (lat. u. it. Form von: Italien); ita|lia|ni|sie|ren, ita|lie-n|sie|ren (italienisch machen); Ita|lien [...i°n]; Ita|lie|ner; ita|lienisch; die -e Schweiz; eine -e Nacht (↑ R 200); italienischer Salat (↑ R 224); aber (↑ R 198): die Italienische Republik; vgl. deutsch; vgl. aber: italisch; Ita|lie|nisch (Sprache) s; -[s]; vgl. Deutsch; Ita|lie|ni|sche s; -n; vgl. Deutsche s; ita|lie|ni|sie|ren, ita|lia|ni|sieren (vgl. d.); Ita|li|enne fr. [...liän] (eine Schriftart) w; -; Ita|li|ker lat. (Italer); Ita|lique fr. [...lik] (eine Schriftart) w; -; ita|lisch (das antike Italien betreffend); vgl. aber: italienisch

ta|zis|mus (Aussprache der altgr. E-Laute wie langes i) m; -

item lat. [auch: it...] (veralt. für: ebenso, desgleichen; ferner; Abk.: it.); Item [auch: it...] (veralt. für: das Fernere, Weitere, ein [Frage]punkt) s; -s, -s

ite|ra|tiv lat. (wiederholend); Ite|ra|tiv (Sprachw.: Zeitw., das eine stete Wiederholung von Vorgängen ausdrückt, z. B. „flattern" = ständig mit den Flügeln schlagen) s; -s, -e [...wᵉ]

Itha|ka [auch: it...] (gr. Insel)

Iti|ne|rar lat. s; -s, -e u. Iti|ne|ra|ri|um (Straßenverzeichnis der röm. Zeit; Verzeichnis der Wegeaufnahmen bei Forschungsreisen) s; -s, ...ien [...i°n]

I-Tüp|fel|chen (↑ R 149); I-Tüp|ferl österr. (I-Tüpfelchen); s; -s, -n; I-Tüp|ferl-Rei|ter österr. ugs. (Pedant)

It|ze|hoe [...ho] (Stadt in Schleswig-Holstein); It|ze|ho|er (↑ R 199)

jt|zo, jtzt, jtz|und (veralt. für: jetzt)

IV = Invalidenversicherung (in der Schweiz)

i. V., I. V. = in Vertretung; in Vollmacht; Klein- od. Großschreibung entsprechend „i. A."

Ivo (m. Vorn.)

Iwan (russ. Form von: Johann[es]; als Spitzname für den russ. Soldaten) m; -s, -s

Iwein (Ritter der Artussage)

i wo! (ugs. für: keineswegs)

Iwrith (Neuhebräisch; Amtssprache in Israel); s; -[s]

Iz|mir [iß...] (heutiger Name von: Smyrna)

J

J [jot, österr.: je] (Buchstabe); das J; des J, die J, aber: das j in Boje (↑ R 123); der Buchstabe J, j; vgl. auch: Jot

J = chem. Zeichen für: Jod; Joule

ja; ja und nein sagen; jaja!, (auch:) ja, ja!; jawohl; ja freilich; ja doch; aber ja; na ja; nun ja; ach ja; zu allem ja und amen sagen (ugs.). Großschreibung (↑ R 119): das Ja und [das] Nein; mit [einem] Ja antworten; mit Ja oder [mit] Nein stimmen; die Folgen seines Ja[s]

Ja|bot fr. [schabo] (Spitzenrüsche [an Hemden usw.]) s; -s, -s

Jacht, (Seemannsspr. auch:) Yacht niederl. ([luxuriös eingerichtetes] Schiff für Sport- u. Vergnügungsfahrten, auch: Segelboot) w; -, -en; Jacht|klub

Jack [dschäk] (engl. Form [neben John] von: Johann[es])

Jäck|chen, Jäck|lein; Jacke² arab.-fr. w; -, -n

¹ Vgl. S. 345, Spalte 1, Anm. 1.
² Trenn.: ...k|k...

Jäckel¹ (Koseform von: Jakob; als verächtl. Bez. für einen dummen Menschen) m; -s, -

Jacken.kleid¹, ...ta|sche; Jacketkro|ne¹ engl. [dschäkit...] (Porzellanmantelkrone, Zahnkronenersatz); Jackett¹ fr. [scha...] (Jäckchen; [kurze] Jacke) s; -s, -e u. -s; Jackettasche¹ [Trenn.: Jackett|ta|sche¹, ↑ R 236]; Jäckloin, Jäck|chen

Jack|stag engl.; dt. [dschäk...] (Seemannsspr.: Eisen zum Festmachen von Segeln; Gleitschiene)

Jac|quard.ge|we|be (↑ R 180) [schakar...; nach dem fr. Erfinder Jacquard], ...ma|schi|ne (Vorrichtung am Webstuhl)

Jacques [schak] (fr. Form von: Jakob)

¹Ja|de (Zufluß der Nordsee) w; -

²Ja|de fr. (ein Mineral; blaßgrüner Schmuckstein) m (auch: w); -

Ja|de|bu|sen (Nordseebucht bei Wilhelmshaven); vgl. ¹Jade

ja|de|grün; vgl. ²Jade

Ja|fet vgl. Japhet

Jaf|fa (Teil der Stadt Tel Aviv-Jaffa in Israel); Jaf|fa|ap|fel|si|ne (↑ R 201)

Jagd w; -, -en; jagd|bar; Jagd.auf|se|her, ...bar|keit (w; -), ...beu|te, ...ei|fer, ...fie|ber, ...flie|ger, ...flin|te, ...flug|zeug, ...ge|nossen|schaft, ...ge|schwa|der, ...gewehr, ...glück, ...grün|de (Mehrz.; die ewigen -), ...horn (Mehrz. ...hörner), ...hund, ...hüt|te; jagd|lich; Jagd.mes|ser s, ...päch|ter, ...ren|nen (Pferdesport), ...re|vier, ...schein, ...schloß, ...si|gnal, ...sprin|gen (Pferdesport), ...staf|fel (Verband von Kampfflugzeugen), ...tro|phäe, ...wurst, ...zeit

Ja|gel|lo|ne (Angehöriger eines lit.-poln. Königsgeschlechtes) m; -n, -n (↑ R 268)

ja|gen; er jagt; gejagt; Ja|gen (forstl. Wirtschaftsfläche) s; -s, -; Jä|ger; Ja|ge|rei (fortwährendes Hetzen) w; -; Jä|ge|rei (Ausübung der Jagd; Gesamtheit der Jäger) w; -; jä|ger|haft; Jä|ger.la|tein, ...mei|ster; Jä|ger|schaft w; -; Jä|gers|mann (veralt., dicht.; Mehrz. ...leute); Jä|ger|spra|che w; -

Ja|giel|lo|ne vgl. Jagellone

Ja|go (span. Form von: Jakob)

Jagst r. (Nebenfluß des Neckars) w; -

Ja|gu|ar indian. (ein Raubtier) m; -s, -e

jäh; Jä|he w; -; Jä|heit (↑ R 163) w; -; jäh|lings

Jahn (der „Turnvater")

Jahnn, Hans Henny (dt. Dichter)

¹ Trenn.: ...k|k...

Jahr s; -[e]s, -e; im -[e] (Abk.: i. J.); laufenden -es (Abk.: lfd. od. l. J.); künftigen -es (Abk.: k. J.); nächsten -es (Abk.: n. J.); ohne - (Abk.: o. J.); vorigen -es (Abk.: v. J.); dieses -es (Abk.: d. J.); über - und Tag; - für -; von - zu -; zwei, viele -e lang; er ist über (mehr als) 14 -e alt; Schüler ab 14 Jahre[n], bis zu 18 Jahren; ein Laufbursche nicht unter 14 -en; zum neuen -e (↑ R 224) Glück wünschen; vgl. achtziger; **jahr|aus**, **jahr|ein**; **Jahr|buch**; **Jähr|chen**, Jähr|lein; **jah|re|lang**, aber: zwei, viele Jahre lang; **jäh|ren**, sich; **Jah|res.abon|ne|ment**, ...**ab|schluß**, ...**aus|stoß**, ...**be|ginn**, ...**bei|trag**, ...**be|richt**, ...**ein|kom|men**, ...**en|de**, ...**frist** (innerhalb -), ...**ring** (meist Mehrz.), ...**tag**, ...**um|satz**, ...**ur|laub**, ...**wech|sel**, ...**wen|de**, ...**zahl**, ...**zeit**; **jah|res|zeit|lich**; **Jahr|fünft** s; -[e]s, -e; **Jahr.gang** (m; Abk.: Jg.; Mehrz. ...gänge [Abk.: Jgg.]), ...**gän|ger** (südd., westösterr. u. schweiz.: Person desselben Geburtsjahres); **Jahr|hun|dert** (Abk.: Jh.) s; **jahr|hun|der|te|alt**, aber: zwei, viele Jahrhunderte alt; **jahr|hun|der|te|lang**; vgl. jahrhundertealt; **Jahr|hun|dert.fei|er**, ...**mit|te**, ...**wein**, ...**wen|de**; **jäh|rig** (veralt.: ein Jahr her; ein Jahr dauernd; ein Jahr alt); ...**jäh|rig** (z. B. vierjährig, mit Ziffer: 4jährig [vier Jahre dauernd, vier Jahre alt]); ein Fünfjähriger (mit Ziffer: 5jähriger); zwei dreijährige mit Ziffer: 3jährige) Pferde; **Jähr|lein**, Jähr|chen; **jähr|lich** (jedes Jahr wiederkehrend); die jährliche Wiederkehr der Zugvögel; ...**jähr|lich** (z. B. alljährlich [alle Jahre wiederkehrend], vierteljährlich); **Jähr|ling** (einjähriges Tier); **Jahr|markt**; **Jahr|marktsbu|de**; **Jahr|mil|lio|nen** Mehrz.; in -; **Jahr|tag** (kath. Kirche: Gottesdienst zum Gedenken an einen Verstorbenen); **Jahr|tau|send** (vgl. Jahrhundert) s; **Jahr|wei|ser** (Kalender); **Jahr|zehnt** s; -[e]s, -e; **jahr|zehn|te|lang**, aber: zwei, viele Jahrzehnte lang **Jah|ve**, (ökum.:) **Jah|we** [jawe] (Name Gottes im A. T.); vgl. auch: Jehova **Jäh|zorn**; **jäh|zor|nig** **Jai|rus** (bibl. m. Eigenn.) **ja|ja** vgl. ja **Jak** tibet. (asiat. Hochgebirgsrind) m; -s, -s; vgl. auch: Yak **Ja|ka|ran|da|holz** indian.; dt. (svw. Palisander) **Ja|ko** fr. (eine Papageienart) m; -s, -s **Ja|kob** (m. Vorn.); (↑ R 224:) der

wahre - (ugs. für: der rechte Mann, das Rechte); der billige - (ugs.: Verkäufer auf Jahrmärkten); **Ja|ko|bi** (Jakobitag) s; -; **Jako|bi|ne** (w. Vorn.); **Ja|ko|bi|ner** (Angehöriger der radikalsten Partei in der Fr. Revolution); **Jako|bi|ner|müt|ze**; **Ja|ko|bi|nertum** s; -s; **Ja|ko|bi|tag**, **Ja|kobstag**; **Ja|kobs|lei|ter** (Himmelsleiter; Seemannsspr.: Strickleiter) w; -, (für Strickleiter Mehrz.:) -n; **Ja|kobs|stab** (Astron.: veralt. Winkelmeßgerät); **Ja|ko|bus** (Apostel); (↑ R 224:) - der Ältere, - der Jüngere **Ja|ku|te** (Angehöriger eines nordasiat. Steppenvolkes) m; -n, -n (↑ R 268) **Ja|la|pe** (trop. Windengewächs) w; -, -n **Ja|lon** fr. [schalong] (Absteckpfahl; Fluchtstab [für Vermessungen]) m; -s, -s **Ja|lou|set|te** fr. [schalu...] (Jalousie aus Leichtmetall- od. Kunststofflamellen) w; -, -n; **Ja|lou|sie** [schalu...] ([hölzerner] Fensterschutz, Rolladen) w; -, ...jen; **Jalou|sie.schrank** (Rollschrank), ...**schwel|len** (bei der Orgel) **Jal|ta** (Hafenstadt auf der Krim); **Jal|ta-Ab|kom|men**; ↑ R 202 **Jam** engl. [dschäm] (engl. Bez. für: Marmelade) s; -s, -s **Ja|mai|ka** (Insel der Großen Antillen); **Ja|mai|ka|ner**, (auch:) Jamai|ker; **ja|mai|ka|nisch**, (auch:) **ja|mai|kisch**; **Ja|mai|ka-Rum** m; -s (↑ R 202) **Jam|be** gr. w; -, -n u. **Jam|bus** (ein Versfuß) m; -, ...ben; **jam|bisch** **Jam|bo|ree** engl. [dschämb^e r i] ([Pfadfinder]treffen; Zusammenkunft) s; -[s], -s **Jam|bus** vgl. Jambe **James** [dschė'ms] (engl. Form von: Jakob) **James Grieve** engl. [dschė'ms griw] (eine Apfelsorte) m; - -, - -; vgl. Grieve **Jam|mer** m; -s; **Jam|mer.bild**, ...**ge|schrei**, ...**ge|stalt**, ...**ge|stell** (ugs.), ...**lap|pen** (ugs.); **jäm|merlich**; **Jäm|mer|lich|keit**; **Jäm|merling**; **jam|mer|mie|ne**; **jam|mern**; ich ...ere (↑ R 327); er jammert mich; es jammert mich; **jam|merscha|de**; es ist -; **Jam|mer|tal** s; -[e]s; **jam|mer|voll** **Jam Ses|sion** engl. [dschäm bäsch^e n] (zwanglose Zusammenkunft von Jazzmusikern zu gemeinsamem Spiel) w; - -, - -s **Jams|wur|zel** engl.; dt. (eine trop. Staude) **Jan** (niederl. Form von: Johann[es]) **Jan.** = Januar

Ja|ná|ček [janatschäk] (tschech. Komponist) **Jane** [dsehė'n] (engl. Kurzform von: Johanna); vgl. Mary Jane **Jang|tse** m; -[s] u. **Jang|tse|ki|ang** (chin. Strom) m; -[s] **Jan|ha|gel** [auch: janhag^e l] (veralt. für: Pöbel) m; -s **Ja|ni|cu|lus mons** [auch: janikuluß monß] m; - - u. **Ja|ni|ku|lus** [auch: janik...] (Hügel in Rom) m; - **Ja|nit|schar** türk. (Angehöriger der ehem. türk. [Kern]truppe) m; -en, -en (↑ R 268) **Jan|ker** südd., österr. (Jacke. [Haus]rock; dicke wollene Trachtenweste) m; -s, - **Jan Maat**, **Jan|maat** niederl. (scherzh. für: Matrose) **Jän|ner** lat. österr., seltener auch südd., schweiz. (Januar) m; -[s. (↑ R 319), - **Jan|se|nis|mus** (Lehre des Cornelius Jansen) m; -; **Jan|se|nist** (↑ R 268) **Ja|nu|ar** lat. (erster Monat im Jahr, Eismond, Hartung. Schneemond, Wintermonat Abk.: Jan.) m; -[s] (↑ R 319), -e. vgl. Jänner; **Ja|nu|a|ri|us** (it. Heiliger); **Ja|nus** (röm. Gott der Türen u. des Anfangs; **Ja|nus|ge|sicht** **Ja|nus|kopf** (doppelgesichtiger Männerkopf); ↑ R 180; **ja|nusköp|fig**; **Ja|nus|köp|fig|keit** w; **Ja|pan**; vgl. Nippon; **Ja|pa|ner**; **japa|nisch**, aber (↑ R 198): das Japanische Meer; vgl. deutsch. **Ja|pa|nisch** (Sprache) s; -[s]; vgl Deutsch; **Ja|pa|ni|sche** s; -n; vgl Deutsche s; **Ja|pa|no|lo|ge** jap. gr. (Erforscher der jap. Sprache u. Kultur) m; -n, -n (↑ R 268) **Ja|pa|no|lo|gie** (Japankunde) w; - **Ja|phet**, (ökum.:) **Ja|fet** (bibl. m. Eigenn.) **jap|pen** niederd. (japsen); **jap|sen** (ugs. für: nach Luft schnappen); du japst (japsest); **Jap|ser** **Jar|di|nie|re** fr. [schardiniär^e] (Blumenschale für lebende Blumen) w; -, -n **Jar|gon** fr. [schargong] ([schlechte Sondersprache einer Berufsgruppe od. Gesellschaftsschicht) m. -s, -s **Ja|sa|ger** **Jas|min** pers.-span. (Zierstrauch mit stark duftenden Blüten) m -s, -e **Jas|mund** (Halbinsel von Rügen) -er Bodden **Ja|son** (gr. Sage: Führer der Argonauten) **Jas|pis** semit. (ein Halbedelstein m; - u. -ses, -se **Jaß** (schweiz. u. südd. Kartenspiel) m; Jasses; **jas|sen** (Jaß spie

len); du jaßt (jassest); er jaßt; du
jaßtest; gejaßt; jaß! u. jasse!; **Ja̱s-
ser**
Ja̱|stim̱|me
Ja̱|ta̱|ga̱n *türk.* (gekrümmter Tür-
kensäbel) *m*; -s, -e
jä̱|ten
Jau̱|che *w*; -, -n; **ja̱u|chen; Jau-
che[n]..fa̱ß, ...gru̱|be, ...wa̱|gen**
Jau̱|chert (hochspr. für: Juchart)
ja̱u|chig
ja̱uch|zen; du jauchzt (jauchzest);
Jau̱ch|zer; vgl. juchzen
Jau̱|kerl österr. ugs. (Injektion) *s*;
-s, -n
ja̱u|len (klagend winseln, heulen)
Jau̱|se *slowen.* österr. (Zwischen-
mahlzeit, Vesper) *w*; -, -n; **ja̱u|sen**
(du jaust [jausest]) u. **ja̱us|nen;
Jau̱|sen.brot, ...sta̱|ti|on** (Gast-
stätte, in der man einen Imbiß
einnehmen kann), **...wurst, ...zeit**
Ja̱|va [...*wa*] (eine der Großen Sun-
dainseln); **Ja̱|va̱|ner; Ja̱|va̱|ne̱|rin**
w; -, -nen; **ja̱|va̱|nisch**
ja̱|wo̱hl
Ja̱|wort (*Mehrz.* ...worte)
Jazz *amerik.* [*dsehä̱ß*, veraltend,
abschätzig: *ja̱z*; engl. Aussrpr.:
dsehd̜s] (zeitgenöss. Musikstil,
der sich aus der Volksmusik der
amerik. Neger entwickelt hat) *m*;
-; **Jazz|band** [*dsehä̱sbänd*] (Jazz-
kapelle) *w*; **ja̱z|zen** [*dsehä̱ß̜'n*]; ge-
jazzt; **Ja̱z|zer** [*dsehä̱ß̜'r*] (Jazzmu-
siker) *m*; -s, -; **Ja̱zz|fan** [*dsehä̱s-
fän*] (jmd., der für Jazz begeistert
ist) *m*; -s, -s; **Jazz..fe̱|sti|val, ...ka-
pel|le, ...kel|ler, ...mu̱|sik, ...mu̱-
si|ker, ...trom|pe̱|ter**
je̱; seit je; je Person; je drei; je
zwei und zwei; je beschäftigter
Arbeiter od. je beschäftigten Arbei-
ter; je länger, je lieber (vgl.
a b e r : Jelängerjelieber); je mehr,
desto lieber; je kürzer, um so
schneller; je nachdem (vgl. d.);
je nach ...; je nun
Jean [*sehã̱*] (fr. Form von:
Johann[es],Hans); **Jeanne** [*sehã̱n*]
(fr. Form von: Johanna); **Jeanne
d'Arc** [*sehandạrk*] (Jungfrau von
Orleans); **Jean|nette** [*sehanạt*] (fr.
w. Vorn.); **Jean Paul** [*sehã̱ng paụl*,
eigtl.: Johann (Jean) Paul Fried-
rich Richter] (dt. Dichter)
Jeans vgl. Blue jeans
je̱|den|falls; vgl. Fall *m*
je̱|den|noch (veralt. für: jedoch)
je̱|der, jede, jedes; zu - Stunde,
Zeit; auf jeden Fall; er benutzt
jede Gelegenheit; zu Anfang je-
des Jahres, (häufig auch schon:)
jeden Jahres; († R 135:) das weiß
ein jeder; jeder beliebige kann
daran teilnehmen; jeder einzelne
wurde gefragt; alles und jedes (al-
les ohne Ausnahme); **je̱|der|le̱i;**
auf-Weise; **je̱|der|mann** († R 135);

es ist nicht -s Sache; **je̱|der|ze̱it**
(immer), a b e r : zu jeder Zeit; **je̱-
der|ze̱i|tig; je̱|des|ma̱l**, a b e r : ein
jedes Mal; **je̱|des|ma̱|lig**
je̱|do̱ch
je̱d|we̱|der (selten noch für: jeder),
jedwede, jedwedes; jedweden In-
halts; jedweder neue Versuch;
jedweder Angestellte
Jeep ⓦ *amerik.* [*dsehı̱p*] (kleiner
amerik. Kriegs-, Geländekraft-
wagen) *m*; -s, -s
je̱g|li|cher;↑ R 135 (selten noch für:
jeder); ein -; jegliches; jeglichen
Geschlechts; jeglicher Angestell-
te; frei von jeglichem neidischen
Gefühl
je̱|her [auch: *je̱her*]; von -
Je̱|ho̱|va [...*wa*] (unrichtig für: Jah-
we)
je̱in (ugs. für: weder *ja* noch *nein*,
zum Ausdruck der Entschlußlo-
sigkeit)
Je̱|län|ger|je̱|lie̱|ber (Geißblatt) *s*;
-s, -
je̱|mals
je̱|mand; *Wesf.* -[e]s, *Wemf.* -em
(auch: -), *Wenf.* -en (auch: -). I.
Kleinschreibung († R 135): irgend
jemand; sonst jemand; jemand
anders; von jemand anders re-
den; mit jemand anderem; je-
mand Fremdes. **II.** *Großschrei-
bung* († R 117): ein gewisser Je-
mand
je̱ mehr
Je̱|men (auch mit Geschlechtsw.:
m; -s); Arabische Republik Je-
men; Demokratische Volksrepu-
blik Jemen; **Je̱|me̱|nit** *m*; -en, -en
(↑ R 268); **je̱|me̱|ni̱tisch**
je̱|mi̱|ne! [entstellt aus *lat.*: Jesu do-
mine! = ,,o Herr Jesus!"] (ugs.);
ojemine!, herrjemine!
Je̱n vgl. Yen
Je̱|na (Stadt an der Saale)
je̱ nach|dem̱; je nachdem[,] ob/wie
(↑ R 63)
Je̱|na̱|er, (auch:) **Je̱|nen|ser** († R
199); Jenaer Glas; **je̱|na̱|isch**
je̱|ner, jene, jenes; in jener Zeit,
Stunde; ich erinnere mich jenes
Tages; († R 135:) da kam jener;
jener war es, der ...
je̱|nisch *zigeuner.* (außer den Zi-
geunern alles fahrende Volk be-
zeichnend); -e Sprache (Gauner-
sprache, Rotwelsch)
Je̱|nis|se̱i [*jenı̱ß*...] (sibir. Strom) *m*;
-[s]
Je̱n|ni, (auch:) **Je̱n|ny** (Kurzform
von: Eugen, Johanna, Johannes)
je̱n|se̱i|tig[1]; **Je̱n|se̱i|tig|ke̱it[1]** *w*; -;
je̱n|se̱its[1]; mit *Wesf.*: - des Flusses;
Je̱n|se̱its[1] *s*; -; **Je̱n|se̱its|glau|be[1]**
Je̱|re̱|mi̱a|de (Klagelied); **Je̱|re̱-
mi̱a**, **Je̱|re̱|mi̱:as** (bibl. Prophet);

die Klagelieder Jeremiä (des Jere-
mia)
Je̱|rez [*chᵉrä̱ß*, span.: *eherä̱th*] (ein
span. Wein) *m*; -; vgl. Sherry; **Je̱-
rez de la Fron|te̱|ra** (span. Stadt);
Je̱|rez|wein († R 201)
Je̱|ri|cho (jordan. Stadt); **Je̱|ri-
cho|ro|se** († R 201)
Je̱|ri|chow [...*cho*] (Stadt südöstl.
von Tangermünde)
Jé̱|rô̱me [*sehero̱m*] (fr. Form von:
Hieronymus)
Je̱r|sey *engl.* [*dsehö̱'si*] (eine Stoff-
art) *m*; -[s], -s (für Trikot des
Sportlers) *s*; -s, -s
je̱|rum!; ojerum!
Je̱|ru̱|sa̱|lem (die Heilige Stadt der
Juden, Christen u. Moham-
medaner)
Je̱|sa̱|ja (bibl. Prophet); vgl. Isaias
Je̱|su̱|it (Mitglied des Jesuitenor-
dens) *m*; -en, -en (↑ R 268); **Je̱|su̱i-
ten|or|den** (Gesellschaft Jesu;
Abk.: SJ) *m*; -s; **Je̱|su̱i|ten|tum** *s*;
-s; **je̱|su̱i|tisch**; **Je̱|sus** (,,Gott
hilft" [vgl. Josua]; bibl. m. Ei-
genn.); **Je̱|sus Chri̱|stus**; *Wesf.* Je-
su Christi, *Wemf.* - - u. Jesu Chri-
sto, *Wenf.* - - u. Je̱sum Chri̱stum,
Anredefall: - - u. Je̱su Chri̱ste;
Je̱|sus|kind *s*; -[e]s; **Je̱|sus Na̱|za-
re̱|nus Re̱x Ju̱|da̱eo̱|rum** *lat.* (,,Je-
sus von Nazareth, König der Ju-
den"; Abk.: I. N. R. I.); **Je̱|sus
People** *engl.* [*dsehı̱s'ß pı̱pl*] (welt-
weit verbreitete Jesusbewegung
der Jugend) *Mehrz.*; **Je̱|sus Si̱-
rach** (Verfasser einer bibl.
Spruchsammlung)
[1]Jet *engl.* [*dsehät*] (ugs. für: Düsen-
flugzeug) *m*; -[s], -s
[2]Jet [*dsehät*] vgl. Jett
Je̱|ton *fr.* [*seh⁴to̱ng*] (Zahlpfennig;
Spielmarke) *m*; -s, -s
Jet-set *engl.* [*dsehä̱tßät*] (sehr rei-
che, einflußreiche Spitze der in-
ternationalen High-Society) *m*;
-s; **Jet|stream** [*dschä̱tßtrı̱m*] (star-
ker Luftstrom in der Tropo- od.
Stratosphäre) *m*; -[s], -s
Jett, (fachspr.:) **Jet** *engl.* [*dsehä̱t*]
(Gagat) *m* od. *s*; -[e]s; **jett|ar|tig**
Jett|chen (Koseform von: Henri-
ette)
jet|ten *engl.* [*dsehä̱t'n*] (mit dem
'Jet fliegen); gejettet
je̱t|zig; je̱t|zo (veralt. für: jetzt);
je̱tzt; bis-; von - an; **Je̱tzt** (Gegen-
wart, Neuzeit) *s*; -; **Je̱tzt..mensch,
...zeit** (*w*; -)
Jeu *fr.* [*sehö̱*] ([Karten]spiel) *s*; -s,
-s
Jeu|nesse do|rée *fr.* [*sehönä̱ß dorḛ̱*]
(früher für: reiche, leichtlebige
Jugend der Großstädte) *w*; - -
Je̱|ver [*jef⁴r, jew⁴r*] (Stadt in Nie-
dersachsen); **Je̱|ve̱|ra̱|ner**, **Je̱|ver-
land** (Gebiet im nördl. Olden-
burg) *s*; -[e]s; **Je̱|ver|län|der**

[1] Auch: *jän*...

je|wei|len (veralt. für: dann und wann; schweiz. neben: jeweils); je|wei|lig; je|weils; je|zu|wei|len (svw. jeweilen)

Jg. = Jahrgang; **Jgg.** = Jahrgänge

Jh. = Jahrhundert

Jhe|ring vgl. Ihering

jid|disch (jüd.-dt.); Jid|disch (jüd.-dt. Sprechart u. Umgangssprache) s; -[s]; vgl. Deutsch; Jid|di|sche s; -n; vgl. Deutsche s; Jid|di|stik (jiddische Sprach- u. Literaturwissenschaft) w; -

Jie|per usw. vgl. Gieper usw.

Jig|ger ⓦ engl. [dschigᵉr] (eine Färbemaschine) m; -s, -

Jim [dschim] (Kurzform von: James); vgl. Jimmy; Jim|my [dschimi] (engl. Koseform von: Jim)

Jin|go [dschinggo] (engl. Bez. für einen Chauvinisten) m; -s, -s

Jir|mi|lik türk. (frühere türk. Silbermünze) m; -s, -s

Jit|ter|bug amerik. [dschitᵉrbag] (in Amerika entstandener Jazztanz) m; -

Jiu-Jit|su jap. [dschiu-dschitßu] (jap. Kunst der Selbstverteidigung) s; -[s]; vgl. Dschiu-Dschitsu

J.-Nr. = Journalnummer

Jo|ab (bibl. m. Eigenn.)

Joa|chim [auch: joa...] (m. Vorn.); Joa|chims|ta|ler [nach dem Ort St. Joachimsthal in Böhmen] (Münze) m; -s, -; vgl. Taler

Jo|as, (ökum.:) Jo|asch (bibl. m. Eigenn.)

¹Job (Schreibung der Vulgata für: Hiob, Ijob)

²Job engl.-amerik. [dschob] (Beschäftigung, Verdienst, Stelle) m; -s. -s; job|ben [dschobᵉn] (ugs. für: einen ²Job ausüben); gejobbt; Job|ber [dschobᵉr] (Händler an der Londoner Börse, der nur in eigenem Namen Geschäfte abschließen darf; auch allg. für: Börsenspekulant; ugs.: jmd., der jobbt) m; -s, -; Job|ber|tum s; -s

Job|sia|de (komisches Heldengedicht von K. A. Kortum) w; -

Jobst, Jo|dok [österr.: jo...], Jo|do-kus, Jost (m. Vorn.)

Joch (auch: älteres Feldmaß) s; -[e]s, -e; (↑R 321 u. 322:) 9 - Acker, 3 - Ochsen; Joch|bein s

Jö|cheln (das Richten fehlerhafter Hörner beim Hausrind) s; -s

Jo|chem, Jo|chen (Kurzform von: Joachim)

jo|chen mdal. (ins Joch spannen)

Jockei [Trenn.: Jok|kei] engl. [dschoke, engl. Ausspr.: dschoki, ugs. auch: dschokai, jokai] (berufsmäßiger Rennreiter) m; -s, -s; Jockey vgl. Jockei

Jod gr. (chem. Grundstoff; Nichtmetall; Zeichen: J) s; -[e]s; Jo|dat (Salz der Jodsäure) s; -[e]s, -e

Jo|del mdal. (Jodelgesang) m; -s, - u. Jödel; jo|deln; ich ...[e]le (↑R 327)

jod|hal|tig; Jo|did gr. (Salz der Jodwasserstoffsäure) s; -[e]s, -e; jo-die|ren (mit Jod versehen); Jo|dit (ein Mineral) s; -s, -e

Jod|ler; Jod|le|rin w; -, -nen

Jo|do|form (Mittel zur Wunddesinfektion) s; -s

Jo|dok, Jo|do|kus vgl. Jobst

Jod|tink|tur ([Wund]desinfektionsmittel) w; -, -en

Jo|el (bibl. Prophet)

Jo|ga, Yo|ga sanskr. (ind. philos. System) m; -[s]

Jo|ghurt türk. (gegorene Milch) m od. s (österr. nur so); -s, -s

Jo|gi, Jo|gin sanskr. (Anhänger des Joga) m; -s, -s

Jo|hann (auch, österr. nur: johan] (m. Vorn.); vgl. Johannes; Jo-han|na, Jo|han|ne (w. Vorn.); jo-han|ne|isch (nach Art des Johannes); -er Geist, aber (↑R 179): Jo|han|ne|isch (von Johannes herrührend); -er Christus; -e Briefe; ¹Jo|han|nes (m. Vorn.); - der Täufer; ²Jo|han|nes (Apostel u. Evangelist)

Jo|han|nes|burg (größte Stadt der Republik Südafrika)

Jo|han|nes|evan|ge|li|um, ...pas|si|on

Jo|hann|ge|or|gen|stadt (Stadt im westl. Erzgebirge)

Jo|han|ni[s] (Johannistag) s; -; Jo-han|nis|bee|re, ...ber|ger (ein Wein), ...brot (Hülsenfrucht des Johannisbrotbaumes), ...feu|er, ...kä|fer, ...tag (am 24. Juni), ...trieb, ...würm|chen; Jo|han|ni-ter (Angehöriger eines geistl. Ritterordens) m; -s, -; Jo|han|ni|ter-or|den m; -s

joh|len

John [dschon] (engl. Form von: Johann[es]); - Bull ("Hans Stier"; scherzh. Bez. des Engländers)

¹John|son [dschonßᵉn] (Präsident der USA)

²John|son, Uwe (dt. Schriftsteller)

Joint engl. [dscheunt] (Zigarette, deren Tabak mit Haschisch od. Marihuana vermischt ist) m; -s, -s

Jo-Jo amerik. (Geschicklichkeitsspiel mit Schnur u. daran befestigter Scheibe) s; -s, -s

Jo|ker engl. [auch: dscho...] (eine Spielkarte) m; -s, -

Jo|ko|ha|ma, (postamtl.:) Yo|ko-ha|ma (jap. Stadt)

jo|kos lat. (veralt. für: scherzhaft); -este (↑R 292); Jo|kus (ugs. für: Scherz, Spaß) m; -, -se

Jo|liot-Cu|rie [scholjokürⁱ], Frédéric u. Irène (fr. Physiker)

Jol|le (kleines [einmastiges] Boot) w; -, -n; Jol|len|kreu|zer

Jo|na, (ökum.:) Jo|nas (bibl. Prophet)

Jo|na|than, (ökum.:) Jo|na|tan (bibl. Eigenn.); Bruder Jonathan (scherzh. Bez. [der Einwohner] der USA)

Jon|gleur fr. [schonglör] (Geschicklichkeitskünstler) m; -s, -e; jon|glie|ren

Jöpp|chen, Jöpp|lein; Jop|pe (Jacke) w; -, -n

Jor|dan (Fluß in Palästina) m; -[s]; Jor|da|ni|en [...iᵉn] (Staat in Vorderasien); vgl. auch: Transjordanien; Jor|da|ni|er [...iᵉr]; jor|da|nisch

Jörg (Nebenform von: Georg)

Jo|sa|phat, (ökum.:) Jo|scha|fat (bibl. m. Eigenn.); das Tal - (östl. von Jerusalem)

Jo|schi|ja vgl. Josia

¹Jo|seph, ¹Jo|sef (↑R 192; m Vorn.); ²Jo|seph, (ökum.:) ²Jo|sef (bibl. m. Eigenn.); Jo|se|pha [auch: ...säfa] (auch u. österr nur:) Jo|se|fa [auch: ...säfa] (w Vorn.); Jo|se|phi|ne, (auch u österr. nur:) Jo|se|fi|ne (w Vorn.); Jo|se|phi|nisch; ↑R 179 -es Zeitalter (Zeitalter Josephs II.); Jo|se|phi|nis|mus (aufgeklär te kath. Staatskirchenpolitik im Österreich des 18. u. 19. Jh.s) m -; Jo|se|phus (jüd. Geschichts-schreiber)

Jo|sia, Jo|si|as, (ökum.:) Jo|schi-ja (bibl. m. Eigenn.)

Jost vgl. Jobst, Jodok

Jo|sua ("Gott hilft" [vgl. Jesus] bibl. m. Eigenn.)

Jot semit. (Buchstabe) s; -, -; Jo|ta (gr. Buchstabe; I, ι) s; -[s], -s; keir - (nicht das geringste); Jo|ta|zis mus (svw. Itazismus)

Joule [dschaul, auch: dschul; nach dem Engländer J. P. Joule] (Physik: Maßeinheit für die Energie Zeichen: J) s; -[s], -; 5 -

Jour fr. [schur] (früher für [Dienst-, Amts-, Empfangs]tag m; -s, -s; - fixe (fester Tag in de Woche [für Gäste, die nicht besonders eingeladen werden]); [d (dü)] jour haben (mit dem „Ta gesdienst" an der Reihe sein) vgl. du jour u. à jour; Jour|nail|l[e [schurnalⁱᵉ] (gewissenlos u. hetze risch arbeitende Tagespresse) w -; Jour|nal [schurnal] (Tagebuc in der Buchhaltung; Zeitschrif gehobener Art, bes. auf dem Ge biet der Mode; veralt. für: Zei tung) s; -s, -e; Jour|nal|be|am|te (österr.: diensthabender Beam ter), ...dienst (österr.: Bereit

schafts-, Tagesdienst); **Jour|na|lis|mus** (bes. Wesen, Eigenart der] Zeitungsschriftstellerei; Pressewesen) *m*; -; **Jour|na|list** (Zeitungs-, Tagesschriftsteller); ↑ R 268; **Jour|na|li|stik** (Zeitungswesen) *w*; -; **Jour|na|li|stin** *w*; -, -nen; **jour|na|li|stisch; Jour|nal|num|mer** (im kaufmänn. od. behördl. Tagebuch; Abk.: J.-Nr.) **Jo|vi|al** *lat.* [...*wi*..., österr. auch: *sehowi*...] (froh, heiter; leutselig, gönnerhaft); **Jo|via|li|tät** *w*; - **Joyce,** James [*dseheuß*] (ir. Schriftsteller)

jr., jun. = junior

[1]**Ju|an** [*ehuan*] (span. Form von: Johann); Don - (vgl. d.)

[2]**Ju|an** vgl. Yuan

Ju|bel *m*; -s; **Ju|bel-fei|er, ...ge-schrei, ...jahr** (bei den Juden: jedes 50., kath. Kirche: jedes 25. Jahr); alle -e (ugs. für: ganz selten); **ju|beln;** ich ...[e]le (↑ R 327); **Ju|bel|ruf; Ju|bi|lar** *lat. m*; -s, -e; **Ju|bi|la|rin** *w*; -, -nen; **Ju|bi|la|te** (,,jubelt!"; dritter Sonntag nach Ostern); **Ju|bi|lä|um** *s*; -s, ...äen; **Ju|bi|lä|ums-aus|ga|be, ...aus|stel|lung, ...fei|er; ju|bi|lie|ren** (jubeln; auch: ein Jubiläum feiern)

[1]**Ju|chart, Ju|chert** mdal. (altes südwestd. Feldmaß) *m*; -s,-e; 10 - Ackerland (↑ R 321 u. 322); vgl. Jauchert; [2]**Ju|chart, Ju|char|te** schweiz. (¹Juchart) *w*; -, ...ten

ju|chen mdal.(jauchzen); **juch|he!; Juch|he** (oberste Galerie im Theater) *s*; -s, -s; **juch|hei!, juch|hei|ras|sa!; juch|hei|ras|sas|sa!; juch|hei|sa!; juch|hei|ßa!**

Juch|ten *russ.* (feines, wasserdichtes Leder) *m* od. *s*; -s; **juch|ten** (aus Juchten); **Juch|ten-le|der, ...stie|fel**

juch|zen (Nebenform von: jauchzen); du juchzt (juchzest); **Juch-zer**

jucken[1]; *Wenfall od. Wemfall?* **1.** *eigentl. Bedeutung:* **a)** *unpersönlicher Gebrauch:* es juckt mich [am Arm]; **b)** *Körperteilbez. als Satzgegenstand:* die Hand juckt mir (seltener: mich) od. mir (seltener: mich) juckt die Hand. **2.** *übertragene Bedeutung:* es juckt mir (seltener: mich) in den Fingern (ugs. für: es drängt mich), dir eine Ohrfeige zu geben; ihm (seltener: ihn) juckt das Fell (ugs. für: er scheint Prügel haben zu wollen). Aber (ohne nähere Angabe): es juckt (reizt) mich, dich an den Haaren zu ziehen

Jucker[1] (leichtes [ung.] Wagenpferd) *m*; -s, -; **Jucker|ge|schirr**[1] **Juck-pul|ver, ...reiz**

[1]**Ju|da** (bibl. m. Eigenn.); [2]**Ju|da** (Sitz des Stammes Juda in u. um Jerusalem); vgl. Judäa; **Ju|däa** (Bez. Südpalästinas, später ganz Palästinas); **Ju|da|is|mus** (jüdische Religion) *m*; -; [1]**Ju|das** (bibl. m. Eigenn.); - Is|cha|ri|ot, (ökum.:) - Is|ka|ri|ot [,,Mann aus Karioth"] (Apostel, Verräter Jesu); - Thaddäus (ein Apostel); [2]**Ju|das** [nach Judas Ischariot] ([heimtückischer] Verräter) *m*; -, -se; **Ju|das-kuß, ...lohn** (↑ R 180); **Ju|de** *m*; -n, -n (↑ R 268); **Ju|den-chri|sten|tum; Ju|den|ge|gner** (für: Antisemit); **Ju|den|heit** *w*; -; **Ju|den-kir|sche** (eine Zierpflanze), ...**stern; Ju|den|tum** *s*; -s; **Ju|den|ver|fol|gung**

Ju|di|ka *lat.* (,,richte!"; Passionssonntag, zweiter Sonntag vor Ostern); **Ju|di|ka|ti|on** [...*zion*] (veralt. für: Beurteilung); **ju|di|ka|to|risch** (veralt. für: richterlich); **Ju|di|ka|tur** (Rechtsprechung) *w*; -, -en

Jü|din *w*; -, -nen; **jü|disch;** jüdische Zeitrechnung, aber (↑ R 224): die Jüdische Illustrierte; [1]**Ju|dith** (w. Vorn.); [2]**Ju|dith** (ökum.:) **Ju|dit** (bibl. w. Eigenn.)

ju|di|zie|ren *lat.* (veralt. für: urteilen, richten); **Ju|di|zi|um** (aus langjähriger Gerichtspraxis sich entwickelndes Rechtsfindungsvermögen; veralt. für: Gericht, Rechtspflege) *s*; -s, ...ien [...*i*ᵉ*n*] [1]**Ju|do** (Kurzw. für: Jungdemokrat) *m*; -s, -s [2]**Ju|do** österr. meist: *dsch*...] *jap.* (sportl. Ausübung des Jiu-Jitsu) *s*; -[s]; **Ju|do|griff; Ju|do|ka** (Judosportler) *m*; -s, -s

Ju|gend *w*; -; **Ju|gend-be|kannt-schaft, ...be|we|gung, ...bild, ...bild|nis, ...bri|ga|de** (DDR), ...**er|in|ne|rung, ...er-zie|hung, ...ese|lei** (ugs.); **ju|gend-frei** (Prädikat für Filme); **Ju-gend|freund, ...freun|din, ...für-sor|ge; ju|gend|ge|fähr|dend;** in -er Film, aber (↑ R 142): die Jugend gefährdend; **Ju|gend-grup-pe, ...her|ber|ge** (vgl. DJH), ...**hof, ...jah|re** (Mehrz.), ...**kri|mi|na|li-tät** (*w*; -); **ju|gend|lich; Ju|gend|li-che** *m* u. *w*; -n, -n (↑ R 287ff.); **Ju|gend|lich|keit** *w*; -; **Ju-gend.lie|be, ...li|te|ra|tur, ...or|ga-ni|sa|ti|on, ...pfar|rer, ...pfle|ge, ...recht, ...rich|ter, ...schutz, ...stil** (*m*; -[e]s), ...**streich, ...sün|de, ...ta-ge** (Mehrz.), ...**tor|heit, ...ver-band, ...vor|stel|lung, ...wei|he** (in der DDR feierliche Veranstaltung beim Übergang der Jugendlichen in das Leben der Erwachsenen), ...**werk, ...zeit, ...zen|trum Ju|go|sla|we** *m*; -n, -n (↑ R 268);

Ju|go|sla|wi|en [...*i*ᵉ*n*]; **ju|go|sla-wisch**

ju|gu|lar *lat.* (Med.: die Kehle betreffend); **Ju|gu|lar|ader** (Drossel-, Kehlader)

Ju|gur|tha (König von Numidien); **Ju|gur|thi|ni|sche Krieg** *m*; -n, -[e]s

ju|he! schweiz. (juchhe!); **ju|hu!** [auch: *ju*...]

Juice *engl.* [*dsehuß*] (Obst- od. Gemüsesaft) *m* od. *s*; -, -s [...*ßis*]

Juist [*jüßt*] (ostfries. Insel)

Ju|ju|be *fr.* (ein Strauch; Beere) *w*; -, -n

Jul|chen (Koseform von: Julia, Julie)

Ju|lei (aus Gründen der Deutlichkeit gesprochene Form von: Juli) **Jul|fest** (Fest der Wintersonnenwende); vgl. Julklapp

Ju|li *lat.* (der siebte Monat im Jahr, Heue[r]t, Heumond, Sommermonat) *m*; -[s] (↑ R 319), -s; vgl. Julei; **Ju|lia, Ju|lie** [...*i*ᵉ] (w. Vorn.); **Ju|li|an, Ju|lia|nus** (röm. Jurist); **Ju|lia|na, Ju|lia|ne** (w. Vorn.); **ju|lia|nisch,** aber (↑ R 179): der Julianische Kalender; **Ju|li|en|ne** *fr.* [*schüljän*] (w. Vorn.); [2]**Ju|li|en|ne** (Suppengemüse; Gemüsesuppe) *w*; -; **Ju|li-en|ne|sup|pe; Ju|lie** vgl. Julia; **Ju-li|er** *lat.* [...*i*ᵉ*r*] (Angehöriger eines röm. [Kaiser]geschlechtes) *m*; -s, -; [2]**Ju|li|er** [...*i*ᵉ*r*] (schweiz. Alpenpaß) *m*; -s, (auch:) **Ju|li|er|paß** *m*; ...passes; **ju|lisch,** aber (↑ R 198): die Julischen Alpen; [1]**Ju|li|us** (röm. Geschlechtsname; m. Vorn.); [2]**Ju|li|us|turm** (noch einen Turm der früheren Zitadelle in Spandau, in dem bis 1914 der Kriegsschatz des Deutschen Reiches lag) (übertr. für: vom Staat gesammelte Gelder) *m*; -[e]s (↑ R 180)

Jul|klapp *altnord.* (am Julfest [Wintersonnenwende] von unerkanntem Geber mit Julklappruf in die Stube geworfenes Geschenk) *m*; -s; **Jul.nacht, ...spiel Jum|bo** *amerik.* (Kurzform für: Jumbo-Jet) *m*; -s, -s; **Jum|bo-Jet** (Großraumdüsenflugzeug)

Ju|me|la|ge *fr.* [*schüm*ᵉ*laseh*] (Bez. für eine [Städte]partnerschaft) *w*; -, -n [...*seh*ᵉ*n*]

jum|pen *engl.* [*dsehamp*ᵉ*n*] (springen); gejumpt

Jum|per *engl.* [engl. Aussspr.: *dsehäm*..., auch (südd., österr.): *dsehäm*...] (selten für: [Damen]strickbluse, Pullover) *m*; -s, -

Jum|per|kleid

jun., jr. = junior

jung; jünger, jüngste (vgl. d.). **I.** *Kleinschreibung* (↑ R 133): von jung auf; jung und alt (jeder-

mann); (↑ R 133:) er ist der jünge-
re, jüngste meiner Söhne. **II.**
Großschreibung: **a)** (↑ R 116:) Jun-
ge und Alte; mein Jüngster; er
ist nicht mehr der Jüngste; er
gehört nicht mehr zu den Jüng-
sten; **b)** (↑ R 224:) Jung Siegfried;
der Jüngere (Abk. [bei Eigenna-
men]: d. J.); das Junge Deutsch-
land (Dichtergruppe des 19.
Jh.s); Jung_aka|de|mi|ker, ...ak-
ti|vist (DDR), ...brun|nen, ...bür-
ger (österr. für: jmd., der das
Wahlalter erreicht hat), ...bür-
ger|fei|er (österr.); Jung|chen
(landsch.); ¹Jun|ge *m*; -n (↑ R
268), -n (ugs. auch: Jungs u. -ns);
²Jun|ge *s*; -n, -n (↑ R 287 f f.); Jün-
gel|chen (oft abschätzig); jun-
gen (Junge werfen; dicht. für:
jung werden); Jung|gen|ge|sicht;
jun|gen|haft; Jun|gen|haf|tig|keit
w; -; Jun|gen_klas|se, ...schu|le,
...streich; Jün|ger *m*; -s, -; jün|ger-
haft; Jün|ge|rin *w*; -, -nen; Jün-
ger|schaft; Jung|fer *w*; -, -n; jüng-
fer|lich; Jung|fern_fahrt (erste
Fahrt, bes. die eines neuerbauten
Schiffes), ...flug; jung|fern|haft;
Jung|fern_häut|chen (für: Hy-
men), ...kranz (veralt. für: Braut-
kranz), ...re|de, ...schaft (*w*; -),
...tum (*s*; -s); Jung|frau; jung|frau-
en|haft; jung|fräu|lich; Jung|fräu-
lich|keit *w*; -; Jung|frau|schaft
(selten für: Jungfernschaft);
Jung|ge|sel|le; Jung|ge|sel|len-
_bu|de (ugs.), ...da|sein, ...tum (*s*;
-s), ...wirt|schaft, ...woh|nung;
Jung|ge|sel|lin *w*; -, -nen; Jung-
_gram|ma|ti|ker (Angehöriger
der Leipziger Schule der indo-
germanischen u. allgemeinen
Sprachwissenschaft um 1900),
...he|ge|lia|ner (Angehöriger der
radikalen Gruppe der Hege-
lianer), ...herr, ...holz, ...kind
(veralt.), ...leh|rer; Jüng|ling;
Jüng|lings|al|ter *s*; -s; jüng|ling[s]-
haft; Jung_mann (*Mehrz.* ...män-
ner), ...mann|schaft, ...pflan|ze,
...re|dak|teur; Jung|so|zia|list
(Angehöriger einer Nachwuchs-
organisation der SPD; Kurzw.:
Juso); jüngst (veraltend) jüng-
ste, aber (↑ R 224): das Jüngste
Gericht, der Jüngste Tag; Jung-
stein_zeit (für: Neolithikum) *w*; -;
Jüng|sten|recht (für: Minorat);
jüng|stens (veralt. für: jüngst);
jüngst|hin (veraltend)
Jung-Stil|ling (dt. Gelehrter u.
Schriftsteller)
jüngst|ver|gan|gen; -e Zeit; Jung-
_tier, ...ver|hei|ra|te|te, ...vieh,
...vo|gel, ...wäh|ler, ...wild
Ju|ni *lat.* (der sechste Monat des
Jahres, Brachet, Brachmonat) *m*;
-[s] (↑ R 319), -s; Ju|ni|kä|fer

ju|ni|or *lat.* (jünger, hinter Namen:
der Jüngere; Abk.: jr. u. jun.);
Karl Meyer junior; Ju|ni|or
(Sohn [im Verhältnis zum Vater];
Mode, Sport: Jugendlicher etwa
zwischen 19 u. 20 Jahren) *m*; -s,
...oren; Ju|nio|rat (Erbgut; Vor-
recht des Jüngsten auf das Erb-
gut) *s*; -[e]s; Ju|ni|or|chef (Sohn
des Geschäftsinhabers); Ju|nio-
ren_mei|ster|schaft, ...ren|nen
(Sport); Ju|ni|or|part|ner
Ju|ni|pe|rus *lat.* [auch: ...*nip*...]
(Wacholder) *m*; -, -
Ju|ni|us (röm. m. Eigenn.)
Jun|ker *m*; -s, -; jun|ker|haft; jun-
ker|lich; Jun|ker|schaft; Jun|ker-
tum *s*; -s
Junk|tim *lat.* (,,verbunden''; Ver-
bindung zwei. Maßnahmen, z.
B. Gesetzesvorlagen, zur gleich-
zeitigen Erledigung) *s*; -s, -s;
Junk|tims|vor|la|ge
¹Ju|no (aus Gründen der Deutlich-
keit gesprochene Form von: Ju-
ni)
²Ju|no (höchste röm. Himmels-
göttin); ³Ju|no (ein Planetoid) *w*;
-; ju|no|nisch; (↑ R 179 ²Juno be-
treffend, der ²Juno ähnlich; fürst-
lich, hehr); -e Schönheit
Jun|ta *span.* [span. Ausspr.: *chun-
ta*] (,,Vereinigung''; Regierungs-
ausschuß, bes. in Südamerika) *w*;
-, ...ten
Jü|pon *fr.* [*schüpõng*, schweiz.:
schüpõng] (schweiz., sonst veralt.
für: Unterrock; schweiz. auch:
Halbrock) *m*; -s, -s
Jupp (m. Vorn.)
Jup|pi|ter vgl. Jupiter
¹Ju|ra (*Mehrz.* von: ¹Jus)
²Ju|ra (Geol.: mittlere Formation
des Mesozoikums) *m*; -s; ³Ju|ra
(Bez. von Gebirgen) *m*; -[s] (↑ R
198:) der Fränkische -, der
Schwäbische -; (↑ R 199:) der
Schweizer -; Ju|ra|for|ma|ti|on
ju|ra|re in verba magi|stri
[- - *wärba* -] (,,auf des Meisters
Worte schwören''; die Meinung
eines anderen nachbeten)
Ju|ras|si|er [...*iᵉr*] (Bewohner des
³Jura); ju|ras|sisch (zum ²Jura ge-
hörend)
Jür|gen (Nebenform von: Georg)
ju|ri|disch *lat.* (österr., sonst ver-
alt. für: juristisch); Ju|ris|dik|ti-
on [...*ziõn*] (Rechtsprechung; Ge-

richtsbarkeit); Ju|ris|pru|denz
(Rechtswissenschaft) *w*; -; Ju|rist
(Rechtskundiger); (↑ R 268; Ju|ri-
sten|deutsch *s*; -[s]; Ju|ri|ste|rei
(oft abschätzig für: Rechtswis-
senschaft, Rechtsprechung) *w*; -;
ju|ri|stisch; -e Fakultät; -e Person
(rechtsfähige Körperschaft;
Ggs.: natürliche Person); Ju|ror
engl. (Mitglied einer Jury) *m*; -s,
...oren
Jur|te *türk.* (rundes Filzzelt mit-
telasiat. Nomaden) *w*; -, -n
Ju|ry *fr.-engl.* [*schüri*, auch: *schüri*;
fr. Ausspr.: *schüri*; engl. Ausspr.:
dschü'ri] (Preisgericht; Schwur-
gericht [bes. USA]) *w*; -, -s; ju|ry-
frei (nicht von Fachleuten zu-
sammengestellt); ¹Jus (österr.:
juß] *lat.* (Recht, Rechtswissen-
schaft) *s*; -; Jura; Jura (die Rech-
te) studieren; (österr.:)- studieren
²Jus *fr.* [*schü*] (Bratenbrühe;
schweiz. auch: Fruchtsaft) *w*; -
(auch [südd., schweiz.]: *s*; - u.
[schweiz.:] *m*; -)
Ju|so (Kurzw. für: Jungsozialist)
m; -s, -s
Jus|stu|dent österr. (Jurastudent)
just *lat.* (veraltend für: eben, gera-
de; recht); das ist - das Richtige;
ju|sta|ment *fr.* (veralt., noch
mdal. für: richtig, genau; es sei
recht, nun gerade); ju|stie|ren *lat.*
(genau einstellen, einpassen, aus-
richten); Ju|stie|rer (Eicher;
Schriftgießer, der der Schrift glei-
che Höhe gibt); Ju|stie|rung; Ju-
stier|waa|ge (Münzwesen); Ju-
sti|fi|ka|ti|on [...*ziõn*] (Anerken-
nung ausländischer Verwal-
tungsakte; veralt. für: Rechtferti-
gung); Ju|sti|fi|ka|tur (Genehmi-
gung von Rechnungen nach Prü-
fung) *w*; -, -en; ju|sti|fi|zie|ren
(rechtfertigen); eine Rechnung
nach Prüfung genehmigen); Ju-
sti|ne (w. Vorn.); Ju|sti|ni|an, Ju-
sti|nia|nus (Name byzant. Kai-
ser); Ju|sti|nus (m. Vorn.); Ju|sti-
tia [...*zia*] (altröm. Göttin der Ge-
rechtigkeit); ju|sti|tia|bel (vom
Gericht abzuurteilen, richter-
licher Entscheidung unterwor-
fen); ...a|ble Vergehen; Ju|sti|ti-
ar (Rechtsberand, Syndikus) *m*;
-s, -e; Ju|sti|ti|um (Stillstand der
Rechtspflege) *s*; -s, ...ien [...*iᵉn*];
Ju|stiz (Gerechtigkeit; Rechts-
pflege) *w*; -; Ju|stiz_be|am|te,
...be|hör|de, ...irr|tum, ...mi|ni-
ster, ...mi|ni|ste|ri|um, ...mord
(Verurteilung eines Unschuldi-
gen zum Tode), ...pa|last, ...rat
(früherer Titel; *Mehrz.* ...räte),
...wa|che|be|am|te (österr.); Ju-
stus (m. Vorn.)
Ju|te *bengal.-engl.* (Faserpflanze
u. deren Faser) *w*; -

Jü|te (Bewohner Jütlands) *m*; -n, -n (↑ R 268)

Jü|ter|bog (Stadt im Fläming)

Ju|te|spin|ne|rei

jü|tisch, aber (↑ R 198): die Jütische Halbinsel; Jüt|land (festländ. Teil Dänemarks)

Jut|ta, Jut|te (Kurzformen von: Judith)

Ju|ve|nal [...we...] (röm. Satiriker)·

ju|ve|na|lisch, aber (↑ R 179): Ju-ve|na|lisch; -e Satiren

ju|ve|nil *lat*. [...we...] (jugendlich)

ju|vi|val|le|ra! [*iuwiwa*... od. *juwifa*...]

¹Ju|wel *niederl*. (ein Edelstein; Schmuckstück) *m* od. *s*; -s, -en, ²Ju|wel (etwas Wertvolles, besonders hoch Gehaltenes, auch von Personen) *s*; -s, -e; Ju|we|len-dieb|stahl; ju|we|len|haft; Ju|we-lier (Goldschmied; Schmuckhändler) *m*; -s, -e; Ju|we|lier|ge-schäft

Jux *lat*. (ugs. für: Scherz, Spaß) *m*; -es, -e; ju|xen (ugs. für: scherzen, Spaß machen); du juxt (juxest)

Jux|ta *lat*. (Stammleiste [an Losen usw.]) *w*; -, ...ten; Jux|ta|po|si|ti-on [...*zion*] (Nebeneinanderstellung; Anlagerung kleinster Teilchen bei Kristallen); Jux|te österr. (Juxta)

jwd [*jotwede*] (= janz weit draußen; ugs. scherzh. für: abgelegen)

K

Vgl. auch C und Z

k = Kilo...

K (Buchstabe); das K; des K, die K, aber: das k in Kakao (↑ R 123); der Buchstabe K, k

K = chem. Zeichen für: Kalium; Kelvin

Κ, κ = Kappa

k.¹ (im ehem. Österreich-Ungarn) = kaiserlich; königlich

Ka|aba *arab*. (Hauptheiligtum des Islams in Mekka) *w*; -

Ka|ba|le *hebr*. (veralt. für: Intrige, Ränke, böses Spiel) *w*; -, -n

Ka|ba|nos|si *it*. (Wurstsorte) *w*; -, -

Ka|ba|rett österr.: ...*re*] *fr*. (Kleinkunstbühne; Speiseplatte, Fächerschüssel) *s*; -s, -e od. -s; Ka-ba|ret|tier [...*tig*] (Besitzer einer Kleinkunstbühne) *m*; -s, -s; Ka-ba|ret|tist (Künstler an einer Kleinkunstbühne); ↑ R 268; ka-ba|ret|ti|stisch

Ka|bäus|chen westmitteld. (kleines Haus od. Zimmer)

¹ Vgl. S. 368, Sp. 2, Anm. 1.

Kab|ba|la *hebr*. (mittelalterl. jüd. Geheimlehre) *w*; -; kab|ba|li-stisch (auf die Kabbala bezüglich; Geheim...)

Kab|be|lei bes. nordd. (Zankerei, Streit); kab|be|lig (Seemannsspr.: unruhig; ungleichmäßig); kab-beln, sich bes. nordd. (zanken, streiten); ich ...[e]le mich (↑ R 327); die See kabbelt (ist ungleichmäßig); Kab|be|lung (Seemannsspr.: [Stelle mit] Kräuselbewegung der See)

¹Ka|bel *niederd*. (Stück, Anteil, Los) *w*; -, -n

²Ka|bel *fr*. (Tau; isolierte elektr. Leitung; Kabelnachricht) *s*; -s, -; Ka|bel|gat[t] (Schiffsraum für Tauwerk), ...be|richt

Ka|bel|jau *niederd*. (ein Fisch) *m*; -s, -e u. -s

Ka|bel|län|ge (seem. Maß), ...le-ger (Kabel verlegendes Schiff), ...lei|tung; ka|beln (über See) drahten); ich ...[e]le (↑ R 327); Ka-bel.nach|richt, ...schuh (Elektrotechnik), ...tau (*s*; -[e]s, -e), ...wort (*Mehrz.* ...wörter)

Ka|bi|ne *engl*. (·*fr*.) (Schlaf-, Wohnkammer auf Schiffen; Zelle [in Badeanstalten usw.]; Abteil) *w*; -, -n; Ka|bi|nen|rol|ler (ein Fahrzeug); Ka|bi|nett *fr*. (Gesamtheit der Minister; kleinerer Museumsraum; früher für: Beratungsraum, Arbeitszimmer [bes. an Fürstenhöfen]; Vertrautenkreis des Herrschers; Geheimkanzlei; österr.: kleines, einfenstriges Zimmer; DDR: Lehru. Beratungszentrum) *s*; -s, -e; Ka|bi|nett.for|mat (eine Bildgröße); Ka|bi|netts.be|schluß, ...bil-dung, ...ent|schei|dung, ...fra|ge (seltener für: Vertrauensfrage; *w*; -), ...sit|zung, ...ju|stiz ([unzulässige] Einwirkung der Regierung auf die Rechtsprechung), ...kri-se, ...mit|glied, ...or|der (Befehl des Herrschers); Ka|bi|nett|stück (Prachtstück; Kunststück); Ka-bi|netts|vor|la|ge; Ka|bi|nett|wein (edler Wein)

Ka|bis *lat*. südd., schweiz. (Kohl) *m*; -; vgl. Kappes

Ka|bo|ta|ge *fr*. [...*tasch*ᵉ] (Küstenschiffahrt); ka|bo|tie|ren (Küstenschiffahrt treiben)

Ka|brio (Kurzform von: Kabriolett) *s*; -[s], -s; Ka|brio|lett österr.: ...*le*] *fr*. (Pkw mit zurückklappbarem Verdeck; früher: leichter, zweirädriger Wagen) *s*; -s, -s; Ka|brio|li|mou|si|ne (geschlossener Pkw mit Schiebedach)

Ka|buff landsch. (kleiner, dunkler Nebenraum) *s*; -s, -e u. -s

Ka|bul [auch: *ka*...] (Hptst. von Afghanistan)

Ka|by|se, Ka|bü|se nordd. (enge Kammer, Alkoven; kleine Hütte; schlechte Wohnung; auch für: Kombüse) *w*; -, -n

Ka|by|le (Angehöriger eines Berberstammes) *m*; -n, -n (↑ R 268)

Ka|chel *w*; -,-n; ka|cheln; ich ...[e]le (↑ R 327); Kach|el|ofen

Kach|exie *gr*. [*kaeh*...] (Med.: Kräfteverfall) *w*; -, ...ien

Kacke [*Trenn.*: Kak|ke] (derb für: Kot); kacken [*Trenn.*: käk|ken] (derb); Kacker [*Trenn.*: Kak|ker] (derbes Schimpfwort); kack|fi-del (derb für: sehr fidel)

Ka|da|ver *lat*. [...*w*ᵉ*r*] (toter [Tier]körper, Aas) *m*; -s, -; Ka|da-ver.ge|hor|sam (blinder Gehorsam), ...mehl, ...ver|wer|tung

Ka|denz *it*. (Schluß eines Verses, eines Musikstückes; unbegleitetes Improvisieren des Solisten im Konzert; Phonetik: Schlußfall der Stimme) *w*; -, -en; ka|den|zie-ren (eine Kadenz spielen)

Ka|der *fr*. (erfahrener Stamm [eines Heeres, einer Sportmannschaft]; DDR: Gruppe leitender Personen in Partei, Staat u. Wirtschaft) *m* (schweiz.: *s*); -s, (auch für Angehörige eines Kaders:) -; Ka|der.ab|tei|lung (DDR), ...lei-ter (DDR) *m*, ...par|tie (bestimmte Partie im Billard)

Ka|dett *fr*. (Zögling einer für Offiziersanwärter bestimmten Erziehungsanstalt; schweiz.: Mitglied einer [Schul]organisation für milit. Vorunterricht) *m*; -en, -en (↑ R 268); Ka|dett.ten.an|stalt, ...korps, ...schu|le

Ka|di *arab*. (Richter in mohammedan. Ländern; ugs. für: Richter) *m*; -s, -s

Kad|mea (von Kadmos erbaute Burg im altgr. Theben) *w*; -; kad-me|isch (aus, von der Kadmea); kad|mie|ren (auch:) ver|kad|men *gr*. (Metalle mit einer Kadmiumschicht überziehen); Kad|mi|um, (fachspr. nur:) Cad|mi|um (chem. Grundstoff, Metall; Zeichen: Cd) *s*; -s; Kad|mi|um|le|gie|rung; Kad|mos (König u. Held der gr. Sage); Kadmus vgl. Kadmos

ka|duk *lat*. (Med.: hinfällig; gebrechlich); ka|du|zie|ren (Rechtsw.: für verfallen erklären)

Ka|far|na|um vgl. Kapernaum

Kä|fer (ugs. auch für: Volkswagen) *m*; -s, -; Kä|fer|samm|lung

¹Kaff *niederd*. (Spreu; wertloses Zeug; Geschwätz) *s*; -[e]s

²Kaff *zigeuner*. (ugs. für: Dorf, armselige Ortschaft) *s*; -s, -s u. -e

Kaf|fee [auch, österr. nur: *kafe*] *arab.-fr*. (Kaffeestrauch, Kaffee-

bohnen; Getränk *m* u. (selten
für: Kaffeehaus, meist Café ge-
schrieben) *s*; -s, (für Kaffeesorte,
-haus auch *Mehrz.*:) -s; Kaf|
fee.baum, ...boh|ne; kaf|fee-
braun; Kaf|fee-Ern|te, Kaf|fee-
Er|satz, Kaf|fee-Ex|port, Kaf|fee-
Ex|trakt (↑ R 148); Kaf|fee|fil|ter;
Kaf|fee Hag ⓦ [aus: Kaffee-
Handels-AG] (koffeinfreier Kaf-
fee) *m*; - -; Kaf|fee|haus österr.
(Café); Kaf|fe|in vgl. Koffein;
Kaf|fee.kan|ne, ...kränz|chen,
...löf|fel, ...ma|schi|ne, ...müh|le,
...satz, ...ser|vice; Kaf|fee|sie|der
(österr. amtl., sonst meist ab-
schätzig für: Besitzer eines Kaf-
feehauses); Kaf|fee.sor|te, ...tan-
te (scherzh.), ...was|ser (*s*; -s),
...zu|satz

¹Kaf|fer (Angehöriger der südöstl.
Bantuvölker in Südafrika) *m*; -n
(↑ R 268), -n (*Mehrz.* meist als
Sammelbez. für diese Völker)
²Kaf|fer jidd. (ugs. für: dummer,
blöder Kerl) *m*; -s, -
Kaf|fern.land (*Mehrz.* ...länder),
...spra|che
Kä|fig *m*; -s, -e; kä|fi|gen (in einem
Käfig halten)
Ka|fil|ler jidd. (Gaunerspr. für:
Schinder, Abdecker) *m*; -s, -; Ka-
fil|le|rei (Abdeckerei)
Ka|fir arab. (,,Ungläubiger''; ab-
schätzig für: Nichtmoham-
medaner) *m*; -s, -n
Kaf|ka (österr. Schriftsteller); kaf-
ka|esk (nach Art der Schöpfun-
gen Kafkas)
Kaf|tan pers. (aus Asien stammen-
des früheres langes Obergewand
der orthodoxen Juden in Osteu-
ropa) *m*; -s, -e
Käf|ter|chen mitteld. (Kämmer-
chen; Verschlag)
kahl; - sein, werden, bleiben; vgl.
aber: kahlfressen, kahlscheren,
kahlschlagen
Kah|len|berg (Berg bei Wien) *m*;
-[e]s
Kahl|fraß *m*; -es; kahl|fres|sen (↑ R
139); die Raupen fressen den
Baum kahl; kahlgefressen; kahl-
zufressen; Kahl.frost (Frost ohne
Schnee), ...heit (*w*; -), ...hieb (ab-
geholztes Waldstück), ...kopf;
kahl|köp|fig; Kahl|köp|fig|keit *w*;
-; kahl|sche|ren; Kahl|schlag (ab-
geholztes Waldstück); Kahl-
schla|gen; einen Wald -; Kahl-
wild (Jägerspr.: weibl. Hirsche)
Kahm (hefeähnl. Pilz-, Bakterien-
art) *m*; -[e]s; kah|men (Kahm an-
setzen); Kahm|haut (aus Kahm
gebildete Haut auf Flüssigkei-
ten); kah|mig
Kahn *m*; -[e]s, Kähne; -fahren (↑ R
140), aber: das Kahnfahren;
Kähn|chen, Kähn|lein; Kahn|fahrt

¹Kai [österr.: *ke*] niederl. (ge-
mauertes Ufer, Uferstraße zum
Beladen u. Entladen von Schif-
fen) *m*; -s, -e u. -s
²Kai, Kay (m. od. w. Vorn.)
Kai|man indian. (Krokodil im
trop. Südamerika) *m*; -s, -e
Kai|mau|er
Ka|in [auch: *kain*] (bibl. m. Ei-
genn.)
Kai|nit gr. (ein Mineral) *m*; -s, -e
Kains.mal (*Mehrz.* ...male), ...zei-
chen
Kai|phas [auch: *kai*...], (ökum.:)
Ka|ja|fas (bibl. m. Eigenn.)
Kai|ro [auch: *kgiro*] (Hptst. Ägyp-
tens); Kai|ro|er [...o^er] (↑ R 199)
Kai|ser *m*; -s, -; Kai|ser.ad|ler
(Greifvogel), ...fleisch (österr.:
geräuchertes Bauchfleisch,
Schweinebauch), ...ge|bir|ge (in
Tirol; *s*; -s); Kai|se|rin *w*; -, -nen;
Kai|se|rin|mut|ter (*Mehrz.*
...mütter); Kai|ser|kro|ne (auch:
eine Zierpflanze); kai|ser|lich;
kaiserlich deutsch; kaiserlich
österreichisch; kaiserlich-
österreichische Staatskanzlei; im
Titel (↑ R 224): Kaiserlich¹; kai-
ser|lich-kö|nig|lich (Abk.: k. k.),
im Titel: Kaiserlich-Königlich¹
(Abk.: K. K.)
Kai|ser|ling (ein Pilz)
Kai|ser.man|tel (ein Schmetter-
ling), ...quar|tett (ein Streich-
quartett von J. Haydn; *s*; -[e]s),
...reich, ...sa|ge, ...schmar|ren
(österr., auch südd.: in kleine
Stücke zerstoßener Eierkuchen,
oft mit Rosinen), ...sem|mel
(österr.: best. Semmelform)
Kai|ser|schnitt (Entbindung durch
einen operativen Schnitt)
Kai|sers|lau|tern (Stadt in Rhein-
land-Pfalz); Kai|sers|lau|te|rer
(↑ R 199)
Kai|ser|tum *s*; -s; Kai|ser Wil|helm-
Ge|sell|schaft²; Kai|ser Wil|helm-
In|sti|tut²; Kai|ser-Wil|helm-Ka-
nal; ↑ R 155 (früherer Name des
Nord-Ostsee-Kanals) *m*; -s
Ka|ja|fas vgl. Kaiphas
Ka|jak eskim. (einsitziges Män-
nerboot der Eskimos; Sportpad-
delboot) *m* (seltener: *s*); -s, -s; Ka-
jak.ei|ner, ...zwei|er
Ka|je niederl. (Uferbefe-
stigung; Kai) *w*; -, -n; Ka|je|deich
Ka|je|put.baum malai.; dt. (ein
Myrtengewächs), ...öl (*s*; -[e]s)

¹ Im ehem. Österreich-Ungarn
schrieb man ,,kaiserlich'' u.
,,königlich'' auch in Titeln von
Ämtern und Personen immer
klein; aber: Ew. Kaiserliche Ho-
heit, Majestät.
² So die von der Regel (↑ R 155)
abweichende amtliche Schrei-
bung.

Ka|jüt.boot, ...deck; Ka|jü|te
(Wohn-, Aufenthaltsraum auf
Schiffen) *w*; -, -n
Kak niederd. (hist.: Pranger) *m*;
-[e]s, -e
Ka|ka|du malai.-niederl. [österr.:
...dy] (ein Papagei) *m*; -s, -s
Ka|kao mexik.-span. [auch: ...kau]
(eine tropische Frucht; Getränk)
m; -s, (für Kakaosorte auch
Mehrz.:) -s; Ka|kao.baum, ...boh-
ne, ...but|ter, ...pul|ver
ka|keln nordd. (über Dummes,
Belangloses reden); ich ...[e]le
(↑ R 327)
Ka|ke|mo|no jap. (ostasiat. Hän-
gebild aus Seide od. Papier) *s*;
-s, -s
Ka|ker|lak (Schabe [Insekt];
[lichtscheuer] Albino) *m*; -s, u.
...en (↑ R 268), -en
Ka|ki vgl. Khaki
kako... gr. (schlecht..., übel...,
miß...); Kako... (Schlecht...,
Übel..., Miß...); Ka|ko|dyl|ver-
bin|dun|gen gr.; dt. (Chemie: Ar-
senverbindungen) *Mehrz.*; Ka-
ko|pho|nie gr. (Mißklang; Ggs.:
Euphonie) *w*; -, ...ien; ka|ko|pho-
nisch
Kak|tee gr. *w*; -, -n u. Kak|tus (eine
Pflanze) *m*; - (ugs. u. österr. auch:
-ses); ...tus (ugs. auch: -se); Kak-
tus|fei|ge ([Frucht des] Feigen-
kaktus)
Ka|ku|mi|nal (veralt.) svw. Zere-
bral
Ka|la-Azar Hindi (,,schwarze
Krankheit''; eine trop. Infek-
tionskrankheit) *w*; -
Ka|la|bas|se *w*; - Kalebasse
Ka|la|bre|se *m*; -n (↑ R 268), -n;
vgl. Kalabrier; Ka|la|bre|se
(breitrandiger Filzhut); Ka|la-
bri|en [...i^en] (Landschaft in Itali-
en); Ka|la|bri|er [...i^er] (Bewoh-
ner Kalabriens); ka|la|brisch
Ka|la|fa|ti it. (Figur im Wiener
Prater) *m*; -
Ka|la|ha|ri[|step|pe] (in Südafrika)
w; -
Ka|la|mai|ka slaw. (slaw.-ung.
Nationaltanz) *w*; -, ...ken
Ka|la|mi|tät lat. (schlimme Ver-
legenheit, Übelstand, Notlage)
Ka|la|min gr. (ausgestorbene
baumhohe Schachtelhalme des
Karbons) *Mehrz.*
Ka|lan|der fr. (Glätt-, Prägema-
schine) *m*; -
Ka|lan|der|ler|che gr.; dt. (Ler-
chenart der Mittelmeerländer)
ka|lan|dern (mit dem Kalander
bearbeiten); ...ere (↑ R 327)
Ka|la|sche russ. landsch. (Tracht
Prügel) *w*; -, -n; ka|la|schen (prü-
geln); du kalaschst (kalaschest)
Ka|lau|er [aus fr. calembour unter
Anlehnung an die Stadt Calau

umgebildet] (ugs. für: alter, nicht sehr geistreicher [Wort]witz) *m*; -s, -; ka|lau|ern (Kalauer machen); ich ...ere († R 327)

Kalb *s*; -[e]s, Kälber; († R 224:) das Goldene - (bibl.); **Kälb|chen**, **Kälb|lein**; **Kal|be** (Kuh, die noch nicht gekalbt hat) *w*; -, -n **Kal|be/Mil|de** (Stadt in der Altmark); vgl. aber: Calbe (Saale)

kal|ben (ein Kalb werfen); **Käl|ber-ma|gen**; **kal|bern** (schweiz. auch für: kalben), **¹käl|bern** (wie junge Kälber spielen, umhertollen; auch für: kalbern); ich ...ere († R 327); **²käl|bern** südd., österr. (aus Kalbfleisch); **Käl|ber|ne** südd., österr. (Kalbfleisch) *s*; -n († R 287 ff.); **Käl|ber|zäh|ne** (ugs. für: große Graupen) *Mehrz.*; **Kalb-fell** vgl. Kalbsfell; **Kal|bin** südd., österr. (svw. Kalbe) *w*; -, -nen; **Kalb.fleisch**, **Kalb|le|der**, Kalbsleder; **Kälb|lein**, Kälb|chen; **Kalbs.bra|ten**, ...bries od. ...brieschen, ...brös|chen, ...brust; **Kalb[s]|fell** (früher auch für: Trommel); **Kalbs.fri|kas|see**, ...hach|se (vgl. Hachse), ...keu|le, ...le|ber; **Kalbs|milch** (Brieschen), ...nie|ren|bra-ten, ...nuß (kugelförmiges Stück der Kalbskeule), ...schle|gel, ...schnit|zel (vgl. ¹Schnitzel), ...stel|ze (österr. für: Kalbshachse)

Kal|chas (gr. Sagengestalt) **Kalck|reuth** (dt. Maler) **Kal|da|ri|um** *lat.* („Warmzelle" im altröm. Bad; veralt. für: warmes Gewächshaus) *s*; -s, ...ien [...*i*ᵉ*n*] **Kal|dau|ne** *lat.* niederd., mitteld. (gereinigter u. gebrühter Magen von frisch geschlachteten Wiederkäuern) *w*; -, -n (meist *Mehrz.*)

Ka|le|bas|se *arab.-fr.* (Flaschenkürbis u. das aus ihm hergestellte Gefäß) *w*; -, -n

Ka|le|do|ni|en [...*i*ᵉ*n*] (veralt. u. dicht. für: nördl. Schottland); **Ka|le|do|ni|er** [...*i*ᵉ*r*]; **ka|le|do-nisch**, aber († R 224): der Kaledonische Kanal (in Schottland) **Ka|lei|do|skop** *gr.* (optisches Spielzeug) *s*; -s, -e; **ka|lei|do|sko|pisch** (das Kaleidoskop betreffend; übertr. für: in bunter Folge, von ständig wechselnder Buntheit)

Ka|lei|ka *poln.* landsch. (Aufheben, Umstände) *s*; -s; [k]ein K. machen

ka|len|da|risch *lat.* (nach dem Kalender); **Ka|len|da|ri|um** (Kalender; Verzeichnis kirchl. Fest- u. Gedenktage) *s*; -s, ...ien [...*i*ᵉ*n*]; **Ka|len|den** (erster Tag des röm. Monats) *Mehrz.*; **Ka|len|der** *m*; -s, -; († R 179:) der Gregorianische, Julianische, Hundertjähri-

ge -; **Ka|len|der.block** (*Mehrz.* ...blocks), ...jahr, ...ma|cher, ...mo|nat, ...re|form, ...spruch **Ka|le|sche** *poln.* (leichte vierrädrige Kutsche) *w*; -, -n **Ka|le|va|la**, (eingedeutscht:) **Ka-le|wa|la** (Titel des finn. Volksepos) *w* od. *s*; - **Kal|fak|ter** *lat. m*; -s, - u. **Kal|fak-tor** („Einheizer"; volkstüml. für: jmd., der allerlei Arbeiten und Dienste verrichtet, z. B. im Gefängnis; landsch. für: Aushorcher, Schmeichler, Nichtstuer) *m*; -s, ...oren

kal|fa|tern *arab.-niederl.* ([hölzerne Schiffswände in den Fugen] abdichten); ich ...ere († R 327); **Kal|fa|te|rung**; **Kal|fat|ham|mer**

¹Ka|li *arab.* (Sammelbez. für Kalisalze [wichtige Ätz- u. Düngemittel]) *s*; -s, -s **²Ka|li** (ind. Göttin, Gemahlin Schiwas)

Ka|li|an, **Ka|li|un** (pers. Wasserpfeife) *m* od. *s*; -s, -e **Ka|li|ban** [nach Caliban, einer Gestalt in Shakespeares „Sturm"] (geh., veralt. für: Unhold, häßliches Ungeheuer) *m*; -s, -e **Ka|li|ber** *gr.* (lichte Weite von Rohren; Durchmesser; auch: Meßgerät; übertr. ugs. für: Art, Schlag) *s*; -s, -; **Ka|li|ber|maß** *s*; **ka|li|brie|ren** (das Kaliber messen; Werkstücke auf genaues Maß bringen; Meßinstrumente eichen); ...ka|li|brig (z. B. kleinkalibrig)

Ka|li|da|sa (altind. Dichter) **Ka|li|dün|ger** **Ka|lif** *arab.* („Statthalter, Nachfolger" [Mohammeds]); ehem. morgenländ. Herrscher) *m*; -en, -en († R 268); **Ka|li|fat** (Reich, Herrschaft eines Kalifen) *s*; -[e]s, -e; **Ka|li|fen|tum** *s*; -s **Ka|li|for|ni|en** [...*i*ᵉ*n*] (mexikan. Halbinsel; Staat in den USA; Abk.: Calif.); **Ka|li|for|ni|er** [...*i*ᵉ*r*]; **ka|li|for|nisch**, aber († R 224): der Kalifornische Meerbusen (älterer Name für: Golf von Kalifornien)

Ka|li|in|du|strie **Ka|li|ko** [nach der ostind. Stadt Kalikut] (dichter Baumwollstoff) *m*; -s, -s

Ka|li|lau|ge **Ka|li|man|tan** (indones. Name von: Borneo) **Ka|li|nin|grad** (sowjetruss. Name von: Königsberg [Pr]) **Ka|li.sal|pe|ter**, ...salz; **Ka|li|um** *arab.-nlat.* (chem. Grundstoff, Metall; Zeichen: K) *s*; -s; **Ka|li-um.bro|mid**, ...chlo|rat, ...hy|dro-xyd (vgl. Oxid), ...per|man|ga-nat, ...ver|bin|dung

Ka|li|un vgl. Kalian **Ka|lixt**, **Ka|lix|tus** (Papstname) **Ka|lix|ti|ner** *lat.* (Anhänger der gemäßigten Hussiten; vgl. Utraquist) *m*; -s, - **Kalk** *m*; -[e]s, -e; - brennen; **Kalk-al|pen** *Mehrz.*; Nördliche, Südliche -

Kal|kant *lat.* (Blasebalgtreter an der Orgel) *m*; -en, -en († R 268) **Kal|kar** (Stadt in Nordrhein-Westfalen) **Kalk.bo|den**, ...bren|ner; **kal|ken**; **käl|ken** landsch. (kalken); **Kalk-gru|be**; **kalk|hal|tig**; **kal|kig**; **Kalk.man|gel**, ...ofen, ...oo|lith (ein Gestein), ...prä|pa|ra|te (Arzneimittel, *Mehrz.*), ...sin|ter (aus Wasser usw. abgesetzter Kalk[spat]), ...spat (ein Mineral), ...stein, ...tuff **Kal|kül** *fr.* ([Be]rechnung, Überschlag; Math.: System von Regeln zur schemat. Konstruktion von Figuren) *m* (auch, österr. nur:) -s, -e; **Kal|ku|la|ti|on** *lat.* [...*zion*] (Ermittlung der Kosten, [Kosten]voranschlag); **Kal|ku|la-tor** (Angestellter des betriebl. Rechnungswesens) *m*; -s, ...oren; **kal|ku|la|to|risch** (rechnungsmäßig); -e Abschreibungen, Zinsen (Wirtsch.); **kal|ku|lie|ren** ([be]rechnen; veranschlagen; überlegen)

Ka|li|kut|ta (größte Stadt Indiens); **kal|kut|tisch** **Kalk.was|ser** *s*; -s; **kalk|weiß** **Käl|la** *gr.* (eine Zierpflanze) *w*; -, -s **Kal|le** *jidd.* (Gaunerspr.: Braut, Geliebte; Dirne) *w*; -, -n **Kal|li|graph** *gr.* (veralt. für: Schönschreiber) *m*; -en, -en († R 268); **Kal|li|gra|phie** (veralt. für: Schönschreibkunst) *w*; -; **kal|li-gra|phisch** **Kal|lio|pe** (Muse der erzählenden Dichtkunst) **Kal|li|py|gos** *gr.* [auch: *kalip...* od. *kalip...*] („mit schönem Gesäß"; Beiname der Aphrodite) **kal|lös** *lat.* (Med.: schwielig); -este († R 292); **Kal|lus** (Bot.: an Wundrändern von Pflanzen entstehendes Gewebe; Med.: Schwiele; bei Knochenbrüchen neugebildetes Gewebe) *m*; -, -se **Käl|mann** (ung. m. Vorn.) **Kal|mar** (schwed. Hafenstadt); **Kal|ma|rer Uni|on** *w*; - - od. **Kal-ma|ri|sche Uni|on** *w*; -n - **Kal|mäu|ser** (veralt., aber noch landsch. für: Grübler, Kopfhänger; Pfennigfuchser, armer Schlucker) *m*; -s, - **Kal|me** *fr.* (Windstille) *w*; -, -n; **Kal|men.gür|tel**, ...zo|ne **Kal|muck** (ein Gewebe) *m*; -[e]s,

-e; Kal|mück, Kal|mücke [Trenn.: ...mük|ke] (Angehöriger eines westmongol. Volkes) m; ...cken, ...cken (↑ R 268)

Kal|mus gr. (eine Heilpflanze) m; -, -se; Kal|mus|öl s; -[e]s

Ka|lo it. (veralt. für: [Gewichts]verlust; Schwund [von Waren]) m; -s, -s

Ka|lo|bio|tik gr. (bei den alten Griechen die Kunst, ein harmon. Leben zu führen) w; -; Ka|lo|der|ma Ⓦ (Hautpflegemittel); Ka|lo|ka|ga|thie (körperl. u. geistige Vollkommenheit als Bildungsideal im alten Griechenland) w; -

Ka|lo|rie lat. (Grammkalorie; physikal. Maßeinheit für die Wärmemenge; auch: Maßeinheit für den Energieumsatz des Körpers; Zeichen: cal) w; -, ...ien; ka|lo|ri|en|arm; Ka|lo|ri|en|ge|halt; Ka|lo|ri|fer („Wärmebringer"; veralt. für: Heißluftofen) m; -s, -s u. -en; Ka|lo|rik (Wärmelehre) w; -; Ka|lo|ri|me|ter lat.; gr. (Gerät zur Bestimmung von Wärmemengen) s; -s, -; Ka|lo|ri|me|trie (Lehre von der Messung von Wärmemengen) w; -; ka|lo|ri|me|trisch; ka|lo|risch lat.; -e Maschine (Generator mit Wärmeantrieb); ka|lo|ri|sie|ren (auf Metallen eine Schutzschicht durch Glühen in Aluminiumpulver herstellen)

Ka|lot|te fr. (Kugelkappe; Schädeldach; Käppchen [der kath. Geistlichen] w; -, -n

Kal|pak, Kol|pak türk. (asiat. Lammfell-, Filzmütze; [Tuchzipfel an der] Husarenmütze) m; -s, -s

kalt kälter, kälteste; kalte Ente (ein Getränk); kalte Fährte; kalte Küche; kalter Krieg; kalte Mamsell (vgl. Mamsell); kalte Miete (Miete ohne Heizung); kalter Schlag (nicht zündender Blitz); auf kalt und warm reagieren; Schreibung in Verbindung mit Zeitwörtern (↑ R 139): a) Getrenntschreibung in ursprünglicher Bedeutung, z. B. kalt blei|ben; das Wetter war kalt geblieben; b) Zusammenschreibung, wenn durch die Verbindung ein neuer Begriff entsteht; vgl. kalt|bleiben, kaltlassen, kaltmachen, kaltstellen, kaltwalzen; kalt|blei|ben; ↑ R 139 (sich nicht erregen); er ist bei dieser Nachricht kaltgeblieben; aber: kalt blei|ben; das Wetter ist kalt geblieben; Kalt|blut (eine Pferderasse); Kalt|blü|ter (Zool.); kalt|blü|tig; Kalt|blü|tig|keit w; -; Kält|te w; -; Käl|te_ein|bruch, ...grad, ...ma|schi-

ne; kal|ten (veralt. für: kalt werden); käl|ten (veralt. für: kalt machen)

Kal|ter bayer., österr., schweiz. ([Fisch]behälter)

Käl|te_pe|ri|ode, ...sturz, ...technik, ...wel|le; Kalt|front (Meteor.); kalt|ge|schla|gen; -es Öl; kalt|her|zig; Kalt|her|zig|keit w; -; kalt|lä|chelnd; kalt|las|sen; ↑ R 139 (ugs. für: nicht beeindrucken); dieses traurige Ereignis hat ihn kaltgelassen; aber: kalt las|sen; sie hat den Wein kalt gelassen; Kalt|luft (Meteor.); kalt|machen; ↑ R 139 (ugs. für: ermorden); er hat ihn kaltgemacht; aber: kalt ma|chen; sie hat den Pudding kalt gemacht; Kalt_mam|sell (kalte Mamsell; vgl. Mamsell), ...scha|le (eine süße Suppe); kalt|schnäu|zig; Kalt|schnäu|zig|keit w; -; Kalt|start (Kfz); kalt|stel|len; ↑ R 139 (ugs. für: aus einflußreicher Stellung bringen, einflußlos machen); er hat ihn kaltgestellt; aber: kalt stel|len; sie hat den Wein kalt gestellt; Kalt_stel|lung, ...ver|pfle|gung; kalt|wal|zen; ↑ R 139 (Technik); nur in der Grundform u. im 2. Mittelwort gebr.; kaltgewalzt; Kalt|walz|werk; Kalt|was|ser_heil|an|stalt, ...kur; Kalt|wel|le (durch ein chem. Mittel hergestellte Dauerwelle)

Ka|lum|bin Bantuspr.-nlat. (Bitterstoff der Kolombowurzel) s; -s

Ka|lu|met gr. [auch fr. Ausspr.: kalümä] (Friedenspfeife der nordamerik. Indianer) s; -s, -s

Ka|lup|pe tschech. landsch. (schlechtes, baufälliges Haus) w; -, -n

Kal|va|ri|en|berg lat.; dt. [...wari-ᵉn...] („Schädelstätte": Kreuzigungsort Christi) m; -[e]s, (für: Nachbildung des Kalvarienberges an kath. Wallfahrtsorten auch Mehrz.:) -e

Kal|vill fr. [...wil] m; -s, -en u. Kal|vil|le (feiner fr. Tafelapfel) w; -, -n

kal|vi|nisch, cal|vi|nisch [...wi...] (nach dem Genfer Reformator J. Calvin); das -e Bekenntnis, aber (↑ R 179): Kal|vi|nisch, Cal|vi|nisch; die „Institutio religionis christianae" ist die Kalvinische Schrift; Kal|vi|nis|mus, Cal|vi|nis|mus (evangelisch-reformierter Glaube) m; -; Kal|vi|nist, Cal|vi|nist (Anhänger des Kalvinismus); ↑ R 268; kal|vi|ni|stisch, cal|vi|ni|stisch

Ka|ly|do|ni|sche Eber [nach der ätol. Stadt Kalydon] (Riesentier der gr. Sage) m; -n -s

Ka|lyp|so (gr. Nymphe); vgl. aber: Calypso

Ka|lyp|tra gr. (Wurzelhaube der Farn- u. Samenpflanzen) w; -, ...ren; Ka|lyp|tro|gen (Gewebeschicht, aus der sich die Kalyptra bildet) s; -s

Kal|zan Ⓦ (kalkhaltiges Präparat) s; -s

Kal|zeo|la|rie lat. [...iᵉ] (eine Zierpflanze, Pantoffelblume) w; -, -n

Kal|zi|na|ti|on lat., (fachspr. nur:) Cal|ci|na|ti|on [...zion] u. Kal|zi|nie|rung, (fachspr. nur:) Cal|ci|nie|rung (Zersetzung einer chem. Verbindung durch Erhitzen; Umwandlung in kalkähnliche Substanz); kal|zi|nie|ren, (fachspr. nur:) cal|ci|nie|ren (Zeitwort zu: Kalzination); kalzinierte Soda; Kal|zi|nier|ofen, (fachspr. nur:) Cal|ci|nier|ofen; Kal|zit, (fachspr. nur:) Cal|cit (Kalkspat) m; -s, -e; Kal|zi|um, (fachspr. nur:) Cal|ci|um (chem. Grundstoff, Metall; Zeichen: Ca) s; -s; Kal|zi|um_chlo|rid, ...kar|bid (fachspr. nur: Cal|ci|um...)

Ka|mal|du|len|ser [nach dem Kloster Camaldoli bei Arezzo] (Angehöriger eines kath. Ordens) m; -s, -

Ka|ma|ril|la span. [...rilja, auch: ...rilja] („Kämmerchen"; die Berater eines Fürsten; Günstlingspartei; einflußreiche, reaktionäre Hofpartei) w; -, ...llen

kam|bi|al it. (veralt. für: auf den Kambio bezüglich); kam|bie|ren (veralt. für: Wechselgeschäfte treiben); Kam|bio (Geldw., veralt. für: Wechsel) m; -s, ...bii; Kam|bi|um nlat. (Bot.: ein zeitlebens teilungsfähig bleibendes Pflanzengewebe) s; -s, ...ien [...iᵉn]

Kam|bo|dscha (Staat in Hinterindien); Kam|bo|dscha|ner; kam|bo|dscha|nisch

Kam|brik [zu: Cambrai; engl. Ausspr.: keᵉm...] (ein Gewebe) m; -s; Kam|brik|ba|tist

kam|brisch (zum Kambrium gehörend); Kam|bri|um [aus: Cambria = alter Name für: Wales] (Geol.: älteste Stufe des Paläozoikums) s; -s

Kam|by|ses (pers. König)

Ka|mee fr. (erhaben geschnittener Stein) w; -, -n; Ka|me|en|schnei|der

Ka|mel semit. (ein Huftier) s; -[e]s, -e; Ka|mel|dorn (ein Steppenbaum; Mehrz. ...dorne) m; Kä|mel|garn od. Käm|mel|garn (Garn aus den Haaren der Angoraziege [früher = Kamelziege]); Ka|mel|haar

Ka|me|lie [...iᵉ; nach dem mähri-

schen Jesuiten Kamel (latinis.: Camellus) (eine Zierpflanze) w; -, -n

Ka|mel|len gr. Mehrz.; olle - (ugs. für: alte Geschichten; Altbekanntes)

Ka|mel|lie vgl. Kamelie

Ka|me|lo|pard gr. (Sternbild der Giraffe) m; -[e]s u. -en (↑ R 268), e[n]

Ka|me|lott (ein Gewebe) m; -s, -e

Ka|me|ne vgl. Kamöne

Ka|menz (Stadt im Bezirk Dresden)

Ka|me|ra lat. w; -, -s; vgl. Camera obscura

Ka|me|rad f... m; en, en (↑ R 268)

Ka|me|ra|den|dieb|stahl, ...hil|fe;

Ka|me|ra|de|rie (Kameradschaft; Cliquengeist) w; -, ...ien;

Ka|me|ra|din w; -, -nen; Ka|me|rad|schaft; ka|me|rad|schaft|lich;

Ka|me|rad|schaft|lich|keit w; -;

Ka|me|rad|schafts...ehe, ...geist

Ka|me|ra...ein|stel|lung, ...füh|rung

Ka|me|ra|list gr. (früher Beamter einer fürstl. Kammer; Vertreter der Kameralwissenschaft; ↑ R 268; Ka|me|ra|li|stik (bei staatswirtschaftl. Abrechnungen gebr. System des Rechnungswesens; veralt. für: Finanzwissenschaft) w; -; ka|me|ra|li|stisch; Ka|me|ral|wis|sen|schaft

Ka|me|ra...mann (Mehrz. ...männer u. ...leute), ...ver|schluß

Ka|me|run (Staat in Westafrika);

Ka|me|ru|ner (↑ R 199); ka|me|ru|nisch; Ka|me|run|nuß (Erdnuß); ↑ R 201

ka|mie|ren, ka|mi|nie|ren it. (Fechtsport: die gegnerische Klinge umgehen)

Ka|mil|la vgl. Camilla

Ka|mil|le gr. (eine Heilpflanze) w; -, -n; Ka|mil|len|öl (s; -[e]s), ...tee

Ka|mil|lo vgl. Camillo

Ka|min gr. (offene Feuerung; landsch. für: Schornstein; Alpinistik: steile, enge Felsenspalte) m (schweiz.: s); -s, -e; Ka|min|fe|ger (landsch.), ...feu|er

ka|mi|nie|ren (im Kamin, zwischen überhängenden Felsen klettern; auch für: kamieren; vgl. d.)

Ka|min|keh|rer, (landsch.), ...kleid (langes Kleid aus Wollstoff)

Ka|mi|sol fr. (früher: Unterjacke, kurzes Wams) s; -s, -e; Ka|mi|söl|chen

Kamm m; -[e]s, Kämme; Kamma|cher [Trenn.: Kamm|ma|cher, ↑ R 236]; Kämmaschine [Trenn.: Kämm|ma|schi|ne, ↑ R 236]; Kämm|chen, Kämm|lein

Käm|mel|garn, Kä|mel|garn (vgl. d.)

käm|meln ([Wolle] fein kämmen); ich ...[e]le (↑ R 327); käm|men

Kam|mer w; -, -n; Kam|mer|bul|le (Soldatenspr.: Unteroffizier, der die Kleiderkammer unter sich hat); Käm|mer|chen, Käm|mer|lein; Käm|mer|die|ner; Käm|me|rei (veralt. für: Finanzverwaltung einer Gemeinde); Käm|me|rer; Kam|mer.frau, ...herr; ...kam|me|rig (z. B. vielkammerig); Kam|mer|jä|ger, ...jung|fer, ...jun|ker; Kam|mer|lein, Kämmer|chen; Kam|mer|ling (ein Wurzelfüßer); Käm|mer|ling (früher für: Kammerdiener); Kam|mer.mu|sik, ...or|che|ster, ...rat (früherer Titel; Mehrz. ...räte), ...sän|ger, ...spiel (in einem kleinen Theater aufgeführtes Stück mit wenigen Rollen), ...spie|le (kleines Theater; Mehrz.), ...ton (Normalton zum Einstimmen der Instrumente; m; -[e]s), ...zo|fe

Kamm.fett (vom Kamm des Pferdes; s; -[e]s), ...garn; Kamm|garn|spin|ne|rei; Kamm.gras (s; -es), ...griff (Turnen; m; -[e]s), ...grind (eine Geflügelkrankheit; m; -[e]s); Kämm|la|ge; Kämm|lein, Kämm|chen; Kämm|ling (Kammgarnabfall); Kammolch [Trenn.: Kamm|molch, ↑ R 236]; Kammu|schel [Trenn.: Kammmu.... ↑ R 236]; Kamm|weg

Ka|mö|ne lat. (altital. Quellnymphe, Muse) w; -, -n

Ka|mor|ra it. (Geheimbund im ehem. Königreich Neapel) w; -

Kamp lat. niederd. (abgegrenztes Stück Land, Feldstück) m; -[e]s, Kämpe

Kam|pa|gne fr. [...panjᵉ] (Presse-, Wahlfeldzug; polit. Aktion; Wirtsch.: Hauptbetriebszeit; Arbeitsabschnitt bei Ausgrabungen; veralt. für: milit. Feldzug) w; -, -n

Kam|pa|ni|en [...iᵉn] (hist. it. Landschaft)

Kam|pa|ni|le it. (frei stehender Glockenturm [in Italien]) m; -, -

Kam|pan|je niederl. (früher: hinterer Aufbau auf dem Schiffsoberdeck) w; -, -n; Kam|pan|je|trep|pe

Käm|pe (dicht. für: Kämpfer, Krieger) m; -n, -n (↑ R 268)

Kam|pe|lei (landsch.); kam|peln, sich landsch. (sich balgen; sich streiten, zanken); ich ...[e]le mich mit ihm (↑ R 327)

Kam|pe|sche|holz [nach dem Staat Campeche (kampätschᵉ) in Mexiko] (Färbeholz, Blauholz) s; -es

Käm|pe|vi|ser dän. [...wis*r] (,,Heldenweisen''; altdän. u. altschwed. Balladen mit Stoffen aus der Heldenzeit) Mehrz.

Kampf m; -[e]s, Kämpfe; - ums Dasein; Kampf.ab|stim|mung, ...an|sa|ge, ...bahn (für: Stadion), ...be|gier[|de] (w; -); kampf|be|reit; Kampf|fen

Kamp|fer sanskr. (eine harzartige Verbindung; ein Heilmittel) m; -s

¹Kämp|fer (Kämpfender)

²Kämp|fer (Teil bei Gewölben, Türen, Fenstern) m; -s, -

Kämp|fe|rin w; -, -nen; kämp|fe|risch (mutig, heldenhaft); -ste (↑ R 294); Kämp|fer|na|tur

Kampf|fer.öl (s; -[e]s), ...spi|ri|tus

Kampf|fes|lärm, Kampf|lärm;

Kampf|fes|lust, Kampf|lust; kampf|fä|hig; Kampf|fä|hig|keit (w; -), ...flie|ger, ...flug|zeug, ...ge|fähr|te, ...geist, ...grup|pe, ...hahn, ...hand|lung (meist Mehrz.), ...kraft, ...lärm od. Kampf|fes|lärm, ...läu|fer (ein Vogel); kampf|los; Kampf.lust od. Kampf|fes|lust, ...mo|ral, ...pa|ro|le, ...pau|se, ...platz, ...preis (vgl. ²Preis), ...rich|ter, ...staf|fel, ...stoff; kampf|un|fä|hig; Kampf|un|fä|hig|keit w; -

kam|pie|ren fr. (im Freien) lagern; ugs. für: wohnen, hausen)

Kam|sin arab. (heiß-trockener Sandwind in der ägypt. Wüste) m; -s, -e

Kam|tscha|da|le (Bewohner von Kamtschatka) m; -n, -n (↑ R 268);

Kam|tschat|ka (nordasiat. Halbinsel)

Ka|muf|fel landsch. (Dummkopf) s; -s, -

Kan. = Kansas

Ka|na (bibl. Ort); Hochzeit zu -

Ka|na|an [...na-an] (das vorisraelitische Palästina); ka|naa|nä|isch; Ka|naa|ni|ter [...t*r]; ka|naa|ni|tisch

Ka|na|da (Bundesstaat in Nordamerika); Ka|na|da|bal|sam m; -s (↑ R 201); Ka|na|di|er [...i*r] (Bewohner von Kanada; österr. auch: ein Polstersessel); ka|na|disch, aber: der Kanadische Schild (Geol.: präkambrischer Festlandskern im Norden der Neuen Welt)

Ka|nail|le fr. [kanaljᵉ] (Schurke; veralt. für: ,,Hundepack'', Gesindel) w; -, -n

Ka|na|ke polynes. (,,Mensch''; Eingeborener der Südseeinseln) m; -n, -n (↑ R 268)

Ka|nal (Einz. auch für: Ärmelkanal) m; -s, ...näle; Ka|nal.ab|ga|ben (Mehrz.), ...bau (Mehrz. ...bauten); Ka|näl|chen (kleiner Kanal); Ka|nal|damp|fer; Ka|na|li|sa|ti|on [...ziọn] (Anlage zur Ableitung der Abwässer); ka|na|li|sie|ren (ein Kanalisation bauen; Flüsse zu Kanälen

ausbauen; übertr.: in eine bestimmte Richtung lenken); **Ka|na|li|sie|rung** (System von Kanälen; Ausbau zu Kanälen); **Ka|nal_schacht**, ...schleu|se

ka|na|nä|isch, **Ka|na|ni|ter**, **ka|na|ni|tisch** vgl. kanaanäisch usw.

Ka|na|pee fr. österr. auch: ...*pe]* (veraltend für: Sitzsofa, Ruhebett) s; -s, -s; **Ka|na|pees** (gefüllte Blätterteigschnitten; pikant belegte, geröstete Weißbrotscheiben) *Mehrz.*

Ka|na|ren (Kanarische Inseln) *Mehrz.*; **Ka|na|ri** (südd., österr. ugs. für: Kanarienvogel) m; -s, -; **Ka|na|rie** [...*rïe*] (fachspr. für: Kanarienvogel) w; -, -n; **Ka|na|ri|en|vo|gel** [...*ï*ⁿn...]; **Ka|na|ri|er** [...*ïⁿr*] (Bewohner der Kanarischen Inseln); **Ka|na|ri|sche Inseln** (an der Nordwestküste Afrikas) *Mehrz.*

Kan|da|har-Ren|nen [nach dem Earl of Kandahar] (jährl. stattfindendes Schirennen); ↑ R 180

Kan|da|re ung. (Gebißstange des Pferdes) w; -, -n; jmdn. an die - nehmen (jmdn. streng behandeln)

Kan|del landsch. ([Dach]rinne) m; -s, -n od. w; -, -n

Kan|de|la|ber fr. (Standleuchte; Laternenträger) m; -s, -

kan|deln landsch. (auskehlen, rinnenförmig aushöhlen); ich ...[e]le (↑ R 327)

Kan|del|zucker [*Trenn.:* ...zuk|ker] landsch. (Kandis[zucker])

Kan|di|da vgl. Candida

Kan|di|dat lat. („Weißgekleideter"; in der Prüfung Stehender; [Amts]bewerber, Anwärter; Abk.: cand.) m; -en, -en (↑ R 268); - der Medizin (Abk.: cand. med.); - der Philosophie (Abk.: cand. phil.); - des [lutherischen] Predigtamtes (Abk.: cand. [rev.] min. od. c. r. m.; vgl. Doktor); **Kan|di|dat]en|li|ste**; **Kan|di|da|tur** (Bewerbung [um ein Amt, einen Parlamentssitz usw.]) w; -, -en; **kan|di|die|ren** (sich [um ein Amt usw.] bewerben)

Kan|di|dus vgl. Candidus

kan|die|ren arab. ([Früchte] durch Zuckern haltbar machen)

Kan|din|sky (russ. Maler u. Graphiker)

Kan|dio|te (ältere Bez. für: Kreter) m; -n, -n (↑ R 268)

Kan|dis arab. m; - u. **Kan|dis|zucker** [*Trenn.:* ...zuk|ker] (an Fäden auskristallisierter Zucker); **Kan|di|ten** bes. österr. (überzuckerte Früchte; Zuckerwaren) *Mehrz.*

Ka|neel sumer. (beste Zimtsorte) m; -s, -e; **Ka|neel_blu|me**

Kan|epho|re gr. („Korbträgerin"; Bauw.: Gebälkträgerin) w; -, -n

Ka|ne|vas fr. [*kan*ᵉ*waß*] („Hanfgewebe"; Gittergewebe; Akt- u. Szeneneinteilung in Stegreifkomödien) m; -u. -ses, - u. -se; **ka|ne|vas|sen** (aus Kanevas)

Kän|gu|ruh austr. [*kängg...*] (ein Beuteltier) s; -s, -s

Ka|nin|den lat. (Sammelbez. für: Hunde u. hundeartige Tiere) *Mehrz.*

Ka|nin iber. (Kaninchenfell) s; -s, -e; **Ka|nin|chen**

Ka|ni|ster sumer. (tragbarer Behälter für Flüssigkeiten) m; -s, -

Kan|ker gr. (eine Spinnenart) m; -s, -; **Kan|kro|id** (veralt. für: Stachelzellenkrebs) s; -[e]s, -e

Kan|na sumer. (ein Schwanenblumengewächs) w; -, -s

Kan|nä [nach dem Schlachtort des Altertums in Italien: Cannae] (übertr.: völlige Vernichtung des Gegners) s; -, -; vgl. kannensisch

Kan|na|da (eine Sprache in Indien) s; -[s]

Kann-Bestim|mung (↑ R 151)

Känn|chen, **Känn|lein**; **Kan|ne** w; -, -n; **Kan|ne|gie|ßer** (polit. Schwätzer); **kan|ne|gie|ßern**; ich ...ere (↑ R 327); gekannegießert

Kän|nel bes. schweiz. (Dachrinne, Regenabfallrohr) m; -s, -; **kan|ne|lie|ren** (mit Kannelüren versehen; auskehlen; riefeln); **Kan|ne|lie|rung**

Kän|nel|koh|le engl.; dt. (eine Steinkohlenart)

Kan|ne|lur sumer.-fr. w; -, -en u. **Kan|ne|lü|re** (senkrechte Rille am Säulenschaft; Hohlkehle) w; -, -n

Kan|nen|bäcker|land, (auch: Kanne|bäcker|land [*Trenn.:* ...bäkker...] (Landschaft im Westerwald) s; -[e]s; **Kan|nen|pflan|ze** (eine insektenfressende Pflanze)

kan|nen|wei|se; das Öl wurde - abgegeben

Kan|ni|ba|le span. (Menschenfresser; übertr.: roher, ungesitteter Mensch) m; -n, -n (↑ R 268); **kan|ni|ba|lisch**; -ste (↑ R 294); **Kan|ni|ba|lis|mus** (Menschenfresserei; übertr.: unmenschliche Roheit; Zool.: Verzehren der Artgenossen) m; -

Kan|nit|ver|stan niederl. („Kann nicht verstehen"; Figur bei J. P. Hebel) m; -s, -e

Känn|lein, **Känn|chen**

Kann-Vor|schrift (↑ R 151)

Kanoldt (dt. Maler)

¹**Ka|non** sumer.-lat. (Maßstab, Richtschnur; Regel; Auswahl; Kettengesang; Liste der kirchl.

anerkannten bibl. Schriften; in der kath. Liturgie das Hochgebet der Eucharistie; kirchenamtl. Verzeichnis der Heiligen; Einzelbestimmung des kath. Kirchenrechts; Verzeichnis mustergültiger Schriftsteller) m; -s, -s; ²**Ka|non** (ein Schriftgrad) w; -

Ka|no|na|de sumer.-fr. (anhaltendes] Geschützfeuer; Trommelfeuer); **Ka|no|ne** sumer.-it. (Geschütz; ugs. für: Sportgröße, bedeutender Könner) w; -, -n; **Ka|no|nen_boot**, ...don|ner, ...fut|ter, (vgl. ¹Futter), ...ku|gel, ...öf|chen, ...rohr, ...schlag (Feuerwerkskörper), ...schuß; **Ka|no|nier** sumer.-fr. (Soldat der Geschützbedienung) m; -s, -e; **ka|no|nie|ren** (veralt. für: mit Kanonen [anhaltend] schießen; ugs. für: einen kraftvollen Schuß auf das Tor abgeben [Fuß-, Handball usw.])

Ka|no|nik sumer.-lat. (Name der Logik bei Epikur) w; -; **Ka|no|ni|kat** (Amt, Würde eines Kanonikers) s; -[e]s, -e; **Ka|no|ni|ker** od. **Ka|no|ni|kus** (Mitglied eines geistl. Kapitels, Chorherr) m; -, ...ker; **Ka|no|ni|sa|ti|on** [...*zion*] (Heiligsprechung); **ka|no|nisch** (den Kanon betreffend, ihm gemäß; mustergültig); -es Recht; -e Schriften; **ka|no|ni|sie|ren** (heiligsprechen, in den Kanon aufnehmen); **Ka|no|nis|se** sumer.-fr. w; -, -n u. **Ka|no|nis|sin** (Stiftsdame) w; -, -nen; **Ka|no|nist** sumer.-lat. (Lehrer des kanon. Rechtes); ↑ R 268

Ka|no|pe gr. (altägypt. u. etrusk. Urne) w; -, -n; **Ka|no|pen|deckel** [*Trenn.:* ...dek|kel]; **Ka|no|pos** vgl. ¹Kanopus; **Ka|no|pus** (altägypt. Gottheit); ²**Ka|no|pus** (ein Stern) m; -

Ka|nos|sa [nach dem jetzt verfallenen Felsenburg Canossa in Norditalien] (übertr.: Demütigung) s; -s, -s; **Ka|nos|sa|gang** m (↑ R 201)

Kä|no|zoi|kum gr. (Geol.: Erdneuzeit [Tertiär u. Quartär]) s; -s; **kä|no|zo|isch**

Kans. = Kansas

Kan|sas (Staat in den USA; Abk.: Kan. u. Kans.)

Kant (dt. Philosoph); **Kant-Gesell|schaft**, aber: Kant|stu|di|um (↑ R 180)

Kan|ta|bi|le it. (Musik: ernstes, getragenes, gesangvolles Tonstück) s; -, -; **Kan|ta|bi|li|tät** lat. (Musik: die Singbarkeit, gesanglicher Ausdruck, melod. Schönheit) w; -

Kan|ta|brer [auch: *kan...*] (Angehöriger eines alten iber. Volkes) m; -s, -; **kan|ta|brisch**

(↑ R 224): das Kantabrische Gebirge

Kan|tar *lat.-arab.* (früher: morgenländ. Gewicht) *m* od. *s*; -s, -e; 5 - (↑ R 322)

¹Kan|ta|te *lat.* (mehrteiliges, instrumentalbegleitetes Gesangsstück für eine Solostimme oder Solo- und Chorstimmen) *w*; -, -n;

²Kan|ta|te („singet!"; vierter Sonntag nach Ostern)

Kan|te *w*; -, -n; ¹Kan|tel (Holzstück mit quadrat. od. rechteckigem Querschnitt für Stuhlbeine usw.) *w*; -, -n; ²Kan|tel (veralt. für: Lineal) *m* od. *s*; -s, -; kan|teln (veralt. für: mit dem ²Kantel Linien ziehen; auf die Kante stellen); ich ...[e]le (↑ R 327); kan|ten (mit Kanten versehen, rechtwinklig behauen; auf die Kante stellen); Kan|ten nordd. (Brotrinde; Anschnitt od. Endstück eines Brotes) *m*; -s, -; Kan|ten.ge|schie|be (Geol.), ...win|kel

¹Kan|ter (veralt. für: Kellerlager; Gestell [für Fässer]; Verschlag) *m*; -s, -

²Kan|ter *engl.* [auch engl. Ausspr.: *kän...*] (Reitsport: leichter, kurzer Galopp) *m*; -s, -; kan|tern (kurz galoppieren); ich ...ere (↑ R 327); Kan|ter|sieg (Sportspr.: müheloser [hoher] Sieg)

Kant|ha|ken (ein Werkzeug); (ugs.:) jmdn. beim - kriegen

Kan|tha|ri|den *gr.* (Weichkäfer, z. B. span. Fliege) *Mehrz.*; Kan|tha|ri|den|pfla|ster; Kan|tha|ri|din, (fachspr.:) Can|tha|ri|din (ein Heilmittel) *s*; -s

Kant|holz

Kan|tia|ner (Schüler, Anhänger Kants)

kan|tig

Kan|ti|le|ne *it.* (gesangartige, getragene Melodie) *w*; -, -n

Kan|til|le *sumer.-roman.* (schraubenförmig gedrehter vergoldeter od. versilberter Draht) *w*; -, -n

Kan|ti|ne *fr.* (Speisesaal in Betrieben, Kasernen o. ä.) *w*; -, -n; Kan|ti|nen.es|sen, ...wirt

kan|tisch [zu: Kant], aber (↑ R 179): Kan|tisch

¹Kan|ton (chin. Stadt)

²Kan|ton *fr.* (Schweiz: Bundesland; Abk.: Kt.; Frankr. u. Belgien: Bezirk, Kreis) *m*; -s, -e; kan|to|nal (den Kanton betreffend); Kan|to|nal|bank (*Mehrz.* ...banken); Kan|tön|chen, Kan|tön|lein (kleiner Kanton); Kan|to|nie|re *it.* (Straßenwärterhaus in den it. Alpen) *w*; -, -n; kan|to|nie|ren *fr.* (veralt. für: Truppen unterbringen; in Standorte legen); Kan|to|nie|rung; Kan|to|nist (veralt. für: ausgehobener Rekrut); ↑ R 268;

unsicherer - (ugs. für: unzuverlässiger Mensch); Kan|tön|lein, Kan|tön|chen; Kan|ton|li|geist (Kirchturmpolitik, Lokalpatriotismus) *m*; -[e]s; Kan|ton|ne|ment [...*mạng*, in der Schweiz: ...*mänt*] (veralt. für: Truppenunterkunft) *s*; -s, -s u. (schweiz.:) -e; Kan|tons.ge|richt, ...rat (*Mehrz.* ...räte), ...schu|le (kantonale Maturitätsanstalt), ...spi|tal

Kan|tor *lat.* („Sänger"; im Gregorian. Choral: Vorsänger; Leiter des Kirchenchores, Organist) *m*; -s, ...oren; Kan|to|rat (Amt eines Kantors) *s*; -[e]s, -e; Kan|to|rei (im MA. Gesangschor der Kloster- u. Domschulen; in der Reformationszeit fürstl. Kapellinstitution; kleine Singgemeinschaft; ev. Kirchenchor); Kan|to|ren|amt

Kan|to|ro|wicz, Alfred [...*witsch*] (dt. Publizist, Literarhistoriker u. Schriftsteller)

Kan|tschu *türk.* (Riemenpeitsche) *m*; -s, -s

Kant|stein nordd. (Bordstein)

Kan|tus *lat.* (Studentenspr.: Gesang) *m*; -, -se

Ka|nu *karib.* [auch, österr. nur: *kanú*] (ausgehöhlter Baumstamm als Boot; heute zusammenfassende Bez. für: Kajak u. Kanadier) *s*; -s, -s

Ka|nü|le *sumer.-fr.* (Röhrchen; Hohlnadel) *w*; -, -n

Ka|nu|te *karib.* (Sport: Kanufahrer) *m*; -n, -n (↑ R 268)

Kan|zel *lat.* *w*; -, -n; Kan|zel_red|ner, ...ton (*m*; -[e]s)

kan|ze|ro|gen (svw. karzinogen)

Kanz|lei *lat.* südd., österr., schweiz. (Büro); Kanz|lei.aus|druck, ...be|am|te, ...for|mat; kanz|lei|mä|ßig; Kanz|lei.spra|che (*w*; -), ...stil (*m*; -[e]s); Kanz|ler; Kanz|ler|kan|di|dat; Kanz|ler|schaft *w*; -; Kanz|list (Schreiber, Angestellter in einer Kanzlei); ↑ R 268

Kan|zo|ne *it.* (Gedichtform; Gesangstück; Instrumentalkomposition) *w*; -, -n

Kao|lin *chin.-fr.* (Porzellanerde) *s* od. *m* (fachspr. nur so); -s, -e; Kao|lin.er|de, ...sand|stein

Kap *niederl.* (Vorgebirge) *s*; -s, -s; Kap der Guten Hoffnung (Südspitze Afrikas); Kap Hoorn (Südspitze Südamerikas)

Kap. = Kapitel (Abschnitt)

ka|pa|bel *fr.* (veralt., noch mdal. für: geschickt; fähig, befähigt); ...a|ble Schüler

Ka|paun *fr.* ([verschnittener] Masthahn) *m*; -s, -e; ka|pau|nen (verschneiden); kapaunt; ka|pau|ni|sie|ren (svw. kapaunen)

Ka|pa|zi|tät *lat.* (Aufnahmefähigkeit, Fassungskraft, -vermögen; auch: hervorragender Fachmann); Ka|pa|zi|täts_aus|la|stung, ...er|wei|te|rung

Ka|pee *fr.* (ugs., mdal. in den Redewendungen:) schwer von - sein (begriffsstutzig sein); - haben (leicht begreifen)

Ka|pe|lan *fr.* (ein Lachsfisch, Lodde) *m*; -s, -e

Ka|pel|la *lat.* (ein Stern) *w*; -

¹Ka|pel|le *lat.* (kleiner kirchl. Raum; Orchester) *w*; -, -n

²Ka|pel|le *lat.*, (auch:) Ku|pel|le (Tiegel, Kessel) *w*; -, -n

Ka|pell|mei|ster

¹Ka|per *gr.* ([in Essig eingemachte] Blütenknospe des Kapernstrauches) *w*; -, -n (meist *Mehrz.*)

²Ka|per *niederl.* (veralt. für: Kaperschiff; Freibeuter, Seeräuber) *m*; -s, -; Ka|per|brief; Ka|pe|rei (früher: Aufbringung feindlicher und Konterbande führender neutraler Handelsschiffe); Ka|per.fahrt, ...gut; ka|pern; ich ...ere (↑ R 327)

Ka|per|na|um, (ökum.:) Ka|far|na|um (bibl. Ort)

Ka|pern_so|ße, ...strauch

Ka|perst|schiff; Ka|pe|rung

Ka|pe|tin|ger [auch: *káp...*] (Angehöriger eines fr. Königsgeschlechtes) *m*; -s, -

Kap|hol|län|der (Bure); kap|hol|län|disch

ka|pie|ren *lat.* (ugs. für: fassen, begreifen, verstehen)

ka|pil|lar *lat.* (haarfein, z. B. von Blutgefäßen); Ka|pil|lar.ana|ly|se, ...che|mie; Ka|pil|la|re (Haargefäß, kleinstes Blutgefäß; Haarröhrchen) *w*; -, -n; Ka|pil|lar|ge|fäß (feinstes Blutgefäß); Ka|pil|la|ri|tät (Physik: Verhalten von Flüssigkeiten in engen Röhren) *w*; -; Ka|pil|lar|mi|kro|sko|pie (Med.: mikroskop. Untersuchung der Kapillaren am Nagelfalz) *w*; -

ka|pi|tal *lat.* (hauptsächlich; vorzüglich, besonders); Ka|pi|tal *s*; -s, -e u. -ien [...*i'n*] (österr. nur so); Ka|pi|tal, (auch: Haupt...); Ka|pi|tal (seltener für: Kapitell); Ka|pi|tal_an|la|ge, ...auf|stok|kung, ...aus|fuhr; Ka|pi|tal|band, Kapi|tal|band (Schutz- u. Zierband am Buchrücken) *s*; -[e]s, ...bänder; Ka|pi|tal.be|darf, ...bil|dung, ...buch|sta|be (Großbuchstabe); Ka|pi|täl|chen (kleines Kapital; lat. Großbuchstabe in der Größe eines kleinen Buchstabens); Ka|pi|ta|le *fr.* (veralt. für: Hauptstadt) *w*; -, -n; Ka|pi|tal.er|hö|hung, ...er|trag[s]|steu|er, ...ex|port, ...feh|ler (be-

sonders schwerer Fehler), ...**flucht** (*w*; -), ...**ge**|**sell**|**schaft**, ...**ge**|**winn**, ...**hirsch**, ...in|ve|sti|ti|on; **Ka**|**pi**|**ta**|**li**|**sa**|**ti**|**on** [...*zion*] (Umrechnung einer laufenden Geldleistung auf den Kapitalwert); **ka**|**pi**|**ta**|**li**|**sie**|**ren**; **Ka**|**pi**|**ta**|**li**|**sie**|**rung** vgl. Kapitalisation; **Ka**|**pi**|**ta**|**lis**|**mus** (Wirtschafts- u. Gesellschaftsordnung, deren treibende Kraft das [übersteigerte] Gewinnstreben einzelner ist) *m*; -; **Ka**|**pi**|**ta**|**list** (oft abschätzig: Vertreter des Kapitalismus); ↑ R 268; **ka**|**pi**|**ta**|**li**|**stisch**; **Ka**|**pi**|**tal**|**kraft**; **ka**|**pi**|**tal**|**kräf**|**tig**; **Ka**|**pi**|**tal**|**markt**, ...**ver**|**bre**|**chen** (schweres Verbrechen), ...**zins** (*Mehrz.* ...*zinsen*)

Ka|**pi**|**tän** *it.*(-*fr.*) *m*; -s, -e; **Ka**|**pi**|**tän**|**leut**|**nant**; **Ka**|**pi**|**täns**_**ka**|**jü**|**te**, ...**pa**|**tent**

Ka|**pi**|**tel** *lat.* ([Haupt]stück, Abschnitt [Abk.: Kap.]; geistl. Körperschaft [von Domherren, Mönchen]) *s*; -s, -; Kapitel XII (nicht: 12); **ka**|**pi**|**tel**|**fest** (ugs. für: fest im Wissen; bibelfest)

Ka|**pi**|**tell** *lat.* (oberer Säulen-, Pfeilerabschluß) *s*; -s, -e; vgl. Kapitäl

ka|**pi**|**teln** *lat.* landsch. (ausschelten); ich ...[e]le (↑ R 327); **Ka**|**pi**|**tel**_**saal** (Sitzungssaal im Kloster), ...**über**|**schrift**

Ka|**pi**|**tol** (Burg Alt-Roms; Kongreßpalast in Washington) *s*; -s; **ka**|**pi**|**to**|**li**|**nisch**; die ...nische Gänse, aber (↑ R 224): der Kapitolinische Hügel, die Kapitolinische Wölfin

Ka|**pi**|**tu**|**lant** *lat.* (früher: sich zu längerem [Heeres]dienst Verpflichtender; DDR: jmd., der vor den Argumenten politischer Gegner kapituliert) *m*; -en, -en (↑ R 268); **Ka**|**pi**|**tu**|**lar** (Mitglied eines Kapitels, z. B. Domherr) *m*; -s, -e; **Ka**|**pi**|**tu**|**la**|**ri**|**en** [...*i^en*] (Satzungen der fränk. Könige) *Mehrz.*; **Ka**|**pi**|**tu**|**la**|**ti**|**on** *fr.* [...*zion*] (Übergabe [einer Truppe od. einer Festung]; früher: Dienstverlängerungsvertrag eines Soldaten); **ka**|**pi**|**tu**|**lie**|**ren**

Kap|**la**|**ken** *niederl.* (Seemannsspr.: dem Kapitän zustehende Sondervergütung) *s*; -s, -

Ka|**plan** *lat.* (kath. Hilfsgeistlicher) *m*; -s, ...**pläne**

Kap|**land** (svw. Kapprovinz) *s*; -[e]s

Ka|**po** [Kurzform von *fr.* caporal] (Unteroffizier; Häftling eines Konzentrationslagers, der ein Arbeitskommando leitete) *m*; -s, -s

Ka|**po**|**da**|**ster** *it.* (bei Lauten u. Gitarren über alle Saiten reichen-

der, auf dem Griffbrett sitzender verschiebbarer Bund) *m*; -s, -

Ka|**pok** *malai.* (Samenfaser des Kapokbaumes, Füllmaterial) *m*; -s

ka|**po**|**res** *jidd.* (ugs. für: entzwei); - gehen, - sein

Ka|**pott**|**te** *fr.* (im 19. Jh. u. um 1900 modische Kopfbedeckung für [ältere] Frauen) *w*; -, -n; **Ka**|**pott**_**hut** *m*

Kap|**pa** (gr. Buchstabe: *K*, *κ*) *s*; -[s], -s

Kap|**pa**|**do**|**ki**|**en** usw. vgl. Kappadozien usw.; **Kap**|**pa**|**do**|**zi**|**en** [...*i^en*] (antike Bez. einer Landschaft im östl. Kleinasien); **Kap**|**pa**|**do**|**zi**|**er** [...*i^er*]; **kap**|**pa**|**do**|**zisch**

Kapp|**beil** (Seemannsspr.)

Käpp|**chen**, Käpp|lein; **Kap**|**pe** *lat.* *w*; -, -n

kap|**pen** (ab-, beschneiden; abhauen)

Kap|**pen**|**abend** (ein Faschingsvergnügen)

Kap|**pes**, **Kap**|**pus** *lat.* westd. (Weißkohl) *m*; -

Kapp|**hahn** (Kapaun)

Käp|**pi** („Käppchen"; [Soldaten]mütze) *s*; -s, -s; **Käpp**|**lein**, Käpp-chen

Kapp|**naht** (eine doppelt genähte Naht)

Kap|**pro**|**vinz** (größte Provinz der Republik Südafrika) *w*; -

Kap|**pung**

Kap|**pus** vgl. Kappes

Kapp|**zaum** *it.* (Halfterzaum ohne Mundstück)

Kapp|**zie**|**gel** (Gaubenziegel)

Ka|**pric**|**cio** vgl. Capriccio; **Ka**|**pri**|**ce** *fr.* [...*priß^e*] (Laune) *w*; -, -n

Ka|**pri**|**fo**|**lia**|**ze**|**en** (Geißblattgewächse) *Mehrz.*

Ka|**prio**|**le** *it.* („Bocksprung"; närrischer Luftsprung; toller Einfall [meist *Mehrz.*]; besonderer Sprung im Reitsport) *w*; -, -n; **ka**|**prio**|**len** (selten für: Kapriolen machen)

Ka|**pri**|**ze** österr. (svw. Kaprice); **ka**|**pri**|**zie**|**ren**, sich *fr.* (eigensinnig auf etwas bestehen); **ka**|**pri**|**zi**|**ös** (launenhaft, eigenwillig); -este (↑ R 292); **Ka**|**priz**|**pol**|**ster** österr. ugs. veralt. (ein kleines Polster) *m*; -s, -

Ka|**prun** (österr. Kraftwerk)

Kap|**sel** *w*; -, -n; **Kap**|**sel**|**chen**; **kap**|**sel**|**för**|**mig**; ...**kap**|**se**|**lig**, ...**kaps**|**lig** (z. B. einkaps[e]lig)

Kap|**si**|**kum** *lat.* (span. Pfeffer) *s*; -s

...**kaps**|**lig** vgl. ...kapselig

Kap|**stadt** (Hptst. der Kapprovinz); **Kap**|**stein** (veralt.: Diamant aus dem Kapland)

Kap|**tal** *lat.* (Kapitalband) *s*; -s, -e; **Kap**|**tal**|**band** vgl. Kapitalband

Kap|**ta**|**ti**|**on** *lat.* [...*zion*] (veralt. für: Erschleichung); **kap**|**ta**|**to**|**risch** (veralt. für: erschleichend); **Kap**|**ti**|**on** [...*zion*] (veralt. für: verfängliche Art zu fragen; verfänglicher Trugschluß); **kap**|**ti**|**ös** (veralt. für: verfänglich); -e Frage; **Kap**|**tur** (veralt. für: Beschlagnahme, Aneignung eines feindlichen Schiffes) *w*; -, -en

Ka|**put** *roman.* schweiz. (Soldatenmantel) *m*; -s, -e

ka|**putt** *fr.* (ugs. für: verloren [im Spiel]; entzwei, zerbrochen; matt); - sein, aber (↑ R 139): **ka**|**putt**|**ge**|**hen**; kaputtgegangen; **ka**|**putt**|**la**|**chen**, sich; kaputtgelacht; **ka**|**putt**|**ma**|**chen**; sich; - kaputtgemacht; **ka**|**putt**|**schla**|**gen**; kaputtgeschlagen

Ka|**pu**|**ze** *it.* (Kopf u. Hals einhüllendes Kleidungsstück) *w*; -, -n; **Ka**|**pu**|**zi**|**na**|**de** *fr.* (veralt. für: Kapuzinerpredigt; Strafrede); **Ka**|**pu**|**zi**|**ner** *it.* (Angehöriger eines kath. Ordens) *m*; -s, -; **Ka**|**pu**|**zi**|**ner**_**af**|**fe**, ...**kres**|**se**, ...**mönch**, ...**or**|**den** (Abk.: O. [F.] M. Cap.; *m*; -s)

Kap Ver|**de** [- *wärd^e*] („grünes Vorgebirge"; Westspitze Afrikas) *s*; - -; **Kap**|**ver**|**den** (Kapverdische Inseln) *Mehrz.*; **Kap**|**ver**|**di**|**sche In**|**seln** (vor Kap Verde) *Mehrz.*

Kap|**wein** (Wein aus dem Kapland)

Kar (Mulde vor Hochgebirgswänden) *s*; -[e]s, -e

Ka|**ra**|**bi**|**ner** *fr.* (kurzes Gewehr; österr. auch für: Karabinerhaken) *m*; -s, -; **Ka**|**ra**|**bi**|**ner**_**ha**|**ken** (federnder Verschlußhaken); **Ka**|**ra**|**bi**|**nier** [...*nie*] ([urspr. mit Karabiner ausgerüsteter] Reiter; später: Jäger zu Fuß) *m*; -s, -s; **Ka**|**ra**|**bi**|**nie**|**re** *it.* (it. Gendarm) *m*; -[s], ...ri

Ka|**ra**|**cho** [...*echo*] *sp.* *s*; -; (ugs. meist in:) mit - (mit großer Geschwindigkeit)

Ka|**rä**|**er** *hebr.* (Angehöriger einer jüd. Sekte) *m*; -s, -

Ka|**raf**|**fe** *arab.-fr.* ([geschliffene] bauchige Glasflasche [mit Glasstöpsel]) *w*; -, -n; **Ka**|**raf**|**fi**|**ne** (veralt., noch mdal. für: kleine Karaffe) *w*; -, -n

Ka|**ra**|**gös** *türk.* (Hanswurst im türk.-arab. Schattenspiel) *m*; -

Ka|**rai**|**be** vgl. Karibe; **ka**|**rai**|**bisch** vgl. karibisch

Ka|**ra**|**jan**, Herbert von [auch: *kar*...] (österr. Dirigent)

Ka|**ra**|**kal** *türk.* (Wüstenluchs) *m*; -s, -s

Ka|**ra**|**kal**|**pa**|**ke** (Angehöriger eines Turkvolkes) *m*; -n, -n (↑ R 268)

Ka|ra|ko|rum [auch: ...*ko̱*...] (Hochgebirge in Mittelasien) *m*; -[s]

Ka|ra|kul|schaf [nach dem See im Hochland von Pamir] (Fettschwanzschaf, dessen Lämmer den Persianerpelz liefern); ↑ R 201

Ka|ra|kum (Wüstengebiet im Süden der Sowjetunion) *w*; -

Ka|ram|bo|la|ge *fr*. [...*a̱ʒə̱*] (Billardspiel: Treffer [Anstoßen des Spielballes an die beiden anderen Bälle]; übertr. ugs. für: Zusammenstoß; Streit); **Ka|ram|bo|le** (Billardspiel: roter Ball) *w*; -, -n; **ka|ram|bo|lie|ren** (Billardspiel: mit dem Spielball die beiden anderen Bälle treffen; übertr. ugs. für: zusammenstoßen)

Ka|ra|mel *fr*. (gebrannter Zucker) *m*; -s; **Ka|ra|mel|bier; ka|ra|me|li|sie|ren** (Zucker[lösungen] trocken erhitzen; Karamel zusetzen); **Ka|ra|mel|le** (Bonbon mit Zusatz aus Milch[produkten]) *w*; -, -n (meist *Mehrz*.); **Ka|ra|mel|pud|ding, ...zucker** [*Trenn*.: ...zuk|ker]

Ka|ra|see [nach dem Fluß Kara] (Teil des Nordpolarmeeres) *w*; -

Ka|rat *gr*. (getrockneter Samen des Johannisbrotbaumes; Gewichtseinheit von Edelsteinen; Maß der Feinheit einer Goldlegierung) *s*; -[e]s, -e; 24 - (↑ R 322)

Ka|ra|te *jap*. (System waffenloser Selbstverteidigung) *s*; -[s]; **Ka|ra|te|ka** (Karatekämpfer) *m*; -s, -s ...**ka|rä|ter** (z. B. Zehnkaräter; mit Ziffern: 10karäter; ↑ R 228); ...**ka|rä|tig** (z. B. zehnkarätig; mit Ziffern: 10karätig; ↑ R 228)

Ka|ra|tschi (ehem. Hptst. von Pakistan)

Ka|rau|sche *slaw*. (ein karpfenartiger Fisch) *w*; -, -n

Ka|ra|vel|le *niederl*. [...*wäḻ*] (ein mittelalterl. Segelschiff) *w*; -, -n

Ka|ra|wa|ne *pers*. (Reisegesellschaft im Orient) *w*; -, -n; **Ka|ra|wa|nen|han|del, ...stra|ße**

Ka|ra|wan|ken (Gruppe der Südl. Kalkalpen) *Mehrz*.

Ka|ra|wan|se|rei *pers*. (Unterkunft für Karawanen)

Kar|bat|sche *türk*. (Riemenpeitsche) *w*; -, -n; **kar|bat|schen** (mit der Karbatsche schlagen); du karbatschst (karbatschest)

Kar|bid *lat*. (Kalziumkarbid) *s*; -[e]s; (chem. fachspr.:) Car|bid (Verbindung aus Kohlenstoff u. einem Metall od. Bor od. Silicium) *s*; -[e]s, -e; **Kar|bid|lam|pe; kar|bo**[1]... (kohlen...); **Kar|bo**[1]... (Kohlen...); **kar|bol**[1] (ugs. für:

[1] Fachsprachlich nur: car|bo..., Car|bo...

Karbolsäure) *s*; -s; **Kar|bo|li|ne|um**[1] (Teerprodukt, Imprägnierungs- und Schädlingsbekämpfungsmittel) *s*; -s; **Kar|bol|säu|re**[1] (ein Desinfektionsmittel) *w*; -; **Kar|bon**[1] (Geol.: Steinkohlenformation); *s*; -s; **Kar|bo|na|de** *fr*. bes. österr. (gebratenes Rippenstück); **Kar|bo|na|do** span. ([1]Karbonat) *m*; -s, -s; **Kar|bo|na|ri** it. (Angehörige einer ehem. gehei men polit. Gesellschaft in Italien) *Mehrz*.; [1]**Kar|bo|nat** *lat*. (eine Diamantenart) *m*; -[e]s, -e; [2]**Kar|bo|nat**[1] (kohlensaures Salz) *s*; -[e]s, -e; **Kar|bo|ni|sa|ti|on**[1] [...*zion*] (Verkohlung, Umwandlung in [2]Karbonat) *w*; -; **kar|bo|nisch**[1] (das Karbon betreffend); **kar|bo|ni|sie|ren**[1] (verkohlen lassen; in [2]Karbonat umwandeln; Zellulosereste in Wolle durch Schwefelsäure od. andere Chemikalien zerstören); **Kar|bon|pa|pier** (österr. neben: Kohlepapier); **Kar|bo|rund** (Carborundum Ⓦ; ein Schleifmittel) *s*; -[e]s; **Kar|bun|kel** (Häufung dicht beieinander liegender Furunkel) *m*; -s, -; **kar|bu|rie|ren** (die Leuchtkraft von Gasgemischen durch Ölgas heraufsetzen)

Kar|da|mom *gr*. (scharfes Gewürz aus den Samen von Ingwergewächsen) *m* od. *s*; -s, -e[n]

Kar|dan|an|trieb (↑ R 180 [nach dem Erfinder G. Cardano]), ...**ge|lenk** (Verbindungsstück zweier Wellen, das Kraftübertragung unter einem Winkel durch wechselnde Knickung gestattet); **kar|da|nisch**; (Math.:) -e Formel; -e Aufhängung (Vorrichtung, die Schwankungen der aufgehängten Körper ausschließt); **Kar|dan|tun|nel** (im Kraftwagen), ...**wel|le** (Antriebswelle [für Kraftwagen] mit Kardangelenk)

Kar|dät|sche *it*. (grobe [Pferde]bürste) *w*; -, -n; **kar|dät|schen** (striegeln); du kardätschst (kardätschest); **Kar|de** *lat*. (eine distelähnliche, krautige Pflanze; eine Maschine zum Auflösen von Faserbüscheln) *w*; -, -n

Kar|deel *niederl*. (Seemannsspr.: Teil der Trosse) *s*; -s, -e

kar|den, kar|die|ren *lat*. (rauhen, kämmen [von Wolle]); **Kar|den.di|stel, ...ge|wächs**

kar|di... *gr*. (herz...; magen...); **Kar|di...** (Herz...; Magen...); **Kar|dia|kum** (ein herzstärkendes Mittel) *s*; -s, ...ka; **kar|di|al** (Med.: das Herz betreffend); **Kar|di|al|gie** (Med.: Magenkrampf; Herzschmerzen) *w*; -, ...ien

[1] Vgl. Sp. 1, Anm. 1.

kar|die|ren vgl. karden

kar|di|nal *lat*. (veralt. für: grundlegend; hauptsächlich); **Kar|di|nal** (Titel der höchsten kath. Würdenträger nach dem Papst) *m*; -s, ...äle; **Kar|di|nal...** (Haupt...; Grund...); **Kar|di|nal.feh|ler, ...fra|ge; Kar|di|na|lia** (Grundzahlen) *Mehrz*.; **Kar|di|nal.pro|blem, ...punkt; Kar|di|nals.hut, ...kol|le|gi|um, kon|gre|ga|ti|on** (eine Hauptbehörde der päpstlichen Kurie); **Kar|di|nal.staats|se|kre|tär; Kar|di|nal.tu|gend, ...vi|kar** (Bez. des Generalvikars von Rom), ...**zahl** (Grundzahl, z. B. "null, eins, zwei")

Kar|dio|gramm *gr*. (mittels des Kardiographen aufgezeichnete Kurve) *s*; -s, -e; **Kar|dio|graph** (Med.: Gerät zur Aufzeichnung der Herzbewegung) *m*; -en, -en (↑ R 268); **Kar|dio|ide** (Math.: Herzlinie) *w*; -, -n; **Kar|dio|lo|gie** (Med.: Lehre vom Herzen u. den Herzkrankheiten) *w*; -; **Kar|dio|spas|mus** (Med.: Krampf des Mageneinganges) *m*; -, ...men

Ka|re|li|en [...*i*[1]*n*] (nordosteurop. Landschaft); **Ka|re|li|er** [...*i*[1]*r*] (Angehöriger eines finn. Volksstammes) *m*; -s, -; **ka|re|lisch**

Ka|ren, Ka|rin (w. Vorn.)

Ka|renz *lat*. (Wartezeit, Sperrfrist) *w*; -, -en; **Ka|renz.frist, ...jahr, ...zeit**

Ka|rer (Bewohner Kariens)

ka|res|sie|ren *fr*. (veralt., aber noch mdal. für: liebkosen; schmeicheln)

Ka|ret|te *fr*. (Meeresschildkröte) *w*; -, -n; **Ka|rett|schild|krö|te**

Ka|rez|za *it*. (Koitus ohne Orgasmus) *w*; -

Kar|fi|ol *it*. südd., österr. (Blumenkohl) *m*; -s

Kar|frei|tag ("Klagefreitag"; Freitag vor Ostern)

Kar|fun|kel *lat*. (Edelstein; volkstüml. auch für: Karbunkel) *m*; -s, -; **kar|fun|kel|rot**

karg; (↑ R 295:) karger (auch: kärger), kargste (auch: kärgste)

Kar|ga|deur *span*.; *fr*. [...*dör*], **Kar|ga|dor** *span*. (Begleiter einer Schiffsladung, der den Transport der Ladung bis zur Übergabe an den Empfänger zu überwachen hat) *m*; -s, -e

kar|gen; Karg|heit *w*; -; **kärg|lich; Kärg|lich|keit** *w*; -

Kar|go *span*. (Schiffsladung) *m*; -s, -s

Ka|ri|be (Angehöriger der Indianerstämme in Mittel- u. Südamerika) *m*; -n, -n (↑ R 268); **Ka|ri|bik** (Karibisches Meer mit den Antillen) *w*; - **ka|ri|bisch**, aber (↑ R 224): das Karibische Meer

Ka|ri|en [...i^en] (hist. Landschaft in Kleinasien)

ka|rie|ren *fr.* (mit Würfelzeichnung mustern, kästeln); ka|riert (gewürfelt, gekästelt)

Ka|ri|es *lat.* [...iäß] (Knochenfraß, bes. Zahnfäule) *w;* -

Ka|ri|ka|tur *it.* (Zerr-, Spottbild, Fratze) *w;* -, -en; Ka|ri|ka|tu|ren|zeich|ner; Ka|ri|ka|tu|rist (Karikaturenzeichner); ↑ R 268; ka|ri|ka|tu|ri|stisch; ka|ri|kie|ren (verzerren, zur Karikatur machen, als Karikatur darstellen)

Ka|rin, Ka|ren (w. Vorn.)

Ka|ri|na (w. Vorn.)

ka|ri|ös *lat.* (von Karies befallen; angefault); -e Zähne

ka|risch (aus Karien)

Ka|ri|sche Meer (ältere Bez. der Karasee) *s;* -n -[e]s

Ka|ri|tas *lat.* ([Nächsten]liebe; Wohltätigkeit) *w;* -; vgl. Caritas; ka|ri|ta|tiv (mildtätig; Wohltätigkeits...)

Kar|kas|se *fr.* (vom 16.–19. Jh. Brandkugel mit eisernem Gerippe; Unterbau [eines Gummireifens]; Rumpf vom Geflügel) *w;* -, -n

Karl (m. Vorn.); Kar|la (w. Vorn.); Karl|heinz; ↑ R 194 (m. Vorn.); Kar|li|ne (Schimpfname für eine weibl. Person) *w;* -, -, -n

kar|lin|gisch (für: karolingisch)

Kar|list (Anhänger der spanischen Thronanwärter mit Namen Don Carlos aus einer bourbonischen Seitenlinie) *m;* -en, -en (↑ R 268)

Karl|mann (dt. m. Eigenn.)

Karl-Marx-Stadt vgl. Chemnitz

Karls|bad (Kurort in der Tschechoslowakei); Karls|ba|der (↑ R 199); - Salz, - Oblaten

Karls|preis (internationaler Preis der Stadt Aachen für Verdienste um die Einigung Europas); vgl. ²Preis

Karls|ru|he (Stadt in Baden-Württemberg); Karls|ru|he-Rüp|purr

Karls|sa|ge; Karls|sa|gen|kreis *m;* -es

¹Karl|stadt (Stadt am Main)

²Karl|stadt (dt. Reformator)

Kar|ma[n] *sanskr.* (ind. Ausprägung der Idee des Schicksals) *s;* -s

Kar|mel (Gebirgszug in Israel) *m;* -s; Kar|me|lit (Angehöriger eines kath. Ordens) *m;* -en, -en (↑ R 268) u. Kar|me|li|ter; Kar|me|li|ter|geist (ein Heilkräuterdestillat) *m;* -[e]s; Kar|me|li|te|rin, Kar|me|li|tin *w;* -, -nen

Kar|men *lat.* (Fest-, Gelegenheitsgedicht) *s;* -s, ...mina

Kar|me|sin *pers.*, Kar|min *fr.* (roter Farbstoff) *s;* -s; kar|me|sin|rot,

kar|min|rot; Kar|min|säu|re *w;* -; kar|mo|sie|ren (einen Edelstein mit weiteren kleinen Steinen umranden)

¹Karn niederd. (Butterfaß) *w;* -, -en

²Karn [nach den Karnischen Alpen] (Geol.: eine Stufe der alpinen Trias) *s;* -s

Kar|nal|lit [nach dem Oberbergrat R. v. Carnall] (ein Mineral) *m;* -s

Kar|na|ti|on *lat.* [...zion] (svw. Inkarnat) *w;* -

Kar|nau|ba|wachs *indian.*; *dt.* (ein Pflanzenwachs) *s;* -es

Kar|ne|ol *it.* (Abart des Quarzes, Schmuckstein) *m;* -s, -e

¹Kar|ner (österr. nur so), Ker|ner landsch. (Beinhaus, Totenkapelle; Fleischkammer) *m;* -s, -

²Kar|ner (Angehöriger eines ehem. kelt. Volkes in den Karnischen Alpen) *m;* -s, -

Kar|ne|val *it.* [...wal] (Fastnacht[fest]) *m;* -s, -e u. -s; Kar|ne|va|list (↑ R 268); kar|ne|va|li|stisch; Kar|ne|vals.ge|sell|schaft, ...prinz, ...tru|bel, ...zeit (*w;* -), ...zug

Kar|nickel [*Trenn.:* ...nik|kel] (landsch. für: Kaninchen; ugs. auch für: Sündenbock) *s;* -s, -

Kar|nies *roman.* (Bauw.: Profil an Baugliedern) *s;* -es, -e; Kar|nie|se, (auch:) Kar|ni|sche österr. mdal. (Gardinenleiste) *w;* -, -n

kar|nisch (Geol.); -e Stufe (vgl. ²Karn), aber (↑ R 224): die Karnischen Alpen

Kar|ni|sche vgl. Karniese

kar|ni|vor *lat.* [...wor] (fleischfressend [von Tieren u. Pflanzen]); Kar|ni|vo|re (Fleischfresser [Tier od. Pflanze]) *m;* -n, -n (↑ R 268)

Kar|nöf|fel, Kar|nüf|fel (ein altes Kartenspiel) *m;* -s

Kärn|ten (österr. Bundesland); Kärn|te|ner, Kärnt|ner; kärntisch (selten für: kärntnerisch); kärnt|ne|risch

Kar|nüf|fel vgl. Karnöffel

¹Ka|ro (Hundename)

²Ka|ro *fr.* (Raute, [auf der Spitze stehendes] Viereck; eine Spielkartenfarbe) *s;* -s, -s; Ka|ro-As *s;* Karo-Asses, Karo-Asse

Ka|ro|la (w. Vorn.); Ka|ro|li|ne (w. Vorn.)

Ka|ro|li|nen (Inselgruppe im Pazifischen Ozean) *Mehrz.*

Ka|ro|lin|ger (Angehöriger eines fränk. Herrschergeschlechtes) *m;* -s, -; Ka|ro|lin|ger|zeit *w;* -; ka|ro|lin|gisch; -e Minuskel; ka|ro|li|nisch (auf einen der fränk. Herrscher mit dem Namen Karl bezüglich)

Ka|ros|se *fr.* (Prunkwagen; Staatskutsche) *w;* -, -n; Ka|ros|se|rie

(Wagenoberbau, -aufbau [von Kraftwagen]) *w;* -, ...jen; Ka|ros|sier [...ßie] (Karosserieentwerfer; veralt. für: Kutschpferd) *m;* -s, -s; ka|ros|sie|ren (mit Karosserie versehen)

Ka|ro|ti|de *gr. w;* -, -n u. Ka|ro|tis (Med.: Kopf-, Halsschlagader) *w;* -, ...iden

Ka|ro|tin, (fachspr. nur:) Ca|ro|tin (pflanzl. Farbstoff, z. B. in Karotten) *s;* -s; Ka|rot|te niederl. (eine Mohrrübenart) *w;* -, -n; Ka|rot|ten|beet

Kar|pa|ten (Gebirge in Mitteleuropa) *Mehrz.*; kar|pa|tisch

Kar|pell *nlat.* (Fruchtblatt) *s;* -s, ...pelle u. ...pella

Kar|pen|ter|brem|se; ↑ R 180 [nach dem amerik. Erfinder J. F. Carpenter]

Kar|pe|ta|ner (Angehöriger eines alten iber. Stammes) *m;* -s, -

Karp|fen (ein Fisch) *m;* -s, -; Karp|fen.teich, ...zucht

Kar|po|lith *gr.* (veralt. für: fossile Frucht) *m;* -s od. -en (↑ R 268), -e[n]; Kar|po|lo|gie (Lehre von den Pflanzenfrüchten) *w;* -

Kar|ra|g[h]een [...gen; nach dem irischen Ort] (Irländisches Moos; eine Droge) *s;* -[s]

Kar|ra|ra usw. eindeutschend für: Carrara usw.

Kärr|chen, Kärr|lein; Kar|re *w;* -, -n u. (österr. nur:) Kar|ren *m;* -s, -

Kar|ree *fr.* (Viereck; Gruppe von vier; bes. österr. für: Rippenstück) *s;* -s, -s

kar|ren (etwas mit einer Karre befördern); ¹Kar|ren *w;* vgl. Karre

²Kar|ren (Geol.: Rinnen u. Furchen in Kalkgestein) *Mehrz.*; Kar|ren|feld

Kär|rer schweiz. (Kärrner, Fuhrknecht; Kar|re|te *it.* bes. ostmitteld. (schlechter Wagen) *w;* -, -n; Kar|ret|te (schweiz.: Schubkarren; Transportmittel der Gebirgstruppen; zweirädriges Einkaufswägelchen) *w;* -, -n

Kar|rie|re [...iär^e] *fr.* (schnellste Gangart des Pferdes; übertr.: [bedeutende, erfolgreiche] Laufbahn) *w;* -, -n; Kar|rie|re|ma|cher; Kar|rie|rist (DDR: rücksichtsloser Karrieremacher); ↑ R 268; kar|rie|ri|stisch (nach Art eines Karrieristen); -ste (↑ R 294)

Kar|ri|ol *fr. s;* -s, -s u. Kar|ri|o|le (veralt.: leichtes, zweirädriges Fuhrwerk mit Kasten; Briefpostwagen) *w;* -, -n; kar|ri|o|len (veralt.: mit Karriol[post] fahren; übertr.: umherfahren, unsinnig fahren); Kar|ri|ol|post (veralt. für: Briefpost)

Kärr|lein, Kärr|chen; Kärr|ner

(Karrenführer, -schieber); **Kärr**|ner|ar|beit

Kar|**sams**|tag (Samstag vor Ostern); vgl. Karfreitag

¹**Karst** (zweizinkige Erdhacke) *m*; -[e]s, -e

²**Karst** (Teil der Dinarischen Alpen) *m*; -[e]s, (Geol.: für Gesamtheit der in löslichen Gesteinen [Kalk, Gips] entstehenden Oberflächenformen auch *Mehrz.*:) Karsterscheinungen

Kar|**sten** (niederd. Form von: Christian)

Karst|hans (alte Bez. für den Bauern der Reformationszeit) *m*; -[es] u. -en, -e u. ...hänse

Karst|**höh**|**le**, **kar**|**stig**; **Karst**|**land**|schaft

kart. = kartoniert

Kar|**tät**|**sche** *it.* (*fr.-engl.*) (veraltetes, mit Bleikugeln gefülltes Artilleriegeschoß; Bauw.: Brett zum Verreiben des Putzes) *w*; -, -n; **kar**|**tät**|**schen** (mit Kartätschen schießen); du kartätschst (kartätschest)

Kar|**tau**|ne *it.* (früher für: grobes Geschütz) *w*; -, -n

Kar|**tau**|se (Kartäuserkloster) *w*; -, -n; **Kar**|**täu**|ser (Angehöriger eines kath. Einsiedlerordens; ein Kräuterlikör) *m*; -s, -; **Kar**|**täu**|ser|**mönch**

Kärt|**chen**, **Kärt**|lein; **Kar**|te *w*; -, -n; alles auf eine - setzen; Karten spielen (↑ R 140); **Kar**|**tei** (Zettelkasten); **Kar**|**tei**.**kar**|**te**, ...**ka**|**sten**, ...**lei**|**che**, ...**zet**|**tel**; **Kar**|**tell** *fr.* (Interessenvereinigung in der Industrie; loser Zusammenschluß von student. Verbindungen mit gleicher Zielsetzung) *s*; -s, -e; **Kar**|**tell**.**amt**, ...**ge**|**setz**; **kar**|**tell**|**lie**|**ren** (in Kartellen zusammenfassen); **Kar**|**tell**|**lie**|**rung**; **Kar**|**tell**|**ver**|**band**; **kar**|**ten** (ugs. für: Karten spielen); **Kar**|**ten**.**blatt**, ...**block** (*Mehrz.* ...blocks), ...**brief**, ...**haus**, ...**le**|**ge**|**rin**, ...**schlä**|**ge**|**rin** (ugs. für: Kartenlegerin; *w*; -, -nen), ...**spiel**, ...[**vor**]**ver**|**kauf**, ...**zeich**|**ner**

kar|**te**|**sia**|**nisch**, **kar**|**te**|**sisch** [nach R. Cartesius (= Descartes) benannt]; -er Teufel od. Taucher, aber (↑ R 179): **Kar**|**te**|**sia**|**nisch**; **Kar**|**te**|**sisch**; -es Blatt

Kar|**tha**|**ger**, (veralt.:) **Kar**|**tha**|**gi**|**ni**|**en**|**ser**; **kar**|**tha**|**gisch**; **Kar**|**tha**|**go** (antike Stadt beim heutigen Tunis)

Kar|**tha**|**min**, (chem. fachspr.:) **Car**|**tha**|**min** *arab.* (ein roter Farbstoff) *s*; -s

kar|**tie**|**ren** *fr.* (Geogr.: eine Landschaft vermessen u. auf einer Karte darstellen; auch für: in eine Kartei einordnen); **Kar**|**tie**|**rung**

Kar|**ting** *engl.* (Ausübung des Go-Kart-Sports) *s*; -s

Kärt|**lein**, **Kärt**|**chen**

Kar|**tof**|**fel** *w*; -, -n (mdal., ugs.: -); **Kar**|**tof**|**fel**.**acker** [*Trenn.*: ...**ak**|**ker**], ...**blo**|**fist**, ...**brei** (*m*; -[e]s); **Kar**|**töf**|**fel**|**chen**; **Kar**|**tof**|**fel**.**chips**, ...**ern**|**te**, ...**feu**|**er**, ...**hor**|**de**, ...**kä**|**fer**, ...**mehl**, ...**mus**, ...**puf**|**fer**, ...**pü**|**ree**, ...**sa**|**lat**, ...**schnaps**, ...**stock** (schweiz. für: Kartoffelbrei; *m*; -[e]s), ...**sup**|**pe**

Kar|**to**|**gramm** *fr.*; *gr.* (Darstellung statistischer Daten auf Landkarten) *s*; -s, -e; **Kar**|**to**|**graph** (Landkartenzeichner; wissenschaftl. Bearbeiter einer Karte) *m*; -en, -en (↑ R 268); **Kar**|**to**|**gra**|**phie** (Technik, Lehre, Geschichte der Herstellung von Karten[bildern]) *w*; -; **kar**|**to**|**gra**|**phie**|**ren** (auf Karten aufnehmen); **kar**|**to**|**gra**|**phisch** (die Kartographie betreffend); **Kar**|**to**|**man**|**tie** (Kartenlegekunst) *w*; -; **Kar**|**to**|**me**|**ter** (Kurvenmesser) *s*; -s, -; **Kar**|**to**|**me**|**trie** (Kartenmessung) *w*; -

Kar|**ton** *fr.* [...*tong*, auch dt. Ausspr.: ...*ton*] ([leichte] Pappe, Steifpapier; Kasten, Hülle od. Schachtel aus [leichter] Pappe; Vorzeichnung zu einem [Wand]gemälde) *m*; -s, -s u. (seltener, bei dt. Ausspr. u. österr. auch:) -e; 5 Karton[s] Seife (↑ R 321 u. 322); **Kar**|**to**|**na**|**ge** [...*gseh°*] (Pappverpackung; Einbandart); **Kar**|**to**|**na**|**ge**|**ar**|**beit**; **Kar**|**to**|**na**|**gen**.**fa**|**brik**, ...**ma**|**cher**; **kar**|**to**|**nie**|**ren** (in Pappe [leicht] einbinden, steif heften); **kar**|**to**|**niert** (in Pappband gebunden; Abk.: kart.)

Kar|**to**|**thek** *fr.*; *gr.* (Kartei, Zettelkasten) *w*; -, -en

Kar|**tu**|**sche** *fr.* (in Metallhülsen liegende Pulverladung der Artilleriegeschosse, auch die Hülse selbst; schildförmiges Ornament des Barocks mit Laubwerk usw.) *w*; -, -n

Ka|**ru**|be *arab.* (Johannisbrot) *w*; -, -n

Ka|**run**|**kel** *lat.* (Med.: Fleischwarze) *w*; -, -n

Ka|**rus**|**sell** *fr.* (sich drehende, der Belustigung von Kindern dienende Vorrichtung mit kleinen Pferden, Fahrrädern u. a., bes. auf Jahrmärkten; [südwestd., schweiz. mdal.:] Reitschule; [österr.:] Ringelspiel) *s*; -s, -s u. -e

Kar|**wen**|**del**.**ge**|**bir**|**ge**, (auch:) **Kar**|**wen**|**del** (im engeren Sinne Gebirgsgruppe östl. von Mittenwald, im weiteren Sinne Teil der Tirolisch-Bayerischen Kalkalpen zwischen Seefelder Sattel, Isartal, Achensee u. Inntal) *s*; -s

Kar|**wo**|**che** (Woche vor Ostern); vgl. Karfreitag u. Karsamstag

Ka|**rya**|**ti**|**de** *gr.* (,,Gebälkträgerin''; w. Säulenfigur an altgr. Tempeln) *w*; -, -n

Ka|**ryo**|**ki**|**ne**|**se** *gr.* (selten für: Mitose) *w*; -, -n; **Ka**|**ry**|**op**|**se** (Bot.: Frucht der Gräser) *w*; -, -n

Kar|**zer** *lat.* (früher für: Schul-, Hochschulgefängnis; verschärfter Arrest) *m*; -s, -

kar|**zi**|**no**|**gen** *gr.* (Med.: Krebs[geschwülste] erzeugend); **Kar**|**zi**|**nom** (Krebs[geschwulst]; Abk.: Ca [Carcinoma]) *s*; -s, -e; **kar**|**zi**|**no**|**ma**|**tös** (krebsartig); -e Geschwulst; **Kar**|**zi**|**no**|**se** (über den Körper verbreitete Krebsbildung) *w*; -, -n

Ka|**sa**|**che** (Angehöriger eines Turkvolkes in Mittelasien) *m*; -n, -n (↑ R 268); **ka**|**sa**|**chisch**; aber (↑ R 198): die Kasachische Sozialistische Sowjetrepublik

¹**Ka**|**sack**, Hermann (dt. Schriftsteller)

²**Ka**|**sack** *türk.* [zu: Kosak] (dreiviertellanges Frauenobergewand) *m*; -s, -s

Ka|**san** (Hptst. der Tatar. Autonomen Sowjetrepublik)

Kasa|**tschok** *russ.* (russ. Volkstanz) *m*; -s, -s

Kasch *m*; -s u. **Ka**|**scha** *russ.* (Brei, Grütze) *w*; -

ka|**scheln** mdal. ([auf der Eisbahn] schlittern); ich ...[e]le (↑ R 327)

Ka|**sche**|**lott** *fr.* (Art des Pottwals) *m*; -s, -e

Ka|**schem** me *zigeuner.* (Verbrecherkneipe; schlechte Schenke) *w*; -, -n

ka|**schen** (ugs. für: ergreifen, verhaften); du kaschst (kaschest)

Käs|**chen**, **Käs**|lein

Kä|**scher**, **Kät**|**scher**, dafür besser: Kescher (vgl. d.)

ka|**schie**|**ren** *fr.* (verdecken, verbergen; Druckw.: überkleben; Theater: nachbilden); **Ka**|**schie**|**rung**

¹**Kasch**|mir (Land in Vorderindien); ²**Kasch**|mir (ein Gewebe) *m*; -s, -e; **Kasch**|**mir**.**garn**, ...**schal**, ...**wol**|le

Kasch|**nitz**, Marie Luise (dt. Dichterin)

Ka|**scho**|**long** *mong.* (ein Halbedelstein) *m*; -s

Ka|**schu**|be, Kas|**su**|be (Angehöriger eines westslaw. Stammes) *m*; -n, -n (↑ R 268); **Ka**|**schu**|bei, Kassu|**bei** (Wohngebiet der Kaschuben) *w*; -; **ka**|**schu**|bisch, kas|su|bisch; **Ka**|**schu**|**bi**|sche **Schweiz** (östl. Teil des Pommerschen Höhenrückens)

Kä|**se** *lat.* *m*; -s, -; **Kä**|**se**.**be**|**rei**|**tung**, ...**blatt** (ugs. für: niveaulose

Zeitung), ...ge|bäck, ...glocke [*Trenn.*: ...glok|ke]; Ka|se|in (Eiweißstoff in der Milch, Käsestoff) *s*; -s; Kä|se|ku|chen

Ka|sel *lat.* (liturg. Meßgewand) *w*; -, -n

Ka|se|mat|te *fr.* (früher: bombensicherer Raum in Festungen; Geschützraum eines Kriegsschiffes) *w*; -, -n; Ka|se|mat|ten|decke [*Trenn.*: ...dek|ke]

Kä|se...mes|ser *s*, ...mil|be; kä|sen; du käst (käsest); er kä|ste; die Milch käst (gerinnt, wird zu Käse); ¹Ka|ser mdal., bes. österr. (Käser); ²Ka|ser westösterr. mdal. (Sennhütte) *w*; -, -n; Kä|ser (Facharbeiter in der Käseherstellung; landsch. auch: Käsehändler, Senn o. ä.); Kä|se|rei (Betrieb für Käseherstellung; auch: Käseherstellung)

Ka|ser|ne *fr.* *w*; -, -n; Ka|ser|nen|hof; Ka|ser|nen|hof|blü|te (komisch wirkende Redewendung von Vorgesetzten an den Kasernenhof); Ka|ser|nen|block (*Mehrz.* ...blocks); ka|ser|nie|ren (in Kasernen unterbringen)

Kä|se...stan|ge, ...stoff (für: Kasein), ...tor|te; kä|se|weiß (ugs.: sehr bleich); kä|sig

Ka|si|mir (m. Vorn.)

Ka|si|no *it.* (Gesellschaftshaus; Offiziersheim; Speiseraum) *s*; -s, -s

Kas|ka|de *fr.* ([künstlicher] stufenförmiger Wasserfall; Artistik: wagemutiger Sprung); kas|ka|den|för|mig; Kas|ka|den|schaltung (Technik: Reihenschaltung gleichgearteter Teile); Kas|ka|deur [...*dör*] (Artist, der eine Kaskade ausführt) *m*; -s, -e

Kas|ka|ril|l|rin|de *span.*; *dt.* (Gewürz aus Westindien)

Kas|kett *fr.* (früher für: einfacher Visier-, leichter Lederhelm) *s*; -s, -e

Kas|ko *span.* (Schiffsrumpf; Fahrzeug [im Ggs. zur Ladung]; Spielart des Lombers) *m*; -s, -s; Kas|ko|ver|si|chert; Kas|ko|ver|si|che|rung (Versicherung gegen Schäden an Transportmitteln)

Käs|lein, Käs|chen

Kas|par (m. Vorn.); Kas|per (ugs. für: alberner Kerl) *m*; -s, -; Kas|perl (österr. nur so) *m*; -s, -[n], Kas|per|le *s* od. *m*; -s, -; Kas|per|le|thea|ter; Kas|per|li (schweiz.) *m*; -s, -; Kas|perl|thea|ter (österr.); kas|pern (ugs.: sich wie ein Kasper benehmen); ich ...ere (↑ R 327)

Kas|pisch (in geogr. Namen; ↑ R 224), z. B. das Kaspische Meer; Kas|pi|sche Meer *s*; -n -[e]s od.

Kas|pi|see (östl. des Kaukasus) *m*; -s

Kas|sa (in Österreich gebrauchte it. Form von: Kasse) *w*; -, Kassen; vgl. per cassa; Kas|sa.buch (Kassenbuch), ...ge|schäft (Geschäft, das sofort od. kurzfristig erfüllt werden soll)

Kas|san|dra (Tochter des Priamos); Kas|san|dra|ruf (unheilverheißende Warnung); ↑ R 180

¹Kas|sa|ti|on [...*zion*] *it.* (mehrsztiges, instrumentales Musikstück im 18. Jh.) *w*; -, -en ²Kas|sa|ti|on [...*zion*], Kas|sa|tion *lat.* (Ungültigmachung einer Urkunde; Aufhebung eines gerichtlichen Urteils; früher für: bedingungslose Dienstentlassung); Kas|sa|ti|ons|hof (Berufungsgericht, oberster Gerichtshof mancher romanischer Länder); Kas|sa|to|risch (die Kassation betreffend); -e Klausel (Verfall-, Verwirkungsklausel, -vorbehalt)

Kas|sa|wa *indian.* (Maniokwurzel; Stärkemehl) *w*; -, -s

Kas|sa|zah|lung *it.*; *dt.* (Barzahlung); Kas|se *it.* (Geldkasten, -vorrat; Zahlraum, -schalter; Bargeld) *w*; -, -n; vgl. Kassa

Kas|sel (Stadt an der Fulda); Kas|se|ler, Kaß|ler, (auch:) Kas|se|la|ner (↑ R 199); Kasseler Leberwurst; Kas|se|ler Blau *s*; - -s; Kas|se|ler Braun *s*; - -s

Kas|se|ler Rip|pe[n]|speer [angeblich nach einem Metzger Kassel] (gepökelte Schweinerippchen)

Kas|se|ler Schwarz *s*; - -[es]

Kas|sen.arzt, ...be|stand, ...block (*Mehrz.* ...blocks), ...bon, ...buch, ...pa|ti|ent, ...schal|ter, ...schla|ger, ...sturz (Feststellung des Kassenbestandes), ...zet|tel

Kas|se|rol|le *fr.* (Schmortopf, -pfanne) *w*; -, -n

Kas|set|te *fr.* (Kästchen für Wertsachen; Bauw.: vertieftes Feld [in der Zimmerdecke]; Schutzhülle für Bücher u. a.; Fotogr.: lichtdichter Behälter für Platten u. Filme im Aufnahmegerät; Behälter für Bild-Ton-Aufzeichnungen) *w*; -, -n; Kas|set|ten.decke [*Trenn.*: ...dek|ke], ...fern|se|hen, ...film, ...re|cor|der; kas|set|tie|ren (mit Kassetten versehen, täfeln)

Kas|sia, Kas|sie *semit.* [...*iᵉ*] (eine Heil- u. Gewürzpflanze) *w*; -, ...ien [...*iᵉn*]; Kas|sia.baum od. Kas|sie|n|baum, ...öl od. Kas|si|en|öl (*s*; -[e]s)

Kas|si|ber *jidd.* (Gaunerspr.: heiml. Schreiben [meist in Geheimschrift] von Gefangenen u. an Gefangene) *m*; -s, -

Kas|si|de *arab.* (arab. Gedichtgattung) *w*; -, -n

Kas|sie vgl. Kassia; Kas|si|abaum usw. vgl. Kassiabaum usw.

Kas|sier *it.* (österr., südd. häufig für: Kassierer) *m*; -s; Kas|sie|ren (Geld einnehmen; [Münzen] für ungültig erklären); Kas|sie|rer; Kas|sie|re|rin *w*; -, -nen; Kas|sie|rin (österr., südd. häufig für: Kassiererin) *w*; -, -nen; Kas|sie|rung vgl. Kassation

¹Kas|sio|peia (Mutter der Andromeda); ²Kas|sio|peia *gr.* (ein Sternbild) *w*; -

Kas|si|te (Angehöriger eines alten Gebirgsvolkes im Iran) *m*; -n, -n (↑ R 268)

Kas|si|te|ri|den (im Altertum die Zinninseln vor Südwestengland) *Mehrz.*; Kas|si|te|rit (Zinnerz) *m*; -s, -e

Kaß|ler vgl. Kasseler

Kas|su|be usw. vgl. Kaschube usw.

Ka|sta|gnet|te *span.*(-*fr.*) [*kaßtanjät*] (Handklapper) *w*; -, -n

Ka|sta|lia (gr. Nymphe); Ka|sta|lische Quel|le (am Parnaß) *w*; -n -

Ka|sta|nie [...*iᵉ*] (ein Baum u. die Frucht) *w*; -, -n; Ka|sta|ni|en|baum; ka|sta|ni|en|braun; Ka|sta|ni|en.holz, ...wald

Käst|chen, Käst|lein

Ka|ste *fr.* ([ind.] Stand; sich streng abschließende Gesellschaftsschicht) *w*; -, -n

ka|stei|en; kasteit (↑ R 304); sich - (sich Entbehrungen auferlegen; kirchl. auch: sich durch Schläge züchtigen, sich Bußübungen auferlegen); Ka|stei|ung

Ka|stell *lat.* (fester Platz, Burg, Schloß; früher: Aufbau [auf Kriegsschiffen]) *s*; -s, -e; Ka|stellan (Schloßvogt, -aufseher; Hausmeister in Universitäten u. ä.) *m*; -s, -e; Ka|stel|la|nei (Schloßverwaltung)

kä|steln (karieren); ich ...[e]le (↑ R 327); Ka|sten (südd., österr., schweiz. auch für: Schrank) *m*; -s, Kästen u. (heute selten:) -; Ka|sten.brot, ...deckel [*Trenn.*: ...dek|kel]

Ka|sten|geist (Standesdünkel; *m*; -[es])

Ka|sten|wa|gen

Ka|sten|we|sen *s*; -s

Ka|stil|li|en [...*iᵉn*] (ehem. Königreich im Innern der Iberischen Halbinsel); ka|sti|lisch

Käst|lein, vgl. Kästchen

Käst|ner, Erich (dt. Schriftsteller)

¹Ka|stor (Held der gr. Sage); - und Pollux (Zwillingsbrüder; übertr. für: engbefreundete Männer)

²Ka|stor (ein Stern) *m*; -s; Ka|storöl (Handelsbez. für: Rizinusöl) *s*; -[e]s

Ka|strat *it.* (Verschnittener) *m*; -en, -en (↑ R 268); **Ka|stra|ti|on** *lat.* [...zi̯on] (Verschneidung); **ka|strie|ren; Ka|strie|rung**

Ka|sua|li|en *lat.* [...i̯ən] („Zufälligkeiten"; [Vergütung für] gelegentl. [geistl.] Amtshandlungen) *Mehrz.*

Ka|su|ar *malai.-niederl.* (straußenähnlicher Laufvogel) *m*; -s, -e; **Ka|sua|ri|na Ka|sua|ri|ne** (Baum, Strauch Indonesiens u. Australiens mit federartigen Zweigen) *w*; -, ...nen

Ka|su|ist *lat.* (Vertreter der Kasuistik; übertr. fur: Wortverdreher, Haarspalter); ↑ R 268; **Ka|sui|stik** (Darstellung der Einzelfälle, bes. in Moraltheologie u. Rechtswissenschaft; Med.: Beschreibung von Krankheitsfällen; auch für: Haarspalterei, Spitzfindigkeit) *w*; -; **ka|sui|stisch**; -ste (↑ R 294); **Ka|sus** (Fall [auch in der Sprachw.]: Vorkommnis) *m*; -, -[kásus]; vgl. Casus belli, Casus obliquus, Casus rectus; **Ka|sus-..bil|dung, ...en|dung** (Sprachw.)

Ka|ta|bo|lis|mus *gr.* (Abbau der Stoffe im Körper beim Stoffwechsel) *m*; -

Ka|ta|chre|se, Ka|ta|chre|sis *gr.* [...chr...] („Mißbrauch"; Rhet., Stilk.: Bildbruch, Vermengung von nicht zusammengehörenden Bildern im Satz, z. B. „das schlägt dem Faß die Krone ins Gesicht") *w*; -, ...chresen; **ka|ta|chre|stisch** (mißbräuchlich)

Ka|ta|falk *fr.* (schwarz verhängtes Gerüst für den Sarg bei Leichenfeiern) *m*; -s, -e

Ka|ta|ka|na *jap.* (jap. Silbenschrift) *s*; -[s] od. *w*; -

ka|ta|kau|stisch *gr.* (Optik: einbrennend); -e Fläche (Optik: Brennfläche)

Ka|ta|kla|se *gr.* (Geol.: Zerbrechen u. Zerreiben einzelner Mineralkomponenten eines Gesteins durch tekton. Kräfte) *w*; -, -, -n; **Ka|ta|klas|struk|tur** *gr.*: *lat.* (Geol.: Trümmergefüge eines Gesteins) *w*; -

Ka|ta|kom|be *it.* (unterird. Begräbnisstätte) *w*; -, -n (meist *Mehrz.*)

Ka|ta|la|ne (Bewohner Kataloniens) *m*; -n, -n (↑ R 268); vgl. Katalonier; **ka|ta|la|nisch; ka|ta|la|nisch** (Sprache) *s*; -[s]; vgl. Deutsch; **Ka|ta|la|ni|sche** *s*; -n; vgl. Deutsche *s*

Ka|ta|la|se *gr.* (ein Ferment) *w*; -n

Ka|ta|lau|ni|sche Fel|der (Gegend in der Champagne, Kampfstätte der Hunnenschlacht) *Mehrz.*

Ka|ta|lek|ten *gr.* (veralt. für:

Bruchstücke alter Werke) *Mehrz.*; **ka|ta|lek|tisch** (Verslehre: verkürzt, unvollständig)

Ka|ta|lep|sie *gr.* (Med.: Starrkrampf der Muskeln) *w*; -, ...ien; **ka|ta|lep|tisch** (von Muskelstarre befallen)

Ka|ta|le|xe, Ka|ta|le|xis *gr.* („Aufhören"; Unvollständigkeit des letzten Versfußes) *w*; -, ...lexen

Ka|ta|log *gr.* (Verzeichnis [von Bildern, Büchern, Waren usw.]) *m*; -[e]s, -e; **ka|ta|lo|gi|sie|ren** (nach bestimmten Regeln] in einen Katalog aufnehmen); **Ka|ta|lo|gi|sie|rung**

Ka|ta|ly|ni|on [...i̯ən] (hist. Provinz in Nordostspanien); **Ka|ta|lo|ni|er** [...i̯ər] (veralt. für: Katalane); **ka|ta|lo|nisch** (für: katalanisch); aber (↑ R 224): das Katalonische Bergland

Ka|tal|pa, Ka|tal|pe *indian.* (Trompetenbaum) *w*; -, ...pen

Ka|ta|ly|sa|tor *gr.* (Stoff, der eine Reaktion auslöst od. in ihrem Verlauf bestimmt) *m*; -s, ...oren; **Ka|ta|ly|se** („Auflösung"; Änderung der Reaktionsgeschwindigkeit) *w*; -, -n; **ka|ta|ly|sie|ren** (eine chem. Reaktion auslösen, verlangsamen od. beschleunigen); **ka|ta|ly|tisch**

Ka|ta|ma|ran *tamil.-engl.* (schnelles, offenes Segelboot mit Doppelrumpf) *m*; -s, -e

Ka|ta|me|ni|en *gr.* [...i̯ən] (Med. selten für: Menstruation) *Mehrz.*

Ka|ta|mne|se *gr.* (Med.: abschließender Krankenbericht) *w*; -, -n

Ka|ta|pho|re|se *gr.* (Wanderung fester od. flüssiger Teilchen in einer Flüssigkeit unter Einwirkung einer elektr. Spannung) *w*; -, -n

Ka|ta|pla|sie *gr.* (Med.: Rückbildung) *w*; -, ...ien

Ka|ta|plas|ma *gr.* (Med.: heißer Breiumschlag) *s*; -s, ...men

ka|ta|plek|tisch *gr.* (zur Kataplexie neigend); **Ka|ta|ple|xie** (Med.: Schrecklähmung) *w*; -, ...ien

Ka|ta|pult (Wurf-, Schleudermaschine im Altertum; Flugzeugschleuder zum Starten von Flugzeugen) *m* od. *s*; -[e]s, -e; **Ka|ta|pult.flie|ger, ...flug** (Schleuderflug), **...flug|zeug; ka|ta|pul|tie|ren** ([ab]schleudern); sich -

Ka|tar [auch: kǎtar] (Scheichtum am Persischen Golf)

¹**Ka|ta|rakt** *gr.* (Wasserfall, niedriger Wassersturz; Stromschnelle) *m*; -[e]s, -e; ²**Ka|ta|rakt** *w*; -, -e u. **Ka|ta|rak|ta** (Med.: grauer Star) *w*; -, ...ten; **ka|ta|rak|tisch**

Ka|ta|rer (Einwohner von Katar); **ka|ta|risch**

Ka|tarrh *gr.* (Schleimhautentzündung) *m*; -s, -e; **ka|tar|rha|lisch; ka|tarrh|ar|tig**

Ka|ta|ster *it.* (amtl. Verzeichnis der Grundstücksverhältnisse, Grundbuch) *m* (österr. nur so) od. *s*; -s, -; **Ka|ta|ster..amt, ...auszug, ...steu|ern** (*Mehrz.*); **Ka|ta|stral|ge|mein|de** österr. (in einem Grundbuch zusammengefaßte Verwaltungseinheit, Steuergemeinde); **Ka|ta|stral|joch** österr. (Amtsspr.: ein Feldmaß); vgl. Joch; **ka|ta|strie|ren** (in ein Kataster eintragen)

ka|ta|stro|phal *gr.* (verhängnisvoll; niederschmetternd; entsetzlich), **Ka|ta|stro|phe** (entscheidende Wendung [zum Schlimmen]; Unglück[sfall]; Verhängnis; Zusammenbruch) *w*; -, -n; **Ka|ta|stro|phen|alarm; ka|ta|stro|phen|ar|tig; Ka|ta|stro|phen-dienst, ...ein|satz, ...fall** *m*, ...gebiet, ...po|li|tik, ...schutz

Ka|ta|to|nie *gr.* (eine Geisteskrankheit) *w*; -, ...ien

Kät|chen, ¹**Ka|te, Kä|te** vgl. Käthchen, Kathe, Käthe

²**Ka|te** niederd. (Kleinbauernhaus) *w*; -, -n

Ka|te|chese *gr.* [...che...] (Religionsunterricht) *w*; -, -n; **Ka|te|chet** (Religionslehrer, insbes. für die kirchl. Christenlehre außerhalb der Schule) *m*; -en, -en (↑ R 268); **ka|te|che|tik** (Lehre von der Katechese) *w*; -; **Ka|te|che|tin** *w*; -, -nen; **ka|te|che|tisch; Ka|te|chi|sa|ti|on** [...zi̯on] (Katechese); **ka|te|chi|sie|ren** (Religionsunterricht erteilen); **Ka|te|chis|mus** (Lehrbuch in Frage u. Antwort, bes. der christl. Religion) *m*; -, ...men; **Ka|te|chist** (einheimischer Laienhelfer in der kath. Mission) (↑ R 268)

Ka|te|chu *malai.-port.* [...chu] (ein Gerbstoff) *s*; -s, -s

Ka|te|chu|me|ne *gr.* [kath.: katechu...] (altkirchl. Name der kirchl. Unterricht genießenden [erwachsenen] Taufbewerber; Teilnehmer am Konfirmandenunterricht, bes. im 1. Jahr) *m*; -n, -n (↑ R 268); **Ka|te|chu|me|nen|un|ter|richt**

ka|te|go|ri|al *gr.*; **Ka|te|go|rie** (Klasse; Gattung; Begriffs-, Anschauungsform) *w*; -, ...ien; **ka|te|go|risch** (einfach aussagend; unbedingt gültig; widerspruchslos); -ste (↑ R 294); -er Imperativ (unbedingtes ethisches Gesetz); **ka|te|go|ri|sie|ren** (nach Kategorien ordnen)

Ka|ten (Nebenform von: ²Kate) *m*; -s, -

Ka|te|ne *lat.* („Kette, Reihe";

Sammlung von Bibelauslegungen alter Schriftsteller) w; -, -n (meist *Mehrz.*)

Ka|ter (männl. Katze; ugs. für: Folge übermäßigen Alkoholgenusses) *m*; -s, -; **Ka|ter.bum|mel** (ugs.), ...**früh|stück** (ugs.), ...**idee** (ugs.), ...**stim|mung** (ugs.)

kat|exo|chen *gr.* [...*chęn*] (schlechthin; beispielhaft)

Kạt|gut *engl.* (Med.: chirurg. Nähmaterial aus Darmsaiten) *s*; -s

kath. = katholisch

Ka|thạ|rer *gr.* [auch: *kạt...*] (Angehöriger einer Sekte im MA.) *m*; -s, -; **Ka|tha|rị|na, Ka|tha|rị|ne** (w. Vorn.); **Ka|thar|sis** (sittliche, innerliche) „Reinigung"; Fachwort der Lehre vom Trauerspiel u. der Psychologie) *w*; -; **ka|thar|tisch** (die Katharsis betreffend)

Käth|chen[1] (Koseform von: Käthe); **Ka|the**[1], **Kä|the**[1] (Kurzform von: Katharina, Katharine)

Ka|the|der *gr.* (Pult, Kanzel; Lehrstelle [eines Hochschullehrers]) *s* (auch: *m*); -s, -; vgl. ex cathedra; **Ka|the|der|blü|te** (ungewollt komischer Ausdruck eines Lehrers); **Ka|the|dra|le** (bischöfl. Hauptkirche) *w*; -, -n; **Ka|the|dral|ent|schei|dung** (unfehlbare päpstl. Entscheidung)

Ka|the|te *gr.* (eine der beiden Seiten im rechtwinkligen Dreieck, die die Schenkel des rechten Winkels bilden) *w*; -, -n

Ka|the|ter *gr.* (med. Röhrchen) *m*; -s, -; **ka|the|te|ri|sie|ren** u. **ka|the|tern** (den Katheter einführen); ich ...ere (↑ R 327); **Ka|the|te|rung**

Ka|thin|ka, **Ka|tin|ka**, **Kạt|ja** (russ. Koseformen von: Katharina, Katharine)

Ka|thọ|de[2] *gr.* (negative Elektrode, Minuspol) *w*; -, -n; **Ka|tho|den|strahl** *m*; -s

Ka|tho|lịk *gr.* (Anhänger der kath. Kirche u. Glaubenslehre) *m*; -en, -en (↑ R 268); **Ka|tho|lị|ken|tag** (Generalversammlung der Katholiken eines Landes); **Ka|tho|lị|kin** *w*; -, -nen; **ka|tho|lisch** (allgemein, umfassend; die kath. Kirche betreffend; Abk.: kath.); -e Kirche, aber (↑ R 224): die Katholische Aktion; **ka|tho|li|sie|ren** (katholisch machen; zum Katholizismus neigen); **ka|tho|li|zis|mus** (Geist u. Lehre des kath. Glaubens) *m*; -; **Ka|tho|li|zi|tät** (Rechtgläubigkeit im Sinne der kath. Kirche) *w*; -

Ka|threin, **Ka|thrị|ne** (Koseformen von: Katharina, Katharine)

[1] Auch: Kätchen, Kate, Käte.
[2] In der Fachsprache auch: Katode.

Ka|threi|ner Ⓦ (ein Malzkaffee) *m*; -s

ka|ti|li|nạ|risch [nach dem röm. Verschwörer Catilina] *-e* (heruntergekommene, zu verzweifelten Schritten neigende) Existenz, aber (↑ R 179): **Ka|ti|li|nạ|risch**

Ka|tin|ka vgl. Kathinka

Kạt|ion *gr.* (das bei der Elektrolyse zur Kathode wandernde Ion)

Kạt|ja vgl. Kathinka

Kạt|man|du [auch: ...*mạ*...] (Hptst. von Nepal)

Kạt|ner niederd. (Besitzer einer Kate)

Ka|tọ|de vgl. Kathode

ka|tọ|nisch [nach dem röm. Zensor Cato]; *-e* Strenge, aber (↑ R 179): **Ka|tọ|nisch**

Kat|op|trik *gr.* (Lehre von der Spiegelreflexion) *w*; -

kạt|schen landsch. (schmatzend kauen); du katschst (katschest); **kạt|schen** (landsch.); du kätschst (kätschest)

Kä[t]scher, besser: Kescher

Kạtt|an|ker (Seemannsspr.: zweiter Anker)

Kạt|te|gat („Katzenloch"; Meerenge zwischen Schweden u. Jütland) *s*; -s

kạt|ten (Seemannsspr.: [Anker] hochziehen)

Kạt|tun *arab.-niederl.* (feinfädiges, leinwandbindiges Gewebe aus Baumwolle od. Chemiefasern) *m*; -s, -e; **kạt|tụ|nen**; -er Stoff

Ka|tụll vgl. Catull

kạtz|bal|gen, sich (ugs.); ich katzbalge mich; gekatzbalgt; zu katzbalgen; **Katz|bal|ge|rei**; **kạtz|buckeln** [*Trenn.:* ...buk|keln] (ugs. für: liebedienern); er hat gekatzbuckelt; **Kätz|chen**, **Kätzlein**; **Kạt|ze** *w*; -, -n; (↑ R 241:) für die Katz (ugs. für: umsonst); Katz und Maus mit jmdm. spielen (ugs.)

Kạt|zel|ma|cher *it.* bes. südd., österr. abschätzig (Italiener)

Kạt|zen|au|ge (auch: Halbedelstein; Rückstrahler); ...**buckel** [*Trenn.:* ...buk|kel] (höchster Berg des Odenwaldes), ...**dreck**, ...**fell**, **kạt|zen|freund|lich** (ugs. für: heuchlerisch freundlich), ...**gleich**; **kạt|zen|haft**; **Kạt|zen-jam|mer** (ugs.), ...**kopf**, ...**mu|sik** (ugs.), ...**sprung** (ugs.), ...**tisch** (ugs.), ...**wä|sche** (ugs.), ...**zun|gen** (Schokoladetäfelchen; *Mehrz.*); **Kätz|lein**, **Kätz|chen**

Kaub (Stadt am Mittelrhein)

Kau|be|we|gung

kau|dạl *lat.* (Biol.: den Schwanz betreffend; Med.: fußwärts liegend)

kau|dern (veralt., aber noch mdal. für: unverständlich sprechen);

ich ...ere (↑ R 327); **kau|der-welsch**; - sprechen (verworrenes Deutsch sprechen, radebrechen); **Kau|der|welsch** *s*; -[s]; ein - sprechen; vgl. Deutsch; **Kau|der|wel|sche** *s*; -n; vgl. Deutsche *s*; **kau|der|wel|schen**; du kauderwelschst (kauderwelschest); gekauderwelscht

kau|di|nisch; ein kaudinisches Joch (allg.: schimpfliche Demütigung), aber (↑ R 224): das Kaudinische Joch (Joch, durch das bei Caudium geschlagenen Römer schreiten mußten); (↑ R 198:) die Kaudinischen Pässe

Kaue („Hütte", „Käfig"; Bergmannsspr.: „Schachthäuschen", Wasch- u. Umkleideraum) *w*; -, -n

kau|en

kau|ern (hocken); ich ...ere (↑ R 327)

Kauf *m*; -[e]s, Käufe; in [den] - nehmen, aber (↑ R 156): das In-[den-]Kauf-Nehmen; **kau|fen**; du kaufst usw. (landsch.: käufst usw.); **kau|fens|wert**; **Käu|fer**; **Kauf|fah|rer** (veralt. für: Handelsschiff); **Kauf|fahr|tei|schiff** (veralt. für: Handelsschiff); **Kauf-frau** (Bez. im Handelsregister); **Kauf.haus**, ...**kraft**; **kauf|kräf|tig**; **Kauf|la|den** (veraltend); **käuf-lich**; **Käuf|lich|keit** *w*; -; **kauf|lu-stig**; **Kauf|mann** (*Mehrz.* ...leute); **kauf|män|nisch**; -ste (↑ R 294); ein -er Angestellter, Leiter, Direktor (↑ R 224); -es Rechnen; **Kauf-mann|schaft** (veraltend) *w*; -; **Kauf|manns.deutsch**, ...**ge|hil|fe** (älter für: Handlungsgehilfe), ...**gil|de** (hist.), ...**spra|che**, ...**stand**; **Kauf.preis** (vgl. ²Preis), ...**sum|me**

Kau|fun|ger Wạld (Teil des Hessischen Berglandes) *m*; - -[e]s

Kauf.ver|trag, ...**wert**

Kau|gum|mi *m*; -s, -[s]

Kau|kamm (Bergmannsspr.: Grubenbeil)

Kau|ka|si|en [...*i⁰n*] (Gebiet zwischen Schwarzem Meer u. Kaspischem Meer); **Kau|ka|si|er** [...*i⁰r*]; **kau|ka|sisch**; **Kau|ka|sus** (Gebirge) *m*; -

Kaul|barsch (ein Fisch); **Käul|chen** vgl. Quarkkäulchen

Kau|le mitteld. (Grube, Loch) *w*; -, -n; vgl. Kuhle, Kule

kau|li|flor *lat.* (Bot.: am Stamm ansetzend [von Blüten])

Kaul|quap|pe (Froschlarve)

kaum; das ist - glaublich; er war - hinausgegangen, da kam ...; **kaum[,]** daß (↑ R 63)

Kau|ma|zit *gr.* (Braunkohlenkoks) *m*; -s, -e

Kau|pe|lei ostmitteld. (heimlicher

Handel); **kau|peln** (ostmitteld.); ich ...[e]le (↑ R 327)

Kau|ri *Hindi* (Porzellanschnecke; „Muschelgeld" [in Asien u. Afrika]) *m*; -s, -s od. *w*; -, -s; **Kau|ri‿fich|te**, ...**mu|schel**, ...**schnecke** [*Trenn*.: ...**schnek|ke**]

kau|sal *lat.* (ursächlich zusammenhängend; begründend); -e Konjunktion (z. B. „denn"); **Kau|sal.be|zie|hung**, ...**ge|setz**; **Kau|sa|li|tät** (Ursächlichkeit); **Kau|sal.ket|te**, ...**kon|junk|ti|on**, ...**ne|xus** (Kausalzusammenhang), ...**satz** (Sprachw.: Umstandssatz des Grundes), ...**zu|sam|men|hang**; **Kau|sa|tiv** [auch: ...*tif*] (Sprachw.: veranlassendes Zeitwort, z. B. „tränken" = „trinken machen") *s*; -s, -e [...*w*"]; **Kau|sa|ti|vum** [...*wum*] (älter für: Kausativ) *s*; -s, ...va [...*wa*]

Kausch, Kau|sche (Seemannsspr.: Ring mit Hohlrand, zur Verstärkung von Tau- u. Seilschlingen) *w*; -, ...schen

Kau|stik *gr.* (Brennfläche in der Optik; svw. Kauterisation) *w*; -; **Kau|sti|kum** (ein Ätzmittel) *s*; -s, ...ka; **kau|stlsch** (ätzend; beißend; scharf); -ste (↑ R 294); -er Witz; **Kau|sto|bio|lith** (brennbares Produkt fossiler Lebewesen) *m*; -s od. -en -e[n] (meist *Mehrz*.); ↑ R 268

Kau|ta|bak
Kau|tel *lat.* (Vorsichtsmaßregel; Vorbehalt) *w*; -, -en
Kau|te|ri|sa|ti|on *gr.* [...*zion*] (Ätzung zu Heilzwecken); **kau|te|ri|sie|ren**; **Kau|te|ri|um** (Chemie: Ätzmittel; Med.: Brenneisen) *s*; -s, ...ien [...*i"n*]
Kau|ti|on *lat.* [...*zion*] (Haftsumme, Bürgschaft, Sicherheit[sleistung]); **kau|ti|ons|fä|hig** (bürgfähig); **Kau|ti|ons|sum|me**
Kautsch (eindeutschende Schreibung für: Couch) *w*; -, -s (ugs. auch: -en)
Kau|tschuk *indian.* (Milchsaft des Kautschukbaumes; Rohstoff für Gummiherstellung) *m*; -s, -e; **Kau|tschuk.milch**, ...**pa|ra|graph** (dehnbare Rechtsvorschrift), ...**plan|ta|ge**, ...**wa|re**; **kau|tschu|tie|ren** (mit Kautschuk überziehen; aus Kautschuk herstellen) **Kau|werk|zeu|ge** *Mehrz*.
Kauz *m*; -es, Käuze; **Käuz|chen**, **Käuz|lein**; **kau|zig**
Ka|val *it.* [...*wạl*] (Spielkarte im Tarockspiel: Ritter) *m*; -s, -s; **Ka|va|lier** *fr.* [...*wa*...] *m*; -s, -e; **ka|va|lier|mä|ßig**; **Ka|va|lier[s]|de|likt**; **Ka|va|lier[s]|start** (scharfes Anfahren eines Autofahrers); **Ka|val|kg|de** (Reiter[auf]zug); **Ka|val|le|rie** [auch: *kạ*...] (Reiterei;

Reitertruppe) *w*; -, ...ien; **Ka|val|le|rist** [auch: *kạ*...] (↑ R 268)
Ka|va|ti|ne *it.* [...*wa*...] (Musik: [kurze] Opernarie; liedartiger Instrumentalsatz) *w*; -, -n
Ka|ve|ling *niederl.* [*kạw*...] (Wirtsch.: Mindestmenge[neinheit], die ein Käufer auf einer Auktion erwerben muß) *w*; -, -en
Ka|vent *lat.* [...*wẹnt*] (veralt. für: Bürge) *m*; -en, -en (↑ R 268); **Ka|vents|mann** mdal. (beleibter, begüterter Mann; Prachtexemplar; selten auch Seemannsspr.: hoher Wellenberg; *Mehrz*. ...**männer**)
Ka|ver|ne *lat.* [...*wär*...] (Höhle, Hohlraum) *w*; -, -n; **Ka|ver|nen|kraft|werk**; **Ka|ver|nom** (Med.: Blutgefäßgeschwulst) *s*; -s, -e; **ka|ver|nös** (Kavernen bildend; voll Höhlungen); -er Kalkstein
Ka|vi|ar *türk.* [...*wi*...] (Rogen des Störs) *m*; -s, -e; **Ka|vi|ar|bröt|chen**
Ka|vi|ta|ti|on *lat.* [*kawitazion*] (Technik: Hohlraumbildung)
Ka|wa *polynes.* (berauschendes Getränk der Polynesier) *w*; -
Ka|waß, Ka|was se *arab.* (früher orientalischer Polizeisoldat; Ehrenwache) *m*; ...wassen, ...wassen (↑ R 268)
Ka|wi *sanskr.* *s*; -[s] od. **Ka|wi|spra|che** (alte Schriftsprache Javas) *w*; -
Kay, Kai (m. od. w. Vorn.)
Ka|zi|ke *indian.* (Häuptling bei den süd- u. mittelamerik. Indianern; auch: indian. Ortsvorsteher) *m*; -n, -n (↑ R 268)
kcal = Kilo[gramm]kalorie (große Kalorie)
Kčs = tschech. Krone
keb|beln vgl. kibbeln
Keb|se (Nebenfrau) *w*; -, -n; **Kebs‿ehe**, ...**weib**
keck
keckern [*Trenn*.: kek|kern] (von Fuchs, Marder, Iltis: Zorneslaut ausstoßen)
Keck|heit; keck|lich (veralt.)
Ke|der (Randverstärkung aus Leder, Gummi od. Kunststoff) *m*; -s, -
Keep (Seemannsspr.: Kerbe, Rille) *w*; -, -en
Keep-smi|ling *engl.* [*kịpßmạil*...] (das „Immer-Lächeln"; die in einem nordamerik. Schlagwort zum Ausdruck kommende optimistische Lebensanschauung) *s*; -
Kees bayr. u. österr. mdal. (Gletscher) *s*; -es, -e; **Kees|was|ser** bayr. u. österr. mdal. (Gletscherbach; *Mehrz*. ...wasser)
Ke|fe schweiz. (Art Zuckererbse, mit der Schote gegessen) *w*; -, -n
Ke|fir *tatar.* (aus Kuhmilch ge-

wonnenes gegorenes Getränk) *m*; -s
Ke|gel (Druckw. auch: Stärke des Typenkörpers) *m*; -s, -; mit Kind und Kegel (eigtl.: uneheliches Kind); vgl. kegelschieben; **Ke|gel.bahn**, ...**bre|cher** (eine Zerkleinerungsmaschine); **ke|gel|för|mig**; **ke|ge|lig**, **keg|lig**; **Ke|gel‿klub**, ...**ku|gel**, ...**man|tel** (Geometrie); **ke|geln**; ich ...[e]le (↑ R 327); **ke|gel|schei|ben** bayr., österr. (kegelschieben); **Ke|gel|schei|ben** (bayr., österr.) *s*; -s; **ke|gel|schie|ben** (↑ R 140); ich schiebe Kegel, weil ich Kegel schob; ich habe Kegel geschoben; um Kegel zu schieben; **Ke|gel‿schie|ben** (*s*; -s), ...**schnitt**, ...**sport**, ...**statt** (österr. neben: Kegelbahn); **Keg|ler**; **keg|lig**, **ke|ge|lig**
Keh|din|gen vgl. Land Kehdingen
Kehl (Stadt am Oberrhein)
Kehl|chen; Keh|le *w*; -, -n; **keh|len** (rinnenartig aushöhlen; veralt., aber noch mdal.: Fisch ausnehmen); **Kehl|ho|bel**; **kehl|lig**; **Kehl|kopf**; **Kehl|kopf.ka|tarrh**, ...**krebs**, ...**mi|kro|phon[1]**, ...**spie|gel**; **Kehl|laut**, ...**lei|ste**; **Kehl|na|schi|ne** (Hohlkehle)
Kehr|aus *m*; -; **Kehr|be|sen**
Keh|re (Wendekurve; turnerische Übung) *w*; -, -n; [1]**keh|ren** (umwenden); sich nicht an etwas - (ugs.: sich nicht um etwas kümmern); ich kehre mich nicht an das Gerede
[2]**keh|ren** (fegen); **Kehr|richt** *m*, auch: *s*; -s; **Kehr|richt.ei|mer**, ...**hau|fen**, ...**schau|fel**; **Kehr|ma|schi|ne**
Kehr‿schlei|fe (für: Serpentine), ...**sei|te**; **kehrt!**; rechtsum kehrt!; **kehrt|ma|chen** (umkehren); ich mache kehrt; kehrtgemacht; kehrtzumachen; **Kehrt‿ma|chen** *s*; -s; **Kehrt|wen|dung**; **Kehr|um** (veralt. für: Sackgasse; Kehrreim) *m*; -s, nur noch mdal. in der Wendung: im - (im Handumdrehen); **Kehr|wert** (für: reziproker Wert); **Kehr|wie|der** (veralt. für: Sackgasse) *m* od. *s*; -s
Kehr|wisch (veralt. für: Flederwisch)
Keib schwäb. u. schweiz. mdal. (Aas; Lump, Kerl [grobes Scheltwort]) *m*; -en, -en (↑ R 268)
Keif (veralt. für: Lärm, Geschimpfe) *m*; -[e]s; **kei|fen**; **Keif|fe|rei**; **kei|fisch** (veralt.); -ste (↑ R 294)
Keil *m*; -[e]s, -e; **Keil|bein** (Schädelknochen); **Kei|le** (ugs. für: Prügel) *w*; -; - kriegen; **kei|len** (ugs. für: stoßen; [für eine Stu-

[1] Auch eindeutschend: ...fon.

dentenverbindung] anwerben); sich - (ugs. für: sich prügeln); **Kei|ler** (Eber); **Kei|le|rei** (ugs. für: Prügelei); **keil|för|mig; Keil_haue** (Bergmannsspr.), ...**ho|se**, ...**kis|sen**, ...**pol|ster** (österr.), ...**rie|men**, ...**schrift**

Keim m; -[e]s, -e; **Keim_blatt**, ...**drü|se; kei|men; keim|frei; keim|haft; Keim|ling; Keim_plasma**, ...**zel|le**

kein, -e. -, Mehrz. -e; - and[e]rer; in -em Falle, auf -en Fall; zu -er Zeit; (↑ R 272 u. 273:) keine unreifen Früchte, keiner großen Erörterungen. Alleinstehend (↑ R 135): keiner, keine, kein[e]s; -er, -e, -[e]s von beiden; keiner, der (nicht/welcher); **kei|ner|lei; kei|nerseits; kei|nes|falls;** vgl. Fall m; **kei|nes|wegs; kein|mal,** aber: kein einziges Mal

...**keit** (z. B. Ähnlichkeit w; -, -en)

Ke|krops (gr. Sagengestalt)

Keks engl. (kleines, trockenes Dauergebäck) m od. s; - u. -es, - u. -e (österr.: s; -, -[e]); **Keks|se**

Kelch m; -[e]s, -e; **Kelch|blatt; kelch|för|mig; Kelch|glas** (Mehrz. ...**gläser**)

Kel|heim (Stadt in Bayern)

Ke|lim türk. (oriental. Teppich) m; -[s], -[s]; **Ke|lim|stich** (schräger Flachstich)

Kel|le w; -, -n

Kel|ler, Gottfried (schweiz. Dichter)

Kel|ler m; -s, -; **Kel|ler|as|sel; Kel|le|rei; Kel|ler_fen|ster,** ...**geschoß; ¹Kel|ler|hals** (ein Heil- u. Zierstrauch) m; - u. -es, -e; **²Kel|ler_hals** (Überbau od. ansteigendes Gewölbe über einer Kellertreppe), ...**kind,** ...**mei|ster,** ...**trep|pe,** ...**tür,** ...**woh|nung; Kell|ner** m; -s, -; **Kell|ne|rin** w; -, -nen; **kell|nern** (ugs.); ich ...ere (↑ R 327)

Kel|logg-Pakt vgl. Briand-Kellogg-Pakt (↑ R 180)

Kelt kelt.-lat. (ein vorgeschichtl. Beil) m; -[e]s, -e

Kel|te (Angehöriger eines indogerm. Volkes) m; -n, -n (↑ R 268)

Kel|ter (Weinpresse) w; -, -n; **Kel|te|rei; Kel|te|rer; kel|tern;** ich ...ere (↑ R 327); **Kel|ter|tanz**

Kelt|ibe|rer (Angehöriger eines Mischvolkes im alten Spanien); **kelt|ibe|risch; kel|tisch; Kel|tisch** s; -[s]; vgl. Deutsch; **Kel|ti|sche** s; -n; vgl. Deutsche s; **kel|to|ro|ma|nisch**

Kel|vin [...win; nach dem engl. Physiker W. T. Kelvin] (Meßeinheit der absoluten Temperaturskala; Zeichen: K); 0 K = −273,15° C (vgl. S. 86, 9, f)

Ke|ma|lis|mus (von dem türk. Prä-

sidenten Kemal Atatürk begründete polit. Richtung) m; -; **Ke|ma|list** (Verfechter des Kemalismus; ↑ R 268

Ke|me|na|te ([Frauen]gemach einer Burg) w; -, -n

Ken jap. (jap. Verwaltungsbezirk, Provinz) s; -, -

Ken. = Kentucky

Ke|nia (Staat in Ostafrika); **Kenia|ner; ke|nia|nisch**

Ken|ne|dy, John F. [kä̲nidi] (Präsident der USA)

Ken|nel engl. (Hundezwinger) m; -s, -

Kennel|ly [kä̲nli] (amerik. Ingenieur u. Physiker); **Kennel|ly-Hea|vi|side-Schicht** [kä̲nlihävißaid...] ([E-Schicht (vgl. d.) der Ionosphäre) w; -; vgl. Heaviside

ken|nen; du kanntest; (selten:) kenntest; gekannt; kenn[e]!; **ken|nen|ler|nen** (↑ R 139): ich lerne kennen; ich habe ihn kennengelernt; kennenzulernen; jmdn. kennen- u. liebenlernen; **Ken|ner; Ken|ner|blick; ken|ne|risch; Ken|ner|mie|ne; Ken|ner|schaft** w; -; **Kenn|far|be**

Ken|ning altnord. (in der altnord. Dichtung bildl. Umschreibung eines Begriffes durch eine mehrgliedrige Benennung) w; -, -ar

Kenn_kar|te, ...**mar|ke; kennt|lich;** - machen; **Kennt|lich|ma|chung; Kennt|nis** w; -, -se; von etwas - nehmen; in - setzen; zur - nehmen; **Kennt|nis|nah|me** w; -; **kennt|nis|reich; Ken|nung** (typ. Kennzeichen von Leuchtfeuern usw.); **Kennwort** (Mehrz. ...wörter), ...**zahl,** ...**zei|chen; kenn|zeich|nen;** gekennzeichnet; zu -; **kennzeich|nen|der|wei|se; Kenn_zeich|nung,** ...**zif|fer**

Ke|no|taph, (auch:) Ze|no|taph gr. (leeres Grabmal zur Erinnerung an einen Toten, der dort nicht begraben ist) s; -s, -e

Kent (engl. Grafschaft)

Ken|taur vgl. Zentaur

ken|tern (umkippen [von Schiffen]); ich ...ere (↑ R 327); **Ken|te|rung**

Ken|tucky [...taki] (Staat in den USA; Abk.: Ken. u. Ky.)

Ken|tum_spra|chen lat.; dt. (eine Gruppe der indogerm. Sprachen) Mehrz.

¹Ke|pheus [...feuß] (gr. Sagengestalt); **²Ke|pheus** (ein Sternbild) m; -

Ke|phi|sos (gr. Fluß) m; -

Kep|ler (dt. Astronom); -sches Gesetz

kep|peln österr. ugs. (fortwährend schimpfen; keifen); ich kepp[e]le (↑ R 327); **Kep|pel|weib; Kepp|le|rin** w; -, -nen

Ke|ra|bau malai. (ind. Wasserbüffel) m; -s, -s

Ke|ra|mik gr. ([Kunst]töpferei) w -, (für Erzeugnis der [Kunst]töpferei auch Mehrz.:) -en; **Ke|ra|mi|ker; Ke|ra|mi|ke|rin** w; -, -nen; **ke|ra|misch**

Ke|ra|tin gr. (Hornstoff) s; -s, -e **Ke|ra|ti|tis** (Med.: Hornhautentzündung des Auges) w; -, ...itiden; **Ke|ra|tom** (Med.: Hornhautschwulst der Haut) s; -s, -e; **Ke|ra|to|skop** (Instrument zur Untersuchung der Hornhautkrümmung) s; -s, -e

Kerb hess.-pfälz. (Kirchweih) w -; -e

Ker|be (Einschnitt) w; -, -n

Ker|bel (eine Gewürzpflanze) m -s; **Ker|bel|kraut** s; -[e]s

ker|ben (Einschnitte machen)

Ker|be|ros vgl. Zerberus

Kerb_holz, fast nur noch in: etwas auf dem - haben (ugs. für: etwas angestellt, verbrochen haben)

Kerb_schnitt (Holzverzierung; m ...[e]s), ...**tier; Ker|bung**

Ke|ren (gr. Schicksalsgöttinnen Mehrz.

Kerf (Kerbtier) m; -[e]s, -e

Ker|gue|len [...ge̲...] (Inseln im Indischen Ozean) Mehrz.

Ker|ker (österr., sonst veralt. für Zuchthaus) m; -s, -; **Ker|ker_mei ster,** ...**stra|fe**

Ker|kops gr. (Kobold der gr. Sage m; -, ...open

Ker|ky|ra [auch: kä̲r...] (gr. Name für: Korfu)

Kerl m; -s (selten: -es), -e (ugs u. verächtl. auch: -s); **Kerl|chen Ker|mes_bee|re** arab.; dt. (Pflanze deren Beeren zum Färben vor Getränken verwendet werden) ...ei|che (Eiche des Mittelmeergebietes), ...**schild_laus** (auf der Kermeseiche lebende Schildlaus, aus der ein roter Farbstoff gewonne wird)

Kern m; -[e]s, -e; **Kern|bei|ßer** (ei Vogel); **kern|deutsch; ker|ne** (seltener für: auskernen); **Kern ener|gie** (Atomenergie)

Ker|ner vgl. ¹Karner

Kern_ex|plo|si|on (Zertrümme rung eines Atomkerns), ...**fäu|l** (Fäule des Kernholzes von leber den Bäumen), ...**feh|ler,** ...**fo schung** (Atomforschung), ...**fr ge,** ...**frucht,** ...**fu|si|on,** ...**gebie** ...**ge|dan|ke,** ...**ge|häu|se; kern _ge_sund,** ...**haft** (veralt.); **ker holz; ker|nig; Kern|kraft|wer Kern|ling** (Wildling aus Samen **kern|los; Kern_obst,** ...**phy|si** (Lehre von den Atomkernen -kernreaktionen); **kern|phy|s ka|lisch; Kern_phy|si|ker,** ...**pr blem,** ...**punkt,** ...**re|ak|ti|on,** ...**r**

ak|tor, ...schat|ten, ...sei|fe, ...spal|tung, ...spruch, ...stück, ...tech|nik, ...tei|lung, ...trup|pe, ...um|wand|lung, ...ver|schmel-
Ke|ro|pla|stik vgl. Zeroplastik.
Ke|ro|sin gr. (ein Brennöl) s; -s
Ke|rou|ac [kăruăk] (amerik. Schriftsteller)
Ker|stin (w. Vorn.)
Ke|rub vgl. Cherub
Ker|we hess. pfälz. (Kirchweih) w; -, -n
ke|ryg|ma|tisch gr. (verkündigend, predigend); -e Theologie
Ker|ze w; -, -n; Ker|zen|be|leuch|tung; ker|zen|ge|ra|de¹; Ker|zen.hal|ter, ...licht (Mehrz. ...lichter)
Ke|scher (Fangnetz) m; -s, -
keß (ugs. für: dreist; draufgängerisch; frech; schneidig; flott); kesser, kesseste; ein kesses Mädchen
Kes|sel m; -s, -; Kes|sel.bo|den, ...ex|plo|si|on, ...flicker [Trenn.: ...flik|ker], ...haus, ...pau|ke, ...schmied, ...stein, ...trei|ben, ...wa|gen (Güterwagen der Eisenbahn mit Kesselaufbau)
Keß|heit
Ketch|up, Catch|up malai.-engl. [kätschap, engl. Aussprache: kätschᵉp] (pikante Würztunke) m od. s; -[s], -s
Ke|ton (eine chem. Verbindung) s; -s, -e; Ke|ton|harz
Ketsch engl. (ein zweimastiges [Sport]segelfahrzeug) w; -, -en
ket|schen (Nebenform von: kätschen)
Ke|tschua vgl. Quechua
Kett|baum vgl. Kettenbaum
Kett|chen, Kett|lein
¹Ket|te (Schar, Reihe; Militär: Einheit [von Flugzeugen]) Jägerspr.: Auer-, Birk-, Hasel-, Rebhuhnfamilie) w; -, -n
²Ket|te (zusammenhängende Glieder aus Metall u. a.; Weberei: in der Längsrichtung verlaufende Fäden) w; -, -n; Ket|tel landsch. (Krampe) m; -s, - od. w; -, -n; Ket|tel|ma|schi|ne; ket|teln ([kettenähnlich] verbinden); ich ...[e]le (↑ R 327); ket|ten; Ket|ten|baum; Kettbaum (Teil des Webstuhles); Ket|ten.blu|me (Löwenzahn), ...brief, ...bruch m (Math.), ...brücke [Trenn.: ...brük|ke]; Ket|ten|fa|den vgl. Kettfaden; Ket|ten|garn vgl. Kettgarn; Ket|ten.glied, ...han|del (vgl. ¹Handel), ...hund, ...la|den, ...pan|zer, ...rad, ...rau|chen (s; -s), ...raucher, ...re|ak|ti|on, ...schluß, ...schutz, ...stich; Ket|ten|fa|den,

...garn (so in der Weberei; auch: Ket|ten.fa|den, ...garn); Kett|lein, Kett|chen; Ket|tung
Ket|zer; Ket|ze|rei; Ket|zer|ge|richt; ket|ze|risch; -ste (↑ R 294); Ket|zer.tau|fe, ...ver|fol|gung
keu|chen; Keuch|hu|sten
Keu|le w; -, -n; Keu|len|är|mel; keu|len|för|mig; Keu|len.gym|na|stik, ...schlag, ...schwin|gen (s; -s)
Keu|per (mdal. für: roter, sandiger Ton; Geol.: oberste Stufe der Trias) m; -s
keusch; -este (↑ R 292)
Keu|sche österr. (Bauernhäuschen, Kate) w; -, -n
Keusch|heit w; -; Keusch|heits.ge|lüb|de, ...gür|tel; Keusch|lamm|strauch
Keusch|ler österr. (Bewohner einer Keusche, Häusler)
Ke|ve|laer [kewᵉlar] (Stadt in Nordrhein-Westfalen)
Key|ser|ling [kai...] (balt. Adelsgeschlecht)
Kfz = Kraftfahrzeug; Kfz-Fah|rer (↑ R 150)
kg = Kilogramm; 2-kg-Dose (↑ R 157)
KG = Kommanditgesellschaft; KGaA = Kommanditgesellschaft auf Aktien
kgl. = königlich, im Titel: Kgl.
k. g. V., kgV = kleinstes gemeinsames Vielfaches
k. H., kh. = kurzerhand
¹Kha|ki pers.-engl. (Erdfarbe, Erdbraun) s; -; ²Kha|ki (gelbbrauner Stoff [für die Tropenuniform]) m; -; kha|ki|far|ben; Kha|ki-jacke [Trenn.: ...jak|ke], ...uni|form
Khan mong. (mong.-türk. Herrschertitel) m; -s, -e; Kha|nat (Amt, Land eines Khans) s; -[e]s, -e
Khar|tum (Provinz u. Hptst. der Republik Sudan)
Khe|di|ve [...wᵉ] (Titel des früheren Vizekönigs von Ägypten) m; -s u. -n, -n (↑ R 268)
Khmer (Angehöriger eines Volkes in Kambodscha) m; -, -; Khmer-re|pu|blik svw. Kambodscha
kHz = Kilohertz
Kiau|tschou [...tschau] (chin. Gebiet); Kiau|tschou|er [...tschauᵉr] (↑ R 199)
kib|beln, keb|beln (landschaftl. Nebenform von: kabbeln)
Kib|buz hebr. (Gemeinschaftssiedlung in Israel) m; -, ...uzim od. -e; Kib|buz|nik (Angehöriger eines Kibbuz) m; -s, -s
Ki|be|rer (österr. Gaunerspr. für: Kriminalpolizist)
Ki|bit|ka russ. w; -, -s u. Ki|bit|ke (Filzzelt asiat. Nomadenstämme; leichter, federloser russ. Bretterwagen, russ. Schlitten mit Mattendach) w; -, -n

Ki|che|rei
Ki|cher|erb|se
ki|chern; ich ...ere (↑ R 327)
Kick engl. (ugs. für: Tritt, Stoß [beim Fußball]) m; -[s], -s
Kickel|hahn¹ (ein Berg im Thüringer Wald) m; -[e]s
kicken¹ engl. (Sport: „stoßen"; Fußball spielen [meist abwertend]); Kicker¹ (Fußballspieler [oft abwertend]) m; -s, -[s]; Kickers¹ (Name von Fußballvereinen) Mehrz.; Kick-off schweiz. (Anstoß beim Fußballspiel) m; -s, -s; kick|sen vgl. gicksen; Kick-star|ter (Anlasser bei Motorrädern in Form eines Fußhebels)
Kick|xia [kikßia; nach dem belg. Botaniker Kickx] (ein Kautschukbaum) w; -, ...ien [...iᵉn]
Kid engl. (Kalb-, Ziegen-, Schafleder) s; -s, (für Handschuhe aus Kid auch Mehrz.:) -s; kid|nap|pen [kidnäpᵉn] (entführen, bes. Kinder); gekidnappt; Kid|nap|per (,,Kindesräuber", Entführer) m; -s, -; Kid|nap|ping s; -s, -s
Ki|dron (Wald östl. von Jerusalem)
Kids vgl. Kid
kie|big landsch. (zänkisch, schlechtgelaunt; selbstbewußt, frech, prahlerisch, aufbegehrend)
Kie|bitz (ein Vogel) m; -es, -e; Kie|bitz|ei
kie|bit|zen (ugs. für: zuschauen beim [Karten-, Schach]spiel); du kiebitzt (kiebitzest)
kie|feln österr. ugs. (nagen); ich kief[e]le (↑ R 327); hartes Brot -
Kie|fen|fuß (ein Krebs)
¹Kie|fer (ein Nadelbaum) w; -, -n
²Kie|fer (ein Schädelknochen) m; -s, -; Kie|fer.an|oma|lie, ...bruch, ...höh|le; Kie|fer|höh|len|ent|zün|dung; Kie|fer|kno|chen
kie|fern (aus Kiefernholz); Kie|fern.eu|le (ein Schmetterling), ...holz, ...na|del|öl (ätherisches Öl), ...schwär|mer (ein Schmetterling), ...span|ner (ein Schmetterling), ...spin|ner (ein Schmetterling), ...wald, ...zap|fen
kie|ke niederd. (Kohlenbecken zum Fußwärmen) w; -, -n
kie|ken nordd. (sehen); Kie|ker (Seemannsspr. u. ugs. für: Fernglas); jmdn. auf dem - haben (ugs. für: jmdn. [wegen schlechter Erfahrungen] streng beobachten; an jmdm. großes Interesse haben; jmdn. nicht leiden können); Kiek|in|die|welt (kleines Kind; auch: Unerfahrener) m; -s, -e
¹Kiel (pflanzl. Blütenteil; Schaft der Vogelfeder) m; -[e]s, -e

Vgl. die Anmerkung zu „gerade".

¹ Trenn.: ...k|k...

²**Kiel** (Hafenstadt a. d. Ostsee)

³**Kiel** (Grundbalken der Wasserfahrzeuge) m; -[e]s, -e; **Kiel|boot**

kie|len (veralt. für: Kielfedern bekommen)

Kie|ler (von ²Kiel; † R 199; Kieler Bucht; Kieler Förde; Kieler Sprotten; Kieler Woche

Kiel|fe|der

kiel|ho|len (Schiff umlegen [zum Ausbessern]; frühere seemänn. Strafe: jmdn. unter dem Schiff durchs Wasser ziehen); er wurde gekielholt

Kiel|kropf (veralt. für: Mißgeburt, Wechselbalg)

Kiel|li|nie (Gefechts-, auch Marschformation von Kriegsschiffen); in - fahren; **kiel|oben**; - liegen; **Kiel_raum**, ...**schwein** (auf dem Hauptkiel von Schiffen liegender Verstärkungsbalken oder -träger), ...**schwert**, ...**wasser** (Wasserspur hinter einem fahrenden Schiff); s; -s)

Kie|me (Atmungsorgan der im Wasser lebenden Tiere) w; -, -n; **Kie|men_at|mer**, ...**at|mung**, ...**spal|te**

Kien (harzreiches [Kiefern]holz) m; -[e]s; **Kien_ap|fel**, ...**fackel** [Trenn.: ...fak|kel], ...**holz**; **kie|nig**; **Kien_span**, ...**zap|fen**

Kie|pe nordd., mitteld. (Rückentragkorb) w; -, -n; **Kie|pen|hut** (Kapotte) m

Kier|ke|gaard [kirk⁴gart, dän. Aussspr.: kérg⁴goʀ] (dän. Philosoph u. Theologe)

Kies (Gaunerspr.: Geld) m; -es, (für Geröll auch Mehrz.:) -e; **Kie|sel** m; -s, -; **Kie|sel_al|ge**, ...**er|de**, ...**gur** (Erdart aus den Panzern von Kieselalgen; w; -); **kie|seln** (mit Kies beschütten); ich ...[e]le († R 327); **Kie|sel_säu|re** (w; -), ...**stein**; ˈkie|sen (svw. kieseln); du kiest (kiesest); er kie|ste; gekiest; kies[e]!

²**kie|sen** (geh. für: wählen); nur in den Gegenwartsformen: du kiest (kiesest); kies[e]!; zu den Formen der Vergangenheit vgl. küren

Kie|se|rit (ein Mineral) m; -s, -e

Kies_gru|be, ...**hau|fen**; **kie|sig**; **Kies|weg**

Kiew [kiäf] (Hptst. der Ukrainischen SSR)

Kiez slaw. landsch. (Ort[steil]) m; -es, -e

kif|fen arab.-amerik. (Haschisch od. Marihuana rauchen); **Kif|fer**

Ki|ga|li (Hptst. des Staates Ruanda)

ki|ke|ri|ki!; ˈ**Ki|ke|ri|ki** (Kinderspr. für: Hahn) m; -s, -s; ²**Ki|ke|ri|ki** (Hahnenschrei) s; -s, -s

Kil|bi schweiz. mdal. (Kirchweih) w; -, ...benen; **Kil|bi|tanz**

Ki|li|an (m. Vorn.)

Ki|li|ki|en, Zi|li|zi|en (im Altertum Landschaft in Kleinasien); **ki|li|kisch, zi|li|zisch**

Ki|li|ma|ndscha|ro (höchster Berg Afrikas) m; -[s]

kil|le|kil|le; - machen (ugs. für: unterm Kinn streicheln)

kil|len engl. (ugs. für: töten; Seemannsspr.: leicht flattern [von Segeln]); er hat ihn gekillt (getötet); **Kil|ler** (ugs. für: Totschläger, Mörder)

Kiln engl. (Schachtofen zur Holzverkohlung od. Metallgewinnung) m; -[e]s, -e

kilo... gr. (tausend...); **Ki|lo** (Kurzform für: Kilogramm) s; -s, -[s]; **Ki|lo...** (Tausend...; das Tausendfache einer Einheit, z. B. Kilometer = 10^3 Meter; Zeichen: k); **Ki|lo|gramm** (1 000 g; Maßeinheit für Masse, früher auch für Gewicht u. Kraft; Zeichen: kg); 3 - († R 322); **Ki|lo|ka|lo|rie** (veralt. für: Kilokalorie)

Ki|lo|hertz (1 000 Hertz; Maßeinheit für die Frequenz; Zeichen: kHz)

Ki|lo|ka|lo|rie (1 000 Kalorien; Zeichen: kcal)

Ki|lo|li|ter (1 000 l; Zeichen: kl)

Ki|lo|me|ter (1 000 m; Zeichen: km) m; 80 Kilometer je Stunde (Abk.: km/h, km/st); **Ki|lo|me|ter_fres|ser** (ugs.), ...**geld**; **Ki|lo|me|ter|geld|pau|scha|le**; **ki|lo|me|ter|lang** aber: 3 Kilometer lang; **Ki|lo|me|ter_mar|ke**, ...**stein**, ...**ta|rif**; **ki|lo|me|ter|weit**; vgl. kilometerlang; **Ki|lo|me|ter|zäh|ler**; **ki|lo|me|trie|ren** ([Straßen, Flüsse usw.] mit Kilometereinteilung versehen); **Ki|lo|me|trie|rung**; **ki|lo|me|trisch**

Ki|lo|pond (1 000 Pond; Maßeinheit für Kraft u. Gewicht; Zeichen: kp); **Ki|lo|pond|me|ter** (Einheit der Energie; Zeichen: kpm)

Ki|lo_volt (1 000 Volt; Zeichen: kV), ...**volt|am|pere** (1 000 Voltampere; Zeichen: kVA)

Ki|lo|watt (1 000 Watt; Zeichen: kW); **Ki|lo|watt|stun|de** (1 000 Wattstunden; Zeichen: kWh)

ˈ**Kilt** alemann. (Abendbesuch der Burschen bei seinem Mädchen) m; -[e]s

²**Kilt** engl. (Knierock der Bergschotten) m; -[e]s, -s

Kilt|gang [zu: ˈKilt]

Kimm (Seew.: Horizontlinie zwischen Meer u. Himmel; Schiffbau: Krümmung des Schiffsrumpfes zwischen Bordwand u. Boden) w; -; **Kim|me** (Einschnitt; Kerbe; Teil der Visiereinrichtung) w; -, -n; **Kimm_ho|bel**; **Kim-**

-mung (Seew.: Luftspiegelung; Horizont)

Ki|mon (athen. Feldherr)

Ki|mo|no jap. [auch: kı... od. kı...] (weitärmeliges Gewand) m; -s, -s; **Ki|mo|no.är|mel** (der angeschnittene Ärmel), ...**blu|se**

Ki|nä|de gr. (männl. Hetäre im alten Griechenland; Päderast) m; -n, -n († R 268)

Kin|äs|the|sie gr. (Med.: Bewegungsgefühl) w; -

Kind s; -[e]s, -er; an -es Statt; vgl. Statt; von - auf; sich bei einem lieb - machen (einschmeicheln); **Kind|bett** s; -[e]s; **Kind|bet|te|rin** (veralt.) w; -, -nen; **Kind|bett_fie|ber**; **Kind|chen** s; -s, - u. Kinderchen; **Kind|lein** s; -s, - u. Kinderlein; **Kin|del|bier** heißend. (Taufschmaus); **Kin|der_ar|beit**, ...**arzt**, ...**bett**, ...**buch**, ...**dorf**, ...**ehe**; **Kin|de|rei**; **Kin|der_er|zie|hung**, ...**fräu|lein**, **kin|der|freund|lich**; **Kin|der_gar|ten**, ...**gärt|ne|rin**, ...**geld**, ...**got|tes|dienst**, ...**heim**, ...**hort**, ...**klei|dung**, ...**krank|heit**, ...**la|den** (nicht autoritär geleiteter Kindergarten), ...**läh|mung**; **kin|der_leicht**, ...**lieb** (die Kinder verstehend und liebend), ...**los**; **Kin|der_lo|sig|keit** w; -; **Kin|der_mäd|chen**, ...**miß|hand|lung**, ...**mund**; **kin|der|reich**; **Kin|der|reich|tum** (m; -s), ...**schreck** (m; -s), ...**spiel**, ...**spra|che**, ...**stu|be**, ...**ta|ges|stät|te**; **kin|der|tüm|lich**; **Kin|der_wa|gen**, ...**zeit**, ...**zim|mer**; **Kin|des_al|ter**, ...**aus|set|zung**, ...**bei|ne** (Mehrz., noch in: von -n an), ...**kin|der** (Mehrz.), ...**lie|be**, ...**mord**, ...**mör|de|rin**, ...**un|ter|schie|bung**; **kind_fremd**, ...**ge|mäß**, ...**haft**; **Kind|heit** w; -; **Kind|heits_er|in|ne|rung**; **kin|disch**; -ste († R 294); **Kind|lein** vgl. Kindchen; **Kind|lich|keit** w; -; **Kinds_be|we|gung**, ...**kopf** (salopp), ...**köp|fig**; **Kinds|pech**; **Kind|tau|fe**

Ki|ne|ma|tik gr. (Physik: Lehre von den Bewegungen) w; -; **ki|ne|ma|tisch** (die Kinematik betreffend; sich aus der Bewegung ergebend); **Ki|ne|ma|to|graph** (Bez für den ersten Apparat zur Aufnahme u. Wiedergabe bewegter Bilder; daraus die Kurzform: Kino) m; -en, -en († R 268); **Ki|ne|ma|to|gra|phie** (umfassende Bez. für Filmwissenschaft u. -technik, Aufnahme u. Wiedergabe von Filmen) w; -; **ki|ne|ma|to|gra|phisch**; **Ki|ne|tik** (Physik: Lehre von den Kräften, die nicht im Gleichgewicht sind) w; -; **ki|ne|tisch** (bewegend); -e Energie (Bewegungsenergie); **Ki|ne|tit** (ein Sprengstoff) s; -s

885 **Klagenfurt**

Kink (niederd. u. Seemannsspr.:
Knoten, Fehler im Tau) *w*; -, -en
Kin|ker|litz|chen *fr.* (ugs. für:
Albernheiten) *Mehrz.*
Kinn *s*; -[e]s, -e; **Kinn_backe[n]**
[*Trenn.:* ...bak|ke(n)], ...ha|ken,
...la|de, ...rie|men, ...spit|ze
Ki|no (Lichtspieltheater) *s*; -s, -s;
vgl. Kinematograph; **Ki|no_be-
sit|zer**, ...be|su|cher, ...kar|te
Ki|non|glas ⓦ (ein Sicherheits-
glas; *Mehrz.* ...gläser)
Ki|no_pro|gramm, ...re|kla|me,
...tech|nik
Kin|sha|sa [...*scha* ...] (Hptst. von
Zaire)
Kin|topp (ugs. für: Kino, Film) *m*
od. *s*; -s, -s u. ...töppe
Kin|zig (r. Nebenfluß des unteren
Mains; r. Nebenfluß des Ober-
rheins) *w*; -; **Kin|zi|git** (eine
Gneisart) *m*; -s
Ki|osk *pers.* [auch: ...*ßk*] (orien-
tal. Gartenhaus; Verkaufshäus-
chen [für Zeitungen, Erfrischun-
gen usw.]) *m*; -[e]s, -e
Kio|to (jap. Stadt)
Kipf südd. (länglich geformtes
Brot) *m*; [e]s, -e; **Kip|fel** *s*; -s,
- u. **Kip|ferl** österr. (Hörnchen
[Gebäck]) *s*; -s, -n; **Kipf|ler** österr.
(Kartoffelsorte) *Mehrz.*
Kip|pe (Spitze, Kante; Turn-
übung; ugs. für: Zigarettenstum-
mel) *w*; -, -n; **kip|pe|lig**, **kipp|lig**;
kip|peln (ugs.); ich ...[e]le (↑ R
327); **kip|pen**; ¹**Kip|per** (früher
für: Münzverschlechterer); - und
Wipper; ²**Kip|per** (Wagen mit
kippbarem Wagenkasten); **Kipp-
fen|ster**; **kipp|lig**, kip|pe|lig;
Kipp_lo|re, ...**pflug**(↑ R 237), ...re-
gel (Meßwerkzeug der Landmes-
ser), ...schal|ter, ...vor|rich|tung,
...wa|gen
Kips *engl.* (getrocknete Haut des
Zebus) *s*; -es, -e (meist *Mehrz.*)
Kir|be bayr. (Kirchweih) *w*; -, -n;
Kir|che *w*; -, -n; **Kir|chen_äl|te|ste**
n, ...amt, ...aus|tritt, ...bann,
...bau (*Mehrz.* ...bauten), ...be|su-
cher, ...bu|ße, ...chor (vgl. ²Chor),
...die|ner, ...fa|brik (Stiftungs-
vermögen einer kath. Kirche),
...fest, ...gän|ger (jmd., der aus
Prinzip fleißig in die Kirche geht;
vgl. aber: Kirchgänger), ...ge|bet,
...ge|schich|te, ...glocke [*Trenn.:*
...glok|ke), ...jahr, ...leh|rer,
...licht (*Mehrz.* -er; er ist kein
großes] Kirchenlicht [ugs. für:
er ist nicht sehr klug]), ...lied,
...mu|sik, ...rat (*Mehrz.* ...räte),
...recht, ...schiff, ...spren|gel od.
...irch|spren|gel, ...staat (*m*;
-[e]s), ...steu|er *w*, ...tag (z. B.
Deutscher Evangelischer Kir-
chentag [↑ R 224]), ...tür, ...va|ter
(Verfasser grundlegender kirchl.

Schriften des christl. Altertums),
...vor|stand; **Kirch_gän|ger** (jmd.,
der gerade in die Kirche geht od.
von ihr kommt; auch für: Kir-
chengänger), ...hof; **Kirch-
hofs_mau|er**, ...stil|le; **kirch|lich**;
Kirch|lich|keit *w*; -; **Kirch|ner**
(veralt. für: Küster); **Kirch_spiel**
(Kirchensprengel), ...spren|gel
od. **Kir|chen|spren|gel**, ...tag
(selten für: Kirchweih), ...turm,
Kirch|turm|po|li|tik (auf engen
Gesichtskreis beschränkte Poli-
tik); **Kirch|va|ter** landsch. (Kir-
chenältester); **Kirch|weih** *w*; -, -en
Kir|gi|se (Angehöriger eines mit-
telasiat. Volkes) *m*; -n, -n (↑ R
268); **kir|gi|sisch**
Kir|ke vgl. Circe
Kir|mes bes. mittel- u. niederd.
(Kirchweih) *w*; -, ...messen; **Kir-
mes|ku|chen**
kir|nen mdal. (buttern; [Erbsen]
ausschoten)
kir|re (ugs. für: zutraulich, zahm);
jmdn. - machen; **kir|ren** (kirre
machen); **Kir|rung** (Jägerspr.:
Lockfutter)
Kirsch (ein Branntwein) *m*; -[e]s,
-; **Kirsch_baum**, ...blü|te; **Kir|sche**
w; -, -n; **Kir|schen|baum** usw. (sel-
tener für: Kirschbaum usw.);
Kirsch_geist (veralt. für: Kirsch-
wasser; *m*; -...holz, ...kern,
...ku|chen, ...li|kör; **kirsch|rot**; -
färben; **Kirsch_saft**, ...sor|te,
...was|ser (ein Branntwein; *s*; -s,-)
Kir|sten (m. od. w. Vorn.)
Kir|tag bayr., österr. (Kirchweih)
Kis|met *arab.* („Zugeteiltes"; Los;
gottergeben hinzunehmendes
Schicksal im Islam) *s*; -s
Kiß|chen; **Kis|sen** *s*; -s, -; **Kis-
sen_be|zug**, ...füll|lung, ...hül|le,
...schlacht (ugs. scherzh.: Hin-
undherwerfen von Kissen),
...über|zug
Ki|ste *w*; -, -n; **Ki|sten_deckel**
[*Trenn.:* ...dek|kel], ...grab; **ki-
sten|wei|se**
Ki|sua|he|li, **Ki|swa|hi|li**, Swa|hi|li
(Suahelisprache) *s*; -[s]
Kit|fuchs vgl. Kittfuchs
Ki|tha|ra *gr.* (altgr. Saiteninstru-
ment) *w*; -, ...-s u. ...tharen; **Ki|thar-
öde** (altgr. Zitherspieler u. Sän-
ger) *m*; -n, -n (↑ R 268)
Ki|thä|ron (gr. Gebirge) *m*; -s
Kitsch (süßlich-sentimentale, ge-
schmacklose Kunst) *m*; -[e]s; **kit-
schen** mdal. (zusammenschar-
ren); **kit|schig**
Kitt *m*; -[e]s, -e
Kitt|chen (ugs. für: Gefängnis) *s*;
-s, -
Kit|tel *m*; -s, -; **Kit|tel|schür|ze**
kit|ten
Kitt|fuchs (Fuchs einer nordame-
rik. Art u. sein Fell)

Kitz *s*; -es, -e u. **Kit|ze** (Junges von
Reh, Gemse, Ziege) *w*; -, -n
Kitz|bü|hel (österr. Stadt)
Kitz|chen, Kitz|lein
Kit|zel *m*; -s; **kit|ze|lig**, kitz|lig; **kit-
zeln**; ich ...[e]le (↑ R 327); **Kitz|ler**
(für: Klitoris)
Kitz|lein, Kitz|chen
kitz|lig, kit|ze|lig
Ki|wi *maorisch* (Schnepfenstrauß)
m; -s, -s
k. J. = künftigen Jahres
Kjök|ken|möd|din|ger vgl. Kök-
kenmöddinger
k. k. = kaiserlich-königlich (im
ehem. österr. Reichsteil von
Österreich-Ungarn für alle Be-
hörden); vgl. kaiserlich; vgl. k.
u. k.
K. K. = Kaiserlich-Königlich;
vgl. kaiserlich
kl = Kiloliter
Kl. = Klasse, österr. auch =
Klappe (für: Telefonnebenstelle,
Apparat)
Kl.-4° = Kleinquart
Kl.-8° = Kleinoktav
kla|ba|stern mdal. (schwerfällig
gehen, aufstampfen); ich ...ere
(↑ R 327)
Kla|bau|ter|mann (ein Schiffsko-
bold) *m*; -[e]s, ...männer
klack!; klack, klack!; **klacken**
[*Trenn.:* klak|ken] (klack ma-
chen); **klackern** [*Trenn.:* klak-
kern] mdal. (kluckern u. kleck-
sen); ich ...ere (↑ R 327); **klacks!**;
Klacks (ugs. für: kleine Menge;
klatschendes Geräusch) *m*; -es,
-e
Klad|de (erste Niederschrift; Ge-
schäftsbuch; Heft) *w*; -, -n
klad|de|ra|datsch! [auch: ...*datsch*]
(krach!); **Klad|de|ra|datsch**
[auch: ...*datsch*] (Krach; übertr.
ugs. für: Zusammenbruch, Miß-
erfolg) *m*; -[e]s, -e
Kla|do|nie *gr.* [...*i*ᵉ] (Rentierflech-
te) *w*; -, -n; **Kla|do|ze|re** (Wasser-
floh) *w*; -, -n (meist *Mehrz.*)
klafff!; klifff, klafff!; **Klafff** *m*; -[e]s;
mit Kliff und -; **klaf|fen; kläf|fen**;
Kläf|fer; **Kläff|mu|schel**
Klaf|ter (Längen-, Raummaß) *m*
od. *s*; -s, - (seltener: *w*; -, -n);
5 - Holz (↑ R 321 u. 322); **Klaf|ter-
holz** *s*; -es; **Klaf|ter|lang**; -er Riß,
aber: 3 Klafter lang; **klaf|tern**;
ich ...ere (↑ R 327) Holz (schichte
es auf); der Adler klaftert (mißt
bei ausgespannten Flügeln) über
2 m; **klaf|ter|tief**; vgl. klafterlang
klag|bar; - werden; **Klag|bar|keit**
w; -; **Kla|ge** *w*; -, -n; **Kla|ge_ge-
schrei**, Klag|ge|schrei; **Kla-
ge_laut**, ...lied, ...mau|er (Überre-
ste des Tempels in Jerusalem);
kla|gen
Kla|gen|furt (Hptst. von Kärnten)

D1, 17. A.

Kla|ge|punkt; Klä|ger; Klag|er|he-
bung (BGB); Kla|ge|rin w; -, -nen;
klä|ge|risch; klä|ge|ri|scher|seits;
Kla|ge_schrift, ...weg; Klag|ge-
schrei, Kla|ge|ge|schrei; kläg-
lich; Kläg|lich|keit; klag|los
Kla|mauk (ugs. für: Lärm; Ulk)
m; -s
klamm (eng, knapp; feucht; steif
[vor Kälte]); -e Finger; Klamm
(Felsenschlucht [mit Wasser-
lauf]) w; -, -en; Klamm|mer w; -,
-n; Klam|mer_af|fe, ...beu|tel;
klam|mern; ich ...ere († R 327);
klamm|heim|lich (ugs. für: ganz
heimlich)
Kla|mot|te (ugs. für: [Ziegel]brok-
ken; minderwertiges Stück) w; -,
-n (ugs. auch für: [alte] Klei-
dungsstücke); meist Mehrz.
Klam|pe (Seemannsspr.: Holz- od.
Metallstück zum Festmachen
der Taue) w; -, -n; Klamp|fe
(volkstüml. für: Gitarre; österr.
auch: Bauklammer) w; -, -n
kla|mü|sern nordd. ugs. (austüf-
teln); ich ...ere († R 327)
Klan (eindeutschende Schreibung
für: Clan)
klan|de|stin lat. (veralt. für: heim-
lich); -e Ehe (nicht nach kanon.
Vorschrift geschlossene Ehe)
klang!; kling, klang!; Klang m;
-[e]s, Klänge; Klang_ef|fekt,
...far|be, ...fül|le, ...kör|per;
klang|lich; klang|los; Klang-
schön|heit; klang|voll; Klang|wir-
kung
Klapf südd., schweiz. mdal.
(Knall, Schlag, Ohrfeige) m; -s,
Kläpfe; kläp|fen (knallen, schla-
gen)
klapp!; klapp, klapp!; klipp,
klapp!; klipp und klapp!; Klapp-
bett; Klap|pe (österr. auch: Ne-
benstelle eines Telefonanschlus-
ses, svw. Apparat) w; -, -n; klap-
pen; Klap|pen_feh|ler (kurz für:
Herzklappenfehler), ...horn (äl-
teres Musikinstrument; Mehrz.
...hörner), ...text (Buchw.); Klap-
per w; -, -n; Klap|per|bein; Freund
- (veralt. für: Tod); klap|per|dürr;
klap|pe|rig, klapp|rig; Klap-
per_ka|sten, ...ki|ste (ugs. für: al-
tes Fahrzeug, insbes. Auto);
klap|pern; ich ...ere († R 327);
Klap|per_schlan|ge, ...storch;
Klapp|fen|ster; Klapp|horn|ver|se
(Scherzverse in Form eines Vier-
zeilers, beginnend mit: Zwei
Knaben ...) Mehrz.; Klapp_hut m,
...lie|ge, ...mes|ser s, ...rad; klapp-
rig, klap|pe|rig; Klapp_sitz,
...stuhl, ...tisch
klaps!; klaps, klaps!; Klaps m; -es,
-e; Kläps|chen, Kläps|lein; klap-
sen; du klapst (klapsest); klap|sig
(ugs. für: leicht verrückt); Klaps-

‿mann (ugs. für: leicht Verrück-
ter; Mehrz. ...männer), ...müh|le
(ugs. für: Irrenanstalt)
klar; -er, -ste; († R 133:) im -en
sein, ins -e kommen; klar Schiff!
(seemänn. Kommando). In Ver-
bindung mit Zeitwörtern († R
139): I. Getrenntschreibung, wenn
„klar“ im urspr. Sinne gebraucht
ist, z. B. klar sein, klar werden
(auch vom Wetter). II. Zusam-
menschreibung, wenn ein neuer
Begriff entsteht († R 139), z. B.
klargehen, klarkommen, klarle-
gen, klarmachen, klarsehen,
klarstellen, klarwerden; Klar vgl.
Eiklar
Kla|ra (w. Vorn.)
Klär|an|la|ge
Klar_ap|fel, ...blick; klar|blickend
[Trenn.: ...blik|kend]; ein -er
Mann
Klär|chen (Koseform von: Klara)
klar|den|kend; ein -er Mann
klä|ren
Kla|rett fr. (gewürzter Rotwein;
schwachroter Jungwein) m; -s, -s
od. -e
klar|ge|hen; † R 139 (ugs. für: rei-
bungslos ablaufen); das ist klar-
gegangen
Klar|heit w; -
kla|rie|ren lat. (beim Ein- u. Aus-
laufen eines Schiffes die Zoll-
formalitäten erledigen); ein
Schiff -
Kla|ri|net|te it.(-fr.) (ein Holz-
blasinstrument) w; -, -n; Kla|ri-
net|tist (Klarinettenbläser); † R
268
Kla|ris|sa (w. Vorn.); Kla|ris|sen-
or|den m; -s; Kla|ris|sin (Angehö-
rige des Klarissenordens) w; -,
-nen
klar|kom|men; † R 139 (ugs. für:
zurechtkommen); ich bin damit,
mit ihm klargekommen; klar|le-
gen; † R 139 (erklären); er hat ihm
den Vorgang klargelegt; klär|lich
(veralt. für: klar, deutlich); klar-
ma|chen; † R 139 (deutlich ma-
chen; [Holz] zerkleinern; [Schiff]
fahr-, gefechtsbereit machen); er
hat ihm den Vorgang klarge-
macht; das Schiff hat klarge-
macht; Klär|mit|tel s; Klar|schiff
(Seemannsspr.: Gefechtsbereit-
schaft) s; -[e]s; Klär|schlamm;
Klar|schrift|le|ser (EDV-Ein-
gabegerät, das Daten in lesbarer
Form verarbeitet); klar|se|hen;
† R 139 (in einer Sache); er hat
während der schwierigen Ver-
handlungen immer klargesehen;
aber: klar se|hen (gut, ohne Trü-
bung sehen); auch ohne Fernglas
hat er klar gesehen; Klar|sicht-
‿do|se, ...fo|lie; klar|sich|tig;
Klar|sicht_packung [Trenn.:

...pak|kung], ...schei|be (Kfz)
klar|stel|len; † R 139 (Irrtümer
beseitigen); er hat diese Mißver
ständnisse klargestellt; Klar|stel
lung; Klar|text (entzifferter [de
chiffrierter] Text) m; Klä|rung
klar|wer|den; † R 139 (verständ
lich werden, einsehen); sich -; ihn
ist endlich sein falsches Handeln
klargeworden; ich bin mir übe
meine Fehler klargeworden
wenn ihm sein Fehler klar wird
aber: klar wer|den; der Himme
ist klar geworden
Klas niederd. (Klaus)
Klaß... südd. (in Zusammenset
zungen für: Klassen... [= Schul
klasse], z. B. Klaßlehrer); klas|s
(ugs. für: hervorragend, großar
tig); eine - Idee; das ist, wird
er hat - gespielt; das Auto ist
-; Klas|se lat.(-fr.) (Abk.: Kl.) v
-, -n; etwas ist [ganz große] - (ug
für: etwas ist großartig, etwa
ganz Besonderes); Klas|se|men
fr. [...mãng] (Einreihung; Re
henfolge) s; -s, -s; Klas|sen_ar
beit, ...auf|satz, ...be|wußt|sein
...buch, ...ge|sell|schaft, ...ha
...in|ter|es|se, ...ju|stiz, ...ka|me
rad, ...kampf, ...leh|rer, ...lei|te
m; klas|sen|los; -e Gesellschaf
Klas|sen_lot|te|rie, ...sie|ge
(Sportspr.), ...spre|cher, ...staa
...tref|fen, ...vor|stand (österr
Klassenlehrer), ...wahl|rech
klas|sen|wei|se; Klas|sen_zie
...zim|mer; klas|sie|ren (Ber
mannsspr.: nach der Größe tren
nen); klassifizieren; Klas|si
rung, Klas|si|fi|ka|ti|on [...zior
Klas|si|fi|zie|rung (Einteilun
Einordnung, Sonderung i
Klassen); klas|si|fi|zie|re
...klas|sig (z. B. erst-, zweitklas
sig); Klas|sik (Epoche kulturelle
Gipfelleistungen u. ihre muste
gültigen Werke) w; -; Klas|si|k
(maßgebender Künstler o
Schriftsteller [bes. der antiken
der dt. Klassik]); klas|sisch (m
stergültig; vorbildlich; die Kla
sik betreffend; von Zeugen: vo
gültig; typisch, bezeichnen
herkömmlich, traditionell); -s
(† R 294); -es Theater; -e Philol
gie; -e Sprachen; -er Jazz; -
Blues (Jazz); Klas|si|zis|mus (d
Klassik nachahmende Stilric
tung; bes.: Stil um 1800) m;
klas|si|zi|stisch; -ste (↑ R 294
Klas|si|zi|tät (Mustergültigke
w; -
...kläß|ler (z. B. Erst-, Zweitklä
ler)
kla|stisch gr. (Geol.: zerbroche
Trümmer...); -es Gestein (Trü
mergestein)
Kla|ter niederd. (Schmutz) m

(für: Lumpen, zerrissenes Kleid auch *Mehrz.:*) -n; kla|te|rig, klat|rig niederd. (schmutzig; schlimm, bedenklich; elend) **klatsch!**; klitsch, klatsch!; **Klatsch** (ugs. auch für: Rederei, Geschwätz) *m;* -[e]s, -e; **Klatsch|ba|se; Klat|sche** (Werkzeug zum Klatschen; Gerüchteverbreiter[in], gehässige[r] Schwätzer[in]) *wi ,* n; **klat|schen;** du klatschst (klatschest); Beifall -; **klat|sche|naß** vgl. klatschnaß; **Klat|scher; Klat|sche|rei; Klat|sche|rin** w; -, -nen; **klat|sch|haft; Klatsch|haf|tig|keit** w; -; **klat|schig** (selten für: klatschsüchtig); **Klatsch..ko|lum|nist,** ...**maui** (ugs. für: geschwätzige Person), ...**mohn; klatsch|naß** (ugs. für: völlig durchnäßt); **Klatsch..nest** (ugs.: kleiner Ort, in dem viel geklatscht wird), ...**spal|te,** ...**sucht** (w; -); **klatsch|süch|tig; Klatsch..tan|te,** ...**weib** **Klau** niederd. (gabelförmiges Ende der Gaffel) w; -, -en **Klaub|ar|beit** (Bergmannsspr.: Sondern des haltigen u. tauben Gesteins, der Steine aus der Kohle); **klau|ben** (sondern; mit Mühe heraussuchen, -bekommen; österr. allgem. für: pflücken, sammeln); **Klau|ber; Klau|be|rei Kläu|chen** (kleine Klaue) **Klau|dia** vgl. Claudia; **Klau|di|ne** vgl. Claudine **Klaue** w; -, -n; **klau|en** (ugs. für: stehlen); **Klau|en|seu|che** w; -; Maul- u. Klauenseuche (↑ R 145); ...**klau|ig** (z. B. scharfklauig) **Klaus** (Kurzform von: Nikolaus; schweiz. ugs. auch für: Dummkopf); **Kläus|chen** (Koseform zu: Klaus) **Klau|se** *lat.* (enger Raum, Klosterzelle, Einsiedelei; Engpaß) w; -, -n **Klau|sel** *lat.* (Nebenbestimmung; Einschränkung, Vorbehalt) w; -, -n **Klau|sen|paß** (ein Alpenpaß) *m;* ...**passes Klau|si|lie** *lat.* [...ie] (Schließmundschnecke) w; -, -n **Klaus|ner** *lat.* (Bewohner einer Klause, Einsiedler) **Klau|sur** *lat.* (abgeschlossener Gebäudeteil [im Kloster]; vaw. Klausurarbeit) w; -, -en; **Klau-sur|ar|beit** (Prüfungsarbeit in einem abgeschlossenen Raum) **Kla|via|tur** *lat.* [...*wi...*] (Tasten [eines Klaviers], Tastbrett) w; -, -en; **Kla|vi|chord** *lat.; gr.* [...*wikort*] (ältere Form des Klaviers) s; -[e]s, -e; **Kla|vier** *fr.* [...*wir*] s; -s, -e; - spielen (↑ R 140); vgl. Wohltemperiertes Klavier; **Kla|vier..abend,** ...**aus|zug,** ...**be|glei|tung;**

kla|vie|ren (ugs. für: herumfingern an etwas); **Kla|vier..kon|zert,** ...**leh|rer,** ...**so|na|te,** ...**spiel,** ...**spie|ler,** ...**stuhl,** ...**stun|de,** ...**unter|richt; Kla|vi|kel** *lat.* [...*wi...*] (veralt. für: Schlüsselbein) *s;* -s, -; **Kla|vi|ku|la** w; -, ...lä u. (med. fachspr.:) Cla|vi|cu|la (Schlüsselbein) w; -, ...lae [...*lä*]; **kla|vi|kular** (das Schlüsselbein betreffend); **Kla|vi|zim|bel** (Tasteninstrument des 14.–18. Jh.s) *s;* -s, -; vgl. Clavicembalo **kle|ben;** vgl. festkleben; **Kle|be-mit|tel, Kleb|mit|tel** *s;* **kle|ben-blei|ben,** ↑ R 139 (ugs. auch für: sitzenbleiben [in der Schule]); ich bleibe klebent klebengeblieben; klebenzubleiben; **Kle|ber** (auch: Bestandteil des Getreideeiweißes); **Kle|be|strei|fen, Kleb|strei-fen; Kleb|mit|tel, Kle|be|mit|tel** *s;* **kleb|rig; Kleb|rig|keit** w; -; **Kleb-stoff; Kleb|strei|fen, Kle|be|strei-fen, Kle|bung** [1]kleck|en[1] mdal. (ausreichen, vonstatten gehen); es kleckt [2]klecken[1] mdal. (von Flüssigkeiten: geräuschvoll fallen); **klek-kern** (ugs. für: beim Essen od. Trinken Flecke machen, sich beschmutzen); ich ...ere (↑ R 327); **klecker|wei|se**[1] (ugs. für: mehrmals in kleinen Mengen); **Klecks** *m;* -es, -e; **kleck|sen** (Kleckse machen); du kleckst (kleckest); **Kleck|ser; Kleck|se|rei; kleck|sig Kle|da|sche** nordd. (Kleidung) w; -, (selten:) -n **Klee** *m;* -s, Kleearten od. -sorten; **Klee|blatt; Klee-Ein|saat** (↑ R 148) w; -, -en; **Klee-Ern|te** (↑ R 148) w; -, -n; **Klee..fal|ter** (ein Schmetterling), ...**gras** (Gemengesaat von Klee u. Gras), ...**salz** (ein Fleckenbeseitigungsmittel; *s;* -es) **Klei** (fetter, zäher Boden) *m;* -[e]s; **klei|ben** mdal. (kleben[bleiben]); **Klei|ber** (ein Vogel; veralt. für: Lehmarbeiter; mdal. für: Klebstoff); **Klei|bo|den Kleid** (schweiz. auch: Herrenzug) *s;* -[e]s, -er; **Kleid|chen** *s;* -s, - u. Kleiderchen; **klei|den;** es kleidet mich gut usw.; **Klei|der..bad,** ...**bü|gel,** ...**bür|ste,** ...**ha|ken,** ...**ka|sten** (südd., österr., schweiz. für: Kleiderschrank), ...**ma|cher** (österr., sonst veralt. für: Schneider), ...**re|chen** (österr. für: Kleiderhaken), ...**schrank,** ...**stoff; kleid|sam; Kleid|sam|keit** w; -; **Klei|dung; Klei|dungs|stück Kleie** (Mühlenabfallprodukt) w; -, -n; **Klei|en|brot; klei|ig** (von Klei od. Kleie)

klein; -er, -ste; kleiner[e]nteils. I. *Kleinschreibung:* **a)** (↑ R 133:) im kleinen verkaufen; die Gemeinde ist ein Staat im kleinen; groß u. klein; von klein auf; über kleinlich wenig; **b)** (↑ R 135:) um ein kleines (wenig); ein kleines (wenig) abhandeln; **c)** (↑ R 134:) über ein kleines (geh. für: bald); bei kleinem (nordd. für: allmählich); am kleinsten; bis ins kleinste (sehr eingehend); **d)** (↑ R 224:) die kleine Anfrage (im Parlament); das Schiff macht kleine Fahrt (Seemannsspr.); das sind kleine Fische (ugs.); der kleine Grenzverkehr; das kleine Latinum; er ist kleiner Leute Kind; das Auto für den kleinen Mann. **II.** *Großschreibung:* **a)** (↑ R 116:) Kleine u. Große; die Kleinen u. die Großen; die Kleinen (Kinder); meine Kleine (junges Mädchen); meine Kleine (ugs.); im Kleinen genau; im Kleinen wie im Großen treu sein; vom Kleinen auf das Große schließen; es ist mir ein Kleines (eine kleine Mühe), dies zu tun; **b)** (↑ R 116:) etwas, nichts, viel, wenig Kleines; **c)** (↑ R 224:) Pippin der Kleine; Klein Dora, Klein Erna, Klein Roland; der Kleine Bär, der Kleine Wagen; die Kleine Strafkammer; **d)** (↑ R 198:) Kleiner Belt; Kleines Walsertal; Kleine Sundainseln. **III.** *Schreibung in Verbindung mit Zeitwörtern* (↑ R 139): klein sein, werden; sich klein machen (um in etwas hineinzukommen); klein beigeben (nachgeben); klein schreiben; kurz u. klein schlagen; vgl. aber: kleinbekommen, kleinhacken, kleinkriegen, kleinmachen, kleinschneiden, kleinschreiben. **IV.** *Über die Schreibung in erdkundlichen Namen* ↑ R 206, *in Straßennamen* ↑ R 221 u. 222; **Klein** (z. B. von Gänsen, Hasen, Kohlen) *s;* -s; **Klein..ak|tio-när,** ...**ar|beit; klein|asia|tisch; Klein|asi|en** [...*ien*] (↑ R 206); **Klein|bahn; klein|be|kom|men;** ↑ R 139 (svw. kleinkriegen); **Klein..be|trieb,** ...**bild|ka|me|ra,** ...**buch|sta|be,** ...**bür|ger; klein-bür|ger|lich; Klein..bür|ger|tum,** ...**bus; Klein|chen** (kleines Kind); **klein|den|kend; Klei|ne** (kleines Kind) *m, w, s;* -n, -n (↑ R 287ff.); **Klei|ne|leu|te|mi|lieu; Klein|emp-fän|ger** (ein Rundfunkgerät); **klei|ne|ren|teils, klei|nern|teils; Klein..fa|mi|lie,** ...**for|mat,** ...**garten,** ...**gärt|ner,** ...**ge|bäck,** ...**geld** (*s;* -[e]s); **klein|ge|mu|stert; klein-ge|wach|sen; klein|gläu|big; Klein|gläu|big|keit** w; -; **klein-hacken** [*Trenn.:* ...hak|ken]; ↑ R

[1] *Trenn.:* klek|ke...

139 (zerkleinern); Klein|han|del (vgl. ¹Handel), ...häus|ler (österr. für: Kleinbauer); Klein|heit w; -; klein|her|zig; Klein|hirn, ...holz; Klei|nig|keit; Klei|nig|keits|krä-mer; Klein|ka|li|ber|schie|ßen s; -s; klein|ka|li|brig; klein|ka|riert (auch übertr. für: engherzig, -stir-nig); Klein|kind; Klein|kin|der|be-wahr|an|stalt w; -, -en; Klein-.kraft|rad, ...kraft|wa|gen, ...kram (m; -[e]s), ...krieg; klein-krie|gen; ↑R 139 (ugs. für: zerkleinern; aufbrauchen; gefü-gig machen); ich kriege klein; klein|gekriegt; klein|zukriegen; Klein|kunst w; -; klein|laut; klein-lich; Klein|lich|keit; klein|ma-chen; ↑R 139 (zerkleinern; ugs. für: aufbrauchen, durchbringen; wechseln; erniedrigen); klein-maß|stäb|lich, (gelegentlich auch:) klein|maß|stä|big; klein-.mö|bel, ...mut (m; -[e]s); klein-mü|tig; Klein|mü|tig|keit w; -; Klein|od s; -[e]s, (für: Kostbarkeit Mehrz.:) -e, (für: Schmuckstück Mehrz.:) ...odien [...iᵉⁿ]; Klein-.ok|tav (Abk.: Kl.-8°; s; -s), ...quart (Abk.: Kl.-4°; s; -[e]s), ...rent|ner; klein|schnei|den; ↑R 139 (zerkleinern); ich schneide klein; klein|geschnitten; kleinzu-schneiden; klein|schrei|ben; ↑R 139 (ugs. für: nicht beachten, nicht wichtig nehmen); Demo-kratie wird in diesem Betrieb kleingeschrieben, aber: klein schrei|ben (mit kleinem Anfangs-buchstaben schreiben); das Wort wird ˌklein geschrieben, also -.schrei|bung, ...sied|lung, ...staat (Mehrz. ...staaten); Klein|staa|te-rei w; -; Klein.stadt, ...städ|ter; klein|städ|tisch; -ste (↑R 294); Kleinst|be|trag; Kleinst|stel|ler (Sparvorrichtung an Ölöfen, Gaskochern usw.); Kleinst.haus, ...kind; kleinst|mög|lich, dafür besser: möglichst klein; falsch: kleinstmöglichst (↑R 299); Kleinst|woh|nung; Klein|tier-zucht; Klein.vieh, ...wa|gen; klein-.weis (österr. ugs.: im kleinen, nach und nach), ...win|zig; Klein-woh|nung
Kleio vgl. Klio
Kleist (dt. Dichter)
Kleist|ster m; -s, -; klei|ste|rig, kleist-rig; klei|stern; ich ...ere (↑R 327); Kleis|ter|topf
klei|sto|gam gr. (Bot.: selbstbe-fruchtend)
kleist|rig, klei|ste|rig
Kle|ma|tis gr. [auch: ...atíß] (Waldrebe, Kletterpflanze) w; -,-
Kle|mens, Kle|men|tia, ¹Kle|men-ti|ne vgl. Clemens, Clementia, ¹Clementine

²Kle|men|ti|ne [vermutl. nach dem ersten Züchter, dem fr. Trap-pistenmönch P. Clément] (kern-lose Sorte der Mandarine) w; -, -n
Klemmappe [Trenn.: Klemm|map-pe; ↑R 236]; Klem|me w; -, -n; klem|men; Klem|mer landsch. (Kneifer, Zwicker); klem|mig (Bergmannsspr. [vom Gestein]: fest); Klemm|schrau|be
klem|pern (veralt. für: Blech häm-mern; lärmen); ich ...ere (↑R 327); Klemp|ner (Blechschmied); Klemp|ne|rei; Klemp|ner.la|den (ugs. für: viele Orden u. Ehrenzei-chen auf der Brust), ...mei|ster; klemp|nern (Klempner sein, spie-len); ich ...ere (↑R 327)
Kleng|an|stalt (Darre zur Gewin-nung von Nadelholzsamen); kleng|en (Nadelholzsamen ge-winnen)
Kleo|pa|tra (ägypt. Königin)
¹Klep|per (ugs. für: schlechtes, ab-getriebenes Pferd) m; -s, -
²Klep|per Ⓦ; Klep|per|boot; ↑R 180 (Faltboot); Klep|per|man|tel; ↑R 180 (wasser-, winddichter Mantel)
Klepsy|dra gr. (altgr. Wasseruhr) w; -, ...ydren
Klep|to|ma|ne gr. (an Kleptoma-nie Leidender) m; -n, -n (↑R 268); Klep|to|ma|nie (krank-hafter Stehltrieb) w; -; Klep|to-ma|nin (an Kleptomanie Leiden-de) w; -, -nen; klep|to|ma|nisch
kle|ri|kal gr. (die Geistlichkeit be-treffend; [streng] kirchlich [ge-sinnt]); Kle|ri|ka|lis|mus (über-starker Einfluß des Klerus auf Staat u. Gesellschaft) m; -; Kle|ri-ker (kath. Geistlicher); Kle|ri|sei (veralt. für: Klerus) w; -; Kle|rus (kath. Geistlichkeit, Priester-schaft) m; -
Klet|te w; -, -n; Klet|ten|wur|zel; Klet|ten|wur|zel|öl s; -[e]s
Klet|te|rei; Klet|te|rer; Klet-ter.farn, ...ge|rüst, ...max od. ...ma|xe (ugs. für: Einsteigdieb, Fassadenkletterer; m; ...xes, ...xe); klet|tern; ich ...ere (↑R 327); Klet|ter.par|tie, ...pflan|ze, ...ro|se, ...stan|ge, ...tour, ...we|ste Klet|ze österr. (getrocknete Birne) w; -, -n; Klet|zen|brot
Kle|ve [...wᵉ] (Stadt im westl. Nie-derrheinischen Tiefland); Kle|ver (↑R 199); kle|visch
klicken¹ (einen dünnen, kurzen Ton geben)
Klicker¹ landsch. (Ton-, Steinkü-gelchen zum Spielen) m; -s, -; klickern¹; ich ...ere (↑R 327)
Klicks (Schnalzlaut) m; -es, -e

¹ Trenn.: ...k|k...

klie|ben (veralt., aber noch mdal. für: [sich] spalten); du klobst u. kliebtest; du klöbest u. kliebtest; gekloben u. gekliebt; klieb[e]!
Kli|ent lat. (im Altertum: Schutz-befohlener; heute: Auftraggeber [eines Rechtsanwaltes]) m; -en -en (↑R 268); Kli|en|tel (im Altertum: Verhältnis der Hörigen zum Schutzherrn; heu-te: Auftraggeberkreis [eines Rechtsanwaltes]) w; -, -en; Kli|en-te|le schweiz. (svw. Klientel) w; -, -n
klie|ren landsch. (unsauber schlecht schreiben)
Kliff niederd. (steiler Abfall eine [felsigen] Küste) s; -[e]s, -e
kliff, klaff!
Kli|ma gr. (Gesamtheit der meteo-rol. Erscheinungen in einem best Gebiet) s; -s, -s u. ...mate; Kli-ma.än|de|rung, ...an|la|ge (↑R 148), ...kam|mer (Raum, in dem zu Versuchs- u. Heilzwecken ein bestimmtes Klima künstlich er-zeugt wird); kli|mak|te|risch (das Klimakterium betreffend); -e Jahre (Wechseljahre); Kli|mak-te|ri|um (Med.: Wechseljahre) s -s; Kli|ma|schwan|kung; kli|ma-tisch (auf das Klima bezüglich) kli|ma|ti|sie|ren (Temperatur u Luftfeuchtigkeit in geschlosse-nen Räumen auf bestimmte kon-stante Werte bringen); Kli|ma|ti-sie|rung; Kli|ma|to|lo|gie (Lehre vom Klima) w; -; Kli|ma|wech|sel Kli|max (Steigerung; Höhe punkt) w; -, (selten:) -e
Klim|bim (ugs. für: unwesent liches, mit Lärm usw. verbunde nes, lächerliches Drum un Dran) m; -s
Klim|me (eine Kletterpflanze) w -, -n; klim|men (klettern); d klommst (klommest, auch klimmtest); du klömmest (auch klimmtest); geklommen (auch geklimmt); klimm[e]!; Klimm|zu (eine turnerische Übung)
Klim|pe|rei (ugs.); Klim|per|ka sten (ugs. scherzh. für: Klavier klim|per|klein landsch. (seh klein)
klim|pern (klingen lassen, z. B. m Geld -; ugs. für: [schlecht] a dem Klavier spielen); ich ...er (↑R 327)
Klimt (österr. Maler)
kling!; kling, klang!
Klin|ge w; -, -n
Klin|gel w; -, -n; Klin|gel.beu|te ...draht, ...knopf; klin|geln; ic ...[e]le (↑R 327); Klin|gel|ze chen, ...zug
klin|gen; du klangst (klangest); d klängest; geklungen; kling[e klingender Verschluß; klin

klang!; Kling|klang m; -[e]s; kling-
ling!

Kling|sor, (bei Novalis:) Klings-
ohr (Name eines sagenhaften
Zauberers)

Kli|nik gr. ([Spezial]krankenhaus;
Unterricht am Krankenbett) w;
-, (für: Krankenanstalt auch
Mehrz.:) -en; Kli|ni|ker (Lehrer,
Lernender an einer Klinik); Kli-
ni|kum (Hauptteil der ärztlichen
Ausbildung u. die Ausbildungs-
stätte) s; -s, ...ka u. ...ken; kli-
nisch

Klin|ke w; -, -n; klin|ken; Klin|ken-
put|zer (ugs. für: Bettler)

Klin|ker (bes. hart gebrannter Zie-
gel) m; -s, -; Klin|ker..bau (Bau
aus Klinkern; Mehrz. ...bauten),
...boot (mit ziegelartig übereinan-
dergreifenden Planken), ...stein

Kli|no|chlor gr. (ein Mineral) s; -s,
-e; Kli|no|me|ter (Neigungsmes-
ser) s; -s, -; Kli|no|mo|bil gr.; lat.
(mit einer klinischen Ausrüstung
ausgestattetes Automobil) s; -s,
-e; kli|no|rhom|bisch gr. (von Kri-
stallen); Kli|no|stat (Apparatur
für Pflanzenversuche) m; -[e]s u.
-en, -e[n] (↑ R 268)

Klin|ße, Klin|ze, Klun|se landsch.
(Ritze, Spalte) w; -, -n

Klio gr. (Muse der Geschichte)

klipp!; klipp, klapp!; klipp u.
klapp!; klipp u. klar (ugs. für:
ganz deutlich)

Klipp engl. (Anhänger an Füllfe-
derhalter; Klammer, Klemme;
auch für: Klips) m; -s, -s

Klip|pe w; -, -n

klip|pen landsch. (hell tönen); -
und klappen

klip|pen|los; Klip|pen|rand; klip-
pen|reich

Klip|per engl. (Seemannsspr.:
Schnellsegler [Mitte 19. Jh.]) m;
-s, -; vgl. aber: Clipper

Klipp|fisch (luftgetrockneter
Schellfisch od. Kabeljau); klip-
pig

klipp, klapp!

Klipp...kram (veralt. für: Trödel-,
Kleinkram), ...schen|ke (veralt.
für: geringe Schenke)

Klipp|schlie|fer (ein Huftier)

Klipp|schu|le landsch. (Elemen-
tar-, Winkelschule, auch abwer-
tend)

Klips engl. (klammerartige Bro-
sche; Ohrklips) m; -es, -e

klirr!; klir|ren; Klirr|fak|tor

Kli|schee fr. (Druck-, Bildstock;
Abklatsch) s; -s, -s; kli|schee|haft;
Kli|schee.vor|stel|lung, ...wort
(Mehrz. ...wörter); kli|schie|ren
(ein Klischee anfertigen); Kli-
scho|graph fr.; gr. (elektr. Gra-
viermaschine für Druckstöcke)
m; -en, -en (↑ R 268)

Kli|stier gr. (Einlauf) s; -s, -e; kli-
stie|ren (einen Einlauf geben, ma-
chen); Kli|stier|sprit|ze

Kli|to|ris gr. (Med.: Teil der weibl.
Geschlechtsorgane) w; -, - u.
...orides

klitsch!; klitsch, klatsch!; Klitsch
mitteld. (Schlag; breiige Masse)
m; -[e]s, -e; Klit|sche (ugs.: [ärm-
liches] Landgut) w; -, -n; klit-
schen (landsch.); du klitschtest
(klitschest); klit|sche|naß vgl.
klitschnaß; klit|schig landsch.
(feucht und klebrig; unausgebak-
ken); klitsch, klatsch!; klitsch|naß
(ugs. für: völlig durchnäßt)

klit|tern (veralt., aber noch mdal.
für: zusammenschmieren; auf-
spalten); ich ...ere (↑ R 327); Klit-
te|rung

klit|ze|klein (ugs. für: sehr klein)

Kli|vie [...wi̯ə] (eindeutschend für:
Clivia) w; -, -n

KLM = Koninklijke Luchtvaart
Maatschappij [kóni̯ŋklǝkǝ lýǝxt-
fartmatš̆ǝhapéi] (Kgl. Niederlän-
dische Luftfahrtgesellschaft)

Klo (ugs. Kurzform von: Klosett)
s; -s, -s

Klo|ke lat. ([unterirdischer] Ab-
zugskanal; Senkgrube; Zool.:
Tasche, in die Darm-, Harn- u.
Geschlechtswege münden) w; -,
-n; Klo|a|ken|tier

Klo|bas|se, Klo|bas|si slaw. österr.
(Wurstsorte) w; -, ...sen

Klo|ben (Eisenhaken; gespaltenes
Holzstück; auch für: unhöflicher,
ungehobelter, roher Mensch) m;
-s, -; Klö|ben niederd. (eine Art
Hefegebäck) m; -s, -; klo|big

Klo|frau [zu: Klo] (ugs. für: Toilet-
tenfrau)

Klon|dike [...daik] (Fluß [u. frühe-
res Goldbergbaugebiet] in Kana-
da) m; -[s]

klö|nen niederd. (gemütlich plau-
dern; schwatzen)

klo|nisch gr. (Med.: krampfartig);
Klo|nus gr. (Med.: krampfartige
Zuckungen) m; -, ...ni

Kloot niederd. (Kloß, Kugel) m;
-[e]s, -e; Kloot|schie|ßen (fries.
Eisspiel [Eisschießen, Boßeln])
s; -s

Klö|pfel (veralt. für: Klöppel) m;
-s, -; klo|pfen; Klo|pfer; Klopf-
fech|ter (früher für: bezahlter
[Schau]fechter; übertr. für: streit-
süchtiger Publizist); klopf|fest;
Klopf..fe|stig|keit, ...peit|sche,
...zei|chen

Klöp|pe nordd., mitteld. (Prügel)
w; -; - kriegen; Klöp|pel m; -s,
-; Klöp|pe|lei; Klöp|pel|ma|schi-
ne; klöp|peln; ich ...[e]le (↑ R 327);
Klöp|pel|spit|ze; klop|pen nordd.,
mitteld. (klopfen, schlagen); sich
-; Klop|pe|rei nordd., mitteld.

(längeres Klopfen; Schlägerei);
Klöpp|le|rin w; -, -nen; Klops
(Fleischkloß) m; -es, -e

Klop|stock (dt. Dichter); klop-
stockisch [Trenn.: ...stok|kisch],
klop|stocksch, aber (↑ R 179):
Klop|stockisch [Trenn.: ...stok-
kisch], Klop|stocksch; -e Ode

Klo|sett engl. s; -s, -e u. -s; Klo-
sett..bür|ste, ...frau, ...pa|pier

Kloß m; -es, Klöße; Kloß|brü|he;
Kloß|chen, Kloß|lein

Klo|ster s; -s, Klöster; Klo|ster.bi-
blio|thek, ...bru|der, ...frau, ...gar-
ten, ...gut, ...kir|che; klö|ster|lich;
Klo|ster.pfor|te, ...schu|le

Klö|ten niederd. (Hoden) Mehrz.

Kloth österr. (svw. Cloth) m;
-[e]s, -e

Kloth|hil|de (w. Vorn.); vgl. Chlot-
hilde

Klo|tho gr. (eine der drei Parzen)

Kloth|ho|se österr. (Turnhose aus
Kloth)

Klotz m; -es, Klötze (ugs.: Klöt-
zer); Klotz|beu|te (eine Art Bie-
nenkorb); Klötz|chen, Klötz|lein

¹klot|zen (färben [auf der Klotz-
maschine]); du klotzt (klotzest)

²klot|zen; -, nicht kleckern (ugs.:
sich nicht mit Kleinigkeiten ab-
geben, sondern etwas Richtiges,
Gewichtiges, Bedeutendes hin-
stellen); klot|zig (ugs. auch für:
sehr viel)

Klötz|lein, Klötz|chen

Klub engl. ([geschlossene] Vereini-
gung, auch deren Räume) m; -s,
-s; Klub.gar|ni|tur (Gruppe von
[gepolsterten] Sitzmöbeln),
...haus, ...ka|me|rad, ...mit|glied,
...raum, ...ses|sel, ...we|ste (kurze,
bequeme Jacke)

kluck! usw. Nebenform von: gluck
usw.; kluckern [Trenn.: kluk-
kern] (Nebenform von: gluk-
kern); ich ...ere (↑ R 327)

¹Kluft jidd. (ugs. für: [alte] Klei-
dung; Uniform) w; -, -en

²Kluft (Spalte) w; -, Klüfte; klüf|tig
(veralt. für: zerklüftet)

klug; klüger, klügste; der Klügste
(↑ R 116) gibt nach, aber (↑ R
134): es ist das klügste (am klügs-
ten) nachzugeben; Schreibung in
Verbindung mit Zeitwörtern (↑ R
139): klug sein, werden; klug re-
den; vgl. aber: klugreden; Klü-
ge|lei; klü|geln; ich ...[e]le (↑ R
327); klu|ger|wei|se, aber ein in klu-
ger Weise; Klug|heit w; -; Klüg|ler;
klüg|lich (veralt.); klug|re|den;
↑ R 139 (alles besser wissen wol-
len); ich rede klug; kluggeredet,
klugzureden; aber: klug re|den
(verständig sprechen); er hat
wirklich, erstaunlich klug gere-
det; Klug.red|ner, ...schei|ßer
(derb), ...schnacker [Trenn.:

...schnak|ker| (niederd. für: Besserwisser), ...schwät|zer

Klump niederd. (Klumpen) m; -[e]s, -e u. Klümpe; Klum|patsch (ugs. für: [ungeordneter, wertloser] Haufen) m; -es; Klümp|chen, Klümp|lein; klum|pen; der Pudding klumpt; sich - (sich [in Klumpen] ballen); Klum|pen m; -s, -; klüm|pe|rig, klümp|rig (landsch.); -er Pudding

Klum|pert, Glum|pert österr. ugs. (wertloses Zeug) s; -s

Klump|fuß; klump|fü|ßig; klum|pig; Klümp|lein, Klümp|chen; klümp|rig, klüm|pe|rig

Klün|gel (verächtl. für: Gruppe, die Vettern-, Parteiwirtschaft betreibt; Sippschaft, Clique) m; -s, -

Klu|nia|zen|ser [vom ostfr. Kloster Cluny] m; -s, -; klu|nia|zen|sisch

Klun|ker niederd. (Quaste, Troddel; Klümpchen) w; -, -n od. m; -s, -; klun|ke|rig, klunk|rig (in Klunkerform; unordentlich, zerlumpt)

Klun|se vgl. Klinse, Klinze

Klup|pe (Schneide-, Meßwerkzeug; mdal. für: Zange, Klemme; veralt. für: Zwang[slage]; bayr. u. österr. ugs. für: Wäscheklammer) w; -, -n; klup|pen (veralt. für: einzwängen)

Klus lat. schweiz. (schluchtartiges Quertal, Gebirgseinschnitt) w; -, -en; Klü|se niederl. (Seemannsspr.: Öffnung im Schiffsbug für die Ankerkette) w; -, -n; Klu|sil lat. (Sprachw.: Verschlußlaut, z. B. p, t, k, b, d, g) m; -s, -e

Klü|ten nordd. (Klumpen) Mehrz.

Klü|ver niederl. [...wᵉr] Seemannsspr.: dreieckiges Vorsegel) m; -s, -; Klü|ver|baum

Klys|ma gr. (Med.: Klistier) s; -s, ...men

Kly|stron gr. (Kurzwellenradioröhre) s; -s, ...one (auch: -s)

Kly|tä|m|nḙ|stra (Gemahlin Agamemnons)

k. M. = künftigen Monats

km = Kilometer

km², qkm = Quadratkilometer

km³, cbkm = Kubikkilometer

km/h, km/st = Kilometer je Stunde

km-Zahl (↑ R 137 u. R 150)

kn = Knoten (Dreh)

knab|bern; ich ...ere (↑ R 327); vgl. auch: knappern, knuppern

Kna|be m; -n, -n (↑ R 268); Kna|ben|al|ter; kna|ben|haft; Kna|ben|haf|tig|keit w; -; Kna|ben|kraut (eine Orchidee einer bestimmten Gattung); Knäb|lein

knack!; vgl. knacks!; Knack (mäßiger Knall) m; -[e]s, -e; Knäcke-

brot¹ schwed.; knacken¹ (aufbrechen; lösen; [beim Betreten] einen Laut geben); die Treppe knackt; Knacker¹ (ugs. abwertend für: Mann; landsch. für: Knackwurst); alter -; knackig¹; etwas ist - frisch; Knack.laut, ...mandel; knacks!; knicks, knacks!; Knacks (ugs. für: Schaden) m; -es, -e; knack|sen (knacken); du knackst (knacksest); Knack-wurst

Knag|ge w; -, -n u. Knag|gen niederd. (Holzstütze, Trittklotz, Leiste; Spannbacken an den Planscheiben der Drehbänke, Anschlag an einer Welle) m; -s, -

Knäk|en|te (Wildente)

Knall m; -[e]s, -e; - und Fall (ugs. für: unerwartet, sofort); Knall-bon|bon; knal|len; Knall.ef|fekt (ugs. für: große Überraschung), ...erb|se; Knallerei; Knall.frosch, ...gas; knall|hart (ugs. für: sehr hart); knall|lig; Knall|kopp (ugs. Schimpfwort: verrückter Kerl) m; -s, ...köppe; knall|rot

knapp; (↑ R 139:) - sein, werden, schneiden usw.; das Brot wird knapp sein; ein knapp sitzender Anzug; vgl. aber: knapphalten

Knap|pe (Edelknabe; Bergmann) m; -n, -n (↑ R 268)

knap|pern (Nebenform von: knabbern); ich ...ere (↑ R 327)

knapp|hal|ten; ↑ R 139 (jmdm. wenig geben); ich habe ihn knappgehalten; Knapp|heit w; -

Knapp|sack (veralt. für: Reisetasche, Brotsack)

Knapp|schaft (Gesamtheit der Bergarbeiter eines Bergwerks od. Bergreviers); knapp|schaft|lich; Knappschafts.kas|se, ...ren|te, ...ver|ein, ...ver|si|che|rung

knaps!; knips, knaps!; knap|sen (ugs. für: geizen; eingeschränkt leben); du knapst (knapsest)

Knar|re (Kinderspielzeug; Soldatenspr. für: Gewehr) w; -, -n; knar|ren

¹Knast niederd. (Knorren; Brotkanten) m; -[e]s, -e

²Knast jidd. (ugs. für: Freiheitsstrafe, Gefängnis) m; -[e]s

¹Kna|ster niederd. (ugs. für: [schlechter] Tabak) m; -s, -

²Kna|ster, Kna|ster|rer, Knast|rer landsch. (grämlicher Mensch); Kna|ster|bart landsch. (mürrischer Mann); Kna|ste|rer vgl. ²Knaster; knas|tern landsch. (verdrießlich brummen); ich ...ere (↑ R 327); Knast|rer vgl. ²Knaster; ²Knaster

knat|tern; ich ...ere (↑ R 327)

Knäu|el m od. s; -s, -; Knäu|el|gras,

Knaul|gras; knäu|eln (selten); ich ...[e]le (↑ R 327); vgl. knäulen

Knauf m; -[e]s, Knäufe; Knäuf|chen, Knäuf|lein

Knaul mdal. (Knäuel) m od. s; -s, -e u. Knäule; Knäul|chen; knäu|len (ugs. für: zusammendrükken); Knaul|gras, Knäu|el|gras

Knau|pe|lei (landsch.); knau|pe|lig, knaup|lig landsch. (knifflig, viel Geschicklichkeit erfordernd); Knau|pel|kno|chen (landsch.); knau|peln landsch. (benagen; Nägel kauen; um etwas sehr besorgt sein); ich ...[e]le (↑ R 327); knaup|lig vgl. knaupelig

Knau|ser (ugs.); Knau|se|rei (ugs.); knau|se|rig, knaus|rig (ugs.); Knau|se|rig|keit, Knaus|rig|keit; knau|sern (ugs. für: sparsam, geizig sein; sparsam mit etwas umgehen); ich ...ere (↑ R 327)

Knaus-Ogi|no-Me|tho|de [nach den österr. u. japan. Gynäkologen H. Knaus u. K. Ogino] (Geburtenregelung auf natürl. Wege durch Beachtung der fruchtbaren u. unfruchtbaren Tage der Frau) w; -

knaus|rig, knau|se|rig; Knaus|rig|keit, Knau|se|rig|keit

Knau|tie [...ziᵉ; nach dem dt. Botaniker Chr. Knaut] (Gattung der Kardengewächse) w; -, -n

knaut|schen (knittern; landsch. für: schmatzend essen; verhalten weinen); du knautschst (knautschest); knaut|schig; Knautsch.lack, ...zo|ne (Kfz)

Kne|bel m; -s, -; Kne|bel|bart; kne|beln; ich ...[e]le (↑ R 327); Kne|be|lung, Kneb|lung

Knecht m; -[e]s, -e; knech|ten; knech|tisch; -ste (↑ R 294); Knecht Ru|precht m; - -[e]s, - -e; Knechts|ar|beit; Knecht|schaft w; -; Knechts.ge|stalt (dicht.), ...sinn (m; -[e]s); Knech|tung

Kneif (Schuster)messer) m; -[e]s, -e; vgl. Kneip; knei|fen; du kniffst (kniffest); du kniffest; geknif|fen; kneif[e]!; er kneift ihn (auch: ihm) in den Arm; vgl. auch: ¹kneipen; Knei|fer nordd. (Klemmer, Zwicker); Kneif|zan|ge; Kneip (Nebenform von: Kneif) m; -[e]s, -e

Knei|pe (student. Trinkabend; ugs. für: [einfaches] Lokal mit Alkoholausschank) w; -, -n

¹knei|pen mdal. (kneifen, zwikken); ich kneipte (auch: knipp); geknipt (auch: gekneippen)

²knei|pen (ugs. für: sich in Kneipen aufhalten; trinken); ich kneipte; gekneipt; Knei|pen|wirt; Knei|pe|rei (ugs.); Knei|pier [...pie] (Kneipenwirt) m; -s, -s

¹ Trenn.: ...k|k...

Kneipp (dt. kath. Geistlicher u. Heilkundiger, der ein bestimmtes Wasserheilverfahren entwickelte); ⒲; **kneip|pen** (nach Kneipps Verfahren eine Wasserkur machen); **Kneipp|kur** (↑ R 180)

Kneip|zan|ge landsch. (Kneifzange)

Knes|set[h] hebr. („Versammlung"; Parlament in Israel) w; - **knet|bar; kne|ten; Knet_kur, ...maschi|ne, ...mas|se**

knib|beln mitteld. (zusammenstoppeln, [verworrene Fäden] mühsam auflösen od. zusammenknüpfen); ich ...[e]le (↑ R 327)

Knick (nicht völliger Bruch; nordd. auch für: Hecke als Einfriedigung) m; -[e]s, -e u. (in der Bedeutung „Hecke als Einfriedigung" nur:) -s; **Knicke|bein** (Eierlikör [als Füllung in Pralinen u. ä.]); **knicken**[1]; **'Knicker**[1] (Jagdmesser; ugs. für: Geizhals) **²Knicker**[1] niederd. (Spielkugel, Murmel) m; -s, -

'Knicker|bocker[1] engl. [auch in engl. Ausspr.: nikᵉr...] (alkohol. Kaltgetränk) m; -[s], -[s], **²Knicker|bocker**[1] (halblange Pumphose) Mehrz.

Knicke|rei[1] (ugs.); **knicke|rig**[1], **knick|rig** (ugs.); **Knicke|rig|keit**[1] (ugs.); **Knick|rig|keit** (ugs.) w; -; **knickern**[1] (ugs. für: geizig sein); ich ...ere (↑ R 327)

knicks!; knicks, knacks!; **Knicks** m; -es, -e; **knick|sen**; du knickst (knicksest)

Knickung[1]

Knie s; -s, - [kniᵉ, auch: kni]; auf den Knien liegen; auf die Knie!; **Knie|beu|ge**

Knie|bis (Erhebung im nördl. Schwarzwald) m; -

Knie|bre|che mitteld. (Name steiler Höhen- od. Bergwege) w; -; **Knie|fall** m; **knie_fäl|lig, ...frei; Knie_gei|ge** (für: Gambe, Violoncello), **...ge|lenk; Knie|gelenk|ent|zün|dung; knie|hoch**; der Schnee liegt -; **Knie_holz** (niedrige Bergkiefern; s; -es), **...keh|le; knie|lang; knie|lings** (selten für: auf den Knien); **knien** [knin, auch: kniᵉn]; ↑R 166; du knietest; kniend; gekniet; knie!

Kniep|au|gen mdal. (kleine, lebhafte Augen)

Knie|riem (veralt. für: Knieriemen; aber: Meister Knieriem (scherzh. für: Schuster); **Knie|rie|men**; vgl. Knieriem

Knies landsch. (Dreck, Streit) m; - **Knie_schei|be, ...schüt|zer, ...strumpf; knie|tief**

kniet|schen vgl. knitschen

Kniff m; -[e]s, -e; **Knif|fe|lei** (Schwierigkeit); **knif|fe|lig, knifflig; Kniff|fe|lig|keit, Kniff|lig|keit; knif|fen; geknifft

Knig|ge [nach dem Schriftsteller Knigge] (Buch über Umgangsformen) m; -[s], -

Knilch vgl. Knülch

knil|le vgl. knülle; **Knil|ler** vgl. Knüller

knips!; knips, knaps!; **Knips** m; -es, -e; **knip|sen**; du knipst (knipsest)

Knip|ser; knips, knaps!

Knirps (auch: ⒲ zusammenschiebbarer Schirm) m; -es, -e; **knirp|sig**

knir|schen; du knirschst (knirschest)

kni|stern; ich ...ere (↑ R 327)

knit|schen mdal. ([zer]quetschen); du knitschst (knitschest)

Knit|tel m; -s, -; **Knit|tel|vers; Knüttel** usw.

Knit|ter m; -s, -; **knit|ter_arm; Knit|ter|fal|le; knit|ter_fest, ...frei; knit|te|rig, knitt|rig; knit|tern; ich ...ere (↑ R 327)

Kno|bel mdal. ([Finger]knöchel; Würfel) m; -s, -; **Kno|bel|be|cher** (soherzh. auch für: Militärstiefel); **kno|beln** ([auslosen; würfeln; lange nachdenken); ich ...[e]le (↑ R 327)

Knob|lauch [kno... u. kno...] (Gewürz- u. Heilpflanze) m; -[e]s; **Knob|lauch_öl, ...wurst, ...ze|he**

Knö|chel m; -s, -; **Knö|chel|chen, Knöch|lein; knö|chel_lang, ...tief; Kno|chen** m; -s, -; **Kno|chen_bau** (m; -[e]s), **...bruch** m, **...ent|zün|dung, ...er|wei|chung, ...fraß** (m; -es), **...ge|rüst** (ugs. auch für: magerer Mensch); **kno|chen_hart** (sehr hart); **Knochen_hau|er** (veralt. nordd. für: Schlächter), **...haut, ...haut|ent|zün|dung, ...mann** (volkstüml. für: Tod als Gerippe; m; -[e]s), **...mark** s, **...mehl, ...müh|le** (altes, ungefähtes Fahrzeug; Unternehmen, in dem strapaziöse Arbeit geleistet werden muß), **...schwund, ...split|ter; knochen|trocken** [Trenn.: ...trok|ken] (ugs. für: sehr trocken); **knö|che|rig, knöch|rig** (aus Knochen, knochenartig); **knö|chern** (aus Knochen); **kno|chig** (mit starken Knochen); **Kno|chig|keit** w; -; **Knöch|lein, Knö|chel|chen; knöch|rig** vgl. knöcherig

knock|out engl. [nokaut] (beim Boxkampf niedergeschlagen, kampfunfähig; Abk.: k. o. [ka o]); jmdn. k. o. schlagen; **Knock|out** (Niederschlag; völlige Vernichtung; Abk.: K. o. [ka o] m; -[s], -s; **Knock|out|schlag** (Abk.: K.-o.-Schlag; ↑ R 155)

Knö|del südd., österr. (Kloß) m; -s, -

Knöll|chen; Knöll|le w; -, -n u. **Knollen** m; -s, -; **Knöll|len|blät|ter|pilz; Knöll|len|fäu|le** (Krankheit der Kartoffel); **knöll|len|för|mig; Knöll|len|frucht; knöll|lig**

Knopf (österr. ugs. auch für: Knoten) m; -[e]s, Knöpfe; **Knopf|au|ge** (meist Mehrz.); **Knöpf|chen; Knöpf|lein, knöpf|en; Knöpf|li** schweiz. (Art Teigwaren, Spätzle) Mehrz.; **Knopf|loch; Knopf_loch|sei|de**

Knop|per (Knorren, Knoten; Galle, z. B. an jungen Eicheln) w; -, -n

knor|ke (ugs. für: fein, tadellos)

Knor|pel m; -s, -; **knor|pe|lig, knorp|lig**

Knorr ⒲ (Familienn.); **Knorr-Brem|se** ⒲ [nach dem dt. Ingenieur G. Knorr] (↑ R 180)

Knor|ren landsch. (Knoten, harter Auswuchs) m; -s, -; **knor|rig; Knorz** südd., schweiz. mdal. (Knorren) m; -es, -e; **knor|zen** schweiz. mdal. (sich abmühen, knausern); du knorzest; du knorzt (landsch. auch für: kleiner Kerl); **knor|zig**

Knösp|chen, Knösp|lein; Knos|pe w; -, -n; **knos|pen; geknospt; knospig; Knos|pung** (eine Vermehrungsart)

Knos|sos (altkret. Stadt)

Knöt|chen, Knöt|lein

Kno|te („Genosse"; ugs. für: plumper, ungebildeter Mensch) m; -n, -n (↑ R 268)

knö|teln (kleine Knoten machen [weibl. Handarbeit]); ich ...[e]le (↑ R 327); geknotet; **Kno|ten** (auch: Marke an der Logleine, Seemeile je Stunde [Zeichen: kn]) m; -s, -; **Kno|ten_amt** (Postw.), **...för|mig; Kno|ten|punkt, ...stock; Knö|tel|rich** (eine Pflanze) m; -s, -e; **kno|tig** (auch: plump); **Knöt|lein, Knöt|chen; Knöt|en|erz** (Buntsandstein mit eingesprengtem Bleiglanz)

Know-how [no"hau] (Wissen um die praktische Verwirklichung einer Sache) s; -[s]

Knub|be (Knorren; Knospe; Geschwulst) w; -, -n u. **Knub|ben** m; -s, -

Knuff (ugs. für: Puff, Stoß) m; -[e]s, Knüffe; **knuf|fen** (ugs.)

Knülch, Knilch (ugs. für: unangenehmer Mensch) m; -s, -e

knüll, knül|le (Studentenspr. u. ugs. für: betrunken); **knül|len** (zerknittern)

Knül|ler (ugs. für: [journalist.] Schlager, publikumswirksame Neuheit)

Knüpfarbeit | 392

Knüpf|ar|beit; knüp|fen; Knüpf|tep|pich; Knüp|fung; Knüpf|werk
Knüp|pel m; -s, -; Knüp|pel|aus|dem|sack [auch: ...sạk] m; -; Knüp|pel|damm; knüp|pel|dịck (ugs. für: übermäßig dick); knüp|peln; ich ...[e]le (↑ R 327); Knüp|pel|schal|tung
knup|pern landsch. (knabbern); ich ...ere (↑ R 327)
knur|ren; Knụrr|hahn (ein Fisch; mürrischer Mensch); knụr|rig; ein -er Mensch; Knụr|rig|keit w; -; Knụrr|laut
knü|se|lig landsch. (unsauber)
Knus|per|chen (Gebäck); Knụs|per.flocken (Trenn.: ...flok|ken; Mehrz.), ...häus|chen; knụs|pe|rig, knụsp|rig; knụs|pern; ich ...ere (↑ R 327)
Knụst niederd. (Brotkanten) m; -[e]s, -e u. Knüste
Knụt (m. Vorn.)
Knu|te germ.-russ. (Lederpeitsche; Symbol grausamer Unterdrükkung) w; -, -n; knụ|ten (knechten, unterdrücken)
knụt|schen (ugs. für: heftig liebkosen); du knutschst (knutschest); Knụt|sche|rei (ugs.); Knụtsch|fleck (ugs.); knụt|schig (ugs.)
Knüt|tel m; -s, -; Knüt|tel|vers
k. o. = knockout; K. o. = Knockout; K.-o.-Schlag, K.-o.-Niederlage
Ko|ad|ju|tor lat. (Amtsgehilfe eines kath. Geistlichen, bes. eines Bischofs) m; -s, ...ọren
Ko|agu|lat lat. (Chemie: aus kolloidaler Lösung ausgeflockter Stoff) s; -[e]s, -e; Ko|agu|la|ti|on [...ziọn] (Ausflockung); ko|agu|lie|ren
ko|ali|e|ren, ko|ali|sie|ren fr. (verbinden; sich verbünden); Ko|ali|ti|on [...ziọn] (Vereinigung, Bündnis; Zusammenschluß [von Staaten]); kleine, große Koalition; Ko|ali|ti|ons.frei|heit, ...krieg, ...par|tei, ...recht, ...re|gie|rung
ko|axi|al lat. (mit gleicher Achse)
Ko|balt [scherzh. nach Kobold gebildet] (chem. Grundstoff, Metall; Zeichen: Co) s; -s; ko|balt|blau; Ko|balt.bom|be, ...ka|no|ne (Med.: Bestrahlungsgerät), ...le|gie|rung, ...ver|bin|dung
Ko|bel südd., österr. (Verschlag, Koben) m; -s, -; Ko|ben (Verschlag; Käfig; Stall) m; -s, -
Ko|ben|havn [kō᪢nhaun] (dän. Form von: Kopenhagen)
Ko|ber ostmitteld., niederd. (Korb [für Eßwaren], auch: Wirt) m; -s, -
Ko|blenz (Stadt an der Mündung der Mosel); Ko|blen|zer (↑ R 199); ko|blen|zisch

Ko|bold (neckischer Geist) m; -[e]s, -e; ko|bold|haft
Ko|bolz m, nur noch in: - schießen (Purzelbaum schlagen); ko|bol|zen; kobolzt
Ko|bra port. (Brillenschlange) w; -, -s
[1]Koch m; -[e]s, Köche; [2]Koch bayr., österr. (Brei) s; -s; Koch|buch; koch|echt
Kö|chel|ver|zeich|nis [nach dem Musikgelehrten Ludwig von Köchel] (Abk.: KV); ↑ R 180
Ko|chem vgl. Cochem
ko|chen; kochendheißes Wasser (↑ jedoch R 143), aber: das Wasser ist kọchend hẹiß; [1]Kọ|cher (Wasserkochgerät)
[2]Kọ|cher (r. Nebenfluß des Nekkars) m; -s
Kö|cher Behälter für Pfeile) m; -s, -
Ko|che|rei w; -; koch.fer|tig, ...fest; Kọch.ge|le|gen|heit, ...ge|schirr; Kö|chin w; -, -nen; Koch.kä|se, ...kunst, ...löf|fel, ...ni|sche, ...plat|te, ...pro|be, ...salz, ...topf, ...was|ser, ...zeit
Kọcke [Trenn.: Kok|ke] (ältere, hochd. Form von: Kogge) m; -s, -n
Ko|da, (auch:) Cọ|da it. (Musik: Schlußteil eines Satzes) w; -, -s
Ko|dak᪢ (fotograf. Erzeugnisse)
Ko|dály, Zoltán [kọ́daj] (ung. Komponist)
kọd|de|rig, kọdd|rig niederd. (schlecht; unverschämt, frech; übel); Kọd|der|schnau|ze (derb)
Kode, (in der Technik meist:) Code engl. [kọd] (System verabredeter Zeichen; Schlüssel zu Geheimschriften; Telegrafenschlüssel) m; -s, -s
Ko|de|in gr. (ein Beruhigungsmittel) s; -s
Kö|der (Lockmittel) m; -s, -; kö|dern; ich ...ere (↑ R 327)
Ko|dex lat. (Handschriftensammlung; Gesetzbuch) m; -es u. -, -e u. ...dizes; ko|die|ren, (in der Technik meist:) co|die|ren (in einem Kode verschlüsseln); Ko|die|rung; Ko|di|fi|ka|ti|on [...ziọn] (zusammenfassende Regelung eines größeren Rechtsgebietes; Gesetzessammlung); ko|di|fi|zie|ren; Ko|di|fi|zie|rung (Kodifikation); Ko|di|zill (letztwillige Verfügung; Zusatz zum Testament) s; -s, -e
Ko|edu|ka|ti|on engl. [...ziọn] (Gemeinschaftserziehung beider Geschlechter in Schulen u. Internaten)
Ko|ef|fi|zi|ent lat. (Math.: Vorzahl der veränderl. Größen einer Funktion; Physik: Zahl, die das Ausdehnungsvermögen eines Stoffes ausdrückt); ↑ R 268

Koe|nig [kö...] (Erfinder der Schnellpresse)
Koe|pe|schei|be [kö...; nach dem Erfinder Koepe]); ↑ R 180 (Bergbau: Treibscheibe bei der Schachtförderung)
Ko|er|zi|tiv|kraft lat., dt. (Physik)
Ko|exi|stenz [auch: kọ...] lat. (gleichzeitiges Vorhandensein mehrerer Dinge od. mehrerer Eigenschaften am selben Ding; friedl. Nebeneinanderbestehen von Staaten mit verschiedenen Gesellschafts- u. Wirtschaftssystemen) w; -, -en; ko|exi|stie|ren
Ko|fel bayr. u. westösterr. (vollständig mit Wald bedeckte Bergkuppe) m; -s, -
Ko|fen vgl. Koben
Kof|fe|in arab. (Wirkstoff von Kaffee u. Tee) s; -s
Kof|fer m; -s, -; Köf|fer|chen, Köf|fer|lein; Kof|fer.deckel [Trenn.: ...dek|kel], ...emp|fän|ger (tragbarer Rundfunkempfänger), ...ge|rät, ...kleid, ...ra|dio, ...raum, ...schlüs|sel, ...schreib|ma|schi|ne
Kog (hochd. Schreibung für: Koog) m; -[e]s, Köge
[1]Kọ|gel südd., österr. (Bergkuppe) m; -s, -
[2]Kọ|gel (veralt. für: Kapuze) w; -, -n
Kọg|ge (dickbauchiges Hanseschiff) w; -, -n; vgl. Kocke
Ko|gnak [kọnjak] (volkstüml. für: Schnaps, Weinbrand) m; -s, -s; drei - (↑ R 322); vgl. aber: [2]Cognac; Ko|gnak.boh|ne, ...glas
Ko|gnat lat. (Blutsverwandter, der nicht Agnat ist) m; -en, -en (↑ R 268)
Ko|gno|men lat. (Beiname) s; -s, - u. ...mina
Ko|ha|bi|ta|ti|on lat. [...ziọn] (Med.: Beischlaf); ko|ha|bi|tie|ren
ko|hä|rent lat. (zusammenhängend); Ko|hä|renz w; -; ko|hä|rie|ren (zusammenhängen; Kohäsion zeigen); Ko|hä|si|on (der innere Zusammenhalt der Moleküle eines Körpers) w; -; ko|hä|siv (zusammenhaltend)
Ko|hi|noor [...nụr], (auch:) Ko|hi|nụr pers.-engl. (ein großer Diamant) m; -s; Koh-i-noor᪢ [...nụr] (ein Bleistift) m; -s, -s; Ko|hi|nur vgl. Kohinoor
[1]Kohl (ein Gemüse) m; -[e]s, -e
[2]Kohl jidd. (ugs. für: Unsinn; Geschwätz) m; -[e]s; - reden
Kohl|art
Kohl|dampf (Soldatenspr. u. ugs. für: Hunger) m; -[e]s; - schieben
Koh|le w; -, -n; Koh|le|fa|den usw. vgl. Kohlenfaden usw.; Koh|le|for|schung, Koh|len|for|schung;

koh|le|füh|rend, koh|len|füh-
rend; koh|le|hal|tig; Koh|le|herd,
Koh|len|herd; Koh|le|hy|drat vgl.
Kohlenhydrat; Koh|le|im|port,
Koh|len|im|port; ¹koh|len (nicht
mit voller Flamme brennen,
schwelen; Seemannsspr.: Kohlen
übernehmen)
²koh|len jidd. (ugs. für: schwatzen,
törichtes Zeug reden; schwin-
deln)
Koh|len.becken [Trenn.: ...bek-
ken], ...berg|werk, ...bun|ker,
...di|oxyd (vgl. Oxid), ...di|oxyd-
ver|gif|tung, ...ei|mer; Koh|le[n]-
fa|den; Koh|le[n]|fa|den|lam|pe;
Koh|len.feu|er, ...flöz; Koh|le[n]-
för|schung w, -, koh|le[n]|füh-
rend, aber (↑ R 142): minderwer-
tige Kohle führend; Koh|len.gas,
...grus, ...hal|de, ...hand|lung,
...hei|zung; Koh|le[n].herd, ...hy-
drat (zucker- od. stärkeartige
chem. Verbindung), ...im|port;
Koh|len.mei|ler, ...säu|re (w; -);
koh|len|sau|re Wäs|ser s; -n -s, -n
Wässer; Koh|len.schau|fel,
...staub, ...stift (Technik; m),
...stoff (chem. Grundstoff; Zei-
chen: C; m; -[e]s), ...trim|mer;
Koh|len|was|ser|stoff; Koh|le|pa-
pier; Koh|ler; Koh|le|rei, Koh|ler-
glau|be; Koh|le|stift (ein Zeichen-
stift) m; Koh|le.ver|flüs|si|gungs-
ver|fah|ren, ...zeich|nung
Kohl.her|nie [...ni̯e] (eine Pflan-
zenkrankheit; w; -), ...kopf
Kohl|mei|se (ein Vogel)
Kohl|ra|be (für: Kolkrabe); kohl-
ra|ben|schwarz
Kohl|ra|bi it. (eine Pflanze) m; -[s],
-[s]; Kohl.rou|la|de, ...rü|be
.ohl|schwarz
Kohl.spros|se (österr. für: Rös-
chen des Rosenkohls), ...sten|gel,
...strunk, ...sup|pe, ...weiß|ling
(ein Schmetterling)
Ko|hor|te lat. (der 10. Teil der röm.
Legion) w; -, -n
Koi|ne gr. [keune̯] (gr. Gemeinspr.
der hellenist. Welt) w; -
o|in|zi|dent lat. (zusammenfal-
lend); Ko|in|zi|denz (Zusammen-
treffen zweier Ereignisse) w; -; ko-
in|zi|die|ren
o|itie|ren lat. (Med.: den Koitus
vollziehen); Ko|itus (Med.: Ge-
schlechtsakt) m; -, -
o|je niederl. (Schlafstelle [auf
Schiffen]; Ausstellungsstand) w;
-, -n
.o|jo|te mexik. (nordamerik. Prä-
riewolf; Schimpfwort) m; -n, -n
(↑ R 268)
o|ka indian. (ein Strauch) w; -;
; Ko|ka|in [nach dem Koka-
strauch] (ein Betäubungsmittel;
Rauschgift) s; -s; Ko|kai|nis|mus
Kokainsucht) m; -

Ko|kar|de fr. (Abzeichen, Ho-
heitszeichen an Uniformmützen)
w; -, -n
Ko|ka|strauch (Koka)
ko|ken engl. (Koks herstellen)
¹Ko|ker (Seemannsspr.: Öffnung
im Schiffsheck für den Ruder-
schaft) m; -s, -
²Ko|ker (Koksarbeiter); Ko|ke|rei
(Koksgewinnung, -werk)
Ko|kett|te w; -, -n (↑ R 291); Ko-
kett|te|rie w; -,...ien; ko|ket|tie|ren
Ko|kil|le fr. (eine Hartgußform)
w; -, -n; Ko|kil|len|guß
Kok|ke w; -, -n u. Kok|kus gr. (Ku-
gelbakterie) m; -, Kokken
Kok|kels|kör|ner gr.; dt. (Giftsa-
men zum Fischfang) Mehrz.
Kök|ken|möd|din|ger dän. (in der
Steinzeit aufgehäufte [Kü-
chen]abfälle) Mehrz.
Kok|ko|lith gr. (Geol.: aus Kalkal-
gen entstandener winziger Kör-
per in Tiefseegesteinen) m; -s u.
-en, -e[n] (↑ R 268); Kok|kus vgl.
Kokke
Ko|ko|lo|res (ugs. für: Umstände;
Unsinn) m; -
Ko|kon fr. [...koṇg, österr.: ...koṇ]
(Hülle der Insektenpuppen) m;
-s, -s; Ko|kon|fa|ser
Ko|kosch|ka [auch: ko...] (österr.
Maler u. Dichter)
Ko|kos|sette span. [...sät] österr.
(Kokosflocken) s; -; Ko|kos.bus-
serl (österr.: ein Gebäck), ...fa-
ser, ...fett, ...flocken ([Trenn.:
...flok|ken; Mehrz.), ...läu|fer,
...mat|te, ...milch, ...nuß, ...öl (s;
-[e]s), ...pal|me, ...tep|pich
Ko|kot|te fr. (Dirne; Halbweltda-
me) w; -, -n; Ko|kot|ten|we|sen s;
-
¹Koks engl. (ein Brennstoff) m; -es,
-e
²Koks (ugs. für: Kokain) m; -es
³Koks jidd. (ugs. für: steifer Hut)
m; -[es], -e
kok|sen (ugs. für: Kokain nehmen;
schlafen, schnarchen; du kokst
(koksest); Kok|ser (ugs. für: Ko-
kainsüchtiger)
Koks.ofen, ...staub
Ko|ky|tos (Fluß der Unterwelt in
der gr. Sage) m; -
Kok|zi|die gr. [...i̯e] (parasit. Spo-
rentierchen) w; -, -n (meist
Mehrz.); Kok|zi|dio|se (durch
Kokzidien verursachte Tier-
krankheit) w; -
¹Ko|la afrik. (Kolanuß; Samen
des Kolastrauches; als ⓦ: Arz-
neimittel) w; -
²Ko|la (Mehrz. von: Kolon)
Ko|la.nuß, ...strauch
Ko|lat|sche, Go|lat|sche tschech.
österr. (kleiner, gefüllter Hefeku-
chen) w; -, -n

Kol|ben m; -s, -; Kol|ben.dampf-
ma|schi|ne, ...hieb, ...ring, ...stan-
ge
Kol|berg (Hafenstadt in Pom-
mern)
kol|big
Kol|chis [...chiß] (antike Land-
schaft am Schwarzen Meer) w; -
Kol|chos russ. (landwirtschaftl.
Produktionsgenossenschaft in
der Sowjetunion) m (auch: s); -,
...ose u. (österr. nur:) Kol|cho|se
w; -, -n; Kol|chos|bau|er [österr.
...chos...]
kol|den mdal. (zanken; [laut]
schmollen); ich ...ere (↑ R 327)
Ko|leo|pter vgl. Coleopter; Ko|leo-
pte|ren gr. (Zool.: Käfer) Mehrz.
Ko|li|bak|te|ri|en gr. [...i̯e n]
([Dick]darmbakterien) Mehrz.
Ko|li|bri karib. (ein Vogel) m; -s,
-s
ko|lie|ren lat. (selten für: [durch]-
seihen); Ko|lier|tuch (Mehrz.
...tücher)
Ko|lik [auch: kolik] gr. (anfallarti-
ge heftige Leibschmerzen) w; -, -en
Ko|li|tis gr. (Dickdarmentzün-
dung) w; -, ...itiden
Kolk niederd. (Wasserloch) m;
-[e]s, -e
Kol|ko|thar arab. (rotes Eisen-
oxyd) m; -s, -e
Kolk|ra|be
Kol|la gr. (Chemie, Med.: Leim)
w; -
kol|la|bie|ren lat. (Med.: einen
Kollaps erleiden)
Kol|la|bo|ra|teur fr. [...tör] (mit
dem Feind Zusammenarbeiten-
der) m; -s, -e; Kol|la|bo|ra|ti|on
[...zion]; Kol|la|bo|ra|tor lat. (ver-
alt. für: Hilfslehrer, -geistlicher)
m; -s, ...oren; Kol|la|bo|ra|tur
(veralt. für: Stelle, Amt eines
Kollaborators) w; -, -en; kol|la-
bo|rie|ren (mitarbeiten; mit
dem Feind zusammenarbeiten)
Kol|la|gen gr. (leimartiges Eiweiß
des Bindegewebes) s; -s, -e
Kol|laps lat. [auch: kọ...] (plötz-
licher Schwächeanfall) m; -es, -e
Koll|ar|gol, ...gol (als ⓦ:) Coll|ar|gol
(ein Heilmittel) s; -
kol|la|te|ral lat. (Bot.: nebenstän-
dig; seitlich)
Kol|la|ti|on lat. [...zion] ([Text]ver-
gleichung; Übertragung, Verlei-
hung [niederer Pfründen usw.];
früher: Hinzufügung der Voraus-
leistungen eines Erblassers zu
dem Gesamtnachlaß; veralt.
aber noch mdal. für: Erfrischung,
Imbiß); kol|la|tio|nie|ren ([Ab-
schrift mit der Urschrift] verglei-
chen); Kol|la|tur (Recht zur Ver-
leihung eines Kirchenamtes) w;
-, -en
Kol|lau|da|ti|on lat. [...zion]

(schweiz. neben: Kollaudierung); kol|lau|die|ren; Kol|lau|die|rung österr. u. schweiz. (amtl. Prüfung eines Bauwerkes, Schlußgenehmigung)

Kol|leg lat. (akadem. Vorlesung; auch für: Kollegium) s; -s, -s u. -ien [...i*e*n]; **Kol|le|ge** m; -n, -n (↑ R 268); **Kol|le|gen|kreis; Kol|le|gen|schaft** w; -; **Kol|leg|heft** (Vorlesungsheft); **kol|le|gi|al; Kol|le|gia|li|tät** w; -; **Kol|le|gi|at** (Stiftsgenosse; Teilnehmer an einem [Funk]kolleg) m; -en, -en (↑ R 268); **Kol|le|gin** w; -, -nen; **Kol|le|gi|um** (Amtsgenossenschaft; Behörde; Lehrkörper; veralt. für: Kolleg) s; -s, ...ien [...i*e*n]; **Kol|leg|map|pe**

Kol|lek|ta|ne|en lat. [auch: ...tan*e*⁴n] (veralt. für: Lesefrüchte; wissenschaftl. Sammelhefte) Mehrz.; **Kol|lek|te** (Einsammeln freiwilliger Gaben, Sammlung bei u. nach dem Gottesdienst; liturg. Gebet) w; -, -n; **Kol|lek|teur** fr. [...tör] (veralt. für: Lotterieeinnehmer) m; -s, -e; **Kol|lek|ti|on** [...zion] ([Muster]sammlung [von Waren], Auswahl); **kol|lek|tiv** (gemeinsam, gemeinschaftlich, gruppenweise, umfassend); **Kol|lek|tiv** (Arbeits- u. Produktionsgemeinschaft, bes. in der sowjet. Wirtschaft; B. Kolchose, Kombinat) s; -s, -e [...w*e*] (auch: -s); **Kol|lek|tiv_ar|beit, ...be|wußt|sein, ...de|likt** (Sammeldelikt), **...ei|gen|tum**); **kol|lek|ti|vie|ren** (DDR: Kollektive bilden); **Kol|lek|ti|vie|rung; Kol|lek|ti|vis|mus** [...wiß...] (stärkste Betonung des gesellschaftl. Ganzen im Gegensatz zum Individualismus) m; -; **Kol|lek|ti|vist** [...wißt] (Anhänger des Kollektivismus); ↑ R 268; **kol|lek|ti|vi|stisch; kol|lek|ti|vi|tät** w; -; **Kol|lek|tiv_no|te** (Politik), **...schritt, ...schuld, ...suf|fix** (Sprachw.); **Kol|lek|ti|vum** [...wum] (Sprachw.: Sammelname, zusammenfassende Bez. in der Einzahl für mehrere gleichgeartete Dinge od. Wesen, z. B. „Wald“) s; -s, ...va und ...ven; **Kol|lek|tiv_ver|trag, ...wirt|schaft; Kol|lek|tor** (Stromabnehmer, -wender) m; -s, ...oren; **Kol|lek|tur** österr. ([Lotto]geschäftsstelle) w; -, -en

Kol|len|chym gr. [...chüm] (Bot.: pflanzl. Festigungsgewebe) s; -s, -e

¹**Kol|ler** (Schulterpasse; veralt., aber noch mdal. für: [breiter] Kragen; Wams) s; -s, -

²**Kol|ler** (Pferdekrankheit) m; -s, -

Kol|ler|gang (Mahlwerk) m

kol|le|rig, kol|lrig (ugs. für: leicht aufbrausend, erregbar); ¹**kol|lern** (veralt. für: den Koller haben; knurrig sein); ich ...ere (↑ 327)

²**kol|lern** mitteld. (purzeln, rollen); ich ...ere (↑ R 327); vgl. auch: kullern

Kol|lett fr. (früher für: Reitjacke, ¹Koller) s; -s, -e

¹**Kol|li** (Mehrz. von: Kollo); ²**Kol|li** österr. (Kollo) s; -s, - (auch: -s)

kol|li|die|ren lat. (zusammenstoßen; sich überschneiden)

Kol|lier fr. [...ig] (Halsschmuck) s; -s, -s

Kol|li|ma|ti|on nlat. [...zion] (Zusammenfallen zweier Linien, z. B. bei Einstellung des Fernrohrs); **Kol|li|ma|ti|ons|feh|ler; Kol|li|ma|tor** (astron. Hilfsfernrohr; auch: Spaltrohr beim Spektralapparat) m; -s, ...oren

Kol|li|si|on lat. (Zusammenstoß; Widerstreit der Pflichten)

Kol|lo it. (Frachtstück, Warenballen) s; -s, -s u. Kolli; vgl. Kolli

Kol|lo|di|um gr. („Klebäther“) s; -s; **kol|lo|id, kol|loi|dal; Kol|lo|id** (in feinster Verteilung befindl. Stoff) s; -[e]s, -e; **Kol|lo|id_che|mie, ...re|ak|ti|on**

Kol|lo|qui|um lat. [auch: ...lo...] ([wissenschaftl.] Unterhaltung; österr. auch: kleine Einzelprüfung an der Universität) s; -s, ...ien [...i*e*n]

kol|lrig vgl. kollerig

kol|lu|die|ren lat. (Zeitwort zu: Kollusion); **Kol|lu|si|on** (Rechtsspr.: geheimes, betrügerisches Einverständnis; rechtswidrige Täuschung durch Verabredung)

Koll|witz (dt. Malerin u. Graphikerin)

Kolm (Nebenform von: ¹Kulm) m; -[e]s, -e

Kol|man, Ko|lo|man (dt. Formen von: Kálmán)

kol|ma|tie|ren fr. ([Sumpfboden u. ä.] aufhöhen); **Kol|ma|ti|on** [...zion]

Köln (Stadt am Rhein); **Köl|ner** (↑ R 199); **Kölner Messe** (↑ R 204); **Köl|ner Braun** s; - s; **köl|nisch**; -es Wesen, aber (↑ R 224): Kölnisches Wasser; **Köl|nisch|braun** w; -; **Köl|nisch Eis** ⓦ; **Köl|nisch|was|ser** [auch: ...*waß*⁴r] s; -s, **Köl|nisch Was|ser** s; -

Ko|lo|man [auch: ko...] vgl. Kolman

Ko|lom|bi|ne, Ko|lum|bi|ne it. („Täubchen“; w. Hauptrolle des it. Stegreiftheaters) w; -, -n

Ko|lom|bo|wur|zel Bantuspr.; dt. (ein Heilmittel)

Ko|lon gr. (veralt. für: Doppelpunkt; Med.: Grimmdarm) s; -s, -s u. Kola

Ko|lo|nat lat. (Grundhörigkeit der röm. Kaiserzeit; später auch für: Erbzinsgut) s (auch: m); -[e]s, -e; **Ko|lo|ne** (persönl. freier, aber an seinen Landbesitz gebundener Pächter in der röm. Kaiserzeit; später auch: Erbzinsbauer) m; -n, -n (↑ R 268)

Ko|lo|nel fr. (ein Schriftgrad) w; -

Ko|lo|nia|kü|bel vgl. Coloniakübel

ko|lo|ni|al lat. (die Kolonie[n] betreffend; zu Kolonien gehörend; aus Kolonien stammend); **Ko|lo|ni|al_fra|ge, ...ge|biet, ...herr|schaft; Ko|lo|nia|lis|mus** (auf Erwerb u. Ausbau von Kolonien ausgerichtete Politik eines Staates) m; -; **Ko|lo|nia|list** (Anhänger des Kolonialismus); ↑ R 268; **Ko|lo|ni|al_krieg, ...po|li|tik, ...stil, ...wa|ren** (veralt.; Mehrz.); **Ko|lo|nie** ([durch Gewalt angeeignetes] auswärtige, bes. überseeische Besitzung eines Staates) w; -, ...ien; **Ko|lo|ni|sa|ti|on** [...zion]; **Ko|lo|ni|sa|tor** m; -s, ...oren; **ko|lo|ni|sa|to|risch; ko|lo|ni|sie|ren; Ko|lo|ni|sie|rung; Ko|lo|nist** (↑ R 268); **Ko|lo|ni|sten|dorf**

Ko|lon|na|de fr. (Säulengang, -halle); Ko|lon|ne w; -, -n; die fünfte -; **Ko|lon|nen_ap|pa|rat** (Destillierapparat), **...fah|ren** (s; -s)

¹**Ko|lo|phon** gr. (Schlußformel mittelalterl. Handschriften u Frühdrucke mit Angabe über Verfasser, Druckort u. Druckjahr; veralt. für: Gipfel; Abschluß) m; -s, -e; ²**Ko|lo|phon** (altgr. Stadt in Lydien); **Ko|lo|pho|ni|um** [nach der antiken gr Stadt Kolophon] (ein Harzprodukt) s; -s

Ko|lo|quin|te gr. (ein Kürbisgewächs; Abführmittel) w; -, -n

Ko|lo|ra|do|kä|fer [nach dem Staat Colorado in den USA] (Kartoffelkäfer); ↑ R 201

Ko|lo|ra|tur it. (Musik: Gesangsverzierung; Läufer, Triller) w; -en; **Ko|lo|ra|tur_sän|ge|rin, ...so|pran; ko|lo|rie|ren** (färben; ausbemalen); **Ko|lo|rie|rung; Ko|lo|ri|me|ter** lat.; gr. (Gerät zur Bestimmung von Farbtönen) s; -; **Ko|lo|ri|me|trie** w; -; **ko|lo|ri|me|trisch; Ko|lo|rist** lat. (jmd der koloriert; Maler, der de Schwerpunkt auf das Kolor legt); ↑ R 268; **ko|lo|ri|stisch; Ko|lo|rit** lat. [auch: ...it] (Farb[en]gebung, Farbwirkung) s; -[e]s, -

Ko|loß gr. (Riesenstandbild; Rie se, Ungetüm) m; -...losses, ...losse

Ko|los|sä (im Altertum Stadt Phrygien); **Ko|los|sai** vgl. Kolo sä

ko|los|sal fr. (riesig, gewaltig, Rie

sen...; übergroß); Ko|los|sal fi-
gur, ...film, ...ge|mäl|de; ko|los-
sa|lisch (veralt. für: kolossal); Ko-
los|sal|sta|tue

Ko|los|ser (Einwohner von Kol-
lossä); Ko|los|ser|brief m; -[e]s;
↑ R 205

Ko|los|se|um (Amphitheater in
Rom) s; -s

Ko|lo|stral|milch lat.; dt. u. Ko|lo-
strum lat. (Med.: Sekret der
Brustdrüsen) s; -s

Ko|lo|to|mie gr. (Med.: operative
Öffnung des Dickdarms zum
Anlegen eines künstl. Afters)
w; -

Kol|pak vgl. Kalpak

Kol|ping (kath. Priester); Kol-
ping.fa|mi|lie[1] (↑ R 180), ...haus,
...ju|gend, ...werk (s; -[e]s)

Kol|pi|tis gr. (Med.: Scheidenent-
zündung) w; -, ...it|den

Kol|por|ta|ge fr. [...taseh^e, österr.:
...taseh](veralt.: Hausier-, Wan-
derhandel mit Büchern; auch:
Verbreitung von Gerüchten);
kol|por|ta|ge|haft; Kol|por|ta-
ge.li|te|ra|tur, ...ro|man; Kol|por-
teur [...tör] (Verbreiter von Ge-
rüchten) m; -s, -e; kol|por|tie|ren

Köl|sch schweiz. („aus Köln";
gewürfelter Baumwollstoff) m;
-[e]s; köl|schen; das -e Gewebe

[1]Kol|ter fr. südwestd. ([gesteppte
Bett]decke) m; -s, -

[2]Kol|ter fr. bes. nordwestd. (Mes-
ser vor der Pflugschar) s; -s, -

Ko|lum|ba|ri|um lat. (altröm.
Grabkammer; heute für: Urnen-
halle) s; -s, ...ien [...i^en]

Ko|lum|big|ner, (auch:) Ko|lum-
bi|er; ko|lum|big|nisch, (auch:)
ko|lum|bisch; Ko|lum|bia-
schwarz; Ko|lum|bi|en [...i^en]
(Staat in Südamerika); Ko|lum-
bi|er vgl. Kolumbianer

Ko|lum|bi|ne vgl. Kolombine

ko|lum|bisch vgl. kolumbianisch

Ko|lum|bus (Entdecker Amerikas)

Ko|lum|ne lat. („Säule"; senk-
rechte Reihe; Spalte; [Druck]-
seite) w; -, -n; Ko|lum|nen.maß
s, ...ti|tel; ko|lum|nen|wei|se
([druck]seitenweise); Ko|lum|nist
(Journalist, dem ständig eine be-
stimmte Spalte einer Zeitung zur
Verfügung steht); ↑ R 268

Köm niederd. (Kümmelschnaps)
m; -s, -e[s]; drei Köm (↑ R 322)

Ko|ma gr. (Med.: tiefe Bewußt-
losigkeit) s; -s, -s u. -ta; ko|ma|tös
(in tiefer Bewußtlosigkeit befind-
lich); -er Zustand

o|mant|sche (Angehöriger eines
nordamerik. Indianerstammes)
m; -n, -n (↑ R 268)

Kom|bat|tant fr. (veralt., aber
noch Rechtsspr. für: [Mit]-
kämpfer; Kriegsteilnehmer) m;
-en, -en (↑ R 268)

Kom|bi [Kurzw. aus: kombiniert]
(kombinierter Liefer- u. Perso-
nenwagen) m; -[s], -s; Kom|bi...
(kombiniert) Zusatz russ.
(Zusammenschluß produktions-
mäßig eng zusammengehören-
der Betriebe in kommunist. Staa-
ten) s; -[e]s, -e; [1]Kom|bi|na|ti|on
lat. [...zion] (berechnende Ver-
bindung; Vermutung; Vereini-
gung; Zusammenstellung von
Kleidungsstücken, sportl. Diszi-
plinen, Farben u. a.; Sport. plan-
mäßiges, flüssiges Zusammen-
spiel); [2]Kom|bi|na|ti|on engl.
[...zion, selten in engl. Ausspr.:
...ne^sch^en] (Hemdhose; einteili-
ger [Schutz]anzug, bes. der Flie-
ger) w; -, -en u. (bei engl. Ausspr.:)
-s; Kom|bi|na|ti|ons.ga|be, ...ver-
mögen; kom|bi|na|to|risch lat.;
-er Lautwandel (Sprachw.);
Komb|ine engl. [kombain] (land-
wirtschaftl. Maschine, die ver-
schiedene Arbeitsgänge gleich-
zeitig ausführt, Mähdrescher) w;
-, -s; kom|bi|nie|ren lat. (vereini-
gen, zusammenstellen; berech-
nen; vermuten; Sport u. Spiele:
planmäßig zusammenspielen);
Kom|bi|nie|rung; Kom|bi-
.schrank, ...wagen, ...zan|ge

Kom|bü|se (Schiffsküche) w; -, -n

Ko|me|do [auch: kom...] lat. (veralt.
für: Fresser, Schlemmer; Med.:
Mitesser [meist Mehrz.]) m; -s,
...onen

Ko|met gr. (Schweif-, Haarstern)
m; -en, -en (↑ R 268); Ko|me|ten-
bahn, ko|me|ten|haft; Ko|me|ten-
schweif

Kö|me|te|ri|on vgl. Zömeterium

Kom|fort engl. [komfor, auch:
komfort] m; -s; kom|for|ta|bel;
...a|ble Wohnung

Ko|mik gr. (Kunst, das Komische
darzustellen) w; -; Ko|mi|ker

Kom|in|form (= Kommunisti-
sches Informationsbüro, 1947–
56) s; -s

Kom|in|tern (= Kommunistische
Internationale, 1919–43; 1947
durch Kominform ersetzt) w; -

ko|misch gr. (possenhaft; belusti-
gend, zum Lachen reizend; son-
derbar, wunderlich, seltsam); -ste
(↑ R 294); ko|mi|scher|wei|se

Ko|mi|tat lat. (früher: feierliches
Geleit, Ehrengeleit; Grafschaft;
chem. Verwaltungsbezirk in Un-
garn) s (auch: m); -[e]s, -e

Ko|mi|tee fr. (leitender Ausschuß)
s; -s, -s

Ko|mi|ti|en [komizi^en] (altröm.
Bürgerversammlungen) Mehrz.

Kom|ma gr. (Beistrich; Musik:
Kleinintervall) s; -s, -s u. -ta;
Kom|ma|ba|zil|lus

Kom|man|dant fr. (Befehlshaber
einer Festung, eines Schiffes
usw.; schweiz. auch svw.
Kommandeur) m; -en, -en (↑ R
268); Kom|man|dan|tur lat.
(Dienstgebäude eines Kom-
mandanten; Befehlshaberamt)
w; -, -en; kom|man|deur fr. [...dör]
(Befehlshaber einer Truppenab-
teilung) m; -s, -e; kom|man|die-
ren; (↑ R 224:) der Kommandie-
rende General (eines Armee-
korps); Kom|man|die|rung

Kom|man|dit|är (fr. schweiz.
(Kommanditist) m; -s, -e; Kom-
man|di|te (Zweiggeschäft, Ne-
benstelle; veralt. für: Komman-
ditgesellschaft) w; -, -n; Kom-
man|dit|ge|sell|schaft (bestimmte
Form der Handelsgesellschaft;
Abk.: KG); - auf Aktien (Abk.:
KGaA); Kom|man|di|tist (Ge-
sellschafter einer Kommandit-
gesellschaft, dessen Haftung auf
seine Einlage beschränkt ist); ↑ R
268

Kom|man|do it. s; -s, -s (österr.
auch: ...den); Kom|man-
do.brücke [Trenn.: ...brük|ke],
...ge|walt, ...kap|sel, ...sa|che,
...stand, ...stim|me, ...zen|tra|le

Kom|mas|sa|ti|on lat.; gr. [...zion]
(Zusammenlegung [von Grund-
stücken]); kom|mas|sie|ren

Kom|me|mo|ra|ti|on lat. [...zion]
(veralt. für: Gedächtnis, Anden-
ken)

kom|men; du kommst (veralt.:
kömmst); er kommt (veralt.:
kömmt); du kamst; du kämest;
gekommen; komm[e]!; - lassen
(↑ R 305); Kom|men s; -s; wir war-
ten auf sein -; das - und Gehen;
im sein

Kom|men|de lat. (früher: kirchl.
Pfründe ohne Amtsverpflich-
tung; Komturei) w; -, -n

Kom|men|sa|lis|mus lat. (Biol.: Er-
nährungsgemeinschaft von Tie-
ren od. Pflanzen) m; -

kom|men|su|ra|bel lat. (mit glei-
chem Maß meßbar; vergleich-
bar); ...a|ble Größen); Kom|men-
su|ra|bi|li|tät w; -

Kom|ment fr. [...mang] (das
„Wie"; [Studentenspr.:] Brauch,
Sitte, Regel) m; -s, -s

Kom|men|tar lat. (Erläuterung[s-
schrift], Auslegung; ugs. für: Be-
merkung) m; -s, -e; kom|men|tar-
los; Kom|men|ta|tor (Kommen-
tarverfasser) m; -s, ...oren; kom-
men|tie|ren; Kom|men|tie|rung

Kom|mers fr. (Studentenspr.: eine
bestimmte festl. Veranstaltung
einer Verbindung) m; -es, -e;

Kom|mers|buch (stud. Lieder-
buch)
Kom|merz lat. (Wirtschaft, Han-
del u. Verkehr) m; -es; **kom|mer-
zia|li|sie|ren** (kommerziellen In-
teressen unterordnen); **Kom|mer-
zia|li|sie|rung** (auch: Umwand-
lung einer öffentl. Schuld in eine
privatwirtschaftliche); **Kom|mer-
zi|al|rat** österr. (Kommerzienrat;
Mehrz. ...räte); **kom|mer|zi|ell**
(auf den Kommerz bezüglich);
Kom|mer|zien|rat [...*zi*ⁿ...]
(*Mehrz.* ...räte)
Kom|mi|li|to|ne lat. (Studen-
tenspr.: Studiengenosse) m; -n,
-n (↑ R 268); **Kom|mi|li|to|nin** w;
-, -nen
Kom|mis fr. [*komi*] (veralt. für:
Handlungsgehilfe) m; - [*komi(ß)*],
- [*komiß*]; **Kom|miß** lat. (ugs. für:
[aktiver] Soldatenstand, Heer) m;
...misses; beim -; **Kom|mis|sar**
([vom Staat] Beauftragter;
Dienstbez.; z. B. Polizeikommis-
sar) m; -s, -e; **Kom|mis|sär** fr.
südd., schweiz., österr. (Kom-
missar); **Kom|mis|sa|ri|at** lat.
(Amt[szimmer] eines Kommis-
sars; österr.: Polizeidienststelle)
s; -[e]s, -e; **kom|mis|sa|risch** (be-
auftragt; auftragsweise, vor-
übergehend); -e Vernehmung
(Rechtsspr.); **Kom|miß|brot**;
Kom|mis|si|on (Ausschuß [von
Beauftragten]; Auftrag; Handel
für fremde Rechnung); **Kom|mis-
sio|när** fr. (Geschäftsvermittler)
m; -s, -e; **kom|mis|sio|nie|ren**
österr. (prüfen und für die
Übergabe an seine Bestimmung
freigeben); **Kom|mis|si|ons|buch-
han|del** (Zwischenbuchhandel
[zwischen Verlag u. Sortiment]),
...ge|schäft (Geschäft im eigenen
Namen für fremde Rechnung),
...gut (unter Bedingungen gelie-
ferte Ware, Bedingtgut), ...sen-
dung (unter Bedingungen gelie-
ferte Sendung, Bedingtsendung);
Kom|miß|stie|fel, ...zeit; **Kom-
mit|tent** (Auftraggeber des Kom-
missionärs); ↑ R 268; **kom|mit|tie-
ren** (beauftragen, [einen Kom-
missionär] bevollmächtigen)
kom|mod fr. (veralt., aber noch
mdal. u. österr. für: bequem; an-
genehm); **Kom|mo|de** w; -, -n;
**Kom|mo|den|schub|la|de; Kom-
mo|di|tät** (veralt., noch mdal. für:
Bequemlichkeit; Abort)
Kom|mo|do|re engl. (Geschwader-
führer; erprobter, ältester Kapi-
tän großer Schiffahrtslinien) m;
-s, -n u. -s
kom|mun lat. (veralt. für: gemein-
schaftlich; gemein); **kom|mu|nal**
(die Gemeinde betreffend, Ge-
meinde..., gemeindeeigen); -es

Kino; **Kom|mu|nal|be|am|te,
...be|hör|de; kom|mu|na|li|sie|ren**
(eine Kommunalisierung durch-
führen); **Kom|mu|na|li|sie|rung**
(Überführung in Gemeindebe-
sitz u. -verwaltung); **Kom|mu-
nal|po|li|tik**, ...ver|wal|tung,
...wahl; **Kom|mu|nar|de** fr. (An-
hänger der Pariser Kommune;
Mitglied einer Wohngemein-
schaft) m; -n, -n; **Kom|mu|ne** (ver-
altend für: Gemeinde; Wohnge-
meinschaft linksgerichteter jun-
ger Leute; nur *Einz.*: Herrschaft
des Pariser Gemeinderates 1792–
1794 und 1871; veraltend für:
Kommunisten) w; -, -n; **Kom|mu-
ni|kant** lat. (Teilnehmer beim
Empfang des Altarsakramentes)
m; -en, -en (↑ R 268); **Kom|mu|ni-
kan|tin** w; -, -nen; **Kom|mu|ni|ka-
ti|on** [...*zion*] (Mitteilung; Ver-
bindung; Verkehr); **Kom|mu|ni-
ka|ti|ons|mit|tel** s, ...weg (veralt.
für: Verbindungsweg); **Kom|mu-
ni|on** („Gemeinschaft"; Emp-
fang des Altarsakramentes);
Kom|mu|ni|on|bank (*Mehrz.*
...bänke), ...kind (↑ R 335); **Kom-
mu|ni|qué** fr. [...*münike*, auch:
...*munike*] (Denkschrift od.
[regierungs]amtliche Mitteilung)
s; -s, -s; **Kom|mu|nis|mus** m; -;
Kom|mu|nist (↑ R 268); **kom|mu-
ni|stisch**; (↑ R 224:) das Kommu-
nistische Manifest; **Kom|mu|ni-
tät** lat. (ev. Bruderschaft; veralt.
für: Gemeinschaft; Gemeingut);
kom|mu|ni|zie|ren (die Kommu-
nion empfangen; zusammenhän-
gen, in Verbindung stehen; ver-
alt. für: mitteilen); **kom|mu|ni-
zie|rend**; -e (verbundene) Röh-
ren
Kom|mu|ta|ti|on lat. [...*zion*] (Um-
stellung, Vertauschung in der
Mathematik; bes. Winkel in der
Astron.); **kom|mu|ta|tiv** (ver-
tauschbar); -e Gruppe; **Kom|mu-
ta|tor** (Technik: Stromwender,
Kollektor) m; -s, ...oren; **kom-
mu|tie|ren** (vertauschen; Strom
wenden)
Ko|mö|di|ant it.(-engl.) (meist ge-
ringschätzig für: Schauspieler)
m; -en, -en (↑ R 268); **ko|mö|di-
an|ten|haft; Ko|mö|di|an|ten|tum**
s; -s; **Ko|mö|di|an|tin** w; -, -nen;
ko|mö|di|an|tisch; Ko|mö|die
[...*i*ⁿ] w; -, -n; **Ko|mö|di|en|schrei-
ber**
Komp., Co. = Kompanie
Kom|pa|gnon fr. [...*panjong*]
(Kaufmannsspr.: [Geschäfts]-
teilhaber; Mitinhaber) m; -s, -s
kom|pakt fr. (gedrungen; dicht;
fest); **Kom|pakt|heit** w; -
Kom|pa|nie it. u. fr. (Truppenab-
teilung; Kaufmannsspr. veralt.

für: [Handels]gesellschaft; Abk.:
Komp., in Firmen meist: Co., sel-
tener: Cie.) w; -, ...ien; **Kom|pa-
nie_chef**, ...füh|rer, ...ge|schäft
kom|pa|ra|bel lat. (veralt. für: ver-
gleichbar); ...a|ble Eigenschaf-
ten; **Kom|pa|ra|ti|on** [...*zion*]
(Sprachw.: Steigerung); **Kom|pa-
ra|tiv** [auch: ...*tif*] (Sprachw.: er-
ste Steigerungsstufe, z. B.
„schöner") m; -s, -e [...*w*ᵉ]; **Kom-
pa|ra|tor** (Gerät zum Vergleichen
von Längenmaßen) m; -s, ...oren
Kom|pa|rent lat. (veralt. für: vor
einer Behörde Erscheinender);
↑ R 268; **Kom|pa|rie|ren**
Kom|par|se fr. (Statist, stumme
Person [bei Bühne und Film]) m;
-n, -n (↑ R 268); **Kom|par|se|rie**
(Anordnung der Aufzüge; Ge-
samtheit der Komparsen) w; -,
...ien
Kom|par|ti|ment lat. (veralt. für:
abgeteiltes Feld; Gemach, Ab-
teil) s; -[e]s, -e
Kom|paß it. (Gerät zur Bestim-
mung der Himmelsrichtung) m;
...passes, ...passe; **Kom|paß_häus-
chen**, ...na|del
kom|pa|ti|bel fr. (-engl.) (veralt.
für: vereinbar, zusammenpas-
send; Technik: die Eigenschaft
der Kompatibilität besitzend);
...i|ble Ämter; **Kom|pa|ti|bi|li|tät**
(Vereinbarkeit [zweier Ämter in
einer Person]; Technik: Emp-
fangsmöglichkeit von Schwarz-
weiß- u. Farbbildern beim Fern-
sehgerät) w; -
Kom|pa|tri|ot fr. (veralt. für:
Landsmann) m; -en, -en (↑ R 268)
kom|pen|dia|risch lat. (selten für:
kompendiös); **kom|pen|di|ös**
(veralt. für: abgekürzt; zusam-
mengefaßt; gedrängt; bequem)
-este (↑ R 292); **Kom|pen|di|um**
(Abriß, kurzes Lehrbuch) s; -s
...ien [...*i*ⁿ]
Kom|pen|sa|ti|on lat. [...*zion*]
(Ausgleich[ung], Entschädigung
BGB: Aufrechnung); **Kom|pen-
sa|ti|ons|ge|schäft; Kom|pen|sa-
tor** (Ausgleicher; Gerät zur Mes-
sung einer Spannung) m; -s
...oren; **kom|pen|sie|ren** (gegen
einander ausgleichen; BGB: auf
rechnen)
kom|pe|tent lat. (zuständig, maß
gebend, befugt); **Kom|pe|ten**
(veralt. für: Mitbewerber); ↑
268; **Kom|pe|tenz** (Zuständigkei
Sprachw. [nur *Einz.*]: Beher
schung eines Sprachsystems) w
-, -en; **Kom|pe|tenz_be|reich
...fra|ge**, ...**kom|pe|tenz** (Befugn
zur Bestimmung der Zuständig
keit), ...kon|flikt, ...strei|tig|kei
kom|pe|tie|ren (veralt. für: ge
bühren, zustehen; sich bewerben

Kom|pi|la|ti|on *lat.* [...*zion*] (Zusammentragen mehrerer [wissenschaftl.] Quellen; durch Zusammentragen entstandene Schrift ohne wissenschaftl. Wert); **Kom|pi|la|tor** (Zusammenträger) *m;* -s, ...oren; **kom|pi|lie|ren**

Kom|ple|ment *lat.* (Ergänzung) *s;* -[e]s, -e; **kom|ple|men|tär** *fr.* (ergänzend); **Kom|ple|men|tär** (persönlich haftender Gesellschafter einer Kommanditgesellschaft; DDR: Eigentümer einer privaten Firma, die mit Staatsbeteiligung arbeitet) *m;* -s, -e; **Kom|ple|men|tär|far|be** (Ergänzungsfarbe); **kom|ple|men|tie|ren** (ergänzen); **Kom|ple|men|tie|rung; Kom|ple|ment|win|kel** (Ergänzungswinkel); **¹Kom|plet** *fr.* [*kongple*] (Mantel [od. Jacke] u. Kleid aus gleichem Stoff) *s;* -[s], -s; **²Kom|plet** *lat.* (Abendgebet als Schluß der kath. kirchl. Tageszeiten) *w;* -, -e; **kom|plett** *fr.* (vollständig, abgeschlossen); **kom|plet|tie|ren** (vervollständigen; auffüllen); **Kom|plet|tie|rung**

kom|plex *lat.* (zusammengefaßt, umfassend; vielfältig verflochten; Math.: aus reellen u. imaginären Zahlen zusammengesetzt); -e Zahlen; **Kom|plex** (Zusammenfassung; Inbegriff; Vereinigung, Gruppe; gefühlsbetonte Vorstellungsverknüpfung) *m;* -es, -e; **Kom|ple|xi|on** (veralt. für: Zusammenfassung); **Kom|plexi|tät** *w;* -; **Kom|plex|salz; Kom|pli|ce** usw. vgl. Komplize usw.; **Kom|pli|ka|ti|on** *lat.* [...*zion*] (Verwicklung; Erschwerung)

Kom|pli|ment *fr.* (Höflichkeitsbezeigung, Gruß; Artigkeit; Schmeichelei) *s;* -[e]s, -e; **kom|pli|men|tie|ren** (veralt. für: bewillkommnen, noch in: hinauskomplimentieren)

Kom|pli|ze, (auch:) **Kom|pli|ce** [*komplís*] *fr.* (Mitschuldiger; Mittäter) *m;* -n, -n (↑ R 268); **Kom|pli|zen|schaft** *w;* -; **Kom|pli|zin** *w;* -, -nen

kom|pli|zie|ren *lat.* (verwickeln; erschweren); **kom|pli|ziert** (beschwerlich, verwickelt, umständlich); **Kom|pli|ziert|heit; Kom|pli|zie|rung**

Kom|plott *fr.* (heimlicher Anschlag, Verschwörung) *s* (ugs. auch: *m*); -[e]s, -e; **kom|plot|tie|ren** (veralt.)

Kom|po|nen|te *lat.* (Teil-, Seitenkraft; Bestandteil eines Ganzen) *w;* -, -n; **kom|po|nie|ren** (,,zusammensetzen''; ein Kunstwerk aufbauen, gestalten; Musik: vertonen); **Kom|po|nist** (Tondichter,

-setzer, Vertoner); ↑ R 268; **Kom|po|si|te** (Korbblütler) *w;* -, -n (meist *Mehrz.*); **Kom|po|si|ti|on** [...*zion*] (Zusammensetzung; Aufbau u. Gestaltung eines Kunstwerkes; Musik: das Komponieren; Tonschöpfung); **kom|po|si|to|risch; Kom|po|si|tum** (Sprachw.: [Wort]zusammengesetztes Wort, z. B. ,,Haustür'') *s;* -s, ...ta u. ...siten; **Kom|post** *fr.* (Dünger) *m;* -[e]s, -e; **Kom|post.er|de, ...hau|fen; kom|po|stie|ren** (zu Kompost verarbeiten); **Kom|po|stie|rung; Kom|pott** (gekochtes Obst) *s;* [e]s, -e; **Kom|pott|el|ler** [*Trenn.:* ...pott|tel..., ↑ R 236]

kom|preß *lat.* (veralt. für: eng zusammengedrängt; kurz und bündig; Druckw.: ohne Durchschuß); ...presseste; **Kom|pres|se** *fr.* (feuchter Umschlag) *w;* -, -n; **kom|pres|si|bel** *lat.* (zusammenpreßbar; verdichtbar); ...i|ble Flüssigkeiten; **Kom|pres|si|bi|li|tät** (Zusammendrückbarkeit) *w;* -; **Kom|pres|si|on** (Zusammendrückung; Verdichtung), **Kom|pres|si|ons.strumpf** (Med.), **...ver|band** (Med.); **Kom|pres|sor** (Technik: Verdichter) *m;* -s, ...oren; **Kom|pret|te** ⓦ vgl. Comprette; **kom|pri|mie|ren** (zusammenpressen; verdichten); **kom|pri|miert;** -e Luft (Druck-, Preßluft); **Kom|pri|mie|rung**

Kom|pro|miß *lat.* (Übereinkunft; Ausgleich) *m* (seltener: *s*); ...misses, ...misse; **kom|pro|miß|be|reit; Kom|pro|miß|be|reit|schaft; Kom|pro|miß|ler** (abschätzig für: jmd., der dazu neigt, Kompromisse zu schließen); **kom|pro|miß|le|risch;** -ste (↑ R 294); **kom|pro|miß|los, ...ver|such, ...vor|schlag; kom|pro|mit|tie|ren** (bloßstellen)

Komp|ta|bi|li|tät *fr.* (Verantwortlichkeit, Rechenschaftspflicht [von der Verwaltung öffentl. Stellen]) *w;* -

Kom|pu|ter vgl. Computer

Kom|so|mol *russ.* (kommunist. Jugendorganisation in der UdSSR) *m;* -; **Kom|so|mol|ze** (Mitglied des Komsomol) *m;* -n, -n (↑ R 268); **Kom|so|mol|zin** *w;* -, -nen

Kom|teß *fr.* [*kongtäß,* auch dt. Ausspr.] *w;* -,...tessen u. **Kom|tes|se** (unverheiratete Gräfin) *w;* -, -n

Kom|tur *fr.* (Ordensritter, Inhaber einer Komturei) *m;* -s, -e; **Kom|tu|rei** (Verwaltungsbezirk eines Ritterordens)

Ko|nak *türk.* (Palast, Amtsgebäude in der Türkei) *m;* -s, -e

Kon|au|tor (Mitautor)

Kon|cha *gr.* [...*cha*] (Nischenwölbung; Med.: muschelähnliches Organ) *w;* -, -s u. ...chen; **Kon|che** (svw. Koncha [Nischenwölbung]) *w;* -, -n; **Kon|chi|fe|re** *gr.; lat.* (Weichtier mit einheitl. Schale) *w;* -, -n (meist *Mehrz.*); **kon|chi|form** (muschelförmig); **Kon|cho|ide** *gr.* (,,Muschellinie''; Math.: Kurve vierten Grades) *w;* -, -n; **Kon|cho|lo|gie** vgl. Konchyliologie; **Kon|chy|lie** [...*i*] (Zool.: Schale der Weichtiere) *w;* -, -n (meist *Mehrz.*); **Kon|chy|lio|lo|ge** *m;* -n, -n (↑ R 268); **Kon|chy|lio|lo|gie** (Zool.: Lehre von den Konchylien, bes. von ihren Gehäusen) *w;* -

Kon|dem|na|ti|on *lat.* [...*zion*] (veralt. für: Verurteilung, Verdammung; Seew.: Verkaufsanordnung für ein als seeuntüchtig erklärtes Schiff; Zusprechung eines im Krieg aufgebrachten Schiffes)

Kon|den|sat *lat.* (Niederschlag[wasser]) *s;* -[e]s, -e; **Kon|den|sa|ti|on** [...*zion*] (Verdichtung; Verflüssigung); **Kon|den|sa|ti|ons|punkt** (Taupunkt); **Kon|den|sa|tor** (,,Verdichter''; Gerät zum Speichern von Elektrizität) *m;* -s, ...oren; **kon|den|sie|ren** (verdichten, eindicken; verflüssigen); **Kon|den|sie|rung; Kon|dens|milch** *lat.; dt.;* **Kon|den|sor** *lat.* (Verdichter; Verstärker) *m;* -s, ...oren; **Kon|dens.strei|fen, ...topf, ...was|ser** (*s;* -s, ...wasser u. ...wässer)

Kon|dik|ti|on *lat.* [...*zion*] (veralt. für: Klage auf Rückgabe)

kon|di|tern *lat.* (Konditorwaren herstellen; ugs. auch: eine Konditorei besuchen); ich ...ere (↑ R 327); - gehen

Kon|di|ti|on *lat.* [...*zion*] (Bedingung; [Gesamt]zustand; veralt. für: Stelle, Dienst); vgl. à condition; **kon|di|tio|nal** (Sprachw.: bedingungsweise geltend; bedingend); **Kon|di|tio|nal** (Sprachw.: Bedingungsform) *m;* -s, -e; **Kon|di|tio|na|lis|mus** (eine philos. Lehre) *m;* -; **Kon|di|tio|nal|satz** (Sprachw.: Umstandssatz der Bedingung); **Kon|di|tio|nier|an|la|ge** (zur Ermittlung des zulässigen Feuchtigkeitsgehalts von Textilien); **kon|di|tio|nie|ren** (Feuchtigkeitsgehalt von Getreide verringern, von Textilien ermitteln; veralt. für: in Diensten stehen); **kon|di|tio|niert** (beschaffen [von Waren]); **Kon|di|tio|nie|rung; Kon|di|tions.schwä|che, ...trai|ning** ([leichtes] Training)

Kon|di|tor *lat.* *m;* -s, ...oren; **Kon|di|to|rei; Kon|di|tor|mei|ster**

Kon|do|lenz *lat.* (Beileid[sbezeigung]) *w;* -, -en; **Kon|do|lenz.be-**

such, ...kar|te, ...schrei|ben; kon|do|lie|ren; jmdm. -
Kon|dom *engl.* (Präservativ) *s* od. *m*; -s, -e (selten: -s)
Kon|do|mi|nat *lat. s* od. *m*; -[e]s, -e u. Kon|do|mi|ni|um (Herrschaft mehrerer Staaten über dasselbe Gebiet; auch dieses Gebiet selbst) *s*; -s, ...ien [...*i*nn]
Kon|dor *indian.* (Riesengeier) *m*; -s, -e
Kon|dot|tie|re *it.* (Söldner-, Freischarenführer im 14. u. 15. Jh.) *m*; -s, ...ri
Kon|dui|te *fr.* [*konduit*e] (veralt. für: Führung, Betragen) *w*; -; Kon|dui|ten|li|ste (Führungsliste)
Kon|dukt *lat.* ([feierl.] Geleit, Gefolge [bei Leichenbegängnissen]) *m*; -[e]s, -e; Kon|duk|tanz (Elektrotechnik: Wirkleitwert) *w*; -; Kon|duk|teur *fr.* [...*tör*, schweiz.: *kọn*...] (schweiz., sonst veralt. für: Schaffner) *m*; -s, -e; Kon|duk|tor *lat.* ([elektr.] Leiter; Med.: Überträger einer Erbkrankheit) *m*; -s, ...oren
Kon|du|ran|go *indian.* [...*nggo*] (südamerik. Kletterstrauch, dessen Rinde Magenmittel liefert) *w*; -, -s; Kon|du|ran|go|rin|de
Kon|dy|lom *gr.* (Feigwarze) *s*; -s, -e
Ko|nen (*Mehrz.* von: Konus)
Kon|fekt *lat.* (Zuckerwerk; südd., schweiz., österr. auch für: Teegebäck) *s*; -[e]s, -e; Kon|fek|ti|on [...*zịọn*] *fr.* (industrielle „Anfertigung" [von Kleidern]; [Handel mit] Fertigkleidung; Bekleidungsindustrie); Kon|fek|tio|när (Unternehmer, auch [leitender] Angestellter in der Konfektion) *m*; -s, -e; Kon|fek|tio|neu|se [...*nös*e] (Angestellte in der Konfektion) *w*; -, -n; Kon|fek|tio|nie|ren (fabrikmäßig herstellen); Kon|fek|tio|nie|rung; Kon|fek|ti|ons|an|zug, ...ge|schäft
Kon|fe|renz *lat. w*; -, -en; Kon|fe|renz|be|schluß, ...pau|se, ...saal, ...schal|tung (Fernmeldetechnik), ...sen|dung (Rundfunk), ...teil|neh|mer, ...tisch, ...zim|mer; kon|fe|rie|ren *fr.* (eine Konferenz abhalten; als Conférencier sprechen)
Kon|fes|si|on *lat.* ([Glaubens]bekenntnis; [christl.] Bekenntnisgruppe); Kon|fes|sio|na|lis|mus (übermäßige) Betonung der eigenen Konfession) *m*; -; kon|fes|sio|nẹll (zu einer Konfession gehörend); kon|fes|si|ons|los; Kon|fes|si|ons|lo|sig|keit *w*; -; Kon|fes|si|ons|schu|le (Bekenntnisschule), ...sta|ti|stik
Kon|fet|ti *it.* (bunte Papierblättchen, die bes. bei Faschings-

veranstaltungen geworfen werden) *Mehrz.*, heute meist: *s*; -[s];
Kon|fi|dẹnt *fr.* (veralt. für: Vertrauter, Busenfreund; österr. für: [Polizei]spitzel); ↑ R 268; kon|fi|den|ti|ẹll [...*ziạl*] (veralt. für: vertraulich)
Kon|fi|gu|ra|ti|on *lat.* [...*zịọn*] (Astron., Astrol.: bestimmte Stellung der Planeten; Med.: Verformung [z. B. des Schädels]; Chemie: räumliche Anordnung der Atome eines Moleküls; Kunst: Gestalt[ung])
Kon|fir|mạnd *lat. m*; -en, -en (↑ R 268); Kon|fir|man|dẹn|stun|de, ...un|ter|richt; Kon|fir|man|din *w*; -, -nen; Kon|fir|ma|ti|on [...*zịọn*]; goldene -; Kon|fir|ma|ti|ons|an|zug, ...ge|schenk, ...spruch; kon|fir|mie|ren
Kon|fi|se|rie *fr.* [*kon...* u. *kong...*] schweiz. (Geschäft, das Süßwaren, Pralinen u. dgl. herstellt und verkauft) *w*; -, ...ien; Kon|fi|seur [...*sör*] schweiz. (Hersteller von Süßwaren, Pralinen usw.) *m*; -s, -e
Kon|fis|kạt *lat.* (nicht zum Verzehr bestimmte Teile von Schlachtvieh) *s*; -[e]s, -e (meist *Mehrz.*); Kon|fis|ka|ti|on [...*zịọn*] (gerichtl.) Einziehung, Beschlagnahme); kon|fis|zie|ren
Kon|fi|tẹnt *lat.* (veralt. für: Beichtender, Beichtkind); ↑ R 268
Kon|fi|tü|re *fr.* (Marmelade mit noch erkennbaren Obststücken) *w*; -, -n
Kon|flikt *lat.* („Zusammenstoß"; Zwiespalt, [Widerstreit) *m*; -[e]s, -e; Kon|flikt|for|schung, ...herd, ...kom|mis|si|on (DDR); kon|flikt|los; Kon|flikt|si|tua|ti|on, ...stoff
Kon|flu|ẹnz *lat.* (Geol.: Zusammenfluß zweier Gletscher) *w*; -, -en
Kon|fö|de|ra|ti|on *lat.* [...*zịọn*] („Bündnis"; [Staaten]bund); kon|fö|de|rie|ren, sich (sich verbünden); Kon|fö|de|rier|te *m* u. *w*; -n, -n (↑ R 287 f.)
kon|fo|kal *lat.* (Physik: mit gleichen Brennpunkten); -e Kegelschnitte
kon|form *lat.* (einig, übereinstimmend); - gehen (einiggehen, übereinstimmen); Kon|for|mis|mus ([Geistes]haltung, die [stets] um Anpassung bemüht ist) *m*; -; Kon|for|mist (Anhänger der anglikan. Kirche; Vertreter des Konformismus); ↑ R 268; kon|for|mi|stisch; Kon|for|mi|tät (Übereinstimmung) *w*; -
Kon|fra|ter *lat.* („Mitbruder"; [kirchl.] Amtsbruder); Kon|fra-

ter|ni|tät (veralt. für: Bruderschaft)
Kon|fron|ta|ti|on *lat.* [...*zịọn*] (Gegenüberstellung [von Angeklagten u. Zeugen]; [polit.] Auseinandersetzung); kon|fron|tie|ren; eine - konfrontiert werden; jmdm. konfrontiert werden; Kon|fron|tie|rung
kon|fun|die|ren *lat.* (veralt. für: vermengen; verwirren); kon|fus (verwirrt, verworren, wirr [im Kopf]); -este (↑ R 292); Kon|fu|si|on (Verwirrung; BGB: Vereinigung von Forderung u. Schuld in einer Person); Kon|fu|si|ons|rat (ugs. für: Wirrkopf; *Mehrz.* ...räte)
Kon|fu|ta|ti|on *lat.* [...*zịọn*] (veralt. für: Widerlegung)
Kon|fu|tse, Kon|fu|zi|us (Gründer der chin. Staatsreligion); kon|fu|zia|nisch; -e Philosophie nach Art des Konfuzius), aber (↑ R 179): Kon|fu|zia|nisch; -e Aussprüche von Konfuzius; Kon|fu|zia|nis|mus (sich auf die Lehre von Konfuzius berufende Geisteshaltung) *m*; -; kon|fu|zia|ni|stisch (den Konfuzianismus betreffend); Kon|fu|zi|us vgl. Konfutse
kon|ge|ni|al *lat.* (geistesverwandt; geistig ebenbürtig); Kon|ge|nia|li|tät *w*; -
kon|ge|ni|tal *lat.* (Med.: angeboren)
Kon|ge|sti|on *lat.* (Med.: Blutandrang; kon|ge|stiv (Blutandrang erzeugend)
Kon|glo|me|rat *lat.* (Sedimentgestein; Gemisch) *s*; -[e]s, -e
^1Kon|go [*kọnggo*] (Strom in Mittelafrika) *m*; -[s]; ^2Kon|go (Staat in Mittelafrika); Volksrepublik Kongo; Demokratische Republik Kongo vgl. Zaire; Kon|go|le|se *m*; -n, -n (↑ R 268); kon|go|le|sisch; Kọn|go|rot; Kọn|go|rot (↑ R 201)
Kon|gre|ga|ti|on *lat.* [...*zịọn*] ([geistl.] Vereinigung [bes. von Kardinälen]); Kon|gre|ga|tio|na|list *engl.* (Angehöriger einer engl.-nordamerik. Kirchengemeinschaft); ↑ R 268; Kon|gre|ga|tio|nist *lat.* (Angehöriger einer Kongregation); ↑ R 268
Kon|greß *lat.* ([größere] fachl. od. polit. Versammlung; nur *Einz.* Parlament in den USA) *m* ...gresses, ...gresse; Kon|greß|hal|le, ...saal, ...stadt, ...teil|neh|mer
kon|gru|ẹnt *lat.* (übereinstimmend, deckungsgleich); Kon|gru|ẹnz (Übereinstimmung) *w*; -, (selten:) -en; Kon|gru|ẹnz|satz (Geometrie); kon|gru|ie|ren
Ko|ni|die *gr.* [...*i*e] (Pilzspore) *w* -, -n (meist *Mehrz.*)

K.-o.-Nie|der|la|ge; ↑ R 155 (Boxsport: Niederlage durch Knockout)

Ko|ni|fe|re *lat.* (Vertreter zapfentragender Nadelhölzer) w; -, -n

Kö|nig m; -[e]s, -e; (↑ R 224:) die Heiligen Drei -e; **Kö|ni|gin** w; -, -nen; **Kö|ni|gin_mut|ter** (*Mehrz.* ...mütter), ...wit|we (↑ R 146); **kö|nig|lich**; königlicher Kaufmann; das königliche Spiel (Schach); im Titel (↑ R 224): Königlich (Abk.: Kgl.); Königliche Hoheit (Anrede eines Kronprinzen); vgl. kaiserlich; **Kö|nig|reich**; **Kö|nigs|ad|ler**

Kö|nigs|berg (Pr) (Hptst. der ehemal. Provinz Ostpreußen); Königsberger Klops (ein Fleischgericht); vgl. Kaliningrad

kö|nigs|blau; **Kö|nigs_blau**, ...burg, ...farn, ...haus, ...hof, ...ker|ze (eine Heil- u. Zierpflanze), ...kro|ne, ...ku|chen, ...pal|me, ...schloß

Kö|nigs|see (in Bayern) m; -s

Kö|nigs_sohn, ...thron, ...ti|ger, ...toch|ter; **kö|nigs|treu**; **Kö|nigs|weg** (bester, idealer Weg zu einem höhen Ziel)

Kö|nigs Wu|ster|hau|sen (Stadt in der Mittelmark); **Kö|nigs|wu|ster|hau|se|ner** (↑ R 199)

Kö|nig|tum

Ko|ni|in *gr.* (ein giftiges Alkaloid) s; -s

ko|nisch *gr.* (kegelförmig, kegelig, verjüngt); -e Spirale

Konj. = Konjunktiv

Kon|jek|ta|ne|en *lat.* [auch: ...tangᵉn] (veralt. für: [Sammlung von] Bemerkungen) *Mehrz.*; **Kon|jek|tur** (mutmaßlich richtige Lesart eines Textes; Textbesserung; veralt. für: Vermutung) w; -, -en; **kon|jek|tu|ral**; (die Konjektur betreffend); **Kon|jek|tu|ral|kri|tik**; **kon|ji|zie|ren** (Konjekturen machen; veralt. für: vermuten) **kon|ju|gal** *lat.* (veralt. für: ehelich); **Kon|ju|ga|te** (Jochalge) w; -, -n (meist *Mehrz.*), **Kon|ju|ga|ti|on** [...*zion*] (Sprachw.: Beugung des Zeitwortes); **Kon|ju|ga|ti|ons|en|dung**; **kon|ju|gier|bar** (beugungsfähig); **kon|ju|gie|ren** ([Zeitwort] beugen; veralt. für: verbinden); **kon|jun|gie|ren** (veralt. für: verbinden); **Kon|junk|ti|on** [...*zion*] (Sprachw.: Bindewort, z. B. „und, oder"; Astron.: Stellung zweier Gestirne im gleichen Längengrad); **Kon|junk|tio|nal_ad|verb**, ...satz (Sprachw.: von einer Konjunktion eingeleiteter Gliedsatz); **Kon|junk|tiv** [auch: ...*tif*] (Sprachw.: Möglichkeitsform; Abk.: Konj.) m; -s, -e [...ᵉ]; **Kon|junk|ti|va** (Med.: Bindehaut [des Auges]) w; -; **kon|junk|ti|visch**

[auch: ...tiw...] (den Konjunktiv betreffend, auf ihn bezüglich); **Kon|junk|ti|vi|tis** (Med.: Bindehautentzündung [des Auges]) w; -, ...itiden; **Kon|junk|tiv|satz** (wirtschaftl. Gesamtlage von bestimmter Entwicklungstendenz) w; -, -en; **kon|junk|tur|be|dingt**; **kon|junk|tu|rell** (der Konjunktur gemäß); **Kon|junk|tur_be|richt**, ...la|ge, ...po|li|tik; **kon|junk|tur|po|li|tisch**; **Kon|junk|tur_rit|ter**, ...schwan|kung, ...schlag**

Kon|ju|rant *lat.* (veralt. für: Verschworener) m; -en, -en (↑ R 268); **Kon|ju|ra|ti|on** [...*zion*] (veralt. für: Verschwörung)

kon|kav *lat.* (hohl, vertieft, nach innen gewölbt); **Kon|kav|glas** (*Mehrz.*: ...gläser); **Kon|ka|vi|tät** [...wi...] (konkaver Zustand) w; -; **Kon|kav|spie|gel**

Kon|kla|ve *lat.* [...wᵉ] (Versammlung[sort] der Kardinäle zur Papstwahl) s; -s, -n

kon|klu|dent *lat.* (schlüssig); -es Verhalten (Rechtsw.); **kon|klu|die|ren** (folgern); **Kon|klu|si|on** (Philos.: Schluß[folgerung]); **kon|klu|siv** (schließend, folgernd)

kon|kor|dant *lat.* (übereinstimmend); **Kon|kor|danz** (Übereinstimmung; alphabet. Verzeichnis von Wörtern od. Sachen zum Vergleich ihres Vorkommens u. Sinngehaltes an verschiedenen Stellen eines Buches, z. B. Bibelk...; Geol.: ungestörte Lagerung mehrerer Gesteinsschichten; Druckw.: ein Schriftgrad) w; -, -en; **Kon|kor|dat|schrift**; **Kon|kor|dat** (Vertrag zwischen Staat u. kath. Kirche; schweiz. für: Vertrag zwischen Kantonen) s; -[e]s, -e; **Kon|kor|dats|po|li|tik**; **Kon|kor|dia** (Name von Vereinen usw.) w; -; **Kon|kor|di|en|for|mel** [...iᶠn...] (letzte luth. Bekenntnisschrift von 1577) w; -

Kon|kre|ment *lat.* (Med.: sich in Körperflüssigkeiten u. -hohlräumen bildende feste Substanzen [z. B. Nierensteine]) s; -[e]s, -e

Kon|kres|zenz *lat.* (veralt. für: Zusammenwachsen) w; -, -en

kon|kret *lat.* (körperlich, gegenständlich, sinnfällig, anschaubar, greifbar); vgl. in concreto; -e Malerei; -e Musik; **Kon|kre|ti|on** [...*zion*] (Med.: Verwachsung; Geol.: mineralischer Körper in Gesteinen); **kon|kre|ti|sie|ren** (konkret machen; verdeutlichen; [im einzelnen] ausführen); **Kon|kre|ti|sie|rung**; **Kon|kre|tum** (Sprachw.: Hauptwort, das et-

was Gegenständliches benennt, z. B. „Tisch") s; -s, ...ta

Kon|ku|bi|nat *lat.* (Rechtsspr.: dauernde außerehel. Geschlechtsgemeinschaft) s; -[e]s, -e; **Kon|ku|bi|ne** (veralt.: im Konkubinat lebende Frau) w; -, -n

Kon|ku|pis|zenz *lat.* (Philos., Theol. für: Begehrlichkeit, Verlangen) w; -

Kon|kur|rent *lat.*; ↑ R 268; **Kon|kur|ren|tin** w; -, -nen; **Kon|kur|renz** (Wettbewerb; Zusammentreffen zweier Feste in der kath. Liturgie) w; -, -en; **Kon|kur|renz_be|trieb**; **kon|kur|renz|fä|hig**; **kon|kur|ren|zie|ren** österr., schweiz. (jmdm Konkurrenz machen); jmdn. -; **Kon|kur|ren|zie|rung**; **Kon|kur|renz|kampf**; **kon|kur|renz|los**; **Kon|kur|renz_neid**, ...un|ter|neh|men; **kon|kur|rie|ren** (wetteifern; miteinander in Wettbewerb stehen; zusammentreffen [von mehreren straf rechtl. Tatbeständen]); **Kon|kurs** („Zusammenlauf" [der Gläubiger]; Zahlungseinstellung, -unfähigkeit) m; -es, -e; **Kon|kurs_er|öff|nung**, ...mas|se, ...pro|zeß, ...ver|fah|ren, ...ver|wal|ter**

kön|nen; du kannst; du konntest; du könntest; gekonnt, aber (↑ R 305): ich habe das nicht glauben können; **Kön|nen** s; -s; **Kön|ner** **Kon|ne|ta|bel** *fr.* (fr. Kronfeldherr [bis ins 17. Jh.]) m; -s, -s

Kon|nex *lat.* (Zusammenhang, Verbindung; Annäherung, Bekanntschaft) m; -es, -e; **Kon|ne|xi|on** (selten für: einflußreiche, fördernde Bekanntschaft; Beziehung; meist *Mehrz.*)

kon|ni|vent *lat.* [...wänt] (nachsichtig); **Kon|ni|venz** (Nachsicht) w; -, -en; **kon|ni|vie|ren** (veralt. für: Nachsicht üben)

Kon|nos|se|ment *it.* (Frachtbrief im Seegüterverkehr) s; -[e]s, -e

Kon|ny_bi|um *lat.* (Rechtsspr. veralt. für: Ehe[gemeinschaft]) s; -s, ...ien [...iᶠn]

Ko|no|id *gr.* (Math.: kegelähnlicher Körper) s; -[e]s, -e

Kon|qui|sta|dor span. (span. Eroberer von Mittel- u. Südamerika im 16. Jh.) m; -en, -en (↑ R 268)

Kon|rad (m. Vorn.); **Kon|ra|din** (m. Vorn.); **Kon|ra|di|ne** (w. Vorn.)

Kon|rek|tor *lat.* (Vertreter des Rektors) m; -s, ...oren

Kon|se|kra|ti|on *lat.* [...*zion*] (liturg. Weihe einer Person od. Sache; Verwandlung von Brot u. Wein beim Abendmahl); **kon|se|krie|ren**

kon|se|ku|tiv *lat.* (folgernd, die Folge bezeichnend); **Kon|seku-tiv|satz** (Sprachw.: Umstandssatz der Folge)

Kon|sens *lat.* (Einwilligung, Genehmigung) *m*; -es, -e; **kon|sentie|ren** (veralt. für: einwilligen, genehmigen)

kon|se|quent *lat.* (folgerichtig; bestimmt; beharrlich, zielbewußt); **Kon|se|quenz** (Folgerichtigkeit; Beharrlichkeit; Zielstrebigkeit; Folge[rung]) *w*; -, -en; die -en tragen, ziehen

Kon|ser|va|tis|mus *lat.* [...*wa*...] vgl. Konservativismus; **kon|serva|tiv; Kon|ser|va|ti|ve** [...*iwᵉ*] (jmd., der am Hergebrachten festhält; Anhänger[in] einer konservativen Partei) *m* u. *w*; -n, -n (↑ R 287 f.); **Kon|ser|va|ti|vis|mus** [...*watiwiß*...] (am Alten, Hergebrachten festhaltende Weltanschauung) *m*; -; **Kon|ser|va|ti|vi-tät** *w*; -; **Kon|ser|va|tor** (für die Instandhaltung von Kunstdenkmälern verantwortl. Beamter) *m*; -s, ...oren; **kon|ser|va|to|risch** (pfleglich; das Konservatorium betreffend); - gebildet (auf einem Konservatorium ausgebildet); **Kon|ser|va|to|rist** (Schüler eines Konservatoriums); ↑ R 268; **Kon-ser|va|to|ri|stin** *w*; -, -nen; **Kon-ser|va|to|ri|um** *it.* (Musik[hoch]-schule) *s*; -s, ...ien [...*iᵉn*]; **Kon-ser|ve** *mlat.* [...*wᵉ*] (haltbar gemachtes Nahrungs- od. Genußmittel; Dauerware; auf Tonband, Schallplatte Festgehaltenes) *w*; -, -n; **Kon|ser|ven.büch|se**, ...do|se, ...fa|brik, ...glas, ...öff|ner, ...ver-gif|tung; **kon|ser|vie|ren** *lat.* (einmachen; haltbar machen; auf Tonband, Schallplatte festhalten); **Kon|ser|vie|rung; Kon|ser-vie|rungs|mit|tel** *s*

Kon|si|gnant *lat.* (Versender von Konsignationsgut im Überseegeschäft) *m*; -en, -en (↑ R 268); **Kon-si|gna|tar, Kon|si|gna|tär** (Empfänger [von Waren zum Weiterverkauf) *m*; -s, -e; **Kon|si|gna-ti·on** [...*zion*] (überseeisches Verkaufskommissionsgeschäft); **Kon|si|gna|ti|ons|gut; Kon|si|gnie|ren** (Waren zum Verkauf übersenden, mit unterzeichnen; [Schiffe, Truppen] mit besonderer Bestimmung [ab]senden)

Kon|si|lia|ri·us *lat.* (zur Beratung hinzugezogener Arzt) *m*; -, ...rii; **Kon|si|li|um** (Beratung; Gutachten; [ernst erteilter] Rat) *s*; -s, ...ien [...*iᵉn*]; vgl. Consilium abeundi

kon|si|stent *lat.* (dicht; zusammenhaltend; haltbar; dickflüssig); **Kon|si|stenz** (Dichtigkeit; Zu-

sammenhang; Beständigkeit) *w*; -;

Kon|si|sto|ri·al|rat *lat.*; *dt.* (Titel; *Mehrz.* ...räte); **Kon|si|sto|ri|um** *lat.* (außerordentl. Versammlung der Kardinäle unter Vorsitz des Papstes; oberste Verwaltungsbehörde mancher ev. Landeskirchen) *s*; -s, ...ien [...*iᵉn*]

kon|skri|bie|ren *lat.* (früher für: zum Heeres-, Kriegsdienst ausheben); **Kon|skri|bier|te** *m*; -n, -n (↑ R 287 ff.); **Kon|skrip|ti·on** [...*zion*]

Kon|sol *engl.* (Staatsschuldschein) *m*; -s, -s (meist *Mehrz.*); **Kon|so|le** *fr.* (Krage, Kragstein, -träger; Wandgestell; Träger für Gegenstände der Kleinkunst) *w*; -, -n; **Kon|so|li|da|ti·on** [...*zion*], **Kon-so|li|die|rung** *lat.(-fr.)* (Vereinigung mehrerer Staatsanleihen zu einer einheitl. Anleihe; Umwandlung kurzfristiger Staatsschulden in Anleihen; Sicherung, Festigung [eines Unternehmens]); **kon|so|li|die|ren** (sichern, festigen); **Kon|so|li|die|rung** vgl. Konsolidation; **Kon|sol|tisch-chen**

Kon|som|mee *fr.* [*kongßomé*] (veralt. für: Kraftbrühe) *w*; -, -s od. *s*; -s, -s

kon|so|nant *lat.* (Musik: harmonisch, zusammenklingend; veralt. für: einstimmig, übereinstimmend); **Kon|so|nant** (Sprachw.: „Mitlaut", z. B. p, t, k) *m*; -en, -en (↑ R 268); **Kon|so|nan|ten-.häu|fung, ...schwund; kon|so-nan|tisch** (Konsonanten betreffend); **Kon|so|nanz** (Musik: Ein-, Zusammen-, Wohlklang; Sprachw.: Anhäufung von Mitlauten, Mitlautfolge) *w*; -, -en

Kon|sor|ten *lat.* („Genossen"; abwertend für: Mittäter; Mitangeklagte) *Mehrz.*; **Kon|sor|ti|um** [...*zium*] (Genossenschaft; vorübergehende Vereinigung von Unternehmen zur Durchführung von Geschäften, die mit großem Kapitaleinsatz u. großem Risiko verbunden sind) *s*; -s, ...ien [...*iᵉn*]

Kon|spekt *lat.* (DDR: schriftl. Inhaltsangabe, Übersicht, Verzeichnis) *m*; -[e]s, -e

Kon|spi|ra|ti·on *lat.* [...*zion*] (Verschwörung); **kon|spi|ra|tiv** (verschwörerisch); **kon|spi|rie|ren** (sich verschwören; eine Verschwörung anzetteln)

[1]**Kon|sta|bler** *lat.* (früher: Geschützmeister usw. [auf Kriegsschiffen] *m*; -s, -; [2]**Kon|sta|bler** *engl.* (in England u. in den USA: Polizist) *m*; -s, -

kon|stant *lat.* (beharrlich, feststehend], ständig, unveränder-

lich, stet[ig]; **Kon|stan|te** (eine mathemat. Größe, deren Wert sich nicht ändert; Ggs.: Veränderliche) *w*; -[n], -n (↑ R 291)

Kon|stan|tin (österr. nur so; auch: ...*tin*) (m. Vorn.); - der Große (röm. Kaiser); **kon|stan|ti|nisch**, aber (↑ R 179): die Konstantinische Schenkung; **Kon|stan|ti|no-pel** (früherer Name für: Istanbul); **Kon|stan|ti|no|pe|ler**, **Kon-stan|ti|no|pel|ler**, **Kon|stan|ti|no|po-li|ta|ner** (↑ R 199); [1]**Kon|stanz** *lat.* (Beharrlichkeit, Unveränderlichkeit; Stetigkeit) *w*; -; [2]**Kon-stanz** (Stadt am Bodensee); **Kon-stan|ze** (w. Vorn.); **kon|sta|tie|ren** *fr.* (feststellen); **Kon|sta|tie|rung**

Kon|stel|la|ti·on *lat.* [...*zion*] (Stellung der Gestirne zueinander; Zusammentreffen von Umständen; Lage)

Kon|ster|na|ti·on *lat.* [...*zion*] (veralt. für: Bestürzung); **kon|ster-nie|ren** (veraltend für: verblüffen, verwirren); **kon|ster|niert** (bestürzt, betroffen)

Kon|sti|pa|ti·on *lat.* [...*zion*] (Med.: Verstopfung, Hartleibigkeit)

Kon|sti|tu|an|te vgl. Constituante; **Kon|sti|tu|en|te** *lat.* (Sprachw.: sprachl. Bestandteil eines größeren Ganzen) *w*; -, -n; **kon|sti|tu-ieren** *lat.(-fr.)* (einsetzen, festsetzen, gründen); sich - (zusammentreten [zur Beschlußfassung]); -de Versammlung; **Kon|sti|tu|ie-rung; Kon|sti|tu|ti·on** [...*zion*] (Rechtsbestimmung; Verfassung [eines Staates, einer Gesellschaft], Grundgesetz; päpstl. Erlaß; Beschaffenheit, Verfassung des [menschl.] Körpers); **Kon|sti-tu|tio|na|lis|mus** (Staatsform auf dem Boden einer Verfassung) *m*; -; **kon|sti|tu|tio|nell** *fr.* (verfassungsmäßig; Med.: auf die Körperbeschaffenheit bezüglich; anlagebedingt); -e Monarchie; **Kon-sti|tu|ti·ons|typ; kon|sti|tu|tiv** *lat.* (das Wesen einer Sache bestimmend; grundlegend)

Kon|strik|ti·on *lat.* [...*zion*] (Med.: Zusammenziehung [von Körpern]; Abbinden von Blutgefäßen); **Kon|strik|tor** (Med.: Schließmuskel) *m*; -s, ...oren· **kon|strin|gie|ren** [...*ßtringgirᵉn*] (Med.: zusammenziehen [von Muskeln])

kon|stru|ieren *lat.*; **Kon|struk|teur** *fr.* [...*tör*] (Erbauer, Erfinder, Gestalter) *m*; -s, -e; **Kon|struk|teu|rin** [...*törin*] *w*; -, -nen; **Kon|struk|ti·on** *lat.* [...*zion*]; **Kon|struk|ti|ons-.bü|ro, ...feh|ler; konstruk|tiv** (die Konstruktion betreffend; folgerichtig; aufbauend); -es Miß-trauensvotum; **Kon|struk|ti|vis-

mus [...*wiß*...] (Richtung der bildenden Kunst u. der Architektur um 1920) *m*; -; Kon|struk|ti|vist (↑ R 268); kon|struk|ti|vi|stisch

Kon|sul *lat.* (höchster Beamter der röm. Republik; heute: Vertreter eines Staates zur Wahrnehmung seiner [wirtschaftl.] Interessen in einem anderen Staat) *m*; -s, -n; Kon|su|lar|agent; kon|su|la|risch; Kon|su|lar|recht; Kon|su|lat (Amt[sgebäude] eines Konsuls) *s*; -[e]s, -e; Kon|su|lats|ge|bäu|de; Kon|su|lent (veralt. für: Anwalt, Berater); ↑ R 268; Kon|sul|ta|ti|on [...*zion*] (Befragung, bes. eines Arztes); Kon|sul|ta|ti|ons|mög|lich|keit; kon|sul|ta|tiv (beratend); kon|sul|tie|ren ([den Arzt] befragen; zu Rate ziehen)

Kon|sum *it.* (Verbrauch; [meist: *kon*..., österr. nur ...*sum* für:] Verkaufsstelle eines Konsumvereins, Konsumverein) *m*; -s, (für: Verkaufsstelle auch *Mehrz*..) Konsums; Kon|sum|ar|ti|kel; Kon|su|ma|ti|on *fr.* [...*zion*] österr. u. schweiz. (Verzehr, Zeche); Kon|su|ment *lat.* (Verbraucher; Käufer); ↑ R 268; Kon|sum|~ge|nos|sen|schaft (Verbrauchergenossenschaft, vgl. co op), ...ge|sell|schaft, ...gut (meist *Mehrz*.); Kon|sum|gü|ter|in|du|strie; kon|su|mie|ren (verbrauchen; verzehren); Kon|su|mie|rung, Kon|sum|ti|on [...*zion*] (Verbrauch); Kon|sum|ti|bi|li|en [...*ien*] (veralt. für: Verbrauchsgüter) *Mehrz*.; Kon|sum|ver|ein (Verbrauchergenossenschaft); vgl. Konsum

Kon|ta|gi|on *lat.* (Med.: Ansteckung); kon|ta|gi|ös (ansteckend, übertragbar); -este (↑ R 292); Kon|ta|gio|si|tät (Med.: Ansteckungsmöglichkeit) *w*; -; Kon|ta|gi|um (Med.: veralt. für: Ansteckung[sstoff]) *s*; -s, ...ien [...*ien*]

Kon|takt *lat.* (Berührung, Verbindung) *m*; -[e]s, -e; kon|takt|arm; Kon|takt_ar|mut, ...auf|nah|me; Kon|takt|ter (Wirtsch.); kon|takt|freu|dig; Kon|takt|glas (*Mehrz*. ...gläser); kon|tak|tie|ren (Kontakt[e] aufnehmen); jmdn. od. mit jmdm. -; Kon|takt_in|fek|ti|on, ...in|sek|ti|zid; kon|takt|los; Kon|takt|lo|sig|keit *w*; -; Kon|takt_lin|se, ...man|gel *m*, ...mann (*Mehrz*. ...männer), ...nah|me (*w*; -, -n), ...scha|le, ...schwä|che, ...stoff, ...stu|di|um, ...zaun

Kon|ta|mi|na|ti|on *lat.* [...*zion*] (Sprachw.: Verschmelzung, Wortkreuzung, z. B. „Gebäulichkeiten“ aus „Gebäude“ u. „Baulichkeiten“; Verseuchung mit schädlichen, bes. radioaktiven Stoffen); kon|ta|mi|nie|ren

kon|tant *it.* (bar); Kon|tan|ten (ausländ. Münzen, die nicht als Zahlungsmittel, sondern als Ware gehandelt werden) *Mehrz*.

Kon|tem|pla|ti|on *lat.* [...*zion*] (schauende Versunkenheit [in Gott]; Beschaulichkeit, Betrachtung); kon|tem|pla|tiv

Kon|te|nance *fr.* [*kongt'ngngß*] (veralt. für: Haltung; Fassung) *w*; -; die - bewahren

Kon|ten_plan, ...rah|men

Kon|ten|ten *lat.* (Ladeverzeichnisse der Seeschiffe) *Mehrz*.; Kon|ten|tiv|ver|band *lat.*; *dt.* (med. Stützverband)

kon|ter... *fr.* (gegen...); Kon|ter... (Gegen...); Kon|tor (Boxen: Konterschlag, das Kontern) *m*; -s, -; Kon|ter|ad|mi|ral (Flaggoffizier); Kon|ter|ban|de (Schmuggelware; Bannware) *w*; -; Kon|ter|fei (auch: ...*fai*] (veralt., aber noch scherzh. für: [Ab]bild, Bildnis) *s*; -s, -s (auch: -e); kon|ter|fei|en (auch: *kon*...] (veralt., aber noch scherzh. für: abbilden); konter|feit (↑ R 304); Kon|ter|mi|ne (Festungswesen: Gegenmine; Börse: Gegen-, Baissespekulation), kon|tern *engl.* (Druckw.: ein Druckbild umkehren; Sport: den Gegner im Angriff durch gezielte Gegenschläge abfangen; durch eine Gegenaktion abwehren); ich ...ere (↑ R 327); Kon|ter_re|vo|lu|ti|on (Gegenrevolution); kon|ter|re|vo|lu|tio|när; Kon|ter_schlag (bes. Boxen), ...tanz (alter Tanz)

Kon|text *lat.* [auch: *kon*...] (umgebender Text; Zusammenhang; Inhalt [eines Schriftstücks]) *m*; -[e]s, -e; Kon|text|glos|se (Glosse [vgl. d.], die in den Text [einer Handschrift] eingefügt ist); kon|tex|tu|ell (den Kontext betreffend)

Kon|ti (*Mehrz*. von: Konto; kon|tie|ren *it.* (ein Konto benennen; auf ein Konto verbuchen)

Kon|ti|gui|tät *lat.* [...*gu-i*...] (Psych.: zeitl. Zusammensein verschiedener Erlebnisinhalte) *w*; -

Kon|ti|nent *lat.* [auch: *kon*...] (Festland; Erdteil) *m*; -[e]s, -e; kon|ti|nen|tal; Kon|ti|nen|tal|eu|ro|pa; kon|ti|nen|tal|eu|ro|pä|isch; Kon|ti|nen|tal|kli|ma (*w*; -s, ...macht, ...sper|re (hist.; *w*; -)

Kon|ti|nenz *lat.* (Med.: Fähigkeit, Stuhl u. Urin zurückzuhalten) *w*; -

Kon|tin|gent *lat.* [...*ngg*...] (Anteil; [Pflicht]beitrag; [Höchst]betrag; [Höchst]menge; Zahl der [von Einzelstaaten] zu stellenden Truppen) *s*; -[e]s, -e; kon|tin|gen|tie|ren (das Kontingent festset-

zen; [vorsorglich] ein-, zuteilen); Kon|tin|gen|tie|rung; Kon|tin|gent[s]|zu|wei|sung

Kon|ti|nua|ti|on *lat.* [...*zion*] (veralt., aber noch Buchw. für: Fortsetzung); kon|ti|nu|ier|lich (stetig, fortdauernd, unaufhörlich; durchlaufend); -er Bruch (Math.: Kettenbruch); Kon|ti|nui|tät [...*nu-i*...] (lückenloser Zusammenhang, Stetigkeit, Fortdauer) *w*; -; Kon|ti|nu|um [...*u-um*] (lückenlos Zusammenhängendes, Stetiges) *s*; -s, ...nua

Kon|to *it.* (Rechnung; Aufstellung über Forderungen u. Schulden) *s*; -s, ...ten (auch: -s u. ...ti); vgl. a conto; Kon|to_aus|zug, ...buch, ...in|ha|ber; Kon|to|kor|rent (laufende Rechnung) *s*; -[e]s, -e; Kon|to|num|mer; Kon|tor *niederl.* (Geschäftsraum eines Kaufmanns) *s*; -s, -e; Kon|to|rist; ↑ R 268; Kon|to|ri|stin *w*; -, -nen

Kon|tor|si|on *lat.* (Med.: Verdrehung, Verrenkung eines Gliedes); Kon|tor|sio|nist (Schlangenmensch); ↑ R 268; kon|tort (Bot.: gedreht, geschraubt [von Blumenblättern]; veralt. für: verdreht, verwickelt)

kon|tra *lat.* (gegen, entgegengesetzt); vgl. auch: contra; Kon|tra (Kartenspiel: Gegenansage) *s*; -s; jmdm. - geben; Kon|tra_baß (Baßgeige), ...bas|sist; Kon|tra|dik|ti|on [...*zion*] (Widerspruch); kon|tra|dik|to|risch (widersprechend); -es Verfahren (normales [Prozeß]verfahren, bei dem beide Parteien gehört werden); Kon|tra|fa|gott (tiefes Fagott); Kon|tra|fak|tur (geistl. Nachdichtung eines weltl. Liedes [u. umgekehrt] unter Beibehaltung der Melodie) *w*; -, -en

Kon|tra|ha|ge *fr.* [...*haseh'*] (Studenterspr.: Verabredung eines Zweikampfes, Forderung); Kon|tra|hent *lat.* (Vertragschließender; Studentenspr.: Gegner [beim Zweikampf]); ↑ R 268; kon|tra|hie|ren (einen Kontrakt abschließen, vereinbaren; Studentenspr.: einen Zweikampf verabreden, jmdn. fordern); sich - (sich zusammenziehen)

Kon|tra|in|di|ka|ti|on *lat.* [...*zion*] (Med.: Gegenanzeige)

kon|trakt *lat.* (veralt. für: zusammengezogen; verkrümmt; gelähmt); Kon|trakt (Vertrag, Abmachung) *m*; -[e]s, -e; Kon|trakt_ab|schluß, ...bruch *m*; kon|trakt|brü|chig; kon|trak|til (Med.: zusammenziehbar); Kon|trak|ti|li|tät (Med.: Fähigkeit, sich zusammenzuziehen) *w*; -; Kon|trak|ti|on [...*zion*] (Zusammenziehung;

Einschnürung; Schrumpfung); Kon|trak|ti|ons|vor|gang; kon|trakt|lich (vertragsgemäß); Kon|trak|tur (Med.: Verkürzung [von Muskeln, Sehnen]; Versteifung) w; -, -en
Kon|tra|post it. (bild. Kunst: Ausgleich [bes. von Stand- u. Spielbein]) m; -[e]s, -e; Kon|tra|punkt lat. (Musik: Führung mehrerer selbständiger Stimmen im Tonsatz) m; -[e]s; Kon|tra|punk|tik (Lehre des Kontrapunktes; Kunst der kontrapunktischen Stimmführung) w; -; kon|tra|punk|tisch; kon|trär fr. (gegensätzlich; widrig); Kon|tra|si|gna|tur lat. (selten für: Gegenzeichnung); kon|tra|si|gnie|ren (selten für: gegenzeichnen); Kon|trast fr. ([starker] Gegensatz; auffallender Unterschied, bes. von Farben) m; -[e]s, -e; Kon|trast|brei (Med.), ...far|be, ...fut|ter (vgl. ²Futter); kon|tra|stie|ren fr. (sich unterscheiden, abstechen, einen [starken] Gegensatz bilden); kon|tra|stiv engl. (gegensätzlich; vergleichend); -e Grammatik; Kon|trast|mit|tel (Med.) s; kon|trast|reich
Kon|tra|zep|ti|on lat. [...zion] (Med.: Empfängnisverhütung) w; -; kon|tra|zep|tiv (empfängnisverhütend); -e Mittel
Kon|trek|ta|ti|ons|trieb lat.; dt. [...zion...] (Med.: Trieb zur körperl. Berührung)
Kon|tri|bu|ti|on [...zion] (veralt. für: Kriegssteuer; Beitreibung)
Kon|troll|ab|schnitt; Kon|troll|am|pe [Trenn.: ...troll|lam..., ↑R 236]; Kon|troll_ap|pa|rat, ...be|fug|nis, ...be|hör|de, ...da|tum; Kon|troll|le fr. w; -, -n; Kon|trol|ler engl. (Fahrschalter, Steuerschalter für elektr. Motoren) m; -s, -; Kon|trol|leur fr. [...lör] (Aufsichtsbeamter, Prüfer) m; -s, -e; kon|troll|ier|bar; Kon|troll|ier|bar|keit w; -; kon|trol|lie|ren; Kon|trol|li|ste [Trenn.: ...troll|li..., ↑R 236]; Kon|troll|kas|se, ...kom|mis|si|on; Kon|troll|lor it. österr. (Kontrolleur) m; -s, -e; Kon|troll_or|gan, ...pflicht, ...punkt, ...rat (oberstes Besatzungsorgan in Deutschland nach dem 2. Weltkrieg; m; -[e]s), ...stel|le, ...stem|pel, ...sy|stem, ...turm, ...uhr
kon|tro|vers [...wärß] (streitig, bestritten); -este (↑R 292); Kon|tro|ver|se [(wissenschaftl.] Streit[frage]) w; -, -n; Kon|tro|vers_theo|lo|gie, ...pre|digt
Kon|tu|maz lat. (veralt. für: Nichterscheinen vor Gericht; österr. veralt. für: Quarantäne) w; -; vgl. in contumaciam; Kon|tu-

ma|zi|al|be|scheid (veralt. für: in Abwesenheit [des Beklagten] ergangener Bescheid); kon|tu|ma|zie|ren (veralt. für: in Abwesenheit verurteilen)
Kon|tur fr. (Umriß[linie]; andeutende Linie[nführung]) w; -, -en (in der Kunst auch: m; -s, -en) meist Mehrz.; Kon|tur|buch|sta|be (Buchstabe der Konturschrift); Kon|tu|ren.schär|fe, ...stift (zum Nachziehen der Lippenkonturen); kon|tu|rie|ren (die äußeren Umrisse ziehen; umreißen; andeuten); Kon|tur|schrift (Druckw.: bestimmte Schriftart)
Kon|tu|si|on lat. (Med.: Quetschung)
Ko|nus gr. (Kegel; der Druckbuchstaben der das Schriftbild tragende Oberteil) m; -, Konusse (Technik auch: Konen)
Kon|va|les|zenz lat. [...wa...] (Rechtsw.: nachträgliches Gültigwerden von ungültigen Rechtsgeschäften; Med.: Genesung) w; -, (selten:) -en; Kon|va|les|zie|ren
Kon|vek|ti|on lat. [...wäkzion] (Phyik: „Mitführung" von Energie od. elektr. Ladung durch die kleinsten Teilchen einer Strömung); kon|vek|tiv; Kon|vek|tor (ein Heizkörper) m; -s, ...oren
kon|ve|na|bel fr. [...we...] (veralt. für: schicklich; passend, bequem; annehmbar); ...a|ble Preise; kon|ve|ni|at lat. (Zusammenkunft der kath. Geistlichen eines Dekanats) s; -s, -s; Kon|ve|ni|enz (Herkommen; Schicklichkeit; Zuträglichkeit; Bequemlichkeit) w; -, -en; kon|ve|nie|ren (veralt. für: passen; annehmbar sein); Kon|vent [...wänt] („Zusammenkunft"; Versammlung der Mitglieder einer Studentenverbindung; Bez. für stud. Verbände; Gesamtheit der Konventualen, Versammlung der Mönche; nur Einz.: Nationalversammlung in Frankreich 1792-95) m; -[e]s, -e; Kon|ven|ti|kel [...kel] ([heimliche] Zusammenkunft; private relig. Versammlung) s; -s, -; Kon|ven|ti|on fr. [...zion] (Übereinkunft, Abkommen; Herkommen, Brauch, Förmlichkeit); kon|ven|tio|nal lat. (die Konvention betreffend); Kon|ven|tio|nal|stra|fe (Vertragsstrafe); kon|ven|tio|nell fr. (herkömmlich; üblich; förmlich); Kon|ven|tua|le lat. (stimmberechtigtes Klostermitglied; Angehöriger eines kath. Ordens) m; -n, -n (↑R 268)
kon|ver|gent [...wär...] (sich zuneigend, zusammenlaufend); Kon|ver|genz (Annäherung,

Übereinstimmung) w; -, -en; kon|ver|gie|ren
Kon|ver|sa|ti|on fr. [...wärsazion] (gesellige Unterhaltung, Plauderei); Kon|ver|sa|ti|ons|le|xi|kon; kon|ver|sie|ren (veralt. für: sich unterhalten)
Kon|ver|si|on lat. [...wär...] (Umwandlung; Umdeutung; Umformung, Umkehrung; Glaubenswechsel; bes. der Übertritt zur kath. Kirche); Kon|ver|ter engl. (Hüttenw., Physik) m; -s, -; kon|ver|ti|bel fr. (frei austauschbar); ...i|ble Währung; Kon|ver|ti|bi|li|tät (Konvertierbarkeit) w; -; Kon|ver|tier|bar; Kon|ver|tier|bar|keit (Möglichkeit, die Landeswährung gegen eine beliebige andere einzutauschen und frei darüber zu verfügen) w; -; kon|ver|tie|ren lat.(-fr.) (umwandeln; umdeuten; umformen, umkehren; ändern; den Glauben wechseln); Kon|ver|tie|rung; Kon|ver|tit engl. (zu einem anderen Glauben Übergetretener) m; -en, -en (↑R 268); Kon|ver|ti|ten|tum s; -s
kon|vex lat. [...wäkß] (erhaben, nach außen gewölbt); Kon|vex|lin|se
Kon|vikt lat. [...wikt] (Stift, Heim für Theologiestudenten; österr. für: Schülerheim) s; -[e]s, -e; Kon|vik|tua|le (veralt. für: Angehöriger eines Konviktes) m; -n, -n (↑R 268); Kon|vi|vi|um [...wiwi...] (veralt. für: Gelage) s; -s, ...ien [...i⁰n]
Kon|voi engl. [konweu, auch: konweu] (Geleitzug, bes. bei Schiffen) m; -s, -s
Kon|vo|ka|ti|on lat. [...wokazion] (veralt. für: Zusammen-, Einberufung)
Kon|vo|lut lat. [...wo...] (Bündel [von Schriftstücken od. Drucksachen]; Sammelband, -mappe) s; -[e]s, -e
Kon|vul|si|on lat. [...wul...] (Med.: Schüttelkrampf); kon|vul|siv, kon|vul|si|visch [...wisch] (krampfhaft zuckend)
kon|ze|die|ren lat. (zugestehen, einräumen)
Kon|zen|trat lat.; gr. (angereicherter Stoff, hochprozentige Lösung; hochprozentiger [Pflanzen-, Frucht]auszug) s; -[e]s, -e; Kon|zen|tra|ti|on [...zion] (Gruppierung [um einen Mittelpunkt]; Zusammenziehung [von Truppen]; [geistige] Sammlung; Chemie: Gehalt einer Lösung); Kon|zen|tra|ti|ons.fä|hig|keit, ...la|ger (Abk.: KZ), ...man|gel m, ...schwä|che; kon|zen|trie|ren ([Truppen] zusammenziehen, vereinigen; Chemie: anreichern,

gehaltreich machen); sich - (sich [geistig] sammeln); kon|zen|triert Chemie: angereichert, gehaltreich; übertr. für: gesammelt, aufmerksam); Kon|zen|triert|heit w; -; Kon|zen|trie|rung; kon|zentrisch (mit gemeinsamem Mittelpunkt; umfassend); -e Kreise; Kon|zen|tri|zi|tät (Gemeinsamkeit des Mittelpunktes) w; -

Kon|zept lat. (Entwurf; erste Fassung, Rohschrift) s; -[e]s, -e; Konzep|ti|on [...zion] (Empfängnis; [künstlerischer] Einfall; Entwurf eines Werkes); kon|zep|tio|nell; kon|zep|ti|ons|los; Kon|zep|ti|ons|lo|sig|keit; Kon|zept|pa|pier

Kon|zern engl. (Zusammenschluß wirtschaftl. Unternehmen) m; -s, -e; Kon|zer|nie|rung (Bildung von Konzernen)

Kon|zert it. s; -[e]s, -e; Konzert_abend, ...agentur; kon|zertant (konzertmäßig, in Konzertform); Kon|zert|flügel; kon|zertie|ren (ein Konzert geben; veralt. für: etwas verabreden, besprechen; eine konzertierte Aktion (bes. Wirtschaftspolitik: gemeinsam zwischen Partnern abgestimmtes Handeln); Kon|zert_mei|ster, ...pro|gramm, ...rei|se, ...saal, ...stück, ...tour|nee, ...veran|stal|tung

Kon|zes|si|on lat. (Zugeständnis; behördl. Genehmigung); Konzes|sio|när (Inhaber einer Konzession) m; -s, -e; kon|zes|sio|nie|ren (behördl. genehmigen); Konzes|si|ons_be|reit|schaft, ...in|haber; kon|zes|siv (Sprachw.: einräumend); Kon|zes|siv|satz (Sprachw.: Umstandssatz der Einräumung)

Kon|zil lat. ([Kirchen]versammlung) s; -s, -e u. -ien [...ien]; kon|zili|ant (versöhnlich, umgänglich, verbindlich); Kon|zi|li|anz (Umgänglichkeit, Entgegenkommen) w; -; Kon|zi|lia|ris|mus (kirchenrechtl. Theorie, die das Konzil über den Papst stellt) m; -; Konzils_er|geb|nis, ...va|ter (stimmberechtigter Teilnehmer an einem Konzil; meist Mehrz.)

kon|zinn lat. (Rhet.: ebenmäßig gebaut, abgerundet; veralt. für: gefällig, angemessen)

Kon|zi|pi|ent lat. (veralt. für: Verfasser eines Schriftstückes; [Jurist.] Hilfsarbeiter; österr.: Jurist [zur Ausbildung] in einem Anwaltsbüro); ↑ R 268; kon|zi|pie|ren (verfassen, entwerfen; Med.: empfangen, schwanger werden)

kon|zis lat. (Rhet.: kurz, gedrängt); -este (↑ R 292)

Koof|mich (verächtl. für: Kaufmann) m; -s, -e u. -s

Koog niederd. (dem Meere abgerungenes u. durch Deiche geschütztes Land; Polder) m; -[e]s, Köge; vgl. Kog

Ko|ope|ra|ti|on lat. [...zion] (Zusammenarbeit, Zusammenwirken); Ko|ope|ra|ti|ons|mög|lichkeit; ko|ope|ra|tiv; Ko|ope|ra|tiv s; -s, -e [...we] (auch: -s) u. Ko|ope|ra|ti|ve (DDR [selten]: Zusammenarbeit; Arbeitsgemeinschaft, Genossenschaft) w; -, -n; Ko|ope|ra|tor (veralt. für: Mitarbeiter; landsch. u. österr.: Kaplan, kath. Hilfsgeistlicher) m; -s, ...oren; ko|ope|rie|ren (zusammenwirken, arbeiten)

Ko|op|ta|ti|on lat. [...zion] (selten für: Ergänzungs-, Zuwahl); ko|op|tie|ren (selten für: hinzuwählen)

Ko|or|di|na|ten lat. (Math.: zusammenfassende Bez. für Abszisse u. Ordinate; Zahlen, die die Lage eines Punktes in der Ebene od. im Raum bestimmen) Mehrz.; Ko|or|di|na|ten_ach|se, ...sy|stem; Ko|or|di|na|ti|on [...zion]; Ko|or|di|na|tor (wer koordiniert, der Beauftragte der Rundfunk- u. Fernsehanstalten, der die verschiedenen Programme aufeinander abstimmt); ko|or|di|nie|ren (in ein Gefüge einbauen; aufeinander abstimmen; nebeneinanderstellen; Sprachw.: beiordnen); koordinierende Konjunktion (nebenordnendes Bindewort, z. B. ,,und"); Ko|or|di|nie|rung

Kop. = Kopeke

Ko|pai|va|bal|sam indian.; hebr. [...wa...] (ein Harz) m; -s

Ko|pal span.-indian. (ein Harz) m; -s, -e; Ko|pal_fich|te, ...harz, ...lack

Ko|pe|ke russ. (russ. Münze; Abk.: Kop.; 100 Kopeken = 1 Rubel) w; -, -n (↑ R 322)

Ko|pen|ha|gen (Hptst. Dänemarks); vgl. København; Ko|pen|ha|ge|ner (↑ R 199)

Kö|pe|nick (Stadtteil von Berlin); Kö|pe|nicker [Trenn.: ...nik|ker] (↑ R 199); Kö|pe|nickia|de [Trenn.: ...nik|kia...] (toller Streich [nach dem Hauptmann von Köpenick])

Ko|pe|po|de gr. (eine Krebstierart, Ruderfüßer) m; -n, -n (meist Mehrz.); ↑ R 268

Kö|per niederl. (ein Gewebe) m; -s, -; Kö|per|bin|dung

ko|per|ni|ka|nisch; -es Weltsystem, aber (↑ R 179): Ko|per|ni|ka|nisch; die Kopernikanischen ,,Sechs Bücher über die Umläufe der Himmelskörper" (Hauptwerk des Kopernikus); Ko|per|ni|kus (dt. Astronom)

Kopf m; -[e]s, Köpfe; von Kopf bis Fuß (↑ R 264); Kopf-an-Kopf-Ren|nen (↑ R 155); Kopf_ar|beit, ...ar|bei|ter, ...bahn|hof, ...ball; Kopf|ball|tor s; Kopf_be|deckung [Trenn.: ...dek|kung], ...be|wegung; Köpf|chen, Köpf|lein; köpfeln österr. (einen Kopfsprung machen; den Ball mit dem Kopf stoßen); ich ...[e]le (↑ R 327); köpfen; Kopf_en|de, ...form, ...fü|ßler, ...geld, ...haar, ...hal|tung, ...hänger; kopf|hän|ge|risch; -ste (↑ R 294); Kopf_haut, ...hö|rer; ...köp|fig (z. B. vielköpfig); ...köp|fisch (z. B. murrköpfisch); Kopf_jäger, ...kis|sen; kopf|la|stig; Kopf|la|stig|keit w; -; Kopf|lein, Köpflein, Köpf|chen; Köpf|ler österr. (Kopfsprung; Kopfstoß); kopf|los; -este (↑ R 292); Kopf_lo|sig|keit; Kopf_nicken [Trenn.: ...nik|ken; s; -s), ...putz; kopf|rech|nen (nur in der Grundform gebräuchlich); Kopf_rech|nen (s; -s), ...sa|lat; kopf|scheu; Kopf_schmerz, ...schmuck, ...schup|pe (meist Mehrz.), ...schuß, ...schüt|teln (s; s), kopf|schüt|telnd; Kopf_schütt|zer, ...sprung, ...stand; kopf|ste|hen (↑ R 140); ich stehe kopf; ich habe kopfgestanden; kopfzustehen; Kopf|ste|hen (s; -s), Kopf|stein_pfla|ster; Kopf_steu|er w, ...stim|me, ...stüt|ze, ...teil (s od. m), ...tuch (Mehrz. ...tücher); kopfüber; kopf|un|ter; Kopf_ver|band, ...ver|let|zung, ...wä|sche, ...wasser (Mehrz. ...wässer), ...weh (s; -s), ...wen|dung, ...wun|de, ...zahl, ...zer|bre|chen (s; -s; viel -)

Koph|ta (geheimnisvoller ägypt. Weiser) m; -[s]; Koph|tisch

Ko|pi|al|buch lat.; dt. (Buch für Abschriften von Urkunden, Rechtsfällen usw.); Ko|pia|li|en lat. [...ien] (veralt. für: Abschreibegebühren) Mehrz.; Ko|pia|tur (veralt. für: Abschreiben) w; -, -en; Ko|pie [österr.: kopie] (Abschrift; Abdruck; Nachbildung; Film: Abzug) w; -, ...ien [...jen, österr.: kopien]; Ko|pier_an|stalt, ...buch, ...druck (Mehrz. ...drucke); ko|pie|ren (eine Kopie anfertigen); Ko|pier_ge|rät, ...pa|pier, ...stift m

Ko|pi|lot (zweiter Flugzeugführer; zweiter Fahrer)

ko|pi|ös fr. (Med.: reichlich, in Fülle); -este (↑ R 292); Ko|pist ([Ab]schreiber; Nachbildner, Nachmaler); ↑ R 268

Kop|pe (ein Fisch; mdal. für: Kuppe, z. B. Schneekoppe) w; -, -n

^1Kop|pel (Riemen; durch Riemen verbundene Tiere; Verbundenes; eingezäunte Weide) w; -, -n; ^2Kop|pel (Leibriemen) s; -s, - (österr.:

w; -, -n); kop|pel|gän|gig (Jä-
gerspr.); -er Hund; kop|peln (ver-
binden); ich ...[e]le (↑ R 327); vgl.
kuppeln; Kop|pel|schloß; Kop|pe-
lung, Kopp|lung; Kop|pe|lungs-
ma|nö|ver od. Kopp|lungs|ma-
nö|ver; Kop|pel.wei|de, ...wirt-
schaft, ...wort (Mehrz. ...wörter)
kop|pen (Luft schlucken [eine
Pferdekrankheit])
kopp|hei|ster niederd. (kopfüber);
- schießen (einen Purzelbaum
schlagen)
Kopp|lung, Kop|pe|lung; Kopp-
lungs|ma|nö|ver od. Kop|pe-
lungs|ma|nö|ver
Ko|pra tamil.-port. (zerkleinerte
u. getrocknete Kokosnußkerne)
w; -
Ko|pro|duk|ti|on [...zion] (Ge-
meinschaftsherstellung, bes.
beim Film); Ko|pro|du|zent; ↑ R
268; ko|pro|du|zie|ren
Ko|pro|lith gr. (versteinerter Kot
[urweltl. Tiere]) m;-s od. -en, -e[n]
(↑ R 268); Ko|prom (Med.: Kotge-
schwulst) s; -s, -e; ko|pro|phag
(kotessend); Ko|pro|pha|ge (Kot-
esser) m u. w; -n, -n (↑ R 268);
Ko|pro|pha|gie (Med.: Kotessen)
w; -
Kops engl. (Spinnhülse mit aufge-
wundenem Garn, Garnkörper,
Kötzer) m; -es, -e
Kop|te gr. (christl. Nachkomme
der alten Ägypter) m; -n, -n (↑ R
268); kop|tisch; -e Schrift
Ko|pu|la lat. („Band"; Sprachw.:
Satzband) w; -, -s u. ...lae [...lä];
Ko|pu|la|ti|on [...zion] (veralt.
für: Verbindung; veralt. für:
Trauung; Biol.: Befruchtung; be-
stimmte Veredelung von Pflan-
zen); ko|pu|la|tiv (Sprachw.: ver-
bindend, anreihend); -e Kon-
junktion (anreihendes Binde-
wort, z. B. „und"); Ko|pu|la|ti-
vum [...tiwum] (Sprachw.: Zu-
sammensetzung aus zwei gleich-
geordneten Bestandteilen, z. B.
„taubstumm", „Hemdhose") s;
-s, ...va [...wa]; ko|pu|lie|ren
(Verb zu: Kopulation)
Ko|rah, (ökum.:) Ko|rach (bibl. m.
Eigenn.); eine Rotte Korah (ver-
alt.: ein randalierender Haufen)
Ko|ral|le gr. (Nesseltier oder
Schmuckstein aus seinem Ske-
lett) w; -, -n; ko|ral|len (aus Koral-
len, korallenrot); Ko|ral|len-
,bank (Mehrz. ...bänke), ...baum,
...in|sel, ...ket|te, ...riff; ko|ral-
len|rot; Ko|ral|lin (roter Farb-
stoff) s; -s
ko|ram lat. („vor aller Augen");
jmdn. - nehmen (veralt. für:
scharf tadeln); vgl. coram publi-
co; ko|ra|mie|ren (koram neh-
men)

Ko|ran arab. [auch: ko...] („Le-
sung"; „Vortrag"; Religions-
buch der Mohammedaner) m;
-s, -e
Korb m; -[e]s, Körbe; Korb|ball-
spiel; Korb|blüt|ler; Körb|chen,
Körb|lein; Kor|ber schweiz.
(Korbmacher); Korb.fla|sche,
...flech|ter
Kor|bi|ni|an [auch: ...bi...] (ein
Heiliger; auch: m. Vorn.)
Körb|lein, Körb|chen; Korb.ma-
cher, ...ses|sel, ...stuhl, ...wa|gen,
...wei|de (vgl. ¹Weide)
¹Kord (niederd. Kurzform von:
Konrad)
²Kord engl. (geripptes Gewebe) m;
-[e]s, -e; Kord|an|zug
Kor|de fr. (veralt. für: schnurarti-
ger Besatz) w; -, -n; Kor|del (süd-
westd. für: Bindfaden; österr.:
svw. Korde) w; -, -n
Kor|de|lia, Kor|de|lie vgl. Corde-
lia, Cordelie
Kord.ho|se, ...rock
kor|di|al lat. (herzlich; vertrau-
lich)
kor|die|ren fr. (feine schrau-
benförmige Linien in Gold- u.
Silberdraht einarbeiten; Griffe
an Werkzeugen zur besseren
Handhabung aufrauhen); Kor-
dier|ma|schi|ne
Kor|dil|le|re span. [...diljer⁰];
(„Gebirgskette") w; -, -n; Kor|dil-
le|ren [südamerik. Gebirgszug]
Mehrz.
Kor|dit fr. (Schießpulver) m; -s
Kord|jacke [Trenn.: ...jak|ke]
Kor|don fr. [...dong, österr.: ...dóŋ]
(Postenkette, Absperrung; Or-
densband; Spalierbaum) m; -s, -s
u. (österr.:) -e; Kor|do|nett.sei|de
(Zwirn-, Schnurseide), ...stich
(Kördelchenstich)
Kord|samt
Kor|du|an (Leder [aus Córdoba])
s; -s
Kor|du|la vgl. Cordula
Ko|re gr. (gebälktragende Frauen-
gestalt) w; -, -n
Ko|rea (eine Halbinsel Ostasiens);
Ko|rea|krieg (1950 bis 1953); Ko-
rea|ner; ko|rea|nisch
Ko|re|fe|rat, Ko|re|fe|rent, ko|re-
fe|rie|ren vgl. Korreferat usw.
Ko|re|gis|seur
kö|ren [männl. Haustiere zur
Zucht] auswählen)
Kor|fi|ot (Bewohner der Insel
Korfu) m; -en, -en (↑ R 268); kor-
fio|tisch; Kor|fu [auch: korfu] (io-
nische Insel u. Stadt)
Ko|ri|an|der gr. (Gewürzpflanze)
m; -s, (selten:) -; Ko|ri|an|der-
schnaps
Ko|ri|an|do|li it. (österr. neben:
Konfetti) s; -[s], -

Ko|rin|na (altgr. Dichterin); vgl.
Corinna
Ko|rinth (gr. Stadt); Ko|rin|the
(kleine Rosinenart) w; -, -n; Ko-
rin|then|brot; Ko|rin|ther (↑ R
199); Ko|rin|ther|brief (↑ R 205);
ko|rin|thisch; -e Säulenordnung,
aber (↑ R 198): der Korinthische
Krieg
Kork (Rinde der Korkeiche; Ne-
benform von: Korken) m; -[e]s,
-e; Kor|ken (Stöpsel aus Kork)
m; -s, -; Kork|ei|che; ¹kor|ken (aus
Kork); ²kor|ken (dafür häufiger:
ent-, zukorken); Kor|ken|geld
(Entschädigung für den Wirt,
wenn der Gast im Wirtshaus
seinen eigenen Wein o. ä. trinkt);
Kor|ken|zie|her; Kork.geld (Ne-
benform von: Korkengeld),
...gür|tel, ...soh|le, ...we|ste, ...zie-
her (Nebenform von: Korkenzie-
her)
Kor|mo|phyt gr. (Sproßpflanze) m;
-en, -en (meist Mehrz.); ↑ R 268
Kor|mo|ran lat. [österr.: kor...] (ein
pelikanartiger Vogel) m; -s, -e
Kor|mus gr. (aus Wurzel u. Sproß-
achse bestehender Pflanzenkör-
per) m; -
¹Korn s; -[e]s, Körner u. (für Ge-
treideart Mehrz.:) -e; ²Korn (Teil
der Visiereinrichtung) s; -[e]s,
(selten:) -e; ³Korn (ugs. für:
Kornbranntwein) m; -[e]s, -; 3 -;
Korn|ähre
Korn|blu|me; korn|blu|men|blau;
Korn|brannt|wein; Körn|chen,
Körn|lein; Körndl|bau|er österr.
(Bauer, der hauptsächlich Ge-
treide anbaut)
Kor|nea vgl. Cornea
Kor|ne|lia, Kor|ne|lie, Kor|ne|li|us
vgl. Cornelia, Cornelie, Corne-
lius
Kor|nel|kir|sche lat.; dt. (ein Zier-
strauch) w; -, -n
kör|nen
Kor|ner vgl. Corner (Aufkäufer-
gruppe)
¹Kör|ner (Werkzeug[maschinen-
teil])
²Kör|ner, Theodor (dt. Dichter;
österr. Bundespräsident)
Kör|ner.fres|ser, ...fut|ter (vgl.
¹Futter)
¹Kor|nett fr. (früher: Fähnrich [bei
der Reiterei]) m; -[e]s, -e u. -s;
²Kor|nett (ein Blechblasinstru-
ment) s; -[e]s, -e u. -s; Kor|net-
tist (Kornettspieler); ↑ R 268
Korn.fäu|le (Stinkbrand des Ge-
treides), ...feld; kör|nig
kor|nisch; Kor|nisch (in Cornwall
gesprochene kelt. Sprache) s; -[s];
vgl. Deutsch; Kor|ni|sche s; -n;
vgl. Deutsche s

Korn|kam|mer; Körn|lein, Körn-
chen; Korn|ra|de (ein Getrei-
deunkraut); Korn|spei|cher; Kör-
nung (bestimmte Größe kleiner
Materialteilchen; das Körnen;
Jägerspr.: Futter zur Wildfütte-
rung; auch für: Futterplatz)
Ko|rol|la, Ko|rol|le gr. (Blumen-
krone) w; -, ...llen; Ko|rol|lar s;
-s, -e u. Ko|rol|la|ri|um (Logik;
Satz, der selbstverständlich aus
einem bewiesenen Satz folgt) s;
-s, ...ien [...ien]
Ko|ro|man|del (vorderind. Kü-
stenstrich); Ko|ro|man|del.holz,
...kü|ste (w; -)
¹Ko|ro|na gr. („Kranz", „Krone";
Heiligenschein in der Kunst;
Strahlenkranz [um die Sonne];
ugs. für: [fröhliche] Runde,
[Zuhörer]kreis; auch für: Horde)
w; -, ...nen; ²Ko|ro|na gr. Corona
Kör|per m; -s, -; Kör|per.bau (m;
-[e]s), ...be|herr|schung; kör|per-
be|hin|dert; Kör|per|be|hin|der|te
m u. w; -n, -n (↑ R 287 ff.); Kör|per-
er|zie|hung, ...fül|le, ...ge|ruch,
...ge|wicht,...grö|ße; kör|per|haft;
Kör|per.hal|tung, ...kraft, ...kul-
tur (w; -), ...län|ge; kör|per|lich;
Kör|per|lich|keit w; -, kör|per|los;
Kör|per.pfle|ge (w; -), ...schaft;
kör|per|schaft|lich; Kör|per-
schafts|steu|er, Kör|per|schaft-
steu|er w (↑ R 334); Kör|per.teil
m,...tem|pe|ra|tur, ...ver|let|zung,
...wär|me
Kor|po|ra (Mehrz. von: ²Korpus)
Kor|po|ral fr.(früher: Führer einer
Korporalschaft; Unteroffizier;
schweiz.: niederster Unteroffi-
ziersgrad) m; -s, -e (auch: ...äle);
Kor|po|ral|schaft (früher: Unter-
gruppe der Kompanie für den in-
neren Dienst)
Kor|po|ra|ti|on lat. [...zion] (Kör-
perschaft, Innung, Personenviel-
heit mit Rechtsfähigkeit; Studen-
tenverbindung); kor|po|ra|tiv
(körperschaftlich; insgesamt, in
Masse; eine Studentenverbin-
dung betreffend); kor|po|riert
(einer stud. Korporation ange-
hörend); Korps fr. [kor] (Hee-
resabteilung; stud. Verbindung)
s; -[korß], - [korß]; Korps.bru|der,
...geist (m; -[e]s), ...stu|dent; kor-
pu|lent lat. (beleibt); Kor|pu|lenz
(Beleibtheit) w; -; ¹Kor|pus (ugs.
scherzh. für: Körper) m; -, ...pus-
se; ²Kor|pus (einer wissenschaftl.
Untersuchung zugrunde liegen-
der Text) s u. m; -, ...pora; ³Kor-
pus (ein Schriftgrad) w; -;Kor|pus-
kel („Körperchen"; kleines Teil-
chen der Materie) s; -s, -n (fach-
spr. häufig: w; -, -n); Kor|pus|ku-
lar|strah|len (Strahlen aus elektr.
geladenen Teilchen) Mehrz.

Kor|ral span. ([Elefanten]pferch;
[Fang]gehege für wilde Tiere) m;
-s, -e
Kor|ra|si|on lat. (Geol.: Ab-
schabung, Abschleifung)
Kor|re|fe|rat lat. [auch: kor...],
(österr.:) Ko|re|fe|rat (zweiter
Bericht; Nebenbericht) s; -[e]s, -e;
Kor|re|fe|rent [auch: kor...],
(österr.:) Ko|re|fe|rent (Mitgut-
achter); ↑ R 268; kor|re|fe|rie|ren,
(österr.:) ko|re|fe|rie|ren
kor|rekt lat.; kor|rekt|ter|wei|se;
Kor|rekt|heit w; -; Kor|rek|ti|on
[...zion] (veralt. für: Besserung,
Verbesserung; Regelung); kor-
rek|tiv (veralt. für: bessernd; zu-
rechtweisend); Kor|rek|tiv (Bes-
serungs-, Ausgleichsmittel) s; -s,
-e [...we]; Kor|rek|tor (Berichtiger
von Schriftsatzabzügen) m; -s,
...oren; Kor|rek|to|rat (Be-
triebsabteilung der Korrektoren)
s; -[e]s, -e; Kor|rek|tur (Berichti-
gung [des Schriftsatzes], Verbes-
serung; Prüfabzug) w; -, -en; Kor-
rek|tur.ab|zug, ...bo|gen, ...fah-
ne, ...zei|chen
kor|re|lat, kor|re|la|tiv lat. (einan-
der wechselseitig erfordernd und
bedingend); Kor|re|lat (Wechsel-
begriff; Ergänzung) s; -[e]s, -e;
Kor|re|la|ti|on [...zion] (Wechsel-
beziehung); Kor|re|la|ti|ons|rech-
nung (Math.); kor|re|lie|ren
kor|re|pe|tie|ren lat. (Musik: mit
jmdm. eine Gesangspartie vom
Klavier aus einüben); Kor|re|pe-
ti|tor (Einüber)
kor|re|spek|tiv lat. (gemeinschaft-
lich); -es Testament; Kor|re|spek-
ti|vi|tät [...wi...] (veralt. für: Ge-
meinschaftlichkeit) w; -
Kor|re|spon|dent lat. (auswärtiger,
fest engagierter [Zeitungs]be-
richterstatter; Bearbeiter des
kaufmänn. Schriftwechsels); ↑ R
268; Kor|re|spon|den|tin w; -,
-nen; Kor|re|spon|denz (Briefver-
kehr, -wechsel; ausgewählter u.
bearbeiteter Stoff für Zeitungen;
veraltend für: Übereinstim-
mung) w; -,-en; Kor|re|spon|denz-
bü|ro; Kor|re|spon|denz|kar|te
österr. veraltend (Postkarte);
kor|re|spon|die|ren (im Briefver-
kehr stehen; übereinstimmen;
korrespondierendes Mitglied
[auswärtiges Mitglied einer ge-
lehrten Gesellschaft])
Kor|ri|dor it. ([Wohnungs]flur,
Gang; schmaler Gebietsstreifen)
m; -s, -e; Kor|ri|dor|tür
kor|ri|gend lat. (veralt. für: [„zu
bessernder"] Sträfling) m; -en,
-en (↑ R 268); Kor|ri|gen|da
([Druck]fehler, Fehlerverzeich-
nis) Mehrz.; Kor|ri|gens (Pharm.:

geschmackverbessernder Zusatz
zu Arzneien) s; -, ...gentia u.
...genzien [...ien] (meist Mehrz.);
kor|ri|gie|ren (berichtigen; ver-
bessern)
kor|ro|die|ren lat. (angreifen, zer-
stören, der Korrosion unter-
liegen); Kor|ro|si|on (Zerna-
gung, Anfressung, Zerstörung
usw.); kor|ro|si|ons.be|stän|dig,
...fest; Kor|ro|si|ons.prä|pa|rat,
...schutz; kor|ro|si|on|ver|hü-
tend, aber (↑ R 142): die Korro-
sion verhütend; kor|ro|siv (an-
greifend, zerstörend)
kor|rum|pie|ren lat. (verderben;
bestechen); kor|rum|piert (ver-
derbt [von Stellen in alten Tex-
ten]); Kor|rum|pie|rung; kor|rupt
([moralisch] verdorben; bestech-
lich); Kor|rup|ti|on [...zion] ([Sit-
ten]verfall, -verderbnis; Bestech-
lichkeit; Bestechung); Kor|rup|ti-
ons.af|fä|re, ...skan|dal
Kor|sa|ge fr. [...asehe] ([träger-
loser] versteifter Büstenhalter
mit tiefem Dekolleté) w; -, -n
Kor|sar it. (Seeräuber[schiff],
Raubschiff) m; -en, -en (↑ R 268)
Kor|se (Bewohner Korsikas) m;
-n, -n (↑ R 268)
Kor|sett fr. (bequemes, leichtes
Korsett) s; -[e]s, -e u. -s; Kor|sett
(Mieder, Schnürleibchen) s; -[e]s,
-e u. -s; Kor|sett|stan|ge
Kor|si|ka (Insel im Mittelmeer);
vgl. Corsica; kor|sisch; der -e Er-
oberer (Napoleon)
Kor|so it. (Schaufahrt; Umzug;
Straße [für das Schaufahren]) m;
-s, -s
Kor|tege fr. [...täseh] (veralt. für:
Gefolge, Ehrengeleit) s; -s, -s
Kor|tex lat. (Med.: äußere Zell-
schicht eines Organs, bes. Hirn-
rinde) m; -[es], ...tizes [...zäß]; kor-
ti|kal (den Kortex betreffend)
Ko|rund tamil. (ein Mineral) m;
-[e]s, -e
Kö|rung [zu: kören]
Kor|vet|te fr. [...wäte] (leichtes [Se-
gel]kriegsschiff; Sport: Sprung in
den Handstand) w; -, -n; Kor|vet-
ten|ka|pi|tän
Kor|vey vgl. Corvey
Ko|ry|bant gr. (Priester der Kybe-
le) m; -en, -en (↑ R 268); ko|ry-
ban|tisch (wild begeistert, ausge-
lassen)
Ko|ry|da|lis [auch: ...rüd...] (eine
Zierpflanze) w; -, -
Ko|ry|phäe gr. (bedeutende Per-
sönlichkeit, hervorragender Ge-
lehrter, Künstler usw.) w; -, -n
(früher auch: m; -n, -n)
Kör|zeit
Kos (Insel des Dodekanes)
Ko|sak russ. (Angehöriger der mi-
litär. organisierten Grenzbewoh-

ner im zarist. Rußland; leichter Reiter) *m*; -en, -en (↑ R 268); **Ko|sa|ken.müt|ze, ...pferd**
Ko|sche|nil|le *span.* [...*nịl*ʲ*] (roter Farbstoff) *w*; -, (für rote Schildlaus auch *Mehrz.*:) -n; **Ko|sche|nịl|le|laus**
ko|scher *jidd.* (tauglich, sauber, bes. im Hinblick auf die Speisegesetze der Juden; rein, in Ordnung)
K.-o.-Schlag; ↑ R 155 (Boxsport: Niederschlag)
Koś|ciusz|ko [*koschtschụschko*] (poln. Nationalheld)
Ko|se|form
Ko|se|kans *lat.* (Seitenverhältnis im Dreieck; Zeichen: cosec) *m*; -, - (auch: ...anten)
ko|sen; du kost (kosest); du kostest; er ko|ste; gekost; **Ko|se.na|me,** ...**wort** (*Mehrz.* ...wörter)
K.-o.-Sie|ger; ↑ R 155
Ko|si|ma vgl. Cosima
Ko|si|nus *lat.* (Seitenverhältnis im Dreieck; Zeichen: cos) *m*; -, - u. -se
Kos|me|tik *gr.* (Schönheitspflege) *w*; -; **Kos|me|ti|ke|rin** *w*; -, -nen; **Kos|me|ti.in|du|strie, ...sa|lon; Kos|me|ti|kum** (Schönheitsmittel) *s*; -s, ...ka; **kos|me|tisch**; -e Chirurgie; -es Mittel
kos|misch *gr.* (im Kosmos; das Weltall betreffend; All...); -e Strahlung; **Kos|mo|bio|lo|gie** (Lehre von den außerird. Einflüssen auf die Gesamtheit der Lebenserscheinungen); **Kos|mo|drom** *gr.-russ.* (Startplatz für Raumschiffe) *s*; -s, -e; **Kos|mo|go|nie** *gr.* (Weltentstehungslehre) *w*; -, ...ien; **kos|mo|go|nisch; Kos|mo|gra|phie** (veralt. für: Weltbeschreibung) *w*; -, ...ien; **kos|mo|lo|gie** (Lehre von der Welt, bes. ihrer Entstehung) *w*; -, ...ien; **kos|mo|lo|gisch; Kos|mo|naut** *gr.-russ.* (Weltraumfahrer) *m*; -en, -en (↑ R 268); **Kos|mo|nau|tik** *w*; -; **Kos|mo|nau|tin** *w*; -, -nen; **Kos|mo|po|lit** *gr.* (Weltbürger) *m*; -en, -en (↑ R 268); **kos|mo|po|li|tisch; Kos|mo|po|li|tis|mus** (Weltbürgertum) *m*; -; **Kos|mos** (Weltall, Weltordnung) *m*; -; **Kos|mo|the|is|mus** (Vergottung der Welt) *m*; -; **Kos|mo|tron** [auch: ...*trọn*] (Kernphysik: Teilchenbeschleuniger) *s*; -s, ...trọne (auch: -s)
Ko|so|blü|ten *äthiop.*; *dt.* (ein Wurmmittel) *Mehrz.*
Kos|sat, Kos|sä|te, Kos|sä|te niederd. (Häusler, Kätner) *m*; ...ten, ...ten (↑ R 268)
Kos|suth [*kọschut*] (ung. Nationalheld)
Kos|sy|gin (sowjet. Politiker)
Kost *w*; -

ko|stal *lat.* (Med.: zu den Rippen gehörend)
Ko|sta|ri|ka usw. (eindeutschend für: Costa Rica usw.)
kost|bar; Kọst|bar|keit
¹**ko|sten** (schmecken)
²**ko|sten** *lat.* (wert sein); es kostet mich viel [Geld], nichts, hundert Mark, große Mühe; das kostet ihn od. ihm die Stellung; **Ko|sten** *Mehrz.*; auf - des ... od. von ...; **Ko|sten.an|schlag, ...be|rech|nung, ...ent|wick|lung, ...er|stat|tung, ...ex|plo|si|on, ...fest|set|zung, ...fra|ge; ko|sten.frei, ...los; Ko|sten|lo|sig|keit** *w*; -; **Ko|sten.mie|te; ko|sten|pflich|tig; Ko|sten.punkt, ...sen|kung, ...stei|ge|rung, ...vor|an|schlag**
Kọst.gän|ger, ...ge|ber, ...geld
köst|lich; Kọst|lich|keit
Kọst|pro|be
Kọ|strit|zer Schwarz|bier Ⓦ *s*; - -[e]s
kost.spie|lig; Kọst|spie|lig|keit *w*; -
Ko|stüm *fr.* *s*; -s, -e; **Ko|stüm.bild|ner, ...fest, ...film, ...ge|schich|te; ko|stü|mie|ren,** sich [ver]kleiden); **Ko|stü|mie|rung; Ko|stüm|ver|leih**
Kọst|ver|äch|ter
K.-o.-Sy|stem (Austragungsmodus sportl. Wettkämpfe, bei dem der jeweils Unterliegende aus dem Wettbewerb ausscheidet)
Kọt *m*; -[e]s
Ko|tan|gens *lat.* (Seitenverhältnis im Dreieck; Zeichen: cot, cotg, ctg) *m*; -, -
Ko|tau *chin.* (demütige Ehrerweisung) *m*; -s, -s; - machen
¹**Kote** *fr.* [*kọt*] (Geländepunkt [einer Karte], dessen Höhenlage genau vermessen ist) *w*; -, -n
²**Ko|te** *w*; -, -n u. **Kọt|ten** niederd. (Häuslerwohnung, Hütte) *m*; -s,-
³**Kọ|te** *schwed.* (Lappenzelt) *w*; -, -n
Kö|te (hintere Seite der Zehe bei Rindern u. Pferden) *w*; -, -n
Ko|te|lett *fr.* („Rippchen"; Rippenstück) *s*; -[e]s, -s (selten: -e); **Ko|te|let|ten** (Backenbart) *Mehrz.*
Kö|ten.ge|lenk (Fesselgelenk)
Ko|ten.ta|fel (Höhentafel)
Kö|ter (verächtlich für: Hund) *m*; -s, -
Kö|te|rei niederd. veralt. (kleines Landgut)
Ko|te|rie *fr.* (veralt. für: Kaste; Klüngel, Sippschaft) *w*; -, ...ien
Kọt|flü|gel
Kö|then (Stadt südwestl. von Dessau); **Kö|the|ner** (↑ R 199)
Ko|thurn *gr.* (hochsohliger Bühnenschuh der Schauspieler im antiken Trauerspiel; übertr.: erhabener Stil) *m*; -s, -e

ko|tie|ren *fr.* (Kaufmannsspr.: Preis, Kurs festsetzen, notieren; veralt. für: Höhen messen); **Ko|tie|rung** (Zulassung eines Wertpapiers zur amtl. Eintragung an der Börse)
kọ|tig
Ko|til|lon *fr.* [*kọtiljong,* auch: *kotiljọng*] (Gesellschaftsspiel in Tanzform) *m*; -s, -s; **Ko|til|lon|ar|ti|kel**
Kọt|ner niederd. (Häusler, Besitzer eines Bauernhauses ohne Landbesitz)
Ko|ton *arab.-fr.* [...*tọng*] (selten für: Baumwolle) *m*; -s, -s; vgl. auch: Cotton; **ko|to|ni|sie|ren** (Chemie: Bastfasern die Beschaffenheit von Baumwolle geben); **Ko|to|ni|sie|rung**
Ko|tor, (auch:) Cạt|ta|ro (jugoslaw. Stadt)
Ko|to|rin.de *indian.*; *dt.* (früher: ein Heilmittel)
Kọt.saß od. ...**sas|se** niederd. (Kötner)
Ko|tschin|chi|na („Kleinchina", alte Bez. des Südteils von Vietnam); **Ko|tschin|chi|na|huhn**
Kọtt|bus vgl. Cottbus
Kọt|ten vgl. ²Kote
Kọt|ter (niederd. für: elende Hütte, Hundehütte; österr. veralt. Arrest) *m*; -s, -; **Kọt|ter** mdal (Inhaber einer ²Kote)
Ko|ty|le|do|ne *gr.* (Zotte der tierischen Embryohülle; pflanzl Keimblatt) *w*; -, -n
¹**Kọt|ze** landsch. (wollene Decke, Wollzeug; wollener Umhang) *w*; -, -n; vgl. Kotzen
²**Kọt|ze** (derb für: Erbrochenes) *w*; -
Kọt|ze mitteld. (Rückentragkorb) *w*; -, -n
Kọt|ze|bue [...*bu*] (dt. Schriftsteller)
kọt|zen (derb für: sich übergeben); du kotzt (kotzest)
Kọt|zen (Nebenform von: ¹Kotze) *m*; -s, -; **kọt|zen|grob** landsch. (sehr grob)
Kọt|zer (Garnkörper) *m*; -s, -
kọt|ze|rig (derb für: übel); **kọtz..jäm|mer|lich, ...lang|wei|lig ...übel** (derb)
Ko|va|ri|an|ten|phä|no|men *lat.; gr.* (Psych.: Täuschung der Raum-, Tiefenwahrnehmung)
Kox|al|gie *lat.; gr.* (Med.: Hüftgelenkschmerz) *w*; -, ...ien; **Ko|xi|tis** *lat.* (Med.: Hüftgelenkentzündung) *w*; -, ...itịden
Ko|zy|tus vgl. Kokytos
kp = Kilopond
KPD = Kommunistische Partei Deutschlands (als verfassungswidrig verboten)
kpm = Kilopondmeter

kr = Krone (Münzeinheit)
Kr = chem. Zeichen für: Krypton
Kr., Krs. = Kreis
Kraal vgl. Kral
Krab|be (Krebs; Bauw.: Steinblume an Giebeln usw.; ugs. für: Kind, junges Mädchen) w; -, -n; Krab|bel|al|ter; Krab|be|lei (ugs.); krab|be|lig, krabb|lig (ugs.); krab|beln (ugs. für: sich kriechend fortbewegen; kitzeln; jucken); ich ...[e]le (↑ R 327); es kribbelt u. krabbelt; vgl. aber: grabbeln
krab|ben (Geweben Glätte u. Glanz verleihen)
krabb|lig, krab|be|lig (ugs.)
krach!; Krach m; -[e]s, -e u. -s (ugs. auch: Kräche [Streitigkeiten]); mit Ach und - (mit Müh und Not); - schlagen; kra|chen; Krachen schweiz. (Schlucht, unwirtliches Tälchen) m; -s, -; Kra|cher; alter - (ugs. für: gebrechlicher Mann); Kra|cherl österr., bayr. (Brauselimonade) s; -s, -n; krachig; Krach|le|der|ne bayr. (kurze Lederhose) w; -n, -n; Krach|man|del; krächzen; du krächzt (krächzest); Krächzer (ugs. für: gekrächzter Laut; scherzh. für: Mensch, der heiser, rauh spricht); Kracke [Trenn.: Krakke] niederd. u. mitteld. (altes Pferd) w; -, -n; kracken [Trenn.: krak|ken] engl. [engl. Ausspr.: kräkⁿn] (Schweröle in Leichtöle umwandeln, spalten); Kräcker [Trenn.: Kräk|ker] m; -s, - vgl. Cracker; Krackung [Trenn.: Krak|kung]; Krack|ver|fah|ren (chem. Spaltverfahren)
Krad ([bes. bei Militär u. Polizei] Kurzform für: Kraftrad) s; -[e]s, Kräder; Krad_fah|rer, ...mel|der, ...schüt|ze
kraft (↑ R 130); mit Wesf.: - meines Wortes; ¹Kraft w; -, Kräfte; in - treten, aber (↑ R 120): das Inkrafttreten; außer - setzen; ²Kraft (m. Vorn.); Kraft_akt, ...an|strengung, ...auf|wand, ...aus|druck, ...brü|he, ...drosch|ke; Kräf|te.bedarf, ...paar (Physik), ...par|al|le|lo|gramm (Physik); kraft|er|füllt, aber (↑ R 142): von Kraft erfüllt; Kräf|te|ver|hält|nis; Kraft|fahrer; Kraft|fah|rer|gruß; deutscher - (ugs. iron.); Kraft|fahr|zeug (Abk.: Kfz); Kraft|fahr|zeug.brief, ...in|stand|set|zung, ...reparatur|werk|statt, ...steu|er w, ...ver|si|che|rung; Kraft_feld, ...fut|ter; kräf|tig; kräf|ti|gen; Kräf|tig|keit (veralt.) w; -; kräftig|lich (veralt.); Kräf|ti|gung; Kräf|ti|gungs|mit|tel s; kraft|los; -este (↑ R 292); kraft- und saftlos (↑ R 145); Kraft|los|er|klä|rung;

Kraft|lo|sig|keit w; -; Kraft_meier (ugs. für: Kraftmensch); ...post, ...pro|be, ...protz, ...rad (Kurzform: Krad), ...sport, ...stoff; Kraft|stoff.pum|pe, ...verbrauch; kraft|strot|zend, aber (↑ R 142): vor Kraft strot|zend; Kraft_ver|geu|dung, ...ver|kehr; kraft|voll; Kraft|wa|gen; Kraftwa|gen|ge|trie|be; Kraft_werk, ...wort (Mehrz. ...worte u. ...wörter)
Kra|ge (für: Konsole) w; -, -n; Krägel|chen, Krä|ge|lein, Krä|g|lein; Kra|gen m; -s, - (südd., österr. u. schweiz. auch: Krägen); Kragen.knopf, ...num|mer, ...wei|te; Krag.stein (voorpringender, als Träger verwendeter Stein), ...träger (für: Konsole)
Krä|he w; -, -n; krä|hen; Krähen.fü|ße (ugs. für: Fältchen in den Augenwinkeln; unleserlich gekritzelte Schrift; auf die Straße gestreute Eisenspitzen, die die Reifen von Polizeifahrzeugen beschädigen sollen; Mehrz.), ...nest (auch für: Beobachtungsstand am Schiffsmast)
Krähl (Bergmannsspr.: besonderer Rechen) m; -[e]s, -e; kräh|len
Kräh|win|kel (Ortsn.; [durch Kotzebues „Kleinstädter"] Inbegriff kleinstädtischer Beschränktheit); Kräh|win|ke|lei; Krähwink|ler (↑ R 199)
Kraich|gau (Hügelland zwischen Odenwald u. Schwarzwald) m; -[e]s; Kraich|gau|er (↑ R 199)
Krain (Westteil von Slowenien)
Krai|ner (österr. Politiker)
Kra|ka|tau (vulkanische Insel zwischen Sumatra u. Java)
Kra|kau (Stadt in Polen); Kra|kauer (eine Art Plockwurst) w; -, -
Kra|ke norw. (Riesentintenfisch; sagenhaftes Seeungeheuer) m; -n, -n (↑ R 268)
Kra|keel (ugs. für: Lärm u. Streit; Unruhe) m; -s; kra|kee|len (ugs.); krakeelt (↑ R 304); Kra|kee|ler (ugs.); Kra|kee|le|rei
Kra|ke|lee (eindeutschend für: Craquelé)
Kra|kel (ugs.: schwer leserliches Schriftzeichen) m; -s, -; Kra|ke|lei; Kra|kel|fuß (ugs. für: krakeliges Schriftzeichen) meist Mehrz.; kra|ke|lig, krak|lig (ugs.); kra|keln (ugs.); ich ...[e]le (↑ R 327)
Kra|ko|wi|ak poln. (poln. Nationaltanz) m; -s, -s
Kral port.-afrikaans (Runddorf afrik. Stämme) m; -s, -e
Kräll|chen; Kral|le w; -, -n; kral|len (mit den Krallen zufassen; ugs. für: unerlaubt wegnehmen); Kral|len_af|fe, ...frosch; kral|lig
Kram m; -[e]s

Kram|bam|bu|li (Studentenspr.: Danziger Branntwein; auch: Getränk aus Rum, Arrak u. Zucker) m; -[s], -[s]
Kräm|chen, Kräm|lein; krä|men (ugs. für: durchsuchen; aufräumen); Krä|mer (veralt., aber noch landsch. für: Kleinhändler); Krame|rei, ¹Krä|me|rei [zu: kramen]; ²Krä|me|rei (veralt., aber noch landsch. für: Kramladen); Krä|mer|geist m; -[e]s, kra|mer|haft; Krä|me|rin (veralt.) w; -, -nen; Krä|mer.la|tein (veralt., aber noch mdal. für: Kauderwelsch, Händlersprache), ...see|le (kleinlicher Mensch); Kram|la|den (abwertend für: kleiner Laden); Kräm|lein, Kräm|chen; Krammarkt
Kram|mets|vo|gel mdal. (Wacholderdrossel)
Kram|pe (U-förmig gebogener Metallhaken) w; -, -n; Kram|pen (Nebenform von: Krampe; bayr., österr. für: Spitzhacke) m; -s, -; kram|pen (anklammern)
Krampf m; -[e]s, Krämpfe; Krampf|ader; Krampf|ader|bildung; krampf|ar|tig; kramp|fen; sich -; krampf|haft; Krampf|husten österr. ugs. (Keuchhusten); kramp|fig; krampf|still|lend, aber (↑ R 142): nach Krampf stillend; Krampf|zit|tern s; -s
¹Kram|pus (Med.: Muskelkrampf) m; -, ...pi
²Kram|pus österr. (Begleiter des Sankt Nikolaus; Knecht Ruprecht) m; - u. -ses, -se
Kra|mu|ri österr. (Kram, Gerümpel) w; -
Kran (Hebevorrichtung; mdal. für: Zapfen, Zapfröhre, Wasserhahn) m; -[e]s. Kräne (fachspr. auch: Krane); Kran|bal|ken (Seemannsspr.); kran|bar (was gekrant werden kann); Krän|chen (mdal. für: Zapfen; auch: das Gezapfte); Emser - (Brunnenwasser); kra|nen (mit dem Kran transportieren)
Kra|ne|wit|ter österr. (Wacholderschnaps) m; -s, -
Kran|füh|rer
krän|gen (Seemannsspr.: sich nach der Seite neigen [vom Schiff]); Krän|gung
kra|ni|al gr. (Med.: den Schädel betreffend, Schädel...; kopfwärts)
Kra|nich (ein Sumpfvogel) m; -s, -e
Kra|nio|klast gr. (Med.: chirurg. Werkzeug) m; -en, -en (↑ R 268); Kra|nio|lo|gie (Schädellehre) w; -; Kra|nio|me|trie (Schädelmessung) w; -, ...ien; Kra|nio|ten (Wirbeltiere mit Schädel)

Mehrz.; Kra|nio|to|mie (Med.: Schädelöffnung) *w*; -, ...ien **krank**; kränker, kränkste. *Schreibung in Verbindung mit Zeitwörtern* (↑ R 139): I. *Getrenntschreibung:* - sein, werden, liegen; sich - fühlen, stellen; jmdn. - schreiben; sich - melden; sich - lachen. II. *Zusammenschreibung:* vgl. krankfeiern, krankmachen, krankschießen; **Kran|ke** *m* u. *w*; -n, -n (↑ R 287 ff.); **krän|keln**; ich ...[e]le (↑ R 327); **kran|ken** (krank sein); **krän|ken** (betrüben); **krän**kend; -ste; **Kran|ken**an**stalt**, ...be|richt, ...be|such, ...bett, ...blatt, ...geld, ...ge|schich|te, ...gut (bestimmte Anzahl untersuchter Patienten; *s*; -[e]s), ...gym|na|stik, ...gym|na|stin, ...haus, ...kas|se, ...la|ger, ...pfle**ge**, ...pfle|ge|rin, ...schwe|ster, ...trans|port; **kran**ken|ver|si|chert; **Kran|ken|ver|siche|rung**; **kran|ken|ver|siche**rungs|pflich|tig; **Kran|ken**wa**gen**, ...zim|mer; **krank|fei|ern**; ↑ R 139 (ugs. für: der Arbeit fernbleiben, ohne ernstlich krank zu sein; landsch. für: arbeitsunfähig sein; er hat gestern krankgefeiert; **krank|haft**; **Krank|haf|tigkeit** *w*; -; **Krank|heit**; **Krank|heits**bild; **Krank|heits|er|re|gend**; **Krank|heits|er|re|ger**; **krankheits|hal|ber**; **kränk|lich**; **Kränk|lich|keit** *w*; -; **krank|ma|chen**; ↑ R 139 (svw. krankfeiern); er hat krankgemacht; a b e r: das hat mich so krank gemacht; **Krankmel|dung**; **krank|schie|ßen**; ↑ R 139 (Jägerspr.: durch einen Schuß verletzen); er hat das Reh krankgeschossen; **Krän|kung** **Kran**wa**gen**, ...win|de

Kranz *m*; -es, Kränze; **Kränz|chen**, **Kränz|lein** (auch: **kränz|zen** (dafür häufiger: bekränzen); du kränzt (kränzest); **Kranz**ge|fäß (Med.), ...geld (Rechtsspr.), ...ge|sims, ...jung|fer (landsch. für: Brautjungfer), ...ku|chen; **Kränzl**jung**fer** bayr., österr. (Brautjungfer); **Kranz|nie|der|le|gung**

Kräpf|chen, **Kräpf|lein**; **Kräp|fel** südd. (Krapfen) *m*; -s, -; vgl. Kräppel; **Krap|fen** (Gebäck) *m*; -s, - **Krapp** *niederl.* (Färberpflanze) *m*; -[e]s

Kräp|pel mitteld. (kleiner Krapfen) *m*; -s, -

krap|pen vgl. krabben

Kra|pü|le *fr.* (veralt. für: Gesindel) *w*; -, -n

Kra|se (seltener für: Krasis) *w*; -, -n; **Kra|sis** *gr.* (Zusammenziehung zweier Wörter in eins) *w*; -, Krasen

kraß (ungewöhnlich; scharf; grell); krasser, krasseste; krasser Fall (unerhörter Fall); **Kraß|heit** [1]**Kra|ter** *gr.* (altgr. Krug) *m*; -s, -e; [2]**Kra|ter** (Mündungsöffnung eines feuerspeienden Berges; Abgrund) *m*; -s, -; **Kra|ter**land**schaft**, ...see *m*

Kratt niederd. (Eichengestrüpp) *s*; -[e]s, -e

Krätten (schweiz. nur so), **Krät**ten südd. u. schweiz. mdal. ([kleiner] Korb) *m*; -s, -

Kratz mdal. (Schramme) *m*; -es, -e; **Kratz**band (Bergmannsspr.) *s*, ...bee|re (mdal. meist für: Brombeere), ...bür|ste; **kratz**|bür**stig** (widerspenstig); **Kratz|bürstig|keit**; **Krätz|chen** (Soldatenspr.: Feldmütze); **Krat|ze** (ein Werkzeug) *w*; -, -n [1]**Krät|ze** südd. (Korb) *w*; -, -n [2]**Krät|ze** (Hautkrankheit; metallhaltiger Abfall) *w*; -; **Kratz|ei|sen**; **krat|zen**; du kratzt (kratzest); **Krät|zen**kraut *s*; -[e]s; **Krat|zer** (ugs. für: Schramme; Biol.: Eingeweidewurm); **Krät|zer** (saurer Wein, gärender Weinmost); **Kratz|fuß** (iron. für: übertriebene Verbeugung); **krat|zig**; **krät|zig**; **Krätz|mil|be**; **Kratz**putz (für: Sgraffito), ...spur

krau|chen bes. mitteld. (kriechen) **Kräu|el** mdal. (Haken, Kratze; Kralle [Werkzeug]) *m*; -s, -; **kräu**eln (selten); ich ...[e]le (↑ R 327); vgl. [2]kraulen; **kräu|en** (mit gekrümmten Fingern kratzen) **Kraul** *engl.* (Schwimmstil) *s*; -[s]; [1]**krau|len** (im Kraulstil schwimmen) [2]**krau|len** (zart krauen, sanft streicheln); vgl. a b e r: graulen **Kraul|er**; **Kraul**schwim**men** (*s*; -s), ...staf|fel

kraus; -este (↑ R 292); **Kraus|se** *w*; -, -n; **Kräu|sel**garn, ...krank|heit (Pflanzenkrankheit), ...krepp; **kräu|seln**; ich ...[e]le (↑ R 327); **Kräu|se|lung**; **Kraus|se|min|ze** (eine Heil- u. Gewürzpflanze); **krau|sen**; du kraust (krausest); er kraus|te; sich -; **Kraus|haar**; **kraus**haa|rig; **Kraus|kopf**; **kraus**köp|fig

Krauss, Clemens (österr. Dirigent) **Kraut** (südd., österr. *Einz.* auch für: Kohl) *s*; -[e]s, Kräuter; **kraut**ar|tig; **Kräut|chen**, **Kräut|lein**; **krau|ten** mdal. (Unkraut jäten); **Krau|ter** (veralt. für: Krautgärtner; heute noch abschätzig); **Kräu|ter** (*Mehrz.* von Kraut; Gewürz- und Heilpflanzen); **Kräuter**buch, ...kä|se, ...li|kör, ...tee, ...werk (veralt. für: Küchenkräuter); **Kraut**fäu|le (Kartoffelkrankheit), ...gar|ten (Gemüse-

garten), ...gärt|ner (Gemüse-, Kohlgärtner), ...häup|tel (österr. für: Kraut-, Kohlkopf); **Kräu**ticht (veralt. für: Bohnen-, Kartoffelkraut usw. nach der Ernte) *s*; -s, -e; **krau|tig** (krautartig); **Kraut**jun|ker, ...kopf (südd., österr. für: Kohlkopf); **Kräut**lein, **Kräut|chen**; **Kräut|lein** **Rühr|mich|nicht|an** *s*; -s -, - -; **Kräut|ler** österr. veralt. (Gemüsehändler); **Kraut**stie|le (schweiz. (Mangoldrippen [als Gemüse]) *Mehrz.*

Kra|wall (Aufruhr; Lärm; Unruhe) *m*; -s, -e; **Kra|wall**ma**cher** **Kra|wat|te** [nach dem fr. Namen der Kroaten] ([Hals]binde, Schlips; im Ringkampf: verbotener drosselnder Halsgriff) *w*; -, -n; **Kra|wat|ten|na|del**

kra|weelge**baut** [von: Karavelle]; -es Boot (mit aneinanderstoßenden Planken)

Kra|xe bayr., österr. (Rückentrage) *w*; -, -n; **Kra|xe|lei** (ugs.); **kra**xeln (ugs. für: mühsam steigen; klettern); ich ...[e]le (↑ R 327); **Krax|ler**

Kray|on *fr.* [*kräjoṇ*] (veralt. für: Blei-, Kreidestift) *m*; -s, -s; **Krayon|ma|nier** (ein Radierverfahren) *m*; -

Krä|ze schweiz. mdal. (Rückentragkorb) *w*; -, -n; vgl. [1]Krätze **Kre|as** *gr.* (ungebleichte Leinwand) *s*; -; **Krea|tin** (Stoffwechselprodukt des Eiweißes im Muskelsaft der Wirbeltiere u. des Menschen) *s*; -s

Krea|ti|on *lat.(-fr.)* [...*zioṇ*] (Modeschöpfung; veralt. für: Wahl; Erschaffung; **krea|tiv** (schöpferisch); **Krea|ti|vi|tät** (das Schöpferische, Schöpfungskraft) *w*; -; **Krea|ti|vi|täts|trai|ning**; **Krea|tur** *lat.* (Lebewesen, Geschöpf; Wicht, gehorsames Werkzeug) *w*; -, -en; **krea|tür|lich**; **Krea|tür|lich|keit** *w*; -

[1]**Krebs** (Krebstier) *m*; -es, -e; [2]**Krebs** (bösartige Geschwulst) *m*; -es, (für Krebsarten *Mehrz.*:) -e; **krebs|ar|tig**; **kreb|sen** (Krebse fangen; ugs. für: sich mühsam bewegen; rückwärtsgehen); du krebst (krebsest); **krebs|er|zeugend** (für: karzinogen); **Krebs**for|schung, ...gang (*m*; -[e]s), ...ge|schwulst (für: Karzinom), ...ge|schwür; **kreb|sig**; **krebskrank**, ...rot; **Krebs**scha|den, ...sup|pe, ...übel, ...zel|le

Kre|denz *it.* (Anrichtetisch; auch: Anrichteschrank) *w*; -; **kre**den|zen ([ein Getränk] feierlich anbieten, darreichen, einschenken); du kredenzt (kredenzest); kredenzt (↑ R 304); **Kre|denz**-

tisch; ¹Kre|d̲i̲t fr. (Fähigkeit u. Bereitschaft, Verbindlichkeiten ordnungsgemäß u. zum richtigen Zeitpunkt zu begleichen; [Ruf der] Zahlungsfähigkeit; befristet zur Verfügung gestellter Geldbetrag od. Gegenstand; übertr. für: Glaubwürdigkeit) m; -[e]s, -e; auf - (auf Borg); ²Kre|d̲i̲t lat. („Haben" [im Geschäftsbuch]; die rechte Seite, Habenseite eines Kontos) s; -s, -s; Kre|d̲i̲t_an_stalt, ...bank (Mehrz. ...banken), ...brief, ...bü|ro, ...ge|ber, ...genos|sen|schaft, ...hil|fe; kre|di|tie|ren fr. (Kredit gewähren, vorschießen; einem Schuldner einen Betrag - od. einen Schuldner für einen Betrag -; Kre|di|t̲i̲e̲|rung; Kre|d̲i̲t_in|sti|tut, ...markt, ...neh|mer; Kre|d̲i̲|tor lat. [österr.: ...di̲...] (Kreditgeber, Gläubiger) m; -s, ...oren; kre|d̲i̲t|wür|dig; Kre|d̲i̲t|wür|dig|keit w; -; Kre|d̲o („ich glaube"; Glaubensbekenntnis) s; -s, -s

Kre|feld (Stadt in Nordrhein-Westfalen); Kre|fel|der († R 199) kre|gel bes. nordd. (gesund, munter)

Kre̲i̲|de w; -, -n; untere, obere - (Geol.); kre̲i̲|de|bleich; Kre̲i̲_de_fel|sen, ...for|ma|ti|on (Geol.), ...kü|ste; kre̲i̲|den (veralt. für: mit Kreide bestreichen); Kre̲i̲|destrich; kre̲i̲|de|we̲i̲ß; Kre̲i̲|dezeich|nung; kre̲i̲|dig

re|ie̲ren lat.(-fr.) ([er]schaffen; etwas erstmals herausbringen od. darstellen); Kre|ie̲rung

_reis (auch für: Verwaltungsgebiet; Abk.: Kr., auch: Krs.) m; -es, -e; Kre̲i̲s_ab|schnitt, ...amt, ...arzt, ...bahn, ...be|we|gung, ...bo̲|gen

re̲i̲|schen; du kreischst (kreischest), er kreischt; du kreischtest (veralt. aber noch mdal.: krischst); gekreischt (veralt. aber noch mdal.: gekrischen); kreisch[e]!

re̲i̲|sel m; -s, -; Kre̲i̲|sel_kom|paß, ...lüf|ter (für: Turboventilator); kre̲i̲|seln; ich ...[e]le († R 327); Kre̲i̲|sel_pum|pe, ...ver|dich|ter (für: Turbokompressor); kre̲i̲en; du kreist (kreisest); er kreiste; vgl. aber: kreißen; Kre̲i̲|ser Jägerspr.: jmd., der bei frisch gefallenem Schnee Wild aus-macht); kre̲i̲s|för|mig; kre̲i̲s|frei; e Stadt

re̲i̲|sky (österr. Politiker)

re̲i̲s|lauf; Kre̲i̲s_lauf_mit|tel s, ...stö|rung; kre̲i̲s|rund; Kre̲i̲s|sä-_e

re̲i̲|ßen (in Geburtswehen liegen); du kreißt (kreißest); vgl. aber: reisen; Kre̲i̲|ßen|de w; -n, -n († R

287 ff.); Kre̲i̲ß|saal (Entbindungsraum im Krankenhaus)
Kre̲i̲s_stadt, ...tag, ...um|fang, ...ver|kehr

Krem (feine [schaumige] Süßspeise; seltener auch für: Hautsalbe) w; -, -s (ugs. auch: m; -s, -e); vgl. auch: Creme
Kre|ma|ti|on lat. [...zi̲o̲n] (veralt. für: Einäscherung [von Leichen]); Kre|ma|to|ri|um (Einäscherungshalle) s; -s, ...ien [...i̲e̲n]; kre|mi̲e̲|ren (veralt. für: einäschern)
Kre|ml (zu: Kreml)
Kreml [auch: krä̲m̲ᵉl] russ. (Stadtteil [in Moskau usw.]; nur Einz. übertr. für: Regierung der UdSSR) m; -s, -
Krem|pe [zu: Krampe] ([Hut]rand) w; -, -n
¹Krem|pel (ugs. für: [Trödel]kram) m; -s
²Krem|pel (Auflockerungsmaschine) w; -, -n; ¹krem|peln (Faserbüschel auflockern); ich ...[e]le († R 327)
²krem|peln (die Krempe aufschlagen); ich ...[e]le († R 327); krem|pen (veralt. für: ²krempeln)
Krems an der Do̲|nau (österr. Stadt)
Krem|ser [nach dem Berliner Fuhrunternehmer Kremser] (offener Wagen mit Verdeck) m; -s, -
Krem|ser We̲i̲ß (Bleiweiß) s; - -[es]
Kren slaw. südd., österr. (Meerrettich) m; -[e]s
Kre|nek (österr. Komponist)
Kren|gel (Nebenform von: Kringel; mdal. für: Brezel) m; -s, -; kren|geln (sich mdal. (sich winden, sich herumdrücken; umherschlendern); ich ...[e]le mich († R 327)
kren|gen usw. (Nebenform von: krängen usw.)
Kreo|le fr. (in Mittel- u. Südamerika urspr. Abkömmling roman. Einwanderer; teilweise auch: Farbiger) m; -n, -n († R 268); ¹Kreo|lin w; -, -nen
²Kreo|lin vgl. Creolin
Kreo|pha|ge gr. (svw. Karnivore) m; -n, -n († R 268); Kreo|sot (ein Räucher- u. Arzneimittel) s; -[e]s; Kreo|so|tal vgl. Creosotal
kre|pie̲|ren it. (bersten, platzen, zerspringen [von Sprenggeschossen]; derb für: verenden); Kre|pi-ta|ti|on lat. [...zi̲o̲n] (Med.: knarrendes, knisterndes Geräusch [bei Knochenbrüchen usw.])
Kre|pon fr. [...po̲ŋ] (Kreppart) m; -s, -s; Krepp (krauses Gewebe) m; -s, -s u. -e; Krepp|pa|pier [Trenn.: Kropp|pa..., † R 236]; krepp|ar|tig; krep|pen (Papier kräuseln); Krepp_flor, ...soh|le

Kre|scen|do vgl. Crescendo
Kre|sol (ein Desinfektionsmittel) s; -s
Kres|se (Name verschiedener Salat- u. Gewürzpflanzen; landsch. für: Gründling) w; -, -n
Kre̲ß|ling landsch. (svw. Kresse)
Kres|zen|tia [...zia̲] (w. Vorn.); ¹Kres|zenz lat. („Wachstum"; Herkunft [edler Weine]; veralt. für: Ertrag) w; -, -en; ²Kres|zenz (w. Vorn.)

kre|ta|ze̲i̲sch, kre|tä̲|zisch lat. (zur Kreideformation gehörend); -e Formation (Kreideschicht)
Kre̲|te schweiz. (Geländekamm, -grat) w; -, -n
Kre̲|ter (Bewohner Kretas) m; -s, -
Kre̲|thi und Ple̲|thi („Kreter und Philister" in Davids Leibwache; gemischte Gesellschaft, allerlei Gesindel) Mehrz. (ugs. auch Einz.: m od. s); Kre̲|ti|kus gr. (ein antiker Versfuß) m; -, ...zi
Kre|tin fr. [...tä̲ŋ] (Schwachsinniger) m; -s, -s; Kre|ti|nis|mus (Med.) m; -; kre|ti|no̲|id (Med.: kretinartig, wie ein Kretin)
kre|tisch (von Kreta); Kre|ti|zi (Mehrz. von: Kretikus)
Kre|ton österr. (Cretonne) m; -s, -e; Kre|ton|ne (eindeutschend für: Cretonne)
Kret|scham, Kret|schem slaw. ostmitteld. (Schenke) m; -s, -e; Kretsch|mer ostmitteld. (Wirt) m; -s, -
kreuchst (veralt. für: kriechst); kreucht (veralt. für: kriecht); was da kreucht u. fleugt
Kreut|zer|so|na|te (von Beethoven dem fr. Geiger R. Kreutzer gewidmet) w; -; † R 180
Kreuz lat.: s; -es, -e; († R 224:) das Blaue, Rote, Weiße, Eiserne Kreuz; über Kreuz; in die Kreuz u. [in die] Quere [laufen], aber († R 129): kreuz u. quer; Kreuz_ab|nah|me, ...as, ...auf|findung (kath. Fest; w;), ...band (s; Mehrz. ...bänder), ...bein (in Knochen), ...blu|me (Bauw.), ...blüt|ler (eine Pflanzenfamilie); kreuz_brav (ugs.), ...ehr|lich (ugs.); kreu|zen (über Kreuz legen; paaren; Seemannsspr.: im Zickzackkurs fahren); du kreuzt (kreuzest); sich - (sich überschneiden); Kreu|zer (ehem. Münze; Kriegsschiff, größere Segeljacht; († R 224:) großer, kleiner -; Kreu|zer|hö̲|hung (kath. Fest) w; -; Kreu|zes_tod, ...weg (Christi Weg zum Kreuze; vgl. Kreuzweg); Kreu|zes|zei|chen, Kreuz|zei|chen; Kreuz_fah|rer, ...fahrt, ...feu|er; kreuz|fi|del (ugs.); kreuz|för|mig; Kreuz_gang

m, ...ge|lenk, ...ge|wöl|be; kreu|zi|gen; Kreu|zi|gung; kreuz|lahm; Kreuz_ot|ter w, ...rit|ter; kreuz|sai|tig (beim Klavier); Kreuz-schmerz (meist Mehrz.), ...schna|bel (ein Vogel), ...spin|ne, ...stich (Zierstich); kreuz und quer; vgl. Kreuz; Kreuz|und|quer-fahrt; Kreu|zung; kreuz|un|glück-lich (ugs.); kreu|zungs|frei; Kreu-zungs|punkt; Kreuz_ver|band, ...ver|hör, ...weg (auch: Darstel-lung des Leidens Christi; vgl. Kreuzesweg); kreuz|wei|se; Kreuz|wort|rät|sel; Kreuz|zei-chen, Kreu|zes|zei|chen; Kreuz-zug

Kre|vet|te fr. [...wät*] (Garnelen-art) w; -, -n

Krib|be niederd. (Buhne) w; -, -n

krib|be|lig, kribb|lig (ugs. für: un-geduldig, gereizt); Krib|bel-krank|heit (Mutterkornvergif-tung); krib|beln (ugs. für: prik-keln, jucken; wimmeln); das Wasser kribbelt; es kribbelt mich; es kribbelt u. krabbelt; krjbb|lig vgl. kribbelig

Krjbs|krabs mdal. (Kauder-welsch, zauberartiges Gerede; wunderliches Durcheinander) m od. s; -

Krickel[1] (Gehörn der Gemse) s; -s, -[n]

krjcke|lig[1], krjck|lig ostmittel. (unzufrieden; tadelsüchtig, nör-gelnd); Krjckel|kra|kel[1] (ugs. für: unleserliche Schrift) s; -s, -; krjk-keln landsch. (streiten, zanken; tadeln; ugs. auch für: kritzeln); ich ...[e]le (↑ R 327)

Krjckel|wild[1] (Gamswild)

Krjck|en|te vgl. Kriekente

Krjcket[1] engl. (ein Ballspiel) s; -s; Krjcket_ball[1], ...spie|ler[1]

krjck|lig vgl. krickelig

Krj|da lat. österr. (Konkursverge-hen) w; -; Kri|dar, Kri|da|tar österr. (Gemeinschuldner) m; -s, -e

Krie|bel|krank|heit vgl. Krib-belkrankheit; Krie|bel_mücke [Trenn.: ...mük|ke], ...nuß

Krie|che (eine Pflaumensorte) w; -, -n

krie|chen; du krochst; du kröchest; gekrochen; kriech[e]!; vgl. kreuchst usw.; Krie|cher (ver-ächtl.); Krie|che|rei (verächtl.); krie|che|risch (verächtl.); -ste (↑ R 294); Krie|cherl österr. (Krieche) s; -s, -n; Krie|cherl|baum; Kriech-spur (Verkehrsw.), ...tier

Krieg m; -[e]s, -e; ¹krie|gen (veralt. für: Krieg führen); ²krie|gen (ugs. für: erhalten, bekommen); Krie-ger; Krie|ger_denk|mal (Mehrz.

¹Trenn.: ...k|k...

...mäler), ...grab; krie|ge|risch; -ste (↑ R 294); Krie|ger_tum (s; -s), ...wai|se, ...wit|we; krieg|füh-rend, aber (↑ R 142): einen langen Krieg führend; Krieg|füh|rung; Kriegs_an|lei|he, ...aus|bruch; kriegs|be|dingt; Kriegs_be|ginn, ...beil, ...be|ma|lung; in voller -; Kriegs|be|richt; Kriegs|be|richt-er|stat|ter; kriegs|be|schä|digt; Kriegs|be|schä|dig|te m u. w; -n, -n (↑ R 287ff.); Kriegs|be|schä-dig|ten|für|sor|ge; Kriegs_blin|de, ...dich|tung, ...dienst; Kriegs-dienst_ver|wei|ge|rer, ...ver|wei-ge|rung; Kriegs_ein|wir|kung, ...en|de, ...er|klä|rung, ...flot|te, ...frei|wil|li|ge, ...fuß; auf [dem] - mit jmdm. stehen; kriegs-ge|fan|gen; Kriegs_ge|fan|ge|ne, ...ge|fan|gen|schaft, ...ge|richt, ...ge|winn|ler; Kriegs|grä|ber-für|sor|ge; Kriegs_ha|fen (vgl. ²Hafen), ...het|ze, ...hin|ter|blie-be|ne, ...hin|ter|blie|be|nen|für-sor|ge, ...in|va|li|de, ...ka|me|rad, ...kunst, ...list, ...ma|ri|ne, ...ma-te|ri|al, ...op|fer, ...pfad, ...rat (m; -[e]s), ...recht, ...ro|man, ...scha-den, ...schau|platz, ...schiff, ...schuld, ...teil|neh|mer, ...trau-ung, ...trei|ber, ...ver|bre|cher, ...ver|let|zung, ...ver|sehr|te; kriegs|ver|wen|dungs|fä|hig (Abk.: kv.); Kriegs_wir|ren (Mehrz.), ...wirt|schaft, ...zu-stand

Kriek|en|te (kleine Wildente)

Kriem|hild, Kriem|hil|de (w. Vorn.)

Krjk|en|te vgl. Kriekente

Kri|ko|to|mie gr. (Med.: Spaltung des Ringknorpels der Luftröhre) w; -, ...ien

Krim (südruss. Halbinsel) w; -

Kri|mi [auch krj...] (ugs. für: Kri-minalroman, -film) m; -[s], -[s]; kri|mi|nal lat. (Verbrechen, schwere Vergehen, das Straf-recht, das Strafverfahren betref-fend); Kri|mi|nal österr. veral-tend u. mdal. (Strafanstalt, Zuchthaus) s; -s, -e; Kri|mi|nal-be|am|te; Kri|mi|na|le (ugs. für: Kriminalbeamte) m; -n, -n; er ist ein Kriminaler (↑ R 287ff.); Kri-mi|nal_film, ...ge|schich|te; kri-mi|na|li|sie|ren (etwas als krimi-nell hinstellen); Kri|mi|na|list (Kriminalpolizist; Strafrechts-lehrer); ↑ R 268; Kri|mi|na|li|stik (Lehre vom Verbrechen, von seiner Aufklärung usw.) w; -; kri-mi|na|li|stisch; Kri|mi|na|li|tät w; -; Kri|mi|nal_kom|mis|sar, ...mu-se|um, ...po|li|zei (Abk.: Kripo); ...pro|zeß (veraltet für: Strafpro-zeß), ...psy|cho|lo|gie, ...recht (Strafrecht), ...ro|man; kri|mi-

nell fr.; Kri|mi|nel|le (straffällig Gewordener) m; -n, -n; ein Kri-mineller (↑ R 287ff.); Kri|mi|no-lo|gie lat.; gr. (Wissenschaft von Verbrechen) w; -

Krim|krieg m; -[e]s; ↑ R 201

krim|meln, nur in (nordd.): es krimmelt u. wimmelt

Krim|mer [nach der Halbinse Krim] (urspr.: ein Lammfell heute: ein Wollgewebe) m; -s, -

krim|pen niederd. (einschrump-fen; einschrumpfen lassen; von Wind: sich von West nach Os drehen); gekrimpt u. gekrumpe

Krims|krams (ugs. für: Plunder durcheinanderliegendes, wer loses Zeug) m; -[es]

Krim|ste|cher [im Krimkrieg au gekommen] (veralt. für: Feldste cher); ↑ R 201

Krjn|gel (ugs. für: [kleiner, ge zeichneter] Kreis; auch für: [Zuk ker]gebäck) m; -s, -; krjn|ge|li (ugs. für: sich ringelnd); sich lachen; krjn|geln (ugs. für: Kreis zeichnen; Kreise ziehen); ic ...[e]le (↑ R 327); sich - (ugs. fü sich [vor Vergnügen] wälzen)

Kri|no|ide gr. (Haarstern od. See lilie, Stachelhäuter) m; -n, - (meist Mehrz.)

Kri|no|li|ne fr. (Reifrock) w; -, -

Kri|po = Kriminalpolizei

Krip|pe w; -, -n; krip|pen (veralt Deichstelle durch Flechtwerk s chern); Krip|pen_bei|ßer o ...set|zer (Pferd, das aus schlec ter Gewohnheit die Zähne au setzt u. Luft hinunterschluckt ...spiel (Weihnachtsspiel)

¹Kris schweiz. mdal. (Tannenre sig) s; -es

²Kris malai. (Dolch der Malaie m; -es, -e

Kri|se, Kri|sis gr. w; -, Krisen; k seln; es kriselt; krj|sen_an|fäl|li ...fest; krj|sen|haft; krj|sen_her ...si|tua|ti|on, ...zei|chen, ...ze Kri|sis vgl. Krise

krjs|peln (Gerberei: narben, d Narben herausarbeiten); ie ...[e]le (↑ R 327)

¹Kri|stall gr. (fester, regelmäß geformter, von ebenen Fläche begrenzter Körper) m; -s, -e; ²K stall (geschliffenes Glas) s; -s; kr stall_ar|tig; Kri|ställ|chen; kr stall|len (aus, von Kristall[gla kristallklar, wie Kristall); K stalleuch|ter [Trenn.: ...sta leuch..., ↑ R 236]; Kri|stall|g (Mehrz. ...gläser); kri|stall kri|stal|li|nisch (aus vielen kl nen Kristallen bestehend); kr stalline Flüssigkeit; Kri|stallin [Trenn.: ...stall|lin..., ↑ R 23 Kri|stal|li|sa|ti|on [...ziọn] (K stallbildung); Kri|stal|li|sa

ons.punkt, ...vor|gang; kri|stall-
lisch (seltener für: kristallen); kri-
stal|li|sier|bar; kri|stal|li|sie|ren
(Kristalle bilden); Kri|stal|li|sie-
rung; Kri|stal|lit (kristallähn-
liches Gebilde) m; -s, -e; kri|stall-
klar; Kri|stall|nacht (Nacht vom
9. zum 10. November 1938, in
der von den Nationalsozialisten
ein Pogrom gegen die deutschen
Juden veranstaltet wurde) w; -;
Kri|stal|lo|gra|phie (Lehre von
den Kristallen) w; -; kri|stal|lo-
gra|phisch; Kri|stal|lo|id (kristall-
ähnlicher Körper) s; -[e]s, -e; Kri-
stal|lü|ster, (österr.:) Kri|stal|lu-
ster [Trenn.: ...stall|lü...; ↑ R 236];
Kri|stall.va|se, ...zucker [Trenn.:
...zuk|ker]
Kri|stia|nia (Name Oslos bis
1924); vgl. Christiania; ²Kri|stia-
nia [nach Kristiania = Oslo]
(Querschwung beim Schilauf) m;
-s, -s
Kri|te|ri|um gr. (Prüfstein; unter-
scheidendes Merkmal, Kennzei-
chen; bes. im Radsport: Zusam-
menfassung mehrerer Wertungs-
rennen zu einem Wettkampf) s;
-s, ...ien [...i^en]; Kri|tik w; -, -en;
Kri|ti|ka|ster (kleinlicher Kriti-
ker, Nörgler) m; -s, -; Kr|ti|ker;
Kri|ti|ke|rin w; -, -nen; Kri|tik|fä-
hig|keit; kri|tik|los; -este (↑ R
292); Kri|tik|lo|sig|keit w; -; kri-
tisch ([wissenschaftl., künstler.]
streng beurteilend, prüfend, wis-
senschaftl. verfahrend; oft für:
anspruchsvoll; die Wendung
zum Guten od. Schlimmen]
bringend; gefährlich, bedenk-
lich); -ste (↑ R 294); -e Ausgabe;
-e Geschwindigkeit; -e Tempera-
tur; kri|ti|sie|ren; Kri|ti|sie|rung;
Kri|ti|zis|mus (philos. Verfahren)
m; -
rit|te|lei; Krit|te|ler, Kritt|ler;
krit|te|lig, kritt|lig; krit|teln
(kleinlich, mäkelnd urteilen; ta-
deln); ich ...[e]le (↑ R 327); Krit-
el|sucht w; -
rit|ze|lei (ugs.); krit|ze|lig, kritz-
ig (ugs.); krit|zeln (ugs.); ich
.[e]le (↑ R 327)
roa|te (Angehöriger eines süd-
law. Volkes) m; -n, -n (↑ R 268);
Kroa|ti|en [...zi^n] (Gliedstaat Ju-
goslawiens); kroa|tisch
roatz|bee|re vgl. Kratzbeere
rocket [Trenn.: Krok|ket] engl.
krok^t, auch: krokät] (ein Rasen-
piel) s; -s; krockie|ren [Trenn.:
rok|kie...] (beim Krocketspiel
Kugel] wegschlagen)
o|kant fr. (mit Zucker überzo-
ene Mandeln od. Nüsse; auch
.leingebäck) m; -s
o|ket|te fr. (gebackenes läng-
ches Klößchen [aus Kartoffeln,

Fisch, Fleisch u. dgl.]) w; -, -n
(meist Mehrz.)
Kro|ki fr. (Riß, Plan, einfache
Geländezeichnung) s; -s, -s; kro-
kie|ren; Kro|ki|zeich|nung
Kro|ko|dil gr. (ein Kriechtier) s;
-s, -e; Kro|ko|dils|trä|ne (heuchle-
rische Träne); Krokodilstränen
weinen; Kro|ko|dil|wäch|ter (ein
Vogel)
Kro|kus gr. (eine Zierpflanze) m;
-, - u. -se
Krol|le rhein. u. nordd. (Locke)
w; -, -n
Krom|lech kelt. [kromläk, auch:
krom..., auch: ...läch] (jungstein-
zeitliche Steinsetzung) m; -s, -e
u. -s
Kro|nach (Stadt in Oberfranken)
Krön|chen, Krön|lein; ¹Kro|ne gr.
(Kopfschmuck usw.) w; -, -n; (↑ R
224:) die Nördliche -, die Süd-
liche - (Sternbilder); ²Kro|ne
(dän., isländ., norw., schwed.,
tschech. Münzeinheit; Abk. [mit
Ausnahme der tschechischen]:
kr) w; -, -n; dän. - (Abk.: dkr);
isländ. - (Abk.: ikr); norw. -
(Abk.: nkr); schwed. - (Abk.:
skr); tschech. - (Abk.: Kčs); kro-
nen; Kro|nen|kor|ken, Kron|kor-
ken; Kro|nen.mut|ter (Mehrz.
...muttern), ...or|den (ehem. Ver-
dienstorden); Kro|nen|ta|ler,
Kron|ta|ler (ehem. Münze);
Kron.er|be m, ...glas (optisches
Glas; Mehrz. ...gläser)
Kro|ni|de gr. (Beiname des Zeus)
m; -n, (für: „Nachkomme des
Kronos" auch Mehrz.:) -n (↑ R
268); Kro|ni|on [auch: ...nion]
(Zeus)
Kron.ko|lo|nie, ...kor|ken, Kro-
nen|kor|ken; Kron|land (Mehrz.
...länder); Krön|lein, Krön|chen;
Kron|leuch|ter
Kro|nos (Vater des Zeus)
Kron.prä|ten|dent, ...prinz, prin-
zes|sin; kron|prin|zeß|lich; kron-
prinz|lich; Kron|rat m; -[e]s
Krons|bee|re nordd. (Preiselbeere)
Kron|schatz; Kron|ta|ler vgl. Kro-
nentaler; Krö|nung; Krö-
nungs.man|tel, ...or|nat; Kron-
zeu|ge (Hauptzeuge)
Krö|pel niederd. (Krüppel) m; -s, -
Kropf m; -[e]s, Kröpfe; Kröpf|chen,
Kröpf|lein; kröp|fen (Technik u.
Bauw.: krumm biegen, in gebro-
chenen Linien führen; Raub-
vögel: fressen); Kröp|fer (für männl.
Kropftaube); kröp|fig; Kropf-
.stein (Bauw.), ...tau|be; Kröp-
fung
Kropp|zeug ugs. für: „kriechen-
de" Wesen; kleine Kinder; Wert-
loses) s; -[e]s
Krö|se|ei|san (ein Böttcherwerk-
zeug); krö|seln ([Glas] wegbre-

chen]; ich ...[e]le (↑ R 327); Krö-
sel|zan|ge (ein Glaserwerkzeug)
kroß nordwestd. (knusperig,
scharf gebacken; spröde, brü-
chig); krosser, krosseste (↑ R 292)
¹Krö|sus gr. (König von Lydien);
²Krö|sus (sehr reicher Mann) m;
-, auch: -ses, -se
Krot österr. mdal. (Kröte) w; -,
-en; Krö|te w; -, -n; Krö|ten (ugs.
für: kleines od. wenig Geld)
Mehrz.; Krö|ten|stein (volksm.
für: tierische Versteinerung)
Kro|ton gr. (ein ostasiat. Wolfs-
milchgewächs) m; -s, -e; Kro|ton-
öl (ein Abführmittel) s; -[e]s
Kröv (Ort an der Mosel); Krö-
ver [...w^er]; - Nacktarsch (ein
Wein)
Kro|wot österr. mdal. (Kroate) m;
-en, -en
Krs., Kr. = Kreis
Krycke¹ (Gemsenhorn) w; -, -n
(meist Mehrz.); Krücke¹ w; -, -n;
Krücken|kreuz¹ oder Krucken-
kreuz¹; Krück|stock (Mehrz.
...stöcke)
krud, kru|de lat. (rauh, grob, roh);
Kru|di|tät
¹Krug (ein Gefäß) m; -[e]s, Krüge
²Krug niederd. (Schenke) m; -[e]s,
Krüge
Krü|gel ostösterr. (Bierglas mit
Henkel) s; -s, -; zwei - Bier; Krü-
gel|chen, Krüg|lein
Krü|ger niederd. (Wirt; Pächter)
Kru|ke niederd. (großer Krug;
Tonflasche; ulkiger, eigenartiger
Mensch) w; -, -n
Krul|le (veralt. für: Halskrause) w;
-, -n
Krüll.schnitt (ein Tabakschnitt),
...ta|bak
Krüm|chen, Krü|mel (Krümel-
lein; Kru|me w; -, -n); Krü|mel
(kleine Krume) m; -s, -; krü|me-
lig, krüm|lig; krü|meln; ich
...[e]le (↑ R 327); Krü|mel|zucker
[Trenn.: ...zuk|ker]
krumm; (↑ R 295:) krummer
(landsch.: krümmer), krummste
(landsch.: krümmste); etwas
krumm biegen, legen; aber:
krummlachen, krummlegen,
krummnehmen; Krumm|bein;
krumm|bei|nig; Krum|me (Jä-
gerspr.: Feldhase) m; -n, -n (↑ R
287ff.); Krüm|me (veralt. für:
[Weg]biegung) w; -, -n; krüm-
men; sich -; Krüm|mer (gebogenes
[Rohr]stück; Gerät zur Boden-
bearbeitung); Krumm|holz (von
Natur gebogenes Holz); Krumm-
holz|kie|fer w; - vgl. Latsche;
Krumm|horn (altes Holzblasin-
strument; Mehrz. ...hörner);
krumm|la|chen, sich; ↑ R 139 (ugs.

¹ Trenn.: ...k|k...

für: heftig lachen); er hat sich krummgelacht; **krumm|le|gen,** sich; ↑ R 139 (ugs. für: sich sehr einschränken, sparsam sein); **Krümm|ling** (gebogener Teil von Treppenwangen u. -geländern); **krumm.li|nig,** ...na|sig; **krumm|neh|men;** ↑ R 139 (ugs. für: übelnehmen); ich habe ihm diesen Vorwurf sehr krummgenommen; **Krumm.schwert,** ...**stab; Krüm|mung; Krüm|mungs|li|nie krum|pe|lig,** krumplig landsch. (zerknittert); **krum|peln** landsch. (zerknittern); ich ...[e]le (↑ R 327) **Krüm|per** (vor 1813 kurzfristig ausgebildeter preuß. Wehrpflichtiger); **Krüm|per|sy|stem** s; -s **krump|fen** (einlaufen lassen [von Stoffen]); **krumpf.echt,** ...**frei krump|lig** vgl. krumpelig **Krupp** fr. (Med.: akute [diphtherische] Entzündung der Schleimhaut des Kehlkopfes) m; -s **Krup|pa|de** fr. (Reitsport: Sprung der Hohen Schule); **Krup|pe** (Kreuz [des Pferdes]) w; -, -n; **Krüp|pel** m; -s, -; **krüp|pel|haft; Krüp|pel|haf|tig|keit** w; -; **Krüppel|heim; krüp|pe|lig, krüpp|lig krup|pös** fr. (kruppartig); -er Husten **kru|ral** lat. (Med.: zum Schenkel gehörend; Schenkel...) **Krü|sel|wind** landsch. (Wirbelwind, Wasserhose auf der Ostsee) **Kru|sta|zee** lat. (Krebstier) w; -, ...een (meist Mehrz.); **Krüst|chen, Krüst|lein; Kru|ste** w; -, -n; **Krusten|tier; kru|stig; Kru|stung Krux** vgl. Crux; **Kru|zi|fe|re** lat. (Kreuzblüter) w; -, -n (meist Mehrz.); **Kru|zi|fix** [auch: kru...] (Darstellung des gekreuzigten Christus, Kreuzbild) s; -es, -e; **Kru|zi|fi|xus** (Christus am Kreuz) m; -; **Kru|zi|tür|ken!** (Fluch) **Kryo|lith** gr. (ein Mineral) m; -s od. -en, -e[n] (↑ R 268) **Kryp|ta** gr. (Gruft, unterirdischer Kirchen-, Kapellenraum) w; -, ...ten; **Kryp|ten** (Med.: verborgene Einbuchtungen in den Rachenmandeln; Drüsen im Darmkanal) Mehrz.; **kryp|to...** (geheim, verborgen); **Kryp|to...** (Geheim...); **Kryp|to|ga|me** (Sporenpflanze) w; -, -n; **kryp|to|gen, kryp|to|ge|ne|tisch** (Biol.: von unbekannter Entstehung); **Kryp|togramm** (Verstext mit verborgener Nebenbedeutung) veralt. für: Geheimtext) s; -s, -e; **Kryp|tograph** (veralt. für: Geheimschreiber; Geheimschriftmaschine) m; -en, -en (↑ R 268); **Kryp|to|graphie** (Psychol.: absichtslos entstandene Kritzelzeichnung

bei Erwachsenen; veralt. für: Geheimschrift) w; -, ...jen; **kryp|to-kri|stal|lin, kryp|to|kri|stal|li-nisch** (erst bei mikroskop. Untersuchung als kristallinisch erkennbar); **Kryp|ton** [auch: ...on] (chem. Grundstoff, Edelgas; Zeichen: Kr) s; -s; **krypt|orch** (mit Kryptorchismus behaftet); **Krypt|or|chis|mus** (Med.: Zurückbleiben des Hodens in Bauchhöhle od. Leistenkanal) m; -, ...men **Kt.** = Kanton **kte|no|id** gr. (kammartig); **Kte|no-id|schup|pe** (Kammschuppe vieler Fische); **Kte|no|pho|re** (Quallenart) w; -, -n (meist Mehrz.) **Ku** = Kurtschatovium **k. u.** = königlich ungarisch (im ehem. Reichsteil Ungarn von Österreich-Ungarn für alle Behörden); vgl. k. k.; vgl. k. u. k. **Kua|la Lum|pur** (Hptst. von Malaysia) **Ku|ba** (mittelamerik. Staat; westind. Insel); vgl. Cuba; **Ku|ba|ner; ku|ba|nisch; Ku|ba|ta|bak** (↑ R 201) **Ku|ba|tur** gr. (Math.: Erhebung zur dritten Potenz; Rauminhalt von [Rotations]körpern) w; - **Küb|bung** (Seitenschiff od. -teil des niedersächs. Bauernhauses) w; -, -en **Ku|be|be** arab. (eine Gewürzpflanze) w; -, -n; **Ku|be|ben.frucht,** ...**pfef|fer Kü|bel** m; -s, -; **kü|beln** (ugs.: viel [Alkohol] trinken); ich ...[e]le (↑ R 327); **Kü|bel|wa|gen Ku|ben** (Mehrz. von: Kubus); **ku-bie|ren** w; - (Festmeter eines Baumstammes aus Länge u. Mittendurchmesser ermitteln; Math.: zur dritten Potenz erheben); **Ku|bie|rung; Ku|bik|de|zi-me|ter** (Zeichen cdm od. dm³); **Ku|bik|fuß** m; -es; - 3 - (↑ R 322); **Ku|bik|ki|lo|me|ter** (Zeichen: cbkm od. km³); **Ku|bik|maß** s; **Ku-bik|me|ter** (Festmeter; Zeichen: cbm od. m³); **Ku|bik|mil|li|me|ter** (Zeichen: cmm od. mm³); **Ku-bik.wur|zel** (Math.: dritte Wurzel), ...**zahl; Ku|bik|zen|ti|me|ter** (Zeichen: ccm od. cm³); **ku|bisch** (würfelförmig; in der dritten Potenz befindlich); -e Form; -e Gleichung (Math.); **Ku|bis|mus** (Malstil, der in kubischen Formen gestaltet) m; -; **Ku|bist** (↑ R 268); **ku|bi|stisch ku|bi|tal** lat. (Med.: zum Ellbogen gehörend) **Ku|bus** gr. (Würfel; dritte Potenz) m; -, - u. ...ben (österr. nur so:) Kuben **Kü|chel** w; -, -n; ¹**Kü|chel|chen,** ¹**Küch|lein** (kleine Küche)

²**Kü|chel|chen,** ²Küch|lein (kleiner Kuchen); **kü|cheln** schweiz. (Fettgebackenes bereiten); ich **küchle; Ku|chen** m; -s, -; **Ku-chen.bäcker** [Trenn.: ...bäk|ker], ...**blech,** ...**brett Kü|chen.bü|fett,** ...**bul|le** (ugs. Soldatenspr. für: Koch einer Großküche, Kantine u. ä.) ...**chef,** ...**fee** (scherzh. für Köchin), ...**fen|ster Ku|chen.form,** ...**ga|bel Kü|chen.hand|tuch,** ...**herd,** ...**hil fe,** ...**la|tein** (scherzh. für: schlechtes Latein), ...**mes|ser** s **Ku|chen|schel|le** (eine Anemone) w; -, -n **Kü|chen.schrank,** ...**schür|ze ...stuhl Ku|chen|teig Kü|chen.tisch,** ...**uhr,** ...**waa|ge ...wa|gen** (Gerätewagen der Feldküche), ...**zet|tel** ¹**Küch|lein** (Küken) ²**Küch|lein** vgl. ¹Küchelchen ³**Küch|lein** vgl. ²Küchelchen **kucken¹** nordd. (gucken) **Kücken¹** österr. (¹Küken) **kuckuck¹; Kuckuck¹** m; -s, -e **Kuckucks¹.blu|me** (Pflanzenname), ...**ei,** ...**uhr Ku'|damm** (ugs. Kurzform von Kurfürstendamm; ↑ R 250) m; -[e]s **Kud|del|mud|del** (ugs. für: Durcheinander, Wirrwarr) m od. s; - **Kud|del|kraut** vgl. Kuttelkraut **Ku|der** (Jägerspr.: männl. Wildkatze) m; -s, - **Ku|du** afrik. (afrik. Antilope) n; -s, -s **Kues** [kuß], Nikolaus von (dt. Philosoph u. Theologe) ¹**Ku|fe** (Gleitschiene [eines Schlitens]) w; -, -n ²**Ku|fe** mdal. (Gefäß) w; -, -n; **Kü-fer** (südwestd. u. schweiz. für Böttcher; auch svw. Kellermeister); **Kü|fe|rei Kuff** (breit gebautes Küstenfahrzeug) w; -, -e **ku|fi|sche Schrift** [nach Kufa (ehem. Stadt bei Bagdad)] (altarab. Schrift) w; -n - **Kuf|stein** [auch: kuf...] (Stadt am Unterinntal, Österreich) **Ku|gel** w; -, -n; **Ku|gel|blitz; Kü|g-chen, Kü|ge|lein; Ku|gel|fang; ku-gel|fest; Ku|gel|form; ku|gel|för-mig; Ku|gel|ge|lenk Kü|gel|gen** (dt. Maler) **ku|ge|lig,** kuglig; **Ku|gel|la|ger; ku|geln;** ich ...[e]le (↑ R 327); ku-; **Ku|gel|pen; ku|gel|rund; ku-gel|schei|ben** österr. (mit Kugel spielen) vgl. kegelschieben; **Kugel|schrei|ber; ku|gel|si|cher; Ku-

¹ Trenn.: ...k|k...

gel|sto|ßen (s; -s); kug|lig, ku|ge|lig

Kuh w; -, Kühe; Kü|her schweiz. (Kuhhirt; Senn; Milchmann); Kuh.dorf, ...dung, ...eu|ter, ...fla|den, ...fuß (auch für: Brechstange), ...glocke [Trenn.: ...glok|ke], ...han|del (ugs. für: unsauberes Geschäft); kuh|han|deln; ich ...[e]le (↑ R 327); gekuhhandelt; Kuh.haut; das geht auf keine - (ugs.: das ist unerhört); kuh|hessig (wie bei den [2]Hessen der Kuh eng zusammenstehend [Fehler der Hinterbeine von Haustieren]); Kuh.hirt, ...ket|te

kühl; (↑ R 116:) im Kühlen; ins Kühle setzen; Kühl|an|la|ge

Kuh|le niederd. (Grube, Loch) w; -, -n; vgl. Kaule, Kule

Kühl|le w; -; küh|len; Kühl|ler (Kühlvorrichtung); Kühl|ler..fi|gur, ...hau|be; Kühl.haus, ...ket|te (Aneinanderreihung von Kühlvorrichtungen) w;

Kuh|lo (kurz für: Kuhlodraht) m; -s, -s; Kuh|lo|draht (Röhrendraht)

Kühl.raum, ...rip|pe, ...schiff, ...schlan|ge (Röhrenkühlanlage), ...schrank; Kühl|te (Seemannsspr.: mäßiger Wind) w; -, -n; Kühl.tru|he, ...turm; Kühl|lung w; -; Kühl.wa|gen, ...was|ser (s; -s)

Kuh.milch, ...mist

kühn; Kühn|heit; kühn|lich (veralt.)

Kuh.pocke [Trenn.: ...pok|ke], ...rei|gen od. ...rei|hen, ...stall; kuh|warm; -e Milch

Ku|jon fr. (veraltend für: Schuft, Quäler) m; -s, -e; ku|jo|nie|ren (veraltend für: verächtlich behandeln; quälen)

k. u. k. = kaiserlich u. königlich (im ehem. Österreich-Ungarn beide Reichsteile betreffend); vgl. k. k.

Kü|ken, (österr.:) Kücken[1] ([1]Küch|lein, das Junge des Huhnes; kleines Mädchen) s; -s, -

Kü|ken (Technik: drehbarer Teil, Kegel des [Faß]hahns) s; -s, -

Ku-Klux-Klan engl.-amerik. [selten mit engl. Ausspr.: kjuklakßklän] (terroristischer Geheimbund in den USA) m; -[s]

Ku|ku|mer lat. südwestd. (Gurke) w; -, -n

Ku|ku|ruz slaw. bes. österr. (Mais) m; -[es]

Ku|lak russ. (Großbauer im zaristischen Rußland) m; -en, -en (↑ R 268)

..u|lan kirgis. (asiat. Wildesel) m; -s, -e

u|lant fr. (gefällig, entgegenkommend, großzügig [im Geschäftsverkehr]); Ku|lanz w; -

Ku|le (Nebenform von: Kuhle); vgl. Kuhle

Ku|li Hindi m; -s, -s

Ku|lier|wa|re fr.; dt. (Wirkware)

ku|li|na|risch lat. (auf die [feine] Küche, die Kochkunst bezüglich); -e Genüsse

Ku|lis|se fr. (Theater: Seiten-, Schiebewand; Technik: Hebel mit verschiebbarem Drehpunkt; Börse: nichtamtl. Börsenmarkt; Personen, die sich auf eigene Rechnung am Börsenverkehr beteiligen) w; -, -n; Ku|lis|sen|schie|ber

Kul|ler|au|gen (ugs. für: erstaunte, große, runde Augen) Mehrz.; kul|lorn (Nebenform von: kollern)

[1]Kulm slaw. u. roman. (abgerundete [Berg]kuppe) m od. s; -[e]s, -e

[2]Kulm engl. (Geol.: schiefrige Ausbildung der Steinkohlenformation) s; -s

Kulm|bach (Stadt in Oberfranken); Kulm|ba|cher (↑ R 199); Kulm|ba|cher (Bier) s; -s

Kul|mi|na|ti|on lat. [...zion] (Erreichung des Höhe-, Scheitel-, Gipfelpunktes; höchster und tiefster Stand eines Gestirns); Kul|mi|na|ti|ons|punkt (Höhepunkt); kul|mi|nie|ren (Höhepunkt erreichen, gipfeln)

Ku|lör vgl. Couleur

Kult lat. m; -[e]s, -e u. ...tus Kul|tus (,,Pflege"; [Gottes]dienst; Verehrung, Hingabe) m; -, Kulte; Kult|hand|lung; kul|tisch; Kul|ti|va|tor [...wa...] (Bodenbearbeitungsgerät) m; -s, ...oren; kul|ti|vie|ren fr. ([Land] bearbeiten, urbar machen; [aus]bilden; sorgsam pflegen); kul|ti|viert (gesittet; hochgebildet); Kul|ti|vie|rung; Kult|stät|te; kul|tur w; -, -en; Kul|tur.ab|kom|men, ...at|ta|ché, ...aus|tausch, ...beu|tel (ugs. für: Beutel für Toilettenartikel), ...denk|mal; kul|tu|rell; Kul|tur.film, ...ge|schich|te (w; -); kul|tur|ge|schicht|lich; Kul|tur.gut, ...kampf (hist.), ...kri|tik, ...leben; kul|tur|lich; kul|tur|los; Kul|tur|ge|gig|keit w; -; Kul|tur|mi|ni|ste|ri|um (DDR), ...pflan|ze, ...po|li|tik, ...re|vo|lu|ti|on (sozialistische Revolution auf dem Gebiet der Kultur); Kul|tur|schaf|fen|de (DDR) m u. w; -n, -n (↑ R 287f.); Kul|tus vgl. Kult; Kul|tus.frei|heit (w; -), ...ge|mein|de, ...mi|ni|ste|ri|um

Ku|ma|ne (Angehöriger eines in südosteurop. Völkern aufgegangenen Turkvolkes) m; -n, -n (↑ R 268)

Ku|ma|rin indian. (pflanzl. Duft- u. Wirkstoff) s; -s; Ku|ma|ron

(chem. Verbindung) s; -s; Ku|ma|ron|harz

Kumm niederd. (Rohr; Hülse, Kasten; tiefe, runde Schüssel, Futtertrog) m; -[e]s, -e; Kum|me (Seemannsspr. u. mdal. für: Schüssel) w; -, -n

Küm|mel (Gewürzkraut; Branntwein) m; -s, -; Küm|mel.branntwein (m; -[e]s), ...brot; küm|meln (mit Kümmel anmachen; ugs. für: [Alkohol] trinken); ich ...[e]le (↑ R 327); Küm|mel|tür|ke (veralt. für: Prahlhans; Philister; heute: leichtes Schimpfwort)

Kum|mer m; -s; Küm|me|rer (krankes Wild; mangelhaft entwickeltes Haustier; bildl. für: vergrämter Mensch); küm|mer|lich; Küm|mer|ling (landsch. für: schwächlicher Mensch; Zool.: schwächliches Tier); [1]küm|mern (Jägerspr. u. Zool.: in der Entwicklung zurückbleiben); ich ...ere (↑ R 327); [2]küm|mern, sich; ich ...ere mich (↑ R 327); es kümmert mich nicht; Küm|mer|nis w; -, -se; kum|mer|voll

Kum|met (für: Kumt) s; -s, -e

Kü|mo: Küstenmotorschiff

Kump (Form zum Wölben von Platten; mdal. für: kleines, rundes Gefäß, [Milch]schale) s; -s, -e

Kum|pan (,,Brotgenosse"; ugs. für: Kamerad, Gefährte; meist abfällig für: Helfer) m; -s, -e; Kum|pa|nei; Kum|pel (Bergmann; ugs. auch für: Arbeitskamerad) m; -s, - u. (ugs.:) -s

kum|peln landsch. (biegen, wölben); ich ...[e]le (↑ R 327); Kum|pen niederd. (Gefäß, Schüssel) m; -s, -; Kumpf (südd.: Gefäß. Behälter; österr.: Behälter für den Schleifstein) m; -[e]s, -e u. Kümpfe

Kum|ran, (auch:) Qum|ran (über dem Wadi Kumran nahe dem Nordwestufer des Toten Meeres entdeckte archäolog. Fundstätte)

Kumst mdal. (Weißkohl), Art Sauerkraut) m; -[e]s

Kumt (gepolsterter Bügel um den Hals der Zugtiere) s; -[e]s, -e; vgl. Kummet

Ku|mu|la|ti|on lat. [...zion] (veralt. für: Anhäufung; Med.: vergiftende Wirkung kleiner, aber fortgesetzt gegebener Dosen bestimmter Arzneimittel); ku|mu|la|tiv (anhäufend); ku|mu|lie|ren (anhäufen); sich -; Ku|mu|lie|rung; Ku|mu|lo|nim|bus (Meteor.: Gewitterwolke); ku|mu|lus (Meteor.: Haufen[wolke]) m; -, ...li

Ku|mys u. Ku|myß russ. [auch: ...müß] (gegorene Stutenmilch) m; -

kund; - und zu wissen tun; kundgeben usw. (vgl. d.); **kund|bar** (veralt. für: bekannt); **künd|bar** (etwas, was verkündet oder gekündigt werden kann); **¹Kun|de** (Kenntnis, Lehre; Botschaft; österr. auch für: Käufer, Kundschaft) w; -, -n; **²Kun|de** (Käufer; verächtl.: Kerl, Landstreicher) m; -n, -n (↑ R 268); **kün|den** (geh. für: kundtun; schweiz. auch svw. kündigen); **Kun|den_be|ra|tung,** ...dienst (m; -[e]s), ...fang (m; -[e]s), ...kreis, ...spra|che (Gaunersprache),...wer|bung;**Kün|der; Kund_fahrt** (selten für: [wissenschaftliche] Exkursion), ...ga|be (w; -); **kund|ge|ben;** ich gebe kund; kundgegeben; kundzugeben; ich gebe etwas kund, a b e r: ich gebe Kunde von etwas; sich -; **Kund_ge|bung; kun|dig; Kun|di|ge** m u. w; -n, -n (↑ R 287ff.); **kün|di|gen;** er kündigt ihm; er kündigt ihm das Darlehen, die Wohnung; es wurde ihm od. ihm wurde gekündigt (nicht: er wurde gekündigt); **Kün|di|gung;** vgl. vierteljährig u. vierteljährlich; **Kün|di|gungs-frist;** sechswöchige usw. (mit Ziffer: 6wöchige) /; **Kün|di-gungs_schrei|ben,** ...schutz; **Kun|din** (Käuferin) w; -, -nen; **kund-ma|chen** (österr. Amtsspr., sonst geh. für: bekanntgeben); ich mache kund; kundgemacht; kundzumachen; **Kund|ma|chung** südd., schweiz. u. österr. (für Bekanntmachung); **Kund|schaft; kund|schaf|ten; Kund|schaf|ter; kund|tun;** ich tue kund; kundgetan; kundzutun; sich -; **kund|wer-den** (geh. für: bekanntwerden); es wird kund; es ist kundgeworden; kundzuwerden

ku|nei|form lat. [...*ne-i*...] (Med.: keilförmig)

Kü|net|te fr. (Abflußgraben) w; -, -n

künf|tig; -en Jahres (Abk.: k. J.); -en Monats (Abk.: k. M.); **künf-tig|hin**

Kun|ge|lei; kun|geln (ugs. für: heimliche, unlautere Geschäfte abschließen); ich ...[e]le (↑ R 327)

Ku|ni|bert (m. Vorn.); **Ku|ni|gund, Ku|ni|gun|de** (w. Vorn.)

Kun|kel südd. u. westd. (Spindel, Spinnrocken) w; -, -n; **Kun|kel-stu|be**

Kunk|ta|tor lat. (Zauderer) m; -s, ...oren

Kün|ne|ke (dt. Operettenkomponist)

Ku|no (m. Vorn.)

Kunst w; -, Künste; **Kunst_aka|de-mie,** ...aus|stel|lung, ...bau|ten (*Mehrz.*), ...be|trach|tung (Würdigung von Kunstwerken),

...denk|mal, ...druck (*Mehrz.* ...drucke); **Kunst|druck|pa|pier; Kunst|dün|ger; Kün|ste|lei; kün-steln;** ich ...[e]le (↑ R 327); **Kunst_er|zie|hung** (w; -), ...fäl-schung, ...fa|ser; **kunst|fer|tig; Kunst_fer|tig|keit,** ...gärt|ner, ...ge|gen|stand, ...ge|lehr|te m u. w; **kunst_ge|mäß,** ...ge|recht; **Kunst_ge|schich|te** (w; -), ...ge-wer|be (s; -s); **Kunst|ge|wer|be-mu|se|um; Kunst_ge|werb|ler,** ...ge|werb|le|rin (w; -, -nen); **kunst|ge|werb|lich; Kunst_griff,** ...han|del, ...händ|ler, ...hand-lung, ...hand|werk, ...harz, ...hi-sto|ri|ker, ...ho|nig, ...horn (chem. gehärtetes Kasein; *Mehrz.* ...hor-ne); **Künst|ler; Künst|le|rin** w; -, -nen; **künst|le|risch;** -ste (↑ R 294); **Künst|ler_knei|pe,** ...ko|lo|nie, ...mäh|ne (ugs.), ...na|me, ...pech (ugs.); **Künst|ler|tum** s; -s; **künst-lich;** -e Atmung; -e Befruchtung; -e Niere; **Künst|lich|keit; kunst-los;** -este (↑ R 292); **Kunst_ma|ler,** ...markt; **kunst|mä|ßig; Kunst_pau|se,** ...pro|sa; **kunst|reich; Kunst_rich|ter** (veralt. für: Kritiker), ...samm|ler, ...samm|lung, ...schu|le, ...sei|de (vgl. Reyon); **kunst|sin|nig; Kunst_spra|che,** ...stein, ...stoff; **Kunststoffolie** [*Trenn.*: Kunst|stoff|fo|lie, ↑ R 236]; **kunst|stop|fen** (nur in der Grundform u. im 2. Mittelwort gebräuchlich); kunstgestopft; **Kunst_stück,** ...stu|dent, ...tisch-ler, ...tur|nen, ...verlag; **kunst_ver|stän|dig,** ...voll; **Kunst_werk,** ...wis|sen|schaft, ...wis-sen|schaft|ler, ...wort (*Mehrz.* ...wörter), ...zeit|schrift

kun|ter|bunt (durcheinander, gemischt); **Kun|ter|bunt** s; -s; **Kun-ter|bunt|heit** w; -

Kunz (Kurzform von: Konrad); vgl. Hinz

Kun|ze-Knorr Ⓦ (Bremsen); **Kun-ze-Knorr-Brem|se** (↑ R 182) w; -, -n

Kuo|min|tang (chin. Partei) w; -

Kü|pe lat. niederd. (Färbebad, -kessel; Lösung eines Küpenfarbstoffes) w; -, -n

Ku|pee (eindeutschend für: Coupé) s; -s, -s

Ku|pel|le vgl. ²Kapelle; **ku|pel|lie-ren** fr. (Silber aus Blei ausscheiden); **Kü|per** niederd. (Küfer)

Kup|fer (chem. Grundstoff, Metall; Zeichen: Cu) s; -s, (für: Bild auch *Mehrz.*:) -; **Kup|fer_druck** (*Mehrz.* ...drucke), ...erz; **kup-fer|far|ben, Kup|fer|geld** s; -[e]s; **kup|fe|rig, kupf|rig; Kup|fer_kan-ne,** ...kes|sel, ...mün|ze; **kup|fern** (aus Kupfer); kupferne Hochzeit, a b e r (↑ R 224): Kupferner

Sonntag; **kup|fer|rot; Kup-fer_schmied,** ...ste|cher, ...stich; **Kup|fer|stich|ka|bi|nett; Kup|fer-tief|druck; Kup|fer_vi|tri|ol; kupf-rig,** kup|fe|rig

ku|pie|ren fr. ([Ohren, Schwanz bei Hunden oder Pferden] stutzen; Med.: [Krankheit] im Entstehen unterdrücken; veralt. für: lochen, knipsen); **ku|piert;** -es (↑von Gräben usw.] durchschnittenes) Gelände; **Ku|pier|zan|ge**

Ku|pol_ofen, **Kup|pel|ofen** (Schmelz-, Schachtofen)

Ku|pon [...*pong*, österr.: ...*pon*] (eindeutschend für: Coupon; Stoffabschnitt, Renten-, Zinsschein) m; -s, -s

Kup|pe w; -, -n

Kup|pel lat. w; -, -n; **Kup|pel|bau** (*Mehrz.* ...bauten)

Kup|pe|lei (eigennützige od. gewohnheitsmäßige Begünstigung der Ausübung von Unzucht); **Kup|pel_grab,** ...lohn, ...mut|ter; **kup|peln** [Nebenform von: koppeln [vgl. d.]) (verbinden; ugs. für: zur Ehe zusammenbringen); ich ...[e]le (↑ R 327); **Kup|pel|ofen** vgl. Kupolofen; **Kup|pel|pelz;** sich einen (den) - verdienen (ugs. für: eine Heirat zustande bringen); **Kup|pel|pro|duk|ti|on** (gemeinsame Herstellung von zwei oder mehreren Gütern, die durch das Ausgangsmaterial und das angewandte Verfahren bedingt ist, z. B. die Herstellung von Koks und Gas aus Kohle) **Kup|pe|lung** vgl. Kupplung

kup|pen (die Kuppe abhauen)

Kupp|ler; Kupp|le|rin w; -, -nen **kupp|le|risch;** -ste (↑ R 294)

Kupp|lung, (seltener:) Kup|pelung; **Kupp|lungs_pe|dal,** ...scha|den

Ku|prein lat. (ein Fiebermittel) **Ku|pris|mus** (Kupfervergiftung) m; -

¹Kur lat. (Heilverfahren; [Heil]behandlung, Pflege) w; -, -en

²Kur (veralt. für: Wahl) w; -, -en noch in: kurbrandenburgisch Kurfürst usw.; **Kür** (Wahl; Wahlübung beim Turnen und im Sport) w; -, -en

ku|ra|bel lat. (Med.: heilbar); ...able Krankheit; **Ku|rand** (Med. Pflegling) m; -en, -en (↑ R 268) **Kur|an|stalt**

ku|rant lat. (veralt. für: Währungs-gängig, umlaufend; Abk.: crt.) **Ku|rant** (veralt. für: Währungsmünze, deren Stoff dem aufgedruckten Wert entspricht) s; -[e]s; -e; zwei Mark -

Ku|ra|re indian.-span. (ein [Pfeil]gift, als Narkosehilfsmittel verwendet) s; -[s]

Kü|raß *fr.* (Brustharnisch) *m*;
...rasses, ...rasse; Kü|ras|sier (früher für: Panzerreiter; schwerer Reiter) *m*; -s, -e

Ku|rat *lat.* (kath. Pfarr[amts]verweser, Hilfspriester) *m*; -en, -en (↑ R 268); Ku|ra|tel (veralt. für: Vormundschaft; Pflegschaft) *w*; -, -en; Ku|ra|tie (Seelsorgebezirk eines Kuraten) *w* - ...ien; Ku|ra|tor (Verwalter einer Stiftung;Vertreter des Staates in der Universitätsverwaltung; österr. auch für: Treuhänder; früher für: Vormund; Pfleger) *m*; -s, ...oren; Ku|ra|to|ri|um (Aufsichtsbehörde) *s*; -s, ...ien [...*i*°*n*]

Kur|auf|ent|halt

Kur|bel *w*; -, -n; Kur|be|lei *w*; -; kur|beln; ich ...[e]le (↑ R 327); Kur|bel_stan|ge, ...wel|le

Kur|bet|te *fr.* (Bogensprung [eines Pferdes]) *w*; -, -n; kur|bet|tie|ren

Kür|bis (eine Kletter- od. Kriechpflanze) *m*; -ses, -se; Kür|bis_fla|sche, ...kern

Kur|de (Angehöriger eines iran. Volkes in Vorderasien) *m*; -n, -n (↑ R 268); kur|disch; Kur|di|stan (Gebirgs- u. Hochland in Vorderasien)

ku|ren bes. schweiz. (eine Kur machen)

kü|ren (geh. für: wählen); du kürtest (seltener: korst, korest); du kürtest (seltener: körest); gekürt (seltener: gekoren); kür[e]!; vgl. kiesen

Kü|ret|ta|ge *fr.* [...*aseh*°] (Med.: Ausschabung mit der Kürette); Kü|ret|te (ein med. Instrument) *w*; -, -n

Kur|fürst; der Große - (↑ R 224); Kur|für|sten|damm (in Berlin; ugs. Kurzform [↑ R 250]) *m*; -[e]s; Kur|für|sten|tum; kur|fürst|lich; kurfürstlich sächsische Staatskanzlei; im Titel (↑ R 224): Kurfürstlich

Kur_gast (*Mehrz.* ...gäste), ...haus

Kur_hes|se[1], ...hes|sen[1] (früheres Kurfürstentum Hessen-Kassel); kur|hes|sisch[1]

ku|ri|al *lat.* (zur päpstl. Kurie gehörend); Ku|ri|at|stim|me (früher für: Gesamtstimme eines Wahlkörpers); Ku|rie [...*i*°] ([Sitz der] päpstl. Zentralbehörde) *w*; -; Ku|rien|kar|di|nal

Kur|rie *fr. m*; -s, -e

ku|rie|ren *lat.* (ärztlich behandeln; heilen)

Ku|rier_flug|zeug, ...ge|päck, ...zug (veralt. für: Schnellzug)

Ku|ri|len (Inseln im Pazifischen Ozean) *Mehrz.*

...u|ri|os *lat.*(-*fr.*) (seltsam, sonderbar); -este (↑ R 292); Ku|rio|si|tät; Ku|rio|si|tä|ten_händ|ler, ...ka|bi|nett; Ku|ri|o|sum *s*; -s, ...sa

ku|risch, aber (↑ R 198): das Kurische Haff, die Kurische Nehrung

Kur_ka|pel|le, (Orchester eines Kurortes), ...kon|zert

Kur|ku|ma *arab.* (eine Heilpflanze) *w*; -, Kur|ku|men; Kur|ku|ma_gelb, ...pa|pier, ...pul|ver, ...tink|tur

Kür|lauf; Kür|lau|fen *s*; -s (Sport)

Kur|mainz [auch: ...*mainz*] (ehem. Erzbistum Mainz)

Kur|mark (Hauptteil der ehem. Mark Brandenburg) *w*; -; Kür|mär|ker; kur|mär|kisch

Kur|mit|tel *s*; Kur|mit|tel|haus; Kur_or|che|ster, ...ort (*m*; -[e]s, -e), ...park

Kur|pfalz[1] (ehem. Kurfürstentum Pfalz) *w*; -; Kur|pfäl|zer[1] (↑ R 199); kur|pfäl|zisch[1]

kur|pfu|schen; ich kurpfusche; gekurpfuscht; zu kurpfuschen; Kur_pfu|scher; Kur|pfu|sche|rei; Kur|pfu|sche|rin *w*; -nen

Kur|prinz (Erbprinz eines Kurfürstentums); kur|prinz|lich

Kur|pro|me|na|de

Kur|re (Seemannsspr.: Grundschleppnetz) *w*; -, -n

Kur|ren|da|ner (Mitglied einer Kurrende); Kur|ren|de (früher: Knabenchor, der gegen Gaben vor den Häusern geistl. Lieder singt; heute: ev. Kinderchor; veralt. für: Umlaufschreiben) *w*; -, -n; Kur|ren|de|schü|ler

kur|rent *lat.* österr. (in deutscher Schrift); Kur|rent|schrift (veralt. für: „laufende“, d. h. Schreibschrift; österr.: deutsche, gotische Schrift)

kur|rig mdal. (mürrisch, launisch)

Kur|ri|ku|lum *lat.* (veralt. für: Laufbahn) *s*; -s, ...la; vgl. Curriculum vitae; vgl. auch: Curriculum

Kurs *lat. m*; -es, -e; Kurs_ab|schlag (für: Deport), ...ab|wei|chung, ...an|stieg, ...auf|schlag (für: Report), ...buch

Kürsch (Heraldik: Pelzwerk) *s*; -[e]s

Kur|schat|ten (ugs. scherzh.: Person, die sich während eines Kuraufenthaltes einem Kurgast des anderen Geschlechts anschließt)

Kürsch|ner (Pelzverarbeiter); Kürsch|ne|rei

Kur|se (*Mehrz.* von: Kurs u. Kursus); Kurs_ein|bu|ße, ...ge|winn; kur|sie|ren *lat.* (umlaufen, im Umlauf sein); kursierende Gerüchte; Kur|sist (veralt. für: Lehrgangsteilnehmer; ↑ R 268; auch

siv (laufend, schräg); Kur|siv_druck *m*; -[e]s; Kur|si|ve [...*w*°] (schrägliegende Druckschrift) *w*; -, -n; Kur|siv_schrift; Kurs_kor|rek|tur; kur|so|risch (fortlaufend, rasch durchlaufend, hintereinander); Kurs_rück|gang, ...stei|ge|rung, ...sturz; Kur|sus (Lehrgang, zusammenhängende Vorträge; auch: Gesamtheit der Lehrgangsteilnehmer) *m*; -, Kurse; Kurs_ver|lust, ...wa|gen, ...wech|sel, ...wert, ...zet|tel

Kurt (Kurzform von: Konrad)

Kur|ta|ge vgl. Courtage

Kur|ta|xe

Kur|ti|ne *fr.* (Festungswesen: Teil des Hauptwalles; Theater veralt., noch österr.: Mittelvorhang) *w*; -, -n

Kur|ti|sa|ne (früher für: Geliebte am Fürstenhof; Halbweltdame) *w*; -, -n

Kur|trier (ehem. Erzbistum Trier); kur|trie|risch

Kur|tscha|to|vi|um [...*owium*; nach dem sowjetruss. Atomphysiker Kurtschatow] (chem. Element; Transuran; Zeichen: Ku) *s*; -s

Kür|tur|nen (Turnen mit freier Wahl der Übungen) *s*; -s; Kür|übung

ku|ru|lisch *lat.*; -er Stuhl (Amtssessel der höchsten röm. Beamten)

Kur|va|tur *lat.* [...*wa*...] (Med.: Krümmung eines Organs, bes. des Magens) *w*;-,-en; Kur|ve [...*w*° od. ...*f*°] (krumme Linie, Krümmung; Bogen[linie]; [gekrümmte] Bahn; Flugbahn) *w*; -, -n; ballistische - (Flug-, Geschoßbahn); kur|ven[...*w*° *n* od. ...*f*° *n*]; gekurvt; kur|ven|för|mig; Kur|ven_li|ne|al, ...mes|ser *m*; kur|ven|reich; Kur|ven|tech|nik

Kur|ver|wal|tung

kur|vig [...*wich*] (bogenförmig, mit vielen Kurven); Kur|vi|me|ter [...*wi*...] (Kurvenmesser) *s*; -, -

Kur|wür|de (Würde eines Kurfürsten) *w*; -

kurz; kürzer, kürzeste; kurz und gut; kurz und bündig; zu - kommen; - angebunden; - entschlossen; - gesagt. I. *Kleinschreibung:* a) (↑ R 134:) am kürzesten; auf das, aufs kürzeste; den kürzer[e]n (z. B. darlegen); binnen, in seit, vor kurzem; b) (↑ R 133:) kurz oder lang; über kurz oder lang; den kürzer[e]n ziehen. II. *Großschreibung:* a) (↑ R 116:) das Lange und Kurze von der Sache ist ...; b) (↑ R 224:) Pippin der Kurze. III. *Schreibung in Verbindung mit Zeitwörtern* (↑ R 139): a) bei Getrenntschreibung in ursprünglicher Bedeutung, z. B. kurz schneiden; sie hat das Kleid zu

[1] Auch: *kur*...

Auch: *kurhäß*...

kurz geschnitten; sich kurz fassen; **b)** *Zusammenschreibung,* wenn durch die Verbindung ein neuer Begriff entsteht; vgl. kurzarbeiten, kurzhalten, kurzschließen, kurztreten; **Kurz|ar|beit** w; -; **kurz|ar|bei|ten;** ↑ R 139 (aus Betriebsgründen eine kürzere Arbeitszeit einhalten); ich arbeite kurz; kurzgearbeitet; **kurzzuarbeiten; a b e r : kurz ar|bei|ten;** ich werde heute nur kurz arbeiten; **Kurz|ar|bei|ter; kurz..är|me|lig** od. ...ärm|lig, ...at|mig; **Kurz|atmig|keit** w; -; **Kurz..be|richt,** ...bio|gra|phie; **Kur|ze** (ugs. für: kleines Glas Branntwein; Kurzschluß) *m*; -n, -n; ↑ R 287 ff.; **Kür|ze** w; -; in -; **Kür|zel** (festgelegtes [kurzschriftl.] Abkürzungszeichen; vgl. Sigel) *s*; -s, -; **kür|zen;** du kürzt (kürzest); **kur|zer|hand** (Abk.: k. H. u. kh.); **Kurz..er|zäh|lung,** ...fas|sung, ...film, ...flüg|ler; **kurz|fri|stig,** ...ge|faßt; **Kurz|ge|schich|te; kurz|ge|schnit|ten;** die kurzgeschnittenen Haare (↑ jedoch R 142), a b e r : die Haare waren kurz geschnitten; **kurz-..ge|schwänzt,** ...haa|rig, ...hal|sig; **Kurz|hal|sig|keit** w; -; **kurz|hal|ten;** ↑ R 139 (ugs. für: in der Freiheit beschränken); ich halte ihn kurz; habe ihn kurzgehalten; er ist kurzzuhalten; a b e r : **kurz hal|ten;** du darfst die Leine nicht so kurz halten; **kurz|hin** (veralt. für: kurz, beiläufig); **kurz|le|big; Kurz|le|big|keit** w; -; **kürz|lich; kurz|schlie|ßen;** ↑ R 139; ich schließe kurz; kurzgeschlossen; kurzzuschließen; **Kurz|schluß; Kurz|schluß|hand|lung; Kurzschrift** (für: Stenographie); **Kurzschrift|ler**(für:Stenograph); **Kurzschrift|lich** (für: stenographisch); **kurz|sich|tig; Kurz|sich|tig|keit** w; -; **kurz..sil|big** (auch übertr. für: wortkarg), ...stäm|mig; **Kurzstrecke** [*Trenn.*: ...strek|ke]; **Kurz|strecken|lauf** [*Trenn.*: ...strek|ken...], ...läu|fer; **Kurz-..streck|ler** (Kurzstreckenläufer), ...stun|de; **kurz|tre|ten;** ↑ R 139 (mit kleinen Schritten marschieren; langsamer arbeiten); sein Gesundheitszustand zwang ihn, längere Zeit kurzzutreten; a b e r : **kurz tre|ten;** gib acht, daß du nicht zu kurz (zu knapp) trittst; **kurz|um** [auch: *kurzum*]; **Kürzung; Kurz|wa|ren|hand|lung; kurz|weg** [auch: *kurzwäk*]; **Kurzweil** w; -; **kurz|wei|lig; Kurz|welle; Kurz|wel|len|sen|der; Kurzwel|lig; Kurz|wort** (*Mehrz.* ...wörter)

kusch! (Befehl an den Hund: leg dich still nieder!); vgl. kuschen

Ku|schel, Kus|sel niederd. (niedrige [verkrüppelte] Kiefer; Gebüsch) *w*; -, -n

ku|scheln, sich (sich anschmiegen); ich ...[e]le mich (↑ R 327); **ku|schen** (vom Hund: sich lautlos hinlegen; ugs. auch für: stillschweigen, den Mund halten); du kuschst (kuschest); kusch dich! (leg dich still nieder!)

Ku|sel (Stadt im Saar-Nahe-Bergland); -er Schichten

Ku|sin|chen; Ku|si|ne (eindeutschende Schreibung für: Cousine)

Kus|kus (ein Beuteltier) *m*; -, -

Küs|nacht (ZH) (Ort am Zürichsee); vgl. a b e r : Küßnacht

Kuß *m*; Kusses, Küsse; **Küß|chen, Küß|lein; kuß|echt**

Kus|sel vgl. Kuschel

küs|sen; du küßt (küssest), er küßt; du küßtest; geküßt; küsse! u. küß!; küß die Hand! (österr. veraltend); sie küßt ihn auf die Stirn; **küs|se|rig,** küß|rig (zum Küssen aufgelegt); **Kuß..hand,** ...händchen; **Küß|lein,** Küß|chen

Küß|nacht am Ri|gi (Ort am Vierwaldstätter See); vgl. a b e r : Küsnacht

küß|rig vgl. küsserig

Kü|ste w; -, -n; **Kü|sten..be|feuerung** (Bez. der Küste durch Leuchtfeuer u. a.), ...be|völ|kerung, ...fah|rer (Schiff), ...ge|birge, ...mo|tor|schiff** (Kurzw.: Kümo), ...schiffahrt [*Trenn.*: ...schiff]fahrt, ↑ R 236], ...strich

Kü|ster (Kirchendiener); **Kü|sterei;** **[1]Ku|sto|de** lat. (früher: Kennzeichen der einzelnen Lagen einer Handschrift; Nebenform von Kustos [Druckw.]) *w*; -, -n; **[2]Ku|sto|de** (Nebenform von Kustos [wissenschaftl. Sachbearbeiter]) *m*; -n, -n (↑ R 268); **Ku|stos** lat. ("Wächter"; wissenschaftl. Sachbearbeiter an Museen und Bibliotheken; Druckw. [veralt.]: Zahl, Silbe od. Wort am Kopf od. meist am Fuß einer Seite zur Verbindung mit der voraufgehenden Seite; veralt. für: Küster, Kirchendiener) *m*; -, Kustoden

Kü|strin (Stadt an der Mündung der Warthe in die Oder)

Ku|te niederd., bes. berlin. (Vertiefung; Grube) *w*; -, -n

Ku|ti|ku|la lat. (Häutchen der äußeren Zellschicht bei Pflanzen u. Tieren) *w*; -, -s u. ...lä; **Ku|tis** (Lederhaut der Wirbeltiere; feine Form nachträglich verkorkten Pflanzengewebes [z. B. an Wurzeln]) *w*; -

Kutsch|bock; Kut|sche [nach dem ung. Ort Kocs (*kotsch*), d. h. Wagen aus Kocs] *w*; -, -n; **kut|schen**

(veralt. für: kutschieren); du kutschst (kutschest); **Kut|schen..schlag; Kut|scher; Kut|scher-..knei|pe, ...ma|nie|ren, ...sitz; kut|schie|ren; Kutsch|ka|sten**

Kut|te w; -, -n

Kut|tel südd., österr., schweiz. (Kaldaune) *w*; -, -n (meist *Mehrz.*); **Kut|tel|fleck** mdal. (Eßbares vom Eingeweide des Schlachttieres) *m*; -[e]s, -e (meist *Mehrz.*); **Kut|tel|hof** (veralt. für: Schlachthof), ...kraut (österr. mdal. für: Thymian; *s*; -[e]s)

kut|ten (Bergmannsspr.: sichten, auslesen)

Kut|ten|trä|ger (veralt. für: Mönch)

Kut|ter engl. (einmastiges Segelfahrzeug) *m*; -s, -

Kü|ve|la|ge fr. [...w[e]laseh[e]] (Bergbau: Ausbau eines wasserdichten Schachtes mit gußeisernen Ringen); **kü|ve|lie|ren; Kü|ve|lie|rung** (svw. Küvelage)

Ku|vert fr. [...wär, auch: ...wärt] ([Brief]umschlag; [Tafel]gedeck für eine Person) *s*; -s u. (bei dt. Ausspr.:) -[e]s, -s u. (bei dt. Ausspr.:) -e; **ku|ver|tie|ren** (mit einem Umschlag versehen); **Ku|ver|tü|re** ([Schokoladen]überzug) *w*; -, -n

Kü|vet|te fr. [...wä...] (veralt. für: Innendeckel [der Taschenuhr]; kleines Gefäß, Trog) *w*; -, -n

ku|vrie|ren fr. [...wri[e]n] (veralt. für: bedecken; verbergen)

Ku|wait [auch: *kuwait*] (Scheichtum am Persischen Golf); **Ku|wai|ter** [auch: *kuwait[e]r*]; **ku|wai|tisch** [auch: *kuwaitisch*]

Kux *tschech.-mlat.* (börsenmäßig gehandelter Bergwerksanteil) *m* -es, -e

kv. = kriegsverwendungsfähig

KV = Köchelverzeichnis

kV = Kilovolt; **kVA** = Kilovoltampere

kW = Kilowatt

Kwaß *russ.* (gegorenes Getränk) *m*; - u. Kwasses

kWh = Kilowattstunde

Ky. = Kentucky

Kya|ni|sa|ti|on [...*zion*] [nach dem engl. Erfinder J. H. Kyan] (ein Holzerhaltungsverfahren) *w*; -; **kya|ni|sie|ren**

Kya|thos [auch: *küa*...] (antiker einhenkliger Becher) *m*; -, -

Ky|bel|le [auch: ...*bg*...] (phryg. Göttin)

Ky|ber|ne|tik gr. (zusammenfassende Bez. für eine Forschungsrichtung, die vergleichende Betrachtungen über Steuerungs- u. Regelungsvorgänge in der Technik anstellt; ev. Theol.: Lehre von der Kirchen- u. Gemeindele-

tung) w; -; Ky|ber|ne|ti|ker; ky-
ber|ne|tisch
Kyff|häu|ser [kif...] (Bergrücken
südl. des Harzes) m; -[s]
Ky|kla|den (Inselgruppe des Ägäi-
schen Meeres) Mehrz.
Ky|kli|ker vgl. Zykliker
Ky|klo|ide vgl. Zykloide
Ky|klon vgl. Zyklon
Ky|klop vgl. Zyklop
Ky|ma s; -s, -s u. Ky|ma|ti|on
gr. (Bauw.: Zierleiste aus sti-
lisierten Blattformen [bes. am
Gesims gr. Tempel]) s; -s, -s u.
...ien [...iⁿn]
Ky|mo|gramm gr. (Med.: Rönt-
genbild von sich bewegenden Or-
ganen) s; -s, -e; Ky|mo|graph (Ge-
rät zur mechanischen Aufzeich-
nung von rhythm. Bewegungen,
z. B. des Pulsschlages) m; -en,
-en (↑ R 268); Ky|mo|gra|phie
(Röntgenverfahren zur Darstel-
lung von Organbewegungen) w;
-; ky|mo|gra|phie|ren (eine Ky-
mographie durchführen)
Kym|re (keltischer Bewohner von
Wales) m; -n, -n (↑ R 268); kym-
risch; Kym|risch (Sprache) s; [s];
vgl. Deutsch; Kym|ri|sche s; -n;
vgl. Deutsche s
Ky|ni|ker gr. (Angehöriger der
von Antisthenes gegründeten
Philosophenschule); vgl. aber:
Zyniker; Ky|no|lo|ge m; -n, -n (↑ R
268); Ky|no|lo|gie (Lehre von
Zucht, Dressur u. Krankheiten
der Hunde) w; -
y|pho|se gr. (Med.: Wirbelsäu-
lenverkrümmung nach hinten)
w; -, -n
y|re|nai|ka vgl. Cyrenaika
y|rie elei|son! gr. [...riᵉ -], Ky|ri-
eleis! („Herr, erbarme dich!");
vgl. Leis; Ky|rie|elei|son (Bittruf
); -s, -s
y|ril|lisch [kü...; nach dem Sla-
venapostel Kyrill genannt); -e
schrift (↑ R 179)
y|ros (pers. König)
y|the|ra (gr. Insel, heute: Kithi-
a); ²Ky|the|ra (Aphrodite)
Z = Konzentrationslager

L

(Buchstabe); das L; des L, die
, aber: das l in Schale (↑ R 123);
er Buchstabe L, l
= lävogyr; Leu; Liter
(röm. Zahlzeichen) = 50
λ = Lambda
= Pfund (Livre) Sterling
= lies!; links
= Linné; Lira Einz. u. Lire
lehrz.; Lucius od. Luzius

La = chem. Zeichen für: Lanthan
LA = Lastenausgleich
La. = Louisiana
Laa an der Tha|ya [taja] (österr.
Stadt)
Laa|cher See (See in der Eifel) m;
- -s
Laa|ser Mar|mor m; - -s
Lab (Ferment im [Kälber]magen)
s; -[s], -e
La|ban (bibl. m. Eigenn.); langer
- (ugs.: hochgewachsene, dünne
männliche Person)
lab|be|rig, labb|rig nordd.
(schwach; fade [vom Ge-
schmack]; weichlich; breiig); lab-
bern nordd. (schlürfen, sich be-
schmutzen; Seemannsspr.:
schlaff werden); ich ...ere (↑ R
327)
Lab|da|num gr. (ein Harz) s; -s
Lab|drü|se
La|be (dicht.) w; -; La|be|fla|sche;
la|ben; sich -
La|ber|dan niederl. (eingesalzener
Kabeljau aus Norwegen) m; -s, -e
la|bern mitteld. (schwatzen, un-
aufhörlich u. einfältig reden); ich
...ere (↑ R 327)
la|bet fr. (veralt., noch mdal. in
der Wendung: - sein = verloren
haben [im Kartenspiel]; übertr.:
müde, abgespannt sein)
La|be|trunk
la|bi|al lat. (die Lippen betref-
fend); La|bi|al m; -s, -e u. La|bi|al-
laut (Sprachw.: Lippenlaut, mit
einer oder beiden Lippen gebilde-
ter Laut, z.B. p, m, f); La-
bi|al|pfei|fe (eine bestimmte
Orgelpfeife) w; -, -n (meist Mehrz.)
la|bil lat. (schwankend; veränder-
lich, unsicher); -es Gleichge-
wicht; La|bi|li|tät w; -
La|bio|den|tal lat. (Sprachw.: Lip-
penzahnlaut, mit Unterlippe u.
oberen Schneidezähnen gebilde-
ter Laut, z. B. f, v); La|bio|ve|lar
(Sprachw.: Lippengaumenlaut)
Lab.kraut (eine Pflanzengattung;
s; -[s]s, ...ma|gen
La|boe [labö] (Ostseebad am Ost-
ufer der Kieler Förde); La|boer
[...öᵉr]
La|bor lat. [österr., schweiz. auch:
la...] (Kurzform von: Laborato-
rium) s; -s, -s (auch: -e); La|bo-
rant (Laborgehilfe) m; -en, -en
(↑ R 268); La|bo|ran|tin w; -, -nen;
La|bo|ra|to|ri|um (Arbeitsstätte;
[bes. chem.] Versuchsraum; For-
schungsstätte; Kurzform: La-
bor) s; -s, ...ien [...iᵉn]; la|bo-
rie|ren (sich abmühen mit ...; lei-
den an ...); La|bor|ver|such
La|bour Par|ty engl. [/leⁱbᵉr pąᵃ'ti]
(engl. Arbeiterpartei) w; - -
¹La|bra|dor (nordamerik. Halbin-

sel); ²La|bra|dor (ein Mineral) m;
-s, -e
Lab|sal s; -[e]s, -e (österr. auch:
w; -, -e)
lab|sal|ben niederl. (Seemanns-
spr.: [zum Schutz] teeren); ich
labsalbe; gelabsalbt; zu -
Labs|kaus engl. (seemänn. Ein-
topfgericht) s; -
La|bung
La|by|rinth gr. (Irrgang, -garten;
Wirrsal, Durcheinander; Med.:
inneres Ohr) s; -[e]s, -e; la|by|rin-
thisch (unentwirrbar)
La Chaux-de-Fonds [la schodfõng]
(Stadt im Schweizer Jura)
¹La|che (ugs. für: Gelächter) w;
-, -n
²La|che (Forstw.: Einschnitt [in
Baumrinde]) w; -, -n
³La|che [auch: lą...] (Pfütze) w; -, -n
lä|cheln; ich ...[e]le (↑ R 327); la-
chen; Tränen -; er hat gut -; La-
chen s; -; das ist zum -; La|cher;
lä|cher|lich; ins Lächerliche zie-
hen; lä|cher|li|cher|wei|se; Lä-
cher|lich|keit; lä|chern landsch.
(zum Lachen reizen); es lächert
mich
La|che|sis (eine der drei Parzen)
Lach|gas; lach|haft; Lach|haf|tig-
keit w; -; Lach.krampf, ...lust (w;
-), ...mö|we, ...sal|ve
Lachs (ein Fisch) m; -es, -e;
Lachs.bröt|chen, ...fang; lachs-
far|ben od. ...far|big; Lachs|schin-
ken
Lach|tau|be
Lach|ter (altes bergmänn. Län-
genmaß) w; -, -n od. s; -s, -
la|cie|ren fr. [laßiᵉⁿ] (einschnü-
ren; mit Band durchflechten)
Lack sanskr. m; -[e]s, -e; Lack|ar-
beit
Lacke¹ österr. mdal. (³Lache) w;
-, -n
Lack|el¹ südd., österr. ugs. (gro-
ber, ungeschlachter, auch unbe-
holfener, tölpelhafter Mensch)
m; -s, -
lacken¹ (seltener für: lackieren);
gelackt; lack|glän|zend, aber:
von Lack glänzend; lackie|ren¹
(mit Lack versehen; ugs. für: an-
führen; übervorteilen); Lackie-
rer¹; Lackie|re|rei¹; Lackie|rung¹;
Lackier¹.werk|statt od. ...werk-
stät|te; Lack|le|der; lack|mei|ern
vgl. gelackmeiert
Lack|mus niederl. (chem. Rea-
gens) m od. s; -; Lack|mus|pa|pier
Lack.scha|den, ...schuh, ...stie|fel
La|cri|mae Chri|sti lat. [...ä -]
(„Christustränen"; Wein von
den Hängen des Vesuvs) m; - -
La|crosse fr. [lakrǫß] [amerik.
Ballspiel) s; -

¹ Trenn.: ...ak|k...

Lac|tam *lat.*; *gr.* [*laktam*] (chem. Verbindung) *s*; -s, -e

La|da|num vgl. Labdanum

Läd|chen, Läd|lein (kleine Lade; kleiner Laden); La|de *w*; -, -n

La|de_baum, ...flä|che, ...ge|wicht, ...gut, ...hem|mung, ...mast *m*; [1]la|den (aufladen); du lädst, er lädt; du ludst (ludest); du lüdest; geladen; lad[e]!

[2]la|den (zum Kommen auffordern); du lädst, er lädt (veralt., aber noch landsch.: du ladest, er ladet); du ludst (ludest); du lüdest; geladen; lad[e]!

La|den *m*; -s, Läden; La|den_hü|ter (schlecht absetzbare Ware), ...kas|se, ...ket|te, ...mäd|chen, ...preis (vgl. [2]Preis), ...schluß; La|den|schluß_ge|setz, ...zeit; La|den_schwen|gel (abschätzig für: junger Verkäufer), ...stra|ße, ...tisch, ...toch|ter (schweiz. für: Ladenmädchen, Verkäuferin)

La|de|platz; La|der (Auflader); La|de_ram|pe, ...raum, ...stock (Teil der früheren Gewehre; Bergbau: runder Holzstock zum Einführen der Sprengstoffpatronen in die Bohrlöcher; *Mehrz.* ...stöcke)

lä|die|ren *lat.* (verletzen; beschädigen); Lä|die|rung

La|din (ladinische Sprache) *s*; -s; La|di|ner (Angehöriger eines rätoroman. Volksteiles in Südtirol); la|di|nisch; La|di|nisch (Sprache) *s*; -[s]; vgl. Deutsch; La|di|ni|sche *s*; -n; vgl. Deutsche *s*

La|dis|laus (m. Vorn.)

Läd|lein, Läd|chen

Lad|ne|rin (südd. u. österr. neben: Verkäuferin) *w*; -, -nen

La|do|ga|see (nordöstl. von Leningrad) *m*; -s

La|dung

La|dy *engl.* [*le'di*] (Titel der engl. adligen Frau; selten für: Dame) *w*; -, -s (auch: ...dies) [*le'dis*]; la|dy|like [*le'dilaik*] (nach Art einer Lady; vornehm)

La|er|tes (Vater des Odysseus)

La Fa|yette, La|fa|yette [*lafajät*] (fr. Staatsmann)

La|fet|te *fr.* (Untergestell der Geschütze) *w*; -, -n; la|fet|tie|ren (veralt. für: auf die Lafette bringen)

[1]Laf|fe (ugs. für: Geck) *m*; -n, -n (↑ R 268); [2]Laf|fe südwestd. (Schöpfteil des Löffels; Ausguß) *w*; -, -n

La Fon|taine [*lafongtän*] (fr. Dichter)

La-France-Ro|se [*lafrangß*...] (Rose einer bestimmten Sorte) *w*; -, -n; ↑ R 155

LAG = Lastenausgleichsgesetz; LAG-be|rech|tigt (↑ R 150)

La|ge *w*; -, -n; in der - sein; La|ge_be|richt, ...be|spre|chung

Lä|gel (landsch. für: Fäßchen [für Fische]; Traggefäß; früheres Maß, Gewicht) *s*; -s, -

la|gen|wei|se; La|ge|plan; vgl. [2]Plan; La|ger *s*; -s, - u. (Kaufmannsspr. für: Warenvorräte auch:) Läger; etwas auf - halten; La|ger_bier; la|ger_fä|hig, ...fest; La|ger_feu|er, ...ge|bühr, ...hal|le, ...hal|tung, ...haus; La|ge|rist (Lagerverwalter); ↑ R 268; La|ge|ri|stin *w*; -, -nen; La|ger|kol|ler

La|ger|löf, Selma (schwed. Dichterin)

la|gern; ich ...ere (↑ R 327); sich -; La|ger_raum, ...schild (Technik; *m*; -es, -e), ...statt (geh. für: Bett, Lager), ...stät|te (Geol.: Fundort; seltener für: Lagerstatt); La|ge|rung; La|ger|verwal|ter; La|ge|skiz|ze

La|go Mag|gio|re *it.* [- *madsehore*] (it. Form von: Langensee) *m*; - -

La|gos (Hptst. von Nigeria)

LAG-Schein (↑ R 150)

Lag|ting *norw.* (das norw. Oberhaus) *s*; -s

La|gu|ne *it.* (durch Nehrung vom Meer abgeschnürter flacher Meeresteil) *w*; -, -n; La|gu|nen-stadt

lahm; Läh|me (eine Jungtierkrankheit) *w*; -; lah|men (lahm gehen); läh|men (lahm machen); Lahm|heit *w*; -; lahm|le|gen (↑ R 139); ich lege lahm; lahmgelegt; lahmzulegen; Lahm|le|gung; Läh|mung; Läh|mungs|er|scheinun|gen *Mehrz.*

[1]Lahn (r. Nebenfluß des Rheins) *w*; -

[2]Lahn *fr.* (ein Metalldraht) *m*; -[e]s, -e

[3]Lahn bayr. u. österr. mdal. (Lawine) *w*; -, -en; lah|nen bayr. u. österr. mdal. (tauen)

Lahn|spu|le (zu [2]Lahn)

Lah|nung (Wasserbau: ins Meer hineingebauter Damm)

Lahn|wind bayr. u. österr. mdal. (Tauwind)

Lahr (Stadt am Westrand des Schwarzwaldes); -er Hinkender Bote (Name eines Kalenders)

Laib landsch. (geformtes Brot od. geformter Käse) *m*; -[e]s, -e

Lai|bach, (offz.:) Lju|blja|na (jugoslaw. Stadt)

Laib|chen österr. (kleines, rundes Gebäck, vgl. Laib)

Lai|bung, (auch:) Leibung (innere Mauerfläche bei Wandöffnungen; innere Wölbfläche bei Wölbungen)

Laich (Eier von Wassertieren) *m*; -[e]s, -e; lai|chen (Laich absetzen); Laich_platz, ...zeit

Laie *gr.* (Nichtpriester; Nichtfachmann) *m*; -n, -n (↑ R 268); Lai|en_apo|sto|lat, ...bre|vier, ...bru|der, ...büh|ne, ...chor (vgl. [2]Chor); lai|en|haft; Lai|en_prie-ster, ...rich|ter, ...spiel, ...stand (*m*; -[e]s), ...tum (*s*; -s); lai|sie|ren [*la-i*...] (einen Kleriker regulär od. strafweise in den Laienstand versetzen); Lai|sie|rung

Lais|ser-al|ler *fr.* [*läßeale*] (das [Sich]gehenlassen) *s*; -; Lais-ser-faire [...*fär*] (das Gewährenlassen; veralt. für: Unge zwungenheit; Ungebundenheit) *s*; -; Lais|ser-pas|ser [...*paße* (veralt. für: Passierschein) *m*; -, -

Lai|zis|mus *gr.* [*la-i*...] (Forderun nach Freiheit von jeder relig. Bir dung im öffentl. Leben) *m*; ...men; lai|zi|stisch [*la-i*...]; -s (↑ R 294)

La|kai *fr.* (Kriecher; früher fü herrschaftl. Diener [in Livree]) *n* -en, -en (↑ R 268); la|kai|en|ha

La|ke (Salzlösung zum Einlege von Fisch, Fleisch) *w*; -, -n

La|ke|dä|mo|ni|er *gr.* [...*i^er*] (B wohner von Sparta); la|ke|dä mo|nisch

La|ken niederd., mitteld. (Bet tuch; Tuch) *s*; -s, -

Lak|ko|lith *gr.* (Geol.: ein Ti fengesteinskörper) *m*; -s u. -e -e[n] (↑ R 268)

La|ko|ni|en [...*i^en*] (Verwaltung bezirk im Peloponnes); la|k nisch *gr.* (knapp für: kurz u. tre fend); -ste (↑ R 294); La|ko|ni mus (Kürze des Ausdrucks) *n* -, ...men

La|kritz landsch. (svw. Lakritz *m*; -es, -e; La|krit|ze *fr.* (Süßho wurzel; eingedickter Süßho saft) *w*; -, -n; La|krit|zen|saft -[e]s; La|krit|zen|stan|ge od. La krit|z|stan|ge

lakt... *lat.* (milch...); Lak (Milch...); Lak|tam vgl. Lacta Lak|ta|se (ein Ferment) *w*; -, Lak|ta|ti|on [...*zion*] (Milcha sonderung; Zeit des Stillens); la tie|ren (Milch absondern; sä gen); Lak|to|me|ter (Vorrichtu zur Milchprüfung) *s*; -s, -; Lak| se (Milchzucker) *w*; -; Lak|t skop *lat.*; *gr.* (Vorrichtung z Milchprüfung) *s*; -s, -e; Lak|t urie (Med.: Ausscheidung v Milchzucker mit dem Harn) -, ...jen

la|ku|när *lat.* (Ausbuchtung enthaltend, Gewebelücken b dend); La|ku|ne (Lücke in eine Text; Hohlraum in Geweben) -, -n; la|ku|strisch (in Seen bildend od. vorkommend [v Gesteinen u. Lebewesen])

la|la (ugs.); es ging ihm so - (einigermaßen)

La|le|buch, La|len|buch (altes volkstüml. Schwankbuch) s; -[e]s

lal|len

L.A.M. = Liberalium artium magister

¹La|ma *peruan.* (südamerik. Kamelart; ein Gewebe) s; -s, -s

²La|ma *tibet* (buddhist. Priester od. Mönch in Tibet u. der Mongolei) m; -[s], -s; La|ma|is|mus (Form des Buddhismus) m; -; la|mai|stisch

La|man|tin *indian.* (amerik. Seekuh) m; -s, -e

La|marck (fr. Naturforscher); Lamar|ckis|mus [zur *Trenn.:* ↑R 189] (von Lamarck begründete Abstammungslehre) m; -

Lam|ba|re|ne (Ort in Gabun; Wirkungsstätte Albert Schweitzers)

Lamb|da (gr. Buchstabe: *Λ, λ*) s; -[s], -s; Lamb|da|zis|mus *gr.* (fehlerhafte Aussprache des R als L) m; -

_am|bert, Lam|brecht, Lamprecht (m. Vorn.); Lam|ber|ta (w. Vorn.)

.am|berts|nuß [zu: lombardisch] (Nuß einer bestimmten Haselnußart)

.am|brecht vgl. Lambert, Lamprecht

am|bre|quin *fr.* [*langbrᵉkäng*] (österr., sonst veralt. für: [gezackter] Querbehang über Fenstern usw.) m; -s, -s

am|brie, Lam|pe|rie *fr.* mdal. (Lambris) w; -, ...ien; Lam|bris *fr.* [*langbrï*] (untere Wandverkleidung aus Holz, Marmor od. Stuck) m; - [...*brï(ß)*], - [...*brïß*] österr.: w; -, - u. ...ien)

mé *fr.* [*lamé*] (mit Lamé durchwirkt); La|mé (Gewebe aus Metallfäden, die mit [Kunst]seide übersponnen sind) m; -s, -s; la-nel|lar *lat.* (streifig, schichtig, gelättert); La|mel|le *fr.* (Streifen, ünne Blättchen; Blatt unter em Hut von Blätterpilzen) w; -n; la|mel|len|för|mig

men|ta|bel *lat.* (veralt. für: jämnerlich, kläglich; beweinens-ert); ...a|ble Lage; La|men|ta|ti-n [...*zion*] (veralt. für: Jammern, Vehklagen); la|men|tie|ren (ugs. ır: laut klagen, jammern); La-en|to *it.* (ugs. für: Gejammer; 1usik: Klagelied) s; -s, -s |met|ta *it.* (Metallfäden [als hristbaumschmuck]) s; -s

mi|nar *lat.* (Physik: ohne Wirbel ebeneinander herlaufend); -e römung); La|mi|na|ria (Blattng, Braunalgengattung) w; -, ien [...*iᵉn*]; La|mi|na|ria|stift Aed.: Stiel von Laminaria, zum

Erweitern von Wunden, Kanälen u. a.) m; La|min|ek|to|mie *lat.; gr.* (operative Entfernung des hinteren Teiles eines Wirbelbogens) w; -, ...ien; la|mi|nie|ren *fr.* (Weberei; Material strecken, um die Fäden längs zu richten; Buchw.: ein Buch mit Glanzfolie überziehen)

Lamm s; -[e]s, Lämmer; Lamm|bra|ten; Lämm|chen, Lämm|lein; lam|men (ein Lamm werfen); Läm|mer|gei|er (ein Raubvogel); Läm|mer|ne bes. österr. (Lammfleisch) s; -n (↑R 287ff.); Läm-mer|wol|ke (meist *Mehrz.*); Lamm|es|ge|duld, Lamms|ge|duld (ugs. für: große Geduld); Lamm-_fell, ...fleisch; lamm|fromm (ugs.); Lämm|lein, Lämm|chen; Lamms|ge|duld, Lam|mes|ge-duld; Lam|mung w; -

Lam|pa|da|ri|us *gr.* (Fackel-, Lampengestell [im alten Rom]) m; -, ...ien [...*iᵉn*] (für: Sklave, der die Fackel trug, *Mehrz.*:) ...rii

Lam|pas *fr.* (Damastgewebe) m; -, -; Lam|pas|sen österr.: [*lam...*] (breite Streifen an [Uniform]hosen) *Mehrz.*

Lämp|chen, Lämp|lein (kleine ²Lampe)

¹Lam|pe (Kurzform von: Lampert; der Hase der Tierfabel); Meister -

²Lam|pe w; -, -n; Lam|pen|docht, ...fie|ber, ...licht (s; -[e]s), ...schirm, ...stube (Bergmannsspr.); Lam|pe|rie vgl. Lambrie; Lam|pi|on *fr.* [...*piong, lampiong,* auch: *lampiong,* österr.: ...*jon*] ([Papier]laterne) m (seltener: s); -s, -s; Lämp|lein, Lämp|chen

Lam|precht vgl. Lambrecht, Lambert

Lam|pre|te *mlat.* (ein Fisch) w; -, -n

Lan|ça|de *fr.* [*langßad*] (Bogensprung eines Pferdes in der Hohen Schule)

Lan|ca|ster [*längkᵉßtᵉr*] (engl. Herzogsfamilie; engl. Stadt); Lan|ca-ster|sche Me|tho|de [nach dem engl. Quäker u. Pädagogen Lancaster] (früheres Unterrichtssystem) w; -n -; Lan|ca|ster|schu|le (↑R 180)

Lan|cier *fr.* [*langßie*] („Lanzenreiter"; Ulan; Tanz) m; -s, -s; lan|cie-ren [*langßïrᵉn*] (in Gang bringen, in Umlauf setzen; auf einen vorteilhaften Platz stellen) lan|ciert; -e (in bestimmter Art gemusterte) Gewebe; Lan|cie|rung

Land s; -[e]s, Länder u. (dicht.:) Lande; aus aller Herren Länder[n]; außer Landes; hierzulande; die Halligen melden „Land unter"; zu Lande u. zu Wasser, aber: bei uns zulande

(daheim); land|ab vgl. landauf; Land.adel, ...am|mann (schweiz.: Titel des Präsidenten einiger Kantonsregierungen), ...ar|beit, ...ar|bei|ter, ...arzt

Land|au|er (viersitziger Wagen) land|auf; -, landab (überall); Land-auf|ent|halt

Land|au in der Pfalz (Stadt i. d. Vorderpfalz); Lan|dau|lett *fr.* [*landolät*]; nach der dt. Stadt Landau] ([Halb]landauer) s; -s, -e land|aus; -, landein (überall); Land.bau, (m; -[e]s), ...be|sitz, ...be|stel|lung, ...be|völ|ke|rung, ...be|woh|ner, ...brot; Länd|chen s; -s, - u. Länderchen; Länd|lein s; -s, - u. Länderlein; Land|drost (früher für: Landvogt); Län|de landsch. (Landungsplatz) w; -, -n; Län|de.bahn, ...bein (Raumfahrt), ...er|laub|nis, ...fäh|re; Länd|ei|gen|tü|mer; land|ein vgl. landaus; land|ein|wärts; Län|de-mä|nö|ver; län|den; län|den landsch. (landen, landen machen); Länd|en|ge; Län|de.pi|ste, ...platz; Län|de|rei|en *Mehrz.*; Län|der.kampf (Sportspr.), ...kun|de (Wissenschaftsfach; w; -); län|der|kun|dig (die Länder kennend); län|der|kund|lich (die Länderkunde betreffend); Län-der.na|me, ...spiel (Sportspr.)

Landes [*langd*] (fr. Landschaft)

Lan|des.amt, ...art (w; -), ...auf-nah|me, ...bank (*Mehrz.* ...banken), ...be|am|te, ...be|hör|de, ...bi|schof, ...brauch, ...far|ben (*Mehrz.*), ...feind; lan|des_flüch-tig, land|flüch|tig; Lan|des_fürst, ...ge|richt (österr. svw. Landgericht), ...ge|richts|rat (österr. svw. Landgerichtsrat), ...ge-schich|te, ...gren|ze, ...haupt-mann (österr. für: Regierungschef eines Bundeslandes; *Mehrz.*: ...leute od. ...männer), ...haupt-stadt, ...herr; lan|des|herr|lich; Lan|des.ho|heit, ...hym|ne (österr. für: offizielle Hymne eines Bundeslandes), ...in|ne|re, ...kind, ...kir|che

Lan|des|kro|ne (Berg bei Görlitz) Lan|des|kun|de (Wissenschaftsfach) w; -; lan|des|kun|dig (das Land kennend); lan|des|kund|lich (die Landeskunde betreffend); Lan|des.li|ste, ...mei|ster|schaft, ...mut|ter (*Mehrz.* ...mütter), ...pla|nung, ...pro|dukt, ...rat (österr. für: Mitglied einer Landesregierung), ...recht (Recht der Länder im Gegensatz zum Reichs- od. Bundesrecht), ...re|gie|rung, ...schul|rat (österr. für: oberste Schulbehörde eines Bundeslandes), ...sit|te, ...spra-che, ...tracht, ...trau|er; lan|des-

üb|lich; Lan|des_va|ter, ...ver|rat, ...ver|rä|ter, ...ver|tei|di|gung, ...ver|wei|sung, ...wäh|rung, ...wap|pen; lan|des|ver|wie|sen; Lan|de|ver|bot; Land|fah|rer; land|fein (Seemannsspr.); sich - machen; Land|flucht (Abwande-rung der ländl. Bevölkerung in die [Groß]städte) w; -; land|flüch-tig, lan|des|flüch|tig; Land|frau; land|fremd

Land_frie|de|[n]; Land|frie|dens-bruch m; Land_ge|mein|de, ...ge-richt (Abk.: LG), ...ge|richts|rat (Mehrz. ...räte), ...ge|win|nung, ...graf,...gut,...haus,...heim,...jä-ger (eine bes. Dauerwurst; frü-her: [Kantons]polizist), ...kar|te; Land Keh|din|gen (Teil der Elb-marschen) s; -es -; Land_kind, ...kli|ma, ...kreis, ...kund|schaft; land|läu|fig; Land|le|ben; Länd-lein vgl. Ländchen; Länd|ler (ländl. Tanz); länd|lich; -e Haus-wirtschaftsgehilfin; -er Blues (Jazz); Länd|lich|keit w; -; land-lie|bend (Zool.), aber († R 142): das Land liebend; Land_luft, ...macht, ...mann (Bauer, Mehrz. ...leute), ...ma|schi|ne, ...mes|ser m, ...nah|me (hist.: Inbesitznah-me von Land durch ein Volk; w; -), ...par|tie, ...pfar|rer, ...pla-ge,...pfle|ger(bibl.),...po|me|ran-ze (spött. für: Mädchen vom Lande, Provinzlerin), ...pra|xis, ...rat (Mehrz. ...räte), ...rat|te (spött. Seemannsausdruck für: Nichtseemann), ...recht (im MA. Recht der landesherrl. Gebiete), ...re|gen, ...rich|ter (veralt.), ...rücken [Trenn.: ...rük|ken]; land|säs|sig (veralt.)

Lands|berg a. Lech (Stadt in Ober-bayern)

Land|schaft; Land|schaf|ter (Landschaftsmaler); land|schaft-lich; Land|schafts|ma|ler; Land-schrei|ber schweiz. (Kanzleivor-steher eines Landkantons, Be-zirks); Land|schu|le; Land|schul-heim; Land|se m; Land|ser (ugs. für: Soldat); Lands|ge|mein|de schweiz. (Versammlung der stimmfähigen Bürger eines Kan-tons, Bezirks)

Lands|hut (Stadt a. d. Isar)

Land|sitz; Lands|knecht

Lands|mål [lánt_smol] norw. ("Landessprache"; ältere Bez. für Nynorsk [vgl. d.]) s; -[s]

Lands_mann (Landes-, Heimat ge-nosse; Mehrz. ...leute), ...män|nin (w; -, -nen); lands|män|nisch; Lands|mann|schaft; Land|stadt; Land|stän|de (hist.) Mehrz.

Lands|ting dän. [lanßteng] (bis 1953 der Senat der dän. Reichsta-ges) s; -s

Land|stör|zer (veralt. für: Fahren-der); Land|stör|ze|rin w; -, -nen; Land_stra|ße, ...strei|cher, ...streit|kräf|te(Mehrz.),...strich, ...sturm (vgl. ¹Sturm); Land-sturm|mann (Mehrz. ...männer); Land|tag; Land|tags|ab|ge|ord-ne|te; Lan|dung; Lan|dungs_boot, ...brücke [Trenn.: ...brük|ke], ...steg; Land_ur|laub, ...ver|mes-ser, ...vogt (hist.), ...volk; land-wärts; Land-Was|ser-Tier († R 155); Land|wehr w; Land|wehr-mann (Mehrz. ...männer); Land-_wein, ...wind, ...wirt, ...wir|tin, ...wirt|schaft; land|wirt|schaft-lich; -e Nutzfläche; landwirt-schaftliche Produktionsgenos-senschaft(DDR), aber († R 224): "Landwirtschaftliche Produk-tionsgenossenschaft Einheit" [in Dallgow] (Abk.: LPG...); Land|wirt|schafts_aus|stel|lung, ...ge|setz, ...kam|mer, ...mei|ster; Land|zun|ge

lang; länger, längste. I. Klein-schreibung: a) († R 135:) ein lan-ges u. breites (viel) reden; b) († R 134:) sich des langen u. breiten, des länger[e]n u. breiter[e]n über etwas äußern; am, zum längsten; seit lange[m]; c) († R 133:) über kurz od. lang. II. Großschreibung: a) († R 116:) das Lange u. Kurze von der Sache ist ...; b) († R 224:) der Lange Marsch (der Marsch der chin. Kommunisten quer durch China 1934 bis 1935). III. Zusammenschreibung: langher, langhin; allzulang; meterlang, jahrelang, tagelang usw., aber: einen Fuß lang, zehn Meter lang, zwei Jahre lang; langlegen, sich (vgl. d.); langziehen (vgl. d.); vgl. lange; lang_är|me|lig od. ...ärm|lig, ...ar|mig, ...at|mig, ...bär|tig; Lang_baum (svw. Langwied[e]), ...bein (scherzh.); lang|bei|nig; lan|ge, lang; länger, am längsten († R 134:); lang er-sehnte Hilfe, lang anhaltender Beifall usw.; es ist lange her; lang, lang ist's her; Län|ge w; -, -n; län-gelang (ugs. für: der Länge nach) hinfallen

Lan|ge|marck (so die seit dem 1. Weltkrieg übliche Schreibung, amtl.: Lan|ge|mark; Ort in West-flandern)

lan|gen (ugs. für: ausreichen; [nach etwas] greifen)

län|gen (länger machen; veralt. für: länger werden); Län|gen-grad, ...kreis, ...maß s

Lan|gen|scheidt; vgl. Toussaint-Langenscheidt

Lan|gen|see (it.-schweiz. See) m; -s; vgl. Lago Maggiore

Lan|ge|oog [...ok] (ostfries. Insel)

län|ger|fri|stig

Lan|get|te fr. (Randstickerei als Abschluß; Trennungswand zwi-schen zwei Schornsteinen) w; -, -n; lan|get|tie|ren (mit Randstik-kereien versehen); Lan|get|tie-rung

Lan|ge|wei|le, Lang|wei|le w; Wesf. der Lang[e]weile u. Lan-genweile; aus - u. Langerweile; Lan|ge|zeit schweiz. (Sehnsucht, Heimweh) w; zur Beugung vgl. Langeweile; lang|fä|dig schweiz. (weitschweifig u. langweilig); Lang|fin|ger (ugs. für: Dieb); lang|fin|ge|rig; lang|fri|stig; Lang|gäs|ser (dt. Dichterin)

lang_ge|hegt, ...ge|stielt, ...ge-streckt, ...ge|zo|gen, ...glie|de|rig od. ...glied|rig, ...haa|rig, ...hal-sig; Lang|haus; lang|her (veralt.). lang|hin; ein langhin rollendes Echo; Lang|holz; lang_jäh|rig ...köp|fig; Lang|lauf (Sportspr.) lang|le|big; Lang|le|big|keit w; - lang|le|gen, sich (ugs. für: schla-fen gehen); lang|lich; lang lich|rund (†R 158); lang|mäh|nig Lang|mut w; -; lang|mü|tig; Lang mü|tig|keit w; -; lang|na|sig

Lan|go|bar|de (Angehöriger eine westgerm. Volkes) m; -n, -n († R 268); lan|go|bar|disch

Lang|ohr (scherzh. für: Hase; Esel s; -[e]s, -en; lang|rip|pig; längs (de Längenach); etwas - trennen; m Wesf.: - des Weges, gelegentl. m Wemf.: - dem Wege; Längs|ach|s lang|sam; -er Walzer; Lang|sam keit w; -

lang|schä|de|lig, lang|schäd|li Lang_schaft|er (Stiefel mit lan gem Schaft), ...schlä|fer; lang schnä|be|lig, lang|schnäb|li längs|deck[s] (auf dem Deck en lang); Lang|seil|te; Längs_fa|de ...fal|te; längs|ge|streift; ein - Stoff († jedoch R 142), aber: d Stoff ist längs gestreift; Längs|l nie; Lang|spiel|plat|te (Abk LP); Lang|rich|tung; längs schiffs (in Kielrichtung); Läng schnitt; längs|seit (Seemannssp an der langen Seite, an die lan Seite des Schiffes); Längs|sei| längs|seits (parallel zur Läng richtung); mit Wesf.: - des Sch fes; längst (seit langem); län sten|ge|lig, lang|steng|lig; län stens landsch. (längst; spä stens); lang|stie|lig (ugs. auch für: langweilig, einförmig; Lan strecken_bom|ber [Tren ...strek|ken...], ...flug, ...la ...läu|fer; Lang|streck|ler (Lan streckenläufer); Längs|wand

Langue|doc [langgdok] (süd Landschaft) s od. w; -; Langu doc|wein († R 201)

Lan|gu|ste *fr.* (ein Krebs) *w;* -, -n

Lang|wei|le vgl. Langeweile; lang|wei|len; du langweilst; gelang-weilt; zu -; sich -; Lang|wei|ler (ugs. für: langweiliger Mensch); lang|wei|lig; Lang|wei|lig|keit; Lang|wei|le; lang|wei|lig; Lang-wied, Lang|wie|de mdal. (langes Rundholz, das Vorder- u. Hintergestell eines großen Leiterwagens verbindet) *w;* -, ...den; lang-wie|rig; Lang|wie|rig|keit; Lang-zei|le; Lang|zeit|pro|gramm; lang|zie|hen, nur in: jmdm. die Hammelbeine - (ugs. für: jmdn. heftig tadeln), die Ohren - (jmdn. [an den Ohren ziehend] strafen)

La|no|lin *lat.* (Wollfett, Salbengrundstoff) *s;* -s

Lan|ta|na *nlat.* (Wandelröschen, Zierstrauch od. -staude) *w;* -

Lan|than *gr.* (chem. Grundstoff, Metall; Zeichen: La) *s;* -s; Lan-tha|nit (ein Mineral) *m;* -s, -e

La|nu|go *lat.* (Wollhaarflaum als Körperbedeckung des Embryos) *w;* -, ...gines

.an|ze *w;* -, -n; Lan|zen|farn, ...otter *w.* ...rei|ter, ...stich, ...stoß, ...spit|ze; Lan|zett|te (chirurg. Instrument) *w;* -, -n; Lan|zett|fen-ster, ...fisch; lan|zett|för|mig; lan-zi|nie|ren (Med.: blitzartig schmerzen [bes. bei Rückenmarksschwindsucht]); -de Schmerzen

ao|ko|on [...*ko-on*] (gr. Sagengestalt)

.aon [*lang*] (fr. Stadt)

.a|os (Staat in Hinterindien); **Lao|te** *m;* -n, -n; ↑ R 268; lao|tisch

.ao|tse [auch: *lau...*] (chin. Weiser)

.a|pa|ro|to|mie *gr.* (Med.: Bauchschnitt) *w;* -, ...ien

.a Paz [- *paß*] (Hptst. von Bolivien)

.|pi|dar *lat.* (kraftvoll, wuchtig; einfach, elementar; kurz u. bündig); La|pi|där (Schleif- u. Poliergerät der Uhrmacher) *m;* -s, -e; **La|pi|da|ri|um** (Sammlung von Steindenkmälern) *s;* -s, ...ien ...*i*[*e*]*n*]; la|pi|dar.schrift (Versalschrift, meist auf Stein) ...stil (in [e]s); La|pi|des (*Mehrz.* von: La-is); La|pi|lli *it.* (kleine Steinchen, die bei einem Vulkanausbruch ausgeworfen werden) *Mehrz.*; La|pis *lat.* (Stein) *m;* -, ...ides [...*däß*]; la|pis|blau; La|pis-a|zu|li (Lasurstein) *m;* -

.|pi|the (Angehöriger eines nyth. Volkes in Thessalien) *m;* :n, -n (↑ R 268)

.|place [...*plaß*] (fr. Astronom und Mathematiker); Laplace-che Theorie

.a Pla|ta vgl. Rio de la Plata;

²La Pla|ta (Mündungsbucht der Flüsse Paraná u. Uruguay) *m;* - -; La-Pla|ta-Staa|ten; ↑ R 155 (Argentinien, Paraguay, Uruguay) *Mehrz.*

Lapp bayr., österr. mdal. (Laffe) *m;* -en, -en

Lap|pa|lie [...*i*ᵉ] (Kleinigkeit; Nichtigkeit) *w;* -, -n; Läpp|chen, Läpp|lein (kleiner Lappen)

Lap|pe (Angehöriger eines Volksstammes im nördl. Nordeuropa) *m;* -n, -n (↑ R 268)

Lap|pen *m;* -s, -

läp|pen (metallische Werkstoffe fein bearbeiten)

Lap|pen|zelt [zu: Lappe]

Lap|pe|rei (seltener für: Läpperei); **Läp|pe|rei** mdal. (Kleinigkeit; Wertloses); läp|pern mdal. (schlürfen; in kleinen Teilen sammeln; zusammenkommen); es ...ere (↑ R 327); es läppert sich

lap|pig

lap|pisch [zu: Lappe]

läp|pisch; -ste (↑ R 294)

Lapp|land (Landschaft in Nordeuropa); Lapp|län|der (Bewohner Lapplands); lapp|län|disch

Läpp|lein vgl. Läppchen

Läpp|ma|schi|ne (Maschine zum Läppen)

Lap|sus *lat.* (geringfügiger) Fehler, Versehen) *m;* -, -; Lap|sus ca-la|mi [- *kg...*] (Schreibfehler) *m;* - -, - -; Lap|sus lin|guae [- ...*guä*] (Sichversprechen) *m;* - -, - -; Lap-sus me|mo|riae [- ...*ä*] (Gedächtnisfehler) *m;* - -, - -

Lär|che (ein Nadelbaum) *w;* -, -n; vgl. aber: Lerche

La|ren *lat.* (altröm. Schutzgeister) *Mehrz.*

large *fr.* [*larseh*] bes. schweiz. (großzügig, weitherzig)

lar|ghet|to *it.* [...*gäto*] (Musik: etwas breit, etwas langsam); Lar-ghet|to; -s, -s u. ...tti; lar|go (Musik: breit, langsam); Lar|go *s;* -s, -s (auch: ...ghi [...*gi*])

la|ri|fa|ri! (ugs.: Geschwätz!, Unsinn!); La|ri|fa|ri *s;* -s

Lärm *m;* -s (seltener -es); Lärm-be|kämp|fung, ...be|lä|sti|gung; lärm|emp|find|lich; lärm|men; lär-mig (schweiz., sonst veralt. für: lärmend laut); Lärm|ma|cher, ...quel|le, ...schutz, ...ta|bel|le

lar|moy|ant *fr.* [...*moajang*] (veralt. für: weinerlich; rührselig)

Lärm|wall (neben Autostraßen)

Lars (m. Vorn.)

L'art pour l'art *fr.* [*lár pur lár*] („die Kunst für die Kunst", die Kunst als Selbstzweck; Schlagwort für eine Kunstauffassung, die einen außerkünstlerischen Maßstab ablehnt) *s;* -

lar|val *lat.* [...*wgl*] (Biol.: die Tier-

larve betreffend); Lärv|chen, Lärv|lein; Lar|ve [*larfᵉ*] (Gespenst, Maske; oft spött. od. verächtl. für: Gesicht; Zool.: Jugendstadium bestimmter Tiere) *w;* -, -n; lar|ven|ähn|lich

La|ryn|gal *gr.* [...*ngg...*] (Sprachw.: Laut, der in der Stimmritze [im Kehlkopf] gebildet wird, Stimmritzen-, Kehlkopflaut) *m;* -s, -e; La|ryn|gen (*Mehrz.* von: Larynx); La|ryn|gi|tis (Med.: Kehlkopfentzündung) *w;* -, ...itiden; La|ryn|go|lo|gie (Lehre vom Kehlkopf u. seinen Krankheiten) *w;* -; La|ryn|go|skop (Kehlkopf-spiegel) *s;* s, -e; la|ryn|go|sko-pisch; La|rynx (Kehlkopf) *m;* -, Laryngen

lasch (ugs. für: schlaff, lässig)

La|sche (ein Verbindungsstück) *w;* -, -n; la|schen (durch Lasche[n] verbinden); du laschst (laschest)

La|schen|ver|bin|dung

Lasch|heit [zu: lasch]

La|schung (Verbindung durch Lasche[n])

La|se mitteld. ([Bier]gefäß) *w;* -, -n

La|ser *engl.* [meist *lᵉ'sᵉr*] (Physik: Gerät zur Verstärkung von Licht od. zur Erzeugung eines scharf gebündelten Lichtstrahles) *m;* -s, -; La|ser|strahl

la|sie|ren *pers.* (mit Lasur versehen); La|sie|rung

Lä|si|on *lat.* (Rechtsspr.: Verletzung)

Las|kar *angloind.* (früher: ostind. Matrose, Soldat) *m;* -s, ...karen

Las|ker-Schü|ler, Else (dt. Dichterin)

Las Pal|mas (Hptst. der span. Insel Gran Canaria)

laß (geh. für: matt, müde, schlaff); lasser, lasseste

Las|salle [*laßgl*] (Mitbegründer der dt. Arbeiterbewegung); Las-sal|lea|ner (Anhänger Lassalles)

Las|se (veralt. für: Höriger) *m;* -n, -n (↑ R 268)

las|sen; du läßt (veralt.: lässest), er läßt; du ließest, er ließ; gelassen; lasse! u. laß!; ich habe es gelassen (unterlassen), aber (↑ R 305): ich habe dich rufen lassen (seltener: gelassen); ich lasse dich wissen, vgl. bleibenlassen, fahrenlassen, fallenlassen usw.

Läß|heit [zu: laß]; läs|sig; Läs|sig-keit; läß|lich (leichter) verzeihlich); -e (kleinere) Sünde; Läß-lich|keit

Las|so *span.* (Wurfschlinge) *s* (österr. nur so) od. *m;* -s, -s

Last (Seemannsspr. auch: Vorratsraum unter Deck) *w;* -, -en; zu -en des... od. von ...; zu meinen -en

La|sta|die *mlat.* [...*iᵉ*] w; -, -n, (auch:) La|sta|die (früher für: [Schiffs]ladeplatz) w; -, ...jen

Last|au|to; la|sten; La|sten_auf|zug, ...aus|gleich (Abk.: LA); La|sten|aus|gleichs|ge|setz (Abk.: LAG); la|sten|frei; La|sten|seg|ler; ¹La|ster (ugs. für: Lastkraftwagen) m; -s, -

²La|ster s; -s, -; Lä|ster|chro|nik (veralt.); Lä|ste|rei; Lä|ste|rer; la|ster|haft; La|ster|haf|tig|keit; La|ster|höh|le; Lä|ste|rin w; -, -nen; La|ster|le|ben s; -s; lä|ster|lich; Lä|ster|lich|keit; Lä|ster|maul (ugs. für: jmd., der viel lästert); lä|stern; ich ...ere (↑ R 327); Lä|ste|rung; Lä|ster_wort (*Mehrz.* ...worte), ...zun|ge

Last|esel

La|stex ([Gewebe aus] Gummifäden, die mit Kunstseiden- od. Chemiefasern umsponnen sind) s; -; La|stex|ho|se

Last|fuh|re; ...la|stig (z. B. zweilastig; Flugw.: schwanzlastig); lä|stig; La|stig|keit (das höchstmögliche Gewicht der Ladung eines Schiffes) w; -; Lä|stig|keit

La|sting *engl.* (ein Gewebe) m; -s, -s

Last_kahn, ...kraft|wa|gen (Abk.: Lkw, auch: LKW)

last, not least *engl.* [*laßt not ließt*] (,,als letzter [letztes], nicht Geringster [Geringstes]"; zuletzt der Stelle, aber nicht dem Werte nach; nicht zu vergessen)

Last_pferd, ...schiff, ...schrift (Buchhaltung); Last|schrift|zet|tel; Last_spit|ze (größte Belastung eines Kraftwerks in einer bestimmten Zeit), ...tier, ...trä|ger, ...wa|gen (Lastkraftwagen), ...zug

La|sur *pers.* (durchsichtige Farbschicht) w; -, -en; La|sur_far|be (durchsichtige Farbe), ...stein

las|ziv *lat.* (schlüpfrig [in sittl. Beziehung]); Las|zi|vi|tät [...*wi*...]

Lä|ta|re *lat.* (,,Freue dich!"; dritter Sonntag vor Ostern)

La|tein s; -s; La|tein|ame|ri|ka (Gesamtheit der spanisch- od. portugiesischsprachigen Staaten Amerikas); la|tein|ame|ri|ka|nisch; La|tei|ner (jmd., der Latein kennt, spricht); la|tei|nisch; -e Schrift; vgl. deutsch; La|tei|nisch (Sprache) s; -[s]; vgl. Deutsch; La|tei|ni|sche s; -n; vgl. Deutsche s; La|tein_schrift, ...schu|le, ...se|gel (dreieckiges Segel), ...un|ter|richt

La-Tène-Zeit [*la tän* ...]; nach der Untiefe im Neuenburger See] (Abschnitt der Eisenzeit) w; -; ↑ R 211; la|tène|zeit|lich

la|tent *lat.* (versteckt, verborgen; ruhend; gebunden, aufgespei-

chert); ein -er Gegensatz; -es Bild (Fotogr.); eine -e Krankheit; -e (gebundene) Wärme; La|tenz w; -; La|tenz_pe|ri|ode, ...zeit

la|te|ral *lat.* (seitlich)

La|te|ran (ehem. Palast des Papstes in Rom) m; -s; La|te|ran-_kon|zil, ...pa|last, ...ver|trä|ge (*Mehrz.*)

La|te|rit *lat.* (roter Verwitterungsboden) m; -s, -e; La|te|rit|bo|den m; -s

La|ter|na ma|gi|ca *lat.* [- ...*ka*] (einfachster Projektionsapparat) w; - -, ...nae ...cae [...*nä* ...*zä*]; La|ter|ne gr. (Architektur auch: turmartiger Aufsatz) w; -, -n; La|ter|nen_ga|ra|ge (ugs.), ...licht, ...pfahl

La|tex gr. (Kautschukmilch) m; -, Latizes [...*zäß*]; la|te|xie|ren

La|thy|ris|mus gr. (Med.: Vergiftung durch eine Erbsenart) m; -

La|tier|baum (Stange im Pferdestall zur Abgrenzung der Plätze)

La|ti|fun|di|en|wirt|schaft; La|ti|fun|di|um *lat.* (Landgut im Röm. Reich; Großgrundbesitz) s; -s, ...ien [...*iᵉn*]

La|ti|ner (Angehöriger eines altitalischen Volkes in Latium) m; -s, -; la|ti|nisch; la|ti|ni|sie|ren *lat.* (in lat. Sprachform bringen; der lat. Sprach angleichen); La|ti|ni|sie|rung; La|ti|nis|mus (dem Lateinischen eigentümlicher Ausdruck in einer nichtlat. Sprache) m; -, ...men; La|ti|nist (Kenner u. Erforscher des Lateinischen); ↑ R 268; La|ti|ni|tät ([klassische, mustergültige] lat. Schreibweise, desgl. Schrifttum) w; -; La|ti|num ([Ergänzungs]prüfung im Lateinischen) s; -s; das kleine, große -

Lä|ti|tia [...*zia*] (w. Vorn.)

la|ti|tu|di|nal *lat.* (den Breitengrad betreffend); La|ti|tu|di|na|ri|er [...*iᵉr*] (anglikan. Theologe freisinniger Richtung im 17. Jh.)

La|ti|um [*lazi*...] (hist. Landschaft in Mittelitalien)

La|tri|ne *lat.* (Abort, Senkgrube) w; -, -n; La|tri|nen_ge|rücht (ugs.), ...pa|ro|le (ugs.), ...rei|ni|gung

Latsch (ugs. für: nachlässig gehender Mensch; Hausschuh) m; -[e]s, -e; ¹Lat|sche w; -, -n u. Lat|schen (ugs. für: Hausschuh, abgetretener Schuh) m; -s, -; vgl. auch: Latsch

²Lat|sche (Krummholzkiefer, Legföhre) w; -, -n

lat|schen (ugs. für: nachlässig, schleppend gehen); du latschst (latschest)

Lat|schen_ge|büsch, ...kie|fer w; Lat|schen|kie|fern|öl s; -[e]s; Lat|schen|öl s; -[e]s

lat|schig (ugs. für: nachlässig in Gang u. Wesen)

Latt|te w; -, -n; Lat|ten_holz, ...ki|ste, ...kreuz (Sportspr.: von Pfosten u. Querlatte gebildete Ecke des Tores), ...rost (vgl. ¹Rost), ...schuß (Sportspr.: Schuß an die Querlatte des Tores), ...ver|schlag, ...zaun

Lat|tich *lat.* (ein Korbblütler) m; -s, -e

Lat|wer|ge gr. (breiförmige Arznei; veralt., aber noch landsch. für: Fruchtmus) w; -, -n

Latz (Kleidungsteil [z. B. Brustlatz]; veralt. für: Schnur Schlinge) m; -es, Lätze (österr. auch: Latze); Lätz|chen, Lätz|lein; Latz|ho|se

lau (↑ R 293)

Laub s; -[e]s; Laub|baum

¹Lau|be w; -, -n

²Lau|be (ein Fisch) m; -n, -n (↑ R 268)

Lau|ben_gang m, ...haus, ...ko|lo|nie

Laub_fall (m; -[e]s), ...fär|bung ...frosch, ...ge|höl|ze (*Mehrz.*) ...holz; Laub|hüt|ten|fest (jüd Fest); lau|big; Laub|sä|ge; laub tra|gend, aber (↑ R 142): nu noch weniges Laub tragend Laub_wald, ...werk (Architektu

Lauch (eine Zwiebelpflanze) n -[e]s, -e; lauch|grün

Lau|da|num *lat.* (ein Beruhigung mittel) s; -s

Lau|da|tio *lat.* [...*zio*] (Lob[rede w; -, ...iones; Lau|des (,,Lobge sänge"; Morgengebet des kath Breviers) *Mehrz.*

Laue, Laui (schweiz. mdal. N benformen von: Lawine) w; Lauen u. Lauenen

¹Lau|er w; -; auf der - sein, lieg

²Lau|er *lat.* (Nachwein, Treste wein) m; -, -

lau|ern; ich ...ere (↑ R 327)

Lauf m; -[e]s, Läufe; im Laufe de Zeit; 100-m-Lauf (↑ R 157); Lau _bahn, ...brett, ...bur|sche; Lau chen

Läu|fel südwestd. (äußere [grün Schale, bes. der Walnuß) w; lau|fen; du läufst, er läuft; du lie (liefest) du liefest; gelaufe lauf[e]!; lau|fend (Abk.: lfd.); Jahr u. -en Jahres (Abk.: lfd. J -er Meter u. -en Meters (Ab lfd. m); -er Monat u. -en Mon (Abk.: lfd. M.); -e Nummer -er Nummer (Abk.: lfd. Nr.); Band; am -en Band arbeiten; (↑ 133:) auf dem -en sein, bleibe [er]halten; lau|fen|las|sen; ↑ R 1 (ugs. für: lossagen, freigeben); lasse sie laufen; ich habe laufenlassen, (seltener:) laufe gelassen (↑ R 305); er beabsic

tigt, sie laufenzulassen; **aber:**
lau|fen las|sen; du sollst den
Hund laufen lassen; er hat den
Karren laufen lassen (ugs.: sich
um nichts gekümmert); **Läu|fer;**
Lau|fe|rei (ugs.); **Läu|fe|rin** w; -,
-nen; **läu|fe|risch; Lauf⌣feu|er,**
...ge|wicht, ...git|ter, ...gra|ben;
läu|fig (von der Hündin: brün-
stig); **Läu|fig|keit** (Brunst der
Hündin) w; -; **Lauf⌣kä|fer, ...kat-**
ze (Technik), **...kund|schaft,**
...ma|sche, ...paß (nur in ugs.:
jmdm. den - geben), **...schritt,**
...ställ|chen, ...steg, ...stuhl,
...zeit, ...zet|tel
.au|ge (alkal. [wässerige] Lösung;
Auszug) w; -, -n; **lau|gen; lau|gen-**
ar|tig; Lau|gen⌣bad, ...faß, ...salz,
...was|ser
au|heit; Lau|ig|keit (veralt.) w; -
.aum mdal. (Wasserdampf) m;
-[e]s
.au|ne lat. w; -, -n; **lau|nen** (veralt.
für: launenhaft sein); gut gelaunt
(vgl. gut, IV); gelaunt (geneigt)
zu ...; **lau|nen|haft; Lau|nen|haf-**
tig|keit; lau|nig (witzig); **lau|nisch**
(launenhaft); -ste (↑ R 294)
.au|ra (Kurzform von: Lauren-
tia)
.au|re|at (gekrönter Dichter) m;
-en, -en (↑ R 268); vgl. Poeta lau-
reatus
.au|ren|tia [...zia] (w. Vorn.); **Lau-**
ren|ti|us [...ziuß] (m. Vorn.)
au|ren|tisch [nach den latinisier-
ten Namen des Sankt-Lorenz-
Stromes]; -e Gebirgsbildung (am
Ende des Archaikums)
.u|re|ta|nisch (aus Loreto), **aber**
(↑ R 224): Lauretanische Litanei
[in Loreto entstandene Marien-
itanei]
au|rin (Zwergkönig, dt. Sagen-
gestalt)
au|rus lat. (Lorbeerbaum) m; -
-.ses, - u. -se
aus w; -, Läuse
au|sanne [losan, schweiz.: losan]
(Stadt am Genfer See); **Lau|san-**
ser (↑ R 199)
aus⌣bub (scherzh.); **Laus|bü|be-**
ei (scherzh.); **laus|bü|bisch**
au|scha|er Glas|wa|ren [nach
em Ort Lauscha im Thüringer
Vald] Mehrz.
ius|chen, Läus|lein
u|schen; du lauschst (lauschest);
.au|scher (Lauschender; Jä-
erspr.: Ohr des Haarwildes);
.au|sche|rin w; -, -nen; **lau|schig**
raulich; veralt. für: gern
uhörend]
au|se|be|fall; Lau|se.ben|gel od.
.jun|ge od. **...kerl** (ugs.); **Läu|se-**
raut (eine Pflanzengattung) s;
e]s; **lau|sen;** du laust (lausest);
lau|ste; **Lau|se|pack; Lau|ser**

(landsch. scherzh. für: Lausbub);
Lau|se|rei (ugs.); **lau|sig** (ugs.
auch für: äußerst; viel; schlecht);
-e Zeiten
Lau|sitz (Gebiet beiderseits der
Görlitzer Neiße u. der oberen u.
mittleren Spree) w; -, (für Ober-
u. Niederlausitz auch Mehrz.:)
-en; **Lau|sit|zer** (↑ R 199); **lau|sit-**
zisch
Läus|lein, Läus|chen
¹**laut;** -er, -este; etwas - werden las-
sen; ²**laut** (↑ R 130; Abk.: lt.); mit
Wesf.: laut [des] amtlichen Nach-
weises; ein alleinstehendes, stark
gebeugtes Hauptw. steht in der
Einz. oft schon ungebeugt: laut
Befehl, laut Bericht, laut
Übereinkommen od. mit Wemf.,
wenn eine Beifügung hinzutritt;
laut ärztlichen Gutachten, in der
Mehrz. mit Wemf., wenn der
Wesf. nicht erkennbar ist: laut
Briefen; **Laut** m; -[e]s, -e; - geben;
laut|bar (veralt.); - werden; **Laut-**
bil|dung (für: Artikulation)
Lau|te arab. (ein Saiteninstru-
ment) w; -, -n
lau|ten (tönen, klingen; die Ant-
wort lautet gut; der Vertrag lautet
auf den Namen ...; das Urteil lau-
tet auf ...; **läu|ten;** die Glocken
läuten; er läutet die Glocken
Lau|te|nist (Lautenspieler); ↑ R
268; **Lau|ten⌣spiel, ...spie|ler**
¹**lau|ter** (rein, ungemischt; unge-
trübt); -er Wein; -e Gesinnung;
²**lau|ter** (nur, nichts als; viel); -
(nur, viel[e]) Knaben; - (nichts
als) Wasser; **Lau|ter|keit** w; -; **läu-**
tern; ich ...ere (↑ R 327); **Läu|te-**
rung
Läu|te|werk, Läut|werk; laut|ge-
setz; laut|[ge]|treu; laut|hals (aus
voller Kehle); **laut|tie|ren** (Worte,
Text nach Lauten zergliedern);
Lau|tier|me|tho|de; Laut|leh|re
(für: Phonetik u. Phonologie);
laut|lich; laut|los; -este (↑ R 292);
Laut|lo|sig|keit w; -; **laut|ma|lend;**
Laut|ma|le|rei; laut|nach|ah-
mend; Laut⌣schrift, ...spre|cher;
Laut|spre|cher|wa|gen; laut-
stark; laut|stär|ke; laut|treu,
laut⌣ge|treu; Laut⌣tung; Laut⌣ver-
än|de|rung, ...ver|schie|bung,
...wan|del, ...wech|sel; Läut|werk,
Läu|te|werk; Laut|zei|chen
lau|warm
La|va it. [...wa] (feurigflüssiger
Schmelzfluß aus Vulkanen u. das
daraus entstandene Gestein) w;
-, Laven
La|va|bel fr. [...wg...] (feinfädiges,
waschbares Kreppgewebe in
Leinwandbindung) m; -s
La|va|bo lat. [...wg..., schweiz.:
lạ...] (Handwaschung des Prie-
sters in der Messe u. das dazu

verwendete Waschbecken mit
Kanne; schweiz. für: Waschbek-
ken) s; -[s], -s
La|vant [lafant] (l. Nebenfluß der
Drau) w; -; **La|vant|tal**
La|va|strom
La|va|ter [lάwą...] (schweiz. Theo-
loge u. Schriftsteller)
La|ven (Mehrz. von: Lava)
La|ven|del it. [...wändᵉl] (Heil- u.
Gewürzpflanze, die zur Gewin-
nung eines ätherischen Öles be-
nutzt wird) m; -s, -; **La|ven|del⌣öl**
(s; -[e]s), **...was|ser** (s; -s)
¹**la|vie|ren** niederl. [...wirᵉn] (mit
Geschick Schwierigkeiten über-
winden; sich durch Schwierigkei-
ten hindurchwinden; veralt. für:
gegen widrigen Wind kreuzen)
²**la|vie|ren** it. [...wirᵉn] (aufgetrage-
ne Farben auf einem Bild verwi-
schen; auch: mit verlaufenen
Farbflächen arbeiten); lavierte
Zeichnung
La|vi|nia [...wị...] (röm. w. Ei-
genn.)
lä|vo|gyr gr. [...wo...] (Chemie:
linksdrehend; Zeichen: l)
La|voir fr. [lawoar] (österr., sonst
veralt. für: Waschbecken) s; -s,
-s; **La|vor** [..for] südd. (Lavoir)
s; -s, -e
Lä|vu|lo|se gr. [...wu...] (Frucht-
zucker) w; -
La|wi|ne lat. w; -, -n; **la|wi|nen|ar-**
tig; La|wi|nen⌣ge|fahr, ...ka|ta-
stro|phe, ...schutz; la|wi|nen|si-
cher
Lawn-Ten|nis engl. [lặn...] usw.
vgl. Tennis usw.
Law|ren|ci|um [lάr...; nach dem
amerik. Physiker Lawrence]
(künstlich hergestellter chem.
Grundstoff, ein Transuran; Zei-
chen: Lw) s; -s
lax lat. (schlaff, lässig; locker, lau
[von Sitten]); -er, -este; **La|xans**
s; -, ...antia [...zia] u. ...an|tien
[...ziᵉn]u. **La|xa|ti|v** s; -s, -e [...wᵉ]
u. **La|xa|ti|vum** [...wum] (Med.:
Abführmittel) s; -s, ...va [...wa];
Lax|heit (Schlaffheit; Lässig-
keit; **la|xie|ren** (Med.: abführen)
Lax|ness, Halldór (isländ. Schrift-
steller)
Lay|out engl. [leᵉaut od. ...aut]
(Druckw.: großzügig angelegte
Skizze von Text- u. Bildgestal-
tung) s; -s, -s; **Lay|ou|ter** (Layout-
Zeichner); **Lay|out-Ty|po|graph;**
Lay|out-Zeich|ner
La|za|rett fr. s; -[e]s, -e; **La|za-**
rett⌣ge|hil|fe, ...schiff, ...zug; La-
za|rist (Angehöriger einer kath.
Kongregation) m; -en, -en (↑R
268); **La|za|rus** (bibl. m. Eigenn.);
der arme -
La|ze|dä|mo|ni|er usw. vgl. Lake-
dämonier usw.

La|ze|ra|ti|on *lat.* [...*zion*] (Med.: Zerreißung, Einriß); **la|ze|rie|ren**
La|zert|te *lat.* (Eidechse) *w*; -, -n
La|zu|lith *nlat.* (ein Mineral) *m*; -s, -e
Laz|za|ro|ne *it.* (Armer, Bettler in Neapel) *m*; -[n] u. -s, -n u. ...ni
l. c. = loco citato
Ld. = limited
LDPD = Liberal-Demokratische Partei Deutschlands (DDR)
Lea (bibl. w. Eigenn.; auch w. Vorn.)
Lead *engl.* [*lid*] (die Führungsstimme im Jazz [oft Trompete od. Kornett]) *s*; -; **Lea|der** [*lid°r*] (kurz für: Bandleader; österr. Sportspr.: Tabellenführer) *m*; -s, - **Le|an|der** (gr. m. Eigenn.; auch m. Vorn.)
Lear [*lir*] (sagenhafter König, Titelheld bei Shakespeare)
lea|sen *engl.* [*lis°n*] (mieten, pachten); geleast; ein Auto -; **Lea|sing** [*lising*] (Vermietung von [Investitions]gütern; moderne Industriefinanzierungsform) *s*; -s, -s
Le|be|da|me; **le|be|hoch** *s*; -s, -s; er rief ein herzliches Lebehoch, a b e r: er rief: „Er lebe hoch!"; **le|be|lang**: mein - (besser: mein Leben lang); **Le|be|mann** (*Mehrz.* ...männer); **le|be|män|nisch**; -ste (↑ R 294); **le|ben**; leben und leben lassen; vgl. Lebehoch u. Lebewohl; **Le|ben** *s*; -s, -; mein Leben lang (vgl. lebelang); am - bleiben; das süße -; **le|ben|be|ja|hend**, **le|bens|be|ja|hend**, a b e r (↑ R 142): das Leben bejahend; **le|bend|ge|bä|rend** u. **le|ben|dig|ge|bä|rend**; **Le|bend|ge|wicht**; **le|ben|dig** *(↑ R 294)*; **le|ben|dig**; **Le|ben|dig|keit** *w*; -; **Le|bend|vieh**; **le|ben|ge|bend**, a b e r (↑ R 142): sein Leben gebend; **Le|bens_abend**, **...ab_schnitt**, **...ader**, **...al|ter**, **...angst**, **...ar|beit**, **...art**, **...auf|fas|sung**, **...auf|ga|be**, **...baum** (für: Thuja), **...be|din|gung** (meist *Mehrz.*); **le|bens|be|ja|hend** vgl. lebenbejahend; **Le|bens_be|ja|hung**, **...be|reich**, **...be|schrei|bung**, **...bild**, **...dau|er**, **...ele|ment**, **...eli|xier**, **...en|de** (*s*; -s), **...er|fah|rung**, **...er|in|ne|run|gen** (*Mehrz.*); **...er|war|tung**, **...er|werb**; **le|bens_fä|hig**; **Le|bens_fä|hig|keit** *w*; -; **le|bens_fern**; **Le|bens_fra|ge**; **le|bens_fremd**; **Le|bens_freu|de**; **le|bens_froh**; **Le|bens_froh** (*s*; -s); **le|bens_ge|fähr|lich**; **Le|bens_ge|fähr|lich** **...ge|fähr|tin**, **...ge|fühl**, **...gei|ster** (*Mehrz.*), **...ge|mein|schaft**, **...ge|nuß**; **le|bens_groß**; **Le|bens_grö|ße**; **Le|bens_hal|tung**, **...hil|fe**, **...hun|ger**, **...in|halt**, **...in|ter|es|se** (meist *Mehrz.*), **...jahr**, **...kampf**, **...kraft** *w*, **...kreis**, **...künst|ler**, **...la|ge**; **le|bens_lang** (auf -), **...läng|lich** (zu

„lebenslänglich" verurteilt werden; „lebenslänglich" erhalten); **Le|bens_lauf**, **...licht** (*s*; -[e]s), **...lust** (*w*; -); **le|bens_lu|stig**; **Le|bens_mit|tel** *s* (meist *Mehrz.*); **le|bens_mü|de**; **Le|bens_mut**; **le|bens_nah**; **Le|bens_nerv**; **le|bens_not_wen|dig**; **le|ben_spen|dend**, a b e r (↑ R 142): das Leben spendend; **Le|bens_pfad**, **...phi|lo|so|phie**; **le|ben_sprü|hend**, a b e r (↑ R 142): vor Leben sprühend; -ste; **Le|bens_raum**, **...re|form**, **...ret|ter**, **...ret|tungs|me|dail|le**, **...schick_sal**, **...stan|dard**, **...stel|lung**, **...still**; **Le|bens_tüch|tig**, **...über|drüs|sig**; **Le|bens_un|ter|halt**, **...ver|si|che_rung**; **Le|bens_ver|si|che|rungs_ge_sell|schaft**; **le|bens_wahr**; **Le|bens_wan|del**, **...weg**, **...wei|se** *w*, **...weis|heit**, **...werk**; **le|bens_wich|tig**; **Le|bens_wil|le**, **...zei_chen**, **...zeit** (auf -), **...ziel**, **...zu_ver|sicht**, **...zweck**; **le|ben_zer|stö_rend**, a b e r (↑ R 142): das Leben zerstörend
Le|ber *w*; -, -n; **Le|ber_ab|szeß** (eitrige Leberentzündung), **...bal|sam** (eine Pflanzengattung), **...blüm|chen** (eine Anemonenart), **...brand** (eine Viehkrankheit; *m*; -[e]s)
Le|be|recht, **Leb|recht** (m. Vorn.)
Le|ber_egel, **...fleck**, **...kä|se** (bes. in Süddeutschland u. Österreich: Art Hackbraten [mit Beigabe von Leber] in rechteckiger Form), **...knö|del**, **...krebs**, **...lei|den**, **...pa|ste|te**, **...tran**, **...wurst**
le|be_we|sen; **Le|be_wohl** *s*; -[e]s, -e u. -s; jmdm. Lebewohl sagen; er rief ein herzliches Lebewohl, a b e r: er rief: „Leb[e] wohl!"; **leb|haft**; lebhaftrot usw.; **Leb|haf|tig|keit** *w*; -; **...le|big** (z. B. kurzlebig)
Leb_ku|chen, **...küch|ler** od. **...küch|ner** (veralt. mdal. für: Lebkuchenbäcker; **Leb_küch|le_rei** od. **...küch|ne|rei** (veralt. mdal.)
leb|los; **Leb|lo|sig|keit** *w*; -
Leb_recht, **Le|be|recht** (m. Vorn.)
Leb_tag (ugs.); ich denke mein (nicht: meinen) - daran; meine -[e], (landsch.:) meiner -e; das werde ich mein - nicht vergessen; daran wirst du dein - denken
Le_bus [auch: *le...*] (Stadt an der mittleren Oder); **Le|bu|ser** [auch: *le...*] (↑ R 199)
Leb|zei|ten *Mehrz.*; bei - seines Vaters; zu seinen -
Leb|zel|ten österr. veralt. (Lebkuchen) *m*; -s, -; **Leb|zel|ter** österr. veralt. (Lebkuchenbäcker)
Lech (r. Nebenfluß der Donau) *m*; -s; **Lech|feld** (Ebene bei Augsburg) *s*; -[e]s

lech|zen; du lechzt (lechzest)
Le|ci|thin vgl. Lezithin
leck (Seemannsspr.: undicht); vg[
leckschlagen; **Leck** (See mannsspr.: undichte Stelle [b] Schiffen, an Gefäßen, Kraftm[schinen u. a.]) *s*; -[e]s, -s; **Lecka ge°** [...*kasch°*] (Gewichtsverlu[bei flüssigen Waren durch Ver dunsten, Aussickern; Leckstelle
Lecke[1] (Jägerspr.: Stelle od. Tro[wo das Wild od. das Vieh Sa[leckt) *w*; -, -n
[1]**lecken**[1] (Seemannsspr.: leck sein es leckt
[2]**lecken**[1] (mit der Zunge berühren
lecker[1] (wohlschmeckend); **Leh ker** (Jägerspr.: Zunge bei[Haarwild); **Lecker|bis|sen**[1]; **Leh ke|rei** (Leckerbissen); **lecker| haft**[1] (veralt.); **Lecker|haf|ti[keit**[1] (veralt.) *w*; -; **Lecker|[schweiz. (in kleine Rechtecke g[schnittenes, honigkuchenäh[liches Gebäck) *s*; -s, -; Basler **Lecker|maul**[1] (ugs. für: jmd., d[gern Süßigkeiten ißt)
leck|schla|gen (vom Schiff: le[werden); leckgeschlagen
Leck|war ungardt. (Obst-, be[Zwetschenmus) *s*; -s
Le Cor|bu|sier, Charles [*l° korb[sje, schar*] (frz.-schweiz. Arch[tekt u. Schriftsteller)
led. (Zeichen: ∞) = ledig
Le|da (sagenhafte Königin v[Sparta)
Le|der *s*; -s, -; **le|der_ar|tig**; L[der_ball, **...band** *m*; **le|der_braun** **Le|der_ein|band**; **Le|de|rer** md[(Gerber); **le|der_far|ben** od. **...farbig**; **Le|der_fett**, **...gür[t ...hand|schuh**, **...haut** (Schicht d[menschlichen u. tierisch[Haut); **Le|der|her|stel|lung**; (↑ 145:) Lederherstellung u. -v[trieb; **Le|der|ho|se**; **le|de|rig**, **le| rig** (lederartig); **Le|der_jac[[*Trenn.*: ...jak|ke], **...man[l ...map|pe**; [1]**le|dern** (mit einem [derlappen putzen, abreib[mdal. für: gerben; mdal. u. u[für: prügeln); ich ...ere (↑ R 32 [2]**le|dern** (von Leder; zäh, langw[lig); **Le|der_pol|ster**, **...ran|z[...rie|men**, **...schuh**, **...schu[...ses|sel**, **...sohl|e**, **...ta|pe|te**, **... sche**; **le|der_ver|ar|bei|tend**; eisenverarbeitend; **Le|der_ver trieb**; (↑ R 145:) Ledervertrieb[-herstellung
le|dig (Abk.: led.; Zeichen: ∞ sein, bleiben; jmdn. seiner S[den - sprechen; **Le|di|ge** *m* u. -n, -n (↑ R 287ff.); **Le| gen_heim**, **...steu|er** *w*; **le|dig hend** (aus beruflichen Grün[

vorübergehend getrennt lebend); **le|dig|lich**

le|di|schiff schweiz. mdal. (Lastschiff)

ed|rig vgl. lederig

ee (Seemannsspr.: die dem Wind abgekehrte Seite; Ggs.: Luv) *w;* - **ee** niederd. (schlecht, falsch; ledig; leer; ohne Ladung)

er; leer essen, leer laufen (vgl. aber: **leerlaufen**), **leer machen, leer stehen** (vgl. aber: **leerstehend**), **leer trinken** usw.; **Lee|re** (Leerheit) *w;* -; **lee|ren** (leer machen); sich -; **Leer...ge|wicht,** ...**gut** *s;* -[e]s); **Leer|heit** *w;* -; **Leer|lauf; leer|lau|fen;** ↑ R 139 (auslaufen, z. B. das Faß), **aber: leer lau|fen** z. B. eine Maschine, ein Wirtschaftsunternehmen); **leer|ste|hend** (unbesetzt); -e Wohnung; *vgl.* leer; **Leer|ta|ste** (bei der Schreibmaschine); **Lee|rung; leer zim|mer**

ee|sei|te (Seemannsspr.: die dem Wind abgekehrte Seite); **leewärts**

e Fort [*l⁰foɾ*], Gertrud van (dt. Dichterin)

ef|ze (Lippe bei Tieren) *w;* -, -n

g. = legato

gal *lat.* (gesetzlich, gesetzmäßig); **Le|ga|li|sa|ti|on** [...*ziọn*] (Beglaubigung von Urkunden); **le|ga|li|sie|ren** (gesetzlich machen); **.e|ga|li|sie|rung; le|ga|li|stisch** (nur der Form nach legal); **Le|ga|li|tät** (Gesetzlichkeit, Rechtsgültigkeit) *w;* -

g|asthe|nie *lat.; gr.* (Med.: chwäche, Wörter od Texte zu ssen od. zu schreiben) *w;* -, ...ien; **eg|asthe|ni|ker** (an Legasthenie eidender); **leg|asthe|nisch**

e|gat *lat.* (im alten Rom: Gesandter, Unterfeldherr; heute: äpstl. Gesandter) *m;* -en, -en R 268); **²Le|gat** (Vermächtnis) -[e]s, -e; **Le|ga|tar** (Vermächtnis|snehmer) *m;* -s, -e; **Le|ga|ti|on** .*ziọn*) ([päpstl.] Gesandtschaft); **Le|ga|ti|ons|rat** (*Mehrz.* räte)

ga|to *it.* (Musik: gebunden; gs.: staccato; Abk.: leg.); **Le|ga|to** *s;* -s, -s u. ...ti

ge mdal. (Lage, Schicht) *w;* -,

ge|hen|ne, Leg|hen|ne

gel (Seemannsspr.: Ring zum festigen eines Segels) *m;* -s, -ten; gelegt; vgl. **aber: gelegen;** **h** -

en|där *lat.* (legendenhaft; unhrscheinlich); **Le|gen|dar** (Legendenbuch; Sammlung von iligenleben) *s;* -s, -e; **Le|gen|ri|um** (älter für: Legendar) *s;* ...ien [...*i⁰n*]; **Le|gen|de** ([Heili-

gen]erzählung; [fromme] Sage; Umschrift [von Münzen, Siegeln]; Zeichenerklärung [auf Karten usw.]) *w;* -, -n; **Le|gen den|er|zäh|ler; le|gen|den|haft**

le|ger *fr.* [...*sehạr*] (ungezwungen)

Le|ger [zu: legen]

Le|ges (*Mehrz.* von: Lex)

Leg|foh|re (ein Nadelbaum); vgl. Latsche

Leg|hen|ne, Le|ge|hen|ne

Leg|horn [nach dem engl. Namen der it. Stadt Livorno] (Huhn der Rasse Leghorn) *s;* -s. -[s] (mdal. auch: Leghörner)

le|gie|ren *it.* (verschmelzen; [Suppen, Tunken] mit Eigelb anrühren, binden); **Le|gie|rung** ([Metall]mischung, Verschmelzung)

Le|gi|on *lat.* (röm. Heereseinheit; in der Neuzeit für: Freiwilligentruppe, Söldnerschar; große Menge); **Le|gio|nar** (Soldat einer röm. Legion) *m;* -s, -e; **le|gio|när** *fr.* (die Legion betreffend, von ihr ausgehend); **Le|gio|när** (Mitglied einer Legion [z. B. Soldat der Fremdenlegion]) *m; -s, -e;* **Le|gi|ons|sol|dat**

le|gis|la|tiv *lat.* (gesetzgebend); **Le|gis|la|ti|ve** [...*w⁰*] (gesetzgebende Versammlung, Gewalt) *w;* -, -n; **le|gis|la|to|risch** (gesetzgeberisch); **Le|gis|la|tur** (selten für: Gesetzgebung; früher auch für: gesetzgebende Körperschaft) *w;* -, -en; **Le|gis|la|tur|pe|ri|ode** (Amtsdauer einer Volksvertretung); **le|gi|tim** (gesetzlich; rechtmäßig; als ehelich anerkannt; begründet); **Le|gi|ti|ma|ti|on** [...*ziọn*] (Echtheitserklärung, Beglaubigung; [Rechts]ausweis; im BGB für: Nachweis der Empfangsberechtigung, Befugnis; Ehelichkeitserklärung); **Le|gi|ti|ma|ti|ons|kar|te; le|gi|ti|mie|ren** (beglaubigen; [Kinder] als ehelich erklären); sich - (sich ausweisen); **Le|gi|ti|mie|rung; Le|gi|ti|mis|mus** (Lehre von der Unabsetzbarkeit des angestammten Herrscherhauses) *m;* -; **Le|gi|ti|mist** (↑ R 268); **le|gi|ti|mi|stisch; Le|gi|ti|mi|tät** (Rechtmäßigkeit einer Staatsgewalt; Gesetzmäßigkeit [eines Besitzes, Anspruchs])

Le|gu|an *karib.* [auch: *le̲...*] (trop. Baumeidechse) *m;* -s, -e

Le|gu|men *lat.* (,,Hülsenfrucht''; Frucht der Hülsenfrüchtler) *s;* -s, -; **Le|gu|min** (Eiweiß der Hülsenfrüchte) *s;* -s; **Le|gu|mi|no|se** (Hülsenfrüchtler) *w;* -, -n (meist *Mehrz.*)

Le|hár [*lehạr*, ung. u. österr.: *lẹ̄hạr*] (ung. Operettenkomponist)

Le Ha|vre [*l⁰ ɑwr⁽⁰⁾*] (fr. Stadt)

Leh|de *niederl.* (,,niedrig ,liegendes' Land''; niederd. für: Brache, Heide) *w;* -, -n

Le|hen (hist.) *s;* -s, -; **Le|hens|we|sen,** Lehns|we|sen (hist.) *s;* -s

Lehm *m;* -[e]s, -e; **Lehm.bat|zen,** ...**bo|den; lehm|gelb; leh|mig**

Leh|ne *w;* -, -n; **¹leh|nen;** sich - **²leh|nen** (hist.: zu Lehen geben; veralt., aber noch mdal. für: leihen); **Lehn|gut** od. **Lehns|gut** (hist.); **Lehns|eid** (hist.)

Lehn|ses|sel

Lehns|gut od. Lehn|gut (hist.); **Lehns|herr** (hist.); **Lehns|mann** (hist.; *Mehrz.* ...männer u. ...leute); **Lehns|trä|ger** (hist.)

Lehn|stuhl

Lehns|we|sen, Le|hens|we|sen (hist.) *s;* -s; **Lehn|über|set|zung** (Sprachw.); **Lehn|über|tra|gung** (Sprachw.); **Lehn|wort** (Sprachw.; *Mehrz.* ...wörter)

Lehr *s;* -[e]s, -e; vgl. ²Lehre; **Lehr.amt,** ...**amts|kan|di|dat,** ...**an|stalt,** ...**auf|trag; lehr|bar; Lehr|bar|keit** *w;* -; **Lehr..be|fä|hi|gung,** ...**be|helf** (österr. für: Lehrmittel), ...**be|ruf....bo|gen** (Bauw.: Gerüst für Bogen-, Gewölbebau; zu **²Lehre),** ...**brief,** ...**bub** (südd., österr., schweiz. für: Lehrjunge), ...**buch;** **¹Leh|re** (Unterricht, Unterweisung) *w;* -, -n; **²Leh|re** (Meßwerkzeug; Muster, Modell) *w;* -, -n; **leh|ren** (unterweisen); jmdn. (auch: jmdm.) etwas -; er lehrt mich (auch: mir) lesen; er lehrt ihn (auch: ihm) das Lesen; er hat gelehrt; (↑ R 305:) er hat ihn reiten gelehrt (selten: lehren); er lehrt ihn ein (seltener: einen) Helfer der Armen sein; er lehrt ihn, ein Helfer der Armen zu sein; **Leh|rer; Leh|rer.aus|bil|dung,** ...**be|ruf; leh|rer|haft; Leh|re|rin** *w;* -, -nen; **Leh|re|rin|nen|schaft** *w;* -; **Leh|rer.kol|le|gi|um,** ...**kon|fe|renz; Leh|rer|schaft** *w;* -; **Leh|rers.frau,** ...**wit|we; Leh|rer|zim|mer**

Lehr.fach, ...**film,** ...**frei|heit** (*w;* -), ...**gang** *m;* **Lehr|gangs|teil|neh|mer; Lehr.ge|dicht,** ...**geld,** ...**ge|rüst** (beim Stahlbetonbau; zu **²Lehre);** **lehr|haft; Lehr|haf|tig|keit** *w;* -; **Lehr.hau|er** (angehender Bergmann), ...**herr** (Ausbildender), ...**jahr,** ...**jun|ge** *m,* ...**kan|zel** (österr.: Lehrstuhl), ...**kör|per,** ...**kraft; Lehr|ling** (Auszubildender); **Lehr|lings-[wohn]heim; Lehr..mäd|chen,** ...**mei|nung,** ...**mei|ster,** ...**me|tho|de,** ...**mit|tel** (Hilfsmittel für den Lehrenden; *s),* ...**plan** (vgl. **²Plan),** ...**pro|be; lehr|reich; Lehr.satz,** ...**schau,** ...**stand** (veralt.), ...**stel-**

le, ...stoff, ...stück, ...stuhl, ...tä-
tig|keit, ...toch|ter (schweiz. für:
Lehrmädchen), ...ver|trag (Aus-
bildungsvertrag), ...werk|statt,
...zeit

¹Lei (Mehrz. von: ²Leu)

²Lei mdal. (Fels; Schiefer) w; -,
-en; Lorelei (vgl. Loreley)

Leib (Körper; veralt. auch für: Le-
ben) m; -[e]s, -er; (↑R 141:) gut
bei Leibe (wohlgenährt) sein,
aber: beileibe nicht; einem zu
Leibe gehen; es geht mir an den
Leib; Leib und Leben wagen;
Leib_arzt, ...bin|de; Leib|chen
(auch: Kleidungsstück, österr.:
Unterhemd, Trikot), Leib|lein;
leib|el|gen¹; Leib|ei|ge|ne¹ m u. w;
-n, -n (↑R 287ff.); Leib|ei|gen-
schaft¹ w; -

lei|ben, nur in: wie er leibt u. lebt;
Lei|bes_er|be m, ...er|zie|hung,
...frucht, ...kraft (aus Leibeskräf-
ten), ...stra|fe (bei -), ...übun|gen
(Mehrz.), ...um|fang, ...vi|si|ta|ti-
on; Leib_gar|de, ...gar|dist, ...ge-
richt, ...gurt; leib|haft (selten für:
leibhaftig); leib|haf|tig²; Leib-
haf|ti|ge² (Teufel) m; -n; Leib|haf-
tig|keit² w; -; ...lei|big (z. B. dick-
leibig); Leib|koch; Leib|lein,
Leib|chen; leib|lich (auch für:
dinglich); Leib|lich|keit w; -

Leib|nitz (österr. Stadt)

Leib|niz (dt. Philosoph); leib|ni-
zisch; -es Denken (nach Art von
Leibniz), aber (↑R 179): Leib|ni-
zisch; -e Philosophie (von Leib-
niz)

Leib_pferd, ...ren|te (lebensläng-
liche Rente), ...rie|men (Gürtel),
...rock (veralt.), ...schmerz (meist
Mehrz.), ...schnei|den (landsch.;
s; -s); Leib-See|le-Pro|blem (↑R
155)

leibt vgl. leiben

Lei|bung vgl. Laibung

Leib_wa|che, ...wäch|ter, ...wä-
sche, ...weh, ...wickel [Trenn.:
...wik|kel]

Lei|ca ⓌⒶ [...ka] (Kurzw. für:
Leitz-Camera [der Firma Ernst
Leitz]) w; -, -s

Leich (mittelhochd. Liedform) m;
-[e]s, -e

Leich|dorn mitteld. (Hühnerauge;
Mehrz. ...dorne u. ...dörner);
Lei|che w; -, -n; Lei|chen_acker
[Trenn.: ...ak|ker] (landsch.),
...be|gäng|nis, ...be|schau|er,
...bit|ter (landsch. für: Person,
die zur Beerdigung einlädt); Lei-
chen|bit|ter|mie|ne (ugs. für: dü-
sterer, grimmiger Gesichtsaus-
druck); lei|chen_blaß, ...fahl; Lei-
chen_fled|de|rer (Gaunerspr.:

¹ Auch: laip-ai...
² Auch: laip...

Ausplünderer toter od. schlafen-
der Menschen), ...frau, ...gift,
...hal|le, ...hemd, ...öff|nung (für:
Obduktion), ...re|de, ...schän-
dung, ...schau|haus, ...schmaus
(ugs.), ...trä|ger, ...tuch, ...ver-
bren|nung, ...wa|gen, ...wär|ter,
...zug; Leich|nam m; -[e]s, -e

leicht; -e Artillerie; -es Heizöl; -e
Musik. I. Kleinschreibung (↑R
134): es ist mir ein leichtes (sehr
leicht). II. Großschreibung (↑R
116): es ist nichts Leichtes; er ißt
gern etwas Leichtes. III. Schrei-
bung in Verbindung mit dem 2.
Mittelwort oder einem Eigen-
schaftswort (↑R 142 u. 143); vgl.
leichtbewaffnet, leichtentzünd-
lich, leichtverdaulich, leichtver-
ständlich, leichtverwundet. IV.
Schreibung in Verbindung mit
Zeitwörtern (↑R 139): a) Ge-
trenntschreibung in ursprüng-
licher Bedeutung, z. B. leicht at-
men; er hat leicht geatmet; b) Zu-
sammenschreibung, wenn durch
die Verbindung ein neuer Begriff
entsteht, z. B. leichtmachen; er
hat es sich leichtgemacht (sich
wenig Mühe gemacht) aber:
Getrenntschreibung in Verbin-
dung mit einem Gradadverb: er
hat es sich zu leicht gemacht;
vgl. leichtfallen, leichtmachen,
leichtnehmen; Leicht|ath|let;
Leicht|ath|le|tik; Leicht|ath|le-
tisch; Leicht|bau|plat|te (Bauw.:
Platte aus leichtem Material);
leicht|be|waff|net; ein leichtbe-
waffneter Soldat (↑ jedoch R
142), aber: der Soldat ist leicht
bewaff|net; Leicht|be|waff|ne|te
m; -n, -n (↑R 287ff.); leicht|blü-
tig; ¹Leich|te (dicht. für: Leicht-
heit) w; -; ²Leich|te niederd.
(Tragriemen beim Schubkarren-
fahren) w; -, -n; leicht|ent|zünd-
lich; ein leichtentzündlicher Stoff
(↑ jedoch R 143), aber: der Stoff
ist leicht entzündlich; Leicht|ter;
Lich|ter ([kleineres] Wasserfahr-
zeug zum Leichtern); leich|tern,
lich|tern (Seemannsspr.: größere
Schiffe entfrachten); ich ...ere
(↑R 327); leicht|fal|len; ↑R 139
(keine Anstrengung erfordern);
die Schularbeiten sind ihm im-
mer leichtgefallen, aber: leicht
fal|len; er ist leicht gefallen, weil
...; vgl. leicht, IV; leicht|fer|tig;
Leicht_fer|tig|keit, ...flug|zeug;
leicht|flüs|sig; Leicht|fuß (ugs.
scherzh.); leicht|fü|ßig; Leicht|fü-
ßig|keit w; -; Leicht|ge|wicht
(Körpergewichtsklasse in der
Schwerathletik); Leicht|ge-
wicht|ler; leicht|gläu|big; Leicht-
gläu|big|keit w; -; Leicht|heit w;
-; leicht|her|zig; Leicht|her|zig-

keit w; -; leicht|hin; Leich|tig|kei
Leicht|in|du|strie; leicht|le|bi
Leicht_le|big|keit w; -; leicht|lic
(veralt. für: mühelos); leicht|ma
chen; ↑R 139 (wenig Mühe ma
chen); du hast es dir leichtge
macht; vgl. leicht, IV; Leicht_ma
tro|se, ...me|tall; leicht|neh|me
↑R 139 (keine Mühe darauf ve
wenden); er hat seine Pflichte
immer leichtgenommen; vg
leicht, IV; Leicht_öl, ...sinn (r
-[e]s); leicht|sin|nig; Leicht|sin
nig|keit w; -; Leicht|sinns|feh|le
leicht|ver|dau|lich; eine leicht
dauliche Speise (↑ jedoch R 14?
aber: die Speise ist leicht verda
lich; leicht|ver|letzt vgl. leichtve
wundet; Leicht|ver|letz|te v
Leichtverwundete; leicht|ver
ständ|lich; eine leichtverstän
liche Sprache (↑ jedoch R 14
aber: die Sprache ist leicht ve
ständlich; leicht|ver|wun|det; e
leichtverwundeter Soldat (↑
doch R 142), aber: der Sold
ist leicht verwundet; Leicht|ve
wun|de|te m u. w; -n, -n (↑R
287ff.)

leid (als Eigenschaftsw. schwe
mdal. für: häßlich, ungut, u
lieb); (↑R 132:) leid sein, tun, w
den; das ist nicht leid sein lasse
Leid s; -[e]s; (↑R 141:) jmdm.
was zuleide tun; (↑R 132:) [sic
ein Leid (veralt.: Leids) [an]t
Leid tragen; (↑R 241:) [in] Fre
und Leid

Lei|de|form (für: Passiv); lei|d
du littst (littest); du littest; ge
ten; leid[e]!; Not -; ¹Lei|den (f
Krankheit) s; -s, -; Freuden
Leiden

²Lei|den (niederl. Stadt)

lei|dend; Lei|den|de m u. w; -n,
(↑R 287ff.)

Lei|de|ner [zu: ²Leiden] (↑R 19
- Flasche

Lei|dens|bru|der; Lei|den|sch
lei|den|schaft|lich; lei|de
schaft|lich|keit w; -; lei|de
schafts|los; -este (↑R 292); I
dens_ge|fähr|te, ...ge|fähr|ti
...ge|nos|se, ...ge|nos|sin, ..
schich|te, ...ge|sicht, ...mi
...weg, ...zeit

lei|der; - Gottes [entstanden
der Beteuerung: (bei dem) Lei
Gottes]

lei|dig (unangenehm)

Leid|kar|te (schweiz. ne
Trauerkarte)

leid|lich (gerade noch aus
chend)

leid|sam (veralt., aber noch n
für: umgänglich, gut zu leide

leid|tra|gend, aber (↑R 1
schweres Leid tragend; Leid
gen|de m u. w; -n, -n (↑R 287

leid|voll; Leid|we|sen s; -s; zu meinem - (Bedauern)

Lei|er gr. (ein Saiteninstrument) w; -, -n; Leie|rei (ugs.); Leie|rer; Lei|er_ka|sten, ...mann (Mehrz. ...männer); lei|ern; ich ...ere (↑ R 327); Lei|er|schwanz (ein austr. Vogel)

Leih_amt, ...bi|blio|thek, ...bü|cherei; Lei|he (BGB für: Darlehen, Vermieten; ugs. für: Leihhaus) w; -, -n; lei|hen; du leihst; du liehst (liehest); du liehest; geliehen; leih[e]!; Leih_ga|be, ...ge|bER, ...ge|bühr, ...haus; Leih-Pacht-Sy|stem (↑ R 155); Leih_schein, ...ver|kehr, wa|gen; leih|wei|se

Leik (hochd. Form für: Liek)

Lei|kauf, Leit|kauf [zu: Leit; veralt. für: Obstwein] mdal. (Trunk zur Bestätigung eines Vertragsabschlusses) m; -[e]s, ...käufe

Lei|lach, Lei|lak [aus: Leinlachen = Leinenlaken] mdal. (Leintuch) s; -[e]s, -e[n]

Leim; m; -[e]s, -e; lei|men; Leim|farbe; lei|mig; Leim_ring, ...ru|te, ...sie|der (mdal. für: langweiliger Mensch), ...topf

...lein (z. B. Brüderlein s; -s, -)

Lein (Flachs) m; -[e]s, -e; Lein_acker [Trenn.: ...ak|ker]; Lei|ne (Strick) w; -, -n; 1lei|nen (aus Leinen); 2lei|nen (an die Leine nehmen); Lei|nen s; -s, -; Lei|nen_band m, ...ein|band, ...garn, ...kleid, ...la|ken (svw. Leilach), ...tuch (Tuch aus Leinen; Mehrz. ...tücher; vgl. aber: Leintuch), ...we|be|rei, ...zeug; Lei|ne|we|ber, Lein|we|ber; Lein_ku|chen, ...öl; Lein|öl|brot; Lein_pfad, ...saat, ...sa|men, ...tuch (südd., westd., österr., schweiz. für: Betttuch; Mehrz. ...tücher; vgl. aber: Leinentuch), ...wand (w; -); Lein_we|ber, Lei|ne|we|ber

Leip|zig (Stadt in Sachsen); Leip|zi|ger (↑ R 199); - Allerlei (Gericht aus verschiedenen Gemüsen); - Messe

leis, lei|se; (↑ R 134:) nicht im leisesten (durchaus nicht) zweifeln

Leis [aus: Kyrieleis (vgl. d.)] (mittelalterl. geistl. Volkslied) m; - u. -es, -e[n]

lei|se vgl. leis; Lei|se|tre|ter; Lei|se|tre|te|rei; lei|se|tre|te|risch

Leist (eine Pferdekrankheit) m; -[e]s

Lei|ste w; -, -n

lei|sten; Lei|sten m; -s, -

Lei|sten_beu|ge, ...bruch m, ...ge|gend (w; -)

Lei|sten|wein (auf der Leiste [Berghang] des Marienberges in Würzburg gewachsener Wein).

Lei|stung; Lei|stungs|druck m; -[e]s; lei|stungs|fä|hig; Lei-

stungs_fä|hig|keit (w; -), ...ge|sell-schaft, ...gren|ze (w; -), ...knick, ...kraft w, ...kur|ve (Arbeitskurve), ...lohn (DDR), ...prä|mie (DDR), ...prin|zip, ...prü|fung, ...schau, ...sport; lei|stungs|stark; Lei_stungs_stei|ge|rung, ...ver-mö|gen (s; -s), ...zu|la|ge, ...zu-schlag

Leit|ar|ti|kel (Stellungnahme der Zeitung zu aktuellen Fragen); Leit|ar|tik|ler (Verfasser von Leitartikeln); leit|bar; Leit|bar-keit w; -; Leit|bild

1Lei|te südd., österr. (Berghang) w; -, -n

2Lei|te schweiz. (Wasserleitung, Holzrutschbahn) w; -, -n

lei|ten; leitender Angestellter; Lei|ten|de m u. w; -n, -n (↑ R 287ff.);

1Lei|ter m

2Lei|ter (ein Steiggerät) w; -, -n; lei|ter|ar|tig; Lei|ter|baum

Lei|te|rin w; -, -nen

Lei|ter_spros|se, ...wa|gen

Leit|fa|den; leit|fä|hig; Leit_fä|hig-keit (w; -), ...form, ...fos|sil (Geol.: für eine oder mehrere Gesteins-schichten charakteristisches Fossil)

Leit|geb m; -en, -en (↑ R 268) u. Leit|ge|ber [zu: Leit; veralt. für: Obstwein] mdal. (Wirt)

Leit_ge|dan|ke, ...ge|we|be (Biol.)

Lei|tha (r. Nebenfluß der Donau) w; -; Leit|ha|ge|bir|ge s; -s

Leit_kauf vgl. Leikauf

Leit_li|nie, ...mo|tiv, ...plan|ke, ...satz, ...schnur (w; -), ...spruch, stel|le, ...stern (vgl. 2Stern), ...strahl (Funkw.), ...tier (führendes Tier einer Herde), ..ton (Mehrz. ...töne)

Lei|tung; Lei|tungs_draht m, ...netz, ...rohr, ...strom, ...was-ser (Mehrz. ...wässer); Leit_ver-mö|gen, ...wäh|rung, ...werk, ...wert, ...wort (Mehrz. ...wörter)

1Lek (Mündungsarm des Rheins) m; -

2Lek (alban. Währungseinheit) m; -, -

Lek|ti|on lat. (Unter-richt[sstunde]; Lernabschnitt, Aufgabe; Zurechtweisung); Lek|tor (Lehrer für praktische Übungen [in neueren Sprachen usw.] an einer Hochschule; Verlagsw.: wissenschaftl. Mitarbeiter zur Begutachtung der bei einem Verlag eingehenden Manuskripte) m; -s, ...oren; Lek|to|rat (Lehrauftrag eines Lektors; Verlagsabteilung, in der eingehende Manuskripte geprüft werden) s; -[e]s, -e; lek|to|rie|ren (ein Manuskript prüfen); Lek|to|rin w; -, -nen; Lek|tü|re fr. (Lesen

[nur Einz.]; Lesestoff) w; -, -n; Lek|tü|re|stun|de

Le|ky|thos gr. (altgr. Salbengefäß) w; -, Lekythen

Lem|ma gr. (Stichwort; Vorder-satz eines Schlusses; veralt. für: Überschrift) s; -s, -ta; lem|ma|ti-sie|ren (mit einem Stichwort versehen)

Lem|ming dän. u. norw. (skand. Wühlmaus) m; -s, -e

Lem|nis|ka|te gr. (math. Kurve) w; -, -n

Le|mur m; -en, -en, Le|mu|re lat. (Geist eines Verstorbenen, Gespenst; Halbaffe) m; -n, -n (meist Mehrz.); ↑ R 268; le|mu|ren|haft; Le|mu|ria (für die Trianszeit ver-mutete Landmasse zwischen Vorderindien u. Madagaskar) w; -

1Le|na (Strom in Sibirien) w; -

2Le|na, Le|ne (Kurzformen von: Magdalene u. Helene)

Le|nau (österr. Lyriker)

Len|chen (Koseform von: Lena, Lene)

Len|de w; -, -n; Len|den_bra|ten; len|den|lahm; Len|den_schmerz, ...schurz, ...stück, ...wir|bel

Le|ne vgl. Lena

Leng (ein Fisch) m; -[e]s, -e

Le|ni|cet ⓦ lat. [...z̧ɛt] (Salben-u. Pudergrundlage) s; -[e]s; Le|ni-cet-Sal|be ⓦ w; -

Le|nin (russ. Politiker); Le|nin-grad (russ. Stadt; früher: Sankt Petersburg); Le|nin|gra|der (↑ R 199); Leningrader Sinfonie (von Schostakowitsch); Le|ni|nis|mus (Lehre Lenins) m; -; Le|ni|nist; le|ni|ni|stisch

Le|nis lat. (Sprachw.: schwacher Mitlaut, mit geringer Intensität gesprochener Mitlaut, z. B. b, w; Ggs.: Fortis [vgl. d.]) w; -, Lenes

Lenk_ach|se, lenk|bar; Lenk|bar-keit w; -; len|ken; Len|ker; Lenk-rad; Lenk|rad_schal|tung, ...schloß; lenk|sam; Lenk|sam-keit w; -; Lenk|stan|ge; Len|kung

Len|ne (l. Nebenfluß der Ruhr) w; -

Le|no|re, Leo|no|re (Kurzformen von: Eleonore)

len|tan|do it. (Musik: nach u. nach langsamer); Len|tan|do s; -s, -s u. ...di; len|to (Musik: langsam, gedehnt); Len|to s; -s, -s u. ...ti

lenz (Seemannsspr.: leer [von Wasser])

Lenz (dicht. für: Frühjahr, Frühling) m; -es, -e (auch für: Jahre); 1len|zen (dicht. für: Frühling werden); es lenzt

2len|zen (Seemannsspr.: vor schwerem Sturm mit stark gereff-ten Segeln laufen; leer pumpen); du lenzt (lenzest)

len|zig (veralt.); Len|zing (März)
m; -s, -e; lenz|lich (veralt.);
Lenz..mo|nat od. ...mond (alte
Bez. für: März)
Lenz|pum|pe (Seemannsspr.)
Lenz|tag (dicht.)
Leo (m. Vorn.: „Löwe" od. Kurz-
form von: Leopold od. Leon-
hard)
Leo|ben (österr. Stadt)
Le|on (m. Vorn.: „Löwe" od.
Kurzform von: Leonhard)
Leo|nar|do da Vin|ci vgl. Vinci
Le|on|hard, Lien|hard (m. Vorn.)
Leo|ni|das (spartan. König)
Leo|ni|den lat. (Sternschnuppen-
schwarm im November) Mehrz.
¹leo|ni|nisch lat. [nach einem mit-
telalterl. Dichter namens Leo od.
nach einem Papst Leo] in der Fü-
gung: -er Vers (ein Vers, dessen
Mitte u. Ende sich reimen); ²leo-
ni|nisch [nach einer Fabel Äsops]
in der Fügung: -er Vertrag (Ver-
trag, bei dem der eine Teil allen
Nutzen, den „Löwenanteil" hat)
leo|nisch [nach der span. Stadt
León]; -e Artikel, Gespinste, Fä-
den (Metallfäden)
Leo|no|re vgl. Lenore
Leo|pard lat. („Löwenpanther",
asiat. u. afrik. Großkatze) m; -en,
-en (↑ R 268)
Leo|pold (m. Vorn.); Leo|pol|da,
Leo|pol|di|ne (w. Vorn.)
Léo|pold|ville [...wil] (früherer Na-
me von: Kinshasa)
Le|po|rel|lo (Diener in Mozarts
„Don Juan"); Le|po|rel|lo|al-
bum;↑ R 180 (harmonikaartig zu-
sammenzufaltende Bilderreihe)
Le|pra gr. (Aussatz) w; -; le|prom
(Lepraknoten) s; -s, -e; le|prös,
le|prös (aussätzig); -e Kranke;
Le|pro|so|ri|um (Krankenhaus
für Leprakranke) s; -s, ...ien
[...i⁰n]
Lep|schi tschech. ostösterr. mdal.,
in: auf - gehen (mit dem Freund
oder der Freundin ausgehen und
sich vergnügen)
Lep|ta (Mehrz. von: ¹Lepton)
lep|to... gr. (schmal...); Lep|to...
(Schmal...); Lep|to|kar|di|er
[...i⁰r] (Lanzettfischchen)
Mehrz.; ¹Lep|ton (altgr. Gewicht;
alt- u. neugr. Münze [100 Lepta
= 1 Drachme] s; -s, Lepta; ²Lep-
ton („leichtes" Elementarteil-
chen) s; -s, ...onen; lep|to|som
(schmal-, schlankwüchsig); -er
Typ; lep|to|so|me (Schmalge-
baute[r] m u. w; -n, -n (↑ R 287 ff.);
lep|to|ze|phal (schmalköpfig);
Lep|to|ze|pha|le (Schmalköpfi-
ge[r]) m u. w; -n, -n (↑ R 268);
Lep|to|ze|pha|lie w; -
Ler|che (ein Vogel) w; -, -n; vgl.
a b e r : Lärche; Ler|chen|sporn

(eine Zierstaude; Mehrz. ...spor-
ne)
Ler|näi|sche Schlan|ge [nach dem
Sumpfsee Lerna] (ein Ungeheuer
der gr. Sage) w; -n -
lern|bar; Lern|be|gier[|de]; lern|be-
gie|rig; Lern|ei|fer; lern|eif|rig;
ler|nen; Deutsch -, aber: lesen
-, schwimmen -, Klavier spielen
-, Schlittschuh laufen -; ich habe
gelernt, (↑ R 305:) ich habe reiten
gelernt (nicht: reiten lernen); vgl.
kennenlernen, schätzenlernen;
ein gelernter Tischler; Lern|mit-
tel (Hilfsmittel für den Lernen-
den) s; Lern|mit|tel|frei|heit w; -;
Lern..stoff, ...zeit
Les|art; les|bar; Les|bar|keit w; -
Les|bi|er [...i⁰r]; Les|bie|rin w; -,
-nen; les|bisch; -e Liebe (Homo-
sexualität bei Frauen); Les|bos
(Insel im Ägäischen Meer)
Le|se (Weinlese) w; -, -n; Le|
se..abend, ...bril|le, ...buch, ...dra-
ma, ...ecke (Trenn.: ...ek|ke),
...frucht, ...hun|ger, ...lam|pe; le-
sen; du liest (liesest), er liest; du
lasest; du läsest; gelesen; lies!
(Abk.: l.); le|sens|wert; le|se..pro-
be, ...pult; Le|ser; Le|se|rat|te
(ugs. für: leidenschaftliche[r] Le-
ser[in]); Le|ser|brief; Le|se|rei w;
-; Le|se|rin w; -, -nen; Le|ser|kreis;
le|ser|lich; Le|ser|lich|keit w; -;
Le|ser|schaft; Le|ser|wunsch,
...zu|schrift; Le|se..saal (Mehrz.
...säle), ...stoff, ...wut, ...zei|chen,
...zim|mer, ...zir|kel
Le|so|ther; le|so|thisch; Le|so|tho
(Staat in Afrika)
Les|sing (dt. Dichter); les|singsch
(nach Art von Lessing); -es Den-
ken, a b e r (↑ R 179): Les|singsch;
„Nathan der Weise" ist eine -e
Dichtung
Le|sung
le|tal lat. (Med.: tödlich)
Le|thar|gie gr. (Schlafsucht; Träg-
heit, Teilnahms-, Interesselosig-
keit) w; -; le|thar|gisch; -ste (↑ R
294); Le|the [nach dem Unter-
weltsfluß der gr. Sage] (dicht. für:
Vergessenheitstrank, Vergessen-
heit) w; -
Let|kiss finn.-engl. (ein Tanz) m; -
let|schert österr. ugs. (schlapp,
kraftlos)
Let|te (Angehöriger eines balt.
Volkes) m; -n, -n (↑ R 268)
Let|ten (Ton, Lehm) m; -s, -
Let|ter lat. (Druckbuchstabe) w;
-, -n; Let|tern..gie|ße|r|ma|schi|ne,
...gut (s; -[e]s), ...me|tall
Let|te-Ver|ein [nach dem Grün-
der] m; -s; ↑ R 180
let|tig [zu: Letten] (ton-, lehmhal-
tig)
Let|tin w; -, -nen; let|tisch; -e Spra-
che; vgl. deutsch; Let|tisch (Spra-

che) s; -[s]; vgl. Deutsch; Let|ti-
sche s; -n; vgl. Deutsche s; Lett-
land
Lett|ner lat. (in mittelalterl. Kir-
chen: Schranke zwischen Chor
u. Langhaus; diente auch als Le-
se- u. Sängerbühne) m; -s, -
letz (südd. u. schweiz. mdal. für:
verkehrt, falsch; österr. mdal.
für: schlecht, mühsam)
let|zen (veralt. für: laben, er-
quicken); du letzt (letzest); sich
-; Let|zi schweiz. (mittelalterl.
Grenzbefestigung) w; -, -nen;
Letzt (veralt. für: Abschieds-
mahl), noch in: zu guter Letzt;
auf die Letzt (österr. mdal. für:
schließlich)
letz|te; der letzte Schrei; das letzte
Stündlein; die letzte Ruhestätte;
letzte Ehre; letzten Endes; zum
letztenmal usw.; vgl. Mal, I u.
II. I. Kleinschreibung: a) (↑ R
135:) der letzte (der Reihe nach);
die zwei letzten Tage des Urlaubs
waren besonders ereignisreich;
die letzten zwei Tage habe ich
fast gar nichts gegessen; er ist der
letzte, den ich wählen würde; dies
ist das letzte, was ich tun würde;
den letzten beißen die Hunde; als
letzter fertig werden; der erste –
der letzte (für: jener – dieser); b)
(↑ R 134:) am, zum letzten (zu-
letzt); im letzten (zutiefst); bis ins
letzte (genau); bis zum letzten
(sehr); fürs letzte (zuletzt). II.
Großschreibung: a) (↑ R 116:) der
Letzte seines Stammes; der Letz-
te des Monats; das Erste und das
Letzte (Anfang und Ende); es
geht ums Letzte; sein Letztes
[her]geben; bis zum Letzten (Äu-
ßersten) gehen; ein Letztes habe
ich zu sagen; er ist Letzter, der
Letzte (dem Range nach); die Er-
sten werden die Letzten sein; b)
(↑ R 224:) der Letzte Wille (Testa-
ment); die Letzten Dinge (nach
kath. Lehre); die Letzte Ölung;
das Letzte Gericht; letzt|end|lich;
letz|tens; letz|te|re (der, die, das
letzte von zweien); immer Klein-
schreibung: der, die, das letztere;
ohne Geschlechtsw.: letzterer,
letztere, letzteres; letzt|ge|nannt;
Letzt|ge|nann|te m u. w; -n, -n
(↑ R 287 ff.); letzt|hän|dig (von
letzter Hand [vorgenommen]);
letzt|hin; letzt|jäh|rig; letzt|lich;
letzt|ma|lig; letzt|mals; letzt|mög-
lich; letzt|wil|lig; -e Verfügung
¹Leu (veralt. für: Löwe) m; -en,
-en (↑ R 268)
²Leu („Löwe"; rumän. Wäh-
rungseinheit; Abk.: l) m; -, Lei
Leucht..bo|je, ...bom|be; Leuch|te
w; -, -n; leuch|ten; leuch|tend,

leuchtendblaue Augen (↑ R 143), **a b e r**: seine Augen waren leuchtend blau; Leuch|ter; Leucht.far|be, ...feu|er, ...gas, ...kä|fer, ...kraft w, ...ku|gel, ...pi|sto|le, ...ra|ke|te, ...re|kla|me, ...röh|re, ...schirm, ...spur; Leucht|stoff|lam|pe; Leucht.turm, ...zif|fer; Leucht|zif|fer|blatt

leug|nen; Leug|ner; Leug|nung

leuk... gr. (weiß...); Leuk... (Weiß...); Leuk|ämie (,,Weißblütigkeit" [Blutkrankheit]) w; -, ...ien; leuk|ämisch (an Leukämie leidend); leu|ko|derm (Med.: hellhäutig); Leu|ko|der|ma (Med.: Auftreten weißer Flecken auf der Haut) s, -s, ...men, Leu|ko|der|mie (Albinismus) w; -; Leu|kom (Med.: weißer Hornhautfleck) s; -s, -e; Leu|ko|pa|thie (Leukoderma) w; -, ...ien; ¹Leu|ko|plast (Bestandteil der Pflanzenzelle) m; -en, -en (↑ R 268); ²Leu|ko|plast ⓦ (Heftpflaster) s, -[e]s, -e; Leu|kor|rhö¹, Leu|kor|rhöe (Med.: ,,weißer Fluß" [Frauenkrankheit]) w; -, ...rrhöen; leu|kor|rhö|isch; Leu|ko|to|mie, Lo|bo|to|mie (chirurg. Eingriff in die weiße Gehirnsubstanz) w; -, ...ien; Leu|ko|zyt (Med.: weißes Blutkörperchen) m; -en, -en (meist Mehrz.: ↑ R 268; Leu|ko|zy|to|se (Med.: krankhafte Vermehrung der weißen Blutkörperchen) w; -

Leu|mund (Ruf) m; -[e]s; Leu|munds|zeug|nis

Leu|na [nach dem Fabrikationsort] ⓦ (chem. Erzeugnisse)

Leut|chen Mehrz.; Leu|te Mehrz.; leu|te|scheu; Leu|te.scheu w, ...schin|der

Leu|then (Ort in Schlesien)

Leut|nant fr. (unterster Offiziersgrad; Abk.: Lt.) m; -s, -s (selten: -e); Leut|nants.rang (m; -[e]s), ...uni|form

Leut|prie|ster (veralt.: Weltgeistlicher, Laienpriester)

leut|se|lig; Leut|se|lig|keit

Leu|wa|gen niederd. (Schrubber) m; -s, -

Leu|zit gr. (ein Mineral) m; -s, -e

Le|va|de fr. [...wa...] (Aufrichten des Pferdes auf der Hinterhand)

Le|van|te it. [...wan...] (,,Morgenland"; Mittelmeerländer östl. von Italien) w; -; Le|van|te|li|nie (↑ R 202); Le|van|ti|ne (ein Gewebe) w; -; le|van|ti|nisch ↑ R 199 (Morgenländer); le|van|ti|nisch

Le|vee fr. [lᵉwẹ] (früher: Aushebung von Rekruten) w; -, -s; Le|ver [lᵉwẹ] (früher: Morgenempfang bei Fürsten) s; -s, -s

Vgl. die Anmerkung zu ,,Diarrhö, Diarrhöe".

Le|ver|ku|sen [...wᵉr..., auch: ...ky...] (Stadt am Niederrhein); Le|ver|ku|se|ner [auch: ...ky...] (↑ R 199)

Le|vet|zow [lᵉwᵉzo] (Familienn.)

Le|vi [lᵉwi] (bibl. m. Eigenn.)

Le|via|than, (ökum.:) Le|via|tan hebr. [lewia...] (Ungeheuer der altoriental. Mythol.) m; -s

Le|vin, Le|win (m. Vorn.)

Le|vi|rats|ehe lat.; dt. [...wi...] (Ehe eines Mannes mit der Frau seines kinderlos verstorbenen Bruders [im A. T. u. bei Naturvölkern])

Le|vit [...wit] (Angehöriger des jüd. Stammes Levi; Tempeldiener im A. T.; Mehrz.: Helfer des Priesters beim feierl. Hochamt) m; -en, -en (↑ R 268); jmdm. die -en lesen (ugs. für: [ernste] Vorhaltungen machen); Le|vi|ti|kus [...wi...] (3. Buch Mosis) m; -; le|vi|tisch [...wi...] (auf die Leviten bezüglich)

Lev|ko|je gr. [läf...] (eine Zierpflanze) w; -, -n; Sommerlevkoje, Winterlevkoje

Lew bulgar. [läf] (,,Löwe"; bulgar. Währungseinheit; Abk.: Lw) m; -[s], Lewa [lawa]

Le|win, Le|vin (m. Vorn.)

Lex lat. (Gesetz; Gesetzesantrag) w; -, Leges; - Heinze

Lex.-8° = Lexikonoktav, Lexikonformat

Le|xem russ. (Sprachw.: lexikal. Einheit, Wortschatzeinheit im Wörterbuch) s; -s, -e; le|xi|gra|phisch gr. (svw. lexikographisch); le|xi|kal (seltener für: lexikalisch); le|xi|ka|lisch (das Lexikon betreffend, in der Art eines Lexikons); Le|xi|ko|graph (Verfasser eines Wörterbuches od. Lexikons) m; -en, -en (↑ R 268); Le|xi|ko|gra|phie ([Lehre von der] Abfassung eines Wörterbuches [auch eines Lexikons]) w; -; le|xi|ko|gra|phisch; Le|xi|ko|lo|gie (Lehre von der Wörterbuch- od. Lexikonherstellung; seltener für: Wortlehre); le|xi|ko|lo|gisch; Le|xi|kon (alphabetisch geordnetes allgemeines Nachschlagewerk [für Wörterbuch]) s; -s, ...ka (auch: ...ken); Le|xi|kon.for|mat (Abk.: Lex.-8°; s; -[e]s), ...ok|tav (Abk.: Lex.-8°; s; -s); le|xisch (für: lexikalisch)

Le|zi|thin, (fachspr.:) Lecithin gr. (zu den Lipoiden gehörende Substanz [u. a. als Nervenstärkungsmittel verwendet]) s; -s

lfd. = laufend (vgl. d.)

lfr vgl. Franc

LG = Landgericht

Lha|sa (Hptst. Tibets)

L'hom|bre [lọngbᵉr] vgl. Lomber

Li = chem. Zeichen für: Lithium

Li|ai|son fr. [liäsọng] ([nicht standesgemäße] Verbindung; Liebesverhältnis, Liebschaft) w; -, -s

¹Lia|ne fr. (eine Schlingpflanze) w; -, -n (meist Mehrz.)

²Lia|ne (w. Vorn.)

Li|as fr. (Geol.: untere Abteilung der Juraformation, Schwarzer Jura) m od. w; -; Li|as|for|ma|ti|on; li|as|sisch (zum Lias gehörend)

Li|ba|ne|se m; -n, -n (↑ R 268); li|ba|ne|sisch; ¹Li|ba|non (auch mit Geschlechtsw.; m; -[s]; Staat im VorderenOrient); ²Li|ba|non(Gebirge im Vorderen Orient) m; -[s]

Li|ba|ti|on lat. [...zion] (altröm. Trankopfer für Götter)

Li|bell lat. (,,Büchlein"; Klageschrift im alten Rom; Schmähschrift) s; -s, -e

Li|bel|le lat. (,,kleine Waage"; Teil der Wasserwaage; Insekt, Wasserjungfer) w; -, -n; Li|bel|len|waa|ge

Li|bell|ist lat. (Verfasser eines Libells); ↑ R 268

li|be|ral lat. (vorurteilslos; freiheitlich, nach Freiheit strebend, freisinnig; veralt. für: freigebig; hochherzig, großzügig); Li|be|ra|le (Anhänger des Liberalismus) m u. w; -n, -n (↑ R 287 ff.); li|be|ra|li|sie|ren (in liberalem Geiste gestalten, bes. die Wirtschaft); Li|be|ra|li|sie|rung (Wirtsch.: Aufhebung staatl. Außenhandelsbeschränkungen); Li|be|ra|lis|mus (Denkrichtung, die das Individuum aus religiösen, polit. u. wirtschaftl. Bindungen zu lösen sucht) m; -; li|be|ra|li|stisch (freiheitlich im Sinne des Liberalismus; auch: extrem liberal); Li|be|ra|li|tät (Freigebigkeit, Hochherzigkeit, Vorurteilslosigkeit) w; -

Li|be|ra|li|um Ar|ti|um Ma|gi|ster lat. (Magister der freien Künste; Abk.: L. A. M.)

Li|be|ria (Staat in Westafrika); Li|be|ria|ner, (auch:) Li|be|ri|er [...iᵉr]; li|be|ria|nisch, (auch:) li|be|risch

Li|be|ro it. (Fußball: nicht mit Spezialaufgaben betrauter freier Verteidiger, der sich in den Angriff einschalten kann) m; -s, -s

Li|ber|tas (röm. Göttin der Freiheit); Li|ber|tät w. (früher für: ständische Freiheit); Éga|li|té, Fra|ter|ni|té [...te ...te ...tẹ] (,,Freiheit, Gleichheit, Brüderlichkeit"; die drei Losungsworte der Fr. Revolution)

Li|ber|tin fr. [...täng] (veralt. für: Freigeist; liederlicher Mensch, Wüstling) m; -s, -s; Li|ber|ti|na|ge [...nasch⁴](veralt. für: Liederlichkeit, Zügellosigkeit)

Li|bi|di|nịst *lat.* (sexuell triebhafter Mensch); ↑ R 268; **li|bi|di|nọs**; -este (↑ R 292); **Li|bi|do** [auch: *lị...*] (Begierde, Trieb; Geschlechtstrieb) *w*; -

Li|bo|rị|us (m. Eigenn.)

Li|bra|ti|on *lat.* [...*zịọn*] (Meteor.: scheinbare Mondschwankung)

Li|bret|tịst *it.* (Verfasser von Librettos); ↑ R 268; **Li|bręt|to** (Textbuch) von Opern, Operetten usw.) *s*; -s, -s u. `...tti

Li|bus|sa (sagenhafte tschech. Königin)

Lị|by|en (Staat in Nordafrika); **Lị|by|er**, **lị|bysch**, aber (↑ R 198): die Libysche Wüste

lic. (schweiz. für: Lic.); **Lic.** = Licentiạtus; vgl. ²Lizentiat

li|cet *lat.* [*lịzät*] (,,es ist erlaubt") **...lich** (z. B. weichlich)

Li|che|no|lo|ge *gr.* [*liche...*] (Flechtenkundler) *m*; -n, -n (↑ R 268); **Li|che|no|lo|gie** (Flechtenkunde) *w*; -

licht; es wird licht; ein lichter Wald; im Lichten (↑ R 116; im Hellen; im Innern gemessen); -e Weite (Abstand von Wand zu Wand bei einer Röhre u. a.); -e Höhe (lotrechter Abstand von Kante zu Kante bei einem Tor u. a.); **Licht** *s*; -[e]s, -er (auch Jägerspr.: Augen des Schalenwildes) u. (veralt. u. dicht.:) Lichte; **Licht⌣an|la|ge**, **...bad** (Med.), **...be|hand|lung** (Med.); **licht|be|stän|dig**; **Licht|bild** (für: Fotografie); **Licht|bild|auf|nah|me|ge|rät**; **Licht|bil|der|vor|trag**; **Licht|bild|ner** (veralt. für: Fotograf); **licht|blau**; **Licht|blick**; **licht|blond**; **Licht|bo|gen**; **licht|bre|chend** (für: dioptrisch); **Licht|bre|chung**; **Licht|chen** *s*; -s, - u. Lichterchen; Lichtlein *s*; -s, - u. Lichterlein; **Licht|druck** (Mehrz. ...drucke); **licht|durch|läs|sig**; **Licht|te** (Weite) *w*; -; **licht|echt**; **Licht|echt|heit** (*w*; -), **...ef|fekt**, **...ein|fall**; **licht|elek|trisch**; **licht|emp|find|lich**; **¹lich|ten** (licht machen); der Wald wird gelichtet; das Dunkel lichtet sich

²lich|ten (Seemannsspr.: licht machen, anheben); den Anker -

Lich|ten|hain (Vorort von Jena); -er Bier; **Lich|ten|hai|ner** (Bier) *s*; -s

Lich|ten|stein (Schloß südlich von Reutlingen); vgl. aber: Liechtenstein

Lich|ter vgl. Leichter

Lich|ter|baum (Weihnachtsbaum); **Lich|ter|chen** (*Mehrz.* von: Lichtchen); **Lich|ter|glanz**; **Lich|ter|lein** (*Mehrz.* von: Lichtlein); **lich|ter|loh**; **Lich|ter|meer**; **lich|tern** vgl. leichtern

Licht⌣fil|ter, **...ge|schwin|dig|keit** (*w*; -), **...ge|stalt**; **licht⌣grau**, **...grün**; **Licht⌣hof**, **...hu|pe**, **...jahr** (astron. Längeneinheit), **...ka|sten** (Med.), **...ke|gel**, **...kreis**, **...leh|re** (für: Optik; *w*; -); **Licht|lein** vgl. Lichtchen; **Licht|lei|tung**; **licht|los**; **Licht⌣man|gel** *m*, **...ma|schi|ne**; **Licht|meß** (kath. Fest); Mariä Lichtmeß; **Licht⌣mes|sung** (für: Photometrie), **...nel|ke**, **...pau|se**; **Licht⌣[putz]|sche|re**; **Licht⌣quel|le**, **...re|flex**, **...re|kla|me**, **...satz** (Druckw.: fotogr.Setzverfahren),**...schacht**, **...schal|ter**, **...schein**; **licht|scheu**; **Licht⌣schim|mer**,**...si|gnal**, **...spiel** (veralt. für: Film; in der *Mehrz.* für: Kino); **Licht⌣spiel⌣haus**, **...thea|ter**; **Licht|stär|ke**, **...strahl**; **licht|strah|lend**; **Licht|tech|nik**; **licht|tech|nisch**; **Licht|the|ra|pie**; **licht|trun|ken**; **Licht|tung**; **Licht|ver|hält|nis|se** *Mehrz.*; **licht|voll**

licht|wen|dig (für: phototropisch); **Licht|wen|dig|keit** (für: Phototropismus) *w*; -

Lic. theol. = Licentiạtus theologiae; vgl. ²Lizentiat

Lid (Augendeckel) *s*; -[e]s, -er; vgl. aber: Lied

Lịd|di (dt. Koseform von: Lydia)

Lịd|dy (engl. Schreibung von: Liddi)

Lị|de|rung ([Ab]dichtung bei Hinterladern)

Lị|di|ce [*lịdijizä*] (tschech. Dorf)

Lịd|krampf (krampfhaftes Schließen der Augenlider)

Lịd|lohn vgl. Liedlohn

Lị|do *it.* (,,Ufer"; Nehrung, bes. die bei Venedig) *m*; -s, -s (auch: Lidi)

Lịd⌣rand, **...sack**, **...schat|ten**, **...spal|te**

lieb; sich bei jmdm. lieb Kind machen; der liebe Gott. **I.** *Kleinschreibung* (↑ R 134): es ist mir das liebste (sehr lieb), am liebsten (sehr lieb). **II.** *Großschreibung*: **a)** (↑ R 116:) viel, nichts Liebes; mein Lieber, meine Liebe, mein Liebes; **b)** (↑ R 224:) [Kirche] Zu Unsrer Lieben Frau[en]. **III.** *Schreibung in Verbindung mit dem 2. Mittelwort* (↑ R 142); vgl. liebgeworden. **IV.** *Schreibung in Verbindung mit Zeitwörtern* (↑ R 139): lieb sein, werden; aber: liebäugeln, liebbehalten, liebgewinnen, liebhaben, liebkosen; **Lieb** (Geliebte[r]) *s*; -s; mein -; **lieb|äu|geln** (↑ R 139); er hat mit diesem Plan geliebäugelt; zu -; **lieb|be|hal|ten** (↑ R 139); er hat sie immer liebbehalten; **Lieb|chen**; **Lieb|den** (veralt. ehrende Bez.) *w*; -; in der Anrede: Euer

(Abk.: Ew.) -; **Lie|be** *w*; -, (ugs. für: Liebschaft *Mehrz.*:) -n; Lieb und Lust (↑ R 241); (↑ R 141:) mir zuliebe; jmdm. etwas zuliebe tun; **lie|be|be|dürf|tig**; **Lie|be|die|ner** (abwertend für: Schmeichler, unterwürfiger Mensch); **Lie|be|die|ne|rei** (abwertend); **lie|be|die|ne|risch**; -ste (↑ R 294); **lie|be|die|nern** (unterwürfig schmeicheln); er hat geliebedienert; zu liebedienern; **lie|be|leer**; **Lie|be|lei**; **lie|beln**; ich ...[e]le (↑R 327); **lie|ben**; **Lie|ben|de** *m* u. *w*; -n, -n (↑R 287 ff.); **lie|ben|ler|nen**; vgl. kennenlernen; **lie|bens|wert**, **...wür|dig**; **Lie|bens|wür|dig|keit**; **lie|ber** vgl. gern

Lie|ber|mann, Max (dt. Maler)

Lie|bes⌣aben|teu|er, **...af|fä|re**, **...ap|fel** (veralt. für: Tomate), **...ban|de** (geh.; *Mehrz.*), **...be|zei|gung**, **...be|zie|hung**, **...bo|te**, **...brief**, **...die|ne|rin** (ugs. für: Prostituierte), **...dienst**, **...er|klä|rung**, **...film**, **...ga|be**, **...ge|dicht**, **...ge|schich|te**, **...gott**, **...hei|rat**, **...kum|mer**, **...le|ben** (*s*; -s), **...lied**, **...müh** od. **...mü|he**, **...nest**, **...paar**, **...ro|man**, **...spiel**; **lie|bes⌣toll**, **...trunken**; **Lie|bes⌣ver|hält|nis**, **...zau|ber**; **lie|be|voll**; **Lieb|frau|en|kir|che** (Kirche Zu Unsrer Lieben Frau[en]); **Lieb|frau|en|milch** (ein Wein); als ⓦ: Liebfraumilch; **lieb|ge|win|nen** (↑ R 139); er hat sie liebgewonnen; **lieb|ge|worden**; eine liebgewordene Gewohnheit (↑ R 142), aber: die Gewohnheit ist ihm lieb geworden; **lieb|ha|ben** (↑ R 139); er hat sie liebgehabt; **Lieb|ha|ber**; **Lieb|ha|ber|büh|ne**; **Lieb|ha|be|rei**; **Lieb|ha|be|rin** *w*; -, -nen; **Lieb|ha|ber⌣preis**, **...wert**

Lieb|hard (m. Vorn.)

Lie|big (dt. Chemiker; ⓦ)

Lieb|knecht, Wilhelm (Mitbegründer des Sozialist. Arbeiterpartei Deutschlands)

lieb|ko|sen [auch, österr. nur ...*kọ*...] (↑ R 139); ↑ R 304: er hat geliebkost (auch: liebkọst); **Lieb|ko|sung** [auch, österr. nur ...*kọ*...]; **lieb|lich**; **Lieb|lich|keit** *w*; -; **Lieb|ling**; **Lieb|lings⌣aus|druck**, **...buch**, **...dich|ter**, **...es|sen**, **...far|be**, **...ge|richt**, **...kind**, **...lied**, **...platz**, **...schü|ler**, **...spei|se**, **...wort** (*Mehrz.* ...wörter); **lieb|los**; -este (↑ R 292); **Lieb|lo|sig|keit**; **lieb|reich**; **Lieb|reiz** *m*; -es; **lieb|rei|zend**; -ste; **Lieb|schaft**; **lieb sein**; **Lieb|ste** *m* u. *w*; -n, - (↑ R 287 ff.)

Lieb|stöckel [*Trenn.:* ...stök|ke (eine Heil- u. Gewürzpflanze) od. *m*; -s, -

lieb wer|den; er ist mir immer lieber geworden; vgl. liebgeworden; **lieb|wert** (veralt.)

Liech|ten|stein (Fürstentum); vgl. aber: Lichtenstein; **Liech|ten|stei|ner; liech|ten|stei|nisch**

Lied (Gedicht; Gesang) *s;* -[e]s, -er; vgl. aber: Lid; **Lied|chen** *s;* -s, - u. Liederchen; **Lied|lein; Lie-der⌣abend, ...buch, ...hand|schrift**

Lie|der|ian, Lied|ri|an (ugs. für: liederlicher, unordentlicher Mensch) *m;* -[e]s, -e

lie|der|lich; Lie|der|lich|keit

lie|der|reich; lied|haft; Lied|lein vgl. Liedchen

Lied|lohn (veralt. für: Dienstbotenlohn); vgl. auch: Lidlohn

Lied|ri|an. Liederjan

Lie|fe|rant [zu: liefern, mit lat. Endung] (Lieferer) *m;* -en, -en (↑ R 268); **Lie|fer|au|to; lie|fer|bar; Lie|fer|be|trieb; Lie|fe|rer; Lie-fer⌣fir|ma, ...frist; Lie|fe|rin** *w;* -, -nen; **lie|fern;** ich ...ere (↑ R 327); **Lie|fer⌣schein, ...ter|min; Lie|fe-rung; Lie|fe|rungs⌣ort** (*m;* -[e]s, -e), **...sper|re; lie|fe|rungs|wei|se; Lie|fer⌣ver|trag, ...wa|gen, ...zeit**

Lie|ge (für: Chaiselongue) *w;* -, -n

Lie|ge⌣couch, ...hal|le, ...kur; lie-gen; du lagst; du lägest; gelegen; liege[e]!; ich habe (südd.: bin) gelegen; ich habe zwanzig Flaschen Wein im Keller liegen; **lie|gen-blei|ben** (↑ R 139); er blieb liegen; er ist liegengeblieben; du mußt im Bett liegenbleiben; die Brille ist liegengeblieben; **lie|gend;** -es Gut, -e Güter; **Lie|gen|de** (Bergmannsspr.) *s;* -n (↑ R 287f.); **lie-gen|las|sen;** ↑ R 139 (vergessen, nicht beachten); er hat seinen Hut liegenlassen; er hat ihn links liegenlassen, (seltener:) liegengelassen (↑ R 305); alles liegen- und stehenlassen; aber: **lie|gen las-sen** (z. B. einen Stein, Verunglückten); den Ort links liegen lassen; **Lie|gen|schaft** (Grundbesitz); **Lie|ge⌣platz, ...pol|ster; Lie-ger** (Wächter auf einem außer Dienst befindlichen Schiff; Notvorrat [an Wasserfässern]); **Lie-ger|statt** südd. u. österr. mdal. (Liegestatt, Bett) *w;* -, ...stätten; **Lie|ge⌣sitz, ...so|fa, ...statt** (*w;* -, ...stätten), **...stuhl, ...stütz** (*m;* -es, -e), **...ter|ras|se, ...wa|gen, ...wie-se, ...zeit**

⌣Lieg|nitz (Stadt an der Katzbach)

⌣Liek (Seemannsspr.: Tauwerk als Einfassung eines Segels) *s;* -[e]s, -en; vgl. Leik

⌣Li|en lat. (Med.: Milz) *m;* -s; **lie|nal** [li-e...] (die Milz betreffend); **Lie-ni|tis** (Med.: Milzentzündung) *w;* -, ...itiden

⌣Lien|hard vgl. Leonhard

Li|enz (Stadt in Osttirol; Österreich)

lies! (Abk.: l.)

Liesch (Grasgattung) *s;* -[e]s; **¹Lie-schen** (Vorblätter am Maiskolben) *Mehrz.*

²Lies|chen (Koseform von: ²Liese); vgl. fleißig

¹Lie|se (Bergmannsspr.: enge Kluft) *w;* -, -n

²Lie|se, Lie|sel, Liesl (Kurzformen von: Elisabeth); **Lie|se|lot|te** [auch: ...lot^e]; ↑ R 194 (Kurzform von: Elisabeth Charlotte); vgl. auch: Liselotte

Lie|sen nordd. (Schweinefett) *Mehrz.*

Liesl vgl. Liesel

Lies|tal (Hptst. des Halbkantons Basel-Landschaft)

Lieue fr. [liø] (altes fr. Längenmaß) *w;* -, -s

Lift engl. (Fahrstuhl, Aufzug) *m;* -[e]s, -e u. -s; **Lift|boy** [...beu]; **lif-ten** (heben, stemmen)

Li|ga span. (Bund, Bündnis; Sport: Bez. einer Wettkampfklasse) *w;* -, ...gen; **Li|ga|de** (Fechten: „Bindung" u. Zurseitedrucken der gegnerischen Klinge); **Li|ga|ment** lat. *s;* -[e]s, -e u. ...ta; **Li|ga|tur** (Druckw.: [Buchstaben]verbindung; Med.: Unterbindung [einer Ader usw.]; Musik: Verbindung zweier gleicher Töne zu einem) *w;* -, -en; **li|gie|ren** (Fechten: die gegnerische Klinge „binden" u. zur Seite drücken); **Li|gist** (Angehöriger einer Liga; Verbündeter); ↑ R 268; **li|gi|stisch**

Li|gnin lat. (Holzstoff) *s;* -s, -e; **Li|gnit** (Braunkohle mit Holzstruktur) *m;* -s, -e

Li|gny [linji] (Dorf in Belgien)

Li|gro|in (Leichtöl, Bestandteil des Erdöls) *s;* -s

Li|gu|la lat. (Blatthäutchen [vor allem bei Gräsern]; Riemenwurm) *w;* -, ...lae [...lä]

Li|gu|rer (Angehöriger eines voridg. Volkes in Südfrankreich u. Oberitalien) *m;* -s, -; **Li|gu|ri|en** [...i^en] (it. Region); **li|gu|risch** aber (↑ R 198): das Ligurische Meer

Li|gu|ster lat. (Ölbaumgewächs mit weißen Blütenrispen) *m;* -s, -; **Li|gu|ster⌣hecke** [*Trenn.:* ...hek|ke], **...schwär|mer** (ein Schmetterling)

li|ie|ren fr. (eng verbinden); sich -; **Li|ie|rung** (enge Verbindung)

Li|kör fr. (süßer Branntwein) *m;* -s, -e; **Li|kör⌣essenz, ...fla|sche, ...glas** (*Mehrz.* ...gläser)

Lik|tor (Diener der Obrigkeit im alten Rom) *m;* -s, ...oren; **Lik|to-ren|bün|del**

li|la sanskr. (fliederblau; ugs. für: mittelmäßig); ein lila Kleid; vgl. blau; **Li|la** (ein fliederblauer Farbton) *s;* -s, - (ugs.: -s); **li|la|far-ben, li|la|far|big; Li|lak** (span. Flieder) *m;* -s, -s; **Li|la|kleid**

Li|lie lat. [...i^e] (stark duftende Gartenpflanze in vielen Spielarten) *w;* -, -n

Li|li|en|cron (dt. Dichter)

Li|li|en|ge|wächs

Li|li|en|thal (dt. Ingenieur, Luftfahrtpionier)

li|li|en|weiß

Li|li|put, (engl. Schreibweise:) **Lil-li|put** (Land der Däumlinge in J. Swifts „Gullivers Reisen"); **Li-li|pu|ta|ner** (Bewohner von Liliput; kleiner Mensch; Zwerg); **Li-li|put⌣bahn, ...for|mat**

Lil|li (Kurzform von: Elisabeth); **Li|ly** (engl. Kurzform von: Elisabeth)

lim = Limes (Math.)

lim., Lim. = limited

Li|ma (Hptst. von Peru)

Li|ma|ko|lo|gie gr. (veralt. für: Lehre von den [Nackt]schnek-ken) *w;* -

Lim|ba (ein Furnierholz) *s;* -s

Lim|bi (*Mehrz.* von: Limbus)

Lim|burg (belg. u. niederl. Landschaft; Stadt in Belgien)

Lim|burg a. d. Lahn (Stadt in Hessen)

¹Lim|bur|ger (↑ R 199); -er Käse (urspr. aus der belg. Landschaft Limburg); **²Lim|bur|ger** (ein Käse) *m,* -s, -

Lim|bus lat. (Teil der Unterwelt; [christl. für:] Vorhölle) *m;* -; (Technik für Gradkreis, Teilkreis an Winkelmeßinstrumenten, Bot.: für Saum einer teilweise verwachsenen Blüte auch *Mehrz.:*) ...bi

Li|me|rick irisch-engl. (fünfzeiliges Gedicht ironischen, groteskkomischen od. unsinnigen Inhalts) *m;* -[s], -s

Li|mes lat. (von den Römern angelegter Grenzwall [vom Rhein bis zur Donau]) *m;* -, (Math. für Grenzwert [Zeichen: lim] auch *Mehrz.:*) **li|mi|tes**

Li|mes|ka|stell

Li|met irisch-it. (westind. Zitrone) *w;* -, ...tten; **Li|met|ten|baum**

Li|mit engl. (Grenze, Begrenzung; Kaufmannsspr.: Preisgrenze, äußerster Preis) *s;* -s, -s u. -e; **Li|mi-ta|ti|on** lat. [...zion] (Begrenzung, Beschränkung); **Li|mi|te** fr. schweiz. (svw. Limit) *w;* -, -n; **li-mi|ted** engl. [limitid] (in engl. u. amerik. Firmennamen:) mit beschränkter Haftung"; Abk.:

Ltd., lim., Lim., Ld.); li|mi|tie|ren *lat.* ([den Preis] begrenzen; beschränken); limitierte Ausgabe; Li|mi|tie|rung

Lim|mat (r. Nebenfluß der Aare) *w;* -

Lim|ni|me|ter *gr.* (Pegel zum Messen des Wasserstandes eines Sees) *s;* lim|nisch (im Süßwasser lebend, abgelagert); Lim|no|graph (svw. Limnimeter) *m;* -en, -en (↑ R 268); Lim|no|lo|ge (Kenner u. Erforscher der stehenden Gewässer) *m;* -n, -n (↑ R 268); Lim|no|lo|gie (Süßwasser-, Seenkunde) *w;* -; lim|no|lo|gisch (auf Binnengewässer bezüglich); Lim|no|plank|ton

Li|mo [auch: *li...*] (ugs. Kurzform für: Limonade *w;* auch: *s*); -, -[s]; Li|mo|na|de *pers. w;* -, -n; Li|mo|ne (dickschalige Zitrone) *w;* -, -n Li|mo|nit (ein Mineral) *m;* -s, -e li|mos, li|mös *lat.* (Biol.: schlammig, sumpfig); -este (↑ R 292) Li|mou|si|ne *fr.* [...*mu...*] (geschlossener Pkw, auch mit Schiebedach) *w;* -, -n

Li|na, Li|ne (Kurzformen von: Karoline od. Pauline); Lin|chen (Koseform von: Lina, Line)

Lin|cke [zur *Trenn.:* ↑ R 189], Paul (dt. Komponist)

Lin|coln [*lingkᵉn*] (Präsident der USA)

Lin|cru|sta vgl. Linkrusta

lind; ein -er Regen

Lin|da (w. Vorn.)

Lind|au (Bo|den|see) (Stadt in Bayern)

Lin|de *w;* -, -n; lin|den (aus Lindenholz); Lin|den.al|lee, ...baum, ...blatt, ...blü|te; Lin|den|blü|ten|tee

Lin|de|rer; lin|dern; ich ...ere (↑ R 327); Lin|de|rung; Lin|de|rungs|mit|tel *s*

lind|grün [zu: Linde]

Lind|heit *w;* -; Lin|dig|keit (veralt. für: Sanftheit, Zartheit) *w;* -

Lind|wurm (Drache)

Li|ne vgl. Lina

Li|ne|al *lat. s;* -s, -e; Li|nea|ment (Med.: Linie [in der Hand od. im Gesicht]; Geol.: Erdnaht) *s;* -[e]s, -e; li|ne|ar (geradlinig; auf gerader Linie verlaufend; linienförmig); -e Gleichung (Math.); -e Programmierung (Math.); Li|ne|ar.be|schleu|ni|ger (Kernphysik), ...mo|tor (Elektrotechnik), ...zeich|nung (Umrißzeichnung, Riß); Li|nea|tur (veralt., aber noch fachspr. für: Linierung) *w;* -, -en

...ling (z. B. Jüngling *m;* -s, -e) Lin|ga[m] *sanskr.* [*lingga(m)*] (Phallus als Sinnbild des ind. Gottes der Zeugungskraft) *s;* -s

Lingerie *fr.* [*längseᵉʳi*] schweiz. (Wäscheraum, betriebsinterne Wäscherei; Wäschegeschäft) *w;* -, ...jen

...lings (z. B. jählings)

lin|gu|al *lat.* [...*ngg...*] (auf die Zunge bezüglich; Zungen...); Lin|gu|al *m;* -s, -e u. Lin|gu|al|laut (Zungenlaut); Lin|gu|ist (Sprachwissenschaftler); ↑ R 268; Lin|gui|stik (Sprachwissenschaft, -vergleichung) *w;* -; lin|gui|stisch

Li|nie *lat.* [...*iᵉ*] *w;* -, -n; - halten (Druckw.); absteigende, aufsteigende Linie (Genealogie); Li|ni|en.blatt, ...dienst, ...flug|zeug, ...füh|rung, ...netz, ...pa|pier, ...rich|ter, ...schiff, ...spie|gel (österr. für: Linienblatt), ...ste|cher (für: Guillocheur); li|ni|en|treu (einer politischen Ideologie genau u. engstirnig folgend); Li|ni|en|ver|kehr; li|nie|ren (österr. nur so), li|ni|ie|ren (mit Linien versehen; Linien ziehen); Li|nier.ma|schi|ne, ...plat|te; Li|nie|rung (österr. nur so), Li|ni|ie|rung; ...li|nig (z. B. geradlinig)

Li|ni|ment *lat.* (Med.: Mittel zum Einreiben) *s;* -[e]s, -e

link; linker Hand; Lin|ke (linke Hand; linke Seite; Politik.: Bez. für linksstehende Parteien, auch für linksstehende Gruppe einer Partei) *w;* -n, -n (↑ R 287ff.); zur -n; in meiner -n; ein kräftiger Druck meiner -n; (Boxen:) er traf ihn mit einer blitzschnellen -n; die radikale - (im Parlament); er gehört der - an; diese Linke (vgl. neu, I, c); Lin|ke|hand|re|gel (ein bestimmtes Verfahren in der Physik) *w;* -; lin|ker Hand; lin|ker|seits; Link|hand (Dolchform); lin|kisch; -ste (↑ R 294)

Lin|kru|sta (abwaschbare Papiertapete) *w;* -

links (Abk.: l.); - von mir, - vom Eingang; von -, nach -; von - nach rechts; von - her, nach - hin; an der Kreuzung gilt rechts vor -; er weiß nicht, was rechts und was - ist; links um! (milit. Kommando; vgl. aber: linksum); auch mit *Wesf.:* - des Waldes; Links|ab|bie|ger (Verkehrsw.); Links|au|ßen (Sportspr.) *m;* -, -; er spielt -; links|dre|hend, aber: nach links drehend; Links|dre|hung; Link|ser (ugs. für: Linkshänder); Links.ex|tre|mist, ...ga|lopp; links|ge|rich|tet (auch Politik); Links|ge|win|de; Links|hän|der; links|hän|dig; Links|hän|dig|keit *w;* -; links|her, aber: von links her; links|her|um; linksherum drehen, aber: nach links herumdrehen; links|hin, aber: nach links hin; Links-

hörn|chen (Schnecke); Links.in|tel|lek|tu|el|le, ...kur|ve; links|läu|fig; Links|par|tei; links|ra|di|kal; Links|ra|di|ka|lis|mus; links|rhei|nisch (auf der linken Rheinseite); links.sei|tig, ...ste|hend (auch Politik), ...uf|rig; links|um [auch: *linkßum*]; - machen; - kehrt! (milit. Kommando); Links.un|ter|zeich|ne|te (vgl. Unterzeichnete), ...ver|kehr, ...wendung

Lin|né [auch: *line*] (schwed. Naturforscher; Abk. hinter biol. Namen: L.); -sches System (Bot.)

lin|nen (dicht. für: leinen); Lin|nen (dicht. für: Leinen)

Lin|ole|um *lat.* [...*le-um*] (ein Fußbodenbelag) *s;* -s; Lin|ole|um|be|lag; Lin|ol|schnitt (ein graph. Verfahren u. dessen Ergebnis)

Li|non *fr.* [...*nong*, auch: *linon*] (Baumwollgewebe [mit Leinencharakter]) *m;* -[s], -s

Li|no|type ⓦ *engl.* [*laino̱taip*] (Setz- u. Zeilengießmaschine) *w;* -s, -s; Li|no|type-Setz|ma|schi|ne (↑ R 152) *w;* -, -n

Lin|se *w;* -, -n; lin|sen (ugs. für: schauen, scharf äugen, blinzeln); Lin|sen|feh|ler; lin|sen|för|mig; Lin|sen.ge|richt, ...sup|pe; ...lin|sig (z. B. vierlinsig, mit Ziffer: 4linsig)

Linth (Oberlauf der Limmat) *w;* -

Li|nus (m. Vorn.)

Linz (Hptst. von Oberösterreich)

Linz am Rhein (Stadt am Mittelrhein)

Lin|zer (↑ R 199)

Li̱o|ba (w. Vorn.)

Lip|ämie *gr.* (Med.: Vermehrung des Fettgehaltes im Blut) *w;* -; lip|ämisch (fettblütig)

Li|pa|ri|sche In|seln, (auch:) Äo|li|sche In|seln (im Mittelmeer) *Mehrz.*

Li|piz|za|ner (Pferd einer bestimmten Rasse) *m;* -s, -

li|po|id *gr.* (fettähnlich); Li|po|id (Biol.: fettähnlicher, lebenswichtiger Stoff im Körper) *s;* -s, -e (meist *Mehrz.*); Li|pom *gr.* (Med.: Fettgeschwulst) *s;* -s, ...omata; Li|po|ma|to|se (Med.: Fettsucht) *w;* -, -n

¹Lip|pe (Rand der Mundöffnung) *w;* -, -n

²Lip|pe (Land des ehem. Deutschen Reiches)

³Lip|pe (r. Nebenfluß des Niederrheins) *w;* -

Lip|pen.be|kennt|nis, ...blüt|ler (*m;* -s, -), ...laut, ...stift *m,* ...syn|chro|ni|sa|ti|on (Film)

Lip|pe-Sei|ten|ka|nal (↑ R 202)

Lipp|fisch; ...lip|pig (z. B. mehrlippig)

lip|pisch, aber (↑ R 198): Lippischer Wald

Lip|tau (slowak. Landschaft); Liptau|er (↑ R 199); - Käse; Lip|tau|er (ein Käse) m; -s, -

Lip|urie gr. (Med.: Ausscheidung von Fett durch den Harn) w; -

Liq. = Liquor; Li|que|fak|ti|on lat. [...zion] (Verflüssigung); liquid, li|qui|de (flüssig; fällig; verfügbar); -e Gelder, -e Forderung; Li|qui|da (Fließlaut) w; -, ...dä u. ...qui|den; Li|qui|da|ti|on [...zion] (Kostenrechnung, Abrechnung freier Berufe; Auseinandersetzung; Auflösung [eines Geschäftes]); Li|qui|da|ti|ons_an|teil|schei|ne (Kurzform: Liquis; Mehrz.), ...ver|hand|lung; Li|qui|da|tor (jmd., der eine Liquidation durchführt) m; -s, ...oren; li|qui|de vgl. liquid; li|qui|die|ren ([eine Forderung] in Rechnung stellen; [Verein, Gesellschaft, Geschäft] auflösen; Sachwerte in Geld umwandeln; einen Konflikt beilegen; jmdn. beseitigen); Li|qui|die|rung (bes. für: Beseitigung [einer Person]; Beilegung eines Konflikts); Li|qui|di|tät (Verhältnis der Verbindlichkeiten eines Unternehmens zu den liquiden Vermögensbestandteilen) w; -; Li|quid|laut; Li|quis (Kurzform für: Liquidationsanteilscheine) Mehrz.; Li|quor (Flüssigkeit; flüssiges Arzneimittel; Abk.: Liq. [auf Rezepten]) m; -s

Li|ra (it. Münzeinheit; Abk.: L., Lit [für Einz. u. Mehrz.]) w; -, Lire

Lis|beth [auch: liß...] (Kurzform von: Elisabeth)

Lis|boa [port. Ausspr.: lisehboa] (port. Name für: Lissabon)

Li|se vgl. Liese; Li|se|lot|te [auch: ...lot^e]; Liselotte von der Pfalz (Herzogin von Orleans); vgl. Lieselotte

Li|se|ne fr. (pfeilerartiger, wenig vortretender Mauerstreifen) w; -, -n

Li|set|te (w. Vorn.)

lis|men schweiz. mdal. (stricken); Lis|mer schweiz. mdal. (gestrickte Weste) m; -s, -

lis|peln; ich ...[e]le (↑ R 327); Lis|pel|ton (Mehrz. ...töne)

Lis|sa|bon (Hptst. Portugals); vgl. auch: Lisboa; Lis|sa|bon|ner (↑ R 199)

[1]List w; -, -en

[2]List (dt. Volkswirt); vgl. Liszt

Li|ste w; -, -n; die schwarze - li|sten (in Listenform bringen); gelistet; Li|sten_aus|zug, ...füh|rer, ...preis li|sten|reich

Li|sten|wahl

li|stig; li|sti|ger|wei|se; Li|stig|keit w; -

Liszt [lißt] (ung. Komponist)

Lit = Lira Einz. u. Lire Mehrz.

lit., Lit. = li|tera; vgl. Litera

Li|ta|nei gr. (Wechsel-, Bittgebet; eintöniges Gerede; endlose Aufzählung) w; -, -en

Li|tau|en[1]; Li|tau|er[1]; li|tau|isch[1]; • Sprache; vgl. deutsch; Li|tau|isch[1] (Sprache) s; -[s]; vgl. Deutsch; Li|taui|sche[1] s; -n; vgl. Deutsche

Li|ter gr. [auch: lit^er] (1 Kubikdezimeter; Zeichen: l) m (schweiz. amtlich nur so) od. s; -s, -; ein halber od. halbes Liter, ein viertel Liter

Li|te|ra lat. (Buchstabe; Abk.: Lit. od. lit.) w; -,-s u. ...rä; Li|te|rar|hi|sto|ri|ker; li|te|rar|hi|sto|risch; li|te|ra|risch (schriftstellerisch, das [schöne] Schrifttum betreffend); Li|te|rar|kri|tik = Literaturkritik; Li|te|rat (oft abschätzig für: Schriftsteller) m; -en, -en (↑ R 268); Li|te|ra|ten|tum s; -; Li|te|ra|tur w; -, -en; Li|te|ra|tur_an|ga|be (meist Mehrz.), ...bei|la|ge, ...denk|mal (Mehrz. ...mäler, geh.: ...male), ...gat|tung, ...geschich|te; li|te|ra|tur|ge|schicht|lich; Li|te|ra|tur_hin|weis, ...kri|tik, ...kri|ti|ker, ...preis, ...spra|che, ...ver|zeich|nis, ...wis|sen|schaft; li|te|ra|tur|wis|sen|schaft|lich; Li|te|ra|tur|zeit|schrift

Li|ter|lei|stung [auch: li...] (Leistung, die aus jeweils 1 000 ccm eines Kfz.-Motors erzielt werden kann); li|ter|wei|se [auch: li...]

Li|tew|ka poln. [litáfka] (früher für: bequemer Uniformrock) w; -, ...ken

Lit|faß|säu|le; ↑ R 180 (nach dem Berliner Buchdrucker E. Litfaß) (Anschlagsäule)

lith...vgl. auch (stein...); Lith... (Stein...);

Li|thi|a|sis (Med.: Steinbildung [in Galle, Niere usw.]) w; -, ...ia|sen; Li|thi|um (chem. Grundstoff, Metall; Zeichen: Li) s; -s;

Li|tho|graph[2] (Steinzeichner) m; -en, -en (↑ R 268); Li|tho|gra|phie[2] (Steinzeichnung; Herstellung von Platten für den Steindruck [nur Einz.]; das Ergebnis dieses Druckes) w; -, -ien; li|tho|gra|phie|ren[2]; li|tho|gra|phisch[2]; Li|tho|klast (med. Instrument zum Zertrümmern von Blasensteinen) m; -en, -en (↑ R 268); Li|tho|lo|ge (Kenner u. Erforscher der Gesteine) m; -n, -n (↑ R 268);

[1] Auch: li...

[2] Auch eindeutschend: Lithograf usw.

Li|tho|lo|gie (Gesteinskunde) w; -; Li|tho|ly|se (Med.: Auflösung von Nieren- und Harnsteinen durch Arzneien) w; -, -n; Li|tho|pä|di|on („Steinkind", verknöcherte Frucht) s; -s, ...ia u. ...ien [...i^en]; li|tho|phag (sich in Gestein einbohrend); Li|tho|po|ne (lichtechte Weißfarbe) w; -; Li|tho|sphä|re (Gesteinsmantel der Erde) w; -; Li|tho|tom (chirurg. Messer zur Durchführung der Lithotomie) m od. s; -s, -e; Li|tho|to|mie ([Blasen]steinoperation) w; -, ...ien; Li|tho|trip|sie ([Blasen]steinzertrümmerung) w; -, ...ien; Li|tho|trip|ter (Lithoklast) m; -s, -; Lith|ur|gik (Lehre von der Verwendung u. Verarbeitung von Gesteinen u. Mineralien) w; -; vgl. aber: Liturgik

li|to|ral lat. (Geogr.: der Küste angehörend); Li|to|ral (Uferzone [Lebensraum im Wasser]) s; -s, -e; Li|to|ra|le it. (Küstenland) s; -s, -s; Li|to|ral|fau|na lat.; Li|to|ral|flo|ra; Li|to|ri|na (Uferschnecke) w; -, ...nen; Li|to|ri|na|meer (Entwicklungsstufe der Ostsee mit Litorinaschnecken als Leitfossil) s; -[e]s

Li|to|tes gr. [litotäß, auch: litotäß] (Rhet.: Bejahung durch doppelte Verneinung, z. B. nicht unklug) w; -

Li|tur|gie gr. (der amtlich od. gewohnheitsrechtlich geregelte öffentl. Gottesdienst) w; -, ...ien; Li|tur|gi|en|samm|lung; Li|tur|gik (Theorie u. Geschichte der Liturgie) w; -; vgl. aber: Lithurgik; li|tur|gisch; -e Gefäße, Gewänder

Lit|ze lat. w; -, -n

live engl. [laif] (von Rundfunk- u. Fernsehübertragungen: direkt, original); etwas - senden, übertragen

Li|ve [...w^e] (Angehöriger eines finn. Volksstammes) m; -n, -n (↑ R 268)

Li|ver|pool [liw^erpul] (engl. Stadt)

Live-Sen|dung engl.; dt. [laif...] (Rundfunk- od. Fernsehsendung, die bei der Aufnahme direkt übertragen wird; Originalübertragung, Direktsendung)

Li|via [...wia] (Gemahlin des Kaisers Augustus)

li|visch [zu: Live]

Li|vi|us [...wi...] (röm. Geschichtsschreiber)

Liv|land [lif...]; Liv|län|der m; liv|län|disch

Li|vre [liwr] fr. (alte fr. Münze) m od. s; -[s], -[s]; 6 - (↑ R 322)

Li|vree fr. [...wre] (uniformartige Dienerkleidung) w; -, ...een; li|vriert (in Livree [gehend])

¹Li|zen|ti|at *lat.* [...*ziat*] (akadem. Grad in der Schweiz, in der BRD selten) *s;* -[e]s, -e; - der Theologie; ²Li|zen|ti|at (Inhaber des ¹Lizentiats; Abk.: Lic. [theol.], (schweiz.:) lic. phil. usw.) *m;* -en, -en (↑ R 268); Li|zenz [behördl.] Erlaubnis, Genehmigung, bes. zur Nutzung eines Patents od. zur Herausgabe einer Zeitung, Zeitschrift od. eines Buches) *w;* -, -en; Li|zenz_aus|ga|be, ...ge|ber, ...ge|bühr; Li|zen|zie|ren (Lizenz erteilen); Li|zenz_in|ha|ber, ...neh|mer, ...spie|ler (Fußball), ...trä|ger, ...ver|trag Li|zi|tant *lat.* (Bieter [bei Versteigerungen]) *m;* -en, -en (↑ R 268); Li|zi|ta|ti|on [...*zion*] (Versteigerung); li|zi|tie|ren

Lju|blja|na vgl. Laibach

Lkw, (auch:) LKW (= Lastkraftwagen) *m;* - (selten: -s), -[s]

Lla|ne|ro *span.* [lja...] (Bewohner der Llanos) *m;* -s, -s; Lla|no [*ljano*] (Hochgrassteppe in Südamerika) *m;* -s, -s (meist *Mehrz.*)

Lloyd [*leud;* nach dem Londoner Kaffeehausbesitzer E. Lloyd] (Seeversicherungs-, auch Schifffahrtsgesellschaft; Name von Zeitungen [mit Schiffsnachrichten]) *m;* -[s], -s; Norddeutscher -; Lloyd|damp|fer (↑ R 180)

lm = Lumen

Lob *s;* -[e]s; - spenden; Lob|be|gier[|de] *w;* -

Lob|by *engl.* [*lobi*] (Wandelhalle im [engl. od. amerik.] Parlament; auch für: Gesamtheit der Lobbyisten) *w* (auch: *m*); -, -s od. Lobbies [*lobis*]; Lob|by|is|mus (Versuch, Gepflogenheit, Zustand der Beeinflussung von Abgeordneten durch Interessenten-[gruppen]) *m;* -; Lob|by|ist (jmd., der Abgeordnete für seine Interessen zu gewinnen sucht); ↑ R 268

Lo|be|lie [...*ie*; nach dem flandrischen Botaniker M. de l'Obel] (aus Afrika stammende beliebte Gartenpflanze) *w;* -, -n

lo|ben; lo|bens_wert, ...wür|dig; lo|be|sam (veralt.); Lob|es_er|he|bung (meist *Mehrz.*), ...hym|ne; Lob_ge|sang, ...gier; lob|gie|rig; Lob|hu|de|lei (abschätzig); Lob_hu|de|ler od. ...hud|ler (abschätzig) lob|hu|deln (abschätzig: übertrieben loben); ich ...[e]le (↑ R 327); gelobhudelt; zu -: löb|lich; Lob|lied

Lo|bo|to|mie vgl. Leukotomie

Lob|preis; lob|prei|sen; du lobpreist (lobpreisest); du lobpreisest und lobpreisest; gelobpreist u. lobgepriesen; zu lobpreisen; lobpreise!; Lob|prei|sung; Lob-

...re|de, ...red|ner; lob|red|ne|risch; lob|sin|gen; du lobsingst; du lobsangst (lobsangest); lobgesungen; zu lobsingen; lobsinge!

Lo|car|no [...*kar*...] (Stadt am Lago Maggiore); Lo|car|ner (↑ R 199)

Loc|cum (Ort südl. von Nienburg [Weser])

Loch *s;* -[e]s, Löcher; Loch|boh|rer; Lö|chel|chen, Löch|lein; lo|chen; Lo|cher (Gerät zum Lochen; Person, die Lochkarten locht); lö|che|rig, löch|rig; Lo|che|rin *w;* -, -nen; lö|chern; ich ...ere (↑ R 327) Lo|chi|an *gr.* [...*i⁰n*] (Wochenfluß nach der Geburt) *Mehrz.*

Loch_ka|me|ra, ...kar|te; Loch|kar|ten|ma|schi|ne; Loch|leh|re (Gerät zur Prüfung der Lochung); Löch|lein, Lö|chel|chen; löch|rig, lö|che|rig; Loch_sti|cke|rei¹, ...strei|fen; Lo|chung; Loch|zan|ge

Löck|chen, Löck|lein; Locke¹ *w;* -, -n; ¹locken¹ (lockig machen) ²locken¹ (anlocken)

löcken¹ (mit den Füßen ausschlagen), noch in: wider den Stachel - (bibl.)

Locken¹_haar, ...kopf; locken|köp|fig¹; Locken¹_pracht, ...wickel¹ od. ...wick|ler

locker¹; - lassen, machen, sitzen, werden; locker|las|sen¹; ↑ R 139 (ugs. für: nachgeben); er hat nicht lockergelassen (nachgegeben); aber: locker¹ las|sen¹; er hat die Bremse des Wagens locker gelassen; Locker|heit¹ *w;* -; locker|ma|chen¹; ↑ R 139 (ugs. für: ausgeben); er hat viel Geld lockergemacht; aber: locker¹ ma|chen; er hat den Knoten ganz locker gemacht; lockern¹; ich ...ere (↑ R 327); Locke|rung¹; Locke|rungs_mit|tel (zum Auflockern des Teiges) *s,* ...übung lockig¹; Löck|lein, Löck|chen

Lock_mit|tel *s,* ...ruf, ...spei|se, ...spit|zel; Lockung¹; Lock|vo|gel

lo|co *lat.* [*loko*] (Kaufmannsspr.: am Ort; hier; greifbar; vorrätig); - Berlin (ab Berlin); vgl. aber: Lokoverkehr; lo|co ci|ta|to [- *zi*...] (am angeführten Orte; Abk.: l. c.)

Lod|de (ein Fisch) *w;* -, -n

Lod|del landsch. (Zuhälter) *m;* -s, - lod|de|rig landsch. (lotterig)

Lo|de (Schößling) *w;* -, -n

Lo|den (in Wollgewebe) *m;* -s, -; Lo|den_man|tel, ...stoff

lo|dern; ich ...ere (↑ R 327)

Lodz [*lotsch*], (auch:) Lodsch (dt. Schreibungen von: Łódź); Łódź [*lotsch,* poln.: "*utßj*] (poln. Stadt)

Löf|fel *m;* -s, -; Löf|fel_bag|ger, ...en|te, ...kraut; Löf|fel|chen; ...[el]e (↑ R 327); Löf|fel_rei|her (fälschlich für: Löffler), ...stiel; löf|fel|wei|se; Löff|ler (ein Vogel) Lo|fo|ten [auch: *lofot*...] (norw. Name der Lofotinseln); Lo|fot|in|seln (Gebiet u. Inselgruppe vor der Küste Nordnorwegens) *Mehrz.*

log = Logarithmus

Log *engl.* (Fahrgeschwindigkeitsmesser eines Schiffes) *s;* -s, -e

Log|arith|men|ta|fel; log|arith|mie|ren *gr.* (mit Logarithmen rechnen); den Logarithmus berechnen); log|arith|misch; Log|arith|mus (math. Größe; Zeichen: log) *m;* -, ...men

Log|buch *engl.; dt.* (Schiffstagebuch)

Lo|ge *fr.* [*loseh⁰*] (Pförtnerraum; Theaterraum; [geheime] Gesellschaft) *w;* -, -n; Lo|ge|ment [*loseh⁰mang*] (veralt. für: Wohnung, Bleibe) *s;* -s, -s; Lo|gen_bru|der (Freimaurer), ...platz, ...schlie|ßer (Beschließer [im Theater])

Log|gast (Matrose zur Bedienung des Logs) *m;* -[e]s, -en; Log|ge (seltener für: Log) *w;* -, -n; log|gen (Seemannsspr.: mit dem Log messen)

Log|ger *niederl.* (Seemannsspr.: ein Fischereifahrzeug) *m;* -s, -

Log|gia *it.* [*lodseha* od. *lodsehja*] (,,Laube"; halboffene Bogenhalle; nach einer Seite offener, überdeckter Raum am Haus) *w;* -, ...ien [...*i⁰n*]

Log|glas (Seemannsspr.: Sanduhr zum Loggen; *Mehrz.* ...gläser)

lo|gier|be|such [*loseh*ir...]; lo|gie|ren *fr.* [*loseh*ir⁰*n*] ([vorübergehend] wohnen; veralt. für: beherbergen); Lo|gier|gast (*Mehrz.* ...gäste)

Lo|gik *gr.* (Denklehre; folgerichtiges Denken) *w;* -; Lo|gi|ker (Lehrer der Logik; scharfer, klarer Denker)

Lo|gis *fr.* [*loseh*i] (Wohnung, Bleibe; Seemannsspr.: Mannschaftsraum auf Schiffen) *s;* - [*loseh*i(ß)], - [*loseh*ißj

lo|gisch *gr.* (folgerichtig; denkrichtig; denknotwendig; ugs. für: natürlich, selbstverständlich, klar); -ste (↑ R 294); lo|gi|scher|wei|se; Lo|gis|mus (Vernunftschluß) *m;* -, ...men; ¹Lo|gi|stik (Behandlung der logischen Gesetze mit Hilfe von math. Symbolen; math. Logik) *w;* - ²Lo|gi|stik *nlat.* (militär. Nachschubwesen) *w;* - Lo|gi|sti|ker (Vertreter der ¹Logistik); ¹lo|gi|stisch (die ¹Logistik betreffend)

¹ *Trenn.:* ...k|k...

²lo|gi|stisch (die ²Logistik betreffend)

Log|lei|ne (Seemannsspr.)

Lo|go|griph gr. (Buchstabenrätsel) m; -s u. -en, -e[n] (↑ R 268); Lo|go|pä|de (Sprachheilkundiger) m; -n, -n; Lo|go|pä|die (Sprachheilkunde) w; -; Lo|go|pä|din w; -, -nen; lo|go|pä|disch; Lo|gor|rhö¹, Lo|gor|rhöe (Med.: krankhafte Geschwätzigkeit) w; -, ...rrhöen; Lo|gos (sinnvolle Rede; Vernunft; Wort) m; -, (selten:) ...goi [...geu]

loh (veralt. für: brennend, flammend); ...loh (in Ortsnamen: Gelände mit strauchartigem Baumwuchs, z. B. Gütersloh)

Loh‿bei|ze, ...blü|te (Schleimpilz); ¹Lo|he (Gerbrinde) w; -, -n

²Lo|he (Glut, Flamme) w; -, -n; lo|hen

Lo|hen|grin (altdt. Sagen- u. Epengestalt)

loh|gar (mit ¹Lohe gegerbt); Loh|ger|ber

Lohn m; -[e]s, Löhne; Lohn‿ab|zug, ...aus|fall, ...aus|zah|lung, ...buch|hal|ter, ...buch|hal|tung, ...bü|ro, ...emp|fän|ger; loh|nen; es lohnt den Einsatz; es lohnt sich, der Mühe nicht; sich -; der Einsatz lohnt sich; löh|nen (Lohn auszahlen); loh|nens|wert; Lohn‿er|hö|hung, ...for|de|rung, ...fort|zah|lung, ...grup|pe, ...kür|zung, ...pfän|dung; Lohn-Preis-Spi|ra|le (↑ R 155); Lohn‿satz, ...steu|er w; Lohn|steu|er|kar|te; Lohn‿stopp m; -s; Lohn|sum|men|steu|er w; Lohn|tü|te; Löh|nung; Lohn‿ver|hand|lung, ...zet|tel

Loh|rin|de (zu: ¹Lohe)

Loi|pe skand. [leup⁶] (Langlaufbahn, -spur [im Schisport]) w; -, -n

Loire [loar] (fr. Fluß) w; -

Lok (Kurzform von: Lokomotive) w; -, -s

lo|kal lat. (örtlich; örtlich beschränkt); Lo|kal (Örtlichkeit; [Gast]wirtschaft) s; -[e]s, -e; Lo|kal‿an|äs|the|sie (Med.: örtl. Betäubung), ...au|gen|schein (österr. für: Lokaltermin), ...bahn, ...be|richt; lo|ka|le (in Zeitungen: Nachrichten aus dem Ort) s; -n; lo|ka|li|sa|ti|on [...zion] (örtl. Beschränkung, Ortsbestimmung, -zuordnung); lo|ka|li|sie|ren; Lo|ka|li|tät (Örtlichkeit; Raum); Lo|kal‿ko|lo|rit, ...nach|richt, ...pa|trio|tis|mus, ...re|por|ter, ...satz (Sprachw.: Umstandssatz des Ortes), ...sei|te, ...ter-

min, ...zei|tung; Lo|ka|tar (früher für: Pächter, Mieter) m; -s, -e; Lo|ka|ti|on [...zion] (Bohrstelle [bei der Erdölförderung]; veralt. für Platz-, Rangbestimmung); Lo|ka|tiv [auch: ...tif] (Sprachw.: Ortsfall) m; -s, -e [...w⁶]; Lo|ka|tor (im MA.: [Kolonial]land verteilender Ritter; veralt. für: Vermieter, Verpächter) m; -s, ...oren

Lok|füh|rer (Kurzform von: Lokomotivführer)

Lo|ki (germ. Gott)

lo|ko vgl. loco; Lo|ko|ge|schäft (Kaufmannsspr.: Geschäft über sofort verfügbare Ware); Lo|ko|mo|bi|le lat. (fahrbare Dampf-, Kraftmaschine) w, -, -n, Lo|ko|mo|ti|on [...zion] (Med.: Ortsveränderung); Lo|ko|mo|ti|ve engl. [...tiw⁶, auch: ...tif⁶] (Kurzform: Lok) w; -, -n; Lo|ko|mo|tiv‿füh|rer (Kurzform: Lokführer), ...schup|pen; lo|ko|mo|to|risch lat. (die Fortbewegung, den Gang betreffend); Lo|ko‿ver|kehr, ...wa|re (Kaufmannsspr.: sofort lieferbare Ware); Lo|kus (ugs. für: ¹Abort) m; - u. -ses, - u. -se

Lo|la (Koseform von: Dolores)

Lolch lat. (eine Grasart) m; -[e]s, -e

Lom|bard [auch: lombart] (Kredit gegen Verpfändung beweglicher Sachen) m od. s; -[e]s, -e; Lom|bar|de (Bewohner der Lombardei) m; -n, -n (↑ R 268); Lom|bar|dei (it. Region) w; -; Lom|bard|ge|schäft [auch: lombart...]; lom|bar|die|ren (bewegliche Sachen beleihen); lom|bar|disch (aus der Lombardei), aber (↑ R 198): die Lombardische Tiefebene; Lom|bard‿schein [auch: lombart...], ...zins|fuß

Lom|ber fr. (ein Kartenspiel) s; -s; Lom|ber|spiel s; -[e]s

Lom|matzsch [lomatsch] (Stadt im Bezirk Dresden); Lom|matz|scher Pfle|ge (Ebene nordwestl. von Meißen) w; - -

Lom|pen|zucker [Trenn.: ...zuk|ker], Lum|pen|zucker niederl. (veralt. für: Zucker in Hutform)

Lon|don (Hptst. von Großbritannien); Lon|do|ner (↑ R 199)

Long|drink engl. (mit Soda, Eiswasser o. a. verlängerter Drink); Long|drink|glas (Mehrz. ...gläser)

Lon|ge fr. [longseh⁶] (Reitsport: Laufleine für Pferde; Akrobatik: Sicherheitsleine) w; -, -n; lon|gie|ren [longsehir⁶n] (Reitsport: ein Pferd an der Longe laufen lassen)

Lon|gi|me|trie lat.; gr. [...ngg...] (Längenmessung) w; -

lon|gi|tu|di|nal lat. [...ngg...] (in

der Längsrichtung, längs...; die geographische Länge betreffend); Lon|gi|tu|di|nal‿schwin|gung (Längsschwingung), ...wel|le

Long|sel|ler engl. (lange zu den Bestsellern gehörendes Buch) m; -s, -

Lo|ni (Kurzform von: Apollonia, Leonie)

Löns (dt. Schriftsteller)

Look engl. [luk] (bestimmtes Aussehen [in bezug auf die Mode gebraucht]; meist in Zusammensetzungen wie Astronautenlook) m; -s, -s

Loo|ping engl. [lup...] (senkrechter Schleifenflug, Überschlagrolle) m (auch: s); -s, -s

Loos (österr. Architekt)

Lo|pe de Ve|ga [- - we...] (span. Dichter)

Lor|baß lit. nordostd. (Lümmel, Taugenichts) m; ...basses, ...basse

Lor|beer lat. (ein Baum; Gewürz) m; -s, -en; Lor|beer‿baum, ...blatt; lor|beer|grün; Lor|beer‿kranz, ...zweig

Lorch m; -[e]s, -e (vgl. Lork) u.

Lor|che mitteld. (Kröte) w; -, -n

Lor|chel (ein Pilz) w, -, -n

Lor|chen (Koseform von: Lore)

Lord engl. (hoher engl. Adelstitel) m; -s, -s; Lord-Kanz|ler (höchster engl. Staatsbeamter); Lord-Mayor [...me⁶r] (Titel der Oberbürgermeister mehrerer engl. Großstädte) m; -s, -s

Lor|do|se gr. (Med.: Rückgratverkrümmung nach vorn) w; -, -n

Lord|ship engl. [...schip] (Lordschaft; Würde [und Anrede] od. Herrschaft eines Lords) w; -

¹Lo|re engl. (offener Eisenbahngüterwagen, Feldbahnwagen) w; -, -n

²Lo|re (Kurzform von: Leonore u. Eleonore); Lo|re|ley [...lai, auch: lo...], (auch:) Lo|re|lei [auch: lo...] (Rheinnixe); Felsen am r. Rheinufer bei St. Goarshausen) w; -

Lo|renz (m. Vorn.); Lo|renz‿strom (↑ R 210 und Sankt-Lorenz-Strom)

Lo|re|to (Wallfahrtsort in Italien); aber: Lo|ret|to|hö|he fr. Anhöhe bei Arras) w; -

Lor|gnet|te fr. [lornjät⁶] (Stielbrille) w; -, -n; lor|gnet|tie|ren [lornja-tir⁶n] (früher für: durch die Lorgnette betrachten; scharf mustern); Lor|gnon [lornjong] (Stieleinglas, -brille) s; -s, -s

¹Lo|ri karib.-span. (ein Papagei) m; -s, -s

²Lo|ri niederl. (schwanzloser Halbaffe) m; -s, -s

¹ Vgl. die Anmerkung zu „Diarrhö, Diarrhöe".

Lork niederd. (Kröte) *m;* -[e]s, Lörke; vgl. Lorch

Lor|ke mitteld. (dünne Brühe, bes. von Kaffee) *w;* -

Lo|ro|kon|to *it.* (das bei einer Bank geführte Kontokorrentkonto einer anderen Bank)

Lort|zing (dt. Komponist)

los, lo|se; das lose Blatt; lose Ware (nicht in Originalpackung, sondern einzeln); ein loses (leichtfertiges) Mädchen; eine lose Zunge haben (leichtfertig reden); die Zügel lose (locker) halten. *In Verbindung mit Zeitwörtern* bis auf „los haben" (vgl. d.) und „los sein" (vgl. d.) immer zusammengeschrieben

...los (z. B. arbeitslos)

Los *s;* -es, -e; das Große - (↑ R 224)

los... (*in Zus. mit Zeitwörtern,* z. B. losmarschieren, du marschierst los, losmarschiert, loszumarschieren; zum 2. Mittelw. ↑ R 304)

Los An|ge|les [- *ändsch^e l^e s*] (größte Stadt Kaliforniens, USA)

lös|bar; Lös|bar|keit *w;* -

los|be|kom|men; den Deckel -

los|bin|den; er hat das Pferd losgebunden

los|bre|chen; ein Unwetter brach los

Lösch..ap|pa|rat, ...ar|beit; lösch|bar; Lösch..blatt, ...boot; [1]lö|schen (einen Brand löschen) (löschest), er löscht; du löschtest; gelöscht; lösch[e]!; [2]lö|schen (nur noch dicht. für: erlöschen); du lischst (lischest), er lischt; du loschst (loschest); du loschest; geloschen; lisch!

[3]lö|schen [zu: los] (Seemannsspr.: ausladen); du löschst (löschest); du löschtest

Lö|scher; Lösch..fahr|zeug, ...kalk, ...pa|pier; Lö|schung

lo|se vgl. los

Lo|se (Seemannsspr.: schlaffes Tau[stück]) *s;* -s, -

Lo|se blatt|aus|ga|be; der Lose[n]blattausgabe; die Lose[n]blattausgaben

Lö|se geld

los|ei|sen (ugs. für: mit Mühe freimachen, abspenstig machen); er ei|ste los; sich -; ich habe mich endlich von ihnen losgeeist

[1]lo|sen, lu|sen südd., österr. mdal. u. schweiz. mdal. (horchen, zuhören); du lost (losest) or lo|ste; gelost; los!

[2]lo|sen (das Los ziehen); du lost (losest) er lo|ste; gelost; lose!

lö|sen (auch für: befreien; Bergmannsspr.: entwässern; mit Frischluft beschicken); du löst (lösest) er lö|ste; gelöst; lös[e]!

Lo|ser, Lu|ser (Jägerspr.: Lauscher [Ohr])

los|fah|ren; endlich ist er losgefahren

los|ge|hen (ugs. auch für: anfangen); der Streit ist losgegangen

los ha|ben (ugs. für: etwas verstehen; mit Leichtigkeit können); er hat in seinem Beruf viel los gehabt

los|heu|len (ugs. für: zu heulen beginnen); die Sirene heulte los

...lo|sig|keit (z. B. Regellosigkeit *w;* -, -en)

Los|kauf; los|kau|fen; früher wurden die Gefangenen losgekauft

los|kom|men; er ist von diesen Gedanken nicht mehr losgekommen

los|krie|gen; den Deckel nicht -

los|las|sen; er hat den Hund von der Kette losgelassen

los|lau|fen; er ist losgelaufen

los|le|gen (ugs. für: sich ins Zeug legen; beginnen); er hat ordentlich losgelegt (z. B. energisch geredet)

lös|lich; Lös|lich|keit *w;* -

los|lö|sen; sich -; er hat die Briefmarke losgelöst; du hast dich von diesen Anschauungen losgelöst; Los|lö|sung

los|ma|chen; er hat das Brett losgemacht; mach los! (ugs. für: beeile dich!)

los|mar|schie|ren; er ist kräftig losmarschiert

Los|num|mer

los|rei|ßen; du hast dich losgerissen

Löß [auch: *löß,* schweiz. nur so] (Ablagerung des Pleistozäns) *m;* Lösses, Lösse (bei langer Aussprache des Selbstlautes: Lößes, Löße)

los|sa|gen; sich von etwas -; du hast dich von ihm losgesagt; Los|sa|gung

Löß|bo|den [auch: *löß...*]

los|schicken [Trenn.: ...schik|ken]; er hat den Trupp losgeschickt

los|schie|ßen (ugs.); er ist auf mich losgeschossen

los|schla|gen; er hat das Brett losgeschlagen; die Feinde haben losgeschlagen (mit dem Kampf begonnen)

los sein; er wird die Sorgen los sein; auf dem Fest ist nichts los gewesen

lö|ß|lig; Löß|kin|del [auch: *löß...*] (Konkretion im Löß) *s;* -s, -; Löß|land|schaft [auch: *löß...*]

Löß|nitz (Nordrand des Dresdner Elbetals unterhalb von Dresden) *w;* -

los|spre|chen (von Schuld); er hat ihn losgesprochen; Los|sprechung (für: Absolution)

Löß|schich|ten [auch: *löß...*] *Mehrz.*

los|steu|ern; auf ein Ziel -

los|stür|zen (ugs.); er ist losgestürzt, als ...

Lost (Deckname für einen chem. Kampfstoff) *m;* -[e]s

Los|ta|ge (nach dem Volksglauben für die Wetterprophezeiung bedeutsame Tage; Merk-, Unglückstage) *Mehrz.*

Los|trom|mel

[1]Lo|sung (Erkennungswort; Wahl-, Leitspruch)

[2]Lo|sung (Jägerspr.: Kot des Wildes u. des Hundes; Kaufmannsspr.: Tageseinnahme [in Kaufhäusern]) *w;* -

Lö|sung; Lö|sungs..mit|tel *s,* ...ver|such

Lo|sungs|wort (*Mehrz.* ...worte)

Los-von-Rom-Be|we|gung (↑ R 155) *w;* -

los|wer|den; etwas - (von etwas befreit werden; ugs. für: etwas verkaufen); er muß sehen, wie er die Ware los wird; es ist ihm glücklich losgeworden; er hat diesen Gegenstand gut losgeworden

los|zie|hen (ugs. für: sich zu einer [vergnüglichen] Unternehmung aufmachen); er ist losgezogen; gegen jmdn. - (ugs. für: gehässig von ihm reden)

[1]Lot (metall. Bindemittel; Vorrichtung zum Messen der Wassertiefe u. zur Bestimmung der Senkrechten; [Münz]gewicht; Hohlmaß) *s;* -[e]s, -e; 3 - Kaffee (↑ R 321 u. 322)

[2]Lot (bibl. m. Eigenn.)

lo|ten (senkrechte Richtung bestimmen; Wassertiefe messen; Flughöhe bestimmen)

lö|ten (durch Lötmetall verbinden); Löt|fu|ge

Lo|thar [auch: *...tar*]; ↑ R 191 (m. Vorn.); vgl. Chlotar

Loth|rin|gen; Loth|rin|ger (↑ R 199); loth|rin|gisch

...lö|tig (z. B. sechzehnlötig)

Lo|ti|on *engl.* [*...zion,* engl. Aussprache: *lo^u sch^e n*] (flüssiges Reinigungs-, Pflegemittel für die Haut) *w;* -, -en u. (bei engl. Aussprache) -s

Löt..kol|ben, ...lam|pe, ...me|tall

Lo|to|pha|ge *gr.* (Angehöriger eines sagenhaften Volkes; Lotosesser) *m;* -n, -n (↑ R 268); Lo|tos (Wasserrose) *m;* -, -; Lo|tos..blu|me, ...sitz

lot|recht; Lot|rech|te *w;* -, -n; vier -[n] (↑ R 291)

Löt|rohr

Lötsch|berg|bahn (*w;* -), ...tun|nel (*m;* -); ↑ R 201; Löt|schen|paß *m;* ...passes

Lot|se *engl. m;* -n, -n (↑ R 268);

lot|sen; du lotst (lotsest); Lot-sen.boot, ...dienst, ...fisch, ...sta-ti|on

Löt|stel|le

Lott|chen (Koseform von: Lotte);
Löt|te (Kurzform von: Charlot-te)

Lot|ter (veralt., aber noch mdal.
für: wilder Kerl, Taugenichts,
Schelm) m; -s, -; Lot|ter.bett (alte
Verdeutschung für: Sofa), ...bu
be; Lot|te|rei (ugs.)

Lot|te|rie niederl. (Los-, Glücks-spiel, Verlosung) w; -, ...jen; Lot-te|rie.ein|neh|mer, ...los, ...spiel

lot|te|rig, lott|rig (ugs. für: unor-dentlich); Lot|te|rig|keit (ugs.) w;
-; Lot|ter|le|ben

lot|tern (veralt., aber noch mdal.
für: ein Lotterleben führen); ich
...ere (↑ R 327); Lot|ter|wirt-schaft (abwertend) w; -

Lot|to it. (Zahlenlotterie; Gesell-schaftsspiel) s; -s, -s; Lot|to.ge-winn, ...kol|lek|tur (österr. für:
Geschäftsstelle für das Lotto-spiel), ...mit|tel (Mehrz.),
...schein, ...spiel, ...zah|len
(Mehrz.)

lott|rig vgl. lotterig

Lo|tung

Lö|tung

Lo|tus gr. (Hornklee) m; -, -

lot|wei|se

[1]Lou|is [lụi] (m. Vorn.); [2]Lou|is
(ugs. für: Zuhälter) m; - [lụi(ß)],
- [lụiß]; Lou|is|dor (alte fr. Mün-ze) m; -s, -e; 6 - (↑ R 322);
Lou|is-qua|torze [luikatǫrs] (Stil
zur Zeit Ludwigs XIV.) s; -

Loui|sia|na [luisiạn^e] (Staat der
USA; Abk.: La.)

Lourdes [lụrd] (fr. Wallfahrtsort);
(↑ R 201:) Lourdes.grot|te [lụrd...]
...was|ser (s; -s)

Lou|vre [lụwr^(e)] (Palast in Paris,
Museum) m; -[s]

Lö|we gr. m; -n, -n (↑ R 268); Lö-wen.an|teil (ugs. für: Hauptan-teil), ...bän|di|ger, ...bräu; Lö-wen|herz (m. Eigenn.); Lö-wen.jagd, ...käf|ig, ...mäh|ne,
...maul (eine Gartenblume; s;
-[e]s), ...mut; lö|wen|stark; Lö-wen|zahn (eine Wiesenblume) m;
-[e]s; Lö|win w; -, -nen

loy|al fr. [loajạl] (gesetzlich, regie-rungstreu; rechtlich; anständig,
redlich); Loya|li|tät w; -; Loya|li-täts|er|klä|rung

Lo|yo|la [lǫjo...]; Ignatius von -

lo|zie|ren lat. (veralt. für: an einen
Ort setzen od. stellen, einordnen;
verpachten)

LP = Läuten u. Pfeifen (Eisen-bahnzeichen); Langspielplatte

LPG = Landwirtschaftliche Pro-duktionsgenossenschaft (DDR);
w; jedoch: landwirtschaftlich

LSD = Lysergsäurediäthylamid
(Halluzinogen)

lt. = laut

Lt. = Leutnant

Ltd. = limited

Ltq = türkisches Pfund

Lu = chem. Zeichen für: Lutetium

Lü|beck (Hafenstadt an der unte-ren Trave); Lü|becker[1] (↑ R 199);
die - Bucht; lü|beckern[1] (auf be-sondere Art kegeln); ich ...ere
(↑ R 327); lü|beckisch[1], lü|bisch
(von Lübeck); -e Währung

Lüb|ke (zweiter dt. Bundespräsi-dent)

Lu|cä vgl. Lukas

Lych mdal. (Bruch, Sumpf) w; -,
Lüche od. s; -[e]s, -e

Luchs (ein Raubtier) m; -es, -e;
Luchs|au|ge (auch übertr. ugs.);
luchs|äu|gig; Lüchs|chen, Lüchs-lein; luch|sen (ugs. für: sehr genau
aufpassen); du luchst (luchsest)

Lucht niederl. niederd. (Luft;
oberes Stockwerk, Bodenraum)
w; -, -en

Lu|cia usw. vgl. Luzia usw.; vgl.
Santa Lucia; Lu|ci|an vgl. Lu-kian; Lu|ci|us [...ziụß] (röm. m.
Vorn.; Abk.: L.)

Luck mdal. (Deckel, Verschluß)
w; -, -e

Lück|chen, Lück|lein; Lücke[1] w; -,
-n; Lücken|bü|ßer[1] (ugs. für: Er-satzmann); lücken|haft[1]; Lücken-haf|tig|keit[1] w; -; lücken|los[1]; -este
(↑ R 292); Lücken|lo|sig|keit[1] w;
-; lückig[1] [Bergmannsspr.: groß-porig); -es Gestein

Lu|cre|tia vgl. Lukretia

Lu|cre|ti|us [...ziụß], (eindeut-schend auch:) Lu|krez (altröm.
Dichter)

Lu|cre|zia (it. w. Vorn.); vgl. Lu-kretia

Lu|cul|lus [lukụ...] (röm. Feld-herr); vgl. Lukullus

Lu|de (Gaunerspr.: Zuhälter) m;
-n, -n (↑ R 268)

Lu|der (Jägerspr.: Köder, Aas
[auch als Schimpfwort]) s; -s, -;
Lu|de|rer (veralt.); Lu|der|haft
(veralt.); Lu|der|jan (svw. Lieder-jan); Lu|der|le|ben s; -s; lu|der-mä|ßig mdal. (sehr, verdammt);
lu|dern (veralt.); ich ...ere (↑ R
327)

Lud|ger (m. Vorn.)

Lud|mil|la (w. Vorn.)

Lu|dolf (m. Vorn.); Lu|dolf|sche
Zahl [nach dem niederdt.-nie-derl. Mathematiker Ludolph van
Ceulen (kǫl^en)] (die Zahl π [Pi])
w; -n -

Lu|dol|fin|ger (Angehöriger eines
mittelalterl. dt. Herrscherge-schlechtes)

Lu|do|wi|ka [zu: Ludwig] (w.
Vorn.)

Lu|do|win|ger (Angehöriger eines
thüring. Landgrafengeschlech-tes)

Lud|wig (m. Vorn.); Lud|wi|ga (w.
Vorn.); Lud|wigs|burg (Stadt
nördl. von Stuttgart); Lud|wigs-ha|fen am Rhein (Stadt am Rhein
gegenüber Mannheim)

Lu|es lat. (Syphilis) w; -; lue|tisch,
lu|isch (auf die Lues bezüglich,
von ihr verursacht)

Luf|fa arab. (eine kürbisartige
Pflanze) w; -, -s; Luf|fa|schwamm
(schwammartige Frucht der Luf-fa)

Luft w; -, ^e, Lüfte; Luft.ab|wehr,
...alarm, ...an|griff, ...auf|klä-rung, ...auf|nah|me, ...auf|sicht,
...bad, ...bal|lon, ...bild, ...bla|se,
...brücke [Trenn.: ...brük|ke];
Lüft|chen, Lüft|lein; luft|dicht; -
verschließen; Luft.dich|te,
...druck (m; -[e]s), ...elek|tri|zi-tät; lüf|ten; Lüf|ter; Luft|fahrt;
Luft|fahrt.for|schung, ...in|du-strie, ...me|di|zin; Luft.fahr|zeug,
...fe|de|rung, ...feuch|te, ...feuch-tig|keit, ...til|ter, ...flot|te,
...fracht, ...ge|fahr; luft|ge|kühlt;
-er Motor; luft|ge|schützt; ein -er
Ort; Luft.ge|wehr, ...ha|fen (vgl.
[2]Hafen), ...han|sa (für: Deutsche
Lufthansa AG), ...hei|zung, ...ho-heit (w; -), ...hül|le; luf|tig; Luf|tig-keit w; -; Luf|ti|kus (scherzh. für:
oberflächlicher Mensch) m; -
(auch: -es), -se; Luft.kampf,
...kis|sen; Luft|kis|sen.fahr|zeug,
...zug; Luft.klap|pe (für: Ventil),
...kor|ri|dor, ...krank|heit,
...krieg, ...küh|lung (w; -), ...kur-ort (m; -[e]s, ...orte); Luft|lan|de-trup|pe (Militär: für die Landung
aus der Luft bes. ausgebildete u.
ausgerüstete militär. Einheit);
luft|leer; Lüft|lein, Lüft|chen;
Luft.li|nie, ...loch, ...man|gel m,
...ma|sche, ...ma|trat|ze, ...mi|ne,
...pi|rat, ...po|li|zist, ...post,
...pum|pe, ...raum, ...rei|fen, ...rei-ni|ger, ...röh|re, ...rü|stung,
...schacht, ...schau|kel, ...schicht,
...schiff; Luftschiffahrt [Trenn.:
Luft|schiff|fahrt, ↑ R 236] w; -,
(für: Fahrt mit dem Luftschiff
auch Mehrz.:) -en; Luft.schif|fer,
...schacht, ...schloß, ...schrau|be
(für: Propeller), ...schutz; Luft-schutz.bun|ker, ...kel|ler, ...raum;
Luft|sper|re; Luft|sper|re|gbiet;
Luft.spie|ge|lung od. ...spieg-lung, ...sprung, ...streit|kräf|te
(Mehrz.), ...ta|xi; luft|tüch|tig;
ein -es Flugzeug; Lüf|tung; Lüf-tungs|klap|pe; Luft.ver|än|de-rung, ...ver|kehr; Luft|ver|kehrs-ge|sell|schaft; Luft.ver|schmut-

zung, ...waf|fe, ...wech|sel, ...wi-
der|stand, ...weg (auf dem -[e]),
...wi|der|stands|brem|se, ...wir-
bel, ...wur|zel, ...zu|fuhr (w; -),
...zug
¹Lug (Lüge) m; -[e]s; [mit] - und
Trug
²Lug mdal. (Ausguck) m; -s, -e
Lu|ga|ner (↑ R 199); Lu|ga|ner See
m; - -s; Lu|ga|ne|se (Luganer) m;
-n, -n (↑ R 268); lu|ga|ne|sisch; Lu-
ga|no (Stadt in der Schweiz)
Lug|aus (landsch., auch geh. für:
Wartturm) m; -, -
Lü|ge w; -, -n; jmdn. Lügen strafen
(der Unwahrheit überführen)
lu|gen landsch. (ausschauen, spä-
hen)
lü|gen; du logst; du lögest; gelogen;
lüg[e]!; Lü|gen|be|richt; Lü|gen-
bold (abschätzig) m; -[e]s, -e; Lü-
gen.de|tek|tor (Gerät zur Fest-
stellung unterdrückter affektiver
Regungen), ...dich|tung, ...feld-
zug, ...ge|bäu|de, ...ge|schich|te,
...ge|spinst, ...ge|we|be; lü|gen-
haft; Lü|gen|haf|tig|keit w; -; Lü-
gen|maul (ugs. für: Lügner)
Lug|ger vgl. Logger
Lug|ins|land (veralt. für: Wacht-,
Aussichtsturm) m; -, -
Lüg|ner; Lüg|ne|rin w; -, -nen; lüg-
ne|risch; -ste (↑ R 294)
lu|isch vgl. luetisch
Lu|is|chen (Koseform zu: Luise);
Lui|se (w. Vorn.)
Lu|it|gard (w. Vorn.); Lu|it|ger (m.
Vorn.); Lu|it|pold (m. Vorn.)
Luk s; -[e]s, -e; vgl. Luke
Lu|kar|ne fr. mdal. (Dachfenster,
-luke) w; -, -n
Lu|kas (Evangelist); Evangelium
Lucä [... zä] (des Lukas)
Lu|ke (kleines Dach- od. Keller-
fenster; Öffnung im Deck od. in
der Wand des Schiffes) w; -, -n
Lu|ki|an (gr. Satiriker)
Luk|ma|ni|er m; -s, (auch:) Luk-
ma|ni|er|paß [...iᵉr] (schweiz. Al-
penpaß) m; ...passes
lu|kra|tiv lat. (gewinnbringend)
Lu|kre|tia [...zia] (w. Vorn.); Lu-
krez vgl. Lucretius; Lu|kre|zia
(w. Vorn.)
Luk|sor vgl. Luxor
lu|kul|lisch (üppig, schwelge-
risch); -ste (↑ R 294); -es Mahl;
Lu|kul|lus (Schlemmer [nach Art
des Lucullus]) m; -, -se
Lu|latsch (ugs. für: langer Bengel)
m; -[e]s, -e
lul|len (volkstüml. für: leise sin-
gen); das Kind in den Schlaf -
Lul|ler südd., österr. u. schweiz.
(Schnuller)
Lu|lu (w. Vorn.)
Lum|ba|go lat. (Med.: Schmerzen
in der Lendengegend; Hexen-
schuß) w; -; lum|bal (die Lenden-

[gegend] betreffend); Lum|bal-
an|äs|the|sie
lum|becken [Trenn.: ...bek|ken;
nach dem dt. Erfinder E. Lum-
beck] (Bücher durch das An-
einanderkleben der einzelnen
Blätter binden); gelumbeckt
Lum|ber|jack engl. [lɑmbᵉrdsehäk]
(eine Art Jacke) m; -s, -s
Lu|men lat. („Licht"; Physik: Ein-
heit des Lichtstromes [Zeichen:
lm]; Biol.: Hohlraum in Zellen
od. Organen von Pflanzen u. Tie-
ren; Med.: der hohle Raum eines
röhrenförmigen Körperorgans)
s; -s, - u. ...mina; Lu|mi|nal ⓦ
(ein Schlafmittel) s; -s; Lu|mi|nes-
zenz (jede Lichterscheinung, die
nicht durch erhöhte Temperatur
bewirkt ist) w; -, -en; lu|mi|nes-
zie|ren; lu|mi|nös fr. (selten für:
lichtvoll, leuchtend); -este (↑ R
292)
Lum|me nord. (ein arktischer See-
vogel) w; -, -n
Lum|mel südd. (Lendenfleisch,
-braten) m; -s, -
Lüm|mel m; -s, -; Lüm|me|lei; lüm-
mel|haft; Lüm|mel|haf|tig|keit;
lüm|meln, sich (ugs.); ich ...[e]le
mich (↑ R 327)
lum|me|rig südd. (schlaff, lappig;
ohne Steife, Appretur [bei Stof-
fen usw.])
Lump (schlechter Mensch; ver-
ächtl. für: Kerl) m; -en, -en (↑ R
268); Lum|pa|zi|us (scherzh. ugs.
für: Lump) m; -, -se; Lum|pa|zi-
va|ga|bun|dus [...wa...] (Land-
streicher) m; -, -se u. ...di; lum|pen
(veralt., aber noch mdal. für: lie-
derlich leben); sich nicht - lassen
(ugs. für: freigebig sein; Geld aus-
geben); Lum|pen (Lappen) m; -s,
-; Lum|pen.ge|sin|del, ...händ|ler,
...kerl, ...pack s, ...sack, ...samm-
ler (auch übertr. scherzh. für:
letzte Fahrgelegenheit mit der
[Straßen]bahn bei Nacht); Lum-
pen|zucker [Trenn.: ...zuk|ker]
vgl. Lompenzucker; Lum|pe|rei;
lum|pig; Lum|pig|keit
Lu|na lat. (röm. Mondgöttin; ver-
alt. dicht. für: Mond; Name so-
wjetrussischer unbemannter
Mondsonden) lu|nar (den Mond
betreffend, Mond...); lu|na|risch
(älter für: lunar); Lu|na|ri|um
(Gerät zur Veranschaulichung
der Mondbewegung) s; -s, ...ien
[...iᵉn]; Lu|na|ti|ker (Med.:
Mondsüchtiger); lu|na|tisch; Lu-
na|tis|mus (Med.: Mondsüchtig-
keit) m; -
Lunch engl. [lɑn(t)sch] (engl. Be-
zeichnung für das um Mittag ein-
genommene Gabelfrühstück) m;
-[es] od. -s, -e[s] od. -s; lunchen
[lɑn(t)schᵉn]; Lunch|zeit

¹Lund (ein Vogel) m; -[e]s, -e
²Lund (Stadt in Schweden)
Lü|ne|burg (Stadt am Nordrand
der Lüneburger Heide); Lü|ne-
bur|ger Hei|de; ↑ R 199 (Teil des
Norddeutschen Tieflandes) w; - -
Lü|net|te fr. (Technik: Setzstock
bei der Metallverarbeitung; Ar-
chitektur: Bogenfeld, Stichkap-
pe; früher: Bauweise der Feld-
schanzen) w; -, -n
Lun|ge w; -, -n; eiserne -; Lun-
gen.bläs|chen, ...blu|tung, ...bra-
ten (österr.: Lendenbraten),
...ent|zün|dung, ...flü|gel, ...für-
sor|ge, ...ha|schee, ...heil|stät|te;
lun|gen|krank; Lun|gen|krebs;
lun|gen|lei|dend; Lun|gen.ödem,
...schwind|sucht; Lun|gen-Tbc
(↑ R 150); Lun|gen.tu|ber|ku|lo-
se, ...tu|mor, ...zug
Lun|ge|rer (veralt.); lun|gern
(ugs.); ich ...ere (↑ R 327)
Lu|nik lat.-russ. (Name unbe-
mannter sowjetrussischer Mond-
sonden) m; -s, -s
Lü|ning niederd. (Sperling) m; -s,
-e
Lun|ker (fehlerhafter Hohlraum
in Gußstücken) m; -s, -
Lu|no|naut lat.; gr. (Mondflieger)
m; -en, -en (↑ R 268)
Lün|se (Achsnagel) w; -, -n
Lünt mdal. (Schweinenierenfett)
w; -
Lun|te (Zündmittel; Jägerspr.:
Schwanz des Fuchses) w; -, -n;
- riechen (ugs. für: Gefahr wit-
tern); Lun|ten|schnur [Mehrz.
...schnüre]
Lun|ze (veralt. Jägerspr.: Einge-
weide des Wildes) w; -, -n
Lu|pe fr. (Vergrößerungsglas) w;
-, -n; lu|pen|rein (von Edelsteinen:
sehr rein; ganz ohne Mängel
übertr. für: einwandfrei, hun-
dertprozentig)
Lu|per|ka|li|en [...iᵉn] (altröm.
„Wolfsfest") Mehrz.
Lupf südd. u. schweiz. (svw. Ho-
senlupf) m; -[e]s, -e; lup|fen, lüp-
fen südd. u. schweiz. u. österr.
mdal. (in die Höhe heben)
Lu|pi|ne lat. (eine Futter-, Zier-
pflanze) w; -, -n; Lu|pi|nen.feld
...krank|heit (w; -s); Lu|pi|no|se
(Leberentzündung bei Wieder-
käuern) w; -
Lup|pe (Technik: Eisenklumpen
w; -, -n; lup|pen (Technik: gerin-
nen lassen)
Lu|pu|lin lat. (Bitterstoff der Hop
fenpflanze) s; -s
Lu|pus lat. (Med.: tuberkulös
Hautflechte) m; -, - u. -se; Lu|pu
in fa|bu|la („der Wolf in de
Fabel"; d. h. jemand, der komm
wenn man gerade von ihr
spricht) m; - - -

¹**Lurch** (Amphibie) *m;* -[e]s, -e

²**Lurch** *österr. ugs.* (zusammengerollter, mit Spinnengewebe durchsetzter Staub) *m;* -[e]s; den - wegkehren

Lu|re *nord.* (altes nord. Blasinstrument) *w;* -, -n

Lu|sche *mdal.* (Spielkarte [von geringem Wert]; Pfütze) *w;* -, -n

lu|sen vgl. ¹losen; **Lu|ser** vgl. Loser

Lu|si|a|de (Abkömmling des Lususs, des sagenhaften Stammvaters der Portugiesen) *m;* -n, -n (↑ R 268); **Lu|si|ta|ner,** (auch:) **Lu|si|ta|ni|er** (Angehöriger eines iber. Volksstammes) *m;* -s, -; **Lu|si|ta|ni|en** [...$i^e n$] (röm. Provinz auf der Iber. Halbinsel); **Lu|si|ta|ni|er** vgl. Lusitaner; **lu|si|ta|nisch**

Lust *w;* -, Lüste; - haben; **Lust|bar|keit** (veraltend); **Lust|bar|keits|steu|er** (veralt. für: Vergnügungssteuer) *w;* **lust|be|tont; Lüst|chen, Lüst|lein; lü|sten** (veralt.); es lüstet mich

Lu|ster *fr. österr.* (Kronleuchter) *m;* -s, -; **Lü|ster** (Kronleuchter; Glanzüberzug auf Glas-, Ton-, Porzellanwaren; glänzendes Gewebe) *m;* -s, -; **Lü|ster.far|be,** ...glas (Mehrz. ...gläser), ...weibchen (weibl. Figur als Kronleuchter)

lü|stern; er hat -e Augen; der Mann ist -; **Lü|stern|heit**

Lust.gar|ten (hist.), ...ge|fühl, ...ge|winn, ...greis; **lu|stig;** vgl. Bruder Lustig; **Lu|stig|keit** *w;* -; **Lüst|lein; Lüst|chen; Lüst|ling; lust|los; Lust|lo|sig|keit; Lust.mord,** ...mör|der

Lu|stra, Lu|stren (Mehrz. von: Lustrum); **Lu|stra|ti|on** *lat.* [...zion] (feierliche Reinigung [durch Sühneopfer]; veralt. für: Prüfung); **lu|strie|ren** (feierlich reinigen; veralt. für: prüfen); **lü|strie|ren** *lat.* ([Baumwoll- u. Leinengarne] fest u. glänzend machen); **Lu|strum** *lat.* (altröm. Sühneopfer; Zeitraum von fünf Jahren) *s;* -s, ...ren u. ...ra

Lust.schloß, ...spiel; **Lust|spieldich|ter; lust|voll; lust|wan|deln;** ich ...[e]le (↑ R 327); er ist gelustwandelt; zu -

Lu|sus vgl. Lusiade

Lu|te|in *lat.* (gelber Farbstoff in Pflanzenblättern u. im Eidotter) *s;* -s

Lu|te|tia [...zia] (w. Eigenn.; lat. Name von Paris); **Lu|te|ti|um** (chem. Grundstoff; Zeichen: Lu) *s;* -s

Lu|ther (dt. Reformator); **Lu|theraka|de|mie** *w;* -; **Lu|the|ra|ner; luther|feind|lich** (↑ R 187); **lu|therisch** [veralt. od. zur Kennzeichnung einer stark orthodoxen Auffassung noch: luterisch]; - Kirche, aber (↑ R 179): **Lu|therisch, Lu|thersch;** die -e Bibelübersetzung; **Lu|ther|tum** *s;* -s

Lütsch|beu|tel; lut|schen (ugs.); du lutschst (lutschest); **Lut|scher lütt** nordd. ugs. (klein)

Lut|te (Bergmannsspr.: Röhre zur Lenkung des Wetterstromes) *w;* -, -n

Lut|ter (noch unreines Spiritusdestillat) *m;* -s, -

Lut|ter am Ba|ren|ber|ge (Ort nordwestl. von Goslar)

Lüt|tich (Stadt in Belgien)

¹**Lutz** (Kurzform von: Ludwig)

²**Lutz** [nach dem österr. Eiskunstläufer A. Lutz] (Drehsprung beim Eiskunstlauf) *m;* -, -

Lüt|zel|burg (ehem. dt. Name von: Luxemburg)

Lüt|zow [...zo] (Familienn.); -scher Jäger

Luv [luf] (Seemannsspr.: die dem Wind zugekehrte Seite; Ggs.: Lee) *w;* -; **lu|ven** [$luf^e n$] (Seemannsspr.: das Schiff mehr an den Wind bringen); **Luv|sei|te; luv|wärts** (Seemannsspr.: dem Winde zugekehrt)

Lux *lat.* (Einheit der Beleuchtungsstärke; Zeichen: lx) *s;* -, -

Lu|xa|ti|on *lat.* [...zion] (Med.: Verrenkung)

¹**Lu|xem|burg** (belg. Provinz); ²**Lu|xem|burg** (Großherzogtum); ³**Lu|xem|burg** (Hptst. von ²Luxemburg); **Lu|xem|bur|ger** (↑ R 199); **lu|xem|bur|gisch**

lu|xie|ren *lat.* (Med.: verrenken, aus der Lage bringen)

Lux|me|ter *lat.; gr.* (Gerät zum Messen der Beleuchtungsstärke) *s;* -s, -

Lu|xor, Luk|sor (ägypt. Stadt)

lu|xu|rie|ren *lat.* (Bot.: üppig wachsen [von Pflanzenbastarden]; veralt. für: schwelgen); **lu|xu|ri|ös,** -este (↑ R 292); **Lu|xus** (Verschwendung, Prunksucht) *m;* -; **Lu|xus.ar|ti|kel,** ...aus|ga|be, ...damp|fer, ...ge|gen|stand, ...gü|ter (Mehrz.), ...ho|tel, ...jacht, ...li|mou|si|ne, ...steu|er *w,* ...vil|la, ...wa|gen, ...woh|nung

Lu|zern (Kanton u. Stadt in der Schweiz)

Lu|zer|ne *fr.* (eine Futterpflanze) *w;* -, -n; **Lu|zer|nen|heu**

Lu|zer|ner (↑ R 199); **lu|zer|nisch**

Lu|zia, Lu|zie [...i^e] (w. Vorn.)

Lu|zi|an vgl. Lukian

lu|zid *lat.* (selten für: hell; durchsichtig); **Lu|zi|di|tät** (Psych.: Hellsehen; selten für: Helle, Durchsichtigkeit) *w;* -

Lu|zie vgl. Luzia

Lu|zi|fer *lat.* („Lichtbringer"; Morgenstern; Name des Satans) *m;* -s; **Lu|zi|fe|rin** (Leuchtstoff vieler Tiere u. Pflanzen) *s;* -s; **lu|zi|fe|risch** (teuflisch)

Lu|zi|us vgl. Lucius

LVA = Landesversicherungsanstalt

Lw = Lawrencium; Lew

lx = Lux

Lyd|dit (ein Sprengstoff) *s;* -s

Ly|der, Ly|di|er [...$i^e r$] (Einwohner Lydiens); **Ly|dia** (w. Vorn.); **Lydi|en** [...$i^e n$] (früher: Landschaft in Kleinasien); **ly|disch**

Ly|ki|en [...$i^e n$] (früher: Landschaft in Kleinasien); **Ly|ki|er** [...$i^e r$]; **ly|kisch**

Ly|ko|po|di|um *gr.* (Bärlapp) *s;* -s, ...ien [...i^n]

Lyk|ore|xie *gr.* (Med.: Wolfshunger, Heißhunger) *w;* -

Ly|kurg (Gesetzgeber Spartas; athen. Redner); **ly|kur|gisch,** aber (↑ R 179): **Ly|kur|gisch**

lym|pha|tisch *gr.* (auf Lymphe, Lymphknötchen, -drüsen bezüglich, sie betreffend); **Lymph.bahn,** ...drü|se (fälschlich für: Lymphknoten); **Lym|phe** (weißliche Flüssigkeit in Gewebe u. Blut; Impfstoff) *w;* -, -n; **Lymph.ge|fäß,** ...knoten; **lympho|gen** (lymphatischen Ursprungs); **lym|pho|id** (lymphartig); **Lym|pho|zyt** (bes. Form der weißen Blutkörperchen) *m;* -en, -en (meist Mehrz.); ↑ R 268; **lympho|zy|to|se** (krankhafte Vermehrung der Lymphozyten im Blut) *w;* -

lyn|chen [$lünch^e n$, auch: $linch^e n$, $lintsch^e n$; wahrscheinlich nach dem amerik. Friedensrichter Charles Lynch] (ungesetzliche Volksjustiz ausüben); er wurde gelyncht; **Lynch.ju|stiz,** ...mord

Ly|on [liong] (Stadt in Frankreich); ¹**Lyo|ner** [$lion^r$] (Bewohner von Lyon) ↑ R 199; ²**Lyo|ner** (Kurzform von: Lyoner Wurst) *w;* -; **Lyo|ner Wurst; Lyo|ne|ser** vgl. Lyoner; **lyo|ne|sisch** (veralt. für: Lyoner)

Ly|ra *gr.* (ein altgr. Saiteninstrument; Leier) *w;* -, ...ren; **Ly|rik** ([liedmäßige] Dichtung) *w;* -; **Ly|ri|ker** (lyrischer Dichter); **Ly|ri|ke|rin** *w;* -, -nen; **ly|risch** (der persönlichen Stimmung u. dem Erleben unmittelbaren Ausdruck gebend; gefühl-, stimmungsvoll; liedartig); -ste (↑ R 294); -es Drama

Ly|san|der (spartan. Feldherr u. Staatsmann)

Ly|si|ne *gr.* (Med.: bakterienauflösende Antikörper) *Mehrz.;* **Ly|sis** (Med.: langsamer Fieberabfall; Psych.: Persönlichkeitszerfall) *w;* -, Lysen

Ly|si|stra|ta (Titelheldin einer Komödie von Aristophanes)
Ly|sol Ⓦ (ein Desinfektionsmittel) s; -s
Lys|sa gr. (Med.: Tollwut, Raserei) w; -
Ly|ze|al|schü|le|rin gr.; dt.; Ly|ze|um gr. (höhere Lehranstalt für Mädchen) s; -s, ...een
Ly|zi|en usw. vgl. Lykien usw.
LZB = Landeszentralbank

M

M (Buchstabe); das M; des M, die M, aber: das m in Wimpel (↑ R 123); der Buchstabe M, m
m = Meter; Milli...; m (Astron.: ...ᵐ), min, Min. = Minute
μ = Mikro...; Mikron
M (römisches Zahlzeichen) = 1000
M = Mark; Modell (bei Schußwaffen); Mega..., Mille
M, μ = My
M. = Markus; Monsieur
M' = Manius
M², Mc = Mac
m², qm = Quadratmeter
m³, cbm = Kubikmeter
ma. = mittelalterlich
Ma = Mach-Zahl
Ma = Masurium (veralt.)
mA = Milliampere
MA. = Mittelalter
M. A. = Magister Artium; Master of Arts
¹Mä|an|der (alter Name eines Flusses in Kleinasien) m; -[s];
²Mä|an|der (starke Flußwindung; Zierband) m; -s, -; Mä|an|der|li|nie; mä|an|dern, mä|an|drie|ren (sich in Mäanderform bewegen); mä|an|drisch
Maar (kraterförmige Senke) s; -[e]s, -e
Maas (ein Fluß) w; -; Maas|tricht (niederl. Stadt an der Maas)
Maat (mdal. für: Genosse; Seemannsspr.: Schiffsmann; Unteroffizier auf Schiffen) m; -[e]s, -e u. -en; Maat|je (kleiner Maat) m; -n, -n (↑ R 268); Maat|schaft
Mac [mäk] („Sohn"; Bestandteil von schottischen [auch irischen] Namen [z. B. MacAdam]; Abk.: M', Mc)
Ma|cau[makau] (port. Kolonie an der südchines. Küste)
Mac|beth [mäkbäth] (König von Schottland; Titelheld eines Dramas von Shakespeare)
Mac|chia it. [makia], Mac|chie [mäkí˙] (charakteristischer immergrüner Buschwald des Mittelmeergebietes) w; -. Macchien

Mach (Kurzform für: Mach-Zahl)
Ma|chan|del niederd. (Wacholder) m; -s, -; Ma|chan|del|baum (niederd.)
Mach|art; mach|bar; Mach|barkeit w; -; Ma|che (ugs. für: Schein, Vortäuschung) w; -
Ma|che-Ein|heit; ↑ R 180 [nach dem österr. Physiker Mache] (Maßeinheit für radioaktive Strahlung; Zeichen ME)
ma|chen; er hat es gemacht; (↑ R 305:) du hast mich lachen gemacht (selten: machen); Ma|chen|schaft w; -, -en (meist Mehrz.); Ma|cher (ugs. für: Person, die etwas [bedenkenlos] zustande bringt); ...ma|cher (z. B. Schuhmacher); Ma|cher|lohn
Ma|che|te span. (Buschmesser) w; -, -n
Ma|chia|vel|li [makiawäli] (it. Politiker, Schriftsteller u. Geschichtsschreiber); Ma|chia|vel|lis|mus (polit. Lehre Machiavellis; auch für: durch keine Bedenken gehemmte Machtpolitik) m; -; ma|chia|vel|li|stisch
Ma|chi|na|ti|on lat. [maehinaziọn] (listiger Anschlag, Umtrieb, Kniff) w; -, (für: Machenschaft, Winkelzug auch Mehrz.:) -en
Ma|chor|ka russ. [maeh...] (russ. Tabak) m; -s, -s
Macht w; -, Mächte; alles in unserer Macht Stehende; Macht an|spruch, ...be|fug|nis, ...be|reich, ...block (Mehrz. ...blöcke, seltener: ...blocks); Mächte|grup|pie|rung; Macht ent|fal|tung, ...fra|ge, ...fül|le; Macht|ha|ber; macht|ha|be|risch; Macht|hun|ger; mäch|tig; Mäch|tig|keit w; -; Macht|kampf; macht|los; -este (↑ R 292); Macht|lo|sig|keit w; -; Macht mit|tel s, ...po|si|ti|on, ...pro|be, ...spruch, ...stel|lung, ...stre|ben, macht|voll; Macht-voll|kom|men|heit, ...wil|le, ...wort (Mehrz. ...worte)
ma|chul|le jidd. [maehụlˀ] (ugs. u. mdal. für: bankrott; mdal. für: ermüdet; verrückt)
Mach|werk (schlechte Leistung; Wertloses)
Mach-Zahl; ↑ R 180 [nach dem österr. Physiker u. Philosophen E. Mach] (Verhältnis der Strömungsgeschwindigkeit eines kompressiblen Mediums [bzw. der Geschwindigkeit eines Körpers in ihm] zur Schallgeschwindigkeit; Mach 1 = Schallgeschwindigkeit, Mach 2 = doppelte Schallgeschwindigkeit)
Macke jidd. [Trenn.: Mak|ke] (ugs. für: Tick; Fehler) w; -, -n
Macker [Trenn.: Mak|ker] (ugs.

für: Kamerad, Freund, Kumpel); mack|lich niederd. (langsam, ruhig, bequem, behaglich)
MAD: Militärischer Abschirmdienst
Ma|da|gas|kar (Insel u. Staat östl. von Afrika); Ma|da|gas|se (Bewohner von Madagaskar) m; -n, -n (↑ R 268); ma|da|gas|sisch
Ma|dam fr. (ugs. für: Hausherrin; die Gnädige; scherzh. für [dickliche, behäbige] Frau) w; -, -s u. -en; Ma|dame [...dạm] (fr. Anrede für eine Frau; als Anrede ohne Geschlechtswort; Abk.: Mme. [schweiz. ohne Punkt]); Mehrz.: Mesdames [mädạm] (Abk.: Mmes. [schweiz. ohne Punkt]); Ma|dạm|chen (ugs. scherzh.)
Ma|da|po|lam [nach der ostind. Stadt] (ein Baumwollgewebe) m; -[s], -s
Mäd|chen; Mäd|chen.au|ge (auch für eine Blume), ...bil|dung, ...er|zie|hung; mäd|chen|haft; Mäd|chen|haf|tig|keit w; -; Mäd|chen.han|del, ...händ|ler, ...herz, ...klas|se, ...na|me, ...schu|le, ...zim|mer
Ma|de (Insektenlarve) w; -, -n
made in Ger|ma|ny engl. [me̱'d in dsehọ̈'m'ni] („hergestellt in Deutschland"; früherer Warenstempel)
¹Ma|dei|ra [...deɽa], Ma|de|ɽa (Insel im Atlantischen Ozean); ²Ma|dei|ra [...deɽa], Ma|de|ɽa (auf Madeira gewachsener Süßwein) m; -s, -s; Ma|dei|ra|wein [...de̱-ɽa...]
Mä|del s; -s, - (ugs. u. landsch.: -s u. -n; ↑ R 271)
Made|leine [madlän] (fr. w. Vorn.)
Made|moi|selle fr. [madmoasä̱l] (fr. Bez. für: Fräulein; als Anrede ohne Geschlechtswort; Abk.: Mlle. [schweiz. ohne Punkt]); Mehrz.: Mesdemoiselles [mädmoasä̱l] (Abk.: Mlles. [schweiz. ohne Punkt])
Ma|den|wurm
Ma|de|ɽa usw. vgl. Madeira usw.
ma|dig; jmdn. - machen (ugs. für: in schlechten Ruf bringen); jmdm. etwas - machen (ugs. für: verleiden)
Ma|di|ar [ung. Schreibung: Magyar usw.] (Ungar) m; -en, -en (↑ R 268); Ma|di|a|ren|reich s; -[e]s; ma|di|a|risch; ma|di|a|ri|sie|ren (ungarisch machen); Ma|di|a|ri|sie|rung w; -
Ma|don|na it. („meine Herrin"; Maria, die Gottesmutter [nur Einz.]; Mariendarstellung mit Jesuskind]) w; -, ...nnen; Ma|don|nen.bild, ...ge|sicht; ma|don|nen|haft
Ma|dras (Stadt u. Bundesstaat in

Vorderindien); Ma|dras|ge|we|be

Ma|dre|po|re fr. (Zool.: Löcherkoralle) w; -, -n (meist Mehrz.); Ma|dre|po|ren|kalk (Korallenkalk der Juraformation)

Ma|drid (Hptst. Spaniens); Ma|dri|der (↑ R 199)

Ma|dri|gal it. ([Hirten]lied; mehrstimmiges Gesangstück) s; -s, -e; Ma|dri|gal|chor; Ma|dri|gal|stil mae|sto|so it. [maäß...] (Musik: feierlich, würdevoll, erhabenwuchtig); Mae|sto|so s; -s, -s u. ...si

Mae|stra|le it. [maäß...] (Mistral) m; -s

Mae|stro it. [maäß...] („Meister") m; -s, -s (auch: ...stri)

Mae|ter|linck [mgt°r...] (belg. Schriftsteller)

Mä|eu|tik gr. (Ausfragekunst des Sokrates) w; -; mä|eu|tisch

Ma|fia, (auch:) Maf|fia it. (Geheimbund [in Sizilien]) w; -, -s; Ma|fio|so (Mitglied der Mafia) m; -[s], ...si

Mag. = Magister

Ma|ga|lhāes [magalją'ngsch] (port. Seefahrer); Ma|ga|lhāes-stra|ße, ↑ R 210 (Meeresstraße zwischen dem Südende des südamerik. Festlandes u. Feuerland) w; -; vgl. auch: Magellanstraße

Ma|ga|zin arab.-it. (-fr. u. engl.) s; -s, -e; Ma|ga|zi|neur fr. [...nǫr] österr. (Magazinverwalter) m; -s, -e; ma|ga|zi|nie|ren (einspeichern; lagern; gedrängt zusammenstellen)

Magd w; -, Mägde

Mag|da (Kurzform von: Magdalena); Mag|da|la (Dorf am See Genezareth); Mag|da|le|na, Mag|da|le|ne (w. Vorn.); Mag|da|le|nen|stift s; ...strom (in Kolumbien; m; -[e]s); Mag|da|lé|ni|en fr. [...leniäng] (Stufe der älteren Steinzeit) s; -[s]

Mag|de|burg (Stadt an der mittleren Elbe); Mag|de|bur|ger (↑ R 199); Mag|de|bur|ger Bör|de (Gebiet westl. der Elbe); mag|de|bur|gisch

Mägd|lein, Mägd|lein; Mäg|de|stu|be; Magd|lohn; Magd|tum (veralt. für: Jungfräulichkeit; s; -s)

Ma|ge (veralt. für: Verwandter) m; -n, -n (↑ R 268)

Ma|gel|lan|stra|ße [Ausspr. auch: mag°ljan... u. mag°ljan...]; ↑ R 210 (eindeutschende Schreibung für: Magalhāesstraße) w; -

Ma|ge|lo|ne (neapolitan. Königstochter; Gestalt des fr. u. dt. Volksbuches)

Ma|gen m; -s, Mägen (auch: -);

Ma|gen_aus|gang, ...aus|he|be|rung (vgl. aushebern), ...be|schwer|den, ...bit|ter (ein Branntwein; m; -s, -); Ma|gen-Darm-Ka|tarrh (↑ R 155) m; -s, -e; Ma|gen_drücken [Trenn.: ...drük|ken] (s; -s), ...fahr|plan (ugs.: für eine bestimmte Zeit aufgestellte Speisekarte mit feststehenden Gerichten), ...fi|stel, ...ge|gend (w; -), ...ge|schwur, ...gru|be, ...ka|tarrh, ...krampf; ma|gen|krank; Ma|gen_krebs, ...lei|den; ma|gen|lei|dend, aber (↑ R 142): am Magen leidend; Ma|gen_ope|ra|ti|on, ...saft, ...säu|re, ...schleim|haut|ent|zün|dung, ...schmerz (meist Mehrz.), ...ver|stim|mung

ma|ger; -er, -ste; Ma|ger|keit w; -; Ma|ger_koh|le, ...milch; ma|gern (dafür üblicher: abmagern); ich ...ere (↑ R 327); Ma|ger_quark, ...sucht (w; -)

Mag|gi [schweiz.: madsche i] (Familienn.; ⓦ); Mag|gi|wür|ze (↑ R 180)

Ma|ghreb arab. („Westen"; der Westteil der arab.-mohammedan. Welt: Tunesien, Nordalgerien, Marokko) m; -; ma|ghre|bi|nisch

Ma|gie pers. (Zauber-, Geheimkunst) w; -; Ma|gi|er [...i°r] (Zauberer); ma|gisch; -ste (↑ R 294); vgl. Laterna magica; -es Auge; -es Quadrat

Ma|gi|ster lat. („Meister"; akadem. Grad; veralt für: Lehrer; Abk. [bei Titeln]: Mag.; österr. oft für: Mag. pharm.) m; -s, -; Magister Artium (akadem. Grad; Abk.: M. A.); - der Philosophie (österr.; Abk.: Mag. phil.); - der Naturwissenschaften (österr.; Abk.: Mag. rer. nat.); - der Theologie (österr.; Abk.: Mag. theol.)

Ma|gi|stra|le (fachspr. für: Hauptverkehrsstraße; Hauptverkehrslinie [Bahn]) w; -, -n; ¹Ma|gi|strat (Stadtverwaltung, -behörde) m; -[e]s, -e; ²Ma|gi|strat schweiz. (hohe Amtsperson) m; -en (↑ R 268); Ma|gi|strats|be|schluß

Mag|ma gr. (Geol.: Gesteinsschmelzfluß des Erdinnern; Med.: knetbare Masse) s; -s, ...men; mag|ma|tisch

Ma|gna Charta lat. [- kgr...] (Englands „Große Freiheitsurkunde" vom Jahre 1215; auch Titel: Grundgesetz, Verfassung) w; - -

Ma|gna|li|um (Legierung aus Magnesium u. Aluminium) s; -s

Ma|gnat lat. (früher für: hoher [meist ung.] Adliger; allgemein für: Grundbesitzer; Großindustrieller) m; -en, -en (↑ R 268)

¹Ma|gne|sia (Landschaft Thessa-

liens; heute Magnisia); ²Ma|gne|sia (Magnesiumoxyd) w; -; Ma|gne|sit (ein Mineral) m; -s, -e; Ma|gne|si|um (chem. Grundstoff, Metall; Zeichen: Mg) s; -s; Ma|gne|si|um_le|gie|rung, ...ver|bin|dung

Ma|gnet gr.; m; -[e]s u. -en, -e[n] (↑ R 268); Ma|gnet_band (s; Mehrz. ...bänder), ...band|ge|rät, ...berg, ...oi|sen|stein, feld; ma|gne|tisch; -e Feldstärke; -er Pol; -er Sturm; Ma|gne|ti|seur [...sör] vgl. Magnetopath; ma|gne|ti|sie|ren (magnetisch machen; Med.: durch magnetische Kraft behandeln); Ma|gne|ti|sie|rung; Ma|gne|tis|mus (Gesamtheit der magnetischen Erscheinungen; Heilverfahren) m; -; Ma|gne|tit (Magneteisenstein) m; -s, -e; Ma|gnet|na|del; Ma|gne|to|me|ter s; -s, - (Physik: Einheit des magnetischen Moments) s; -s, -[s]; 2 - (↑ R 322); Ma|gne|to|path m; -en, -en (↑ R 268) u. Ma|gne|ti|seur fr. [...sör] (mit magnetischen Kräften behandelnder Heilkundiger) m; -s, -e; Ma|gne|to|phon ⓦ (ein Tonbandgerät) s; -s, -e; Ma|gne|to|sphä|re (höchster Teil der Atmosphäre) w; -; Ma|gne|tron [auch: ...trǫn] (Elektronenröhre, die magnetische Energie verwendet [für hohe Impulsleistungen]) s; -s, ...one (auch: -s); Ma|gnet|ton|ge|rät

ma|gni|fik fr. [manji...] (veralt. für: herrlich, prächtig, großartig); Ma|gni|fi|kat lat. [mag...] (Lobgesang Marias) s; -[s]; Ma|gni|fi|kus (veralt. für: Rektor einer Hochschule) m; -, ...fizi; vgl. Rector magnificus; Ma|gni|fi|zen|tis|si|mus m; -, ...mi; vgl. Rector magnificentissimus; Ma|gni|fi|zenz (Titel für Hochschulrektoren u. a.) w; -, -en; als Anrede: Euer, Eure (Abk.: Ew.) -

Ma|gni|sia vgl. Magnesia

Ma|gno|lie [...i°; nach dem fr. Mediziner u. Botaniker Magnol] (ein Zierbaum) w; -, -n

Ma|gnus (m. Vorn.)

Ma|gog (Reich des Gog); vgl. Gog

Mag. pharm. = Magister pharmaciae (österr. akadem. Titel)

Mag. phil. = Magister philosophiae (österr. akadem. Titel)

Mag. rer. nat. = Magister rerum naturalium (österr. akadem. Titel)

Mag. theol. = Magister theologiae (österr. akadem. Titel)

Ma|gyar [madjar] usw. vgl. Madjar usw.

mäh!; mäh, mäh!; mäh schreien

Ma|ha|go|ni indian. (ein Edelholz) s; -s; Ma|ha|go|ni_holz, ...mö|bel

Ma|ha|ra|dscha *sanskr.* (ind. Großfürst) *m;* -s, -s; Ma|ha|ra|ni (Frau eines Maharadschas, ind. Fürstin) *w;* -, -s

Ma|hat|ma *sanskr.* („große Seele"; ind. Ehrentitel für geistig hochstehende Männer) *m;* -s, -s; - Gandhi

Mäh|bin|der; ¹Mahd mdal. (das Mähen; das Abgemähte; meist Gras) *w;* -, -en; ²Mahd schweiz. u. österr. (Bergwiese) *s;* -[e]s, Mähder; Mäh|der landsch. (Mäher)

Mah|di [*mɐehdi*] (von den Mohammedanern erwarteter Welt-, Glaubenserneuerer) *m;* -[s], -s ...mäh|dig (z. B. einmähdig); Mäh|dre|scher; ¹mä|hen ([Gras] schneiden)

²mä|hen (ugs. für: mäh schreien)

Mä|her

Mahl (Gastmahl) *s;* -[e]s, -e (älter: Mähler)

mah|len (Korn u. a.); gemahlen

Mah|ler, Gustav (österr. Komponist u. Dirigent)

Mahl_gang *m,* ...geld, ...gut

mäh|lich (veralt. für: allmählich)

Mahl|jah|re (veralt. für: Jahre der Verwaltung eines Bauerngutes für einen Minderjährigen) *Mehrz.*

Mahl_knecht (veralt.), ...sand

Mahl|schatz (veralt. für: Brautgabe); Mahl_statt od. ...stät|te (Gerichts- u. Versammlungsstätte der alten Germanen)

Mahl_stein, ...steu|er (frühere Steuer; *w*), ...strom (Strudel), ...werk, ...zahn (für: Molar)

Mahl|zeit; gesegnete Mahlzeit!

Mäh|ma|schi|ne

Mahn|brief

Mäh|ne *w;* -, -n

mah|nen

mäh|nen|ar|tig

Mah|ner

mäh|nig [zu: Mähne]

Mahn_mal (*Mehrz.* ...male, selten: ...mäler), ...ruf, ...schrei|ben; Mah|nung; Mahn_ver|fah|ren, ...wort (*Mehrz.* ...worte), ...zei|chen, ...zet|tel

Ma|ho|nie [...*iᵉ*; nach dem amerik. Gärtner B. MacMahon] (ein Zierstrauch) *w;* -, -n

Mahr (quälendes Nachtgespenst, Alp *m*) *m;* -[e]s, -e

¹Mäh|re ([elendes] Pferd) *w;* -, -n

²Mäh|re *m;* -n, -n († R 268); Mäh|ren (hist. Gebiet in der mittleren Tschechoslowakei); Mäh|rer (sww. ²Mähre); Mäh|re|rin, Mäh|rin *w;* -, -nen; mäh|risch, aber († R 198): die Mährische Pforte

Mähr|te vgl. Märte

Mai *lat.* (der fünfte Monat des Jahres, Wonnemond, Weidemo-

nat) *m;* -[e]s u. - († R 319; dicht. gelegentl. noch: -en), -e;(† R 224:) der Erste Mai (Feiertag); Maia vgl. ²Maja; Mai|an|dacht (kath.); Mai|baum¹; Mai|blu|me¹; Mai|blu|men|strauß; Mai|bow|le

Maid (veralt. dicht., heute noch spött. für: Mädchen) *w;* -, -en

Maie (junge Birke; Birkengrün; Laubschmuck; geschmückter Maibaum) *w;* -, -n; Mai|de|mon|stra|ti|on; mai|en (dicht.); es grünt und mait; Mai|en schweiz. mdal. (Blumenstrauß) *m;* -s, -; mai|en|haft; Mai|en|säß schweiz. (Frühlingsbergweide) *s;* -es, -e; Mai_fei|er, ...glöck|chen (eine Blume), ...kä|fer; Mai_kö|ni|gin¹, ...kund|ge|bung

Mai|land (it. Stadt); vgl. Milano; Mai|län|der († R 199); Mailänder Scala; mai|län|disch

mai|lich; Mai|luft¹; Mai|lüf|terl (mdal.) *s;* -s, -

Main (r. Nebenfluß des Rheins) *m;* -[e]s

Mai|nacht¹

Main|au (Insel im Bodensee) *w;* -

Main-Do|nau-Ka|nal († R 203) *m;* -s

Maine [*meⁱn*] (Staat in den USA; Abk.: Me.)

Main|fran|ken; Main|li|nie (Südgrenze des Nordd. Bundes 1866/71) *w;* -; Main-Neckar-Schnell|weg [*Trenn.:* ...Nek-kar...] († R 203) *m;* -[e]s

Mainz (Stadt am Rhein gegenüber der Mündung des Mains); Main|zer († R 199); main|zisch

Maire *fr.* [*mär*] (Bürgermeister in Frankreich) *m;* -s, -s; Mai|rie (Bürgermeisterei in Frankreich) *w;* -, ...ien

Mais *indian.* (eine Getreidepflanze) *m;* -es, (für: Maisarten auch *Mehrz.*:) -e; Mais_brei, ...brot

Maisch *m;* -[e]s, -e u. Mai|sche (Mischung, bes. bei der Bierherstellung) *w;* -, -n; Maisch_bot|tich; mai|schen; du maischst (maischest)

mais_gelb; Mais_kol|ben, ...korn, ...mehl

Mai|so|nette, (nach fr. Schreibung auch:) Mai|son|nette *fr.* [*mäsonät*; „Häuschen"] (zweistöckige Wohnung in einem Hochhaus) *w;* -, -s

Maiß bayr., österr. (Holzschlag; Jungwald) *m;* -es, -e od. *w;* -, -en

Mais_stär|ke, ...stroh

Maî|tre de plai|sir *fr.* [*mätrᵉdᵉpläsir*] (veralt., aber noch scherzh. für: jmd., der bei gesellschaftlichen Vergnügungen die Leitung hat) *m;* - - -, -s [*mätrᵉ*] --

Mai|um|zug

Mai|ze|na ⓌⓏ (reiner Maisstärkepuder) *s;* -s

¹Ma|ja *sanskr.* (ind. Philos.: [als verschleierte Schönheit dargestellte] Erscheinungswelt, Blendwerk) *w;* -

²Ma|ja („die Hehre"; röm. Göttin des Erdwachstums; in der gr. Mythol.: Mutter des Hermes)

Ma|ja|kow|ski (sowjetruss. Dichter)

Ma|je|stät *lat.* (Herrlichkeit, Erhabenheit) *w;* -, (als Titel u. Anrede von Kaisern u. Königen auch *Mehrz.:*) -en; Seine - (Abk.: S[e]. M.), Ihre - (Abk.: I. M.), Euer - od. Eure - (Abk.: Ew. M.); ma|je|stä|tisch (herrlich, erhaben); -ste († R 294); Ma|je|stäts|be|lei|di|gung

Ma|jo|li|ka [nach der Insel Mallorca] (eine Tonware) *w;* -, ...ken u. -s

Ma|jo|nä|se (eindeutschend für: Mayonnaise)

Ma|jor *lat.-span.* (unterster Stabsoffizier) *m;* -s, -e

Ma|jo|ran [auch: *maj...*], Mei|ran *mlat.* (ein[e] Gewürz[pflanze]) *m;* -s, -e

Ma|jo|rat *lat.* (Vorrecht des Ältesten auf das Erbgut, Ältestenrecht; nach dem Ältestenrecht zu vererbendes Gut; Ggs.: Minorat) *s;* -[e]s, -e; Ma|jo|rats_gut, ...herr

Ma|jor|do|mus *lat.* [*majordômuß*] („Hausmeier"; Stellvertreter der fränk. Könige) *m;* -, -; ma|jo|renn *lat.* (veralt. für: groß-, volljährig, mündig); Ma|jo|ren|ni|tät (veralt. für: Volljährigkeit, Mündigkeit) *w;* -; Ma|jo|rette *fr.* [...*rät*] (junges Mädchen in Uniform, das bei festlichen Umzügen paradiert) *w;* -, -s; ma|jo|ri|sie|ren *lat.* (überstimmen, durch Stimmenmehrheit zwingen); Ma|jo|ri|tät ([Stimmen]mehrheit); Ma|jo|ri|täts_be|schluß, ...prin|zip (*s;* -s), ...wahl (Mehrheitswahl)

Ma|jors|rang *m;* -[e]s

Ma|jorz *lat.* schweiz. (Mehrheitswahlsystem) *m;* -es; vgl. Proporz

Ma|jus|kel *lat.* (Großbuchstabe) *w;* -, -n

ma|ka|ber *fr.* (totenähnlich; unheimlich; schaudererregend; frivol); ma|ka|bres Aussehen

Ma|ka|dam [nach dem schott. Ingenieur McAdam] (Straßenbelag) *m* od. *s;* -s, -e; ma|ka|dam|mi|sie|ren (mit Makadam versehen, belegen)

Ma|kak (meerkatzenartiger Affe) *m;* -s u. ...kaken, ...kaken († R 268)

Ma|ka|me *arab.* (kunstvolle alte arab. Stegreifdichtung; im

¹ Dicht. auch: Maien...

Orient das Podium der höfischen Sänger u. deren Gesang) *w*; -, -n

¹**Ma|kao** *Hindi-port.* [auch: *makau*] (ein Papagei) *m*; -s, -s

²**Ma|kao** [auch: *makau*; nach der port. Kolonie Macau] (ein Glücksspiel) *s*; -s

Ma|kart (österr. Maler); **Ma|kart|bu|kett**; ↑ R 180 (Strauß aus getrockneten Blumen)

Ma|kas|sar (Hptst. der indones. Provinz Celebes); **Ma|kas|sar|öl** (ein Haaröl *s*; -[e]s (↑ R 201)

Ma|ke|do|ni|en [...*i*ⁿ] (Balkanlandschaft); **Ma|ke|do|ni|er** [...*i*ⁿr]; **ma|ke|do|nisch**

Ma|kel ([Schand]fleck; Schande) *m*; -s, -

Mä|ke|lei (ugs. für: Nörgelei); **mä|ke|lig**, mäk|lig (ugs. für: gern mäkelnd)

ma|kel|los; -este (↑ R 292); **Ma|kel|lo|sig|keit** *w*; -

ma|keln (Vermittlergeschäfte machen); ich ...[e]le (↑ R 327); **mä|keln** (ugs. für: etwas [am Essen usw.] auszusetzen haben, nörgeln); ich ...[e]le (↑ R 327)

Make-up *engl.* [*me'k-ap*] (kosmetische Pflege) *s*; -s, -s

Ma|ki *madagass.-fr.* (ein Halbaffe) *m*; -s, -s

Ma|ki|mo|no *jap.* (chin. od. jap. „Roll"bild) *s*; -s, -s

Mak|ka|bä|er (Angehöriger eines jüd. Geschlechtes) *m*; -s, -; **Mak|ka|bä|er|mün|ze**; **mak|ka|bä|isch**

Mak|ka|bi *hebr.* (Name jüd. Sportvereinigungen) *m*; -[s], -s; **Mak|ka|bia|de** (jüd. Sporttreffen nach Art der Olympiade)

Mak|ka|ro|ni *it.* (röhrenförmige Nudeln) *Mehrz.*; **mak|ka|ro|nisch** (aus lateinischen u. lateinisch aufgeputzten Wörtern lebender Sprachen gemischt); -e Dichtung

Mak|ler (Geschäftsvermittler); ¹**Mäk|ler** (landsch. u. gelegentl. rechtsspr. für: Makler); ²**Mäk|ler** (ugs. für: jmd., der etwas auszusetzen hat, Tadler); **Mak|ler|ge|bühr**; **mäk|lig**, mäk|lig vgl. mäkelig

Ma|ko [nach dem Ägypter Mako Bey] (ägypt. Baumwolle) *w*; -, -s od. *m* od. *s*; -[s], -s

Ma|ko|ré *fr.* [...*re*] (afrik. Hartholz) *s*; -[s]

Ma|kra|mee *arab.-it.* (Knüpfarbeit, -franse) *s*; -[s], -s

Ma|kre|le *niederl.* (ein Fisch) *w*; -, -n

ma|kro... *gr.* (lang..., groß...); **Makro...** (Lang..., Groß...); **Ma|kro|bio|tik** (Med.: Kunst, das Leben zu verlängern) *w*; -; **Ma|kro|chei|lie** [...*chaili*] (Med.: abnorme Verdickung der Lippen) *w*; -; **Ma-**

kro|chei|rie (Med.: abnorme Größe der Hände) *w*; -; **Ma|kro|dak|ty|lie** (Med.: abnorme Größe der Finger) *w*; -; **ma|kro|ke|phal** usw. vgl. makrozephal usw.; **Ma|kro|kos|mos**, **Ma|kro|kos|mus** [auch: *makro*...] (die große Welt, Weltall; Ggs.: Mikrokosmos) *m*; -; **Ma|kro|mo|le|kül** [auch: *makro*...] (aus 1000 u. mehr Atomen aufgebautes Molekül), **ma|kro|mo|le|ku|lar**

Ma|kro|ne *it.* (ein Gebäck) *w*; -, -n

ma|kro|seis|misch *gr.* (ohne Instrumente wahrnehmbar [von starken Erdbeben]); **ma|kro|sko|pisch** (mit freiem Auge sichtbar); **Ma|kro|spo|re** (große weibliche Spore einiger Farnpflanzen; meist *Mehrz.*); **Ma|kro|struk|tur** (ohne optische Hilfsmittel erkennbare Struktur); **Ma|kro|tie** (Med.: abnorme Größe der Ohren) *w*; -; **ma|kro|ze|phal** (Med.: großköpfig); **Ma|kro|ze|pha|le** *m* u. *w*; -n, -n (↑ R 268); **Ma|kro|ze|pha|lie** *w*; -; **Ma|kru|lie** (Med.: Wucherung des Zahnfleisches) *w*; -

Ma|ku|la|tur *lat.* (beim Druck schadhaft gewordene u. fehlerhafte Bogen, Fehldruck; Altpapier; Abfall) *w*; -, -en; **ma|ku|lie|ren** (zu Makulatur machen)

mal; acht mal zwei (mit Ziffern [u. Zeichen]: 8 mal 2, 8 × 2 od. 8 · 2); acht mal zwei ist, macht, gibt (nicht: sind, machen, geben) sechzehn; mal (ugs. für: einmal [vgl. Mal, II], z. B. komm mal her!; wenn das mal (nur) gutgeht!; das ist nun mal so; sag das noch mal!); vgl. auch: Mal, II; ¹**Mal** *s*; -[e]s, -e. I. *Groß- und Getrenntschreibung als Hauptwort:* das erste, zweite usw. Mal; das and[e]re, einzige, letzte, nächste, vorige usw. Mal; das eine Mal; ein erstes usw. Mal; ein and[e]res, einziges, letztes Mal; ein Mal über das and[e]re, ein ums and[e]re Mal; von Mal zu Mal; dieses, manches, nächstes, voriges Mal; manches liebe, manch liebes Mal; mit einem Mal[e]; beim, zum ersten, zweiten, letzten, ander[e]n, soundsovielten, x-ten Mal[e]; die letzten, nächsten Male; alle, einige, etliche, mehrere, unendliche, unzählige, viele, viele tausend, wie viele Male; ein paar, ein Dutzend, eine Million Male; ein od. mehrere Male; ein für alle Male; zu fünf Dutzend Male; zu verschiedenen, wiederholten Malen. II. *Zusammenschreibung als Umstandswort:* einmal (vgl. mal); zweimal (mit Ziffer: 2mal);

drei- bis viermal (mit Ziffern: 3- bis 4mal od. 3–4mal); fünfundsiebzigmal; [ein]hundertmal; noch einmal, noch einmal soviel; dutzendmal; keinmal; manchmal; vielmal, sovielmal, wievielmal, vieltausendmal, x-mal; allemal, beidemal, jedesmal, dutzendmal, hundertmal, einigemal; etlichemal, mehreremal, unendlich[e]mal, unzähligemal, verschiedenemal, wieoftmal, diesmal; das erstemal, das letztemal, das x-temal; ein andermal, ein dutzendmal, ein paarmal; ein halbes hundertmal, ein paar dutzendmal; auf einmal, mit ein[em]mal; ein fur allemal; beim, zum erstenmal, zweitenmal, letztenmal, x-tenmal; zum andernmal, nächstenmal; ²**Mal** (Zeichen, Fleck; Denk-, Merkmal; Sport: Ablaufstelle usw.) *s*; -[e]s, -e u. Mäler

Ma|la|bar [auch: *mal*...] (südl. Teil der Westküste Vorderindiens); **Ma|la|bar|gum|mi** [auch: *mal*...] (↑ R 201)

Ma|la|chi|as [...*ehiaß*], (ökum.:) **Ma|lea|chi** (bibl. Prophet)

Ma|la|chit *gr.* [...*ehit*] (ein Mineral) *m*; -s, -e; **ma|la|chit|grün**; **Ma|la|chit|va|se**

ma|lad, **ma|la|de** *fr.* (ugs. für: krank, unpäßlich)

ma|la fi|de *lat.* (in böser Absicht; wider besseres Wissen)

Ma|la|ga (ein in Südwein) *m*; -s, -s; **Má|la|ga** (span. Provinz u. Hafenstadt); **Ma|la|ga|wein**

Ma|laie (Angehöriger mongol. Völker Südostasiens) *m*; -n, -n (↑ R 268); **Ma|lai|in** *w*; -, -nen; **ma|lai|isch**, aber (↑ R 198): der Malaiische Archipel; Malaiischer Bund

Ma|lai|se *fr.* [*maläs*ᵉ] (Übelkeit, Übelbefinden; Mißstimmung, -behagen) *w*; -, -n (schweiz. *s*; -s, -)

Ma|lak|ka (südostasiat. Halbinsel)

Ma|la|ko|lo|gie *gr.* (Lehre von den Weichtieren) *w*; -; **Ma|la|ko|phi|le** (Schneckenblütler [Pflanze]) *w*; -, -n (meist *Mehrz.*); **Ma|la|ko|zo|on** (veralt. Bez. für: Weichtier) *s*; -s, ...zoen (meist *Mehrz.*)

Ma|la|ria *it.* (Sumpf-, Wechselfieber) *w*; -; **Ma|la|ria|er|re|ger**; **ma|la|ria|krank**; **Ma|la|ria|lo|gie** (Erforschung der Malaria) *w*; -

Ma|la|wi (Staat in Afrika); **Ma|la|wi|er**; **ma|la|wisch**

Mal|axt (Axt zum Bezeichnen der zu fällenden Bäume)

Ma|lay|sia [...*ai*...] (Föderation in Südostasien); **Ma|lay|si|er**; **ma|lay|sisch**

Mal|bar|te (Malaxt)
Mal|buch
¹Mal|chen vgl. Melibocus
²Mal|chen, Ma|le, (österr.:) Ma|li
(Koseformen von: Amalie)
Mal|chus (bibl. m. Eigenn.)
Ma|lea|chi vgl. Malachias
Ma|le|di|ven (Inselstaat im Ind.
Ozean) Mehrz.; Ma|le|di|ver; ma-
le|di|visch
Ma|le|fiz|kerl lat.; dt.
ma|len (Bilder usw.); gemalt
Ma|le|par|tus (Wohnung des
Fuchses in der Tierfabel) m; -
Ma|ler; Ma|ler|ar|beit; Ma|le|rei;
Ma|ler.email (Schmelzmalerei),
...far|be; Ma|le|rin w; -, -nen; ma-
le|risch; -ste (↑ R 294); Ma|ler-
mei|ster; ma|lern (ugs.: Malerar-
beiten ausführen); ich ...lere (↑ R
327)
Ma|lä|sche fr. [„Malaise“] nordd.
(Ungelegenheit, Unannehmlich-
keit, Umstände) w; -, -n
Mal|heur fr. [malör] (veralt. für:
Unglück, Unfall; ugs. für: Pech;
Mißgeschick, bes. im sexuellen
Bereich) s; -s, -e u. -s
mal|ho|nett fr. (veralt. für: unfein,
unredlich)
¹Ma|li (österr. Koseform von:
Amalie)
²Ma|li (Staat in Afrika); vgl. Mali-
er, malisch
Ma|li|ce fr. [...liß'] (veralt. für:
Bosheit; boshafte Äußerung) w;
-, -n
Ma|li|er (Bewohner von ²Mali)
...ma|lig (z. B. dreimalig [mit Zif-
fer: 3malig])
ma|li|gne lat. (Med.: bösartig);
Ma|li|gni|tät (Med.: Bösartigkeit
[einer Krankheit], bes. einer Ge-
schwulst) w; -
ma|lisch [zu: ²Mali]
ma|li|zi|ös (boshaft, hämisch);
-este (↑ R 292)
Mal|ka|sten
mal|kon|tent fr. (veralt., noch
mdal. für: [mit polit. Zuständen]
unzufrieden, mißvergnügt)
mall niederl. (Seew.: [vom Wind]
umspringend, verkehrt, ver-
dreht; übertr. nordd. für: von
Sinnen, verrückt); Mall (See-
mannsspr.: Modell für Schiffstei-
le, Spantenschablone) s; -[e]s, -e
Mal|lauf
mal|len (Seew.: nach dem Mall be-
hauen; messen; umspringen [vom
Wind])
Mal|lor|ca [...ka, auch: major...;
span. Aussspr.: maljorka] (Haupt-
insel der Balearen)
Mal|lung (Seemannsspr.: Hinund-
herspringen des Windes)
Malm engl. (Geol.: obere Abtei-
lung der Juraformation; Weißer
Jura) m; -[e]s; mal|men (selten für:

zermalmen, laut aneinander rei-
ben, knirschen)
Mal|mö (schwed. Hafenstadt)
mal|neh|men (Math.: vervielfälti-
gen); ich nehme mal; malgenom-
men; malzunehmen
Mal|oc|chio it. [...ọkio] (it. Bez.
für: böser Blick) m; -s, -s u. ...oc-
chi [...ọki]
ma|lo|chen jidd. (ugs. für: schwer
arbeiten, schuften)
...passes
mal|pro|per fr. (veralt., noch mdal.
für: unsauber); malpropre Schür-
ze
...mals (z. B. mehrmals)
Mal.säu|le (veralt. für: Grenz-
stein; Gedenksäule), ...stein (ver-
alt. für: Denkstein)
Mal|ta (Insel u. Staat im Mittel-
meer); Mal|ta|fie|ber (↑ R 201)
Mal|te (m. Vorn.)
Mal|tech|nik
Mal|ter (veraltetes Getreide-,
Kartoffelmaß; österr. ugs. auch:
Mörtel) m od. s; -s, -
Mal|te|ser (Bewohner von Malta);
(↑ R 199:) Malteser Hündchen,
aber (↑ R 205): Mal|te|ser.kreuz,
...or|den, ...rit|ter; mal|te|sisch,
aber (↑ R 198:) Maltesische In-
seln
Mal|thus (engl. Volkswirtschaft-
ler u. Sozialphilosoph); Mal|thu-
sia|ner (Vertreter des Malthu-
sianismus); Mal|thu|sia|nis|mus
m; -; Mal|thu|sisch (↑ R 179); -es
Bevölkerungsgesetz
Mal|to|se (Malzzucker) w; -
mal|trä|tie|ren fr. (mißhandeln,
quälen); Mal|trä|tie|rung
Ma|lus (Kfz-Versicherung:
nachträglicher Prämienzuschlag
bei Häufung von Schadensfällen)
m; - u. -ses, - u. -se
Mal|uten|si|li|en Mehrz.
Mal|va|sier [...wa...] (ein Süßwein)
m; -s; Mal|va|sier|wein
Mal|ve it. [...w'] (eine Zier-, Heil-
pflanze) w; -, -n; mal|ven|far|big
Mal|wi|ne (w. Vorn.)
Malz m; -es; Malz.bier, ...bon|bon
Mal|zei|chen (Erinnerungszei-
chen; Gedenkstein; Multiplika-
tionszeichen; Zeichen: · od. ×)
Mäl|zel (dt. Instrumentenma-
cher); -s Metronom (Abk.: M.
M.)
mäl|zen (Malz bereiten); du mälzt
(mälzest); Mäl|zer; Mäl|ze|rei;
Malz.ex|trakt, ...kaf|fee, ...zuk-
ker [Trenn.: ...zuk|ker]
Ma|ma [Kinderspr. u. ugs. auch:
mama] w; -, -s; Ma|ma|chen
Mam|bo kreol. (mäßig schneller
Tanz im ⁴/₄-Takt) m; -[s], -s

Ma|me|luck arab.-it. (Sklave,
Leibwächter morgenländ. Herr-
scher) m; -en, -en (↑ R 268)
Ma|mer|tus (ein Heiliger)
Ma|mi (Kinderspr.)
Mam|ma|lia lat. (Sammelbez. für
alle Säugetiere) Mehrz.
Mam|mon aram. (abschätzig für:
Reichtum; Geld) m; -s; Mam|mo-
nis|mus (Geldgier, -herrschaft)
m; -; Mam|mons|die|ner
Mam|mut russ.-fr. (Elefant einer
ausgestorbenen Art) s; -s, -e u.
-s; Mam|mut.baum, ...höh|le (im
Staat Kentucky [USA]), ...kno-
chen, ...pro|gramm, ...pro|zeß,
...schau, ...ske|lett, ...ta|ges|ord-
nung, ...un|ter|neh|men (Riesen-
unternehmen), ...ver|an|stal-
tung, ...ver|samm|lung, ...zahn
mamp|fen (ugs. für: mit vollen
Backen kauen)
Mam|sell fr. (Angestellte im Gast-
stättengewerbe; veralt., jetzt nur
noch spöttisch-scherzh. für:
Fräulein, Hausgehilfin) w; -, -en
u. -s; (↑ R 224:) kalte - (für die
Zubereitung der kalten Speisen)
¹man (↑ R 135); Wemf. einem,
Wenf. einen; man kann nicht wis-
sen, was einem zustoßen wird;
du siehst einen an, als ob man
...
²man nordd. (nur); das laß -
bleiben!
¹Man [män] (Insel in der Irischen
See)
²Man pers. (pers. Gewicht) m od.
s; -s, -s; 3 - (↑ R 322)
m. A. n. = meiner Ansicht nach
M.A.N. = Maschinenfabrik
Augsburg-Nürnberg AG
Mä|na|de gr. (Bacchusverehrerin;
rasendes Weib) w; -, -n
Ma|na|ge|ment engl.-amerik. [mä-
nidsehm'nt] (Leitung eines Un-
ternehmens [bes. in den USA])
s; -s, -s; ma|na|gen [mänidseh'n]
(ugs. für: leiten, unternehmen;
zustande bringen); gemanagt
[...mänidseht]; Ma|na|ger [mä-
nidseh'r] (Leiter [eines großen
Unternehmens]; Betreuer [eines
Berufssportlers]) m; -s, -; Ma|na-
ger|krank|heit
Ma|nas|se (bibl. m. Eigenn.)
manch; -er, -e, -es; in manchem;
manche sagen (↑ R 135); so man-
cher, so manches; manch einer;
mancher Tag; mancher Art;
manche Stunde; manches u.
manch Buch; mancher, der; man-
ches, was. Beugung (↑ R 277):
manch guter Vorsatz; mancher
gute Vorsatz; mit manch gutem
Vorsatz, mit manchem guten
Vorsatz, manch böses Wort;
manches böse Wort; manchmal;
manches Mal; manch liebes Mal.

manches liebe Mal; (↑ R 290:) manch Schönes und manches Schöne; mit manch Schönem u. mit manchem Schönen; (↑ R 283:) manche vortreffliche (auch noch: vortrefflichen) Einrichtungen, mancher stimmfähiger (auch noch: stimmfähigen) Mitglieder, für manche ältere (auch noch: älteren) Leute; (↑ R 290:) manche Stimmberechtigte (auch: Stimmberechtigten)

Man|cha [...tscha] (span. Landschaft) w; -

man|chen|orts; man|cher, der; man|cher|lei; man|cher|lei, was; man|cher|or|ten (selten): **mancher|orts**

[1]**Man|che|ster** [mäntschäßt'r, engl. Ausspr.: mäntschißt'r] (engl. Stadt); [2]**Man|che|ster** [mansch...] (ein Gewebe) m; -s; vgl. Manschester; **Man|che|ster|ho|se;** vgl. Manschester; **Man|che|ster|tum** [män...] (liberalistische volkswirtschaftliche Anschauung) s; -s

man|ches, was; manch|mal; vgl. manch

Man|dant lat. (Auftraggeber; Vollmachtgeber [bes. eines Rechtsanwaltes]) m; -en, -en (↑ R 268); **Man|dan|tin** w; -, -nen

Man|da|rin sansk.-port. (europ. Name früherer hoher chin. Beamter) m; -s, -e; **Man|da|ri|ne** (kleine apfelsinenähnliche Frucht) w; -, -n; **Man|da|ri|nen|öl** s; -[e]s

Man|dat lat. (Auftrag, Vollmacht; Sitz im Parlament; in Treuhand von einem Staat verwaltetes Gebiet) s; -[e]s, -e; **Man|da|tar** (jmd., der im Auftrag eines anderen handelt; Rechtsanwalt; österr. für: Abgeordneter) m; -s, -e; **Man|da|tar|staat;** vgl. [1]Staat; **man|da|tie|ren** (veralt. für: zum Mandatar machen); **Mandats.ge|biet, ...macht, ...ver|lust**

[1]**Man|del** gr. (Frucht; Drüse) w; -, -n

[2]**Man|del** mlat. (altes Zählmaß; Haufe von etwa 15 Garben; kleine Mandel = 15 Stück, große Mandel = 16 Stück) w; -, -[n]; 3 - Eier (↑ R 322)

Man|del.au|ge; man|del|äu|gig; Man|del.baum, ...blü|te, ...entzün|dung; man|del|för|mig; Mandel.kleie, ...krä|he (svw. Blaurakke), **...öl** (s; -[e]s, ...sei|fe

Man|derl vgl. Mandl

Man|di|beln lat. (als Oberkiefer dienende Mundwerkzeuge der Gliedertiere) Mehrz.; **man|di|bular** (Med.: zum Unterkiefer gehörend)

Mandl bayr. u. österr. mdal.

(,,Männlein''; Wild-, Vogelscheuche; Wegzeichen aus Steinen) s; -s, -n

Man|do|la it. (eine Oktave tiefer als die Mandoline klingendes Zupfinstrument) w; -, ...len; **Man|do|li|ne** fr. (ein Saiteninstrument) w; -, -n

Man|dor|la it. (mandelförmiger Heiligenschein) w; -, ...len

Man|dra|go|ra, Man|dra|go|re gr. (ein Nachtschattengewächs) w; -, ...oren

Man|drill engl. (Affe einer bestimmten Art im Kongogebiet) m; -s, -e

[1]**Man|dschu** (Angehöriger eines mongol., den Tungusen verwandten Volkes) m; -[s], -; [2]**Mandschu** (Sprache) s; -[s]; **Man|dschu|kuo** (Name der Mandschurei als Kaiserreich 1934–45); **Man|dschu|rei** (nordostchin. Tiefland) w; -; **man|dschu|risch;** -es Fleckfieber

Ma|ne|ge fr. [manesch'] (runde Vorführfläche od. Reitbahn im Zirkus) w; -, -n

Ma|nen lat. (die guten Geister der Toten im altröm. Glauben) Mehrz.

Ma|nes|sisch; -e Handschrift (Minnesängerhandschrift)

Ma|net [manä], Edouard [ed''ar] (fr. Maler)

Man|fred (m. Vorn.)

mang nordd. ugs. (unter, dazwischen); mittenmang (vgl. d.)

Man|ga|be afrik. [...ngg...] (Affe einer bestimmten Art in Afrika) w; -, -n

Man|gan gr. [...ngg...] (chem. Grundstoff, Metall; Zeichen: Mn) s; -s; **Man|ga|nat** (Salz der Mangansäure) s; -[e]s, -e; **Man|gan|ei|sen; Man|ga|nit** (ein Mineral) m; -s, -e

Man|ge mdal. (Mangel) w; -, -n; [1]**Man|gel** ([Wäsche]rolle) w; -, -n

[2]**Man|gel** (das Fehlen) m; -s, (für: Fehler auch Mehrz.:) Mängel; **Man|gel.be|ruf, ...er|schei|nung; man|gel|frei; man|gel|haft;** vgl. ausreichend; **Man|gel|haf|tig|keit** w; -

Man|gel|holz

Man|gel|krank|heit; [1]**man|geln** (nicht [ausreichend] vorhanden sein); es hat an allem gemangelt [2]**man|geln** ([Wäsche] rollen); es ...[e]le (↑ R 327)

Man|gel|rü|ge (Klage über mangelhaft gelieferte Ware od. Arbeit); **man|gels** (↑ R 130); mit Wesf.: des nötigen Geldes, mangels eindeutiger Beweise; der Mehrz. mit Wemf., wenn im Wesf. nicht erkennbar ist: mangels Beweisen; **Man|gel|wa|re**

Man|gel|wä|sche; man|gen mdal. ([2]mangeln)

Mang.fut|ter mdal. (Mischfutter; vgl. [1]Futter), **...ge|trei|de**

Mäng|le|rin [zu: [2]mangeln] w; -, -nen

Man|go tamul.-port. [manggo] (eine tropische Frucht) w; -, ...onen od. -s; **Man|go|baum**

Man|gold (Blatt- u. Stengelgemüse) m; [e]s, -e

Man|gro|ve engl. [manggrow'] (immergrüner Laubwald in Meeresbuchten u. Flußmündungen tropischer Gebiete) w; -, -n; **Man|gro|ve[n]|baum; Man|gro|ve[n]|kü|ste**

Man|hat|tan [manhät'n] (Flußinsel; Stadtteil von New York)

Ma|ni|chä|er (Anhänger des Manichäismus; Studentenspr. veralt. für: [drängender] Gläubiger); **Ma|ni|chä|is|mus** (von Mani gestiftete Religionsform) m; -

Ma|nie gr. (Sucht; Besessenheit; Leidenschaft; Liebhaberei; Raserei, Wahnsinn) w; -, ...ien

Ma|nier fr. (Art u. Weise, Eigenart; Unnatur, Künstelei) w; -; **Ma|nie|ren** (Umgangsformen, [gutes] Benehmen) Mehrz.; **ma|nie|riert** (gekünstelt; unnatürlich); **Ma|nie|riert|heit; Ma|nie|ris|mus** lat. (Stilbegriff für die Kunst der Zeit zwischen Renaissance u. Barock; gekünstelte Nachahmung eines Stils) m; -; **Ma|nie|rist** (Vertreter des Manierismus); ↑ R 268; **ma|nie|ri|stisch; ma|nier|lich** (gesittet, fein; wohl erzogen)

ma|ni|fest lat. (handgreiflich, offenbar, deutlich); **Ma|ni|fest** (öffentl. Erklärung, Kundgebung; Verzeichnis der Güter auf einem Schiff) s; -es, -e; das Kommunistische -; **Ma|ni|fe|stant** (veralt. für: den Offenbarungseid Leistender; schweiz., sonst veralt. für: Teilnehmer an einer politischen Kundgebung) m; -en, -en (↑ R 268); **Ma|ni|fe|sta|ti|on** [...zion] (Offenbarwerden; Rechtsw.: Offenlegung; Bekundung; Med.: Erkennbarwerden [von Krankheiten]; schweiz. für: politische Kundgebung); **ma|ni|fe|stie|ren** (offenbaren; kundgeben, bekunden; veralt. für: Offenbarungseid leisten; schweiz. für: demonstrieren); sich -

Ma|ni|kü|re fr. (Handpflege, bes. Nagelpflege) w; -, (für: Hand-, Nagelpflegerin auch Mehrz.:) -n; **ma|ni|kü|ren;** manikürt

Ma|ni|la (größte Stadt auf den Philippinen); **Ma|ni|la|hanf;** ↑ R 201 (Spinnfaser der philippinischen Faserbanane)

Manille

Ma|nil|le *fr.* [...*nᵢlje̯*] (Trumpfkarte im Lomberspiel) *w*; -, -n

Ma|ni|ok *indian.-fr.* (eine tropische Nutzpflanze) *m*; -s, -s; **Ma|ni|ok_mehl** (*s*; -[e]s), ...**wur|zel**

¹**Ma|ni|pel** *lat.* (Teil der röm. Kohorte) *m*; -s, -; ²**Ma|ni|pel** (Teil der kath. Priestergewandung) *m*; -s, - (auch: *w*; -, -n); **Ma|ni|pu|lant** *m*; -en, -en (↑ R 268); **Ma|ni|pu|la|ti|on** [...*ziǫn*] (Hand-, Kunstgriff; Verfahren; meist *Mehrz.*: Machenschaft); **ma|ni|pu|la|tiv**; **Ma|ni|pu|la|tor** (Vorrichtung zur Handhabung radioaktiver Substanzen aus größerem Abstand [hinter Strahlenschutzwänden]; fingerfertiger Zauberkünstler) *m*; -s, ...**ǫren**; **ma|ni|pu|lier|bar**; **Ma|ni|pu|lier|bar|keit** *w*; -; **ma|ni|pu|lie|ren**; manipulierte (gesteuerte) Währung; der manipulierte Mensch; **Ma|ni|pu|lie|rung ma|nisch** *gr.* (tobsüchtig, an Manie leidend); **ma|nisch-de|pres|siv**; ↑ R 158 (abwechselnd heiter-zornig und schwermütig)

Ma|nis|mus *lat.* (Völkerk.: Ahnenkult, Totenverehrung) *m*; -

Ma|ni|to|ba [engl. Ausspr.: *mänitǫᵘbᵉ*] (kanad. Provinz)

Ma|ni|tu *indian.* (zauberhafte Macht des indian. Glaubens, oft personifiziert als „Großer Geist") *m*; -s

Ma|ni|us (altröm. m. Vorn.; Abk.: M')

man|kie|ren *fr.* (veralt., aber noch mdal. für: fehlen, mangeln; verfehlen); **Man|ko** *it.* (Fehlbetrag; Ausfall; Mangel) *s*; -s, -s; **Man|ko|geld** (Fehlgeldentschädigung)

¹**Mann**, Heinrich u. Thomas (dt. Schriftsteller)

²**Mann** *m*; -[e]s, Männer u. (dicht. für Lehnsleute, ritterl. Dienstleute od. scherzh.:) -en; (↑ R 322:) vier - hoch (ugs.), alle - an Bord, an Deck!, tausend -; er ist -s genug; seinen - stehen, stellen

Man|na *hebr.* (legendäres Brot der Israeliten; Pflanzensaft) *s*; -[s] (österr. nur so) od. *w*; -; **Man|na-zucker** [*Trenn.*: ...**zuk|ker**]

mann|bar; **Mann|bar|keit** *w*; -; **Männ|chen**, Männ|lein; Männlein u. Weiblein *Mehrz.*; **Män|ne** (Koseform zu: Mann); **man|nen** (Seemannsspr.: [Stück]gut von Mann zu Mann reichen); **Man|nen|treue**

Man|le|quin *fr.* [*manᵉkäng*] (Vorführdame; veralt. für: Gliederpuppe) *s* (selten: *m*); -s, -s

Män|ner_be|kannt|schaft, ...**chor** *m*, ...**fang** (meist nur in: auf - ausgehen), ...**freundschaft**; ...**män|ne[r]|lig** (z. B. dreimänn[er]lig [Bot.]); **Män|ner_sa|che**, ...**stim-**

me; **Män|ner|treu** (Name verschiedener Pflanzen) *w*; -, -

Man|nes_al|ter (*s*; -s), ...**jah|re** (*Mehrz.*), ...**kraft**

Mann|nes|mann (Familienname; ⑫); **Mann|nes|mann|rohr** (↑ R 180; ⑫; *Mehrz.* ...rohre u. ...röhren)

Mann|nes_stamm, ...**stär|ke**, ...**treue**, ...**wort** (*Mehrz.* ...worte), ...**zucht**; **Mann|geld** (früher für: Wergeld); **mann|haft**; **Mann|haf|tig|keit** *w*; -

Mann|heim (Stadt a. d. Mündung des Neckars in den Rhein); **Mann|hei|mer** (↑ R 199); - Schule

Mann|heit *w*; -; ...**män|nig** vgl. ...**männerig**

man|nig|fach; **man|nig|fal|tig**; **Man|nig|fal|tig|keit** *w*; -

män|nig|lich (veralt. für: jeder); **Män|nin** (nur bibl.) *w*; -; ...**män|nisch** (z. B. bergmännisch)

Man|nit *hebr.* (sechswertiger Alkohol im Manna) *m*; -s, -e

Männ|lein vgl. Männchen; **männlich**; -es Hauptwort (für: Maskulinum); **Männ|lich|keit** *w*; -; **Mann|loch** (Einsteigeöffnung in Gefäßwandungen; **Manns|bild** (ugs., oft abschätzig); **Mann|schaft**; **mann|schaft|lich**; **Mann|schafts_auf|stel|lung**, ...**ka|pi|tän**, ...**raum**, ...**sie|ger**, ...**stär|ke**, ...**stu|be**, ...**wa|gen**, ...**wer|tung**; **manns|dick**; **manns|hoch**; **Manns|hö|he**; in -; **Manns_leu|te** (ugs. abschätzig: *Mehrz.* ...**per|son**; **manns|toll**; **Manns|volk**; **Mann|weib** (abschätzig für: Zwitter; männlich auftretende weibliche Person)

Man|nus (Gestalt der germ. Mythol.)

Ma|no|me|ter *gr.* (Druckmesser) *s*; -s, -; **ma|no|me|trisch**

Ma|nö|ver *fr.* [...*wᵉr*] (größere Truppen-, Flottenübung; Bewegung, die mit einem Schiff ausgeführt wird; Kunstgriff, Scheinmaßnahme) *s*; -s, -; **Ma|nö|ver_ge|län|de**, ...**scha|den**; **ma|nö|vrie|ren** (Manöver vornehmen; geschickt zu Werke gehen); **ma|nö|vrier|fä|hig**; **Ma|nö|vrier|fä|hig|keit** *w*; -

Man|sar|de [nach dem fr. Baumeister Mansart] (Dachgeschoß, -zimmer) *w*; -, -n; **Man|sar|den_woh|nung**, ...**zim|mer**

Mansch (ugs. für: schlechtes Wetter, Schneewasser; Suppe, wässeriges Essen u. a.) *m*; -es; **man|schen** (ugs. für: mischen; im Wasser planschen); du manschst (manschest); **Man|sche|rei** (ugs.)

Man|sche|ster usw. (eindeutschende Schreibung für: ²Manchester usw.)

Man|schet|te *fr.* (Ärmelaufschlag;

Papierkrause für Blumentöpfe; unerlaubter Würgegriff beim Ringkampf) *w*; -, -n; Manschetten haben (ugs. für: Angst haben); **Man|schet|ten|knopf**

Mans, Le [*lᵉ mãns*] (fr. Stadt); Le Mans' [*lᵉ mãngß*] Umgebung (↑ R 317)

Man|teau *fr.* [*mãngtǫ*] (fr. Bez. für: Mantel) *m*; -s, -s; **Man|tel** *m*; -s, Mäntel; **Män|tel|chen**, **Män|te|lein**; **Man|tel_fut|ter** (vgl. ²Futter), ...**ge|schoß**, ...**ge|setz** (Rahmengesetz), ...**kra|gen**, ...**rohr**, ...**sack** (veralt. für: Reisetasche), ...**ta|rif**, ...**ta|sche**

Man|tik *gr.* (Seher-, Wahrsagekunst) *w*; -

Man|til|le *span.* [...*il(j)ᵉ*] (Schleiertuch) *w*; -, -n

Man|tis|se *lat.* (Math.: hinter dem Beistrich stehende Ziffern der Logarithmen) *w*; -, -n

Mantsch usw. (Nebenform von Mansch usw.)

Man|tua (it. Stadt); **Man|tua|ner**, **man|tua|nisch**

Ma|nu|al *lat.* (Handklaviatur der Orgel; veralt. für: Handbuch, Tagebuch) *s*; -s, -e

Ma|nu|ell (m. Vorn.); **Ma|nu|la** (w. Vorn.); vgl. Emanuel

ma|nu|ell *lat.* (mit der Hand Hand...); -e Fertigkeit (Handfertigkeit); **Ma|nu|fakt** (veralt. für: Erzeugnis menschlicher Handarbeit) *s*; -[e]s, -e; **Ma|nu|fak|tu** (veralt. für: Handarbeit; Web- u. Wirkwaren; früherer gewerblicher Großbetrieb) *w*; -, -en; **Ma|nu|fak|tur|be|trieb**; **ma|nu|fak|tu_rie|ren** (veralt. für: anfertigen verarbeiten); **Ma|nu|fak|tu|ris** (früher für: Leiter einer Manufaktur; Händler in Manufakturwaren); ↑ R 268; **Ma|nu|fak|tur_wa|ren** (Textilwaren) *Mehrz.*

Ma|nul|druck [aus der Umstellun des Namens des Erfinders Ull mann] (besonderes Druckve fahren; *Mehrz.* ...drucke)

ma|nu pro|pria *lat.* [auch: - *prǫ..* (mit eigener Hand; eigenhändig Abk.: m. p.); **Ma|nus** (österr Kurzform von: Manuskript) *s*; -; **Ma|nu|skript** *lat.* (hand- od maschinenschriftl. Ausarbe tung; Urschrift; Satzvorlage Abk.: Ms. [*Mehrz.*: Mss.] od Mskr.) *s*; -[e]s, -e; **Ma|nu skript_blatt**, ...**sei|te**

Ma|nu|ti|us [...*ziuß*] (it. Buchdruker); vgl. Aldine usw.

Man|za|nil|la *span.* [...*nilja*] (ei Südwein) *m*; -s; **Man|za|nil|l** [...*niljo*] (Stadt auf Kuba; **Man za|nil|lo|baum** [...*niljo...*] u. **Man zi|nel|la** [...*näja*] (mittelameri Wolfsmilchgewächs) *w*; -

Mao|is|mus (kommunist. Ideologie in der chin. Ausprägung von Mao Tse-tung) m; -; Mao|ist (Anhänger des Maoismus); ↑ R 268; mao|is|tisch

Mao|ri [auch: *mauri*] (Eingeborener auf Neuseeland) m; -[s], -[s]

Mao Tse-tung [auch: *mauzetung*] (chin. Staatsmann u. Schriftsteller)

Ma|pai *hebr.* (gemäßigte sozialist. Partei Israels) w; -; Ma|pam (Arbeiterpartei Israels) w; -

Mäpp|chen; Map|pe [urspr.: Landkarte] w; -, -n; Map|peur *fr.* [...*pör*] (veralt. für: Geländezeichner) m; -s, -e; map|pie|ren (veralt. für: Landkarten zeichnen)

Ma|quis *fr.* [*maki*; „Gestrüpp, Unterholz"] (fr. Widerstandsorganisation im 2. Weltkrieg) m; -

Mär, Mä|re (veralt., heute noch scherzh. für: Kunde, Nachricht; Sage) w; -, Mären

Ma|ra|bu *arab.* (ein Storchvogel) m; -s, -s; Ma|ra|but (mohammedan. Einsiedler, Heiliger) m; - od. -[e]s, - od. -s

Ma|rä|ne *slaw.* (ein Fisch) w; -, -n

ma|ran|tisch vgl. marastisch

Ma|ras|chi|no *it.* [*maraßkino*] (ein Kirschlikör) m; -s, -s

Ma|ras|mus *gr.* (Med.: Entkräftung, [Alters]schwäche) m; -; ma|ra|stisch (an Marasmus leidend, entkräftet, erschöpft); -ste (↑ R 294); vgl. marantisch

Ma|rat [...*ra*] (fr. Revolutionär)

Ma|ra|thon [auch: *mar*...] (Ort nördl. von Athen); Ma|ra|thon|lauf (↑ R 201; leichtathletischer Wettlauf über 42,2 km), ...läu|fer, ...sit|zung

Mar|bel, Mär|bel, Mar|mel, Murmel landsch. (kleine [marmorne] Kugel zum Spielen) w; -, -n

Mar|bod (markomann. König)

Marc (dt. Maler u. Graphiker)

mar|ca|to *it.* [...*kato*] (Musik: markiert, betont)

Mar|cel [*marßäl*] (fr. m. Vorn.)

¹March (l. Nebenfluß der Donau)

²March (Gebiet am Ostende des Zürichsees) w; -

³March schweiz. (Flurgrenze, Grenzzeichen) w; -, -en

Mär|chen; Mär|chen|buch, ...dich|tung, ...er|zäh|ler, ...film, ...for|schung; mär|chen|haft; Mär|chen|land, ...prinz, ...samm|lung

Mar|che|sa *it.* [...*kesa*] (w. Form von: Marchese); Mar|che|se [...*kes*ᵉ] (hoher it. Adelstitel) m; -, -n (↑ R 268)

March|feld (Ebene in Niederösterreich) s; -[e]s

March|zins schweiz. (bis zu einem Zwischentermin aufgelaufener Zins; Mehrz. ...zinsen)

Mar|ci vgl. Markus

Mar|co|ni [...*koni*] (it. Physiker)

Mar|co Po|lo [...*ko* -] (it. Reisender u. Schriftsteller)

Mar|der m; -s, -; Mar|der|fell

Mä|re vgl. Mär

Ma|ré|chal Niel vgl. Marschall-Niel-Rose

Ma|rées [*mare*] (dt. Maler)

Ma|rel|le (Nebenform von: Morelle u. Marille)

Ma|rem|men *it.* (sumpfige Küstengegend in Mittelitalien) Mehrz.; Ma|rem|men|land|schaft

mä|ren altmärkisch, mitteld. (in etwas herumwühlen; langsam sein; unüberlegt daherreden)

Ma|ren (w. Vorn.)

Ma|rend *it.* schweiz. mdal. (Marende) s; -s, -i; Ma|ren|de tirol. (Zwischenmahlzeit, Vesper) w; -, -n

Ma|ren|go [nach dem oberit. Ort] (graumelierter Kammgarnstoff) m; -[s]

Mä|re|rei [zu: mären]

Mar|ga|re|ta, Mar|ga|re|te (w. Vorn.); Mar|ga|re|ten_blu|me, ...tag

Mar|ga|ri|ne *fr.* w; -; Mar|ga|ri|ne_fa|brik, ...in|du|strie (↑ R 148), ...wür|fel

Mar|ge *fr.* [*marseh*ᵉ] (Spielraum, Spanne zwischen zwei Preisen) w; -, -n

Mar|ge|ri|te *fr.* (eine Wiesenblume) w; -, -n; Mar|ge|ri|ten_blu|me, ...strauß

Mar|ghe|ri|ta [...*ge*...] (it. Schreibung von: Margarete)

mar|gi|nal (auf dem Rand stehend; am Rande liegend; Bot.: randständig); Mar|gi|nal_be|mer|kung, ...glos|se (an den Rand der Seite geschriebene od. gedruckte Glosse [vgl. d.]); Mar|gi|na|lie [...*i*ᵉ] (Randbemerkung an der Seite einer Handschrift od. eines Buches) w; -, -n (meist Mehrz.)

Mar|git, Mar|got, Mar|grit (Kurzformen von: Margarete); Marguerite [*marg*(ᵉ)*rit*] (w. Vorn.)

Ma|ria (w. Vorn.); gelegentl. zusätzlicher m. Vorn.); Mariä (der Maria) Himmelfahrt (kath. Fest); die Himmelfahrt Mariens; vgl. Marie

Ma|ria|ge *fr.* [...*aseh*ᵉ] (König-Dame-Paar in Kartenspielen; veralt. für: Heirat, Ehe)

Ma|riä-Him|mel|fahrts-Fest (↑ R 182) s; -[e]s

Ma|ria Laach (Benediktinerabtei in der Eifel)

Ma|ria|nen (Inselgruppe im Pazifischen Ozean) Mehrz.

ma|ria|nisch [zu: Maria]; -e Frömmigkeit, aber (↑ R 224): Marianische Kongregation; Ma|ri|an|ne (w. Vorn.; scherzh. Bez. für die Französische Republik)

maria-the|re|sia|nisch; Ma|ria|the|re|si|en|ta|ler (frühere Münze)

Ma|ria|zell (Wallfahrtsort in der Steiermark)

Ma|rie (fr. Form von: Maria); Ma|rie|chen (Koseform von: Marie, Maria); Ma|rie-Lui|se, (auch:) Ma|rie|lui|se; Ma|ri|en_bild, ...dich|tung, ...kä|fer; Ma|ri|en-kir|che (↑ R 180), aber (↑ R 182): St.-Marien-Kirche, Ma|ri|en_kult, ...le|ben (Kunstwiss.), ...le|gen|de, ...tag

Ma|ri|en|wer|der (Stadt am Ostrand des Weichseltales); Ma|ri|en|wer|der|stra|ße (↑ R 219)

Ma|ri|et|ta (w. Vorn.)

Mar|i|gna|no [*marinjano*] (Schlachtort in Italien)

Ma|ri|hua|na *mexik.* [mexik. Ausspr.: ...*ehuana*; aus den Vornamen Maria u. Juana (= Johanna); vgl. Mary Jane] (ein Rauschgift) s; -s

Mu|ri|ka (w. Vorn.)

Ma|ril|le *it.* bes. österr. (Aprikose) w; -, -n; vgl. Marelle u. Morelle; Ma|ril|len|mar|me|la|de

ma|rin *lat.* (zum Meer gehörend, Meer[es]...)

Ma|ri|na (w. Vorn.)

Ma|ri|na|de *fr.* (in Würztunke od. Öl eingelegte Fische); Ma|ri|ne (Seewesen eines Staates; Flottenwesen; Kriegsflotte, Flotte) w; -, -n; Ma|ri|ne_ar|til|le|rie, ...at|ta|ché; ma|ri|ne|blau (dunkelblau); Ma|ri|ne_flie|ger, ...in|fan|te|rie, ...ma|ler, ...of|fi|zier; ¹Ma|ri|ner (ugs. scherzh. für: Matrose, Marinesoldat) m; -s, -; ²Ma|ri|ner amerik. [*märin*ᵉ*r*] (unbemannte amerik. Raumsonde zur Planetenerkundung) m; -s, -; Ma|ri|ne_sol|dat, ...sta|ti|on, stütz|punkt, ...uni|form; ma|ri|nie|ren (in Marinade einlegen)

Ma|rio|la|trie *gr.* (relig. Marienverehrung); Ma|rio|lo|gie (Vertreter der Mariologie) m; -n, -n (↑ R 268); Ma|rio|lo|gie (kath.-theol. Lehre von der Gottesmutter); ma|rio|lo|gisch

Ma|ri|on (fr. w. Vorn.); Ma|rio|net|te (fr. Vorn.); Ma|rio|net|te (Gliederpuppe; willenloser Mensch als Werkzeug anderer) w; -, -n; Ma|rio|net|ten|büh|ne; ma|rio|net|ten|haft; Ma|rio|net|ten_re|gie|rung, ...spiel, ...thea|ter

Ma|ri|otte [...*riot*] (fr. Physiker); -sches Gesetz

Ma|rist [zu: Maria] (Angehöriger einer kath. Missionskongregation); ↑ R 268

Ma|ri|ta (w. Vorn.)

ma|ri|tim *lat.* (das Meer, das Seewesen betreffend; Meer[es]..., See...); -es Klima

Ma|ri|us (röm. Feldherr u. Staatsmann)

¹Mark (Währungseinheit; Abk.: M) *w;* -, *Mehrz.:* - u. Markstücke (ugs. scherzh.: Märker); 4 - (↑ R 322); BRD: Deutsche Mark (Abk.: DM); DDR: Mark der Deutschen Demokratischen Republik (Abk.: M). Über die Schreibung der Dezimalstellen ↑ R 324; vgl. Hundertmarkschein

²Mark (Grenzland) *w;* -, -en; die - Brandenburg

³Mark (Med., Bot.; übertr.: Inneres, das Beste einer Sache) *s;* -[e]s

⁴Mark (m. Vorn.)

mar|kant *fr.* (bezeichnend; auffallend; ausgeprägt; scharf geschnitten [von Gesichtszügen])

Mar|ka|sit *arab.* (ein Mineral) *m;* -s, -e

Mark Au|rel (röm. Kaiser)

mark|durch|drin|gend

Mar|ke (Zeichen; Handels-, Waren-, Wertzeichen) *w;* -, -n; 4 - (↑ R 322); Deutsche Mark österr. ([Namens]zeichen) *w;* -, -n; mär|ken österr. (mit einer Märke versehen); Mar|ken_ar|ti|kel, ...block (*Mehrz.* ...blocks), ...but|ter, ...er|zeug|nis, ...fa|bri|kat, ...samm|ler, ...schutz, ...wa|re

Mär|ker (Bewohner der ²Mark)

mark|er|schüt|ternd

Mar|ke|ten|der *it.* (früher: Händler bei der Feldtruppe) *m;* -s, -; Mar|ke|ten|de|rei; Mar|ke|ten|de|rin *w;* -, -nen; Mar|ke|ten|der_wa|gen, ...wa|re

Mar|ke|te|rie *fr.* (Einlegearbeit [von farbigem Holz usw.]) *w;* -, ...ien

Mar|ke|ting *engl.* [*mạ'k^e*...] (Wirtsch.: Ausrichtung der Teilbereiche eines Unternehmens auf das absatzpolit. Ziel u. die Verbesserung der Absatzmöglichkeiten) *s;* -s

Mark_graf (hist. für: Verwalter einer ²Mark), ...grä|fin (hist.); Mark|gräf|ler (oberbad. Wein) *m;* -s; mark|gräf|lich; Mark|graf|schaft (hist.)

mar|kie|ren *fr.* (be-, kennzeichnen; eine Rolle o. ä. [bei der Probe] nur andeuten; österr.: Fahrkarte entwerten, stempeln; ugs. für: vortäuschen; so tun, als ob); Mar|kier|ham|mer (Forstw.); Mar|kie|rung; Mar|kie|rungs_li|nie, ...punkt

mar|kig; Mar|kig|keit *w;* -

mär|kisch (aus der ²Mark stammend, sie betreffend); -e Heimat, aber (↑ R 224): das Märkische Museum

Mar|ki|se *fr.* ([leinenes] Sonnendach, Schutzdach, -vorhang) *w;* -, -n; vgl. aber: Marquise; Mar|ki|sen|drell

Markka *germ.-finn.* (svw. Finnmark; Abk.: mk) *w;* -, Markkaa; zehn Markkaa

Mark|kno|chen; mark|los

Mar|ko (m. Vorn.)

Mar|ko|brun|ner (ein Rheinwein)

¹Mar|kolf ("Grenzwolf"; mdal. für: Häher) *m;* -[e]s, -e

¹Mar|kolf (m. Vorn.)

Mar|ko|man|ne (Angehöriger eines germ. Volksstammes) *m;* -n, -n (↑ R 268)

Mar|kör *fr.* (Aufseher, Punktezähler beim Billardspiel; Landw.: Gerät zur Anzeichnung der Reihen, in denen angepflanzt oder ausgesät wird, Furchenzieher; österr. veralt. auch für: Kellner) *m;* -s, -e

Mark|ran|städt (Stadt südwestl. von Leipzig)

Mark|schei|de (Grubenfeldgrenze); Mark|schei|de_kun|de (*w;* -), ...kunst (Bergmannsspr.: Vermessung, Darstellung der Lagerungs- u. Abbauverhältnisse; *w;* -); Mark|schei|der (Vermesser im Bergbau); mark|schei|de|risch

Mark|stein

Mark|stück; mark|stück|groß; vgl. fünfmarkstückgroß

Markt *m;* -[e]s, Märkte; zu -e tragen; Markt_ab|spra|che, ...ana|ly|se, ...an|teil; markt|be|herr|schend; Markt_be|richt, ...brun|nen, ...bu|de, ...chan|ce; mark|ten (abhandeln, feilschen); Markt_fah|rer (österr. Wanderhändler), ...flecken [*Trenn.:* ...flek|ken], ...for|schung, ...frau; markt|gän|gig; Markt_hal|le, ...la|ge

Markt|ober|dorf (Stadt im Allgäu)

Markt_ord|nung, ...ort (*m;* -[e]s, -e), ...platz, ...preis (vgl. ²Preis), ...psy|cho|lo|gie, ...recht, ...schrei|er; markt|schreie|risch; -ste (↑ R 294); Markt|tag

Mark Twain [- *twẹ'n*] (amerik. Schriftsteller)

Markt_weib, ...wert, ...wirt|schaft (Wirtschaftssystem mit freiem Wettbewerb); freie -; soziale -

Mar|kung (veralt. für: Grenze)

Mar|kus (Evangelist; röm. m. Vorn. [Abk.: M.]); Evangelium Marci [...*zi*] (des Markus); Mar|kus|kir|che (↑ R 180)

Mark|ward (m. Vorn.)

Marl|bo|rough [*mạlb^e ro*] (engl. Feldherr u. Staatsmann)

Mär|lein (veralt. für: Märchen)

Mar|le|ne (w. Vorn.)

Mar|lies, Mar|lis (w. Vorn.)

Mar|lowe [...*lo*] (engl. Dramatiker)

Mar|ma|ra_meer *s;* -[e]s

¹Mar|mel vgl. Marbel; ²Mar|mel *lat.* (veralt. für: Marmor) *m;* -s, -

Mar|me|la|de *port.* (Obst-, Fruchtmus) *w;* -, -n; Mar|me|la|de[n]_ei|mer, ...glas (*Mehrz.* ...gläser), ...in|du|strie, ...re|zept

mar|meln *lat.* landsch. (mit Marmeln spielen); ich ...[e]le (↑ R 327); Mar|mel|stein (veralt. für: Marmor); Mar|mor (Gesteinsart) *m;* -s, -e; mar|mor_ar|tig; Mar|mor_block (*Mehrz.* ...blökke), ...bü|ste; mar|mo|rie|ren (marmorartig bemalen, ädern); Mar|mor_ku|chen; mar|morn (aus Marmor); Mar|mor_plat|te, ...säu|le, ...sta|tue, ...tisch, ...treppe

Mar|ne [*mạrn^e*, fr. Ausspr.: *mạrn*] (fr. Fluß) *w;* -

Ma|ro|cain *fr.* [...*käng*] (feingerippter Kleiderstoff) *m;* -s, -s

ma|rod österr. ugs. (leicht krank); ma|ro|de *fr.* (urspr. Soldatenspr. für: marschunfähig; heute veralt., aber noch mdal. für: ermattet, erschöpft); Ma|ro|deur [...*dör*] (plündernder Nachzügler) *m;* -s, -e; ma|ro|die|ren

Ma|rok|ka|ner; ma|rok|ka|nisch; Ma|rok|ko (Staat in Nordwestafrika)

¹Ma|ro|ne *fr.* (geröstete eßbare Kastanie) *w;* -, -n u. ...ni; ²Ma|ro|ne (ein Pilz) *w;* -, -n; Ma|ro|nen_pilz; Ma|ro|ni bes. österr. (svw. ¹Marone) *w;* -, -; Ma|ro|ni_bra|ter

Ma|ro|nit [nach dem hl. Maro] (Angehöriger der mit Rom unierten syrischen Christen im Libanon) *m;* -en, -en (↑ R 268); ma|ro|ni|tisch; -e Liturgie

Ma|ro|quin *fr.* [...*käng*] (Ziegenleder ["aus Marokko"]) *m* (auch: *s*); -s

Ma|rot|te *hebr.* (Schrulle, wunderliche Neigung, Grille) *w;* -, -n

Mar|quart|stein (Ort in den Chiemgauer Alpen)

Mar|quis *fr.* [...*ki*] ("Markgraf"; fr. Titel) *m;* - [...*ki(ß)*], - [...*kiß*]; Mar|qui|sat (Würde, Gebiet eines Marquis) *s;* -[e]s, -e; Mar|qui|se ("Markgräfin"; fr. Titel) *w;* -, -n; vgl. aber: Markise; Mar|qui|set|te (Gardinengewebe) *w;* - (auch: *m;* -s)

¹Mars (röm. Kriegsgott); ²Mars (ein Planet) *m;* -

³Mars *niederd.* (Seemannsspr.: Plattform zur Führung u. Befestigung der Marsstenge) *m;* -, -e

¹Mar|sa|la (it. Stadt); ²Mar|sa|la (ein Süßwein) *m;* -s, -s; Mar|sa|la|wein (↑ R 201)

Mars|be|woh|ner
narsch!; marsch, marsch!; vorwärts marsch!; [1]Marsch m; -[e]s, Märsche

[1]Marsch (vor Küsten angeschwemmter fruchtbarer Boden) w; -, -en

Mar|schall („Pferdeknecht"; hohe milit. Würde; Haushofmeister) m; -s, ...schälle; Mar|schall-Niel-Ro|se [...nißl... meist; ...nil...; nach dem fr. Marschall Niel] (eine Rose); ↑ R 182; Mar|schall[s]|.stab, ...würde (w; -)

Marsch|be|fehl; marsch|be|reit; Marsch..be|reit|schaft (w; -), ..s|block (Mehrz. ...blocks)

Marsch|bu|den, Mar|schen|dorf

narsch|fer|tig; Marsch|ge|päck; mar|schie|ren; Marsch|ko|lon|ne, ...kom|paß

Marsch|land (svw. [2]Marsch; Mehrz. ...länder)

Marsch|lied; marsch|mäßig; Marsch..mu|sik, ...ord|nung, ...rich|tung, ...rou|te, ...stie|fel, ...tritt, ...ver|pfle|gung, ...ziel

Mar|seil|lai|se [marßäjäs⁴] (fr. Revolutionslied, dann Nationalhymne) w; -; Mar|seille [...ßäj] (fr. Stadt); Mar|seil|ler [...ßäj⁴r] (↑ R 199)

Mars|feld (im alten Rom; Übungsfeld; großer Platz in Paris) s; -[e]s

Mar|shall|in|seln [ma'sch⁴l...]; ↑ R 210 (Inseln im Pazifischen Ozean) Mehrz.

Mar|shall|plan [ma'sch⁴l..., auch: marschal...; nach dem amerik. Außenminister G. C. Marshall]; ↑ R 180 (amerik. Hilfsprogramm für Europa nach dem 2. Weltkrieg) m; -[e]s

Mars..mensch, ...ober|flä|che, ..son|de

Mars|sten|ge (Seemannsspr.: erste Verlängerung des Mastes)

Mar|stall („Pferdestall"; Pferdehaltung eines Fürsten u. a.) m; -[e]s, ...ställe

Mar|sy|as (altgr. Meister des Flötenspiels)

Mar|ta vgl. Martha

Mär|te obersächs. (Mischmasch; Kaltschale) w; -, -n

Mar|ter w; -, -n; Mar|ter|in|stru|ment; Mar|terl bayr. u. österr. Tafel mit Bild und Inschrift zur Erinnerung an Verunglückte; Holz- od. Steinpfeiler mit Nische od. Kruzifix od. Heiligenbild) s; s, -n; mar|tern; ich ...ere (↑ R 327); Mar|ter..pfahl, ...tod; Mar|e|rung; mar|ter|voll; Mar|ter|werk|zeug

Mar|tha; ↑ R 190 (w. Vorn.); Mar|tha, (ökum.:) Mar|ta (bibl. w. Eigenn.); Mar|tha|haus (Ein-

richtung der Inneren Mission); Marth|chen (Koseform von: Martha)

mar|tia|lisch lat. [...zi...] (kriegerisch; grimmig; verwegen); -ste (↑ R 294) [1]Mar|tin (m. Vorn.)

[2]Mar|tin [martäng], Frank (schweiz. Komponist)

Mar|ti|na (w. Vorn.)

Mar|tin|gal engl. [ma'tingge'l; auch dt. Ausspr.] (zwischen den Vorderbeinen des Pferdes durchlaufender Sprungzügel) s; -s, -e u. -s

Mar|tin-Horn Ⓦ vgl. Martinshorn

Mar|ti|ni (Martinstag) s; -

Mar|ti|nique [...nik] (Insel der Kleinen Antillen)

Mar|tins..gans, ...horn (als Ⓦ: Martin-Horn; Mehrz. ...hörner), ...tag (11. Nov.); Mar|tins|wand (Felswand über dem Inntal) w; -

Mar|tin|ver|fah|ren [nach dem fr. Erfinder]; ↑ R 180 (Verfahren zur Erzeugung von Stahl) s; -s

Mär|ty|rer¹ gr. (Blutzeuge, Glaubensheld) m; -s, -; Mär|ty|[re]|rin¹ w; -, -nen; Mär|ty|rer.kro|ne, ...tod, ...tum (s; -s); Mar|ty|ri|um (Opfertod, schweres Leiden [um des Glaubens od. der Überzeugung willen]) s; -s, ...ien [...i⁴n]; Mar|ty|ro|lo|gi|um (liturg. Buch mit Verzeichnis der Märtyrer u. Heiligen u. ihrer Feste) s; -s, ...ien [...i⁴n]

Ma|run|ke ostmitteld. (Pflaume) w; -, -n

Marx, Karl (Begründer der nach ihm benannten Lehre vom Sozialismus); Mar|xis|mus (die von Marx u. Engels begründete Theorie des Sozialismus) m; -; Mar|xis|mus-Le|ni|nis|mus (in den kommunist. Ländern gebräuchl. Bez. für die kommunist. Ideologie nach Marx, Engels u. Lenin) m; -; Mar|xist (↑ R 268); Mar|xi|stin w; -, -nen; mar|xi|stisch; Mar|xist-Le|ni|nist (↑ R 268); Mar|xsch (von Karl Marx stammend); ↑ R 179; die Marxsche Philosophie

Ma|ry [märi] (engl. Form von: Marie); Mary Jane (Marihuana [vgl. d.]); Ma|ry|land [märiländ] (Staat der USA; Abk.: Md.)

März lat. [nach dem röm. Kriegsgott Mars] (dritter Monat im Jahr, Lenzing, Lenzmond, Frühlingsmonat) m; -[es] (↑ R 319; dicht. auch noch: -en), -e; März|be|cher, Mär|zen|be|cher (Name verschiedener Pflanzen); Mär|zen|bier, Mär|zen|bier; März|feld

¹ Kath. kirchl. auch: Mar|tyrer usw.

(merowing. Wehrmännerversammlung; s; -[e]s), ...ge|fal|le|ne (m; -n, -n; ↑ R 287 ff.), ...glöck|chen (eine Frühlingsblume)

Mar|zi|pan arab. [auch, österr. nur: mar...] (Süßware aus Mandeln u. Zucker) s (österr., sonst selten: m); -s, -e; Mar|zi|pan.ei, ...kar|tof|fel, ...schwein|chen

märz|lich; März..nacht, ...re|vo|lu|ti|on (1848), ...son|ne, ...veil|chen

Ma|sai [auch: maß...] vgl. Massai

Ma|sa|ryk [...rik] (tschechoslowak. Soziologe u. Staatsmann)

Mas|ca|gni [...kanji] (it. Komponist)

Ma|schans|ker tschech. österr. (Dorsdorfer Apfel) m; s.

Ma|sche (Schlinge; österr. auch für: Schleife; ugs. für: großartige Sache; Lösung; Trick) w; -, -n; das ist die neu[e]ste -

Ma|schek|sei|te vgl. Maschikseite

Ma|schen|draht (Drahtgeflecht), ...in|du|strie (Gesamtheit der Strickereien u. Wirkereien), ...mo|de, ...netz, ...pan|zer, ...ware, ...werk, ...zahl; Ma|scherl österr. (Schleife) s; -s, -n; ma|schig

Ma|schik|sei|te, Ma|schek|sei|te ung. ostösterr. (entgegengesetzte Seite, Rückseite)

Ma|schi|ne fr. w; -, -n; ma|schi|nell (maschinenmäßig [hergestellt]); Ma|schi|nen.bau (m; -[e]s), ...fa|brik, ...ge|wehr (Abk.: MG), ...haus; ma|schi|nen|mä|ßig; Ma|schi|nen.mei|ster, ...mo|dell, ...nä|he|rin, ...öl, ...pi|sto|le, ...re|vi|si|on (Druckw.: Überprüfung der Druckbogen vor Druckbeginn), ...satz (zwei miteinander starr gekoppelte Maschinen; Druckw.: mit der Setzmaschine hergestellter Schriftsatz; m; -es), ...scha|den, ...set|zer (Druckw.), ...schlos|ser; Ma|schi|ne[n]-schrei|ben (Abk.: Masch.-Schr.; s; -s), ...schrei|ber, ...schrei|be|rin; Ma|schi|nen.schrift, ...te|le|graf; Ma|schi|nen-Trak|to|ren-Sta|ti|on; ↑ R 155 (DDR; Abk.: MTS); Ma|schi|nen.wär|ter, ...zeit|al|ter; Ma|schi|ne|rie (maschinelle Einrichtung; Getriebe) w; -, ...ien; ma|schi|ne|schrei|ben (↑ R 140); ich schreibe Maschine; ich habe maschinegeschrieben; ma|schi|ne|schrei|ben österr. (Maschinenmeister); ↑ R 268; ma|schin|schrei|ben österr. (maschineschreiben); Ma|schin-schrei|ben (österr.) s; -s; Ma|schin|schrei|ber (österr.); ma|schin|schrift|lich (österr.); Masch.-Schr. = Maschine[n]-schreiben (↑ R 154)

[1]Ma|ser engl. [meist: me'ß⁴r] (Phy-

sik: Gerät zur Verstärkung oder
Erzeugung von Mikrowellen m;
-s, -

²Ma|ser (Zeichnung [im Holz];
Narbe) w; -, -n

Ma|se|reel, Frans [maß°rél] (belg.
Graphiker u. Maler)

Ma|ser|holz; ma|se|rig; ma|sern;
ich ...ere (↑ R 327); Ma|sern (eine
Kinderkrankheit) Mehrz.; Ma-
se|rung (Zeichnung des Holzes)

Ma|set|te it. österr. (Eintrittskar-
tenblock) w; -, -n

Mas|ka|rill span. (span. Lustspiel-
gestalt) m; -[s], -e

Mas|ka|ron fr. (Baukunst: Men-
schen- od. Fratzengesicht) m; -s,
-e

Mas|kat und Oman (unabhängi-
ges Sultanat im Osten der Arab.
Halbinsel)

Mas|ke fr. (künstl. Hohlgesichts-
form; Verkleidung; kostümierte
Person) w; -, -n; Mas|ken|ball,
...bild|ner; mas|ken|haft; Mas-
ken|ko|stüm, ...spiel; Mas|ke|ra-
de span. (Verkleidung; Masken-
fest; Mummenschanz); mas|kie-
ren fr. ([mit einer Maske] un-
kenntlich machen; verkleiden;
verbergen, verdecken); sich -;
Mas|kie|rung

Mas|kott|chen fr. (glückbringen-
der Talisman, Anhänger; Puppe
u. a. [als Amulett]); Mas|kott|e
w; -, -n

mas|ku|lin [auch: ma...] lat.
(männlich); mas|ku|li|nisch (älter
für: maskulin); Mas|ku|li|num
[auch: ma...] (Sprachw.: männ-
liches Hauptwort, z. B. „der Wa-
gen") s; -s, ...na

Ma|so|chis|mus [...ehiß..; nach
dem Österr. Schriftsteller Sacher-
Masoch]) (geschlechtl. Erregung
durch Erdulden von Mißhand-
lungen) m; -; Ma|so|chist (↑ R
268); ma|so|chi|stisch

Ma|so|wi|en [...i°n] (hist. Gebiet
beiderseits der Weichsel um War-
schau)

¹Maß [zu: messen] s; -es, -e; - neh-
men, aber (↑ R 120): das Maß-
nehmen; vgl. maßhalten; ²Maß
bayr., österr. u. schweiz. (ein
Flüssigkeitsmaß) w; -, -[e]; 2 Maß
Bier (↑ R 321 u. 322)

Mass. = Massachusetts

Mas|sa|chu|setts [mäß'tschu...]
(Staat in den USA; Abk.: Mass.)

Mas|sa|ge fr. [...aseh°] (Kneten;
Knetkur); Mas|sa|ge|in|sti|tut,
...sa|lon

Mas|sai ([auch: mas...] (Angehöri-
ger eines Nomadenvolkes in
Ostafrika) m; -, -

Mas|sa|ker fr. (Gemetzel) s; -s, -;
mas|sa|krie|ren (niedermetzeln);
Mas|sa|krie|rung

Maß|ana|ly|se; maß|ana|ly|tisch;
Maß|an|ga|be, ...an|zug, ...ar|beit

Mas|saua [auch it. Ausspr.: maßa-
ua] (Stadt in Äthiopien)

Maß|be|zeich|nung; Maß|chen,
Mäß|lein (altes Hohlmaß); Ma-
ße (veralt. für: Mäßigkeit; Art u.
Weise) w; -, -n; vgl. Maßen

Mas|se w; -, -n; Mas|se|gläu|bi|ger
Mehrz.

Maß|ein|heit, ...ein|tei|lung

¹Mas|sel jidd. (Gaunersprache:
Glück) m; -s

²Mas|sel (Form für Roheisen;
Roheisenbarren) w; -, -n

maßen (veralt. für: weil); Ma|ßen
(vgl. Maße); in, mit, ohne -; über
die -; über alle -; ...ma|ßen (z.
B. einigermaßen)

Mas|sen|ab|satz, ...an|drang, ...ar-
beits|lo|sig|keit, ...ar|ti|kel, ...auf-
ge|bot, ...be|darf, ...ent|las|sung,
...fa|bri|ka|ti|on, ...ge|sell|schaft,
...grab; mas|sen|haft; Mas|sen-
kund|ge|bung, ...me|di|um (meist
Mehrz.), ...mord, ...mör|der, ...or-
ga|ni|sa|ti|on, ...pro|duk|ti|on (w;
-), ...quar|tier, ...ster|ben (s; -s),
...tou|ris|mus, ...ver|kehrs|mit|tel
s, ...ver|nich|tungs|mit|tel s, ...ver-
samm|lung; mas|sen|wei|se; Mas-
se|schul|den Mehrz.

Mas|seur fr. [...ßör] (die Massage
Ausübender) m; -s, -e; Mas|seu-
rin [...ßör...] (bes. österr.) w; -,
-nen, (sonst meist:) Mas|seu|se
[...ßös°] w; -, -n

Maß|ga|be (Amtsdt. für: Bestim-
mung) w; -; mit der -; nach - (ent-
sprechend); maß|ge|bend, -ste;
maß|geb|lich; maß|ge|schnei|dert;
maß|hal|ten (↑ R 140); er hält
maß; ... daß er maßhält; maßge-
halten; maßzuhalten; aber: das
rechte Maß halten (↑ R 145:)
maß- u. Disziplin halten, aber:
Disziplin u. maßhalten; maß|hal-
tend, aber (↑ R 142): rechtes Maß
haltend; maß|hal|tig (Technik:
das erforderliche Maß einhal-
tend); Maß|hal|tig|keit w; -

Maß|hol|der (Feldahorn) m; -s, -

¹mas|sie|ren fr. (Truppen zusam-
menziehen)

²mas|sie|ren fr. (Massage ausüben,
kneten)

Mas|sie|rung [zu: ¹massieren]

mä|ßig; ...mä|ßig (z. B. behelfsmä-
ßig)

mas|sig

mä|ßi|gen; sich -; Mä|ßig|keit w;-;
Mä|ßig|keit w; -

Mä|ßi|gung

mas|siv fr. (schwer; voll [nicht
hohl]; fest, dauerhaft; roh, grob);
Mas|siv (Gebirgsstock) s; -s, -e
[...w°]; Mas|siv|bau (Mehrz.
...bauten); Mas|siv|bau|wei|se;
Mas|si|vi|tät w; -

Maß|kon|fek|ti|on, ...krug; maß-
lei|dig bayr. u. alemann. (ver-
drossen); Mäß|lein vgl. Mäßchen

Maß|lieb niederl. [auch: ...lip] (eine
Blume) s; -[e]s, -e; Maß|lieb-
chen [auch: ...lip...]

maß|los, -este (↑ R 292); Maß|lo-
sig|keit; Maß|nah|me w; -, -n;
Maß|neh|men s; -s; vgl. Maß

Mas|so|ra hebr. ([jüd.] Textkritik
des A. T.) w; -; Mas|so|ret (mit
der Massora beschäftigter jüd.
Schriftgelehrter u. Textkritiker)
m; -en, -en (↑ R 268); mas|so|re-
tisch

Maß|re|gel; maß|re|geln; ich ...[e]le
(↑ R 327); gemaßregelt; zu -; Maß-
re|ge|lung, Maß|reg|lung; Maß-
sa|chen (ugs.; Mehrz.), ...schnei-
der, ...stab; maß|stäb|lich; ...maß-
stäb|lich, (gelegentlich auch:)
...maß|stä|big (z. B. großmaß-
stäblich, (gelegentl. auch:) groß-
maßstäbig); maß|stab[s]-ge-
recht, ...ge|treu; maß|voll; Maß-
werk s; -[e]s

¹Mast (Mastbaum) m; -[e]s, -er
(auch: -e)

²Mast (Mästung) w; -, -en

Ma|sta|ba arab. (altägypt. Grab-
kammer) w; -, -s u. ...staben

Mast|baum

Mast|darm; Mast|darm|fi|stel
mä|sten; Mast|en|te

Ma|sten|wald

Ma|ster engl. („Meister"; engl.
Anrede an junge Leute; akadem.
Grad in England u. in den USA
Leiter bei Parforcejagden) m; -s
-; - of Arts (engl. u. amerik. aka
dem. Würde; Abk.: M. A.)
...ma|ster (z. B. Dreimaster)

Mä|ster; Mä|ste|rei; Mast|fut|te
(vgl. ¹Futter), ...gans, ...huhn; ma
stig landsch. (fett, feist; auch
feucht [von Wiesen])

Ma|sti|ka|tor lat. (Fleisch
zerkleinerungszange; Knetma
schine) m; -s, ...oren; Ma|stix (ei
Harz) m; -[es]

Mast|korb

Mast|kur, ...och|se

Mast|odon gr. (ausgestorben
Elefantenart) s; -s, ...donten

Mast|schwein

Mast|spit|ze

Mä|stung

Ma|stur|ba|ti|on lat. [...zion] (ge
schlechtl. Selbstbefriedigung
ma|stur|bie|ren

Mast|vieh

Ma|su|re (Bewohner Masuren
m; -n, -n (↑ R 268); Ma|su|re
(Landschaft im südl. Ostpre
ßen); ma|su|risch, aber (↑ R 198
die Masurischen Seen; Ma|sur|k
vgl. Mazurka

Ma|sut russ. (ein Kesselheizmitte
s; -[e]s

Ma|ta|dor *span.* (Hauptkämpfer im Stierkampf; hervorragender Mann; Hauptkerl) *m*; -s, -e

Match *engl.* [*mätsch*] (Wettkampf, -spiel) *s* (auch: *m*); -[e]s, -s (auch: -e); Match.ball [*mätsch...*] (spielentscheidender Ball [Aufschlag] beim Tennis), ...beu|tel, ...sack, ...stra|fe (Feldverweis für die gesamte Spieldauer beim Eishockey)

[1]Ma|te *indian.* (ein Tee) *m*; -; [2]Ma|te (südamerik. Stechpalmengewächs, Teepflanze) *w*; -, -n; Ma|te.baum, ...blatt

Ma|ter *lat.* (Druckw.: Papptafel mit negativer Prägung eines Schriftsatzes; Matrize; Med.: die das Hirn einhüllende Haut) *w*; -, -n; Ma|ter do|lo|ro|sa („schmerzensreiche Mutter" [Maria]) *w*; - -

ma|te|ri|al *lat.* (stofflich, inhaltlich, sachlich); -e Ethik; Ma|te|ri|al *s*; -s, ...ien [...*i*ᵉ*n*]; Ma|te|ri|al|be|darf, ...be|schaf|fung, ...ein|spa|rung, ...feh|ler; Ma|te|ri|al|i|en|samm|lung, Ma|te|ri|al|samm|lung; Ma|te|ria|li|sa|ti|on [...*zion*] (im Spiritismus: Entwicklung körperhafter Gebilde in Abhängigkeit von einem Medium); ma|te|ria|li|sie|ren; sich -; Ma|te|ria|lis|mus (philos. Anschauung, die alles Wirkliche auf Kräfte od. Bedingungen der Materie zurückführt; Streben nach bloßem Lebensgenuß) *m*; -; Ma|te|ria|list (↑ R 268); ma|te|ria|li|stisch; -ste (↑ R 294); Ma|te|ri|al|ko|sten (*Mehrz.*), ...man|gel, ...prü|fung; Ma|te|ri|al|samm|lung, Ma|te|ria|li|en|samm|lung; Ma|te|ri|al|schlacht, ...wa|re (veralt. für: Haushaltware; Droge; Farbware; meist *Mehrz.*); Ma|te|ri|al|wa|ren|händ|ler (veralt.); Ma|te|rie [...*i*ᵉ] (Philos.: Urstoff; die außerhalb unseres Bewußtseins vorhandene Wirklichkeit) *w*; -, (für Stoff; Inhalt: Gegenstand [einer Untersuchung] auch *Mehrz.*:) -n; ma|te|ri|ell *fr.* (stofflich, körperlich; sachlich; handgreiflich greifbar; auf Gewinn eingestellt; genußsüchtig)

ma|tern *lat.* (von einem Satz Matern herstellen); ich ...ere (↑ R 327); [2]ma|tern (Med.: mütterlich); Ma|ter|ni|tät (Med.: Mutterschaft)

Ma|te|tee

Math. = Mathematik

Mathe (Schülerspr. für: Mathematik) *w*; -; Ma|the|ma|tik *gr.* [österr. ...*matik*] (Wissenschaft von den Raum- u. Zahlengrößen; Abk.: Math.) *w*; -; Ma|the|ma|ti|ker; ma|the|ma|tisch; -e Logik

(vgl. [1]Logistik); -er Zweig; ma|the|ma|ti|sie|ren

Mat|hil|de; ↑ R 191 (w. Vorn.); vgl. Mechthild[e]

Mai|ti|nee *fr.* [auch: *mą...*] (künstler. Morgenunterhaltung, Morgenfeier; Frühvorstellung) *w*; -, ...een

Ma|tisse [...*tiß*] (fr. Maler u. Graphiker)

Mat|jes|he|ring *niederl.\ dt.* (junger Hering)

Ma|trat|ze (Bettpolster; Sprungmatte beim Turnen; Uferabdeckung aus Weidengeflecht) *w*; -, -n

Mä|tres|se *fr.* (Geliebte [eines Fürsten] *w*; -, -n; Ma|tres|sen|wirtschaft *w*; -

ma|tri|ar|cha|lisch *lat.*; *gr.* (das Matriarchat betreffend); Ma|tri|ar|chat (Mutterherrschaft, Mutterrecht) *s*; -[e]s, -e; Ma|tri|kel *lat.* (Verzeichnis; österr. für: Personenstandsregister) *w*; -, -n; Ma|trix (Math.: geordnetes Schema von Werten, für das bestimmte Rechenregeln gelten; Med.: Mutterboden) *w*; -, Matrizes und Matrizen; Ma|tri|ze *fr.* (bei der Setzmaschine Hohlform [zur Aufnahme der Patrize]; die von einem Druckstock zur Anfertigung eines Galvanos hergestellte [Wachs]form) *w*; -, -n; Ma|tri|zen|rand; Ma|tro|ne *lat.* (ältere, ehrwürdige Frau, Greisin) *w*; -, -n; ma|tro|nen|haft

Ma|tro|se *niederl.* *m*; -n, -n (↑ R 268); Ma|tro|sen.an|zug, ...blu|se, ...kra|gen, ...müt|ze, ...schen|ke, ...uni|form

matsch *it.* (ugs. für: völlig verloren; schlapp, erschöpft); - sein; jmdn. - machen (Sport: vollständig schlagen); [1]Matsch (gänzlicher Verlust des Spieles) *m*; -[e]s, -e

[2]Matsch (ugs. für: weiche Masse; nasser Straßenschmutz) *m*; -[e]s; mat|schen (ugs.); du matschst (matschest); mat|schig (ugs.)

matsch|kern ostösterr. ugs. (schimpfen, maulen)

Matsch-und-Schnee-Reifen (Abk.: M-und-S-Reifen); ↑ R 155; Matsch|wet|ter

matt *arab.* (schwach; kraftlos; glanzlos); -er, -este (↑ R 292); jmdn. - setzen (kampf-, handlungsunfähig machen); Schach und -!; mattblau u. a.; Matt *s*; -s, -s

Mat|tä|us vgl. Matthäus

[1]Mat|te (Decke, Unterlage; Bodenbelag; mitteld. *Einz.* für: Quark) *w*; -, -n

[2]Mat|te (dicht.: Weide [in den Hochalpen]; schweiz. für: Wiese) *w*; -, -n

Mat|ter|horn (Berg in den Walliser Alpen) *s*; -[e]s

Matt.glas, ...gold; matt|gol|den; -er Schmuck

Mat|thäi vgl. Matthäus; Mat|thä|us, (ökum.:) Mat|tä|us (Apostel u. Evangelist; Evangelium Matthäi (des Matthäus); Matthäi am letzten sein [mit Bezug auf das letzte Kapitel des Matthäusevangeliums] (ugs für: zu Ende sein); Mat|thä|us|pas|si|on (Vertonung der Leidensgeschichte Christi nach Matthäus)

Matt|heit *w*; -; matt|her|zig; Matt|her|zig|keit *w*; -

[1]Mat|thi|as (m. Vorn.); [2]Mat|thi|as, (ökum..) Mat|ti|as (bibl. m. Eigenn.)

mat|tie|ren *fr.* (matt, glanzlos machen); Mat|tie|rung; Mat|tig|keit *w*; -; Matt|schei|be; - haben (übertr. ugs. für: begriffsstutzig, benommen, benebelt sein)

Ma|tur, Ma|tu|rum *lat.* (Reife-, Schlußprüfung) *s*; -s (schweiz.: Ma|tur *w*; -); Ma|tu|ra österr. u. schweiz. (Reifeprüfung) *w*; -; Ma|tu|rand (veralt. für: Abiturient) *m*; -en, -en (↑ R 268); Ma|tu|rant österr. (Abiturient) *m*; -en, -en (↑ R 268); ma|tu|rie|ren (österr., sonst veralt. für: die Reifeprüfung ablegen); Ma|tu|ri|tas prae|cox [- *präkokß*] (Med., Psych.: [sexuelle] Frühreife) *w*; - -; Ma|tu|ri|tät (veralt. für: Reife; schweiz. für: Hochschulreife) *w*; -; Ma|tu|ri|täts.prü|fung, ...zeug|nis; Ma|tu|rum vgl. Matur

Ma|tu|tin *lat.* (nächtliches Stundengebet) *w*; -, -e[n]

Matz (scherzh.; meist in Zusammensetzungen, z. B. Hosenmatz) *m*; -es, -e u. Mätze; Mätz|chen; - machen (ugs. für: Ausflüchte machen, sich sträuben)

Mat|ze *hebr.* *w*; -, -n u. Mat|zen (ungesäuertes Passahbrot der Juden) *m*; -s, -

mau (ugs. für: schlecht; dürftig), nur in: das ist -; mir ist -

Maud *engl.* [*mąd*] (Kurzform von: Magdalena, Mathilde)

Mau|er *w*; -, -n; Mau|er|ar|beit, Mau|rer|ar|beit; Mau|er.as|sel, ...blüm|chen (Mädchen, das auf Bällen usw. nicht od. wenig zum Tanzen aufgefordert wird); Maue|rei, Mau|re|rei (Mauern) *w*; -; mau|er|fest; Mau|er|ha|ken; Mau|er|kel|le, Mau|rer|kel|le; Mau|er.kro|ne, ...loch; Mau|er|mei|ster, Mau|rer|mei|ster; mau|ern; ich ...ere (↑ R 327); Mau|er|po|lier, Mau|rer|po|lier (Vorarbeiter); Mau|er.rit|ze, ...seg|ler (ein Vogel); Maue|rung; Mau|er.vor|sprung, ...werk

Maugham [mǫm] (engl. Schriftsteller)

Mau|ke (Hauterkrankung bei Tieren) w; -

Maul s; -[e]s, Mäuler; **Maul|af|fen** Mehrz.; - feilhalten (ugs. für: mit offenem Mund dastehen u. nichts tun)

Maul|beer|baum; Maul|bee|re; Maul|beer|sei|den|spin|ner

Mäul|chen (kleiner Mund) s; -s, - u. Mäulerchen; **mau|len** (ugs. für: murren, schmollen, widersprechen)

Maul|esel (Kreuzung aus Pferdehengst u. Eselstute)

maul|faul (ugs.); **Maul|held** (ugs.); **...mäu|lig** (z. B. hartmäulig)

Maul.korb, ...**schel|le** (ugs.), ...**sper|re** (ugs.), ...**ta|schen** (schwäb. Pastetchen aus Nudelteig) Mehrz.

Maul|tier (Kreuzung aus Eselhengst u. Pferdestute)

Maul-und Klau|en|seu|che († R145); Abk.: MKS); **Maul|werk** (ugs.)

Maul|wurf (ein Säugetier; Pelz) m; -[e]s, ...würfe; **Maul|wurfs|hau|fen**

Mau-Mau engl. (Geheimbund in Kenia) Mehrz.

maun|zen landsch. (von Kindern u. Wehleidigen, auch von Katzen: winseln, weinerlich sein, klagen); du maunzt (maunzest)

Mau|pas|sant [mopasãng] (fr. Schriftsteller)

Mau|re (Angehöriger eines nordafrik. Mischvolkes) m; -n, -n († R 268)

Mau|rer; Mau|r[er]ar|beit; Mau|re|rei, Maue|rei w; -; **Mau|rer.ge|sel|le,** ...**hand|werk** (s; -[e]s); **mau|re|risch** (freimaurerisch), aber († R 224): Maurerische Trauermusik (Orchesterstück von W. A. Mozart); **Mau|[r|er|kel|le; Mau|[r]er|mei|ster; Mau|[r]er|po|lier; Mau|rer|zunft**

Mau|res|ke vgl. Moreske

Mau|re|ta|ni|en [...iⁿn] (im Altertum Name Marokkos; heute: selbständiger Staat in Afrika); **Mau|re|ta|ni|er; mau|re|ta|nisch**

Mau|rice fr. [morïß] (fr. Form von: Moritz)

Mau|rin w; -, -nen

Mau|ri|ner [nach dem hl. Patron Maurus] (Angehöriger einer Kongregation der Benediktiner) m; -s, -

mau|risch (auf die Mauren bezüglich); -er Bau, -er Stil

Mau|ri|ti|er [...ziⁿr] (Bewohner von Mauritius); **mau|ri|tisch;** ¹**Mau|ri|ti|us** [...ziuß] (Insel im Ind. Ozean); blaue - (bestimmte Briefmarke der Insel Mauritius aus dem Jahre 1847)

²**Mau|ri|ti|us** lat. [...ziuß] (ein Heiliger)

Maus w; -, Mäuse

Mau|schel jidd. („Moses"; armer Jude) m; -s, -; **Mau|schel|be|te** jidd.; fr. (Kartenspiel: doppelter Strafsatz beim Mauscheln) w; -, -n; **Mau|sche|lei** jidd. (Redeweise der Juden); **mau|scheln** (jiddisch sprechen; übertr. für: unverständlich sprechen; Mauscheln spielen; betrügen); ich ...[e]le († R 327); **mau|scheln** (ein Kartenglücksspiel) s; -s

Mäus|chen, Mäus|lein; mäus|chen|still; Mäu|se|bus|sard; Mau|se|fal|le, (seltener:) **Mäu|se|fal|le; Mäu|se.fraß,** ...**gift; mau|seln, mäu|seln** (Jägerspr.: den Mäuseruf nachahmen); ich ...[e]le († R 327); **Mau|se|loch,** (seltener:) **Mäu|se|loch; mau|sen** (ugs. scherzh. für: stehlen; landsch. für: Mäuse fangen); du maust (mausest); er mau|ste; **Mäu|se.nest,** ...**pla|ge**

¹**Mau|ser** lat. (jährlicher Ausfall und Ersatz der Federn bei Vögeln) w; -

²**Mau|ser** (Familienn.; ®); vgl. Mauserpistole

Mau|se|rei (ugs. scherzh. für: Stehlerei)

Mäu|se|rich (männliche Maus) m; -s, -e

mau|sern, sich

Mau|ser|pi|sto|le († R 180 u. ²Mauser)

Mau|se|rung

mau|se|tot, (österr.:) **maus|tot** (ugs.); - schlagen; **Mäu|se|turm** (Turm auf einer Rheininsel bei Bingen) m; -[e]s; **maus.far|ben** od. ...**far|big,** ...**grau**

mau|sig [„nach der Mauser"]; sich - machen (ugs. für: übermütig sein)

Mäus|lein, Mäus|chen

Mau|so|le|um gr. (prächtiges Grabmal [des Königs Mausolos]) s; -s, ...een

maus|tot österr. (svw. mausetot)

Maut (veralt. für: Zoll; bayr., österr. für: Gebühr für Straßen- u. Brückenbenutzung) w; -, -en; **maut|bar** (veralt. für: zollpflichtig); **Maut|ge|bühr**

Maut|hau|sen (Ort in Oberösterreich; Konzentrationslager der Nationalsozialisten)

Maut|ner (veralt. für: Zolleinnehmer, Zöllner); **Maut|stra|ße** (Straße, die nur gegen Gebühr befahren werden darf)

mauve fr. [mọw] (malvenfarbig); **mauve|far|ben; Mau|ve|in** [mo|we...] (Anilinfarbstoff) s; -s

mau|zen (svw. maunzen); du mauzt (mauzest)

m. a. W. = mit ander[e]n Worten

Max (Kurzform von: Maximilian); **Mäx|chen** (Koseform von: Max)

ma|xi lat. (von Röcken, Kleidern od. Mänteln: knöchellang); - tragen; Ggs.: mini; **Ma|xi...** (Mode: bis zu den Knöcheln reichend, z. B. Maximantel)

Ma|xil|la lat. (Med.: Oberkiefer) w; -, ...llae [...ä]; **ma|xil|lar**

Ma|xi|ma (Mehrz. von: Maximum); **ma|xi|mal** lat. (sehr groß, größt..., höchst...); **Ma|xi|mal.be|trag** (Höchstbetrag), ...**for|de|rung,** ...**hö|he,** ...**lei|stung,** ...**preis** (vgl. ²Preis), ...**pro|fit,** ...**stra|fe,** ...**wert; Ma|xi|me** (allgemeiner Grundsatz, Hauptgrundsatz) w; -, -n; **ma|xi|mie|ren** (maximal machen); **Ma|xi|mie|rung; Ma|xi|mi|li|an** (m. Vorn.); **Ma|xi|mum** („das Höchste"; Höchstwert, -maß) s; -s, ...ma; vgl. barometrisch

Max-Planck-Ge|sell|schaft; † R 182 (früher: Kaiser Wilhelm-Gesellschaft) w; -; **Max-Planck-In|sti|tut** s; -[e]s, -e; **Max-Planck-Me|dail|le** (seit 1929 für besondere Verdienste um die theoretische Physik verliehen) w; -, -n

Max|well [mǟkßwₑl] (engl. Physiker)

May, Karl (Jugendschriftsteller)

Ma|ya (Angehöriger eines indian. Kulturvolkes in Mittelamerika; m; -[s], -[s]; **Ma|ya|kul|tur** w; -

Ma|yon|nai|se fr. [majonäsᵉ; nach der Stadt Mahón (maọn) auf Menorca] (dickflüssige Tunke aus Eigelb u. Öl) w; -, -n

Mayor engl. [mẹ⁴r] (Bürgermeister in England u. in den USA) m; -s, -s; vgl. Lord-Mayor

Maz|daz|nan [maßdaß...] (System der Lebensführung nach O. Hanish auf Grund der Erneuerung altiran. Gedanken) s (auch m); -s; **Maz|daz|nan|an|hän|ger**

Ma|ze|do|ni|en usw. vgl. Makedonien usw.

Mä|zen lat. [nach dem Römer Maecenas] (Kunstfreund; freigebiger Gönner) m; -s, -e; **Mä|ze|na|ten|tum** s; -s; **mä|ze|na|tisch**

Ma|ze|ra|ti|on lat. [...ziọn] (Med. Erweichung u. Auflösung von Gewebe durch Flüssigkeit; Auslaugung); **ma|ze|rie|ren**

Ma|zis fr. m; - u. **Ma|zis|blü|te** (getrocknete Samenhülle des Muskatnußbaumes, Gewürz und Heilmittel)

Ma|zur|ka poln. [masụrka] (poln. Nationaltanz) w; -, -s

Maz|zi|ni (it. Politiker u. Freiheitskämpfer)

mb = Millibar

mbH = mit beschränkter Haftung

Mc, M' = Mac

m. c. = mensis currentis, dafür besser: lfd. M.

Mc|Car|thy|is|mus *amerik.* [*m*ᵉ*kₐtiß*...; nach dem amerik. Politiker Joseph McCarthy] (1950 bis 1954 in den USA praktizierter Terror gegen Kommunisten u. Linksintellektuelle) *m*; -

MD = Musikdirektor

Md. = Maryland

Md., Mrd. = Milliarde[n]

mdal. = mundartlich

M. d. B., MdB = Mitglied des Bundestages

M. d. L., MdL = Mitglied des Landtages

Me. = Maine

ME = Mache-Einheit

m. E. = meines Erachtens

Me|cha|nik *gr.* (Lehre von den Kräften u. Bewegungen) *w*; -, (für: Getriebe, Trieb-, Räderwerk auch *Mehrz.*:) -en; **Me|cha|ni|ker; Me|cha|ni|ke|rin** *w*; -, -nen; **me|cha|nisch** (den Gesetzen der Mechanik entsprechend; maschinenmäßig; unwillkürlich, gewohnheitsmäßig, gedankenlos); -ste (↑ R 294); -es Lernen; **me|cha|ni|sie|ren** *fr.* (auf mechanischen Ablauf umstellen); **Me|cha|ni|sie|rung; Me|cha|ni|sie|rungs|pro|zeß; Me|cha|nis|mus** (alles maschinenmäßig vor sich Gehende; [Trieb]werk; [selbsttätiger] Ablauf; Zusammenhang) *m*; -, ...men; **me|cha|ni|stisch** (nur mechanische Ursachen anerkennend)

Me|cheln (Stadt in Belgien)

Mecht|hild, Mecht|hil|de (ältere Formen von: Mathilde)

meck!; meck, meck!

Mecke|rei¹; Mecke|rer¹ (ugs. für: Nörgler u. Besserwisser); **Mek|ker|frit|ze** (ugs. abschätzig); **meckern¹** (ugs.); ich ...ere (↑ R 327); **Meckern|stim|me¹**, ...zie|ge

Meck|len|burg (Gebiet in Norddeutschland); **Meck|len|bur|ger** (↑ R 199); **meck|len|bur|gisch**, aber (↑ R 198): die Mecklenburgische Seenplatte; **Meck|len|burg-Schwe|rin, Meck|len|burg-Stre|litz**

Me|dail|le *fr.* [...*dalj*ᵉ, österr.: ...*dalj*ᵉ] (Denk-, Schaumünze) *w*; -, -n; **Me|dail|len|ge|win|ner**, ...kunst (*w*; -), ...samm|lung; **Me|dail|leur** [...*dalj*ø*r*] (Stempelschneider) *m*; -s, -e; **me|dail|lie|ren** [...*daljir*ᵉ*n*] (selten für: mit einer Medaille auszeichnen); **Me|dail|lon** [...*daljoŋ*] (große Schaumünze; Bildkapsel; Rund-

¹ *Trenn.:* ...ek|ke...

bild[chen]; Kunstwiss.: rundes oder ovales Relief; Gastr.: Fleischschnitte) *s*; -s, -s

Me|dard, Me|dar|dus (Heiliger)

Me|dea (in der gr. Sage kolchische Königstochter)

Me|den|spiel [nach dem 1. Präsidenten des Tennis-Bundes, C. A. von der Meden] (Mannschaftswettkampf im Tennis); ↑ R 180

Me|der (Bewohner von Medien) *m*; -s, -

¹**Me|dia** *lat.* (stimmhafter Laut, der durch die Aufhebung eines Verschlusses entsteht, z. B. b; Med.: mittlere Schicht der Gefäßwand) *w*; -, ...diä u. ...dien [...*i*ᵉ*n*]; ²**Me|dia** [auch engl. Ausspr.: *mįdi*ᵉ] (Werbeträger wie Zeitungen, Zeitschriften, Rundfunk, Fernsehen usw.) *Mehrz.*; **me|di|al** (Sprachw.: von passiv. Form in aktiv. Bedeutung; Med.: in der Mitte befindlich; Parapsych.: das spiritistische Medium betreffend); **me|di|an** (Med.: nach der Mittellinie des Körpers zu gelegen); **Me|di|a|ne** (veralt. für: halbierende Linie eines Winkels am Dreieck) *w*; -, -n; **Me|di|an|ebe|ne** (Symmetrieebene des menschl. Körpers); **Me|di|an|te** *it.* (Musik: Mittelton der Tonleiter; gelegentlich auch: Dreiklang über der 3. Stufe) *w*; -, -n

Me|dia|ti|on *lat.* [...*zion*] (Vermittlung eines Staates in einem Streit); **me|dia|ti|sie|ren** *fr.* (früher für: „mittelbar" machen, bisher reichsunmittelbare Besitzungen der Landeshoheit unterwerfen); **Me|dia|ti|sie|rung**

me|di|äval *lat.* [...*wạl*] (mittelalterlich); **Me|di|äval** [fachspr. auch: *medį*ᵉ*węl*] (eine Schriftgattung) *w*; -; **Me|di|ävist** [...*wißt*] (Erforscher u. Kenner des MA.) ↑ R 268; **Me|di|ävi|stik** (Erforschung des MA.) *w*; -

Me|dia|wer|bung *w*; -; vgl. ²Media

Me|di|ce|er [*mediz*ę*ʳ*] *m*; -s, - u. **Me|di|ci** [*meditschi*] (Angehöriger eines florentinischen Geschlechts) *m*; -, -; **me|di|ce|isch** [*medize*...], aber (↑ R 179): **Me|di|ce|isch;** -e Venus

¹**Me|di|en** (*Mehrz.* von: ¹Media u. Medium)

²**Me|di|en** [...*i*ᵉ*n*] (früher: Land in Iran)

Me|di|en|ver|bund (Kombination verschiedener Kommunikationsmittel [Medien])

Me|di|ka|ment *lat.* (Heilmittel, Arznei) *s*; -[e]s, -e; **me|di|ka|mentös;** -e Behandlung; **Me|di|ka|ster** (Quacksalber) *m*; -s, -; **Me|di|ka|ti|on** [...*zion*] (Arzneiverabrei-

chung, -verordnung); **Me|di|kus** (scherzh. für: Arzt) *m*; -, Medizi

¹**Me|di|na** (saudiarab. Stadt)

²**Me|di|na** *arab.* (islam. Stadt od. alte islam. Stadtteile im Ggs. zu den Europäervierteln) *w*; -, -s

me|dio, Me|dio *it.* („in der Mitte"); (Kaufmannsspr.:) - (Mitte) Mai

me|dio|ker *fr.* (selten für: mittelmäßig); ...o|kre Leistung; **Me|dio|kri|tät**

Me|dio|wech|sel (in der Mitte eines Monats fälliger Wechsel)

Me|di|san|ce *fr.* [...*sanß*ᵉ] (veralt. für: Verleumdung, Schmähsucht) *w*; -, -n; **me|di|sant** (veralt. für: schmähsüchtig)

Me|di|ta|ti|on *lat.* [...*zion*] (Nachdenken; sinnende Betrachtung; religiöse Versenkung); **me|di|ta|tiv**

me|di|ter|ran *lat.* („mittelländisch"; mit dem Mittelmeer zusammenhängend); **Me|di|ter|ran|flo|ra** (Pflanzenwelt der Mittelmeerländer)

me|di|tie|ren *lat.* (nachdenken; sinnend betrachten; sich versenken)

Me|di|um *lat.* („Mitte"; Mittel[glied]; Mittler[in], Mittelsperson [bes. beim Spiritismus]; Kommunikationsmittel; Sprachw.: mediale Verhaltensrichtung des Zeitwortes) *s*; -s, ...ien [...*i*ᵉ*n*]; **Me|di|um|js|mus** (Glaube an den Verkehr mit einer angenommenen Geisterwelt) *m*; -; **me|di|um|js|tisch**

Me|di|zi (*Mehrz.* von: Medikus); **Me|di|zin** *lat.* (Heilkunde; Heilmittel, Arznei) *w*; -, -en; **Me|di|zi|nal|rat** (*Mehrz.* ...räte), ...sta|ti|stik, ...we|sen (*s*; -s); **Me|di|zin|ball** (großer, schwerer, nicht elastischer Lederball); **Me|di|zi|ner** (Arzt; auch: Medizinstudent); **Me|di|zi|ne|rin** *w*; -, -nen; **me|di|zi|nisch** (heilkundlich); -e Fakultät; **me|di|zi|nisch-technisch;** -e Assistentin (Abk.: MTA); **Me|di|zin|mann** (*Mehrz.* ...männer), ...schränk|chen, ...stu|dent, ...stu|di|um

Med|ley *engl.* [*mẹdli*] (Melodienstrauß, Potpourri) *s*; -s, -s

Me|doc [...*dok*; nach der fr. Landschaft Médoc] (fr. Rotwein) *m*; -s, -s

Me|dre|se, Me|dres|se *arab.* (islam. jurist. u. theolog. Hochschule; Koranschule einer Moschee) *w*; -, -n

Me|du|sa, ¹Me|du|se (eine der Gorgonen) *w*; -; ²**Me|du|se** (Quallenform der Nesseltiere) *w*; -, -n; **Me|du|sen|blick, ...haupt** (*s*; -[e]s); **me|du|sisch** (medusenähnlich, schrecklich)

Meer s; -[e]s, -e

Mee|ra|ne (Stadt nördl. von Zwickau)

Meer.bu|sen, ...en|ge; **Mee|res.algelage**, ...arm, ...bo|den, ...bucht, ...frei|heit (w; -), ...grund (m; -[e]s), ...kun|de (für: Ozeanographie; w; -), ...leuch|ten (s; -s), ...ober|flä|che (w; -), ...spie|gel (m; -s; über dem - [Abk.: ü. d. M.]; unter dem - [Abk.: u. d. M.]), ...stil|le, ...strand, ...stra|ße, ...strö|mung, ...tie|fe; **Meer.frau**, ...gott; **meer|grün; Meer.jung|frau**, ...kat|ze (Affe einer bestimmten Art)

Meer|ret|tich (eine Heil- u. Gewürzpflanze); **Meer|ret|tich|so|ße; Meer|rohr** (veralt. für: spanisches Rohr)

Meer|salz

Meers|burg (Stadt am Bodensee); [1]**Meers|bur|ger** (↑ R 199); [2]**Meers|bur|ger** (Meersburger [Rot]wein) m; -s

Meer|schaum m; -[e]s; **Meer-schaum.pfei|fe**, ...spit|ze; **Meer-schwein|chen; meer|um|schlungen; meer|wärts; Meer.was|ser** (s; -s), ...weib, ...zwie|bel

Mee|ting engl. [mịt...] ("[Zusammen]treffen"; Versammlung; Sportveranstaltung in kleinerem Rahmen) s; -s, -s

me|fi|tisch [nach der altital. Göttin Mephịtis] (auf die Schwefelquellen bezüglich; verpestend); -e Dünste

me|ga... gr. (groß...); **Me|ga...** (Groß...; das Millionenfache einer Einheit, z. B. Megawatt = 10^6 Watt; Zeichen: M)

Me|ga|lith gr. ("großer Stein") m; -s u. -en, -e[n] (↑ R 268); **Me|ga-lith|grab** (vorgeschichtl. Großsteingrab); **Me|ga|li|thi|ker** (Träger der Megalithkultur [Großsteingräberleute]) m; -s, -; **me-ga|li|thisch** (aus großen Steinen bestehend); **Me|ga|lith|kul-tur** w; -

Me|ga|lo|ma|nie gr. (Größenwahn) w; -, ...ien

Me|ga|lo|po|lis gr. (Zusammenballung von benachbarten Millionenstädten, Riesenstadt) w; -, ...polen

Me|ga|ohm, (auch:) **Meg|ohm** (1 Million Ohm; Zeichen: MΩ)

Me|ga|phon gr. (Sprachrohr) s; -s, -e

[1]**Me|gä|re** (gr. Mythol.: eine der drei Erinnyen); [2]**Me|gä|re** (böses Weib) w; -, -n

Me|ga|the|ri|um gr. (ausgestorbenes Riesenfaultier) s; -s, ...ien [...i*n]

Me|ga|ton|ne (das Millionenfache einer Tonne; Abk.: Mt; 1 Mt = 1 000 000 t); **Me|ga|ton|nen|bombe**

Me|ga|watt (1 Million Watt; Zeichen: MW)

Meg|ohm vgl. Megaohm

Mehl s; -[e]s, (für Mehlsorte Mehrz.:) -e; **mehl|ar|tig; Mehl-.bee|re**, ...brei; **mehl|lig; Mehl-.klei|ster**, ...papp, ...sack, ...schwit|ze (Einbrenne, gebranntes Mehl), ...sor|te, ...spei|se (österr. für: Süßspeise, Kuchen); **Mehl|tau** (durch bestimmte Pilze hervorgerufene Pflanzenkrankheit) m; vgl. aber: Meltau; **Mehl-wurm**

mehr; - Freunde als Feinde; - Gold; mit - Hoffnung; - oder weniger (minder); um so -; - denn je; **Mehr** (auch: Mehrheit) s; -[s]; ein - an Kosten; das - od. Weniger; **Mehr-.ar|beit**, ...auf|wand, ...aus|ga|be, ...be|darf, ...be|la|stung; **mehr-deu|tig; Mehr|deu|tig|keit; mehr-di|men|sio|nal; Mehr|di|men|sio-na|li|tät** w; -; **Mehr|ein|nah|me; mehr|ren; Mehr|rer; mehr|re|re** (↑ R 135 [einige, eine Anzahl]); - Bücher, Mark; (↑ R 286:) - tüchtige Soldaten, -r tüchtiger (seltener: tüchtigen) Soldaten; (↑ R 290:) - Abgeordnete, -r Abgeordneter (seltener: Abgeordneten); **meh-re|res** (↑ R 135); ich habe noch - zu tun; ein - (veralt. für: mehr); **meh|rer|lei; Mehr.er|lös**, ...er-trag; **mehr|fach; Mehr|fa|che** s; -n; ein -s; vgl. Achtfache; **Mehr|fach.ra|ke|te; Mehr|fa|mi-li|en|haus; Mehr|far|ben|druck** (Mehrz. ...drucke); **mehr|far|big**, (österr.:) **mehr|fär|big; Mehr|ge-bä|ren|de** (Med.) w; -n, -n (↑ R 287ff.); **mehr.glie|de|rig** od. ...glied|rig; **Mehr|heit**; einfache, qualifizierte, absolute -; die schweigende -; **mehr|heit|lich; Mehr|heits.be|schluß**, ...wahl-recht; **mehr|jäh|rig; Mehr.kampf**, ...kämp|fer, ...ko|sten (Mehrz.), ...la|der (eine Feuerwaffe), ...lei-stung; **Mehr|ling** (Zwilling, Drilling usw.); **Mehr|loch|ma|schi|ne; mehr|ma|lig; mehr|mals; Mehr-pha|sen|strom** (mehrfach verketteter Wechselstrom); **mehr.sil-big**, ...spra|chig, ...stim|mig, ...stöckig [Trenn.: ...stök|kig]; **Mehr|stu|fe** (für: Komparativ); **Mehr|stu|fen.ra|ke|te; mehr.stu-fig**, ...stün|dig, ...tä|gig; **Mehr-rung; Mehr|völ|ker|staat** (für: Nationalitätenstaat; Mehrz. ...staaten); **Mehr|wert; Mehr-wert|steu|er** w (Abk.: Mw.-St. od. MwSt.); **mehr|wö|chig; Mehr-zahl; mehr|zei|lig**, ...zel|lig; **Mehr-zweck.ge|rät**, ...hal|le, ...ma|schi-ne, ...mö|bel, ...tisch

mei|den; du miedst (miedest); du miedest; gemieden; meid[e]!

Mei|er (veralt. für: Gutspächter, -verwalter); **Mei|e|rei** (veralt. für: Molkerei; Pachtgut); **Mei|er|hof** (veralt.); **Mei|e|rin** (veralt.) w; -, -nen

Mei|le (ein Längenmaß) w; -, -n; **mei|len|lang** (auch: mail*nlạng), aber: drei Meilen lang; **Mei|len-.stein** (veralt.), ...stie|fel (seltener für: Siebenmeilenstiefel); **mei-len|wei|se; mei|len|weit** (auch: mail*nwạit), aber: zwei Meilen weit

Mei|ler (zum Verkohlen bestimmter Holzstoß) m; -s, -; **Mei|ler-ofen**

mein, meine, mein; mein ein u. [mein] alles; vgl. dein u. deine; **mei|ne**, **mei|ni|ge**; vgl. deine, deinige

Mein|eid ("Falsch"eid); **mein|ei-dig; Mein|eid|ig|keit** w; -

mei|nen; ich meine es gut mit ihm; **mei|ner** (Wesf. des Fürwortes "ich"); **mei|ner An|sicht nach** (Abk.: m. A. n.); **mei|ner|seits; mei|nes Er|ach|tens** (Abk.: m. E.); falsch: meines Erachtens nach; **mei|nes|glei|chen; mei|nes|teils; mei|nes Wis|sens** (Abk.: m. W.); **mei|net|hal|ben; mei|net|we|gen; mei|net|wil|len**; um -

Mein|hard (m. Vorn.); **Mein|hild, Mein|hil|de** (w. Vorn.)

mei|ni|ge vgl. meine

Mei|nin|gen (Stadt an der oberen Werra); **Mei|nin|ger** (↑ R 199); **mei|nin|gisch**

Mei|nolf, Mei|nulf (m. Vorn.); **Mein|rad** (m. Vorn.)

Mein|tat (veralt. für: Verbrechen)

Mei|nulf vgl. Meinolf

Mei|nung; Mei|nungs.äu|ße|rung, ...aus|tausch; **mei|nungs|bil|dend; Mei|nungs.bil|dung**, ...for|scher, ...for|schung, ...frei|heit (w; -), ...streit, ...test, ...um|fra|ge, ...ver-schie|den|heit

Mei|ran vgl. Majoran

Mei|se (ein Vogel) w; -, -n; **Mei|sen-nest**

Mei|ßel m; -s, -; **Mei|ße|ler, Meiß-ler** (Bildhauer); **mei|ßeln**; ich ...[e]le (↑ R 327); **Mei|ße|lung** w; -

Mei|ßen (Stadt an der Elbe); **Mei-ße|ner, Meiß|ner** (↑ R 199); - Porzellan; **mei|ße|nisch, meiß|nisch**

Meiß|ler vgl. Meißeler

[1]**Meiß|ner** (Teil des Hessischen Berglandes) m; -s; der Hohe -

[2]**Meiß|ner** vgl. Meißener; **meiß-nisch** vgl. meißenisch

meist; - kommt er zu spät; vgl. meiste; **meist|be|gün|stigt; Meist-be|gün|sti|gung; Meist|be|gün|sti-gungs|klau|sel; meist|be|tei|ligt; meist|bie|tend** (↑ R 296); meistbie-

tend verkaufen, versteigern, aber: Meistbietender bleiben; **Meist|bie|ten|de** *m* u. *w*; -n, -n (↑ R 287ff.); **mei|ste**; der - Kummer, die - Zeit, das - Geld; die -n Menschen; in den -n Fällen; (↑ R 134:) am -en; (↑ R 135:) die meisten glauben ...; das meiste ist bekannt; (schweiz.) **mei|stens**; **mei|sten|teils**

Mei|ster; **Mei|ster.brief**, ...**de|tek|tiv**, ...**dieb**, ...**ge|sang** (Kunstdichtung des 15. u. 16. Jh.s; *m*; -[e]s); **mei|ster|haft**; **Mei|ster|haf|tig|keit** *w*; -; **Mei|ster|hand**; **Mei|ste|rin** *w*; , non; **Mei|ster.klas|se**, ...**lei|stung**; **mei|ster|lich** (eigenwillig, unbeherrscht); **mei|stern**; ich ...**ere** (↑ R 327); **Mei|ster.prü|fung**; **Mei|ster.sän|ger** od. ...**sin|ger**; **Mei|ster|schaft**; **Mei|ster|schafts.spiel**, ...**ti|tel**; **Mei|ster.schuß**, ...**stück**; **Mei|ste|rung** *w*; -; **Mei|ster.werk**, ...**wür|de**, ...**wurz** (Doldenblütler)

Meist|ge|bot; **meist.ge|bräuch|lich**, ...**ge|fragt**, ...**ge|kauft**, ...**ge|le|sen**, ...**ge|nannt**; **Meist|stu|fe** (für: Superlativ)

Mek|ka (saudiarab. Stadt)

Me|kong [auch: ...*kong*] (Fluß in Südostasien) *m*; -[s]; **Me|kong|del|ta** *s*; -s (↑ R 201)

Me|lan|cho|lie *gr.* [...*langkoli*] (Trübsinn, Schwermut) *w*; -, ...**jen**; **Me|lan|cho|li|ker**; **me|lan|cho|lisch**; -ste (↑ R 294)

Me|lan|chthon *gr.* („Schwarzerd", eigtl. Name Schwarzert; dt. Humanist u. Reformator)

Me|la|ne|si|en *gr.* [...*i⁵n*] („Schwarzinselland"; westpazif. Inseln nordöstl. von Australien); **Me|la|ne|si|er** [...*i⁵r*]; **me|la|ne|sisch**

Me|lan|ge *fr.* [...*langseh*], österr.: ...**langseh**] (Mischung, Gemengsel; österr.: Milchkaffee) *w*; -, -n

Me|la|nie *...i⁵*, auch: ...*anj* od. *melani*] (w. Vorn.)

Me|la|nin *gr.* (brauner od. schwarzer Farbstoff) *s*; -s, -e; **Me|la|nis|mus** *m*; - u. **Me|la|no|se** (Med.: krankhafte Dunkelfärbung der Haut) *w*; -, -n; **Me|la|nit** (ein Mineral) *m*; -s, -e; **Me|la|no|se** vgl. Melanismus; **Me|la|phyr** (ein Gestein) *m*; -s, -e; **Me|las|ma** (Med.: schwärzliche Hautflecken) *s*; -s, ...men u. ...**lasmata**

Me|las|se *fr.* (Rückstand bei der Zuckergewinnung) *w*; -, -n

Mel|ber bayr. (Mehlhändler) *m*; -s, -

Mel|bourne [*mälb⁵rn*] (austr. Stadt)

Mel|chi:or (m. Vorn.)

Mel|chi|se|dek [auch, österr. nur: ...*chi*...] (bibl. m. Eigenn.)

Melch|ter schweiz. (hölzernes [Milch]geschirr) *w*; -, -n

Mel|de (Name verschiedener Pflanzen) *w*; -, -n

Mel|de.amt, ...**bü|ro**, ...**fah|rer**, ...**frist**, ...**hund**; **mel|den**; **Mel|de|pflicht**; polizeiliche -; **mel|de|pflich|tig**; -e Krankheit; **Mel|der**; **Mel|de.rei|ter**, ...**schluß**, ...**stel|le**, ...**ter|min**, ...**zet|tel** (österr.: Formular, Bestätigung für polizeiliche Anmeldung); **Mel|dung**

Me|li|bo|cus, (auch:) **Me|li|bo|kus** od. Mal|chen (Berg im Odenwald) *m*; -

me|lie|ren *fr.* (mischen; sprenkeln); **me|liert** (scheckig, gescheckt; gesprenkelt)

Me|lis|se (Gelberde) *m*; -s

Me|lio|ra|ti|on *lat.* [...*zion*] ([Boden]verbesserung); **me|lio|rie|ren** ([Acker] verbessern); **Me|lio|rie|rung**

Me|lis *gr.* (Verbrauchszucker aus verschiedenen Zuckersorten) *m*; -

me|lisch [zu: Melos] *gr.* (liedmäßig); **Me|lis|ma** (melod. Verzierung, Koloratur) *s*; -s, ...men; **Me|lis|ma|tik** (Musik: melod. Verzierungsstil); **me|lis|ma|tisch**

Me|lis|sa vgl. Melitta; **Me|lis|se** *gr.* (eine Heil- u. Gewürzpflanze) *w*; -, -n: **Me|lis|sen|geist** Ⓦ (Heilkräuterdestillat) *m*; -[e]s; **Me|lit|ta**, Me|lis|sa (w. Vorn.)

melk (veralt. für: milchgebend, melkbar)

Melk (österr. Stadt)

Mel|ke|i|mer; **mel|ken**; du melkst (veralt.: milkst); du melktest (seltener: molkst); du mölkest (seltener: gemelkt); molken (seltener: gemelkt); melk[e]! (veralt.: milk!); frisch gemolkene Milch; eine melkende Kuh (ugs. für: gute Einnahmequelle); **Mel|ker**; **Mel|ke|rei** (Melken; Milchwirtschaft); **Mel|ke|rin** *w*; -, -ncn; **Melk|kü|bel**, ...**ma|schi|ne**, ...**sche|mel**

Me|lo|die *gr.* ([Sing]weise; abgeschlossene u. geordnete Folge von Tönen) *w*; -, ...**jen**; **Me|lo|di|en.fol|ge**, ...**rei|gen**; **Me|lo|dik** (Lehre von der Melodie) *w*; -; **me|lo|di|ös**; -este (↑ R 292); vgl. melodisch; **me|lo|disch** (wohllautend); -ste (↑ R 294); **Me|lo|dram**, **Me|lo|dra|ma** (Deklamation od. Schauspiel mit Musikbegleitung) *s*; -s, ...men; **Me|lo|dra|ma|tik**; **me|lo|dra|ma|tisch**

Me|lo|ne *gr.* (großes Kürbisgewächs wärmerer Gebiete [zahlreiche Arten]; ugs. scherzhaft für: runder steifer Hut) *w*; -, -n; **me|lo|nen|ar|tig**

Me|los *gr.* [auch: *me*...] (Lied, Gesang; melodische Eigenschaft) *s*; -

Mel|po|me|ne (Muse des Trauerspiels)

Mel|tau (Blattlaushonig, Honigtau) *m*; vgl. aber: Mehltau

Me|lu|si|ne (altfr. Sagengestalt, Meerfee)

Mem|bran *lat.* *w*; -, -en u. **Mem|bra|ne** (gespanntes Häutchen; Schwingblatt) *w*; -, -n

Mem|mel (ein Fluß) *w*; -; **Mem|me|ler** (↑ R 199)

Me|men|to *lat.* (Erinnerung, Mahnruf) *s*; -s, -s; memento mori! („gedenke des Todes!")

Mem|me (ugs. verächtl. für: Feigling) *w*; -, -n

mem|meln bayr., österr. mdal. (mummeln)

mem|men|haft (ugs.); **Mem|men|haf|tig|keit** *w*; -

Mem|non (sagenhafter äthiop. König); **Mem|nons|säu|len** (bei Luxor in Ägypten) *Mehrz.*; ↑ R 180

Me|moire *fr.* [...*moar*] (Memorandum) *s*; -s, -s; **Me|moi|ren** [...*moar⁵n*] (Denkwürdigkeiten; Lebenserinnerungen) *Mehrz.*; **Me|mo|ra|bi|li|en** *lat.* [...*i⁵n*] (Denkwürdigkeiten) *Mehrz.*; **Me|mo|ran|dum** („Erwähnenswertes"; Denkschrift) *s*; -s, ...den u. ...da; **¹Me|mo|ri|al** *lat.*(-fr. u. engl.) (Festveranstaltung zu Ehren eines Verstorbenen; veralt. für: Tagebuch; Erinnerungs-, [Vor]merkbuch) *s*; -s, -e u. -ien [...*i⁵n*]; **²Me|mo|ri|al** *engl.* [*mimări'l*] (sportl. Veranstaltung zum Gedenken an einen Verstorbenen) *s*; -s, -s; **me|mo|rie|ren** (auswendig lernen); **Me|mo|rier|stoff** (Lernstoff)

Mem|phis (altägypt. Stadt)

Me|na|ge *fr.* [...*nasch'*] (veralt. für: Haushalt; [sparsame] Wirtschaft; noch österr.: Truppenverpflegung; gelegentlich für: Gewürzständer); **Me|na|ge|rie** (Sammlung lebender [wilder] Tiere in Käfigen) *w*; -, ...**jen**; **me|na|gie|ren** [...*naschir'n*] (veralt., aber noch mdal. für: sich selbst verköstigen; sparen; einrichten; schonen); sich - (sich mäßigen); österr. für: Essen fassen [beim Militär])

Men|ar|che *gr.* (Med.: erster Eintritt der Regel) *w*; -

Men|del (österr. Biologe); (↑ R 179:) -sche Regeln

Men|de|le|vi|um [...*wium*; nach dem russ. Chemiker Mendelejew] (chem. Grundstoff, ein Transuran; Zeichen: Md) *s*; -s

Men|de|lis|mus (Mendelsche Ver-

erbungslehre) *m*; -; **men|deln** (nach den Vererbungsregeln Mendels in Erscheinung treten); **Men|delsch** († R 179); -e Regeln **Men|dels|sohn-Bar|thol|dy** (dt. Komponist) **Men|dès-France** [*mängdäßfrangß*] (fr. Politiker); Mendès-France' Politik († R 310) **Men|di|kant** *lat.* (Bettelmönch) *m*; -en, -en († R 268); **Men|di|kan|ten|or|den** **Me|ne|la|os** (gr. Sagengestalt, König von Sparta); **Me|ne|la|us** vgl. Menelaos **Me|ne|lik|ta|ler** [auch: *män...*] (äthiop. Münze); † R 180 **Me|ne|te|kel** *aram.* (Warnungsruf) *s*; -s, - **Men|ge** *w*; -, -e **men|gen** (mischen) **Men|gen|an|ga|be**, ...**be|griff**, ...**be|zeich|nung**, ...**kon|junk|tur**, ...**leh|re** (*w*; -); **men|gen|mä|ßig** (für: quantitativ); **Men|gen|preis** (vgl. [2]Preis), ...**ra|batt** **Meng|sel** (landsch.) *s*; -s, - **Men|hir** *fr.* (unbehauene vorgeschichtl. Steinsäule) *m*; -s, -e **Me|nin|gi|tis** *gr.* (Med.: Hirnhautentzündung) *w*; -, ...**iti|den** **me|nip|pisch**; -e Satire, aber († R 179): **Me|nip|pisch**; **Me|nip|pos** (altgr. Philosoph); **Me|nip|pus** vgl. Menippos **Me|nis|kus** *gr.* (,,Möndchen''; gekrümmte Oberfläche einer Flüssigkeit in engem Rohr; Linse; Zwischenknorpel im Kniegelenk) *m*; -, ...ken; **Me|nis|kus|ope|ra|ti|on**, ...**riß** (Sportverletzung) **Men|jou|bärt|chen** [*mänßehu...*; nach dem amerik. Filmschauspieler A. Menjou] (schmaler, gestutzter Schnurrbart); † R 180 **Men|ke|ke** mitteld. (Durcheinander; Umstände) *w*; - **Men|ni|ge** *iber.* (Bleiverbindung; rote Malerfarbe) *w*; -; **men|nig|rot** **Men|no|nit** [nach dem Gründer Menno Simons] (Angehöriger einer verbreiteten täufer. Freikirche) *m*; -en, -en († R 268) **Me|no|pau|se** *gr.* (Med.: Aufhören der Regel in den Wechseljahren der Frau) *w*; -, -n **Me|nor|ca** [...*ka*] (Baleareninsel) **Me|nor|rha|gie** *gr.* (Med.: langdauernde u. starke Menstruation) *w*; -, ...**ien**; **Me|nor|rhö**[1], **Me|nor|rhöe** (Menstruation) *w*; -, ...**rhöen**; **me|nor|rhö|isch**; **Me|no|sta|se** (Med.: Ausbleiben der Monatsblutung) *w*; -, -n **Me|not|ti** (amer. Komponist it. Herkunft)

[1] Vgl. die Anmerkung zu ,,Diarrhö, Diarrhöe''.

Men|sa *lat.* (Mittags,,tisch'' für Studenten; Altarplatte) *w*; -, -s u. ...sen; **Men|sa aca|de|mi|ca** [- *akademika*] (Mittagstisch an Hochschulen) *w*; - -, ...sae [...*sä*] ...cae [...*zä*]; **Mensch** [1]**Mensch** *m*; -en, -en († R 268); [2]**Mensch** (verächtl. für: [verdorbene] Frau, Dirne) *s*; -[e]s, -er; **men|scheln** (ugs.); es menschelt; **Men|schen|af|fe**, ...**al|ter**; **men|schen|arm**, ...**schen|auf|lauf**, ...**feind**, ...**fleisch**, ...**fres|ser**, ...**freund**; **men|schen|freund|lich**; **Men|schen|füh|rung**, ...**ge|den|ken** (seit -), ...**geist** (*m*; -[e]s), ...**ge|schlecht** (*s*; -[e]s), ...**ge|wühl**, ...**hand** (von -), ...**han|del** (vgl. [1]Handel, ...**händ|ler**, ...**herz**, ...**hirn**, ...**ken|ner**, ...**kennt|nis** (*w*; -), ...**kind**, ...**kun|de** (für: Anthropologie; *w*; -), ...**le|ben**; **men|schen|leer**, ...**schen|lie|be**, ...**mas|se**, ...**men|ge**; **men|schen|mög|lich** († R 135:) er hat das -e (alles) getan; **Men|schen|op|fer**, ...**ras|se**, ...**raub**, ...**recht**; **men|schen|scheu**; **Men|schen|scheu**, ...**see|le** (keine -); **Men|schens|kind!** (ugs. Ausruf); **Men|schen|tum** *s*; -s; **men|schen|un|wür|dig**; **Men|schen|ver|ach|tung**, ...**ver|stand**, ...**werk**, ...**wür|de**; **men|schen|wür|dig** **Men|sche|wik** *russ.* (Anhänger des Menschewismus) *m*; -en († R 268), -en u. -i; **Men|sche|wis|mus** (ehem. gemäßigter russ. Sozialismus) *m*; -; **Men|sche|wist** (svw. Menschewik); † R 268; **men|sche|wi|stisch** **Mensch|heit** *w*; -; **mensch|heit|lich**; **Mensch|heits|ent|wick|lung**, ...**ge|schich|te** (*w*; -); **mensch|lich**; Menschliches, Allzumenschliches († R 116); **Mensch|lich|keit** *w*; -; **Mensch|wer|dung** *w*; - **Men|sel**, **Men|sul** *lat.* (Geogr.: Meßtisch) *w*; -, -n **men|sen|diecken** [Trenn.: ...diek|ken] (nach der Methode von B. Mensendieck Gymnastik treiben): ich ...diecke **men|sis cur|ren|tis** *lat.* [- *ku...*] (veralt. für: laufenden Monats; Abk.: m. c.); dafür besser der dt. Ausdruck; **men|stru|al** (monatlich); **Men|stru|al|blu|tung**; **Men|strua|ti|on** [...*zion*] (Monatsblutung, Regel); **men|stru|ie|ren** **Men|sul** vgl. Mensel **Men|sur** *lat.* (,,Maß''; Fechterabstand; stud. Zweikampf; Zeitmaß der Noten; Verhältnis von Weite u. Länge bei Orgelpfeifen; Verhältnis der Saiten zum Geigenkörper; Beziehung der Griffe zu den Tonlöchern bei Holzblas-

instrumenten; Durchmesser des Rohres bei Blechblasinstrumenten; Chemie: Meßglas) *w*; -en; **men|su|ra|bel** (meßbar); ...a|ble Größe; **Men|su|ra|bi|li|tät** *w*; -; **Men|su|ral|mu|sik** (die in Mensuralnotenschrift [mit Angabe der Tonlänge] aufgezeichnete Musik des 13.–16. Jh.s); **Men|su|ral|no|ta|ti|on** (im 13. Jh. ausgebildete, die Dauergeltung der Notenwerte notierende Notenschrift) **men|tal** *lat.* (geistig; in Gedanken, heimlich); **Men|ta|li|tät** (Denk-, Anschauungs-, Auffassungsweise; Sinnes-, Geistesart); **Men|tal|re|ser|va|ti|on** [...*wazion*] (stiller Vorbehalt); **men|te cap|tus** *lat.* [- *ka*...] (begriffsstutzig; nicht bei Verstand) **Men|thol** *lat.* (Bestandteil des Pfefferminzöls) *s*; -s [1]**Men|tor** *gr.* (Erzieher des Telemach); [2]**Men|tor** (Erzieher; Ratgeber) *m*; -s, ...**oren** **Me|nü** *fr.* (Speisenfolge) *s*; -s, -s; **Me|nu|ett** (ein Tanz) *s*; -[e]s, -e (auch: -s) **Me|nu|hin** [auch: ...*hin*], Yehudi (amerik. Geigenvirtuose) **Men|zel** (dt. Maler u. Graphiker) **Me|phi|sto**, **Me|phi|sto|phe|les** (Teufel in Goethes ,,Faust''); **me|phi|sto|phe|lisch** († R 179) **me|phi|tisch** vgl. mefitisch **Me|ran** (Stadt in Südtirol) **Mer|ca|tor** [...*ka*...] (flandrischer Geograph); **Mer|ca|tor|pro|jek|ti|on**; † R 180 (Netzentwurf von Landkarten) **Mer|ce|des-Benz** [W] [...*ze*...] (Kraftfahrzeuge) **Mer|ce|rie** *fr.* [*märß[r]r]*] schweiz. (Kurzwaren[handlung]) *w*; -, ...**ien** **Mer|ce|ri|sa|ti|on** [...*zion*] usw. vgl. Merzerisation usw. **mer|ci!** *fr.* [*märßi*] (Dank!, danke!) **Mer|cu|ry-Kap|sel** *amerik.*; dt. [*mö[r]kjuri*...] (amerik. Raumkapsel); † R 180 **Me|re|dith** [*mär[r]dith*] (engl. Dichter); Meredith' Dichtungen († R 310) **Mer|gel** (Sammelbez. für Sedimentgesteine der Mischungsreihe Ton-Kalk) *m*; -s, (für: Mergelart Mehrz.:) -; **Mer|gel|bo|den**; **mer|ge|lig**, **mer|glig** **Mer|gen|tha|ler** (Erfinder der Linotype) **Me|ri|di|an** *lat.* (Mittags-, Längenkreis) *m*; -s, -e; **Me|ri|di|an|kreis** (astron. Meßinstrument); **me|ri|dio|nal** (den Längenkreis betreffend) **Mé|ri|mée** [*merimε*; auch: ...*mε*], Prosper [*proßpär*] (fr. Schriftsteller)

Me|rin|ge *fr.* w; -, -n. Me|rin|gel s; -s, - u. (schweiz.:) **Meringue** [*merāng*, ugs.: *māräng*] (ein Schaumgebäck) w; -, -s

Me|ri|no *span.* (Schaf einer bestimmten Rasse) m; -s, -s; Me|ri|no..schaf, ...wol|le

Me|ri|stem *gr.* (pflanzl. Bildungsgewebe) s; -s, -e; me|ri|ste|ma|tisch (teilungsfähig [von pflanzl. Geweben])

me|ri|to|risch *lat.* (veralt. für: verdienstlich; sachlich); Me|ri|tum (Verdienst s) s; -s, ...ten (meist *Mehrz.*)

[1]Merk (ein Doldengewächs) m; -s, □

[2]Merk (veralt. für: Merkzeichen, Marke) s; -s, -e

mer|kan|til, mer|kan|ti|lisch *lat.* (kaufmännisch; Handels...); Mer|kan|ti|lis|mus (Volkswirtschaftslehre des Absolutismus) m; -; Mer|kan|ti|list (↑ R 268); mer|kan|ti|li|stisch ; Mer|kan|til|sy|stem

merk|bar; Merk..blatt, ...buch; mer|ken; Mer|ker (veralt.; aber noch ugs. spött. für: jmd., der alles bemerkt); Merk..heft, ...hil|fe; merk|lich; ein Merkliches (↑ R 116); (↑ R 134:) um ein merkliches; Merk..mal (*Mehrz.* ...male), ...satz, ...spruch

[1]Mer|kur (röm. Gott des Handels; Götterbote); [2]Mer|kur (ein Planet) m; -s; [3]Mer|kur ([alchimist.] Bez. für: Quecksilber) m od. s; -s; Mer|ku|ria|lis|mus (Quecksilbervergiftung) m; -; Mer|kur|stab

Merk..vers, ...wort (*Mehrz.* ...wörter); merk|wür|dig; merk|wür|di|ger|wei|se; Merk..wür|dig|keit (w; -, -en), ...zei|chen, ...zet|tel

Mer|le *lat.* landsch. (Amsel) w; -, -n

[1]Mer|lin [auch: *mär*...] (kelt. Sagengestalt, Zauberer)

[2]Mer|lin [auch: *mär*...] (ein Greifvogel) m; -s, -e

Me|ro|win|ger (Angehöriger eines fränk. Königsgeschlechtes) m; -s, -; Me|ro|win|ger|reich s; -[e]s; me|ro|win|gisch

Mer|se|burg/Saa|le (Stadt an der Saale); Mer|se|bur|ger (↑ R 199); Mer|se|bur|ger Zaubersprüche; mer|se|bur|gisch

Mer|ten (mdal. für: Martin)

Mer|ze|ri|sa|ti|on [...*zion*] [nach dem engl. Erfinder Mercer] (Veredlungsverfahren [bes. bei Baumwolle]); mer|ze|ri|sie|ren; Mer|ze|ri|sie|rung

Merz..schaf, ...vieh (auszusonderndes, zur Zucht untaugliches Vieh)

Mes|al|li|ance *fr.* [*mesaljangß*]

(Mißheirat; übertr. für: unglückliche Verbindung) w; -, -n

me|schant *fr.* mdal. (boshaft, ungezogen)

me|schug|ge *jidd.* (ugs. für: verrückt)

Mes|dames [*mädam*] (*Mehrz.* von: Madame); Mesde|moi|selles [*mädmoasäl*] (*Mehrz.* von: Mademoiselle)

Mes|en|chym *gr.* [...*chüm*] (embryonales Bindegewebe) s; -s, -e

Me|se|ta *span.* (zentralspanische Hochebene) w; -, (für Hochebene ähnlicher Art *Mehrz.:*) ...ten

Mes|ka|lin *indian.-span.* (Alkaloid einer mexik. Kaktee. Rauschmittel) s; -s

Mes|mer schweiz. (Mesner) m; -s, -

Mes|me|ris|mus [nach dem dt. Arzt Mesmer] (Lehre vom tierischen Magnetismus) m; -

Mes|ner *mlat.* landsch. (Kirchen-, Meßdiener); Mes|ne|rei (veralt. für: Amt und Wohnung des Mesners)

meso... *gr.* (mittel..., mitten...); Meso... (Mittel..., Mitten...); Me|so|derm (mittleres Keimblatt in der menschl. u. tier. Embryonalentwicklung) s; -s, -e; Me|so|ga|stri|um (Mittelbauchgegend; Gekröse des Magens) s; -s; Me|so|karp s; -s, -e u. Me|so|kar|pi|um (Mittelschicht von Pflanzenfrüchten) s; -s, ...ien [...*i*ⁿ*n*]; Me|so|ke|pha|le usw. vgl. Mesozephale usw.; Me|so|li|thi|kum (Mittelsteinzeit) s; -s; me|so|li|thisch

Me|son, Me|so|tron *gr.* (unbeständiges Elementarteilchen) s; -s, ...onen (meist *Mehrz.*)

Me|so|phyt *gr.* (Pflanze, die Böden mittlerer Feuchtigkeitsgrades bevorzugt) m; -en, -en (↑ R 268); Me|so|phy|ti|kum (das Mittelalter der Entwicklung der Pflanzenwelt) s; -s

Me|so|po|ta|mi|en [...*i*ⁿ*n*] (hist. Landschaft des Iraks); Me|so|po|ta|mi|er [....*i*ⁿ*r*]; me|so|po|ta|misch

Me|so|sphä|re *gr.* (Meteor.: in etwa 50 bis 80 km Höhe liegende Schicht der Erdatmosphäre) w; -

Me|so|tho|ri|um *gr.; altnord.* (Zerfallsprodukt des Thoriums; Abk.: MsTh) s; -s; Me|so|tron (älter für: Meson); Me|so|ze|pha|le gr. (Med.: Person mit mittelhoher Kopfform) m u. w; -n, -n (↑ R 268); Me|so|ze|pha|lie (mittelhohe Kopfform) w; -; Me|so|zoi|kum (Geol.: Mittelalter der Erde) s; -s; me|so|zo|isch

Mes|sa|li|na (Gemahlin des Kaisers Claudius); [1]Mes|sa|li|ne (veralt. für: ausschweifend lebende,

sittenlose Frau) w; -, -n; [2]Mes|sa|li|ne ([Kunst]seidenatlas für Futter u. Besatz) w; -

Meß|band s (*Mehrz.* ...bänder); meß|bar; Meß|bar|keit w; -; Meß-..be|cher, ...brief (amtl. Bescheinigung über die Vermessung eines Schiffes)

Meß|buch (für: Missale)

Meß|da|ten *Mehrz.*

Meß|die|ner; [1]Mes|se *lat.* (kath. Hauptgottesdienst; Chorwerk; Großmarkt, Ausstellung) w; -, -n; die, eine - lesen, aber (↑ R 120): das Messelesen

[2]Mes|se *engl.* (Tischgenossenschaft auf [Kriegs]schiffen, auch der Raum dafür) w; -, -n

Mes|se..amt, ...an|ge|bot, ...ausweis, ...be|su|cher, ...ge|län|de, ...hal|le, ...haus, ...ka|ta|log

Mes|se|le|sen s; -s

mes|sen; du mißt (missest), er mißt; ich maß, du maßest; du mäßest; gemessen; miß!; sich -

Mes|sen|ger boy *engl.* [*mäßindsch*ᵉ*r bey*] (veralt. für: Eilbote) m; - -, - -s

Mes|se|ni|en [...*i*ⁿ*n*] (altgr. Landschaft des Peloponnes); mes|se|nisch, aber (↑ R 224): die Messenischen Kriege

[1]Mes|ser [zu: messen] (Messender, Meßgerät; nur als 2. Bestandteil in Zusammensetzungen, z. B. in: Fiebermesser) m

[2]Mes|ser (ein Schneidwerkzeug) s; -s, -; Mes|ser..bänk|chen, ...held (abwertend); mes|ser|scharf; Mes|ser..schmied, ...spit|ze, ...stecher; Mes|ser|ste|che|rei; Mes|ser|stich

Mes|se..schla|ger, ...stand

Meß|ge|rät

Meß|ge|wand

Meß|glas

Mes|sia|de (Dichtung vom Messias) w; -, -n

Mes|si|aen [*mäßjang*] (fr. Komponist)

mes|sia|nisch (auf den Messias bezüglich); Mes|si|as *hebr.* (,,Gesalbter"; Jesus Christus) m; -

Mes|si|dor (,,Erntemonat" der Fr. Revolution: 19. Juni bis 18. Juli) m; -[s], -s

Mes|sieurs [*mäßjö*] (*Mehrz.* von: Monsieur)

Mes|si|na (Stadt auf Sizilien; Mes|si|na|ap|fel|si|ne; ↑ R 201 (Zitrusfrucht)

Mes|sing (Kupfer-Zink-Legierung) s; -s; Mes|sing|draht; mes|sin|gen (aus Messing); messing[e]ne Platte; Mes|sing..griff, ...leuch|ter, ...schild s, ...stan|ge

Meß..in|stru|ment, ...lat|te

Meß|op|fer (kath. Hauptgottesdienst)

Meß.schnur (*Mehrz.* ...schnüre), ...schrau|be, ...stab, ...tech|nik, ...tisch; **Meß|tisch|blatt; Mes|sung; Meß|ver|fah|ren, ...werk|zeug, ...wert, ...zy|lin|der** (Maß-, Standglas)

Me|ste (altes mitteld. Maß; [Holz]gefäß) *w*; -, -n

Me|sti|ze (Mischling zwischen Weißen u. Indianern) *m*; -n, -n (↑ R 268)

Met (gegorener Honigsaft) *m*; -[e]s

¹**Me|ta** (Kurzform von: Margareta od. Mathilde)

²**Me|ta** ⓦ ([schweiz.:] Brennstoff in Tablettenform)

me|ta... *gr.* (zwischen..., mit..., um..., nach...); **Me|ta...** (Zwischen..., Mit..., Um..., Nach...); **me|ta|bol, me|ta|bo|lisch** (verändernd, veränderlich)

Me|ta|chro|nis|mus *gr.* [...*kro*...] (Zuweisung in eine zu späte Zeit) *m*; -, ...men

Me|ta|ge|ne|se *gr.* (Generationswechsel bei Tieren u. Pflanzen) *w*; -, -n; **me|ta|ge|ne|tisch**

Me|ta|ge|schäft *it.; dt.* (gemeinschaftlich durchgeführtes Warenod. Bankgeschäft zweier Firmen mit gleichmäßiger Verteilung von Gewinn u. Verlust)

Me|ta|kri|tik *gr.* (auf die Kritik folgende Kritik; Kritik der Kritik) *w*; -; **Me|ta|lep|se, Me|ta|lep|sis** (Rhet.: Verwechselung) *w*; -, ...epsen

Me|tall *gr. s*; -s, -e; **Me|tall.ar|bei|ter, ...be|ar|bei|tung, ...block** (*Mehrz.* ...blöcke); **Me|tal|le|gie|rung** [*Trenn.*: ...tall|le..., ↑ R 236]; **me|tal|len** (aus Metall); **Me|tal|ler** (ugs. Kurzw. für: Metallarbeiter); **Me|tall|le|rin** *w*; -, -nen; **Me|tall.ge|wer|be, ...guß; me|tall|hal|tig; Me|tall|hal|tig|keit** *w*; -; **Me|tall|in|du|strie; Me|tall|li|sa|ti|on** [...*zion*] (Vererzung beim Versteinerungsvorgang); **me|tal|lisch** (metallartig); **mé|tal|li|sé** (mit einer widerstandsfähigen Schicht aus Metall überzogen); **me|tal|li|sie|ren** (mit Metall überziehen); **Me|tal|li|sie|rung; Me|tal|lis|mus** (Theorie, die den Geldwert aus dem Stoff- od. Metallwert des Geldes zu erklären versucht) *m*; -; **Me|tall|kun|de** *w*; -; **Me|tall|kund|ler; Me|tall|mohr** (fein verteiltes, schwarzes Metall) *s*; -s, -e; **Me|tall|lo|chro|mie** (galvanische Metallfärbung) *w*; -; **Me|tal|lo|gra|phie** (Zweig der Metallkunde) *w*; -; **Me|tal|lo|id** (veralt. Bez. für: nichtmetall. Grundstoff) *s*; -[e]s, -e; **Me|tall.schi, ...über|zug; Me|tall.urg, Me|tall|ur|ge** *m*; ...gen, ...gen (↑ R 268); **Me|tall|ur|gie** (Hüttenkun-

de) *w*; -; **me|tall|ur|gisch** (hüttenkundlich, Hütten...); **me|tall|ver|ar|bei|tend;** die -e Industrie (vgl. S. 45, Merke, 2), **aber** (vgl. S. 45, Merke, 1): viel Metall verarbeitend

me|ta|morph, me|ta|mor|phisch *gr.* (die Gestalt, den Zustand wandelnd); **Me|ta|mor|pho|se** (svw. Metamorphose) *m*; -, ...men; **Me|ta|mor|pho|se** (Umgestaltung, Verwandlung) *w*; -, -n (meist *Mehrz.*); **me|ta|mor|pho|sie|ren; Me|ta|pher** (Sprachw.: Wort mit übertragener Bedeutung, bildliche Wendung, z. B. „Haupt der Familie") *w*; -, -n; **Me|ta|pho|rik** (Verbildlichung, Übertragung in eine Metapher) *w*; -; **me|ta|pho|risch** (bildlich, im übertragenen Sinne [gebraucht]); **Me|ta|phra|se** (Umschreibung) *w*; -, -n; **me|ta|phra|stisch** (umschreibend); **Me|ta|phy|sik** (philos. Lehre von den letzten Gründen u. Zusammenhängen des Seins); **Me|ta|phy|si|ker; me|ta|phy|sisch; Me|ta|plas|mus** (Umbildung von Wortformen) *m*; -, ...men; **Me|ta|psy|chik** (svw. Parapsychologie) *w*; -; **me|ta|psy|chisch; Me|ta|psy|cho|lo|gie** (svw. Parapsychologie); **Me|ta|se|quo|ia** [...*ja*] (Vertreter einer Gattung der Sumpfzypressengewächse) *w*; -, ...oien; **Me|ta|spra|che** (Sprachw., Math., EDV: Sprache, die zur Beschreibung einer anderen Sprache benutzt wird); **me|ta|sprach|lich; Me|ta|sta|se** (Rhet.: Redefigur, durch die die Verantwortung für irgendeine Sache auf einen andern übertragen wird; Med.: Verschleppung von Krankheitskeimen [bes. Tochterzellen einer Krebsgeschwulst] auf andere Körperteile; Tochtergeschwulst) *w*; -, -n; **me|ta|sta|sie|ren** (Med.: Tochtergeschwülste bilden); **me|ta|sta|tisch; Me|ta|the|se, Me|ta|the|sis** (Buchstabenversetzung, Lautumstellung) *w*; -, ...esen; **Me|ta|tro|pis|mus** („Umkehrung"; Psych.: andersgeschlechtl. Empfinden od. Gefühlsleben); **me|ta|ze|n|trisch** (Schwank...); -es Maß (Schwankmaß); **Me|ta|zen|trum** (Schiffbau: Schwankpunkt); **Me|ta|zo|on** (mehrzelliges [höheres] Tier) *s*; -s, ...zoen

Met|em|psy|cho|se *gr.* (Seelenwanderung) *w*; -, -n

Me|te|or *gr.* (Feuerkugel, Sternschnuppe) *m* (fachspr.: *s*); -s, -e; **me|teo|risch** (auf Lufterscheinungen, -verhältnisse bezüglich); **Me|teo|rit** (Meteorstein) *m*; -s, -e;

me|teo|ri|tisch (vom Meteor herstammend, meteorartig); **Me|teo|ro|lo|ge** *m*; -n, -n (↑ R 268); **Me|teo|ro|lo|gie** (Lehre von Wetter u. Klima) *w*; -; **me|teo|ro|lo|gisch**; -e Station (Wetterwarte); **me|teo|ro|trop** (wetter-, klimabedingt); **Me|teo|ro|tro|pis|mus** (wetterfühliger Krankheitszustand) *m*; -; **Me|te|or|stein**

Me|ter *gr.* (Längenmaß; Zeichen: m) *m* (schweiz. amtlich nur so) od. *s*; -s, -; eine Länge von zehn Metern, (auch:) Meter (↑ R 322); eine Mauer von drei Meter Höhe; von 10 Meter, (auch:) Metern an (↑ R 322); ein[en] Meter lang, acht Meter lang; laufender Meter (Abk.: lfd. m); -.me|ter (z. B. Zentimeter); **me|ter|dick**; -e Mauern; **aber:** die Mauern sind zwei Meter dick; **me|ter|hoch;** der Schnee liegt -; **aber:** der Schnee liegt drei Meter hoch; **me|ter|lang, aber:** ein[en] Meter lang; **Me|ter|lat|te** (Geh- und Meßstock des Grubensteigers), ...**maß** *s*, ...wa|re; **me|ter|wei|se; me|ter|weit, aber:** drei Meter weit; **Me|ter|zent|ner** (österr. veralt.: Doppelzentner [100 kg]; Zeichen: q [vgl. Quintal); vgl. Zentner

Me|than *gr.* (Gruben-, Sumpfgas) *s*; -s; **Me|than|gas; Me|tha|nol** (Methylalkohol) *s*; -s

Me|tho|de *gr.* (Verfahren; [Unterrichts-, Forschungs-, Untersuchungs-, Behandlungs-, Herstellungs]weise; Absicht; planmäßiges Vorgehen) *w*; -, -n; **Me|tho|den|leh|re; Me|tho|dik** ([Lehr]anweisung, -kunde; Vortrags-, Unterrichtslehre) *w*; -; -en; **Me|tho|di|ker** (planmäßig Verfahrender; Begründer einer Forschungsrichtung); **me|tho|disch** (planmäßig; überlegt, durchdacht); -ste (↑ R 294); **me|tho|di|sie|ren; Me|tho|dist** (Angehöriger einer ev. Erweckungsbewegung); ↑ R 268; **Me|tho|di|sten|kir|che** *w*; -n; **me|tho|di|stisch; Me|tho|do|lo|gie** (Methodenlehre, Lehre von den Wegen wissenschaftl. Erkenntnis) *w*; -, ...ien; **me|tho|do|lo|gisch**

Me|tho|ma|nie *gr.* (Med.: Säuferwahnsinn) *w*; -

¹**Me|thu|sa|lem,** (ökum.:) Me|tu|sche|lach (bibl. Eigenname)

²**Me|thu|sa|lem** (übertr. für: sehr alter Mann) *m*; -[s], -s

Me|thyl *gr.* (einwertiger Methanrest in zahlreichen organ.-chem. Verbindungen) *s*; -s; **Me|thyl|al|ko|hol** (Holzgeist, Methanol) *m*; -s; **Me|thyl|amin** (einfachste organ. Base) *s*; -s, -e; **Me|thy|len|blau** (synthet. Farbstoff)

Me|tier *fr.* [...*tie*] (veralt., **aber**

noch scherz. u. mdal. für: Handwerk; Beruf; Geschäft) *s*; -s, -s

Me|tist *it.* (Teilnehmer an einem Metageschäft); ↑ R 268

Met|öke *gr.* (eingesessener Fremdling ohne polit. Rechte [in den Städten des alten Griechenlands]) *m*; -n, -n (↑ R 268)

Me|tul ⓦ (fotogr. Entwickler) *s*; -s

Me|ton (altgr. Mathematiker); **Me|to|nisch** (↑ R 179); -er Zyklus (Zeitraum von 19 Jahren [12 Gemeinjahre zu 12 Monaten u. 7 Schaltjahre zu 13 Monaten])

Met|ono|ma|sie *gr.* (Namenveränderung durch Übersetzung in eine fremde Sprache) *w*; -, ...ien; **Met|ony|mie** (Rhet.: übertragener Gebrauch eines Wortes für einen verwandten Begriff, z. B. „jung und alt" = „alle") *w*; -, ...ien; **met|ony|misch**

Met|ope *gr.* (Architektur: Zwischenfeld in einem antiken Tempelfries) *w*; -, -n

Me|tra, **Me|tren** (*Mehrz.* von: Metrum); **Me|trik** *gr.* (Verswissenschaft, -lehre; Musik: Lehre vom Takt) *w*; -, -en; **Me|tri|ker**; **metrisch** (die Verslehre, das Versmaß betreffend; in Versen abgefaßt; nach dem Meter); -er Raum; -es System

Me|tro *gr.-fr.* [auch: me...] (Untergrundbahn in Paris u. Moskau) *w*; -, -s

Me|tro|lo|gie *gr.* (Maß- u. Gewichtskunde) *w*; -; **me|tro|lo|gisch**

Me|tro|nom *gr.* (Musik: Taktmesser) *s*; -s, -e; vgl. Mälzel

Me|tro|po|le *gr.* („Mutterstadt"; Hauptstadt, -sitz) *w*; -, -n; **Me|tro|po|lis** (älter für: Metropole) *w*; -, ...polen; **Me|tro|po|lit** (Erzbischof) *m*; -en, -en (↑ R 268); **Me|tro|po|li|tan|kir|che**

Me|trum *gr.* (Versmaß; Musik: Takt) *s*; -s, ...tren u. (älter:) ...tra

Mett niederd. (gehacktes Schweinefleisch ohne Fett) *s*; -[e]s

Met|ta|ge *fr.* [...tasche] (Umbruch [in einer Zeitungsdruckerei])

Met|te *lat.* (kirchl. Gottesdienst; nächtl. Gebet) *w*; -, -n

Met|ter|nich (österr. Staatskanzler)

Met|teur *fr.* [...tör] (Druckw.: Umbrecher, Hersteller der Seiten) *m*; -s, -e

Mett|wurst

Me|tu|sche|lach vgl. ¹Methusalem

¹Met|ze *w*; -, -n u. (südd. u. österr.:) **Met|zen** (altes Getreidemaß) *m*; -s, -

²Met|ze (veralt. für: Dirne) *w*; -, -n

Met|ze|lei (ugs.); **met|zeln** (veralt., aber noch mdal. für: schlachten;

ungeschickt schneiden; niedersäbeln); ich ...[e]le (↑ R 327); **Met|zel|sup|pe** südd. (Wurstsuppe)

Met|zen vgl. ¹Metze; **met|zen|wei|se** (veralt.)

Metzg schweiz. (Metzge) *w*; -, -en; **Metz|ge** südd. (Metzgerei, Schlachtbank) *w*; -, -n; **metz|gen** (landsch.); **Metz|ger** westmitteld., südd., schweiz. (Fleischer); **Metz|ge|rei** (westmitteld., südd., schweiz.); **Metz|ger|mei|ster**; **Metz|ger[s]|gang** landsch. (Erfolgloses) *m*; **Metz|ge|te** schweiz. (Schlachten im Hause, Schlachtfest; Schlachtplatte) *w*; -, -n; **Metzig** (Metzge) *w*; -, -en

Metz|ler mdal. (Fleischwarenhändler)

Meu|ble|ment *fr.* [möbl*ᵉmang*] (veralt. für: Zimmer-, Wohnungseinrichtung) *s*; -s, -s

Meu|chel.mord, ...mör|der; **meucheln**; ich ...[e]le (↑ R 327); **Meuch|ler**; **meuch|le|risch**; **meuch|lings**

Meu|nier [*mönje*] (belg. Bildhauer u. Maler)

Meu|te (Jägerspr.: Anzahl Hunde; übertr. auch für: wilde Rotte) *w*; -, -n; **Meu|te|rei**; **Meu|te|rer**; **meu|tern**; ich ...ere (↑ R 327)

MeV = 1 Million Elektronenvolt

Me|xi|ka|ner; **me|xi|ka|nisch**; **Me|xi|ko** (Staat in Mittelamerika u. dessen Hptst.)

Mey|er, Conrad Ferdinand (schweiz. Dichter)

Mey|er|beer (dt. Komponist)

MEZ = mitteleuropäische Zeit

Mez|za|nin *it.* (Halb-, Zwischengeschoß, bes. in der Baukunst der Renaissance u. des Barocks, österr. auch noch in älteren Wohnhäusern) *s*; -s, -e; **Mez|za|nin|woh|nung**

mez|za vo|ce *it.* [- wotsche] (Musik: mit halber Stimme; Abk.: m. v.); **mez|zo|for|te** (Musik: halbstark; Abk.: mf); **Mez|zo|gior|no** [...*dschorno*] („Mittag"; der Teil Italiens südl. von Rom, einschließlich Siziliens) *m*; -; **mez|zo|pia|no** (Musik: halbleise; Abk.: mp); **Mez|zo|so|pran** [auch: ...*pran*] (mittlere Frauenstimme zwischen Diskant u. Alt; Sängerin der mittleren Stimmlage); **Mez|zo|tin|to** (Schabkunst, bes. Technik des Kupferstichs [nur *Einz.*]; auch: Erzeugnis dieser Technik) *s*; -[s], -s od. ...ti

mf = mezzoforte

μF = Mikrofarad

mg = Milligramm

μg = Mikrogramm

Mg = chem. Zeichen für: Magnesium

MG = Maschinengewehr; MG-Schütze (↑ R 150)

MGH = Monumenta Germaniae historica

M.Glad|bach = Mönchengladbach

¹Mgr. = Monseigneur

²Mgr., Msgr. = Monsignore

mhd. = mittelhochdeutsch

MHz = Megahertz

Mia (Koseform von: Maria)

Mia. = Milliarde[n]

Mi|ami [*maiämi*] (Badeort und Hafenstadt an der Küste Floridas)

Mi|as|ma *gr.* (giftige Ausdünstung des Bodens) *s*; -s, ...men; **mi|as|ma|tisch** (giftig)

mi|au!; **mi|au|en**; die Katze hat miaut

mich (*Wenf.* des Fürwortes „ich")

Mich. = Michigan

Mi|cha (bibl. Prophet)

Mi|cha|el [...*aäl*] (einer der drei Erzengel; *m.* Vorn.); **Mi|chae|la** (w. Vorn.); **Mi|chae|li[s]** (Michaelstag) *s*; -; **Mi|chae|ls|tag** (29. Sept.); **¹Mi|chel** (Kurzform von: Michael); **²Mi|chel** (Spottname für den Deutschen) *m*; -s, -; deutscher -

Mi|chel|an|ge|lo Buo|nar|ro|ti [*mikᵉ landsehelo -*] (it. Künstler)

Mi|chels|tag landsch. (Michaelstag)

Mi|chi|gan [*mischigᵉn*] (Staat in den USA; Abk.: Mich.); **Mi|chi|gan|see** *m*

mjcke|rig [*Trenn.*: mik|ke...], **mick|rig** (ugs. für: schwach, zurückgeblieben); **Micke|rig|keit** [*Trenn.*: mik|ke...], **Mick|rig|keit**

Mic|kie|wicz [*mizkjäwitsch*] (poln. Dichter)

Micky|maus [*Trenn.*: Mik|ky...] (groteske Trickfilmfigur) *w*; -

Mi|das (phryg. König); **Mi|das|oh|ren**; ↑ R 180 (Eselsohren) *Mehrz.*

Mid|der westniederd. (Kalbsmilch) *s*; -

Mid|gard (nord. Mythol.: die Welt der Menschen, die Erde) *m*; -; **Mid|gard|schlan|ge** (Sinnbild des die Erde umschlingenden Meeres) *w*; -

mi|di (von Mänteln, Kleidern, Röcken: wadenlang, halblang); - tragen; **Mi|di...** (Mode: bis zu den Waden reichend, halblang, z. B. Midikleid); vgl. Maxi... u. Mini...

Mi|dia|ni|ter (Angehöriger eines nordarab. Volkes im A. T.) *m*; -s, -

Mi|di|nette *fr.* [...*nät*] (Pariser Modistin; veralt. für: leichtlebiges Mädchen) *w*; -, -n [...*tᵉn*]

Mid|ship|man [...*schipmᵉn*] (unter-

ster brit. Marineoffiziersrang; nordamerik. Seeoffiziersanwärter) *m*; -s, ...men
Mie|der *s*; -s, -; **Mie|der|wa|ren** (*Mehrz.*)
Mief (ugs. für: schlechte Luft) *m*; -[e]s; **mie|fen** (ugs.)
Mie|ke (niederd. Koseform von: Maria)
Mie|ne (Gesichtsausdruck) *w*; -, -n; **Mie|nen|spiel**
Mie|re (Name einiger Pflanzen) *w*; -, -n
mies *jidd.* (ugs. für: häßlich, übel, schlecht, unangenehm); -er, -este (↑ R 292); -e Laune; jmdn. od. etwas - finden; etwas - machen
¹**Mies** (Nebenform von: Miez, Mieze) *w*; -, -en
²**Mies** südd. (Sumpf; Moos) *s*; -es, -e
Mies|chen vgl. Miezchen; **Mie|se|kat|ze** vgl. Miezekatze
Mie|se|pe|ter (ugs. für: stets unzufriedener Mensch) *m*; -s, -; **mie|se|pe|te|rig** od. ...pet|rig (ugs.); **Mie|sig|keit** *w*; -; **Mies|ma|cher** (ugs. abwertend für: Schwarzseher); **Mies|ma|che|rei** (ugs.)
Mies|mu|schel (Pfahlmuschel)
Mies van der Ro|he (dt.-amerik. Architekt)
Miet|aus|fall, ...au|to, ...be|trag
¹**Mie|te** *lat.* (gegen Frost gesicherte Grube u. a. zur Aufbewahrung von Feldfrüchten) *w*; -, -n
²**Mie|te** (Geldbetrag für Wohnung u. a.) *w*; -, -n; ²**mie|ten**; eine Wohnung -
²**mie|ten** *lat.* landsch. (einmieten, Feldfrüchte in Mieten setzen)
Mie|ten|re|ge|lung, **Miet|er|ge|lung;** **Mie|ter; Miet|er|hö|hung;** **Mie|te|rin** *w*; -, -nen; **Miet|erschutz;** **Miet|er|trag; miet|frei;** **Miet|ge|setz;** **Miet|ling** (veralt. für: gedinger Knecht, käuflicher Söldling); **Miet|preis,** ...**preis|po|li|tik,** ...**recht; Miet|re|ge|lung,** **Mie|ten|re|ge|lung;** **Miets|haus,** ...**ka|ser|ne** (abwertend für: großes Mietshaus); **Miet[s]|stei|ge|rung,** ...**strei|tig|kei|ten** (*Mehrz.*), ...**ver|lust,** ...**ver|trag,** ...**wa|gen,** ...**woh|nung; Mie|tung;** **Miet|ver|lust|ver|si|che|rung; Miet|wu|cher,** ...**zah|lung,** ...**zins** (südd., österr., schweiz.: Miete; *Mehrz.* ...zinse)
Miez *w*; -. ¹**Mieze; Miez|chen** (Kätzchen); ¹**Mie|ze** (Kosename für: Katze) *w*; -, -n; ²**Mie|ze** (Koseform von: Maria); **Mie|ze|kat|ze; Mie|ze|kätz|chen** (Kinderspr.); **mie|zeln** (veralt. für: zärtlich tun, liebeln); ich [e]le (↑ R 327)
Mifrifi = mittelfristige Finanzplanung

Mi|gnon [*minjõṅg, minjõṅg*] (w. Vorn.; Gestalt aus Goethes „Wilhelm Meister") **Mi|gno|nette** [*minjõṅt*] (kleingemusterter Kattun; schmale Zwirnspitze) *w*; -, -s
Mi|grä|ne *gr.* ([halb-, einseitiger] heftiger Kopfschmerz) *w*; -, -en
Mi|gra|ti|on *lat.* [...*zion*] (Wanderung [der Zugvögel]); **Mi|gra|ti|ons|theo|rie**
Mi|guel [*migäl*] (span. u. port. Form von: Michael)
Mijn|heer *niederl.* [*m⁽ᵉ⁾nēr*] („mein Herr", niederl. Anrede [ohne Geschlechtswort]; auch scherzh. Bez. für den Holländer) *m*; -s, -s
¹**Mi|ka|do** *jap.* (frühere Bez. für den jap. Kaiser) *m*; -s, -s; vgl. Tenno; ²**Mi|ka|do** (Geschicklichkeitsspiel mit Holzstäbchen) *s*; -s, -s; ³**Mi|ka|do** (das Hauptstäbchen im ²Mikado) *m*; -s, -s
Mi|ko (ugs. Kurzw. für: Minderwertigkeitskomplex) *m*; -, -s
mi|kro... *gr.* (klein...); **Mi|kro...** (Klein...; ein Millionstel einer Einheit, z. B. Mikrometer = 10^{-6} Meter; Zeichen: μ); **Mi|kro|be** (kleinstes, meist einzelliges Lebewesen) *w*; -, -n; **mi|kro|bi|ell** (die Mikroben betreffend, durch Mikroben); **Mi|kro|bio|lo|gie** (Lehre von den kleinsten Lebewesen), ...**che|mie** (Zweig der Chemie, der den Ablauf chem. Reaktionen unter dem Mikroskop untersucht), ...**fa|rad** (ein millionstel Farad; Zeichen: μF) ...**fau|na** (Biol.: Kleintierwelt); **Mi|kro|film; Mi|kro|fon** (eindeutschend für: Mikrophon); **Mi|kro|gramm** (ein millionstel Gramm; Zeichen: μg); **mi|kro|ke|phal** usw. vgl. mikrozephal usw.; **Mi|kro|kli|ma** (Klima der bodennahen Luftschicht); **Mi|kro|kok|kus** (Kugelbakterie; *m*; -, ...kokken), ...**ko|pie** (fotogr. Kleinaufnahme, meist von Buchseiten); **Mi|kro|kos|mos,** **Mi|kro|kos|mus** [auch: *mikro...*] („die kleine Welt"; Welt im kleinen; Ggs.: Makrokosmos) *m*; -; ¹**Mi|kro|me|ter** (Feinmeßgerät) *s*; -s, -; ²**Mi|kro|me|ter** (ein millionstel Meter; Zeichen: μm) *s*; -s, -; ²**Mi|kro|me|ter|schrau|be** (Feinmeßgerät, Bügelmeßschraube) **Mi|kron** (noch übliche Bez. für ²Mikrometer; Kurzform: My; Zeichen: μ) *s*; -s, -; **Mi|kro|ne|si|en** [...*i⁽ᵉ⁾n*] („Kleininselland"; Inselgruppe im Pazifischen Ozean); **Mi|kro|ne|si|er** [...*i⁽ᵉ⁾r*]; **mi|kro|ne|sisch** **Mi|kro|or|ga|nis|mus** *gr.* [auch: *mi...*] (kleinstes Lebewesen) meist *Mehrz.*; **Mi|kro|phon,** (eindeut-

schend auch:) **Mi|kro|fon** (Schallumwandler) *s*; -s, -e; **mi|kro|pho|nisch** (schwach-, feinstimmig); **Mi|kro|phthal|mus** (Med.: angeborene krankhafte Kleinheit des Auges) *m*; -; **Mi|kro|phy|sik** [auch: *mi...*] (Physik der Moleküle u. Atome); **Mi|kro|phy|ten** (Med.: Bakterien) *Mehrz.*; **Mi|kro|psie** (Med.: Sehstörung mit Verkleinerung der Gegenstände) *w*; -; **Mi|kro|ra|dio|me|ter** [auch: *mi...*] (Meßgerät für kleinste Strahlungsmengen) *s*; -s, -; **mi|kro|seis|misch** (von Erdbeben: nur mit Instrumenten wahrnehmbar); **Mi|kro|skop** (optisches Vergrößerungsgerät) *s*; -s, -e; **mi|kro|sko|pie|ren** (mit dem Mikroskop arbeiten, untersuchen; vergrößern); **mi|kro|sko|pisch** (nur durch das Mikroskop erkennbar; verschwindend klein); **Mi|kro|spo|re** (kleine männl. Spore einiger Farnpflanzen); **Mi|kro|tom** (Gerät zur Herstellung feinster Schnitte für mikroskop. Untersuchungen) *m* od. *s*; -s, -e; **Mi|kro|wel|len** (Elektrotechnik: Dezimeter-, Zentimeter- u. Millimeterwellen) *Mehrz.*; **Mi|kro|zen|sus** *gr.*; *lat.* (statistische Repräsentativerhebung der Bevölkerung u. des Erwerbslebens); **mi|kro|ze|phal** (kleinköpfig); **Mi|kro|ze|pha|le** *m* u. *w*; -n, -n (↑ R 268); **Mi|kro|ze|pha|lie** (Med.: Kleinköpfigkeit) *w*; -
¹**Mi|lan** *fr.* [auch: *milan*] (ein Greifvogel) *m*; -s, -e
²**Mi|lan** (serb. Fürstenname)
Mi|la|no (it. Form von: Mailand)
Mil|be (ein Spinnentier) *w*; -, -n; **mil|big**
Milch *w*; -, (fachspr.) -en; **Milch|bar** *w,* ...**bart** (Milchgesicht); ...**brei,** ...**bröt|chen,** ...**bru|der** (veralt. für: jmd., der gleichzeitig mit einem anderen dieselbe Amme gehabt hat); ...**ei|weiß; ¹mil|chen** (aus Milch); ²**Milcher** landsch. (Milch geben); ²**Mil|cher** vgl. Milchner; ²**Mil|cher** landsch. (Melker); **Mil|che|rin** (landsch.) *w*; -, -nen; **Milch|fla|sche,** ...**frau,** ...**ge|biß,** ...**ge|sicht** (heute spött. für: unreifer, junger Bursche), ...**glas** (*Mehrz.* ...gläser); **mil|chig; Milch|kaf|fee,** ...**kan|ne,** ...**känn|chen,** ...**kuh,** ...**kur; Milch|ling** (ein Pilz); **Milch|mäd|chen; Milch|mäd|chen|rech|nung** (ugs. für: auf Trugschlüssen beruhende Rechnung); **Milch|mann** (selten *Mehrz.* ...männer); **Milch|nähr|scha|den** (eine Ernährungsstörung bei Säuglingen); **Milch|ner,**

Mil|cher (männl. Fisch); Milch-
..pro|dukt, ...pul|ver, ...pum|pe,
...reis, ...saft (Bot.), ...säu-
re (Chemie), ...scho|ko|la|de,
...schwe|ster (vgl. Milchbruder),
...stra|ße (w; -), ...tü|te; milch-
weiß; Milch..wirt|schaft, ...zahn,
...zucker [Trenn.: ...zuk|ker]

mild, mil|de; Mil|de w; -; mil|dern;
ich ...ere (↑ R 327); mildernde
Umstände (Rechtsspr.); Mil|de-
rung; Mil|de|rungs|grund; mild-
her|zig; Mild|her|zig|keit w; -;
mild|tä|tig; Mild|tä|tig|keit w; -
Mi|le (volkst. Kurzform von:
Emilie)

Mi|le|na [auch: mi|lena] (w. Vorn.)
Mi|le|si|er [...i^er] (Bewohner von
Milet); Mi|let (altgr. Stadt)
Mil|haud [mijø, auch: milɔ], Da-
rius (fr. Komponist)

Mi|li|ar|tu|ber|ku|lo|se lat. (Med.:
meist rasch tödlich verlaufende
Allgemeininfektion des Körpers
mit Tuberkelbazillen)

Mi|lieu fr. [...liö] (Lebensumstän-
de, Umwelt; österr. veraltet auch:
kleine Tischdecke; schweiz. auch
für: Dirnenwelt) s; -s, -s; Mi|lieu-
for|schung; mi|lieu|ge|schä|digt;
Mi|lieu|ge|schä|dig|te m u. w; -n,
-n (↑ R 287ff.); Mi|lieu.schil|de-
rung, ...theo|rie, ...wech|sel

mi|li|tant lat. (kämpferisch); [1]Mi-
li|tär fr. (höherer Offizier) m; -s,
-s; [2]Mi|li|tär (Soldatenstand;
Heerwesen, Wehrmacht) s; -s;
Mi|li|tär.aka|de|mie, ...arzt,
...at|ta|ché, ...block (Mehrz.
...blöcke od. ...blocks), ...bud-
get, ...bünd|nis, ...dienst, ...dik|ta-
tur, ...etat, ...flug|ha|fen (vgl. [2]Ha-
fen), ...ge|richts|bar|keit; Mi|li-
ta|ria lat. (Bücher über das
Militärwesen, veralt. für:
Heeresangelegenheiten, -sachen)
Mehrz.; mi|li|tä|risch fr.; mi|li|ta-
ri|sie|ren (milit. Anlagen errich-
ten, Truppen aufstellen); Mi|li-
ta|ri|sie|rung; Mi|li|ta|ris|mus lat.
(Vorherrschen milit. Gesinnung)
m; -; Mi|li|ta|rist (↑ R 268); mi|li-
ta|ri|stisch; Mi|li|tär.marsch,
...mis|si|on, ...mu|sik, ...pflicht (w;
-); mi|li|tär|pflich|tig; Mi|li|tär-
pflich|ti|ge m; -n, -n (↑ R 287ff.);
Mi|li|tär.po|li|zei, ...re|gie|rung,
...schu|le, ...seel|sor|ge, ...zeit (w;
-); Mi|li|ta|ry engl. [mi̯lit^er̥i] (Viel-
seitigkeitsprüfung [im sportl.
Reiten]) w; -, -s; Mi|liz lat. (kurz
ausgebildete Truppen, Bürger-
wehr, Volksheer u. dgl. [im Ge-
gensatz zum stehenden Heer]) w;
-, -en; Mi|liz.heer, ...sol|dat; Mi-
li|zio|när (Milizsoldat) m; -s, -e
Mil|ke schweiz. (Kalbsmilch)
w; -

Mill., Mio. = Million[en]

Mil|le lat. (Tausend; Zeichen M)
s; -, -; 5 -; vgl. per, pro mille
Mil|le|fio|ri|glas it.; dt. (vielfarbi-
ges, verziertes Kunstglas; Mehrz.
...gläser)

Mil|le Mi|glia it. [- mi̯lia] (Lang-
streckenrennen für Sportwagen
in Italien) Mehrz.

Mill|en|ni|um lat. (selten für:
Jahrtausend) s; -s, ...ien [...i^en];
Mill|en|ni|ums[s]fei|er (Tausend-
jahrfeier)

Mil|li (Koseform von: Emilie)
Mil|li... lat. (ein Tausendstel einer
Einheit, z. B. Millimeter = 10^{-3}
Meter; Zeichen: m); Mil|li|am-
pere [...ampär] (Maßeinheit klei-
ner elektr. Stromstärken; Zei-
chen: mA); Mil|li|am|pere|me|ter
[...ä̯r...] (Gerät zur Messung ge-
ringer Stromstärken) s; -s, -

Mil|li|ar|där fr. (Besitzer eines
Vermögens von mindestens einer
Milliarde) m; -s, -e; Mil|li|ar|de
(1000 Millionen; Abk.: Md. u.
Mrd.) w; -, -n; Mil|li|ar|den.an-
lei|he, ...be|trag; mil|li|ard|stel; vgl.
achte; mil|li|ard|stel; vgl. ach-
tel; Mil|li|ard|stel; vgl. Achtel

Mil|li|bar (1/₁₀₀₀ Bar; Maßeinheit
für den Luftdruck; Abk.: mbar,
in der Meteor. nur: mb) s; -s, -;
Mil|li|gramm (1/₁₀₀₀ g; Zeichen: mg); 10
-; Mil|li|li|ter (1/₁₀₀₀ l; Zeichen:
ml); Mil|li|me|ter (1/₁₀₀₀ m; Zei-
chen: mm); Mil|li|me|ter|pa|pier

Mil|li|on lat. (1000 mal 1000; Abk.:
Mill. u. Mio.) w; -, -en; eine -;
ein[und]drei|vier|tel -, eine und
drei viertel -en; zwei -en; mit 0,8
-en; Mil|lio|när fr. (Besitzer eines
Vermögens von mindestens einer
Million; seine kleine Mann) m;
-s, -e; Mil|lio|när|chen; Mil|lio|nen-
.auf|la|ge, ...auf|trag, ...be|trag;
mil|lio|nen|fach; Mil|lio|nen.ge-
schäft, ...ge|winn, ...heer; mil|lio-
nen|mal; Mil|lio|nen.scha|den,
...stadt; mil|lion|stel; vgl. achte;
mil|li|on[s]tel; vgl. achtel; Mil|li-
on[s]tel s (schweiz. meist: m); -s,
-; vgl. Achtel

Mil|löcker [Trenn.: ...lök|ker]
(österr. Komponist)

Mill|statt (österr. Ort); Mill|stät-
ter (↑ R 199); - See

Mil|ly (engl. Koseform von: Emi-
lie)

Mil|reis port. (1000 Reis; ehem.
Währungseinheit in Portugal u.
Brasilien) s; -, -

Mil|stein (amerik. Geiger russ.
Herkunft)

Mil|tia|des (athen. Feldherr)
Mil|ton [...t^en] (engl. Dichter)

Milz (Organ) w; -, -en; Milz|brand
w; -[e]s

[1]Mi|me (eingedeutschte Form
von: Mimir)

[2]Mi|me gr. (veralt. für: Schauspie-
ler) m; -n, -n (↑ R 268); mi|men
(veralt. für: als Mime wirken;
übertr. ugs. für: so tun, als ob);
Mi|men (Mehrz. von: Mime u.
Mimus); Mi|me|se (Nachah-
mung; Schutztracht mancher
Tiere) w; -, -n; Mi|me|sie (bei Kri-
stallen) w; -, ...ien; Mi|me|sis
(Nachahmung) w; -, ...esen; mi-
me|tisch (die Mimese betreffend;
durch Mimesie wirkend); Mi|mik
(Gebärden- u. Mienenspiel [des
Schauspielers]) w; -; Mi|mi|ker
vgl. Mimus; Mi|mi|kry engl.
[...kri] („Nachahmung" wehr-
hafter Tiere durch nichtwehrhaf-
te in Körpergestalt u. Färbung;
übertr. für: Schutzfärbung, An-
passung) w; -

Mi|mir (Gestalt der nord. Mythol.; Gestalt der germ. Heldensage)

mi|misch gr. (schauspielerisch; mit
Gebärden); -ste (↑ R 294)

Mi|mo|se gr. (Pflanzengattung;
Blüte der Silberakazie) w; -, -n;
mi|mo|sen|haft (zart, fein; emp-
findlich)

Mi|mus gr. (Possenreißer der An-
tike; auch die Posse selbst) m;
-, ...men

min, m (Astron.: ...^m, z. B. 8^m),
Min. = Minute

Mi|na, Mi|ne (Kurzform von:
Wilhelmine)

Mi|na|rett arab.-fr. (Moschee-
turm) s; -s, -e u. -s

Min|chen (Koseform von: Mina,
Mine)

Min|da|nao (Insel der Philippinen)

Min|den (Stadt a. d. Weser); Min-
de|ner (↑ R 199)

min|der; - gut, - wichtig; min|der-
.be|deu|tend, ...be|gabt; Min|der-
be|gab|te m u. w; -n, -n (↑ R
287ff.); min|der|be|gü|tert; Min-
der|be|gü|ter|te m u. w; -n, -n (↑ R
287ff.); min|der|be|mit|telt; Min-
der|be|mit|tel|te m u. w; -n, -n (↑ R
287ff.); Min|der|bru|der (Ange-
höriger des I. Ordens des hl.
Franz von Assisi), ...ein|nah|me;
Min|der|heit; Min|der|hei|ten-
.fra|ge, ...schutz; Min|der|heits-
re|gie|rung; min|der|jäh|rig; Min-
der|jäh|ri|ge m u. w; -n, -n (↑ R
287ff.); Min|der|jäh|rig|keit w; -;
Min|der|lei|stung; min|dern; ich
...ere (↑ R 327); Min|de|rung;
Min|der|wert; min|der|wer|tig; -es
Fleisch; Min|der|wer|tig|keit;
Min|der|wer|tig|keits.ge|fühl,
...kom|plex (ugs. Kurzw.: Miko);
Min|der|zahl w; -; Min|dest.ab-
stand, ...al|ter, ...an|for|de|rung,
...bei|trag, ...be|steue|rung, ...be-
trag; Min|dest|bie|ten|de m u. w;
-n, -n (↑ R 287ff.); min|de|ste;

mindestens. *Kleinschreibung* (↑ R 134): nicht das mindeste (gar nichts), zum mindesten (wenigstens), nicht im mindesten (gar nicht); (↑ R 135:) das -, was er tun sollte, ist ...; m**i**n|de|stens; M**i**n|dest|for|dern|de *m*; u. *w*; -n, -n (↑ R 287ff.); M**i**n|dest.|for|de|rung, ...ge|schwin|dig|keit, ...grö|ße, ...lohn, ...maß *s*, ...preis (vgl. [2]Preis), ...re|ser|ve (Bankw.; meist *Mehrz.*), ...stra|fe, ...zahl, ...zeit

m**i**n|disch (aus Minden)

[1]M**i**|ne *fr.* (unterird. Gang; Bergwerk; Sprengkörper[gang]; Kugelschreiber-, Bleistifteinlage) *w*; -, -n

[2]M**i**|ne *gr.* (altgr. Münze, Gewicht) *w*; -, -n

[3]M**i**|ne vgl. Mina

M**i**|nen.|feld, ...krieg, ...le|ger, ...räum|boot, ...stol|len, ...such|boot, ...such|ge|rät, ...wer|fer

M**i**|ne|r**a**l *fr.* (anorgan., chem. einheitl. u. natürlich gebildeter Bestandteil der Erdkruste) *s*; -s, -e u. ...i|*en [...iᵉn]*; M**i**|ne|r**a**l.|bad, ...dün|ger; M**i**|ne|r**a**|lien|samm|lung; mi|ne|ra|lisch; M**i**|ne|ra|lo|ge *fr.*; *gr.* *m*; -n, -n (↑ R 268); M**i**|ne|ra|lo|gie (Gesteinskunde) *w*; -; m**i**|ne|ra|lo|gisch; M**i**|ne|r**a**l|öl; M**i**|ne|r**a**l.|öl.|ge|sell|schaft, ...in|du|strie, ...steu|er *w*; M**i**|ne|ral.|quel|le, ...salz, ...was|ser (*Mehrz.* ...wässer)

M**i**|ner|va [...*wa*] (röm. Göttin, Schützerin der Künste)

M**i**|ne|stra *it.* (it. Gemüsesuppe mit Reis u. Parmesankäse; österr. auch: Kohlsuppe) *w*; -, -stren

M**i**|net|te *fr.* (Eisenerz) *w*; -, -n; M**i**|neur [...*nör*] (früher für: im Minenbau ausgebildeter Pionier) *m*; -s, -e

m**i**ni (von Röcken, Kleidern: äußerst kurz); - tragen, - gehen; Ggs.: maxi; M**i**|ni... (Mode: weit oberhalb des Knies endend, äußerst kurz, z. B. Minirock); vgl. Maxi... u. Midi...; M**i**|nia|tor *it.* (früher für: Handschriften-, Buchmaler) *m*; -s, ...oren; M**i**|nia|tur (mennigrot ausgeführter) Anfangsbuchstabe; zierliches Bildchen [darin]; Kleinmalerei; Schachproblem mit höchstens sieben Figuren) *w*; -, -en; M**i**|nia|tur.|aus|ga|be (Kleinausgabe), ...bild; m**i**|nia|tu|ri|sie|ren (verkleinern); M**i**|nia|tu|ri|sie|rung; M**i**|nia|tur|ma|le|rei

M**i**|ni|bi|ki|ni, (auch die Kurzform:) M**i**|ni|ki|ni (1964 aufgekommener einteiliger, die Brust freilassender Damenbadeanzug) *m*; -s, -s; M**i**|ni|car *engl.* [*mínika*ʳ] (Kleintaxi) *m*; -s, -s

m**i**|nie|ren *fr.* (unterirdische Gänge, Stollen anlegen); vgl. [1]Mine

M**i**|ni|golf (Miniaturgolfanlage; Kleingolfspiel)

M**i**|ni|ki|ni vgl. Minibikini; M**i**|ni|kleid

m**i**|n**i**m *lat.* (veralt. für: geringfügig, minimal) [auch: *mi*...] (Mehrz. von: Minimum); m**i**|ni|mal (sehr klein, niedrigst, winzig); M**i**|ni|mal.|be|trag (Mindestbetrag), ...for|de|rung, ...pro|gramm, ...wert; M**i**|ni|max ⓦ (Feuerlöscher) *m*; -, -e; m**i**|ni|mie|ren (minimal machen); M**i**|ni|mie|rung; M**i**|ni|mum [auch: *mi*...] („das Geringste, Mindeste"; Mindestpreis, -maß, -wert, Kleinstmaß) *s*; -s, ...ma; vgl. barometrisch; -visibile [*wi*...] (Psychol.: kleinster, gerade noch empfindbarer Gesichtsreiz); M**i**|ni|mum|ther|mo|me|ter [auch: *mi*...]; M**i**|ni.|rock, ...spion (Kleinstabhörgerät)

M**i**|ni|ster *lat.* („Diener, Gehilfe"; einen bestimmten Geschäftsbereich leitendes Regierungsmitglied) *m*; -s, -; M**i**|ni|ste|ri|al.|be|am|te, ...di|rek|tor, ...di|ri|gent; M**i**|ni|ste|ri|a|le (Angehöriger des mittelalterl. Dienstadels) *m*; -n, -n (↑ R 268); M**i**|ni|ste|ri|al|rat (*Mehrz.* ...räte); m**i**|ni|ste|ri|e**l**l *fr.* (von einem Minister od. Ministerium ausgehend usw.); M**i**|ni|ste|rin *w*; -, -nen; M**i**|ni|ste|ri|um *lat.* (höchste [Verwaltungs]behörde des Staates mit bestimmtem Aufgabenbereich) *s*; -s, ...ien [...*iᵉn*]; M**i**|ni|ster.|prä|si|dent, ...prä|si|den|tin, ...rat (*Mehrz.* ...räte); M**i**|ni|strant (kath. Meßdiener) *m*; -en, -en (↑ R 268); m**i**|ni|strie|ren (bei der Messe dienen)

M**i**|ni|um *lat.* (Mennige) *s*; -s

M**i**nk *engl.* (Nerz) *m*; -s, -e

M**i**n|ka (Koseform von: Dominika)

M**i**nk|fell

Minn. = Minnesota

M**i**n|na (Koseform von: Wilhelmine, Hermine); vgl. grün, I, b

M**i**n|ne (mhd. Bez. für: Liebe; heute noch altertümelnd scherzh.) *w*; -; M**i**n|ne.dienst, ...lied; m**i**n|nen; M**i**n|ne|sang; M**i**n|ne|s**ä**n|ger, M**i**n|ne|sin|ger

M**i**n|ne|so|ta (Staat in den USA; Abk.: Minn.)

M**i**n|ni (Koseform von: Wilhelmine, Hermine)

m**i**n|nig|lich (veralt.)

m**i**|no|isch [nach dem sagenhaften altgriech. König Minos auf Kreta]; -e Kultur

M**i**|no|rat *lat.* (Vorrecht des Jüngsten auf das Erbgut, Jüngstenrecht; nach dem Jüngstenrecht zu vererbendes Gut; Ggs.: Majorat) *s*; -[e]s, -e; m**i**|no|renn (veralt. für: minderjährig); M**i**|no|ren|ni|tät (veralt.) *w*; -; M**i**|no|rist (kath. Kleriker, der eine niedere Weihe erhalten hat); ↑ R 268; M**i**|no|rit (Minderbruder) *m*; -en, -en (↑ R 268); M**i**|no|ri|tät (Minderzahl, Minderheit); M**i**|no|ri|t**ä**ts|gut|ach|ten

M**i**|no|taur *gr. m*; -s u. M**i**|no|tau|rus (Ungeheuer der gr. Sage, halb Mensch, halb Stier) *m*; -

M**i**nsk (Hptst. der Belorussischen Sozialistischen Sowjetrepublik)

M**i**n|strel *engl.* (Spielmann; Minnesänger in England) *m*; -s, -s

M**i**|nu|end *lat.* (Zahl, von der etwas abgezogen werden soll) *m*; -en, -en (↑ R 268); m**i**|nus (weniger; Zeichen: - [negativ; Ggs.: plus); fünf minus drei ist, macht, gibt (nicht: sind, machen, geben) zwei; minus 15 Grad od. 15 Grad minus; M**i**|nus (Minder-, Fehlbetrag, Verlust) *s*; -, -; M**i**|nus|be|trag; M**i**|nus|kel (Kleinbuchstabe) *w*; -, -n; M**i**|nus.pol, ...punkt, ...zei|chen (Subtraktionszeichen); M**i**|nu|te („kleiner Teil"; $\frac{1}{60}$ Stunde [Zeichen: m (Astron.: ...ᵐ), min; Abk.: Min.]; Geometrie: $\frac{1}{60}$ Grad [Zeichen: ']) *w*; -, -n; m**i**|nu|ten|lang; -er Beifall; aber: mehrere Minuten lang; M**i**|nu|ten|zei|ger; ...mi|n**ü**|tig, (auch:) ...mi|nu|tig (z. B. fünfminütig, mit Ziffer: 5minütig [fünf Minuten dauernd]); m**i**|nu|ti**ö**s vgl. minuziös; m**i**|n**ü**t|lich (jede Minute); ...mi|nüt|lich (z. B. fünfminütlich, mit Ziffer: 5minütlich [alle fünf Minuten wiederkehrend]); M**i**|nu|zi|en *lat.* [...*iᵉn*] (veralt. für: Kleinigkeiten; Nichtigkeiten) *Mehrz.*; M**i**|nu|zi|en|stift (Aufstecknadel für Insektensammlungen) *m*; m**i**|nu|zi**ö**s *fr.* (peinlich genau; veralt. für: kleinlich); -este (↑ R 292)

M**i**n|ze (Name verschiedener Pflanzenarten) *w*; -, -n

Mio., Mill. = Million[en]

mio|z**ä**n *gr.* (zum Miozän gehörend); Mio|zän (Geol.: zweitjüngste Abteilung des Tertiärs) *s*; -s

M**i**|po|l**a**m ⓦ [gekürzt aus: Mischpolymerisat] (ein Kunststoff) *s*; -s

mir (*Wemf.* des Fürwortes „ich"); - nichts, dir nichts; (↑ R 275:) mir alten (selten: alter) Frau; mir jungem (auch: jungen) Menschen; (↑ R 290:) mir Geliebten (weibl.; selten: Geliebter); mir Geliebtem (männl.; auch: Geliebten)

Mir (früher: russ. Dorfgemein-

schaft, Gemeinschaftsbesitz einer Dorfgemeinde) *m*; -s

Mi|ra *lat.* (ein Stern) *w*; -

Mi|ra|bel|le *fr.* (Pflaume einer bestimmten Art) *w*; -, -n

Mi|ra|bi|li|en *lat.* [...*i͏eͭn*] (veralt. für: Wunderdinge) *Mehrz.*

Mi|ra|ge *fr.* [...*raseʰ*] (Luftspiegelung; veralt. übertr. für: leichter Selbstbetrug, Selbsttäuschung; Bez. für einen fr. Jagdbomber)

Mi|ra|kel *lat.* (veraltend für: Wunder[werk]) *s*; -s, -; **mi|ra|ku-lös** (veralt. für: wunderbar); -este (↑ R 292)

Mi|ra|ma|re *it.* („Schau das Meer!", Schloß unweit von Triest)

Mi|re *fr.* (Meridianmarke zur Einstellung des Fernrohres in Meridianrichtung) *w*; -, -n

Miró [*miró*], Joan (span. Maler u. Graphiker)

Mir|za *arab.* („Fürstensohn"; vor dem Namen: Herr; hinter dem Namen: Prinz) *m*; -s, -s; **Mir|za Schaf|fy** (Dichtername für Friedrich v. Bodenstedt)

Mis|an|drie *gr.* (Med.: Männerhaß, -scheu) *w*; -; **Mis|an|throp** (Menschenhasser, -feind) *m*; -en, -en (↑ R 268); **Mis|an|thro|pie** *w*; -, ...ien; **mis|an|thro|pisch**; -ste (↑ R 294)

Misch|bat|te|rie, ...**brot**, ...**ehe** (Ehe zwischen Angehörigen verschiedener Religionen, verschiedener christl. Bekenntnisse, verschiedener Volkszugehörigkeit); **mi|schen**; du mischst (mischest); sich -; **Mi|scher**; **Mi|sche|rei** (ugs.); **Misch|far|be**; **misch|far-ben**, **misch|far|big**; **Misch|form**, ...**fut|ter** (vgl. ¹Futter), ...**gas** (Gemisch von Kohlengas mit Wassergas), ...**krug**, ...**kul|tur**; **Misch-ling** (Bastard); **Misch|masch** (ugs. für: Durcheinander verschiedener Dinge) *m*; -[e]s, -e

Misch|na *hebr.* (grundlegender Teil des Talmuds) *w*; -

Misch|po|che, **Misch|po|ke** *hebr.* (ugs. abschätzig für: Verwandtschaft; Gesellschaft) *w*; -

Misch|pult (Rundfunk, Film), ...**ras|se**, ...**sen|dung** (Postw.); **Misch.trieb|werk**, ...**trom|mel** (zum Mischen des Baustoffs); **Mi|schung**; **Mi|schungs|ver|hält-nis**; **Misch|wald**

Mi|se *fr.* [*misᵉ*] (Einmalprämie bei der Lebensversicherung; Spieleinsatz) *w*; -, -n

Mi|sel ([Goethe:] junges Mädchen, Liebchen) *w*; -, -n

mi|se|ra|bel *fr.* ⟨ugs. für: erbärmlich; nichtswürdig), ...a|bler Kerl; **Mi|se|re** (Jammer, Notlage), Elend, Armseligkeit) *w*; -,

-n; **Mi|se|re|or** *lat.* („ich erbarme mich"; kath. Fastenopferspende für die Entwicklungsländer) *s*; -[s]; **Mi|se|re|re** („erbarme dich!"; Anfang u. Bez. des 51. Psalms [Bußpsalm] in der Vulgata; Med.: Kotbrechen) *s*; -[s]; **Mi-se|ri|cor|di|as Do|mi|ni** [...*kọr*... -] („die Barmherzigkeit des Herrn" [Psalm 89,2]; zweiter Sonntag nach Ostern); **Mi|se|ri|kor|die** [...*i͏eͭ*] (Vorsprung an den Klappsitzen des Chorgestühls als Stütze während des Stehens) *w*; -, -n

Mi|so|gam *gr.* (Verächter der Ehe) *m*; -s u. -en, -e[n] (↑ R 268); **Mi|so-ga|mie** (Med., Psych.: Ehescheu) *w*; -; **Mi|so|gyn** (Weiberfeind) *m*; -s u. -en, -e[n] (↑ R 268); **Mi|so|gy-nie** (Med., Psych.: Weiberhaß, -scheu) *w*; -; **Mi|so|pä|die** (Med., Psych.: Haß gegen [die eigenen] Kinder) *w*; -

Mis|pel *gr.* (Obstgehölz, Frucht) *w*; -, -n

Mis|ra|chi *hebr.* (eine Weltorganisation orthodoxer Zionisten) *w*; -

Miß, (in engl. Schreibung:) **Miss** *engl.* (als Anrede vor dem Eigenn., = Fräulein; engl. Fräulein; in Verbindung mit einem Länderod. Ortsnamen für: Schönheitskönigin, z. B. Miß Australien) *w*; -, Misses [*mißis*]

miß... (Vorsilbe von Zeitwörtern, z. B. mißachten; zum 2. Mittelw. ↑ R 304)

Miss. = ²Mississippi

Mis|sa *lat.* (kirchenlat. Bez. der Messe) - so|lem|nis (feierliches Hochamt; auch Titel eines Werkes von Beethoven)

miß|ach|ten; ich mißachte ich habe mißachtet (↑ R 304); zu mißachten; seltener: mißachten, gemißachtet, zu mißachten; **Miß-ach|tung**

¹**Mis|sal** *lat.* *s*; -s, -e u. ...**ali-**en; ²**Mis|sal** (Bez. eines Schriftgrades) *w*; -

miß|be|ha|gen; es mißbehagt mir; es hat mir mißbehagt; mißzubehagen; **Miß|be|ha|gen**; ...**iß|be-hag|lich**

miß|be|schaf|fen; **Miß|be|schaf-fen|heit**

miß|bil|den; ich mißbilde; mißgebildet (↑ R 304); mißzubilden; **Miß|bil|dung**

miß|bil|li|gen; ich mißbillige; ich habe mißbilligt (↑ R 304); zu mißbilligen; **Miß|bil|li|gung**

Miß|brauch; **miß|brau|chen**; ich mißbrauche; ich habe mißbraucht (↑ R 304); zu mißbrauchen; **miß|bräuch|lich**; **miß-bräuch|li|cher|wei|se**

miß|deu|ten; ich mißdeute; ich

habe mißdeutet (↑ R 304); zu mißdeuten; **Miß|deu|tung**

mis|sen; du mißt (missest); gemißt; misse! od. miß!

Miß|er|folg

Miß|ern|te

Misses (*Mehrz.* von: Miß)

miß|fal|len; ich mißfalle; ich habe mißfallen (↑ R 304); zu mißfallen; es mißfällt mir; **Miß|fal|len** *s*; -s; **Miß|fal|lens|äu|ße|rung**; **miß|fäl-lig** (mit Mißfallen)

Miß|far|be; **miß|far|ben**, **miß|far-big**

Miß|ge|burt

Miß|ge|launt **Miß|ge|launt|heit** *w*; -

Miß|ge|schick

Miß|ge|stalt; **miß|ge|stalt** (von Natur aus); -er Mensch; **miß|ge|stal-ten**; er mißgestaltet; er hat mißgestaltet (↑ R 304); mißzugestalten; **miß|ge|stal|tet** (von Menschenhand); -e Form

miß|ge|stimmt

miß|ge|wach|sen, **miß|wach|sen**; ein -er Mensch

miß|glücken [*Trenn.*: ...glük|ken]; es mißglückt; es ist mißglückt (↑ R 304); zu mißglücken

miß|gön|nen; ich mißgönne; ich habe mißgönnt (↑ R 304); zu - **Miß|griff**

Miß|gunst; **miß|gün|stig**; ein -er Mensch

miß|han|deln; ich mißhandle (↑ R 327); ich habe mißhandelt (↑ R 304); zu mißhandeln; **Miß-hand|lung**

Miß|hei|rat

Miß|hel|lig|keit *w*; -, -en (meist *Mehrz.*)

Mis|sing link *engl.* („fehlendes Glied"; Biol.: fehlende Übergangsform zwischen Mensch u. Affe; fehlende Übergangsform in tier. u. pflanzl. Stammbäumen) *s*; - -

mis|singsch; **Mis|singsch** (der Schriftsprache angenäherte [niederdeutsche] Sprachweise) *s*; -

Mis|sio ca|no|ni|ca *lat.* [- *kanọni-ka*] (Ermächtigung zur Ausübung der kirchl. Lehrgewalt) *w*; -, -; **Mis|si|on** („Sendung"; Bestimmung, Auftrag, Botschaft, [innere] Aufgabe; Heidenbekehrung; diplomatische Vertretung im Ausland); die Innere - (Organisation der ev. Kirche); **Mis|sio-nar**, (auch, österr. nur so:) **Mis-sio|när** (Sendbote; Heidenbekehrer) *m*; -s, -e; **mis|sio|na|risch**; **mis-sio|nie|ren** (eine Glaubenslehre verbreiten); **Mis|sio|nie|rung**; **Mis|si|ons.chef**, ...**ge|sell|schaft**, ...**kon|fe|renz**, ...**pra|xis**, ...**sta|ti-on**, ...**wis|sen|schaft** (*w*; -), ...**zelt**

¹**Mis|sis|sip|pi** (nordamerik. Strom) *m;* -[s]; ²**Mis|sis|sip|pi** (Staat in den USA; Abk.: Miss.)

Mis|siv *lat. s;* -s, -e [...*w*ᵉ] u. **Mis|si|ve** [...*w*ᵉ] (veralt. für: Sendschreiben; auch für: verschließbare Aktentasche) *w;* -, -n

Miß|jahr

Miß|klang

Miß|kre|dit (schlechter Ruf; mangelndes Vertrauen) *m;* -[e]s; jmdn. in - bringen

miß|lau|nig

Miß|laut

miß|lei|ten; ich mißleite; ich habe mißleitet (auch mißgeleitet; ↑ R 304); zu mißleiten; **Miß|lei|tung**

miß|lich (unangenehm); die Verhältnisse sind -; **Miß|lich|keit**

miß|lie|big (unbeliebt); ein -er Vorgesetzter; **Miß|lie|big|keit**

miß|lin|gen; es mißlingt; es mißlang; es mißlänge; es ist mißlungen (↑ R 304); zu mißlingen; **Miß|lin|gen** *s;* -s

Miß|mut; **miß|mu|tig**

¹**Mis|sou|ri** [...*ßu...*] (r. Nebenstrom des Mississippi) *m;* -[s]; ²**Mis|sou|ri** (Staat in den USA; Abk.: Mo.)

Miß|pickel [*Trenn.:* ...pik|kel] (Arsenkies, ein Mineral) *m;* -s

miß|ra|ten (schlecht geraten; selten für: ab-, widerraten); ich mißrate; es mißrät; es ist mißraten (↑ R 304); zu mißraten; **Miß|stand**

Miß|stim|mung

Miß|ton (*Mehrz.* ...töne); **miß|tö|nend;** -ste; **miß|tö|nig**

miß|trau|en; ich mißtraue; ich habe mißtraut (↑ R 304); zu mißtrauen; **Miß|trau|en** *s;* -s; - gegen jmdn. hegen; **Miß|trau|ens|an|trag,** ...vo|tum; **miß|trau|isch;** -ste (↑ R 294)

Miß|ver|gnü|gen *s;* -s; **miß|ver|gnügt**

Miß|ver|hält|nis

Miß|ver|stand (veralt.); **miß|ver|ständ|lich;** **Miß|ver|ständ|nis;** **miß|ver|ste|hen;** ich mißverstehe; ich habe mißverstanden (↑ R 304); mißzuverstehen; sich -

Miß|wachs (Landw.) *m;* -es; **miß|wach|sen** vgl. mißgewachsen

Miß|wahl [zu: Miß]

Miß|wei|sung (für: Deklination [Abweichung der Magnetnadel])

Miß|wirt|schaft

Miß|wuchs (Pflanzenkunde) *m;* -es

miß|zu|frie|den

Mist (österr. auch für: Kehricht) *m;* -[e]s; **Mist|beet,** ...kü|bel (österr.: Abfalleimer), ...schau|fel (österr.: Kehrichtschaufel)

Mi|stel (immergrüne Schmarotzerpflanze) *w;* -, -n; **Mi|stel|gewächs,** ...zweig

mi|sten

Mi|ster vgl. Mr.

Mist_fink (verächtl. ugs. für: unsauberer Mensch; Zotenreißer; *m;* -en [auch: -s], -en), ...ga|bel, ...hau|fen, ...hund (Schimpfwort); **mi|stig** landsch. (schmutzig); **Mi|stig|keit** (landsch.) *w;* -; **Mist_jau|che,** ...kerl (Schimpfwort), ...kä|fer

Mi|stral *fr.* (kalter, stürmischer Nord[west]wind im Rhonetal) *m;* -s, -e

Mi|streß vgl. Mrs.

Mist_stock (schweiz. für: Misthaufen; *Mehrz.* ...stöcke), ...stück (Schimpfwort), ...vieh (Schimpfwort), ...wet|ter (ugs. für: sehr schlechtes Wetter)

Mis|zel|la|ne|en [auch: ...*lang*ᵉ*n*], **Mis|zel|len** *lat.* (Vermischtes; kleine Aufsätze verschiedenen Inhalts) *Mehrz.*

mit; **I.** *Verhältniswort* mit *Wemf.;* mit dem Hute; mit anderen Worten (Abk.:m.a.W.). **II.** *In Verbindung mit Zeitwörtern* (↑ R 139): **1.** *Getrenntschreibung* („mit" ist selbständige Umstandsangabe), wenn „mit" die vorübergehende Beteiligung od. den Gedanken des Anschlusses (svw. „auch") ausdrückt, z. B. du kannst ausnahmsweise einmal mit arbeiten; das ist mit zu berücksichtigen; die Kosten sind mit berechnet; das kann ich nicht mit ansehen. **2.** *Zusammenschreibung* („mit" ist „Vorwort"): **a)** wenn „mit" eine dauernde Vereinigung od. Teilnahme ausdrückt; vgl. mitarbeiten, mitfahren usw. **b)** wenn durch die Verbindung ein neuer Begriff entsteht; vgl. mitbringen, mitreißen, mitteilen usw.

Mit_an|ge|klag|te, ...ar|beit; **mit|ar|bei|ten** (dauernd Mitarbeiter sein); er hat an diesem Werk mitgearbeitet; **aber:** mit ar|bei|ten (gelegentlich an einer Arbeit teilnehmen); kannst du eine Stunde mit arbeiten? vgl. mit, II, 1 u. 2, a; **Mit_ar|bei|ter,** ...ar|bei|te|rin; **Mit|ar|bei|ter|stab; Mit_grün|der; mit|be|kom|men; mit|be|nut|zen,** (bes. südd.:) **mit|be|nüt|zen; Mit_be|nut|zung,** ...be|stim|mung (*w;* -); **Mit_be|stim|mungs_ge|setz,** ...recht; **Mit_be|wer|ber,** ...be|woh|ner

mit|brin|gen (schenken); er hat mir diese Bücher von der Reise mitgebracht; **Mit|bring|sel** *s;* -s, -

Mit_bür|ger; Mit|bür|ger|schaft *w;* -

mit|den|ken

Mit|ei|gen|tum; Mit|ei|gen|tü|mer

mit|ein|an|der; *Schreibung in Verbindung mit Zeitwörtern:* mitein-

ander (mit sich gegenseitig) aus|kommen, le|ben, spielen usw.; vgl. aneinander; **Mit|ein|an|der** [auch: *mit...*] *s;* -s

Mit_emp|fin|den, ...er|le|be *m*

mit|er|le|ben

Mit|es|ser

mit|fah|ren; Mit_fah|rer, ...fahrt

mit|füh|len; mit|füh|lend; -ste

mit|füh|ren

mit|ge|ben

mit|ge|fan|gen; -, mitgehangen

Mit_ge|fühl *s;* -[e]s

mit|ge|hen

mit|ge|nom|men; er sah sehr - (ermattet) aus

Mit|gift (Mitgabe; Aussteuer) *w;* -, -en; **Mit|gift|jä|ger** (abschätzig)

Mit|glied; - des Bundestages (Abk.: M. d. B. od. MdB); - des Landtages (Abk.: M. d. L. od. MdL); **Mit_glie|der_li|ste,** ...ver|samm|lung, ...ver|zeich|nis, ...zahl; **Mit_glieds_aus|weis,** ...bei|trag; **Mit|glied|schaft** *w;* -; **Mit_glieds_kar|te,** ...land (*Mehrz.* ...länder); **Mit_glieds_staat,** ...glied|staat (*Mehrz.* ...staaten)

mit|ha|ben; alle Sachen -

mit|hal|ten; mit jmdm. -

mit|hel|fen; im Haushalt -; **Mit|hel|fer**

Mit|her|aus|ge|ber

mit Hil|fe; der Zucker, mit Hilfe dessen oder mit dessen Hilfe sie den Teig süßte

Mit|hil|fe *w;* -

mit|hin (somit)

mit|hö|ren; am Telefon -

Mi|thra[s] (altiranischer Lichtgott)

Mi|thri|da|tes (König von Pontus)

Mit|in|ha|ber

Mit|kämp|fer

Mit|klä|ger

mit|klin|gen

mit|kom|men

mit|kön|nen; mit jmdm. nicht - (ugs. für: nicht konkurrieren können)

mit|krie|gen (ugs.)

mit|lau|fen; Mit|läu|fer

Mit_laut (für: Konsonant); **Mit_laut|fol|ge**

Mit_leid *s;* -[e]s; **Mit|lei|den** *s;* -s; **Mit|lei|den|schaft,** nur in: etwas od. jmdn. in - ziehen; **mit|lei|dig; mit|leid[s]_los,** ...voll

mit|ma|chen (ugs.)

Mit_mensch *m;* **mit|mensch|lich**

mit|mi|schen (ugs. für: sich aktiv an etwas beteiligen)

mit|müs|sen; auf die Wache -

Mit_nah|me (Mitnehmen) *w;* -; **mit|neh|men;** vgl. mitgenommen; **Mit|neh|mer** (Technik)

mit|nich|ten; vgl. nichte

Mi|to|se *gr.* (Art der Zellkernteilung) *w;* -, -n

Mi|tra *gr.* (Bischofsmütze; Med.: haubenartiger Kopfverband) *w;* -, -, ...tren

Mi|trail|leu|se *fr.* [*mitra(l)jös*ᵉ] („Kugelspritze", - Salvagenschütz [1870–71], Vorläufer des Maschinengewehrs) *w;* -, -n

mit|re|den; aus Erfahrung - können

mit|rei|sen; er ist mit ihnen mitgereist; Mit|rei|sen|de

mit|rei|ßen; von der Menge mitgerissen werden; der Redner riß alle Zuhörer mit (begeisterte sie); mit|rei|ßend; eine -e Musik

Mit|ro|pa (Mitteleuropäische Schlaf- u. Speisewagen Aktiengesellschaft; nach dem 2. Weltkrieg in der BRD ersetzt durch DSG = Deutsche Schlafwagen- u. Speisewagen-Gesellschaft mbH) *w;* -

mit|sam|men landsch. (zusammen, gemeinsam); mit|samt; mit *Wemf.* (gemeinsam mit): - seinem Eigentum

mit|schlei|fen

mit|schlep|pen

mit|schnei|den (vom Rundf. od. Fernsehen Gesendetes auf Tonband aufnehmen); Mit|schnitt

mit|schrei|ben

Mit|schuld; mit|schul|dig; Mit|schul|di|ge

Mit|schü|ler

mit|schwin|gen

mit|sin|gen

mit|spie|len; Mit|spie|ler

Mit|spra|che *w;* -; Mit|spra|che|recht; mit|spre|chen

mit|ste|no|gra|phie|ren

Mit|strei|ter

Mitt|acht|zi|ger vgl. Mittdreißiger

¹Mit|tag *m;* -[e]s, -e. I. *Großschreibung:* über - wegbleiben; zu - essen, Mittag (ugs. für: Mittagspause) machen; des Mittags, eines Mittags. II. *Kleinschreibung* (↑ R 129): mittag; [bis, von] gestern, heute, morgen mittag; Dienstag mittag; vgl. mittags; ²Mit|tag¹ (ugs. für: Mittagessen) *s;* -[e]s; ein karges -; Mit|tag|es|sen¹; mit|tä|gig¹; vgl. ...tägig; mit|täg|lich¹; vgl. ...täglich; mit|tags¹ (↑ R 129), aber: des Mittags; 12 Uhr -; vgl. Abend u. Dienstag; Mit|tag[s]|brot¹; Mit|tags¹.hit|ze, ...kreis (für: Meridian), ...li|nie (für: Meridianlinie); Mit|tag[s]-mahl¹; Mit|tags|pau|se¹; Mit|tag[s]¹_schicht, ...schlaf (vgl. ²Schlaf), ...son|ne, ...stun|de; Mit|tags¹_tisch, ...zeit
Mit.tä|ter, ...tä|ter|schaft
Mitt|drei|ßi|ger (Mann in der Mit-

te der Dreißigerjahre); Mitt|drei-ßi|ge|rin *w;* -, -nen

Mit|te *w;* -, -n; in der -; - Januar (↑ R 319); - Dreißig, - der Dreißiger

mit|tei|len (melden); er hat ihm das Geheimnis mitgeteilt; aber: mit tei|len (zu einer Teilung teilnehmen); er hat mit geteilt; vgl. mit, II, 1 u. 2, b; mit|teil|sam; Mit|teil-sam|keit *w;* -; Mit|tei|lung, Mit-tei|lungs|be|dürf|nis *s;* -ses

¹Mit|tel *s;* -s, -; sich ins - legen; ²Mit|tel (in Schriftgrad) *w;* -; Mit|tel|al|ter (Abk.: MA) *s;* -s; mit|tel|al|te|rig, mit|tel|alt|rig (in mittlerem Alter stehend); mit|tel-al|ter|lich (dem Mittelalter angehörend; Abk.: ma.); Mit|tel|ame-ri|ka

mit|tel|bar; -e Täterschaft (Rechtsspr.)

Mit|tel|bau *m;* -[e]s

Mit|tel|chen

mit|tel|deutsch; vgl. deutsch; Mit-tel|deutsch (Sprache) *s;* -[s]; vgl. Deutsch; mit|tel|deut|sche *s;* -n; vgl. Deutsche *s;* Mit|tel|deutsch-land

Mit|tel|ding

Mit|tel|eu|ro|pa; mit|tel|eu|ro|pä-isch; -e Zeit (Abk.: MEZ)

Mit|tel|feld (bes. Sport)

Mit|tel|fin|ger

Mit|tel|fran|ken

mit|tel|fri|stig (auf eine mittlere Zeitspanne begrenzt); -e Finanzplanung (Abk.: Mifrifi)

Mit|tel|ge|bir|ge; Mit|tel|ge|birgs-form; Mit|tel.ge|wicht (Körpergewichtsklasse in der Schwerathletik), ...glied; mit|tel.groß, ...gut

Mit|tel|hand *w;* -

mit|tel|hoch|deutsch (Abk.: mhd.); vgl. deutsch; Mit|tel|hoch-deutsch (Sprache) *s;* -[s]; vgl. Deutsch; Mit|tel|hoch|deut|sche *s;* -n; vgl. Deutsche *s*

Mit|tel|in|stanz

Mit|tel|klas|se; Mit|tel|klas|se-wa|gen

mit|tel|län|disch; -es Klima, aber (↑ R 198): das Mittelländische Meer

Mit|tel|land|ka|nal *m;* -s

Mit|tel|la|tein; mit|tel|la|tei|nisch (Abk.: mlat.)

Mit|tel|läu|fer (Sport)

Mit|tel|li|nie

mit|tel|los; -este (↑ R 292); Mit|tel-lo|sig|keit *w;* -

Mit|tel|maß *s;* mit|tel|mä|ßig; Mit-tel|mä|ßig|keit

Mit|tel|meer *s;* -[e]s; Mit|tel|meer-raum; mit|tel|mee|risch

mit|tel|nie|der|deutsch (Abk.: mnd.)

mit|tel|präch|tig (ugs. scherzh. für: mittelmäßig)

Mit|tel|punkt; Mit|tel|punkt|schu-le; Mit|tel|punkts|glei|chung (Astron.)

mit|tels [erstarrter Wesf. zu: Mittel], daneben auch noch die Form: mittelst (↑ R 130); *Verhält-nisw.* mit *Wesf.:* - eines Löffels; besser: mit einem Löffel; - Wasserkraft; mittels Drahtes; ein alleinstehendes, stark gebeugtes Hauptw. steht in der *Einz.* ungebeugt: - Draht, in der *Mehrz.* mit *Wemf.*, wenn der Wesf. nicht erkennbar ist: - Drähten

Mit|tel.schei|tel, ...schicht, ...schiff, ...schu|le (Realschule; österr. ugs., schweiz. für: höhere Schule, Lehrerseminar, Handelsschule); Mit|tel|schul|leh|rer

mit|tel|schwer; -e Verletzungen

Mit|tels.mann (Vermittler; *Mehrz.* ...leute od. ...männer), ...per|son

Mit|tel|stand *m;* -[e]s; mit|tel|stän-dig (Bot.,Genetik für: intermediär); -e Blüte; mit|tel|stän|disch (den Mittelstand betreffend); Mit|tel|ständ|ler; Mit|tel|stands-be|we|gung

mit|telst vgl. mittels; mit|tel|ste; die mittelste Säule; vgl. mittlere

Mit|tel.stein|zeit (für: Mesolithikum), ...stel|lung, ...strecke [*Trenn.:* ...strek|ke]; Mit|tel-strecken_flug|zeug [*Trenn.:* ...strek|ken...], ...lauf, ...ra|ke|te; Mit|tel.streck|ler, ...strei|fen, ...stück, ...stu|fe, ...stür|mer, ...teil *m,* ...was|ser, (*Mehrz.* ...wasser) ...weg, ...wel|le, ...wert, ...wort (für: Partizip[ium]; *Mehrz.* ...wörter)

mit|ten; (↑ R 129); inmitten (vgl. d.). *Getrennt- od. Zusammenschreibung* (↑ R 139): mitten dar|in; er stellte die Bücher mitten dar|in; vgl. aber: mittendrin; mitten darin; er befand sich mitten dar-in; vgl. aber: mittendrin; mitten darunter; Draht, der Stein lag mitten darunter; vgl. aber: mittendrun-ter; mitten durch; er ging mitten durch den Wald; vgl. aber: mittendurch; mitten entzwei; das Glas brach mitten entzwei; mitten hindurch; die Grenze geht mitten hindurch; mitten in; mitten in dem Becken; vgl. aber: mitteninne; mitten mang (nordd.); er ging mitten mang die Leute (*Wenf.*); vgl. aber: mittenmang; mit|ten|drein (ugs. für: mitten hinein); er hat den Stein mittendrein geworfen; vgl. aber: mitten; mit|ten|drin (ugs. für: mitten darin); er befand sich mittendrin; vgl. aber: mitten; mit|ten-

¹ *Trenn.:* ↑ R 236.

drun|ter (ugs. für: mitten darunter); er geriet mittendrunter; vgl. aber: mitten; mit|ten|durch (ugs. für: mitten hindurch); der Stab brach mittendurch; vgl. aber: mitten; mit|ten|in|ne; mitteninne sitzen; vgl. aber: mitten; mit|ten|mang (nordd.); er befand sich mittenmang; vgl. aber: mitten Mit|ten|wald (Ort an der oberen Isar)

Mit|ter|nacht; um -; vgl. Abend; mit|ter|näch|tig (seltener für: mitternächtlich); mit|ter|nächt|lich; mit|ter|nachts (↑ R 129), aber: des Mitternachts; vgl. Abend; Mit|ter|nachts|got|tes|dienst, ...mes|se, ...son|ne (w; -), ...stun|de

Mitt|fas|ten (Mittwoch vor Lätare oder Lätare selbst) Mehrz.

Mitt|fünf|zi|ger vgl. Mittdreißiger

mit|tig (Technik für: zentrisch)

Mitt|ler (Vermittler; im Einz. auch: Christus); mitt|le|re; - Reife (Schulabschluß der Realschule u. der Mittelstufe der höheren Schule), aber (↑ R 224): der Mittlere Osten; vgl. mittelste; Mitt|ler|rol|le; Mitt|ler|tum s; -s

mitt|ler|wei|le

mitt|schiffs (in der Mitte des Schiffes)

Mitt|sech|zi|ger, Mitt|sieb|zi|ger vgl. Mittdreißiger

Mitt|som|mer; Mitt|som|mer|nacht; Mitt|som|mer|nachts|traum vgl. Sommernachtstraum; mitt|som|mers (↑ R 129)

mit|tun (ugs.); er hat kräftig mitgetan

Mitt|vier|zi|ger vgl. Mittdreißiger

mitt|wegs (veralt. für: auf halbem Wege)

Mitt|win|ter; Mitt|win|ter|käl|te; mitt|win|ters (↑ R 129)

Mitt|woch m; -[e]s, -e; vgl. Dienstag; mitt|wochs (↑ R 129); vgl. Dienstag

Mitt|zwan|zi|ger vgl. Mittdreißiger

mit|un|ter (zuweilen), aber: ich trete mit unter den Baum

mit|ver|ant|wort|lich; Mit|ver|ant|wort|lich|keit; Mit|ver|ant|wor|tung

mit|ver|die|nen; - müssen

Mit|ver|fas|ser

Mit|ver|gan|gen|heit österr. (Imperfekt)

Mit|ver|schul|den

Mit|ver|schwo|re|ne od. ⌐ver|schwor|ne; ...ver|schwö|rer

Mit|ver|si|che|rung

Mit|welt w; -

mit|wir|ken; er hat bei diesem Theaterstück mitgewirkt; Mit|wir|ken|de m u. w; -n, -n (↑ R 287ff.); Mit|wir|kung; Mit|wir|kungs|recht

Mit|wis|ser; Mit|wis|ser|schaft w; -

mit|wol|len; jmd., der noch mitwill; er hat noch mitgewollt

mit|zäh|len

Mit|zi (Koseform von: Maria)

mit|zie|hen

Mix|be|cher; Mixed Pickles engl. [mixt piklz], Mix|pickles [mix-pikls] (in Essig eingemachtes Mischgemüse) Mehrz.; mi|xen (Getränke mischen; die auf verschiedene Bänder aufgenommenen akust. Elemente eines Films aufeinander abstimmen u. auf ein Tonband überspielen); Mi|xer (Barmeister, Getränkemixer; Gerät zum Mischen; Mitarbeiter beim Film mit der Aufgabe des Mixens) m; -s, -; Mix|ge|tränk; Mix|pickles vgl. Mixed Pickles; Mix|tum com|po|si|tum lat. [- kom...] (Durcheinander, buntes Gemisch) s; - -, ...ta ...ta; Mix|tur (Mischung; mehrere flüssige Bestandteile enthaltende Arznei; bestimmtes Orgelregister) w; -, -en

Mjöll|nir ("Zermalmer"; Thors Hammer [Waffe]) m; -s

mk = Markka

MKS = Maul- und Klauenseuche

MKS-Sy|stem (internationales Maßsystem, das auf den Grundeinheiten Meter [M], Kilogramm [K] u. Sekunde [S] aufgebaut ist; verdrängt nach u. nach das CGS-System) s; -s

ml = Milliliter

mlat. = mittellateinisch

Mlle.¹ = Mademoiselle

Mlles.¹ = Mesdemoiselles

mm = Millimeter

μm = ²Mikrometer

mm², qmm = Quadratmillimeter

mm³, cmm = Kubikmillimeter

MM. = Messieurs (vgl. Monsieur)

m. m. = mutatis mutandis

M. M. = Mälzels Metronom

Mme.¹ = Madame

Mmes.¹ = Mesdames

Mn = chem. Zeichen für: Mangan

mnd. = mittelniederdeutsch

Mne|me gr. (Erinnerung, Gedächtnis) w; -; Mne|mis|mus (Lehre von der Mneme) m; -; Mne|mo|nik, Mne|mo|tech|nik (Gedächtniskunst) w; -; Mne|mo|ni|ker, Mne|mo|tech|ni|ker; mne|mo|nisch, mne|mo|tech|nisch; Mne|mo|sy|ne (gr. Göttin des Gedächtnisses, Mutter der Musen)

Mo = chem. Zeichen für: Molybdän

Mo. = ²Missouri

MΩ = Megaohm

Mo|ab (Landschaft östl. des Jordans); Moa|bit (Stadtteil von Berlin); Moa|bi|ter (Bewohner von Moab; Bewohner von Berlin-Moabit); ↑ R 199

Mo|ar [mǫ̈ɐr] (Kapitän einer Moarschaft) m; -s, -e; Mo|ar|schaft (Vierermannschaft beim Eisschießen) w; -, -en

Mob engl. [mǫp] (Pöbel) m; -s

Mö|bel s; -s, - (meist Mehrz.); Mö|bel|fa|brik, ...fir|ma, ...händ|ler, ...la|ger, ...packer [Trenn.: ...pak-ker], ...po|li|tur, ...stoff, ...stück, ...tisch|ler, ...wa|gen; mo|bil lat. (beweglich, munter; ugs. für: wohlauf; Militär: auf Kriegsstand gebracht); -e Küche; mobil machen (auf Kriegsstand bringen); mo|bi|le it. ("beweglich"; Musik: nicht steif); Mo|bi|le engl. (durch Luftzug in Schwingung geratendes, von der [Zimmer]decke hängendes Gebilde aus [Metall]blättchen) s; -s, -s; Mo|bi|li|ar lat. (bewegliche Habe; Hausrat, Möbel) s; -s, -e; Mo|bi|li|ar|kre|dit, ...ver|si|che|rung; Mo|bi|li|en [...i⁽ᵉ⁾n] (veralt. für: Hausrat, Möbel) Mehrz.; Mo|bi|li|sa|ti|on [...zion] (Mobilmachung); mo|bi|li|sie|ren (Militär: auf Kriegsstand bringen; Geld flüssigmachen; ugs. für: in Bewegung setzen); Mo|bi|li|sie|rung; Mo|bi|li|tät (geistige) Beweglichkeit; Bevölkerungsstatistik: Häufigkeit des Wohnsitzwechsels) w; -; Mo|bil|ma|chung; mö|blie|ren fr. (mit Hausrat) einrichten, ausstatten); mö|bliert; -es Zimmer; Mö|blie|rung

Mob|ster amerik. (Gangster) m; -s, -

Mo|çam|bique [port. Aussp.: mu-ßambik⁽ᵉ⁾; fr. Aussp.: mosangbik], (dt. auch:) Mo|sam|bik (Port.-Ostafrika; auch Hafenstadt)

Moc|ca (österr. auch für: ²Mokka)

Mo|cha [auch: ...ka; nach der jemenit. Hafenstadt am Roten Meer, heute Mokka] (ein Mineral) m; -s

Möch|te|gern (spött.) m; -[s], -e; Möch|te|gern|künst|ler

Mocke [Trenn.: Mok|ke] fränk. (Zuchtschwein) w; -, -n

Mocken [Trenn.: Mok|ken] südd. u. schweiz. mdal. (Brocken, dickes Stück) m; -s, -

Mock|tur|tle|sup|pe engl. [mǫk-tö̈'tl...] (unechte Schildkrötensuppe)

mod. = moderato

mo|dal lat. (die Art u. Weise bezeichnend); Mo|dal|be|stim|mung (Sprachw.); Mo|da|li|tä|

¹ Schweiz. auch ohne Punkt.

(Art u. Weise, Ausführungsart) meist *Mehrz.*; Mo|da|li|tä|ten|lo|gik (Zweig der math. Logik); Mo|dal|satz (Sprachw.: Umstandssatz der Art u. Weise); Mo|dal|verb (Sprachw.: Zeitw., das vorwiegend ein anderes Sein od. Geschehen modifiziert, z. B. „wollen" in: „er will kommen") Mod|der altmärk. u. nordd. (Morast, Schlamm) *m*; -s; mod|de|rig, modd|rig

Mo|de *fr.* („Art und Weise"; Brauch, Sitte; [Tages-, Zeit]geschmack; Kleidung; Putz) *w*; -, -n; in - sein, kommen; Mo|de.ar|ti|kel, ...aus|druck, ...cen|ter, ...far|be, ...haus od. Mo|den-haus, ...krank|heit

Mo|del *lat.* (Backform; Hohlform für Gußerzeugnisse; erhabene Druckform für Zeugdruck) *m*; -s, -; vgl. Modul u. modeln; Mo|dell *it.* (Muster, Vorbild, Typ; Entwurf, Nachbildung; Gießform; nur einmal in dieser Art hergestelltes Kleidungsstück; Person od. Sache als Vorbild für ein Werk der bildenden Kunst; Mannequin) *s*; -s, -e; - stehen; Mo|dell-ei|sen|bahn; Mo|dell|leur *fr.* [...lör] (sw. Modellierer) *m*; -s, -e; Mo|dell|fall *m*; Mo|dell|lie|bo|gen; mo|dell|lie|ren (künstlerisch formen, bilden; ein Modell herstellen); Mo|dell|lie|rer (f[Muster]former); Mo|dell|lier|holz; Mo|del-lie|rung; mo|dell|lig (von Kleidungsstücken: in der Art eines Modells); Mo|dell.kleid, ...schutz, ...thea|ter, ...tisch|ler, ...ver|such, ...zeich|nung; mo|deln *lat.* (selten für: gestalten, in eine Form bringen); ich ...[e]le (↑ R 327); Mo|del|tuch (Mustertuch zum Sticken; *Mehrz.* ...tücher); Mo|de|lung

Mo|de|mensch *m*

Mo|de|na (it. Stadt); Mo|de|na|er [...na²r] (↑ R 199); mo|de|na|isch [...na-isch]

Mo|de[n].haus, ...schau, ...zeit-schrift; Mo|de.pup|pe, ...püpp-chen

Mo|der (Faulendes, Fäulnisstoff) *m*; -s

Mo|de|ra|ti|on *lat.* [...zion] (Rundfunk, Fernsehen: Tätigkeit des Moderators; veralt. für: Mäßigung); mo|de|ra|to *it.* (Musik: mäßig [bewegt]; Abk.: mod.); Mo|de|ra|to *s*; -s, -su. ...ti; Mo|de-ra|tor *lat.* (Rundfunk, Fernsehen: jmd., der eine Sendung moderiert; Bremsvorrichtung in Kernreaktoren) *m*; -s, ...oren

Mo|der|ge|ruch

mo|de|rie|ren *lat.* (Rundfunk, Fernsehen: durch eine Sendung

führen, eine Sendung mit einleitenden u. verbindenden Worten versehen; veralt., aber noch mdal. für: mäßigen)

mo|de|rig, mod|rig; ¹mo|dern (faulen); es modert

²mo|dern *fr.* (modisch, der Mode entsprechend; neu[zeitlich]; in neuestem Geschmack gehalten; Gegenwarts..., Tages...); -er Fünfkampf; Mo|der|ne (moderne Richtung [in der Kunst]; moderner Zeitgeist) *w*; -; mo|der|ni-sie|ren (modisch machen, erneuern); Mo|der|ni|sie|rung; Mo|der|nis|mus *lat.* (moderner Geschmack; Bejahung des Modernen; Bewegung innerhalb der kath. Kirche) *m*; -; Mo|der-nist (↑ R 268); Mo|der|ni|tät (neuzeitl. Gepräge; Neues; Neuheit)

Mo|de.sa|che, ...sa|lon, ...schaf-fen; Mo|de.schau, Mo|den|schau; Mo|de.schmuck, schön|fer|, ...schrift|stel|ler

mo|dest *lat.* (veralt. für: bescheiden, sittsam); -este (↑ R 292)

Mo|de.tanz, ...tor|heit, ...wa|re; Mo|de|wa|ren|ge|schäft, Mo|de-welt (Welt, die nach der Mode lebt; *w*; -), ...wort (*Mehrz.* ...wör-ter), ...zeich|ner, ...zeit|schrift od. Mo|den|zeit|schrift

Mo|di (*Mehrz.* von: Modus); Mo|di|fi|ka|ti|on *lat.* [...zion], Mo|di-fi|zie|rung *lat.*; mo|di|fi|zie|ren (abwandeln; auf das richtige Maß bringen; [ab]ändern)

mo|disch *fr.* (in od. nach der Mode); -ste (↑ R 294); Mo|dist (veralt. für: Modewarenhändler); ↑ R 268; Mo|di|stin (Putzmacherin, Angestellte eines Hutgeschäftes) *w*; -, -nen

mod|rig, mo|de|rig

Mo|dul *lat.* (Verhältniszahl techn. Größen; Model) *m*; -s, -n; Mo|du-la|ti|on *lat.* [...zion] (Musik: das Steigen u. Fallen der Stimme, des Tones; Übergang in eine andere Tonart; Technik: Änderung einer Schwingung); Mo|du|la|ti-ons|fä|hig|keit (Anpassungsvermögen, Biegsamkeit [der Stimme]) *w*; -; mo|du|lie|ren (abwandeln; in eine andere Tonart übergehen); Mo|dul|zei|chen

Mo|dus *lat.* [auch: mo...] (Art u. Weise; Sprachw.: Aussageweise; ein Begriff der Musik) *m*; -, Modi; Mo|dus pro|ce|den|di [- ...ze...; auch: mo... -] (Art und Weise des Verfahrens) *m*; - -, Modi - ; Mo|dus vi|ven|di [- wiw...; auch: mo... -] (leidliches Verhältnis; erträgliche Übereinkunft; Verständigung) *m*; - -, Modi -

Moers [mörß] (Stadt westl. von Duisburg)

Mo|fa (Kurzw. für: Motorfahr-rad) *s*; -s, -s

Mo|fet|te *fr.* (Kohlensäureausströmung in vulkan. Gebiet) *w*; -, -n

Mo|ge|lei (ugs. für: [leichte] Betrügerei [beim Spiel]); mo|geln (ugs.); ich ...[e]le (↑ R 327)

mö|gen; ich mag, du magst, er mag; du mochtest; du möchtest; du hast es nicht gemocht, aber (↑ R 305): das hätte ich hören -

Mog|ler [zu: mogeln] (ugs.)

mög|lich; soviel als od. wie möglich; so gut als od. wie möglich; wo möglich (Auslassungssatz; wenn es möglich ist), vgl. aber: womöglich. I. *Kleinschreibung* (↑ R 135): das mögliche (alles) tun; alles mögliche (viel, allerlei) tun, versuchen; sein möglichstes tun. II. *Großschreibung:* a) (↑ R 116:) im Rahmen des Möglichen; Mögliches und Unmögliches verlangen; Mögliches und Unmögliches zu unterscheiden wissen; b) (↑ R 116:) alles Mögliche (alle Möglichkeiten) bedenken; etwas, nichts Mögliches; mög|li-chen|falls; vgl. Fall *m* mög|li|cher-wei|se; Mög|lich|keit; nach -; Mög|lich|keits|form (für: Konjunktiv); mög|lichst; - schnell; - viel Geld verdienen

Mo|gul *pers.* [österr.: ...gul] (früher: Beherrscher eines oriental. Reiches) *m*; -s, -n

Mo|hair [...här] vgl. Mohär

Mo|ham|med (Stifter des Islams); Mo|ham|me|da|ner (Anhänger [der Lehre] Mohammeds); mo-ham|me|da|nisch; -er Glaube; -e Zeitrechnung

Mo|här *arab.-it.-engl.* (Wolle der Angoraziege) *m*; -s, -e; vgl. Mohair

Mo|hi|ka|ner (Angehöriger eines ausgestorbenen nordamerik. Indianerstammes) *m*; -s, -; der Letzte der - od. der letzte - (auch scherzh. für: das letzte Stück [Geld])

Mohn *m*; -[e]s, -e; Mohn.blu|me, ...bröt|chen, ...kip|fer| (österr.), ...ku|chen, ...öl, ...saft, ...sa|men, ...stru|del (österr.)

¹Mohr (veralt. für: Neger) *m*; -en, -en (↑ R 268); ²Mohr (schwarzes Metallpulver) *m*; -s; vegetabilischer Mohr (gerösteter Blasentang)

Möh|re (Gemüsepflanze) *w*; -, -n

Mohr|ren.fal|ter (ein Schmetterling), ...hir|se, ...kopf (ein Gebäck); mohr|ren|schwarz (veralt.); Mohr|ren|wä|sche (Versuch, einen Schuldigen als unschuldig hinzustellen); Möh|rin (veralt.) *w*; -, -nen

Mohr|rü|be (eine Gemüsepflanze)
Moi|ra *gr.* [*mɛu*...] (gr. Schicksalsgöttin [Atropos, Klotho, Lachesis]) *w*; -, ...ren (meist *Mehrz.*)
Moi|ré *fr.* [*moare*] (Gewebe mit geflammtem Muster; Druckw.: fehlerhaftes Fleckenmuster in der Bildreproduktion) *m* od. *s*; -s, -s; **moi|rie|ren** (flammen); **moi|riert** (geflammt)
mo|kant *fr.* (spöttisch)
Mo|kas|sin *indian.* [auch: *mo*...] (lederner Halbschuh der nordamerik. Indianer) *m*; -s, -s u. -e
Mo|kett *fr.* (Möbel-, Deckenplüsch) *m*; -s
mo|kie|ren, sich *fr.* (sich tadelnd od. spöttisch äußern, sich lustig machen)
[1]**Mok|ka** (Stadt im Jemen); [2]**Mokka** (Kaffee[sorte]) *m*; -s, -s; vgl. Mocca; **Mok|ka|kaf|fee,** ...**löf|fel,** ...**tas|se**
Mol (svw. Grammolekül) *s*; -s, -e; **mo|lar** *lat.* (auf das Mol bezüglich; je 1 Mol)
Mo|lar *lat.* (Med.: [hinterer] Backenzahn, Mahlzahn) *m*; -s, -en; **Mo|lar|zahn**
Mo|las|se *fr.* (Tertiärschicht) *w*; -
Molch (Lurch) *m*; -[e]s, -e
[1]**Mol|dau** (l. Nebenfluß der Elbe) *w*; -; [2]**Mol|dau** (hist. Landschaft in Rumänien) *w*; -; **mol|dau|isch,** aber (↑ R 198): die Moldauische SSR
[1]**Mo|le** *it.* (Hafendamm) *w*; -, -n; vgl. Molo
[2]**Mo|le** *gr.* (Med.: abgestorbene, entartete Leibesfrucht) *w*; -, -n
Mo|le|kel *lat.* *w*; -, -n (österr. auch: *s*; -s, -) u. **Mo|le|kül** *fr.* (kleinste Einheit einer chem. Verbindung) *s*; -s, -e; **mo|le|ku|lar; Mo|le|ku|lar|bio|lo|gie** (Forschungszweig der Biologie); **Mo|le|ku|lar|ge|ne|tik,** ...**ge|wicht**
Mo|len|kopf (Ende der [1]Mole)
Mole|skin *engl.* [*mo^nlßkin*] („Maulwurfsfell"; Englischleder, Baumwollgewebe) *m* od. *s*; -s, -s
Mo|le|sten *lat.* (veralt., aber noch mdal. für: Beschwerden; Belästigungen) *Mehrz.*; **mo|le|stie|ren** (veralt., aber noch mdal. für: belästigen)
Mo|let|te *fr.* (Rändelrad; Prägwalze; Mörserkeule) *w*; -, -n
Mo|lière [...*ljär*] (fr. Lustspieldichter); **mo|lie|risch,** aber (↑ R 179): **Mo|liè|risch**
Mo|li|nis|mus [nach dem Jesuiten Molina] (frühere kath.-theol. Richtung, nach der göttl. Gnade u. menschl. Willensfreiheit sich nicht ausschließen, sondern zusammenwirken sollen) *m*; -
Mol|ke (Käsewasser) *w*; -; **Mol-**

ken landsch. (Molke) *m*; -s; **Molken|kur; Mol|ke|rei; Mol|ke|rei.but|ter,** ...**ge|nos|sen|schaft,** ...**pro|dukt** (meist *Mehrz.*); **mol|kig**
[1]**Moll** *lat.* („weiche" Tonart mit kleiner Terz; vgl. Dur) *s*; -, -; a-Moll; a-Moll-Tonleiter
[2]**Moll** (svw. Molton) *m*; -[e]s, -e u. -s
Mol|la, Mul|la *arab.* u. *Hindi* (Titel von mohammedan. Geistlichen u. Gelehrten) *m*; -s, -s
Moll.ak|kord (Musik), ...**dreiklang**
Mol|le (nordd. für: Mulde, Backtrog; berlin. für: Bierglas, ein Glas Bier) *w*; -, -n
Möl|ler (Gemenge von Erz u. Zuschlag) *m*; -s, -; **möl|lern** (mengen); ich ...ere (↑ R 327); **Möl|lerung**
mol|lert bayr., österr. ugs. (mollig)
Mol|li (Koseform von: Marie); vgl. Molly
mol|lig (ugs. für: behaglich; angenehm warm; dicklich [von Personen])
Mol|li|no *it.* (ein Baumwollgewebe) *m*; -[s], -s
Moll.ton|art, ...**ton|lei|ter**
Mol|lus|ke *lat.* (Weichtier) *w*; -, -n (meist *Mehrz.*); **mol|lus|ken|ar|tig**
Mol|ly (engl. Schreibung von: Molli)
Mo|lo österr. ([1]Mole) *m*; -s, Moli
[1]**Mo|loch** [auch: *mo*...] („König"; semit. Gott); [2]**Mo|loch** [auch: *mo*...] (Macht, die alles verschlingt) *m*; -s, -e
Mo|lo|tow|cock|tail [...*tof*...; nach dem ehemaligen sowjetruss. Außenminister W. M. Molotow] (mit Benzin u. Phosphor gefüllte Flasche)
Molt|ke (Familienn.); **molt|kesch,** aber (↑ R 179): **Molt|kesch**
mol|to *it.* (Musik: sehr); - vivace [- *wiwatʃe*] (sehr lebhaft)
Mol|ton *fr.* (ein Gewebe) *m*; -s, -s
Mol|to|pren Ⓦ (sehr leichter, druckfester, schaumartiger Kunststoff) *s*; -s, -e
Mo|luk|ken (indones. Inselgruppe) *Mehrz.*
Mo|lyb|dän *gr.* (chem. Grundstoff, Metall; Zeichen: Mo) *s*; -s
Mom|ba|sa (Hafenstadt in Kenia)
[1]**Mo|ment** *lat.* (Augenblick; Zeit[punkt]; kurze Zeitspanne) *m*; -[e]s, -e; [2]**Mo|ment** ([ausschlaggebender] Umstand; Merkmal; Gesichtspunkt) *s*; -[e]s, -e; **mo|men|tan** (augenblicklich; vorübergehend); **Mo|ment.auf|nah|me** (Schnappschuß), ...**bild**
Momm|sen, Theodor (dt. Historiker)

[1]**Mo|na|co** [...*ko*, auch: *monako*] (Staat in Südeuropa); [2]**Mo|na|co** (auch:) **Mo|na|ko** [auch: ...*na*...] (Hptst. von [1]Monaco); vgl. Monegasse
Mo|na|de *gr.* (das Einfache, Unteilbare) *w*; -, [meist] *Mehrz.*: bei Leibniz die letzten, in sich geschlossenen, vollendeten, einheitl. Wesen, aus denen die Weltsubstanz zusammengesetzt ist -n; **Mo|na|den|leh|re** *w*; -; **Mo|na|do|lo|gie** (Lehre von den Monaden) *w*; -
Mo|na|ko (eindeutschende Schreibung von: [2]Monaco)
Mon|arch *gr.* (legitimer [Allein]herrscher) *m*; -en, -en (↑ R 268); **Mon|ar|chen|ge|schlecht; Monar|chie** *w*; -, ...ien; **Mon|ar|chin** *w*; -, -nen; **mon|ar|chisch; Mon|archis|mus** *m*; -; **Mon|ar|chist** (Anhänger der monarchischen Regierungsform); ↑ R 268; **mon|ar|chi|stisch**
Mo|na|ste|ri|um *gr.* (Kloster[kirche], Münster) *s*; -s, ...ien [...*iᵉn*]
Mo|nat *m*; -[e]s, -e; alle zwei -e; dieses -s (Abk.: d. M.); laufenden -s (Abk.: lfd. M.); künftigen -s (Abk.: k. M.); nächsten -s (Abk.: n. M.); vorigen -s (Abk.: v. M.); **mo|na|te|lang,** aber: viele Monate lang; **mo|na|tig;** ...**mo|na|tig** (z. B. dreimonatig, mit Ziffer: 3monatig [drei Monate dauernd]); **mo|nat|lich;** ...**mo|nat|lich** (z. B. dreimonatlich, mit Ziffer: 3monatlich [alle drei Monate wiederkehrend]); **Mo|nats.an|fang,** ...**bin|de,** ...**blu|tung,** ...**ein|kom|men,** ...**en|de,** ...**er|ste,** ...**frist** (innerhalb -), ...**ge|halt** *s,* ...**geld,** ...**hälf|te,** ...**heft,** ...**kar|te,** ...**letz|te,** ...**lohn,** ...**mit|te,** ...**na|me,** ...**ra|te,** ...**schrift,** ...**tag,** ...**wech|sel; mo|nat[s]|wei|se**
Mon|azit *gr.* (ein Mineral) *m*; -s, -e
Mönch („allein" Lebender; Angehöriger eines Ordens mit Klosterleben) *m*; -[e]s, -e
Mön|chen|glad|bach (Stadt in Nordrhein-Westfalen)
mön|chisch; Mönchs.ka|pu|ze, ...**klo|ster,** ...**kut|te,** ...**la|tein** (mittelalterl. [verderbtes] Latein), ...**or|den,** ...**san|da|le; Mönch[s]tum** *s*; -s; **Mönchs.we|sen,** ...**zel|le**
[1]**Mond** (ein Himmelskörper) *m*; -[e]s, -e; [2]**Mond** (veralt. dicht. für: Monat) *m*; -[e]s, -e
Mon|da|min Ⓦ (reiner Maisstärkepuder) *s*; -s
mon|dän *fr.* (nach Art der großen Welt, von auffälliger Eleganz)
Mond.an|gang, ...**auf|gang,** ...**bahn; mond|be|schie|nen,** aber (↑ R 142): vom Mond beschienen;

Mond|blind|heit (Augenentzündung der Pferde); Mon|den|schein (dicht.) m; -[e]s; Mon|des|glanz (dicht.); Mon|des|fin|ster|nis (österr. meist für: Mondfinsternis); Mond|fäh|re, ...fin|ster|nis; mond_för|mig, ...hell; Mond_jahr, ...kalb (abgestorbene Leibesfrucht; abwertend ugs. für: Dummerian), ...kra|ter, ...lan|de|fäh|re, ...land|schaft, ...lan|dung, ...licht (s; -[e]s); mond|los; Mond_mo|bil (s; -[e]s, -e), ...nacht, ...ober|flä|che, ...or|bit, ...pha|se, ...schein (m; -[e]s)

Mond|see (österr. Ort und See); Mond|seer (↑ R 199 u. R 205) - Rauchhaus; vgl. Monseer

Mond_si|chel, ...son|de (zur Erkundung des Mondes gestarteter, unbemannter Raumflugkörper), ...stein (ein Mineral), ...sucht (w; -); mond|süch|tig; Mond_um|lauf|bahn, ...un|ter|gang, ...wech|sel

Mo|ne|gas|se (Bewohner Monacos) m; -n, -n (↑ R 268); Mo|ne|gas|sin w; -, -nen; mo|ne|gas|sisch

Mo|net [monä], Claude [klọd] (fr. Maler)

mo|ne|tär lat. (das Geld betreffend, geldlich); Mo|ne|ten ("Münzen"; ugs. für: [Bar]geld) Mehrz.

Mon|go|le [monggol'] (Angehöriger einer Völkergruppe in Asien) m; -n, -n (↑ R 268); Mon|go|lei (Staat und Hochland in Zentralasien) w; -; (↑ R 198:) die Innere, Äußere -; Mon|go|len.fal|te, ...fleck (Menschenrassen); Mon|go|lid (Anthropol.: Rassenmerkmale der Mongolen zeigend); -er Zweig (der Menschenrassen); Mon|go|li|de m u. w; -n, -n (↑ R 287ff.); mon|go|lisch, aber (↑ R 198): die Mongolische Volksrepublik; Mon|go|lis|mus (Med.: Form der Idiotie mit mongolenähnlicher Kopf- u. Gesichtsbildung) m; -; mon|go|lo|id (den Mongolen ähnlich); Mon|go|lo|ide m u. w; -n, -n (↑ R 268)

Mo|nier_bau|wei|se [auch: monje...]; nach dem fr. Gärtner J. Monier] (↑ R 180; Stahlbetonbauweise) w; -, ...ei|sen (veralt. Bez. für das im [Stahl]beton eingebettete [Rund]eisen)

mo|nie|ren lat. (mahnen; rügen)

Mo|nier|zan|ge [auch: monje...] (nach dem fr. Gärtner J. Monier; ↑ R 180 (Zange für Eisendrahtarbeiten mit kleinem Zangenkopf u. langen Griffen)

Mo|ni|ka (w. Vorn.)

Mo|ni|lia lat. (Polsterschimmel [Pilzart] an Obstbäumen) w; -; Mo|ni|lia|krank|heit w; -

Mo|nis|mus (Einheitslehre) m;

-; Mo|nist (Anhänger des Monismus); ↑ R 268

Mo|ni|teur fr. [...tör] (Anzeiger [Name fr. Zeitungen]) m; -s, -e; Mo|ni|tor engl. ("Erinnerer"; Kontrollgerät beim Fernsehen; Strahlennachweis- u. -meßgerät; Bergbaugerät; veralt. für: Aufseher; veralt. Panzerschiffstyp) m; -s, ...oren; Mo|ni|to|ri|um lat. (veralt. für: Ermahnung, Mahnschreiben) s; -s, ...ien [...i^'n]; Mo|ni|tum (Mahnung; Rüge, Beanstandung) s; -s, ...ta

mo|no gr. (allein...); Mo|no... (Allein...)

Mo|no|chord gr. [...kọrt] (ein Instrument zur Ton- und Intervallmessung) s; -[e]s, -e

mo|no|chrom gr. [...krọm] (einfarbig)

mo|no|co|lor gr.; lat. (österr. ugs.); eine -e Regierung (Einparteienregierung)

Mon|odie gr. (einstimmiger Gesang; einstimmige Melodieführung) w; -; mon|odisch

Mo|no|ga|mie gr. (Einehe; Ggs.: Polygamie) w; -; mo|no|gam, mo|no|ga|misch (einchig)

Mo|no|ge|ne|se, Mo|no|go|nie gr. (ungeschlechtl. Fortpflanzung) w; -

Mo|no|gramm gr. (Namenszug; Verschlingung der Anfangsbuchstaben eines Namens) s; -s, -e; Mo|no|gra|phie (wissenschaftl. Untersuchung über einen einzelnen Gegenstand; Einzeldarstellung) w; -, ...ien; mo|no|gra|phisch (in Einzeldarstellung; einzeln)

mo|no|hy|brid gr.; lat. (sich in einem erblichen Merkmal unterscheidend [von pflanzl. od. tier. Kreuzungsprodukten]); Mo|no|hy|bri|de (Bastard, dessen Eltern monohybrid sind) m; -n, -n (↑ R 268)

Mon|okel fr. (Einglas) s; -s, -

Mo|no|ki|ni vgl. Minikini

mo|no|klin gr. (Geol.: mit einer geneigten Achse; Bot.: gemischtgeschlechtig [Staub- u. Fruchtblätter in einer Blüte tragend])

Mo|no|ko|ty|le|do|ne gr. (Bot.: einkeimblättrige Pflanze) w; -, -n

mon|oku|lar gr.; lat. (mit einem Auge, für ein Auge)

Mo|no|kul|tur gr.; lat. (einseitiger Anbau einer bestimmten Wirtschafts- od. Kulturpflanze)

Mo|no|la|trie gr. (Verehrung nur eines Gottes) w; -

Mo|no|lith gr. (Säule, Denkmal aus einem Steinblock) m; -s od. -en, -e[n] (↑ R 268); mo|no|li|thisch

Mo|no|log gr. (Selbstgespräch) m;

-s, -e; mo|no|lo|gisch; mo|no|lo|gi|sie|ren

Mo|nom, Mo|no|nom gr. (math.: eingliedrige Zahlengröße) s; -s, -e

mo|no|man, mo|no|ma|nisch gr.; Mo|no|ma|ne (an Monomanie Leidender) m; -n, -n (↑ R 268); Mo|no|ma|nie (auf einen Punkt gerichtete Wahnvorstellung, fixe Idee)

mo|no|mer gr. (Chemie: aus einzelnen, voneinander getrennten, selbständigen Molekülen bestehend); Mo|no|mer s; -s, -e u. Mo|no|me|re (Chemie: Stoff, dessen Moleküle monomer sind) s; -s, -n (meist Mehrz.)

mo|no|misch, mo|no|no|misch gr. (eingliedrig); Mo|no|nom gr. vgl. Monom; mo|no|no|misch vgl. monomisch

Mo|no|phthong gr. (Sprachw.: einfacher Selbstlaut, z. B. a, i; Ggs.: Diphthong) m; -s, -e; mo|no|phthon|gie|ren [...ngg...] (einen Diphthong zum Monophthong umbilden)

mo|no|phy|le|tisch gr. (einer Stammform entsprossen, auf eine [Stamm]form zurückgehend)

Mo|no|phy|sit gr. (Anhänger des Monophysitismus) m; -en, -en (↑ R 268); mo|no|phy|si|tisch; Mo|no|phy|si|tis|mus (Lehre von der einen Natur Christi) m; -

Mo|no|ple|gie gr. (Med.: Lähmung eines einzelnen Gliedes) w; -, ...ien

Mo|no|pol gr. (das Recht auf Alleinhandel u. -verkauf; Vorrecht; alleiniger Anspruch) s; -s, -e; Mo|no|pol.bren|ne|rei, ...in|ha|ber; mo|no|po|li|sie|ren (ein Monopol aufbauen, die Entwicklung von Monopolen vorantreiben); Mo|no|po|li|sie|rung; Mo|no|po|list (Besitzer eines Monopols); ↑ R 268; mo|no|po|li|stisch; Mo|no|pol.ka|pi|tal, ...ka|pi|ta|lis|mus, ...ka|pi|ta|list; mo|no|pol|ka|pi|ta|li|stisch; Mo|no|pol|stel|lung

Mo|no|po|sto it. (Automobilrennsport: Einsitzer mit freilaufenden Rädern) m; -s, -s

Mo|no|pte|ros gr. (von einer Säulenreihe umgebener antiker Tempel) m; -, ...eren

mo|no|sti|chisch gr. (in Einzelversen [abgefaßt usw.]); Mo|no|sti|chon (Einzelvers) s; -s, ...cha

mo|no|syl|la|bisch gr. (von Wörtern; einsilbig)

mo|no|syn|de|tisch gr. (Sprachw.: nur das letzte Glied durch Konjunktion verbunden, z. B. "Ehre, Macht u. Ansehen")

Mo|no|the|is|mus gr. (Glaube an

einen einzigen Gott) *m*; -; **Mo|no|the|ist** (↑ R 268); **mo|no|the|istisch**

Mo|no|the|let *gr.* (Anghöriger einer altchristl. Sekte) *m*; -en, -en (↑ R 268); **Mo|no|the|le|tis|mus** (altchristl. Sektenlehre von dem einen Willen Christi) *m*; -

mo|no|ton *gr.* (eintönig; gleichförmig; ermüdend); **Mo|no|to|nie** *w*; -, ...ien

Mo|no|tre|men *gr.* (Kloakentiere) *Mehrz.*

mo|no|trop *gr.* (Biol.: beschränkt anpassungsfähig)

Mo|no|type ⓦ *gr.-engl.* [...*taip*] (Gieß- u. Setzmaschine für Einzelbuchstaben) *w*; -, -s; **Mo|no|ty|pie** (ein graph. Verfahren) *w*; -, ...ien

Mon|oxyd *gr.* [auch: ...*üt*] (Oxyd, das ein Sauerstoffatom enthält); vgl. Oxid

Mon|özie *gr.* (Bot.: Einhäusigkeit, Vorkommen männl. u. weibl. Blüten auf ei n er Pflanze) *w*; -; **mon|özisch** (einhäusig)

Mo|no|zy|ten *gr.* (Med.: größte [weiße] Blutkörperchen) *Mehrz.*; **Mo|no|zy|to|se** (Med.: krankhafte Vermehrung der Monozyten) *w*; -, -n

Mon|roe|dok|trin [*monro*..., auch: *monro*...]; ↑ R 180 (von der nordamerik. Präsidenten Monroe aufgestellter Grundsatz der gegenseitigen Nichteinmischung) *w*; -

Mon|ro|via [...*wia*] (Hptst. von Liberia)

Mon|seer; Mon|see-Wie|ner Fragmen|te; ↑ R 204 (altd. Schriftdenkmal); vgl. Mondsee

Mon|sei|gneur *fr.* [*mongßänjör*] (Titel der fr. Ritter, später der Prinzen usw., auch für hohe Geistliche; Abk.: Mgr.) *m*; -s, -e u. -s

Mon|ser|rat vgl. Montserrat

Mon|sieur *fr.* [*m*ᵉ*ßjö*] („mein Herr"; fr. Bez. für: Herr; als Anrede ohne Geschlechtswort; Abk.: M.) *m*; -[s], Messieurs [*mäßjö*] (Abk.: MM.); **Mon|si|gno|re** *it.* [*monßinjore*] (Titel hoher kath. Geistlicher in Italien; in Deutschland Titel der Päpstl. Geheimkämmerer; Abk.: Mgr., Msgr.) *m*; -[s], ...ri

Mon|ster... *engl.* (auch:) Monstre...*fr.* (riesig, Riesen...)

Mon|ste|ra *nlat.* (Zimmerpflanze) *w*; -, ...rae [...*rä*]

Mon|ster.bau (*Mehrz.* ...bauten), ...film, ...kon|zert, ...pro|gramm, ...pro|zeß, ...schau; **Mon|stra** (*Mehrz.* von Monstrum)

Mon|stranz *lat.* (Gefäß zum Tragen u. Zeigen der geweihten Hostie) *w*; -, -en

Mon|stre...vgl. Monster...

mon|strös *lat.*(-*fr.*) (ungeheuerlich; mißgestaltet; ungeheuer aufwendig); -este (↑ R 292); **Mon|stro|si|tät** (Mißbildung; Ungeheuerlichkeit); **Mon|strum** (Mißbildung; Ungeheuer; Ungeheuerliches) *s*; -s, ...ren u. ...ra

Mon|sun *arab.* (jahreszeitlich wechselnder Wind, bes. im Indischen Ozean) *m*; -s, -e; **mon|sunisch; Mon|sun|re|gen**

Mont. = Montana

Mon|ta|baur [auch: ...*bau*ᵉ*r*] (Stadt im Westerwald)

Mon|ta|fon (Talschaft der oberen Ill in Vorarlberg) *s*; -s; **mon|ta|fo|ne|risch**

Mon|tag *m*; -[e]s, -e; vgl. Dienstag

Mon|ta|ge *fr.* [*montgaseh*ᵉ, meist: *montgaseh*ᵉ, österr.: *montgaseh*] (Aufstellung [einer Maschine], Auf-, Zusammenbau); **Mon|ta-ge|band** *s*, ...bau|wei|se, ...hal|le, ...zeit

mon|tä|gig (vgl. ...tägig); **mon|täglich** (vgl. ...täglich)

Mon|ta|gnard [*montganjar*] (Mitglied der „Bergpartei" der Fr. Revolution) *m*; -s, -s

mon|tags (↑ R 129); vgl. Dienstag; **Mon|tags|aus|ga|be** (einer Tageszeitung)

Mon|tai|gne [*montänj*(ᵉ)] (fr. Schriftsteller u. Philosoph)

mon|tan, mon|ta|ni|stisch *lat.* (Bergbau u. Hüttenwesen betreffend)

Mon|ta|na (Staat in den USA; Abk.: Mont.)

Mon|tan|ge|sell|schaft (Bergbaugesellschaft), ...in|du|strie (Gesamtheit der bergbaulichen Industrieunternehmen); **Mon|ta-nis|mus** [nach dem Begründer Montanus] (schwärmer., sittenstrenge Sekte in Kleinasien [2.-8. Jh.]); **Mon|ta|nist** (Sachverständiger im Bergbau- u. Hüttenwesen; Anhänger des Montanus); ↑ R 268; **mon|ta|ni|stisch** vgl. montan; **Mon|tan|uni|on** (Europäische Gemeinschaft für Kohle u. Stahl) *w*; -

Mon|ta|nus (christl. Eiferer)

Mon|tan|wer|te *Mehrz.*

Mont|blanc *fr.* [*mongblang*] (höchster Gipfel der Alpen u. Europas) *m*; -[s]

Mont|bre|tie [*mongbrezi*ᵉ] (nach dem fr. Naturforscher de Montbret) (Gattung der Irisgewächse) *w*; -, -n

Mont Ce|nis [*mong ßeni*] (Alpenpaß) *m*; -; **Mont-Ce|nis-Stra|ße** *w*; - (↑ R 203)

Mon|te Car|lo [- *karlo*] (Nachbarstadt von Monaco)

Mon|te Cas|si|no, (it. Schreibung:) **Mon|te|cas|si|no** [...*ka*...] (Berg, Kloster bei Cassino) *m*; - [-]

Mon|tec|chi und Ca|pu|let|ti [...*teki* - *ka*...] (feindl. Geschlechter in Shakespeares „Romeo und Julia")

Mon|te|cri|sto, (bei Dumas in dt. Übersetzung:) **Mon|te Chri|sto** (Insel des Toskanischen Archipels)

Mon|te|ne|gri|ner; mon|te|ne|gri|nisch; Mon|te|ne|gro (Gliedstaat Jugoslawiens)

Mon|te Ro|sa (Gebirgsmassiv in den Westalpen) *m*; - -

Mon|tes|quieu [*montgäßkjö*] (fr. Staatsphilosoph u. Schriftsteller)

Mon|teur *fr.* [*montgör*, meist: *montör*] (Montagefacharbeiter) *m*; -s, -e

Mon|te|vi|deo [...*wi*...] (Hptst. von Uruguay)

Mont|gol|fie|re [*monggol*...]; nach den Brüdern Montgolfier (...*fig*) (früher für: Warmluftballon) *w*; -, -n

mon|tie|ren *fr.* ([eine Maschine, ein Gerüst u. a.] [auf]bauen, aufstellen, zusammenbauen); **Mon|tie|rung** (auch veralt. für: Bekleidung)

Mont|mar|tre [*mongmartr*ᵉ] (Stadtteil u. Vergnügungsviertel von Paris)

Mont|re|al [engl. Aussspr.: ...*triäl*] (Stadt in Kanada)

Mon|treux [*montgrö*, schweiz.: *mong*...] (Stadt am Genfer See)

Mont-Saint-Mi|chel [*mongßäng-mischäl*] (Felsen mit gleichnamigem Ort an der fr. Atlantikküste)

Mont|sal|watsch *altfr.* („wilder Berg"; der Berg mit der Gralsburg) *m*; -[es]

Mont|ser|rat [*montßerat*], (auch:) **Mon|ser|rat** [*monßerat*] (Berg, Kloster nordwestl. von Barcelona)

Mon|tur *fr.* (ugs. für: Arbeitsanzug; österr., sonst veralt. für: Dienstkleidung, Uniform) *w*; -, -en

Mo|nu|ment *lat.* (Denkmal) *s*; -[e]s, -e; **Mo|nu|men|ta Ger|ma|ni|ae hi|sto|ri|ca** [- ...*niä* ...*ka*] („Historische Denkmäler Deutschlands"; wichtigste Quellensammlung zur Geschichte des dt. MA.; Abk.: MGH); **mo|nu|men|tal** (denkmalartig; gewaltig; großartig); **Mo|nu|men|tal_aus|ga|be**, ...bau (*Mehrz.* ...bauten) ...ge|mäl|de; **Mo|nu|men|ta|li|tät** (Großartigkeit) *w*; -

Moor *s*; -[e]s, -e; **Moor|bad; moor|ba|den** (nur in der Grundform gebäuchlich); **Moor|bo|den** *m*; -s; **moo|rig; Moor|ko|lo|nie**, ...**kul|tur**, ...lei|che, ...sied|lung

¹Moos (Pflanzengruppe; bayr., österr., schweiz. auch für: Sumpf, Bruch) s; -es, -e u. (für: Sumpf usw. *Mehrz.*:) Möser

²Moos *jidd.* (ugs. u. Studentenspr.: Geld) s; -es

Moos|art; moos|ar|tig; moos|be-deckt, aber (↑ R 142): von Moos bedeckt; Moos|bee|re, ...farn; moos|grün, moo|sig; Moos|krenn

Mop *engl.* (Staubbesen mit ölgetränkten Fransen) m; -s, -s

Mo|ped [...*ät*, auch: *mópet*] (leichtes Motorrad) s; -s, -s; Mo|ped-fah|rer

Mop|pel (ugs. für: kleiner dicklicher, rundlicher Mensch) m, -s, -

mop|pen (mit dem Mop reinigen)

Mops (ein Hund) m; -es, Möpse; Möps|chen, Möps|lein; mop|sen (ugs. für: stehlen; du mopst mopsest); sich - (ugs. für: sich langweilen; sich ärgern); mops|fi-del (ugs. für: sehr fidel); Mops|ge-sicht; mop|sig (ugs. für: langweilig; dick [von Personen]); Möps-lein, Möps|chen

Mo|quette vgl. Mokett

¹Mo|ra *it.* (ein Fingerspiel) w; -

²Mo|ra *lat.* (kleinste Zeiteinheit im Verstakt; veralt. für: Verzögerung, Verzug) w; -, ...ren; vgl. periculum in mora

Mo|ral *lat.* (Sittlichkeit; Sittenlehre; sittl. Nutzanwendung) w; -, (selten:) -en; Mo|ral|be|griff; Mo-ra|lin (abschätzig für: muckerische Entrüstung in moral. Dingen) s; -s; Mo|ral in|sa|ni|ty *engl.* [*mor'l inßäniti*] (moral. Defekt beisonst normaler Intelligenz) w; - - -; mo|ra|lin|sau|er (abschätzig); ...saures Gehabe; mo|ra|lisch *lat.* (der Moral gemäß; sittlich); -ste (↑ R 294); -e Maßstäbe, aber (↑ R 224): die Moralische Aufrustung (Organisation); mo|ra-li|sie|ren *fr.* (sittl. Betrachtungen anstellen; den Sittenprediger spielen); Mo|ra|lis|mus *lat.* (Anerkennung der Sittlichkeit als Zweck u. Sinn des menschl. Lebens; [übertrieben] Beurteilung aller Dinge unter moral. Gesichtspunkten) m; -; Mo|ra|list (Sittenlehrer, -prediger); ↑ R 268; Mo|ra|li|stisch; Mo-ra|li|tät *fr.* (Sittenlehre; Sittlichkeit) w; -, (für: mittelalterl. geistl. Schauspiel [meist]*Mehrz.*:) -en; Mo|ral.ko|dex, ...pau|ke (ugs.), ...phi|lo|so|phie, ...pre|di|ger (abschätzig), ...pre|digt (abschätzig), ...theo|lo|gie

Mo|rä|ne *fr.* (Gletschergeröll) w; -, -n; Mo|rä|nen.bil|dung, ...land-schaft

Mo|rast (sumpfige schwarze Erde, Sumpfland; übertr. für: Sumpf,

Schmutz [bes. in sittl. Beziehung]) m; -[e]s, -e u. Moräste; mo|ra|stig

Mo|ra|to|ri|um *lat.* (befristete Stundung [von Schulden]) s; -s, ...ien [...*i*ᵉ*n*]

mor|bid *lat.* (krank[haft]; weich; zart); Mor|bi|di|tät (Med.: Krankheitsstand; Erkrankungsziffer) w; -; mor|bi|phor (Med.: ansteckend)

mor|bleu! *fr.* [...*blö*] (veralt. für: verwünscht!)

Mor|bo|si|tät *lat.* (Med.: Kränk-lichkeit, Siechtum) w; -; Mor|bus (Krankheit) m; -, ...bi

Mor|chel (ein Pilz) w; -, -n

Mord m; -[e]s, -e; Mord_an|kla|ge, ...an|schlag; mord [be]|gie|rig; Mord_bren|ner, ...bu|be (veralt.), ...dro|hung; mor|den

Mor|dent *lat.* (nach unten ausgeführter Pralltriller) m; -s, -e

Mör|der; Mör|der|gru|be; aus seinem Herzen keine - machen (ugs. für: mit seiner Meinung nicht zurückhalten); Mör|der|hand; Mör-de|rin w; -, -nen; mör|de|risch (veralt., heute noch aus. figur. für: furchtbar, z. B. -e Kälte); -ste (↑ R 294); mör|der|lich (ugs.); er hat ihn - verprügelt; Mord_fall m, ...gier; mord|gie|rig; Mord|in-stru|ment; mor|dio! (veralt. für: Mord!; zu Hilfe!); vgl. zetermordio; Mord_kom|mis|si|on, ...lust, ...nacht, ...pro|zeß, Mords..., mords... (ugs. für: sehr groß, gewaltig); Mords_ar|beit, ...ding, ...durst, ...du|sel, ...gau|di, ...ge-schrei, ...glück, ...hit|ze, ...hun-ger, ...kerl, ...lärm; mords|mä|ßig (ugs. für: sehr, ganz gewaltig); das war ein -er Lärm; Mords-rausch, ...schreck od. ...schrek-ken, ...spaß (ugs. für: großer Spaß), ...spek|ta|kel; mords|we-nig (ugs. für: sehr wenig); er hatte - zu sagen; Mord_tat, ...ver|dacht, ...ver-such, ...waf|fe

Mo|rea (neugr. für: Peloponnes)

Mo|rel|le *it.* (eine Sauerkirschenart) w; -, -n

Mo|ren (*Mehrz.* von: ²Mora)

mo|ren|do *it.* (Musik: hinsterbend, verlöschend, verhauchend); Mo-ren|do s; -s, -s u. ...di

Mo|res *lat.* (Sitte[n], Anstand) *Mehrz.*; ich will dich - lehren (ugs. drohend)

Mo|res|ke, Mau|res|ke *fr.* (Arabeske) w; -, -n

mor|ga|na|tisch *mlat.* (zur linken Hand [getraut]); -e Ehe (standesungleiche Ehe)

Mor|gar|ten [auch: *mor...*] (schweiz. Berg) m; -s; die Schlacht am -

mor|gen (am folgenden Tage); - abend, - früh, - nachmittag; bis, für, zu -; die Technik von - (der nächsten Zukunft), Entscheidung für - (die Zukunft); vgl. Abend u. Dienstag; ¹Mor|gen (Zeit) m; -s, -; guten -! (Gruß); (↑ R 129:) morgens; frühmorgens; vgl. Abend; ²Mor|gen [urspr.: Land, das ein Gespann an einem Morgen pflügen kann] (ein Feldmaß) m; -s, -; fünf -Land; ³Mor|gen (die Zukunft) s; -; das Heute und das -; mor|gend (veralt. für: morgig); der -e Tag; Mor|gen.däm|me|rung; mor-gend|lich (am Morgen geschehend); Mor|gen.dunst, ...es|sen (schweiz. neben: Frühstück); mor|gen|frisch; Mor|gen.frü|he, ...ga|be, ...grau|en, ...gym|na|stik, ...land (veralt. für: Orient; Land, in dem die Sonne aufgeht; s; -[e]s), ...län|der (veralt.; m; -s, -); mor-gen|län|disch; Mor|gen.licht (s, -[e]s), ...luft, ...man|tel, ...mes|se (vgl. ¹Messe), ...ne|bel, ...rock, ...rot od. ...rö|te; mor|gens (vgl. ¹Morgen u. ↑ R 129), aber: des Morgens; vgl. Abend u. Dienstag; Mor|gen.son|ne, ...spa|zier-gang, ...stern (auch: mittelalterl. Schlagwaffe; vgl. ²Stern), ...stun-de, ...zei|tung

Mor|gen|thau|plan [nach dem USA-Finanzminister Henry Morgenthau]; ↑ R 180 (Vorschlag, Deutschland nach dem 2. Weltkrieg in einen Agrarstaat umzuwandeln) m; -[e]s

mor|gig; der -e Tag

Morgue *fr.* [*morg*] (Leichenschau-haus [in Paris]) w; -, -n [...*g*ᵉ*n*]

Mo|ria *gr.* (Med.: krankhafte Geschwätzigkeit und Albernheit) w; -

mo|ri|bund *lat.* (Med.: im Sterben liegend)

Mö|ri|ke (dt. Dichter)

Mo|ri|nell *span.* (Schnepfenvogel Schottlands u. Skandinaviens) m; -s, -e

Mo|risk |e *span.* (Maure) m; -n, -n (↑ R 268)

Mo|ri|tat (,,Mordtat''; Abbildung eines Mordes, Unglücks usw.; Erklärung einer solchen Abbildung durch den Bänkelsänger) w; -, -en; Mo|ri|ta|ten.lied, ...sän-ger

Mo|ritz, (österr. auch:) Mo|riz (m. Vorn.); der kleine - (ugs. für: einfältiges, schlichtes Gemüt)

Mor|mo|ne (Angehöriger einer nordamerik. Sekte) m; -n, -n (↑ R 268); Mor|mo|nen|tum s; -s

mo|ros *lat.* (veralt. für: mürrisch, verdrießlich); -este (↑ R 292); Mo-ro|si|tät w; -

Mor|phe gr. (Gestalt, Form, Aussehen) w; -; Mor|phem (Sprachw.: kleinste bedeutungstragende Gestalteinheit in der Sprache, z. B. „Rein-heit, brachte") s; -s, -e

Mor|pheus [...euß] (gr. Gott des Traumes); in Morpheus' Armen; Mor|phin [nach Morpheus] (Hauptalkaloid des Opiums; Schmerzlinderungsmittel) s; -s; Mor|phi|nis|mus gr. (Morphiumsucht) m; -; Mor|phi|nist († R 268); Mor|phi|ni|stin w; -, -nen; mor|phi.um (allgemeinsprachlich für: Morphin) s; -s; Mor|phi|um|sprit|ze, ...sucht (w; -); mor|phi|um|süch|tig; Mor|pho|ge|ne|se, Mor|pho|ge|ne|sis [auch: ...gen...] (Ursprung u. Entwicklung von Organen u. Geweben eines pflanzl. od. tierischen Organismus) w; -, ...nesen; Mor|pho|ge|nie (sww. Morphogenese) w; -, ...ien; mor|pho|ge|ne|tisch (gestaltbildend); Mor|pho|gra|phie (veralt. für: Gestaltenbeschreibung u. -lehre, bes. von der Erdoberfläche) w; -; Mor|pho|lo|ge m; -n, -n († R 268); Mor|pho|lo|gie (Gestaltlehre; Sprachw.: Formenlehre) w; -; mor|pho|lo|gisch („bildungsgesetzlich"; die äußere Gestalt betreffend; gestaltlich)

morsch; -este († R 292); es morscht; Morsch|heit w; -

Mor|se|al|pha|bet; ↑ R 180 [nach dem nordamerik. Erfinder Morse] (Alphabet für die Telegrafie); Mor|se|ap|pa|rat (Telegrafengerät); mor|sen (den Morseapparat bedienen); du morst (morsest)

Mör|ser (schweres Geschütz; schalenförmiges Gefäß zum Zerkleinern) m; -s, -; mör|sern; ich ...ere († R 327); Mör|ser|stö|ßel

Mor|se|zei|chen

Mor|ta|del|la w. it. (it. Zervelatwurst) w; -, -s

Mor|ta|li|tät lat. (Med.: Sterblichkeit[sziffer]) w; -

Mör|tel m; -s, -; Mör|tel|kel|le, mör|teln; ich ...[e]le († R 327); Mör|tel|pfan|ne

Mor|ti|fi|ka|ti|on lat. [...zion] (veralt. für: [tödliche] Kränkung; Abtötung [der Begierde in der Askese]; Med.: Absterben von Organen u. Geweben); Mor|ti|fi|ka|ti|ons|er|klä|rung (veralt. für: Kraftlos-, Ungültigkeitserklärung; Tilgung); mor|ti|fi|zie|ren (veralt. für: kraftlos, ungültig erklären; tilgen)

Mo|ru|la lat. (Biol.: Entwicklungsstufe der Tierkeimes) w; -

Mo|sa|ik gr.-fr. (Bildwerk aus bunten Steinchen; Einlegearbeit; auch übertr. gebraucht) s; -s, -en (auch: -e); Mo|sa|ik|ar|beit; mo|sa|ik|ar|tig; Mo|sa|ik_bild, ...fuß-bo|den, ...stein

mo|sa|isch (nach Moses benannt; jüdisch); -es Bekenntnis, aber († R 179); Mo|sa|ismus (von Moses herrührend); die -en Bücher; Mo|sa|is|mus (veralt. für: Judentum) m; -

Mo|sam|bik vgl. Moçambique

Mosch mdal. (allerhand Abfälle, Überbleibsel) m; -[e]s

Mo|schaw hebr. (Genossenschaftssiedlung von Kleinbauern mit Privatbesitz in Israel) m; -s, ...wim

Mo|schee arab.-fr. (mohammedan. Bethaus) w; -, ...scheen

mo|schen mdal. (verschwenderisch umgehen, wüsten, vergeuden); du moschst (moschest)

Mo|schus sanskr. (ein Riechstoff) m; -; mo|schus|ar|tig; Mo|schus-_ge|ruch, ...och|se, ...tier

Mo|se vgl. Moses

Mö|se (derb für: weibl. Geschlechtsteile) w; -, -n

¹Mo|sel (l. Nebenfluß des Rheins) w; -; ²Mo|sel (kurz für: Moselwein) m; -s; Mo|sel|la|ner, (auch:) Mo|sel|la|ner (Bewohner des Mosellandes); Mo|sel|wein

mo|sern (ugs. für: nörgeln); ich ...ere († R 327)

¹Mo|ses, (ökum.:) Mo|se (jüd. Gesetzgeber); fünf Bücher Mosis (des Moses) od. Mose; ²Mo|ses (Seemannsspr.: Beiboot [kleinstes Boot] einer Jacht; spöttisch für: jüngstes Besatzungsmitglied an Bord, Schiffsjunge) m; -, -

Mos|kau (Hptst. der UdSSR u. der RSFSR); Mos|kau|er († R 199); Moskauer Zeit; mos|kau|isch

Mos|ki|to span. (eine Stechmücke) m; -s, -s (meist Mehrz.); Mos|ki|to|netz

Mos|ko|wi|ter (veralt. für: Bewohner von Moskau; veralt. für: typischer Russe); Mos|ko|wi|ter|tum s; -s; mos|ko|wi|tisch; ¹Mos|kwa (russ. Fluß) w; -; ²Mo|skwa (russ. Form von: Moskau)

Mos|lem arab. (Anhänger des Islams, Muselman) m; -s, -s; vgl. auch: Muselman u. Muslim; mos-le|mi|nisch, mos|le|misch (muselmanisch); vgl. auch: muselmanisch; Mos|lem|bru|der|schaft (ägypt. polit. Vereinigung); Mos-li|me (Muselmanin) w; -, -n; vgl. auch: Muselmanin, Muselmännin u. Muslime

Moss, Stirling [ßtö´ling] (engl. Automobilrennfahrer)

Mos|sul vgl. Mosul

Most (unvergorener Frucht-, bes. Traubensaft; südd., österr. u. schweiz. für: Obstwein, -saft) m; -[e]s, -e; Most|bir|ne; mo|sten; Mo|stert nordwestd. (Senf) m; -s; Most|rich [mit „Most" angemacht] nordostd. (Senf) m; -[e]s

Mo|sul, Mos|sul (Stadt im Irak)

Mo|tel amerik. [mgt´l, auch: motäl; Kurzw. aus: motorists' hotel] (Hotel an großen Autostraßen, das besonders für die Unterbringung von motorisierten Reisenden bestimmt ist) s; -s, -s

Mo|tet|te it. (Kirchengesang-[stück]) w; -, -n

Mo|ti|li|tät lat. (Beweglichkeit, bes. der Muskeln) w; -; Mo|ti|on fr. [...zion] (Abwandlung bes. des Eigenschaftswortes nach dem jeweiligen Geschlecht; schweiz. für: Antrag in einer Versammlung; veralt. für: [Leibes]bewegung; Tanzbewegung); Mo|tio|när schweiz. (jmd., der eine Motion einreicht) m; -s, -e; Mo|tiv lat.(-fr.) ([Beweggrund, Antrieb, Ursache; Zweck; Leitgedanke; Gegenstand; künstler. Vorwurf; kleinstes musikal. Gebilde) s; -s, -e [...w´]; Mo|ti|va|ti|on lat. (Psych.: das Sich-gegenseitig-Bedingen seel. Geschehnisse; die Beweggründe des Willens); Mo|tiv|for|schung (Zweig der Marktforschung) w; -; mo|tiv-gleich; -e Texte; mo|ti|vie|ren fr. [...wir´n] (etwas begründen; jmdn. anregen); Mo|ti|vie|rung; Mo|ti|vik lat. (Kunst der Motivverarbeitung [in einem Tonwerk]) w; -; mo|ti|visch; Mo|tiv-samm|ler (Philatelie); Mo|to fr. (schweiz. Kurzform von: Motorrad) s; -s, -s; Mo|to-Cross engl. (Gelände-, Vielseitigkeitsprüfung für Motorradsportler) s; -; Mo|to|drom (Rennstrecke [Rundkurs]) s; -s, -e; Mo|tor¹ lat. („Beweger"; Antriebskraft erzeugende Maschine; übertr. für: vorwärtstreibende Kraft) m; -s, ...oren; Mo|tor.block (Mehrz. ...blöcke), ...boot¹; Mo|tor|ren-bau (m; -[e]s), ...ge|räusch, ...lärm, ...öl; Mo|tor|hau|be¹; ...mo|to|rig (z. B. zweimotorig, mit Ziffer: 2motorig); Mo|to|rik (Gesamtheit der Bewegungsabläufe des menschl. Körpers; die Lehre von den Bewegungsfunktionen) w; -; Mo|to|ri|ker (jmd. der vorwiegend mit Bewegungsvorstellungen arbeitet); mo|to-risch; -es Gehirnzentrum (Sitz-

¹ Auch Betonung auf der zweiten Silbe: Motor (m; -s, -e), Mo torboot usw.

der Bewegungsantriebe); mo|to-ri|sie|ren (mit Kraftmaschinen, -fahrzeugen ausstatten); Mo|to-ri|sie|rung; Mo|tor¹.jacht, ...lei-stung, ...rad; Mo|tor|rad¹.brem-se, ...fah|rer, ...ren|nen; Mo|tor¹-.rol|ler, ...sä|ge, ...scha|den, ...schiff, ...schlep|per, ...schlit|ten, ...seg|ler, ...sport, ...sprit|ze

Mot|te w; -, -n

mot|ten südd. u. schweiz. (schwe-len, glimmen)

Mot|ten|be|kämp|fung; mot|ten-.echt, ...fest; Mot|ten.fraß, ...kis-te, ...ku|gel, ...pul|ver

Mot|to it. (Denk-, Wahl-, Leit-spruch; Kennwort) s; -s, -s

Mo|tu|pro|prio lat. (ein „aus eige-nem Antrieb" hervorgegangener päpstl. Erlaß) s; -s, -s

mot|zen (ugs. für: verdrießlich sein, schmollen)

mouil|lie|ren fr. [mujir⁽ᵉ⁾n] (Sprachw.: erweichen; ein „j" nachklingen lassen, z. B. nach l in „brillant = briljant"); Mouil-lie|rung

Mou|la|ge fr. [mulaseh⁽ᵉ⁾] (Ab-druck, Abguß, bes. farbiges ana-tom. Wachsmodell) m; -, -s (auch: w; -, -n)

Mou|li|na|ge fr. [mulinaseh⁽ᵉ⁾] (ver-alt. für: Zwirnen der Seide) w; -; Mou|li|né [...ne] (Garn, Gewe-be) m; -s, -s; mou|li|nie|ren (Seide zwirnen)

Mount Eve|rest engl. [maunt äw⁽ᵉ⁾-iß¹] (höchster Berg der Erde) m; -[s]

Mous|seux fr. [mußö] (veralt. für: Schaumwein) m; -, -; mous|sie|ren (schäumen, aufbrausen)

Mous|té|ri|en fr. [mußteriäng] (Stufe der älteren Altsteinzeit; Gerätetyp dieser Stufe) s; -[s]

Mö|we (ein Vogel) w; -, -n; Mö-ven.ei, ...ko|lo|nie, ...schrei

Mo|zam|bi|que vgl. Moçambique

Moz|ara|ber [auch: moza...] (An-gehöriger der „arabisierten" span. Christen der Maurenzeit 711–1492]) meist Mehrz.; moz-ara|bisch

Mo|zart (österr. Komponist); Mo-zar|te|um (Musikinstitut in Salz-burg) s; -s; mo|zar|tisch, aber († R 179): Mo|zar|tisch; Mo|zart-.on|zert|abend († R 181); Mo-zart|zopf (am Hinterkopf mit ei-ner Schleife zusammengebunde-ner Zopf); † R 180

p = mezzopiano

. p. = manu propria

Mr. = Mister engl. (engl. Anrede nur mit Eigenn.])

Auch Betonung auf der zweiten Silbe: Motor (m; -s, -e), Mo-torboot usw.

Mrd. = Milliarde[n]

Mrs. = Mistreß, (in engl. Schrei-bung:) Mistress engl. [mißis] (engl. Anrede für verheiratete Frauen)

MS = Motorschiff

Ms., Mskr. = Manuskript

m/s = Meter je Sekunde

Msgr., Mgr. = Monsignore

Mskr., Ms. = Manuskript

Mss. = Manuskripte

MsTh = Mesothorium

Mt = Megatonne

MTA = medizinisch-technische Assistentin

MTS = Maschinen-Traktoren-Station (DDR)

Muba = Schweizerische Muster-messe Basel

Much|tar arab. (Dorfschulze) m; -s, -s

Mu|ci|us [...ziuß] (altröm. m. Ei-genn.); - Scävola [- ßzäwola] (röm. Sagengestalt)

Muck vgl. Mucks

Mücke¹ (ugs. für: Grille, Laune; südd. für: Mücke) w; -, -n; er kann seine -n nicht lassen; Mücke¹ w; -, -n

Mucke|fuck¹ (ugs. für: dünner Kaffee) m; -s

mucken¹ (ugs. für: leise murren)

Mücken¹.pla|ge, ...schwarm, ...stich

Mucker¹ (heuchlerischer Frömm-ler); mucke|risch¹, -ste († R 294); Mucker|tum¹ s; -s; muckisch¹ (veralt., aber noch landsch. für: launisch, unfreundlich), -ste († R 294); Mucks m; -es, -e, (auch:) Muck m; -s, -e u. Muck|ser m; -s, - (ugs.: leiser, halb unterdrück-ter Laut); keinen - tun; mucksch (ugs. für: leise murren); muck|schen landsch. (muckisch sein); du muckschst (muckschest); muck-sen (ugs. für: einen Laut geben; eine Bewegung machen); du muckst (mucksest); er hat sich nicht gemuckst (ugs. für: er hat sich kleinlaut verhalten, sich nicht gerührt); Muck|ser vgl. Mucks; mucks|mäus|chen|still (ugs. für: ganz still)

Mud niederd. (Seemannsspr.: Schlamm [an Flußmündungen]; Morast) m; -s; mud|dig niederd. (schlammig)

mü|de; sich - arbeiten; einer Sache - (überdrüssig) sein; ich bin es (vgl. „es" [alter Wesf.]) -; Mü|dig-keit w; -

Mu|dir arab.(-türk.) (Leiter eines Verwaltungsbezirkes [in Ägyp-ten]) m; -s, -e; Mu|di|ri|je (Ver-waltungsbezirk, Provinz [in Ägypten]) w; -, -n u. -s

M. U. Dr. (österr.) = medicinae universae doctor (Doktor der ge-samten Medizin); vgl. Dr. med. univ.

Mües|li (schweiz. Form von: Müs-li)

Mu|ez|zin arab. [österr.: mu...] (Gebetsrufer im Islam) m; -s, -s

¹Muff niederd. (Schimmel [Pilz], Kellerfeuchtigkeit) m; -[e]s

²Muff niederd. (Handwärmer) m; -[e]s, -e; Müff|chen, Müff|lein; Muf|fe (Rohr-, Ansatzstück) w; -, -n

¹Muf|fel (Jägerspr.: kurze Schnau-ze; ugs. abschätzig für: brummi-ger, mürrischer Mensch; jmd., der für etwas nicht zu haben ist; Zool.: Nasenspiegel) m; -s, -

²Muf|fel (Schmelztiegel) w; -, -n

³Muf|fel (dt. Form für: Mufflon) s; -s, -

muf|fe|lig, muff|lig niederd. (den Mund verziehend; mürrisch); ¹muf|feln (ugs. für: andauernd kauen; mürrisch sein); ich ...[e]le († R 327)

²muf|feln österr. (müffeln); müf-feln landsch. (nach Muff [Schim-mel] riechen); ich ...[e]le († R 327); muf|fen (landsch.)

Muf|fel|wild (Mufflon)

¹muf|fig landsch. (mürrisch)

²muf|fig (nach Muff [Schimmel] riechend)

Muf|fig|keit [zu: ¹,²muffig] w; -

Müff|lein, Müff|chen [zu: ²Muff]

muff|lig vgl. muffelig

Muff|lon fr. (Wildschaf) m; -s, -s

Muf|ti arab. (islam. Gesetzeskun-diger) m; -s, -s

Mu|gel österr. ugs. (Hügel) m; -s, -[n]; mu|ge|lig, mug|lig (mdal., fachspr.: mit gewölbter Fläche)

muh!; muh machen, muh schreien; muh, muh!

Mü|he w; -, -n; mit Müh und Not († R 241); es kostet mich keine -; sich redlich - geben; mü-he|los, -este († R 292); Mü|he|lo-sig|keit w; -

mu|hen (muh schreien)

mü|hen, sich; mü|he|voll; Mü|he-wal|tung

Muh|kuh (Kinderspr. für: Kuh)

Mühl|bach; Müh|le w; -, -n; Müh-len.be|rei|ter (erster Arbeiter in einer Papiermühle), ...[be|]-schei|der (erster Müllerknecht); Müh|len_rad od. Mühl|rad, ...stein od. Mühl|stein, ...wehr s od. Mühl|wehr s; Müh|le|spiel; Mühl|gra|ben

Mühl|hau|sen i. Thür. (Stadt an der oberen Unstrut); Mühl|häu|ser († R 199)

Mühl|heim a. Main (Stadt bei Of-fenbach)

¹ Trenn.: ...k|k...

Mühl|heim an der Do|nau (Stadt in Baden-Württemberg)
Mühl_rad od. Mühl|len|rad, ...stein od. Müh|len|stein, ...wehr s od. Müh|len|wehr s; Mühl|werk
Mühm|chen, Mühm|lein; Muh|me (veralt. für: Tante) w; -, -n
muh, muh!
Müh|sal w; -, -e; müh|sam; Müh|sam|keit w; -; müh|se|lig; Müh|se|lig|keit
Muk|den (Stadt in der Mandschurei)
mu|kös lat. (Med.: schleimig; -este (↑ R 292)
Mu|lat|te span. (Mischling zwischen Schwarzen u. Weißen) m; -n, -n (↑ R 268); Mu|lat|tin w; -, -nen
Mulch (organ. Isolierschicht auf dem Acker- od. Gartenboden) m; -[e]s, -e; Mulch|blech (Laubzerkleinerer an Rasenmähern); mul|chen (mit Mulch bedecken)
Mul|de w; -, -n; mul|den|för|mig
Mül|hau|sen (Stadt im Elsaß)
Mül|heim (Ort bei Koblenz)
Mül|heim a. d. Ruhr (Stadt im Ruhrgebiet)
Mu|li lat. südd., österr. (Mulus [Maulesel]) s; -s, -[s]
Mu|li|nee (eindeutschend für: Mouliné); mu|li|nie|ren (eindeutschend für: moulinieren)
¹Mull Hindi-engl. (ein feinfädiges, weitmaschiges Baumwollgewebe) m; -[e]s, -e
²Mull (eine Humusform) m; -[e]s, -e
Müll (Stauberde; Schutt, Kehricht; Technik: nicht verwertbares Restprodukt, z. B. Atommüll) m; -[e]s
Mul|la vgl. Molla
Müll_ab|fuhr, ...ab|la|de|platz
Mul|lah (armen. Priester) m; -s, -s
Mülläppchen [Trenn.: Mull|läppchen, ↑ R 236]
Mul|lat|schag, Mul|lat|schak ung. österr. (ausgelassenes Fest) m; -s, -s
Müll|bin|de
Müll_de|po|nie, ...ei|mer
Mül|ler; Mül|ler_bursch od. ...bursche; Mül|le|rei; Mül|le|rin w; -, -nen; mül|lern (nach den Vorschriften des dän. Gymnastiklehrers J. P. Müller Gymnastik betreiben); ich ...ere (↑ R 327)
Mül|ler-Thur|gau [nach dem schweiz. Pflanzenphysiologen H. Müller-Thurgau] (eine Rebensorte) m; -
Müll|gar|di|ne
Müll_gru|be, ...hau|fen
¹Müll|heim (Stadt in Baden-Württemberg)
²Müll|heim (schweiz. Ort nahe der Thur)

Müll|kip|pe
Müll|kleid
Müll_mann (ugs.; Mehrz. ...männer od. Mülleute), ...schlucker [Trenn.: ...schluk|ker], ...ton|ne, ...ver|bren|nung, ...wa|gen
Müll|win|del
Mulm (lockere Erde; faules Holz) m; -[e]s; mul|men (zu Mulm machen; in Mulm zerfallen); mul|mig (auch ugs. für: bedenklich, faul, z. B. die Sache ist -; übel, unwohl, z. B. mir ist -)
mul|ti|la|te|ral lat. (mehrseitig); -e Verträge; Mul|ti|me|dia (Medienverbund) Mehrz.; vgl. ²Media; mul|ti|me|di|al (viele Medien betreffend, berücksichtigend, für viele Medien bestimmt); Mul|ti|me|dia|sy|stem; Mul|ti|mil|lio|när; mul|ti|na|tio|nal (aus vielen Nationen bestehend; in vielen Staaten vertreten); -e Unternehmen; mul|ti|pel (vielfältig); ...e Sklerose (Gehirn- u. Rückenmarkskrankheit); mul|ti|plex (veralt. für: vielfältig); mul|ti|pli|kand (Zahl, die mit einer anderen multipliziert werden soll) m; -en, -en (↑ R 268); Mul|ti|pli|ka|ti|on [...zion] (Vervielfältigung); Mul|ti|pli|ka|tor (Zahl, mit der eine vorgegebene Zahl multipliziert werden soll) m; -s, ...oren; mul|ti|pli|zie|ren (vervielfältigen, malnehmen, vervielfachen); zwei multipliziert mit zwei ist, macht, gibt (nicht: sind, machen, geben) vier; mul|ti|va|lent [...walänt] (Psych.: mehr-, vielwertig [von Tests, die mehrere Lösungen zulassen]); Mul|ti|va|lenz (Psych.: Mehrwertigkeit von psychischen Eigenschaften, Schriftmerkmalen, Tests)
mul|tum, non mul|ta lat. („viel [= ein Gesamtes], nicht vielerlei [= viele Einzelheiten]", d. h. Gründlichkeit, nicht Oberflächlichkeit)
Mu|lus lat. („Maulesel"; scherzh. für: Abiturient vor Beginn des Studiums) m; -, Muli
Mu|mie pers.-it. [...i⁶⁷] ([durch Einbalsamieren usw.] vor Verwesung geschützter Leichnam) w; -, -n; mu|mi|en|haft; Mu|mi|en|sarg; Mu|mi|fi|ka|ti|on pers.-it.; lat. [...zion] (seltener für: Mumifizierung; Med.: trockener Brand); mu|mi|fi|zie|ren; Mu|mi|fi|zie|rung (Einbalsamierung)
Mumm (ugs. für: Mut, Schneid) m; -s; keinen rechten Mumm haben
¹Mum|me mdal. (Malzbier) w; -; Braunschweiger -
²Mum|me (veralt. für: Larve; Vermummter) w; -, -n
Mum|mel (Teichrose) w; -, -n

Mum|mel_greis (ugs. für: alter [zahnloser] Mann); Mum|mel|mann niederd. scherzh. (Hase) m; -[e]s; mum|meln landschaftl. (murmeln; behaglich kauen, wie ein Zahnloser kauen; auch für: mummen); ich ...[e]le (↑ R 327); müm|meln (fressen [vom Hasen, Kaninchen])
Mum|mel|see m; -s
mum|men (veralt. für: einhüllen; dafür heute: ein- vermummen); Mum|men|schanz (Maskenfest) m; -es; Mum|me|rei (veralt.)
Mumpf (schweiz. neben: Mumps) m; -s
Mum|pitz (ugs. für: Unsinn; Schwindel) m; -es
Mumps engl. (Med.: Ziegenpeter) m (ugs. meist: w); -
Mün|chen (Stadt a. d. Isar); München-Schwabing (↑ R 212); Mün|che|ner, Münch|ner (↑ R 199); - Kindl; Münchener Straße (↑ R 222)
¹Münch|hau|sen, Karl Friedrich Hieronymus von, genannt „Lügenbaron" (Verfasser unglaubhafter Abenteuergeschichten)
²Münch|hau|sen (Aufschneider) m; -, -; Münch|hau|s[e|n]ia|de (Erzählung in Münchhausens Art) münch|hau|sisch, aber (↑ R 179) Münch|hau|sisch
Münch|ner vgl. Münchener
¹Mund m; -[e]s, Münder (selter auch: Munde u. Münde)
²Mund, Munt („Schutz"; germ Rechtsinstitution) w; -; vgl. Mun dium
Mund_art, Mund|art.dich|ter ...dich|tung; Mund|ar|ten|for schung, Mund|art|for|schung mund|art|lich (Abk.: mdal.); Mund_art_spre|cher, ...wör|ter buch; Mund|bröt|chen (landsch.) Münd|chen, Münd|lein
Mün|del [zu: Mund, Munt] s (BGI [für beide Geschlechter]: m); -s - (in der Anwendung auf ein Mädchen selten auch: w; -, -n) Mün|del|geld; mün|del|si|cher Mün|del|si|cher|heit w; -
mun|den (schmecken); mün|den
Mün|den (Stadt am Zusammenfluß der Fulda u. der Werra zu Weser); Mün|de|ner (↑ R 199)
mund_faul; Mund_fäu|le (Geschwüre auf der Mundschleim haut u. an den Zahnrändern) mund_ge|recht; Mund_ge|ruch ...har|mo|ni|ka, ...höh|le
mün|dig; - sein, werden; Mün|dig keit w; -; Mün|dig|keits|er|klä rung; mün|dig_spre|chen (↑ R 139) ich spreche mündig; mündige sprochen; mündigzusprechen Mün|dig|spre|chung
Mun|di|um germ.-mlat. (Schutz

verpflichtung, -gewalt im frühen dt. Recht) *s*; -s, ...ien [...*i*ⁿ*n*] u. ...ia; vgl. ²Mund, Munt

Münd|lein, Münd|chen; **münd|lich; Münd|lich|keit** *w*; -; **mund|of|fen** (mit offenem Munde, starr vor Staunen); er schaut - zu; **Mund_pfle|ge**, ...**pro|pa|gan|da**, ...**raub** (*m*; -[e]s), ...**rohr** (veralt. für: Mundstück)

Mund|schaft (früher für: Verhältnis zwischen Schützer u. Beschütztem; Schutzverhältnis)

Mund_schenk (früheres Hofamt), ...**schen|kin**, ...**schleim|haut**, ...**schutz** (Med.; *Mehrz.* ...-e)

M-und-S-Reifen = Matsch-und-Schnee-Reifen

Mund_stück; mund|tot; Mund|tuch (*Mehrz.* ...tücher)

Mün|dung; Mün|dungs_feu|er, ...**scho|ner; Mund|voll** *m*; -, -; einen, zwei, einige, ein paar - Fleisch u. a.] nehmen, a b e r: den Mund voll Brot haben; den Mund voll nehmen (ugs. für: großsprecherisch sein); **Mund_vor|rat**, ...**was|ser** (*Mehrz.*: ..wässer), ...**werk** (in festen Wendungen, z. B. ein großes, gutes haben [ugs. für: tüchtig, viel reden können]), ...**werk|zeug**, ..**win|kel; Mund-zu-Mund-Be|at|mung** (↑ R 155)

Mung|ben|ast (österr. Barockmauermeisterfamilie)

Mun_go *angloind.* (Schleichkatzengattung Afrikas u. Asiens mit zahlreichen Arten) *m*; -s, -s

Mun_go *engl.* (Garn, Gewebe aus Reißwolle) *m*; -[s], -s

Mu|ni schweiz. mdal. (Zuchtstier) *m*; -s, -

Mu|nin („der Erinnerer"; nord. Mythol.: einer der beiden Raben Odins); vgl. Hugin

mu|ni|tio|nie|ren (mit Munition versehen); ich -; **Mu|ni|tio|nie|rung; Mu|ni|tions_bun|ker**, ...**de|pot**, ...**fa|rik**, ...**la|ger**, ...**zug**

mu|ni|zi|pal *lat.* (veralt. für: städtisch; Verwaltungs...); **Mu|ni|zi|pi|um** (altröm. Landstadt; veralt. für: Stadtverwaltung) *s*; -s, ...ien ...*i*ⁿ*n*]

Mun|ke|lei (veralt.); **mun|keln** (ugs.); ich ...[e]le (↑ R 327)

Mün|ster (Stiftskirche, Dom) *s* ‹elten: *m*›; -s, -

Mün|ste|ra|ner (Einwohner von Münster [Westf.])

Mün|ster|bau (*Mehr.* ...bauten)

Mün|ster|land (Teil der Westfälischen Bucht nördl. der Lippe) *s*; -[e]s

Mün|ster|turm

Mün|ster (Westf.) (Stadt im Münsterland)

Munt vgl. ²Mund

mun|ter; munt[e]rer, -ste; Mun|ter|keit *w*; -

Münz_amt, ...**au|to|mat; Mün|ze** (Zahlungsmittel, Geld; Geldprägestätte) *w*; -, -n; **mün|zen**; du münzt (münzest); das ist auf mich gemünzt (ugs. für: das zielt auf mich ab); **Mün|zen|samm|lung**, **Münz|samm|lung; Mün|zer** (veralt. für: Münzenpräger), **Münz_fern|spre|cher**, ...**ge|wicht**, ...**ho|heit**, ...**ka|bi|nett**, ...**kun|de** (für: Numismatik; *w*; -); **münz|mä|ßig**; **Münz_recht**, ...**samm|lung** od. **Mün|zen|samm|lung**, ...**sor|tier|ma|schi|ne**, ...**tank**, ...**tech|nik**, ...**ver|bre|chen**, ...**we|sen** (*s*; -s)

Mu|päd österr. ugs. (musisch-pädagog. Realgymnasium) *s*; -s, -s

¹**Mur** (österr. neben: Mure) *w*; -, -en

²**Mur** (l. Nebenfluß der Drau) *w*; -

Mu|rä|ne *gr.* (ein Fisch) *w*; -, -n

mürb, (häufiger:) **mür|be**; -s Gebäck; er hat ihn - gemacht (ugs. für: seinen Widerstand gebrochen); **Mür|be** *w*; -; **Mür|be_bra|ten** (nordd. für: Lendenbraten), ...**teig; Mürb|heit**, (älter:) **Mür|big|keit** *w*; -

Mur_bruch *m*; -[e]s, ...brüche; **Mu|re** (Schutt-od. Schlammstrom im Hochgebirge) *w*; -, -n

mu|ren *engl.* (Seew.: mit einer Muring verankern)

mu|ria|tisch *lat.* (kochsalzhaltig); -e Quelle (Kochsalzquelle)

mu|rig [zu: Mure]; -es Gelände

Mu|ril|lo [...*iljo*] (span. Maler)

Mu|ring *engl.* (Seew.: Vorrichtung zum Verankern mit zwei Ankern) *w*; -, -e; **Mu|rings_bo|je**, ...**schä|kel**

Mur|kel (Wickelkind; nordd. mdal. für: kleines Kind) *m*; -s

Murks (ugs. für: unordentliche Arbeit; Unangenehmes) *m*; -es; **murk|sen** (ugs.); du murkst (murksest); **Murk|ser**

Mur|mansk (Hafenstadt auf der Halbinsel Kola)

Mur|mel landsch. (Spielkügelchen; Marmel) *w*; -, -n

mur|meln; ich ...[e]le (↑ R 327)

Mur|mel|tier (ein Nagetier)

Mur|ner (Kater in der Tierfabel) *m*; -s

Murr (r. Nebenfluß des Neckars) *w*; -

mur|ren; mür|risch; -ste (↑ R 294); **Mür|risch|keit** *w*; -; **Murr|kopf** (veralt.); **murr|köp|fig** (veralt.); **murr|köp|fisch** (veralt.)

Mur|ten (schweiz. Ortsn.)

Mürz (l. Nebenfluß der Mur) *w*; -

Mus (s landsch.: *m*); -es, -e; vgl. Müsli

Mu|sa *arab.* (Bananenart) *w*; -; **Mu|sa|fa|ser** (Manilahanf)

¹**Mus|agl** *gr.* („Musen[an]führer"; Beiname Apollos) *m*; -en (↑ R 268); ²**Mus|agl** (veralt. für: Musenfreund, Förderer der Künste u. Wissenschaften) *m*; -en, -en (↑ R 268)

mus|ar|tig

Mu|sche *fr.* (Schönheitspflästerchen; mdal. für: unordentliche, sittenlose Frau) *w*; -, -n

Mu|schel *w*; -, -n; **Mu|schel|bank** (*Mehrz.* ...bänke); **Mü|schel|chen; mu|schel|för|mig; mu|sche|lig**, **musch|lig; Mu|schel_kalk** (Geol.: mittlere Abteilung der Triasformation; *m*; -[e]s), ...**samm|lung**, ...**scha|le**, ...**tier**

Mu|schik *russ.* [auch: ...*ik*] (veralt. Bez. für den russ. Bauern) *m*; -s, -s

Mu|schir *arab.* („Ratgeber"; früher: hoher türk. Beamter; türk. Feldmarschall) *m*; -s, -e

Musch|ko|te [zu: Musketier] (ugs. für: Soldat zu Fuß) *m*; -n, -n (↑ R 268)

musch|lig, **mu|sche|lig**

Mu|se *gr.* (eine der [neun] gr. Göttinnen der Künste) *w*; -, -n; die zehnte - (scherzh. für: Kleinkunst, Kabarett); **mu|se|al** (zum, ins Museum gehörend; Museums...); **Mu|se|en** (*Mehrz.* von: Museum)

Mu|sel|man *arab.* [verderbt aus: Moslem] (Anhänger des Islams) *m*; -en, -en (↑ R 268); vgl. Moslem u. Muslim; **Mu|sel|ma|nin** *w*; -, -nen; vgl. Moslime u. Muslime; **mu|sel|ma|nisch; Mu|sel|mann** (eindeutschend veralt. für: Muselman; *Mehrz.* ...männer); **Mu|sel|män|nin** (veralt.) *w*; -, -nen; **mu|sel|män|nisch** (veralt.)

Mu|sen_al|ma|nach; mu|sen|haft; Mu|sen_sohn, ...**tem|pel; Mu|seo|lo|gie** (Museumskunde) *w*; -

Mu|sette *fr.* [*müsät*] (fr. Bez. für: kleiner Dudelsack; Tanz; Zwischensatz der Gavotte; Bez. für die Schwebetonstimmung des Akkordeons) *w*; -, -s od. -n [...*t*ⁿ*n*]

Mu|se|um *gr.* („Musentempel"; Sammlung) *s*; -s, ...een; **Mu|se|ums_auf|se|her**, ...**bau** (*Mehrz.* ...bauten), ...**die|ner**, ...**füh|rer**, ...**kä|fer** (Vorratsschädling), ...**ka|ta|log; mu|se|ums|reif; Mu|se|ums|stück**

Mu|si|cal *amerik.* [*mjusik*ⁱ*l*] (aktuelle Stoffe behandelnde, einfache Lied- u. Tanzformen verwendende Sonderform der Operette) *s*; -s, -s

mu|si|ert *gr.* (svw. musivisch)

Mu|sik *gr.* (Tonkunst) *w*; -, (für Komposition, Musikstück *Mehrz.*:) -en; **Mu|sik_aka|de|mie; Mu|si|ka|li|en** [...*i*ⁿ*n*] (gedruckte

Musikwerke) *Mehrz.*; Mu|si|ka|li|en|hand|lung;　mu|si|ka|lisch (tonkünstlerisch; musikbegabt, musikliebend); -ste (↑ R 294); Mu|si|ka|li|tät (musikal. Wirkung; musikal. Empfinden od. Nacherleben) *w*; -; Mu|si|kant (mdal., ugs. gelegentl. abschätzig für: Musiker, der zum Tanz u. dgl. aufspielt) *m*; -en, -en (↑ R 268);　Mu|si|kan|ten|kno|chen (ugs. für: schmerzempfindlicher Ellenbogenknochen); mu|si|kan|tisch (musizierfreudig, musikliebhaberisch);　Mu|sik_au|to|mat, ...bi|blio|thek; Mu|sik|box *amerik.* (Schallplattenapparat in Gaststätten); Mu|sik|di|rek|tor (Abk.: MD); Mu|si|ker *gr.*; Mu|sik_er|zie|hung, ...freund, ...ge|schich|te, ...hoch|schu|le, ...in|stru|ment; Mu|sik|in|stru|men|ten|in|du|strie; Mu|sik_ka|pel|le, ...leh|rer, ...le|xi|kon; mu|sik|lie|bend, aber (↑ R 142): schöne Musik liebend; Mu|si|ko|lo|ge (Musikwissenschaftler) *m*; -n, -n (↑ R 268); Mu|si|ko|lo|gie (Musikwissenschaft) *w*; -; Mu|sik_preis (vgl. ²Preis), ...stück, ...thea|ter (*s*; -s), ...tru|he, ...über|tra|gung, ...un|ter|richt; Mu|si|kus (scherzh. für: Musiker) *m*; -, ...sizi; Mu|sik|ver|lag; mu|sik|ver|stän|dig; Mu|sik_werk, ...wis|sen|schaft, ...wis|sen|schaft|ler, ...zeit|schrift

Mu|sil, Robert (österr. Schriftsteller)

mu|sisch *gr.* (den Musen geweiht; künstlerisch [durchgebildet, hochbegabt usw.]; auch: die Musik betreffend); -es Gymnasium; musisch-pädagogisches Realgymnasium (österr.)

Mu|siv_ar|beit (eingelegte Arbeit), ...gold (unechtes Gold); mu|si|visch *gr.* [...*wisch*] (eingelegt); -e Arbeit; Mu|siv|sil|ber (Legierung aus Zinn, Wismut u. Quecksilber zum Bronzieren)

mu|si|zie|ren; Mu|si|zier_freu|dig|keit, ...stil

Mus|kat *sanskr.-fr.* [österr.: *muß*...] (ein Gewürz) *m*; -[e]s, -e; Mus|kat|blü|te [österr.: *muß*...]; Mus|ka|te (veralt. für: Muskatnuß) *w*; -, -n; Mus|ka|tel|ler *it.* (Rebensorte, Wein) *m*; -s, -; Mus|ka|tel|ler|wein; Mus|kat|nuß [österr.: *muß*...]; Mus|kat|nuß|baum

Mus|kel *lat.* *m*; -s, -n; Mus|kel_durch|blu|tung, ...ent|zün|dung, ...fa|ser; mus|ke|lig; Mus|kel_ka|ter (ugs. für: Muskelschmerzen), ...kraft, ...krampf, ...mann (ugs.; *Mehrz.* ...männer), ...protz (ugs.), ...riß, ...schwund, ...zer|rung

Mus|ke|te *fr.* (früher: schwere

Handfeuerwaffe) *w*; -, -n; Mus|ke|tier („Musketenschütze"; veralt. für: Soldat zu Fuß) *m*; -s, -e

Mus|ko|vit [...*wit*], (auch:) Mus|ko|wit (heller Glimmer) *m*; -s

mus|ku|lär *lat.* (auf die Muskeln bezüglich, sie betreffend); Mus|ku|la|tur (Muskelgefüge, starke Muskeln) *w*; -, -en; mus|ku|lös *fr.* (mit starken Muskeln versehen; äußerst kräftig); -este (↑ R 292)

Müs|li *schweiz.* (ein Rohkostgericht) *s*; -s; vgl. Müesli

Mus|lim (fachspr. für: Moslem) *m*; -, -e; Mus|li|me, mus|li|misch (fachspr. für: Moslime, moslemisch)

Mus|pel|heim (nord. Mythol.: Welt des Feuers, Reich der Feuerriesen) *s*; -[e]s; Mus|pil|li („Weltbrand"; altd. Gedicht vom Weltuntergang) *s*; -s

Muß (Zwang) *s*; -; es ist ein - (notwendig); wenn nicht das harte - dahinterstünde;　Muß-Be|stim|mung (↑ R 151)

Mu|ße (freie Zeit) *w*; -; in aller -; mit -

Mus|se|lin [nach der Stadt Mosul] (ein Gewebe) *m*; -s, -e; mus|se|li|nen (aus Musselin)

müs|sen; ich muß, du mußt; du mußtest; du müßtest; gemußt, müsse!; ich habe gemußt, aber (↑ R 305): was habe ich hören -!

Mus|se|ron *fr.* [...*rong*] (ein Pilz) *m*; -s, -s

Mu|ße|stun|de

Muß|hei|rat

mü|ßig; - sein, gehen; mü|ßi|gen (veranlassen), nur noch geläufig in: sich gemüßigt sehen; Mü|ßig|gang (*m*; -[e]s), ...gän|ger; mü|ßig|gän|ge|risch; -ste (↑ R 294); Mü|ßig|keit *w*; -

Mus|sorg|ski (russ. Komponist)

Mus|sprit|ze (ugs. für: Regenschirm)

Muß-Vor|schrift (↑ R 151)

Mu|sta|fa (türk. m. Vorn.)

Mu|stang *engl.* (ein Steppenpferd) *m*; -s, -s

Mus|teil (früher für: Witwenteil) *m*

Mus|ter; -s, -; nach -; Mu|ster_bei|spiel, ...be|trieb, ...bild, ...ehe, ...ex|em|plar (meist iron.), ...gat|te (meist iron.); mu|ster|gül|tig; Mu|ster|gül|tig|keit *w*; -; mu|ster|haft; Mu|ster|haf|tig|keit *w*; -; Mu|ster_kar|te, ...kna|be (iron.), ...kof|fer, ...mes|se; mu|stern; ich ...ere (↑ R 327); Mu|ster_schü|ler, ...schutz, ...stück (meist iron.); Mu|ste|rung; Mu|ster_wirt|schaft, ...zeich|ner, ...zeich|nung

ten Mut[e]s sein (↑ R 275); mi_ ist schlecht zumute

Mu|ta *lat.* (veralt. für: Explosiv_ laut) *w*; -, ...tä; - cum liquida (Verbindung von Verschluß- u_ Fließlaut)

mu|ta|bel *lat.* (veränderlich) ...a|ble Merkmale; Mu|ta|bi|li|tä_ (Veränderlichkeit) *w*; -; Mu|tan_ bes. österr. (Jugendlicher, der im Stimmbruch ist) *m*; -en, -en; Mu_ ta|ti|on [...*zion*] (biol.: spontan_ od. künstlich erzeugte Verände_ rung im Erbgefüge; Med_ Stimmwechsel; schweiz.: Ände_ rung im Personalbestand); mu_ ta|tis mu|tan|dis (mit den nötige_ Abänderungen; Abk.: m. m.)

mut|be|seelt, aber (↑ R 142): vo_ Mut beseelt; Müt|chen; an jmdm_ sein - kühlen (ugs. für: jmdn_ seinen Ärger od. Zorn fühlen las_ sen); Müt|lein *s*; -s

mu|ten (veralt. für: begehren Bergmannsspr.: Erlaubnis au_ Ausbeutung erbitten; Bergba_ treiben; Handw.: das Meister_ recht begehren, um die Erlaubni_ nachsuchen, das Meisterstück z_ machen); [wohl] gemutet (veral_ für: gestimmt, gesinnt) sei_ aber: wohlgemut sein; Mu|te_ (Bergmannsspr.: jmd., der Mu_ tung einlegt)

mut|er|füllt, aber (↑ R 142): vo_ Mut erfüllt

Mut|geld (Abgabe für das Me_ sterstück); vgl. muten

mu|tie|ren *lat.* (Biol.: sich sponta_ im Erbgefüge ändern; Med.: d_ Stimme wechseln)

mu|tig; ...mü|tig (z. B. wehmüti_ Müt|lein vgl. Mütchen

mut|los; -este (↑ R 292); Mut|lo|sig_ keit

mut|ma|ßen (vermuten); du mu_ maßt (mutmaßest); du mutmaß_ test; gemutmaßt; zu -; mut|ma_ lich; der -e Täter; Mut|ma|ßu_ Mut|pro|be

Mut|schein (Bergmannsspr.); v_ muten

Mütt|chen (landsch. Kosefor_ von: Mutter)

¹Mut|ter (Schraubenteil) *w*; -,

²Mut|ter *w*; -, Mütter; Mutter E_ de; Müt|ter|be|ra|tungs|stel_ Mut|ter|bo|den (sww. Mutter_ de); Müt|ter|chen, Müt|ter|le_ Mut|ter|er|de (besonders fruch_ bare Erde) *w*; -; Müt|ter|ge_ sungs|heim;　Müt|ter-Ge_ sungs|werk; Deutsches -; Mu_ ter_ge|sell|schaft　(Wirtsch_ ...ge|stein; Mut|ter Got|tes *w*; -, (auch:) Mut|ter|got|tes *w*; Mut|ter|got|tes|bild;　Mut|te_ _haus, ...herz, ...korn (*Meh_ ...korne), ...ku|chen (für: Plaze_

ta), ...land (*Mehrz.* ...länder), ...leib; Müt|ter|lein, Müt|ter-chen; müt|ter|lich; müt|ter|li-cher|seits; Müt|ter|lich|keit *w*; -; Müt|ter|lie|be, mut|ter|los; Müt-ter|lo|sig|keit *w*; -; Müt|ter_mal (*Mehrz.* ...male), ...milch, ...mund (Med.; *m*; -[e]s)

Mut|tern_fa|brik, ...schlüs|sel

Mut|ter_pflan|ze, ...recht (*s*; -[e]s), ...schaf; Müt|ter|schaft *w*; -; Müt-ter|schafts|hil|fe; Müt|ter_schiff, ...schutz; Müt|ter|schutz|ge|setz; Müt|ter|schwein; mut|ter|see|len-al|lein; Müt|ter_söhn|chen (verächtl. für: verhätschelter Jugendlicher), spra|che stel|le (an jmdm. - vertreten), ...tag, ...tier, ...witz (*m*; -es); Müt|ti (Koseform von: Mutter) *w*; -, -s

mu|tu|al, mu|tu|ell *lat.* (wechselseitig); Mu|tua|lis|mus (Biol.: Form der Lebensgemeinschaft zwischen Tieren od. Pflanzen mit gegenseitigem Nutzen; System des utopischen Sozialismus von Proudhon; Wirtsch.: finanzwirtschaftliche Hypothese) *m*; -

Mu|tung (Bergmannsspr.: Erhebung von Anspruch auf Ausbeutung, Antrag auf Verleihung des Bergwerkseigentums); - einlegen (Antrag stellen)

mut|voll; Mut|wil|le *m*; -ns; mut-wil|lig; Mut|wil|lig|keit

Mutz (mdal. für: Bär; auch allg. für: Tier mit abgehauenem Schwanz u. ä.; Tabakspfeife) *m*; -es, -e

Müt|z|chen, Müt|z|lein; Müt|ze *w*; -, -n; Müt|zen_schild *s*, ...schirm

m. v. = mezza voce

m. W. = meines Wissens

MW = Megawatt

Mw.-St., MwSt. = Mehrwertsteuer

My (gr. Buchstabe: *M*, *μ*) *s*; -[s], -s; ²My (übliches Buchstabenwort für: Mikron; vgl. d.)

My|al|gie *gr.* (Med.: Muskelschmerz) *w*; -, ...ien; My|asthe|nie (Med.: krankhafte Muskelschwäche) *w*; -, ...ien; My|ato|nie (Med.: [angeborene] Muskelerschlaffung) *w*; -, ...ien

My|ke|nä (gr. Ort u. antike Ruinenstätte); my|ke|nisch

My|ko|lo|ge *gr.* (Kenner u. Erforscher der Pilze) *m*; -n, -n († R 268); My|ko|lo|gie (Pilzkunde) *w*; -; My|kor|rhi|za (Lebensgemeinschaft zwischen den Wurzeln von Blütenpflanzen u. Pilzen) *w*; -, ...zen

My|la|dy *engl.* [*mile'di*] (frühere engl. Anrede an eine Dame = gnädige Frau)

My|lo|nit *gr.* (Gestein) *m*; -s, -e

My|lord *engl.* [*mi...*] (frühere engl.

Anrede an einen Herrn = gnädiger Herr)

Myn|heer *niederl.* [*mᵉʾnēr*] vgl. Mijnheer

Myo|kard *s*; -s u. Myo|kar|di|um *gr.* (Med.: Herzmuskel) *s*; -s; Myo|kar|die *w*; -, ...ien u. Myo-kar|do|se (Med.: Kreislaufstörungen mit Beteiligung des Herzmuskels) *w*; -, -n; Myo|kard|in-farkt (Untergang eines Gewebebezirks des Herzens nach schlagartiger Unterbrechung der Blutzufuhr); Myo|kar|di|tis (Med.: Herzmuskelentzündung) *w*; -, ...itjden; Myo|kar|do|se vgl. Myokardie; Myo|kard|scha|den; Myo|klo|nie (Med.: Schüttelkrampf) *w*; -, ...ien; Myo|ky|mie (Med.: langsam verlaufende Muskelzuckungen) *w*; -; Myo|lo-gie (Med.: Muskellehre) *w*; -; My-om (Med.: gutartige Muskelgewebsgeschwulst) *s*; -s, -e; myo-morph (Med.: muskelfaserig); my|op, my|opisch *gr.* (Med.: kurzsichtig); My|ope (Kurzsichtige[r]) *m* od. *w*; -n, -n († R 268); My|opic (Kurzsichtigkeit) *w*; -; my|opisch vgl. myop

My|or|rhe|xis *gr.* (Med.: Muskelzerreißung) *w*; -; Myo|sin (Muskeleiweiß) *s*; -s; Myo|si|tis (Muskelentzündung) *w*; -, ...itjden; Myo|to|mie (Med.: operative Muskeldurchtrennung) *w*; -, ...ien; Myo|to|nie (Med.: Muskelkrampf) *w*; -, ...ien

My|ria... *gr.* (10000 Einheiten enthaltend); My|ria|de (Anzahl von 10000; übertr. für: Unzahl, unzählig große Menge [meist *Mehrz.*]) *w*; -, -n; My|ria|gramm (10000 g); My|ria|me|ter (10000 m; Zehnkilometerstein); My|ria-po|de, My|rio|po|de (Tausendfüßler) *m*; -n, -n (meist *Mehrz.*); † R 268

Myr|me|ko|lo|ge *gr.* (Wissenschaftler, der sich mit der Ameisenkunde befaßt) *m*; -n, -n († R 268); Myr|me|ko|lo|gie (Ameisenkunde) *w*; -

Myr|mi|do|ne (Angehöriger eines antiken Volksstammes; gr. Sage: Gefolgsmann des Achill) *m*; -n, -n († R 268)

Myr|ro|bala|ne *gr.* (Gerbstoff enthaltende Frucht vorderind. Holzgewächse) *w*; -, -n

Myr|rhe *semit.* (ein aromat. Harz) *w*; -, -n; Myr|rhen_öl (*s*; -[e]s), ...tink|tur (*w*; -); Myr|te (immergrüner Baum od. Strauch des Mittelmeergebietes u. Südamerikas) *w*; -, -n; Myr|ten_kranz, ...zweig

My|ste|ri|en|spiel *gr.*; *dt.* [*...iᵉʾn...*] (mittelalterl. geistl. Drama); my-

ste|ri|ös *fr.* (geheimnisvoll; rätselhaft); -este († R 292); My|ste-ri|um *gr.* ([relig.] Geheimnis; Geheimlehre, -dienst; insbes. das Sakrament) *s*; -s, ...ien [*...iᵉʾn*]; My|sti|fi|ka|ti|on *gr.*; *lat.* [*...zion*] (Täuschung; Vorspiegelung); my|sti|fi|zie|ren (mystisch betrachten; täuschen, vorspiegeln); My|sti|fi|zie|rung; My|stik *gr.* (ursprüngl.: Geheimlehre, relig. Richtung, die den Menschen durch Hingabe u. Versenkung zu persönl. Vereinigung mit Gott zu bringen sucht) *w*; -; My|sti|ker (Anhänger der Mystik); my-stisch (geheimnisvoll; dunkel); -ste († R 294); My|sti|zis|mus (Wunderglaube, [Glaubens]schwärmerei) *m*; -

My|the (älter für: Mythos) *w*; -, -n

My|then [*mjt*ᵉ*n*] (Gebirgsstock bei Schwyz) *m*; -s, -; der Große, der Kleine -

My|then_bil|dung, ...for|schung; my|then|haft; my|thisch *gr.* (sagenhaft, erdichtet); My|tho|lo|gie (wissenschaftl. Behandlung der Götter-, Helden-, Dämonensage; Sagenkunde, Götterlehre) *w*; -, ...ien; my|tho|lo|gisch (sagengötterkundlich); my|tho|lo|gi|sie-ren (etwas in mythischer Form darstellen od. mythologisch erklären); My|thos, (älter:) My-thus (Sage u. Dichtung von Göttern, Helden u. Geistern; die aus den Mythen sprechende Glaubenshaltung; Legendenbildung, Legende) *m*; -, ...then

My|ti|le|ne (alter Name der Hptst. von Lesbos)

Myx|ödem *gr.* (Med.: körperl. u. geistige Erkrankung mit heftigen Hautanschwellungen); My|xom (Med.: gutartige Schleimgewebsgeschwulst) *s*; -s, -e; My|xo|ma-to|se (tödlich verlaufende Viruskrankheit bei Hasen u. Kaninchen) *w*; -, -n; My|xo|my|zet (Schleimpilz) *m*; -en, -en († R 268) My|zel *gr. s*; -s, -ien [*...iᵉʾn*] u. My-ze|li|um (die Gesamtheit der Pilzfäden eines höheren Pilzes) *s*; -s, ...lien [*...iᵉʾn*]; My|zet (selten für: Pilz) *m*; -en, -en († R 268); My|ze-tis|mus (Pilzvergiftung) *m*; -, ...men

N

N (Buchstabe); das N; des N, die N, aber: das n in Wand († R 123); der Buchstabe N, n

N = Nahschnellverkehrszug; Nationalstraße; Neper; Newton;

Nitrogenium (chem. Zeichen für: Stickstoff); Nord[en]

n = Nano...; Neutron

N, v = Ny

'n; ↑ R 238 (ugs. für: ein, einen)

Na = chem. Zeichen für: Natrium

na!; na, na!; na ja!; na und?

na! bayr., österr. mdal. (nein!); vgl. ne!

Naab (l. Nebenfluß der Donau) w; -; Naab|eck (Ortsn.); aber: Nab|burg (Stadt an der Naab)

Na|be (Mittelhülse des Rades) w; -, -n; Na|bel m; -s, -; Na|bel..bin|de, ...bruch m, ...schnur (Mehrz. ...schnüre); Na|ben|boh|rer

Na|bob Hindi-engl. („Statthalter" in Indien; reicher Mann) m; -s, -s

Na|buc|co (it. Kurzform von Nabucodonosor = Nebukadnezar; Oper von Verdi)

nach; - und -; - wie vor; mit Wemf.: - ihm; - Hause od. Haus; - langem, schwerem Leiden (↑ R 274); nacheinander; nachher; nachmals

nach... (in Zus. mit Zeitwörtern, z. B. nachmachen, du machst nach, nachgemacht, nachzumachen; zum 2. Mittelw. ↑ R 304)

nach|äf|fen; Nach|äf|fe|rei; Nach|äf|fung

nach|ah|men; er hat ihn nachgeahmt; nach|ah|mens|wert; Nach|ah|mung; Nach|ah|mung; Nach|ah|mungs|trieb; nach|ah|mungs|wür|dig

Nach|bar m; -n (↑ R 268) u. (weniger gebr.:) -s, -n; Nach|bar..dorf, ...gar|ten, ...haus; Nach|ba|rin w; -, -nen; Nach|bar|land (Mehrz. ...länder); nach|bar|lich; Nach|bar..ort (vgl. ¹Ort), ...recht, ...schaft; nach|bar|schaft|lich; Nach|bar|schafts|heim; Nach|bars..fa|mi|lie, ...frau, ...kind, ...leu|te (Mehrz.); Nach|bar..staat (Mehrz. ...staaten), ...stadt, ...wis|sen|schaft

nach|be|han|deln; Nach|be|handlung

nach|bes|sern; ich bessere u. beßre nach; Nach|bes|se|rung, Nach-beß|rung

nach|be|stel|len; Nach|be|stel|lung

nach|be|ten; Nach|be|ter

nach|be|zeich|net; -e Waren

nach|bil|den; Nach|bil|dung

nach|blicken [Trenn.: ...blik|ken]

nach|börs|lich (nach der Börsenzeit)

nach Chri|sti Ge|burt (Abk.: n. Chr. G.); nach|christ|lich; nach Chri|sto, nach Chri|stus (Abk.: n. Chr.)

nach|da|tie|ren (etwas mit einem früheren, [aber auch:] späteren Datum versehen); er hat das Schreiben nachdatiert; vgl. zu-

rückdatieren u. vorausdatieren; Nach|da|tie|rung

nach|dem (landsch., bes. südd. auch für: da, weil); je -; je - [,] ob ... od. wie ... (↑ R 62)

nach|den|ken; nach|denk|lich; Nach|denk|lich|keit w; -; nachdenk|sam (veralt.)

Nach|dich|tung

nach|dop|peln schweiz. (nachbessern; zum zweitenmal in Angriff nehmen); im dopp[e]lle nach

nach|drän|gen

Nach|druck m; -[e]s, (Druckwesen:) ...drucke; nach|drucken [Trenn.: ...druk|ken]; Nach-druck|er|laub|nis; nach|drücklich; Nach|drück|lich|keit w; -; nach|drucks|voll; Nach|druck-ver|fah|ren

nach|dun|keln; der Anstrich ist od. hat nachgedunkelt

nach|ei|fern; nach|ei|ferns|wert; Nach|ei|fe|rung

nach|ei|len

nach|ein|an|der; Schreibung in Verbindung mit Zeitwörtern (↑ R 139); sie wollen nacheinander (gegenseitig nach sich) schauen, die Wagen werden nacheinander (in Abständen) starten usw.; vgl. aneinander

nach|emp|fin|den; Nach|emp|fin-dung

Na|chen (landsch. u. dicht. für: Kahn) m; -s, -

Nach|er|be m; Nach|erb|schaft

nach|er|le|ben

Nach|ern|te

nach|er|zäh|len; Nach|er|zäh|lung

N[a]chf. = Nachfolger, Nachfolgerin

Nach|fahr m; -s, -en u. Nach|fah|re (selten noch für: Nachkomme) m; -n, -n (↑ R 268); nach|fah|ren; Nach|fah|ren|ta|fel

Nach|fall (Bergmannsspr.: Gesteinsmassen oberhalb eines Flözes, die bei der Gewinnung nachfallen und die Kohle verunreinigen) m

nach|fas|sen

Nach|fei|er; nach|fei|ern

Nach|fol|ge; nach|fol|gen; nach-fol|gend; (↑ R 135:) -es; (↑ R 134:) im -en (weiter unten), aber (↑ R 116): das Nachfolgende; vgl. folgend; Nach|fol|gen|de m u. w; -n, -n (↑ R 287ff.); Nach|fol|ge|rin (Abk.: N[a]chf.) w; -, -nen; Nach-fol|ger|schaft; Nach|fol|ge|staat (Mehrz. ...staaten)

nach|for|dern; Nach|for|de|rung

nach|for|men; er hat die Plastik nachgeformt

nach|for|schen; Nach|for|schung

Nach|fra|ge; nach|fra|gen

nach|füh|len; nach|füh|lend

nach|fül|len; Nach|fül|lung

Nach|gang; im - (Amtsdt. für: als Nachtrag)

nach|gä|ren; Nach|gä|rung

nach|ge|ben

nach|ge|bo|ren; nachgebor[e]ner Sohn; Nach|ge|bo|re|ne m u. w; -n, -n (↑ R 287ff.)

Nach|ge|bot (bei Versteigerungen; landsch.)

Nach|ge|bühr (z. B. Strafporto)

Nach|ge|burt

Nach|ge|fühl

nach|ge|hen; einer Sache -

nach|ge|las|sen (veraltend für: hinterlassen); ein -es Werk

nach|ge|ord|net (Amtsdt.: dem Rang nach zunächst kommend); die -en Behörden

nach|ge|ra|de

nach|ge|ra|ten; jmdm. -

Nach|ge|schmack m; -[e]s

nach|ge|wie|se|ner|ma|ßen

nach|gie|big; Nach|gie|big|keit

nach|gie|ßen

nach|grü|beln

nach|gucken [Trenn.: ...guk|ken] (ugs.)

Nach|guß

Nach|hall; nach|hal|len

nach|hal|tig; Nach|hal|tig|keit w; -

nach|hän|gen; ich hing nach, du hingst nach; nachgehangen; einer Sache -; vgl. ¹hängen

nach Hau|se, Hau|se; Nach|hau|se|weg

nach|hel|fen; Nach|hel|fer

nach|her [auch, österr. nur: naeh her]; nach|he|rig

Nach|hil|fe; Nach|hil|fe.stun|de ...un|ter|richt

nach|hin|ein; im - (bes. österr. für hinterher)

Nach|hol|be|darf; nach|ho|len

Nach|hut w; -, -en

nach|ja|gen; dem Glück -

Nach|kind (veralt. für: nachgebor[e]nes Kind)

Nach|klang; nach|klin|gen

Nach|kom|me m; -n, -n (↑ R 268) nach|kom|men; Nach|kom|menschaft; Nach|kömm|ling

nach|kon|trol|lie|ren

Nach|kriegs.er|schei|nung, ...ge-ne|ra|ti|on, ...zeit

Nach|kur

Nach|laß m; ...lasses, ...lasse u. ...lässe; nach|las|sen; Nach|las-sen|schaft (veralt.); Nach|las|se (selten für: Erblasser); Nach|laß-ge|richt; nach|läs|sig; nach|läs|si-ger|wei|se; Nach|läs|sig|keit

Nach|laß.pfle|ger; Nach|laß|sung

Nach|laß.ver|wal|ter, ...ver|waltung

nach|lau|fen; Nach|läu|fer

nach|le|gen

Nach|le|se; nach|le|sen

nach|lie|fern; Nach|lie|fe|rung

nach|lö|sen

nachm., (bei Raummangel:) nm. = nachmittags

nach|ma|chen (ugs. für: nachahmen); jmdm. etwas -; er hat die Stimme der Vögel nachgemacht

Nach|mahd (landsch.)

nach|ma|lig (veraltend für: später); nach|mals (veralt. für: hernach, später)

nach|mes|sen, Nach|mes|sung

Nach|mit|tag; nachmittags; ↑ R 129 (Abk.: nachm., [bei Raummangel:] nm.), aber: des Nachmittags; vgl. ¹Mittag; nach|mit|tä|gig (vgl. ...tägig); nach|mit|täg|lich (vgl. ...täglich); nach|mit|tags; vgl. mittags; Nach|mit|tags|kaf|fee, ...schlaf (m; -[e]s), ...stun|de, ...vor|stel|lung

Nach|nah|me w; -, -n; Nach|nah|me.ge|bühr, ...sen|dung

Nach|na|me (Familienname)

nach|plap|pern (ugs.)

nach|prä|gen; Nach|prä|gung

nach|prüf|bar; Nach|prüf|bar|keit w; -; nach|prü|fen; Nach|prü|fung

Nach|raum (Forstw.: Ausschuß) m; -[e]s

nach|rech|nen; Nach|rech|nung

Nach|re|de; nach|re|den

Nach|rei|fe; nach|rei|fen

Nach|richt w; -, -en; Nach|rich|ten.agen|tur, ...bü|ro, ...dienst (Allgemeiner Deutscher - [DDR]; Abk.: ADN), ...sa|tel|lit, ...sen|dung, ...sper|re, ...spre|cher, ...sy|stem, ...tech|nik, ...über|mitt|lung, ...ver|bin|dung, ...we|sen (s; -s)

nach|richt|lich

nach|rücken [Trenn.: ...rük|ken]

Nach|ruf m; -[e]s, -e; nach|ru|fen

Nach|ruhm; nach|rüh|men

nach|sa|gen; jmdm. etwas -

Nach|satz

nach|schaf|fen (ein Vorbild nachgestalten); vgl. ²schaffen; ²nach|schaf|fen (nacharbeiten); vgl. ¹schaffen

nach|schau|en

nach|schicken [Trenn.: ...schik|ken]

nach|schim|mer

nach|schlag (Musik; ugs. für: zusätzliche Essensportion) m; -[e]s, Nachschläge; nach|schla|gen; er st seinem Vater nachgeschlagen (nachgeartet); er hat in einem Buch nachgeschlagen; Nach|schla|ge|werk

nach|schlei|chen

nach|schlüs|sel; Nach|schlüs|sel.dieb|stahl (Diebstahl mit Hilfe von Nachschlüsseln)

nach|schöp|fung

nach|schrei|ben; Nach|schrift Abk.: NS)

Nach|schub m; -[e]s, Nachschübe; Nach|schub.ein|heit, ...ko|lon|ne, ...weg

Nach|schuß (Wirtsch.: Einzahlung über die Stammeinlage hinaus; Sportspr.: erneuter Schuß auf das Tor); Nach|schuß|pflicht

nach|se|hen; jmdm. etwas -; Nach|se|hen s; -s

nach|sen|den; Nach|sen|dung

nach|set|zen; jmdm. (jmdn. vor folgen)

Nach|sicht w; -; nach|sich|tig; Nach|sich|tig|keit w; -; nach|sichts|voll

Nach|sicht|wech|sel (Bankw.)

Nach|sil|be

nach|sin|nen (geh.)

nach|sint|flut|lich vgl. nachsündflutlich

nach|sit|zen (ugs. für: zur Strafe nach dem Unterricht noch dableiben müssen); er hat nachgesessen

Nach|som|mer

Nach|sor|ge (Med.)

Nach|spann (Film, Fernsehen: Abschluß einer Sendung, eines Films); vgl. Vorspann

Nach|spei|se

Nach|spiel; nach|spie|len

nach|spio|nie|ren (ugs.)

nach|spre|chen; Nach|spre|cher

nach|spü|len

nach|spü|ren

¹nächst; nächsten Jahres (Abk.: n. J.), nächsten Monats (n. M.); nächstes Mal (vgl. Mal, I); nächstdem. I. Kleinschreibung: a) (↑ R 135:) der nächste, bitte!; der nächste (erste) beste; b) (↑ R 134:) am nächsten, fürs nächste, mit nächstem; c) (↑ R 134:) das nächste [zu tun] wäre ..., das nächste [zu tun] wäre ...; als nächstes (darauf); d) wir fragten den nächstbesten Polizisten. II. Großschreibung (↑ R 116:) der Nächste (vgl. d.); das Nächstbeste od. das Nächste u. Beste, was ihm bietet; als Nächstes (als nächste Nummer, Sendung usw.); ²nächst (hinter, gleich nach); mit Wemf.: - dem Hause, - ihm; nächst|bes|ser; die -e Plazierung; nächst|be|ste; vgl. nächst, I, c u. d; Nächst|be|ste m u. w u. s; -n, -n (↑ R 287ff.); nächst|dem; Nächst|ste (Mitmensch) m; -n, -n (↑ R 287ff.)

nach|ste|hen; nach|ste|hend; (↑ R 135:) nachstehendes (folgendes); ich möchte Ihnen nachstehendes zur Kenntnis bringen; (↑ R 134:) im -en (weiter unten); Einzelheiten werden im nachstehenden behandelt, aber (↑ R 116:) das Nachstehende; das Nachstehende muß nachgeprüft werden; vgl. folgend

nach|stei|gen (ugs. für: folgen)

nach|stel|len; er hat ihm nachgestellt; Nach|stel|lung

Näch|sten|lie|be; näch|stens; nächstes Mal, das nächste Mal; vgl. Mal, I; Näch|sten|lie|be; nächst|fol|gen|de m u. w u. s; -n, -n (↑ R 287ff.); nächst|ge|le|gen; nächst|fol|gen|de m u. w u. s; -n, -n (↑ R 287ff.); nächst|jäh|rig; nächst|lie|gend (↑ R 299); vgl naheliegend; Nächst|lie|gen|de s; -n (↑ R 287ff.); nächst|mög|lich; zum -en Termin; falsch: nächstmöglichst (↑ R 299)

nach|sto|ßen

nach|stür|zen

nach|su|chen; Nach|su|chung

nach|sünd|flut|lich (volkstümlich für: nachsintflutlich)

Nacht w; -, Nächte. I. Großschreibung: bei, über -; die - über; Tag und -; des Nachts, eines Nachts. II. Kleinschreibung (↑ R 129): nacht; [bis, von] gestern heute, morgen nacht; Dienstag nacht; österr. ugs. bei Zeitangaben: 12 Uhr nacht (für: nachts); vgl. nachts; Nacht.ar|beit, ...aus|ga|be, ...blind|heit, ...dienst; nacht|dun|kel

Nacht|teil m; nach|teil|lig

näch|te|lang; aber: drei Nächte lang; nach|ten (schweiz. u. dicht. für: Nacht werden); Nacht|es|sen bes. südd. u. schweiz. (Abendessen); Nacht|eu|le (übertr. ugs. auch für: jmd., der bis spät in die Nacht hinein aufbleibt), ...fal|ter; nacht|far|ben; -er Stoff; Nacht.frost, ...ge|bet, ...ge|schirr, ...ge|spenst, ...ge|wand (geh.); Nacht|glei|che w; -, -n; Tagundnachtgleiche; Nacht.hemd, ...him|mel; näch|tig (veralt., aber noch mdal. u. in Zusammensetzungen, z. B. übernächtig; Jägerspr.: schon in der Nacht getreten [von einer Fährte])

Nach|ti|gal (dt. Afrikaforscher)

Nach|ti|gall ("Nachtsängerin"; Vogel) w; -, -en; Nach|ti|gal|len|schlag m; -[e]s; näch|ti|gen (übernachten); er hat bei uns genächtigt

Nach|tisch m; -[e]s

Nacht.ka|ba|rett, ...käst|chen (bes. österr. für: Nachttisch), ...kastl (österr. ugs.; s; -s, -n), ...ker|ze (Pflanzengattung), ...klub, ...küh|le, ...la|ger (Mehrz. ...lager), ...le|ben; nacht|lich; näch|li|cher|wei|le; Nacht_licht (Mehrz. ...lichter), ...lo|kal, ...luft, ...mahl (bes. österr. neben: Abendessen); nacht|mah|len österr. (zu Abend essen); ich nachtmahle; genachtmählt; zu -;

Nacht_mahr (Spukgestalt im Traum), ...marsch, ...mu|sik, ...müt|ze, ...por|tier, ...quar|tier
Nach|trab (veralt.) m; -[e]s, -e
Nach|trag m; -[e]s, ...träge; nach|tra|gen; nach|trä|ge|risch (nachtragend, nicht vergebend); -ste (↑R 294); nach|träg|lich (hinterdreinkommend); nachträgerisch: Nach|träg|lich|keit; Nach|trags|haus|halt
nach|trau|ern
Nacht|ru|he
Nacht|trupp
nachts (↑R 129), aber: des Nachts, eines Nachts; nachtsüber (↑R 129), aber: die Nacht über; vgl. Abend; Nacht|schat|ten (Pflanzengattung); Nacht|schat|ten|ge|wächs; Nacht|schicht, ...schlaf; nacht|schla|fend; zu, bei -er Zeit; Nacht|schränk|chen (landsch. für: Nachttisch), ...schwär|mer (scherzh. für: jmd., der sich die Nacht über vergnügt), ...schweiß, ...schwe|ster, ...sei|te, ...strom (m; -[e]s), ...stun|de; nachts|über; vgl. nachts; Nacht_ta|rif, ...tier, ...tisch, ...topf
nach|tun; es jmdm. -
Nacht_vio|le (Waldpflanze), ...vo|gel, ...vor|stel|lung, ...wa|che, ...wäch|ter; Nacht|wäch|ter|lied; nacht|wan|deln; ich ...[e]le (↑R 327); ich bin (auch: habe) genachtwandelt; zu -; Nacht|wan|de|rung, ...wand|ler; Nacht|wand|le|rin w; -, -nen; nacht|wand|le|risch; mit -er Sicherheit; Nacht_zeit (zur -), ...zug, ...zu|schlag
Nach_un|ter|su|chung, ...ver|an|la|gung, ...ver|mächt|nis (Rechtsspr.); Nach|ver|mächt|nis|neh|mer
nach|voll|zieh|bar; nach|voll|zie|hen
nach|wach|sen
Nach|wahl
Nach|währ|schaft schweiz. (Gewährleistung für nachträglich entdeckte Mängel eines Hauses od. eines Haustieres)
Nach|we|hen Mehrz.
nach|wei|nen
Nach|weis m; -es, -e; nach|weis|bar; nach|wei|sen (beweisen); er hat den Tatbestand nachgewiesen; nach|weis|lich
nach|wei|ßen (noch einmal weißen)
Nach|wei|sung (älter für: Nachweis)
Nach|welt w; -
nach|wer|fen
nach|wie|gen
nach|win|ken
Nach|win|ter; nach|win|ter|lich; Nach|wir|kung

nach|wol|len (ugs. für: folgen wollen); er hat ihm nachgewollt
Nach|wort (Mehrz. ...worte)
Nach|wuchs m; -es; Nach|wuchs-_au|tor, ...fah|rer, ...kraft, ...spie|ler
nach|zah|len; Nach|zah|lung; nach|zäh|len; Nach|zäh|lung
nach|zeich|nen; Nach|zeich|nung
Nach|zei|tig|keit (Sprachw.) w; -
nach|zie|hen
Nach|zoll
nach|zot|teln (ugs. für: langsam hinterherkommen)
Nach|zucht
Nach|zug; Nach|züg|ler; nach|züg|le|risch
Nacke|dei¹ (scherzh. für: nacktes Kind) m; -[e]s, -e u. -s
Nacken¹ m; -s, -
nackend¹ landsch. (nackt)
Nacken¹_haar (meist Mehrz.), ...lei|der, ...schlag, ...schutz, ...star|re, ...stüt|ze
nackert¹ österr. mdal. (nackt)
Nack|frosch vgl. Nacktfrosch; nackig¹ (ugs. für: nackt)
...nackig¹ (z. B. kurznackig)
nackt; nackt|ar|mig; Nackt|ba|den s; -s, aber: nackt baden; Nackt|frosch, (seltener:) Nack|frosch (scherzh. für: nacktes Kind); Nackt|heit w; -; Nackt_kul|tur (w; -), ...mo|dell; Nackt|sa|mer (Bot.: Pflanze, deren Samenanlage offen an den Fruchtblättern sitzt; Ggs.: Bedecktsamer) m; -s, - (meist Mehrz.); nackt|sa|mig (Bot.); Nackt_schnecke¹, ...tän|ze|rin
Na|del w; -, -n; Na|del_ar|beit, ...baum, ...büch|se; Nä|del|chen, ...lein; na|del|fer|tig (vom Gewebe: verarbeitbar), ...för|mig; Na|del|ge|höl|ze (Mehrz.), ...geld (früher: Art Taschengeld für Frau od. Tochter), ...holz (für: Konifere; Mehrz. ...hölzer), ...kis|sen, ...ma|le|rei (gesticktes buntes Bild); na|del|los (von Tannen u. a.: Nadeln verlieren); Na|del_öhr, ...spit|ze, ...stich, ...strei|fen (sehr feiner Streifen in Stoffen), ...wald
Na|dir arab. (Astron.: Fußpunkt, Gegenpunkt des Zenits an der Himmelskugel) m; -s; Na|dir-spie|gel
Nad|ja (w. Vorn.)
Nad|ler (früher für: Nadelmacher)
Na|do|wes|sier [...i°r] m; -s, - (svw. Sioux)
nad|wes|sisch
Naf|ta|li vgl. Naphthali
Na|gai|ka russ. (Lederpeitsche [der Kosaken]) w; -, -s
Na|ga|na Zuluspr. (eine afrik. Viehseuche) w; -

Na|ga|sa|ki (jap. Stadt; am 9. 8. 1945 durch eine Atombombe fast völlig zerstört)
Na|gel m; -s, Nägel; Na|gel_bett (Mehrz. ...betten [seltener: ...bette]), ...boh|rer, ...bür|ste; Nä|gel|chen, Nä|gel|lein, Näg|lein (kleiner Nagel); Na|gel_falz, ...fei|le; na|gel|fest, in: niet- u. nagelfest (↑R 145); Na|gel_fluh (ein Gestein), ...kopf, ...lack; na|gel|n; ich ...[e]le (↑R 327); na|gel|neu (ugs.); Na|gel_pfle|ge, ...pro|be, ...rei|ni|ger, ...ring (Schwert der german. Heldensage; m; -[e]s), ...schaft, ...sche|re, ...schuh, ...stie|fel, ...wur|zel; Näg|lein vgl. Nägelchen
na|gen; Na|ger; Na|ge|tier
NAGRA (Kurzwort für: Fachnormenausschuß für das graphische Gewerbe) m; -s
nah, ¹na|he; näher (vgl. d.); nächst (vgl. d.); nächstens; nahebei, nahehin, nahezu; nah[e] daran sein; von nah u. fern; von nahem; nahe bekannt, verwandt usw., aber (↑R 224): der Nahe Osten. In Verbindung mit Zeitwörtern (↑R 139): I. Getrenntschreibung, wenn „nahe" in eigentlicher örtlicher Bedeutung (= in der Nähe, in die Nähe) od. in zeitlicher Bedeutung gebraucht wird, z. B. nahe gehen (in die Nähe gehen); jmdm. bedrohlich näher rücken; weil der Termin jetzt nahe rückt. II. Zusammenschreibung in übertragenem Sinne, z. B. nahegehen [vgl. d.] (seelisch ergreifen), es geht nahe, nahegegangen, nahezugehen; obgleich es ihm sehr naheging
Näh|ar|beit
Nah_auf|nah|me; ²na|he; mit Wemf.: - dem Flusse; Nä|he w -; in der -; na|he|bei; er wohnt -, aber: er wohnt nahe bei der Post; na|he|brin|gen; ↑R 139 (Verständnis erwecken); der Dichter wurde uns in der Schule nahegebracht; aber: na|he brin|gen; er hat den Apparat sehr nahe gebracht; na|he|ge|hen; ↑R 13 (seelisch ergreifen); der Tod seines Freundes ist ihm nahegegangen; aber: na|he ge|hen (in die Nähe gehen od. in die Nähe gehen); er ist ganz nahe gegangen; Nah|ein|stel|lung; na|he|kom|men; ↑R 139 (fast gleichen); sie sind sich sehr nahegekommen; aber: na|he kom|men (in die Nähe kommen); er ist dem Ufer sehr nahe gekommen; na|he|le|gen; ↑R 139 (empfehlen); er hat ihm die Erfüllung seiner Bitte sehr nahegelegt; aber: na|he le|gen (in die Nähe legen); er hat das Buch sehr nahe

¹ Trenn.: ...k|k...

gelegt; na|he|lie|gen; ↑R 139 (leicht zu finden sein; leicht verständlich sein); die Lösung des Rätsels hat nahegelegen; a b e r : na|he lie|gen (in der Nähe liegen); das Buch hat nahe gelegen; na|he|lie|gend (leicht zu finden; leichtverständlich); näherliegend, nächstliegend (↑R 296); ein naheliegender Gedanke; a b e r : na|he lie|gend (in der Nähe liegend); ein nahe liegendes Haus; na|hen; sich -; ich habe mich ihm mit einer Bitte genaht nä|hen

nä|her; **I.** *Kleinschreibung* (↑R 134): des näher[e]n (genauer) auseinandersetzen. **II.** *Großschreibung:* **a)** (↑R 116:) Näheres folgt; das Nähere findet sich bei ...; ich kann mich des Näher[e]n (der für den vorliegenden Fall besonderen Umstände) nicht entsinnen; **b)** (↑R 116:) alles Nähere können Sie der Gebrauchsanweisung entnehmen. **III.** *Schreibung in Verbindung mit Zeitwörtern* entsprechend „nah[e]" (vgl. d.); nä|her|brin|gen; ↑R 139 (erklären, leichter verständlich machen); er hat uns den Gehalt dieser Dichtungen nahergebracht; a b e r : nä|her brin|gen (in größere Nähe bringen); er hat den Apparat näher gebracht

Nä|he|rei

Nah|er|ho|lungs|ge|biet

Nä|he|rin *w;* -, -nen

nä|her|kom|men; ↑R 139 (Fühlung bekommen, verstehen lernen); sie sind sich in letzter Zeit nähergekommen; a b e r : nä|her kom|men (in größere Nähe kommen); er ist immer näher gekommen; nä|her|lie|gen; ↑R 139 (besser, sinnvoller, vorteilhafter sein); ich denke, daß es näherliegt zu gehen als zu bleiben; a b e r : nä|her lie|gen (in größerer Nähe liegen); ich glaube, daß das Dorf X näher liegt; nä|her|lie|gend vgl. naheliegend; nä|hern, sich; ich ...ere mich (↑R 327); Nä|her|recht (veralt. für: näheres Anrecht, Vorkaufsrecht); nä|her|ste|hen; ↑R 139 (vertrauter sein); sie hat mir nähergestanden; dem linken Flügel der Partei näherstehen (mit ihm sympathisieren); a b e r : nä|her ste|hen (in größere Nähe stehen); er hat heute näher gestanden; nä|her|tre|ten; ↑R 139 (vertrauter werden); er ist seinem Vorschlag nähergetreten; a b e r : nä|her tre|ten (in größere Nähe treten); er ist nach seiner Aufforderung näher getreten; Nä|he|rung (Math. für: Annäherung); Nä|he|rungs|wert; na|he|ste|hen;

↑R 139 (befreundet, vertraut, verbunden sein); er hat dem Verstorbenen sehr nahegestanden; a b e r : na|he ste|hen (in der Nähe stehen); er hat dem Ufer sehr nahe gestanden; na|he|ste|hend (befreundet, vertraut); näherstehend, nächststehend (↑R 296); ein nahestehender Mensch; a b e r : na|he ste|hend (in der Nähe stehend); ein sehr nahe stehendes Haus; na|he|tre|ten; ↑R 139 (befreundet, vertraut werden); er ist mir in letzter Zeit sehr nahegetreten; a b e r : na|he tre|ten (in die Nähe treten); er ist dem Ufer sehr nahe getreten; jmdm. zu nahe treten (jmdn. verletzen, beleidigen); na|he|zu

Näh.fa|den, ...garn

Nah|kampf; Nah|kampf|mit|tel *Mehrz.*

Näh.ka|sten, ...kis|sen, ...korb, ...ma|schi|ne; Näh|ma|schi|nen.in|du|strie, ...öl; Näh|na|del

Nah|ost (Naher Osten); für, in, nach, über -; nah|öst|lich

Nähr.bo|den, ...creme; näh|ren; sich - ; nahr|haft; Nahr|haf|tig|keit *w;* -; Nähr.he|fe, ...kli|stier, ...lö|sung, ...mit|tel (*Mehrz.*), ...prä|pa|rat, ...sal|ze (*Mehrz.*), ...stof|fe (*Mehrz.*); nähr|stoff.arm, ...reich; Näh|rung *w;* -; Nahrungs.auf|nah|me, ...man|gel *m*, ...mit|tel *s*; Nah|rungs|mit|tel.che|mie, ...in|du|strie, ...ver|gif|tung; Nah|rungs.sor|gen (*Mehrz.*), ...su|che, ...ver|wei|ge|rung; Nähr|wert

Nah|schnell|ver|kehrs|zug (Zeichen: N)

Näh|sei|de; Naht *w;* -, Nähte; Näh|te|rin (veralt. für: Näherin); Näh|tisch; naht|los; Naht|stel|le

Na|hum (bibl. Prophet)

Näh|ver|ker|per; nah|ver|wandt; (↑R 142:) nahverwandte Personen, a b e r : die Personen sind nah verwandt

Näh|zeug

Näh.ziel, ...zün|der

Na|im, (ökum.:) Na|in (bibl. Ort in Galiläa)

Nai|ro|bi (Hptst. des Staates Kenia)

na|iv *lat.-fr.* (natürlich; unbefangen; kindlich; treuherzig; einfältig, töricht); -e Malerei; -e u. sentimentalische Dichtung; Nai|ve *w;* -n, -n (↑R 287ff.); (Darstellerin naiver Mädchenrollen) *w;* -n, -n (↑R 287ff.); Nai|vi|tät [*na-iwi...*]; Na|iv|ling (abschätzig für: gutgläubiger, törichter Mensch)

na ja!

Na|ja|de *gr.* (gr. Quellnymphe; Flußmuschel) *w;* -, -n (meist *Mehrz.*)

Na|ma (Angehöriger eines Hottentottenstammes) *m;* -[s], -[s]; Na|ma|land *s;* -[e]s

Na|me *m;* -ns, -n; im Namen; mit Namen; Na|men (seltener für: Name) *m;* -s, -; Na|men.buch, ...deu|tung, ...for|schung, ...gebung, ...ge|dächt|nis; Na|men-Jesu-Fest (↑R 182); Na|men|kun|de *w;* -; na|men|kund|lich; Na|men|li|ste; na|men|los; Na|men|lo|se *m* u. *w;* -n, -n (↑R 287ff.); Na|men|lo|sig|keit *w;* -; Na|men_nen|nung, ...re|gi|ster; na|men|reich; na|mens; ↑R 129 u. 130 (im Namen, im Auftrag [von]; mit Namen); Na|mens.än|de|rung, ...form, ...pa|pier (für: Rektapapier), ...schild (*Mehrz.* ...schilder), ...tag, ...vet|ter, ...zei|chen, ...zug; na|ment|lich (↑R 19); namentlich wenn (↑R 62); Na|men.ver|wechs|lung, ...ver|zeich|nis; nam|haft; - machen; Nam|haft|ma|chung; ...na|mig (z. B. vielnamig); näm|lich (↑R 19); nämlich da/wenn (↑R 62); näm|li|che; (↑R 135:) der, die, das -; er ist noch der - (derselbe); er sagt immer das - (dasselbe); Näm|lich|keit (selten für: Identität) *w;* -; Näm|lich|kelts|be|schel|ni|gung (Zollw.): svw. Identitätsnachweis)

Na|mur [...*mür*] (belg. Stadt)

na, na!

Nan|cy [*ngngßi*; auch: ...*ßi*] (Stadt in Frankreich)

Nan|du *indian.-span.* (Pampasstrauß) *m;* -s, -s

Nan|ga Par|bat (Berg im Himalaja) *m;* -

Nä|nie *lat.* [...*i^e*] (altröm. Totenklage, Klagegesang) *w;* -, -n

Na|nis|mus *gr.* (Med., Biol.: Zwergwuchs) *m;* -

¹Nan|king (chines. Stadt); ²Nan|king (ein Baumwollgewebe) *m;* -s, -e u. -s

Nan|net|te (w. Vorn.); Nan|ni (Koseform von: Anna); Nan|ny (engl. w. Vorn.)

Na|no... *gr.* (ein Milliardstel einer Einheit, z. B. Nanometer = 10^{-9} Meter; Zeichen: n); Na|no.fa|rad, ...me|ter, ...se|kun|de

Nan|sen (norw. Polarforscher); Nan|sen-Paß (Ausweis für Staatenlose); ↑R 180

na|nu!

Na|palm *amerik.* (hochwirksamer Füllstoff für Benzinbrandbomben) *s;* -s; Na|palm|bom|be

Napf *m;* -[e]s, Näpfe; Näpf|chen; Näpf|lein; Napf|ku|chen

Naph|tha *pers.* (Roherdöl) *s;* -s od. *w;* -

Naph|tha|li, (ökum.:) Naf|ta|li (bibl. m. Eigenn.)

Naph|tha|lin pers. (Kohlenwasser-stoff) s; -s; Naph|the|ne (hydro-aromatische Kohlenwasserstof-fe) Mehrz.; Naph|tho|le (aromat. Alkohole) Mehrz.

Na|po|le|on (Kaiser der Franzo-sen); Na|po|le|on|dor fr. (unter Napoleon I. u. III. geprägte Münze) m; -s, -e; fünf - (↑ R 322); Na|po|leo|ni|de (Abkömmling der Familie Napoleons) m; -n, -n (↑ R 268); na|po|leo|nisch; -er Eroberungsdrang, aber (↑ R 179): Na|po|leo|nisch; -e Feldzü-ge, -e Schriften; Na|po|le|on|kra-gen (↑ R 180)

Na|po|li (it. Form von: Neapel); Na|po|li|tain fr. [...täng] (Scho-koladentäfelchen) s; -s, -s; Na|po-li|taine [...tän] (ein Gewebe) w; -

Nap|pa [nach der kaliforn. Stadt Napa] (kurz für: Nappaleder) s; -; Nap|pa|le|der

Nar|be w; -, -n; nar|ben (Gerberei: [Leder] mit Narben versehen); Nar|ben (Gerberei für: Narbe) m; -s. -; Nar|ben.bil|dung, ...ge|we-be, ...le|der; nar|ben|voll; nar|big

Nar|bonne [...bon] (fr. Stadt)

Nar|cis|sus vgl. Narziß

Nar|de semit. (Bez. für verschiede-ne wohlriechende Pflanzen, die schon im Altertum für Salböle verwendet wurden) w; -, -n; Nar-den|öl s; -[e]s

Nar|gi|leh pers. [auch: ...gi...] (oriental. Wasserpfeife) w; -, -[s] od. s; -s, -s

Nar|ko|ma|nie gr. (Med.: Sucht nach Narkotika) w; -; Nar|ko|se (Med.: Betäubung) w; -, -n; Nar-ko|se.ap|pa|rat, ...arzt, ...mas|ke, ...mit|tel s, ...schwe|ster; Nar|ko-ti|kum (Rausch-, Betäubungs-mittel) s; -s, ...ka; Nar|ko|tin (Opiumalkaloid) s; -s; nar|ko-tisch (berauschend, betäubend); -ste (↑ R 294); nar|ko|ti|sie|ren (betäuben); Nar|ko|tis|mus (Sucht nach Narkotika) m; -

Narr m; -en, -en (↑ R 268); Närr-chen, Närr|lein; nar|ren; Nar|ren-frei|heit; nar|ren|haft; Nar|ren-.haus, ...kap|pe; nar|ren|si|cher; Nar|ren[s]|pos|se; -n treiben; das sind -; Nar|ren|streich; Nar|ren-tei|ding (veralt., aber noch mdal. für: Narrenpossen); Nar-ren|tum s; -s; Nar|re|tei [gekürzt aus: Narrenteiding]; Narr|heit; Närr|in w; -, -nen; när|risch; -ste (↑ R 294); Närr|lein, Närr|chen

Narvik [narwik] (norw. Hafen-stadt)

Nar|wal nord. (Wal einer bestimm-ten Art)

[1]Nar|ziß gr. (in sein Bild verliebter schöner gr. Jüngling); [2]Nar|ziß (eitler Selbstbewunderer) m; - u.

...zisses, ...zisse; Nar|zis|se (eine Zwiebelpflanze) w; -, -n; Nar|zis-sen|blü|te; Nar|ziß|mus (krank-hafte Verliebtheit in den eigenen Leib, ins eigene Wesen) m; -; Nar-zißt (vom Narzißmus Befallener) m; -en, -en (↑ R 268); nar|ziß|tisch

NASA = National Aeronautics and Space Administration [nä-sch^e n^e l ä^e r^e nätikß ^end ßpe^eß ^e dmi-nißtre^e sch^e n] (USA: Nationale Luft- und Raumfahrtbehörde) w; -

na|sal lat. (durch die Nase gespro-chen, genäselt; zur Nase ge-hörend); Na|sal (Sprachw.: mit Beteiligung des Nasenraumes od. durch die Nase gesprochener Laut, z. B. m, ng) m; -s, -e; na|sa-lie|ren (einen Laut) durch die Nase aussprechen, näseln); Na-sa|lie|rung; Na|sal.laut (Nasen-laut), ...vo|kal (Selbstlaut mit na-saler Färbung, z. B. o in Bon [bong])

na|schen; du naschst (naschest)

Näs|chen, Näs|lein

Na|scher, (älter:) Nä|scher; Na-sche|rei (wiederholtes Naschen [nur Einz.]; auch für: Näscherei); Nä|sche|rei (veraltend für: Süßig-keit) meist Mehrz.; Na|sche|rin, (älter:) Nä|sche|rin w; -, -nen; nasch|haft; -este (↑ R 292); Nasch-haf|tig|keit w; -; Nasch.kat|ze, ...maul (derb), ...sucht (w; -); nasch|süch|tig; Nasch|werk (ver-alt. für: Leckerei, Süßigkeit) s; -[e]s

Na|se w; -, -n; na|se|lang vgl. na-se[n]lang; nä|seln; ich ...[e]le (↑ R 327); Nä|se|lung (für: Nasalie-rung); Na|sen.bär, ...bein, ...blu-ten (s; -s), ...du|sche, ...flü|gel, ...höh|le; na|se[n]|lang, na|se[n] lang (ugs.); alle - (jeden Augenblick, kurz hintereinander); vgl. all; Na|sen.län|ge, ...laut, ...loch; Na-sen-Ra|chen-Raum (↑ R 155); Na-sen.ring, ...rücken [Trenn.: ...rük-ken], ...schleim|haut, ...schmuck, ...spie|gel, ...spit|ze, ...stü|ber, ...trop|fen, ...wur|zel; na|se|rümp-fend, aber (↑ R 142): die Nase rümpfend; na|se|weis; Na|se|weis m; -es, -e; Herr -, Jungfer -; nas-füh|ren; ich nasführe; genasführt; zu -; Nas|füh|rung; Nas|horn (Mehrz. ...hörner); Nas|horn.kä-fer, ...vo|gel; ...na|sig (z. B. lang-nasig); ...nä|sig (z. B. hochnäsig)

Na|si|rä|er hebr. (bei den Israeli-ten: Träger eines besonderen Ge-lübdes der Enthaltsamkeit) m; -s, -

nas|lang vgl. nase[n]lang; Näs|lein, Näs|chen

naß; nasser (auch: nässer), nasse-ste (auch: nässeste); sich - ma-chen; Naß (dicht. für: Wasser) s; Nasses

Nas|sau (Stadt a. d. Lahn; ehem. Herzogtum); [1]Nas|sau|er (↑ R 199); [2]Nas|sau|er (ugs. für: auf anderer Leute Kosten Lebender; scherzh. für: Regenschauer); nas-sau|ern (ugs. für: auf Kosten an-derer leben); ich ...ere (↑ R 327); nas|sau|isch

Näs|se w; -: näs|seln (ugs. für: ein wenig naß sein, werden); es näs-selt; näs|sen; du näßt (nässest), er näßt; du näßtest; genäßt; näs-se! u. näß!; naß|fest; -es Papier; naß|forsch (ugs. für: bes. forsch, keck, dreist); Naß-in-naß-Druck (Druckw.; Mehrz. ...drucke); ↑ R 155; naß|kalt; näß|lich (feucht an-mutend); Naß.ra|sie|rer, ...ra-sur, ...schnee, ...wä|sche

Na|stie gr. (Bot.: durch Reiz aus-gelöste Bewegung von Organen festgewachsener Pflanzen) w; -

Nas|tuch (südd., schweiz. neben: Taschentuch; Mehrz. ...tücher)

nas|zie|rend lat. (entstehend, im Werden begriffen)

Na|tal (Provinz der Republik Süd-afrika)

Na|ta|lie [...i^e] (w. Vorn.)

Na|ta|li|tät lat. (Geburtenhäufig-keit) w; -

Na|tan vgl. Nathan

Na|ta|na|el vgl. Nathanael

Na|ta|scha (russ. w. Vorn.)

Na|than, (ökum.:) Na|tan (bibl. Prophet); Nathan der Weise („dramatisches Gedicht" von Lessing)

[1]Na|tha|na|el [...aäl], (ökum.:) Na|ta|na|el (Jünger Jesu); [2]Na-tha|na|el (m. Vorn.)

Na|ti|on lat. [...zion] (Staatsvolk); na|tio|nal; -es Interesse, aber (↑ R 224): Nationale Front (Zusam-menschluß aller polit. Parteien u. Organisationen in der DDR unter Führung der SED 1949); Nationales Olympisches Komi-tee (Abk.: NOK); na|tio|nal|be-wußt; Na|tio|nal|be|wußt|sein; ...cha|rak|ter; na|tio|nal|de|mo-kra|tisch, aber (↑ R 224): die Na-tionaldemokratische Parte[i] Deutschlands (Abk.: NPD); Na-tio|nal|denk|mal; Na|tio|na|le (veralt. für: Stammrolle; österr. für: Personalangaben, Personen beschreibung) s; -s, -; Na|tio|nal-.ein|kom|men, ...elf, ...epos ...far|ben (Mehrz.), ...fei|er|tag ...flag|ge, ...ge|fühl, ...ge|richt ...ge|tränk, ...held, ...hym|ne; na-tio|na|li|sie|ren [einem Staats-Volksverband] einverleiben, ein bürgern; verstaatlichen; Na|tio na|li|sie|rung; Na|tio|na|lis|mu (übertriebenes Nationalbewußt

sein) *m*; -, ...men; **Na|tio|na|list** (↑ R 268); **na|tio|na|li|stisch**; -ste (↑ R 294); **Na|tio|na|li|tät** (Volkstum; Staatsangehörigkeit; nationale Minderheit); **Na|tio|na|li|tä|ten.fra|ge**, ...**staat** (Mehr-, Vielvölkerstaat; *Mehrz.* ...staaten); **Na|tio|na|li|täts|prin|zip** *s*; -s; **Na|tio|nal.kir|che**, ...**kon|vent**, ...**kon|zil**; **na|tio|nal|li|be|ral**; **Na|tio|nal.li|ga** (in Österreich die höchste, über den Regionalligen stehende Spielklasse im Fußball; vgl. Regionalliga), ...**li|te|ra|tur**, ...**mann|schaft**, ...**öko|nom** (Volkswirtschaftler), ...**öko|no|mie** (Volkswirtschaftslehre), ...**park**, ...**rat** (Bez. von Volksvertretungen in der Schweiz u. in Österreich; auch für deren Mitglied), ...**so|zia|lis|mus**, ...**so|zia|list**; **na|tio|nal|so|zia|li|stisch**; **Na|tio|nal.spei|se**, ...**spie|ler**, ...**sport**, ...**spra|che**, ...**staat** (*Mehrz.* ...staaten); **na|tio|nal|staat|lich**; **Na|tio|nal.stolz**, ...**stra|ße** (schweiz.: Autobahn, Autostraße; Zeichen: N 1, N 2 usw.), ...**tanz**, ...**thea|ter**, ...**tracht**, ...**ver.samm|lung**

Na|tive *engl.* [ne'tiw] (Eingeborener in den ehem. brit. Kolonien) *m*; -s, -s; **Na|ti|vis|mus** *lat.* [...*wiß*...] (Lehre, nach der es angeborene Vorstellung, Begriffe, Grundeinsichten usw. gibt) *m*; -; **Na|ti|vist** (↑ R 268); **na|ti|vi|stisch**; **Na|ti|vi|tät** (veralt. für: Geburt; Astrologie: Stand der Gestirne bei der Geburt, auch das angeblich dadurch vorbestimmte Schicksal); **Na|ti|vi|tät|s|ten|stel|ler**

NATO, (auch:) **Nato** = North Atlantic Treaty Organization [no'th 'tläntik triti o'g*e*naise'-sch'n] (Organisation der Signatarmächte des Nordatlantikpaktes, westl. Verteidigungsbündnis) *w*; -

Ja|tri|um *ägypt.* (chem. Grundstoff, Metall; Zeichen: Na) *s*; -s; **Na|tro|kal|zit**, (chem. fachspr.:) **Na|tro|cal|cit** (ein Mineral); **Na|tron** (ugs. für: doppeltkohlensaures Natrium) *s*; -s

Jat|té *fr.* [nate] (,,geflochten''; Sammelbez. für Gewebe in sog. Würfelbindung) *m*; -[s], -s

Jat|ter *w*; -, -n; **Nat|tern.brut**, ...**gezücht**

a|tur *lat. w*; -, -en; vgl. in natura; **Na|tu|ral.be|zü|ge** (Sachbezüge) *Mehrz.*, ...**ein|kom|men**; **Na|tu|ra|li|en** [...*i*'*n*] (Natur-, Bodenerzeugnisse) *Mehrz.*; **Na|tu|ra|li|en.ka|bi|nett** (naturwissenschaftliche Sammlung), ...**samm|lung**; **Na|tu|ra|li|sa|ti|on** [...*zion*], **Na|tu|ra|li|sie|rung** (Einbürgerung,

Aufnahme in den Staatsverband; allmähl. Anpassung von Pflanzen u. Tieren); **na|tu|ra|li|sie|ren**; **Na|tu|ra|lis|mus** (Naturglaube; Wirklichkeitstreue, [Streben nach] Natürlichkeit, Naturwahrheit; auf der Wirklichkeit fußende Kunstrichtung) *m*; -, (für naturalist. Zug an Kunstwerken *Mehrz.*:) ...men; **Na|tu|ra|list** (↑ R 268); **na|tu|ra|li|stisch**; -ste (↑ R 294); **Na|tu|ral.lohn**, ...**wirtschaft**; **Na|tur.apostel**, ...**arzt**; **na|tur|be|las|sen**; **Na|tur.be|ob|ach|tung**, ...**be|schrei|bung**, ...**bursche**, ...**denk|mal**; **na|tu|rell** *fr.* (natürlich; unbearbeitet, ungefärbt; Gastr.: ohne besondere Zutaten zubereitet); **Na|tu|rell** (Veranlagung; Eigenart; Gemütsart) *s*; -s, -e; **Na|tur.er|eig|nis**, ...**er|schei|nung**; **na|tur|far|ben**; -es Holz; **Na|tur.far|ben|druck** (Farbendruck nach fotografischen Farbaufnahmen), ...**film**, ...**for|scher**, ...**freund**, ...**ge|fühl** (*s*; -[e]s); **na|tur.ge|ge|ben**, ...**ge|mäß**; **Na|tur.ge|schich|te** *w*; -; **na|tur|ge|schicht|lich**; **Na|tur.ge|setz**; **na|tur.ge|treu**, ...**haft**; **Na|tur.heil|kun|de** (*w*; -), ...**heil|ver|fah|ren**; **Na|tu|ris|mus** (Freikörperkultur); **Na|tu|rist** (↑ R 268); **Na|tur.ka|ta|stro|phe**, ...**kind**, ...**kraft** *w*, ...**kun|de** (*w*; -); **na|tur|kund|lich**; **Na|tur|leh|re** (physikalischchemischer Teil des naturwissenschaftlichen Unterrichts an Grundschulen); **na|tür|lich**; -e Geometrie, Gleichung (Math.); -e Kinder (rechtl. Kinder, ehel. Abkömmlinge ihrer Eltern); -e Person (Ggs.: juristische Person); **na|tür|li|cher|wei|se**; **Na|tür|lich|keit** *w*; -; **Na|tur.mensch**, ...**nä|he**, ...**not|wen|dig|keit**, ...**park**, ...**phi|lo|so|phie**, ...**pro|dukt**, ...**recht** (*s*; -[e]s); **na|tur|rein**; **Na|tur.re|li|gi|on**, ...**schau|spiel**, ...**schön|heit**, ...**schutz**; **Na|tur|schutz.ge|biet**, ...**park**; **Na|tur|spiel** (Naturwissa.: Abweichen von der Regel), ...**thea|ter** (Freilichtbühne), ...**treue**, ...**trieb**; **na|tur.trüb**, ...**ver|bun|den**,**voll**, ...**wid|rig**; **Na|tur.wis|sen|schaft** (meist *Mehrz.*), ...**wis|sen|schaft|ler**; **na|tur|wis|sen|schaft|lich**; -er Zweig; **na|tur|wüch|sig**; **Na|tur|wüch|sig|keit** *w*; -; **Na|tur.wun|der**, ...**zu|stand** (*m*; -[e]s)

Nau|arch *gr.* (Schiffsbefehlshaber im alten Griechenland) *m*; -en, -en (↑ R 268)

Naue *w*; -, -n u. (schweiz. nur so:) **Nau|en** (südd., schweiz. neben: Nachen, Kahn; schweiz.: großer [Last]kahn auf Seen) *m*; -s, -

'**nauf** ↑ R 238 landsch. (hinauf)

Nau|pli|us *gr.* (Krebstierlarve) *m*; -, ...ien [...*i*'*n*]

Nau|ru (Inselrepublik im Stillen Ozean); **Nau|ru|er**; **nau|ru|isch**

'**naus** ↑ R 238 landsch. (hinaus)

Nau|sea *gr.* (Med.: Übelkeit; Seekrankheit) *w*; -

Nau|si|kaa [...*ka-a*] (phäakische Königstochter)

Nau|tik *gr.* (Schiffahrtskunde) *w*; -; **Nau|ti|ker**; **Nau|ti|lus** (Tintenfisch) *m*; -, - u. -se; **nau|tisch**; -es Dreieck (svw. sphärisches Dreieck)

Na|var|ra [...*war*...] (nordspan. Prov.; auch für: hist. Provinz in den Westpyrenäen); **Na|var|re|se** *m*; -n, -n (↑ R 268); **Na|var|re|sin** *w*; -, -nen; **na|var|re|sisch**

Na|vel.oran|ge, (kurz:) **Na|vel** *engl.* [*ne'w*'*l*...] (kernlose Orange, die eine zweite kleine Frucht einschließt)

Na|vi.cert *engl.* [*nä'wißö*'*t*] ([im Kriege] engl. Geleitschein für neutrale [Handels]schiffe) *s*; -s, -s

Na|vi|ga|ti|on *lat.* [*nawigazion*] (Schiffahrt[skunde]; Schiffs-, Flugzeugführung; Einhaltung des gewählten Kurses) *w*; -; **Na|vi|ga|ti|ons.feh|ler**, ...**in|stru|men|te** (*Mehrz.*), ...**of|fi|zier** (für die Navigation verantwortlicher Offizier), ...**schu|le** (Seefahrtsschule); **Na|vi|ga|tor** (Mitglied der Flugzeugbesatzung, das für die Navigation verantwortlich ist) *m*; -s, ...oren; **na|vi|ga|to|risch**; **na|vi|gie|ren** (ein Schiff od. Flugzeug führen)

Na|xa|lit (Angehöriger einer kommunist. Partei in Indien) *m*; -en, -en (↑ R 268)

na|xisch (von Naxos) (*gr.* Insel)

'**Na|za|rä|er**, (ökum.:) **Na|zo|rä|er** *hebr.* (Beiname Jesu) *m*; -s; [2]**Na|za|rä|er**, (ökum.:) **Na|zo|rä|er** (Mitglied der frühen Christengemeinden) *m*; -s, -; '**Na|za|re|ner** (lat. Beiname Jesu) *m*; -s; [2]**Na|za|re|ner** (Angehöriger einer Künstlergruppe der Romantik) *m*; -s, -; **Na|za|reth**, (ökum.:) **Na|za|ret** (Stadt in Israel)

Na|zi (verächtl. für: Nationalsozialist) *m*; -s, -s; **Na|zi.dik|ta|tur**, ...**herr|schaft**, ...**par|tei**, ...**re|gime**; **Na|zis|mus** (verächtl. für: Nationalsozialismus) *m*; -; **na|zi|stisch** (verächtl. für: nationalsozialistisch) (↑ R 268)

Na|zo|rä|er vgl. '**Na|za|rä|er** u. [2]**Na|za|rä|er**

Nb = chem. Zeichen für Niob

NB = notabene!

n. Br., nördl. Br. = nördlicher Breite

N. C. = North Carolina; vgl. Nordkarolina

Nchf., Nachf. = Nachfolger

n. Chr. = nach Christus, nach Christo; vgl. Christus; **n. Chr. G.** = nach Christi Geburt; vgl. Christus

Nd = chem. Zeichen für: Neodym

nd. = niederdeutsch

N. D. = Norddakota

NDB = Neue Deutsche Biographie

Ne = chem. Zeichen für: Neon

ne!, nee! (mdal. u. ugs. für: nein!) 'ne; ↑ R 238 (ugs. für: eine); 'nen (ugs. für: einen)

Ne|an|der|ta|ler [nach dem Fundort Neandertal bei Düsseldorf] (vorgeschichtlicher Mensch)

Nea|pel (it. Stadt); vgl. Napoli; **Nea|peler,** Ne|ap|ler, ¹Nea|po|li|ta|ner (↑ R 199); ²Nea|po|li|ta|ner (Mehrz.), Nea|po|li|ta|ner|schnit|ten österr. (gefüllte Waffeln); **nea|po|li|ta|nisch**

ne|ark|tisch gr. (der westlichen gemäßigten Zone angehörend); -e Region (Tiergeogr. für: Nordamerika bis Mexiko)

neb|bich [Herkunft unsicher] (Gaunerspr. für: leider!, schade!; ugs. für: nun, wenn schon!; was macht das!)

Ne|bel m; -s, -; **Ne|bel|bank** (Mehrz. ...bänke), ...bil|dung, ...feld; ne|bel|grau, ...haft; **Ne|bel|horn** (Mehrz. ...hörner), ...kap|pe (Tarnkappe), ...ker|ze, ...krä|he; ne|be|lig, neb|lig; **Ne|bel|lam|pe,** ...meer, ...mo|nat od. ...mond (alte Bez. für: November); ne|beln; es nebelt; **Ne|bel|schein|wer|fer,** ...schlei|er, ...schluß|leuch|te, ...schwa|den, ...strei|fen, ...trup|pe; **Ne|be|lung,** Neb|lung (November) m; -s, -e; **Ne|bel|wand**

ne|ben; Verhältnisw. mit Wemf. u. Wenf.: - dem Hause stehen, aber: - das Haus stellen; als Umstandsw. vereinzelt u. in Zusammensetzungen wie: nebenan, nebenbei u. a.; **Ne|ben|ab|sicht,** ...amt; ne|ben|amt|lich; ne|ben|an; **Ne|ben|an|schluß,** ...ar|beit, ...aus|ga|ben (Mehrz.), ...bahn, ...be|deu|tung; ne|ben|bei; **Ne|ben|be|ruf;** ne|ben|be|ruf|lich; **Ne|ben|be|schäf|ti|gung,** ...buh|ler, ...buh|le|rin, ...buh|ler|schaft; ne|ben|ein|an|der; Schreibung in Verbindung mit Zeitwörtern (↑ R 139): nebeneinander herunterrutschen, aber: die Sachen nebeneinanderlegen, die Fahrräder nebeneinanderstellen, vgl. aneinander; nebeneinandersitzen, aber: nebeneinander sitzen (nicht: stehen); **Ne|ben|ein|an|der**

[auch: neb...] s; -s; **ne|ben|ein|an|der|her;** ne|ben|ein|an|der|schal|ten; Ne|ben|ein|an|der|schal|tung; **Ne|ben|ein|gang,** ...ein|künf|te (Mehrz.), ...er|schei|nung, ...er|werb, ...er|zeug|nis, ...fach, ...fluß, ...form, ...frau, ...ge|dan|ke, ...ge|lei|se od. ...gleis, ...ge|räusch, ...ge|stein (Bergmannsspr.: Gestein unmittelbar über u. unter dem Flöz), ...haus; ne|ben|her; ne|ben|her|fah|ren, ...ge|hen, ...lau|fen; ne|ben|hin; etwas - sagen; **Ne|ben|kla|ge,** ...klä|ger, ...ko|sten (Mehrz.), ...li|nie, ...mann (Mehrz. ...männer u. ...leute), ...mensch m, ...me|tall, ...nie|re, ...nut|zung; ne|ben|ord|nen (Sprachw.); zwei Hauptsätze -; nebenordnende Konjunktionen; **Ne|ben|ord|nung** (Sprachw.), ...per|son, ...pro|dukt, ...raum, ...rol|le, ...sa|che; ne|ben|säch|lich; **Ne|ben|säch|lich|keit;** Ne|ben|satz (Sprachw.); ne|ben|schal|ten (für: parallel schalten); **Ne|ben|schal|tung** (für: Parallelschaltung); ne|ben|ste|hend; (↑ R 135:) -es; (↑ R 134:) im -en (hierneben), aber (↑ R 116): das Nebenstehende; vgl. folgend; **Ne|ben|stel|le,** ...stra|fe, ...stra|ße, ...strecke (Trenn.: ...strek|ke], ...tisch, ...ton; ne|ben|to|nig; **Ne|ben|um|stand,** ...ver|dienst m, ...wir|kung, ...woh|nung, ...zim|mer, ...zweck

neb|lig, ne|be|lig; **Neb|lung** vgl. Nebelung

Nebr. = Nebraska

Ne|bras|ka (Staat in den USA; Abk.: Nebr.)

ne|bst; mit Wemf.: - seinem Hunde; **nebst|bei** (österr. neben: nebenbei)

Ne|bu|kad|ne|zar, (ökum.:) Ne|bu|kad|nez|zar (Name babylon. Könige); vgl. Nabucco

ne|bu|los, ne|bu|lös lat. (unklar, verworren, geheimnisvoll); -este (↑ R 292)

Ne|ces|saire fr. [neßäßär] („Notwendiges"; [Reise]behältnis für Toiletten-, Nähutensilien u. a.) s; -s, -s

Ne|cho [necho] (ägypt. Pharao) **n-Eck** (↑ R 149)

Neck m; -en, -en (↑ R 268) u. **Necken¹** (ein Wassergeist) m; -s, - **Neckar¹** (rechter Nebenfluß des Rheins) m; -s; Neckar|sulm¹ (Stadt an der Mündung der Sulm in den Neckar)

necken¹; Necke|rei¹

Necking¹ amerik. (Schmuserei, Knutscherei) s; -[s]

neckisch¹; -ste (↑ R 294)

¹ Trenn.: ...k|k...

Ned|bal (tschech. Komponist) **nee!** vgl. ne!

Neer niederd. (Wasserstrudel mit starker Gegenströmung) w; -, -en; **Neer|strom**

Neff fe m; -n, -n (↑ R 268)

Ne|ga|ti|on lat. [...zion] (Verneinung, Verwerfung einer Aussage; Verneinungswort, z. B. „nicht"); ne|ga|tiv¹ (verneinend; ergebnislos; kleiner als Null; Fotogr.: in den Farben gegenüber dem Original vertauscht; Elektrotechnik: Gegensatz zu positiv); -e Katalyse (Chemie); -e Theologie; **Ne|ga|tiv¹** (Fotogr. Gegen-, Kehrbild) s; -s, -e [...w⁴] **Ne|ga|tiv|bild¹;** Ne|ga|ti|ve [...w⁴] (veralt. für: Verneinung w; -, -n; sich in der - halten

Ne|geb [nägäp] (Wüstenland schaft im Süden Israels) m; - (auch: w; -)

ne|ger ostösterr. ugs. (ohne Geld) er ist -

Ne|ger lat. m; -s, -; **Ne|ger|fra|ge** ...haar; ne|ger|haft; Ne|ge|rin w -, -nen; ne|ge|risch; Ne|ger ...kuß (schokoladeüberzogene Schaumgebäck), ...sän|ger ...skla|ve

Ne|gev vgl. Negeb

ne|gie|ren lat. (verneinen; bestrei ten); **Ne|gie|rung**

Ne|gli|gé, (schweiz.:) Né|gli|gé fr [...glische] (Hauskleid; Morgen rock) s; -s, -s; ne|gli|geant [...gli sehant] (veralt. für: nachlässig) ne|gli|gen|te it. [...dschänte] (Mu sik: nachlässig, flüchtig, darübe hinweghuschend); ne|gli|gie|re [...glisehir°n] (veralt. für: verr nachlässigen)

ne|grid lat. (zu den Negern gehö rend); -er Zweig (der Menschen rassen); **Ne|gri|de** m u. w; -n, - (↑ R 268); Ne|gri|to m; -[s], -[s („negerähnliche" Volksstämm [auf den Philippinen]); Né|gri tude fr. [negritüd(°)] („Negerhei Negersein"; [Forderung nach kulturelle[r] Eigenständige der Französisch sprechende Länder Afrikas) w; -; ne|gro|i (den Negern ähnlich); Ne|gro ide m u. w; -n, -n (↑ R 268)

Ne|gus („König" von Abessinie m; -, -u. -se

Ne|he|mja, (auch:) Ne|he|mj; (Gestalt des A. T.)

neh|men; du nimmst, er nimm ich nahm, du nahmst; du näl mest; genommen; nimm!; ic nehme es an mich; (↑ R 120:) G ben (auch: geben) ist seliger den Nehmen (auch: nehmen); **Neh mer** (auch für: Käufer)

¹ Auch: negatíf, neg... usw.

Neh|ru (indischer Staatsmann)
Neh|rung (Landzunge)
Neid m; -[e]s; nei|den; Nei|der; neid|er|füllt, aber (↑ R 142): von Neid erfüllt; Neid|ham|mel (abwertend für: neidischer Mensch); Neid|hard, ¹Neid|hart (m. Vorn.); ²Neid|hart (abwertend für: Neider) m; -[e]s, -e; nei|dig mdal. (beneidend); jmdm. - sein; nei|disch; -ste (↑ R 294), neid|los, -este (↑ R 292); Neid|lo|sig|keit w; -
Neid|na|gel (Nebenform von: Niednagel)
neid|voll
Nei|ge w; -, -n; auf die -, zur - gehen; nei|gen; sich -; Nei|gung; Nei|gungs_ehe, ...mes|ser m, ...win|kel
nein; nein sagen; (↑ R 119:) das Ja und das Nein; mit [einem] Nein antworten; das ist die Folge seines Neins
nein; ↑ R 238 landsch. (hinein)
Nein|sa|gen s; -s; Nein|sa|ger; Nein|stim|me
Nei|ße (ein Flußname) w; -; die Oder-Neiße-Linie (↑ R 203); Nei|sse (Stadt an der Glatzer Neiße)
Ne|kro|bio|se gr. (Biol.: langsames Absterben einzelner Zellen) w; -; Ne|kro|log (Lebensabriß [eines Verstorbenen]; Nachruf) m; -[e]s, -e; Ne|kro|lo|gi|um (Totenverzeichnis in Klöstern und Stiften) s; -s, ...ien [...iᵉn]; Ne|kro|mant (Toten-, Geisterbeschwörer, des Altertums) m; -en, -en (↑ R 268); Ne|kro|man|tie (Toten-, Geisterbeschwörung) w; -; Ne|kro|po|le (Totenstadt, Gräberfeld alter Zeit) w; -, ...polen; Ne|krop|sie (Leichenbesichtigung, -öffnung) w; -, ...ien; Ne|kro|se (Med.: Abgestorbensein [von Geweben, Organen od. Organteilen]; Brand) w; -, -n; Ne|kro|sper|mie (Med.: Zeugungsunfähigkeit infolge minderwertiger Beschaffenheit der männl. Samenzellen) w; -; ne|kro|tisch (Med.: abgestorben; brandig)
Nek|tar gr. (der ewige Jugend spendende Göttertrank; zuckerhaltige Blütenabsonderung) m; -s; nek|ta|risch, nek|tarn (süß wie Nektar; göttlich); Nek|ta|ri|um (Nektardrüse bei Blütenpflanzen) s; -s, ...ien [...iᵉn]
ek|ton gr. („Schwimmendes"; Biol.: die Gesamtheit der im Wasser sich aktiv bewegenden Tiere) s; -s; nek|to|nisch
Nel|ke (Blume; Gewürz) w; -, -n; Nel|ken_öl, ...strauß (Mehrz. ...sträuße), ...wurz (eine Pflanze)
nell schweiz. (Trumpfneun beim Jaß) s; -s

Nel|li (Kurzform von: Helene u. Kornelie); Nel|ly (engl. w. Vorn.)
¹Nel|son [nällßᵉn] (engl. Admiral)
²Nel|son [nach einem nordamerik. Sportler] (Ringergriff) m; -[s], -[s]
Ne|ma|to|de gr. (Fadenwurm) m; -n, -n (meist Mehrz.)
ne|me|isch (aus Nemea [Tal in Argolis]); aber (↑ R 224): der Nemeische Löwe, die Nemeischen Spiele
Ne|me|sis gr. [auch: näm...] (strafende Gerechtigkeit) w; -
'nen; ↑ R 238 (ugs. für: einen)
Nenn|be|trag; nen|nen; du nanntest; (selten:) du nenntest; genannt; nenn[e]!; er nannte ihn einen Dummkopf; das ist nen|nens|wert; Nen|ner; Nenn|form (für: Grundform, Infinitiv); Nenn|form|satz (für: Grundformsatz, Infinitivsatz); Nen|nung; Nenn_wert, ...wort (für: Nomen; Mehrz. ...wörter)
Nen|ze (swv. Samojede) m; -n, -n (↑ R 268)
neo... gr. (neu...); Neo... (Neu...); Neo|dym (chem. Grundstoff, Metall; Zeichen: Nd) s; -s; Neo|fa|schis|mus (Bez. für die faschist. Bestrebungen nach dem 2. Weltkrieg), ...fa|schist (↑ R 268); neo|fa|schi|stisch; Neo|klas|si|zis|mus, ...ko|lo|nia|lis|mus; Neo|kom (Geol.: zusammenfassender Name für die vier unteren Stufen der unteren Kreide) s; -s; Neo|li|the|ra|lis|mus; Neo|li|thi|kum [auch: ...lit...] (Jungsteinzeit) s; -s; neo|li|thisch [auch: ...lit...]; Neo|lo|ge (,,Neuerer"; veralt. für: Verkünder einer neuen Lehre) m; -n, -n (↑ R 268); Neo|lo|gie (veralt. für: Neuerung; Bildung neuer Wörter; -Abschnitt der aufklärerischen Theologie des 18. Jh.s) w; -, ...ien; Neo|lo|gis|mus (veralt. für: Neuerungssucht; oft tadelnd für: sprachl. Neubildung) m; -, ...men; Ne|on (chem. Grundstoff, Edelgas; Zeichen: Ne) s; -s; Neo_na|zis|mus, ...na|zist; neo|na|zi|stisch; Ne|on_fisch, ...lam|pe, ...licht (Mehrz. ...lichter), ...re|kla|me, ...röh|re; Neo|phyt (Neugetaufter im Urchristentum) m; -en, -en (↑ R 268); Neo|plas|ma (Med.: bösartige] Geschwulst); Neo|po|si|ti|vis|mus; Neo|sal|var|san ⓦ (ein Heilmittel); Neo|te|ben ⓦ (ein Tuberkuloseheilmittel) s; -s; Neo|te|nie (Med.: unvollkommener Entwicklungszustand eines Organs; Biol.: Eintritt der Geschlechtsreife im Larvenstadium) w; -; neo|tro|pisch (den Tropen der Neuen Welt angehörend); -e Region (Tier-

geogr.: Mittel- u. Südamerika); Neo|vi|ta|lis|mus (auf den Biologen Hans Driesch zurückgehende Lehre von den Eigengesetzlichkeiten des Lebendigen); Neo|zo|i|kum (swv. Känozoikum) s; -s; neo|zo|isch (swv. känozoisch)
Ne|pal [auch: ne...] (Himalajastaat); Ne|pa|ler vgl. Nepalese; Ne|pa|le|se m; -n -n (↑ R 268); vgl. Nepaler; ne|na|le|sisch; ne|pa|lisch vgl. nepalesisch
Ne|per [nach dem schott. Mathematiker J. Napier (ne'piᵉr)] (eine physikalische Maßeinheit; Abk.: Np, auch: N) s; -s, -
Ne|phe|lin gr. (ein Mineral) m; -s, -e; Ne|phe|lo|me|ter (optisches Gerät, Trübungsmesser) s; -s, -; Ne|phe|lo|me|trie (Chem.: Messung der Trübung von Flüssigkeiten) w; -; Ne|pho|graph (Meteor.: Gerät, das die verschiedenen Arten u. die Dichte der Bewölkung fotogr. aufzeichnet) m; -en, -en (↑ R 268); Ne|pho|skop (Gerät zur Bestimmung der Windverhältnisse, die die Wolkenbewegungen bedingen) s; -s, -e
Ne|phral|gie gr. (Med.: Nierenschmerzen) w; -, ...ien; Ne|phrit (ein Mineral) m; -s, -e; Ne|phri|tis (Med.: Nierenentzündung) w; -, ...it|den
Ne|po|muk [auch: näp...] (m. Vorn.)
Ne|po|te lat. (veralt. für: Neffe, Enkel; Vetter, Verwandter) m; -n, -n (↑ R 268); Ne|po|tis|mus (Vetternwirtschaft) m; -
Nepp (ugs. für: das Neppen) m; -s; nep|pen (ugs. für: Gäste in Lokalen u. a. übervorteilen); Nep|per (ugs.); Nep|pe|rei (ugs.); Nepp|lo|kal (ugs.)
¹Nep|tun (röm. Gott des Meeres); ²Nep|tun (ein Planet) m; -s; nep|tu|nisch (durch Einwirkung des Wassers entstanden); -e Gesteine (veralt. für: Sedimentgesteine); Nep|tu|nis|mus lat. (veralt. Lehre, nach der die Gesteine durch Absatz aus Wasser entstanden sein sollten) m; -; Nep|tu|nist (↑ R 268); Nep|tu|ni|um (chem. Grundstoff, ein Transuran; Zeichen: Np) s; -s
Ne|re|ide (meerbewohnende ,,Tochter des Nereus") w; -, -n (meist Mehrz.); Ne|re|iden|mo|nu|ment (Grabtempel in Xanthos); Ne|reus [auch: ...e-uß] (gr. Meergott)
Nerf|ling (ein Fisch)
Nernst|lam|pe; ↑ R 180 [nach dem dt. Physiker u. Chemiker Walther Nernst]
Ne|ro (röm. Kaiser)

Ne|ro|li|öl it.; dt. (Pomeranzenblütenöl) s; -[e]s

ne|ro|nisch, aber (↑ R 179): Ne|ro|nisch

Ner|thus (germ. Göttin)

Ne|ru|da [nerúdha], Pablo (chilen. Lyriker)

Nerv lat. [närf] m; -s, -en

Ner|va [...wa] (röm. Kaiser)

Ner|va|tur lat. [...wa...] (Aderung des Blattes, der Insektenflügel) w; -, -en; Ner|ven|an|span|nung [närf^n...], ...arzt; ner|ven|aufpeit|schend, ...auf|rei|bend, ...beru|hi|gend, aber (↑ R 142): die Nerven aufpeitschend usw.; Nerven|bün|del, ...chir|ur|gie, ...entzün|dung, ...gas, ...gift, ...heil|anstalt, ...kit|zel, ...kli|nik, ...kostüm (ugs. scherzh.), ...kraft w, ...krank|heit, ...krieg, ...kri|se, ...lei|den, ...nah|rung, ...pro|be, ...sa|che (ugs.), ...sä|ge (ugs.), ...schmerz (meist Mehrz.), ...schock m; ner|ven|schwach; Ner|ven|schwä|che, ...sy|stem (animales, vegetatives -), ...zusam|men|bruch; ner|vig [närw...], auch: närf...] (sehnig, kräftig); nerv|lich (das Nervensystem betreffend); ner|vös [...wöß] (nervenschwach; reizbar); -este (↑ R 292); Ner|vo|si|tät w; -; nerv|tötend; Ner|vus pro|ban|di [närwuß -] (veralt. für: der eigentliche, entscheidende Beweisgrund) m; - -; Ner|vus re|rum (Hauptsache, scherzh. für: Geld) m; - -

Nerz slaw. (Pelz[tier]) m; -es, -e; Nerz_fell, ...kra|gen, ...man|tel, ...sto|la

Nes|ca|fé ⓦ [nach der schweiz. Firma Nestlé] (löslicher KaffeeExtrakt in Pulverform)

Nes|chi arab. [näßki] (arab. Schreibschrift) s od. w; -

[1]Nes|sel w; -, -n; [2]Nes|sel (kurz für: Nesseltuch) m; -s, -; Nes|sel_ausschlag, ...fie|ber, ...pflan|ze, ...stoff, ...sucht (w; -), ...tier, ...tuch (Mehrz. ...tuche)

Nes|sus|ge|wand; ↑ R 180 [nach dem vergifteten Gewand des Herakles in der gr. Sage] (verderbenbringende Gabe)

Nest s; -[e]s, -er; Nest|bau (Mehrz. ...bauten); Nest|chen s; -s, - u. Nesterchen, Nest|lein

Ne|stel landsch. (Schnur) w; -, -n; Ne|stel|knüp|fen (landsch.) s; -s; ne|steln; ich ...[e]le (↑ R 327)

Ne|ster|chen (Mehrz. von: Nestchen); Nest_flüch|ter, ...häk|chen, ...hocker [Trenn.: ...hok|ker], ...jüng|ste (s; -n, -n; ↑ R 287ff.); Nest|lein od. Nestchen

Nest|le|mehl ⓦ; ↑ R 180 (Kindermehl des schweiz. Nahrungsmittelbetriebes Nestlé)

Nest|ling (noch nicht flügger Vogel; kleines Kind)

[1]Ne|stor (greiser König der gr. Sage); [2]Ne|stor (ältester Gelehrter einer bestimmten Wissenschaft; veralt. für: Greis) m; -s, ...oren

Ne|sto|ria|ner (Anhänger des Nestorius) m; -s, -; Ne|sto|ria|nismus (Lehre des Nestorius) m; -; Ne|sto|ri|us (Patriarch von Konstantinopel)

Ne|stroy [näßtreu] (österr. Bühnendichter)

Nest|treue; nest_warm; -e Eier; Nest|wär|me

nett (niedlich, zierlich; freundlich)

Nett|chen, Net|te (Kurzformen von: Antoinette u. Nannette)

net|ter|wei|se (ugs.); Net|tig|keit [zu: nett]; net|to it. (rein, nach Abzug der Verpackung und der Unkosten); Net_to_er|trag (Reinertrag), ...ein|kom|men, ...er|trag, ...ge|wicht, ...ge|winn, ...lohn, ...preis (vgl. [2]Preis), ...re|gi|sterton|ne (Abk.: NRT), ...ver|dienst m

Netz s; -es, -e; Netz|an|schluß; Netz|an|schluß|ge|rät (Rundfunk); Netz|ar|beit (Filetarbeit); netz|ar|tig

net|zen (netze, du netzt [netzest])

Netz_flüg|ler m; -s, - (Insektengruppe); netz|för|mig; Netz_garn, ...gleich|rich|ter (Rundfunk), ...haut; Netz_haut_ab|lö|sung, ...ent|zün|dung; Netz_hemd, ...kar|te, ...mit|tel s, ...plan (Wirtschaft); Netz|plan_tech|nik (Wirtsch.); Netz_span|nung, ...werk

neu; neuer, neu[e]ste; neu[e]stens; seit neuestem; neue Sprachen. I. Kleinschreibung: a) (↑ R 134:) aufs neue; auf ein neues; von neuem; b) (↑ R 133:) auf neu waschen, plätten; neu für alt (Kaufmannsspr.); c) (↑ R 224:) das neue Jahr fängt gut an; zum neuen Jahr[e] Glück wünschen; die neue Linke (neomarxistische, im Ggs. zu den traditionellen sozialistischen u. kommunistischen Parteien stehende philosophische u. politische Richtung); die neue Mathematik (auf der formalen Logik u. der Mengenlehre basierende Mathematik). II. Großschreibung: a) (↑ R 116:) das Alte und das Neue; er ist aufs Neue (auf Neuerungen) erpicht; b) (↑ R 116:) etwas, nichts, allerlei Neues; c) (↑ R 224:) der Neue Bund; die Neue Welt (Amerika); das Neue Testament (Abk.: N. T.); Neue Kerze (vgl. d.). III. In Verbindung mit Zeitwörtern (↑ R 139): Meist ist die Getrenntschreibung üblich, z. B. neu bauen, neu

bearbeiten, neu hinzukommen, neu entstehende Siedlungen. Für das 2. Mittelwort gilt folgendes: 1. Getrenntschreibung (↑ R 142), wenn „neu" als selbständige Umstandsangabe beim 2. Mittelwort steht (die Vorstellung der Tätigkeit herrscht vor u. beide Wörter tragen Starkton), z. B. das Geschäft ist neu eröffnet; das [völlig] neu bearbeitete Werk; viele Kunden waren neu hinzugekommen. 2. Zusammenschreibung (↑ R 142), wenn die Verbindung in eigenschaftswörtlicher Bedeutung gebraucht wird (nur das erste Glied trägt Starkton), z. B. die neugeborenen Kinder, die neubearbeiteten Bände der Sammlung, die neuhinzugekommenen Kunden, die neugeschaffenen Anlagen, das neueröffnete Zweiggeschäft

Neu_an|fer|ti|gung, ...an|kömmling, ...an|schaf|fung; neu|ar|tig; Neu|ar|tig|keit w; -; Neu_auf|lage, ...aus|ga|be; neu_backen [Trenn.: ...bak|ken]; Neu|bau (Mehrz. ...bauten); Neu_bau_viertel, ...woh|nung; neu|be|ar|bei|tet die -e Auflage (↑ jedoch R 142) aber: die Auflage ist neu bear beitet; Neu|be|ar|bei|tung; neu be|kehrt; die -en Christen (↑ je doch R 142), aber: diese Chri sten sind neu bekehrt; Neu|be kehr|te m u. w; -n, -n (↑ R 287ff.) Neu|bil|dung

Neu|braun|schweig (kanad. Pro vinz)

Neu|bür|ger

Neu|châ|tel [nöschatä̆l, schweiz. nöschatä̆l] (fr. Name von: Neuen burg)

Neu-De|lhi (Regierungssitz de Republik Indien)

neu|deutsch; Neu|druck (Mehrz ...drucke)

Neue (Jägerspr.: frisch gefallene Schnee) w; -

Neu_ein|rich|tung, ...ein|stel|lung ...ein|stu|die|rung

Neue Ker|ze (bis 1948 dt. Licht stärkeeinheit; Zeichen: NK; heu te: Candela)

Neu|en|ahr, Bad (Stadt an der Ahr Neu|en|burg (Stadt in de Schweiz); vgl. Neuchâtel; Neu en|bur|ger (↑ R 199); Neu|en|bur ger See m; - -s

neu_eng|lisch; vgl. deutsch

Neu|ent|wick|lung

neu|er|dings (kürzlich; vo neuem); Neue|rer; neu|er|lic (neulich; von neuem); neu|ern (veralt. für: erneuern); ich ...er (↑ R 327); neu|er|öff|net; das Zweiggeschäft (↑ jedoch R 142 aber: das Zweiggeschäft ist ne

eröffnet worden; Neu|er|öff|nung, ...er|schei|nung; Neue|rung; neu[e]|stens

Neu.fas|sung, ...fest|set|zung; neu|fran|zö|sisch; vgl. deutsch

Neu|fund|land (kanad. Provinz); Neu|fund|län|der (Bewohner von Neufundland; auch: Hund einer bestimmten Rasse)

eu|ge|backen [Trenn.: hak|ken]; ein -er Ehemann; neu|ge|bo|ren; die -en Kinder (↑ jedoch R 142), aber: diese Kinder sind neu geboren; gelegentlich auch schon klassenbildend gebraucht (†S. 45, Merke, 2): die neugeborenen Kinder; die Kinder sind neugeboren; Neu|ge|bo|re|ne (Säugling) s; -n, -n (↑ R 287 ff.); Neu|ge|burt; neu|ge|schaf|fen; die -en Anlagen (↑ jedoch R 142), aber: diese Anlagen sind neu geschaffen; Neu.ge|stal|tung, ...ge|würz (österr. für: Piment; s; -es); Neu|gier; Neu|gier|de w; -; neu|gie|rig; Neu.glie|de|rung, ...go|tik; Neu|grad vgl. Gon

eu|grie|chisch; vgl. deutsch; Neu|grie|chisch (Sprache) s; -[s]; vgl. Deutsch; Neu|grie|chi|sche s; -n; vgl. Deutsche s; vgl. Iwrith

feu|grün|dung

feu|gui|nea [...gi...]; ↑ R 206 (Insel nördl. von Australien)

eu|he|brä|isch; vgl. deutsch; Neu.e|brä|isch (Sprache) s; -[s]; vgl. Deutsch; Neu|he|brä|sche s; -n; vgl. Deutsche s; vgl. Iwrith

feu|he|ge|lun|g|nis|mus m; -

eu|heit; neu|hoch|deutsch (Abk.: nhd.); vgl. deutsch; Neu|hoch|deutsch (Sprache) s; -[s]; vgl. Deutsch; Neu|hoch|deut|sche s; -n; vgl. Deutsche s; Neu|hu|ma|nis|mus; Neu|ig|keit; Neu|in|sze|nie|rung; Neu|jahr [auch: neujár]; Neu|jahrs_fest, ...glück|wunsch, ..kar|te, ...tag, ...wunsch

eu|kalle|do|ni|en [...i*n] (Inselgruppe östlich von Australien)

eu.kan|tia|ner, ...kan|tia|nis|mus philos. Schule; m; -), ...klas|si|zis|mus; Neu|kon|struk|ti|on

eu|kölln (Stadtteil von West-Berlin)

eu|land s; -[e]s

eu|la|tein; neu|la|tei|nisch (Abk.: nlat.); vgl. deutsch

eu|lich; Neu|ling

eu|mark (Landschaft in der Mark Brandenburg) w; -

eu|me gr. (mittelalterl. Notenzeichen) w; -, -n (meist Mehrz.)

eu|mo|disch; -ste (↑ R 294)

eu|mond m; -[e]s

eu|n, (ugs.): neu|ne; alle neun[e]!; wir sind zu neunen od. zu neunt; vgl. acht; Neun (Ziffer, Zahl) w; -en; vgl. ¹Acht; Neun_au|ge (ein

Fisch), ...eck; neun_bän|dig, ...ek|kig; neun|ein|halb, neun|und|ein|halb; Neu|ner (ugs.); einen - schieben; vgl. Achter; neu|ner|lei; neun|fach; Neun|fa|che s; -n; vgl. Achtfache; neun|hun|dert; vgl. achtmal; neun|mal; vgl. achtmal; neun|ma|lig; neun|mal|klug (spött. für: überklug); neun|mal|wei|se (spött. für: überweise); neun_stel|lig, ...stückig [Trenn.: ...stök|kig], ...stün|dig; neunt; vgl. neun; neun|tä|gig; neun|tau|send; vgl. tausend; neun|te; vgl. achte, neun|tel; vgl. achtel; Neun|tel s (schweiz. meist: m); -s, -, vgl. Achtel; noun|tons; Neun|tö|ter (ein Vogel); neun[und]|ein|halb; neun|und|zwan|zig; vgl. acht; neun|zehn; vgl. acht; neun|zig usw. vgl. achtzig usw.

Neu_ord|nung (w; -), ...or|ga|ni|sa|ti|on (w; -), ...ori|en|tie|rung (w; -) Neu_phi|lo|lo|ge, ...pla|to|ni|ker, ...pla|to|nis|mus (m; -)

neur- gr. (nerven...); Neur... (Nerven...); Neur|al|gie (Med.: in Anfällen auftretender Nervenschmerz) w; -, ...ien, Neur|al|gi|ker (an Neuralgie Leidender); neur|al|gisch; Neur|asthe|nie (Med.: Nervenschwäche) w; -, ...ien; Neur|asthe|ni|ker (an Nervenschwäche Leidender); neur|asthe|nisch

Neu|re|ge|lung, Neu|reg|lung; neu|reich

Neu|ren (Mehrz. von: Neuron)

Neu|ries (Papiermaß; 1000 Bogen)

Neu|rin gr. (starkes Fäulnisgift) s; -s; Neu|ri|tis (Med.: Nervenentzündung) w; -, ...it|den; Neu|ro|chir|ur|gie (Chirurgie des Nervensystems); neu|ro|gen (Med.: von den Nerven ausgehend); Neu|ro|lo|ge (Nervenarzt) m; -n, -n (↑ R 268); Neu|ro|lo|gie (Lehre von den Nerven und ihren Erkrankungen) w; -; neu|ro|lo|gisch; Neu|rom (Med.: Nervenfasergeschwulst) s; -s, -e

Neu_ro|man|tik, ...ro|man|ti|ker; neu|ro|man|tisch

Neu|ron gr. (Med.: Nervenzelle) s; -s, ...onen u. Neuren; Neu|ro|pa|thie (Med.: Nervenleiden, nervöse Veranlagung) w; -, ...ien; neu|ro|pa|thisch; Neu|ro|pa|tho|lo|gie (Lehre von den Nervenkrankheiten) w; -; Neu|ro|pte|ren (Zool.: zusammenfassende Bezeichnung für die Netzflügler) Mehrz.; Neu|ro|se (Med.: nicht organisch bedingtes Nervenleiden) w; -, -n; Neu|ro|ti|ker (an Neurose Leidender); neu|ro|tisch; Neu|ro|to|mie (Med.: Nervendurchtrennung) w; -, ...ien

Neu|rup|pin (Stadt in Branden-

burg); Neu|rup|pi|ner (↑ R 199); neu|rup|pi|nisch

Neu_satz (Druckw.), ...schnee

Neu|scho|la|stik (Erneuerung der Scholastik; vgl. d.)

Neu|schott|land (kanad. Prov.)

Neu|see|land;↑ R 206 (Inselgruppe u. Staat im Pazifischen Ozean); Neu|see|län|der (↑ R 199); neu|see|län|disch

Neu|sledl am See (österr. Stadt); Neu|sied|ler See (See im nördlichen Burgenland) m; - -s

Neu|sil|ber (eine Legierung); neu|sil|bern; -e Uhr; Neu|sprach|ler (Lehrer, Kenner der neueren Sprachen); neu|sprach|lich; -er Unterricht, Zweig

Neuss (Stadt am Niederrhein); Neu|sser (↑ R 199)

neu|stens, neue|stens

Neu|stre|litz (Stadt auf der Mecklenburg. Seenplatte)

Neu|stri|en [...i*n] (alter Name für das westliche Frankenreich)

Neu|süd|wales [...*e'lß] ↑ R 206 (Gliedstaat des Australischen Bundes)

Neu|te|sta|ment|ler; neu|te|sta|ment|lich; Neu|tö|ner (Vertreter neuer Musik); neu|tö|ne|risch (auch: ganz modern)

Neu|tra [österr.: ne-utra] (Mehrz. von: Neutrum); neu|tral lat.; -e Ecke (Boxen); Neu|tra|li|sa|ti|on [...zion], Neu|tra|li|sie|rung w; -; neu|tra|li|sie|ren; Neu|tra|lis|mus (Grundsatz der Nichteinmischung in fremde Angelegenheiten [vor allem in der Politik]) m; -; Neu|tra|list (Verfechter u. Vertreter des Neutralismus); ↑ R 268; neu|tra|li|stisch; Neu|tra|li|tät w; -; Neu|tra|li|täts_ab|kom|men, ...bruch m, ...er|klä|rung, ...po|li|tik, ...ver|let|zung, ...zei|chen; Neu|tren (Mehrz. von: Neutrum); Neu|tri|no it. (Physik: Elementarteilchen mit Ladung und Ruhmasse null) s; -s, -s; Neu|tron lat. (Physik: Elementarteilchen mit der Ladung null und der Masse des Wasserstoffkernes; Zeichen: n) s; -s, ...onen; Neu|tro|nen|strah|len (Neutronen hoher Geschwindigkeit) Mehrz.; Neu|trum [österr.: ne-utrum] (Sprachw.: sächliches Hauptwort, z. B. ,,das Buch") s; -s, ...tra (auch: ...tren)

neu|ver|mählt; die -en Paare (↑ jedoch R 142), aber: diese Paare sind neu vermählt; gelegentlich auch schon klassenbildend gebraucht (†S. 45, Merke, 2): die neuvermählten Ehepaare; die Ehepaare sind neuvermählt; Neu|ver|mähl|te m u. w; -n, -n (↑ R 287 ff.)

Neu|wahl
neu|wa|schen landsch. (frisch ge-
waschen); -e Hemden
Neu|weiß
Neu|wert; neu|wer|tig; Neu|wert-
ver|si|che|rung
Neu-Wien (↑ R 206); Neu|wie|ner;
neu|wie|ne|risch
Neu|wort (Mehrz. ...wörter)
Neu|york (eindeutschend für:
New York); Neu|yor|ker (↑ R
199); neu|yor|kisch
Neu|zeit w; -; neu|zeit|feind|lich;
neu|zeit|lich; Neu|zu|las|sung
Nev. = Nevada
Ne|va|da [newạda] (Staat in den
USA; Abk.: Nev.)
Ne|veu fr. [nᵉwö] (veralt. für: Nef-
fe) m; -s, -s
Ne|wa (Abfluß des Ladogasees)
w; -
New Deal amerik. [nju̲ dị̲l] (Re-
formprogramm des amerik. Präsi-
denten F. D. Roosevelt) m; - -
New Hamp|shire [njuhämpsch`ᵉr]
(Staat in den USA; Abk.: N. H.);
New Jer|sey [njudsehö`si] (Staat
in den USA; Abk.: N. J.); New-
Jersey-Tee; New Look amerik.
[nju̲ lụ̲k] („neues Aussehen";
neue Linie, neuer Stil [bes. in der
Model] m od. s; - -[s]; New Me|xi-
co (Staat in den USA; Abk.: N.
Mex.); New Or|le|ans [njuorlịns
od. njuo̲`li̲ᵉns] (Stadt in Loui-
siana); New-Or|leans-Jazz [...o̲`-
lịnsdsehäs] (frühester, improvi-
sierender Jazzstil der nordame-
rik. Neger) m; -; News engl. [njụs]
(„Neuigkeiten", „Nachrichten";
auch Name von Zeitungen, z. B.
Daily News) Mehrz.
¹New|ton [nju̲t`n] (engl. Physiker);
²New|ton (Einheit der Kraft; Zei-
chen: N) s; -s, -
New York [nju̲ jọ̲`k] (Staat [Abk.:
N. Y.] u. Stadt in den USA); New
Yor|ker; New Yorker Staatszei-
tung und Herold (deutschspra-
chige amerik. Tageszeitung)
Ne|xus lat. (selten für: Zusammen-
hang, Verbindung) m; -, -
N. F. = Neue Folge
n-fach (↑ R 149)
N. H. = New Hampshire
N. H. = Normalhöhenpunkt
nhd. = neuhochdeutsch
Ni = chem. Zeichen für: Nickel
Nia|ga|ra|fall (österr. auch: nịa...]
m; ↑ R 201
Niạm-Niạm (Negerstamm im
Sudan) Mehrz.
ni|beln südd. (nebeln, fein regnen)
es nibelt
Ni|be|lun|gen (die Mannen Sieg-
frieds; die Burgunden); Ni|be-
lun|gen.hort (m; -[e]s), ...lied (s;
-[e]s), ...sa|ge (w; -), ...treue
Ni|cäa usw. vgl. Nizäa usw.

Ni|ca|ra|gua [...ka...] (Staat in
Mittelamerika); Ni|ca|ra|gua|ner
(↑ R 199); ni|ca|ra|gua|nisch
nicht; - wahr?; gar -; mitnichten,
zunichte machen, werden. I. Zu-
sammenschreibung, wenn die
Verbindung von „nicht" mit ei-
nem Eigenschafts- od. Mittel-
wort eine andauernde Eigen-
schaft bezeichnet, d. h. klassen-
bildend gebraucht wird (nur das
erste Glied trägt Starkton), z. B.
die nichtrostenden Stähle, die
nichtzielenden Zeitwörter. II.
Getrenntschreibung bei einfacher
Verneinung (beide Wörter besit-
zen selbständige Satzgliedwert
und tragen Starkton): die nicht
zuständige Stelle; diese Frauen
sind nicht berufstätig; dieser Auf-
satz ist noch veröffentlicht
Nicht|ach|tung; nicht|amt|lich; vgl.
nicht; die -e Darstellung, aber:
die Darstellung war nicht amt-
lich; Nicht|an|ders|kön|nen s; -s;
Nicht|an|er|ken|nung; Nicht|an-
griffs|pakt
Nicht.be|ach|tung, ...be|fol|gung;
nicht|be|rufs|tä|tig; vgl. nicht; die
-en Frauen, aber: die Frauen,
die nicht berufstätig sind; Nicht-
be|rufs|tä|ti|ge m u. w; -n, -n (↑ R
287ff.)
Nicht|christ m; nicht|christ|lich
Nicht|te w; -, -n
nicht|ehe|lich (Rechtsspr. für: un-
ehelich)
Nicht|ein|brin|gungs|fall österr.
Amtsspr. (Zahlungsunfähig-
keit); im -
Nicht.ein|hal|tung, ...ein|mi-
schung
Nicht|ei|sen|me|tall; Nicht|ei|sen-
me|tall|wirt|schaft w; -
Nicht|er|fül|lung
nicht|eukli|disch; -e Geometrie;
vgl. Euklid
Nicht|fach|mann
nicht|flek|tier|bar (Sprachw.: un-
beugbar); vgl. nicht; das -e Wort,
aber: das Wort ist nicht flektier-
bar
Nicht|ge|fal|len s; -s; bei -
Nicht|ge|schäfts|fä|hi|ge m u. w;
-n, -n (↑ R 287ff.); Nicht|ge-
wünsch|te s; -n (↑ R 287ff.)
Nicht-Ich s; -[s], -[s]
nich|tig; null u. -; Nich|tig|keit;
Nich|tig|keits|kla|ge
Nicht|in|an|spruch|nah|me
(Amtsdt.)
Nicht|ka|tho|lik
nicht|kom|mu|ni|stisch
nicht|krieg|füh|rend (neutral); vgl.
nicht
Nicht|lei|ter m (für: Isolator)
Nicht|me|tal|le (Metalloide)
Mehrz.
Nicht|mit|glied

nicht|öf|fent|lich; vgl. nicht; die -
Konferenz, aber: die Konferen-
war nicht öffentlich
nicht|or|ga|ni|siert; -e Arbeiter
Nicht|rau|cher; Nicht|rau|cher|ab
teil
nicht|ro|stend; vgl. nicht; -es Mes
ser
nichts; für -; zu -; gar -; um - un
[um] wieder -; sich in - untersche
den; - tun; mir -, dir - (ohne weite
res); viel Lärm um -; nach - ausse
hen; (↑ R 116:) - Genaues, - Nähe
res, - Neues u. a., aber (↑ R 135
- und[e]res; - weniger als (durc
aus nicht, auch in der Bedeutun
nichts Geringeres als); nichts a
nend, ein nichts Ahnender u. a
aber (↑ R 142): nichtsbedeuten
nichtssagend; ein nichtssagende
Gesicht; Nichts s; -; nichts|be|de
tend; vgl. nichts
Nicht|schwim|mer; nichts|de|st
min|der; nichts|de|sto|trotz (ugs.
nichts|de|sto|we|ni|ger; nich
selb|stän|dig; Nicht|ser; Nich
seß|haf|te m u. w; -n, -n (↑
287ff.); Nichts|kön|ner; Nicht
nutz m; -es, -e; nichts|nut|zi
Nichts|nut|zig|keit; nichts|s
gend (inhaltslos, ausdruckslo
vgl. nichts; Nichts|tu|er (ugs.
nichts|tue|risch; Nichts|tun s; -
nichts|wür|dig; Nichts|wür|di
keit
Nicht.tänzer, ...wei|ter|ga|be
nicht|zie|lend (für: intransitiv
vgl. nicht; -es Zeitwort (fü
Intransitiv)
Nicht.zu|las|sung, ...zu|stan|d
kom|men, ...zu|tref|fen|de (Nich
zutreffendes streichen)
¹Nickel¹ (mdal. Kurzform vo
Nikolaus); ²Nickel¹ mdal. (mu
williger Knirps) m; -s, -; ³Nickel
(chem. Grundstoff, Metall; Z
chen: Ni) s; -s; ⁴Nickel¹ (früher
Zehnpfennigstück) m; -s,
Nickel¹.bril|le, ...hoch|zeit (auc
kupferne Hochzeit, Feier d
Hochzeitstages nach zwölfe
halbjähriger Ehe), ...mün|ze
nicken¹; Nicker¹ (ugs. für: Schla
chen); Nicker|chen¹ (ugs.); Ni
fän|ger (Jägerspr.: Genickfä
ger); Nick|haut (Augenlid b
Wirbeltieren)
Nicki¹ (Pullover aus samtartige
Baumwollstoff) m; -s, -s
Ni|col [nịkol; nach dem engl. Er
finder W. Nicol] (Optik: Pola
sationsprisma) s; -s, -s
Ni|co|sia vgl. Nikosia
Ni|co|tin vgl. Nikotin
nid südd. u. schweiz. altertür
(unter[halb]); - dem Berg
¹Nid|da (r. Nebenfluß des Mai

¹ Trenn.: ...k|k...

w; -; ²Nid|da (Stadt an der ¹Nid-da)

¹|del schweiz. mdal. (Rahm) m; -s od. w; -

Nid|wal|den vgl. Unterwalden nid dem Wald; Nid|wald|ner (↑R 199); nid|wald|ne|risch

nie; nie mehr, nie wieder; nie u. nimmer

nie|den (dicht. für: unten; auf der Erde)

nie|der; nieder mit ihm!; auf und nieder

nie|der... (in Zus. mit Zeitwörtern, z. B. niederlegen, du legst nieder, niedergelegt, niederzulegen; zum 2. Mittelw ↑R 304)

nie|der|bay|ern (↑R 206)

nie|der|beu|gen; sich -

nie|der|bren|nen

nie|der|brin|gen; einen Schacht - (Bergmannsspr.: herstellen)

nie|der|deutsch (Abk.: nd.); vgl. deutsch; Nie|der|deutsch (Spra-che) s; -[s]; vgl. Deutsch; Nie|der-deut|sche s; -n; vgl. Deutsche s;

Nie|der|deutsch|land (↑R 206)

Nie|der|druck m; -[e]s, ...drücke; nie|der|drücken¹; nie|der|drük-kend; -ste; Nie|der|druck.ge-biet, ...hei|zung

nie|de|re, niederer, niederste; I. Kleinschreibung: a) (↑R 224:) die niedere Jagd; das niedere Volk; aus niederem Stande; der niedere Adel; die niedere Gerichtsbarkeit (Rechtsspr.); b) (↑R 133:) hoch und nieder (jedermann). II. Groß-schreibung: a) (↑R 116:) Hohe und Niedere trafen sich bei dem Fest; b) (↑R 198:) die hohe Tatra (Teil der Westkarpaten); die Niederen Tauern (Teil der Zentralalpen) Mehrz.

nie|der|fal|len

nie|der|flur|wa|gen (Technik)

nie|der|fran|ke

nie|der|fre|quenz

nie|der|gang m; -[e]s; nie|der|ge-hen; das Flugzeug ist niederge-gangen

nie|der|ge|las|se|ne schweiz. (Ein-wohner mit dauerndem Wohn-sitz) m u. w; -n, -n (↑R 287ff.)

nie|der|ge|schla|gen (auch für: traurig); er ist sehr -; Nie|der|ge-schla|gen|heit w; -

nie|der|hal|ten; die Empörung wurde niedergehalten; Nie|der-hal|tung w; -

nie|der|hau|en; er hieb den Flüch-tenden nieder

nie|der|ho|len; die Flagge wurde niedergeholt

nie|der|holz (Unterholz; s; -es), .jagd (Jägerspr.: Jagd auf Klein-wild; w; -)

nie|der|kämp|fen

nie|der|kau|ern, sich

nie|der|knal|len

nie|der|kni|en; er ist niedergekniet

nie|der|knüp|peln

nie|der|kom|men; meine Tochter ist [mit einem Sohn] niederge-kommen; Nie|der|kunft w; -, ...künfte

Nie|der|la|ge

Nie|der|lan|de Mehrz., Nie|der-län|der (↑R 199); Nie|der|län-disch, aber (↑R 224:) Niederlän-disches Dankgebet; Nie|der|län-disch (Sprache) s; -[s]; vgl. Deutsch; Nie|der|län|di|sche s; -n; vgl. Deutsche s

nie|der|las|sen; sich auf dem od. auf den Stuhl -; der Vorhang wur-de niedergelassen; Nie|der|las-sung; Nie|der|las|sungs frei heit

Nie|der|lau|sitz [auch: ...lau...]; ↑R 206 (südöstl. Teil der Mark Bran-denburg)

nie|der|le|gen; etwas in dem od. in das Fach -; er hat den Kranz niedergelegt; sich -; Nie|der|le-gung

nie|der|ma|chen

nie|der|mä|hen

nie|der|met|zeln

Nie|der|öster|reich; ↑R 206 (österr. Bundesland)

nie|der|pras|seln

nie|der|rei|ßen; das Haus wurde niedergerissen

Nie|der|rhein; nie|der|rhei|nisch

nie|der|rin|gen; der Feind wurde niedergerungen

Nie|der|sach|se; Nie|der|sach|sen; ↑R 206 (Land); nie|der|säch|sisch

nie|der|schie|ßen; der Adler ist auf die Beute niedergeschossen; er hat ihn niedergeschossen

Nie|der|schlag m; -[e]s, ...schläge; nie|der|schla|gen; sich -; der Pro-zeß wurde niedergeschlagen; nie-der|schla|gend; -e Mittel; nie|der-schlags_arm, ...frei; Nie|der-schlags|men|ge; nie|der|schlags-reich; Nie|der|schlags|ver|fah-ren; Nie|der|schla|gung (Rechts-spr.); Nie|der|schlag|was|ser (für: Kondensat) s; -s

Nie|der|schle|si|en [...siᵉn] (↑R 206)

nie|der|schmet|tern; jmdn., etwas -; diese Nachricht hat ihn nie-dergeschmettert

nie|der|schrei|ben

nie|der|schrei|en; die Menge hat ihn niedergeschrien

Nie|der|schrift

nie|der|set|zen; ich habe mich nie-dergesetzt

nie|der|sin|ken

nie|der|sit|zen landsch. (sich [nie-der]setzen)

Nie|der|span|nung (Elektrotech-nik)

nie|der|ste; vgl. niedere

nie|der|stei|gen; er ist niedergestie-gen

nie|der|sto|ßen; er hat ihn nieder-gestoßen

nie|der|strecken [Trenn.: ...strek-ken]; er hat ihn niedergestreckt

Nie|der|sturz; nie|der|stür|zen; die Lawine ist niedergestürzt

nie|der|tou|rig [...tu...]; -e Maschi-ne

Nie|der|tracht w; -; nie|der|träch-tig; Nie|der|träch|tig|keit

Nie|de|rung; Nie|de|rungs_moor, ...vieh

Nie|der|wald (Teil des Rheingau-gebirges) m; -[e]s; Nie|der|wald-denk|mal s; -[e]s

nie|der|wal|zen

nie|der|wärts

nie|der|wer|fen; der Aufstand wur-de niedergeworfen; Nie|der|wer-fung

Nie|der|wild

nie|der|zie|hen

nie|der|zwin|gen

nied|lich; Nied|lich|keit

Nied|na|gel (im Nagelfleisch haf-tender Nagelsplitter; am Nagel losgelöstes Hautstückchen); vgl. Neidnagel

nied|rig; das Brett niedrig[er] hal-ten; I. Kleinschreibung: a) (↑R 224:) niedrige Absätze; niedrige Beweggründe; von niedriger Ge-burt; niedriger Wasserstand; b) (↑R 133:) hoch und niedrig (je-dermann). II. Großschreibung (↑R 116:) Hohe und Niedrige. III. In Verbindung mit dem 2. Mit-telwort Getrennt- oder Zusam-menschreibung: niedrig gesinnt sein, aber (↑R 142:) die niedrig-gesinnten Gegner; Nied|rig|hal-tung w; -; Nied|rig|keit; nied|rig-pro|zen|tig; nied|rig|ste|hend (↑R 142); ein -es Volk; Nied|rig|was-ser (Mehrz.: ...wasser)

Ni|el|lo it. ("schwarze" Verzie-rung auf Metallarbeiten) s; -[s]. -s u. ...llen (auch [Kunstwerke]: ...lli); Ni|el|lo|ar|beit

nie|mals

nie|mand (↑R 135); Wesf. -[e]s; Wemf. -em (auch: -); Wenf. -en (auch: -); (↑R 116:) - Fremdes usw., aber (↑R 135): - anders; - kann es besser wissen als er; Nie|mand m; -[e]s; der böse - (auch für: Teufel); Nie|mands-land (Kampfgebiet zwischen feindlichen Linien; unerforsch-tes, herrenloses Land) s; -[e]s

Nie|re w; -, -n; eine künstliche - (med. Gerät); Nie|ren|becken [Trenn.: ...bek|ken]; Nie|ren-_becken|ent|zün|dung [Trenn.: ...bek|ken...], ...bra|ten, ...ent-zün|dung, ...fett; nie|ren|för|mig;

Nie|ren|ko|lik; nie|ren|krank;
Nie|ren_sen|kung, ...stein, ...tisch,
...trans|plan|ta|ti|on, ...tu|ber|ku|lo|se; nie|rig (nierenförmig [von
Mineralien]); Nierndl österr.
(Niere [als Gericht]) s; -s, -n
Nier|stei|ner (ein Rheinwein)
nie|seln (ugs. für: leise regnen); es
nieselt; Nie|sel|re|gen
nie|sen; du niest (niesest); er nie-
ste; geniest; Nies_pul|ver, ...reiz
Nieß|brauch [zu: nießen (veralt.)
= genießen] (Nutzungsrecht) m;
-[e]s
Nies|wurz [zu: niesen] (ein Heil-
kraut) w; -, -en
Niet (Metallbolzen) [nur so in der
Technik] m (auch: s); -[e]s, -e;
¹Nie|te (nichtfachspr. für: Niet)
w; -, -n
²Nie|te niederl. (Los, das nichts ge-
wonnen hat; Reinfall, Versager)
w; -, -n
nie|ten; Nie|ten|ho|se, Niet|ho|se;
Niet_ham|mer, ...na|gel, ...pres-
se; niet- und na|gel|fest (↑R 145);
Nie|tung
Nietz|sche (dt. Philosoph); Nietz-
sche-Ar|chiv (↑R 180)
Ni|fe [nife] Geol.: Kurzwort aus
Ni[ckel] u. Fe [Eisen]; Bezeich-
nung des hypothetisch aus Nickel
u. Eisen bestehenden Erdkernes)
s; -; Ni|fe|kern
Nifl|heim [auch: nị...] (,,Nebel-
heim"; nord. Mythol.: Reich der
Kälte; auch: Totenreich) s; -[e]s
ni|gel|na|gel|neu (schweiz. neben:
funkelnagelneu)
¹Ni|ger (afrik. Strom) m; -[s]; ²Ni-
ger (Staat in Westafrika); vgl. Ni-
grer; Ni|ge|ria (Staat in Westafri-
ka); Ni|ge|ria|ner; ni|ge|ria|nisch
Nig|ger amerik. (verächtl. für: Ne-
ger) m; -s, -
Ni|grer [zu: ²Niger]; ni|grisch
Ni|gro|sin lat. (ein Farbstoff) s; -s,
-e
Ni|hi|lis|mus lat. (Standpunkt der
allgemeinen u. bedingungslosen
Verneinung) m; -; Ni|hi|list (↑R
268); ni|hi|li|stisch; -ste (↑R 294)
Nij|me|gen [ná¹mʸeeh^e] (niederl.
Stadt)
Ni|käa usw. vgl. Nizäa usw.
Ni|ka|ra|gua usw. vgl. Nicaragua
usw.
Ni|ke (gr. Siegesgöttin)
Ni|ki|ta (slaw. Koseform von: Ni-
kolaus); Ni|klas (Kurzform von:
Nikolaus); Ni|klaus (schweiz.
Kurzform von: Nikolaus)
Ni|ko|ba|ren (Inselgruppe im Ind.
Ozean) Mehrz.
Ni|ko|de|mus (Jesus anhängender
jüd. Schriftgelehrter)
Ni|kol vgl. Nicol
¹Ni|ko|laus gr. [auch: nịk...]
(,,Volkssieger"; als hl. Nikolaus

verkleidete Person; den hl. Niko-
laus darstellende Figur aus Scho-
kolade, Marzipan u. a.) m; -, -e
(volkstümlich: ...läuse); ²Ni|ko-
laus [auch: nịk...] (m. Vorn.); Ni-
ko|laus|tag [auch: nịk...] (6. De-
zember); Ni|ko|lo (auch: Nik|lọ)
it. österr. (hl. Nikolaus) m; -s,
-s; Ni|ko|lo_abend, ...tag, ...zeit
Ni|ko|sia [auch: ...kọ...] (Hptst.
von Zypern)
Ni|ko|tin, (chem. fachspr.:) Ni|co-
tịn [nach dem fr. Gelehrten Nicot
(nikọ)] (Alkaloid im Tabak) s; -s;
ni|ko|tịn_arm, ...frei; Ni|ko|tịn-
ge|halt m; ni|ko|tịn|hal|tig; Ni|ko-
tịn|hal|tig|keit w; -; Ni|ko|tịn|ver-
gif|tung
Nil (afrik. Strom) m; -[s]; Nil_del|ta
(↑R 201; s; -s), ...flut (w; -), ...gans
Nil|gau Hindi (antilopenartiger
ind. Waldbock) m; -[e]s, -e
nil|grün; Ni|lo|te (Angehöriger ne-
grider Völker am oberen Nil) m;
-n, -n (↑R 268); ni|lo|tisch; Nil-
pferd
Nim|bus lat. (Heiligenschein,
Strahlenkranz; [unverdienter]
Ruhmesglanz) m; -, -se
nim|mer landsch. (niemals; nicht
mehr); nie und -; Nim|mer|leins-
tag (spött.); nim|mer|mehr
(landsch. für: niemals); nie und
-, nun und -; Nim|mer|mehrs|tag
(spött.); nim|mer|mü|de; Nim-
mer|satt (abwertend für: jmd.,
der nicht genug bekommen
kann) m; - u. -[e]s, -e; Nim|mer-
wie|der|se|hen s; -s; auf - (ugs.)
¹Nim|rod hebr. (Herrscher von
Babylon, Gründer Ninives, „ein
gewaltiger Jäger von dem Herrn"
[1. Mos. 10, 9]); ²Nim|rod ([lei-
denschaftlicher] Jäger) m; -s, -e
Nim|we|gen (dt. Form von:
Nijmegen)
Ni|na (it. u. russ. Koseform von
Namen auf ...n]ina, z. B. Katha-
rina, Antonina)
Ni|ni|ve [nịniwe] (Hptst. Assy-
riens); Ni|ni|vit (Bewohner von
Ninive) m; -en, -en (↑R 268); ni-
ni|vi|tisch
Ni|no|flex ⓦ (wasserdichtes, luft-
durchlässiges Gewebe) m od. s; -
Ni|ob [nach Niobe] (chem. Grund-
stoff, Metall; Zeichen: Nb) s; -s
Nio|be (gr. w. Sagengestalt); Nio-
bi|de (Abkömmling der Niobe)
m u. w; -n, -n (↑R 268); Nio|bi-
den|grup|pe
Nipf österr. ugs. (Mut); jmdm. den
- nehmen
Nip|pel (kurzes Rohrstück mit Ge-
winde) m; -s, -
nip|pen
Nip|pes fr. [nịpˀß; nịp(ß)] (kleine
Ziergegenstände [aus Porzellan])
Mehrz.

Nipp|flut niederd. (geringe Flu
Nip|pon (jap. Name von: Japar
Nipp|sa|chen (kleine Ziergegei
stände) Mehrz.
Nipp|zeit (Nippflut)
nir|gend (geh. für: nirgends); ni
gends; nir|gend[s]|her; nir|gend[s
hin; nir|gend[s]|wo; nir|gend[s
wo|her; nir|gend[s]|wo|hin
Ni|ro|sta ⓦ (Kurzwort aus: nich
rostender Stahl)
Nir|wa|na sanskr. (,,Erlöschen
völlige, selige Ruhe als Endzv
stand des gläubigen Buddhiste
s; -[s]
Ni|sche fr. w; -, -n
Ni|schel bes. mitteld. (Kopf) r
-s, -
Ni|schen|al|tar
Nisch|ni Now|go|rod, (heute
Gor|ki (sowjet. Stadt)
Niß w; -, Nisse u. Nis|se (Ei d
Laus) w; -, -n
Nis|sen|hüt|te; ↑R 180 [nach de
engl. Offizier Peter Norman Ni
sen] (halbrunde Wellblechbara
ke im 2. Weltkrieg)
nis|sig (voller Nisse[n], filzig [au
übertr.])
ni|sten; Nist_höh|le, ...ka|ste
...platz, ...zeit
Nit|hard (fränk. Geschichtsschre
ber)
Ni|trat ägypt. (Salz der Salpete
säure) s; -[e]s, -e; Ni|trid (Meta
Stickstoff-Verbindung) s; -[e]s
-e; ni|trie|ren (mit Salpetersäu
behandeln); Ni|tri|fi|ka|ti|
[...zịọn] (Salpeterbildung dur
Bodenbakterien); ni|tri|fi|zie|r
(durch Bodenbakterien Salpet
bilden); nitrifizierende Bakte
en; Ni|tri|fi|zie|rung; Ni|t
(Zyanverbindung) s; -s, -e; Nit|t
(Salz der salpetrigen Säure) s;
-e; Ni|tro|ge|la|ti|ne (ein Spren
stoff); Ni|tro|ge|ni|um (Stic
stoff; Zeichen: N) s; -s; Ni|tro|g
ze|rin (ein Heilmittel; Spren
stoff); Ni|tro|se (eine chem. V
bindung) w; -; Ni|tro|zel|lu|lo
(Schießbaumwolle, Kollodiu
wolle); Ni|trum (alte Bezeic
nung für: Salpeter) s; -s
nit|scheln (Streichgarnspinner
auf dem Nitschelwerk Vliesstre
fen zu Vorgarnen verdichten); i
...[e]le (↑R 327); Nit|schel|wer
vgl. nitscheln
ni|tsche|wo! russ. (scherzh. fü
macht nichts!, hat nichts zu t
deuten!)
Ni|vea ⓦ lat. [niw...] (Hautpfleg
mittel u. a.)
Ni|veau fr. [niwọ] (waagerech
Fläche; [gleiche] Höhe, Höhen
ge; Rang, Stufe, [Bildungs]star
Gesichtskreis) s; -s, -s; Ni|veau
_dif|fe|renz; ni|veau|frei (Ve

491

kehrsw.: sich nicht in gleicher Höhe kreuzend), ...**gleich**; **Ni|veau|li|ni|en** (*Mehrz.*); **ni|veau-los**; -este (↑ R 292); **Ni|veau.sen-kung**, ...**un|ter|schied**; **ni|veau-voll**; **Ni|vel|le|ment** [*niwäl*ᵉ*mãŋs*] (Ergebnis des Nivellierens, Ebnung, Gleichmachung; Höhenmessung) *s*; -s, -s; **ni|vel|lie|ren** (gleichmachen; ebnen; Höhenunterschiede [im Gelände] bestimmen); **Ni|vel|lier|in|stru-ment**; **Ni|vel|lie|rung**

Ni|vose *fr.* [*niwọs*] („Schneemonat" der Fr. Revolution: 21. Dez. bis 19. Jan.) *m*; - [*niwọs*], -s [*niwọs*] -e; **Nix** (germ. Wassergeist) *m*; -es; **Nix|chen**, **Nix|lein**; **Nixe** *w*; -, -n; **ni|xen|haft**

Ni|xon [*nix*ᵉ*n*] (Präsident der USA) **Ni|zäa** (Stadt [jetziger Name: Isnik] im alten Bithynien); **ni|zä-isch**, aber (↑ R 224): das Nizäische Glaubensbekenntnis; **ni|zä-nisch** vgl. nizäisch; **Ni|zä|num**, **Ni|zä|um** (Nizäisches Glaubensbekenntnis) *s*; -s

Niz|za (fr. Stadt); **Niz|za|er** (↑ R 199); **niz|za|isch**

n. J. = nächsten Jahres

N. J. = New Jersey

Njas|sa (afrik. See) *m*; -[s]; **Njas|sa-land** (ehem. brit. Protektorat in Ostafrika; heute als Malawi selbständig) *s*; -[e]s

Nje men (in der Schreibung eingedeutschter russ. Name der Memel) *m*; -[s]

NK = Neue Kerze

nkr = norwegische Krone

NKWD (Abk. für: Naródny Kommissariát Wnutrennich Del] *russ.* (Name des russ. Volkskommissariats des Innern; Bez. für die diesem Ministerium unterstellte polit. Geheimpolizei [1934–41]) *m*; -

lat. = neulateinisch

n., **nachm.** = nachmittags

n. M. = nächsten Monats

N. Mex. = New Mexico

N. N. = nomen nescio *lat.* [- *näßzio*] („den Namen weiß ich nicht"; Name unbekannt) od. nomen nominandum („der zu nennende Name", z. B. Herr N. N.)

N. N., NN = Normalnull

NO = Nordnordost[en]

NNW = Nordnordwest[en]

No = Nobelium

No., **N°** = Numero (veralt.)

O = Nordost[en] (Himmelsrichtung)

N.Ö. = Niederösterreich

'o|ah, (ökum.:) **No|ach** (bibl. m. Eigenn.); *Wesf.*: des -, aber (ohne Geschlechtswort); Noah[s] u. **Noä**; Arche -

no|bel *fr.* (adlig, edel, vornehm; ugs. für: freigebig); **no|bler** Mensch

'No|bel (Löwe in der Tierfabel) *m*; -s

²No|bel [fälschlich: *nọb*ᵉ*l*] (schwed. Chemiker); **No|bel|in|sti|tut**; **No-be|li|um** (chem. Element, Transuran; Zeichen: No) *s*; -s; **No|bel-preis**; vgl. ²Preis; **No|bel|preis|trä-ger**; **No|bel|stif** tung *w*, -

No|bi|li|tät *lat.* (Adel); **no|bi|li|tie-ren** (früher für: adeln)

No|bis|krug *Gaunerspr.* (veralt. für: Herberge für die Seelen auf der Wanderung zum Jenseits; Hölle)

No|bles|se *fr.* [*nọbläß*ᵈ] (veralt. für: Adel; adelige, vornehme Welt; veraltend nur *Einz.* für: vornehmes Benehmen) *w*; -, -n; **no|blesse ob|lige** [*nọbläß obliseh*] (Adel verpflichtet)

noch; - nicht; - immer; - mehr; - und -; - einmal; - einmal soviel; - mal (ugs. für: noch einmal); **Noch|ge|schäft** (Börse); **noch|ma-lig**; **noch|mals**

'Nock *niederl.* (Seemannsspr.: Ende eines Rundholzes) *s*; -[e]s, e (auch: *w*; -, -en)

²Nock bayr. u. österr. (Felskopf, Hügel) *m*; -s, -e

Nöck vgl. Neck

Nocke¹, **'Nocken¹** österr. ugs. (dummes, eingebildetes Frauenzimmer) *w*; -, -n; **²Nocken¹** (Technik: Vorsprung von kurvenartiger Form auf einer Welle oder Scheibe) *m*; -s, -; **Nocken|wel|le¹**

Nockerl¹ österr. ([Suppen]einlage, Klößchen); naives Mädchen) *s*; -s, -n¹ **Nockerl|sup|pe¹** (österr.)

Noc|turne [*noktürn*] *s*; -s, -s od. *w*; -, -s; vgl. Nokturne

No|esis *gr.* (geistiges Wahrnehmen, Denken, Erkennen) *w*; -; **No|etik** (Denklehre, Erkenntnislehre) *w*; -; **no|e|tisch**

No|fre|te|te (altägypt. Königin)

no iron *engl.* [*nọ*ᵘ *air*ᵉ*n*] (nicht bügeln, bügelfrei [Hinweis an Kleidungsstücken])

NOK = Nationales Olympisches Komitee

Nok|tür|ne *fr.* (Nachtmusik; Klavierstück träumerischen Inhalts) *w*; -, -n

nö|len nordd. (im Reden u. a.] langsam sein)

no|lens vo|lens *lat.* [- *wọ...*] („nicht wollend wollend"; wohl oder übel); **No|li|me|tan|ge|re** [...*tang*gᵉ*r*ᵉ] („rühr mich nicht an"; Springkraut) *s*; -, -

Nöl.pe|ter (nordd. für: langsamer, langweiliger Mensch; *m*; -s, -),

...**su|se** (nordd. für: langsam arbeitende oder gehende Frau; *w*; -, -n)

Nom. = Nominativ

No|ma|de *gr.* (Umherschweifender; Wanderhirt; Angehöriger eines Hirten-, Wandervolkes) *m*; -n, -n (↑ R 268); **No|ma|den|da-sein**; **no|ma|den|haft**; **No|ma|den-le|ben**, ...**volk**; **no|ma|disch** (umherziehend, unstet); **no|ma|di|sie-ren** ([wie ein Hirtenvolk] umherschweifen)

No|men *lat.* (Name; Sprachw.: Nennwort, Hauptwort, z. B. „Haus"; häufig auch für Eigenschaftswort u. andere deklinierbare Wortarten) *s*; -s, ...mina; **No|men ac|ti** [- *akti*] (Sprachw.: Hauptwort, das den Abschluß od. das Ergebnis eines Geschehens bezeichnet, z. B. „Lähmung, Guß") *s*; - -, ...mina -; **No|men ac|tio|nis** [- *akziọniß*] (Sprachw.: Hauptwort, das ein Geschehen bezeichnet, z. B. „Schlaf") *s*; - -, ...mina -; **No|men agen|tis** (Sprachw.: Hauptwort, das den Träger eines Geschehens bezeichnet, z. B. „Schläfer") *s*; - -, ...mina -; **No|men in|stru-men|ti** (Sprachw.: Hauptwort, das im Werkzeug oder Gerät bezeichnet, z. B. „Bohrer") *s*; - -, ...mina -; **No|men|kla|tor** (Buch, das die in einem Wissenschaftszweig vorkommenden gültigen Namen verzeichnet) *m*; -s, ...oren; **no|men|kla|to|risch**; **No-men|kla|tur** (Zusammenstellung von Fachausdrücken, bes. in Biologie u. Physik) *w*; -, -en; **No|men pro|pri|um** [auch: - *prọp...*] (Eigenname) *s*; - -, ...mina ...pria; **No|mi|na** (*Mehrz.* von: Nomen); **no|mi|nal** (zum Namen gehörend; zum Nennwert); **No|mi|nal-be|trag** (Nennbetrag); **No|mi|na-lis|mus** (eine philos. Lehre) *m*; -; **No|mi|na|list** (↑ R 268); **No|mi-nal.lohn**, ...**stil** (Stil, der das Hauptwort, das Nomen, bevorzugt; Ggs.: Verbalstil), ...**wert**; **No|mi|na|ti|on** [...*ziọn*] (Ernennung der bischöfl. Beamten; Benennung eines Bewerbers für das Bischofsamt durch die Landesregierung [kath. Kirchenrecht]; seltener für: Nominierung); **No|mi-na|tiv** [auch: ...*tif*] (Sprachw.: Werfall, 1. Fall; Abk.: Nom.) *m*; -s, -e [...*w*ᵉ]; **no|mi|nell** ([nur] dem Namen nach [bestehend], vorgeblich; zum Nennwert); vgl. nominal; **no|mi|nie|ren** (benennen, bezeichnen; ernennen); **No|mi-nie|rung**

No|mo|gramm *gr.* (Math.: Schaubild od. Zeichnung zum graph.

¹ *Trenn.:* ...k|k...

Rechnen) s; -s, -e; No|mo|gra|phie (Lehre vom Nomogramm) w; -

No|na|gon lat.; gr. (Neuneck) s; -s, -e

Non|cha|lance fr. [nongschalangß] ([Nach]lässigkeit, formlose Ungezwungenheit) w; -; non|cha|lant [...lang, als Beifügung: ...ant] ([nach]lässig, formlos, ungezwungen)

No|ne lat. (neunter Ton [vom Grundton an]; Intervall; Teil des kath. Stundengebets) w; -, -n; Nonen (im altröm. Kalender: neunter Tag vor den Iden) Mehrz.; No|nen|ak|kord (Musik); No|nętt (Musikstück für neun Instrumente; auch: die neun Ausführenden) s; -[e]s, -e

Non-food-Ab|tei|lung engl.; dt. [nonfúd...] („keine Lebensmittel"; Abteilung in Einkaufszentren, die langlebige Gebrauchsgüter im Sortiment führt)

No|ni|us [nach dem Portugiesen Nunes (nunisch)] (verschiebbarer Meßstabzusatz) m; -, ...ien [...ien] u. -se

Non|kon|for|mis|mus lat.-engl. (individualist. Haltung in polit. u. sozialen Fragen); Non|kon|for|mist (↑ R 268); non|kon|for|mi|stisch

Nönn|chen, Nönn|lein; Non|ne w; -, -n; Non|nen|gans; non|nen|haft; Non|nen|klo|ster, ...zie|gel (ein Dachziegel)

Non|pa|reille fr. [nongparäj] (ein Schriftgrad) w; -

Non|plus|ul|tra lat. („nicht darüber hinaus"; Unübertreffbares, Unvergleichliches) s; -

Non|pro|li|fe|ra|tion engl.-amerik. [nonprolifer$_e^i$schen] (Nichtweitergabe [von Atomwaffen]) w; -

non scho|lae, sed vi|tae dis|ci|mus lat. [- ß-chola - wita dißzi...] („nicht für die Schule, sondern für das Leben lernen wir")

Non|sens lat.-engl. (Unsinn; törichtes Gerede) m; - u. -es

non|stop engl. (ohne Halt, ohne Pause); - fliegen, spielen; Nonstop.flug (Ohnehaltflug), ...ki|no (Kino mit fortlaufenden Vorführungen u. durchgehendem Einlaß)

Non|va|leur fr. [nongwalör] (entwertetes Wertpapier; Investition, die keinen Ertrag abwirft) m; -s, -s

non vi|tae, sed scho|lae dis|ci|mus lat. [- wita - ß-chola dißzi...] ([leider] „lernen wir nicht für das Leben, sondern für die Schule")

Noor dän. niederd. (Haff, flaches Gewässer, das durch einen Kanal mit dem Meer verbunden ist) s; -[e]s, -e

Nop|pe (Knoten in Geweben) w; -, -n; Nopp|ei|sen; nop|pen (Knoten aus dem Gewebe entfernen, abzupfen); Nop|pen.garn, ...gewe|be, ...stoff; nop|pig; Nopp|zan|ge

No|ra (Kurzform von: Eleonore)

Nor|bert (m. Vorn.)

Nör|chen [zu: nören] nordwestd. (Schläfchen)

^1Nord (Himmelsrichtung; Abk.: N); Nord und Süd; (fachspr.:) der kalte Wind kommt aus -; bei Ortsnamen: Frankfurt (Nord); vgl. Norden; ^2Nord (dicht. für: Nordwind) m; -[e]s, (selten:) -e; der eisige Nord heulte um das Haus; Nord.afri|ka, ...ame|ri|ka; nord|ame|ri|ka|nisch, aber (↑ R 224): der Nordamerikanische Bürgerkrieg (Sezessionskrieg); Nord|at|lan|tik|pakt (North Atlantic Treaty Organization; Kurzwort: NATO) m; -[e]s; Nord|au|stra|li|en [...ien]; Nord.ba|den; vgl. Baden; Nord|brabant (niederl. Prov.); Nord|da|ko|ta (Staat in den USA; Abk.: N. D.);nord|deutsch, aber (↑ R 198): das Norddeutsche Tiefland, (auch:) die Norddeutsche Tiefebene; (↑ R 224:) der Norddeutsche Bund; vgl. deutsch; Nord|deutsch|land; Nor|den (Abk.: N) m; -s; das Gewitter kommt aus -; gen Norden; vgl. Nord; Nor|den|skiöld [nueden-schöld] (schwed. Polarforscher); Nor|der (Nord[west]sturm im westlichen Südamerika; niederd. für: Nord); Nor|der|dith|marschen (Landkreis in Schleswig-Holstein); Nor|der|ney [...naj] (ostfries. Nordseeinsel); ↑ R 217); Nord.eu|ro|pa, ...frank|reich; nord|frie|sisch, aber (↑ R 198): die Nordfriesischen Inseln; Nord|fries|land; nord|ger|manisch; Nord|hang; Nord|häu|ser [nach der Stadt Nordhausen] ([Korn]branntwein); Nord|ir|land; nor|disch (den Norden betreffend); -e Kälte; -e Kombination (Schisport); die -e Rasse, aber (↑ R 224): der Nordische Krieg (1700–1721); Nor|dist (Kenner u. Erforscher der nord. Sprachen und Kulturen sowie der nord. Altertumskunde); ↑ R 268; Nord|ita|li|en; Nord|kap (nördlichster Punkt Europas) s; -s; Nord|ka|ro|li|na (Staat in den USA; Abk.: N. C.); Nord-Ko|rea, (meist:) Nord|ko|rea (↑ R 206); Nord|ko|rea|ner; nord|ko|reanisch; Nord|kü|ste; Nord|län|der m; Nord.land|fahrt; nord|ländisch; Nord|land|rei|se; n[ördl]. Br. = nördlicher Breite; nörd-

lich; - des Meeres, - vom Meere; - von München (selten: - Münchens); -er Breite (Abk.: n[örd]l. Br.); -er Stern[en]himmel, aber (↑ R 198): das Nördliche Eismeer (älter für: Nordpolarmeer); Nörd|li|che Dwi|na (russischer Strom; vgl. Dwina) w; -n. -; Nordlicht (Mehrz. ...lichter); Nörd|lingen (Stadt im Ries in Bayern); Nörd|lin|ger (↑ R 199); Nordmark (ursprüngl.: „Grenzland im Norden", Name der Altmark; auch für: Schleswig-Holstein) w; -; ^1Nord|nord|ost (Himmelsrichtung; Abk.: NNO); vgl Nordnordosten; ^2Nord|nord|ost (Nordnordostwind; Abk. NNO) m; -[e]s, -e; Nord|nord|osten (Abk.: NNO) m; -s; vgl Nordnordost; ^1Nord|nord|west (Himmelsrichtung; Abk. NNW); vgl. Nordnordwesten; ^2Nord|nord|west (Nordnordwestwind; Abk.: NNW) m; -[e]s -e; Nord|nord|we|sten (Abk. NNW) m; -s; vgl. Nordnordwest; ^1Nord|ost (Himmelsrichtung Abk.: NO); vgl. Nordosten; ^2Nord|ost (Nordostwind) m; -[e]s -e; Nord|osten (Abk.: NO) m; -s vgl. Nordost; nord|öst|lich, abe (↑ R 224): die Nordöstliche Durchfahrt; Nord-Ost|see-Ka|nal [auch: nordost...] (eigentlich Nordsee-Ostsee-Kanal; Seekanal zwischen der Nordsee un der Ostsee) m; -s; Nord|ost|wind Nord|pol m; -s; Nord|po|lar.ge biet (s; -[e]s), ...län|der (Mehrz. ...meer; Nord|pol.ex|pe|di|ti|on ...fah|rer; Nord|punkt m; -[e]s; Nord|rhein-West|fa|len; ↑ R 21 (Land); nord|rhein-west|fä|lisch Nord|rho|de|si|en [...ien] (bis 196 Name des heutigen Sambia Nord|see (Meer) w; -; Nord|see ka|nal m; -s; Nord|sei|te; nor süd|lich; in -er Richtung; Nor Vi|et|nam, (meist:) Nord|vi|e nam [auch: ...wiät...] (↑ R 206 Nord|vi|et|na|me|se; nord|vi|e na|me|sisch; Nord|wand; nor wärts; Nord|welt (veralt.) w; nord|welt|lich (veralt.). ^1Nor west (Himmelsrichtung; Abk NW); vgl. Nordwesten; ^2Nor west (Nordwestwind) m; -[e]s, - Nord|we|sten (Abk.: NW) m; vgl. Nordwest; nord|west|lic aber (↑ R 224): die Nordwes liche Durchfahrt; Nord|west|te ri|to|ri|en [...ien] (in Kanad Mehrz.; Nord|west|wind; Nor wind

nö|ren nordwestd. (schlummern vgl. Nörchen

Nor|ge (norweg. Name für: No wegen)

Nör|ge|lei; Nör|gel|frit|ze (ugs.) *m*; -n. -n; nör|ge|lig, nörg|lig; nör|geln; ich ...[e]le (↑ R 327); Nörg|ler; nörg|le|risch; Nörg|ler|tum *s*; -s

no|risch (ostalpin) -es Pferd, a b e r (↑ R 198): die Norischen Alpen

Norm *w*. (Richtschnur, Regel; sittliches Gebot oder Verbot als Grundlage der Rechtsordnung; Größenanweisung der Technik; Druckerspr.: am Fuß der ersten Seite eines Bogens stehende Kurzfassung des Buchtitels) *w*; -, -en; nor|mal (der Norm entsprechend, regelrecht, vorschriftsmäßig; gewöhnlich, üblich, durchschnittlich; geistig gesund); Nor|mal_aus|füh|rung, ...druck (*Mehrz*. ...drücke); Nor|ma|le (Mathematik: Senkrechte) *w*; -, -n; nor|ma|ler|wei|se; Nor|mal_fall *m*, ...film, ...for|mat, ...ge|wicht, ...grö|ße, ...hö|he, ...hö|hen|punkt (*m*; -[e]s; Zeichen: N. H.), ...ho|ri|zont (Ausgangsfläche für Höhenmessungen); Nor|ma|li|en [...*i*ⁿ] (Grundformen; Regeln, Vorschriften) *Mehrz*.; nor|ma|li|sie|ren (einheitlich gestalten, vereinheitlichen, normen); Nor|ma|li|sie|rung; Nor|ma|li|tät (seltener für: Vorschriftsmäßigkeit) *w*; -; Nor|mal_maß *s*, ...null (*s*; -s; Abk.: N. N., NN), ...pro|fil (Walzeisenquerschnitt, Lademaß; Bergmannsspr.: Hauptschichtenschnitt), ...spur (Vollspur); nor|mal|spu|rig (vollspurig); Nor|mal_tem|pe|ra|tur, ...ton, ...ty|pus, ...uhr, ...ver|brau|cher, ...wert, ...zeit (Einheitszeit), ...zu|stand

Nor|man|die [auch: ...*mangdí*] (Landschaft in Nordwestfrankreich) *w*; -; Nor|man|ne (Angehöriger eines nordgerm. Volkes) *m*; -n, -n (↑ R 268); nor|man|nisch; -er Eroberungszug, a b e r (↑ R 198): die Normannischen Inseln (gelegentlich für: Kanalinseln)

nor|ma|tiv *gr*. (maßgebend, zur Richtschnur dienend); vgl. normig; Nor|ma|tiv_be|steue|rung; Norm|blatt; nor|men (einheitlich festsetzen, gestalten; [Größen] regeln); Nor|men_aus|schuß; Deutscher - (Abk.: DNA); Nor|men|kon|trol|le (Rechtsspr.); Nor|men|kon|troll|kla|ge; nor|mie|ren (älter für: normen); Nor|mie|rung (älter für: Normung); Nor|mung (einheitliche Gestaltung, [Größen]regelung)

Nor|ne *altnord.* (nord. Schicksalsgöttin [Urd, Werdandi, Skuld]) *w*; -, -n (meist *Mehrz*.)

North|um|ber|land [*no'thambᵉr- lᵉnd*] (engl. Grafschaft)

Nor|we|gen; vgl. Norge; Nor|we|ger (↑ R 199); Nor|we|ger|tuch; ↑ R 205 (Stoff für Schianzüge) *s*; -[e]s; nor|we|gisch; Nor|we|gisch (Sprache) *s*; -[s]; vgl. Deutsch; Nor|we|gi|sche *s*; -n; vgl. Deutsche *s*

Nor|se|ma|seu|che *gr*.; *dt*. (eine Bienenkrankheit)

No|so|gra|phie *gr*. (Krankheitsbeschreibung) *w*; -; No|so|lo|gie (Lehre von den Krankheiten, systematische Beschreibung der Krankheiten) *w*; -

Nos|sack, Hans Erich (dt. Schriftsteller)

Nö|ßel (veraltetes Flüssigkeitsmaß) *m* od. *s*; -s, -

Nost|al|gie *gr*. (Med.: Heimweh; Sehnsucht) *w*; -; nost|al|gisch (heimwehkrank; sehnsuchtsvoll)

No|stra|da|mus (fr. Astrologe des 16. Jh s)

No|stri|fi|ka|ti|on *lat.* [...*zion*] (Einbürgerung; Anerkennung eines ausländischen Diploms); no|stri|fi|zie|ren; No|stri|fi|zie|rung (svw. Nostrifikation)

No|stro|gut|ha|ben od. ...kon|to *it.* (Eigenguthaben im Verkehr zwischen Banken)

Not *w*; -, Nöte; in Not, in Nöten sein; in Ängsten und in Nöten; zur Not; wenn Not am Mann ist; seine [liebe] Not haben; Not leiden, a b e r (↑ R 132): not sein, tun, werden; das ist unnötig

No|ta *lat.* (Wirtsch.: [kleine] Rechnung, Vormerkung) *w*; -, -s; vgl. ad notam; No|ta|beln *fr.* (die durch Bildung, Rang und Vermögen ausgezeichneten Mitglieder der königl. Ratsversammlungen in Frankreich [seit dem 15. Jh.]) *Mehrz*.; no|ta|be|ne *lat.* (,,merke wohl!''; übrigens; Abk.: NB); No|ta|be|ne (Merkzeichen, Vermerk, Denkzettel) *s*; -[s], -[s]; No|ta|bi|li|tät (veralt. für: 1. *Einz.*: Vornehmheit. 2. meist *Mehrz*.: Berühmtheit, hervorragende Persönlichkeit); No|tar (Amtsperson zur Beurkundung von Rechtsgeschäften) *m*; -s, -e; No|ta|ri|at (Amt eines Notars) *s*; -[e]s, -e; No|ta|ri|ats|ge|hil|fe; no|ta|ri|ell (von einem Notar ausgefertigt und beglaubigt); no|ta|risch (seltener für: notariell); No|ta|ti|on [...*zion*] (Aufzeichnung in Notenschrift)

Not_an|ker, ...auf|nah|me (Genehmigung zum ständigen Aufenthalt in der BRD für Personen dt. Staatsangehörigkeit od. Volkszugehörigkeit); Not_auf|nah|me_la|ger (*Mehrz*. ...lager), ...ver|fah|ren, Not_aus|gang,

...aus|rü|stung, ...be|helf, ...be|leuch|tung, ...bi|wak, ...brem|se, ...brücke [*Trenn.*: ...brük|ke]

Not_burg, Not_bur|ga (w. Vorn.)

Not|durft *w*; -; not|dürf|tig

No|te *lat.* *w*; -, -n; er hat die Note ,,ausreichend'' erhalten; No|ten (ugs. für: Musikalien) *Mehrz*.; No|ten_aus|tausch, ...bank (*Mehrz*. ...banken); No|ten|bank|aus|weis; No|ten_blatt, ...heft, ...li|nie (meist *Mehrz*.), ...pa|pier, ...pres|se, ...pult, ...satz, ...schlüssel, ...schrift, ...stän|der, ...system, ...um|lauf, ...wech|sel

Not_er|be (Erbe, der nicht übergangen werden darf) *m*, ...fall *m*, not|fal|lo (vgl. Fall *m* u. R 129); Not_feu|er, ...ge|biet; not|ge|drun|gen; Not_geld, ...ge|mein|schaft, ...ge|setz, ...ge|spräch, ...gro|schen, ...ha|fen (vgl. ²Hafen); Not|hel|fer; (↑ R 224:) die Vierzehn - (kath. Heilige); Not_hel|fe|rin (*w*; -, -nen), ...hil|fe (*w*; -)

no|tie|ren *lat.* (aufzeichnen; vormerken; Kaufmannsspr.: den Kurs eines Papiers, den Preis einer Ware festsetzen), No|tie|rung; No|ti|fi|ka|ti|on [...*zion*] (veralt. für: Anzeige; Benachrichtigung); no|ti|fi|zie|ren (veralt.)

no|tig südd., österr. (arm, in Not); nö|tig; für - halten; etwas - haben, machen; das Nötigste (↑ R 116); nö|ti|gen; nö|ti|gen|falls; vgl. Fall *m*; Nö|ti|keit (veralt.) *w*; -; Nö|ti|gung

No|tiz *lat.* *w*; -, -en; von etwas - nehmen

No|tiz_block (*Mehrz*. ...blocks), ...buch; No|ti|zen|samm|ler; No|tiz|samm|lung, No|ti|zen|samm|lung; No|tiz|zet|tel

Not|ker (m. Vorn.)

Not_la|ge; not|lan|den; ich notlande; notgelandet (↑ R 304); notzulanden; Not_lan|dung; not|lei|dend; -ste; Not_lei|den|de, ...lei|ne, ...lei|ter *w*, ...licht, ...lö|sung, ...lü|ge, ...maß|nah|me, ...op|fer

no|to|risch *lat.* (offenkundig, allbekannt; berüchtigt)

Not_pfen|nig, ...prü|fung

No|tre-Dame [*notrᵉ dam*] (fr. Bez. der Jungfrau Maria; Name fr. Kirchen) *w*; -

not|reif; Not_rei|fe, ...ruf; Not|ruf_an|la|ge, ...säu|le; not|schlach|ten; ich notschlachte; notgeschlachtet; notzuschlachten; Not_schlach|tung, ...schrei, ...si|gnal, ...sitz, ...stand; Not|stands_ar|bei|ten (*Mehrz*.), ...ge|biet, ...ge|setz|ge|bung; Not|tau|fe; not|tau|fen; ich nottaufe; notgetauft; notzutaufen; Not|tür

Not|tur|no *it.* (svw. Nokturne) *s;*
-s, -s u. ...ni

Not_un|ter|kunft, ...ver|band,
...ver|ord|nung; not|voll; not|was-
sern; ich notwassere; notgewäs-
sert; notzuwassern; Not|was|se-
rung, Not|waß|rung; Not|wehr *w;*
-; not|wen|dig [auch: *notwän*...]
(↑ R 116:) [sich] auf das, aufs Not-
wendigste beschränken; es fehlt
am Notwendigsten; not|wen|di-
gen|falls; vgl. Fall *m;* not|wen|di-
ger|wei|se; Not|wen|dig|keit
[auch: *notwän*...]; Not_wirt-
schaft, ...woh|nung, ...zei|chen,
...zucht (*w;* -); not|züch|ti|gen; ge-
notzüchtigt; zu -

Nou|gat *fr.* [*nugat*] (Süßware aus
Zucker und Nüssen oder Man-
deln) *m* (auch: *s*); -s, -s; vgl. Nu-
gat; Nou|gat_fül|lung, ...scho|ko-
la|de

Nou|veau|té *fr.* [*nuwotę*] (Neuheit,
Neuigkeit [der Mode u. a.]) *w;*
-, -s

Nov. = November

¹No|va *lat.* [*nọwa*] (neuer Stern)
w; -, ...vä; ²Nọ|va [auch: *nọ*...]
(*Mehrz.* von: Novum; Neuer-
scheinungen des Buchhandels)

No|va|lis [...*wa*...] (dt. Dichter)

No|va|ti|on *lat.* [*nowaziọn*]
(Rechtsw.: Schuldumwandlung,
Aufhebung eines bestehenden
Schuldverhältnisses durch
Schaffung eines neuen); No|vel|le
[*nowä|l*] (Prosaerzählung; Nach-
tragsgesetz) *w;* -, -n; no|vel|len|ar-
tig; No|vel|len_band *m,* ...dich|ter,
...form, ...samm|lung, ...schrei-
ber; No|vel|let|te (kleine Novelle
w; -, -n; no|vel|lie|ren (ein Gesetz-
buch mit Novellen versehen);
No|vel|lie|rung; No|vel|list (No-
vellenschreiber, -dichter); ↑ R
268; no|vel|li|stisch (novellenar-
tig; unterhaltend)

No|vem|ber *lat.* [...*wäm*...] (elfter
Monat im Jahr; Nebelmond, Ne-
b[e]lung, Windmonat, Winter-
monat; Abk.: Nov.) *m;* -[s] (↑ R
319), -; no|vem|ber|haft; no|vem-
ber|lich; No|vem|ber_ne|bel, ...re-
vo|lu|ti|on (1918 in Deutschland)

No|ve|ne *lat.* [...*wen*...] (neuntägi-
ge kath. Andacht) *w;* -, -n

No|vi|lu|ni|um *lat.* [*nowi*...]
(Astron.: Augenblick des ersten
Sichtbarwerdens der Neumond-
sichel) *s;* -s, ...ien [...*i*r*n*]

No|vi|tät *lat.* [*nowi*...] (Neu-
erscheinung; Neuheit [der Mode
u. a.]; veralt. für: Neuigkeit); No-
vi|ze (Mönch od. Nonne wäh-
rend der Probezeit; Neuling) *m;*
-n, -n (↑ R 268) u. *w;* -, -n; No|vi-
zen|mei|ster; No|vi|zi|at (Probe-
zeit [in Klöstern]) *s;* -[e]s, -e; No-
vi|zi|at|jahr; No|vi|zin *w;* -, -nen;

No|vo|ca|in Ⓦ [...*ka*...] (ein Mittel
zur örtlichen Betäubung) *s;* -s;
No|vum *lat.* [*nọwum,* auch: *nọ*...]
("Neues"; Neuheit; neuhinzu-
kommende Tatsache, die die bis-
herige Kenntnis oder Lage [eines
Streitfalles] ändert) *s;* -s, ...va;
vgl. ²Nova

No|wa|ja Sem|lja *russ.* [- *semljạ*]
(zwei Inseln im Nordpolarmeer)

No|xe *lat.* (Med.: Schädlichkeit;
krankheitserregende Ursache) *w;*
-, -n; No|xi|ne (Med.: aus zugrun-
de gegangenem Körpereiweiß
stammende Giftstoffe) *Mehrz.*

Np = chem. Zeichen für: Neptu-
nium

Np = Neper

NPD = Nationaldemokratische
Partei Deutschlands

Nr. = Nummer; Nrn. = Num-
mern

NRT = Nettoregistertonne

NS = Nachschrift; (auf Wech-
seln:) nach Sicht

n. St. = neuen Stils (Zeitrech-
nung: nach dem Gregorianischen
Kalender)

NSU Ⓦ (Kraftfahrzeugmarke)

Nt = Niton

N. T. = Neues Testament

nu (ugs. für: nun); Nu (sehr kurze
Zeitspanne) *m,* nur in: im -, in
einem -

Nu|an|ce *fr.* [*nügngß*, österr.:
nügngß] (Abstufung, feiner
Übergang; Feinheit; Ton, [Ab]-
tönung; Schimmer, Spur, Klei-
nigkeit) *w;* -, -n; nu|an|cen|reich;
nu|an|cie|ren; Nu|an|cie|rung
'nü|ber; [↑ R 238 landsch. (hinüber)

Nu|bi|en [...*i*r*n*] (Landschaft in
Nordafrika); Nu|bi|er [...*i*r*r*]; nu-
bisch, aber (↑ R 198): die Nubi-
sche Wüste

Nu|buk *engl.* (nachgeahmtes
Wildleder) *s;* -

nüch|tern; Nüch|tern|heit *w;* -

Nucke¹, Nücke¹ mdal. (Laune,
Schrulle) *w;* -, -n; seine -n haben

Nuckel¹ (ugs. für: Schnuller) *m;*
-s, -; nuckeln¹ (ugs. für: saugen);
ich ...[e]le (↑ R 327)

nückisch¹ [zu: Nucke]

Nud|del landsch. (Schnuller) *m;* -s,
-[e]; nud|deln (ugs. für: dudeln);
landsch. für: [am Schnuller] sau-
gen); ich ...[e]le (↑ R 327)

Nu|del *w;* -, -n; Nu|del|brett; nu|del-
dick (ugs. für: sehr dick); Nu|del-
holz; nu|deln; ich ...[e]le (↑ R 327);
Nu|del_sup|pe, ...teig, ...wal|ker
(österr. für: Teigrolle, Nudel-
holz)

Nu|dis|mus *lat.* (Freikörperkul-
tur) *m;* -; Nu|dist (↑ R 268); nu|dis-
ver|bis [- *wär*...] (mit nackten,

dürren Worten); Nu|di|tät (selten
für: Nacktheit; Schlüpfrigkeit)

Nu|gat (eindeutschend für: Nou-
gat)

Nug|get *engl.* [*nạgit*] (natürlicher
Goldklumpen) *s;* -[s], -s

Nug|gi schweiz. mdal. (Schnuller)
m; -s, -

nu|kle|ar *lat.* (den Atomkern be-
treffend); -e Waffen (Kernwaf-
fen); Nu|kle_ar_macht, ...me|di-
zin (Teilgebiet der Strahlen-
medizin); Nu|klea|se (Chemie:
Nukleinsäuren spaltendes Fer-
ment) *w;* -, -n; Nu|kle|in (svw.
Nukleoproteid) *s;* -s, -e; Nu|kle-
in|säu|re; Nu|kle|on [auch: *nụ*...]
(Atomkernbaustein) *s;* -s,
...onen; Nu|kleo|nik (Atomlehre)
w; -; Nu|kleo|pro|te|id (Eiweiß-
verbindung des Zellkerns) *s;* -[e]s,
-e; Nu|kle|us [auch: *nụkle-uß*]
(Biol.: [Zell]kern) *m;* -, ...ei [...*e-i*]

null *lat.;* - und nichtig; - Fehler
haben; - Grad, - Uhr, - Sekunden;
- Komma eins (0,1); sie verloren
drei zu - (3 : 0); ¹Null (Ziffer;
Nullpunkt; Wertloses) *w;* -, -en;
Nummer -; die Zahl -; das Ther-
mometer steht auf -; das Ergebnis
der Untersuchungen war gleich
-; in - Komma nichts; er ist eine
reine - ; es handelt sich um eine
Zahl mit fünf Nullen; ²Null (Skat-
spiel: Nullspiel) *m* (auch: *s*); -[s],
-s; null_acht_fünf_zehn, in Ziffern:
08/15 (ugs. für: wie üblich, durch-
schnittlich, Allerweits-); Null_
acht_fünf_zehn-So|ße; Nul|la|ge
[*Trenn.:* Null|la..., ↑ R 236] (Null-
stellung bei Meßgeräten) *w;* -;
nul|la poe|na si|ne le|ge *lat.*
[- *pö...* - -] ("keine Strafe ohne
Gesetz"); Nul|lei|tung [*Trenn.:*
Null|lei..., ↑ R 236] (Elektr.); nul-
len (mit der Nulleitung verbin-
den; ugs. für: ein Jahrzehnt voll-
machen); Nul|ler| österr. ugs.
(Mensch, der nichts zu sagen hat,
nichts bedeutet) *s;* -s -n; Nul|li|fi-
ka|ti|on [...*ziọn*); nul|li|fi|zie|ren
(zunichte machen; für nichtig er-
klären); Nul|li|nie [*Trenn.:* Null-
l..., ↑ R 236] *w;* -, -n; Nul|li|tät
(selten für: Nichtigkeit; Ungül-
tigkeit; Person od. Sache ohne
Bedeutung; Null_me|ri|di|an;
Null ou|vert *lat.;* *fr.* [- *uwär*]
(offenes Nullspiel [beim Skat]) *m*
(selten: *s*); - -, - -s [- *uwärß*];
Null_punkt (auf dem -), ...se|rie
(erste Versuchsserie einer Ferti-
gung), ...ta|rif (kostenlose Benut-
zung der öffentl. Verkehrsmittel)

Nul|pe (ugs. für: einfältiger
Mensch, Dummkopf; unbedeu
tender Mensch) *w;* -, -n

Nu|me|ra|le *lat.* (Sprachw.: Zahl
wort, z. B. "eins") *s;* -s, ...lier

¹ *Trenn.:* ...k|k...

[...*i*ⁿ] u. ...lia; Nu̱|me̱|ri [auch: *nu̱*...] (*Mehrz.* von: Numerus; Namedes 4. Buches Mosis; *Mehrz.*); nu|me|rie̱|ren (beziffern, [be]nummern); numerierte Ausgabe (Druckw.); Nu̱|me|rie̱|rung; Nu̱me̱|rik (EDV: numerische Steuerung) *w*; -; nu|me̱|risch (zahlenmäßig, der Zahl nach; mit Ziffern [verschlüsselt]); Nu̱|me̱|ro *it.* [auch: *nu̱*...] (veralt. für: Zahl; Abk.: No., N²) *s*; -s, -s; vgl. Nummer; Nu̱|me̱|rus *lat.* [auch: *nu̱*...] (Zahl; Takt; Ebenmaß; Sprachw.: Zahlform des Hauptwortes [Singular, Plural]) *m*; -, ...ri; Nu̱|mo̱|rus clau̱|sus [auch; *nu̱*...] (,,geschlossene Zahl''; zahlenmäßig beschränkte Zulassung [zu einem Beruf, bes. zum Studium]) *m*; - -

Nu̱|mi̱|der [auch: *nu̱*...], Nu̱|mi̱|di̱er [...*i*ⁿr]; Nu̱|mi̱|di̱|en [...*i*ⁿn] (im Altertum nordafrik. Reich); nu̱mi̱|disch

Nu̱|mis|ma̱|tik *gr.* (Münzkunde) *w*; -; Nu̱|mis|ma̱|ti|ker; nu̱|mis|ma̱|tisch

Nu̱m|mer *lat.* (Zahl; Abk.: Nr.) *w*; -, -n (Abk.: Nrn.); - fünf; etwas ist Gesprächsthema - eins; - Null; - Sicher (scherzh. für: Gefängnis); laufende - (Abk.: lfd. Nr.); vgl. Numero; nu̱m|me̱|risch (für: numerisch); ich ...ere (↑ R 327); Nu̱m|mern|schei̱|be, ...schild *s*, ...stem|pel, ...ta|fel; Nu̱m|me̱|rung (für: Numerierung)

Nu̱m|mu|lit *lat.* (versteinerter Wurzelfüßer im Eozän) *m*; -s, -e

nun; - [ein]mal; - wohlan!; - und nimmer; von - an; - du gekommen bist (svw. da ...); nun da du gekommen bist

nun|me̱hr; nun|me̱h|rig

'nun|ter; ↑ R 238 landsch. (hinunter)

Nu̱n|tia|tu̱r *lat.* [...*zi*...] (Amt und Sitz eines Nuntius) *w*; -, -en; Nu̱n|ti̱|us (,,Bote''; ständiger Botschafter des Papstes bei weltlichen Regierungen) *m*; -, ...ien [...*i*ⁿn]

nup|ti̱|al *lat.* (veralt. für: auf die Ehe bezüglich, hochzeitlich)

nur; - Gutes empfangen; - mehr (landsch. für: nur noch)

Nür|burg|ring; ↑ R 201 (Autorennstrecke in der Eifel) *m*; -[e]s

Nürn|berg (Stadt in Mittelfranken); Nürn|ber|ger (↑ R 199); Nürnberger Trichter

Nurse *engl.* [nö̱ʳß] (engl. Bez. für: Kinderpflegerin) *w*; -, -s [nö̱ʳßis] u. -n [...ß*ⁿ*n]

nu̱|scheln (ugs. für: undeutlich reden); ich ...[e]le (↑ R 327)

Nu̱ß *w*; -, Nüsse; Nu̱ß|baum; nuß-

braun; Nü̱ß|chen, Nü̱ß|lein; Nu̱ß-_.kip|ferl (österr.), ...knacker [*Trenn.*: ...knak|ker], ...ko̱h|le; Nü̱ß|li|sa|lat schweiz. (Feldsalat); Nu̱ß.scha|le (auch spött. für: kleines Schiff), ...schin|ken, ...stru|del (österr.), ...tor|te

Nü̱|ster [auch: *nü̱*...] *w*; -, -n (meist *Mehrz.*)

Nu̱t (in der Technik nur so) *w*; -, -en u. Nu̱|te (Furche, Fuge) *w*; -, -n

Nu̱|ta|ti̱|on *lat.* [...*zio̱n*] (Astron.: Schwanken der Erdachse gegen den Himmelspol; Bot.: selbsttätige Wachstumsbewegung der Pflanze)

Nu̱t|ei̱|sen; nu̱|ten

Nu̱|the (l. Nebenfluß der Havel) *w*; -

Nu̱t|ho̱|bel

Nu̱|tria *span.* ([Pelz der] Biberratte) *w*; -, -s

Nu̱|tri|me̱nt *lat.* (Med.: Nahrungsmittel) *s*; -[e]s, -e; Nu̱|tri|ti̱|on [...*zio̱n*] (Med.: Ernährung); nu̱tri|ti̱v (Med.: nährend, nahrhaft, nahrungsmäßig)

Nu̱t|sche (Chemie: Filtriereinrichtung, Trichter) *w*; -, -n; nu̱t|schen (ugs. u. mdal. für: lutschen; Chemie: durch einen Filter absaugen); du nutschst (nutschest)

Nu̱t|te (derb für: Straßenmädchen) *w*; -, -n

nu̱tz; zu nichts - sein (südd., österr. für: zu nichts nütze sein); vgl. Nichtsnutz; Nu̱tz (veralt. für: Nutzen) *m*; zu Nutz und Frommen; sich etwas zunutze machen; Nu̱tz|an|wen|dung; nu̱tz|bar -; machen; Nu̱tz|bar|keit *w*; -; Nu̱tzbar|ma|chung; Nu̱tz|bau (*Mehrz.* ...bauten); nu̱tz|brin|gend; -er, -ste; nü̱t|ze; [zu] nichts -; Nu̱tz|effekt (Nutzleistung, Wirkungsgrad); nu̱t|zen; du nutzt (nutzest) u. (häufiger:) nü̱t|zen; du nützt (nützen); es nützt mir nichts; Nu̱t|zen *m*; -s; es ist von -; Nu̱t|zer; Nu̱tz.fahr|zeug, ...flä|che, ...garten, ...holz, ...last, ...lei̱|stung; nü̱tz|lich; Nü̱tz|lich|keit *w*; -; Nü̱tz|lich|keits.den|ken, ...prin|zip, ...stand|punkt; Nü̱tz|ling (Ggs.: Schädling); nu̱tz|los; -este (↑ R 292); Nu̱tz|lo̱s|ig|keit *w*; -; nu̱tz|nie̱|ßen (selten für: von etwas Nutzen haben); du nutznießt (nutznießest); genutznießt; Nu̱tznie̱|ßer; nu̱tz|nie̱|ße|risch; Nu̱tznie̱|ßung; Nu̱tz.pflan|ze, ...satellit; Nu̱t|zung; Nu̱t|zungs|recht

Nu̱|vo|la̱|ri [...*wo*...], Tazio (it. Automobilrennfahrer)

NVA: Nationale Volksarmee (DDR)

NW = Nordwest[en] (Himmelsrichtung)

Ny (gr. Buchstabe; *N*, *v*) *s*; -[s], -s

N. Y. = New York (Staat)

Ny|lon *engl.* [*nai̱lon*] (haltbare synthet. Textilfaser) *s*; -[s], (für Strumpf auch *Mehrz.*:) -s; Ny|lon|strumpf

Nymph|chen, Nym|phäe (Seerose) *w*; -, ...äen; Nym|phä|um (Brunnentempel [in der Antike]) *s*; -s ...äen; Nym|phe ((Naturgeist; Zool.: Entwicklungsstufe [der Libelle]) *w*; -, -n; nym|phen|haft; Nym|pho|ma̱|nie̱ (krankhaft gesteigerter Geschlechtstrieb bei der Frau) *w*; -; Nym|pho|ma̱|nin (Frau, die an Nymphomanie leidet) *w*; -, -nen

Ny|norsk *norw.* (norweg. Schriftsprache, die auf den Dialekten beruht; früher Landsmål [vgl. d.] genannt) *s*; -

Ny|stag̱|mus *gr.* (Med.: Zittern des Augapfels) *m*; -

Nyx (gr. Göttin der Nacht)

O

O (Buchstabe); das O; des O, die O, aber: das o in Tor (↑ R 123); der Buchstabe O.)

o, (alleinstehend:) oh!; o ja!; o nein!; o weh!; o daß ...!; o wie das klänge!; o König!, aber mit besonderem Nachdruck (↑ R 17): Oh, das ist schade!; oh, oh!; oha!; o je!

Ö, Oe = Örsted

O = Ost[en] (Himmelsrichtung)

O = Oxygenium (chem. Zeichen für: Sauerstoff)

o. ä. = oder ähnliche[s]

O. = Omikron

Ω, ω = Omega

Ω = Ohm (elektr. Maßeinheit)

O. = Ohio

O' (,,Nachkomme'', ,,Sohn''; Bestandteil irischer Eigennamen)

ÖAAB = Österr. Arbeiter- und Angestelltenbund

ÖAMTC = Österr. Automobil-, Motorrad- und Touring-Club

Oa̱|se *ägypt.* (Wasserstelle in der Wüste) *w*; -, -n; Oa̱|sen|land-schaft

¹ob; (↑ R 119:) das Ob und Wann
²ob; mit *Wemf.* (veralt., aber noch mdal. für: oberhalb, über), z. B. - dem Walde, Rothenburg - der Tauber; mit *Wesf.*, seltener mit *Wemf.* (gehoben für: über, wegen), z. B. Ob des Glückes, ob gutem Fang erfreut sein

Ob (Strom in Sibirien) *m*; -[s]

OB = Oberbürgermeister

o. B. = ohne Befund

Ob|acht w; -; - geben; in - nehmen

Obad|ja (bibl. Prophet)

ÖBB = Österr. Bundesbahnen

Ob|dach s; -[e]s; ob|dach|los; Ob-
dach|lo|se m u. w; -n, -n († R
287ff.); Ob|dach|lo|sen.asyl,
...für|sor|ge, ...heim; Ob|dach|lo-
sig|keit w; -

Ob|duk|ti|on lat. [...zion] (Med.:
Leichenöffnung); Ob|duk|ti|ons-
be|fund; ob|du|zie|ren

Ob|edi|enz lat. (kanonischer Ge-
horsam der Kleriker gegenüber
den geistl. Oberen) w; -

O-Bei|ne († R 149) Mehrz.; O-bei-
nig

Obe|lisk gr. (freistehender Spitz-
pfeiler) m; -en, -en († R 268); Obe-
lis|ken|form; obe|lis|ken|för|mig

oben; nach, von, bis -; nach - hin;
nach - zu; von - her; von - herab;
das - Angeführte, Gesagte, Er-
wähnte (vgl. obenerwähnt); die
- angeführte, gegebene Erklä-
rung; alles Gute kommt von -;
man wußte kaum noch, was - und
was unten war; - sein, - bleiben,
- liegen, - stehen usw.; - ohne
(ugs. für: busenfrei); oben|an; -
stehen, - sitzen; oben|auf; -
schwimmen, - liegen; oben|drauf
(ugs.); - liegen; - stellen; oben-
drein; oben|drü|ber (ugs.); - legen;
oben|durch; oben|er|wähnt (ge-
nannt); († R 142:) der obener-
wähnte Dichter, aber: der [wei-
ter] oben erwähnte Dichter, der
Dichter wurde oben erwähnt; der
Obenerwähnte, aber: der [wei-
ter] oben Erwähnte, das [weiter]
oben Erwähnte; oben|ge|nannt;
vgl. obenerwähnt; oben|her; du
mußt - gehen, aber: von oben
her; oben|her|ein, aber: von oben
herein; oben|hin (flüchtig); aber:
nach oben hin; oben|hin|aus; -
wollen, aber: bis nach oben hin-
aus; Oben-oh|ne-Ba|de|an|zug
(† R 155); oben|ste|hend; († R
134:) im -en (weiter oben), aber
(† R 116:) das Obenstehende; vgl.
folgend; oben|zi|tiert; vgl. oben-
erwähnt

[1]ober österr. (über); mit Wemf.,
z. B. das Schild hängt ober der
Tür

[2]ober; vgl. obere

Ober (Spielkarte; [Ober]kellner)
m; -s, -

Ober|am|mer|gau; † R 206 (Ort am
Oberlauf der Ammer)

Ober.arm, ...arzt, ...auf|sicht,
...bau (Mehrz. ...bauten)

Ober|bay|ern († R 206)

Ober.be|fehl (m; -[e]s), ...be|fehls-
ha|ber, ...be|griff, ...be|klei|dung,
...bett, ...bür|ger|mei|ster (Abk.:
OB)

Ober|deck

ober|deutsch; vgl. deutsch; Ober-
deutsch (Sprache) s; -[s]; vgl.
Deutsch; Ober|deut|sche s; -n;
vgl. Deutsche s

Ober|dorf (oberer Teil eines Dor-
fes)

obe|re; -r Stock; die ober[e]n Klas-
sen; [1]Obe|re (Höheres) s; -n;
[2]Obe|re (Vorgesetzter) m; -n, -n
(† R 287ff.)

ober|faul (ugs. für: sehr faul)

Ober|flä|che; Ober|flä|chen.be-
hand|lung, ...schicht, ...span-
nung, ...ver|bren|nung; ober|fläch-
lich; Ober|fläch|lich|keit; Ober-
för|ster

Ober|fran|ken († R 206)

ober|gä|rig; -es Bier; Ober.ge|frei-
te, ...ge|richt (schweiz. svw. Kan-
tonsgericht), ...ge|schoß, ...ge-
wand, ...gren|ze

ober|halb; mit Wesf.; - des Dorfes

Ober|hand w; -

Ober.haupt, ...haus (Verfassungs-
wesen), ...hemd, ...herr|schaft

Ober|hes|sen († R 206)

Ober|hof|mei|ster [auch: ob[e]r-
hof...]; Ober|ho|heit

Obe|rin w; -, -nen

Ober|in|ge|nieur (Abk.: Ob.-Ing.)

ober|ir|disch

Ober|ita|li|en († R 206)

Ober.kan|te, ...kell|ner, ...kie|fer,
...kom|man|die|ren|de (m; -n, -n;
† R 287ff.), ...kir|chen|rat [auch:
ob[e]rkir...], ...kom|man|do, ...kör-
per, ...kreis|di|rek|tor [auch: ob[e]r-
kraiß...]

Ober|land s; -[e]s; Ober|län|der
(Bewohner des Oberlandes) m;
-s, -

Ober|lan|des|ge|richt [auch: ob[e]r-
la...] (Abk.: OLG)

Ober|län|ge

ober|la|stig (Seemannsspr.: zu
hoch liegender Schwerpunkt,
weil zu hoch geladen worden ist);
-es Schiff

Ober|lauf m; -[e]s

Ober|lau|sitz [auch: ...lau...]; † R
206 (westl. Teil Schlesiens u. östl.
Teil Sachsens)

Ober.le|der, ...leh|rer, ...leib, ...lei-
tung; Ober|lei|tungs|om|ni|bus
(Kurzform: Obus); Ober.leut-
nant (Abk.: Oblt.; - z. [zur] See),
...licht (Mehrz. ...lichter u. ...lich-
te), ...li|ga, ...lip|pe, ...maat

Obe|ron (König der Elfen)

Ober|öster|reich; † R 206 (österr.
Bundesland)

Ober|pfalz; † R 206 (Regierungs-
bezirk des Landes Bayern) w; -

Ober.pfar|rer, ...post|di|rek|ti|on
[auch: ob[e]rpo...], ...prä|si|dent,
...prie|ster, ...pri|ma, ...rat (Aka-
demischer -), ...rä|tin (Wissen-
schaftliche -), ...re|al|schu|le,

...re|gie|rungs|rat [auch: ob[e]rr[e]-
gi...]

ober|rhei|nisch, aber († R 198):
das Oberrheinische Tiefland

Obers bayr. u. österr. (Sahne) s; -

Ober.satz (Philos.), ...schen|kel,
...schicht; ober|schläch|tig (durch
Wasser von oben getrieben);
ober|schlau (ugs.)

Ober|schle|ma (Stadtteil von
Schneeberg im westl. Erzgebirge;
Radiumbad)

Ober|schle|si|en († R 206)

Ober.schul|amt, ...schu|le, ...schü-
ler, ...schwe|ster, ...se|kun|da

oberst; vgl. oberste; Oberst m; -en
(† R 268) u. -s, -en (seltener: -e)

Ober.staats|an|walt [auch: ob[e]r-
schtg...], ...stabs|arzt [auch: ob[e]r-
schtg...]; Ober|stadt|di|rek|tor
[auch: ob[e]rschtg...]; ober|stän|dig
(Bot.: oberhalb stehend)

Oberst|dorf (Ort in den Allgäuer
Alpen)

ober|ste; oberstes Stockwerk; die
obersten Gerichtshöfe (vgl. aber
unten); dort das Buch, das ober-
ste, hätte ich gern; († R 116:) das
Oberste zuunterst, das Unterste
zuoberst kehren; († R 224:) der
Oberste Gerichtshof; der Oberste
Sowjet (oberste Volksvertretung
der UdSSR); Ober|ste (Vorge-
setzter) m; -n, -n († R 287ff.)

Oberst.gei|ger, ...stim|me

Oberst|leut|nant [auch: ob[e]rßt-
leu...]

Ober|stock (Stockwerk) m; -[e]s,
Ober|stüb|chen, meist in: im -
nicht ganz richtig sein (ugs. für:
nicht ganz normal sein) Ober-
stu|di|en|di|rek|tor [auch: ob[e]r-
schtu...]

Ober.stu|fe, ...teil (s od. m), ...ter-
tia, ...ton (Mehrz. ...töne)

Ober|ver|wal|tungs|ge|richt [auch:
ob[e]rfärwal...]

Ober|vol|ta [...wo...] (Staat in
Westafrika); Ober|vol|ta|er;
ober|vol|ta|isch

Ober|vor|mund|schafts|ge|richt
[auch: ob[e]rfor...]

Ober|wärts (veralt. für: oberhalb)

Ober|was|ser (auch übertr. ugs. in
den Wendungen: - haben, be-
kommen: im Vorteil sein, in Vor-
teil kommen) s; -s; Ober.wei|te,
...welt (w; -)

ob|ge|nannt (österr. Amtsspr.,
sonst veralt. für: obengenannt)

ob|gleich

Ob|hut w; -

obig; († R 135:) -es; († R 134:) im
-en (weiter oben), aber († R 116):
der Obige (Abk.: d. O.), das Obi-
ge; vgl. folgend

Ob.-Ing. = Oberingenieur

Ob|jekt lat. (Ziel, Gegenstand;
österr. Amtsspr. auch: Gebäude;

Sprachw.: [Sinn-, Fall]ergänzung) *s;* -[e]s, -e; **Ob|jek|te|macher** (Kunstwiss.); **Ob|jekt**|erotik (Befriedigung des Sexualtriebs an einem Objekt); **ob|jektiv** (gegenständlich; tatsächlich; sachlich); -es Verfahren (Rechtsspr.); **Ob|jek|tiv** (bei opt. Instrumenten die dem Gegenstand zugewandte Linse) *s;* -s, -e [...*w^e*]; **Ob|jek|ti|va|ti|on** [...*wuzion*] (Vergegenständlichung); **ob|jekti|vie|ren** (vergegenständlichen); **Ob|jek|ti|vie|rung; Ob|jek|ti|vismus** [...*wiß*...] (Anerkennung gegebener Tatsachen, Wahrheiten) *m;* -; **ob|jek|ti|vi|stisch** (im Sinne des Objektivismus); -ste (↑ R 294); **Ob|jek|ti|vi|tät** (strenge Sachlichkeit; Vorurteilslosigkeit; objektive Darstellung) *w;* -; **Ob|jekt|satz** (Sprachw.: Neben-, Gliedsatz in der Rolle eines Objektes); **Ob|jekts|ge|ni|tiv; Ob|jekt.spra|che** (Sprachw.), ...**tisch**, ...**trä|ger** (Mikroskopie)

¹**Ob|la|te** *lat.* [österr.: *ob*...] (ungeweihte Hostie; dünnes Gebäck; Unterlage für Konfekt, Lebkuchen) *w;* -, -n; ²**Ob|la|te** (Laienbruder; Angehöriger einer kath. Genossenschaft) *m;* -n, -n (↑ R 268); **Ob|la|ti|on** [...*zion*] (Darreichung, Darbringung; Liebesgabe der Gemeinde [in der alten Kirche])

Ob|leu|te (*Mehrz.* von: Obmann) **ob|lie|gen** [auch, österr. nur: *opli*...]; es liegt, lag mir ob, (daneben, vor allem südd. u. österr.:) es obliegt, oblag mir; es hat mir obgelegen; obzuliegen; **Ob|lie|gen|heit**

ob|li|gat *lat.* (unerläßlich, erforderlich, unentbehrlich); mit -er Flöte (Musik); **Ob|li|ga|ti|on** [...*zion*] (veralt. für: Verpflichtung; Rechtsw.: persönl. Haftung für eine Verbindlichkeit; Wirtsch.: Schuldverschreibung); **Ob|li|ga|tio|nen|recht** (Schuldrecht; schweiz. Abk.: OR); **ob|li|ga|to|risch** (verpflichtend, bindend, verbindlich, Zwangs...); -e Stunden (Pflichtstunden); **Ob|li|ga|to|ri|um** schweiz. (verbindl. Geltung; Pflichtfach, -leistung) *s;* -s, ...ien [...*i^e n*]; **Ob|li|go** *it.* (Verbindlichkeit; Haftung; Verpflichtung) *s;* -s, -s; ohne - (unverbindlich; ohne Gewähr; Abk.: o. O.), österr.: außer -

~**ob|lique** *lat.* [*oblik*] (veralt. für: schräg, schief; Sprachw.: abhängig); -r [...*jkw^e r*] Kasus (abhängiger Fall); vgl. Casus obliquus; **Ob|li|qui|tät** [...*kwi*...] *w;* - **Ob|li|te|ra|ti|on** *lat.* [...*zion*] (Med.: Verstopfung von Hohl-

räumen, Gefäßen des Körpers) **ob|long** *lat.* (veralt. für: länglich, rechteckig)

Oblt. = Oberleutnant

Qb.macht (veralt. für: Vorherrschaft, Übermacht; *w;* -), ...**mann** (*Mehrz.* ...männer u. ...leute), ...**män|nin**

Oboe *it.* [österr.: *oboe*] (ein Holzblasinstrument) *w;* -, -n; **Obo|ist** (Oboebläser)↑ R 268

Obo|lus *gr.* (kleine Münze im alten Griechenland; übertr. für: Scherflein; kleiner Beitrag) *m;* -, - u. -se

Obo|trit (Angehöriger eines westslaw. Volksstammes) *m;* -en, -en (↑ R 268)

Obral|druck (von der Firma Oskar Brandstetter geübtes Druckverfahren; *Mehrz.* ...drucke)

Ob|rig|keit; von -s wegen; **ob|rig|keit|lich; Ob|rig|keits|staat**

Obrist (veralt. für: Oberst); ↑ R 268 **ob|schon**

Ob|ser|vant *lat.* [...*want*] (Mönch der strengeren Ordensregel) *m;* -en, -en (↑ R 268); **Ob|ser|vanz** („Beobachtung" der eingeführten Regel; Herkommen; Gewohnheitsrecht) *w;* -, -en; **Ob|ser|va|ti|on** [...*zion*] (wissenschaftl. Beobachtung in einem Observatorium); **Ob|ser|va|tor** (Beamter an einer Sternwarte) *m;* -s, ...oren; **Ob|ser|va|to|ri|um** ([astronom., meteorolog., geophysikal.] Beobachtungsstation) *s;* -s, ...ien [...*i^e n*]; **ob|ser|vie|ren** (Amtsspr. für: beobachten, prüfen, untersuchen)

Ob|si|di|an *lat.* (ein Gestein) *m;* -s, -e

ob|sie|gen [auch: *opsi*...]; ich sieg[t]e ob, (daneben, vor allem südd. u. österr.:) ich obsieg[t]e; er hat obgesiegt (auch: obsiegt); obzusiegen (auch: zu obsiegen)

ob|skur *lat.* (dunkel; unbekannt; verdächtig; unbekannter Herkunft); vgl. Clair-obscur; **Ob|sku|rant** (veralt. für: Dunkelmann, Finsterling) *m;* -en, -en (↑ R 268); **Ob|sku|ran|tis|mus** (veralt. für: Denkart der Dunkelmänner; Verdummungseifer) *m;* -; **Ob|sku|ri|tät** (Dunkelheit, Unbekanntheit)

ob|so|let *lat.* (veraltet, ungebräuchlich)

Ob|sor|ge (österr. Amtsspr., sonst veralt. für: sorgende Aufsicht) *w;* -

Obst *s;* -[e]s, (*Mehrz.:*) Obstsorten **Obst|bau** *m;* -[e]s; **Obst|bau|ge|sell|schaft; obst|bau|lich; Obst.baum**, ...**blü|te**, ...**ern|te**, ...**es|sig Ob|ste|trik** *lat.* (Med.: Geburtshilfe) *w;* -

Obst.gar|ten, ...**händ|ler ob|sti|nat** *lat.* (veraltend für: starrsinnig, widerspenstig)

Ob|sti|pa|ti|on *lat.* [...*zion*] (Med.: Verstopfung)

Obst|ku|chen; Obst|ler; Öbst|ler mdal. (Obsthändler; aus Obst gebrannter Schnaps); **Obst|le|rin**, **Öbst|le|rin** mdal. (Obstverkäuferin) *w;* -, -nen; **Qbst.mes|ser** *s*, **plan|ta|ge; obst|reich**

ob|stru|ie|ren *lat.* (hindern; entgegenarbeiten; Widerstand leisten; Med.: verstopfen); **Ob|struk|ti|on** [...*zion*] (Verschleppung [der Arbeiten], Verhinderung [der Beschlußfassung]; Verzögerungstaktik, Med.: Verstopfung, Hartleibigkeit); **Ob|struk|ti|ons.po|li|tik**, ...**tak|tik; ob|struk|tiv** (hemmend; Med.: verstopfend)

Obst.saft, ...**sa|lat**, ...**schaum|wein**, ...**sekt**, ...**tor|te**, ...**wein ob|szön** *lat.* (unanständig, schamlos, schlüpfrig); **Ob|szö|ni|tät**

Qbus (Kurzform von: Oberleitungsomnibus) *m;* Obusses, Obusse

Ob|wal|den; vgl. Unterwalden ob dem Wald; **Ob|wald|ner** (↑ R 199); **ob|wald|ne|risch**

ob|wal|ten [auch: *opwal*...]; es waltet[e] ob (selten: es obwaltet[e]); obgewaltet, obzuwalten; **ob|wal|tend;** unter den Umständen **ob|wohl; ob|zwar** (veraltend)

Oc|ca|si|on *fr.* (schweiz. für: Okkasion [Gelegenheitskauf, Gebrauchtware] *w;* -. -en

och! (ugs. für: ach!)

Och|lo|kra|tie *gr.* (Pöbelherrschaft [ein altem Griechenland]) *w;* -, ...ien; **och|lo|kra|tisch**

ochot|skisch [*oeh*...] (die sowjetruss. Stadt Ochotsk betreffend) (↑ R 198:) das Ochotskische Meer **Ochs** (österr. nur so, sonst ugs. u. mdal. für: Ochse) *m;* -en, -en (↑ R 268); **Qch|se** *m;* -n, -n (↑ R 268); **Öchs|chen, Öchs|lein; och|sen** (ugs. für: angestrengt arbeiten); du ochst (ochsest); **Och|sen-.au|ge** (landsch. auch für: Spiegelei), ...**fie|sel** (landsch. für: Ochsenziemer), ...**fleisch**, ...**frosch**, ...**kar|ren; Och|sen-maul.sa|lat; Och|sen.schlepp** (österr. für: Ochsenschwanz; *m;* -[e]s, -e); **Och|sen|schlepp|sup|pe** (österr.); **Och|sen|schwanz; Och|sen|schwanz|sup|pe; Och|sen-.tour** (ugs. für: langsame, mühselige Arbeit, [Beamten]laufbahn), ...**zie|mer;** **Och|se|rei; och|sig**

Öchs|le [nach dem Mechaniker Öchsle] (Maßeinheit für das spezif. Gewicht des Mostes) *s;* -s, -; 90° -; **Öchs|le|grad** (↑ R 180) **Öchs|lein,** Öchs|chen

Ocker[1] *gr.* (zur Farbenherstellung verwendete Tonerde) *m* od. *s*; -s, -; ocker|braun[1]; Ocker|far|be[1]; ocker|gelb[1]; ocker|hal|tig[1]

Ock|ham [*okäm*] (engl. mittelalterl. Theologe); Ock|ha|mis|mus (Lehre des Ockham) *m*; -

Oc|ta|via usw. vgl. Oktavia usw.

Od (angebliche Ausstrahlung des menschl. Körpers) *s*; -[e]s

od. = oder

öd, öde

Oda (w. Vorn.)

Odal („Besitz"; germ. Recht: Sippeneigentum an Grund und Boden) *s*; -s, -e

Oda|lis|ke *türk.* (früher: weiße türk. Haremssklavin) *w*; -, -n

Odd|fel|low *engl.* [...*fälo*[u]] (Angehöriger einer urspr. engl. humanitären Bruderschaft) *m*; -s, -s

Odds *engl.* (engl. Bez. für: Vorgaben [Sport]) *Mehrz.*

Ode *gr.* (feierliches Gedicht) *w*; -, -n

öd[e]; Öde *w*; -, -n

Odel vgl. ²Adel

Odem (dicht. für: Atem) *m*; -s

Ödem *gr.* (Gewebewassersucht) *s*; -s, -e; öde|ma|tös (ödemartig)

öden; sich -

Oden|burg (ung. Stadt)

Oden|wald (Bergland östl. des Oberrheinischen Tieflandes) *m*; -[e]s; Oden|wäl|der *m*

Odeg|on (österr. nur so) vgl. Odeum

oder (Abk.: od.); oder ähnliche[s] (Abk.: o. ä.); vgl. entweder

Oder (ein Strom) *w*; -; Oder|bruch *s*; -[e]s; Oder|haff vgl. Stettiner Haff

Oder|men|nig, Acker|men|nig (ein Heilkraut) *m*; -[e]s, -e

Oder-Nei|ße-Li|nie († R 203) *w*; -

Oder-Spree-Ka|nal († R 203) *m*; -s

Odes|sa (Hafenstadt der UdSSR am Schwarzen Meer)

Odeg|um *gr.* (Name von Gebäuden, in denen bes. musikal. Aufführungen stattfinden) *s*; -s

Odeur *fr.* [...*dör*] (wohlriechender Stoff, Duft) *s*; -s, -s u. -e

OdF = Opfer des Faschismus

Öd|heit *w*; -

Odi|lia, Odi|lie [...*i*[e]] (ältere Formen von: Ottilia usw.); Odi|lo (m. Vorn.)

Odin (nord. Form für: Wodan; vgl. d.)

odi|ös, odi|os *lat.* (gehässig; unausstehlich, widerwärtig), -este († R 292)

ödipal (Psychoanalyse); die -e Phase (Entwicklungsphase des Kindes); Ödi|pus (in der gr. Sage König von Theben); Ödi|pus|komplex (psychoanalytische Bez.)

Odi|um *lat.* (Haß, Feindschaft; Makel) *s*; -s

Öd|land (*Mehrz.* ...ländereien); Öd|nis *w*; -

Odo (m. Vorn.)

Odoa|ker (germ. Heerführer)

Odo|ar|do (it. m. Vorn.)

Odol ⓦ (Mundwasseressenz) *s*; -s; Odon|to|lo|ge *gr.* *m*; -n, -n († R 268); Odon|to|lo|gie (Zahnheilkunde) *w*; -

Odys|see (gr. Heldengedicht; übertr. für: Irrfahrt) *w*; -, (für: Irrfahrt auch *Mehrz.*) ...sseen; odys|se|isch (die Odyssee betreffend); Odys|seus [...*ßeuß*] (in der gr. Sage König von Ithaka); vgl. Ulixes, Ulysses

Oebis|fel|de [*öbißfäld*[e]] (Stadt im Bezirk Magdeburg)

OECD = Organization for Economic Cooperation and Development *engl.* [*o*[u]*g*[e]*naise'sch*[e]*n fo' ik*[u]*nomik ko*[u]*op*[e]*re'sch*[e]*n* [e]*nd diwäl'pm*[e]*nt*] (Organisation für wirtschaftliche Zusammenarbeit und Entwicklung)

Oels|nitz (Stadt im Vogtland); Oels|nitz/Erzgeb. (Stadt am Rande des Erzgebirges)

Oer|sted, Ör|sted [*örßtät*; nach dem dän. Physiker Ørsted] (Einheit der magnetischen Feldstärke; Zeichen: Oe) *s*; -[s], - ; 4 - († R 322)

Oeso|pha|gus [*ö...*] vgl. Ösophagus

Oet|ker [*öt...*] (Familienname; ⓦ)

Œu|vre *fr.* [*öwr*[e]] (franz. Bez. für: Opus) *s*; -, -s [*öwr*[e]]

Oeyn|hau|sen [*ön...*], Bad (Badeort im Ravensberger Land)

OEZ = osteuropäische Zeit

Öf|chen, Öf|lein; Ofen *m*; -s, Öfen; Ofen|bank (*Mehrz.* ...bänke); ofen|frisch (frisch aus dem Backofen); Ofen_hei|zung, ...ka|chel, ...lack, ...rohr, ...röh|re, ...set|zer, ...tür

Off *engl.* (Fernsehen: das Unsichtbarbleiben des [kommentierenden] Sprechers; Ggs.: On) *s*; -; im, aus dem - sprechen

of|fen; of|fe]ner, -ste; ein offener Brief; Beifall auf offener Bühne, Szene; eine offene Hand haben (freigebig sein); mit offenen Karten spielen (übertr. für: ohne Hintergedanken handeln); das offene Meer; offene Rücklage (Wirtsch.); offene Silbe; auf offener Straße, Strecke; Tag der offenen Tür; ein offener Wagen (ohne Verdeck); ein offener Wein (vom Faß), aber († R 224): Offene Handelsgesellschaft (Abk.: OHG). *Schreibung in Verbindung mit Zeitwörtern* († R 139): - gestanden, gesagt (frei herausgesagt); - (geöffnet; ehrlich) sein;

- (geöffnet; ehrlich) bleiben; - (allen sichtbar) halten; - (allen erkennbar) stehen; vgl. aber: offenbleiben, offenhalten, offenlassen, offenlegen, offenstehen

Of|fen|bach am Main; Of|fen|ba|cher († R 199)

of|fen|bar [auch: ...*bar*]; of|fen|ba|ren [österr.: *of* ...]; du offenbarst; offenbart (auch noch: geoffenbart); zu -: offenbart [österr.: *of*...]; Of|fen|ba|rung [österr.: *of*...]; Of|fen|ba|rungs|eid [österr.: *of*...]; Of|fen|blei|ben († R 139); das Fenster ist offengeblieben; die Entscheidung ist noch offengeblieben; aber: of|fen blei|ben (ehrlich bleiben); er ist bei der Vernehmung immer offen geblieben; of|fen|hal|ten; († R 139 (vorbehalten; offenstehen lassen); er hat sich offengehalten (vorbehalten), dorthin zu gehen; er hat das Tor offengehalten (vorbehalten) zu gehen; aber: of|fen hal|ten (frei, allen sichtbar halten); Of|fen|heit; of|fen|her|zig; Of|fen|her|zig|keit; of|fen|kun|dig [auch: ...*kun*...]; Of|fen|kun|dig|keit *w*; -; of|fen|las|sen († R 139); er hat das Fenster offengelassen; of|fen|le|gen († R 139); er hat die letzten Geheimnisse offengelegt; Of|fen|le|gung; Of|fen|markt|po|li|tik (Bankw.); of|fen|sicht|lich [auch: ...*sicht*...]; Of|fen|sicht|lich|keit *w*; -

of|fen|siv *lat.* (angreifend; angriffslustig); Of|fen|siv|bünd|nis; Of|fen|si|ve [...*w*[e]] ([militär.] Angriff) *w*; -, -n; Of|fen|siv_kampf ...krieg, ...waf|fe

Of|fen|stall; of|fen|ste|hen; † R 139 (geöffnet sein; freistehen, gestattet sein); offenstehendes Konto; das Schloß, dessen Tore offenstanden, offengestanden haben; aber: of|fen ste|hen (frei, allen erkennbar stehen); man sollte zu seiner Überzeugung offen stehen (sollte sich dazu bekennen); öf|fent|lich; -e Meinung, -e Hand; im öffentlichen Dienst († R 145;) öffentliche und Privatmittel, aber: Privat- und öffentliche Mittel; Öf|fent|lich|keit *w* -; Öf|fent|lich|keits|ar|beit (für Public Relations) *w*; -; öf|fent|lich-recht|lich; -er Vertrag

of|fe|rie|ren *lat.* (anbieten, darbieten); Of|fert (österr.) *s*; -[e]s, -e u. Of|fer|te *fr.* (Angebot, Anerbieten) *w*; -, -n; Of|fer|ten|ab|ga|be; Of|fer|to|ri|um *lat.* („Opferhandlung"; ein Hauptteil der kath. Messe) *s*; -s, ...ien [...*i*[e]*n*]

¹Of|fice *engl.* [*ofiß*] (engl. Bez. für Büro) *s*; -, -s [...*biß*]; ²Of|fice *fr.* [*ofiß*]; schweiz. (Anrichter...

¹ *Trenn.:* ...k|k...

[im Gasthaus]) *s*; -, -s [*ofißt*]; **Of|fi|zi|al** *lat.* (Beamter, bes. Vertreter des Bischofs bei Ausübung der Gerichtsbarkeit; österr. Beamtentitel, z. B. **Of|fi|zi|al|ver|tei|di|ger** (amtlich bestellter Verteidiger); **Of|fi|zi|ant** (einen Gottesdienst haltender kath. Geistlicher; veralt. für: Unterbeamter, Bediensteter) *m*; -en, -en (↑ R 268), **of|fi|zi|ell** *fr.* (amtlich; beglaubigt, verbürgt; feierlich, förmlich)

Of|fi|zier *fr.* [österr.: ...*ßir*] *m*; -s, -e; **Of|fi|ziers\|an|wär|ter**, ...**bur|sche**, ...**ka|si|no**, ...**korps**, ...**lauf|hahn**, ...**lehr|gang**, ...**mes|se**, ...**rang**, ...**schu|le**, ...**uni|form**

Of|fi|zin *lat.* ([größere] Buchdruckerei; Apotheke) *w*; -, -en; **of|fi|zi|nal**, **of|fi|zi|nell** (arzneilich; als Heilmittel anerkannt)

of|fi|zi|ös *lat.* (halbamtlich; nicht verbürgt); -este (↑ R 292); **Of|fi|zi|um** (veralt. für: [Dienst]pflicht, Obliegenheit) *s*; -s, ...ien [...*i*n*]; vgl. ex officio

off limits! *engl.* (Eintritt verboten!, Sperrzone!)

öff|nen; sich ⌐; **Öff|nung**; **Öff|nungs_win|kel**, ...**zeit**

Off|set|druck *engl.*; *dt.* (Gummidruck[verfahren]; *Mehrz.* ...drucke); **Off|set|druck|ma|schi|ne**

Ofir vgl. Ophir

Öf|lein, **Öf|chen**

O. F. M. = Ordinis Fratrum Minorum *lat.* (vom Orden der Minderbrüder; Franziskaner)

O. [F.] M. Cap. = Ordinis [Fratrum] Minorum Capucinorum *lat.* (vom Orden der Minderen Kapuziner[brüder])

O-för|mig; ↑ R 149 (in Form eines lat. O)

oft; öfter (vgl. d.); öftest (vgl. d.); so - (vgl. sooft), wie -; **öf|ter**; - als...; (↑ R 134:) des öfter[e]n; **öf|ters** (landsch. für: öfter); **öf|test**; am -en (selten für: am häufigsten) erwähnen; **oft|ma|lig**; **oft|mals**

ÖGB = Österr. Gewerkschaftsbund

Oger *fr.* (Bez. des Menschenfressers in fr. Märchen) *m*; -s, -

ogi|val *fr.* [...*wal*, auch: *oschiwal*] (selten für: spitzbogig); **Ogi|val|stil** (Baustil der [fr.] Gotik)

oh!; vgl. o; **oha!**

Oheim (veralt. für: Onkel) *m*; -s, -e; vgl. auch: ⁴Ohm

OHG = Offene Handelsgesellschaft

¹Ohio [*ohaio*] (Nebenfluß des Mississippi) *m*; -[s]; **²Ohio** (Staat in den USA; Abk.: O.)

oh, là, là! *fr.* (Ausruf der Verwunderung, Anerkennung)

¹Ohm *gr.* (frühere Flüssigkeitsmaß) *s*; -[e]s, -e; 3 - (↑ R 322)

²Ohm (dt. Physiker); **³Ohm** (Maßeinheit für den elektr. Widerstand; Zeichen: Ω) *s*; -[s], -; 4 - (↑ R 322); vgl. Ohmsch

⁴Ohm (veralt. aber noch mdal. für: Onkel; vgl. Oheim) *m*; -[e]s, -e; **Öhm** südwestd. (Oheim) *m*; -[e]s, -e

Öhmd südwestd. (das zweite Mähen, Grasnachschur) *s*; -[e]s; **öhm|den** (mdal. für: nachmähen)

O. H. M. S. = On His (Her) Majesty's Service *engl.* [- - *mädsehißtis ßö*wiß*] („Im Dienste Seiner [Ihrer] Majestät"; amtlich)

ohmsch (nach ⁷Ohm benannt); der ohmsche Widerstand (Gleichstromwiderstand), aber (↑ R 179): **Ohmsch** (von ²Ohm selbst stammend); das Ohmsche Gesetz

oh|ne; *Verhältnisw.* mit *Wenf.*: ohne ihren Willen; ohne daß (↑ R 62); ohne weiteres (↑ R 134); er kaufte ohne Zögern (↑ R 120), aber: er kaufte, ohne zu zögern; oben ohne (ugs. für: busenfrei); **oh|ne Be|fund** (Abk.: o. B.); **oh|ne|dem** (veralt. für: ohnedies); **oh|ne|dies**; **oh|ne|ein|an|der**; - auskommen; **oh|ne|glei|chen**; **Oh|ne|halt|flug**; **oh|ne|hin**; **oh|ne Jahr** (bei Druckwerken; Abk.: o. J.); **Ohne-mich-Stand|punkt** (↑ R 155); **oh|ne Ob|li|go** [auch: ...*ob*...] (ohne Verbindlichkeit; Abk.: o. O.); **oh|ne Ort** (bei Buchtitelangaben; Abk.: o. O.); **oh|ne Ort und Jahr** (bei Buchtitelangaben; Abk.: o. O. u. J.); **oh|ne wei|te|res**; **oh|ne|wei|ters** (österr. für: ohne weiteres)

Ohn|macht *w*; -, -en; **ohn|mäch|tig**; **Ohn|machts|an|fall**

oho!; **oh, oh!**

Ohr *s*; -[e]s, -en; **Öhr** (Nadelloch) *s*; -[e]s, -e; **Öhr|chen**, **Ohr|lein** (kleines Ohr; kleines Öhr)

Ohr|druf (Stadt im Bezirk Erfurt)

Oh|ren.arzt, ...**beich|te**; **oh|ren|be|täu|bend**; **Oh|ren|blä|ser** (abschätzig für: heimlicher Aufhetzer, Zuträger); **oh|ren|fäl|lig**; **Oh|ren_heil|kun|de** (*w*; -), ...**klap|pe**; **Oh|ren|klips** vgl. Ohrklips; **oh|ren|krank**; **Oh|ren_krie|cher** (Ohrwurm), ...**sau|sen** (*s*; -s), ...**schmalz**, ...**schmaus** (ugs. für: Genuß für die Ohren), ...**schmerz** (meist *Mehrz.*), ...**schüt|zer**, ...**ses|sel**, ...**zeu|ge**; **Ohr|fei|ge**; **ohr|fei|gen**; er hat mich geohrfeigt; **Ohr|fei|gen|ge|sicht** (ugs.); **Ohr|ge|hän|ge**; ...**oh|rig** (z. B.

langohrig); **Ohr|klips**, **Oh|ren|klips** (Ohrschmuck); **Ohr|läpp|chen**; **Öhr|lein**, **Ohr|chen**; **Ohr_luft|du|sche**, ...**mu|schel**, ...**ring**, ...**schmuck**, ...**spei|chel|drü|se**, ...**spü|lung**, ...**trom|pe|te**, ...**wa|schel** (österr. ugs.: Ohrläppchen; *s*; -s, -n), ...**wurm** (ugs. auch: beliebter Hit, der einem ständig in den Ohren klingt)

Oie [*eu*e*] (Insel) *w*; -, -n; Greifswalder -

Oi|strach [*eußtraeh*], David u. Igor (ukrain.-sowjet. Geiger [Vater u. Sohn])

o. J. = ohne Jahr

oje!; **oje|mi|ne!**; vgl. jemine; **oje|rum**

o. k., O. K. = okay

Oka (r. Nebenfluß der Wolga) *w*; -

Oka|pi *afrik.* (kurzhalsige Giraffe) *s*; -s, -s

Oka|ri|na *it.* (tönernes Blasinstrument) *w*; -, -s und ...nen

okay [*o**kē*] (amerik. für: richtig, in Ordnung; Abk.: o. k. od. O. K.); **Okay** *s*; -[s], -s; sein - geben

Okea|ni|de, (auch:) **Ozea|ni|de** *gr.* (Meernymphe) *w*; -, -n; **Okea|nos** [auch: *oke*...] (*gr.* Sage: Welt strom; Gott des Weltstromes)

Oker (l. Nebenfluß der Aller) *w*; -; **Oker|tal|sper|re** *w*; -; ↑ R 201

Ok|ka (früheres türk. Handels- u. Münzgewicht) *w*; -, -

Ok|ka|si|on *lat.* (veralt. für: Gelegenheit, Anlaß; Kaufmannsspr.: Gelegenheitskauf); **Ok|ka|sio|na|lis|mus** (eine philos. Lehre) *m*; -; **Ok|ka|sio|na|list** (↑ R 268); **ok|ka|sio|nell** *fr.* (veralt. für: gelegentlich, Gelegenheits...)

ok|klu|die|ren *lat.* (Zeitwort zu Okklusion); **Ok|klu|si|on** (Med.: normale Schlußbißstellung der Zähne; Meteor.: Zusammentreffen von Kalt- u. Warmfront); **ok|klu|siv**; **Ok|klu|siv** (Sprachw.: Verschlußlaut, z. B. p, t, k) *m*; -s, -e

ok|kult *lat.* (verborgen; heimlich, geheim); **Ok|kul|tis|mus** („Geheimwissenschaft"; Erforschung des Übersinnlichen) *m*; -; **Ok|kul|tist** (↑ R 268); **ok|kul|ti|stisch**

Ok|ku|pant *lat.* (im kommunist. Sprachgebrauch: jmd., der eine Okkupation unternimmt) *m*; -en, -en; **Ok|ku|pa|ti|on** [...*zion*] (Besetzung [fremden] Gebietes mit od. ohne Gewalt; Rechtsw.: Aneignung herrenlosen Gutes); **Ok|ku|pa|ti|ons|heer**; **ok|ku|pie|ren**

Okla. = Oklahoma

Okla|ho|ma (Staat in den USA; Abk.: Okla.)

Öko|lo|gie *gr.* (Lehre von den Beziehungen der Lebewesen zur Umwelt) *w*; -; **öko|lo|gisch**

¹ Beim Militär werden die Zusammensetzungen meist ohne Fugen-s gebraucht.

Öko|nom *gr.* (nur noch selten für: [Land]wirt; Verwalter) *m*; -en, -en (↑ R 268); Öko|no|mie (Wirtschaftlichkeit, sparsame Lebensführung [nur *Einz.*]; Lehre von der Wirtschaft [nur *Einz.*]; veraltet. für: Landwirtschaft[sbetrieb]) *w*; -, ...ien; Öko|no|mie|rat (österr. Titel); Öko|no|mik (bes. DDR: Produktionsweise einer Gesellschaftsordnung; Wirtschaftsverhältnisse eines Landes od. Gebietes) *w*; -; öko|no|misch; -ste (↑ R 294); -es Prinzip (Wirtsch.)

Okt. = Oktober

Ok|ta|chord *gr.* [...*kǫrt*] (achtsaitiges Instrument *s*; -[e]s, -e; Ok|ta|eder (Achtflächner) *s*; -s, -; ok|ta|edrisch; Ok|ta|gon vgl. Oktogon; Ok|tant *lat.* (,,achter Teil" des Kreises od. der Kugel; nautisches Winkelmeßgerät) *m*; -en, -en (↑ R 268); Ok|tan|zahl (Maßzahl für die Klopffestigkeit von Treibstoffen); Ok|tav (Achtelbogengröße [Buchformat]; Zeichen: 8°, z. B. Lex.-8°; österr. auch svw. Oktave) *s*; -s, -e [...*w*ᵉ]; in -; Großoktav (vgl. d.); Ok|ta|va österr. (8. Klasse des Gymnasiums) *w*; -, ...ven; Ok|tav|band *m*; ...bogen; Ok|tav|e [...*w*ᵉ], (österr.:) Oktav (achter Ton [vom Grundton an]; svw. Ottaverime; kirchl. Feier) *w*; -, -n; Ok|tav|for|mat (Achtelgröße)

Ok|ta|via, Ok|ta|vie [...*wi*ᵉ] (röm. w. Vorn.); Ok|ta|vi|an, Ok|ta|via|nus (röm. Kaiser); vgl. Augustus

ok|ta|vie|ren *lat.* [...*wir*ᵉ*n*] (bei Blasinstrumenten: in die Oktave überschlagen); Ok|tav|sieb (Elektrotechnik); Ok|tett *it.* (Musikstück für acht Stimmen od. acht Instrumente; auch: die acht Ausführenden; Achtergruppe von Elektronen in der Außenschale der Atomhülle) *s*; -[e]s, -e; Ok|to|ber *lat.* (zehnter Monat im Jahr; Gilbhard, Weinmonat, Weinmond; Abk.: Okt.) *m*; -[s] (↑ R 319), -; Ok|to|ber|fest (in München), ...re|vo|lu|ti|on (die bolschewist. Revolution im Oktober 1917 [Kalender alten Stils]); Ok|to|de|ka|gon *gr.* (Achtzehneck) *s*; -s, -e; Ok|to|dez *lat.* (Achtzehntelgröße [seltenes Buchformat]) *s*; -es, -e; Ok|to|dez|for|mat; Ok|to|gon *gr.* (Achteck; Bau mit achteckigem Grundriß) *s*; -s, -e; ok|to|go|nal (achteckig); Ok|to|po|de *gr.* (Achtfüßer [Tintenfisch]) *m*; -n, -n ↑ R 268)

Ok|troi *fr.* [...*troą*] (frühere Verbrauchssteuer auf eingeführte Lebensmittel) *m* od. *s*; -s, -s; ok|troy|ie|ren [...*troajir*ᵉ*n*] (aufdrängen, aufzwingen [dafür üblicher: aufoktroyieren]; veralt. für: verleihen)

oku|lar *lat.* (mit dem Auge, fürs Auge); Oku|lar (die dem Auge zugewandte Linse eines optischen Gerätes) *s*; -s, -e; Oku|lar|in|spek|ti|on (Med.: Besichtigung mit bloßem Auge); Oku|la|ti|on [...*zion*] (Pflanzenveredelungsart); Oku|li (,,Augen"; vierter Sonntag vor Ostern); oku|lie|ren (Pflanzen durch Okulation veredeln, äugeln); Oku|lier|mes|ser *s*; Oku|lie|rung

Öku|me|ne *gr.* (die bewohnte Erde; Gesamtheit der Christen) *w*; -; öku|me|nisch (allgemein; die ganze bewohnte Erde betreffend, Welt...); -e Bewegung (zwischen- u. überkirchl. Bestrebungen christlicher Kirchen u. Konfessionen zur Einigung in Fragen des Glaubens u. der religiösen Arbeit); -es Konzil (allgemeine kath. Kirchenversammlung; aber(↑ R 224): der Ökumenische Rat der Kirchen; Öku|me|nismus (kath. Theol.: bes. vom 2. Vatikan. Konzil gebr. Bez. für die Bemühungen um die Einheit der Christen) *m*; -

Ok|zi|dent *lat.* [auch: ...*dạnt*] (Abendland; Westen; vgl. Orient) *m*; -s; ok|zi|den|tal, ok|zi|den|ta|lisch

ö. L. = östliche Länge

Öl *s*; -[e]s, -e

Olaf (nordgerm. m. Vorn.)

Öl|alarm, ...baum; Öl|baum|bor|ken|kä|fer; Öl|be|häl|ter; Öl|berg (bei Jerusalem) *m*; -[e]s; Öl|bild, ...boh|rung

Ol|den|burg (Verwaltungsbezirk des Landes Niedersachsen); ¹Ol|den|bur|ger (↑ R 199); ²Ol|den|bur|ger (Pferd einer bestimmten Rasse) *m*; -s, -; Ol|den|bur|ger Geest (Gebiet in Niedersachsen) *w*; - -; Ol|den|burg (Hol|stein) (Stadt in Schleswig-Holstein); ol|den|bur|gisch, aber(↑ R 198): Oldenburgisches Münsterland; Ol|den|burg (Ol|den|burg) (dt. Stadt)

Ol|des|loe [...*lǫ*], Bad (Stadt in Schleswig-Holstein); Ol|des|lo|er (↑ R 199)

Öl|druck (Technik:] nur *Einz.*; [Druckw.:] *Mehrz.* ...drucke); Öl|druck|brem|se

Old|ti|mer *engl.* [*oᵘldtaim*ᵉ*r*] (Auto-, Eisenbahn-, Schiffs-, Flugzeugmodell aus der Frühzeit; auch für: langjähriges Mitglied einer Sportmannschaft od. bewährtes Rennpferd; alter Kämpe) *m*; -s, -

Olea (*Mehrz.* von: Oleum)

Ole|an|der *it.* (immergrüner Strauch od. Baum, Rosenlorbeer) *m*; -s, -; Ole|an|der|schwär|mer (ein Schmetterling)

Ole|at *gr.* (Salz der Ölsäure) *s*; -[e]s, -e; Ole|fin (ungesättigter Kohlenwasserstoff) *s*; -s, -e; ole|fin|reich; Ole|in (ungereinigte Ölsäure) *s*; -s, -e; ölen; Ole|um [*oleum*] (Öl; rauchende Schwefelsäure) *s*; -s; Ole|a (*gr.*); Öl|far|be; Öl|far|ben|druck (*Mehrz.* ...drucke); Öl|.feue|rung, ...film (dünne Ölschicht auf der Oberfläche eines anderen Stoffes), ...fleck, ...för|de|rung, ...frucht

OLG = Oberlandesgericht

Ol|ga (russ. Form von: Helga)

Öl|.ge|mäl|de, ...göt|ze (ugs. für: verständnislos dreinschauender Mensch), ...haut, ...hei|zung; öl|höf|fig (reiches Erdölvorkommen versprechend)

Oli|fant [auch: *olifạnt*] ([Rolands] ,,elfenbeinernes" Hifthorn) *m*; -[e]s, -e

ölig

Olig|ämie *gr.* (Med.: Blutarmut) *w*; -, ...ien; Olig|arch (Anhänger der Oligarchie) *m*; -en, -en (↑ R 268); Olig|ar|chie (Herrschaft einer kleinen Gruppe) *w*; -, ...ien; olig|ar|chisch; Oli|go|chä|ten [...*chä*...] (Borstenwürmer) *Mehrz.*; Oli|go|phre|nie (Med.: Schwachsinn) *w*; -, ...ien; oli|go|troph (von Ackerböden: nährstoffarm); oli|go|zän (das Oligozän betreffend); Oli|go|zän (Geol.: mittlerer Teil des Tertiärs) *s*; -s; Oli|gu|rie (Med.: verminderte Harnabsonderung) *w*; -

Olim *lat.* (,,ehemals"), nur scherzh. in: seit, zu Olims Zeiten

Öl|in|du|strie

oliv *gr.* (olivenfarben); ein - Kleid; Oliv *s*; -s, - (ugs.: -s); ein Kleid in -

Oli|va [...*wa*] (Teil der Stadt Danzig)

Oli|ve *gr.* [...*w*ᵉ], österr.: ...*f*ᵉ] (Frucht des Ölbaumes) *w*; -, -n; Oli|ven|baum; oli|ven|far|ben, oli|ven|far|big; Oli|ven|öl

Oli|ver [...*w*ᵉ*r*] (Paladin Karls d. Gr.; m. Vorn.)

Oli|vet|te *fr.* [...*wät*ᵉ] (olivenförmige, längliche Koralle; Glasperle [früher in Afrika zum Tauschhandel verwendet]) *w*; -, -n

oliv.grau, ...grün

Oli|vin *gr.* [...*wịn*] (ein Mineral) *m*; -s, -e

Öl|.kan|ne, ...ku|chen, ...lam|pe, ...lei|tung

Ol|le (landsch. für: Alte) *m* u. *w*; -n, -n (↑ R 287ff.); ol|le Ka|mel|len vgl. Kamellen

Öl|.luft|pum|pe

Olm (Lurch) *m*; -[e]s, -e

OLMA, Ol|ma = Ostschweizerische land- und milchwirtschaftliche Ausstellung (heute: Schweizerische Messe für Land- und Milchwirtschaft, St. Gallen)

Öl.ma|le|rei, ...meß|stab, ...motor, ...müh|le

Ol|mütz (tschech. Stadt)

Öl.ofen, nal|me, ...pa|pier, ...pest (Verklebung des Gefieders von Seevögeln mit Öl, die zum Tod der Vögel führt; vgl. [1]Pest), ...pflan|ze, ...raf|fi|ne|rie, ...rettich, ...sar|di|ne, ...säu|re (*w*; -); Öl|säu|re|rei|he; Öl.schicht, ...suß (Glyzerin, *s*, -es), ...tan|ker

Ol|ten (schweiz. Stadt); Ol|te|ner, Olt|ner (↑ R 199)

Ölung; die Letzte - (↑ R 224); Öl-.vor|kom|men, ...wan|ne, ...wechsel

Olymp (Gebirgsstock in Griechenland; Wohnsitz der Götter; ugs. für: Galerieplatz im Theater) *m*; -s; [1]Olym|pia (altgr. Nationalheiligtum); [2]Olym|pia (geh. für: Olympische Spiele) *s*; -[s]; Olym|pia|de (Zeitraum von vier Jahren zwischen zwei Olympischen Spielen; Olympische Spiele) *w*; -, -n; Olym|pia.dorf, ...jahr, ...kämp|fer, ...mann|schaft, ...medail|le, ...sieg, ...sie|ger, ...sie|ge-rin, ...sta|di|on, ...stadt, ...teilneh|mer; Olym|pi|er [...i*e*r] (Beiname der gr. Götter, bes. des Zeus; Gewaltiger, Herrscher in seinem Reich; gelegentlicher Beiname Goethes); Olym|pio|ni|ke (Sieger in den Olympischen Spielen; Olympiakämpfer) *m*; -n, -n (↑ R 268); Olym|pio|ni|kin *w*; -, -nen; olym|pisch (göttlich, himmlisch; die Olympischen Spiele betreffend); -e Ruhe, -e Fahne, -er Eid,-es Dorf, aber (↑ R 224): die Olympischen Spiele, Internationales Olympisches Komitee (Abk.: IOK); Nationales Olympisches Komitee (Abk.: NOK)

Olynth (altgr. Stadt); olyn|thisch, aber (↑ R 224): die Olynthischen Reden des Demosthenes

Öl.zeug, ...zweig

Oma (kindersprachl. Koseform von: Großmama) *w*; -, -s

Omai|ja|de (Angehöriger eines arab. Herrschergeschlechtes) *m*; -n, -n (↑ R 268)

Oma|ma (kindersprachl. Koseform von: Großmama) *w*; -, -s

Oman vgl. Maskat und Oman; Oma|ner; oma|nisch

Omar [auch: *om*...] (arab. Eigenn.)

Om|bro|graph *gr.* (Meteor.: Regenschreiber) *m*; -en, -en (↑ R 268)

Om|buds|mann *schwed.* (jmd., der die Rechte des Bürgers gegen-

über den Behörden wahrnimmt) *m*; -[e]s, ...männer

O. M. Cap. vgl. O. [F.] M. Cap.

Ome|ga (gr. Buchstabe [langes O]: Ω, ω) *s*; -[s], -s; vgl. Alpha

Ome|lett [*oml*...] *s*; -[e]s, -e u. -s u. (österr., schweiz. nur so:) Omelette *fr.* [...*lät*] (Eierkuchen) *w*; -, -n; Omelette aux confitures [- *o konfitür*] (mit eingemachten Früchten od. mit Marmelade gefüllter Eierkuchen); Omelette aux fines herbes [- *o finsärb*] (Eierkuchen mit Kräutern); Omelette soufflée [- *ßuflé*] (Auflauf aus Eierkuchen)

Omen *lat.* (Vorzeichen; Vorbedeutung) *s*; -s, - u. Omina; vgl. nomen est omen

Omi|kron [auch: *om*...] (gr. Buchstabe [kurzes O]: O, o) *s*; -[s], -s

Omi|na (*Mehrz.* von: Omen); ominös *lat.* (von schlimmer Vorbedeutung; unheilvoll; bedenklich; anrüchig); -este (↑ R 292)

Omis|si|on *lat.* (veralt. für: Auslassung; Unterlassung); Omis|siv|de|likt (Rechtsw.: Unterlassungsdelikt)

Om|la|di|na *slaw.* (früherer serb. Geheimbund) *w*; -

Om ma|ni pad|me hum (magischreligiöse Formel den lamaistischen Buddhismus)

om|nia ad maio|rem Dei glo|ri|am vgl. ad maiorem...

Om|ni|bus *lat.* (,,für alle''; vielsitziger Kraftverkehrswagen, Personenbeförderungsmittel; Kurzw.: Bus) *m*; -ses, -se; Om|ni|bus.bahn-hof, ...fahrt, ...li|nie; om|ni|po|tent (selten für: allmächtig, einflußreich); Om|ni|po|tenz *w*; -; Om|ni-um (Radsport: aus mehreren Bahnwettbewerben bestehender Wettkampf) *s*; -s, ...ien [...i*e*n]; Om|ni|vo|re [...*wọr*] (Zool.: ,,Allesfresser'') *m*; -n, -n (meist *Mehrz.*); ↑ R 268

Om|pha|le [*ọmfale*] (lydische Königin)

Om|pha|li|tis *gr.* (Med.: Nabelentzündung) *w*; -, ...itiden

On *engl.* (Fernsehen: das Sichtbarsein des Sprechers; Ggs.: Off) *s*; -; im -

Onan (bibl. m. Eigenn.); Ona|nie [zu Unrecht nach der bibl. Gestalt Onan] (geschlechtl. Selbstbefriedigung) *w*; -; ona|nie|ren; Ona|nist (↑ R 268); ona|ni|stisch

ÖNB = Österr. Nationalbank, Österr. Nationalbibliothek

On|dit *fr.* [*ọngdi*] (,,man sagt''; Gerücht) *s*; -, -s; einem - zufolge

On|du|la|ti|on *fr.* [...*zion*] (das Wellen der Haare mit der Brennschere); on|du|lie|ren; On|du|lie|rung

One|ga|see (in der SU) *m*; -s

Onei|da|see (See im Staate New York) *m*; -s

O'Neill [*o''nįl*] (amerik. Dramatiker)

One|ra (*Mehrz.* von: Onus)

One|step *engl.* [''*anßtäp*] (ein Tanz) *m*; -s, -s

On|kel [*onk*...] *m*; -s, - (ugs., bes. nordd. auch: -s); On|kel|ehe (volkstüml. für: Zusammenleben einer Witwe mit einem Mann, den sie aus Versorgungsgründen nicht heiraten will); on|kel|haft

On|ko|lo|gie *gr.* (Med.: Lehre von den Geschwülsten) *w*; -

ONO = Ostnordost[en]

Öno|lo|gie *gr.* (Wein[bau]kunde) *w*; -; öno|lo|gisch, Öno|ma|nie (Med.: Säuferwahnsinn) *w*; -

Ono|ma|sio|lo|gie *gr.* (Sprachw.: Bezeichnungslehre) *w*; -; Ono-ma|sti|kon *gr.* (Wörterverzeichnis der Antike u. des Mittelalters) *s*; -s, ...ken u. ...ka; ono|ma|to-poe|tisch (laut-, klang-, schallnachahmend); Ono|ma|to|pöie (Sprachw.: Bildung eines Wortes durch Lautnachahmung, Lautmalerei, z. B. ,,Kuckuck'') *w*; -, ...ien

Öno|me|ter *gr.* (Weinmesser [zur Bestimmung des Alkoholgehaltes]) *s*; -s, -

Önorm (österr. Norm)

On|ta|rio (nach dt. Ausspr., engl. Ausspr.: *ontä''rio''*] (kanad. Provinz)

On|to|ge|ne|se, On|to|ge|nie *gr.* (Biol.: Entwicklung des Einzelwesens) *w*; -; on|to|ge|ne|tisch; On|to|lo|gie (Wissenschaft vom Seienden) *w*; -; on|to|lo|gisch; -er Gottesbeweis

Onus *lat.* (veralt. für: Last; Beschwerde; Abgabe) *s*; -. Onera

Onyx *gr.* (ein Halbedelstein) *m*; -[es], -e

o. O. = ohne Obligo; ohne Ort

o. ö. = ordentlicher öffentlicher (z. B. Professor [Abk.: o. ö. Prof.])

OÖ. = Oberösterreich

Oo|ge|ne|se *gr.* [*o-o*...] (Med.: Entwicklung der Eizelle) *w*; -; oo|ge-ne|tisch; Oo|lith (ein Gestein) *m*; -s u. -en, -e[n] (↑ R 268); Oo|lo|gie (Wissenschaft vom Vogelei) *w*; -

o. ö. Prof. = ordentlicher öffentlicher Professor

o. O. u. J. = ohne Ort und Jahr

op. = opus; vgl. Opus

o. P. = ordentlicher Professor; vgl. Professor

OP = Operationssaal

O. P., O. Pr. = Ordinis Praedicatorum *lat.* - *prädika*...] (vom Predigerorden, d. h. Dominikaner)

Opa (kindersprachl. Koseform von: Großpapa) *m*; -s, -s

opak *lat.* (fachspr. für: nur durchschimmernd, undurchsichtig)

¹**Opal** *sanskr.* (ein Halbedelstein) *m*; -s, -e; ²**Opal** (ein Gewebe) *m*; -[s]; **opa|len** (aus Opal, durchscheinend wie Opal); **Opa|les|zenz** (Opalschiller) *w*; -; **opa|les|zie|ren, opa|li|sie|ren** (wie ein Opal schillern); **Opal|glas** (*Mehrz.* ...gläser)

Opan|ke *serb.* (sandalenartiger Damenschuh) *w*; -, -n

Opa|pa (kindersprachl. Koseform von: Großpapa) *m*; -s, -s

Opa|zi|tät [zu: opak] *lat.* (Optik: Undurchsichtigkeit) *w*; -

OPD = Oberpostdirektion

Opel ⓦ (Kraftfahrzeuge)

Oper *it.* *w*; -, -n; **Ope|ra** (*Mehrz.* von: Opus); **Ope|ra buf|fa** (komische Oper) *w*; - -, ...re ...ffe; **Ope|ra se|ria** (ernste Oper) *w*; - -, ...re ...rie [...*i*ᵉ]

Ope|ra|teur *fr.* [...*tör*] (eine Operation vornehmender Arzt; Kameramann; Filmvorführer; auch für: Operator) *m*; -s, -e; **Ope|ra|ti|on** *lat.* [...*zion*] (chirurg. Eingriff; militärische) Unternehmung; Rechenvorgang; Verfahren); **Ope|ra|ti|ons_ba|sis, ...saal** (Abk.: OP), ...**schwe|ster, ...tisch**; **ope|ra|tiv** (auf chirurgischem Wege, durch Operation; planvoll tätig; strategisch); -er Eingriff; **Ope|ra|tor** (jmd., der eine EDV-Anlage überwacht u. bedient) *m*; -s, ...oren; **Ope|ra|to|rin** *w*; -, -nen

Ope|ret|te *it.* (heiteres musikal. Bühnenwerk) *w*; -, -n; **ope|ret|ten|haft**; **Ope|ret|ten_kom|po|nist, ...me|lo|die, ...mu|sik, ...schla|ger**

ope|rie|ren *lat.* (einen chirurgischen Eingriff vornehmen; militärische Operationen durchführen; in bestimmter Weise vorgehen; mit etwas arbeiten)

Oper|ment *lat.* (Auripigment) *s*; -[e]s, -e

Opern_arie, ...büh|ne, ...füh|rer, ...glas (*Mehrz.* ...gläser), ...**guk|ker** (ugs. für: Opernglas); **opernhaft**; **Opern_haus, ...kom|po|nist, ...me|lo|die, ...mu|sik, ...par|ti|tur, ...sän|ger, ...sän|ge|rin**

Op|fer *s*; -s, -; **op|fer|be|reit**; **Op|fer_be|reit|schaft, ...freu|dig|keit, ...gang** *m*, ...**geist** (*m*; -[e]s), ...**geld, ...lamm, ...mut**; **op|fern** (ich ...ere (↑ R 327); sich -; **Op|fer_sinn** (*m*; -[e]s), ...**stock** (in Kirchen aufgestellter Sammelkasten; *Mehrz.* ...stöcke), ...**tier, ...tod**; **Op|fe|rung**; **Op|fer_wil|le**; **op|fer|wil|lig**; **Op|fer|wil|lig|keit**

Ophe|lia (Frauengestalt bei Shakespeare)

Ophio|la|trie *gr.* (religiöse Schlangenverehrung) *w*; -

Ophir, (ökum.:) **Ofir** *hebr.* (Goldland im A. T.)

Ophit *gr.* (Schlangenanbeter, Angehöriger einer Sekte) *m*; -en, -en (↑ R 268); **Ophi|uchus** (ein Sternbild) *m*; -

Oph|thal|mia|trie, Oph|thal|mia|trik *gr.* (Med.: Augenheilkunde) *w*; -; **Oph|thal|mie** (Med.: Augenentzündung) *w*; -, ...ien; **Oph|thal|mo|lo|ge** (Augenarzt) *m*; -n, -n (↑ R 268); **Oph|thal|mo|lo|gie** (Lehre von den Augenkrankheiten) *w*; -

Opi|at *gr.* (opiumhaltiges Arzneimittel) *s*; -[e]s, -e; **Opi|um** (aus dem Milchsaft des Schlafmohnes gewonnenes Betäubungsmittel u. Rauschgift) *s*; -s; **Opi|um|ge|setz; opi|um|hal|tig; Opi|um_han|del** (vgl. ¹Handel), ...**krieg** (*m*; -[e]s; 1840–42), ...**pfei|fe, ...rau|cher, ...schmug|gel, ...sucht** (*w*; -), ...**ver|gif|tung**

Op|la|den (Stadt in Nordrhein-Westfalen)

Op|del|dok (ein Heilmittel) *m* od. *s*; -s; **Opo|pa|nax** *gr.* [auch: *opo*..., ...*pa*...] (als Heilmittel verwendetes Pflanzenharz) *m*; -[es]

Opos|sum *indian.* (Beutelratte mit wertvollem Fell) *s*; -s, -s

Op|peln (Stadt an der oberen Oder); **Op|pel|ner** (↑ R 199)

Op|po|nent *lat.* (Gegner [im Redestreit]); ↑ R 268; **op|po|nie|ren** (entgegnen, widersprechen; sich widersetzen; gegenüberstellen)

op|por|tun *lat.* (passend, nützlich, angebracht; zweckmäßig); **Op|por|tu|nis|mus** (Anpassen an die jeweilige Lage, Handeln nach Zweckmäßigkeit) *m*; -; **Op|por|tu|nist** (↑ R 268); **op|por|tu|ni|stisch; Op|por|tu|ni|tät** (günstige Gelegenheit, Vorteil, Zweckmäßigkeit); **Op|por|tu|ni|täts|prin|zip** (ein bestimmter strafrechtlicher Grundsatz)

Op|po|si|ti|on *lat.* [...*zion*] **op|po|si|tio|nell** *fr.* (gegensätzlich; gegnerisch; zum Widerspruch neigend); **Op|po|si|ti|ons_füh|rer, ...geist** (*Mehrz.* ...geister), ...**par|tei, ...wort** (für: Antonym; *Mehrz.* ...wörter)

Op|pres|si|on *lat.* (veralt. für: Unterdrückung; Med.: Beklemmung)

Op|pro|bra|ti|on *lat.* [...*zion*] (veralt. für: Beschimpfung)

O. Pr. = Ostpr. O. P.

Op|tant *lat.* (jmd., der optiert) *m*; -en, -en (↑ R 268); **Op|ta|tiv** [auch: ...*tif*] (Sprachw.: Wunsch-, auch: Möglichkeitsform des Zeitwortes) *m*; -s, -e [...*w*ᵉ]; **op|tie|ren** (sich für etwas [bes. für eine Staatsangehörigkeit] entscheiden)

Op|tik *gr.* (Lehre vom Licht; die Linsen enthaltender Teil eines opt. Gerätes; optischer Eindruck, optische Wirkung) *w*; -, (selten:) -en; **Op|ti|ker** (Hersteller od. Verkäufer von optischen Geräten)

Op|ti|ma (*Mehrz.* von: Optimum); **op|ti|ma fi|de** *lat.* (,,in bestem Glauben"); **op|ti|ma for|ma** (,,in bester Form"); **op|ti|mal** (sehr gut, beste, Best...); **Op|ti|mat** (Angehöriger der herrschenden Geschlechter im alten Rom) *m*; -en, -en (↑ R 268); **op|ti|mie|ren** (optimal gestalten); **Op|ti|mie|rung; Op|ti|mis|mus** (Ggs.: Pessimismus) *m*; -; **Op|ti|mist** (↑ R 268); **op|ti|mi|stisch; -ste** (↑ R 294); **Op|ti|mum** (,,das Beste"; das Wirksamste; Bestwert; Biol.: beste Lebensbedingungen) *s*; -s, ...tima

Op|ti|on *lat.* [...*zion*] (Wahl einer bestimmten Staatsangehörigkeit, Entscheidungsrecht; Rechtsw.: Voranwartschaft auf Erwerb einer Sache od. das Recht zur zukünftigen Lieferung einer Sache)

op|tisch *gr.* (Licht..., Augen..., Seh...; die Optik betreffend); -e Täuschung (Augentäuschung); -e Erscheinung; **Op|to|me|ter** (Med.: Sehweitenmesser) *s*; -s, -; **Op|to|me|trie** (Med.: Sehkraftbestimmung) *w*; -

opu|lent *lat.* (reich[lich], üppig); **Opu|lenz** *w*; -

Opun|tie *lat.* [...*zi*ᵉ] (Feigenkaktus) *w*; -, -n

Opus *lat.* ([musikal.] Werk; Abk. in der Musik: op.) *s*; -, **Opera**

OR = Obligationenrecht

Ora|de *it.* (ein Fisch) *w*; -, -n

Ora|dour-sur-Glane [...*durßür-glaṇ*] (fr. Ort)

ora et la|bo|ra! *lat.* (,,bete und arbeite!" [Mönchsregel des Benediktinerordens])

Ora|kel *lat.* (Ort, an dem Götter geheimnisvolle Weissagungen erteilen; auch: die Weissagung selbst) *s*; -s, -; **ora|kel|haft; ora|keln** (weissagen); ich ...[e]le (↑ R 327); **Ora|kel|spruch**

oral *lat.* (Med.: den Mund betreffend, am Mund gelegen, durch den Mund)

oran|ge *pers.-fr.* [...*angseh*ᵉ] (goldgelb; orangenfarbig, kreß); ein -; Band; ¹**Oran|ge** (schweiz., bes. südd. u. österr. für: Apfelsine) *w*; -, -n; ²**Oran|ge** (orange Farbe) *s*; -,-(ugs.:-s); **Oran|gea|de** [*orangseh|ad*ᵉ] (Getränk aus Orangen- u. Zitronensaft) *w*; -, -n; **Oran|geat** [*orangsehat*] (eingezuckerte Apfelsinenschalen) *s*; -s, -e; **oran-**

gen [*orangseh*[e]*n*] (svw. orange);
-e Bänder; Oran|gen.baum,
...blü|te; oran|ge[n].far|ben od.
...far|big; Oran|gen.kon|fi|tü|re,
...mar|me|la|de, ...öl, ...saft,
...scha|le; Oran|ge|rie (Gewächshaus zum Überwintern von
Orangenbäumen u. a. Pflanzen)
w; -, ...ien

Orang-Utan *malai.* („Waldmensch"; Menschenaffe) *m*; -s,
-s

Ora|ni|en [...*i*[e]*n*] (niederl. Fürstengeschlecht); Ora|ni|er [...*i*[e]*r*] (zu
Oranien Gehörender) *m*; -s, -;
Oran|je (Fluß in Südafrika) *m*;
[ɔ]; Oran|je|frei|staat ↑ R 201
(Provinz der Republik Südafrika) *m*; -[e]s

ora pro no|bis! *lat.* („bitte für
uns!")

Ora|tio ob|li|qua *lat.* [...*zio* -]
(Sprachw.: indirekte Rede) *w*; -
-; Ora|tio rec|ta (Sprachw.: direkte Rede) *w*; - -; Ora|to|ria|ner *m*; -s, - (Weltpriesterkongregation); ora|to|risch (rednerisch;
schwungvoll, hinreißend); Ora|to|ri|um (Hauskapelle; Haus und
Gebetsraum der Oratorianer;
opernartiges Musikwerk [meist
mit bibl. Inhalt]) *s*; -s, ...ien [...*i*[e]*n*])

Or|bis pic|tus *lat.* („gemalte
Welt"; Unterrichtsbuch des Comenius) *m*; - -; Or|bit *engl.* (Umlaufbahn) *m*; -s, -s; Or|bi|ta *lat.*
(Med.: Augenhöhle) *w*; -, ...tae
[...*tä*]; or|bi|tal (Raumfahrt: den
Orbit betreffend, für ihn bestimmt; Med.: zur Augenhöhle
gehörend); Or|bi|tal.bahn,
...bom|be, ...ra|ke|te, ...sta|ti|on

Or|che|ster *gr.* [ɔr*käß*..., auch, bes.
österr.: *orchäß*...] (Vereinigung
einer größeren Zahl von Instrumentalisten; vertiefter Raum vor
der Bühne) *s*; -s, -; Or|che|ster.be|glei|tung, ...lei|ter *m*; Or|che|stra
[...*chäß*...] (Tanzraum des Chors
im altgr. Theater) *w*; -, ...stren;
or|che|stral [...*käß*..., auch: or-
chäß...] (zum Orchester gehörend); or|che|strie|ren (für Orchester bearbeiten, instrumentieren); Or|che|strie|rung; Or|che-
stri|on [...*chäß*...] (mechanisches
Musikinstrument bes. auf Rummelplätzen) *s*; -s, ...ien [...*i*[e]*n*]

Or|chi|dee *gr.* [*orchi*...] (eine exotische Zierpflanze) *w*; -, -n; Or|chi-
de|en|art; Or|chis (Knabenkraut)
w; -, -; Or|chi|tis (Med.: Hodenentzündung) *w*; -, ...itiden

Or|dal *angels.* (Gottesurteil) *s*; -s,
...ien [...*i*[e]*n*]

Or|den *lat.* (Vereinigung mit bestimmten Regeln; Ehrenzeichen,
Auszeichnung) *m*; -s, -; or|den.ge-
schmückt, aber (↑ R 142): mit Or-

den geschmückt; Or|dens.band
(*s*; *Mehrz.* ...bänder), ...bru|der,
...frau, ...mann (*Mehrz.* ...leute),
...mit|glied, ...re|gel, ...rit|ter,
...schwe|ster, ...span|ge, ...stern
(vgl. [2]Stern), ...tracht, ...ver|lei-
hung, ...we|sen (*s*; -s); or|dent|lich;
-es (zuständiges) Gericht; -er
öffentlicher Professor (Abk.: o. P.); -er öffentlicher Professor (Abk.: o. ö.
Prof.), -e Versammlung; or|dent-
li|cher|wei|se; Or|dent|lich|keit *w*;
-; Or|der *fr.* (veralt., aber noch
mdal. für: Befehl; Kaufmannsspr.: Bestellung, Auftrag)
w; -, -s od. -n; - parieren (einen
Befehl ausführen; ugs. für: gehorchen); Or|der.buch, ...em|gang,
...man|gel *m*; or|dern (Kaufmannsspr.: eine Order erteilen);
Or|der|pa|pier (Wertpapier, das
durch Indossament der im Papier
bezeichneten Person übertragen
werden kann); Or|di|na|le *lat.*
(seltener für: Ordinalzahl) *s*; -s,
...lia; Or|di|nal|zahl (Ordnungszahl, z. B. „zweite"); or|di|när *fr.*
(gewöhnlich, alltäglich; unfein,
unanständig); Or|di|na|ri|at *lat.*
(Amt eines ordentlichen Hochschulprofessors; eine kirchl. Behörde) *s*; -[e]s, -e; Or|di|na|ri|um
(ordentlicher Staatshaushalt) *s*;
-s, ...ien [...*i*[e]*n*]; Or|di|na|ri|us (ordentlicher Professor an einer
Hochschule) *m*; -, ...ien [...*i*[e]*n*];
Or|di|nar|preis (vom Verleger
festgesetzter Buchverkaufspreis;
Marktpreis im Warenhandel);
vgl. [2]Preis; Or|di|na|te (Math.:
auf der Ordinatenachse abgetragene zweite Koordinate eines
Punktes) *w*; -, -n; Or|di|na|ten-
ach|se (senkrechte Achse des
rechtwinkligen Koordinatensystems); Or|di|na|ti|on [...*zion*]
(Weihe, Einsetzung [eines Geistlichen] ins Amt; ärztl. Verordnung, Sprechstunde; österr. auch
für: ärztl. Behandlungsräume,
einschl. Wartezimmer usw.); Or|di|na|ti|ons.hil|fe (österr.), ...zim|mer (österr.); or|di|nie|ren (Zeitwort zu: Ordination); ord|nen;
Ord|ner; Ord|nung; - halten; Ord|nungs.amt; ord|nungs.ge|mäß,
...hal|ber (aber: der Ordnung
halber); Ord|nungs.hü|ter (spött.
für: Polizist), ...lie|be; ord|nungs-
lie|bend, aber (↑ R 142): die Ordnung liebend; Ord|nungs.po|li-
zei, ...prin|zip, ...ruf, ...sinn (*m*;
-[e]s), ...stra|fe, ...wid|rig|keit,
...zahl (für: Ordinalzahl); Or-
don|nanz *fr.* (milit.: zu dienstlichen Zwecken, bes. zur Befehlsübermittlung abkommandierter
Soldat; schweiz., sonst veralt.:
Anordnung, Befehl, Meldung) *w*;

-, -en; Or|don|nanz|of|fi|zier;
Ord|re *w*; -, -s vgl. Order
Öre (dän., norw., schwed. Münze;
100 Öre = 1 Krone) *s*; -s, -, (auch:
w; -, -); 5 - (↑ R 322)
Orea|de *gr.* (Bergnymphe des altgriech. Volksglaubens) *w*; -, -n
(meist *Mehrz.*)
Oreg. = Oregon
Ore|ga|no vgl. Origano
Ore|gon [*ɔrig*[e]*n*] (Staat in den
USA; Abk.: Oreg.)
Orest, Ore|stes (Sohn Agamemnons); Ore|stie (eine Trilogie des
Äschylus) *w*; -
ORF = Österr. Rundfunk
Or|fe *gr.* (ein Fisch) *w*; -, -n
Orff, Carl (dt. Komponist)
Or|gan *gr.* (Sinneswerkzeug, Körperteil; Sinn, Empfindung, Empfänglichkeit; Stimme; Beauftragter; Fach-, Vereinsblatt) *s*; -s, -e;
Or|gan|bank (*Mehrz.* ...banken)
Or|gan|din österr. (svw. Organdy); Or|gan|dy *engl.* (ein leichtes
Baumwollgewebe) *m*; -s
Or|ga|nell *gr.* *s*; -s, -en u. Or|ga-
nel|le (Protoplasmateile der Einzeller mit organartiger Funktion)
w; -, -n; Or|gan.emp|fän|ger,
...ent|nah|me; Or|ga|nik (Wissenschaft von den Organismen) *w*;
-; Or|ga|ni|sa|ti|on *fr.* [...*zion*]
(Anlage, Aufbau, planmäßige
Gestaltung, Einrichtung, Gliederung [nur *Einz.*]; Gruppe, Verband mit bestimmten Zielen);
Or|ga|ni|sa|ti|ons.bü|ro, ...fehler, ...form, ...ga|be, ...ge|walt,
...plan (vgl. [2]Plan), ...ta|lent; Or-
ga|ni|sa|tor *m*; -s, ...oren; or|ga-
ni|sa|to|risch; or|ga|nisch *gr.* (belebt, lebendig; auf ein Organ od.
auf den Organismus bezüglich,
zu ihm gehörend), -ste (↑ R 294);
-e Krankheit; -e Verbindung
(Chemie); or|ga|ni|sie|ren *fr.*
(auch ugs. für: sich etwas auf
nicht ganz redliche Weise verschaffen); sich -; or|ga|ni|siert (einer polit. od. gewerkschaftl. Organisation angehörend); Or|ga-
ni|sie|rung; or|ga|nis.misch (zu einem Organismus gehörend); Or-
ga|nis|mus (Gefüge; einheitliches, gegliedertes [lebendiges]
Ganzes [meist *Einz.*]; Lebewesen)
m; -, ...men; Or|ga|nist *gr.* (Kirchenmusiker, Orgelspieler); ↑ R
268; Or|ga|ni|stin *w*; -, -nen; Or-
gan.kon|ser|ve, ...kon|ser|vie-
rung, ...man|dat (österr. Amtsspr.: vom Polizisten direkt verfügtes Strafmandat); or|ga|no-
gen (Organe bildend; organischen Ursprungs); Or|ga|no|gra-
phie (Beschreibung der Organe
und ihrer Entstehung) *w*; -, ...ien;
or|ga|no|gra|phisch; Or|ga|no|lo-

gie (Med., Biol.: Organlehre; Musik: Orgel[bau]kunde) *w;* -; or|ga|no|lo|gisch

Or|gan|sin *fr.* (Kettenseide) *m* od. *s;* -s

Or|gan.spen|der, ...straf|ver|fü|gung vgl. Organmandat, ...ver|pflan|zung

Or|gan|tin österr. (svw. Organdy)

Or|gan|za *it.* (ein Seidengewebe) *m;* -s

Or|gas|mus *gr.* (Höhepunkt der geschlechtl. Erregung) *m;* -, ...men; vgl. aber: Orgiasmus; or|ga|stisch

Or|gel *gr. w;* -, -n; Or|gel.bau|er (*m;* -s, -), ...kon|zert, ...mu|sik; or|geln (veralt. für: auf der Orgel spielen; Jägerspr.: Brunstlaute ausstoßen [vom Rothirsch]); ich ...[e]le (↑ R 327); Or|gel.pfei|fe (auch übertr. scherzh. ugs. in der Wendung: wie die -n [der Größe nach]), ...punkt, ...re|gi|ster, ...spiel

Or|gi|as|mus *gr.* (ausschweifende kult. Feier in antiken Mysterien) *m;* -, ...men; vgl. aber: Orgasmus; or|gia|stisch (schwärmerisch; wild, zügellos); -ste (↑ R 294); Or|gie [...*i*ᵉ] (ausschweifendes Gelage; Ausschweifung) *w;* -, -n

Ori|ent *lat.* [*ori-änt*, auch: *oriǎnt*] (die vorder- u. mittelasiat. Länder; östl. Welt; veralt. für: Osten; vgl. Okzident) *m;* -s; (↑ R 198:) der Vordere -; Ori|en|ta|le (Bewohner der Länder des Orients) *m;* -n, -n (↑ R 268); Ori|en|ta|lin *w;* -, -nen; ori|en|ta|lisch (den Orient betreffend; östlich); -e Region (Tiergeogr.: Indien, Südchina, die Großen Sundainseln u. die Philippinen); -e Sprachen, aber (↑ R 224): das Orientalische Institut (in Rom); Ori|en|ta|list (Kenner der oriental. Sprachen u. Kulturen); ↑ R 268; Ori|en|ta|li|stik (Wissenschaft von den orientalischen Sprachen u. Kulturen) *w;* -; ori|en|ta|li|stisch; Ori|ent.ex|preß (↑ R 201); ori|en|tie|ren; sich -; Ori|en|tie|rung; Ori|en|tie|rungs.hil|fe, ...sinn (*m;* -[e]s), ...ver|mö|gen; Ori|ent.kun|de (*w;* -), ...tep|pich

Ori|ga|no *it.* (Gewürzpflanze [Dost]) *m;* -

ori|gi|nal *lat.* (ursprünglich, echt; urschriftlich); - Lübecker Marzipan; Ori|gi|nal (Urschrift; Urbild, Vorlage; Urtext; eigentümlicher Mensch, Sonderling) *s;* -s, -e; Ori|gi|nal.auf|nah|me, ...aus|ga|be, ...do|ku|ment, ...druck (*Mehrz.* ...drucke), ...fas|sung; ori|gi|nal-fran|zö|sisch (↑ R 158); Ori|gi|na|li|tät

fr. (Selbständigkeit; Ursprünglichkeit) *w;* -, (für Besonderheit, wesenhafte Eigentümlichkeit auch *Mehrz.*) -en; Ori|gi|nal-.spra|che, ...text *m,* ...zeich|nung; ori|gi|när *lat.* (ursprünglich); ori|gi|nell *fr.* (eigenartig, einzigartig; urwüchsig; komisch)

Ori|no|ko (Strom in Venezuela) *m;* -[s]

¹Ori|on (Held der gr. Sage); ²Ori|on (ein Sternbild) *m;* -[s]; Ori|on|ne|bel *m;* -s

Or|kan *karib.* (stärkster Sturm) *m;* -[e]s, -e; or|kan|ar|tig; Or|kan|stär|ke

Ork|ney|in|seln [...*ni*...] (Inselgruppe nördl. von Schottland) *Mehrz.*

¹Or|kus (in der röm. Sage Beherrscher der Unterwelt); ²Or|kus (Unterwelt) *m;* -

Or|lea|ner; ↑ R 199 (Einwohner der Stadt Orleans); Orlea|nist (Anhänger des Hauses Orleans); ↑ R 268; ¹Or|le|ans [*orleang*], (fr. Schreibung:) ¹Or|lé|ans [*orleang*] (fr. Stadt); ²Or|le|ans (ein Gewebe) *m;* -; ¹Or|lé|ans, (fr. Schreibung:) ²Or|lé|ans (Angehöriger eines Zweiges der ehem. fr. Königshauses) *m;* -, -

Or|log *niederl.* (veralt. für: Krieg) *m;* -s, -e u. -s; Or|log|schiff (früher für: Kriegsschiff)

Or|lon ⓦ *amerik.* (synthet. Textilfaser) *s;* -s; Or|lon|ge|we|be

Or|muzd (spätpers. Name für den altiran. Gott Ahura Masdah)

Or|na|ment *lat.* (Verzierung; Verzierungsmotiv) *s;* -[e]s, -e; or|na|men|tal (schmückend, zierend); or|na|men|tie|ren (mit Verzierungen versehen); Or|na|men|tik (Verzierungskunst) *w;* -; Or|na|ment|stich

Or|nat *lat.* (feierl. [kirchl.] Amtstracht) *m;* -[e]s, -e

Or|nis *gr.* (Vogelwelt [einer Landschaft]) *w;* -; Or|ni|tho|lo|ge *m;* -n, -n (↑ R 268); Or|ni|tho|lo|gie (Vogelkunde) *w;* -; or|ni|tho|lo|gisch (vogelkundlich); Or|ni|tho|phi|lie (Blütenbefruchtung durch Vögel) *w;* -

oro-...*gr.* (berg..., gebirgs...); Oro...(Berg..., Gebirgs...); Oro|ge|ne|se (Geol.: Gebirgsbildung) *w;* -, -n; Oro|ge|nie (veralt. für: Lehre von der Entstehung der Gebirge) *w;* -; Oro|gno|sie (veralt. für: Gebirgsforschung u. -beschreibung) *w;* -, ...ien; Oro|gra|phie (Geogr.: Beschreibung der Reliefformen eines Landes) *w;* -, ...ien; oro|gra|phisch; Oro|hy|dro|gra|phie (Geogr.: Gebirgs- und Wasser-

laufbeschreibung) *w;* -, ...ien; oro|hy|dro|gra|phisch; Oro|lo|gie (veralt. für: vergleichende Gebirgskunde) *w;* -; Oro|me|trie (Methode, die alle charakterist. Größen- und Formenverhältnisse der Gebirge durch Mittelwerte ziffernmäßig erfaßt) *w;* -; oro|me|trisch; Oro|pla|stik (Lehre von der äußeren Form der Gebirge) *w;* -; oro|pla|stisch

Or|phe|um *gr.* (Tonhalle; Vergnügungsstätte) *s;* -s, ...een; Or|pheus [*orfeuß*] (sagenhafter gr. Sänger); Or|phi|ker (Anhänger einer altgr. Geheimsekte) *m;* -s, -; or|phisch (geheimnisvoll)

Or|ping|ton *engl.* [...*t*ⁿn] (Huhn einer bestimmten Rasse) *s;* -s, -s

Or|plid [auch: *orplit*] (von Mörike u. seinen Freunden erfundener Name einer Wunsch- u. Märcheninsel)

Ör|sted vgl. Oersted

¹Ort (Örtlichkeit; Ortschaft) *m;* -[e]s, -e u. (Seemannsspr. u. Math. fachspr.:) Örter; geometrische Örter; am angeführten (auch: angegebenen) - (Abk.: a. a. O.); an - und Stelle; geologen -[e]s, höher|e|n -[e]s; allerorten, allerorts

²Ort (Bergmannsspr.: Ende einer Strecke, Arbeitsort) *s;* -[e]s, Örter; vor -

³Ort (schweiz. früher für: Bundesglied, Kanton) *m* od. *s;* -[e]s, -e; die 13 Alten Ort

⁴Ort (früher: vierter Teil eines Maßes od. einer Münze) *m* od. *s;* -[e]s, -e

⁵Ort ([Schuster]ahle, Pfriem; veralt., aber noch in erdkundlichen Namen für: Spitze, z. B. Darßer Ort [Nordspitze der Halbinsel Darß]) *m* od. *s;* -[e]s, -e

Ort.band (untere Zwinge [an der Säbelscheide] *s; Mehrz.* ...bänder), ...brett (mdal. für: Eckbrett)

Ört|chen, Ört|lein

Or|te|ga y Gas|set [- *i* -] (span. Philosoph u. Soziologe)

or|ten (den augenblicklichen Ort, Stand [des Flugzeuges] festlegen); Or|ter (mit dem Orten Beauftragter)

Ör|ter.bau (Bergmannsspr.: Abbauverfahren, bei dem ein Teil der Lagerstätte stehenbleibt) *m;* -[e]s; ör|tern (Bergmannsspr.: an der Schichtstrecke Örter anschlagen); ich ...ere (↑ R 327)

or|tho-...*gr.* (gerade..., aufrecht...; richtig..., recht...); Or|tho...(Gerade..., Aufrecht...; Richtig..., Recht...); Or|tho|chro|ma|sie [...*kro*...] (Fähigkeit einer fotogr. Schicht, für alle Farben außer Rot empfindlich zu sein) *w;* -;

or|tho|chro|ma|tisch; or|tho|dox (recht-, strenggläubig); -este († R 292); († R 224:) die Orthodoxe Kirche[1]; Or|tho|do|xie w; -; Or|tho|epie (Lehre von der richtigen Aussprache der Wörter) w; -; Or|tho|epik (seltener für: Orthoepie) w; -; or|tho|episch; Or|tho|ge|ne|se (Biol.: gerichtete Merkmalsumprägung im Verlauf der Stammesgeschichte) w; -, -n; Or|tho|gna|thie (Med.: gerade Kieferstellung) w; -; Or|tho|gon (Rechteck) s; -s, -e; or|tho|go|nal (rechtwinklig); Or|tho|gra|phie (Rechtschreibung) w; -, ...ien; or|tho|gra|phisch (rechtschreiblich): -er Fehler (Rechtschreibfehler); Or|tho|ke|pha|le vgl. Orthozephale; Or|tho|klas (ein Feldspat) m; -es, -e; Or|tho|pä|de (Facharzt für Orthopädie) m; -n, -n († R 268); Or|tho|pä|die (Lehre und Behandlung von Fehlbildungen und Erkrankungen der Bewegungsorgane) w; -; Or|tho|pä|die-me|cha|ni|ker, ...schuh|ma|cher; or|tho|pä|disch (Hersteller orthopädischer Geräte); † R 268; Or|tho|pte|re w; -, -n u. Or|tho|pte|ron (Geradflügler) s; -s, ...pteren (meist Mehrz.); Orth|op|ti|stin (Helferin bei der Heilbehandlung von Sehstörungen) w; -, -nen; Or|tho|sko|pie (unverzeichnete Abbildung durch Linsen) w; -; or|tho|sko|pisch (verzeichnungsfrei); Or|tho|stig|mat ([fotogr.] Objektiv) m od. s; -[e]s, -e; Or|tho|ver|bin|dung (Chemie); Or|tho|ze|pha|le (Med.: Mensch mit mittelhoher Kopfform) m u. w; -n, -n († R 287ff.); Or|tho|ze|ras (auch: ortọ...] (versteinerter Tintenfisch) m; -, ...zeren

Ort|ler (höchster Gipfel der Ortlergruppe) m; -s; Ort|ler|grup|pe (Gebirgsgruppe der Zentralalpen) w; -

ört|lich; Ört|lich|keit

Ort|lieb (m. Vorn.)

Ort|mal (veralt. für: Grenzzeichen; Mehrz. ...male u. ...mäler)

Or|to|lan it. (ein Vogel) m; -s, -e

Or|trud (w. Vorn.)

Or|trun (w. Vorn.)

Orts|an|ga|be; orts|an|säs|sig; Orts...aus|gang, ...bei|rat, ...be|stim|mung; Ort|schaft

Ort|scheit (Querholz zur Befestigung der Geschirrstränge am Fuhrwerk; Mehrz. ...scheite)

Orts...ein|gang, ...et|ter (vgl. Etter);

[1] Die Bezeichnung wird häufig nicht mehr als Name empfunden und deshalb auch klein geschrieben: orthodoxe Kirche.

orts...fest, ...fremd; Orts...ge|spräch (Telefonw.), ...grup|pe, ...kennt|nis, ...klas|se; Orts|kran|ken|kas|se; Allgemeine - († R 224; Abk.: AOK); Orts|kun|de w; -; orts|kun|dig; Orts|na|me; Orts|na|men|for|schung; Orts|netz (Telefonw.); Orts|netz|kenn|zahl (Telefonw.); Orts...po|li|zei, ...sinn (m; -[e]s), ...teil m

Ort|stein (Eckstein; durch Witterungseinflüsse verfestigte Bodenschicht)

orts|üb|lich; Orts...ver|kehr, ...wech|sel, ...zeit, ...zu|schlag

Or|tung [zu: orten]; Or|tungs|kar|te

Ort|win (m. Vorn.)

Ort|zie|gel (Dachziegel)

Os = chem. Zeichen für: Osmium

Os schwed. (Geol.: Wallberg) m (auch: s); -[es], -er (meist Mehrz.)

Osa|ka (jap. Stadt)

OSB = Ordinis Sancti Benedicti lat. („vom Orden des hl. Benedikt", d. h. Benediktiner)

Os|car amerik. (Statuette, die als Filmpreis verliehen wird) m; -[s], -[s]

Ose w; -, -n

Osel (estnische Insel)

Oser (Mehrz. von: Os)

Osi|ris (ägypt. Gott des Nils und des Totenreiches)

Os|kar (m. Vorn.)

Os|ker (Angehöriger eines idg. Volksstammes in Mittelitalien) m; -s, -; os|kisch

Os|ku|la|ti|on lat. [...zion] (Math.: Berührung zweier Kurven); os|ku|lie|ren (eine Oskulation bilden)

Os|lo (Hptst. Norwegens); vgl. Christiania u. Kristiania

Os|man (Gründer des Türk. Reiches); Os|ma|ne (Stammesgenosse Osmans, Türke) m; -n, -n († R 268); Os|ma|nen|tum s; -s; os|ma|nisch, aber († R 224): das Osmanische Reich

Os|mi|um gr. (chem. Grundstoff, Metall; Zeichen: Os) s; -s; Os|mo|lo|gie (Lehre von den Riechstoffen u. vom Geruchssinn) w; -; Os|mo|se (Übergang des Lösungsmittels einer Lösung in eine stärker konzentrierte Lösung durch eine feinporige, halbdurchlässige Scheidewand) w; -; os|mo|tisch

Os|na|brück (Stadt in Niedersachsen)

Os|ning (mittlerer Teil des Teutoburger Waldes) m; -s

OSO = Ostsüdost[en]

Öso|pha|gus (anatom. fachspr. nur:) Oeso|pha|gus [ö...] gr. (Speiseröhre) m; -, ...gi

Os|ram ® [aus: Osmium und

Wolfram] (Glühlampen, Leuchtröhren u. a.); Os|ram|lam|pe (elektrische Metalldrahtlampe)

Os|sa|ri|um, Os|sua|ri|um lat. (Beinhaus auf Friedhöfen; antike Gebeinurne) s; -s, ...ien [...i°n]

Os|ser|va|to|re Ro|ma|no [...wa... -] („Röm. Beobachter" [päpstl. Zeitung]) m; - -

Os|se|te (Angehöriger eines Bergvolkes im Kaukasus) m; -n, -n; os|se|tisch

Os|si|an [auch: oßian] (sagenhafter kelt. Barde)

Os|si|etz|ky, Carl von (dt. Publizist)

Os|si|fi|ka|ti|on lat. [...zion] (Med.: Knochenbildung, Verknöcherung); os|si|fi|zie|ren

Os|sua|ri|um vgl. Ossarium

[1]Ost (Himmelsrichtung; Abk.: O); Ost und West; (fachsprachl.:) der Wind kommt aus -; (bei Ortsnamen:) Frankfurt (Ost); vgl. Osten; [2]Ost (dicht. für: Ostwind) m; -[e]s, (selten:) -e; Ost|afri|ka; Ost|an|geln (altgerm. Volk der Jütischen Halbinsel) Mehrz.

ost|asia|tisch; Ost|asi|en; ost|bal|tisch; -e Rasse; Ost-Ber|lin († R 206), Ost|ber|li|ner († R 206); Ost|block m; -[e]s; Ost|block|land (Mehrz. ...länder), ...staat; Ost|chi|na; ost|deutsch; Ost|deutsch|land

Oste|al|gie gr. (Med.: Knochenschmerzen) w; -, ...ien

Ost|el|bi|er [...i°r] (früher für: Großgrundbesitzer und Junker); osten (nach Osten [aus]richten); Osten (Himmelsrichtung; Abk.: O) m; -s; gen Osten; († R 224:) der Ferne Osten; der Nahe Osten; vgl. Ost

Ost|en|de (Seebad in Westflandern); Ost|en|de-Wien-Ex|preß († R 203) m; ...presses

osten|si|bel lat. (veralt. für: zum Vorzeigen geeignet od. berechnet, zur Schau gestellt, auffällig, offenkundig); ...i|ble Gegenstände; osten|siv (veralt. für: augenscheinlich, handgreiflich, offensichtlich); Osten|ta|ti|on [...zion] (veralt. für: Schaustellung; Prahlerei); osten|ta|tiv (zur Schau gestellt, betont; herausfordernd, prahlend); osten|ti|ös (veralt. für: prahlerisch); -este († R 292)

Osteo|lo|gie gr. (Med.: Knochenlehre) w; -; Osteo|ma|la|zie (Med.: Knochenerweichung) w; -, ...ien; Osteo|pla|stik (Schließung von Knochenlücken durch osteoplastische Operationen); osteo|pla|stisch

Oster...brauch, ...ei, ...fest; Oster-

fest|streit (Streit über den Termin des Osterfestes im 2. Jahrhundert) *m*; -[e]s; Oster_feu|er, ...glocke [*Trenn.*: ...glok|ke], ...ha|se

Oste|ria (Wirtshaus, Schenke [in Italien]) *w*; -, -s u. ...ien

Oster_in|sel (im Pazif. Ozean, *w*; -), ...lamm; öster|lich; Oster|lu|zei [auch: *ost_rluzai*] (Schlinggewächs) *w*; -, -en; Oster_marsch *m*, ...mar|schie|rer, ...mes|se, ...mo|nat od. ...mond (alte Bezeichnung für: April), ...mon|tag; Ostern (Osterfest) *s*; -; - fällt früh; - ist bald vorbei; (landsch., bes. österr. u. schweiz. als *Mehrz.*:) die[se] - fallen früh; nach den -; (in Wunschformeln auch allg. als *Mehrz.*:) fröhliche -!; zu -, (landsch., bes. südd. auch:) an- Öster|reich, Öster|rei|cher; öster|rei|chisch, aber (↑ R 224): die Österreichischen Bundesbahnen; öster|rei|chisch-un|ga|risch; -e Monarchie, aber (↑ R 224): die Österreichisch-Un|garn (ehem. Doppelmonarchie) Oster_sonn|tag, ...ver|kehr, ...was|ser (*s*; -s), ...wo|che Ost|eu|ro|pa; ost|eu|ro|pä|isch; -e Zeit (Abk.: OEZ); Ost|fa|le (Angehöriger eines altsächsischen Volksstammes) *m*; -n, -n (↑ R 268); Ost|flan|dern (belg. Prov.); Ost|flücht|ling; Ost|fran|ken (hist.); ost|frie|sisch, aber (↑ R 198): die Ostfriesischen Inseln; Ost|fries|land; ost|ger|ma|nisch Ostia (Hafenstadt des alten Roms) osti|nat, osti|na|to *it.* (Musik: stetig wiederkehrend, ständig wiederholt [vom Baßthema]) Ost|in|di|en; ost|in|disch; -e Waren, aber (↑ R 224): die Ostindische Kompanie (frühere Handelsgesellschaft); ostisch; -e Rasse (auch alpine Rasse genannt) Osti|tis *gr.* (Med.: Knochenentzündung) *w*; -, ...itiden Ost|ja|ke (Angehöriger eines finn.-ugr. Volkes in Westsibirien) *m*; -n, -n (↑ R 268) Ost|kir|che, ...kü|ste; öst|lich; - des Waldes, - vom Wald; -er Länge (Abk.: ö. L.); Ost|mark (hist.); [1]Ost|nord (Himmelsrichtung; Abk.: ONO); vgl. Ostnordosten; [2]Ost|nord|ost (Ostnordostwind; Abk.: ONO) *m*; -[e]s, -e; Ost|nord|osten (Abk.: ONO) *m*; -s; vgl. Ostnordost; Ost|po|li|tik; Ost|preu|ßen; ost|preu|ßisch Ostra|ko|de *gr.* (Muschelkrebs) *m*; -n, -n (↑ R 268); Ostra|zis|mus (Scherbengericht, altathen. Volksgericht) *m*; - Östro|gen *gr.* (Follikelhormon) *s*; -s, -e



Ost|rom; ost|rö|misch, aber (↑ R 224): das Oströmische Reich Ostrow|ski (russ. Dramatiker) Ost|see *w*; - [1]Ost|süd|ost (Himmelsrichtung; Abk.: OSO); vgl. Ostsüdosten; [2]Ost|süd|ost (Ostsüdostwind; Abk.: OSO) *m*; -[e]s, -e; Ost|süd|osten (Abk.: OSO) *m*; -s; vgl. Ostsüdost; Ostung [zu: osten] *w*; - Ost|wald (dt. Chemiker); -sche Farbenlehre ost|wärts; Ost-West-Ge|spräch *s*; -[e]s, -e; ↑ R 155; Ost|wind Os|wald (m. Vorn.); Os|win (m. Vorn.) Os|zil|la|ti|on *lat.* [...*zion*] (Physik: Schwingung); os|zil|lie|ren (schwingen, pendeln, schwanken); Os|zil|lo|gramm *lat.*; *gr.* (Physik: Schwingungsbild); Os|zil|lo|graph (Physik: Schwingungsschreiber) *m*; -en, -en (↑ R 268) Ota (mittelgr. Gebirge) *m*; -[s] Otal|gie *gr.* (Med.: Ohrenschmerz) *w*; -, ...ien Ot|fried (m. Vorn.) Othel|lo (Titelheld bei Shakespeare) Oth|mar vgl. Otmar Otho (röm. Kaiser) Oti|ia|trie *gr.* (Med.: Ohrenheilkunde) *w*; -; Oti|tis (Ohrenentzündung) *w*; -, ...itiden Ot|mar, Oth|mar (↑ R 191); Ot|to|mar (m. Vorn.) Oto|lith *gr.* ("Gehörsteinchen" im Gleichgewichtsorgan des Ohres) *m*; -s, -e; Oto|lo|gie (sw. Otiatrie) *w*; -; Oto|phon (Schallverstärker für Schwerhörige, Hörrohr) *s*; -s, -e; Oto|skop (Med.: Ohrenspiegel) *s*; -s, -e Öt|scher (Berg in Niederösterreich) *m*; -s Ot|ta|ve|ri|me *it.* [...*we*...] (Stanze) *Mehrz.* [1]Ot|ta|wa (Fluß in Kanada) *m*; -[s]; [2]Ot|ta|wa (Hptst. Kanadas); [3]Ot|ta|wa (Angehöriger eines nordamerik. Indianerstammes) *m*; -[e]s, -[s] [1]Ot|ter (eine Marderart) *m*; -s, -; [2]Ot|ter (eine Schlange) *w*; -, -n; Ot|tern|brut, ...ge|zücht (bibl.) Ot|ter|spitz|maus (ein Wassertier) Ot|ter|zun|ge (versteinerter Fischzahn) Ott|hein|rich (m. Vorn.) Ott|ti|lia, Ott|ti|lie [...*i*ⁿ] (w. Vorn.); Ot|to (m. Vorn.); Ot|to|kar (m. Vorn.) Ot|to|man *türk.* (ein Ripsgewebe) *m*; -s, -e; [1]Ot|to|ma|ne (veraltet für: niedriges Sofa) *w*; -, -n; [2]Ot|to|ma|ne *m*; -n, -n (↑ R 268); vgl. Osmane; ot|to|ma|nisch; vgl. osmanisch



Ot|to|mar vgl. Otmar Ot|to|mo|tor ⚙ ↑ R 180 [nach dem Ingenieur Nikolaus Otto] (Vergasermotor) Ot|to|ne (Bez. für einen der sächsischen Kaiser Otto I., II. und III.) *m*; -n, -n (↑ R 268); ot|to|nisch Ötz|tal; Ötz|ta|ler; - Alpen out *engl.* [*aut*] (österr., sonst veralt. für: aus, außerhalb des Spielfeldes [bei Ballspielen]; unzeitgemäß, unmodern); Out *s*; -[s], -[s] Out|law [*autlâ*] (Geächteter, Verfemter, Verbrecher) *m*; -[s], -s; Out|li|nie (österr. Sportspr.); Out|put *engl.* (Wirtsch.: Produktion[smenge], Ausbringung, -stoß; EDV: Arbeitsergebnisse einer Datenverarbeitungsanlage, Ausgabe) *s*; -s, -s ou|trie|ren *fr.* [*ut*...] (selten für: übertreiben); Ou|trie|rung Out|si|der *engl.* [*autßaid*ⁿ*r*] ("Außenseiter") *m*; -s, -; Out|wach|ler österr. ugs. (Linienrichter) Ou|ver|tü|re *fr.* [*uwär*...] (Eröffnung; Vorspiel [einer Oper u. a.]) *w*; -, -n oval *lat.* [*ow*...] (eirund, länglichrund); Oval (Ei-, Langrund) *s*; -s, -e; Ova|ri|um *lat.*; *gr.* (Biol., Med.: Eierstock) *s*; -s, ...ien [...*i*ⁿ*n*] Ova|ti|on *lat.* [*owazion*] (Huldigung, Beifallskundgebung) Over|all *engl.* [*o*ⁿ*w*ⁿ*râl*, österr.: ...*al*] (Schutz-, Überziehanzug für Mechaniker, Sportler u. a.) *m*; -s, -s Ovid [*owit*] (röm. Dichter); ovi|disch, aber (↑ R 179): Ovi|disch ovi|par *lat.* [*owi*...] (Biol.: eierlegend, sich durch Eier fortpflanzend); ovo|id, ovo|idisch *lat.*; *gr.* (Biol.: eiförmig); ovo|vi|vi|par *lat.* [*owowiwi*...] (Biol.: Eier legend, die schon sehr weit entwickelt sind) ÖVP = Österreichische Volkspartei Ovu|la|ti|on *lat.* [...*zion*] (Biol.: Ausstoßung des reifen Eies aus dem Eierstock); Ovu|la|ti|ons|hem|mer Owen [*au*ⁿ*n*] (Stadt in Baden-Württemberg) Oxa|lit *gr.* (ein Mineral) *m*; -s, -e; Oxal|säu|re *gr.*; *dt.* (Kleesäure) *w*; - Oxen|stier|na [*ukß*ⁿ*nschärna*] (schwed. Familienn.) Oxer *engl.* (Hindernis zwischen Viehweiden; Pferdesport: Hindernis bei Springprüfungen) *m*; -s, - Ox|ford (engl. Stadt) Ox|hoft (früheres Flüssigkeitsmaß) *s*; -[e]s, -e; 10 - (↑ R 322)

Oxid usw. vgl. Oxyd usw.

oxy... gr. (scharf...; sauerstoff...), Oxy... (Scharf...; Sauerstoff...); Oxyd, (chem. fachspr.:) Oxid (Sauerstoffverbindung) s; -[e]s, -e; Oxy|da|ti|on (chem. fachspr.:) Oxi|da|ti|on [...zion], Oxy|die|rung, (chem. fachspr.:) Oxi|die|rung (Tätigkeit, auch Ergebnis des Oxydierens); oxy|die|ren, (chem. fachspr.:) oxi|die|ren (sich mit Sauerstoff verbinden; Sauerstoff aufnehmen, verbrennen); oxy|disch, (chem. fachspr.:) oxi|disch; Oxy|gen, Oxy|ge|ni|um (Sauerstoff); chem. Grundstoff; Zeichen: O) s; -s; Oxy|hä|mo|glo|bin gr.; lat. (sauerstoffhaltiger Blutfarbstoff); Oxy|mo|ron gr. (Zusammenstellung zweier sich widersprechender Begriffe als rhet. Figur, z. B. „bittersüß“) s; -s, ...ra; Oxy|to|non (gr. Sprachw.: auf der letzten Silbe betontes Wort) s; -s, ...na

Oza|lid ⓦ (Papiere, Gewebe, Filme mit lichtempfindlichen Emulsionen); Oza|lid..pa|pier, ...ver|fah|ren

Oze|an gr. (Weltmeer; Teile des Weltmeeres) m; -s, -e; der große (endlos scheinende) -, aber (↑ R 198): der Große (Pazifische) -; Ozea|naut (svw. Aquanaut) m; -en, -en; Oze|an|damp|fer; Ozea|ni|de (Okeanide; Oze|ni|en [...i*n] (Gesamtheit der Pazifikinseln bei den Wendekreisen); ozea|nisch (Meeres...; zu Ozeanen gehörend); Ozea|ni|tät (Geogr.: Abhängigkeit des Küstenklimas von den großen Meeresflächen) w; -; Ozea|no|gra|phie (Lehre von den Ozeanen usw., Meereskunde) w; -; ozea|no|gra|phisch

Ozel|le lat. (Zool.: Lichtsinnesorgan niederer Tiere) w; -, -n

Oze|lot aztek. [auch: oz...] (ein Raubtier Nord- u. Südamerikas; auch Bez. für den Pelz m; -s, -e

Ozo|ke|rit gr. (Erdwachs; natürlich vorkommendes mineralisches Wachs) m; -s

Ozon gr. (besondere Form des Sauerstoffs) s (ugs.: m); -s; Ozonge|halt m; -[e]s; ozon|hal|tig, (österr.:) ozon|häl|tig; ozo|ni|sie|ren (mit Ozon behandeln); ozon|reich

P

P (Buchstabe); das P; des P, die P, aber: das p in hupen (↑ R 123); der Buchstabe P, p

p = ¹Para; Penni; Penny (nur für den neuen Penny im engl. Dezimalsystem); piano; Pico..., Piko...; Pond; typographischer Punkt

P (auf dt. Kurszetteln) = Papier (dasselbe wie: B; vgl. d.); chem. Zeichen für: Phospor; Poise

p. = pinxit

p., pag. = pagina (vgl. Pagina)

П, *π* = ¹Pi; *π* = ²Pi

P. = Pastor; Pater; ²Papa

Pa = chem. Zeichen für: Protactinium

Pa. = Pennsylvanien

p. a. = pro anno

p. A. = per Adresse, besser: bei

PAA = Pan American World Airways System [*pän* ⁱ*märik*ᵉ*n wö'ld ä'we's ßißt*ᵉ*m*] (amerik. Luftverkehrsgesellschaft)

Pä|an gr. (feierl. altgr. [Dank-, Preis]lied) m; -s, -e

¹paar lat. (einige; ↑ R 131); ein - Leute, mit ein - Worten; ein - Dutzend Male, aber: ein - dutzendmal; ein paar Male, aber: ein paarmal (vgl. ¹Mal); die - Groschen; ²paar (gleich); -e Zahlen; - oder unpaar; Paar (zwei zusammengehörende Personen od. Dinge) s; -[e]s, -e; ein - Schuhe; ein - neue[r] Schuhe; für zwei - neue[r] Schuhe; mit einem - Schuhe[n]; mit einem - wollenen Strümpfen oder wollener Strümpfe; mit etlichen - Schuhen; mit zwei - neuen Schuhen od. neuer Schuhe; zu Paaren treiben (veralt. für: bändigen, bewältigen); Paar|bil|dung; paa|ren; sich -; Paar|hu|fer; paa|rig (paarweise vorhanden); Paa|rig|keit w; -; Paar|lauf; paar|lau|fen (nur in der Grundform u. im 2. Mittelw. gebr.); paar|mal; ein -; Paa|rung; paa|rungs|be|reit; paar|wei|se; Paar|ze|her

Pace engl. [pe'ß] (Gangart des Pferdes; Renntempo [eines Pferderennens]) w; -

Pacht w; -, -en; pach|ten; Päch|ter; Päch|te|rin w; -, -nen; Pacht..geld, ...gut, ...sum|me; Pacht|jung Pacht|ver|trag; pacht|wei|se; Pacht|zins (Mehrz. ...zinsen)

Pa|chul|ke slaw. landsch. (ungehobelter Bursche, Tölpel; veralt. für: Setzergehilfe [Druckw.]) m; -n, -n (↑ R 268)

¹Pack (Gepacktes; Bündel) m; -[e]s, -e u. Päcke; ²Pack (verächtl.: Pöbel) s; -[e]s; Package¹ Tour engl. [*päkidsch tur*] (durch ein Reisebüro vorbereitete Reise im eigenen Auto mit vorher bezahlten Unterkünften u. sonsti-

gen Leistungen) w; - -, - -s; Päck-chen, Päck|lein; Pack|eis (übereinandergeschobenes] Schollen-eis in den Polarländern); Packe|lei¹ österr. ugs. (heimliche Übereinkunft, fauler Kompromiß), packeln¹ österr. ugs. („paktieren“, [heimlich] verabreden, übereinkommen); ich ...[e]le (↑ R 327); Päckeln¹ österr. ugs. (Fußballochuhe) *Mehrz.*; packon¹; Packen¹ m; -s, -; Packer¹; Packe-rei¹; Packe|rin¹ w; -, -nen; Pack-esel (verächtl. für: jmd., dem alles aufgepackt wird)

Pack|fong chin. (im 18. Jh. aus China eingeführte Kupfer-Nik-kel-Zink-Legierung) s; -s

Pack|ki|ste; Päck|lein, Päck|chen; Pack..lein|wand, ...pa|pier, ...raum, ...trä|ger (veralt.); Packung¹; Pack..wa|gen, ...werk, ...zet|tel

Päd|ago|ge gr. (Erzieher; Lehrer; Erziehungswissenschaftler) m; -n, -n (↑ R 268); Päd|ago|gik (Erziehungslehre, -wissenschaft) w; -; päd|ago|gisch (erzieherisch); -e Fähigkeit; [eine] -e Hochschule, aber (↑ R 224): die Pädagogische Hochschule [Abk.: PH] in Münster; päd|ago|gi|sie|ren; Päd|ago|gi|um (früher: Vorbereitungsschule für das Studium an einer pädagog. Hochschule) s; -s, ...ien [...i*n]

Pad|del engl. (freihändig geführtes Ruder mit schmalem Blatt) s; -, -; Pad|del|boot; Pad|del|boot-fahrt; pad|deln; ich ...[e]le (↑ R 327); Padd|ler

Pad|dock engl. [pädok] (Laufgarten für Pferde) m; -s, -s

¹Pad|dy malai.-engl. [pädi] (ungeschälter, noch mit Spelzen behafteter Reis) m; -s

²Pad|dy [pädi] (engl. Koseform zum Vorn. Patrick; Spitzname des Irländers) m; -s, -s u. ...dies [*pädis*]

Päd|erast gr. (der Knabenliebe Ergebener) m; -en, -en (↑ R 268); Päd|era|stie w; -

Pa|der|born (Stadt in Nordrhein-Westfalen)

Päd|ia|ter gr. (Kinderarzt) m; -s, -; Päd|ia|trie (Kinderheilkunde) w; -; päd|ia|trisch

Pa|di|schah pers. (früher: Titel islamit. Fürsten) m; -s, -s

Pä|do|ge|ne|se, Pä|do|ge|ne|sis gr. [auch: ...gen...] (Fortpflanzung im Larvenstadium) w; -

Pa|dro|na it. (it. Bez. für: Gebieterin; Wirtin; Hausfrau) w; -, ...ne; Pa|dro|ne it. (it. Bez. für: Herr; Chef; Besitzer) m; -s, ...ni

¹ Trenn.: ...k|k...

Pa|dua (it. Stadt); Pa|dua|ner (↑ R 199); pa|dua|nisch

Pa|el|la *span.* [*paǻlja*] (span. Reisgericht mit versch. Fleisch- u. Fischsorten, Muscheln u. a.) *w*; -, -s

Pa|fel (Nebenform von: Bafel)

Pa|fe|se *it.* bayr. u. österr. (gebackene Weißbrotschnitte, armer Ritter) *w*; -, -n (meist *Mehrz.*)

paff!; piff, paff!; piff, paff, puff!

paf|fen (ugs. für: [schnell u. stoßweise] rauchen)

pag., p. = pagina (vgl. Pagina)

Pa|ga|ni|ni (it. Geigenvirtuose u. Komponist)

Pa|ga|nis|mus *lat.* (Heidentum; auch für: heidnische Elemente im christl. Glauben u. Brauch) *m*; -

Pa|gat *it.* (Karte im Tarockspiel) *m*; -[e]s, -e; pa|ga|to|risch (Wirtsch.: auf Zahlungsvorgänge bezogen)

Pa|ge *fr.* [*paʃeᵉ*] (früher: Edelknabe; heute: uniformierter junger Diener, Laufbursche) *m*; -n, -n (↑ R 268); Pa|gen|dienst, ...kopf

Pa|gi|na *lat.* (veralt. für: [Buch-, Blatt]seite; Seitenzahl; Abk.: p. od. pag.) *w*; -, -s; pa|gi|nie|ren (mit Seitenzahl[en] versehen); Pa|gi|nie|ma|schi|ne

¹Pa|go|de *drawid.-port.* (,,heiliges Haus''; [buddhist.] Tempel in Indien, China u. Japan) *w*; -, -n; ²Pa|go|de (veralt., aber noch österr. für: ostasiat. Götterbild; kleine sitzende Porzellanfigur mit beweglichem Kopf) *w*; -, -n od. *m*; -n, -n (↑ R 268); Pa|go|den...är|mel, ...dach, ...kra|gen (aus mehreren in Stufen übereinandergelegten Teilen bestehender Kragen)

pah!, bah! (ugs.)

pail|le *fr.* [*paj̓ᵉ*] (veralt. für: strohfarben, -gelb; Pail|let|te [*pajät*] (glitzerndes Metallblättchen zum Aufnähen, Flitter) *w*; -, -n (meist *Mehrz.*)

Pair *fr.* [*pär*] (früher: Mitglied des höchsten fr. Adels) *m*; -s, -s; vgl. Peer; Pai|rie (Würde eines Pairs) *w*; -, ...ien; Pairs|wür|de

Pak (Kurzw. für: Panzerabwehrkanone) *w*; -, -[s]

Pa|ket *n*; -[e]s, -e; Pa|ket_adres|se, ...boot; pa|ke|tie|ren (zu einem Paket machen, verpacken); Pa|ke|tier|ma|schi|ne; Pa|ket_kar|te, ...post, ...zu|stel|lung

Pa|ki|stan (Staat in Vorderasien); Pa|ki|sta|ner; Pa|ki|sta|ni (Pakistaner) *m*; -[s], -[s]; pa|ki|sta|nisch

Pa|ko *indian.-span.* (svw. ¹Alpaka) *m*; -s, -s

Pakt *lat.* (Vertrag; Bündnis); *m*; -[e]s, -e; pak|tie|ren (Vertrag schließen; gemeinsame Sache machen)

pa|lä|ark|tisch *gr.* (altarktisch); -e Region (Tiergeogr.: Europa, Nordafrika, Asien außer Indien)

Pa|la|din *lat.* [auch: *pa...*] (Angehöriger des Heldenkreises am Hofe Karls d. Gr.; Hofritter; Berater des Fürsten; treuer Gefolgsmann) *m*; -s, -e; Pa|lais *fr.* [*palä*] (Palast, Schloß) *s*; - [*palä́ß*], - [*pa-läß*]

Pa|lan|kin *Hindi* (Tragsessel; Sänfte) *m*; -s, -e u. -s

pa|läo... *gr.* (alt..., ur...); Pa|läo... (Alt..., Ur...); Pa|läo|bio|lo|gie (Biologie ausgestorbener Lebewesen), ...bo|ta|nik (Botanik ausgestorbener Pflanzen), ...geo|gra|phie (Geographie der Erdgeschichte, ein Zweig der Geologie); Pa|läo|graph (Wissenschaftler auf dem Gebiet der Paläographie) *m*; -en, -en (↑ R 268); Pa|läo|gra|phie (Lehre von den Schriftarten des Altertums u. des MA., auch: Handschriftenkunde) *w*; -; pa|läo|gra|phisch; Pa|läo|hi|sto|lo|gie (Lehre von den Geweben der fossilen Lebewesen), ...kli|ma|to|lo|gie (Lehre von den Klimaten der Erdgeschichte); Pa|läo|li|then (Steinwerkzeuge des Paläolithikums) *Mehrz.*; Pa|läo|li|thi|kum (Altsteinzeit) *s*; -s; pa|läo|li|thisch; Pa|läo|on|to|lo|ge *m*; -n, -n (↑ R 268); Pa|lä|on|to|lo|gie (Lehre von den Lebewesen vergangener Erdperioden); pa|lä|on|to|lo|gisch; Pa|läo|phy|ti|kum (Altpflanzenzeit der Erde) *s*; -s; Pa|läo|zoi|kum (,,Alttierzeit'', erdgeschichtl. Altertum [Kambrium bis Perm]) *s*; -s; pa|läo|zo|isch; Pa|läo|zoo|lo|gie (Zoologie der fossilen Tiere) *w*; -

Pa|las *lat.* (Hauptgebäude der Ritterburg) *m*; -, -se; Pa|last (schloßartiges Gebäude) *m*; -es, Paläste; Pa|last_da|me (frühere Bez. für die fr. Hofdame), ...re|vo|lu|ti|on, ...wa|che

Pa|lä|sti|na (Gebiet zwischen Mittelmeer u. Jordan); Pa|lä|sti|na_for|schung, ...pil|ger; Pa|lä|sti|nen|ser; pa|lä|sti|nen|sisch, pa|lä|sti|nisch

Pa|lä|stra *gr.* (altgr. Ring-, Fechtschule) *w*; -, ...stren

pa|la|tal *lat.* (den Gaumen betreffend, Gaumen...); Pa|la|tal *m*; -s, -e u. Pa|la|tal|laut (Sprachw.: am vorderen Gaumen gebildeter Laut, Vordergaumenlaut, z. B. k)

¹Pa|la|tin *lat.* (ein Hügel in Rom) *m*; -s; ²Pa|la|tin (Pfalzgraf) *m*; -s, -e; Pa|la|ti|na (Heidelberger [kurpfälzische] Bücherei) *w*; -; Pa|la|ti|nat (Pfalz[grafschaft]) *s*; -[e]s, -e; Pa|la|ti|ne (nach der Pfalzgräfin Elisabeth Charlotte genannte frühere Ausschnittumrandung aus Pelz u. a.) *w*; -, -n; pa|la|ti|nisch (pfälzisch), aber (↑ R 198): der Palatinische Hügel (in Rom)

Pa|la|tschin|ke *ung.* österr. (gefüllter Eierkuchen) *w*; -, -n (meist *Mehrz.*)

Pa|la|ver *lat.-port.-engl.* [*...wᵉr*] ([Neger]versammlung; übertr. ugs. für: endloses Gerede u. Verhandeln) *s*; -s, -; pa|la|vern; sie haben palavert

Pa|le mdal. (Schote, Hülse) *w*; -, -n

Pale Ale *engl.* [*pe̓l e̓l*] (helles engl. Bier) *s*; - -

pa|len mdal. ([Erbsen] aus den Hülsen [Palen] lösen)

Pal|eo|zän *gr.* (Geol.: unterste Abteilung der Tertiärformation) *s*; -s

Pa|ler|mer (↑ R 199); pa|ler|misch; Pa|ler|mo (Stadt auf Sizilien)

Pa|le|stri|na (it. Komponist)

Pa|le|tot *fr.* [*palᵉto*, österr.: *paltó*] (veralt. für: doppelreihiger Herrenmantel mit Samtkragen; heute allg. für: dreiviertellanger Damen- od. Herrenmantel) *m*; -s, -s

Pa|let|te *fr.* (Mischbrett für Farben; genormtes Lademittel für Stückgüter [Eisenbahn]; übertr. für: bunte Mischung) *w*; -, -n; pa|let|tie|ren (Versandgut auf einer Palette [Eisenbahn] stapeln u. von dort verladen)

Pa|li (Schriftsprache der Buddhisten Ceylons u. Hinterindiens) *s*; -[s]

pa|lim..., pa|lin... *gr.* (wieder...); Pa|lim..., Pa|lin... (Wieder...); Pa|lim|psest (von neuem beschriebenes Pergament) *m* od. *s*; -es, -e; Pa|lin|drom (Wort[folge] od. Satz, die vorwärts wie rückwärts gelesen [den gleichen] Sinn ergeben, z. B. ,,Otto'', ,,Reliefpfeiler'') *s*; -s, -e; Pa|lin|ge|ne|se (Wiedergeburt; Biol.: Auftreten von Merkmalen stammesgeschichtl. Vorfahren während der Keimesentwicklung [biogenetisches Grundgesetz]; Geol.: Aufschmelzung eines Gesteins u. Bildung einer neuen Gesteinsschmelze) *w*; -, -n; Pa|lin|odie ([dichterischer] Widerruf) *w*; -, ...ien

Pa|li|sa|de *fr.* (Hindernis-, Schanzpfahl); Pa|li|sa|den_pfahl, ...wand

Pa|li|san|der *indian.-fr.* (brasil. Holzart) *m*; -s, -; Pa|li|san|derholz; pa|li|san|dern (aus Palisander)

¹**Pal|la|di|um** gr. (Bild der Pallas; Schutzbild; schützendes Heiligtum) s; -s, ...ien [...i*ᵉn*]; ²**Pal|la|di|um** (chem. Grundstoff, Metall; Zeichen: Pd) s; -s

Pal|las gr. (Beiname der Athene)

Pal|lasch ung. (schwerer [Korb]säbel) m; -[e]s, -e

Pal|la|watsch österr. mdal. (Durcheinander, Blödsinn) m; -

Pal|lia|tiv lat. (Med.: Linderungsmittel) s; -s, -e [...wᵉ]; **Pal|lia|tiv|mit|tel** s; **Pal|lia|ti|vum** [...wum] (svw. Palliativ) s; -s, ...va [...wa];

Pal|li|um (Schulterbinde des erzbischöfl. Ornats [Hauptabzeichen des Erzbischofs]) s; s, ...ien [...i*ᵉn*]

Pal|lot|ti|ner [nach dem it. Priester Pallotti] Angehöriger einer kath. Vereinigung) m; -s, -; **Pal|lot|ti|ne|rin** w; -, -nen; **Pal|lot|ti|ner|or|den** m; -s

Palm lat. („flache Hand"; altes Maß zum Messen von Rundhölzern) m; -s, -e; 10 - (↑ R 322);

Palm|art, **Pal|men|art**; **Pal|ma|rum** (Palmsonntag); **Palm|baum**; **Palm|blatt**, **Pal|men|blatt**; **Pal|me** w; -, -n; **Pal|men|art**, **Palm|art**; **pal|men|ar|tig**; **Pal|men|blatt**, **Palm|blatt**; **Pal|men|hain**; **Pal|men|zweig**, **Palm|zweig**; **Pal|met|te** fr. ([palmblattartige] Verzierung; fächerförmiges Obstgehölz) w; -, -n; **Pal|min** ⓦ nlat. (aus Kokosöl hergestelltes Speisefett) s; -s; **Pal|mi|tin** (Hauptbestandteil der meisten Fette) s; -s; **Palm|kätz|chen**, ...öl (s; -[e]s); **Palm|sonn|tag** [auch: *pạlm*...]; **Palm|wei|de**, ...wein

Pal|my|ra ([Ruinen]stadt in der Syrischen Wüste); **Pal|my|ra|pal|me**; **Pal|my|rer**; **pal|my|risch**

Palm|zweig, **Pal|men|zweig**

Pa|lo|lo|wurm polynes.; dt. (trop. Borstenwurm)

pal|pa|bel lat. (Med.: tast-, fühl-, greifbar; veralt. für: offenbar); ...a|ble Gegenstände; **Pal|pa|ti|on** [...zion] (Med.: Untersuchung durch Tasten, Klopfen); **Pal|pe** (Zool.: Taster [bei Gliederfüßern]) w; -, -n; **pal|pie|ren** (Med.: betasten, betastend untersuchen); **Pal|pi|ta|ti|on** [...zion] (Pulsschlag, Herzklopfen); **pal|pi|tie|ren** (Med.: schlagen, klopfen, zucken)

Pa|me|la [auch: *pamḁ*...], **Pa|me|le** [auch: *pamḁ*...] (w. Vorn.)

Pa|mir [auch: *pg*...] (Hochland in Innerasien) m (auch: s); -[s]

Pamp, **Pampf** landsch. (dicker Brei [zum Essen]) m; -s

Pam|pa indian. (ebene, baumlose Grassteppe in Südamerika) w; -, -s (meist Mehrz.)

Pam|pe mitteld. (Schlamm, Sandu. Schmutzbrei) w; -

Pam|pel|mu|se niederl. [auch: *pampᵉlmuse*] (eine Zitrusfrucht) w; -, -n

Pam|per|letsch vgl. Bamperletsch

Pampf vgl. Pamp

Pam|phlet fr. (Flug-, Streit-, Schmähschrift) s; -[e]s, -e; **Pam|phle|tist** (Verfasser von Pamphleten); ↑ R 268

pam|pig (mdal. für: breiig; übertr. ugs. für: frech)

Pam|pu|sche vgl. Babusche

¹**Pan** (plötzl. Schrecken verursachender) gr. Hirten-, Waldgott)

²**Pan** poln. (früher in Polen; [klei-ner] bäuerl.] Herr; polnisch: Herr [in Verbindung mit dem Namen] m; -s, -s; vgl. Panje

pan... gr. (gesamt..., all...); **Pan...** (Gesamt..., All...)

Pa|na|ché [...*sche*] usw. vgl. Panaschee usw.

Pa|na|de fr. (Weißbrotbrei zur Bereitung von Füllungen); **Pa|na|del|sup|pe** südd. u. österr. (eine Art Brotsuppe)

pan|afri|ka|nisch; (↑ R 224:) Panafrikanische Spiele

Pa|na|ma [auch: *pg*..., u. ...*ma*] (Staat u. Hptst. in Mittelamerika); **Pa|na|ma|er** [auch: *pg*..., u. ...*g-er*] (↑ R 199); **Pa|na|ma|hut** m (↑ R 201); **pa|na|ma|isch**; **Pa|na|ma|ka|nal** m; -s (↑ R 201); **Pa|na|me|ne** (österr.) m; -n, -n (↑ R 268); **pa|na|me|nisch** (österr.)

Pan|ame|ri|ka (Allamerika); **pan|ame|ri|ka|nisch**; -e Bewegung; **Pan|ame|ri|ka|nis|mus** (Bestreben, die wirtschaftl. u. polit. Zusammenarbeit aller amerik. Staaten zu verstärken) m; -

Pan|ara|bis|mus; **pan|ara|bisch**; -e Bewegung

Pa|na|ri|ti|um gr. [...zium] (Med.: Fingerentzündung, Nagelgeschwür) s; -s, ...ien [...i*ᵉn*]

Pa|nasch fr. (Feder-, Helmbusch) m; -[e]s, -e, **Pa|na|schee** (veralt. für: gemischtes, mehrfarbiges Eis, auch: Kompott, Gelee; auch für: Panaschierung) s; -s, -s; **pa|na|schie|ren** (bei einer Wahl seine Stimme für Kandidaten verschiedener Parteien abgeben); **Pa|na|schier|sy|stem** (Wahlsystem); **Pa|na|schie|rung** (weiße Musterung auf Pflanzenblättern durch Mangel an Blattgrün); **Pa|na|schü|re** (svw. Panaschierung) w; -, -n

Pan|athe|nä|en gr. (Fest zu Ehren der Athene in alten Athen) Mehrz.

Pan|azee gr. [auch: ...*ze*] (Allheil-, Wundermittel) w; -, -n [...e*ᵉn*]

Pan|cra|ti|us vgl. Pankratius

pan|chro|ma|tisch gr. [...*kro*...]

(Fotogr.: empfindlich für alle Farben u. Spektralbereiche)

Pan|da (ein Kleinbär) m; -s, -s

Pan|dai|mo|ni|on gr.; vgl. Pandämonium; **Pan|dä|mo|ni|um** (Aufenthalt od. Gesamtheit der [bösen] Geister) s; -s, ...ien [...i*ᵉn*]

Pan|da|ne malai. (Schraubenbaum, Zierpflanze) w; -, -n

Pan|dek|ten gr. (Sammlung altröm. Rechtssprüche als Grundlage des gemeinen dt. Rechts) Mehrz.

Pan|de|mie gr. (Med.: Epidemie größeren Ausmaßes) w; -, ...ien; **pan|de|misch** (allgemein verbreitet)

Pan|dit sanskr.-Hindi (Titel brahman. Gelehrter) m; -s, -e

Pan|do|ra (gr. Mythol.: das alles Unheil bringende erste Weib); die Büchse der -

Pandsch|ab sanskr. [auch: *pạn*...] („Fünfstromland"; Landschaft in Vorderindien) s; **Pandsch|ab|beu|le** (eine Hautkrankheit); ↑R 201; **Pandsch|abi** (Sprache) s; -[s]

Pan|dur ung. (früher: ung. Leibdiener; leichter ung. Fußsoldat) m; -en, -en (↑ R 268)

Pa|neel niederl. (Täfelung der Innenwände) s; -s, -e; **pa|nee|lie|ren**

Pan|egy|ri|ker gr. (Verfasser eines Panegyrikus); **Pan|egy|ri|kon** (liturg. Buch der Orthodoxen Kirche mit predigtartigen Lobreden auf die Heiligen) s; -[s], ...ka; **Pan|egy|ri|kos**; vgl. Panegyrikus; **Pan|egy|ri|kus** (Fest-, Lobrede, -gedicht) m; -, ...ken u. ...zi; **pan|egy|risch**

Panel engl. [*pän*ᵉl] (repräsentative Personengruppe für die Meinungsforschung) s; -s, -s; **Panel|tech|nik** [*pän*ᵉl...] (Methode der Meinungsforscher, die gleiche Gruppe von Personen innerhalb eines bestimmten Zeitraums mehrfach zu befragen)

pa|nem et cir|cen|ses lat. [- - zirz...] („Brot u. Zirkusspiele" [Wenf.; das Hauptverlangen des Volkes im alten Rom])

Pan|en|the|is|mus gr. (Lehre, nach der das All in Gott eingeschlossen ist) m; -; **pan|en|the|istisch**

Pan|eu|ro|pa (Bez. für die [von vielen Seiten erstrebte] künftige Gemeinschaft aller europ. Staaten); **Pan-Eu|ro|pa-Be|we|gung** w; - (↑ R 155)

Pan|flö|te (antike Hirtenpfeife); vgl. ¹Pan

Pan|has (niederrhein.-westfäl. Gericht aus Wurstbrühe u. Buchweizenmehl) m; -es, -e

Pan|hel|le|nis|mus (Allgriechentum)

Pa|ni (Angehöriger eines nordamerik. Indianerstammes) *m*; -, -

¹Pa|nier *germ.-fr.* (veralt. für: Banner; übertr. für: Wahlspruch) *s*; -s, -e

²Pa|nier *fr.* österr. (Hülle aus Ei und Semmelbröseln) *w*; -; pa|nie|ren (in Ei u. Semmelbröseln wenden); Pa|nier|mehl; Pa|nie|rung

Pa|nik [nach ¹Pan] (plötzl. Schrekken; Massenangst) *w*; -, -en; pa|nik|ar|tig; Pa|nik..ma|che, ...stim|mung; pa|nisch (lähmend); -er Schrecken

Pan|is|la|mis|mus (Streben, alle islam. Völker zu vereinigen)

Pan|je *slaw.* (poln. od. russ Bauer; poln. Anrede [ohne Namen]: Herr) *m*; -s, -s; vgl. ²Pan; Pan|je|pferd (poln. od. russ. Landpferd)

Pan|kar|di|tis *gr.* (Med.: Entzündung aller Schichten der Herzwand) *w*; -, ...itiden

Pan|kra|ti|on *gr.* (altgr. Ring- u. Faustkampf) *s*; -s, -s

Pan|kra|ti|us, Pan|kraz [österr.: pan...] (m. Vorn.)

Pan|kre|as *gr.* (Med.: Bauchspeicheldrüse) *s*; -, ...kreaten

Pan|lo|gis|mus *gr.* (philos. Lehre, nach der das ganze Weltall als Verwirklichung der Vernunft aufzufassen ist) *m*; -

Pan|mi|xie *gr.* (Biol.: Mischung aller Erbanlagen bei der Fortpflanzung) *w*; -, ...ien

Pan|ne *fr.* (ugs. für: Unfall, Schaden, Bruch, Störung [bes. bei Fahrzeugen]; Mißgeschick) *w*; -, -n; pan|nen|frei; Pan|nen..kof|fer, ...kurs (Lehrgang zum Beheben von Autopannen)

Pan|no|ni|en [...*iᵉn*] (röm. Donauprovinz); pan|no|nisch

Pan|op|ti|kum *gr.* (,,Gesamtschau''; Sammlung von Sehenswürdigkeiten; Wachsfigurenschau) *s*; -s, ...ken; Pan|ora|ma (Rundblick; Rundgemälde; fotogr. Rundaufnahme) *s*; -s, ...men; Pan|ora|ma..bus, ...spie|gel (Kfz-Wesen)

Pan|ple|gie *gr.* (Med.: allgemeine, vollständige Lähmung) *w*; -

Pan|psy|chis|mus *gr.* (Philos.: Allbeseelungslehre) *m*; -

pan|schen (ugs. für: mischend verfälschen; mit den Händen od. Füßen im Wasser patschen, planschen); du panschst (panschest); vgl. pantschen; Pan|scher (ugs.); Pan|sche|rei (ugs.)

Pan|sen (Magenteil der Wiederkäuer) *m*; -s, -; vgl. Panzen

Pan|se|xua|lis|mus *gr.*; *lat.* (kritische Bez. der nur von sexuellen Trieben ausgehenden frühen Richtung der Psychoanalyse Freuds) *m*; -

Pans|flö|te vgl. Panflöte

Pan|sla|vis|mus usw. vgl. Panslawismus usw.; Pan|sla|wis|mus (Streben, alle slaw. Völker zu vereinigen; Allslawentum) *m*; -

Pan|sla|wist (↑ R 268); pan|sla|wi|stisch

Pan|so|phie *gr.* (,,Gesamtwissenschaft''; Gesamtdarstellung aller Wissenschaften) *w*; -

Pan|sper|mie *gr.* (Theorie von der Entstehung des Lebens auf der Erde durch Keime von anderen Planeten) *w*; -

Pan|ta|le|on (ein Heiliger)

Pan|ta|lo|ne *it.* (lustige Maske des it. Volkslustspieles) *m*; -s, -s u. ...ni; Pan|ta|lons *fr.* [*pang*...], auch: *pantalongß*] (lange Hose) *Mehrz.*

pan|ta rhei *gr.* (,,alles fließt''; Heraklit [fälschlich?] zugeschriebener Grundsatz, nach dem das Sein als ewiges Werden, ewige Bewegung gedacht wird)

Pan|the|is|mus *gr.* (Weltanschauung, nach der Gott u. Welt eins sind) *m*; -; Pan|the|ist (↑ R 268); pan|thej|stisch; Pan|the|on (Tempel für alle Götter; Ehrentempel) *s*; -s, -s

Pan|ther *gr.* (sww. Leopard) *m*; -s, -; Pan|ther|fell

Pan|ti|ne *niederl.* (Holzschuh, -pantoffel) *w*; -, -n (meist *Mehrz.*)

pan|to... *gr.* (all...); Pan|to... (All...)

Pan|tof|fel *fr.* (Hausschuh) *m*; -s, -n (ugs.: -; meist *Mehrz.*); Pan|tof|fel|blu|me; Pan|töf|fel|chen, Pan|töf|fe|lein; Pan|tof|fel|held (ugs. spött. Bez. für einen Mann, der von der Ehefrau beherrscht wird), ...ki|no (ugs. scherzh. für: Fernsehen), ...tier|chen

Pan|to|graph *gr.* (,,Allzeichner''; Storchschnabel, Instrument zum Übertragen von Zeichnungen im gleichen, größeren od. kleineren Maßstab) *m*; -en, -en (↑ R 268); Pan|to|gra|phie (mit dem Pantographen hergestellter Bild) *w*; -, ...ien

Pan|to|let|te (leichter Sommerschuh ohne Fersenteil) *w*; -, -n (meist *Mehrz.*)

Pan|to|me|ter *gr.* (Technik: Instrument zur Messung von Längen, Horizontal- u. Vertikalwinkeln) *s*; -s, -

¹Pan|to|mi|me *gr.*(-*fr.*) (Darstellung einer Szene nur mit Gebärden; stummes Gebärdenspiel) *w*; -, -n; ²Pan|to|mi|me (Darsteller einer Pantomime) *m*; -n, -n (↑ R 268); Pan|to|mi|mik (Gebärdenspiel; Kunst der Pantomime) *w*; -; pan|to|mi|misch

Pan|try *engl.* [*päntri*] (Speise-, An-

richtekammer [auf Schiffen]) *w*; -, -s

pant|schen usw. (Nebenformen von: panschen usw.)

Pant|schen-La|ma *tibet.* (zweites, kirchl. Oberhaupt des tibet. Priesterstaates) *m*; -[s], -s

Pan|ty *engl.* [*pänti*] (Strumpfhose; eigtl.: Miederhöschen) *w*; -, ...ties [*päntis*]

Pan|zen (veralt., aber noch mdal. für: Magen [vgl. Pansen]; übertr. verächtl. für: Wanst, Schmerbauch eines Menschen) *m*; -s, -;

Pan|zer (Kampffahrzeug; früher: Rüstung, Harnisch; übertr. für: feste Hülle); Pan|zer|ab|wehr; Pan|zer|ab|wehr|ka|no|ne (Kurzw.: Pak); Pan|zer..di|vi|si|on, ...faust, ...glas, ...gre|na|dier, ...hemd (hist.), ...kampf|wa|gen, ...kreu|zer; pan|zern; ich ...ere (↑ R 327); sich -; Pan|zer..plat|te, ...schiff, ...schrank, ...späh|wa|gen, ...sper|re, ...turm; Pan|ze|rung; Pan|zer|wa|gen

Päo|nie *gr.* [...*iᵉ*] (Pfingstrose) *w*; -, -n

¹Pa|pa *fr.* [ugs. auch: *papá*] *m*; -s, -s; ²Pa|pa *gr.* (,,Vater'', kirchl. Bez. des Papstes; in der Orthodoxen Kirche Titel höherer Geistlicher; Abk.: P.) *m*; -s; Pa|pa|bi|li *lat.* (it. Bez. der als Papstkandidaten in Frage kommenden Kardinäle) *Mehrz.*; Pa|pa|gal|lo *it.* (it. Halbstarker) *m*; -[s], -s u. ...lli; Pa|pa|gei *fr.* [österr auch: *páp...*] (ein trop. Vogel) *m*; -en u. -s, -en (seltener: -e); Pa|pa|gei|blu|me; Pa|pa|gei|en|grün; pa|pa|gei|en|bunt; pa|pa|gei|en|krank|heit *w*; -; Pa|pa|gei|fisch; pa|pa|gei|isch

Pa|pa|ge|no (Vogelhändler in Mozarts ,,Zauberflöte'')

pa|pal *lat.* (päpstlich); Pa|pal|sy|stem *s*; -s; Pa|pat (Amt u. Würde des Papstes) *m* (auch: *s*); -[e]s

Pa|pa|ve|ra|ze|en *lat.* [...*we*... (Bot.: Familie der Mohngewächse) *Mehrz.*; Pa|pa|ve|rin [...*we*... (Opiumalkaloid) *s*; -s

Pap|chen [auch: *páp*...] (Koseform für: Papagei; niederd. auch für: ¹Papa)

Pa|per *engl.* [*pɛⁱpᵉr*] (Schriftstück schriftl. Unterlage) *s*; -s, -s; Pa|per|back [*pɛⁱpᵉrbäk*] (,,Papier rücken''; kartoniertes Buch, ins bes. Taschenbuch) *s*; -s, -s

Pa|pe|te|rie *fr.* schweiz. (Briefpapierpackung; Schreibwarenhandlung) *w*; -, ...ien

pa|phisch (aus Paphos)

Pa|phla|go|ni|en [...*iᵉn*] (antik. Landschaft in Kleinasien)

Paphos (im Altertum zwei Städte auf Zypern)

Pa|pi (Kinderspr. für: ¹Papa) *m*; -[s], -s

Pa|pier (Abk. auf dt. Kurszetteln: P) *s*; -s, -e; **Pa|pier.bahn**, ...block (*Mehrz.* ...blocks), ...bo|gen, ...deutsch (umständliches, geschraubtes, unanschauliches Deutsch); **pa|pie|ren** (aus Papier); papier[e]ner Stil; papier[e]nes *Gesetz*; **Pa|nier.fa|brik**, ...fetzen, ...for|mat, ...garn, ...geld (*s*; -[e]s), ...ge|we|be, ...in|du|strie, ...korb, ...krieg (ugs.); **Pa|pierma|ché** *fr.* [*papiemasché*] (verformbares Hartpapier) *s*; -s, -s; **Pa|pier.müh|le**, ...sack, ...sche|re, ...schlan|ge, ...schnit|zel (vgl ²Schnitzel), ...ser|vi|et|te, ...stoff, ...ta|schen|tuch, ...ti|ger (übertr. für: nur dem Schein nach starke Person, Macht); **pa|pier|ver|arbei|tend**; -e Industrie (vgl. S. 45, Merke. 2), **aber** (vgl. S. 45, Merke. 1): viel Papier verarbeitend; **Pa|pier.ver|ar|bei|tung**, ...werker (Arbeiter in der Papierindustrie)

pa|pil|lar *lat.* (warzenartig, -förmig); **Pa|pil|lar.ge|schwulst**, ...kör|per; **Pa|pil|le** (Warze) *w*; -, -n; **Pa|pil|lom** (warzenartige Geschwulst) *s*; -s, -e

Pa|pil|lon *fr.* [*papijong*] (fr. Bez. für: Schmetterling; Vertreter einer Kleinhundrasse; veralt. für: flatterhafter Mensch) *m*; -s, -s; **Pa|pil|lo|te** [*papijot*'] (Haarwikkel) *w*; -, -n

Pa|pin [*papäng*] (fr. Physiker); **Papin|sche Topf**; ↑ R 179 (fest schließendes Gefäß zum Erhitzen von Flüssigkeit über deren Siedepunkt hinaus) *m*; -n -[e]s, -n Töpfe

Pa|pi|ros|sa (russ. Zigarette mit langem Pappmundstück) *w*; -, ...ossy

Pa|pis|mus *gr.* (abschätzige Bez. für: Papsttum) *m*; -; **Pa|pist** (Anhänger des Papsttums); ↑ R 268; **pa|pi|stisch**

papp; nicht mehr - sagen können (ugs. für: sehr satt sein)

Papp landsch. (Brei; Kleister) *m*; -[e]s, -e; **Papp|band** (in Pappe gebundenes Buch; Abk.: Pp[bd].) *m*; **Papp|deckel**, Pap|pen|deckel (*Trenn.*: ...dek|kel]; **Papp|pe** (starker Bogen aus Papiermasse) *w*; -, -n

Pap|pel *lat.* (ein Laubbaum) *w*; -, -n; **Pap|pel.al|lee**, ...holz; ¹**pappeln** (aus Pappelholz)

²**pap|peln**, **päp|peln** landsch. [Kind] füttern); ich ...[e]le (↑ R 327); **pap|pen** (ugs. für: kleistern, kleben); **Pap|pen|deckel**, Pappdeckel [*Trenn.*: ...dek|kel]

pap|pen|hei|mer (Angehöriger des Reiterregiments des dt. Reiterge

nerals Graf zu Pappenheim) *m*; -s, -; ich kenne meine - (ugs. für: ich kenne diese Leute; ich weiß Bescheid)

Pap|pen|stiel (Stiel der Pappenblume [Löwenzahn]; ugs. für: Wertloses); für einen - bekommen, verkaufen (ugs.)

pap|per|la|papp!

pap|pig; **Papp.ka|me|rad** (Figur [meist Polizist] aus Pappe), ...karton; **Papp|ma|ché** [...*masché*] vgl. Papiermaché; **Papp|pla|kat** (↑ R 237); **Papp.schach|tel**, ...schild *s*

Pap|pus (Bot.: Haarkrone der Frucht von Korbblütlern) *m*; -, -u -se

Pa|pri|ka *serb.-ung.* (ein Gewürz [nur *Einz.*]; ein Gemüse) *m*; -s, -[s]; **Pa|pri|ka|scho|te** (vgl. ³Schote)

Paps (Kinderspr. für: ¹Papa [ohne Geschlechtsw. u. Beugung; meist nur in der Anrede])

Papst *gr.* (Oberhaupt der kath. Kirche) *m*; -[e]s, Päpste; **Papst.fa|mi|lie** (Umgebung des Papstes), ...ka|ta|log (Verzeichnis der Päpste); **päpst|lich**, im Titel (↑ R 224): Päpstlich, z. B. das Päpstliche Bibelinstitut; **Papst.na|me**, ...tum (*s*; -s), ...ur|kun|de (meist *Mehrz.*), ...wahl

Pa|pua [auch. ...*pua*] (Eingeborener Neuguineas) *m*; -[s], -[s]; **papua|nisch**; **Pa|pua|spra|che** [auch: ...*pua...*]

Pa|py|rin *gr.* (Pergamentpapier) *s*; -s; **Pa|py|ro|lo|gie** (Wissenschaft vom Papyrus, Papyruskunde) *w*; -; **Pa|py|rus** (Papierstaude; Schreibmaterial; Papyrusrolle) *m*; -, ...ri; **Pa|py|rus.kun|de** (*w*; -), ...rol|le, ...stau|de, ...text *m*

par..., **pa|ra...** *gr.* (bei..., neben..., entgegen..., falsch...); **Par...**, **Para...** (Bei..., Neben..., Entgegen..., Falsch...)

¹**Pa|ra** *pers.* (kleinste türk. Münzrechnungseinheit; Währungseinheit in Jugoslawien [100 Para = 1 Dinar]; Abk.: p) *m*; -, - (für die türk. Einheit auch: -s)

²**Pa|ra** *fr.* (Kurzform für: parachutiste [*paraschütißt*]; fr. Fallschirmjäger) *m*; -s, -s

Pa|ra|ba|se *gr.* (Teil der attischen Kömödie) *w*; -, -n

Pa|ra|bel *gr.* (Gleichnis[rede]; Kegelschnittkurve) *w*; -, -n

Pa|ra|bel|lum|pi|sto|le (Ⓦ): Parabellum)

pa|ra|bo|lisch *gr.* (gleichnisweise; parabelförmig gekrümmt); **Para|bo|lo|id** *gr.* (gekrümmte Fläche ohne Mittelpunkt) *s*; -[e]s, -e; **Pa|ra|bol|spie|gel** (Hohlspiegel von der Form eines Paraboloids)

Pa|ra|cel|sisch [...*zäl...*], **aber** (↑ R

179): **Pa|ra|cel|sisch**; **Pa|ra|celsus** (dt. Naturforscher, Arzt u. Philosoph); **Pa|ra|cel|sus-Ausga|be**; **Pa|ra|cel|sus-Me|dail|le** (↑ R 180)

Pa|ra|de *fr.* (Truppenschau, prunkvoller Aufmarsch; Reitsport: kürzere Gangart des Pferdes, Anhalten; Fecht- u. Boxsport: Abwehr eines Angriffs; bei Ballspielen: Abwehr durch den Torhüter)

Pa|ra|dei|ser österr. (Tomate) *m*; -s, -; **Pa|ra|deis.sa|lat**, ...sup|pe

Pa|ra|de|marsch *m*

Pa|ra|den|to|se *gr.*; *lat.* (fachspr. veralt. Bez. für: Parodontose)

Pa|ra|de.stück, ...uni|form

pa|ra|die|ren *fr.* (parademäßig vorüberziehen; ein Pferd kurz anhalten; mit etwas prunken)

Pa|ra|dies *pers.* ("Garten"; Himmel [nur *Einz.*]; Lustgefilde, Ort der Seligkeit; Portalvorbau an mittelalterl. Kirchen) *s*; -es, -e; **Pa|ra|dies|ap|fel** (mdal. für: Tomate; auch: Zierapfel); **pa|ra|diesisch** (wonnig, himmlisch); -ste (↑ R 294); **Pa|ra|dies|vo|gel**

Pa|ra|dig|ma *gr.* (Beispiel, Muster; Sprachw.: Flexionsmuster) *s*; -s, ...men (auch: -ta), **pa|ra|digma|tisch** (beispielhaft)

pa|ra|dox *gr.* ("gegen die allgemeine Geltung gehend"; widersinnig; sonderbar); -este (↑ R 292); **Pa|ra|dox** *s*; -es, -e u. Pa|rado|xon (widersinnige Behauptung, eine scheinbar zugleich wahre u. falsche Aussage) *s*; -s, ...xa; **pa|ra|do|xer|wei|se**; **Pa|rado|xie** (Widersinnigkeit) *w*; -, ...ien; **Pa|ra|do|xon** vgl. Paradox

Par|af|fin *lat.* (wachsähnlicher Stoff) *s*; -s, -e; **Par|af|fi|ne** (Gesamtheit der gesättigten, aliphat. Kohlenwasserstoffe, z. B. Methan, Propan, Butan) *Mehrz.*; **par|af|fi|nisch**; **Par|af|fin.ker|ze**, ...öl (*s*; -[e]s)

Pa|ra|gramm *gr.* (Buchstabenänderung in einem Wort od. Namen, wodurch ein scherzhaft-komischer Sinn entstehen kann); **Pa|ra|graph** ([in Gesetzestexten u. wissenschaftl. Werken] fortlaufend numerierter Absatz, Abschnitt; Zeichen: §, *Mehrz.*: §§) *m*; -en, -en (↑ R 268; zur Schreibung des Zeichens § vgl. S. 85, 6, a; **Pa|ra|gra|phen|rei|ter** (abschätzig für: sich übertrennd an Vorschriften haltender Mensch); **Pa|ra|gra|phen|wei|se**; **Pa|ra|graphie** (Med.: Störung des Schreibvermögens) *w*; -; **pa|ragra|phie|ren** (in Paragraphen einteilen); **Pa|ra|gra|phie|rung**; **Para|graph|zei|chen**

¹Pa|ra|guay [...gᵘai, auch: para-
gwai] (r. Nebenfluß des Paraná)
m; -[s]; ²Pa|ra|guay (südamerik.
Staat); Pa|ra|gua|yer (↑ R 199);
pa|ra|gua|yisch
Pa|ra|ki|ne|se gr. (Med.: Koordi-
nationsstörungen im Bewe-
gungsablauf) w; -, -n
Pa|ra|kla|se gr. (Geol.: Verwer-
fung) w; -, -n
Pa|ra|klet gr. (Heiliger Geist) m;
-[e]s u. -en, (für Helfer, Fürspre-
cher vor Gott auch Mehrz.:) -e[n]
(↑ R 268)
Pa|ra|la|lie gr. (Med., Psych.:
Wort- u. Lautverwechslung) w;-
Pa|ra|le|xie gr. (Med., Psych.: Le-
sestörung mit Verwechslung der
gelesenen Wörter) w; -
Pa|ra|li|po|me|non gr. [auch:
...pom...] (veralt. für: „Ausgelas-
senes"; Ergänzung, Nachtrag) s;
-s, ...mena (meist Mehrz.); par|al-
lak|tisch (die Parallaxe betref-
fend); Par|al|la|xe („Abwei-
chung"; Winkel, den zwei Gera-
de bilden, die von verschiedenen
Standorten zu einem Punkt ge-
richtet sind; Entfernung eines
Sternes, die mit Hilfe zweier von
verschiedenen Standorten ausge-
hender Geraden bestimmt wird;
Fotogr.: Unterschied zwischen
dem Bildausschnitt im Sucher u.
auf dem Film) w; -, -n
par|al|lel (gleichlaufend,
gleichgerichtet; genau entspre-
chend); - schalten (nebenschal-
ten); [mit etwas] - laufen; Par|al-
le|le (Gerade, die zu einer ande-
ren Geraden in gleichem Ab-
stand u. ohne Schnittpunkt ver-
läuft; Vergleich, vergleichbarer
Fall) w; -, -n; vier -[n] (↑ R 291);
Par|al|lel|epi|ped s; -[e]s, -e u.
Par|al|lel|epi|pe|don [auch:
...pip...] (Parallelflach) s; -s, ...da
u. ...peden; Par|al|lel|er|schei-
nung, ...fall m, ...flach (Math.:
von drei Paaren paralleler Ebe-
nen begrenzter Raumteil; m;
-[e]s, -e); par|al|le|li|sie|ren ([ver-
gleichend] nebeneinander-, zu-
sammenstellen); Par|al|le|li|sie-
rung; Par|al|le|lis|mus ([formale]
Übereinstimmung verschiedener
Dinge od. Vorgänge; Sprachw.:
inhaltlich und grammatisch
gleichmäßiger Bau von Satzglie-
dern od. Sätzen) m; -, ...men; Par-
al|le|li|tät (Eigenschaft zweier
paralleler Geraden; Gleichlauf)
w; -; Par|al|lel|klas|se, ...kreis
(Breitenkreis); par|al|lel|lau|fend
(gleichlaufend); Par|al|lel|li|nie;
Par|al|le|lo it. (längsgestrickter
Pullover) m; -[s], -s; Par|al|le|lo-
gramm gr. (Viereck mit paarwei-
se parallelen Seiten) s; -s, -e;

Par|al|lel|pro|jek|ti|on (Math.),
...schal|tung (Elektrotechnik:
Nebenschaltung), ...stel|le,
...ton|art (Musik)
Pa|ra|lo|gie gr. (Vernunftwidrig-
keit) w; -, ...ien; Pa|ra|lo|gis|mus
(„Fehlschluß"; aus dem Urteil
des „ich denke" gezogener
Schluß der rationalen Seelenleh-
re[Kant]) m; -, ...men; Pa|ra|ly|se
(Lähmung; Endstadium der Sy-
philis, Gehirnerweichung) w; -,
-n; pa|ra|ly|sie|ren; Pa|ra|ly|sis
[auch: ...ral...] (älter für: Paraly-
se) w; -, ...lysen; Pa|ra|ly|ti|ker
(an Paralyse Erkrankter); pa|ra-
ly|tisch
pa|ra|ma|gne|tisch gr. (Physik: den
Magnetismus verstärkend); Pa-
ra|ma|gne|tis|mus (Verstärkung
des Magnetismus) m; -
Pa|ra|ma|ri|bo (Hptst. von ²Su-
rinam)
Pa|ra|ment lat. (Altar- u. Kanzel-
decke; liturg. Kleidung) s; -[e]s,
-e (meist. Mehrz.); Pa|ra|men-
ten|ma|cher
Pa|ra|me|ter gr. [auch: ...ram...]
(Math.: charakteristische Kon-
stante; bei Kegelschnitten die im
Brennpunkt die Hauptachse
senkrecht schneidende Sehne) m;
-s, -
pa|ra|mi|li|tä|risch (halbmilitä-
risch, militärähnlich)
Pa|ra|ná (südamerik. Strom) m;
-[s]
Pa|ra|noia gr. [...neua] (Med.:
Geistesgestörtheit) w; -; pa|ra|no-
id (der Paranoia ähnlich); Pa|ra-
noi|ker; pa|ra|no|isch (geistesge-
stört, verwirrt)
Pa|ra|nuß [nach dem bras. Staat
u. Ausfuhrhafen Pará]; ↑ R 201
(fettreicher Samen eines trop.
Baumes)
Pa|ra|phe gr. (Namenszug; Na-
menszeichen; Stempel mit Na-
menszug) w; -, -n; pa|ra|phie|ren
(mit dem Namenszug versehen,
zeichnen); Pa|ra|phie|rung
Pa|ra|phra|se gr. (verdeutlichende
Umschreibung, Erklärung; Mu-
sik: ausschmückende Bearbei-
tung[von Liedern, Opernmelodi-
en u. a.]) w; -, -n; pa|ra|phra|sie-
ren
Pa|ra|ple|gie gr. (Med.: doppelsei-
tige Lähmung) w; -, ...ien
Pa|ra|pluie fr. [...plü] (veralt. für:
Regenschirm) m od. s; -s, -s
Pa|ra|psy|cho|lo|gie gr. (Psycholo-
gie der okkulten seelischen Er-
scheinungen) w; -
Pa|ra|san|ge pers. (altpers. Wege-
maß) w; -, -n
Pa|ra|sit gr. (Schmarotzer[pflan-
ze, -tier]) m; -en, -en (↑ R 268);
pa|ra|si|tär fr. (schmarotzerhaft;

durch Schmarotzer hervorge-
bracht); Pa|ra|si|ten|tum gr. s; -s;
pa|ra|si|tisch (schmarotzerartig);
Pa|ra|si|tis|mus (Schmarotzer-
tum) m; -; Pa|ra|si|to|lo|gie (Leh-
re von den [krankheitserregen-
den] Schmarotzern) w; -
¹Pa|ra|sol fr. (veralt. für: Sonnen-
schirm) m od. s; -s, -s; ²Pa|ra|sol
(Schirmpilz) m; -s, -e u. -s; Pa|ra-
sol|pilz
Par|äs|the|sie gr. (anormale Kör-
perempfindung, z. B. Einschla-
fen der Glieder) w; -, ...ien
pa|rat lat. (bereit; [gebrauchs]fer-
tig); etwas - haben
pa|ra|tak|tisch (Sprachw.: ne-
benordnend, -geordnet); Pa|ra-
ta|xe, (älter:) Pa|ra|ta|xis [auch:
...rat...] (Nebenordnung) w; -
...taxen
Pa|ra|ty|phus (Med.: dem Ty-
phus ähnliche Erkrankung)
Pa|ra|vent fr. [...wang] (veralt. für
Wind-, Ofenschirm; span
Wand) m od. s; -s, -s
par avion fr. [- awiong] („durch
Luftpost")
pa|ra|zen|trisch (Math.: um
den Mittelpunkt liegend od. be
weglich)
par|bleu! fr. [...blö] (veralt., abe
noch mdal. für: potztausend!
Donnerwetter!)
Pär|chen, Pär|lein [zu: Paar]
Par|cours fr. [parkur] (Reitspor
Hindernisbahn für Springturnie
re) m; - [...kur(ß)], - [...kurß]
Pard gr. m; -en, -en (↑ R 268) u
Par|del, Par|der (svw. Leopard
m; -s, -
par|dauz!, bar|dauz!
Par|del, Par|der vgl. Pard
par di|stance fr. [par dißtangß]
(aus der Ferne)
Par|don fr. [...dong, österr. auch
...don] (veralt. für: Verzeihung
Gnade; Nachsicht) m; -s; - geber
um - bitten; Pardon! (landsch
für: Verzeihung!); par|do|nie|re
(veralt., aber noch mdal. für: ve
zeihen, begnadigen)
Par|dun niederl. s; -[e]s, -s u. Pa
du|ne (Seemannsspr.: Tau, da
die Masten od. Stengen nach hin
ten hält) w; -, -n; Par|du|nen|ha
Par|en|chym gr. [...chüm] (Biol
pflanzl. u. tier. Grundgewebe
Bot.: Schwammschicht des Bla
tes) s; -s, -e
Pa|ren|tel lat. (Rechtsw.: Gesam
heit der Abkömmlinge eine
Stammvaters) w; -, -en; Pa|re
tel|sy|stem (Rechtsw.: für die
bis 3. Ordnung gültige Erbfolg
Par|en|the|se gr. (Redeteil, der a
ßerhalb des eigtl. Satzverband
steht; Einschaltung; Gedanke
striche; Klammer[zeichen]) w;

-n; in - setzen; par|en|the|tisch (eingeschaltet; nebenbei [gesagt])

Pa|re|re it. (veralt. Kaufmannsspr.: Gutachten; österr.: medizin. Gutachten) s; -[s], -[s]

Par|er|ga gr. (veralt. für: Beiwerk, Anhang; gesammelte kleine Schriften) Mehrz.

par ex|cel|lence fr. [par äkßälangß] (vorzugsweise, vor allem andern, schlechthin); par force [par forß] (veralt., aber noch mdal. für: mit Gewalt; unbedingt); Par|force.jagd (Hetzjagd), ...rei|ter, ...ritt

Par|fum fr. [...föng] s; -s, -s usw. vgl. Parfüm usw.; Par|füm (,,wohlriechender Stoff''; Duft-[stoff]) s; -s, -e u. -s; Par|fü|me|rie (Betrieb zur Herstellung oder zum Verkauf von Parfümen) w; -, ...jen; Par|fü|meur [...mör] (Fachkraft der Parfümherstellung) m; -s, -e; par|fü|mie|ren (wohlriechend machen); sich -; Par|füm.stoff, ...zer|stäu|ber

pa|ri it. (Bankw.: zum Nennwert; gleich); über-, unter -; die Chancen stehen -; vgl. al pari

Pa|ria tamil.-angloind. (europ. Bez. für: kastenloser Inder; übertr. für: von der menschlichen Gesellschaft Ausgestoßener, Entrechteter) m; -s, -s; Pa|ria|tum s; -s

[1]pa|rie|ren fr. ([einen Hieb] abwehren; [Pferd] zum Stehen bringen)
[2]pa|rie|ren lat. (unbedingt gehorchen)

Pa|rie|tal|au|ge [...i–e...] (lichtempfindl. Sinnesorgan niederer Wirbeltiere)

[1]Pa|ris (Nennwert)
[1]Pa|ris (gr. Sagengestalt)
[2]Pa|ris (Hptst. Frankreichs)
pa|risch (von der Insel Paros); -er Marmor

Pa|ri|ser (↑ R 199); - Höhe (Schriftletternhöhe); - Kreide (eine Mineralfarbe); - Verträge (von 1954); Pa|ri|ser Blau s; - -s; pa|ri|se|risch (nach Art des Parisers); Pa|ri|si|enne [...siän] (,,Pariserin''; Seidengewebe; fr. Freiheitslied; veralt. Schriftgattung) w; -; pa|ri|sisch (von [der Stadt] Paris)

pa|ri|syl|la|bisch lat.; gr. (gleichsilbig in allen Beugungsfällen); Pa|ri|syl|la|bum (in Einz. u. Mehrz. parisyllabisches Wort) s; -s, ...ba

Pa|ri|tät lat. (Gleichstellung, Gleichberechtigung; Austauschverhältnis zwischen zwei od. mehreren Währungen) w; -; pa|ri|tä|tisch (gleichgestellt, gleichberechtigt); - getragene Kosten; aber (↑ R 224): Deutscher Paritätischer Wohlfahrtsverband

Pa|ri|wert (Bankw.)

Park fr.(-engl.) (großer Landschaftsgarten); Depot, meist in Zusammensetzungen, z. B. Wagenpark) m; -s, -s (seltener: -e)

Par|ka eskim. (knielanger, warmer Anorak mit Kapuze) w; -, -s od. m; -[s], -s

Park-and-ride-Sy|stem engl.-amerik. [pa'k°ndraid...] (eine Form der Verkehrsregelung); Park|an|la|ge; park|ar|tig; Park.bahn (Raumfahrt: Bahn eines Raumschiffs [um den Mond] während des Abstiegs der Landefähre), ...bucht, ...deck; par|ken (Kraftfahrzeuge abstellen); Par|ker; Par|kett (im Theater meist vorderer Raum zu ebener Erde; an der Pariser Börse Raum für Kursmakler; getäfelter Fußboden) s; -[e]s, -e; Par|kett|bo|den; Par|ket|te österr. (Einzelbrett des Parkettfußbodens) w; -, -n; par|ket|tie|ren (mit getäfeltem Fußboden versehen); Par|kett|sitz; Park|haus; par|kie|ren (schweiz. neben: parken)

Par|kin|son [pa'kins°n], James [dsche'ms] (engl. Chirurg); Par|kin|son|sche Krank|heit (↑ R 179) w; -n -

Park.licht, ...lücke [Trenn.: ...lük|ke]; Par|ko|me|ter (Parkzeituhr) s; -s, -; Park.platz, ...raum, ...raum|not, ...schei|be, ...tor s, ...uhr (für: Parkzeituhr), ...ver|bot, ...weg, ...zeit

Par|la|ment engl. (Volksvertretung) s; -[e]s, -e; Par|la|men|tär fr. (Unterhändler) m; -s, -e; par|la|men|tär flag|ge; Par|la|men|ta|ri|er engl. [...i°r] (Abgeordneter, Mitglied des Parlamentes) m; -s, -; Par|la|men|ta|rie|rin w; -, -nen; par|la|men|ta|risch (das Parlament betreffend) -e Anfrage; -er Staatssekretär, aber (↑ R 224): Parlamentarischer Rat (das aus 65 Ländervertretern gebildete u. am 1. 9. 1948 in Bonn zusammengetretene Versammlung); par|la|men|ta|risch-de|mo|kra|tisch (↑ R 158); par|la|men|ta|ri|sie|ren (selten für: den Parlamentarismus einführen); Par|la|men|ta|ri|sie|rung; Par|la|men|ta|ris|mus (Regierungsform, in der die Regierung dem Parlament verantwortlich ist) m; -; par|la|men|tie|ren fr. (veralt. für: unterverhandeln, sel und mdal. für: hin u. her reden); Par|la|ments|.aus|schuß, ...be|schluß, ...re|de (Mehrz.), ...mit|glied, ...sit|zung, ...wahl (meist Mehrz.)

par|lan|do it. (Musik: mehr gesprochen als gesungen); Par|lan|do s; -s, -s u. ...di

Pär|lein vgl. Pärchen -n

par|lie|ren fr. (spött., bes. mdal. für: eifrig u. schnell sprechen; schwätzen; in einer fremden Sprache [bes. französisch] reden)

Par|ma (it. Stadt); Par|ma|er [...a°r] (↑ R 199); par|ma|isch [...a-isch]

Par|mä|ne (eine Apfelsorte) w; -, -n

Par|me|sa|ner vgl. Parmaer; par|me|sa|nisch vgl. parmaisch; Par|me|san|kä|se

Par|naß (mittelgr. Gebirgszug; Musenberg, Dichtersitz) m; ...nasses; par|nas|sisch; Par|nas|sos, Par|nas|sus m; -; vgl. Parnaß

par|ochi|al gr. [...ehi...] (zum Kirchspiel gehörend); Par|ochi|al|kir|che (Pfarrkirche); Par|ochie (Kirchspiel; Amtsbezirk eines Geistlichen) w; -, ...ien

Par|odie gr. (komische Umbildung ernster Dichtung; scherzh. Nachahmung; Musik: Vertauschung geistl. u. weltl. Texte u. Kompositionen [zur Zeit Bachs]) w; -, ...jen; Par|odie|mes|se (Messenkomposition unter Verwendung eines schon vorhandenen Musikstücks); vgl. [1]Messe; par|odie|ren; Par|odist (jmd., der parodiert); ↑ R 268; Pa|ro|di|stik; par|odi|stisch

Par|odon|to|se gr. (älter:) Pa|raden|to|se (Med.: ohne Entzündung verlaufende Erkrankung des Zahnbettes mit Lockerung der Zähne) w; -, -n

Pa|ro|le fr. (milit. Kennwort; Losung; auch für: Leit-, Wahlspruch) w; -, -n; Pa|ro|le|aus|ga|be; Pa|role d'hon|neur fr. [...rol donör] (Ehrenwort) s; - -

Pa|ro|li fr. (Verdoppelung des ersten Einsatzes beim [2]Pharao) s; -s, -s; Paroli bieten (Widerstand entgegensetzen)

Par|ömie gr. (Sprichwort, Denkspruch) w; -, ...jen; Par|ömio|lo|gie (Sprichwortkunde) w; -; Par|ono|ma|sie (Rhet.: Zusammenstellung lautlich gleicher od. ähnlich klingender Wörter von gleicher Herkunft) w; -, ...jen; Par|ony|ma, Par|ony|me (Mehrz. von: Paronymon); Par|ony|mie (veralt. für: Ableitung vom Stammwort) w; -; Par|ony|mik (Lehre von der Ableitung der Wörter) w; -; par|ony|misch (stammverwandt); Par|ony|mon (veralt. für: mit anderen Wörtern vom gleichen Stamm abgeleitetes Wort) s; -s, ...ma u. ...onyme

Pa|ros (gr. Insel)

Pa|rotis gr. (Med.: Ohrspeicheldrüse) w; -, ...jden; Par|oti|tis (Med.: Ohrspeicheldrüsenent-

zündung; Mumps) *w*; -, ...it|den; **Par|oxys|mus** (Med.: Höhepunkt einer Krankheit, heftiger Anfall; Geol.: aufs höchste gesteigerte Tätigkeit eines Vulkans) *m*; -, ...men; **Par|oxy|tonon** [auch: ...xǘt...] (gr. Sprachw.: auf der vorletzten Silbe betontes Wort) *s*; -s, ...tona

Par|ri|ci|da, Par|ri|zi|da *lat.* (selten für: Verwandtenmörder, bes. Vatermörder) *m*; -s, -s

Par|se *pers.* (Anhänger des Zoroaster) *m*; -n, -n (↑ R 268)

Par|sec [Kurzw. aus „Paralaxe" u. „Sekunde"] (astron. Längenmaß; Abk.: pc) *s*; -, -; 3 -

Par|si|fal (von Richard Wagner gebrauchte Schreibung für: Parzival)

par|sisch (die Parsen betreffend); **Par|sis|mus** (Religion der Parsen) *m*; -

Pars pro toto *lat.* (Redefigur, die einen Teil für das Ganze setzt) *s*; - - -

Part *fr.* (Anteil; Stimme eines Instrumental- od. Gesangstücks) *m*; -s, -e; vgl. halbpart

part. = parterre

Part. = Parterre

¹Par|te *it.* österr. (Todesanzeige) *w*; -, -n; **²Par|te** landsch. (Mietpartei; Gruppe) *w*; -, -n

Par|tei *fr.* *w*; -, -en; **Par|tei_ab|zei|chen,** ...ak|tiv (DDR; vgl. ²Aktiv), ...amt; **par|tei|amt|lich; Par|tei_an|hän|ger,** ...ap|pa|rat, ...buch, ...bü|ro, ...chef, ...chi|ne|sisch (iron. abwertend für: dem Außenstehenden unverständliche Parteisprache; *s*; -[s]; vgl. Deutsch), ...dis|zi|plin; **Par|tei_en_kampf,** ...staat (*Mehrz.* ...staaten), ...ver|kehr (österr.: Amtsstunden); **Par|tei_freund,** ...füh|rer, ...füh|rung, ...gän|ger, ...geno|sse, ...ideo|lo|ge, ...in|stanz; **par|tei|isch** (nicht neutral, nicht objektiv; voreingenommen; der einen od. anderen Seite zugeneigt); -ste (↑ R 294); **Par|tei_ka|der,** ...kon|greß, ...lei|tung; **par|tei|lich** (im Sinne einer polit. Partei, ihr nahestehend); **Par|tei|lich|keit** *w*; -; **Par|tei|li|nie; par|tei|los; Par|tei|lo|se** *m* u. *w*; -n, -n (↑ R 287 ff.); **Par|tei|lo|sig|keit** *w*; -; **par|tei|mä|ßig; Par|tei_mit|glied,** ...nah|me (*w*; -, -n), ...or|gan, ...or|ga|ni|sa|ti|on, ...po|li|tik; **par|tei|po|li|tisch:** -neutral sein; **Par|tei_prä|si|di|um,** ...pro|gramm, ...pro|pa|gan|da, ...se|kre|tär, ...tag; **Par|tei|ung** (veralt. für: Zerfall in Parteien); **Par|tei|vor|sit|zen|de**

par|terre *fr.* [...tär] (zu ebener Erde; Abk.: part.); - wohnen; **Par-**

terre (Erdgeschoß [Abk.: Part.]; Saalplatz im Theater, auch: Plätze hinter dem Parkett) *s*; -s, -s; **Par|terre_akro|ba|tik** (artist. Bodenturnen), ...woh|nung

Par|te|zet|tel österr. (svw. ¹Parte) **Par|the|no|ge|ne|se,** (auch noch:) **Par|the|no|ge|ne|sis** [auch: ...gen...] *gr.* (Biol.: Jungfernzeugung, Entwicklung aus unbefruchteten Eizellen) *w*; -; **par|the|no|ge|ne|tisch; Par|the|non** (Tempel der „Jungfrau" Athene) *m*; -s; **Par|the|no|pe** [...pe; auch: ...ten...] (Sirene; veralt. dicht. für: Neapel); **par|the|no|pe|isch,** a b e r (↑ R 224): die Parthenopeische Republik (1799)

Par|ther (Angehöriger eines nordiran. Volksstammes) *m*; -s, -; **Par|thi|en** [...i*ᵉ*n] (Land der Parther) **par|thi|al** *lat.* [...zi̯al] (veralt. für: partiell); **par|ti|al...** (Teil...); **par|ti|al_bruch** (Math.: Teilbruch eines Bruches mit zusammengesetztem Nenner; *m*), ...ob|li|ga|ti|on (Teilschuldverschreibung), ...tö|ne (Musik: Obertöne, Teiltöne eines Klanges; *Mehrz.*); **Par|tie** *fr.* [...tí] (Heirat[smöglichkeit]; Abschnitt, Ausschnitt, Teil; veralt., aber noch mdal. für: Ausflug; einzelne [Gesangs]rolle; Kaufmannsspr.: Anzahl [von Waren]; österr. auch: für eine bestimmte Aufgabe zusammengestellte Gruppe von Arbeitern) *w*; -, ...ien; **Par|tie_be|zug** (*m*; -[e]s), ...füh|rer (österr. für: Vorarbeiter); **par|ti|ell** [*parzi...*] (teilweise [vorhanden]; einseitig, anteilig); -e Sonnenfinsternis; **par|ti|en|wei|se, par|tie|wei|se; Par|tie_preis;** vgl. ²Preis; **Par|ti|kel** *lat.* („Teilchen" der Hostie, Kreuzreliquie; Physik: [materielles] Teilchen; Sprachw.: unbeugbares Wort, z. B. „dort, in, und") *w*; -, -n; **par|ti|ku|lar, par|ti|ku|lär** (einen Teil betreffend, einzeln); **Par|ti|ku|la|ris|mus** (Sonderbestrebungen staatl. Teilgebiete, Kleinstaaterei) *m*; -; **Par|ti|ku|la|rist** (↑ R 268); **par|ti|ku|la|ri|stisch;** -ste (↑ R 294); **Par|ti|ku|lar|recht** (veralt. für: Einzel-, Sonderrecht); **Par|ti|ku|lier** *fr.* (selbständiger Schiffseigentümer; Selbstfahrer in der Binnenschiffahrt) *m*; -s, -e; **Par|ti|men|to** *it.* (Musik: Generalbaßstimme) *m*; -[s], ...ti; **Par|ti|san** *fr.* (bewaffneter Widerstandskämpfer im feindl. Hinterland) *m*; -s, -en, -en (↑ R 268); **Par|ti|sa|ne** (spießartige Stoßwaffe [15.-18. Jh.]) *w*; -, -n; **Par|ti|sa|nen_kampf,** ...krieg; **Par|ti|ta** *it.* (Musik: svw. Suite) *w*; -, ...iten; **Par|ti|te** (Geld-

summe, die in Rechnung gebracht wird; veralt. für: Schelmenstreich) *w*; -, -n; **Par|ti|ti|on** *lat.* [...zion] (Logik: Zerlegung des Begriffsinhaltes in seine Teile od. Merkmale); **par|ti|tiv** (Sprachw.: die Teilung bezeichnend); **Par|ti|tur** *it.* (Zusammenstellung aller zu einem Tonstück gehörenden Stimmen) *w*; -, -en; **Par|ti|zip** *lat.* (Sprachw.: Mittelwort) *s*; -s, -ien [...i*ᵉ*n]; erstes - (Partizip Präsens, Mittelwort der Gegenwart, z. B. „erwachend"); zweites - (Partizip Perfekt, Mittelwort der Vergangenheit, z. B. „erwacht"); **Par|ti|zi|pa|ti|on** [...zion] (Teilnahme); **Par|ti|zi|pa|ti|ons_ge|schäft,** ...kon|to; **par|ti|zi|pi|al** (Sprachw.: mittelwörtlich, Mittelwort...); **Par|ti|zi|pi|al_bil|dung,** ...kon|struk|ti|on, ...satz; **par|ti|zi|pie|ren** (Anteil haben, teilnehmen); **Par|ti|zi|pi|um** (älter für: Partizip) *s*; -s, ...pia; **Part|ner** *engl.* (Teilhaber; Teilnehmer; Mitspieler; Genosse) *m*; -s, -; **Part|ne|rin** *w*; -, -nen; **Part|ner_land,** ...schaft, ...staat (*Mehrz.* ...staaten), ...tausch, ...wahl

par|tout *fr.* [...tu] (ugs. für: durchaus; unbedingt; um jeden Preis) **Par|ty** *engl.-amerik.* [pá'ti] (geselliges Beisammensein, zwangloses Hausfest) *w*; -, -s u. Parties [pá'tis]; **Par|ty|girl**

Par|usie *gr.* (Wiederkunft Christi beim Jüngsten Gericht) *w*; - **Par|ve|nü** *fr.* [...we...] u. (österr.:) **Par|ve|nu** [...wenü] (Emporkömmling; Neureicher) *m*; -s, -s **Par|ze** *lat.* (röm. Schicksalsgöttin [Atropos, Klotho, Lachesis]) *w*; -, -n (meist *Mehrz.*) **Par|zel|lar_ver|mes|sung; Par|zel|le** *lat.* (vermessenes Grundstück, Baustelle) *w*; -, -n; **Par|zel|len_wirt|schaft; par|zel|lie|ren** (Großfläche in Parzellen zerlegen) **Par|zi|val** [...fal] (Held der Artussage); vgl. Parsifal

Pas *fr.* [pa] ([Tanz]schritt) *m*; - [pa(ß)], - - [paß] **Pas|cal** [...kál] (fr. Mathematiker u. Philosoph) **Pasch** *fr.* (Wurf mit gleicher Augenzahl auf mehreren Würfeln beim Domino Stein mit Doppelzahl) *m*; -[e]s, -e u. Päsche **¹Pa|scha** vgl. Passah **²Pa|scha** *türk.* (früherer oriental. Titel; ugs. für: rücksichtsloser herrischer Mann [, der sich von Frauen bedienen läßt]) *m*; -s, -s **Pa|scha|lik** (Amtsbezirk eines Paschas) *s*; -s, -e u. -s **Pa|scha|lis** [auch: *paßelis*...] *hebr.* (Papstname)

¹pa|schen *fr.* (würfeln; bayr. u. österr. mdal.: in die Hände klatschen, schlagen); du paschst (paschest)

²pa|schen *hebr.* (ugs. für: schmuggeln); du paschst (paschest); **Pa|scher; Pa|sche|rei**

pa|scholl! *russ.* (ugs. für: pack dich!; vorwärts!)

Pas de Ca|lais *fr.* [pa dᵉ kalä] (fr. Name der Straße von Dover) *m*; - - -

Pas de deux *fr.* [pa dᵉ dö] (Tanz od. Ballett für zwei) *m*; - - -, - - -

Pas|lack *slaw.* nordostd. (jmd., der für andere schwer arbeiten muß) *m*; -s, -s

Pa|so do|ble *span.* (ein Tanz) *m*, - -, - -

Pas|pel *fr.* w; -, -n (selten: *m*; -s, -) u. (bes. österr.:) **Passe|poil** [paßpoal] (schmaler Nahtbesatz bei Kleidungsstücken, Vorstoß) *m*; -s, -s; **pas|pe|lie|ren**, (bes. österr.:) **passe|poi|lie|ren** (mit Paspeln versehen); **Pas|pe|lie|rung**, Passe|poi|lie|rung; **pas|peln**; ich pasp[e]le († R 327)

Pas|quill *it.* (Schmäh-, Spottschrift) *s*; -s, -e; **Pas|quil|lant** (Verfasser od. Verbreiter eines Pasquills) *m*; -en, -en († R 268); **Pas|qui|na|de** *fr.* [paßkinadᵉ] (selten für: Pasquill)

|aß *lat.* (Bergübergang; Ausweis [für Reisende]; [genaue] Ballabgabe beim Fußball) *m*; Passes, Pässe; aber († R 141): zu|paß, zupasse kommen

|as|sa usw. vgl. Passah usw.

as|sa|bel *lat.* (annehmbar; leidlich); ...a|ble Gesundheit; **Pas|sa-ca|glia** *it.* [...kalja] (tanzartiges Tonstück) w; -, ...ien [...je]

Pas|sa|de *fr.* (Reitsport: schulgerechtes schnelles Aufundabreiten derselben Strecke); **Pas|sa|ge** [...ßageh] (Durchfahrt, -gang; Überfahrt, Reise mit Schiff od. Flugzeug; Lauf, Gang [in einem Musikstück]; fortlaufender Teil einer Rede od. eines Textes; Reitsport: Gangart der Hohen Schule); **Pas|sa|gier** *it.*(-*fr.*) [...ßaschir] (Schiffsreisender, Fahrgast, Fluggast) *m*; -s, -e; **Pas|sa|gier-damp|fer**, ...flug|zeug, ...gut

as|sah, (ökum.:) ¹**Pas|cha** [paßcha] *hebr.* (jüd. Fest zum Gedenken an den Auszug aus Ägypten; das beim Passahmahl gegessene [Oster]lamm) *s*; -s; **Pas|sah|fest od.** Pas|cha|fest, ...mahl od. Pas|cha|mahl

|aß|amt; Pas|sant *fr.* (Fußgänger; Vorübergehender) *m*; -en, -en († R 268)

as|sar|ge (Zufluß des Frischen Haffs) w; -

Pas|sat *niederl.* (gleichmäßig wehender Tropenwind) *m*; -[e]s, -e; **Pas|sat_staub** (*m*; -[e]s), ...trift, ...wind

Pas|sau (Stadt am Zusammenfluß von Donau, Inn u. Ilz); **Pas|sau-er** († R 199)

Paß|bild

pas|sé *fr.* [paßé] (ugs. für: vorbei, vergangen, abgetan, überlebt); das ist -

Pas|se *fr.* ([doppeltes] Schulterstück bei Kleidungsstücken) w; -, -n

Pas|sei|er (Alpental) *s*; -s u. **Pas|sei|er|tal** *s*; -[e]s

pas|sen *fr.* (räumlich, zeitlich, sinngemäß entsprechen; Kartenspiel: das Spiel abgeben); du paßt (passest); gepaßt; passe! u. paß!; das paßt sich nicht (ugs.); **pas-send;** etwas Passendes; **Passe|partout** [paßpartu, schweiz.: paß...] ([breiter] Wechselrahmen ohne Glas; veralt. u. schweiz. auch: Freipaß; Dauerkarte; Hauptschlüssel) *s* (schweiz.: *m*); -s, -s; **Passe|par|tout-Rand** († R 152) Paspel usw.

Pas|ser (Druckw.: das genaue Übereinanderliegen der einzelnen Formteile u. Druckelemente, bes. beim Mehrfarbendruck) *m*; -s, -

Paß_form, ...fo|to, ...gang (bei [Reit]tieren: gleichzeitiges Heben der Beine derselben Seite) *m*, ...gän|ger; **paß|ge|recht; Paß|hö-he; pas|sier|bar** (überschreitbar); **pas|sie|ren** *fr.* (vorübergehen, -fahren; durch-, überqueren; geschehen; angehen; gerade noch erträglich sein; Gastr.: durchseihen, durch eine Passiermaschine geben); **Pas|sier_ball** (Tennis), ...ge|wlcht (veralt. für: Mindestgewicht, gerade noch gültiges Gewicht), ...ma|schi|ne, ...schein; **Pas|sier_schein|ab|kom|men,** ...stel|le; **Pas|sier_schlag** (Tennis), ...sieb

pas|sim *lat.* (da u. dort zerstreut)

Pas|si|on *lat.* (Leiden[sgeschichte Christi]; Leidenschaft, leidenschaftl. Hingabe, Vorliebe); **pas|sio|na|to** *it.* (Musik: mit Leidenschaft); **Pas|sio|na|to** *s*; -s, -s u. ...ti; **pas|sio|nie|ren** *fr.* (veralt. für: begeistern); sich -; **pas|sio|niert** (leidenschaftlich [für etwas begeistert]); **Pas|si|ons_blu|me,** ...sonn|tag (zweiter Sonntag vor Ostern), ...spiel (Darstellung der Leidensgeschichte Christi), ...weg, ...wo|che, ...zeit

pas|siv *lat.* [auch: ...if] (leidend; untätig; teilnahmslos; still; seltener für: passivisch); -e [...wᵉ] Be-

stechung; -e [Handels]bilanz; -es Wahlrecht (Recht, gewählt zu werden); **Pas|siv** [auch: ...if] (Sprachw.: Leideform) *s*; -s, (selten:) -e [...wᵉ]; **Pas|si|va** [...wa], **Pas|si|va** [...wᵉn] (Schulden, kaufmänn. Verbindlichkeiten) Mehrz.; **Pas|siv_bil|dung,** ...ge-schäft, ...han|del; **pas|si|vie|ren** [...wi...] (Verbindlichkeiten aller Art in der Bilanz erfassen u. ausweisen; Chemie: unedle Metalle in den vorübergehenden Zustand chem. Widerstandskraft überführen); **pas|si|visch** [...iwisch] (das Passiv betreffend, in der Leideform stehend); **Pas|si|vi|tät** (Untätigkeit; Teilnahmslosigkeit) w; -; **Pas|siv_le|gi|ti|ma|ti|on** (vgl. Aktivlegitimation), ...mas-se, ...po|sten, ...sal|do (Verlustvortrag), ...zin|sen (Mehrz.)

paß|lich (veralt. für: angemessen; bequem); **Paß_stel|le,** ...stra|ße; **Pas|sung** (Maschinenbau: Beziehung zwischen zusammengefügten Maschinenteilen); **Pas|sus** *lat.* ([Schrift]stelle, Absatz; Angelegenheit, Fall) *m*; -, -; **paß-wärts; Paß_wort** (veralt. für: Kennwort; Mehrz. ...wörter), ...zwang

Pa|ste *it.*, (auch:) **Pa|sta** (streichbare Masse; Teigmasse als Grundlage für Arzneien und kosmet. Mittel; Abdruck, Nachbildung [von Münzen u. a.]) w; -, ...sten; **Pa|sta asciut|ta** *it.* [paßta aschuta] (it. Spaghettigericht) w; - -, ...te ...tte [...te aschute]; **Pa-stell** *it.*(-*fr.*) (mit Pastellfarben gemaltes Bild) *s*; -[e]s, -e; **pa|stell|len;** **Pa|stell_far|be; pa|stell|far|ben; pa|stell|lig; Pa|stell_ma|le|rei,** ...stift (vgl. ²Stift), ...ton (Mehrz. ...töne)

Pa|ster|nak (russ. Schriftsteller)

Pa|ster|ze (größter österr. Gletscher am Großglockner) w; -

Pa|stet|chen, Pa|stet|lein; Pa|ste-te *roman.* (Fleisch-, Fischspeise u. a. in Teighülle) w; -, -n

Pa|steur [...tör] (fr. Bakteriologe); **Pa|steu|ri|sa|ti|on** [...zion], **Pa-steu|ri|sie|rung** (Entkeimung); **pa|steu|ri|sie|ren;** pasteurisierte Milch; vgl. Pastmilch

Pa|stil|le *lat.* (Kügelchen, Plätzchen, Pille) w; -, -n

Pa|sti|nak *lat.* *m*; -s, -e u. **Pa|sti|na-ke** (krautige Pflanze, deren Wurzeln als Gemüse u. Viehfutter dienen) w; -, -n

Past|milch (schweiz. Kurzform von: pasteurisierte Milch)

Pa|stor [auch: ...or] *lat.* („Hirte“; ev. od. kath. Geistlicher; Abk.: P.) *m*; -s, ...oren (nordd. auch: ...ore, mdal. auch: ...öre); **pa|sto-**

ral (seelsorgerisch; feierlich, würdig); Pa|sto|ral (im kath. Sprachgebrauch für: Pastoraltheologie) w; -; Pa|sto|ral|brief; Pa|sto|ra|le it. (Musik: ländlich-friedvolles Tonstück; kleines Schäferspiel) s; -s, -s od. w; -, -n, (für Hirtenstab des kath. Bischofs nur: s; -s, -s); Pa|sto|ra|li|en [...*i^e n*] (selten für: Pfarramtsangelegenheiten) Mehrz.; Pa|sto|ral|theo|lo|gie; Pa|sto|rat (Pfarramt, -wohnung) s; -[e]s, -e; Pa|sto|rel|le it. (Hirtenliedchen) w; -, -n; Pa|sto|rin w; -, -nen; Pa|stor pri|ma|ri|us lat. (ev. Oberpfarrer; Abk.: P. prim.) m; -, -, ...ores ...rii [...ri-i]

pa|stos it. („teigig"; bild. Kunst: dick aufgetragen); -este (↑ R 292); pa|stös fr. (Med.: gedunsen, aufgeschwemmt; Technik: pastenartig); -este (↑ R 292)

Pa|ta|go|ni|en [...*i^e n*] (südlichster Teil Amerikas); Pa|ta|go|ni|er [...*i^e r*]; pa|ta|go|nisch

Pat|chen (Patenkind)

Patch|work amerik. [*pätschwö'k*] (aus bunten Stoff- od. Lederflikken zusammengesetztes Kleidungsstück im Zigeunerlook) s; -s

¹Pa|te (Taufzeuge, auch: Patenkind) m; -n, -n (↑ R 268); ²Pa|te w; -, -n u. (österr. nur:) Pa|tin (Taufzeugin) w; -, -nen

Pa|tel|la lat. (Med.: Kniescheibe) w; -, ...llen; Pa|tel|lar|re|flex

Pa|te|ne gr. (Hostienteller) w; -, -n

Pa|ten.ge|schenk, ...kind, ...on|kel; Pa|ten|schaft; Pa|ten|sohn

pa|tent lat. (ugs. für: geschickt, praktisch, tüchtig, brauchbar; großartig, famos; mdal. für: hübsch gekleidet, flott, angeregelt); Pa|tent (Urkunde über die Berechtigung, eine Erfindung allein zu verwerten; Bestallungsurkunde eines [Schiffs]offiziers) s; -[e]s, -e; Pa|tent|amt

Pa|ten|tan|te

Pa|tent|an|walt; pa|tent|fä|hig; pa|ten|tie|ren (durch Erteilung eines Patents schützen); Pa|tent_in|ha|ber, ...knopf, ...lö|sung (ugs.)

Pa|ten|toch|ter

Pa|tent|recht, ...re|zept (ugs.), ...sa|che, ...schrift, ...schutz, ...streit, ...ver|schluß

Pa|ten|wein

Pa|ter lat. („Vater"; kath. Ordensgeistlicher; Abk.: P.) m; -s, Patres, (ugs. auch:) - (Abk.: PP.); Pa|ter|fa|mi|li|as (altröm. Bez. für: Haus-, Familienvater) m; -, -; Pa|ter|ni|tät (veraltet für: Vaterschaft) w; -; ¹Pa|ter|no|ster (Vaterunser) s; -s, -; ²Pa|ter|no|ster (ständig umlaufender Auf-

zug; Becherwerk, Wasserhebewerk; Baggermaschine) m; -s, -; Pa|ter|no|ster|auf|zug; pa|ter, pec|ca|vi [- *pekawi*] („Vater, ich habe gesündigt"); - - sagen (flehentlich um Verzeihung bitten); Pa|ter|pec|ca|vi (reuiges Geständnis) s; -, -

Pa|the|tik gr. w; -; pa|the|tisch (ausdrucksvoll; feierlich; salbungsvoll); -ste (↑ R 294); pa|tho|gen (Med.: krankheitserregend); -e Bakterien; Pa|tho|ge|ne|se ([Lehre von der] Krankheitsentstehung) w; -, -n; Pa|tho|ge|ni|tät (Fähigkeit, Krankheiten hervorzurufen) w; -; pa|tho|gno|mo|nisch, pa|tho|gno|stisch (für eine Krankheit kennzeichnend); Pa|tho|lo|ge m; -n, -n (↑ R 268); Pa|tho|lo|gie (allgemeine Lehre von den Krankheiten) w; -; pa|tho|lo|gisch (krankhaft); -e Anatomie (Anatomie, die sich mit den krankhaften Veränderungen der Gewebe u. der Organe beschäftigt); Pa|tho|pho|bie (Furcht vor Krankheiten) w; -; Pa|tho|phy|sio|lo|gie (Lehre von den Krankheitsvorgängen u. Funktionsstörungen [in einem Organ]); Pa|tho|psy|cho|lo|gie svw. Psychopa|tho|lo|gie; Pa|thos („Leidenschaft"; [übertriebene] Gefühlserregung; Schwung) s; -

Pa|ti|ence fr. [*paßiangß*] (Geduldsspiel mit Karten) w; -, -n; Pa|ti|ence|spiel; Pa|ti|ent lat. [*pazient*] (Kranker in ärztl. Behandlung); ↑ R 268; Pa|ti|en|tin w; -, -nen

Pa|tin vgl. Pate w

¹Pa|ti|na it. (grünlicher Überzug auf Kupfer, Edelrost) w; -; ²Pa|ti|na, Pa|ti|ne (veralt. für: Schüssel) w; -, ...inen; pa|ti|nie|ren (eine ¹Patina chemisch erzeugen)

Pa|tis|se|rie fr. ([in Hotels] Raum zur Herstellung von Backwaren; schweiz., sonst veralt. für: feines Gebäck wie Mohrenköpfe, Sahnerollen u. a.) w; -, ...jen; Pa|tis|sier [...*je̜*] ([Hotel]konditor) m; -s, -s

Pat|mos (gr. Insel; Verbannungsort des Evangelisten Johannes)

Pat|na|reis [nach der ind. Stadt Patna]; (langkörniger Reis) ↑ R 201

Pa|tois fr. [...*toa*] (fr. Bez. für: Volksmundart, Provinzidiom [bes. der Landbevölkerung]) s; -

Pa|tras (gr. Stadt)

Pa|tres (Mehrz. von: Pater); Pa|tri|arch gr. (Erzvater; Ehren-, Amtstitel von Bischöfen; Titel der obersten Geistlichen in Moskau u. Konstantinopel sowie der leitenden Bischöfe in selbständigen Ostkirchen) m; -en, -en (↑ R

268); pa|tri|ar|cha|lisch (altväterlich, nach Altväterweise; ehrwürdig); -ste (↑ R 294); Pa|tri|ar|cha_kir|che (Hauptkirche), ...staat (Mehrz. ...staaten) Pa|tri|ar|chat (Würde, Sitz u. Amtsbereich e nes Patriarchen; auch: Vate recht) s (Theol. auch: m); -[e]s, -

Pa|tri|cia, Pa|tri|zia lat. (w. Vorn pa|tri|mo|ni|al lat. (erbherrlich Pa|tri|mo|ni|al|ge|richt ([Grund herrschaftsgericht; hist.); Pa|tr mo|ni|um (väterl. Erbgut) s; - ...ien [...*i^e n*]; Pa|tri|ot gr. (Vate landsfreund, vaterländisch G sinnter) m; -en, -en (↑ R 268 pa|tri|o|tisch; -ste (↑ R 294); Pa trio|tis|mus m; -; Pa|tri|stik (Wi senschaft von den Schriften Lehren der Kirchenväter) w; Pa|tri|sti|ker (Kenner, Erfo scher der Patristik); pa|tri|stisch

Pa|tri|ze lat. (Druckw.: Stempe Prägestock; Gegenform zur M trize) w; -, -n

Pa|tri|zia, Pa|tri|cia lat. (w. Vorn Pa|tri|zi|at lat. (Bürger-, Stad adel) s; -[e]s, -e; Pa|tri|zi|er [...*i^e* (vornehmer Bürger [im alte Rom]) m; -s, -; Pa|tri|zi|e|rin w; -, -nen; pa|tri|zisch

Pa|tro|klos lat. (swv. Patro... (Freund Achills); Pa|tro|klo [auch: *pat*..., *pat*...] vgl. Patrokl Pa|tro|lo|gie gr. (swv. Patristik) -; Pa|tron lat. (Schutzher Schutzheiliger; veralt. für: Gö ner, Förderer; meist verächtl. fü armseliger od. unliebsam Mensch) m; -s, -e; Pa|tro|na ([he lige] Beschützerin) w; -, ...nä; P tro|na|ge fr. [...*aseh*²] (Güns lingswirtschaft, Protektion); P tro|nanz lat. (veralt. für: Patron ge; österr. auch für: Ehrenschat Schirmherrschaft) w; -; Pa|tr nat (Würde, Amt, Recht ein Schutzherrn [im alten Rom Rechtsstellung des Stifters ein Kirche od. seines Nachfolger Schirmherrschaft) s; -[e]s, -e; P tro|nats_fest, ...herr; Pa|tro|ne (Geschoß u. Treibladung; M sterzeichnung auf kariertem P pier bei der Jacquardweber Tintenbehälter im Füllfederha ter; Behälter für Kleinbildfilm w; -, -n; Pa|tro|nen_hül|se, ...sche|nung, ...ta|sche, ...trom|me pa|tro|nie|ren österr. (Zimme wände mit Schablone maler Pa|tro|nin lat. (Schutzherrin Schutzheilige) w; -, -nen; pa|tr ni|sie|ren (veralt. für: beschütze begünstigen); pa|tro|ny|misch gr., Pa|tro|ny|mi|kum (nach de Namen des Vaters gebildeter N me, z. B. Petersen = Peters Soh s; -s, -ka; pa|tro|ny|misch

Pa|trouil|le fr. [*patrulj^e*] (Späh-
trupp, Streife) w; -, -n; **Pa|trouil-
len|füh|rer**, ...**gang**; **pa|trouil|lie-
ren** [*patruljir^en*] (veralt. für: auf
Patrouille gehen; [als Posten] auf
u. ab gehen)
Pa|tro|zi|ni|um lat. (im alten Rom
die Vertretung durch einen Pa-
tron vor Gericht; im MA. vom
Gutsherrn seinen Untergebenen
gewährter Rechtsschutz gegen
Staat u. Stadt; Schutzherrschaft
eines Heiligen über eine Kirche)
s; -s, ...ien [...*i^en*]; **Pa|tro|zi|ni-
um|fest**
patsch!; pitsch, patsch!; **¹Patsch**
(klatschender Schlag; ugs. für:
Uhrteage) m; -[e]s, -e; vgl. Pat-
sche; **²Patsch** österr. ugs. (Tol-
patsch) m; -, -en; **Pat|sche** [Ne-
benform von: Patsch] (Straßen-
kot, Schneeschlick) w; -, (für:
klatschender Schlag; Gegen-
stand zum Schlagen [z. B. Feuer-
patsche]; ugs. auch für: Hand
Mehrz.:) -n; in der - stecken (ugs.
für: in Verlegenheit sein); **pät-
scheln** landsch. ([spielerisch] ru-
dern); ich ...[e]le († R 327); **pat-
schen** (ugs.); du patschst (pat-
schest); **Pat|schen** österr. (Haus-
schuh; ugs.: Reifendefekt) m; -s,
-; **pat|sche|naß**, **patsch|naß** (ugs.
für: sehr naß); **Pat|scherl** österr.
ugs. (Tolpatsch) s; -s, -n; **pat-
schert** österr. ugs. (unbeholfen);
Patsch|hand, **Patsch|händ|chen**
(Kindersprw.)
Pat|schu|li tamil. (,,grüne Blätter"
eines asiat. Lippenblütlers; Duft-
stoff) s; -s, -s; **Pat|schu|li|kamp-
fer**
att fr. (zugunfähig [von einer
Stellung beim Schachspiel]); -
sein; **Patt** s; -s, -s
¹at|te fr. (Taschenklappe, Ta-
schenbesatz) w; -, -n; **pat|tie|ren**
(rastern, mit Notenlinien verse-
hen)
at|zen (ugs. für: etwas verderben,
ungeschickt tun; klecksen; auf ei-
nem Musikinstrument fehlerhaft
spielen); du patzt (patzest); **Pat-
zen** bayer. u. österr. (Klecks) m;
-s, -; **Pat|zer** (jmd., der patzt; Feh-
ler); **Pat|ze|rei** (ugs.); **pat|zig** (ugs.
für: frech, aufgeblasen; grob;
südd. auch für: klebrig, breiig);
Pat|zig|keit (ugs.)
au|kant (Studentenspr.: Zwei-
kämpfer) m; -en, -en († R 268);
Pauk|arzt (Studentenspr.), ...**bo-
den** (Studentenspr.), ...**bril|le**
(Studentenspr.); **Pau|ke** w; -, -n;
ugs.:) auf die - hauen (ausgelas-
sen sein); er haute auf die -; **pau-
ken** (Studentenspr.: sich mit
scharfen Waffen schlagen; ugs.
auch für: angestrengt lernen);

Pau|ken.fell, ...**höh|le** (Teil des
Mittelohrs), ...**schall**, ...**schlag**,
...**schlä|ger**, ...**schle|gel**, ...**wir|bel**;
Pau|ker (Schülerspr. auch für:
Lehrer); **Pau|ke|rei** (ugs.); **Pau-
kist** (Paukenspieler); † R 268;
Pauk|tag (Studentenspr.)
Paul (m. Vorn.); vgl. Paulus; **Pau-
la**, **Pau|li|ne** (w. Vorn.); **pau|li-
nisch**; -er Lehrbegriff, aber († R
179): **Pau|li|nisch**; • Briefe,
Schriften; **Pau|li|nis|mus** (Lehre
des Paulus) m; -; **Pau|low|na**
(russ. w. Vorn.)
Pau|low|nia (ein Zierbaum) w; -,
...ien [...*i^en*]
Pauls|kir|che w; -
Pau|lus (Apostel); Pauli (des Pau-
lus) Bekehrung (kath. Fest)
Pau|pe|ris|mus lat. (veralt. für:
Massenarmut) m; -; **Pau|per|tät**
(veralt. für: Armut, Dürftigkeit)
w; -
Pau|sa|ni|as (spartan. Feldherr u.
Staatsmann; gr. Reiseschriftstel-
ler)
Paus|back landsch. (pausbackiger
Mensch) m; -[e]s, -e; **Paus-
backen¹** landsch. (dicke Wangen)
Mehrz; **paus|hackig¹**, **paus-
bäckig¹**
pau|schal (alles zusammen; rund);
Pau|schal.ab|schrei|bung, ...**be-
steue|rung**, ...**be|wer|tung**; **Pau-
scha|le** [latinisierende Bildung zu
dt.: Bauschsumme] (geschätzte
Summe; Gesamtbetrag; Ge-
samtabfindung) s; -s, ...lien (seltener:) s; -s, ...lien [...*i^en*]; **pau|scha-
lie|ren** (abrunden); **Pau|scha|li-
tät**, **Pau|schal.preis** (vgl. ²Preis),
...**rei|se**, ...**sum|me**, ...**ur|teil**,
...**ver|si|che|rung**; **Pau|schal|wert-
be|rich|ti|gung** (Wirtsch.: Be-
rücksichtigung des Ausfallrisi-
kos für eine Vielzahl kleinerer
Forderungen); **Pausch|be|trag**;
Pau|sche (Wulst am Sattel) w; -,
-n; **Päu|schel** vgl. Bäuschel;
Pausch.quan|tum, ...**sum|me**
¹Pau|se gr. (Ruhezeit) w; -, -n; die
große - (in der Schule, im Thea-
ter)
²Pau|se fr. (Durchzeichnung) w;
-, -n; **pau|sen** (durchzeichnen); du
paust (pausest); er pauste
Pau|sen.gym|na|stik, ...**halle**; **pau-
sen|los**; **Pau|sen|zei|chen**; **pau|sie-
ren** gr. (innehalten, ruhen, zeit-
weilig aufhören)
Paus.pa|pier, ...**zeich|nung**
Pa|via [...*wja*] (it. Stadt)
Pa|vi|an niederl. [...*wi...*] (ein Affe)
m; -s, -e
Pa|vil|lon fr. [*pawiljong*, österr.:
...*wijong*] (kleines frei stehendes
[Garten]haus; [Fest]gebäude,

Festzelt; vorspringender Gebäu-
deteil) m; -s, -s; **Pa|vil|lon.schu|le**,
...**stil** (Architektur), ...**sy|stem**
Paw|lat|sche tschech. österr. (offe-
ner Gang an der Hofseite eines
[Wiener] Hauses; Bretterbühne;
baufälliges Haus) w; -, -n; **Paw-
lat|schen|thea|ter** österr. (Bret-
terbühne)
Pax lat. (Friede; Friedensgruß) w;
-; **Pax vo|bis|cum!** [- *wobißkum*]
(,,Friede [sei] mit euch!")
Paying guest engl. [*pe^ing gäßt*]
(,,zahlender Gast" im Ausland,
der in einer Familie mit vollem
Familienanschluß aufgenom-
men wird) m; - -, - -s
Pa|zi|fik lat.-engl. [auch: pa...]
(Großer od. Pazifischer Ozean)
m; -s; **Pa|zi|fi|ka|ti|on** lat.
[...*zion*], Pa|zi|fi|zie|rung (veralt.
für: Beruhigung, Befriedung);
Pa|zi|fik|bahn w; -; **pa|zi|fisch**
lat.-engl.; -e Inseln, aber († R
198): der Pazifische Ozean; **Pa|zi-
fis|mus** lat. (Ablehnung des Krie-
ges aus religiösen od. ethischen
Gründen) m; -; **Pa|zi|fist** († R
268); **pa|zi|fi|stisch**; **pa|zi|fi|zie-
ren** (beruhigen; befrieden); **Pa-
zi|fi|zie|rung** vgl. Pazifikation
Pb = Plumbum (chem. Zeichen
für: Blei)
P. b. b. = Postgebühr bar bezahlt
(Österreich)
pc = Parsec
p. c., %, v. H. = pro centum;
vgl. Prozent
p. Chr. [n.] = post Christum [na-
tum]
Pd = chem. Zeichen für: ²Palla-
dium
PdA = Partei der Arbeit (kommu-
nistische Partei in der Schweiz)
Pearl Har|bor [*pö^rl ha^r b^ər*] (ame-
rik. Flottenstützpunkt im Pazi-
fik)
Pe-Ce-Fa|ser (eine synthet. Textil-
faser)
Pech s; -s (seltener: -es), (für: Pech-
arten *Mehrz*:) -e; **Pech.blen|de**,
...**draht**, ...**fackel** [*Trenn.*: ...fak-
kel]; **pech|fin|ster** (ugs.); **pe|chig**;
Pech.koh|le, ,,,**nel|ke**; **pech|ra-
ben|schwarz** (ugs.); **pech|schwarz**
(ugs.); **Pech|sträh|ne** (ugs. für:
Folge von Fällen, in denen man
Unglück hat), ...**vo|gel** (ugs. für:
Mensch, der [häufig] Unglück
hat)
Pe|dal lat. (Vorrichtung zum
Übertragen einer Bewegung mit
dem Fuß) s; -s, -e; **Pe|dal.ach|se**,
...**kraft**, ...**rah|men**, ...**schie|ne**,
...**weg**
Pe|dant gr. (ein in übertriebener
Weise genauer, kleinlicher
Mensch) m; -en, -en († R 268);
Pe|dan|te|rie w; -, ...ien; **pe|dan-**

¹ *Trenn.:* ...k|k...

tisch; -ste († R 294); **Pe|dan|tis-mus** (veralt. für: Kleinlichkeit) *m*; -

Ped|dig|rohr (geschältes span. Rohr)

Pe|dell (Rektoratsgehilfe einer Hochschule; veralt. für: Hausmeister einer Schule) *m*; -s, -e (österr. meist: *m*; -en, -en)

Pe|di|gree *engl.* [*pädigrī*] (Stammbaum bei Tieren u. Pflanzen) *m*; -s, -s

Pe|di|kü|re *fr.* (Fußpflege) *w*; -, (für: Fußpflegerin auch *Mehrz.*:) -n; **pe|di|kü|ren**; er hat pedikürt; **Pe|di|ment** *lat.* (Geogr.: Fläche am Fuß eines Felsens in der Wüste); **Pe|do|graph** *lat.*; *gr.* (Wegmesser) *m*; -en, -en († R 268)

Pe|do|lo|gie *gr.* (Bodenkunde, Lehre vom Boden) *w*; -; **pe|do|lo-gisch**

Pe|do|me|ter *lat.*; *gr.* (Schrittzähler, Wegmesser) *s*; -s, -

Pe|dro (span. u. port. Form von: Peter)

Pee|ne (westl. Mündungsarm der Oder) *w*; -

¹**Peer, Per** (skandinav. Formen von: Peter); vgl. Peer Gynt

²**Peer** *engl.* [*pīr*] (Mitglied des höchsten engl. Adels; Mitglied des engl. Oberhauses) *m*; -s, -s; vgl. Pair; **Pee|rage** [*pīridsch*] (Würde eines Peers; Gesamtheit der Peers) *w*; -; **Pee|reß** [*pīriß*] (Gemahlin eines Peers) *w*; -, ...resses [...*ßis*]

Peer Gynt (norweg. Sagengestalt, Titelheld eines Schauspiels von Ibsen)

Peers|wür|de

Pe|ga|sos *gr.*; vgl. Pegasus; ¹**Pe|ga-sus** (geflügeltes Roß der gr. Sage; Dichterroß) *m*; -; ²**Pe|ga|sus** (ein Sternbild) *m*; -

Pe|gel (Wasserstandsmesser) *m*; -s, -; **Pe|gel_hö|he, ...stand**

Peg|ma|tit (ein Gestein) *m*; -s, -e

¹**Peg|nitz** (r. Nebenfluß der Rednitz [Regnitz]) *w*; -; ²**Peg|nitz** (Stadt an der Pegnitz); **Peg|nitz-or|den** *m*; -s († R 201)

Peh|le|wi [*päch*...] (Mittelpersisch) *s*; -

Pei|es *hebr.* (Schläfenlocken [der orthodoxen Ostjuden]) *Mehrz.*

pei|len (die Himmelsrichtung, Richtung einer Funkstation, Wassertiefe bestimmen); **Pei|ler** (Einrichtung zum Peilen; das Peilen Ausführender); **Pei|fre-quenz, ...li|nie, ...lot, ...rah|men, ...ring, ...sen|der; Pei|lung**

Pein *w*; -; **pei|ni|gen; Pei|ni|ger; Pei|ni|gung; pein|lich;** (Rechtsspr., hist.:) das -e (an Leib u. Leben gehende) Gericht; -es Recht (Strafrecht); -e Gerichtsordnung

(Strafprozeßordnung); **Pein|lich-keit; pein|sam; pein|voll**

Pei|si|stra|tos (Tyrann von Athen)

Peit|sche *w*; -, -n; **peit|schen**; du peitschst (peitschest); **Peit|schen-_fisch, ...hieb, ...kak|tus, ...knall, ...leuch|te** (moderne Straßenlaterne mit gebogenem Mast), **...schlag, ...schlan|ge, ...stiel, ...wurm; Peit|schung**

pe|jo|ra|tiv (Sprachw.: verschlechternd, abschätzig); **Pe|jo|ra|ti-vum** [...*wum*] (Sprachw.: mit verkleinerndem od. abschwächendem Suffix gebildetes Wort mit abschätzigem Sinn) *s*; -s, ...va

Pe|ke|sche *poln.* (Schnürenrock) *w*; -, -n

Pe|ki|ne|se [nach der chin. Hptst. Peking] (Hund einer chin. Rasse) *m*; -n, -n († R 268)

Pe|king (Hptst. Chinas)

Pek|ten|mu|schel *lat.*; *dt.* (Zool.: Kammuschel)

Pek|tin *gr.* (gelierender Pflanzenstoff in Früchten, Wurzeln u. Blättern) *s*; -s, -e (meist *Mehrz.*)

pek|to|ral *lat.* (Med.: die Brust betreffend; Brust...); **Pek|to|ra|le** (Brustkreuz kath. geistl. Würdenträger; mittelalterl. Brustschmuck) *s*; -[s], -s u. ...lien [...*iᵉn*]

pe|ku|ni|är *lat.-fr.* (geldlich; in Geld bestehend; Geld...)

pek|zie|ren *lat.* mdal. (sich vergehen, Böses tun; [etwas] versehen); vgl. pexieren

Pe|la|gi|al (Geol.: Region des freien Meeres; Biol.: Gesamtheit der Lebewesen des freien Meeres u. weiträumiger Binnenseen) *s*; -s

Pe|la|gia|ner (Anhänger der Lehre des Pelagius); **Pe|la|gia|nis|mus** *m*; -

pe|la|gisch *gr.* (im freien Meer u. in weiträumigen Binnenseen lebend; in landfernen Teilen des Meeres abgesetzt), aber († R 198): Pelagische Inseln (Inselgruppe südl. von Sizilien)

Pe|la|gi|us (engl. Mönch)

Pe|lar|go|nie *gr.* [...*iᵉ*] (eine Zierpflanze) *w*; -, -n; **Pe|lar|go|nien-beet**

Pe|las|ger (Angehöriger einer sagenhaften Urbevölkerung Griechenlands; meist *Mehrz.*); **pe|las-gisch**

pêle-mêle *fr.* [*pälmäl*] (durcheinander); **Pele|mele** [*pälmäl*] Mischmasch; Süßspeise) *s*; -

Pe|le|ri|ne *fr.* (ärmelloser Umhang, bes.: Regenmantel) *w*; -, -n

Pe|leus [...*leuß*] (Vater des Achill); **Pe|li|de** (Peleussohn, Beiname Achills) *m*; -n († R 268)

Pe|li|kan [auch: ...*an*] (ein Vo-

gel) *m*; -s, -e; **Pe|li|kan** Ⓦ (Schreibwaren); **Pe|li|ka|nol** Ⓦ (ein Klebstoff) *s*; -s

Pe|li|on (Gebirge in Thessalien) *m*; -s

Pel|la|gra *it.* (Krankheit durch Mangel an Vitamin B₂) *s*; -; **Pel|landsch.** (dünne Haut, Schale) *w*; -, -n; jmdm. auf die - rücken (ugs. für: jmdm. energisch zusetzen); jmdm. auf der - sitzen (ugs. für jmdm. lästig sein); **Pel|landsch.** (schälen); **Pell|kar|tof-fel**

Pe|lo|pi|das (theban. Feldherr); **Pe|lo|pon|nes** (südgr. Halbinsel) *m*; -[es] (fachspr. auch: *w*; -); vgl Morea; **pe|lo|pon|ne|sisch,** aber († R 224): der Peloponnesische Krieg; **Pe|lops** (Sohn des Tantalus)

Pe|lo|rie *gr.* [...*iᵉ*] (Bot.: Blütenmißbildung) *w*; -, -n

Pe|lo|ton *fr.* [...*tong*] (früher für kleine Abteilung, Reihe von Soldaten) *s*; -s, -s; **Pe|lot|te** (ballenförmiges Druckpolster) *w*; -, -n

Pel|sei|de *it.*; *dt.* (geringwertige Rohseidengarn) *w*; -

Pel|tast (altgr. Leichtbewaffneter) *m*; -en, -en († R 268)

Pe|lusch|ke *slaw.* ostd. (Sanderbse) *w*; -, -n

Pelz *m*; -es, -e; jmdm. auf den rücken (jmdn. drängen); jmdm. setzt; ¹**pel|zen** (veralt. für: der Pelz abziehen; ugs. für: faul sein sich vor der Arbeit drücken); d pelzt (pelzest)

²**pel|zen** (pfropfen); du pelzt (pe zest)

pel|zig; Pelz|gar|ni|tur; pelz|ge|fü-tert; Pelz_kap|pe, ...kra|ge ...man|tel, ...mär|te[l] [nach de hl. Martin] (bayr., schwäl schles.: Knecht Rupprecht **...müt|ze, ...nickel** [*Trenn.:* ...ni kel] (vgl. Belznickel), **...stie|f ...sto|la, ...tier; Pelz|tier|far pelz|ver|brämt; Pelz_ver|b mung, ...wa|re, ...werk**

Pem|mi|kan *indian.* (bei den I dianern in Nordamerika g trocknetes und zerstampft Fleisch u. Fett) *m*; -s

Pem|phi|gus *gr.* (Med.: ei Hautkrankheit) *m*; -

Pe|nal|ty *engl.* [*pän^elti*] (Strafst [bes. im Eishockey]) *m*; -[s],

Pe|na|ten *lat.* (röm. Hausgött übertr. für: häuslicher He Wohnung, Heim) *Mehrz.*

Pence [*pänß*] (*Mehrz.* von: Penn

PEN-Club *engl.* [Kurzw. a poets, essayists, novelists Club] (internationale Schriftst lervereinigung) *m*; -s

Pen|dant *fr.* [*pangdang*] (Gege Seitenstück; Ergänzung) *s*; -s,

Pen|del *lat.* (um eine Achse od. einen Punkt frei drehbarer Körper) *s*; -s, -; Pen|del|aus|schlag, ...lam|pe, ...län|ge; pen|deln (schwingen; hin- u. herlaufen); ich ...[e]le (↑ R 327); Pen|del|sä|ge, ...schnur (*Mehrz.* ...schnüre), ...schwin|gung, ...tür, ...uhr, ...ver|kehr; pen|dent *it.* schweiz. (schwebend, unerledigt); Pen|den|tif *fr.* [*pã̄dãtíf*] (Architektur) Zwickel; auch: Schmuckanhänger) *s*, -s, -s; Pen|denz *it.* schweiz. (schwebendes Geschäft, unerledigte Aufgabe) *w*; -, -en; Pend|ler; Pen|du|le [*pãdǘl'*] (fr. Schreibung für: Pendüle); Pen|dü|le (früher für: Pendel-, Stutzuhr) *w*; -, -n

Pe|ne|lo|pe (Odysseus' Gemahlin)

Pe|ne|plain *engl.* [...*plḗ'n*] (svw. Fastebene) *w*; -, -s

Pe|nes (*Mehrz.* von: Penis)

pe|ne|trant *fr.* (durchdringend); Pe|ne|tranz (für: Durchschlag [Erblehre]; Aufdringlichkeit) *w*; -, -en; Pe|ne|tra|ti|on *lat.* [...*zión*] (Durchdringung, Durchsetzung; Eindringtiefe); pe|ne|trie|ren; Pe|ne|tro|me|ter *lat.*; *gr.* (Gerät zum Messen der Viskosität von Schmierfetten) *s*; -s, -

peng!; peng, peng!

pe|ni|bel *fr.* (ugs. für: sehr eigen, sorgfältig, genau, empfindlich; mdal. für: peinlich); ...i|ble Lage

Pe|ni|cil|lin vgl. Penizillin

Pen|in|su|la *lat.* (Halbinsel) *w*; -, ...suln; pen|in|su|lar, pen|in|su|la|risch

Pe|nis *lat.* (männl. Glied) *m*; -, -se u. Penes

Pe|ni|zil|lin *lat.*, (fachspr. u. österr.:) Pe|ni|cil|lin (ein antibiotisches Heilmittel) *s*; -s, -e; Pe|ni|zil|lin|am|pul|le, ...sprit|ze

pen|nal *lat.* (österr., sonst veralt. für: Federbuchse; Schülerspr. früher für: höhere Lehranstalt) *s*; -s, -e; Pen|nä|ler (ugs. für: Schüler einer höheren Lehranstalt) *m*; -s, -; pen|nä|ler|haft; Pen|na|lis|mus (auf den früheren Universitäten Gewaltherrschaft älterer Studierender über jüngere) *m*; -

pen|nbru|der (verächtl.); Pen|ne *jidd.* (Gaunerspr. für: einfache Herberge) *w*; -, -n

Pen|ne *lat.* (Schülerspr. für: höhere Lehranstalt) *w*; -, -n

pen|nen (ugs. für: schlafen); Pen|ner (svw. Pennbruder)

Pen|ni (finn. Münze; Abk.: p; 100 Penni = 1 Markka) *m*; -[s], -[s]

Penn|syl|va|ni|en [...*wani̯'n*] (Staat in den USA; Abk.: Pa.); penn|syl|va|nisch

Pen|ny *engl.* [*pä̃ni*] (engl. Münze;

Abk. [für *Einz.* u. *Mehrz.* beim neuen Penny im Dezimalsystem]: p, früher: d [= denarius]) *m*; -s, Pennies [*pä̃nis*] (einzelne Stücke) u. Pence [*pä̃nß*] (Wertangabe)

Pen|sa (*Mehrz.* von: Pensum)

pen|see *fr.* [*pãßé*] (dunkellila); ein pensée Kleid; vgl. blau; Pen|see (Gartenstiefmütterchen) *s*; -s, -s; pen|see|far|big; Pen|see|kleid

Pen|son (*Mehrz.* von: Pensum):

Pen|si|on *fr.* [*pãsión, pãßión*] (Ruhestand; Kost u. Wohnung) *w*; -, (für: Ruhe-, Witwengehalt; Fremdenheim; gelegentl. für: Pensionat auch *Mehrz.:*) -en; Pen|sio|när *fr.*' (Ruheständler; bes. schweiz. für: Kostgänger, [Dauer]gast einer Pension) *m*; -s, -e; Pen|sio|nä|rin' *w*; -, -nen; Pen|sio|nat' (Internat, bes. für Mädchen) *s*; -[e]s, -e; pen|sio|nie|ren' (in den Ruhestand versetzen); Pen|sio|nie|rung'; Pen|sio|nist [*pãnsi...*] österr. (Ruheständler); ↑ R 268; Pen|si|ons|al|ter, ...an|spruch; pen|si|ons|be|rech|tigt'; Pen|sions'-gast, ...ge|schäft (Bankw.: Aufnahme eines Darlehens gegen Verpfändung von Wechseln od. Effekten), ...kas|se (Einrichtung in Großbetrieben, die den Betriebsangehörigen Alters-, Hinterbliebenen- u. Invaliditätsrente gewähren), ...preis (vgl. ²Preis); pen|si|ons|reif' (ugs.); Pen|sions'-rück|stel|lun|gen (Wirtsch.; *Mehrz.*), ...ver|pflich|tung (Verpflichtung eines Arbeitgebers gegenüber seinem Arbeitnehmer); Pen|sum *lat.* (zugeteilte Aufgabe, Arbeit; Abschnitt) *s*; -s, ...sen u. ...sa

pent... *gr.* (fünf...); Pent... (Fünf...); Pen|ta|de (Zeitraum von fünf Tagen) *w*; -, -n; Pen|ta|eder (veralt. für: Fünfflach) *s*; -s, -; Pen|ta|gon [auch: *pãn...*] (für: das auf einem fünfeckigen Grundriß errichtete amerik. Verteidigungsministerium) *s*; -s, (für Fünfeck auch *Mehrz.:*) -e; Pen|ta|gon|do|de|ka|eder (von zwölf Fünfecken begrenzter Körper); Pen|ta|gramm (Drudenfuß) *s*; -s, -e; Pent|al|pha (svw. Pentagramm) *s*; -s, -s; Pent|ame|ron (neapolitan. Erzählungen der „fünf Tage“) *s*; -s; Pen|ta|me|ter (ein fünffüßiger Vers) *m*; -s, -; Pen|tan (ein Kohlenwasserstoff) *s*; -s, -e; Pent|ar|chie (Fünfherrschaft) *w*; -, ...ien; Pen|ta|teuch („fünf Bücher“ [Mosis]) *m*; -s; Pent|ath|lon [auch: *pãnt...*] (antiker „Fünfkampf“) *s*; -s; Pen|te-

ko|ste („,50. Tag“ [nach Ostern]: Pfingsten) *w*; -

Pen|te|li|kon (Gebirge in Attika) *m*; -s; pen|te|lisch; -er Marmor

Pen|te|re *gr.* („Fünfruderer“ [antikes Kriegsschiff]) *w*; -, -n

Pen|the|si|lea *gr.* (eine Amazonenkönigin); Pen|the|si|leia vgl. Penthesilea

Pent|house amerik. [*pä̃nthauß*] (exklusive Dachterrassenwohnung über einem Etagenhaus) *s*; -, -s [...*sis*]

Pent|ode *gr.* (Bremsgitterröhre, Fünfpolröhre) *w*; -, -n

pen|zen österr. ugs. (betteln, unablässig bitten; ständig ermahnen)

Pep *amerik.* [von pepper – Pfeffer] (Schwung, Elan) *m*; -[s]; Pep|..mit|tel (Aufputschmittel), ...pil|le; Pe|pe|rin *it.* („Pfefferstein“; ein Gestein) *m*; -s, -e; Pe|pe|ro|ni (scharfe, kleine [in Essig eingemachte] Pfefferschoten, auch Paprikaschoten) *Mehrz.*

Pe|pi (Kurzform von: Joseph, Josephine u. Sophie)

Pe|pi|ta *span.* (kariertes Gewebe) *m* od. *s*; -s, -s; Pe|pi|ta|kleid, ...ko|stüm

Pe|plon *gr.* *s*; -s, ...plen u. -s, Pe|plos (griech. Umschlagtuch der Frauen) *m*; -, ...plen u. -

¹Pep|ping, Ernst (dt. Komponist u. Musikschriftsteller)

²Pep|ping *engl.* (kleiner Apfel) *m*; -s, -e u. -s

Pep|po (it. Kurzform von: Joseph)

Pep|sin *gr.* (Ferment des Magensaftes; Heilmittel) *s*; -s, -e; Pep|ti|sa|ti|on [...*zión*] vgl. Peptisierung; pep|tisch (verdauungsfördernd); pep|ti|sie|ren (in kolloide Lösung überführen); Pep|ti|sie|rung; Pep|ti|sa|ti|on [...*zión*] *w*; -; Pep|ton (Abbaustoff des Eiweißes) *s*; -s, -e; Pep|ton|urie (Med.: Ausscheidung von Peptonen im Harn) *w*; -

per *lat.* (durch, mit, gegen, für); sehr häufig in der Amts- u. Kaufmannsspr., z. B. - Adresse ([Abk.: p. A.], besser: bei); - Bahn (besser: mit der Bahn); - Eilboten (durch Eilboten); - Monat (besser: jeden Monat, im Monat, monatlich); - Pfund (besser: das od. je Pfund); - sofort (besser: [für] sofort); - Stück (besser: das, je od. pro Stück); - ersten Januar (besser: für ersten Januar, zum ersten Januar); - eingeschriebenen (besser: als eingeschriebenen) Brief

Per, Peer (skandinav. Formen von:)

per as|pe|ra ad astra *lat.* („auf rauhen Wegen zu den Sternen“; durch Nacht zum Licht)

Per|bo|ra|te *lat.*; *pers.* (techn.

¹ Südd., österr. meist, schweiz. auch: *pänsion* usw.

wichtige chem. Verbindungen aus Wasserstoffperoxyd [vgl. Oxid] u. Boraten) *Mehrz.*; **Per|bor|säu|re** *w*; -

per cas|sa *it*. ([gegen] bar, bei Barzahlung); vgl. Kassa

Perch|ten (Dämonengruppe) *Mehrz.*; **Perch|ten-ge|stal|ten** (*Mehrz.*), ...mas|ken (*Mehrz.*)

per|du *fr*. [*pärdü*] (ugs. für: verloren, weg, auf u. davon)

per|eant! *lat*. (Studentenspr.: „sie mögen zugrunde gehen!", nieder!); **per|eat!** (Studentenspr.: „er gehe zugrunde!", nieder!); **Per|eat** (Studentenspr.) *s*; -s, -s

Père-La|cha|ise [*pärlaschäs*] (Friedhof in Paris) *m*; -

Per|em[p]|ti|on *lat*. [...*zion*] (veralt. für: Verjährung, Verfall); **per|em[p]|to|risch** (vernichtend, aufhebend; endgültig)

per|en|nie|rend *lat*. (Bot.: ausdauernd, überwinternd; mehrjährig [von Stauden- u. Holzgewächsen])

per|fekt *lat*. (vollendet, vollkommen [ausgebildet]; abgemacht; gültig); -este (↑ R 292); **Per|fekt** [auch: ...*fäkt*] (Sprachw.: Vollendung in der Gegenwart, Vorgegenwart, zweite Vergangenheit) *s*; -[e]s, -e; **per|fek|ti|bel** (vervollkommnungsfähig); ...i|ble Dinge; **Per|fek|ti|bi|lis|mus** (Lehre von der Vervollkommnung [des Menschengeschlechtes]) *m*; -; **Per|fek|ti|bi|list** (↑ R 268); **Per|fek|ti|bi|li|tät** (Vervollkommnungsfähigkeit) *w*; -; **Per|fek|ti|on** *lat*. [...*zion*] (Vollendung, Vollkommenheit; veralt. für: Zustandekommen [eines Rechtsgeschäftes]); **per|fek|tio|nie|ren; Per|fek|tio|nis|mus** (übertriebenes Streben nach Vervollkommnung) *m*; -; **per|fek|tio|nis|tisch** (bis in alle Einzelheiten vollständig, umfassend); **per|fek|tisch** (das Perfekt betreffend); **per|fek|tiv**, in der Fügung: -e Aktionsart (Aktionsart eines Zeitwortes, die eine zeitliche Begrenzung des Geschehens ausdrückt, z. B. „verblühen"); **per|fek|ti|visch** [...*wisch*] (perfektivisch)

per|fid (österr. nur so), **per|fi|de** *lat*.-*fr*. (treulos; hinterlistig, tükkisch); **Per|fi|die** *w*; -, ...ien; **Per|fi|di|tät** (selten für: Perfidie)

Per|fo|ra|ti|on *lat*. [...*zion*] (Durchbohrung, Durchlöcherung; Lochung; Reiß-, Trennlinie); **Per|fo|ra|tor** (Gerät zum Perforieren) *m*; -s, ...oren; **per|fo|rie|ren; Per|fo|rier|ma|schi|ne**

per|ga|me|nisch (aus Pergamon), aber (↑ R 224): die Pergamenischen Altertümer (in Berlin);

Per|ga|ment *gr*. („aus Pergamon stammend"; bearbeitete Tierhaut; alte Handschrift [auf Tierhaut]) *s*; -[e]s, -e; **Per|ga|ment|band** *m*; **per|ga|men|ten** (aus Pergament); **Per|ga|ment|pa|pier; Per|ga|min** (durchsichtiges Papier, Pergamentersatz) *s*; -s; **Per|ga|mon, Per|ga|mum** (antike Stadt in Nordwestkleinasien); **Per|ga|mon-al|tar, ...mu|se|um** *s*; -s (↑ R 201)

Per|gel *it*. südd. (Weinlaube) *s*; -s, -; **Per|go|la** (offener Laubengang) *w*; -, ...len

per|hor|res|zie|ren *lat*. (verabscheuen, zurückschrecken)

Pe|ri *pers*. (feenhaftes Wesen der altpers. Sage) *m*; -s, -s od. *w*; -, -s (meist *Mehrz.*)

pe|ri... *gr*. (um..., herum...); **Pe|ri...** (Um..., Herum...)

Pe|ri|ar|thri|tis *gr*. (Med.: Entzündung in der Umgebung von Gelenken)

Pe|ri|car|di|um vgl. Perikardium

Pe|ri|chon|dri|tis *gr*. [...*chon*...] (Med.: Knorpelhautentzündung) *w*; -, ...itiden; **Pe|ri|chon|dri|um** (Med.: Knorpelhaut) *s*; -s, ...ien [...*i*ⁿ*n*]

Pe|ri|cho|re|se *gr*. [...*cho*...] (die wechselseitige Durchdringung der drei göttl. Personen in der Trinität u. der zwei Naturen in Christus) *w*; -

pe|ri|cu|lum in mo|ra *lat*. [*periku*... - -] (Gefahr [ist] im Verzuge)

Pe|ri|derm *gr*. (ein Pflanzengewebe) *s*; -s, -e

Pe|ri|dot *fr*. (ein Mineral) *m*; -s; **Pe|ri|do|tit** (ein Tiefengestein) *m*; -s, -e

Pe|ri|gä|um *gr*. (Astron.: der Punkt der Mondbahn, der der Erde am nächsten liegt; Ggs.: Apogäum) *s*; -s, ...äen; **Pe|ri|gon** *s*; -s, -e u. **Pe|ri|go|ni|um** (Blütenhülle aus gleichartigen Blättern) *s*; -s, ...ien [...*i*ⁿ*n*]; **Pe|ri|hel** (Astron.: der Punkt einer Planeten- od. Kometenbahn, der der Sonne am nächsten liegt; Ggs.: Aphel) *s*; -s, -e [...*i*ⁿ*n*]; **Pe|ri|he|pa|ti|tis** (Med.: Entzündung der Bauchfellüberzuges der Leber) *w*; -, ...itiden; **Pe|ri|kard** *s*; -[e]s, -e u. **Pe|ri|kar|di|um** (med. fachspr.:) Pe|ri|car|di|um (Med.: Herzbeutel) *s*; -s, ...ien [...*i*ⁿ*n*]; **Pe|ri|kar|di|tis** (Med.: Herzbeutelentzündung) *w*; -, ...itiden; **Pe|ri|karp** (Bot.: Fruchtwand der Früchte von Samenpflanzen) *s*; -[e]s, -e; **Pe|ri|klas** (ein Mineral) *m*; - u. -es, -e

pe|ri|kle|isch; -er Geist, aber (↑ R 179): **Pe|ri|kle|isch**; -e Verwaltung; **Pe|ri|kles** (athen. Staatsmann)

Pe|ri|klin *gr*. (ein Mineral) *m*; -s, -e; **Pe|ri|ko|pe** (zu gottesdienstl. Verlesung vorgeschriebener Bibelabschnitt; Strophengruppe) *w*; -, -n; **Pe|ri|kra|ni|um** *gr*. (Med.: Knochenhaut des Schädeldaches) *s*; -s

Pe|ri|me|ter (Med.: Vorrichtung zur Messung des Gesichtsfeldes) *s*; -s, -; **pe|ri|me|trie|ren** (Med.); **pe|ri|me|trisch** (Med.)

pe|ri|na|tal (die Zeit kurz vor, während u. nach der Geburt betreffend); -e Medizin

Pe|ri|ode *gr*. (Umlauf[szeit] eines Gestirns, Kreislauf; Zeit[abschnitt, -raum]; Menstruation; Satzgefüge, Glieder-, Großsatz; Schwingungsdauer) *w*; -, -n; **Pe|ri|oden.ab|gren|zung** (Wirtsch.) ...**bau** ([Glieder-, Groß]satzbau *m*; -[e]s), ...**er|folg** (Wirtsch.) ...**lei|stung** (Wirtsch.), ...**rech|nung** (Wirtsch.), ...**sy|stem** (Chemie), ...**zahl**; ...**pe|ri|odig** (z. B zweiperiodig); **Pe|ri|odik** (svw Periodizität); **Pe|ri|odi|kum** (periodisch erscheinende [Zeit] schrift) *s*; -s, ...ka (meist *Mehrz.*)

pe|ri|odisch (regelmäßig auftretend, wiederkehrend); -er Dezimalbruch; -es System; **pe|ri|odi|sie|ren** (in Zeitabschnitte einteilen); **Pe|ri|odi|sie|rung; Pe|ri|odi|zi|tät** (regelmäßige Wiederkehr *w*; -

Pe|ri|odon|ti|tis *gr*. (Med.: Entzündung der Zahnwurzelhaut) *w* -, ...itiden; **Pe|ri|öke** *gr*. („Umwohner"; freier, aber polit. rechtloser Bewohner Spartas) *m*; -n -n (↑ R 268); **pe|ri|oral** (Med.: um den Mund herum); **Pe|ri|os** (Med.: Knochenhaut) *s*; -[e]s, -e **Pe|ri|osti|tis** (Med.: Knochen hautentzündung) *w*; -, ...itiden

Pe|ri|pa|te|ti|ker *gr*. (Philosoph aus der Schule des Aristoteles) **pe|ri|pa|te|tisch; Pe|ri|pa|to** (Promenade, Wandelgang, Teil der Schule in Athen, wo Aristoteles lehrte) *m*; -; **Pe|ri|pe|tie** (ent scheidender Wendepunkt, Umschwung) *w*; -, ...ien; **pe|ri|phe** (am Rande befindlichen, Rand... **Pe|ri|phe|rie** ([Kreis]umfang Umkreis; Randgebiet [der Groß städte], Stadtrand) *w*; -, ...ien; **pe ri|phe|risch** (älter für: peripher **Pe|ri|phra|se** (Umschreibung) *w* -, -n; **pe|ri|phra|sie|ren; per phra|stisch** (umschreibend); **Pe ri|pte|ros** (gr. Tempel mit einer umlaufenden Säulengang) *m* - od. ...pteren

Pe|ri|skop *gr.* (Fernrohr [für Unterseeboote] mit geknicktem Strahlengang) *s*; -s, -e; pe|ri|sko|pisch; Pe|ri|spo|me|non (gr. Sprachw.: Wort mit dem Zirkumflex auf der letzten Silbe) *s*; -s, ...na; Pe|ri|stal|tik (Med.: fortschreitende Bewegung des Magens, Darms u. Harnleiters) *w*; -; pe|ri|stal|tisch; Pe|ri|stal|se (die auf die Entwicklung des Organismus einwirkende Umwelt) *w*; -, -n; pe|ri|sta|tisch (umweltbedingt); Pe|ri|ste|ri|um (mittelalterl. Hostiengefäß in Gestalt einer Taube) *s*; -s, ...ien [...*i*ⁿ*n*]; Pe|ri|styl *s*; -s, -e u. Pe|ri|sty|li|um (von Säulen umgebener Innenhof des antiken Hauses) *s*; -s, ...ien [...*i*ⁿ*n*]; Pe|ri|to|ne|um (Med.: Bauchfell) *s*; -s, ...neen; Pe|ri|to|ni|tis (Med.: Bauchfellentzündung) *w*; -, ...itjden

Per|kal *pers.* (ein Baumwollgewebe) *m*; -s, -e; Per|ka|lin (ein Baumwollgewebe [für Bucheinbände]) *s*; -s, -e

Per|ko|lat *lat.* (durch Perkolation gewonnener Pflanzenauszug) *s*; -[e]s, -e; Per|ko|la|ti|on [...*zion*] (Herstellung konzentrierter Pflanzenauszüge); Per|ko|la|tor (Gerät zur Vornahme der Perkolation) *m*; -s, ...oren; per|ko|lie|ren

Per|kus|si|on *lat.* (Zündung durch Stoß od. Schlag [beim Perkussionsgewehr des 19. Jh.s]; ärztl. Organuntersuchung durch Beklopfen der Körperoberfläche; Anschlagvorrichtung beim Harmonium); Per|kus|si|ons-ge|wehr, ...ham|mer, ...mas|se, ...schall, ...schloß, ...zün|dung; per|kus|so|risch (Med.: durch Perkussion nachweisbar)

per|ku|tan *lat.* (Med.: durch die Haut hindurch)

per|ku|tie|ren *lat.* (Med.: beklopfen); per|ku|to|risch (svw. perkussorisch)

Perl (ein Schriftgrad) *w*; -; Per|le *w*; -, -n; ¹per|len (tropfen; Bläschen bilden); ²per|len (aus Perlen); per|len_be|setzt, ...be|stickt; Per|len_fi|scher, ...ket|te, ...kol|tier, ...schnur (*Mehrz.* ...schnüre); Per|len_sticke|rei [*Trenn.*: ...stik-ke...], ...tau|cher; Perl|garn; perl|grau; Perl|huhn; per|lig; Per|lit *lat.* (ein Gestein; Gefügebestandteil des Eisens) *m*; -s, -e; Per|lit|guß (Spezialgußeisen für hohe Beanspruchungen); Perl|mu-schel; Perl|mutt [verstümmeltes „Perlmutter"] *s*; -s; Perl|mutt-band *s* (*Mehrz.* ...bänder); Perl|mut|ter (glänzende Innenschicht von Perlmuschel- u. Seeschnek-

kenschalen) *w*; - od. *s*; -s; perl|mut|ter|far|ben; Perl|mut|ter-knopf, Perl|mutt|knopf; Perl|mut|ter|fal|ter; perl|mut|tern (aus Perlmutter)

Per|lon ⓦ (eine synthet. Textilfaser) *s*; -s; Per|lon|strumpf; per|lon-ver|stärkt

Perl_schrift, ...stich, ...tang

Per|lu|stra|ti|on *lat.* [...*zion*], Per|lu|strie|rung (österr., sonst veralt.) Durchmusterung, genaue Untersuchung [eines Verdächtigen]; per|lu|strie|ren

Perl|wein; perl|weiß; Perl|zwie|bel

¹Perm (Stadt in der UdSSR); ²Perm (Geol. jüngster Teil des Paläozoikums) *s*; -s

per|ma|nent *lat.* (dauernd, anhaltend, ununterbrochen, ständig); Per|ma|nent_gelb, ...weiß; Per|ma|nenz (Dauer, Ständigkeit) *w*; -; sich in - erklären (die Sitzung u. a. nicht schließen), Per|ma-nenz|theo|rie (Geol.)

Per|man|ga|nat *lat.*; *gr.* (Salz der Übermangansäure) *s*; -[e]s, -e; Per|man|gan|säu|re *lat.*; *gr.*; *dt.* (Übermangansäure) *w*; -

per|mea|bel *lat.* (durchdringbar, durchlässig); ...a|ble Körper; Per|mea|bi|li|tät *w*; -

per mil|le (svw. pro mille)

per|misch [zu: ²Perm]

Per|miß *lat.* (veralt. für: Erlaubnis, Erlaubnisschein) *m*; ...misses, ...misse; mit - (mit Verlaub); Per-mis|si|on (veralt. für: Erlaubnis); per|mit|tie|ren (veralt., aber noch mdal. für: erlauben, zulassen)

per|mu|ta|bel *lat.* (umstellbar, aus-, vertauschbar [Math.]); ...a|ble Größen; Per|mu|ta|ti|on [...*zion*] (Math.: Bildung aller Zusammenstellung, die aus einer bestimmten Anzahl von Elementen möglich sind); per|mu|tie|ren

Per|nam|bu|co (bras. Staat); vgl. Recife; Per|nam|buk|holz, Pernam|buk|holz; Per|nam|bu|ko vgl. Pernambuco

Per|nio|nen *lat.* (Med.: Frostbeulen) *Mehrz.*; Per|nio|sis (Frostschaden der Haut) *w*; -, ...ses

per|ni|zi|ös *fr.* (schlimm, bösartig); -este (↑ R 292); -e Anämie

Per|nod *fr.* [...*no*] (ein alkohol. Getränk) *m*; -[s], -[s]

Pe|ro|nis|mus [nach dem ehem. argentinischen Staatspräsidenten Perón] (diktatorisches Regierungssystem) *m*; -; Pe|ro|nist (Anhänger Peróns; ↑ R 268; pe|ro|ni-stisch

Pe|ro|no|spo|ra *gr.* (Pflanzenkrankheiten hervorrufender Algenpilz) *w*; -

per|oral *lat.* (durch den Mund)

per pe|des *lat.* (ugs. scherzh. für:

zu Fuß); per pe|des apo|sto|lo-rum (scherzh. für: zu Fuß [wie die Apostel])

Per|pen|di|kel *lat.* (Uhrpendel; Senk-, Lotrechte) *s* od. *m*; -s, -; per|pen|di|ku|lar, per|pen|di|ku-lär (senk-, lotrecht)

Per|pe|tua (eine Heilige)

Per|pe|tu|um mo|bi|le *lat.* [...*u-um*] -l (das [von selbst] ständig in Bewegung Befindliche"); utopische Maschine, die ohne Energieverbrauch dauernd Arbeit leistet; Musik: in kurzwertigen schnellen Noten verlaufendes virtuoses Instrumentalstück) *s*; - -, - -[s] u. ...tua ...bilia

per|plex *lat.* (ugs. für: verwirrt, verblüfft; bestürzt); -este (↑ R 292); Per|ple|xi|tät (Bestürzung, Verwirrung, Ratlosigkeit)

per pro|cu|ra *lat.* [- ...*kura*] (in Vollmacht; Abk.: pp., ppa.); vgl. Prokura

Per|ron *fr.* [...*rong*, österr.: ...*ron*, schweiz.: *päron*e] (veralt. für: Bahnsteig, Plattform; schweiz. für: Bahnsteig) *m*; -s, -s

per sal|do *it.* (als Rest zum Ausgleich [auf einem Konto])

per se *lat.* (,,durch sich"; von selbst); das versteht sich - -

Per|sen|ning *niederl.* (Gewebe für Segel, Zelte u. a.) *w*; -, -e[n]

Per|se|pho|ne (gr. Göttin der Unterwelt)

Per|se|po|lis (Hptst. Altpersiens); Per|ser (Bewohner von Persien; Perserteppich); Per|ser_krieg, ...tep|pich

¹Per|seus [...*seuß*] (Held der gr. Sage); ²Per|seus (ein Sternbild) *m*; -

Per|se|ve|ranz *lat.* [...*we*...] (veralt. für: Ausdauer) *w*; -; Per|se|ve|ra-ti|on [...*zion*] (Psych.); per|se|ve-rie|ren (Psych.)

Per|sia|ner (Karakulschafpelz [früher über Persien gehandelt]); Per|sia|ner|man|tel; Per|si|en [...*i*ⁿ*n*] (bis 1935 u. 1949 bis 1951 Bez. für: Iran)

Per|si|fla|ge *fr.* [...*flasch*e] (Verspottung); per|si|flie|ren

Per|si|ko *fr.* (aus Pfirsich- od. Bittermandelkernen bereiteter Likör) *m*; -s, -s

Per|sil ⓦ (ein Waschmittel) *s*; -s

Per|si|mo|ne *indian.* (eßbare Frucht einer nordamerik. Dattelpflaumenart) *w*; -, -n

per|sisch; -er Teppich, aber (↑ R 198): der Persische Golf; Per-sisch (Sprache) *s*; -[s]; vgl. Deutsch; Per|si|sche *s*; -n; vgl. Deutsche *s*

per|si|stent *lat.* (anhaltend, dauernd, beharrlich); Per|si-stenz *w*; -, -en

Per|son *etrusk.-lat.* (,,Maske";

Mensch; Wesen) w; -, -en; vgl. in persona; **Per|so|na gra|ta** (gern gesehener Mensch; Diplomat, gegen den von seiten des Gastlandes kein Einwand erhoben wird) w; - -; **Per|so|na in|gra|ta** w; - - u. **Per|so|na non gra|ta** (unerwünschte Person; Diplomat, dessen [genehmigter] Aufenthalt vom Gastland nicht mehr gewünscht wird) w; - - -; **per|so|nal** (persönlich; Persönlichkeits...); im -en Bereich; **Per|so|nal** (Belegschaft, alle Angestellten [eines Betriebes]) s; -s; **Per|so|nal.ab|bau** (m; -[e]s), ...ab|tei|lung, ...ak|te (meist Mehrz.), ...aus|weis, ...bü|ro, ...di|rek|tor, ...ein|spa|rung, ...form (vgl. finite Form); **Per|so|nal|gut|ach|ter|aus|schuß**; **Per|so|na|li|en** [...i^en] (Angaben über Lebenslauf u. Verhältnisse eines Menschen) Mehrz.; **Per|so|na|li|tät** (Persönlichkeit); **Per|so|na|li|täts|prin|zip; per|so|na|li|ter** (veralt. für: persönlich); **Per|so|nal.kar|tei**, ...ko|sten (Mehrz.), ...lei|ter m, ...pla|nung, ...po|li|tik, ...pro|no|men (Sprachw.: persönliches Fürwort, z. B. „er, wir"), ...rat (Mehrz. ...räte), ...re|fe|rent, ...uni|on (Vereinigung mehrerer Ämter in einer Person; früher: die [durch Erbfolge bedingte] zufällige Vereinigung selbständiger Staaten unter einem Monarchen), ...ver|wal|tung; **Per|sön|chen, Per|sön|lein; per|so|nell** fr. (das Personal betreffend); **Per|so|nen.auf|zug**, ...be|för|de|rung; **Per|so|nen|be|för|de|rungs|ge|setz; Per|so|nen.be|schrei|bung**, ...fir|ma (Firma, deren Name aus mindestens einem Personennamen [mit od. ohne Zusatz] od. aus mehreren Personennamen besteht; Ggs.: Sachfirma), ...kraft|wa|gen (Abk.: Pkw, auch: PKW), ...kreis, ...kult, ...na|me, ...scha|den (Ggs.: Sachschaden), ...stand (Familienstand); **Per|so|nen|stands|re|gi|ster; Per|so|nen.ver|kehr**, ...ver|si|che|rung (Versicherungsw.), ...waa|ge, ...wa|gen, ...zahl, ...zug; **Per|so|ni|fi|ka|ti|on** [...zion], **Per|so|ni|fi|zie|rung** (Verkörperung, Vermenschlichung); **per|so|ni|fi|zie|ren; Per|sön|lein, Per|sön|chen; per|sön|lich** (in [eigener] Person; eigen[artig]; selbst); -es Eigentum; -es Fürwort; **Per|sön|lich|keit; per|sön|lich|keits|be|wußt; Per|sön|lich|keits|ent|fal|tung; per|sön|lich|keits|fremd; Per|sön|lich|keits.kult**, ...recht, ...wahl, ...wert; **Per|sons|be|schrei|bung** österr. (Personenbeschreibung)

Per|spek|tiv lat. (kleines Fernrohr) s; -s, -e [...w^e]; **Per|spek|ti|ve** [...w^e] (Darstellung von Raumverhältnissen in der ebenen Fläche; Ausblick, Durchblick; Raumsicht; Aussicht [für die Zukunft]) w; -, -n; **per|spek|ti|visch** (die Perspektive betreffend, fluchtig); -e Verkürzung; **Per|spek|tiv.plan**, ...pla|nung (Wirtsch.: langfristige Globalplanung [Rahmenplanung]) **Per|spi|ra|ti|on** lat. [...zion] (Med.: Hautatmung) w; -; **per|spi|ra|to|risch**

[1]**Perth** [pö^rth] (schott. Grafschaft u. deren Hptst.)

[2]**Perth** [pö^rth] (Hptst. Westaustraliens)

Pe|ru[1] (südamerik. Staat); **Pe|rua|ner; pe|rua|nisch; Pe|ru|bal|sam** m; -s; ↑ R 201

Pe|rücke [Trenn.: ...rük|ke] fr. (Haupthaarersatz, Haaraufsatz) w; -, -n; **Pe|rücken|ma|cher** [Trenn.: ...rük|ken]

Pe|ru|rin|de[1] w; - (↑ R 201)

per|vers lat.(-fr.) [...wärß] ([geschlechtlich] verkehrt [empfindend], widernatürlich; verderbt, entartet); -este (↑ R 292); **Per|ver|si|on, Per|ver|si|tät; per|ver|tie|ren** (vom Normalen abweichen, entarten); **Per|ver|tiert|heit**

Per|vi|gi|li|en lat. [...wigili^n] (altröm. relig. Nachtfeier) Mehrz.

Per|zent lat. usw. (österr. neben: Prozent usw.)

per|zep|ti|bel lat. (wahrnehmbar; faßbar); ...i|ble Geräusche; **Per|zep|ti|bi|li|tät** (Wahrnehmbarkeit; Faßlichkeit); **Per|zep|ti|on** [...zion] (sinnliche Wahrnehmung); **per|zep|to|risch** (wahrnehmend); **Per|zept** (veralt. für: Empfänger); ↑ R 268; **per|zi|pie|ren** (wahrnehmen; erfassen; veralt. für: [Geld] einnehmen)

Pe|sa|de fr. (Reitsport: Figur der Hohen Schule)

pe|san|te it. (Musik: schleppend, wuchtig); **Pe|san|te** s; -s, -s

Pe|sel niederd. (bäuerl. Wohnraum) m; -s, -

pe|sen (ugs. für: eilen, rennen); du pest (pesest); er pe|ste

Pe|se|ta span. (span. Münzeinheit; Abk.: Pta) w; -, ...ten; **Pe|so** (südamerik. Münzeinheit) m; -[s], -[s]

Pes|sar gr. (Med.: Mutterring; Muttermundverschluß zur Empfängnisverhütung) s; -s, -e

Pes|si|mis|mus lat. (seelische Gedrücktheit; Schwarzseherei; Ggs.: Optimismus) m; -; **Pes|si|mist** (↑ R 268); **pes|si|mi|stisch**; -ste (↑ R 294); **Pes|si|mum** (Biol.:

[1] Auch: *peru* usw.

schlechteste Umweltbedingungen) s; -s, ...ma

[1]**Pest** lat. (eine Seuche) w; -

[2]**Pest** (Stadtteil von Budapest)

Pe|sta|loz|zi (schweiz. Pädagoge u. Sozialreformer)

pest|ar|tig; Pest.beu|le, ...hauch; **Pe|sti|lenz** lat. (Pest, schwere Seuche) w; -, -en; **pe|sti|len|zia|lisch**; -ste (↑ R 294); **Pe|sti|zid** (ein Schädlingsbekämpfungsmittel); **pest|krank; Pest.kran|ke**, ...seu|che

Pe|tar|de fr. (früher: Sprengmörser, -ladung) w; -, -n

Pe|tent lat. (veralt. für: Bittsteller); ↑ R 268

Pe|ter (m. Vorn.)

Pe|ter|le landsch. (Petersilie) s; -[s]

Pe|ter|männ|chen (ein Fisch)

Pe|ter-Paul-Kir|che (↑ R 182)

Pe|ters|burg (kurz für: Sankt Petersburg; heute: Leningrad)

Pe|ter|sil süd|gr.(österr. neben:) Petersilie) m; -s; **Pe|ter|si|lie** [...i^e] (ein Küchenkraut) w; -, -n; **Pe|ter|si|li|en.kar|tof|feln** (Mehrz.), ...wur|zel

Pe|ters.kir|che (w; -), ...pfen|nig; **Pe|ter-und-Paul-Kir|che** (↑ R 182; w; -, -n; **Pe|ter-und-Pauls-Tag** ↑ R 182 (kath. Fest) m; -[e]s

Pe|ter|wa|gen (Bez. für: Funkstreifenwagen)

Pe|tit fr. [p^eti] (ein Schriftgrad) w; -

Pe|ti|ti|on lat. [...zion] (Bittschrift, Eingabe); **pe|ti|tio|nie|ren; Pe|ti|ti|ons|recht** (Bittrecht, Beschwerderecht); **Pe|ti|tor** (Rechtsw.: Privatkläger; veralt. für: [Amts]bewerber) m; -s, ...oren

Pe|tit.satz [p^eti...], ...schrift

Pe|ti|tum lat. (veralt. für: Gesuch, Antrag) s; -s, ...tita

Pe|tra (w. Vorn.)

Pe|trar|ca (it. Dichter u. Gelehrter)

Pe|tras|si (it. Komponist)

Pe|tre|fakt gr.; lat. (Versteinerung von Pflanzen od. Tieren) s; -[e]s, -e[n]

Pe|tri vgl. Petrus

Pe|tri|fi|ka|ti|on gr.; lat. [...zion] (Versteinerungsprozeß); **pe|tri|fi|zie|ren**

Pe|tri|jün|ger (scherzh. für: Angler); **Pe|tri|kir|che; pe|tri|nisch**; -er Lehrbegriff, aber (↑ R 179) **Pe|tri|nisch**; -e Briefe

Pe|tro|che|mie gr. (Wissenschaft von der chem. Zusammensetzung der Gesteine); **pe|tro|che|misch; Pe|tro|ge|ne|se** (Gesteinbildung) w; -, -n; **pe|tro|ge|ne|tisch; Pe|tro|graph** (Kenner u. Forscher auf dem Gebiet der Petrographie); ↑ R 268; **Pe|tro|graphie** (Gesteinskunde, -beschre-

bung) w; -; pe|tro|gra|phisch; Pe-
trol (schweiz. neben: Petroleum)
s; -s; Pe|trol|che|mie (auf Erdöl
u. Erdgas beruhende techn. Roh-
stoffgewinnung in der chem. In-
dustrie); Pe|tro|le|um [...le-um]
(„Steinöl"; Destillationsprodukt
des Erdöls, Leuchtöl) s; -s; Pe-
tro|lo|um kn|cher, ...lam|pe,
...licht, ...quel|le; Pe|tro|lo|gie
(Wissenschaft von der Bildung
u. Umwandlung der Gesteine)
Pe|trus (Apostel); Petri Heil!
(Anglergruß); Petri (des Petrus)
Stuhlfeier (kath. Fest), Petri Ket-
tenfeier (kath. Fest), aber: Petri-
kirche usw.
Pet|schaft tschech. (Handstempel
zum Siegeln, Siegel) s; -s, -e
Pe|tsche|ne|ge (Angehöriger eines
türk. Nomadenvolkes) m; -n, -n
(↑ R 268)
pe|tschie|ren tschech. (mit einem
Petschaft schließen); pe|tschiert
österr. ugs. (in einer peinlichen
Situation, ruiniert); - sein
Pet|ti|coat engl. [pätiko°t] (steifer
Taillenunterrock) m; -s, -s
Pet|ting amerik. (sexueller Aus-
tausch ohne eigentlichen Ge-
schlechtsverkehr, bes. unter Ju-
gendlichen) s; -s, -s
pet|to top in petto
Pe|tu|nie indian. [...i°] (eine Zier-
pflanze) w; -, -n
Petz (scherzh. für: Bär) m; -es, -e;
¹Pet|ze (Hündin; Bärin) w; -, -n
²Pet|ze (Schülerspr.: Angeber[in],
Verräter[in]) w; -, -n; ¹pet|zen
(Schülerspr.: angeben, verraten);
du petzt (petzest)
²pet|zen landsch. (zwicken, knei-
fen); du petzt (petzest)
Pet|zer [zu: ¹petzen]
peu à peu fr. [pö a pö] (ugs. für:
nach und nach, allmählich)
Peu|geot ℗ [pöschoh] (fr. Kraft-
fahrzeugmarke)
pe|xie|ren (Nebenform von: pek-
zieren)
pF = Picofarad
Pf = Pfennig
Pfad m; -[e]s, -e; Pfäd|chen, Pfäd-
lein; Pfa|der (schweiz. Kurzform
für: Pfadfinder); Pfad|fin|der;
pfad|los
Pfaf|fe (abwertend für: Geistli-
cher) m; -n, -n (↑ R 268); Pfaf-
fen.hüt|chen (ein giftiger Zier-
strauch), ...knecht (abwertend);
Pfaf|fen|tum (abwertend) s; -s;
pfäf|fisch (abwertend)
Pfahl m; -[e]s, Pfähle; Pfahl.bau
(Mehrz. ...bauten), ...bau|er (m;
-s, -), ...bür|ger (verächtl. für:
Kleinbürger); Pfähl|chen; pfäh-
len; Pfahl.gra|ben, ...grün|dung,
...mu|schel; Pfäh|lung; Pfahl-
werk

Pfaid, Pfaid|ler vgl. Pfeid, Pfeidler
¹Pfalz lat. ([kaiserl.] Palast; Hof-
burg für kaiserl. Hofgericht; Ge-
biet, auch Burg des Pfalzgrafen)
w; -, -en; ²Pfalz (Regierungsbe-
zirk des Landes Rheinland-
Pfalz) w; -; Pfäl|zer (↑ R 199); -
Wald; - Wein; Pfalz|graf; pfalz-
gräf|lich; pfäl|zisch
Pfand s, -[e]s, Pfünder: pfänd|bar;
Pfänd|bar|keit w; -; Pfand.be-
stel|lung (Vereinbarung zwischen
Verpfänder u. Pfandgläubiger,
wonach dem Gläubiger das
Pfandrecht an einer beweglichen
Sache zusteht), ...brief, ...bruch
(Beseitigung gepfändeter Sa-
chen; m; -[e]s, ...brüche), ...ef|fek-
ten (Bankw.: Mehrz.); pfän|den;
¹Pfän|der südd. (Gerichtsbeam-
ter, -vollzieher)
²Pfän|der (Berg bei Bregenz) m;
-s
Pfän|der|spiel; Pfand.haus, ...kehr
(Rechtsspr.; w; -), ...leih|an|stalt
(österr.), ...lei|he, ...lei|her,
...recht, ...schein; Pfän|dung;
Pfän|dungs.auf|trag, ...schutz
(Schutz des Schuldners vor zu
weit gehenden Pfändungen),
...ver|fü|gung; Pfand.ver|kauf,
...ver|trag, ...ver|wah|rung, ...ver-
wer|tung; pfand|wei|se; Pfand-
zet|tel
Pfänn|chen, Pfänn|lein; Pfan|ne w;
-, -n; jmdn. in die - hauen (ugs.
für: jmdn. erledigen, ausschal-
ten); Pfan|nen.schau|fel (Berg-
mannsspr.), ...stiel; Pfän|ner (frü-
her: Besitzer einer Saline); Pfän-
ner|schaft (Genossenschaft zur
Ausnutzung der Solquellen);
Pfann|ku|chen; Pfänn|lein;
Pfänn|chen; Pfan|zel bayr. (Fri-
kadelle) s; -s, -
Pfarr.ad|mi|ni|stra|tor, ...amt;
Pfar|re (veralt.) w; -, -n; Pfar|rei;
pfar|rei|lich; Pfar|rer; Pfar|re|rin
w; -, -nen; Pfar|rers.kö|chin,
...toch|ter; Pfarr.fa|mi|lie, ...frau,
...haus, ...hel|fe|rin (w; -, -nen),
...herr (veralt.), ...hof; pfarr|lich;
Pfarr|vi|kar
Pfau (ein Vogel) m; -[e]s od. -en,
-[e]n (österr. auch: -e)
pfau|chen (südd. u. österr., sonst
veralt. für: fauchen)
Pfau|en.au|ge, ...rad, ...thron,
...we|del; Pfau|hahn, ...hen|ne;
Pfau|in (veralt. für: Pfauhenne)
w; -, -nen
Pfd., ℔ = Pfund
£, £Stg = Pfund Sterling
Pfef|fer sanskr. (eine Pflanze; Ge-
würz) m; -s, (für Pfeffersorten
Mehrz.:) -e; Pfeffer u. Salz;
schwarzer, weißer - (↑ R 224);
Pfef|fer|ku|chen; Pfef|fer|ku-
chen|häus|chen; Pfef|fer|ling (sel-

ten für: Pfifferling [Pilz]); Pfef-
fer.minz¹ (Likör; m; -es, -e; Plätz-
chen: s; -es, -e), ...min|ze¹ (eine
Heil- u. Gewürzpflanze; w; -);
Pfef|fer|minz.pa|stil|le¹ (meist
Mehrz.), ...tee¹; Pfef|fer.müh|le,
...mu|schel; pfef|fern; ich ...ere
(↑ R 327); Pfef|fer|nuß; Pfef|fe|ro-
ne (svw. Pfefferoni) m; -, ...oni
(selten: -n); Pfef|fe|ro|ni sanskr.;
it. österr. (Peperoni) m; -, - Pfef-
fer.sack, ...schote; Pfef|fer-und-
Salz-Mu|ster (↑ R 155) s; -s
Pfeid österr. mdal. (Hemd); Pfeid-
ler österr. veralt. (Hemdenma-
cher, Wäschehändler)
Pfei|fe w; -, -n; pfei|fen; du pfiffst
(pfiffest); du pfiffest; gepfiffen;
pfeif[e]!; auf etwas - (ugs. für: an
etwas uninteressiert sein); Pfei-
fen.deckel [Trenn.: ...dek|kel],
...kopf, ...kraut, ...rauch, ...stän-
der, ...stock (Mehrz. ...stöcke),
...stop|fer, ...strauch, ...ta|bak;
Pfei|fer; Pfei|fe|rei; Pfeif.kes|sel,
...kon|zert, ...ton (Mehrz. ...töne),
...topf
Pfeil m; -[e]s, -e
Pfei|ler m; -s, -; Pfei|ler.ba|si|li|ka,
...bau (Bergmannsspr.; Abbau-
verfahren; m; -[e]s); pfeil|ge-
schwind; Pfeil.gift, ...kö|cher,
...kraut; pfeil|schnell; Pfeil|schuß
pfeil|zen österr. landsch. (pelzen)
Pfen|nig (Münze; Abk.: Pf; 100
Pf = 1 [Deutsche] Mark) m; -[e]s,
-e; das Blatt kostet 6 - (↑ R 322);
Pfen|nig.ab|satz (ugs. für: hoher,
dünner Absatz bei Damenschu-
hen), ...be|trag, ...fuch|ser (ugs.
für: Geizhals); Pfen|nig.fuch|se-
rei; pfen|nig|groß; Pfen|nig|stück;
pfen|nig|stück|groß; Pfen|nig|wa-
re (Kleinigkeit); pfen|nig|wei|se
Pferch (Einhegung, eingezäunte
Fläche) m; -[e]s, -e; pfer|chen
Pferd s; -[e]s, -e; zu -e; Pfer.de.ap-
fel, ...bahn (früher, von Pfer-
den gezogene Straßenbahn),
...drosch|ke, ...fleisch, ...fuß, ...ge-
schirr, ...huf, ...kopf, ...ko|ppel,
...kur (ugs.), ...län|ge (Reitsport),
...schwanz (auch für eine be-
stimmte Frisur), ...se|rum,
...sport, ...stall, ...stär|ke (techn.
Maßeinheit; Abk.: PS; vgl. HP),
...stau|pe, ...strie|gel, ...zucht;
...pfer|dig (z. B. hundertpferdig)
Pfet|te (waagerechter, tragender
Balken im Dachstuhl) w; -, -en
pfet|zen vgl. ²petzen
Pfiff m; -[e]s, -e
Pfif|fer|ling (ein Pilz; ugs. für: et-
was Wertloses); keinen - wert
pfif|fig; Pfif|fig|keit w; -; Pfif|fi|kus
(ugs. für: schlauer Mensch) m;
- u. -ses, - u. -se

¹ Auch: ...min...

Pfing|sten *gr.* („50. Tag" [nach Ostern]) *s*; -; - fällt früh; - ist bald vorüber; (landsch., bes. österr. u. schweiz. als *Mehrz.*:) die[se] - fallen früh; nach den -; (in Wunschformeln auch allg. als *Mehrz.*:) fröhliche -!; zu - (südd. auch:) an -; **Pfingst|fest; pfingst|lich; Pfingst|mon|tag; Pfingst_och|se,** ...ro|se (Päonie); **Pfingst|sonn|tag; Pfingst_ver|kehr,** ...wie|se, ...wo|che
Pfir|sich (Frucht; Pfirsichbaum) *m*; -s, -e; **Pfir|sich_baum,** ...blü|te, ...bow|le
Pfi|ster (veralt. für: Bäcker [noch als Familienname]) *m*; -s, -
Pfit|scher Joch (Alpenpaß in Südtirol) *s*; - -s
Pfitz|ner (dt. Komponist)
Pflänz|chen, Pflänz|lein; Pflan|ze *w*; -, -n; **pflan|zen;** du pflanzt (pflanzest); **pflan|zen|ar|tig; Pflan|zen_bau** (*m*; -[e]s), ...ter, ...decke [*Trenn.*: ...dek|ke], ...extrakt, ...fa|ser, ...fett, ...fres|ser, ...gift, ...grün; **pflan|zen|haft; Pflan|zen_kost,** ...kun|de (*w*; -s), ...laus, ...milch, ...reich (*s*; -[e]s), ...schutz; **Pflan|zen|schutz|mit|tel** *s*; **Pflan|zen|züch|tung; Pflan|zer; Pflanz_gar|ten,** ...kar|tof|feln (*Mehrz.*); **Pfländz|lein,** Pflänzchen; **pflanz|lich; Pflänz|ling; Pflanz_stadt** (hist.= [antike] Kolonie), ...stät|te, ...stock (*Mehrz.* ...stöcke); **Pflan|zung**
Pfla|ster („aufgestrichenes" Heilmittel; Straßenbelag) *s*; -s, -; ein teures - (ugs. für: Stadt mit teuren Lebensverhältnissen); **Pfläster|chen, Pflä|ster|lein; Pfla|sterer,** (mdal. u. schweiz.:) **Pflä|sterer; pfla|ster|mü|de; pfla|stern,** (mdal. u. schweiz.:) **pflä|stern;** ich ...ere (↑ R 327); **Pfla|ster_stein,** ...tre|ter (veralt. für: müßig Herumschlendernder); **Pfla|sterung,** (mdal. u. schweiz.:) **Pfläste|rung**
Pflatsch *m*; [e]s, -e u. **Pflat|schen** (ugs. u. mdal. für: Fleck durch verschüttete Flüssigkeit, jäher Regenguß) *m*; -s, -; **pflat|schen** (ugs. u. mdal. für: schallend aufschlagen); du pflatschst (pflatschest)
Pfläum|chen, Pfläum|lein; Pflaume *w*; -, -n; **pflau|men** (ugs.: necken, scherzhafte Bemerkungen machen); **Pflau|men_baum,** ...brannt|wein (Slibowitz), ...kuchen, ...mus, **pflau|men|weich, pflaum|weich; Pfläum|lein, Pfläum|chen**
Pfle|ge *w*; -, -n; **Pfle|ge|amt; pflege_arm,** ...be|dürf|tig; **Pfle|ge|befoh|le|ne** *m* u. *w*; -n, -n (↑ R 287 ff.); **Pfle|ge_el|tern,** ...fall *m,* ...geld,

...heim, ...kind; **pfle|ge|leicht; Pfle|ge|mut|ter; pfle|gen;** du pflegtest; gepflegt; pflege[]!; in der Wendung „Rat[s], der Ruhe pflegen" auch: du pflogst (pflogest); du pflögest; gepflogen; **Pfle|ger** (auch: Vormund); **Pflege|rin** *w*; -, -nen; **pfle|ge|risch; Pfle|ge_satz,** ...sohn, ...stät|te, ...toch|ter, ...va|ter; **pfleg|lich; Pfleg|ling; pfleg|sam** (selten für: sorgsam); **Pfleg|schaft**
Pflicht [zu: pflegen] *w*; -, -en; die bürgerliche -; eine heilige -; **Pflicht_ar|beit,** ...be|griff, ...besuch; **pflicht|be|wußt; Pflicht_bewußt|sein,** ...ei|fer; **pflicht|eif|rig; Pflicht_ein|la|ge,** ...ein|stel|lung; **Pflicht_en_kreis,** ...leh|re, ...streit; **Pflicht_er|fül|lung,** ...ex|em|plar, ...fach, ...ge|fühl; **pflicht|ge|mäß; pflich|tig** (bes. in Zusammensetzungen, z. B. schulpflichtig); **Pflicht_in|nung** (Innung, die zur Mitgliedschaft verpflichtet), ...jahr, ...kür (Sport), ...lauf (Sport), ...lau|fen (Sport; *s*; -s), ...lei|stung, ...lek|tü|re; **pflichtmä|ßig; Pflicht_mit|glied,** ...platz (Arbeitsplatz, der mit einem Schwerbeschädigten besetzt werden muß), ...prü|fung, ...re|ser|ve (Wirtsch.); **pflicht|schul|dig; Pflicht|teil** *m* (österr. nur so) od. *s*; **pflicht|treu; Pflicht_treue,** ...übung; **pflicht|ver|ges|sen;** der -e Mensch; **Pflicht_ver|ges|senheit,** ...ver|let|zung; **pflicht|ver|sichert; Pflicht_ver|si|che|rung,** ...ver|tei|di|ger; **pflicht|wid|rig**
Pflock *m*; -[e]s, Pflöcke; **Pflöckchen, Pflöck|lein; pflöcken** [*Trenn.*: pflök|ken]
Pflotsch schweiz. mdal. (Schneebrei) *m*; -[e]s; **pflot|schig**
Pflücke[1] (Pflücken [des Hopfens]) *w*; -, -n; **pflücken**[1]; **Pflücker**[1]; **Pflückerin**[1] *w*; -, -nen; **Pflück|salat**
Pflug *m*; -[e]s, Pflüge; **pflü|gen; Pflü|ger; Pflug_mes|ser** *s*, ...schar (*w*; -, -en; [landw. auch:] *s*; -[e]s, -e), ...sterz (*m*; -es, -e)
Pfort_ader; Pfört|chen, Pfört|lein; Pfor|te *w*; -, -n; (↑ R 224:) die Burgundische -, die Hohe - (türk. Regierung (bis 1918]); **Pfor|tenring** (früher: Klopfring an einer Pforte); **Pfört|lein, Pfört|chen; Pfört|ner; Pfört|ne|rin** *w*; -, -nen; **Pfört|ner_lo|ge**
Pforz|heim (Stadt am Nordrand des Schwarzwaldes)
Pföst|chen, Pföst|lein; Pfo|ste (veralt. Nebenform von: Pfosten) *w*; -, -n; **Pfo|sten** *m*; -s, -; **Pfo|stenschuß** (Sport)

...

[1] *Trenn.*: ...ük|k...

Pföt|chen, Pföt|lein; Pfo|te *w*; -, -n
Pfriem (ein Werkzeug) *m*; -[e]s, -e; vgl. Ahle; **Pfrie|men_gras**
Pfril|le, Ęl|rit|ze (ein Fisch) *w*; -, -n
Pfropf (Nebenform von: Pfropfen) *m*; -[e]s, -e; **Pfröpf|chen,** Pfröpf|lein
[1]**pfrop|fen** (Pflanzen durch ein Reis veredeln)
[2]**pfrop|fen** ([Flasche] verschließen); **Pfropf|en** (Kork, Stöpsel) *m*; -s, -; vgl. Pfropf; **Pfröpf|lein,** Pfröpf|chen
Pfröpf|ling; Pfropf_mes|ser *s,* ...reis *s*
Pfrün|de (in der kath. Kirche Einkommen durch ein Kirchenamt; Stelle in einem Versorgungsheim; scherzh. für: [fast] müheloses Einkommen) *w*; -, -n; **Pfründer** schweiz. (Pfründner); **Pfründhaus; Pfründ|ner** (Pfründeninhaber); **Pfründ|ne|rin** *w*; -, -nen
Pfuhl (große Pfütze; Sumpf; mdal. für: Jauche) *m*; -[e]s, -e
Pfühl (veralt. dicht. für: Kissen) *m* od. *s*; -[e]s, -e; vgl. Pfulmen
pfui! *[pfu̯i]*; pfui, pfui!; (derb:) –äks!; - Teufel!; pfui rufen; pfui, schäm dich!; **Pfui** *s*; -s, -s; ein verächtliches - ertönte; **Pfui|ruf**
Pful|men schweiz. (breites Kopfkissen) *m*; -s, -; vgl. Pfühl
Pfund [1] *lat.* (Gewicht; Abk.: Pfd.; Zeichen: ℔; Münzeinheit [vgl. Sterling]) *s*; -[e]s, -e; 4 - Butter (↑ R 321 u. 322); **Pfünd|chen, Pfünd|lein;** ...**pfün|der** (z. B. Zehnpfünder, mit Ziffern: 10pfünder; ↑ R 228); **Pfund|he|fe** (Preßhefe); **pfun|dig;** -er Kerl (ugs. für: ordentlicher, ganzer Kerl); ...**pfün|dig** (z. B. zehnpfündig, mit Ziffern: 10pfündig; ↑ R 228); **Pfund|no|te; Pfunds|kerl** (svw. pfundiger Kerl); **Pfund Ster|ling** [- *ßtär...,* auch: -schtär...] (brit. Münzeinheit; Zeichen u. Abkürzung: £) *s*; -[e]s -, - -; **pfund|wei|se**
Pfusch (Pfuscherei) *m*; -[e]s; **pfuschen** (ugs.); du pfuschst (pfuschest); **Pfu|scher** (ugs.); **Pfusche|rei** (ugs.); **pfu|scher|haft** (ugs.); **Pfu|scher|haf|tig|keit** (ugs.); **Pfu|sche|rin** (ugs.) *w*; -, -nen
pfutsch österr. ugs. (futsch)
Pfütz_chen, Pfütz|lein; Pfüt|ze *w*; -, -n; **Pfütz|ei|mer** (Bergmannsspr.: Schöpfeimer); **Pfützen|was|ser** *s*; -s; **pfüt|zig** (ugs.)
PGH = Produktionsgenossenschaft des Handwerks (DDR)

[1] In Deutschland und in der Schweiz als amtliche Gewichtsbezeichnung abgeschafft.

ph = Phot
PH = Pädagogische Hochschule; vgl. pädagogisch
Phä|ake (Angehöriger eines [glücklichen, genußliebenden] Seefahrervolkes der gr. Sage; übertr. für: sorgloser Genießer) *m*; -n, -n († R 268); Phä|aken|le|ben *s*; -s
Phä|don (alt gr. Philosoph)
Phä|dra (Gattin des Theseus)
Phä|drus (röm. Fabeldichter)
Phae|thon (gr. Sagengestalt; Sohn des Helios); phae|tho|nisch [*fae*...] (selten für: kühn, verwegen); -er Flug
Pha|ge vgl. Bakteriophage
Pha|go|zy|te gr. ("Freßzelle", die Fremdstoffe, bes. Bakterien, unschädlich macht) *w*; -, -n (meist *Mehrz.*)
Pha|lanx gr. (geschlossene Schlachtreihe [vor allem in übertr. Sinne]; Kerntruppe; bildl. für: Mauer; Med.: Finger-, Zehenglied) *w*; -, ...langen
Pha|le|ron [*faleron*] (Vorstadt von Athen)
phal|lisch gr. (den Phallus betreffend); Phall|los *m*; -, ...lloi [...*eu*] u. ...llen; vgl. Phallus; Phal|lus (männl. Glied) *m*; -, ...lli u. ...llen (auch: -se); Phal|lus|kult (relig. Verehrung des Phallus als Sinnbild der Naturkraft [bei Pflanzervölkern])
Pha|ne|ro|ga|me gr. (Blütenpflanze) *w*; -, -n (meist *Mehrz.*)
Phä|no|lo|gie gr. ("Lehre von den Erscheinungsformen" im Tier- u. Pflanzenreich innerhalb eines tägl. od. jährl. Zeitlaufs, z. B. die Laubverfärbung der Bäume) *w*; -; Phä|no|men [Natur]erscheinung; ugs. für: seltenes Ereignis; Wunder[ding]; überaus kluger Kopf) *s*; -s, -e; Phä|no|me|nal (ugs. für: außerordentlich, außergewöhnlich, erstaunlich); Phä|no|me|na|lis|mus (philos. Lehre, nach der die Erscheinungen der Dinge, nicht diese selbst erkannt werden können) *m*; -; Phä|no|me|no|lo|gie (Lehre von den Wesenserscheinungen der Dinge, Wissenschaft von der Wesensschau) *w*; -; phä|no|me|no|lo|gisch; Phä|no|me|non [auch: ...*nom*...] (sww. Phänomen) *s*; -s, ...na; Phä|no|typ (Biol.: Erscheinungsbild, -form eines Organismus) *m*; -...pen
Phan|ta|sie gr. (Vorstellungs[kraft], Einbildungs[kraft]; Trugbild) *w*; -, ...ien; vgl. auch: Fantasie; phan|ta|sie|arm; Phan|ta|sie|ar|ti|kel; phan|ta|sie|be|gabt;

Phan|ta|sie|bild, ...blu|me, ...ge|bil|de, ...ko|stüm; phan|ta|sie|los; -este († R 292); Phan|ta|sie|lo|sig|keit; phan|ta|sie|reich; Phan|ta|sie|ren (sich [dem Spiel] der Einbildungskraft hingeben; irrereden; Musik: frei über eine Melodie od. über ein Thema musizieren); phan|ta|sie|voll; Phan|tas|ma (Med.: Trugbild) *s*; -s, ...men; Phan|tas|ma|go|rie (Zauber-, Truggebilde; künstl. Darstellung von Trugbildern, Gespenstern u. a.) *w*; -, ...ien; phan|tas|ma|go|risch; Phan|ta|sos vgl. Phantasius; Phan|tast (Träumer, Schwärmer) *m*; -en, -en († R 268); Phan|ta|ste|rei; Phan|ta|stik *w*; -; phan|ta|stisch (schwärmerisch; verstiegen; überspannt; seltsam; unwirklich; ugs. für: großartig, sehr [schön, hoch u. a.]); -ste († R 294); Phan|ta|sus (Traumgott); Phan|tom (Trugbild; Med.: Körper[teil]modell für Übungszwecke) *s*; -s, -e; Phan|tom|bild (Kriminalistik: nach Zeugenaussagen gezeichnetes Porträt eines gesuchten Täters), ...schmerz (Med.: Schmerzgefühl an einem amputierten Glied)
¹Pha|rao ägypt. (ägypt. König) *m*; -s, ...onen; ²Pha|rao fr. (altes fr. Kartenglücksspiel) *s*; -s; Pha|rao| amei|se; Pha|rao|nen|grab, ...rat|te (Ichneumon), ...reich; pha|rao|nisch
Pha|ri|sä|er hebr. (Angehöriger einer altjüd., streng gesetzesfrommen, religiös-polit. Partei; übertr. für: selbsthafter, selbstgerechter Heuchler); pha|ri|sä|er|haft; Pha|ri|sä|er|tum *s*; -s; pha|ri|sä|isch; Pha|ri|sä|is|mus (Lehre der Pharisäer; übertr. für: Selbstgerechtigkeit, Heuchelei) *m*; -
Phar|ma|ko|lo|ge gr. (Wissenschaftler auf dem Gebiet der Pharmakologie) *m*; -n, -n († R 268); Phar|ma|ko|lo|gie (Arzneimittelkunde; Arzneiverordnungslehre) *w*; -; phar|ma|ko|lo|gisch; Phar|ma|kon (Arzneimittel; Gift) *s*; -s, ...ka; Phar|ma|ko|pöe [...*pö*, selten: ...*pö*e] (amtl. Arzneibuch) *w*; -, -n [...*pö*en]; Phar|ma|zeut (Arzneikundiger) *m*; -en, -en († R 268); Phar|ma|zeu|tik (Arzneimittelkunde) *w*; -; Phar|ma|zeu|ti|kum (Arzneimittel) *s*; -s, ...ka; phar|ma|zeu|tisch; Phar|ma|zie (Lehre von der Arzneimittelzubereitung) *w*; -
Pha|ro (verkürzte Bildung zu: ²Pharao) *s*; -s
Pha|rus [nach der Insel Pharus] (veralt. für: Leuchtturm) *m*; -, - u. -se
Pha|ryn|gis|mus gr. [...*ngg*...]

(Med.: Schlundkrampf) *m*; -, ...men; Pha|ryn|gi|tis (Rachenentzündung) *w*; -, ...it|den; Pha|ryn|go|skop (Kehlkopfspiegel) *s*; -s, -e; Pha|ryn|go|sko|pie (Ausspiegelung des Rachens) *w*; -, ...ien
Pha|se gr. (Abschnitt einer [stetigen] Entwicklung, Gang, [Zu]stand, Stufe; Elektrotechnik: Schwingungszustand beim Wechselstrom) *w*; -, -n; Pha|sen|bild (Filmtechnik), ...mes|ser (elektr. Meßgerät; *m*), ...span|nung, ...ver|schie|bung, ...zeich|ner (Filmtechnik: Zeichner für die einzelnen Phasen eines Trickfilms); ...pha|sig (z. B. einphasig) Pha|ze|lie gr. [...*i*e] (ein Enziangewächs) *w*; -, -n
Phei|di|as vgl. Phidias
Phe|nol (Karbolsäure) *s*; -s; Phe|nol|phtha|le|in (chem. Reagens) *s*; -s; Phe|no|plast (Phenolharz) *m*; -[e]s, -e (meist *Mehrz.*); Phe|nyl (einwertige Atomgruppe in vielen aromat. Kohlenwasserstoffen) *s*; -s
Phi [*fi*] (gr. Buchstabe: *Φ, φ*) *s*; [s], -s
Phia|le gr. (altgr. flache Schale, Trinkschale) *w*; -, -n
Phi|di|as (altgr. Bildhauer); phi|di|as|sisch, aber († R 179); Phi|di|as|sisch
phil... gr. (...liebend); Phil... (...freund)
Phi|lä (Nilinsel bei Assuan)
Phil|adel|phia (Stadt in Pennsylvanien); Phil|adel|phi|er [...*i*r]; phil|adel|phisch
Phil|an|throp gr. (Menschenfreund) *m*; -en, -en († R 268); Phil|an|thro|pie (Menschenliebe) *w*; -; Phil|an|thro|pi|nis|mus, Phil|an|thro|pis|mus [von Basedow u. a. geforderte] Erziehung zu Natürlichkeit, Vernunft u. Menschenfreundlichkeit) *m*; -; phil|an|thro|pisch (menschenfreundlich; menschlich [gesinnt]); -ste († R 294); Phil|ate|lie (Briefmarkenkunde) *w*; -; Phil|ate|list († R 268); phil|ate|li|stisch
Phi|le|mon (phryg. Sagengestalt; Gatte der Baucis); Phi|le|mon und Bau|cis (antikes Vorbild ehelicher Liebe u. Treue sowie selbstloser Gastfreundschaft)
Phil|har|mo|nie gr. (Name für Gesellschaften zur Förderung des Musiklebens einer Stadt u. für Konzertsäle) *w*; -, ...ien; Phil|har|mo|ni|ker [österr. auch: *fil*...] (Künstler, der in einem philharmonischen Orchester spielt); phil|har|mo|nisch aber († R 224): das Philharmonische Orchester der Pfalz

Phil|hel|le|ne gr. (Griechenfreund, [der den Befreiungskampf der Griechen gegen die Türken unterstützte]) m; -n, -n (↑ R 268); Phil|hel|le|nis|mus m; -

Phil|ipp [auch: fi...] (m. Vorn.); Phil|ip|per|brief (Brief des Paulus an die Gemeinde von Philippi) m; -[e]s; ↑ R 205; Phil|ip|pi (im Altertum Stadt in Makedonien); Phil|ip|pi|ka (Kampfrede [des Demosthenes gegen König Philipp von Makedonien]; Strafrede) w; -, ...ken; Phil|ip|pi|ne (w. Vorn.); Phil|ip|pi|nen (Inselgruppe u. Staat in Südostasien) Mehrz.; vgl. Filipino; Phil|ip|pi|ner; phil|ip|pi|nisch; phil|ip|pisch, aber (↑ R 179): Philippische Reden (Philippiken des Demosthenes); Phil|ip|pus (Apostel)

Phi|li|ster (Angehöriger des Nachbarvolkes der Israeliten im A. T.; übertr. für: Spießbürger; Stammtenspr.: im [engen] Berufsleben stehender Alter Herr) m; -s, -; Phi|li|ste|rei; phi|li|ster|haft; Phi|li|ste|ri|um (Studentenspr.: das spätere [enge] Berufsleben eines Studenten) s; -s; Phi|li|ster|tum s; -s; phi|li|strös (beschränkt; spießbürgerlich); -este (↑ R 292)

Phil|lu|me|nist gr.; lat. (selten für: Sammler von Zündholzschachteln od. Zündholzschachteletiketten); ↑ R 268

Phi|lo|den|dron gr. (eine Blattpflanze) s (auch m); -s, ...dren

Phi|lo|lo|ge gr. (Sprach- u. Literaturforscher) m; -n, -n (↑ R 268); Phi|lo|lo|gie (Sprach- und Literaturwissenschaft) w; -, ...ien; phi|lo|lo|gisch

¹Phi|lo|me|la, ¹Phi|lo|me|le gr. (veralt. dicht. für: Nachtigall) w; -, ...len; ²Phi|lo|me|la, ²Phi|lo|me|le (w. Vorn.)

Phi|lo|me|na (w. Vorn.)

Phi|lo|se|mit gr. (Judenfreund) m; -en, -en (↑ R 268); phi|lo|se|mi|tisch

Phi|lo|soph gr. (,,Weisheitsfreund"; ein Denker, der nach ursprüngl. Wahrheit, dem letzten Sinn fragt, forscht) m; -en, -en (↑ R 268); Phi|lo|so|pha|ster (Scheinphilosoph) m; -s, -; Phi|lo|so|phem (Ergebnis philos. Lehre, Ausspruch des Philosophen) s; -s, -e; Phi|lo|so|phie (,,Weisheitsliebe"; Streben nach Erkenntnis des Zusammenhanges der Dinge in der Welt; Denk-, Grundwissenschaft) w; -, ...ien; phi|lo|so|phisch

Phi|mo|se gr. (Med.: Verengung der Vorhaut) w; -, -n

Phio|le gr. (bauchiges Glasgefäß mit langem Hals) w; -, -n

Phle|bi|tis gr. (Med.: Venenentzündung) w; -, ...itiden

Phleg|ma gr. (Ruhe, [Geistes]trägheit, Gleichgültigkeit, Schwerfälligkeit) s; -s; Phleg|ma|ti|ker (körperlich träger, geistig wenig regsamer Mensch); Phleg|ma|ti|kus (ugs. scherzh. für: träger, schwerfälliger Mensch) m; -, -se; phleg|ma|tisch; -ste (↑ R 294); Phleg|mo|ne (Med.: eitrige Zellgewebsentzündung) w; -, -n

Phlox gr. (eine Zierpflanze) m; -es, -e, (auch:) w; -, -e; Phlo|xin (roter Säurefarbstoff) s; -s

Phnom Penh [pnom pán] (Hauptstadt der Khmer-Republik)

Phö|be (gr. Mondgöttin)

Pho|bie gr. (Med.: krankhafte Angst) w; -, ...ien

Phö|bos vgl. Phöbus; Phö|bus (Beiname Apollos)

Pho|kis (Landschaft in Mittelgriechenland)

phon... gr. (laut...); Phon... (Laut...); Phon (Maßeinheit für die Lautstärke) s; -s, -s; 50 - (↑ R 322); Pho|nem (Sprachw.: Laut, kleinste sprachl. Einheit, die zur Unterscheidung von Wörtern dient) s; -s, -e; pho|ne|misch; Pho|ne|tik (Sprachw.: Lehre von der Lautbildung) w; -; Pho|ne|ti|ker; pho|ne|tisch; Pho|nik (veralt. für: Schall-, Tonlehre) w; -

Phö|ni|ker usw. vgl. Phönizier usw.

pho|nisch gr. (die Stimme betreffend)

Phö|nix gr. (Vogel der altägypt. Sage, der sich im Feuer verjüngt; christl. Sinnbild der Unsterblichkeit) m; -[es], -e

Phö|ni|zi|en [...i'n] (im Altertum Küstenland Syriens); Phö|ni|zi|er [...i'r]; phö|ni|zisch

Pho|no|gramm gr. (jede Aufzeichnung eines Schalles od. Lautes auf Schallplatten, Tonbändern usw.) s; -s, -e; Pho|no|graph (von Edison 1877 erfundenes Tonaufnahmegerät) m; -en, -en (↑ R 268); Pho|no|gra|phie (veralt. für: Lautschrift, lautgetreue Schreibung; früheres Kurzschriftsystem) w; -, ...ien; pho|no|gra|phisch (lautschreibend, -getreu; mittels Phonographen); Pho|no|kof|fer (tragbarer Plattenspieler); Pho|no|lith (,,Klingstein"; ein Ergußgestein) m; -s od. -en, -e[n] (↑ R 268); Pho|no|lo|gie (Wissenschaft, die das System u. die bedeutungsmäßige Funktion der einzelnen Laute u. Lautgruppen untersucht) w; -; pho|no|lo|gisch; Pho|no|me|ter (Lautstärkemesser) s; -s, -; Pho|no|me|trie (Vergleichung von Gesprochenem durch Maß und

Zahl) w; -; Pho|no|pho|bie (Med.: Stottern) w; -; Pho|no|tech|nik; Pho|no|thek (Diskothek) w; -, -en; Pho|no|ty|pi|stin (weibl. Schreibkraft, die vorwiegend nach einem Diktiergerät schreibt) w; -, -nen; phon|stark; Phon|zahl

Phos|gen gr. (Gas, Kampfgas) s; -s; Phos|phat (Salz der Phosphorsäure; wichtiger techn. Rohstoff [z. B. für Düngemittel]) s; -[e]s, -e; Phos|phin (Phosphorwasserstoff) s; -s; Phos|phit (Salz der phosphorigen Säure) s; -s, -e; Phos|phor (chem. Grundstoff; Zeichen: P; Leuchtstoff) m; -s; Pos|pho|res|zenz (Nachleuchten vorher bestrahlter Stoffe) w; -; phos|pho|res|zie|ren; phos|phor|hal|tig; phos|pho|rig; phos|pho|ris|mus (Phosphorvergiftung) m; -, ...men; Phos|pho|rit (ein Sedimentgestein) m; -[e]s, -e; Phos|phor|lat|wer|ge (ein Rattengift); Phos|phor|säu|re (w; -), ...ver|gif|tung

Phot gr. (Leuchtstärkeeinheit; Zeichen: ph) s; -s, -; pho|to... (licht...); Pho|to... (Licht...); Pho|to vgl. Foto; Pho|to_al|bum usw. vgl. Foto_al|bum usw.; Pho|to|che|mie (Lehre von der chem. Wirkung des Lichtes); Pho|to|che|mi|gra|phie (Herstellung von Ätzungen aller Art im Lichtbildverfahren); pho|to|che|mi|gra|phisch; pho|to|che|misch (durch Licht bewirkte chem. Reaktionen betreffend); Pho|to|ef|fekt; Pho|to|elek|tri|zi|tät; Pho|to_elek|tron, ...ele|ment; pho|to|gen usw. vgl. fotogen usw.; Pho|to|gramm (Lichtbild für Meßzwecke) s; -s, -e; Pho|to|gramm|me|trie (Herstellung von Grund- u. Aufrissen, Karten aus Lichtbildern w; -; pho|to|gramm|me|trisch [Trenn.: ...gramm|me..., ↑ R 236] Pho|to|graph usw. vgl. Fotograf usw.; Pho|to|gra|vü|re (swv. Heliogravüre); Pho|to|in|du|strie vgl. Fotoindustrie; Pho|to|ko|pie usw. vgl. Fotokopie usw.; Pho|to|li|tho|gra|phie (Verfahren zur Herstellung von Druckformen für den Flachdruck); Pho|to|ma|ton ⓦ (automat. Apparat zu Aufnahme u. Herstellung fotogr Bilder) s; -s, -e; pho|to|me|cha|nisch; -es Verfahren (Anwendung der Fotografie zur Herstellung von Druckformen); Pho|to|me|ter (Gerät zur Lichtmessung) s -s, -; Pho|to|me|trie w; -; pho|to|me|trisch; Pho|to|mo|dell vgl. Fotomodell; Pho|to|mon|ta|ge vgl Fotomontage; Pho|to|ton (kleinste

Energieteilchen einer elektromagnet. Strahlung) *s*; -s, ...onen; **Pho|to|phy|sio|lo|gie** (modernes Teilgebiet der Physiologie); **Pho|to|re|por|ter** vgl. Fotoreporter; **Pho|to|sphä|re** (strahlende Gashülle der Sonne) *w*; -; **Pho|to|syn|the|se** (Aufbau chem. Verbindungen durch Lichteinwirkung); **pho|to|tak|tisch**; -e Bewegungen (Bewegungen von Pflanzenteilen zum Licht hin); **Pho|to|thek** (Sammlung von Lichtbildern) *w*; -, -en; **Pho|to|the|ra|pie** (Med.: Lichtheilverfahren) *w*; -; **Pho|to|tro|pisch** (lichtwendig); **Pho|to|tro|pis|mus** (Krümmungsreaktion vieler Pflanzenteile bei einseitigem Lichteinfall) *m*; -, ...men; **Pho|to|zeit|schrift** vgl. Fotozeitschrift; **Pho|to|zin|ko|gra|phie** vgl. Fotozinkografie

Phra|se *gr.* (Redewendung; selbständiger Abschnitt eines musikal. Gedankens; abschätzig für: leere Redensart) *w*; -, -n; **Phra|sen|dre|sche|rei** (abschätzig); **phra|sen|haft** (abschätzig); **Phra|sen|held** (abschätzig), ...ma|cher (abschätzig); **phra|sen|reich** (abschätzig); **Phra|seo|lo|gie** (Lehre von den eigentümlichen Redewendungen einer Sprache; Sammlung solcher Redewendungen) *w*; -, ...ien; **phra|seo|lo|gisch**; **phra|sie|ren** (Musik: ein Tonstück sinngemäß einteilen); **Phra|sie|rung** (melodisch-rhythmische Einteilung eines Tonstücks; Gliederung der Motive, Themen u. ä. beim musikal. Vortrag)

Phre|ne|sie *gr.* (Med.: Wahnsinn) *w*; -; **phre|ne|tisch** (Med.: wahnsinnig); vgl. aber: frenetisch; **Phre|ni|tis** (Med.: Zwerchfellentzündung) *w*; -, ...itjden

Phry|gi|en [...*iⁿn*] (antikes Reich in Nordwestkleinasien); **Phry|gi|er** [...*iᵉr*]; **phry|gisch**; -e Mütze (in der Fr. Revolution Sinnbild der Freiheit, Jakobinermütze)

Phry|ne *gr.* Hetäre)

Phthi|si|ker *gr.* (Med.: Schwindsüchtiger); **Phthi|sis** (Med.: Schwindsucht) *w*; -, ...sen

pH-Wert [*pehg...*]; ↑ R 149 (negativer dekadischer Logarithmus der Konzentration der Wasserstoffionen)

Phy|ko|lo|gie *gr.* (veralt. für: Algenkunde) *w*; -

Phy|lax *gr.* (,,Wächter''; ein Hundename)

Phy|le *gr.* (altgr. Geschlechterverband) *w*; -, -n; **phy|le|tisch** (Biol.: die Abstammung betreffend)

Phyl|lis (w. Eigenn.)

Phyl|lit *gr.* (ein Gestein) *m*; -s, -e; **Phyl|lo|kak|tus** (ein amerik. Kaktus); **Phyl|lo|kla|di|um** (blattähnlicher Pflanzensproß) *s*; -s, ...ien [...*iᵉn*]; **Phyl|lo|pha|ge** (Bot.: Pflanzenfresser, im engeren Sinn: Blattfresser) *m*; -n, -n (↑ R 268); **Phyl|lo|po|de** (Blattfüßer [Krebs]) *m*; -n, -n (meist *Mehrz.*); ↑ R 268; **Phyl|lo|ta|xis** (Bot.: Blattstellung) *w*; -, ...xen, **Phyl|lo|xe|ra** (Reblaus) *w*; -, ...ren

Phy|lo|ge|ne|se *gr.* (svw. Phylogenie) *w*; -, -n; **phy|lo|ge|ne|tisch**; **Phy|lo|ge|nie** (Stammesgeschichte der Lebewesen) *w*; -, ...ien; **Phy|lum** (Biol.: Tier- oder Pflanzenstamm) *s*; -s, ...la

Phy|sa|lis *gr.* (Nachtschattengewächs) *w*; -, ...alen

Phys|ia|ter *gr.* (Naturarzt) *m*; -s, -; **Phys|ia|trie** (Naturheilkunde) *w*; -; **Phy|sik** (diejenige Naturwissenschaft, die mit mathematischen Mitteln die Grundgesetze der Natur untersucht) *w*; -; **phy|si|ka|lisch**; -e Chemie, -e Maßeinheit, -e Karte (Bodenkarte), a b e r (↑ R 224): das Physikalische Institut der Universität Frankfurt; **Phy|si|ker**; **Phy|si|ko|che|mie** (physikalische Chemie); **phy|si|ko|che|misch**; **Phy|si|kum** (Vorprüfung der Medizinstudenten) *s*; -s; **Phy|si|kus** (veralt. für: Kreis-, Bezirksarzt) *m*; -, -se

Phy|sio|gnom *gr.* *m*; -en, -en (↑ R 268) u. **Phy|sio|gno|mi|ker** (Deuter der äußeren Erscheinung eines Menschen); **Phy|sio|gno|mie** (äußere Erscheinung eines Lebewesens, bes. Gesichtsausdruck) *w*; -, ...ien; **Phy|sio|gno|mik** (Ausdrucksdeutung [Kunst, von der Physiognomie her auf seelische Eigenschaften zu schließen]) *w*; -; **Phy|sio|gno|mi|ker** vgl. Physiognom; **phy|sio|gno|misch**

Phy|sio|kli|ma|to|lo|gie *gr.* (Meteor.: erklärende Klimabeschreibung) *w*; -

Phy|sio|krat *gr.* (Vertreter des Physiokratismus) *m*; -en, -en (↑ R 268); **phy|sio|kra|tisch**; **Phy|sio|kra|tis|mus** (volkswirtschaftl. Theorie des 18. Jh.s, die die Landwirtschaft als die Quelle des Nationalreichtums ansah) *m*; -

Phy|sio|lo|ge *gr.* (Erforscher der Lebensvorgänge) *m*; -n, -n (↑ R 268); **Phy|sio|lo|gie** (Lehre von den Lebensvorgängen) *w*; -; **phy|sio|lo|gisch** (die Physiologie betreffend); **Phy|sio|no|mie** (veralt. für: Lehre von den Naturgesetzen) *w*; -; **Phy|sio|the|ra|pie** (Pfleger, der die Physiotherapie anwendet); **phy|sio|the|ra|peu-**

tisch; **Phy|sio|the|ra|pie** (Heilbehandlung mit Licht, Luft, Wasser, Bestrahlungen, Massage usw.); **Phy|sis** (die Natur, das Reale, Gewachsene, Erfahrbare) *w*; -; **phy|sisch** (in der Natur begründet; natürlich; körperlich)

Phy|so|stig|min *gr.* (ein Heilmittel) *s*; -s

phy|to|gen *gr.* (aus Pflanzen entstanden); **Phy|to.geo|gra|phie** (Pflanzengeographie), ...gno|sie (früher für: Pflanzenkunde auf Grund äußerer Merkmale; *w*; -, ...ien), ...me|di|zin (Pflanzenmedizin), ...pa|tho|lo|gie (Lehre von den Pflanzenkrankheiten); **phy|to|pa|tho|lo|gisch**; **phy|to|phag** (Biol.: pflanzenfressend); **Phy|to|pha|ge** (Biol.: Pflanzenfresser) *m*; -n, -n (meist *Mehrz.*); ↑ R 268; **Phy|to.plank|ton** (Gesamtheit der im Wasser lebenden pflanzl. Organismen), ...the|ra|pie (Pflanzenheilkunde) *w*; -; **Phy|to|zo|on** (veralt. für: Meerestier von pflanzenähnlichem Bau) *s*; -s, ...zoen

¹Pi *(gr.* Buchstabe; *Π, π)* *s*; -[s], -s; **²Pj** (Ludolfsche Zahl, die das Verhältnis von Kreisumfang zu Kreisdurchmesser angibt; *π* = 3,1415...) *s*; -[s]

Pia (w. Vorn.)

Pi|af|fe *fr.* (Reitsport: Trab auf der Stelle) *w*; -, -n; **pi|af|fie|ren** (selten für: die Piaffe ausführen)

Pia|ni|no *it.* (kleines ²Piano) *s*; -s, -s; **pia|nis|si|mo** (Musik: sehr leise; Abk.: pp); **Pia|nis|si|mo** *s*; -s, -s u. ...mi; **Pia|nist** (Klavierspieler, -künstler); ↑ R 268; **Pia|ni|stin** *w*; -, -nen; **pia|ni|stisch** (klaviermäßig, klavierkünstlerisch); **pia|no** (Musik: leise; Abk.: p); **¹Pia|no** (leises Spielen, Singen) *s*; -s, -s u. ...ni; **²Pia|no** (Kurzform von: Pianoforte) *s*; -s, -s; **Pia|no|for|te** (Klavier) *s*; -s, -s; vgl. Fortepiano; **Pia|no|la** (selbsttätig spielendes Klavier) *s*; -s, -s

Pia|rist *lat.* (Angehöriger eines kath. Lehrordens); ↑ R 268

Pi|as|sa|va *indian.-port.* [...*wa*] (Palmenblattfaser) *w*; -, ...ven; **Pi|as|sa|va|be|sen**

Pi|ast (Angehöriger eines poln. Geschlechtes) *m*; -en, -en (↑ R 268)

Pia|ster *gr.* (Bez. für den span. u. amerik. Peso im europ. Handelsverkehr; Münze im Libanon, Sudan, in Syrien, Ägypten) *m*; -s, -

Pia|ve [...*we*] (it. Fluß) *w*; -

Pi|az|za *it.* (Marktplatz) *w*; -, ...zze; **Pi|az|zet|ta** (kleine Piazza) *w*; -, ...tten

Pi|car|de *m*; -n, -n (↑ R 268); **Pi|car|die** (hist. Provinz in Nordfrank-

reich) w; -; vgl. Pi-
karde usw.
Pi|cas|so [_pikạßo_], Pablo (span.
Maler u. Graphiker)
Pic|ca|dil|ly [_pikˀdịlị_] (eine Haupt-
straße in London)
Pic|card [_pikạr_] (schweiz. Physi-
ker)
Pic|co|lo (österr. meist für: ¹Pik-
kolo)
Pic|co|lo|mi|ni [_piko..._] (Angehöri-
ger eines it. Geschlechtes) m;
-[s], -
Pi|che|ler, Pịch|ler (ugs. für: Trin-
ker); pi|cheln (ugs.); ich ...[e]le
(↑ R 327)
Pi|chel|stei|ner Fleisch (ein Ge-
richt) s; - -[e]s
pi|chen landsch. (mit Pech ver-
schmieren)
Pịch|ler vgl. Picheler
¹Pick vgl. ²Pik
²Pịck österr. ugs. (Klebstoff) m;
-s
Picke¹ (Spitzhacke) w; -, -n; ¹Pịk-
kel¹ (Spitzhacke) m; -s, -
²Pịckel¹ (Hautpustel, Mitesser) m;
-s, -
Pịckel|flö|te¹ vgl. Pikkoloflöte
Pịckel|hau|be¹ (ugs.: früherer
[preuß.] Infanteriehelm)
Pịckel|he|ring¹ (veralt. für: ein-
gepökelter Hering; übertr. für:
Spaßmacher im älteren Lust-
spiel)
picke|lig¹, pịck|lig [zu: ²Pickel]
pịckeln¹ landsch. (mit der Spitz-
hacke arbeiten); ich ...[e]le (↑ R
327)
pịcken¹ (österr. ugs. auch für: kle-
ben, haften)
pịckern¹ mdal. (leise pochen, tik-
ken; essen); ich ...ere (↑ R 327)
Pịck|ham|mer (Bergmannsspr.:
Abbauhammer)
Pịck|les vgl. Mixed Pickles
pịck|lig vgl. pickelig
Pịck|nick fr. (Essen im Freien [,zu
dem jeder Teilnehmer beiträgt])
s; -s, -e u. -s; pịck|nicken¹; gepick-
nickt
Pick-up engl. [_pikạp_] (elektr.
Tonabnehmer für Schallplatten)
m; -s, -s
Pi|co..., Pị|ko... it. (ein Billionstel
einer Einheit, z. B. Picofarad, Pi-
kofarad = 10⁻¹² Farad; Zeichen:
p)
pi|co|bel|lo it. [_piko..._] (ugs. für:
ganz besonders fein)
Pi|co|fa|rad, Pị|ko|fa|rad (der bil-
lionste Teil der Kapazitätsein-
heit; Abk.: pF)
Pi|cot fr. [_pikọ_] (Spitzenmasche;
Spitzkeil) m; -s, -s
Pic|pus-Mis|sio|nar [_pikpüß..._]
[nach dem ersten Haus in der Pic-

pusstraße in Paris] (Angehöriger
der kath. Genossenschaft von
dem hl. Herzen Jesu u. Mariä)
Pid|gin-Eng|lisch [_pịdsehin..._] (frü-
here engl.-chines. Mischsprache
in Ostasien) s; -[s]; Pid|gin-Eng-
lish [..._ingglisch_]; vgl. Pidgin-
Englisch
Pie|ce fr. [_piặß^e_] (Tonstück; musi-
kal. Zwischenspiel) w; -, -n
Pie|de|stal fr. [_pi-e..._] (Fußgestell;
Sockel; Untersatz) s; -s, -e
Pief|ke landsch. (abwertend für:
Spießer, Kleinbürger; bes. österr.
abschätzig für: [Nord]deutscher)
m; -s, -s
Piek (Seemannsspr.: unterster
Teil des Schiffsraumes) w; -, -en
Pie|ke (svw. ²Pik) w; -, -n
piek.fein (ugs. für: besonders
fein), ...sau|ber (ugs. für: beson-
ders sauber)
Pie|mont [_pi-e..._] (Landschaft in
Nordwestitalien); Pie|mon|te|se
m; -n, -n (↑ R 268); pie|mon|te-
sisch, (auch:) pie|mon|tisch
piep!; piep, piep!; Piep m, nur in
ugs. Wendungen wie: einen - ha-
ben (ugs. für: nicht recht bei Ver-
stand sein); er tut, sagt, macht
keinen - mehr (ugs. für: er ist
tot); pie|pe, piep|egal landsch.
(gleichgültig); das ist mir -; pie-
pen; es ist zum Piepen (landsch.
für: es ist zum Lachen); Pie|pen
(ugs. für: Geld) Mehrz.; Piep-
.hahn (landsch.), ...matz (ugs.);
pieps (ugs.); er kann nicht mehr
- sagen; Pieps (ugs.) m; -es, -e;
keinen - von sich geben; piep|sen;
du piepst (piepsest); piep|sig
(ugs.); Piep|sig|keit (ugs.) w;
Piep|vo|gel (Kinderspr.)
¹Pier engl. (Hafendamm; Lan-
dungsbrücke) m; -s, -e od. -s (See-
mannsspr.: w; -, -s)
²Pier niederd. (Sandwurm als
Fischköder) m; -[e]s, -e
Pierre [_pjär_] (fr. Form von: Peter)
Pi|er|ret|te fr. [_piä..._] (weibl. Lust-
spielfigur) w; -, -n; Pi|er|rot [_piä-
rọ_] („Peterchen"; männl. Lust-
spielfigur) m; -s, -s
pie|sacken [_Trenn.: ...sak|ken_]
(ugs. für: quälen); gepiesackt;
Pie|sacke|rei [_Trenn.: ...sak|ke..._]
Pie|se|pam|pel landsch. (derb für:
dummer, engstirniger Mensch)
m; -s, -
Pies|por|ter (ein Moselwein)
Pie|ta, (in it. Schreibung:) Pie|tà
it. [_pi-etạ_] (Darstellung der Maria
mit dem Leichnam Christi auf
dem Schoß; Vesperbild) w; -, -s
Pie|tät lat. [_pi-e..._] (Frömmigkeit;
Ehrfurcht, Rücksichtnahme,
Anhänglichkeit) w; -; pie|tät|los;
-este (↑ R 292); Pie|tät|lo|sig|keit;
pie|tät|voll; Pie|tis|mus [_pi-e..._]

(ev. Erweckungsbewegung; auch
für: schwärmerische Frömmig-
keit) m; -; Pie|tist (↑ R 268); pie|ti-
stisch; -ste (↑ R 294)
Pietsch mdal. (Trinker; Kraft-
mensch) m; -es, -e; piet|schen
mdal. (tüchtig trinken); du
pietschst (pietschest)
pie|zo|elek|trisch gr. [_pi-e..._] (elek-
trisch durch Druck); Pie|zo.elek-
tri|zi|tät (durch Druck auf Kri-
stalle entstehende Elektrizität;
w; -), ...me|ter (Druckmesser; s;
-s, -), ...quarz
piff, paff!; piff, paff, puff!
Pi|geon-Eng|lisch [_pịdsehin..._] vgl.
Pidgin-Englisch
Pig|ment lat. (Farbstoff, -körper)
s; -[e]s, -e; Pig|men|ta|ti|on
[..._ziọn_] (Färbung); Pig|ment-
.druck (nur Einz.: für: Kohle-
druck, photogr. Kopierverfah-
ren; für: in dieser Weise herge-
stelltes Erzeugnis auch Mehrz.:
...drucke), ...far|be, ...fleck; pig-
men|tie|ren (Farbstoffe in klein-
ste Teilchen [Pigmentkörnchen]
zerteilen; sich durch Pigmente
einfärben); Pig|men|tie|rung; pig-
ment|los; Pig|ment|mal (Mutter-
mal; Mehrz.: ...male)
Pi|gno|le it. [_pinjọl^e_] (Pinienfrucht)
w; -, -n; Pi|gno|lie [_pinjọli^e_] österr.
(vgl. Pignole) w; -, -n
Pi|jacke [_Trenn.: Pi|jak|ke_] engl.
niederd. (blaue Seemannsüber-
jacke) w; -, -n
¹Pik fr. (Bergspitze) m; -s, -e u.
-s; vgl. Piz; ²Pik (ugs. für: heim-
licher Groll) m; -s, -e; einen - auf
jmdn. haben; ³Pik (Spielkarten-
farbe) s; -s, -s; (österr. auch: w;
-, -); pi|kant (scharf [gewürzt];
prickelnd; reizvoll; anzüglich;
schlüpfrig); vgl. Abenteuer; Pi-
kan|te|rie w; -, ...ien; pi|kan|ter-
wei|se
Pi|kar|de usw. (eindeutschend
für: Picarde usw.)
Pik-As s; Pik-Asses, Pik-Asse; ¹Pi-
ke fr. (Spieß) w; -, -n; von der
- auf dienen (ugs. für: im Be-
ruf bei der untersten Stellung
anfangen); ²Pi|ke (Nebenform
von: ²Pik) w; -, -n; Pi|kee (Baum-
wollgewebe) m (österr. auch: s);
-s, -s; pi|kee|ar|tig; Pi|kee-kra-
gen, ...we|ste; pi|ken, pik|sen (ugs.
für: stechen); du pikst (piksest);
Pi|ke|nier (mit der ¹Pike bewaff-
neter Landsknecht) m; -s, -e; Pi-
kett (ein Kartenspiel; schweiz.
für: einsatzbereite Mannschaft
[Militär u. Feuerwehr]; veralt.
für: Feldwache, Vorposten-
kompanie) s; -[e]s, -e; Pi|kett-
stel|lung schweiz. (Bereitstel-
lung); pi|kie|ren („stechen"; [jun-
ge Pflanzen] in größeren Abstän-

¹ Trenn.: ...ik|k...

den neu einpflanzen); pi|kiert (etwas beleidigt, verstimmt)

¹Pik|ko|lo it. (Kellnerlehrling) m; -s, -s; ²Pik|ko|lo (svw. Pikkolflöte) m (auch: s); -s, -s; Pik|ko|lo_fla|sche (kleine [Sekt]-flasche für eine Person), ...flö|te (kleine Querflöte)

Pik|ko|lo|mi|ni (dt. Schreibung für: Piccolomini)

Pi|ko... vgl. Pico...

Pi|ko|fa|rad vgl. Picofarad

Pi|kör fr. (Vorreiter bei der Parforcejagd) m; -s, -e

Pi|krat gr. (Pikrinsäuresalz) s; -[e]s, -e; Pi|krin|säu|re (explosible organ. Verbindung) w, -

pik|sen vgl. piken

Pik|te (Angehöriger der ältesten Bewohner Schottlands) m; -n, -n (↑ R 268)

Pik|to|gramm [lat.; gr.] (graph. Symbol [mit international festgelegter Bedeutung] s; -s, -e

Pi|kul malai. (Gewicht in Ostasien) m od. s; -s, -

Pi|lar span. (Pflock, Rundholz zum Anbinden der Halteleine bei der Abrichtung der Pferde) m; -en, -en (↑ R 268); Pi|la|ster lat. ([flacher] Wandpfeiler) m; -s, -

¹Pi|la|tus (röm. Landpfleger in Palästina); von Pontius zu - (ugs. für: [vergeblich] von einem zum andern)

²Pi|la|tus (Berg bei Luzern) m; -

Pi|lau, Pi|law pers. u. türk. (orient. Reisspeise) m; -s

Pile engl. [pail] (engl. Bez. für: Reaktor) m; -s, -s

Pil|ger (Wallfahrer; auch: Wanderer); Pil|ger_chor m; ...fahrt, ...ge|wand, ...hut m; Pil|ge|rin w; -, -nen; pil|gern; ich ...ere (↑ R 327); Pil|ger|schaft w; -; Pil|gers|mann (älter für: Pilger) m; -[e]s, ...män|ner u. ...leute; Pil|ger|stab; Pil|ge|rung; Pil|ger|zug; Pil|grim (veralt. dicht. für: Pilger) m; -s, -e

pi|lie|ren fr. (stampfen, zerstoßen, schnitzeln [bes. Rohseife])

Pil|le lat. (Kügelchen; Arzneimittel) w; -, -n; Pil|len.dre|her (Käfer; scherzh. für: Apotheker), ...schach|tel; pil|lie|ren (Landw.: Saatgut mit einer Hüllmasse umgeben); Pil|lie|rung; Pil|ling engl. (Knötchenbildung in Textilien) s; -s; pil|ling|frei

Pi|lo|kar|pin gr. (speichel- u. schweißtreibendes Mittel) s; -s

Pi|lot fr. (Flugzeugführer; Lotsenfisch; veralt. für: Lotse, Steuermann) m; -en, -en (↑ R 268); Pi|lot_bal|lon (unbemannter Ballon zur Feststellung der Höhenwindes); Pi|lo|te (Rammpfahl) w; -; pi|lo|tie|ren ([Pfahl] einrammen; [ein Auto, Flugzeug] steu-

ern); Pi|lo|tie|rung; Pi|lot_stu|die (vorläufige, wegweisende Untersuchung), ...ton (Film, Fernsehen: bildsynchroner Ton)

Pils (ugs. Kurzform von: Pils[e]ner Bier) s; -, -; 3 -; Pil|sen (Hptst. des Westböhm. Gebietes); vgl. Plzeň; ¹Pil|se|ner, Pils|ner (↑ R 199); ²Pil|se|ner, Pils|ner (Bier) s; -s -

Pilz m; -es, -e; eßbarer -, giftiger -; Pilz|fa|den; pil|zig; Pilz_kopf (scherzh. für: Beatle), ...krank|heit, ...kun|de (w; -), ...ver|gif|tung

Pi|me|lo|se gr. (Med.: Fettleibigkeit) w; -

Pi|ment lat (Nelkenpfeffer, Küchengewürz) m od. s; -[e]s, -e

Pim|mel (ugs. für: Penis) m; -s, -

pim|pe nordd. (gleichgültig)

Pim|pe|lei (ugs.); pim|pe|lig, pimp|lig (ugs.); pim|peln (ugs. für: weinerlich tun; kränkeln); ich ...[e]le (↑ R 327)

Pim|per|lin|ge (ugs. für: Geld) Mehrz.

pim|pern bayer. (klimpern; klingeln); ich ...ere (↑ R 327)

Pim|per|nell sanskr. m; -s, -e u. Pim|pi|nel|le (wilder Kümmel, Küchen- u. Heilpflanze) w; -, -n

Pim|per|nuß [zu: pimpern] (ein Zierstrauch)

Pim|pi|nel|le vgl. Pimpernell

pimp|lig, pim|pe|lig vgl.

Pi|na|ko|id gr. (Kristallform) s; -[e]s, -e; Pi|na|ko|thek (Bilder-, Gemäldesammlung) w; -, -en

Pi|nas|se niederl. (Beiboot [von Kriegsschiffen]) w; -, -n

Pin|ce|nez fr. [pängß⁸ne] (,,Nasenklemmer''; veralt. für: Klemmer, Kneifer) s; - [...ne(ß)], - [...neß]

Pin|dar (altgr. Lyriker); pin|da|risch, aber (↑ R 179): Pin|da|risch; Pin|da|ros vgl. Pindar

Pin|ge vgl. Binge

pin|ge|lig (ugs. für: kleinlich, pedantisch; empfindlich)

Ping|pong engl. (österr.: ...pong] (Tischtennis) s; -s, -s; Ping|pong_plat|te, ...schlä|ger, ...spie|ler

Pin|gu|in (selten: ...in] (ein Vogel der Antarktis) m; -s, -e

Pi|nie lat. [...iⁿ] (Kiefer einer bestimmten Art) w; -, -n; Pi|ni|en_wald, ...zap|fen

¹Pink engl. (,,Nelke''; lichtes Rosa) s; -s, -

²Pink w; -, -en u. ¹Pin|ke niederd. (Segelschiff; Fischerboot) w; -, -n

²Pin|ke, Pin|ke|pin|ke slaw.-gaunersprachl. (ugs. für: Geld) w; -

Pin|kel (ugs. für: Geck) m; -s, -

pin|keln (ugs. für: harnen); ich ...[e]le (↑ R 327); Pin|kel|pau|se (ugs.)

pin|ken landsch. (hämmern, schmieden, ticken)

Pin|ke|pin|ke vgl. ²Pinke

pink, pink!

Pin|ne ([Kompaß]stift; Schusterzwecke; Hebelarm am Steuerruder; Teil des Hammers) w; -, -n; pin|nen landsch. (mit Pinnen versehen, befestigen)

Pi|no|le it. (Maschinenteil der Spitzendrehbank, in dem die Spitze gelagert ist) w; -, -n

Pin|scher (Hund einer bestimmten Rasse; übertr. für: kümmerlicher, einfältiger Mensch) m; -s, -

¹Pin|sel (ugs. für: törichter Mensch, Dummkopf) m; -s, -

²Pin|sel lat. m; -s, -; pin|sel|ar|tig; ¹Pin|se|lei (ugs. abschätzig für: Malerei)

²Pin|se|lei (veralt. für: große Dummheit)

Pin|se|ler, Pins|ler (abwertend); pin|seln; ich ...[e]le (↑ R 327); Pin|sel_stiel, ...strich

Pint engl. [paint] (engl. u. amerik. Hohlmaß; Abk.: pt.) s; -, -s; Pin|te fr. landsch. (Wirtshaus, Schenke) w; -, -n

Pin-up-girl engl.-amerik. [pinąpgö'l] (leichtbekleidetes Mädchen auf Anheftbildern) s; -s, -s

pinx. = pinxit, pin|xit lat. (neben dem Namen des Künstlers auf Gemälden: ,,hat [es] gemalt''; Abk.: p. od. pinx.)

Pin|zet|te fr. (Greif-, Federzange) w; -, -n

Pinz|gau (österr. Landschaft) m; -[e]s

Piom|bi it. (Bleidächer, hist. Bez. für die Staatsgefängnisse im Dogenpalast von Venedig) Mehrz.

Plo|nier fr. (,,Fußsoldat''; Soldat der techn. Truppe; übertr. für: Wegbereiter, Vorkämpfer, Bahnbrecher; DDR: Angehöriger einer Organisation für Kinder) m; -s, -e; Pio|nier_ab|tei|lung, ...ar|beit, ...freund|schaft (DDR), ...la|ger (DDR; Mehrz. ...lager), ...lei|ter (DDR; m), ...rol|le, ...tref|fen (DDR), ...trupp

¹Pi|pe österr. (Faß-, Wasserhahn) w; -, -n

²Pipe engl. [paip] (engl. u. amerik. Hohlmaß für Wein u. Branntwein) s od. w; -, -s; Pipe|line [paiplain] (Rohrleitung [für Gas, Erdöl]) w; -, -s; Pi|pet|te fr. (Saugröhre, Stechheber) w; -, -n

Pi|pi (Kinderspr.) s; -s; - machen

Pip|pau (eine Pflanzengattung) m; -[e]s

Pip|pin [auch, österr. nur: pi...] (Name fränk. Fürsten)

Pips (eine Geflügelkrankheit) m; -es; pip|sig

Pi|qué vgl. Pikee

Pi|ran|del|lo (it. Schriftsteller)

Pi|ran|ha *indian.-port.* [...*nja*], Pi-ra|ya *indian.* (ein Raubfisch) *m*; -[s], -s

Pi|rat *gr.* (Seeräuber) *m*; -en, -en (↑ R 268); Pi|ra|ten_schiff, ...sen-der, ...tum (*s*; -s); Pi|ra|te|rie *fr. w*; -, ...ien

Pi|rä|us (Hafen von Athen) *m*; - Pi|ra|ya vgl. Piranha

Pir|ma|sens (Stadt in Rheinland-Pfalz)

Pi|ro|ge *karib.-fr.* (primitives Indianerboot; Einbaum [mit Plankenaufsatz]) *w*; -, -n

Pi|rog|ge *russ.* (Art Pastete; russ. Gericht) *w*; -, -n

Pi|rol (ein Vogel) *m*; -s, -e

Pi|rou|et|te *fr.* [...*ru*...] (Standwirbel um die eigene Körperachse [Eiskunst-, Rollschuhlauf, Tanz]; Drehschwung im Ringkampf; Drehung in der Hohen Schule) *w*; -, -n; pi|rou|et|tie|ren

Pirsch (Einzeljagd) *w*; -; pir|schen; du pirschst (pirschest); Pirsch-gang *m*

Pi|sa (it. Stadt); der Schiefe Turm von -(↑ R 224); Pi|sa|ner (↑ R 199)

Pi|sang *malai.-niederl.* (Bananenart) *m*; -s, -e

pi|sa|nisch [zu: Pisa]

Pi|see|bau *fr.*; *dt.* (Stampfbau[weise]) *m*; -[e]s

Pi|si|stra|tus (lat. Form von: Peisistratos)

pis|pern landsch. (wispern); ich ...ere (↑ R 327)

Piß *m*; Pisses u. Pis|se (derb für: Harn) *w*; -; pis|sen (derb); du pißt (pissest); Pis|soir *fr.* [*pißoar*] (veralt. für: Bedürfnisanstalt für Männer) *s*; -s, -e u. -s

Pi|sta|zie *pers.* [...*i^e*] (ein Strauch od. Baum; Frucht) *w*; -, -n; Pi|sta-zi|en|nuß

Pi|ste *fr.* (Schispur; Schi- od. Radrennstrecke; Rollbahn auf Flugplätzen; Rand der Manege) *w*; -, -n

Pi|still *lat.* (Stampfer, Keule; Bot.: Blütenstempel) *s*; -s, -e

Pi|sto|ia (it. Stadt); Pi|sto|ia|er [...*ja^e r*] (↑ R 199); pi|sto|ia|isch [...*ja-isch*]

Pi|stol (alte Nebenform von: ²Pistole) *s*; -s, -en; ¹Pi|sto|le *tschech.-roman.* (alte Goldmünze) *w*; -, -n; ²Pi|sto|le *tschech.* (kurze Handfeuerwaffe) *w*; -, -n; jmdm. die - auf die Brust setzen (ugs. für: jmdn. zu einer Entscheidung zwingen); wie aus der - geschossen (ugs. für: spontan, sehr schnell, sofort); Pi|sto|len_griff, ...knauf, ...ku|gel, ...lauf, ...mündung, ...schuß, ...ta|sche, ...vo|gel (ein Schmetterling)

Pi|ston *fr.* [...*tong*] („Stampfer"; Zündstift bei Perkussionsgewehr-

ren; Pumpenventil der Blechinstrumente; Pumpenkolben) *s*; -s, -s; Pi|ston|blä|ser

Pi|ta|val [...*wal*; nach dem fr. Rechtsgelehrten Pitaval] (Sammlung berühmter Rechtsfälle) *m*; -[s]. -s; Neuer -

Pitch|pine *engl.* [*pitschpain*] (nordamerik. Pechkiefer) *w*; -, -s; Pitch-pine|holz

Pi|thek|an|thro|pus *gr.* (javan. u. chin. Frühmensch des Diluviums) *m*; -, ...pi; pi|the|ko|id (dem Pithekanthropus ähnlich)

pit|sche|pat|sche|naß, pitsch-patsch|naß (ugs.); pitsch, patsch!

pit|to|resk *fr.* (malerisch)

Pi|us (m. Vorn.)

Pi|vot *fr.* [...*wo*] (Schwenkzapfen an Drehkränen u. a.) *m* od. *s*; -s, -s

Piz *ladin.* (Bergspitze) *m*; -es, -e; Piz Bu|in (Gipfel in der Silvrettagruppe); Piz Pa|lü (Gipfel in der Berninagruppe); vgl. ¹Pik

Piz|za *it.* (neapolitan. Hefegebäck mit Tomaten, Käse u. Sardellen o. ä.) *w*; -, -s; Piz|ze|ria (Lokal, in dem Pizzas angeboten werden) *w*; -, -s

piz|zi|ca|to *it.* [...*kato*] (Musik: mit den Fingern gezupft); Piz|zi|ka-to *s*; -s, -s u. ...ti

Pkt. = Punkt

Pkw, (auch:) **PKW** (= Personenkraftwagen) *m*; - (selten: -s), -[s]

pl., Pl. = Plural

Pla|ce|ment *fr.* [*plaß^e mang*] (Anlage, Unterbringung von Kapitalien; Absatz von Waren; selten für: Placierung) *s*; -s, -s

pla|chan|dern ostdt. (plaudernd umherziehen; schwätzen)

Pla|cet vgl. Plazet

Pla|che vgl. Blahe

Pla|ci|dia [...*zi*...] (altröm. w. Eigenn.); Pla|ci|dus [...*zi*...] (altröm. m. Vorn.)

pla|cie|ren [*plazir^e n*, älter: *plaßi-r^e n*] usw. vgl. plazieren usw.

placken [*Trenn.*: plak|ken], sich (ugs.)

Placken [*Trenn.*: plak|ken] landsch. (großer [schmutziger od. bunter] Fleck) *m*; -s, -

Plackerei [*Trenn.*: Plak|ke|rei] (ugs.)

pla|dauz! nordwestd. (pardauz!)

plad|dern niederd. (verschütten; niederströmen, in großen Tropfen regnen); es pladdert

Plä|deur *fr.* [...*dör*] (veralt. für: Strafverteidiger) *m*; -s, -e; plä|die-ren; Plä|doyer [...*doaje*] (zusammenfassende Rede des Strafverteidigers od. Staatsanwaltes vor Gericht) *s*; -s, -s

Pla|fond *fr.* [...*fong*, österr. meist: ...*fon*] ([Zimmer]decke; oberer

Grenzbetrag bei der Kreditgewährung) *m*; -s, -s; pla|fo|nie|ren *fr.* schweiz. (nach oben hin begrenzen, beschränken)

Pla|ge *w*; -, -n; Pla|ge|geist (*Mehrz.* ...geister); pla|gen; sich -

Plag|ge niederd. (Rasenstück zur Bodenverbesserung) *w*; -, -n

Pla|gi|ar *lat. m*; -s, -e u. -e. Pla|gi|a|ri-us (veralt. für: Plagiator) *m*; -, ...rii [...*ri-i*]; Pla|gi|at (Diebstahl geistigen Eigentums) *s*; -[e]s, -e; Pla|gia|tor *m*; -s, ...oren; pla|gia-to|risch; pla|gi|ie|ren (ein Plagiat begehen)

Pla|gio|klas *gr.* (ein Mineral) *m*; -es, -e; Pla|gio|sto|men (Quermäuler; zusammenfassende Bez. für Haie u. Rochen) *Mehrz.*

Plaid *engl.* [*ple'd*] ([Reise]decke; auch: großes Umhangtuch aus Wolle) *s* (älter: *m*); -s, -s

Pla|kat *niederl.* ([öffentl.] Aushang, Bekanntmachung, Werbeanschlag) *s*; -[e]s, -e; pla|ka|tie-ren (ein Plakat ankleben; durch Plakate bekanntmachen; öffentl. anschlagen); Pla|ka|tie|rung; pla-ka|tiv; Pla|kat_kunst, ...ma|le|rei, ...säu|le, ...schrift; Pla|ket|te *fr.* (kleine, eckige [meist geprägte] Platte mit einer Reliefdarstellung) *w*; -, -n

Pla|ko|der|men *gr.* (ausgestorbene Panzerfische) *Mehrz.*; **Plak-odont** („Breitzahner"; ausgestorbene Echsenart) *m*; -en, -en (↑ R 268); Pla|ko|id|schup|pe (Schuppe der Haie)

plan *lat.* (flach, eben; veralt. für: deutlich); - geschliffene Fläche; ¹Plan (veralt. für: Ebene; Kampfplatz) *m*; -[e]s, Pläne

²Plan (Grundriß; Vorhaben) *m*; -[e]s, Pläne

Pla|nar ⓦ (symmetr. Reproduktionsobjektiv) *s*; -s, -e

Pla|na|rie [...*i^e*] (Strudelwurm) *w*; -, -n

Plan|auf|ga|be (DDR); Plän|chen, Plän|lein

Plan|che *fr.* [*plangsch*] („Brett"; Fechtbahn) *w*; -, -n [...*sch^e n*]

Plan|chet|te [*plangschät^e*] (Miederstäbchen) *w*; -, -n

Planck, Max (dt. Physiker); Plancksch; ↑ R 179; -es Strahlungsgesetz

Pla|ne (Wagen]decke) *w*; -, -n

Plä|ne *fr.* (veralt. für: Ebene) *w*; -, -n

pla|nen; Pla|ner

Plä|ner (ein Gestein) *m*; -s

Plan|er|fül|lung (DDR); pla|ne-risch; Pla|ne_schmied, ...schmie-den (*s*; -s)

Pla|net *gr.* (Wandelstern) *m*; -en, -en (↑ R 268); pla|ne|tar vgl. planetarisch; pla|ne|ta|risch; -er

531 platten

Nebel; Pla|ne|ta|ri|um (Instrument zur Darstellung der Bewegung, Lage u. Größe der Gestirne; auch Gebäude dafür) s; -s, ...ien [...i^en]; Pla|ne|ten.ge|trie|be (Technik), ...jahr, ...kon|stel|la|ti|on, ...sy|stem; Pla|ne|to|id (kleiner Planet) m; -en, -en (↑ R 268) Plan|fest|stel|lung; Plan|fest|stel|lungs|ver|fah|ren
Plan|film (flach gelagerter Film im Gegensatz zum Rollfilm); plan|ge|mäß; Plan|heit (Flächigkeit; veralt. für; Deutlichkeit) w; -; Pla|nier|bank (Technik; Mehrz. ...bänke); pla|nie|ren ([ein]ebnen); Pla|nier.rau|pe, ...schild m, Pla|nie|rung; Pla|ni|fi|ka|teur [...tör] (Fachmann für volkswirtschaftliche Gesamtplanung) m; -s, -e; Pla|ni|fi|ka|ti|on [...zion] (Bez. für eine Art von zwangloser, staatlich organisierter, langfristiger gesamtwirtschaftlicher Programmierung) Pla|ni|glob lat. s; -s, -en u. Pla|ni|glo|bi|um (Darstellung der Erdhalbkugel in der Ebene) s; -s, ...ien [...i^en]
Pla|ni|me|ter lat.; gr. (Gerät zum Messen des Flächeninhaltes, Flächenmesser) s; -s, -; Pla|ni|me|trie (Geometrie der Ebene) w; -; pla|ni|me|trisch
Plan|kal|ku|la|ti|on (Kalkulation mit den auf Grund der Plankostenrechnung ermittelten Standardkostensätzen)
Plan|ke (starkes Brett, Bohle) w; -, -n
Plän|ke|lei; plän|keln; ich ...[e]le (↑ R 327)
Plan|ken|zaun
Plänk|ler
Plan|ko|sten Mehrz.; Plan|ko|sten|rech|nung
Plank|ton gr. ("Treibendes"; im Wasser schwebende Lebewesen mit geringer Eigenbewegung) s; -s; plank|to|nisch; Plank|ton|netz; Plank|tont (im Wasser schwebendes Lebewesen) m; -en, -en (↑ R 268)
Plän|lein, Plän|chen; plan|los; Plan|lo|sig|keit; plan|mä|ßig; Plan|mä|ßig|keit; Plan|num|mer
pla|no lat. (von Druckbogen u. [Land]karten: glatt, ungefalzt)
Plan.preis (Wirtsch.: der in der Plankostenrechnung für die Bewertung der Faktormengen zugrunde gelegte Preis; vgl. ²Preis), ...qua|drat, ...rück|stand (DDR)
Plansch|becken [Trenn.: ...bek-ken]; plan|schen; du planschst (planschest)
Plan.schul|den (DDR; Mehrz.), ...soll (DDR; vgl. ²Soll), ...stel|le
Plan|ta|ge fr. [...tasch^e, österr.:

...tasch] ([An]pflanzung, landwirtschaftl. Großbetrieb [in trop. Gegend]); Plan|ta|gen|be|sit|zer
Plan|ta|ge|net [pläntädschinit] (Angehöriger eines engl. Herrscherhauses) m; -[s], -s
Plan|ta|gen|wirt|schaft
plan|tar lat. (Med.: die Fußsohle betreffend)
Pla|num lat. (vorbereitete eingeebnete Unterlagsfläche für Fahrbahnbettung) s; -s
Pla|nung; Pla|nungs.ab|tei|lung, ...kom|mis|si|on, ...rech|nung (Math.), plan|voll
Plan|wa|gen
Plan.wirt|schaft; plan|zeich|nen (nur in der Grundform gebräuchlich); Plan.zeich|nen, ...zeich|ner, ...zeich|nung, ...ziel
Plap|pe|rei (ugs.); Plap|pe|rer, Plapp|rer (ugs.); plap|per|haft (ugs.); Plap|per|haf|tig|keit (ugs.) w; -; plap|pe|rig, plapp|rig (ugs.); Plap|pe|rin (ugs.) w; -, -nen; Plap|per.maul (ugs.), ...mäul|chen (ugs.); plap|pern (ugs.); ich ...ere (↑ R 327); Plap|per|ta|sche (abschatzig ugs.); Plapp|rer, Plap|pe|rer (ugs.); plapp|rig, plap|pe|rig (ugs.)
plär|ren (ugs.); Plär|rer (ugs.)
Plä|san|te|rie fr. (veralt. für: Scherz) w; -, ...ien [Plä|sier (veralt., scherzh. für: Vergnügen; Spaß; Unterhaltung) s; -s, -e; plä|sier|lich (veralt., aber noch mdal. für: vergnüglich, heiter, angenehm, freundlich)
Plas|ma gr. (Protoplasma; flüssiger Bestandteil des Blutes; leuchtendes Gasgemisch; Halbedelstein) s; -s, ...men; Plas|mo|di|um gr. (vielkernige Protoplasmamasse; Protoplasmakörper der Schleimpilze; Malariaerreger) s; -s, ...ien [...i^en]; Plas|mo|go|nie (Urzeugung) w; -
Plast gr. (makromolekularer Kunststoff) m; -[e]s, -e; Pla|stics engl. [pläßtikß] (engl. Bez. für: Kunststoffe, Plaste) Mehrz.; Pla|sti|den gr. (Chromatophoren u. Leukoplasten der Pflanzenzelle) Mehrz.; ¹Pla|stik (Bildhauerkunst; Bildwerk; übertr. für: Körperlichkeit; Med.: operativer Ersatz von zerstörten Gewebs- u. Organteilen) w; -, -en; ²Pla|stik (Kunststoff) s; -s, -e (seltener: w; -, -en); Pla|stik... (in der Handelsspr. übl. Bestimmungswort von Zusammensetzungen mit der Bedeutung "Kunststoff" [vgl. Plastics], z. B. Plastikfolie); Pla|stik.bom|be, ...ein|band; Pla|sti|ker (Bildhauer); Pla|stik.fo|lie, ...helm; Pla|sti|lin s; -s (österr. nur so) u. Pla|sti|li|na (Knetmasse

zum Modellieren) w; -; pla|stisch (bildsam; knetbar; körperlich, deutlich hervortretend, anschaulich; gestaltend; einprägsam); -ste (↑ R 294); -e Masse; -e Sprache; Pla|sti|zi|tät (Formänderungsvermögen, Formbarkeit, Körperlichkeit; Bildhaftigkeit, Anschaulichkeit) w; -
Pla|stron fr. [...ßtrong, österr.: ...ßtron] (breiter Schlips zur festl. Herrenkleidung; gestickter Brustlatz an Frauentrachten; früher für: Brust- od. Armschutz; auch: Stoßkissen zu Übungszwecken beim Fechten) m od. s; -s, -s
Pla|täa (im Altertum Stadt in Böotien); Pla|tä|er
Pla|ta|ne gr. (ein Laubbaum) w; -, -n; Pla|ta|nen.blatt, ...ge|wächs
Pla|teau fr. [...to] (Hochebene, Hochfläche; Tafelland) s; -s, -s; pla|teau|för|mig [...to...]
pla|te|resk span. (selten für: wunderlich verziert); Pla|te|resk (Schmuckstil der span. Spätgotik u. der it. Frührenaissance) s; -[e]s
Pla|tin span. [österr.: platin] (chem. Grundstoff, Edelmetall; Zeichen: Pt) s; -s; Pla|tin|draht; pla|ti|nie|ren (mit Platin überziehen); Pla|ti|no|id span.; gr. (eine Legierung) s; -[e]s, -e
Pla|ti|tü|de fr. (Plattheit, Seichtheit) w; -, -n
Pla|to vgl. Platon; Pla|ton (altgr. Philosoph); Pla|to|ni|ker (Anhänger der Lehre Platos); pla|to|nisch (nach Art Platos; geistig, unsinnlich); -e Liebe; -es Jahr, aber (↑ R 179): Pla|to|nisch (von Plato herrührend); -e Schriften; Pla|to|nis|mus (Weiterentwicklung u. Abwandlung der Philosophie u. bes. der Ideenlehre Platos) m; -
platsch!; plat|schen; du platschst (platschest); plat|schern; ich ...ere (↑ R 327); platsch|naß (ugs.)
platt (flach); -er, -este (↑ R 292), die Nase - drücken; da bist du -! (ugs. für: da bist du sprachlos, sehr erstaunt!); er hat - gemacht od. er hat einen Platten (ugs. für: eine Reifenpanne); das -e (flache) Land; Platt (Niederdeutsche) s; -[s]; Platt|brett; Platt|chen, Platt|lein; platt|deutsch; vgl. deutsch; Platt|deutsch (Sprache) s; -[s]; vgl. Deutsch; Platt|deutsch|e das s; -n; vgl. Deutsche s; Plat|te w; -, -n (österr. ugs. auch: [Gangster]bande); Plät|te (landsch. für: Bügeleisen; bayr. u. österr. für: flaches Schiff) w; -, -n; Plat|tei ([Adrema]plattensammlung); Plätt|ei|sen; plät|ten landsch.

(platt machen; Platten legen); **plät|ten** nordd. (bügeln); **Plätten.ar|chiv**, ...**bau|wei|se**, ...**be-lag**, ...**gie|ßer**, ...**le|ger**
Plat|ten|see (ung. See) m; -s; vgl. Balaton; [1]**Plat|ten|seer** [...se[e]r] (↑R 166, 199 u. 205); [2]**Plat-ten|seer** (ein Wein) m; -s
Plat|ten.spie|ler, ...**ste|cher** (ein Lehrberuf), ...**wechs|ler**, ...**weg**
Platt|erb|se; plat|ter|dings (veralt.); **Plät|te|rei; Plät|te|rin** w; -, -nen; **Platt.fisch**, ...**form**, ...**frost** (Frost ohne Schnee), ...**fuß; platt-fü|ßig; Platt.heit**, ...**hirsch** (geweihloser Rothirsch); **plat|tie|ren** fr. ([mit Metall] überziehen; umspinnen); **Plat|tie|rung; Plat|tier-ver|fah|ren; plat|tig** (von Felsen: glatt); **Plätt|lein**, Plätt|chen; **Platt|ler** (Älplertanz); **Plätt|ma-schi|ne; platt|na|sig; Platt|stich;** Platt- und Stielstich; **Platt|stich-sticke|rei** [Trenn.: ...stik|ke...]; **Platt|sticke|rei** [Trenn.: ...stik-ke...]
Platz (Fläche, Raum; Kaufmannsspr.: [Handels]ort, Sitz; landsch. für: flacher Kuchen, [Zucker]plätzchen) m; -es, Plätze; **Schreibung in Straßennamen**: ↑R 219ff.; - finden, greifen; - machen, nehmen; am -[e] sein; **Platz-.angst** (w; -), ...**an|wei|ser**, ...**an-wei|se|rin** (w; -, -nen), ...**be|darf; Plätz|chen**, Plätz|lein
Plat|ze, nur in: die - kriegen (ugs. für: wütend werden); **plat|zen;** du platzt (platzest); **plät|zen** (landsch. für: mit lautem Knall schießen; Forstw.: [den Baum] durch Abschlagen eines Rindenstückes zeichnen; vom Schalenwild: [den Boden mit den Vorderläufen aufscharren; du plätzt (plätzest)
...**plät|zer** schweiz. (...sitzer); **Platz.hal|ter**, ...**hirsch** (stärkster Hirsch eines Brunftplatzes); ...**plät|zig** schweiz. (...sitzig); **Platz.kar|te**, ...**kon|zert**, ...**ko-sten|rech|nung** (Wirtsch.: verfeinerte Kostenstellenrechnung); **Plätz|lein**, Plätz|chen; **Plätz|li** schweiz. mdal. (flaches Stück; bes.: Plätzchen; Schnitzel) s; -s, -; **Platz.man|gel** (m; -s), ...**mie|te**
Platz.pa|tro|ne, ...**re|gen**
Platz.ver|tre|ter, ...**ver|tre|tung**, ...**vor|schrift** (Plazierungsvorschrift), ...**wart**, ...**wech|sel**, ...**wet|te**
Platz|wun|de
Plau|der|bei; Plau|de|rer, Plaudrer; **Plau|de|rin**, Plaud|re|rin w; -, -nen; **plau|dern;** ich ...ere (↑R 327); **Plau|der.stünd|chen**, ...**ta-sche** (scherzh.), ...**ton** (m; -[e]s);

Plaud|rer, Plau|de|rer; **Plaud|re-rin**, Plau|de|rin w; -, -nen
Plau|en (Stadt im Vogtland); **Plaue|ner** (↑R 199); **plau|ensch**, (auch:) plau|isch; -e Ware
Plau|en|sche Grund (bei Dresden) m; -n, -[e]s
Plau|er Ka|nal [nach Plaue (in Brandenburg)] m; - -s; **Plau|er See** m; - -s
Plaue|sche Grund (bei Erfurt) m; -n -[e]s
plau|isch vgl. plauensch
Plausch (gemütl. Plauderei) m; -[e]s, -e; **plau|schen** südd., österr., schweiz. (gemütl. plaudern); du plauschst (plauschest)
plau|si|bel lat. (annehmbar, einleuchtend, triftig); ...i|ble Gründe; **Plau|si|bi|li|tät**
plau|stern mdal. (plustern); sich - (die Federn spreizen)
Plau|tus (röm. Komödiendichter)
plauz! Plauz (ugs. für: Fall; Schall) m; -es, -e; einen - tun
Plau|ze slaw. mdal. (Lunge) w; -, -n
plau|zen [zu: Plauz]; du plauzt (plauzest)
Play-back, (auch schon:) **Play|back** engl. [ple̯|bäk] (Film-u. Tonbandtechnik: zusätzliche synchrone Bild- od. Tonaufnahme zu einem bereits bespielten Band) s; -; **Play|boy** engl.-amerik. [ple̯|beu] (reicher junger Mann, der nicht arbeitet u. nur dem Vergnügen nachgeht); **Play|girl** [ple̯|gö̱r l] (scherzh., leicht abwertende Bez. für ein attraktives Mädchen aus den Kreisen des Dolce vita)
Pla|zen|ta gr. (Med., Biol.: Mutterkuchen, Nachgeburt) w; -, -s u. ...ten; **pla|zen|tal, pla|zen|tar**
Pla|zet lat. (,,es gefällt"; Bestätigung, Erlaubnis) s; -s, -s
pla|zie|ren, (auch noch:) pla|cie-ren fr. (aufstellen, an einen bestimmten Platz stellen; Kaufmannsspr.: Kapitalien unterbringen, anlegen; Sport: einen gezielten Schuß od. Wurf [Ballspiel], Hieb od. Schlag [Boxen] abgeben); sich - (Sport: einen vorderen Platz, einen Preis erringen); **Pla|zie|rung**, (auch noch:) Pla|cie|rung; **Pla|zie|rungs|vor-schrift** (Platzvorschrift eines Werbungtreibenden an den Werbemittler, bes. Zeitungs- od. Zeitschriftenverlag)
Ple|be|jer lat. (Angehöriger der niederen Schichten [im alten Rom]; gewöhnlicher, ungehobelter Mensch) m; -s, -; **ple|be|jisch** (ungebildet, ungehobelt, pöbelhaft); -ste (↑R 294); **Ple|bis|zit** (,,Volksbeschluß"; Volksab-

stimmung) s; -[e]s, -e; **ple|bis|zi-tär** (das Plebiszit betreffend); [1]**Plebs** [auch: plep̱ß] (niederes Volk, Pöbel) m; -es; [2]**Plebs** [auch: plep̱ß] (das gemeine Volk im alten Rom) w; -
Plein|air fr. [plänär] (Freilichtmalerei) s; -s, -s; **Plein|air|ma|le|rei; Plein|pou|voir** [plänɛpuwoar] (unbeschränkte Vollmacht) s; -s
Plei|ße (r. Nebenfluß der Weißen Elster) w; -
plei|sto|zän gr.; **Plei|sto|zän** (Geol.: Diluvium) s; -s
plei|te jidd. (ugs. für: zahlungsunfähig); - gehen, sein, werden; er ist, geht -; er wird - werden; **Plei-te** (ugs.) w; -, -n; - machen; er macht -; das ist ja eine - (ein Reinfall); das gibt eine völlige - (es geht schief); **Plei|te|gei|er** (ugs.)
Ple|ja|de (gr. Regengöttin) w; -; **Ple|ja|den** (Siebengestirn [Sterngruppe]) Mehrz.
Plek|tron gr. (Stäbchen od. Plättchen, mit dem die Saiten verschiedener Zupfinstrumente angerissen werden) s; -s, ...tren u. ...tra; **Plek|trum** vgl. Plektron
Plem|pe (spött. für: breites Seitengewehr; plumper Säbel; ugs. für: schlechtes minderwertiges Getränk) w; -, -n; **plem|pern** (ugs. für: seine Zeit unnütz od. mit nichtigen Dingen hinbringen; herumlungern); ich ...ere (↑R 327)
plem|plem (ugs. für: verrückt)
Ple|nar|sit|zung lat.; dt. (Vollsitzung), ...**ver|samm|lung** (Vollversammlung); **ple|ni|po|tent** (veralt. für: ohne Einschränkung bevollmächtigt, voll befugt, allmächtig); **Ple|ni|po|tenz** w; -
ple|no or|ga|no lat. (bei der Orgel: mit vollen Registern)
ple|no ti|tu|lo lat. (österr., sonst veralt. für: mit vollem Titel; Abk.: P. T.)
Plent te it. südd. ([Speise aus Maisod.] Buchweizen[mehl]) w; -, -n
Plen|ter|be|trieb (Art des Forstbetriebes); **plen|tern**; ich ...ere (↑R 327)
Ple|num lat. (Gesamtheit [des Parlaments, Gerichts u. a.], Vollversammlung) s; -s; vgl. in pleno
Pleo|chro|is|mus gr. [...kro...] (Eigenschaft gewisser Kristalle, Licht nach mehreren Richtungen in verschiedene Farben zu zerlegen) m; -; **pleo|morph** usw. vgl. polymorph usw.; **Pleo|nas|mus** (überflüssige Häufung sinngleicher od. sinnähnlicher Ausdrücke) m; -, ...men; **pleo|na|stisch** (überflüssig gesetzt; überladen)
Pleo|on|exie (Habsucht; Begehrlichkeit; Geltungssucht) w; -

Ple|sio.sau|ri|er od. ...sau|rus gr. (Reptil einer ausgestorbenen Gattung) m; -, ...rier [...i^er]

Pleß (ehem. Fürstentum)

Ple|thi vgl. Krethi

Ple|tho|ra gr. (Med.: Überfülle; Vollblütigkeit) w; -, ...ren (fachspr.: ...rae)

Ple|tys|mo|graph gr. (Med.: Apparat zur Messung von Umfangsveränderungen eines Gliedes od. Organs) m; -en, -en (↑ R 268)

Pleu|el (Schubstange) m; -s, -; Pleu|el|stan|ge

Pleu|ra gr. (Brust-, Rippenfell) w; -, ...ren

Pleu|reu|se fr. [plörö͞s^ʼ] (früher: Trauerbesatz an Kleidern, Trauerschleier; seit 1900 lange [herabhängende] Straußenfeder auf Frauenhüten) w; -, -n

Pleu|ri|tis gr. (Med.: Brust-, Rippenfellentzündung) w; -, ...itiden; Pleur|ody|nie (Med.: Seitenschmerz, Seitenstechen) w; -, ...ien; pleu|ro|karp (seitenfrüchtig); Pleu|ro|pneu|mo|nie (Rippenfell- u. Lungenentzündung) w; -, ...ien

ple|xi|form lat. (Med.: geflechtartig)

Ple|xi|glas ⓦ lat.; dt. (ein glasartiger Kunststoff)

Ple|xus lat. (Med.: Gefäß- od. Nervengeflecht) m; -, -

Pli fr. („Falte"; mdal. für: Gewandtheit, Schliff [im Benehmen]) m; -s

Plicht (offener Sitzraum hinten in Motor- u. Segelbooten) w; -, -en

plie|ren nordd. (mit den Augen kneifen, blinzeln; weinen); plie|rig nordd. (blinzelnd; verweint, triefäugig); -e Augen

plietsch niederd. (pfiffig, schlau)

Plie|vier [...wie] (dt. Schriftsteller)

Pli|ni|us (röm. Schriftsteller)

Plin|se slaw. (Eier- od. Kartoffelspeise) w; -, -n

plin|sen nordd. (weinen); du plinst (plinsest)

Plin|sen|teig ostmitteld.

Plin|the gr. ([Säulen]platte; Sokkel[mauer]) w; -, -n

Plin|ze (Nebenform von: Plinse) w; -, -n

olio|zän gr.; Plio|zän (Geol.: jüngste Stufe des Tertiärs) s; -s

Plis|see fr. (in Fältchen gelegtes Gewebe) s; -s, -s; Plis|see.rock, ...strei|fen (Faltenstreifen, Preßfalte); plis|sie|ren (in Falten legen, fälteln)

olitz, platz!

Plock|wurst

Plom|be fr. (Bleisiegel, -verschluß; zollamtl. kurz: Blei; [Zahn]füllung) w; -, -n; plom|bie|ren; Plom|bie|rung

Plo|ni (Kurzform von: Apollonia)

Plot engl. (Handlung[sablauf], tragischer Konflikt im Drama) m; (auch: s); -s, -s

Plöt|ze slaw. (ein Fisch) w; -, -n

plötz|lich; Plötz|lich|keit w; -

Plu|der|ho|se; plu|de|rig, plud|rig; plu|dern (sich bauschen, bauschig schwellen)

Plum|bum lat (Blei: chem. Grundstoff; Zeichen: Pb) s; -s

Plu|meau fr. [plümo] (Federdeckbett) s; -s, -s

plump; eine -e Falle

Plum|pe ostmitteld. (Pumpe) w; -, -n; plum|pen ostmitteld. (pumpen)

Plump|heit; plumps!; Plumps (ugs.) m; -es, -e; Plump|sack (heute noch im Kinderspiel); plump|sen (ugs. für: dumpf fallen); du plumpst (plumpsest)

Plum|pud|ding engl. [plampud...] (engl. Rosinenspeise)

plump-ver|trau|lich (↑ R 158)

Plun|der (ugs. für: altes Zeug; Backwerk aus Blätterteig mit Hefe) m; -s, (für das Backwerk auch Mehrz.:) -n; Plun|der|bre|zel; Plün|de|rei; Plün|de|rer, Plünd|rer; Plun|der.ge|bäck, ...kam|mer (veralt.), ...markt (veralt.); plün|dern; ich ...ere († R 327); Plün|der|teig; Plün|de|rung; Plünd|rer, Plün|de|rer

Plün|nen niederd. ([alte] Kleider) Mehrz.

Plun|ze ostmitteld. (Blutwurst) w; -, -n, Plun|zen bayr. (Blutwurst; scherzh. für; dicke, schwerfällige Person) w; -, -

Plur. = Plural; plu|ral vgl. pluralistisch; Plu|ral lat. [auch: plural] (Sprachw.: Mehrzahl, Abk.: pl., Pl., Plur.) m; -s, -e; Plu|ral|en|dung; Plu|ra|le|tan|tum (Sprachw.: nur in der Mehrzahl vorkommendes Wort, z. B. „die Leute") s; -s, -s u. Plu|ra|li|atan|tum; Plu|ra|lisch (in der Mehrzahl gebraucht, vorkommend)); Plu|ra|li|sie|rung; Plu|ra|lis ma|je|sta|tis (auf die eigene Person angewandte Mehrzahlform) m; - -, ...les -; Plu|ra|lis|mus (philos. Meinung, daß die Wirklichkeit aus vielen selbständigen Weltprinzipien besteht; Vielgestaltigkeit gesellschaftlicher, politischer u. anderer Phänomene) m; -; plu|ra|li|stisch (e Gesellschaft; Plu|ra|li|tät (Mehrheit; Vielfältigkeit); Plu|ral|wahl|recht (Mehrstimmenwahlrecht); plu|ri|form (vielgestaltig); plus (umg.: zuzüglich; Zeichen: + [positiv]; Ggs.: minus); drei plus drei ist, macht, gibt (nicht: sind, machen, geben) sechs; plus 15 Grad od.

15 Grad plus; Plus (Mehr, Überschuß, Gewinn; Vorteil) s; -, -; Plus|be|trag

Plüsch [auch: plü...] fr. (Florgewebe) m; -[e]s, -e; Plüsch.decke [Trenn.: ...dek|ke], ...mö|bel, ...ses|sel, ...so|fa, ...tep|pich

Plus.pol, ...punkt

Plus|quam|per|fekt lat. [auch: ...fäkt] (Sprachw.: Vollendung in der Vergangenheit, Vorvergangenheit, dritte Vergangenheit) s; -s, -e

plu|stern; die Federn - (sträuben, aufrichten); sich -; vgl. plaustern

Plus|zei|chen (Zusammenzähl-, Additionszeichen); Zeichen: +)

Plut|arch (gr. Schriftsteller); Plut|ar|chos; vgl. Plutarch

[1]Plu|to (Beiname des Gottes Hades; gr. Gott des Reichtums und des Überflusses); [2]Plu|to (ein Planet) m; -; Plu|to|krat gr. (jmd., der durch seinen Reichtum politische Macht ausübt) m; -en, -en (↑ R 268); Plu|to|kra|tie (Geldherrschaft; Geldmacht) w; -, ...ien; Plu|ton vgl. [1]Pluto; plu|to|nisch (der Unterwelt zugehörig); -e Gesteine (Tiefengesteine); Plu|to|nis|mus (Tiefenvulkanismus; veralt. geol. Lehre, daß die Gesteine ursprünglich in glutflüssigem Zustande waren) m; -; Plu|to|nist (↑ R 268); Plu|to|ni|um (chem. Grundstoff, Transuran; Zeichen: Pu) s; -s

Plutz|er österr. mdal. (Kürbis; Steingutflasche; bildl. für: grober Fehler)

Plu|vi|a|le lat. [...wi...] („Regenmantel"; Rauchmantel des kath. Priesters; Krönungsmantel) s; -s, -[s]; Plu|vi|al|zeit (Geogr.: in den subtrop. Gebieten eine den Eiszeiten der höheren Breiten entsprechende Periode mit kühlerem Klima u. stärkeren Niederschlägen); Plu|vio|graph lat.; gr. (Meteor.: Regenmesser) m; -cn, -en (↑ R 268); Plu|vio|me|ter (Meteor.: Regenmesser) s; -s, -; Plu|vio|ni|vo|me|ter [...niwo...] (Meteor.: Gerät zur Aufzeichnung des als Regen od. Schnee fallenden Niederschlags) s; -s, -; Plu|vi|ose fr. [plüwiös] („Regenmonat" der Fr. Revolution: 20. Jan. bis 18. Febr.) m; -, -s; Plu|vi|us lat. (Beiname Jupiters)

Ply|mouth [plim^eth] (engl. Stadt); Ply|mouth-Rocks (eine Hühnerrasse) Mehrz.

Plzeň [plsänj] (tschech. Name für: Pilsen)

p. m. = post meridiem; post mortem; pro memoria

p. m., v. T., ⁰/₀₀ = per od. pro mille

Pm = chem. Zeichen für: Promethium

Pneu *gr.* (Kurzform für: ²Pneumatik od. Pneumothorax) *m; -s, -s;* **Pneu|ma** (Hauch; bes. für: Heiliger Geist) *s; -s;* **¹Pneu|ma|tik** (Lehre vom Verhalten der Gase) *w; -;* **²Pneu|ma|tik** (Luftreifen; Kurzform: Pneu) *m; -s, -s* (österr.: *w; -, -en*); **³Pneu|ma|tik** (Luftdruckmechanik bei der Orgel) *w; -, -en;* **pneu|ma|tisch** (die Luft, das Atmen betreffend; durch Luft[druck] bewegt, bewirkt; Luft...); -e Bremse (Luftdruckbremse); -e Kammer (luftdicht abschließbare Kammer mit Klimaanlage u. regulierbarem Luftdruck); **Pneu|mo|graph** (Vorrichtung zur Aufzeichnung der Atembewegungen) *m;* -en, -en (↑R 268); **Pneu|mo|kok|kus** (Med.: Erreger der Lungenentzündung) *m;* -, ...kken; **Pneu|mo|ko|nio|se** (Med.: Staublunge) *w;* -; **Pneu|mo|nie** (Med.: Lungenentzündung) *w;* -, ...ien; **Pneu|mo|pe|ri|kard** (Med.: Luftansammlung im Herzbeutel) *s;* -[e]s; **Pneu|mo|pleu|ri|tis** (Med.: heftige Rippenfellentzündung bei leichter Lungenentzündung) *w;* -, ...it|den; **Pneu|mo|tho|rax** (krankhafte od. künstl. Luft-, Gasansammlung im Brustfellraum; Kurzform: Pneu) *m;* -[e]s, -e

Pnom|penh vgl. Phnom Penh

¹Po (it. Fluß) *m;* -[s]

²Po (kurz für: Popo) *m; -s, -s*

Po = chem. Zeichen für: Polonium

P. O. = Professor ordinarius (ordentlicher Professor; vgl. d.)

Pö|bel *fr.* (Pack, Gesindel) *m;* -s; **Pö|be|lant** *m;* -en, -en (↑R 268); **Pö|be|lei; pö|bel|haft; Pö|bel|haf|tig|keit; Pö|bel|herr|schaft; pö|beln;** ich ...[e]le (↑R 327)

Poch (ein Kartenglücksspiel) *s* (auch: *m*); -[e]s; **Poch|brett; po|chen**

po|chie|ren *fr.* [*poschir̂n*] (Gastr.: Speisen, bes. aufgeschlagene Eier, in kochendem Wasser gar werden lassen)

Poch_stem|pel (Balken zum Zerkleinern [„Pochen"] von Erzen), **...werk** (Bergbau)

Pocke¹ (Impfpustel) *w;* -, -n; **Pocken¹** (eine Infektionskrankheit) *Mehrz.;* **Pocken¹_imp|fung, ...nar|be; pocken|nar|big¹; Pocken¹_schutz|imp|fung, ...vi|rus; Pock|holz** (Guajakholz, trop. Holz); **pockig¹**

po|co *it.* [*poko*] (Musik: [ein] we-

¹Trenn.: ...ok|k...

nig); - a - (nach und nach); - largo ([ein] wenig langsam)

Pod|agra *gr.* (Fußgicht, Zipperlein) *s;* -s; **pod|agrisch; Pod|al|gie** (Med.: Fußschmerzen) *w;* -, ...ien

Po|dest *gr.* ([Treppen]absatz; größere Stufe) *s* (österr. nur so) od. *m;* -[e]s, -e

Po|de|sta, (in it. Schreibung:) **Po|de|stà** *it.* (it. Bez. für: Ortsvorsteher, Bürgermeister) *m;* -[s], -s

Po|dex *lat.* (scherzh. für: Gesäß) *m;* -[es], -e

Pod|gor|ny (sowjet. Politiker)

Po|di|um *gr.* (Fußgestell, trittartige Erhöhung [für Schauspieler, Musiker, Redner]) *s;* -s, ...ien [...i^en]; **Po|di|ums_dis|kus|si|on, ...ge|spräch; Po|do|me|ter** *gr.* (Schrittzähler) *s;* -s, -

Pod|sol *russ.* (Bodenart) *m;* -s

Poe [*po^u*], Edgar Allan [*ädg^er älin*] (amerik. Schriftsteller)

Po|ebe|ne; ↑R 201 (Ebene des Flusses Po) *w;* -

Po|em *gr.* (meist abschätzig für: Gedicht; Tondichtung) *s;* -s, -e; **Poe|sie** [*po-e...*] (Dichtung; Dichtkunst; dicht. Stimmungsgehalt, Zauber) *w;* -, ...ien; **Poe|sie|al|bum; poe|sie|los;** -este (↑R 292); **Poe|sie|lo|sig|keit** *w;* -; **Po|et** (meist spött. für: Dichter) *m;* -en, -en (↑R 268); **Poe|ta lau|rea|tus** *lat.* ([lorbeer]gekrönter, mit einem kaiserl. od. königl. Ehrentitel ausgezeichneter Dichter) *m;* - -, ...tae [...ä] ...ti; **Poe|ta|ster** *gr.* (abwertend für: schlechter Dichter) *m;* -s, -; **Poe|tik** (Lehre von der Dichtkunst) *m;* -, -en; **poe|tisch** (dichterisch); -ste (↑R 294); eine -e Sprache; er hat eine -e Ader (ugs. für: Veranlagung); **poe|ti|sie|ren** [*po-e...*] (dichterisch ausschmücken; dichtend erfassen u. durchdringen)

Po|fel südd. u. österr. (svw. Bafel; Wertloses) *m;* -s

Po|fe|se vgl. Pafese

Po|gat|sche *ung.* österr. (ein Gericht) *w;* -, -n

Po|grom *russ.* (Hetze, Ausschreitungen gegen nationale, religiöse, rassische Gruppen) *m* (auch: *s*); -s, -e

Poi|ki|lo|der|mie *gr.* [*peu...*] (Med.: buntscheckig gefleckte Haut) *w;* -; **poi|ki|lo|therm** [*peu...*] (von Tieren: wechselwarm)

Poi|lu *fr.* [*poalü*] (Spitzname des fr. Soldaten) *m;* -[s], -s

Point *fr.* [*poãns*] („Punkt"; Würfelspiel: Auge; Kartenspiel: Stich; Kaufmannsspr.: Notierungseinheit von Warenpreisen an Produktenbörsen) *m;* -s, -s; **Point d'hon|neur** [- *donör*] (veralt. für: Punkt, an dem sich

jmd. in seiner Ehre getroffen fühlt) *m;* - -; **Poin|te** [*poãngt^e*] (springender Punkt; Hauptpunkt; überraschendes Ende eines Witzes, einer Erzählung) *w;* -, -n; **Poin|ter** *engl.* [*peunt^er*] (Vorstehhund) *m;* -s, -; **poin|tie|ren** *fr.* [*poãngtir̂n*] (unterstreichen, betonen); **poin|tiert** (betont; zugespitzt); **Poin|til|lis|mus** [*poãngtijß...*] (Richtung der impressionist. Malerei) *w;* -; **Poin|til|list** (Vertreter des Pointillismus); ↑R 268; **poin|til|li|stisch**

Poi|se [*poas^e*] [nach dem fr. Arzt Poiseuille] (Maßeinheit der Viskosität von Flüssigkeiten u. Gasen; Zeichen: P) *s;* -, -

Po|jatz landsch. („Bajazzo", Hanswurst) *m;* -, -e

Po|kal *it.* (Trinkgefäß mit Fuß; Sportpreis) *m;* -s, -e; **Po|kal_sie|ger, ...sy|stem**

Pö|kel [Salzlaken] *m;* -s, -; **Pö|kel_fleisch, ...he|ring, ...la|ke; pö|keln** (Fleisch einsalzen); ich ...[e]le (↑R 327)

Po|ker *amerik.* (ein Kartenglücksspiel) *s;* -s

Pö|ker (nordd. Kinderspr. für: Podex, Gesäß) *m;* -s, -

Po|ker_ge|sicht, ...mie|ne; po|kern; ich ...ere (↑R 327); **Po|ker|spiel**

Pök|ling (veralt. für: ²Bückling)

po|ku|lie|ren *lat.* (veralt., aber noch mdal. für: „bechern"; zechen, stark trinken)

¹Pol *gr.* (Drehpunkt; Endpunkt der Erdachse; Math.: Bezugspunkt; Elektrotechnik: Aus- u. Eintrittspunkt des Stromes) *m;* -s, -e

²Pol *fr.* (Oberseite von Samt u. Plüsch, die den Flor trägt) *m;* -s, -e

po|lar *gr.* (am Pol befindlich, die Pole betreffend; entgegengesetzt wirkend); -e Strömungen; -e Luftmassen u. Kälte; **Polare** (Math.: Verbindungslinie der Berührungspunkte zweier Tangenten an einem Kegelschnitt) *w;* -, -n; **Po|lar_eis, ...ex|pe|di|ti|on, ...fau|na, ...for|scher, ...front** (Meteor.: Front zwischen polarer Kaltluft u. trop. Warmluft) **...fuchs, ...ge|biet, ...ge|gend ...hund; Po|la|ris** (amerik. Rakete, die unter Wasser von einem U-Boot aus abgeschossen werden kann) *w;* -, -; **Po|la|ri|sa|ti|on** [*...zion*] (gegensätzliches Verhalten von Substanzen od. Erscheinungen); **Po|la|ri|sa|ti|ons_ebe|ne, ...fil|ter, ...mi|kro|skop ...strom; Po|la|ri|sa|tor** (Vorrichtung, die linear polarisierte Licht aus natürlichem erzeugt) *m;* -s, ...oren; **po|la|ri|sie|ren** (de-

Polarisation unterwerfen); sich - (in seiner Gegensätzlichkeit immer stärker hervortreten); Po|la|ri|sie|rung; Po|la|ri|tät (Vorhandensein zweier Pole, Gegensätzlichkeit); Po|lar_kreis, ...land (Mehrz. ...länder), ...licht (Mehrz. ...lichter), ...luft (w; -), ..meer (Eismeer), ...nacht, ...stern (vgl. ²Stern), ...zo|ne

Pol|del (Kurzform von: Leopold) Pol|der niederl. (eingedeichtes Land) m; -s, -; Pol|der|deich

Pol|di (Kurzform von: Leopold, Leopolda u. Leopoldine)

Pu|le (Angehöriger eines slaw. Volkes) m; -n, -n († R 268)

Po|lei lat. (Bez. verschiedener Arznei- u. Gewürzpflanzen) m; -[e]s, -e; Po|lei|min|ze

Po|le|mik gr. (wissenschaftl., literar. Fehde, Auseinandersetzung; [unsachlicher] Angriff) w; -, -en; Po|le|mi|ker; po|le|misch; -ste († R 294); po|le|mi|sie|ren

po|len gr. (an einen elektr. Pol anschließen)

Po|len

Po|len|ta it. (ein Maisgericht) w; -, ...ten u. -s

Po|len|te jidd. (Gaunerspr., abschätzig usw. für: Polizei) w; -

Po|len|tum s; -s

Po|le|si|en [...i^en]; vgl. Polesje; Po|les|je (osteurop. Wald- u. Sumpflandschaft) w; -

Pol|gar, Alfred (österr. Schriftsteller)

Pol|hö|he

Po|li|ce fr. [...liß^e] (Versicherungsschein) w; -, -n]; vgl. auch: Polizze

Po|li|ci|nel|lo it. [politschinä̱lo] (veralt. Nebenform von: Pulcinella) m; -s, ...lli

Po|lier fr. („Sprecher"; Vorarbeiter der Maurer u. Zimmerleute; Bauführer) m; -s, -e

Po|lier|bür|ste; po|lie|ren fr. (glätten, schleifen, reiben, putzen; glänzend, blank machen); Po|lie|rer; po|lie|re|rin w; -, -nen; Po|lier_mit|tel s, ...stahl, ...tuch (Mehrz. ...tücher), ...wachs

Po|li|kli|nik gr. [auch: po̱li...] ([Stadt]krankenhaus zur ambulanten Krankenbehandlung]; po|li|kli|nisch [auch: po̱li...]

Po|lin w; -, -nen

Po|lio [auch: po̱...] (Kurzform von: Poliomyelitis) w; Po|lio|mye|li|tis gr. (Med.: Kinderlähmung) w; -, ...it|den; Po|lio|in|fek|ti|on [auch: po̱...]

Po|lit|bü|ro (Kurzw. für: Politisches Büro; Zentralausschuß einer kommunistischen Partei, z. B. in der Sowjetunion)

¹Po|li|tes|se fr. (veralt. für: Höflichkeit, Artigkeit) w; -

²Po|li|tes|se [aus Polizei u. Hostess] (Bez. für eine von einer Gemeinde angestellte Hilfspolizistin für bestimmte Aufgaben) w; -, -n

po|li|tie|ren lat.-fr. ostösterr. (mit Politur einreiben u. glänzend machen)

Po|li|tik gr. ([Lehre von der] Staatsführung; Berechnung) w; -, (selten) -en; Po|li|ti|ka|ster (abwertend) m; -s, -; Po|li|ti|ker; Po|li|ti|kum (Tatsache, Vorgang von polit. Bedeutung) s; -s, ...ka; Po|li|ti|kus (ugs. für: Schlaukopf) m; -, -se; po|li|tisch (die Politik betreffend; staatsmännisch, staatsklug); -ste († R 294); -e Karte (Staatenkarte); -er Beamter; -e Wissenschaft; -e Geographie; -e Geschichte; -e Ökonomie; politisch-gesellschaftlich († R 146); po|li|ti|sie|ren (von Politik reden; politisch behandeln); Po|li|ti|sie|rung; Po|lit|of|fi|zier; Po|li|to|lo|ge (Wissenschaftler auf dem Gebiet der Politologie) m; -n, -n († R 268); Po|li|to|lo|gie (Wissenschaft von der Politik) w; -; Po|lit|_por|no|gra|phie, ...re|vue; Po|li|truk russ. (polit. Offizier einer sowjetischen Truppeneinheit) m; -s, -s

Po|li|tur lat. (Glätte, Glanz; Poliermittel; nur Einz.: äußerer Anstrich, Lebensart) w; -, -en

Po|li|zei gr. w; -, (selten:) -en; Po|li|zei_ak|ti|on, ...amt, ...ap|pa|rat, ...auf|ge|bot, ...auf|sicht, ...be|am|te, ...be|hör|de, ...chef, ...dienst, ...di|rek|ti|on; Po|li|zei|er (ugs. für: Polizist); Po|li|zei_funk, ...griff, ...haft, ...hund, ...kom|mis|sar, ...kon|tin|gent, ...kon|trol|le; po|li|zei|lich; -e Meldepflicht; -e Aufsicht; Po|li|zei_ober|mei|ster, ...or|gan, ...prä|sident, ...prä|si|di|um, ...re|vier, ...schutz, ...si|re|ne, ...spit|zel, ...staat (Mehrz. ...staaten), ...strei|fe, ...stun|de (w; -), ...ver|fü|gung, ...ver|ord|nung, ...wa|che, ...we|sen (s; -s); po|li|zei|wid|rig; Po|li|zist (Schutzmann); † R 268; Po|li|zi|stin w; -, -nen

Po|liz|ze österr. (Police) w; -, -n

Polk vgl. Pulk

Pölk niederd. (männliches kastriertes Schwein im Läuferstadium) s; od. m; -[e]s, -e

Pol|ka poln.-tschech. („Halbschritt"; Rundtanz) w; -, -s

pol|ken nordd. (bohren) (in der Nase -

Pol|lack (eine Schellfischart) m; -s, -s

Pol|len lat. (Blütenstaub) m; -s, -; Pol|len_ana|ly|se, ...an|ti|gen,

...blu|me, ...korn (s; Mehrz. ...körner), ...schlauch

Pol|ler (Seemannsspr.: Holz- od. Metallpfosten zum Befestigen der Taue; Markierungsklotz für den Straßenverkehr); m; -s, -

Pol|lu|ti|on lat. [...zion] (Med.: unwillkürliche [nächtl.] Samenentleerung)

¹Pol|lux (Held der gr. Sage); Kastor und - (Zwillingsbrüder, bildl. für: engbefreundete Männer); ²Pol|lux (ein Stern) m; -

pol|nisch; -e Wurst, aber († R 224): der Polnische Erbfolgekrieg, der Polnische Korridor; Pol|nisch (Sprache) s- -[s]; vgl. Deutsch; Pol|ni|sche s; -n; vgl. Deutsches

Po|lo engl. (Ballspiel vom Pferd, Rad od. Boot aus) s; -s, -s; Po|lo_hemd (kurzärmelige Männerhemdbluse)

Po|lo|nai|se fr. [...näs^e] (fr. Schreibung von: Polonäse); Po|lo|nä|se („polnischer" Nationaltanz) w; -, -n; Po|lo|nia (lat. Name von Polen); po|lo|ni|sie|ren (polnisch machen); Po|lo|ni|um (chem. Grundstoff; Zeichen: Po) ; -s

Po|lo|spiel s; -[e]s

Pol|ster (österr. auch für: Kissen) s (österr.: m); -s, - (österr. auch: Pölster); Pol|ste|rer; Pol|ster_klas|se (veralt.), ...mö|bel; pol|stern; ich ...ere († R 327); Pol|ster_ses|sel, ...stoff, ...stuhl; Pol|ste|rung

Pol|ter südwestd. (Holzstoß) m; od. s; -s, -

Pol|ter|abend; Pol|te|rer; Pol|ter|geist (Mehrz. ...geister); pol|te|rig, pol|t|rig; pol|tern; ich ...ere († R 327)

Pol_wechs|ler, ...wen|der (Technik)

po|ly... gr. (viel...); Po|ly... (Viel...) Po|ly|an|drie gr. (Vielmännerei) w; -

Po|ly|ar|thri|tis gr. (Med.: Entzündung mehrerer Gelenke) w; -, ...it|iden

Po|ly|äs|the|sie (Med.: das Mehrfachempfinden eines Berührungsreizes der Haut) w; -

Po|ly|äthy|len (thermoplastischer, säure- und laugenbeständiger Kunststoff) s; -s, -e

Po|ly|bi|os, vgl. Polybius; Po|ly|bi|us (gr. Geschichtsschreiber)

po|ly|chrom gr. [...kro̱m] (vielfarbig, bunt); Po|ly|chro|mie (Vielfarbigkeit; bunte Bemalung von Bau- u. Bildwerken) w; -, ...ien; po|ly|chro|mie|ren (selten für: bunt ausstatten); Po|ly|chro|mie|rung

Po|ly|dak|ty|lie gr. („Vielfingrigkeit"; Bildung von überzähligen Fingern od. Zehen) w; -

Po|ly|deu|kes vgl. Pollux

Po|ly|dip|sie gr. (Med.: krankhafter Durst) w; -

Po|ly|eder gr. (Math.: Vielflächner) s; -s, -; Po|ly|eder|krank|heit (Raupenkrankheit) w; -; po|ly|edrisch (vielflächig)

Po|ly|ester gr. (aus Säuren u. Alkoholen gebildete Verbindung hohen Molekulargewichtes, ein Kunststoff) m; -s, -

Po|ly|ga|la gr. (eine Pflanzengattung) w; -, -s

po|ly|gam gr. (mehr-, vielehig); Po|ly|ga|mie (Mehr-, Vielehe; Vielweiberei) w; -; Po|ly|ga|mist (↑ R 268)

po|ly|gen gr. (vielfachen Ursprungs [z. B. von Vulkanen]; Biol.: durch mehrere Erbfaktoren bedingt)

po|ly|glott gr. (vielsprachig; viele Sprachen sprechend); ¹Po|ly|glot|te (Vielsprachiger) m; -n, -n (↑ R 268); ²Po|ly|glot|te (Buch in vielen Sprachen) w; -, -n; Po|ly|glot|ten|bi|bel; po|ly|glot|tisch (veralt. für: polyglott)

Po|ly|gon gr. (Vieleck) s; -s, -e; po|ly|go|nal (vieleckig); Po|ly|gon|aus|bau (Bergmannsspr.: Vieleckausbau; m; -[e]s, ...bo|den (Geol.)

Po|ly|graph gr. (Gerät zur Registrierung mehrerer [medizin. od. psych.] Erscheinungen; Lügendetektor; DDR: Angehöriger des graph. Gewerbes) m; -en, -en (↑ R 268); Po|ly|gra|phie (Med.: Röntgenuntersuchung mit mehrmaliger Belichtung zur Darstellung von Organbewegungen; DDR [nur Einz.]: zusammenfassende Bez. für alle Zweige des graph. Gewerbes) w; -, -n [...iᵉn]

Po|ly|gy|nie gr. (Vielweiberei) w; -

Po|ly|hi|stor gr. („Vielwisser"; in vielen Fächern bewanderter Gelehrter) m; -s, ...oren

po|ly|hy|brid gr.; lat. (Biol.: spalterbig in bezug auf die Erbfaktoren); Po|ly|hy|bri|de (Nachkomme von Eltern, die sich in mehreren Erbmerkmalen unterscheiden) m; -n, -n (↑ R 268)

Po|ly|hym|nia, Po|lym|nia (Muse des ernsten Gesanges)

Po|ly|karp (ein Heiliger)

po|ly|karp, po|ly|kar|pisch (Bot.: in einem bestimmten Zeitraum mehrmals Blüten und Früchte ausbildend); -e Pflanzen

Po|ly|kla|die (Bot.: Bildung von Seitensprossen nach Verletzung einer Pflanze) w; -

Po|ly|kon|den|sa|ti|on (Chemie: Zusammenfügen einfachster Moleküle zu größeren zur Gewinnung von Kunststoffen)

Po|ly|kra|tes (Tyrann von Samos)

po|ly|mer gr. („vielteilig"; aus größeren Molekülen bestehend); Po|ly|mer s; -s, -e u. Po|ly|me|re (Chemie: eine Verbindung aus Riesenmolekülen) s; -n, -n (meist Mehrz.); ↑ R 268; Po|ly|me|rie (Biol.: das Zusammenwirken mehrerer gleichartiger Erbfaktoren bei der Ausbildung eines Merkmals; Chemie: Bez. für die besonderen Eigenschaften polymerer Verbindungen) w; -, ...ien; Po|ly|me|ri|sat (Chemie: durch Polymerisation entstandener neuer Stoff) s; -[e]s, -e; Po|ly|me|ri|sa|ti|on [...zion] (auf Polymerie beruhendes chem. Verfahren zur Herstellung von Kunststoffen); po|ly|me|ri|sier|bar; po|ly|me|ri|sie|ren; Po|ly|me|ri|sie|rung

Po|ly|me|ter gr. (meteor. Meßgerät) s; -s, -; Po|ly|me|trie (Anwendung verschiedener Metren in einem Gedicht; häufiger Taktwechsel in einem Tonstück) w; -, ...ien

Po|lym|nia vgl. Polyhymnia

po|ly|morph gr. (viel-, verschiedengestaltig); Po|ly|mor|phie w; - u. Po|ly|mor|phis|mus (Vielgestaltigkeit) m; -

Po|ly|ne|si|en gr. [...iᵉn] („Vielinselland"; die östl. Südseeinseln); Po|ly|ne|si|er [...iᵉr]; po|ly|ne|sisch

Po|ly|nom gr. (Math.: vielgliedrige Größe) s; -s, -e; po|ly|no|misch

po|ly|nu|kle|ar gr.; lat. (Med.: vielkernig)

Po|ly|opie gr. (Med.: Vielfachsehen) w; -

Po|lyp gr. („Vielfuß"; veralt., noch volkstüml. Bez. für: Tintenfisch; Gestaltform der Nesseltiere; Med.: gestielte Geschwulst, [Nasen]wucherung; ugs. scherzh. für: Polizeibeamter) m; -en, -en (↑ R 268); po|ly|pen|ar|tig

Po|ly|pha|ge gr. (Vielfresser) m; -n, -n (meist Mehrz.); ↑ R 268; Po|ly|pha|gie w; -

Po|ly|phem (gr. Sagengestalt; Zyklop); Po|ly|phe|mos vgl. Polyphem

po|ly|phon gr. (mehrstimmig, vielstimmig); -er Satz; Po|ly|pho|nie (Musik: Mehrstimmigkeit, Vielstimmigkeit; Kompositionsstil) w; -; po|ly|pho|nisch (älter für: polyphon)

po|ly|plo|id gr. (Biol. [von Zellen]: mit mehrfachem Chromosomensatz)

Po|ly|pio|nie gr. (Med.: Fettleibigkeit) w; -

Po|ly|prag|ma|sie (Med.: das Ausprobieren vieler Behandlungsmethoden u. Arzneien) w; -

Po|ly|re|ak|ti|on (Chemie: Bildung hochmolekularer Verbindungen)

Po|ly|rhyth|mik gr. (verschiedenartige, aber gleichzeitig ablaufende Rhythmen in einer Komposition [im Jazz]); po|ly|rhyth|misch

Po|ly|sac|cha|rid gr. [...eha...] (Vielfachzucker) s; -[e], -e

po|ly|se|man|tisch gr. (Sprachw.: Polysemie besitzend; mehr-, vieldeutig); Po|ly|se|mie (Sprachw.: Mehrdeutigkeit [von Wörtern]) w; -

Po|ly|sty|rol gr.; lat. (ein Kunststoff) s; -s, -e

po|ly|syn|de|tisch gr. („vielfach verbunden"; Sprachw.: durch mehrere Bindewörter verbunden)

po|ly|syn|the|tisch gr. (vielfach zusammengesetzt); Po|ly|syn|the|tis|mus (Verschmelzung von Bestandteilen des Satzes in ein großes Satzwort) m; -

Po|ly|tech|ni|ker gr. (Besucher des Polytechnikums), ...tech|ni|kum (höhere techn. Fachschule); po|ly|tech|nisch (viele Zweige der Technik umfassend); polytechnische Erziehung (UdSSR u. DDR: Erziehungsprinzip mit Betonung des naturwissenschaftl. Unterrichts u. seiner Verbindung mit der prakt. Arbeit); polytechnischer Lehrgang (9. Jahr der allgemeinen Schulpflicht in Österr.); Polytechnische Oberschule

Po|ly|the|is|mus gr. (Vielgötterei), ...the|ist (↑ R 268); po|ly|the|istisch

Po|ly|to|na|li|tät gr. (Musik: gleichzeitiges Durchführen mehrerer Tonarten in den verschiedenen Stimmen eines Tonstücks) w; -

po|ly|trop gr. (vielfach anpassungsfähig); Po|ly|tro|pis|mus

Po|ly|vi|nyl|chlo|rid gr. (säurefester Kunststoff; Abk.: PVC) s; -[e]s

pöl|zen österr. ([durch Verschalung] stützen); eine Mauer -

Po|ma|de fr. (wohlriechendes [Haar]fett); po|ma|den|hengst (spött.); po|ma|dig (mit Pomade eingerieben; ugs. für: langsam, träge, gleichgültig); po|ma|di|sie|ren (mit [Haar]fett bestreichen)

Po|me|ran|ze it. (Zitrusfrucht, bittere Apfelsine) w; -, -n; Po|me|ran|zen|eli|xier, ...öl (s; -[e]s), ...scha|le

Pom|mer m; -n, -n (↑ R 268); Pom|me|rin w; -, -nen; pom|me|risch, pom|mersch, aber (↑ R 198): die Pommersche Bucht; Pom|mer|land s; -[e]s; Pom|mern

Pommes frites *fr.* [*pomfrit*] (in Fett gebackene Kartoffelstäbchen) *Mehrz.*

Po|mo|lo|ge *lat.; gr. m;* -n, -n (↑ R 268); **Po|mo|lo|gie** (Obst[bau]kunde) *w;* -; **po|mo|lo|gisch**; **Po|mo|na** (röm. Göttin der Baumfrüchte)

Pomp *fr.* (Schaugepränge, Prunk; großartiges Auftreten) *m;* -[e]s ¹**Pom|pa|dour** [*pongpadur*] (Mätresse Ludwigs XV.); ²**Pom|padour** [auch mit dt. Ausspr.: *pompadur*] (früher für: Strick-, Arbeitsbeutel für Damen) *m;* -s, -e u. -s

Pom|pei vgl. Pompeji; **Pom|pe|ja|ner** (↑ R 199); **pom|pe|ja|nisch**, **pom|pe|jisch**; **Pom|pe|ji**, Pom|pei (Stadt u. Ruinenstätte am Vesuv)

Pom|pe|jus (röm. Feldherr u. Staatsmann)

pomp|haft; **Pomp|haf|tig|keit** *w;* - **Pom|pon** *fr.* [*pongpong* od. *pompong*] (knäuelartige Quaste aus Wolle od. Seide) *m;* -s, -s

pom|pös *fr.* ([übertrieben] prächtig; prunkhaft) -este (↑ R 292)

Po|mu|chel *slaw.* nordostd. (Dorsch) *m;* -s, -; **Po|mu|chels|kopp** nordostd. (dummer, plumper Mensch) *m;* -s, ...köppe

Pön (veralt. für: Strafe, Buße) *w;* -, -en; **pö|nal** (veralt. für: die Strafe, das Strafrecht betreffend); **Pö|na|le** (bes. österr. sonst veralt. für: Strafe, Buße) *s;* -s, ...lien [...*i^en*] (österr.: -); **Pö|nal|ge|setz** (kath. Moraltheol.)

Po|na|pe (Karolineninsel)

pon|ceau *fr.* [*pongßo*] (hochrot); **Pon|ceau** (hochrote Farbe, hochroter Farbstoff) *s;* -s

Pon|cho *indian.* [*pontscho*] (capeartiger [Indianer]mantel) *m;* -s, -s

pon|cie|ren *fr.* [*pongßir^en*] (mit Bimsstein abreiben, schleifen; mit Kohlenstaubbeutel durchpausen)

Pond *lat.* (physikal. Krafteinheit; Zeichen: p) *s;* -s, -; **pon|de|ra|bel** (veralt. für: wägbar); ...a|ble Angelegenheiten; **Pon|de|ra|bi|li|en** [...*i^en*] (veralt. für: faßbare, wägbare Dinge) *Mehrz.*

Pon|gau (salzburgische Alpenlandschaft) *m;* -[e]s

po|nie|ren *lat.* (veralt. für: als gegeben annehmen, den Fall setzen)

Pö|ni|tent *lat.* (kath. Kirche: Büßender, Beichtender) *m;* -en, -en (↑ R 268); **Pö|ni|ten|ti|ar** [...*zigr*] (Beichtvater) *m;* -s, -e; **Pö|ni|tenz** (Buße, Bußübung) *w;* -, -en

Pon|te *lat.* mdal. (breite Fähre) *w;* -, -n; **Pon|ti|cel|lo** *it.* [...*titschälo*] (Steg der Streichinstrumente) *m;* -s, -s u. ...lli; **Pon|ti|fex** (Oberprie-

ster im alten Rom) *m;* -, ...tifizes; **Pon|ti|fex ma|xi|mus** (oberster Priester im alten Rom; Titel des röm. Kaisers u. danach des Papstes) *m;* - -, ...tifices [...*zäß*] ...mi; **pon|ti|fi|kal** (bischöflich); vgl. in pontificalibus; **Pon|ti|fi|kal|amt** (eine von einem Bischof od. Prälaten gehaltene feierl. Messe) *s;* -[e]s; **Pon|ti|fi|ka|le** (liturg. Buch für die bischöflichen Amtshandlungen) *s;* -[s], ...lien [...*i^en*]; **Pon|ti|fi|ka|li|en** [...*i^en*] (die den kath. Bischof auszeichnenden liturg. Gewänder u. Abzeichen) *Mehrz.*; **Pon|ti|fi|kat** (Amtsdauer u. Würde des Papstes od. eines Bischofs) *s* od. *m,* -[e]s, -e; **Pon|ti|fi|zes** (*Mehrz.* von: Pontifex)

Pon|ti|ni|sche Sümp|fe (ehem. Sumpfgebiet südöstl. von Rom) *Mehrz.*

pon|tisch *gr.* (steppenhaft, aus der Steppe stammend)

Pon|ti|us Pi|la|tus [...*ziuß* -] (röm. Landpfleger in Palästina); von Pontius zu Pilatus laufen (ugs. für: mit einem Anliegen [vergeblich] von einer Stelle zur anderen gehen)

Pon|ton *fr.* [*pongtong* od. *pontong*, österr.: *ponton*] (Brückenschiff) *m;* -s, -s; **Pon|ton|brücke** [*Trenn.:* ...brük|ke], ...form

Pon|tre|si|na (schweiz. Kurort)

Pon|tus (im Altertum Reich in Kleinasien); **Pon|tus Eu|xi|nus** *lat.* (Schwarzes Meer) *m;* - -

Po|ny *engl.* [*poni,* selten: *poni*] (für kleinwüchsiges Pferd) *s;* -s, -s, (für eine Damenfrisur:) *m;* -s, -s; **Po|ny|fran|sen** (*Mehrz.*), ...frisur

Pool *amerik.* [*pul*] (Gewinnverteilungskartell) *m;* -s, -s

Po|panz *slaw.* (vermummtes Schreckgestalt; ugs. für: Marionette, Strohpuppe) *m;* -es, -e

Pop-art *amerik.* [*pop^p't*] (eine moderne Kunstrichtung) *w;* -

Pop|corn *engl.* (Puffmais) *s;* -s

Po|pe *gr.-russ.* (volkstüml. Bez. des Priesters der Ostkirche) *m;* -n, -n (↑ R 268)

Po|pel (landsch. u. ugs. für: verhärteter Nasenschleim; schmutziger kleiner Junge) *m;* -s, -

po|pe|lig, **pop|lig** [von lat. populus = Volk] (ugs. für: von niederer Gesinnung; nicht freigebig; minderwertig, armselig); er ist ein -er Mensch

Po|pe|lin *fr. m;* -s, -e u. **Po|pe|li|ne** [*pop^lin,* österr.: *poplin*] (,,päpstlich"; urspr. Gewebe aus Avignon, dem Papstsitz im 14. Jh.; heute: Sammelbez. für feinere ripsartige Stoffe in Leinenbindung) *w;* -, -

po|peln (ugs. für: in der Nase bohren); ich ...[e]le (↑ R 327)

Pop.fes|ti|val, ...kon|zert, ...kunst (*w:* -)

pop|lig vgl. popelig

Pop.mo|de, ...mu|sik

Po|po (Kinderspr. für: Podex [Gesäß]) *m;* -s, -s

Po|po|ca|te|petl [...*ka*...] (Vulkan in Mexiko) *m;* -[s]

pop|pig (mit Stilelementen der Pop-art); ein -es Plakat; **Pop.star**, ...sze|ne

po|pu|lär *lat.* (volksmäßig; volksfreundlich, beliebt; volkstümlich; gemeinverständlich); -e (volkstümliche) Darstellung; -er (beim Volk beliebter) Politiker; **po|pu|la|ri|sie|ren** (gemeinverständlich darstellen; in die Öffentlichkeit bringen); **Po|pu|la|ri|sie|rung**; **Po|pu|la|ri|tät** (Volkstümlichkeit, Beliebtheit) *w;* -; **po|pu|lär|wis|sen|schaft|lich**; eine -e Buchreihe; **Po|pu|la|ti|on** [...*zion*] (veralt. für: Bevölkerung; Biol.: Gesamtheit der Individuen einer Art od. Rasse in einem engbegrenzten Bereich) *w;* -

Por|cia [...*ziu*] (altröm. w. Vorn.)

Po|re *gr.* (feine [Haut]öffnung) *w;* -, -n; **po|rig** (für: porös); ...po|rig (z. B. großporig)

Pör|kel[t], **Pör|költ** *ung.* (dem Gulasch ähnliches Fleischgericht mit Paprika) *s;* -s

Por|ling (ein Pilz)

Por|no (Kurzform für: pornographischer Film, Roman u. ä.) *m;* -s, -s; **Por|no...** (kurz für: Pornographie..., z. B. Pornofilm, Pornohändler, Pornostück); **Por|no|gra|phie** *gr.* (Abfassung pornographischer Werke, pornographisches Schrifttum) *w;* -; **por|no|gra|phisch** (unzüchtig, obszön); -e Bilder, Schriften; **por|no|phil** (die Pornographie liebend)

po|rös *gr.* (durchlässig, löchrig, porig); -este (↑ R 292); **Po|ro|si|tät** *w;* -

Por|phyr *gr.* [auch, österr. nur: ...*für*] (ein Ergußgestein) *m;* -s, -e; **Por|phy|rit** (ein Ergußgestein) *m;* -s, -e; **Por|phyr|säu|le**

Por|ree *fr.* (eine Gemüse- u. Gewürzpflanze) *m;* -s, -s

Por|ridge *engl.* [*poridsch*] (Haferbrei) *s* od. *m;* -s

Por|sche (dt. Autokonstrukteur)

Porst (ein Heidekrautgewächs) *m;* -[e]s, -e

Port *lat.* (veralt. dicht. für: Hafen, Zufluchtsort) *m;* -[e]s, -e; **Por|ta** (Kurzform von: Porta Westfalica) *w;* -

Por|ta|ble *engl.* [*pg't^eb^el*] (tragbares Fernsehgerät) *m;* -s, -s

Por|ta Hun|ga|ri|ca [- ...*ka*] *lat.*

("Ungarische Pforte"; Durch-bruchstal der Donau zwischen Wiener Becken u. Oberungari-schem Tiefland) w; - -; Por|tal ([Haupt]eingang, [prunkvolles] Tor) s; -s, -e; Por|tal|ver|zie|rung Por|ta|ment it. (Musik: Hinüber-schleifen von einem Ton zum an-dern) s; -[e]s, -e; Por|ta|tiv lat. (kleine tragbare Zimmerorgel) s; -s, -e [...wᵉ]; por|ta|to it. (Musik: getragen, abgehoben, ohne Bin-dung)

Por|ta Ni|gra lat. ("schwarzes Tor"; monumentales röm. Stadt-tor in Trier) w; - -; Por|ta West|fa|li|ca [- ...ka], (auch:) West|fä|li-sche Pfor|te (Durchbruch der Weser zwischen Weser- u. Wie-hengebirge) w; - -

Porte|chai|se fr. [portschäsᵉ] (frü-her für: Tragsessel, Sänfte) w; -, -n; Porte|feuille [portföj] (veralt. für: Brieftasche; Mappe; auch: Geschäftsbereich eines Mini-sters) s; -s, -s; Porte|mon|naie [portmonе] (Geldtäschchen, Bör-se) s; -s, -s; Port|epee (Degen-, Säbelquaste) s; -s, -s; Port|epee-trä|ger (Offizier)

Por|ter engl. (starkes [engl.] Bier, urspr. hauptsächlich von Londo-ner Lastträgern [porters] getrun-ken) m (auch: s); -s, -

Por|ti (Mehrz. von: Porto)

Por|ti|ci [portitschi] (it. Stadt); Die Stumme von - (Oper von Auber)

Por|tier fr. [...tiе, österr.: ...tir] (Pförtner; Hauswart) m; -s, -s (österr.: -e); Por|tie|re (Türvor-hang) w; -, -n

por|tie|ren fr. schweiz. (zur Wahl vorschlagen)

Por|tiers|frau [...tießˍ...]

Por|ti|kus lat. (Säulenhalle) m (fachspr. auch: w); -, - od. ...ken

Por|ti|on lat. [...zion] ([An]teil, ab-gemessene Menge); er ist nur eine halbe - (ugs. für: er ist sehr klein, er zählt nicht); Por|ti|ön|chen; por|tio|nen|wei|se od. por|ti|ons-wei|se; por|tio|nie|ren (in Portio-nen einteilen)

Port|land|ze|ment m; -[e]s (↑ R 201)

Por|to it. (Beförderungsgebühr für Postsendungen, Postgebühr, -geld) s; -s, -s od. ...ti; Por|to|buch; por|to|frei; Por|to|kas|se; por|to-pflich|tig (gebührenpflichtig)

Por|to Ri|co [- riко] (alter Name für: Puerto Rico); Por|to|ri|ko (eindeutschend für: Porto Rico); vgl. Puerto Rico

Por|trait fr. [...trä] (veralt. für: Porträt); Por|trät [...trä, oft:

...trät] (Bildnis) s; -s, -s od. (bei dt. Ausspr.:) s; -[e]s, -e; Por|trät-auf|nah|me; por|trä|tie|ren; Por-trä|tist (Bildnismaler); ↑ R 268; Por|trät.ma|ler, ...sta|tue, ...stu-die

Port Said [- ßait] (ägypt. Stadt) Ports|mouth [på'tßmᵉth] (engl. u. amerik. Ortsn.)

Port Su|dan (Stadt am Roten Meer)

Por|tu|gal; vgl. Lusitanien; Por|tu-ga|le|ser (alte Goldmünze) m; -s, -; Por|tu|gie|se (Bewohner von Portugal) m; -n, -n (↑ R 268); Por-tu|gie|ser (eine Rebensorte); Por-tu|gie|sin w; -, -nen; por|tu|gie-sisch; Por|tu|gie|sisch (Sprache) s; -[s]; vgl. Deutsch; Por|tu|gie|si-sche s; -n; vgl. Deutsche s; Por|tu-gie|sisch-Gui|nea [...gi...]; ↑ R 207 (port. Überseegebiet in Westafri-ka)

Por|tu|lak lat. (eine Gemüse- u. Zierpflanze) m; -s, -e u. -s

Port|wein

Por|zel|lan it. (feinste Tonware) s; -s, -e; echt Meißner -; chinesi-sches -; por|zel|la|nen (aus Por-zellan); Por|zel|lan.er|de, ...fi-gur; por|zel|lan|haft; Por|zel|lan-.la|den, ...ma|le|rei, ...ma|nu|fak-tur, ...mar|ke, ...schnecke [Trenn.: ...schnek|ke]

Por|zia (it. w. Vorn.)

Pos. = Position

Po|sa|da span. (Wirtshaus) w; -, -en

Po|sa|ment lat. (Besatzartikel, Borte, Schnur) s; -[e]s, -en (meist Mehrz.); Po|sa|men|ter m; -s, - u. Po|sa|men|tier m; -s, -e u. (österr. nur:) Po|sa|men|tie-rer (Posamentenhersteller und -händler); Po|sa|men|te|rie (Be-satzartikel[handlung]) w; -, ...ien; Po|sa|men|tier vgl. Po|sa|menter; Po|sa|men|tier|ar|beit; po|sa-men|tie|ren; Po|sa|men|tie|rer vgl. Posamenter

Po|sau|ne lat. (ein Blechblasin-strument) w; -, -n; die Posaunen des [Jüngsten] Gerichtes; po|sau-nen; ich habe posaunt; Po|sau-nen.blä|ser, ...chor, ...en|gel (meist übertr. scherzh. für: paus-bäckiges Kind), ...schall, ...ton (Mehrz. ...töne); Po|sau|nist (↑ R 268)

¹Po|se (Federspule, Feder[kiel]) w; -, -n

²Po|se gr. [gekünstelte) Stellung; [gesuchte] Haltung w; -, -n

Po|sei|don (gr. Gott des Meeres) Po|se|muckel [Trenn.: ...muk|kel], Po|se|mu|kel [nach Groß u. Klein Posemukel im ehemal. Kreis Bomst (Mark Brandenburg)] (ugs. für: kleines Nest, ²Kaff)

po|sen svw. posieren; er po|ste; Po-seur fr. [...ßör] (Wichtigtuer) m; -s, -e; po|sie|ren (eine Pose anneh-men, schauspielern)

Po|si|lip (eindeutschend für: Posil-lipo); Po|sil|li|po, (auch:) Po|si|li-po (Bergrücken am Golf von Neapel) m; -[s]

Po|si|ti|on fr. [...zion] ([An]-stellung, Stelle, Lage; Einzel-posten [Abk.: Pos.]; Stück, Teil; Standort eines Schiffes od. Flug-zeuges; Philosophie: Setzung, Bejahung); eine führende -; er hat eine starke -; po|si|tio-nell (die Position, Stellung be-treffend); po|si|tio|nie|ren (ein-ordnen, in eine bestimmte Posi-tion bringen); Po|si|tio|nie|rung; Po|si|ti|ons.lam|pe, ...la|ter|ne, ...licht (Mehrz. ...lichter), ...win-kel; po|si|tiv¹ lat. (bejahend, zu-treffend; bestimmt, gewiß); -es Wissen; -e Kenntnisse; -es Ergeb-nis; -e Religion; (Math.:) -e Zah-len; (Physik:) -e Elektrizität; -er Pol; ¹Po|si|tiv¹ (kleine Standorgel ohne Pedal im Gegensatz zum Portativ; Fotogr.: vom Negativ gewonnenes, seitenrichtiges Bild) s; -s, -e [...wᵉ]; ²Po|si|tiv¹ (Sprachw.: Grundstufe, unge-steigerte Form, z. B. „schön") m; -s, -e [...wᵉ]; Po|si|ti|vis|mus [...wiß...] (Wissenschaft, die nur Tatsachen feststellt u. erforscht; Wirklichkeitsstandpunkt) m; -; Po|si|ti|vist [...wißt] m; -en, -en (↑ R 268); po|si|ti|vi|stisch; Po|si-ti|vum lat. [...wum] (das Positive) s; -s, ...va; Po|si|tron lat.; gr. (po-sitiv geladenes Elementarteil-chen) s; -s, ...onen; Po|si|tur lat. ([herausfordernde] Haltung; mdal. für: Gestalt, Figur, Statur; vgl. Postur) w; -, -en; sich in - setzen, stellen

Pos|se (derbkomisches Bühnen-stück) w; -, -n

Pos|se|kel niederd. (schwerer Aufschlaghammer) m; -s, -

Pos|sen (derber, lustiger Streich) m; -s, -; jmdm. einen - spielen; - reißen; pos|sen|haft; Pos|sen-haf|tig|keit; Pos|sen.ma|cher, ...rei|ßer, ...spiel

Pos|ses|si|on lat. (Rechtsw.: Be-sitz); pos|ses|siv² (besitzanzei-gend); Pos|ses|siv² (Possessivpro-nomen) s; -s, -e [...wᵉ]; Pos|ses|siv-pro|no|men² (Sprachw.: besitz-anzeigendes Fürwort, z. B. „mein"); Pos|ses|si|vum [...iwum] (älter für: Possessivpronomen) s; -s, ...va [...wa]; pos|ses|so|risch (Rechtsw.: den Besitz betreffend)

¹ Auch: ...tif.
² Auch: ...ßif...

pos|sier|lich (spaßhaft, drollig);
Pos|sier|lich|keit
Pößl|neck (Stadt im Bezirk Gera)
Post it. (öffentl. Einrichtung, die
gegen Gebühr Nachrichten, Pa-
kete u. a. an einen bestimmten
Empfänger weiterleitet; Postge-
bäude, -amt; Postsendung) w; -,
-en; (↑R 224:) er wohnt im Gast-
haus „Zur Alten Post"; Post|ab-
ho|lor; po|sta|lisch (die Post be-
treffend, von der Post ausgehend,
Post ...)
Po|sta|ment it. (Unterbau) s;
-[e]s, -e
Post|amt; post|amt|lich; Post..an-
stalt, ...an|wei|sung, ...ar|beit
(österr. ugs. für: dringende Ar-
beit), ...auf|trag, ...au|to, ...bar-
scheck, ...be|am|te, ...be|am|tin;
Post|be|ar|bei|tungs|ma|schi|ne;
Post|be|gleit|pa|pier (meist
Mehrz.); Post..be|zirk, ...be|zug,
...boot, ...bo|te, ...brief|ka|sten,
...bus
Pöst|chen, Pöst|lein (kleiner Po-
sten; Nebenberuf)
post Chri|stum [na|tum] lat. (ver-
alt. für: nach Christi Geburt,
nach Christus; Abk.: p. Chr. [n.]);
post|da|tie|ren (veralt. für: mit ei-
ner früheren [aber auch: späte-
ren] Zeitangabe versehen)
Post..de|bit (Zeitungsvertrieb
durch die Post; m; -s; vgl. Debit),
...dienst, ...di|rek|ti|on
post|em|bryo|nal lat.; gr. (nach der
Geburt)
po|sten it. schweiz. mdal. (einkau-
fen; Botengänge tun); Po|sten
(Waren; Rechnungsbetrag; Amt,
Stellung; Wache; Schrotsorte) m;
-s, -; ein - Kleider; [auf] - stehen,
- fassen (↑R 140); Po|sten..dienst,
...jä|ger (abschätzig), ...ket|te
Po|ster engl. [auch: pọ^u^ßt^e^r] (pla-
katartiges, modernes Bild) s
(auch: m); -s, - u. (bei engl.
Ausspr.:) -s
poste re|stante fr. [pọßt räßtạngt]
(fr. Bez. für: postlagernd)
Po|ste|rio|ra lat. (selten u. scherzh.
für: Gesäß) Mehrz.; Po|ste|rio|ri-
tät (veralt. für: Nachstehen [im
Amt]) w; -; Po|ste|ri|tät (veralt.
für: Nachkommenschaft, Nach-
welt)
Post|fach
post fe|stum lat. („nach dem
Fest"; hinterher, zu spät)
Post..flag|ge, ...flug|zeug, ...form-
blatt; post|frisch (Philatelie);
Post..ge|bühr, ...ge|heim|nis
post|gla|zi|al lat. (Geol.: nacheis-
zeitlich)
Post..gut, ...hal|ter; Post|hal|te|rei;
Post|hilfs|stel|le (w; -, -n), ...horn
(Mehrz. ...hörner)
po|sthum vgl. postum

po|stie|ren fr. (aufstellen); sich -;
Po|stie|rung
Post|stil|le lat. (Erbauungs-, Pre-
digtbuch) w; -, -n
Po|stil|li|on it.(-fr.) [...tiljọn, auch,
österr. nur: pọßtiljọn] (früher für:
Postkutscher) m; -s, -e; Po|stil|lon
d'amour fr. [pọßtüjọng damụr]
(Liebesbote, Überbringer eines
Liebesbriefes) m; - -, -s [...jọng]-
post|kar|bo|nisch lat. (Geol.: nach
der Kohlenzeit [liegend])
Post|kar|te; Post|kar|ten..grö|ße
(w; -), ...gruß; Post|ka|sten
(landsch.)
Post|kom|mu|ni|on lat. (Schlußge-
bet der kath. Messe)
post|kul|misch (Geol.: nach dem
Kulm [liegend])
Post..kun|de m, ...kut|sche; post|la-
gernd; -e Sendungen
Pöst|lein vgl. Pöstchen
Post|leit|zahl; Post|ler (südd. u.
österr. ugs.) u. (schweiz. ugs.:)
Pöst|ler (Postbeamter, Postange-
stellter); Post|mei|ster
post me|ri|di|em lat. [- ...diäm]
(nachmittags; Abk.: p. m.)
Post|mi|ni|ste|ri|um
post|mor|tal, post mor|tem lat.
(nach dem Tode; Abk.: p. m.)
Post|ne|ben|stel|le
post|nu|me|ran|do lat. (nachträg-
lich [zahlbar]); Post|nu|me|ra|ti-
on [...zion] (Nachzahlung)
Po|sto it., in der Wendung: - fassen
(veralt. für: Stellung einnehmen)
post|ope|ra|tiv (nach der Opera-
tion)
Post..pa|ket, ...rat (Mehrz. ...räte),
...re|gal (Recht des Staates, das
gesamte Postwesen in eigener Re-
gie zu führen), ...sack, ...schaff-
ner, ...schal|ter, ...scheck; Post-
scheck.amt (Abk.: PSchA),
...kon|to (↑R 268), ...ver|kehr;
Post|schiff
Post|skript lat. s; -[e]s, -e u. (österr.
nur:) Post|skrip|tum (veralt. für:
Nachschrift; Abk.: PS) s; -s, ...ta
Post..spar|buch, ...spar|kas|se;
Post|spar|kas|sen|dienst; Post-
stem|pel
Post|sze|ni|um lat.; gr. (Raum hin-
ter der Bühne; Ggs.: Proszenium)
s; -s, ...ien [...i^e^n]
post|ter|ti|är lat. (Geol.: nach dem
Tertiär [liegend]; post|trau|ma-
tisch lat.; gr. (Med.: nach einer
Verletzung auftretend)
Po|stu|lant lat. (Bewerber; Kandi-
dat) m; -en, -en (↑R 268); Po|stu-
lat (Forderung) s; -[e]s, -e; po|stu-
lie|ren; Po|stu|lie|rung
po|stum lat. (nachgeboren; nach-
gelassen); Po|stu|mus (Rechtsw.:
Spät-, Nachgeborener) m; -, ...mi

Po|stur schweiz. (Gestalt, Figur,
Statur; vgl. Positur) w; -, -en
post ur|bem con|di|tam lat. [- -
kọn...] (nach Gründung der Stadt
[Rom]; Abk.: p. u. c.)
Post.ver|bin|dung, ...ver|ein; Post-
ver|wal|tungs..ge|setz (s; -es),
...rat (m; -[e]s); Post|voll|macht;
post|wen|dend; Post..wert|zei-
chen, ...we|sen (s; -s), ...wurf|sen-
dung, ...zug, ...zu|stel|lung
Pot engl. (ugs. für: Marihuana)
s; -s
Po|tem|kin|sche Dör|fer [potặm-
kịn..., auch russ.: patjọm...-; nach
dem russ. Fürsten Potemkin]
(Trugbilder, Vorspiegelungen)
Mehrz.
po|tent lat. (mächtig, einflußreich;
zahlungskräftig, vermögend;
Med.: beischlafs-, zeugungsfä-
hig); Po|ten|tat (Machthaber; re-
gierender Fürst) m; -en, -en (↑R
268); po|ten|ti|al [...zial] (mög-
lich; die [bloße] Möglichkeit be-
zeichnend); Po|ten|ti|al (Leis-
tungs-, Wirkungsfähigkeit;
Physik: Maß für die Stärke eines
Kraftfeldes) s; -s, -e; Po|ten|tial-
dif|fe|renz (Physik: Unterschied
elektr. Kräfte bei aufgelade-
nen Körpern); Po|ten|tia|lis
(Sprachw.: Modus der Möglich-
keit, Annahme, Vorstellung;
Möglichkeitsform) m; -, ...les;
Po|ten|tia|li|tät (Möglichkeit);
po|ten|ti|ell fr. (möglich [im Ge-
gensatz zu wirklich]; der Anlage,
der Möglichkeit nach); -e Energie
(Energie, die ein Körper wegen
seiner Lage in einem Kraftfeld
besitzt)
Po|ten|til|la lat. (Pflanzengattung,
Fingerkraut) w; -, ...llen
Po|ten|tio|me|ter lat.; gr. [...zio...]
(Elektrotechnik: Gerät zur Ab-
nahme od. Herstellung von
Teilspannungen) s; -s, -; po|ten-
tio|me|trisch; Po|tenz lat.
(„Macht"; innewohnende Kraft,
Leistungsfähigkeit; Zeugungsfä-
higkeit; Med.: Bez. des Verdün-
nungsgrades einer Arznei;
Math.: Produkt aus gleichen
Faktoren) w; -, -en; Po|tenz|ex-
po|nent (Hochzahl einer Potenz);
po|ten|zie|ren (erhöhen, steigern;
zur Potenz erheben, mit sich
selbst vervielfältigen); potenzier-
te Wirkung (bei Anwendung
zweier Arzneimittel die Verstär-
kung ihrer Wirkung durch ge-
genseitige Beeinflussung); Po-
ten|zie|rung
Po|te|rie fr. (veralt. für: Töpferwa-
re; Töpferwerkstatt) w; -, -s
Po|ti|phar (ökum.:) Po|ti|far
(bibl. m. Eigenn.)
Pot|pour|ri fr. [pọtpuri, österr.:

...**rj**] (Allerlei, Kunterbunt; Zusammenstellung verschiedener Musikstücke zu einem Musikstück) *s*; -s, -s

Pots|dam (Stadt an der Havel); **Pots|da|mer** (↑ R 199); das - Abkommen (1945)

Pott niederd. (Topf; auch abschätzig für: [altes] Schiff) *m*; -[e]s, Pötte; **Pott|asche** (Kaliumverbindung) *w*; -; **Pott|bäcker** [*Trenn.*: ...bäk|ker] niederfränk. (Töpfer); **Pott|fisch** (Pottwal); **Pott|lot** (Graphit) *s*; -[e]s; **Pott|wal** (zur Familie der Zahnwale gehörend)

potz Blitz!; **potz|tau|send!**

Po|ufer; ↑ R 201 (Ufer des Flusses Po) *s*; -s, -

Pou|lard *fr.* [*pular*] *s*; -s, -s u. **Pou|lar|de** [*pulard*[e]] (junges, verschnittenes Masthuhn) *w*; -, -n; **Poule** [*pul*] ([Spiel]einsatz; Billard-od. Kegelspiel) *w*; -, -n; **Pou|let** [*pule*] (junges, zartes Masthuhn) *s*; -s, -s

pour le mé|rite fr. [*pur l* mer*it*] („für das Verdienst"); der Orden pour le mérite, a b e r: der Pour le mérite

Pous|sa|de fr. [*pußad*[e]]. **Pous|sa|ge** [*pußaseh*[e]] (veralt. ugs. für: Geliebte; Liebelei); **pous|sie|ren** [*pußir*[e]*n*] (ugs. für: flirten, mit jmdm. oberflächliche Liebesbeziehungen pflegen; hofieren, umwerben, um etwas zu erreichen); **Pous|sier|sten|gel** (scherzh. für: jmd., der eifrig poussiert)

Po|ve|se [*pofes*[e]] vgl. Pafese

po|wer fr. (ugs., für: armselig); **pow[e]re** Leute

Power|play engl. [*pau*[e]*rple*[i]] („Kraftspiel"; gemeinsames Anstürmen aller fünf Feldspieler auf das gegnerische Tor beim Eishockey) *s*; -[s]; **Power|slide** [*pau*[e]*r|ßlaid*] (im Autorennsport die Technik, mit erhöhter Geschwindigkeit durch eine Kurve zu schliddern, ohne das Fahrzeug aus der Gewalt zu verlieren) *s*; -[s]

Po|widl tschech. ostösterr. (Pflaumenmus) *m*; -s, -; **Po|widl|knö|del**

Poz|z[u]o|lan|er|de [nach Pozzuoli bei Neapel] *w*; -

pp = pianissimo

pp. = pe̱rge, pe̱rge lat. („fahre fort"; und so weiter)

pp., ppa. = per procura

Pp., Ppbd. = Pappband

PP. = Patres

P. P. = praemissis praemittendis

ppa., pp. = per procura

Ppbd., Pp. = Pappband

P. prim. = Pastor primarius

Pr = chem. Zeichen für: Praseodym

prä... lat. (vor...); **Prä...** (Vor...); **Prä** („Vor"), in der Wendung: das - haben (ugs. für: den Vorrang haben); **Prä|am|bel** (Einleitung [in Form einer feierl. Erklärung]; Musik: Vorspiel) *w*; -, -n

Pra|cher slaw. mdal. (zudringlicher Bettler) *m*; -s, -; **pra|chern** mdal. (betteln; prahlen, großtun); ich ...ere (↑ R 327)

Pracht *w*; -; eine falsche -; eine kalte -; **Pracht..aus|ga|be**, ...**band** *m*, ...**bau** (*Mehrz.* ...bauten), ...**ex|em|plar**, ...**fas|sa|de**; **prächtig**; **Präch|tig|keit** *w*; -; **Pracht_jun|ge** *m*, ...**kerl** (ugs.), ...**kleid**; **Pracht|lie|be** *w*; -; **pracht|lie|bend**; **Pracht..mensch** (ugs.), ...**num|mer** (ugs.), ...**stra|ße**, ...**stück**; **pracht|voll**; **Pracht..weib** (ugs.), ...**werk**

Pracker [*Trenn.*: Prak|ker] österr. ugs. (Schläger; Teppichklopfer)

Prä|de|sti|na|ti|on lat. [...*zion*] (Vorherbestimmung) *w*; -; **Prä|de|sti|na|ti|ons|leh|re** *w*; -; **prä|de|sti|nie|ren**; **prä|de|sti|niert** (vorherbestimmt; wie geschaffen [für etwas]); **Prä|de|sti|nie|rung** (Vorherbestimmung) *w*; -

Prä|di|kant lat. ([Hilfs]prediger) *m*; -en, -en (↑ R 268); **Prä|di|kan|ten|or|den** (gelegentliche Bez. für den Orden der Dominikaner) *m*; -s; **Prä|di|kat** (grammatischer Kern der Satzaussage; Rangbezeichnung; [gute] Zensur) *s*; -[e]s, -e; **prä|di|ka|tie|ren** u. **prä|di|ka|ti|sie|ren** (mit einer Zensur versehen); **prä|di|ka|tiv** (aussagend); **Prä|di|ka|tiv** (Grammatik: auf das Subjekt od. Objekt bezogener Teil des Prädikats) *s*; -s, -e [...*we*]; **Prä|di|ka|tiv|satz** (Grammatik); **Prä|di|ka|ti|vum** [...*iwum*] (älter für: Prädikativ) *s*; -s, ...va; **Prä|di|kats_ex|amen** (mit einer guten Note bestandenes Examen), ...**no|men** (älter für: Prädikativ)

prä|dis|po|nie|ren lat. (vorher bestimmen; empfänglich machen, bes. für Krankheiten); **Prä|dis|po|si|ti|on** [...*zion*] Med.: Anlage, Empfänglichkeit [für eine Krankheit]

prä|do|mi|nie|ren lat. (vorherrschen, überwiegen)

Prä|exi|stenz lat. („Vorherdasein"; Bestehen der Seele vor der jetzigen Verbindung mit dem Leib) *w*; -

prä|fa|bri|ziert (vorgefertigt)

Prä|fa|ti|on lat. [...*zion*] („Einleitung"; Dankgebet als Teil der kath. Eucharistiefeier u. des ev. Abendmahlsgottesdienstes)

Prä|fekt lat. (hoher Beamter im alten Rom; oberster Verwaltungsbeamter eines Departe-

ments in Frankreich, einer Provinz in Italien; Leiter des Chors als Vertreter des Kantors) *m*; -en, -en (↑ R 268); **Prä|fek|tur** (Amt, Bezirk, Wohnung eines Präfekten) *w*; -, -en

Prä|fe|renz lat. (Vorzug, Vorrang; Trumpffarbe [bei Kartenspielen]) *w*; -, -en; vgl. Preference; **Prä|fe|renz_li|ste**, ...**span|ne**, ...**stel|lung**, ...**sy|stem**, ...**zoll** (Zoll, der einen Handelspartner gegenüber einem anderen begünstigt)

Prä|fix lat. (Sprachw.: Vorsilbe, z. B. „be-" in „beladen") *s*; -es, -e

Prä|for|ma|ti|on lat. [...*zion*] (Biol.: angenommene Vorherbildung des fertigen Organismus im Keim); **prä|for|mie|ren** (im Keim vorbilden); **Prä|for|mie|rung**

Prag (Hptst. der Tschechoslowakei); vgl. Praha

präg|bar; **Präg|bar|keit** *w*; -; **Präge..bild**, ...**druck** (*Mehrz.* ...drucke), ...**ei|sen**, ...**form**, ...**ma|schi|ne**; **prä|gen**; **Prä|ge|pres|se**

Pra|ger [zu: Prag] (↑ R 199); der Prager Fenstersturz (1618)

Prä|ger; **Prä|ge.stät|te**, ...**stempel**, ...**stock** (*m*; -[e]s, ...stöcke)

prä|gla|zi|al lat. (Geol.: voreiszeitlich)

Prag|ma|tik gr. österr. (Dienstpragmatik) *w*; -, -en; **Prag|ma|ti|ker**; **prag|ma|tisch** (auf Tatsachen beruhend, sachlich, sach-, fach-, geschäftskundig); -e (den ursächlichen Zusammenhang darlegende) Geschichtsschreibung; a b e r (↑ R 224): Pragmatische Sanktion (Grundgesetz des Hauses Habsburg von 1713); **prag|ma|ti|sie|ren** österr. (auf Lebenszeit] fest anstellen); **Prag|ma|ti|sie|rung** (österr.); **Prag|ma|tis|mus** (philos. Lehre, die im [erfolgreichen, nützlichen] Handeln das Wesen des Menschen erblickt) *m*; -; **Prag|ma|tist** *m*; -en, -en (↑ R 268)

prä|gnant lat. (sinn-, bedeutungsvoll u. doch gedrängt [im Ausdruck]; knapp, aber gehaltvoll); **Prä|gnanz** *w*; -

präg|sam; **Prä|gung**

Pra|ha (tschech. Form von: Prag)

Prä|hi|sto|rie lat. [...*i*[e], auch, österr. nur: *prä*...] (Vorgeschichte) *w*; -; **Prä|hi|sto|ri|ker** [auch, österr. nur: *prä*...]; **prä|hi|sto|risch** [auch, österr. nur: *prä*...] (vorgeschichtlich)

prah|len; **Prah|ler**; **Prah|le|rei**; **prah|le|risch** -ste (↑ R 294); **Prahl..hans** (ugs. für: Angeber, Übertreiber; *m*; -es, ...hänse), ...**sucht** (*w*; -); **prahl|süch|tig**

Prahm tschech. (flaches Wasser-

fahrzeug für Arbeitszwecke) *m*; -[e]s, -e od. Prähme

Prai|ri|al [*präriál*] ("Wiesenmonat" der Fr. Revolution: 20. Mai bis 18. Juni) *m*; -[s], -s

Prä|ju|diz *lat.* (Vorentscheidung; hochrichterl. Entscheidung, die bei Beurteilung künftiger ähnl. Rechtsfälle herangezogen wird; Rechtsnachteil; Vorurteil) *s*; -es, -e od. -ien [...*i*ᵉ*n*]: **prä|in|di|zi|ell** *fr.* (bedeutsam für die Beurteilung eines späteren Sachverhalts); **prä|ju|di|zie|ren** *lat.* (der [richterl.] Entscheidung vorgreifen); präjudizierter Wechsel (Geldw.: nicht eingelöster Wechsel, dessen Protest versäumt wurde [, was zum Verlust der Ersatzansprüche führt])

prä|kam|brisch (Geol.: vor dem Kambrium [liegend]); **Prä|kam|bri|um** (zusammenfassender Name für: Archaikum u. Algonkium) *s*; -s

prä|kar|bo|nisch *lat.* (Geol.: vor dem Karbon [liegend])

prä|kar|di|al, **prä|kor|di|al** (Med.: in der Herzgegend); **Präkar|di|al|gie** *lat.; gr.* (Med.: Schmerzen in der Herzgegend) *w*; -, ...ien

prä|klu|die|ren *lat.* (jmdm. die Geltendmachung eines Rechtes gerichtlich verweigern); **Prä|klu|si|on** (Hauptwort zu: präkludieren); **prä|klu|siv**, **prä|klu|si|visch**; **Prä|klu|siv|frist**

prä|ko|lum|bisch (die Zeit vor der Entdeckung Amerikas durch Kolumbus betreffend)

prä|kor|di|al vgl. präkardial; **Prä|kor|di|al|angst**

Pra|krit Sammelbez. für die mittelind. Volkssprachen) *s*; -s

prakt. Arzt vgl. praktisch

prak|ti|fi|zie|ren *gr.; lat.* (in die Praxis umsetzen, handhaben); **Prak|ti|fi|zie|rung**; **Prak|tik** *gr.* ([Art der] Ausübung von etwas; Handhabung; Verfahren; meist *Mehrz.*: Kniff, listiger Streich, Gaunerei) *w*; -, -en; **Prak|ti|ka** (*Mehrz.* von: Praktikum); **prak|ti|ka|bel** (brauchbar; benutzbar; zweckmäßig); ...a|ble Einrichtung; **Prak|ti|ka|bel** österr. (zerlegbares Podium) *s*; -s, -; **Prak|ti|ka|bi|li|tät** *w*; -; **Prak|ti|kant** (in praktischer Ausbildung Stehender) *m*; -en, -en († R 268); **Prak|ti|kan|tin** *w*; -, -nen; **Prak|ti|ken** (*Mehrz.* von: Praktik u. Praktikum); **Prak|ti|ker** (Mann der prakt. Arbeitsweise und Erfahrung, Ggs.: Theoretiker); **Prak|ti|kum** (die zur praktischen Anwendung des Erlernten eingerichtete Übungsstunde, bes. an Hochschulen; vorübergehende

praktische Tätigkeit von Studenten zur Vorbereitung auf ihren Beruf) *s*; -s, ...ka u. ...ken; **Prak|ti|kus** (scherzh. für: Mann, der immer u. überall Rat weiß) *m*; -, -se; **prak|tisch** (auf die Praxis bezüglich, ausübend; zweckmäßig, gut zu handhaben; geschickt, erfahren; tatsächlich, in Wirklichkeit); -ste († R 294); -er Arzt (nicht spezialisierter Arzt, Arzt für Allgemeinmedizin, Abk.: prakt. Arzt); -es Jahr (einjähriges Praktikum); -es (tätiges) Christentum; († R 116:) etwas Praktisches schenken; **prak|ti|zie|ren** (eine Sache betreiben; [Methoden] anwenden, als Arzt usw. tätig sein; ein Praktikum durchmachen); ein praktizierender Arzt

prä|kul|misch *lat.; engl.* (Geol.: vor dem Kulm [liegend])

Prä|lat *lat.* (geistl. Würdenträger) *m*; -en, -en († R 268); **Prä|la|tur** (Prälatenamt, -wohnung) *w*; -, -en

Prä|li|mi|nar... *lat.* (vorläufig, einleitend); **Prä|li|mi|nar|be|stim|mung**, ...frie|de[n]; **Prä|li|mi|na|ri|en** [...*i*ᵉ*n*] ([diplomatische] Vorverhandlungen; Einleitungssätze) *Mehrz.*; **prä|li|mi|nie|ren** (vorläufig feststellen, festlegen)

Pra|line [nach dem fr. Marschall du Plessis-Praslin (*dü pläßipraläng*)] (schokoladenüberzogene Süßigkeit) *w*; -, -n; **Pra|li|né** [...*né*], **Pra|li|nee** österr. u. schweiz., sonst veralt. für: Praline) *s*; -s, -s

prall (voll; stramm; derb, kräftig); **Prall** (kräftiger Stoß; Anprall) *m*; -[e]s, -e; **prall|en**; **prall|voll**

prä|lu|die|ren *lat.* (Musik: einleitend spielen); **Prä|lu|di|um** (Vorspiel) *s*; -s, ...ien [...*i*ᵉ*n*]

Prä|ma|tu|ri|tät *w*; - (Med.: Frühreife) *w*; -

Prä|me|di|ta|ti|on *lat.* [...*zion*] (Vorüberlegung)

Prä|mie *lat.* [...*i*ᵉ*]* (Belohnung, Preis; [Zusatz]gewinn; Vergütung; Versicherungsgebühr, Beitrag) *w*; -, -n; **Prä|mi|en|an|lei|he**, ...aus|lo|sung; **prä|mi|en|be|gün|stigt**; -es Sparen; **Prä|mi|en|de|pot** (Versicherungsw.); **prä|mi|en|frei**; -e Versicherung; **Prä|mi|en|ge|schäft**, ...lohn; **Prä|mi|en|lohn|sy|stem**; **Prä|mi|en|los**, ...re|ser|ve (Deckungsrücklage), ...rück|ge|währ (Gewähr für Beitragsrückzahlung), ...schein; **prä|mi|en|spa|ren**; **Prä|mi|en|spa|rer** (*s*; -s), ...spa|rer, ...spar|ver|trag, ...zah|lung, ...zu|schlag; **prä|mie|ren**, **prä|mi|ie|ren**; **Prä|mie|rung**

Prä|mis|se *lat.* ("Vorausgeschicktes"; Voraussetzung, Vordersatz eines Schlusses) *w*; -, -n; **prae|mis|sis prae|mit|ten|dis** (veralt. für: man nehme an, der gebührende Titel sei vorausgeschickt; Abk.: P. P.); **prae|mis|so ti|tu|lo** (veralt. für: nach vorausgeschicktem gebührendem Titel; Abk.: P. T.)

Prä|mon|stra|ten|ser (Angehöriger eines kath. Ordens) *m*; -s, -

Prand|tau|er (österr. Barockbaumeister)

Prandtl-Rohr [nach dem dt. Physiker L. Prandtl]; † R 180 (Physik: Gerät zum Messen des Drucks in einer Strömung)

pran|gen

Pran|ger (früher für: Halseisen; Schandpfahl; heute noch in Redewendungen [an den - stellen]) *m*; -s, -

Pran|ke (Klaue, Tatze) *w*; -, -n; **Pran|ken|hieb**

Prä|no|men *lat.* (Vorname)

prä|nu|me|ran|do *lat.* ([von der Zahlung:] vor der Leistung im voraus [zahlbar]); **Prä|nu|me|ra|ti|on** [...*zion*] (Voraus[be]zahlung); **prä|nu|me|rie|ren**

Pranz nordostd., sächs. (Prahlerei) *m*; -es; **pran|zen**; **Pran|zer**

Prä|pa|rand *lat.* (früher für: Vorbereitungsschüler) *m*; -en, -en († R 268); **Prä|pa|rat** ("Vorbereitetes"; kunstgerecht Vor-, Zubereitetes, z. B. Arzneimittel; auch: konservierter Pflanzen- od. Tierkörper [zu Lehrzwecken]) *s*; -[e]s, -e; **Prä|pa|ra|ten|samm|lung**; **Prä|pa|ra|ti|on** [...*zion*] (Herstellung eines Präparates; veralt. für: Vorbereitung; häusliche Aufgabe); **Prä|pa|ra|ti|ons|heft**; **Prä|pa|ra|tor** (Hersteller von Präparaten) *m*; -s, ...oren; **prä|pa|rie|ren**; einen Stoff, ein Kapitel - (vorbereiten); sich - (vorbereiten); Körper- od. Pflanzenteile - (dauerhaft, haltbar machen); ein präparierter Vogel

Prä|pon|de|ranz *lat.* (veralt. für: Übergewicht) *w*; -; **prä|pon|de|rie|ren** (veralt. für: überwiegen)

Prä|po|si|ti|on *lat.* [...*zion*] (Sprachw.: Verhältniswort, z. B. "in, auf"); **prä|po|si|ti|o|nal**; **Prä|po|si|ti|o|nal|at|tri|but**, ...aus|druck, ...fall *m*, ...ge|fü|ge, ...ka|sus, ...ob|jekt; **Prä|po|si|tur** (Stelle eines Präpositus) *w*; -, -en; **Prä|po|si|tus** (Vorgesetzter; Propst) *m*; -, -ti

prä|po|tent *lat.* (veralt. für: übermächtig, österr.: überheblich, aufdringlich); **Prä|po|tenz**

Prä|pu|ti|um *lat.* [...*zium*] (Med.: Vorhaut) *s*; -s, ...ien [...*i*ᵉ*n*]

Prä|raf|fae|lit *lat.; it.* [...*fa-eliīt*] (Nachahmer des vorraffaelischen Malstils) *m*; -en, -en (↑ R 268)

Prä|rie *fr.* (Grasebene [in Nordamerika]) *w*; -, ...ien; **Prä|rie-gras**, ...**hund**, ...**in|dia|ner**, ...**wolf** *m*

Prä|ro|ga|tiv *lat. s*; -s, -e [...*wᵉ*] u. **Prä|ro|ga|ti|ve** [...*wᵉ*] (Vorrecht, insbes. früher des Herrschers bei der Auflösung des Parlaments, dem Erlaß von Gesetzen u. a.) *w*; -, -n

Prä|sens *lat.* (Sprachw.: Gegenwart) *s*; -, ...sẹntia od. ...sẹnzien [...*iᵉn*]; **prä|sẹnt** (anwesend; gegenwärtig; bei der Hand); - sein; etwas - haben; **Prä|sẹnt** *fr.* (Geschenk; kleine Aufmerksamkeit) *s*; -[e]s, -e; **prä|sen|ta|bel** (ansehnlich; vorzeigbar); ...a|ble Ergebnisse; **Prä|sen|tạnt** *lat.* (Vorzeiger eines fälligen Wechsels) *m*; -en, -en (↑ R 268); **Prä|sen|ta|ta** (*Mehrz.* von: Präsentatum); **Prä|sen|ta|ti|on** [...*zion*] (Vorzeigung eines fälligen Wechsels; Ausstellung; seltener für: Präsentierung); **Prä|sen|ta|ti|ons|recht** (Vorschlagsrecht); **Prä|sen|ta|tum** (veralt. für: Tag der Einreichung eines Schriftstückes) *s*; -s, -s od. ...ta; **Prä|sẹn|tia** (*Mehrz.* von: Präsens); **prä|sen|tie|ren** *fr.* (überreichen, darbieten; vorlegen, -zeigen, bes. einen Wechsel zur Zahlung; milit. Ehrenbezeigung [mit dem Gewehr] machen); sich - (sich zeigen); **Prä|sen|tier|tel|ler**, nur noch in der Wendung: auf dem - sitzen (ugs. für: allen Blicken ausgesetzt sein); **Prä|sen|tie|rung** (Vorstellung, Vorlegung, Vorzeigung, Überreichung, Darstellung); **prä|sen|tisch** *lat.* (das Präsens betreffend); **Prä|sẹnz** (Gegenwart, Anwesenheit) *w*; -; **Prä|sẹnz.bi|blio|thek** (Bibliothek, deren Bücher nicht nach Hause mitgenommen werden können), ...**die|ner** (österr.: Soldat im österr. Bundesheer während der normalen gesetzlichen Wehrpflicht), ...**dienst** (österr.: Militärdienst); **Prä|sẹn|zi|en** (*Mehrz.* von: Präsens); **Prä|sẹnz.li|ste** (Anwesenheitsliste), ...**stär|ke** (augenblickliche Personalstärke [bei der Truppe])

Pra|seo|dym *gr.* (chem. Grundstoff, seltene Erde; Zeichen: Pr) *s*; -s

prä|ser|va|tiv *lat.* [...*wa*...] (vorbeugend, verhütend); **Prä|ser|va|tiv** (Gummiüberzug für das männl. Glied zur mechan. Empfängnisverhütung) *s*; -s, -e [...*wᵉ*] (selten:

-s); **Prä|sẹr|ve** [...*wᵉ*] (nicht vollständig keimfreie Konserve, sog. Halbkonserve) *w*; -, -n (meist *Mehrz.*); **prä|ser|vie|ren** (vor einem Übel bewahren; vorbeugen; erhalten; schützen); **Prä|ser|vie|rung**

Prä|ses *lat.* (geistl. Vorstand eines kath. kirchl. Vereins, Vorsitzender einer ev. Synode, im Rheinland u. in Westfalen zugleich Kirchenpräsident) *m*; -, ...sides u. ...siden; **Prä|si|de** (Studentenspr.: Leiter einer Kneipe, eines Kommerses) *m*; -n, -n (↑ R 268); **Prä|si|dẹnt** (Vorsitzender; Staatsoberhaupt in einer Republik) *m*; -en, -en (↑ R 268); **Prä|si|dẹn|ten|wahl**; **Prä|si|dẹn|tin** *w*; -, -nen; **Prä|si|dẹnt|schaft**; **Prä|si|dẹnt|schafts|kan|di|dat**; **Prä|si|des** (*Mehrz.* von: Präses); **prä|si|di|al**; **Prä|si|di|al.ge|walt**, ...**re|gie|rung**, ...**sy|stem** (Regierungsform, bei der das Staatsoberhaupt gleichzeitig Regierungschef ist); **prä|si|die|ren** (den Vorsitz führen, leiten); einem Ausschuß - (schweiz.:) einem Ausschuß -; **Prä|si|di|um** (Vorsitz; Amtsgebäude eines [Polizei]präsidenten) *s*; -s, ...ien [...*iᵉn*]

prä|si|lu|risch *nlat.* (Geol.: dem Silur vorangehend)

prä|skri|bie|ren *lat.* (veralt. für: vorschreiben; verordnen; für verjährt erklären); **Prä|skrip|ti|on** [...*zion*] (veralt.); **prä|skrip|tiv**

Praß (veralt. für: wertlose Masse, Plunder) *m*; Prasses

pras|seln; es prasselt

pras|sen (schlemmen); du praßt (prassest), er praßt; du praßtest; gepraßt; prasse! u. praß!; **Pras|ser**; **Pras|se|rei**

prä|sta|bi|lie|ren *lat.* (veralt. für: vorher festsetzen); prästabilierte Harmonie (Leibniz); **Prä|stant** (die große, zinnerne Orgelpfeife) *m*; -en, -en (↑ R 268)

prä|su|mie|ren *lat.* (annehmen; voraussetzen); **Prä|sum|ti|on** [...*zion*] (Annahme; Rechtsvermutung; Voraussetzung); **prä|sum|tiv** (mutmaßlich; wahrscheinlich)

Prä|ten|dẹnt *lat.* (Ansprüche [auf die Krone od. ein Amt] Erhebender, Bewerber) *m*; -en, -en (↑ R 268; **prä|ten|die|ren**; **Prä|ten|ti|on** [...*zion*] (selten für: Anspruch; Anmaßung); **prä|ten|ti|ös** (anspruchsvoll, anmaßend, selbstgefällig) -este (↑ R 292)

Prä|ter (Park mit Vergnügungsplatz in Wien) *m*; -s

Prä|ter|itio *lat.* [...*zio*], **Prä|ter|iti|on** (Rhet.: scheinbare Übergehung) *w*; -, ...onen; **Prä|ter|ito-**

prä|sens [*präteritoprä*...] (Sprachw.: Zeitwort, dessen „Präsens" [Gegenwart] ein früheres starkes „Präteritum" [Vergangenheit] ist u. dessen neue Vergangenheitsformen schwach gebeugt werden, z. B. „können, wissen") *s*; -, ...sẹntia od. ...sẹnzien [...*iᵉn*]; **Prä|ter|itum** (Sprachw.: Vergangenheit) *s*; -s, ...ta

prä|ter|prop|ter *lat.* (etwa, ungefähr)

Prä|tor *lat.* (höchster [Justiz]beamter im alten Rom) *m*; -s, ...oren; **Prä|to|ria|ner** (Angehöriger der Leibwache der röm. Feldherren od. Kaiser) *m*; -s; **Prä|tur** (Amt eines Prätors) *w*; -, -en

Prät|ti|gau (Talschaft in Graubünden) *s*; -s

Pratze (meist übertr. verächtl. für: breite, ungefüge Hand) *w*; -, -n

Prau *malai.* (Boot der Malaien) *w*; -, -e

prä|ve|nie|ren *lat.* [...*wen*...] (veralt. für: zuvorkommen); **Prä|ve|ni|re** (veralt. für: Zuvorkommen) *s*; -[s]; das - spielen (einem andern zuvorkommen); **Prä|ven|ti|on** [...*zion*] (das Zuvorkommen [mit einer Rechtshandlung]; Vorbeugung; Abschreckung); **prä|ven|tiv**; **Prä|ven|tiv.be|hand|lung**, ...**krieg**, ...**maß|nah|me**, ...**me|di|zin**, ...**mit|tel** s, ...**ver|kehr** (Geschlechtsverkehr mit Anwendung eines Verhütungsmittels); **prä|ver|bal**; -e Periode (erste Lebenszeit eines Kindes, bevor es sprechen lernt)

Pra|wda *russ.* („Wahrheit"; eine Moskauer Tageszeitung) *w*; -

Pra|xe|dis [auch: *pra*...] (eine Heilige)

Pra|xis *gr.* (Tätigkeit, Ausübung; tätige Auseinandersetzung mit der Wirklichkeit, Ggs.: Theorie; Beruf, bes. des Arztes u. des Anwalts) *w*; -, (für die Berufsausübung, bes. des Arztes od. Anwalts, u. als Bez. der Gesamtheit der Räume für die Berufsausübung dieser Personen auch *Mehrz.*:) ...xen; vgl. in praxi; **pra|xis.fern**, ...**fremd**, ...**ge|recht**, ...**nah**

Pra|xi|tel|les (altgr. Bildhauer)

Prä|ze|dens *lat.* (früherer Fall, früheres Beispiel; Beispielsfall) *s*; -, ...denzien (↑ R 292); **Prä|ze|denz.fall** (Präzedens; *m*), ...**strei|tig|keit** (Rangstreitigkeit); **Prä|zep|tor** (veralt. für: Lehrer; Erzieher) *m*; -s, ...oren; **Prä|zes|si|on** (Astron.: „Vorrücken" des Frühlingspunktes); **Prä|zi|pi|tat** (Chemie: Bodensatz, Nieder-

schlag) s; -[e]s, -e; Prä|zi|pi|ta|ti-
on [...zión] (Chemie: Ausfällung)
w; -; prä|zi|pi|tie|ren; Prä|zi|pi|tin
(Med.: immunisierender Stoff im
Blut) s; -s, -e; Prä|zi|pu|um (Geld-
betrag, der vor Aufteilung des
Gesellschaftsgewinnes einem
Gesellschafter für besondere Lei-
stungen aus dem Gewinn gezahlt
wird) s; -s, ...pua
prä|zis (österr. nur so), prä|zi|se
lat. (gewissenhaft; genau; pünkt-
lich; unzweideutig, klar); ...iseste
(↑ R 292); prä|zi|sie|ren (genau
angeben; knapp zusammenfas-
sen); Prä|zi|sie|rung; Prä|zi|si|on
(Genauigkeit) w; -; Prä|zi|si|ons-
...ar|beit, ...in|stru|ment, ...ka|me-
ra, ...mes|sung, ...mo|tor, ...uhr,
...waa|ge
Pre|del|la it. w; -, -s u. ...llen,
Pre|del|le (Sockel eines Altarauf-
satzes) w; -, -n
pre|di|gen; Pre|di|ger; Pre|di|ger-
or|den, ...se|mi|nar; Pre|digt w;
-, -en; Pre|digt_amt, ...stil, ...stuhl
(veralt. für: Kanzel); ...text
Pre|fe|rence fr. [...ferangß] (ein fr.
Kartenspiel) w; -, -n [...ß^en]; vgl.
Präferenz
Pre|gel (Hauptfluß der ehem. Pro-
vinz Ostpreußen) m; s
pre|ien niederl. (Seemannsspr.);
ein Schiff - (anrufen)
Preis m; -es, -e u. Prei|se, Prie|se
mdal. (Einfassung, Saum, Bund)
w; -, -n
Preis (Belohnung; Lob; [Geld]-
wert) m; -es, -e; um jeden, keinen
-; - freibleibend (Kaufmanns-
spr.); stabile Preise; feste Preise;
niedrige Preise; er gewann den
ersten Preis; Preis_ab|bau, ...ab-
re|de, ...an|ge|bot, ...an|stieg,
...auf|ga|be, ...auf|trieb, ...aus-
gleichs|prin|zip (Wirtsch.), ...aus-
schrei|ben (s; -s, -), ...ba|sis; preis-
be|gün|stigt; Preis_be|hör|de,
...be|we|gung; preis|be|wußt;
Preis_bil|dung, ...bin|dung, ...bre-
cher, ...dis|zi|plin
prei|se vgl. ¹Preis
prei|sel|bee|re
prei|sen; du preist (preisest), er
preist; du priesest, er pries; ge-
priesen; preis[e]!
Preis_ent|wick|lung, ...er|hö|hung,
...er|mä|ßi|gung, ...ex|plo|si|on,
...fah|ren (sportl. Veranstaltung;
s; -s, -), ...fra|ge
preis|ga|be w; -; preis|ge|ben; du
gibst preis; preisgegeben; preis-
ugeben
preis_ge|fäl|le, ...ge|fü|ge; preis-
ge|krönt; Preis_ge|richt, ...ge-
stal|tung, ...gren|ze; preis|gün-
tig; Preis_in|dex, ...kal|ku|la|ti-
on, ...kar|tell; preis|ge|geln (nur
in der Grundform gebräuchlich);

wir wollen -; Preis|ke|geln s; -s;
Preis_kon|junk|tur, ...kon|trol|le,
...kon|ven|ti|on (Wirtsch.), ...kor-
rek|tur; preis|kri|tisch; Preis|la-
ge; preis|lich (veralt. für: löb-
lich; als Umstandsw. [Kauf-
mannsspr.]: auf den Preis bezüg-
lich); Preis_lied, ...li|ste; Preis-
Lohn-Spi|ra|le (↑ R 155); Preis-
_nach|laß (für: Rabatt), ...ni|veau,
...no|tie|rung, ...po|li|tik, ...rich-
ter, ...rück|gang, ...schie|ßen,
...schild s, ...schla|ger (besonders
preiswertes Angebot), ...schrift,
...sen|kung, ...skat; preis|sta|bil;
Preis_sta|bi|li|tät, ...stei|ge|rung,
...stopp (Verbot der Preiserhö-
hung; m; -s); Preis_stopp|ver|ord-
nung; Preis_sturz, ...ta|fel, ...trä-
ger, ...trei|ber; Preis|trei|be|rei;
Preis_über|wa|chung, ...über|wa-
chungs|stel|le, ...un|ter|gren|ze,
...ver|fall, ...ver|gleich, ...ver|gün-
sti|gung, ...ver|lei|hung, ...ver|tei-
lung, ...ver|zeich|nis, ...vor-
schrift; preis|wert; Preis|wu|cher;
preis|wür|dig; Preis|wür|dig|keit
w; -
pre|kär fr. (mißlich, schwierig, be-
denklich)
Prell_ball (ein dem Handball
ähnliches Mannschaftsspiel),
...bock; prel|len; Prel|ler; Prel|le-
rei; Prell_schuß, ...stein; Prel|lung
Pre|mier fr. [pr^emié, premjé] (,,Er-
ster", Erstminister, Ministerprä-
sident) m; -s, -s; Pre|mie|re (Erst-,
Uraufführung) w; -, -n; Pre|mie-
ren_abend, ...be|su|cher, ...pu|bli-
kum; Pre|mier|mi|ni|ster [pr^e-
mié..., premjé...]
Pres|by|ter gr. ([urchristl.] Ge-
meindeältester; Priester; Mit-
glied des Presbyteriums) m; -s,
-; Pres|by|te|ri|al|ver|fas|sung w;
-; Pres|by|te|ria|ner (Angehöri-
ger protestant. Kirchen mit Pres-
byterialverfassung in England u.
Amerika) m; -s, -; pres|by|te|ria-
nisch; Pres|by|te|ri|um (Ver-
sammlung[sraum] der Presbyter;
Kirchenvorstand; Chorraum) s;
-s, ...ien [...i^en]
pre|schen (ugs. für: rennen, eilen);
du preschst (preschest)
Pres|sen|ning w. Persenning
preß (Sportspr.: eng, nah); jmdn.
- decken; Preß_ball (Sportspr.:
von zwei Spielern gleichzeitig ge-
tretener Ball)
pres|sant fr. (veralt., aber noch
mdal. für: dringlich, eilig); Pres-
se (Vorrichtung zur Ausübung ei-
nes Druckes, z. B. Druckpresse,
Buchpresse u.a.; Gerät zum Aus-
pressen von Obst; übertr. ugs.
für: Schule, die in gedrängter
Weise auf Prüfungen vorbereitet;
nur Einz.: Gesamtheit der period.

Druckschriften; Zeitungs-, Zeit-
schriftenwesen) w; -, -n; die freie
Presse; Pres|se_agen|tur, ...amt,
...be|richt|er|stat|ter, ...büro
(Agentur), ...dienst, ...emp|fang,
...er|klä|rung, ...fo|to|graf, ...frei-
heit (w; -), ...ge|setz, ...kam|pa-
gne, ...kom|men|tar, ...kon|fe-
renz; pres|sen; du preßt (pressest),
er preßt; du preßtest; gepreßt;
presse! u. preß!; Pres|se_no|tiz,
...or|gan, ...recht, ...re|fe|rent,
...stel|le (Abteilung für Presseein-
formation), ...stim|me, ...tri|bü-
ne, ...ver|tre|ter, ...we|sen (s; -s),
...zen|sur (w; -); Preß_form, ...glas
(Mehrz. ...gläser), ...he|fe, ...holz;
pres|sic|ren bes. südd., österr. u.
schweiz. ugs. (drängen, treiben,
eilig sein); es pressiert; Pres|si|on
lat. (Druck; Nötigung; Zwang);
Preß_koh|le, ...kopf (eine Wurst-
art; m; -[e]s); Preß|ling (für: Bri-
kett); Preß_luft w; -; Preß_luft_boh-
rer, ...ham|mer; Preß_sack (eine
Wurstart; m; -[e]s), ...span, ...stoff,
...stroh; Pres|sung; Pres|su|re-
group engl.-amerik. [präsch^er-
grup] (Interessenverband, der
[oft mit Druckmitteln] auf Par-
teien, Parlament, Regierung u.a.
Einfluß zu gewinnen sucht) w;
-, -s; Preß|wurst
Pre|sti|ge fr. [...isch^e] (Ansehen,
Geltung) s; -s; Pre|sti|ge_ge|winn,
...sa|che, ...ver|lust
pre|stis|si|mo it. (Musik: sehr
schnell); Pre|stis|si|mo (Musik:
äußerst schnelles Tempo; Musik-
stück in schnellstem Zeitmaß) s;
-s, -s und ...mi; pre|sto (Musik:
schnell); Pre|sto s; -s, -s und ...ti
Pre|tio|sen lat. [prezi...] (veralt.
für: Kostbarkeiten; Geschmeide)
Mehrz.; vgl. Preziosen
Pre|to|ria (Hptst. von Transvaal
u. Regierungssitz der Republik
Südafrika)
Preu|ße m; -n, -n (↑ R 268); Preu-
ßen; Preu|ßin w; -, -nen; preu-
ßisch; die preußischen Behörden,
aber (↑ R 198): der Preußische
Höhenrücken; Preu|ßisch|blau
pre|zi|ös fr. (veralt. für: kostbar;
geziert, geschraubt); -este (↑ R
292); Pre|zio|sa w. Eigenn.); Pre-
zio|sen (eingedeutscht für: Pre-
tiosen; vgl. d.)
Pria|mel lat. [auch: prig...]
(Spruchgedicht, bes. des dt. Spät-
mittelalters) w; -, -n (auch: s;
-s, -)
Pria|mos (gr. Sagengestalt); Pria-
mus vgl. Priamos
pria|pe|isch (gr. (den Priapus be-
treffend; veralt. für: unzüchtig);
-e Gedichte; Pria|pos [auch: pri...,
pri...] vgl. Priapus; Pria|pus (gr.-
röm. Gott der Fruchtbarkeit)

Pricke¹ (ein Seezeichen) w; -, -n
Pricke|lei¹ (ugs.); pricke|lig¹,
prick|lig; prickeln¹; († R 120:) ein
Prickeln auf der Haut empfin-
den; prickelnd¹; -ste; der -e Reiz
der Neuheit; († R 116:) etwas
Prickelndes für den Gaumen;
¹pricken¹ mdal. ([aus]stechen; ab-
stecken)
²pricken¹ (ein Fahrwasser mit
Pricken versehen)
prick|lig, pricke|lig¹
Prie|che nordd. (Kirchenempore)
w; -, -n
¹Priel (Bergname) m; -s; († R 198:)
der Große -, der Kleine -
²Priel (schmaler Wasserlauf im
Wattenmeer) m; -[e]s, -e
Priem niederl. („Pflaume"; Stück
Kautabak) m; -[e]s, -e; prie|men
(Tabak kauen); Priem|ta|bak
Prie|se vgl. ¹Preis
Prieß|nitz (Begründer einer Na-
turheilmethode); Prieß|nitz.kur
(† R 180; Kaltwasserkur), ...um-
schlag
Prie|ster m; -s, -; ein geweihter -;
Prie|ster|amt; prie|ster|haft; Prie-
ste|rin w; -, -nen; Prie|ster.kon-
gre|ga|ti|on, ...kö|nig; prie|ster-
lich; Prie|ster|schaft w; -; Prie-
ster|se|mi|nar; Prie|ster|tum s; -s;
Prie|ster|wei|he
Priest|ley [prístli] (engl. Erzähler
u. Dramatiker)
Prig|nitz (Gebiet in Brandenburg)
w; -
Prim lat. (Fechthieb; Morgenge-
bet im kath. Brevier; svw. Prime
[Musik]) w; -, -en
Prim. = Primar, Primararzt, Pri-
marius
pri|ma it. (Kaufmannsspr. veralt.:
vom Besten, erstklassig; Abk.: Ia;
ugs. für: vorzüglich, prächtig,
wunderbar); ein prima Kerl; pri-
ma Essen; Pri|ma lat. (,,erste";
als Unter- u. Oberprima 8. u. 9.
[in Österr.: 1.] Klasse einer höhe-
ren Lehranstalt; Erste in einer
Schulklasse) w; -, ...men; Pri|ma-
bal|le|ri|na it. (erste Tänzerin);
Pri|ma|don|na (erste Sängerin) w;
-, ...nnen
Pri|ma|ge fr. [...maseʰ] (Prim-
geld)
Pri|ma|ner lat. (Schüler der Pri-
ma); Pri|ma|ne|rin w; -, -nen; Pri-
ma|qua|li|tät (erste Güte); Pri-
mar österr. (Chefarzt einer Abtei-
lung eines Krankenhauses; Abk.:
Prim.) m; -s, -e; pri|mär fr. (die
Grundlage bildend, wesentlich;
ursprünglich, erst...); Pri|mar-
arzt (österr.); vgl. Primar; Pri-
ma|ria lat. österr. (weibl. Primar)
w; -, ...iae; Pri|ma|ri|us lat. (der

Erste, Oberste; Oberpfarrer;
Primgeiger; österr. svw. Primar)
m; -, ...ien [...iⁿn]; Pri|mar|leh|rer
(schweiz.); Pri|mär|li|te|ra|tur
(der eigtl. dichterische Text;
Ggs.: Sekundärliteratur); Pri-
mar|schu|le schweiz. (allgemeine
Volksschule); Pri|mär.strom
(Hauptstrom), ...wick|lung
(Elektrotechnik); Pri|mas (der
Erste, Vornehmste; Ehrentitel
bestimmter Erzbischöfe; Solist u.
Vorgeiger einer Zigeunerkapelle)
m; -, -se (auch: ...aten); ¹Pri|mat
(Vorrang, bevorzugte Stellung;
[Vor]herrschaft; oberste Kir-
chengewalt des Papstes) m od.
s; -[e]s, -e; ²Pri|mat (Biol.: Her-
rentier, höchstentwickeltes Säu-
getier) m; -en, -en († R 268); meist
Mehrz.; Pri|ma.wa|re, ...wech-
sel; Pri|me (Musik: erste Tonstu-
fe, Einklang zweier auf derselben
Stufe stehender Noten; Druk-
kerspr.: am Fuß der ersten Seite
eines Bogens stehende Kurzfas-
sung des Buchtitels; vgl. auch
Norm) w; -, -n; vgl. Prim; Pri|mel
(Vertreter einer Pflanzengattung
mit zahlreichen einheimischen
Arten [Schlüsselblume, Aurikel])
w; -, -n; Pri|men (Mehrz. von:
Prim, Prime u. Prima); Prim|gei-
ger (erster Geiger im Streich-
quartett)
Prim|geld lat. (Belohnung des
Schiffskapitäns für besondere
der Fracht gewidmete Sorgfalt)
Pri|mi (Mehrz. von: Primus); pri-
mis|si|ma it. (ugs.: ganz prima,
ausgezeichnet); pri|mi|tiv lat. (ur-
zuständlich, urtümlich; geistig
unterentwickelt, einfach; dürf-
tig); ein -er Mensch; ein -es Be-
dürfnis; ein -es Volk; Pri|mi|ti|ve
[...wᵉ] (Angehörige[r] eines Vol-
kes, das auf einer niedrigen Kul-
turstufe steht) m u. w; -n, -n († R
287ff.);meist Mehrz.; pri|mi|ti|vi-
sie|ren [...wi...]; Pri|mi|ti|vi|sie-
rung; Pri|mi|ti|vis|mus [...wiß...]
(moderne Kunstrichtung, die
sich von der Kunst der Primitiven
anregen läßt) m; -; Pri|mi|ti|vi-
tät; Pri|mi|tiv|kul|tur; Pri|mi|ti-
vum [...vum] (Stamm-, Wurzel-
wort) s; -s, ...va; Pri|miz¹ (,,erste"
[feierl.] Messe des Primizianten)
w; -, -en; Pri|miz|fei|er¹; Pri|mi|zi-
ant (neugeweihter kath. Pri-
ster) m; -en, -en († R 268); Pri|mi-
zi|en [...iⁿn] (den röm. Göttern
dargebrachte ,,Erstlinge" von
Früchten u. ä.) Mehrz.; Pri|mo-
ge|ni|tur (Erbfolgerecht des Erst-
geborenen u. seiner Nachkom-
men) w; -, -en; Pri|mus (Erster

in einer Schulklasse) m; -, ...mi
und -se; Pri|mus in|ter pa|res (der
Erste unter Gleichen, ohne Vor-
rang) m; - - -, ...mi - -; Prim|zahl
(nur durch 1 u. durch sich selbst
teilbare Zahl)
Prince of Wales [prinß ᵉw "gᵉls]
(Titel des engl. Thronfolgers) m;
- - -
Prin|te niederl. (ein Gebäck) w; -,
-n (meist Mehrz.); Aachener -n
Prin|ted in Ger|ma|ny engl. [prin-
tid in dsehöᵣmᵉni] (Vermerk in
Büchern: in Deutschland ge-
druckt)
Prinz lat. m; -en, -en († R 268)
Prin|zen|in|seln (im Marmara-
meer) Mehrz.; Prin|zen|paar
(Prinz u. Prinzessin [im Karne-
val]) s; -[e]s, -e; Prin|zeß (für
Prinzessin) w; -, ...zessen; Prin-
zeß|boh|nen (Mehrz.); Prin|zes-
sin w; -, -nen; Prin|zeß|kleid;
Prinz|ge|mahl; Prin|zip (Grund-
lage; Grundsatz) s; -s, -ien [...iⁿn
(seltener: -e); föderalistisches
od. zentralistisches - (bundes-
staatlicher Aufbau od. Einheits-
staat); ¹Prin|zi|pal (veralt. für
Lehrherr; Geschäftsinhaber, -lei-
ter) m; -s, -e; ²Prin|zi|pal (Haupt-
register der Orgel) s; -s, -e; Prin
zi|pal|gläu|bi|ger (Hauptgläubi-
ger); Prin|zi|pa|lin (veralt.
Geschäftsführerin; Theaterleite-
rin) w; -, -nen; prin|zi|pa|li|ter
(veralt. für: vor allem, in erster
Linie); Prin|zi|pat (veralt. für:
Vorrang; röm. Verfassungsform
der ersten Kaiserzeit) s (auch: m.
-[e]s, -e; prin|zi|pi|ell (grundsätz-
lich); prin|zi|pi|en|fest [...iⁿn...
Prin|zi|pi|en|fra|ge; prin|zi|pi|en-
los; -este († R 292); Prin|zi|pi|en-
lo|sig|keit; Prin|zi|pi|en.rei|te
(abschätzig), ...rei|te|rei, ...strei
prin|zi|pi|en|treu; Prin|zi|pi|en
treue; prinz|lich; Prinz|re|gen
Prinz-Thron|fol|ger
Pri|or lat. (Kloster]oberer, -vor
steher; auch: Vorsteher eine
Priorates [Kloster] od. Stellve
treter eines Abtes) m; -s, Prio|re
Prio|rat (Amt, Würde eine
Priors; meist von einer Abtei ab
hängiges [kleineres] Kloster eine
Konvents) s; -[e]s, -e; Prio|ri
[auch: pri...] w; -, -nen; Prio|ri|tä
fr. (Vor[zugs]recht, Erstrech
Vorrang; nur Einz.: zeitl. Vor
hergehen); Prio|ri|tä|ten (Wer
papiere mit Vorzugsrech
ten) Mehrz.; Prio|ri|täts_ak|ti
en (Mehrz.), ...ob|li|ga|tio|ne
(Mehrz.), ...recht
Pris|chen, Pris|lein (kleine Pr
[Tabak u. a.]); Pri|se fr. (aufg
brachtes feindl. Schiff od. Ko
terbande führendes neutral

¹ Trenn.: ...ik|k...

¹ Auch: ...miz usw.

Schiff od. die beschlagnahmte Ladung eines solchen Schiffes; soviel [Tabak, Salz u. a.], wie zwischen zwei Fingern zu greifen ist) *w;* -, -n; **Pri|sen..ge|richt, ...komman|do; Pri|s|lein** vgl. Prischen

Pris|ma *gr.* (Polyeder; Licht-, Strahlenbrecher) *s;* -s, ...men; **pris|ma|tisch** (prismenförmig); **Pris|ma|to|id** (prismenähnlicher Körper) *s;* -[e]s, -e; **Pris|men..fern|rohr, ...form, ...glas** (*Mehrz.* ...gläser)

Pri|son *fr.* [...*soŋ*] (veralt. für: Gefängnis) *w;* -, -s od. *s;* -s, -s **Prit|sche** (leichtes Schlaggerät; hölzerne Lagerstätte) *w;* -, -n; **prit|schen** (veralt., aber noch mdal. für: mit der Pritsche schlagen; Sportspr.: den Volleyball mit den Fingern weiterspielen, ohne ihn zu fangen od. zu halten); du pritschst (pritschest); **Pritschen|wa|gen; Pritsch|mei|ster** landsch. (Hanswurst; lustige Person)

Prit|sta|bel *slaw.* (früher in der Mark Brandenburg: Wasservogt, Fischereiaufseher) *m;* -s, - **pri|vat** *lat.* [...*wat*] (persönlich; nicht öffentlich, außeramtlich; vertraulich; häuslich; vertraut); -e Meinung, Angelegenheit; -e Ausgaben; -e Wirtschaft; -er Eingang; Verkauf an, Kauf von Privat; **Pri|vat..an|ge|le|gen|heit, ...au|di|enz, ...bahn, ...bank** (*Mehrz.* ...banken), **..be|sitz, ...brief, ...de|tek|tiv, ...do|zent** (Hochschullehrer ohne Amtscharakter), **...druck** (*Mehrz.* ...drucke); **Pri|va|te** (Privatperson) *m* u. *w;* -n, -n (↑ R 287); **Pri|vat..ei|gen|tum, ...flug|zeug, ...ge|brauch** (*m;* -[e]s), **...ge|lehr|te, ...ge|spräch, ...gläu|bi|ger, ...hand, ...haus; Pri|va|tier** [französierende Bildung; ...*tig*] (veralt. für: Mann ohne Beruf, Rentner) *m;* -s, -s; **Pri|va|tie|re** [französierende Bildung; ...*är*] (veralt. für: Rentnerin) *w;* -, -n; **pri|va|tim** ([ganz] persönlich, unter vier Augen, vertraulich [*Umstandsw.*]); **Pri|vat..in|itia|ti|ve, ...in|ter|es|se; Pri|va|ti|on** [...*wa-zion*] (veralt. für: Beraubung; Entziehung); **pri|va|ti|sie|ren** [...*wa...*] (staatl. Vermögen in Privatvermögen umwandeln; als Rentner[in] od. als Privatmann vom eigenen Vermögen leben); **Pri|va|ti|sie|rung; pri|va|tis|si|me** (Vorlesung für einen ausgewählten Kreis; übertr. für: Ermahnung) *s;* -s, ...ma; **Pri|va|tist** österr.: Schüler, der sich privat

auf die Prüfung an einer Schule vorbereitet) *m;* -en, -en; **Pri|vat..kla|ge, ...kli|nik, ...kon|tor, ...kund|schaft, ...le|ben** (*s;* -s), **...leh|rer, ...leu|te** (*Mehrz.*), **...mann** (*Mehrz.* ...männer u. ...leute); **Pri|vat|mit|tel** *Mehrz.;* (↑ R 145:) Privat- u. öffentliche Mittel, aber: öffentliche und Privatmittel; **Pri|vat..pa|ti|ent, ...per|son, ...quar|tier, ...recht; pri|vat|recht|lich; Pri|vat..sa|che, ...schu|le, ...se|kre|tär, ...se|kre|tä|rin, ...spiel, ...sta|ti|on, ...stun|de, ...un|ter|neh|men, ...un|ter|richt, ...ver|gnü|gen, ...ver|mö|gen, ...ver|si|che|rung, ...weg, ...wirt|schaft; pri|vat|wirt|schaft|lich; Pri|vat..woh|nung, ...zim|mer, ...zweck**

Pri|vi|leg *lat.* [...*wi...*] (Vor-, Sonderrecht) *s;* -[e]s, -ien [...*iᵉn*] (auch: -e); **pri|vi|le|gie|ren; Pri|vi|le|gi|um** (älter für: Privileg) *s;* -s, ...ien [...*iᵉn*]

Prix *fr.* [*pri*] (fr. Bez. für: Preis) *m;* -, -

pro *lat.* (,,für''; je); - Stück, dafür besser: das Stück zu ...; **Pro** (Für) *s;* -; das - und Kontra (das Für u. Wider); **pro an|no** (veralt. für: aufs Jahr, jährlich; Abk.: p. a.); dafür besser der dt. Ausdruck

pro|ba|bel *lat.* (wahrscheinlich); ...a|ble Gründe; **Pro|ba|bi|lis|mus** (Wahrscheinlichkeitslehre, -standpunkt; kath. Moraltheologie: Lehre, daß in Zweifelsfällen eine Handlung erlaubt ist, wenn gute Gründe dafür sprechen) *m;* -; **Pro|ba|bi|li|tät** (Wahrscheinlichkeit, Glaubwürdigkeit); **Pro|band** (,,der zu Erweisende''; Testperson, an der etwas ausprobiert od. gezeigt wird; Genealogie: jmd., für den eine Ahnentafel aufgestellt werden soll) *m;* -en, -en (↑ R 268); **pro|bat** (erprobt; bewährt); **Pröb|chen**, Pröb|lein; **Pro|be** *w;* -, -n; zur, auf -; **Pro|be..ab|zug, ...alarm, ...ar|beit, ...be|la|stung, ...druck** (*Mehrz.* ...drucke), **...ex|em|plar; pro|be|fah|ren** (meist nur in der Grundform u. im 2. Mittelw. gebr.); **probege|fahren; Pro|be|fahrt: pro|be|hal|ber, ...hal|tig** (veralt. für: die Probe bestehend, aushaltend); **Pro|be|jahr, ...lauf; pro|be|lau|fen** (meist nur in der Grundform u. im 2. Mittelw. gebr.); die Maschine ist probegelaufen; **Pro|be|lehrer** österr. (Lehrer an einer höheren Schule im Probejahr); **Pro|be|lek|ti|on; prö|belß** schweiz. (allerlei Versuche anstellen); ich ...[e]le (↑ R 327); **pro|ben; Pro|ben.ar|beit** (Theater-, Konzertw.), **...ent|nah|me; Pro|be|num|mer; pro|be-**

schrei|ben (meist nur in der Grundform u. im 2. Mittelw. gebr.); **pro|be|geschrieben; Pro|be..sei|te** (Druckw.), **...sen|dung; pro|be|sin|gen** (meist nur in der Grundform u. im 2. Mittelw. gebr.); **probegesungen; Pro|be|stück; pro|be|tur|nen** (meist nur in der Grundform u. im 2. Mittelw. gebr.); **probegeturnt; pro|he|wei|se; Pro|he|zeit; pro|hie|ren** (versuchen, kosten, prüfen); (↑ R 120:) Probieren (auch: probieren) geht über Studieren; **Pro|bie|rer** (Prüfer); **Pro|bier.glas** (*Mehrz.* ...gläser), **...kunst** (*w;* -), **...na|del, ...stu|be; Pröb|lein, Pröb|chen**

Pro|blem *gr.* (zu lösende Aufgabe; Frage[stellung]; unentschiedene Frage; Schwierigkeit) *s;* -s, -e; **Pro|ble|ma|tik** (Fraglichkeit, Schwierigkeit [etwas zu klären]) *w;* -; **pro|ble|ma|tisch; -ste** (↑ R 294); **Pro|blem..den|ken, ...kreis; pro|blem..los** (-este; ↑ R 292), **...ori|en|tiert; Pro|blem..schach, ...stel|lung**

Probst|zel|la (Ort im nordwestl. Frankenwald)

Pro|bus (altröm. Eigenn.)

pro cen|tum *lat.* [- *zǝn...*] (für hundert, auf das Hundert; Abk.: p. c., v. H.; Zeichen: %); vgl. Prozent

Pro|de|kan *lat.* (Vertreter des Dekans an einer Hochschule)

pro do|mo [auch: - *do...*] *lat.* (,,für das [eigene] Haus''; in eigener Sache; zum eigenen Nutzen, für sich selbst); - reden

Pro|drom *gr. s;* -s, -e, **Pro|dro|mal|sym|ptom** (Med.: Vorbote, Vorläufer einer Krankheit)

Pro|du|cer *engl.* [*prodjußᵉr*] (engl. Bez. für: Hersteller, Fabrikant, [Film]produzent; Regisseur) *m;* -s, -; **Pro|dukt** *lat.* (Erzeugnis; Ertrag; Folge, Ergebnis [Math.: der Multiplikation]) *s;* -[e]s, -e; **Pro|duk|ten.bör|se** (Güterbörse), **...han|del, ...markt; Pro|duk|ti|on** [...*zion*] (Herstellung, Erzeugung); **Pro|duk|ti|ons..an|la|gen** (*Mehrz.*), **...ap|pa|rat, ...aus|fall, ...ba|sis, ...be|ra|tung, ...bri|ga|de** (DDR), **...er|fah|rung, ...fak|tor, ...form, ...gang, ...ge|nos|sen|schaft, ...ge|win, ...ka|pa|zi|tät, ...kol|lek|tiv** (DDR), **...ko|sten** (*Mehrz.*), **...kraft, ...lei|stung, ...men|ge, ...me|tho|de, ...mit|tel** *s,* **...plan** (vgl. ²Plan), **...pro|gramm, ...pro|zeß, ...stät|te, ...stei|ge|rung, ...ver|fah|ren, ...vo|lu|men, ...wei|se, ...wert, ...zahl, ...zeit, ...zif|fer, ...zweig; pro|duk|tiv** (ergiebig; fruchtbar, schöpferisch); **Pro|duk|ti|vi|tät** [...*wi...*] *w;* -; **Pro-**

duk|ti|vi|täts_ef|fekt, ...ren|te (Rente, die der wirtschaftl. Produktivität angepaßt wird), ...stei|ge|rung, ...stu|fe; Pro|duk|tiv_kraft, ...kre|dit (Kredit, der Unternehmen der gewerbl. Wirtschaft zur Errichtung von Anlagen od. zur Bestreitung der laufenden Bestriebsausgaben gewährt wird); Pro|du|zent (Hersteller, Erzeuger); ↑ R 268; produ|zie|ren ([Güter] hervorbringen, [er]zeugen, schaffen); sich - (sich darstellerisch vorführen, sich sehen lassen)

Prof. = Professor

pro|fan lat. (unheilig, weltlich; alltäglich); Pro|fa|na|ti|on [...zion], Pro|fa|nie|rung (Entweihung); Pro|fan|bau (Kunstgesch.: nichtkirchl. Bauwerk; Ggs.: Sakralbau); Pro|fa|ne (Unheilige[r], Ungeweihte[r]) m u. w; -n, -n (↑ R 287ff.); pro|fa|nie|ren (entweihen); Pro|fa|nie|rung vgl. Profanation; Pro|fa|ni|tät (Unheiligkeit, Weltlichkeit; Alltäglichkeit) w; -

pro|fa|schi|stisch (sich für den Faschismus einsetzend)

¹Pro|feß lat. (Mitglied eines geistl. Ordens nach Ablegung der Gelübde) m; ...fessen, ...fessen (↑ R 268); ²Pro|feß (Ablegung der [Ordens]gelübde) w; -, ...fesse; Pro|feß|haus; Pro|fes|si|on fr. (veralt. für: Beruf; Gewerbe); Pro|fes|sio|nal [in engl. Ausspr.: profäschenel] (Berufssportler; Kurzw.: Profi) m; -s, -e u. (bei engl. Ausspr.: -) -s; pro|fes|sio|na|li|sie|ren (zum Beruf machen, als Erwerbsquelle ansehen); pro|fes|sio|na|li|sie|rung; Pro|fes|sio|na|lis|mus lat. (Berufssportlertum); pro|fes|sio|nell fr. (berufsmäßig); pro|fes|sio|niert (selten für: gewerbsmäßig); Pro|fes|sio|nist (österr., sonst nur mdal. für: Handwerker, Facharbeiter); ↑ R 268; pro|fes|si|ons|mä|ßig; Pro|fes|sor lat. (Hochschullehrer; Titel für verdiente Lehrkräfte, Forscher u. Künstler; österr. auch: definitiv angestellter Lehrer an höheren Schulen; Abk.: Prof.) m; -s, ...oren; ordentlicher öffentlicher Professor (Abk.: o. ö. Prof.); ordentlicher Professor (Abk.: o. P.); außerordentlicher Professor (Abk.: ao., a. o. Prof.); ein emeritierter Professor; pro|fes|so|ral (professorenhaft, würdevoll); Pro|fes|so|ren_aus|tausch, ...kol|le|gi|um; pro|fes|so|ren|mä|ßig; Pro|fes|so|ren|schaft (Gesamtheit der Professoren einer Hochschule); Pro|fes|so|ren|ti|tel, Pro|fes|sor|ti|tel; Pro|fes|so|rin [auch:

profäß...] (im Titel u. in der Anrede: Frau Professor) w; -, -nen; Pro|fes|sors_frau, ...wit|we; Pro|fes|sor|ti|tel, Pro|fes|so|ren|ti|tel; Pro|fes|sur (Lehrstuhl, -amt) w; -, -en; Pro|fi (Kurzw. für: Professional) m; -s, -s; Pro|fi|bo|xer

Pro|fil it.(-fr.) (Seitenansicht; Längs- od. Querschnitt; Riffelung bei Gummireifen) s; -s, -e; ein geologisches - (senkrechter Schnitt); Pro|fil_bild, ...ei|sen; pro|fi|lie|ren (im Querschnitt darstellen); sich -; pro|fi|liert (auch: gerillt, geformt; scharf umrissen; von ausgeprägter Art); Pro|fi|lie|rung; pro|fil_los, -este (↑ R 292); Pro|fil_neu|ro|se (seel. Zustand, in dem man sich in übertriebener Weise um die Profilierung der eigenen Persönlichkeit sorgt), ...soh|le, ...stahl (Technik), ...tiefe

Pro|fit lat. (Nutzen; Gewinn; Vorteil) m; -[e]s, -e; pro|fi|ta|bel (veralt. für: gewinnbringend); -ables Geschäft; pro|fit|brin|gend; ein -es Geschäft, aber (↑ R 142): großen Profit bringend; Pro|fit|chen, Pro|fit|lein (meist für: nicht ganz ehrlicher Gewinn); Pro|fi|teur fr. [...ör] m; -s, -e; Pro|fit|gier; pro|fi|tie|ren (Nutzen ziehen); Pro|fit|jä|ger; Pro|fit|lein vgl. Profitchen; pro|fit|lich mdal. (sparsam; nur auf eigenen Vorteil bedacht); Pro|fit_ma|cher, ...ra|te, ...stre|ben

pro for|ma lat. (der Form wegen, zum Schein); Pro-for|ma-An|kla|ge (↑ R 155)

Pro|fos niederl. ("Vorgesetzter"; früher: Verwalter der Militärgerichtsbarkeit, Stockmeister) m; -es u. -en, -e[n] (↑ R 268)

pro|fund lat. (tief, tiefgründig; gründlich; Med.: tiefliegend); Pro|fun|di|tät; pro|fus (Med.: verschwenderisch, stark); -este (↑ R 292)

pro|gam gr. (Med., Biol.: vor der Befruchtung [festgelegt])

Pro|ge|ne|se gr. (Med.: vorzeitige Geschlechtsentwicklung); Pro|ge|ni|tur lat. (Nachkommen[schaft]) w; -, -en

Pro|gno|se gr. (Vorhersage [des Krankheitsverlaufes, des Wetters usw.]) w; -, -n; die ärztliche -; Pro|gno|stik (Lehre von der Prognose) w; -; Pro|gno|sti|kon, Pro|gno|sti|kum (Vorzeichen) s; -s, ...ken u. ...ka; pro|gno|sti|zie|ren (vorhersagend); pro|gno|sti|zie|rung

Pro|gramm gr. (Plan; Darlegung von Grundsätzen; Ankündigung[sschrift] einer höheren Schule, Hochschule]; gelehrte Abhandlung; Spiel-, Sende-

Fest-, Arbeits-, Vortragsfolge; Lehrplan; Tagesordnung; bei elektron. Rechenanlagen: Rechengang, der der Maschine eingegeben wird) s; -s, -e; ein künstlerisches -; ein neues -; das kulturelle - einer Stadt; Pro|gramm_än|de|rung; pro|gramm|mä|ßig [Trenn. ...gramm|mä..., ↑ R 236]; Pro|gramm|ma|tik (Zielsetzung, -vorstellung); Pro|gram|ma|ti|ker pro|gram|ma|tisch (dem Programm gemäß; einführend; richtungweisend; vorbildlich); Pro|gramm_fol|ge; pro|gramm_fül|lend; Pro|gramm|fül|ler (Fernsehen: Kurzfilm, der eingesetzt werden kann, um Lücken im Programm zu füllen); Pro|gramm_ge|mäß; Pro|gramm|ge|stal|tung pro|gramm|ge|steu|ert; Pro|gramm_heft, ...zet|tel; pro|gram|mier|bar; Pro|gram|mie|rer (Datenverarbeitung); pro|gram|mie|ren (auf ein Programm setzen; für elektron. Rechenmaschinen ein Programm aufstellen, d. h. die Maschine mit Instruktionen versehen); Pro|gram|mie|rer (Fachmann für die Erarbeitung u. Aufstellung von Schaltungen u. Ablaufplänen elektron. Datenverarbeitungsmaschinen); Pro|gram|mie|rung Pro|gramm|punkt; Pro|gram|mu|sik [Trenn. ...gramm|mu..., ↑ R 236] w; -; Pro|gramm_steue|rung (automat. Steuerung), ...vor|schau

Pro|greß lat. (Fortschritt) m; ...gresses, ...gresse; Pro|gres|si|on (Fortschreiten, [Stufen]folge; Steigerung; Reihe [von math. Größen]); arithmetische - pro metrische -; Pro|gres|sis|mus (Fortschrittsdenken) m; -; Pro|gres|sist (Anhänger einer Fortschrittspartei); ↑ R 268; pro|gres|si|stisch; pro|gres|siv fr. (stufenweise fortschreitend, sich entwickelnd; fortschrittlich); Pro|gres|si|vi|st (↑ R 268); Pro|gres|siv|steu|er w

Pro|gym|na|si|um (Gymnasium ohne Oberstufe)

pro|hi|bie|ren lat. (veralt. für: verhindern; verbieten); Pro|hi|bi|ti|on [...zion] (Verbot von Alkoholherstellung u. -abgabe, Trockenlegung; veralt. für: Verhinderung); pro|hi|bi|tio|nist (↑ R 268 pro|hi|bi|tiv (verhindernd, abhaltend, vorbeugend); Pro|hi|bi|tiv_maß|re|gel, ...sy|stem, ...zo (Sperr-, Schutzzoll); Pro|hi|bi|to|ri|um (veralt. für: Aus- u. Einfuhrverbot für bestimmte Waren) s; -s, ...ien [...ien]

Pro|jekt lat. (Plan[ung], Entwur

Vorhaben) s; -[e]s, -e; Pro|jek|tant (Planer) m; -en, -en († R 268); Pro|jek|ten|ma|cher (ugs.); Pro|jekt|grup|pe (Arbeitsgruppe, die sich für ein bestimmtes Projekt einsetzt); pro|jek|tie|ren; Pro|jek|tie|rung; Pro|jek|til *fr.* (Geschoß) s; -s, -e; Pro|jek|ti|on *lat.* [...*zion*] (Darstellung auf einer Fläche; Vorführung mit dem Bildwerfer); Pro|jek|ti|ons_ap|pa|rat (Bildwerfer), ...ebe|ne (Math.), ...lam|pe, ...schirm, ...ver|fah|ren, ...wand; Pro|jekt|kun|de (gezielte Unterweisung) w; -; Pro|jek|tor (Bildwerfer) m; -s, ...oren; pro|ji|zie|ren (auf einer Fläche darstellen; mit dem Bildwerfer vorführen); Pro|ji|zie|rung

Pro|ke|leus|ma|ti|kus *gr.* (aus vier Kürzen bestehender antiker Versfuß) m; -, ...zi

Pro|kla|ma|ti|on *lat.* [...*zion*] (amtl. Bekanntmachung, Verkündigung; Aufruf); pro|kla|mie|ren; Pro|kla|mie|rung

Pro|kli|se, Pro|kli|sis [auch: *pro*...] *gr.* (Sprachw.: Anlehnung eines unbetonten Wortes an das folgende betonte; Ggs.: Enklise) w; -, ...klisen; Pro|kli|ti|kon (unbetontes Wort, das sich an das folgende betonte anlehnt, z. B. „und 's Mädchen [= das Mädchen] sprach") s; -s, ...ka; pro|kli|tisch

Pro|ko|fjew, Sergei (russ. Komponist)

Pro|kon|sul *lat.* [auch: *pro*...] (gewesener Konsul; Statthalter einer röm. [senator.] Provinz); Pro|kon|su|lat [auch: *pro*...] (Amt des Prokonsuls; Statthalterschaft)

Pro|kop, Pro|ko|pi|us (byzant. Geschichtsschreiber)

pro Kopf; Pro-Kopf-Ver|brauch († R 155)

Pro|kru|stes (Gestalt der gr. Sage); Pro|kru|stes|bett; † R 180 (gewaltsame Einengung; Schema, in das jmd. od. etwas nicht hineinpaßt)

Prokt|al|gie *gr.* (Med.: neuralg. Schmerzen in After u. Mastdarm) w; -, ...ien; Prok|ti|tis (Mastdarmentzündung) w; -, ...itiden; Prok|to|lo|ge (Facharzt für Erkrankungen im Bereich des Mastdarms) m; -n, -n; † R 268; Prok|to|lo|gie; prok|to|lo|gisch; Prok|to|spas|mus (Krampf des Afterschließmuskels) m; -, ...men; Prok|to|sta|se (Kotzurückhaltung im Mastdarm) w; -

Pro|ku|ra|tur-it- (Handlungsvollmacht; Recht, den Geschäftsinhaber zu vertreten) w; -, ...ren; in Prokura; vgl. per procura; Pro|ku|ra|ti|on *lat.* [...*zion*] (Stellvertretung durch einen Bevollmächtigten; Vollmacht); Pro|ku|ra|tor (Statthalter einer röm. Provinz; hoher Staatsbeamter der Republik Venedig; bevollmächtigter Vertreter einer Person im kath. kirchl. Prozeß; Wirtschafter eines Klosters) m; -s, ...oren; Pro|ku|ra|zi|en [...*i*ⁿ*n*, it. Betonung: ...*i*ⁿ*n*] (Palast der Prokuratoren in Venedig) *Mehrz.*; Pro|ku|rist (Inhaber einer Prokura); † R 268; Pro|ku|ri|sten|stel|le

Pro|ky|on *gr.* [auch: *pro*...] (ein Stern) m; -[s]

Pro|laps *lat.* m; -es, -e u. Pro|lap|sus (Med.: Vorfall, Heraustreten von inneren Organen) m; -, -

Pro|le|go|me|na *gr.* [auch: ...*gom*...] (veralt. für: einleitende Vorbemerkungen, Vorwort) *Mehrz.*

Pro|lep|se, Pro|lep|sis *gr.* [auch: *prol*..., *prol*..., *proleg*...] (Reth.: Vorwegnahme eines Satzgliedes) w; -, ...lepsen [auch: ...*le*...]; pro|lep|tisch (vorgreifend; vorwegnehmend)

Pro|let *lat.* (ungebildeter, ungehobelter Mensch) m; -en, -en († R 268); Pro|le|ta|ri|at (Gesamtheit der Proletarier) s; -[e]s, -e; Pro|le|ta|ri|er [...*i*ⁿ*r*] (Angehöriger der wirtschaftlich unselbständigen, besitzlosen Klasse) m; -s, -; pro|le|ta|risch; pro|le|ta|ri|sie|ren (zu Proletariern machen); Pro|le|ta|ri|sie|rung w; -

¹Pro|li|fe|ra|ti|on *lat.* [...*zion*] (Med.: Sprossung, Wucherung); ²Pro|li|fe|ra|tion *engl.-amerik.* [*prolif*ⁿ*r*ᵉ*sch*ⁿ*n*] (Weitergabe [von Atomwaffen]) w; -; pro|li|fe|rie|ren *lat.* (Med.: sprossen, wuchern)

pro lo|co *lat.* [auch: - *loko*] (veralt. für: für den Platz, für die Stelle)

Pro|log *gr.* (Einleitung; Vorspruch, -wort, -spiel, -rede) m; -[e]s, -e

pro me|mo|ria *lat.* (zum Gedächtnis; Abk.: p.m.); Pro|me|mo|ria (veralt. für: Denkschrift; Merkzettel) s; -s, ...ien [...*i*ⁿ*n*] u. -s

Pro|me|na|de *fr.* (Spaziergang, -weg); *Schreibung in Straßennamen*: † R 219ff.; Pro|me|na|den_deck, ...mi|schung (ugs. scherzh. für: nicht reinrassiger Hund), ...weg; pro|me|nie|ren (spazierengehen)

Pro|mes|se *fr.* (Schuldverschreibung; Urkunde, in der eine Leistung versprochen wird) w; -, -n; Pro|mes|sen|ge|schäft

pro|me|the|isch *gr.*; † R 179 (auch: himmelstürmend); -es Ringen; Pro|me theus [...*theuß*] (gr. Sagengestalt); Pro|me|thi|um (chem. Grundstoff, Metall; Zeichen: Pm) s; -s

pro mil|le *lat.* (für tausend, für das Tausend, vom Tausend; Abk.: p. m., v. T.; Zeichen: ‰); Pro|mil|le (das Vomtausend) s; -[s], -; 2 - († R 322); Pro|mil|le_gren|ze, ...satz (Vomtausendsatz)

pro|mi|nent *lat.* (hervorragend, bedeutend, maßgebend); Pro|mi|nen|te (hervorragende, bedeutende Persönlichkeit; Tagesgröße) m u. w; -n, -n († R 287ff.); Pro|mi|nenz (Gesamtheit der Prominenten; veralt. für: [hervorragende] Bedeutung) w; -; Pro|mi|nen|zen (hervorragende Persönlichkeiten) *Mehrz.*

pro|mis|cue *lat.* [...*ku-e*] (selten für: vermengt, durcheinander); Pro|mis|kui|tät (Vermischung; häufig wechselnder Geschlechtsverkehr [ohne eheliche Bindung] w; -; pro|mis|kui|tiv

pro|mis|so|risch *lat.* (Rechtsw. veralt. für: versprechend); -er Eid (vor der Aussage geleisteter Eid); Pro|mit|tent (Rechtsw. veralt. für: Versprechender); † R 268; pro|mit|tie|ren (Rechtsw. veralt.)

Pro|mo|ter *engl.* [...*m*ⁿ*t*ᵉ*r*] (Veranstalter von Berufssportwettkämpfen) m; -s, -; ¹Pro|mo|ti|on *lat.* [...*zion*] („Beförderung" [zur Doktorwürde]; - sub auspiciis [praesidentis] (österr.: Ehrenpromotion in Anwesenheit des Bundespräsidenten); ²Pro|mo|tion *amerik.* [*promo*ᵘ*sch*ᵉ*n*] (Wirtsch.: Absatzförderung durch gezielte Werbemaßnahmen) w; -; Pro|mo|tor *lat.* (Förderer, Manager) m; -en, -en († R 268); pro|mo|vie|ren [...*wir*ⁿ*n*] (zur Doktorwürde befördern; die Doktorwürde erlangen); ich habe promoviert; ich bin [von, an der Hochschule zu ...] promoviert worden

prompt (unverzüglich; schlagfertig; pünktlich; sofort; rasch); -e (schnelle) Bedienung; Prompt|heit w; -

Pro|mul|ga|ti|on *lat.* [...*zion*] (Verbreitung, Veröffentlichung [eines Gesetzes]); pro|mul|gie|ren

Pro|no|men *lat.* (Sprachw.: Fürwort, z. B. „ich, mein") s; -s u. ältere: ...mina; pro|no|mi|nal (fürwörtlich); Pro|no|mi|nal_ad|jek|tiv (Sprachw.: unbestimmtes Für- od. Zahlwort, nach dem das

folgende [hauptwörtlich ge-
brauchte] Eigenschaftswort wie
nach einem Fürwort oder wie
nach einem Eigenschaftswort ge-
beugt wird, z. B. „manche":
„manche geeignete [auch noch:
geeigneten] Einrichtungen"; zu
den einzelnen Pronominaladjek-
tiven ↑ R 277ff.), ...ad|verb
(Sprachw.: Umstandswort, das
für eine Fügung aus Verhältnis-
wort u. Fürwort steht, z. B. „dar-
über" = „über das" od. „über
es")
pro|non|cie|ren *fr.* [...nongßir^en]
(veralt. für: aussprechen; scharf
betonen); pro|non|ciert
Pro|ömi|um *gr.* (Vorrede; Einlei-
tung) s; -s, ...ien [...i^en]
Pro|pä|deu|tik *gr.* (Einführung in
die Vorkenntnisse, die zu einem
Studium gehören) w; -; Pro|pä-
deu|ti|kum *schweiz.* (medizin.
Vorprüfung) s; -s, ...ka; pro|pä-
deu|tisch
Pro|pa|gan|da *lat.* (Werbung für
polit. Grundsätze, kulturelle Be-
lange u. wirtschaftl. Zwecke)
w; -; Pro|pa|gan|da-ap|pa|rat,
...chef, ...feld|zug, ...film, ...lü|ge,
...ma|te|ri|al, ...schrift, ...sen-
dung; pro|pa|gan|da|wirk|sam;
Pro|pa|gan|dist (jmd., der Pro-
paganda treibt, Werber); ↑ R 268;
pro|pa|gan|di|stisch; Pro|pa|ga-
ti|on [...zion] (Biol.: Fortpflan-
zung, Vermehrung); pro|pa|gie-
ren (verbreiten, werben für et-
was); Pro|pa|gie|rung
Pro|pan *gr.* (ein Brenn-, Treibgas)
s; -s; Pro|pan|gas
Pro|par|oxy|to|non *gr.* (gr.
Sprachw.: auf der drittletzten Sil-
be mit dem scharfen Tonzeichen
[Akut] versehenes Wort) s; -s,
...tona
Pro|pel|ler *engl.* (Antriebsschrau-
be bei Schiffen od. Flugzeugen)
m; -s, -; Pro|pel|ler-an|trieb,
...flug|zeug, ...tur|bi|ne
Pro|pen vgl. Propylen
pro|per *fr.* (eigen, sauber; nett);
vgl. propre; Pro|per|ge|schäft
(Wirtsch.: Eigengeschäft, Ge-
schäft für eigene Rechnung)
Pro|pe|ri|spo|me|non *gr.* (gr.
Sprachw.: auf der vorletzten Sil-
be mit einem Dehnungszeichen
[Zirkumflex] versehenes Wort) s;
-s, ...mena
Pro|phet *gr.* (Weissager, Seher;
Mahner) m; -en, -en (↑ R 268);
ein falscher = ein guter -, aber
(↑ R 224): die Großen Propheten
(z. B. Isaias), die Kleinen Prophe-
ten (z. B. Hosea); Pro|phe|ten-
ga|be w; -; Pro|phe|tie (Weissagung)
w; -, ...ien; Pro|phe|tin w; -, -nen;
pro|phe|tisch (seherisch, weissa-
gend, vorausschauend); -ste (↑ R
294); pro|phe|zei|en (weis-, vor-
aussagen); er hat prophezeit (↑ R
304); Pro|phe|zei|ung
Pro|phy|lak|ti|kum *gr.* (Med.: vor-
beugendes Mittel) s; -s, ...ka; pro-
phy|lak|tisch (vorbeugend, ver-
hütend); Pro|phy|la|xe (Vorbeu-
gung, [Krankheits]verhütung) w;
-, -n
Pro|po|nent *lat.* (veralt. für: An-
tragsteller); ↑ R 268; pro|po|nie-
ren
Pro|pon|tis *gr.* (Marmarameer)
w; -
Pro|por|ti|on *lat.* [...zion] ([Grö-
ßen]verhältnis; Eben-, Gleich-
maß; Math.: Verhältnisglei-
chung); pro|por|tio|nal (verhält-
nismäßig; in gleichem Verhältnis
stehend; entsprechend); Pro|por-
tio|na|le (Math.: Glied einer Ver-
hältnisgleichung) w; -, -n; drei -[n]
(↑ R 291); mittlere -; Pro|por|tio-
na|li|tät (Verhältnismäßigkeit,
richtiges Verhältnis); Pro|por-
tio|nal|wahl (Verhältniswahl);
pro|por|tio|niert (im [rechten]
Verhältnis stehend; ebenmäßig,
wohlgebaut); Pro|por|tio|niert-
heit w; -; Pro|por|ti|ons|glei-
chung; Pro|porz bes. österr. u.
schweiz. (Verhältniswahlsystem,
Verteilung von Sitzen u. Ämtern
nach dem Stimmenverhältnis
bzw. dem Verhältnis der Partei-
oder Konfessionszugehörig-
keit) m; -es, -e; Pro|porz.den|ken
(abschätzig), ...wahl (Verhältnis-
wahl)
Pro|po|si|ti|on *lat.* [...zion] (Aus-
schreibung bei Pferderennen;
veralt. für: Vorschlag, Antrag);
Pro|po|si|tum (veralt. für: Äuße-
rung, Rede) s; -s, ...ta
Prop|pen *niederd.* (Pfropfen) m;
-s, -; prop|pen|voll (ugs. für: ganz
voll; übervoll)
Pro|prä|tor (gewesener Prätor;
röm. Provinzstatthalter)
pro|pre *fr.* proper: Pro|pre|ge-
schäft vgl. Propergeschäft; Pro-
pre|tät *fr.* (veralt., aber noch
mdal. für: Reinlichkeit, Sauber-
keit) w; -; Pro|prie|tär [...pri-e...]
(veralt. für: Eigentümer) m; -s,
-e; Pro|prie|tät (veralt. für: Eigen-
tum); Pro|prie|täts|recht; Pro-
pri|um *lat.* [auch: pro...] (Bez. für
die wechselnden Texte u. Gesän-
ge der kath. Messe) s; -s
Propst *lat.* („Vorgesetzter"; Klo-
ster-, Stiftsvorsteher; Superin-
tendent) m; -[e]s, Pröpste; Propst-
ei (Amt, Sprengel, Wohnung ei-
nes Propstes); Pröp|stin w; -, -nen
pro|pul|siv *lat.* (Med.: nach vor-
wärts stolpernd [von Gei-
steskranken])
Pro|pusk *russ.* [auch: ...pußk]
(russ. Bez. für: Passierschein,
Ausweis) m; -s, -e
Pro|py|lä|en *gr.* (Vorhalle eines
Tempel; übertr. für: Zugang,
Eingang) Mehrz.
Pro|py|len, Pro|pen *gr.* (gasförmi-
ger ungesättigter Kohlenwasser-
stoff) s; -s
Pro|rek|tor *lat.* [auch: proräk...]
(Vorgänger u. Stellvertreter des
amtierenden Rektors an Hoch-
schulen); Pro|rek|to|rat (Amt u.
Würde eines Prorektors)
Pro|ro|ga|ti|on *lat.* [...zion] (Auf-
schub, Vertagung, Verlänge-
rung); pro|ro|ga|tiv (aufschie-
bend); pro|ro|gie|ren
Pro|sa *lat.* (Rede [Schrift] in un-
gebundener Form; übertr. für:
Nüchternheit) w; -; gereimte -;
Pro|sa|dich|tung; Pro|sa|iker
(nüchterner Mensch; älter für:
Prosaist); pro|sa|isch (in Prosa
[abgefaßt]; übertr. für: nüch-
tern); -ste (↑ R 294); Pro|sa|ist
(Prosa schreibender Schriftstel-
ler); ↑ R 268; Pro|sa.schrift|stel-
ler, ...werk
Pro|sek|tor *lat.* [auch: prosäk...]
(„Vorschneider"; Arzt, der Sek-
tionen durchführt; Leiter der pa-
thologischen Abteilung eines
Krankenhauses) m; -s, ...oren;
Pro|sek|tur (Abteilung eines
Krankenhauses, in der Sektionen
durchgeführt werden) w; -, -en
Pro|se|ku|ti|on *lat.* [...zion]
(Rechtsw. selten für: Verfolgung;
gerichtliche Belangung); Pro|se-
ku|tor (Rechtsw. selten für: Ver-
folger, Ankläger) m; -s, ...oren
Pro|se|lyt *gr.* (urspr.: ein zum Ju-
dentum übergetretener Heide;
Neubekehrter) m; -en, -en (↑ R
268); Pro|se|ly|ten.ma|cher (ab-
schätzig)
Pro|se|mi|nar *lat.* (Vorseminar,
einführende Übung an der Hoch-
schule)
Pro|ser|pi|na (lat. Form von: Per-
sephone)
pro|sit!, prost! *lat.* („es möge nüt-
zen"; wohl bekomm's!); pros[i]t
Neujahr!; pros[i]t allerseits!;
prost Mahlzeit! (ugs.); Pro|sit s;
-s, -s u. Pro|st (Zutrunk) s; -[e]s,
-e; ein - dem Gastgeber, der Ge-
mütlichkeit!
pro|skri|bie|ren *lat.* (ächten); Pro-
skrip|ti|on [...zion] (Ächtung)
Pros|odie *gr.* (Silbenmessungs-
lehre; Lehre von der metrisch-
rhythmischen Behandlung der
Sprache) w; -, ...ien; Pros|odik
(seltener für: Prosodie); pros|odisch
pro|so|wje|tisch (sich für die So-
wjets einsetzend)

Pro|spekt *lat.* (Werbeschrift; Ansicht [von Gebäuden, Straßen u. a.]; Bühnenhintergrund; Pfeifengehäuse der Orgel) *m* (österr. auch: *s*); -[e]s, -e; **pro|spek|tie|ren**; **Pro|spek|tie|rung**, **Pro|spek|ti|on** (Erkundung nutzbarer Bodenschätze; Form der Drucksachenwerbung; Herausgabe der Lageberichts einer Unternehmung vor einer Wertpapieremission); **pro|spek|tiv** (der Aussicht, Möglichkeit nach); **Pro|spek|tor** (jmd., der Bodenschätze erkundet) *m*; -s, ...oren

pro|spe|rie|ren *lat.* (gedeihen, vorankommen); **Pro|spe|ri|tät** (Wohlstand, wirtschaftl. Aufschwung, [Wirtschafts]blüte) *w*; -

Pro|sper|mie *gr.* (Med.: vorzeitiger Samenerguß) *w*; -, ...ien

prost! vgl. prosit!; **Prost** vgl. Prosit

Pro|sta|ta *gr.* (Vorsteherdrüse) *w*; -; **Pro|sta|ti|tis** (Med.: Entzündung der Vorsteherdrüse) *w*; -, ...itiden

pro|sten; **Prö|ster|chen!** (ugs.)

pro|sti|tu|ie|ren *lat.* (veralt. für: bloßstellen); sich - (sich preisgeben); **Pro|sti|tu|ier|te** (Dirne) *w*; -n, -n († R 287 ff.); **Pro|sti|tu|ti|on** *fr.* [...zion] (gewerbsmäßige Unzucht; Dirnenwesen) *w*; -

Pro|stra|ti|on *lat.* [...zion] (Niederwerfung, Fußfall; Med.: Erschöpfung, Entkräftung)

Pro|sze|ni|um *gr.* (vorderster Teil der Bühne, Vorbühne) *s*; -s, ...ien [...iᵉn]; **Pro|sze|ni|ums|lo|ge** (Bühnenloge)

prot. = protestantisch

Pro|tac|ti|ni|um *gr.* (radioaktiver chem. Grundstoff, Metall; Zeichen: Pa) *s*, -s

pro|tago|nist *gr.* (altgr. Theater: erster Schauspieler; übertr.: Vorkämpfer) *m*; -en, -en († R 268)

pro|tan|drie *gr.* (Reifwerden der männlichen Geschlechtsprodukte zwittriger Tiere u. Pflanzen vor den weiblichen; Ggs.: Protogynie) *w*; -; **prot|an|drisch** (die Protandrie betreffend)

pro|te|gé *fr.* [...teschᵉ] (Günstling; Schützling) *m*; -s, -s; **pro|te|gie|ren** [...teschirᵉn]

pro|te|id *gr.* (mit anderen chem. Verbindungen zusammengesetzter Eiweißkörper) *s*; -[e]s, -e; **Pro|te|in** (einfacher Eiweißkörper) *s*; -s, -e

pro|te|isch (in der Art des ¹Proteus, wandelbar, unzuverlässig)

pro|tek|ti|on *lat.* [...zion] (Gönnerschaft; Förderung; Schutz); **Pro|tek|tio|nis|mus** (schutzzöllnerische Wirtschaftspolitik; Günstlingswirtschaft) *m*; -; **Pro|tek|tio|nist** († R 268); **pro|tek|tio|ni-**

stisch; **Pro|tek|tor** (Beschützer; Förderer; Schutz-, Schirmherr; Ehrenvorsitzender) *m*; -s, ...oren; **Pro|tek|to|rat** (Schirmherrschaft; Schutzherrschaft; das unter Schutzherrschaft stehende Gebiet) *s*; -[e]s, -e

Pro|test *lat.-it.* (Einspruch, Verwahrung; [beurkundete] Verweigerung der Annahme od. der Zahlung eines Wechsels od. Schecks) *m*; -[e]s, -e; zu - gehen (von Wechseln); **Pro|test|ak|ti|on**; **Pro|te|stant** *lat.* ("Einspruch Erhebender"; Angehöriger des Protestantismus) *m*; -en, -en († R 268); **Pro|te|stan|tin** *w*; -, -nen; **pro|te|stan|tisch** (Abk.: prot.); **Pro|te|stan|tis|mus** (Gesamtheit der auf die Reformation zurückgehenden ev. Kirchengemeinschaften) *m*; -; **Pro|te|sta|ti|on** [...zion] (veralt. für: Protest); **Pro|test|be|we|gung**, ...de|mon|stra|ti|on, ...er|klä|rung, ...hal|tung; **pro|te|stie|ren** (Einspruch erheben, Verwahrung einlegen); einen Wechsel - (Nichtzahlung od. Nichtannahme eines rechtzeitig vorgelegten Wechsels beurkunden [lassen]); **Pro|test|kund|ge|bung**, ...marsch *m*, ...no|te, ...ruf, ...sän|ger, ...schrei|ben, ...song, ...streik, ...sturm, ...ver|samm|lung, ...wel|le

¹**Pro|teus** [...teuß, auch: ...te-uß] (verwandlungsfähiger gr. Meergott); ²**Pro|teus** (wetterwendischer Mensch; Gattung der Olme) *m*; -, -; **pro|teus|haft**

Prot|evan|ge|li|um vgl. Protoevangelium

Pro|the|se *gr.* (Ersatzglied; Zahnersatz; Sprachw.: Bildung eines neuen Lautes am Wortanfang) *w*; -, -n; **Pro|the|sen|trä|ger**; **pro|the|tisch** (ersetzend)

Pro|tist *gr.* (einzelliges Lebewesen, Einzeller); † R 268

Pro|to|evan|ge|li|um *gr.* (erste Verkündigung des Erlösers [1. Mose, 3, 15])

pro|to|gen *gr.* (Geol.: am Fundort entstanden [von Erzlagern]); **pro|to|gyn** (die Protogynie betreffend); **Pro|to|gy|nie** (Reifwerden der weiblichen Geschlechtsprodukte zwittriger Tiere u. Pflanzen vor den männlichen; Ggs.: Protandrie) *w*; -

Pro|to|koll *gr.* (förml. Niederschrift, Tagungsbericht; Beurkundung einer Aussage, Verhandlung u. a.; Gesamtheit der im diplomat. Verkehr gebräuchl. Formen) *s*; -s, -e; zu - geben; **Pro|to|koll|ab|tei|lung**; **Pro|to|kol|lant** ([Sitzungs]schriftführer) *m*; -en, -en († R 268); **pro|to|kol|la-**

risch (durch Protokoll festgestellt, festgelegt); **Pro|to|koll|be|am|ter**, ...chef, ...füh|rer (Schriftführer); **pro|to|kol|lie|ren** (ein Protokoll aufnehmen; beurkunden); **Pro|to|kol|lie|rung**

Pro|ton *gr.* (positiv geladenes, schweres Elementarteilchen; Wasserstoffkern) *s*; -s, ...onen; **Pro|to|nen|be|schleu|ni|ger**; **Pro|to|no|tar** *gr.; lat.* (Notar der päpstl. Kanzlei; auch: Ehrentitel); **Pro|to|phy|te** *gr.* *w*; -, -n u. **Pro|to|phy|ton** (einzellige Pflanze) *s*; -s, ...yten (meist *Mehrz.*); **Pro|to|plas|ma** ("Urgebilde"; Lebenssubstanz aller pflanzl., tier. u. menschl. Zellen); **Pro|to|typ** [selten: ...tüp] (Muster; Urbild; Inbegriff) *m*; -s, -en; **pro|to|ty|pisch** (urbildlich); **Pro|to|zo|on** (Urtierchen) *s*; -s, ...zoen (meist *Mehrz.*)

pro|tra|hie|ren *lat.* (Med.: verzögern)

Pro|tu|be|ranz *lat.* (stumpfer Vorsprung an Organen, bes. an Knochen; teils ruhende, teils aus dem Sonneninnern aufschießende glühende Gasmasse) *w*; -, -en (meist *Mehrz.*)

Protz (abschätzig für: Angeber; mdal. für: Kröte) *m*; -en u. -es, -e[n] († R 268)

Prot|ze *it.* (Vorderwagen von Geschützen u. a.) *w*; -, -n

prot|zen; du protzt (protzest); **protzen|haft**; **Prot|zen|haf|tig|keit** *w*; -; **Prot|zen|tum** *s*; -s; **Prot|ze|rei**; **prot|zig**; **Prot|zig|keit**

Protz|ka|sten, ...wa|gen

Proust [*prußt*], Marcel [*marßäl*] (fr. Schriftsteller)

Prov. = Provinz

Pro|vence *fr.* [...*wangß*] (fr. Landschaft) *w*; -; **Pro|ven|cer|öl**

Pro|ve|ni|enz *lat.* [...*weniänz*] (Herkunft, Ursprung [von Waren, auch von mittelalterl. Hss.]) *w*; -, -en

Pro|ven|za|le [...*wänßal*ᵉ, auch: ...*wangßal*ᵉ] (Bewohner der Provence) *m*; -n, -n († R 268); **pro|ven|za|lisch**

Pro|verb *lat.* [...*wärp*] *s*; -s, -en u. **Pro|ver|bi|um** (veralt. für: Sprichwort) *s*; -s, ...ien [...iᵉn]; **pro|ver|bi|al**, **pro|ver|bia|lisch**, **pro|ver|bi|ell** (veralt., sprichwörtlich)

Pro|vi|ant *it.* u. *fr.* [...*wi...*] ([Mund]vorrat; Wegzehrung; Verpflegung) *m*; -s, (selten:) -e; **pro|vi|an|tie|ren** (veralt. für: mit Proviant versorgen; dafür heute: verproviantieren); **Pro|vi|ant|wa|gen**

pro|vi|den|ti|ell *fr.* [...*widänziäl*] (veralt. für: von der Vorsehung bestimmt); **Pro|vi|denz** (veralt.

für: Vorsicht; Vorsehung) w; -, -en
Pro|vinz lat. [...winz] (Land[esteil]; größeres staatliches od. kirchliches Verwaltungsgebiet; das Land im Gegensatz zur Hauptstadt; iron. abwertend für: [kulturell] rückständige Gegend; Abk.: Prov.) w; -, -en; Pro|vinz‿be|woh|ner, ...büh|ne; Pro|vin|zi|al (Vorsteher einer Ordensprovinz) m; -s, -e; Pro|vin|zia|le (veralt. für: Provinzbewohner) m; -n, -n (↑ R 268); pro|vin|zia|li|sie|ren; Pro|vin|zia|lis|mus ([auf eine Landschaft beschränkter] vom hochsprachl. Wortschatz abweichender Ausdruck; Engstirnigkeit) m; -, ...men; Pro|vin|zi|al|stadt; pro|vin|zi|ell fr. (die Provinz betreffend; landschaftlich; mundartlich; hinterwäldlerisch); Pro|vinz|ler (iron. abwertend für: Provinzbewohner; [kulturell] rückständiger Mensch); pro|vinz|le|risch; Pro|vinz‿luft, ...stadt, ...thea|ter
Pro|vi|si|on it. [...wi...] (Vergütung [für Geschäftsbesorgung], [Vermittlungs]gebühr, [Werbeanteil]; Pro|vi|si|ons|rei|sen|de; Pro|vi|sor lat. (Verwalter einer Apotheke; früher für: erster Gehilfe des Apothekers; österr.: als Vertreter amtierender Geistlicher) m; -s, ...oren; pro|vi|so|risch (vorläufig); Pro|vi|so|ri|um (vorläufige Einrichtung; Behelfs..., Hilfs...) s; -s, ...ien [...iⁿn]
Pro|vit|amin (Vorstufe eines Vitamins)
Pro|vo [prowo] lat.-niederl. (Vertreter einer [1965 in Amsterdam entstandenen] antibürgerlichen Protestbewegung) m; -s, -s; pro|vo|kant lat.; Pro|vo|ka|teur fr. [prowokatör] (jmd., der provoziert) m; -s, -e; Pro|vo|ka|ti|on [...zion], Pro|vo|zie|rung (Herausforderung; Aufreizung); pro|vo|ka|tiv, pro|vo|ka|to|risch (herausfordernd); pro|vo|zie|ren (herausfordern; aufreizen; hervorlocken, -rufen)
pro|xi|mal lat. (Med.: rumpfwärts, der Körpermitte zu gelegen)
pro|ze|die|ren lat. (veralt. für: zu Werke gehen, verfahren); Pro|ze|dur (Verfahren, [schwierige, unangenehme] Behandlungsweise) w; -, -en
Pro|zent it. ([Zinsen, Gewinn] „vom Hundert", Hundertstel; Abk.: p. c., v. H.; Zeichen: %) s; -[e]s, -e; 5 - (↑ R 322) od. 5 %; vgl. Fünfprozentklausel; ...zen|tig (z. B. fünfprozentig [mit Ziffer: 5prozentig]; 5%ige od. 5%-Anleihe usw.); pro|zen|tisch

vgl. prozentual; Pro|zent‿kurs (Börse), ...rech|nung, ...satz (Hundert-, Vomhundertsatz), ...span|ne (Wirtsch.); pro|zen|tu|al, (österr.:) pro|zen|tu|ell (im Verhältnis zum Hundert, in Prozenten ausgedrückt); an einem Unternehmen - beteiligt sein (einen in Prozenten festgelegten Anteil vom Reinertrag erhalten); pro|zen|tua|li|ter (Umstandsw., veralt. für: prozentual); pro|zen|tu|ell vgl. prozentual; pro|zen|tu|ieren (in Prozenten ausdrücken); Pro|zent|wert
Pro|zeß lat. (Vor-, Arbeits-, Hergang, Verlauf, Ablauf; Verfahren; Entwicklung, Vorschreiten; gerichtl. Durchführung von Rechtsstreitigkeiten) m; ...zesses, ...zesse; Pro|zeß‿be|richt, ...tei|lig|te; pro|zeß|be|voll|mäch|tigt; Pro|zeß|be|voll|mäch|tig|te; pro|zeß|fä|hig; Pro|zeß|fä|hig|keit w; -; Pro|zeß|füh|rungs|klau|sel (Versicherungsw.); Pro|zeß‿geg|ner, ...glie|de|rungs|prin|zip (ein Grundsatz industriewirtschaftlicher Organisation); pro|zes|sie|ren (einen Prozeß führen); Pro|zes|si|on ([feierl. kirchl.] Umzug, Umgang, Bitt- od. Dankgang); Pro|zes|si|ons‿kreuz, ...spin|ner (Schmetterling); Pro|zeß‿ko|sten (Mehrz.), ...par|tei, ...rech|ner (besonderer Computer für industrielle Fertigungsabläufe), ...recht; pro|zeß|süch|tig; pro|zes|su|al (auf einen Rechtsstreit bezüglich); Pro|zeß‿ver|fah|ren, ...ver|schlep|pung, ...voll|macht
pro|zöl gr. (Biol.: vom Wirbelknochen: vorn ausgehöhlt)
pro|zyk|lisch (Wirtsch.: einem bestehenden Konjunkturzustand gemäß)
prü|de fr. (zimperlich, spröde [in sittl.-erot. Beziehung])
Pru|de|lei mdal. (Pfuscherei); pru|de|lig, prud|lig (unordentlich); pru|deln mdal. (pfuschen); ich ...[e]le (↑ R 327)
Pru|den|tia [...zia] (w. Vorn.); Pru|den|ti|us (christl.-lat. Dichter)
Prü|de|rie fr. (Zimperlichkeit, Ziererei) w; -, ...ien
prud|lig, pru|de|lig
prüf|bar; Prüf‿au|to|mat, ...be|richt; prü|fen; Prü|fer; Prü|fer|bi|lanz, Prü|fungs|bi|lanz; Prüf‿feld, ...gang, ...ge|rät, ...ko|sten (Mehrz.); Prüf|ling; Prüf‿me|tho|de, ...norm, ...stand, ...stein; Prü|fung; mündliche, schriftliche -; Prü|fungs‿angst, ...ar|beit, ...auf|ga|be, ...be|din|gun|gen (Mehrz.); Prü|fungs|bi|lanz, Prü|fer|bi|lanz; Prü|fungs‿fahrt, ...fra|ge,

...ge|bühr, ...kom|mis|si|on, ...ord|nung, ...strecke [Trenn.: ...strek|ke], ...ter|min, ...un|ter|la|gen (Mehrz.), ...ver|fah|ren, ...ver|merk, ...zeug|nis; Prüf‿ver|fah|ren, ...vor|schrift
¹Prü|gel (Stock) m; -s, -; ²Prü|gel (ugs. für: Schläge) Mehrz.; Prü|ge|lei (ugs.); Prü|gel|kna|be (übertr. für: jmd., der an Stelle des Schuldigen bestraft wird); prü|geln; ich ...[e]le (↑ R 327); sich -; Prü|gel|stra|fe; Prü|gel|sze|ne
Prü|nel|le fr. (entsteinte, getrocknete Pflaume) w; -, -n
Prunk m; -[e]s; Prunk‿bau (Mehrz. ...bauten), ...bett; prun|ken; Prunk‿ge|mach, ...ge|wand; prunk|haft; prunk|lie|bend, aber (↑ R 142): großen Prunk liebend; -ste; prunk|los; -este (↑ R 292); Prunk|lo|sig|keit w; -; Prunk‿saal, ...sit|zung (Karnevalsveranstaltung), ...stück, ...sucht (abwertend; w; -); prunk|süch|tig; ...voll; Prunk|wa|gen
Pru|ri|go lat. (Med.: Juckflechte) m; -s od. w; -; Pru|ri|tus (Med.: Hautjucken) m; -
pru|sten (ugs. für: stark schnauben)
Pruth (l. Nebenfluß der Donau) m; -[s]
Pry|ta|ne gr. (Mitglied in der altgr. Staaten regierenden Behörde) m; -n, -n (↑ R 268); Pry|ta|nei|on s; -s, ...eien; vgl. Prytaneum; Pry|ta|ne|um (Versammlungshaus der Prytanen) s; -s, ...een
PS = Pferdestärke (736 Watt); vgl. auch: h. p.
PS = Postskript[um]
Psa|li|gra|phie gr. (Kunst des Scherenschnittes) w; -; psa|li|gra|phisch
Psalm gr. ([geistl.] Lied) m; -s, -en Psal|men‿dich|ter, ...sän|ger; Psal|mist (Psalmendichter); ↑ R 268; Psalm|odie (Psalmengesang. w; -, ...ien; psalm|odie|ren (Psalmen vortragen; eintönig singen) psalm|odisch (psalmartig; Psal|ter (Buch der Psalmen im A. T. Saiteninstrument; Blättermagen der Wiederkäuer) m; -s, -
Psam|me|tich (Name altägypt. Pharaonen)
PschA = Postscheckamt
pscht!, pst!
pseud..., pseu|do... gr. (falsch...), Pseud..., Pseu|do... (Falsch...)
Pseud|epi|gra|phen (Schriften aus der Antike, die einem Autor fälschlich zugeschrieben wurden) Mehrz.; pseu|do|lo|gisch; Pseu|do|de|kre|ta|len (mittelalter kirchenrechtl. Fälschungen, die man irrtümlich auf den Bischof Isidor von Sevilla zurückführte

Mehrz.; **Pseu|do|lo|gie** (Med.: krankhaftes Lügen) *w*; -, ...ien; **pseu|do|morph** (Pseudomorphose zeigend); **Pseu|do|mor|pho|se** ([Auftreten eines] Mineral[s] in der Kristallform eines anderen Minerals) *w*; -, -n; **pseud|onym** (unter Decknamen [verfaßt]); **Pseud|onym** (Deckname, Künstlername) *s*; -s, -e; **Pseu|do|po|di|um** (Biol.: Scheinfüßchen mancher Einzeller) *s*; -s, ...ien [...*i^en*]; **pseu|do|wis|sen|schaft|lich**

Psi (gr. Buchstabe: Ψ, ψ) *s*; -[s], -s

Psi|lo|me|lan gr. (ein Manganerz) *m*; -s, -e

Psit|ta|ko|se gr. (Med.: Papageienkrankheit) *w*; -, -n

Pso|ria|sis gr. (Med.: Schuppenflechte) *w*; -, ...iasen

PS-stark (↑ R 137 u. R 150)

pst!, pscht!

Psych|agg|ge gr. *m*; -, -n (↑ R 268); **Psych|ago|gik** (Führung Gesunder u. Kranker durch seelische Beeinflussung) *w*; -; **Psych|ago|gin** *w*; -, -nen; **Psy|che** (Seele; österr. für: mit Spiegel versehene Frisiertoilette) *w*; -, -n; **psy|che|de|lisch** (in einem [durch Rauschmittel hervorgerufenen] euphorischen, tranceartigen Gemütszustand befindlich; Glücksgefühle hervorrufend); -e Mittel; **Psychi|a|ter** (Nerven-, Irrenarzt; Arzt für Gemütskranke) *m*; -s, -; **Psych|ia|trie** (Lehre von den seelischen Störungen, von den Geisteskrankheiten; österr. auch: psychiatrische Klinik) *w*; -; **psych|ia|trie|ren** (österr.: von einem Psychiater in bezug auf den Geisteszustand untersuchen lassen); **psych|ia|trisch**; **psy|chisch** (seelisch); eine -e Krankheit, Störung; die -e Gesundheit; **Psy|cho|ana|ly|se** (,,Seelengliederung"; Verfahren zur Untersuchung u. Behandlung seelischer Störungen) *w*; -; **Psy|cho|ana|ly|ti|ker** (die Psychoanalyse vertretender od. anwendender Psychologe, Arzt); **psy|cho|ana|ly|tisch**; **Psy|cho|dia|gno|stik** (Lehre von den Methoden zur Erkenntnis u. Erforschung fremden Seelenlebens); **Psy|cho|dra|ma**; **psy|cho|gen** (seelisch bedingt); **Psy|cho|ge|ne|se, Psy|cho|ge|ne|sis** [auch: ...*gén*...] (Entstehung u. Entwicklung der Seele, des Seelenlebens [Forschungsgebiet der Entwicklungspsychologie]) *w*; -, ...nesen; **Psy|cho|gramm** (graph. Darstellung von Fähigkeiten u. Eigenschaften einer Persönlichkeit [z. B. in einem Koordinatensystem]; psycholo-

gische Persönlichkeitsstudie [im Fernsehen od. Film]; *s*; -s, -e; **Psy|cho|graph** (Gerät zum automat. Buchstabieren u. Niederschreiben angeblich aus dem Unbewußten stammender Aussagen) *m*; -en, -en (↑ R 268); **Psy|cho|id** (seelenartiges Gebilde, das Seelenähnliche) *s*; -[e]s; **Psy|cho|ki|ne|se** (seel. Einflußnahme auf Bewegungsvorgänge ohne physikal. Ursache) *w*; -; **Psy|cho|lo|ge** *m*; -n, -n (↑ R 268); **Psy|cho|lo|gie** (Seelenkunde) *w*; -; **psy|cho|lo|gisch** (seelenkundlich); ein -er Roman; **psy|cho|lo|gi|sie|ren** (nach psychologischen Gesichtspunkten untersuchen od. darstellen); **Psy|cho|lo|gi|sie|rung**; **Psy|cho|lo|gis|mus** (Überbewertung der Psychologie als Grundwissenschaft einer Wissenschaft) *m*; -; **Psy|cho|ly|se** (bes. Form der Psychotherapie) *w*; -, -n; **Psy|cho|man|tie** (svw. Nekromantie); **Psy|cho|me|trie** (Messung seel. Vorgänge; Hellsehen durch Betasten von Gegenständen) *w*; -; **Psy|cho|neu|ro|se** (seel. bedingte Neurose) *w*; -, -n; **Psy|cho|path** *m*; -en, -en (↑ R 268); **Psy|cho|pa|thie** (Abweichen des geistig-seel. Verhaltens von der Norm) *w*; -; **Psy|cho|pa|thin** *w*; -, -nen; **psy|cho|pa|thisch**; **Psy|cho|pa|tho|lo|gie** (Lehre von krankhaften Erscheinungen u. deren Ursachen im Seelenleben; Lehre von den durch körperliche Krankheiten bedingten seelischen Störungen); **...phar|ma|kon** (auf die Psyche einwirkendes Arzneimittel), **...phy|sik** (Lehre von den Wechselbeziehungen des Physischen u. des Psychischen); **psy|cho|phy|sisch**; **Psy|cho|se** (Seelenstörung; Geistes- od. Nervenkrankheit) *w*; -, -n; **Psy|cho|so|ma|tik** (Wissenschaft von den körperl. Rückwirkungen auf seel. Einflüsse, bes. während einer Krankheit) *w*; -; **psy|cho|so|ma|tisch**; **Psy|cho|tech|nik** (praktisch-technisch angewandte Psychologie, Eignungskunde; *w*; -), **...the|ra|peut** (Facharzt für Psychotherapie); **Psy|cho|the|ra|peu|tik** (Seelenheilkunde), *w*; -; **psy|cho|the|ra|peu|tisch**; **Psy|cho|the|ra|pie** (seel. Heilbehandlung) *w*; -

Psy|chro|me|ter gr. [...*kro*..., auch: ...*chro*...] (Luftfeuchtigkeitsmesser) *s*; -s, -; **Psy|chro|phy|ten** (Pflanzen, die niedrige Temperaturen bevorzugen) *Mehrz.*

Pt = chem. Zeichen für: Platin

pt. = Pint

P. T. = pleno titulo; praemisso titulo

Pta = Peseta

Ptah (ägypt. Hauptgott)

Pter|an|odon gr. (Flugsaurier der Kreidezeit) *s*; -s, ...donten; **Pte|ro|dak|ty|lus** (Flugsaurier des Juras) *m*; -, ...ylen; **Pte|ro|po|de** (Ruderschnecke) *w*; -, -n (meist *Mehrz.*); **Pte|ro|sau|ri|er** [...*i^er*] (urzeitliche Flugechse) meist *Mehrz.*; **Pte|ry|gi|um** (Schwimmhaut zwischen Fingern und Zehen) *s*; -s, ...ia

Pto|le|mä|er (Angehöriger eines makedon. Herrschergeschlechtes in Ägypten) *m*; -s, -; **pto|le|mä|isch** (↑ R 179); das ptolemäische Weltsystem; **Pto|le|mä|us** (Geograph, Astronom u. Mathematiker in Alexandria

Pto|ma|in gr. (Leichengift) *s*; -s, -e

PTT (schweiz. Abk. für: Post, Telegraf, Telefon)

Ptya|lin gr. (Med.: Speichelferment) *s*; -s; **Ptya|lis|mus** (Med.: Speichelfluß)

Pu = chem. Zeichen für: Plutonium

Pub *engl.* [*pɑb*] (kurz für: public house; Wirtshaus im engl. Stil, Bar) *s*; -s, -s

pu|ber|tär *lat.* (mit der Geschlechtsreife zusammenhängend); **Pu|ber|tät** ([Zeit der eintretenden] Geschlechtsreife; Mannbarkeit, Reifezeit) *w*; -; **Pu|ber|täts|zeit**; **pu|ber|tie|ren** (in die Pubertät eintreten, sich in ihr befinden); **Pu|bes|zenz** (Geschlechtsreifung, Mannbarwerden) *w*; -

pu|bli|ce *lat.* [...*ze*] (*Umstandswort*; von bestimmten Universitätsvorlesungen: öffentlich); **Pu|bli|ci|ty** *engl.* [*pablíßiti*] (Öffentlichkeit; Reklame, [Bemühung um] öffentl. Aufsehen; öffentl. Verbreitung) *w*; -; **pu|bli|ci|ty|scheu**; **Pu|blic Re|la|tions** *amerik.* [*pablik rileⁱsch^ens*] (Bemühungen eines Unternehmens u. a. um Vertrauen in der Öffentlichkeit) *Mehrz.*; **pu|blik** *fr.* (öffentlich; offenkundig; allgemein bekannt); - machen, werden; **Pu|bli|ka|ti|on** [...*zión*] (Veröffentlichung; Schrift); **Pu|bli|ka|ti|ons|mit|tel**, ...or|gan; **pu|bli|ka|ti|ons|reif**; **Pu|bli|kum** *lat.* (teilnehmende, beiwohnende Menschenmenge; Zuhörer-, Leser-, Besucher[schaft], Zuschauer[menge]; allg. für: die Umstehenden; selten für: öffentl. Vorlesung) *s*; -s, (für Vorlesung auch *Mehrz.*:) ...ka; das breite -; **Pu|bli|kums|er|folg**, ...in|ter|es|se, ...lieb|ling, ...ver|kehr; **pu|bli|kums|wirk|sam** (auf das Publikum wirkend, es beeinflussend)

pu|bli|zie|ren (ein Werk, einen Aufsatz veröffentlichen; seltener für: publik machen, bekanntmachen); pu|bli|zier|freu|dig; Pu|bli|zist (polit. Schriftsteller; Tagesschriftsteller; Journalist); ↑ R 268; Pu|bli|zi|stik w; -; pu|bli|zistisch; Pu|bli|zi|tät (Öffentlichkeit, Offenkundigkeit, Bekanntheit) w; -

p. u. c. = post urbem conditam
Puc|ci|ni [putschini], Giacomo [dsehakomo] (it. Komponist)
Puch Ⓦ (österr. Unternehmer, Fahrzeugmarke)
Puck engl. (Kobold; Hartgummischeibe beim Eishockey) m; -s, -s
puckern [Trenn.: puk|kern] (ugs. für: klopfen, stoßweise schlagen); eine -de Wunde
Pud russ. (früheres russ. Gewicht) s; -, -; 5 - (↑ R 322)
Pud|del|ei|sen engl.; dt. (Hüttenw.)
¹pud|deln vgl. buddeln
²pud|deln engl. (Hüttenw.: aus Roheisen Schweißstahl gewinnen); ich ...[e]le (↑ R 327); Pud|del|ofen
Pud|ding engl. (eine Süß-, Mehlspeise) m; -s, -e u. -s; Pud|ding-form, ...pul|ver
Pu|del (ugs. für: Fehlwurf [beim Kegeln]; Verstoß; ein Hund) m; -s, -; Pu|del|müt|ze; pu|deln (ugs. für: einen Fehler machen; vorbeiwerfen [beim Kegeln]); ich ...[e]le (↑ R 327); pu|del|nackt (ugs.), ...naß (ugs.), ...wohl (ugs.); sich - fühlen
Pu|der fr. (feines Pulver) m (landsch. ugs.: s); -s, -; Pu|der|do|se; pu|de|rig, pud|rig; pu|dern; Pu|der|quaste; Pu|de|rung; Pu|der|zucker [Trenn.: ...zuk|ker]
pue|ril lat. [pu-eril] (knabenhaft; kindlich); Pue|ri|li|tät (veralt. für: Kinderei); Pu|er|pe|ra (Med.: Wöchnerin) w; -, ...rä; Pu|er|pe|ral|fie|ber (Med.: Kindbettfieber) s; -s; Pu|er|pe|ri|um (Med.: Kindbett, Wochenbett) s; -s, ...ien [...iᵉn]
Pu|er|to|ri|ca|ner [...kanᵉr] (Bewohner von Puerto Rico); pu|er|to|ri|ca|nisch; Pu|er|to Ri|co [- ...ko] (Insel der Großen Antillen); vgl. Porto Rico u. Portoriko
Pu|fen|dorf (dt. Rechts- u. Geschichtsgelehrter)
puff!; ¹Puff (veralt., aber noch mdal. für: Bausch; landsch. für: gepolsterter Wäschebehälter) m; -[e]s, -e; ²Puff (ein Spiel) s; -[e]s; ³Puff (ugs. für: Bordell) m (auch: s); -s, -s; ⁴Puff (ugs. für: Stoß) m; -[e]s, Püffe (seltener: Puffe); Püff_är|mel, ...boh|ne; Püff|chen,

Püff|lein (kleiner ¹,⁴Puff); Puf|fe (Bausch von Zeug) w; -, -n; puf|fen (bauschen; ugs. für: stoßen); er pufft (stößt) ihn (auch: ihm) in die Seite; Puf|fer (federnde, Druck u. Aufprall abfangende Vorrichtung [an Eisenbahnwagen u. a.]; nordd. auch für: gebackener flacher Kuchen aus dem Teig roher Kartoffeln); Püff|fer|chen; Puf|fer|staat (Mehrz. ...staaten); puf|fig (bauschig); Püff|lein vgl. Püffchen; Puff-mais, ...mut|ter [zu: ³Puff], ...reis (m; -es), ...spiel [zu: ²Puff]
puh!
Pul pers. (afghan. Münze; 100 Puls = 1 Afghani) m; -, -s; 5 - (↑ R 322)
Pül|cher österr. ugs. (Strolch) m; -s, -
Pul|ci|nell (eindeutschend für: Pulcinella) m; -s, -e; Pul|ci|nel|la it. [pultschi...] (komischer Diener, Hanswurst in der it. Komödie) m; -[s], ...lle; vgl. Policinello
pu|len niederd. (bohren, herausklauben)
Pulk slaw. (Verband von Kampfflugzeugen od. milit. Kraftfahrzeugen; Anhäufung; Schar; Schwarm) m; -[e]s, -s (selten auch: -e)
Pul|le lat. (ugs. für: Flasche) w; -, -n
¹pul|len (niederd. für: rudern; Reitsport [vom Pferd]: in unregelmäßiger Gangart ohne Einwirkungsmöglichkeit für den Reiter vorwärts drängen)
²pul|len (derb, landsch. für: harnen)
Pul|li (ugs. Kurzform von: Pullover) m; -s, -s
Pull|man|kap|pe österr. (Baskenmütze); Pull|man|wa|gen [nach dem amerik. Konstrukteur Pullman]; ↑ R 180 (komfortreicher [Schnellzug]wagen)
Pull|over engl. [...owᵉr] (gestrickte od. gewirkte Überziehbluse) m; -s, -; vgl. Pulli; Pull|over|hemd (leichter modischer Pullover mit hemdartigem Einsatz); Pull|un|der (längere, leichte Strickweste) m; -s, -
pul|mo|nal lat. (Med.: die Lunge betreffend, Lungen...); Pul|mo|nie (veralt. für: Lungenschwindsucht) w; -, ...ien
Pulp engl. m; -s, -en u. Pul|pe lat., Pül|pe fr. (breiige Masse mit größeren od. kleineren Fruchtstücken zur Marmeladenherstellung) w; -, -n; Pul|pa lat. (Med.: weiche, gefäßreiche Gewebemasse im Zahn u. in der Milz) w; -, ...pae [...pä]; Pul|pi|tis (Med.: Zahnmarkentzündung) w; -,

...it|den; pul|pös (Med.: fleischig; markig; aus weicher Masse bestehend); -este (↑ R 292)
Pul|que indian.-span. [...kᵉ] (gegorener Agavensaft) m; -[s]
Puls lat. („Schlag"; Aderschlag; Pulsader am Handgelenk) m; -es, -e; Puls|ader (Schlagader); Pul|sar (kosmische Radioquelle mit periodischen Strahlungspulsen) m; -s, -e; Pul|sa|ti|on [...zion] (Pulsschlag); Puls|tor|ma|schi|ne (Druckwechsler bei Melkmaschinen; Werkstoffprüfmaschine; Entlüftungsapparat); Püls|chen, Püls|lein; pul|sen, pul|sie|ren (schlagen, klopfen; sich lebhaft regen, fließen, strömen); du pulst (pulsest); Pul|si|on (Stoß, Schlag; Pul|so|me|ter lat.; gr (kolbenlose Dampfpumpe, die durch Dampfkondensation arbeitet) s; -s, -; Puls_schlag, ...wär|mer, ...zahl
Pult lat.; s; -[e]s, -e; Pült|chen, Pült|lein; Pult|dach
Pul|ver lat. [...fᵉr] s; -s, -; Pül|ver|chen, Pül|ver|lein; Pul|ver-dampf, ...faß; pul|ver|fein; -er Kaffee; pul|ve|rig, pulv|rig; Pul|ve|ri|sa|tor (Maschine zur Pulververstellung durch Stampfer od. Mahlen) m; -s, ...oren; pul|ve|ri|sie|ren (zu Pulver zerreiben [zer]pulvern); Pul|ve|ri|sie|rung; Pul|ver|kaf|fee; Pül|ver|lein, Pül|ver|chen; Pul|ver_ma|ga|zin ...müh|le (veralt.); pul|vern; ich ...ere (↑ R 327); Pul|ver|schnee pul|ver|trocken [Trenn.: ...trok ken]; Pul|ver|turm; pulv|rig, pul|ve|rig
Pu|ma peruan. (ein Raubtier) m; -s, -s
Pum|mel (scherzh. für: rundliches Kind) m; -s, -; Pum|mel|chen (scherzh.); pum|me|lig, pumm|lig (scherzh. für: dicklich)
Pump (ugs. für: Borg; veralt., aber noch mdal. für: dumpfer Schlag od. Schall) m; -[e]s, -e; (ugs.:) et was auf - nehmen; (ugs.:) auf leben; Pump|brun|nen; Pum|pe w; -, -n; pum|pen (ugs. auch für: borgen); Pum|pen_haus, ...schwengel
pum|perl|ge|sund österr. (kerngesund)
pum|pern (ostmitteld. u. fränk für: tönen, schallen; anklopfen; österr. ugs.: stark klopfen); ich ...ere (↑ R 327)
Pum|per|nickel [Trenn.: ...nik|kel (Schwarzbrot) m; -s, -
Pump|ho|se
Pumps engl. [pömpß] (ausgeschnitener, nicht durch Riemen o Schnürung gehaltener [Damenschuh) m; -, - (meist Mehrz.)

Pump|werk

Pu|na *indian.* (Hochfläche der südamerik. Anden mit Steppennatur) *w;* -

Pun|ching|ball *engl.* [*pạntsching...*] (Übungsball für Boxer)

Punc|tum sa|li|ens *lat.* [- *saliänß*] („springender Punkt"; Kernpunkt; Entscheidendes) *s;* - -

Pu|ni|er [...*i^er*] (Karthager); **punisch;** -e Treue (iron. für: Untreue, Wortbrüchigkeit), aber (↑ R 224): die Punischen Kriege; der Erste, Zweite, Dritte Punische Krieg

Punkt *lat. m;* -[e]s, -e (Abk.: Pkt.); Punkt (österr. u. schweiz.: punkt) 8 Uhr; typographischer Punkt (Druckw.: Maßeinheit für Schriftgröße u. Zeilenabstand; Abk.: p); (↑ R 322:) 2 Punkt Durchschuß; (↑ R 123:) der Punkt auf dem i; **Punk|tal|glas** (Optik; *Mehrz.* ...gläser); **Punk|ta|ti|on** [...*ziọn*] (Vorvertrag, vorläufige Abmachung, Festlegung); **Punkt|ball** (Übungsgerät für Boxer); **Pünkt|chen, Pünkt|lein;** **Punk|te|kampf** (Sport); **punk|ten;** **Punk|te|spiel** (Sport); **punkt|gleich** (Sport); **Punkt|gleich|heit;** **punk|tie|ren** (mit Punkten versehen, tüpfeln; Med.: eine Punktion ausführen); punktierte Note (Musik) *w;* -; **Punk|tier|na|del; Punk|ti|on** [...*ziọn*], Punk|tur (Med.: Einstich in eine Körperhöhle zur Entnahme von Flüssigkeiten) *w;* -, -en; **Punkt|lan|dung** (Flugw., Raumfahrt: Landung genau an vorausberechneten Punkt); **Pünkt|lein**, Pünkt|chen; **pünkt|lich; Pünkt|lich|keit** *w;* -; mit militärischer -; **Punkt|nie|der|la|ge** (Sport); **punk|to** (svw. betreffs): *Verhältnisw.* mit *Wesf.:* - gottloser Reden; ungebeugt bei alleinstehendem, einzähligem, stark gebeugtem Hauptw.: - Geld; vgl. in puncto; **Punkt.rich|ter** (Sport), ...rol|ler (Massagegerät), ...schrift (Blindenschrift); **punkt|schwei|ßen** (nur in der Grundform u. im 2. Mittelw. gebr.); punktgeschweißt; **Punkt|schwei|ßung; punkt|si|cher;** -e Linse; **Punkt_sieg** (Sport), ...spiel (Sport), ...sy|stem; **Punk|tua|li|tät** (veralt. für: Genauigkeit, Strenge) *w;* -; **punk|tu|ell** (punktweise; einzelne Punkte betreffend); **Punk|tum**, nur in: und damit - ! (und damit Schluß!); **Punk|tur** vgl. Punktion; **Punk|tur|zan-ge; Punkt_wer|tung**, ...zahl

'unsch *engl.* (alkohol. Getränk)

m; -[e]s, -e; **Punsch_es|senz,** ...schüs|sel

Punz|ar|beit; Pun|ze (Stahlstäbchen für Treibarbeit, österr. auch: eingestanztes Zeichen zur Angabe des Edelmetallgehalts) *w;* -, -n; **pun|zen,** pun|zie|ren (Metall treiben; ziselieren; den Feingehalt von Gold- u. Silberwaren kennzeichnen); du punzt (punzest); **Punz|ham|mer; pun|zie|ren** vgl. punzen

Pup *m;* -[e]s, -e u. **Pups** *m;* -es, -e u. **Pup|ser** (familiär für: abgehende Blähung)

Pu|pe landsch. abschätzig (Homosexueller; berlin. auch für: abgestandenes, verdorbenes Weißbier) *m* od. *w;* -n, -n

pu|pen, pup|sen; du pupst (pupsest)

pu|pil|lar, pu|pil|la|risch *lat.* (zur Pupille gehörend; das Mündel betreffend); -e Sicherheit (Mündelsicherheit); **Pu|pil|le** (Sehloch, -öffnung; veralt. für: Mündel, Pflegebefohlene) *w;* -, -n; **Pu|pil|len.er|wei|te|rung,** ...gel|der (veralt. für: Mündelvermögen; *Mehrz.*), ...ver|en|gung

pu|pi|ni|sie|ren [nach dem serb.-amerik. Elektrotechniker Pupịn] (Fernmeldetechnik: Pupinspulen einbauen); **Pu|pịn|spu|le;** ↑ R 180 (Fernmeldetechnik: mit Eisenkern gefüllte Induktionsspule zur Erhöhung der Übertragungsqualität bei langen Fernsprech- od. Rundfunkleitungen)

pu|pi|par *lat.;* -e Insekten (Insekten, deren Larven sich gleich nach der Geburt verpuppen); **Püpp|chen,** Püpp|lein; **Pup|pe** *w;* -, -n; **Pup|pen.film, ...ge|sicht; pup|pen.haft; Pup|pen.haus,** ...kli|nik, ...kü|che, ...mut|ter, ...spiel, ...spie|ler, ...stu|be, ...thea|ter, ...wa|gen, ...woh|nung **pup|pern** (ugs. für: zittern, sich zitternd bewegen); ich ...ere (↑ R 327)

pup|pig (ugs. für: klein u. niedlich); **Püpp|lein**, Püpp|chen

Pups vgl. Pup; **pup|sen** vgl. pupen; **Pup|ser** vgl. Pup

pur *lat.* (rein, unverfälscht, lauter); die -e (reine) Wahrheit; -es Gold; Whisky -; **Pü|ree** *fr.* (Brei, breiförmige Speise) *s;* -s, -s; **Pur|gans** (Med.: Abführmittel) *s;* -, ...anzien [...*i^en*] u. ...antia; **Pur|ga|ti|on** [...*ziọn*] (veralt. für: Reinigung); **Pur|ga|to|ri|um** (Fegefeuer) *s;* -s; **pur|gie|ren** (reinigen; abführen); **Pur|gier|mit|tel** *s;* **Pu|ri|fi|ka|ti|on** [...*ziọn*] (liturg. Reinigung); **Pu|ri|fi|ka|ti|ons.eid** (früher für: Reinigungseid); **pu-**

ri|fi|zie|ren (veralt. für: reinigen, läutern)

Pu|rim *hebr.* [auch: *pu...*] (jüd. Fest) *s;* -s

Pu|ris|mus *lat.* (Reinigungseifer; [übertriebenes] Streben nach Sprachreinheit) *m;* -; **Pu|rist** (↑ R 268); **pu|ri|stisch; Pu|ri|ta|ner** (Anhänger des Puritanismus); **pu|ri|ta|nisch** (sittenstreng); **Pu|ri|ta|nis|mus** (streng kalvinistische Richtung in England des 16./17. Jh.s) *m;* -; **Pu|ri|tät** (veralt. für: Reinheit; Sittenreinheit) *w;* -; **Pur|pur** *gr.* (hochroter Farbstoff; purpurfarbiges, prächtiges Gewand) *m;* -s; **pur|pur|far|ben, pur|pur|far|big; Pur|pur|man|tel; purpurn** (mit Purpur gefärbt; purpurfarben); **pur|pur|rot; Pur|pur.rö|te,** ...schnecke [*Trenn.:* ...schnek|ke]

pur|ren landsch. (stochern; nekken, stören; Seemannsspr.: [zur Wache] wecken)

Pur|zel (kleiner Kerl; Purzelbaum) *m;* -s, -

Pür|zel (Jägerspr.: Schwanz des Wildschweins) *m;* -s, -

Pur|zel|baum; pur|zeln; ich ...[e]le (↑ R 327)

Pu|schel landsch. (Quaste; Steckenpferd, Liebhaberei) *w;* -, -n; **Pü|schel** landsch. (Quaste, Troddel, Stutz) *m;* -s, -

Puschkin (russ. Dichter)

Pus|sel|chen (ugs. Kosewort für kleines Kind u. Tier); **pus|se|lig, puß|lig** (ugs. für: nach Art eines Pusselchens; auch: Ausdauer verlangend); **pus|seln** (ugs. für: sich mit Kleinigkeiten beschäftigen); ich pussele und pußle (↑ R 327); **puß|lig** vgl. pusselig

Pußta *ung.* (Grassteppe, Weideland in Ungarn) *w;* -, ...ten

Pu|ste (ugs. für: Atem; bildl. für: Kraft, Vermögen, Geld) *w;* -; aus der - (außer Atem) sein; [ja,] Puste, Pustekuchen! (ugs. für: nichts, gar nichts; das hast du dir wohl so gedacht); **Pu|ste|ku|chen** (ugs.), nur in: [ja,] Pustekuchen! (vgl. Puste)

Pu|stel *lat.* (Hitze-, Eiterbläschen, Pickel) *w;* -, -n

pu|sten (landsch.); er hat ihm den Rauch in das Gesicht gepustet; nach dem Wettlauf hat er sehr gepustet

Pu|ster|tal (ein Alpental) *s;* -[e]s

pu|stu|lös *lat.* (voll Hitze-, Eiterbläschen); -e Haut

pu|ta|tiv *lat.* (vermeintlich, irrigerweise für gültig gehalten); **Pu|ta|tiv.ehe,** ...not|wehr

Put|bus (Ort auf Rügen); **Put|bus|ser,** (auch:) **Put|bu|ser** (↑ R 199)

Pu|te (Truthenne) w; -, -n; Pu|ter (Truthahn); pu|ter|rot; Put|hahn put, put! (Lockruf für Hühner); Put|put (Lockruf: Kinderspr.: Huhn) s; -s, -[s]

Pu|tre|fak|ti|on lat. [...zion], Pu|tres|zenz (Verwesung, Fäulnis) w; -, -en; pu|tres|zie|ren

Putsch (polit. Handstreich; schweiz. mdal. auch für: Stoß) m; -[e]s, -e; put|schen; du putschst (putschest)

püt|sche|rig niederd. (kleinlich, umständlich, pedantisch); püt|schern niederd. (umständlich arbeiten, ohne etwas zustande zu bringen)

Put|schist (↑ R 268); put|schi|stisch; Putsch⌐plan (vgl. ²Plan), ...ver|such

Pütt rhein. u. westfäl. (Bergwerk) m; -s, -s (auch: -e)

Put|te it. w; -, -n u. Put|to (bild. Kunst: nackte Kinder-, kleine Engelsfigur) m; -s, ...tti u. ...tten

Put|ter engl. (Spezialgolfschläger) m; -s, -

Putz m; -es

Pütz, Püt|ze (Seemannsspr.: Eimer) w; -, ...tzen

put|zen; du putzt (putzest); sich -; Put|zen (Druckw.) m; -s, -; Put|zer; Put|ze|rei (österr. auch für: chem. Reinigung); Put|ze|te südd. u. schweiz. mdal. (Reinigungsarbeit, Großreinemachen) w; -, -n; Putz|frau

put|zig (drollig; sonderbar; mdal. für: klein); ein -es Mädchen

Putz⌐ka|sten, ...lap|pen, ...ma|che|rin (w; -, -nen), ...mit|tel s, ...sucht (w; -); putz|süch|tig; Putz⌐tag, ...tuch (Mehrz. ...tücher), ...wol|le, ...zeug

puz|zeln engl. [paß⌐ln] (Puzzlespiele machen); mühsam zusammensetzen); Puz|zle engl. [paß⌐l, engl. Ausspr.: pasl] (Geduldsspiel) s; -s, -s; Puzz|ler; Puz|zle|spiel

Puz|zo|lan|er|de vgl. Pozzuolanerde

PVC = Polyvinylchlorid

Py|ä|mie gr. (Med.: herdbildende Form einer Allgemeininfektion des Körpers durch Eitererreger in der Blutbahn) w; -, ...ien; Py|ar|thro|se (Med.: eitrige Gelenkentzündung) w; -, -n

Py|el|ek|ta|sie gr. (Med.: Erweiterung des Nierenbeckens)· w; -; Pye|li|tis (Med.: Nierenbeckenentzündung) w; -, ...itiden; Pye|lo|gramm (Med.: Röntgenbild von Nierenbecken und Harnwegen) s; -s, -e; Pye|lo|gra|phie (Med.: Röntgenaufnahme des Nierenbeckens) w; -; Pye|lo|ne|phri|tis (Med.: Entzündung von Nierenbecken u. Nieren) w; -,

...itjden; Pye|lo|zy|sti|tis (Med.: Entzündung von Nierenbecken u. Blase) w; -, ...itiden

Pyg|mäe gr. („Fäustling"; Angehöriger einer zwergwüchsigen Rasse Afrikas u. Südostasiens) m; -n, -n (↑ R 268); pyg|mä|en|haft; pyg|mä|isch (zwerghaft)

Pyg|ma|li|on (gr. Sagengestalt)

Pyhrn|paß (österr. Alpenpaß) m; ...passes

Py|ja|ma Hindi-engl. [pü(d)seh..., pi(d)seh..., auch: pü...] (Schlafanzug) m (österr. u. schweiz. auch: s); -s, -s; Py|ja|ma|ho|se

Py|kni|die gr. [...iⁿ] (Fruchtkörper der Rostpilze) w; -, -n; Py|kni|ker (kräftiger, gedrungen gebauter Mensch); py|knisch (untersetzt, dickleibig); Py|kno|me|ter (Dichtemesser) s; -s, -; py|kno|tisch (Med.: verdickend, verdichtet)

Py|la|des (Freund des Orest)

Py|lon gr. m; -en, -en (↑ R 268) u. Py|lo|ne (großes Eingangstor altägypt. Tempel u. Paläste, von zwei wuchtigen Ecktürmen flankiert; toähnlicher, tragender Pfeiler einer Hängebrücke; kegelförmige, bewegliche Absperrmarkierung auf Straßen) w; -, -n

Py|lo|rus gr. (Med.: Pförtner; Schließmuskel am Magenausgang) m; -, ...ren

pyo|gen gr. (eitererregend); Pyorrhö¹, Pyor|rhöe (Med.: eitriger Ausfluß) w; -, ...rrhöen; pyor|rho|isch

py|ra|mi|dal ägypt. (pyramidenförmig; ugs. für: gewaltig, riesenhaft); Py|ra|mi|de (ägypt. Grabbau; geometr. Körper) w; -, -n; py|ra|mi|den|för|mig; Py|ra|mi|don Ⓦ (ein Schmerzlinderungsu. Fiebermittel) s; -s

Pyr|ano|me|ter gr. (Meteor.: Gerät zur Messung der Sonnen- u. Himmelsstrahlung) s; -s, -

Py|re|nä|en (Gebirge zwischen Spanien u. Frankreich) Mehrz.; Py|re|nä|en|halb|in|sel w; -; py|re|nä|isch

Py|re|thrum gr. (eine Pflanzengattung der Chrysanthemum; Droge) s; -s, ...ra

Pyr|exie gr. (Med.: Fieber[anfall]) w; -, ...ien

Py|rit gr. (Eisen-, Schwefelkies) m; -s, -e

Pyr|mont, Bad (Stadt im Weserbergland)

Py|ro|gal|lus|säu|re gr.; lat.; dt. w; -; py|ro|gen gr. (fiebererregend; von Mineralien: aus Schmelze entstanden); Py|ro|ly|se (Zersetzung von Stoffen durch Hitze)

¹ Vgl. die Anmerkung zu „Diarrhö, Diarrhöe".

w; -, -n; Py|ro|ma|ne (an Pyromanie Leidende[r]) m u. w; -n, -n (↑ R 287ff.); Py|ro|ma|nie (krankhafter Brandstiftungstrieb; w; -), ...me|ter (Meßgerät für hohe Temperaturen, Hitzemesser; s; -s, -); py|ro|phor (selbstentzündlich, in feinster Verteilung an der Luft aufglühend); Py|ro|phor (Cer-Eisen-Legierung mit pyrophoren Eigenschaften) m; -s, -e; Py|ro.sphä|re (veralt. für: glühend flüssiger Erdkern; w; -), ...tech|nik (Feuerwerkerei; w; -), ...tech|ni|ker; py|ro|tech|nisch

Pyr|rhus (König von Epirus); Pyrrhus|sieg; ↑ R 180 (Scheinsieg, zu teuer erkaufter Sieg)

Pyr|rol gr. (eine chem. Verbindung) s; -s -e

Py|tha|go|rä|er vgl. Pythagoreer

¹Py|tha|go|ras (altgr. Philosoph); ²Py|tha|go|ras (kurz für: pythagoreischer Lehrsatz) m; -; Py|tha|go|re|er, (österr.:) Py|tha|go|rä|er (Anhänger der Lehre des Pythagoras); py|tha|go|re|isch, (österr.:) py|tha|go|rä|isch; -er Lehrsatz (grundlegender Satz der Geometrie, der aber nicht von Pythagoras selbst aufgestellt wurde), aber (↑ R 179): Py|tha|go|re|isch; -e Philosophie

¹Py|thia (Priesterin in Delphi) ²Py|thia (Frau, die orakelhafte Anspielungen macht) w; -, ...ien [...iⁿn]; py|thisch (selten für: dunkel, orakelhaft), aber (↑ R 224): Pythische (zu Pytho [Delphi] gefeierte) Spiele; Py|thon (Gattung der Riesenschlangen) m; -s, -s u ...onen

Py|xis gr. (Hostienbehälter) w; -, ...iden, (auch:) ...ides

Q

Q (Buchstabe) [ku; österr.: kwe in der Math.: ku]; das Q; des Q die Q, aber: das q in verque (↑ R 123); der Buchstabe Q, q

Q, Ø = Quetzal

q = Quintal

q (österr.) = Meterzentner

Q. = Quintus

qcm vgl. cm²; qdm vgl. dm²

q. e. d. = quod erat demonstran dum

qkm vgl. km²; qm vgl. m²; qmm vgl. mm²

qu. = quästioniert

qua lat. ([in der Eigenschaft] als gemäß, z. B. - Beamter = in de Eigenschaft als Beamter; - Will = dem Willen gemäß)

Quab|be niederd. (Fettwulst) w; -, -n; quab|be|lig, quabb|lig niederd. (vollfleischig; fett); quab|beln (niederd.); ich ...[e]le (↑ R 327); quab|big (niederd.); quabb|lig vgl. quabbelig

Quack niederd. (landsch.) m; -[e]s, -e; Quacke|lei [Trenn.: Quakke...] landsch. (unstetes, schwankendes Verhalten; unnützes Zeug; Geschwätz); Quacke|ler [Trenn.: Quak|ke...], Quackler landsch. (Schwätzer; auch: Umstände machender Mensch); quackeln [Trenn.: Quak|ke...] (landsch.); ich ...[e]le (↑ R 327); Quack|sal|ber (abschätzig für: Kurpfuscher); Quack|sal|be|rei (ugs.); quack|sal|be|risch (abschätzig); quack|sal|bern (abschätzig); ich ...ere (↑ R 327); gequacksalbert; zu quacksalbern

Quad|del (juckende Anschwellung) w; -, -n

Qua|de (Angehöriger eines westgerm. Volkes) m; -n, -n (↑ R 268)

Qua|der lat. (Math.: ein von drei Paar gegenüberliegenden, gleichen Rechtecken begrenzter Körper; behauener [viereckiger] Bruchsteinblock) m; -s, - (auch: w; -, -n; österr. nur: m; -s, -n); Qua|der|bau (Mehrz. ...bauten); qua|dern (selten für: [sich] in Vierecken aufbauen, darstellen); ich ...ere (↑ R 327); Qua|der|stein

Qua|dra|ge|si|ma lat. ([„vierzig"-tägige] Fastenzeit vor Ostern) w; -

Qua|dran|gel lat. (ma. Baukunst: Viereck) s; -s, -

Qua|drant lat. (Viertelkreis) m; -en, -en (↑ R 268); Qua|dran|ten|elek|tro|me|ter s; -s, -; Qua|drant|sy|stem (Maßsystem) s; -s

Qua|drat lat. (Viereck mit vier rechten Winkeln u. vier gleichen Seiten; zweite Potenz einer Zahl) s; -[e]s, -e u. (Druckw.: Geviert, Bleiklötzchen zum Ausfüllen freier Räume beim Schriftsatz) s; -[e]s, -e[n]; Qua|drat|de|zi|me|ter (Zeichen: dm², älter: qdm); qua|drä|teln (Würfelspiel der Buchdrucker u. Setzer: mit Geviertstücken würfeln); ich ...[e]le (↑ R 327); Qua|drat|fuß m; -es, -; 10 - (↑ R 322); vgl. Fuß; qua|dra|tisch (im Geviert); -e Gleichung (Gleichung zweiten Grades); Qua|drat.ki|lo|me|ter (Zeichen: km², älter: qkm), ...lat|schen (ugs. scherzh. für: große, unförmige Schuhe), ...maß s, ...mei|le s, ...me|ter (Geviertmeter; Zeichen: m², älter: qm), ...mil|li|me|ter (Zeichen: mm², älter: qmm), ...ru|te (Maß; Zeichen: □ R), ...schä|del

(ugs.: breiter, eckiger Kopf; übertr.: starrsinniger, begriffsstutziger Kopf); Qua|dra|tur (Vierung; Verfahren zur Flächenberechnung) w; -, -en; Qua|dra|tur|ma|le|rei; Qua|drat.wur|zel, ...zahl, ...zen|ti|me|ter (Zeichen: cm², älter: qcm), ...zoll Qua|dri|en|na|le it. (alle vier Jahre stattfindende Veranstaltung od. Ausstellung) w; -, -n; Qua|dri|en|ni|um lat. (veralt. für: Zeit von vier Jahren) s; -s, ...ien [...i̯n] qua|drie|ren lat. (Math.: eine Zahl in die zweite Potenz erheben) Qua|dri|ga lat. (das von einem Streit-, Renn- od. Triumphwagen [der Antike] aus gelenkte Viergespann u. seine Darstellung in der Kunst) w; -, ...gen Qua|dril|le span.-fr. [kwadriljə, seltener: ka...; österr.: kadril] (ein Tanz) w; -, -n Qua|dril|li|on [r] (vierte Potenz einer Million); Qua|dri|nom lat.; gr. (Math.: die Summe aus vier Gliedern) s; -s, -e; Qua|dri|re|me lat. („Vierruderer" [antikes Kriegsschiff]) w; , n; Qua|dri|vi|um [...wi...] („Vierweg"; im mittelalterl. Universitätsunterricht die vier höheren Fächer: Arithmetik, Geometrie, Astronomie, Musik) s; -s Qua|dro|nal ® (schmerzlinderndes Mittel) s; -s Qua|dro|pho|nie lat.; gr. (Vierkanalstereophonie) w; -; qua|dro|pho|nisch Qua|dru|pe|de lat. (Vierfüß[l]er) m; -n, -n (meist Mehrz.); ↑ R 268; ¹Qua|dru|pel fr. (vier zusammengehörende math. Größen) s; -s, -; ²Qua|dru|pel (frühere span. Goldmünze) m; -s, -; Qua|dru|pel|al|li|anz (hist.: Vierbund)

Quag|ga hottentott. (ausgerottetes zebraartiges Wildpferd) s; -s, -s Quai fr. [kä] schweiz. (Uferstraße) m od. s; -s, -s; vgl. Kai; Quai d'Or|say fr. [ke dorßä] (Straße in Paris; übertr. für: das fr. Außenministerium) m; - -

quak!; Quä|ke (Instrument zum Nachahmen des Angstschreis der Hasen) w; -, -n; qua|kel|chen (scherzh. für: Nettjüngstes); quaken rhein. (undeutlich reden); ich ...[e]le (↑ R 327); qua|ken; der Frosch quakt; quä|ken; quäkende Stimme

Quä|ker engl. (Angehöriger einer Sekte) m; -s, -; quä|ke|risch

Qual w; -, -en; quä|len; sich -; qua|len|reich; Quä|ler; Quä|le|rei; quä|le|risch; -ste (↑ R 294); Qual|geist (meist vorwurfsvoll für: Kind, das durch ständiges Bitten lästig wird; Mehrz. ...geister)

Qua|li|fi|ka|ti|on lat. [...zion] (Beurteilung; Befähigung[snachweis]; Teilnahmeberechtigung für sportl. Wettbewerbe); Qua|li|fi|ka|ti|ons.be|richt, ...lauf, ...rennen, ...run|de, ...spiel; qua|li|fi|zie|ren (bezeichnen; befähigen); sich - (sich eignen; sich als geeignet erweisen; weitere Qualifikationen erwerben); qua|li|fi|ziert; -este (↑ R 292); zu etwas (geeignet); ein -er Arbeiter; -es Vergehen (Rechtsspr.: Vergehen unter erschwerenden Umständen); eine -e (bestimmte) Mehrheit; Qua|li|fi|zie|rung (selten für: Qualifikation); Qua|li|tät (Beschaffenheit, Güte, Wert); erste, zweite, mittlere -; qua|li|ta|tiv (dem Wert, der Beschaffenheit nach); Qua|li|täts.ar|beit (Wertarbeit), ...bezeich|nung, ...ein|bu|ße, ...funk|ti|on (Funktion des Handels, um eine Ware zu verbessern), ...klau|sel, ...kon|trol|le, ...maß (Maßeinheit zur Bestimmung der Qualität einer Ware) s, ...min|de|rung, ...skala, ...staf|fel, ...stei|ge|rung, ...typ, ...un|ter|su|chung, ...wa|re, ...wein (- mit Prädikat)

Quall (veralt., aber noch mdal. für: Wasserspudel, emporquellende Wassermenge) m; -[e]s, -e; Qual|le (Nesseltier; ugs. für: Schleim, Auswurf) w; -, -n; qual|lig; eine -e Masse

Qualm m; -[e]s; qual|men; qual|mig Qual|ster (ugs. für: Schleim, Auswurf) m; -s, -; qual|ste|rig, qualstrig (ugs.); qual|stern (ugs.); ich ...ere (↑ R 327)

Qual|tin|ger, Helmut (österr. Schriftsteller u. Schauspieler)

qual|voll

Quant lat. (Physik: kleinste Energiemenge) s; -s, -en; Quan|ten (Mehrz. von: Quant u. Quantum); Quan|ten.bio|lo|gie, ...me|cha|nik, ...theo|rie (atomphysikal. Theorie; w; -); quan|ti|fi|zie|ren (Eigenschaften) in Zahlen u. meßbare Größen umformen, umsetzen); Quan|ti|fi|zie|rung; Quan|ti|tät (Menge, Masse, Größe; Sprachw.: Dauer [Maß der Silben nach Länge od. Kürze]); Quan|ti|täts_glei|chung (Wirtsch.), ...theo|rie (Wirtsch.: Theorie, die einen Kausalzusammenhang zwischen Geldmenge u. Preisniveau statuiert; w; -); quan|ti|ta|tiv (der Quantität nach, mengenmäßig); Quan|ti|té né|gli|geable fr. [kangtite negli-sehabl] (wegen ihrer Kleinheit außer acht zu lassende Größe, Belanglosigkeit) w; --; quan|ti|tie|ren lat. (die Silben [nach der Länge od. Kürze] messen); Quan|tum

(Menge, Anzahl, Maß, Summe, Betrag) *s*; -s, ...ten

Quap|pe (ein Fisch; Lurchlarve, Kaulquappe) *w*; -, -n

Qua|ran|tä|ne *fr.* [*karant*..., selten: *karaŋ*...] ([„vierzig"tägige] Beobachtungszeit, räumliche Absonderung Ansteckungsverdächtiger oder Absperrung eines Infektionsherdes von der Umgebung) *w*; -, -n; **Qua|ran|tä|ne|sta|ti|on**

Quar|gel österr. (ein kleiner, runder Käse) *s* od. *m*; -s, -

[1]**Quark** *engl.* [*kwǎ̱'k*] (hypothetisches „Elementarteilchen") *s*; -s, -s

[2]**Quark** (Käsestoff; ugs. für: Wertloses) *m*; -s; **Quark|brot; quar|kig; Quark|kä|se,** ...**käul|chen** (obersächs.: gebackenes [2]Küchlein aus Kartoffeln u. Quark), ...**ku|chen** (landsch.), ...**schnit|te**

Quar|re niederd. (weinerliches Kind; zänkische Frau) *w*; -, -n; **quar|ren** (niederd.); **quar|rig** (niederd.); das Kind ist -

[1]**Quart** *lat.* (Fechthieb; Musik: auch Quarte: vierter Ton [vom Grundton an]) *w*; -, -en; [2]**Quart** (Flüssigkeitsmaß; nur *Einz.*: Viertelbogengröße [Buchformat]; Abk.: 4°) *s*; -s, -e; 3 - (↑ R 322); in -; Großquart (Abk.: Gr.-4°); **Quar|ta** („vierte"; dritte [in Österr.: vierte] Klasse einer höheren Lehranstalt) *w*; -, ...ten; **Quar|tal** (Vierteljahr) *s*; -s, -e; **Quar|tal|ab|schluß,** Quar|tals|ab|schluß; **quar|ta|li|ter** (veralt. für: vierteljährlich); **Quar|tal|kün|di|gung; Quar|tal|s|_ab|schluß,** ...**säu|fer; quar|tal[s]|wei|se** (vierteljahrsweise); **Quar|ta|ner** (Schüler der Quarta); **Quar|ta|ne|rin** *w*; -, -nen; **Quar|ta|na|fie|ber** (Viertagefieber, Art der Malaria) *s*; -s; **Quar|tant** (nur noch selten für: Buch in Viertelbogengröße) *m*; -en, -en (↑ R 268); **quar|tär** (zum Quartär gehörend); **Quar|tär** (Geol.: obere Formation des Neozoikums) *s*; -s; **Quar|tär|for|ma|ti|on; Quar|t.band** *m*, ...**blatt; Quar|te** vgl. [1]Quart; **Quar|tel** bayr. (kleines Biermaß) *s*; -s, -; **Quar|ten** (*Mehrz.* von: Quart, Quarte u. Quarta); **Quar|ter** *engl.* [*kwā̱'t*ə*r*] (engl. u. amerik. Hohlmaß u. Gewicht) *m*; -s, -; **Quar|ter|deck** ([Schiffs]hinterdeck); **Quar|tett** *it.* (Musikstück für vier Stimmen od. vier Instrumente; auch: die vier Ausführenden; Unterhaltungsspiel mit Karten) *s*; -[e]s, -e; **Quart|for|mat; Quar|tier** *fr.* (Unterkunft, bes. von Truppen; schweiz., österr. auch für: Stadtviertel) *s*; -s, -e; **quar|tie|ren**

(früher für: [Soldaten] in Privatunterkünften unterbringen; heute nur noch selten für: Quartier nehmen, [sich] einquartieren); **Quar|tier|ma|cher; Quar|tiers_frau,** ...**wirt; Quart|ma|jor** *lat.* (bestimmte Reihenfolge von [Spiel]karten) *w*; -; **Quart|to it.** (it. Bez. für: Quartformat; Viertel[bogen]größe) *s*; -; in - (Abk.: in 4°); **Quart|sext|ak|kord; quart|wei|se**

Quarz (ein Mineral) *m*; -es, -e; **Quarz_fels,** ...**fil|ter,** ...**gang** *m*, ...**glas** (*Mehrz.* ...gläser); **quarz_hal|tig; quar|zig; Quar|zit** (ein Gestein) *m*; -s, -e; **Quarz_lam|pe,** ...**uhr**

Quas *slaw.* niederd., mitteld. (Gelage, Schmaus; bes. Pfingstbier mit festl. Tanz) *m*; -es, -e

Qua|sar *lat.* (sternenähnliches Objekt im Kosmos mit extrem starker Radiofrequenzstrahlung) *m*; -s, -e

qua|sen niederd., mitteld. (schmausen; prassen; vergeuden); du quast (quasest)

qua|si *lat.* (gewissermaßen, gleichsam, sozusagen); **Qua|si|mo|do|gen|i|ti** (erster Sonntag nach Ostern) *Mehrz.*; **qua|si|of|fi|zi|ell** (scheinbar offiziell; halb offiziell); **qua|si|op|tisch** (Physik: ähnlich den Lichtwellen sich ausbreitend); **Qua|si|sou|ve|rä|ni|tät** (scheinbare Souveränität)

Quas|se|lei (ugs. für: törichtes Gerede); **quas|seln** (ugs. für: langweiliges, törichtes Zeug reden); ich quassele u. quaßle (↑ R 327); **Quas|sel|strip|pe** (scherzh. ugs. für: Fernsprecher; auch: jmd., der viel redet, erzählt)

Quas|sie [...*iə*; angeblich nach dem Entdecker] (südamerik. Baum, dessen Holz einen früher als Magenmittel verwendeten Bitterstoff liefert) *w*; -, -n

Quast landsch. ([Borsten]büschel, breiter Pinsel) *m*; -[e]s, -e; **Quäst|chen,** Quäst|lein; **Qua|ste** (Troddel, Schleife) *w*; -, -n; **Qua|sten_be|hang,** ...**flos|ser; qua|sten|för|mig**

Quä|sti|on *lat.* (wissenschaftl. Streitfrage); **quä|stio|niert** (veralt. für: fraglich, in Rede stehend; Abk.: qu.)

Quäst|lein, Quäst|chen

Quä|stor *lat.* (altröm. Beamter, Schatzmeister an Hochschulen; schweiz. neben Rechnungsführer, Säckelmeister für: Kassenwart eines Vereins) *m*; -s, ...oren; **Quä|stur** (Amt eines Quästors; Kasse an einer Hochschule) *w*; -, -en

Qua|tem|ber *lat.* (vierteljährlicher

kath. Fasttag) *m*; -s, -; **Qua|tem|ber|fa|sten** *s*; -s

qua|ter|när *lat.* (Chemie: aus vier Teilen bestehend); **Qua|ter|ne** (Reihe von vier gesetzten od. gewonnenen Nummern in der alten Zahlenlotterie) *w*; -, -n; **Qua|ter|nio** (Zahl, Ganzes aus vier Einheiten, Stücken) *m*; -s, ...onen

quatsch! (Schallwort)

Quatsch (ugs. für: dummes Gerede) *m*; -es; - reden; das ist ja -! ach -!; **quat|schen** (ugs.); du quatschst (quatschest); **Quat|sche|rei** (ugs.); **Quatsch|kopf** (ugs. abschätzig)

quatsch|naß (ugs. für: sehr naß)

Quat|tro|cen|tist *it.* [...*trotschän*...] (Dichter, Künstler des Quattrocentos); ↑ R 268; **Quat|tro|cen|to** [...*trotschänto*] (Kunstzeitalter in Italien: 15. Jh.) *s*; -[s]

Que|bec [*kwibäk*] (Provinz u. Stadt in Kanada)

Que|bra|cho *span.* [*kebratscho*] (gerbstoffreiches Holz eines südamerik. Baumes) *s*; -s; **Que|bra|cho_le|der,** ...**rin|de** (ein Arzneimittel)

[1]**Que|chua** [*ketschua*] (Angehöriger eines indian. Volkes in Peru) *m*; -[s], -[s]; [2]**Que|chua** (indian. Sprache) *s*; -[s]

queck (für: quick); **Queck|born** vgl. Quickborn; **Quecke** [*Trenn.:* Quek|ke] (lästiges Ackerunkraut) *w*; -, -n; **queckig** [*Trenn.:* quek|kig] (voller Quecken); **Queck|sil|ber** (chem. Grundstoff, Metall; Zeichen: Hg); **Queck|sil|ber|dampf; Queck|sil|ber_dampf_gleich|rich|ter,** ...**lam|pe; queck|sil|ber|hal|tig; queck|sil|be|rig,** queck|silb|rig (unruhig wie Quecksilber); **queck|sil|bern** (aus Quecksilber); **Queck|sil|ber_prä|pa|rat,** ...**röh|re,** ...**sal|be,** ...**säu|le,** ...**ver|gif|tung; queck|silb|rig** vgl. quecksilberig

Qued|lin|burg (Stadt im nördl. Harzvorland)

Queens|land [*kwinsl'nd*] (Staat des Australischen Bundes); **Queenstown** [*kwinstaun*] (früherer Name von: Cobh)

Queich (Fluß in der Pfalz) *w*; -

Queis (l. Nebenfluß des Bobers) *m*; -

Quell (dicht. veralt. für: Quelle) *m*; -[e]s, -e; **Quell|ader; Quell|chen; Quel|le** *w*; -, -n; Nachrichten aus amtlicher, erster -; [1]**quel|len** (mächtig ans Licht drängen; sprudeln); du quillst; du quollst; du quöllest; gequollen; quill!; Wasser quillt; [1]**quel|len** (im Wasser weichen lassen); du quillst; du quelltest; gequellt; quell[e]!; ich quelle Bohnen; **Quel|len_an-**

ga|be, ...for|schung, ...kri|tik, ...kun|de (w; -); quel|len|mä|ßig; Quel|len|ma|te|ri|al; quel|len-reich; Quel|len.samm|lung, ...stu-di:um; Quel|ler (eine Strand-pflanze); Quell.fas|sung, ...fluß; quell|frisch; Quell|ge|biet; quel-lig (veralt.); Quell.nym|phe, ...stär|ke; Quel|lung; Quell.was-ser (Mehrz. ...wasser), ...wol|ke Quen|del (Name für verschiedene Pflanzen) m; -s, - Quen|ge|lei (ugs.); quen|ge|lig, queng|lig (ugs.); quen|geln (ugs.: weinerlich-nörgelnd immer wie-der um etwas bitten [von Kin-dern]); ich ...[e]le (↑ R 327); Queng|ler (ugs.)

Quent lat. (früheres dt. Gewicht) s; -[e]s, -e; 5 - (↑ R 322); Quent-chen, Quent|lein (eine kleine Menge); ein - Salz; quent|chen-wei|se

quer; kreuz und -. In Verbindung mit Zeitwörtern (↑ R 139): a) Ge-trenntschreibung in ursprüng-licher Bedeutung, z. B. quer le-gen, liegen, sich quer stellen; b) Zusammenschreibung, wenn durch die Verbindung ein neuer Begriff entsteht; vgl. quergehen, querschließen, querschreiben; vgl. auch: quergestreift; Quer-.bahn|steig, ...bal|ken, ..bau (Mehrz. ...bauten), ...baum (älte-res Turngerät); querbeet (ugs.)

Quer|der (Zool.: Larve der Neun-auges)

quer|durch; er ist - gelaufen, aber: er läuft quer durch die Felder; Que|re w; -; in die - kommen (ugs.); in die Kreuz und [in die] Quer[e]

Que|re|le lat. (Klage; Streit; in der Mehrz.: Streitigkeiten) w; -, -n (meist Mehrz.)

que|ren (veralt. für: überschreiten, überschneiden); quer|feld|ein; Quer|feld|ein.fah|ren (s; -s), ...lauf, ...ritt; Quer.flö|te, ...for-mat; quer|ge|hen; ↑ R 139 (ugs. für: mißglücken); mir geht alles quer, ist alles quergegangen; quer|ge|streift; ein -er Stoff (↑ je-doch R 142), aber: der Stoff ist quer gestreift; Quer.haus, ...holz, ...kopf (abschätzig für: jmd., der immer anders handelt, der sich nicht einordnet); quer|köp|fig; Quer|köp|fig|keit; Quer.la|ge, ...lat|te, ...lei|ste, ...li|nie, ...paß (Sportspr.), ...pfei|fe, ...ru|der; quer|schie|ßen; ↑ R 139 (ugs. für: hintertreiben); ich schieße quer; habe quergeschossen; Quer-schiff (einer Kirche); quer|schiffs (Seemannsspr.); Quer.schlag (Bergmannsspr.: Gesteinsstrek-ke, die senkrecht od. annähernd

senkrecht zu den Schichten ver-läuft), ...schlä|ger (quer od. seitl. aufschlagendes Geschoß), ...schnitt; quer|schnitt[s]|ge-lähmt; Quer|schnitt[s].ge|lähm-te, ...läh|mung; quer|schrei|ben; ↑ R 139 (einen Wechsel akzeptie-ren); ich schreibe den Wechsel quer, habe ihn quergeschrieben; Quer.schuß, ...stra|ße, ...strich, ...summe, ...trei|ber (abschätzig für: jmd., der gegen etwas han-delt, etwas zu durchkreuzen trachtet); Quer|trei|be|rei (ab-schätzig); quer|über (veralt.); - liegt ein Haus, aber: er geht quer über den Hof

Que|ru|lant lat. (Nörgler, Queng-ler) m; -en, -en (↑ R 268); Que|ru-la|ti|on [...zion] (veralt. für: Be-schwerde, Klage; Nörgelei); que-ru|lie|ren (nörgeln, ohne Grund klagen)

Quer.ver|bin|dung, ...ver|weis, ...wall

Quer|ze|tin lat. (gelber Farb- u. Arzneistoff) s; -s; Quer|zit (Ei-chelzucker) m; -s, -e; Quer|zi|tron (gemahlene Rinde der Färberei-che) s; -s

Que|se niederd. (Quetschblase; Schwiele; Blasenwurm [im Ge-hirn der Schafe, der die Drehkrankheit verursacht]) w; -, -n; que|sen niederd. (verdrießlich, nörgelig sein); du quest (quesest); Que|sen.band|wurm; que|sig (nie-derd. auch für: verdrießlich, nör-gelig)

¹Quet|sche landsch. (Zwetsche); w; -, -n

²Quet|sche (landsch. für: Presse; ugs. für: kleines Geschäft, kleine Schankwirtschaft, kleines Gut u. a.) w; -, -n; quet|schen; du quetschst (quetschest); Quet-scher (landsch.); Quetsch.fal|te, ...kom|mo|de (ugs. scherzh. für: Ziehharmonika); Quet|schung; Quetsch|wun|de

¹Quet|zal [kä...] (bunter Urwald-vogel; Wappenvogel von Guate-mala) m; -s, -s; ²Quet|zal [kä...] (Münzeinheit in Guatemala; Abk.: Q, Ø) m; -[s], -[s]; 5 -

¹Queue fr. [kö] (,,Schwanz''; Bil-lardstock) s (österr. auch: m); -s, -s; ²Queue (lange Reihe, ,,Schlan-ge''; veralt. für: Nachhut) w; -, -s

Qui|chotte [kischot] vgl. Don - quick landsch. (lebendig, schnell); Quick|born (veralt. für: Jung-brunnen); quicken [Trenn.: quik-ken] (veralt. für: mit Quecksilber mengen); Quick|gold (veralt.); quick|le|ben|dig (ugs.); Quick-step engl. [kwikßtäp] (ein Tanz) m; -s, -s

Qui|dam lat. (ein gewisser Je-mand) m; -; ein gewisser - Quid|pro|quo lat. (Verwechslung, Ersatz) s; -s, -s quiek!; quiek, quiek!; quie|ken, quiek|sen; du quiekst (quieksest); Quiek|ser (ugs.) Quie|tis|mus lat. [kwi-e...] (Stre-ben nach gottseliger Ruhe; relig. Bewegung) m; -; Quie|tist (An-hänger des Quietismus); ↑ R 268; quie|ti|stisch; Quie|tiv (Beruhi-gungs-, Besänftigungsmittel) s; -s, -e [...wᵉ] quiet|schen; du quietschst (quiet-schest); Quiet|scher (ugs.); quietsch|ver|gnügt (ugs. für: sehr vergnügt)

Qui|jo|te [kiehote] vgl. Don - Quil|la|ja indian. [kwi...] (chilen. Seifenbaum) w; -, -s; Quil|la|ja-rin|de quil|len (dicht. für: ¹quellen) Qui|nar lat. (,,Fünfer''; altröm. Münze) m; -s, -e quin|ke|lie|ren lat. mdal. (schwach, fein singen; Winkelzü-ge machen) Quin|qua|ge|si|ma lat. [kwing-kwa...] (,,fünfzigster'' Tag; sieb-ter Sonntag vor Ostern) w; -; Quin|quen|ni|um (veralt. für: Jahrfünft) s; -s, ...ien [...iᵉn]; Quin|quil|li|on (svw. Quintil-lion); Quint, Quin|te (Musik: fünfter Ton [vom Grundton an]; Fechthieb) w; -, ...ten; Quin|ta (,,fünfte''; zweite [in Österr.: fünfte] Klasse einer höheren Lehranstalt) w; -, ...ten; Quin|tal roman. (bei fr. Ausspr.: ...käng-tal, bei span. u. port. Ausspr.: kintal] (Gewichtsmaß [Zentner] in Frankreich, Spanien u. in mit-tel- u. südamerik. Staaten; Zei-chen: q) m; -s, -[e]; 2 - (↑ R 322); Quin|ta|na lat. (Med.: Fünftage-[wechsel]fieber) w; -; Quin|ta-na|fie|ber s; -s; Quin|ta|ner (Schüler der Quinta); Quin-ta|ne|rin w; -, -nen; Quin|tar alban. (alban. Münze; 100 Quin-tar = 1 Lek) m; -[s], -[e]; 100 - (↑ R 322); Quin|te vgl. Quint; Quin|ten (Mehrz. von: Quinta u. Quinte); Quin|ten|zir|kel (Musik) m; -s; Quin|ter|ne (Reihe von fünf gesetzten od. gewonnenen Num-mern in der alten Zahlenlotterie) w; -, -n; Quint|es|senz lat. (,,fünf-tes Wesen''; Endergebnis, Hauptgedanke, -inhalt, Wesen einer Sache) w; -, -en; Quin|tett it. (Musikstück für fünf Stimmen od. fünf Instrumente; auch: die fünf Ausführenden) s; -[e]s, -e; Quint|sext|ak|kord Quin|ti|li|an, Quin|ti|li|a|nus (röm. Redner, Verfasser des grundle-

genden lat. Lehrbuches der Be-
redsamkeit); **Quin|ti|li|us** (alt-
röm. m. Eigenn.)
Quin|til|li|on lat. (fünfte Potenz ei-
ner Million); **Quin|to|le** (Gruppe
von fünf Tönen, die einen Zeit-
raum von drei, vier od. sechs
Tönen gleichen Taktwertes in
Anspruch nehmen) w; -, -n
Quin|tus (altröm. m. Vorn.; Abk.:
Q.)
Qui|pro|quo lat. (Verwechslung ei-
ner Person mit einer anderen) s;
-s, -s
Qui|pu indian. [kipu] (Knoten-
schnur der Inkas, die als Schrift-
ersatz diente) s; -[s], -[s]
Qui|rin, Qui|ri|nus (röm. Gott;
röm. Tribun; Heiliger); **Qui|ri|nal** (Hügel in Rom; seit 1948 Sitz
des it. Staatspräsidenten [früher
des Königs]) m; -s
Qui|ri|te (altröm. Vollbürger) m;
-n, -n (↑ R 268)
Quirl m; -[e]s, -e; **quir|len; quir|lig**
(meist übertr. für: lebhaft, unru-
hig [vom Menschen])
Qui|si|sa|na it. („hier wird man
gesund"; Name von Kur- und
Gasthäusern) s; -
Quis|ling [nach dem norweg. Fa-
schistenführer V. Quisling] (ab-
schätzige Bez. für: ausländischer
Politiker, der im 2. Weltkrieg mit
der dt. Besatzungsmacht kol-
laborierte; [prominenter, pro-
deutscher] Landesverräter, Kol-
laborateur) m; -s, -e
Quis|qui|li|en lat. [...i⁽ᵉ⁾n] (Kleinig-
keiten) Mehrz.
Qui|to [kito] (Hptst. Ecuadors)
quitt fr. (ausgeglichen, wett, fertig,
los u. ledig); wir sind - (ugs.);
mit jmdm. - sein
Quit|te [österr. auch: kitᵉ] (baum-
artiger Strauch; Frucht) w; -, -n;
quit|te|gelb od. **quit|ten|gelb;
Quit|ten_ap|fel, ...brot, ...kä|se**
(österr. für: Quittenmarmelade),
...mar|me|la|de, ...mus
quit|tie|ren fr. ([den Empfang]
bescheinigen, bestätigen; Amt
niederlegen); übertr. für: zur
Kenntnis nehmen, hinnehmen);
Quit|tung (Empfangsbescheini-
gung); **Quit|tungs|block** (Mehrz.
...blocks), **...for|mu|lar**
Qui|vive fr. [kiwif] (Werdaruf), in
der Wendung: auf dem - sein
(ugs. für: auf der Hut sein)
Quiz engl. [kwif] (Frage-und-Ant-
wort-Spiel) s; -, -; **Quiz|ma|ster**
(Fragesteller [u. Conférencier]
bei einer Quizveranstaltung) m;
-s, -; **quiz|zen** [kwiß⁽ᵉ⁾n]
Qum|ran vgl. Kumran
quod erat de|mon|stran|dum lat.
[auch: - erat -] („was zu beweisen
war"; Abk. q.e.d.)

Quod|li|bet lat. („was beliebt";
Durcheinander, Mischmasch);
ein Kartenspiel; Musik: scherzh.
Zusammenstellung verschiede-
ner Melodien u. Texte) s; -s, -s
quor|ren (Jägerspr.: balzen [von
der Schnepfe])
Quo|rum lat. bes. schweiz. (die zur
Beschlußfassung in einer Kör-
perschaft erforderl. Zahl anwe-
sender Mitglieder) s; -s
quos ego! lat. [auch: - ego] (euch
will ich!)
Quo|ta|ti|on lat. [...zion] (Kursno-
tierung an der Börse); **Quo|te**
(Anteil [von Personen], der bei
Aufteilung eines Ganzen auf den
einzelnen od. eine Einheit ent-
fällt) w; -, -n; **Quo|ten|kar|tell**
(Wirtsch.); **Quo|ti|ent** [...ziänt]
(Zahlenausdruck, bestehend aus
Zähler u. Nenner); ↑ R 268; **quo-
tie|ren** (den Preis angeben oder
mitteilen); **Quo|tie|rung** (svw.
Quotation); **quo|ti|sie|ren** (eine
Gesamtmenge od. einen Gesamt-
wert in Quoten aufteilen); **Quo|ti-
sie|rung**
quo|us|que tan|dem! lat. („wie lan-
ge noch[, Catilina, willst du unse-
re Geduld mißbrauchen)"!; An-
fang von Ciceros 1. Rede gegen
den Verschwörer Catilina)
quo va|dis? lat. [- wadiß] (wohin
gehst du?)

R

R (Buchstabe); das R; des R, die
R, aber das r in fahren (↑ R 123);
der Buchstabe R, r
R = Rand; Reaumur
P, ϱ = Rho
r, R = Radius
r. = rechts
R., Reg[t]., Rgt. = Regiment
¹Ra (ägypt. Sonnengott)
²Ra = chem. Zeichen für: Radium
¹Raab (ung. Stadt); **²Raab** (rechter
Nebenfluß der Donau) w; -
Raa|be (dt. Dichter)
Ra|ba|nus Mau|rus vgl. Hrabanus
Maurus
Ra|bat [auch: rabat] (Hptst. von
Marokko)
Ra|batt it. (vereinbarter od. übl.]
Abzug [vom Preis], Preisnach-
laß) m; -[e]s, -e; **Ra|bat|te** niederl.
([Rand]beet; veralt. für: Um-
schlag, Aufschlag an Kleidern)
w; -, -n; **ra|bat|tie|ren** it. (Rabatt
gewähren); **Ra|bat|tie|rung; Ra-
batt_mar|ke, ...spar|ver|ein
Ra|batz** (ugs. für: lärmendes Trei-
ben, Unruhe, Krach) m; -es; -
machen; **Ra|bau** niederrhein.

(kleine graue Renette; Rabau-
ke) m; -s u. -en, -e[n] (↑ R 268);
Ra|bau|ke (ugs. für: grober,
gewalttätiger junger Mensch,
Rohling) m; -n, -n (↑ R 268)
Rab|bi hebr. (Ehrentitel jüd. Ge-
setzeslehrer u. a.) m; -[s], ...inen
(auch: -s); **Rab|bi|nat** (Amt, Wür-
de eines Rabbi[ners]) s; -[e]s, -e;
Rab|bi|ner (jüd. Gesetzes-, Reli-
gionslehrer, Geistlicher, Predi-
ger) m; -s, -; **rab|bi|nisch;** -e Spra-
che (das wissenschaftl. jünge-
re Hebräisch; nicht zu verwech-
seln mit: Neuhebräisch)
Räb|chen, Räb|lein; **Ra|be** m; -n,
-n (↑ R 268)
Ra|belais [rab⁽ᵉ⁾lä] (fr. Satiriker)
Ra|ben_aas (Schimpfwort), **...el-
tern** (abwertend für: lieblose El-
tern; Mehrz.), **...krä|he, ...mut|ter**
(abwertend für: lieblose Mutter;
Mehrz. ...mütter)
Ra|ben|schlacht (Schlacht bei
Raben [Ravenna]) w; -
ra|ben|schwarz (ugs.); **Ra|ben-
_stein** ([Richtstätte unter dem]
Galgen), **...va|ter** (abwertend für:
lieblose Vater), **...vo|gel**
ra|bi|at lat. (wütend; grob, roh)
Ra|bitz|wand; ↑ R 180 [nach dem
Erfinder Karl Rabitz] (Gips-
wand mit Drahteinlage)
Räb|lein, Räb|chen
Ra|bu|list (Wortverdreher,
Haarspalter); ↑ R 268; **Ra|bu|li-
ste|rei; Ra|bu|li|stik; ra|bu|li-
stisch**
Ra|che w; -; **Ra|che_akt, ...durst;
rä|che|dür|stend,** aber (↑ R 142):
nach Rache dürstend; **ra|che|dur-
stig; Ra|che_ge|dan|ke, ...ge|fühl**
Ra|chel (w. Vorn.)
Ra|chen m; -s, -
rä|chen; gerächt (veralt., aber
noch scherzh.: gerochen); sich -
**Ra|chen_blüt|ler, ...höh|le, ...ka-
tarrh, ...man|del, ...put|zer**
(scherzh. ugs. für: saurer Wein
u. a.), **...reiz|stoff**
Ra|che|plan; vgl. ²Plan; **Rä|cher;
Rä|che|rin** w; -, -nen; **Ra|che-
schwur; Rach|gier; rach|gie|rig**
Ra|chi|tis gr. [raeh...] (englische
Krankheit) w; -; **ra|chi|tisch**
Rach|ma|ni|now [...nof] (russ.
Komponist)
Rach|sucht w; -; **rach|süch|tig**
Ra|cine [raßin] (fr. Dramendich-
ter)
Racke¹ (ein Vogel) w; -, -n
Rackel¹_huhn, ...wild
Racker¹ (meist gutmütig zurecht-
weisend, auch kosend für:
Schalk, Schelm, drolliges Kind)
m; -s, -; **Racke|rei¹** (ugs. für:
schwere, mühevolle Arbeit,

¹ Trenn.: ...k|k...

Schinderei); rackern[1], sich;
(meist:) ab|rackern, sich (ugs.
für: sich abarbeiten); ich ...ere
mich (↑ R 327)
Racket[1] [räkᵉt] (engl. u. österr.
Schreibung von: Rakett) s; -s, -s
Ra|clette fr. [rąklät] (Walliser Kä-
segericht) w; - (auch: s; -s)
Rad s; -[e]s, Räder; zu Rad[e]; un-
ter die Räder kommen (ugs. für:
moralisch verkommen); radfah-
ren (vgl. d.); radschlagen (vgl. d.)
Ra|dar [auch, österr. nur: rą...];
aus: radio detection and ranging]
m od. -s; Ra|dar_astro|no|mie,
...ge|rät, ...kon|trol|le, ...me|teo-
ro|lu|gie, ...pei|lung, schirm,
...sta|ti|on, ...tech|ni|ker
Ra|dau (ugs. für: Lärm; Unfug)
m; -s; - machen; Ra|dau_bru|der,
...ma|cher (abwertend)
Rad_ball, ...bal|ler, ...ball|spiel;
Rad|ler, Ra|de|ber ostmitteldt.
(Schubkarre) w; -, -en; Rad_brem-
se, ...bruch m; Räd|chen s; -s, -
u. Räderchen; Räd|lein; Rad-
damp|fer
Ra|de (Kornrade) w; -, -n
Ra|de|ber vgl. Radber, Ra|de|ber-
ge mdal. (Schubkarre) w; -, -n
ra|de|bre|chen; du radebrechst; du
radebrechtest; geradebrecht; zu -
Ra|de|gund, Ra|de|gun|de (w.
Vorn.)
Ra|de|hacke[1], ...haue (sächs. für:
Rodehacke)
ra|deln (radfahren); ich ...[e]le (↑ R
327); rä|deln (mit dem Rädchen
[Teig] ausschneiden oder
[Schnittmuster] durchdrücken);
ich ...[e]le (↑ R 327)
Rä|dels|füh|rer
Ra|den|thein (österr. Ort)
Rä|der|chen (Mehrz. von: Räd-
chen); Rä|der|ge|trie|be; ...rä|de-
rig, ...rädrig (z. B. dreirad[e]rig);
rä|dern; ich ...ere (↑ R 327); Rä-
der_tier (Rundwurm), ...werk
Ra|detz|ky (österr. Feldherr); Ra-
detz|ky|marsch m; -es (↑ R 180)
rad|fah|ren (↑ R 140); ich fahre
Rad; ich weiß, daß er radfährt;
ich bin radgefahren; radzufah-
ren; (↑R 145:) rad- und Auto fah-
ren, aber: Auto und radfahren;
Rad|fah|ren s; Rad|fah|rer;
Rad|fah|re|rin w; -, -nen; Rad-
fahr|weg; Rad|fel|ge
Ra|di bayr. u. österr. (Rettich) m;
-s, -; einen - kriegen (ugs.: gerügt
werden)
ra|di|al lat. (auf den Radius bezüg-
lich, strahlenförmig; von einem
Mittelpunkt ausgehend); Ra-
di|al_ge|schwin|dig|keit, ...li|nie
(österr. für: Straße, Straßen-
bahnlinie u. dgl., die von der

Stadtmitte zum Stadtrand führt),
...sym|me|trie, ...tur|bi|ne; Ra|di-
ant (Astron.: scheinbarer Aus-
gangspunkt der Sternschnuppen
am Himmel) m; -en, -en (↑ R 268);
ra|di|är fr. (strahlig); Ra|dia|ten
lat. (veralt. Bez. für: Tiere mit
strahligem Bau [Hohltiere, Sta-
chelhäuter]) Mehrz.; Ra|dia|ti|on
[...zion] (Strahlung; Biol.: Aus-
strahlung neuer Anpassungen);
Ra|dia|tor (Heizkörper) m; -s,
...ǫren; Ra|di|en (Mehrz. von:
Radius)
ra|die|ren lat.; Ra|die|rer (Verferti-
ger von Radierungen); Ra|dier-
_gum|mi m; ...kunst (Ätzkunst),
...mes|ser s, ...na|del; Ra|die|rung
Ra|dies|chen lat. (eine Pflanze); ra-
di|kal (tief, bis auf die Wurzel
gehend; gründlich; rücksichts-
los); Ra|di|kal (Atomgruppe che-
mischer Verbindungen) s; -s, -e;
Ra|di|ka|le m u. w; -n, -n (↑ R
287ff.); Ra|di|ka|lin|ski (ugs. ab-
schätzig für: politischer Radika-
list) m; -s, -s; ra|di|ka|li|sie|ren
(radikal machen); Ra|di|ka|li|sie-
rung (Entwicklung zum Radika-
len); Ra|di|ka|lis|mus (rück-
sichtslos bis zum Äußersten ge-
hende [politische, religiöse usw.]
Richtung) m; -, ...men; Ra|di|ka-
list (↑ R 268); Ra|di|kal|kur (ugs.);
Ra|di|kand (Zahl, deren Wurzel
gezogen werden soll) m; -en, -en
(↑ R 268)
ra|dio... lat., Ra|dio... (Strahlen...,
[Rund]funk...); Ra|dio (Rund-
funk[gerät]) s (ugs., bes. schweiz.
für das Gerät auch: m) -s, -s; ra-
dio|ak|tiv (er Niederschlag; ra-
dioaktive Stoffe; Ra|dio|ak|ti|vi|tät (Eigen-
schaft der Atomkerne gewisser
Isotope, sich ohne äußere Ein-
flüsse umzuwandeln und dabei
bestimmte Strahlen auszusen-
den); Ra|dio_ama|teur, ...an|la-
ge, ...ap|pa|rat, ...astro|no|mie,
...che|mie, ...ele|ment (radioakti-
ves chem. Element), ...ge|rät; Ra-
dio|gramm lat.; gr. (früher für:
Funktelegramm) s; -s, -e; Ra|dio-
la|rie lat. [...iᵉ] (Strahlentierchen)
w; -, -n (meist Mehrz.); Ra|dio|lo-
ge lat.; gr. (Med.: Facharzt für
Röntgenologie u. Strahlenheil-
kunde) m; -n, -n (↑ R 268); Radio-
lo|gie (Strahlenkunde) w; -; ra-
dio|lo|gisch; Ra|dio|me|teo|ro|lo-
gie; Ra|dio_me|ter (Gerät zum
Demonstrieren eines photother-
mischen Effekts; s; -s, -), ...pho-
nie (drahtlose Telephonie; w; -);
Ra|dio_pro|gramm, ...quel|le,
...röh|re, ...sen|der, ...son|de (vgl.
Sonde [Physik]), ...sta|ti|on,
...stern, ...tech|nik, ...te|le|gra|fie,
...te|le|fo|nie, ...te|le|skop, ...the-

ra|pie (Heilbehandlung durch
Bestrahlung; w; -); Ra|di|um lat.
(radioaktiver chem. Grundstoff,
Metall; Zeichen: Ra) s; -s; Ra|di-
um_be|strah|lung, ...blei, ...ema-
na|ti|on (ein Edelgas, ein Isotop
des Radons); ra|dium|hal|tig; Ra-
di|um|the|ra|pie w; -; Ra|di|us
(Halbmesser des Kreises; Abk.:
r, R) m; -, ...ien [...iᵉn]; Ra|di|us-
vek|tor (Leit-, Fahrstrahl)
Ra|dix lat. (Wurzel) w; -, ...izes;
ra|di|zie|ren (Math.: die Wurzel
aus einer Zahl ziehen)
Rad_kap|pe, ...ka|sten, ...kranz;
Räd|lein vgl. Rädchen; Rad|ler
(Radfahrer); Rad|le|rin w; -, -nen;
Rad_ma|cher (landsch. für: Stell-
macher), ...man|tel, ...mei|ster-
schaft
Ra|dolf, Ra|dulf (m. Vorn.)
Ra|dom engl. (Radarschutzkup-
pel, Traglufthalle) s; -s, -s; Ra-
dome [reᵉdoᵘm] (engl. Form von:
Radom)
Ra|don lat. [auch: ...dǫn] (radioak-
tiver chem. Grundstoff, Edelgas;
Zeichen: Rn) s; -s
Ra|do|ta|ge fr. [...tąscheᵉ] (veralt.
für: leeres Geschwätz, Faselei);
ra|do|tie|ren (veralt.)
Rad_renn|bahn; Rad|ren|nen;
...räd|rig vgl. ...räderig
rad|schla|gen; vgl. radfahren; ich
kann -, aber: er kann ein Rad
schlagen; Rad|schla|gen s; -s;
Rad_schuh (der Radkrümmung
angepaßter Bremsklotz aus Holz
od. Eisen), ...sport (m; -[e]s),
...sport|ler
Rad|stadt (Stadt in Salzburg);
Rad|städ|ter Tau|ern Mehrz.
Rad_stand, ...sturz, ...tour
Ra|dulf, Ra|dolf (m. Vorn.)
Rad_wech|sel, ...weg
Ra|dzi|will (Adelsgeschlecht)
Raes|feld [rąß...] (Ort in Nord-
rhein-Westfalen)
R. A. F. = Royal Air Force
Räf (schweiz. Nebenform von:
[1]Reff u. [2]Reff) s; -s, -e
Raf|fa|el vgl. Raphael; vgl. aber:
Raffael
Raf|fa|el [...faäl] (it. Maler); vgl.
aber: Raphael; raf|fae|lisch; -e
Farbgebung; aber (↑ R 179):
Raf|fae|lisch; -e Madonna
Raf|fel landsch. (großes Maul mit
bleckenden Zähnen, loses Mund-
werk; zänkisches, schwätziges
Weib; Gerät zum Abstreifen von
Heidelbeeren; Reibeisen; Klap-
per) w; -, -n; raf|feln landsch.
(schaben; rasseln; schwatzen;
verleumden); ich ...[e]le (↑ R 327)
raf|fen; Raff|gier; raff|gie|rig; raf-
fig landsch. (raff-, habgierig)

Raf|fi|na|de *fr.* (gereinigter Zuk-
ker); Raf|fi|na|ge [...*naseʰ*] (ver-
alt. für: Verfeinerung); Raf|fi|na-
tion [...*ziọn*] (Verfeinerung, Ver-
edelung); Raf|fi|ne|ment [...*finᵉ-
mang*] (Überfeinerung; durch-
triebene Schlauheit) *s*; -s, -s; Raf-
fi|ne|rie (Anlage zum Reinigen
von Zucker od. zur Verarbeitung
von Rohöl) *w*; -, ...ien; Raf|fi|nes-
se (Überfeinerung; Durchtrie-
benheit, Schlauheit) *w*; -, -n; Raf-
fi|neur [...*nör*] (Maschine zur Ver-
arbeitung des Holzschliffs) *m*; -s,
-e; raf|fi|nie|ren (Zucker reinigen;
Rohöl zu Brenn- od. Treibstoff
verarbeiten); Raf|fi|nier_ofen,
...stahl (*m*; -[e]s); raf|fi|niert (ge-
reinigt; durchtrieben, schlau, ab-
gefeimt); ein -er (gereinigter) Zuk-
ker; ein -er (durchtriebener) Be-
trüger; Raf|fi|niert|heit; Raf|fi-
no|se (zuckerartige chem. Ver-
bindung) *w*; -
Raff|ke (ugs. abschätzig für: unge-
bildeter Neureicher) *m*; -s, -s;
Raff|sucht *w*; -; Raf|fung; Raff-
zahn (landsch. für: stark überste-
hender, auch: abgebrochener
Zahn; übertr. verächtl. für: Nim-
mersatt)
Raft *engl.* (schwimmende Insel aus
Treibholz) *s*; -s, -s
Ra|gaz, Bad (schweiz. Badeort)
Ra|ge *fr.* [*raseʰ*] (ugs. für: Wut,
Raserei) *w*; -; in der -; in -brin-
gen
ra|gen
Ra|gio|nen|buch *it.*; *dt.* [*radsehọ-
nᵉn...*] schweiz. (Verzeichnis der
ins Handelsregister eingetrage-
nen Firmen)
Ra|glan *engl.* [*räglᵉn*] (meist in
dt. Ausspr.: *räglan* nach dem
einarmigen engl. Lord) ([Sport]-
mäntel mit angeschnittenem Är-
mel) *m*; -s, -s; Ra|glan_är|mel,
...schnitt
Rag|na|rök *altnord.* (in der nord.
Mythol. der Weltuntergang) *w*; -
Ra|gout *fr.* [*ragụ*] (Mischgericht)
s; -s, -s; Ra|goût fin [*ragufäng*]
(„feines" Ragout [in Muschel-
schalen]) *s*; - -, -s [*ragufäng*]
Rag|time *amerik.* [*rägtaim*] (stark
synkopierte Musik der nordame-
rik. Neger; Negertanz [seit 1920
in Europa]) *m*; -
Ra|gu|sa (it. u. dt. oft für: Du-
brovnik)
Rah, Ra|he (Seemannsspr.:
Querstange am Mast für das
Rahsegel) *w*; -, Rahen
Ra|hel (w. Vorn.)
Rahm landsch. (Sahne) *m*; -[e]s (selte-
ner: -es)
Rähm (Bauw.: waagerechter Teil
des Dachstuhls) *m*; -[e]s, -e;
Rähm|chen, Rähm|lein; rah|men;

Rah|men *m*; -s, -; Rah|men_an-
ten|ne, ...bruch (*m*; -[e]s, ...brü-
che), ...er|zäh|lung; rah|men|ge-
näht; Rah|men_ge|schich|te, ...ge-
setz, ...plan (vgl. ²Plan), ...ta|rif,
...ver|trag
rah|mig (landsch.); Rahm|kä|se
(landsch.)
Rähm|lein, Rähm|chen
Rahm|spei|se (landsch.)
Rah|ne südd. (rote Rübe) *w*; -, -n;
vgl. Rande
Rah|se|gel (Seemannsspr.)
Raid *engl.* [*reʲd*] ([Reiter]streifzug,
Einfall) *m*; -s, -s
Raiff|ei|sen (Familienn.); -sche
Kassen (Darlehenskassenver-
eine); Raiff|ei|sen|bank (*Mehrz.*
..banken)
Rai|gras *engl.*; *dt.* (fr. Glatthafer;
einige Arten des Weidelgrases)
s; -es
Rail|le|rie *fr.* [*raⁱᵉrị*] (veralt. für:
Scherz, Spöttelei) *w*; -, ...ien
¹Rai|mund, Rei|mund (m. Vorn.)
²Rai|mund (österr. Dramatiker)
Rain (Ackergrenze) *m*; -[e]s, -e
Rai|nald (ältere Form von:
Reinald); - von Dassel (Kanzler
Friedrichs I.)
rai|nen (veralt. für: ab-, umgren-
zen); - und steinen (veralt. für:
wohl umgrenzen)
Rai|ner, Rei|ner (m. Vorn.)
Rain|farn (eine Pflanzenart)
Rai|nung (veralt. für: Festsetzung
der Ackergrenze); - und Steinung
(veralt.); Rain|wei|de (Liguster)
Rai|son *fr.* [*räsọng*] usw. (fr. Schrei-
bung von: Räson usw.)
ra|jo|len (svw. rigolen)
Ra|ke vgl. Racke
Ra|kel (Druckw.: Vorrichtung
zum Abstreichen überschüssiger
Farbe von der eingefärbten
Druckform) *w*; -, -n
rä|keln vgl. rekeln
Ra|ke|te *it.* (Feuerwerkskörper;
Flugkörper) *w*; -, -n; Ra|ke|ten-
ab|schuß, ...ab|schuß|ram|pe,
...ab|wehr, ...an|trieb, ...ap|pa|rat
(Rettungswesen), ...au|to, ...ba-
sis; ra|ke|ten|be|stückt, aber († R
142): mit Raketen bestückt; Ra-
ke|ten_feu|er, ...flug|zeug, ...ge-
schoß, ...ge|schwin|dig|keit,
...start, ...stu|fe, ...stütz|punkt,
...treib|stoff, ...trieb|werk, ...waf-
fe, ...wa|gen, ...zeit|al|ter, ...zen-
trum
Ra|kett *engl.* ([Tennis]schläger) *s*;
-[e]s, -e u. -s; vgl. Racket
Rá|kó|czi *[rákọzi]* (ung. Adelsge-
schlecht)
Ralf (m. Vorn.)
Ral|le (ein Vogel) *w*; -, -n
ral|li|ieren *fr.* (veralt. für: zerstreu-
te Truppen sammeln)
Ral|lye *engl.-fr.* [*ralị* od. *rälị*] (Au-

tosternfahrt) *w*; -, -s (schweiz.:
s; -s, -s); Ral|lye|fah|rer
Ralph (engl. Schreibung von:
Ralf)
Ra|ma|dan *arab.* (Fastenmonat
der Mohammedaner) *m*; -[s]
Ra|ma|ja|na *sanskr.* (ind. reli-
giöses Nationalepos von den Ta-
ten des göttl. Helden Rama) *s*; -
Ra|ma|su|ri *it.* bayr. u. österr. ugs.
(großes Durcheinander; Trubel)
w; -
Ram|bouil|let [*rangbuje*] (fr.
Stadt); Ram|bouil|let|schaf (fein-
wolliges Schaf); † R 201
Ram|bur *fr.* (Apfel einer bestimm-
ten säuerlichen Sorte) *m*; -s, -e
Ra|mels_lo|her Hüh|ner od. Ra-
mels_lo|her Land|hüh|ner *Mehrz.*
Ra|mes|si|de (Herrscher aus dem
Geschlecht des Ramses) *m*; -n,
-n († R 268)
Ra|mie *malai.-engl.* (Bastfaser,
Chinagras) *w*; -, ...ien
Ramm (Rammsporn [früher an
Kriegsschiffen]) *m*; -[e]s, -e;
Ramma|schi|ne [*Trenn.*: Ramma-
ma...; † R 236] *w*; -, -n; Ramm_bal-
ken, ...bär (*m*; -s, -en, fachspr.
auch: -e), ...bock, ...bug; rammᵈ-
dö|sig (ugs. für: benommen;
überreizt); Ram|me (Fallklotz) *w*;
-, -n; ¹Ram|mel (veralt. für: Ram-
me) *w*; -, -n; ²Ram|mel mdal. (un-
geschickter Kerl, Tölpel) *m*; -s,
-; Ram|me|lei (ugs.); ram|meln
(auch Jägerspr.: belegen, decken
[bes. von Hasen und Kaninchen];
rammen); ram|men (mit der
Ramme eintreiben; ein Schiff
oder Hindernis anrennen);
Ramm_ham|mer, ...klotz; Ramm-
ler (Männchen [bes. von Hasen
und Kaninchen]); Ramms|kopf
(Pferdekopf mit stark gekrümm-
tem Nasenrücken); Ramm|sporn
Ram|pe *fr.* (schiefe Ebene zur
Überwindung von Höhenunter-
schieden; Auffahrt; Verladebüh-
ne; Theater: Vorbühne) *w*; -, -n;
Ram|pen|licht *s*; -[e]s; ram|po|nie-
ren *it.* (ugs. für: stark beschädi-
gen)
Rams_au [auch: *rạms...*] (Name
verschiedener Orte in Süd-
bayern)
¹Ramsch (bunt zusammengewür-
felte Warenreste; Altware,
Schleuderware) *m*; -[e]s, (selten:)
-e; im - (in Bausch und Bogen)
kaufen
²Ramsch *fr.* (Skat: Spiel mit ver-
decktem Skat, jeder gegen jeden
mit dem Ziel, möglichst wenig
Punkte zu bekommen) *m*; -[e]s,
-e
'ram|schen (zu: ¹Ramsch; ugs. für:
Ramschware billig aufkaufen);
dụ ramschst (ramschest);

²**ram|schen** (zu: ²Ramsch; ein Spiel mit verdecktem Skat spielen); du ramschst (ramschest)
Ram|scher (zu: ¹Ramsch; ugs. für: Aufkäufer zu Schleuderpreisen);
Ramsch|la|den (ugs. abschätzig);
Ramsch|wa|re (ugs. abschätzig);
ramsch|wei|se (ugs.)
Ram|ses (Name ägypt. Könige)
ran; ↑ R 238 (ugs. für: heran)
Ran (nord. Mythol.: Gattin des Ägir)
Ranch amerik. [räntsch, auch: rantsch] (nordamerik. Viehwirtschaft, Farm) w; -, -[e]s; **Ran|cher** (nordamerik. Viehzüchter, Farmer) m; -s, -[s]
¹**Rand** m; -[e]s, Ränder; außer Rand und Band sein (ugs.); zu Rande kommen
²**Rand** engl. [ränd] (Währungseinheit der Republik Südafrika; Abk.: R) m; -s, -[s]; 5 - (↑ R 322)
Ran|dal (Studentenspr. veralt. aber noch mdal. für: Lärm, Gejohle) m; -s, -e; **ran|da|lie|ren**
Rand_aus|gleich, ...**beet,** ...**be|merkung,** ...**be|zirk; Ränd|chen** s; -s, - u. Ränderchen; **Ränd|lein**
Ran|de schweiz. (rote Rübe) w; -, -n; vgl. Rahne
Rän|del|mut|ter (Mehrz. ...muttern); **rän|deln** (durch Rädchen, Walzen verzieren, aufrauhen), ich ...[e]le (↑ R 327); **Rän|del_rad,** ...**schraube; Rän|de|lung**
Rän|der (Mehrz. von: Rand); ...**rän|de|rig,** ...**ränd|rig,** ...**ran|dig** (z. B. breitränd[e]rig od. -randig); **rän|dern,** ich ...ere (↑ R 327);
Rand_fi|gur, ...**ge|biet,** ...**ge|bir|ge,** ...**glos|se; Ränd|lein** vgl. Rändchen; **Rand_lei|ste,** ...**lö|ser** (Schreibmaschine)
Ran|dolf, Ran|dulf (m. Vorn.)
...**ränd|rig** vgl. ...ränderig
Rand_sied|lung, ...**staat** (Mehrz. ...staaten), ...**stein,** ...**stel|ler** (an der Schreibmaschine)
Ran|dulf, Ran|dolf (m. Vorn.)
Rand_ver|zie|rung, ...**zeich|nung,** ...**zo|ne**
Ranft mdal. (Brotkanten, -kruste) m; -[e]s, Ränfte; **Ränft|chen, Ränft|lein**
Rang fr. m; -[e]s, Ränge; jmdm. den - (eigtl.: Rank; vgl. d.) ablaufen (zuvorkommen); der erste, zweite -; ein Sänger von -; **Rang_ab|zei|chen,** ...**äl|te|ste**
Ran|ge mdal. (unartiges Kind) m; -n, -n (↑ R 268) od. w; -, -n
ran|ge|hen; ↑ R 238 (ugs. für: herangehen; etwas energisch anpacken)
ran|geln mdal. (sich balgen, ringen, sich ungebärdig bewegen); ich ...[e]le (↑ R 327)
Ran|ger amerik. [re͕′ndsch͕ʰr] (An-

gehöriger einer berittenen [Polizei]truppe in Nordamerika [z. B. die Texas Rangers]; amerik. Mondsonde) m; -s, -s
Ran|ger_hö|hung, ...**fol|ge; rang-_gleich,** ...**höchst,** ...**hö|her**
Ran|gier|bahn|hof [rangsehir...], auch: rangsehir..., österr.: ransehir... u. rangsehir...] (Verschiebebahnhof); **ran|gie|ren** fr. (einen Rang innehaben [vor, hinter jmdm.]; Eisenbahnw.: verschieben; mdal. für: ordnen); **Rangier_ge|lei|se** od. ...**gleis,** ...**lok** (für:) ...**lo|ko|mo|ti|ve,** ...**mei|ster; Ran|gie|rung**
...**ran|gig** (z. B. zweitrangig);
Rang_klas|se, ...**li|ste,** ...**ord|nung; rang|mä|ßig; Rang_ord|nung,** ...**streit**
Ran|gun [ranggun] (Hptst. von Birma); **Ran|gun|reis** m
Rang|un|ter|schied
ran|hal|ten, sich; ↑ R 238 (ugs. für: sich beeilen)
rank (schlank; geschmeidig); - und schlank
Rank mdal. (Wegkrümmung; List) m; -[e]s, Ränke (meist Mehrz.); Ränke schmieden, (schweiz. auch:) den Rank (eine geschickte Lösung) finden; vgl. auch: Rang
Ran|ke (Gewächsteil) w; -, -n
Rän|ke (Mehrz. von: Rank)
ran|ken; sich -
Ran|ken mdal. (derbes Stück Brot) m; -s, -
ran|ken|ar|tig; Ran|ken_ge|wächs, ...**werk** (für: Ornament)
Rän|ke_schmied (abwertend), ...**spiel,** ...**sucht** (w; -); **ränke-_süch|tig,** ...**voll**
ran|kig
Ran|kü|ne fr. (veralt. für: Groll, heimliche Feindschaft; Rachsucht) w; -, -n
Ra|nun|kel lat. (eine Gartenpflanze) w; -, -n
Rän|zel, auch: **Rän|zel** s (nordd. auch: m); -s, -, **Rän|zel|lein** (kleiner Ranzen)
ran|zen (Jägerspr.: begatten [vom Haarraubwild])
Ran|zen (ugs. für: Buckel, Bauch; Schultertasche) m; -s, -
ran|zig niederl.; die Butter ist -
Ran|zi|on fr. (früher für: Lösegeld); **ran|zio|nie|ren** (früher für: freikaufen)
Ränz|lein vgl. Ränzchen
Ranz|zeit [zu: ranzen]
Ra|oul [raul] (fr. Form von: Rudolf [Rollo])
Ra|pac|ki [...pạtßki] (polnischer Staatsmann); **Ra|pac|ki-Plan** m; -[e]s (↑ R 180)
Ra|pal|lo (Seebad bei Genua); **Ra-_pal|lo|ver|trag** m; -[e]s; ↑ R 201

Rap|fen (Art Karpfen) m; -s, -
Ra|pha|el, (ökum. u. österr.:) **Ra-_fa|el** [...faäl] (einer der Erzengel); vgl. aber: Raffael
Ra|phia madagass. (afrik. Bastpalme, Nadelpalme) w; -, ...ien [...i͕ʰn]; **Ra|phia|bast**
Ra|phi|den gr. (nadelförmige Kristalle in Pflanzenzellen) Mehrz.
ra|pid (österr. nur so), **ra|pi|de** lat. (reißend, [blitz]schnell); ...deste; **Ra|pi|di|tät** w; -; **ra|pi|do** it. (Musik: sehr schnell, rasch)
Ra|pier fr. (Fechtwaffe, Degen) s; -s, -e
Rapp mdal. (Traubenkamm; entbeerte Traube) m; -s, -e
Rap|pe f. (,,rabenschwarzes'' Pferd) m; -n, -n (↑ R 268)
Rap|pel (ugs. für: plötzlicher Zorn; Verrücktheit) m; -s, -; **rap-_pe|lig, rapp|lig** (ugs.); **Rap|pel-_kopf** (ugs.); **rap|pel|köp|fisch** (ugs.); -ste (↑ R 294); **rap|peln** (klappern); österr.: verrückt sein) ich ...[e]le (↑ R 327)
Rap|pen (schweiz. Münze; Abk.: Rp.); 100 Rappen = 1 Schweizer Franken) m; -s, -; **Rap|pen|spal-_ter** schweiz. (Pfennigfuchser)
rapp|lig, rap|pe|lig
Rap|port fr. (Wirtsch.: Bericht, Meldung; Textilwesen: Musterwiederholung bei Geweben; Militär veralt.: dienstl. Meldung; veralt. für: wechselseitige Beziehung) m; -[e]s, -e; **rap|por|tie|ren** (Zeitwort zu Rapport)
Rapp|schim|mel (Pferd)
raps!; rips, raps!
Raps (Ölpflanze) m; -es, (für Rapsart Mehrz.:) -e; **Raps_acker** [Trenn.: ...ak|ker], ...**blü|te**
rap|schen landsch. (hastig wegnehmen); du rapschst (rapschest) u. **rap|sen;** du rapst (rapsest)
Raps_erd|flöh, ...**feld,** ...**glanz|kä|fer,** ...**kohl,** ...**ku|chen,** ...**öl** (s; -[e]s), ...**saat**
Rap|tus lat. (Med.: Anfall von Raserei; Rechtsw.: veralt. für: Raub, Entführung) m; -, - u. (scherzh. für Rappel Mehrz.:) -se
Ra|pünz|chen, Ra|pünz|lein (Salatpflanze)
Ra|pun|ze w; -, -n; vgl. Rapunzel; **Ra|pun|zel** (Salatpflanze) w; -, -n
Rar lat. (selten); sich - machen (ugs. für: selten kommen); **Ra|ri|tät; Ra|ri|tä|ten_ka|bi|nett,** ...**ka|sten**
Ras arab. (Vorgebirge; Berggipfel; abessin. Titel) m; -, -
ra|sant lat. (sehr flach [Flugbahn]; ugs. für: rasend, sehr schnell, wild bewegt); **Ra|sanz** w; -

ra|sau|nen mittel-, niederd. (lärmen, poltern, schimpfen); er hat rasaunt

rasch; -este (↑ R 292)

Rasch [„aus Arras"] (ein Wollgewebe) m; -[e]s, -e

ra|scheln; ich ...[e]le (↑ R 327)

ra|sche|stens; Rasch|heit w; -; rasch.|le|big, ...wüch|sig

ra|sen (wüten; toben; sehr eilig fahren, gehen); du rast (rasest); er ra|ste

Ra|sen m; -s, -; Ra|sen|bank (Mehrz. ...bänke); ra|sen.be-deckt, ...be|wach|sen; Ra|sen|blei-che

ra|send (wütend; schnell); - werden, aber (↑ R 120): es ist zum Rasendwerden

Ra|sen.flä|che, ...mä|her, ...mäh-ma|schi|ne, ...platz, ...spiel, ...sport, ...spren|ger

Ra|ser (ugs. für: überschnell Fahrender [Kraftfahrer u. a.]); Ra|se-rei (ugs.)

Ra|seur fr. [...sör] (veralt. für: Bartscherer) m; -s, -e; Ra|sier.ap-pa|rat, ...cre|me; ra|sie|ren; sich -; Ra|sier.flech|te, ...klin|ge, ...mes|ser s, ...pin|sel, ...sei|fe, ...spie|gel, ...was|ser (Mehrz. ...wasser od. ...wässer, ...zeug

ra|sig (mit Rasen bewachsen)

Rä|son fr. [...song] (veraltend für: Vernunft, Einsicht) w; -; jmdn. zur - bringen; Rä|so|neur [...nör] (veralt. für: Schwätzer, Klugredner, ewig Tadelnder) m; -s, -e; rä|so|nie|ren (veralt. für: vernünftig reden, Schlüsse ziehen; veraltend, aber noch ugs. für: laut, lärmend reden; schimpfen); Rä-son|ne|ment [...mang] (veralt. für: vernünftige Beurteilung; Überlegung, Erwägung; Vernunftschluß) s; -s, -s

Ras|pa span. (um 1950 eingeführter lateinamerik. Gesellschaftstanz) w; -, -s (ugs. auch: m; -s, -s)

Ras|pel w; -, -n; ras|peln; ich ...[e]le (↑ R 327)

Ras|pu|tin [auch: ...pu...] (russ. Eigenn.)

raß, räß südd., schweiz. mdal. (scharf gewürzt, beißend [Speisen])

Ras|se fr. w; -, -n; die weiße, gelbe, schwarze, rote -; Ras|se|hund

Ras|sel (Knarre, Klapper) w; -, -n; Ras|sel|ban|de (ugs. scherzh. für: übermütige, zu Lärm u. Streichen aufgelegte Kinderschar) w; -; Ras|se|lei (ugs.); Ras|se|ler, Raß|ler; ras|seln; ich rassele u. raßle (↑ R 327)

Ras|sen.dis|kri|mi|nie|rung, ...for-scher, ...for|schung, ...fra|ge, ...ge|schich|te, ...haß, ...hy|gie|ne,

...kreu|zung, ...kun|de (w; -), ...merk|mal, ...mi|schung, ...pro-blem; Ras|se|pferd; ras|se|rein; Ras|se|rein|heit w; -; ras|se|ver-edelnd; ras|sig (von ausgeprägter Art); -e Erscheinung; vgl. reinras-sig; ras|sisch (der Rasse entsprechend, auf die Rasse bezüglich), -ste (↑ R 294); -e Eigentümlichkeiten; Ras|sis|mus (übersteigertes Rassenbewußtsein, Rassenhetze) m; -; Ras|sist (Vertreter des Rassismus); ↑ R 268; ras|si|stisch

Raß|ler, Ras|se|ler

Rast w; -, -en; ohne - und Ruh (↑ R 241)

Ra|statt (Stadt im nördl. Oberrhein. Tiefland); Ra|stat|ter (↑ R 199)

Ra|ste (Stützkerbe) w; -, -n

Ra|stel it. österr. (Schutzgitter, Drahtgeflecht) s; -s, -; Ra|stel-bin|der (Siebmacher, Kesselflicker)

ra|sten

Ra|ster lat. (Glasplatte mit engem Liniennetz zur Zerlegung eines Bildes in Rasterpunkte; Fläche des Fernsehbildschirmes, die sich aus Lichtpunkten zusammensetzt) m (Fernsehtechnik: s); -s, -; Ra|ster|ät|zung (Autotypie); ra|stern (ein Bild durch Raster in Rasterpunkte zerlegen); ich ...ere (↑ R 327); Ra|ster.plat|te, ...punkt

Rast.haus, ...hof; rast|los; -este (↑ R 292); Rast|lo|sig|keit w; -; Rast|platz

Ra|stral lat. ([Noten]linienzieher) s; -s, -e; ra|strie|ren; Ra|strier|ma-schi|ne

Rast.stät|te, ...tag

Ra|sur lat. (Radieren, [Schrift]tilgung; Rasieren) w; -, -en

Rat m; -[e]s, Räte u. (Auskünfte u. a.:) Ratschläge; sich - holen (↑ R 140); zu Rate gehen, ziehen; jmdn. um - fragen; (↑ R 224:) der Große - (schweiz. Bez. für: Kantonsparlament); der Hohe - (in Jerusalem)

Rät (Rhät [nach den Rätischen Alpen] (jüngste Stufe des Keupers) s; -s

Ra|tan|hia|wur|zel indian.; dt. [...anja...] (als Heilmittel verwendete Wurzel eines peruan. Strauches)

Ra|te it. (verhältnismäßiger) Teil, Anteil; Teilzahlung; Teilbetrag) w; -, -n

ra|ten; du rätst, er rät; du rietst (rietest); du rietest; geraten; ra-te[!]

Ra|ten.be|trag, ...kauf, ...wech|sel; ra|ten|wei|se; Ra|ten|zah|lung; Ra|ten|zah|lungs|kre|dit

Ra|ter

Rä|ter (Bewohner des alten Rätien)

Rä|te.re|gie|rung, ...re|pu|blik, ...re|vo|lu|ti|on; Rä|te|rin w; -, -nen; Rä|te|ruß|land; rä|te|rus-sisch; Rä|te.staat (Mehrz. ...staaten), ...sy|stem; Rat.ge|ber, ...ge-be|rin (w; -, -nen); rat|ge|be|risch; Rat|haus; Rat|haus|saal

Ra|the|nau (dt. Wirtschaftsführer u. Staatsmann)

Ra|the|now [rat°no] (Stadt an der Havel)

Rä|ti|en [räzi°n] (altröm. Prov., auch für: Graubünden); vgl. Räter u. rätisch

Ra|ti|fi|ka|ti|on lat. [...zion] (Genehmigung; Bestätigung, Anerkennung, bes. von völkerrechtl. Verträgen); Ra|ti|fi|ka|ti|ons|ur-kun|de; ra|ti|fi|zie|ren; Ra|ti|fi-zie|rung

Rä|ti|kon (Teil der Ostalpen an der österr.-schweiz. Grenze) m; -s (auch: s; -[s])

Rä|tin (Titel) w; -, -nen

Ra|ti|né fr. [...ne] (ein Gewebe) m; -s, -s; ra|ti|nie|ren (Textilwesen: zu Löckchen formen)

Ra|tio lat. [razio] (Vernunft; Grund; Verstand) w; -; vgl. Ultima ratio; Ra|ti|on fr. [...zion] (zugeteiltes Maß, [An]teil, Menge; Militär: täglicher Verpflegungssatz); die eiserne -; ra|tio|nal (die Ratio betreffend; vernünftig, aus der Vernunft stammend); (Math.:) -e Zahlen; ra|tio|na|li-sie|ren fr. ([möglichst] vereinheitlichen; [die Arbeit] zweckmäßig gestalten); Ra|tio|na|li|sie|rung; Ra|tio|na|li|sie|rungs|maß|nah|me; Ra|tio|na|lis|mus lat. (Geisteshaltung, die das rationale Denken als einzige Erkenntnisquelle ansieht) m; -; Ra|tio|na|list (↑ R 268); ra|tio|na|li|stisch; -ste (↑ R 294); Ra|tio|na|li|tät (rationales, vernünftiges Wesen; Vernünftigkeit) w; -; ra|tio|nell fr. (verständig; ordnungsgemäß; zweckmäßig, sparsam, haushälterisch); ra|tio|nen|wei|se od. ra-ti|ons|wei|se; ra|tio|nie|ren (einteilen; abgeteilt zumessen); Ra-tio|nie|rung

rä|tisch (zu: Räter, Rätien), aber (↑ R 198): die Rätischen Alpen

rät|lich (veralt.); Rät|lich|keit (veralt.) w; -; rat|los; -este (↑ R 292); Rat|lo|sig|keit w; -

Ra|ton|ku|chen fr.; dt. westd. (turbanähnlicher Kuchen, Napf-kuchen)

Rä|to|ro|ma|ne; ↑ R 215 (Angehöriger eines Alpenvolkes mit eigener roman. Sprache) m; -n, -n (↑ R 268); rä|to|ro|ma|nisch; Rä-to|ro|ma|nisch (Sprache) s; -[s];

vgl. Deutsch; Rä|to|ro|ma|ni|sche s; -n; vgl. Deutsche s

rat|sam; Rats|be|schluß

ratsch!; ritsch, ratsch!; Rat|sche, Rät|sche südd., österr. (Rassel, Klapper) w; -, -n; rat|schen, rät|schen (südd., österr.); du ...schst (...schest)

Rat|schlag m; -[e]s, ...schläge; rat|schla|gen; du ratschlagst, er ratschlagt; du ratschlagtest, geratschlagt; zu -; Rat|schluß; Rats|die|ner

Rät|sel s; -s, -; - raten, aber (↑ R 120); das Rätselraten; Rät|sel|fra|ge; rät|sel|haft; Rät|sel|haf|tig|keit; Rät|sel|lö|ser; Rät|sel|lö|sung; rät|seln; ich ...[e]le (↑ R 327); Rät|sel|ra|ten s; -s; rät|sel|voll; Rät|sel|zei|tung

Rats.ge|schlecht, ...herr, ...kel|ler, ...schrei|ber, ...sit|zung, ...stu|be; rat|su|chend; Rat|su|chen|de m u. w; -n, -n (↑ R 287ff.); Rats|ver|samm|lung

Rat|te w; -, -n; Rat|ten.fal|le, ...fän|ger, ...gift s; rat|ten|kahl (volksmäßige Umdeutung aus: radikal); vgl. ratzekahl; Rat|ten.kö|nig (übertr. ugs. für: unentwirrbare Schwierigkeit), ...schwanz (übertr. ugs. für: endlose Folge)

Rät|ter (Technik: Sieb) m; -s, - (auch: w; -, -n)

rat|tern; ich ...ere (↑ R 327)

rät|tern (mit dem Rätter sieben); ich ...ere (↑ R 327); Rät|ter|wä|sche (Siebverfahren)

Ratt|ler (veralt.: Schnauzer od. Pinscher, der bes. Ratten scharf verfolgt) m; -s, -

Ratz (landsch. für: Ratte, Hamster; Jägerspr.: Iltis) m; -es, -e; Rat|ze (ugs. für: Ratte) w; -, -n; rat|ze|kahl (volksmäßige Umdeutung aus: radikal); vgl. rattenkahl; Rät|zel landsch. ([Mensch mit] zusammengewachsene[n] Augenbrauen) s; -s, -

rat|zen landsch. (ritzen, kratzen)

Raub m; -[e]s; Raub|bau m; -[e]s; - treiben; rau|ben; Räu|ber; Räu|ber|ban|de; Räu|be|rei (ugs.); Räu|ber.ge|schich|te, ...hauptmann, ...höh|le; rau|be|risch; -ste (↑ R 294); räu|bern; ich ...ere (↑ R 327); Räu|ber.pi|sto|le (Räubergeschichte), ...ro|man, ...zi|vil (ugs. scherzh.); Raub.fisch, ...gier; raub|gie|rig; Raub.mord, ...mör|der, ...rit|ter; Raub|rit|ternest; Raub|rit|ter|tum; s; -s; raubsüch|tig; Raub.tier, ...über|fall, ...vo|gel, ...wild (Jägerspr.: alle jagdbaren Raubtiere), ...zeug (Jägerspr.: alle nicht jagdbaren Raubtiere; s; -[e]s), ...zug

Rauch m; -[e]s; Rauch.ab|zug,

...bom|be; rau|chen; rauchende Schwefelsäure; Rau|cher; Räucher|aal; Rau|cher|ab|teil; Raucher|hu|sten; räu|che|rig; Rauche|rin w; -, -nen; Räu|cher.kammer, ...ker|ze; räu|chern; ich ...ere (↑ R 327); Räu|cher.pfan|ne, ...schin|ken, ...speck, ...stäb|chen; Räu|che|rung; Räu|cher|wa|re; Rauch.fah|ne, ...fang (österr. für: Schornstein), Rauch|fang|kehrer (österr. für: Schornsteinfeger); rauch|far|ben, rauch|far|big; Rauch.faß (ein kult. Gerät), ...fleisch, ...ga|se (Mehrz.); rauchig; rauch|los; rauchloses Pulver

Rauch|näch|te, Rauh|näch|te (im Volksglauben Nächte der bösen Geister in der Weihnachtszeit) Mehrz.

Rauch.op|fer, ...sa|lon, ...säu|le, ...stu|be, ...ta|bak, ...tisch, ...utensi|li|en (Mehrz.), ...ver|bot, ...vergif|tung, ...ver|zeh|rer

Rauch|wa|re (Pelzware; meist Mehrz.)

Rauch|wa|ren (ugs. für: Tabakwaren) Mehrz. Rauch|wa|ren.handel (vgl. ¹Handel). ...mes|se

Rauch|werk (Pelzwerk) s; -[e]s

Räu|de (Krätze, Grind) w; -, -n; räu|dig; Räu|dig|keit w; -

Raue landsch. (Leichenschmaus) w; -, -n

rauf; ↑ R 238 (ugs. für: herauf, hinauf)

Rauf.bold (abschätzig) m; -[e]s, -e; Rau|fe w; -, -n; rau|fen; Rau|fer; Rau|fe|rei; Rauf.han|del (vgl. ²Handel), ...lust (w; -); rauf|lu|stig

Rau|graf (früherer oberrhein. Grafentitel)

rauh; -er, -[e]ste (↑ R 293); die -e Seite hervorkehren; ein -es Wesen; ein -er Ton; eine -e Luft, aber (↑ R 224): Rauhes Haus (Name des von J. H. Wichern gegründeten Erziehungsheimes); Rauh.bank (langer Hobel; Mehrz. ...bänke); Rauh|bauz (ugs. für: grober Mensch) m; -es, -e; rauh|bau|zig (grob, derb); Rauh|bein (ugs. für: nach außen grober, aber von Herzen guter Mensch); rauh|bei|nig (ugs.); rauh|bor|stig (ugs.); Rau|heit (↑ R 163) w; -, -en; rau|hen (rauh machen); Rau|he|rei [Anstalt zum] Aufrauhen]; Rauh|fa|ser; Rauhfa|ser|ta|pe|te; Rauh.frost, ...futter (vgl. ²Futter); Rauh.haardackel [Trenn.: ...dak|kel]; rauhhaa|rig; Rauh|hig|keit; Rauh|nächte vgl. Rauchnächte; Rauh.putz, ...reif (m; -[e]s), ...wacke [Trenn.: ...wak|ke] (eine Kalksteinart), ...wa|re (landsch. für: Rauchware)

Rau|ke (Name verschiedener Pflanzen) w; -, -n

raum (Seemannsspr.: schräg; -er Wind: Wind, der schräg von hinten weht; Forstw.: offen, licht; -er Wald); Raum m; -[e]s, Räume; Raum.aku|stik, ...an|ga|be (Sprachw.: Umstandsangabe des Raumes; des Ortes), ...an|zug, ...bild; Raum|bild|ver|fah|ren (Herstellung von Bildern, die einen räumlichen Eindruck hervorrufen); Räum|boot (zum Beseitigen von Minen); Räum|chen, Räum|lein; räu|men; Räu|mer; raum|er|spa|rend, aber (↑ R 142): viel Raum ersparend; Raum.erspar|nis, ...fah|rer, ...fahrt, Raumfahrt.be|hör|de, ...me|di|zin, ...pro|gramm, ...tech|ni|ker; Raum.fahr|zeug, ...film, ...flugkör|per, ...flug|zeug, ...for|schung (w; -), ...ge|fühl (s; -[e]s), ...ge|staltung; räu|mig (früher dicht. für: geraumig); Raum.in|halt, ...kapsel, ...kli|ma, ...ko|sten (Mehrz.), ...kunst (w; -), ...leh|re (für: Geometrie; w; -); Räum|lein, Räumchen; räum|lich; Räum|lich|keit; Raum|man|gel (vgl. ²Mangel); Räum|ma|schi|ne; Raum.maß s, ...me|ter (1 cbm geschichteten Holzes mit Zwischenräumen, im Gegensatz zu Festmeter; Zeichen: rm), ...ord|nung, ...ordnungs|plan (vgl. ²Plan), ...pendler, ...pfle|ge|rin, ...pla|nung, ...pro|gramm, ...schiff; Raumschiffahrt [Trenn.: ...schiff|fahrt, ↑ R 236], ...sinn (m; -[e]s), ...son|de (unbemanntes Raumfahrzeug); raum|spa|rend, aber (↑ R 142): viel Raum sparend; Raum|sta|tion; Raum|te (Seemannsspr.: verfügbarer [Schiffs]laderaum w; -, -n; Raum|trans|por|ter; Räumung; Räu|mungs.frist, ...kla|ge, ...ver|kauf, ...wahr|neh|mung; Raumwirt|schafts|theo|rie

rau|nen (dumpf, leise sprechen; flüstern); Rau|nen s; -s

raun|zen landsch. (widersprechen, nörgeln; weinerlich klagen); du raunzt (raunzest); Raun|zer landsch. (Nörgler); Raun|ze|rei (landsch.); raun|zig (landsch.)

Räup|chen, Räup|lein; Rau|pe w; -, -n; rau|pen landsch. (von Raupen befreien, abraupen); Raupen|an|trieb; rau|pen|ar|tig; Raupen.bag|ger, ...band (s; Mehrz. ...bän|der), ...fahr|zeug; rau|penför|mig; Rau|pen.fraß, ...ket|te, ...nest, ...sche|re, ...schlep|per

Rau|ri|ker (Angehöriger eines kelt. Volksstammes) m; -s, -

raus; ↑ R 238 (ugs. für: heraus, hinaus)

Rausch (Betrunkensein; Zustand der Erregung, Begeisterung) *m*; -[e]s, Räusche

rausch|arm (Technik); -er Verstärker (dient zur Unterdrückung von Störsignalen)

Rausch.bee|re (mdal. für: Moosbeere), ...**brand** (eine Tierkrankheit; *m*; -[e]s)

Räusch|chen, Räusch|lein

Rau|sche|bart [von it. rosso, d. i. „rot“, „Rotbart“] (Beiname Graf Eberhards II. von Württemberg)

rau|schen (Jägerspr. auch: brünstig sein [vom Schwarzwild]); du rauschst (rauschest); **Rau|scher** rhein. (schäumender [Apfel]most) *m*; -s

Rausch|gelb (ein Mineral [Auripigment]) *s*; -s

Rausch|gift *s*; **Rausch|gift|bekämp|fung; rausch|gift|süch|tig; Rausch|gift|süch|ti|ge** *m* u. *w*; -n, -n (↑ R 287ff.); **Rausch|gold** (dünnes Messingblech); **rausch|haft; Räusch|lein,** Räusch|chen; **Rausch.nar|ko|se** (Med.: kurze Narkose für kleine chirurg. Eingriffe), ...**sil|ber** (dünnes Neusilberblech), ...**zeit** (Brunstzeit des Schwarzwildes)

Räus|pe|rer; räus|pern, sich; ich ...ere mich (↑ R 327)

Raus|schmei|ßer (ugs.: jmd., der randalierende Gäste aus dem Lokal entfernt; letzter Tanz); **Rausschmiß** (ugs. für: [fristlose] Entlassung); **raus|wer|fen** (ugs. für: hinauswerfen)

¹Rau|te *lat.* (eine Pflanze) *w*; -, -n

²Rau|te (schiefwinkliges gleichseitiges Viereck, Rhombus) *w*; -, -n

Rau|ten|de|lein (elfisches Wesen; Gestalt bei Gerhart Hauptmann)

rau|ten|för|mig; Rau|ten.kranz, ...**kro|ne**

ra|va|gie|ren *fr.* [*rawasehir^en*] (veralt. für: verwüsten)

Ra|vel [*rawäl*], Maurice [*moríß*] (fr. Komponist)

Ra|ve|lin *fr.* [*raw'läng*] (früher: Außenwerk von Festungen) *m*; -s, -s

Ra|ven|na [*rawäna*] (it. Stadt)

Ra|vens|berg [*raw'nß*...] (ehem. westfäl. Grafschaft); **Ra|vensber|ger** (↑ R 199); - Land; **ra|vensber|gisch; Ra|vens|burg** (Stadt in Oberschwaben)

Ra|vio|li *it.* [*rawioli*] (kleine it. Pasteten aus Nudelteig) *Mehrz.*

ra|vi|vi|van|do [*rawiwando*] *it.* (Musik: wieder belebend, schneller werdend)

Ra|wal|pin|di (Stadt in Pakistan)

Rax (österr. Berg) *w*; -

Rayé *fr.* [*räję*] (ein gestreiftes Gewebe) *m*; -[s], -s

Ray|gras vgl. Raigras

Ray|on *fr.* [*räjong*] (österr., sonst veralt. für: Bezirk, [Dienst]bereich; früher: Vorfeld von Festungen; engl. Schreibung von Reyon; Warenhausabteilung) *m*; -s, -s; **Ray|on|chef** (Abteilungsleiter [im Warenhaus]); **rayo|nie|ren** [*räjonir^en*] (österr., sonst veralt. für: [nach Bezirken] einteilen; zuweisen); **Ray|ons|in|spek|tor** (österr.)

ra|ze|mös (traubenförmig); -e Blüte, Verzweigung

Raz|zia *arab.-fr.* (überraschende Fahndung der Polizei nach verdächtigen Personen) *w*; -, ...ien [...*i^en*] u. (seltener:) -s

Rb = chem. Zeichen für: Rubidium

Rbl = Rubel

rd. = rund

Re *fr.* (Kartenspiel: Erwiderung auf ein Kontra) *s*; -s, -s

Re = chem. Zeichen für: Rhenium

Rea|der *engl.* [*rid^er*] (Lesebuch mit Auszügen aus der [wissenschaftlichen] Literatur u. verbindendem Text) *m*; -s, -; **Rea|der's Di|gest** [*rid^ers daidsehäßt*] (amerik. Monatsschrift mit Aufsätzen u. mit Auszügen aus neuerschienenen Büchern) *m* od. *s*; - -

Rea|gens *lat.* *s*; -, ...genzien [...*i^en*] u. **Rea|genz** (Chemie: jeder Stoff, der mit einem anderen eine bestimmte chem. Reaktion herbeiführt u. ihn so identifiziert) *s*; -es, -ien [...*i^en*]; **Rea|genz.glas** (Prüfglas, Probierglas für [chem.] Versuche; *Mehrz.* ...gläser), ...**pa|pier; rea|gie|ren** (aufeinander einwirken); auf eine Sache - (für etwas empfindlich sein, auf etwas ansprechen; auf etwas eingehen); **Re|ak|tanz** (Elektrotechnik: Blindwiderstand) *w*; -, -en; **Re|ak|ti|on** [...*zion*] (Rück-, Gegenwirkung, Gegenströmung, -druck, Rückschlag; chem. Umsetzung; nur *Einz.*: Rückschritt; Gesamtheit aller nicht fortschrittl. polit. Kräfte, seit 1830 politisches Schlagwort); eine chemische -; eine nervöse -; **re|ak|tio|när** *fr.* (Gegenwirkung erstrebend oder ausführend; abwertend für: nicht fortschrittlich); **Re|ak|tio|när** (jmd., der sich jeder fortschrittl. Entwicklung entgegenstellt) *m*; -s, -e; **Re|ak|ti|ons.ge|schwin|dig|keit,** ...**mo|tor,** ...**psy|cho|se; re|ak|ti|ons|schnell; Re|ak|ti|ons.turm** (Technik), ...**zeit; re|ak|tiv** *lat.* (rückwirkend; auf Reize reagierend); **re|ak|ti|vie|ren** [...*wir^en*] (wieder in Tätigkeit setzen; wieder anstellen; chem. wieder umsetzungsfä-

hig machen); **Re|ak|ti|vie|rung; Re|ak|ti|vi|tät** (Subst. zu: reaktiv) *w*; -, -en; **Re|ak|tor** (Vorrichtung, in der eine chemische od. eine Kernreaktion abläuft) *m*; -s, ...oren; **Re|ak|tor|phy|sik**

re|al *lat.* (wirklich, tatsächlich; dinglich, sachlich)

¹Re|al *span.* u. *port.* (alte span. u. port. Münze) *m*; -s, (span.:) -es u. (port.:) Reís

²Re|al mdal. (Regal [Gestell mit Fächern]) *s*; -[e]s, -e

Re|al.akt (Rechtsw.: jede eine Rechtswirkung begründende Erfolgshandlung), ...**ein|kom|men,** ...**en|zy|klo|pä|die** (Sachwörterbuch)

Re|al|gar *arab.* (ein Mineral) *m*; -s, -e

Re|al|ge|mein|de (Bez. für den Zusammenschluß von Personen, die zur Nutzung forstwirtschaftlichen Grundbesitzes berechtigt sind)

Re|al|gym|na|si|um (Form der höheren Schule); **Rea|li|en** *lat.* [...*i^en*] (wirkliche Dinge, Wirklichkeitswissenschaften; Sachkenntnisse) *Mehrz.*; **Rea|li|en.buch; Rea|li|en|dex** (veralt. für: Sachverzeichnis), ...**in|ju|rie** [...*i^e*] (Rechtsw.: tätliche Beleidigung); **Rea|li|sa|ti|on** [...*zion*] (seltener für: Realisierung; Wirtsch.: Umwandlung in Geld); **Rea|li|sa|tor** (Fernsehjournalist) *m*; -s, ...oren; **rea|li|sier|bar; rea|li|sier|bar|keit** (*w*; -); **rea|li|sie|ren** (verwirklichen; einsehen, begreifen; Wirtsch.: in Geld umwandeln); **Rea|li|sie|rung; Rea|lis|mus** ([nackte] Wirklichkeit; Kunstdarstellung des Wirklichen; Wirklichkeitssinn; Bedachtsein auf die Wirklichkeit, den Nutzen usw.); **Rea|list** (↑ R 268); **Rea|li|stik** (ungeschminkte Wirklichkeitsdarstellung) *w*; -; **rea|li|stisch;** -ste (↑ R 294); **Rea|li|tät** (Wirklichkeit, Gegebenheit); **Rea|li|tä|ten** (Gegebenheiten; bes. österr. für: Grundstücke) *Mehrz.*; **Rea|li|tä|ten|händ|ler** österr. (Grundstücksmakler); **Rea|li|täts.an|pas|sung,** ...**sinn** (*m*; -[e]s); **rea|li|ter** (in Wirklichkeit); **Re|al.ka|pi|tal,** ...**ka|ta|log** (Bibliotheksw.), ...**kon|kor|danz** (Theol.), ...**kon|kur|renz** (Rechtsw.), ...**kon|trakt** (Rechtsw.), ...**kre|dit,** ...**last** (meist *Mehrz.*), ...**le|xi|kon** (Sachwörterbuch), ...**lohn,** ...**po|li|tik** (Politik auf realen Grundlagen), ...**pro|dukt** (Wirtsch.), ...**schu|le** (Schule, die mit der 10. Klasse u. der mittleren Reife abschließt), ...**steu|er** (*w*; meist

Column 1

Mehrz.), ...wert, ...wör|ter|buch (Sachwörterbuch)

Re|ani|ma|ti|on lat. [...ziọn] (Med. für: Wiederbelebung); Re|ani|ma|ti|ọns.bett, ...tisch, ...zen|trum; re|ani|mie|ren (wiederbeleben)

re|as|su|mie|ren lat. (Rechtsw. veralt. für: ein Verfahren wiederaufnehmen); Re|as|sump|ti|on [...ziọn] (Rechtsw. veralt.)

Re|au|mur [reomür; nach dem fr. Physiker Réaumur] (Einheit der Grade beim heute veralteten 80teiligen Thermometer; Zeichen: R); 3° R (vgl. S. 86, 9, f)

Reb|bach jidd. (Gaunerspr. für: Verdienst, Gewinn) m; -s

Reb|bau m; -[e]s; Reb|berg; Re|be w; -, -n

Re|bek|ka (w. Vorn.)

Re|bell fr. (Aufrührer, Aufständischer) m; -en, -en (↑ R 268); re|bel|lie|ren; Re|bel|li|on; re|bel|lisch; -ste (↑ R 294)

re|beln landsch. ([Trauben u. a.] abbeeren); ich ...[e]le (↑ R 327); vgl. Gerebelte; Re|ben.blü|te, hü|gel, ...saft (m; -[e]s); re|ben|um|spon|nen; Re|ben.ver|edelung od. ...ver|ed|lung

Reb|hendl (österr. neben: Rebhuhn) s; -s, -n; Reb|huhn

Reb|laus (ein Insekt); Reb|ling (Rebenschößling)

Re|bound engl. [ribaunt] (Basketball: vom Brett od. Korbring abprallender Ball) m; -s, -s

Reb|schnitt

Reb|schnur österr. (starke Schnur; Mehrz. ...schnüre)

Reb.schu|le, ...sor|te, ...stock (Mehrz. ...stöcke)

Re|bus lat. („durch Sachen"; Bilderrätsel) m od. s; -, -se

Rec. = recipe

Re|cei|ver engl. [rißiw°r] (Kombination von Rundfunkempfänger u. Verstärker für Hi-Fi-Wiedergabe) m; -s, -

Re|chaud fr. [reschọ] südd. u. österr. ([Gas]kocher; Gastr.: Wärmeplatte) m od. s; -s, -s

re|chen südd. u. mitteld. (harken); Re|chen südd. u. mitteld. (Harke) m; -s, -

Re|chen.auf|ga|be, ...au|to|mat, ...brett, ...buch; Re|che|nei, Rech|nei (veralt. für: Rentamt); Re|che|nei.amt, Rech|nei.amt (veralt.); Re|chen.ex|em|pel, ...feh|ler, ...heft, ...kniff, ...künst|ler, ...ma|schi|ne; Re|chen|schaft w; -; Re|chen|schafts.be|richt, ...le|gung; Re|chen.schie|ber, ...stab

Re|chen|stiel (Stiel des Rechens)

Re|chen.stun|de, ...ta|fel, ...un|ter|richt, ...zen|trum (mit Rechenmaschinen ausgestattetes Institut)

Column 2

Re|cher|che fr. [reschärsch°] (Nachforschung, Ermittlung) w; -, -n (meist Mehrz.); Re|cher|cheur [...schör] m; -s, -e; re|cher|chie|ren

Rech|nei usw. vgl. Rechenei usw.

rech|nen; Rech|nen.s; -s; Rech|ner; Rech|ne|rei (ugs.); rech|ne|risch; Rech|nung; einer Sache - tragen; Rech|nungs.ab|la|ge, ...ab|gren|zung (in der Buchführung), ...ab|gren|zungs|po|sten, ...art, ...be|trag, ...block (Mehrz.: ...blocks), ...buch, ...ein|heit (Währungswesen), ...füh|rung, ...hof, ...jahr, ...le|gung, ...pe|ri|ode, ...prü|fer, ...prü|fung, we|sen (s; -s)

recht; erst recht; das ist [mir] durchaus, ganz, völlig recht; das geschieht ihm recht; es ist recht und billig; ich kann ihm nichts recht machen; rechter Hand; (übertr.:) jmds. rechte Hand sein; rechter Winkel. Großschreibung (↑ R 116): du bist mir der Rechte; an den Rechten kommen; das Rechte treffen, tun; zum, nach dem Rechten sehen; etwas, nichts Rechtes können, wissen; vgl. auch: zurecht usw.; Recht s; -[e]s, -e; mit, ohne Recht; nach Recht und Gewissen; zu Recht bestehen, erkennen; Recht finden, sprechen, suchen; im Recht[e] sein; ein Recht haben; ein Recht verleihen, geben; von Rechts wegen; es ist Rechtens. Kleinschreibung (↑ R 132): recht behalten, recht bekommen, erhalten, geben, haben, sein, tun; recht.dre|hend (Meteor.); -er Wind (sich in Uhrzeigerrichtung drehender Wind, z. B. von Nord auf Nordost; Ggs.: rückdrehend); Rech|te (rechte Hand; rechte Seite; Politik: Bez. für die rechtsstehenden Parteien, für eine rechtsstehende Gruppe einer Partei) w; -n, -n (↑ R 287ff.); zur -n: in meiner -n; ein kräftiger Druck seiner -n; (Boxen:) er traf ihn mit einer blitzschnellen -n; (Politik:) die gemäßigte, äußerste - (im Parlament); er gehört der -n an; Recht|eck; recht|eckig [Trenn.: ...ek|kig]; Rech|te|han|d|re|gel (ein bestimmtes Verfahren in der Physik) w; -; rech|ten; Rech|tens; es ist -; rech|ter Hand; rech|ter|seits; recht|fer|ti|gen; er hat sich vor ihm gerechtfertigt; durch seine Worte bist du gerechtfertigt; Recht|fer|ti|gung; Recht|fer|ti|gungs.schrift, ...ver|such

recht|gläu|big; Recht|gläu|big|keit w; -

Recht|ha|be|rei w; -; recht|ha|be|risch; -ste (↑ R 294)

Recht|kant s od. m; -[e]s, -e

Column 3

recht|läu|fig (Astron.: im umgekehrten Sinne des Uhrzeigers laufend)

Recht|lau|tung (gelegentlich für: Hochlautung) w; -

recht|lich; -es Gehör (Rechtsw.: verfassungsrechtl. garantierter Anspruch des Staatsbürgers, seinen Standpunkt vor Gericht vorzubringen); Recht|lich|keit w; -; recht|los; Recht|lo|sig|keit w; -; recht|mä|ßig; Recht|mä|ßig|keit w; -

rechts (Abk.: r.); vgl. links; Rechts.ab|bie|ger (Verkehrsw.)

Rechts.an|ge|le|gen|heit, ...an|spruch, ...an|walt, ...an|wäl|tin; Rechts|an|walt[s]|bü|ro, Rechts.auf|fas|sung

Rechts.aus|la|ge (Sportspr.); ...aus|le|ger (Sportspr.); Rechts.au|ßen (Sportspr.) m; -, -; er spielt -

rechts.be|flis|sen (veralt., noch scherzh.); Rechts.bei|stand, ...be|leh|rung, ...be|schwer|de, ...beu|gung, ...bre|cher, ...bruch m; recht|schaf|fen; ein -er Beruf, aber (↑ R 116): etwas Rechtschaffenes lernen; Recht|schaf|fen|heit w; -

Recht|schreib|buch, Recht|schrei|be|buch; recht|schrei|ben (nur in der Grundform gebr.); er kann nicht rechtschreiben, aber: er kann nicht recht schreiben (er schreibt unbeholfen); Recht|schrei|ben s; -s; Recht|schreib.feh|ler, ...fra|ge; recht|schreib|lich; Recht|schreib|re|form; Recht|schrei|bung

rechts.dre|hend, aber: nach rechts drehend; Rechts|dre|hung

Rechts.ein|wen|dung, ...emp|fin|den

Recht|ser (ugs. für: Rechtshänder)

rechts.er|fah|ren, ...fä|hig; Rechts.fä|hig|keit w; -; Rechts.fall m; ...gang (für: gerichtl. Verfahren; m); Rechts|ge|lehr|sam|keit; rechts|ge|lehrt; Rechts.ge|lehr|te, ...ge|schäft; rechts|ge|schäft|lich; Rechts.ge|schich|te, ...grund, ...grund|satz; rechts|gül|tig; Rechts|gül|tig|keit w; -; Rechts.han|del (vgl. ²Handel)

Rechts.hän|der; rechts|hän|dig; Rechts|hän|dig|keit w; -; rechts.her, aber: von rechts her; rechts|her|um; rechtsherum drehen, aber: nach rechts herumdrehen

Rechts.hil|fe; Rechts|hil|fe.ab|kom|men, ...ord|nung

rechts|hin, aber: nach rechts hin

Rechts|kon|su|lent (österr.); Rechts|kraft w; -; formelle (äußere) -; materielle (sachliche) -; rechts|kräf|tig; rechts|kun|dig

Rechts|kur|ve
Rechts|la|ge
rechts|läu|fig
Rechts.leh|re, ...leh|rer, ...mit|tel s,
...nach|fol|ge, ...nach|fol|ger,
...norm, ...ord|nung
Rechts|par|tei
Rechts.per|son, ...pfle|ge, ...pfle-
ger, ...phi|lo|so|phie; Recht|spre-
chung
rechts|ra|di|kal; Rechts|ra|di|ka-
lis|mus; rechts|rhei|nisch (auf der
rechten Rheinseite)
Rechts.sa|che, ...schrift, ...schutz;
Rechts|schutz|ver|si|che|rung
rechts|sei|tig
Rechts.si|cher|heit, ...spra|che,
...spruch, ...staat (Mehrz. ...staa-
ten); rechts|staat|lich; Rechts-
staat|lich|keit w; -
rechts.ste|hend (auch Politik)
Rechts.stel|lung, ...streit, ...ti|tel;
recht|los|chend; der -e Bürger;
aber (↑R 142): sein Recht su-
chend
rechts|uf|rig; rechts|um [auch:
rechtzum|]; - machen; rechtsum!
Rechts|un|si|cher|heit
Rechts|un|ter|zeich|ne|te; vgl. Un-
terzeichnete
rechts|ver|bind|lich; Rechts.ver-
bind|lich|keit, ...ver|dre|her (ab-
schätzig), ...ver|fah|ren, ...ver-
glei|chung, ...ver|hält|nis
Rechts|ver|kehr
Rechts.ver|let|zung, ...ver|ord-
nung, ...ver|wei|ge|rung, ...vor-
schlag (schweiz. für: Rechtsein-
wendung gegen Zwangsvoll-
streckung), ...weg
Rechts|wen|dung
rechts|wid|rig; Recht.wis|sen-
schaft, ...wohl|tat (im früheren
Recht)
recht|win|ke|lig, recht|wink|lig
recht|zei|tig; Recht|zei|tig|keit w; -
Re|ci|fe [reßifi] (Hptst. von Per-
nambuco)
re|ci|pe! lat. [rezipe] (,,nimm!" [auf
ärztl. Rezepten]; Abk.: Rec. u.
Rp.)
re|ci|tan|do it. [retschi...] (vortra-
gend, sprechend, rezitierend)
Reck (ein Turngerät) s; -[e]s, -e
Recke[1] (altertüml. Bezeichnung
für: Held, Krieger) m; -n, -n (↑R
268)
recken[1]; Wäsche - (landsch. für:
geradelegen); sich -
Recken|art[1] w; -; recken|haft[1];
Recken|tum[1] s; -s
Reck|ling|hau|sen (Stadt im Ruhr-
gebiet); Reck|ling|häu|ser (↑R
199)
Reck.stan|ge, ...tur|nen, ...wal|ze
(Walztechnik)
Re|clam (Familienn.); Re|clam-

band|chen; ↑R 180 [nach dem
Verleger]
Re|cor|der engl. (Tonwiedergabe-
gerät) m; -s, -
rec|te lat. (veralt. für: richtig); Rec-
to vgl. Rekto
Rec|tor ma|gni|fi|cus lat. [- ...kuß]
(,,erhabener Leiter"; Titel des
Hochschulrektors) m; - -, ...ores
...fici [...zi]
Re|dak|teur fr. [...tör] (Schriftlei-
ter; jemand, der Beiträge für die
Veröffentlichung [in Zeitungen,
Zeitschriften] bearbeitet) m; -s,
-e; Re|dak|teu|rin [...örin] w; -,
-nen; Re|dak|ti|on [...zion] (Tätig-
keit des Redakteurs; Gesamtheit
der Redakteure u. deren Arbeits-
raum); re|dak|tio|nell (die Re-
daktion betreffend; von der Re-
daktion stammend); Re|dak|ti-
ons.ge|heim|nis, ...schluß (m;
...usses); Re|dak|tor lat. (wissen-
schaftl. Herausgeber; schweiz.
auch svw. Redakteur) m; -s,
...oren
Red|der niederd. (enger Weg zwi-
schen zwei Hecken) m; -s, -
Re|di|ti|on lat. [...zion] (veralt.
für: Rückgabe)
Re|de w; -, -n; - und Antwort ste-
hen; in - stehen, zur - stellen; Re-
de.blü|te, ...du|ell, ...fi|gur, ...fluß,
...frei|heit (w; -), ...ga|be (w; -);
re|de|ge|wandt; Re|de.ge|wandt-
heit, ...kunst (w; -)
Red|emp|to|rist lat. (Angehöriger
einer kath. Kongregation); ↑R
268
re|den; gut - haben; von sich - ma-
chen; (↑R 120:) er bringt selbst
schweigsame Menschen zum Re-
den; nicht viel Redens von einer
Sache machen; Re|dens|art; re-
dens|art|lich; Re|de|rei (ugs.); Re-
de.schrift, ...schwall, ...schwulst,
...strom, ...übung, ...ver|bot,
...wei|se w, ...wen|dung
re|di|gie|ren fr. (druckfertig ma-
chen; abfassen; bearbeiten; als
Redakteur tätig sein)
Re|din|gote fr. [redänggot] (tail-
lierter Damenmantel mit Revers-
kragen) w; -, -n [.. t[e]n]
Red|in|te|gra|ti|on lat. [...zion]
(veralt. für: Wiederherstellung)
Re|dis|fe|der ⓦ (Schreibfeder)
re|dis|kon|tie|ren it. ([einen ,,dis-
kontierten" Wechsel] an-od.
weiterverkaufen); Re|dis|kon|tie-
rung
re|di|vi|vus lat. [...wiwuß] (wieder-
erstanden)
red|lich; Red|lich|keit w; -
Red|ner; Red|ner|büh|ne, ...ga|be
(w; -); red|ne|risch; Red|ner.pult,
...tri|bü|ne
Re|dou|te fr. [...dut[e]] (früher: ge-
schlossene Schanze; österr.,

sonst veralt. für: Maskenball) w;
-, -n
re|dres|sie|ren fr. (veralt. für: [wie-
der]gutmachen; rückgängig ma-
chen; Med.: wieder einrenken)
red|se|lig; Red|se|lig|keit w; -
Re|duit fr. [redüi] (früher: bom-
bensichere Verteidigungsanlage
im Kern einer Festung) m od.
s; -s, -s
Re|duk|ti|on lat. [...zion] (Haupt-
wort zu: reduzieren); Re|duk|ti-
ons.mit|tel (Chemie; s), ...ofen
(Technik), ...tei|lung (Biol.); Re-
duk|tor (Elektrotechnik) m; -s,
...oren
red|un|dant lat. (überreichlich, üp-
pig; weitschweifig); Red|un|danz
(Überfluß, Üppigkeit, Überla-
dung [einer Aussage, einer Infor-
mation mit überflüssigen
Sprach- bzw. Informationsele-
menten]) w; -, -en; red|un|danz-
frei
Re|du|pli|ka|ti|on lat. [...zion]
(Sprachw.: Verdoppelung eines
Wortes oder einer Anlautsilbe,
z. B. ,,Bonbon"); re|du|pli|zie|ren
re|du|zie|ren lat. (zurückführen;
herabsetzen, einschränken; ver-
kleinern, mindern; Chemie:
Sauerstoff wegnehmen; Wasser-
stoff zuführen); Re|du|zie|rung;
Re|du|zier|ven|til (Technik)
Ree|de (Ankerplatz vor dem Ha-
fen) w; -, -n; Ree|der (Schiffseig-
ner); Ree|de|rei (Geschäft eines
Reeders); Ree|de|rei|flag|ge
re|ell fr. (zuverlässig; ehrlich; red-
lich); (Math.:) -e Zahlen; Re|el|li-
tät [re-e...] w; -
Reep [rep] niederd. (Seil, Tau) s;
-[e]s, -e; Reep|er|bahn (niederd.
für: Seilerbahn; Straße in Ham-
burg); Reep|schlä|ger niederd.
(Seiler); vgl. Rebschnur
Reet niederd. (Ried) s; -s; Reet-
dach
REFA = Reichsausschuß für Ar-
beitszeitermittlung (seit 1924),
Reichsausschuß für Arbeitsstu-
dien (seit 1936), heute (seit 1948):
Verband für Arbeitsstudien, RE-
FA e. V. (mit dem Sitz in Darm-
stadt); REFA-Fach|mann (↑R
150); REFA-Leh|re
Re|fak|tie niederd. [refakzi[e]] (Ge-
wichts- od. Preisabzug wegen be-
schädigter oder fehlerhafter Wa-
ren; Frachtnachlaß, Rückvergü-
tung) w; -, -n; re|fak|tie|ren
(Frachtnachlaß gewähren)
Re|fek|to|ri|um lat. (Speisesaal [in
Klöstern]) s; -s, ...ien [...i[e]n]
Re|fe|rat lat. ([gutachtl.] Bericht,
Vortrag, [Buch]besprechung;
Sachgebiet eines Referenten) s;
-[e]s, -e; Re|fe|ra|ten|blatt; Re|fe-
ree engl. [ref[e]ri] (Schiedsrichter;

Boxen: Ringrichter) *m*; -s, -s; Re|fe|ren|dar *lat.* (Anwärter auf die höhere Beamtenlaufbahn nach der ersten Staatsprüfung) *m*; -s, -e; Re|fe|ren|da|rin *w*; -, -nen; Re|fe|ren|dum (Volksabstimmung, Volksentscheid [insbes. in der Schweiz]) *s*; -s, ...den u. ...da; Re|fe|rent (Berichterstatter; Sach-bearbeiter)¹ ↑ R 268; vgl. aber; Reverend; Re|fe|ren|tin *w*; -, -nen; Re|fe|renz (Beziehung, Empfehlung; auch: jmd., der eine - erteilt) *w*; -, -en; vgl. aber: Reverenz; Re|fe|ren|zen|li|ste; re|fe|rie|ren *fr.* (berichten; vortragen; [ein Buch] besprechen)

¹Reff (ugs. abschätzig für: altes Weib) *s*; -[e]s, -e

²Reff *landsch.* (Rückentrage) *s*; -[e]s, -e

³Reff (Seemannsspr.: Vorrichtung zum Verkürzen eines Segels) *s*; -[e]s, -e; ref|fen

Re|flek|tant *lat.* (Bewerber; Kauf-, Pachtlustiger) *m*; -en, -en (↑ R 268); re|flek|tie|ren (Izu]rückstrahlen, wiedergeben, spiegeln; nachdenken, erwägen; in Betracht ziehen; Absichten haben auf etwas); Re|flek|tor ([Hohl]spiegel; Teil einer Richtantenne; Fernrohr mit Parabolspiegel) *m*; -s, ...oren; re|flek|to|risch (durch einen Reflex bedingt, Reflex...); Re|flex *fr.* (Widerschein, Rückstrahlung zerstreuten Lichts; unwillkürliches Ansprechen auf einen Reiz) *m*; -es, -e; Re|flex|be|we|gung; Re|fle|xi|on *lat.* (Rückstrahlung von Licht, Schall, Wärme u. a.; Vertiefung in einen Gedankengang, Betrachtung); Re|fle|xi|ons|win|kel (Physik); re|fle-xiv (Psych.: durch Reflexion gewonnen, durch [Nach]denken u. Erwägen; Sprachw.: rückbezüglich); -es Verb (rückbezügliches Verb, z. B. „sich schämen"); Re|fle|xiv (svw. Reflexivpronomen) *s*; -s, -e [...wᵉ]; Re|fle|xiv|pro|no|men (Sprachw.: rückbezügliches Fürwort, z. B. „sich" in: „er wäscht sich"); Re|fle|xi|vum [...jwum] (älter für: Reflexivpronomen) *s*; -s, ...va [...wa]; Re|flex-.licht (*Mehrz.* ...lichter), ...schal-tung (Elektrotechnik: Wendeschaltung)

Re|form *lat.* (Umgestaltung, Verbesserung des Bestehenden; Neuordnung) *w*; -, -en; re|form. = reformiert; Re|for|ma|ti|on [...zion] (Umgestaltung; christl. Glaubensbewegung des 16. Jh.s, die zur Bildung der ev. Kirchen führte); Re|for|ma|ti|ons|fest, ...zeit (*w*; -), ...zeit|al|ter (*s*; -s);

re|for|ma|to|risch; re|form|be|dürf-tig; Re|form.be|stre|bung (meist *Mehrz.*), ...be|we|gung; Re|for-mer *engl.* (Verbesserer, Erneuerer) *m*; -s, -; re|for|me|risch; re-form|freu|dig; Re|form|haus; re-for|mie|ren *lat.*; re|for|miert (Abk.: reform.); -e Kirche (↑ R 224); Re|for|mier|te (Anhänger[in] der reformierten Kirche) *m u. w*; -n, -n (↑ R 287 ff.), Re|for-mie|rung; Re|for|mis|mus (Bewegung zur Verbesserung eines Zustandes od. Programms; im kommunistischen Sprachgebrauch: Bewegung innerhalb der Arbeiterklasse, die soziale Verbesserungen durch Reformen, nicht durch Revolution erreichen wollte oder will) *m*; -; Re|for|mist (↑ R 268); re|for|mi|stisch; Re-form.klei|dung, ...kon|zil, ...kost, ...wa|re (meist *Mehrz.*)

Re|frain *fr.* [rᵉfräŋ] (Kehrreim) *m*; -s, -s

re|frak|tär *lat.* (Med.: unempfindlich; unempfänglich für neue Reize); Re|frak|ti|on [...zion] (Strahlen]brechung an Grenzflächen zweier Medien); Re|frak|to|me-ter (Gerät zur Messung des Brechungsvermögens) *s*; -s, -; Re-frak|tor (aus Linsen bestehendes Fernrohr) *m*; -s, ...oren; Re|frak-tu|rie|rung (Med.: Wiederbrechen eines schlecht geheilten Knochens)

Re|fri|ge|ra|tor *lat.* („Kühler"; Gefrieranlage) *m*; -s, ...oren

Re|fu|gié *fr.* [rᵉfüsehie] (Flüchtling, bes. aus Frankreich geflüchteter Protestant [17. Jh.]) *m*; -s, -s; Re|fu|gi|um *lat.* (Zufluchtsort) *s*; -s, ...ien [...iᵉn]

Re|fus, Re|füs *fr.* [rᵉfü] (veralt. für: abschlägige Antwort, Ablehnung; Weigerung) *m*; - [rᵉfü(ß)], - [rᵉfüß]; re|fü|sie|ren (veralt.)

Reg *hamit.* (Geröllwüste) *w*; -, -

re|gal *lat.* (selten für: königlich, fürstlich)

¹Re|gal ([Bücher-, Waren]gestell mit Fächern; Druckw.: Schriftkastengestell) *s*; -s, -e

²Re|gal *fr.* (kleine, nur aus Zungenstimmen bestehende Orgel; Zungenregister der Orgel) *s*; -s, -e

³Re|gal *lat.* ([wirtschaftlich nutzbares] Hoheitsrecht, z. B. Zoll-, Münz-, Postrecht) *s*; -s, -lien [...iᵉn] (meist *Mehrz.*)

re|ga|lie|ren *fr.* mdal. (reichlich bewirten; sich an etwas satt essen, gütlich tun)

Re|ga|li|tät *lat.* (veralt. für: Anspruch auf Hoheitsrechte)

Re|gat|ta *it.* (Bootswettkampf) *w*; -, ...tten; Re|gat|ta.strecke [*Trenn.*: ...strek|ke], ...ver|band

Reg.-Bez. = Regierungsbezirk (↑ R 154)

re|ge; - sein, werden; er ist körperlich und geistig -

Re|gel *lat. w*; -, -n; re|gel|bar; Re-gel|de|tri (Dreisatzrechnung) *w*; -; re|gel|los; -este (↑ R 292); Re-gel|lo|sig|keit; re|gel|mä|ßig; -e Zeitwörter (Sprachw.); Re|gel-mä|ßig|keit; re|geln; ich ...[e]le (↑ R 327); re|gel|recht; Re|gel.tech|nik, ...tech|ni|ker; Re|ge-lung, Reg|lung; Re|ge|lungs.tech-nik; re|gel|wid|rig; Re|gel|wid|rig-keit

re|gen; sich -; sich - bringt Segen

Re|gen *m*; -s, -; re|gen|arm; Re|gen-bo|gen; Re|gen|bo|gen|far|ben (*Mehrz.*); in allen - schillern; re-gen|bo|gen.far|ben od. ...far|big; Re|gen|bo|gen|haut (für: „Iris); Re|gen|bo|gen|haut|ent|zün|dung; Re|gen|bo|gen.pres|se (unterhaltende, vor allem über Vorkommnisse innerhalb der Prominenz sensationell berichtende Wochenzeitschriften mit bunten [regenbogenfarbigen] Kopfleisten), ...tri|kot (Trikot des Radweltmeisters; *s*); Re|gen|dach; re-gen|dicht

Re|ge|ne|ra|ti|on *lat* [...zion] (Neubildung [tier. od. pflanzl. Körperteile und zerstörter menschl. Körpergewebe]); re|ge-ne|ra|ti|ons|fä|hig; Re|ge|ne|ra-tiv|ofen (Speicher-, Vorwärmeofen); Re|ge|ne|ra|tor (Wärmespeicher; Luftvorwärmer) *m*; -s, ...oren; re|ge|ne|rie|ren (wiedererzeugen, erneuern, wieder wirksam machen)

Re|gen.er|zeu|gung, ...fall *m*, ...faß, ...guß, ...haut (②: aus Ölstoff hergestellter Regenmantel), ...kar|te, ...man|tel, ...men|ge, ...mes|ser *m*; re|gen|naß; Re|gen-pfei|fer (ein Vogel); re|gen|reich

Re|gens *lat.* (Vorsteher, Leiter [bes. kath. Priesterseminare]) *m*; -, Regentes u. ...enten

Re|gens|burg (Stadt an der Donau); ¹Re|gens|bur|ger (↑ R 199); - Domspatzen; ²Re|gens|bur|ger (Wurstsorte) *w*; -, -

Re|gen|schat|ten (die regenarme Seite eines Gebirges), ...schau|er *m*, ...schirm

Re|gens cho|ri *lat.* [- kọ...] (Chorleiter in der kath. Kirche) *m*; - -, Regentes -; vgl. Regenschori; Re|gens cho|ri [...kọ...] österr. (svw. Regens chori) *m*; -, -

re|gen|schwer; -e Wolken

Re|gent *lat.* (Staatsoberhaupt; Herrscher; [Landes]verweser); ↑ R 268

Re|gen|tag

Re|gen|ten|tu|gend; Re|gen|tes
(*Mehrz.* von: Regens); Re|gen|tin
w; -, -nen
Re|gen.ton|ne, ...trop|fen
Re|gent|schaft; Re|gent|schafts-
rat (*Mehrz.* ...räte)
Re|gen.was|ser (*s*; -s), ...wet|ter (*s*;
-s), ...wol|ke, ...wurm, ...zeit
Re|ger, Max (dt. Komponist)
Re|ge|sten *lat.* (zeitlich geordnete
Urkundenverzeichnisse) *Mehrz.*
Re|gie *fr.* [*reschi*] (Spielleitung [bei
Theater, Film, Fernsehen usw.];
Verwaltung; *Mehrz.* österr. für:
Regie-, Verwaltungskosten) *w*; -,
...ien; Re|gie.as|si|stent, ...be-
trieb (Betrieb der öffentlichen
Hand), ...feh|ler, ...ko|sten (Ver-
waltungskosten; *Mehrz.*); re|gie-
lich
re|gie|ren *lat.* (lenken; [be]-
herrschen; Sprachw.: einen be-
stimmten Fall fordern); (↑ R 224):
Regierender Bürgermeister (im
Titel, sonst: regierender Bürger-
meister); Re|gie|re|rei (ugs. für:
schlechte Staatslenkung); Re|gie-
rung; Re|gie|rungs.bank (*Mehrz.*
...bänke), ...be|am|te, ...be|zirk
(Abk.: Reg.-Bez.), ...bil|dung,
...chef (ugs.), ...di|rek|tor, ...form;
re|gie|rungs|freund|lich; Re|gie-
rungs.kri|se, ...par|tei, ...prä|si-
dent, ...prä|si|di|um, ...rat (höhe-
rer) Verwaltungsbeamter [Abk.:
Reg.-Rat]; schweiz. für: Kan-
tonsregierung u. deren Mitglied;
Mehrz. ...räte); re|gie|rungs|sei-
tig (Amtsdt.: von [seiten] der Re-
gierung); Re|gie|rungs.sitz,
...spre|cher, ...sy|stem, ...um|bil-
dung, ...vor|la|ge, ...wech|sel,
...zeit; Re|gier|werk (die Einzel-
pfeifen der Orgel, Manuale u. Pe-
dale, Traktur, Registrator)
Re|gie|spe|sen (veralt. für: all-
gemeine Geschäftsunkosten)
Mehrz.
Re|gime *fr.* [...*schim*] (Regierungs-
form; Herrschaft) *s*; -[s], - [*re-
schim'*] (selten noch: -s)
Re|gi|ment *lat.* (Regierung; Herr-
schaft; größere Truppeneinheit;
Abk.: R., Regt[t]., Rgt.) *s*; -[e]s,
-e u. (Truppeneinheiten:) -er; re|
gi|men|ter|wei|se; Re|gi|ments-
.arzt, ...be|fehl, ...kom|man|deur,
...stab
Re|gi|na, Re|gi|ne (w. Vorn.)
Re|gi|nald, Rei|nald (m. Vorn.)
Re|gi|on *lat.* (Gegend; Bereich);
re|gio|nal (gebietsmäßig, -weise);
Re|gio|na|lis|mus (Ausprägung
landschaftlicher Sonderbestre-
bungen; Heimatkunst der Zeit
nach 1900) *m*; -; Re|gio|na|list
(Verfechter des Regionalismus);
↑ R 268; Re|gio|nal.li|ga (in der
BRD Bez. für die unter der Bun-

desliga [vgl. d.] stehenden regio-
nalen Spielklassen [Vereine für
Vertragsfußballspieler]), ...pro-
gramm (Rundfunk, Fernsehen)
Re|gis|seur *fr.* [*reschißör*] (Spiellei-
ter [bei Theater, Film, Fernsehen
usw.]) *m*; -s, -e; Re|gis|seu|rin *w*;
-, -nen
Re|gi|ster *lat.* ([alphabet. Inhalts]-
verzeichnis, Sach- oder Wortwei-
ser, Liste; Stimmenzug bei Orgel
und Harmonium) *s*; -s, -; Re|gi-
ster|ge|büh|ren *Mehrz.*; Re|gi-
ster|hal|ten (Druckw.: genaues
Aufeinanderpassen von Farben
beim Mehrfarbendruck od. von
Vorder- und Rückseite) *s*; -s; Re-
gi|ster|ton|ne (Raummaß für
Schiffe; Abk.: RT); Bruttoregi-
stertonne; Nettoregistertonne;
Re|gi|stran|de (veralt. für: Ein-
gangsbuch) *w*; -, -n; Re|gi|stra|tor
(früher für: Register führender
Beamter; auch: Ordner[mappe])
m; -s, ...oren; Re|gi|stra|tur (Auf-
bewahrungsstelle für Akten; Ak-
tengestell, -schrank; die die Regi-
ster und Koppeln auslösende
Schaltvorrichtung bei Orgel und
Harmonium) *w*; -, -en; Re|gi-
strier|bal|lon (unbemannter) mit
Meßinstrumenten versehener
Treibballon zur Erforschung der
höheren Luftschichten); re|gi-
strie|ren ([in ein Register] eintra-
gen; selbsttätig aufzeichnen; ein-
ordnen; übertr. für: bewußt
wahrnehmen; bei Orgel u. Har-
monium Stimmkombinationen
einschalten, Register ziehen); Re-
gi|strier|kas|se; Re|gi|strie|rung
Re|gle|ment *fr.* [*regl'mang*],
schweiz.: ...*mänt*; österr.: *regl-
mang*] ([Dienst]vorschrift; Ge-
schäftsordnung) *s*; -s, -s und
(schweiz.:) -e; re|gle|men|ta|risch
(der [Dienst]vorschrift, Ge-
schäftsordnung gemäß, von ihr
bedingt, bestimmungsgemäß);
re|gle|men|tie|ren (durch Vor-
schriften regeln); Re|gle|men|tie-
rung (Unterstellung [besonders
von Prostituierten] unter behörd-
liche Beaufsichtigung); re|gle-
ment.mä|ßig (vorschriftsmäßig),
...wid|rig
Reg|ler
Re|glet|te *fr.* (Druckw.: Bleistrei-
fen für den Zeilendurchschuß) *w*;
-, -n
reg|los
Reg|lung, Re|ge|lung
reg|nen; Reg|ner (Gerät); reg|ne-
risch; -ste (↑ R 294)
Reg.-Rat = Regierungsrat (↑ R
154)
Re|greß *lat.* (Ersatzanspruch,
Rückgriff) *m*; ...gresses, ...gresse;
Re|greß|an|spruch (Ersatzan-

spruch); Re|gres|si|on (Rückbil-
dung, -bewegung); re|gres|siv
(zurückgehend, rückläufig; rück-
wirkend; rückschrittlich); Re-
greß|pflicht; re|greß|pflich|tig
reg|sam; Reg|sam|keit *w*; -
Regt[t]., Rgt., R. = Regiment
Re|gu|la (w. Vorn.)
Re|gu|lar *lat.* (Mitglied eines ka-
tholischen Ordens mit feierlichen
Gelübden) *m*; -s, -e; re|gu|lär (der
Regel gemäß; vorschriftsmäßig,
üblich); -es System (Mineralogie:
Kristallsystem mit drei gleichen,
aufeinander senkrecht stehenden
Achsen); -e Truppen (gemäß dem
Wehrgesetz eines Staates aufge-
stellte Truppen); Re|gu|lar|geist-
li|che; Re|gu|la|ri|en (auf der Ta-
gesordnung stehende, regelmä-
ßig abzuwickelnde Vereinsange-
legenheiten) *Mehrz.*; Re|gu|la|ri-
tät (Regelmäßigkeit; Richtig-
keit); Re|gu|la|ti|on [...*zion*]
(Biol.: die Regelung der Organsy-
steme eines lebendigen Körpers
durch verschiedene Steue-
rungseinrichtungen; Anpassung
eines Lebewesens an Störungen);
Re|gu|la|ti|ons.stö|rung, ...sy-
stem; re|gu|la|tiv (zur Regel die-
nend, regelnd); Re|gu|la|tiv (re-
gelnde Verfügung, Vorschrift,
Verordnung) *s*; -s, -e [...*we*]; Re-
gu|la|tor (Regler; Ordner; eine
besondere Art Pendeluhr) *m*; -s,
...oren; re|gu|lie|ren (regeln, ord-
nen; [ein]stellen); Re|gu|lier|he-
bel (Stellhebel); Re|gu|lie|rung
re|gu|li|nisch *lat.* (aus reinem Me-
tall bestehend); ¹Re|gu|lus (alt-
röm. Feldherr); ²Re|gu|lus (ein
Stern [nur *Einz.*]; gediegenes Me-
tall) *m*; -, -se; ³Re|gu|lus (Gold-
hähnchen [sehr kleiner Singvo-
gel]) *m*; -, ...li u. -se
Re|gung; re|gungs|los; Re|gungs-
lo|sig|keit *w*; -
Reh *s*; -[e]s, -e
Re|ha|be|am (jüd. König)
Re|ha|bi|li|tand *lat.* (jmd., dem die
Wiedereingliederung in das be-
rufl. u. gesellschaftl. Leben er-
möglicht werden soll) *m*; -en, -en
(↑ R 268); Re|ha|bi|li|ta|ti|on
[...*zion*] (Gesamtheit der Maß-
nahmen, die mit der Wiederein-
gliederung von Versehrten in die
Gesellschaft zusammenhängen;
auch für: Rehabilitierung; Re-
ha|bi|li|ta|ti|ons|zen|trum; re|ha-
bi|li|tie|ren; sich - (sein Ansehen
wiederherstellen); Re|ha|bi|li|tie-
rung (Wiedereinsetzung [in die
ehemaligen Rechte, in den frühe-
ren Stand]; Ehrenrettung)
Re|haut *fr.* [*r'o*] (selten für: Erhö-
hung, lichte Stelle [auf Gemäl-
den]) *m*; -s, -s

Reh|bein (auch für: Überbein beim Pferd), ...blatt, ...bock, ...bra|ten; reh|braun; Reh|brunft

Re|he (Hufkrankheit) w; -

reh|far|ben, reh|far|big; Reh_geiß, ...jun|ge (österr. für: Rehklein; s; -n), ...kalb, ...keu|le, ...kitz, ...klein (Gericht; s; -s); reh|le|dern; Reh|ling landsch. (Pfifferling); Reh..po|sten (grober Schrot), ...rücken [Trenn.: ...rük-ken], ...schle|gel, ...wild, ...zie-mer

Rei|bach vgl. Rebbach

Reib|ah|le, Rei|be w; -, -n; Rei|be-brett (zum Glätten des Putzes); Reib|ei|sen; Rei|be ku|chen (westfäl., niederrhein. für: Kartoffelpuffer), ...laut (für: Frikativ); rei|ben; du riebst (riebest); du riebest; gerieben; reib[e]!; († R 120:) durch kräftiges Reiben säubern; Rei|ber (auch landsch. für: Reibe); Rei|be|rei (ugs. für: kleine Zwistigkeit); Rei|be|rin w; -, -nen; Reib.flä|che, ...gerstl (österr.: eine Suppeneinlage; s; -s); Rei-bung; Rei|bungs.elek|tri|zi|tät, ...fla|che; rei|bungs|los, -este († R 292); Rei|bungs|lo|sig|keit w; -; Rei|bungs.wär|me, ...wi|der|stand

reich; († R 133:) arm u. reich (jedermann), aber († R 116): Arme und Reiche; der reichgeschmückte, reichverzierte Altar († jedoch R 142), aber: der Altar war reich geschmückt, reich verziert

Reich s; -[e]s, -e; von -s wegen; († R 224:) das Deutsche -; das Römische -; das Heilige Römische - Deutscher Nation

reich|be|gü|tert; Rei|che m u. w; -n, -n († R 287ff.)

rei|chen (hinhalten, geben; sich erstrecken; auskommen; genügen)

reich|ge|schmückt; vgl. reich; reich|hal|tig; Reich|hal|tig|keit w; -; reich|lich; († R 134:) auf das, aufs -ste; Reich|lich|keit w; -

Reichs.abt (hist.), ...äb|tis|sin (hist.), ...acht (hist.), ...ad|ler, ...ap|fel (Teil der Reichsinsignien; m; -s), ...ar|chiv (Sammelstelle der Reichsakten von 1871 bis 1945; s; -[e]s), ...bann (hist.), ...frei|herr (hist.), ...ge|richt (höchstes dt. Gericht [1879 bis 1945]; s; -[e]s), ...grün|dung (Gründung des Deutschen Reiches am 18. 1. 1871), ...in|si|gni|en (hist.; Mehrz.); Reichs|kam|mer-ge|richt (höchstes dt. Gericht [1495 bis 1806]) s; -[e]s; Reichs-kanz|ler (leitender dt. Reichsminister [1871 bis 1945]), ...klein-odi|en (hist.; Mehrz.), ...mark (dt. Währungseinheit [bis 20. 6. 1948]; Abk.: RM), ...pfen|nig (dt. Scheidemünze [bis 20. 6. 1948]),

...prä|si|dent (dt. Staatsoberhaupt [1919 bis 1934], ...rat (Vertretung der dt. Länder beim Reich [1919 bis 1934]; m; -[e]s), ...stadt (Bez. für die früheren reichsunmittelbaren Städte), ...tag (dt. Volksvertretung [bis 1945]); Reichs|tags|brand (Brand des Reichstagsgebäudes am 27. 2. 1933); reichs|un|mit|tel|bar (hist. für: Kaiser und Reich unmittelbar unterstehend); Reichs-ver|si|che|rungs|ord|nung (umfassendes Gesetz zur Regelung der öffentl.-rechtl. Invaliden-, Kranken- u. Unfallversicherung; Abk.: RVO) w; -; Reichs|wehr (Bez. des deutschen 100 000-Mann-Heeres von 1921–1935) w; -

Reichs|tum m; -s, ...tümer

reich|ver|ziert; vgl. reich

Reich|wei|te w; -, -n

Rei|der|land, (auch:) Rhei|der-land (Teil Ostfrieslands) s; -[e]s

reif (vollentwickelt; geeignet)

[1]Reif (gefrorener Tau) m; -[e]s

[2]Reif (Ring; Spielzeug) m; -[e]s, -e

Rei|fe (von Früchten) w; -; Rei|fe-grad

[1]rei|fen (reif werden); die Frucht ist gereift; ein gereifter Mann

[2]rei|fen (Reif ansetzen); es hat gereift

Rei|fen ([2]Reif) m; -s, -; Rei|fen-pan|ne, ...pro|fil, ...scha|den, ...spiel o. Reif|spiel, ...wech|sel

Rei|fe|prü|fung; Rei|fe|rei (gewerblicher Raum zum Reifwerden von Früchten, bes. von Bananen); Rei|fe.zeit, ...zeug|nis; Reif|heit (Reifsein) w; -; reif|lich

Reif|rock (veralt.); Reif|spiel, Rei-fen|spiel

Rei|fung (das Reifwerden) w; -; Rei|fungs|pro|zeß

Rei|gen, Rei|hen (Tanz) m; -s, -; Rei|gen.füh|rer, ...tanz

Rei|he w; -, -n; in, außer der -; der nach; an der - sein; an die - kommen; in Reih und Glied († R 241); (Math.:) arithmetische -, geometrische -, unendliche -; rei|hen (in Reihen ordnen; lose, vorläufig nähen; Jägerspr.: die Enten - [wenn in der Paarungszeit mehrere Erpel einer Ente folgen])

[1]Rei|hen südd. (Fußrücken) m; -s, -

[2]Rei|hen vgl. Reigen

Rei|hen.bil|dung, ...dorf, ...fol|ge, ...haus, ...schal|tung (für: Serienschaltung), ...sied|lung, ...un|ter-su|chung; reih|en|wei|se; rei|hum

Rei|her (ein Storchvogel) m; -s, -; Rei|her.bei|ze, ...fe|der, ...horst, ...schna|bel (eine Pflanze)

Reih|garn

...rei|hig (z. B. einreihig); reih|um; es geht -; Rei|hung

Reim m; -[e]s, -e; (Verslehre:) ein stumpfer (männlicher) -, ein klingender (weiblicher) -; Reim-_art, ...chro|nik; rei|men; sich -; Rei|mer (jmd., der Verse schreibt); Rei|me|rei (abschätzig); Reim|le|xi|kon; reim|los

Re|im|port lat. [re-im...] (Wiedereinfuhr bereits ausgeführter Güter); † R 148

Reims [fr. Ausspr.: rängß] (fr. Stadt)

Reim|schmied (scherzh.)

Reim|ser [zu: Reims] († R 199)

Reim|sucht (abschätzig) w; -

Rei|mund vgl. Raimund

rein|wei|se; Reim|wort (Mehrz. ...wörter)

[1]rein; † R 238 (ugs. für: herein, hinein)

[2]rein; ein reingoldener, reinsilberner Ring († jedoch R 143), aber: der Ring ist rein golden, rein silbern; (vgl. S. 45, Merke, 2:) reinleinen, reinseiden, reinwollen u. a., aber: rein Leder od. reines Leder (Kaufmannsspr.); - halten, machen, aber († R 120:) das große Rein[e]machen; vgl. reinwaschen, sich; († R 133:) ins reine bringen, kommen, schreiben; mit etwas, mit jmdm. im reinen sein; († R 275:) reinen Sinnes; rein Schiff! (seemänn. Kommando); [3]rein (ugs. für: durchaus, ganz, gänzlich); er ist - toll; er war - weg (ganz hingerissen); vgl. rein[e]weg

Rein südd. u. österr. ugs. (flacher Kochtopf; Pfannentopf) w; -, -en

Rei|nald vgl. Reginald

Rein|an|ke w; -. vgl. Rheinanke

Rein|del, Reindl (südd. u. österr. Verkleinerungsform von: Rein) s; -s, -n; Reind|ling südostösterr. (ein Kuchen)

Rei|ne (dicht. für: Reinheit) w; -

Rei|ne|clau|de [rän°klod°] vgl. Reneklode

Rein|ein|nah|me

Rei|ne|ke Fuchs (Name des Fuchses in der Tierfabel)

Rei|ne|ma|che|frau, Rein|ma|che-frau; Rei|ne|ma|chen, Rein|ma-chen s; -s; vgl. rein

Rei|ner, Rai|ner (m. Vorn.)

rein|er|big (für: homozygot); Rein-_er|lös, ...er|trag

Rei|net|te vgl. Renette

rei|ne|weg, rein|weg (ugs. für: ganz und gar); das ist - zum Tollwerden, aber: er war rein weg (ganz hingerissen)

Rein|fall; † R 238 (ugs.) m; rein|fal-len; † R 238 (ugs.)

Re|in|fek|ti|on lat. [re-infäkzion] (Med.: erneute Infektion)

Rein|ge|schmeck|te vgl. Hereinge-
schmeckte
Rein.ge|wicht, ...ge|winn, ...hal-
tung
Rein|hard (m. Vorn.)
Rein|heit w; -
Rein|hild, Rein|hil|de (w. Vorn.);
Rein|hold (m. Vorn.); vgl. auch:
Rainold u. Reinold
rei|ni|gen; Rei|ni|gung; die rituelle
- (nach gottesdienstlichen Vor-
schriften); Rei|ni|gungs_in|sti|tut,
...milch, ...mit|tel s
Re|in|kar|na|ti|on lat. [...zion]
(„Wiederverfleischlichung";
Wiederverkörperung von Ge-
storbenen)
Rein|kul|tur
rein|le|gen; ↑ R 238 (ugs.)
rein|lei|nen; vgl. rein; rein|lich;
Rein|lich|keit w; -; rein|lich|keits-
lie|bend, a b e r (↑ R 142): die Rein-
lichkeit liebend; Rein|ma|che-
frau, Rei|ne|ma|che|frau; Rein-
ma|chen vgl. Reinemachen
Rein|mar (m. Eigenn.)
Rein|nickel [Trenn.: ...nik|kel] s
Rei|nold (ältere Form von: Rein-
hold)
rein|ras|sig; Rein|ras|sig|keit w; -;
Rein|schiff (gründliche Schiffs-
reinigung) s; -[e]s; Rein|schrift;
rein|schrift|lich; rein|sei|den; vgl.
rein; Rein|ver|mö|gen; rein|wa-
schen, sich; ↑ R 139 (seine Un-
schuld beweisen); rein|weg vgl.
reinweg; rein|wol|len; vgl. rein;
Rein|zucht
¹Reis (Mehrz. von: ¹Real [port.])
²Reis, Johann Philipp (Erfinder
des Telefons)
³Reis (Zweiglein; Pfropfreis) s; -es,
-er
⁴Reis gr. (Getreide) m; -es, (Reisar-
ten:) -e; Reis|bau m; -[e]s
Reis|be|sen, Rei|ser|be|sen
Reis_brannt|wein, ...brei
Reis|chen (kleines Reis) s; -s, - u.
Reiserchen; Reis|lein s; -s, -
Rei|se w; -, -n; Rei|se_apo|the|ke,
...ar|ti|kel, ...be|darf, ...be|glei-
ter, ...be|glei|te|rin, ...be|richt,
...be|schrei|bung, ...be|steck,
...buch, ...buch|han|del, ...bü|ro;
Rei|se|bü|ro|kauf|mann; rei|se-
fer|tig; Rei|se_füh|rer, ...füh|rer,
...geld, ...ge|päck, ...ge|sell-
schaft, ...ko|sten (Mehrz.),
...krank|heit, ...kre|dit|brief,
...lei|ter m, ...lek|tü|re, ...lust (w;
-); rei|se|lu|stig; rei|sen; du reist
(reisest); du reistest; gereist;
reis[e]!; reisende Kaufleute,
Handwerksburschen; Rei|sen|de
m u. w; -n, -n (↑ R 287ff.); Rei-
se_ne|ces|saire, ...on|kel (scherzh.
für: jemand, der oft und gern
reist), ...paß, ...plan (vgl. ²Plan),
...pro|vi|ant

Rei|ser|be|sen, Reis|be|sen
Rei|se|rei (ugs.)
rei|sern (Jägerspr. vom [Leit]-
hund, der die Witterung von
Ästen und Zweigen nimmt)
Rei|se_rou|te, ...scheck, ...schil|de-
rung, ...schreib|ma|schi|ne, ...spe-
sen (Mehrz.), ...ta|sche, ...tip,
...ver|kehr, ...vor|be|rei|tun|gen
(Mehrz.), ...wet|ter, ...wet|ter-
ver|si|che|rung, ...zeit, ...ziel
Reis|feld
Reis|holz (veraltet. für: Reisig) s; -es
rei|sig (veraltet. für: beritten)
Rei|sig s; -s; Rei|sig_be|sen, ...bün-
del
Rei|si|ge (im Mittelalter: beritte-
ner Söldner) m; -n, -n (↑ R 287ff.)
Rei|sig|holz s; -es
Reis|korn (Mehrz. ...körner)
Reis|lauf (früher in der Schweiz:
Eintritt in fremden Dienst als
Söldner) m; -[e]s; Reis|läu|fer
Reis|lein vgl. Reischen
Reis|pa|pier
Reiß|ah|le; Reiß|aus, im allg. nur
in: - nehmen (ugs. für: davonlau-
fen); Reiß|bahn (Vorrichtung
zum schnellen Entleeren eines
Luftballons), ...blei (Graphit; s),
...brett (Zeichenbrett)
Reis_schleim, ...schnaps
rei|ßen; du reißt (reißest), er reißt;
du rissest, er riß; gerissen; reiß[e]!;
reißende (wilde) Tiere; Rei|ßen
(auch für: ziehender Glieder-
schmerz) s; -s; rei|ßend; er Strom,
-e Schmerzen, -er Absatz; Rei|ßer
(ugs. für: Erfolgsbuch, -film u.
a.); rei|ße|risch, -ste (↑ R 294);
Reiß|fe|der, ...reiß|fest; Reiß|fe-
stig|keit; Reiß|lei|ne (am Fall-
schirm u. an der Reißbahn), ...li-
nie (für: Perforation), ...na|gel,
...schie|ne
Reis|sup|pe
Reiß_ver|schluß, ...vor|rich|tung,
...wolf m, ...wol|le (Abfallwolle;
früher: Kunstwolle), ...zahn,
...zeug, ...zir|kel, ...zwecke
[Trenn.: ...zwek|ke]
Rei|ste schweiz. (Holzrutsche;
³Riese) w; -, -n; rei|sten schweiz.
(Holz von den Bergen niederrut-
schen lassen)
Reit|bahn
Rei|tel mitteld. (Drehstange,
Knebel) m; -s, -; Rei|tel|holz (mit-
teld.)
rei|ten; du reitest; du rittst (rittest),
er ritt; du rittest; geritten; reit[e]!;
rei|tend; -e Artillerie, -e Post;
¹Rei|ter
²Rei|ter schwäb., mitteld., österr.
([Getreide]sieb) w; -, -n
Rei|ter|an|griff; Rei|te|rei; Rei|te-
rin w; -, -nen; rei|ter|lich; Rei-
ter|re|gi|ment; Rei|ters|mann
(Mehrz. ...männer)

Rei|te|rung veralt. schwäb., mit-
teld. (das Sieben)
Reit.ger|te, ...ho|se
Reit im Winkl (Ort in den Chiem-
gauer Alpen)
Reit.knecht, ...kunst, ...leh|re,
...leh|rer, ...peit|sche, ...pferd,
...schu|le (südwestd. auch für:
Karussell), ...sitz, ...sport, ...stie-
fel, ...tier, ...tur|nier; Reit- und
Fahr|tur|nier (↑ R 145); Reit.un-
ter|richt, ...weg
Reiz m; -es, -e; (↑ R 116:) der Reiz
des Neuen; reiz|bar; Reiz|bar|keit
w; -; rei|zen; du reizt (reizest); du
reizt; du reiztest; gereizt; rei|zend;
-ste; Reiz|hu|sten
Reiz|ker slaw. (ein Pilz) m; -s, -
Reiz|kli|ma; reiz|los, -este (↑ R
292); Reiz|lo|sig|keit w; -; Reiz-
mit|tel s; reiz|sam (veralt.); Reiz-
sam|keit (veralt.) w; -; Reiz-
_schwel|le (bei der Werbung),
...the|ra|pie, ...über|flu|tung; Rei-
zung; reiz|voll; Reiz|wä|sche
Re|ka|pi|tu|la|ti|on lat. [...zion]
(Wiederholung, Zusammenfas-
sung); re|ka|pi|tu|lie|ren
Re|kel niederd. (grober, unge-
schliffener Mensch) m; -s, -; Re-
ke|lei (abschätzig); re|keln (sich
(abschätzig für: sich strecken;
sich flegelig hinlegen); ich ...[e]le
mich (↑ R 327)
Re|kla|mant lat. (Rechtsw.: Be-
schwerdeführer) m; -en, -en (↑ R
268); Re|kla|ma|ti|on ...[...zion]
(Beanstandung)
Re|kla|me lat. (meist abschätzig
für: Werbung) w; -, -n; Re|kla|me-
feld|zug; re|kla|me|haft; Re|kla-
me|ma|che|rei (ugs.); Re|kla-
me_pla|kat, ...trick; re|kla|mie|ren
([zurück]fordern; Einspruch er-
heben, beanstanden)
re|ko|gnos|zie|ren lat. (veralt. für:
[die Echtheit einer Person oder
Sache] anerkennen; scherzh. für:
auskundschaften; früher beim
Militär: erkunden, aufklären);
Re|ko|gnos|zie|rung
Re|kom|man|da|ti|on fr. [...zion]
(veralt. für: Empfehlung; Postw.:
Einschreibung); Re|kom|man-
da|ti|ons|schrei|ben (veralt.); re-
kom|man|die|ren (veralt., aber
noch mdal. für: empfehlen, ein-
schärfen; österr. für: [einen Brief]
einschreiben lassen)
Re|kom|pens lat. (Wirtsch.: Ent-
schädigung) w; -, -en; re|kom|pen-
sie|ren
re|kon|stru|ieren lat. ([den ur-
sprüngl. Zustand] wiederherstel-
len oder nachbilden; den Ablauf
eines früheren Vorganges oder
Erlebnisses wiedergeben); Re-
kon|stru|ierung, Re|kon|struk|ti-
on [...zion]

Re|kon|va|les|zent [...wa...] lat. (Genesender); ↑ R 268; Re|konva|les|zen|tin w; -, -nen; Re|konva|les|zenz w; -; re|kon|va|les|zieren

Re|kord engl. m; -[e]s, -e; Re|kordbe|such, ...er|geb|nis, ...ern|te, ...flug, ...hal|ter, ...hal|te|rin, ...ha|sche|rei, ...lei|stung, ...marke, ...ver|such, ...wa|gen, ...wei|te, ...zahl, ...zeit

Re|krea|ti|on lat. [...zion] (veralt. für: Erholung; Erfrischung); rekre|ieren (veralt.)

Re|krut fr. (Soldat in der ersten Ausbildungszeit) m; -en, -en (↑ R 268); Re|kru|ten|aus|bil|der, ...aus|bil|dung, ...aus|he|bung, ...zeit; re|kru|tie|ren (Rekruten ausheben, mustern); sich - (bildl. für: sich zusammensetzen, sich bilden); Re|kru|tie|rung

Rek|ta (Mehrz. von: Rektum); rek|tal lat. (Med.: auf den Mastdarm bezüglich); Rek|tal.er|nährung, ...nar|ko|se; rekt|an|gu|lär (veralt. für: rechtwinklig); Rekta.pa|pier (Namenspapier), ...wech|sel (auf den Namen des Inhabers ausgestellter Wechsel); Rekt|as|zen|si|on („gerades Aufsteigen" eines Sternes); rek|te val. recte; Rek|ti|fi|ka|ti|on [...zion] (veralt. für: Berichtigung; Zurechtweisung; Läuterung; Chemie: Reinigung durch wiederholte Destillation; Math.: Bestimmung der Länge einer Kurve); Rek|ti|fi|zier|an|la|ge (Läuterungsanlage); rek|ti|fi|zie|ren (Zeitwort zu: Rektifikation); Rek|ti|on lat. [...zion] (Sprachw.: Fähigkeit eines Wortes [Verb, Adjektiv, Präposition], den Kasus des von ihm abhängenden Wortes zu bestimmen); Rek|to ([Blatt]vorderseite) s; -s, -s; Rektor (Leiter einer [Hoch]schule; kath. Geistlicher an einer Nebenkirche u. ä.) m; -s, ...oren; Rek|torat (Amt[szimmer] eines Rektors) s; -[e]s, -e; Rek|to|rats|re|de (Rede eines Hochschulrektors bei der Übernahme seines Amtes); Rek|to|ren|kon|fe|renz; Rekto|rin [auch: räk...] w; -, -nen; Rek|tor|re|de; Rek|to|skop lat.; gr. (Med.: Spiegel zur Mastdarmuntersuchung) s; -s, -e; Rek|tosko|pie w; -, ...ien; Rek|tum lat. (Med.: Mastdarm) s; -s, ...ta

Re|kul|ti|vie|rung

Re|ku|pe|ra|tor lat. (Vorwärmer in techn. Feuerungsanlagen) m; -s, ...oren

re|kur|rens|fie|ber (Med.: Rückfallfieber); re|kur|rie|ren (auf etwas zurückkommen; zu etwas seine Zuflucht nehmen; Rechtsw.

selten: Berufung einlegen); Rekurs (das Zurückgehen, Zuflucht; Rechtsw.: Beschwerde, Berufung, Einspruch) m; -es, -e; Re|kurs|an|trag; re|kur|siv (Math.: zurückgehend bis zu bekannten Werten)

Re|lais fr. [r³lä] (Elektrotechnik: Schalteinrichtung; hist. Postw.: Auswechslung der Pferde, Einsatzstelle für diesen Wechsel; früher beim Militär: Melder-, Läuferkette) s; - [r³lä(ß)], - [r³läß]; Re|lais.dia|gramm, ...sta|ti|on

Re|la|ti|on lat. [...zion] (Beziehung, Verhältnis; veralt. für: Bericht, Mitteilung); Re|la|ti|onsbe|griff (Philos.: Begriff der Vergleichung und Entgegensetzung); re|la|tiv [auch: re...] (bezüglich; verhältnismäßig; vergleichsweise; bedingt); -e (einfache) Mehrheit; Re|la|tiv (Sprachw.: bezügliches Fürwort, Relativpronomen; bezügliches Umstandswort, Relativadverb) s; -s, -e [...w³]; Re|la|tiv|ad|verb (Sprachw.: bezügliches Umstandswort, z. B. „flora, wo die Stelle, an der Fluß tief ist"); re|la|ti|vie|ren [...wir³n] (in eine Beziehung bringen; einschränken); Re|la|ti|vis|mus (philosophische Lehre, für die alle Erkenntnis nur relativ, nicht allgemeingültig ist) m; -; re|la|ti|vistisch; Re|la|ti|vi|tät (Bezüglichkeit; Bedingtheit); Re|la|ti|vitäts|theo|rie (physikalische Theorie von Einstein u. a.) w; -; Re|la|tiv.pro|no|men (Sprachw.: bezügliches Fürwort, z. B. „das" in: „ein Buch, das ich kenne"), ...satz

Re|lease engl. [riliß] (Zentrale zur Heilung Rauschgiftsüchtiger) s; -s

Re|le|ga|ti|on lat. [...zion] (Verweisung von der [Hoch]schule); rele|gie|ren

re|le|vant lat. [...want] (erheblich, wichtig); Re|le|vanz w; -, -en

Re|li|ef fr. (über eine Fläche erhaben hervortretendes Bildwerk; plastische Nachbildung der Oberfläche eines Geländes) s; -s, -s u. -e; Re|li|ef.druck (Hoch-, Prägedruck; Mehrz. ...drucke), ...kar|te (Kartographie), ...lischee (Druckw.), ...pfei|ler, ...sticke|rei [Trenn.: ...stik|ke...]

Re|li|gi|on lat.; natürliche, [ge]offenbarte, positive, monotheistische - ; Re|li|gi|ons.be|kennt|nis, ...buch, ...er|satz, ...frei|heit (w; -), ...frie|de (m; -ens), ...ge|meinschaft, ...ge|schich|te, ...ge|sellschaft, ...krieg, ...leh|re, ...leh|rer; re|li|gi|ons|los; Re|li|gi|ons.lo

sig|keit (w; -), ...phi|lo|so|phie, ...psy|cho|lo|gie, ...so|zio|lo|gie, ...stif|ter, ...strei|tig|kei|ten (Mehrz.), ...stun|de, ...un|terricht, ...wis|sen|schaft; re|li|gi|ös fr.; -este (↑ R 292); eine -e Bewegung; Re|li|gio|sen lat. (Mitglieder einer religiösen Genossenschaft) Mehrz.; Re|li|gio|si|tät w; -

Re|likt lat. (Überbleibsel, Restgebiet, -vorkommen]) s; -[e]s, -e; Re|lik|ten (veralt. für: Hinterbliebene; Hinterlassenschaft) Mehrz.; Re|lik|ten.fau|na (Überbleibsel einer früheren [Meeres]tierwelt; w; -), ...flo|ra (w; -)

Re|ling (Schiffs]geländer, Drüstung) w; -, -s (seltener auch: -e)

Re|li|qui|ar lat. (Reliquienbehälter) s; -s, -e; Re|li|quie [...i³] (Überrest, Gegenstand von Heiligen; kostbares Andenken) w; -, -n; Re|li|qui|en.be|häl|ter, ...schrein

Re|ma|gen (Stadt am Mittelrhein)

Re|ma|nenz (Restmagnetismus) w; -

Re|marque [r³mark] (dt. Schriftsteller)

Re|ma|su|ri vgl. Ramasuri

Rem|bours fr. [rangbur] (Begleichung einer Forderung aus einem Geschäft durch Vermittlung einer Bank) m; -, -; Rem|bours.geschäft, ...kre|dit

Rem|brandt (niederl. Maler u. Radierer); - van Rijn [fan od. wan re³n]

re|me|die|ren lat. (Med.: heilen; abhelfen); Re|me|di|um (Heil-, Abhilfsmittel; zulässiger Mindergehalt [der Münzen an edlem Metall]) s; -s, ...ien [...i³n] u. ...ia; Re|me|dur (veralt. für: Abhilfe) w; -, -en; - schaffen

Re|mi|gi|us (ein Heiliger)

Re|mi|grant lat. (Rückwanderer, zurückgekehrter Emigrant) m; -en, -en (↑ R 268)

re|mi|li|ta|ri|sie|ren fr. (wiederbewaffnen; das aufgelöste Heerwesen eines Landes von neuem organisieren); Re|mi|li|ta|ri|sierung w; -

Re|mi|nis|zenz lat. (Erinnerung; Anklang) w; -, -en; Re|mi|nis|zere („Gedenke!"; fünfter Sonntag vor Ostern)

re|mis fr. [r³mi] (unentschieden); Re|mis [r³mi] (unentschiedenes Spiel) s; - [r³mi(ß)], - [r³miß] u. -en [...s³n]; Re|mi|se (veralt. für: Geräte-, Wagenschuppen; Schutzgehölz für Wild; Schachpartie mit unentschiedenem Ausgang) w; -, -n; Re|mis|si|on lat. (veralt. für: Erlaß; Buchhandel: Rücksendung von Remittenten

Med.: vorübergehendes Nach-
lassen von Krankheitser-
scheinungen; Physik; das Zu-
rückwerfen von Licht an un-
durchsichtigen Flächen); Re|mit-
ten|de (Buchhandel: „Zurückzu-
sendendes"; Buch, Büchersen-
dung, die vom Sortiment an den
Verlag zurückgegeben wird) w;
-, -n; Re|mit|tent (Wirtsch.:
Wechselnehmer);↑R 268; re|mit-
tie|ren (zurücksenden; Zahlung
für Empfangenes einsenden;
Med.: nachlassen [vom Fieber])
Rem|mi|dem|mi (ugs. für: lärmen-
des Treiben, Trubel, Betrieb, Un-
ruhe) s; -s
re|mon|tant fr. [auch: remongtant]
(Bot.: wiederkehrend, zum zwei-
tenmal blühend); Re|mon|tant-
ro|se; Re|mon|te [auch: remongte]
(früher: junges Militärpferd) w;
-, -n; Re|mon|te|pferd; re|mon|tie-
ren [auch: remong...] (Bot.: zum
zweitenmal blühen oder fruch-
ten; früher: den militär. Pferde-
bestand durch Jungpferde ergän-
zen); Re|mon|tie|rung; Re|mon-
toir|uhr [remongtoar...] (ohne
Schlüssel aufzieh- und stellbare
Taschenuhr [veralt.])
Re|mor|queur fr. [...kör] österr.
(kleiner Schleppdampfer) m; -s,
-e; re|mor|quie|ren
Re|mou|la|de fr. [...mu...] (eine
Kräutermayonnaise)
Rem|pe|lei (ugs.); rem|peln (ugs.
für: absichtlich stoßen); ich
...[e]le (↑R 327)
Rem|pla|çant fr. [rangplaßang]
(früher: Stellvertreter, Ersatz-
mann eines Wehrpflichtigen) m;
-s, -s; rem|pla|cie|ren
Remp|ler (ugs.)
Remp|ter vgl. Remter
Rems (r. Nebenfluß des Neckars)
w; -
Rem|scheid (Stadt in Nordrhein-
Westfalen)
Rem|ter lat. (Speise-, Versamm-
lungssaal [in Burgen und
Klöstern]) m; -s, -
Re|mu|ne|ra|ti|on lat. [...zion] (ver-
alt., aber noch österr. für: Gratifi-
kation, Entschädigung, Vergü-
tung); vgl. aber: Renumeration;
re|mu|ne|rie|ren
Re|mus (Zwillingsbruder des Ro-
mulus)
¹Ren nord. (Hirschart, Haustier
der Lappen) s; -s, -s od. (bei lan-
ger Aussprache: ren) s; -s, -e
²Ren lat. (Med.: Niere) m; -s, -es
Re|nais|sance fr. [renäßangß]
(„Wiedergeburt", bes. die Er-
neuerung der antiken Lebens-
form auf geistigem u. künstleri-
schem Gebiet vom 14. bis 16. Jh.)
w; -, -n [...ßen]; Re|nais|sance-

...dich|ter, ...künst|ler, ...ma|ler,
...mensch, ...stil (m; -[e]s), ...zeit
Re|na|ta, Re|na|te (w. Vorn.); Re-
na|tus (m. Vorn.)
Re|nault ® [reno] (fr. Kraftfahr-
zeugmarke)
Ren|contre vgl. Renkontre
Ren|dant fr. (Rechnungsführer)
m; -en, -en (↑R 268); Ren|dan|tur
lat. (veralt. für: Gelder einneh-
mende und auszahlende Behör-
de) w; -, -en; Ren|de|ment fr.
[rangdemang] (Gehalt an reinen
Bestandteilen, bes. Gehalt an
reiner Wolle) s; -s, -s; Ren|dez-
vous [rangdewu] (scherzh. für:
Verabredung [von Verliebten];
Begegnung von Raumfahrzeu-
gen im Weltall) s; - [...wu(ß)], -
[...wuß]; Ren|dez|vous.ma|nö|ver,
...tech|nik; Ren|di|te it. (Verzin-
sung, Ertrag) w; -, -n; Ren|di|ten-
haus schweiz. (Miethaus); Ren-
di|te|ob|jekt
Re|né [...ne] (fr. Form von: Rena-
tus)
Re|ne|gat lat. ([Glaubens]abtrün-
niger) m; -en, -en (↑R 268); Re|ne-
ga|ten|tum s; -s
Re|ne|klo|de fr. (Pflaume einer be-
stimmten Sorte) w; -, -n; vgl.
Reineclaude u. Ringlotte
Re|net|te fr. (ein Apfel) w; -, -n
Ren|for|cé fr. [rangforße] (ein
Baumwollgewebe) m od. s; -s, -s
re|ni|tent lat. (widerspenstig; Re-
ni|ten|te m u. w; -n, -n (↑R 287ff.);
Re|ni|tenz w; -
Ren|ke w; -, -n u. Ren|ken (ein Fisch
in den Voralpenseen) m; -s, -
ren|ken (veralt. für: drehend hin
und her bewegen)
Ren|kontre fr. [rangkongtr] (sel-
ten noch für: feindliche Begeg-
nung; Zusammenstoß) s; -s, -s
Renk|ver|schluß (für: Bajonett-
verschluß)
Renn.bahn, ...boot; ren|nen; du
ranntest, (selten:) du renntest; ge-
rannt; renn[e]!; Ren|nen s; -s, -;
Ren|ner; Ren|ne|rei (abschätzig);
Renn.fahrer, ...fie|ber, ...jacht,
...lei|ter m; ...ma|schi|ne, ...pferd,
...pi|ste, ...platz, ...rad, ...rei|ter,
...ro|deln (s; -s), ...schlit|ten,
...schuh, ...sport, ...stall
Renn|steig, (auch:) Renn|stieg
(Kammweg auf der Höhe des
Thüringer Waldes u. Franken-
waldes)
Renn|strecke [Trenn.: ...strek|ke]
Renn|tier (übliche, aber falsche
Bez. für: ¹Ren)
Renn.wa|gen ...wolf (Tretschlit-
ten; m)
Re|noir [renoar] (fr. Maler und
Graphiker)
Re|nom|ma|ge fr. [...masche] (ver-
alt. für: Prahlerei); Re|nom|mee

([guter] Ruf, Leumund) s; -s, -s;
re|nom|mie|ren (prahlen); Re-
nom|mier|stück; re|nom|miert
(berühmt, angesehen, namhaft);
Re|nom|mist (Prahlhans); ↑R
268; Re|nom|mi|sten|tum s; -s; Re-
nom|mi|ste|rei
Re|non|ce fr. [renongß] (Karten-
spiel: Fehlfarbe) w; -, -n; re|non-
cie|ren [renongßiren] (veralt. für:
verzichten)
Re|no|va|ti|on lat. [...wazion] (ver-
alt. für: Renovierung); re|no|vie-
ren [...wiren] (erneuern, instand
setzen); Re|no|vie|rung
Ren|sei|gne|ment fr. [rangßänje-
mang] (veralt. für: Auskunft,
Nachweis) s; -s, -s
ren|ta|bel (zinstragend; einträg-
lich); ...a|bles Geschäft; Ren|ta-
bi|li|tät (Einträglichkeit, Ver-
zinsung[shöhe]) w; -; Ren|ta|bi|li-
täts.ge|sichts|punkt, ...prü|fung,
...rech|nung; Rent|amt (veralt.
für: Rechnungsamt); Ren|te fr.
(regelmäßiges Einkommen [aus
Vermögen od. rechtl. Ansprü-
chen] w; -, -n; eine lebenslängli-
che -; Ren|tei (Rentamt); Ren-
ten.an|lei|he (Anleihe des Staa-
tes, für die kein Tilgungszwang
besteht), ...an|pas|sung, ...an-
spruch, ...bank (Mehrz. ...ban-
ken), ...be|mes|sungs|grund|la|ge,
...emp|fän|ger, ...haus, ...mark
(dt. Währungseinheit [1923]; w;
-, -), ...markt (Börsenmarkt
der festverzinsl. Wertpapiere),
...neu|ro|se; ren|ten|pflich|tig;
Ren|ten.rech|nung, ...re|form,
...schein, ...schuld, ...ver|schrei-
bung (ein Wertpapier, das die
Zahlung einer Rente verbrieft),
...ver|si|che|rung, ...wert (ein
Wertpapier mit fester Verzin-
sung), ...zah|lung
¹Ren|tier (dafür besser: ¹Ren)
²Ren|tier fr. [...tie] (veraltend für:
Rentner) m; -s, -s; Ren|tie|re
[...tiäre] (veralt. für: Rentnerin)
w; -, -n; ren|tie|ren (für: Zins, Gewinn,
Rehte bringen); sich - (sich loh-
nen)
Ren|tier|flech|te (Flechte arkti-
scher Gebiete [liefert Futter für
das ¹Ren])
Rent|ner; Rent|ne|rin w; -, -nen
Re|nu|me|ra|ti|on lat. [...zion]
(Wirtsch.: Rückzahlung); vgl.
aber: Remuneration; re|nu|me-
rie|ren
Re|nun|tia|ti|on [...zion] vgl. Re-
nunziation; Re|nun|zia|ti|on lat.
[...zion] (Verzichtleistung, Ab-
dankung [eines Monarchen]); re-
nun|zie|ren
Re|ok|ku|pa|ti|on lat. [...zion]
(Wiederbesetzung); re|ok|ku|pie-
ren

Re|or|ga|ni|sa|ti|on *lat.; fr.* [...*zịọn*] (Neugestaltung, Neuordnung); Re|or|ga|ni|sa|tor *m*; -s, ...ọren; re|or|ga|ni|sie|ren

re|pa|ra|bel *lat.* (wiederherstellbar); ...a|ble Schäden; Re|pa|ra|teur [...*tör*] (jmd., der etwas berufsmäßig repariert) *m*; -s, -e; Re|pa|ra|ti|on [...*zịọn*] (Wiederherstellung; nur *Mehrz.*: Kriegsentschädigung); Re|pa|ra|ti|ons-.kom|mis|si|on, ...lei|stung, ...zah|lung; Re|pa|ra|tur *w*; -, -en; re|pa|ra|tur_an|fäl|lig, ...be|dürf|tig; Re|pa|ra|tur_ko|sten, ...werk|statt; re|pa|rie|ren

re|par|tie|ren *fr.* (im Börsenhandel: Wertpapiere einzelnen Zeichnern [nach Verhältnis der Beteiligten] zuteilen); Re|par|ti|ti|on [...*zịọn*]

re|pas|sie|ren *fr.* (Laufmaschen aufnehmen, aufmaschen); Re|pas|sie|re|rin (Arbeiterin, die Laufmaschen aufnimmt) *w*; -, -nen

re|pa|tri|ieren *lat.* (Staatsangehörigkeit wiederverleihen; Kriegs-, Zivilgefangene in die Heimat entlassen); Re|pa|tri|ierung

Re|per|kus|si|on *lat.* (Sprechton beim Psalmenvortrag; einmaliger Durchgang alle Stimmen bei der Fuge)

Re|per|toire *fr.* [...*tọar*] (Stoffsammlung; Vorrat einstudierter Stücke usw., Spielplan) *s*; -s, -s; Re|per|toire|stück (Spielplanstück); Re|per|to|ri|um *lat.* (wissenschaftl. Verzeichnis; Nachschlagewerk) *s*; -s, ...ien [...*i*ᵉ*n*]

Re|pe|tent *lat.* (Schüler, der eine Klasse wiederholt; veralt. für: Nachhelfer, Einpauker); ↑ R 268; re|pe|tie|ren (wiederholen); Re|pe|tier_ge|wehr, ...uhr (Taschenuhr mit Schlagwerk); Re|pe|ti|ti|on [...*zịọn*] (Wiederholung); Re|pe|ti|tor (Nachhelfer, Einpauker [an Hochschulen]) *m*; -s, ...ọren; Re|pe|ti|to|ri|um (Wiederholungsunterricht, -buch) *s*; -s, ...ien [...*i*ᵉ*n*]

Re|plik *fr.* (Gegenrede, Erwiderung) *w*; -, -en; re|pli|zie|ren *lat.* e|po|nj|bel *lat.* (Med.: wiederherstellbar); ...i|bler Bruch; re|po|nie|ren (veralt. für: zurücklegen; [Aktenstück] einordnen; Med.: gebrochene Knochen, verrenkte Glieder wiedereinrichten)

Re|port *fr.* (Bericht, Mitteilung; Börse: Kursaufschlag bei der Verlängerung von Termingeschäften) *m*; -[e]s, -e; Re|por|ta|ge [...*tạseh*ᵉ, österr.: ...*tạseh*] (Bericht[erstattung] über ein aktuelles Ereignis); Re|por|ter *engl.* (Zeitungs-, Fernseh-, Rundfunk-

berichterstatter) *m*; -s, -; Re|por|te|rin *w*; -, -nen

Re|po|si|ti|on *lat.* [...*zịọn*] (Med.: Wiedereinrichtung [von Verrenkungen, Brüchen]); Re|po|si|to|ri|um (veralt. für: Büchergestell; Aktenschrank) *s*; -s, ...ien [...*i*ᵉ*n*]

re|prä|sen|ta|bel *fr.* (würdig; stattlich; wirkungsvoll); ...a|ble Erscheinung; Re|prä|sen|tant (Vertreter, Abgeordneter); ↑ R 268; Re|prä|sen|tan|ten|haus; Re|prä|sen|tan|tin (Vertreterin) *w*; -, -nen; Re|prä|sen|tanz (österr., sonst veralt. für: [geschäftl.] Vertretung) *w*; -, -en; Re|prä|sen|ta|ti|on [...*zịọn*] ([Stell]vertretung; standesgemäßes Auftreten; gesellschaftlicher Aufwand); Re|prä|sen|ta|ti|ons_auf|wen|dung, ...gel|der (*Mehrz.*), ...schluß (Statistik: bei Stichproben u. Schätzungen angewandtes Schlußverfahren); re|prä|sen|ta|tiv (vertretend; würdig, ansehnlich); -e Demokratie; Re|prä|sen|ta|tiv_be|fra|gung, ...er|he|bung, ...ge|walt, ...sy|stem (Politik), ...wer|bung; re|prä|sen|tie|ren (vertreten; etwas darstellen; standesgemäß auftreten)

Re|pres|sa|lie *lat.* [...*i*ᵉ] (Vergeltungsmaßnahme, Druckmittel) *w*; -, -n (meist *Mehrz.*); Re|pres|si|on (Unterdrückung; Abwehr, Hemmung); re|pres|si|ons|frei; Re|pres|si|ons|in|stru|ment; re|pres|siv (unterdrückend); -e Maßnahmen; Re|pres|siv|zoll

Re|pri|man|de *fr.* (veralt., aber noch mdal. für: Tadel) *w*; -, -n

Re|print *engl.* (Buchw.: unveränderter Nachdruck, Neudruck) *m*; -s, -s

Re|pri|se *fr.* (Wirtsch.: Kurserholung; Musik: Wiederholung; Theater, Film: Wiederaufnahme [eines Stückes] in den Spielplan; Neuaufnahme einer vergriffenen Schallplatte; dem Feind wieder abgenommene Prise) *w*; -, -n

Re|pri|va|ti|sie|rung *fr.* (Wiederumwandlung öffentl. Vermögens in Privatvermögen)

Re|pro|ba|ti|on *lat.* [...*zịọn*] (veralt. für: Zurückweisung; Mißbilligung); re|pro|bie|ren

Re|pro|duk|ti|on *lat.* [...*zịọn*] (Nachbildung; Wiedergabe [durch Druck]; Vervielfältigung); Re|pro|duk|ti|ons_fak|tor, ...tech|nik; re|pro|duk|tiv (wiederherstellend, wiederersetzend); re|pro|du|zie|ren (Zeitwort zu: Reproduktion); Re|pro|gra|phie (Bez. für die Vielzahl von Methoden, die der Vervielfältigung und Sicherung von Originalen dienen) *w*; -, ...ien

Reps südd. (Raps) *m*; -es, (für Repsarten:) -e

Rep|til *fr.* (Kriechtier) *s*; -s, -ien [...*i*ᵉ*n*] u. (selten:) -e; Rep|ti|li|enfonds (spött. für: Geldfonds, über dessen Verwendung Regierungsstellen keine Rechenschaft abzulegen brauchen)

Re|pu|blik *fr. w*; -, -en; Re|pu|bli|ka|ner; re|pu|bli|ka|nisch; -ste (↑ P. 294); Re|pu|bli|ka|njs|mus (veralt. für: Anhänglichkeit an die republikan. Verfassung) *m*; -; Re|pu|blik|flucht (DDR); vgl. ²Flucht; re|pu|blik|flüch|tig (DDR); Re|pu|blik|flücht|ling (DDR)

Re|pu|dia|ti|on *lat.* [...*zịọn*] (veralt. für: Verwerfung; Wirtsch.: Verweigerung der Annahme von Geld wegen geringer Kaufkraft)

Re|puls *lat.* (veralt. für: Ab-, Zurückweisung [eines Gesuches]) *m*; -es, -e; Re|pul|si|on (Technik: Ab-, Zurückstoßung); Re|pul|si|ons|mo|tor (Technik); re|pul|siv (zurück-, abstoßend)

Re|pun|ze *lat.; it.* (Stempel [für Feingehalt bei Waren aus Edelmetall]) *w*; -, -n; re|pun|zie|ren (mit einem Feingehaltsstempel versehen)

Re|pu|ta|ti|on *lat.-fr.* [...*zịọn*] ([guter] Ruf, Ansehen) *w*; -; re|pu|tier|lich (veralt., aber noch mdal. für: ansehnlich; achtbar; ordentlich)

Re|qui|em *lat.* [...*iäm*] (Toten-, Seelenmesse [nach dem Anfangswort ihres Eingangsgebetes]) *s*; -s, -s (österr.: ...quien [...*i*ᵉ*n*]); re|qui|es|cat in pa|ce [...*ßkat - paze*] („er [sie] ruhe in Frieden!"; Abk.: R. I. P.)

re|qui|rie|ren *lat.* (herbeischaffen; beschlagnahmen [für Heereszwecke]; untersuchen; um Rechtshilfe ersuchen); Re|qui|sit (Theatergerät; Rüst-, Handwerkszeug, Zubehör) *s*; -[e]s, -en (meist *Mehrz.*); Re|qui|si|ten|kam|mer; Re|qui|si|teur *fr.* [...*tör*] (Theater, Film: Verwalter der Requisiten) *m*; -s, -e; Re|qui|si|ti|on *lat.* [...*zịọn*] (Hauptwort zu requirieren); Re|qui|si|ti|ons|schein

resch bayr. u. österr. (knusprig; auch übertr. ugs.: lebhaft, munter)

Re|schen|paß *m*; ...passes u. Re|schen|schei|deck (österr.-ital. Alpenpaß) *s*; -s

Re|se|da *lat. w*; -, -s (österr. nur so) u. Re|se|de (eine Pflanze) *w*; -, -n

Re|sek|ti|on *lat.* [...*zịọn*] (Med.: operative Entfernung kranker Organteile)

Re|ser|va|ge *fr.* [...*wạseh*ᵉ] (Zeugdruckerei: Schutzbeize) *w*; -; Re-

ser|vat *lat.* [...wạt] (Vorbehalt; Sonderrecht; großes Freigehege für gefährdete Tierarten; auch für: Reservation) *s*; -[e]s, -e; Re|ser|va|tio men|tạ|lis [...wạzio -] (svw. Mentalreservation) *w*; - -, ...tiọnes ...tạles; Re|ser|va|ti|on [...ziọn] (Vorbehalt; den Indianern vorbehaltenes Gebiet in Nordamerika); Re|ser|vat|recht (Sonderrecht); Re|sẹr|ve *fr.* (nur *Einz.*: Zurückhaltung, Verschlossenheit; Ersatz; Vorrat; Militär: Ersatz[mannschaft]; Kaufmannsspr.: Rücklage, Rückstellung) *w*; -, -n; in - (vorrätig); [Leutnant usw.] der - (Abk.: d. R.); Re|sẹr|ve an|ker, ...fonds (Rücklage), ...kon|to, ...mann (*Mehrz.* ...männer u. ...leute), ...of|fi|zier, ...rad, ...rei|fen, ...stoff, ...tank, ...übung; re|ser|vie|ren *lat.* (aufbewahren; vormerken, vorbestellen, [Platz] belegen); re|ser|viert (auch: zurückhaltend, zugeknöpft); Re|serviert|heit *w*; -; Re|ser|vie|rung; Re|ser|vist (Soldat der Reserve); ↑ R 268; Re|ser|voir *fr.* [...woạr] (Sammelbecken, Behälter, Speicher; Reservebestand) *s*; -s, -e re|se|zie|ren *lat.* (Zeitwort zu: Resektion)

Re|si (südd., österr. u. schweiz. Kurzform von: Theresia)
Re|si|dent *fr.* (Regierungsvertreter; Geschäftsträger; Statthalter); ↑ R 268; Re|si|dẹnz *lat.* (Wohnsitz des Staatsoberhauptes, eines Fürsten, eines hohen Geistlichen; Hauptstadt) *w*; -, -en; Re|si|denz pflicht, ...stadt, ...thea|ter; re|si|die|ren (seinen Wohnsitz haben [bes. von regierenden Fürsten]); re|si|du|al (Med.: zurückbleibend, restlich); Re|si|du|um [...u-um] (Überrest, Bodensatz, Rückstand) *s*; -s, ...duen [...du^e n]
Re|si|gna|ti|on *lat.* [...ziọn] (Verzichtleistung; Entsagung); re|si|gna|tiv (von Resignation durchdrungen; verzichtleistend); re|si|gnie|ren; re|si|gniert (ergeben, gefaßt; auch: widerstands-, mutlos)
Re|si|nat *lat.* (Salz der Harzsäure) *s*; -[e]s, -e
Ré|si|stance *fr.* [resißtạngß] (fr. Widerstandsbewegung gegen die deutsche Besatzung im 2. Weltkrieg) *w*; -; re|si|stẹnt *lat.* (widerstandsfähig); Re|si|stẹnz (Widerstand[sfähigkeit]; Ausdauer; Härtegrad) *w*; -, -en; passive -; re|si|stie|ren (widerstehen; ausdauern); re|si|stiv (widerstehend, hartnäckig); Re|si|sti|vi|tät [...wi...] (Med.: Widerstandsfähigkeit) *w*; -

re|skri|bie|ren *lat.* (veralt. für: schriftlich antworten, bescheiden); Re|skript (feierl. Rechtsentscheidung des Papstes od. eines Bischofs in Einzelfällen; veralt. für: amtlicher Bescheid, Verfügung, Erlaß) *s*; -[e]s, -e
re|so|lụt *lat.* (entschlossen, beherzt, tatkräftig, zupackend); Re|so|lu|ti|on [...ziọn] (Beschluß, Entschließung; Med.: Sichlösen krankhafter Zustände); re|sol|vie|ren [...wir^e n] (veralt. für: auflösen; beschließen)
Re|so|nạnz *lat.* (Widerhall; Mittönen, -schwingen; bildl. für: Anklang, Verständnis, Wirkung) *w*; -, -en; Re|so|nạnz bo|den (Schallboden), ...fre|quenz (Physik), ...ka|sten, ...kör|per, ...sai|te, ...ton (*Mehrz.* ...töne); Re|so|na|tor (mitschwingender Körper; Holzgehäuse bei Saiteninstrumenten) *m*; -s, ...ọren
Re|so|pal ⓦ (ein Kunststoff) *s*; -s
re|sor|bie|ren *lat.* (ein-, aufsaugen); Re|sorp|ti|on [...ziọn] (Ein-, Aufsaugung [in die Blut- od. Lymphbahn]); Re|sorp|ti|ons|fä|hig|keit
Re|so|zia|li|sie|rung *lat.* (Rechtsw.: schrittweise Wiedereingliederung von Straffälligen, die ihre Strafe abgebüßt haben, in die soziale Lebensgemeinschaft)

resp. = respektive
Re|spekt *fr.* (Rücksicht, Achtung; Ehrerbietung; leerer Rand [bei Kupferstichen]) *m*; -[e]s; re|spek|ta|bel (ansehnlich; beachtlich; ...a|ble Größe; Re|spek|ta|bi|li|tät (veralt. für: Achtbarkeit, Ansehen) *w*; -; Re|spekt|blatt (leeres Blatt am Anfang eines Buches); re|spekt|ein|flö|ßend, aber: (↑ R 142) großen Respekt einflößend; re|spek|tie|ren (achten, in Ehren halten; Wirtsch.: einen Wechsel bezahlen); re|spek|tier|lich (veralt. für: ansehnlich, achtbar); Re|spek|tie|rung; re|spek|tiv *lat.* (veralt. für: jedesmalig, jeweilig); re|spek|ti|ve [...w^e] (beziehungsweise; oder; und; Abk.: resp.); re|spekt|los; -este (↑ R 292); Re|spekt|lo|sig|keit; re|spekts|per|son; Re|spekt|tag (veralt. für: Fristtag nach dem Verfallstag des Wechsels); re|spekt|voll
Re|spi|ra|ti|on *lat.* [...ziọn] (Med.: Atmung) *w*; -; Re|spi|ra|ti|ons|ap|pa|rat; Re|spi|ra|tor ("Atmer"; Atmungsgerät, Atemfilter [zur Erleichterung des Atmens]) *m*; -s, ...ọren; re|spi|rie|ren (Med.: atmen)
re|spon|die|ren *lat.* (veralt. für: antworten, entsprechen; widerle-

gen); re|spon|sa|bel (veralt. für: verantwortlich); ...a|ble Stellung; Re|spon|sọ|ri|um (kirchl. Wechselgesang) *s*; -s, ...ien [...i^e n]
Res|sen|ti|ment *fr.* [reßangtimạng] (Wiedererleben eines meist schmerzl. Nachgefühls; heimlicher Groll, Neid) *s*; -s, -s
Res|sort *fr.* [...ßọr] (Geschäfts-, Amtsbereich) *s*; -s, -s; res|sor|tie|ren (veralt. für: zugehören, unterstehen); res|sort|mä|ßig (amts|zuständig); Res|sort|mi|ni|ster
Res|sour|ce [...reßurß^e] (meist *Mehrz.*: Hilfsmittel; Hilfsquellen; Geldmittel; veralteter Name geselliger Vereine u. ihrer Häuser) *w*; -, -n
Rest *lat.* *m*; -[e]s, -e u. (Kaufmannsspr., bes. von Schnittwaren:) -er u. (schweiz.:) -en; Rest ab|schnitt; Re|stant (rückständiger Schuldner; ausgelostes od. gekündigtes, aber nicht abgeholtes Wertpapier; Ladenhüter) *m*; -en, -en (↑ R 268); Re|stan|ten|li|ste
Re|stau|rant *fr.* [reßtorạng] (Gaststätte) *s*; -s, -s; Re|stau|ra|teur [...toratọr] (veralt. für: Gastwirt) *m*; -s, -e; ¹Re|stau|ra|ti|on *lat.* [...taurazio n] (Wiederherstellung eines Kunstwerkes; Wiederherstellung der alten Ordnung nach einem Umsturz); ²Re|stau|ra|ti|on [...torazion] (veraltend für: Gastwirtschaft); Re|stau|ra|ti|ons|ar|beit [...tau...]; Re|stau|ra|ti|ons|be|trieb [...tor...]; Re|stau|ra|ti|ons po|li|tik [...tau...], ...zeit; Re|stau|ra|tor [...tau...] (Wiederhersteller [von Kunstwerken]) *m*; -s, ...ọren; re|stau|rie|ren [...tau...] (wiederherstellen, ausbessern, bes. von Kunstwerken); sich - (sich erholen, sich erfrischen); Re|stau|rie|rung [...tau...]
Rest be|stand, ...be|trag; Re|sten; Re|ster (*Mehrz.* von: Rest); Re|ste|ver|kauf; re|stie|ren (veralt für: übrig sein; im Rückstand sein)
re|sti|tu|ie|ren *lat.* (wiedererstatten, -herstellen, -einsetzen); Re|sti|tu|ti|on [...ziọn]; Re|sti|tu|ti|ons|edikt (von 1629), ...kla|ge (Rechtsw.: Klage auf Wiederaufnahme eines Verfahrens wegen schwerwiegender Verfahrensmängel)
Rest|ko|sten|rech|nung (Wirtsch. ein Kalkulationsverfahren bei Kuppelproduktion); rest|lich; rest|los; Rest|nut|zungs|dau|er (Wirtsch.: die nach teilweiser Nutzung u. Abschreibung von Anlagegegenständen verbleiben de restl. Lebensdauer); Rest|po|sten

Re|strik|ti|on *lat.* [...*zion*] (Einschränkung, Vorbehalt); **Re|strik|ti|ons_er|schei|nung, ...maß|nah|me;** re|strik|tiv (ein-, beschränkend, einengend); -e Konjunktion (Sprachw.: einschränkendes Bindewort, z. B. „insofern"); re|strin|gie|ren [...*ßtringgir^en*] (veralt. für einschränken; Med.: zusammenziehen)

Rẹst_sum|me, ...zah|lung

Re|sul|tạn|te *fr.* (Ergebnisvektor von verschieden gerichteten Bewegungs- od. Kraftvektoren) *w;* -, -n; **Re|sul|tạt** (Ergebnis) *s;* -[e]s, -e; re|sul|ta|tiv (ein Resultat bewirkend); -e Aktionsart (Aktionsart eines Zeitwortes, die das Ende eines Geschehens bezeichnet, z. B. „finden"); re|sul|tạt|los; re|sul|tie|ren (sich als Resultat ergeben); **Re|sul|tie|ren|de** (svw. Resultante) *w;* -n, -n (↑ R 287 ff.)

Re|sü|mee *fr.* (Zusammenfassung) *s;* -s, -s; re|sü|mie|ren

re|szin|die|ren *lat.* (veralt. für: aufheben, für nichtig erklären); **Re|szis|si|on**

Rẹt *vgl.* R eet

Re|tạ|bel *fr.* (Altaraufsatz) *s;* -s, -; re|ta|blie|ren *fr.* (veralt. für: wiederherstellen); **Re|ta|blis|se|ment** [...*bliß^emang*] (veralt. für: Wiederherstellung) *s;* -s, -s

Re|ta|lia|ti|on *lat.* [...*zion*] (veralt. für: [Wieder]vergeltung)

Re|tard *fr.* [*r^etạr*] (Uhr: Verzögerung); **Re|tar|dạt** *lat.* (veralt. für: Verzögerung [einer Zahlung]) *s;* -[e]s, -e; **Re|tar|da|ti|on** [...*zion*] (Verzögerung; Musik: Verzögerung der oberen Stimme gegenüber der unteren); **re|tar|die|ren** (verzögern; veralt. bei der Uhr: nachgehen); retardierendes Moment (bes. im Drama); **Re|tar|die|rung**

Re|ten|ti|on *lat.* [...*zion*] (Med.: Zurückhaltung von auszuscheidenden Stoffen im Körper; Rechtsw.: veralt. für: Vorenthaltung)

Re|thel (dt. Maler)

Re|ti|kül *fr.* (früher für: Arbeits-, Strickbeutel) *m* od. *s;* -s, -e u. -s; vgl. Ridikül; re|ti|ku|lar, re|ti|ku|lär *lat.* (netzartig, netzförmig); re|ti|ku|liert (netzförmig); -e Gläser; **Re|ti|na** (Med.: Netzhaut des Auges) *w;* -, ...nae [...*nä*]; **Re|ti|ni|tis** (Med.: Netzhautentzündung) *w;* -, ...itịden

Re|ti|ra|de *fr.* (veralt. für: Rückzug; Abort); re|ti|rie|ren (veralt. für: sich zurückziehen [von Truppen]; meist scherzh. noch für: sich in Sicherheit bringen)

Re|tor|si|on *lat.* (Erwiderung einer Beleidigung; [Wieder]vergel-

tung[smaßregel] im diplomat. Verkehr); **Re|tọr|te** *fr.* (Destillationsgefäß) *w;* -, -n; **Re|tọr|ten|koh|le** (Gaskohle)

re|tour *fr.* [*retụr*] (österr. u. mdal., sonst veraltend für: zurück); **Re|tour|bil|lett** (schweiz., sonst veralt. für: Rückfahrkarte); **Re|tou|re** [*retụr*] (Rücksendung an den Verkäufer) *w;* -, -n (meist *Mehra.*); **Re|tour_[fahr]|kar|te** (veralt., noch österr.: Rückfahrkarte), ...**gang** (österr.: Rückwärtsgang), ...**kut|sche** (ugs. für: Zurückgeben eines Vorwurfs, einer Beleidigung); **re|tour|nie|ren** [*returni^en*] (zurücksenden [an den Verkäufer]); **Re|tour_sen|dung** [*retụr...*], ...**spiel** (österr.: Rückspiel)

Re|trai|te *fr.* [*r^eträt^e*] (veralt. für Rückzug; früher: Zapfenstreich der Kavallerie) *w;* -, -n

Re|trakt *lat.* (veralt. für: Näherrecht, Vorkaufsrecht) *s;* -[e]s, -e; **Re|trak|ti|on** [...*zion*] (Med.: Zusammenziehung, Schrumpfung)

re|tro|da|tie|ren (veralt. für: zurückdatieren); **Re|tro|fle|xi|on** (Med.: Rückwärtsknickung von Organen); re|tro|grad (rückläufig; rückgebildet); **Re|tro|spek|tiv** (rückschauend, rückblickend); **Re|tro|spek|ti|ve** [...*iw^e*] (Rückblick, Rückschau) *w;* -, -n; **Re|tro|ver|si|on** [...*wär...*] (Med.: Rückwärtsneigung, bes. der Gebärmutter); **re|tro|ver|tie|ren** (zurückwenden, zurückneigen); **re|tro|ze|die|ren** (veralt. für: zurückweichen; [etwas] wieder abtreten; Wirtsch.: rückversichern); **Re|tro|zes|si|on** (veralt. für: Wiederabtretung; Wirtsch.: besondere Form der Rückversicherung)

rẹtt|bar; rẹt|ten; Rẹt|ter; Rẹt|te|rin *w;* -, -nen

Rẹt|tich *lat. m;* -s, -e; **Rẹt|tich|bir|ne** (Birnenart)

rẹtt|los (Seemannsspr.: unrettbar); -es Schiff; **Rẹt|tung** (*Einz.* österr. auch kurz für: Rettungsdienst); **Rẹt|tungs_ak|ti|on, ...an|ker, ...boot, ...dienst, ...flug|zeug, ...gür|tel, ...kom|man|do; rẹt|tungs|los; Rẹt|tungs_mann|schaft, ...me|dail|le, ...ring, ...schwim|men (*s;* -s), ...sta|ti|on, ...trupp, ...we|sen (*s;* -s)

Re|turn *engl.* [*ritö^en*] ([Tisch]tennis: nach dem Aufschlag des Gegners zurückgeschlagener Ball) *m;* -s, -s

Re|tụ|sche *fr.* (Nachbesserung [bes. von Lichtbildern]) *w;* -, -n; **Re|tu|scheur** [...*schör*] *m;* -s, -e;

re|tu|schie|ren (nachbessern [bes. Lichtbilder])

Reuch|lin (dt. Humanist)

Reue *w;* -; Reu und Leid erwecken (↑ R 241); es reut mich; **reue|voll;** **Reu|geld** (Abstandssumme); veralt. auch für: verfehltes Unternehmen); **reu|mü|tig**

re|unie|ren *fr.* [...*ünir^en*] (veralt. für: [wieder]vereinigen, versöhnen; sich versammeln); ¹**Re|uni|on** [dt. Ausspr.] (veralt. für: [Wieder]vereinigung); ²**Re|uni|on** [*reüniọns*] (veralt. für: Gesellschaft[sball]) *w;* -, -s

Ré|uni|on [*reüniọng*] (Insel im Ind. Ozean)

Re|uni|ons|kam|mern [dt. Ausspr.] (durch Ludwig XIV. eingesetzte fr. Gerichte zur Durchsetzung territorialer Annexionen) *Mehrz.*

Reu|se (Korb zum Fischfang) *w;* -, -n

¹Reuß (r. Nebenfluß der Aare) *w;* -

²Reuß (früheres dt. Land); Reuß älterer Linie (Reuß-Greiz; Abk.: Reuß a. L.); Reuß Jüngerer Linie (Reuß-Gera-Schleiz-Lobenstein; Abk.: Reuß j. L.); **Reu|ßer** (von Reuß [Land]); ↑ R 199

re|üs|sie|ren *fr.* (gelingen; Erfolg, Glück haben)

reu|ßisch [zu: ²Reuß]

reu|ten südd., österr., schweiz. geh. (roden)

Reu|ter, Fritz (niederd. Mundartdichter)

Reu|ter|bü|ro; ↑ R 180 (engl. Nachrichtenbüro)

Reut|te (Stadt in Tirol)

Reut|ter, Hermann (dt. Komponist)

Rev. = Reverend

Re|vak|zi|na|ti|on *lat.* [...*wakzinazion*] (Med · Wiederimpfung); **re|vak|zi|nie|ren**

Re|val [*rewal*] (früherer Name von: Tallin)

re|va|lie|ren *lat.* [...*wa...*] (sich für eine Auslage schadlos halten; Kaufmannsspr.: [eine Schuld] decken); **Re|va|lie|rung** (Kaufmannsspr.: Deckung [einer Schuld]); **Re|val|va|ti|on** (Aufwertung); **re|val|vie|ren**

Re|van|che *fr.* [*rewangsch^e*] (Vergeltung; Rache) *w;* -, -n; **Re|van|che|krieg** *(m;* -); **re|van|che|lu|stig; Re|van|che_par|tie, ...po|li|tik, ...spiel; re|van|chie|ren** [*rewangschir^en*], sich (vergelten; sich rächen; einen Gegendienst erweisen; **Re|van|chis|mus** (im kommunist. Sprachgebrauch: Wiedervergeltungs-, Rachepolitik nationalistischer Kreise bes. in

der BRD) *m*; -; Re|van|chist; ↑ R 268; re|van|chi|stisch

Re|veil|le *fr.* [*rewäj*^e] (veralt. für: militär. Weckruf) *w*; -, -n

Re|ve|nue *fr.* [*r*^e*w*^e*nü*] (Einkommen, Einkünfte) *w*; -, -n [...*nü*^e*n*]

Re|ve|rend *lat.* [*rä̱w*^e*r*^e*nd*] (Titel der Geistlichen in England und Amerika; Abk.: Rev.) *m*; -; vgl. aber: Referent; Re|ve|renz [...*we*...] (Ehrerbietung; Verbeugung) *w*; -, -en; vgl. aber: Referenza

Re|ve|rie *fr.* [*rew*^e*ri̱*] („Träumerei"; Tonstück) *w*; -, ...ien

¹Re|vers *fr.* [*rewār*, auch: *r*^e...] (Umschlag od. Aufschlag an Kleidungsstücken) *s* od. (österr. nur:) *m*; - [*rewār(ß)*], - [*rewārß*];

²Re|vers [*rewārß*, fr. Ausspr.: *rewār*, auch: *r*^e...] (veraltend für: Rückseite [einer Münze]) *m*; -es u. (bei fr. Ausspr.:) - [...*wār(ß)*], -e und (bei fr. Ausspr.:) - [...*wārß*];

³Re|vers [*rewārß*] (Erklärung, Verpflichtungsschein) *m*; -es, -e; re|ver|si|bel *lat.* (umkehrbar; ...ible Prozesse (Physik); Re|ver|si|ble [*rewärsib*^e*l*] (Abseitenstoff, Gewebe mit einer glänzenden u. einer matten Seite) *m*; -s, -s u. (Kleidungsstück, das beidseitig getragen werden kann:) *s*; -s, -s; Re|ver|si|on (Umkehrung, Umdrehung); Re|vers|sy|stem (Wirtsch.)

Re|vi|dent *lat.* [...*wi*...] (jmd., der das Rechtsmittel der Revision anwendet; österr.: Beamtentitel); ↑ R 268; re|vi|die|ren (nachsehen, überprüfen); sein Urteil - ([nach eingehender Prüfung] ändern)

Re|vier *niederl.* [...*wi̱r*] (Bezirk, Gebiet; Militär.: Krankenstube; Bergw.: Teil des Grubengebäudes, der der Aufsicht eines Reviersteigers untersteht; Forstw.: begrenzter Jagdbezirk; kleinere Polizeidienststelle) *s*; -s, -e; re|vie|ren (von Jagdhunden: in einem Revier nach Beute suchen); Re-vier|för|ster; re|vier|krank (Soldatenspr.); Re|vier|kran|ke (Soldatenspr.)

Re|view *engl.* [*riwju̱*] (Übersicht, Rundschau [Titel engl. u. amerik. Zeitschriften]) *w*; -, -s

Re|vi|re|ment *fr.* [*rewir*^e*mãng*] (Umbesetzung diplomat. od. militär. Stellen; Wirtsch.: Form der Abrechnung zwischen Schuldnern u. Gläubigern) *s*; -s, -s

Re|vi|si|on *lat.* [...*wi*...] (nochmalige Durchsicht; [Nach]prüfung; Änderung [einer Ansicht]; Rechtsw.: Überprüfung eines Urteils); Re|vi|sio|nis|mus (Streben nach Änderung eines bestehenden Zustandes oder eines Programms) *m*; -; Re|vi|sio|nist

(Verfechter des Revisionismus); ↑ R 268; re|vi|sio|ni|stisch; Re|vi|si|ons.frist, ...ge|richt, ...ver|fah-ren, ...ver|hand|lung; Re|vi|sor (Wirtschaftsprüfer; Korrektor, dem die Überprüfung der letzten Korrekturen im druckfertigen Bogen obliegt) *m*; -s, ...oren

Re|vi|ta|li|sie|rung (Med.: Wiedererlangung der früheren Vitalität) *w*; -

Re|vo|ka|ti|on *lat.* [...*wokazi̱on*] (Widerruf, z. B. eines wirtschaftl. Auftrages)

Re|vol|te *fr.* [...*wolt*^e] (Empörung, Auflehnung, Aufruhr) *w*; -, -n; re|vol|tie|ren; Re|vo|lu|ti|on *fr.* [...*zion*]; re|vo|lu|tio|när *fr.* ([staats]umwälzend); Re|vo|lu-tio|när *m*; -s, -e; re|vo|lu|tio|nie-ren; Re|vo|lu|tio|nie|rung; Re|vo-lu|ti|ons.gar|de (Vorkämpfer der Revolution), ...re|gie|rung, ...wir-ren; Re|vo|luz|zer *it.* (verächtl. für: kleiner Revolutionär) *m*; -s, -; Re|vol|ver *engl.* [...*wolw*^e*r*] (kurze Handfeuerwaffe; drehbarer Ansatz an Werkzeugmaschinen) *m*; -s, -; Re|vol|ver.blatt, ...dreh-bank, ...griff, ...held, ...knauf, ...lauf, ...mün|dung, ...pa|tro|ne, ...pres|se, ...schnau|ze (derb für: freches, vorlautes Mundwerk; frecher, unverschämter, vorlauter Mensch); re|vol|vie|ren (Technik: zurückdrehen)

re|vo|zie|ren *lat.* [...*wo*...] (zurücknehmen, widerrufen)

Re|vue *fr.* [*rewü̱*] (Zeitschrift mit allgemeinen Überblicken; musikal. Ausstattungsstück; veralt. für: Truppenschau) *w*; -, -n [...*wü̱*^e*n*]; - passieren lassen (vorbeiziehen lassen); Re|vue.büh|ne, ...film, ...girl

Rex|ap|pa|rat Ⓦ österr. (Einkochapparat); Rex|glas Ⓦ österr. (Einkochglas)

Reyk|ja|vik [*re̱ⁱkjawik*, auch: *ra̱ik-jawik*] (Hptst. Islands)

Rey|nolds|sche Zahl [*rän^elds*... -] nach dem engl. Physiker Reynolds) *w*; -n -

Rey|on *fr.* [*rä̱jõng*] (in Deutschland festgelegte Schreibung für: Rayon [Kunstseide]) *m* od. *s*; -

Re|zen|sent *lat.* (Verfasser einer Rezension); ↑ R 268; re|zen|sie-ren; Re|zen|si|on (kritische Besprechung von Büchern, Theateraufführungen u. a.; Druckw.: sicht eines alten Textes); Re|zen-si|ons.ex|em|plar, ...stück (Besprechungsstück)

re|zent *lat.* (Biol.: gegenwärtig lebend, neu, frisch; landsch. für: säuerlich, pikant); -e Kulturen (noch bestehende altertümliche Kulturen)

Re|zept *lat.* ([Arznei-, Koch]vorschrift, Verordnung) *s*; -[e]s, -e; Re|zep|ta|ku|lum (Bot.: Blütenboden; Blattgewebshöcker; Biol.: Ausstülpung des Eileiters) *s*; -s, ...kula; Re|zept.block (*Mehrz.*: ...blocks), ...buch; re-zept|frei; re|zep|tie|ren (Rezepte verschreiben); Re|zep|tier|kunst (Lehre von der [Ab]fassung der Rezepte) *w*; -; Re|zep|ti|on [...*zion*] (Auf-, An-, Übernahme); re|zep|tiv [nur] aufnehmend, empfangend; empfänglich); Re-zep|ti|vi|tät [...*wi*...] (Aufnahmefähigkeit, Empfänglichkeit) *w*; -; Re|zep|tor (veralt. für: Empfänger; Steuereinnehmer) *m*; -s, ...oren; Re|zep|to|ren (Med.: Organe, die zur Aufnahme äußerer Reize dienen) *Mehrz.*; Re-zept|pflicht; re|zept|pflich|tig; Re-zep|tur (Anfertigung von Rezepten u. der entsprechende Raum in der Apotheke; früher für: Steuereinnehmerei) *w*; -, -en

Re|zeß *lat.* (Rechtsw.: Auseinandersetzung, Vergleich, Vertrag) *m*; ...zesses, ...zesse; Re|zes|si|on (leichter Rückgang der Konjunktur); Re|zes|si|ons.pha|se; re-zes|siv (Biol.: zurücktretend; nicht in Erscheinung tretend [von Erbfaktoren])

re|zi|div *lat.* (Med.: rückfällig); Re|zi|div (Med.: Rückfall [bei einer Krankheit]) *s*; -s, -e [...*w*^e]; re|zi|di|vie|ren [...*wir*^e*n*] (Med.: in Abständen wiederkehren)

Re|zi|pi|ent *lat.* (Glasglocke für eine Vakuumpumpe zum Herstellen eines luftleeren Raumes); ↑ R 268; re|zi|pie|ren (aufnehmen, übernehmen)

re|zi|prok *lat.* (wechsel-, gegenseitig, aufeinander bezüglich); -er Wert (für: Kehrwert); -es Pronomen (Sprachw.: wechselbezügliches Fürwort, „einander"); (Math.:) -e Zahlen; Re|zi|pro|zi-tät (Wechselseitigkeit [der im Außenhandel eingeräumten Bedingungen]) *w*; -n -

re|zi|tan|do vgl. recitando; Re|zi-ta|ti|on *lat.* [...*zion*] (Vortrag von Dichtungen); Re|zi|ta|tiv *it.* (dramat. Sprechgesang) *s*; -s, -e [...*w*^e]; re|zi|ta|ti|visch [...*tiwi*...] (in der Art des Rezitativs); Re|zi-ta|tor *lat.* (Vortragskünstler, Sprecher von Dichtungen) *m*; -s, ...oren; re|zi|tie|ren

rf., rfz. = rinforzando

R-Ge|spräch; ↑ R 149 (Ferngespräch, bei dem die Fernsprechgebühren im Einverständnis mit dem Gesprächspartner diesem angerechnet werden)

Rgt., Reg[t]., R. = Regiment

h, Rh vgl. Rhesusfaktor
Rh = chem. Zeichen für: Rhodium
Rha|ba|nus Mau|rus vgl. Hrabanus Maurus
Rha|bar|ber gr. (Gartenpflanze) m; -s; **Rha|bar|ber|kom|pott hab|do|idisch** gr. (stabförmig), **Rhab|dom** (Med.: Sehstäbchen in der Netzhaut des Auges) s; -s, -e
Rha|da|man|thys (gr. Sage: Totenrichter)
Rha|ga|den gr. (Med.: Hautschrunden; schmerzhafte Hautrisse) Mehrz.
Rhap|so|de gr. (fahrender Sänger bei den alten Griechen) m; -n, -n (↑ R 268); **Rhap|so|die** (erzählendes Gedicht, Heldenlied; [aus Volksweisen zusammengesetztes] Musikstück) w; -, ...ien; (↑ R 224:) die Ungarische Rhapsodie (Instrumentalstück von Liszt); **rhap|so|disch** (zum Rhapsoden, zur Rhapsodie gehörend; in Rhapsodieform; unzusammenhängend, bruchstückartig)
°hät vgl. Rät
Rhe|da (Stadt im Münsterland)
Rhe|de (Ort östlich von Bocholt)
Rhei|der|land vgl. Reiderland
Rheidt (Ort nördl. von Bonn)
Rhein (Strom) m; -[e]s; **rhein|ab|[wärts]; Rhein|an|ke** (ein Fisch) w; -, -n; **rhein|auf[|wärts]; Rhein|bund** (dt. Fürstenbund unter fr. Führung) m; -[e]s; ↑ R 201), ...fall m, ...gau (m [landsch.: s]; -[e]s); **Rhein-Her|ne-Ka|nal** (↑ R 203) m; -s; **Rhein|hes|sen; rhei|nisch**, aber ↑ R 198): das Rheinische Schiefergebirge; (↑ R 224:) Rheinischer Merkur; Rheinische Stahlwerke; **Rhei|nisch-Ber|gi|sche Kreis** (Landkreis im Reg.-Bez. Köln) m; -n -es; **rhei|nisch-west|fä|lisch** (↑ R 214), aber (↑ R 224:) das Rheinisch-Westfälische Elektrizitätswerk (Abk.: RWE); Rheinisch-Westfälisches Industriegebiet; **Rhein|land** (nichtamtl. Bezeichnung für die ehem. preuß. Rheinprovinz; Abk.: Rhld.) s; -[e]s; **Rhein|lan|de** (Siedlungsgebiete der Franken beiderseits des Rheins) Mehrz.; **Rhein|län|der** (auch: Tanz); **Rhein|län|de|rin** w; -, -nen; **rhein|län|disch; Rhein|land-Pfalz;** ↑ R 212 (Land); **rhein|land-pfäl|zisch; Rhein-Main-Do|nau-Groß|schiffahrts-weg** [Trenn.: ...schiff]fahrts...; ↑ R 236] (↑ R 203) m; -[e]s; **Rhein-Main-Flug|ha|fen** (↑ R 203) m; -s; **Rhein-Mar|ne-Ka|nal** (↑ R 203) m; -s; **Rhein|.pfalz, ...pro|vinz** (ehem. preuß. Provinz beiderseits des Mittel- und Nieder-

rheins) w; -; **Rhein-Rho|ne-Ka|nal** (↑ R 203) m; -s; **Rhein-Schie-Ka-nal** [...behi...] (↑ R 203) m; -s; **Rhein|sei|ten|ka|nal** m; -s; **Rhein-wein; Rhein-Wup|per-Kreis;** ↑ R 203 (Landkreis im Reg.-Bez. Düsseldorf) m; -es
rhe|na|nisch lat. (rheinisch); **Rhe-ni|um** (chem. Grundstoff, Metall; Zeichen: Re) s; -s
Rheo|lo|gie gr. (Fließlehre, Wissenschaft vom Fließen u. Verformen der Materie) w; -; **Rheo|me-ter** (veralt. für: Strommesser; ein bestimmtes Viskosimeter) s; -s, -; **Rheo|stat** ([elektr. Regulier]widerstand) m; -[e]s, -e
Rhe|sus lat. (Affe einer bestimmten Art) m; -, -; **Rhe|sus_af|fe, ...fak|tor** (erbliches Merkmal der roten Blutkörperchen; Abk.: Rh-Faktor; Zeichen: Rh = Rhesusfaktor positiv, rh = Rhesusfaktor negativ) m; -s
Rhe|tor gr. (Redner der Antike) m; -s, ...oren; **Rhe|to|rik** (Redekunst) w; -; **Rhe|to|ri|ker** (Redekünstler); **rhe|to|risch** (redekünstlerisch; phrasenhaft, schönrednerisch); -ste (↑ R 294); -e Figur (Stilk.: kunstmäßige Gestaltung eines Ausdrucks, Redefigur); -e Frage (Frage, die gestellt wird, um den Partner zur Anerkennung einer bereits vorhandenen Meinung zu bewegen)
Rheu|ma gr. (Kurzw. für: Rheumatismus) s; -s; **Rheu|ma|ti|ker** (an Rheumatismus Leidender); **rheu|ma|tisch; Rheu|ma|tis|mus** (schmerzhafte Erkrankung der Gelenke, Muskeln, Nerven, Sehnen) m; -, ...men; **Rheu|ma|to|lo-ge** (Med.: Arzt mit speziellen Kenntnissen auf dem Gebiet rheumatischer Krankheiten) m; -n, -n (↑ R 268)
Rheydt [rait] (dt. Stadt)
Rh-Fak|tor = Rhesusfaktor (↑ R 150)
Rhi|ni|tis gr. (Med.: Nasenschleimhautentzündung, Schnupfen) w; -, ...itjden; **Rhi|no-lo|gie** (Nasenheilkunde) w; -; **Rhi-no|pla|stik** (Ersatz bei Nasenverletzungen) w; -, -en; **Rhi|no|skop** (Nasenspiegel) s; -s, -e; **Rhi|no|ze|ros** (Nashorn) s; - u. -ses, -se
Rhi|zom gr. (Bot.: Wurzelstock) s; -s, -e; **Rhi|zo|po|de** (Biol.: Wurzelfüßer [Einzeller]) m; -n, -n (meist Mehrz.); ↑ R 268
Rhld. = Rheinland
Rho (gr. Buchstabe: P, ϱ) s; -[s], -s
Rhod|ami|ne (Gruppe lichtechter Farbstoffe) Mehrz.; **Rho|dan** gr. (einwertige Gruppe in chem. Verbindungen) s; -s

Rhode Is|land [roᵘd ail'nd] (Staat in den USA; Abk.: R. I.); **Rho|de-län|der** (Huhn einer Wirtschaftsrasse) s; -s, -
Rho|de|si|en [...iᵉn; nach Cecil Rhodes] (ehemals brit. Gebiet in Südafrika); **rho|de|sisch**
rho|di|nie|ren gr. (eine Oberfläche mit Rhodium überziehen)
rho|disch [zu: Rhodos]
Rho|di|um gr. (chem. Grundstoff, Metall; Zeichen: Rh) s; -s
Rho|do|den|dron gr. (eine Pflanzengattung der Erikagewächse) s (auch: m); -s, ...dren
Rho|do|pen (Gebirge in Bulgarien u. Griechenland) Mehrz.
Rho|dos (Insel im östl. Teil des Mittelmeeres)
rhom|bisch gr. (rautenförmig); **Rhom|bo|eder** (von sechs Rhomben begrenzte Kristallform) s; -s, -; **Rhom|bo|id** (Parallelogramm mit paarweise ungleichen Seiten) s; -[e]s, -e; **Rhom|bus** (²Raute; gleichseitiges Parallelogramm) m; -, ...ben
Rhön (Teil des Hessischen Berglandes) w; -
Rho|ne, (in fr. Schreibung:) Rhône [ron] (fr. Fluß) w; -; vgl. Rotten
Rhön|rad (ein Turngerät)
Rho|ta|zis|mus gr. (Sprachw.: Übergang eines zwischen Vokalen stehenden stimmhaften s zu r, z. B. gr. „geneseos" gegenüber lat. „generis") m; -, ...men
Rhus gr. (Essigbaum u. Perückenstrauch [Zierstrauch]) m; -
Rhyn|cho|te gr. [...cho...] (Schnabelkerbtier [z. B. Wanze]) m; -n, -n (meist Mehrz.); ↑ R 268
Rhyth|men (Mehrz. von: Rhythmus); **Rhyth|mik** gr. (Lehre vom Rhythmus) w, -; **Rhyth|mi|ker** (moderner, das rhythm. Element besonders hervorhebender Komponist); **rhyth|misch** (den Rhythmus betreffend, gleich-, taktmäßig); -ste (↑ R 294); -e Gymnastik; -e Prosa; **rhyth|mi-sie|ren** (in einen bestimmten Rhythmus bringen); **Rhyth|mus** (Wiederkehr des Ähnlichen in annähernd gleichen Zeitabschnitten, z. B. der Jahreszeiten; geregelter Wechsel; Zeit-, Gleich-, Ebenmaß; taktmäßige Gliederung) m; -, ...men
R.I. = Rhode Island
Rja (Kurzform von: Maria)
Ri|al pers. u. arab. (iran. Münzeinheit; 1 Rial = 100 Dinar; Abk.: Rl) m; -, -s; 100 - (↑ R 322); vgl. Riyal
RIAS = Rundfunksender im amerikanischen Sektor [von Berlin]
rib|bel|fest; rib|beln (landsch. für:

zwischen Daumen und Zeigefinger rasch reiben, zerkleinern; reibend schaben); ich ...[e]le (↑ R 327)

Ri|bi|sel arab.-it. österr. (Johannisbeere) w; -, -n; Ri|bi|sel|saft (österr.)

Ri|car|da [rikạrda] (w. Vorn.); Ri|chard (m. Vorn.); Ri|char|da (w. Vorn.)

Ri|chard-Wag|ner-Fest|spie|le (↑ R 182) Mehrz.

Ri|che|lieu [rịsch^e liö] (fr. Staatsmann); Ri|che|lieu|sticke|rei [Trenn.: ...stik|ke...; rịsch^e liö...]; ↑ R 180 (Weißstickerei mit ausgeschnittenen Mustern)

Rịch|hild, Rịch|hil|de, Rị|child, Ri|chil|de (w. Vorn.); Rịch|lind, Rịch|lin|de (w. Vorn.)

Rịcht_an|ten|ne, ...bal|ken (Richtungsbalken), ...baum, ...beil (Stellmacherwerkzeug; Henkerbeil), ...blei s, ...block (Mehrz. ...blöcke), ...büh|ne (veralt. für: Schafott); Rịch|te landsch. (gerade Richtung) w; -; in die - bringen usw.; rịch|ten; sich -; richt't euch! (milit. Kommando); Rịch|ter; Rịch|ter|amt s; -[e]s; Rịch|te|rin w; -, -nen; rịch|ter|lich; Rịch|ter|schaft w; -

Rịch|ter-Skala [nach dem amerik. Seismologen Ch. F. Richter]; ↑ R 180 (Skala zur Messung der Erdbebenstärke)

Rịch|ter_spruch, ...stuhl; Rịcht|fest; rịch|tig; (↑ R 134:) es ist das richtige (richtig), zu gehen; das ist genau das richtige für mich; wir halten es für das richtigste (am richtigsten), daß ..., aber (↑ R 116:) tue das Richtige, er hat das Richtige getroffen, du bist mir der Richtige; (↑ R 139:) etwas richtig machen (auf richtige Weise), aber: etwas richtigmachen (ugs. für: begleichen, z. B. eine Rechnung); rịchtiggemacht; vgl. rịchtigliegen, rịchtigstellen; Rịch|tig|be|fund; rịch|tig|ge|hend (von der Uhr; auch ugs. für: ausgesprochen, vollkommen); Rịch|tig|keit w; -; rịch|tig|lie|gen; ↑ R 139 (ugs. für: eine [von der Regierung o. a.] gewünschte Überzeugung vertreten); er hat immer rịchtiggelegen; aber: rịch|tig lie|gen (am rechten Platz liegen); das Besteck hat richtig gelegen; rịch|tig|ma|chen; vgl. richtig; rịch|tig|stel|len; ↑ R 139 (berichtigen); er hat den Irrtum richtiggestellt; aber: rịch|tig stel|len (an den rechten Platz stellen); er hat den Schrank richtig gestellt; Rịch|tig|stel|lung (Berichtigung); Rịcht_ka|no|nier, ...kranz, ...lat|te, ...li|nie (meist Mehrz.), ...platz,

...preis (vgl. ²Preis), ...satz, ...scheit (Richtlatte), ...schmaus, ...schnur (Mehrz. ...schnuren), ...schüt|ze, ...schwert, ...stät|te, ...strah|ler (Antenne für Kurzwellensender), ...strecke [Trenn.: ...strek|ke] (Bergmannsspr.: waagerechte Strecke, die möglichst geradlinig hergestellt wird); Rịch|tung; rịch|tung_än|dernd, ...ge|bend, aber (↑ R 142): die Rịchtung ändernd, gebend; Rịch|tungs|an|zei|ger; rịch|tungs|los; Rịch|tungs|lo|sig|keit w; -; rịch|tungs|sta|bil; Rịch|tungs_sta|bi|li|tät, ...wech|sel; rịch|tung_wei|send, aber (↑ R 142): die Rịchtung weisend; Rịcht_waa|ge, ...zahl

Rịck mitteld. (Ofenstange; Gestell, Bord) s; -[e]s, -e

Rịcke [Trenn.: Rik|ke] (weibl. Reh) w; -, -n

ri|di|kül fr. (veralt. für: lächerlich)

Ri|di|kül [volksetymolog. umgedeutet aus: Retikül] (früher für: Arbeitsbeutel; Strickbeutel) m od. s; -s, -e u. -s

riech|bar; rie|chen; du rochst; du röchst; gerochen; riech[e]!; Rie|cher (ugs. für: Nase [bes. im übertr. Sinne]); einen guten - für etwas haben (alles gleich merken); Riech_fläsch|chen, ...kol|ben (derb, scherzh. für: Nase), ...or|gan, ...salz, ...stoff

Ried (Schilf; Röhricht; österr.: Flurform [in Weingärten]) s; -[e]s, -e u. (österr.:) Rie|de w; -, -n; Ried_an|ti|lo|pe od. ...bock, ...gras

Rie|fe (Längsrinne; Streifen, Rippe) w; -, -n; rie|feln; ich ...[e]le (↑ R 327) u. rie|fen (furchen); Rie|fe|lung; rie|fig

Rie|ge (Turnerabteilung) w; -, -n

Rie|gel m; -s, -; Rie|gel|chen, Rie|ge|lein

Rie|gel|hau|be (Art Frauenhaube); rie|geln; ich ...[e]le (↑ R 327); Rie|gel_werk (landsch. für: Fachwerk), ...stel|lung (Militär)

Rie|gen|füh|rer; rie|gen|wei|se

Riem|chen, Riem|lein; ¹Rie|men (Lederstreifen) m; -s, -

²Rie|men lat. (Ruder) m; -s, -; sich in die Riemen legen

Rie|men_an|trieb, ...schei|be (Radscheibe am Riemenwerk)

Rie|men|schnei|der, Tilman (dt. Bildhauer u. Holzschnitzer)

Rie|mer mdal. (Riemenmacher); Riem|lein, Riem|chen

rien ne va plus fr. [riạng n^e wạ plü] („nichts geht mehr"; beim Roulettspiel die Ansage des Croupiers, daß nicht mehr gesetzt werden kann)

Ri|en|zi (röm. Volkstribun)

¹Ries (Becken zwischen Schwäb. u. Fränk. Alb) s; -es; Nördlinger

²Ries arab. (Papiermaß) s; -es, -e 4 - Papier (↑ R 321 u. 322)

¹Rie|se [eigtl.: Ries], Adam (dt. Rechenmeister); nach Adam Riese

²Rie|se (außergewöhnl. große Mensch; auch: myth. Wesen) m; -n, -n (↑ R 268)

³Rie|se südd., österr. ([Holz]rutsche im Gebirge) w; -, -n

Rie|sel_fel|der Mehrz.; rie|seln; das Wasser rieselt

Rie|sen_amei|se, ...ar|beit (ugs. ...fräu|lein, ...ge|bir|ge (s; -s), ...ge|stalt; rie|sen|groß; rie|sen|haft; Rie|sen|hai; Rie|sen|hun|ger, Rie|sen_kraft, ...rad, ...schlan|ge, ...schritt, ...sla|lom; rie|sen|stark; rie|sig (gewaltig groß); Rie|sin w; -, -nen; rie|sisch (zu den Riesen gehörend)

Ries|ling (eine Rebensorte)

Rie|ster (Lederflicken auf der Schuh) m; -s, -

ries|wei|se [zu: ²Ries]

Riet (Weberkamm) s; -[e]s, -e
Riet|blatt

Rif s; -s u. Rif|at|las (Gebirge i Marokko) m; -

Riff (Felsenklippe; Sandbank) -[e]s, -e

Rif|fel (Flachs-, Reffkamm; erhabener, rippenähnlicher Streifen bayr. u. österr. für: gezackter Berggrat [bes. in Bergnamen, z. B. die Hohe -]) w; -, -n; Rif|fel_glas (Mehrz. ...gläser); rif|fel ([Flachs] kämmen; aufrauhen) ich ...[e]le (↑ R 327); Rif|fel|lun...
Riff|ko|ral|le

Ri|fi|ot (veralt. für: Rifkabyle) m; -en, -en (↑ R 268); Rif_ka|by|le (Bewohner des Rifatlas)

Ri|ga (Hptst. der Lettischen SSR
Ri|ga|er [...gạ^er] (↑ R 199); Bucht; ri|ga|isch, aber (↑ R 198) der Rigaische Meerbusen (svw Rigaer Bucht)

Ri|gel arab. (ein Stern) m; -

Rigg engl. (svw. Riggung) s; - rig|gen ([auf]takeln); Rig|gung (Takelung)

Ri|gi (schweiz. Berg) m; -[s] (auch w; -)

ri|gid lat. (Med.: steif, starr); Ri|gi|di|tät (Med.: Versteifung, [Muskel]starre) w; -

Ri|go|le fr. (tiefe Rinne, Abzugsgraben) w; -, -n; ri|go|len (tief pflügen oder umgraben); ich habe rigolt

Ri|go|let|to (Titelheld in der gleichnamigen Oper von Verdi)

Ri|gol|pflug

Ri|go|ris|mus lat. (übertriebene Strenge; strenges Festhalten an Grundsätzen) m; -; Ri|go|rist (f...

268); **ri|go|ri|stisch** (überaus streng); -ste (↑ R 294); **ri|go|ros** ([sehr] streng; unerbittlich; hart); -este (↑ R 292); **Ri|go|ro|si|tät** w; -; **Ri|go|ro|sum** (mündliche Doktorprüfung) s; -s, ...sa u. (österr.:) ...sen

tig|we|da sanskr. (Sammlung der ältesten ind. Opferhymnen) m; -[s]

Rijeka (Hafenstadt in Jugoslawien); vgl. Fiume

rijs|wijk [rɛ̞ˈßweˈk, auch: raißwaik] (niederl. Ort); der Friede von

Ri|kam|bio it. (Rückwechsel) m; -s, ...ien [...i̯ᵉn]

Rik|chen, Ri|ke (Kurzformen von: Friederike)

ri|ko|schet|tie|ren fr. (früher für: aufschlagend abprallen [von Vollkugeln]); **Ri|ko|schett|schuß**

rik|scha jap. (zweirädriger Wagen, der von einem Menschen gezogen wird u. zur Beförderung von Personen dient) w; -, -s

riks|mål norw. (,,Reichssprache''; ältere Bez. für: Bokmål) s; -[s]

ril|ke, Rainer Maria (österr. Dichter)

ril|le w; -, -n; **ril|len; Ril|len|pro|fil; ril|lig**

ri|mes|se it. (Wirtsch.: Wechsel vom Standpunkt des Wechselnehmers aus) w; -, -n; **Ri|mes|sen|wech|sel**

ri|mi|ni (Hafenstadt am Adriatischen Meer)

im|ski-Kor|sa|kow [...kof] (russ. Komponist)

i|nal|do Ri|nal|di|ni (Held eines Räuberromans von Chr. A. Vulpius)

ind s; -[e]s, -er

rind w; -, -n; **Rin|den|boot, ...hüt|te; rin|den|los**

in|der|bra|ten, Rinds|bra|ten (österr. nur so); **Rin|der|her|de, ..hirt; rin|de|rig** (von der Kuh: brünstig); **rin|dern** (von der Kuh: brünstig sein); **Rin|der|pest** w; ...ras|se; **Rin|der|talg**, Rinds|talg; **Rin|der|zun|ge**, Rinds|zunge; **Rind|fleisch**

in|dig (mit Rinde versehen)

inds|bra|ten (österr.nur so), Rin|der|bra|ten; **Rind[s]|le|der; rind[s]|le|dern** (aus Rindsleder); **Rinds|talg**, Rin|der|talg; **Rind|tück** (Beefsteak); **Rind|sup|pe** österr. (Fleischbrühe); **Rinds|zun|ge**, Rin|der|zun|ge; **Rind|vieh** Mehrz. ugs. und verächtlich: Rindviecher)

in|for|zan|do it. (Musik: stärker werdend; Abk.: rf., rfz.); **Rin|for|zan|do** s; -s, -s u. ...di

ng südd., schweiz. mdal. (leicht, mühelos)

Ring m; -[e]s, -e; **ring|ar|tig; Ring|bahn, ...blitz** (Fotogr.: ringförmig um das Objektiv der Kamera angebrachte Entladungsröhre eines Elektronenblitzgerätes); **Rin|gel** (kreisförmig Gewundenes) m; -s, -; **Rin|gel|blu|me; Rin|gel|chen**, Ring|lein; **rin|ge|lig**, ring|lig; **Rin|gel|locke** [Trenn.: ...lok|ke]; rin|geln; ich ...[e]le (↑ R 327); sich -; **Rin|gel|nat|ter**

Rin|gel|natz (dt. Dichter); Ringelnatz' Gedichte (↑ R 310)

Rin|gel|piez (ugs. scherzh. für: anspruchsloses Tanzvergnügen) m; -[e]s, -e; - mit Anfassen; **Rin|gel|rei|gen** od, ,,rei|hen, ...spiel** (österr. für: Karussell), ...spin|ner** (ein Schmetterling), ...ste|chen** (früheres ritterliches Spiel; s; -s, -), ...tau|be, ...wurm**

rin|gen; du rangst; du rängest; gerungen; ring[e]!; **Rin|gen** s; -s; **Rin|ger; Rin|ger|griff; rin|ge|risch; Ring|fin|ger; Ring|flü|gel flug|zeug** (für: Coleopter); **ring|för|mig; Ring|ge|schäft, ...gra|ben; ring|hö|rig** schweiz. mdal. (schalldurchlässig, hellhörig)

Ring|kampf, ...kämp|fer

Ring|knor|pel (Kehlkopfknorpel); **Ring|lein**, Rin|gel|chen; **ring|lig**, rin|ge|lig

Ring|lot|te mdal. u. österr. (Reneklode) w; -, -n

Ring|mau|er, ...rich|ter (↑ R 129); vgl. ringsum; **Ring|sen|dung** (Rundf.); **rings|her|um; Ring|stra|ße; rings|um;** - (rundherum) läuft ein Geländer; - (überall) stehen blühende Sträucher, aber: die Kinder standen rings um ihren Lehrer; rings um den See standen Bäume; **rings|um|her**

Ring|tausch, ...ten|nis, ...ver|kehr, ...wall

Rink m; -en, -en (↑ R 268) u. **Rin|ke** w; -, -n u. **Rin|ken** landsch. (Schnalle, Spange) m; -s, -; **rin|keln** (veralt. für: schnallen); ich ...[e]le (↑ R 327)

Rinn|chen, Rinn|lein; Rin|ne w; -, -n; **rin|nen;** es rann; es ränne (selten: rönne); geronnen; rinn[e]!; **Rinn|sal** s; -[e]s, -e; **Rinn|stein**

Rio de Ja|nei|ro [- - sehanero] (Stadt in Brasilien); **Rio de la Pla|ta** (Fluß); **Rio-de-la-Pla|ta-Bucht** (↑ R 203) w; -; **Rio de Oro** (ehem. span. Kolonie in Nordwestafrika); **Rio Gran|de do Sul** (Bundesstaat in Brasilien)

R. I. P. = requiescat in pace!

Ripp|chen, Ripp|lein; **Rip|pe** w; -, -n

rip|peln, sich mdal. (sich regen, sich beeilen); ich ...[e]le mich (↑ R 327)

rip|pen (mit Rippen versehen); ge-

rippt; **Rip|pen|bruch** m; ...fell; **Rip|pen|fell|ent|zün|dung; Rip|pen|heiz|kör|per; Rip|pe[n]|speer** (gepökeltes Schweinebruststück mit Rippen) m od. s; -[e]s; vgl. Kasseler Rippe[n]speer; **Rip|pen|stich, ...stoß, ...stück; Ripp|lein**, Ripp|chen; **Ripp|li** schweiz. (Schweinerippchen) s; -s, -

rips!; rips, raps!

Rips engl. (geripptes Gewebe) m; -es, -e

ri|pua|risch lat. (am [Rhein]ufer wohnend); -e Franken (um Köln)

ri|ra|rutsch!

Ri|sa|lit it. (Bauw.: Vorbau, Vorsprung) m; -s, -e

ri|scheln landsch. (rascheln, knistern); es rischelt

Ri|si|ko it. s; -s, -s u. ...ken (österr.: Risken); **ri|si|ko|frei; Ri|si|ko|leh|re** (wiss. Analyse der wirtschaftl. Risiken, bes. unter dem Aspekt ihrer Eindämmung); **ri|si|ko|los; Ri|si|ko|mi|schung** (Wirtsch.: Ersetzung eines großen Risikos durch mehrere kleinere Risiken), ...prä|mie

Ri|si-Pi|si it. (Gericht aus Reis und Erbsen) Mehrz.; **Ri|si|pi|si** österr. (svw. Risi-Pisi) s; -[s], -

ris|kant fr. (gefährlich, gewagt); **ris|kie|ren** (wagen, aufs Spiel setzen)

Ri|skon|tro vgl. Skontro

Ri|sor|gi|men|to it. [...ßordsehi..., auch: ...sordsehi...] (,,Wiedererstehung'' und Einigung Italiens im 19. Jh.) s; -[s]

Ri|sot|to it. (Reisspeise) m; -[s], -s (österr. auch: s; -s, -[s])

Risp|chen, Risp|lein; Ris|pe (Blütenstand) w; -, -n; **ris|pen|för|mig; Ris|pen|gras; ris|pig**

Riß m; Risses, Risse; **ris|sig; Riß|öf|fen|ma|schi|ne** (bei der Schuhfabrikation)

Rist (Fußrücken; Handgelenk) m; -es, -e

Ri|ste (Flachsbündel) w; -, -n

Rist|griff (Sport)

ri|stor|nie|ren it. (Wirtsch.: einen irrig eingetragenen Posten zurückschreiben); **Ri|stor|no** (Wirtsch.: Gegen-, Rückbuchung, Rücknahme) m od. s; -s, -s

ri|sve|glian|do it. [rißwäljando] (Musik: aufgeweckt, munter, lebhaft werdend); **ri|sve|glia|to** [...jato] (Musik: [wieder] munter, lebhaft)

rit. = ritardando, ritenuto

Ri|ta (Kurzform von: Margherita)

ri|tar|dan|do it. (Musik: langsamer vorzutragen; Abk.: rit.); **Ri|tar|dan|do** s; -s, -s u. ...di

ri|te lat. (in üblicher, ordnungsmäßiger, feierlicher Weise; geringstes Prädikat bei Doktorprüfun-

gen [genügend]); Ri|ten (*Mehrz.* von: Ritus)

ri|ten. = ritenuto

Ri|ten|kon|gre|ga|ti|on (päpstl. Behörde) w; -

ri|te|nu|to *it.* (Musik: zögernd, zurückgehalten; Abk.: rit., riten.);

Ri|te|nu|to s; -s, -s u. ...ti

Ri|tor|nell *it.* (instrumentales Vor-, Zwischen- u. Nachspiel in der Arie; dreizeilige Strophe) s; -s, -e

Ri|trat|te *it.* (svw. Rikambio) w; -, -n

ritsch!; ritsch, ratsch!

Rit|scher[t] österr. (Speise aus Rollgerste und Hülsenfrüchten) m; -s, -

Ritt m; -[e]s, -e

Ritt|ber|ger [nach dem dt. Eiskunstläufer W. Rittberger] (klassischer Kürsprung im Eiskunstlauf) m; -s, -

Rit|ter (der Ritter des Deutschen Ordens, des Pour le mérite; der Ritter von der traurigen Gestalt (Don Quichotte); Rit|ter.bur, ...dienst, ...gut; Rit|ter|guts|be-sit|zer; rit|ter|haft; rit|ter|lich; Rit|ter|lich|keit; Rit|ter.or|den, ...ro|man, ...schaft (w; -); rit|ter-schaft|lich; Rit|ter|schlag; Rit-ters|mann (*Mehrz.* ...leute); Rit-ter.sporn (eine Blume; *Mehrz.* ...sporne), ...tum (s; -s); Rit|ter-und-Räu|ber-Ro|man (↑ R 155); Rit|ter.we|sen (s; -s), ...zeit; rit|tig (zum Reiten geschult, reitgerecht); Rit|tig|keit; Rit|tig|keits-ar|beit (Pferdesport); ritt|lings; Ritt|mei|ster

Ri|tu|al *lat.* (gottesdienstl. Brauchtum) s; -s, -e u. -ien [...i°n]; Ri|tu|al.buch, ...ge|setz, ...hand-lung; Ri|tua|lis|mus (Richtung der anglikan. Kirche) m; -; Ri-tua|list (↑ R 268); Ri|tu|al|mord; ri|tu|ell *fr.* (zum Ritus gehörend; durch den Ritus geboten); Ri|tus *lat.* (gottesdienstlicher [Fest]brauch; Zeremoniell; Übung) m; -, ...ten

Ritz (Kerbe, Schramme, Kratzer; auch für: Ritze) m; -es, -e; Rit|ze (sehr schmale Spalte od. Vertiefung) w; -, -n

Rit|zel (kleines Zahnrad) s; -s, -

rit|zen; du ritzt (ritzest); Rit|zer (ugs. für: kleine Schramme, Kratzer); Rit|zung

Riu|kiu|in|seln (Inselkette im Pazifik) *Mehrz.*

Ri|va|le *fr.* (Nebenbuhler, Mitbewerber) m; -n, -n (↑ R 268); Ri|va-lin w; -nen; ri|va|li|sie|ren (wetteifern); Ri|va|li|tät; Ri|va|li|täts-kampf

Ri|ver|boat|shuffle *amerik.* [ríw°r-bo°tschaf°l] (zwanglose Gesellig-

keit mit Jazzband auf Binnenwasserschiffen) w; -

ri|ver|so *it.* [riwärßo, auch: ...so] (Musik: umgekehrt, vor- und rückwärts zu spielen)

Ri|vie|ra [...wi...] (Küstengebiet am Mittelmeer) w; -, ...ren (meist *Einz.*)

Ri|yal *arab.* (Münzeinheit in Saudi-Arabien; Abk.: SRl, Rl) m; -, -s; 100 - (↑ R 322); vgl. Rial

Ri|zi|nus *lat.* [österr.: rizi...] (Zier- und Heilpflanze mit fettreichem Samen) m; -, - u. -se; Ri|zi|nus|öl s; -[e]s

RKW = Rationalsisierungs-Kuratorium der Deutschen Wirtschaft

Rl = Rial; Riyal

rm = Raummeter

RM = Reichsmark

Rn = chem. Zeichen für: Radon

Road|ster *engl.* [r°°dßt°r] (offener, zweisitziger Sportwagen) m; -s, -

Roast|beef *engl.* [roßtbif]. (Rostbraten) s; -s, -s

Rob|be (Seesäugetier) w; -, -n

Robbe-Gril|let [robgrijä] (fr. Schriftsteller)

rob|ben (robbenartig kriechen); Rob|ben.fang, ...fän|ger, ...schlag (Erlegung der Robben durch einen Knüppelschlag auf die Nase)

Rob|ber *engl.* (Doppelpartie im Whist- od. Bridgespiel) m; -s, -

Ro|be *fr.* (kostbares, langes [Abend]kleid; Amtstracht, bes. für Richter, Anwälte, Geistliche, Professoren) w; -, -n

Ro|bert (m. Vorn.); Ro|ber|ta, Ro-ber|ti|ne (w. Vorn.)

Ro|bes|pi|erre [robäßpiär] (Führer in der Fr. Revolution)

Ro|bi|nie [...i°] nach dem fr. Botaniker Robin (robäng)] (ein Zierbaum od. -strauch) w; -, -n

Ro|bin|son|a|de *nlat.* (Robinsongeschichte; kühne Parade eines Torwarts [nach dem engl. Torwart J. Robinson]); Ro|bin|son Cru|soe [- krуso] (Held in einem Roman von Daniel Defoe)

Ro|bot *tschech.* (früher für: Frondienst) w; -, -en; ro|bo|ten (ugs. für: schwer arbeiten); er hat gerobotet (auch: robotet); Ro|bot|er (Maschinenmensch; ugs. für: Schwerarbeiter); ro|bo|ter|haft; Ro|bot-Ka|me|ra Ⓦ (Kamera mit sehr schneller Aufnahmefolge)

Ro|bu|rit *lat.* (ein Sprengstoff) m; -s; ro|bust (stark, stämmig; vierschrötig; derb, unempfindlich); Ro|bust|heit

Ro|caille *fr.* [rokaj] (Muschelwerk; Rokokoornament) s od. w; -, -s

Ro|cha|de *pers.-arab.-span.-fr.*

[roch..., auch: rosch...] (Schach ein unter bestimmten Vorausset zungen zulässiger Doppelzug von König u. Turm)

Roche|fort [roschfor] (fr. Stadt)

rö|cheln; ich ...[e]le (↑ R 327)

Ro|chen (ein Seefisch) m; -s, -

Ro|cher de bronze *fr.* [rosché d° brongß] („eherner Fels"; uner schütterliche Macht) m; - - - , -° [rosché] - -

Ro|chett *fr.* [rosch...] (Chorhemc des kath. Geistlichen) s; -s, -s

ro|chie|ren *pers.-arab.-span.-fr [roch..., auch: rosch...] (die Ro chade ausführen; die Positionen wechseln [z. B. beim Fußball spiel])

Ro|chus (Heiliger)

[1]Rock m; -[e]s, Röcke; (veralt.: den bunten - anziehen; (↑ R 224: der Heilige - von Trier

[2]Rock (kurz für: Rock and Roll m; -[s]; Rock and Roll, Rock 'n Roll *amerik.* [auch: rok°nro engl. Ausspr.: roknro°l (star synkopierter amerik. Tanz) m - - -

Röck|chen, Röck|lein

Rocke|fel|ler|in|sti|tut; ↑ R 18 [nach dem amerik. Stifter] (For schungsanstalt)

rocken[1] ([in der Art des] Rock an Roll spielen)

Rocken[1] (Spinngerät) m; -s, -

Rocken|bol|le[1] [eingedeutscht aus Rokambole] nordd. (Perlzwie bel) w; -, -n

Rocken|stu|be[1] (Spinnstube)

Rocker[1] *amerik.* (Angehöriger ju gendlicher Banden [mit Lede kleidung u. Motorrad als Status symbolen]) m; -s, -

Rock.fal|te, ...fut|ter (vgl. [2]Fu ter), ...kra|gen (↑ R 236); Röck lein, Röck|chen

Rock|mu|sik; Rock 'n' Roll vg 'Rock and Roll

Rocks *engl.* (Fruchtbonbons *Mehrz.*

Rock.saum, ...schoß, ...ta|sche

Rocky Moun|tains [roki mauntin° (nordamerik. „Felsengebirge" *Mehrz.*

Rock|zip|fel

Ro|de|hacke [Trenn.: ...hak|ke]

[1]Ro|del aleman. (Akten-, Schrif rolle) m; -s, Rödel

[2]Ro|del (bayr. für: Schlitten) n -s, -; [3]Ro|del österr. (kleine Schlitten; mdal. Kinderrassel) -, -n; Ro|del|bahn; ro|deln; ic ...[e]le (↑ R 327); Ro|del|schlit|te ro|den

Ro|deo *engl.* (Reiterschau de Cowboys in den USA) m od. -s, -s

<hr>

[1] Trenn.: ...k|k...

Ro|de|rich (m. Vorn.)
Ro|di|nal Ⓦ (fotogr. Entwickler) s; -s
Rod|ler
Ro|do|mon|ta|de fr. (selten für: Aufschneiderei, Großsprecherei); ro|do|mon|tie|ren (selten für: aufschneiden)
Ro|don|ku|chen vgl. Ratonkuchen
Ro|dri|go (span. Form von: Roderich)
Ro|dung
Ro|ga|te lat. („Bittet!"; fünfter Sonntag nach Ostern [nach einem Wort aus dem Evangelium]); Ro|ga|ti|on [...zion] (veralt. für: Fürbitte; kath. Bittumgang)
Ro|gen (Fischeier) m; -s, -; Ro|ge|ner, Rog|ner (weibl. Fisch); Ro|gen|stein (rogenartige Versteinerung)
Ro|ger [fr. Aussspr.: roscheᵉ, engl. Aussspr.: rodscheᵉ] (m. Vorn.)
Rög|gel|chen rhein. (Roggenbrötchen); Rog|gen (Getreide) m; -s, (fachspr.:) -; Rog|gen.brot, ...ern|te, ...feld, ...mehl, ...saat
Rog|ner vgl. Rogener
oh; - behauener, bearbeiteter Stein; († R 133:) aus dem rohen arbeiten, im rohen fertig; Roh.ar|beit, ...bau (Mehrz. ...bauten), ...baum|wol|le, ...bi|lanz (Wirtsch.), ...blech, ...ei|sen; Roh.ei|sen|ge|win|nung; Ro|heit († R 163); Roh|er|trag; ro|her|wei|se; Roh..ge|wicht, ...kost, ...köst|ler; Roh|ling; Roh_ma|te|ri|al, ...öl, ...pro|dukt; Roh|pro|duk|ten|händ|ler
ohr (Schilf; Pflanzenschaft; langer Hohlzylinder; landsch., bes. österr. für: Backröhre) s; -[e]s, -e; Rohr_am|mer, ...bruch m; Röhr|chen, Röhr|lein (kleines Rohr; kleine Röhre); Rohr|dom|mel (ein Vogel) w; -, -n; Röh|re (walzenförmiger Hohlkörper, (walzenförmige) Höhlung) w; -, -n; ¹röh|ren (veralt. für: mit Röhren versehen, Rohre legen)
²röh|ren (brüllen [vom Hirsch zur Brunftzeit])
Röh|ren.be|wäs|se|rung, ...brun|nen (Brunnen, aus dem das Wasser ständig rinnt), ...em|bar|go, ...ho|se, ...kno|chen, ...pilz, ...prüf|ge|rät; rohr|far|ben (für: beige); Rohr_flech|ter, ...flö|te, ...ge|flecht; Röh|richt (Rohrdickicht) s; -s, -e; ...röh|rig (z. B. vielröhrig); Rohr_kol|ben, ...kre|pie|rer (Soldatenspr.: Geschoß, das im Geschützrohr u. a. explodiert), ...le|ger; Röhr|lein, Röhr|chen; Rohr|lei|tung; Röhr|ling (ein Pilz); Rohr_netz, ...post; Rohr|post|büch|se; Rohr_rück-

lauf (m; -[e]s), ...sän|ger (ein Singvogel), ...spatz (in: schimpfen wie ein - [ugs. für: aufgebracht schimpfen]), ...stock (Mehrz. ...stöcke), ...stuhl, ...zan|ge, ...zucker [Trenn.: ...zuk|ker]
Roh.schrift (für: Konzept), ...sei|de; roh|sei|den; ein -es Kleid; Roh_stahl (vgl. ¹Stahl), ...stoff; Roh|stoff|fra|ge († R 237); Roh|stoff_vor|ar|bei|tung; Roh_ta|bak ...über|set|zung, ...wol|le, ...zuk|ker [Trenn.: ...zuk|ker], ...zu|stand (m; -[e]s)
ro|jen (Seemannsspr.: rudern); ge|rojet
Ro|kam|bo|le fr. (Perlzwiebel) w; -, -n; vgl. Rockenbolle
Ro|kit|no|sümp|fe (in Polessien) Mehrz.
Ro|ko|ko fr. [auch: rokoko, österr.: ...kọ] ([Kunststil des 18. Jh.s) s; -s (fachspr. auch: -)
Ro|land (m. Vorn.); Klein - († R 224); Ro|lan|de (w. Vorn.); Ro|lands|lied s; -[e]s; Ro|land[s]|säu|le
Rolf (Kurzform von: Rudolf)
Rol|laden [Trenn.: Roll|laden, † R 236] m; -s, Rolläden u. (seltener:) -; Rol|laden|schrank [Trenn.: Rollladen..., † R 236]
Roll|back engl. [rǫ"lbäk] (milit.: erzwungener Rückzug) s; -s, -s
Roll.bahn, ...bal|ken (österr.: Rolladen), ...ball (Mannschaftsballspiel); Röll|chen; Rol|le w; -, -n
Roll|lei|flex Ⓦ (fotogr. Apparate)
rol|len; († R 120:) der Wagen kommt ins Rollen; Roll|len|be|set|zung; rol|len_för|mig, ...spe|zi|fisch; Rol|len.tausch, ...ver|tei|lung; Roll|ler (Motorroller; Kinderfahrzeug); männl. [Kanarien]vogel mit rollendem Schlag; veralt. für: Rollfuhrmann; österr. für: Rollo; österr. auch: an einem Spannseil mit Rollen befestigtes Boot; [mit dem] Roller fahren, aber († R 120:) das Rollerfahren; rol|lern; ich ...ere († R 327); Roll.fäh|re (österr.: Seilfähre mit Spannseil und Rolle), ...fahr|stuhl, ...feld, ...film; Roll|fuhr_dienst, ...mann (Mehrz. ...männer u. ...leute), ...un|ter|neh|men; Roll_geld, ...ger|ste, ...kra|gen, ...kunst|lauf (m; -[e]s), ...kur (Med.), ...kut|scher, ...mops (gerollter eingelegter Hering)
Rol|lo [auch, österr. nur: rolǫ] (eindeutschend für: Rouleau) s; -s, -s; Roll|loch [Trenn.: Roll|loch, † R 236] (Bergmannsspr.: Grubenbau zum Abwärtsbefördern von Mineralien); Roll_schie|ne, ...schin|ken, ...schnellauf [Trenn.: ...schnell|lauf, † R 236],

...schrank; Roll|schuh; - laufen, aber († R 120): das Rollschuhlaufen; Roll|schuh_bahn, ...sport; Roll_sitz, ...splitt, ...sport
Rolls-Royce Ⓦ [rolsrẹuß, engl. Aussspr.: rọ"lsrẹuß] (engl. Kraftfahrzeugmarke) m; -, -
Roll_stuhl, ...trep|pe
Rom (Hptst. Italiens)
Ro|ma|dur fr. [österr.: ...dur] (ein Weichkäse) m; -[s]
Ro|ma|gna [...mạnja] (it. Landschaft) w; -
Ro|man fr. m; -s, -e; ein historischer -; ro|man|ar|tig; Ro|man|au|tor; Ro|mạn|chen; Ro|man|cier [romangßie] (Romanschriftsteller) m, -s, -s, Ro|ma|ne lat. (Angehöriger eines Volkes mit roman. Sprache) m; -n, -n († R 268); Ro|ma|nen|tum s; -s; ro|man|haft; Ro|man|held; Ro|ma|ni (Zigeunersprache) s; -; Ro|ma|nik ([Kunst]stil vom 11. bis 13. Jh.) w; -; Ro|ma|nin w; -, -nen; ro|ma|nisch (zu den Romanen gehörend; im Stil der Romanik; die Romanik betreffend; schweiz. auch für: rätoromanisch [vgl. romantsch]); -e Sprachen; ro|ma|ni|sie|ren (römisch, romanisch machen); Ro|ma|nis|mus (veralt. für: römisch-katholische Einstellung) m; -; Ro|ma|nist (Kenner und Erforscher der roman. Sprachen u. Literaturen; veralt. für: Vertreter des Romanismus); † R 268; Ro|ma|ni|stik (Wissenschaft von den romanischen Sprachen und Literaturen, auch: des römischen Rechts) w; -; ro|ma|ni|stisch; Ro|man.le|ser, ...li|te|ra|tur
Ro|ma|now [...nof; auch, österr. nur: rọma...] (ehem. russ. Herrschergeschlecht)
Ro|man_schrei|ber, ...schrift|stel|ler; Ro|man|tik lat. (die Kunst- und Literaturrichtung von etwa 1800 bis 1830) w; -; Ro|man|ti|ker (Anhänger, Dichter usw. der Romantik; abschätzig für: Phantast, Gefühlsschwärmer); ro|man|tisch („romanhaft"; zur Romantik gehörend; abschätzig für: phantastisch, abenteuerlich); -ste († R 294); ro|man|ti|sie|ren (romantisch darstellen, gestalten); ro|mantsch (rätoromanisch); rätoroman. Sprache [in Graubünden]) s; -; Ro|ma|nus (m. Vorn.); Ro|man|ze fr. (erzählendes volkstüml. Gedicht; liedartiges Musikstück mit besonderem Stimmungsgehalt; romantische Liebesepisode) w; -, -n; Ro|man_zen_dich|ter, ...samm|lung; Ro|man|ze|ro span. (span. Romanzensammlung) m; -s, -s

Ro|meo (Gestalt bei Shakespeare) ¹Rö|mer *niederl.* (bauchiges Kelchglas für Wein) ²Rö|mer (Einwohner Roms; Angehöriger des Römischen Reiches); ³Rö|mer (das alte Rathaus in Frankfurt am Main) *m*; -s; Rö|mer|brief *m*; -[e]s (↑ R 205); Rö|me|rin *w*; -, -nen; Rö|mer_stra|ße (↑ R 219), ...topf (↑ R 205); Rö|mer|tum *s*; -s; Rom_fah|rer, ...fahrt (↑ R 201); rö|misch (auf Rom, auf die alten Römer bezüglich); -e Zeitrechnung, -e Ziffern, -es Bad, -es Recht, die -en Kaiser, aber (↑ R 224): das Römische Reich, das Heilige Römische Reich Deutscher Nation; rö|misch-irisch (↑ R 158); römisch-irisches Bad; rö|misch-ka|tho|lisch (↑ R 158; Abk.: röm.-kath.); die römisch-katholische Kirche; röm.-kath. = römisch-katholisch

Rom|mé *fr.* [*romẹ*, auch: *rọme*] (ein Kartenspiel) *s*; -s, -s

Rọm|rei|se (↑ R 201)

Ro|mu|ald, Ru|mold (m. Vorn.)

Ro|mu|lus (in der röm. Sage Gründer Roms; - und Remus; - Augustulus (letzter .weströmischer Kaiser)

Ron|ces|valles [meist: *rọngßᵉwal,* span. Ausspr.: *rontheswạljẹß*] (span. Ort)

¹Ron|de *fr.* [*rọndᵉ,* *rọngdᵉ*] (früher für: Runde, Rundgang, Streifwache; Wachen u. Posten kontrollierender Offizier) *w*; -, -n; ²Ron|de (eine Schriftart) *w*; -; Ron|deau [*rondọ*] österr. (rundes Beet, runder Platz) *s*; -s, -s; Ron|dell, Run|dell (Rundteil [an der Bastei]; Rundbeet) *s*; -s, -e; Ron|den|gang *m*; Ron|do *it.* („Rundgesang"; mittelalterl. Tanzlied mit mehrmals wiederkehrendem Thema) *s*; -s, -s

Ron|ka|li|sche Fel|der (Ebene in Oberitalien) *Mehrz.*

rönt|gen [*rọntgᵉn*] (mit Röntgenstrahlen durchleuchten); geröntgt; Rönt|gen (deutscher Physiker); Rönt|gen_ap|pa|rat (↑ R 180), ...auf|nah|me, ...be|strah|lung, ...bild, ...dia|gno|stik; rönt|ge|ni|sie|ren österr. (röntgen); Rönt|gen|ki|ne|ma|to|gra|phie (Filmen des durch Röntgenstrahlen entstehenden Bildes); Rönt|ge|no|gramm (Röntgenbild) *s*; -s, -e; Rönt|ge|no|gra|phisch (Strukturuntersuchung u. Bildaufnahme von Werkstoffen mit Röntgenstrahlen) *w*; -; rönt|ge|no|gra|phisch; Rönt|ge|no|lo|gie (Lehre von den Röntgenstrahlen, Teilgebiet der Physik)

w; -; rönt|ge|no|lo|gisch; Röntgen_röh|re (↑ R 180), ...schwe|ster, ...spek|trum, ...strah|len (*Mehrz.*); Rönt|gen|struk|tur|ana|ly|se (Untersuchung der Struktur von Kristallen mit Hilfe von Röntgenstrahlen); Rönt|gen|tie|fen|the|ra|pie *w*; -; Rönt|gen|un|ter|su|chung

Roof (Seemannsspr.: [Schlaf]raum auf Deck) *m* od. *s*; -[e]s

Roo|se|velt [*rọᵘsᵉwält*] (Name zweier Präsidenten der USA)

Roque|fort [nach dem gleichnamigen fr. Ort: *rokfọr,* auch: *rọk...*] (ein Käse) *m*; -s, -s; Roque|fort|kä|se (↑ R 201)

rö|ren (Nebenform von: ²röhren)

Ror|schach (schweiz. Stadt)

ro|sa *lat.* (rosenfarbig, blaßrot); die rosa Kleider; vgl. blau; ¹Ro|sa (rosa Farbe) *s*; -s, - (ugs.: -s); vgl. Blau; ²Ro|sa (w. Vorn.); Ro|sa|band *s* (*Mehrz.* ...bänder); ro|sa|far|ben, ro|sa|far|big; Ro|sa|lia, Ro|sa|lie [...iᵉ] (w. Vorn.); Ro|sa|li|en|ge|bir|ge (Ausläufer der Zentralalpen südöstl. von Wiener Neustadt) *s*; -s; Ro|sa|lin|de (w. Vorn.); Ro|sa|mund, Ro|sa|mun|de (w. Vorn.); Ros|ani|lin (ein Farbstoff) *s*; -s; Ro|sa|ri|um (Rosenpflanzung; kath. Rosenkranzgebet) *s*; -s, ...ien [...iᵉn]; ro|sa|rot (↑ R 158)

rösch (Bergmannsspr.: grob [gepocht]; bes. südd., auch schweiz. mdal. für: knusprig); vgl. resch

Rö|sche (Bergmannsspr.: Graben) *w*; -, -n

¹Rös|chen, Rös|lein (kleine Rose); ²Rös|chen (Koseform von: Rosa und den damit gebildeten Vornamen); ¹Ro|se *w*; -, -n; ²Ro|se (w. Vorn.); ro|sé *fr.* [*rosẹ*] (rosig, zartrosa); ¹Ro|sé (rosé Farbe) *s*; -[s], -[s]; ²Ro|sé (Roséwein) *m*; -s, -s

Ro|seg|ger [auch: *rosä...,* *rọs...*] (österr. Schriftsteller)

Ro|sel, Rosl (w. Vorn.); Ro|se|ma|rie (w. Vorn.); Ro|sen_blatt, ...duft; ro|sen|far|ben, ro|sen|far|big; ro|sen|fin|ge|rig, ro|sen|fing|rig (veralt. dicht.); die -e Morgenröte; Ro|sen_gar|ten, ...hoch|zeit (ugs. für: 10. Jahrestag der Eheschließung), ...holz, ...knos|pe, ...kohl (*m*; -[e]s), ...kranz

Ro|sen|mon|tag [auch: *rọ...*; aus mdal. Rasenmontag (von rasen = tollen)] (Fastnachtsmontag); Ro|sen|mon|tags|zug

Ro|se|no|bel *engl.* [auch: ...*nọbᵉl*] (alte engl. Goldmünze) *m*; -s, -

Ro|sen_öl, ...quarz (ein Schmuckstein); ro|sen|rot; Ro|sen_schau, ...stock (*Mehrz.* ...stöcke)

Ro|sen|stock-Hues|sy [...*hüßi*] (dt Rechtshistoriker u. Soziologe)

Ro|sen|strauß (*Mehrz.* ...sträuße

Ro|sen|thal ⓦ (Porzellan, Glau. a.)

Ro|sen|was|ser *s*; -s

Ro|seg|le *lat.* (Med.: rotfleckiger Hautausschlag) *w*; -, -n

¹Ro|set|te [*rosät*] (Stadt in Unterägypten)

²Ro|set|te *fr.* (Verzierung in Rosenform; Bandschleife; Edelsteinschliff) *w*; -, -n; Ro|sé|wein [*rosẹ...*] (blaßroter Wein aus hell gekelterten Rotweintrauben) ro|sig; ro|sig|weiß (↑ R 158)

Ro|si|nan|te *span.* (Don Quichottes Pferd; selten für Klepper) *w* (eigtl.: *m*); -, -n

Ro|si|ne *fr.* (getrocknete Weinbeere) *w*; -, -n; Ro|si|nen_brot, ...ku|chen; ro|sin|far|ben

Rosl vgl. Rosel; Rös|lein, Rös|chen

Ros|ma|rin *lat.* [auch: ...*rịn*] (immergrüner Strauch, Zier- u. Gewürzpflanze) *m*; -s; Ros|ma|rin|öl

Ro|so|lio *it.* (ein Likör) *m*; -s

¹Roß (dicht., geh. für: edles Pferd südd., österr. u. schweiz. für Pferd) *s*; Rosses, Rosse (landsch. Rösser)

²Roß *s*; -es, -e u. Ro|ße (mittelalterl. für: Wabe) *w*; -, -n

Roß_ap|fel (landsch. scherzh. für Pferdekot), ...arzt (frühere Bez der Tierärzte im dt. Heer), ...brei ten (windschwache Zone im subtrop. Hochdruckgürtel; *Mehrz.*); Röß|chen, Rö߶lein, Rö̈s|sel, Rößl (kleines Roß)

Rö|ße vgl. ²Roß

Rös|sel vgl. Rößchen; Rọs|se|len|ker; Rös|sel|sprung (Rätselart)

ros|sen (von der Stute: brünstig sein); die Stute roßt; Roß_haar, Roß|haar|ma|trat|ze; roß|sig [zu rossen]

Ros|si|ni (it. Komponist)

Ros|sit|ten (Ort auf der Kurischen Nehrung)

Roß_kamm (Pferdestriegel; spött für: Pferdehändler), ...ka|sta|nie ...kur (ugs. für: mit drastischen Mitteln durchgeführte Kur); Rößl, Röß|lein vgl. Rößchen; Roß|täu|scher (veralt. für: Pferdehändler); Roß|täu|sche|rei Roß|trap|pe (Felsen im Harz) *w*;

¹Rost ([Heiz]gitter; landsch. für Stahlmatratze) *m*; -[e]s, -e

²Rost (Zersetzungsschicht auf Eisen; Pflanzenkrankheit) *m*; -[e]s

Rost|an|satz

Rost_bra|ten, ...brat|wurst

Röst|brot [auch: *rö̈st...*]; Rö|ste [auch: *rö...*] (Röstvorrichtung Erhitzung von Erzen und Hüt

tenprodukten; Rotten [von Flachs]) w; -, -n

o|sten (Rost ansetzen)

ö|sten [auch: rö...] (braten; Brot u. a. rösten; Erze u. Hüttenprodukte erhitzen; rotten [von Flachs]); **Rö|ster** österr. (Kompott od. Mus aus Holunderbeeren od. Zwetschen) m; -s, -; **Rö-ste|rei**

rost|far|ben, rost|far|big, Rost-fleck; rost|frei; -er Stahl

rö|sti schweiz. ([grob geraspelte] Bratkartoffeln) w; -

o|stig

röst|kar|tof|feln [auch: *rößt...*] **landsch.** (Bratkartoffeln) *Mehrz.*

'o|stock (Hafenstadt an der Ostsee)

rost|pilz (Erreger von Pflanzenkrankheiten)

o|stra lat. (Rednerbühne im alten Rom) w; -, ...ren

rost|rot; - färben

röst|schnit|te [auch: *rößt...*]

rost_schutz, ...schutz|mit|tel s

ö|stung [auch: *rö...*]

o|swith, Ro|swi|tha (w. Vorn.)

ot; röter, röteste (seltener, vor allem übertragen: roter, roteste); ↑R 295. **I.** *Kleinschreibung* (↑R 224): rote Bete; rote Blutkörperchen; die rote Fahne (der Kommunisten; vgl. aber II, a); rote Farbe; rote Grütze; der rote Planet (Mars); rote Rübe; der rote Faden; der rote Hahn (Feuer); Kartenspiel:) das rote As; er wirkt auf sie wie ein rotes Tuch; er hat keinen roten Heller, Pfennig mehr. **II.** *Großschreibung:* **a)** ↑R 224:) das Rote Kreuz; die Rote Armee (früher für: Sowjetarmee); Die Rote Fahne (Name kommunistischer Zeitungen; vgl. aber I); **b)** (↑R 198:) das Rote Meer; die Rote Erde (Bezeichnung für Westfalen); die Rote Fluß (in Vietnam); die Rote Wand (in Österreich); vgl. blau; vgl. rotsehen; **Rot** (rote Farbe) *;* -s, - (ugs.: -s); - auflegen; bei ist das Überqueren der Straße verboten; die Ampel steht auf, zeigt -; (Kartenspiel:) er spielte aus; vgl. Blau; **Röt** (Stufe der unteren Triasformation) s; -[e]s

o|ta it. w; - u. Ro|ta Ro|ma|na *at.* (höchster Gerichtshof der kath. Kirche) w; - -

o|tan[g] malai. (eine Palmenart) w; -s, -e; **Ro|tan[g]|pal|me**

o|ta|print ⓦ *lat.; engl.* (Offsetdruck- und -vervielfältigungsmaschinen)

o|ta|ri|er [...*iᵉr*] (Mitglied des Rotary Club); ro|ta|risch

ot|ar|mist

o|ta Ro|ma|na vgl. Rota

Ro|ta|ry Club engl. [*roᵘtᵉri klᵃb*] und **Ro|ta|ry In|ter|na|tio|nal** [*roᵘtᵉri ...näschᵉnᵉl*] (internationale Vereinigung führender Persönlichkeiten unter dem Gedanken des Dienstes) m; - -

Ro|ta|ti|on lat. [...*zion*] (Umdrehung, Umlauf); **Ro|ta|ti|ons_ach-se, ...druck** (*Mehrz.* ...drucke), **...el|lip|so|id, ...flä|che, ...kör|per, ...ma|gne|tis|mus, ...ma|schi|ne, ...pa|ra|bo|lo|id, ...pres|se; Ro|ta-to|ri|en** [...*iᵉn*] (Rädertierchen) *Mehrz.*

Rot|au|ge (ein Fisch); **rot_backig** [*Trenn.:* ...bak|kig] oder ...**bäckig** [*Trenn.:* ...bäk|kig]; **Rot_barsch, ...bart; rot_bär|tig, ...blond, ...braun** (↑R 158); **Rot_bu|che, ...dorn** (*Mehrz.* ...dorne); **Rö|te** w; -

Ro|te-Be|te-Sa|lat[1]

Ro|te-Kreuz-Los[1] s; Rote[n]-Kreuz-Loses, Rote[n]-Kreuz-Lose; **Ro|te-Kreuz-Lot|te|rie**[1] w; Rote[n]-Kreuz-Lotterie, Rote[n]-Kreuz-Lotterien; **Ro|te-Kreuz-Schwester**[1] w; Rote[n]-Kreuz-Schwester, Rote[n]-Kreuz-Schwestern; vgl. Rotkreuzschwester

Rö|tel (roter Mineralfarbstoff, -stift) m; -s, -; **Rö|teln** (eine Infektionskrankheit) *Mehrz.*; **Rö|tel-stift** m, ...**zeich|nung; rö|ten;** sich -

Ro|ten|burg a. d. Ful|da (Stadt in Hessen); **Ro|ten|burg (Han|no-ver)** (Stadt in Niedersachsen); vgl. aber: Rothenburg

Ro|te|turm|paß (in den Karpaten) m; Rote[n]turmpasses

Rot_fe|der (ein Fisch), ...**fil|ter** (Fotogr.), ...**fo|rel|le, ...fuchs ...gar|dist; rot|ge|sich|tig; rot|glü-hend; Rot|glut**

Rot|grün|blind|heit; ↑R 158 (Farbenfehlsichtigkeit, bei der Rot u. Grün verwechselt werden) w; -

Rot|gül|dig|erz; Rot|guß (Gußbronze); **Rot|haar|ge|bir|ge** (Teil des Rhein. Schiefergebirges) s; -s; **rot|haa|rig; Rot|haut** (scherzh. für: Indianer)

[1]**Roth,** Eugen (dt. Schriftsteller)

[2]**Roth,** Joseph (österr. Schriftsteller)

Ro|then|burg (schweiz. Ort bei Luzern); **Ro|then|burg ob der Tau-ber** (Stadt in Bayern); **Ro|then-burg (Ober|lau|sitz)** [auch: *...lau...*] (Stadt an der Lausitzer Neiße); **Ro|then|burg (Oder)** (Stadt in Niederschlesien); vgl. aber: Rotenburg ...

Rot|hirsch

Roth|schild (Bankierfamilie)

[1] ↑R 155.

ro|tie|ren lat. (umlaufen, sich um die eigene Achse drehen)

Rot_ka|bis (schweiz. für: Rotkohl), ...**käpp|chen, ...kehl|chen** (ein Singvogel), ...**kohl, ...kopf** (Mensch mit roten Haaren), ...**kraut** (s; -[e]s); **Rot|kreuz-schwe|ster,** Ro|te-Kreuz-Schwester (vgl. d.); **Rot|lauf** ([Tier]-krankheit) m; -[e]s; **röt|lich;** rötlichbraun usw. (↑R 158); **Rot licht** s; -[e]s; **Rot|lie|gen|de** (untere Abteilung der Permformation) s; -n (↑R 287ff.); **Röt|ling** (Vogel; Fisch; Pilz); **rot|na|sig**

Ro|tor lat. (sich drehender Teil von [elektr.] Maschinen) m; -s, ...oren; **Ro|tor|schiff**

Ro|traud (w. Vorn.)

Rot_schen|kel (ein Vogel), ...**schwanz** od. ...**schwänz|chen** (ein Vogel); **rot|se|hen;** ↑R 139 (ugs. für: wütend werden); er sieht rot; rotgesehen; rotzusehen; **Rot|spon** (ugs. für: Rotwein) m; -[e]s, -e; **Rot_stift** m, ...**tan|ne**

Rot|te w; -, -n; 'rot|ten (veralt. für: eine Rotte bilden)

[2]**rot|ten, röt|ten** (Landw.: [Flachs] zum Rotten, zum Rösten, zum Mürbewerden bringen)

Rot|ten (dt. Name des Oberlaufes der Rhone) m; -s

Rot|ten|burg a. d. Laa|ber (Ort in Niederbayern); **Rot|ten|burg am Neckar** [*Trenn.:* - - Nek|kar] (Stadt in Baden-Württemberg) **Rot|ten|füh|rer; rot|ten|wei|se Rot|ter|dam** [auch *rot...*] (niederl. Stadt); **Rot|ter|da|mer** (↑R 199) **Rot|tier** (Hirschkuh)

Rott|mei|ster (veralt.)

Rott|wei|ler (Hund einer bestimmten Rasse) m; -s, -

Ro|tu|lus lat. (veralt. für: Stoß Urkunden; [Akten]verzeichnis; Theaterrolle) m; -, ...li

Ro|tun|de lat. (Rundbau; runder Saal) w; -, -n

Rö|tung

rot|wan|gig; Rot|wein rot|welsch; Rot|welsch (Gaunersprache) s; -[es]; vgl. Deutsch; **Rot|wel|sche** s; -n; vgl. Deutsche s

Rot_wild, ...wurst (landsch. für: Blutwurst)

Rotz (derb für: Nasenschleim; [Tier]krankheit) m; -es, -e; **Rotz-ben|gel** (derb); **rot|zen** (derb für: sich schneuzen); du rotzt (rotzest); **Rotz|fah|ne** (derb für: Taschentuch); **rot|zig** (derb); **Rotz-jun|ge** (derb) m, ...**krank|heit** (derb), ...**na|se** (derb; auch übertr. abschätzig für: naseweises, freches Kind); **rotz|nä|sig** (derb) **Rotz|zun|ge** (ein Fisch)

Roué fr. [*rue*] (Wüstling mit feinen Sitten) m; -s, -s

Rouen [*ruãŋg*] (fr. Stadt an der unteren Seine); **Rouen-En|te** *w*; -, -n (↑ R 202)

Rouge *fr.* [*ruseh*] („rote" Schminke) *s*; -s, -s

Rouge et noir *fr.* [*ruseh e noar*] („Rot und Schwarz"; ein Glücksspiel) *s*; - - -

Rou|la|de *fr.* [*ru...*] (gerollte u. gebratene Fleischscheibe; Musik: perlender Lauf); **Rou|leau** [*...lo*] (aufrollbarer Vorhang) *s*; -s, -s; vgl. Rollo; **Rou|lett** (ein Glücksspiel) *s*; -[e]s, -e u. -s; **Rou|lette** [*rulãt*] *s*; -s, -s; vgl. Roulett; **rou|lie|ren** (veralt. für: umlaufen; Schneiderei: den Rand einrollen)

Round-table-Kon|fe|renz *engl.* [*raundteʼbl...*] (Konferenz am „runden Tisch" zwischen Gleichberechtigten); ↑ R 155

Rous|seau [*rußo*] (schweiz.-fr. Schriftsteller)

Rout *engl.* [*raut*] (veralt. für: Abendgesellschaft, -empfang) *m*; -s, -s; **Rou|te** *fr.* [*rutʼ*] (Weg[strecke], Reiseweg; [Marsch]richtung) *w*; -, -n; **Rou|ten_auf|nah|me**, **...ver|zeich|nis**; **Rou|ti|ne** ([handwerksmäßige] Gewandtheit; Fertigkeit, Übung) *w*; -; **Rou|ti|ne|an|ge|le|gen|heit**; **rou|ti|ne|mä|ßig**; **Rou|ti|ne_sa|che**, **...über|prü|fung**, **...un|ter|su|chung**; **Rou|ti|nier** [*...nie*] (jmd., der Routine hat) *m*; -s, -s; **rou|ti|niert** (gerissen, gewandt)

Row|dy *engl.* [*raudi*] (roher, gewalttätiger Mensch, Raufbold, Rohling) *m*; -s, -s (auch: ...dies [*raudis*]); **Row|dy|tum** *s*; -s

roy|al *fr.* [*roajal*] (königlich; königstreu); **Roy|al Air Force** *engl.* [*reuʼel är foʼß*] („Königl. Luftwaffe"; Bez. der brit. Luftwaffe; Abk.: R. A. F.) *w*; - - -; **Roya|lis|mus** *fr.* [*roajal...*] (Königstreue) *m*; -; **Roya|list** (↑ R 268); **roya|li|stisch**; -ste (↑ R 294)

Rp = Rupiah

Rp., **Rec.** = recipe

RP (bei Telegrammen) = Réponse payée *fr.* [*repoŋgß päjg*] (Antwort bezahlt)

Rp. = Rappen

RSFSR = Russische Sozialistische Föderative Sowjetrepublik

RT = Registertonne

Ru = chem. Zeichen für: Ruthenium

Ru|an|da (Staat in Zentralafrika); vgl. Rwanda; **Ru|an|der**; **ru|an|disch**

ru|ba|to *it.* (Musik: nicht im strengen Zeitmaß); **Ru|ba|to** *s*; -s, -s u. ...ti

rub|be|lig landsch. (rauh; polternd); **rub|beln** landsch. (reiben, frottieren); ich ...[e]le (↑ R 327)

Rub|ber *engl.* [*rãbʼr*] (engl. Bez. für: Gummi) *m*; -s

Rüb|chen, **Rüb|lein**; **Rü|be** *w*; -, -n

Ru|bel *russ.* (russ. Münzeinheit; Abk.: Rbl; 1 Rubel = 100 Kopeken) *m*; -s, -

Ru|ben (bibl. m. Eigenn.)

rü|ben|ar|tig; **Rü|ben|feld**

Ru|bens (fläm. Maler); -sche Gestalten (↑ R 179)

Rü|ben_schnit|zel (vgl. ²Schnitzel), **...si|rup**, **...zucker** [*Trenn.: ...zuk-ker*]

rü|ber; ↑ R 238 (ugs. für: herüber, hinüber)

Rü|be|zahl (schles. Berggeist)

Ru|bi|di|um *lat.* (chem. Grundstoff, Metall; Zeichen: Rb) *s*; -s

Ru|bi|kon (it. Fluß) *m*; -[s]; den - überschreiten (übertr. für: eine wichtige Entscheidung treffen)

Ru|bin *lat.* (ein Edelstein) *m*; -s, -e; **Ru|bin|glas** (*Mehrz.* ...gläser); **ru|bin|rot**

Ru|bra, **Ru|bren** (*Mehrz.* von: Rubrum); **Ru|brik** *lat.* ([urspr. rotgehaltener] Titel[kopf]; Abteilung[slinie]; übertr. für: Spalte, Klasse, Fach) *w*; -, -en; **ru|bri|zie|ren** (urspr. Überschriften u. Initialen malen; übertr. für: einordnen, einstufen); **Ru|bri|zie|rung**; **Ru|brum** (veralt. für: [Akten]aufschrift; kurze Inhaltsangabe) *s*; -s, ...bra u. ...bren

Rüb|sa|me[n] (Rübsen) *m*; ...mens; **Rüb|sen** (eine Pflanze) *m*; -s

Ruch [auch: *ruseh*] (dicht. für: Geruch; selten für: zweifelhafter Ruf) *m*; -[e]s, (selten:) Rüche

ruch|bar (durch das Gerücht bekannt); das Verbrechen wurde -

Ruch|gras (eine Grasgattung)

ruch|los (niedrig, gemein, böse, verrucht); -este (↑ R 292); **Ruch|lo|sig|keit**

ruck!; hau ruck!, ho ruck!; **Ruck** *m*; -[e]s, -e

Rück (Nebenform von: Rick)

Rück_an|sicht, **...ant|wort** (meist besser: Antwort)

ruck|ar|tig

Rück_äu|ße|rung, **...be|sin|nung**; **rück|be|züg|lich**; -es Fürwort (für: Reflexivpronomen); **Rück|bil|dung**; **Rück|bleib|sel** (veralt. für: Überbleibsel, Rückstand) *s*; -s, -; **Rück_blen|de**, **...blick**; **rück|blickend**[1]; **Rück|deckungs|ver|si|che|rung**[1] (Wirtsch.: eine Risikoversicherung); **rück|dre|hend** (Meteor.); -er Wind (sich entgegen der Uhrzeigerrichtung drehender Wind, z. B. von Nord auf Nordwest; Ggs.: rechtdrehend)

rucken[1], **ruck|sen** (von Tauben: gurren)

rücken[1]; jmdm. zu Leibe -

Rücken[1] *m*; -s, -; **Rücken|dek|kung**, **...lage**, **...leh|ne**, **...mar**; *s*; **Rücken|marks_ent|zün|dung**, **...schwind|sucht**; **Rücken|mus|kel**, **...schmerz**, **...schwim|men** (*s*; -s); **rücken|schwim|men**[1] (im allg. nur in der Grundform gebr.); e kann nicht -; **Rücken|stär|kun**; **...tra|ge**

Rück_ent|wick|lung

Rücken|wind[1]

Rück|er|bit|tung; unter - (Abk.: R.); **Rück_er|in|ne|rung**, **...er|stat|tung**, **...fahr|kar|te**, **...fahr**; **...fall** *m*; **Rück|fall_dieb|stah**; **...fie|ber**; **rück|fäl|lig**; **Rück_flu**; **...fra|ge**; **rück|fra|gen**; er hat noc einmal rückgefragt; **Rück_from**; **...füh|rung**, **...ga|be**, **...gang** *m*; **rück|gän|gig**; -e Geschäfte; **Rück_ent|wicklung**; - machen; **Rück** **gän|gig|ma|chung**; **rück|ge|b** det; **Rück_ge|win|nung**, **...glie|d rung**; **Rück|grat** *s* (schweiz. auch *m*); -[e]s, -e; **Rück_grat|ver|krü** **mung**; **Rück_griff** (auch für: R greß), **...halt**; **rück|halt|los**

Rück_hand (*w*; -), **...kampf**, **...kau** (↑ R 236); **Rück_kaufs_rech** **...wert**; **Rück|kehr** (↑ R 236) *w*; **rück|kop|peln**; ich ...[e]le (↑ 327); **Rück_kop|pe|lung** ode **...kopp|lung** (Rundf.), **...kopp|l** (Rundf.), **...kunft** (*w*; -)

Rück_la|ge (zurückgelegter B trag), **...lauf**; **rück|läu|fig**; -e B wegung; -e Entwicklung; **Rück licht** (*Mehrz.* ...lichter); **rück** **lings**

Rück_marsch, **...nah|me** *w*; -, -n ...por|to, ...rei|se, ...ruf

Ruck|sack

Rück_schau; **Rück|schlag** (schwei auch für: Defizit); **Rück|schla** **ven|til** (Ventil, das ein Gas o eine Flüssigkeit nur in einer Ric tung durchströmen läßt); **Rüc** **_schluß**, **...schritt** *s*; **rück|schri** **lich**; **Rück_sei|te**; **Rück|sei|te** **wet|ter** (Meteor.: Wetter an d seiner Zugrichtung abgewandt Seite eines Tiefs); **rück|sei|tig**

Rück_sen|dung

Rück|sicht *w*; -, -en; ohne, in, m - auf; - nehmen; **Rück|sicht|li** (mit Rücksicht auf); mit *Wes* - seiner Fähigkeiten; **Rück|sicht nah|me** *w*; -; **rück|sichts_los**, -es (↑ R 292); **Rück|sichts_lo|sig|ke rück|sichts|voll**; er ist ihr gege über od. gegen sie immer -

Rück_sied|lung, **...sitz**, **...spie|g kung** (Sportspr.; Ggs.: Hi spiel), **...spra|che**, **...stand** (im bleiben, in - kommen); **rüc**

[1] *Trenn.: ...k|k...*
 [1] *Trenn.: ...k|k...*

stand|frei, rück|stands|frei; rück-
stän|dig
Rück.start, ...stau, ...stel|lung
(Wirtsch.: Passivposten in der Bi-
lanz zur Berücksichtigung un-
gewisser Verbindlichkeiten),
...stoß; Rück|stoß|an|trieb (für:
Raketenantrieb); Rück.strah|ler
(Schlußlicht bei Fahrzeugen),
...strom, ...trans|port, ...tritt;
Rück|tritt|brem|se; Rück|tritts-
.dro|hung, ...ge|such
ück|über|set|zen; nur in der
Grundform u. im 2. Mittelwort
gebräuchlich: ich werde den Text
-; der Text ist rückübersetzt;
Rück|über|set|zung
ück|ver|gü|ten; nur in der Grund-
form u. im 2. Mittelwort ge-
bräuchlich: ich werde ihm den
Betrag -; der Betrag wurde ihm
rückvergütet; Rück|ver|gü|tung
ück|ver|si|chern, sich; ich rück-
versichere mich († R 327); rück-
versichert; rückzuversichern;
Rück|ver|si|che|rung; Rück|ver-
si|che rungs|ver|trag; Rück-
.wand, ...wan|de|rer, ...wan|de-
rung, ...wa|re (Wirtsch.: in das
Zollgebiet zurückkehrende Wa-
re)
ück|wär|tig; -e Verbindungen;
rück|wärts; - fahren, - gehen
usw.; er ist rückwärts gegangen;
aber († R 139): rückwärtsgehen
(sich verschlechtern); es ist mit
dem Umsatz immer mehr rück-
wärtsgegangen; Rück|wärts|gang
(beim Kraftfahrzeug) m; rück-
wärts|ge|hen; vgl. rückwärts;
rück|wärts|ge|wandt; Rück-
wärts|ver|si|che|rung (Versiche-
rungsw.: Gewährung von Versi-
cherungsschutz für einen vor
dem Vertragsabschluß liegenden
Zeitraum)
ück_wech|sel (für: Rikambio),
..weg
ack|wei|se
ück|wen|dung; rück|wir|kend;
Rück.wir|kung, ...zah|lung, ...zie-
her; einen - machen (ugs. für: zu-
rückweichen; ein Versprechen
zurückziehen); rück|zie|lend
(auch veralt. für: rückbezüglich)
ück, zuck!
ück|zug; Rück|zugs|ge|fecht
ü|de, (österr. auch:) rüd fr. (roh,
grob, ungesittet)
ü|de (männl. Hund, Hetzhund)
m; -n, -n († R 268)
u|del s; -s, -; ru|del|wei|se
u|der s; -s, -; ans - (ugs. für: in
leitende Stellung) kommen
u|de|ral|pflan|ze lat.; dt. (Pflan-
ze, die auf stickstoffreichen
Schutt- od. Abfallplätzen ge-
deiht)
u|der.bank (Mehrz. ...bänke),

...boot; Ru|de|rer; Ru|der_fü|ßer
(für: Kopepode), ...gän|ger (Se-
geln: jmd., der das Ruder be-
dient), ...haus; ...ru|de|rig, ...rud-
rig (z. B. achtrud[e]rig); Ru|de-
rin, Rud|re|rin w; -, -nen; Ru|der-
ma|schi|ne; ru|dern; ich ...ere († R
327); Ru|der.re|gat|ta, ...schlag,
...sport, ...ver|band (Deutscher -)
Rü|des|heim am Rhein (Stadt in
Hessen), ¹Rü|des|hei|mer († R
199); ²Rü|des|hei|mer (Wein)
Ru|di (Kurzform von: Rudolf)
Rü|di|ger (m. Vorn.)
Ru|di|ment lat. (Rest, Überbleib-
sel, Bruchstück; verkümmertes
Organ) s; -[e]s, -e; ru|di|men|tär
(nicht ausgebildet, zurückgeblie-
ben, verkümmert); -es Organ
Ru|dolf (m. Vorn.); Ru|dol|fa, Ru-
dol|fi|ne (w. Vorn.); Ru|dol|fi|ni-
sche Ta|feln (von Kepler für Kai-
ser Rudolf II. zusammengestellte
Tafeln über Sternenbahnen)
Mehrz.
Ru|dol|stadt (Stadt a. d. Saale);
Ru|dol|städ|ter († R 199)
Rud|re|rin vgl. Ruderin; ...rud|rig
vgl. ...ruderig
Ruf m; -[e]s, -e
Ru|fe, Rü|fe schweiz. (Erdrutsch,
Steinlawine, Mure) w; -, -n
ru|fen; du rufst; du riefst (riefest);
du riefest; gerufen; ruf[e]!; er ruft
mich, den Arzt; Ru|fer
Rüf|fel (Verweis) m; -s, -; rüf|feln;
ich ...[e]le († R 327); Rüff|ler
Ruf.mord (schwere Verleum-
dung), ...na|me, ...num|mer,
...säu|le, ...wei|te (w; -), ...zei|chen
Rug|by engl. [rggbi] (ein Ballspiel)
s; -
Rü|ge w; -, -n; Rü|ge|ge|richt; rü-
gen
Rü|gen (Insel vor der vorpommer-
schen Ostseeküste); Rü|ge|ner
(† R 199); rü|gensch vgl. rügisch
rü|gens|wert; Rü|ger
Ru|gi|er [...iˀr] (Angehöriger eines
ostgerm. Volksstammes)
rü|gisch, (auch:) rü|gensch [zu R ü-
gen]
Ru|he w; -; jmdn. zur [letzten] Ru-
he betten (geh. für: beerdigen);
sich zur Ruhe setzen; Ru|he|bank
(Mehrz. ...bänke); Ru|he|be|dürf-
tig; Ru|he|bett (veralt. für: Liege-
sofa, übertr. auch für: [letzte] Ru-
hestätte), ...ge|halt s; ru|he|ge-
halts|fä|hig; Ru|he.geld, ...ge|nuß
(österr. Amtsspr.: Ruhegehalt,
Pension), ...kis|sen, ...la|ge; ru-
he|lie|bend, aber († R 142): die
Ruhe liebend; ru|he|los; -este († R
292); Ru|he|lo|sig|keit w; -; Ru|he-
mas|se w; -; Ruhmasse; ru|hen;
vgl. ruhenlassen; ruht! (österr.
für: rührt euch!); ru|hend; er ist
der -e Pol; die -e Venus (auf Bil-

dern); der ruhende Verkehr; ru-
hen|las|sen; † R 139 ([vorläufig]
nicht bearbeiten); er wird den
Fall -, (seltener:) ruhengelassen
(† R 305); aber: ru|hen las|sen
(ausruhen lassen); er wird uns
nicht länger ruhen lassen; Ru|he-
.pau|se, ...platz, ...punkt; ru|he-
se|lig, ruh|se|lig (veralt.); Ru|he-
sitz; Ru|he|stand m; -[e]s; des -[e]s
(Abk.: d. R.); im -[e] (Abk.: i
R.); Ru|he|ständ|ler; Ru|he|statt
od. Ru|he|stät|te; Ru|he|stel|lung;
ru|he|stö|rend; -er Lärm, aber
(† R 142): die Ruhe störend; Ru-
he|stö|rer; Ru|he.stö|rung, ...tag,
...zeit; ru|hig; ein -es Gewissen;
eine -e Hand; - sein, werden, blei-
ben usw.; aber: ru|hig|stel|len;
† R 139 (Med.); der Arm wurde
ruhiggestellt; Ru|hig|stel|lung
(Med.) w; -
Ruhm m; -[e]s
Ruh|mas|se, Ru|he|mas|se (Phy-
sik)
ruhm|be|deckt, aber († R 142): mit
Ruhm bedeckt; Ruh|me|gier[de]
w; -; ruhm|be|gie|rig, aber († R
143): nach Ruhm begierig; rüh-
men; sich seines Wissens -; († R
120:) nicht viel Rühmens von ei-
ner Sache machen; rüh|mens-
wert; Ruhm|mes.blatt, ...hal|le,
...tag, ...tat; rühm|lich; ruhm|los;
-este († R 292); Ruhm|lo|sig|keit
w; -; ruhm|re|dig; Ruhm|re|dig-
keit w; -; ruhm|reich; Ruhm|sucht
w; -; ruhm|süch|tig; Ruh|mung;
ruhm|voll
¹Ruhr (Infektionskrankheit des
Darmes) w; -, (selten:) -en
²Ruhr (rechter Nebenfluß des Nie-
derrheins) w; -; vgl. aber: Rur
Rühr|ei; rüh|ren; sich -; rüh|rend;
-ste
Ruhr|ge|biet s; -[e]s
rühr|haft (veralt. für: schnell ge-
rührt); rüh|rig; Rüh|rig|keit w; -
ruhr|krank
Rühr.löf|fel, ...ma|schi|ne; Rühr-
mich|nicht|an (eine Pflanze) s; -,
-; das Kräutlein -
Ruhr|ort (Stadtteil von Duisburg)
rühr.sam (veralt.), ...se|lig; Rühr-
.se|lig|keit, ...stück; Rüh|rung w;
-; Rühr|werk
ruh|sam (veralt.); ruh|se|lig vgl.
ruheselig
Ru|in lat.-fr. (Zusammenbruch,
Untergang, Verfall; Verderb,
Verlust [des Vermögens]) m; -s;
Ru|i|ne (zerfallen[d]es Bauwerk,
Trümmer) w; -, -n; rui|nen.ar|tig,
...haft; rui|nie|ren lat. (zerstören,
verwüsten); sich -; rui|nös
(schadhaft; verderblich); -este
(† R 292)
Ruis|dael [reußdal], Jacob (nie-
derl. Maler)

Ru|län|der (eine Traubensorte)

Rülps (derb für: hörbares Aufsto-
ßen; landsch. für: Flegel, roher
Kerl) m; -es, -e; rülp|sen (derb);
du rülpst (rülpsest); Rülp|ser
(derb)

rum; ↑ R 238 (ugs. für: herum)

Rum engl. [südd. u. österr. auch:
rum] (Branntwein [aus Zucker-
rohr]) m; -s, -s

Ru|mä|ne m; -n, -n (↑ R 268); Ru-
mä|ni|en [...iⁿn]; ru|mä|nisch; Ru-
mä|nisch (Sprache) s; -[s]; vgl.
Deutsch; Ru|mä|ni|sche s; -n; vgl.
Deutsche s

Rum|ba kuban. (ein Tanz) w; -,
-s (ugs. auch: m; -s, -s)

Rum|fla|sche

rum|krie|gen (ugs. für: herumkrie-
gen)

Rum|mel (ugs. für: lärmender Be-
trieb; Durcheinander) m; -s; rum-
meln landsch. (lärmen) (ugs.);
Rum|mel|platz (ugs.)

Rum|my engl. [rǫmi, engl. Ausspr.:
rǫmi] österr. (Rommé) s; -s, -s

Ru|mold vgl. Romuald

Ru|mor lat. (veralt., aber noch
mdal. für: Lärm, Unruhe) m; -s;
ru|mo|ren; er hat rumort

¹Rum|pel südd. u. mitteld. (Ge-
rumpel; Gerümpel) m; -s, -;
²Rum|pel mitteld. (Waschbrett)
w; -, -n; rum|pe|lig, rump|lig
landsch. (holprig); Rum|pel|kam-
mer (ugs.); rum|peln (ugs.); ich
...[e]le (↑ R 327); Rum|pel|stilz-
chen (Märchengestalt) s; -s

Rumpf m; -[e]s, Rümpfe

rümp|fen

Rumpf.ge|schäfts|jahr, ...krei|sen
(eine gymnast. Übung; s; -s),
...par|la|ment, ...stück (Rump-
steak)

rump|lig vgl. rumpelig

Rump|steak engl. [rǫmpßtẹk] (ge-
bratenes Rumpfstück) s; -s, -s

rums!

Rum.topf, ...ver|schnitt

Run engl. [rạn] (Ansturm [auf die
Kasse]) m; -s, -s

rund ([im Sinne von: etwa] Abk.:
rd.); -er, -este (↑ R 292); Gespräch
am -en Tisch; - um die Welt,
aber: rundum; es geht - (ugs.:
es ist viel Betrieb; es gibt viel Ar-
beit); Rund s; -[e]s, -e; Run|da
(Zechgesang; Volkslied im Vogt-
land) s; -s, -s; Rund.bank (Mehrz.
...bänke), ...bau (Mehrz. ...bau-
ten), ...beet (für: Rondell),
...blick, ...bo|gen, ...brief; Run|de
w; -, -n; die - machen; die erste
-; Rün|de (veralt. für: Rundsein)
w; -; Run|dell vgl. Rondell; run-
den (rund machen); sich -; rün|den
(veralt. für: runden); Run|den.re-
kord (Sportspr.), ...zeit (Sport-
spr.); Rund|er|laß; rund|er|neu-

ert; -e Reifen; Rund.er|neue|rung,
...fahr|kar|te, ...fahrt, ...flug,
...fra|ge, ...funk (m; -[e]s); Rund-
funk.an|stalt, ...ap|pa|rat, ...emp-
fän|ger, ...ge|bühr, ...ge|neh|mi-
gung, ...ge|rät, ...hö|rer, ...pro-
gramm, ...sen|der, ...spre|cher,
...sta|ti|on, ...über|tra|gung,
...wer|bung, ...zeit|schrift; Rund-
.gang m, ...ge|sang, ...ge|spräch;
Rund|heit w; -; rund|her|aus; et-
was - sagen; rund|her|um; Rund-
.holz, ...ho|ri|zont (Theater),
...kurs, ...lauf (ein Turngerät);
rund|lich; Rund|lich|keit w; -;
Rund|ling (Dorfanlage); Rund-
rei|se; Rund|rei|se|kar|te; Rund-
.schä|del, ...schau, ...schild m,
...schrei|ben, ...schrift, ...sicht,
...spruch (schweiz. für: [Draht]-
rundfunk; m; -[e]s), ...strecke
[Trenn.: ...strek|ke], ...stück
(nordd. für: Brötchen); rund|um;
rund|um|her; Run|dung; Rund-
ver|kehr; rund|weg; Rund|weg

Ru|ne altnord. (germ. Schriftzei-
chen) w; -, -n; Ru|nen.al|pha|bet,
...for|schung, ...schrift, ...stein

Run|ge (Stange zwischen Wagen-
seite u. Radachse) w; -, -n; Run-
gen|wa|gen

ru|nisch [zu: Rune]

Run|kel (österr.) w; -, -n; Run|kel-
rü|be

Run|ken mitteld. (unförmiges
Stück Brot) m; -s, -; Runks (ugs.
für: ungeschliffener Mensch) m;
-es, -e; runk|sen (ugs. für: sich
wie ein Runks benehmen; Sport:
rücksichtslos spielen); du runkst
(runksest)

Ru|no|lo|ge altnord.; gr. (Runen-
forscher) m; -n, -n (↑ R 268); Ru-
no|lo|gie (Runenforschung) w; -

Runs (Nebenform von Runse) m;
-es, -e; Run|se südd., österr.;
schweiz. (Rinne an Berghängen,
mit Wildbach) w; -, -n

run|ter; ↑ R 238 (ugs. für: herunter,
hinunter)

Run|zel w; -, -n; run|ze|lig, runz|lig;
run|zeln; ich ...[e]le (↑ R 327)

Ru|od|lieb [auch: rụodliäp]
(Hauptperson des gleichnamigen
lat. Romans eines Tegernseer
Geistlichen [um 1050])

Rü|pel m; -s, -; Rü|pe|lei; rü|pel-
haft; Rü|pel|haf|tig|keit w; -

Ru|pert, Ru|precht (m. Vorn.);
Knecht Ruprecht; Ru|per|tus vgl.
Rupert

¹rup|fen; Gras -; ²rup|fen (aus
Rupfen); Rup|fen (Jutegewebe)
m; -s, -; Rup|fen|lein|wand

Ru|pi|ah Hindi (indones. Wäh-
rungseinheit; 1 Rupiah = 100
Sen; Abk.: Rp) w; -, -; Ru|pie
[...iⁿ] (Münzeinheit in Indien,
Ceylon u. a.) w; -, -n

rup|pig; Rup|pig|keit; Rupp|sack
(ugs. für: ruppiger Mensch)

Ru|precht vgl. Rupert u. Knech
Ruprecht

Rup|tur lat. (Med.: Zerreißung) w
-, -en

Rur (r. Nebenfluß der Maas) w
-; vgl. aber: ²Ruhr

ru|ral lat. (veralt. für: ländlich
bäuerlich)

Rus russ. [rụßj] (alte Bez. der ost
slaw. Stämme für Rußland, russ
Gebiet) w; -; Kiewer -

Rusch lat. nordd. mdal. (Binse
m; -es, -e; in - und Busch

Rü|sche (gefalteter Besatz) w; -
-n

Ru|schel mdal. (ruschelige Per
son) w; -, -n (auch: m; -s, -); ru
sche|lig, rusch|lig mdal. (unor
dentlich, schlampig); ru|scheln
(mdal.); ich ...[e]le (↑ R 327)

Rush-hour engl. [rạsch-auⁿr
(Hauptverkehrszeit) w; -

Ruß m; -es; ruß|be|schmutzt, abe
(↑ R 142): von Ruß beschmutzt
ruß|braun

¹Rus|se (Angehöriger eines ost
slaw. Volkes in der UdSSR) m
-n, -n (↑ R 268); ²Rus|se landsch
(Schabe); m; -n, -n (↑ R 268)

Rüs|sel m; -s, -; rüs|sel|för|mig; rüs
se|lig, rüß|lig; Rüs|sel.kä|fer
...tier

ru|ßen (schweiz. auch: [Ofenrohr
Rauchfang] von Ruß reinigen.
du rußt (rußest); es rußt

Rus|sen|stie|fel

ruß|far|ben, ruß|far|big; ruß|ge
schwärzt; vgl. rußbeschmutzt; ru
ßig; Ru|ßig|keit w; -

Rus|sin w; -, -nen; rus|sisch; -e Eier
-er Salat; -es Roulett, aber (↑ R
224): der (bestimmte) Russisch
Türkische Krieg; vgl. deutsch
Rus|sisch (Sprache) s; -[s]; vgl
Deutsch; Rus|si|sche s; -n; vgl
Deutsche s; rus|sisch-rö|misc
(↑ R 158); russisch-römische
Bad; Ruß|land

rüß|lig, rüs|se|lig

ruß|schwarz

Rüst|an|ker (Ersatzanker)

¹Rü|ste landsch. (Rast, Ruhe) w
-; zur - gehen (dicht. von der Son
ne u. a.: untergehen, zu Ende ge
hen)

²Rü|ste (Seemannsspr.: stark
Planke an der Schiffsaußenseit
zum Befestigen von Ketten oc
Stangen) w; -, -n

rü|sten; sich - (schweiz. auch: sic
festlich kleiden); Gemüse
(schweiz.: putzen, vorbereiten)

Rü|ster (Ulme) w; -, -n; rü|stern
(aus Rüsterholz); Rü|ster[n]|hol
rü|stig; Rü|stig|keit w; -

Ru|sti|ka lat. (Mauerwerk aus

Quadern mit roh bearbeiteten Außenflächen, Bossenwerk) w; -; ru|sti|kal (ländlich, bäuerlich); Ru|sti|kus (veralt. für: plumper Mensch) m; -, -se u. ...stizi; Ru|sti|zi|tät (veralt. für: plumpes Wesen) w; -

Rüst..kam|mer, ...tag; Rü|stung; Rü|stungs..be|gren|zung, ...be|schrän|kung, ...be|trieb, ...in|dustrie, ...kon|trol|le, ...wett|lauf; Rüst..zeit, ...zeug

Rut vgl. ²Ruth

Ru|te (Stock; früheres Längenmaß; Jägerspr.: Schwanz; allg. für: männl. Glied bei Tieren) w; , -n; Ru|ten hin|del, ...gän|ger ([Quellen-, Gestein-, Erz]sucher mit der Wünschelrute)

Ruth (w. Vorn.); ²Ruth, (ökum.:) Rut (bibl. w. Eigenn.); das Buch - Rut|hard (m. Vorn.)

Ru|the|ne (früher: Bez. für den im ehem. Österreich-Ungarn lebenden Ukrainer) m; -n, -n (↑ R 268); ru|the|nisch; Ru|the|ni|um (chem. Grundstoff, Metall; Zeichen: Ru) s; -s

Ru|ther|ford [rᴐdhᵉrfᵉrd], Ernest [ᴐnißt] (engl. Physiker); Ru|ther|for|di|um (svw: Kurtschatovium) s; -s

Ru|til lat. (ein Mineral) m; -s, -e; Ru|ti|lis|mus (Med.: Rothaarigkeit) m; -

Ru|ti|ne usw. (eindeutschende Schreibung von: Routine usw.)

Rüt|li (Bergmatte am Vierwaldstätter See) s; -s; Rüt|li|schwur; ↑ R 201 (sagenumwobene Verschwörung bei der Gründung der Schweiz. Eidgenossenschaft [1291]) m; -[e]s

utsch!; Rutsch (ugs.) m; -[e]s, -e; Rutsch|bahn; Rut|sche (Gleitbahn) w; -, -n; rut|schen; du rutschst (rutschest); Rut|scher (früher landsch. für einen Tanz; österr. ugs.: kurze Fahrt, Abstecher); Rut|sche|rei; rutsch|fest; rut|schig, Rutsch|par|tie (ugs. für: [unfreiwillige] gleitende Abfahrt); rutsch|si|cher

Rüt|te (ein Fisch) w; -, -n

Rüt|tel|be|ton; Rüt|te|lei; Rüt|telfal|ke; rüt|teln; ich ...[e]le (↑ R 327); Rüt|tel|sieb; Rütt|ler (ein Baugerät)

Rütt|stroh (geknicktes, kurzes Stroh)

RVO = Reichsversicherungsordnung

Ru|wer (r. Nebenfluß der Mosel) w; -; ²Ru|wer (Wein) m; -s, -

tuys|dael vgl. Ruisdael

twan|da (fr. Schreibung von: Ruanda)

RWE = Rheinisch-Westfälisches Elektrizitätswerk

S

S (Buchstabe); das S; des S, die S, aber: das s in Hase (↑ R 123); der Buchstabe S, s

s (Astron.: ...ˢ), sec, sek, Sek = Sekunde; s, sh = Shilling

S = Schilling; Sen; ²Siemens; Süd[en]; Sulfur (chem. Zeichen für: Schwefel)

$ = Dollar

Σ, σ, ç = Sigma

s. = sieh[e]!

S. = San, Sant', Santa, Santo, São; Seite

S., Se, = Seine (Exzellenz usw.)

Sa. = Summa; Sachsen; Samstag

s. a. = sine anno

Saal m; -[e]s; Säle; aber: Sälchen (vgl. d.); Saal|bau (Mehrz. ...bauten)

Saal|burg (röm. Grenzbefestigung im Taunus) w; -

Saa|le (l. Nebenfluß der Elbe) w; -; Saal|feld/Saa|le

Saal..ord|ner, ...schlacht, ...tochter (schweiz. für: Kellnerin im Speisesaal), ...tür

Saa|ne (l. Nebenfluß der Aare) w; -; Saa|nen (schweiz. Ort); Saanen|kä|se

Saar (r. Nebenfluß der Mosel) w; -; Saar|brücken [Trenn.: ...brükken] (Hptst. des Landes Saarland); Saar|brücker [Trenn.: ...brük|ker] (↑ R 199); Saar|gebiet; Saar|land (Land) s; -[e]s; Saar|län|der; saar|län|disch, aber (↑ R 224): Saarländischer Rundfunk; Saar-Na|he-Bergland (↑ R 203)

Saat w; -, -en; Saa|ten..pfle|ge (w; -), ...stand (m; -[e]s); Saat..furche, ...ge|trei|de, ...gut, ...kar|toffel, ...korn (Mehrz. ...körner), ...krä|he, ...land

Saaz (Stadt an der Eger); Saa|zer (↑ R 199)

Sa|ba (hist. Landschaft in Südarabien)

Sa|ba|dil|le mex.-span. (amerik. Liliengewächs, Heilpflanze) w; -, -n; Sa|ba|dil|len|sol|be

Sa|bä|er (Angehöriger eines alten Volkes in Südarabien) m; -s, -

Sab|bat hebr. (jüd. „Ruhetag"; Samstag) m; -s, -e; Sab|ba|ta|ri|er [...iᵉr] u. Sab|ba|ti|sten (Bez. verschiedener christl. Sekten) Mehrz.; Sab|bat|stil|le

Sab|bel, Sab|ber niederd. u. ostmitteld. (ausfließender Speichel) m; -s; Sab|bel|lätz|chen, Sab|berlätz|chen (Kinderspr.): sab|bern (ugs.); ich ...[e]le (↑ R 327); sab|bern (ugs.); ich ...ere (↑ R 327)

Sä|bel ung.-poln. m; -s, -; Sä|bel|bei|ne (O-Beine) Mehrz.; sä|bel-

bei|nig; Sä|bel|fech|ten s; -s; sä|bel|för|mig; Sä|bel|ge|ras|sel; Sä|bel|hieb; sä|beln (ugs. für: ungeschickt schneiden); ich ...[e]le (↑ R 327); Sä|bel..ras|seln (s; -s), ...raßler

Sa|be|na = Société Anonyme Belge d'Exploitation de la Navigation Aérienne (belg. Luftfahrtgesellschaft) w; -

Sa|bi|na, Sa|bi|ne (w. Vorn.); Sa|bi|ner (Angehöriger eines ehem. Volksstammes in Mittelitalien) m; -s, -; Sa|bi|ne|rin w; -, -nen; sa|bi|nisch

Sa|bo|ta|ge fr. [...taseh^e], österr.: ...taseh] ([planmäßige] Beeinträchtigung eines wirtschaftl. Produktionsablaufs, militär. Operationen u. ä. durch [passiven] Widerstand od. durch Beschädigung od. Zerstörung der [Betriebs]einrichtungen); Sa|bo|ta|ge|akt; Sa|bo|teur [...tör] m; -s, -e; sa|bo|tie|ren

Sa|bri|na (engl. w. Vorn.)

SAC = Schweizer Alpen-Club

Sac|cha|ra|se, Sa|cha|ra|se sanskr. [saeha...] (ein Enzym) w; -; Sac|cha|ri|me|ter, Sa|cha|ri|me|ter sanskr.; gr. (Gerät zur Bestimmung der Konzentration von Rohrzuckerlösungen) s; -s, -; Sac|cha|ri|me|trie, Sa|cha|ri|me|trie (Bestimmung des Zuckergehaltes einer Lösung) w; -; Sac|cha|rin, Sa|cha|rin (ein Süßstoff) s; -s

Sa|cha|lin [auch: sa...] (ostasiat. Insel)

Sach|an|la|ge|ver|mö|gen (Wirtschaft)

Sa|cha|ra|se usw. vgl. Saccharase

Sa|char|ja (jüd. Prophet)

Sach..be|ar|bei|ter, ...be|fug|nis (Rechtsw.; w; -), ...be|reich, ...be|schä|di|gung, ...buch; sach|dien|lich; Sa|che w; -, -n; für die gute - opfern; in -n des Geschmacks; in Sachen Meyer [gegen Müller]; zur - kommen; Sach|ein|la|ge (Wirtsch.: Einlage bei der Gründung einer AG); Sä|chel|chen, Säch|lein; Sa|chen|recht; Sach..er|klä|rung

Sa|cher|tor|te [nach dem Wiener Hotelier Sacher] (eine Schokoladentorte); ↑ R 180

Sach|fir|ma (Firmenname, der den Gegenstand des Unternehmens angibt; Ggs.: Personenfirma); sach|fremd; Sach|ge|biet; sach..ge|mäß, ...ge|recht; Sach..grün|dung (Wirtsch.: Gründungsform einer AG), ...ka|pi|tal|er|hö|hung (Wirtsch.), ...ka|ta|log, ...kennt|nis, ...kun|de (w; -); sach|kun|dig; Sach..la|ge, ...le-

Sächlein 588

gi|ti|ma|ti|on (Rechtsw.); **Säch-**
lein, Sä|chel|chen; **Sach|lei|stung;**
sach|lich (zur Sache gehörend;
auch für: objektiv); -e Kritik;
-er Ton; -er Unterschied; -e
Angaben; **säch|lich;** -es Ge-
schlecht; **Sach|lich|keit;** die Neue
- (Kunststil); **Sach|män|gel|haf-**
tung (Wirtsch.); **Sach|re|gi|ster**
[1]**Sachs** (dt. Meistersinger u. Dich-
ter); Hans Sachs' Gedichte († R
310)
[2]**Sachs** (altes Eisenmesser) *m;* -es,
-e
Sach|scha|den (Ggs.: Personen-
schaden)
Sach|se *m;* -n, -n († R 268); **säch-**
seln (sächsisch sprechen); ich
...[e]le († R 327); **Sach|sen** (Abk.:
Sa.); **Sach|sen-An|halt;** ↑ R 212;
Sach|sen_spie|gel (Rechtssamm-
lung des dt. MA.; *m;* -s), ...**wald**
(Waldgebiet östl. von Hamburg;
m; -[e]s); **Säch|sin** *w;* -, -nen; **säch-**
sisch, aber († R 198): die Sächsi-
sche Schweiz (Teil des Elbsand-
steingebirges)
sacht (leise); **sacht|chen** obersächs.
(ganz sachte); **sach|te** (ugs.);
sachte!; sachte voran! (ugs.)
Sach_über|nah|me, ...**ver|halt** (*m;*
-[e]s, -e); **Sach|ver|si|che|rung;**
sach|ver|stän|dig; Sach|ver|stän-
di|ge *m* u. *w;* -n, -n († R 287ff.);
Sach|ver|stän|di|gen_aus|schuß,
...**eid,** ...**gut|ach|ten; Sach_ver-**
zeich|nis, ...**wal|ter; sach|wal|te-**
risch; Sach_wei|ser (Sachregi-
ster), ...**wert,** ...**wör|ter|buch**
Sack *m;* -[e]s, Säcke; 5 - Mehl († R
321 u. 322); mit - und Pack; **Sack-**
_bahn|hof, ...**band** *s* (*Mehrz.*
...bänder); **Säck|chen,** Säck|lein;
Säckel[1] (landschaftl.) *m;* -s, -;
...[e]le († R 327); **Säckel|wart**[1]
(landsch.); [1]**sacken**[1] landsch. (in
einen Sack füllen); [2]**sacken**[1], sich
(sich senken, sich zu Boden set-
zen, sinken)
säcken[1] (veralt. für: in einem Sack
ertränken)
sacker|lot![1] vgl. sapperlot!; **sacker-**
ment![1] vgl. sapperment!
säcke|wei|se (in Säcken); **sack-**
för|mig; Sack|gas|se; sack|grob
(ugs. für: sehr grob); **Sack|hüp-**
fen *s;* -s
Säckin|gen[1] (bad. Stadt am Hoch-
rhein); **Säckin|ger**[1]
Sack_lau|fen *s;* -s; **Säck|lein,** Säck-
chen; **Sack_lei|nen,** ...**lein|wand;**
Säck|ler landsch. (Lederarbei-
ter); **Sack_pfei|fe,** ...**spin|ner**
(Schmetterling), ...**trä|ger,** ...**tuch**

(grobes Tuch; südd., österr. ugs.
neben: Taschentuch; *Mehrz.*
...tücher); **sack|wei|se** (Sack für
Sack)
Sad|du|zä|er hebr. (Angehöriger
einer altjüd. Partei) *m;* -s, -
Sä|de|baum *lat.; dt.* (wacholderar-
tiger Nadelbaum)
Sa|dis|mus [nach dem fr. Schrift-
steller de Sade] [wollüstige]
Freude an Grausamkeit) *m;* -; **Sa-**
dist († R 268); **sa|di|stisch; Sa-**
dist († R 294); **Sa|do|ma|so|chis|mus**
[...*chiß*...] (Verbindung von Sa-
dismus u. Masochismus); **sa|do-**
ma|so|chi|stisch
Sa|do|wa (Dorf bei Königgrätz)
sä|en; du säst, er sät; du sätest;
gesät; säe!; **Sä|er**
Sa|fa|ri arab. (meist mit Trägerko-
lonnen ausgeführte Überlandrei-
se in Afrika; Gesellschaftsrei-
se in Afrika zum Jagen, Fotografie-
ren) *w;* -, -s; **Sa|fa|ri_an|zug,**
...**kleid**
Safe engl. [*ße'f*] („sicher"; Geld-
schrank, Stahlkammer, Sicher-
heits-, Bank-, Schließfach) *m*
(auch: *s*); -s, -s
Saf|fi|an pers. (feines Ziegenleder)
m; -s; **Saf|fi|an_le|der**
Saf|flor *arab.-it.* (Färberdistel) *m;*
-s, -e; **saf|flor_gelb**
Sa|fran pers. (Krokus; Farbe; Ge-
würz) *m;* -s, -e; **saf|fran_gelb**
Saft *m;* -[e]s, Säfte; roter - (ugs.
für: Blut); **Saft_bra|ten; Säft-**
chen, Säft|lein; **saf|ten; saft|grün;**
saf|tig (ugs. auch für: derb); **Saf-**
tig|keit; Saft_kur (mit Obst- oder
Gemüsesäften durchgeführte
Kur), ...**la|den** (ugs. abwertend
für: schlecht funktionierender
Betrieb); **Säft|lein,** Säft|chen;
saft|los, -este († R 292); saft- und
kraftlos († R 145); **Saft_pres|se,**
...**stockung** [*Trenn.:* ...stok|kung],
...**tag** (vgl. Saftkur)
Sa|ga altnord. [auch: *ßaga*] (altis-
länd. Prosaerzählung) *w;* -, -s
Sa|ga|zi|tät *lat.* (veralt. für:
Scharfsinn) *w;* -
sag|bar; Sa|ge *w;* -, -n
Sä|ge *w;* -, -n; **Sä|ge_blatt,** ...**bock,**
...**dach,** ...**fisch,** ...**gat|ter,** ...**ma-**
schi|ne, ...**mehl**
sa|gen; er hat mir sage und schrei-
be (tatsächlich; Ausdruck der
Entrüstung) zwanzig Mark abge-
nommen
sä|gen
Sa|gen_buch, ...**dich|tung,** ...**for-**
scher; sa|gen|haft; Sa|gen|kreis;
sa|gen|mä|ßig; sa|gen|um|wo|ben,
aber († R 142): von Sagen umwo-
ben
Sä|ger; Sä|ge|rei; Sä|ge_spä|ne
(*Mehrz.*), ...**werk,** ...**wer|ker,**
...**zahn**

sa|git|tal *lat.* (parallel zur Mittel-
achse liegend); **Sa|git|tal_ebe|ne**
(jede der Mittelebene des Kör-
pers parallele Ebene)
Sa|go indones. (gekörntes Stärke-
mehl aus Palmenmark) *m* (österr.
meist: *s*); -s; **Sa|go_pal|me,** ...**sup-**
pe
Sa|ha|ra arab. [auch: *sahara*]
(„Wüste" in Nordafrika) *w;* -
Sa|hib arab.-Hindi („Herr"; in In-
dien u. Persien vor europ. Na-
men) *m;* -[s], -
Sah|ne *w;* -; **Sah|ne_bon|bon,** ...**eis**
...**känn|chen,** ...**kä|se,** ...**kuchen,**
sah|nen; Sah|ne|tor|te; sah|nig
Saib|ling (ein Fisch); vgl. Salbling
Sai|gon [auch: ...*on*] (Hptst. vor
Süd-Vietnam)
[1]**Saint** engl. [*ße'nt*] [männl. u
weibl. Form] „heilig"; in der
u. amerik. Heiligennamen u. auf
solche zurückgehenden Ortsna-
men, z. B. Saint Louis[1] [*ße'n_*
lui(ß)] = Stadt in Missouri, Saint
Anne[1] [- *än*]; Abk.: St.); vgl. San
Sankt, São; [2]**Saint** fr. [*ßäng*]
(männl. Form) „heilig"; in fr
Heiligennamen u. auf solche zu
rückgehenden Ortsnamen, z. B
Saint-Cyr[1] [...*ßir*] = Kriegsschu
le in Frankreich, Sainte-Marie[1]
Abk.: St bzw. Ste); vgl. San
Sankt, São
Saint-Ger|main-en-Laye [*ßäng_*
schermängangla] (Stadt an de
Seine)
Saint Louis [*ße'ntlui(ß)*] (Stadt i
Missouri)
Saint-Si|mo|nis|mus [*ßäng*...; nach
dem fr. Sozialreformer Saint-Si
mon] (sozialist. Lehre) *m;* -
Saint-Si|mo|nist († R 268)
Sa|is (altägypt. Stadt im Nildelta
Sai|son fr. [*ßäßong,* auch: *säsong_*
säsong] (Hauptbetriebs-, Haupt
geschäfts-, Hauptreisezeit, Thea
terspielzeit) *w;* -, -s (österr. meist
...nen); **sai|so|nal** [...*songl*]; **Sa**
son_ar|beit, ...**ar|bei|ter,** ...**aus**
ver|kauf (Winter-, Sommer
schlußverkauf); **sai|son|be|ding**
Sai|son_beginn, ...**be|schäf|t**
gung, ...**be|trieb,** ...**er|öff|nung**
...**in|dex** (Wirtsch.), ...**kre|d**
(Wirtsch.), ...**schluß,** ...**schluß**
ver|kauf, ...**schwan|kung,** ...**war**
de|rung (saisonbedingte Wande
rung von Arbeitskräften); **sai**
son|wei|se; Sai|son|zahl (Stat
stik)
Sai|te (gedrehter Darm, gespann
ter Metallfaden) *w;* -, -n; vg

[1] *Trenn.:* ...k|k...

[1] Hinter „Saint" steht in fr. Name
ein Bindestrich, in engl. u. amerik
nicht. Hinter „Sainte" steht im
mer ein Bindestrich.

aber: Seite; Sai|ten_be|zug, ...hal|ter (Teil eines Saiteninstrumentes), ...in|stru|ment, ...klang, ...spiel; ...sai|tig (z. B. fünfsaitig); Sait|ling (Schafdarm)

Sa|ke jap. (in Japan aus Reis hergestellter Wein) m; -

Sak|ko [österr.: ...kọ] (Herrenjakket) m (auch, österr. nur: s); -s, -s; Sak|ko|an|zug

sạ|kra! lat. (ugs. für: verdammt!)ɪ sa|kral (den Gottesdienst betreffend; Med.: zum Kreuzbein gehörend); Sa|kral|bau (Kunstgesch.: kirchl. Bauwerk; Ggs.: Profanbau; Mehrz. ...bauten); Sa|kra|ment (Gnadenmittel) s; -[e]s, -e; sa|kra|men|tal (Sakrament...; heilig); Sa|kra|men|ta|li|en [...i^en] (in der kath. Kirche sakramentähnliche Zeichen u. Handlungen, z. B. Wasserweihe; auch Bez. für die geweihten Dinge, z. B. Weihwasser) Mehrz.; sa|kra|ment|lich; Sa|kra|ments|häus|chen; sa|krie|ren (veralt. für: weihen, heiligen); Sa|kri|fi|zi|um (Opfer, bes. das kath. Meßopfer) s; -s, ...ien [...i^en]; Sa|kri|leg s; -s,-eu. Sa|kri|le|gi|um (Vergehen gegen Heiliges; Kirchenraub; Gotteslästerung) s; -s, ...ien [...i^en]; sa|kri|le|gisch; sa|krisch mdal. (verdammt); Sa|kri|stan (kath. Küster, Mesner) m; -s, -e; Sa|kri|stei (Kirchenraum für den Geistlichen u. die gottesdienstl. Geräte); sa|kro|sankt (hochheilig; unverletzlich)

sä|ku|lar lat. (alle hundert Jahre wiederkehrend; weltlich); Sä|ku|lar|fei|er (Hundertjahrfeier); Sä|ku|la|ri|sa|ti|on [...ziọn] (Einziehung geistl. Besitzungen; Verweltlichung; sä|ku|la|ri|sie|ren (kirchl. Besitz in weltl. umwandeln); Sä|ku|la|ri|sie|rung (Verweltlichung; Loslösung des einzelnen, des Staates u. der gesellschaftl. Gruppen aus den Bindungen an die Kirche; Erlaubnis für Ordensgeistliche, in den Weltklerus überzutreten); Sä|ku|la|ri|sie|rungs|pro|zeß; Sä|ku|lum (Jahrhundert) s; -s, ...la

Sa|kun|ta|la (Dramenfigur des Inders Kalidasa)

...sal (z. B. Drangsal)

Sa|la|din arab. (Sultan)

Sa|lam vgl. Selam

Sa|la|man|ca [...ka] (span. Stadt u. Provinz)

Sa|la|man|der gr. (ein Molch) m; -s, -

Sa|la|mi it. (eine Dauerwurst) w; -, -[s] (schweiz. auch: m; -s, -)

Sa|la|mi|ni|er [...i^er]; Sa|la|mis (gr. Insel; Stadt auf der Insel Salamis)

Sa|la|mi|tak|tik (Bez. für eine Po-

litik, die durch kleinere Übergriffe und Forderungen, die von der Gegenseite zur Vermeidung einer großen militär. Auseinandersetzung hingenommen bzw. erfüllt werden, Erfolge zu erzielen sucht); Sa|la|mi|wurst

Sa|lär fr. schweiz. (Gehalt, Lohn) s; -s, -e; sa|la|rie|ren schweiz. (besolden, entlohnen)

Sa|lat m; -[e]s, -e; gemischter -; Sa|lat_be|steck, ...gur|ke; Sa|la-tie|re (veralt. für: Salatschüssel) w; -, -n; Sa|lat_öl, ...pflan|ze, ...plat|te, ...schüs|sel

Sal|ba|der (abschätzig für: langweiliger [frömmelnder] Schwätzer); Sal|ba|de|rei (abschätzig); sal|ba|dern (abschätzig); ich ...ere (↑ R 327); er hat salbadert

Sal|band (Gewebekante, -leiste; Geol.: Berührungsfläche eines Ganges mit dem Nebengestein) s (Mehrz. ...bänder)

Sal|be w; -, -n

Sal|bei lat. [auch: ...ba͞i] (eine Pflanzengattung, Heilpflanze) m; -s (österr. nur so) od. w; -; Sal|bei|tee

sal|ben; Sal|ben|büch|se; sal|ben-duf|tend, aber (↑ R 142): nach Salben duftend; Sal|ber (veralt .); sal|big

Salb|ling (Nebenform von: Saibling)

Salb|öl; Sal|bung; sal|bungs|voll

Säl|chen (kleiner Saal)

Sal|chow [...o; auch dem. ehem. schwed. Weltmeister im Eiskunstlauf U. Salchow] (ein Drehsprung beim Eiskunstlauf) m; -[s], -s; einfacher, doppelter, dreifacher -

Sal|den_bi|lanz (Wirtsch.), ...li|ste (Wirtsch.)

sal|die|ren it. ([Rechnung] ausgleichen, abschließen; österr. für: die Bezahlung einer Rechnung bestätigen); Sal|die|rung; Sal|do (Unterschied der beiden Seiten eines Kontos) m; -s, ...den u. -s u. ...di; Sal|do_an|er|kennt|nis (Wirtsch.: Schuldanerkenntnis dem Gläubiger gegenüber; s), ...kon|to (Kontokorrentbuch), ...über|trag, ...vor|trag

Sä|le (Mehrz. von: Saal)

Sa|lem vgl. Selam

Sa|lep arab. (getrocknete Knolle einiger Orchideen, die für Heilzwecke verwendet wird) m; -s, -s

Sa|le|sia|ner (Mitglied der Gesellschaft des hl. Franz von Sales; Angehöriger der Priestergenossenschaft der Jugendseelsorge)

Sales-ma|na|ger engl. [ßẹ'lsmä-nidsch^er] (Wirtsch.: Verkaufsleiter, [Groß]verkäufer) m; -s, -; Sales|man|ship [ßẹ'lsmänschip]

(Bez. für eine in den USA wissenschaftlich u. empirisch entwickelte Verkaufslehre) s; -s; Sales-pro|mo|ter [ßẹ'lspromo"t'r] (Vertriebskaufmann mit besonderen Kenntnissen auf dem Gebiet der Marktbeeinflussung) m; -s, -; Sales-pro|mo|tion [ßẹ'lspromo"-sch^n] (Verkaufswerbung, Verkaufsförderung) w; -

Sa|let|tel, Sa|lettl it. bayr. u. österr. mdal. (Pavillon, Laube, Gartenhäuschen) s; -s, -n

Sa|li|cyl|säu|re [...zül...] vgl. Salizylsäure

¹Sa|li|er lat. [...i^r] („Tänzer"; altröm. Priester) Mehrz.

²Sa|li|er [...i^r] (Angehöriger der salischen Franken; Angehöriger eines dt. Kaisergeschlechtes) m; -s, -

Sa|li|ne lat. (Salzwerk) w; -, -n; Sa|li|nen_be|trieb, ...salz; sa|li|nisch

Salis|bu|ry [ßălsb^ri] (Hptst. von Rhodesien)

sa|lisch; -e Franken; -e Gesetze, aber (↑ R 224): das Salische Gesetz (über die Thronfolge)

Sa|li|zyl|säu|re, (fachspr. nur.) Sa-li|cyl|säu|re lat.; gr.; dt. (eine organ. Säure; im Rheumamittel) w; -

Sal|kan|te (Gewebeleiste)

Salk-Vak|zi|ne; ↑ R 180 [ßặk...] (Impfstoff des amerik. Bakteriologen J. Salk gegen Kinderlähmung)

Sal|lei|ste (Gewebeleiste)

Sal|lust (röm. Geschichtsschreiber); Sal|lu|sti|us vgl. Sallust

Sal|ly (m. u. w. Vorn.)

¹Salm lat. (ein Fisch) m; -[e]s, -e

²Salm [zu: Psalm] (ugs. für: Gerede) m; -s, (selten:) e

Sal|ma|nas|sar (Name assyr. Könige)

Sal|mi|ak lat. [auch, österr. nur: sạl...] (Ammoniakverbindung) m (auch: s) -s; Sal|mi|ak_geist (Ammoniaklösung; m; -[e]s), ...lö|sung, ...pa|stil|le

Salm|ler (ein Fisch)

Sal|mo|nel|len [nach dem amerik. Pathologen u. Bakteriologen Salmon] (Darmkrankheiten hervorrufende Bakterien) Mehrz.; Sal-mo|nel|lo|se (durch Salmonellen verursachte Erkrankung) w; -, -n

Sal|mo|ni|den lat.; gr. (Lachse u. lachsartige Fische) Mehrz.

Sa|lo|me (Stieftochter des Herodes); Sa|lo|mon, (ökum.:) Sa|lo-mo (bibl. König, Sohn Davids); Wesf.: Salomo[n]s u. Salomonis; Sa|lo|mon|in|seln Mehrz.; sa|lo-mo|nisch; -es (weises) Urteil; -e Weisheit, aber (↑ R 179): Sa|lo-mo|nisch; -e Schriften; Sa|lo-

mon[s]|sie|gel (Weißwurz; ein Liliengewächs)
Sa|lon fr. [...lǫng, auch: ...lǫng, österr.: ...lǫn] (Gesellschafts-, Empfangszimmer; Geschäft besonderer Art, z. B. für Haar- u. Körperpflege; Kunstausstellung) m; -s, -s; Sa|lon|da|me (Theater); sa|lon|fä|hig
Sa|lo|ni|ki (gr. Stadt); vgl. Thessaloniki, Thessalonich; Sa|lo|ni|ker, Sa|lo|ni|ki|er [...iᵉr] († R 199)
Sa|lon..lö|we, ...mu|sik, ...or|che|ster, ...wa|gen (Eisenbahnw.)
sa|lopp fr. (ungezwungen; nachlässig; ungepflegt); -e Kleidung; Sa|lopp|heit
Sal|pen gr. (eine Gruppe der Manteltiere) Mehrz.
Sal|pe|ter lat. (Bez. für einige Salze der Salpetersäure) m; -s; Sal|pe|ter.dampf, ...dün|ger, ...er|de; sal|pe|ter|hal|tig; sal|pe|te|rig, salpet|rig; -e Säure; Sal|pe|ter|säu|re w; -; sal|pe|te|rung w; -; sal|pet|rig, sal|pe|te|rig
Sal|pinx gr. ([Ohr]trompete; Eileiter) w; -, ...ingen
Sal|se it. (Schlammsprudel, Schlammvulkan; veralt. für: [salzige] Tunke) w; -, -n
Sal|ta lat. (,,spring!''; ein Brettspiel) s; -s; Sal|ta|rel|lo it. (,,Hüpfer''; it. u. span. Springtanz) m; -s, ...lli; Sal|ta|to (,,gesprungen''; Musik: Spiel mit hüpfendem Bogen) s; -s, -s u. ...ti; Sal|to (freier Überschlag; Luftrolle) m; -s, -s u. ...ti; Sal|to mor|ta|le (,,Todessprung''; gefährlicher Kunstsprung der Artisten; Ganzdrehung nach rückwärts bei Flugzeugen) m; - -, - - u. ...ti ...li
Sa|lu|bri|tät lat. (Med.: gesunde [Körper]beschaffenheit) w; -
Sa|lut fr. (milit.] Ehrengruß) m; -[e]s, -e; Sa|lu|ta|ti|on lat. [...zion] (veralt. für: feierl. Begrüßung, Gruß); sa|lu|tie|ren (milit. grüßen); Sa|lut|schuß
Sal|va|dǫr. El usw. vgl. El Salvador usw.; Sal|va|do|ri|a|ner; sal|va|do|ri|a|nisch
Salv|ar|san ⓦ [...war...] (ein Heilmittel gegen Syphilis) s; -s
Sal|va|ti|on lat. [...wazion] (veralt. für: Rettung; Verteidigung); ¹Sal|va|tor (Jesus als Retter, Erlöser) m; -s; ²Sal|va|tor ⓦ (ein bayr. Starkbier) s od. m; -s; Sal|va|tor.bier (als ⓦ): Salvator-Bier), ...bräu (als ⓦ): Salvator-Bräu); Sal|va|to|ri|a|ner (Angehöriger einer kath. Priesterkongregation für Seelsorge u. Mission; Abk.: SDS [vgl. d.])
sal|va ve|nia lat. [...wa wenia] (veralt. für: mit Erlaubnis, mit Verlaub [zu sagen]; Abk.: s. v.)

sal|ve! lat. [...we] (sei gegrüßt!); Sal|ve fr. [...wᵉ] (gleichzeitiges Schießen von mehreren Feuerwaffen [auch als Ehrengruß]) w; -, -n; Sal|ven|feu|er; sal|vie|ren lat. [...wir ᵉn] (veralt. für: retten); sich - (sich in Sicherheit bringen); sal|vo ti|tu|lo [salwo -] (veralt. für: mit Vorbehalt des richtigen Titels; Abk.: S. T.)
Sal|wei|de (eine Weidenart)
Salz s; -es, -e
Salz|ach (r. Nebenfluß des Inns) w; -
Salz|ader; salz.arm, ...ar|tig; Salz.bad, ...bo|den, ...bre|zel
Salz|burg (österr. Bundesland u. dessen Hptst.); Salz|bur|ger († R 199); - Festspiele
Salz|furth, Bad (Stadt südl. von Hildesheim)
sal|zen; du salzt (salzest); gesalzen (in übertr. Bedeutung nur so, z. B. die Preise sind gesalzen, ein gesalzener Witz) od. (selten:) gesalzt; Sal|zer (veralt. für: Salzsieder, -händler; jmd., der [Fleisch, Fische] einsalzt); Salz.farb|stoff, ...faß, ...fleisch, ...gar|ten (Anlage zur Salzgewinnung), ...ge|halt m, ...gru|be (Salzbergwerk), ...gur|ke; salz|hal|tig; Salz|he|ring; sal|zig; -e Tränen
Salz|kam|mer|gut (österr. Alpenlandschaft) s; -s
Salz.kar|tof|feln (Mehrz.), ...korn (Mehrz. ...körner), ...ko|te (Salzsiedehaus), ...la|ger, ...la|ke, ...lecke [Trenn. ...lek|ke]; salzlos; Salz lö|sung, ...man|del, ...pfan|ne, ...pflan|ze, ...quel|le; salz|sau|er; Salz.säu|le, ...säu|re (w; -), ...see, ...so|le, ...stan|ge, ...steu|er w, ...streu|er
Salz|uf|len, Bad (Stadt am Teutoburger Wald)
Salz.was|ser (Mehrz. ...wässer), ...wü|ste, ...zoll
-sam (z. B. langsam)
Sam [ßäm] (engl. Kurzform von: Samuel; vgl. Sammy); Onkel - (scherzh. Bez. für: USA; vgl. Uncle Sam)
Sa|ma|el [...ääl] vgl. Samiel
Sä|mann (Mehrz. ...männer)
Sa|ma|ria [auch: samarịa] (antike Stadt u. hist. Landschaft in Palästina); Sa|ma|ri|ta|ner (Angehöriger eines Volkes in Palästina); vgl. Samariter; sa|ma|ri|ta|nisch; der -e Pentateuch; Sa|ma|ri|ter (Bewohner von Samaria; [freiwilliger] Krankenpfleger, -wärter); barmherziger -, aber († R 224): der Barmherzige - (der Bibel); Sa|ma|ri|ter.dienst, ...tum (s; -s)
Sa|ma|ri|um (chem. Grundstoff, Metall; Zeichen: Sm) s; -s
Sa|mar|kand (russ. Stadt)

Sä|ma|schi|ne
Sam|ba afrik.-port. (ein Tanz) w; -, -s (ugs. auch u. österr. nur: m; -s, -s)
Sam|be|si (Strom in Afrika) m; -[s]
Sam|bia (Staat in Afrika); Sam|bi|er [...iᵉr]; sam|bisch
Sa|me (gehoben für: Samen) m; -ns, -n; Sa|men m; -s, -; Sa|men..an|la|ge, ...er|guß, ...fa|den, ...flüs|sig|keit, ...hand|lung, ...hül|le, ...kap|sel, ...kern, ...korn (Mehrz. ...körner), ...lei|ter, ...pflan|ze, ...strang, ...über|tra|gung, ...zel|le, ...zucht; Sa|me|rei w; -, -en (meist Mehrz.)
Sa|mi|el, Sa|ma|iel hebr. [...äl] (böser Geist, Teufel)
...sa|mig (z. B. vielsamig)
sä|mig mdal. (seimig; dickflüssig); Sä|mig|keit mdal. (Dickflüssigkeit) w; -
sa|misch (von Samos)
sä|misch slaw. (fettgegerbt); Sä|misch.ger|ber, ...le|der
Sam|land (Halbinsel zwischen dem Frischen u. dem Kurischen Haff) s; -[e]s; Sam|län|der m; sam|län|disch
Säm|ling (aus Samen gezogene Pflanze)
Sam|mel.an|schluß (Postw.), ...auf|trag, ...band m, ...becken [Trenn. ...bek|ken], ...be|griff, ...be|stel|lung, ...be|zeich|nung, ...brun|nen, ...büch|se, ...de|pot (Wirtsch.: eine Form der Wertpapierverwahrung), ...ei|fer, ...frucht (Biol.), ...ge|fäß, ...gut; Sam|mel|gut|ver|kehr; Sam|mel.kon|to, ...la|dung, ...lei|den|schaft, ...lin|se, ...map|pe; sam|meln; ich ...[e]le († R 327); Sam|mel.na|me, ...num|mer, ...paß, ...platz, ...schie|ne (Technik) ...stel|le; Sam|mel|su|ri|um (ugs für: Unordnung, Durcheinander) s; -s, ...ien [...iᵉn]; Sam|mel.trans|port, ...trieb, ...über|wei|sung, ...wer|bung, ...werk, ...wert|be|rich|ti|gung (Bankw.), ...wut
Sam|met (veralt.; schweiz. neben Samt) m; -s, -e
Samm|ler; Samm|ler.fleiß, ...freu|de, ...ver|ei|ni|gung; Samm|lung
Sam|my [ßämi] (engl. Kurzform von Samuel; vgl. Sam)
Sam|ni|te m; -n, -n († R 268) od. Sam|ni|ter (Angehöriger eines italischen Volkes) m; -s, -
Sa|moa (Inselgruppe im Pazifischen Ozean); Sa|moa|in|sel|n († R 201) Mehrz.; Sa|moa|ner; sa|moa|nisch
Sa|mo|je|de (Angehöriger eines asiat. Volkes) m; -n, -n († R 268; ¹Sa|mos (gr. Insel); ²Sa|mos (Wein von der Insel Samos) m; -, -; Sa|mo|thra|ke (gr. Insel)

Sa|mo|war russ. (russ. Teemaschine) m; -s, -e

Sam|pan chin. (chin. Wohnboot) m; -s, -s

Sam|son vgl. Simson

Sams|tag hebr. („Sabbattag"; Abk.: Sa.) m; -[e]s, -e; vgl. Dienstag; sams|tags (↑R 129); vgl. Dienstag

samt; mit Wemf.; - dem Gelde; - und sonders

Samt (ein Gewebe) m; -[e]s, -e; samt|ar|tig; Samt|band; sam|ten (aus Samt); ein -es Band; Samthand|schuh; jmdn. mit -en anfassen (jmdn. vorsichtig behandeln), sam|tig (samtartig); eine -e Haut; Samt|kleid

samt|lich; (↑R 277:) -er aufgehäufte Sand, der Verlust -er vorhandenen Energie, mit -em gesammelten Material, -es vorhandene Eigentum; (↑R 282:) -e vortrefflichen (seltener: vortreffliche) Einrichtungen, -er vortrefflicher Einrichtungen; (↑R 290:) -e Stimmberechtigten (auch: Stimmberechtigte)

Samt|pföt|chen; samt|weich

Sa|mu|el [...uäl] (bibl. m. Eigenn.)

Sa|mum arab. [auch: ...mum] (heißer Wüstenwind) m; -s, -s u. -e

Sa|mu|rai jap. (Angehöriger des jap. Adels) m; -[s], -[s]

San lat. (heilig) usw. in Heiligennamen u. auf solche zurückgehenden Ortsnamen. I. Im Italienischen: a) San (vor Mitlauten [außer Sp... u. St...] in männl. Namen; Abk.: S.), z. B. San Giuseppe [- dsehu...], S. Giuseppe; b) Sant' (vor Selbstlauten in männl. u. weibl. Namen; Abk.: S.), z. B. Sant'Angelo [...andseh^elo], S. Angelo; Sant'Agata, S. Agata; c) Santa (vor Mitlauten in weibl. Namen; Abk.: S.), z. B. Santa Lucia [- lutschia], S. Lucia; d) Sante Mehrz. (vor weibl. Namen; Abk.: SS.), z. B. Sante Maria e Maddalena, SS. Maria e Maddalena; e) Santi Mehrz. (vor männl. Namen; Abk.: SS.), z. B. Santi Pietro e Paolo, SS. Pietro e Paolo; f) Santo (vor Sp... u. St... in männl. Namen; Abk.: S.), z. B. Santo Spirito, S. Spirito; Santo Stefano, S. Stefano. II. Im Spanischen: a) San (vor männl. Namen [außer vor Do... u. To...]; Abk.: S.), z. B. San Bernardo, S. Bernardo; b) Santa (vor weibl. Namen; Abk.: Sta.), z. B. Santa Maria, Sta. Maria; c) Santo (vor Do... u. To... in männl. Namen; Abk.: Sto.), z. B. Santo Domingo, Sto. Domingo; Santo Tomás, Sto. Tomás. III. Im Portugiesi-

schen: a) Santa (vor weibl. Namen; Abk.: Sta.), z. B. Santa Clara, Sta. Clara; b) Santo [...tu] (vor männl. Namen, bes. vor Selbstlaut; Abk.: S.), z. B. Santo André, S. André; vgl. Saint, Sankt u. São

Sa|na|to|gen Ⓦ lat.; gr. (ein Stärkungsmittel) s; -s

Sa|na|to|ri|um lat. (Heilstätte; Heilanstalt; Genesungsheim) s; -s, ...ien [...i^en]

San Ber|nar|di|no (ein Alpenpaß) m; - -

San|cho Pan|sa [ßantscho -] (Knappe Don Quichottes)

Sanc|ta Se|des lat. (lat. Bez. für: Heiliger [Apostolischer] Stuhl) w; - -; sanc|ta sim|pli|ci|tas! [- ...plizi...] („heilige Einfalt!");

Sanc|ti|tas („Heiligkeit"; Titel des Papstes) w; -; Sanc|tus (Lobgesang in der kath. Messe) s; -, -

Sand m; -[e]s, -e; Sand|aal (ein Fisch)

San|da|le gr. (eine Schuhart [Holzod. Ledersohle, durch Riemen gehalten]) w; -, -n (meist Mehrz.); San|da|let|te (sandalenartiger Sommerschuh) w; -, -n (meist Mehrz.)

San|da|rak gr. (ein trop. Harz) m; -[e]s

Sand_bad, ...bahn; Sand|bahn|rennen (Sport); Sand_bank (Mehrz. ...bänke), ...blatt (beim Tabak), ...bo|den, ...burg, ...dorn (eine Pflanzengattung; m; -[e]s)

San|del|holz sanskr.; dt. (duftendes Holz verschiedener Sandelbaumgewächse) s; -es; Sandel[holz]|öl s; -[e]s

san|deln südd. (im Sand spielen); ich ...[e]le (↑R 327); san|den schweiz., sonst veralt. (mit Sand bestreuen); schweiz. auch: Sand streuen)

sand_far|ben od. ...far|big (für: beige); Sand|faß (veralt.), ...förm|chen (ein Kinderspielzeug), ...gru|be, ha|se (Fehlwurf beim Kegeln; Soldatenspr.: Fußsoldat), ...hau|fen, ...ho|se (Sand führender Wirbelsturm); san|dig; Sand_kä|fer, ...ka|sten, ...korn (Mehrz. ...körner), ...ku|chen, ...loch, ...mann (eine Märchengestalt; m; -[e]s), ...pa|pier, ...sack

San|dschak („Banner"; ehem. Bez. für einen türk. Reg.-Bez.) m; -s, -s

Sand_schie|fer, ...stein; Sand|stein_fels od. ...fel|sen, ...ge|bir|ge; sand|strah|len; gesandstrahlt; (fachspr. auch:) sandgestrahlt; Sand|strahl|ge|blä|se; Sand_strand, ...tor|te, ...uhr, ...we|be od. ...we|he (veralt.)

Sand|wich engl. [säntwitsch] (belegte Weißbrotschnitte; österr.: belegtes Brötchen) m od. s; -s od. -[es], -s od. -es [...is] (auch: -e); Sand|wich_bau|wei|se (Technik), ...wecken ([Trenn.: ...ek|k...] österr.: langes, dünnes Weißbrot)

Sand|wül|ste

San Fran|cis|co (Stadt in den USA; Kurzform: Frisco); San Fran|zis|ko (eindeutschend für: San Francisco; Kurzform: Frisko)

sanft; -este (↑R 292); Sänf|te (Tragstuhl) w; -, -n; Sänf|ten|trä|ger; Sanft|heit w; -; sänf|ti|gen (dicht.); sänf|tig|lich (veralt.); Sanft|mut w; -; sanft|mü|tig

Sang m; -[e]s, Sänge; sang- u. klanglos vgl. sanglos; sang|bar; Sän|ger; fahrender -; Sän|ger_bund m, ...chor m, ...fest; Sän|ge|rin w; -, -nen; Sän|ger|schaft; Sanges|bru|der; san|ges_freu|dig, ...kun|dig; San|ges|lust w; -; san|ges|lu|stig; sang|los; (↑R 145:) sang- u. klanglos (ugs. für: plötzlich, unbemerkt) abtreiben

San|gui|ni|ker lat. [...u-i...] (lebhafter, temperamentvoller Mensch); san|gui|nisch; -ste (↑R 294)

San|he|drin (hebr. Form von: Synedrion) m; -s

San|he|rib (ein assyr. König)

Sa|ni (Soldatenspr. verkürzt für: Sanitäter) m; -s, -s; sa|nie|ren lat. (gesund machen); desinfizieren; gesunde Lebensverhältnisse schaffen; wieder leistungsfähig machen); sich - (ugs. für: mit Manipulationen den bestmöglichen Gewinn aus einem Unternehmen od. einer Position herausholen; den Rahm abschöpfen; auch für: wirtschaftlich gesunden); Sa|nie|rung; Sa|nie|rungs_bi|lanz, ...ge|winn, ...plan, ...maß|nah|me, ...über|sicht; sa|ni|tär fr. (gesundheitlich); -e Anlagen; sa|ni|ta|risch lat. schweiz. (den amtl. Gesundheitsdienst betreffend); Sa|ni|tät schweiz. u. österr. (Sanitätswesen) w; -; Sa|ni|tä|ter (in der Ersten Hilfe Ausgebildeter, Krankenpfleger; Soldatenspr. verkürzt: Sani [vgl. d.]); Sa|ni|täts_au|to, ...be|hör|de (Gesundheitsbehörde), ...dienst, ...hund, ...ka|sten, ...ko|lon|ne, ...kom|pa|nie, ...korps, ...kraft_wa|gen (Soldatenspr.; Kurzw.: Sanka, Sankra [vgl. d.]), ...of|fi|zier, ...per|so|nal, ...rat (Abk.: San.-Rat; Mehrz. ...räte), ...sol|dat; Sa|ni|täts- und Hilfs|dienst (↑R 145); Sa|ni|täts_wa|che, ...wa|gen, ...we|sen, ...zug

San-Jo|sé-Schild|laus [*...ehoßę...*] (↑ R 203) *w*; -, *...läuse*

San|ka, San|kra (Soldatenspr.; Kurzw. für: Sanitätskraftwagen) *m*; -s, -s

Sankt *lat.* (heilig); in Heiligennamen u. auf solche zurückgehenden Ortsnamen; ohne Bindestrich: Sankt Peter, Sankt Elisabeth, Sankt Gallen; die Sankt Gallener od. Sankt Galler Handschrift; (↑ R 203:) die Sankt-Gotthard-Gruppe; Abk.: St., z. B. St. Paulus, St. Elisabeth, St. Pölten, aber (↑ R 182:) das St.-Elms-Feuer, die St.-Marien-Kirche; (↑ R 208:) die St. Andreasberger Bergwerke; vgl. Saint, San u. São

Sankt An|dre|as|berg (Stadt im Harz); vgl. Sankt

Sankt Bern|hard *m*; - -[s]; der Große - -; der Kleine - -; vgl. Sankt; **Sankt-Bern|har|din-Paß** *m*; ...passes; vgl. Sankt

Sankt Bla|si|en [- *...i*ⁿ*n*] (Stadt im südl. Schwarzwald); vgl. Sankt; **Sankt-Bla|si|en-Stra|ße** (↑ R 220)

Sankt Flo|ri|an (österr. Stift)

Sankt Gal|len (Kanton u. Stadt in der Schweiz); vgl. Sankt; **Sankt Gal|le|ner**, (in der Schweiz nur:) **Sankt Gal|ler** (↑ R 199 und R 208); **Sankt Gal|l[e|n]er Handschrift** (↑ R 208); **sankt|gal|lisch**

Sankt Gott|hard (schweiz. Alpenpaß) *m*; - -[s]; vgl. Sankt

Sankt He|le|na (Insel im südl. Atlant. Ozean); vgl. Sankt

Sank|ti|on *lat.* [*...zion*] (Bestätigung; Erteilung der Gesetzeskraft) *w*; -, (für: Sicherung, Sicherungsbestimmung, Zwangsmaßnahme auch *Mehrz.:*) -en; **sanktio|nie|ren** (bestätigen, gutheißen, Gesetzeskraft erteilen); **Sankt|tio|nie|rung**; **Sankt|tis|si|mum** (Allerheiligstes, geweihte Hostie) *s*; -s

Sankt-Lo|renz-Strom; ↑ R 211 (in Nordamerika) *m*; -[e]s

Sankt Mär|gen (Ort im südl. Schwarzwald); vgl. Sankt

Sankt-Mi|chae|lis-Tag; ↑ R 182 (29. Sept.) *m*; -[e]s, -e; vgl. Sankt

Sankt Mo|ritz [schweiz. - *moriz*] (Ort im Oberengadin); vgl. Sankt

Sankt-Nim|mer|leins-Tag; ↑ R 182; (Nimmermehrstag) *m*; -[e]s; vgl. Sankt

Sankt Pau|li (Stadtteil Hamburgs); vgl. Sankt

Sankt Pe|ters|burg (ehem. Name von Leningrad); vgl. Sankt

Sankt Pöl|ten (österr. Stadt)

Sankt|tua|ri|um *lat.* („Heiligtum"; Altarraum in der kath. Kirche; [Aufbewahrungsort eines] Reliquienschrein[s]) *s*; -s, ...ien [*...i*ⁿ*n*]

Sankt-Wolf|gang-See, (auch:) **Wolf|gang|see** od. **Aber|see**; ↑ R 211 (ein See im Salzkammergut) *m*; -s

San Ma|ri|no (Staat u. seine Hptst. auf der Apenninenhalbinsel); **San|ma|ri|ne|se** *m*; -n, -n (↑ R 268); **san|ma|ri|ne|sisch**

Sann|chen (Koseform von: Susanna)

San.-Rat = Sanitätsrat

San Sal|va|dor [- *...wa...*] (Hptst. von El Salvador); vgl. San

Sans|cu|lot|te *fr.* [*ßangßkü...*] („Ohne[knie]hose"; spött. Bez. für einen der fr. Revolutionäre) *m*; -n, -n (↑ R 268)

San|se|vie|ria [*...wieria*; nach dem it. Gelehrten Raimondo di Sangro, Fürst von San Severo] (ein trop. Liliengewächs mit wertvoller Blattfaser) *w*; -, *...rien* [*...i*ⁿ*n*]

sans gêne *fr.* [*ßang sehän*] (veralt. für: zwanglos; nach Belieben)

San|si|bar (Insel an der Ostküste Afrikas); **San|si|ba|rer** (↑ R 199); **san|si|ba|risch**

Sans|krit österr.: *...krit*] (Literatur- u. Gelehrtensprache der Altindischen) *s*; -s; **Sans|krit for|scher**; **sans|kri|tisch**; **Sans|kri|ti|st** (Kenner u. Erforscher des Sanskrits; ↑ R 268; **Sans|kri|ti|stik** (Wissenschaft vom Sanskrit) *w*; -

Sans|sou|ci *fr.* [*ßangßußi*] („Sorgenfrei"; Schloß in Potsdam)

Sant' vgl. San, I, b; **San|ta** vgl. San, I, c; II, b; III, a

San|ta Lu|cia [- *lutschia*] (neapolitan. Schifferlied) *w*; - -; vgl. San, I, c

Sant|an|der (span. Stadt u. Provinz)

San|te vgl. San, I, d; **San|ti** vgl. San, I, e

Sant|ia|go, (auch:) **Sant|ia|go de Chi|le** [- - *tschile*] (Hptst. von Chile)

Sant|ia|go de Com|po|ste|la [- - *kom...*] (span. Stadt)

Sän|tis (schweiz. Alpengipfel) *m*; -

San|to vgl. San, I, f; II, c

San|to Do|min|go [- *...inggo*] (Hptst. der Dominikanischen Republik); vgl. San, II, c

San|to|nin (ein Wurmmittel) *s*; -s

San|to|rin (gr. Insel)

San|tos (brasil. Stadt)

São port. [*ßgu*] (vor Mitlauten in port. männl. Heiligennamen u. auf solche zurückgehenden Ortsnamen: heilig; Abk.: S.), São Paulo, S. Paulo

Saône [*ßon*] (fr. Fluß) *w*; -

Sa|phir semit.-gr. [auch, österr. nur: *...ir*] (ein Edelstein) *m*; -s, -e

sa|pi|en|ti sat! *lat.* („genug für den Verständigen!"; es bedarf keiner weiteren Erklärung für den Eingeweihten)

Sa|pin *m*; -s, -e, **Sa|pi|ne** *w*; -, -n od. **Sap|pel** österr. (Werkzeug zum Wegziehen gefällter Bäume) *m*; -s, -

Sa|po|nin *lat.* (ein pflanzl. Wirkstoff) *s*; -s, -e

Sap|pe *fr.* (früher für: Lauf-, Annäherungsgraben) *w*; -, -n

Sap|pel vgl. Sapin

Sap|pen|kopf, ...po|sten

sap|per|lot!, sacker|lot! [*Trenn.*: sak|ker...] *fr.* (veralt., aber noch mdal. Ausruf des Unwillens od. des Erstaunens); **sap|per|ment!**, sacker|ment! [*Trenn.*: sak|ker...] (svw. sapperlot)

Sap|peur *fr.* [*...pör*] (früher: Soldat für den Sappenbau; schweiz.: Soldat der techn. Truppe, Pionier) *m*; -s, -e

sap|phisch [*sapfisch*, auch: *safisch*] (↑ R 179); -e Strophe, -es Versmaß; **Sap|pho** (gr. Dichterin)

Sap|po|ro (jap. Stadt)

sa|pri|sti! *fr.* (veralt. Ausruf des Erstaunens od. des Unwillens)

Sa|pro|bie *gr.* [*...i*ᵉ] (von faulenden Stoffen lebender tier. od. pflanzl. Organismus) *w*; -, -n (meist *Mehrz.*); **Sa|pro|bi|ont** (svw. Saprobie) *m*; -en, -en (↑ R 268); **sa|pro|bisch** (in faulenden Stoffen lebend; die Fäulnis betreffend); **sa|pro|gen** (fäulniserregend); **Sa|pro|pel** (Faulschlamm, der unter Sauerstoffabschluß in Seen u. Meeren entsteht) *s*; -s, -e; **sa|pro|phil** (auf, in od. von faulenden Stoffen lebend); **Sa|pro|pha|gen** (Pflanzen od. Tiere, die sich von faulenden Stoffen ernähren) *Mehrz.*; **Sa|pro|phyt** (Pflanze, die von faulenden Stoffen lebt) *m*; -en, -en (↑ R 268)

Sa|ra (w. Vorn.)

Sa|ra|ban|de *pers.-arab.-span.-fr.* (ein Tanz) *w*; -, -n

Sa|ra|gos|sa (eindeutschend für: Zaragoza)

Sa|ra|je|vo [*...wo*] (jugoslaw. Stadt)

Sa|ra|sa|te (span. Geiger)

Sa|ra|ze|ne *arab.* (Bez. des Arabers im MA., später der Mohammedaner) *m*; -n, -n (↑ R 268); **sa|ra|ze|nisch**

Sar|da|na|pal (assyr. König)

Sar|de *m*; -n, -n (↑ R 268) u. **Sar|di|ni|er** [*...i*ᵉ*r*] (Bewohner Sardiniens)

Sar|del|le *it.* (ein Fisch) *w*; -, -n; **Sar|del|len_but|ter**, ...pa|ste

Sar|des (Hptst. des alten Lydiens)

Sar|di|ne *it.* (ein Fisch) *w*; -, -n: **Sar|di|nen_büch|se**, ...ga|bel

Sar|di|ni|en [...*i*ᵉ*n*] (it. Insel im Mittelmeer); Sar|di|ni|er vgl. Sarde; sar|di|nisch, sar|disch

sar|do|nisch *lat.*; -es (krampfhaftes) Lachen

Sard|onyx *gr.* (ein Halbedelstein) *m*; -[es], -e

Sarg *m*; -[e]s, Särge; Sarg|deckel [*Trenn.*: ...dek|kel]; Särg|lein; Sarg.ma|ga|zin, ...na|gel (ugs. abwertend auch für: Zigarette), ...trä|ger, ...tuch

Sa|ri *sanskr.-Hindi* (kunstvoll gewickeltes, auch den Kopf umhüllendes Gewand der Inderin) *m*; -[s], -s

Sar|kas|mus *gr.* ([beißender] Spott) *m*; -, (selten:) ...men; sar|ka|stisch (spöttisch; höhnisch); -ste (↑ R 294)

sar|ko|id *gr.* (Med.: sarkomähnlich, -artig); Sar|kom *s*; -s, -e u. -en; Sar|ko|ma (Med.: bösartige Geschwulst) *s*; -s, -ta; sar|ko|ma|tös (Med.: sarkomartig); Sar|ko|ma|to|se (Med.: ausgebreitete Sarkombildung) *w*; -; Sar|ko|phag ("Fleischverzehrer"; Steinsarg, [Prunk]sarg) *m*; -s, -e

Sar|ma|te (Angehöriger eines ehem. asiat. Nomadenvolkes) *m*; -n, -n (↑ R 268); Sar|ma|ti|en [...*zi*ᵉ*n*] (alter Name des Landes zwischen Weichsel u. Wolga); sar|ma|tisch

Sar|nen (Hauptort von Obwalden)

Sa|rong *malai.* (rockartig um die Hüfte geschlungenes, buntes, oft gebatiktes Tuch der Malaien) *m*; -[s], -s

Sar|raß *poln.* (Säbel mit schwerer Klinge) *m*; ...rasses, ...rasse

Sar|raute [*ßarọt*], Nathalie [...*li*] (fr. Schriftstellerin)

Sar|se|nett *engl.* (dichter, baumwollener Futterstoff) *m*; -[e]s, -e

Sar|te (ehem. Bez. für: Angehöriger turkisierter Iranier) *m*; -n, -n (↑ R 268)

Sar|tre [*ßartᵉ*], Jean-Paul [*schạng pọl*] (fr. Philosoph u. Schriftsteller)

SAS = Scandinavian Airlines System [*ßkänding'wj'n ä'lains ßißt'm*] (Skandinavische Luftlinien)

sa|sa!

Sa|scha (russ. Kurzform von: Alexander u. Alexandra)

Sas|kat|che|wan *engl.* [*ß'ßkätschᵉw'n*] (kanad. Provinz)

Saß, Sas|se (veralt. für: Besitzer von Grund und Boden, Grundbesitzer; Ansässiger) *m*; Sassen, Sassen (↑ R 268)

Sas|sa|fras *fr.* (nordamerik. Laubbaum) *m*; -, -; Sas|sa|fras|öl (ein Heilmittel)

Sas|sa|ni|de (Angehöriger eines

pers. Herrschergeschlechtes) *m*; -n, -n (↑ R 268); sas|sa|ni|disch

¹Sas|se vgl. Saß; ²Sas|se (Jägerspr.: Hasenlager) *w*; -, -n

Saß|nitz (Hafen a. d. Ostküste von Rügen)

Sa|tan *hebr. m*; -s, -e u. Sa|ta|nas ("Widersacher"; Teufel) *m*; -, -se

Sa|tang *siam.* (Münze in Thailand; Abk.: St. od. Stg.; 100 Satangs = 1 Baht) *m*; -[s], -[s]; 100 -- (↑ R 322)

sa|ta|nisch (teuflisch); -ste (↑ R 294); Sa|tans.bra|ten (ugs. scherzh. für: pfiffiger, durchtriebener Kerl; Schlingel), ...pilz, ...tücke [*Trenn.*: ...tük|ke]

Sa|tel|lit *lat.* (verächtl. für: Gefolgsmann, Helfershelfer; Astron.: Mond der Planeten; künstlicher Erdmond, Raumsonde) *m*; -en, -en (↑ R 268); Sa|tel|li|ten.ab|schuß, ...bahn, ...flug, ...flug|ha|fen (Flugw.: Teil eines großen Flughafens, der nur nach einer Flugrichtung hin offen ist od. der nur einer Fluggesellschaft dient; Ggs.: Zentralflughafen), ...staat (von einer Großmacht abhängiger, formal selbständiger Staat; Mehrz. ...staaten), ...stadt (Trabantenstadt), ...über|tra|gung (Übertragung über einen Fernsehsatelliten)

Sa|tem|spra|chen (eine Gruppe der idg. Sprachen) *Mehrz.*

Sa|ter|land (oldenburg. Landschaft) *s*; -[e]s

Sa|ter|tag *lat.* westf., ostfries. (Sonnabend) *m*; -[e]s, -e

Sa|tin *arab.-fr.* [*ßatäng*] (Sammelbez. für Gewebe in Atlasbindung mit glänzender Oberfläche) *m*; -s, -s; Sa|ti|na|ge [*ßatinạsch*ᵉ] (Glättung [von Papier u. a.]); Sa|tin.blu|se, ...holz (eine glänzende Holzart); sa|ti|nie|ren [...*tin*...] ([Papier] glätten); Sa|ti|nier|ma|schi|ne

Sa|ti|re *lat.* (iron.-witzige literar. od. künstler. Darstellung menschlicher Schwächen und Laster) *w*; -, -n; Sa|ti|ren|dich|ter; Sa|ti|ri|ker (Spötter; Verfasser von Spottschriften, -gedichten); sa|ti|risch (spöttisch; beißend); -ste (↑ R 294)

Sa|tis|fak|ti|on *lat.* [...*zion*] (Genugtuung); sa|tis|fak|ti|ons|fä|hig

Sa|trap *pers.* (altpers. Statthalter) *m*; -en, -en (↑ R 268); Sa|tra|pen|wirt|schaft; Sa|tra|pie (altpers. Statthalterschaft) *w*; -, ...ien

satt; -er, -este (↑ R 292); ein -es Blau; sich satt essen; ich bin od. habe es satt (ugs. für: habe keine Lust mehr); sich an einer Sache - sehen (ugs.); etwas - bekommen, haben (ugs.); sattblau usw.

Sat|te nordd. (Gefäß, Napf) *w*; -, -n

Sat|tel *m*; -s, Sättel; Sät|tel|chen; Sat|tel.dach, ...decke [*Trenn.*: ...dek|ke]; sat|tel|fest (auch: kenntnissicher, -reich); Sat|tel.gurt, ...kis|sen, ...knopf; sat|teln; ich ...[e]le (↑ R 327); Sat|tel.pferd (das im Gespann links gehende Pferd), ...schlep|per, ...ta|sche; Sat|te|lung, Satt|lung; Sat|tel|zeug

satt|grün; Satt|heit *w*; -; sät|ti|gen; eine gesättigte Lösung; Sät|ti|gung; Sät|ti|gungs.grad, ...punkt

Satt|ler; Satt|ler|ar|beit; Satt|le|rei; Satt|lung, Sat|te|lung; Satt|ler.hand|werk, ...mei|ster

satt|rot; satt|sam (hinlänglich, genug)

Sa|tu|ra|ti|on *lat.* [...*zion*] (Sättigung, ein bes. Verfahren bei der Zuckergewinnung)

Sa|tu|rei *lat.* (Gattung der Lippenblütler mit Heil- u. Würzkräutern [z. B. Bergminze, Bohnenkraut]) *w*; -

sa|tu|rie|ren *lat.* (sättigen; [Ansprüche] befriedigen); sa|tu|riert (zufriedengestellt; gesättigt)

¹Sa|turn *lat.* (ein Planet) *m*; -s; ²Saturn vgl. Saturnus; ³Sa|turn (kurz für: Saturnrakete) *w*; -, -s; Sa|turna|li|en [...*i*ᵉ*n*] (altröm. Fest zu Ehren des Gottes Saturn) *Mehrz.*; sa|tur|nisch; -er Vers; aber (↑ R 179): Saturnisches Zeitalter (Goldenes Zeitalter); Sa|turn|ra|ke|te (amerik. Trägerrakete); Sa|tur|nus (röm. Gott der Aussaat)

Sa|tyr *gr.* (derb-lüsterner, bocksgestaltiger Waldgeist u. Begleiter des Dionysos in der gr. Sage) *m*; -s u. -n, -n od. -e (meist *Mehrz.*); ↑ R 268; sa|tyr|ar|tig; Sa|ty|ria|sis (krankhafte Steigerung des männl. Geschlechtstriebes) *w*; -; Sa|tyr|spiel

Satz *m*; -es, Sätze; ein verkürzter, elliptischer -; Satz.aus|sa|ge, ...band (für: Kopula; *s*; *Mehrz.* ...bänder), ...bau (*m*; -[e]s), ...bauplan, ...bruch (*m*; Sätz|chen, Sätzlein; Satz.er|gän|zung, ...ge|fü|ge, ...ge|gen|stand, ...glied; ...sät|zig (Musik, z. B. viersätzig); Satz.kon|struk|ti|on, ...leh|re, ...reihe, ...zei|chen; Satz|spie|gel (Druckw.); ...teil *m*; Satz.zung|sat|zungs|ge|mäß; Satz|ver|bin|dung; satz|wei|se; satz|wer|tig; -er Infinitiv; -es Partizip; Satz.zei|chen, ...zu|sam|men|hang

¹Sau *w*; -, Säue u. (bes. von Wildschweinen:) -en

²Sau vgl. ²Save

sau|ber; saub[e]rer, sauberste; saubere (strahlungsverminderte,

-freie) Bombe; sau|ber|hal|ten (↑ R 139); ich halte sauber; saubergehalten; sauberzuhalten; Sau|ber|keit w; -; säu|ber|lich; sau|ber|ma|chen vgl. sauberhalten; säu|bern; ich ...ere (↑ R 327); Säu|be|rung; Säu|be|rungs|ak|ti|on

sau|blöd, sau|blö|de (ugs. für: sehr blöd[e]; Sau|boh|ne

Sau|ce [soß⁰, österr.: soß] (fr. Schreibung von: Soße) w; -, -n Säu|chen, Säu|lein

Sau|cie|re fr. [soßiär⁰, österr.: ...iär] (Soßenschüssel, -napf) w; -, -n; sau|cie|ren [soßir⁰n] ([Tabak] mit einer Soße behandeln); Sau|cis|chen [soßiß...] (kleine Bratwurst, Würstchen)

Sau|di-Ara|bi|en [...iⁿn]; ↑ R 202 (Staat in Arabien); Sau|di|ara|ber; sau|di|ara|bisch

sau|dumm (ugs. für: sehr dumm); sau|en (vom Schwein: Junge bekommen; derb auch für: beschmutzen; zoten)

sau|er; saurer, -ste; saure Gurken; saure Heringe; (↑ R 116:) gib ihm Saures! (ugs. für: prügle ihn!); Sau|er (Druckw.: bezahlte, aber noch nicht geleistete Arbeit; fachspr. für: Sauerteig) s; -s; Sau|er_amp|fer, ...bra|ten, ...brun|nen, ...dorn (Mehrz. ...dorne)

Saue|rei (derb)

Sau|er_kir|sche, ...klee, ...kohl (m; -[e]s), ...kraut (s; -[e]s)

Sau|er|land (westfäl. ˙Landschaft) s; -[e]s; Sau|er|län|der m; sau|er|län|disch

säu|er|lich; Säu|er|lich|keit w; -; Säu|er|ling (Mineralwasser; Sauerampfer); Sau|er|milch; säu|ern (sauer machen; auch: sauer werden); ich ...ere (↑ R 327); das Brot wird gesäuert; Sau|er|stoff (chem. Grundstoff; Zeichen: O) m; -[e]s; Sau|er|stoff_ap|pa|rat, ...bad; Sau|er|stoff|fla|sche (↑ R 237); Sau|er|stoff|ge|rät; sau|er|stoff|hal|tig; Sau|er|stoff_man|gel (m; -s), ...pa|tro|ne, ...tank, ...ver|sor|gung, ...zelt, ...zu|fuhr; sau|er|süß; Sau|er|teig; sau|er|töp|fisch (griesgrämig); -ste (↑ R 294); Säue|rung; Sau|er|was|ser (Mehrz. ...wässer)

Sauf|aus (verächtl. derb für: Trinker) m; -, -; Sauf|bold (svw. Saufaus) m; -[e]s, -e

Sau|fe|der (Spieß zum Abfangen des Wildschweines)

sau|fen (derb in bezug auf Menschen); du säufst; du soffst (soffest); du söffest; gesoffen; sauf[e]!; Säu|fer (verächtl. derb); Säu|fe|rei (derb); Säu|fer|wahn|sinn; Sauf_ge|la|ge (ugs.), ...kum|pan (ugs.)

Saul|fraß (derb für: minderwertiges Essen)

Saug|ader; Säug|am|me; sau|gen; du saugst; du sogst (sogest [auch: saugtest]); du sögest; gesogen (auch: gesaugt), (Technik nur: saugte, gesaugt); saug[e]!; säu|gen; Sau|ger (saugendes Junges; Schnuller); Säu|ger (Säugetier); Säu|ge|tier; saug|fä|hig; Saug.fä|hig|keit, ...fla|sche, ...he|ber, ...kol|ben, ...kraft; Säug|ling ([von d. Mutter genährtes] Neugeborenes im 1. Lebensjahr; abschätzig für: Dummkopf); Säug|lings_gym|na|stik, ...heim, ...pfle|ge, ...schwe|ster, ...sterb|lich|keit (w; -), ...waa|ge; Saug_mas|sa|ge, ...napf (Haftorgan bei bestimmten Tieren), ...pum|pe

saug|grob (derb für: sehr grob)

Saug|rohr

Saug|hatz (Jägerspr.); Sau_hau|fen (derb), ...hund (derb); säu|isch (ugs. für: sehr unanständig); -ste (↑ R 294); Sau|jagd (Jägerspr.); sau|kalt (ugs. für: sehr kalt); Sau|kerl (derb)

Saul (König von Israel)

Säul|chen; Säu|le (Stütze; stützendes Mauerwerk u. ä.) w; -, -n

Säu|lein, Säu|chen

Säu|len_ab|schluß (für: Kapitell); säu|len|för|mig; Säu|len.fuß, ...gang m, ...hal|le, ...hei|li|ge, ...ord|nung, ...por|tal, ...schaft m, ...tem|pel; ...säu|lig (z. B. mehrsäulig)

Sau|lus (bibl. m. Eigenn.)

¹Saum (veralt. für: Last) m; -[e]s, Säume

²Saum (Rand; Besatz) m; -[e]s, Säume

Sau|ma|gen; sau|mä|ßig (derb)

Säum|chen, Säum|lein (kleiner ²Saum)

¹säu|men (mit Rand, Besatz versehen)

²säu|men (veralt. für: Saumtiere führen; auf Saumtieren befördern)

³säu|men (zögern)

¹Säu|mer (Werkzeug zum Säumen)

²Säu|mer (veralt. für: Saumtier, Lasttier; Saumtiertreiber)

³Säu|mer (Säumender, Zögernder); säu|mig; Säu|mig|keit w; -; Säum|lein, Säum|chen (kleiner ²Saum); Saum|naht

Säum|nis w; -, -se od. s; -ses, -se

Saum|pfad [zu: ¹Saum] (Gebirgsweg für Saumtiere)

Saum|sal (veralt. für: Säumigkeit, Nachlässigkeit) w; -, -e od. s; -[e]s, -e; saum|se|lig; Saum|se|lig|keit

Saum|tier [zu: ¹Saum] (Tragtier)

Sau|na (finn. Heißluftbad) w; -, -s od. ...nen; sau|nen, sau|nie|ren

(in die Sauna gehen, sich in der Sauna befinden)

Sau|rach (ein Strauch) m; -[e]s, -e

Säu|re w; -, -n; säu|re_be|stän|dig, ...fest, ...frei; Säu|re|ge|halt

Sau|re|gur|ken|zeit (scherzh. für: die polit. od. geschäftl. meist ruhige Zeit des Hochsommers) w; -, -en

säu|re|hal|tig; Säu|re_mes|ser m, ...schutz|an|zug, ...the|ra|pie, ...ver|gif|tung, ...zahl

Sau|ri|er gr. [...iⁿr] (urweltl. Kriechtier; meist Mehrz.)

Saus m; -es; in - und Braus; säu|seln; ich ...[e]le (↑ R 327); sau|sen; du saust (sausest); er sau|ste; Sau|ser landsch. (neuer Wein u. dadurch hervorgerufener Rausch); Sau|se|wind (auch für: oberflächlich-rascher, leichtlebiger Bursche)

Saus|sure [ßoßür], Ferdinand de (schweiz. Sprachwissenschaftler)

Sau|stall (meist übertr. derb für: schmutzige Verhältnisse, Unordnung)

Sau|ternes [ßotärn] [nach der gleichnamigen Ortschaft] (ein fr. Wein) m; -, -

Sauve|garde fr. [ßowgard] (früher: [Schutz]wache; Schutzbrief) w; -, -n [...d⁰n]

Sau|wet|ter (ugs. für: sehr schlechtes Wetter); Sau|wohl (derb für: sehr wohl); Sau|wut (derb für: heftige Wut)

Sa|van|ne indian. [...wą...] (Steppe mit einzeln od. gruppenweise stehenden Bäumen) w; -, -n

¹Save [ßąw] (l. Nebenfluß der Garonne)

²Sa|ve (r. Nebenfluß der Donau)

Sa|vi|gny [ßąwinji], Friedrich Carl von (dt. Jurist)

Sa|voir-vi|vre fr. [ßawoarwjwr⁽⁰⁾] (feine Lebensart, Lebensklugheit) s; -

Sa|vo|na|ro|la [...wo...] (it. Bußprediger u. Reformator)

Sa|vo|yar|de fr. [ßawojard⁰] (Savoyer) m; -n, -n (↑ R 268); Sa|vo|yar|den|kna|be; Sa|vo|yen [sa|weu⁰n] (hist. Provinz in Ostfrankreich); Sa|vo|yer (↑ R 199); Sa|vo|yer|kohl (Wirsingkohl); sa|vo|yisch

Sa|xi|fra|ga lat. (Steinbrech [geschützte Alpenpflanze]) w; -, ...fragen

Sa|xo|ne (Angehöriger einer altgerm. Stammesgruppe; besser: [Alt]sachse) m; -n, -n (↑ R 268)

Sa|xo|phon [nach dem belg. Erfinder A. Sax] (ein Blasinstrument) s; -s, -e; Sa|xo|pho|nist (Saxophonbläser); ↑ R 268

Sä|zeit

Sa|zer|do|tal lat. (priesterlich); Sa-

zer|do|ti|um [...zium] (Priester-
tum, Priesteramt; im MA. die
geistl. Gewalt des Papstes s; -s
sb = Stilb
Sb = chem. Zeichen für: Antimon
(lat. Stibium)
S-Bahn; ↑ R 149 (Schnellbahn) w;
-, -en; **S-Bahn|hof; S-Bahn-Wa-**
gen (↑ R 155) m; -s, -
SBB = Schweizerische Bundes-
bahnen
Sbir|re it. (früher: it. Polizeidiener,
Scherge) m; -n, -n (↑ R 268)
s. Br., südl. Br. = südlicher Breite
Sbrinz (ein [Schweizer] Hartkäse)
m; -[es]
Sc = chem. Zeichen für: Scan-
dium
sc., sculps. = sculpsit
sc., scil. = scilicet
S. C. = South Carolina; vgl. Süd-
karolina
Sca|la it. [ßk...] („Treppe"); vgl.
auch: Skala; Mailänder Scala
(berühmtes Mailänder Opern-
haus) w; -
Scan|di|um (chem. Grundstoff,
Metall; Zeichen: Sc) s; -s
Scan|pa Flow [ßkapa flo] (engl.
Bucht)
¹Scha|be, Schwa|be (ein Insekt) w;
-, -n; **²Scha|be** (ein Werkzeug) w;
-, -n
Schä|be (Holzteilchen vom
Flachs) w; -, -n
Scha|be|fleisch; Schab|ei|sen;
Scha|be|mes|ser, Schab|mes|ser
s; **scha|ben; Scha|ben,gift,**
...kraut (s; -[es]); **Scha|ber; Scha-**
be|rei (ugs.)
Scha|ber|nack (übermütiger
Streich, Possen) m; -[e]s, -e
schä|big (ugs.); **Schä|big|keit**
Schab|kunst w; -; **Schab|kunst-**
blatt
Scha|blo|ne (ausgeschnittene Vor-
lage; Muster; herkömmliche
Form) w; -, -n; **Scha|blo|nen,ar-**
beit, ...druck (Mehrz. ...drucke);
scha|blo|nen|haft, ...mä|Big; scha-
blo|nic|ren, scha|blo|ni|sie|ren
(nach der Schablone [be]arbei-
ten, behandeln)
Schab|mes|ser, Schabemesser s
Scha|bot|te fr. (schweres Funda-
ment für Maschinenhämmer) w;
-, -n
Scha|bracke [Trenn.: ...brak|ke]
türk. (früher: verzierte Decke
über [od. unter] dem Sattel; Un-
tersatteldecke; Prunkdecke; ugs.
abwertend für: abgenutzte, alte
Sache, baufälliges Gebäude) w;
-, -n; **Scha|brun|ke** (früher für:
Decke über den Pistolenhalftern)
w; -, -n
Schab|sel s; -s, -; **Schab|zi|ger** (har-
ter [Schweizer] Kräuterkäse) m;
-s, -

Schach pers. (Brettspiel; der
Schachspielzuruf: Schach!) s; -s,
-s; - spielen, bieten; im od. in -
halten (auch für: nicht zur Ruhe
kommen lassen; jmds. Handeln
bestimmen); **Schach_auf|ga|be,**
...brett; **schach|brett|ar|tig;**
Schach|brett_fi|gur, ...mu|ster
Scha|chen südd., österr. mdal. u.
schweiz. (Waldstück, -rest;
schweiz. auch für: Niederung,
Uferland) m; -s, -
Scha|cher jidd. (übles, feilschen-
des Geschäftemachen) m; -s
Schä|cher (veralt. für: Räuber,
Mörder)
Scha|che|rei jidd. (ugs.); **Scha-**
che|rer; scha|chern (handeln,
feilschen); ich ...ere (↑ R 327)
Schach|fi|gur; schach|matt;
Schach|mei|ster; Schach|mei-
ster|schaft; Schach_par|tie, ...pro-
blem, ...spiel, ...spie|ler
Schacht m; -[e]s, Schächte
Schach|tel (auch verächtl. für:
ältere weibl. Person) w; -, -n;
Schäch|tel|chen, Schäch|te|lein;
Schach|tel_di|vi|den|de(Wirtsch.),
ge|sell|schaft (Wirtsch.)
Schach|tel|halm
schach|teln; ich ...[e]le (↑ R 327);
Schach|tel_pri|vi|leg (Wirtsch.),
...satz (Sprachw.)
schach|ten (eine Grube, einen
Schacht graben)
schäch|ten hebr. (nach jüdischer
Vorschrift schlachten); **Schäch-**
ter
Schacht_kran, ...mei|ster, ...ofen
(für: Kupolofen), ...ru|te (altes
Raummaß)
Schäch|tung [zu: schächten]
Schacht_tur|nier, ...uhr, ...welt|mei-
ster, ...welt|mei|ster|schaft, ...zug
scha|de (↑ R 132); es ist schade um
jmdn. od. um etwas; schade, daß
...; ich bin mir dafür zu schade;
o wie schade!; es ist jammerscha-
de; **Scha|de** (veralt. für: Schaden)
m; nur noch in: es soll, wird dein
- nicht sein
Schä|del m; -s, -; **Schä|del_ba|sis,**
...ba|sis|bruch m, ...boh|rer,
...bruch, ...dach, ...decke [Trenn.:
...dek|ke], ...form, ...höh|le;
...schä|de|lig, ...schäd|lig (z. B.
langschäd[e]lig) **Schä|del_in|dex,**
...leh|re, ...mes|sung, ...stät|te
scha|den; Scha|den m; -s, Schäden;
(Papierdt.:) zu - kommen; **Scha-**
den_be|rech|nung, Scha|dens|be-
rech|nung; **Scha|den|be|richt,**
Scha|dens|be|richt; **Scha|den|er-**
satz (BGB: Schadensersatz);
Scha|den|er|satz_an|spruch, ...lei-
stung, ...pflicht; scha|den|er|satz-
pflich|tig; Scha|den|fest|stel|lung,
Scha|dens|fest|stel|lung; **Scha-**
den_feu|er, ...freu|de; scha|den-

froh; **Scha|den|nach|weis,** Scha-
dens|nach|weis; **Scha|dens|be-**
rech|nung vgl. Schadenberech-
nung; **Scha|dens|be|richt,** Scha-
den|be|richt; **Scha|dens|er|satz**
(BGB für: Schadenersatz); **Scha-**
dens|fest|stel|lung vgl. Schaden-
feststellung; **Scha|dens|nach-**
weis, Scha|den|nach|weis; **Scha-**
den_ver|hü|tung, ...ver|si|che-
rung; **schad|haft; Schad|haf|tig-**
keit w; **schä|di|gen; Schä|di|ger;**
Schä|di|gung; schäd|lich; Schäd-
lich|keit w; -
...schäd|lig vgl. ...schädelig
Schäd|ling; Schäd|lings|be|kämp-
fung w; -; **Schäd|lings|be|kämp-**
fungs|mit|tel s, **schad|los;** sich
halten; **Schad_los|bür|ge**
(Wirtsch.: Bürge bei der Ausfall-
bürgschaft), ...hal|tung (w; -);
Schad|stoff
Scha|duf arab. (ägypt. Schwing-
brunnen, Wasserschöpfer an ei-
nem Hebebaum) m; -s, -s
Schaf s; -[e]s, -e; **Schaf|bock;**
Schäf|chen, Schäf|lein; sein
Schäfchen ins trockene bringen,
im trockenen haben, **Schäf|chen-**
wol|ken Mehrz.; **Schä|fer; Schä-**
fe|rei; **Schä|fer_ge|dicht,** ...hund;
Schä|fe|rin w; -, -nen; **Schä|fer-**
kar|ren, ...ro|man, ...spiel,
...stünd|chen, ...stun|de
Schaff südd., österr. ([offenes] Ge-
fäß; Schrank) s; -[e]s, -e;
vgl. ²Schaft u. Schapp; **Schäff-**
chen, Schäff|lein; **Schaf|fel**
österr. mdal.([kleines] Schaff) s;
-s, -n
Schaf|fell
¹schaf|fen (vollbringen); landsch.
für: arbeiten; in [reger] Tätigkeit
sein; Seemannsspr.: essen); du
schafftest (schaffst; schafft[e]!; er
hat den ganzen Tag geschafft; sie
haben es geschafft; er hat die Ki-
ste auf den Boden geschafft; diese
Sorgen sind aus der Welt ge-
schafft (sind beseitigt); ich möch-
te mit dieser Sache nichts mehr
zu schaffen haben; ich habe mir
daran zu schaffen gemacht;
²schaf|fen (schöpferisch, gestal-
tend hervorbringen); du schufst
(schufest); du schüfest; geschaffen;
schaff[e]!; Schiller hat „Wil-
helm Tell" geschaffen; er ist zum
Lehrer wie geschaffen; er stand
da, wie ihn Gott geschaffen hat;
er schuf (auch: schaffte) [endlich]
Abhilfe, Ordnung, Platz, Raum;
es muß [endlich] Abhilfe, Ord-
nung, Platz, Raum geschaffen
(selten: geschafft) werden; **Schaf-**
fen s; -s; **Schaf|fens_drang** (m;
-[e]s), ...freu|de; **schaf|fens|freu-**
dig; **Schaf|fens_freu|dig|keit** (w;
-), ...kraft (w; -); **schaf|fens|kräf-**

tig; Schaf|fens|lust (w; -); schaf-
fens|lu|stig; ¹Schaf|fer landsch.
(Schaffender; tüchtiger Arbeiter;
Mann, der die Schiffsmahlzeit
besorgt u. anrichtet; ²Schaf|fer
(Nebenform von: Schaffner;
österr. veralt. für: Aufseher auf
einem Gutshof)
Schaf|fe|rei (Schiffsvorratskam-
mer)
Schaff|hau|sen (Kanton u. Stadt
in der Schweiz); Schaff|hau|ser;
schaff|hau|se|risch
schaf|fig landsch. u. schweiz.
mdal. (arbeitsam)
Schäff|lein vgl. Schäffchen;
Schäff|ler bayr. (Böttcher);
Schäff|ler|tanz (Zunfttanz der
Münchener Schäffler)
Schaff|ner (Kassier- u. Kontroll-
beamter bei öffentl. Verkehrsbe-
trieben; veralt. für: Verwalter;
Aufseher); Schaff|ne|rei (veralt.
für: Schaffneramt, -wohnung);
Schaff|ne|rin w; -, -nen; schaff-
ner|los; ein -er Wagen; Schaf|fung
Schaf|gar|be (eine Pflanzengat-
tung) w; -, -n; Schaf_häut|chen
(ein Pilz), ...her|de, ...hirt, ...hür-
de; scha|fig
Scha|fi|it (Angehöriger einer mo-
hammedan. Rechtsschule) m;
-en, -en (↑ R 268)
Schaf|kä|se; Schaf|kopf, Schafs-
kopf (ein Kartenspiel) m; -[e]s;
Schaf|le|der, Schäf|lein, Schäf-
chen; Schaf|milch
Scha|fott niederl. (Blutgerüst,
erhöhte Stätte für Hinrichtun-
gen) s; -[e]s, -e
Schaf_pelz, ...que|se (Drehwurm),
...schur; Schafs_kleid, ...kopf
(Scheltwort); Schaf[s]|kopf (ein
Kartenspiel) m; -[e]s; Schafs_na-
se (auch: Apfel-, Birnensorte;
verächtl. für: dummer Mensch);
Schaf|stall
¹Schaft (z. B. Lanzenschaft) m;
-[e]s, Schäfte
²Schaft südd. u. schweiz. (Gestell-
[brett], Schrank) m; -[e]s, Schäfte;
vgl. auch: Schaff u. Schapp
...schaft (z. B. Landschaft w; -, -en)
Schäft|chen, Schäft|lein; schäf|ten
(mit einem Schaft versehen;
Pflanzen veredeln; mdal. für:
prügeln); Schäf|ter; Schaft_le-
der, ...stie|fel
Schaf_wei|de, ...wol|le, ...zecke
[Trenn.: ...zek|ke] (ein Insekt),
...zucht
Schah pers. („König"; pers. Herr-
schertitel; häufig für: Schah-in-
schah) m; -s, -s; Schah-in-schah
(„Schah der Schahs"; Titel des
Herrschers des Iran) m; -s, -s
Scha|kal sanskr. [auch: scha...]
(ein hundeartiges Raubtier) m;
-s, -e

Scha|ke (Ring, Kettenglied) w; -,
-n; Schä|kel (Technik, See-
mannsspr.: Kettenglied) m; -s, -;
schä|keln (Technik, See-
mannsspr.: Kettenstücke verbin-
den); ich ...[e]le (↑ R 327)
Schä|ker jidd.; Schä|ke|rei; Schä-
ke|rin w; -, -nen; schä|kern (bes.
zwischen Personen verschiede-
nen Geschlechts: sich im Spaß
[mit Worten] necken); ich ...ere
(↑ R 327)
schal; ein schales (abgestandenes)
Bier; ein schaler (fader, geist-
loser) Witz
Schal pers.-engl. (ein langes,
schmales Halstuch) m; -s, -e u. -s
Schal|brett (auf einer Seite noch
berindetes Brett; zur Verscha-
lung dienendes Brett)
¹Schäl|chen (kleiner Schal)
²Schäl|chen (kleine ²Schale)
³Schäl|chen (kleine ¹Schale);
¹Scha|le (Trinkschale; südd. u.
österr. auch für: Tasse) w; -, -n
²Scha|le (Hülle; auch: Huf beim
zweihufigen Wild) w; -, -n; Schäl-
ei|sen (ein Werkzeug); schä|len;
Scha|len_guß (Hartguß), ...kreuz
(Windgeschwindigkeitsmesser),
...obst
Scha|len_ses|sel [zu: ¹Schale],
...sitz
Scha|len_wild (Rot-, Schwarz-,
Steinwild)
Schal|heit [zu: schal] w; -
Schäl|hengst (Zuchthengst)
Schal|holz; ...scha|lig (z. B. dünn-
schalig)
Schalk (Spaßvogel, Schelm) m;
-[e]s, -e u. Schälke
Schal|ke (Seemannsspr.: wasser-
dichter Abschluß einer Schiffslu-
ke) w; -, -n; schal|ken (See-
mannsspr.: wasserdicht schlie-
ßen)
schalk|haft; Schalk|haf|tig|keit w;
-; Schalk|heit w; -
Schal_kra|gen, ...kra|wat|te
Schalks_knecht (veralt. für:
nichtsnutziger Knecht), ...narr
(veralt.)
Schäl|kur (Med.)
Schall m; -[e]s, (selten:) -e od.
Schälle; Schall_be|cher (bei Blas-
instrumenten), ...bo|den; schall-
däm|mend, aber (↑ R 142): den
Schall dämmend; Schall_däm-
mung, ...dämp|fer, ...deckel
[Trenn.: ...dek|kel]; schall|dicht;
Schall|do|se; Schallehre [Trenn.:
Schall|leh|re, ↑ R 236] w; -;
Schalleiter [Trenn.: Schall|lei|ter,
↑ R 236] m; schal|len; es schallt;
es schallte (seltener: scholl); es
schallte (seltener: schölle); ge-
schallt; schall[e]!; schallendes
Gelächter; Schall_ge|schwin|dig-
keit, ...mau|er (große Zunahme

des Luftwiderstandes bei einem
die Schallgeschwindigkeit errei-
chenden Flugobjekt) w; -; die
durchbrechen; Schalloch [Trenn.:
Schall|loch, ↑ R 236] s; -[e]s,
Schallöcher
schall|los (ohne Schale)
Schall_plat|te; Schall|plat|ten_al-
bum, ...ar|chiv, ...in|du|strie;
schall_schluckend [Trenn.:
...schluk|kend], aber (↑ R 142):
den Schall schluckend; Schall_si-
cher; schall|tot; -er Raum; Schall-
_trich|ter (trichterförmiges Gerät
zur Schallverstärkung), ...wel|le
(meist Mehrz.), ...wort (durch
Lautnachahmung entstandenes
Wort; Mehrz. ...wörter)
Schalm (Forstw.: mit der Axt an
einen Baum geschlagenes Zei-
chen) m; -[e]s, -e
Schal|mei (ein Holzblasinstru-
ment; auch: Register der Klari-
nette u. der Orgel); Schal|mei_blä-
ser; Schal|mei|en|klang
schal|men (Forstw.: einen Baum
mit einem Schalm versehen)
Schal|obst (hartschaliges Obst,
z. B. Walnuß)
Scha|lot|te fr. (eine kleine Zwie-
bel) w; -, -n
Schalt_an|la|ge, ...bild, ...brett;
schal|ten; er hat geschaltet (beim
Autofahren den Gang gewech-
selt; ugs. für: begriffen, verstan-
den, reagiert); er hat den Strom
geschaltet; er hat mit seinem Ei-
gentum nach Belieben geschaltet
[u. gewaltet]; Schal|ter; Schal|ter-
_be|am|te, ...dienst, ...hal|le,
...raum, ...stun|den (Mehrz.);
Schalt_ge|trie|be (für: Aphonge-
triebe), ...he|bel
Schalt_tier (Muschel; Schnecke)
Schalt_jahr, ...knüp|pel,
...plan (vgl. ²Plan), ...pult, ...satz
(Sprachw.), ...sche|ma (Schalt-
plan), ...schrank, ...skiz|ze, ...ta-
fel, ...tag, ...tisch; Schal|tung;
Schal|tungs_über|sicht; Schalt-
_vor|rich|tung, ...werk
Scha|lung (Bretterverkleidung);
Schä|lung (Entfernung der Scha-
le, der Haut u. a.)
Scha|lup|pe fr. (Küstenfahrzeug;
auch: großes [Bei]boot) w; -, -n
Schal|wild vgl. Schalenwild
Scham w; -
Scha|ma|de fr. (früher für: [mit der
Trommel oder Trompete gegebe-
nes] Zeichen der Ergebung); -
schlagen (übertr. für: klein beige-
ben, sich ergeben)
Scha|ma|ne sanskr.-tungus. (Zau-
berpriester asiat. Naturvölker)
m; -n, -n (↑ R 268); Scha|ma|nis-
mus (eine Religionsform) m; -
Scham_bein, ...berg; schä|men,

sich; ich schäme mich meiner Eltern nicht; er schämte sich seines Verhaltens, (in der gesprochenen Sprache häufiger:) wegen seines Verhaltens; ich schäme mich vor meinem Freund (fürchte seinen Tadel), für meinen Freund (an seiner Stelle)

scham|fi|len (Seemannsspr.: reiben, [ab]scheuern); schamfilt (↑ R 304)

Scham.ge|fühl, ...**ge|gend**, ...**haar** (meist *Mehrz.*); **scham|haft**; **Scham|haf|tig|keit** w; -; **schä|mig**; **Schä|mig|keit** w; -; **Scham|lip|pen** (äußere weibl. Geschlechtsorgane) *Mehrz.*; **scham|los**; -este (↑ R 292); **Scham|lo|sig|keit**

Scha|mott jidd. (ugs. für: Kram, Zeug, wertlose Sachen) m; -s

Scha|mot|te it. (feuerfester Ton) w; -; **Scha|mot|te.stein**, ...**zie|gel**; **scha|mot|tie|ren** österr. (mit Schamottesteinen auskleiden)

Scham|pun Hindi-engl. (ein Haarwaschmittel) s; -s; vgl. Shampoo; **scham|pu|nie|ren** (das Haar mit Schampun waschen)

Scham|pus (ugs. für: Champagner) m; -

scham|rot; **Scham.rö|te**, ...**tei|le** (*Mehrz.*)

schand|bar; **Schand|bu|be** (veralt.); **Schan|de** w; - (↑ R 132:) zuschanden gehen, machen, werden

Scham|deck, **Schan|deckel** [*Trenn.:* ...**dek|kel**] (Seemannsspr.: die oberste Schiffsplanke)

schän|den; **schan|de[n]|hal|ber** südd., österr. u. schweiz. mdal. veralt. (anstandshalber); **Schän|der**; **Schand|fleck**; **schänd|lich**; **Schänd|lich|keit**; **Schand_mal** (*Mehrz.* ...male u. ...mäler), ...**maul** (abschätzig), ...**pfahl** (Pranger), ...**preis** (vgl. ²Preis), ...**tat**; **schand- und eh|ren|hal|ber** (↑ R 145); **Schän|dung**; **Schand|ur|teil**

Schang|hai (postamtlich:) Shanghai (größte Stadt und Wirtschaftszentrum Chinas); **schang|hai|en** [auch: schang...] (Matrosen gewaltsam heuern); schanghait (↑ R 304)

Scha|ni ostösterr. ugs. (Handlanger, Kellnerbursche) m; -s, -

¹**Schank** (veralt. für: Ausschank) m; -[e]s, Schänke; ²**Schank** österr. (Raum für den Ausschank, Theke) w; -, -en; **Schank|be|trieb**

Schan|ker lat.-fr. (eine Geschlechtskrankheit) m; -s, -

Schank_er|laub|nis|steu|er w, ...**ge|rech|tig|keit** (behördl. Genehmigung, geistige Getränke auszuschenken), ...**kon|zes|si|on**; **Schank|stu|be**, Schenk|stube; **Schank|tisch**, Schenk|tisch;

Schank|wirt, Schenk|wirt; **Schank|wirt|schaft**, Schenk|wirtschaft

Schan|si (chin. Provinz.)

Schan|tung (chin. Prov.); **Schan|tung|sei|de**

Schanz|ar|beit; **Schanz|bau**, Schan|zen|bau (*Mehrz.* ...bauten)

¹**Schan|ze** altfr. (veralt. für: Glückswurf, -umstand) w, nur noch gebräuchlich in: in die - schlagen (aufs Spiel setzen)

²**Schan|ze** („Reisigbündel"; geschlossene, feldmäßig hergestellte Verteidigungsanlage; Oberdeck des Achterschiffes; Sprungschanze) w; -, -n; **schan|zen** (an einer Schanze arbeiten, Erdarbeit verrichten; ugs. für: schwer arbeiten); du schanzt (schanzest); **Schan|zen.bau** (vgl. Schanzbau), ...**re|kord** (Sportspr.), ...**tisch** (Absprungfläche einer Sprungschanze); **Schan|zer**; **Schanz.kleid** (Seemannsspr.: Schiffsschutzwand), ...**korb**, ...**pfahl**, ...**werk**, ...**zeug**

Schapf m; -[e]s, -e u. **Schan|fe** südd. u. schweiz. mdal. (Schöpfgefäß mit langem Stiel) w; -, -n

Schap|po niederd. (Schrank) m od. s; -s, -s; vgl. auch: Schaff u.
²**Schaft**

¹**Schap|pe** fr. (ein Gewebe aus Seidenabfall) w; -, -n
²**Schap|pe** (Bergmannsspr.: Tiefenbohrer) w; -, -n

Schap|pel landsch. (Kopfschmuck, Brautkrone) s; -s, -

Schap|pe.sei|de (¹Schappe), ...**spin|ne|rei**

¹**Schar** (größere Anzahl, Menge, Gruppe) w; -, -en; ²**Schar** (Pflugschar) w; -, -en (Landw. auch: s; -[e]s, -e)

Scha|ra|de fr. (ein Silbenrätsel)

Schär|baum (Weberei: Garn- od. Kettenbaum)

Schar|be (ein Vogel) w; -, -n

Schar|bock niederl. (veralt. für: Skorbut) m; -[e]s; **Schar|bockskraut** (eine Heilpflanze) s; -[e]s

Schä|re schwed. (kleine Felsinsel, Küstenklippe der skand. u. der finn. Küsten) w; -, -n (meist *Mehrz.*)

scha|ren, sich

schä|ren (Webfäden aufwinden)

Schä|ren|kü|ste

Schä|ren|wei|se

scharf; schärfer, schärfste; scharfe (deutliche) Umrisse; eine scharfe (schneidende) Stimme; ein scharfes (sehr gutes) Auge; ein scharfer Verstand; ein scharfes Getränk; (↑ R 116:) er ist ein Scharfer (ugs. für: ein strenger Polizist, Beamter u. ä.); scharf anfassen, durchgreifen, sehen, schießen usw.; vgl. aber: scharfmachen; **Scharf** (dem Schiffsende zu schmal verlaufendes Stück; abgeschrägtes Ende [eines Brettes, Balkens]) s; -[e]s, -e; **Scharf|blick** m; -[e]s; **Schär|fe** w; -, -n; **Scharf|ein|stel|lung**; **schär|fen**; **Schär|fen|tie|fe** (Fotogr.); **scharf|kan|tig**

Schärf|lein (falsch für: Scherflein)

scharf|ma|chen; ↑ R 139 (ugs. für: aufhetzen, scharfe Maßregeln befürworten); ich mache scharf; scharfgemacht; scharfzumachen; aber: **scharf ma|chen** (schärfen); das Messer scharf machen; **Scharf|ma|cher** (ugs. für: Hetzer, Befürworter scharfer Maßregeln); **Scharf|ma|che|rei**; **Scharf_rich|ter**, ...**schüt|ze**; **Scharf|schüt|zen|ab|tei|lung**; **scharf|sich|tig**; **Scharf|sich|tig|keit** w; -; **Scharf|sinn** m; -[e]s; **scharf|sin|nig**; **Schär|fung**; **scharf_zackig** [*Trenn.:* ...**zak|kig**], ...**zäh|nig**

Schär|has|pel [zu: schären]

¹**Schar|lach** mlat. (lebhaftes Rot) m; -s, -e; ²**Schar|lach** (eine Infektionskrankheit) m; -s; **Schar|lach.aus|schlag**; **schar|la|chen** (hochrot); **Schar|lach.far|be**, ...**far|big**; **Schar|lach|fie|ber** s; -s; **schar|lach|rot**

Schar|la|tan fr. (Schwätzer, Marktschreier; Quacksalber, Kurpfuscher) m; -s, -e; **Schar|la|ta|ne|rie** w; -, ...ien; **schar|la|ta|ni|sie|ren**; **Schar|la|ta|nis|mus** m; -

Scharm (eindeutschend für: Charme [vgl. d.]) m; -s; **schar|mant** (eindeutschend für: charmant [vgl. d.]); **Schar|man|te** (veralt. für: Liebste) w; -, -n

Schär|ma|schi|ne (zum Aufwinden der Webfäden); vgl. schären

schar|mie|ren (veralt. für: bezaubern; entzücken)

Schar|müt|zel (kurzes, kleines Gefecht, Plänkelei) s; -s, -; **schar|müt|zeln**; ich ...[e]le (↑ R 327); **schar|mut|zie|ren** (veralt., aber noch mdal. für: plänkeln; liebeln)

Scharn m; -[e]s, -e u. **Schar|ren** mdal. (Fleisch-, Brotbank) m; -s, -

Schar|nier fr. (Drehgelenk [für Türen]) s; -s, -e; **Schar|nier_band** (s; *Mehrz.* ...bänder), ...**ge|lenk**, ...**wa|re** (hohlgezogene Goldware)

Schärp|chen, Schärp|lein; **Schär|pe** (um Schulter od. Hüften getragenes breites Band) w; -, -n

Schar|pie fr. (früher für: zerzupfte Leinwand als Verbandmaterial) w; -

Schärp|lein, Schärp|chen
Schär|rah|men [zu: schären]
Schar|re (ein Werkzeug zum
Scharren) w; -, -n; Scharr|ei|sen;
schär|ren
Schär|ren vgl. Scharn
Schär|rer; Scharr|fuß (veralt. für:
Kratzfuß); ich ...[e]le (↑ R 327); ge-
scharrfüßelt
Schar|rier|ei|sen (ein Steinmetz-
werkzeug); schar|rie|ren fr. (mit
dem Scharriereisen bearbeiten)
Schar|schmied (Pflugscharherstel-
ler; Schmied)
Schar|te (Einschnitt; [Mauer]-
lücke; Hasenscharte) w; -, -n; eine
- auswetzen (ugs. für: einen Feh-
ler wiedergutmachen; eine Nie-
derlage o. ä. wettmachen)
Schar|te|ke (wertloses Buch,
Schmöker; abschätzig für: ält-
liche Frau) w; -, -n
schar|tig
Schär|trom|mel [zu: schären]
Scha|rung (Grenzstelle zweier Ge-
biete von stärkerer Gebirgsfal-
tung)
Schar|wa|che (früher für: [nächtl.]
Streifenwache)
Schar|wen|zel, Scher|wen|zel
tschech. (Unter, Bube in Karten-
spielen; ugs. für: Allerweltsdie-
ner; Jägerspr.: Pudel) m; -s, -;
schar|wen|zeln, scher|wen|zeln
(sich dienernd hin u. her bewe-
gen; dafür heute meist: herum-
scharwenzeln); ich ...[e]le (↑ R
327); scharwenzelt, scherwenzelt
(↑ R 304)
Schar|werk (veralt. für: Fronar-
beit; harte Arbeit); schar|wer|ken
(mdal.); gescharwerkt; Schar-
wer|ker (mdal.); Schar|werks-
mau|rer
Schasch|lik russ. [auch: ...lik] (am
Spieß gebratene [Hammel]-
fleischstückchen) m od. s; -s, -s
schas|sen fr. (ugs. für: [von der
Schule, der Lehrstätte, aus dem
Amt] wegjagen); du schaßt
(schassest), er schaßt; du schaß-
test; geschaßt; schasse! u. schaß!;
schas|sie|ren (beim Tanz mit kur-
zen, gleitenden Schritten sich ge-
radlinig fortbewegen)
schat|ten (dicht. für: Schatten ge-
ben); geschattet; Schat|ten m; -s,
-; Schat|ten_bild, ...da|sein; schat-
ten|haft; Schat|ten_ka|bi|nett,
...kö|nig; schat|ten|los; Schat|ten-
mo|rel|le; schat|ten|reich; Schat-
ten_reich, ...riß; Schat|ten|sei|te,
Schatt|sei|te (österr.); schat|ten-
sei|tig, schatt|sei|tig (österr.);
schat|ten|spen|dend, aber (↑ R
142): kühlen Schatten spendend;
Schat|ten|spiel; schat|tie|ren
([ab]schatten); Schat|tie|rung;

schat|tig; Schatt|sei|te (österr. ne-
ben: Schattenseite); schatt|sei|tig
(österr. neben: schattenseitig)
Scha|tul|le mlat. (Geld-,
Schmuckkästchen; früher für:
Privatkasse des Staatsoberhaup-
tes, eines Fürsten) w; -, -n
Schatz m; -es, Schätze; Schatz-
_amt, ...an|wei|sung; schätz|bar;
Schätz|chen, Schätz|lein; schat-
zen (veralt. für: mit Abgaben be-
legen); du schatzt (schatzest);
schät|zen; du schätzt (schätzest);
schät|zen|ler|nen; vgl. kennenler-
nen; schät|zens|wert; Schätz-
zer; Schatz_fund, ...grä|ber, ...kam-
mer, ...käst|chen od. ...käst|lein;
Schätz|lein, Schätz|chen; Schatz-
mei|ster; Schätz|preis; vgl. ²Preis;
Schat|zung (veralt. für: Belegung
mit Abgaben; schweiz.: [amt-
liche] Schätzung des Geldwerts);
Schät|zung; schät|zungs|wei|se;
Schatz|wech|sel (Kaufmanns-
spr.: kurzfristige Schatzanwei-
sung in Wechselform); Schätz-
wert
schau (ugs. für: ausgezeichnet,
wirkungsvoll, wunderbar);
Schau (heute bes. für: Ausstel-
lung, Überblick; Vorführung) w;
-, -en; zur - stehen, stellen, tragen;
jmdm. die - stehlen (ugs. für: ihn
um die Beachtung u. Anerken-
nung der anderen bringen); vgl.
schaustehen, schaustellen
Schaub süd., österr., schweiz.
(Garbe, Strohbund; Strohwisch)
m; -[e]s, Schäube; 3 - (↑ R 322)
schau|bar (veralt. für: sichtbar)
Schau|be arab. (weiter, vorn offe-
ner Mantelrock des MA.) w; -,
-n
schau|be|gie|rig
Schau|ben_dach (veralt. für:
Strohdach), ...hut (veralt. für:
Strohhut; m)
Schau_be|richt, ...bild, ...brot,
...bu|de, ...büh|ne, ...burg (Name
von Kinos)
Schau|der m; -s, -; schau|der|bar
(ugs. scherzh. für: schauderhaft);
schau|der|er|re|gend, aber (↑ R
142): großen Schauder erregend;
-ste; Schau|der|ge|schich|te;
schau|der|haft; schau|dern; ich
...ere (↑ R 327); mir od. mich
schaudert; schau|der|voll
¹Schau|er niederd. (Hafen-,
Schiffsarbeiter) m; -s, -
²Schau|er (veralt. für: Schauen-
der)
³Schau|er (Schreck; kurzes, plötz-
liches Unwetter) m; -s, -
⁴Schau|er landsch. (Schutzdach;
auch: offener Schuppen) m od.
s; -s, -
Schau|er_bild, ...ge|schich|te;

schau|er|lich; Schau|er|lich|keit
Schau|er|mann (Seemannsspr.:
Häfen-, Schiffsarbeiter) m; -[e]s,
...leute
Schau|er|mär|chen; schau|ern; ich
...ere (↑ R 327); mir od. mich
schauert; Schau|er|ro|man;
schau|er|voll
Schau|fel w; -, -n; Schau|fel|blatt;
schau|fel|för|mig; schau|fe|lig,
schauf|lig; schau|feln; ich ...[e]le
(↑ R 327); Schau|fel|rad
Schau|fen|ster, Schau|fen|ster-
_bum|mel, ...de|ko|ra|teur, ...de-
ko|ra|ti|on, ...ge|stal|tung, ...wett-
be|werb
Schauf|ler (Damhirsch)
Schau|ge|schäft s; -[e]s
Schau|ins|land (Berg im südl.
Schwarzwald)
Schau_kampf, ...ka|sten
Schau|kel w; -, -n; Schau|ke|lei;
schau|ke|lig, schauk|lig; schau-
keln; ich ...[e]le (↑ R 327); Schau-
kel_pferd, ...po|li|tik, ...reck,
...stuhl; Schauk|ler
Schau_lau|fen (Eiskunstlauf; s; -s),
...lust (w; -); schau|lu|stig; Schau-
lu|sti|ge m u. w; -n, -n (↑ R 287ff.)
Schaum m; -[e]s, Schäume;
Schaum|bad; schaum|be|deckt,
aber (↑ R 142): von Schaum be-
deckt; Schaum|bla|se
Schaum|burg-Lip|pe (Landkreis in
Niedersachsen); schaum|burg-
lip|pisch
schäu|men; Schaum_ge|bäck, ...ge-
bo|re|ne (Beiname der aus dem
Meer aufgetauchten Aphrodite
[vgl. Anadyomene]; w; -n);
schaum|ge|bremst; -e Waschmit-
tel; Schaum_gold, ...gum|mi;
schau|mig; Schaum_kel|le,
...kraut, ...kro|ne, ...löf|fel,
...lösch|ge|rät, ...rol|le (österr.:
Gebäck), ...schlä|ger (Küchenge-
rät; übertr. für: Blender);
Schaum|schlä|ge|rei; Schaum-
_spei|se, ...stoff
Schau|mün|ze
Schaum_wein; Schaum|wein|steu-
er w
Schau_packung [Trenn.: ...pak-
kung], ...platz, ...pro|zeß
Schau_rig; schaurig-schön (↑ R
158); Schau|rig|keit
Schau_sei|te, ...spiel; Schau|spiel-
dich|ter; Schau|spie|ler; Schau-
spie|le|rei; Schau|spie|le|rin;
schau|spie|le|risch; schau|spie-
lern; ich ...ere (↑ R 327); geschau-
spielert; zu -; Schau_spiel_haus,
...kunst (w; -), ...schu|le, ...schü-
ler, ...schü|le|rin, ...un|ter|richt
schau|ste|hen, fast nur in der
Grundform gebräuchlich; schau-
stel|len, fast nur in der Grund-
form gebräuchlich; Schau_stel-
ler, ...stel|lung, ...stück, ...tanz

Schau|te vgl. [1]Schote
Schau|tur|nen s; -s
Schech (Nebenform von: Scheich)
[1]Scheck engl. (Zahlungsanweisung [an eine Bank, an die Post]) m; -s, -s (seltener: -e); ein ungedeckter, weißer -; Scheck_ab|tei|lung, ...amt, ...be|trug, ...be|trü|ger, ...buch, ...bürg|schaft, ...dis|kon|tie|rung
[2]Scheck, [1]Schecke[1] fr. (scheckiges Pferd od. Rind) m; Schecken, Schecken; [2]Schecke[1] (scheckige Stute od. Kuh) w; -, -n
Scheck_fä|hig|keit, ...fäl|schung, ...ge|setz
scheckig[1]; scheckig|braun[1]
Scheck_in|kas|so, ...pro|zeß, ...recht (s; -[e]s), ...rück|ga|be_ab|kom|men, ...rück|griff, ...sper|re, ...ver|kehr
Scheck|vieh (scheckiges Vieh)
Sched|bau, Shed|bau engl.; dt. [sch...] (Eingeschoßbau mit sägeförmigem Dach; Mehrz. ...bauten); Sched|dach, Shed|dach (Sägedach)
scheel; scheel|äu|gig; scheel|blickend (Trenn.: ...blik|kend]; Scheel|sucht w; -; scheel|süch|tig
Sche|fe südd. ([3]Schote) w; -, -n
Schef|fel (ehem. Hohlmaß; Ackermaß) m; -s, -; schef|feln (auch für: zusammenraffen, geizig erraffen); ich ...[e]le († R 327); es scheffelt (es kommt viel ein); schef|fel|wei|se
Sche|he|ra|za|de, Sche|he|re|za|de pers. [...sgd[e]] (Märchenerzählerin aus Tausendundeiner Nacht)
Scheib|band bayr. (Brustriemen zum Karrenziehen; Mehrz. ...bänder); Scheib|chen, Scheiblein; scheib|chen|wei|se; Schei|be w; -, -n; schei|ben bayr., österr. (rollen, [kegel]schieben); Schei|ben|brem|se; schei|ben|för|mig; Schei|ben_gar|di|ne, ...ho|nig, ...kupp|lung, ...schie|ßen, ...schüt|ze; Schei|ben|wasch|an|la|ge; Schei|ben|wa|scher, ...wi|scher; schei|big; Scheib|lein, Scheibchen; Scheib|tru|he österr. (Schubkarren)
Scheich arab. (,,Ältester‘‘; Häuptling eines Beduinenstammes; Dorfältester) m; -s, -e u. -s; Scheich|tum
Schei|de w; -, -n; Schei|de|brief (veralt. für: Scheidungsurkunde)
Schei|degg (Paß in der Schweiz) w; -; die Große -, die Kleine -
Schei|de|kunst (alter Name der Chemie; w; -), ...mei|ster (veralt. für: Schiedsmann), ...mün|ze; schei|den; du schiedst (schiedest); du schiedest; geschieden (vgl. d.);

scheid[e]!; Schei|den|ent|zün|dung; Schei|de_wand, ...was|ser (Chemie; Mehrz. ...wässer), ...weg; Schei|ding (September) m; -s, -e; Schei|dung; Schei|dungs_grund, ...kla|ge, ...pro|zeß, ...ur|teil
Scheik vgl. Scheich
Schein m; -[e]s, -e; Schein|ar|chi|tek|tur (die nur gemalten Architekturteile auf Wand od. Decke); schein|bar (nur dem [der Wirklichkeit nicht entsprechenden] Scheine nach); er hörte scheinbar aufmerksam zu (in Wirklichkeit war das nicht der Fall), aber: er hörte anscheinend aufmerksam zu (wie es den Anschein erweckte, hörte er aufmerksam zu); Schein_blü|te, ...da|sein; schei|nen; du schienst (schienest); du schienest; geschienen; schein[e]!; scheint's (ugs. für: scheint es, wie es scheint, anscheinend); er kommt scheint's morgen; Schein_fir|ma, ...frucht (Biol.), ...füß|chen (bei Amöben), ...ge|fecht, ...ge|schäft, ...ge|sell|schaft, ...ge|sell|schaf|ter, ...ge|winn, ...grund, ...grün|dung, ...hand|lungs_voll|macht; schein|hei|lig; Schein|hei|li|ge m und w; Schein|hei|lig|keit; Schein_kauf, ...kauf|mann (Rechtsw.), ...kurs, ...tod; schein|tot; Schein_ver|trag, ...welt, ...wer|fer, ...we|sen (s; -s), ...wi|der|stand
Scheiß|dreck (derb); Schei|ße (derb für: Kot) w; -; schei|ßen (derb); ich schiß; du schissest; geschissen; scheiß[e]!; Schei|ßer (derb); Schei|ße|rei (derb) w; -; scheiß_egal, ...freund|lich (derb); Scheiß_haus (derb), ...kerl (derb)
Scheit (Grabscheit; Holzscheit) s; -[e]s, -e (österr. nur, schweiz. meist: -er)
Schei|tel m; -s, -; Schei|tel_bein (ein Schädelknochen), ...li|nie; schei|teln; ich ...[e]le († R 327); Schei|tel_punkt; schei|tel|recht (veralt. für: senkrecht); Schei|tel|wert, ...win|kel
schei|ten schweiz. (Holz spalten); Schei|ter|hau|fen; schei|tern; ich ...ere († R 327); Scheit|holz; scheit|recht (veralt. für: geradlinig; flach); Scheit|stock schweiz. (Holzklotz zum Holzspalten; Mehrz. ...stöcke)
Sche|kel vgl. Sekel
Schelch rhein., ostfränk. (größerer Kahn) m od. s; -[e]s, -e
Schel|de (Zufluß der Nordsee) w; -
Schelf engl. (Geogr.: untermeerischer Teil der Kontinenttafeln, Flachmeer entlang der Küste) m od. s; -s, -e
Schel|fe, Schil|fe mdal. ([Frucht]-

hülse, Schale) w; -, -n; schel|fen, schil|fen (seltener für: schelfern, schilfern); schel|fe|rig, schelf|rig, schil|fe|rig, schilf|rig; schel|fern, schil|fern (in kleinen Teilen od. Schuppen abschälen); ich ...ere († R 327)
Schel|lack niederl. (ein Harz) m; -[e]s, -e
[1]Schel|le (Haltering) w; -, -n
[2]Schel|le (Glöckchen; Ohrfeige) w; -, -n; [3]Schel|le w; -, -n u. Schel|len (eine Spielkartenfarbe) s; -, -; schel|len; Schel|len_as, ...baum (Instrument der Militärkapelle), ...bu|be (vierthöchste Schellenkarte), ...ge|läut od. ...ge|läu|te, ...kap|pe, ...kö|nig, ...schlit|ten
Schell|fisch
Schell|ham|mer (ein Werkzeug)
Schell|hengst vgl. Schälhengst
Schel|ling (dt. Philosoph)
Schell|kraut s; -[e]s; vgl. Schöllkraut; Schell|wurz
Schelm (urspr. für: Aas, Abdecker, Betrüger, Narr; heute für: Schalk) m; -[e]s, -e; Schel|men_ge|sicht (Mehrz. -er), ...lied, ...ro|man, ...streich, ...stück, ...zunft; Schel|me|rei; schel|misch; -ste († R 294)
Schel|te (Tadelwort; ernster Vorwurf) w; -, -n; schel|ten; du schiltst, er schilt; du schaltst (schaltest), er schalt; du schöltest; gescholten; schilt!
Schel|to|pu|sik russ. (eine Schleiche) m; -s, -e
Schelt_re|de, ...wort (Mehrz. ...wörter u. ...worte)
Sche|ma gr. (Muster, Aufriß; Entwurf; Plan, Form, Gerippe; bildl. für: vorgeschriebener Weg) s; -s, -s u. -ta (auch: Schemen); nach - F; Sche|ma_brief; schema|tisch; -ste († R 294); eine -e Zeichnung; sche|ma|ti|sie|ren (nach einem Schema behandeln; in eine Übersicht bringen); Sche|ma|ti|sie|rung; Sche|ma|tis|mus (gedankenlose Nachahmung eines Schemas; verächtl. für: Formenkram; statist. Handbuch einer kath. Diözese od. eines geistl. Ordens, österr. auch der öffentlich Bediensteten) m; -, ...men
Schem|bart (Maske mit Bart, bärtige Maske); Schem|bart_lau|fen (s; -s), ...spiel
Sche|mel m; -s, -e
[1]Sche|men (Schatten[bild]; mdal. für: Maske) m; -s, -
[2]Sche|men (Mehrz. von: Schema)
sche|men|haft [zu: [1]Schemen]
Schenk (veralt. für: Diener [zum Einschenken]; Wirt) m; -en, -en († R 268); Schen|ke w; -, -n
Schen|kel m; -s, -; Schen|kel_bruch m, ...hals; Schen|kel|hals|bruch

m; ...schen|ke|lig, ...schenk|lig
(z. B. gleichschenk[e]lig); Schen-
kel_kno|chen, ...stück
schen|ken (als Geschenk geben);
älter für: einschenken); Schen-
ken|amt (veralt.)
Schen|ken|dorf (dt. Dichter)
Schen|ker (veralt. für: Bierwirt,
Biereinschenker); Schen|kin w; -,
-nen
...schenk|lig vgl. ...schenkelig
Schenk|stu|be, Schank|stu|be;
Schenk|tisch, Schank|tisch;
Schen|kung; Schen|kungs_brief,
...steu|er w, ...ur|kun|de, ...ver-
trag; Schenk|wirt, Schank|wirt;
Schenk|wirt|schaft, Schank|wirt-
schaft
schepp landsch. (schief)
schep|pern südd., österr. mdal u.
schweiz. (klappern, klirren); ich
...ere (↑ R 327)
Scher südd., österr. mdal. u.
schweiz. mdal. (Maulwurf) m;
-[e]s, -e; vgl. Schermaus
Scher|be (irdenes Bruchstück) w;
-, -n; Scher|bel mdal. (Scherbe)
m; -s, -
scher|beln mdal. (tanzen; schweiz.:
unrein, spröde klingen; klirren,
rascheln); ich ...e[e]le (↑ R 327)
Scher|ben südd., österr. (Scherbe;
veralt. für: Blumentopf; in der
Keramik Bez. für den gebrannten
Ton) m; -s, -; Scher|ben_ge|richt
(für: Ostrazismus) s; -[e]s
Scher|bett arab. vgl. Sorbett
Sche|re w; -, -n; ¹sche|ren (ab-
schneiden); du scherst, er schert;
du schorst (schorest; selten:
schertest); du schörest (selten:
schertest); geschoren (selten: ge-
schert); scher[e]!
²sche|ren, sich (ugs. für: sich fort-
machen; sich um etwas küm-
mern); scher dich zum Teufel!;
er hat sich nicht im geringsten
darum geschert
Sche|ren_fern|rohr, ...git|ter,
...schlei|fer, ...schnitt, ...zaun;
Sche|rer
Sche|re|rei (ugs. auch für: Unan-
nehmlichkeit, unnötige Schwie-
rigkeit)
Scher|fe|stig|keit (Technik)
Scherf|lein; sein - beitragen
Scher|ge (verächtl. für: Vollstrek-
ker der Befehle eines
Machthabers, Büttel) m; -n, -n
(↑ R 268); Scher|gen_amt, ...dienst
Sche|rif arab. (,,erhaben''; arab.
Titel) m; -s u. -en, -s u. -e[n] (↑ R
268)
Scher_kopf (am elektr. Rasierap-
parat), ...kraft w, ...ma|schi|ne
(zum Scheren), ...maus (vgl.
Scher)
Scher|mes|ser s
Schern|ken österr. (breiter Nagel

an Bergschuhen) m; -s, -; Schern-
ken|schuh
Sche|rung (Math., Physik)
Scher|wen|zel vgl. Scharwenzel
scher|wen|zeln vgl. scharwenzeln
Scher|wol|le
¹Scherz bayr., österr. ugs. (Brot-
anschnitt, dickes Stück Brot) m;
-es, -e
²Scherz m; -es, -e; aus, im -; scher-
zan|do it. [ßkär...] (Musik: heiter
[vorzutragen]); Scher|zan|do s; -s,
-s u. ...di; Scherz|ar|ti|kel
Scher|zel bayr., österr. (Brotan-
schnitt; österr. auch: eine Rind-
fleischsorte) s; -s, -
scher|zen; du scherzt (scherzest);
Scherz_fra|ge,...ge|dicht; scherz-
haft; scherz|haf|ter|wei|se;
Scherz|haf|tig|keit w; -; Scher|zo
it. [ßkärzo] (heiteres Tonstück)
s; -s, -s u. ...zi; Scherz_rät|sel,
...re|de; scherz|wei|se; Scherz-
wort (Mehrz. ...worte)
sche|sen landsch. (eilen); du schest
(schesest)
scheu; -[e]ste (↑ R 293); - sein, wer-
den; - machen; Scheu (Angst,
banges Gefühl) w; -; ohne -;
Scheu|che (Schreckbild, -gestalt
[auf Feldern usw.]) w; -, -n; scheu-
chen; scheu|en; sich -; das Pferd
hat gescheut; ich habe mich vor
dieser Arbeit gescheut
Scheu|er (Scheune) w; -, -n
Scheu|er_be|sen, ...frau, ...kraut
(Ackerschachtelhalm), ...lap-
pen, ...lei|ste; scheu|ern; ich ...ere
(↑ R 327); Scheu|er_sand, ...tuch
(Mehrz. ...tücher)
Scheu|klap|pe (meist Mehrz.),
...le|der (svw. Scheuklappe);
scheu|los
Scheu|ne w; -, -n; Scheu|nen|tor s
Scheu|sal s; -s, -e (ugs.: ...säler);
scheuß|lich; -ste; Scheuß|lich|keit
Schi, Ski norw. (Schneeschuh) m;
-s, -er (selten: -); (↑ R 140:) Schi fah-
ren, - laufen; (↑ R 145:) Schi u.
eislaufen, aber: eis- u. Schi
laufen; Schi Heil! (Schiläufer-
gruß)
Schib|ke, Schib|bi|ke slaw.
obersächs. (Holunderbeere) w; -,
-n
Schib|bo|leth hebr. (selten für: Er-
kennungszeichen, Losungswort)
s; -s, -e u. -s
Schi|bob (einkufiger Schlitten)
Schicht (Schichtung; Gesteins-
schicht; Überzug; Arbeitszeit,
bes. des Bergmanns; Belegschaft)
w; -, -en; die führende Schicht;
in drei Schichten arbeiten; zur
Schicht gehen; Schicht|ar|beit;
Schicht|ar|bei|ter; Schicht|te
österr. ([Gesteins]schicht) w; -,
-n; schich|ten; Schich|ten_fol|ge
(Geol.), ...kopf (Bergmannsspr.),

...spe|zi|fik (Sprachw., Soziolo-
gie; w; -); schich|ten_spe|zi|fisch;
schich|ten_wei|se, schicht|wei|se;
Schicht|holz (Forstw.); schich|tig
(für: lamellar); ...schich|tig (z. B.
zweischichtig); Schicht|lohn;
Schicht|tung; Schicht_un|ter|richt,
...wech|sel; schicht|wei|se, schich-
ten|wei|se; Schicht_wol|ke (für:
Stratuswolke), ...zeit
schick (fein; modisch, elegant);
-ste; ein -er Mantel; der Mantel
ist -; Schick ([modische] Feinheit;
schweiz. für: einzelner [vorteil-
hafter] Handel) m; -[e]s; diese Da-
me hat -; schicken [Trenn.: schik-
ken]; sich -; es schickt sich nicht;
er hat sich schnell in diese Ver-
hältnisse geschickt; Schicke|ria
[Trenn.: Schik|ke...] it. (bes. mo-
debewußte obere Gesellschafts-
schicht) w; -; schick|lich; ein
schickliches Betragen; (↑ R 116:)
das Schickliche betonen; Schick-
lich|keit w; -; Schick|sal s; -s, -e;
schick|sal|haft; schick|sal[s]|er-
ge|ben; Schick|sals_fra|ge, ...fü-
gung, ...ge|fähr|te, ...ge|mein-
schaft, ...glau|be, ...schlag;
schick|sals|schwan|ger; Schick-
sals|tra|gö|die; schick|sals|ver-
bun|den; Schick|sals_ver|bun-
den|heit (w; -), ...wen|de; Schick-
schuld (am Wohnsitz des Schuld-
ners zu erfüllende Schuld)
Schick|se jidd. (urspr. nichtjüd.
Mädchen, dann [von Nichtjuden
gebraucht für:] jüd. Mädchen;
heute nur noch ugs. verächtl. für:
leichtes Mädchen) w; -, -n
Schickung [Trenn.: Schik|kung]
(Fügung, Schicksal; ernste Prü-
fung)
Schie|be_bock, ...dach, ...deckel
[Trenn.: ...dek|kel], ...fen|ster;
schie|ben; du schobst (schobest);
du schöbest; geschoben; schie-
b[e]!; Schie|ber (Riegel; Maschi-
nenteil; auch: gewinnsüchtiger
[Zwischen]händler); Schie|be-
rei; Schie|be_tür, ...wi|der|stand
(Physik); Schieb|leh|re (bes. fach-
spr.); Schie|bung (auch: gewinn-
süchtiger [Zwischen]handel, Be-
trug)
schiech bayr. u. österr. mdal. (häß-
lich, zornig, furchterregend)
Schied (veralt. für: Scheidung) m;
-s, -e
Schie|dam [ßchi...] (niederl. Stadt);
¹Schie|da|mer (↑ R 199); ²Schie-
da|mer (ein Branntwein)
schied|lich (friedfertig); - und
friedlich; Schieds_ge|richt,
...klau|sel, ...mann (Mehrz.
...männer), ...rich|ter; Schieds-
rich|ter|ent|schei|dung; schieds-
rich|ter|lich; schieds|rich|tern; ich
...ere (↑ R 327); er hat das Spiel

geschiedsrichtert; Schieds|richter.stuhl, ...ur|teil; Schieds_spruch, ...ur|teil, ...ver|fah|ren, ...ver|gleich, ...vertrag
schief; die schiefe Ebene; ein schiefer Winkel; er macht ein schiefes (mißvergnügtes) Gesicht; ein schiefer (scheeler) Blick; schiefe (nicht zutreffende) Bilder gebrauchen; in ein schiefes Licht geraten (falsch beurteilt werden), aber (↑ R 224): der Schiefe Turm von Pisa. Schreibung in Verbindung mit Zeitwörtern (↑ R 139):
- sehen, werden, stehen, halten, ansehen, urteilen, denken; vgl. aber: schiefgehen, schieflachen, schiefliegen, schieftreten; schief gewachsen, geladen (ugs. für: betrunken); vgl. schiefgewickelt; Schie|fe w; -
Schie|fer (ein Gestein; auch: Holzsplitter) m; -s, -; Schiefer.bruch m, ...dach, ...decker [Trenn.: ...dek|ker], ...ge|bir|ge; schie|fer|grau; schie|fe|rig, schief|rig; schie|fern (schieferig sein); Weinbau: Erde mit [zerkleinertem] Schiefer bestreuen); ich ...ere (↑R 327); Schie|fer_stift m, ...ta|fel, ...ton (Mehrz. ...tone); Schie|fe|rung
schief|ge|hen; ↑ R 139 (ugs. für: mißlingen); die Sache ist schiefgegangen; aber: schief ge|hen; er ist immer schief (mit schiefer Haltung) gegangen; schief|ge|wickelt [Trenn.:...wik|kelt]; ↑ R 139 (ugs. für: im Irrtum); wenn du das glaubst, bist du schiefgewickelt; aber: schief ge|wickelt [Trenn.: ...wik|kelt]; er hat den Draht schief gewickelt; Schief|hals; Schief|heit; schief|la|chen, sich; ↑ R 139 (ugs. für: heftig lachen); er hat sich während dieser Aufführung schiefgelacht; schief|lie|gen; ↑R 139 (ugs. für: einen falschen Standpunkt vertreten); in diesem Falle hat er schiefgelegen; aber: schief lie|gen; die Decke hat schief gelegen; schief|lie|gend; schief|mäu|lig (ugs. für: mißgünstig, neidisch)
schief|rig, schie|fe|rig
schief|tre|ten (↑ R 139); er hat die Absätze immer schiefgetreten; aber: schief tre|ten; ich bin schief getreten; schief|win|ke|lig, schief|wink|lig
schieg (veralt. für: schief); schie|gen mdal. (mit einwärts gekehrten Beinen gehen; [Schuhe] schieftreten)
schiel|äu|gig
Schie|le, Egon (österr. Maler)
schie|len; er schielt
Schie|mann niederd. (Matrose) m; -[e]s, ...männer; schie|man|nen

(Matrosendienste verrichten); geschiemannt
Schien|bein; Schie|ne w; -, -n; schienen; Schie|nen.bahn, ...brem|se, ...bruch m, ...bus, ...fahr|zeug, ...kon|takt, ...netz, ...räu|mer, ...stoß (Stelle, an der zwei Schienen aneinandergefügt sind), ...strang, ...weg; Schie|ne-Stra-Be-Pro|blem (↑ R 155)
schier; Umstandsw. (bald, beinahe, gar); das ist - unmöglich; Eigenschaftsw. (lauter, rein); etwas in schierer Butter braten
Schi|er (Mehrz. von: Schi)
schie|ren südd. (klären, auslesen, durchleuchten)
Schier|ling (eine Giftpflanze); Schier|lings|be|cher
Schier|mon|nik|oog [Behirmonikóeh] (eine westfries. Insel)
Schier|tuch (Segeltuch) s; -[e]s
Schieß_aus|bil|dung, ...baum|wolle (w; -), ...be|darf, ...be|fehl, ...bude; Schieß|bu|den.be|sit|zer, ...figur (ugs.); Schieß|ei|sen (ugs. für: Schußwaffe); schie|ßen (auch Bergmannsspr.: sprengen; südd., österr. auch: verbleichen); du schießt (schießest), er schießt; du schossest, er schoß; du schössest; geschossen; schieß[e]!; Schie|ßen s; -s, - (↑ R 120:) es ist zum Schießen (ugs. für: es ist zum Lachen); schie|ßen|las|sen; ↑ R 139 (ugs. für: aufgeben); er hat seinen Plan schießenlassen (↑ R 305) aber: schie|ßen las|sen (die Erlaubnis zum Schießen geben); Schie|ßer (auch: Einschieber [in Bäckereien]); Schie|ße|rei; Schieß.gewehr, ...hund (veralt. für: Hund, der angeschossenes Wild aufspürt), ...mei|ster (Bergmannsspr.: Sprengmeister), ...platz, ...prü|gel (scherzhaft für: Gewehr; m), ...pul|ver, ...schar|te, ...schei|be, ...sport, ...stand, ...übung
Schiestl (Name verschiedener dt. Künstler)
Schiet (,,Scheiße''; niederd. für: Dreck; übertr.: Unangenehmes) m od. s; -s
Schi.fah|rer, ...fahrt
Schiff s; -[e]s, -e; Schiffahrt [Trenn.: Schiff|fahrt, ↑ R 236] (Verkehr zu Schiff) w; -, -en; Schiffahrts.ab|ga|be [Trenn.: Schiff|fahrts...,↑ R 236], ...bör|se, ...funk, ...ge|richt, ...ge|sellschaft, ...kun|de (für: Navigation; w; -), ...li|nie, ...recht, ...stra|ße, ...weg; schiff|bar; - machen; Schiff|bar|keit w; -; Schiff|barma|chung; Schiff|bau (bes. fachspr.; Mehrz. ...bauten), Schiffsbau; Schiff|bau_in|ge|nieur, ...wesen (s; -s); Schiff|bord m; ...bruch

m; schiff|brü|chig; Schiff|brü|chige m u. w; -n, -n (↑ R 287ff.); Schiff|brücke [Trenn.: ...brükke]; Schiff|chen (auch: milit. Kopfbedeckung), Schiff|lein; schiff|feln mdal. (Kahn fahren); ich ...[e]le (↑ R 327); schif|fen (veralt. für: zu Wasser fahren; derb für: harnen); Schiff|fer; Schiff|ferin w; -, -nen; Schiff|fer_kla|vier (ugs. für: Ziehharmonika), ...kno|ten, ...müt|ze; Schiff|lein, Schiff|chen; Schiffs_agent (Vertreter einer Reederei), ...an|teil, ...arzt, ...aus|rü|ster, ...bau (Mehrz. ...bau|ten; vgl. Schiffbau), ...be|sat|zung, ...brief; Schiff|schau|kel, Schiffs|schaukel (eine große Jahrmarktsschaukel); Schiffs_eig|ner, ...fahrt (Fahrt mit einem Schiff), ...flagge, ...fracht, ...hal|ter, ...he|bewerk, ...hy|po|thek, ...jour|nal (Logbuch), ...jun|ge, ...ka|pi|tän, ...ka|ta|stro|phe, ...koch m, ...körper, ...krei|sel, ...kü|che, ...ladung, ...last, ...li|ste, ...mak|ler, ...ma|ni|fest (für die Verzollung im Seeverkehr benötigte Aufstellung der geladenen Waren), ...mann|schaft, ...ma|schi|ne, ...mo|dell, ...na|me, ...plan|ke, ...raum, ...re|gi|ster, ...rip|pe, ...rumpf, ...schau|kel (vgl. Schiffschaukel), ...schna|bel, ...schraube, ...ta|ge|buch, ...tau s, ...tau|fe, ...ver|kehr, ...ver|mö|gen, ...ver|stei|ge|rung, ...volk (s; -[e]s), ...werft, ...zer|ti|fi|kat, ...zet|tel, ...zim|mer|mann, ...zoll, ...zwieback
Schi_flie|gen (s; -s), ...flug
schif|ten (Bauw.: [Balken] nur durch Nägel verbinden; [zu]spitzen, dünner machen; Jägerspr.: dem Beizvogel neue Schwungfedern einsetzen; Seemannsspr.: die Lage verändern); Schif|ter (Bauw.: Dachsparren); Schif|tung
Schi_ge|biet, ...ge|län|de, ...ha|serl (ugs. für: ängstlicher Anfänger im Schilaufen; auch: junge Schiläuferin; s; -s, -[n])
Schi|is|mus arab. (Lehre der Schiiten) m; -; Schi|it (Angehöriger einer mohammedan. Sekte) m; -en, -en (↑ R 268)
Schi|ka|ne fr. (Schurigelei, Bosheit, böswillig bereitete Schwierigkeit; Sportspr.: [eingebaute] Schwierigkeit in einer Autorennstrecke) w; -, -n; Schi|ka|neur [...nör] (selten für: böswilliger Quäler) m; -s, -e; schi|ka|nie|ren; schi|ka|nös (boshaft); -este (↑ R 292)
Schi|kjö|ring norw. [schijöring] (Schilauf mit Pferde- od. Motorradvorspann); s; -s, -s; Schi_kurs,

...lauf, ...lau|fen (s; -s), ...läu|fer, ...läu|fe|rin
Schil|cher österr. (²Schiller [hellroter Wein])
¹Schild (Erkennungszeichen, Aushängeschild u. a.) s; -[e]s, -er; ²Schild (Schutzwaffe) m; -[e]s, -e
Schild|bür|ger [„mit Schild bewaffneter Städter"; erst später zum Namen der Stadt Schilda (heute Schildau) gezogen] (Kleinstädter, Spießer); Schild|bür|ger|streich
Schild|drü|se; Schild|drü|sen|hormon; schil|den (mit einem Schild versehen); geschildetes Rebhuhn (Rebhuhn mit Brustfleck); Schil|de|rei; Schil|de|rer; Schil|der-.haus od. ...häus|chen, ...ma|ler; schil|dern; ich ...ere (↑ R 327); Schil|de|rung; Schil|der|wald (ugs.); Schild_farn, ...knap|pe; Schild|krot landsch. (Schildpatt) s; -[e]s; Schild|krö|te; Schild|kröten|sup|pe; Schild_laus, ...patt (Hornplatte einer Seeschildkröte; s; -[e]s), ...wa|che od. ...wacht (veralt.)
Schi|leh|rer
Schilf lat. (eine Grasart) s; -[e]s, -e; schilf|be|deckt, aber (↑ R 142): von Schilf bedeckt; Schilf|dach
Schil|fe usw. vgl. Schelfe usw.
¹schil|fen landsch. (Schilf entfernen); ²schil|fen, schil|fern (aus Schilf)
schil|fe|rig, schilf|rig vgl. schelferig; ¹schil|fern vgl. schelfern
²schil|fern vgl. ²schilfen; Schilf|gras; schil|fig
schilf|rig, schil|fe|rig
Schilf|rohr; Schilf|rohr|sän|ger (ein Vogel)
Schi|lift
Schill (ein Flußfisch, Zander) m; -[e]s, -e
Schil|le|bold niederd. (Libelle) m; -[e]s, -e
¹Schil|ler (dt. Dichter)
²Schil|ler (Farbenglanz; mdal. für: zwischen Rot u. Weiß spielender Wein) m; -s, -; schil|le|rig, schill|rig (selten für: schillernd)
schil|le|risch, schil|lersch (nach Art Schillers; nach Schiller benannt); ihm gelangen Verse von schiller[i]schem Pathos (nach Schillers Art), aber (↑ R 179): Schil|le|risch, Schil|lersch (von Schiller herrührend); Schiller[i]sche Balladen (Balladen von Schiller); Schil|ler_kra|gen, ...locke [Trenn.: ...lok|ke] (Gebäck; geräuchertes Fischstück); Schil|ler-Mu|se|um (↑ R 180)
schil|lern; das Kleid schillert in vielen Farben
schil|lersch vgl. schillerisch
Schil|lersch vgl. Schillerisch

Schil|ler_taft, ...wein
Schil|ling (österr. Münzeinheit; Abk.: S, öS) m; -s, -e; -e (↑ R 322); vgl. aber: Shilling
schill|rig vgl. schillerig
schil|pen (vom Sperling: zwitschern)
Schil|ten schweiz. (eine Farbe der dt. Spielkarten) Mehrz.
Schi|mä|re gr. (Trugbild, Hirngespinst) w; -, -n; vgl. Chimära; schi|mä|risch (trügerisch); -ste (↑ R 294)
Schi|mei|ster|schaft
¹Schim|mel (verschiedene Pilzarten) m; -s; ²Schim|mel (weißes Pferd) m; -s, -; Schim|mel_bo|gen (Druckw.; nicht od. nur einseitig bedruckter Bogen), ...ge|spann; schim|me|lig, schimm|lig; schim|meln; das Brot schimmelt; Schim|mel_pilz, ...rei|ter (geisterhaftes Wesen; „Wilder Jäger"; Wodan; m; -s)
Schim|mer; schim|mer|los; schim|mern; ein Licht schimmert
schimm|lig, schim|me|lig
Schim|pan|se afrik. (ein Affe) m; -n, -n (↑ R 268)
Schimpf m; -[e]s, -e; mit - und Schande; schimp|fen; Schimp|fer; Schimp|fe|rei, schimp|fie|ren (veralt. für: verunstalten; verderben); Schimpf|ka|no|na|de; schimpf|lich; Schimpf|lich|keit; Schimpf_na|me, ...wort (Mehrz. ...worte u. ...wörter)
Schi|na|kel ung. österr. mdal. (kleines Boot) s; -s, -
Schind_aas, ...an|ger
Schin|del w; -, -n; Schin|del|dach; schin|deln (auch: Med. veralt. für: schienen); ich ...[e]le (↑ R 327)
schin|den; (selten im Imperfekt:) du schindetest; geschunden; schind[e]!; Schin|der (jmd., der gestorbenes Vieh verwertet; übertr. für: Quäler); Schin|de|rei
Schin|der|han|nes; ↑ R 195 (Führer einer Räuberbande am Rhein um 1800)
Schin|der|kar|re[n]; schin|dern sächs. (auf dem Eise gleiten); ich ...ere (↑ R 327); Schin|dersknecht; Schind|lu|der; mit jmdm. - treiben (ugs. für: jmdn. schmählich behandeln); Schind_mäh|re
Schin|kel (dt. Baumeister u. Maler)
Schin|ken m; -s, -; Schin|ken_bröt|chen, ...kno|chen, ...sa|lat, ...wurst
Schinn niederd. (Kopfschuppen) m; -[e]s; Schin|ne (Kopfschuppe) w; -, -n (meist Mehrz.)
Schin|to|is|mus jap. (jap. Nationalreligion) m; -; schin|toi|stisch
Schi|pi|ste
Schipp|chen, Schipp|lein; ein

Schippchen machen od. ziehen (von Kindern: das Gesicht mit unmutig aufgeworfener Unterlippe zum Weinen verziehen); Schip|pe (Schaufel; unmutig aufgeworfene Unterlippe) w; -, -n; schip|pen; Schip|pen (eine Spielkartenfarbe) s; -, -; Schip|pen|as; Schipp|lein vgl. Schippchen
Schi|ras [nach der gleichnamigen Stadt in Iran] (handgeknüpfter Teppich; Fettschwanzschaf, dessen Fell als Halbpersianer gehandelt wird) m; -, -
Schi|ri (ugs. Kurzw. für: Schiedsrichter) m; -s, -s
schir|ken mdal. (einen flachen Stein über das Wasser hüpfen lassen)
Schirm m; -[e]s, -e; Schirm|bild; Schirm|bild|fo|to|gra|fie (röntgenologische Reihenuntersuchung); Schirm|dach; schir|men; Schir|mer; Schirm_fa|brik, ...futte|ral, ...git|ter (Elektrotechnik); Schirm|git|ter|röh|re (Elektrotechnik); Schirm_herr, ...herrschaft, ...hül|le, ...ka|sten (Schirmlade); Schirm|ling (Schirmpilz); Schirm_ma|cher, ...müt|ze, ...pilz, ...stän|der; Schir|mung; Schirm_vogt, ...wand
Schi|rok|ko arab.-it. (warmer Mittelmeerwind) m; -s, -s
schir|ren; Schirr|mei|ster; Schir|rung
Schir|ting engl. (ein Baumwollgewebe) m; -s, -e u. -s
Schi_schu|le, ...schwung
Schis|ma¹ gr. ([Kirchen]spaltung; kleinstes musikal. Intervall) s; -s, ...men u. -ta; Schis|ma|ti|ker¹ (Abtrünniger); schis|ma|tisch¹
Schi_sport (m; -[e]s), ...sprin|ger, ...sprung, ...spur
Schiß (derb für: Kot; übertr. derb für: Angst) m; Schisses
Schi|stock (Mehrz. ...stöcke)
Schi|wa sanskr. (eine der Hauptgottheiten des Hinduismus)
Schi|wachs
schi|zo|gen¹ gr. (Biol.: durch Spaltung entstanden); Schi|zo|go|nie¹ (eine Form der ungeschlechtl. Fortpflanzung) w; -; schi|zo|id¹ (nicht einheitlich, seelisch zerrissen); Schi|zo|my|zet¹ („Spaltpilz", veralt. Bez. für: Bakterie) m; -en, -en (meist Mehrz.); ↑ R 268; Schi|zo|pha|sie¹ (Med.: Sprachverwirrtheit) w; -; schi|zo|phren¹ (an Schizophrenie erkrankt); Schi|zo|phre|nie¹ (Med.: Bewußtseinsspaltung, Spaltungsirresein) w; -, ...ien; Schi|zo|phy|ten¹ (Biol.: Spaltpflanzen) Mehrz.

¹ Auch: ßch...

Schlab|be|rei; schlab|be|rig, schlabb|rig; schlab|bern (ugs. für: schlürfend trinken u. essen; schwätzen); ich ...ere (↑ R 327) Schlacht w; -, -en Schlacht|ta *poln.* (der ehem. poln. Adel) w; - Schlacht|bank (*Mehrz.* ...bänke); schlacht|bar; schlach|ten; Schlach|ten_bumm|ler (ugs.), ...ma|lor; Schlachhof|tor, Schlächh|ter nordd. (Fleischer); Schlach|te-rei, Schläch|te|rei nordd. Fleischerei; Gemetzel, Metzelei); Schlacht_feld, ...fest, ...ge|sang, ...ge|wicht, ...haus, ...hof, ...kreuzer, ...li|nie, ...mes|ser s, ...op|fer, ...ord|nung, ...plan (vgl. [2]Plan), ...raum; schlacht|reif; Schlacht-.roß (s; ...rosses, ...rosse), ...schiff Schlach|tschitz (Angehöriger der Schlachta) m; -en, -en (↑ R 268) Schlach|tag; Schlach|tung; Schlacht|vieh; Schlacht|vieh|be-schau schlack bayr. u. schwäb. (träge; schlaff); Schlack niederd. (breiige Masse; Gemisch aus Regen u. Schnee) m; -[e]s; Schlack|darm (Mastdarm) Schlacke[1] (Abfall beim Verbrennen od. Schmelzen) w; -, -n; schlacken[1]; geschlackt; Schlacken_bahn, ...erz; schlacken|frei[1]; Schlacken[1]_gru|be, ...hal|de; schlacken|reich[1]; Schlacken[1]-.rost, ...stein [1]schlackern[1] landsch. (schlenkern); ich ...ere (↑ R 327); mit den Ohren - [2]schlackern[1] niederd. (regnen u. schneien); es schlackert; Schlak-ker_schnee, ...wet|ter s schlackig[1]; Schlack|wurst Schlad|ming (Stadt im Ennstal); Schlad|min|ger (↑ R 199); - Tauern [1]Schlaf (veralt. für: Schläfe) m; -[e]s, Schläfe; [2]Schlaf (Schlafen) m; -[e]s; Schlaf_an|zug, ...baum (Baum, auf dem bestimmte Vögel regelmäßig schlafen), ...bur|sche (Schlafgänger); Schläf|chen, Schläf|lein; Schlä|fe (Schädelteil) w; -, -n; schla|fen; du schläfst; du schliefst (schliefest); du schliefest; geschlafen; schlaf[e]!; schlafen gehen; [sich] schlafen legen; Schläf|fen_bein, ...ge|gend; Schla-fen|ge|hen s; -s; Schla|fens|zeit; Schlä|fer; Schlä|fe|rin w; -, -nen; schläf|fern; mich schläfert; schlaff; -[e]ste (↑ R 293); Schlaff|heit w; -; Schlaf_gän|ger (Mieter einer Schlafstelle), ...gast (*Mehrz.* ...gäste), ...ge|le|gen|heit, ...ge-mach

Schla|fitt|chen s u. Schla|fit|tich (Schwungfedern des Flügels; übertr. für: Rockschoß) m, ugs. in: jmdn. am od. beim - nehmen, kriegen Schlaf|krank|heit w; -; Schläf|lein, Schläf|chen; schlaf|los; Schlaf|lo-sig|keit w; -; Schlaf_mit|tel s, ...müt|ze (auch scherzh. für: Viel-, Langschläfer od. träger, schwerfälliger Mensch); schlaf müt|zig; Schlaf|müt|zig|keit w; -; Schlaf_pul|ver, ...raum; schläf-rig; Schläf|rig|keit w; -; Schlaf-.rock, ...saal, ...sack, ...stadt (hauptsächlich Wohnzwecken dienende Satellitenstadt), ...stel-le, ...sucht (w; -); Schlaf|süch|tig; Schlaf_ta|blet|te, ...trunk; schlaf-trun|ken; Schlaf_trun|ken|heit, ...wa|gen, ...wan|del; schlaf|wan-deln; ich ...[e]le (↑ R 327); er schlafwandelte; er hat (auch: ist) geschlafwandelt; zu -: Schlaf-wand|ler; Schlaf|wand|le|rin w; -, -nen; schlaf|wand|le|risch; Schlaf_zen|trum (bestimmte Gehirnzone), ...zim|mer [1]Schlag m; -[e]s, Schläge; Schlag (österr. u. schweiz.: schlag) 2 Uhr; Schlag auf Schlag; [2]Schlag österr. (kurz für: Schlagobers) m; -[e]s; Kaffee mit -; Schlag_ab-tausch (Sportspr.), ...ader, ...an-fall; schlag|ar|tig; Schlag|ball; schlag|bar; Schlag_baum, ...boh-rer, ...bol|zen; Schlag|ge landsch. (Hammer) w; -, -n; schlä|ge|faul (veralt. für: unempfindlich gegen Schläge); Schlag|ei|sen; Schlä|gel (Bergmannshammer) m; -s, -; vgl. Schlegel; Schlä|gel|chen, Schläg-lein (kleiner Schlag); schla|gen; du schlägst; du schlugst (schlugest); du schlügest; geschlagen; schlage[e]!; er schlägt ihn (auch: ihm) ins Gesicht; schlagende Wetter (Bergmannsspr.: explo-sionsgefährliches Gemisch aus Grubengas und Luft); Schla|ger ([Tanzlied, das in Mode ist; Bez. für alles, was durchschlagenden Erfolg hat); Schlä|ger (Raufbold; Fechtwaffe; Rakett); Schlä|ge|rei; Schla|ger_fe|sti|val, ...mu|sik; schlä|gern österr. (Bäume fällen, schlagen); ich ...ere (↑ R 327); Schla|ger_star (vgl. [2]Star), ...text, ...tex|ter (Verfasser von Schlagertexten); Schlä|ge|rung; Schlag|ge|tot österr. für: Raufbold, Totschläger) m; -s, -s; schlag|fer|tig; Schlag_fer-tig|keit (w; -), ...fluß (veralt. für: Schlaganfall), ...ham|mer, ...holz, ...in|stru|ment, ...kraft (w; -); schlag|kräf|tig; Schläg|lein vgl. Schlägelchen; Schlag|licht (*Mehrz.* ...lichter); schlag|licht-

ar|tig; Schlag_loch, ...mann (Rudersport; *Mehrz.* ...männer); Schlag|obers österr. (Schlagsah-ne); Schlag_rahm, ...ring, ...sah-ne, ...schat|ten, ...sei|te, ...werk (Uhr), ...wet|ter (schlagende Wetter), ...wort (für Ausspruch, der einen bestimmten Standpunkt wiedergibt, *Mehrz.:* ...wor-te, seltener ...wörter, für Stichwort eines Schlagwortkatalogs *Mehrz.:* ...wörter); Schlag|wort-ka|ta|log; Schlag_zei|le, ...zeug, ...zeu|ger (Schlagzeugspieler) Schlaks bes. nordd. (lang aufge-schossener, ungeschickter Mensch) m; -es, -e; schlak|sig Schla|mas|sel *dt.; jidd.* (ugs. für: Unglück; Widerwärtiges) m (auch, österr. nur: s); -s, -; Schla-ma|stik ostösterr. mdal. (Schla-massel) w; -, -en Schlamm m; -[e]s, (selten:) -e [*Trenn.:* Schlamm|mas|se, ↑ R 236]; Schlamm_bad, ...bei|ßer (ein Fisch), ...be|lie|bungs|ver|fah-ren (Technik); schlam|men (Schlamm absetzen; mit Wasser aufbereiten); schläm|men (von Schlamm reinigen); schlam|mig; Schlämm_krei|de (w; -), ...putz (ähner, aufgestrichener Putz-überzug), ...ver|fu|gung (Bauw.) Schlamp (veralt. für: Schmauserei, Völlerei; landsch. für: Schleppe [am Frauenkleid]; unordent-licher Mensch) m; -[e]s, -e; schlam|pam|pen (ugs. für: schlemmen, sein Gut verpras-sen); schlampampt; Schlam|pe (ugs. für: unordentliche Frau) w; -, -n; schlam|pen (ugs. für: unor-dentlich sein); Schlam|per südd. (unordentlich Arbeitender; Mensch mit unordentlicher Klei-dung); Schlam|pe|rei (ugs. für: Unordentlichkeit); schlam|pert österr. ugs. (schlampig); schlam-pig (ugs. für: unordentlich); Schlam|pig|keit (ugs.) Schlan|ge w; -, -n; Schlange stehen (↑ R 140); Schlän|gel|chen, Schlän|gel|lein; schlän|ge|lig, schläng|lig; schlän|geln, sich; ich ...[e]le mich (↑ R 327); schlan|gen_ar|tig, ...au|ge, ...be-schwö|rer, ...biß, ...brut, ...farm, ...fraß (ugs. für: schlechtes Es-sen), ...ge|zücht, ...gift; schlan-gen|haft; Schlan|gen_haut, ...le-der, ...li|nie, ...mensch; Schläng-lein, Schlän|gel|lein; schläng|lig, schlän|ge|lig Schlank w; -, -n; Schlange stehen schlank; -[e]ste; auf die schlanke od. lange Linie achten; Schlän|kel österr. ugs. (Schelm, Schlingel) m; -s, -; Schlank|heit w; -; Schlank|heits|kur; schlank|ma-

[1] *Trenn.:* ...ak|k...

chen; ↑ R 139; landsch. (sich fein anziehen); ich mache schlạnk; schlạnkgemacht; schlạnkzumachen; a b e r : **schlạnk mạ|chen** (schlanker erscheinen lassen); das Kleid mạcht schlạnk; **schlạnk|weg; schlạnk|wegs** (ugs. für: schlankweg)

Schlạp|fen bayr., österr. ugs. (Pantoffel) *m*; -s, -

schlạpp (ugs. für: schlaff, müde, abgespannt); **Schlạp|pe** (ugs. für: [geringfügige] Niederlage); landsch. für: Schlag) *w*; -, -n; **schlạp|pen** (ugs. für: lose sitzen [vom Schuh]; landsch. für: schlürfend gehen); **Schlạp|pen** (ugs. für: bequemer Hausschuh) *m*; -s, -; **Schlạp|per|milch** landsch. (saure Milch); **schlạp|pern** obersächs. (schlürfend trinken u. essen; lecken; vor Frost zittern; ugs. für: schwätzen); ich ...ere (↑ R 327); **Schlạpp|heit; Schlạpp|hut** *m*; **schlạp|pig** landsch. (nachlässig); **schlạpp|ma|chen**; ↑ R 139 (ugs. für: am Ende seiner Kräfte sein u. nicht durchhalten); er hat schlạppgemacht; **Schlạpp.ohr** (scherzh. für: Hase), ...**schuh** (Schlappen), ...**schwanz** (ugs. für: willensschwacher Mensch)

Schla|rạf|fe (veralt. für: [auf Genuß bedachter] Müßiggänger; Mitglied der Schlaraffia) *m*; -n, -n (↑ R 268); **Schla|rạf|fen.land** (*s*; -[e]s), ...**le|ben** (*s*; -s); **Schla|rạf|fia** (Schlaraffenland; Vereinigung zur Pflege der Geselligkeit unter Künstlern u. Kunstfreunden) *w*; -; **Schla|rạf|fia|ma|trat|ze** ⓦ; **schla|rạf|fisch** (veralt.); -ste (↑ R 294)

Schlạr|fe, Schlạr|pe mdal. (Pantoffel) *w*; -, -n

schlạu; -er, -[e]ste

Schlau|be landsch. (Fruchthülle, Schale) *w*; -, -n; **schlau|ben** landsch. (enthülsen)

Schlau|ber|ger (ugs. für: Schlaukopf); **Schlau|ber|ge|rei** (ugs.) *w*; -

Schlauch *m*; -[e]s, Schläuche; **schlauch|ar|tig; Schlauch|boot; Schläu|chel|chen, Schläuch|lein; schlau|chen** (ugs. für: jemanden [beim Exerzieren] scharf hernehmen); **Schlauch|lei|tung; schlauch|los;** -e Reifen; **Schlauch .pilz, ...rol|le** (Aufrollgerät für den Wasserschlauch), ...**wa|gen, ...wurm**

Schlau|der (Bauw.: eiserne Verbindung an Bauwerken) *w*; -, -n; **schlau|dern** (Bauw.: durch Schlaudern befestigen); ich ...ere (↑ R 327)

Schläue (Schlauheit) *w*; -; **schlau|er|wei|se**

Schlau|fe (Schleife) *w*; -, -n

Schlau|heit; Schlau|ig|keit (veralt.); **Schlau.kopf** (scherzh.), ...**mei|er** (scherzh.)

Schla|wi|ner bes. südd., österr. (Nichtsnutz)

schlẹcht; eine schlechte Ware; der schlechte Ruf; ein schlechtes Zeichen; schlechte Zeiten; schlecht (schlicht) und recht. I. *Großschreibung* (↑ R 116): im Schlechten und im Guten; etwas, nichts, viel, wenig Schlechtes. II. *Schreibung in Verbindung mit Zeitwörtern* (↑ R 139): a) *Getrenntschreibung*, wenn „schlecht" in ursprünglichem Sinne gebraucht wird, z. B. er wird schlecht sẹin, wẹrden, sịngen usw.; er wird mit ihm schlẹcht ạuskommen; b) *Zusammenschreibung in übertragenem Sinne*; vgl. schlechtgehen, schlẹchtmachen. III. *Schreibung in Verbindung mit dem 2. Mittelwort:* der schlechtgelaunte Besucher (↑ jedoch R 142), a b e r : der ausgesprochen schlecht gelạunte Vater, der Besucher war schlecht gelạunt; **schlẹcht|be|ra|ten;** (↑ R 296:) schlechter beraten, am schlechtesten beraten; vgl. schlecht, III; **schlẹcht|be|zahlt;** (↑ R 296:) schlechter bezahlt, am schlechtesten bezahlt; vgl. schlecht, III; **schlẹcht|ter|dịngs** (durchaus); **schlẹcht|ge|hen;** ↑ R 139 (sich in einer üblen Lage befinden); es ist ihm nach dem Kriege schlẹchtgegangen; a b e r : schlẹcht gẹhen; in diesen Schuhen ist er schlẹcht gegangen; das wird schlẹcht (kaum) gẹhen; **schlẹcht|ge|launt;** (↑ R 296:) schlechter gelaunt, am schlechtesten gelaunt; vgl. schlecht, III; **Schlẹcht|heit; schlẹcht|hịn** (durchaus); **schlẹcht|hịn|nig; Schlẹch|tig|keit; schlẹcht|ma|chen;** ↑ R 139 (häßlich reden über ..., herabsetzen); er hat ihn überall schlẹchtgemacht; a b e r : schlẹcht mạ|chen (schlecht ausführen); er hat seine Aufgaben schlecht gemạcht; **schlẹcht|weg** (ohne Umstände; einfach); a b e r : er kam bei dieser Sache schlecht weg; **Schlẹcht|wẹt|ter** *s*; -s; bei -; **Schlẹcht|wẹt|ter.front, ...geld** (Bauw.), ...**pe|ri|o|de**

Schlẹck südd. u. schweiz. (Leckerbissen) *m*; -s, -e; **schlẹcken**[1]; **Schlẹcker**[1]; **Schlẹcke|rei**[1]; **schlẹcker|haft**[1]; **Schlẹcker|maul**[1] (scherzh. ugs.); **schlẹckern**[1]; ich ...ere (↑ R 327); **schlẹckrig**[1] landsch. (naschhaft); **Schlẹck|werk** (landsch.)

Schlẹ|gel (ein Werkzeug zum Schlagen; landsch. für: [Kalbs-, Reh]keule) *m*; -s, -; vgl. Schlägel; **schlẹ|geln** landsch. (mit dem Schlegel schlagen; stampfen); ich ...[e]le (↑ R 327)

Schlẹh|dorn (Strauch; *Mehrz.* ...dorne); **Schlẹ|he** (ein Strauch) *w*; -, -n; **Schlẹ|hen.blü|te, ...li|kör, ...schnaps**

[1]**Schlei** (Förde an der Ostküste Schleswigs) *w*; -

[2]**Schlei** *m*; -[e]s, -e u. Schleie (ein Fisch) *w*; -, -

Schlei|che (Echse) *w*; -, -n; **schlei|chen;** du schlịchst (schlichest); du schlichest; geschlichen; schleich[e]!; **Schlei|cher; schlei|che|risch** (ugs.); **Schleich.han|del, ...händ|ler, ...kat|ze, ...pfad, ...wa|re, ...weg** (auf -en), ...**wer|bung**

Schleie vgl. [2]Schlei

Schlei|er *m*; -s, -; **Schlei|er|eu|le; schlei|er|haft** (ugs. für: rätselhaft; dunkel); **Schlei|er.schwanz** (ein Fisch), ...**stoff, ...tuch** (*Mehrz.* ...tücher), ...**tanz**

Schleif.ap|pa|rat, ...au|to|mat, ...band (*s; Mehrz.* ...bänder), ...**bank** (*Mehrz.* ...bänke)

[1]**Schlei|fe** (Schlinge) *w*; -, -n

[2]**Schlei|fe** mdal. (Gleitbahn; Schlitten) *w*; -, -n; [1]**schlei|fen** (schärfen; Soldatenspr.: schinden); du schlịffst (schliffest); du schliffest; geschliffen; schleif[e]!; [2]**schlei|fen** (über den Boden ziehen; sich am Boden [hin] bewegen; Militär [Festungsanlagen] dem Boden gleichmachen); du schleiftest; geschleift; schleif[e]!

Schlei|fen.fahrt, ...flug

Schlei|fer (auch für: [Walzer]tanz; Musik: kleine Vierzierung); **Schlei|fe|rei; Schleif.kon|takt** (Elektrotechnik), ...**lack; Schleiflack.mö|bel; Schleif.ma|schi|ne, ...mit|tel s, ...pa|pier, ...ring; Schleif|sel** (veralt. für: Abfall beim Schleifen) *s*; -s, -; **Schleifstein; Schlei|fung**

Schleim *m*; -[e]s, -e; **Schleim|beu|tel; Schleim.beu|tel|ent|zün|dung; Schleim.drü|se; ...ha|men; Schleim.fie|ber** (*s*; -s), ...**fisch; schleim|haft** (veralt.); **Schleimhaut; schlei|mig; Schleim.pilz, ...schei|ßer** (derb für: Kriecher, Schmeichler), ...**sup|pe, ...tier**

Schlei|ße (dünner Span; Schaft der Feder nach Abziehen der Fahne; Zupf[linnen] *w*; -, -n; **schlei|ßen** (abnutzen, zerreißen; auseinanderreißen); du schleißt (schleißest); er schleißt; du schlissest und schleißtest u. schliß und schleißte; geschlissen u. geschleißt; schleiß[e]!; **Schlei|ßen.span; Schlei|ße|rin** (veralt.) *w*; -,

[1] *Trenn.:* ...ek|k...

-nen; **Schleiß|fe|der; schlei|ßig** mdal. (verschlissen, abgenutzt)

Schleiz (Stadt im Vogtland); **Schlei|zer** (↑ R 199)

Schle|mihl hebr. (ugs. für: Pechvogel) m; -s, -e

schlemm engl.; - machen, werden; **Schlemm** (alle Stiche [im Bridge u. im Whist]) m; -s, -e

schlem|men (üppig leben); **Schlem|mer, Schlem|me|rei; schlem|mer|haft; schlem|me|risch;** -ste (↑ R 294); **Schlem|mer|mahl|[zeit]; Schlem|mer|tum** s; -s

Schlem|pe Rückstand bei der Spirituserzeugung; Viehfutter) w; -, -n

schlen|dern; ich ...ere (↑ R 327); **Schlen|dri|an** (abwertend für: Säumigkeit, Schlamperei) m; -[e]s

Schlen|ge niederd. (Reisigbündel; Buhne) w; -, -n

Schlen|ker (schlenkernde Bewegung, kurzer Gang); **Schlen|ke|rich, Schlenk|rich** obersächs. (Stoß, Schwung; leichtleibiger Mensch) m; -s, -e; **schlen|kern;** ich ...ere (↑ R 327)

schlen|zen (Eishockey u. Fußball); du schlenzt (schlenzest)

Schlepp.an|ten|ne (Flugw.), **...damp|fer; Schlepp|pe** w; -, -n; **schlep|pen; Schlepp|pen|kleid, Schlepp|kleid; Schlepp|pen|trä|ger; Schlepp|per; Schlepp|pe|rei** (ugs.); **Schleppinsel** [Trenn.: Schlepp|pin|sel, ↑ R 236] (Haarpinsel für den Steindruck) m; -s, -; **Schlepp.kahn, ...kleid** od. Schlepp|pen|kleid, **...man|tel, ...mo|no|pol, ...netz, ...rock, ...schiff, ...schiffahrt** [Trenn.: ...schiff|fahrt, ↑ R 236] **...se|gel, ...start** (Segelflugstart durch Hochschleppen mit Motorflugzeug), **...tau** s; -[e]s, -e], **...zug**

Schle|si|en [...i⁰n], **Schle|si|er** [...i⁰r]; **schle|sisch;** (↑ R 200:) schlesisches Himmelreich (eine Speise), aber (↑ R 224:) der Erste Schlesische Krieg

Schles|wig; Schles|wi|ger (↑ R 199); **Schles|wig-Hol|stein** (Land); **Schles|wig-Hol|stei|ner** (↑ R 199); **schles|wig-hol|steinisch** (↑ R 212); **schles|wi|gisch, schles|wigsch**

schlet|zen schweiz. mdal. ([Tür] zuschlagen); du schletzt (schletzest)

Schleu|der w; -, -n; **Schleu|der.ar|beit** (veralt. für: liederliche Arbeit), **...bahn, ...ball, ...be|ton, ...brett** (Sport); **Schleu|de|rei; Schleu|de|rer, Schleud|rer; Schleu|der.ge|schäft, ...ho|nig, ...ma|schi|ne; schleu|dern;** ich ...ere (↑ R 327); **Schleu|der.preis** (vgl. ²Preis), **...pum|pe** (für: Zentrifugalpumpe), **...sitz** (Flugw.), **...start** (Flugw.), **...wa|re; Schleud|rer, Schleu|de|rer**

schleu|nig (schnell); **schleu|nigst** (auf dem schnellsten Wege)

Schleu|se w; -, -n; **schleu|sen** (Schiff durch eine Schleuse bringen); du schleust (schleusest); **Schleu|sen.kam|mer, ...mei|ster, ...tor** s, **...wär|ter**

schleu|ßt! (veralt. für: schließß[e]!); **schleußt** (veralt. für: schließt)

¹Schlich (feinkörniges Erz) m; -[e]s, -e; **²Schlich** (ugs. für: Schleichweg; Kunstgriff, Kniff) m; -[e]s, -e

schlicht; ein schlichtes Gewand; schlichte Leute; **Schlich|te** (Klebflüssigkeit zum Glätten u. Verfestigen der Gewebe) w; -, -n; **schlich|ten** (auch: mit Schlichte behandeln); **Schlich|ter; Schlich|te|rei; Schlicht.heit** (w; -), **...ho|bel; Schlich|tung; Schlich|tungs.aus|schuß, ...ver|fah|ren, ...ver|hand|lung, ...ver|such; schlicht|weg**

Schlick (Schlamm, Schwemmland) m; -[e]s, -e; **schlicken¹** ([sich] mit Schlick füllen); **schlicke|rig¹, schlick|rig; schlickig¹; Schlicker|milch¹** landsch. (Sauermilch); **schlickern¹** landsch. ([hin u. her] schwanken; auf dem Eise gleiten); ich ...ere (↑ R 327); **schlickrig, schlicke|rig¹; Schlick|watt**

Schlief landsch. (klitschige Stelle [im Brot]) m; -[e]s, -e; vgl. Schliff; **schlie|fen** (Jägerspr. u. südd., österr. ugs.: in den Bau schlüpfen, kriechen); du schloffst (schloffest); du schlöffest (schlöffe!): **schlie|fen** (Jägerspr.: Einfahren des Dachshundes in den Bau) s; -s; **Schlie|fer** (Jägerspr.: Dachs)

Schlief|fen (ehem. Chef des dt. Generalstabes)

schlie|fig landsch. (klitschig [vom Brot])

Schlie|mann (dt. Altertumsforscher)

Schlier bayr. u. österr. (Mergel) m; -s; **Schlie|re** obersächs. (schleimige Masse; fadenförmige od. streifige Stelle [im Glas]) w; -, -n; **schlie|ren** (Seemannsspr.: gleiten, rutschen); **schlie|rig** (schleimig, schlüpfrig); **Schlier|sand** österr. (feiner, angeschwemmter Sand)

¹Schlier|see (Ort am Schliersee); **²Schlier|see** m; -s; **Schlier|seer** [...se⁰r] (↑ R 199, R 205 u. R 166)

schlie|ßen; du schließt (schließest), er schließt (veralt.: er schleußt); du schlossest, er schloß; du schlössest (schlossessen; schließ[e]! (veralt.: schleuß!); **Schlie|ßer; Schlie|ße|rin** w; -, -nen; **Schließ.fach, ...ket|te, ...korb; schließ|lich; Schließ.mus|kel, ...rah|men** (Druckw.); **Schlie|ßung**

Schliff (Schleifen; Geschliffensein; ugs. für: feine Bildung; auch für: Schlief) m; -[e]s, -e; **Schliff|fläche** (↑ R 237); **schlif|fig** (Nebenform von: schliefig)

schlimm; -er, -ste; - sein, stehen; im schlimmsten Fall[e]; schlimme Zeiten; eine schlimme Lage. **I.** *Kleinschreibung* (↑ R 134): er ist am schlimmsten d[a]ran; es ist das schlimmste (sehr schlimm), daß ... **II.** *Großschreibung:* **a)** (↑ R 116:) das ist noch lange nicht das Schlimmste; ich bin auf das, aufs Schlimmste gefaßt; sich zum Schlimmen wenden; das Schlimmste fürchten; zum Schlimmsten kommen; **b)** (↑ R 116:) nichts Schlimmes; **schlimm|sten|falls;** vgl. Fall m

Schling.be|schwer|de (meist Mehrz.)

Schlin|ge w; -, -n; **¹Schlin|gel** landsch. (Häkchen, Spange) s; -s, -

²Schlin|gel (eigtl. Müßiggänger; scherzh. für: vergnügter, übermütiger Junge) m; -s, -; **Schlin|gel|chen, Schlin|ge|lein; schlin|gel|haft**

schlin|gen; du schlangst (schlangest); du schlängest; geschlungen; schling[e]!

Schlin|gen|stel|ler

Schlin|ger|kiel (Seitenkiel zur Verminderung des Schlingerns); **schlin|gern** (von Schiffen: um die Längsachse schwanken); das Schiff schlingert; **Schlin|ger|tank** (Tank zur Verminderung des Schlingerns)

Schling.ge|wächs, ...kraut, ...nat|ter, ...pflan|ze

Schlipf (schweiz. neben: [Berg-, Fels-, Erd]rutsch) m; -[e]s, -e

Schlipp engl. (svw. Slip [schiefe Ebene]) m; -[e]s, -e

Schlip|pe (nordd. für: Rockzipfel; ostmitteld. für: enger Durchgang) w; -, -n

schlip|pen (Seemannsspr.: lösen, loslassen)

Schlip|per ostmitteld. (abgerahmte, dicke Milch) m; -s; **schlip|pe|rig, schlipp|rig** landsch. (gerinnend); **Schlip|per|milch** (landsch.)

Schlips (Krawatte) m; -es, -e; **Schlips|na|del**

Schlit|tel landsch. (kleiner Schlit-

¹ *Trenn.:* ...ik|k...

ten) *s*; -s, -; **schlit|teln** schweiz.
(rodeln); ich ...[e]le (↑ R 327);
- lassen (laufen lassen, sich
nicht kümmern um); **schlit|ten**
(landsch.); **Schlit|ten** *m*; -s, -; (↑ R
140:) - fahren; ich bin Schlitten
gefahren; **Schlit|ten|bahn**, ...**fah-
ren** (*s*; -s), ...**fahrt**, ...**sport**; **Schlit-
ter|bahn**; **schlit|tern** ([auf dem Ei-
se] gleiten); ich ...ere (↑ R 327);
Schlitt|schuh; - laufen (↑ R 140);
ich bin Schlittschuh gelaufen;
Schlitt|schuh|bahn, ...**lau|fen** (*s*;
-s), ...**läu|fer**, ...**läu|fe|rin**

Schlitz *m*; -es, -e; **Schlitz|au|ge**;
schlitz|äu|gig; **schlit|zen**; du
schlitzt (schlitzest); **Schlitz|ohr**
(ugs. für: gerissener Bursche;
Gauner); **schlitz|oh|rig** (ugs.);
Schlitz|ver|schluß (Fotogr.)

schloh|weiß (weiß wie Schloßen)
Schlor|re landsch. (Hausschuh) *w*;
-, -n (meist *Mehrz.*); **schlor|ren**
landsch. (schlurfen)
Schloß *s*; Schlosses, Schlösser;
Schlöß|chen, Schlöß|lein
Schlo|ße (Hagelkorn) *w*;
-, -n; **schlo|ßen** (landsch.); es
schloßt; es hat geschloßt
Schloss|ser; **Schloss|se|rei**; **Schloss-
ser|hand|werk**; **schloss|sern**; ich
schlossere und schloßre (↑ R 327);
Schloss|ser_werk|statt od. ...**werk-
stät|te**; **Schloß_frau**, ...**füh|rung**,
...**gar|ten**, ...**herr**, ...**hof**; **Schlöß-
lein**, Schlöß|chen; **Schloß_rui|ne**,
...**vogt**
schloß|weiß (Nebenform von:
schlohweiß)
Schlot (ugs. auch für: Mensch mit
rücksichtslosem Benehmen) *m*;
-[e]s, -e u. (seltener:) Schlöte;
Schlot|ba|ron (abschätzig für:
Großindustrieller [im Ruhrge-
biet]); **Schlot|fe|ger** landsch.
(Schornsteinfeger)
Schlot|te (Zwiebelblatt; Abfall-
rohr [beim Abort]; Berg-
mannsspr.: Hohlraum im Ge-
stein) *w*; -, -n; **Schlot|ten|zwie|bel**
schlot|te|rig, **schlott|rig**; **schlot-
tern**; ich ...ere (↑ R 327)
Schlucht *w*; -, -en (dicht. veralt.:
Schlüchte)
schluch|zen; du schluchzt
(schluchzest); **Schluch|zer**;
Schluck *m*; -[e]s, -e u. (seltener:)
Schlücke [*Trenn.*: Schlük|ke];
Schluck|auf (krampfhaftes Auf-
stoßen) *m*; -s; **Schluck|be|schwer-
den** *Mehrz.*; **Schlück|chen**,
Schlück|lein; **schlucken[1]**; **Schluk-
ken[1]** (krampfhaftes Aufstoßen)
m; -s; **Schlucker[1]** (bemitleidend:
armer Kerl, armer Teufel);
Schluck|imp|fung; **Schlück|lein**,
Schlück|chen; **Schluck|ser** (ugs.

für: Schluckauf) *m*; -s; **schluck-
wei|se**
Schlu|der|ar|beit; **Schlu|de|rei**;
schlu|de|rig, **schlud|rig** (nachläs-
sig; minderwertig); **schlu|dern**
(nachlässig arbeiten); ich ...ere
(↑ R 327)
Schluff (Ton; [Schwimm]sand;
mdal. für: Schlupfwinkel; südd.
für: Muff) *m*; -[e]s, -e u. Schlüffe
Schluft mitteld. (Schlucht) *w*; -,
Schlüfte
Schlum|mer *m*; -s; **Schlum|mer-
.kis|sen**, ...**lied**; **schlum|mern**; ich
...ere (↑ R 327); **Schlum|mer|rol|le**
Schlum|per usw. (Nebenform von:
Schlampe usw.); **Schlum|per**
sächs. (leicht übergeworfenes
Umschlagtuch, Kleid) *m*; -s, -;
schlum|pe|rig
Schlund *m*; -[e]s, Schlünde;
Schlund|röh|re
Schlun|ze mdal. (unordentliche
Frau) *w*; -, -n; **schlun|zig** mdal.
(unordentlich)
Schlup vgl. Sloop
Schlupf (landsch.) *m*; -[e]s, Schlüp-
fe und -e; **schlüp|fen**; **Schlüp|fer**
(Teil der Damenunterwäsche,
Höschen); **Schlupf_jacke** [*Trenn.*:
...**jak|ke**], ...**loch**; **schlüpf|rig**;
Schlüpf|rig|keit; **Schlupf_wes|pe**,
...**win|kel**
Schlup|pe niederd., mitteld.,
westd. ([Band]schleife) *w*; -, -n
[1]**Schlurf** (veralt. für: Schluck) *m*;
-[e]s, Schlürfe; [2]**Schlurf** österr.
ugs. veralt. (geckenhaft gekleide-
ter, arbeitsscheuer junger Mann)
m; -[e]s, -e u. **schlur|fen**; **Schlürf**
(schleppend gehen); er hat ge-
schlurft; er ist dorthin geschlurft;
schlür|fen (hörbar trinken); mdal.
auch für: schlurfen); **Schlür-
fer** (Schlürfender); **Schlür|fer**
(Schlürfender; auch für: Schlur-
fer); **Schlür|re** nordd. (Pantoffel)
w; -, -n (meist *Mehrz.*); **schlur|ren**
vgl. schlurfen
Schluß *m*; Schlusses, Schlüsse;
Schluß_ab|stim|mung, ...**akt**,
...**ball**, ...**be|mer|kung**, ...**be|spre-
chung**, ...**bi|lanz** (Wirtsch.);
...**bild**, ...**brief** (Wirtsch.); **Schlüs-
sel** *m*; -s, -; **Schlüs|sel_bein**, ...**blu-
me**, ...**brett**, ...**bund** (*m* [österr. nur
so] od. *s*; -[e]s, -e); **Schlüs|sel_chen**,
Schlüs|se|lein; **Schlüs|sel|er|leb-
nis** (Psych.); **schlüs|sel|fer|tig**
(von Neubauten: bezugsfertig);
Schlüs|sel_fi|gur, ...**ge|walt**, ...**in-
du|strie**, ...**kind** (Kind, dem der
Wohnungsschlüssel umgehängt
wird, weil die Mutter berufstätig
ist), ...**loch**; **schlüs|seln** (nach ei-
nem bestimmten Verhältnis
[Schlüssel] aufteilen); ich ...sele
u. schlüßle (↑ R 327); **Schlüs-
sel.po|si|ti|on**, ...**reiz** (bestimmter

Reiz, der eine bestimmte Reak-
tion bewirkt), ...**ring**, ...**ro|man**,
...**stel|lung**; **Schlüs|se|lung**;
Schlüs|sel|wort (*Mehrz.* ...wör-
ter); **schluß|end|lich**; **Schluß_fei-
er**, ...**fol|ge**; **schluß|fol|gern**; ich
schlußfolgere (↑ R 327); ich
schlußfolgerst; geschlußfolgert;
um zu schlußfolgern; **Schluß_fol-
ge|rung**, ...**for|mel**; **schlüs|sig** -
sein; [sich] - werden; ich wurde
mir darüber -; ein -er Beweis; eine
-e Folgerung; **Schluß_ka|pi|tel**,
...**kurs** (Börse), ...**läu|fer** (Sport-
spr.), ...**läu|fe|rin** (Sportspr.),
...**licht** (*Mehrz.* ...lichter), ...**mann**
(*Mehrz.* ...männer), ...**no|te**
(Wirtsch.), ...**pfiff** (Sportspr.),
...**pha|se**, ...**prü|fung**, ...**punkt**,
...**rech|nung**; **Schluß-s** (↑ R 149)
s; -, -; **Schluß_satz**, ...**schein**
(Schlußnote), ...**si|gnal**, ...**stein**,
...**strich**, ...**ver|kauf**, ...**ver|tei|lung**
(Wirtsch.), ...**wort** (*Mehrz.*
...worte), ...**zei|chen**

Schlut|te schweiz. mdal. (weite
Jacke) *w*; -, -n; **Schlütt|chen** u.
(mdal.:) **Schlütt|li** schweiz.
(Säuglingsjäckchen) *s*; -s, -
Schmach *w*; -; **schmach|be|deckt**,
aber (↑ R 142): mit Schmach be-
deckt; **schmach|be|la|den**, aber
(↑ R 142): mit Schmach beladen
schmach|ten; **Schmacht|fet|zen**
(spött. für: rührseliges Lied; ver-
liebter Jüngling); **schmach|tig**;
Schmacht|korn (verkümmertes
Korn; *Mehrz.* ...körner), ...**lap-
pen** (ugs. für: Hungerleider;
spött. für: verliebter Jüngling),
...**locke** [*Trenn.*: ...lok|ke]
(spött.), ...**rie|men** (ugs. für: Gür-
tel, Koppel)
schmach|voll
[1]**Schmack** (gepulverte Blätter u.
Zweige vom Gerbersumach [Fär-
berbaum]; Mittel zum Schwarz-
färben) *m*; -[e]s, -e
[2]**Schmack**, **Schmacke** [*Trenn.*:
Schmak|ke] niederd. (kleines
Küsten- od. Fischerfahrzeug) *w*;
-, ...cken
schmack|haft; **Schmack|haf|tig-
keit** *w*; -
Schmad|der niederd. ([nasser]
Schmutz) *m*; -s; **schmad|dern** nie-
derd. (sudeln); ich ...ere (↑ R 327)
Schmäh österr. ugs. (Trick) *m*; -s,
-; - führen (Witze machen);
schmä|hen; **schmäh|lich**; **Schmäh-
lich|keit** (veralt.); **Schmäh_re|de**,
...**schrift**, ...**sucht** (*w*; -); **schmäh-
süch|tig**; **Schmäh|tand|ler** österr.
ugs. (jmd., der billige Tricks oder
Witze macht); **Schmä|hung**;
Schmäh|wort (*Mehrz.* ...worte)
schmal; (↑ R 295:) schmaler u.
schmäler, schmalste (auch:
schmälste); **schmal|brü|stig**;

schmä|len (veralt., aber noch mdal. für: zanken; lästern; Jägerspr. [vom Rehwild]: einen bellenden Laut im Schreck ausstoßen); schmä|lern (schmaler machen); ich ...ere (↑ R 327); Schmä|le|rung; Schmal|film; Schmal|fil|mer; Schmal|film|ka|me|ra; Schmal|hans (ugs.) m; -en, -en u. ...hänse (↑ R 268); Schmal|heit w; -

Schmal|kal|den (Stadt am Südwestfuß des Thüringer Waldes); Schmal|kal|de|ner (↑ R 199); schmal|kal|disch, aber: (↑ R 224): die Schmalkaldischen Artikel, der Schmalkaldische Bund; Schmal|le|der (Oberleder); schmal|lip|pig, ...ran|dig; Schmal|reh (weibl. Reh vor dem ersten Setzen), ...sei|te, ...spur (Eisenbahnw.; w; -); Schmal|spur|bahn; schmal|spu|rig; Schmalz (für: Email) m; -s, -e; Schmal|te it. (Kobaltschmelze, Blaufärbemittel [für Porzellan u. Keramik]) w; -, -n; schmal|ten (für: emaillieren)

Schmal|tier (weibl. Rot-, Dam od. Edelwild vor dem ersten Setzen), ...vieh (Kleinvieh)

Schmal|ton|film

Schmalz s; -es, -e; Schmäl|ze (zum Schmälzen der Wolle benutzte Flüssigkeit) w; -, -n; schmal|zen (Speisen mit Schmalz zubereiten); du schmalzt (schmalzest); geschmalzt u. geschmalzen (in übertr. Bedeutung nur so, z. B. ugs.: es ist mir zu geschmalzen [tcuer]); gesalzen u. geschmalzen; schmäl|zen (auch für: Wolle vor dem Spinnen einfetten); du schmälzt (schmälzest); geschmälzt; Schmalz|ge|backe|ne [Trenn.: ...bak|ke...]; ↑ R 287 ff.; schmäl|zig; Schmalz|ku|bel; Schmalz|ler (Schnupftabak) m; -s

Schman|kerl bayr. u. österr. (eine süße Mehlspeise; Leckerbissen) s; -s, -n

Schmant landsch. (Sahne; auch: [fettiger] Schmutz) m; -[e]s; Schmant|kar|tof|feln (landsch.) Mehrz.

schma|rot|zen (auf Kosten anderer leben); du schmarotzt (schmarotzest); du schmarotztest; er hat schmarotzt; Schma|rot|zer; schma|rot|zer|haft; schma|rot|ze|risch; Schma|rot|zer|pflan|ze, ...tier, ...tum (s; -s), ...wes|pe

Schmar|re (ugs. für: lange Hiebwunde, Narbe) w; -, -n

Schmar|ren (bayr. u. österr.: eine Mehlspeise; ugs. abwertend für: Wertloses) m; -s, -

Schma|sche poln. schles. (Fell neugeborener Lämmer) w; -, -n

Schmatz landsch. ([lauter] Kuß) m; -es, -e; Schmätz|chen, Schmätz|lein; schmat|zen; du schmatzt (schmatzest); Schmät|zer (ein Vogel)

Schmauch landsch. (qualmender Rauch) m; -[e]s; schmau|chen

Schmaus (reichhaltiges u. gutes Mahl) m; -es, Schmäuse; schmau|sen; du schmaust (schmausest); Schmau|se|rei (ugs.)

schmecken [Trenn.: schmek|ken]; Schmecker [Trenn.: Schmek|ker] (Feinschmecker; Schmeckwerkzeug)

Schmei|che|lei; schmei|chel|haft; Schmei|chel|kätz|chen od. ...kat|ze; schmei|cheln; ich ...[e]le (↑ R 327); Schmei|chel|wort (Mehrz. ...worte); Schmeich|ler; schmeich|le|risch; -ste (↑ R 294)

schmei|dig (dicht. u. landsch. für: geschmeidig); schmei|di|gen (veralt. für: geschmeidig machen)

¹schmei|ßen (ugs. für: werfen); du schmeißt (schmeißest); du schmissest od. schmißt; geschmissen; schmeiß[e]!; ²schmei|ßen (Jägerspr.: Kot auswerfen, besudeln); das Wild schmeißt; das Wild schmeißet; geschmeißt; Schmeiß|flie|ge

Schmelz m; -es, -e; Schmelz|bad; schmelz|bar; Schmelz|bar|keit w; -; Schmelz|but|ter; Schmelz|ei w; -, -n; ¹schmel|zen (flüssig werden); du schmilzt (schmilzest), er schmilzt; du schmolzest; du schmölzest; geschmolzen; schmilz!; ²schmel|zen (flüssig machen); du schmilzt od. schmilzest (veralt.: schmelzt od. schmelzest); er schmilzt (veralt.: schmelzt); du schmölzest (veralt.: schmelztest); geschmolzen (veralt.: schmelzet); schmilz! (veralt.: schmelze!); Schmel|zer, Schmel|ze|rei; Schmelz|far|be, ...glas (Mehrz. ...glä|ser), ...hit|ze, ...hüt|te, ...kä|se, ...ma|le|rei, ...ofen, ...punkt, ...schwei|ßung, ...tie|gel; Schmel|zung; Schmel|ze|ofen, ...pres|se

Schmer mdal. (Schmalz; rohes [Schweine]fett; Schmiere) m od. s; -s; Schmer|bauch (ugs.), ...fluß (übermäßiges Ausscheiden von Hauttalg; m; ...flusses)

Schmer|le (ein Fisch) w; -, -n

Schmer|ling (ein Pilz)

Schmerz m; -es, -en; schmerz|emp|find|lich; Schmerz|emp|find|lich|keit; Schmerz|emp|fin|dung; schmer|zen; du schmerzt (schmerzest); die Füße schmerzten ihm od. ihn vom langen Stehen; die Wunde schmerzte ihn;

Schmer|zens_geld, ...kind, ...la|ger (Mehrz. ...lager), ...laut, ...mann (Darstellung des leidenden Christus; m; -[e]s), ...mut|ter (Darstellung der trauernden Maria; w; -); schmer|zen[s]|reich; Schmer|zens|schrei; schmerz|frei; der Patient ist heute -; Schmerz|ge|fühl; schmerz|haft; -e Operation; Schmerz|haf|tig|keit w; -; Schmerz|kli|nik (Klinik, in der Patienten mit bestimmten sehr schmerzhaften Krankheiten behandelt werden); schmerz|lich; -er Verlust; Schmerz|lich|keit; schmerz|los; -este (↑ R 292); -e Geburt; Schmerz|lo|sig|keit w; -; schmerz|still|end, -e Tabletten, aber (↑ R 142): einige den Schmerz stillende Mittel; schmerz|voll

Schmet|ten tschech. schles., österr. mdal. (Sahne) m; -s; Schmet|ten|kä|se (schles., österr.)

Schmet|ter|ling; Schmet|ter|lings_blü|te, ...blüt|ler, ...ka|sten, ...netz, ...samm|lung, ...stil (Schwimmstil; m; -[e]s)

schmet|tern; ich ...ere (↑ R 327)

Schmicke [Trenn.: Schmik|ke] niederd. (Peitsche; Ende der Peitschenschnur) w; -, -n

Schmied m; -[e]s, -e; schmied|bar; Schmied|bar|keit w; -; Schmie|de w; -, -n; Schmie|de_ar|beit, ...ei|sen; schmie|de|ei|sern; Schmie|de_feu|er, ...ge|sel|le, ...ham|mer, ...hand|werk, ...kunst (w; -), ...mei|ster; schmie|den; Schmie|de_ofen, ...pres|se

Schmie|ge landsch. (Winkelmaß mit beweglichen Schenkeln; zusammenklappbarer Maßstab) w; -, -n; schmie|gen; sich -; schmieg|sam; Schmieg|sam|keit w; -

Schmie|le (Name verschiedener Grasarten) w; -, -n; Schmiel|gras

Schmie|ra|lie [...i̯ə]; Scherzbildung zu: schmieren (Schmiererei) w; - (beim Auto); ¹Schmie|re (abwertend auch für: dürftige Theatertruppe; schlechte [Wander]bühne) w; -, -n

²Schmie|re hebr. (Gaunerspr.: Wache) w; -; - stehen (↑ R 140)

schmie|ren (ugs. auch für: bestechen); Schmie|ren_ko|mö|di|ant, ...schau|spie|ler; Schmie|rer; Schmier_fett, ...film, ...fink (m; -en [auch: -s], -en), ...geld (meist Mehrz.), ...heft, ...geld rig; Schmie|rig|keit w; -; Schmier|kä|se, ...la|ger (Mehrz. ...lager), ...mit|tel s, ...nip|pel, ...öl, ...pres|se, ...pum|pe, ...sei|fe; Schmie|rung; Schmier|zet|tel

Schmink|büch|se; Schmin|ke w; -, -

-n; schmin|ken; Schmink_stift m, ...tisch

¹Schmir|gel (Tabakspfeifensaft) m; -s, -

²Schmir|gel it. (ein Schleifmittel) m; -s; schmir|geln; ich ...[e]le (↑ R 327); Schmir|gel|pa|pier

Schmiß (ugs.) m; Schmisses, Schmisse; schmis|sig (ugs.); eine -e Zeichnung, Musik

¹Schmitz (veralt., aber noch landsch. für: Fleck, Klecks; Druckw.: verschwommene Wiedergabe) m; -es, -e

²Schmitz landsch. ([leichter] Hieb, Schlag) m; -es, -e; Schmit|ze (landsch. für: Längenmaß; Peitsche, Ende der Peitschenschnur; Bergmannsspr.: dünne Zwischenschicht) w; -, -n; schmit|zen landsch. ([mit der Peitsche, Rute] schlagen, hauen)

Schmock slowen. [nach Freytags „Journalisten"] (gesinnungsloser Zeitungsschreiber) m; -[e]s, -e u. -s

Schmök niederd. (Rauch) m; -s; Schmö|ker (niederd. für: Raucher; ugs. für: [altes, minderwertiges] Buch) m; -s, -; schmö|kern (ugs. für: behaglich u. viel unterhaltsame Literatur lesen); ich ...ere (↑ R 327)

Schmol|le bayr., österr. mdal. (Brotkrume) w; -, -n

Schmoll|ecke [Trenn.: ...ek|ke]; schmol|len

schmol|lis! (stud. Zuruf beim [Brüderschaft]trinken); Schmol|lis s; -, -; mit jmdm. - trinken

Schmölln (Stadt in Ostthüringen)

Schmoll_mund, ...win|kel

Schmon|zes (ugs. für: leeres, albernes Gerede) m; -, -

Schmor|bra|ten; schmo|ren; Schmor|fleisch

schmor|gen westmitteld. (knausern; sich abdarben)

Schmor_obst, ...pfan|ne, ...topf

Schmu (ugs. für: leichter Betrug; betrügerischer Gewinn) m; -s; - machen (durch [leichten] Betrug Nutzen ziehen; etwas für sich behalten)

schmuck; -er, -[e]ste; Schmuck m; -[e]s, (selten:) -e; Schmuck|bild; schmücken [Trenn.: schmük-ken]; schmuck|haft; Schmuck|ka|sten; Schmuck|käst|chen; diese Wohnung ist ein - (rein u. nett gehalten); Schmuck|kof|fer; schmuck|los; -este (↑ R 292); Schmuck|lo|sig|keit w; -; Schmuck_na|del, ...platz, ...ring, ...sa|chen (Mehrz.), ...stück, ...te|le|gramm; Schmückung [Trenn.: Schmük|kung]; schmuck|voll; Schmuck|wa|ren Mehrz.; Schmuck|wa|ren|in|du|strie

Schmud|del (ugs. für: Unsauberkeit) m; -s; Schmud|de|lei (ugs. für: Sudelei); schmud|de|lig, schmudd|lig (ugs. für: unsauber); schmud|deln (ugs. für: sudeln); ich ...[e]le (↑ R 327); Schmud|del|wet|ter (ugs.); schmudd|lig vgl. schmuddelig

Schmug|gel (Schleichhandel) m; -s; Schmug|ge|lei; schmug|geln; ich ...[e]le (↑ R 327); Schmug|gel|wa|re; Schmugg|ler; Schmuggler_ban|de, ...pfad, ...schiff

schmun|zeln; ich ...[e]le (↑ R 327)

schmur|geln (ugs. für in Fett braten); ich ...[e]le (↑ R 327)

Schmus jidd. (ugs. für: leeres Gerede; schmeichelndes Zureden [zum Kauf]; Schöntun) m; -es; schmu|sen (ugs.); du schmusest (schmusest); er schmu|ste; Schmu|ser (ugs.); Schmu|se|rei (ugs.)

Schmutt niederd. (feiner Regen) m; -es

Schmutz (alemann. auch für: Fett) m; -es; Schmutz_blatt (Druckw.), ...bür|ste; schmut|zen; du schmutzt (schmutzest); schmutz_fän|ger, ...fink (m; -en [auch: -s], -en), ...flech|te, ...fleck; Schmutzzi|an österr. ugs. (Geizhals) m; -[e]s, -e; schmut|zig; schmutziggrau usw. Schmut|zig|keit; Schmutz_li|te|ra|tur, ...schicht, ..ti|tel (Druckw.), ...was|ser (Mehrz. ...wässer)

Schna|bel m; -s, Schnäbel; Schnä|bel|chen, Schnä|be|lein, Schnäblein; Schnä|be|lei (ugs. für: Küssen); Schna|bel_fisch, ...flö|te; schna|bel|för|mig; Schna|bel-hieb; ...schnä|be|lig, ...schnäb|lig (z. B. langschnäb[e]lig); Schna-bel|kerf; schnä|beln (ugs. für: küssen); ich ...[e]le (↑ R 327); sich -; Schna|bel_schuh, ...tas|se, ...tier; ...schnäb|lig vgl. ...schnä|be|lig; schna|bu|lie|ren (ugs. für: mit Behagen essen)

Schnack niederd. ugs. (leeres Gerede; Unsinn) m; -[e]s; schnackeln [Trenn.: schnak|keln] oberbayr. (schnalzen u. mit Fingern schnellen); ich ...[e]le (↑R 327); schnacken [Trenn.: schnak|ken] niederdt. (plaudern); Schnackerl [Trenn.: Schnak|kerl] österr. (Schluckauf) s; -s

Schna|der|hüp|fel bayr. u. österr. („Schnitterlied"; volkstümlicher satir. Vierzeiler, oft improvisiert zum Tanz gesungen) s; -s, -

schna|dern mdal. (schnattern, viel reden); ich ...ere (↑ R 327)

¹Schna|ke niederd. (Ringelnatter) w; -, -n

²Schna|ke nordd. (Schnurre; Scherz) w; -, -n

³Schna|ke (eine Stechmücke) w; -, -n; Schna|ken_pla|ge, ...stich

schna|kig nordd. (schnurrig)

schnä|kig landsch. (wählerisch [im Essen])

Schnäll|chen; Schnäl|le w; -, -n (österr. auch svw.: Klinke); schnal|len (auch für: schnalzen); Schnal|len|schuh

schnal|zen; du schnalzt (schnalzest); Schnal|zer; Schnalz|laut

Schnä|pel (ein Fisch) m; -s, -

schnapp!; schnipp, schnapp!; schnap|pen; Schnap|per; Schnäp|per (ein Vogel; Werkzeug zum Aderlassen; Armbrust; Schnappschloß); Schnap|pe|rer; schnäp|pern [[Billardball] seitlich stoßen; mdal. für: schwatzen); ich ...ere (↑ R 327); Schnapp_hahn (hist.: Raubritter, Wegelagerer), ...mes-ser s, ...sack (veralt.: Vorratsranzen), ...schloß, ...schuß (nicht gestellte Momentaufnahme); schnaps!; Schnaps m; -es, Schnäpse; Schnaps_bren|ner, ...brenne|rei, ...bu|de (abschätzig); Schnäps|chen, Schnäps|lein; schnap|sen; du schnapst (schnapsest); Schnaps_fah|ne (ugs.), ...fla|sche, ...glas (Mehrz. ...gläser), ...idee (ugs. für: seltsame, verrückte Idee), ...lei|che (ugs.); Schnäps|lein, Schnäps|chen; Schnaps_na|se (ugs.), ...stam|perl (bayr., österr. für: Schnapsglas), ...zahl (ugs. für: aus gleichen Ziffern bestehende Zahl)

schnar|chen; Schnar|cher

Schnar|re w; -, -n; schnar|ren; Schnarr_werk (bei der Orgel)

Schnat, Schna|te mdal. (junges abgeschnittenes Reis; Grenze einer Flur) w; -, -n; Schnä|tel mdal. (Pfeifchen aus Weidenrinde) s; -, -

Schnat|te|rer; Schnat|ter_gans (ugs. abschätzig für: schwatzhaftes Mädchen); schnat|te|rig, schnatt|rig; Schnat|te|rin w; -, -nen; Schnat|ter|lie|se (ugs. abschätzig für: schwatzhaftes Mädchen); ↑ R 195; schnat|tern; ich ...ere (↑ R 327); schnatt|rig vgl. schnat|te|rig

Schnatz hess. (Kopfputz [der Braut, der Taufpatin] mit Haarkrönchen) m; -es, Schnätze; schnät|zeln hess. (svw. schnatzen); ich ...[e]le (↑ R 327); sich -; schnät|zen hess. (sich putzen, das Haar aufstecken); du schnatzt (schnatzest); sich -

Schnau niederd. (geschnäbeltes Schiff) w; -, -en

schnau|ben; du schnaubst; du schnaubtest (veralt.: schnobst); du schnöbest; geschnaubt (veralt.:

geschnoben); schnaub[e]!; schnäu|big hess. (wählerisch [im Essen]); Schnauf m; -[e]s, -e; schnau|fen; Schnau|fer; Schnau|ferl (ugs. scherzh. für: altes Auto) s; -s, -, (österr.:) -n

Schnau|pe südd. (Ausguß an Kannen u. a.) w; -, -n

Schnauz (bes. schweiz. neben: Schnurrbart) m; -es Schnäuze; Schnauz|bart; schnauz|bär|tig; Schnäu|zchen, Schnäuz|lein; Schnau|ze w; -, -n; schnau|zen; du schnaut (schnauzest); Schnauzer (Hund einer bestimmten Rasse) m; -s, -; schnau|zig (grob); ...scnnau|zig, ...schnäu|zig (z. D. großschnauzig, großschnäuzig); Schnäuz|lein, Schnäuz|chen

Schneck m; -s, -en u. 1Schnecke1 mdal. (ein Kosewort für Kinder und Mädchen) w; -, -n; 2Schnecke1 (ein Weichtier) w; -, -n; Schnecken|boh|rer1 (ein Werkzeug); schnecken|för|mig1; Schnecken1|fri|sur, ...gang (m; -[e]s), ...ge|häu|se, ...ge|trie|be, ...haus, ...li|nie, ...nu|del (landsch. für ein spiralförmiges Gebäck), ...post, ...tem|po, ...win|dung; Schneckerl1 österr. ugs. (Locke) s; -s, -n

schned|de|reng|teng!, schned|de|reng|teng|teng! (Nachahmung des Trompetenschalles)

Schnee m; -s; im Jahre, anno - (österr.; vor langer Zeit); Schneeball (auch: Pflanzenart); schneeballen; geschneeballt (fast nur in der Grundform u. im 2. Mittelwort gebräuchlich); Schnee|ball-...schlacht, ...sy|stem (eine bestimmte, in Deutschland verbotene Form des Warenabsatzes) s; -s; schnee|be|deckt, aber (↑ R 142): von Schnee bedeckt

1Schnee|berg (Stadt im westl. Erzgebirge)

2Schnee|berg (höchster Gipfel des Fichtelgebirges) m; -[e]s

Schnee|be|sen (ein Küchengerät); schnee|blind; Schnee..blind|heit (w; -), ...bril|le, ...bruch (Baumschaden durch zu große Schneelast), ...decke [Trenn.: ...dek|ke]; Schnee-Ei|fel (↑ R 148); vgl. Schneifel; schnee|er|hellt (↑ R 148); Schnee-Eu|le (↑ R 148); Schnee..fall m, ...feld, ...flä|che, ...flocke [Trenn.: ...flok|ke], ...frä|se; schnee|frei; Schnee..gans, ...ge|stö|ber, ...glöck|chen, ...gren|ze, ...hang, ...ha|se, ...huhn; schnee|ig; Schnee..ka|no|ne (Gerät zur Erzeugung von künstlichem Schnee), ...ket|te, ...kö|nig (ostmitteld. für:

Zaunkönig [Vogel]); er freut sich wie ein - (ugs. für: er freut sich sehr)

Schnee|kop|pe (höchster Berg des Riesengebirges) w; -

Schnee..land|schaft, ...mann (Mehrz. ...männer), ...matsch, ...mo|bil (s; -s, -e), ...mond (Januar), ...pflug, ...räu|mer, ...ru|te (österr. für: Schneebesen), ...schip|per (ugs.), ...schleu|der|ma|schi|ne, ...schmel|ze; Schneeschuh (veralt. für: Schi); - laufen (↑ R 140); Schnee..sturm (vgl. 1Sturm), ...trei|ben, ...ver|wehung, ...wäch|te, ...was|ser, ...webe (veralt. für: Schneewehe; w; -, -n), ...we|he w; schnee|weiß; Schnee|witt|chen (,,Schneeweißchen"; dt. Märchengestalt) s; -s; vgl. Sneewittchen

Schne|gel mdal. ([hauslose] Schnecke) m; -s, -

1Schneid (ugs. für: Mut; Tatkraft) m; -[e]s (bayr., schwäb., österr.: w; -); Schneid..backen [Trenn.: ...bak|ken] (Mehrz.), ...boh|rer, ...bren|ner; Schnei|de w; -, -n; Schneid|ei|sen; Schnei|de|hol|z (Forstw.: abgehauene Nadelholzzweige) s; -es; Schnei|de|holz|be|trieb; Schnei|de|müh|le (Sägemühle); schnei|den; du schnittst (schnittest); du schnittest; geschnitten; schneid[e]!; Schnei|der; Schnei|der|ar|beit; Schnei|de|rei; Schnei|der|ge|selle; Schnei|de|rin w; -, -nen; Schnei|der|ko|stüm, ...krei|de (w; -), ...mei|ster; schnei|dern; du ...ere (↑ R 327); Schnei|der..pup|pe, ...werk|statt; Schnei|de..tisch (Filmw.), ...zahn; schnei|dig (tüchtig, forsch); Schnei|dig|keit w; -; schnei|en; es schneit; es schneite; es hat geschneit

Schnei|fel, (auch:) Schnee-Eifel (ein Teil des Eifel)

Schnei|se ([gerader] Durchhau [Weg] im Walde; veralt. für: Schlinge) w; -, -n

schnei|teln (Forstw.: [Baum, Rebe] beschneiden, Nebenzweige ausschneiden); ich ...[e]le (↑ R 327)

schnell; schnellstens; so - wie möglich; (ugs.:) auf die schnelle [Tour]; Schnellaster [Trenn.: Schnell|la|ster, ↑ R 236] (schnellfahrender Lastkraftwagen); Schnelläu|fer [Trenn.: Schnelläu|fer, ↑ R 236]; Schnell..bahn (Abk.: S-Bahn), ...boot, ...dampfer; Schnell|dre|hen (↑ R 120) s; -s; Schnel|le (Schnelligkeit) w; -, (für: Stromschnelle Mehrz.:) -n; schnelllebig [Trenn.: schnell|le|big, ↑ R 236]; schnel|len; Schnel|ler (knipsendes Geräusch, das durch

Schnippen mit zwei Fingern entsteht), Schnell|feu|er; Schnellfeu|er|ge|schütz; schnell|fü|ßig; Schnell|fü|ßig|keit w; -; Schnell..gang m, ...gast|stät|te, ...ge|richt, ...hef|ter, ...heft|map|pe; Schnell-heit (veralt. für: Schnelligkeit); Schnell|lig|keit; Schnell..im|biß, ...ko|cher, ...koch|topf, ...kraft (w; -), ...pa|ket, ...pres|se, ...schreiber, ...schrift; schnell|stens, schnellst|mög|lich, dafür besser: möglichst schnell; falsch: schnellstmöglichst (↑ R 299); Schnell..stra|ße, ...trieb|wa|gen, ...ver|fah|ren, ...ver|kehr, ...waage; Schnell|wä|sche|rei; Schnellzug (Zeichen: D); Schnell|zug-...ver|bin|dung, ...zu|schlag

Schnepf (ein Vogel) w; -, -n; Schnep|fen..jagd, ...strich (m; -[e]s), ...zug

Schnep|pe (mitteld. für: Schnabel [einer Kanne]; schnabelförmige Spitze [eines Kleidungsstückes]; landsch. auch für: Dirne) w; -, -n

Schnep|per (Nebenform von: Schnäpper); schnep|pern (Sport: in Hohlkreuzhaltung springen); ich ...ere (↑ R 327); vgl. schnäppern; Schnep|per|sprung

Schner|fer österr. mdal. (Rucksack)

schnet|zeln bes. schweiz. ([Fleisch] fein zerschneiden); ich ...[e]le (↑ R 327); geschnetzeltes Fleisch

Schneuß (Bauw.: Fischblase [Ornament im Maßwerk]) m; -es, -e

Schneu|ze (früher für: Lichtputze) w; -, -n; schneu|zen; du schneuzt (schneuzest); sich -

schnicken [Trenn.: schnik|ken] landsch. (schnellen, zucken); Schnick|schnack ([törichtes] Gerede) m; -[e]s

schnie|ben, schnie|fen mitteld. (schnauben); auch mit starker Beugung: du schnobst; du schnöbest; geschnoben

schnie|geln (älter für: putzen); ich ...[e]le (↑ R 327); geschniegelt und gebügelt (ugs. für: fein hergerichtet)

schnie|ke niederd., berlin. (fein, schick)

Schnie|pel (burschikos für: Frack; verächtl. für: Angeber, Geck) m; -s, -

Schnip|fel landsch. (kleines abgeschnittenes Stück) m; -s, -; schnip|feln landsch. (in kleine Stücke zerschneiden); ich ...[e]le (↑ R 327); schnipp!; schnipp, schnapp!; Schnip|pchen mitteld. u. niederd. ([Finger]schneller); jmdm. ein - schlagen (ugs. für: einen Streich spielen); Schnip|pel (ugs. für: kleines abgeschnittenes Stück) m od. s; -s, -; Schnip|pel-

Trenn.: ...ek|k...

chen; Schnip|pe|lei (ugs.); schnip|peln (ugs.); ich ...[e]le (↑ R 327); schnip|pen

schnip|pisch; -ste (↑ R 294)

schnipp, schnapp!; Schnipp-schnapp[|schnurr] (ein [Karten]spiel) s; -[s]; schnips!; Schnip|sel (ugs.) m od. s; -s, -; Schnip|se|lei (ugs.); schnip|seln (ugs. für: in kleine Stücke zerschneiden); ich ...[e]le (↑ R 327); schnip|sen

Schnitt m; -[e]s, -e; Schnitt_blu|me, ...boh|ne; Schnit|te (österr. auch für: Waffel) w; -, -n; Schnit|ter; Schnit|te|rin w; -, -nen; Schnitt-_flä|che, ...ge|schwin|dig|keit, ...holz; schnit|tig (auch für: [scharf] ausgeprägt, rassig); ein -es Auto; Schnitt_lauch (m; -[e]s), ...li|nie, ...mu|ster; Schnitt|mu|ster|bo|gen; Schnitt_punkt, ...wa|re; schnitt|wei|se; Schnitt|wun|de; Schnitz landsch. ([Obst]schnittchen) m; -es, -e; Schnitz_ar|beit (Schnitzerei), ...bank (Mehrz. ...bänke), ...bild; ¹Schnit|zel (Rippenstück) s; -s, -; Wiener Schnitzel; ²Schnit|zel (ugs. für: abgeschnittenes Stück) s (österr. nur so) od. m; -s, -; Schnit|zel|bank (veralt. für: Bank zum Schnitzen; Bänkelsängerverse mit Bildern; Mehrz. ...bänke); Schnit|zel|jagd, ...mes|ser s; schnit|zeln ich ...[e]le (↑ R 327); schnit|zen (du schnitzt (schnitzest) Schnit|zer (Schnitzender; ugs. für: Fehler); Schnit|ze|rei; Schnit|zler; Schnitz_mes|ser s, ...schu|le, ...werk

schno|bern (Nebenform von: schnuppern); ich ...ere (↑ R 327)

schnöd vgl. schnöde

Schnod|der (derb für: Nasenschleim); schnod|de|rig, schnodd|rig (ugs. für: in provozierender, respektloser Weise vorlaut); -e Bemerkungen; Schnod|de|rig|keit, Schnodd|rig|keit (ugs.)

schnö|de, schnöd, schnöder Gewinn, Mammon; schnö|den schweiz. (schnöde reden); Schnöd|heit (seltener für: Schnödigkeit); Schnö|dig|keit

schno|feln österr. (ugs. (schnüffeln; durch die Nase sprechen); ich ...[e]le (↑ R 327)

Schnor|chel (Luftrohr für das tauchende U-Boot; Teil eines Sporttauchgerätes) m; -s, -; schnor|cheln (mit dem Schnorchel tauchen); ich ...[e]le (↑ R 327)

Schnör|chel (eine Geflügelkrankheit) m; -s

Schnör|kel m; -s, -; Schnör|ke|lei; schnör|kel|haft; schnör|ke|lig, schnörk|lig; Schnör|kel|kram; schnör|keln; ich ...[e]le (↑ R 327)

schnor|ren, schnur|ren (ugs. für:

betteln; auch: eine Vorlesung o. ä. unrechtmäßig hören); Schnor|rer, Schnur|rer (ugs. für: Bettler, Landstreicher; Schmarotzer)

Schnö|sel (ugs. für: dummfrecher junger Mensch) m; -s, -; schnö|se|lig

Schnucke¹ (Schaf einer bestimmten Rasse) w; -, -n; Schnuckel-chen¹ (Schäfchen; Kosewort); schnucke|lig¹, schnuck|lig (ugs. für: nett, süß; appetitlich); schnuckern¹ niederd. (sich langsam bewegen); ich ...ere (↑ R 327); Schnucki¹ (svw. Schnuckelchen) s; -s, -s

schnud|de|lig, schnudd|lig (ugs.: unsauber; landsch.: lecker)

Schnüf|fel (veralt. für: Schnüffler) m; -s, -; Schnüf|fe|lei; schnüf|feln, schnüf|feln; ich ...[e]le (↑ R 327); Schnüff|ler

schnul|len landsch. (saugen); Schnul|ler (Gummisauger)

Schnul|ze (ugs. für: sentimentales Kino-, Theaterstück, Lied) w; -, -n; schnul|zig

schnup|fen; Schnup|fen m; -s, -; Schnup|fer; Schnup|fe|rin w; -, -nen; Schnupf|ta|bak; Schnupf-ta|bak[s]|do|se; Schnupf|tuch (Mehrz. ...tücher)

schnup|pe (ugs. für: gleichgültig); es ist mir -; Schnup|pe niederd. u. mitteld. (verkohlter Docht) w; -, -n

schnup|pern; ich ...ere (↑ R 327)

¹Schnur (Bindfaden, Kordel; dünne Leine) w; -, Schnüre (im Buchw., sonst selten: Schnuren)

²Schnur (veralt. für: Schwiegertochter) w; -, -en

Schnur_al|ge, ...as|sel, ...baum; Schnür|bo|den (Theater; Mehrz. ...böden); Schnür|chen, Schnürlein; das geht wie am Schnürchen (ugs. für: das geht reibungslos); schnü|ren (auch von der Gangart des Fuchses); schnur|ge|ra|de²; Schnur_ke|ra|mik (Kulturkreis der jüngeren Steinzeit; w; -), ...ke|ra|mi|ker; Schnür_leib, ...leib-chen; Schnür|lein, Schnür|chen; Schnürl_re|gen (bes. in Salzburg), ...samt (österr. für: Kord); Schnür|mie|der

Schnur|rant landsch. ([Bettel]musikant) m; -en, -en (↑ R 268); Schnurr|bart; schnurr|bär|tig; Schnur|re (Posse, Albernheit; landsch. für: altes Weib) w; -, -n; ¹schnur|ren (leise vor sich in knurren [Katzen]); ²schnur|ren vgl. schnorren; Schnur|rer vgl.

Schnorrer; Schnurr|haa|re Mehrz.

Schnür|rie|men (Schuhsenkel)

schnur|rig; ein -er Kauz; Schnurrig|keit

Schnur|rock, Schnür|rock (früher für: Rock mit Schnüren)

Schnurr|pfei|fe|rei (veralt. für: läppische Kleinigkeit)

Schnür_schuh, ...sen|kel, ...stie|fel; schnur|stracks; Schnü|rung

schnurz (ugs. für: gleich[gültig]; das ist mir -

Schnüt|chen, Schnüt|lein; Schnu|te (niederd. für: Schnauze; ugs. für: [Schmoll]mund, unwilliger Gesichtsausdruck) w; -, -n

Scho|ber südd., österr. (geschichteter Getreidehaufen; Feimen) m; -s, -; Schö|berl österr. (eine Suppeneinlage) s; -s, -[n]; scho|bern, schö|bern bes. österr. (in Schober setzen); ich ...ere (↑ R 327)

Scho|chen alemann. (kleinerer Heuhaufen) m; -s, Schöchen

¹Schock (60 Stück) s; -[e]s, -e; 3 - Eier (↑ R 322)

²Schock engl. (Stoß, Schlag; plötzliche [Nerven]erschütterung) m; -[e]s, -s (selten: -e); schockant¹ fr. (anstößig); Schock|be|hand|lung; schöcken¹ engl. (Nervenkranke mit künstlichem Schock behandeln; einen Schock versetzen); Schocker¹ (ugs. für: Schauerroman, Schauerfilm) m; -s, -; schockie|ren¹ fr. (einen Schock versetzen, in Entrüstung versetzen); schocking¹ vgl. shocking

Schock|schwe|re|not!

Schock|the|ra|pie w; -

schock|wei|se; dreischockweise

Schof (niederd. für: Strohdecke; Jägerspr.: Kette [von Gänsen od. Enten]) m; -[e]s, -e

scho|fel, scho|fe|lig, schof|lig jidd. (ugs. für: gemein; geizig); eine schof[e]l[e]od. schof[e]l[i]ge Person; Scho|fel (ugs. für: schlechte Ware) m; -s, -

Schöf|fe m; -n, -n (↑ R 268); Schöf|fen|bank (Mehrz. ...bänke); schöf|fen|bar (veralt. für: zum Schöffen wählbar); Schöf|fen_ge-richt, ...stuhl; Schöf|fin w; -, -nen

Schof|för (eindeutschend für: Chauffeur) m; -s, -e

scho|flig vgl. schofelig

Scho|ko|la|de mexik.; scho|ko|la|den (aus Schokolade); scho|ko|la|de[n] braun; Scho|ko|la|de[n]_eis, ...fa|brik; scho|ko|la|de[n]_far-ben od. ...far|big; Scho|ko|la|de[n]_guß, ...oster|ha|se, ...plätz-chen, ...pud|ding, ...pul|ver, ...tafel, ...tor|te, ...ver|brauch

¹ Trenn.: ...uk|k...
² Vgl. die Anmerkung zu „gerade".

¹ Trenn.: schok|k...

Scho|lar gr. ([fahrender] Schüler, Student [im MA.]) m; -en, -en (↑ R 268); **Schol|arch** (mittelalterl. Schulaufseher, -vorsteher) m; -en, -en (↑ R 268); **Schol|ar|chat** (Amt eines Scholarchen) s; -[e]s, -e; **Scho|la|stik** (mittelalterl. Philosophie; engstirnige Schulweisheit) w; -; **Scho|la|sti|ker** (Anhänger, Lehrer der Scholastik; abschätzig für: reiner Verstandesmensch, spitzfindiger Mensch); **scho|la|stisch**; -ste (↑ R 294); **Scho|la|sti|zis|mus** (einseitige Überbewertung der Scholastik; abschätzig für: Spitzfindigkeit) m; -

Scho|li|ast gr. (Verfasser von Scholien) m; -en, -en (↑ R 268); **Scho|lie** [...iᵉ] w; -, -n und **Scho|li|on** (gelehrte Anmerkung [zu gr. u. röm. Schriftstellern], Erklärung) s; -s, ...lien [...iᵉn]

Schol|le ([Erd-, Eis]klumpen; Heimat[boden]; Fisch) w; -, -n; **Schol|len_bre|cher, ...ge|bir|ge; schol|lern** (dumpf rollen, tönen); **schol|lig**

Schöll|kraut (Nebenform von: Schellkraut)

Scho|lo|chow (sowjet. Dichter)

Scholl|ti|sei niederd. veralt. (Amt des Gemeindevorstehers) w; -, -en

schon; obschon, wennschon; wennschon – dennschon

schön; I. *Kleinschreibung:* a) (↑ R 224:) die schöne Literatur; die schönen Künste; das schöne (weibliche) Geschlecht; gib die schöne (ugs. für: rechte) Hand!; b) (↑ R 134:) am schönsten; auf das od. aufs schönste (schönstens). II. *Großschreibung:* a) (↑ R 116:) die Schönste unter ihnen; die Welt des Schönen; das Gefühl für das Schöne und Gute; auf das Schönste bedacht sein; b) (↑ R 116:) etwas Schönes; c) (↑ R 224:) Schön Rotraud; Philipp der Schöne. III. *In Verbindung mit Zeitwörtern* (↑ R 139): a) *Getrenntschreibung,* wenn „schön" in selbständiger Bedeutung gebraucht wird, z. B. schön sein, werden, anziehen, singen usw.; b) *Zusammenschreibung,* wenn ein neuer Begriff entsteht; vgl. schönfärben, schönmachen, schönreden, schönschreiben, schöntun

Schön|berg, Arnold (österr. Komponist)

schön|druck (Bedrucken der Vorderseite des Druckbogens; *Mehrz.* ...drucke); **¹Schön|e** (schönes Mädchen) w; -n, -n (↑ R 287ff.); **²Schö|ne** (dicht. für: Schönheit) w; -

scho|nen; sich -

schö|nen ([Färbung] verschönern [vgl. avivieren]; [Flüssigkeiten] klären; [Nahrungsmittel] in Aussehen, Geschmack, Geruch verbessern)

Scho|nen (hist. Provinz u. Halbinsel im Süden Schwedens)

¹Scho|ner (Schutzdeckchen)

²Scho|ner *engl* (mehrmastiges Segelschiff) m; -s, -

schön|fär|ben; ↑ R 139 ([zu] günstig darstellen); ich färbe schön; schöngefärbt; schönzufärben; aber: **schön fär|ben**; das Kleid wurde [besonders] schön gefärbt; **Schön|fär|ber, Schön|fär|be|rei** (Über-, Umfärben; [zu] günstige Darstellung)

Schön|frist

Schön|geist (*Mehrz.* ...geister); **Schön|gei|ste|rei; schön|gei|stig; Schön|heit; Schön|heits_feh|ler, ...fleck, ...ide|al, ...kö|ni|gin, ...mit|tel** s, **...ope|ra|ti|on, ...pfla|ster|chen, ...pfle|ge** (w; -), **...sinn** (m; -[e]s); **schön|heits|trun|ken; Schön|heits|wett|be|werb**

Schön|kost (für: Diät)

Schön|ling (abwertend); **schön|ma|chen**; ↑ R 139 (verschönern, herausputzen); sich -; der Hund hat schöngemacht (hat Männchen gemacht); sie hat sich schöngemacht; aber: **schön ma|chen**; das hat er [besonders] schön gemacht; **schön|re|den**; ↑ R 139 (schmeicheln); er hat schöngeredet; aber: **schön re|den**; der Vortragende hat schön geredet; **Schön|red|ner, Schön_re|de|rei** od. **...red|ne|rei; schön|red|ne|risch**; -ste (↑ R 294); **Schön Rotraud** (↑ R 224)

schön|sam (veralt. für: schonend) **schön|schrei|ben**; ↑ R 139 (Schönschrift schreiben); sie haben während des Unterrichts schöngeschrieben; aber: **schön schrei|ben**; er hat diesen Aufsatz [besonders] schön geschrieben; **Schön|schreib.heft, ...kunst, ...übung; Schön|schrift** w; -; **schön|stens; Schön|tu|er; Schön|tu|e|rei; schön|tue|risch**; -ste (↑ R 294); **schön|tun**; ↑ R 139 (sich zieren; schmeicheln); er hat in ihrer Anwesenheit immer schöngetan; **Schön-und-Wi|der|druck-Ma|schi|ne;** ↑ R 155 (Druckmaschine)

Scho|nung (Nachsicht, Gnade; junger, zu schonender Forstbezirk)

Scho|nung [zu: schönen]; **scho|nungs|be|dürf|tig; scho|nungs|los**; -este (↑ R 292); **Scho|nungs|lo|sig|keit** w; -

Schön|wet|ter|la|ge

Schon|zeit

Scho|pen|hau|er (dt. Philosoph); **Scho|pen|haue|ria|ner** (Anhänger Schopenhauers); **scho|pen|haue|risch, scho|pen|hau|ersch**; -es Denken (nach Art von Schopenhauer), aber (↑ R 179): **Scho|pen|haue|risch, Scho|pen|hau|ersch**; „Über die Freiheit des menschlichen Willens" ist ein -es Werk (ein Werk von Schopenhauer)

Schöpf (Haarbüschel; landsch. auch für: Wetterdach; Nebengebäude, [Wagen]schuppen) m; -[e]s, Schöpfe

Schöpf|brun|nen

Schöpf|chen, Schöpf|lein (kleiner Schopf)

Schöp|fe (veralt. für: Gefäß zum Schöpfen; Platz zum Schöpfen) w; -, -n; **Schöpf|ei|mer**

¹schöp|fen (Flüssigkeit entnehmen, herausschöpfen)

²schöp|fen (veralt. für: erschaffen) **¹Schöp|fer** (Schöpfgefäß)

²Schöp|fer (Erschaffer, Urheber); **Schöp|fer.geist, ...hand; schöp|fe|risch**; -ste (↑ R 294); schöpferische Arbeit leisten; eine schöpferische Pause einlegen; **Schöp|fer|kraft** w

Schöpf_ge|fäß, ...kel|le

Schöpf|lein, Schöpf|chen; Schopf|ler|che

Schöpf|löf|fel

Schöp|fung; Schöp|fungs_be|richt, ...ge|schich|te, ...tag

Schöpp|chen, Schöpp|lein (kleiner Schoppen)

Schöp|pe landsch. (Schöffe) m; -n, -n (↑ R 268)

schöp|peln mdal. (gern oder gewohnheitsmäßig [einen Schoppen] trinken); ich ...[e]le (↑ R 327)

schop|pen südd., österr. u. schweiz. mdal (hineinstopfen, nudeln, zustecken)

Schop|pen (Flüssigkeitsmaß [für Bier, Wein]; südd. u. schweiz. auch: Babyflasche; landsch. für: Schuppen) m; -s, -

Schöp|pen|stedt (Stadt in Niedersachsen); **Schöp|pen|sted|ter** (↑ R 199); **schöp|pen|sted|tisch**

Schöp|pen|wei|se; Schöpp|lein, Schöpp|chen

Schöps ostmittel. u. österr. (Hammel) m; -es, -e; **Schöps|chen, Schöps|lein; Schöp|sen_bra|ten, ...fleisch; Schöp|ser|ne** (Hammelfleisch) s; -n

schöp|sen mdal. (umgraben)

Schorf m; -[e]s, -e; **schorf|ar|tig; schor|fig**

Schörl (Turmalin) m; -[e]s, -e

Schor|le, Schor|le|mor|le (ein Getränk) w; -, -n (seltener: s; -s, -s)

Schorn|stein; Schorn|stein|fe|ger

Schorsch (volkstüml. Form von: Georg)

Scho|se fr. [eindeutschend für:

Chose] (ugs. für: Sache; Angelegenheit; unangenehmes, peinliches Vorkommnis) w; -, -n

¹Schoß (Mitte des Leibes, das Innere; Teil der Kleidung) m; -es, Schöße; ²Schoß österr. (Frauenrock) w; -, Schoßen u. Schöße

³Schoß (veralt. für: Zoll, Steuer, Abgabe) m; Schosses, Schosse[n] u. Schösse[r]

⁴Schoß (junger Trieb) m; Schosses, Schosse

Schoß|brett bayr. (Schutzbrett)

Schöß|chen (an der Taille eines Frauenkleides angesetzter [gekräuselter] Stoffstreifen); Schößel österr. (Schößchen) m; -s, -

schös|sen (veralt. für: keimen, sprossen); du schoßt (schossest), er schoßt; du schoßtest; geschoßt

Schös|ser (veralt. für: Abgabenerheber); vgl. ³Schoß

Schoß|gat|ter (veralt. für: Fallgatter)

Schoß|hund

Schoß|kel|le (veralt. für: Gepäckhalter; auch: Kutschersitz)

Schoß|kind

Schöß|ling (Ausläufer, Trieb einer Pflanze)

Scho|sta|ko|witsch (sowjet. Komponist)

Schot w; -, -en vgl. ²Schote

Schöt|chen, Schöt|lein (kleine ³Schote)

¹Scho|te jidd. mdal. (Narr, Einfaltspinsel) m; -n, -n (↑ R 268)

²Scho|te (Segelleine) w; -, -n

³Scho|te (Fruchtform) w; -, -n; scho|ten|för|mig; Scho|ten_frucht, ...pfef|fer

¹Schott arab. (mit Salzschlamm gefülltes Becken [im Atlasgebirge]) m; -s, -s

²Schott s; -[e]s, -e u. ¹Scho|te (Seemannsspr.: wasserdichte [Quer]wand im Schiff) w; -, -n

²Schot|te (Bewohner von Schottland) m; -n, -n (↑ R 268)

³Schot|te niederd. (junger Hering) m; -n, -n (↑ R 268)

⁴Schot|te südd., schweiz. (Molke) w; -; vgl. auch: Topfen; ¹Schot|ten südd., westösterr. (Quark) m; -s

²Schot|ten (ein Gewebe) m; -s, -

Schot|ter (zerkleinerte Steine; auch: von Flüssen abgelagerte kleine Steine) m; -s, -; Schot|ter_decke [Trenn.: ...dek|ke]; schot|tern (mit Schotter belegen); ich ...ere (↑ R 327); Schot|ter|stra|ße; Schot|te|rung

Schot|tin w; -, -nen; schot|tisch; Schot|tisch, Schot|ti|sche (ein Tanz) m; ...schen, ...schen (↑ R 287 ff.); (einen Schottischen tanzen; Schott|land; Schott|län|der; Schott|län|de|rin w; -, -nen; schott|län|disch

Schraf|fe (Strich einer Schraffur) w; -, -n (meist Mehrz.); schraf|fen (für: schraffieren); schraf|fie|ren (mit Schraffen versehen; stricheln); Schraf|fie|rung, Schraffung, (meist:) Schraf|fur (Zeichnung mit parallelen Strichen; Strichzeichnung auf Karten; Strichelung) w; -, -en

schräg; - halten, stehen, stellen, liegen; - gegenüber; (ugs.:) er ist ein schräger Vogel, schräge Musik; Schräg_ach|se, ...bau (Bergmannsspr.: Abbauverfahren in steil ansteigenden Flözen; m; -[e]s); Schrä|ge w; -, -n; schrä|gen (veralt. für: zu Schragen verbinden); schrä|gen (schief abkanten); Schra|gen landsch. (schräg od. kreuzweise zueinander stehende Holzfüße od. Pfähle; Gestell; auch für: Sägebock; Sarg) m; -s, -; Schräg|heit w; -; schräg|hin; Schräg|la|ge; schräg|lau|fend; Schräg_schnitt, ...schrift, ...streifen, ...strich; schräg|über; Schrägung

schral (Seemannsspr.: schwach, ungünstig) -er Wind; schra|len (Seemannsspr.); der Wind schralt

Schram (Bergmannsspr.: Einschnitt im Flöz, der parallel zum Hangenden u. Liegenden verläuft) m; -[e]s, Schräme; Schram_boh|rer, Schräm|boh|rer; schrämen (Bergmannsspr.: Schräme machen); Schräm|ma|schi|ne (Bergmannsspr.: Maschine zur Herstellung eines Schrams); Schräm|me w; -, -n

Schram|mel|mu|sik (↑ R 180 [nach dem österr. Musiker Johann Schrammel]), ...quar|tett

schram|men; schram|mig

Schrank m; -[e]s, Schränke; Schrank|bett; Schränk|chen, Schränk|lein; Schran|ke w; -, -n; Schränk|ei|sen (Gerät zum Schränken der Säge); Schran|ken mdal. u. österr. (Schranke) m; -s, -; schrän|ken (kreuzweise übereinanderlegen; die Zähne eines Sägeblattes wechselweise abbiegen; Jägerspr.: die Tritte etwas versetzt hintereinandersetzen [Rothirsch]); schran|ken|los; -este (↑ R 292); Schran|ken_lo|sig|keit; Schran|ken|wärter; Schrank_fach, ...kof|fer; Schränk|lein, Schränk|chen, Schrank_spie|gel, ...tür, ...wand

Schran|ne südd. u. österr.: Bank zum Feilhalten; Getreidemarkt; mittelalterl. Vorrats- u. Verkaufshaus) w; -, -n; Schran|nen_platz

Schranz südd., schweiz. mdal. (Riß) m; -es, Schränze; Schran|ze

(verächtl. für: Höfling) m; -n, -n (↑ R 268) od. w; -, -n; schran|zen (veralt. für: sich wie ein Schranze gebärden); du schranzt (schranzest); Schran|zen_art w; -; schran|zen|haft

Schra|pe (Kratzeisen) w; -, -n; schra|pen vgl. schrappen

Schrap|nell [nach dem engl. Artillerieoffizier H. Shrapnel] (früher: Sprenggeschoß mit Kugelfüllung; verächtl. für: häßliche Frau) s; -s, -e u. -s

Schrapp_ei|sen; schrap|pen niederd. ([ab]kratzen); Schrap|per (ein Fördergefäß); Schrap|sel (das Abgekratzte) s; -s, -

Schrat, Schratt m; -[e]s, -e u. Schrä|tel (zottiger Waldgeist) m; -s, -

Schrat|te (Geogr.: Rinne, Schlucht in Kalkgestein) w; -, -n

Schrat|ten|kalk m; -[e]s

Schräub|chen, Schräub|lein; Schrau|be w; -, -n; Schrau|bel (ein Blütenstand) w; -, -n; schrau|ben; eine geschraubte Formulierung; Schrau|ben_be|we|gung, ...dampfer, ...fe|der, ...flü|gel, ...ge|trie|be, ...ge|win|de, ...kopf, ...kupp|lung, ...li|nie, ...mut|ter (Mehrz. ...muttern; ↑ R 269), ...pres|se, ...rad, ...schlüs|sel, ...win|de, ...zie|her; Schräub|lein, Schräub|chen; Schrau|ben_stock (Mehrz. ...stöcke); Schraub|ver|schluß

Schrau|fen österr. ugs. (Schraube hohe Niederlage) m; -s, -

Schre|ber|gar|ten; ↑ R 180 [nach dem Leipziger Arzt Schreber (Kleingarten in Gartenkolonien

Schreck m; -[e]s, -e u. Schrecken m; -s, -; Schreck|bild; Schrecke (Heupferdchen; Wachtelkönig w; -, -n; ¹schrecken¹ (in Schrecker geraten: nur noch in zusammengesetzten Zeitwörtern u. Zeitwörtern mit Vorsilbe, z. B er-, auf-, hoch-, zurück-, zusammenschrecken [vgl. d.]); du schrickst, er schrickt; du schrakst (schrakest), er schrak; du schrakest; geschrocken; schrick! schrecke! Schrecken¹ vgl Schreck; schrecken|er|re|gend¹ aber (↑ R 142): einen großen Schrecken erregend; schreckens¹ _blaß, ...bleich; Schreckens¹_bot schaft, ...herr|schaft, ...nach richt, ...tat, ...vi|si|on, ...zei schreck|er|füllt; Schreck|ge spenst; schreck|haft; Schreck|haf tig|keit w; -; schreck|lich

¹ Trenn.: ...ek|k...

Schreck|lich|keit; Schreck|nis s; -ses, -se; Schreck.schrau|be (ugs. abschätzig für: unbeliebte, unangenehme Frau), ...schuß; Schreck|schuß|pi|sto|le; Schreck|se|kun|de
Schred|der vgl. Shredder
Schrei m; -[e]s, -e; Schrei|ad|ler (ein Raubvogel)
Schreib.art, ...be|darf, ...block (Mehrz. ...blocks); Schrei|be (Geschriebenes; Schreibstil) w; -; schrei|ben; du schriebst (schriebest); du schriebest; geschrieben; schreib[e]!; er hat mir sage und schreibe (tatsächlich; Ausdruck der Entrüstung) zwanzig Mark abgenommen; Schrei|ben (Schriftstück) s; -s, -; Schrei|ber; Schrei|be|rei (ugs.); Schrei|be|rin w; -, -nen; Schrei|ber|ling, Schreiber|see|le (verächtl. für: bürokratischer, kleinlicher Mensch); schreib|faul; Schreib.faul|heit (w; -), ...fe|der, ...feh|ler, ...heft, ...kraft w, ...krampf, ...kunst (w; -), ...map|pe, ...ma|schi|ne; Schreib|ma|schi|nen.pa|pier, ...schrift; Schreib.pa|pier, ...pult, ...schrift, ...stu|be, ...tisch; Schreib|tisch|tä|ter (jmd., der den Befehl zu einem Verbrechen vom Schreibtisch aus gibt); Schreib|übung; Schrei|bung; Schreib.un|ter|la|ge, ...un|ter|richt, ...wa|ren (Mehrz.), ...wei|se w, ...zeug, ...zim|mer
schrei|en; du schriest; du schrieest; geschrie[e]n; schrei[e]!; die schreiendsten Farben; Schrei|er; Schreie|rei (ugs.); Schrei.hals (abschätzig), ...krampf
Schrein lat. (veralt. für: Schrank; Sarg; [Reliquien]behältnis) m; -[e]s, -e; Schrei|ner südd., westd. (Tischler); Schrei|ne|rei (südd., westd.); schrei|nern (südd., westd.); ...ere (↑ R 327)
Schreit|bag|ger; schrei|ten; du schrittst (schrittest); du schrittest; geschritten; schreit[e]!; Schreit.tanz, ...vo|gel, ...wan|ze
Schrei|vo|gel
Schrenz (veralt. für: minderwertiges Papier, Löschpapier; biegsame Pappe) m; -es, -e
Schrieb (ugs., meist abschätzig für: Brief) m; -s, -e; Schrift w; -, -en; die deutsche, gotische, lateinische, griechische, kyrillische -; Schrift.art, ...bild; schriftdeutsch; Schrift|deutsch s; -[s]; Schrift|deut|sche s; -n; Schrif|ten (schweiz. auch für: Ausweispapiere) Mehrz.; Schrif|ten.nachweis, ...ver|zeich|nis; Schrift|fäl|scher, ...form, ...füh|rer, ...gelehr|te; schrift|ge|mäß; Schrift|gie|ßer; Schrift|gie|ße|rei;

Schrift.grad, ...hö|he, ...lei|ter m, ...lei|tung; schrift|lich; schriftliche Arbeit; schriftliche Prüfung; schriftliche Überlieferung; etwas Schriftliches (↑ R 116) geben; Schrift|lich|keit (Form für rechtsgeschäftl. Erklärungen; Unterschriftsleistung); Schrift.mu|ster|buch, ...pro|be, ...rol|le, ...sach|ver|stän|di|ge, ...satz, ...set|zer, ...spie|gel, spra|che; schrift|sprach|lich; Schrift|stel|ler; Schrift|stel|le|rei w; -; schriftstel|le|risch; schrift|stel|lern; ich ...ere (↑ R 327); geschriftstellert; Schrift|stel|ler|na|me; Schrift|stück; Schrift|tum s; -s; Schrift.typ, ...ver|glei|chung, ...ver|kehr; schrift|ver|stän|dig; Schrift.wart, ...wech|sel, ...zei|chen, ...zeug (s; abgenutzte Drucktypen od. m; zum Schriftguß bestimmtes Metall), ...zug
schrill; schril|len
schrin|nen niederd. (schmerzen); die Wunde schrinnt
Schrip|pe berlin. (Weißbrötchen) w; -, -n
Schritt m; -[e]s, -e; 5 - weit (↑ R 322); - für -; auf - und Tritt; -fahren, - halten; den zweiten - vor dem ersten tun; Schrittanz [Trenn.: Schritt|tanz, ↑ R 236]; Schrit|tem|po [Trenn.: Schritt|tem..., ↑ R 236]; Schritt.kom|bi|na|ti|on, ...län|ge; schrittlings (veralt.); Schritt|ma|cher; Schritt|ma|cher|ma|schi|ne; Schritt|mes|ser m; schritt|wei|se; Schritt.wei|te (bei der Hose), ...zäh|ler
Schro|fen vgl. Schroffen; schroff; -[e]ste (↑ R 293); Schroff (Nebenform von: Schroffen) m; -[e]s u -en, -en (↑ R 268); Schrof|fen südd., österr. (Felsklippe) m; -s, -; Schroff|heit
schroh fränk. u. hess. (rauh, roh, grob)
schröp|fen; Schröp|fer; Schröpfkopf
Schropp|ho|bel, Schrupp|ho|bel
Schrot m od. s; -[e]s, -e; vgl. Schrott; Schrot.blatt (mittelalterl. Kunstblatt in Metallschnitt), ...brot; schro|ten (grob zerkleinern); geschrotet (älter: geschroten); vgl. schrotten; Schrö|ter (ein Käfer; veralt. für: [Bier]fuhrmann); Schrot.flin|te, ...kä|fer, ...ku|gel; Schröt|ling (veralt. für: Münzplatte); Schrot.mehl, ...mei|ßel, ...müh|le, ...sä|ge, ...sche|re, ...schuß; Schrot|schuß|krank|heit (eine Pilzkrankheit); Schrott (Alteisen) m; -[e]s, -e; vgl. Schrot; schrot|ten (zu Schrott machen); Schrott.han|del, ...händ|ler, ...pres|se; schrott-

reif; Schrott.trans|port (↑ R 237), ...ver|fah|ren, ...wert; Schrott|waa|ge (Vorrichtung zur Prüfung waagerechter Flächen)
schrub|ben (mit einem Schrubber reinigen); vgl. schruppen; Schrub|ber ([Stiel]scheuerbürste); Schrubbe|sen [Trenn.: Schrubb|be..., ↑ R 236] m; -s, -
Schrul|le (Laune, unberechenbarer Einfall; ugs. verächtl. für: eigensinnige alte Frau) w; -, -n; schrul|len|haft, Schrul|len|haf|tig|keit; schrul|lig; Schrul|lig|keit w; -
schrumm!; schrumm|fi|de|bumm!
Schrum|pel niederd. u. mitteld. (Falte, Runzel; alte Frau) w; -, -n; schrum|pe|lig, schrump|lig (niederd., mitteld.); schrum|peln (niederd., mitteld. für: schrumpfen); ich ...[e]le (↑ R 327); schrumpf|be|stän|dig; -e Stoffe; schrump|fen; schrump|fig; Schrumpf.kopf (eine Art Kopftrophäe), ...le|ber, ...nie|re; Schrump|fung; schrump|lig, schrum|pe|lig
Schrund südd., österr., schweiz. ([Gletscher]spalte) m; -[e]s, Schründe; Schrun|de (Riß, Spalte) w; -, -n; schrun|dig (rissig)
schrup|pen (grob hobeln); vgl. schrubben; Schrupp|fei|le; Schrupp|ho|bel, Schropp|ho|bel; Schrupp|stahl
Schub m; -[e]s, Schübe
Schub|be|jack niederd. (Bettler, der sich in der Jacke schubbt [kratzt]; Schuft) m; -s, -s; schub|ben niederd. (kratzen)
Schu|ber (für: [Buch]schutzkarton; österr. auch: Absperrvorrichtung, Schieber) m; -s, -; Schub.fach, ...kar|re[n], ...kasten, ...kraft w, ...la|de, ...leh|re (Längenmeßinstrument), ...leistung; Schub|lig (schweiz. mdal.) u. Schüb|ling südd., schweiz. ([leicht geräucherte] lange Wurst); Schub|mo|dul (Begriff der Elastizitätslehre); Schubs mdal. (Stoß) m; -es, -e; Schub|schiff (Binnenschiffahrt); schub|sen mdal. ([an]stoßen); du schubst (schubsest); Schub.stan|ge, ...stei|fe (für: Schubmodul); schub|wei|se; Schub|wir|kung
schüch|tern; Schüch|tern|heit w; -
schu|ckeln [Trenn.: schuk|keln] (ugs. für: wackeln); ich ...[e]le (↑ R 327)
Schuft m; -[e]s, -e
schuf|ten (ugs. für: hart arbeiten); Schuf|te|rei
schuf|tig; Schuf|tig|keit
Schuh m; -[e]s, -e; 3 - lang (↑ R 322); Schuh.an|zie|her, ...band (s; Mehrz. ...bänder), ...bür|ste;

Schüh|chen, Schüh|lein; Schuh|cre|me, ...fa|brik, ...ge|schäft, ...grö|ße, ...haus; ...schu|hig (z. B. fünfschuhig, mit Ziffer: 5schuhig; ↑ R 228); Schuh|kar|ton, ...knecht, ...la|den, ...lap|pen; Schüh|lein, Schüh|chen; Schuh|lei|sten, ...löf|fel (Schuhanzieher), ...ma|cher; Schuh|ma|che|rei; Schuh|num|mer, ...pa|ste, ...platt|ler (ein Volkstanz), ...put|zer, ...rie|men, ...sen|kel, ...soh|le, ...span|ner, ...werk, ...wich|se (ugs.), ...zeug (ugs.), ...zwecke [Trenn.: ...zwek|ke]

Schu|ko ⍟ (Kurzw. für: Schutzkontakt), in Verbindungen wie: Schu|ko|stecker [Trenn.: ...stek|ker] (Kurzw. für: Stecker mit besonderem Schutzkontakt)

Schu|lam|mit vgl. ²Sulamith

Schul_ab|gän|ger, ...amt, ...an|fän|ger, ...ar|beit (meist Mehrz.; österr. svw. Klassenarbeit), ...arzt; schul|ärzt|lich; Schul_at|las, ...auf|ga|be (meist Mehrz.); Schul|auf|sichts_be|hör|de, ...ge|setz; Schul_bank (Mehrz. ...bänke), ...bau (Mehrz. ...bauten), ...be|ginn, ...bei|spiel, ...be|such, ...bil|dung, ...bub (südd., österr. für: Schuljunge), ...buch, ...bus

Schuld w; -, -en; [die] Schuld tragen; es ist meine Schuld; jmdm. die Schuld geben, aber (↑ R 132): schuld geben, haben, sein; sich etwas zuschulden (↑ R 141) kommen lassen; Schuld_ab|än|de|rung (Wirtsch.), ...an|er|kennt|nis (Wirtsch.; s), ...bei|tritt (Wirtsch.), ...be|kennt|nis, ...buch|for|de|rung (Wirtsch.); schuld|be|la|den, aber (↑ R 142): mit großer Schuld beladen; Schuld|be|weis; schuld|be|wußt, aber (↑ R 142): seiner Schuld bewußt; Schuld|be|wußt|sein; schul|den; schul|den|frei (ohne Schulden), aber (↑ R 143): von Schulden frei; Schul|den|haf|tung (Wirtsch.); schul|den|hal|ber; Schul|den|last; Schuld|fra|ge; schuld|frei (ohne Schuld), aber (↑ R 143): von großer Schuld frei; Schuld|ge|fühl; schuld|haft; Schuld|haft (hist.) w; -

Schul|dienst m; -[e]s; im - [tätig] sein (als Lehrer unterrichten)

schul|dig; der -e Teil; auf - plädieren (Schuldigsprechung beantragen); eines Verbrechens - sein; jmdn. - sprechen (↑ R 287ff.); Schul|di|ger (bibl. für: Schuldner); schul|di|ger_ma|ßen; Schul|dig|keit w; -; Schul|dig|spre|chung; Schuld|kom|plex; schuld|los; -este (↑ R 292); Schuld|lo|sig|keit w; -; Schuld|ner; Schuld|ne|rin w; -,

-nen; Schuld|ner_mehr|heit (Wirtsch.), ...schutz, ...ver|zeich|nis, ...ver|zug (Rechtsw.); Schuld_recht, ...schein; Schuld|schein|dar|le|hen; Schuld_spruch, ...über|nah|me, ...um|wand|lung, ...ver|hält|nis, ...ver|schrei|bung, ...ver|spre|chen (Rechtsw.), ...wech|sel, ...zins (Mehrz. ...zinsen)

Schu|le gr. w; -, -n; (↑ R 224:) die Hohe Schule (vgl. d.); aber: die höhere Schule (vgl. höher); schu|len; schul_ent|las|sen, ...ent|wach|sen, Schü|ler; Schü|ler|aus|tausch; schü|ler|haft; Schü|ler_haf|tig|keit w; -; Schü|le|rin w; -, -nen; Schü|ler|lot|se (Schüler, der als Verkehrshelfer eingesetzt ist); Schü|ler_mit|ver|ant|wor|tung, ...mit|ver|wal|tung (Abk.: SMV); Schü|ler_par|la|ment; Schü|ler|schaft; Schü|ler_spra|che, ...zei|tung; Schü|ler|fe|ri|en Mehrz.; schul|frei; Schul_freund, ...funk, ...gang m, ...geld; Schul|geld|frei|heit w; -; Schul_ge|lein|ber|sam|keit, ...ge|mein|de, ...ge|rät, ...ge|setz, ...ge|sund|heits|pfle|ge, ...haus, ...heft, ...hof, ...hy|gie|ne; schu|lisch; Schul_jahr, ...ju|gend, ...jun|ge m, ...ka|me|rad, ...kennt|nis|se (Mehrz.), ...kind, ...klas|se, ...land|heim, ...leh|rer, ...leh|re|rin, ...lei|ter m, ...mäd|chen; schul|mä|ßig; Schul_me|di|zin, ...mei|ster; schul|mei|ster|lich; schul|mei|stern; ich ...ere (↑ R 327); geschulmeistert; zu -; Schul|mei|sters|sohn; Schul_mu|sik, ...ord|nung

Schulp (die verkalkte, seltener verhornte Schale der Tintenfische) m; -[e]s, -e

Schul_pflicht w; -; schul|pflich|tig; -es Alter; -es Kind; Schul_pfor|ta ([früher: Fürstenschule] bei Naumburg); Schul_po|li|tik, ...psy|cho|lo|ge, ...ran|zen, ...rat (Mehrz. ...räte), ...recht, ...re|form, ...re|gel, ...rei|fe, ...sack (schweiz. für: Schulranzen), ...schiff, ...schluß (m; ...schlusses), ...schrift, ...spei|sung, ...stun|de, ...sy|stem

Schul_ter w; -, -n; Schul|ter|blatt; schul|ter|frei; Schul|ter|ge|lenk; ...schul|te|rig, ...schult|rig (z. B. breitschult[e]rig); Schul|ter|klap|pe; schul|ter|lang; -es Haar; schul|tern; ich ...ere (↑ R 327); Schul|ter_pol|ster, ...rie|men, ...sieg (beim Ringen)

Schult|heiß (früher für: Gemeindevorsteher; im Kanton Luzern: Präsident des Regierungsrates) m; -en, -en (↑ R 268); Schult|hei|ßen|amt

...schult|rig vgl. ...schulterig

Schu|lung; Schul_un|ter|richt, ...ver|wal|tung, ...weg, ...weis|heit, ...we|sen (s; -s)

Schul|ze (früher für: Gemeindevorsteher) m; -n, -n (↑ R 268)

Schul|zeit

Schul|zen|amt

Schul_zen|trum, ...zeug|nis, ...zwang (m; -[e]s)

Schu|man (fr. Politiker)

Schu|mann (dt. Komponist)

schum|meln (ugs. für: [leicht] betrügen); ich ...[e]le (↑ R 327)

Schum|mer landsch. (Dämmerung) m; -s, -; schum|me|rig, schumm|rig (landsch.); schum|mern (landsch. für: dämmern; [Landkarte] schattieren); ich ...ere (↑ R 327); (↑ R 120:) im Schummern (landsch. für: in der Dämmerung); Schum|mer|stun|de; Schum|me|rung (Schattierung); schumm|rig vgl. schumme|rig

Schum|per|lied obersächs. (Liebeslied, derbes Volkslied); schum|pern lausitz. (auf dem Schoße schaukeln); ich ...ere (↑ R 327)

Schund (verächtl. für: Wertloses) m; -[e]s; Schund|li|te|ra|tur (verächtl.)

schun|keln (schaukeln; [sich] hin u. her wiegen); ich ...[e]le (↑ R 327); Schun|kel|wal|zer

Schupf südd., schweiz. mdal. (Schub, Stoß, Schwung) u. Schupp nordd. (Schub, Stoß, Schwung) m; -[e]s, -e; schup|fen, schup|pen

Schup|fen südd., österr. mdal. (Schuppen, Wetterdach) m; -s, -

Schup|fer österr. mdal. (Stoß, Schub)

¹Schu|po (Kurzw. für: Schutzpolizei) w; -; ²Schu|po (Kurzw. für: Schutzpolizist) m; -s, -s

Schupp vgl. Schupf

Schüpp|chen, Schüpp|lein (kleine Schuppe); Schup|pe (Haut-, Hornplättchen) w; -, -e

Schüp|pe landsch. (Schippe)

Schüp|pel bayr. u. österr. mdal. (Büschel) m; -s, -

schüp|peln (veralt. für: schiebend bewegen); ich ...[e]le (↑ R 327); ¹schup|pen, schüp|fen

²schup|pen ([Fisch]schuppen entfernen)

schüp|pen landsch. (schippen)

Schup|pen (Raum für Holz u. a.) m; -s, -; vgl. Schupfen

Schüp|pen landsch. (svw. Schippen) s; -, -

schup|pen|ar|tig; Schup|pen_bil|dung, ...flech|te, ...pan|zer, ...tier; schup|pig; Schüpp|lein, Schüpp|chen

Schups südd. (Stoß) m; -es, -e

schup|sen südd. ([an]stoßen); du
schupst (schupsest)

Schur (Scheren [der Schafe]) w; -,
-en

Schür|ei|sen; schü|ren; Schü|rer

Schurf (veralt. für: Suche nach
nutzbaren Lagerstätten) m; -[e]s,
Schürfe; schür|fen; Schür|fer;
Schürf|gru|be; Schürf|kü|bel (ein
Fördergerät); Schürf|kü|bel|rau-
pe; Schürf.loch, ...recht, ...schein;
Schür|fung

schür|gen mdal. (schieben, stoßen,
treiben; verklagen)

Schür|ha|ken

...schü|rig (z. B. dreischürig, mit
Ziffer: 3schürig; ↑ R 228)

schu|ri|ge|lei (ugs.) schu|ri|geln
(ugs. für: quälen; zurechtweisen);
ich ...[e]le (↑ R 327)

Schur|ke (verächtl.) m; -n, -n (↑ R
268); Schur|ken.streich, ...tat;
Schur|ke|rei (verächtl.); Schur-
kin (verächtl.) w; -, -nen; schur-
kisch; -ste (↑ R 294)

Schur|re landsch. ([Holz]gleit-
bahn, Rutsche) w; -, -n; schur|ren
landsch. (mit knirschendem Ge-
räusch über den Boden gleiten,
scharren); Schurr|murr landsch.
(Durcheinander; Gerümpel) m;
-s

Schur|wol|le

Schurz m; -es, -e; Schür|ze w; -,
-n; schür|zen; du schürzt (schür-
zest); Schür|zen.band (s; Mehrz.
...bänder), ...jä|ger (spött. für:
Mann, der den Frauen nach-
läuft); Schurz|fell

Schusch|nigg (österr. Politiker)

Schuß m; Schusses, Schüsse; 2 -
Rum (↑ R 321 u. 322); 2 - (auch:
Schüsse) abgeben; in Schuß (ugs.
für: Ordnung) halten, haben;
Schuß.ab|ga|be, ...be|reich m;
schuß|be|reit

Schus|sel mdal. (fahrige, unruhige
Person) m; -s, - od. w; -, -n

Schüs|sel w; -, -n; Schüs|sel|chen,
Schüs|se|lein; schüs|sel|för|mig

schus|se|lig, schuß|lig (ugs. für:
fahrig, unruhig); schus|seln (ugs.
für: fahrig, unruhig sein); ich
schussele u. schußle (↑ R 327)

Schus|ser landsch. (Spielkügel-
chen); schus|sern (landsch.); ich
schussere u. schußre (↑ R 327)

Schuß.fa|den (Weberei), ...fahrt,
...feld; schuß|fer|tig; Schuß|garn
(Weberei); schuß|ge|recht;
Schuß|ge|rin|ne (Wasserbau)

schus|sig mdal. ([über]eilig, ha-
stig); Schuß|ler landsch. (mit
Schussern Spielender; österr.
ugs. svw. Schussel)

schuß|lig vgl. schusselig

Schuß.li|nie, ...rich|tung, ...ver|let-
zung, ...waf|fe, ...wei|te, ...win-
kel, ...zahl

Schu|ster (oft abwertend); Schu-
ster.ah|le, ...draht; Schu|ste|rei
(veralt.); Schu|ster.jun|ge m,
...ku|gel, ...lehr|ling; schu|stern
(landsch., sonst veralt. für:
das Schuhmacherhandwerk aus-
üben; abschätzig für: Pfuschar-
beit machen; landsch. für: sich
anbiedern); ich ...ere (↑ R 327);
Schu|ster.pech, ...pfriem od.
...pfrie|men, ...soh|le|mol, ...werk
statt

Schu|te (flaches, offenes Wasser-
fahrzeug ohne Takelwerk; auch:
haubenartiger Frauenhut) w; -,
-n

Schutt m; -[e]s; Schutt|ab|la|de-
platz; Schutt.be|ton, ...bo|den;
Schüt|te (Bund Stroh) w; -, -n;
eine - Stroh; Schüt|tel.frost,
...läh|mung; schüt|teln; ich ...[e]le
(↑ R 327); Schüt|tel.reim, ...rut-
sche; schüt|ten

schüt|ten (lose; undicht)

schüt|tern (schütteln); der Wagen
schüttert

Schütt.gut, Schütt.hal|de, ...hau-
fen, ...ke|gel; Schütt.ofen, ...stein
(schweiz. für: Ausguß), ...stroh;
Schüt|tung

Schutz m; -es; zu - und Trutz

[1]Schütz (veralt. für: [1]Schütze) m;
-en, -en (↑ R 268)

[2]Schütz (Elektrotechnik: ferng-
steuerter Schalter) s; -es, -e;
[3]Schütz (Elektrotechnik: be-
wegliches Wehr) w; -, -n

Schutz.an|strich, ...an|zug, ...är-
mel (veralt.), ...auf|sicht; schutz-
be|dürf|tig, ...be|foh|len; Schutz-
be|foh|le|ne m u. w; -n, -n (↑ R
287ff.); Schutz.be|haup|tung,
...be|reich, ...blech, ...brief, ...bril-
le, ...bünd|nis, ...dach

[1]Schüt|ze (Schießender) m; -n, -n
(↑ R 268)

[2]Schüt|ze vgl. [3]Schütz

Schüt|zen|ein|rich|tung; schüt|zen; du
schützt (schützest)

Schüt|zen (Weberei: Gerät zur
Aufnahme der Schußspulen) m;
-s, -

Schüt|zen.bru|der, ...fest

Schüt|zen|gel

Schüt|zen.ge|sell|schaft, ...gil|de,
...gra|ben, ...haus, ...hil|fe, ...ket-
te, ...kö|nig, ...lie|sel (w; -, -; ↑ R
195), ...li|nie, ...platz, ...schnur;
Schüt|zen|steue|rung, Schütz-
steue|rung (Elektrotechnik);
Schüt|zen.ver|ein, ...wie|se

Schüt|zer; Schutz.far|be, ...fär-
bung, ...frist, ...ge|biet, ...ge|bühr,
...geist (Mehrz. ...geister), ...ge-
mein|schaft, ...git|ter, ...glas
(Mehrz. ...gläser), ...ha|fen (vgl.
[2]Hafen), ...haft w, ...hei|li|ge,
...herr, herr|schaft, ...hül|le;
schutz|imp|fen; ich schutzimpfe;

schutzgeimpft; schutzzuimpfen;
Schutz.imp|fung, ...klau|sel;
Schütz|ling; schutz|los; -este (↑ R
292); Schutz|lo|sig|keit w; -;
Schutz.macht, ...mann (Mehrz.
...männer u. ...leute), ...mar|ke,
...mas|ke, ...maß|nah|me, ...mit-
tel s, ...pa|tron, ...po|li|zei
(Kurzw.: Schupo), ...po|li|zist
(Kurzw.: Schupo), ...raum,
...staat (Mehrz. ...staaten);
Schütz|steue|rung, Schüt|zen-
steue|rung (Elektrotechnik);
Schutz.trup|pe, ...trupp|ler,
...um|schlag; Schutz-und-Trutz-
Bünd|nis (↑ R 155); Schutz-
.ver|trag, ...vor|rich|tung, ...wall,
...weg (österr. für: Fußgänger-
überweg), ...wehr w, ...zoll (↑ R
236), ...zöll|ner (↑ R 236); schutz-
zöll|ne|risch (↑ R 236); Schutz-
zoll|po|li|tik (↑ R 236)

Schw. = Schwester

Schwa|bach (Stadt in Mittelfran-
ken); [1]Schwa|ba|cher (↑ R 199);
[2]Schwa|ba|cher (eine Schriftgat-
tung) w; -; Schwa|ba|cher Schrift
w; - -

Schwa|be|lei (ugs. für: Wackelei;
Geschwätz); schwa|be|lig,
schwabb|lig (ugs. für: schwam-
mig, fett; wackelnd); schwa|beln
(ugs. für: wackeln; übertr. für:
unnötig viel reden); ich ...[e]le
(↑ R 327); Schwa|ber (Besenart
auf Schiffen) m; -s, -; schwa|bern;
ich ...ere (↑ R 327); schwabb-
lig, schwa|be|lig

[1]Schwa|be (Einwohner von
Schwaben) m; -n, -n (↑ R 268)

[2]Schwa|be vgl. [1]Schabe

schwä|beln (schwäbisch spre-
chen); ich ...[e]le (↑ R 327);
Schwa|ben; Schwa|ben.al|ter
(scherzh. für: 40. Lebensjahr; s;
-s), ...spie|gel (Rechtssammlung
des dt. MA.; m; -s), ...streich;
Schwä|bin w; -, -nen; schwäb|lig,
aber (↑ R 198): die Schwäbische
Alb; Schwä|bisch Gmünd (Stadt
in Baden-Württemberg; Schwä-
bisch Hall (Stadt in Baden-Würt-
temberg); schwä|bisch-häl|lisch

schwach; schwächer, schwächste;
das -e (weibliche) Geschlecht; ei-
ne -e Stunde; -e Leistungen; -e
Hoffnung; (Sprachw.:) -e Dekli-
nation; ein -es Zeitwort; (↑ R
116:) das Recht des Schwachen;
schwach|at|mig; schwach|be|tont;
eine schwachbetonte Silbe (↑ je-
doch R 142), aber: die Silbe ist
schwach betont; schwach|be|völ-
kert; die schwachbevölkerte Ge-
gend (↑ jedoch R 142), aber: die
Gegend ist schwach bevölkert;
schwach|be|wegt; die schwachbe-
wegte See (↑ jedoch R 142), aber:
die See war schwach bewegt;

Schwä|che w; -, -n; Schwä|che|an|fall; schwä|chen; Schwä|che‿punkt, ...zu|stand; Schwach|heit; schwach|her|zig; Schwach|kopf; schwach|köp|fig; schwäch|lich; Schwäch|lich|keit; Schwäch|ling; Schwach|ma|ti|kus (scherzh. für: Schwächling) m; -, -se u. ...tiker; schwach|sich|tig; Schwach|sich|tig|keit w; -; Schwach|sinn m; -[e]s; schwach|sin|nig; Schwach|strom m; -[e]s; Schwach|strom‿lei|tung, ...tech|nik; Schwä|chung

Schwa|de w; -, -n u. ¹Schwa|den (Reihe abgemähten Grases od. Getreides) m; -s, -

²Schwa|den (Dampf, Dunst; schlechte [gefährliche] Grubenluft) m; -s, -

schwa|den|wei|se [zu: Schwade]

schwa|dern südd. (plätschern; schwatzen, schnattern); ich ...ere (↑ R 327)

Schwa|dron it. (früher beim Militär: Reiterabteilung) w; -, -en; schwa|dro|nen|wei|se, schwadrons|wei|se

Schwa|dro|neur fr. [...nör] (jmd., der schwadroniert) m; -s, -e; schwa|dro|nie|ren (prahlerisch schwatzen)

Schwa|drons|chef; schwa|drons|wei|se, schwa|dro|nen|wei|se

Schwa|fe|lei (ugs. für: törichtes Gerede); schwa|feln; ich ...[e]le (↑ R 327)

Schwa|ger (veralt. auch für: Postkutscher) m; -s, Schwäger; Schwä|ge|rin w; -, -nen; schwä|ger|lich; Schwä|ger|schaft; Schwä|her (veralt. für: Schwiegervater) m; -s, -; Schwä|her|schaft (veralt.)

schwai|en vgl. schwoien

Schwai|ge bayr. u. österr. (Sennhütte) w; -, -n; schwai|gen bayr. u. westösterr. (eine Schwaige betreiben, Käse bereiten); Schwai|ger bayr. u. westösterr. (Almhirt); Schwaig|hof (bayr. u. österr.)

Schwälb|chen, Schwälb|lein; Schwal|be w; -, -n; Schwal|ben‿nest, ...schwanz, ...wurz (eine giftige Pflanze)

Schwalch (früher für: Öffnung zwischen Schmelz- u. Heizraum) m; -[e]s, -e; schwal|chen (veralt. für: blaken, rauchen); Schwalk niederd. (Dampf, Qualm; Bö) m; -[e]s, -e

schwal|ken niederd. (herumbummeln)

Schwall (Gewoge, Welle, Guß [Wasser]) m; -[e]s, -e

Schwalm (Fluß u. Landschaft in Hessen) w; -; Schwäl|mer (↑ R 199); Schwäl|me|rin w; -, -nen

Schwamm (südd. u. österr. auch für: Pilz) m; -[e]s, Schwämme;

Schwämm|chen, Schwämm|lein; Schwam|merl bayr. u. österr. ugs. (Pilz) s; -s, -[n]; Schwamm|gum|mi; schwam|mig; Schwamm|mig|keit; Schwamm‿kür|bis, ...spin|ner (Schmetterling)

Schwan (ein Vogel) m; -[e]s, Schwäne; Schwän|chen, Schwän|lein

schwa|nen; (unpersönl. ugs.:) es schwant mir (ich ahne)

Schwa|nen‿ge|sang, ...hals; Schwa|nen|jung|frau, Schwan|jung|frau; Schwa|nen|teich; schwa|nen|weiß

Schwang (Schwingung, Schwung) m, nur in: im -[e] (sehr gebräuchlich) sein

schwan|ger; Schwan|ge|ren‿be|ra|tung, ...für|sor|ge, ...geld; schwän|gern; ich ...ere (↑ R 327); Schwan|ger|schaft; Schwan|ger|schafts‿ab|bruch, ...test (Test zum Nachweis einer bestehenden Schwangerschaft), ...un|ter|bre|chung, ...ver|hü|tung; Schwän|ge|rung

Schwan|jung|frau, Schwa|nen|jung|frau

schwank (dicht. u. gehoben für: biegsam, unsicher); Schwank m; -[e]s, Schwänke; schwan|ken; Schwank|fi|gur; Schwan|kung; Schwan|kungs‿kurs (Wirtsch.), ...re|ser|ve (Wirtsch.), ...rück|stel|lung (Wirtsch.), ...wert (Wirtsch.)

Schwän|lein, Schwän|chen

Schwanz m; -es, Schwänze; Schwänz|chen, Schwänz|lein; Schwän|ze|lei; schwän|zeln (sich zierend auf u. ab gehen); ich ...[e]le (↑ R 327); schwän|zen (ugs. für: [die Schule u. a.] absichtlich versäumen); du schwänzt (schwänzest); Schwanz|en|de; Schwän|zer (ugs.); Schwanz‿fe|der, ...flos|se; ...schwän|zig (z. B. langschwänzig); schwanz|la|stig (Flugwesen); Schwänz|lein, Schwänz|chen; Schwanz‿lurch, ...spit|ze, ...stern (veralt. für: Komet; vgl. ²Stern), ...stück, ...wir|bel

schwapp!, schwaps!; Schwapp m; -[e]s, -e u. Schwaps (ugs. für: Klatsch, Schlag) m; -es -e; schwap|pen, schwap|sen (ugs. von Flüssigkeiten: in schwankender Bewegung sein); schwaps!, schwapp!; Schwaps vgl. Schwapp!; schwap|sen; du schwapst (schwapsest); vgl. schwappen

Schwär (älter für: Schwäre) m; -[e]s, -e; Schwä|re (Geschwür) w; -, -n; schwä|ren (Schwären bekommen; eitern); es schwärt (veralt.: schwiert); es schwärte (veralt.: schwor); geschwärt (veralt.:

geschworen); schwär[e]! (veralt.: schwier!); Schwä|ren (älter für: Schwäre) m; -s, -; schwä|rig

Schwarm m; -[e]s, Schwärme; schwär|men; Schwär|mer; Schwär|me|rei; Schwär|me|rin w; -, -nen; schwär|me|risch; -ste (↑ R 294); Schwarm|geist (Mehrz. ...geister); schwarm|wei|se; Schwärm|zeit (bei Bienen)

Schwar|te (dicke Haut; ugs. für: altes [minderwertiges] Buch; zur Verschalung dienendes rohes Brett) w; -, -n; schwar|ten (ugs. für: derb schlagen; in das Lesen [einer Schwarte] vertieft sein); Schwar|ten‿ma|gen (eine Wurstart); schwar|tig

schwarz; schwärzer, schwärzeste (↑ R 295); vgl. blau. I. Kleinschreibung: a) (↑ R 133:) schwarz auf weiß; aus schwarz weiß machen wollen; b) (↑ R 224:) schwarze Pocken; schwarze Blattern; ein schwarzes (verbotenes) Geschäft; eine schwarze Messe; schwarzer Kreis (Ggs.: weißer Kreis; vgl. weiß I, b); der schwarze Star; der schwarze Mann (Schornsteinfeger; Schreckgestalt); das schwarze Schaf; die schwarze Liste; die schwarze Rasse; ein schwarzer Tag; ein schwarzer Freitag, vgl. aber: der Schwarze Freitag (II, c); schwarzer Markt; schwarzes Pulver (Schießpulver); schwarzer Diamant (Kohle); schwarzer Humor; schwarzer Tee. II. Großschreibung: a) (↑ R 116:) ein Schwarzer (dunkelhäutiger, -haariger Mensch); das Schwarze die Farbe Schwarz; b) (↑ R 198: das Schwarze Meer; c) (↑ R 224: das Schwarze Brett (Anschlagbrett); der Schwarze Erdteil (Afrika); die Schwarze Kunst (Buchdruck; Zauberei); Schwarze Magie (böse Zauberei); die Schwarze Hand (ehemalige serb. Geheimbund); Schwarzer September (palästinens. Untergrundorganisation); Schwarzer Peter (Kartenspiel); der Schwarze Tod (Beulenpest im MA); der Schwarze Freitag (Name eines Freitags mit großen Börsenstürzen in den USA); d) (↑ R 133: ins Schwarze treffen. III. In Verbindung mit Zeitwörtern (↑ R 139:) a) Getrenntschreibung in ursprünglicher Bedeutung, z. B. schwarz färben, werden; b) Zusammenschreibung, wenn durch die Verbindung ein neuer Begriff entsteht; vgl. schwarzarbeiten; schwarzfahren, schwarzgehen, schwarzhören, schwarzschlachten, schwarzsehen. IV. In Verbin-

dung mit dem 2. Mittelwort Getrennt- oder Zusammenschreibung: ein schwarzgestreifter Stoff (↑ jedoch R 142), a b e r: der Stoff ist schwarz gestreift; der Stoff ist schwarz und weiß gestreift; schwarzgefärbtes Haar (↑ jedoch R 142), a b e r: auffallend schwarz gefärbtes Haar, das Haar ist schwarz gefärbt. **V.** *Farbenbezeichnungen* ↑ R 158) **Schwarz** (schwarze Farbe) *s;* -[e]s; (Kartenspiel:) er spielte - aus; in -; in - (Trauerkleidung) gehen; Frankfurter -; vgl. Blau; **Schwarz|ach** (↑ R 217); **Schwarz- .am|sel,** ...**ar|beit; schwarz|ar|bei- ten;** ↑ R 139 (ugs. für: unerlaubte Lohnarbeit verrichten); ich arbeite schwarz; schwarzgearbeitet; schwarzzuarbeiten; **schwarz- äu|gig; Schwarz|bee|re** (südd. u. österr. neben: Heidelbeere); **Schwarz|blätt|chen,** Schwarzplätt|chen (ein Vogel); **schwarz- braun; Schwarz|bren|ner; Schwarz|bren|ne|rei, Schwarz- brot,** ...**bu|che,** ...**büf|fel; schwarz|bunt; Schwarz.dorn** (*Mehrz.* dorne), ...**dros|sel;** ¹**Schwar|ze** (Neger; dunkelhäutiger, -haariger Mensch) *m* u. *w;* -n, -n (↑ R 287 ff.); ²**Schwar|ze** (Teufel) *m;* -n; ³**Schwar|ze** (schwarze Stelle) *s;* -n (↑ R 287 ff.); ins - treffen (↑ R 133); ⁴**Schwar|ze** (österr.: Mokka ohne Milch) *m;* -n, -n (↑ R 287 ff.); **Schwär|ze** (das Schwarzsein) *w;* -, (in der Bedeutung Farbe zum Schwarzmachen auch *Mehrz.*:) -n; **Schwar|ze-Meer-Flot|te** (↑ R 155) *w; Wesf.* die Schwarze[n]-Meer-Flotte; vgl. Schwarzmeer|flot|te; **schwär|zen** (ugs. für: schmuggeln; hintergehen); du schwärzt (schwärzest); **Schwär|zer** (Schwarzmacher; mdal. für: Schmuggler); **Schwarz|er|de** (dunkler Humusboden); **schwarz|fah|ren;** ↑ R 139 (ugs. für: ohne Berechtigung ein Kraftfahrzeug benutzen, auf der Eisenbahn u. a. unberechtigt fahren); er ist schwarzgefahren; **Schwarz- .fah|rer,** ...**fahrt,** ...**fäu|le** (eine Pflanzenkrankheit), ...**fil|ter,** ...**fleisch** (landsch. für: durchwachsener geräucherter Speck); **schwarz|ge|hen;** ↑ R 139 (ugs. für: auf Wilddieberei gehen; unerlaubt über die Grenze gehen); er ist schwarzgegangen; **schwarz- ge|streift;** vgl. schwarz IV; **schwarz|haa|rig; Schwarz|han- del; Schwarz|han|dels|ge|schäft; Schwarz|händ|ler; schwarz|hö- ren;** ↑ R 139 (ugs.; Hochschule,

Rundfunk: ohne Genehmigung mithören); er hat schwarzgehört; **Schwarz.hö|rer,** ...**kit|tel** (Wildschwein; abschätzig für: kath. Geistlicher), ...**küm|mel,** ...**kunst** (*w;* -), ...**künst|ler; schwärz|lich;** schwärzlichbraun u. a. (↑ R 158); **schwarz|ma|len;** ↑ R 139 (ugs. für: pessimistisch sein); er hat immer nur schwarzgemalt; **Schwarz|ma- ler** (ugs. für: Pessimist), **Schwarz- ma|le|rei** (ugs. für: Pessimismus); **Schwarz|markt; Schwarz|markt- preis; Schwarz|meer|flot|te;** *w;* -; Schwarze-Meer-Flot|te (vgl. d.); **Schwarz|meer|ge|biet** (↑ R 201) *s;* -[e]s; **Schwarz|plätt|chen** vgl. Schwarzblättchen; **Schwarz.pul- ver,** ...**rock** (abschätzig für: kath. Geistlicher); **schwarz|rot|gol|den** (↑ R 158); eine schwarzrotgold[e]- ne Fahne, a b e r: die Fahne Schwarz-Rot-Gold; **Schwarz- sau|er** nordd. (ein Gericht) *s;* -s; **schwarz|schlach|ten;** ↑ R 139 (ugs. für: ohne amtl. Genehmigung heimlich schlachten); er hat schwarzgeschlachtet; **Schwarz- schlach|tung; schwarz|se|hen;** ↑ R 139 (ugs. für: ungünstig beurteilen; ohne amtl. Genehmigung fernsehen); er hat schwarzgesehen; **Schwarz|se|her** (ugs. für: Pessimist; jmd., der ohne amtl. Genehmigung fernsieht); **Schwarz|se|he|rei** (ugs. für: Pessimismus); **schwarz|se|he|risch** (ugs. für: pessimistisch); **Schwarz|sen|der; Schwarz- specht; Schwär|zung; Schwarz- wald** (dt. Gebirge) *m;* -[e]s; **Schwarz|wald|bahn** *w;* -; ↑ R 201; **Schwarz|wäl|der** (↑ R 199); Schwarzwälder Kirsch; **Schwarz- wäl|de|rin** *w;* -, -nen; **schwarzwäl- de|risch; Schwarz|wald|haus; Schwarz|wald|hoch|stra|ße;** *w;* - (↑ R 201); **Schwarz|was|ser|fie- ber** (schwere Malaria); **schwarz- weiß** (↑ R 158) ein - verzierter Rand; - geringelte Socken; **Schwarz|weiß.film,** ...**fo|to|gra- fie,** ...**kunst** (*w;* -); **schwarz|weiß- ma|len** (kontrastreich darstellen); schwarzweißgemalt; **Schwarz|weiß|ma|le|rei; schwarz- weiß|rot** (↑ R 158) a b e r: die Farben, die Fahne Schwarz-Weiß-Rot; **Schwarz|weiß|zeich|nung; Schwarz|wild; Schwarz|wurz** (eine Heilpflanze) *w;* -; **Schwarz- wur|zel** (eine Gemüsepflanze) **Schwatz** (ugs. für: Geplauder, Geschwätz) *m;* -es, -e; **Schwätz|ba- se; Schwätz|chen; schwat|zen, schwät|zen;** du schwatzt (schwätzest), du schwätzt (schwätzest); **Schwat|zer; Schwät|ze|rei; Schwät|ze|rin** *w;* -, -nen; **schwät-**

ze|risch; -ste (↑ R 294); **schwatz- haft; Schwatz|haf|tig|keit** *w;* -; **Schwatz|maul** (derb) **Schwaz** (österr. Stadt im Inntal) **Schwe|be** *w;* -; **Schwe|be.bahn,** ...**bal|ken,** ...**baum** (ein Turngerät); **schwe|ben,** -de Schuld; **Schwe|be|rei; Schwe|be.stoff,** ...**stütz,** ...**teil|chen,** ...**zu|stand; Schwe|bung** (Physik) **Schwe|de** *m;* -n, -n (↑ R 268); **Schwe|den; Schwe|den.kü|che,** ...**plat|te,** ...**punsch,** ...**schan|ze; Schwe|din** *w;* -, -nen; **schwe|disch;** (↑ R 200:) -e Gardinen (ugs. für: [Gitterfenster im] Gefängnis); vgl. deutsch; **Schwe|disch** (Sprache) *s;* -[s]; vgl. Deutsch; **Schwe- di|sche** *s;* -n; vgl. Deutsche **Schwe|fel** (chem. Grundstoff; Zeichen: S) *m;* -s; **schwe|fel|ar|tig; Schwe|fel.band|e** (ugs. für: zu mutwilligen Streichen aufgelegte Gesellschaft), ...**blu|me** od. ...**blü- te** (Chemie; *w;* -), ...**fa|den,** ...**far- be; schwe|fel.far|ben** od. ...**far- big,** ...**gelb,** ...**hal|tig; Schwe|fel- .holz** od. ...**hölz|chen** (veralt. für: Streichholz); **schwe|fe|lig,** schwef[l]ig; schwef[l]ige Säure; **Schwe|fel|kies** (ein Mineral); **Schwe|fel|koh|len|stoff; Schwe- fel.kopf** (ein Pilz), ...**kur,** ...**le|ber** (Schwefelverbindung); **schwe- feln;** ich ...[e]le (↑ R 327); **Schwe- fel.pu|der,** ...**quel|le,** ...**re|gen,** ...**sal|be; schwe|fel|sau|er; Schwe- fel|säu|re** *w;* -; **Schwe|fe|lung; Schwe|fel|was|ser|stoff; schwef- lig,** schwe|fe|lig **Schwe|gel,** Schwie|gel (mittelalterl. Querpfeife; Flötenwerk an älteren Orgeln) *w;* -, -n; **Schweg- ler** (Schwegelbläser) **Schweif** *m;* -[e]s, -e; **schwei|fen; Schweif.sä|ge,** ...**stern** (für: Komet; vgl. ²Stern); **Schwei|fung; schweif|we|deln** (veralt. auch für: kriecherisch schmeicheln); ich ...[e]le (↑ R 327); geschweifwedelt; zu - **Schweif|wed|ler** (veralt. für: Kriecher) **Schwei|ge.geld,** ...**marsch; schwei- gen** (still sein); du schweigst (schwiegst); du schweigest; geschwiegen; schweig[e]!; die schweigende Mehrheit; **Schwei|- gen** *s;* -s; **Schwei|ge|pflicht; Schwei|ger** (↑ R 224:) der Große Schweiger (Bez. für Moltke); **schwei|gsam; Schweig|sam|keit** *w;* - **Schwein** (in der *Einz.* ugs. auch für: Glück) *s;* -[e]s, -e; kein - (ugs. für: niemand); **Schwei|ne.bauch,** ...**be|stand,** ...**bra|ten,** ...**fett,** ...**fleisch; Schwei|ne|hund** (ugs. für: Lump); der innere - (ugs. für: niedrige Gesinnung); **Schwei|ne-**

.ko|ben od. ...ko|fen, ...mast w, ...mä|ste|rei, ...pest; Schwei|ne|rei; Schwei|ne|ripp|chen; schwei|nern (vom Schwein stammend); Schwei|ner|ne landsch. (Schweinefleisch) s; -n (↑ R 287ff.); Schwei|ne_schmalz, ...schnit|zel (vgl. ¹Schnitzel), ...stall, ...treiber, ...wirt|schaft (verächtl. für: Mißwirtschaft), ...zucht; Schwein|furt (Stadt am Main); Schwein|fur|ter (↑ R 199); Schwein|fur|ter Grün (ein Farbstoff) s; - -s; Schwein|igel (ugs. für: schmutziger od. unflätiger Mensch); Schwein|ige|lei; schwein|igeln (ugs. für: Zoten reißen); ich ...[e]le (↑ R 327); geschweinigelt; zu -: schwei|nisch; -ste (↑ R 294); Schweins_bor|ste, ...bra|ten (südd. u. österr. für: Schweinebraten), ...keu|le, ...kno|chen, ...kopf, ...le|der; schweins|le|dern; Schweins_ohr (auch für: ein Gebäck), ...rücken [Trenn.: ...rük|ken], ...rüs|sel, ...schnit|zel (österr. für: Schweineschnitzel), ...stel|ze (österr. für: Eisbein)
Schweiß (Jägerspr. auch: Wildblut) m; -es, -e; Schweiß_ap|pa|rat, ...aus|bruch; schweiß|bedeckt, aber (↑ R 142): von Schweiß bedeckt; Schweiß_bil|dung, ...blatt (veralt. für: Armblatt), ...bren|ner, ...draht, ...drüse; schwei|ßen (bluten [vom Wild]; Metalle durch Hämmern od. Druck bei Weißglut verbinden); du schweißt (schweißest); du schweißtest; geschweißt; Schwei|ßer (Facharbeiter für Schweißarbeiten); Schweiß_fähr|te, ...fleck, ...fuß; schweiß|ge|ba|det, aber (↑ R 142): er war in Schweiß gebadet; Schweiß|hund; schwei|ßig; Schweiß_le|der, ...naht, ...per|le, ...po|re, ...stahl; schweiß|trei|bend; schweiß|triefend, aber (↑ R 142): von vor Schweiß triefend; Schweiß_tropfen, ...tuch (Mehrz. ...tücher); Schwei|ßung
Schweit|zer, Albert (elsäss. Theologe, Arzt u. Musiker)
Schweiz w; -; (↑ R 224:) die französische, welsche - (fr. Teil der -), aber (↑ R 198): die Holsteinische -; ¹Schwei|zer (Bewohner der Schweiz; auch für: Kuhknecht, Melker; Türhüter; Aufseher in kath. Kirchen); ²Schwei|zer; ↑ R 204 (schweizerisch); - Jura (Gebirge), - Käse, - Kühe, - Land (schweizerisches Gebiet; vgl. aber: Schweizerland), - Reise; Schwei|zer|de|gen (Schriftsetzer, der auch das Drucken versteht, od. Drucker,

der auch das Setzen versteht); schwei|zer|deutsch; ↑ R 215 (schweizerisch mundartlich); vgl. deutschschweizerisch; Schwei|zer|deutsch; ↑ R 215 (deutsche Mundart[en] der Schweiz) s; -[s]; Schwei|zer_gar|de (↑ R 205), ...häus|chen; Schwei|ze|rin w; -, -nen; schwei|ze|risch; die -en Eisenbahnen; -e Post; aber (↑ R 224): die Schweizerische Eidgenossenschaft; Schweizerische Bundesbahnen (Abk.: SBB); Schwei|zer|land; ↑ R 205 (Land der Schweizer) s; -[e]s; vgl. aber: Schweizer Land; Schweiz|rei|se
Schwelch|malz (an der Luft getrocknetes Grünmalz)
schwe|len (langsam flammenlos [ver]brennen; glimmen); schwelender Haß; Schwe|le|rei
schwel|gen; Schwel|ger; Schwel|ge|rei; schwel|ge|risch; -ste (↑ R 294)
Schwel_koh|le, ...koks
Schwell (veralt. für: Anschwellung) m; -[e]s, -e
Schwel|le w; -, -n
¹schwel|len (größer, stärker werden, sich ausdehnen); du schwillst, er schwillt; du schwollst (schwollest); du schwöllest; geschwollen, schwill!; sein Hals ist geschwollen; die Brust schwoll ihm vor Freude; ²schwel|len (größer, stärker machen, ausdehnen); du schwellst; du schwelltest; geschwellt; schwell[e]!; der Wind schwellte die Segel; der Stolz hat seine Brust geschwellt; mit geschwellter Brust
Schwel|len_angst (Psych.: Hemmung eines potentiellen Käufers, eine Ladenschwelle zu überschreiten; w; -), ...län|ge, ...rost, ...wert (Psych.)
Schwel|ler (Teil der Orgel u. des Harmoniums); Schwell|kopp mdal. (von einem Träger bewegter übergroßer Maskenkopf auf relativ kleinem Körper) m; -s, ...köppe; Schwell|kör|per; Schwel|lung; Schwell|werk (Schweller)
Schwel|teer; Schwe|lung
Schwemm|bo|den; Schwemm|me (Badeplatz für das Vieh; einfacher Gastwirtschaftsraum; österr. für Warenhausabteilung mit niedrigen Preisen) w; -, -n; schwem|men (österr. auch für: Wäsche spülen); Schwemm_land (s; -[e]s), ...sand; Schwemm|sel (Angeschwemmtes) s; -s; Schwemm|stein
Schwen|de (durch Abbrennen urbar gemachter Wald, Rodung)

w; -, -n; schwen|den [,,schwinden machen"]
Schwen|gel m; -s, -; Schwenk (Filmw.: durch Schwenken der Kamera erzielte Einstellung) m; -[e]s, -s (selten: -e); schwenk|bar; Schwenk|büh|ne (Bergmannsspr.); Schwen|ke lausitz. (Schaukel) w; -, -n; schwen|ken; Schwen|ker (Kognakglas; obersächs. für: Herrenschoßrock); Schwenk_glas, ...kran, ...seil; Schwenk|kung schwer; (↑ R 224:) -e Musik; -es Wasser (Sauerstoff-Deuterium-Verbindung); -e Artillerie; -er Kreuzer; ein -er Junge (ugs. für: Gewaltverbrecher); der Tod war ein -er Schlag (großer Verlust) für die Familie; mit -er Zunge sprechen. I. Schreibung in Verbindung mit dem 2. Mittelwort oder einem Eigenschaftswort (↑ R 142 u. 143), z. B. schwerbeschädigt (vgl. d.), schwerbewaffnet (vgl. d.), schwerkrank (vgl. d.) II. Schreibung in Verbindung mit Zeitwörtern (↑ R 139): a) Getrenntschreibung in ursprünglicher Bedeutung, z. B. schwer fallen; er ist sehr schwer gefallen; b) Zusammenschreibung, wenn durch die Verbindung ein neuer Begriff entsteht, z. B. schwerfallen; diese Aufgabe ist ihm schwergefallen; aber: Getrenntschreibung in Verbindung mit einem Gradadverb: diese Aufgabe ist ihm allzu schwer gefallen; vgl. schwerfallen, schwerhalten, schwermachen, schwernehmen; Schwer_ar|bei|ter, ...ath|let; ...ath|le|tik; schwer|be|la|den (↑ R 296:) schwerer, am schwersten beladen; ein schwerbeladener Wagen (↑ jedoch R 142) aber: ein überaus schwer beladener Wagen; der Wagen ist schwer beladen; schwer|be|schädigt (durch gesundheitl. Schädigungen in der Erwerbsfähigkeit stark beschränkt); aber: der Wagen wurde bei dem Unfall schwer beschädigt; Schwer|be|schädig|te m u. w; -n, -n (↑ R 287ff.). Schwer|be|schä|dig|ten_aus|weis ...ge|setz; schwer|be|waff|net¹; ein schwerbewaffneter Soldat (↑ jedoch R 142), aber: ein besonder schwer bewaffneter Soldat; der Soldat ist schwer bewaffnet Schwer|be|waff|ne|te m; -n, -n (↑ R 287ff.); Schwer|blü|tig keit w; -; Schwe|re (Gewicht) w; -; Schwe|re|feld schwe|re|los; -er Zustand; Schwe|re|lo|sig|keit; Schwe|re|not w, nu

<hr />

¹ Zur Steigerung vgl. schwerbeladen.

in veralteten Fügungen wie: - [noch einmal]!; daß dich die -!; es ist, um die - zu kriegen; Schwe|re|nö|ter (Schürzenjäger; Leichtfuß; schweiz. meist svw. schlauer, durchtriebener Geselle); schwer|er|zieh|bar[1]; ein schwererziehbares Kind (↑ jedoch R 143), aber: ein sehr schwer erziehbares Kind; das Kind ist schwer erziehbar; Schwer|er|zieh|ba|re m u. w; -n, -n (↑ R 287 ff.); schwer|fal|len; ↑ R 139 (Mühe verursachen); es fällt schwer; es ist schwergefallen; schwerzufallen; aber: schwer fal|len; er konnte es nicht vermeiden, schwer zu fallen; vgl. schwer, II; schwer|fäl|lig; Schwer|fäl|lig|keit (w; -), ...ge|wicht (Körpergewichtsklasse in der Schwerathletik); schwer|ge|wich|tig; Schwer|ge|wicht|ler; Schwer|ge|wichts_mei|ster, ...mei|ster|schaft; schwer|hal|ten; ↑ R 139 (schwierig sein); es hat schwergehalten, ihn davon zu überzeugen; aber: schwer hal|ten (mit Schwierigkeit halten); er konnte das Pferd [nur] schwer halten; vgl. schwer, II; schwer|hö|rig; Schwer|hö|rig|keit w; -; schwer_in|du|strie, ...in|du|stri|el|ler, ...kraft (w; -); schwer|krank (Jägerspr. auch: angeschossen); ein schwerkrankes Kind (↑ jedoch R 143), aber: das Kind ist schwer krank; schwer|kran|ke; schwer|kriegs|be|schä|digt; Schwer|kriegs|be|schä|dig|te; schwer|lich (kaum); schwer|lös|lich; eine schwerlösliche Substanz (↑ jedoch R 143), aber: die Substanz ist schwer löslich; schwer|ma|chen; ↑ R 139 (Schwierigkeiten machen); er hat ihm das Leben schwergemacht; aber: schwer ma|chen; das läßt sich nur schwer machen; vgl. schwer, II; Schwer|me|tall; Schwer|mut w; -; schwer|mü|tig; Schwer|mü|tig|keit (veralt. für: Schwermut) w; -; schwer|neh|men; ↑ R 139 (ernst nehmen); er hat diese Nachricht schwergenommen; aber: schwer neh|men; der Reiter hat das Hindernis nur schwer genommen; vgl. schwer, II; Schwer|öl|mo|tor; Schwer|punkt; Schwer|punkt|streik; schwer|reich (ugs. für: sehr reich); ein schwerreicher Mann (↑ jedoch R 143), aber: der Mann ist schwer reich; Schwer|spat (ein Mineral); Schwert_ar|bei|ter; Schwerst|be|schä|dig|te m u. w; -n, -n (↑ R 287 ff.)

Schwert s; -[e]s, -er; Schwer|tel (Gartenzierpflanze, Gladiolenart; auch für: Schwertlilie) m

(österr.: s); -s, -; Schwert|ter_ge|klirr od. Schwert_ge|klirr; Schwert|fisch; schwert|för|mig; Schwert_fort|satz (Teil des Brustbeins), ...knauf, ...lei|te (hist.), ...li|lie (²Iris) ...streich, ...tanz, ...trä|ger (ein Fisch)

schwer|tun, sich; ↑ R 139, ich habe mir od. (seltener:) mich schwergetan, aber: ich habe mir od. (seltener:) mich allzu schwer getan; vgl. schwer, II; Schwer|ver|bre|cher; schwer|ver|dau|lich[1]; eine schwerverdauliche Speise (↑ jedoch R 143), aber: eine sehr schwer verdauliche Speise; die Speise ist schwer verdaulich; schwer|ver|letzt usw. vgl. schwerverwundet usw.; schwer|ver|ständ|lich[1]; eine schwerverständliche Sprache (↑ jedoch R 143), aber: eine überaus schwer verständliche Sprache; die Sprache ist schwer verständlich; schwer|ver|träg|lich[1]; ein schwerverträglicher Wein (↑ jedoch R 143), aber: ein überaus schwer verträglicher Wein; der Wein ist schwer verträglich; schwer|ver|wun|det[1]; ein schwerverwundeter Soldat (↑ jedoch R 142), aber: ein sehr schwer verwundeter Soldat; der Soldat war schwer verwundet; Schwer|ver|wun|de|te m u. w; -n, -n (↑ R 287 ff.); schwer|wie|gend; -ste; (↑ R 298:) schwerwiegendere od. schwerer wiegende Bedenken, aber (mit Nachdruck): viel schwerer wiegende Bedenken

Schwe|ser niederd. (Bries, Kalbsmilch) m; -s

Schwe|ster (Abk.: Schw.) w; -, -n; Schwe|ster|an|stalt (gleichartige Anstalt); Schwe|ster_fir|ma, ...kind; schwe|ster|lich; Schwe|ster|lich|keit w; -; Schwe|ster|lie|be (Liebe, die von der Schwester ausgeht); Schwe|stern|lie|be (Liebe zwischen Schwestern); Schwe|stern_or|den, ...paar; Schwe|stern|schaft (alle Schwestern); Schwe|stern_schu|le, ...tracht, ...wohn|heim; Schwe|ster|schiff

Schwet|zin|gen (Stadt südl. von Mannheim); Schwet|zin|ger (↑ R 199)

Schwib|bo|gen (zwischen zwei Mauerteilen frei stehender Bogen)

Schwie|bus (Stadt in Ostbrandenburg); Schwie|bus|ser, (auch:) Schwie|bu|ser (↑ R 199); schwie-bus|sisch, (auch:) schwie|bu|sisch

Schwie|gel vgl. Schwegel

Schwie|ger (veralt. für: Schwiegermutter) w; -, -n; Schwie|ger_el-

tern (Mehrz.), ...mut|ter (Mehrz. ...mütter), ...sohn, ...toch|ter, ...va|ter

Schwie|le w; -, -n; schwie|lig

Schwie|mel niederd. u. mitteld. (Rausch; Leichtsinniger, Zechbruder) m; -s, -; Schwie|me|lei (niederd., mitteld.); Schwie|me-ler, Schwiem|ler niederd., mitteld. (Zechbruder); schwie|me-lig, schwiem|lig niederd., mitteld. (taumelig); Schwie|mel|kopf niederd., mitteld. abschätzig (Zechbruder, Herumtreiber); schwie|meln niederd., mitteld. (taumeln; bummeln, leichtsinnig leben); ich ...[e]le (↑ R 327); Schwiem|ler, Schwie|me|ler; schwiem|lig, schwie|me|lig

schwie|rig; Schwie|rig|keit; Schwie|rig|keits|grad

Schwimm_an|stalt, ...an|zug, ...art, ...bad, ...bas|sin, ...becken [Trenn.: ...bek|ken], ...bla|se, ...dock; Schwimm|ei|ster [Trenn.: Schwimm|mei..., ↑ R 236]; schwim|men; du schwammst (schwammest); du schwömmst (auch: schwämmest); geschwommen; schwimm[e]!; etwas in -dem Fett backen; Schwim|mer; Schwim|me|rei (ugs.); Schwim|me|rin w; -, -nen; Schwimm_flos-se, ...fuß, ...gür|tel, ...haut, ...he-be|werk, ...ho|se, ...kä|fer, ...kom-paß, ...leh|rer, ...sand, ...sport, ...stil, ...tri|kot, ...vo|gel, ...we|ste

Schwin|del (ugs. auch für: unnützes Zeug; Erlogenes) m; -s; Schwin|del|an|fall; Schwin|de|lei (ugs.); schwin|del|er|re|gend, ...frei; Schwin|del|ge|fühl; schwin|del|haft; schwin|de|lig, schwind|lig; schwin|deln; ich ...[e]le (↑ R 327); es schwindelt mir; schwin|den; du schwandst (schwandest); du schwändest; geschwunden; schwind[e]!; Schwind|ler; Schwind|le|rin w; -, -nen; schwind-le|risch; -ste (↑ R 294); Schwind-ler|we|sen s; -s, schwind|lig, schwin|de|lig; Schwind_maß (Gießereitechnik; s), ...span-nung, ...sucht (w; -); schwind|süch-tig; Schwin|dung (Technik) w; - Schwing_ach|se, ...blatt (für: Membrane), ...büh|ne (Technik); Schwin|ge w; -, -n; Schwin|gel (eine Grasgattung) m; -s, -; schwin-gen (schweiz. auch für: in bes. Weise ringen); du schwangst (schwangst); du schwängest; geschwungen; schwing[e]!; Schwin-gen schweiz. (eine Art des Ringens) s; -s; Schwin|ger (Boxschlag mit gestrecktem Arm; schweiz. für: jmd., der das Schwingen betreibt); Schwin|get schweiz. (Schwingveranstaltung) m; -s;

Schwing.fest (schweiz.), ...ma|schi|ne, ...me|tall Ⓦ, ...pflug, ...tür; Schwin|gung; Schwin|gungs.dämp|fer, ...dau|er, ...kreis (Technik), ...zahl
schwipp!; schwipp, schwapp!; Schwip|pe (mdal., sonst veralt. für: biegsames Ende [einer Gerte, Peitsche]; Peitsche) w; -, -n; schwip|pen (landsch.); Schwipp-.schwa|ger (ugs. für: Ehemann der Schwägerin; Bruder des Schwagers od. der Schwägerin), ...schwä|ge|rin; schwipp, schwapp!; Schwips (ugs. für: leichter Rausch) m; -es, -e
schwir|be|lig, schwirb|lig landsch. (schwindlig); schwir|beln landsch. (schwindeln; sich im Kreise drehen); ich ...[e]le (↑ R 327)
Schwirl (ein Vogel) m; -[e]s, -e
schwir|ren; Schwirr|vo|gel (Kolibri)
Schwitz|bad; Schwit|ze (Einbrenne [zum Sämigmachen von Speisen]) w; -, -n; schwit|zen; du schwitzt (schwitzest); du schwitztest; geschwitzt; schwitz|zig; Schwitz.ka|sten, ...kur
Schwof (ugs. für: öffentl. Tanzvergnügen) m; -[e]s, -e; schwo|fen (ugs.)
schwoi|en, schwo|jen niederl. (von Schiffen: sich [vor Anker] drehen)
schwö|ren; du schworst (veralt.: schwurst); du schwürest; geschworen; schwör[e]!; auf jemanden, auf eine Sache -
schwul (derb für: homosexuell); schwül; Schwü|le w; -; Schwu|le (derb für: Homosexueller) m; -n, -n; ↑ R 287ff.; Schwu|li|bus, nur in: in - sein (ugs. scherzh. für: bedrängt sein); Schwu|li|tät (Studentenspr. u. ugs. für: Verlegenheit, Klemme) w; -, -en; in großen -en sein
Schwulst m; -[e]s, Schwülste; schwul|stig (aufgeschwollen, aufgeworfen; österr. für: schwülstig); schwül|stig (im Gedanken u. Ausdruck) überladen, weitläufig); ein -er Stil; ein -er Ausdruck; Schwül|stig|keit
schwum|me|rig, schwumm|rig mdal. (schwindelig; nicht in Ordnung)
Schwund m; -[e]s; Schwund.ausgleich (Technik), ...stu|fe (Sprachw.)
Schwung m; -[e]s, Schwünge; in - kommen; Schwung.brett, ...feder; schwung|haft; Schwung|kraft w; -; schwung|los; Schwung.rad, ...rie|men; schwung|voll; eine -e Rede
schwupp!; Schwupp m; -[e]s, -e u.

Schwups (ugs. für: Stoß) m; -es, Schwüpse; schwupp|di|wupp!; schwups!
Schwur m; -[e]s, Schwüre; Schwur.ge|richt; Schwur|ge|richts|verhand|lung
Schwyz [schwiz] (Kanton u. Stadt der Schweiz); Schwy|zer (↑ R 199); schwy|ze|risch; Schwy|zerdütsch, Schwy|zer|tütsch schweiz. mdal. (Schweizerdeutsch) s; -[s]
Sci|ence-fic|tion amerik. [ßai^enßfiksch^en](amerik.Bez.für den naturwissenschaftlich-technischen utopischen Roman) w; -, -s; Sci|ence-fic|tion-Film m; -[e]s, -e
scil., sc. = scilicet
sci|li|cet lat. [ßzilizät] (nämlich; Abk.: sc., scil.)
Sci|pio [ßzi...] (Name berühmter Römer)
Scor|da|tu|ra w; - u. Skor|da|tur it. (Umstimmen von Saiten der Streich- u. Zupfinstrumente) w; -
Scotch engl. [ßkotsch] (schottischer Whisky) m; -s, -s; Scotch-ter|ri|er (schottischer Jagdhund)
Sco|tis|mus [ßko...] (philos. Lehre nach dem Scholastiker Duns Scotus); Sco|tist (Vertreter des Scotismus); ↑ R 268
Scot|land Yard engl. [ßkotl^end jg^ed] (Londoner Polizei[gebäude]) m; - -
Scott, Walter (schottischer Dichter)
Scrip engl. [ßkrip] (Gutschein über nicht gezahlte Zinsen) m; -s, -s
Scu|do it. [ßkudo] (alte it. Münze) m; -, ...di
sculp|sit lat. [ßkulp...] (,,hat [es] gestochen"; Abk.: sc., sculps.)
Scyl|la [ßzüla] (lat. Form von: Szylla, gr. Skylla)
s. d. = sieh[e] dies!
S.D., S. Dak. = Süddakota
SDR = Süddeutscher Rundfunk
SDS = Societatis Divini Salvatoris [sozi-e... diwini ...wa...] (,,von der Gesellschaft vom Göttlichen Heiland"; Salvatorianer)
Se = chem. Zeichen für: Selen
Se., S. = Seine (Exzellenz usw.)
Seal engl. [ßil] (Fell der Pelzrobbe; ein Pelz) m od. s; -s, -s; Seal|mantel
Seals|field [ßilßfild] (österr. Schriftsteller)
Seal|skin engl. [ßil...] (svw. Seal; Plüschgewebe als Nachahmung des Seals) m od. s; -s, -s
Sé|an|ce fr. [ßeangß^e] ([spiritistische] Sitzung) w; -, -n
SEATO (Kurzw. aus: South East Asia Treaty Organization; [ßauth ißt eⁱsch^e triti o^rg^enaiseⁱsch^en]) (der 1955 gegen einen eventuellen kommunistischen Angriff abge-

schlossene Südostasien[verteidigungs]pakt)
Se|attle [ßiätl] (Stadt in den USA)
Se|bald, Se|bal|dus (m. Vorn.)
Se|ba|sti|an (m. Vorn.)
Se|ba|sto|pol vgl. Sewastopol
Se|bor|rhö¹, Se|bor|rhöe lat.; gr. (Med.: krankhaft gesteigerte Absonderung der Talgdrüsen, Schmerfluß) w; -, ...rrhöen
sec = Sekans; sec, s (Astron.: ...^s), sek. Sek. = Sekunde
Se|cen|tis|mus it. [ßetschän...] (Stilrichtung schwülstiger Barockpoesie im Italien des 17. Jh.s) m; -; Se|cen|tist (Dichter, Künstler des Secentos); ↑ R 268; Se|cen|to (toskan. Form von: Seicento) s; -[s]
Sech (Pflugmesser) s; -[e]s, -e
sechs; wir sind zu sechsen od. zu sechst, wir sind sechs; vgl. acht; Sechs (Zahl) w; -, -en; er hat eine Sechs gewürfelt; er hat in Latein eine Sechs geschrieben; vgl. Eins u. ¹Acht; Sechs|ach|ser (Wagen mit sechs Achsen; mit Ziffer: 6achser; ↑ R 228); sechs|ach|sig (mit Ziffer: 6achsig; ↑ R 228); Sechs|ach|tel|takt m; -[e]s (mit Ziffern: ⁶/₈-Takt; ↑ R 157) im -; sechs|eck; sechs|eckig [Trenn.: ...ek|kig]; sechs|ein|halb, sechs-und|ein|halb; Sechs|en|der (Jägerspr.); Sech|ser berlin. (Fünfpfennigstück); ich gebe keinen Sechser (nichts) mehr für sein Leben; vgl. Achter; sech|ser|lei; auf - Art; Sechs|ser|rei|he; in -n; sechs-fach; Sechs|fa|che s; -n; vgl. Achtfache; Sechs|flach s; -[e]s, -e u. Sechs|fläch|ner (für: Hexaeder); sechs|hun|dert; vgl. hundert; Sechs|kant s od. m; -[e]s, -e (↑ R 228); Sechs|kant|ei|sen (↑ R 228); sechs|kan|tig; Sechs|ling; sechs-mal; vgl. achtmal; sechs|ma|lig; Sechs|paß (Maßwerkfigur in der Hochgotik) m; ...passes, ...passe; Sechs|spän|ner; sechs|spän|nig; sechs|stellig; Sechs|stern (sechsstrahliger Stern der Volkskunst); vgl. ²Stern; sechst; vgl. sechs; Sechs|ta|ge|ren|nen (↑ R 120 u. R 155); sechs|tau|send; vgl. tausend; sech|ste; er hat den sechsten Sinn (ein Gespür) dafür; vgl. achte; sech|stel; vgl. achtel; Sech|stel s (schweiz. meist: m); -s, -; vgl. Achtel; sech|stens; Sechs|und|dreißig|flach s; -[e]s, -e u. Sechs-und-drei|ßig|fläch|ner (für: Triakisdodekaeder); sechs|und|ein|halb, sechseinhalb; Sechs|und|sech|zig (im Kartenspiel) s; -; sechs|und-zwan|zig; vgl. acht; Sechs|zy|lin-

<hr>

¹ Vgl. die Anm. zu ,,Diarrhö, Diarrhöe".

der (ugs. für: Sechszylindermotor od. damit ausgerüsteter Kraftwagen); **Sechs|zy|lin|der|mo|tor;** **sechs|zy|lind|rig** (mit Ziffer: 6zylindrig; ↑ R 228)

Sech|ter lat. (altes [Getreide]maß; österr.: Eimer, Milchgefäß) m; -s, -

sech|zehn; vgl. acht; **sech|zig** usw. vgl. achtzig usw.; **sech|zig|jäh|rig;** vgl. acht|jäh|rig

Se|cret Ser|vice engl. [βi̯kr⁵t βö̈r-wiß] (brit. [polit.] Geheimdienst) m; - -

SED = Sozialistische Einheitspartei Deutschlands (DDR)

Se|da (Mehrz. von: Sedum)

se|dat lat. (veralt., aber noch mdal. für: ruhig, von gesetztem Wesen); **se|da|tiv** (Med.: beruhigend, schmerzstillend); **Se|da|tiv** s; -s, -e [...wᵉ] u. **Se|da|ti|vum** [...wum] (Med.: Beruhigungsmittel) s; -s, ...va [...wa]

Se|dez lat. (Sechzehntelbogengröße [Buchformat]; Abk.: 16°) s; -es; **Se|dez|for|mat**

Se|dia ge|sta|to|ria it. [- dsehä...] (Tragsessel des Papstes bei feierl. Aufzügen) w; - -

Se|di|ment lat. (Ablagerung, Niederschlag, Schicht) s; -[e]s, -c; **se|di|men|tär** (durch Ablagerung entstanden); **Se|di|men|tär|ge|stein; Se|di|men|ta|ti|on** [...zion] (Ablagerung); **Se|di|men|tär|ge|stein; se|di|men|tie|ren**

Se|dis|va|kanz lat. [...wa...] (Freistehen des Päpstlichen od. eines bischöflichen Stuhles) w; -, -en

Se|dum lat. (Pflanzengattung der Dickblattgewächse [Fetthenne, Mauerpfeffer]) s; -s, Seda

¹**See** (Landsee) m; -s, -n [se̯ᵉn]; ²**See** (Meer) w; -, (für: [Sturz]wellen Mehrz.:) -n [se̯ᵉn]; **See|aal,** ...ad|ler, ...amt; **see|ar|tig,** seen|ar|tig; **See|bad,** ...bär, ...be|ben; **see|be|schä|digt** (für: havariert); **See|brücke** [Trenn.: ...brük|ke]; **See-Ele|fant;** ↑ R 148 (große Robbe) m; -en, -en (↑ R 268); **see|er|fah|ren** (↑ R 148); **See-Er|fah|rung** (↑ R 148); **See-Er|ze** Mehrz. (↑ R 148); **see|fah|rend; See-fah|rer,** ...fahrt; **See|fahrt|buch**¹; **see|fahrt|schu|le**¹; **see|fest; See|fisch; See|fracht; See|fracht|ge|schäft; See|gang** m; **See Ge|ne|za|reth,** (ökum.:) Gen|ne|sa|ret (bibl. Name für den See von Tiberias) m; -s -; **See|gfrör|ni,** (auch:) **See|ge-frör|ne** schweiz. mdal. (Zugefrieren, Zugefrorensein eines Sees) w; -, -nen; **See|gras; See|gras|ma|trat|ze; See-gur|ke** (Stachel-

häuter), ...ha|fen (vgl. ²Hafen), ...han|del (vgl. ¹Handel), ...heil-bad, ...herr|schaft (w; -), ...hund; **See|hunds|fän|ger,** ...fell, ...fett; **See|igel** (↑ R 148); **See|igel|kak-tus; See-jung|fer** (eine Libelle), ...jung|frau, ...ka|dett, ...ka|nal, ...kar|te, ...kas|se (Versicherung für alle in der Seefahrt beschäftigten Personen); **see|klar;** ein Schiff - machen; **See|kli|ma; see|krank;** **See-krank|heit** (w; -), ...krieg, ...kuh, ...lachs

See|land (dän. Insel; niederl. Provinz)

See|lchen; See|le w; -, -n; meiner Seel! (↑ R 241); die unsterbliche Seele, **See|len|ach|se** (in Feuerwaffen), ...adel, ...amt (kath. Religion: Totenmesse), ...arzt, ...blind|heit (Med.), ...frie|de[n] (m; ...dens), ...grö|ße (w; -), ...gü-te, ...heil, ...hirt, ...kun|de (für: Psychologie; w; -); **see|len|kun-dig,** ...kund|lich (für: psychologisch); **See|len|le|ben,** ...leh|re; **see|len|los; See|len|mas|sa|ge** (ugs.), ...mes|se, ...not, ...qual, ...re|gung, ...ru|he; **see|len|ru|hig; see|len|s]|gut; see|len|stark; see-len|ver|gnügt** (ugs. für: heiter); **See|len|ver|käu|fer; see|len|ver-wandt; See|len|ver|wandt|schaft; see|len|voll; See|len|wan|de|rung,** ...zu|stand

See|leuch|te (Leuchtturm)

see|lisch; -ste (↑ R 294); -e Schmerzen; das -e Gleichgewicht; die -en Kräfte; **See|sor|ge** w; -; **See|sor-ger; see|sor|ge|risch,** -ste (↑ R 294); **see|sor|ger|lich, see|sorg-lich**

See|luft, ...macht, ...mann (Mehrz. ...leute); **see|män|nisch;** -ste (↑ R 294); **See|manns|amt,** ...brauch; **See|mann|schaft** (seemännisches Verhalten; w; -); **See|manns|gam** (s; -[e]s), ...heim, ...le|ben, ...los, ...ord|nung, ...spra|che; **See-mei-le** (Zeichen: sm), ...mi|ne; **seen|ar-tig,** seear|tig; **See|not; seen|kun|de** (für: Limnologie; w; -); **See|not** w; -; **See|not|ret|tungs|dienst; See|not-zei|chen; Seen|plat|te**

s. e. e. o., s. e. et o. = salvo errore et omissione lat. (Irrtum und Auslassung vorbehalten)

See-pferd, ...pferd|chen, ...pocke [Trenn.: ...pok|ke] (ein Krebstier), ...räu|ber, ...recht, ...rei|se, ...ro|se, ...sack, ...sand, ...schei|de (ein Manteltier), ...schiff, ...schlan|ge, ...sper|re, ...stadt, ...stern (vgl. ²Stern), ...stra|ße, ...stra|ßen|ord|nung, ...stück (Gemälde mit Seemotiv), ...tang, ...we|sen

s. e. e. et o. vgl. s. e. e. o.

see|tüch|tig; See|ufer (↑ R 148);

See-ver|si|che|rung, ...war|te; die Deutsche - in Hamburg; **see-wärts; See-weg,** ...wet|ter|dienst, ...zei|chen, ...zoll|ha|fen, ...zun|ge (ein Fisch)

Sef|fi (Kurzform von: Josephine)

Se|gan|ti|ni (it. Maler)

Se|gel s; -s, -; **Se|gel|boot; se|gel-fer|tig; se|gel|flie|gen** (nur in der Grundform gebräuchlich); **Se-gel.flie|ger,** ...flug, ...flug|zeug; **se|gel|los; se|geln;** ich ...[e]le (↑ R 327); **Se|gel.re|gat|ta,** ...schiff, ...sport, ...tuch (Mehrz. ...tuche)

Se|gen m; -s, -; **se|gen|brin|gend,** aber (↑ R 142): großen Segen bringend; **se|gens|reich; Se|gens-spruch, se|gens|voll; Se|gens-wunsch**

Se|ger (dt. Technologie); **Se|ger-ke|gel**Ⓦ (↑ R 180; Zeichen: SK), ...por|zel|lan

Se|ge|stes (Cheruskerfürst; Vater der Thusnelda)

Segge niederd. (Riedgras, Sauergras) w; -, -n

Se|ghers, Anna (dt. Schriftstellerin)

Seg|ler

Seg|ment lat. ([Kreis-, Kugel]abschnitt, Glied) s; -[e]s, -e; **seg-men|tal** (in Form eines Segmentes); **seg|men|tär** (aus Abschnitten gebildet); **Seg|men|tie-rung** (Gliederung des Körpers in einzelne Abschnitte)

seg|nen; gesegnete Mahlzeit; **Seg-nung**

Se|gre|gat lat. (veralt. für: Ausgeschiedenes) s; -[e]s, -e; ¹**Se|gre|ga-ti|on** [...zion] (Biol.: Aufspaltung der Erbfaktoren während der Reifeteilung der Geschlechtszellen; veralt. für: Ausscheidung, Trennung) w; -, -en; ²**Se|gre|ga-tion** engl. [βägrig̯e'sch`ᵉn] (amerik. Bez. für: Absonderung einer Menschengruppe aus gesellschaftl., eigentumsrechtl. od. räuml. Gründen) w; -, -s

Seh|ach|se; Se|he (veralt. für: Sehvermögen) w; -, -n; **se|hen;** du siehst, er sieht; ich sah, du sähst; du sähest, siehst, sieh!, bei Verweisen u. als Ausrufewort: sieh[e]!; sieh[e] da!; ich habe es kommen sehen (selten: gesehen); (↑ R 120:) ich kenne ihn nur vom Sehen; ihm wird Hören u. Sehen (auch: hören u. sehen) vergehen (ugs.); **se|hens.wert,** ...wür|dig; **Se|hens|wür|dig|keit; Se|her** (Jägerspr. auch: Auge des Raubwildes); **Se|her|ga|be** w; -; **Se|he|rin** w; -, -nen; **se|he|risch; Seh-.feh|ler,** ...kraft w, ...kreis, ...lin|se, ...loch (für: Pupille)

Seh|ne w; -, -n

¹ So die amtl. Schreibung ohne Fugen-s.

sehnen 622

seh|nen, sich; (↑ R 120:) stilles Seh-
nen
Seh|nen|schei|de; Seh|nen|schei-
den|ent|zün|dung; Seh|nen|riß,
...ver|län|ge|rung, ...zer|rung
Seh|nerv
seh|nig
sehn|lich; -st; Sehn|sucht w; -,
...süchte; sehn|süch|tig; sehn-
suchts|voll
Seh_öff|nung, ...or|gan (Auge),
...pro|be, ...prü|fung
sehr; so -; zu -; gar -; - fein (Abk.:
ff); - viel, - vieles; - bedauerlich;
er hat die Note „sehr gut" erhal-
ten; vgl. ausreichend
seh|ren (veralt., aber noch mdal.
für: verletzen)
Seh_rohr, ...schär|fe, ...schwä|che,
...stäb|chen, ...stö|rung, ...test,
...ver|mö|gen, ...wei|te, ...win|kel,
...zen|trum
Sei|ber, Sei|fer landsch. (ausflie-
ßender Speichel [bes. bei kleinen
Kindern]) m; -s; sei|bern, sei|fern
(landsch.); ich ...ere (↑ R 327)
Sei|cen|to it. [Be-itschänto]
([Kunst]zeitalter des 17. Jh.s in
Italien) s; -[s]
Seich m; -[e]s u. Sei|che (derb für:
Harn; seichtes Geschwätz; scha-
les Getränk) w; -; seichtes (derb
für:) Geschwätz; vgl. ausreichend
Seiches fr. [Bäsch] (periodische Ni-
veauschwankungen von Seen
usw.) Mehrz.
seicht; -este (↑ R 292); -es Gewäs-
ser; Seicht|heit, Seich|tig|keit
seid (2. Pers. Mehrz. Indikativ
Präs. von ²sein); ihr seid; seid vor-
sichtig!; vgl. aber: seit
Sei|de (Gespinst; Gewebe) w; -, -n
Sei|del lat. (Gefäß; Flüssigkeits-
maß) s; -s, -; 3 - Bier (↑ R 322)
Sei|del|bast (Strauch)
sei|den (aus Seide); sei|den|ar|tig;
Sei|den_at|las (Mehrz. -se), ...bau
(m; -[e]s), ...fa|den, ...glanz, ...pa-
pier, ...rau|pe, ...spin|ner, ...stoff;
sei|den|weich; Sei|den|zeug; sei-
dig
Sei|fe (Waschmittel; Geol.: Ab-
lagerung) w; -, -n; grüne -; sei|fen;
sei|fen|ar|tig; Sei|fen_bla|se, ...ge-
bir|ge (erz- od. edelsteinhalti-
ges Gebirge), ...ki|sten|ren|nen,
...lau|ge, ...napf, ...pul|ver,
...scha|le, ...schaum, ...sie|der (in
der Wendung: jmdm. geht ein
Seifensieder auf [ugs. für: jmd.
begreift etwas]), ...was|ser
Sei|fer vgl. Seiber; sei|fern vgl. sei-
bern
sei|fig; Seif|ner (veralt. für: Erzwä-
scher)
Sei|ge (Bergmannsspr.: vertiefte
Rinne, in der das Grubenwasser
abläuft) w; -, -n; sei|ger (Berg-
mannsspr.: senkrecht); Sei|ger
landsch. (Uhr) m; -s, -; sei|gern

(veralt. für: seihen, sickern; Hüt-
tenw.: [sich] ausscheiden; aus-
schmelzen); ich ...ere (↑ R 327);
Sei|ger_riß (bildl. Durchschnitt
eines Bergwerks), ...schacht
(senkrechter Schacht); Sei|ge-
rung (Hüttenw.)
Sei|gneur fr. [Bänjör] (vornehmer
Weltmann) m; -s, -s
Sei|he (landsch.) w; -, -n; sei|hen;
(durch ein Sieb gießen, filtern);
Sei|her (Sieb für Flüssigkeiten);
Seih|tuch (veralt.; Mehrz. ...tü-
cher)
Seil s; -[e]s, -e; auf dem Seil tanzen
(vgl. aber: seiltanzen); über das
Seil springen (vgl. aber: seilsprin-
gen); über das Seil hüpfen (vgl.
aber: seilhüpfen); Seil_an|spra-
che (Bergsteigen), ...bahn; ¹sei|len
(veralt.); Seil|en|de
²sei|len niederd. (segeln)
Sei|ler; Sei|ler|bahn; Sei|le|rei;
Sei|ler|mei|ster; Seil_fäh|re, ...ge-
schirr, seil|hüp|fen; seilgehüpft
(vorwiegend in der Grundform
u. im 2. Mittelwort gebräuch-
lich); vgl. Seil; Seil_hüp|fen (s; -s),
...rei|bung, ...schaft (die durch ein
Seil verbundenen Bergsteiger),
...schwe|be|bahn; seil|sprin|gen;
seilgesprungen (vorwiegend in
der Grundform u. im 2. Mittel-
wort gebräuchlich); vgl. Seil;
Seil_sprin|gen (s; -s), ...steue-
rung; seil|tan|zen; seilgetanzt
(vorwiegend in der Grundform
u. im 2. Mittelwort gebräuch-
lich); vgl. Seil; Seil_tän|zer, ...tän-
ze|rin, ...trom|mel, ...win|de,
...zie|hen (s; -s), ...zug
Seim (dicker [Honig]saft) m; -[e]s,
-e; sei|mig (dickflüssig)
¹sein, sei|ne, sein; aber (↑ R 122:)
Seine (Abk.: S[e].), Seiner (Abk.:
Sr.) Exzellenz; (↑ R 117:) jedem
das Seine; er muß das Seine dazu
beitragen, tun; sie ist die Seine;
er sorgte für die Seinen; vgl. dein
²sein; ich bin, du bist, er ist, wir
sind, ihr seid, sie sind; ich sei,
du seist (seiest), er sei, wir seien,
ihr seiet, sie seien; ich war, du
warst, er war, wir waren, ihr wart
(waret), sie waren; ich wäre, du
wärst (wärest), er wäre, wir wä-
ren, ihr wärt (wäret), sie wären;
seiend; gewesen; sei!; seid!; Sein
s; -s; das - und das Nichtsein;
das wahre, vollkommene -
sei|ne, sei|ni|ge; vgl. deine, deinige
Sei|ne [Bän²] (fr. Fluß) w; -
sei|ner|seits; sei|ner|zeit; ↑ R 139
(damals, dann; Abk.: s. Z.),
aber: alles zu seiner Zeit; sei|ner-
zei|tig; sei|nes|glei|chen; Leute -;
er hat nicht -; sei|net|hal|ben; sei-
net|we|gen; sei|net|wil|len; um -;
seine

sein|las|sen; ich möchte das lieber
seinlassen (ugs. für: nicht tun);
er hat es seinlassen; aber: er
wollte ihn nicht Sieger sein lassen
Sei|sing vgl. Zeising
Seis|mik gr. (Erdbebenkunde) w;
-; seis|misch (auf Erdbeben be-
züglich); Seis|mo|gramm (Auf-
zeichnung der Erdbebenwellen)
s; -s, -e; Seis|mo|graph (Gerät zur
Aufzeichnung von Erdbeben) m;
-en, -en (↑ R 268); Seis|mo|lo|ge
m; -n, -n (↑ R 268); Seis|mo|lo|gie
(sww. Seismik) w; -; seis|mo|lo-
gisch; Seis|mo|me|ter (Gerät zur
Messung der Erdbebenstärke) s;
-s, -; seis|mo|me|trisch
seit; Verhältniswort mit Wemf.: -
dem Zusammenbruch; - alters
(↑ R 129), - damals, - gestern, -
heute; (↑ R 134:) - kurzem, lan-
gem; Bindew.: - ich hier bin; vgl.
aber: seid; seit|ab; seit|dem; Um-
standsw.: seitdem ist er gesund;
Bindew.: seitdem (od. seit) ich
hier bin
Sei|te (Abk.: S.) w; -, -n; die linke,
rechte Seite; von allen Seiten; von
zuständiger Seite; zur Seite tre-
ten, stehen; abseits; allerseits;
meinerseits; deutscherseits; müt-
terlicherseits; (↑ R 141:) beiseite;
seitens (mit Wesf.); auf seiten,
von seiten, zu seiten; vgl. aber:
Saite; Sei|ten_al|tar, ...an|sicht,
aus|gang, ...bau (Mehrz. ...bau-
ten), ...blick, ...deckung [Trenn.:
...dek|kung], ...ein|gang, ...flü-
gel, ...gang m, ...ge|wehr, ...gra-
ben, ...hal|bie|ren|de (w; -n, -n;
zwei-), ...hieb, ...kan|te, ...lang; -
vier Seiten lang; Sei|ten_leit-
werk, ...li|nie, ...por|tal, ...ram|pe,
...ru|der; sei|tens (↑ R 130); mit
Wesf.: - des Angeklagten (dafür
besser: von dem Angeklagten)
wurde folgendes eingewendet;
Sei|ten_schiff, ...schnei|der (ein
Werkzeug), ...sprung, ...ste|chen
(s; -s), ...stra|ße, ...stück, ...teil s,
...tür; sei|ten|ver|kehrt; Sei|ten-
_wa|gen, ...wind, ...zahl
seit|her (zu einer gewissen Zeit
an bis jetzt); seit|he|rig
...sei|tig (z. B. allseitig); seit|lich;
seit|lings (veralt.); seit|wärts; - ge-
hen
Seim poln. [Bäim, Bâim] (poln.
Volksvertretung) m; -
sek, Sek., s (Astron.: ...⁵), sec =
Sekunde
Se|kans lat. (Seitenverhältnis im
Dreieck; Zeichen: sec) m; -, -
(auch: Sekanten); Se|kan|te (jede
Gerade, die eine Kurve schnei-
det) w; -, -n
Se|kel, (auch:) Sche|kel hebr.
(altbabylonische u. hebr. Ge-
wichts- u. Münzeinheit) m; -s, -

sek|kant *it.* (veralt., noch österr. für: lästig, zudringlich); **Sek|ka|tur** (veralt., noch österr. für: Quälerei, Belästigung) *w;* -, -en; **sek|kie|ren** (veralt., noch österr. für: quälen, belästigen)

Se|kond|hieb *it.; dt.* (ein Fechthieb)

se|kret *lat.* (veralt. für: geheim; abgesondert); ¹**Se|kret** (Absonderung; selten vertrauliche Mitteilung) *s;* -[e]s, -e; ²**Se|kret** (Stillgebet des Priesters während der Messe) *w;* -; **Se|kre|tär** (Geschäftsführer, Abteilungsleiter gelehrter Körperschaften; sonst selten für: Sekretär) *m;* -s, -e; **Se|kre|tär** (Beamter des mittleren Dienstes; Schriftführer; selten: jmd., der einem Höhergestellten bei der Korrespondenz u. a. zur Seite steht; Schreibschrank; Kranichgeier) *m;* -s, -e; vgl. Sekretar; **Se|kre|ta|ri|at** (Kanzlei, Geschäftsstelle; Schriftführeramt) *s;* -[e]s, -e; **Se|kre|tä|rin** *w;* -, -nen; **se|kre|tie|ren** (absondern; verschließen); **Se|kre|ti|on** [...*zion*] (Absonderung); **se|kre|to|risch** (die Sekretion betreffend)

Sekt *it.* (Schaumwein) *m;* -[e]s, -e **Sek|te** *lat.* („abgesonderte" [kleinere Glaubens]gemeinschaft) *w;* -, -n; **Sek|ten|we|sen** *s;* -s **Sekt_fla|sche**, ...**glas** (*Mehrz.* ...gläser)

Sek|tie|rer *lat.* (Anhänger einer Sekte); **sek|tie|re|risch;** -ste († R 294); **Sek|tie|rer|tum** *s;* -s

Sek|ti|on *lat.* [...*zion*] (Abteilung, Gau, Gruppe, Zweig[verein]; Med.: Leichenöffnung); **Sek|ti|ons.be|fund**, ...**chef** (Abteilungsvorstand; in Österr.: höchster Beamtentitel); **Sek|ti|ons|wei|se**; **Sek|tor** ([Sach]gebiet, Bezirk, Teil; [Kreis-, Kugel]ausschnitt) *m;* -s, ...oren; **Sek|to|ren|gren|ze**

Sekt_scha|le, ...**steu|er** *w*

Se|kund *lat.* bes. österr. (Musik: svw. Sekunde) *w;* -, -en; **se|kun|da** (Kaufmannsspr. veralt. für: „zweiter" Güte); die Ware ist -; **Se|kun|da** („zweite"; als Unter- u. Obersekunda 6. u. 7. [in Österr. 2.] Klasse an höheren Lehranstalten) *w;* -, ...den; **Se|kund|ak|kord** (Musik); **Se|kun|da|ner** (Schüler einer Sekunda); **Se|kun|dant** (Beistand, Zeuge [im Zweikampf]; Berater, Betreuer eines Sportlers; Helfer, Schützer) *m;* -en, -en († R 268); **Se|kun|där** *fr.* (zur zweiten Ordnung gehörend; in zweiter Linie in Betracht kommend; nachträglich hinzukommend; Neben...); **Se|kun|där|arzt** österr. (Assistenzarzt, Unterarzt an einem Krankenhaus); **Se|kun|där|bahn** (veralt. für: Nebenbahn); **Se|kun|där_elek|tron** (Physik: durch Beschuß mit irgendeiner primären Strahlung aus einem festen Stoff ausgelöstes Elektron), ...**emis|si|on** (Physik: Auslösung von Sekundärelektronen aus der Oberfläche eines festen Stoffes durch Beschuß des Körpers mit schnellen Elektronen); **Se|kun|där|leh|rer** (schweiz.); **Se|kun|där|li|te|ra|tur** (wiss. u. krit. Literatur über Dichter, Dichtungen, Dichtungsepochen; Ggs.: Primärliteratur); **Se|kun|där|schu|le** schweiz. (höhere Volksschule); **Se|kun|där_sta|ti|stik**, ...**strom** (Nebenstrom), ...**wicke|lung** [*Trenn.:* ...wik|ke|lung], ...**wicklung** (Elektrotechnik); **Se|kun|da|wech|sel** (Bankw.); **Se|kun|de** („zweite" [Teilung]; ¹/₆₀ Minute, Abk.: Sek. [Zeichen: s (Astron. ...˘); älter: sec, sek] Geometrie: ¹/₆₀ Minute [Zeichen: ˝]; Musik: zweiter Ton [vom Grundton an]; Druckerspr.: die am Fuß der dritten Seite eines Bogens stehende Zahl mit Sternchen) *w;* -, -n; **Se|kun|den|ge|schwin|dig|keit;** se|kun|den|lang; aber: vier Sekunden lang; **Se|kun|den_pen|del**, ...**schnel|le** (in -), ...**zei|ger**; **se|kun|die|ren** (beistehen [im Zweikampf]; helfen, schützen); **se|künd|lich**, (auch:) **se|kund|lich** (in jeder Sekunde); **Se|kun|do|ge|ni|tur** (Besitz[recht] des zweitgeborenen Sohnes u. seiner Linie) *w;* -, -en

Se|ku|rit ⓦ *nlat.* (nicht splitterndes Glas) *s;* -s; **Se|ku|ri|tät** *lat.* (Sicherheit, Sorglosigkeit)

sel. = selig

se|la! *hebr.* (ugs. für: abgemacht!, Schluß!); **Se|la** (Musikzeichen in den Psalmen) *s;* -s, -s

Se|la|chi|er *gr.* [...*chiᵉr*] (Haifisch) *m;* -s, - (meist *Mehrz.*)

Se|la|don (auch: *sal*..., fr. Ausspr. ...*dong*; Name aus einem fr. Schäferroman) (veralt. für: schmachtender Liebhaber) *m;* -s, -s; **Se|la|don|por|zel|lan** (chin. Porzellan aus der Zeit des Mittelalters)

Se|la|gi|nel|le *it.* (Moosfarn) *w;* -, -n

Se|lam *arab.* [auch: *sᵉ*...] (arab. Grußwort: Wohlbefinden, Heil) *m;* -s; - aleikum! (Heil über euch!); **Se|lam|lik** *arab.-türk.* (Empfangsraum im mohammedan. Haus) *m;* -s, -s

selb; zur -en Stunde, zur -en Zeit; **selb|an|der** (veralt. für: zu zweit); **selb|dritt** (veralt. für: zu dritt); **sel|ber** (alltagssprachl. für: selbst); **Selb|ber|ma|chen** († R 120) *s;* -s; **sel|big** (veralt.); zu -er Stunde, zur -en Stunde; **selbst** (vgl. auch: selber); von -; - wenn († R 62); selbst (sogar) bei Glatteis fährt er schnell; **Selbst** *s;* -; ein Stück meines -; **Selbst_ach|tung** (*w;* -), ...**ana|ly|se**; **selb|stän|dig**; sich - machen; **Selb|stän|di|ge** *m* u. *w;* -n, -n († R 287ff.); **Selb|stän|dig|keit** *w;* -; **Selbst_an|fer|ti|gung** (Wirtsch.), ...**an|kla|ge**, ...**an|le|ger** (Druckw.), ...**an|schluß; Selbst|an|schluß_be|trieb** (Fernspr.) *m;* -[e]s; **Selbst_an|steckung** [*Trenn.:* ...stek|kung], ...**an|zei|ge**, ...**an|zei|ger**, ...**auf|op|fe|rung**, ...**aus|le|ger** (Druckw.), ...**aus|lö|ser** (Fotogr.), ...**be|die|nung** (*Mehrz.* selten), **Selbst_be|die|nungs|la|den; Selbst_be|frie|di|gung**, ...**be|fruch|tung**, ...**be|halt** (Versicherungswesen; *m;* -[e]s), ...**be|herr|schung**, ...**be|kennt|nis**, ...**be|sin|nung**, ...**be|stä|ti|gung**, ...**be|stäu|bung**, ...**be|stim|mung; Selbst_be|stim|mungs|recht** *s;* -[e]s; **Selbst_be|tei|li|gung**, ...**be|trug; selbst|be|wußt; Selbst_be|wußt|sein**, ...**bild|nis**, ...**bin|der**, ...**bio|gra|phie**, ...**dis|zi|plin**, ...**ein|schät|zung**, ...**ein|tritt** (Wirtsch.), ...**ent|fal|tung**, ...**ent|zün|dung**, ...**er|fah|rung**, ...**er|hal|tung** (*w;* -); **Selbst_er|hal|tungs|trieb; Selbst_er|kennt|nis**, ...**er|nied|ri|gung**, ...**er|zeu|ger**, ...**er|zie|hung**, ...**fah|rer**, ...**fi|nan|zie|rung; selbst|ge|fäl|lig; Selbst_ge|fäl|lig|keit** (*w;* -), ...**ge|fühl** (*s;* -[e]s); **selbst_ge|macht** (e- Marmelade; aber: sie hat die Marmelade selbst gemacht), ...**ge|nüg|sam**, ...**ge|recht**, ...**ge|schrie|ben** (-er Brief; aber: er hat den Brief selbst geschrieben), ...**ge|spon|nen; Selbst_ge|spräch; selbst|ge|strickt** (-er Pullover; aber: sie hat den Pullover selbst gestrickt); **selbst|herr|lich; Selbst_herr|lich|keit** (*w;* -), ...**herr|scher**, ...**hil|fe**, ...**in|duk|ti|on**, ...**iro|nie; selb|stisch;** -ste († R 294); **Selbst_ju|stiz; Selbst|ko|sten** *Mehrz.*; **Selbst|ko|sten_preis** (vgl. ²Preis), ...**rech|nung**, ...**sen|kung; Selbst_kri|tik; selbst|kri|tisch; Selbst_la|der**, ...**laut** (für: Vokal); **selbst_lau|tend; Selbst|lob; selbst|los**; -este († R 292); -er Verzicht; **Selbst_lo|sig|keit** *w;* -; **Selbst_mit|leid**, ...**mord**, ...**mör|der; selbst_mör|de|risch; Selbst|mord_ver|such; Selbst|por|trät; selbst|quä|le|risch**; -ste († R 294); **selbst_re|dend** (ugs. für: selbstverständlich); **Selbst_reg|ler; Selbst_rei|ni|gung** (ein biolog. Vorgang in gesunden Gewässern); biologische

-; Selbst_schrei|ber, ...schuß, ...schutz; selbst|si|cher; Selbst_si|cher|heit (w; -), ...stel|ler (Polizeiw.), ...stu|di|um (s; -s), ...sucht (w; -); selbst_süch|tig, ...tä|tig; Selbst_tä|tig|keit (w; -), ...täuschung, ...über|schät|zung, ...über|win|dung, ...un|ter|richt, ...ver|ach|tung (w; -), ...ver|brauchen, ...ver|bren|nung; selbst|verdient (-es Geld; aber: er hat das Geld selbst verdient); selbst|verges|sen; Selbst_ver|göt|te|rung, ...ver|lag, ...ver|leug|nung, ...versor|ger; selbst|ver|länd|lich; Selbst_ver|länd|lich|keit, ...verländ|nis, ...ver|stüm|me|lung, ...ver|such (Experiment am eigenen Körper), ...ver|trau|en, ...verwal|tung, ...ver|wirk|li|chung, ...vor|wurf; Selbst_wähl|ferndienst (Fernspr.); selbst wenn (↑R 62); selbst|zer|stö|re|risch; Selbstzer|stö|rung; Selbst|zucht w; -; selbst|zu|frie|den; Selbst_zu|frieden|heit, ...zün|der, ...zweck (m; -[e]s)

sel|chen bayr. u. österr. (räuchern); Sel|cher bayr. u. österr. (jmd., der mit Geselchtem handelt); Sel|che|rei bayr. u. österr. (Fleisch- u. Wurstäucherei); Selch_fleisch, ...kam|mer (bayr. u. österr.), ...kar|ree (österr. für: Kasseler Rippenspeer) s; -s, -s

Sel|dschu|ke (Angehöriger eines türk. Volksstammes) m; -n, -n (↑R 268)

Se|lek|ta lat. (früher: „auserlesene" Klasse; Oberklasse, Begabtenklasse) w; -, ...ten; Se|lek|ta|ner (Schüler einer Selekta); Se|lek|ta|ne|rin w; -, -nen; se|lek|tie|ren (auswählen [für züchterische Zwecke]); Se|lek|ti|on [...zion] (Auslese; Zuchtwahl); se|lek|tio|nie|ren (svw. selektieren); Se|lek|ti|ons_leh|re, ...theo|rie; se|lek|tiv (auswählend; mit Auswahl; Funkwesen: trennscharf); vgl. elektiv; Se|lek|ti|vi|tät [...wi...] (Trennschärfe bei Rundfunkempfängern) w; -

Se|len gr. (chem. Grundstoff; Zeichen: Se) s; -s; Se|le|nat (Salz der Selensäure) s; -[e]s, -e; Se|le|ne (gr. Mondgöttin); Se|le|nit (Salz der seleniegen Säure) s; -s, -e; Se|le|no|gra|phie (Beschreibung u. Darstellung der topographischen u. physikalischen Beschaffenheit des Mondes) w; -; Se|le|no|lo|gie (Lehre von der Entstehung des Mondes) w; -; se|le|no|lo|gisch (mondkundlich); Se|len|zel|le (lichtempfindliches Widerstandsgerät)

Se|leu|ki|de (Angehöriger einer makedon. Dynastie in Syrien) m;

-n, -n (↑R 268); Se|leu|zi|de vgl. Seleukide

Self... engl. (Selbst...); Self|ak|tor [sälf...] (Spinnmaschine) m; -s, -s; Self|go|vern|ment [ßälfgaw^rn...] (Selbstverwaltung) s; -s, -s; Selfmade|man [ßälfme'dmän] (jmd., der aus eigener Kraft etwas geworden ist) m; -s, ...men [m^en]

se|lig (Abk.: sel.); ein -es Ende haben; aber: er hat das Geld selbst verdient; selbst|verges|sen; selig sein, machen, werden; vgl. aber seligpreisen, seligsprechen

...se|lig (z. B. armselig)

Se|lig|en m u. w; -n, -n, -n (↑R 287ff.); Se|lig|keit; se|lig|prei|sen (↑R 139); ich preise selig; seliggepriesen; seligzupreisen; Se|lig|prei|sung; se|lig|spre|chen (↑R 139); zur Beugung vgl. seligpreisen; Se|lig|spre|chung; Se|lig|zu|spre|chen|de m u. w; -n, -n (↑R 287ff.)

Sel|le|rie gr.[österr. nur: ...ri] (eine Gemüse- und Gewürzpflanze) m; -s, -[s] od. (österr. nur so) w; -, - (österr.: ...rien); Sel|le|rie|sa|lat

Sel|ma (m. Vorn.)

Sel|mar (m. Vorn.)

sel|ten; seltener, -ste; -e Erden (Chemie: Oxide der Seltenerdmetalle; unrichtige Bez. für die Seltenerdmetalle selbst); - gut (ugs. für: besonders gut); Sel|ten|erd_me|tal|le (Chemie: Metalle der seltenen Erden; eine Gruppe chem. Elemente) Mehrz.; Sel|ten|heit; Sel|ten|heits|wert m; -[e]s

Sel|ters (Name versch. Orte); Selterser Wasser; Sel|ters|was|ser (Mineralwasser; Mehrz. ...wässer)

selt|sam; selt|sa|mer|wei|se; Selt|sam|keit

Sem (bibl. m. Eigenn.)

Se|man|tik gr. (svw. Semasiologie) w; -; se|man|tisch (svw. semasiologisch); Se|ma|phor („Zeichenträger"; Signalmast; opt. Telegraph) s (auch, österr. nur: m); -s, -e; se|ma|pho|risch; Se|ma|sio|lo|gie (Sprachw.: Wortbedeutungslehre) w; -; se|ma|sio|lo|gisch; Se|meio|gra|phie (Zeichenschrift; Lehre von den musikal. Zeichen; Notenschrift) w; -; Se|meio|tik (Bedeutungslehre, Lehre vom Ausdruck) w; -

Se|me|ster lat. („sechs Monate"; [Studien]halbjahr) s; -s, -; Se|me|ster_fe|ri|en (Mehrz.), ...zeug|nis; se|me|stral (veralt. für: halbjährig; halbjährlich); Se|me|stral_prü|fung; ...se|me|strig (z. B. sechssemestrig)

Se|mi...lat. (Halb...); Se|mi|fi|na|le (Sportspr.)

Se|mi|ko|lon lat.; gr. (Strichpunkt)

s; -s, -s u. ...la; se|mi|lu|nar lat. (halbmondförmig); Se|mi|lu|nar|klap|pe (eine Herzklappe)

Se|mi|nar lat. (früher, aber noch schweiz.: Lehrerbildungsanstalt; kath. Priesterausbildungsanstalt; Hochschulinstitut; Übungskurs im Hochschulunterricht) s; -s, -e österr. auch: -ien [...i^rn]); Se|mi|nar_ar|beit; Se|mi|na|rist (Seminarschüler); ↑R 268; se|mi|na|ri|stisch; se|mi|nar|übung

Se|mio|lo|gie w; - u. Se|mio|tik gr. (Lehre von den Krankheitsanzeichen; Semasiologie; Semeiotik) w; -

se|mi|per|mea|bel lat. (Chemie, Biol.: halbdurchlässig); ...a|ble Membran

Se|mi|ra|mis (sagenumsponnene assyr. Königin)

Se|mit [nach Sem, dem Sohne Noahs] (Angehöriger einer eine semitische Sprache sprechenden Völkergruppe) m; -en, -en (↑R 268); Se|mi|tin w; -, -nen; se|mi|tisch; Se|mi|tist (Erforscher der alt- u. der neusemit. Sprachen u. Literaturen) (↑R 268); Se|mi|ti|stik w; -; se|mi|ti|stisch

Se|mi|vo|kal (Halbvokal)

Sem|mel w; -, -n; sem|mel|blond; Sem|mel_brö|sel, ...kloß, ...knö|del, ...mehl

Sem|mel|weis (österr. Arzt)

Sem|me|ring (Alpenpaß) m; -[s]

Sem|pach (schweiz. Ortsn.); Sem|pa|cher See (See im Schweizer Mittelland) m; - -s

sem|per a|li|quid hae|ret lat. [- - härät] („es bleibt immer etwas [vom bösen Gerede] hängen"); sem|per i|dem („immer derselbe")

sem|pern österr. ugs. (nörgeln, jammern)

Sems|two russ. (ehem. russ. Selbstverwaltung[sverband]) s; -s, -s

Sen (jap. Münze; 100 Sen = 1 Yen; indones. Münze; Abk.: S; 100 Sen = 1 Rupiah) m; -[s], -[s] (↑R 322)

sen. = senior

Se|nat lat. (Rat [der Alten] im alten Rom; Teil des Volksvertretung, z. B. in den USA; Regierungsbehörde in Hamburg, Bremen u. West-Berlin; akadem. Verwaltungsbehörde; Richterkollegium bei Obergerichten) m; -[e]s, -e; Se|na|tor (Mitglied des Senats; Ratsherr) m; -s, ...oren; se|na|to|risch; Se|nats_be|schluß, ...prä|si|dent, ...sit|zung, ...sprecher, ...ver|wal|tung, ...vor|la|ge; Se|na|tus Po|pu|lus|que Ro|ma|nus („Senat und Volk von Rom"; Abk.: S. P. Q. R.)

Sen|cken|berg [zur Trenn.: ↑R

189] (dt. Arzt u. Naturforscher); sen|cken|ber|gisch [zur Trenn.: ↑ R 189]; aber (↑ R 179): Sen|cken|ber|gisch [zur Trenn.: ↑ R 189]; Senckenbergische Stiftung; Senckenbergische Naturforschende Gesellschaft (↑ R 224) Send (früher für: [Kirchen]versammlung; geistl. Gericht) m; -[e]s, -e

Send|bo|to; Sen|de.an|la|ge einrich|tung, ...fol|ge, ...ge|biet, ...haus, ...lei|stung, ...lei|ter m; sen|den; du sandtest u. sendetest; (selten:) du sendetest; gesandt und gesendet); send[e]!; in der Bedeutung „[vom Rundfunk] übertragen" nur schwach: er sendete, hat gesendet; Sen|de.pau|se, ...plan (vgl. ²Plan); Sen|der; (↑ R 224:) Sender Freies Berlin (Abk.: SFB); Sen|der|an|la|ge; Sen|de.raum, ...rei|he, ...sta|tion, ...stelle, ...turm; Sen|de- und Empfangs|ge|rät (↑ R 145); Sen|de.zei|chen, ...zeit

Send|ge|richt [zu: Send]

Send|ling (veralt. für: Bote); Sendschrei|ben; Sen|dung; Sen|dungsbe|wußt|sein

Se|ne|ca [...ka, auch: seneka] (röm. Dichter und Philosoph)

Se|ne|fel|der (österr. Erfinder des Steindruckes)

¹Se|ne|gal (afrik. Fluß) m; -[s]; ²Se|ne|gal (Staat in Afrika); Se|ne|ga|le|se m; -n, -n (↑ R 268), (auch:) Se|ne|ga|ler m; -s, -; se|ne|ga|le|sisch, (auch:) se|ne|ga|lisch

Se|ne|ga|wur|zel indian.; dt. (ein Arzneimittel) w; -

Se|nes|blät|ter usw. vgl. Sennesblätter usw.

Se|ne|schall fr. („alter Diener"; Oberhofbeamter im merowing. Reich) m; -s, -e

Se|nes|zenz lat. (Med.: Altern; Altwerden) w; -

Senf gr. m; -[e]s, -e; senf|far|ben, senf|far|big; Senf.gur|ke, ...korn, (Mehrz. ...körner), ...mehl, ...pfla|ster, ...so|ße, ...teig, ...tun|ke, ...um|schlag

Sen|ge nordd. u. mitteld. ugs. (Prügel) Mehrz.; - beziehen; sen|gen; seng|rig, seng|rig (ugs. für: brenzlig; angebrannt); es riecht -

Se|nhor port. [ßänjor] (port. Bez. für: Herr; Gebieter, Besitzer) m; -s, -es; Se|nho|ra (port. Bez. für: Dame, Frau; Herrin, Besitzerin) w; -, -s; Se|nho|ri|ta (port. Bez. für: Fräulein) w; -, -s

se|nil lat. (greisenhaft); Se|ni|li|tät (Greisenhaftigkeit) w; -; se|ni|or (älter, hinter Namen: der Ältere; Abk.: sen.); Karl Meyer senior; Se|ni|or („der Ältere"; Ältester;

Vorsitzender; Altmeister; Sprecher; Sportler etwa zwischen 20 u. 30 Jahren) m; -s, ...oren; Se|nio|rat (veralt. für: Ältestenwürde, Amt des Vorsitzenden; auch für: Majorat, Ältestenrecht) s; -[e]s, -e; Se|nior|chef; Se|nio|ren.klas|se (Sportspr.), ...kon|vent

Senk|blei s; Sen|ke w; -, -n; Sen|kel (Schnürband; schweiz. auch für: Senkblei) m; -s, -; etwas, jmdn. in den - stellen (schweiz. für: etwas zurechtrücken, jmdn. zurechtweisen); sen|ken; Senk|ker (ein Werkzeug); Senk.fuß, ...grube, ...ka|sten, ...lot; senk|recht; eine -e Wand; das -e Lot; - [herunter]fallen, stehen; (↑ R 116:) das ist das einzig Senkrechte (ugs. für: Richtige); Senk|rech|te w; -n, -n; zwei -[n] (↑ R 291); Senk|recht.start, ...star|ter (ein Flugzeugtyp); Senk|rücken [Trenn.: ...rük|ken]; Sen|kung; Sen|kungs.ab|szeß; Senk|waa|ge

Senn m; -[e]s, -e u. Sen|ne bayr., österr. und schweiz. (Bewirtschafter einer Sennhütte, Almhirt) m; -n, -n (↑ R 268)

Sen|na arab. (Blätter mehrerer Kassiaarten) w; -; vgl. Kassia

¹Sen|ne vgl. Senn; ²Sen|ne bayr. u. österr. (Weide) w; -, -n

³Sen|ne (südwestl. Vorland des Teutoburger Waldes) w; -

sen|nen bayr. u. österr. (Käse bereiten); ¹Sen|ner (Nebenform zu: Senn)

²Sen|ner (Pferd aus der ³Senne)

Sen|ne|rei bayr., österr. und schweiz. (Sennhütte, Käserei in den Alpen); Sen|ne|rin (Nebenform von: Sennin) w; -, -nen

Sen|nes|blät|ter arab.; dt. (ein Abführmittel, Mehrz.), ...pflan|ze, ...scho|te

Senn|hüt|te; Sen|nin (weibl. Senn) w; -, -nen; vgl. Sennerin; Sennwirt|schaft

Se|non [nach dem kelt. Stamm der Senonen] (Geol.: Name für drei Stufen des oberen Kreideformationen) s; -s

Se|ñor span. [ßänjor] (Herr) m; -s, -es; Se|ño|ra (Frau) w; -, -s; Se|ño|ri|ta (Fräulein) w; -, -s

Sen|sal it. österr. (freiberufl. Handelsmakler) m; -s, -e; Sen|sa|lie, Sen|sa|rie (Maklergebühr, Courtage) w; -, ...ien

Sen|sa|ti|on fr. [...zion] („Empfindung"; Aufsehen, aufsehenerregendes Ereignis); sen|sa|tio|nell (aufsehenerregend); Sen|sa|ti|ons.be|dürf|nis s; -ses; sen|sa|ti|ons.lü|stern; Sen|sa|ti|ons.mel|dung, ...nach|richt, ...pres|se, ...pro|zeß, ...sucht (w; -)

Sen|se w; -, -n; [jetzt ist aber] Sense!

(ugs. für: Schluß!, aus!, jetzt ist es genug!); sen|sen (mit der Sense mähen); Sen|sen.mann (Symbol des Todes; m; -[e]s), ...schmied, ...wurf (Sensenstiel)

sen|si|bel fr. (empfindlich, empfindsam; feinfühlig; ...i|ble Nerven; Sen|si|bi|li|sa|tor lat. (die Lichtempfindlichkeit der fotograf. Platte verstärkender Farbstoff) m; -s, ...oren; sen|si|bi|li|sie|ren ([licht]empfindlich[er] machen); Sen|si|bi|li|sie|rung; Sen|si|bi|li|tät fr. (Empfindlichkeit, Empfindsamkeit; Feinfühligkeit) w; -; sen|si|tiv lat.(.-fr.) (sehr empfindlich; leicht reizbar; feinnervig); Sen|si|ti|vi|tät [wi .] ([Über]empfindlichkeit) w; -; Sen|si|to|me|ter lat.; gr. (Fotografie: Lichtempfindlichkeitsmesser) s; -s, -; Sen|si|to|me|trie (Lichtempfindlichkeitsmessung) w; -; Sen|sor (elektron. Fühler, Signalmesser) m; -s, Sensoren (meist Mehrz.); Sen|so|ri|en lat. [...iⁿn] (Med.: Gebiete der Großhirnrinde, in denen Sinnesreize bewußt werden) Mehrz.; sen|so|risch (die Sinne betreffend); Sen|so|ri|um (Bewußtsein; vgl. Sensorien) s; -; Sen|sua|lis|mus (Lehre, nach der alle Erkenntnis allein auf Sinneswahrnehmung zurückführbar ist) m; -; Sen|sua|list (Vertreter des Sensualismus); ↑ R 268; sen|sua|li|stisch; Sen|sua|li|tät (Med.: Empfindungsvermögen) w; -; sen|su|ell fr. (die Sinne betreffend, sinnlich wahrnehmbar)

Sen|ta (w. Vorn.)

Sen|te niederd. ([dünne, biegsame] Latte) w; -, -n

Sen|tenz lat. (einprägsamer Ausspruch, Denkspruch; Sinnspruch; [richterliches] Urteil) w; -, -en; sen|ten|zi|ar|tig (gedanken-, spruchreich); sen|ten|zi|ös fr. (sentenzartig; sentenzenreich)-este (↑ R 292)

Sen|ti|ment fr. [ßangtimang] (Empfindung, Gefühl, Gefühlsäußerung) s; -s, -s; sen|ti|men|tal engl. [säntimäntl] (empfindsam; rührselig); sen|ti|men|ta|lisch (veralt. für: sentimental); naive und -e Dichtung; Sen|ti|men|ta|li|tät (Empfindsamkeit, Rührseligkeit; Gefühlseligkeit)

Se|nus|si (Anhänger eines mohammedan. Ordens) m; -, -u. ...ssen

Se|oul [ße-ul, auch: se-ul; sä-ul; korean. Ausspr.: saul] (Hptst. von [Süd]korea)

se|pa|rat (abgesondert; einzeln); Se|pa|rat.ab|druck (Sonderabdruck; Mehrz. ...abdruk-

ke), ...**druck** (Sonderdruck; *Mehrz.* ...drucke), ...**ein|gang**, ...**frie|de[n]**; Se|pa|ra|ti|on [...*zion*] (veralt. für: Absonderung; Trennung; Flurbereinigung); Se|pa|ra|tis|mus (Streben nach Loslösung eines Gebietes aus dem Staatsganzen) *m*; -; Se|pa|ra|tist (↑ R 268); se|pa|ra|ti|stisch; Se|pa|ra|tor (Trennschleuder) *m*; -s, ...oren; Sé|pa|rée *fr.* [...*re̱*] (Sonderraum, Nische in einer Gaststätte) *s*; -s, -s; se|pa|rie|ren (absondern)

Se|phar|dim [auch: ...*dim*] (Bez. für die span. u. port. Juden) *Mehrz.*; se|phar|disch

se|pia *gr.* (graubraunschwarz); Se|pia (Tintenfisch; nur *Einz.*: ein Farbstoff) *w*; -, ...ien [...*i̱ᵉn*]; Se|pia.kno|chen, ...schal|le, ...zeich|nung; Se|pie [...*i̱ᵉ*] (Sepia [Tintenfisch]) *w*; -, -n

Sepp, Seppl (Kurzformen von: Josef)

Sep|sis *gr.* (Med.: ,,Fäulnis''; allgemeine, durch Bakterien verursachte Blutvergiftung) *w*; -, Sepsen

Sept. = September

Sep|ta (*Mehrz.* von: Septum)

Sep|ta|rie *lat.* [...*i̱ᵉ*] (Geol.: Knolle mit radialen Rissen in kalkhaltigen Tonen) *w*; -, -n; Sep|ta|ri|en|ton *m*; -[e]s

Sep|tem|ber *lat.* (der neunte Monat des Jahres, Herbstmond, Scheiding; Abk.: Sept.) *m*; -[s] (↑ R 319), -; Sep|tem|ber-Ok|to|ber-Heft (↑ R 155); sept|en|nal (veralt. für: siebenjährig); Sept|en|nat (veralt. für: Zeitraum von sieben Jahren) *s*; -[e]s, -e; Sep|tett *it.* (Musikstück für sieben Stimmen od. sieben Instrumente; auch die sieben Ausführenden) *s*; -[e]s, -e

Sept|hä|mie, Sep|tik|ämie, Sep|tik|hä|mie *gr.* (svw. Sepsis) *w*; -, ...ien

Sep|tim *lat.* österr. (svw. Septime) *w*; -, -en; Sep|ti|ma österr. (,,siebte'' Klasse des Gymnasiums) *w*; -, ...en; Sep|ti|me (Musik: ,,siebter'' Ton [vom Grundton an]) *w*; -, -n; Sep|ti|men|ak|kord

sep|tisch *gr.* (Med.: die Sepsis betreffend; Fäulnis erregend)

Sep|tua|ge|si|ma *lat.* (,,siebzigster'' Tag; neunter Sonntag vor Ostern) *w*; -; Sonntag - od. Septuagesimä; Sep|tua|gin|ta ([angeblich] von ,,siebzig'' Gelehrten angefertigte Übersetzung des A. T. ins Griechische) *w*; -

Sep|tum *lat.* Med.: Scheidewand, Zwischenwand in einem Organ) *s*; -s, ...ta u. ...ten

se|pul|kral *lat.* (veralt. für: das

Grab[mal] oder Begräbnis betreffend)

seq. = sequens; seqq. = sequentes

se|quens *lat.* (veralt. für: folgend; Abk.: seq.); vgl. vivat sequens; se|quen|tes (veralt. für: die Folgenden; Abk.: seqq.); vgl. vivant sequentes; Se|quenz ([Aufeinander]folge, Reihe; kirchl. Chorlied; Wiederholung einer musikal. Figur auf verschiedenen Tonstufen; kleinere filmische Handlungseinheit; Serie aufeinanderfolgender Karten) *w*; -, -en

¹Se|que|ster *lat.* (svw. Sequestration; abgestorbenes Knochenstück) *s*; -s, -; ²Se|que|ster ([Zwangs]verwalter) *m*; -s, -; Se|que|stra|ti|on [...*zion*] (Beschlagnahme; [Zwangs]verwaltung); se|que|strie|ren

Se|quo|ie *indian.* [...*jᵉ*] (ein Nadelbaum, Mammutbaum) *w*; -, -n

Se|ra (*Mehrz.* von: Serum)

Sé|rac *fr.* [*ße̱rak*] (Geogr.: Eisbruch od. Gletschersturz durch größeren Gefällsknick) *m*; -s, -s

Se|ra|fim (ökum. für: Seraphim) *Mehrz.*; vgl. Seraph

¹Se|rail *pers.* [...*ra̱j*, auch: ...*ra̱i̱l*] (Wolltuch) *m*; -s, -s; ²Se|rail (,,Haus'', ,,Palast'' [des Sultans]; fürstliches Schloß) *s*; -s, -s

Se|ra|pei|on *ägypt.-gr.* (svw. Serapeum) *s*; -s, ...eia; Se|ra|pe|um (Serapistempel) *s*; -s, ...peen

Se|raph *hebr.* ([Licht]engel des A. T.) *m*; -s, -e u. -im; vgl. Serafim; Se|ra|phi|ne (w. Vorn.); Se|ra|phi|nen|or|den; se|ra|phisch (zu den Engeln gehörend, engelgleich; verzückt)

Se|ra|pis (altägypt. Gott)

Ser|be (Angehöriger eines südslaw. Volkes) *m*; -n, -n (↑ R 268)

ser|beln (schweiz. neben: kränkeln, welken); ich ...[e]le (↑ R 327)

Ser|bi|en [...*i̱ᵉn*] (Gliedstaat Jugoslawiens); Ser|bin *w*; -, -nen; ser|bisch

ser|bo|kro|a|tisch (↑ R 215); Ser|bo|kro|a|tisch (Sprache) *s*; -[s]; vgl. Deutsch; Ser|bo|kro|a|ti|sche *s*; -n; vgl. Deutsche *s*

Se|ren (*Mehrz.* von: Serum)

Se|re|na|de *fr.* (Abendmusik, -ständchen)

Se|re|nis|si|mus *lat.* (Durchlaucht; meist scherzh. für: Fürst eines Kleinstaates) *m*; -, ...mi; Se|re|ni|tät (Heiterkeit)

Serge, Sersche *fr.* [*ßärsch*] (ein Gewebe) *w* (österr. auch: *m*); -, -n

Ser|geant *fr.* (-*engl.*) [*ßärsche̱ant*, engl. Ausspr.: *ßą̈dsche̱ⁿt*] (Unteroffizier[sdienstgrad]) *m*; -en, -en (bei engl. Ausspr.: *m*; -s, -s); ↑ R 268

Ser|gi|us (m. Vorn.)

Se|rie *lat.* [...*i̱ᵉ*] (Reihe; Folge; Gruppe gleichartiger Dinge) *w*; -, -n; se|ri|ell (serienmäßig; in Reihen, Serien; von einer Sonderform der Zwölftonmusik: eine Reihentechnik verwendend, die vorgegebene, konstruierte Tonreihen zugrunde legt); -e Musik; Se|ri|en.an|fer|ti|gung, ...bau (Reihenherstellung; in Reihenherstellung gebautes Haus; *Mehrz.* ...bauten), ...bild, ...fa|bri|ka|ti|on, ...fer|ti|gung, ...her|stel|lung, ...kal|ku|la|ti|on; se|ri|en|mä|ßig; Se|ri|en.pro|duk|ti|on, ...schal|ten, ...schal|tung (Reihung, Reihenschaltung), ...tä|ter (Kriminalistik); se|ri|en|wei|se

Se|ri|fe *engl.* (kleiner Abschlußstrich am Kopf u. Fuß der Buchstaben) *w*; -, -n (meist *Mehrz.*); se|ri|fen|los

Se|ri|gra|phie *gr.* (Siebdruck) *w*; -

se|ri|ös *fr.* (ernsthaft, gediegen, anständig); -este (↑ R 292); ein -er Bewerber; Se|rio|si|tät *w*; -

Ser|mon *lat.* (veralt. für: Rede; heute meist: langweiliges Geschwätz; [Straf]predigt) *m*; -s, -e

Se|ro|dia|gno|stik *lat.*; *gr.* (Med.: Erkennen einer Krankheit durch Untersuchung des Serums); Se|ro|lo|gie (Lehre vom Blutserum) *w*; -; se|ro|lo|gisch; se|rös *lat.* (aus Serum bestehend; Serum absondernd); -e Häute

Ser|pel *lat.* (röhrenbewohnender Borstenwurm) *w*; -, -n; Ser|pen|tin (ein Mineral, Schmuckstein) *m*; -s, -e; Ser|pen|ti|ne ([in] Schlangenlinie [ansteigender Weg an Berghängen]; Windung, Kehre, Kehrschleife) *w*; -, -n; Ser|pen|ti|nen|stra|ße; Ser|pen|tin|ge|stein

Ser|ra|del|la, Ser|ra|del|le *port.* (eine Futterpflanze) *w*; -, ...llen

Sersche [*ßärsch*] vgl. Serge

Se|rum *lat.* (wäßriger Bestandteil des Blutes; Impfstoff) *s*; -s, ...ren u. ...ra; Se|rum.be|hand|lung, ...kon|ser|ve, ...krank|heit

Ser|val *fr.* [...*wal*] (ein Raubtier) *m*; -s, -e u. -s

Ser|van|te *fr.* [...*wą̈ntᵉ*] (veralt. für: Anrichte; Nebentisch; Glasschränkchen für Nippsachen) *w*; -, -n

Ser|va|ti|us [...*wa̱ziuß*], Ser|vaz [...*wa̱z*] (ein Heiliger)

Ser|ve|la *fr.* mdal. (Zervelatwurst; schweiz. neben: Cervelat) *w* od. *m*; -, -s (schweiz.: -); Ser|ve|lat|wurst vgl. Zervelatwurst

¹Ser|vice *fr.* [...*wi̱ß*] ([Tafel]geschirr) *s*; -[...*wi̱ß*] u. -s [...*wi̱ß*/*ß*]; -[...*wi̱ß* od. ...*wi̱ßᵉ*]; ²Ser|vice *engl.* [*ßö̱'wiß*] ([Kunden]dienst, Bedie-

nung, Kundenbetreuung, z. B.
für Autos; Tennis: Aufschlag-
[ball]) *m* od. *s*; -, -s [...*wiß* od.
...*wißis*]; **ser|vie|ren** *fr.* [...*wir*ᵉ*n*]
(bei Tisch bedienen; auftragen;
Tennis: den Ball aufschlagen; ei-
nem Mitspieler den Ball [zum
Torschuß] genau vorlegen [bes.
beim Fußball]); **Ser|vie|re|rin** *w*;
-, -nen; **Ser|vier.tisch**, ...**toch|ter**
(schweiz. für. Serviererin, Kell
nerin); **Ser|vi|et|te** (Mundtuch)
w; -, -n; **Ser|vi|et|ten|ring**
ser|vil *lat.* [...*wil*] (unterwürfig,
kriechend, knechtisch); **Ser|vi-
lis|mus** (Unterwürfigkeit, Krie-
cherei) *m*; -, ...men; **Ser|vi|li|tät**
(Unterwürfigkeit) *w*; -
Ser|vis *fr.* [...*wiß*] (veralt. für:
Dienst[leistung]) *m*; -, (veralt. für
Quartier-, Verpflegungsgeld;
Wohnungs-, Ortszulage auch
Mehrz.); **Ser|vis|ge|bühr** (veralt.),
...**klas|se** (ver-
alt. für: Ortsklasse)
Ser|vit *lat.* [...*wit*] (Angehöriger
des Bettelordens der „Diener"
[Mariä]; Abk.: OSM) *m*; -en, -en
(↑ R 268); **Ser|vi|teur** *fr.* [...*witör*]
(veralt. für: kleine Anrichte; Die-
ner, Verbeugung; Vorhemdchen)
m; -s, -e; **Ser|vi|tin** *lat.* [...*wi*...]
(„Dienerin" [Mariä]; Angehöri-
ge des weibl. Zweiges der Servi-
ten) *w*; -, -nen; **Ser|vi|ti|um**
[...*wizium*] (veralt. für: Dienst-
barkeit; Sklaverei) *s*; -s, ...ien
[...*i*ᵉ*n*]; **Ser|vi|tut** [...*wi*...] (Dienst-
barkeit, Grundlast) *s*; -[e]s, -e
(schweiz. u. österr. noch häufig:
w; -, -en); **Ser|vo.bremse** [...*wo*...],
...**ge|rät** (Technik: Hilfsgerät),
...**len|kung**, ...**mo|tor**, ...**prin|zip**
(Steuerung durch Hilfskraftma-
schine; *s*; -s); **Ser|vus!** [...*wuß*]
(„[Ihr] Diener"; österr. Gruß)
Ser|we|la (Nebenform von: Serve-
la)
Se|sam *semit.* (eine Ölpflanze) *m*;
-s, -s; Sesam, öffne dich! (Zauber-
formel zur Schatzgewinnung);
Se|sam.bein (Knochen), ...**ku-
chen**, ...**öl** (*s*; -[e]s), ...**pflan|ze**
Se|schel|len vgl. Seychellen
Se|sel *gr.* (eine Heil- u. Gewürz-
pflanze, Bergfenchel) *m*; -s, -
Ses|sel (Stuhl mit Armlehnen;
österr.: einfacher Stuhl) *m*; -s, -;
Ses|sel.leh|ne, ...**lift**
seß|haft; **Seß|haf|tig|keit** *w*; -
Ses|si|on *lat.* (Sitzung[szeit, Sit-
zungsdauer])
Se|ster *lat.* (altes Hohlmaß) *m*;
-s, -
Se|sterz *lat.* (altröm. Münze) *m*;
-es, -e; **Se|ster|zi|um** (1000 Sester-
ze) *s*; -s, ...ien [...*i*ᵉ*n*]
Se|sti|ne *it.* (eine Lied- u. Stro-
phenform) *w*; -, -n

¹**Set** vgl. Seth
²**Set** *engl.* (Satz [= Zusammen-
gehöriges]) *s* od. *m*; -[s], -s; ³**Set**
(Bez. der Dicktenheit bei den
Monotypeschriften) *s*; -[s]; **Sets**
[zu: ²Set] (kleine Tischservietten
an Stelle einer Tischdecke)
Mehrz.
Seth, (ökum.:) **Set** (bibl. m. Ei-
genn.); **Se|thit** (Abkömmling von
Seth) *m*; -en, -en (↑ R 268)
Set|ter *engl.* (Hund einer bestimm-
ten Rasse) *m*; -s, -
Setz.ar|beit (Bergmannsspr.: nas-
se Aufbereitung), ...**ei**; **set|zen**
(Jägerspr. auch: gebären [von
Hasen u. einigem Hochwild]); du
setzt (setzest); sich ...; **Setz|er**
(Schriftsetzer); **Set|ze|rei**; **Setz-
er.lehr|ling**, ...**saal**; **Setz.feh|ler**
(Druckw.), ...**gut** (Landw.; *s*;
-[e]s), ...**ham|mer** (ein Schmiede-
hammer), ...**ha|se** (Jägerspr.),
...**holz** (Gartengerät), ...**ka|sten**
(Gärtnerei), ...**kopf** (Nietkopf),
...**lat|te** (Richtscheit); **Setz-
ling** (junge Pflanze zum Ver-
setzen; Zuchtfisch); **Setz-
.li|nie** (Druckw.), ...**ma|schi|ne**
(Druckw.), ...**mei|ßel** (Schmiede-
werkzeug), ...**re|gal** (Druckw.),
...**stück** (Theater); **Setz|zung**; **Setz-
.waa|ge**, ...**zwie|bel**
Seu|che *w*; -, -n; **Seu|chen.be-
kämp|fung**, ...**ge|fahr**; **seu|chen-
haft**; **Seu|chen|herd**
seuf|zen; du seufzt (seufzest); **Seuf-
zer**; **Seuf|zer|brücke** [*Trenn.*:
...**brük|ke**] (in Venedig) *w*; -
Se|ve|rin, **Se|ve|ri|nus** [...*we*...,
österr.: *sewerin*] (m. Vorn.)
Se|ve|rus [...*we*...] (röm. Kaiser)
Se|vil|la [*sewilja*] (span. Stadt)
Sèvres [*sävr*] (Vorort von Paris);
Sèvres|por|zel|lan (↑ R 201)
Se|wa|sto|pol [russ. Aussspr.:
...*ßtopol*] (russ. Stadt auf der
Krim)
Sex *engl.* (Geschlecht; Erotik;
Sex-Appeal) *m*; -[es]
Se|xa|ge|si|ma *lat.* („sechzigster"
Tag; achter Sonntag vor Ostern)
se|xa|ge|si|mal (sechzigteilig, auf
sechzig als Grundzahl zurückge-
hend); **Se|xa|ge|si|mal|sy|stem**
(Zahlensystem, das auf der Basis
60 aufgebaut ist)
Sex-Ap|peal *engl.-amerik.* [...ᵉ*pil*]
(sexuelle Anziehungskraft) *m*; -s
Sex.bom|be (ugs. spött. für: Frau
mit starkem sexuellem Reiz
[meist von Filmdarstellerinnen]),
...**bou|ti|que**, ...**film**, ...**mes|se**; **Se-
xo|lo|ge** (Sexualforscher) *m*; -n,
-n (↑ R 268); **Se|xo|lo|gie** *w*; -
Sext *lat.* (svw. Sexte) *w*; -, -en;
Sex|ta („sechste"; erste im
Österr.: sechste) Klasse einer hö-

heren Lehranstalt) *w*; -, ...ten;
Sext|ak|kord (erste Umkehrung
des Dreiklangs mit der Terz im
Baß); **Sex|ta|ner** (Schüler der
Sexta; **Sex|ta|ne|rin** *w*; -, -nen;
Sex|tant (Winkelmeßinstru-
ment) *m*; -en, -en (↑ R 268); **Sex|te**
(sechster Ton [vom Grundton
an]) *w*; -, -n; **Sex|tett** *it.* (Musik-
stück für sechs Stimmen od. sechs
Instrumente; auch die von sechs
aufführenden) *s*; -[e]s, -e; **Sex|till|li|on**
lat. (sechste Potenz einer Mil-
lion); **Sex|to|le** (Musik: Figur
von 6 Noten gleicher Form mit
dem Zeitwert von 4 od. 8 Noten)
w; -, -n
se|xu|al *lat.* (meist nur in Zusam-
mensetzungen, seltener für: se-
xuell); **Se|xu|al.emp|fin|den**,
...**er|zie|hung**, ...**ethik**, ...**for-
scher**, ...**for|schung**, ...**hor|mon**,
...**hy|gie|ne**; **se|xua|li|sie|ren** (mit
Sexualität erfüllen); **Se|xua|li-
sie|rung**; **Se|xua|li|tät** (Ge-
schlechtlichkeit) *w*; -; **Se|xu|al-
.päd|ago|gik**, ...**pa|tho|lo|gie**,
...**psy|cho|lo|gie**, ...**trieb**, ...**ver-
bre|chen** (Sittlichkeitsverbre-
chen), **se|xu|ell** *fr.* (den Sexus be-
treffend, geschlechtlich); **Se|xus**
lat. (Geschlecht) *m*; -, -; **se|xy**
engl. (ugs. für: geschlechtsbetont,
erotisch-attraktiv)
Sey|chel|len [*ßeschäl*...] (Insel-
gruppe im Indischen Ozean)
Mehrz.; vgl. Seschellen; **Sey|chel-
len|nuß** (Frucht der Seychellen-
palme); ↑ R 201
Seyd|litz (preuß. Reitergeneral)
se|zer|nie|ren *lat.* (Med.: abtren-
nen, absondern, entfernen); **Se-
zer|nie|rung**
Se|zes|si|on *lat.* (Absonderung,
Trennung von einer [Künstler-]
gemeinschaft; Abfall der amerik.
Südstaaten); **Se|zes|sio|nist** (An-
gehöriger einer Sezession; früher
für: Angehöriger der Südstaaten
Nordamerikas); ↑ R 268; **se|zes-
sio|ni|stisch** (der Sezession ange-
hörend); **Se|zes|si|ons.krieg**
(1861–65), ...**stil** (*m*; -[e]s)
se|zie|ren *lat.* ([Leiche] öffnen,
anatomisch zerlegen); **Se|zier-
mes|ser** *s*
sf = sforzando, sforzato
SFB = Sender Freies Berlin
S-för|mig; ↑ R 149 (in der Form
eines S)
sfor|zan|do, **sfor|za|to** *it.* (Musik:
verstärkt, stark [hervorgehoben];
Abk.: sf); **Sfor|zan|do** *s*; -s, -s u.
...di u. **Sfor|za|to** *s*; -s, -s u. ...ti
sfr. (schweiz. nur:) **sFr.**; vgl. ²Fran-
ken
sfu|ma|to *it.* (bild. Kunst: duftig;
mit verschwimmenden Umrissen
[gemalt])

SG = Sportgemeinschaft

S. g. = Sehr geehrt... (österr. veralt. vor Briefanschriften)

Sgraf|fi|to *it.* (Kratzputz [Wandmalerei]) *s;* -s, -s u. ...ti

's-Gra|ven|ha|ge [*ßehraf*nhgeh*e*] (offz. niederl. Form von: Haag, Den)

sh, s = Shilling

Shag *engl.* [*schäg,* meist: *schäk*] (eine Tabaksorte) *m;* -s, -s; **Shag-_pfei|fe, ...ta|bak**

¹**Shake** *engl.* [*sche'k*] (ein Mischgetränk) *m;* -s, -s; ²**Shake** (ein bestimmter Rhythmus im Jazz) *s;* -s, -s; **Shake|hands** [*sche'khänds*] (Händedruck, Händeschütteln) *s;* -, - (meist *Mehrz.*); **Sha|ker** [*she'k*e*r*] (Mixbecher) *m;* -s, -

Shake|speare [*schekßpir*] (engl. Dichter); **shake|spea|resch, shake|spea|risch** (nach Art von Shakespeare); -e Lebensnähe, aber (↑R 179): **Shake|spea|resch, Shake|spea|risch;** -e Dramen, Sonette (Dramen, Sonette von Shakespeare)

Sham|poo usw. *Hindi-engl.* [*schämpu*] vgl. Schampun usw.; **Sham|poon** usw. [*schämpun,* österr. meist: *schampon*] vgl. Schampun usw.

Shang|hai vgl. Schanghai

Shan|non [*schän*e*n*] (irländ. Fluß) *m;* -[s]

Shan|ty *engl.* [*schänti,* auch: *schanti*] (Seemannslied) *s;* -s, -s u. ...ties [*schäntis*]

Sha|ping|ma|schi|ne *engl.; gr.* [*sche'p...*] (Metallhobelmaschine, Schnellhobler)

Share *engl.* [*schä'*] (engl. Bez. für: Aktie) *m;* -s, -s

Shaw [*schå*] (ir.-engl. Dichter)

Shed|bau usw. vgl. Schedbau usw.

Shef|field [*schäfild*] (engl. Stadt)

Shell Ⓦ [*schäl*] (ein Kraftstoff) *s;* -s

She|riff *engl.* [*schä...*] (höchster Vollzugsbeamter in England u. in den USA [in den USA auch mit richterl. Befugnissen]) *m;* -s, -s

Sher|lock Holmes [*schörlok ho*e*ms*] (engl. Romanfigur [Detektiv])

Sher|pa *tibet.-engl.* [*sch...*] (Angehöriger eines thebet. Volksstammes, der als Lastträger bei Expeditionen im Himalajagebiet dient; daher auch: Lastträger) *m;* -s, -s

Sher|ry *engl.* [*schäri*] (span. Wein, Jerez) *m;* -s, -s

Shet|land [*schätlant,* engl. Ausspr.: *schätl*e*nd;* nach dem schott. Inseln] (ein graumelierter Wollstoff) *m;* -[s], -s; **Shet|land_in|seln** (Inselgruppe nordöstl. von Schottland; *Mehrz.*), ...po|ny, ...wol|le (↑R 201)

Shil|ling *engl.* [*schil...*] (Münzeinheit in Großbritannien u. a.; 20 Shilling = 1 Pfund Sterling; Abk.: s od. sh) *m;* -s, -s; 10 - (↑R 322); vgl. aber: Schilling

Shit *engl.* [*schit*] (ugs. für: Haschisch) *s;* -s

shocking [Trenn.: shok|king] *engl.* [*schok...*] (anstößig; peinlich)

Shod|dy *engl.* [*schodi*] (Reißwolle [aus Trikotagen]) *s* (auch: *m*); -s, -

Shop *engl.* [*schop*] (Laden, Geschäft) *m;* -s, -s; **Shop|ping-Center** [*schopingßänt*e*r*] („Einkaufszentrum") *s;* -s, -

Shorts *engl.* [*schå'z*] („kurze" Hose) *Mehrz.;* **Short sto|ry** [*schå't ßtåri*] (angelsächs. Bez. für: Kurzgeschichte u. Novelle) *w;* - -, - stories

Show *engl.* [*scho"*] (Schau, Darbietung, Vorführung; buntes, aufwendiges Unterhaltungsprogramm) *w;* -, -s; **Show|busi|neß** [*scho"bisniß*] („Schaugeschäft", Vergnügungsindustrie) *s;* -; **Show|ge|schäft** [*scho"...*]; **Show-man** [*scho"m*e*n*] (im Showgeschäft Tätiger; geschickter Propagandist) *m;* -s, ...men; **Show-ma|ster** *anglisierend* [*scho"...*] (Unterhaltungskünstler, der eine Show präsentiert)

Shred|der *engl.* [*schr...*] (Autoreißwolf) *m;* -s, -

Shrimps *engl.* [*schr...*] (konservierte Krabben) *Mehrz.*

Shunt *engl.* [*schant*] (elektr. Nebenschlußwiderstand) *m;* -s, -s

Shy|lock [*schai...*] [nach der Figur in Shakespeares „Kaufmann von Venedig"] (hartherziger Geldverleiher; mitleidloser Gläubiger) *m;* -[s], -s

Si = chem. Zeichen für: Silizium

SIA = Schweizerischer Ingenieur- und Architektenverein

Si|al (Geol.: oberer Teil der Erdkruste) *s;* -[s]

Si|am (alter Name von Thailand); **Sia|me|se** *m;* -n, -n (↑R 268); **Sia-me|sin** *w;* -, -nen; **sia|me|sisch;** -e Zwillinge; **Sia|mo|sen** (Schürzenstoffe) *Mehrz.*

Si|bi|lant *lat.* (Sprachw.: Zischlaut, Reibelaut, z. B. s) *m;* -en, -en (↑R 268)

Si|bi|ri|en [*...i*e*n*]; **Si|bi|ri|er** [*...i*e*r*]; **si|bi|risch**

Si|biu (rumän. Name für: Hermannstadt)

Si|byl|la, ¹Si|byl|le [*...bi...*] (w. Vorn.); ²**Si|byl|le** *gr.* (weissagende Frau, Wahrsagerin) *w;* -, -n; **si|byl|li|nisch** (wahrsagerisch; geheimnisvoll), aber (↑R 179): **Si-byl|li|nisch;** die Sibyllinischen Bücher (Bücher der Sibylle von Cumae [*kymä*])

sic! *lat.* [*sik* od. *sik*] (so!, wirklich so!)

sich; Sich|aus|lau|fen (↑R 120) *s;* -s; **Sich|aus|wei|nen** (↑R 120) *s;* -s

Si|chel *w;* -, -n; **si|chel|för|mig; si|cheln** (mit der Sichel abschneiden, mähen); ich ...[e]le (↑R 327); **Si|chel|wa|gen** (früherer Streitwagen)

si|cher; ein sicheres Geleit; sichere Quelle; (↑R 133:) im sichern (geborgen) sein; - sein; (↑R 134:) es ist das sicherste, am sichersten (ganz sicher), wenn ...; (↑R 116:) es ist das Sicherste, was du tun kannst; wir suchen etwas Sicheres; auf Nummer Sicher sein (ugs. für: im Gefängnis sein); auf Nummer Sicher gehen (ugs. für: nichts wagen). **I.** *Schreibung in Verbindung mit Zeitwörtern* (↑R 139): **a)** *Getrenntschreibung in ur*sprünglicher Bedeutung, z. B. sicher sein, werden, gehen; über diese Brücke ist er sicher gegangen; sich sicher fühlen; **b)** *Zusammenschreibung,* wenn durch die Verbindung ein neuer Begriff entsteht; vgl. sichergehen, sicherstellen. **II.** *Schreibung in Verbindung mit einem Mittelwort* (↑R 142); vgl. sicherwirkend; **si|cher-ge|hen;** ↑R 139 (Gewißheit haben); ich gehe sicher; sicher-gegangen; sicherzugehen; aber: **si|cher ge|hen** (ohne Gefahr od. Schwanken gehen); **Si|cher|heit; Si|cher|heits_ab|stand, ...au|to, ...be|hör|de, ...bin|dung, ...fach** (für: Safe), **...glas** (*Mehrz.* ...gläser), **...gurt; si|cher|heits|hal|ber; Si|cher|heits_ket|te, ...lam|pe, ...lei|stung** (Wirtsch.), **...maß-nah|me, ...nach|laß** (Wirtsch.), **...na|del, ...rat** (eine UNO-Behörde; *m;* -[e]s), **...schloß, ...schlüs-sel, ...schwel|le** (Statistik), **...ven-til, ...ver|schluß, ...vor|keh|rung; si|cher|lich; si|chern;** ich ...ere (↑R 327); **si|cher|stel|len;** ↑R 139 (sichern; feststellen; in polizeil. Gewahrsam geben od. nehmen); das Motorrad wurde sichergestellt; aber: **si|cher stel|len** (an einen sicheren Ort stellen); **Si|cher|stel-lung; Si|che|rung; Si|che-rungs_ab|tre|tung** (Wirtsch.), **...ge|ber** (Wirtsch.), **...grund-schuld** (Rechtsw.), **...hy|po-thek** (Rechtsw.), **...neh|mer** (Wirtsch.), **...schein** (Wirtsch.), **...über|eig|nung** (Rechtsw.), **...ver|wah|rung** (Rechtsw.); **si|cher|wir|kend;** (↑R 296:) sicherer, am sichersten wirkend; ein -es Mittel, aber (↑R 142:) ein ganz sicher wirkendes Mittel

sich|ge|hen|las|sen (↑ R 120) s; -s
sich|ler (ein Vogel)
sicht w; -; auf, bei – (Kaufmanns-
spr. auch für: a vista); nach –
(Kaufmannsspr.); auf lange -;
außer, in - kommen, sein; sicht-
bar; Sicht|bar|keit w; -; sicht|bar|-
lich (veralt.); Sicht|bar|wer|den
(↑ R 120) s; -s
sicht|ein|la|ge (Bankw.)
sich|ten (auswählen, ausschei-
den)
sich|ten (erblicken); Sicht|gren|ze
(auch für: Horizont); sich|tig
(Seemannsspr.: klar); -es Wetter;
Sich|tig|keit (veralt.) w; -; Sicht-
kar|te (Zeitkarte im Personen-
verkehr); sicht|lich (offenkundig)
sicht|ma|schi|ne (für: Sortierma-
schine); ¹Sich|tung (Ausschei-
dung)
²Sich|tung (das Erblicken); Sicht-
·ver|hält|nis|se (Mehrz.), ...ver-
merk; sicht|ver|merk|frei; Sicht-
·wech|sel, ...wei|te, ...wer|bung
Sicke¹ (Technik: rinnenförmige
Biegung, Kehlung; Randverzie-
rung, -versteifung) w; -, -n
Sicke¹, Sio|ke (Jägerspr.: Vogel-
weibchen) w; -, -n
icken¹ (mit 'Sicken versehen); ge-
sickt; Sicken|ma|schi|ne¹ (Tech-
nik)
icker¹·gra|ben, ...gru|be; sik-
kern; das Wasser sickert; Sicker-
was|ser¹
ic tran|sit glo|ria mun|di! lat. (so
vergeht die Herrlichkeit der
Welt!)
id|dhar|tha sanskr. [sidárta]
(weltl. Name Buddhas)
ide|board engl. [ßaidbå'd] (An-
richte, Büfett) s; -s, -s
ide|risch lat. (auf die Sterne be-
züglich; Stern...); siderisches
Jahr (Sternenjahr), aber (↑ R
224): das Siderische Pendel
i|de|rit gr. (gelbbraunes Eisen-
erz) m; -s, -e; Si|de|ro|lith (Ei-
sensteinmeteorit) m; -s u. -en,
-e[n] (↑ R 268); Si|de|ro|lith|wa-
ren gr.; dt. (veralt. für: lackierte
Tonwaren) Mehrz.
i|don (phöniz. Stadt); Si|do|nia,
Si|do|nie [...iᵉ] (w. Vorn.); Si|do-
ni|er [...iᵉr] (Bewohner von Si-
don); si|do|nisch; Si|do|ni|us (m.
Eigenn.)
ie; - kommt, - kommen; ¹Sie; ↑ R
122 (veralt. Anrede an eine Per-
son weibl. Geschlechts:) höre
Sie!; ↑ R 122 (Höflichkeitsanrede
an eine Person od. mehrere Per-
sonen gleich welchen Ge-
schlechts:) kommen Sie bitte!;
mdn. mit Sie anreden; (↑ R 117:)
das steife Sie; ²Sie (ugs. für:

Trenn.: ...ik|k...

Mensch od. Tier weibl. Ge-
schlechts) w; -, -s; es ist eine Sie;
ein Er u. eine Sie saßen dort
Sieb s; -[e]s, -e; sieb|ar|tig; Sieb-
bein; Sieb|druck (Druckw.: Scha-
blonierverfahren) m; -[e]s; vgl.
Serigraphie; ¹sie|ben (durchsie-
ben)
²sie|ben (Ziffer, Zahl); I. Klein-
schreibung (↑ R 135): wir sind zu
sieben od. zu siebt (älter: siebent),
wir sind sieben; er kommt mit
sieben[en]; die sieben Sakramen-
te; die sieben Todsünden; die sie-
ben Bitten des Vaterunsers; ein
Buch mit sieben Siegeln (ein un-
verständliches Buch); die sieben
fetten u. die sieben mageren Jah-
re; die sieben Wochentage; sieben
auf einen Streich; um sieben Ek-
ken (ugs. für: weitläufig) mit
jmdm. verwandt sein. II. Groß-
schreibung: a) (↑ R 118:) der Zug
der Sieben gegen Theben; b) (↑ R
224:) die Sieben Raben (Mär-
chen); die Sieben Schwaben
(Märchen); die Sieben Freien
Künste; die Sieben Weltwunder;
die Sieben Weisen; vgl. acht; Sie-
ben (Zahl) w; -, - (auch: -en); eine
böse -; vgl. ¹Acht; sie|ben|ar|mig;
-er Leuchter; Sie|ben|bür|gen
(hist. Gebiet in Rumänien); Sie-
ben|bür|ger (↑ R 199); sie|ben|bür-
gisch; Sie|ben|eck; sie|ben|eckig
[Trenn.: ...ek|kig]; sie|ben|ein-
halb, sie|ben|und|ein|halb; Sie-
be|ner; vgl. Achter; sie|be|ner|lei;
auf - Art; sie|ben|fach; Sie|ben|fa-
che s; -n; vgl. Achtfache; Sie|ben-
ge|bir|ge s; -s; Sie|ben|ge|stirn
(Sterngruppe) s; -[e]s; sie|ben-
hun|dert; vgl. hundert; sie|ben-
jäh|rig, aber (↑ R 224:) der Sie-
benjährige Krieg; sie|ben|köp|fig;
ein -es Gremium; Sie|ben|ling;
sie|ben|mal; vgl. achtmal; sie|ben-
ma|lig; Sie|ben|mei|len|stie|fel
Mehrz.; Sie|ben|mo|nats|kind;
Sie|ben|sa|chen (ugs. für: Habse-
ligkeiten; auch: kleines Gepäck)
Mehrz.; seine - packen; Sie|ben-
·schlä|fer (Nagetier; in der
Mehrz. auch: Heilige), ...schritt
(ein Volkstanz; m; -[e]s); Sie|ben-
stel|lig; Sie|ben|stern (eine Pflan-
zengattung; vgl. ²Siebent; Sie|bent
(älter für: siebt); Sie|ben|tau|send;
vgl. tausend; sie|ben|te vgl. sieb-
te; sie|ben|tel vgl. siebtel; Sie|ben-
tel vgl. Siebtel; sie|ben|tens vgl.
siebtens; sie|ben|und|ein|halb,
sie|ben|ein|halb; sie|ben|und-
sieb|zig; sie|ben|und|sieb|zig|mal;
vgl. acht; Sie|ben|zahl w; -
sieb|för|mig; Sieb·ma|cher, ...ma-
schi|ne, ...mehl, ...röh|re (Bot.),
...schal|tung (Elektrotechnik)
siebt; vgl. ²sieben; sieb|te; vgl. ach-

te; sieb|tel; vgl. achtel; Sieb|tel
s (schweiz. meist. m); -s, -; sieb-
tens, (auch:) sieb|ten|tens; sieb-
zehn; vgl. acht; sieb|zehn|te; (↑ R
224:) Siebzehnter (17.) Juni (Tag
des Gedenkens an den 17. Juni
1953, den Tag des Aufstandes in
der DDR); vgl. achte; Sieb|zehn
und vier (ein Kartenglücksspiel)
s; - - -; sieb|zig; vgl. achtzig;
sieb|zig|jäh|rig; vgl. achtjährig
siech (veralt.); Siech|bett (veralt.);
sie|chen (siech sein); Sie|chen-
haus (veralt.); Siech|heit (veralt.)
w; -; Siech|tum s; -s
Sie|de landsch. (eingesottenes
Viehfutter; Spreu, Häcksel) w; -;
sie|de|heiß; Sie|de|hit|ze
sie|deln; ich ...[e]le (↑ R 327)
sie|den; du sottest u. siedetest; du
söttest u. siedetest; gesotten u.
gesiedet; sied[e]!; siedend heiß;
Sie|de|punkt; Sie|der; Sie|de|rei;
Sie|de|tren|nung (für: fraktio-
nierte Destillation); Sied|fleisch
südd., schweiz. (Suppenfleisch)
Sied|ler; Sied|ler·frau, ...haus;
Sied|lung; Sied|lungs·bau (meist
Mehrz....bauten), ...ein|heit (Sta-
tistik), ...form, ...ge|biet, ...geo-
gra|phie, ...haus, ...kun|de (w; -),
...po|li|tik, ...pro|gramm, ...werk
(s; -[e]s), ...we|sen (s; -s)
¹Sieg m; -[e]s, -e
²Sieg (r. Nebenfluß des Rheins)
w; -
Sie|gel lat. (Stempelabdruck;
[Brief]verschluß, Bekräftigung)
s; -s, -; Sie|gel|be|wah|rer; Sie|ge-
ler, Sieg|ler; Sie|gel|lack; sie|geln;
ich ...[e]le (↑ R 327); Sie|gel|ring;
Sie|ge|lung, Sieg|lung
sie|gen; Sie|ger; Sie|ger|eh|rung;
Sie|ge|rin w; -, -nen; Sie|ger-
kranz, Sie|ges|kranz
Sie|ger|land (Landschaft) s; -[e]s;
Sie|ger|län|der; sie|ger|län|disch
sie|ges·bot-
schaft, ...fei|er; sie|ges|froh; Sie-
ges·ge|schrei; sie|ges|ge|wiß; Sie-
ges·ge|wiß|heit, ...göt|tin; Sie-
ges·kranz, Sie|ger|kranz; Sie|ges-
·lauf (m; -[e]s), ...preis (vgl.
²Preis), ...säu|le, ...se|rie; sie|ges-
·si|cher, ...trun|ken; Sie|ges|zug
Sieg|fried (germ. Sagengestalt; m.
Vorn.); (↑ R 224:) Sieg -
sieg·ge|krönt, ...ge|wohnt; sieg-
haft
Sieg|hard (m. Vorn.)
Sieg|ler vgl. Siegeler
Sieg|lind, Sieg|lin|de (w. Vorn.)
sieg|los
Sieg|lung, Sie|ge|lung
Sieg|mund, Si|gis|mund (m.
Vorn.)
sieg|reich
Sieg|wurz (eine Pflanzengattung,
Gladiole)

sie|he! (Abk.: s.); - da!; sie|he dies!
(Abk.: s. d.); sie|he oben! (Abk.:
s. o.); sie|he un|ten! (Abk.: s. u.)
Sie|ke vgl. ²Sicke
Siel (Röhrenleitung für Abwässer;
kleine Deichschleuse) m od. s;
-[e]s, -e
Sie|le (Riemen[werk der Zugtie-
re]) w; -, -n (meist Mehrz.); in
den -n sterben
sie|len, sich (mdal. für: sich suhlen;
auch: sich wälzen; sich rekeln)
Sie|len|ge|schirr; Sie|len|zeug,
Siel|zeug
¹Sie|mens (Familienn.; ⓦ); ²Sie-
mens (elektr. Leitwert; Zeichen:
S) s; -, -; Sie|mens-Mar|tin-Ofen;
↑R 182 (zur Stahlerzeugung;
Abk.: SM-Ofen); Sie|mens|ofen
(↑R 180); Sie|mens|stadt (Stadt-
teil von Berlin)
sie|na it. (rotbraun); ein - Muster;
vgl. blau; Sie|na (it. Stadt); Sie-
na|er|de; ↑R 201 (Malerfarbe) w;
-; Sie|ne|se [si-e...] m; -n, -n (↑R
268); Sie|ne|ser (↑R 199)
Sien|kie|wicz [ßjängkjäwitsch]
(poln. Schriftsteller)
Si|er|ra span. („Säge"; Gebirgs-
kette) w; -, ...rren u. -s; Si|er|ra
Leo|ne (Staat in Afrika); Si|er|ra-
leo|ner; si|er|ra|leo|nisch; Si|er|ra
Ne|va|da [- ...wa...] („Schneege-
birge"; span. u. amerik. Gebirge)
w; - -
Sie|sta it. („sechste" Tagesstunde;
[Mittags]ruhe) w; -, ...sten u. -s
Siet|land niederd. (tiefliegendes
Marschland) s; -[e]s, ...länder;
Siet|wen|dung (Binnendeich)
sie|zen (ugs. für: mit „Sie" anre-
den; du siezt (siezest)
Sif (nord. Mythol.: Gemahlin
Thors)
Sif|flö|te fr. (hohe Orgelstimme)
Si|gel lat. s; -s, - u. Si|gle fr. [sig^el]
(festgelegtes [kurzschriftl.] Ab-
kürzungszeichen, Kürzel) w; -, -n
Sight|see|ing engl. [ßáitßjing] (Be-
sichtigung von Sehenswürdigkei-
ten) s; -
Si|gi (Koseform von: Siegfried od.
Sieglind[e])
Si|gill lat. (veralt. für: Siegel) s;
-s, -e; Si|gill|la|rie [...i^e] (fossile
Pflanzengattung) w; -, -n; si|gil-
lie|ren (veralt. für: [ver]siegeln)
Si|gis|mund vgl. Siegmund
Si|gle vgl. Sigel
Sig|ma (griech. Buchstabe: Σ, σ,
ç) s; -[s], -s
Sig|ma|rin|gen (Stadt a. d. Do-
nau); Sig|ma|rin|ger (↑R 199);
sig|ma|rin|ge|risch
sign. = signatum
Si|gna (Mehrz. von: Signum)
Si|gnal lat. [signal] (Zeichen mit
festgelegter Bedeutung; [Warn]-
zeichen; Anstoß) s; -s, -e; geben;

Si|gnal.an|la|ge, ...buch; Si|gna-
le|ment fr. [...mang, schweiz.
auch: ...mänt] ([Personen]-
beschreibung; Kennzeichnung)
s; -s, -s (schweiz. auch: -e); Si-
gnal.feu|er, ...flag|ge, ...gast
(Matrose; Mehrz. ...gasten),
...glocke [Trenn.: glok|ke], ...horn
(Mehrz. ...hörner); si|gna|li|sie-
ren (Signal, Signalement geben;
ankündigen); Si|gna|li|sie|rung;
Si|gnal.knopf, ...lam|pe, ...mast
m, ...pa|tro|ne, ...pfiff, ...reiz
(svw. Schlüsselreiz), ...ring (im
Auto), ...sy|stem, ...ver|bin|dung;
Si|gna|tar lat. (selten für: Unter-
zeichner) m; -s, -e; Si|gna|tar-
macht ([einen Vertrag] unter-
zeichnende Macht); si|gna|tum
(unterzeichnet; Abk.: sign.); Si-
gna|tur (Kurzzeichen als Auf-,
Unterschrift, Namenszug;
Künstlerzeichen; Kenn-, Bildzei-
chen; symbol. Landkartenzei-
chen; Druckw.: runde od. eckige
Einkerbung an Drucktypen;
Nummer eines Druckbogens;
[Buch]nummer in einer Biblio-
thek) w; -, -en; Si|gnet fr. [sinje,
auch dt. Ausspr.: signät] (Buch-
drucker-, Verlegerzeichen; über-
tr. für: Aushängeschild, Visiten-
karte; veralt. für: Handsiegel,
Petschaft) s; -s, -s u. (bei dt. Aus-
spr.:) -e; si|gnie|ren lat. (mit einer
Signatur versehen); si|gni|fi|kant
(bedeutsam); Si|gni|fi|kanz (Be-
deutsamkeit) w; -; si|gni|fi|zie|ren
(selten für: bezeichnen; anzeigen)
Si|gnor it. [ßinjor], Si|gno|re [ßinjo-
re] (Herr) m; -, ...ri; Si|gno|ra
(Frau) w; -, ...re [...jore] u. -s;
Si|gno|ria [...jorja], Si|gno|rie
[...jori] (die höchste [leitende] Be-
hörde der it. Stadtstaaten, bes.
der Rat in Florenz) w; -, ...jen;
Si|gno|ri|na (Fräulein) w; -, -s
(selten: ...ne); Si|gno|ri|no (junger
Herr) m; -, -s (auch: ...ni)
Si|gnum lat. („Zeichen"; Bezeich-
nung; verkürzte Unterschrift) s;
-s, ...gna
Sig|rid (w. Vorn.)
Si|grist lat. schweiz. (Küster, Mes-
ner) m; -en, -en (↑R 268); vgl.
Sakristan u. Mesmer
Sig|run (w. Vorn.)
Si|gurd (m. Vorn.)
Sikh (Angehöriger einer Reli-
gionsgemeinschaft im Pandsch-
ab) m; -[s], -s
Sik|ka|tiv lat. (Trockenmittel,
-stoff für Ölfarben) s; -s, -e [...w^e]
Sik|kim (ind. Protektorat im Hi-
malaja); Sik|ki|mer; sik|ki|misch
Si|ku|ler (Angehöriger eines anti-
ken Volkes auf Sizilien) m; -s, -
Si|la|ge vgl. Ensilage
Sil|be w; -, -n; Sil|ben.klau|ber

(ugs. abschätzig), ...maß s, ...rät-
sel, ...ste|cher (ugs. abschätzig)
...tren|nung; ...sil|ber vgl. ...silb-
ler
Sil|ber (chem. Grundstoff, Edel-
metall; Zeichen: Ag) s; -s, -; vgl.
Argentum; Sil|ber.bar|ren
...berg|werk, ...blick (dicht. für
hervorbrechender Glanz; volks-
tüml. für: Schielen), ...bro|kat
...di|stel, ...draht; sil|ber|far|ben
sil|ber|far|big; Sil|ber.fisch|che
(ein Insekt), ...fuchs, ...geld
...glanz; sil|ber.glän|zend, ...grau
...haa|rig, ...hal|tig, ...hell; Sil-
ber|hoch|zeit; sil|be|rig, silb|rig
Sil|ber.kor|del, ...le|gie|rung; Sil
ber|ling (alte Silbermünze); Sil
ber.lö|we (Puma), ...me|dail|le
...mö|we, ...mün|ze; sil|bern (au
Silber); -e Hochzeit, aber (↑R
224): Silberner Sonntag; Sil-
bernes Lorbeerblatt (Auszeich-
nung für besondere Sportleistun-
gen); Sil|ber.pa|pier, ...pap|pel,
...schmied, ...stift (Zeichenwerk
zeug), ...strei|fen (in: Silberstrei
fen am Horizont [Zeichen begin
nender Besserung], ...strich
(Schmetterling), ...tan|ne, ...wäh
rung; sil|ber|weiß; Sil|ber|zeu
(ugs. für: Silberbesteck, -gerät
...sil|big (z. B. dreisilbig); sil|bisch
(eine Silbe bildend); ...silb|ler
...sil|ber (z. B. Zweisilber, -silb
silb|rig, sil|be|rig
Sild skand. ([eingelegter] Fisch) m
-s, -[e]
Si|len gr. (dickbäuchiger Pferde
mensch der gr. Sage, als ältere
Satyr Erzieher des Dionysos) m
-s, -e; Si|le|nos; vgl. Silen
Si|len|ti|um! lat. [...zium] (Ruhe!
Sil|ge gr. (Name verschiedene
Pflanzen) w; -, -n
Sil|hou|et|te fr. [siluät^e] (Schatten
riß, -bild, Scherenschnitt) w; -
-n; sil|hou|et|tie|ren (im Schat
tenriß zeichnen od. schneiden)
Si|li|cat [...kat] vgl. Silikat; Si|li|ci
um lat. [...zium] (chem. Grund
stoff, Nichtmetall; Zeichen: Si
s; -s; Si|li|fi|ka|ti|on [...zion] (Ver
kieselung); si|li|fi|zie|ren; si|li
kat, (fachspr.:) si|li|cat (Salz de
Kieselsäure) s; -[e]s, -e; Si|li|ko|ne
(Kunststoffe von großer Wärme
u. Wasserbeständigkeit) Mehrz
Si|li|ko|se (Med.: Steinstaub
lunge) w; -, -n
Sil|ke (w. Vorn.)
Si|lo span. (Großspeicher [für Ge
treide, Erz u. a.]; Gärfutterbehäl
ter) m (auch: s); -s, -s; Si|lo.fut|te
(vgl. ¹Futter), ...turm, ...wa|gen
...zel|le

Sils (Name mehrerer Dörfer in der Schweiz)

Si|lu|min Ⓦ (Leichtmetallegierung aus Aluminium u. Silicium) s; -[s]

Si|lur (Geol.: eine Formation des Paläozoikums) s; -s; Si|lu|rer (Angehöriger eines vorkelt. Volksstammes in Wales); si|lu|risch (das Silur betreffend)

Sil|van, Sil|va|nus [...wu...] (m. Vorn.)

Sil|va|ner [...wa...] (eine Rebensorte)

¹Sil|ve|ster [...wä...] (m. Vorn.); ²Sil|ve|ster [nach dem Fest des Papstes Silvester I. am 31. Dezember] (letzter Tag im Jahr) s; -s, -; Sil|ve|ster_abend, ...ball, ...fei|er, ...nacht

Sil|via [...wia] (w. Vorn.)

Sil|vret|ta, Sil|vret|ta|grup|pe [...wr...] (Gebirgsgruppe der Zentralalpen) w; -; Sil|vret|ta-Hoch|al|pen|stra|ße (↑ R 202) w; -

¹Si|ma gr. (Traufrinne antiker Tempel) w; -, -s u. ...men

²Si|ma nlat. (Geol.: unterer Teil der Erdkruste) s; -[s]

Si|mandl [eigtl.: Mann, der durch eine Frau, eine „Sie" beherrscht wird] bayr. u. österr. ugs. (Pantoffelheld) m od. s; -s, -

Si|mar|re it. (langer Männermantel im Italien des 16. Jh.s; veralt. für: Schleppkleid) w; -, -n

Sim|ca ® [simka, fr. Ausspr.: ßimka; = Société industrielle de mécanique et carrosserie automobile] (fr. Kraftfahrzeugmarke)

Si|me|on (bibl. m. Eigenn. u. Vorn.); Si|me|ons_kraut (s; -[e]s), ...tag

Si|mi|li|stein lat.; dt. (unechter [Edel]stein)

Si|men|tal (schweiz. Landschaft); Si|men|ta|ler (↑ R 199); - Vieh

Sim|mer (altes Getreidemaß) s; -s,

Sim|mer|ring (Antriebswellendichtung)

Si|mon (Apostel; m. Vorn.)

Si|mo|ni|des (gr. Lyriker)

Si|mo|nie [nach dem Zauberer Simon] (Kauf od. Verkauf von geistl. Ämtern) w; -, ...ien; si|mo|nisch (↑ R 179) (nach Art Simons)

sim|pel fr. (einfach, einfältig); simple Leute; Sim|pel mdal. (Dummkopf, Einfaltspinsel) m; -s, -; sim|pel|haft; sim|peln mdal. (unvernünftig, töricht reden; stieren); ich ...[e]le (↑ R 327); vor sich hin -

Sim|perl österr. mdal. (flacher geflochtener [Brot]korb) s; -s, -n

Sim|pla (Mehrz. von: Simplum)

Sim|plex lat. (einfaches, nicht zusammengesetztes Wort) s; -, -e u. ...ple|zia; Sim|pli|cis|si|mus, (eingedeutscht:) Sim|pli|zis|si|mus nlat. („Einfältigster"; Titel-[held] eines Romans von Grimmelshausen; pol.-satir. Wochenschrift) m; -; sim|pli|ci|ter lat. [...zi...] (veralt. für: schlechthin); Sim|pli|fi|ka|ti|on [...zion] (seltener für: Simplifizierung; sim|pli|fi|zie|ren (in einfacher Weise darstellen; [stark] vereinfachen); Sim|pli|fi|zie|rung (Vereinfachung); Sim|pli|zia (Mehrz. von: Simplex); Sim|pli|zia|de (Abenteuerroman um einen einfältigen Menschen, in Nachahmung des „Simplicissimus" von Grimmelshausen) w; -, -n; Sim|pli|zis|si|mus vgl. Simplicissimus; Sim|pli|zi|tät (Einfachheit; Einfalt) w; -

Sim|plon m; -[s], (auch:) Sim|plon|paß (↑ R 201) m; ...passes; Sim|plon_stra|ße (↑ R 201; w; -), ...tun|nel (↑ R 201; m; -s)

Sim|plum lat. (Wirtsch.: einfacher Steuersatz) s; -s, ...pla

Sim|rock (dt. Germanist, Dichter u. Schriftsteller)

Sims (bandartige Bauform; vorspringender Rand; Leiste) m od. s; -es, -e

Sim|se (eine Pflanze, mdal. für: Binse) w; -, -n

Sims|ho|bel

Sim|son (bibl. m. Eigenn.)

Si|mu|lant lat. ([Krankheits]heuchler) m; -en, -en (↑ R 268); Si|mu|la|ti|on [...zion] (Verstellung, Vortäuschung [von Krankheiten]; Nachahmung im Simulator o. ä.); Si|mu|la|ti|ons|an|la|ge; Si|mu|la|tor (Gerät, in dem bestimmte Bedingungen u. [Lebens]verhältnisse wirklichkeitsgetreu herstellbar sind) m; -s, ...oren; si|mu|lie|ren (vorgeben, sich verstellen; übungshalber im Simulator o. ä. nachahmen; ugs. auch für: nachsinnen, grübeln); si|mu|liert (auch für: Schein...)

si|mul|tan lat. (gemeinsam; gleichzeitig); Si|mul|tan_büh|ne (Theater), ...grün|dung (Wirtsch.); Si|mul|ta|nei|tät [...ne-i...], Si|mul|ta|ni|tät (Gemeinsamkeit, Gleichzeitigkeit); Si|mul|tan_kir|che (Kirchengebäude für mehrere Bekenntnisse), ...schu|le (Schule mit konfessionell getrenntem Religions-, sonst „gemeinsamem" Unterricht), ...spiel (Schachspiel gegen mehrere Gegner gleichzeitig)

sin = Sinus

Si|nai [sina-i] (Gebirgsmassiv auf der gleichnamigen ägypt. Halbinsel) m; -[s]; Si|nai_ge|bir|ge (↑ R 201; s; -[e]s), ...halb|in|sel (↑ R 201; w; -)

Si|nau (eine Pflanzengattung [Frauenmantel]; Wiesenpflanze) m; -s, -e

si|ne an|no lat. (veralt. Hinweis bei Buchtitelangaben: ohne Angabe des Jahres; Abk.: s. a.); si|ne ira et stu|dio („ohne Zorn u. Eifer"; ohne Haß und Vorliebe, unbedingt sachlich)

Si|ne|ku|re lat. („ohne Sorge"; Pfründe ohne Amtsgeschäfte; müheloses, einträgliches Amt) w; -, -n

si|ne lo|co lat. [- loko] (veralt. Hinweis bei Buchtitelangaben: ohne Angabe des Ortes; Abk.: s. l.), si|ne lo|co et an|no (veralt. Hinweis bei Buchtitelangaben: ohne Angabe von Ort und Jahr; Abk.: s. l. e. a.); si|ne tem|po|re (ohne akadem. Viertel, d. h. pünktlich; Abk.: s. t.); vgl. cum tempore

Sin|fo|nie, Sym|pho|nie gr. [süm...] (mehrsätziges, auf das Zusammenklingen des ganzen Orchesters hin angelegtes Instrumentalmusikwerk) w; -, ...ien; Sin|fo|nie|or|che|ster, Sym|pho|nie|or|che|ster; Sin|fo|ni|et|ta it. (kleine Sinfonie) w; -, ...tten; Sin|fo|ni|ker, Sym|pho|ni|ker (Verfasser von Sinfonien; Mitglied eines Sinfonieorchesters); sin|fo|nisch, sym|pho|nisch (sinfonieartig); -e Dichtung

Sing. = Singular

Sing|aka|de|mie

Sin|ga|pore [ßingg°po̱'] (engl. Schreibung von: Singapur); Sin|ga|pur [singga...] (Hafenstadt an der Südspitze der Halbinsel Malakka); Sin|ga|pu|rer (↑ R 199); sin|ga|pu|risch

sing|bar; Sing|dros|sel; sin|gen; du sangst (sangest); du sängest; gesungen; sing[e]!; die Singende Säge (ein Musikinstrument)

Sin|gen (Hohen|twiel) (Stadt im Hegau); Sin|ge|ner (↑ R 199)

Sin|ge|rei w; -; Sin|ge|stun|de vgl. Singstunde

Sin|gha|le|se [...ngg...] (Angehöriger eines ind. Volkes auf Ceylon) m; -n, -n (↑ R 268); sin|gha|le|sisch

¹Sin|gle engl. [ßingg°l] ([Tisch]tennis: Einzelspiel) s; -, -[s]; ²Sin|gle engl. [ßingg°l] (kleine Schallplatte) w; -, -[s]

Sin|grün (eine Pflanze, Immergrün) s; -

Sing|sang (ugs.) m; -[e]s; Sing|schu|le

Sing-Sing [sing...] (Staatsgefängnis von New York bei der Industriestadt Ossining [früherer Name der Stadt: Sing Sing])

Sing_spiel (...stim|me, ...stun|de

Sin|gu|lar *lat.* [auch: *singgulár*] (Sprachw.: Einzahl; Abk.: Sing.) *m;* -s, -e; sin|gu|lär (vereinzelt [vorkommend]; selten); Sin|gu|la|re|tan|tum (Sprachw.: nur in der Einzahl vorkommendes Wort, z. B. „das All") *s;* -s, -s u. Singulariatantum; sin|gu|la|risch (in der Einzahl [gebraucht, vorkommend]); Sin|gu|la|ris|mus (Philos.); Sin|gu|la|ri|tät (vereinzelte Erscheinung; Seltenheit; Besonderheit) *w;* -, -en (meist *Mehrz.*)

Sing.vo|gel, ...wei|se *w*

si|ni|ster *lat.* („links"; selten für: unheilvoll, unglücklich)

sin|ken; er sinkt; ich sank, du sankst (sankest); du sänkest; gesunken; sink[e]!; Sink.ka|sten (an Abwasseranlagen), ...stoff (Substanz, die sich im Wasser absetzt)

Sinn *m;* -[e]s, -e; bei, von -en sein; sinn|be|tö|rend; Sinn|bild; sinn|bild|lich; sin|nen; du sannst (sannest); du sännest (veralt.: sönnest); gesonnen; sinn[e]!; vgl. gesinnt u. gesonnen; sin|nen|froh; Sin|nen.lust, ...mensch; sin|nen.nah, ...nahe; Sin|nen.rausch, ...reiz (Reiz auf die Sinne, sinnlicher Reiz); sinn|ent|stel|lend, a ber (↑ R 142): eine den ganzen Sinn (der Äußerung) entstellende Darstellung; Sinn|nen|welt *w;* -; Sinn|er|gän|zung; Sin|nes.än|de|rung, ...art, ...ein|druck, ...or|gan, ...reiz (Reiz, der auf ein Sinnesorgan einwirkt), ...schär|fe, ...stö|rung, ...täu|schung, ...wahr|neh|mung, ...werk|zeug, ...zel|le; sinn|fäl|lig; Sinn.fäl|lig|keit *(w;* -), ...ge|bung, ...ge|dicht, ...ge|halt *m;* sinn|ge|mäß; Sinn|grün vgl. Singrün; sinn|haft; sin|nie|ren (ugs. für: in Nachdenken versunken sein); Sin|nie|rer; sin|nig; ein -er Brauch; Sin|nig|keit *w;* -; Sinn.kopp|lung; sinn|lich; eine -e Empfindung; Sinn|lich|keit *w;* -; sinn|los; -este (↑ R 292); eine -e Handlung; Sinn|lo|sig|keit; sinn|reich; eine -e Deutung; Sinn|spruch; sinn.ver|wandt, ...ver|wir|rend, ...voll, ...wid|rig; Sinn|wid|rig|keit

Si|no|lo|ge *gr.* (Chinakundiger, bes. Lehrer u. Erforscher der chin. Sprache) *m;* -n, -n (↑ R 268); Si|no|lo|gie *w;* -; si|no|lo|gisch

sin|te|mal (veralt. für: da, weil); in altertümelnder Sprache: - und alldieweil

Sin|ter (mineral. Absatz aus Quellen) *m;* -s, -; Sin|ter|glas; sin|tern ([durch]sickern; Sinter bilden; auch: erhitzen [von sand- od. pulverförmigen Metallen od. keramischen Massen]); Sin|ter|ter|ras|se

Sint|flut („allgemeine, dauernde Flut") *w;* -; vgl. Sündflut

Si|nus *lat.* (Med.: Ausbuchtung, Hohlraum, bes. in Schädelknochen; Math.: Winkelfunktion im rechtwinkligen Dreieck, das Verhältnis der Gegenkathete zur Hypotenuse darstellt; Zeichen: sin) *m;* -, - [...*uß*] u. -se; Si|nus.kur|ve, ...li|nie, ...rei|he, ...satz, ...schwin|gung

Si|on vgl. Zion

Si|oux *[sjukß]* (Angehöriger einer Sprachfamilie der nordamerik. Indianer) *m;* -, -

Si|pho gr. (Atemröhre der Schnecken, Muscheln u. Tintenfische) *m;* -s, ...onen; Si|phon *fr.* [*sifong,* österr.: *sifon*] (Ausschankgefäß mit Schraubverschluß; Geruchverschluß; österr. ugs. für: Sodawasser) *m;* -s, -s; Si|pho|no|pho|re *gr.* (Staats- od. Röhrenqualle) *w;* -, -n (meist *Mehrz.*); Si|phon|ver|schluß *[sifong...,* österr.: *sifon...]*

Sip|pe *w;* -, -n; Sip|pen.for|schung, ...haf|tung, ...kun|de *(w;* -); sip|pen|kund|lich; Sip|pen|ver|band; Sipp|schaft (abschätzig)

Sir *fr.* [*ßö*] (allg. engl. Anrede [ohne Namen]: „Herr"; vor Vorn.: engl. Adelstitel) *m;* -s, -s

Si|rach (bibl. m. Eigenn.); vgl. Jesus Sirach

Sire *fr.* [*ßir*] (in der Anrede für: Majestät)

Si|re|ne *gr.* (Meerwesen der gr. Sage [meist *Mehrz.*]; übertr. für: Verführerin; eine Seekuh; Nebelhorn, Warnvorrichtung) *w;* -, -n; Si|re|nen.ge|heul, ...ge|sang; si|re|nen|haft (verführerisch); Si|re|nen|pro|be

Si|ri|us *gr.* (ein Stern) *m;* -; si|ri|us|fern

Sir|rah *arab.* (ein Stern) *w;* -

sir|ren (hell klingen[d surren])

Si|rup *arab.* (dickflüssiger Zuckerrübenauszug; Lösung aus Zucker u. Fruchtsaft) *m;* -s, -e; Si|rup|topf

Si|sal *m;* -s; Si|sal|hanf; ↑ R 201 [nach der mex. Hafenstadt Sisal] (Faser aus den Blättern einer Agave)

si|stie|ren *lat.* ([Verfahren] einstellen; jmdn. zur Feststellung seiner Personalien auf die Polizeiwache bringen); Si|stie|rung

Si|strum *gr.* (Rasselinstrument der alten Ägypter) *s;* -s, Sistren

Si|sy|phos *gr.;* vgl. Sisyphus; Si|sy|phus (Gestalt der gr. Sage, die zu nie ans Ziel führendem Steinwälzen verurteilt war); Si|sy|phus|ar|beit (↑ R 180 vergebliche Arbeit)

Si|tar *iran.* (Gitarreninstrument) *m;* -[s], -s

Sit-in *amerik.* [*ßi...*] (demonstratives Sichhinsetzen einer Gruppe zum Zeichen des Protestes) *s;* -[s], -s

Sit|ta (Kurzform von: Sidonie)

Sit|te *w;* -, -n

Sit|ten (Hptst. des Kantons Wallis)

Sit|ten.de|zer|nat, ...ge|mäl|de, ...ge|schich|te *(w;* -), ...ge|setz, ...ko|dex, ...kon|trol|le, ...leh|re; sit|ten|los; -este (↑ R 292); Sit|ten|lo|sig|keit; Sit|ten.po|li|zei; sit|ten|rein; Sit|ten.rich|ter, ...schil|de|rung; sit|ten|streng; Sit|ten.stren|ge, ...ver|derb|nis; sit|ten|wid|rig

Sit|tich (ein Papagei) *m;* -s, -e

sit|tig (veralt.); sit|ti|gen (veralt. für: gesittet machen); sitt|lich; -e Forderung; er Maßstab; -er Wert; Sitt|lich|keit *w;* -; Sitt|lich|keits.de|likt, ...ver|bre|chen; sitt|sam; Sitt|sam|keit *w;* -

Si|tua|ti|on *lat.* [...*zion*] ([Sach]lage, Stellung, [Zu]stand); Si|tua|ti|ons.ethik, ...ko|mik, ...plan (Lageplan; vgl. ²Plan), ...stück; si|tua|tiv (durch die Situation bedingt); si|tu|iert (gestellt, in Verbindung mit Eigenschaftswörtern wie „gut", z. B. gutsituiert)

Si|tu|la *lat.* (bronzezeitl. Eimer) *w;* -, ...ulen

Si|tus *lat.* (Med.: Lage [von Organen]) *m;* -, -; vgl. in situ

sit ve|nia ver|bo *lat.* [*ßit wénia wärbo*] (man verzeihe das Wort!; Abk.: s. v. v.)

Sitz *m;* -es, -e; Sitz|bad; sit|zen; du sitzt (sitzest), er sitzt; du saßest, er saß; du säßest; gesessen; sitz[e]!; ich habe (südd.: bin) gesessen, einen - haben (ugs. für: betrunken sein); (↑ R 120:) ich bin noch nicht zum Sitzen gekommen; sit|zen|blei|ben; ↑ R 139 (ugs. für: in der Schule nicht versetzt werden; nicht geheiratet werden; nicht verkaufen können); ich bleibe sitzen; sitzengeblieben; sitzenzubleiben; a ber: sit|zen blei|ben (z. B. auf einem Stuhl); sit|zend; -e Lebensweise; sit|zen|las|sen; ↑ R 139 (ugs. für: in der Schule nicht versetzen; im Stich lassen; unwidersprochen lassen); ich lasse sitzen; ich habe ihn sitzenlassen, (seltener:) sitzengelassen (↑ R 305); sitzenlassen; ich habe den Vorwurf nicht auf mir sitzenlassen; a ber: sit|zen las|sen (z. B. auf einem Stuhl); ...sit|zer (z. B. Zweisitzer); Sitz.fleisch (ugs.), ...ge|le|gen|heit; ...sit|zig (z. B. viersitzig); Sitz.platz, ...rie|se (ugs. scherzh. für: jmd. mit kurzen Beinen u. langem Oberkörper), ...stan|ge,

...**streik**; **Sit|zung**; **Sit|zungs..be-richt**, ...**geld**, ...**saal**, ...**zim|mer**
Si|wa[h] (eine Oase) w; -
Six! = meiner Six! (veraltete Beteuerung: meiner Seel!)
Six|ti|na [nach Papst Sixtus IV.] (Kapelle im Vatikan) w; -; **six|ti-nisch**, **aber** (↑ R 179): **Six|ti-nisch**; -e Kapelle, -e Madonna; **Six|tus** (m. Vorn.)
Si|zi|lia|ne it. (Versform) w; -, -n;
Si|zi|lia|ner, Si|zi|li|er [...*i*ᵉ*r*] (Bewohner von Sizilien); **si|zi|lia-nisch**, si|zi|lisch, **aber** (↑ R 224): Sizilianische Vesper (Volksaufstand in Palermo während der Ostermontagsvesper 1282?); **Si|zi-li|en** [...*i*ᵉ*n*] (südit. Insel); **Si|zi|li-enne** fr. [...*liän*] (svw. Eolienne) w; -; **Si|zi|li|er** vgl. Sizilianer; **si|zi-lisch** vgl. sizilianisch
SJ = Societatis Jesu lat. [*sozi-e*...] („von der Gesellschaft Jesu", d. h. Jesuit); vgl. Societas Jesu
SK = Segerkegel
Ska|bi|es lat. [...*biäß*] (Med.: Krätze) w; -; **ska|bi|ös** (krätzig); **Ska|bio|se** (Pflanzengattung der Kardengewächse) w; -, -n
ska|brös fr. (veralt. für: heikel, schlüpfrig); -este (↑ R 292)
Ska|denz it. (veralt. für: Verfalltag, Fälligkeitstag) w; -, -en
Ska|ger|rak (Meeresteil zwischen Norwegen u. Jütland) s od. m; -s
Skai ⓦ (ein Kunstleder) s; -[s]
skål! skand. [*ßkǻl*] skand. (prost!, zum Wohl!)
Ska|la it. („Treppe"; Maßeinteilung [an Meßgeräten]; Tonleiter) w; -, ...len u. -s; vgl. Skale u. Scala; **Ska|la|hö|he**; **ska|lar** (Math.: durch reelle Zahlen bestimmt); **Ska|lar** (Math.) m; -s, -e
Skald altnord. (altnord. Dichter u. Sänger) m; -en, -n (↑ R 268); **Skal|den|dich|tung**
Ska|le (in der Bedeutung „Maßeinteilung" bes. in der Fachspr. gebrauchte eindeutschende Nebenform von: Skala) w; -, -n
Ska|le|no|eder gr. (Kristallform mit 12 ungleichseitigen Dreiecken als Oberfläche) s; -s, -
Ska|len|zei|ger
Skalp skand.-engl. (früher bei den Indianern: abgezogene Kopfhaut des Gegners als Siegeszeichen) m; -s, -e
Skal|pell lat. ([kleines chirurg.] Messer [mit feststehender Klinge]) s; -s, -e
skal|pie|ren skand.-engl. (den Skalp nehmen)
Skan|dal gr. (Ärgernis; Aufsehen; Lärm) m; -s, -e; **Skan|dal|ge-schich|te**; **skan|da|lie|ren** (veralt.

für: lärmen); **skan|da|li|sie|ren** (veralt. für: Ärgernis geben, Anstoß nehmen); sich über etwas - (an etwas Ärgernis nehmen); **skan|da|lös** (ärgerlich; anstößig; unglaublich, unerhört); -este (↑ R 292); **skan|dal..süch|tig**, ...**um|wit-tert**
skan|die|ren lat. (taktmäßig nach Versfüßen lesen)
Skan|di|na|ve [...*wᵉ*] m; -n, -n (↑ R 268) u. **Skan|di|na|vi|er** [...*i*ᵉ*r*]; **Skan|di|na|vi|en** [...*i*ᵉ*n*]; **Skan|di-na|vie|rin** w; -, -nen; **skan|di|na-visch**, aber (↑ R 198): die Skandinavische Halbinsel
Ska|po|lith lat.; gr. (ein Mineral) m; -s od. -en, -e[n] (↑ R 268)
Ska|pu|lier lat. (bei der Mönchstracht Überwurf über Brust u. Rücken) s; -s, -e
Ska|ra|bä|en|gem|me; **Ska|ra|bä-us** gr. (Pillendreher, Mistkäfer des Mittelmeergebietes; altägypt. geschnittener Siegelstein mit Nachbildung des Mistkäfers) m; -, ...äen
Ska|ra|muz it. (Gestalt des it. Lustspiels; prahlerischer Soldat) m; -es, -e
Skarn schwed. (Geol.: Lagerstätte mit Eisen u. Edelmetallen) m; -s, -e
skar|tie|ren it. österr. Amtsdt. (alte Akten u. a. ausscheiden); **Skat** (ein Kartenspiel; zwei verdeckt liegende Karten beim Skatspiel) m; -[e]s, -e u. -s; **Skat|brü|der** (ugs.) Mehrz.; **ska|ten** (ugs. für: Skat spielen); **Ska|ter** (ugs. für: Skatspieler)
Ska|tol s; lat. (chem. Verbindung) s; -s; **Ska|to|pha|ge** vgl. Koprophage; **Ska|to|pha|gie** vgl. Koprophagie
Skat..par|tie, ...**spiel**, ...**spie|ler**, ...**tur|nier**
Skeet|schie|ßen engl.; dt. [*ßkit*...] (Wurftaubenschießen mit Schrotgewehren) s; -s
Ske|let gr. (teilweise noch im med. Fachschrifttum gebrauchte Nebenform von: Skelett); **Ske|le|ton** engl. [*ßkälᵉtᵉn*] (niedriger Sportrennschlitten) m; -s, -s; ¹**Ske|lett** gr. (Knochengerüst, Gerippe; Rahmen; in Zusammensetzungen: Ripp[en]...) s; -[e]s, -e; ²**Ske-lett** (eine Schrift[art]) w; -; **Ske-lett..bau** (Gerüst-, Gerippebau; Mehrz. ...**bauten**), ...**bo|den**, ...**form**; **ske|lett|tie|ren** (das Skelett bloßlegen); **Ske|lett|tü|ber|ku-lo|se** [Trenn.: ...lett|tu..., ↑ R 236]
Skep|sis gr. (Zweifel, Bedenken; Zurückhaltung; Ungläubigkeit; Zweifelsucht) w; -; **Skep|ti|ker** (mißtrauischer Mensch; Zweifler); **skep|tisch** (zum Zweifel nei-

gend; mißtrauisch; kühl u. streng prüfend); -ste (↑ R 294); **Skep|ti-zis|mus** (Zweifel [an der Möglichkeit sicheren Wissens], Zweifelsucht; Bedenklichkeit) m; -
Sketch engl. [*ßkätsch*] („Skizze"; kurze, effektvolle Bühnenszene im Kabarett od. Varieté) m; -[es], -e[s] od. -s; **Skętsch** (eindeutschende Schreibung für: Sketch) m; [ə]s, -ə
Ski [*schi*] usw. vgl. Schi usw.
Skia|gra|phie gr. (selten für: Schattenriß; Schattenmalerei; w; -, ...ien), ...**me|ter** (Meßgerät für die Intensität der Röntgenstrahlen; s; -s, -); **Skia|sko|pie** (Med.: Schattenprobe zur Prüfung der Ferneinstellung des Auges; Durchleuchtungsröntgenbild) w; -, ...ien
Skiff engl. (Sport: nord. Einmannruderboot) s; -[e]s, -e
Ski|fu|ni norw.; roman. [*schi*...] schweiz. (großer Schlitten, der im Pendelbetrieb [Drahtseilbahnprinzip] Schifahrer bergaufwärts befördert) m; -, -s
Skink gr. (Eidechse einer bestimmten Art) m; -[e]s, -e
Ski|no|id ⓦ (ein Kunststoff) s; -[e]s
Skiz|ze it. ([erster] Entwurf; flüchtige Zeichnung; kleine Geschichte) w; -, -n; **Skiz|zen.block** (Mehrz. ...**blocks**), ...**buch**; **skiz-zen|haft**; **Skiz|zen|map|pe**; **skiz-zie|ren** (entwerfen; andeuten); **Skiz|zie|rer**; **Skiz|zier|pa|pier**; **Skiz|zie|rung**
Skla|ve slaw. [...*wᵉ*, auch: ...*fᵉ*] (Leibeigener; unfreier, entrechteter Mensch) m; -n, -n (↑ R 268); **Skla|ven|ar|beit**; **skla|ven|ar|tig**; **Skla|ven|hal|ter**, ...**händ|ler**, ...**markt**, ...**tum** (s; -s); **Skla|ve|rei**; **Skla|vin** w; -, -nen; **skla|visch**; -ste (↑ R 294); -er Gehorsam; e Gesinnung
Skle|ra gr. (Med.: Lederhaut [des Auges], „das Weiße" im Auge) w; -, ...ren; **Skler|ade|ni|tis** (Med.: Drüsenverhärtung) w; -, ...itiden; **Skle|rem** (Med.: krankhafte Hautverhärtung) s; -s; **Skle|ri|tis** (Med.: Entzündung der Lederhaut des Auges) w; -, ...itiden; **Skle|ro|der|mie** (svw. Sklerem); **Skle|ro|me|ter** (Härtemesser [bei Kristallen]) s; -s, -; **Skle|ro|se** (Med.: Verkalkung, krankhafte Verhärtung von Geweben u. Organen) w; -, -n; **skle|ro|tisch** (verhärtet)
Sko|lex gr. (Bandwurmkopf) m; -, ...lizes [*ßkǫlizäß*]
Sko|li|on gr. [auch: *skǫ*...] (altgr. Tischlied, Einzelgesang beim Gelage) s; -s, ...ien [...*i*ᵉ*n*]

Sko|li|o̱|se *gr.* (Med.: seitliche Verkrümmung der Wirbelsäule) *w*; -, -n

Sko|lo|pen|der *gr.* (trop. Tausendfüßer) *m*; -s, -

skon|tie̱|ren *it.* (Skonto gewähren); **Sko̱n|to** ([Zahlungs]abzug, Nachlaß [bei Barzahlungen]) *m* od. *s*; -s, -s (selten auch: ...ti)

Sko̱n|tra|ti|o̱n *it.* [...zio̱n] (Wirtschaft: Fortschreibung, Bestandsermittlung von Waren durch Zu- u. Abschreibungen der Zu- u. Abgänge); **skon|trie̱|ren**; **Sko̱n|tro** (Nebenbuch der Buchhaltung zur tägl. Ermittlung von bestimmten Bestandsmengen) *s*; -s, ...ren; **Sko̱n|tro|buch**

Skoo̱|ter *engl.* [ßku̱t𝑒r] ([elektr.] Kleinauto auf Jahrmärkten) *m*; -s, -

Sko̱p *angels.* (in den westgerm. Sprachen hist. Bez. für den Dichter u. Sänger in der Gefolgschaft eines Fürsten) *m*; -s, -s

Sko̱p|ze *russ.* (Angehöriger einer schwärmerischen russ. Sekte) *m*; -n, -n († R 268)

Skor|bu̱t *mlat.* (Krankheit durch Mangel an Vitamin C) *m*; -[e]s; **skor|bu̱|tisch**

Skor|da|tu̱r vgl. Scordatura

sko̱|ren*mlat.* österr. Sportspr. (ein Tor schießen)

Skor|pi|o̱n *gr.* (ein Sternbild) *m*; -s, (für: Spinnentier auch *Mehrz.*:) -e

Sko̱|te (Angehöriger eines alten ir. Volksstammes in Schottland) *m*; -n, -n († R 268)

Sko̱|tom *gr.* (Med.: dunkler Fleck vor dem Auge) *s*; -s, -e

skr = schwedische Krone

Skri|be̱nt *lat.* (Schreiberling; Vielschreiber); † R 268; **Skri|bi|fax** (selten für: Skribent) *m*; -[es], -e; **Skri̱pt** *engl.* (schriftl. Ausarbeitung; Nachschrift einer Hochschulvorlesung, bes. bei den Juristen; auch, österr. nur in dieser Bedeutung: Drehbuch) *s*; -[e]s, -en u. (für Drehbuch meist:) -s; **Skri̱pt|girl** [...gö̱rl] (Filmateliersekretärin, die die Einstellung für jede Aufnahme einträgt) *s*; -s, -s; **Skri̱p|tum** *lat.* (älter, noch bes. österr. für: Skript) *s*; -s, ...ten u. ...ta; **Skri̱p|tur** (veraltet. für: Schriftstück) *w*; -, -en (meist *Mehrz.*)

Skro̱|fel, Skro̱|fu|lo̱|se *lat.* (Med.: Haut- u. Lymphknotenerkrankung bei Kindern) *w*; -, -n; **skro̱|fu|lö̱s**; -este († R 292)

skro̱|tal *lat.* (zum Hodensack gehörend); **Skro̱|tal|bruch** *m*; **Skro̱|tum** (Med.: Hodensack) *s*; -s, ...ta

Skru̱b|ber *engl.* [ßkra̱b𝑒r] (Waschturm zur Gasreinigung) *m*; -s, -

Skru̱bs *engl.* [ßkra̱pß] (minderwertige Tabakblätter) *Mehrz.*

¹Skru̱|pel *lat.* (altes Apothekergewicht) *s*; -s, -; **²Skru̱|pel** (Zweifel, Bedenken; Gewissensbiß) *m*; -s, - (meist *Mehrz.*); **skru̱|pel|los**; -este († R 292); **Skru̱|pel|lo|sig̱|keit**; **skru|pu|lö̱s** (veralt. für: bedenkenvoll, ängstlich; peinlich genau); -este († R 292)

Skru̱|ti̱|ni|um *lat.* (Sammlung u. Prüfung der Stimmen bei einer kath. kirchl., seltener polit. Wahl; bischöfl. Prüfung der Kandidaten für die Priesterweihe) *s*; -s, ...ien [...i𝑒n]

Sku̱ld (nord. Mythol.: Norne der Zukunft; auch: Schildmädchen [Walküre] Odins)

Sku̱ll|boot *engl.*; *dt.*; **sku̱ll|len** (rudern); **Sku̱ll|ler** (Sportruderer)

skulp|tie̱|ren *lat.* (ausmeißeln); **Skulp|tu̱r** (Bildhauerkunst [nur *Einz.*]; Bildhauerwerk) *w*; -, -en; **Skulp|tu̱|ren|samm|lung**

Sku̱nk *indian.-engl.* (ein Stinktier; Pelz [meist *Mehrz.*]) *m*; -s, -s u. (für das Tier meist:) -e

Sku̱p|schti̱|na *serbokroat.* (jugoslaw. Parlament) *w*; -, -s

sku̱r|ri̱l *etrusk.-lat.* (verschroben, eigenwillig; drollig); **Skur|ri̱|li|tät** *w*; -, -en

Skü̱s *fr.* (Trumpfkarte im Tarockspiel) *m*; -, -

Sky̱|ta̱|ri (albanische Stadt); **Sky̱|ta̱|ri|see** *m*; -s

Skye̱|ter|ri|er *engl.* [ßka̱iteri𝑒r] (Hund einer bestimmten Rasse)

Sky̱|light *engl.* [ßka̱ilait] (Seemannsspr.: Oberlicht [auf Schiffen]) *s*; -s, -s; **Sky̱|line** [ßka̱ilain] (Horizont[linie], Kontur) *w*; -, -s

Sky̱l|la *gr.* (gr. Form von: Szylla)

Sky̱|the (Angehöriger eines alten nordiran. Reitervolkes) *m*; -n, -n († R 268); **Sky̱|thi|en** [...i𝑒n] (Land); **sky̱|thisch**

s. l. = sine loco

Sla̱|lom *norw.* (Schi- u. Kanusport: Torlauf; auch übertr. für: Zickzacklauf, -fahrt) *m*; -s, -s; **Sla̱|lom_kurs**, ...lauf, ...läu|fer

Sla̱ng *engl.* [ßläng] (niedere Umgangssprache; auch für: Jargon) *m*; -s, -s

S-Laut († R 149)

Sla̱p|stick *engl.* [ßläpßtik] (grotesk-komischer Gag vor allem im [Stumm]film) *m*; -s, -s

Sla̱|we *slaw.* *m*; -n, -n († R 268); **Sla̱|wen|tum** *s*; -s; **Sla̱|wi** *w*; -, -nen; **sla̱|wisch**; **sla̱|wi|sie̱|ren** (slawisch machen); **Sla̱|wi̱s|mus** (slaw. Spracheigentümlichkeit in einer nichtslaw. Sprache) *m*; -, ...men; **Sla̱|wi̱st** (Kenner u. Erforscher des Slawischen; † R 268; **Sla̱|wi̱|stik** *w*; -; **sla̱|wi̱|stisch**; **Sla̱-**

wo̱|ni|en [...i𝑒n] (jugoslaw. Landschaft); **Sla̱|wo̱|ni|er** [...i𝑒r]; **sla̱-wo̱|nisch**; **Sla̱|wo̱|phi̱|le** *slaw.*; *gr.* (Slavenfreund) *m* u. *w*; -n, -n († R 268)

s. l. e. a. = sine loco et anno

Sle̱ip|nir *altnord.* (nord. Mythol.: das achtbeinige Pferd Odins)

Sli̱|bo|witz, **Sli̱|wo|witz** *serbokroat.* (Pflaumenbranntwein) *m*; -[es], -e

Sli̱|ding-tack|ling [ßla̱idingtäk...] vgl. Tackling

Sli̱p *engl.* (schiefe Ebene in einer Werft für den Stapellauf eines Schiffes; beinloser Damen- od. Herrenschlüpfer; Technik: Vortriebsverlust) *m*; -s, -s; **Sli̱p|on** (bequemer Herrensportmantel mit Raglanärmeln) *m*; -s, -s; **Sli̱p|per** (Schlupfschuh mit niedrigem Absatz) *m*; -s, -

Sli̱|wo|witz vgl. Slibowitz

Slo̱|gan *gälisch-engl.* [ßlo̱u̱g𝑒n] ([Werbe]schlagwort) *m*; -s, -s

Sloo̱p *engl.* [ßlu̱p] (Küsten- u. Fischerfahrzeug, Segeljacht) *w*; -, -s

Slo̱p *engl.-amerik.* (ein Modetanz) *m*; -s, -s

Slo̱|wa̱|ke (Angehöriger eines westslaw. Volkes) *m*; -n, -n († R 268); **Slo̱|wa̱|kei** (östl. Teil der Tschechoslowakei) *w*; -; **slo̱|wa̱-kisch**; -e Literatur, aber († R 198): Slowakische Erzgebirge; **Slo̱|wa̱|kisch** (Sprache) *s*; -[s]; vgl. Deutsch; **Slo̱|wa̱|ki̱|sche** *s*; -n; vgl. Deutsche; **Slo̱|we̱|ne** (Angehöriger eines südslaw. Volkes) *m*; -n, -n († R 268); **Slo̱|we̱|ni|en** [...i𝑒n]; **Slo̱|we̱|ni|er** [...i𝑒r] (Slowene); **slo̱-we̱|nisch**; **Slo̱|we̱|nisch** (Sprache) *s*; -[s]; vgl. Deutsch; **Slo̱|we̱|ni̱|sche** *s*; -n; vgl. Deutsche

Slo̱w|fox *engl.* [ßlo̱u̱...] (ein Tanz) *m*; -[es], -e

Slu̱m *engl.* [ßla̱m] (schmutziges Hintergäßchen; *Mehrz.*: Elendsviertel) *m*; -s, -s

sm = Seemeile

Sm = chem. Zeichen für: Samarium

S. M. = Seine Majestät

Sma̱l|te vgl. Schmalte

Sma̱|ra̱gd *gr.* (ein Edelstein) *m*; -[e]s, -e; **Sma̱|ra̱gd|ei|dech|se**; **sma̱|ra̱g|den** (aus Smaragd; grün wie ein Smaragd); **sma̱|ra̱gd|grün**

sma̱rt *engl.* (gewandt; gerieben; schneidig)

Sme̱|ta̱|na (tschech. Komponist)

SM-Ofen = Siemens-Martin-Ofen

Smo̱g *engl.* (dicker, undurchdringlicher Nebelrauch über Industriestädten) *m*; -[s], -s

Smo̱k|ar|beit (Verzierungsarbeit an Kleidern u. Blusen); **smo̱|ken**

(Stoff reihen u. bündeln); ge-smokt

Smo|king engl. (Gesellschaftsan-zug mit seidenen Revers für Herren) m; -s, -s

Smo|lensk (russ. Stadt)

mor|zan|do it. (Musik: immer schwächer werdend); Smor|zan-do s; -s, -s u. ...di

smut|je (Seemannsspr.: Schiffs-koch) m; -s, -s

SMV = Schülermitverwaltung

Smyr|na [βmürna] (türk. Stadt; heutiger Name: Izmir); Smyr|na-er;↑R 199 (auch: Teppich); - Tep-pich; smyr|na|isch; Smyr|na|tep-pich

Sn = Stannum (chem. Zeichen für: Zinn)

Snack|bar engl. [βnäk...] (engl. Bez. für: Imbißstube) w

Snee|witt|chen niederd. (Schnee-wittchen)

Snob engl. [βnɔp] (vornehm tuen-der, eingebildeter Mensch, Geck) m; -s, -s; Sno|bie|ty [...bai*ti] (ab-wertend: vornehm tuende Gesell-schaft); Sno|bis|mus m; -, ...men; sno|bi|stisch; -ste (↑R 294)

so; - sein, - werden, - bleiben; so ein Mann; so einer, so eine, so ein[e]s; so etwas (ugs.: so was); so daß (immer getrennt); so schnell wie od. als möglich; die Meisterschaft war so gut wie ge-wonnen; so gegen acht Uhr; so wahr mir Gott helfe. Über Ge-trennt- oder Zusammenschrei-bung in sobald, sofern, sogleich, soso usw. vgl. die einzelnen Stichwörter

SO = Sudost[en]

s. o. = sieh[e] oben!

soa|ve it. [...we] (Musik: lieblich, sanft, angenehm, süß)

so|bald; Bindew.: sobald er kam, aber (Umstandsw.): er kam so bald nicht, wie wir erwartet hat-ten; komme so bald (so früh) wie od. als möglich

So|brie|tät lat. [...i-e...] (veralt. für: Mäßigkeit) w; -

So|cie|tas Je|su lat. [sozi-e... -] („Gesellschaft Jesu", der Orden der Jesuiten; Abk.: SJ); lat. Wesf.: Societatis Jesu; So|cie|tas Ver|bi Di|vi|ni [- wärbi diwini] („Gesellschaft des Göttlichen Wortes"; kath. Missionsgesell-schaft von Steyl in der niederl. Provinz Limburg; Abk.: SVD)

Socke; Socke|l¹ gr. w; -, -n (meist Mehrz.); Sockel¹ (unterer Mauervor-sprung; Unterbau, Fußgestell, z. B. für Statuen) m; -s, -; Socken¹ landsch. (Socke) m; -s, -; Socken-hal|ter¹

¹ Trenn.: Sok|k...

Sod (veralt. für: Sieden; Sodbren-nen) m; -[e]s, -e

So|da span. (Natriumkarbonat; Sodawasser) w; - u. (für Sodawas-ser nur:) s; -s

Sodalle lat. (Mitglied einer kath. Sodalität) m; -n, -n (↑R 268); So-da|li|tät (kath. Genossenschaft, Bruderschaft)

So|da|lith span.; gr. (ein Mineral) m; -s, -e

so|dann

so daß (österr. nur: sodaß); er ar-beitete so, daß er krank wurde; er arbeitete Tag und Nacht, so daß er krank wurde

So|da|was|ser (künstliches kohlensäurehaltiges Mineralwasser; Mehrz. ...wässer)

Sod|bren|nen (bei Magenkrank-heit) s; -s; Sod|brun|nen (schweiz. neben: Ziehbrunnen)

So|de (Rasenstück; getrocknetes Stechtorfstück von Ziegelform; veralt. für: Salzsiederei) w; -, -n

So|dom (bibl. Stadt); - u. Gomor-rha (Symbol der Sünde u. der Lasterhaftigkeit); vgl. Gomor-rha; So|do|mie nlat. (widernatür-liche Unzucht mit Tieren; auch für: Päderastie) w; -, ...ien; So|do-mit (Einwohner von Sodom; Sodomie Treibender) m; -en, -en (↑R 268); so|do|mi|tisch (widernatürlich [unzüchtig]); So|doms-ap|fel (Gallapfel, Gerbemittel)

so|eben (vor einem Augenblick); er kam soeben, aber: so eben (gerade) noch; er ist so eben dem Unglück entgangen

Soen|noo|ken [Trenn.: ...nek|ken] Ⓦ [sö...] (Schreib-, Zeichen- u. Meßgeräte)

Soest [sößt] (Stadt in Nordrhein-Westfalen); Soe|ster (↑R 199); - Börde (Landstrich)

So|fa arab. s; -s, -s; So|fa.ecke [Trenn.: ...ek|ke] (↑R 148), ...kis-sen

so|fern (falls); Bindew.: so|fern er seine Pflicht getan hat, ..., aber (Umstandsw.): die Sache liegt mir so fern, daß ...

Soff (Nebenform von: Suff) m; -[e]s; Söf|fel, Söf|fer landsch. (Trinker) m; -s, -

Sof|fit|te it. (Deckendekorations-stück einer Bühne) w; -, -n (meist Mehrz.); Sof|fit|ten|lam|pe

So|fia (auch: só...] (Hptst. Bulga-riens); So|fia|er [...a*r] (↑R 199); So|fie [auch: só...] vgl. Sophia

so|fort (in [sehr] kurzer Zeit [erfol-gend], auf der Stelle); er soll so-fort kommen; aber: immer so fort (immer so weiter); So|fort-hil|fe; So|fort|hil|fe|ge|setz; so-for|tig; So|fort|maß|nah|me

Sof|ta pers. [für die Wissenschaft

„Erglühter"] (früher für: Student einer islam. Hochschule) m; -[s], -[s]

Soft-Eis engl.; dt. [βoft...] (sahni-ges Weicheis) s; -es; drei -; Soft-ware engl. [...*ä*] (Datenverar-beitung: die nichtapparativen [„weichen"] Bestandteile der An-lage; Ggs.: Hardware) w; -, -s

Sog (unter landwärts gerichteten Wellen seewärts ziehender Mee-resstrom; saugende Nachströ-mung hinter fahrenden Schiffen, Kraft-, Luftfahrzeugen u. a.) m; -[e]s, -e

sog. = sogenannt

so|gar (noch darüber hinaus); er kam sogar zu mir nach Hause, aber: er hat so gar kein Vertrau-en zu mir

so|ge|nannt (Abk.: sog.); die so-genannten ewigen Gesetze, aber (↑R 142): der fälschlich so ge-nannte ...

sog|gen (vom Salz in der verdamp-fenden Sole: sich in Kristallform niederschlagen)

so|gleich (sofort); er soll sogleich kommen; aber: sie sind sich alle so gleich, daß ...; so|hin (Amtsdt. veralt. für: somit, also), aber: er sagte es nur so hin (ohne beson-deren Nachdruck)

Sohl|bank (Fensterbank; Mehrz. ...bänke); Sohle lat. (Fuß-, Tal-sohle; Bergmannsspr.: untere Be-grenzungsfläche einer Strecke; landsch. auch für: Lüge) w; -, -n; sohllen (landsch. auch für: lü-gen); Sohl|len|durch|näh|ma|schi-ne; Sohl|len|gän|ger (Gruppe von Säugetieren); Sohl|len|le|der, Sohl|le|der; ...sohl|lig (z. B. dop-pelsohlig); söh|lig (Berg-mannsspr.: waagerecht); Sohl|le-der, Sohl|len|le|der

Sohn m; -[e]s, Söhne; Söhn-chen, Söhn|lein; Sohl|nes.lie|be, ...pflicht

sohr niederd. (dürr, welk)

Sohr niederd. (Sodbrennen) m; -s

¹Söh|re (Teil des Hessischen Berg-landes) w; -

²Söh|re niederd. (Dürre) w; -; söh-ren niederd. (verdorren)

soi|gniert fr. [βoanjirt] (gepflegt)

Soi|ree fr. [βoare] (Abendgesell-schaft) w; -, ...reen

So|ja jap.-niederl. (eiweiß- u. fett-haltige Nutzpflanze) w; -, ...jen; So|ja|boh|ne, ...mehl, ...öl (s; -[e]s)

So|jus („Bund, Bündnis"; Bez. für eine sowjetruss. Raumschiffse-rie)

So|kra|tes (gr. Philosoph); So|kra-tik gr. (Lehrart des Sokrates) w; -; So|kra|ti|ker (Schüler des So-krates; Verfechter der Lehre des Sokrates); so|kra|tisch; -e Lehr-

art, aber (↑ R 179); So|kra̲|tisch;
-e Lehre
¹So̲l (röm. Sonnengott); ²So̲l span.
(peruan. Münzeinheit) m; -[s],
-[s], 5 - (↑ R 322)
³So̲l (Chemie: kolloide Lösung) s;
-s, -e
so|la̲ng, so|la̲n|ge (während, währenddessen); Bindew.: solang[e]
ich krank war, bist du bei mir
geblieben; aber (Umstandsw.):
so̲ lang[e] wie od. als möglich;
dreimal so lang[e] wie ...; du hast
mich so la̲nge warten lassen, daß
...; du mußt so la̲nge warten, bis
...; du mußt so la̲nge warten,
...
So|la̲|ni̲n lat. (giftiges Alkaloid
verschiedener Nachtschattengewächse, bes. der Kartoffel) s;
-s; So|la̲|num (Pflanzengattung
der Nachtschattengewächse;
Bez. für: Kartoffelkraut als
Werkstoff) s; -s, ...nen; So|la̲num|holz
so|la̲r lat. (auf die Sonne bezüglich, von der Sonne herrührend);
So|la̲r|bat|te̲|rie (Sonnenbatterie); So|la̲ri|sa̲|ti̲on [...zio̲n] (Fotogr.: Erscheinung der Umkehrung der Lichteinwirkung bei
starker Überbelichtung des
Films); so|la̲|risch vgl. solar; Sola̲ri|um (Anlage zur Ganzbräunung durch Höhensonnen) s; -s,
...ien [...iᵉn]; So|la̲r|jahr, ...konstan|te, ...öl (s; -[e]s), ...theo|rie
So|la̲|wech|sel it.; dt. (Wirtschaft:
Eigenwechsel)
So̲l|bad
so̲lch; -er, -e, -es; - ein Mann; ein
-er Mann; - einer, - eine, - ein[e]s.
Beugung (↑ R 278:) solch feiner
Stoff od. solcher feine Stoff; mit
- schönem Schirm, mit - einem
schönen Schirm, mit einem -[en]
schönen Schirm, in -er erzieherischen (gelegentlich: erzieherischer) Absicht; (↑ R 282:) - gute
od. -e guten (auch: gute) Menschen; das Leben - frommer Leute od. -er frommen (auch: frommer) Leute; (↑ R 290:) -e Gefangenen (auch: Gefangene); so̲l|cherart; - Dinge, aber: Dinge solcher
Art; so̲l|cher|ge|sta̲lt; aber: er
war von solcher Gestalt, daß ...;
so̲l|cher|lei; so̲l|cher|ma|ßen (veralt.); so̲l|cher|wei̲|se; aber: in solcher Weise
So̲ld lat. m; -[e]s, -e
Sol|da|ne̲l|le it. (Alpenglöckchen)
w; -, -n
Sol|da̲t lat. m; -en, -en (↑ R 268);
Sol|da̲|ten.fried|hof, ...le|ben,
...rock, ...spra|che, ...stand (m;
-[e]s), ...tum (s; -s); Sol|da̲|tes|ka
([rohes, zügelloses] Kriegsvolk)
w; -, ...ken; sol|da̲|tisch; -ste (↑ R
294); So̲ld|buch; Söld|ling (ab-

schätzig); Söld|ner; Söld|nerheer; So̲l|do (frühere it. Münze)
m; -s, -s u. ...di
So̲|le (kochsalzhaltiges Wasser) w;
-, -n; So̲l|ei; So̲|len|lei|tung
so|le̲nn lat. (feierlich, festlich); solen|ni|sie̲|ren (veralt. für: feierlich
begehen; feierlich bestätigen);
So|len|ni|tät (veralt. für: Feierlichkeit)
So|le|no|i̲d gr. (zylindrische Metallspule, die bei Stromdurchfluß
wie ein Stabmagnet wirkt) s; -[e]s,
-e
Sol|fa̲|ta̲|ra, Sol|fa̲|ta̲|re it. (Aushauchung schwefelhaltiger heißer Wasserdämpfe in ehem.
Vulkangebieten) w; -, ...ren
sol|feg|gie̲|ren it. [ßolfädsche̲h̲i̲rᵉn]
(Musik: Solfeggien singen); Solfeg|gio [...fädscho̲] (auf die Solmisationssilben gesungene Gesangsübung) s; -s, ...ggien
[...dscheᵉn]
Sol|fe̲|ri̲|no (it. Dorf)
So̲|li (Mehrz. von: Solo)
so̲|lid, so̲|li̲|de lat. (fest; haltbar;
zuverlässig; gediegen); ...deste
(↑ R 292); So|li|dar̲|haf̲|tung (Haftung von Gesamtschuldnern); soli|da̲|risch (gemeinsam, übereinstimmend, eng verbunden); so|lida|ri|sie̲|ren, sich (sich solidarisch erklären); So|li|da|ri|sie̲rung; So|li|da|ri̲s|mus (Richtung
der [kath.] Sozialphilosophie) m;
-; So|li|da|ri|tät (Zusammengehörigkeitsgefühl, Gemeinsinn;
Übereinstimmung) w; -; So|li|dari|täts|ge|fühl; So|li|da̲r|schuldner (Gesamtschuldner); so|li̲|de
vgl. solid; so|li|die̲|ren (veralt. für:
befestigen, versichern); So|li|ditä̲t (Festigkeit, Haltbarkeit; Zuverlässigkeit; Mäßigkeit) w; -
So|li|lo|qui̲um lat. (Allein-,
Selbstgespräch der antiken Bekenntnisliteratur) s; -s, ...ien
[...iᵉn]
So̲|ling (ein Rennsegelboot) s od.
m; -s, -s
So|li̲n|gen (Stadt in Nordrhein-
Westfalen); So|li̲n|ger (↑ R 199);
- Stahl
Sol|ip|si̲s|mus lat. (philos. Lehre,
nach der die Welt für den Menschen nur in seinen Vorstellungen besteht) m; -; Sol|ip|si̲st (Vertreter des Solipsismus); ↑ R 268;
sol|ip|si̲|stisch; So̲|list (Einzelsänger, -spieler); ↑ R 268; So|li̲|stenkon|zert; So|li̲|stin w; -, -nen; so|li̲stisch; So|li|tä̲r fr. (einzeln gefaßter Edelstein; Brettspiel für eine
Person) m; -s, -e; So|li|tü|de
(,,Einsamkeit"; Name von
Schlössern u. a.) w; -, -n
¹So̲ll [zu: Suhle] (runder kleiner
See eiszeitl. Herkunft) s; -[e]s, Sölle

²So̲ll (Bergmannsspr. auch: festge
legte Fördermenge) s; -[s], -[s
das - und [das] Haben; das -
das Muß; So̲ll-Be|stand (↑ R 151
m; -[e]s, ...stände; So̲ll-Be|tra
(↑ R 151) m; -[e]s, ...träge; So̲l
Ein|nah|me (↑ R 151) w; -, -n; so̲l
len; ich habe gesollt, aber (↑ F
305): ich hätte das nicht tun
Söl|ler lat. (erhöhter offener Saa
Vorplatz im oberen Stockwer
eines Hauses, offener Dachum
gang) m; -s, -
So̲ll|ling (Teil des Weserberg
landes) m; -s
So̲ll-I̲st-Ver|gleich; ↑ R 155 (Wirt
schaft: Gegenüberstellung u. Ab
weichungskontrolle von So̲ll
Zahlen) m; -[e]s, -e
So̲ll|li̲|zi|ta̲nt lat. (veralt. für: Bitt
steller) m; -en, -en (↑ R 268); So̲l
li|zi|ta̲|ti̲|on [...zio̲n] (veralt. für
Bitte, Gesuch; Betreibung eine
Rechtsgesuches); So̲l|li|zi|ta̲|to
österr. veralt. (Gehilfe eines An
walts) m; -s, ...ore̲n; so̲l|li|zi|tie
ren (veralt. für: nachsuchen; [un
Rechtshilfe) bitten)
So̲ll-Kauf|mann (↑ R 151) m; -[e]s
...leute; So̲ll-Ko|sten (↑ R 151
Mehrz.; So̲ll-Ko|sten|rech|nun
(↑ R 151); So̲ll|sei|te; So̲ll-Stär|k
(↑ R 151) w; -, -n
So̲l|lux|lam|pe Ⓦ (elektr. Wärme
strahlungslampe)
So̲ll-Zahl (Wirtsch.; ↑ R 151); w
-, -en; So̲ll-Zeit (Wirtsch.; ↑ R
151); w; -, -en; So̲ll|zin|se
(Mehrz.)
Sol|mi|sa̲|ti̲on [...zio̲n] (Tonleiter
system mit den Silben Do, Re
Mi, Fa, Sol, La, Si) w; -; So̲l|mi
sa̲|ti̲ons|sil|be; sol|mi|sie̲|ren
Soln|ho|fen (Ort in Mittelfran
ken); Soln|ho|fe|ner (↑ R 199);
Schiefer, Platten
so̲|lo it. (ugs. für: allein); ganz -
- tanzen; So̲|lo (Einzelvortra
-spiel, -tanz) s; -s, -s u. ...li; ein
- singen, spielen, tanzen; So̲|lo
...ge|sang, ...in|stru|ment, ...kan
ta|te, ...ma|schi|ne
So̲|lon (gr. Gesetzgeber); So̲|lo
nisch; (weise wie Solon); -e Weis
heit, aber (↑ R 179): So̲|lo|nisch
-e Gesetzgebung
So̲lo-sän|ger ...sän|ge|rin, ...stim
me, ...sze|ne (Einzelauftritt
-spiel), ...tanz, ...tän|zer, ...tän
ze|rin
So̲|lo|thurn (Kanton u. Stadt i
der Schweiz); So̲|lo|thur|ner (↑ R
199); so̲|lo|thur|nisch
So|lö|zis|mus gr. (Rhet.: grobe
Sprachfehler) m; -, ...men
So̲l|per (,,Salpeter"; westmitteld
für: Salzbrühe) m; -s; So̲l|per
fleisch westmitteld. (Pökel
fleisch)

Sol_quel|le, ...salz

Sol|sche|nj|zyn (sowjetruss. Schriftsteller)

Sol|sti|ti:um *lat.* [...*zium*] (Sonnenwende) *s*; -s, ...ien [...*i*ⁿ*n*]

Sol|ti [*scholti*], György [*djördj*] (ung. Dirigent)

so|lu|bel *lat.* (Chemie: löslich, auflösbar); ...u|ble Mittel; So|lu|ti:on [...*sign*] (Arzneimittellösung); sol|va|bel [...*wg*...] (auflösbar; veralt. für: zahlungsfähig); ...a|ble Geschäftspartner); Sol|vens (Med.: [schleim]lösendes Mittel) *s*; -, ...ventien [...*i*ⁿ*n*] u. ...ventia [...*zia*]; sol|vent (zahlungsfähig; tüchtig); Sol|venz (Zahlungsfähigkeit) *w*; -, -en; sol|vie|ren (Chemie: auflösen)

Sol|was|ser (*Mehrz.* ...wässer)

So|ma *gr.* (Med.: „Körper") *s*; -s, -ta

So|ma|li (Angehöriger eines ostafrik. Volkes) *m*; -[s], Soma|lia (Staat in Afrika); So|ma|li|er; So|ma|li|land (nordostafrik. Landschaft) *s*; -[e]s; so|ma|lisch so|ma|tisch *gr.* (Med.: das Soma betreffend, körperlich); so|ma|to|gen (körperlich bedingt, verursacht); So|ma|to|lo|gie (Lehre vom menschlichen Körper) *w*; -

Som|bre|ro *span.* (breitrandiger, leichter Tropenhut) *m*; -s, -s

so|mit [auch: *so*...] (mithin, also); so|mit [auch: *so*...] bist du der Aufgabe enthoben; aber: ich nehme es so (in dieser Form, auf diese Weise) mit

Som|mer *m*; -s, -; - wie Winter; sommers (vgl. d.); sommersüber (vgl. d.); Som|mer_an|fang od. Som|mers|an|fang, ...auf|enthalt, ...fahr|plan, ...fe|ri|en (*Mehrz.*), ...fri|sche (veraltend; *w*; -, -n), ...frisch|ler (veraltend) ...ger|ste, ...ge|wächs, ...halb|jahr. ...hanf, ...hit|ze; söm|me|rig landsch. (einen Sommer alt); -e Karpfen; Som|mer_kleid, ...kollek|ti|on (Mode); som|mer|lich; Som|mer|mo|nat; som|mern (veralt. für: sommerlich werden); es sommert; söm|mern landsch. (sonnen; [Vieh] im Sommer auf der Weide halten); ich ...ere (↑ R 327); Som|mer|nacht; Som|mernachts|traum (Komödie von Shakespeare; eigtl. Mittsommernachtstraum, engl. Midsummer Night's Dream), Som|mer_pau|se, ...preis (vgl. ²Preis), ...regen, ...rei|se; som|mers (↑ R 129), aber: des Sommers; Som|mersaat; Som|mers|an|fang, Som|mer|an|fang; Som|mer_schlußver|kauf, ...se|me|ster, ...son|nenwen|de, ...spros|se (meist *Mehrz.*); som|mer|spros|sig; som-

mers|über, aber: den Sommer über; Som|mer[s]|zeit (Jahreszeit) *w*; -; vgl. Sommerzeit; Som|mer|tag; som|mer|tags (↑ R 129); Som|me|rung (Sommergetreide) *w*; -; Söm|me|rung (das Sömmern); Som|mer_vo|gel (mdal. für: Schmetterling), ...weg, ...zeit (Jahreszeit; Vorverlegung der Stundenzählung während des Sommers; *w*; -; vgl. Sommer[s]zeit)

Som|mi|tä|ten *fr.* (veralt. für: hochstehende Personen) *Mehrz.*

som|nam|bul *lat.* (schlafwandelnd, mondsüchtig); Som|nam|bu|le (Schlafwandler[in]) *m* u. *w*; -n, -n (↑ R 287ff.); Som|nam|bu|lismus (Schlafwandeln; Mondsüchtigkeit) *m*; -

so|nach [auch: *so*...] (folglich, also); aber: sprich es so nach, wie ich es dir vorspreche

So|na|gramm *lat.*; *gr.* (Phonetik) *s*; -s, -e; So|nant *lat.* (silbenbildender Laut) *m*; -en, -en (↑ R 268); So|na|te *it.* (aus drei od. vier Sätzen bestehendes Musikstück für ein oder mehrere Instrumente) *w*; -, -n; So|na|ti|ne (kleinere Sonate) *w*; -, -n

Son|de *fr.* (Med.: Instrument zum Einführen in Körperhöhlen; auch: dünner Schlauch zur künstlichen Ernährung; Bergmannsspr.: Probebohrung; Physik, Meteor.: Gerät zur Erforschung der Verhältnisse in der Erdatmosphäre; Raumsonde) *w*; -, -n; Son|den|hal|ter

son|der (veralt. für: ohne); mit *Wenf.*: - allen Zweifel, - Furcht; Son|der_ab|druck (*Mehrz.* ...drucke), ...ab|schrei|bung, ...ab|zug, ...an|fer|ti|gung, ...ange|bot, ...an|spruch, ...aus|führung, ...aus|ga|be; son|der|bar; Son|der|bar|wei|se; Son|derbar|keit; Son|der_be|auf|trag|te, ...be|hand|lung, ...be|stim|mung, ...bund *m*; Son|der|bün|de|lci (tadelnd); Son|der|bünd|ler; Son|der|bunds|be|stre|bung

Son|der|burg (dän. Stadt)

Son|der|druck (*Mehrz.* ...drucke), ...ei|gen|tum, ...ein|satz, ...fahrt, ...fall *m*, ...form, ...ge|neh|migung, ...ge|richt; son|der|gleichen; Son|der|heit, aber: insonderheit; Son|der_klas|se, ...konto, ...ko|sten (*Mehrz.*); son|derlich; (↑ R 116:) nichts Sonderliches (Ungewöhnliches); Son|der|ling; Son|der|ma|schi|ne; ¹son|dern; nicht nur der Bruder, sondern auch die Schwester; ²son|dern; ich ...ere(↑ R 327); Son|der_preis (vgl. ²Preis), ...ra|batt, ...recht, ...re|ge|lung od. ...reg-

lung; son|ders; samt und -; Son|der_schu|le

Son|ders|hau|sen (Stadt im Bezirk Erfurt); Son|ders|häu|ser (↑ R 199)

Son|der_spra|che (Sprachw.), ...stel|lung, ...stem|pel, ...tum (veralt.; *s*; -s); son|der|tüm|lich (veralt.); Son|der|ur|laub, ...ver|kauf, ...wunsch, ...zu|hungs|recht (Wirtsch.; meist *Mehrz.*; Abk.: SZR), ...zug

son|die|ren *fr.* (mit der Sonde untersuchen; ausforschen, vorfühlen); Son|die|rung; Son|die|rungs|ge|spräch

So|nett *it.* (Gedichtform) *s*; -[e]s, -e

Song *engl.* (Sonderform des Liedes, oft mit sozialkrit. Inhalt) *m*; -s, -s

Son|ja (w. Vorn.; russ. Verkleinerungsform von: Sophia)

Sonn|abend *m*; -s, -e; vgl. Dienstag; sonnabends (↑ R 129); vgl. Dienstag; sonn|durch|flu|tet, son|nendurch|flu|tet; Son|ne *w*; -, -n; (↑ R 224:) Gasthof „Zur Goldenen Sonne"

Son|ne|berg (Stadt am Südrand des Thüringer Waldes)

son|nen; sich -; Son|nen_auf|gang, ...bad; son|nen|ba|den (meist nur in der Grundform u. im 2. Mittelw. gebr.); sonnengebadet; Sonnen_bahn, ...ball (*m*; -[e]s), ...batte|rie (Vorrichtung, mit der Sonnenenergie in elektr. Energie umgewandelt wird), ...blen|de, ...blume; Son|nen|blu|men|kern; Sonnen_brand, ...bräu|ne, ...bril|le, ...dach, ...deck; son|nen|durch|flutet, son|nen|durch|flu|tet; Son|nen_fin|ster|nis, ...fleck; son|nen|gebräunt; Son|nen_glast, ...glut (*w*; -), ...gott; son|nen|hell; Son|nen_hut, ...jahr; son|nen|klar (ugs.); Son|nen|kö|nig (Beiname Ludwigs XIV. von Frankreich; *m*; -[e]s), ...kraft|werk (Anlage zur Nutzung der Sonnenenergie), ...krin|gel, ...kult, ...licht (*s*; -[e]s), ...nä|he, ...öl, ...pro|tu|be|ran|zen (*Mehrz.*), ...rad, ...schei|be, ...schein (*m*; -[e]s), ...schirm, ...schutz, ...sei|te (österr.: Sonnseite); son|nen|se|lig; Sonnen_stäub|chen, ...stich, ...strahl, ...sy|stem, ...tag, ...tau (eine Pflanze; *m*), ...tier|chen (Einzeller), ...uhr, ...un|ter|gang; sonnen|ver|brannt, sonn|ver|brannt; Son|nen|war|te (Observatorium zur Sonnenbeobachtung); Sonnen_wen|de, Son|nen|wend_fei|er, Sonn|wend|fei|er; son|nig; Sonnsei|te (österr. für: Sonnenseite); sonn|sei|tig (österr.); Sonn|tag; des Sonntags, aber (↑ R 129): sonntags; (↑ R 145:) sonn- und

638

alltags, sonn- und feiertags, sonn- und festtags, sonn- und werktags; vgl. Dienstag; **Sonntag|abend** (vgl. Dienstagabend); am -; **sonn|tä|gig** (vgl. ...tägig); **sonn|täg|lich** (vgl. ...täglich); **sonn|tags** († R 129); vgl. Dienstag u. Sonntag; **Sonn|tags_ar|beit,** ...**bei|la|ge** (einer Zeitung), ...**fahrer** (spött.), ...**jä|ger** (spött.), ...**kind,** ...**rei|ter** (spött.), ...**rückfahr|kar|te,** ...**ru|he; sonn|verbrannt,** son|nen|ver|brannt; **Sonn|wend|fei|er,** Son|nen|wendfei|er

so|nor lat. (klangvoll, volltönend); **So|no|ri|tät** w; -

sonst; hast du sonst (außerdem) noch eine Frage, sonst noch etwas auf dem Herzen?; ist sonst jemand, sonst wer (ugs.) bereit mitzuhelfen?; Zusammenschreibung, wenn „sonst" die Bedeutung von ,,irgend" hat; vgl. sonstjemand, sonstwas, sonstwer sonstwie, sonstwo, sonstwohin; **son|stig;** († R 135:) -es (anderes); **sonst|je|mand** (ugs. für: irgend jemand); da könnte ja - kommen; **sonst|was** (ugs. für: irgend etwas, wer weiß was); ich hätte fast - gesagt; **sonst|wer** vgl. sonstjemand; **sonst|wie; sonst|wo; sonstwo|hin**

Sont|ho|fen (Ort in den Allgäuer Alpen)

so|oft; Bindew.: sooft du zu mir kommst, immer ..., aber (Umstandsw.): ich habe es dir so oft gesagt, daß ...

Soon|wald (Gebirgszug im südöstl. Hunsrück) m; -[e]s

Soor (Pilzbelag in der Mundhöhle) m; -[e]s, -e; **Soor|pilz**

Soot niederd. (Brunnen) m; -[e]s, -e

So|phia, So|phie [auch: sofi⁴, österr.: sofi] (w. Vorn.), (auch:) Sofie (vgl. d.); vgl. Sonja; **So|phien|kir|che** († R 180); **So|phis|ma** gr.; s; -s, ...men u. So|phis|mus (Trugschluß; Spitzfindigkeit) m; -, ...men; **So|phist** (urspr. gr. Wanderlehrer; dann: Scheingelehrter; Klügler, Wortverdreher); † R 268; **So|phi|ste|rei** (Spitzfindigkeit); **So|phi|stik** (gr. philos. Lehre; Scheinwissen; Spitzfindigkeit) w; -; **so|phistisch;** -ste († R 294)

so|pho|kle|isch; -es Denken (nach Art des Sophokles), aber († R 179): **So|pho|kle|isch;** -e (von Sophokles stammende) Tragödien; **So|pho|kles** (gr. Tragiker)

So|phro|sy|ne gr. (antike Tugend der Selbstbeherrschung, Besonnenheit) w; -

So|phus (m. Vorn.)

So|por lat. (Med.: starke Benommenheit) m; -s; **so|po|rös;** -este († R 292)

So|pot (poln. Name für: Zoppot)

So|pran it. (höchste Frauen- od. Knabenstimme; Sopransänger[in]) m; -s, -e; **So|pra|nist** (Knabe mit Sopranstimme); † R 268; **Sopra|ni|stin** w; -, -nen

So|pra|por|te, Su|pra|por|te it. ([reliefartiges] Wandfeld über einer Tür) w; -, -n

So|ra|ya (w. Vorn.)

Sor|be (Angehöriger einer westslaw. Volksgruppe) m; -n, -n († R 268); **Sor|ben|sied|lung**

Sor|bet [fr. Aussspr.: sorbä] vgl. Sorbett) m od. s; -s, -s; **Sor|bett** arab. u. Scherbett (eisgekühltes Getränk, Halbgefrorenes) m od. s; -[e]s, -e

sor|bisch; Sor|bisch (Sprache) s; -[s]; vgl. Deutsch; **Sor|bi|sche** s; -n; vgl. Deutsche s

¹**Sor|bit** lat. (sechswertiger Alkohol; pflanzl. Wirkstoff) m; -s

²**Sor|bit** [nach dem engl. Forscher Sorby (so'bi)] (Bestandteil der Stähle) m; -s

Sor|bonne [sorbon] (Name der Pariser Universität) w; -

Sor|di|ne it. w; -, -n u. **Sor|di|no** (Musik: Dämpfer) m; -s, -s u. ...ni; vgl. con sordino; **Sor|dun** (Schalmei des 16. u. 17. Jh.s; früheres dunkel klingendes Orgelregister) m od. s; -s, -e

Sor|ge w; -, -n; - tragen († R 140); **sor|gen;** sich -; **Sor|gen|bre|cher** (scherzh. für: alkohol. Getränk, bes. Wein); **sor|gen|frei; Sor|gen_frei|heit** (w; -), ...**kind,** ...last; **sorgen|los** (ohne Sorgen); -este († R 292); **Sor|gen|lo|sig|keit** w; -; **sorgen_schwer,** ...**voll; Sor|ge|recht** (Rechtsw.); **Sorg|falt** w; -; **sorgfäl|tig; Sorg|fäl|tig|keit** w; -; **Sorgfalts|pflicht**

Sor|gho it. [...go] m; -s, -s u. **Sorghum** (Getreidepflanze, Mohrenod. Kaffernhirse) s; -s, -s

sorg|lich; sorg|los (ohne Sorgfalt; unbekümmert); -este († R 292); **Sorg|lo|sig|keit** w; -; **sorg|sam; Sorg|sam|keit** w; -

Sorp|ti|on [...zion] (Chemie: Aufnahme eines Gases od. gelösten Stoffes durch einen anderen festen od. flüssigen Stoff)

Sor|rent (it. Stadt)

Sor|te lat. (Art, Gattung; Wert, Güte) w; -, -n; **Sor|ten** (Bankw. für: ausländ. Geldsorten, Devisen) Mehrz.; **Sor|ten_fer|ti|gung** (Wirtsch.), ...**ge|schäft,** ...**han|del** (Börse), ...**kal|ku|la|ti|on,** ...**kurs** (Börse), ...**markt** (Börse), ...**produk|ti|on** (Wirtsch.), ...**ver|zeichnis,** ...**zet|tel; sor|tie|ren** (sondern,

auslesen, sichten); **Sor|tie|rer; Sor|tie|re|rin** w; -, -nen; **Sor|tierma|schi|ne; sor|tiert** (auch für: hochwertig); **Sor|tie|rung; Sor|tile|gi|um** (Weissagung durch Lose) s; -s, ...ien [...i⁴n]; **Sor|timent** it. (Warenangebot, -auswahl eines Kaufmanns; auch für: Sortimentsbuchhandel) s; -[e]s, -e; **Sor|ti|men|ter** (Angehöriger des Sortimentsbuchhandels, Ladenbuchhändler); **Sor|ti|ments_buch|han|del,** ...**buch|händ|ler**

SOS (internationales Seenotzeichen, gedeutet als: save our ship [be'w au⁴r schip] = Rette[t] unser Schiff! od. save our souls [be'w au⁴r ßo⁴ls] = Rette[t] unsere Seelen!)

so|sehr; Bindew.: sosehr ich das auch billige, ..., aber (Umstandsw.): er lief so sehr, daß ...

SOS-Kin|der|dorf; † R 150 (besondere Art eines Kinderdorfes) s; -[e]s, ...**dörfer**

so|so (ugs. für: nicht [gerade] gut; ungünstig); es steht damit -; soso! (nun ja!)

SOS-Ruf († R 150) m; -[e]s, -e; vgl. SOS

So|ße fr. (Brühe, Tunke; in der Tabakbereitung: Beize) w; -, -n; vgl. Sauce; **so|ßen; So|ßen_löf|fel,** ...**re|zept,** ...**schüs|sel**

sost. = sostenuto

so|ste|nu|to it. (Musik: gehalten, getragen; Abk.: sost.)

so|tan (veralt. für: so beschaffen, solch); -e Begebenheit; unter -en Umständen

Sol|ter gr. (Retter, Heiland; Ehrentitel Jesu Christi) m; -, -e; **So|terio|lo|gie** (Theol.: Erlösungswerk Christi, Heilslehre) w; -; **so|te|riolo|gisch**

Sott niederd. (Ruß) m od. s; -[e]s

Sot|ti|se fr. [...tis⁴] (veralt., aber noch mdal. für: Dummheit; Grobheit) w; -, -n

sot|to vo|ce it. [- wotsche] (Musik: halblaut, gedämpft)

Sou fr. [ßu] (fr. Münze im Wert von 5 Centimes) m; -, -s [ßu]

Sou|bret|te fr. [ßu...] (Sängerin heiterer Sopranpartien in Oper u. Operette) w; -, -n

Sou|che fr. [ßusch⁴] (Wirtsch.: Teil eines Wertpapiers, der zur späteren Kontrolle die Echtheit zurückbehalten wird) w; -, -n

Sou|chong chin.-fr. [ßuschong] (chin. Tee mittlerer Qualität) m; -[s], -s; **Sou|chong|tee**

Souf|flé fr. [ßufle] (Gastr.: Eierauflauf) s; -s, -s; **Souf|fleur** [ßuflör] (Theater: jmd., der souffliert) m; -s, -e; **Souf|fleur|ka|sten; Souffleu|se** [ßuflös⁴] w; -, -n; **souf|flieren** (flüsternd vorsagen)

Soul *amerik.* [*ßǫ"l*] (best. Art von Jazz od. Beat mit starker Betonung des Expressiven) *m*; -s

Söul vgl. Seoul

Sound *amerik.* [*ßau̯nd*] (Musik: Klang[wirkung, -richtung]) *m*; -s

so|und|so (ugs. für: unbestimmt wie); soundso breit, groß, viel usw.; Paragraph soundso; a b e r : Paragraph soundso; a b e r : etwas sǫ und sǫ (sǫ und wieder anders) erzählen; (↑ R 119:) [der] Herr Soundso; sǫ|und|so|viel|te; der - Mai, Abschnitt usw., a b e r (↑ R 118:) am Soundsovielten des Monats

Sou|per *fr.* [*ßupę*] (festliches Abendessen) *s*; -s, -s; **sou|pie|ren**

Sous|chef *fr.* [*ßuschä̈f*] schweiz. (Stellvertreter des [Bahnhofs]vorstandes) *m*; -s, -s

Sou|ta|che *ung.-fr.* [*sutạsch*[e]] (schmale, geflochtene Schnur für Besatzzwecke) *w*; -, -n; **sou|ta|chie|ren** [*sutaschir*[e]*n*]

Sou|ta|ne *fr.* [*su...*] (Gewand der kath. Geistlichen) *w*; -, -n; **Sou|tanel|le** (bis ans Knie reichender Gehrock der kath. Geistlichen) *w*; -, -n

Sou|ter|rain *fr.* [*sutärä̈ng*, auch: *su̯...*] (Kellergeschoß) *s*; -s, -s; **Sou|ter|rain|woh|nung**

South|amp|ton [*ßauthämpt*[e]*n*] (engl. Stadt)

Sou|ve|nir *fr.* [*ßuw*[e]*...*] ([kleines Geschenk als] Andenken, Erinnerungsstück) *s*; -s, -s

sou|ve|rän *fr.* [*ßuw*[e]*...*] (unumschränkt; selbständig; jeder Lage gewachsen, überlegen); ein -er Herrscher; ein -er Staat; **Sou|verän** (Herrscher; Landes-, Oberherr; bes. schweiz.: Gesamtheit der Wähler) *m*; -s, -e; **Sou|ve|räni|tät** (Unabhängigkeit; Landes-, Oberhoheit) *w*; -; **Sou|ve|räni|täts|an|spruch**

Sove|reign *engl.* [*sǫwrin*] (frühere engl. Goldpfundmünze) *m*; -s, -s

so|viel; soviel ich weiß; sein Wort bedeutet soviel (dasselbe) wie ein Eid; soviel (dieses) für heute; rede nicht soviel!; du kannst haben, soviel [wie] du willst; du kannst soviel haben, wie du willst; soviel als (Abk.: sva.); soviel wie (Abk.: svw.); soviel wie od. als möglich; noch einmal soviel; er hat doppelt soviel Geld wie (seltener: als) du; halb soviel; a b e r : du weißt sǫ viel, daß ...; er liest sǫ viel, daß ...; sǫ viel [Geld] wie du hat er auch; ich habe sǫ viel Zeit, daß ...; sǫ viel ist daran richtig, daß ...; sǫ viele Gelegenheiten; er mußte sǫ viel leiden; **so|viel|mal**; a b e r : sǫ viele Male

so wahr; so wahr mir Gott helfe

sǫ was (ugs. für: so etwas)

Sow|chos *russ.* [*sǫfehoß*] *m* od. *s*; -, ...chǫse u. (österr. nur:) **Sow|cho|se** (Staatsgut in der Sowjetunion) *w*; -, -n

so|weit; soweit ich es beurteilen kann, wird ...; ich bin [noch nicht] soweit; es, die Sache ist soweit; soweit wie od. als möglich will ich nachgeben. a b e r : wirf den Ball sǫ weit wie möglich; es geht ihm soweit gut, nur ...; a b e r : sǫ weit, so gut; ich kann den Weg sǫ weit übersehen, daß ...; er ist sǫ weit gereist, daß ...; eine Sache sǫ weit fördern, daß ...

so|we|nig; ich bin sowenig (ebensowenig) dazu bereit wie du; ich kann es sowenig (ebensowenig) wie du; tu das sowenig wie od. als möglich; ich habe sowenig Geld wie du (wir beide haben keins); sowenig ich einsehen kann, daß ...; sowenig du auch gelernt hast, das wirst du doch wissen; a b e r : ich habe sǫ wenig (gleich wenig) Geld wie du; du hast sǫ wenig gelernt, daß du die Prüfung nicht bestehen wirst

[1]**so|wie** (sobald), sowie er kommt, soll er nachsehen; a b e r : sǫ, wie ich ihn kenne; kommt er nicht; er kam sǫ, wie ich ihn zuletzt gesehen hatte; [2]**so|wie** (und, und auch); wissenschaftliche und technische sowie schöne Literatur

so|wie|so

So|wjet *russ.* („Rat"; Form der Volksvertretung in der Sowjetunion; meist *Mehrz.*: Anhänger des Sowjetsystems) *m*; -s, -s; **So|wjet'|ar|mee**, ...bür|ger; so|wjetisch; Sowjet..re|gie|rung, ...re|pu|blik[1], ...rus|se; so|wjet|rus|sisch[1]; **So|wjet'|ruß|land**, ...stern, ...uni|on (*w*; -; Abk.: SU; vgl. auch: UdSSR), ...ver|fas|sung, ...volk

so|wohl; Bindew.; sowohl die Eltern als [auch] od. wie [auch] die Kinder; a b e r (*Umstandsw.*): du siehst sǫ wohl aus, daß ...; **Sowohl-Als-auch** *s*; -

Sǫxh|let Ⓦ [nach dem dt. Chemiker] (Nährzucker; Apparat zur Milchsterilisation)

Sǫ|zi (abschätzige Kurzform von: Sozialdemokrat) *m*; -s, -s; **Sǫ|zia** *lat.* (meist scherzh. für: Beifahrerin auf einem Motorrad od. -roller) *w*; -, -s; **so|zia|bel** (gesellschaftlich; gesellig; umgänglich; menschenfreundlich); ...a|ble Menschen; **So|zia|bi|li|tät**; **so|zi|al** (die Gesellschaft, die Gemeinschaft betreffend, gesellschaftlich; Gemeinschafts..., Gesellschafts...; gemeinnützig, wohltä-

tig); (↑ R 224:) die soziale Frage; soziale Sicherheit; sozialer Wohnungsbau; soziale Marktwirtschaft; So|zi|al..ab|ga|ben (*Mehrz.*), ...ar|beit, ...bei|rat, ...be|richt, ...be|ruf, ...de|mo|krat (Mitglied [od. Anhänger] einer sozialdemokratischen Partei), ...de|mo|kra|tie ([Gesamtheit der] Sozialdemokratische[n] Par-tei[en]) *w*; -; so|zi|al|de|mo|kra|tisch, a b e r (↑ R 224): die Sozialdemokratische Partei Deutschlands (Abk.: SPD); So|zi|al..ein|kom|men, ...ethik, ...ge|richt, ...ge|richts|bar|keit, ...ge|setz|ge-bung, ...hil|fe, ...hy|gie|ne; So|zia-li|sa|ti|on [...*zi̯ọn*] (Prozeß der Einordnung des Individuums in die Gesellschaft) *w*; -; so|zia|li|sie-ren (vergesellschaften, verstaatlichen); So|zia|li|sie|rung (Verstaatlichung, Vergesellschaftung der Privatwirtschaft); So|zia|lis-mus (eine im Gegensatz zur liberalen Gesellschafts- u. Wirtschaftsordnung entstandene Bewegung zur Sicherung der Freiheit und des Glücks des einzelnen im Staat, u. a. durch Überführung wenigstens der wichtigsten Produktionsmittel in das Gemeineigentum) *m*; -; So|zia|list (↑ R 268); so|zia|li|stisch; -er Realismus (eine auf dem Marxismus gründende künstler. Richtung in den kommunist. Ländern), a b e r (↑ R 224): Sozialistische Einheitspartei Deutschlands (DDR; Abk.: SED); So|zi|al|kri|tik; so|zi|al|kri|tisch; So|zi|al|la|sten (*Mehrz.*), ...lei|stun|gen (*Mehrz.*); so|zi|al|li|be|ral; So|zi|al-..lohn, ...öko|no|mie, ...päd|ago-gik, ...part|ner, ...po|li|tik, ...po|li-ti|ker; so|zi|al|po|li|tisch; So|zi-al_pre|sti|ge, ...pro|dukt, ...psy-cho|lo|gie, ...recht, ...re|form, ...ren|te, ...rent|ner, ...staat (*Mehrz.* ...staaten), ...sta|ti|stik, ...struk|tur, ...ta|rif, ...ver|mö|gen (Wirtsch.), ...tou|ri|stik, ...ver-si|che|rung, ...ver|si|che|rungs-bei|trag, ...wis|sen|schaf|ten (*Mehrz.*), ...zu|la|ge; So|zie|tät [...*zi-e...*] (Gesellschaft; Genossenschaft); So|zio|gra|phie (Soziologie: Darstellung der Formen menschlichen Zusammenlebens innerhalb bestimmter Räume u. Zeiten) *w*; -; So|zio|lekt (Sprachw.: Sprachgebrauch von Gruppen, Schichten, Institutionen o. ä.) *m*; -[e]s, -e; So|zio|lin-gui|stik (Sprachw.: wissenschaftl. Betrachtungsweise des Sprechverhaltens verschiedener Gruppen, Schichten o. ä.); so|zio-lin|gui|stisch; So|zio|lo|ge *lat.*; *gr.*

[1] Auch: *sǫw...* usw.

(Erforscher u. Lehrer der Soziologie) *m*; -n, -n (↑ R 268); So|zio|lo|gie (Gesellschaftslehre, -wissenschaft) *w*; -; so|zio|lo|gisch; So|zio|me|trie (soziolog. Verfahren zur testmäßigen Erfassung der Gruppenstruktur) *w*; -; so|zio|me|trisch; So|zi|us *lat.* (Genosse, Teilhaber; Beifahrer) *m*; -, -se; So|zi|us|sitz (Rücksitz auf dem Motorrad)

so|zu|sa|gen (gewissermaßen), a b e r : er versucht, es so zu sagen, daß es für jedermann verständlich ist

Sp. = Spalte (Buchw.)

Spa (belg. Stadt)

Spach|tel, Spa|tel (kleines spatenod. schaufelähnl. Werkzeug) *m*; -s, - od. *w*; -, -n (österr. nur: Spachtel *w* od. Spatel *m*); Spachtel|ma|le|rei; spach|teln (ugs. auch für: [tüchtig] essen); ich ...[e]le (↑ R 327)

spack landsch. (dürr; eng)

Spa|da *it.* (degenähnl. Fechtwaffe) *w*; -, -s; Spa|dil|le *span.* [*ʃpadílʲ*] (höchste Trumpfkarte im Lomber) *w*; -, -n

Spa|er [zu: Spa] (↑ R 199)

¹Spa|gat *it.* (Gymnastik: völliges Beinspreizen) *m* (österr. nur so) od. *s*; -[e]s, -e

²Spa|gat *it.* (südd., österr. (Bindfaden) *m*; -[e]s, -e

Spa|ghet|ti [*ʃpagäti*] (Fadennudeln) *Mehrz.*

Spa|gi|rik *gr.* (früher: Alchimie; heute: Arzneimittelzubereitung auf mineral.-chem. Basis) *w*; -; Spa|gi|ri|ker (früher für: Alchimist, Goldmacher); spa|gi|risch

spä|hen; Spä|her; Spä|he|rei (abwertend)

Spa|hi *pers.* („Krieger"; früher: [adliger] Reiter im türk. Heer; Angehöriger einer aus afrik. Eingeborenen gebildeten fr. Reitertruppe) *m*; -s, -s

Späh|trupp (für: Patrouille)

Spa|ke niederd. (Hebel, Hebebaum) *w*; -, -n; spa|kig niederd. (faulig, schimmelig, stockfleckig)

Spa|la|to (it. Form von: Split)

Spa|lett *it.* österr. (hölzerner Fensterladen) *s*; -[e]s, -e

Spa|lier *it.* (Gitterwand; Doppelreihe von Personen als Ehrengasse) *s*; -s, -e; - bilden, stehen; Spa|lier|baum; spa|lier|bil|dend; Spa|lier|obst

Spalt *m*; -[e]s, -e; spalt|bar; Spalt|bar|keit *w*; -; spalt|breit; eine -e Öffnung; Spalt|breit *m*; -; die Tür einen - öffnen; Spält|chen, Spaltlein; Spal|te (österr. auch für: Schnitz, Scheibe; Abk.: [Buchw.]: Sp.) *w*; -, -n; spal|ten;

gespalten und gespaltet; in eigenschaftswörtlichem Gebrauch nur: gespalten; gespaltenes Holz, eine gespaltene Zunge; Spal|ten|brei|te; spal|ten|lang; ein -er Artikel, a b e r : drei Spalten lang; spal|ten|wei|se; Spalt|fuß; ...spal|tig (z. B. zweispaltig); Spalt|le|der; Spält|lein, Spält|chen, Spalt.pil|ze (*Mehrz.*), ...pro|duk|te (bei der Atomkernspaltung; *Mehrz.*); Spalt-Ta|blet|te ⓦ, (auch:) Spalt|ta|blet|te ⓦ (schmerzlinderndes Mittel); Spal|tung; Spalt|ver|fah|ren

Span *m*; -[e]s, Späne; span|ab|he|bend (vgl. S. 45, Merke, 2); Spänchen, Spän|lein

Span|dril|le *it.* (Bauw.: Bogenzwickel) *w*; -, -n

spa|nen (Späne abheben); spanende Werkzeuge; ¹spä|nen (mit Metallspänen abreiben)

²spä|nen (mdal. für: säugen; auch für: entwöhnen); Span|fer|kel (ein vom Muttertier noch nicht entwöhntes Saugferkel)

Späng|chen (veralt. für: Spängelchen); Spän|ge *w*; -, -n; Spän|gel|chen, Spän|ge|lein (dicht.), Späng|lein; Span|gen|schuh

Spa|ni|el *engl.* [...*i-el*; auch in engl. Aussspr.: *ʃpänᵉl*] (Hund einer bestimmten Rasse) *m*; -s, -s; Spa|ni|en [...*iᵉn*]; Spa|ni|er [...*iᵉr*]; Spa|ni|ol *span.* (span. Schnupftabak) *m*; -s, -e; Spa|ni|o|le (Nachkomme von einst aus Spanien vertriebenen Juden) *m*; -n, -n (↑ R 268); spa|nisch; das kommt mir - (ugs. für: seltsam) vor; (↑ R 200:) -e Fliege (Insekt); die Spanische Reitschule (in Wien); -es Rohr; -er Reiter (milit. Bez. für ein bestimmtes Hindernis); -er Stiefel (ein Folterwerkzeug); -e Wand, a b e r (↑ R 198): der Spanische Erbfolgekrieg; Spa|nisch (Sprache) *s*; -[s]; vgl. Deutsch; Spa|nische *s*; -n; vgl. Deutsche *s*; Spanisch|flie|gen|pfla|ster; Spanisch|gelb; Spa|nisch-Gui|nea (↑ R 207)

Spän|lein, Spän|chen

Spann (oberer Teil, Rist des menschl. Fußes) *m*; -[e]s, -e; Spann|be|ton; Spann|be|ton-brücke [*Trenn.*: ...brük|ke], ...kon|struk|tion; Spann|dienst (hist.: Frondienst; auch: Gemeinschaftsdienst); Hand- und Spanndienst leisten; Span|ne (altes Längenmaß) *w*; -, -n; span|nen; span|nend; -ste; span|nen|lang, a b e r : vier Spannen lang; Span|ner; ...spän|ner (z. B. Einspänner); spann|fä|hig; ...spän|nig (z. B. zweispännig); Spann.kraft (*w*;

-), ...rah|men (Buchbinderei) Span|nung; Span|nungs.ab|fal (Elektrotechnik), ...feld; spannung[s]|füh|rend; Span|nungs|ko-ef|fi|zi|ent (Physik); span|nungslos; -este (↑ R 292); Span|nungs-mes|ser *m*, ...mo|ment, ...prü|fer ...ver|hält|nis, ...zu|stand; Spann-vor|rich|tung, ...wei|te; Span-plat|te (Bauw.); Spant (rippenähnlicher Bauteil zum Verstärken der Außenwand von Schiffsund Flugzeugrümpfen) *s* (in der Luftfahrt auch: *m*); -[e]s, -en (meist *Mehrz.*); Span|ten|riß (eine best. Schiffskonstruktionszeichnung)

Spar.be|trag, ...bren|ner, ...buch, ...büch|se, ...ein|la|ge; spa|ren; Spa|rer; Spar.flam|me, ...för|de-rung

Spar|gel (Gemüse[pflanze]) *m*; -s, - (schweiz. auch: *w*; -, -n); Spar-gel.beet, ...ge|mü|se

Spar|gi|ro|ver|kehr [...*sehiro*...]; Spar.gro|schen, ...gut|ha|ben

Spark (Futterpflanze) *m*; -[e]s

Spar.kas|se, ...kas|sen|buch, ...kon|to;spär|lich; Spär|lich|keit; Spar.maß|nah|me (meist *Mehrz.*), ...nei|gung, ...pfen|nig, ...prä|mie, ...quo|te, ...ra|te

Spar|re (für: Sparren) *w*; -, -n; Spar|ren *m*; -s, -; Spar|ren|werk ¹Spar|ring *engl.* (Boxsport: Übungsball) *m*; -s, -s; ²Spar|ring (Boxtraining) *s*; -s; Spar|ringskampf (Übungsboxkampf mit dem Sparringspartner), ...partner

spar|sam; Spar|sam|keit *w*; -; Spar.schuld|ver|schrei|bung, ...schwein

Spart (svw. Esparto) *m* od. *s*; -[e]s, -e

Spar|ta (altgr. Stadt)

Spar|ta|ki|a|de (in den Ostblockstaaten: Sportlertreffen mit Wettkämpfen); Spar|ta|kist (Angehöriger des Spartakusbundes); ↑ R 268; Spar|ta|kus (Führer eines röm. Sklavenaufstandes); Spar|ta|kus|bund (kommunist. Kampfbund 1917/18) *m*; -[e]s

Spar|ta|ner (Bewohner von Sparta);spar|ta|nisch; -e (strenge, harte) Zucht

Spar|te (Abteilung, Fach, Gebiet; Geschäfts-, Wissenszweig; Zeitungsspalte) *w*; -, -n

Spar|te|rie *fr.* (Flechtwerk aus längeren Spänen od. Bast) *w*; -; Spart|gras (svw. Espartogras)

Spar|ti|at (dorischer Vollbürger im alten Sparta) *m*; -en, -en (↑ R 268)

spar|tie|ren *it.* (Musik: ein nur in den einzelnen Stimmen vorhandenes Werk in Partitur setzen)

Spar- und Dar|le|hens|kas|se (↑ R 145); Spar|zins (*Mehrz.* ...zinsen)

spas|ma|tisch *gr.* (selten für: spasmisch); spas|misch (Med.: krampfhaft, -artig); spas|mo|disch (vgl. spasmisch); spas|mo|gen (Med.: krampferzeugend); Spas|mo|ly|ti|kum (Med.: krampflösendes Mittel) *s*; -s, ...ka; spas|mo|ly|tisch; Spas|mus (Med... Krampf) *m*; ...men

Spaß *m*; -es, Späße; - machen; Späß|chen, Späß|lein; spa|ßen; du spaßt (spaßest); Spa|ße|rei; spa|ßes|hal|ber; Spa|ßet|tel[n] österr. mdal. (Witz, Scherz) *Mehrz.*; -machen; spaß|haft; Spaß|haf|tig|keit *w*; -; spa|ßig; Spa|ßig|keit; Späß|lein, Späß|chen; Spaß|ma|cher, ...ver|der|ber, ...vo|gel (scherzh.)

spa|stisch (svw. spasmisch)

spat (veralt. für: spät)

¹Spat (ein Mineral) *m*; -[e]s, -e u. Späte

²Spat (eine Pferdekrankheit) *m*; -[e]s

spät; -er, -est; -estens (↑ R 292); spät sein, werden; zu spät kommen; von [morgens] früh bis [abends] spät; am, zum -esten (↑ R 134); (↑ R 129:) spätabends, spätnachmittags usw., aber: eines Spätabends, Spätnachmittags, -; in der -

Spa|tel vgl. Spachtel; Spa|ten *m*; -s, -; Spa|ten|for|schung (Vorgeschichtsforschung durch Ausgrabungen; *w*; -), ...stich

Spät|ent|wick|ler; spä|ter; spä|ter|hin; spä|te|stens; Spät..ge|burt, ...go|tik

Spa|tha *gr.* (Blütenscheide kolbiger Blütenstände) *w*; -, ...then

spat|hal|tig

Spät|herbst; spät|herbst|lich

Spa|ti|en [...ziᵉn] (*Mehrz.* von Spatium); Spa|ti|en..brei|te (Druckw.), ...keil (Druckw.)

spa|tig (spatkrank)

spa|ti|ie|ren *lat.* [...zi...] (seltener für: spationieren); spa|tio|nie|ren (Druckw.: [mit Zwischenräumen] durchschießen, sperren); spa|ti|ös (vom Druck: weit, geräumig); Spa|ti|um (Druckw.: Zwischenraum; schmales Ausschlußstück) *s*; -s, ...ien [...iᵉn]

spät|jahr, ...la|tein; spät|la|tei|nisch; Spät|le|se; Spät|ling; Spät|mit|tel|al|ter; Spät|nach|mit|tag; eines -s, aber: eines späten Nachmittags; spät|nach|mit|tags; Spät..re|nais|sance, ...ro|man|tik, ...schicht, ...som|mer

¹Spatz *m*; -en (auch: -es), -en; Spätz|chen, Spätz|lein; Spat|zen|nest; Spätz|le (schwäb. Mehlspeise) *Mehrz.*; Spätz|lein, Spätz|chen; Spätz|li schweiz. (Spätzle)

Spät|zün|dung

spa|zie|ren *lat.* (sich ergehen); (↑ R 139:) spa|zie|ren..fah|ren (ich fahre spazieren; ich bin spazierengefahren; spazierenzufahren), ...füh|ren (vgl. spazierenfahren), ...ge|hen (vgl. spazierenfahren); Spa|zie|ren|ge|hen (↑ R 120) *s*; -s; spa|zie|ren|rei|ten; vgl. spazierenfahren; Spa|zier..fahrt, ...gang *m*, ...gän|ger, ...ritt, ...stock (*Mehrz.* ...stöcke), ...weg

SPD = Sozialdemokratische Partei Deutschlands

Specht (ein Vogel) *m*; -[e]s, -e

Speck *m*; -[e]s, -e; Speck|hals; speckig [*Trenn.*: spek|kig]; Speck..ku|chen, ...schwar|te, ...sei|te, ...so|ße, ...stein (für: Steatit)

spe|die|ren *it.* ([Güter] versenden, befördern, verfrachten); Spe|di|teur [...tör] (Transportunternehmer) *m*; -s, -e; Spe|di|ti|on [...zion] (gewerbsmäßige Verfrachtung, Versendung [von Gütern]; Transportunternehmen; Versand[abteilung in großen Betrieben]); Spe|di|ti|ons_fir|ma, ...ge|schäft; spe|di|tiv schweiz. (rasch vorankommend, zügig)

Speech *engl.* [ßpitsch] (ugs. scherzh. für: Rede; Ansprache) *m*; -es, -e u. -es [...tschis]

¹Speed *engl.* [ßpid] (Sportspr.: Geschwindigkeit[steigerung], Spurt) *m*; -[e]s, -s; ²Speed (Aufputsch-, Rauschmittel) *s*; -s, -s

Speer *m*; -[e]s, -e; den - werfen; Speer..län|ge, ...schaft (vgl. ¹Schaft), ...wer|fen (↑ R 120; *s*; -s), ...wer|fer

spei|ben bayr. u. österr. mdal. (erbrechen); er hat gespieben

Spei|che *w*; -, -n

Spei|chel *m*; -s, Spei|chel..drü|se, ...fluß, ...lecker [*Trenn.*: lek|ker] (abschätzig); Spei|chel|leckerei [*Trenn.*: ...lek|kerei] (abschätzig); spei|cheln; ich ...[e]le (↑ R 327)

Spei|chen|kranz

Spei|cher *lat. m*; -s, -; Spei|cher_ka|pa|zi|tät, ...mög|lich|keit; spei|chern; ich ...ere (↑ R 327); Spei|cher|ofen (für: Regenerativofen); Spei|che|rung

spei|en; du spiest; du spieest; gespie[e]n; spei[e]!; Spei|gat[t] (Seemannsspr.: rundes Loch in der Schiffswand zum Wasserablauf)

Speik *lat.* (Name verschiedener Pflanzenarten) *m*; -[e]s, -e

Speil (Holzstäbchen [zum Verschließen des Wurstdarmes]) *m*; -s, -e; spei|len

¹Speis *lat.* landsch. (Mörtel) *m*; -es;

²Speis bayr. u. österr. ugs. (Speisekammer) *w*; -, -en; Spei|se (auch für: Mörtel) *w*; -, -n; Speis und Trank (↑ R 241); Spei|se..brei, ...eis, ...haus, ...kam|mer; Spei|se|kar|te, Spei|sen|kar|te; spei|sen; du speist (speisest); er spei|ste; gespeist; (schweiz. übertr. od. schweiz. mdal., auch scherzh.:) gespiesen; Spei|sen_auf|zug, fol|ge; Spei|sen|kar|te, Spei|se|kar|te; Spei|sen|wa|gen (Wagen zur Beförderung von Speisen); Spei|se..öl, ...op|fer, ...rest, ...röh|re, ...saal, ...schrank, ...täub|ling (ein Pilz), ...wa|gen (bei der Eisenbahn), ...was|ser (für Dampfkessel; *Mehrz.* ...wäs|ser), ...wü|ze, ...zet|tel, ...zim|mer; Speis|ko|balt (ein Mineral); Spei|sung

Spei..täub|ling, ...teu|fel (ein Pilz); spei|übel (ugs.)

Spek|ta|bi|li|tät *lat.* („Ansehnlichkeit"; an Hochschulen Anrede an den Dekan); Eure (Abk.: Ew.) -; ¹Spek|ta|kel (ugs. für: Krach, Lärm) *m*; -s, -; ²Spek|ta|kel (geh. für: Schauspiel) *s*; -s, -; Spek|ta|kel|ma|cher (abschätzig); spek|ta|keln (veralt. für: lärmen); ich ...[e]le (↑ R 327); spek|ta|ku|lär (aufsehenerregend)

Spek|tra (*Mehrz.* von: Spektrum); spek|tral *lat.* (auf das Spektrum bezüglich od. davon ausgehend); Spek|tral..ana|ly|se, ...ap|pa|rat, ...far|ben (*Mehrz.*), ...klas|sen (Astron.; *Mehrz.*), ...li|nie; Spek|tren (*Mehrz.* von: Spektrum); Spek|tro|me|ter *lat.; gr.* (Vorrichtung zum genauen Messen von Spektren) *s*; -s, -; Spek|tro|skop (Vorrichtung zum Bestimmen der Wellenlängen von Spektrallinien) *s*; -s, -e; Spek|tro|sko|pie *w*; -; spek|tro|sko|pisch; Spek|trum *lat.* (durch Lichtzerlegung entstehendes farbiges Band) *s*; -s, ...tren u. ...tra

Spe|ku|la (*Mehrz.* von: Spekulum); Spe|ku|lant *lat.* (kühner, waghalsiger Unternehmer; bes. jmd., der gewagte Börsengeschäfte macht) *m*; -en, -en (↑ R 268); Spe|ku|la|ti|on [...zion] (Vernunftstreben nach Erkenntnis jenseits der Sinnenwelt; Berechnung; Einbildung; gewagtes Geschäft); Spe|ku|la|ti|ons_bank (*Mehrz.* ...banken), ...ge|schäft, ...ge|winn, ...kauf, ...pa|pier, ...steu|er *w*, ...wert; Spe|ku|la|ti|us *niederl.* (ein Gebäck) *m*; -, -; spe|ku|la|tiv *lat.* (in reinen Begriffen denkend; mit Wagnis verbunden); spe|ku|lie|ren (gewagte Geschäfte machen; mit etwas rechnen); Spe|ku|lum (Med.: Spiegel) *s*; -s, ...la

Spe|läo|lo|ge gr. m; -n, -n (↑ R 268); Spe|läo|lo|gie (Höhlenkunde) w; -; spe|läo|lo|gisch

Spelz m; -[e]s, -e u. Spelz (eine Getreideart) m; -es, -e

Spe|lun|ke gr. (verächtl. für: schlechter, unsauberer Wohnraum; Schlupfwinkel; verrufene Kneipe) w; -, -n

Spelz vgl. Spelt; Spel|ze (Teil des Gräserblütenstandes) w; -, -n; spel|zig

Spen|cer [ßpänß'r] (engl. Philosoph); vgl. aber: Spenser

spen|da|bel lat. (ugs. für: freigebig); ...a|ble Laune; Spen|de w; -, -n; spen|den (für wohltätige o. ä. Zwecke Geld geben); Spen|den|ak|ti|on; Spen|der; spen|die|ren (in freigebiger Weise für jmdn. bezahlen); Spen|dier|ho|se, in: die -n anhaben (ugs. für: freigebig sein); Spen|dung

Speng|ler westmitteld., südd., österr., schweiz. (Klempner)

Spen|ser [ßpänß'r] (engl. Dichter); vgl. aber: Spencer

Spen|zer engl. (kurzes, enganliegendes Jäckchen) m; -s, -

Sper|ber (am Raubvogel) m; -s, -; Sper|ber|baum; sper|bern schweiz. (scharf blicken); ich ...ere (↑ R 327)

Spe|renz|chen, Spe|ren|zi|en lat. [...i'n] (ugs. für: Umschweife, Schwierigkeiten) Mehrz.; [keine] - machen

Sper|gel (eine Futterpflanze) m; -s, -

Sper|ling m; -s, -e; Sper|lings|vo|gel

Sper|ma gr. (Biol.: männl. Samenzellen enthaltende Flüssigkeit) s; -s, ...men u. -ta; Sper|ma|ti|tis (Med.: Samenstrangentzündung) w; -, ...itiden; Sper|ma|to|ge|ne|se (Samenbildung im Hoden) w; -; Sper|ma|tor|rhö¹, Sper|ma|tor|rhöe (Med.: Samenfluß ohne geschlechtl. Erregung) w; -, ...rrhöen; Sper|ma|to|zo|on (svw. Spermium) s; -s, ...oen; Sper|ma|zet s; -[e]s u. Sper|ma|ze|ti (Walrat; vgl. d.) s; -s; Sper|men (Mehrz. von: Sperma); Sper|mi|en (Mehrz. von: Spermium); Sper|min (Bestandteil des männl. Samens) s; -s; Sper|mio|ge|ne|se (svw. Spermatogenese) w; -; Sper|mi|um (Samenfaden, männl. Keimzelle) s; -s, ...ien [...i'n]

Sper|rad [Trenn.: Sperr|rad, ↑R 236] s; -[e]s, ...räder; sperr|an|gel|weit (ugs.); Sperr.|bal|ken, ...bal|lon, ...bat|te|rie, ...baum, ...be|trag; Sper|re w; -, -n; sper|ren (südd., österr. auch für: schlie-

ßen); Sperr.|feu|er, ...frist, ...ge|biet, ...ge|trie|be, ...gür|tel, ...gut, ...gut|ha|ben, ...holz, ...holz|plat|te; Sper|riegel [Trenn.: Sperr|rie..., ↑ R 236] m; -s, -; sper|rig; Sperr.|jahr (Wirtsch.), ...ket|te, ...klau|sel, ...kon|to, ...kreis; Sperr|ling (veralt. für: Holzstück zum Sperren); Sperr.|mau|er, ...mi|no|ri|tät (Wirtsch.), ...müll, ...sitz, ...stun|de; Sper|rung; sperr|weit (ugs.); Sperr.|zeit (Polizeistunde), ...zoll (Mehrz. ...zölle)

Spe|sen it. ([Un]kosten; Auslagen) Mehrz.; spe|sen|frei; Spe|sen|platz (Bankw.), ...rech|nung

Spes|sart („Spechtswald"; Bergland im Mainviereck) m; -s

spet|ten it. schweiz. ([im Haushalt, in einem Geschäft] aushelfen); Spet|te|rin schweiz. (Stundenhilfe) w; -, -nen

Spey|er (Stadt am Rhein); Spey|e|rer (↑ R 199); spey|e|risch

Spe|ze|rei it. (veralt. für: Gewürz[ware]) meist Mehrz.; Spe|ze|rei.|händ|ler südd. veralt. (Kolonialwarenhändler), ...hand|lung, ...wa|ren (veralt. für: Lebensmittel; schweiz. für: Gemischtwaren; Mehrz.)

Spe|zi lat. [schpe...] südd., österr. (Kurzform von: Spezial Busenfreund) m; -s, -[s]; spe|zi|al (veralt. für: speziell); Spe|zi|al (mdal. für: Busenfreund [kleinere Menge] Tageswein, Schankwein) m; -s, -e; Spe|zi|al... (Sonder..., Einzel..., Fach...); Spe|zi|al.arzt (Facharzt), ...aus|füh|rung, ...dis|zi|plin, ...fach, ...fahr|zeug, ...far|be, ...ge|biet, ...ge|schäft; Spe|zia|li|en [...i'n] (veralt. für: Besonderheiten, Einzelheiten) Mehrz.; Spe|zia|li|sa|ti|on [...zion] (seltener für: Spezialisierung); spe|zia|li|sie|ren (gliedern, sondern, einzeln anführen, unterscheiden); sich - (sich [beruflich] auf ein Teilgebiet beschränken); Spe|zia|li|sie|rung; Spe|zia|list (Facharbeiter, Fachmann; bes. Facharzt; ↑ R 268; Spe|zia|li|sten|tum s; -s); Spe|zia|li|tät (Besonderheit; Fachgebiet, Hauptfach; Liebhaberei, Stärke); Spe|zia|l.sla|lom (eine Wettbewerbsart im alpinen Schisport), ...sprung|lauf (Schispringen), ...trai|ning; spe|zi|ell (besonders, eigentümlich; eigens; einzeln; eingehend); (↑ R 134:) im - en (im einzelnen); Spe|zies [...iäß] (besondere Art einer Gattung, Tier- od. Pflanzenart; die vier Grundrechnungsarten; Teegemisch) w; -, -; Spe|zi|es|ta|ler [...iäß...] (früher: ein harter Taler im Gegensatz zu Papiergeld); Spe|zi|fi|ka|ti|on [...zion]

(Einteilung der Gattung in Arten; Einzelaufzählung); Spe|zi|fi|ka|ti|ons|kauf (Wirtsch.); Spe|zi|fi|kum (Besonderes, Entscheidendes; gegen eine bestimmte Krankheit wirksames Mittel) s; -s, ...ka; spe|zi|fisch (einem Gegenstand seiner Eigenart nach zukommend; kennzeichnend, eigentümlich); -es Gewicht (Physik: Gewicht der Volumeneinheit, Wichte); -e Wärme; -er Widerstand (Physik); -es Volumen (Physik); Spe|zi|fi|tät (Eigentümlichkeit, Besonderheit); spe|zi|fi|zie|ren (einzeln aufführen; zergliedern); Spe|zi|fi|zie|rung; Spe|zi|men [österr.: ...zi...] (veralt. für: [Probe]arbeit) s; -s, ...imina

Sphä|re gr. (Himmelsgewölbe; [Gesichts-, Wirkungs]kreis; [Macht]bereich) w; -, -n; Sphä|ren.har|mo|nie, ...mu|sik; Sphä|rik (Math.: Geometrie von Figuren, die auf Kugeloberflächen durch größte Kreise gebildet sind) w; -; sphä|risch (die [Himmels]kugel betreffend); -e Trigonometrie (Math.: Berechnung von Dreiecken auf der Kugeloberfläche); -es Dreieck (Math.); Sphä|ro|id (kugelähnl. Figur, Rotationsellipsoid) s; -[e]s, -e; sphä|ro|i|disch (kugelähnlich); Sphä|ro|lith (kugeliges Mineralgebilde; m; -s u. -en, -e[n]; ↑ R 268), ...lo|gie (Lehre von der Kugel), ...me|ter (Kugelmesser, Dickenmesser) s; -s, -), ...si|de|rit (ein Mineral; m; -s, -e)

Spha|gnum s (ein Mineral; m; -s, -e) Sphe|no|id (eine Kristallform) s; -[e]s, -e; sphe|noi|dal (keilförmig)

Sphink|ter gr. (Med.: Schließmuskel) m; -s, ...ere

¹Sphinx (geflügelter Löwe mit Frauenkopf in der gr. Sage; Sinnbild des Rätselhaften) w; -; ²Sphinx (ägypt. Steinbild in Löwengestalt, meist mit Männerkopf; Symbol des Sonnengottes od. des Königs) w; -, -e (in der archäolog. Fachspr. meist: m; -, -e u. Sphingen)

Sphra|gi|stik gr. (Siegelkunde) w; -

Sphyg|mo|gramm gr. (Med. durch den Sphygmographen selbsttätig aufgezeichnete Pulskurve) s; -s, -e; Sphyg|mo|graph (Pulsschreiber) m; -en, -en (↑ R 268); Sphyg|mo|ma|no|me|ter (Blutdruckmesser) s; -s, -

Spick (Schülerspr.: Spickzettel) m; -[e]s, -e

Spick|aal niederd. (Räucheraal)

Spickel [Trenn.: Spik|kel] schweiz. (Zwickel an Kleidungsstücken) m; -s, -

¹spicken [Trenn.: spik|ken

¹ Vgl. die Anmerkung zu „Diarrhö, Diarrhöe".

(Fleisch zum Braten mit Speckstreifen durchziehen) ²spicken [Trenn.: spik|ken] (Schülerspr.: in der Schule abschreiben)

Spick.gans (niederd. für: geräucherte u. gepökelte Gänsebrust), ...na|del

Spick|zet|tel (Schülerspr.: ein zum Abschreiben vorbereiteter Zettel)

Spi|der engl. [βpaid°r] (offener Rennsportwagen) m; -s, -

Spie|gel lat. m; -s, -; Spie|gel|bild; spie|gel|bild|lich; spie|gel|blank; Spie|gel.ei, ...fech|ter; Spie|gel-fech|te|rei; Spie|gel.flä|che, ...glas (Mehrz. ...gläser); spie|gel-glatt; spie|ge|lig (veralt. für: spiegelartig, glänzend); spie|geln; ich ...[e]le (↑ R 327); Spie|gel|re|flex-ka|me|ra; Spie|gel.saal, ...schrift, ...te|le|skop; Spie|ge|lung, Spieglung

Spie|ker nordd. (großer [Schiffs]-nagel) m; -s, -; spie|kern (nordd.); ich ...ere (↑ R 327)

Spie|ker.oog (eine ostfries. Insel)

Spiel s; -[e]s, -e; Spiel.al|ter, ...art, ...au|to|mat, ...ball, ...bank (Mehrz. ...banken), ...bein (Sport, bild. Kunst; Ggs. Standbein), ...do|se; spie|len; -e ben; Schach; sich mit etwas - (österr. für: etwas nicht ernsthaft betreiben; etwas spielend leicht bewältigen); Spie|ler; Spie|le|rei; Spie-le|rin w; -, -nen; spie|le|risch (ohne Anstrengung); -ste (↑ R 294); mit -er Leichtigkeit; Spiel.feld, ...fi-gur, ...fil|me, ...flä|che, ...fol|ge; spiel|frei; Spiel.füh|rer (Sportspr.), ...ge|fähr|te, ...ge|fähr|tin, ...geld, ...hahn (Birkhahn), ...höl-le, ...hös|chen, ...ka|me|rad, ...kar|te, ...ka|si|no, ...klas|se, ...lei|den|schaft, ...lei|ter m, ...mann (Mehrz. ...leute); Spiel-manns.dich|tung (w; -), ...zug; Spiel.mar|ke, ...mi|nu|te (Sportspr.), ...oper, ...pha|se, ...plan (vgl. ²Plan), ...platz, ...rat|te (ugs. für: leidenschaftlich spielendes Kind), ...raum, ...re|gel, ...saal, ...sa|chen (Mehrz.), ...schuld, ...schu|le, ...teu|fel, ...tisch (auch: Teil der Orgel), ...uhr, ...ver|bot (Sportspr.), ...ver|der|ber, ...ver-ei|ni|gung (Abk.: Spvg., Spvgg.); Spiel|wa|ren Mehrz.; Spiel|wa-ren.händ|ler, ...hand|lung, ...in-du|strie; Spiel.wei|se, ...werk, ...wie|se, ...witz (Einfallsreichtum beim Spiel; m; -es), ...zeit, ...zeug, ...zim|mer

spien|zeln schweiz. mdal. (etwas prahlerisch, foppend vorzeigen, spiegeln) ich ...[e]le (↑ R 327)

Spier niederd. (Spitze; Grasspitze) m od. s; -[e]s, -e; Spier|chen niederd. (Grasspitzchen); ein spierchen; ↑ R 131 (nordd. für: ein wenig); Spie|re (Seemannsspr.: Rundholz, Segelstange) w; -, -n; Spier|ling (ein Fisch; Vogelbeerbaum); Spier-lings|baum; Spier.stau|de, ...strauch; ¹Spieß (Bratspieß) m; -es, -e

²Spieß (Kampf-, Jagdspieß; Erstlingsform des Geweihs der Hirscharten; Soldatenspr.: Hauptfeldwebel, Kompaniefeldwebel; Druckw.: im Satz zu hoch stehendes, deshalb mitdruckendes Ausschlußstück) m; -es, -e; Spieß|bock (einjähriger Rehbock); Spieß|bür|ger, Spie|ßer (abwertend für: kleinlicher, engstirniger Mensch); spieß|bür|ger-lich; Spieß.bür|ger|lich|keit, ...bür|ger|tum (s; -s); spie|ßen; du spießt (spießest); sich - (österr. für: sich nicht bewegen lassen; übertr. für: stocken); Spie|ßer vgl. Spießbürger; spieß|haft; spie|ße|risch; -ste (↑ R 294); spieß-för|mig; Spieß.ge|sel|le (veralt. für: Waffengefährte; heute abschätzig für: Mittäter), ...glanz (Name verschiedener Minerale; m; -[e]s, -e); spie|ßig; Spie|ßig-keit; Spieß.ru|te; -n laufen (↑ R 140); Spieß|ru|ten|lau|fen (↑ R 120) s; -s

Spi|ka lat. ("Ähre"; ein Stern) w; -; Spi|ke (Lavendelart) w; -, -n

Spike engl. [βpaik] (Spezialstift für Rennschuhe od. Autoreifen) m; -s, -s; Spikes [βpaikβ] (Rennschuhe; Autoreifen mit Spezialstiften) Mehrz.; Spike[s]|rei|fen

Spill (Ankerwinde) s; -[e]s, -e; Spil|la|ge [...lasch°] (Wertverlust trockener Güter zu Schiff infolge Eindringens von Feuchtigkeit, Warenabgang); Spil|le mdal. (Spindel) w; -, -n; spil|le|rig, spill-rig landsch. (dürr); Spill|geld landsch. (Nadelgeld); Spil|ling (gelbe Pflaume) m; -s, -e

Spin engl. (Phys.: Drehimpuls der Elementarteilchen im Atom) m; -s, -s

Spi|na lat. (Med.: Stachel, Dorn, Gräte; Rückgrat) w; -, -nen; spi-nal (die Wirbelsäule, das Rückenmark betreffend); -e Kinderlähmung

Spi|nat pers.-arab. (ein Gemüse) m; -[e]s, -e; Spi|nat|wach|tel (derb abschätzig für: schrullige [alte] Frau)

Spind ([Kleider]schrank; einfaches Behältnis) m u. s; -[e]s, -e

Spin|del w; -, -n; Spin|del|baum (Evonymus); spin|del|dürr; Spin-del.la|ger (Mehrz. ...lager),

...schnecke [Trenn.: ...schnek|ke]

Spi|nell it. (ein Mineral) m; -s, -e

Spi|nen (Mehrz. von: Spina)

Spi|nett it. (alte Form des Klaviers) s; -[e]s, -e

Spin|na|ker engl. (Seemannsspr.: großes Beisegel) m; -s, -

Spinn.dü|se (bei Textilmaschinen); Spin|ne w; -, -n; spin|ne|feind (ugs.); jmdm. - sein; spin|nen; du spinnst; du spannst (spannest) du spönnest (auch: spännest); gesponnen; spinn[e]!; Spin|nen|ge-we|be, Spinn|ge|we|be; Spin|nen-.krebs, ...netz; Spin|ner; Spin|ne-rei; Spin|ne|rin w; -, -nen; Spin-ner|lied; Spinn.fa|ser, ...ge|we|be od. Spin|nen|ge|we|be, Spinn-.ma|schi|ne, ...rad, ...rocken [Trenn.: ...rok|ken], ...stoff, ...stu-be, ...web (österr. neben: Spinnwebe; s; -[e]s, -e), ...we|be (landsch. für: Spinnengewebe; w; -, -n), ...wir|tel

spi|nös lat. (schwierig, knifflig; spitzfindig; tadelsüchtig); -este (↑ R 292)

Spi|no|za [βpinoza od. schpi..., spinoza] (niederl. Philosoph); spi-no|za|isch; -e Lehre, aber (↑ R 179): Spi|no|za|isch (-e Schriften; Spi|no|zis|mus (Lehre des Spinoza) m; -; Spi|no|zist (↑ R 268); spi-no|zi|stisch

Spint landsch. (Fett; weiches Holz) m od. s; -[e]s, -e

Spin|the|ris|mus gr. (Med.: Funkensehen) m; -

spin|tig landsch. (fettig; weich)

spin|ti|sie|ren (ugs. für: grübeln); Spin|ti|sie|re|rei

Spi|on it. (Späher, Horcher, heiml. Kundschafter; Spiegel außen am Fenster; Beobachtungsglas in der Tür) m; -s, -e; Spio|na|ge fr. [...asch°] (Auskundschaftung, Späh[er]dienst) w; -; Spio|na|ge-.ab|wehr, ...af|fä|re, ...film, ...netz, ...ring; Spio|nen|dienst; spio|nie|ren; Spio|nie|re|rei (ugs.); Spio|nin w; -, -nen

Spi|räe gr. (Pflanzengattung der Rosengewächse, Spierstrauch) w; -, -n

spi|ral gr. (schneckenförmig gedreht); Spi|ral|boh|rer (fälschlich für: Wendelbohrer); Spi|ra|le w; -, -n; Spi|ra|len|an|ord|nung; Spi-ral|fe|der; spi|ral|för|mig; spi|ra-lig (schrauben-, schneckenförmig); Spi|ral.li|nie, ...ne|bel, ...tur|bi|ne

Spi|rans lat. w; -, ...ranten u. Spi-rant (Sprachw.: Reibelaut, Frikativlaut, z. B. f) m; -en, -en (↑ R 268); spi|ran|tisch

Spi|ril|le gr. (Bakterie von gedrehter Form, Schraubenbakterie) w; -, -n (meist Mehrz.)

Spi|rit *lat.-engl.* [*βp...*] ([mediumistischer] Geist) *m*; -s, -s; **Spi|ri|tis|mus** *lat.* (Glaube an vermeintliche Erscheinungen von Seelen Verstorbener; Geisterlehre) *m*; -; **Spi|ri|tist** (↑ R 268); **spi|ri|tistisch**; **spi|ri|tu|al** (geistig; übersinnlich); **¹Spi|ri|tu|al** (Seelsorger, Beichtvater in kath. theol. Anstalten u. Klöstern) *m*; -s u. -en, -en (↑ R 268); **²Spi|ri|tu|al** *amerik.* [*βp|ritjuᵉl*] (geistliches Volkslied der im Süden Nordamerikas lebenden afrikanischen Neger mit schwermütiger, synkopierter Melodie) *m* od. *s*; -s, -s; **Spi|ri|tu|a|li|en** *lat.* [*...iᵉn*] (geistl. Dinge) *Mehrz.*; **spi|ri|tua|li|sie|ren** (vergeistigen); **Spi|ri|tua|lis|mus** (Lehre von der Wirklichkeit u. Wirksamkeit des Geistes) *m*; -; **Spi|ri|tua|list** (↑ R 268); **Spi|ri|tua|li|tät** (Geistigkeit, geistiges Wesen) *w*; -; **spi|ri|tu|ell** *fr.* (geistig; geistlich); **spi|ri|tu|os**, **spi|ri|tu|ös** (Weingeist enthaltend, geistig); -este (↑ R 292); -e Getränke; **Spi|ri|tuo|sen** (geistige [alkohol.] Getränke) *Mehrz.*; **¹Spi|ri|tus** *lat.* [*βp...*] (Hauch, Atem, [Lebens]geist) *m*; -, -; **²Spi|ri|tus** [*schp...*] (Weingeist, Alkohol) *m*; -, -se; **Spi|ri|tus fa|mi|lia|ris** [*βp... -*] (Schutz-, Hausgeist) *m*; - -; **Spi|ri|tus|ko|cher** [*schp...*]; **Spi|ri|tus rec|tor** [*βp... -*] (leitender, belebender, treibender Geist; Seele [eines Betriebes, Vorhabens]) *m*; - -
Spi|ro|chä|te *gr.* [*...chät̆ᵉ*] (Krankheitserreger) *w*; -, -n
Spi|ro|me|ter *lat.*; *gr.* (Atemmesser) *s*; -s, -
Spir|re (Blütenstand) *w*; -, -n
Spis|sen (Balz-, Lockruf des Haselhahns) *s*; -s
Spi|tal *lat.* (veralt., aber noch landsch. für: Krankenhaus, Altersheim, Armenhaus); *s*; -s, ...täler; **Spi|ta|ler**, **Spi|tä|ler**, **Spitt|ler** (veralt., aber noch landsch. für: Insasse eines Spitals)
Spit|tal an der Drau (Stadt in Kärnten)
Spit|tel (Spital) *s* (auch: *m*); -s, -
Spit|te|ler (schweiz. Dichter)
Spitt|ler vgl. Spitaler
spitz; er, -este (↑ R 292); eine -e Zunge haben (gehässig reden); ein -er Winkel; **Spitz** (Hund einer bestimmten Rasse); ugs. für: leichter Rausch) *m*; -es, -e; **Spitz|bart**; **spitz|bär|tig**; **spitz|be|kom|men**; ↑ R 139 (ugs. für: merken, durchschauen); ich bekomme etwas spitz; ich habe etwas spitzbekommen; **spitzzubekommen**
Spitz|ber|gen (Inselgruppe im Nordpolarmeer); vgl. Svalbard

Spitz|bo|gen; **spitz|bo|gig**; **Spitz‿boh|rer**, **...bu|be**; **Spitz|bü|be|rei**; **Spitz|bü|bin**; **spitz|bü|bisch**; -ste (↑ R 294); **Spit|ze** *w*; -, -n; **Spit|zel** (Aushorcher, Spion) *m*; -s, -; **spit|zeln**; ich ...[e]le (↑ R 327); **spit|zen**; du spitzt (spitzest); **Spit|zen‿erzeug|nis**, **...fah|rer**, **...film**, **...funk|tio|när**, **...gar|ni|tur**, **...ge|schwin|dig|keit**, **...grup|pe**, **...kan|di|dat**, **...klas|se**, **...klöp|pe|lei**, **...klöpp|le|rin**, **...kraft**, **...lei|stung**, **...kön.**‿**or|ga|ni|sa|ti|on**, **...po|si|ti|on**, **...rei|ter**, **...ser|vi|et|te**, **...sportler**, **...tanz**, **...tuch** (*Mehrz.* ...tücher), **...ver|band**, **...ver|kehr**; **spitz|fin|dig**; **Spitz‿fin|dig|keit**, **...form**, **...fuß**, **...hacke** [*Trenn.*: **...hak|ke**], **...ham|mer**; **spit|zig**; **Spitz|keh|re**; **spitz|krie|gen**; ↑ R 139 (ugs. für: merken, durchschauen); ich kriege etwas spitz; ich habe etwas spitzgekriegt; **Spitzzukriegen**; **Spitz‿mar|ke** (Druckw.), **...maus**, **...na|me**; **spitz|oh|rig**; **Spitz‿pfei|ler** (für: Obelisk), **...we‿ge|rich** (eine Pflanze); **spitz|win|ke|lig**, **spitz|wink|lig**
Splanch|no|lo|gie *gr.* (Med.: Lehre von den Eingeweiden) *w*; -
Spleen *engl.* [*schplin*, seltener *βplin*] (phantast. Einfall; verrückte Angewohnheit, seltsame Eigenart, Verschrobenheit; Eingebildetheit) *m*; -s, -e u. -s; **splee|nig**
Spleiße landsch. (Span, Splitter) *w*; -, -n; **splei|ßen** (landsch. für: fein spalten; Seemannsspr.: Tauenden miteinander verflechten); du spleißt (spleißest); du splisset; gesplissen; spleiß[e]!
Splen *gr.* (Med.: Milz) *m*; -
splen|did *lat.* (freigebig; glanzvoll; kostbar); **Splen|did iso|la|tion** *engl.* [*- aiβ̆'le̓'sch̆ᵉn*] (Bez. für die Bündnislosigkeit Englands im 19. Jh.) *w*; - -; **Splen|di|di|tät** (veralt. für: Freigebigkeit) *w*; -
Spließ (Holzspan unter den Dachziegelfugen; Schindel) *m*; -es, -e
Splint (bei Maschinen u. a.: Vorsteckstift als Sicherung) *m*; -[e]s, -e; **Splint|holz** (weiche Holzschicht unter der Rinde)
Spliß landsch. (Splitter; kleiner Abschnitt) *m*; Splisses, Splisse; **splis|sen** landsch. (spleißen); du spließt (splissest); du spließtest; gespließt; splisse! u. spliß!
Split [*βplit*] (Stadt in Jugoslawien); vgl. Spalato
Splitt (zerkleinertes Gestein für den Straßenbau; niederd. für: Span, Schindel) *m*; -[e]s, -e; **Split|ter** *m*; -s, -; **split|ter|fa|ser|nackt** (ugs. für: völlig nackt); **Split|ter‿grup|pe**; **split|te|rig**, **splitt|rig**;

split|tern; ich ...ere (↑ R 327); **split|ter|nackt** (ugs. für: völlig nackt); **Split|ter|par|tei**, **...rich|ter** (veralt. für: kleinlicher Beurteiler); **split|ter|si|cher**
Split|ting *engl.*, **Split|ting|sy|stem** (Form der Haushaltsbesteuerung, bei der das Einkommen der Ehegatten zusammengezählt, halbiert u. jeder Ehegatte mit der Hälfte des Gesamteinkommens bei der Steuerberechnung berücksichtigt wird) *s*; -s
split|trig, **split|te|rig**
Splü|gen *m*; -s, (auch:) **Splü|gen‿paß** (Paß von Chiavenna nahe dem Comer See in das Hinterrheintal) *m*; ...passes
SPÖ = Sozialistische Partei Österreichs
Spo|di|um *gr.* (Chemie: Knochenkohle) *s*; -s; **Spo|du|men** (ein Mineral) *m*; -s, -e
Spoerl [*spörl*], Heinrich (dt. Schriftsteller)
Spoiler *amerik.* (Luftleitblech bes. an Rennwagen)
Spö|ken|kie|ker niederd. (Geisterseher, Hellseher)
Spo|li|ant *lat.* (veralt.: wegen Beraubung Angeklagter) *m*; -en, -en (↑ R 268); **Spo|lia|ti|on** [*...zion*] (veralt. für: Beraubung); **Spo|li|en|recht** [*...iᵉn...*] (im MA. das Recht, den Nachlaß kath. Geistlicher einzuziehen); **spo|li|ieren** (veralt., aber noch mdal. für: berauben); **Spo|li|um** (altröm. Beutestück, erbeutete Waffe) *s*; -s, ...ien [*...iᵉn*]
Spom|pa|na|de[l]n österr. ugs. (Dummheiten, Abenteuer) *Mehrz.*
spon|de|isch *gr.* (in, mit Spondeen); **Spon|de|us** (ein Versfuß) *m*; -, ...deen
Spon|dyl|ar|thri|tis *gr.* (Med.: Entzündung der Wirbelgelenke); **Spon|dy|li|tis** (Med.: Wirbelentzündung) *w*; -, ...itiden; **Spon|dy|lo|se** (Med.: krankhafte Veränderung an den Wirbelkörpern u. Bandscheiben) *w*; -, -n
Spon|gia *gr.* (Schwamm) *w*; -, ...ien [*...iᵉn*]; **Spon|gin** (Stoff, aus dem das Skelett der Hornschwämme besteht) *s*; -s; **spon|gi|ös** (schwammig; locker); -este (↑ R 292)
Spon|sa|li|en *lat.* [*...iᵉn*] (Rechtsw.: Verlöbnis, Verlobungsgeschenke) *Mehrz.*; **Spon|sion** österr. ([akad. Feier zur] Verleihung des Magistertitels) *w*; -, -en; **Spon|sor** *engl.* [*...sᵉr*] (Berater, Förderer; Wirtsch.: Bürge; Auftrag-, Geldgeber, bes. für [Werbe]sendungen in Funk u. Fernsehen) *m*; -s, -s

spon|tan *lat.* (von selbst; von innen heraus, freiwillig, aus eigenem plötzl. Antrieb); **Spon|ta|nei|tät** [*...ne-i...*] (Selbsttätigkeit ohne äußere Anregung; Unwillkürlichkeit; eigener, innerer Antrieb)

Spor landsch. (Schimmel[pilz]) *m*; -[e]s, -e

Spo|ra|den *gr.* (Inseln im Ägäischen Meer), **spo|ra|disch** (vereinzelt [vorkommend], zerstreut); **Spor|an|gi_um** [*...ngg...*] (Bot.: Sporenbildner u. -behälter) *s*; -s, ...ien [*...i^e n*]

spor|co *it.* [*...ko*] (mit Verpackung); vgl. Sporko

Spo|re *gr.* (ungeschlechtl. Fortpflanzungszelle der Pflanzen; Dauerform von Bakterien) *w*; -, -n

Spo|ren (*Mehrz.* von: Sporn)

Spo|ren_be|häl|ter, ...**pflan|ze,** ...**schlauch**

Spör|gel vgl. Spergel

spo|rig landsch. (schimmelig)

Spor|ko *it.* (Bruttogewicht) *s*; -s; vgl. sporco; **Spor|ko|ge|wicht**

Sporn *m*; -[e]s, Sporen (meist *Mehrz.*); **spor|nen; Spor|nrädchen; sporn|streichs** (↑ R 129)

Spo|ro|phyt *gr.* (Sporenpflanze) *m*; -en, -en (↑ R 268); **Spo|ro|zo_on** (Sporentierchen) *s*; -s, ...zoen (meist *Mehrz.*)

Sport *engl.* (Spiel, Leibesübungen; Liebhaberei) *m*; -[e]s, (selten:) -e; **Sport_ab|zei|chen,** ...**art,** ...**ar|ti|kel,** ...**arzt; sport|be|gei|stert,** aber (↑ R 142): vom Sport begeistert; **Sport|dreß**

Spor|tel *gr.* (im MA. Teil des Beamteneinkommens [eingenommene Gebühren]) *w*; -, -n (meist *Mehrz.*); **Spor|tel|frei|heit** (Kostenfreiheit) *w*; -

Spor|ter_eig|nis, ...**feld,** ...**fi|schen** (*s*; -s), ...**flug|zeug,** ...**freund,** ...**gemein|schaft** (Abk.: SG); **sport|gerecht; Sport_hal|le,** ...**hemd,** ...**herz,** ...**hoch|schu|le,** ...**ho|se; spor|tiv** *fr.* (sportlich); **Sport_jour|na|list,** ...**ka|no|ne** (ugs.), ...**klei|dung,** ...**klub,** ...**leh|rer; Sport|ler; Sport|ler|herz; Sport|le|rin** *w*; -, -nen; **sport|lich; Sport|lich|keit** *w*; -; **sport|mä|ßig, sports|mä|ßig; Sport_me|di|zin,** ...**mel|dung,** ...**mo|tor,** ...**müt|ze,** ...**platz,** ...**re|por|ter,** ...**schuh,** ...**sen|sa|ti_on; Sports|mann** (*Mehrz.* ...leute, auch: ...männer); **sports|mä|ßig,** auch: **sport|mä|ßig; Sport_spra|che,** ...**strumpf,** ...**stu|dent; sport|trei|bend,** aber (↑ R 142): viel Sport treibend; **Sport_un|fall,** ...**ver|band,** ...**verein** (Abk.: SV); (↑ R 145:) Turnu. Sportverein (Abk.: TuS);

Sport_wa|gen, ...**welt** (*w*; -), ...**wis|sen|schaft** (*w*; -), ...**zei|tung,** ...**zwei|sit|zer**

Spot *engl.* (Werbekurzfilm; in Tonfunksendungen eingeblendeter Werbetext) *m*; -s, -s; **Spot_ge|schäft** (Geschäft gegen sofortige Lieferung u. Kasse im Geschäftsverkehr der internationalen Warenbörsen); **Spot|light** [*...luit*] (auf einen Punkt gerichtetes Bühnen-, Rampenlicht) *s*; -s, -s

Spott *m*; -[e]s; **Spott|bild; spott|bil|lig** (ugs.); **Spott|dros|sel; Spott_te|lei; spöt|teln; ich ...[e]le** (↑ R 327); **spot|ten; Spöt|ter; Spöt|te|rei; Spott_ge|burt,** ...**ge|dicht,** ...**geld** (*s*; -[e]s); **spöt|tisch; -ste** (↑ R 294); **Spott_lust,** ...**na|me,** ...**preis** (vgl. [2]Preis), ...**sucht** (*w*; -), ...**vo|gel**

S.P.Q.R. = Senatus Populusque Romanus

Sprach_at|las (Kartenwerk zur dt. Sprachgeographie, Forschungsstätte in Marburg; vgl. [4]Atlas), ...**bar|rie|re** (Sprachw.), ...**bau** (*m*; -[e]s), ...**be|ra|tung,** ...**denk|mal; Spra|che** *w*; -, -n; **Sprach_ecke** [*Trenn.*: ...ck|ke] (in Zeitungen und Zeitschriften); **Spra|chen_fra|ge,** ...**kampf,** ...**recht** (*s*; -[e]s); **Sprach_ent|wick|lung,** ...**fa|mi|lie,** ...**feh|ler; sprach|fer|tig; Sprach_fer|tig|keit,** ...**for|scher,** ...**ge|biet,** ...**ge|brauch,** ...**ge|fühl** (*s*; -[e]s), ...**ge|nie,** ...**geo|gra|phie,** ...**ge|schich|te,** ...**ge|setz; sprach_ge|wal|tig,** ...**ge|wandt; Sprach_gewandt|heit,** ...**gren|ze,** ...**gut** (*s*; -[e]s), ...**hei|mat; ...spra_chig** (z. B. fremdsprachig [vgl. d.]); **Sprach_in|sel,** ...**ken|ner,** ...**kri|tik,** ...**kun|de,** ...**kund|ler: sprach_kun|dig,** ...**kund|lich; Sprach_kunst** (*w*; -), ...**la|bor,** ...**la|bo|ra|to|ri|um,** ...**leh|re; sprach|lich; ...sprach|lich** (z. B. fremdsprachlich [vgl. d.]); **sprach_los; sprach_lo|sig|keit; Sprach_pfle|ge,** ...**phi|lo|so|phie,** ...**re|ge|lung,** ...**rein|heit; sprach_rich|tig; Sprach_rich|tig|keit,** ...**rohr,** ...**schatz,** ...**schicht,** ...**schnit|zer,** ...**sil|be,** ...**so|zio|lo|gie,** ...**stil,** ...**stö|rung,** ...**stu|di_um,** ...**ta|lent,** ...**übung,** ...**un|ter|richt,** ...**ver|ein,** ...**ver|glei|chung; sprach|wid|rig; Sprach_wis|sen|schaft; wis|sen|schaft|ler; sprach|wis|sen|schaft|lich; Sprach|zen|trum** (Teil des Gehirns)

Spray *engl.* [*ßpre'*] (Apparat zum Zerstäuben von Flüssigkeiten; Flüssigkeitsnebel; Sprühflüssigkeit) *m* od. *s*; -s, -s; **spray|en; ge|sprayt**

Sprech_an|la|ge, ...**bla|se** (in Bildergeschichten), ...**büh|ne,** ...**chor**

m; **spre|chen; du sprichst; du sprachst** (sprachest); **du sprächest; gesprochen; sprich!; vor sich hin sprechen** (↑ R 120:) das lange Sprechen strengt mich an; **Spre|cher; spre|che|risch; Sprecher_zie|hung,** ...**ge|sang,** ...**kun|de** (*w*; -); **sprech|kund|lich; Sprech_kunst** (*w*; -), ...**mu|schel** (am Telefon), ...**plat|te** (Schallplatte mit gesprochenem Text), ...**sil|be,** ...**stun|de; Sprech|stun|den|hil|fe; Sprech_übung,** ...**un|ter|richt,** ...**wei|se** (*w*; -, -n), ...**werk|zeu|ge** (*Mehrz.*), ...**zeit,** ...**zel|le** (Telefon), ...**zim|mer**

Spree (l. Nebenfluß der Havel) *w*; -; **Spree-Athen** (scherzh. für: Berlin); **Spree|wald** (↑ R 201) *m*; -[e]s; [1]**Spree|wäl|der** (↑ R 199); - Tracht; [2]**Spree|wäl|der** (Bewohner des Spreewaldes); **Spree_wäl|de|rin,** ...**wäld|le|rin** *w*; -, -nen

Spre|he mitteld. u. nordwestd. ([3]Star) *w*; -, -n

Sprei|ßel südd. u. mitteld. (Splitter, Span) *m* (österr.: *s*); -s, -; **Sprei|ßel|holz** österr. (Kleinholz)

Sprei|t_decke [*Trenn.*: ...dek|ke] od. **Sprei|te** landsch. (Lage [Getreide zum Dreschen]; [Bett]decke) *w*; -, -n; **sprei|ten** (ausbreiten); **Sprei|t_la|ge**

spreiz|bei|nig; Sprei|ze (Strebe, Stütze; Turnübung: bayr. auch für: Zigarette) *w*; -, -n; **sprei|zen; du spreizt** (spreizest); **gespreizt; Spreiz_fuß; Sprei|zung**

Spren|gel (Amtsgebiet [eines Bischofs, Pfarrers]) *m*; -s, -; **spren|gen; Spreng_ge|schoß,** ...**kap|sel,** ...**kör|per,** ...**la|dung,** ...**laut** (für: Explosiv), ...**mei|ster,** ...**mit|tel** (*s*; -), ...**pul|ver,** ...**punkt,** ...**satz; Spreng|sel** (Sprenkel); landsch. für: Heuschrecke) *m* od. *s*; -s, -; **Spreng_stoff; spreng|stoff|hal|tig; Spreng|stück; Spreng_gung; Spreng_wa|gen,** ...**wir|kung**

Spren|kel (Fleck, Punkt, Tupfen; früher für: Rute zum Vogelfang) *m*; -s, -; **spren|ke|lig, sprenk|lig; spren|keln; ich ...[e]le** (↑ R 327); **gesprenkelt** (getupft); ein -es Fell, Kleid

spren|zen südwestd. (stark sprengen; regnen); **du sprenzt** (sprenzest)

Spreu *w*; -; **spreu|ig**

Sprich|wort (*Mehrz.* ...wörter); **Sprich|wör|ter|samm|lung; sprich|wört|lich; -e Redensart**

Sprie|gel mdal. (Aufhängeholz der Fleischer; [Wagen]bügel [zum Überspannen mit Leinen]) *m*; -s, -

Sprie|ße (Stütze, Quer-, Stützbalken, Sprosse) *w*; -, -n; **Sprie|ßel** österr. mdal. (Sprieße) *s*; -s, -;

¹sprie|ßen (stützen); du sprießt (sprießest); du sprießtest; gesprießt; sprieß[e]!

²sprie|ßen (hervorwachsen); es sprießt; es sproß; es sprösse; gesprossen; sprieß[e]!

Spriet (Seemannsspr.: dünne Spiere) s; -[e]s, -e

¹Spring landsch. (Sprudeln; Quelle) m; -[e]s, -e; ²Spring (Seemannsspr.: zum ausgeworfenen Anker führende Trosse) w; -, -e; Spring..blen|de (Fotogr.), ...brun|nen; Sprin|gel (früheres Turngerät) m; -s,-; sprin|gen; du springst; du sprangst (sprangest); du spräng[e]st; gesprungen; spring[e]!; etwas - lassen (ugs. für: ausgeben); Sprin|ger; Sprin|ger|le südd. (ein Gebäck) s; -s, -; Spring..flut, ...form (eine Kuchenform); Spring|ins|feld (scherzh.) m; -[e]s, -e; Spring..kä|fer, ...kraut (Nolimetangere, eine Pflanze; s; -[e]s); spring|le|ben|dig; Spring..maus, ...seil (ein Kinderspielzeug)

Sprink|ler engl. (Berieselungsgerät) m; -s, -; Sprink|ler|an|la|ge

Sprint engl. (Sportspr.: Kurzstreckenlauf) m; -s, -s; sprin|ten (Sportspr.: über kurze Strecken laufen); Sprin|ter (Sportspr.: Kurzstreckenläufer) m; -s, -; Sprint..strecke [Trenn.: ...strek|ke], ...ver|mö|gen

Sprit (Kurzform von: Spiritus; veralt. für: Essig; ugs. für: Treibstoff) m; -[e]s, -e; sprit|tig (spritähnlich)

Spritz..ap|pa|rat, ...ar|beit, ...be|ton,...dü|se; Spritz|e w; -, -n; sprit|zen; du spritzt (spritzest); Spritzen..haus (veralt.), ...mei|ster (veralt.); Spritzer; Spritz..zu|backe|ne [Trenn.: ...bak|ke...], ...fahrt (ugs.), ...guß (Technik); sprit|zig; -er Wein; Spritz..ku|chen, ...le|der, ...ma|le|rei, ...pi|sto|le, ...tour (ugs.)

spröd, sprö|de; ¹Sprö|de (älter für: Sprödigkeit) w; -; ²Sprö|de (sprödes Mädchen) w; -n, -n (↑ R 287 ff.); Spröd|ig|keit w; -

Sproß (Nachkomme; Pflanzentrieb; Jägerspr.: Teil des Geweihs) m; Sprosses, Sprosse u. (Jägerspr.:) Sprossen; Spröß|chen, Spröß|lein; Spros|se (Querholz der Leiter; Hautfleck; auch für: Sproß [Geweihteil] w; -, -n; spros|sen; du sproßt (sprossest); er sproßte; du sproßtest; gesproßt; sprosse! u. sproß!; Spros|sen..kohl (österr. für: Rosenkohl), ...wand (ein Turngerät)

Spros|ser (ein Vogel) m; -s, -

Spröß|lein, Spröß|chen; Spröß|ling; Spros|sung; Sprot|te (ein Fisch) w; -, -n; Kieler Sprotten; ↑ R 199 (dafür landsch. auch: Kieler Sprott)

Spruch m; -[e]s, Sprüche; Spruch..band (s; Mehrz. ...bänder), ...buch, ...dich|tung; Sprü|chel|chen, Sprüch|lein; Spruch|kam|mer (frühere Entnazifizierungsbehörde); spruch|reif

Spru|del m; -s, -; Spru|del|kopf (abschätzig); spru|deln (österr. auch für: quirlen); ich ...[e]le (↑ R 327); Spru|del..quel|le, ...stein (für: Aragonit); Sprud|ler österr. (Quirl); Sprüh|do|se; sprü|hen; Sprüh..feu|er, ...fla|sche, ...re|gen, ...was|ser (Mehrz. ...wässer)

Sprung m; -[e]s, Sprünge; auf dem - sein; jmdn. auf einen - besuchen; Sprung..an|la|ge, ...bein; sprung|be|reit; Sprung..brett, ...fe|der; Sprung|fe|der|ma|trat|ze; sprungfer|tig; Sprung..ge|lenk, ...gru|be; sprung|haft; Sprung|haf|tig|keit; Sprung..hö|he, ...hü|gel, ...lauf (Schisport), ...schan|ze (Schisport), ...stab (Stabhochsprung), ...tuch (Mehrz. ...tücher), ...turm

SPS = Sozialdemokratische Partei der Schweiz

Spucke [Trenn.: Spuk|ke] (ugs. für: Speichel) w; -; spucken [Trenn.: spuk|ken] (speien); Spuck|napf

Spuk (Gespenst[ererscheinung]) m; -[e]s, (selten:) -e; spu|ken (gespensterhaftes Unwesen treiben); Spu|ke|rei; Spuk..ge|schich|te, ...ge|stalt; spuk|haft

Spül..au|to|mat, ...becken [Trenn.: ...bek|ken]

Spu|le w; -, -n; spu|len

Spü|le w; -, -n; spü|len

Spu|ler (an der Nähmaschine)

Spü|ler; Spü|le|rin w; -, -nen; Spü|licht (Spülwasser) s; -s, -e

Spul|ma|schi|ne

Spül..ma|schi|ne, ...mit|tel s

Spul|rad, ...spin|del

Spül..stein, ...tisch; Spü|lung; Spül|was|ser Mehrz. ...wässer

Spul|wurm

Spu|man|te it. (Kurzform für: Asti spumante) m; -s, -s

¹Spund it. (Faßverschluß; Feder; Nut) m; -[e]s, Spünde

²Spund (ugs. für: junger Kerl) m; -[e]s, -e

Spund..ap|pa|rat, ...boh|rer; spun|den (mit Spund versehen); gespundetes Bier; spun|dig landsch. (klitschig); Spund|loch, Spun|dung; Spund..wand, ...zap|fen

Spur w; -, -en; spür|bar; Spur|brei|te; spu|ren (Schisport: die erste Spur legen); ugs. für: sich einordnen, gefügig sein); spü|ren; Spu|ren..ele|men|te (anorgan. chem. Grundstoffe, die in geringsten Mengen lebensnotwendig sind;

Mehrz.), ...le|ger (Schisport), ...nach|weis, ...si|che|rung; Spü|rer; Spür|hund; ...spu|rig (z. B. schmalspurig); Spur|kranz; spur|los; Spur|maß s; Spür|na|se (übertr. ugs.); spur|si|cher; Spür|sinn m; -[e]s

Spurt engl. (Steigerung der Geschwindigkeit bei Rennen über eine längere Strecke, bes. bei der Leichtathletik) m; -[e]s, -s (selten: -e); spur|ten

Spur|wei|te

Spu|ta (Mehrz. von: Sputum)

spu|ten, sich (sich beeilen)

Sput|nik russ. ("Gefährte"; Bez. für die ersten sowjet. Erdsatelliten) m; -s, -s

Spu|tum lat. (Med.: Auswurf) s; -s, ...ta

Spvg., Spvgg. = Spielvereinigung

Square engl. [ßkwä'] (engl. Bez. für: Quadrat; [Schmuck]platz) m od. s; -[s], -s

Squash engl. [ßkwǎsch] (Inneres von Orangen, Zitronen o. ä. od. deren Saft; ein dem Tennis ähnliches Ballspiel) s; -

Squat|ter engl. [ßkwǎt'r] (amerik. Ansiedler, der sich ohne Rechtsanspruch auf einem Stück unbebauten Landes niedergelassen hat) m; -s, -

Squaw indian.-engl. [ßkwǎ] (nordamerik. Indianerfrau) w; -, -s

Squi|re engl. [ßkwai'r] (engl. Gutsherr) m; -[s], -s

Sr = chem. Zeichen für: Strontium

Sr. = Seiner (Durchlaucht usw.)

Srbik [ßirbik] (österr. Historiker)

SRG = Schweizerische Radio- und Fernsehgesellschaft

SRI vgl. Riyal

Sri Lanka singhal. [- langka] (amtl. für: Ceylon); Sri|lan|ker; sri|lan|kisch

SS. = Sante, Santi

SSD = Staatssicherheitsdienst (DDR)

SSO = Südsüdost[en]

SSR = Sozialistische Sowjetrepublik

SSSR = russ. (Union der Sozialistischen Sowjetrepubliken; für russ. СССР)

SSW = Südsüdwest[en]

st, h (Astron.: h) = Stunde

st! (beim Anruf: Achtung!; Ruhe!)

St = ²Saint; Stratus

St. = Sankt; ¹Saint; Satang; Stück; Stunde

s. t. = sine tempore

S. T. = salvo titulo

Sta. = Santa

¹Staat lat. m; -[e]s, -en; von -s wegen; ²Staat (ugs. für: Prunk) m; -[e]s; - machen (mit etwas prunken); staa|ten|bil|dend; -e Insek-

ten; staa|ten|los; Staa|ten|lo|se *m* u. *w*; -n, -n (↑ R 287ff.); Staa|ten-lo|sig|keit *w*; -; staat|lich; Staats-
.af|fä|re, ...akt, ...ak|ti|on, ...an-ge|hö|ri|ge *m* u. *w*, ...an|ge|hö|rig-keit, ...an|lei|he, ...an|walt, ...an-walt|schaft, ...ap|pa|rat, ...ar-chiv, ...auf|sicht, ...bank (*Mehrz.* ...banken), ...bank|rott, ...be|am-te, ...be|gräb|nis, ...be|such, ...be-tt|eb, ...bi|blio|thek, ...bür|ger; Staats|bür|ger|kun|de *w*; -; staats-bür|ger|lich; -e Rechte; Staats-
.bürg|schaft, ...dienst; staats|ei-gen; Staats|ei|gen|tum; staats|er-hal|tend; Staats_ex|amen, ...fei-er|tag; staats|feind|lich; Staats-
.fi|nan|zen (*Mehrz.*), ...flag|ge, ...form, ...ge|biet; staats_ge|fähr-dend; -e Schriften; Staats_ge-fähr|dung, ...ge|heim|nis, ...ge-richts|hof (*m*; -[e]s), ...ge|walt (*w*; -), ...gren|ze, ...haus|halt, ...ho-heit (*w*; -), ...kanz|lei, ...ka|pi|ta-lis|mus, ...ka|ros|se, ...kir|che (*w*; -), ...kleid (ugs. für: Festtags-kleid), ...ko|sten (*Mehrz.*), kunst (*w*; -), ...lot|te|rie, ...mann (*Mehrz.* ...männer); staats|män-nisch; Staats_mi|ni|ster, ...ober-haupt, ...ord|nung, ...or|gan, ...pa-pier, ...par|tei, ...po|li|tik; staats-po|li|tisch; Staats_prä|si|dent, ...prü|fung, ...rai|son od. ...rä-son, ...rat (*Mehrz.* ...räte), ...recht (*s*; -[e]s), ...re|li|gi|on, ...schul|den (*Mehrz.*), ...se|kre-tär, ...se|kre|tä|rin, ...si|cher|heit (*w*; -); Staats|si|cher|heits|dienst (polit. Geheimpolizei in der DDR; Abk.: SSD) *m*; -[e]s; Staats_so|zia|lis|mus, ...steu|er *w*, ...stra|ße, ...streich, ...thea|ter, ...ver|bre|chen, ...ver|trag, ...volk, ...we|sen, ...wirt|schaft, ...wis-sen|schaft, ...wohl

Stab *m*; -[e]s, Stäbe; 25 - Roheisen (↑ R 321 u. 322)
Sta|bat ma|ter *lat.* („die Mutter [Jesu] stand [am Kreuze]"; Anfangsworte einer kath. Sequenz) *s*; - -, - -
Stäb|chen, Stäb|lein; **Stab|ei|sen**
Sta|bel|le *roman.* schweiz. (hölzer-ner Stuhl, Schemel) *w*; -, -n
stä|beln landsch. (Pflanze an eine Stütze binden); ich ...[e]le (↑ R 327); sta|bend (für: alliterierend)
Sta|berl *s*; -s, -e u. **Sta|ber|le** (Ge-stalt der Wiener Posse) *s*; -s, -s
stab|för|mig; **Stab|füh|rung** (musi-kal. Leitung); unter der - von ...;
Stab|hoch|sprung (Sport)
sta|bil *lat.* (beständig, dauerhaft, fest, haltbar; [körperlich] kräftig, widerstandsfähig); **Sta|bi|le** *engl.* (Kunstwerk in Form einer [im Gegensatz zum Mobile] auf dem Boden \ stehenden metallenen

Konstruktion) *s*; -s, -s; **sta|bi|lie-ren** *lat.* (veralt. für: stabilisieren);
Sta|bi|li|sa|ti_on [...*zion*]; **Sta|bi-li|sa|tor** (Gerät zur Gleichhal-tung elektr. Größen; bei Kraft-wagen verwendete Federung zum Mildern vertikaler Stoß-schwingungen; Zusatz, der die Zersetzung chem. Verbindungen verhindern soll; gerinnungshem-mende Flüssigkeit für die Kon servierung des Blutes) *m*; -s, ...oren; **sta|bi|li|si_e|ren** (festset-zen; festigen; standfest machen);
Sta|bi|li|sie|rung; **Sta|bi|li|sie-rungs_flä|che** (Flugw.), ...flos|se (bei[Renn]wagen), ...ge|setz; **Sta-bi|li|tät** (Beständigkeit, Dauer-haftigkeit; [Stand]festigkeit) *w*; -
Stab|lam|pe; **Stäb|lein**, Stäb|chen;
Stab|reim (Anlautreim, Alliterati-on); **stab|rei|mend** (für: alliterie-rend); **Stabs_arzt**, ...feld|we|bel;
stab|sich|tig (für: astigmatisch);
Stab|sich|tig|keit (für: Astigma-tismus) *w*; -; **Stabs_of|fi|zier**, ...ve-te|ri|när, ...wacht|mei|ster; **Stab-ta|schen|lam|pe**; **stab|wei|se**;
Stab|werk (got. Bauk.)

stacc. ‒ staccato
stac|ca|to *it.* [*ʃtakato*] (Musik: ab-gestoßen; Abk.: stacc.); vgl. Stak-kato
Sta|chel *m*; -s, -n; **Sta|chel|bee|re**; **Sta|chel|draht**; **Sta|chel|draht-ver|hau**; **Sta|chel|hals|band**, ...häu|ter; sta|che|lig, stach|lig;
Sta|che|lig|keit, Stach|lig|keit *w*; -; sta|cheln; ich ...[e]le (↑ R 327);
Sta|chel_schwein, ...zaun
¹**Sta|ches**, Sta|chus (Kurzform von: Eustach[ius]); ²**Sta|ches** schwäb. (widerspenstiger, närri-scher Kerl) *m*; -, -
stach|lig, sta|che|lig; **Stach|lig-keit**, Stache|lig|keit *w*; -
Sta|chus vgl. ¹Staches
Stack niederd. (Buhne) *s*; -[e]s, -e;
Stack|deich
Sta|del südd., österr., schweiz. (Scheune, kleines [offenes] Ge-bäude) *m*; -s, - u. (schweiz.:) Stä-del
Sta|den südd. (Ufer[straße]) *m*; -s, -
Sta|di_on *gr.* (altgr. Wegmaß; Kampfbahn, Sportfeld) *s*; -s, ...ien [...*iᵉn*]; **Sta|di_um** ([Zu]stand, [Entwicklungs]stufe, Ab-schnitt) *s*; -s, ...ien [...*iᵉn*]
Stadt *w*; -, Städte¹; **Stadt_ar|chiv**; **stadt_aus|wärts**; **Stadt_au|to-bahn**, ...bahn, ...bau (städt. Bau; *Mehrz.* ...bauten), ...bau|rat; **Stadt|be|kannt**; **Stadt_be|völ|ke-rung**, ...be|woh|ner, ...be|zirk, ...bib|lio|thek, ...bild; **Städt|chen**¹,

Städt|lein¹; **Stadt|di|rek|tor**;
Städ|te|bau¹ (Anlage u. Planung von Städten) *m*; -[e]s; **städ|te|bau-lich**¹; **Städ|te_bild|der**¹ (*Mehrz.*), ...bund¹ *m*; stadt_ein|wärts; Städ-te_kampf¹, ...part|ner|schaft¹;
Städ|ter¹; **Städ|te|tag**¹; **Stadt-
.fahrt**, ...flucht (vgl. ¹Flucht), ...gas, ...ge|biet, ...ge|spräch, ...gue|ril|la, ...haus; städ|tisch¹;
**ea Loben; e Vorwaltung; Stadt-
.käm|me|rer**, ...kern, ...klatsch (abschätzig), ...kreis; stadt|kun-dig; stadt- und landkundig (↑ R 145); **Städt|lein**¹, Städt|chen¹;
Stadt_mau|er, ...mis|si_on, ...mit-te, ...park, ...plan (vgl. ²Plan), ...pla|nung, ...rand, ...rand|sied-lung, ...rat (*Mehrz.* ...räte), ...recht, ...rund|fahrt, ...schrei-ber, ...staat (*Mehrz.* ...staaten), ...strei|cher, ...strei|che|rin (*w*; -, -nen), ...teil *m*, ...thea|ter, ...tor *s*, ...vä|ter (*Mehrz.*), ...ver|kehr, ...ver|ord|ne|te *m* u. *w*; -n, -n (↑ R 287ff.); **Stadt|ver|ord|ne|ten|ver-samm|lung**; **Stadt_ver|wal|tung**, ...vier|tel, ...wer|ke (*Mehrz.*)
Staël [*ʃtal*], Madame de (fr. Schriftstellerin)
Sta|fel *roman.* schweiz. (Alpwei-de, -hütte) *m*; -s, Stäfel
Sta|fet|te *it.* (früher für: [reitender] Eilbote, Melderreiter; Sport: Staf-fel, Staffellauf in der Leichtathle-tik) *w*; -, -n; **Sta|fet|ten|lauf** (Staf-fellauf)
Staf|fa|ge [...*gášᵉ*]; französierende Bildung) (Beiwerk, Belebung ei-nes Bildes) durch Figuren; Ne-bensächliches, Ausstattung)
Staf|fel *w*; -, -n; (↑ R 157:) 4 × 100-m-Staffel od. 4mal-100-Me-ter-Staffel; **Staf|fel_an|lei|he** (Wirtsch.), ...be|tei|li|gung (Wirtsch.); **Staf|fe|lei**; staf|fel-för|mig; staf|fe|lig, staff|lig; **Staf-fel|lauf** (Leichtathletik, Schi-sport: Wettlauf mehrerer Mann-schaften, deren einzelne Mitglie-der einander ablösen); staf|feln; ich ...[e]le (↑ R 327); **Staf|fel_preis** (vgl. ²Preis), ...rech|nung, ...span-ne (Wirtsch.); **Staf|fe|lung**, Staff-lung; **staf|fel|weise**
staff|lig, staf|fe|lig; **Staff|lung**, Staf|fe|lung
Stag (Seemannsspr.: Halte-, Stütztau auf Schiffen) *s*; -[e]s, -e[n]
Stag|fla|ti_on [...*zion*] (aus „Sta-

¹ Auch: *schtä*...

¹ Auch: *schtä*...

gnation" u. „Inflation"; von
wirtschaftlichem Stillstand be-
gleitete Inflation) w; -
Sta|gio|ne it. [ʃtadsehǫnᵉ] (Spiel-
zeit it. Operntheater) w; -, -n
Sta|gna|ti|on lat. [...zi̯on] (Stok-
kung, Stillstand; [...]: kalte Wasser-
schicht in Binnenseen); sta|gnie-
ren; Sta|gnie|rung
Stag|se|gel (Seemannsspr.)
¹Stahl (schmiedbares Eisen) m;
-[e]s, Stähle u. (selten:) Stahle
²Stahl niederd. (Muster, Probe) m;
-[e]s u. -en, Stähle u. -en (↑ R 268)
Stahl_bad, ...band (s; Mehrz.
...bänder), ...bau (Mehrz. ...bau-
ten), ...be|ton; stahl|blau; Stahl-
_blen|de, ...draht; stäh|len; stäh-
lern (aus Stahl); -e Waffe; -er Wil-
le; Stahl_er|zeu|gung, ...fe|der,
...flach|stra|ße od. ...stra|ße
(Straßenbau), ...fla|sche; stahl-
_grau, ...hart; Stahl_helm (vgl.
¹Helm), ...kam|mer; Stahl|rip-
pen|bau, Stahl|rip|pen|bau; Stahl-
rohr; Stahl|rohr|mö|bel; Stahl-
_roß (scherzh. für: Fahrrad; s;
...rosses, ...rosse), ...stich, ...stra-
ße od. ...flach|stra|ße (Straßen-
bau), ...trä|ger, ...werk
stahn (veralt. für: stehen)
Sta|ke w; -, -n u. Sta|ken landsch.
(Stange zum Schieben von
Flößen, Kähnen) m; -s, -; sta|ken
(landsch. für: mit Staken fort-
bewegen; übertr. ugs. für: mit
steifen Schritten gehen); Sta|ket
niederl. (Lattenzaun, Gestäbe) s;
-[e]s, -e; Sta|ke|te österr. (Latte)
w; -, -n; Sta|ke|ten|zaun
Stak|ka|to it. (Musik: kurz abge-
stoßener Vortrag) s; -s, -s u. ...ti;
vgl. staccato
stak|sen (ugs. für: mit steifen
Schritten gehen)
Sta|lag|mit gr. (Tropfstein vom
Boden her, Auftropfstein) m; -s
u. -en, -e[n] (↑ R 268); sta|lag|mi-
tisch; Sta|lak|tit (Tropfstein an
Decken, Abtropfstein) m; -s u.
-en, -e[n] (↑ R 268); Sta|lak|ti|ten-
ge|wöl|be (Gewölbeform der is-
lam. Baukunst); sta|lak|ti|tisch
Sta|lin (sowjet. Staatsmann); Sta-
lin|grad vgl. Wolgograd; Sta|li-
nis|mus m; -; Sta|li|nist (↑ R 268);
sta|li|ni|stisch
Stall m; -[e]s, Ställe; Stal|la|ter|ne
[Trenn.: Stall|la..., ↑ R 236]; Stall-
bur|sche; Ställ|chen; Stall|dün|ger
(natürl. Dünger); stall|en; Stall-
_feind (schweiz. Umschreibung
für: Maul- u. Klauenseuche; m;
-[e]s), ...füt|te|rung, ...ha|se
(scherzh.), ...knecht, ...magd;
Stal|lung
Stam|bul (Stadtteil von Istanbul)
Stamm m; -[e]s, Stämme; Stamm-
ak|tie (Wirtsch.); Stamm|mann|schaft [Trenn.:

Stamm|mann..., ↑ R 236];
Stamm_baum, ...be|leg|schaft,
...buch; stamm|bür|tig (Bot.: von
Pflanzen, deren Blüten od.
Früchte direkt am Stamm anset-
zen); Stämm|chen, Stämm|lein;
Stamm|ein|la|ge (Wirtsch.)
stam|meln; ich ...[e]le (↑ R 327)
stamm|men
Stamm_mes_be|wußt|sein, ...ei|gen-
heit, ...ge|schich|te, ...kun|de (w;
-), ...na|me, ...sa|ge, ...spra|che,
...ver|band, ...zu|ge|hö|rig|keit;
Stamm_form, ...frücht|ler, ...gast
(Mehrz. ...gäste), ...ge|richt;
stamm|haft; Stamm_hal|ter,
...haus; Stammiete [Trenn.:
Stamm|mie|te, ↑ R 236] w; -, -n;
Stamm_mie|ter [Trenn.: Stamm|mie-
ter,↑ R 236]; stäm|mig; Stäm|mig-
keit w; -; Stamm_ka|pi|tal, ...knei-
pe (ugs.), ...kun|de m, ...kund-
schaft; Stämm|lein, Stämm|chen;
Stamm|ler; Stamm_lo|kal, ...per-
so|nal, ...re|gi|ster (Bankw.),
...rol|le (milit.), ...sil|be, ...ta|fel,
...tisch, ...ton (Musik); Stamm_mut-
ter [Trenn.: Stamm|mut..., ↑ R
236] (Mehrz. ...mütter); Stamm_
va|ter; stamm|ver|wandt; Stamm_
_ver|wandt|schaft, ...vo|kal,
...wort (Mehrz. ...wörter)
Sta|mo|kap = staatsmonopolisti-
scher Kapitalismus
Stam|perl bayr. u. österr.
(Schnapsgläschen) s; -s, -n
Stampf_as|phalt, ...bau (m; -[e]s),
...be|ton; Stampf|fe w; -, -n; stamp-
fen; Stampf|fer
Stam|pi|glie it. [...piljᵉ] österr. (Ge-
rät zum Stempeln; Stempelauf-
druck) w; -, -n
Stan [ʃtän] (Kurzform von: Stan-
ley)
Stand m; -[e]s, Stände; einen
schweren Stand haben; standhal-
ten (vgl. d.); (↑ R 141:) außerstan-
de, imstande sein, aber: er ist
gut im Stande (bei guter Gesund-
heit) (↑ R 141:) instand halten,
aber: etwas [gut] im Stande hal-
ten (in gutem Zustande) erhalten, (↑ R
141:) instand setzen (ausbessern,
wiederherstellen), aber: jmdn.
in den Stand setzen, etwas zu tun;
(↑ R 141:) zustande bringen,
kommen
Stan|dard engl. (Normalmaß,
Durchschnittsmuster; Richt-
schnur, Norm) m; -s, -s; Stan-
dard_aus|rü|stung, ...far|be,
...form; stan|dar|di|sie|ren (nor-
men); Stan|dar|di|sie|rung; Stan-
dard_kal|ku|la|ti|on (Wirtsch.),
...ko|sten (Wirtsch.; Mehrz.);
Stan|dard|ko|sten|ab|rech|nung
(Wirtsch.); Stan|dard|ko|sten-
rech|nung (Wirtsch.); Stan|dard-
_lö|sung (Vergleichslösung),

...preis (vgl. ²Preis), ...tanz,
...werk (mustergültiges Sach- od.
Fachbuch), ...wert (Festwert)
Stan|dar|te fr. (Banner; Feldzei-
chen; Fahne berittener u. moto-
risierter Truppen; Jägerspr.:
Schwanz des Fuchses) w; -, -n;
Stan|dar|ten|trä|ger
Stand_bein (Sport, bild. Kunst;
Ggs.: Spielbein), ...bild; Ständ-
chen, Ständ|lein; Stän|de
(landsch. u. schweiz.) w; -, -n u.
Stän|den landsch. (²Kufe, Bot-
tich) m; -, -; Stän|de (ständische
Volksvertretung) Mehrz.; Stän-
de_kam|mer; Stan|den vgl. Stän-
de; Stän|de_ord|nung, ...or|ga|ni-
sa|ti|on
Stan|der (Dienstflagge am Auto
z. B. von hohen Regierungs-
beamten; Seemannsspr.: kurze,
dreieckige Flagge) m; -s, -
Stän|der (Jägerspr. auch: Fuß des
Federwildes) m; -s, -; Stän|de_rat
(in der Schweiz: Vertretung der
Kantone in der Bundesversamm-
lung u. deren Mitglied; m; -[e]s,
...räte), ...recht; Stan|des_amt;
stan|des|amt|lich; -e Trauung;
Stan|des|be|am|te; stan|des|be-
wußt; Stan|des_be|wußt|sein,
...dün|kel, ...eh|re; stan|des|ge-
mäß; -es Auskommen; -e Heirat;
Stan|des_herr, ...herr|schaft,
...per|son, ...pflicht, ...recht; Stän-
de_staat (Mehrz. ...staaten); stan-
des_un|ter|schied, ...wür|de; stan-
des|wür|dig; Stan|des|zu|ge|hö-
rig|keit; Stän|de|tag, ...we|sen (s;
-s); stand|fä|hig; stand|fest;
Stand_fe|stig|keit (w; -), ...fo|to
(Filmw.), ...geld (Marktgeld),
...ge|richt (Militär), ...ge|wicht,
...glas (für: Meßzylinder; Mehrz.
...gläser); stand|haft; Stand|haf-
tig|keit w; -; stand|hal|ten (↑ R
140); er hält stand (↑ R 132); hat
standgehalten; aber: den Stand
zu halten; stän|dig (dauernd); -er Aufent-
halt; -e Wohnung; -es Mitglied,
aber (↑ R 224): Ständiger Inter-
nationaler Gerichtshof; Ständige
Konferenz der Kultusminister
der Länder; stän|disch (die Stän-
de betreffend); nach Ständen ge-
gliedert); -er Aufbau; Stand|licht
(bei Kraftfahrzeugen); Stand|ort
(auch Militär für: Garnison) m;
-[e]s, -e; Stand_ort_äl|te|ste m,
...fak|tor (Wirtsch.), ...leh|re
(Wirtsch.), ...ori|en|tie|rung
(Wirtsch.), ...pfle|ge (Baumkul-
tur); Stand_pau|ke (ugs. für:
Strafrede), ...punkt, ...quar|tier,
...recht (Kriegsstrafrecht); stand-
recht|lich; -e Erschießung; Stand-
re|de (Strafrede); stand|si|cher;
Stand_si|cher|heit (w; -), ...uhr,
_waa|ge

Stạn|ge (Jägerspr. auch: Stamm des Hirschgeweihes, Schwanz des Fuchses) w; -, -n; von der - kaufen (Konfektionsware [Ggs.: Maßarbeit] kaufen); Stạn|gel|chen, Stạng|lein; Stạn|geln (mit Stangen versehen, an Stangen anbinden); ich ...[e]le (↑ R 327); Stạn|gen_boh|ne, ...holz, ...pferd (das an der Deichsel gehende Pferd eines Fahrzeuges), ...rei|ter (Reiter auf dem Stangenpferd), ...spar|gel; stạn|gig; Stạng|lein, Stạn|gel|chen

Stạ|nis|laus, Stạ|nis|law (m. Vorn.)

Stạ|ni̱t|zel bayr. u. österr. ugs. (spitze Tüte) m od. s; -s, -

Stạnk (ugs. für: Zank) m; -[e]s; Stän|ke|rei (ugs.); Stạn|k[e|r]er (verächtl.); stän|ke|rig, stänk|rig (ugs.); stạn|kern (ugs.); ich ...ere (↑ R 327)

Stạn|ley [ßtänli] (engl. m. Vorn.)

Stạn|ni̱|ol nlat. (eine silberglänzende Zinnfolie, ugs. auch für: silberglänzende Aluminiumfolie) s; -s, -e; Stạn|ni̱|ol.blätt|chen, ...pa|pier; Stạn|num (Zinn; chem. Zeichen: Sn) s; -s

Stạns (Hauptort des Halbkantons Unterwalden nid dem Wald); Stạn|ser Horn (ein Berg) s; - -[e]s

stạn|te pe̱|de lat. (ugs. scherzh. für: „stehenden Fußes"; sofort)

[1]Stạn|ze it. (achtzeilige Strophenform) w; -, -n

[2]Stạn|ze (Ausschneidewerkzeug, -maschine für Bleche u. a., Prägestempel) w; -, -n; stạn|zen; du stanzt (stanzest); Stạnz|form

Stạn|zi (Kurzform von: Konstanze)

Stạnz|ma|schi|ne

Stạ|pel (Schiffsbaugerüst; Platz od. Gebäude für die Lagerung von Waren; aufgeschichteter Haufen; Faserlänge) m; -s, -; vom (auch: von) - gehen, lassen, laufen; Stạ|pel_fa|ser, ...glas (Mehrz. ...gläser), ...holz Stạ|pe|lie [...i̱ᵉ; nach dem niederl. Arzt J. B. van Stapel] (Aasblume od. Ordenskaktus) w; -, -n ...sta|pe|lig (z. B. langstapelig); Stạ|pel|lauf; stạ|peln; ich ...[e]le (↑ R 327); Stạ|pel|platz; Stạ|pe|lung w; -; Stạ|pel|wa|re

Stạp|fe w; -, -n u. Stạp|fen (Fußspur) m; -s, -; stạp|fen

Stạ|phy|lo|kọk|kus gr. (Med.: traubenförmige Bakterie) m; -, ...kken (meist Mehrz.)

Stạps sächs. (ungelenker Bursche) m; -es, -e

[1]Star [zu: starr] (Augenkrankheit) m; -[e]s, -e; (↑ R 224:) der graue, grüne, schwarze Star (Augenkrankheiten)

[2]Star engl. („Stern"; berühmte Persönlichkeit [beim Theater, Film]; Sportsegelboot) m; -s, -s

[3]Star (ein Vogel) m; -[e]s, -e

[4]Star landsch. (Widder) m; -[e]s, -e

Star_al|lü|ren (eitles, launenhaftes Benehmen, Eigenheiten eines Stars [vgl. [2]Star]; Mehrz.), ...be|set|zung

stạr|blind, Stạr|br̠il|le

stä|ren landsch. (brünstig sein nach dem Stär)

Stạ|ren|ka|sten, Stạr|ka|sten

Star|figh|ter amerik. [ßtaᵉ fait͗ᵉr] (amerik. Kampfflugzeug) m; -s, -

Star|hem|berg (Name eines österr. Adelsgeschlechtes)

stạrk; stärker, stärkste; das -e (männliche) Geschlecht; eine -e Natur; er hat -e Nerven; (Sprachw.:) -e Deklination; ein -es Zeitwort; (↑ R 116:) das Recht des Starken. In Verbindung mit Zeitwörtern immer getrennt, z. B. stark sein, werden, machen; stark erhitzt; stark gehopftes Bier, stark verdünnter Alkohol

Stạr|ka|sten, Stạ|ren|ka|sten

Stạrk|bier; Stär|ke w; -, -n; -n; Stär|ke_fa|brik, ...mehl; stär|ken Stạr|ken|burg (Südteil des Regierungsbezirks Darmstadt); stạr|ken|bur|gisch Stär|ke|zucker [Trenn.: ...zuk-ker]; stạrk_ker|zig, ...kno|chig, ...lei|big; Stạrk|mut (veralt.) m; -[e]s; Stạrk|strom m; -[e]s; Stạrk-strom_lei|tung, ...tech|nik, ...tech-ni|ker; Stär|kung; Stär|kungs-mit|tel s

Star|let[t] engl. [ßta̱ᵉ lät] („Sternchen"; Nachwuchsfilmschauspielerin) s; -s, -s

Star|matz (scherzh. für: Star [als Käfigvogel])

Stạrn|ber|ger See (↑ R 199) m; - -s

Stạ|rost poln. (in Polen: Landeshauptmann, Landrat) m; -en, -en (↑ R 268); Stạ|ro|stei (Amt[sbezirk] eines Starosten)

stạrr; in -es Gesetz; ein -es Prinzip; Stạr|re w; -; stạr|ren; von od. vor Schmutz -; Stạrr|heit w; -; Stạrr|kopf (abschätzig für: Eigensinniger); stạrr|köp|fig; Stạrr-krampf m; -[e]s; Stạrr|krampf|ba-zil|lus; Stạrr|sinn m; -[e]s; stạrr-sin|nig; Stạrr|sucht w; -

Stạrt engl. (Beginn; Ablauf-, Abfahrt-, Abflug[stelle]) m; -[e]s, -s (selten: -e); ein fliegender -; ein stehender -; Stạrt_au|to|ma|tik, ...bahn; stạrt|be|reit; Stạrt|block (Mehrz. ...blöcke); stạr|ten (einen Flug, einen Wettkampf, ein Rennen beginnen, auch: beginnen lassen); übertr. für: etwas anfan-

gen, losgehen lassen); Stạr|ter (Sport: Person, die das Zeichen zum Start gibt, Rennwart; jmd., der startet; Anlasser eines Motors); Stạrt_er|laub|nis, ...flä|che, ...flag|ge, ...geld, ...hil|fe, ...li|nie, ...li|ste, ...loch, ...ma|schi|ne (Pferdesport), ...num|mer, ...platz, ...ram|pe, ...schuß, ...verbot, ...zei|chen

Stạ|se, Stạ|sis gr. (Med.: Stauung) w; -, Stasen

Stạ|si (Kurzform von: Anastasia)

Stạ|si|mor|phie̱ gr. (Bot.: Entwicklungsstillstand bei Pflanzen) w; -, ...ien; Stạ|sis vgl. Stase

Staß|furt (Stadt im Süden der Magdeburger Börde); Staß|fur-ter (↑ R 199)

sta|ta̱|risch lat. (stehend, verweilend; langsam fortschreitend), in der Wendung: -e Lektüre

State De|part|ment engl. [ßte̠ᵗ di-pa̱ᵗ tm͗ᵉnt] (das Außenministerium der USA) s; - -

State|ment engl. [ßte̠ᵗ tm͗ᵉnt] (Erklärung, Verlautbarung) s; -s, -s

sta|tie̱|ren lat. (als Statist tätig sein)

Stä|tig|keit (von Pferden: Störrigkeit) w; -; vgl. aber: Stetigkeit

Stạ|tik gr. (Lehre von den Kräften im Gleichgewicht) w; -; Stạ|ti|ker (Bauingenieur mit speziellen Kenntnissen auf dem Gebiet der Statik)

Stạ|ti|on lat. [...zio̱n] (Haltestelle; Bahnhof; Haltepunkt, Aufenthalt; Bereich, Krankenhausabteilung; Ort, an dem sich eine techn. Anlage befindet; sta|tio-när (standörtlich; bleibend; ortsfest; die Behandlung, den Aufenthalt in einem Krankenhaus betreffend); -e Behandlung; Statio|nen|fol|ge; sta|tio|nie̱|ren (an bestimmte Plätze stellen; auf-, anstellen); Stạ|tio|nie|rung; Stạtio|nie|rungs|ko|sten Mehrz.; Stạ|ti|ons_arzt (Abteilungsarzt), ...ko|sten (Mehrz.), ...schwe|ster, ...vor|stand (österr. u. schweiz. für: Stationsvorsteher), ...vor-ste|her (Bahnhofsvorsteher)

sta|ti|ös lat. [...zi̱ŏß] mdal. (prunkend; stattlich); -este (↑ R 292)

stạ|tisch gr. (die Statik betreffend; stillstehend, ruhend); -e Gesetze; -e Organe (Gleichgewichtsorgane)

stä|tisch (von Pferden: störrisch, widerspenstig; nicht von der Stelle zu bringen); -ste (↑ R 294)

Stạ|tist lat. (Theater u. übertr.: nur „dastehende", stumme Person); ↑ R 268; Stạ|ti|ste|ri̱e (Gesamtheit der Statisten) w; -, ...ien; vgl. statieren; Stạ|ti|stik ([vergleichende] zahlenmäßige Erfas-

sung, Untersuchung u. Darstellung von Massenerscheinungen) *w*; -, -en; **Sta|ti|sti|ker** (Bearbeiter u. Auswerter von Statistiken); **sta|ti|stisch** (zahlenmäßig), aber (↑ R 224): das Statistische Bundesamt (in Wiesbaden); **Sta|tiv** (Gestell, Ständer [für physikal., chem., fotogr. u. a. Apparate]) *s*; -s, -e [*...w^e*]

Sta|to|blast *gr.* (Biol.: ungeschlechtl. Fortpflanzungskörper der Moostierchen) *m*; -en, -en (↑ R 268); **Sta|to|lith** (Steinchen im Gleichgewichtsorgan; Stärkekorn in Pflanzenwurzeln; *m*; -s u. -en, -e[n] (meist *Mehrz.*); ↑ R 268

Sta|tor *lat.* (feststehender Teil einer elektr. Maschine, Ständer) *m*; -s, ...oren

statt, an|statt; ↑ R 130; *Verhältnisw.* mit *Wesf.*: - dessen, - meiner, - eines Rates; veralt. od. ugs. mit *Wemf.*: - einem Stein; - dem Vater; hochsprachlich mit *Wemfall*, wenn der *Wesf.* nicht erkennbar wird: - Worten will ich Taten sehen; *Bindew.*: - mit Drohungen wird man besser mit Ermahnungen zum Ziel kommen; die Nachricht ist an mich - an dich gekommen; er gab das Geld ihm - mir; **Statt** *w*; -; an meiner -; an Eides, an Kindes, an Zahlungs-; ein gutes Wort findet eine gute-; **Stät|te** *w*; -, -n; **statt|fin|den** (↑ R 140); es findet statt (↑ R 132), aber: es findet eine gute Statt; es hat stattgefunden; stattzufinden; **statt|ge|ben** (↑ R 140); zur Beugung vgl. stattfinden; **statt|ha|ben** (↑ R 140); es hat statt (↑ R 132); es hat stattgehabt; stattzuhaben; **statt|haft; Statt|haf|tig|keit** *w*; -; **Statt|hal|ter** (Stellvertreter); **Statt|hal|te|rei; Statt|hal|ter|schaft**

statt|lich [zu: Staat (Prunk)] (ansehnlich); **Statt|lich|keit** *w*; -

sta|tu|a|risch *lat.* (auf die Bildhauerkunst od. die Statue bezüglich, statuenmäßig); **Sta|tue** [*...u^e*] (Standbild, Bildsäule) *w*; -, -n; **sta|tu|en|haft; Sta|tu|et|te** *fr.* (kleine Statue) *w*; -, -n; **sta|tu|ieren** *lat.* (aufstellen; festsetzen; bestimmen); ein Exempel - (ein warnendes Beispiel geben); **Sta|tur** (Gestalt; Wuchs) *w*; -, -en; **Sta|tus** (Zustand, Bestand, Stand; Vermögensstand) *m*; -, -; **Sta|tus nas|cen|di** [*...zän|di*] (Chem.: Zustand chem. Stoffe im Augenblick ihres Entstehens) *m*; - -; **Sta|tus quo** (gegenwärtiger Zustand) *m*; - -; **Sta|tus quo an|te** (Stand vor dem bezeichneten Tatbestand, Ereignis) *m*; - - -; **Sta-**

tus|sym|bol; Sta|tut (Satzung, [Grund]gesetz) *s*; -[e]s, -en; **sta|tu|ta|risch** (auf Status beruhend, satzungs-, ordnungsgemäß); **Sta|tu|ten|än|de|rung; sta|tu|ten|ge|mäß**, ...**wid|rig**

Stau *m*; -[e]s, -e (auch: -s); im - (zwischen Ebbe u. Flut) sein; **Stau|an|la|ge** (↑ R 148)

Staub *m*; -[e]s, (Technik:) -e u. Stäube; - saugen, aber: staubsaugen (vgl. d.); **staub|ab|wei|send**; ein -es Gewebe, aber (↑ R 142): ein den Staub abweisendes Gewebe; **staub|be|deckt**; ein -er Tisch, aber (↑ R 142): ein von Staub bedeckter Tisch; **Staub-.be|sen**, ...**beu|tel**, ...**blatt**; **Stäub|chen**, ...**Stäub|lein**; **Staub|ecke** [*Trenn.*: ...ek|ke]

Staub|becken [*Trenn.*: ...bek|ken] **stau|ben** (vom Staub: aufwirbeln); es staubt; **stäu|ben** (zerstieben); **Stäu|ber** (veralt.); **stäu|ben** landsch. (Staub entfernen); ich ...ere (↑ R 327); **Staub.ex|plo|si|on**, ...**fa|den**, ...**fän|ger** (ugs.); **staub|frei**; **staub|ge|bo|ren**; **Staub.ge|bo|re|ne**, ...**ge|bor|ne** *m* u. *w*; -n, -n (↑ R 287 ff.); **Staub|ge|fäß**; **staub|ig**; **Staub.kamm**, ...**korn** (*Mehrz.* ...körner), ...**lap|pen**, ...**la|wi|ne**; **Stäub|lein**, **Stäub|ling** (ein Pilz); **Staub.lun|ge**, ...**man|tel**, ...**pin|sel**; **Staub sau|gen**; saugte Staub; Staub gesaugt, aber: **staub|sau|gen**; staubsaugte; staubgesaugt; **Staub.sau|ger**, ...**tuch** (*Mehrz.* ...tücher), ...**we|del**, ...**wol|ke**, ...**zucker** [*Trenn.*: ...zuk|ker]

Stau|che *südd. ugs.* (Pulswärmer) *w*; -, -n (meist *Mehrz.*); **stau|chen**; **Stau|cher** (ugs. für: Zurechtweisung)

Stau|damm

Stau|de *w*; -, -n; **stau|den** (veralt. für: krautig wachsen); **stau|den|ar|tig; Stau|den.ge|wächs**, ...**sa|lat; stau|dig**

stau|en (fließendes Wasser hemmen; Seemannsspr.: Ladung auf Schiffen unterbringen); sich -; das Eis, das Wasser staut sich; **Stau|er** (Person, die gewerbsmäßig das Beladen von Schiffen besorgt)

Stauf (veralt. für: Humpen; Flüssigkeitsmaß) *m*; -[e]s, -e; 5 - (↑ R 322)

Stau|fe (Angehöriger eines schwäb. Fürstengeschlechts) *m*; -n, -n (↑ R 268); **Stau|fer** *m*; -s, -; **Stau|fer|zeit** *w*; -

Stauf|fer.büch|se (↑ R 180 [nach dem Hersteller]; Schmiervorrichtung), ...**fett** (*s*; -[e]s)

stau|fisch [zu: Staufe]

Stau|mau|er

stau|nen; Stau|nen *s*; -s; - erregen; **stau|nen|er|re|gend**; eine -e Fingerfertigkeit, aber (↑ R 142): ein großes Staunen erregendes Ereignis; **stau|nens|wert**

Staup|be|sen (veralt. für: Besen zum Stäupen)

[1]**Stau|pe** (eine Hundekrankheit) *w*; -, -n

[2]**Stau|pe** (veralt. für: Züchtigung; Schandpfahl) *w*; -, -n; **stäu|pen** (veralt. für: auspeitschen)

Stau.see *m*; **Stau|strahl|trieb|werk** (Flugw.); **Stau|stu|fe**; **Stau|ung**; **Stau.ungs|be|hand|lung**; **Stau.was|ser** (*Mehrz.* ...wasser), ...**wehr**, ...**werk**

Std. = Stunde

Ste = Sainte

Steak *engl.* [ßtēk] (rasch gebratene Fleischschnitte) *s*; -s, -s

Stea|mer *engl.* [ßtīm'r] (engl. Bez. für: Dampfer) *m*; -s, -

Stea|rin *gr.* (festes Gemisch aus Stearin- u. Palmitinsäure; Rohstoff für Kerzen) *s*; -s, -e; **Stea|rin-ker|ze; Stea|tit** (Speckstein) *m*; -s, -e; **Stea|to|py|gie** (Med.: starker Fettansatz am Gesäß) *w*; -; **Stea|to|se** (Med.: Verfettung) *w*; -

Stech.ap|fel; Stech|becken[1], Stechbecken[1]; **Stech|ei|sen**; **ste|chen**; du stichst; du stachst (stachest); du stächest; gestochen; stich!; er sticht ihn (auch: ihm) ins Bein; **Ste|chen** (Sportspr.) *s*; -s, -; **Ste|cher; Stech.flie|ge**, ...**he|ber**, ...**kar|te** (Karte für die Stechuhr), ...**mücke**[1], ...**pal|me**, ...**schritt**, ...**uhr** (eine Kontrolluhr), ...**vieh** (österr. für: Kälber u. Schweine)

Steck|becken[1], Steckbecken[1]; **Steck|brief**, **steck|brief|lich**; jmdn. - suchen; **Steck|do|se**; [1]**stecken** (sich irgendwo, in etwas befinden, dort festsitzen, befestigt sein); du steckst; du stecktest u. (mehr geh.:) stakst (stakest); du stecktest u. (mehr geh.:) stäkest; gesteckt; steck[e]!; [2]**stecken**[1] (etwas in etwas einfügen, hineinbringen, etwas festheften); du stecktest; gesteckt; steck[e]!; **Stecken**[1] (Stock) *m*; -s, -; **stecken|blei|ben**[1]; ↑ R 139; ich bleibe stecken; steckengeblieben; steckenzubleiben; der Nagel ist steckengeblieben; er ist während des Vortrages steckengeblieben; **Stecken|blei|ben**[1] *s*; -s; **stecken|las|sen**[1]; ↑ R 139 (vergessen; im Stich lassen); er hat den Schlüssel steckenlassen, (seltener:) steckengelassen (↑ R 305); jmdn. in der Not steckenlassen; aber: **stecken**[1] **las|sen**; du sollst ihn die Bohnenstangen stecken lassen;

[1] *Trenn.*: ...k|k...

Stecken|pferd¹; Stecker¹ (elektr. Anschlußteil); Steck_kis|sen (↑ R 236), ...kon|takt (↑ R 236), ...lei|ter w; Steck|ling (abgeschnittener Pflanzenteil, der, in Erde od. Wasser gesteckt, neue Wurzeln bildet); Steck_mu|schel, ...na|del, ...reis s, ...rü|be, ...schach, ...scha|le (in der Blumenbinderei), ...schlüs|sel, ...schuß schwamm (in der Blumenbinderei), ...tuch (österr. für: Kavalierstaschentuch), ...zwie|bel
Ste|din|gen, (auch:) Ste|din|ger Land (Marsch zwischen der Hunte u. der Weser unterhalb von Bremen); Ste|din|ger (,,Gestadebewohner''); Ste|din|ger Land (svw. Stedingen) s; - -[e]s
Stee|ple|chase engl. [ßtip'ltsche'ß] (Wettrennen mit Hindernissen, Jagdrennen) w; -, -n [...tsche'ß'n]; Steep|ler [ßtipl'r] (Rennpferd für Hindernisrennen) m; -s, -
Ste|fan, Stef|fen vgl. Stephan
Steg m; -[e]s, -e; Schreibung in Straßennamen: ↑ R 219ff.
Steg|odon gr. (urweltl. Rüsseltier) m; -s, ...donten; Ste|go|sau|ri|er [...i'r] (urweltl. Kriechtier); Ste-go|ze|pha|le (urweltl. Panzerlurch) m; -n, -n (↑ R 268)
Steg|reif (,,Steigbügel''); vgl. ²Reif; aus dem - (unvorbereitet); Steg|reif_dich|ter, ...ko|mö|die, ...spiel, ...zwei|zei|ler
Steh|auf (veralt. für: Trinkgefäß) m; -, -; Steh|auf|männ|chen; Steh-bier|hal|le; Steh|emp|fang; ste-hen; du stehst; du standst (standest); du stündest, (häufig auch:) ständest; gestanden; steh[e]!; ich habe (südd.: bin) gestanden; zu Diensten, zu Gebote, zur Verfügung -; das wird dich (auch: dir) teuer zu stehen kommen; auf jmdn., auf etwas stehen (ugs.: für jmdn., für etwas eine besondere Vorliebe haben); (↑ R 120:) er kann im Stehen schlafen; ihm fällt das Stehen schwer; ein guter Platz zum Stehen; zum Stehen bringen; vgl. stehend; ste|hen-blei|ben; ↑ R 139 (nicht weitergehen; übrigbleiben); ich bleibe stehen; stehengeblieben; stehenzubleiben; die Uhr ist stehengeblieben; der Fehler ist leider stehengeblieben; aber: ste|hen blei|ben; du sollst bei der Begrüßung stehen bleiben; vgl. bleiben; ste|hend; -en Fußes; das -e Heer (vgl. Miliz); (↑ R 116:) alles in meiner Macht Stehende; ste|hen_las|sen; ↑ R 139 (nicht anrühren; vergessen); er hat die Suppe stehenlassen; er hat den Schirm

stehenlassen, man hat ihn einfach stehenlassen, (seltener:) stehengelassen (↑ R 305); aber: ste|hen las|sen; du sollst ihn bei dieser Arbeit stehen lassen; Ste|her (Radrennfahrer auf Langstrecken hinter einem Schrittmacher; Rennpferd für lange Strecken; österr. für: [Zaun]pfosten); Ste-her|ren|nen (Radsport; Pferdesport); Steh_gei|ger, ...kon|vent (scherzh. für: Gruppe, Ansammlung vor Personen, die sich stehend unterhalten), ...kra|gen, ...lam|pe, ...lei|ter w
steh|len; du stiehlst, er stiehlt; du stahlst; du stählest (selten: stöhlest); gestohlen; stiehl!; Steh|ler; Stehl|trieb m; -[e]s
Steh_platz, ...pult, ...satz (Druckw.; m; -es), ...ver|mö|gen
Stei|e|rin w; -, -nen; Stei|er|mark (österr. Bundesland) w; -; Stei|er-mär|ker; stei|er|mär|kisch; vgl. Steirer, steirisch, Steyr
steif; ein -er Hals; ein -er Gang; ein -er Grog; ein -er Wind; - sein, werden, machen, kochen, schlagen usw., vgl. aber: steifhalten; steif|bei|nig; Stei|fe (Steifheit; Stütze) w; -, -n; stei|fen
Steiff ⓦ (Stofftiere); Steiff|tier
steif|hal|ten; ↑ R 139 (ugs.); er hat die Ohren steifgehalten (ugs. für: er hat sich nicht entmutigen lassen); er hat den Nacken steifgehalten (ugs. für: er hat sich behauptet); aber: steif hal|ten; du sollst das Bein steif halten; Steif|heit; Stei|fig|keit; steif|lei-nen (aus steifem Leinen); Steif-lei|nen, ...lein|wand; Stei|fung
Steig (steiler, schmaler Weg) m; -[e]s, -e; Steig|bü|gel; Stei|ge (steile Fahrstraße; Lattenkistchen [für Obst]) w; -, -n; stei|gen; du stiegst; gestiegen; steigle]!; (↑ R 120:) das Steigen der Kurse; Stei-ger (Aufsichtsbeamter im Bergbau); Stei|ge|rer (jmd., der an einer Versteigerung teilnimmt und bietet); stei|gern; ich ...ere (↑ R 327); Stei|ge|rung (auch ↑ R Komparation; schweiz. auch für Versteigerung); Stei|ge|rungs|ra-te (Wirtsch.); Stei|ge|rungs|stufe; erste - (für: Komparativ); zweite - (für: Superlativ); Steig_fä|hig-keit (bei Kraftfahrzeugen), ...hö-he, ...lei|ter w, ...lei|tung, ...rie-men (am Pferdesattel), ...rohr, ...übung; Steig|gung; Steig|gungs-ta|fel; Steig|wachs
steil; der -e Pfad der Tugend; Steil-ab|fahrt (Schisport); Stei|le w; -, -n; stei|len (dicht. für: steil emporsteigen, -ragen); Steil|feu|er; Steil|feu|er|ge|schütz; Steil|hang;

Steil|heit w; -; Steil_kur|ve, ...kü-ste, ...paß (Sportspr.), ...rand, ...schrift, ...spiel (Sportspr.; s; -[e]s), ...ufer, ...vor|la|ge (Sportspr.), ...wand
Stein m; -[e]s, -e; eine zwei - starke Mauer (↑ R 322); Stein|ad|ler; stein|alt (ugs. für: sehr alt); Stein_axt, ...bank (Mehrz. ...bän-ke), ...bau (Mehrz. ...bauten), bau|ka|oton, ...bei|ßer (ein Fisch), ...block (Mehrz. ...blöcke), ...bock, ...bo|den, ...boh|rer, ...brech (Saxifraga, Pflanzengattung der Steinbrechgewächse; m; -[e]s, -e), ...bre|cher (Hartzerkleinerungsmaschine), ...bruch m, ...butt (ein Fisch), ...damm, ...druck (für: Druckverfahren nur Einz.; für: Erzeugnis dieses Druckverfahrens auch Mehrz. ...drucke); Stein_drucke-rei [Trenn.: ...druk|ke...]; Stein-ei|che; stei|nen (veralt. für: ab-, umgrenzen); vgl. rainen; stei|nern (aus Stein); ein -es Kreuz; ein -es (mitleidsloses) Herz, aber (↑ R 198): Steinernes Meer; Stein_er-wei|chen s, nur ugs. in: zum -; Stein_flie|se, ...frucht, ...tuß|bo-den, ...gar|ten (Felsengarten), ...grab, ...gut s; -[e]s, -e)
stein|hä|ger ⓦ (ein Schnaps)
stein|hart; Stein|hau|er; Stein|hau-er|lun|ge; Stein_hau|fen, ...holz (ein Fußbodenbelag)
Stein|hu|der Meer (See zwischen Weser u. Leine) s; - -[e]s
stei|nig; Stei|ni|gen; Stei|ni|gung; Stein_kauz, ...klee, ...koh|le; Stein_koh|len_berg|werk, ...förde|rung, ...for|ma|ti_on (Geol.: zweitoberste Formation des Paläozoikums; w; -), ...in|du|strie, ...la|ger, ...teer, ...ze|che, ...zeit (Karbon; w; -); Stein_mar|der, ...metz (m; -en, -en; ↑ R 268), ...nel|ke, ...obst, ...öl (veralt. für: Petroleum; s; -[e]s), ...pilz; ¹stein-reich; -er Boden; ²stein|reich; ein -er Mann; Stein_salz (s; -es), ...sarg, ...schlag, ...schleu|der, ...schmät|zer (ein Vogel), ...schnei|de|kunst (w; -), ...set-zer (Pflasterer), ...set|zung, ...wein (ein Frankenwein), ...werk (Steinbruch[groß]betrieb), ...wild, ...wurf, ...wü|ste, ...zeich|nung, ...zeit (w; -), ...zeug
Stei|per mdal. (untergestellte Stütze) m; -s, -
Stei|rer; ↑ R 199 (Bewohner der Steiermark); Stei|rer|an|zug (österr. Trachtenanzug); stei-risch; vgl. Steirin
Steiß m; -es, -e; Steiß_bein, ...la|ge
Ste|le gr. (altgr. Grabsäule mit Inschrift od. mit dem Bildnis des Toten) w; -, -n

Stel|la (w. Vorn.)
Stel|la|ge niederl. [schtälasek[e]] (Gestell, Ständer; heute meist ugs. tadelnd für: sperriger, hinderlicher Gegenstand); Stel|la|ge|ge|schäft (Börsentermingeschäft)
stel|lar lat. (die Fixsterne betreffend); Stel|lar|astro|nom lat.; gr. (Fixsternforscher); Stel|lar|astro|no|mie
Stell|dich|ein (veralt. für: Verabredung) s; -[s], -[s]; Stel|le w; -, -n; an Stelle, (jetzt häufig:) anstelle (vgl. an Stelle u. ↑R 141) von Worten; an - (anstelle) des Vaters, aber: an die Stelle des Vaters ist der Vormund getreten; zur Stelle sein; an erster, zweiter Stelle; stel|len; Stell|len_an|ge|bot, ...be|set|zung, ...bil|dung, ...dienst|al|ter, ...ge|such; stel|len|los; Stel|len|lo|sig|keit w; -; Stel|len|nach|weis, ...plan (vgl. ²Plan), ...ver|mitt|lung; stel|len|wei|se; Stel|len|wert; Stel|ler (veralt.); Stell|he|bel; ...stel|lig (z. B. vierstellig, mit Ziffer: 4stellig; ↑R 228)
Stell_ma|cher landsch. (Wagenbauer), ...netz, ...pro|be (Theater), ...rad, ...schrau|be; Stel|lung; - nehmen; Stel|lung|nah|me w; -, -n; Stel|lungs|krieg; stel|lungs|los; Stel|lungs|lo|se m u. w; -n, -n (↑R 287ff.); Stel|lungs|lo|sig|keit w; -; Stel|lungs|spiel (Sportspr.); stel|lung[s]|su|chend; Stel|lung[s]|su|chen|de m u. w; -n, -n (↑R 287ff.); stell|ver|tre|tend; der -e Vorsitzende; Stell_ver|tre|ter, ...ver|tre|tung, ...werk; Stell|werks|mei|ster; Stell|win|kel (ein Gerät)
St.-Elms-Feu|er (↑R 182); vgl. Elmsfeuer u. Sankt
Stelz|bein (abschätzig); Stel|ze (österr. auch abgekürzt für: Schweinsstelze [Eisbein]) w; -, -n; -n laufen (↑R 140); stel|zen (meist iron.); du stelzt (stelzest); Stelzen_baum (Bot.), ...gang (abschätzig) m, ...gei|er (ein Vogel), ...läu|fer; Stelz|fuß (abschätzig); stel|zig; Stelz|wur|zel (Bot.)
Stem|ma (Stammbaum, bes. der verschiedenen Fassungen eines literar. Denkmals) s; -s, -ta
Stemm_ap|pa|rat, ...ar|beit, ...bo|gen (Schisport); Stem|me w; -, -n; Stemm|ei|sen; Stemmei|ßel [Trenn.: Stemm|mei..., ↑R 236] m; -s, -; stem|men; sich gegen etwas - [stemmen]; Stemm|kri|stia|nia (Schischwung)
Stem|pel m; -s, -; Stem|pel_far|be, ...geld (ugs. für: Arbeitslosenunterstützung), ...kis|sen, ...mar|ke; stem|peln; ich ...[e]le (↑R 327); - gehen (ugs. für: Arbeitslosenun-

terstützung beziehen); stem|pel|pflich|tig österr. (gebührenpflichtig); Stem|pel_schnei|der, ...stän|der, ...steu|er w, ...strei|fen; Stem|pe|lung, Stempl|ung
Sten|dal (Stadt in der Altmark)
Sten|del m; -s, - u. Sten|del|wurz (Orchideengattung)
Sten|dhal [ßtangdal] (fr. Schriftsteller)
Sten|ge (Seemannsspr.: Verlängerung des Mastes) w; -, -n; Sten|gel (Teil der Pflanze) m; -s, -; Sten|gel|blatt; sten|gel|blü|tig; Sten|gel|chen, Sten|ge|lein, Sten|ge|lein; ...sten|ge|lig, ...steng|lig (z. B. kurzsteng[e]lig); sten|gel|los
ste|no...gr. (eng...); Ste|no... (Engl...); Ste|no (ugs. Kurzw. für: Stenographie) w; -; Ste|no|block (ugs. svw. Stenogrammblock; Mehrz. ...blocks); Ste|no|dak|ty|lo (schweiz. neben: Stenotypistin) w; -, -s; Ste|no|graf usw. (eindeutschende Schreibung von: Stenograph usw.); Ste|no|gramm (nachgeschriebenes Diktat od. nachgeschriebene Rede in Kurzschrift) s; -s, -e; Ste|no|gramm_block (Mehrz. ...blocks), ...hal|ter; Ste|no|graph (Kurzschriftler) m; -en, -en (↑R 268); Ste|no|gra|phie (Kurzschrift) w; -, ...ien; ste|no|gra|phie|ren; ste|no|gra|phisch; Ste|no|kar|die (Med.: Angina pectoris [Herzkrankheit]) w; -, ...ien; Ste|no|kon|to|ri|stin w; -, -nen; Ste|no|se, Ste|no|sis (med.: Verengung [der Blutgefäße]) w; -, ...osen; ste|no|therm (Biol.: nur geringe Temperaturschwankungen ertragend [von Pflanzen u. Tieren]); ste|no|top (Biol.: begrenzt verbreitet); ste|no|ty|pie|ren (in Kurzschrift aufnehmen u. danach in Maschinenschrift übertragen); Ste|no|ty|pist (Kurzschriftler u. Maschinenschreiber); ↑R 268; Ste|no|ty|pi|stin w; -, -nen
Sten|tor (stimmgewaltiger Held der gr. Sage); Sten|tor|stim|me (↑R 180)
Stenz (Geck, Flaneur) m; -es, -e
Step engl. (ein Tanz) m; -s, -s; -tanzen
¹Ste|phan, (↑R 192:) Ste|fan, Steffen (m. Vorn.); ²Ste|phan (Organisator des dt. Postwesens); Ste|pha|nie [...ie, auch: schtefani, österr.: schtefani] (w. Vorn.); Ste|pha|nit (ein Mineral) m; -s; Ste|pha|ni|tag; Ste|phans_dom (in Wien), ...tag
Ste|phen|son [ßtiw[e]nß[e]n] (Begründer des engl. Eisenbahnwesens)
Stepp|decke [Trenn.: ...dek|ke]
Step|pe russ. (baumlose, wasserarme Pflanzenregion) w; -, -n

¹step|pen (Stofflagen zusammennähen)
²step|pen engl. (Step tanzen)
Step|pen_an|ti|lo|pe, ...be|woh|ner, ...flo|ra, ...fuchs, ...gras, ...huhn, ...hund, ...wolf m
Step|per (Steptänzer)
Step|pe|rei [zu: ¹steppen] (Tätigkeit [u. Ort] des Steppens); ¹Step|pe|rin w; -, -nen
²Step|pe|rin (Steptänzerin) w; -, -nen
Stepp|ke (ugs., bes. berlin. für: kleiner Kerl) m; -[s], -s
Stepp_ma|schi|ne, ...naht, ...sei|de, ...stich
Step_schritt, ...tanz, ...tän|zer, ...tän|ze|rin
Ster gr. (Raummaß für Holz) m; -s, -e u. -s; 3 - (↑R 322)
Ster|be_al|laß, ...bett, ...da|tum, ...fall m, ...geld, ...glocke [Trenn.: ...glok|ke], ...hil|fe, ...kas|se, ...ker|ze, ...kreuz; ster|ben; du stirbst; du starbst, du stürbest; gestorben (vgl. d.); stirb!; Ster|ben s; -s; im - liegen; das große - (die Pest); es ist zum Sterben langweilig (ugs. für: sehr langweilig); Ster|bens_angst; ster|bens|krank, ...lang|wei|lig (ugs.); Ster|bens|wort, Ster|bens|wört|chen (ugs.), nur in: kein -; Ster|be_ort, ...sa|kra|ment, ...stun|de; Ster|be_bet (schweiz. neben: [Massen]sterben) m; -s; Ster|be_tag, ...ur|kun|de, ...zim|mer; sterb|lich; Sterb|lich|keit w; -; Sterb|lich|keits|zif|fer
ste|reo...gr. (starr, massiv, unbeweglich; räumlich, körperlich); Ste|reo...(Körper...); Ste|reo (Kurzw. für: Stereotypplatte u. Stereophonie) s; -s, -s; Ste|reo_an|la|ge (Anlage für den stereophonen Empfang), ...che|mie (Lehre von der räuml. Anordnung der Atome im Molekül), ...chro|mie [...kro...] (altes Wandmalereiverfahren; w; -, für: Ergebnis dieses Verfahrens auch Mehrz. ...ien), ...film (stereoskopischer Film), ...fo|to|gra|fie (Herstellung von Stereoskopbildern; w; -), ...kom|pa|ra|tor (Instrument zur Ausmessung stereoskopischer Fotografien); Ste|reo|me|ter (opt. Gerät zur Messung des Volumens fester Körper) s; -s, -; Ste|reo|me|trie (Lehre von der Berechnung der geometrischen Körper) w; -; ste|reo|me|trisch (körperlich, Körper...); ste|reo|phon, ste|reo|pho|nisch; Ste|reo|pho|nie (Technik der räuml. wirkenden Tonübertragung) w; -; ste|reo|pho|nisch. ste|reo|phon; Ste|reo|pho|to|gramme|trie [Trenn.: ...gramm-

me...] (Auswertung u. Ausmessung von räuml. Meßbildern bei der (Geländeaufnahme) w; -; Stereo|pho|to|gra|phie vgl. Stereofotografie; Ste|reo|plat|te (stereophonische Schallplatte); Ste|reoskop (Vorrichtung, durch die man Bilder plastisch sieht) s; -s, -e; Ste|reo|sko|pie (Raumbildtechnik) w; -; ste|reo|sko|pisch (von Bildern: plastisch erscheinend, raumbildlich); Ste|reo|to|mie (veralt. für: Teil der Stereometrie, der die Körperschnitte behandelt) w; -; Ste|reo|ton (räuml. wirkender Ton) m; -[e]s, ...töne; ste|reo|typ ([fest]stehend unveränderlich; übertr.: ständig [wiederkehrend], leer, abgedroschen; mit feststehender Schrift gedruckt); Ste|reo|typ|druck (Druck von der Stereotypplatte; für: Erzeugnis dieses Druckes auch Mehrz. ...drucke); Ste|reo-ty|peur fr. [...pör] (Druckw.: jmd., der Matern herstellt u. ausgießt; m; -s, -e), ...ty|pie gr. (Druckw.: Herstellen u. Ausgießen von Matern; w; -; für Arbeitsraum der Stereotypeure auch Mehrz.: ...ien); ste|reo|ty|pie|ren; Ste|reo|typ_me|tall, ...plat|te (feste Druckplatte)
ste|ril lat. (unfruchtbar; keimfrei); Ste|ri|li|sa|ti|on [...zion] (Unfruchtbarmachung; Entkeimung); Ste|ri|li|sa|tor (Entkeimungsapparat) m; -s, ...oren; Ste|ri|li|sier|ap|pa|rat; ste|ri|li|sie|ren (haltbar machen [von Nahrungsmitteln]; zeugungsunfähig machen); Ste|ri|li|sie|rung; Ste|ri|li|tät (Unfruchtbarkeit; Keimfreiheit, übertr. für: geistiges Unvermögen, Ertraglosigkeit, Dürre) w; -
Ste|rin gr. (eine organ. chem. Verbindung) s; -s, -e
Ster|ke niederd. (Kuh, die noch nicht gekalbt hat; Färse) w; -, -n
Ster|let[t] russ. (ein Fisch) m; -s, -e
Ster|ling [ßtär..., od. ßtör..., auch: schtär...] (engl. Münzeinheit) m; -s, -e; Pfund - (Zeichen u. Abk.: £, £Stg); 2 Pfund -
¹Stern engl. (Hinterteil des Schiffes) m; -s, -e
²Stern (Himmelskörper) m; -[e]s, -e; Stern_bild, ...blu|me, ...deu|ter; Stern|deu|te|rei; Stern|deu|tung; Ster|nen|ban|ner; ster|nen|hell, stern|hell; Ster|nen|him|mel, Stern|him|mel m; -s; ster|nen|klar, stern|klar; Ster|nen|licht s; -[e]s; ster|nen_los, ...wärts; Ster|nen|zelt (dicht.) s; -[e]s; Stern-fahrt (Rallye); ster|n|för|mig; Stern_for|scher,ge|wöl|be

(Baukunst), ...grup|pe, ...gucker [Trenn.: ...guk|ker] (ugs.); stern|ha|gel|voll (ugs. für: sehr betrunken); stern|hell, ster|nen|hell; Stern|him|mel, Ster|nen|himmel; stern|klar, ster|nen|klar; Stern|kun|de w; -; stern|kun|dig; Stern_ort (m; -[e]s, ...örter), ...schnup|pe, ...sin|gen (Volksbrauch zur Dreikönigszeit; s; -s), ...sin|ger, ...stun|de (glückliche Schicksalsstunde), ...sy|stem, ...war|te, ...zeit
Stert niederd. (²Sterz [Schwanz usw.]) m; -[e]s, -e
¹Sterz südd. u. österr. (eine [Mehl]speise) m; -es, -e
²Sterz (Schwanz[ende]; Führungs- u. Haltevorrichtung an Geräten) m; -es, -e
stet; -e Vorsicht; Ste|te w; -; Stetheit w; -; Ste|tho|skop gr. (med. Hörrohr) s; -s, -e
ste|tig; Ste|tig|keit w; -; vgl. aber: Stätigkeit; stets; stets|fort schweiz. (fortwährend)
Stet|tin (Hafenstadt a. d. Oder); vgl. Szczecin; Stet|ti|ner (↑ R 199); Stet|ti|ner Haff s; - -[e]s, (auch:) Oder|haff s; -[e]s
¹Steu|er (Lenkvorrichtung) s; -s, -; ²Steu|er (Abgabe; Beihilfe) w; -,-n; direkte, indirekte, staatliche -; Steu|er|ab|zug; Steu|er|ach|se (Lenkachse); Steu|er|amt; Steu|er|än|de|rungs|ge|setz; Steu|er|an|pas|sungs|ge|setz; Steu|er_an|spruch, ...auf|kom|men, ...auf|sicht, ...aus|gleichs|kon|to, ...ausschuß; steu|er|bar (Amtsspr.: zu versteuern); das -e Einkommen; steu|er|be|gün|stigt; -es Sparen; Steu|er_be|hör|de, ...be|ra|ter, ...be|scheid, ...be|trag, ...be|vollmäch|tig|te(r), ...bi|lanz; steu|er|bord[s]; Steu|er|bord (rechte Schiffsseite) s; -[e]s, -e; Steue|rer; Steu|er; Steu|er_er|hö|hung, ...er|klä|rung, ...er|laß, ...er|leich|te|rung, ...er|mä|ßi|gung, ...er|mitt|lungs|ver|fah|ren, ...fahn|dung, ...flucht (w; -); steu|er|frei; -er Betrag; Steu|er_gel|der (Mehrz.), ...ge|rät (Teil einer Stereoanlage), ...ge|setz, ...hel|fer, ...hin|ter|zie|hung, ...kar|te, ...klas|se, ...knüp|pel, ...kurswert, ...leh|re; steu|er|lich; Steu|er_mann (Mehrz. ...männer und ...leute), ...mar|ke; steu|ern; ich ...ere (↑ R 327); Steu|er|oa|se (Land mit bes. günstigen steuerlichen Verhältnissen für Ausländer); steu|er|pflich|tig; Steu|er-po|li|tik, ...pro|gres|si|on, ...prü|fer, ...rad, ...recht, ...re|form, ...ru|der, ...satz, ...schrau|be, ...sen|kung, ...straf|recht, ...sy|stem, ...ta|bel|le, ...ta|rif, ...trä-

ger; Steue|rung; Steue|rungs_he|bel, ...ven|til; Steu|er_ver|an|la|gung, ...ver|ge|hen, ...ver|gün|sti|gung, ...ver|gü|tung, ...vor|aus|zah|lung, ...vor|rich|tung, ...zah|ler, ...zet|tel, ...zu|schlag; Steu|rer, Steue|rer
Ste|ven [...wᵉn] niederd. (das Schiff vorn u. hinten begrenzender Balken) m; -s, -
Ste|ward engl. [ßtju͗ᵉrt] (Betreuer auf Wasser- u. Luftfahrzeugen, auch in Omnibussen) m; -s, -s; Ste|war|deß [ßtju͗ᵉrdäß, auch: ...däß] (Betreuerin auf Wasser- u. Luftfahrzeugen, auch in Omnibussen) w; -, ...dessen
Steyr (oberösterr. Stadt)
Stg., St. = Satang
StGB = Strafgesetzbuch
Sthe|nie gr. (Med.: Vollkraft) w; -; sthe|nisch; -ste (↑ R 294)
sti|bit|zen (ugs. für: sich listig aneignen); du stibizst (stibitzest); er hat stibitzt (↑ R 304)
Sti|bi|um gr. (svw. Antimon) s; -s
Stich m; -[e]s, -e; im - lassen; Stich_bahn (Eisenbahnw.), ...blatt (Handschutz bei Fechtwaffen); Sti|chel (ein Werkzeug) m; -s, -; Sti|che|lei (meist übertr. für: [boshafte] Neckerei); sti|chel-haa|rig; ein -er Hund; sti|cheln (auch übertr. für: mit Worten necken, hetzen); ich ...[e]le (↑ R 327); (↑ R 120:) er kann das Sticheln nicht lassen; stich|fest; hieb- und stichfest (↑ R 145); Stich_flam|me, ...fra|ge, ...gra-ben; stich|hal|tig, (österr.:) stich|häl|tig; Stich|hal|tig|keit, (österr.:) Stich|häl|tig|keit w; -; stich|chlg (einen Stich habend, säuerlich); ...sti|chig (z. B. wurmstichig); Stich_kampf (Sport), ...ka|nal, ...kap|pe (Bauw.); Stich|ler [zu: sticheln]; Stich|ling (ein Fisch)
Sti|cho|man|tie gr. [...cho...] (Wahrsagung aus einer zufällig aufgeschlagenen Buchstelle) w; -, ...ien
Stich_pro|be; stich|pro|ben|wei|se; Stich_tag, ...waf|fe, ...wahl, ...wort (für: [an der Spitze eines Artikels stehendes] erläutertes Wort od. erläuterter Begriff in Nachschlagewerken Mehrz.: ...wörter; für: Endwort eines Schauspielers od. für kurze Aufzeichnung aus einzelnen wichtigen Wörtern Mehrz.: ...worte); Stich|wort|ver|zeich|nis; Stich-wun|de
Stickel[1] südd. u. schweiz. (Stecken; Stützstange für Erbsen, Reben u. a.) m; -s, -

sticken[1]; **Sticker**[1]; **Sticke|rei**[1]; **Sticke|rin**[1] w; -, -nen; **Stick|garn**; **Stick|hu|sten**; **stickig**[1]; **Stick.luft** (w; -), ...**ma|schi|ne**, ...**mu|ster**, ...**rah|men**, ...**stoff** (chem. Grundstoff; Zeichen: N; m; -[e]s; vgl. Nitrogenium); **Stick|stoff.bak|te|ri|en** (Mehrz.), ...**dün|ger**; **stick|stoff|frei** (↑ R 237); **stick|stoff|hal|tig**

stie|ben; du stobst (stobest; auch: stiebtest); du stöbest (auch: stiebtest); gestoben (auch: gestiebt); stieb[e]!

Stief|bru|der

Stie|fel (Fußbekleidung; Trinkglas in Stiefelform) m; -s, -; **Stie|fel|an|zie|her**; **Stie|fel|chen**, **Stie|fe|lein**; **Stie|fe|let|te** (Halbstiefel) w; -, -n; **Stie|fel|knecht**; **stie|feln** (ugs. für: gehen, stapfen, trotten); ich ...[e]le (↑ R 327); **Stie|fel|schaft** m

Stief.el|tern (Mehrz.), ...**ge|schwi|ster**, ...**kind**, ...**mut|ter** (Mehrz. ...mütter), ...**müt|ter|chen** (eine Zierpflanze); **stief|müt|ter|lich**

Stie|fo|gra|phie [nach dem dt. Stenographen H. Stief] (Kurzschriftsystem) w; -

Stief.schwe|ster, ...**sohn**, ...**toch|ter**, ...**va|ter**

Stie|ge (Treppe; Verschlag, Kiste; Zählmaß [20 Stück]) w; -, -n; **Stie|gen.be|leuch|tung**, ...**haus**

Stieg|litz slaw. (Distelfink) m; -es, -e

Stiel (Handhabe; Griff; Stengel) m; -[e]s, -e; mit Stumpf und -; **Stiel.au|ge** (ugs. scherzh. in: -n machen), ...**be|sen**, ...**bril|le** (veralt.: Lorgnette); **stie|len** (selten für: mit Stiel versehen); vgl. gestielt; ...**stie|lig** (z. B. kurzstielig); **stiel|los**; vgl. aber: stillos; **Stiel|stich** (Stickerei) m; -[e]s; Platt- u. Stielstich

stie|men niederd. (dicht schneien, qualmen); **Stiem|wet|ter** niederd. (Schneesturm)

stier (starr; österr. ugs. auch: ohne Geld)

Stier m; -[e]s, -e

¹stie|ren (starr blicken)

²stie|ren (von der Kuh: nach dem Stier verlangen); **stie|rig** (von der Kuh: brünstig; stößig); **Stier|kampf**; **Stier|kampf|are|na**; **Stier.kämp|fer**, ...**nacken**[1]; **stier|nackig**[1]

Stie|sel, **Stie|ßel** (ugs. für: ungeschickter Mensch, Dummkopf) m; -s, -; **stie|se|lig**, **sties|lig**, **stie|ße|lig**, **stieß|lig**

¹Stift (Bleistift; Nagel) m; -[e]s, -e

²Stift (ugs. für: halbwüchsiger Junge, Lehrling) m; -[e]s, -e

³Stift (fromme Stiftung; auch: Altersheim) s; -[e]s, -e (seltener: -er); **stif|ten**

stif|ten|ge|hen (ugs. für: sich heimlich, schnell u. unauffällig entfernen)

Stif|ter; **Stif|ter|ver|band**; - für die Deutsche Wissenschaft; **stif|tisch** (veralt. für: zu einem ³Stift gehörend); **Stift|ler** (veralt. für: Stiftsangehöriger); **Stifts.da|me**, ...**fräu|lein**, ...**herr**, ...**kir|che**, ...**schu|le**; **Stif|tung**; **Stif|tungs.brief**, ...**fest**, ...**rat** (kath. Kirche: der einem Pfarrer unterstehende Ausschuß aus Kirchengemeindemitgliedern zur Kirchenvermögensverwaltung; Mehrz. ...räte), ...**ur|kun|de**

Stift|zahn

Stig|ma gr. (,,Stich''; [Wund-, Brand]mal; Bot.: Narbe der Blütenpflanzen; Zool.: äußere Öffnung der Tracheen; Augenfleck der Einzeller) s; -s, ...men und -ta; **Stig|ma|ti|sa|ti|on** [...zion] (Auftreten der fünf Wundmale Christi; Brandmarkung der Sklaven im Altertum); **stig|ma|ti|sie|ren**; **Stig|ma|ti|sier|te** m u. w; -n, -n (↑ R 287 ff.); **Stig|ma|ti|sie|rung**

Stil lat. (Einheit der Ausdrucksformen [eines Kunstwerkes, eines Menschen, einer Zeit]; Darstellungsweise, Art [Bau-, Schreibart usw.]) m; -[e]s, -e; (Zeitrechnung:) alten -s (Abk.: a. St.), neuen -s (Abk.: n. St.); **Stil.art**

Stilb gr. (Physik: Einheit der Leuchtdichte auf einer Fläche; Zeichen: sb) s; -s, -; 4 -

Stil.blü|te, ...**bruch** m, ...**ele|ment**, ...**emp|fin|den**, ...**ent|wick|lung**

Sti|lett it. (kleiner Dolch) s; -s, -e

Stilf|ser Joch (ein Alpenpaß) s; --[e]s

Stil.ge|fühl s; -[e]s; **stil|ge|recht**; **sti|li|sie|ren** lat. (die Naturformen in ihrer Grundstruktur gestalten); **Sti|li|sie|rung**; **Sti|list** (Sprachgestalter; Beherrscher der sprachl. Formen); ↑ R 268; **Sti|li|stik** (Stilkunde, -lehre) w; -, -en; **sti|li|stisch**; **Stil|kun|de** w; -, -en; **stil|kund|lich**

still; I. Kleinschreibung: a) (↑ R 134:) im stillen (unbemerkt); b) (↑ R 224:) stiller Teilhaber (Kaufmannsspr.); stille Reserven, Rücklagen (Kaufmannsspr.); stille Beteiligung (Kaufmannsspr.); stille Gesellschaft (Kaufmannsspr.); das stille Örtchen (ugs. scherzh. für: Toilette); stilles Wasser; stilles Glück; eine stille Messe. II. Großschreibung: a) (↑ R 198:) der Stille Ozean; b) (↑ R 224:) der Stille Freitag (Karfrei-

tag); die Stille Woche (Karwoche); die Stille Nacht (Heilige Nacht). III. Schreibung in Verbindung mit Zeitwörtern (↑ R 139): still sein, werden, sitzen, stehen, halten; vgl. aber: stillbleiben, stillegen, stillhalten, stilliegen, stillschweigen, stillsitzen, stillstehen; **still|blei|ben** (↑ R 139); ich bleibe still; stillgeblieben; stillzubleiben; **stil|le** (ugs. für: still); **Stil|le** w; -; in aller, in der -; **stil|le|ben** [Trenn.: Still|le..., ↑ R 236] (Malerei: Darstellung lebloser Gegenstände in künstl. Anordnung) s; -s, -; **stil|le|gen**; ↑ R 139 [Trenn.: still|le..., ↑ R 236] (außer Betrieb setzen); ich lege still; stillgelegt; stillzulegen; die Fabrik wurde stillgelegt; **Stil|le|gung** [Trenn.: Still|le..., ↑ R 236]

Stil|leh|re

stil|len; **Still|geld** (Unterstützung für stillende Mütter); **still|ge|stan|den!**; **Still|hal|te|ab|kom|men**; **still|hal|ten**; ↑ R 139 (sich nicht bewegen; erdulden, geduldig ertragen); er hat beim Zahnarzt tapfer stillgehalten; aber: **still hal|ten** (ruhig halten); du mußt die Lampe still halten; **Still|hal|tung** w; -; **stil|lie|gen**; ↑ R 139 [Trenn.: still|lie..., ↑ R 236] (außer Betrieb sein); die Fabrik hat stillgelegen; aber: **still lie|gen** (ruhig liegen); das Kind hat still gelegen

still|los; vgl. aber: stiellos; **Still|lo|sig|keit**

still|schwei|gen (↑ R 139); er hat stillgeschwiegen; **Still|schwei|gen**; jmdm. - auferlegen; **still|schwei|gend**; **still|sit|zen**; ↑ R 139 (nicht beschäftigt sein); aber: **still sit|zen** (ruhig sitzen); **Still|stand** m; -[e]s; **still|ste|hen**; ↑ R 139 (aufhören); sein Herz hat stillgestanden; aber: **still ste|hen** (ruhig stehen); das Kind hat trotz seiner inneren Unruhe still gestanden; **Still|sung**; **still|ver|gnügt**

Stil.mö|bel, ...**no|te**, ...**übung**, ...**un|ter|su|chung**; **stil.voll**, ...**wid|rig**; **Stil|wör|ter|buch**

Stimm.ab|ga|be, ...**auf|wand**, ...**band** (s; Mehrz. ...bänder); **stimm|be|rech|tigt**; **Stimm|be|rech|tig|te** m u. w; -n, -n (↑ R 287 ff.); **Stimm.be|rech|ti|gung**, ...**be|zirk**, ...**bil|dung**, ...**bruch** (m; -[e]s), ...**bür|ger** (schweiz.); **Stimm|chen**, **Stimm|lein**; **Stim|me** w; -, -n; **stim|men**; **Stim|men.ge|wirr**, ...**gleich|heit**, ...**mehr|heit**; **Stimm|ent|hal|tung**; **Stim|men|ver|hält|nis**; **Stim|mer** (eines Musikinstrumentes); **stimm|fä|hig**; **Stimm.füh|rung** (Musik), ...**ga|bel**; **stimm|ge|wal|tig**; **stimm|haft** (,,weich'' auszuspre-

chen); Stimm|haf|tig|keit w; -; stim|mig (passend, richtig, [überein]stimmend); ..stim|mig (z. B. vierstimmig, mit Ziffer: 4stimmig); Stimm|mig|keit; Stimm|tel [Trenn.: Stimmmit..., ↑ R 236] s; -s, -; Stimm|la|ge; Stimm|lein, Stimm|chen; stimm|lich; stimm|los („hart" auszusprechen); Stimm|lo|sig|keit w; -; Stimm_recht, ...rit|ze, ...schlüs|sel (Gerät zum Klavierstimmen), ..stock (in Streichinstrumenten); Stim|mung; Stimmungs_ba|ro|me|ter, ...bild, ...ka|pel|le, ...ma|che, ...um|schwung; stim|mungs|voll; Stimm_vieh (verächtl.), ...zet|tel

Sti|mu|lans lat. (Med.: anregendes Mittel, Reizmittel) s; -, ...lantia [...lqnzia] u. ...lanzien [...lqnzi°n]; Sti|mu|la|ti|on [...zion] (seltener für: Stimulierung); sti|mu|lie|ren; Sti|mu|lie|rung (Erregung, Anregung, Reizung); Sti|mu|lus (veralt. für: Reiz, Antrieb) m; -, ...li

Sti|ne (Kurzform von: Christine u. Ernestine)

Stink|bom|be, stin|ken; du stankst (stankest); du stänkest; gestunken; stink[e]!; stink|faul (ugs.); Stink|fritz (ugs.) m; -en, -en (↑ R 268); stink|kig; Stink_kä|fer, ...mar|der, ...mor|chel; stink|reich (derb für: sehr reich); Stink_tier, ...wan|ze; Stink|wut (derb für: große Wut)

Stint (ein Fisch) m; -[e]s, -e

Sti|pen|di|at lat. (ein Stipendium Empfangender, Unterstützter) m; -en, -en (↑ R 268); Sti|pen|di|en|ver|wal|tung; Sti|pen|di|um (Stiftung; Geldbeihilfe für Schüler, Studierende, Gelehrte) s; -s, ...ien [...i°n]

Stipp m; -[e]s, -e u. Stip|pe niederd. (Kleinigkeit; Punkt; Pustel; Tunke) w; -, -; auf den Stipp (sofort); Stipp|be|such (ugs. für: kurzer Besuch); Stipp|chen, Stipp|lein; stip|pen (ugs. für: tupfen, tunken); stip|pig (ugs. für: gefleckt; mit Pusteln besetzt); Stip|pig|keit (ugs.); Stipp|vi|si|te (ugs. für: kurzer Besuch)

Sti|pu|la|ti|on lat. [...zion] (röm. Recht: durch mündl. Vereinbarung rechtswirksam werdender Vertragsschluß); sti|pu|lie|ren; Sti|pu|lie|rung

Stirn, (geh.:) Stir|ne w; -, ...nen; Stirn_band (s; Mehrz. ...bänder), ...bein; Stir|ne vgl. Stirn; Stirn_fal|te, ...flä|che, ...glat|ze, ...höh|le; Stirn|höh|len_ent|zün|dung, ...ver|ei|te|rung; ...stir|nig (z. B. breitstirnig); Stirn_reif, ...rie|men, ...run|zeln (s; -s), ...sei|te, ...wand, ...zie|gel

Sto. = Santo

Stoa gr. (altgr. Philosophenschule) w; -

Stö|ber (Jägerspr.: Hund, der zum [Auf]stöbern des Wildes gebraucht wird) m; -s, -; Stö|be|rei mdal. (Großreinemachen); stö|bern (ugs. für: [hastig, heimlich] durchsuchen; Jägerspr.: aufjagen; flockenartig umherfliegen; mdal. für: rein machen); ich ...ere (↑ R 327); es stöbert

Sto|cha|stik gr. [...cha...] (Betrachtungsweise der analyt. Statistik nach der Wahrscheinlichkeitstheorie); w; -; sto|cha|stisch

Sto|cher (Werkzeug zum Stochern; Feuerhaken) m; -s, -; sto|chern; ich ...ere (↑ R 327)

¹Stock (Stab u. a.) m; -[e]s, Stöcke; über - und Stein; in den - (Fußblock) legen; ²Stock (Stockwerk) m; -[e]s, - u. Stockwerke; das Haus hat zwei -, ist zwei - hoch; ein Haus von drei -; ³Stock engl. [ßtqk] (Vorrat, Warenlager; Bankw.: Grundkapital) m; -s, -s

stock_be|trun|ken (ugs. für: völlig betrunken), ...blind (ugs.: völlig blind); Stöck|chen, Stöck|lein; Stöck|de|gen; stock_dumm (ugs.: sehr dumm), ...dun|kel (ugs.: völlig dunkel); Stöck|ei|sen; ¹Stö|kel (ugs. für hoher Absatz) m; -s, -; ²Stöckel¹ österr. (Nebengebäude, bes. von Schlössern od. Bauernhäusern); s; stöckeln¹ (ugs. für: auf ¹Stöckeln laufen); ich ...[e]le (↑ R 327); Stöckel-schuh¹ (ugs.); stocken¹ (nicht vorangehen; bayr. u. österr. auch für: gerinnen); (↑ R 120:) ins Stokken geraten, kommen; gestockte Milch (bayr. u. österr. für: Dickmilch); Stockerl¹ bayr. u. österr. (Hocker) s; -s, -[n]; Stock|fäu|le; stock|fin|ster (ugs. für: völlig finster); Stock_fisch, ...fleck; stock-fleckig¹; stock|hei|ser (ugs. für: sehr heiser)

Stock|holm [auch: ...hqlm] (Hptst. Schwedens); Stock|hol|mer [auch: ...hqlm...] (↑ R 199)

stockig¹ (stockfleckig); ...stöckig¹ (z. B. vierstöckig, mit Ziffer: 4stöckig; ↑ R 228); stock|kon|ser|va|tiv (ugs. für: sehr konservativ); Stöck|lein, Stöck|chen; Stöck|li schweiz. mdal. (Altenteil) s; -s, -; stock_nüch|tern (ugs. für: ganz nüchtern), ...punkt (Temperatur der Zähigkeitszunahme von Ölen), ...ro|se (eine Heil- u. Gewürzpflanze), ...schirm, ...schnup|fen; stock_steif (ugs. für: völlig steif), ...taub (ugs. für:

völlig taub); Stock_uhr österr. (Standuhr); Stockung [Trenn.: ...ok|ku...]; Stock|werk; Stockzahn südd., österr., schweiz. (Backenzahn)

Stoff m; -[e]s, -e; Stoffar|be [Trenn.: Stoff|far..., ↑ R 236]; Stoff_bahn, ...be|hang ¹Stof|fel (Kurzform von: Christoph); ²Stof|fel (ugs. für: ungeschickter, unhöflicher Mensch, Tölpel) m; -s, -; stof|fe|lig, stoff-lig (ugs. für: tölpisch, unhöflich) Stoffet|zen [Trenn.: Stoff|fet..., ↑ R 236] m; -s, -; stoff|hal|tig; stoff|lich (dem Stoffe nach); Stoff|lich|keit w; -

stoff_lig vgl. stoffelig

Stoffül|le [Trenn.: Stoff|fül..., ↑ R 236] w; -; Stoff_rest, ...wech|sel; Stoff_wech|sel|krank|heit

stöh|nen; (↑ R 120:) ein leises Stöhnen

Stoi|ker gr. (Anhänger der Stoa; Vertreter des Stoizismus); sto|isch (zur Stoa gehörend; unerschütterlich, gleichmütig); (Höchststufe, nur in der zweiten Bedeutung) -ste (↑ R 294); Stoi|zis|mus (Lehre der Stoiker, Unerschütterlichkeit, Gleichmut) m; -

Sto|la gr. (altröm. Ärmelgewand; gottesdienstl. Gewandstück des kath. Geistlichen; langer, schmaler Umhang) w; -, ...len

Stol|berg/Harz (dt. Stadt); Stol|berg (Rhld.) (dt. Stadt)

Stol|ge|büh|ren (Pfarramtsnebenbezüge) Mehrz.

Stol|berg/Erzgeb. (dt. Stadt)

Stol|le w; -, -n od. ¹Stol|len (Weihnachtsgebäck) m; -s, -; ²Stol|len (Zapfen am Hufeisen, an [Fußball]schuhen; Bergmannsspr.: waagerechter Grubenbau, der zu Tage ausgeht; Absatz [des Meisterliedes]) m; -s, -; Stol|len_bau m; -[e]s, ...brett, ...gang m, ...mund|loch (Bergmannsspr.)

Stol|per_stein (Fehltritt) m; -s, -; Stol|per_draht, ...draht|hin|der|nis; stol|pe|rer; stol|pe|rig, stol|prig; stol|pern (straucheln); ich ...ere (↑ R 327)

stolz; -este (↑ R 292); Stolz m; -es Stol|ze (Erfinder eines Kurzschriftsystems); Stol|zesch, Stol|zisch (↑ R 179); Stolzesche od. Stolzische Stenographie; Stol|ze-Schrey; das Kurzschriftsystem Stolze-Schrey

stol|zie|ren (stolz einherschreiten) Stol|zisch vgl. Stolzesch

Sto|ma gr. [auch: stq...] (Med.: Mund-, Spaltöffnung; Biol.: Spaltöffnung des Pflanzenblattes) s; -s, -ta; sto|ma|chal [...chgl] (Med.: durch den Magen gehend, den Magen betreffend); Sto|ma-

¹ Trenn.: ...k|k...

ti|tis (Med.: Entzündung der Mundschleimhaut) w; -, ...itiden; Sto|ma|to|lo|gie (Lehre von den Erkrankungen der Mundhöhle) w; -; sto|ma|to|lo|gisch

Stone|henge [ßto͟"nhändseh] (Kultstätte der Jungsteinzeit u. frühen Bronzezeit in Südengland)

stop! engl. (halt! [auf Verkehrsschildern]; im Telegrafenverkehr: Punkt); vgl. stopp!

Stopf|buch|se oder Stopf|büch|se (Maschinenteil); stop|fen; Stopfen landsch. (Stöpsel, Kork) m; -s, -; Stop|fer; Stopf.garn, ...korb, ...na|del, ...pilz; Stop|fung

stopp! (halt!); vgl. stop!; Stopp m; -s, -s; Stopp|ball (Sportspr.)

¹Stop|pel österr. (Stöpsel) m; -s, -[n]

²Stop|pel w; -, -n; Stop|pel.bart (ugs.), ...feld, ...haar; stop|pe|lig, stopp|lig; Stop|pe|lig|keit, Stopplig|keit w; -; stop|peln; ich ...[e]le (↑R 327)

Stop|pel|zie|her österr. (Korkenzieher)

stop|pen (anhalten; mit der Stoppuhr messen); Stop|per (Fußball: Mittelläufer)

Stopp|kurs (Börse)

Stopp|ler

Stopp|licht (Mehrz. ...lichter)

stopp|lig, stop|pe|lig; Stopp|ligkeit, Stop|pe|lig|keit

Stopp.preis (vgl. ²Preis; ↑R 237), ...schild s, ...stra|ße, ...uhr

Stöp|sel m; -s, -; stöp|seln; ich ...[e]le (↑R 327)

¹Stör (ein Fisch) m; -[e]s, -e

²Stör bayr., österr. u. schweiz. (Arbeit, die ein Gewerbetreibender im Hause des Kunden verrichtet) w; -, -en; auf der - arbeiten; auf die od. in die - gehen

Stör|ak|ti|on; stör|an|fäl|lig; ein -es Gerät; Stör|an|fäl|lig|keit

Sto|rax w; -. Styrax

Storch m; -[e]s, Störche; Storchbein; storch|bei|nig; Stör|chelchen, Störch|lein; stor|chen (ugs. für: wie ein Storch einherschreiten); Stor|chen|nest, Storch|nest; Stör|chin w; -, -nen; Storch|schnabel (eine Pflanze; Gerät zum mechan. Verkleinern od. Vergrößern von Zeichnungen)

¹Store fr. [ßtọr, schweiz.: schtọr'] (Fenstervorhang; schweiz.: Markise; Sonnenvorhang aus Segeltuch od. aus Kunststofflamellen) m; -s, -s (schweiz.: w; -, -n); Stören [schtọr'n] (schweiz. neben: Store) w; -, -

²Store engl. [ßtọr] (engl. Bez. für: Vorrat, Lager; Laden) m; -s, -s

¹stö|ren bayr. u. österr. (auf der ²Stör arbeiten od. auf die, in die Stör gehen)

²stö|ren (hindern, belästigen); sich -; ich störte mich an seinem Benehmen; Stö|ren|fried (abwertend) m; -[e]s, -e; ¹Stö|rer

²Stö|rer bayr. u. österr. (auf der ²Stör Arbeitender; Landfahrer) Stö|re|rei (ugs.); stör|frei stor|gen fränk., mitteld. (im Lande umherziehen); Stor|ger fränk., mitteld. (Landstreicher) Stör|ma|nö|ver Stor|marn (Gebiet u. Landkreis im südl. Holstein); Stor|mar|ner (↑R 199); stor|marnsch Stor|nel|lo it. (dreizeilige, gesungene volkstüml. [Liebes]dichtung in Italien) s (auch: m); -s, -s u. ...lli; stor|nie|ren (Kaufmannsspr.: Fehler [in der Buchung] berichtigen; allg. [österr. nur] für: rückgängig machen); Stor|no (Berichtigung; Rückbuchung, Löschung) m u. s; -s, ...ni; Stor|no|bu|chung stör|rig (seltener für: störrisch); Stör|rig|keit w; -; stör|risch; -ste (↑R 294); Stör|risch|keit (seltener für: Störrigkeit) Stör|schnei|de|rin [zu: ²Stör] Stör.schutz (Schutz gegen Rundfunkstörungen), ...sen|der, ...stel|le, ...su|cher Stör|te|be|ker (Seeräuber) Stor|ting [ßtọr..., norw. Ausspr.: ßtụr...] (norw. Volksvertretung) s; -s, -e u. -s Stö|rung; Stö|rungs|feu|er (Militär); stö|rungs|frei (frei von Rundfunkstörungen); Stö|rungsstel|le (für Störungen im Fernsprechverkehr zuständige Abteilung bei der Post) Sto|ry engl. [ßtọ̄ri] ([Kurz]geschichte) w; -, -s Stoß (Bergmannsspr. auch: seitl. Begrenzung eines Grubenbaus) m; -es, Stöße; Stöß|chen, Stößlein; Stoß.dämpfer, ...de|gen; Stößel (Stoßgerät) m; -s, -; stoß|empfind|lich; sto|ßen; du stößt (stößest), er stößt; du stießest; gestoßen; stoß[e]!; er stößt ihn (auch: ihm) in die Seite; Stö|ßer (auch für: Sperber); Stö|ße|rei (ugs.); stoß|fest; Stoß.geld; stö|ßig (vom Vieh); Stoß|kraft w; -; stoß|kräf|tig; Stöß|lein, Stößchen; Stoß.schlit|ten (Technik), ...seuf|zer; stoß|si|cher; Stoß.stan|ge, ...the|ra|pie, ...trupp (Militär), ...trupp|ler, ...ver|kehr (Verkehr zur Zeit der stärksten Verkehrsdichte), ...waf|fe; stoßwei|se; Stoß.zahn, ...zeit Sto|ti|na bulgar. (bulgar. Münze; 100 Stotinki = 1 Lew) w; -, ...ki Stot|te|rei (ugs.); Stot|te|rer; stotte|rig, stott|rig; stot|tern; ich ...ere (↑R 327); (↑R 120:) ins Stottern | geraten; etwas auf Stottern (ugs. für: auf Ratenzahlung) kaufen; Stott|re|rin w; -, -nen; stott|rig, stot|te|rig

Stotz m; -es, -e u. ¹Stot|zen südd., österr. ([Baum]stumpf) m; -s, -; ²Stot|zen südd. u. mitteld. (Bottich) m; -s, -; stot|zig alemann. (steil)

Stout engl. [ßtaut] (dunkles engl. Bier) m; -s, -s

Stöv|chen, Stov|chen niederd. (Kohlenbecken; Wärmevorrichtung für Tee od. Kaffee); Sto|ve niederd. (Trockenraum) w; -, -n; sto|wen niederd. (dämpfen); gestowtes Obst

StPO = Strafprozeßordnung

Str. = Straße

stra|ban|zen bayr. u. österr. mdal. (sich herumtreiben); Stra|ban|zer Stra|bo (gr. Geograph, Geschichtsschreiber u. Schriftsteller); Stra|bon vgl. Strabo; stra|bonisch, aber (↑R 179): Stra|bonisch

Strac|chi|no it. [ßtrakịno] (ein it. Käse) m; -[s]

strack südd. (gerade, straff, steif); stracks (geradeaus; sofort)

Strad|dle engl. [ßträd⁰l] (ein Sprungstil im Hochsprung) m; -[s], -s

¹Stra|di|va|ri [...wạri] (it. Meister des Geigenbaues); ²Stra|di|va|ri w; -, -[s] u. Stra|di|va|ri|us (Stradivarigeige) w; -, -; Stra|di|va|ri|gei|ge (↑R 180)

Straf.ak|ti|on, ...an|dro|hung, ...an|stalt, ...an|trag, ...an|zei|ge, ...ar|beit, ...auf|he|bung; Straf.auf|he|bungs|grund; Straf.aufschub, ...aus|set|zung; bedingte -; straf|bar; -e Handlung; Straf|barkeit w; -; Straf.be|fehl, ...be|fugnis, ...be|scheid; Stra|fe w; -, -n; stra|fen; Straf|ent|las|se|ne m u. w; -n, -n (↑R 287ff.); Straf|er|laß; straf|er|schwe|rend; straf|ex|erzie|ren

straff; -[e]ste (↑R 293)

straf|fäl|lig; Straf|fäl|lig|keit w; - straf|fen (straff machen); sich - (sich recken); Straff|heit

straf|frei; Straf.frei|heit (w; -), ...ge|fan|ge|ne, ...ge|richt, ...gerichts|bar|keit, ...ge|setz, ...gesetz|buch (Abk.: StGB), ...ge|setz|ge|bung, ...ge|walt, ...kammer, ...ko|lo|nie; sträf|lich; -er Leichtsinn; Sträf|lich|keit w; -; Sträf|ling; Sträf|lings|klei|dung; straf|los; Straf|lo|sig|keit w; -; Straf.man|dat, ...maß s; straf|mildernd; Straf.por|to, ...pre|digt, ...pro|zeß, ...pro|zeß|ord|nung (Abk.: StPO), ...punkt (Sport), ...raum (Sport), ...recht; straf|recht|lich; Straf|rechts|re|form;

Straf_re|gi|ster, ...sa|che, ...se-nat, ...stoß (Sport), ...tat, ...tä|ter, ...til|gung; Straf|til|gungs|grund; Straf_um|wand|lung, ...ver|bü-ßung, ...ver|fah|ren, ...ver|fü|gung (Strafmandat); straf|ver|schär-fend; straf|ver|set|zen; nur in der Grundform u. im 2. Mittelwort „strafversetzt" gebr.; Straf-_ver|tei|di|ger, ...voll|streckung [Trenn.: ...strek|kung], ...voll|zie-hung, ...voll|zug; straf|wei|se; straf|wür|dig; Straf_zet|tel, ...zu-mes|sung

Stra|gu|la (Ⓦ) (ein Bodenbelag) m; -s

Strahl m; -[e]s, -en; Strähl|an|trieb; strah|len

sträh|len mdal. (kämmen)

Strah|len_be|hand|lung, ...bio|lo-gie, ...bre|chung, ...bün|del, ...che-mie; strah|lend; -ste; strah|len|för-mig; Strah|len.krank|heit, ...kranz, ...pilz, ...schä|di|gung, ...schutz, ...the|ra|pie, ...tier|chen; Strah|ler (schweiz. veralt. auch für: Kristallsucher); Strahl_flug-zeug (Düsenflugzeug); strah|lig; ...strah|lig (z. B. achtstrahlig, mit Ziffer: 8strahlig; ↑ R 228); Strahl-_kraft w, ...rich|tung, ...rohr, ...stär|ke, ...trieb|werk; Strah-lung; Strah|lungs_ener|gie, ...gür-tel, ...in|ten|si|tät, ...wär|me

Strähn österr. (Strähne) m; -[e]s, -e; Sträh|ne w; -, -n; sträh|nig; ...sträh|nig (z. B. dreisträhnig, mit Ziffer: 3strähnig; ↑ R 228)

Strak (Seemannsspr.: das Gerich-tetsein, Verlauf der Linien) s; -s, -e; stra|ken (Seemannsspr.; Tech-nik: vorschriftsmäßig verlaufen [von einer Kurve]; streichen, strecken)

Stral|sund [auch: ...sunt] (Hafen-stadt an der Ostsee); Stral|sun|der [auch: ...sund*r*] (↑ R 199)

stral|zie|ren lt. (Kaufmannsspr. veralt. für: liquidieren, gütlich abtun); Stral|zie|rung; Stral|zio österr. (Liquidation) m; -s, -s

Stra|min niederl. (Gittergewebe für Kreuzstickerei) m; -s, -e; Stra-min|decke [Trenn.: ...dek|ke]

stramm; ein -er Junge. Schreibung in Verbindung mit Zeitwörtern; vgl. strammstehen, strammzie-hen; stram|men landsch. (straff anziehen); Stramm|heit w; -; stramm|ste|hen (↑ R 139); ich ste-he stramm; strammgestanden; strammzustehen; stramm|zie|hen (↑ R 139); ich ziehe ihm die Hose stramm; strammgezogen; strammzuziehen

Stram|pel|hös|chen; stram|peln; ich ...[e]le (↑ R 327); stramp|fen südd. u. österr. (stampfen; stram-peln)

Strand m; -[e]s, Strände; Strand-_an|zug, ...bad; stran|den; Strand-_gut, ...ha|fer, ...kleid, ...korb, ...krab|be, ...läu|fer (ein Vogel), ...recht; Stran|dung; Strand|wa-che

Strang m; -[e]s, Stränge; Stran|ge schweiz. (Strang, Strähne) w; -, -n; eine - Garn, Wolle; strän|gen ([Pferd] anspannen)

Stran|gu|la|ti|on [...zion], Stran-gu|lie|rung gr. Erdrosselung; Med.: Abklemmung); stran|gu-lie|ren; Strang|urie (Med.: Harnzwang) w; -, ...jen

Stra|paz... österr. (Strapazier..., z. B. Strapazhose); Stra|pa|ze it. (große[r] Anstrengung, Beschwer-lichkeit) w; -, -n; stra|paz|fä|hig österr. (strapazierfähig); Stra-paz|ho|se österr. (Strapazierho-se); stra|pa|zie|ren (übermäßig anstrengen, in Anspruch neh-men; abnutzen); sich - (ugs. für: sich [ab]mühen); stra|pa|zier|fä-hig; Stra|pa|zier.ho|se (strapa-zierfähige Hose für den Alltag), ...schuh; stra|pa|zi|ös (anstren-gend); -este (↑ R 292); Stra|paz-schuh österr. (Strapazierschuh)

Straps engl. [auch: ßträpß] (Strumpfhalter) m; -es, -e

Stras|bourg [ßtraßbur] (fr. Schrei-bung von: Straßburg)

Stras|burg (Stadt in der nördl. Uk-kermark)

Straß [nach dem Erfinder Straßer] (Edelsteinnachahmung aus Blei-glas) m; - u. Strasses, Strasse

straß|auf, straß|ab

Straß|burg (Stadt im Elsaß); Straß|bur|ger (↑ R 199); - Mün-ster; - Eide; straß|bur|gisch; vgl. Strasbourg

Sträß|chen, Sträß|lein; Stra|ße (Abk.: Str.) w; -, -n; Schreibung in Straßennamen: ↑ R 219ff.; Stra-ßen_an|zug, ...ar|bei|ter, ...bahn, ...bah|ner (ugs. für: Angestellter der Straßenbahn); Stra|ßen-bahn.hal|te|stel|le, ...schaff|ner, ...wa|gen; Stra|ßen.ban|kett (vgl. [2]Bankett), ...bau (Mehrz. ...bauten), ...bau|amt, ...be-kannt|schaft, ...be|leuch|tung, ...bö|schung, ...brei|te, ...damm, ...decke [Trenn.: ...dek|ke], ...dorf, ...ecke [Trenn.: ...ek|ke], ...füh|rung, ...gra|ben, ...han|del, ...kar|te, ...keh|rer, ...kreu|zer (ugs. für: großer Pkw), ...kreu-zung, ...la|ge, ...la|ter|ne, ...mäd-chen (Prostituierte), ...na|me, ...netz, ...pfla|ster, ...rei|ni|gung, ...ren|nen (Radsport), ...rol|ler (svw. Culemeyer), ...sän|ger, ...schild s, ...sei|te, ...sper|re, ...sper|rung, ...thea|ter, ...über-füh|rung, ...ver|kehrs|ord|nung (w; -; Abk.: StVO); Stra|ßen|ver-kehrs-Zu|las|sungs-Ord|nung (w; -; Abk.: StVZO); Stra|ßen_wal-ze, ...zug, ...zu|stand; Stra|ße-Schie|ne-Verkehr (↑ R 155) m; -[e]s; Sträß|lein, Sträß|chen

Stra|te|ge gr. (Feldherr, [Heer]-führer) m; -n, -n (↑ R 268); Stra|te-gie (Kriegskunst) w; -, ...jen; stra-te|gisch

Stra|ti|fi|ka|ti|on lat. [...zion] (Geol.: Schichtung; Landw.: Schichtung von Saatgut in feuch-tem Sand od. Wasser); stra|ti|fi-zie|ren (Geol.: die Schichtenfolge feststellen; Landw.: Saatgut schichten); Stra|ti|gra|phie lat.; gr. (Geol.: Schichtenkunde) w; -; stra|ti|gra|phisch; Stra|to|sphä|re (die Luftschicht in einer Höhe von etwa 12 bis 80 km) w; -; Stra-to|sphä|ren|flug; stra|to|sphä-risch; Stra|tus lat. (Meteor.: tiefer hängende, ungegliederte Schichtwolke; Abk.: St) m; -, ...ti; Stra|tus|wol|ke (Schichtwolke)

sträu|ben; sich -; (↑ R 120:) da hilft kein Sträuben; strau|big mdal. (struppig)

Strau|bin|ger; Bruder - (scherzh. für: Landstreicher)

Strauch m; -[e]s, Sträucher; strauch|ar|tig; Strauch|dieb (ab-schätzig); Sträu|chel|chen, Sträuch|lein; strau|cheln; ich ...[e]le (↑ R 327)

Strau|chen, Strau|ken österr. mdal. (Schnupfen) m; -s, -

strau|chig; Sträuch|lein, Sträu-chel|chen; Strauch_rit|ter (ab-schätzig), ...werk

Strau|ken vgl. Strauchen

Straus, Oscar (österr. Komponist)

Straus|berg (Stadt östl. von Ber-lin)

[1]Strauß, David Friedrich (dt. ev. Theologe)

[2]Strauß (Name mehrerer Komponisten)

[3]Strauß gr. (ein Vogel) m; -es, -e; Vogel -; vgl. Vogel-Strauß-Poli-tik

[4]Strauß (Blumenstrauß); geh. für: Kampf) m; -es, Sträuße

Strauss, Richard (dt. Komponist)

Sträuß|chen, Sträuß|lein

Strauß|en.ei, ...farm, ...fe|der

Strauß|wirt|schaft landsch. (durch Zweige [Strauß] kenntlich ge-machte Wirtschaft für zeitweisen Ausschank selbstgezogenen Weines)

Stra|win|sky[1] (russ. Komponist)

[1] So die eigene Schreibung des Komponisten entgegen dem vom Duden verwendeten russ. Tran-skriptionssystem, nach dem Stra-winski geschrieben werden muß.

Strazza 658

Straz|za it. (Abfall [bei der Seiden-
bearbeitung]) w; -, ...zzen; Straz-
ze (Kaufmannsspr.: Kladde) w;
-, -n

Streb (Bergmannsspr.: Kohlen-
abbaufront zwischen zwei
Strecken) m; -[e]s, -e; Streb|bau
(bergmänn. Gewinnungsverfah-
ren) m; -[e]s; Stre|be (schräge
Stütze) w; -, -n; Stre|be.bal|ken,
...bo|gen; stre|ben; (↑ R 120:) das
Streben nach Geld; Stre|be|pfei-
ler; Stre|ber (abschätzig); Stre-
be|rei (abschätzig) w; -; stre|ber-
haft; stre|be|risch; Stre|ber|tum
(abschätzig) s; -s; Stre|be|werk
(Bauw.); streb|sam; Streb|sam-
keit w; -; Stre|bung
streck|bar; Streck|bar|keit;
Streck|bett (Med.); Strecke[1]
(Bergmannsspr. auch: meist
waagrecht vorgetriebener Gru-
benbau) w; -, -n; zur - bringen
(Jägerspr.: erlegen); Streck|ei|sen
(ein Werkzeug); strecken[1]; jmdn.
zu Boden -; Strecken[1].ar|bei|ter,
...flug, ...netz, ...strich (Druckty-
pe), ...wär|ter; strecken|wei|se[1];
Strecker[1] (Streckmuskel);
Streck|mus|kel; Streckung[1];
Streck.ver|band, ...win|kel (für:
Supplementwinkel)
Streh|ler (ein Werkzeug zum Ge-
windeschneiden)
Streich m; -[e]s, -e; Streich|bür|ste;
Strei|che (früher: Flanke einer
Festungsanlage) w; -, -n; strei-
cheln; ich ...[e]le (↑ R 327); Strei-
che|ma|cher; strei|chen; du
strichst (strichest); du strichest;
gestrichen; streich[e]!; Strei|chen
(der nach den Himmelsrichtung
angegebene Verlauf der Streichli-
nie) s; -s; Strei|cher (Spieler eines
Streichinstrumentes); Strei|che-
rei (ugs.); Streich.flä|che, ...form,
...garn, ...holz (Zündholz);
Streich|holz|schach|tel; Streich-
.in|stru|ment, ...kä|se, ...kon|zert,
...li|nie (waagrechte Linie auf der
Schichtfläche einer Gebirgs-
schicht), ...mu|sik, ...or|che|ster,
...quar|tett, ...quin|tett, ...trio;
Strei|chung
Streif (Nebenform von: Streifen)
m; -[e]s, -e; Streif|band (Postw.)
s (Mehrz. ...bänder); Strei|fe (zur
Kontrolle eingesetzte kleine Mi-
litär- od. Polizeieinheit, auch:
Fahrt, Gang einer solchen Ein-
heit) w; -, -n; strei|fen; Strei|fen
m; -s, -; Strei|fen.dienst, ...si|che-
rung, ...wa|gen; strei|fen|wei|se;
Strei|fe|rei (Streifzug); strei|fig;
Streif|licht (Mehrz. ...lichter);
Streif|ling (Apfel mit rötl. Strei-
fen); Streif.schuß, ...zug

Streik engl. (Arbeitsniederlegung)
m; -[e]s, -s; Streik.bre|cher,
...bruch m; streik|brü|chig; strei-
ken; Strei|ken|de m u. w; -n, -n
(↑ R 287ff.); Streik.geld, ...kas|se,
...po|sten, ...recht
Streit m; -[e]s, -e; Streit|axt; streit-
bar; Streit|bar|keit w; -; strei|ten;
du strittst (strittest); du strit-
test; gestritten; streit[e]!; Strei-
ter; Strei|te|rei; Streit.fall m,
...fra|ge, ...ge|gen|stand, ...ge-
spräch, ...hahn (ugs. abschätzig
für: streitsüchtiger Mensch),
...ham|mel (ugs. abschätzig für:
streitsüchtiger Mensch), ...han-
sel od. ...hansl (österr. ugs. für:
streitsüchtiger Mensch; m; -s, -n);
strei|tig, strit|tig; die Sache ist
strittig od. strittig; aber nur:
jmdm. etwas streitig machen;
Strei|tig|kei|ten Mehrz.; Streit-
.kraft (w; meist Mehrz.), ...lust
(w; -); strei|tlu|stig; Streit.macht
(w; -), ...ob|jekt, ...roß, ...sa|che,
...schrift, ...sucht (w; -); streit-
süch|tig; Streit.ver|kün|dung
(Rechtsspr.), ...wa|gen, ...wert
strem|men landsch. ugs. (been-
gen); es stremmt; sich - (landsch.
ugs. für: sich anstrengen)
streng; (↑ R 134:) auf das od. aufs
strengste; strengstens; Schrei-
bung in Verbindung mit Zeitwör-
tern (↑ R 139): streng sein, bestra-
fen, urteilen usw.; vgl. aber:
strengnehmen; Stren|ge w; -; eine
drakonische -; stren|gen (veralt.
für: einengen; straff anziehen);
streng|ge|nom|men; streng|gläu-
big; Streng|gläu|big|keit w; -;
streng|neh|men; ↑ R 139 (genau
nehmen); ich nehme streng;
strenggenommen; strengzuneh-
men; er hat seine Aufgabe streng-
genommen; streng|stens
stren|zen südd. ugs. (stehlen); du
strenzt (strenzest)
Strep|to|kok|kus gr. (kettenbil-
dende Bakterie) m; -, ...ken
(meist Mehrz.); Strep|to|my|cin,
(eingedeutscht:) Strep|to|my|zin
(ein Antibiotikum) s; -s
[1]Stre|se|mann (dt. Staatsmann);
[2]Stre|se|mann (ugs. Bez. für einen
bestimmten Gesellschaftsanzug)
m; -s
Streß engl. (Med.: starke körper-
liche Belastung, die zu körper-
lichen Schädigungen führen
kann; Überbeanspruchung, An-
spannung) m; ...sses, ...sse; Streß-
si|tua|ti|on
Stretch engl. [ßträtsch] (ein elasti-
sches Gewebe, bes. für Strümpfe)
m; -[e]s, -es [...is]
Streu w; -, -en; Streu|büch|se;
streu|en; Streu|er (Streubüchse);
Streu|ge|biet; Streu|kü|gel|chen

streu|nen (sich umhertreiben);
Streu|ner (ugs.)
Streu.plan (vgl. [2]Plan), ...pul|ver,
...salz, ...sand; Streu|sel s; -s, -;
Streu|sel|ku|chen; Streu|sied-
lung; Streu|ung; Streu|ungs.ko-
ef|fi|zi|ent (Statistik), ...maß (Sta-
tistik; s)
Strich (südd. u. schweiz. mdal.
auch für: Zitze) m; -[e]s, -e; Strich-
.ät|zung, ...ein|tei|lung; Strich|chen,
Strich|lein; strich|eln (feine
Striche machen; mit feinen Stri-
chen versehen); ich ...[e]le (↑ R
327); gestrichelte Blätter; Strich-
jun|ge; strich|lie|ren (österr.: stri-
cheln); Strich.mäd|chen, ...punkt
(für: Semikolon), ...re|gen, ...vo-
gel; strich|wei|se; Strich.zeich-
nung, ...zeit (der Strichvögel)
Strick (ugs. scherzh. auch für:
Lausejunge, Spitzbube) m; -[e]s,
-e; Strick|beu|tel; stricken[1]; Strik-
ker; Stricke|rei[1]; Stricke|rin[1] w;
-, -nen; Strick.garn, ...jacke
[Trenn.: ...jak|ke], ...kleid, ...lei-
ter w; Strick|lei|ter|ner|ven|sy-
stem (Zool.); Strick.ma|schi|ne,
...mu|ster, ...na|del, ...stoff,
...strumpf, ...wa|ren (Mehrz.),
...zeug
Stri|du|la|ti|ons|or|gan lat.; gr.
[...zigņß...] (Werkzeug mancher
Insekten zur Erzeugung zirpen-
der Töne)
Strie|gel lat. (Schabeisen [zum
Pferdeputzen]) m; -s, -; strie|geln
(ugs. auch für: hart behandeln);
ich ...[e]le (↑ R 327)
Strie|me (selten) w; -, -n u. Strie-
men m; -s, -; strie|mig
[1]Strie|zel (ugs. für: Lausbub) m;
-s, -
[2]Strie|zel landsch., bes. südd.,
österr. (eine Gebäckart) m; -s, -
strie|zen (ugs. für: quälen; nordd.
ugs. auch für: stehlen); du striezt
(striezest)
strikt lat. (streng; genau; pünkt-
lich; auch für: strikte) (Umstandsw.;
streng, genau); strik|te
(Umstandsw.; streng, genau);
etw. - befolgen; Strik|ti|on
[...zign] (selten für: Zusammen-
ziehung); Strik|tur (Med.:
[krankhafte] Verengung von
Körperkanälen) w; -, -en
Strind|berg (schwed. Dichter)
string. = stringendo; strin|gen|do
it. [ßtrindsehándo] (Musik:
schneller werdend)
strin|gent lat. (bündig, zwingend);
-este (↑ R 292); Strin|genz w; -
Strip engl.-amerik. [ßtrip] (ugs.
für: Striptease) m; -s, -s
Strip|pe (ugs. für: Band; Bindfa-
den; Schürsenkel; scherzh. für:
Fernsprechleitung) w; -, -n

[1] Trenn.: ...ek|k... [1] Trenn.: ...ik|ke...

strip|pen engl.-amerik. [ßtri̩...] (ugs.: eine Entkleidungsnummer vorführen); Strip|pe|rin (ugs.: Stripteasetänzerin) w; -, -nen; Strip|tease [ßtrípti̩s] (Entkleidungsvorführung [in Nachtlokalen]) m (auch: s); -; Strip|tease_lo|kal, ...tän|ze|rin, ...vor|füh|rung stri|scian|do it. [ßtrischando] (Musik: schleifend)· Stri|scian|do s; -s, -s u. ...di
Stritt bayr. (Streit) m; -[e]s; stritt|ig vgl. streitig
Stritt|mat|ter, Erwin (dt. Schriftsteller)
Striz|zi bes. südd. u. schweiz. mdal., österr. ugs. (Strolch, leichtsinniger Mensch; Zuhälter) m; -s, -s
Stro|bel (ugs. für: wirrer Haarschopf) m; -s, -; stro|be|lig, stroblig, strub|be|lig, strubb|lig (ugs.); Stro|bel|kopf, (landsch.:) Strubbel|kopf; stro|beln (ugs. für: struppig machen; struppig sein); ich ...[e]le (↑R 327); strob|lig, stro|be|lig, strub|be|lig, strubblig (ugs.)
Stro|bo|skop gr. (ein opt. Gerät) s; -s, -e; stro|bo|sko|pisch
Stroh s; -[e]s; stroh|blond; Stroh_blu|me, ...bund s, ...dach; strohern (aus Stroh); stroh|far|ben, stroh|far|big; Stroh_feim od. ...fei|me od. ...fei|men, ...feu|er, ...halm; stro|hig (auch für: wie Stroh, saftlos, trocken); Stroh_hut, ...hüt|te, ...kopf (ugs. scherzh. für: Dummkopf), ...mann (vorgeschobene Person; Mehrz. ...männer), ...pup|pe, ...sack, ...schuh, ...wisch, ...wit|we (ugs.), ...wit|wer (ugs.)
Strolch m; -[e]s, -e; strol|chen; Strol|chen|fahrt schweiz. (Schwarzfahrt)
Strom m; -[e]s, Ströme; der elektrische, magnetische -; es regnet in Strömen; strom|ab; strom|abwärts; Strom_ab|nah|me, ...abneh|mer; strom|an; strom|auf, strom|auf|wärts; Strom|bett
Strom|bo|li (eine der Liparischen Inseln u. der Vulkan auf dieser Insel)
strö|men
Stro|mer (ugs. für: Landstreicher) m; -s, -; stro|mern; ich ...ere (↑R 327)
Strom_er|zeu|gung, ...ka|bel, ...kreis; Ström|ling (eine Heringsart); Strom|li|nie; Strom|li|ni|enform w; -; Strom|li|ni|en|för|mig; Strom|li|ni|en|wa|gen; Strom_men|ge, ...mes|ser m, ...netz, ...re|gu|lie|rung, ...schie|ne, ...schnel|le, ...sper|re, ...spu|le, ...stär|ke, ...stoß; Strö|mung; Strö|mungs|leh|re; Strom_un|terbre|cher, ...ver|brauch, ...ver|sor

gung; strom|wei|se; Strom|wender, ...zäh|ler
Stron|ti|um [...zium; nach dem schott. Dorf Strontian (...schiᵉn)] (chem. Grundstoff, Metall; Zeichen: Sr) s; -s
Stroph|an|thin gr. (ein Arzneimittel) s; -s; Stroph|an|thus (Heilpflanze, die das Strophanthin liefert) m; -, -
Stro|phe gr. (sich in gleicher Form wiederholender Liedteil, Gedichtabschnitt) w; -, -n; Strophen|an|fang; ...stro|phig (z. B. dreistrophig, mit Ziffer: 3strophig; ↑R 228); stro|phisch (in Strophen geteilt)
Stropp (Seemannsspr.: Ring od. Schlinge aus Tau; Kette, Draht; scherzh. für: kleines Kind) m; -[e]s, -s
Stros|se (Bergmannsspr.: Rinne am Boden der Strecke, in der das Wasser abfließt) w; -, -n
strot|zen; du strotzt (strotzest); er strotzt vor od. von Energie
strub schweiz. mdal. (struppig; schwierig); strüber, strübste; strub|be|lig, strubb|lig, stro|belig, strob|lig (ugs.); Strub|belkopf vgl. Strobelkopf
Struck engl. [engl. Aussspr.: ßtrak] (ein Gewebe) s (österr. auch: m); -[s]
Stru|del ([Wasser]wirbel; Gebäck) m; -s, -; Stru|del|kopf (veralt. für: Wirrkopf); stru|deln; das Wasser strudelt
Struk|tur lat. ([Sinn]gefüge, Bau; Aufbau, innere Gliederung; Geol.: Gefüge von Gesteinen; geol. Bauform) w; -, -en; struk|tural (seltener für: strukturell); Struk|tu|ra|lis|mus (Lehre von der Struktur der Sprache) m; -; Struk|tu|ra|list (Vertreter des Strukturalismus); ↑R 268; struktu|ra|li|stisch (den Strukturalismus betreffend); Struk|tur_analy|se (Chemie: Untersuchung des inneren Aufbaus von Körpern mittels Röntgenstrahlen; Wirtsch.: Erfassung u. Systematisierung der Strukturelemente einer Volkswirtschaft); Struktur|än|de|rung; struk|tu|rell; Struk|tur|for|mel (Chemie); struk|tu|rie|ren (mit einer Struktur versehen); Struk|tu|rie|rung; Struk|tur_kri|se, ...po|li|tik, ...reform, ...wan|del
Stru|ma lat. (Med.: Kropf) w; -, ...men u. ...mae; stru|mös (kropfartig)
Strumpf m; -[e]s, Strümpfe; Strumpf|band s (Mehrz. ...bänder); Strümpf|chen, Strümpf|lein; Strumpf_fa|brik, ...hal|ter, ...hose, ...wir|ker, ...wir|ke|rei

Strunk m; -[e]s, Strünke; Strünkchen, Strünk|lein
Strup|fe südd. u. österr. veralt. ([Stiefel]strippe, Schuhlasche) w; -, -n; strup|fen südd. u. schweiz. mdal. ([ab]streifen); Strup|fer schwäb. (Pulswärmer)
strup|pig; Strup|pig|keit w; -
Struw|wel|kopf landsch. (Strobelkopf); Struw|wel|pe|ter (Gestalt aus einem Kinderbuch) m; -s, -
Strych|nin gr. (ein Alkaloid; ein Arzneimittel) s; -s
Stu|art (Angehöriger eines schott. Geschlechts) m; -s, -s; Stu|artkra|gen
Stu|bai|er Al|pen Mehrz.; Stubal[|tal] (Tiroler Alpental)
Stüb|chen niederd. ([Baum]stumpf) m; -s, -
Stüb|ben|kam|mer (Kreidefelsen auf Rügen) w; -
¹Stüb|chen (ehem. Flüssigkeitsmaß) s; -s, -
²Stüb|chen, Stüb|lein (kleine Stube); Stu|be w; -, -n; Stu|ben_arrest ...dienst, ...far|be (sehr blasse Gesichtsfarbe), ...flie|ge, ...gelehr|te, ...hocker [Trenn.: ...hokker] (ugs. abschätzig), Stu|benhocke|rei [Trenn.: ...hok|ke...] (ugs. abschätzig); Stu|ben|mädchen; stu|ben|rein; Stu|ben_wagen (Kinderwagen für die Stube)
Stü|ber niederl. (ehem. niederrhein. Münze; Schneller mit dem Finger an die Nase, Nasenstüber) m; -s, -
Stüb|lein, Stüb|chen
Stubs|na|se (Nebenform von: Stupsnase)
Stuck it. (aus einer Gipsmischung hergestellte Ornamentik) m; -[e]s; vgl. Stukkateur
Stück (Abk.: St.) s; -[e]s, -e; (↑R 321 u. 322:) 5 - Zucker; [ein] Stücker zehn (ugs. für: ungeführ zehn)
Stuck|ar|beit; vgl. Stukkateur
Stück|ar|beit (Akkordarbeit); stückeln¹; ich ...[e]le (↑R 327); Stücke|lung¹, Stück|lung
stücken¹ österr. ugs. (büffeln, angestrengt lernen)
stücken¹ (selten für: zusammen-, aneinanderstücken); Stücker¹ vgl. Stück
stuckern¹ (holpern, rütteln; ruckweise fahren)
Stücke|schrei|ber¹ (Schriftsteller, der Theaterstücke, Fernsehspiele o. ä. verfaßt); Stück_faß (ein Weinmaß), ...ge|wicht, ...gut (stückweise verkaufte od. als Frachtgut aufgegebene Ware)
stuckie|ren¹ it. (selten für: [Wände] mit Stuck versehen)

¹ Trenn.: ...k|k...

Stückkohle 660

Stück|koh|le, ...lohn; Stück|lung,
Stücke|lung; Stück_no|tie|rung
(Börse), ...rech|nung (Wirtsch.);
stück|wei|se; Stück_werk, ...zahl
(Kaufmannsspr.), ...zin|sen
(Wirtsch.: bis zu einem Zwi-
schentermin aufgelaufene Zin-
sen) *Mehrz.*
stud. = studiosus, z. B. - medici-
nae *lat.* [- ...*zinä*] (Student der
Medizin; Abk.: stud. med.); vgl.
Studiosus; Stu|dent *lat.* (Hoch-
schüler; österr. auch für: Schüler
einer höheren Schule); ↑ R 268;
vgl. Studiosus; Stu|den|ten_blu-
me (Name verschiedener Pflan-
zen), ...bu|de (ugs.), ...fut|ter (vgl.
¹Futter), ...ge|mein|de, ...heim,
...pfar|rer; Stu|den|ten|schaft;
Stu|den|ten_spra|che, ...ver|bin-
dung, ...wohn|heim; Stu|den|tin *w*;
-, -nen; stu|den|tisch; Stu|die [...*i*]
(Entwurf, kurze [skizzenhafte]
Darstellung; Vorarbeit [zu einem
Werk der Wissenschaft od.
Kunst]) *w*; -, -n; Stu|di|en (*Mehrz.*
von: Studie u. Studium); Stu|di-
en_as|ses|sor, ...as|ses|so|rin,
...di|rek|tor, ...freund; stu|di|en-
hal|ber; Stu|di|en_pro|fes|sor
(in Bayern noch üblicher Titel),
...rat (*Mehrz.* ...räte), ...rä|tin,
...re|fe|ren|dar, ...re|fe|ren|da|rin,
...rei|se, ...zeit, ...zweck (zu -en);
stu|die|ren (er|forschen, lernen;
die Hochschule [österr. auch:
höhere Schule] besuchen); ein
studierter Mann; (↑ R 120:) Pro-
bieren (auch: probieren) geht
über Studieren (auch: studieren);
Stu|die|ren|de *m* u. *w*; -n, -n (↑ R
287ff.); Stu|dier_lam|pe, ...stu|be;
Stu|dier|te (ugs. für: jmd., der stu-
diert hat) *m* u. *w*; -n, -n (↑ R
287ff.); Stu|dier|zim|mer; Stu|di-
ker (ugs. scherzh. für: Student);
Stu|dio *it.* (Studierstube; Atelier;
Film- u. Rundfunk: Aufnahme-
raum; Versuchsbühne) *s*; -s, -s;
Stu|dio_büh|ne, ...film; Stu|dio-
sus (scherzh. für: Studierender;
Student) *m*; -, ...sen u. ...si; vgl.
stud.; Stu|di|um (wissenschaftl.
[Er]forschung; geistige Arbeit;
Hochschulbesuch, -ausbildung)
s; -s, ...ien [...*i*n]; Stu|di|um ge-
ne|ra|le (frühe Form der Univer-
sität im MA.; Vorlesungen allge-
meinbildender Art an den
westdeutschen Hochschulen)
s; - -
Stu|fe *w*; -, -n; stu|fen; Stu|fen-
_dach, ...fol|ge; stu|fen|för|mig;
Stu|fen_gang *m*, ...heck (vgl.
²Heck), ...lei|ter *w*, ...py|ra|mi|de,
...schei|be (Technik); stu|fen|wei-
se; stu|fig (mit Stufen versehen)
...stu|fig (z. B. fünfstufig, mit Zif-
fer: 5stufig; ↑ R 228); Stu|fung

Stuhl *m*; -[e]s, Stühle; der Heilige,
der Päpstliche - (↑ R 224); Stuhl-
bein; Stühl|chen; Stuhl|fei|er *w*; -;
Petri - (kath. Fest); Stuhl_gang
(*m*; -[e]s), ...ge|flecht, ...leh|ne
Stu|ka [auch: *schtu*...] (Sturz-
kampfflugzeug) *m*; -s, -s
Stuk|ka|teur *fr.* [...*tör*] (Stuckar-
beiter) *m*; -s, -e; vgl. Stuck; Stuk-
ka|tur *it.* (Stuckarbeit) *w*; -, -en;
vgl. Stuck
Stül|le nordd. (Brotschnitte [mit
Aufstrich, Belag]) *w*; -, -n
Stül|pe *w*; -, -n; stül|pen; Stülp[en]-
_är|mel, ...hand|schuh, ...stie|fel;
Stülp|na|se
stumm; - sein, werden, machen;
Stum|me *m* u. *w*; -n, -n (↑ R 287ff.).
Stum|mel *m*; -s, -; Stum|mel|af|fe;
Stüm|mel|chen, Stüm|mel|chen;
stüm|meln (selten für: verstüm-
meln; landsch. für: Bäume stark
zurückschneiden); ich ...[e]le (↑ R
327); Stum|mel|pfei|fe
Stumm|film; Stumm|heit *w*; -
Stümp_e niederd. u. mitteld.
[Baum]stumpf) *m*; -s, -e; Stümp-
chen, Stümp|lein; Stum|pe *m*; -n,
-n u. ¹Stum|pen südd. ([Baum]-
stumpf) *m*; -s, -; ²Stum|pen
(Grundform des Filzhutes; Zi-
garre) *m*; -s, -; Stüm|per (ugs. für:
Nichtskönner); Stüm|pe|rei
(ugs.); stüm|per|haft; Stüm|pe|rin
(ugs.) *w*; -, -nen; stüm|per|mä|ßig;
stüm|pern (ugs.); ich ...ere (↑ R
327); stumpf; Stumpf *m*; -[e]s,
Stümpfe; mit - und Stiel; Stümpf-
chen, Stümpf|lein; stump|fen
(stumpf machen) Stumpf|heit;
Stumpf_näs|chen od. ...näs|lein
od. ...na|se (landschaftl.); stumpf-
na|sig (landschaftl.); Stumpf|sinn
m; -[e]s; stumpf_sin|nig, ...win|ke-
lig, ...wink|lig; Stümp|lein,
Stümp|chen
Stünd|chen, Stünd|lein; Stun|de
(Abk.: Std.; Zeichen: st, h
[Astron.: ʰ]) *w*; -, -n; eine halbe
Stunde, eine viertel Stunde (vgl.
Viertelstunde); von Stund an;
vgl. stundenlang; stun|den (Zeit,
Frist zur Zahlung geben); Stun-
den_buch ([Laien]gebetbuch des
MA.), ...frau (landsch. für: Frau,
die einige Stunden im Haushalt
hilft), ...ge|bet, ...ge|schwin|dig-
keit, ...glas (Sanduhr), ...halt
(schweiz. für: [stündl.] Marsch-
pause), ...ho|tel; Stun|den|ki|lo-
me|ter (für: Kilometer je Stunde;
vgl. km/h); stun|den|lang, aber:
eine Stunde lang, ganze Stunden
lang; Stun|den_lohn, ...plan (vgl.
²Plan), ...schlag; stun|den|wei|se;
stun|den|weit, aber: drei Stun-
den weit; Stun|den|zei|ger (bei der
Uhr); ...stün|dig (z. B. zweistün-
dig, mit Ziffer: 2stündig [zwei

Stunden dauernd]; ↑ R 228);
Stünd|lein, Stünd|chen; stünd-
lich (jede Stunde); ...stünd|lich (z.
B. zweistündlich, mit Ziffer:
2stündlich [alle zwei Stunden
wiederkehrend]; ↑ R 228); Stun-
dung
Stunk (ugs. für: Zank, Unfrieden,
Nörgelei) *m*; -s
Stunt|man *engl.-amerik.* [*ßtąnt-
män*] (Film: Double für gefähr-
liche, akrobatische o. ä. Szenen)
m; -s, ...men
stu|pend *lat.* (erstaunlich); -este
(↑ R 292)
Stupf südd., schweiz. mdal. (Stoß)
m; -[e]s, -e; stup|feln, stup|fen
(südd., österr. ugs., schweiz.
mdal. neben: stoßen, stupsen);
Stup|fer österr. ugs. (Stoß)
stu|pid (österr. nur so), stu|pi|de
lat. (dumm, beschränkt, stumpf-
sinnig); stupideste; Stu|pi|di|tät;
Stu|por (Med.: Starrheit; Un-
empfindlichkeit) *m*; -s
Stupp österr. (Streupulver, Puder)
w; -; stup|pen österr. (einpudern)
stu|prie|ren *lat.* (schänden); Stu-
prum (Schändung; Vergewalti-
gung) *s*; -s, ...pra
Stups (ugs. für: Stoß) *m*; -es, -e;
stup|sen (ugs. für: stoßen); du
stupst (stupsest); Stups|na|se
(ugs.); vgl. Stubsnase
stur (ugs. für: stier, unbeweglich,
hartnäckig)
Stur|heit (ugs.) *w*; -
sturm alemann. (verworren,
schwindelig); ¹Sturm *m*; -[e]s,
Stürme; Sturm laufen; Sturm läu-
ten; ²Sturm österr. (in Gärung
übergegangener Most) *m*; -[e]s;
Sturm_an|griff, ...band (*s*; *Mehrz.*
...bänder); sturm_be|flü|gelt,
...be|reit; Sturm_bock, ...deich
(ugs.); Stür|mer und Drän|ger *m*;
-s - -s, - - -; Stur|mes_brau|sen
s; -s; Sturm_fah|ne, ...flut; sturm-
frei; Sturm|glocke [*Trenn.:*
...glok|ke]; Sturm_hau|be; die
Große -, Kleine - (Gipfel im Rie-
sengebirge); Sturm|hut (eine Arz-
neipflanze, svw. Akonit) *m*; -[e]s;
stür|misch; -ste (↑ R 294); Sturm-
_la|ter|ne, ...läu|ten (*s*; -s), ...lei-
ter *w*, ...schritt, ...si|gnal, ...tief
(Meteor.); Sturm und Drang *m*;
- - -[e]s u. - -; Sturm-und-Drang-
Zeit (↑ R 155) *w*; -; Sturm_vo|gel,
...war|nung, ...wind, ...zei|chen
Sturz (jäher Fall; Bauw.: Ober-
schwelle) *m*; -es, Stürze u. -
Oberschwelle:) Sturze; Sturz-
_acker [*Trenn.:* ...ak|ker], ...bach,
...bad, ...blech (dünne Sorte Ei-
senblech); Stür|ze landsch. (Dek-
kel) *w*; -, -n; Stur|zel, Stür|zel
landsch. (stumpfes Ende,

[Baum]stumpf *m*; -s, -; stür|zen; du stürzt (stürzest); Stürz.flug, ...flut, ...ge|burt (Med.), ...gut (z. B. Kohle, Schotter), ...helm (vgl. ¹Helm), ...kampf|flug|zeug (Abk.: Stuka), ...pflug, ...re|gen, ...see *w*

Stuß *jidd.* (ugs. für: Narrheit, Unsinn) *m*; Stusses; - reden

Stut|buch (Stammtafeln der zur Zucht verwendeten Pferde); Stu|te *w*; -, -n

Stu|ten niederd. ([längliches] Weißbrot) *m*; -s, -; Stu|ten|bäcker [*Trenn.*: ...bäk|ker] (niederd.)

Stu|ten|zucht; Stu|te|rei (Gestüt)

Stutt|gart (Stadt am Neckar); Stutt|gart-Bad Cann|statt (↑ R 213); Stutt|gar|ter (↑ R 199)

Stutz (landsch. für: Stoß; Gewehr; verkürztes Ding [Federstutz u. a.]; Wandbrett; schweiz. mdal. für: steiler Hang, bes. steiles Wegstück) *m*; -es, -e u. (schweiz. auch:) Stütze; auf den - (mdal. für: plötzlich; sofort)

Stütz (Turnen) *m*; -es, -e; Stützbal|ken; Stüt|ze *w*; -, -n

stut|zen (erstaunt, argwöhnisch sein; verkürzen); du stutzt (stutzest); Stut|zen (kurzes Gewehr; Wadenstrumpf; Ansatzrohrstück) *m*; -s, -

stüt|zen; du stützt (stützest)

Stut|zer (schweiz. auch für: Stutzen [Gewehr]); stut|zer|haft; Stutzer|haf|tig|keit *w*; -; stut|zer|mäßig; Stut|zer|tum *s*; -s

Stutz|flü|gel (Musik: kleiner, kurzer Flügel)

Stütz|ge|we|be (Med.)

stut|zig; stüt|zig südd., österr. (stutzig; widerspenstig)

Stütz.mau|er, ...pfei|ler, ...punkt, ...rad (beim Pflug)

Stütz|uhr (für: Pendüle)

Stüt|zung; Stütz|ver|band (Med.)

StVO = Straßenverkehrsordnung

StVZO = Straßenverkehrs-Zulassungs-Ordnung

sty|gisch (zum Styx gehörend; schauerlich, kalt)

Sty|ling *engl.* [*ßtailing*] (Formgebung; Karosseriegestaltung) *s*; -s; Sty|list [*ßtailißt*] (Formgestalter); ↑ R 268

Sty|lit *gr.* (frühchristl. Säulenheiliger) *m*; -en, -en (↑ R 268)

Sty|lo|gra|phie *gr.* (Herstellung von Kupferdruckplatten) *w*; -

Stym|pha|li|den *gr.* (in der gr. Sage: Vogelungeheuer) *Mehrz.*

Sty|rax, Sto|rax *gr.* (eine Heilpflanze; Balsam) *m*; -[es], -e

Sty|rol *gr.*; *arab.* (eine chem. Verbindung) *s*; -s

Sty|ro|por ⦿ *w*; *lat.* [*ßtü...*] (ein Kunststoff) *s*; -s

Styx (in der gr. Sage: Fluß der Unterwelt) *m*; -

SU = Sowjetunion

s. u. = sieh[e] unten!

Sua|da (österr. nur so), Sua|de *lat.* (Beredsamkeit, Redefluß) *w*; -, ...den

¹Sua|he|li, Swa|hi|li (Angehöriger eines afrik. Volkes) *m*; -[s], -[s]; ²Sua|he|li, Swa|hi|li (Sprache) *s*; [s] [s]; vgl. Kisuaheli

Suá|rez [*ßuaräth*] (span. Theologe, Jesuit)

sua|so|risch *lat.* (überredend); -ste (↑ R 294)

sub... *lat.* (unter...); Sub... (Unter...)

sub|al|pin, sub|al|p|nisch *lat.* (Geogr.: räumlich an die Alpen anschließend; bis zur Nadelwaldgrenze reichend); subalpine Stufe (eine Vegetationszone im Gebirge)

sub|al|tern *lat.* (untergeordnet; unselbständig); Sub|al|tern|be|am|te; Sub|al|ter|ne *m* u. *w*; -n, -n (↑ R 287ff.)

sub|ant|ark|tisch *lat.*; *gr.* (Geogr.: zwischen Antarktis und gemäßigter Klimazone gelegen)

sub|apen|n|nisch *lat.* (Geogr.: unmittelbar an die Apenninen anschließend)

sub|ark|tisch *lat.*; *gr.* (Geogr.: zwischen Arktis u. gemäßigter Klimazone gelegen); subarktische Zone (südl. an die Arktis anschließender Klimagürtel)

Sub|dia|kon *lat.*; *gr.* (kath. Kirche: Inhaber der untersten von den höheren Weihen, Gehilfe des Priesters)

Sub|do|mi|nan|te (Musik: die Quarte vom Grundton aus)

sub|fos|sil *lat.* (in geschichtl. Zeit ausgestorben)

sub|gla|zi|al *lat.* (unter dem Eis befindlich, z. B. Schmelzwasserflüsse)

Sub|jekt *lat.* (Sprachw.: Satzgegenstand; Philos.: wahrnehmendes, denkendes Wesen; Person [meist verächtl.]; gemeiner Mensch) *s*; -[e]s, -e; Sub|jek|ti|on [...*zion*] (Rhet.: Aufwerfen einer Frage, die man selbst beantwortet); sub|jek|tiv (dem Subjekt angehörend, in ihm begründet; persönlich; einseitig, parteiisch, unsachlich); Sub|jek|ti|vis|mus [...*wiß*...] (philos. Lehre, nach der das Subjekt für die Geltung der Erkenntnis entscheidend ist; auch: Ichbezogenheit) *m*; -; sub|jek|ti|vi|stisch [...*wi*...]; Sub|jek|ti|vi|tät [...*wi*...] (persönl. Auffassung, Eigenart; Einseitigkeit) *w*; -; Sub|jekt|satz

Sub|junk|tiv [auch: ...*tif*] *lat.* (in

der dt. Sprachw. ungebräuchl. Bez. für: Konjunktiv) *m*; -s, -e [...*wᵉ*]

Sub|kon|ti|nent (geogr. geschlossener Teil eines Kontinents, der auf Grund seiner Größe u. Gestalt eine gewisse Eigenständigkeit hat)

Sub|kul|tur *lat.* (bes. Kulturgruppierung innerhalb eines übergeordneten Kulturbereichs)

sub|ku|tan *lat.* (Med.: unter der Haut befindlich)

sub|lim *lat.* (erhaben; fein; nur einem feineren Verständnis od. Empfinden zugänglich); Sub|li|mat (Ergebnis einer Sublimation; Quecksilberverbindung) *s*; -[e]s, -e; Sub|li|ma|ti|on [...*zion*] (Chemie: unmittelbarer Übergang eines festen Stoffes in den Gaszustand u. umgekehrt); sub|li|mie|ren (erhöhen; läutern, verfeinern; Chemie: der Sublimation unterwerfen); Subli|mie|rung; Sub|li|mier|vor|rich|tung; Sub|li|mi|tät (selten für: Erhabenheit) *w*; -

sub|lu|na|risch *lat.* (Meteor.: unter dem Monde befindlich, irdisch)

sub|ma|rin (Biol.. unterseeisch)

Sub|mer|si|on *lat.* (veralt. für: Untertauchung, Überschwemmung)

Sub|mi|ni|stra|ti|on *lat.* [...*zion*] (veralt. für: Vorschubleistung)

Sub|mis|si|on *lat.* (Vergebung, Verdingung [an den Geringstfordernden]; öffentl. Ausschreibung; Angebot; veralt. für: Ehrerbietigkeit, Unterwürfigkeit; Unterwerfung); Sub|mis|si|ons.kar|tell (Wirtsch.), ...weg (im -[e]), Sub|mit|tent (Bewerber [um einen Auftrag]; [An]bieter); ↑ R 268; sub|mit|tie|ren (sich [um einen Auftrag] bewerben)

Sub|or|di|na|ti|on *lat.* [...*zion*] (Sprachw.: Unterordnung; veraltend für: Unterordnung, Gehorsam); sub|or|di|na|ti|ons|wid|rig; sub|or|di|nie|ren; subordinierende Konjunktion (unterordnendes Bindewort, z. B. „weil")

sub|po|lar *lat.* (Geogr.: zwischen Polarzone u. gemäßigter Klimazone gelegen)

sub|se|ku|tiv *lat.* (veralt. für: nachfolgend); sub|se|quent (den weicheren Schichten folgend [von Nebenflüssen])

sub|si|di|är, sub|si|dia|risch *lat.* (helfend, unterstützend; zur Aushilfe dienend); Sub|si|dia|ris|mus *m*; - u. Sub|si|dia|ri|tät (gegen den Zentralismus gerichtete Anschauung, die dem Staat nur die helfende Ergänzung der Selbst-

verantwortung kleiner Gemeinschaften, bes. der Familie, zugestehen will) w; -; Sub|si|dia|ri|täts|prin|zip; Sub|si|di|um (veralt. für: Rückhalt, Unterstützung) s; -s, ...ien [...i᷊ⁿ]; Sub|si|di|en [...i᷊ⁿ] (veralt. für: Hilfsgelder)
Sub|si|stenz lat. (veralt. für: [Lebens]unterhalt) w; -, -en; sub|si|stenz|los (veralt.); Sub|si|stenz|mit|tel s (veralt.; meist Mehrz.); sub|si|stie|ren (veralt. für: seinen [Lebens]unterhalt haben)
Sub|skri|bent lat. (Vorausbesteller von Büchern); ↑ R 268; sub|skri|bie|ren; Sub|skrip|ti|on [...zion] (Vorausbestellung von erst später erscheinenden Büchern [durch Namensunterschrift]); Sub|skrip|ti|ons_ein|la|dung, ...preis (vgl. ²Preis), ...schein
sub spe|cie aeter|ni|ta|tis lat. [-βpeʒi-e ät...] (unter dem Gesichtspunkt der Ewigkeit); Sub|spe|zi|es lat. [...iäß] (in der Tier- u. Pflanzensystematik Bez. für: Unterart) w; -, -
Sub|stan|tia|li|tät lat. [...βtanzia...] (Wesentlichkeit, Substanzsein) w; -; sub|stan|ti|ell (wesenhaft, wesentlich; stofflich; materiell; nahrhaft); sub|stan|ti|ieren (Philos.: etwas als Substanz unterlegen, begründen); Sub|stan|tiv [auch: ...tif] (Sprachw.: Hauptwort, Dingwort, Nomen, z. B. „Haus, Wald, Ehre") s; -s, -e [...wᵉ]; sub|stan|ti|vie|ren [...wi-rᵉn] (Sprachw.: zum Hauptwort machen; als Hauptwort gebrauchen, z. B. „das Schöne, das Laufen"); sub|stan|ti|viert; Sub|stan|ti|vie|rung; sub|stan|ti|visch [auch: ...iwisch] (hauptwörtlich); Sub|stanz (Wesen; körperl. Masse, Stoff, Bestand[teil]); Philos.: Dauerndes, Beharrendes, bleibendes Wesen, Wesenhaftes, Urgrund, auch: Materie) w; -, -en
sub|sti|tu|ieren lat. (Philos.: einen Begriff an die Stelle eines anderen setzen, [dafür] einsetzen); Sub|sti|tu|ierung; Sub|sti|tut (Stellvertreter, Ersatzmann, Untervertreter; Verkaufsleiter) m; -en, -en (↑ R 268); Sub|sti|tu|tin w; -, -nen; Sub|sti|tu|ti|on [...zion] (Stellvertretung, Ersetzung); Sub|sti|tu|ti|ons_ef|fekt (Wirtschaft), ...gü|ter (Mehrz.)
Sub|strat lat. (Unterlage; Grundlage; Nährboden; Substanz) s; -[e]s, -e
sub|su|mie|ren lat. (ein-, unterordnen; Philos.: einen Begriff von engerem Umfang einem Begriff von weiterem Umfang unterordnen; Rechtsw.: einen Sachverhalt rechtlich würdigen, d. h. prüfen,

ob er die Tatbestandsmerkmale einer Rechtsnorm erfüllt); Subsum|ti|on [...zion]; sub|sum|tiv (Philos.: unterordnend; einbegreifend)
Sub|teen amerik. [βặbtịn] (ugs. für: Mädchen, auch Junge im Alter von etwa zehn Jahren) m; -s, -s (meist Mehrz.)
sub|til lat. (zart, fein, sorgsam; spitzfindig, schwierig); Sub|ti|li|tät
Sub|tra|hend lat. (abzuziehende Zahl) m; -en, -en (↑ R 268); sub|tra|hie|ren (Math.: abziehen, vermindern); Sub|trak|ti|on [...zion] (Abziehen); Sub|trak|ti|ons|ver|fah|ren
Sub|tro|pen lat.; gr. (Geogr.: Gebiete des thermischen Übergangs von den Tropen zur gemäßigten Klimazone) Mehrz.; sub|tro|pisch [auch: ...trọ...] (Geogr.: zwischen Tropen u. gemäßigter Zone gelegen)
Sub|urb engl. [βạbö᷊b] (engl. Bez. für: Vorstadt; amerik. Trabantenstadt) w; -, -s; sub|ur|bi|ka|risch lat. (zu Rom gehörend) -es Bistum
sub|ve|nie|ren lat. [...we...] (veralt. für: zu Hilfe kommen); Sub|ven|ti|on [...zion] (zweckgebundene Unterstützung aus öffentl. Mitteln); sub|ven|tio|nie|ren; Sub|ven|ti|ons|be|geh|ren
Sub|ver|si|on lat. [...wär...] (Umsturz); sub|ver|siv (zerstörend, umstürzlerisch, Umsturz...)
sub vo|ce lat. [- wọʒe] (Sprachw.: unter dem [Stich]wort; Abk. s. v.)
Such_ak|ti|on ...ar|beit, ...dienst; Su|che w; -, (Jägerspr.:) -n; auf der - sein; auf die - gehen; su|chen; Su|cher; Su|che|rei (ugs.); Such_li|ste, ...mel|dung
Sucht (Krankheit; krankhaftes Verlangen [nach Rauschgift]) w; -, Süchte; süch|tig; Süch|tig|keit w; -
suckeln [Trenn.: suk|keln (mdal. für: in kleinen Zügen) saugen]; ich ...[e]le (↑ R 327)
Su|cre span. [βu̯kr᷊] (ecuadorian. Münzeinheit; 1 Sucre = 100 Centavos) m; -, -
Sud (veralt., aber noch mdal. für: Sieden; Wasser, in dem etwas gekocht worden ist) m; -[e]s, -e
¹Süd (Himmelsrichtung; Abk.: S); Nord und Süd; (fachspr.:) der Wind kommt aus -; (bei Ortsnamen:) Frankfurt (Süd); vgl. Süden; ²Süd (dicht. für: Südwind) m; -[e]s, (selten:) -e; der warme Süd blies um das Haus; Süd|afri|ka; Süd|afri|ka|ner; süd|afri|ka|nisch, aber (↑ R 198): die Südafri-

kanische Union (ehem. Bez. für: Republik Südafrika); Süd|ame|ri|ka; Süd|ame|ri|ka|ner; süd|ame|ri|ka|nisch
Su|dan arab. [auch: sud...] (Staat in Mittelafrika) m; -s; Su|da|ner vgl. Sudanese; Su|da|ne|se (Bewohner des Sudans) m; -n, -n (↑ R 268); su|da|ne|sisch; su|da|nisch vgl. sudanesisch
süd|asia|tisch; Süd|asi|en
Su|da|ti|on lat. [...zion] (Med.: Schwitzen) w; -; Su|da|to|ri|um (Med.: Schwitzbad, -kasten) s; -s, ...ien [...i᷊ⁿ]
Süd|au|stra|li|en; Süd|ba|den; vgl. Baden; Süd|da|ko|ta (Staat in den USA; Abk.: S. Dak., S. D.); süd|deutsch, aber (↑ R 224): Süddeutscher Rundfunk (Abk.: SDR); vgl. deutsch; Süd|deutsche m u. w; Süd|deutsch|land
Su|del schweiz. (flüchtiger Entwurf, Kladde) m; -s, -; Su|de|lei (ugs.); Su|de|ler, Sud|ler (ugs.): su|de|lig; sud|lig (ugs.)
Su|del|koch [zu: sieden] m
su|deln (ugs.); ich ...[e]le (↑ R 327); Su|del|wet|ter (landsch.)
Sü|den (Himmelsrichtung; Abk.: S) m; -s; der Wind kommt aus -; gen Süden; vgl. Süd; Süder|dith|mar|schen (Landkreis in Schleswig-Holstein); Sü|der|oog (eine Hallig)
Su|de|ten (Gebirge in Mitteleuropa) Mehrz.; su|de|ten|deutsch; Su|de|ten|land; su|de|tisch (die Sudeten betreffend)
Süd|eu|ro|pa; süd|eu|ro|pä|isch; Süd|frank|reich; Süd|frucht (meist Mehrz.); Süd|früch|ten_händ|ler (österr.), ...hand|lung (österr.); Süd|hang
Sud|haus (bei der Bierherstellung)
Süd|hol|land; Süd|ita|li|en; Süd|ka|ro|li|na (Staat in den USA; Abk.: S. C.); Süd-Ko|rea (meist:)
Süd|ko|rea (↑ R 206); Süd|kü|ste; Süd|län|der m; Süd|län|de|rin w; -, -nen; süd|län|disch; s[üdl]. Br. = südlicher Breite
Süd|ler, Su|de|ler (veralt.)
süd|lich; der Breite (Abk.: s[üdl]. Br.); - des Waldes, - vom Wald; - von München (selten: - Münchens); -er Sternenhimmel, aber (↑ R 224): das Südliche Kreuz (Sternbild)
süd|lig, su|de|lig (ugs.)
Süd|nord|ka|nal (Kanal in Nordwestdeutschland) m; -s; ¹Süd|ost (Himmelsrichtung; Abk.: SO) m; -[e]s; ²Süd|ost (Wind) m; -[e]s, (selten:) -e; Süd|ost_asien; Süd|osten (Abk.: SO) m; -s; gen Südosten; vgl. Südost; süd|öst|lich; Süd|ost|wind; Süd|pol m; -s; Süd|po|lar_ex|pe|di|ti|on, ...land (Mehrz. ...länder),

...meer; Süd|rho|de|si|en; Süd|see (Pazifischer Ozean, bes. der südl. Teil) w; -; Süd|see|in|su|la|ner (↑ R 148); Süd|sei|te; Süd|sla|we m; -n, -n (↑ R 268); Süd|sla|win; süd|sla-wisch; Süd|staa|ten (in den USA) Mehrz.; Süd|süd|ost (Himmels-richtung; Abk.: SSO); Süd|süd-osten (Abk.: SSO) m; -s; Süd|süd-west (Himmelsrichtung; Abk.: SSW); Süd|süd|we|sten (Abk.: SSW) m; -s; Süd|ti|rol (Gebiet der Provinz Bozen; hist.: der 1919 an Italien gefallene Teil des alt-österr. Kronlandes Tirol); Süd|ti-ro|ler; süd|ti|ro|lisch; Süd-Vi|et-nam, (meist:) Süd|vi|et|nam [auch: ...wiät...] (↑ R 206); Süd-vi|et|na|me|se; süd|vi|et|na|me-sisch; süd|wärts; Süd|wein; Süd-welt (veralt.) w; -; ¹Süd|west (Himmelsrichtung; Abk.: SW); ²Süd|west (Wind) m; -[e]s, -e; Süd-west|afri|ka (Treuhandgebiet); süd|west|deutsch; vgl. deutsch; Süd|west|deutsch|land; Süd|we-sten (Abk.: SW) m; -s; gen Südwe-sten; Süd|we|ster (wasserdichter Seemannshut) m; -s, -; süd|west-lich; Süd|west|staat (anfängl. Bez. des Landes Baden-Württem-berg; m; -[e]s, ...wind; Süd-wind

Sues (ägypt. Stadt); Su|es|ka|nal; ↑ R 201 (zwischen Mittelmeer u. Rotem Meer) m; -s

Suez (fr. Schreibung von: Sues)

Süff (ugs.) m; -[e]s; der stille -; Süf-fel landsch. (Säufer) m; -s, -; suf-feln (österr. neben: süffeln); süf-feln (ugs. für: gern trinken); ich ...[e]le (↑ R 327); süf|fig (ugs. für: gut trinkbar, angenehm schmek-kend); ein -er Wein

Süf|fi|sance fr. [...sãgß] (Selbst-gefälligkeit; Spott) w; -; süf|fi-sant (selbstgefällig; spöttisch)

Suf|fix lat. (Sprachw.: Nachsilbe, z. B. „-heit" in „Weisheit") s; -es, -e

suf|fi|zi|ent lat. (Med.: hinläng-lich, genügend, ausreichend); Suf|fi|zi|enz (Med.: Hinlänglich-keit, ausreichendes Vermögen) w; -

Süff|ler, Süff|ling (veralt., aber ge-legentlich noch landsch. für: jmd., der gern u. viel trinkt)

Suf|fra|gan lat. (einem Erzbischof unterstellter Diözesanbischof) m; -s, -e; Suf|fra|get|te engl. (engl. Frauenrechtlerin) w; -, -n

Suf|fu|si|on lat. (Med.: Blutaus-tritt unter die Haut)

Su|fis|mus [von arab. Sufi = Asket im Wollkleid] (asketisch-mysti-sche Richtung im Islam) m; -; Su|fist (↑ R 268)

Su|gam|brer (Angehöriger eines germ. Volkes) m; -s, -

sug|ge|rie|ren lat. (seelisch beein-flussen; etwas einreden); sug|ge-sti|bel (beeinflußbar); ...i|ble Menschen; Sug|ge|sti|bi|li|tät (Empfänglichkeit für Beeinflus-sung) w; -; Sug|ge|sti|on (seelische Beeinflussung); sug|ge|stiv (see-lisch beeinflussend; verfänglich); Sug|ge|stiv|fra|ge (Frage, die dem Partner eine bestimmte Ant-wort in den Mund legt)

Suh|le (Lache; feuchte Bodenstel-le) w; -; suh|len, sich (Jägerspr. vom Rot- und Schwarzwild: sich in einer Suhle wälzen)

Süh|ne w; -, -n; Süh|ne|al|tar, ...geld, ...ge|richt, ...maß|nah|me; süh|nen; Süh|ne|rich|ter, ...ter-min, ...ver|such; Sühn|op|fer; Süh-nung

sui ge|ne|ris lat. (nur durch sich selbst eine Klasse bildend, einzig, besonders)

Sui|te fr. [ßwit°] (Gefolge [eines Fürsten]; Folge von [Tanz]sät-zen) w; -, -n; vgl. à la suite; Sui-tier [ßwitig] (veralt. für: lustiger Bruder; Schürzenjäger) m; -s, -s

Sui|zid lat. (Selbstmord) m (auch: s); -[e]s, -e; sui|zi|dal (selbstmör-derisch); Sui|zi|dent (Selbstmör-der); ↑ R 268

Su|jet fr. [ßüsche] (Gegenstand; Stoff; [künstler.] Aufgabe, The-ma) s; -s, -s

Suk|ka|de roman. (kandierte Fruchtschale) w; -, -n

Suk|ku|bus lat. (weibl. Buhlteufel des mittelalterl. Volksglaubens) m; -, ...kuben; vgl. Inkubus

suk|ku|lent lat. (Biol.: saftvoll, flei-schig); Suk|ku|len|te (Pflanze trockener Gebiete) w; -, -n; Suk-ku|lenz (Bot.: Saftfülle) w; -

suk|ze|die|ren lat. (veralt. für: nachfolgen); Suk|zeß (veralt. für: Erfolg) m; ...esses, ...esse; Suk-zes|si|on (Rechtsnachfolge; Thronfolge); Suk|zes|si|ons|staat (Nachfolgestaat; Mehrz. ...staa-ten); suk|zes|siv (allmählich ein-tretend; auch für: sukzessive); suk|zes|si|ve [...ßiw°] (Umstands-wort; allmählich, nach und nach); Suk|zes|sor (veralt. für: [Rechts]-nachfolger) m; -s, ...oren

¹Su|la|mith [auch: ...mit] (w. Vorn.); ²Su|la|mith, (ökum.:) Schu|lam|mit (bibl. w. Eigenn.)

Su|lei|ka (w. Vorn.)

Sul|fat lat. (Salz der Schwefelsäu-re) s; -[e]s, -e; Sul|fid (Salz der Schwefelwasserstoffsäure) s; -[e]s, -e; sul|fi|disch (Schwefel ent-haltend); Sul|fit (Salz der schwef-ligen Säure) s; -s, -e; Sul|fit|lau|ge

eines Salzwerkes; niederd. für: Pfuscher)

Sul|fon|amid (wirksames chemo-therapeutisches Heilmittel gegen Infektionskrankheiten) s; -[e]s, -e (meist Mehrz.); Sul|fur lat. (Schwefel, chem. Grundstoff; Zeichen: S) s; -s

Sul|ky engl. (zweirädriger Wagen für Trab-rennen) r; -s, -s

Süll (niederd. für: Unterschwelle, Rand; Seemannsspr.: Lukenein-fassung) m od. s; -[e]s, -e

Sul|la (röm. Feldherr u. Staats-mann)

Sul|tan arab. („Herrscher"; Titel mohammedan. Herrscher) m, -s, -e; Sul|ta|nat (Sultansherrschaft) s; -[e]s, -e; Sul|ta|nin w; -, -nen; Sul|ta|ni|ne (große kernlose Ro-sine) w; -, -n

Sulz w; -, -en u. Sul|ze südd., österr., schweiz. (Sülze) w; -, -n; Sül|ze (Fleisch od. Fisch in Gal-lert) w; -, -n; sul|zen südd., österr., schweiz. (sülzen) du sulzt (sul-zest); gesulzt; sül|zen; du sülzt (sülzest); gesülzt

Sülz|hayn (Ort am Südrand des Harzes)

Sülz|ko|te|lett

Su|mach arab. (Schmack [Gerb-stoffe lieferndes Holzgewächs]) m; -s, -e

Su|ma|tra [auch: su...] (zweitgröß-te der Großen Sundainseln)

Su|mer (das alte Südbabylonien)

Su|me|rer (Angehöriger der älte-sten Volkes in Südbabylonien) m; -s, -; su|me|risch; vgl. deutsch; Su-me|risch (Sprache) s; -[s]; vgl. Deutsch; Su|me|ri|sche s; -n; vgl. Deutsche s

summ!; summ, summ!

Sum|ma lat. (in der Scholastik die zusammenfassende Darstellung von Theologie u. Philosophie; veralt. für: Summe; Abk.: Sa.) w; -, Summen; vgl. in summa; sum|ma cum lau|de [- kum -] (höchstes Prädikat bei Doktor-prüfungen: mit höchstem Lob, ausgezeichnet); Sum|mand (hin-zuzuzählende Zahl) m; -en, -en (↑ R 268); sum|ma|risch (kurz zu-sammengefaßt); -ste (↑ R 294); Sum|ma|ri|um (veralt. für: kurze Inhaltsangabe, Inbegriff) s; -s, ...ien [...i°n]; sum|ma sum|ma|rum (alles in allem); Sum|ma|ti|on [...zion] (Math.: Bildung einer Summe, Aufrechnung); Süm|m-chen, Sümm|lein; Sum|me w; -, -n; ¹sum|men, sich (veralt. für: sich summieren, anwachsen)

²sum|men (leise brummen)

Sum|men_bi|lanz (Wirtsch.), ...ver|si|che|rung (Wirtsch.)

Sum|mer (Apparat, der Summ-
od. Pfeiftöne erzeugt); Sum|mer-
zei|chen
sum|mie|ren lat. (zusammenzäh-
len, vereinigen); sich - (anwach-
sen); Sum|mie|rung; Summ|lein,
Sümm|chen
Summ|ton
Sum|mum bo|num lat. (Philos.:
höchstes Gut; Gott) s; - -; Sum-
mus Epi|sco|pus [- ...ßko...] (ober-
ster Bischof, Papst; früher:
Landesherr als Oberhaupt der ev.
Landeskirchen in Deutschland)
m; - -
Sum|per österr. ugs. (Spießer,
Banause) m; -s, -
Sumpf m; -[e]s, Sümpfe; Sumpf-
_blü|te (abschätzig; ...bo|den;
Sümpf|chen, Sümpf|lein; Sumpf-
dot|ter|blu|me; sump|fen (veralt.
für: sumpfig sein, werden; ugs.
für: liederlich leben); sümp|fen
(Bergmannsspr.: entwässern;
Töpferei: kneten); Sumpf_fie|ber
(für: Malaria), ...ge|gend, ...huhn
(auch scherzh. ugs. für: unsolider
Mensch); sump|fig; Sumpf|land s;
-[e]s; Sümpf|lein, Sümpf|chen;
Sumpf_ot|ter (Nerz), ...pflan|ze,
...zy|pres|se
Sums nordd. u. mitteld. (Gesum-
me; Gerede) m; -es; [einen] gro-
ßen - (ugs. für: viel Aufhebens)
machen; sum|sen (landsch.); du
sumst (sumsest)
Sund (Meerenge, bes. die zwischen
Ostsee u. Kattegat) m; -[e]s, -e
Sun|da|in|seln; ↑R 201 (südost-
asiat. Inselgruppe) Mehrz.; die
Großen, die Kleinen -
Sün|de w; -, -n; Sün|den_ba|bel
(meist scherzh.; s; -s), ...be|kennt-
nis, ...bock (ugs.), ...fall m, ...last,
...lohn; sün|den|los, sünd|los;
Sün|den|lo|sig|keit, Sünd|lo|sig-
keit w; -; Sün|den_pfuhl (veräcntl.
od. scherzh.), ...re|gi|ster (ugs.),
...ver|ge|bung; Sün|der; Sün|de-
rin w; -, -nen; Sün|der|mie|ne
(ugs.); Sünd|flut (volksmäßige
Umdeutung von: Sintflut; vgl.
d.); sünd|haft; (ugs.:) - teuer
(überaus teuer); Sünd|haf|tig|keit
w; -; sün|dig; sün|di|gen; sünd|lich
(landsch.); sünd|los, sün|den|los;
Sünd|lo|sig|keit, Sün|den|lo|sig-
keit w; -; sünd|teu|er österr. (über-
aus teuer)
Sun|nit (Angehöriger einer mo-
hammedan. Sekte) m; -en, -en
(↑R 268)
Sün|tel (Bergzug im Weserbergland)
m; -s
¹Suo|mi (finn. Name für: Finn-
land); ²Suo|mi (finn. Sprache) s; -
su|per lat. (ugs. für: hervorragend,
großartig); das war -, eine -
Schau; sie haben - gespielt; Su-

per (Kurzform von: Superhetero-
dynempfänger) m; -s, -; su|per...
(über...); Su|per... (Über...); su-
perb österr. (svw. süperb); sü|perb
fr. (vorzüglich; prächtig); su|per-
fein (sehr fein); Su|per|het (Kurz-
form von: Superheterodynemp-
fänger) m; -s, -s; Su|per|he|te|ro-
dyn|emp|fän|ger lat.; gr.; dt.
(Überlagerungsempfänger mit
hoher Verstärkung, guter Reg-
lung u. hoher Trennschärfe); Su-
per|in|ten|dent lat. [auch; sup^e_r...]
(höherer ev. Geistlicher); ↑R 268;
Su|per|in|ten|den|tur (Superin-
tendentenamt, -wohnung) w; -,
-en; Su|pe|ri|or (Oberer, Vorge-
setzter, bes. in Klöstern) m; -s,
...oren; Su|pe|rio|rin w; -, -nen;
Su|pe|rio|ri|tät (Überlegenheit;
Übergewicht) w; -; Su|per|kar|go
lat.; span. (Seemannsspr. u.
Kaufmannsspr.: bevollmächtig-
ter Frachtbegleiter) m; -s, -s; su-
per|klug (ugs.); Su|per|la|tiv
[auch ...tif] (Sprachw.: 2. Steige-
rungsstufe, Höchststufe, Meist-
stufe, z. B. „schönste"; bildl.:
Übersteigerung) m; -s, -e [...w^e];
su|per|la|ti|visch [auch: ...ti-
wisch]; su|per|leicht (sehr leicht);
Su|per|mar|ket amerik. [ßup^e_r-
ma^i_k^e_t] m; -s, -s u. Su|per|markt
(großes Warenhaus mit Selbstbe-
dienung, umfangreichem Sorti-
ment u. niedrigen Preisen [oft au-
ßerhalb der Verkehrszentren ge-
legen]); su|per|mo|dern (sehr mo-
dern); Su|per|na|tu|ra|lis|mus vgl.
Supranaturalismus; su|per|na|tu-
ra|li|stisch vgl. supranaturali-
stisch; Su|per|no|va (Astron.: bes.
lichtstarke Nova), vgl. ¹Nova;
Su|per|phos|phat lat.; gr. (ein
Düngemittel); Su|per|re|vi|si|on
[...wi...] (Wirtsch.: Nach-, Über-
prüfung); su|per|schnell (sehr
schnell); Su|per|star (bes. großer,
berühmter Star); vgl. ²Star; Su-
per|sti|ti|on [...zion] (veralt. für:
Aberglaube) w; -; su|per|sti|ti|ös
(veralt. für: abergläubisch); -este
(↑R 292)
Su|pi|num (lat. Zeitwortform) s;
-s, ...na
Süpp|chen, Süpp|lein; Sup|pe w; -,
-n
Sup|pé [ßupę] (österr. Komponist)
Sup|pen_fleisch, ...grün (s; -s),
...huhn, ...kas|par (Gestalt aus
dem Struwwelpeter; m; -s; ↑R
195), ...kas|per (ugs. für: ein
Kind, das seine Suppe nicht essen
will), ...löf|fel, ...nu|del, ...schüs-
sel, ...tel|ler, ...ter|ri|ne, ...wür|fel;
sup|pig
Sup|ple|ant fr. schweiz. (Ersatz-
mann [in einer Behörde]) m; -en,
-en (↑R 268)

Süpp|lein, Süpp|chen
Sup|ple|ment lat. (Ergänzung[s-
band, -teil]; Ergänzungswinkel)
s; -[e]s, -e; Sup|ple|ment_band m,
...lie|fe|rung, ...win|kel (Streck-
winkel, gestreckter Winkel); Sup-
plent österr. (Hilfslehrer); ↑R
268; sup|ple|to|risch (veralt. für:
ergänzend, stellvertretend, nach-
träglich); sup|plie|ren (veralt. für:
ergänzen, ausfüllen, vertreten)
Sup|pin|burg, Lothar von (dt.
Kaiser)
sup|po|nie|ren lat. (voraussetzen;
unterstellen)
Sup|port lat. (schlittenförmiger
Werkzeugträger auf dem Bett ei-
ner Drehbank) m; -[e]s, -e; Sup-
port|dreh|bank
Sup|po|si|ti|on lat. [...zion] (Vor-
aussetzung; Unterstellung); Sup-
po|si|to|ri|um (Med.: Arzneizäpf-
chen) s; -s, ...ien [...i^e_n]; Sup|po|si-
tum („Vorausgesetztes"; veralt.
für: Annahme) s; -s, ...ta
Sup|pres|si|on lat. (Med.: Unter-
drückung; Zurückdrängung);
sup|pres|siv (unterdrückend, zu-
rückdrängend); sup|pri|mie|ren
(unterdrücken; zurückdrängen)
Sup|pu|ra|ti|on lat. [...zion] (Med.:
Eiterung); sup|pu|ra|tiv (Med.: ei-
ternd, eiterig)
su|pra|na|tio|nal (übernational
[von Kongressen, Gemeinschaf-
ten, Parlamenten u. a.])
Su|pra|na|tu|ra|lis|mus, Su|per-
na|tu|ra|lis|mus lat. (Glaube an
Übernatürliches) m; -; su|pra|na-
tu|ra|li|stisch, su|per|na|tu|ra|li-
stisch
Su|pra|por|te vgl. Soporaporte
Su|pra|re|nin Ⓦ (ein Arzneimittel,
synthet. Adrenalin) s; -s
Su|pre|mat lat. m. od. s; -[e]s, -e
u. Su|pre|ma|tie ([päpstl.] Ober-
gewalt; Überordnung) w; -, ...ien;
Su|pre|mat[s]|eid
Su|re arab. (Kapitel des Korans)
w; -, -n
Sur|fing engl. [ßö^rfing] (Wellenrei-
ten, Brandungsreiten [auf einem
Brett]) s; -s
Sur|fleisch österr. (Pökelfleisch)
Surf|ri|ding engl. [ßö^rfraiding] vgl.
Surfing
¹Su|ri|nam (Fluß im nördl. Süd-
amerika) m; -[s]; ²Su|ri|nam (Nie-
derländisch-Guayana); Su|ri|na-
mer; su|ri|na|misch
Sur|plus engl. [ßö^rpl^'ß] (engl.-ame-
rik. Bez. für: Überschuß, Ge-
winn) s; -, -
Su|rre arab. (früher jährlich vom
türk. Sultan der Pilgerka-
rawane nach Mekka gesandtes
Geldgeschenk) w; -, -n
Sur|rea|lis|mus fr. [auch: sür...]
(Kunst- u. Literaturrichtung,

die das Traumhaft-Unbewußte künstlerisch darstellen will); Surrea|list (↑ R 268); sur|rea|li|stisch; sur|ren

Šur|ro|gat *lat.* (Ersatz[mittel, -stoff], Behelf; Rechtsw.: ersatzweise eingebrachter Vermögensgegenstand) *s*; -[e]s, -e; Sur|ro|ga|ti|on [...*zion*] (Rechtsw.: Austausch eines Vermögensgegenstandes gegen einen anderen, der den gleichen Rechtsverhältnissen unterliegt)

Šu|sa (altpers. Stadt)

Šu|san|na, Su|san|ne (w. Vorn.); Šus|chen (Koseform von: Susanna, Susanne); Su|se, Su|si (Kurzformen von: Susanna, Susanne)

Šu|si|ne *it.* (eine it. Pflaume) *w*; -, -n

su|spekt *lat.* (verdächtig)

sus|pen|die|ren *lat.* (zeitweilig aufheben; [einstweilen] des Dienstes entheben; Med.: schwebend aufhängen; Chemie: eine Suspension herbeiführen); Sus|pen|si|on (zeitweilige Aufhebung; [einstweilige] Dienstenthebung; Med.: schwebende Aufhängung; Chemie: Aufschwemmung feinster Stoffe in einer Flüssigkeit); sus|pen|siv (aufhebend, -schiebend); Sus|pen|so|ri|um (Med.: Tragbeutel, Tragverband; Sport: beutelartiger Schutz der männl. Geschlechtsteile) *s*; -s, ...ien [...*iⁿn*]

süß; -este (↑ R 292); am -esten (↑ R 134); süß-sauer (↑ R 158); das süß-saure Bonbon; Süß (Druckw.: geleistete, aber noch nicht bezahlte Arbeit) *s*; -es; Süße *w*; -; sü|ßen (süß machen; veralt. für: süß werden); du süßt (süßest); Süß|holz (eine Pflanzengattung; Droge); Süß|holz|rasp|ler (ugs. für: jmd., der jmdm. mit schönen Worten schmeichelt); Sü|Big|keit; süß|lich; Süß|lich|keit *w*; -; Süß|ling (veralt. für: fader, süßlich tuender Mensch); Süß|most; Süß|mo|ste|rei; Süß|rahm|but|ter; süß-sau|er; vgl. süß; Süß|spei|se, ...stoff, ...wa|ren (*Mehrz.*), ...was|ser (*Mehrz.* ...wasser); Süß|was|ser|tier; Süß|wein

Šust (früher schweiz. für: öffentl. Rast- u. Lagerhaus) *w*; -, -en

Šu|sten *m*; -s, (auch:) Su|sten|paß *m*; ...passes

sus|zep|ti|bel *lat.* (veralt. für: empfänglich; reizbar); ...i|ble Natur; Sus|zep|ti|bi|li|tät (veralt. für: Empfänglichkeit; Reizbarkeit) *w*; -; Sus|zep|ti|on [...*zion*] (Reizaufnahme der Pflanze; veralt. für: An-, Übernahme); sus|zi|pie|ren (von der Pflanze: einen Reiz aufnehmen; veralt. für: an-, übernehmen)

Su|ta|ne vgl. Soutane

Su|tasch vgl. Soutache

Süt|ter|lin|schrift; ↑ R 180 [nach dem dt. Pädagogen u. Graphiker L. Sütterlin] (eine Schreibschrift) *w*; -

Su|tur *lat.* (Med.: [Knochen-, Schädel]naht) *w*; -, -en

Su|um cui|que *lat.* [...*ku*...] (,,jedem das Seine''; Wahlspruch des preuß. Hohen Ordens vom Schwarzen Adler) *s*; - -

SUVA, Su|va = Schweizerische Unfallversicherungsanstalt

s. v. = salva venia; sub voce

SV = Sportverein

sva. = soviel als

Sval|bard *norw.* [*ßwal*...] (norw. Besitzungen im Nordpolarmeer)

SVD = Societas Verbi Divini

SVP = Schweizerische Volkspartei

s. v. v. = sit venia verbo

svw. = soviel wie

SW = Südwest[en]

Swa|hi|li vgl. ¹·²Suaheli

Swap|ge|schäft *engl.; dt.* [*ßwǫp*...] (Devisenaustauschgeschäft)

Swa|si (Bewohner von Swasiland) *m*; -, -; Swa|si|land (in Südafrika); swa|si|län|disch

Swa|sti|ka *sanskr.* (altind. Bez. des Hakenkreuzes) *w*; -, ...ken; Swa|sti|ka|kreuz

Swea|ter *engl.* [*ßwętᵉr*] (,,Schwitzer''; ältere Bez. für: Pullover) *m*; -s, -

Swe|be (Angehöriger eines Verbandes westgerm. Stämme) *m*; -n, -n (↑ R 268); swe|bisch

Swe|den|borg (schwed. Naturphilosoph); Swe|den|bor|gia|ner (Anhänger Swedenborgs)

Swid|bert (m. Vorn.)

Swift (engl.-ir. Schriftsteller)

Swim|ming-pool *engl.* [*ßwǐmǐng-pul*] (Schwimmbecken) *m*; -s, -s

Swi|ne (Hauptmündungsarm der Oder) *w*; -

Swi|ne|gel *niederd.* (Igel) *m*; -s, -

Swi|ne|mün|de (Hafenstadt u. Seebad auf der Insel Usedom)

Swing *engl.* (Stil in der modernen Tanzmusik, bes. im Jazz; Kreditgrenze bei bilateralen Handelsverträgen) *m*; -[s]; swin|gen; swingte; geswingt; Swing|fox

Swiss|air *fr.* [...*ßär*] (schweiz. Luftfahrtgesellschaft) *w*; -

Sy|ba|ris [*sü*...] (antike gr. Stadt in Unteritalien); Sy|ba|rit (Einwohner von Sybaris; veralt. für: Schlemmer, Schwelger) *m*; -en, -en (↑ R 268); sy|ba|ri|tisch (Sybaris od. den Sybariten betreffend; veralt. für: verweichlicht, genußsüchtig); -ste (↑ R 294)

Sy|bel [*sü*...] (dt. Geschichtsforscher)

Syd|ney [*ßjdni*] (Hptst. von Neusüdwales in Australien)

Sye|ne [*sü*...] (alter Name von Assuan); Sye|nit *gr.* (ein Tiefengestein) *m*; -s, -e; Sye|nit_gneis, ...por|phyr

Sy|ko|mo|re *gr.* [*sü*...] (ägypt. Maulbeerfeigenbaum) *w*; -, -n; Sy|ko|mo|ren|holz; Sy|ko|phant (im alten Athen gewerbsmäßiger Ankläger; veralt. für: Verräter, Verleumder) *m*; -en, -en (↑ R 268); sy|ko|phan|tisch (veralt. für: anklägerisch, verräterisch, verleumderisch); -ste (↑ R 294)

Šy|ky|se *gr.* [*sü*...] (Med.: Dartflechte[nbildung]) *w*; -, -n

syll... *gr.* [*sül*...] (mit..., zusammen...); Syll...(Mit..., Zusammen...)

Syl|la|bar *gr.* [*sül*...] *s*; -s, -e u. Syl|la|ba|ri|um (veralt. für: Buchstabierbuch, Abc-Buch, Lesebuch) *s*; -s, ...ien [...*iⁿn*]; syl|la|bie|ren (veralt. für: die Buchstaben silbenmäßig aussprechen); syl|la|bisch (veralt. für: silbenweise); Syl|la|bus (Zusammenfassung; Verzeichnis [der durch den Papst verurteilten Lehren]) *w*; -, - u. ...bi; Syl|lep|se, Syl|lep|sis (Rhet.: ,,Zusammenfassung'', eine Form der Ellipse) *w*; -, ...epsen; syl|lep|tisch

Syl|lo|gis|mus *gr.* [*sü*...] ([Vernunft]schluß vom Allgemeinen auf das Besondere) *m*; -, ...men; syl|lo|gi|stisch

¹Syl|phe *lat.* [*sülfᵉ*] (luftiges Wesen; männl. Luftgeist des mittelalterl. Zauberglaubens) *m*; -n, -n (auch: *w*; -, -n); ↑ R 268; ²Syl|phe (ätherisch zartes weibliches Wesen) *w*; -, -n; Syl|phi|de (weibl. Luftgeist; schlankes, leichtfüßiges Mädchen) *w*; -, -n; syl|phi|den|haft (zart, schlank)

Sylt [*sült*] (eine nordfries. Insel)

Syl|ve|ster vgl. ¹Silvester

Syl|vin [*sülwin*; nach dem fr. Arzt Sylvius] (ein Mineral) *s* (auch: *m*); -s, -e

sym ...*gr.* [*süm*...] zusammen...); Sym... (Mit..., Zusammen...)

Sym|bi|ont *gr.* [*süm*...] (Partner einer Symbiose) *m*; -en, -en (↑ R 268); Sym|bio|se (Biol.: ,,Zusammenleben'' ungleicher Lebewesen zu gegenseitigem Nutzen) *w*; -, -n; sym|bio|tisch (in Symbiose lebend)

Sym|bol *gr.* [*süm*...] ([Wahr]zeichen; Sinnbild; christl. Bekenntnisschrift; Zeichen für eine physikal. Größe) *s*; -s, -e; sym|bol|haft; Sym|bo|lik (sinnbildl. Bedeutung od. Darstellung; Bildersprache;

Verwendung von Symbolen; Theol. veralt. für: Lehre vom dogmat. Unterschied der verschiedenen christl. Bekenntnisse *w*; -; **sym|bo|lisch** (sinnbildlich); -ste (↑ R 294); -e Bücher (Bekenntnisschriften); -e Logik (Behandlung log. Gesetze mit Hilfe von mathemat. Symbolen); **sym|bo|li|sie|ren** (sinnbildlich darstellen); **Sym|bo|li|sie|rung**; **Sym|bo|lis|mus** (von Frankreich ausgehende literar. Strömung als Reaktion auf Realismus und Naturalismus) *m*; -; **Sym|bo|list** (↑ R 268); **sym|bo|li|stisch**; **Sym|bol|kraft** *w*; -; **sym|bol|träch|tig**; **Sym|bol|träch|tig|keit**

Sym|ma|chie *gr. [süm...]* (Bundesgenossenschaft der altgr. Stadtstaaten) *w*; -, ...ien

Sym|me|trie *gr. [süm...]* (Gleich-, Ebenmaß) *w*; -, ...ien; **Sym|me|trie|ach|se** (Math.: Spiegelachse), ...ebe|ne (Math.), ...ver|hält|nis; **sym|me|trisch** (gleich-, ebenmäßig); -ste (↑ R 294)

sym|pa|the|tisch *gr. [süm...]* (von geheimer [Gefühls]wirkung; veralt. für: auf Sympathie beruhend; mitfühlend); -ste (↑ R 294); -e Kur (Wunderkur); -es Mittel (Geheimmittel); -e Tinte (unsichtbare Geheimtinte); **Sym|pa|thie** ([Zu]neigung; Wohlgefallen) *w*; -, ...ien; **Sym|pa|thie|kund|ge|bung**; **Sym|pa|thi|kus** (Med.: Teil des vegetativen Nervensystems; Grenzstrang) *m*; -; **Sym|pa|thi|sant** (jmd., der einer Gruppe od. einer Anschauung wohlwollend gegenübersteht) *m*; -en, -en (↑ R 268); **sym|pa|thisch** (gleichgestimmt; anziehend; ansprechend; zusagend); -ste (↑ R 294); **sym|pa|thi|sie|ren** (übereinstimmen; gleiche Neigung haben); mit jemandem, mit einer Partei -

Sym|pa|tol ⓌⓅ *gr. [süm...]* (ein Heilmittel zur Anregung des Kreislaufes) *s*; -s

Sym|pho|nie vgl. Sinfonie; **Sym|pho|nie|or|che|ster** vgl. Sinfonieorchester; **Sym|pho|ni|ker** vgl. Sinfoniker; **sym|pho|nisch** vgl. sinfonisch

Sym|phy|se *gr. [süm...]* (Med.: Verwachsung; Knochenfuge) *w*; -, -n; **sym|phy|tisch** (zusammengewachsen)

Sym|ple|ga|den *[süm...]* (in der gr. Sage: „zusammenschlagende" Felsen vor dem Eingang ins Schwarze Meer) *Mehrz.*

Sym|po|si|on, **Sym|po|si|um** *gr. [süm...]* (Trinkgelage im alten Griechenland; Tagung, auf der in zwanglosen Vorträgen u. Diskussionen die Ansichten über eine wissenschaftl. Frage festgestellt werden) *s*; -s, ...ien [...*i*ⁿ*n*]

Sym|ptom *gr. [süm...]* (Anzeichen; Vorbote; Kennzeichen; Merkmal; Krankheitszeichen) *s*; -s, -e; **sym|pto|ma|tisch** (anzeigend, warnend; bezeichnend); -ste (↑ R 294); **Sym|pto|ma|to|lo|gie** (svw. Semiotik) *w*; -

syn... *gr. [süm...]* (mit..., zusammen...); **Syn...** (Mit..., Zusammen...)

syn|ago|gal *gr. [süm...]* (den jüd. Gottesdienst od. die Synagoge betreffend); **Syn|ago|ge** *[süm...]* („Versammlung"; gottesdienstl. Versammlungsstätte der Juden) *w*; -, -n

Syn|al|la|ge *gr. [sünalage]* (Rechtsw.: gegenseitiger Vertrag) *w*; -, -n; **syn|al|lag|ma|tisch** (Rechtsw.: gegenseitig); ein -er Vertrag

Syn|alö|phe *gr. [sünalöf"]* (Verslehre: Verschmelzung zweier Silben) *w*; -, -n

syn|an|drisch *gr. [süm...]* (Bot.: mit verwachsenen Staubblättern); -e Blüte

Syn|äre|se, **Syn|äre|sis** *gr. [süm...]* (Zusammenziehung [zweier Selbstlaute zu einer Silbe]) *w*; -, ...resen

Syn|äs|the|sie *gr. [süm...]* (Med.: Miterregung eines Sinnesorgans bei Reizung eines andern; Stilk.: sprachliche Verschmelzung verschiedener Sinneseindrücke) *w*; -, ...ien; **syn|äs|the|tisch**

syn|chron *gr. [sünkrọn]* (gleichzeitig, zeitgleich, gleichlaufend); **Syn|chron|ge|trie|be**; **Syn|chro|ni|sa|ti|on** *[...ziọn]*, Syn|chro|ni|sie|rung (Herstellen der Synchronismus; Zusammenstimmung von Bild, Sprechton u. Musik im Film; bild- und bewegungsechte Übertragung fremdsprachiger Sprechpartien eines Films); **syn|chro|ni|sie|ren** (Zeitwort zu: Synchronisation); **Syn|chro|ni|sie|rung** vgl. Synchronisation; **Syn|chro|nis|mus** (Gleichzeitigkeit; Gleichlauf; zeitl. Übereinstimmung) *m*; -, ...men; **syn|chro|ni|stisch** (Gleichzeitiges zusammenstellend); -e Tafeln; **Syn|chron|ma|schi|ne**, ...mo|tor, ...uhr; **Syn|chro|tron** (Kernphysik: Beschleuniger für geladene Elementarteilchen) *s*; -s, -e (auch: -s)

Syn|dak|ty|lie *gr. [süm...]* (Med.: Verwachsung von Fingern od. Zehen) *w*; -, ...ien

Syn|de|ti|kon ⓌⓅ *gr. [süm...]* („Bindendes"; dickflüssiger Klebstoff) *s*; -s; **syn|de|tisch** (Sprachw.: durch Bindewort verbunden)

Syn|di|ka|lis|mus *gr. [süm...]* (Bez. für sozialrevolutionäre Bestrebungen mit dem Ziel der Übernahme der Produktionsmittel durch autonome Gewerkschaften) *m*; -; **Syn|di|ka|list** (↑ R 268) **Syn|di|kat** (Amt eines Syndikus; Verkaufskartell; Bez. für geschäftlich getarnte Verbrecherorganisation in den USA) *s*; -[e]s. -e; **Syn|di|kus** ([meist angestellter] Rechtsbeistand einer Körperschaft) *m*; -, -se u. ...dizi

Syn|drom *gr. [süm...]* (Med.: Krankheitsbild) *s*; -s, -e

Syn|echie *gr. [süm-ächị]* (Med.: Verwachsung) *w*; -, ...ien

Syn|edri|on *gr. [süm...]* (altgriech. Ratsbehörde; svw. Synedrium) *s*. -s, ...ien [...*i*ⁿ*n*]; **Syn|edri|um** (Hoher Rat der Juden in der gr. u. röm. Zeit) *s*; -s, ...ien [...*i*ⁿ*n*]

Syn|ek|do|che *gr. [süm-äkdoche]* (Rhet.: Setzung des engeren Begriffs für den umfassenderen) *w*; -, -n

syn|er|ge|tisch *gr. [süm...]* (zusammen-, mitwirkend); **Syn|er|gie** (Zusammenwirken) *w*; -; **Syn|er|gis|mus** (Theol.: Lehre vom Zusammenwirken des menschlichen Willens u. der göttlichen Gnade; Med.: Zusammenwirken von Muskeln, Organen [auch: Arzneimitteln]) *m*; -; **syn|er|gi|stisch**

Syn|esis *gr. [süm...]* (Sprachw.: sinngemäß richtige Wortfügung, die strenggenommen nicht den grammatischen Regeln entspricht, z. B. „die Fräulein Meier" statt „das Fräulein Meier") *w*; -, ...esen

Syn|ize|se, **Syn|ize|sis** *gr. [süm...]* (svw. Synärese) *w*; -, ...zesen

Syn|kar|pie *gr. [süm...]* (Bot.: Zusammenwachsen der Fruchtblätter zu einem einzigen Fruchtknoten) *w*; -

syn|kli|nal *gr. [süm...]* (Geol.: zum Muldenkern hin einfallend [von der Gesteinslagerung]); **Syn|kli|na|le**, (auch:) **Syn|kli|ne** (Geol.: Mulde) *w*; -, -n

Syn|ko|pe *gr.* ([*sünkopė*] Sprachw.: Ausfall eines unbetonten Selbstlautes zwischen zwei Mitlauten im Wortinnern, z. B. „ich handle" statt „ich handele"; Verslehre: Ausfall einer Senkung im Vers; Med.: plötzl. Herzstillstand; *[sünkop"]* Musik: Betonung eines unbetonten Taktwertes) *w*; -, ...open; **syn|ko|pie|ren**; **syn|ko|pisch**

Syn|kre|tis|mus *gr. [süm...]* (Vermischung [von Lehren od. Religionen]) *m*; -; **Syn|kre|tist** (↑ R 268); **syn|kre|ti|stisch**

Syn|kri|se, Syn|kri|sis *gr.* [*sün...*] (Philos.: Vergleichung; Zusammensetzung, Mischung) *w; -,* ...kri|sen; syn|kri|tisch (vergleichend; zusammensetzend) Syn|od *gr.* [*sün...*] (früher: oberste russ. Kirchenbehörde) *m; -[e]s,* -e; Heiliger -; syn|odal (die Synode betreffend); Syn|oda|le (Mitglied einer Synode) *m* od. *w; -n,* -n (↑ R 287 ff.); Syn|odal.ver|fas|sung, ...ver|samm|lung; Syn|ode (Kirchenversammlung, bes. die evangelische) *w; -, -n;* syn|odisch (seltener für: synodal) Syn|ökie vgl. Synözie syn|onym *gr.* (Sprachw.: sinnverwandt); -e Wörter; Syn|onym (Sprachw.: sinnverwandtes Wort, z. B. „Frühjahr, Lenz, Frühling") *s; -s, -e;* Syn|ony|mik (Sprachw.: Lehre von den sinnverwandten Wörtern) *w; -;* syn|ony|misch (älter für: synonym) Syn|op|se, Syn|op|sis *gr.* (knappe Zusammenfassung; vergleichende Übersicht; Nebeneinanderreihung der Evangelien des Matthäus, Markus u. Lukas) *w; ,* ...opsen; Syn|op|tik (Meteor.: für eine Wettervorhersage notwendige großräumige Wetterbeobachtung) *w; -;* Syn|op|ti|ker (die Evangelisten Matthäus, Markus u. Lukas) *Mehrz.;* syn|op|tisch (übersichtlich) zusammengestellt, nebeneinandergereiht); -e Evangelien Syn|özie *gr.* [*sün...*] (Zusammenleben verschiedener Organismen, das dem Wirtstieren weder schadet noch nützt) *w; -,* ...ien Syn|tag|ma *gr.* [*sün...*] (Sprachw.: syntaktisch gefügte Wortgruppe, in der jedes Glied seinen Wert erst durch die Fügung bekommt) *s; -s,* ...men od. -ta; syn|tag|ma|tisch (das Syntagma betreffend); syn|tak|tisch (die Syntax betreffend); -er Fehler (Fehler gegen die Syntax); -e Fügung; Syn|tax (Sprachw.: Lehre vom Satzbau, Satzlehre) *w; -, -en* Syn|the|se *gr.* [*sün...*] (Aufhebung des sich in These u. Antithese Widersprechenden in eine höhere Einheit; Zusammenfügung [einzelner Teile zu einem Ganzen]; Aufbau [einer chem. Verbindung]) *w; -,* ...thesen; Syn|the|se|pro|dukt (Kunststoff); Syn|the|si|zer *gr.-engl.* [*ßint°ßaiß°r* od. *ßinth°...*] (ein elektron. Musikgerät); Syn|the|tics [*süntetikß*] (Sammelbez. für synthet. erzeugte Kunstfasern u. Produkte daraus) *Mehrz.;* syn|the|tisch *gr.* (zusammensetzend; Chemie: künstlich hergestellt); -es Urteil; syn-

the|ti|sie|ren (Chemie: aus einfacheren Stoffen herstellen); Syn|the|ton (aus einer ursprüngl. Wortgruppe zusammengezogenes Wort, z. B. „kopfstehen" = „auf dem Kopf stehen") *s; -s,* ...ta Syn|zy|ti|um *gr.* [*sün...*] (mehrkernige, durch Zellenfusion entstandene Plasmamasse) *s; -s,* ...ien [...*i°n*] Sy|phi|lis [*sü...;* nach dem Titel eines lat. Lehrgedichts des 16. Jh.s] (eine Geschlechtskrankheit) *w; -;* sy|phi|lis|krank; Sy|phi|lis|se|rum; Sy|phi|li|ti|ker (an Syphilis Leidender); sy|phi|li|tisch Sy|ra|kus [*sü...*] (Stadt auf Sizilien); Sy|ra|ku|ser (↑ R 199); sy|ra|ku|sisch Sy|rer [*sü...*], (auch:) Sy|ri|er [...*i°r*]; Sy|ri|en [...*i°n*] (Staat im Vorderen Orient) Sy|rin|ge *gr.* [*sürinx°*] (Flieder) *w; -, -n;* ¹Sy|rinx (gr. Nymphe); ²Sy|rinx (Hirtenflöte; Stimmorgan der Vögel) *w; -,* ...ingen sy|risch [*sü...*] (aus Syrien; Syrien betreffend), aber (↑ R 198): die Syrische Wüste Syr|jä|ne [*sür...*] (Angehöriger eines finnisch-ugrischen Volkes) *m; -n, -n* (↑ R 268) Sy|ro|lo|ge [*sü...*] (Erforscher der Sprachen, der Geschichte u. der Altertümer Syriens) *m; -n, -n* (↑ R 268); Sy|ro|lo|gie *w; -* Syr|te *gr.* [*sürt°*] (veralt. für: Untiefe, Sandbank) *w; -, -n;* die Große -, die Kleine - (zwei Meeresbuchten an der Küste Nordafrikas) Sy|stem *gr.* [*sü...*] („Zusammenstellung"; Gliederung, Aufbau; Ordnungsprinzip; einheitlich geordnetes Ganzes; Staatsgebäude; Regierungs-, Staatsform; Einordnung [von Tieren, Pflanzen u. a.] in verwandte od. ähnlich gebaute Gruppen) *s; -s, -e;* Sy|stem.ana|ly|se, ...ana|ly|ti|ker (Fachmann in der elektron. Datenverarbeitung); Sy|ste|ma|tik (planmäßige Darstellung, einheitl. Gestaltung) *w; -, -en;* Sy|ste|ma|ti|ker (auch für: jmd., der alles in ein System bringen will); sy|ste|ma|tisch (das System betreffend; in ein System gebracht, planmäßig, folgerichtig); -ste (↑ R 294); sy|ste|ma|ti|sie|ren (in ein System bringen; systematisch behandeln); Sy|ste|ma|ti|sie|rung; sy|stem_im|ma|nent, ...kon|form; Sy|stem.leh|re; sy|stem.los (planlos); -este (↑ R 292); Sy|stem.ma|na|ge|ment (systematische Unternehmensführung), ...ma|na|ger, ...zwang Sy|sto|le *gr.* [*süßtole,* auch: ...*tol°*]

(Med.: Zusammenziehung des Herzmuskels) *w; -,* ...olen Sy|zy|gie *gr.* (Astron.: Konjunktion u. Opposition von Sonne u. Mond) *w; -,* ...ien [*sü...*] s. Z. = seinerzeit Szcze|cin [*schtschäzjin*] (poln. Name von: Stettin) Sze|ged *ung.,* (dt.:) Sze|ge|din [*ßä...*] (ung. Stadt) Szek|ler [*ßß...,* auch: *ßä...*] (Angehöriger eines ung. Volksstammes) *m; -s,* - Sze|nar *gr.* (Angaben über die Szenenfolge, das szenische Beiwerk u. a.) *s; -s, -e;* Sze|na|ri|um (älter für: Szenar) *s; -s,* ...ien [...*i°n*]; Sze|ne (Bühne, Schauplatz, Gebiet; Auftritt als Unterabteilung des Aktes; Vorgang, Anblick; Zank, Vorhaltungen) *w; -, -n;* Sze|nen_fol|ge, ...wech|sel; Sze|ne|rie (Bühnen-, Landschaftsbild) *w; -,* ...jen; sze|nisch (bühnenmäßig) Szep|ter (österr. meist für: Zepter) szi|en|ti|fisch *lat.* [*ßziän...*] (wissenschaftlich); Szi|en|tis|mus (die auf Wissen u. Wissenschaft gegründete Haltung; Lehre der Szientisten) *m; -;* Szi|en|tist (Angehöriger einer christl. Sekte) *m; -en, -en* (↑ R 268); szi|en|ti|stisch Szil|la *gr.* (eine Heil- u. Zierpflanze, Blaustern) *w; -,* ...llen Szin|til|la|ti|on *lat.* [...*zion*] (Funkeln [von Sternen]; Lichtblitze beim Auftreffen radioaktiver Strahlung auf fluoreszierende Stoffe); Szin|til|la|ti|ons|me|tho|de; szin|til|lie|ren (funkeln, leuchten, flimmern) SZR = Sonderziehungsrecht Szyl|la *gr.* [*ßzüla*] (eindeutschend für *lat.* Scylla, *gr.* Skylla; bei Homer Seeungeheuer in einem Felsenriff in der Straße von Messina) *w; -;* zwischen - und Charybdis (in einer ausweglosen Lage) Szy|ma|now|ski [*schimanofski*], Karol (poln. Komponist) Szy|the usw. vgl. Skythe usw.

T

T (Buchstabe); das T; des T, die T, aber: das t in Rate (↑ R 123); der Buchstabe T, t
t = Tonne
T, τ = Tau
Θ, ϑ = Theta
T = Tera...; chem. Zeichen für: Tritium
T. = Titus
Ta = chem. Zeichen für: Tantal
Tab *engl.* [engl. Ausspr.: *täb*] (vor-

springender Teil einer Karteikarte zur Kenntlichmachung bestimmter Merkmale) *m*; -[e]s, -e u. (bei engl. Aussspr.:) *m*; -s, -s **Ta|bak** *span*. [auch: *ta̲...* u. (bes. österr.:) *...a̲k*] *m*; -s, (für Tabaksorten:) -e; **Ta|bak.̲bau** (*m*; -[e]s), ...brü|he, ...in|du|strie, ...mo|no|pol, ...pflan|zer, ...pflan|zung, ...plan|ta|ge, ...rau|cher; **Ta|baks.̲beu|tel**, ...do|se, ...kol|le|gi|um (hist.), ...pfei|fe; **Ta|bak.̲steu|er** *w*, ...strauch; **Ta|bak.̲tra|fik** (österr.: Laden für Tabakwaren, Briefmarken, Zeitungen u. ä.), ...tra|fi|kant (österr.: Besitzer einer Tabaktrafik); **Ta|bak|wa|ren** *Mehrz.*; **Ta|ba|tie|re** *fr.* (früher für: Schnupftabaksdose; österr. auch noch für: Zigaretten-, Tabaksdose) *w*; -, -n **ta|bel|la|risch** *lat*. (in der Anordnung einer Tabelle; übersichtlich); **ta|bel|la|ri|sie|ren** (übersichtlich in Tabellen [an]ordnen); **Ta|bel|la|ri|sie|rung**; **Ta|bel|le** *w*; -, -n; **Ta|bel|len|form**; **ta|bel|len|för|mig**; **Ta|bel|len.̲füh|rer**, ...platz, ...stand (*m*; -[e]s; Sportspr.); **Ta|bel|lie|rer** (jmd., der eine Tabelliermaschine einstellen und bedienen kann); **Ta|bel|lier|ma|schi|ne** (im Lochkartensystem eingesetzte Büromaschine, die Aufstellungen anfertigt)
Ta|ber|na̲|kel *lat*. (in der kath. Kirche Aufbewahrungsort der Eucharistie [auf dem Altar]; Ziergehäuse in der got. Baukunst) *s* (auch, bes. in der kath. Kirche: *m*); -s, -; **Ta|ber̲|ne** (veralt. Nebenform von: Taverne)
Ta̲|bes *lat*. ([Rückenmarks]-schwindsucht) *w*; -; **Ta̲|bi|ker** (Tabeskranker); **ta̲|bisch**
Ta̲|blar *fr*. [*ta̲blar*] schweiz. (Gestellbrett) *s*; -s, -e; **Ta̲|bleau** [*tablo̲*] (wirkungsvoll gruppiertes Bild, bes. im Schauspiel; veralt. für: Gemälde; österr. auch: übersichtliche Zusammenstellung von einzelnen Tafeln, die einen Vorgang darstellen) *s*; -s, -s; **Ta̲-ble d'hôte** [*tabl꞉do̲t*] ([gemeinschaftliche] Gasthaustafel) *w*; -; **Ta|blet̲|te** (Arznei„täfelchen") *w*; -, -n; **Ta|blet̲|ten.̲röh|re**; **ta|blet-tie̲|ren** (in Tablettenform bringen); **Ta|bli̲|num** *lat*. (getäfelter Hauptraum des altröm. Hauses) *s*; -s, ...na
[1]**Ta̲|bor** (Berg in Israel) *m*; -[s]
[2]**Ta̲|bor** (tschech. Stadt); **Ta|bo|ri̲t** [nach der Stadt Tabor] (strenger Hussit) *m*; -en, -en (↑ R 268)
ta|bu̲ *polynes*. („verboten"; unverletzlich, unantastbar); nur in der Satzaussage: das ist -; **Ta|bu̲** (bei

Naturvölkern die zeitweilige od. dauernde Heiligung eines Menschen oder Gegenstandes mit dem Verbot, ihn anzurühren; allgem.: etwas, wovon man nicht sprechen darf) *s*; -s, -s; es ist ihm ein -; **ta|bu|ie̲|ren**; **Ta|bu|ie̲|rung**; **ta|bui̲|sie̲|ren** vgl. tabuieren
Ta̲|bu|la ra̲|sa *lat*. („abgeschabte Tafel"; meist übertr.: unbeschriebenes Blatt) *w*; - -; aber: tabula rasa machen (reinen Tisch machen, rücksichtslos Ordnung schaffen); **Ta|bu|la̲|tor** (Spaltensteller an der Schreibmaschine) *m*; -s, ...oren
Ta|bu̲|rett *arab.-fr.* (schweiz., sonst veralt. für: niedriger Stuhl ohne Lehne) *s*; -[e]s, -e
ta|chi|nie̲|ren österr. ugs. (faulenzen); **Ta|chi|nie̲|rer** österr. ugs. (Drückeberger, Faulenzer)
Ta̲|chis|mus *nlat*. [*taschi̲...*] (Richtung der abstrakten Malerei, die Empfindungen durch spontanes Auftragen von Farbflecken auszudrücken sucht) *m*; -
Ta̲|cho (ugs. kurz für: Tachometer) *m*; -s, -s; **Ta̲|cho|graph**, Tachy̲|graph *gr.* (selbstschreibender Tachometer) *m*; -en, -en (↑ R 268); **Ta̲|cho|me̲|ter** (Instrument an Maschinen zur Messung der Augenblicksdrehzahl, auch mit Anzeige der Stundenkilometerzahl; Geschwindigkeitsmesser [meist mit einem Kilometerzähler verbunden] bei Fahrzeugen) *m* (auch: *s*); -s, -; **Ta|chy̲|graph** vgl. Tachograph; **Ta|chy|gra|phie̲** (aus Zeichen für Silben bestehendes Kurzschriftsystem des Altertums) *w*; -, ...ien; **ta|chy|graphisch**; **Ta|chy|kar|die̲** (Med.: beschleunigter Herzschlag) *w*; -; **Ta|chy|me̲|ter** (Schnellmesser für Geländeaufnahmen) *s*; -s, -
ta|ci|te̲|isch [*tazi...*], aber (↑ R 179): **Ta|ci|te̲|isch**; **Ta|ci|tus** (altröm. Geschichtsschreiber)
Tack|ling *engl*. [*täk...*]; eigtl. Sliding-tackling (*ß̲la̲iding...*)] (im modernen kampfbetonten Fußball kompromißlos-harte Zerstörung eines Angriffs, wobei der Verteidigende in die Füße des Gegners hineinrutscht) *s*; -s, -s
Täcks, Täks, (österr.:) **Tacks** *engl*. (kleiner keilförmiger Stahlnagel zur Verbindung zur Oberleder und Brandsohle bei der Schuhherstellung) *m*; -es, -e
Tad|dä̲|us vgl. Thaddäus
Ta̲|del *m*; -s, -; **Ta̲|de|lei̲** (ugs.); **ta̲|del|frei**; **ta̲|del|haft**; **ta̲|del|los**; -este (↑ R 292); **ta̲|deln**; ich ...[e]lle (↑ R 327); **ta̲|delns.̲wert**, ...wür-dig; **Ta̲|del|sucht** *w*; -; **ta̲|del|süch|tig**; **Ta̲d|ler**; **Ta̲d|le|rin** *w*; -, -nen

Ta|dschi̲|ke (Angehöriger eines iran. Volkes in Mittelasien) *m*; -n, -n (↑ R 268); **ta|dschi̲|kisch**
Ta̲dsch Maha̲l (Mausoleum bei Agra in Indien)
Tae|kwon̲|do *korean*. (korean. Abart des Karate) *s*; -
Tael [*täl*] (frühere chin. Gewicht) *s*; -s, -s; 5 - (↑ R 322)
Taf. = Tafel; **Ta̲|fel** *w*; -, -n; **ta̲|fel|ar|tig**; **Ta̲|fel.̲auf|satz**, ...berg, ...bild; **Tä̲|fel|chen**, **Tä̲|fe|lein**, **Täf̲|lein**; **Ta̲|fel|en|te**; **ta̲|fel|för|mig**; **Ta̲|fel.̲freu|den** (*Mehrz*.), ...ge|bir|ge, ...ge|rät, ...ge|schirr, ...glas (*Mehrz.* ...gläser), ...leuch|ter, ...ma|le|rei, ...mu|sik; **ta̲|feln** (speisen); ich ...[e]le (↑ R 327); **tä̲|feln** (mit Steinplatten, Holztafeln bekleiden); ich ...[e]lle (↑ R 327); **Ta̲|fel.̲obst**, ...öl, ...run|de, ...sche-re, ...spitz (österr. für eine Rindfleischspeise), ...tuch (*Mehrz*. ...tücher); **Tä̲|fe|lung**, Täf̲|lung; **Ta̲|fel.̲waa|ge**, ...was|ser (*Mehrz*. ...wässer), ...wein, ...werk; **Tä̲|fer** schweiz. (Getäfel) *s*; -s, -; **Tä̲|fe-rung** schweiz. u. westösterr. (Täfelung); **Täf̲|lein** vgl. Täfelein, Tä̲|fel|chen; **Täf̲|lung**, Tä̲|fe|lung
Taft *pers*. ([Kunst]seidengewebe in Leinwandbindung) *m*; -[e]s, -e; **taf̲|ten** (aus Taft); **Taft|kleid**
Tag *m*; -[e]s, -e. I. *Großschreibung*: am, bei Tage; heute über acht Tage, heute in acht Tagen, heute vor vierzehn Tagen; von Tag zu Tag; Tag für Tag; des Tags; eines [schönen] Tages; nächsten Tag[e]s; im Laufe des heutigen Tag[e]s; (Bergmannsspr.:) über Tag, unter Tage; unter Tags (den Tag über); vor Tag[e], vor Tags; den ganzen Tag; guten Tag sagen, bieten; Tag und Nacht. II. *Kleinschreibung* (↑ R 129): tags darauf, tags zuvor; tagsüber; tagaus, tagein; tagtäglich; heutigentags (vgl. d.); heutzutage; tagelang (vgl. d.); zutage bringen, fördern, kommen, treten; Tag... südd., österr. u. schweiz. (in Zusammensetzungen für: Tage..., z. B. Tagbau, Tagblatt, Tagdieb, Taglohn u. a.); **tag̲|aus**, **tag̲|ein**; **Tag̲|dienst** (Ggs.: Nachtdienst); **Ta̲|ge.̲ar|beit** (früher für: Arbeit des Tagelöhners), ...bau (*Mehrz.* ...baue; vgl. Tag...), ...blatt (vgl. Tag...), ...buch, **Ta̲|ge|buch|num-mer** (Abk.: Tgb.-Nr.); **Ta̲|ge.̲dieb** (abschätzig; vgl. Tag...), ...geld; **ta̲|ge|lang**, aber: ganze, mehrere, zwei Tage lang; **Ta̲|ge.̲lied**, ...lohn (vgl. Tag...), ...löh|ner (vgl. Tag...); **ta̲|ge|löh|nern** (vgl. Tag...); ich ...ere (↑ R 327); **Ta̲|ge-marsch** vgl. Tagesmarsch; **ta̲|ge|n**; **Ta̲|ge|rei̲|se**; **Ta̲|ges.̲ab|lauf**,

...an|bruch, ...an|zug, ...ar|beit (Arbeit eines Tages), ...be|darf, ...be|fehl, ...decke [*Trenn.*: ...dek-ke], ...dienst (Dienst an einem bestimmten Tag), ...ein|nah|me, ...er|eig|nis, ...ge|spräch; ta|ges-hell,tag|hell;Ta|ges_kar|te,...kas-se, ...kurs, ...lauf, ...lei|stung, ...licht (*s*; -[e]*s*), ...lo|sung, ...mäd-chen, ...marsch *m*, ...ord|nung, ...po|li|tik, ...pres|se (*w*; -), ...ru-ti|on, ...raum, ...zeit, ...zei|tung

ˈa|ge|tes *lat.* (Studenten-- od. Samtblume) *w*; -

a|ge|wei|se; Tag|ge|werk, Tag-werk (früheres Feldmaß); tägliche Arbeit, Aufgabe); Tag_fahrt (Bergmannsspr.: Ausfahrt aus dem Schacht), ...fal|ter, ...ge|bäu-de (Bergmannsspr.: Schachtge-bäude); tag|hell, ta|ges|hell; ...tä-gig (z. B. sechstägig, mit Ziffer: 6tägig [sechs Tage alt, dauernd]; ↑ R 228); täg|lich (alle Tage); -es Brot; -e Zinsen; -er Bedarf, aber (↑ R 224): die Täglichen Gebete [kath.]; ...täg|lich (z. B. sechstäg-lich, mit Ziffer: 6täglich [alle sechs Tage wiederkehrend]; ↑ R 228); Tag|lohn vgl. Tag...

ˈa|go|re [...*gor*^(e)], Ra|bin|dra-nath (ind. Dichter u. Philosoph)

ˈag|raum österr. (Tagesraum); tags; - darauf, - zuvor; vgl. Tag; Tag_sat|zung (österr. für: be-hördlich bestimmter Termin; schweiz. [früher] für: Tagung der Ständevertreter), ...schicht (Ggs.: Nachtschicht); tags|über; tag-täg|lich; Tag|traum; Tag|und-nacht|glei|che *w*; -, -n; Frühlings-Tagundnachtgleiche; Ta|gung; Ta|gungs_ort, ...teil|neh|mer; Tag|wa|che österr., schweiz. (Weckruf der Soldaten); Tag-wacht schweiz. (Weckruf der Sol-daten); Tag|werk vgl. Tagewerk

ˈai|fun *chin.* (Wirbelsturm in den Zonen der Roßbreiten) *m*; -s, -e

ˈai|ga *russ.* (sibirischer Waldgür-tel) *w*; -

...ˈail|le *fr.* [*talj*^e, österr.: *talj*^e] (schmalste Stelle des Rumpfes; Gürtelweite; Mieder; Karten-spiel: Aufdecken der Blätter für Gewinn oder Verlust) *w*; -, -s; ˈTail|leur [*tajör*] (fr. Bez. für: Schneider) *m*; -s, -s; ²Tail|leur schweiz. (Schneiderkleid, Jak-kenkleid) *s*; -s, -s; tail|lie|ren [*tajir*^en]; ...tail|lig [*taljich*] (z. B. kurz-taillig)

ˈaine [*tän*] (fr. Geschichtsschrei-ber)

ˈai|wan (Republik China; chin. u. jap. Name für: Formosa)

Ta|jo [*tącho*] (span.-port. Fluß) *m*; -[s]; vgl. Tejo

Take *engl.* [*te'k*] (Film, Fernsehen: einzelne Szenenaufnahme, Sze-nenabschnitt) *m* od. *s*; -, -s

Ta|kel niederd. (schwere Talje; Takelage) *s*; -s, -; Ta|ke|la|ge [...*asch*^e; mit fr. Endung] (Segel-ausrüstung eines Schiffes); Ta-ke|ler, Tak|ler (im Takelwerk Ar-beitender), ta|keln; ich ...[e]le (↑ R 327); Ta|ke|lung, Tak|lung; Ta-kel|werk *s*; -[e]s

Täks vgl. Täcks

¹Takt *lat.* (das abgemessene Zeit-maß einer rhythmischen Bewe-gung, bes. in der Musik; Bewe-gung der Töne nach einem zähl-baren Zeitmaß; Metrik: Entfer-nung von Hebung zu Hebung im Vers; Technik: einer von mehre-ren Arbeitsgängen im Motor, Hub; Arbeitsabschnitt in der Fließbandfertigung oder in der Automation) *m*; -[e]s, -e; - halten (↑ R 228); ²Takt *fr.* (Feingefühl; Lebensart; Zurückhaltung) *m*; -[e]s; Takt-feh|ler; takt|fest; Takt|ge|fühl *s*; -[e]s; ¹tak|tie|ren (den Takt ange-ben)

²tak|tie|ren [zu: Taktik] (taktisch vorgehen); Tak|tik *gr.* (Truppen-führung; übertr. für: kluges Ver-halten, planmäßige Ausnutzung einer Lage) *w*; -, -en; Tak|ti|ker; tak|tisch (die Taktik betreffend; übertr. für: planvoll vorgehend); -ste (↑ R 294)

takt|los; -este (↑ R 292); Takt|lo-sig|keit; Takt|maß *s*; takt|mä|ßig; Takt_mes|ser *m*, ...stock (*Mehrz.* ...stöcke), ...stra|ße (Technik), ...strich (Trennstrich zwischen den Takten); takt|voll

Tal *s*; -[e]s, Täler (dicht. veralt.: -e); zu -[e] fahren; tal|ab|wärts

Ta|lar *it.* (langes Amtskleid) *m*; -s, -e; ta|lar|ar|tig

tal_auf|wärts; Tal|bo|den; Täl-chen; Tal|en|ge

Ta|lent *gr.* (altgr. Gewicht und Geldsumme; Begabung, Fähig-keit) *s*; -[e]s, -e; ta|len|tiert (be-gabt); ta|lent|los; -este (↑ R 292); Ta|lent|pro|be; ta|lent|voll

Ta|ler (ehem. Münze) *m*; -s, -; vgl. Joachimstaler; ta|ler|groß; Ta-ler|stück

Tal|fahrt (Fahrt den Strom hinab; Ggs.: Bergfahrt)

Talg (starres [Rinder-, Hammel]-fett) *m*; -[e]s, (Talgarten:) -e; talg-ar|tig; Talg|drü|se; tal|gen; tal-gig; Talg|licht (*Mehrz.* ...lichter)

Ta|li|on *lat.* (Vergeltung durch das gleiche Übel); Ta|li|ons|leh-re (Rechtslehre von der Wieder-vergeltung) *w*; -

Ta|lis|man *gr.* (zauberkräftiger,

glückbringender Gegenstand) *m*; -s, -e

Tal|je *niederl.* (Seemannsspr.: Flaschenzug) *w*; -, -n; tal|jen (See-mannsspr.: aufwinden); Tal|je-reep (Seemannsspr.: Tau *s*)

Talk *arab.* (ein Mineral) *m*; -[e]s; Talk_er|de (*w*; -),pu|der; Tal-kum *arab.* (feiner weißer Talk als Streupulver) \s; -s; tal|ku|mie|ren (Talkum einstreuen)

Tal|ley|rand [*talärạng*] (fr. Staats-mann)

Tal|lin (russ. Schreibung für die Hptst. der Estnischen SSR); Tal-linn (estn. Schreibung von: Tal-lin); vgl. Reval

tal|mi *fr.* österr. (unecht); vgl. tal-min; Tal|mi (vergoldete [Kupfer-Zink-]Legierung; übertr. für: Unechtes) *s*; -s; Tal|mi_glanz, ...gold; tal|min (selten für: aus Talmi; unecht); vgl. talmi; Tal-mi|wa|re

Tal|mud *hebr.* („Lehre"; Samm-lung der Gesetze und religiösen Überlieferungen des nachbibl. Judentums) *m*; -[e]s, -e; tal|mu-disch; Tal|mu|dis|mus *m*; -; Tal-mu|dist (Talmudkenner); ↑ R 268

Tal|mul|de

Ta|lon *fr.* [*talọng*, österr.: ...*lọn*] (Kartenrest [beim Geben], Kar-tenstamm [bei Glücksspielen]; Kaufstein [beim Dominospiel]; Erneuerungsschein bei Wertpa-pieren; Musik: Griffende [„Frosch"] des Bogens) *m*; -s, -s

Tal_schaft (schweiz. u. west-österr.: Land und Leute eines Ta-les; Geogr.: Gesamtheit eines Ta-les und seiner Nebentäler), ...sen-ke, ...soh|le, ...sper|re, ...über|füh-rung; Ta|lung (Geogr.); tal|wärts

Ta|ma|ra (russ. w. Vorn.)

Ta|ma|rin|de *arab.* (trop. Pflan-zengattung) *w*; -, -n

Ta|ma|ris|ke *vulgärlat.* (Pflanze mit immergrünen Blättern) *w*; -, -n

Tam|bour *pers.* [...*bur*] (Trommel-schläger; Trommel; Zwischen-stück bei Kuppelgewölben; mit Stahlzähnen besetzte Trommel an Krempeln [Spinnerei]; Trom-mel zum Aufrollen von Papier) *m*; -s, -e (schweiz.: ...bouren [...*bur*^en]); Tam|bour|ma|jor (Lei-ter eines Spielmannszuges); Tam-bur (Stickrahmen; Stichfeld) *m*; -s, -e; tam|bu|rie|ren (mit Tam-burstichen sticken; bei der Pe-rückenherstellung: Haare zwi-schen Tüll und Gaze einknoten); Tam|bu|rier|stich (flächenfüllen-der Zierstich); Tam|bu|rin (kleine Hand-, Schellentrommel; Stick-rahmen) *s*; -s, -e

Ta|mil (Sprache der Tamilen) *s*;

-[s]; Ta|mi|le (Angehöriger eines vorderind. Volkes) *m*; -n, -n (↑ R 268); ta|mi|lisch; -e Sprache

Tamp *m*; -s, -e u. Tam|pen (Seemannsspr.: Tau-, Kettenende) *m*; -s, -

Tam|pi|ko|fa|ser [nach der mex. Stadt Tampico]; ↑ R 201 (Agavenfaser)

Tam|pon *fr.* [fr. Aussprache: *tangpong*] (Med.: [Watte-, Mull]bausch; Druckw.: Einschwärzballen für den Druck gestochener Platten) *m*; -s, -s; Tam|po|na|de (Med.: Aus-, Zustopfung); tam|po|nie|ren (Med.: [mit Tampons] dicht machen)

Tam|tam *Hindi* [auch: *tamtam*] (chinesisches, mit einem Klöppel geschlagenes Becken; Gong; nur *Einz.* ugs. für: marktschreierischer Lärm, aufdringliche Reklame) *s*; -s, -s

Ta|mu|le usw. vgl. Tamile usw.

tan, (auch:) tang, tg = Tangens

Ta|na|gra [auch: *tan*..., neugr. Ausspr.: *tanehra*] (altgr. Stadt); Ta|na|gra|fi|gur [auch: *tan*...]; ↑ R 201 (Tonfigur aus Tanagra)

Ta|na|na|ri|vo [...*wo*] (Hptst. von Madagaskar)

Tand *lat.* (Wertloses [mit Scheinwert]; Spielzeug) *m*; -[e]s; Tän|de|lei; Tän|de|ler, Tänd|ler (Schäker; landsch. für: Trödler); Tan|del|markt österr. (Tändelmarkt); Tän|del|markt landsch. (Trödelmarkt); tän|deln; ich ...[e]le (↑ R 327)

Tan|dem *lat.-engl.* (Wagen mit zwei hintereinandergespannten Pferden; Zwei- oder Dreirad mit zwei Sitzen hintereinander; Technik: zwei hintereinandergeschaltete Antriebe) *s*; -s, -s; Tan|dem|stra|ße (Technik)

Tand|ler bayr. u. österr. ugs. (Tänd[e]ler); Tänd|ler vgl. Tändeler

tang vgl. tan

Tang *nord.* (Bezeichnung mehrerer größerer Arten der Braunalgen) *m*; -[e]s, -e

Tan|ga [*tangga*] (Stadt in Tanganjika); Tan|ga|nji|ka (Teilstaat der Vereinigten Republik Tansania); Tan|ga|nji|ka|see (↑ R 201) *m*; -s

Tan|gens *lat.* [*tanggänß*] (ein Seitenverhältnis im Dreieck; Zeichen: tan, auch: tang od. tg) *m*; -, -; Tan|gens.kur|ve, ...satz; Tan|gen|te (Gerade, die eine gekrümmte Linie in einem Punkt berührt) *w*; -, -n; Tan|gen|ten|flä|che; tan|gen|ti|al [...*zial*] (eine gekrümmte Linie od. Fläche berührend); tan|gie|ren (berühren [auch übertr.])

Tan|go *span.* [*tanggo*] (ein Tanz) *m*; -s, -s

Tank *engl.* *m*; -s, -s (seltener: -e); tan|ken; Tan|ker (Tankschiff); Tan|ker|flot|te; Tank.fahr|zeug, ...in|halt, ...la|ger

Tank|red (m. Vorn.)

Tank.schiff, stel|le, ...uhr, ...wa|gen, ...wart

Tann (dicht. für: [Tannen]forst, [Tannen]wald) *m*; -[e]s, -e; im - Tann|ast (schweiz. neben: Tannenast)

Tan|nat *fr.* (Gerbsäuresalz) *s*; -[e]s,-e

Tänn|chen, Tänn|lein; Tan|ne *w*; -, -n; tan|nen (aus Tannenholz); Tan|nen.ast, ...baum

Tan|nen|berg (Ort in Ostpreußen)

Tan|nen.hä|her, ...harz *s*, ...holz, ...mei|se, ...na|del, ...wald; Tan|nen|zap|fen, Tann|zap|fen

Tann|häu|ser (ein Minnesänger)

Tann|nicht, Tän|nicht (veralt. für: Tannenwäldchen) *s*; -[e]s, -e

tan|nie|ren *fr.* (mit Tannin behandeln); Tan|nin (Gerbsäure) *s*; -s; Tan|nin|bei|ze

Tänn|lein, Tänn|chen; Tänn|ling (junge Tanne); Tann|zap|fen, Tan|nen|zap|fen

Tan|sa|nia [auch: ...*nia*] (Staat in Afrika); Tan|sa|ni|er [...*i^er*]; tan|sa|nisch; Tan|sa|nit (ein Edelstein) *m*; -s, -e

Tan|se schweiz. (Rückentragegefäß für Milch, Wein, Trauben u. ä.) *w*; -, -n

Tan|tal *gr.* (chem. Grundstoff, Metall; Zeichen: Ta) *s*; -s; Tan|ta|li|de; ↑ R 268 (Nachkomme des Tantalus) *m*; -n, -n (meist *Mehrz.*); Tan|ta|lus (in der gr. Sage König in Phrygien); Tan|ta|lus|qua|len (↑ R 180) *Mehrz.*

Tant|chen; Tan|te *w*; -, -n; tan|ten|haft (abschätzig)

Tan|tes vgl. Dantes

Tan|tie|me *fr.* [*tangtiäm^e*] (Kaufmannsspr.: Gewinnanteil, Vergütung nach der Höhe des Geschäftsgewinnes) *w*; -, -n

Tanz *m*; -es, Tänze; Tanz.abend, ...bar *w*, ...bär, ...bein (in der Wendung: das - schwingen [ugs. für: tanzen]), ...bo|den (*Mehrz.* ...böden), ...ca|fé; Tänz|chen, Tänz|lein; Tanz|die|le; tän|zeln; ich ...[e]le (↑ R 327); tan|zen; du tanzt (tanzest); Tän|zer; Tan|ze|rei; Tän|ze|rin *w*; -, -nen; tän|ze|risch; Tanz.flä|che, ...girl, ...grup|pe, ...ka|pel|le, ...kar|te, ...kränz|chen, ...kunst, ...kurs od. ...kur|sus, ...leh|rer; Tänz|lein, Tänz|chen; Tanz.lied, ...lo|kal; tanz|lu|stig; Tanz.mei|ster, ...mu|sik, ...part|ner, ...part|ne|rin, ...platz, ...saal, ...schritt, ...schu|le,

...sport, ...stun|de, ...tee, ...tur|nier, ...un|ter|richt, ...ver|an|stal|tung

Tao *chin.* [*tau*] („der Weg"; da All-Eine, das absolute, vollkommene Sein in der chin. Philosophie) *s*; -; Tao|is|mus (chin Volksreligion) *m*; -

Ta|per|greis (ugs. abschätzig); ta|pe|rig, tap|rig niederd. (unbeholfen, gebrechlich); ta|pern niederd. (sich unbeholfen bewegen) ich ...ere (↑ R 327)

Ta|pet *gr.* (veralt. für: [Tisch]decke) *s*, noch üblich in: etwas aufs - (ugs.: zur Sprache) bringen; Ta|pe|te (Wandverkleidung) *w*; -, -n; Ta|pe|ten.bahn, ...rol|le ...tür, ...wech|sel; Ta|pe|zier *it* (in Süddeutschland bevorzugte Form für: Tapezierer) *m*; -s, -e; Ta|pe|zier|ar|beit, Ta|pe|zie|rer|beit; ta|pe|zie|ren; Ta|pe|zie|rer; Ta|pe|zie|rer|werk|statt, Ta|pe|zier|werk|statt

Tapf|fe|w; -, -n u. Tapf|fen (Fußspur) *m*; -s, - (meist *Mehrz.*)

tap|fer; Tapf|fer|keit *w*; -; Tapf|fer|keits|me|dail|le

Ta|pio|ka *bras.* (gereinigte Stärke aus Maniokwurzeln) *w*; -; Ta|pio|ka|stär|ke *w*; -

Ta|pir *indian.* [österr.: ...*ir*] (südamerik. u. asiat. Unpaarhufer *m*; -s, -e

Ta|pis|se|rie *fr.* (teppichartige Stickerei; Verkaufsstelle für Handarbeiten) *w*; -, ...ien

tapp!; tapp, tapp!

Tapp (ein Kartenspiel) *s*; -s

tap|pen; tap|pig (landsch.); tap|pisch; -ste (↑ R 294); tap|prig (Nebenform von: taperig); tap|rig vgl. taperig; Taps (landsch. für Schlag; ugs. für: täppischer Bursche) *m*; -es, -e; Hans -; tap|sen (ugs. für: plump auftreten); du tapst (tapsest); tap|sig (ugs.)

Ta|ra *arab.* (die Verpackung u deren Gewicht) *w*; -, ...ren

Ta|ran|tel *it.* (südeurop. Wolfsspinne) *w*; -, -n; Ta|ran|tel|la (süd it. Volkstanz) *w*; -, -s u. ...llen

Ta|rar *fr.* (Getreidereiniger) *m*; -s-e

Tar|busch *pers.* (fesartige Kopfbedeckung) *m*; -[e]s, -e

tar|dan|do *it.* (Musik: zögernd langsam); Tar|dan|do *s*; -s, -s u ...di

Ta|ren (*Mehrz.* von: Tara)

Ta|rent (it. Stadt); Ta|ren|ter, Ta|ren|ti|ner (↑ R 199); ta|ren|ti nisch

Tar|gi (Angehöriger berberische Volksstämme in der Sahara) *m* -[s], Tuareg; vgl. Tuareg

Tar|hon|ya *ung.* [*tarhonja*] (ein ung. Mehlspeise) *w*; -

ta|rie|ren *arab.* (Gewicht eines Gefäßes oder einer Verpackung bestimmen oder ausgleichen); **Ta-rier|waa|ge**

Ta|rif *arab.-fr.* (planvoll geordnete Zusammenstellung von Güter- oder Leistungspreisen, auch von Steuern und Gebühren; Preis-, Lohnstaffel; Gebührenordnung) *m;* -s, -e; **Ta|rif|an|ge|stell|te;** ta-ri|ta|risch, ta|ri|fisch (seltener für: tariflich); **Ta|rif_au|to|no-mie,** ...er|hö|hung, ...grup|pe; **ta-ri|fie|ren** (die Höhe einer Leistung durch Tarif bestimmen; in einen Tarif aufnehmen); **Ta|ri-fie|rung;** **ta|ri|fisch** vgl. tarifarisch; **Ta|rif|kom|mis|si|on;** **ta|rif-lich; Ta|rif|lohn; ta|rif|los; ta|rif-mä|ßig; Ta|rif_ord|nung,** ...part-ner, ...vertrag

Tar|la|tan *fr.* (feines Baumwollod. Zellwollgewebe) *m;* -s, -e

Tarn_an|strich, ...an|zug; **tar|nen;** sich -; **Tarn_far|be,** ...kap|pe, ...man|tel, ...netz; **Tar|nung**

Ta|ro *polynes.* (eine trop. Knollenfrucht) *m;* -s, -s

Ta|rock *it.* (ein Kartenspiel) *s* (österr. nur so) od. *m;* -s, -; **ta-rockie|ren** [*Trenn.:* ta|rok|kie-ren]; **Ta|rock|spiel**

Tar|pe|ji|sche Fels *m;* -n -en od. **Tar|pe|ji|sche Fel|sen** (Richtstätte im alten Rom) *m;* -n -s

Tar|quin, Tar|qui|ni|us (in der röm. Sage Name zweier Könige); **Tar|qui|ni|er** [...*i^er*] (Angehöriger eines etrusk.-röm. Geschlechtes) *m;* -s, -

¹Tar|ra|go|na (span. Stadt); **²Tar-ra|go|na** (ein span. Wein) *m;* -s, -s; **Tar|ra|go|ne|se** *m;* -n, -n (↑ R 268)

Tar|ser; tar|sisch; **¹Tar|sus** *gr.* (Stadt in Kleinasien)

²Tar|sus *gr.* (Fußwurzel; Lidknorpel; aus mehreren Abschnitten bestehender „Fuß" des Insektenbeines) *m;* -, ...sen

Tar|tan|bahn *amerik.* [*tg^′t^en...*] (Leichtathletik: Kunststofflaufbahn)

Tar|ta|ne *it.* (Fischerfahrzeug im Mittelmeer) *w;* -, -n

tar|ta|re|isch *gr.* (zur Unterwelt gehörend, unterweltlich); **Tar|ta-ros;** vgl. **¹Tartarus;** **¹Tar|ta|rus** (Unterwelt, Schattenreich in der gr. Mythologie) *m;* -

²Tar|ta|rus *mlat.* (Weinstein) *m;* -; **Tar|trat** (Salz der Weinsäure) *s;* -[e]s, -e

Tart|sche *fr.* (mittelalterlicher Schild) *w;* -, -n

Tar|tu (estn. Name von: Dorpat)

Tar|tüff [nach einer Gestalt bei Molière] (Heuchler) *m;* -s, -e

Tar|zan (Dschungelheld in Büchern von E. R. Burroughs)

Täsch|chen, Täsch|lein; Ta|sche *w;* -, -n; **Tä|schel|kraut** *s;* -[e]s; **Ta-schen_aus|ga|be,** ...buch, ...dieb, ...fahr|plan, ...for|mat, ...geld, ...ka|len|der, ...kamm, ...krebs, ...lam|pe, ...mes|ser *s,* ...spie|gel, ...spie|ler; **Ta|schen|spie|le|rei;** ta-schen|spie|lern; ich ...ere (↑ R 327); getaschenspielert: zu -; **Ta-schen|tuch** (*Mehrz.* ...tücher), ...uhr, ...wör|ter|buch; **Ta|scherl** bayr. u. österr. ugs. (eine Mehlspeise) *s;* -s, -n; **Täsch|lein,** Täschchen; **Tasch|ner, Täsch|ner** südd. u. österr. (Taschenmacher)

¹as|ma|ni|en [...*i^en*] (austral. Insel); **Tas|ma|ni|er; tas|ma|nisch**

TASS (Telegraphenagentur der UdSSR) *w;* -

Täß|chen, Täß|lein; Tas|se (österr. auch für: Tablett) *w;* -, -n; **Tas-sen_kopf,** ...rand

Tas|so (it. Dichter)

Ta|sta|tur *it.* *w;* -, -en; **tast|bar; Ta-ste** *w;* -, -n; **Tast_emp|fin|dung; ta-sten** (Druckw. auch für: den Taster bedienen); **Ta|sten|sch|o|ner; Ta|ster** (Feingerät; Zoologie: svw. Palpe; Druckw.: schreibmaschinenähnl. Teil der Setzmaschine; auch: Setzer, der den Taster bedient); **Tast_or|gan,** ...sinn (*m;* -[e]s)

Tat *w;* -, -en; in der -

...**tät** (z. B. Realität *w;* -, -en)

¹Ta|tar (Angehöriger eines Mischvolkes im Wolgagebiet in Südrußland, der Ukraine u. Westsibirien) *m;* -en, -en (↑ R 268); **²Ta-tar** *s;* -[s] und **Ta|tar|beef|steak** [nach den Tataren] (rohes, geschabtes Rindfleisch mit Ei und Gewürzen) *s;* -s; **Ta|ta|rei** (die innerasiatische Heimat der Tataren) *w;* -; (↑ R 198:) die Kleine -, **Ta|ta|ren|nach|richt** (früher für: unwahrscheinliche Schreckensnachricht); **ta|ta-risch, aber** (↑ R 224): Tatarische Autonome Sozialistische Sowjetrepublik

ta|tau|ie|ren *tahit.* (in der Völkerkunde übliche Form von: tätowieren)

Tat_be|richt, ...be|stand; **ta|ten,** nur u. raten und -; **Ta|ten_drang,** ...durst; **tag|ten und -; ta|ten-froh,** tat|froh; **ta|ten|los; -este** (↑ R 292); **Ta|ten|lo|sig|keit** *w;* -; **ta-ten|lu|stig; Tä|ter; Tä|te|rin** *w;* -, -nen; **Tä|ter|schaft** *w;* -; **Tat|form, Tä|tig|keits|form** (für: Aktiv); **tat|froh,** ta|ten|froh

ti|an [...*zign*] (frühchristl. Schriftsteller)

tä|tig; tä|ti|gen (Kaufmannsspr.); einen Abschluß - (dafür besser:

abschließen); **Tä|tig|keit; Tä|tig-keits_be|reich, be|richt,** ...drang, ...form od. **Tat|form** (vgl. d.); **Tä-tig|keits|wort** (für: Verb; *Mehrz.* ...wörter); **Tä|ti|gung**

Tat|ja|na (russ. w. Vorn.)

Tat_kraft *w;* -; **tat|kräf|tig; tät|lich;** - werden; -er Angriff; **Tät|lich-kei|ten** *Mehrz.;* **Tat_mensch,** ...mo|tiv, ...ort (*m;* -[e]s, ...orte)

tä|to|wie|ren *tahit.* (Zeichnungen mit Farbstoffen in die Haut einritzen); **Tä|to|wie|rung**

Ta|tra (Gebirgskette der Karpaten) *w;* -; (↑ R 198:) die Hohe, die Niedere -

Tat_sa|che; Tat|sa|chen_be|richt, ...ma|te|ri|al, ...sinn (*m;* -[e]s)· **tat-säch|lich** [auch: ...*säch...*]; **Tat-säch|lich|keit** [auch: ...*säch...*]

Tätsch südd. (Brei; Backwerk) *m;* -[e]s, -e

Tat|sche landsch. (Hand; leichter Schlag, Berührung) *w;* -, -n; **tät-scheln;** ich ...[e]le (↑ R 327); **tat-schen** (ugs. für: plump anfassen); du tatschst (tatschest)

Tatsch|kerl ostösterr. ugs. (svw. Tascherl)

Tat_tedl vgl. Thaddädl

Tat|ter_greis (ugs.); **Tat|te|rich** (ugs. für: [krankhaftes] Zittern) *m;* -[e]s; **tat|te|rig,** tattrig (vgl. d.); **tat|tern** (ugs. selten für: zittern); ich ...ere (↑ R 327)

Tat|ter|sall [nach dem ersten Gründer eines solchen Unternehmens] (geschäftl. Unternehmen für Reitsport; Reitbahn, -halle) *m;* -s, -s

Tat|too *engl.* [*tätu*] (Zapfenstreich) *s;* -[s], -s

tatt|rig, tat|te|rig

ta|tü|ta|ta!

Tat_ver|dacht; tat|ver|däch|tig; **Tat_ver|däch|ti|ge,** ...waf|fe

Tät|ze|hen, Tätz|lein; Tät|ze (Pfote, Fuß der Raubtiere; ugs. für: plumpe Hand) *w;* -, -n

Tat|zeit

Tat|zel|wurm (sagenhaftes Kriechtier im Volksglauben einiger Alpengebiete) *m;* -[e]s

Tätz|lein, Tätz|chen

¹Tau (Niederschlag) *m;* -[e]s

²Tau (starkes [Schiffs]seil) *s;* -[e]s, -e

³Tau (gr. Buchstabe: *T*, τ) *s;* -[s], -s

taub; -e (leere) Nuß; -es Gestein (Bergmannsspr.: Gestein ohne Erzgehalt)

Täub|chen, Täub|lein; **¹Tau|be** *w;* -, -n

²Tau|be *m* u. *w.* *w;* -n, -n (↑ R 287ff.)

tau|ben|blau (blaugrau); **Tau|ben-ei**

tau|be|netzt, aber (↑ R 142): von Tau benetzt

taubengrau

tau|ben|grau (blaugrau); Tau|ben-
.haus, ...ko|bel (südd., österr.:
Taubenschlag), ...nest, ...post,
...schlag, ...stö|ßer (Wanderfal-
ke), ...zucht; ¹Tau|ber, Täu|ber m;
-s, - u. Tau|be|rich, Täu|be|rich
m; -s, -e
²Tau|ber (linker Nebenfluß des
Mains) w; -
Tau|be|rich, Täu|be|rich vgl. ¹Tau-
ber
Taub|heit w; -
Täu|bin w; -, -nen; Täub|lein,
Täub|chen
Täub|ling (Apfel; Pilz)
Taub|nes|sel (eine Heilpflanze);
taub|stumm; Taub|stum|me;
Taub|stum|men.an|stalt, ...leh-
rer, ...un|ter|richt; Taub|stumm-
heit
Tauch|boot (Unterseeboot); tau-
chen; Tau|chen s; -s; Tau|cher;
Tau|cher.an|zug, ...glocke
[Trenn.: ...glok|ke], ...helm (vgl.
¹Helm), ...ku|gel
Tauch|nitz-Aus|ga|be; ↑R 180
[nach dem Verleger] w; -, -n
Tauch.sie|der, ...sta|ti|on, ...tie|fe
¹tau|en; es taut
²tau|en niederd. (mit einem Tau
vorwärts ziehen, schleppen);
Tau|en|de; Tau|er (früher für:
Kettenschleppschiff); Taue|rei
(früher für: Kettenschleppschiff-
fahrt)
¹Tau|ern (Bez. für Übergänge in
den Tauern) m; -s, -; ²Tau|ern
(Gruppe der Ostalpen) Mehrz.;
(↑R 198:) die Hohen -, die Niede-
ren -; Tau|ern.bahn (↑R 201; w;
-), ...ex|preß, ...tun|nel
Tauf.becken [Trenn.: ...bek|ken],
...be|kennt|nis, ...brun|nen; Tau|fe
w; -, -n; tau|fen; getauft (vgl. d.);
Täu|fer; Tauf.for|mel, ...ge|bühr,
...ge|lüb|de; Tauf|ge|sinn|te An-
gehöriger der Sekte der Men-
noniten) m u. w; -n, -n; ↑R 287ff.;
Täuf|ling; Tauf.na|me, ...pa|te m
u. w, ...pa|tin, ...re|gi|ster
tau|frisch
Tauf.scha|le, ...schein, ...stein
tau|gen; Tau|ge|nichts m; - u. -es,
-e; taug|lich; Taug|lich|keit w; -
tau|ig (betaut)
Tau|mel m; -s; Tau|me|ler, Taum-
ler; tau|me|lig, taum|lig; Tau|mel-
lolch (ein Getreideunkraut); tau-
meln; ich ...[e]le (↑R 327)
tau|naß, aber (↑R 142): von Tau
naß
Tau|nus (Gebirge) m; -
Tau|punkt m; -[e]s
Tau|ri|en [...i^en] (früheres russ.
Gouvernement); Tau|ri|er [...i^er];
Tau|ris (alter Name für die Krim)
Tau|rus (Gebirge in Kleinasien)
m; -
Tausch m; -[e]s, -e; tau|schen; du

tauschst (tauschest); täu|schen;
du täuschst (täuschest); Täu-
scher; Tau|sche|rei (ugs.);
Tausch.ge|schäft, ...han|del (vgl.
¹Handel)
tau|schie|ren arab.-fr. (Edelmetal-
le in unedle Metalle zur Verzie-
rung einhämmern); Tau|schie-
rung
Tausch.ob|jekt; Täu|schung; Täu-
schungs|ma|nö|ver; Tausch.ver-
fah|ren, ...ver|trag; tausch|wei|se;
Tausch.wert, ...wirt|schaft (w; -)
tau|send (als röm. Zahlzeichen:
M); vgl. hundert; Land der tau-
send Seen (Finnland); tausend
und aber (abermals) tausend
(österr.: tausend und aber-
tausend); Tausende und aber
(abermals) Tausende (österr.:
Tausende und Abertausende);
vgl. aber; ¹Tau|send (veralt. für:
Teufel) m, nur noch in: ei der
Tausend!, potztausend!; ²Tau-
send (Zahl) w; -, -en; vgl. ¹Acht;
³Tau|send (Abk.: Tsd.) s; -s, -e;
das ist ein Tausend Zigarren (eine
Kiste mit einem Tausend Zigar-
ren), aber: das sind eintausend
Zigarren (1 000 Stück, unver-
packt); einige Tausend Zigarren,
aber: einige tausend Zigarren
(ugs. für: tausend und einige Zi-
garren); [fünf] vom Tausend
(Abk.: v. T., p. m.; Zeich.: %oo);
vgl. tausend, II; Tau|send|blatt
(eine Pflanze) s; -[e]s; tau|send-
ein, tau|send|und|ein (vgl. d.);
tau|send|eins, tau|send|und|eins;
Tau|sen|der; vgl. Achter; tau|sen-
der|lei; tau|send|fach; Tau|send-
fa|che s; -n; vgl. Achtfache; tau-
send|fäl|tig; Tau|send.fü|ßer,
...füß|ler; Tau|send|gul|den-
kraut, Tau|send|gül|den|kraut
(eine Heilpflanze) s; -[e]s; tau-
send|jäh|rig, aber (↑R 224): das
Tausendjährige Reich (bibl.), je-
doch klein, weil kein Name: das
tausendjährige Reich (ironisch
für die Zeit der nationalsoz.
Herrschaft); vgl. achtjährig; Tau-
send|künst|ler; tau|send|mal; vgl.
achtmal u. hundertmal; tau|send-
ma|lig; Tau|send|mark|schein;
vgl. Hundertmarkschein; tau-
send|sacker|ment! [Trenn.: ...sak-
ker...] (veralt.); Tau|send|sa|sa
(bes. österr. u. schweiz. auch:)
Tau|send|sas|sa (ugs. für:
Schwerenöter; leichtsinniger
Mensch; auch: Alleskönner,
Mordskerl) m; -s, -[s]; Tau|send-
schön s; -s, -e u. Tau|send|schön-
chen (eine Pflanze); tau|send|ste;
tau|send|ste|l; vgl. achte u. hun-
dertste; tau|send|stel, vgl. achtel;
Tau|send|stel s; tau|send-

stel|se|kun|de; tau|send|stens;
tau|send|[und]|ein; vgl. hundert-
[und]ein; ein Märchen aus
Tausendundeiner Nacht; tau-
send|[und]|eins
Tau|ta|zis|mus gr. (Stilk.: un-
schöne Häufung von gleichen
[Anfangs]lauten in aufeinander-
folgenden Wörtern) m; -, ...men;
Tau|to|lo|gie (Fügung, die einen
Sachverhalt doppelt wiedergibt,
z. B. „runder Kreis, weißer
Schimmel") w; -, ...jen; tau|to|lo-
gisch; tau|to|mer (der Tautomerie
unterliegend); Tau|to|me|rie
(Chemie: Art der chem. Isome-
rie) w; -, ...jen
Tau|trop|fen
Tau|werk s; -[e]s
Tau.wet|ter (s; -s), ...wind
Tau|zie|hen s; -s
Ta|ver|ne it. [tawärn^e] (it. Wein-
schenke, Wirtshaus) w; -, -n
Ta|xa|me|ter lat.; gr. (Fahr-
preisanzeiger in Taxis; veralt. für:
²Taxe, Taxi) m; Ta|xa|me|ter-
drosch|ke (veralt.); Tax|amt; Ta-
xa|ti|on [...zion], Ta|xie|rung lat.
(Bestimmung des Geldwertes,
[Ab]schätzung, Wertermitt-
lung); Ta|xa|tor ([Ab]schätzer,
Wertermittler) m; -s, ...oren; ¹Ta-
xe ([Wert]schätzung; [amtlich]
festgesetzter Preis; Gebühr[en-
ordnung]) w; -, -n; ²Ta|xe w; -,
-n u. Ta|xi (Kurzw. für: Taxame-
ter; Mietauto) s (schweiz.
auch: m); -[s], -[s]; tax|frei (gebüh-
renfrei); Ta|xi|chauf|feur; ta|xie-
ren ([ab]schätzen, den Wert er-
mitteln); Ta|xie|rung vgl. Taxa-
tion; Ta|xi.fah|rer, ...stand; Ta|x-
ler österr. ugs. (Taxifahrer); Tax-
preis
Ta|xus lat. (Eibe) m; -, -; Ta|xus-
hecke [Trenn.: ...hek|ke]
Tax|wert (Schätzwert)
Tay|lor|sy|stem [te'l'r...; nach dem
Amerikaner Taylor]; ↑R 180 (Sy-
stem der Betriebsführung zur
bestmöglichen Ausnutzung der
menschl. Arbeitskraft) s; -s
Ta|zet|te it. (eine Narzissenart) w;
-, -n
Taz|zel|wurm vgl. Tatzelwurm
Tb = chem. Zeichen für: Terbium
Tb, Tbc = Tuberkulose
Tbc-krank, Tb-krank; ↑R 150 u.
R 137 (tuberkulosekrank); Tbc-
Kran|ke, Tb-Kran|ke m u. w; -n,
-n (↑R 287ff. u. R 150)
Tbi|li|si (grusinische Form von:
Tiflis)
Tc = chem. Zeichen für: Techne-
tium
TCS = Touring-Club der Schweiz
Te = chem. Zeichen für: Tellur
Teach-in amerik. [tįtsch-ín]
(Protestdiskussion) s; -[s], -s

Teak|holz *engl.; dt.* [*tīk*...] u. Tiek-holz (wertvolles Holz des südost-asiat. Teakbaumes)

Team *engl.* [*tīm*] (Arbeitsgruppe; Sport: Mannschaft, österr. auch: Nationalmannschaft) *s*; -s, -s; **Team|ar|beit; Team|work** [*tīm-"ö'k*] (Gemeinschaftsarbeit) *s*; -s

Tea-room, (schweiz.:) **Tea-Room** *engl.* [*tīrum*] („Teeraum", -stube; schweiz.: alkoholfreies Café) *m*; -s, -s

Tech|ne|ti|um *gr.* [...*zium*] (chem. Grundstoff; Metall; Zeichen: Tc) *s*; -s

tech|ni|fi|zie|ren *gr.; lat.* (technisch gestalten); **Tech|ni|fi|zie|rung; Tech|nik** *gr.* (für: Ingenieurwissenschaften) *w*; -, (für: Handhabung, Herstellungsverfahren, Arbeitsweise; Hand-, Kunstfertigkeit u. österr. Kurzw. für: techn. Hochschule *Mehrz.*:) -en; **Tech|ni|ker; Tech|ni|ke|rin** *w*; -, -nen; **Tech|ni|kum** (technische Fachschule, Ingenieurfachschule) *s*; -s, ...ka (auch: ...ken); **tech|nisch** *gr.-fr.* (zur Technik gehörend, sie betreffend, mit ihr vertraut; kunstgerecht, fachgemäß); -e Atmosphäre (vgl. Atmosphäre); -er Ausdruck (Fachwort, Kunstausdruck); -e Fächer (Künste und Fertigkeiten); [eine] -e Hochschule, [eine] -e Universität, -es Zeichnen, aber (↑ R 224): die Technische Hochschule (Abk.: TH) Darmstadt, die Technische Universität (Abk.: TU) Berlin; Hans Meyer, Technischer Zeichner (als Titel, sonst: [er wird] technischer Zeichner); Technisches Hilfswerk (Name einer freiwilligen Hilfsorganisation; Abk.: THW); Technischer Überwachungs-Verein[1] (Abk.: TÜV); Technische Nothilfe; **tech|ni|sie|ren** (für technischen Betrieb einrichten); **Tech|ni|sie|rung; Tech|ni|zis|mus** (technische Ausdrucksweise) *m*; -, ...men; **Tech|no|krat** (Vertreter der Technokratie) *m*; -en, -en (↑ R 268); **Tech|no|kra|tie** (eine Wirtschaftslehre) *w*; -; **Tech|no|lo|ge** *m*; -n, -n (↑ R 268); **Tech|no|lo|gie** (Lehre von der Umwandlung von Rohstoffen in Fertigprodukte) *w*; -; **tech|no|lo|gisch**

Tech|tel|mech|tel (ugs. für: Liebelei) *s*; -s, -

Teckel [*Trenn.*: Tek|kel] (Dackel) *m*; -s, -

Ted|dy *engl.* [Koseform von: Theodor] (Stoffbär als Kinderspielzeug) *m*; -s, -s; **Ted|dy|bär,** ...fut|ter (vgl. [2]Futter), ...man|tel

[1] So die offizielle Schreibung.

Te|de|um *lat.* (Bez. des altkirchl. Lobgesangs „Te Deum laudamus" = „Dich, Gott, loben wir!") *s*; -s, -s

TEE = Trans-Europ-Express

Tee *chin. m*; -s, -s; schwarzer, grüner, chinesischer -; **Tee|abend** (↑ R 148), ...**bäckerei** ([*Trenn.*: ...äk|ke...] österr. für: Teegebäck), ...**blatt,** ...**brett; Tee-Ei** (↑ R 148); **Tee Ern|te** (↑ R 148); **Tee-ge|bäck,** ...**ge|sell|schaft,** ...**haus,** ...**kan|ne,** ...**kes|sel,** ...**licht** (*Mehrz.* ...lichter), ...**löf|fel; tee-löf|fel|wei|se**

Teen *amerik.* [*tīn*] (ugs. für: Junge od. Mädchen im Alter zwischen 13 und 19 Jahren, Halbwüchsige[r]) *m*; -s, -s (meist *Mehrz.*); **Teen|ager** [*tīne'dseh^er*] (Mädchen im Alter von 13 bis 19 Jahren; gelegentlich auch auf Jungen bezogen) *m*; -s, -

Teer *m*; -[e]s, -e; **Teer|dach|pap|pe,** ...**decke** [*Trenn.*: ...dek|ke]; **tee-ren;** - und teeren; **Teer|far|be,** ...**farb|stoff; teer|hal|tig; tee|rig; Teer|jacke** [*Trenn.*: ...jak|ke] (scherzh. für: Matrose)

Tee|ro|se (eine Rosensorte)

Teer|pap|pe; Teer|schwe|le|rei; Teer|sei|fe, ...**stra|ße; Tee|rung**

Tee ser|vice, ...**sieb,** ...**stau|de,** ...**strauch,** ...**stu|be,** ...**tas|se,** ...**tisch,** ...**wa|gen,** ...**wurst**

Te|fil|la *hebr.* (jüd. Gebet[buch]) *w*; -; **Te|fil|lin** (Gebetsriemen der Juden) *Mehrz.*

[1]**Te|gel** (kalkreicher Ton) *m*; -s

[2]**Te|gel** (Ortsteil von Berlin); -er Schloß, -er See

Te|gern|see (See [*m*; -s] u. Stadt in Oberbayern); **Te|gern|seer** [...*se^er*] (↑ R 166, 199 u. 205)

Te|he|ran [auch: *te*...] (Hptst. von Iran)

Teich (Gewässer) *m*; -[e]s, -e; **Teich|huhn,** ...**molch,** ...**mu|schel**

Tei|cho|sko|pie *gr.* („Mauerschau"; Mittel im Drama, nicht darstellbare Ereignisse dem Zuschauer dadurch nahezubringen, daß ein Schauspieler sie schildert, als sähe er sie außerhalb der Bühne vor sich gehen) *w*; -

Teich|pflan|ze, ...**ro|se,** ...**schilf**

teig landsch. (überreif, weich [vom Obst]); **Teig** (dickbreiige Masse) *m*; -[e]s, -e; den - gehen lassen; **Teig|far|be; tei|gig; Teig mas|se,** ...**wa|ren** (*Mehrz.*)

Teil *m* od. *s*; -[e]s, -e. **I.** *Großschreibung*: zum Teil (Abk.: z. T.); der große Teil des Tages; jedes Teil (Stück) prüfen; das (selten: der) bessere Teil; er hat sein Teil getan; ein gut Teil; sein[en] Teil dazu beitragen; ich für mein[en] Teil. **II.** *Kleinschreibung*: **a)** (↑ R

129:) teils (vgl. d.); eines-, meines-, ander[e]nteils; großen-, größten-, meistenteils; **b)** (↑ R 141:) zuteil werden; vgl. auch: teilhaben, teilnehmen; **Teil_an-sicht,** ...**as|pekt; teil|bar; Teil|bar-keit** *w*; -; **Teil_be|reich** *m*, ...**be-trag; Teil|chen; Teil|chen|be-schleu|ni|ger** (Kernphysik); **tei-len;** geteilt; zehn geteilt durch fünf ist, macht, gibt (nicht: sind macht, geben) zwei; sich -; **Tei-ler;** größter gemeinsamer - (Abk.: g. g. T., ggT); **Tei|le|zu|rich|ter** (Anlernberuf); **Teil_fa|bri|kat,** ...**ge|biet; Teil|ha|be** *w*; -; **teil|ha-ben** (↑ R 140); du hast teil (↑ R 132), aber: du hast keinen Teil, teilgehabt; teilzuhaben; **Teil|ha-ber; Teil|ha|be|rin** *w*; -, -nen; **Teil-ha|ber_schaft** (vgl. ...); ...**ver|si|che-rung; teil|haft** (älter für: teilhaftig); **teil|haf|tig; teil|haf|tig;** einer Sache - sein, werden; ...**teil|lig** (z. B. zehnteilig, mit Ziffern: 10teilig; ↑ R 228); **teil|kas|ko|ver|si|chert; Teil|kas|ko|ver|si|che|rung; Teil-ko|sten|rech|nung; Teil|lei|stung; Teil|nah|me** *w*; -; **teil|nah|me|be-rech|tigt; Teil|nah|me|be-rech|tig|te** *m* u. *w*; **teil|nahms|los;** -este (↑ R 292); **Teil|nahms|lo|sig|keit** *w*; -; **teil|nahms|voll; teil|neh|men** (↑ R 140); du nimmst teil (↑ R 132); teilgenommen; teilzunehmen; **teil|neh|mend,** -ste; **Teil|neh-mer; Teil|neh|me|rin** *w*; -, -nen; **Teil|neh|mer|zahl; teils** (↑ R 129); - gut, - schlecht; ...**teils** (z. B. einesteils); vgl. Teil, II, a; **Teil-schuld|ver|schrei|bung** (für: Partialobligation); **Teil_strecke** [*Trenn.*: ...strek|ke], ...**strich,** ...**stück; Teil|lung; Teil|lungs|ver-hält|nis; teil|wei|se; Teil|zah|lung; Teil|zeit|ar|beit**

Teint *fr.* [*täng*] (Gesichts-, Hautfarbe; [Gesichts]haut) *m*; -s, -s

T-Ei|sen;(↑ R 149 (von T-förmigem Querschnitt)

Tei|ste (ein Vogel) *w*; -, -n

Te|ja[s] (letzter Ostgotenkönig)

Te|jo [*teschu*] (port. Form von: Tajo)

Tek|to|nik *gr.* (Lehre von der Zusammenfügung von Bauteilen zu einem Gefüge; Geol.: Lehre vom Bau der Erdkruste u. ihren inneren Bewegungen) *w*; -; **tek|to-nisch**

Tek|tur *lat.* (Buchw.: Deckblatt, -streifen) *w*; -, -en

Tel Aviv [*tälawīw*] (Stadt in Israel)

te|le... *gr.* (fern...); **Te|le...** (Fern...)

Te|le|fon *gr.* -s, -e; **Te|le|fon_an-ruf; Te|le|fo|nat** (Ferngespräch, Anruf) *s*; -[e]s, -e; **Te|le|fon_buch,** ...**ge|spräch; te|le|fo|nie|ren; te|le-fo|nisch; Te|le|fo|nist** (Angestell-

22 D1, 17. A.

ter im Fernsprechverkehr); ↑ R 268; Te|le|fo|ni|stin w; -, -nen; Te|le|fon.netz, ...num|mer, ...seel|sor|ge, ...ver|bin|dung, ...zel|le, ...zen|tra|le Te|le.fo|to (kurz für: Telefotografie), ...fo|to|gra|fie (fotograf. Fernaufnahme) Te|le|fun|ken Ⓦ (Unternehmen der Elektroindustrie) te|le|gen gr. (für Fernsehaufnahmen geeignet) Te|le|go|nie gr. (Biol.: angebliche Beeinflussung aller späteren Geburten durch den zuerst Begattenden) w; - Te|le|graf („Fernschreiber"; Apparat zur Übermittlung von Nachrichten durch vereinbarte Zeichen) m; -en, -en (↑ R 268); Te|le|gra|fen.amt, ...be|am|te, ...bü|ro, ...draht, ...lei|tung, ...mast m, ...netz, ...stan|ge; Te|le|gra|fie (elektrische Fernübertragung von Nachrichten über Kabelleitungen od. drahtlos mit vereinbarten Zeichen) w; -; te|le|gra|fie|ren; te|le|gra|fisch; -e Antwort (Drahtantwort); Te|le|gra|fist (Telegrafenbeamter); ↑ R 268; Te|le|gra|fi|stin w; -, -nen Te|le|gramm gr. (telegrafisch beförderte Nachricht, Drahtnachricht) s; -s, -e; Te|le|gramm-.adres|se (Drahtanschrift), ...bo|te, ...nach|richt, ...stil (im -) Te|le|graph usw. vgl. Telegraf usw. Te|le|ka|me|ra Te|le|ki|ne|se gr. (das angebl. Bewegtwerden von Gegenständen in der Parapsychologie) w; - Te|le|kol|leg (Unterricht mit Hilfe des Fernsehens) Te|le|mach (Sohn des Odysseus) Te|le|mann (dt. Komponist) ¹Te|le|mark (norw. Verwaltungsgebiet); ²Te|le|mark (Bremsschwung im Schilauf) m; -s, -s; Te|le|mar|ken (früherer Name von: ¹Telemark); Te|le|mark-schwung Te|le|me|ter gr. (Entfernungsmesser) s; -s, -; Te|le|me|trie (Entfernungsmessung) w; -; te|le|me-trisch; -e Daten Te|le|ob|jek|tiv gr.; lat. (Linsenkombination für Fernaufnahmen) Te|leo|lo|gie gr. (Lehre vom Zweck u. von der Zweckmäßigkeit) w; -; te|leo|lo|gisch (durch den Zweck bestimmt; aus der Zweckmäßigkeit der Welt; zweckhaft); -er Gottesbeweis Te|le|path gr. (für Telepathie Empfänglicher) m; -en, -en (↑ R 268); Te|le|pa|thie (Fernfühlen ohne körperliche Vermittlung) w; -; te|le|pa|thisch

Te|le|phon usw. vgl. Telefon usw. Te|le|pho|to|gra|phie vgl. Telefotografie Te|le|plas|ma gr. (im Spiritismus: angeblich von Medien abgesonderter Stoff) Te|le|skop gr. (Fernrohr) s; -s, -e; Te|le|skop.au|ge, ...fisch; te|le-sko|pisch (das Teleskop betreffend; [nur] durch das Teleskop sichtbar); Te|le|skop|mast (Mast, der aus aus- u. einziehbaren Teilen besteht) m Te|le|vi|si|on gr. [engl. Ausspr.: te-liwisch°n] (Fernsehen; Abk.: TV) w; -; Te|lex engl. (Kurzw. aus engl. teleprinter exchange [teli-print°r ikßtsche'ndsch] international übl. Bez. für: Fernschreiber[teilnehmer]netz) s; - Tell (Schweizer Volksheld) Tel|le mdal. (Delle) w; -, -n Tel|ler m; -s, -; Tel|ler.brett, ...eisen (Fanggerät für Raubwild), ...fleisch (eine Speise); tel|ler-för|mig; tel|lern (in Rückenlage durch Handbewegungen schwimmen); ich ...ere (↑ R 327); Tel|ler.samm|lung, ...tuch (Mehrz. ...tücher), ...wä|scher Tells|ka|pel|le w; - Tel|lur lat. (chem. Grundstoff, Halbmetall; Zeichen: Te) s; -s; tel|lu|rig (Chemie) -e Säure; tel|lu|risch (auf die Erde bezüglich, von ihr herrührend) -e Kräfte (Geol.); Tel|lu|rit (Salz der tellurigen Säure) s; -s, -e; Tel|lu|ri|um (Astron.: Gerät zur Veranschaulichung der Bewegung der Erde um die Sonne) s; -s, ...ien [...i°n] ¹Tel|tow [tälto] (Stadt bei Berlin); ²Tel|tow (Gebiet südl. von Berlin) m; -s; Tel|tow|er (↑ R 199 u. R 167); Teltower Rübchen; Tel-tow|ka|nal (↑ R 201) m; -s Tem|pel lat. m; -s, -; Tem|pel.bau (Mehrz. ...bauten), ...ge|sell-schaft, ...herr (Templer); tem|peln (Tempeln spielen); ich ...[e]le (↑ R 327); Tem|peln (ein Kartenglücksspiel) s; -s; Tem|pel.or|den (Templerorden; m; -s), ...pro|sti-tu|ti|on, ...rit|ter Tem|pe|ra.far|be it. (Deckfarbe mit Eigelb, Honig, Leim), ...ma-le|rei Tem|pe|ra|ment lat. („Mischung"; Wesens-, Gemütsart; nur Einz.: Gemütserregbarkeit, Lebhaftigkeit, Munterkeit, Schwung, Feuer) s; -[e]s, -e; tem|pe|ra|ment|los; -este (↑ R 292); Tem|pe|ra|ment-lo|sig|keit w; -; Tem|pe|ra|ments-aus|bruch; tem|pe|ra|ment|voll Tem|pe|ra|tur lat. (Wärme[grad, -zustand]; [leichtes] Fieber) w; -, -en; Tem|pe|ra|tur.an|stieg, ...er-hö|hung, ...reg|ler, ...rück|gang,

...sturz, ...wech|sel; Tem|pe|renz (selten für: Mäßigkeit, bes. im Alkoholgenuß) w; -; Tem|pe-renz|ler (Anhänger der Mäßigkeits- oder der Enthaltsamkeitsbewegung); Tem|pe|renz|ver|ein; Tem|per|guß engl.; dt.; tem|pe|rie-ren lat. (mäßigen; Temperatur regeln); Tem|per|koh|le; tem|perin (Hüttenw.: Eisen in Glühkisten unter Hitze halten, um es hämmer- und schmiedbar zu machen); ich ...ere (↑ R 327) Tem|pest|boot engl. [tämpißt...] (Sportsegelboot) Tem|pi pas|sa|ti (vergangene Zeiten) Mehrz.; vgl. Tempo Tem|plei|se fr. (Gralsritter) m; -n, -n (meist Mehrz.); ↑ R 268; Templer (Angehöriger eines geistl. Ritterordens u. einer Sekte); Templer|or|den (geistl. Ritterorden des Mittelalters) m; -s Tem|po it. (Zeit[maß], Takt; nur Einz.: Geschwindigkeit, Schnelligkeit, Hast) s; -s, -s u. ...pi; vgl. Tempi passati; Tem|po|ra (Mehrz. von: Tempus); Tem|po-ral lat. (zeitlich; das Tempus betreffend; veralt. für: weltlich; Med.: zu den Schläfen gehörend); -e Bestimmung (Sprachw.); Tem|po|ra|li|en [...i°n] (mit der Verwaltung eines kirchl. Amtes verbundene weltl. Rechte und Einkünfte der Geistlichen) Mehrz.; Tem|po|ral|satz (Sprachw.: Umstandssatz der Zeit); tem|po|rär fr. (zeitweilig, vorübergehend); tem|po|rell (veralt. für: zeitlich, weltlich); tem-po|ri|sie|ren (veralt. für: hinhalten, verzögern; sich den Zeitumständen fügen); Tem|po|ver|lust; Tem|pus lat. (Sprachw.: Zeitform [des Zeitwortes]) s; -, ...pora ten. = tenuto Te|na|kel lat. (Druckw.: Gerät zum Halten des Manuskriptes beim Setzen, Blatthalter) s; -s, -; Te|na|zi|tät (Chemie, Physik: Zähigkeit; Ziehbarkeit) w; - Ten|denz lat. (Streben nach bestimmtem Ziel, Absicht; Hang, Neigung, Strömung; Zug, Richtung, Entwicklung[slinie]; Stimmung [an der Börse]) w; -, -en; Ten|denz.be|trieb, ...dich|tung; ten|den|zi|ell (der Tendenz nach, entwicklungsmäßig); ten|den|zi-ös (etwas bezweckend, beabsichtigend; parteilich zurechtgemacht, gefärbt); -este (↑ R 292); Ten|denz|stück; Ten|der engl. (Vorratswagen der Lokomotive [für Kohle u. Wasser]; Seew.: Begleitschiff, Hilfsfahrzeug; m; -s, -; ten|die|ren lat. (streben, hinzu ...); vgl. ab er: tentieren

Te|ne|ri|fe (span. Schreibung von: Teneriffa); Te|ne|rif|fa (eine der Kanarischen Inseln)

Te|niers [...nị*rß] (niederl. Malergeschlecht)

Tenn schweiz. (Nebenform von: Tenne) s; -s, -e

Tenn. = Tennessee

Ten|ne w; -, -n; Ten|nen|raum

[1]Ten|nes|see [...ßi̲, auch: tä̲n...] (l. Nebenfluß des Ohio) m; [о]; [2]Ten|nes|see (Staat in den USA; Abk.: Tenn.)

Ten|nis engl. (Ballspiel) s; -; - spielen (↑ R 140); Ten|nis..ball, ...platz, ...schlä|ger, ...schuh, ...spie|ler, ...tur|nier

Ten|no jap. (jap. Kaisertitel) m; -s, -s; vgl. Mikado

Ten|ny|son [tä̲niß*n] (engl. Dichter)

[1]Te|nor lat. (Haltung; Inhalt, Sinn, Wortlaut) m; -s; [2]Te|nor it. (hohe Männerstimme; Tenorsänger) m; -s, ...nöre; Te|nor..ba|ri|ton, ...baß (Blasinstrument, svw. Tuba), ...buf|fo, ...horn (Mehrz. ...hörner); Te|no|rist (Tenorsänger); ↑ R 268; Te|nor|schlüs|sel

Ten|sid lat. (grenzflächenaktiver Stoff, z. B. Waschmittel) s; -[e]s, -e (meist Mehrz.); Ten|si|on (Physik: Spannung der Gase und Dämpfe; Druck)

Ten|ta|kel lat. (Fanghaar fleischfressender Pflanzen; fadenförmiger Körperanhang niederer Tiere [zum Ergreifen der Beute]) m od. s; -s, - (meist Mehrz.); Ten|ta|ku|lit (fossile Flügelschnecke) m; -en, -en (↑ R 268); Ten|ta|men (Vorprüfung [z. B. beim Medizinstudium]; Med.: Versuch) s; -s, ...mina; ten|tie|ren (veralt., aber noch mdal. für: untersuchen, prüfen; versuchen, unternehmen; betreiben; österr. ugs. für: beabsichtigen; vgl. aber: tendieren

Te|nü fr. [t*nü] schweiz. (Art u. Weise, wie jmd. gekleidet ist; Anzug, Uniform) s; -s, -s

Te|nu|is lat. [...uiß] (stimmloser Verschlußlaut, z. B. p) w; -, ...ues [...uäß]

te|nu|to it. (Musik: ausgehalten; Abk.: ten.); ben - (gut gehalten)

Teo vgl. Theo; Teo|bald vgl. Theobald; Teo|de|rich vgl. Theoderich

Te|pi|da|ri|um lat. (Raum im römisch-irischen Bad) s; -s, ...ien [...i*n]

Tep|lice [täplizä] (tschech. Form von: Teplitz); Tep|litz (Kurort in Böhmen; früher: Tep|litz-Schön|au (↑ R 212)

Tepp vgl. Depp; tep|pert vgl. deppert

Tep|pich m; -s, -c; Tep|pich..bo|den, ...kä|fer, ...kehr|ma|schi|ne,

...klop|fer, ...mu|ster, ...stan|ge, ...wir|ker

Te|ra... gr. (das Billionenfache einer Einheit, z. B. Terameter = 10^{12} Meter; Zeichen: T)

Te|ra|to|lo|gie gr. (Lehre von den Mißbildungen der Lebewesen) w; -

Ter|bi|um [nach dem schwed. Ort Ytterby] (chem. Grundstoff, Metall; Zeichen: Tb) s; -s

Te|re|bin|the gr. (Terpentinbaum) w; -, -n

Te|renz (altröm. Lustspieldichter)

Term lat. (Math.: Glied einer Formel, bes. einer Summe; Physik: ein Zahlenwert von Frequenzen od. Wellenzahlen eines Atoms, Ions od. Moleküls; Sprachw. für: Terminus) m; -s, -e; Ter|me (veralt. für: Grenzstein) m; -n, -n; Ter|min (,,Grenze''; Frist; [Liefer-, Zahlungs-, Gerichtsverhandlungs]tag, Zeit[punkt], Ziel) m; -s, -e; ter|mi|nal (veralt. für: die Grenze, das Ende betreffend; Math.: am Ende stehend); Ter|mi|nal engl. [tö̲'min*l] (Abfertigungshalle für Fluggäste; Zielbahnhof für Containerzüge; EDV: Datenendstation, Abfragestation) m (auch: s, für Datenendstation nur: s); -s, -s; ter|mi|nie|ren (befristen; zeitlich festlegen); Ter|mi|nie|rung; ter|mi|nka|len|der; ter|min|lich; ter|mi|no|lo|ge lat.; gr. m; -n, -n (↑ R 268); Ter|mi|no|lo|gie (Gesamtheit der in einem Fachgebiet üblichen Fachwörter u. die Lehre von ihnen) w; -, ...ien; ter|mi|lo|gisch; Ter|mi|nus lat. (Fachwort, -ausdruck, -begriff) m; -, ...ni; Ter|mi|nus tech|ni|cus [-...ku̲ß] (Fachwort, -ausdruck) m; - -, ...ni ...ci [...zi]

Ter|mi|te lat. (ein Insekt) w; -, -n (meist Mehrz.); Ter|mi|ten..hü|gel, ...staat

ter|när lat. (Chemie: dreifach; Dreistoff...); -e Verbindung; Ter|ne it. (Reihe von drei gesetzten od. gewonnenen Nummern in der alten Zahlenlotterie) w; -, -n;

Ter|ni|on lat. (veralt. für: Verbindung von drei Dingen; Ter|no österr. (svw. Terne) m; -s, -s

Ter|pen gr. (Bestandteil ätherischer Öle) s; -s, -e; ter|pen|frei; Ter|pen|tin (Harz) s (österr. meist: m); -s, -e

Ter|psi|cho|re (gr. Muse des Tanzes und des Chorgesanges)

Ter|ra di Sie|na it. (Sienaerde, braune Farbe) w; - - -

Ter|rain fr. [...rä̲ng] (Gebiet; [Bau]gelände, Grundstück) s; -s, -s; Ter|rain|be|schrei|bung

Ter|ra in|co|gni|ta lat. [- inkọ...] ([meist übertr.:] unbekanntes Land; Unerforschtes) w; - -; Ter|ra|kọt|ta w; -, ...tten (österr. nur so) u. Ter|ra|kọt|te it. (für: gebrannter Ton) w; -, (für: Gefäß od. Bildwerk daraus auch Mehrz.:) -n

Ter|ra|ri|en|kun|de [...i*n...] w; -; Ter|ra|ri|um lat. (Behälter für die Haltung kleiner Lurche u. ä.) s; -s, ...ien [...i*n]

Ter|ras|se fr. w; -, -n; ter|ras|sen|ar|tig; Ter|ras|sen|dach; ter|ras|sen|för|mig; Ter|ras|sen|gar|ten, ...haus, ...kleid; ter|ras|sie|ren (terrassenförmig anlegen, erhöhen); Ter|ras|sie|rung; Ter|raz|zo it. (mosaikartiger Fußbodenbelag) m; -[s], ...zzi; Ter|raz|zo|fuß|bo|den

ter|re|strisch lat. (die Erde betreffend; Erd...); -es Beben (Erdbeben)

ter|ri|bel lat. (veralt. für: schrecklich); ...i|ble Zustände

Ter|ri|er engl. [...i*r] (kleiner bis mittelgroßer engl. Jagdhund) m; -s, -

ter|ri|gen lat.; gr. (Biol.: vom Festland stammend)

Ter|ri|ne fr. ([Suppen]schüssel) w; -, -n

ter|ri|to|ri|al lat. (zu einem Gebiet gehörend, ein Gebiet betreffend); -e Verteidigung; Ter|ri|to|ri|al..ge|walt (w; -), ...ge|wäs|ser, ...ho|heit (w; -); Ter|ri|to|ria|li|tät (Zugehörigkeit zu einem Staatsgebiet) w; -; Ter|ri|to|ria|li|täts|prin|zip; Ter|ri|to|ri|al.kom|man|do (milit.), ...staat; Ter|ri|to|ri|um (Grund; Bezirk; [Herrschafts-, Staats-, Hoheits]gebiet) s; -s, ...ien [...i*n]

Ter|ror lat. (Gewaltherrschaft; rücksichtsloses Vorgehen) m; -s; Ter|ror..akt, ...an|griff, ...herr|schaft; ter|ro|ri|sie|ren fr. (Terror ausüben, unterdrücken); Ter|ro|ri|sie|rung; Ter|ro|ris|mus (Schreckensherrschaft) m; -; Ter|ro|rist (↑ R 268); ter|ro|ri|stisch; -ste (↑ R 294); Ter|ror.ju|stiz, ...me|tho|de

[1]Ter|tia lat. [...zia] (,,dritte''; als Unter- u. Obertertia 4. u. 5. [in Österr.: 3.] Klasse an höheren Lehranstalten) w; -, ...ien [...i*n]; [2]Ter|tia (ein Schriftgrad); Ter|ti|al (veralt. für: Jahresdrittel) s; -s, -e; Ter|ti|a|na (Med.: Dreitagewechselfieber) w; -; Ter|tia|ner (Schüler der [1]Tertia); Ter|tia|ne|rin w; -, -nen; ter|ti|är fr. (die dritte Stelle in einer Reihe

einnehmend; das Tertiär betreffend); Ter|ti|är (Geol.: der ältere Teil der Erdneuzeit) s; -s; Ter|ti|är|for|ma|ti|on; Ter|tia|ri|er vgl. Terziar; Ter|tie [...i°] (der 60. Teil einer Sekunde) w; -, -n; Ter|ti|um com|pa|ra|tio|nis lat. [- komparazioniß] (Vergleichspunkt) s; - -, ...ia -; Ter|ti|us gau|dens (,,der sich freuende Dritte" [wenn zwei sich streiten]) m; - - Ter|tul|li|an (röm. Kirchenschriftsteller) Terz lat. (Fechthieb; Musik: dritter Ton [vom Grundton aus]) w; -, -en; Ter|zel (Jägerspr.: männl. Falke) m; -s, -; Ter|ze|rol it. (kleine Pistole) s; -s, -e; Ter|zett (dreistimmiges Gesangstück) s; -[e]s, -e; Ter|zi|ar lat. m; -s, -en u. Ter|tia|ri|er [...ziari°r] (Angehöriger des Dritten Ordens); Ter|zi|ne it. (Strophe von drei Versen) w; -, -n (meist Mehrz.)

Te|sa|film Ⓦ (ein Klebeband) Te|sching (kleine Handfeuerwaffe) s; -s, -e u. -s Tes|la|strom; ↑ R 180 [nach dem amerik. Entdecker] (Elektrotechnik: Hochfrequenzstrom sehr hoher Spannung) Tes|sar Ⓦ (lichtstarkes fotogr. Objektiv) s; -s, -e tes|sel|la|risch gr. (Kunstwiss.: gewürfelt) ¹Tes|sin (schweiz.-it. Fluß) m; -s; ²Tes|sin (schweiz. Kanton) s; -s; Tes|si|ner (↑ R 199); tes|si|nisch Test engl. (Probe; Prüfung; psycholog. Experiment; Untersuchung) m; -[e]s, -s (auch: -e) Te|sta|ment lat. (letztwillige Verfügung; Bund Gottes mit den Menschen, danach das Alte u. das Neue Testament der Bibel) s; -[e]s, -e; (↑ R 224:) Altes - (bibl.; Abk.: A. T.), Neues - (bibl.; Abk.: N. T.); te|sta|men|ta|risch (durch letztwillige Verfügung, letztwillig); -e Verfügung; Te|sta|ments|-er|öff|nung, ...voll|strecker [Trenn.: ...strek|ker]; Te|stat (Zeugnis, Bescheinigung) s; -[e]s, -e; Te|sta|tor (Person, die ein Testament errichtet; Erblasser) m; -s, ...oren Te|sta|zee lat. (Biol.: schalentragende Amöbe, Wurzelfüßer) w; -, -n (meist Mehrz.) Test|bild (Fernsehen); te|sten [zu: Test]; Te|ster (jmd., der testet); Test_fah|rer, ...fall m, ...fra|ge; te|stie|ren lat. (ein Testat geben, bescheinigen; Rechtsw.: ein Testament errichten); Te|stie|rer (die ein Testament errichtende Person; Erblasser); Te|stie|rung Te|sti|kel lat. (Med.: Hode) m; -s, -

Te|sti|mo|ni|um lat. (Rechtsw.: Zeugnis) s; -s, ...ien [...i°n] u. ...ia; Te|sti|mo|ni|um pau|per|ta|tis ([amtl.] Armutszeugnis) s; - -, ...ia - Test_me|tho|de, ...ob|jekt, ...pi|lot, ...rei|he, ...sa|tel|lit, ...se|rie Te|stu|do lat. (,,Schildkröte"; im Altertum Schutzdach [bei Belagerungen]; Med.: Schildkrötenverband) w; -, ...dines Te|stung; Test|ver|fah|ren Te|ta|nie gr. (schmerzhafter Muskelkrampf) w; -, ...ien; te|ta|nisch; Te|ta|nus [auch: tä...] (Med.: Wundstarrkrampf) m; -; Te|ta|nus_imp|fung, ...se|rum Te|te fr. [tät°] (,,Kopf"; veralt. für: Anfang, Spitze [eines Truppenkörpers]) w; -, -n; tête-à-tête [tätatät] (veralt. für: vertraulich, unter vier Augen); Tête-à-tête (Gespräch unter vier Augen; vertrauliche Zusammenkunft; zärtliches Beisammensein) s; -, -s ¹Te|thys (in der altgr. Mythol. Gattin des Okeanos u. Mutter der Gewässer); vgl. aber: Thetis; ²Te|thys (urzeitliches Meer) w; - Te|tra|chlor|koh|len|stoff gr.; Te|tra|chord [...kort] (Folge von vier Tönen einer Tonleiter) m od. s; -[e]s, -e; Te|tra|eder (Vierflächner, dreiseitige Pyramide) s; -s, -; Te|tra|gon (Viereck) s; -s, -e; Te|tra|kis|he|xa|eder (vierundzwanzigflächige Kristallform); Te|tra|lin Ⓦ (Lösungsmittel) s; -s Te|tra|lo|gie (Folge von vier eine innere Einheit bildenden Dichtwerken, Kompositionen u. a.) w; -, ...ien; Te|tra|me|ter (aus vier Einheiten bestehender Vers) m; -s, -; Te|tra|po|die (Vierfüßigkeit [der Verse]) w; -; Te|trarch (,,Vierfürst"; im Altertum Herrscher über den vierten Teil eines Landes) m; -en, -en (↑ R 268); Te|trar|chie (Vierfürstentum) w; -, ...ien; Te|tro|de (Vierpolröhre) w; -, -n Tet|zel (Ablaßprediger zur Zeit Luthers) Teu|chel südd. u. schweiz. (hölzerne Wasserleitungsröhre) m; -s, - teu|er; teurer, -ste; ein teures Kleid; das kommt mir od. mich teuer zu stehen; Teu|e|rung; Teue|rungs_wel|le, ...zu|schlag Teu|fe (Bergmannsspr.: Tiefe) w; -, - Teu|fel m; -s, -; zum - jagen (ugs.); zum -! (ugs.); Teu|fe|lei; Teu|fe|lin w; -, -nen; Teu|fels_ar|beit (ugs.), ...aus|trei|bung, ...bra|ten (ugs.), ...brücke [Trenn.: ...brük|ke], ...brut (ugs.), ...kerl (ugs.), ...kir|sche, ...kunst, ...werk (ugs.)

teu|fen (Bergmannsspr.: einen Schacht herstellen) teuf|lisch; -ste (↑ R 294); -er Plan Teu|to|bur|ger Wald (Höhenzug des Weserberglandes) m; - -[e]s; Teu|to|ne (Angehöriger eines germ. Volksstammes) m; -n, -n (↑ R 268); Teu|to|nia (lat. Bezeichnung für: Deutschland); teu|to|nisch (auch abschätzig für: deutsch) tex = Tex; Tex lat. (Maß für die längenbezogene Masse textiler Fasern u. Garne; Zeichen: tex) s; -, - Tex. = Texas Te|xa|ner; Te|xas (Staat in den USA; Abk.: Tex.); Te|xas|fie|ber (Rindermalaria); ↑ R 201; Te|xas Ran|gers [- re'ndseh°rs] vgl. Ranger; Te|xas|seu|che (↑ R 201) ¹Text lat. (Wortlaut, Beschriftung; [Bibel]stelle) m; -[e]s, -e; ²Text (ein Schriftgrad) w; -; Text-_ab|druck (Mehrz. ...drucke), ...buch, ...dich|ter; tex|ten (einen [Schlager-, Werbe]text gestalten); Tex|ter (Verfasser von [Schlager-, Werbe]texten); text-ge|mäß; Text|ge|stal|tung; tex|tie|ren (selten für: Unterschrift unter einer Abbildung anbringen; mit einem bestimmten Text versehen); Tex|tie|rung; tex|til (die Textiltechnik, die Textilindustrie betreffend; Gewebe...); Tex|til_ar|bei|ter, ...be|trieb, ...che|mi|ker, ...fa|brik, ...fa|bri|kant; tex|til|frei (scherzh. für: nackt); Tex|til|ge|wer|be; Tex|til-groß|han|del; (↑ R 145:) Textilgroß- u. -einzelhandel; Tex|ti|li|en [...i°n] (Gewebe, Faserstofferzeugnisse [außer Papier]) Mehrz.; Tex|til_in|du|strie, ...wa|ren (Mehrz.), ...wer|ker; Text|kri|tik; text|lich; Tex|tin|gui|stik, ...stel|le; Tex|tur (Chemie, Technik: Gewebe, Faserung, Verbindung) w; -, -en; tex|tu|rie|ren (ein Höchstmaß an textilen Eigenschaften verleihen); Text|wort (Mehrz. ...worte) Te|zett [auch: tezät] (Buchstabenverbindung ,,tz") s, in: bis ins, bis zum - (ugs. für: vollständig) T-för|mig; ↑ R 149 (in Form eines lat. T) tg vgl. tan Tgb.-Nr. = Tagebuchnummer Th = chem. Zeichen für: Thorium TH = technische Hochschule; vgl. technisch Thacke|ray [thäk°ri] (engl. Schriftsteller) Thad|dä|us, (ökum.:) Tad|dä|us (Apostel); Thad|däd| österr. ugs. (willensschwacher, einfältiger Mensch); m; -s, -[n]

¹Thai [auch: *tạ-i*] (Angehöriger von paläomongoliden Völkerstämmen in Südchina u. Hinterindien) *m*; -[s], -[s]; ²Thai (thailändische Sprache) *s*; -; Thai|land („Land der Freien"; Staat in Hinterindien); Thai|län|der; thai|län|disch

Tha|is [*tạ-iß*] (altgr. Hetäre) tha|las|so|gen *gr.* (Geogr.: durch das Meer entstanden), Tha|las|so|me|ter (Meerestiefenmesser; Meßgerät für Ebbe und Flut) *s*; -s, -; Tha|lat|ta, Tha|lat|ta! („das Meer, das Meer!"; Freudenruf der Griechen nach der Schlacht von Kunaxa, als sie das die Nähe der Heimat kündende Meer erblickten)

Thal|le (Harz) (Stadt an der Bode) Tha|les (altgr. Philosoph)

Tha|lia (Muse der heiteren Dichtkunst u. des Lustspieles; eine der drei gr. Göttinnen der Anmut, der Chariten)

Thal|li|um *gr.* (chem. Grundstoff, Metall; Zeichen: Tl) *s*; -s; Thal|lus (primitiver Pflanzenkörper ohne Wurzel, Stengel u. Blätter) *m*; -, ...lli

Thäl|mann (dt. kommunist. Politiker)

Tha|ly|sia Ⓦ (Reformartikel) Tha|na|to|lo|gie *gr.* (Sterbekunde) *w*; -

Thank|mar vgl. Dankmar

Thanks|gi|ving Day *engl.* [*thängkßgiwing dẹ¹*] (Erntedanktag in den USA [4. Donnerstag des November]) *m*; - -, - -s

Tha|randt (Stadt südwestl. von Dresden)

Thau|mat|urg *gr.* (Wundertäter) *m*; -en, -en (↑ R 268)

Thaya (niederöster. Fluß)

Thea (Kurzform von: Dorothea)

Thea|ter *gr.* (Schaubühne; Schauspielhaus, Opernhaus; [Schauspiel-, Opern]aufführung, Vorstellung, Spiel; ugs. nur *Einz.* für: Unruhe, Aufregung; Vortäuschung) *s*; -s, -; Thea|ter.abon|ne|ment, ...auf|füh|rung, ...bau (*Mehrz.* ...bauten), ...de|ko|ra|ti|on, ...kar|te, ...kas|se, ...kri|ti|ker, ...pro|be, ...raum, ...re|gis|seur, ...ring (Besucherorganisation), ...saal, ...stück, ...vor|stel|lung

Thea|ti|ner (Angehöriger eines it. Ordens) *m*; -s, -

Thea|tra|lik *gr.* (übertriebenes schauspielerisches Wesen; Gespreiztheit) *w*; -; thea|tra|lisch (bühnenmäßig; übertrieben schauspielermäßig; gespreizt); -ste (↑ R 294)

The|bais (altgr. Bez. des südl. Ägyptens); The|ba|ner (Bewohner der altgr. Stadt Theben); the-

ba|nisch; The|ben (Stadt im gr. Böotien; im Altertum auch: Stadt in Oberägypten)

Thé dan|sant *fr.* [*tẹ dangßạng*] („Tanztee"; kleiner [Haus]ball) *m*; - -, - -s [*tẹ dangßạng*]; The|in *chin.-nlat.* (chem. fachspr. älter für: Koffein) *s*; -s

The|is|mus *gr.* (Glaube an einen persönlichen, außerweltlichen Gott) *m*;

Theiß (l. Nebenfluß der Donau) *w*; -

The|ist *gr.* (Anhänger des Theismus); ↑ R 268; thei|stisch

The|ke *gr.* (Schanktisch; auch: Ladentisch) *w*; -, -n

The|kla (w. Vorn.)

The|le|ma *gr.* [auch: *tẹl...*] (Philos.: [Eigen]wille) *s*; -s, ...lemata; The|le|ma|tis|mus *m*; - u. The|le|ma|to|lo|gie *w*; - u. The|lis|mus (Willenslehre) *m*; -; the|le|ma|to|lo|gisch; The|lis|mus vgl. Thelematismus; the|li|stisch

The|ma *gr.* (Aufgabe, [zu behandelnder] Gegenstand; Gesprächsstoff; Grund-, Haupt-, Leitgedanke [bes. in der Musik]) *s*; -s, ...men u. -ta; The|ma|tik (Themenstellung; Ausführung eines Themas) *w*; -, -en; the|ma|tisch (dem Thema entsprechend, zum Thema gehörend); The|men.be|reich *m*, ...kreis, ...stel|lung, ...wahl

The|mis (gr. Göttin des Rechtes) The|mi|sto|kles (athenischer Staatsmann)

Them|se (Fluß in England) *w*; -

Theo, Tẹo (Kurzform von: Theodor)

Theo|bald (↑ R 191 (m. Vorn.)

Theo|bro|min *gr.* (Alkaloid der Kakaobohnen) *s*; -s

Theo|de|rich; ↑ R 191 (m. Vorn.)

Theo|di|zee *gr.* (Rechtfertigung Gottes hinsichtlich des von ihm in der Welt zugelassenen Übels) *w*; -, ...een

Theo|do|lit (ein Winkelmeßgerät) *m*; -[e]s, -e

Theo|dor (m. Vorn.); Theo|do|ra, Theo|do|re (w. Vorn.)

Theo|do|sia (w. Vorn.); Theo|do|sia|nisch; ↑ R 179 (von Kaiser Theodosius herrührend); Theo|do|si|us (röm. Kaiser)

Theo|gno|sie *gr.* (Gotteserkenntnis) *w*; -; Theo|go|nie (myth. Lehre von Entstehung und Abstammung der Götter) *w*; -, ...jen; Theo|krat (selten für: Anhänger der Theokratie) *m*; -en, -en (↑ R 268); Theo|kra|tie („Gottesherrschaft"; Herrschaftsform, bei der die Staatsgewalt allein religiös legitimiert ist) *w*; -, ...jen; theo|kra|tisch; -ste (↑ R 294)

Theo|krit (altgr. Idyllendichter); theo|kri|tisch, aber (↑ R 179): Theo|kri|tisch

Theo|lo|ge *gr.* (Gottesgelehrter, wissenschaftl. Vertreter der Theologie) *m*; -n, -n (↑ R 268); Theo|lo|gie (Wissenschaft von Gott u. seiner Offenbarung, von den Glaubensvorstellungen einer Religion) *w*; -, ...jen; theo|lo|gisch; theo|lo|gi|sie|ren (Theologie treiben; das Gebiet der Theologie berühren); Theo|ma|nie (religiöser Wahnsinn) *w*; -, ...jen; Theo|man|tie (Weissagung durch göttliche Eingebung) *w*; -, ...jen; theo|morph, theo|mor|phisch (in göttlicher Gestalt [auftretend, erscheinend]); Theo|pha|nie (Gotteserscheinung) *w*; -, ...jen; Theo|phil, Theo|phi|lus (m. Vorn.)

Theo|pneu|stie *gr.* (Eingebung von Gott) *w*; -, ...jen

The|or|be it. (tiefgestimmte Laute des 16. bis 18. Jh.s) *w*; -, -n

Theo|rem *gr.* ([mathemat., philos.] Lehrsatz) *s*; -s, -e; Theo|re|ti|ker (Ggs.: Praktiker); theo|re|tisch; -ste (↑ R 294); theo|re|ti|sie|ren (etwas rein theoretisch erwägen); Theo|rie *w*; -, ...jen; Theo|ri|en|streit

Theo|soph *gr.* (Gottesweiser"; Anhänger der Theosophie) *m*; -en, -en (↑ R 268); Theo|so|phie („Gottesweisheit"; Erlösungslehre, die in der Meditation über Gott den Sinn des Weltgeschehens erkennen will) *w*; -, ...jen; theo|so|phisch

The|ra|peut *gr.* („Pfleger"; behandelnder Arzt, Heilkundiger) *m*; -en, -en (↑ R 268); The|ra|peu|tik (Lehre von der Behandlung der Krankheiten) *w*; -; The|ra|peu|ti|kum (Heilmittel) *s*; -s, ...ka; the|ra|peu|tisch; The|ra|pie (Krankenbehandlung, Heilbehandlung) *w*; -, ...jen; The|ra|pie|for|schung

The|res|chen (Koseform von: Therese, Theresia); The|re|se, The|re|sia (w. Vorn.); The|re|sia|nisch; ↑ R 179 (von der Kaiserin Maria Theresia herrührend); -e Akademie (in Wien); The|re|si|en|stadt (Stadt in der Tschechoslowakei; Konzentrationslager der Nationalsozialisten)

The|ri|ak (ein Heilmittel des MA.) *m*; -s; The|ri|ak[s]|wur|zel therm... *gr.* (warm...); Therm... (Wärme...); Therm... (Warm...); Ther|mal.bad (Warm[quell]bad), ...quel|le, ...salz; Ther|me (warme Quelle) *w*; -, -n; Ther|men (warme Bäder im antiken Rom) *Mehrz.*; Ther|mi|dor *fr.* („Hitzemonat" der Fr. Revolution: 19. Juli bis

17. Aug.) *m*; -[s], -s; **Ther|mik** *gr.* (Meteor.: aufwärtsgerichtete Warmluftbewegung) *w*; -; **ther|misch** (die Wärme betreffend, Wärme...); -e Ausdehnung (Physik); **Ther|misch-Flie|gen** (dem Segelflug) *s*; -s; **Ther|mit** Ⓦ（großße Hitze entwickelndes Metallgemisch; Füllung für Brandbomben) *s*; -s, -e; **Ther|mit|bom|be** (Brandbombe); **Ther|mo|che|mie** (Untersuchung der Wärmeumsetzung bei chem. Vorgängen); **ther|mo|che|misch**; **Ther|mo|chro|se** [...*krō̧sᵉ*] (Chemie: Wärmefärbung) *w*; -; **Ther|mo|dy|na|mik** (Lehre von den makroskopischen Beziehungen zwischen Wärme und Kraft [od. Arbeit]); **ther|mo|dy|na|misch**; -e Temperaturskala; **ther|mo|elek|trisch**; -er Ofen; **Ther|mo.elek|tri|zi|tät** (durch Wärmeunterschied erzeugte Elektrizität); ...**ele|ment** (Temperaturmeßgerät); **Ther|mo|graph** (Temperaturschreiber) *m*; -en, -en (↑ R 268); **Ther|mo|kau|ter** (Med.: Glüheisen, -stift für Operationen) *m*; -s, -; **Ther|mo|me|ter** (Temperaturmeßgerät) *s*; -s, -; **ther|mo|nu|kle|ar** (Physik: die bei der Kettenreaktion auftretende Wärme betreffend); -e Reaktion; **Ther|mo|nu|kle|ar|waf|fe**; **ther|mo|phil** (Biol.: wärmeliebend); **Ther|mo|phor** (wärmespeicherndes Gerät) *m*; -s, -e; **Ther|mo|py|len** (gr. Engpaß) *Mehrz.*; **Ther|mos|fla|sche** Ⓦ (Warmhaltegefäß); **Ther|mo|stat** (Temperaturregler; Apparat zur Herstellung konstanter Temperatur in einem Raum) *m*; -[e]s u. -en, -e[n] (↑ R 268)

Ther|si|tes (schmäh- u. streitsüchtiger Grieche vor Troja)

the|sau|rie|ren *gr.* (Geld od. Edelmetalle horten); **The|sau|rie|rung**; **The|sau|rus** [Wort]schatz, Titel wissenschaftlicher Sammelwerke) *m*; -, ...ren u. ...ri

The|se *gr.* (aufgestellter [Leit]satz, Behauptung) *w*; -, -n; vgl. aber: Thesis

The|sei|on (Heiligtum des Theseus in Athen) *s*; -s; **The|seus** [...*seuß*] (gr. Sagenheld)

The|sis *gr.* [auch: *tȩ̄...*] (älter für: These) *w*; -, ...sen

Thes|pis (Begründer der altathen. Tragödie); **Thes|pis|kar|ren**; ↑ R 180 (Wanderbühne)

Thes|sa|li|en [...*iᵉn*] (Landschaft in Nordgriechenland); **Thes|sa|li|er** [...*iᵉr*]; **thes|sa|lisch**; **Thes|sa|lo|nich** (alte Form von: Thessaloniki); **Thes|sa|lo|ni|cher**; **Thes|sa|lo|ni|ki** (gr. Name für: Saloniki); **thes|sa|lo|nisch**

The|ta (gr. Buchstabe: Θ, ϑ) *s*; -[s], -s

The|tis (Meernymphe der gr. Sage, Mutter Achills); vgl. aber: Tethys

The|urg *gr.* (heidnischer Zauberer) *m*; -en, -en (↑ R 268); **The|ur|gie** (heidn. Zauberkunst) *w*; -

Thj|dreks|sa|ga; ↑ R 180 (norw. Sammlung dt. Heldensagen um Dietrich von Bern als Mittelpunkt) *w*; -

Thig|mo|ta|xis *gr.* (Biol.: durch Berührungsreiz ausgelöste Orientierungsbewegung bei Tieren u. niederen Pflanzen) *w*; -, ...xen

Thil|de (Kurzform von: Mathilde)

Thj|lo, Tj|lo (m. Vorn.)

Thj|mig (österr. Schauspielerfamilie)

Thing [nord. Form von: Ding] (germ. Volksversammlung) *s*; -[e]s, -e; vgl. ²Ding; **Thing|platz**

Thio|kol Ⓦ (kautschukähnlicher Kunststoff) *s*; -s; **Thio|phen** *gr.* (schwefelhaltiger Bestandteil des Steinkohlenteers) *s*; -s

Thi|xo|tro|pie *gr.* (Verflüssigung von Gallerten durch Rühren, Schütteln u. ä.) *w*; -

Tho|los *gr.* [auch: *tȏ̧...*] (altgr. Rundbau mit Säulenumgang) *w* (auch: *m*); -, ...loi [...*eu*] u. ...len

¹**Tho|mas** (m. Vorn.); ²**Tho|mas**, (ökum.:) To̧|mas (Apostel): ungläubiger Thomas, ungläubige Thomasse; **Tho|mas a Kem|pis** (mittelalterl. Theologe); **Tho|mas|kan|tor** (Leiter des Thomanerchores der Thomaskirche in Leipzig) *m*; -s; **Tho|mas|mehl**; ↑ R 180 (Düngemittel) *s*; -[e]s; **Tho|mas|ver|fah|ren**; ↑ R 180 (Eisenverhüttungsverfahren); **Thomas von Aquin** (mittelalterl. Kirchenlehrer); **Tho|mis|mus** (Lehre des Thomas von Aquin) *m*; -; **Tho|mist** (Vertreter des Thomismus); ↑ R 268; **tho|mi|stisch**

Thon *fr.* schweiz. (Thunfisch) *m*; -s

Thor (nord. Mythol.: Sohn Odins); vgl. Donar

Tho|ra *hebr.* [auch, österr. nur: *to̧ra*] („Lehre“; die 5 Bücher Mosis, das mosaische Gesetz) *w*; -

tho|ra|kal *gr.* (Med.: den Brustkorb betreffend); **Tho|ra|ko|pla|stik** (Operation mit Rippenentfernung); **Tho|rax** (Brustkorb [auch der Wirbeltiere u. der Gliederfüßer]) *m*; -[es], -e

Tho|ri|um [nach dem Gott Thor] (chem. Grundstoff, Metall; Zeichen: Th) *s*; -s

Thorn (poln. Stadt); vgl. Toruń

Thor|vald|sen, (auch eindeutschend:) **Thor|wald|sen** (dän. Bildhauer)

Thot[h] (ägypt. Gott)

Thra|ker (Bewohner von Thrakien); **Thra|ki|en** [...*iᵉn*] (Gebiet auf der Balkanhalbinsel); **thra|kisch**; **Tra|zi|er** [...*iᵉr*] usw. vgl. Thraker

Thren|o|die *gr.* (altgr. Trauergesang) *w*; -, ...ien

Thrill|ler *amerik.* [*thril̄ᵉr*] (ein ganz auf Spannungseffekte abgestellter, nervenkitzelnder Film, Roman u. ä.; Reißer) *m*; -s, -

Thrips *gr.* (Blasenfüßer; schädliches Insekt) *m*; -, -

Throm|bo|se *gr.* (Med.: Verstopfung von Blutgefäßen durch Blutgerinnsel) *w*; -, -n; **Throm|bo|se.nei|gung**, ...ver|hü|tung; **throm|bo|tisch**; **Throm|bo|zyt** (Med.: Blutplättchen) *m*; -en, -en (meist *Mehrz.*); ↑ R 268; **Throm|bus** (Med.: Blutgerinnsel, Blutpfropf) *m*; -, ...ben

Thron *gr.* *m*; -[e]s, -e; **Thron.an|wär|ter**, ...be|stei|gung; **thro|nen**; **Thron.er|be** *m*, ...fol|ge, ...fol|ger, ...him|mel, ...prä|ten|dent, ...räu|ber, ...re|de, ...saal, ...ses|sel

Thrym (in der nord. Mythol. ein Riese)

thu|cy|di|de|isch usw. vgl. thukydideisch usw.

Thu|ja, (österr. auch:) **Thu|je** *gr.* (Pflanzengattung, Lebensbaum) *w*; -, ...jen

thu|ky|di|de|isch *gr.*, aber (↑ R 179): **Thu|ky|di|de|isch**; **Thu|ky|di|des** (altgr. Geschichtsschreiber)

Thu|le (in der Antike sagenhafte Insel im hohen Norden)

Thu|li|um (chem. Grundstoff, Metall; Zeichen: Tm) *s*; -s

Thun (schweiz. Stadt); **Thu|ner See** *m*; - -s

Thun|fisch *gr.*; *dt.* vgl. Thon

Thur (l. Nebenfluß des Hochrheins) *w*; -; **Thur|gau** (schweiz. Kanton) *m*; -s; **Thur|gau|er** (↑ R 199); **thur|gau|isch**

Thü|rin|gen; **Thü|rin|ger** (↑ R 199); - Wald; **thü|rin|gisch**

Thurn und Ta|xis (Adelsgeschlecht); die Thurn-und-Taxissche Post (↑ R 188)

Thus|nel|da (Gattin des Arminius)

THW = Technisches Hilfswerk

Thy|mi|an *gr.* (eine Heilpflanze) *m*; -s, -e; **Thy|mol** (Wurmmittel) *s*; -s

Thy|mus|drü|se *gr.*; *dt.* (hinter dem Brustbein gelegene innere Brustdrüse, Wachstumsdrüse)

Thy|reo|idi|tis *gr.* (Med.: Schilddrüsenentzündung) *w*; -, ...itj|den

Thy|ri|stor *gr.-lat.* (steuerbares Halbleiterventil) *m*; -s, ...oren; **Thy|ri|stor.schal|tung**, ...tech|nik

Thyr|sos *m*; -, ...soi [...*eu*] u. **Thyr-**

sus *gr.* (Bacchantenstab) *m*; -,
...si; **Thyr|sos|stab, Thyr|sus|stab**
Ti = chem. Zeichen für: ²Titan
Tia|ra *pers.* (Kopfbedeckung der
altpers. Könige; dreifache Krone
des Papstes) *w*; -, ...ren
Ti|ber (it. Fluß) *m*; -[s]
Ti|be|ri|as (Stadt am See Geneza-
reth)
Ti|be|ri|us (röm. Kaiser)
¹**Ti|bet** (Hochland in Zentralasi-
en), ²**Ti|bet** (wollgewebe; Reiß-
wollart) *m*; -[e]s, -e; **Ti|be|ta|ner**
vgl. Tibeter; **ti|be|ta|nisch** vgl. ti-
betisch; **Ti|be|ter** [auch: *tj*...]; **ti-**
be|tisch [auch: *tj*...]
Tic *fr.* [*tjk*] (krampfartiges Zu-
sammenziehen der Muskeln;
Zucken) *m*; -s, -s; **Tick** (wunder-
liche Eigenart, Schrulle; Fimmel,
Stich; auch für: Tic) *m*; -[e]s, -s
ticken [*Trenn.*: tik|ken]
Ticket [*Trenn.*: Tik|ket] *engl.*
(„Zettel"; engl. Bez. für: Fahr-,
Eintrittskarte) *s*; -s, -s
tick|tack!; Tick|tack *s*; -s
Ti|de (niederd.: „Zeit"; die regel-
mäßig wechselnde Bewegung der
See; Flut) *w*; -, -n; **Ti|den** (Gezei-
ten) *Mehrz.*; **Ti|den|hub** (Was-
serstandsunterschied bei den Ge-
zeiten)
Tieck (dt. Dichter)
tief; auf das, aufs -ste beklagen
(↑ R 134); zutiefst; tiefblau usw.;
tief sein, werden, graben, stehen;
ein tief ausgeschnittenes Kleid;
Tief (Fahrrinne; Meteor.: Tief-
stand [des Luftdrucks]) *s*; -s, -s;
Tief.aus|läu|fer (Meteor.), ...**bau**
(*m*; -[e]s); **Tief|bau|amt;** tief|be-
wegt; der tiefbewegte alte Mann
(↑ jedoch R 142), a b e r : er ist tief
bewegt; **tief|blau; tief|blickend**
[*Trenn.*: ...blik|kend]; (↑ R 296:)
tiefer blickend, am tiefsten blik-
kend od. tiefstblickend; der tiefer
Blickende; **Tief.boh|rung, ...bun-**
ker, ...decker [*Trenn.*: ...dek|ker]
(Flugzeugtyp); **tief|drin|gend;**
vgl. tiefblickend; **Tief|druck** *m*;
-[e]s, (Druckw.:) -e; **Tief|druck-**
ge|biet (Meteor.); **Tief|druck-**
ge|bie|te (Meteor.) *w*; -, -n;
Tief.ebe|ne; tief|emp|fun|den; die
tiefempfundenen Verse (↑ jedoch
R 142), a b e r : die Verse sind tief
empfunden; **Tie|fen.be|strah-**
lung, ...ge|stein, ...in|ter|view,
...la|ge, ...mes|sung, ...psy|cho|lo-
gie, ...schär|fe, ...wir|kung; tief-
ernst; tief|er|schüt|tert; der tiefer-
schütterte Mann (↑ R 142), a b e r :
der Mann ist tief erschüttert;
Tief.flie|ger (Flugzeug), ...**flie-**
ger|an|griff, ...flug, ...gang (*m*;
-[e]s); **Tief|gang|mes|ser** *m*; -[e]s;
tief|ge|fühlt; tiefstge-
fühlter Dank (↑ R 296); **tief|ge-**
hend; vgl. tiefblickend; **tief|ge-**

kühlt; (vgl. S. 45, Merke, 2:) tief-
gekühltes Gemüse od. Obst; das
Obst ist tiefgekühlt; **tief|grei-**
fend; vgl. tiefblickend; **tief|grün-**
dig; -ste; **Tief|kühl.fach,** ...**ket|te,**
...kost, ...tru|he; Tief|la|der (kurz
für: Tiefladewagen, Wagen mit
tiefliegender Ladefläche); **Tief-**
land (*Mehrz.* ...lande u. ...länder);
Tief|land.bucht, ...**ge|biet,** ...**vieh;**
tief|lie|gend; vgl. tiefblickend;
Tief.moor, ...**punkt,** ...**schlag**
([Box]hieb unterhalb der Gürtel-
linie); **tief|schür|fend;** vgl. tief-
blickend; **tief|schwarz; Tief|see** *w*;
Tief|see.for|schung, ...**tau|cher;**
Tief|sinn *m*; -[e]s; **tief|sin|nig;** -ste;
Tief|sin|nig|keit; Tief.stand *m*,
-[e]s; **Tief|sta|pe|lei; tief|sta|peln**
(Ggs.: hochstapeln); ich stap[e]le
tief (↑ R 327); ich habe tiefgesta-
pelt; um tiefzustapeln; **Tief|stap-**
ler; Tief|start (Sportspr.); **tief|ste-**
hend; vgl. tiefblickend; **Tief-**
.flug, ...preis, ...tem|pe|ra|tur,
...wert; tief|trau|rig

Tie|gel *m*; -s, -; **Tie|gel|druck**
(*Mehrz.* ...drucke); **Tie|gel-**
druck|pres|se; Tie|gel.guß,
...**stahl**

Tiek.baum, ...**holz** (*s*; -es; vgl.
Teakholz)

Tien|jan/Hochrhein [*tjng*ᵉ*n*] (Stadt
in Baden-Württemberg)

Ti|en|schan (Gebirgssystem In-
nerasiens) *m*; -[s]

Ti|en|tsin (chin. Stadt)

Tier *s*; -[e]s, -e; **Tier.art,** ...**arzt;**
tier|ärzt|lich; [eine] -e Hochschu-
le, a b e r (↑ R 224): die Tierärzt-
liche Hochschule Hannover;
Tier.asyl, ...**bän|di|ger,** ...**bild,**
...buch, ...**epos,** ...**fa|bel,** ...**freund,**
...gar|ten, ...**ge|schich|te,** ...**ge|stalt**
(in ...); **tier|haft; Tier.hal-**
ter, ...**hand|lung,** ...**heil|kun|de,**
...heim; tie|risch; -ste (↑ R 294);
Tier.kör|per|be|sei|ti|gungs|an-
stalt (Amtsspr. für: Abdeckerei);
Tier.kreis (Astron.); **Tier|kreis-**
zei|chen; Tier.kun|de (für: Zoolo-
gie), ...**lie|be; tier|lie|bend; Tier-**
.me|di|zin, ...**park,** ...**pfle|ger,**
...quä|ler; Tier|quä|le|rei; Tier-
.reich (*s*; -[e]s), ...**schau,** ...**schutz;**
Tier.schutz|ver|ein; Tier.stück
(Tierbild), ...**ver|such,** ...**welt** (*w*;
-), ...**zucht**

Tif|lis [auch: *tj*...] (Hptst. der Gru-
sinischen SSR)

Ti|ger *m*; -s, -; **Ti|ger.au|ge** (ein
Mineral), ...**fär|bung,** ...**fell,**
...kat|ze; ti|gern (bunt, streifig
machen; ugs. für: eilen); ich ...ere
(↑ R 327)

Ti|gris (Strom in Vorderasien)
m; -

Ti|gu|ri|ner (Angehöriger eines
kelt. Volkes in der Schweiz)

Ti|kal *malai.* (alte Münzeinheit in
Thailand) *m*; -[s], -[s]

Til|bu|ry *engl.* [...*b*ᵉ*ri*] (leichter
zweirädriger Wagen in Nord-
amerika) *m*; -s, -s

Til|de *span.* (span. Aussprachezei-
chen auf dem n [ñ]; [Druckw.:]
Wiederholungszeichen: ~) *w*; -,
-n

tilg|bar; til|gen; Til|gung; Til-
gungs.an|lei|he, ka|pi|tal, ...**ra-**
te, ...sum|me

Til|la (w. Vorn.)

Till Eu|len|spie|gel (niederd.
Schalksnarr)

Til|ly (Feldherr im Dreißigjähri-
gen Krieg)

Tim|mann (m. Vorn.)

Ti|lo, Thi|lo (m. Vorn.)

Til|sit (Stadt an der Memel); ¹**Til-**
si|ter (↑ R 199); - Friede[n], - Kä-
se; ²**Til|si|ter** (ein Käse) *m*; -s, -

Tim|bre *fr.* [*tǟngbr*ᵉ] (Klangfarbe
der Gesangsstimme) *s*; -s, -s; **tim-**
bri|e|ren (Klangfarbe geben); tim-
briert

Tim|buk|tu (Stadt in ²Mali)

Times [*tajms*] („Zeiten"; engl. Zei-
tung) *Mehrz.* (auch: *w*; -)

Ti|ming *engl.* [*tajming*] (Wahl,
Festlegung des [für eine Unter-
nehmung günstigen] Zeitpunk-
tes) *s*; -s, -s

Ti|mo|kra|tie *gr.* (Herrschaft der
Besitzenden) *w*; -, ...ien

Ti|mon; - von Athen (athen. Philo-
soph u. Sonderling; Urbild des
Menschenhassers); **ti|mo|nisch**
(veralt. für: menschenfeindlich),
a b e r (↑ R 179): **Ti|mo|nisch**

Ti|mor (eine Sundainsel)

Ti|mo|thee|gras, Ti|mo|the|us|gras
[...*e-uß*...], **Ti|mo|thy|gras** *s*; -es

Ti|mo|the|us [...*e-uß*] (Gehilfe des
Paulus)

Ti|mo|thy|gras [auch: *timoti*...]
vgl. Timotheegras, Timotheus-
gras

Tim|pa|ni *gr.* ([Kessel]pauken)
Mehrz.

Ti|mur, Ti|mur-Leng (mittelasiat.
Eroberer)

Ti|na, Ti|ne, Ti|ni (Kurzformen
von Christine, Ernestine usw.)

Tin|chen (Koseform von: Tine)

Ti|ne vgl. Tina

tin|geln (ugs. für: Tingeltangel
spielen; im Tingeltangel auftre-
ten); ich ...[e]le (↑ R 327); **Tin|gel-**
tan|gel (ugs. für: Musik niederen
Ranges; Musikkneipe) *m* u. *s*;
-s, -

Ti|ni vgl. Tina

Tink|ti|on *lat.* [...*zion*] (Chemie:
Färbung); **Tink|tur** (Arznei]aus-
zug; veralt. für: Färbung) *w*; -,
-en

Tin|nef *jidd.* (ugs. für: Schund,
Wertloses; dummes Zeug) *m*; -s

Tin|te w; -, -n; Tin|ten.faß, ...fisch, ...fleck, ...klecks, ...kleck|ser (abschätzig ugs.), ...ku|li, ...stift (vgl. ¹Stift), ...wi|scher; tin|tig; Tint|ling (ein Pilz)

Tip engl. ([bes. beim Sport:] Wink, Andeutung, Vorhersage) m, -s, -s

tipp!; tipp, tapp!

Tip|pel (niederd.: Punkt; österr. ugs.: Beule) m; -s, -; vgl. Dippel; Tip|pel|bru|der (veralt. für: wandernder Handwerksbursche; ugs. für: Landstreicher); Tip|pel|chen landsch. (Tüpfelchen); bis aufs -; Tip|pe|lei (ugs.) w; -; tip|pe|lig, tipp|lig mdal. (kleinlich); tip|peln (landsch. für: mit Punkten versehen; landsch. für: mit kleinen Schritten laufen; ugs. für: beständig [auf der Landstraße] wandern); ich ...[e]le (↑ R 327)

¹tip|pen nieder-, mitteld. (leicht berühren; Dreiblatt spielen); er hat ihn (auch: ihm) auf die Schulter getippt

²tip|pen engl. (wetten); er hat richtig getippt

³tip|pen (ugs. für: maschineschreiben)

Tip|pen (Dreiblattspiel, Zwicken) s; -s

Tip|per [zu: ²tippen]

Tip|pett [tipit], Michael (engl. Komponist)

Tipp.feh|ler (ugs. für: Fehler beim Maschineschreiben), ...fräu|lein (ugs. scherzh. für: Maschinenschreiberin)

Tipp|ge|mein|schaft [zu: ²tippen]

tipp|lig vgl. tippelig

Tippse (abwertend ugs. für: Maschinenschreiberin) w; -, -n

tipp, tapp!; tipp|topp engl. (ugs. für: hochfein; tadellos)

Tipp|zet|tel (Wettzettel)

Ti|ra|de fr. (Worterguß; Musik: Lauf schnell aufeinanderfolgender Töne, bes. in Gesangsstücken)

Ti|ra|na (Hptst. von Albanien)

Ti|raß fr. (Jägerspr.: Deckgarn, -netz) m; ...sses, ...sse; ti|ras|sie|ren ([Vögel] mit dem Tiraß fangen)

ti|ri|li! (Naturlaut); Ti|ri|li s; -s; ti|ri|lie|ren (von Vögeln: pfeifen, singen)

ti|ro! fr. (,,schieße hoch!''; Zuruf an den Schützen, wenn Federwild vorbeistreicht)

Ti|ro (Freigelassener u. gelehrter Freund Ciceros)

Ti|rol (österr. Bundesland); Ti|ro|ler (↑ R 199); Tiroler Ache (↑ R 204); Ti|ro|ler|fest; ↑ R 205 (Fest, das von Tirolern veranstaltet wird); Ti|ro|le|rin w; -, ...innen; ti|ro|le|risch (österr. nur so); Ti-ro|li|enne fr. [...liän] (Tiroler Lied, Tiroler Tanz) w; -, -n; ti|ro|lisch

ti|ro|nisch [zu Tiro], aber (↑ R 179): Ti|ro|nisch; -e Noten (altröm. Kurzschriftsystem)

Ti|ryns (altgr. Stadt); Ti|ryn|ther; ti|ryn|thisch.

Tisch m; -[e]s, -e; bei - (beim Essen) sein; am - sitzen; zu - gehen; Gespräch am runden -; Tisch-bein, ...be|sen, ...da|me, ...decke [Trenn.: ...dek|ke]; ti|schen landsch. (den Tisch bereiten); du tischst (tischest); Tisch.fern|sprecher, ...ge|bet, ...ge|sell|schaft, ...ge|spräch, ...grup|pe (vgl. ¹Gruppe), ...herr, ...kan|te, ...kar-te, ...lam|pe, ...läu|fer; Tisch|lein-deck|dich s; -; Tisch|ler; Tisch|ler-ar|beit; Tisch|le|rei; tisch|lern; ich ...ere (↑ R 327); Tisch|ler|werk-statt; Tisch.mes|ser s, ...nach|bar, ...ord|nung, ...plat|te, ...rand (Mehrz. ...ränder), ...rech|ner, ...re|de, ...rücken [Trenn.: rük-ken] (s; -s), ...se|gen, ...te|le|fon, ...ten|nis, ...tuch (Mehrz. ...tücher); Tisch|tuch|klam|mer; Tisch.wein, ...zeit

Ti|si|pho|ne (eine der drei Erinnyen)

Tit. = Titel

¹Ti|tan, Ti|ta|ne (einer der riesenhaften, von Zeus gestürzten Götter der gr. Sage; übertr. für: großer, starker Mann) m; ...nen, ...nen (meist Mehrz.); ↑ R 268; ²Ti|tan gr. (chem. Grundstoff, Metall; Zeichen: Ti) s; -s; Ti|ta|ne vgl. ¹Titan; Ti|tan|ei|sen|erz; ti-ta|nen|haft (riesenhaft); Ti|ta|nia (Titanentochter, Göttin; Gemahlin Oberons); Ti|ta|nic (engl. Schnelldampfer, der 1912 nach Zusammenstoß mit einem Eisberg unterging) w; -; Ti|ta|ni|de gr. (Abkömmling der Titanen) m; -n, -n (↑ R 268); ti|ta|nisch (riesenhaft); Ti|ta|no|ma|chie [...chi] (Kampf der Titanen gegen Zeus in der gr. Sage) w; -

Ti|tel lat. (Aufschrift, Überschrift; Amts-, Dienstbezeichnung; [Ehren]anrede[form]; Rechtsgrund; Abschnitt; Abk.: Tit.) m; -s, -; Ti|tel.an|wär|ter, ...auf|la|ge, ...bild, ...blatt, ...bo|gen; Ti|te|lei (Gesamtheit der dem Textbeginn vorangehenden Seiten mit den Titelangaben eines Druckwerkes); Ti|tel.held, ...kampf (Sportspr.), ...kir|che (Kirche eines Kardinalpriesters in Rom); ti|tel-los; ti|teln (keinen Film mit Titel versehen); ich ...[e]le (↑ R 327); Ti|tel.rol|le, ...schrift; Ti|tel-schrift|ka|sten; Ti|tel.schutz, ...sei|te, ...sucht (w; -); ti|tel|süch-tig; Ti|tel.trä|ger, ...ver|tei|di|ger (Sportspr.), ...we|sen (s; -s), ...zei-le

Ti|ter [eindeutschend für: Titre] (Feinheit eines Seiden-, Reyonfadens; Gehalt einer Lösung) m; -s, -

Ti|thon gr. (Geol.: oberste Stufe des Malms) s; -s

Ti|ti|ca|ca|see [...kaka...] (See in Südamerika) m; -s

Ti|ti|see (See im südl. Schwarzwald) m; -s

Ti|to|is|mus [nach dem jugoslaw. Staatspräsidenten Josip Broz Tito] (bes. im kommunistischen Sprachgebrauch verwendetes Schlagwort für: eine kommunistische, aber von der Sowjetunion unabhängige Politik u. Staatsform) m; -; Ti|to|ist (Vertreter des Titoismus); ↑ R 268

Ti|tra|ti|on lat. [...zion] (Bestimmung des Titers, Ausführung einer chem. Maßanalyse); Ti|tre [tit'r] (veralt. für: Titer; im fr. Münzwesen Bezeichnung für: Korn) m; -s, -s; ti|tri|e|ren

tit|schen landsch. (eintauchen); du titschst (titschest)

Tit|te (ugs. derb für: weibl. Brust) w; -, -n (meist Mehrz.)

Ti|tu|lar lat. (veralt. für: Titelträger) m; -s, -e; Ti|tu|lar.bi|schof, ...rat (Mehrz. ...räte); Ti|tu|la|tur (Betitelung) w; -, -en; ti|tu|lie|ren (Titel geben, benennen); Ti|tu|lie|rung; Ti|tu|lus (mittelalterliche Bildunterschrift [meist in Versform]) m; -, ...li

Ti|tus (röm. Kaiser; Abk.: T.)

Tiu [auch: tju] (altgerm. Gott); vgl. Tyr, Ziu

¹Ti|vo|li [...wo...] (it. Stadt); ²Ti|vo-li (Vergnügungsort; Gartentheater; it. Kugelspiel) s; -[s], -s

Ti|zi|an (it. Maler); ti|zi|a|nisch, aber (↑ R 179): Ti|zi|a|nisch; ti|zi-an|rot

tja! [auch: tja]

Tjalk niederl. (einmastiges Küstenfahrzeug) w; -, -en

Tjost fr. (Turnierzweikampf mit scharfen Waffen in der Ritterzeit) w; -, -en od. m; -[e]s, -e

tkm = Tonnenkilometer

Tl = Zeichen für: Thallium

Tm = chem. Zeichen für: Thulium

Tme|sis gr. (Sprachw.: Trennung eigentlich zusammengehörender Wortteile durch dazwischentretende Wörter, z. B. ,,ich vertraue dir ein Geheimnis an'') w; -, ...sen

TNT = Trinitrotoluol

Toast engl. [toßt] (geröstete Weißbrotschnitte; Trinkspruch) m; -[e]s, -e u. -s; toa|sten (Weißbrot rösten; einen Trinkspruch ausbringen); Toa|ster (elektr. Gerät)

To|ba|go vgl. Trinidad

To|bak (alte, heute nur noch scherzh. gebrauchte Form von: Tabak) *m*; -[e]s, -e; vgl. Anno

To|bel südd., österr., schweiz. (enge [Wald]schlucht) *m* (österr. nur so) od. *s*; -s, -

to|ben; To|be|rei

To|bi|as (m. Vorn.)

To|bog|gan *indian.* (kufenloser [kanad. Indianer]schlitten) *m*; -s, -s

Tob|sucht *w*; -; tob|süch|tig; Tob|suchts|an|fall

Toc|ca|ta vgl. Tokkata

Toch|ter (schweiz. auch für: Mädchen, Fräulein, Angestellte) *w*; -, Töchter; Toch|ter|chen, Töchter|lein; Toch|ter.fir|ma, ...geschwulst (für: Metastase), ...gesell|schaft (Wirtsch.); Toch|ter|heim; Toch|ter|kir|che; Toch|ter|lein, Töch|ter|chen; töch|ter|lich; Töch|ter|schu|le (veralt.); höhere -; Toch|ter.stadt (Zweigsiedlung), ...zel|le (Med.)

Tod *m*; -[e]s, (selten:) -e; zu -e fallen, hetzen, erschrecken; tod.bang, ...be|reit; tod|blaß, to|tenblaß; tod|bleich, to|ten|bleich; tod|brin|gend aber: († R 142): den Tod bringend

Tod|dy *Hindi-engl.* (Palmwein; grogartiges Getränk) *m*; -[s], -s

tod.elend (ugs.), ...ernst (ugs.); To|des.angst, ...an|zei|ge, ...art, ...bereit|schaft, ...da|tum, ...fall *m*, ...fol|ge (Rechtsspr.), ...furcht, ...ge|fahr, ...jahr, ...kampf, ...kandi|dat; to|des|mu|tig; To|des|-.nach|richt, ...not (in Todesnöten), ...op|fer, ...qual, ...ritt, ...schüt|ze, ...stoß, ...stra|fe, ...stun|de, ...tag, ...ur|sa|che, ...urteil, ...ver|ach|tung; to|des|würdig; To|des|zeit; tod|feind; Todfeind; tod|ge|weiht; tod|krank; töd|lich; tod.matt (ugs.), ...mü|de (ugs.), ...schick (ugs. für: sehr schick), ...si|cher (ugs.: so sicher wie der Tod); tod|still, to|tenstill; Tod|sün|de

Todt|moos (Ort im Schwarzwald) tod.trau|rig, ...un|glück|lich, ...wund

Toe-loop *engl.* [[*toᵘlup*] (Drehsprung beim Eiskunstlauf) *m*; -[s], -s

töff; töff, töff!

Tof|fee *engl.* [*tofi*] (eine Weichkaramelle) *s*; -s, -s

Tof|fel, Töf|fel (Kurzform von: Christoph[el]; dummer Mensch) *m*; -s, -

töf|fen (veralt.); töff, töff!; Töff-töff (veralt. scherzh. für: Kraftfahrzeug) *s*; -s, -s

To|ga *lat.* ([altröm.] Obergewand) *w*; -, ...gen

To|gal ⓦ (ein Heilmittel) *s*; -s

Tog|gen|burg (schweiz. Talschaft) *s*; -s

To|gliat|ti [*toljáti*] (it. Politiker)

To|go (Staat in Westafrika); To|go|er [...oᵉr] *m*; -s, -, (auch:) To|go|le|se *m*; -en, -en († R 268); to|go|isch [...o-isch], (auch:) to|go|le|sisch

To|hu|wa|bo|hu *hebr.* (,,wüst und leer"; Wirrwarr, Durcheinander) *s*; -[s], -s

Toi|let|te *fr.* [*toal...*] (Frisiertisch; [feine] Kleidung; Ankleideraum; Abort u. Waschraum) *w*; -, -n; - machen (sich [gut] anziehen); Toi|let|ten¹.ar|ti|kel, ...frau, ...pa|pier, ...raum, ...sei|fe, ...spiegel, ...tisch, ...was|ser (*Mehrz.* ...wässer)

Toise *fr.* [*toas*] (früheres fr. Längenmaß) *w*; -, -n [*toas'n*]

toi, toi, toi! [*teu, teu, teu*] (ugs. für: unberufen!)

To|ka|dil|le *span.* [...*dilj*ᵉ] (ein Brettspiel) *s*; -s

To|kai|er, To|ka|jer [nach der ung. Stadt Tokaj] (ung. Natursüßwein); To|kai|er. od. To|ka|jer.trau|be, ...wein; To|kaj [*tokai*] (ung. Stadt)

To|klo (Hptst. von Japan); To|klo|er [...oᵉr], To|kio|ter († R 199)

Tok|ka|ta, (auch:) Toc|ca|ta *it.* (ein Musikstück) *w*; -, ...ten

Tö|le (niederd., ugs. verächtl. für: Hund, Hündin) *w*; -, -n

To|le|da|ner († R 199); - Klinge; To|le|do (span. Stadt)

to|le|rant *lat.* (duldsam; nachsichtig; weitherzig; versöhnlich) To|le|ranz (Duldung, Duldsamkeit; Technik: Unterschied zwischen Größt- und Kleinstmaß, zulässige Abweichung) *w*; -, (Technik:) -en; To|le|ranz.do|sis (für den Menschen zulässige Strahlungsbelastung), ...edikt, ...gren|ze; to|le|rie|ren (dulden, gewähren lassen); To|le|rie|rung

toll; toll|dreist

Tol|le (ugs. für: Büschel; Haarschopf; selten für: Quaste) *w*; -, -n

tol|len; Toll.haus, ...häus|ler (veralt.), ...heit; Tol|li|tät (Fastnachtsprinz od. -prinzessin) *w*; -, -en (meist *Mehrz.*); Toll|kir|sche; toll|kühn; Toll.kühn|heit, ...wut; toll|wü|tig

Toll|patsch *ung.* (ugs. für: ungeschickter Mensch) *m*; -[e]s, -e; toll|pat|schig (ugs.)

Töl|pel (ugs.) *m*; -s, -; Töl|pe|lei

¹ Die Form Toiletteartikel [*toa-lät...*] ist österr. u. kommt sonst nur gelegentlich vor.

(ugs.); töl|pel|haft; töl|peln (selten für: einherstolpern); ich ...[e]le († R 327); töl|pisch; -ste († R 294)

Tol|stoi [...*steu*] (russ. Dichter)

Tölt *isländ.* (Gangart des Islandponys zwischen Schritt u. Trab mit sehr rascher Fußfolge) *m*; -s

Tol|te|ke (Angehöriger eines altmexikanischen Kulturvolkes) *m*; -n, -n († R 268); tol|te|kisch

To|lu|bal|sam [nach der Hafenstadt Santiago de Tolú in Kolumbien]; † R 201 (Pflanzenbalsam) *m*; -s; To|lui|din (Farbstoffgrundlage) *s*; -s; To|lu|ol (ein Lösungsmittel) *s*; -s

To|ma|hawk *indian.* [*tómahąk*, auch: ...*hḁk*] (Streitaxt der [nordamerik.] Indianer) *m*; -s, -s

To|mas vgl. Thomas

To|ma|te *mex.* (Gemüsepflanze; Frucht) *w*; -, -n; gefüllte -; To|ma|ten.mark *s*, ...so|ße; to|ma|ti|sie|ren (Gastr.: mit Tomatenmark versehen)

Tom|bak *sanskr.* (Legierung) *m*; -s

Tom|bo|la *it.* (Verlosung bei Festen) *w*; -, -s, (selten:) ...len

Tom|my *engl.* [*tȯmi*; Verkleinerungsform von: Thomas] (Spitzname des engl. [Fuß]soldaten) *m*; -s, -s

Tomsk (westsibir. Stadt)

¹Ton (Verwitterungsrückstand tonerdehaltiger Silikate) *m*; -[e]s, (Tonsorte *Mehrz.*:) -e

²Ton *gr.* (Laut usw.) *m*; -[e]s, Töne, den - angeben; Ton|ab|neh|mer; to|nal (auf einen Grundton bezogen); To|na|li|tät (Bezogenheit aller Töne auf einen Grundton) *w*; -; ton|an|ge|bend, aber († R 142): den Ton angebend; ¹Ton|art

²Ton|art [zu: ¹Ton]; ton|ar|tig

Ton.auf|nah|me, ...band *s* (*Mehrz.* ...bänder); Ton|band.auf|nah|me (kurz: Bandaufnahme); ...ge|rät

Ton|bank niederd. (Ladentisch; Schanktisch; *Mehrz.* ...bänke)

Ton.bild, ...blen|de

Ton|der (dän. Form von: Tondern); Ton|dern (dän. Stadt)

Ton|dich|ter

Ton|do *it.* (Rundbild, bes. in der Florentiner Kunst des 15. u. 16. Jh.s) *s*; -s, -s u. ...di

to|nen (Fotogr.: den Farbton verbessern); ¹tö|nen (Farbton geben)

²tö|nen (klingen)

tö|ner|de; essigsaure - († R 224); tö|nern (aus ¹Ton); es klingt - (hohl); -es Geschirr

Ton.fall (*m*; -[e]s), ...film; Ton|film|ge|rät; Ton.fol|ge, ...frequenz

Ton|ga [*tȯngga*] (Inselstaat im Pazifik); Ton|ga|in|seln *Mehrz.*; ton|ga|isch; Ton|ga|spra|che *w*; -

Ton|ge|bung
Ton_ge|fäß, ...ge|schirr; ton|hal-
tig; -e Erde
Ton|hö|he
To|ni (Kurzform von: Anton u.
Antonie)
to|nig [zu: ¹Ton] (tonartig)
...to|nig (z. B. hochtonig); ...tö|nig
(z. B. eintönig)
To|ni|ka gr. (Grundton eines Ton-
stücks; erste Stufe der Tonleiter)
w; -, ...ken
To|ni|kum gr. (Med.: stärkendes
Mittel) s; -s, ...ka
Ton|in|ge|nieur
to|nisch [zu: Tonikum]
Ton|ka_baum, ...boh|ne
Ton_ka|bi|ne, ...ka|me|ra, ...kon-
ser|ve, ...kopf, ...kunst (w; -),
...künst|ler, ...la|ge, ...lei|ter w;
ton|los; -e Stimme; Ton|lo|sig|keit
w; -; Ton|ma|le|rei; Ton|mei|ster
(Film, Rundfunk)
Ton|na|ge fr. [...geheᵉ] (Rauminin-
halt eines Schiffes; Schiffs-,
Frachtraum); Tönn|chen, Tönn-
lein; Ton|ne mlat. (auch Rauminhein-
heit für Masse: 1000 kg; Abk.:
t) w; -, -n; Ton|neau fr. [...no]) (ver-
alt. für: Schiffslast von 1000-kg)
m; -s, -s; Ton|nen_ge|halt (Raum-
gehalt eines Schiffes; m), ...ge-
wöl|be, ...ki|lo|me|ter (Maßein-
heit für Frachtsätze; Zeichen:
tkm), ...le|ger (Fahrzeug, das
schwimmende Seezeichen [Ton-
nen] auslegt); ton|nen|wei|se;
...ton|ner (z. B. Dreitonner [La-
ster mit 3 t Ladegewicht]; mit
Ziffer: 3tonner; ↑ R 228); Tönn-
lein, Tönn|chen
Ton_schnei|der (beim Tonfilm),
...set|zer (für: Komponist)
Ton|sil|le lat. (Med.: Gaumen-,
Rachenmandel) w; -, -n (meist
Mehrz.); Ton|sil|li|tis (Med.:
Mandelentzündung) w; -, ...iti-
den
Ton_spur (Film), ...stück (Musik-
stück)
Ton|sur lat. (Haarausschnitt als
Standeszeichen der kath. Kleri-
ker) w; -, -en; ton|su|rie|ren (die
Tonsur machen)
Ton_ta|fel, ...tau|be (Wurftaube)
Ton|tau|ben|schie|ßen s; -s
Ton|trä|ger
Tö|nung (Art der Farbengebung)
To|nus gr. (Med.: Spannungszu-
stand der Gewebe, bes. der Mus-
keln) m; -
Ton|wa|re
Ton_wert, ...zei|chen
Top... engl. (in Zusammensetzun-
gen = Spitzen..., z. B. Topmo-
dell, Topstar)
To|pas gr. [österr.: topaß] (ein
Halbedelstein) m; -es, -e; to|pas-
_far|ben od. ...far|big

Topf m; -[e]s, Töpfe; Topf_blu|me,
...bra|ten; Töpf|chen, Töpf|lein;
top|fen (in einen Topf pflanzen);
getopft; Top|fen bayr. u. österr.
(Quark) m; -s; Top|fen_knö|del
(bayr. u. österr.), ...pa|lat|schin-
ke (österr.), ...ta|scherl (bayr. u.
österr.); Töp|fer; Töp|fe|rei; Töp-
fer_er|de, ...hand|werk, ...markt,
...mei|ster; ¹töp|fern (irden,
tönern); ²töp|fern (Töpferwaren
machen); ich ...ere (↑ R 327); Töp-
fer_schei|be, ...ton (Mehrz. ...to-
ne), ...wa|re; Topf_flicker [Trenn.:
...flik|ker], ...gucker [Trenn.:
...guk|ker]

top|fit engl. [top-fit] (gut in Form,
in bester körperlicher Verfassung
[von Sportlern])
Topf_ku|chen, ...lap|pen; Töpf-
lein, Töpf|chen; Topf_markt,
...pflan|ze
To|pik gr. (Lehre von den Gemein-
plätzen; vgl. Topos; die mit dem
Schein von Gründlichkeit auftre-
tende vielschwätzerische antike
Redekunst; veralt. für: Lehre von
der Wort- und Satzstellung) w; -
To|pi|nam|bur bras. (Gemüse- u.
Futterpflanze mit stärkereichen
Knollen) m; -s, -s u. -e od. w;
-, -en
to|pisch gr. (Med.: örtlich, äußer-
lich wirkend)
top|less... engl.-amerik. [topleᵉß]
(,,oben ohne", busenfrei); Top-
less_mäd|chen, ...nacht|klub;
Top|ma|nage|ment [topmänidseh-
mᵉnt] (Wirtsch.: engl.-amerik.
Bez. für: Spitze der Unterneh-
mensleitung)
To|po|graph gr. (Vermessungsin-
genieur) m; -en, -en (↑ R 268); To-
po|gra|phie (Ortskunde; Orts-,
Lagebeschreibung) w; -, ...ien; to-
po|gra|phisch; -e Karte (Gelände-
karte); To|poi [...eu] (Mehrz. von:
Topos); To|po|lo|gie (Lehre von
der Lage u. Anordnung geome-
trischer Gebilde im Raum) w; -;
To|pos (Sprachw.: festes Kli-
schee, sprachl. Gemeinplatz, z.
B. ,,wenn ich mich recht erinne-
re") m; -, ...poi [...eu]
topp! (zustimmender Ausruf)
Topp (oberstes Ende eines Mastes
oder einer Stenge; ugs. scherzh.
für: oberster Rang im Theater)
m; -s, -e u. -s; Töp|pel landsch.
(Kopffederbüschel [bei Vögeln])
m; -s, -; Töp|pel|en|te
top|pen (Seemannsspr.: die Rahen
waagerecht stellen)
Topp_flag|ge, ...la|ter|ne, ...mast
m, ...se|gel; Topps|gast (Matrose,
der im Topp arbeitet; Mehrz.
...gasten)
Toque span. [tok] (kleiner barett-
artiger Frauenhut) w; -, -s

¹Tor (große Tür; Angriffsziel
[beim Fußballspiel u. a.]) s; -[e]s,
-e; Schreibung in Straßennamen:
↑ R 219ff.
²Tor (törichter Mensch) m; -en,
-en (↑ R 268)
Tor|bo|gen
Tord_alk schwed. (arkt. Seevogel)
m; -[e]s od. -en, -e[n] (↑ R 268)
To|rea|dor span. ([berittener]
Stierkämpfer) m; -s u. -en, -e[n]
(↑ R 268)
Tor|ein|fahrt
To|re|ro span. (nicht berittener
Stierkämpfer) m; -[s], -s
To|reut gr. (Künstler, der Metalle
ziseliert od. ,,treibt") m; -en, -en
(↑ R 268); To|reu|tik (Kunst der
Metallbildnerei) w; -
Torf (verfilzte, vermoderte Pflan-
zenreste) m; -[e]s; Torf_bo|den,
...er|de, ...feue|rung, ...ge|win-
nung; tor_fig; Torf_la|ger (Mehrz.
...lager), ...moor, ...moos, ...mull,
...ste|cher, ...stich, ...streu
Tor|gau (Stadt a. d. mittleren El-
be); Tor|gau|er (↑ R 199); tor|gau-
isch
törg|ge|len [zu: ¹Torkel] südtirol.
(im Spätherbst den neuen Wein
trinken); ich ...[e]le (↑ R 327)
Tor|heit
Tor_hö|he, ...hü|ter
tö|richt; tö|rich|ter|wei|se
To|ries [tóriß] ([früher:] konserva-
tive Partei in England) Mehrz.;
vgl. Tory
To|ri|no w; -, -nen
To|ri|no (it. Form von: Turin)
Tor|jä|ger (Sportspr.)
¹Tor|kel (bes. im Bodenseegebiet:
Weinkelter) m; -s, - od. w; -, -n
²Tor|kel (veralt. für: Taumel; un-
verdientes Glück) m; -s, (für: un-
geschickter Mensch auch
Mehrz.:) - ; tor|keln (ugs. für:
taumeln); ich ...[e]le (↑ R 327)
Tor|kret Ⓦ (Spritzbeton) m; -s;
tor|kre|tie|ren
Törl österr. (Felsendurchgang;
Gebirgsübergang) s; -s, -; Tor-
_lauf (für: Slalom), ...li|nie,
...mann (svw. Torwart, -hüter;
Mehrz. ...männer)
Tor|men|till lat. (Blutwurz, Heil-
pflanze) m; -s
Tor|na|do engl. (Wirbelsturm im
südlichen Nordamerika) m; -s, -s
Tor|ni|ster slaw. ([Fell-, Segel-
tuch]ranzen, bes. des Soldaten)
m; -s, -
To|ron|to (kanad. Stadt)
tor|pe|die|ren lat. (mit Torpedo[s]
beschießen, versenken; übertr.
für: durchkreuzen); Tor|pe|die-
rung; Tor|pe|do (Unterwassergge-
schoß) m; -s, -s; Tor|pe|do_boot,
...boot[s]|zer|stö|rer
Tor_pfei|ler, ...pfo|sten

tor|pid *lat.* (regungslos; stumpfsinnig; schlaff); Tor|pi|di|tät *w*; - u.
[Ehrenname])

Tor|por (Regungslosigkeit, Trägheit, Schlaffheit) *m*; -s

Tor|qua|tus (altröm. m. Eigenn. [Ehrenname])

tor|quie|ren *lat.* (Technik: krümmen, drehen; veralt. für: peinigen)

Torr [nach dem it. Physiker E. Torricelli (...*tschäli*)] (Maßeinheit des Luftdruckes) *s*; -s, -

Tor|ren|te *it.* (Geogr.: Regenbach) *m*; -, -n

Tor|res|stra|ße;↑R 210 (Meerenge zwischen Australien u. Neuguinea) *w*; -

Tor|ri|cel|li [*torritschäli*] (it. Physiker); tor|ri|cel|lisch, aber (↑R 179): Tor|ri|cel|lisch; -e Leere (im Luftdruckmesser)

Tor|schluß *m*; ...schlusses; vor -;
Tor|schluß|pa|nik

Tor|si|on *lat.* (Verdrehung, Verdrillung, Verwindung; Tor|si|ons.ela|sti|zi|tät, ...fe|stig|keit (Technik: Verdrehungsfestigkeit), ...mo|dul (Technik: Materialkonstante, die bei der Torsion auftritt), ...waa|ge (Drehwaage)

Tor|so *it.* (allein erhalten gebliebener Rumpf einer Statue; Bruchstück, unvollendetes Werk) *m*; -s, -s u. ...si

Tort *fr.* (Kränkung, Unbill) *m*; -[e]s; jmdm. einen - antun; zum -

Tört|chen, Tört|lein; Tor|te *it. w*; -, -n; Tor|te|lett *s*; -s, -s u. Tor|te|let|te (Törtchen aus Mürbeteigboden) *w*; -, -n; Tor|ten.bo|den, ...guß, ...he|ber, ...schau|fel; Tört|lein, Tört|chen

Tor|tur *lat.* (Folter, Qual) *w*; -, -en

To|ruń [*torunj*] (poln. Form von: Thorn)

Tor.ver|hält|nis (Sport), ...wa|che, ...wäch|ter, ...wart (Sport), ...wär|ter, ...weg

To|ry [*tori*] (Vertreter der konservativen Politik in England) *m*; -s, -s u. ...ries [*tóris*]; vgl. Tories; to|ry|stisch

Tos|becken [*Trenn.:* ...bek|ken] (Wasserbau)

Tos|ca|ni|ni [...*ka*...] (it. Dirigent)

To|schi ⓦ (Asbestzementbaustoff) *m*; -

to|sen; der Bach to|ste

To|si|sche Schloß [nach dem it. Schlosser Tosi] (ein Sicherheitsschloß) *s*; -n Schlosses, -n Schlösser

Tos|ka|na (it. Region); Tos|ka|ner (↑R 199); tos|ka|nisch

tot; der tote Punkt; ein totes Gleis; toter Mann (Bergmannsspr.: abgebaute Teile der Grube); toter Briefkasten (Agentenversteck für Mitteilungen u. a.). I. *Groß-*

schreibung: **a)** (↑ R 116:) etwas Starres und Totes; der, die Tote (vgl. d.); **b)** (↑ R 198:) das Tote Gebirge (in Österr.), das Tote Meer; **c)** (↑ R 224:) die Tote Hand (öffentlich-rechtliche Körperschaft oder Stiftung, bes. Kirche, Klöster, im Hinblick auf nicht veräußerbares od. vererbbares Vermögen). II. *Schreibung in Verbindung mit dem 2. Mittelwort;* vgl. totgeboren. III. *Schreibung in Verbindung mit Zeitwörtern* (↑ R 139): tot sein; vgl. aber totarbeiten, totfahren usw.

to|tal *fr.* (gänzlich, völlig; Gesamt...); To|tal schweiz. (Gesamt, Summe) *s*; -s, -e, To|tal.an|sicht, ...an|spruch; To|ta|le (Film: Ort der Handlung mit allen Dingen u. Personen) *w*; -, -n; To|tal|ein|druck; To|ta|li|sa|tor (amtliche Wettstelle auf Rennplätzen; Kurzw.: Toto) *m*; -s, ...oren; to|ta|li|sie|ren (Wirtsch.: zusammenzählen); to|ta|li|tär (die Gesamtheit umfassend, ganzheitlich; vom Staat: alles erfassend u. seiner Kontrolle unterwerfend); To|ta|li|ta|ris|mus *lat. m*; -; To|ta|li|tät *fr.* (Gesamtheit, Vollständigkeit, Ganzheit) *w*; -; To|ta|li|täts|an|spruch; To|tal|re|flek|to|me|ter *lat.* (Gerät zur Bestimmung des Brechungsquotienten) *s*; -s, -; To|tal|scha|den

tot|ar|bei|ten, sich, ↑ R 139 (ugs. für: angestrengt arbeiten); ich arbeite mich tot; totgearbeitet; tot|zuarbeiten, tot|är|gern, sich; ↑ R 139 (ugs. für: sich sehr ärgern); ich habe mich totgeärgert; To|te (Leichnam) *m* u. *w*; -n, -n (↑ R 287 ff.)

To|tem *indian.* (bes. bei nordamerik. Indianern das Ahnentier u. Stammeszeichen der Sippe) *s*; -s, -s; To|tem.fi|gur, ...glau|be; To|te|mis|mus (Glaube an die übernatürliche Kraft des Totems und seine Verehrung) *m*; -; to|te|mi|stisch; To|tem.pfahl, ...tier

tö|ten; To|ten|acker [*Trenn.:* ...ak|ker] (veralt. dicht.); to|ten|ähn|lich; To|ten.amt, ...bah|re, ...baum (schweiz. veralt. neben: Sarg), ...be|schwö|rung, ...be|stat|tung, ...bett; to|ten|blaß, tod|blaß; To|ten|bläs|se; to|ten|bleich, tod|bleich; To|ten.eh|rung, ...fei|er, ...fest, ...glocke [*Trenn.:* ...glok|ke], ...grä|ber, ...hemd, ...kla|ge, ...kopf, ...mas|ke, ...mes|se (vgl. [1]Messe), ...op|fer, ...schä|del, ...schein, ...sonn|tag, ...star|re; to|ten|still, tod|still; To|ten.stil|le, ...tanz, ...vo|gel, ...wa|che; Tö|ter; Tot|er|klär|te *m* u. *w*; -n, -n (↑ R 287 ff.); tot|fah|ren (↑ R 139); er

hat ihn totgefahren; tot|fal|len, sich (↑ R 139); er hat sich totgefallen; tot|ge|bo|ren; ein totgeborenes Kind (↑ jedoch R 142), aber: das Kind ist tot geboren; Tot|ge|burt; Tot|ge|glaub|te *m* u. *w*; -n, -n (↑ R 287 ff.); Tot|ge|sag|te *m* u. *w*; -n, -n (↑ R 287 ff.)

To|ti|la (Ostgotenkönig)

tot|küs|sen; ↑ R 139 (ugs. für: heftig küssen); er hat sie totgeküßt; tot|la|chen, sich; ↑ R 139 (ugs. für: heftig lachen); ich habe mich [fast, halb] totgelacht; (↑ R 120:) das ist zum Totlachen; tot|lau|fen, sich; ↑ R 139 (ugs. für: von selbst zu Ende gehen); es hat sich totgelaufen; Tot|lie|gen|de (Geol.: Rotliegendes) *s*; -n; tot|ma|chen; ↑ R 139 (ugs. für: töten); er hat den Käfer totgemacht; Tot|mann.brem|se, ...knopf (Bremsvorrichtung)

To|to (Kurzw. für: Totalisator; Sport-, Fußballtoto) *m* (ugs. auch, österr. meist, schweiz. nur: *s*); -s, -s; To|to.er|geb|nis, (meist *Mehrz.*), ...ge|winn, ...schein

Tot|punkt (toter Punkt); tot|sa|gen (↑ R 139); er wurde totgesagt; tot|schie|ßen (↑ R 139); der Hund wurde totgeschossen; Tot|schlag *m*; -[e]s, ...schläge; tot|schla|gen (↑ R 139); er wurde [halb] totgeschlagen; er hat seine Zeit totgeschlagen (ugs. für: nutzlos verbracht); Tot|schlä|ger; tot|schwei|gen (↑ R 139); er hat den Vorfall totgeschwiegen; tot|stel|len, sich (↑ R 139); ich hatte mich totgestellt; tot|stür|zen, sich (↑ R 139); er hat sich totgestürzt; tot|tre|ten (↑ R 139); er hat den Käfer totgetreten; Tö|tung; fahrlässige -; To|tungs.ab|sicht, ...ver|such

Touch *engl.* [*tatsch*] (Anstrich; Anflug, Hauch) *m*; -s, -s

Tou|lon [*tulong*] (fr. Stadt)

Tou|louse [*tulus*] (fr. Stadt)

Tou|louse-Lau|trec [*tulúsloträk*] (fr. Maler u. Graphiker)

Tou|pet *fr.* [*tupe*] (Halbperücke; Haarersatz) *s*; -s, -s; tou|pie|ren (dem Haar durch Auflockern ein volleres Aussehen geben); Tou|pie|rung

Tour *fr.* [*tur*] (Umlauf, [Um]drehung, z. B. eines Maschinenteils; Wendung, Runde, z. B. beim Tanz; Ausflug, Wanderung; [Geschäfts]reise, Fahrt, Strecke; ugs. für: Art und Weise) *w*; -, -en; in einer - (ugs. für: ohne Unterbrechung); auf -en kommen (hohe Geschwindigkeit erreichen); übertr.: mit großem Eifer etwas betreiben); vgl. Tur

Tou|raine [*turän*, auch: *turáng*] (westfr. Landschaft) *w*; -

Tour de France [tur(d)e͜frãgß] (in Frankreich alljährlich von Berufsradsportlern ausgetragenes schweres Etappenrennen) w; -, -; **Tou|ren.schi** [tur...], ...wa|gen; **tou|ren|wei|se**; **Tou|ren.zahl** (Umdrehungszahl in der Zeiteinheit), ...zäh|ler (Zähler zur Feststellung der Tourenzahl); **Tou|ris|mus** engl. (Fremdenverkehr, Reisewesen) m; -; **Tou|rist** (Ausflügler, Wanderer, Bergsteiger, Reisender); ↑ R 268; **Tou|ri|sten|klas|se** (preiswerte Reiseklasse auf Dampfern u. in Flugzeugen) w; -; **Tou|ri|stik** (Reisewesen, Touristenverkehr) w; -; **tou|ri|stisch**

Tour|nai [turnã] (belg. Stadt); **Tour|nai|tep|pich** (↑ R 201)

Tour|né fr. [turne] (Kartensp.: aufgedecktes Kartenblatt, dessen Farbe als Trumpffarbe genommen wird) s; -s, -s; **Tour|nedos** fr. [turnᵉdo] (daumendickes, rundes Lendenschnittchen) s; - [turnᵉdo(ß)], - [turnᵉdoß]; **Tour|nee** (Gastspielreise von Künstlern) w; -, -s u. ...neen

Tour|ro|pa ⓦ [tu...] (ein Reiseunternehmen)

tour-re|tour [tur-retur] österr. veralt. (hin und zurück)

Tous|saint-Lan|gen|scheidt ⓦ [tußãng ...] (eine Unterrichtsmethode)

Tower engl. [tauᵉr] („Turm“; ehemalige Königsburg in London [Einz.]; Flughafenkontrollturm) m; -s, -; **Tower|brücke** [Trenn.: ...brük|ke] w; -

Tox|al|bu|min gr.; lat. (Chemie: giftiger Eiweißstoff); **To|xi|ko|den|dron** gr. (südafrik. Giftbaum) s; -s, ...dren u. ...dra; **To|xi|ko|lo|ge** m; -n, -n; **To|xi|ko|lo|gie** (Lehre von den Giften u. den Vergiftungen) w; -; **to|xi|ko|lo|gisch**; **To|xi|kum** (Med.: Gift) s; -s, ...ka; **To|xin** (organischer Giftstoff, insbes. Bakteriengift) s; -s, -e; **to|xisch**

Toyn|bee [teunbi] (engl. Historiker)

Trab m; -[e]s; - laufen, rennen, reiten (↑ R 140)

Tra|bant (früher: Begleiter; Diener; Leibwächter; Astron.: Mond; Technik: künstl. Erdmond, Satellit) m; -en, -en (↑ R 268); **Tra|ban|ten|stadt** (wirtschaftl. u. polit. selbständige Randsiedlung einer Großstadt)

tra|ben; **Tra|ber** (Pferd); **Tra|ber|bahn**; **Tra|ben.renn|bahn**, ...ren|nen

Trab|zon (türk. Form von: Trapezunt)

Tra|chea gr. [trachea, auch: tra...] (Med.: Luftröhre) w; -, ...een

Tra|chee (Atmungsorgan der meisten Gliedertiere; durch Zellfusion entstandenes Gefäß der Pflanzen) w; -, ...een

Tracht w; -, -en; eine - Holz, eine - Prügel

trach|ten

Trach|ten.fest, ...grup|pe (vgl. ¹Gruppe), ...jacke [Trenn.: ...jak|ke], ...ka|pel|le, ...ko|stüm; **trächtig**; **Träch|tig|keit** w; -; **Tracht|ler** (Tracht tragender Teilnehmer an einem Trachtenfest); **Tracht|le|rin** w; -, -nen

Tra|chyt gr. [...ehüt] (ein Ergußgestein) m; -s, -e

Trade|mark engl. [treᵉd...] (engl. Bez. für: Warenzeichen) w; -, -s

Tra|des|kan|tie [...ziᵉ; nach dem Engländer Tradescant (treᵉdskänt)] (Dreimasterblume, Zierpflanze) w; -, -n

Trade-Uni|on engl. [treᵉdjunjᵉn] (engl. Bez. für: Gewerkschaft) w; -, -s

tra|die|ren lat. (überliefern, mündlich fortpflanzen); **Tra|di|ti|on** [...zion] (mündl.) Überlieferung; Herkommen; Brauch); **Tra|di|tio|na|lis|mus** (bedingungsloser Anschluß an die Tradition [als Glaubensquelle]) m; -; **Tra|di|tio|na|list** (↑ R 268); **tra|di|tio|na|li|stisch**; **tra|di|tio|nell** fr. (überliefert, herkömmlich); **tra|di|ti|ons.be|wußt**, ...ge|bun|den, ...ge|mäß, ...reich

träf (schweiz. neben: treffend); -er, -st

Tra|fal|gar (Kap an der span. Atlantikküste südöstl. von Cadiz)

Tra|fik fr. bes. österr. ([Tabak]laden) m; -s, -s od. (österr. nur so:) w; -, -en; **Tra|fi|kant** m; -en, -en (↑ R 268); **Tra|fi|kan|tin** w; -, -nen; vgl. Tabaktrafik usw.

Tra|fo (Kurzw. für: Transformator) m; -[s], -s

Traft poln. nordostd. (großes Floß auf der Weichsel) w; -, -en; **Traf|ten|füh|rer**

träg, trä|ge

Tra|gant gr. (eine Pflanze; Gummisubstanz als Bindemittel) m; -[e]s, -e

Trag.bah|re, ...band (s; Mehrz. ...bänder); **trag|bar**; **Trag|decke** [Trenn.: ...dek|ke]; **Tra|ge** (Gestell zum Tragen; Bahre) w; -, -n

trä|ge, träg

Tra|ge|laph gr. („Bockhirsch“; altgr. Fabeltier) m; -en, -en (↑ R 268)

tra|gen; du trägst, er trägt; du trugst, du trügest; getragen; tra|ge]!; (↑ R 120:) zum Tragen kommen; **Trä|ger**; **Trä|ge|rin** w; -, -nen; **Trä|ger.kleid**, ...ko|lon|ne,

...lohn, ...ra|ke|te, ...rock, ...schür|ze, ...wel|le** (Elektrotechnik); **Trag|ge|zeit**, Trag|zeit (Dauer der Trächtigkeit); **trag|fä|hig**; **Trag|fä|hig|keit** w; -; **trag|fest**; **Trag.fe|stig|keit**, ...flä|che; **Trag|flä|chen|boot**, Trag|flü|gel|boot

Träg|heit w; -; **Träg|heits.ge|setz** (s; -es), ...mo|ment s

Trag.him|mel (Baldachin), ...holz (landsch. für: Schulterjoch; fruchttragendes Holz der Obstbäume)

tra|gie|ren gr. (eine Rolle [tragisch] spielen); **Tra|gik** (Kunst des Trauerspiels; erschütterndes Leid) w; -; **Tra|gi|ker** (Trauerspieldichter); **Tra|gi|ko|mik; tra|gi|ko|misch** (halb tragisch, halb komisch); **Tra|gi|ko|mö|die** (Schauspiel, in dem Tragisches u. Komisches miteinander verbunden sind); **tra|gisch** (die Tragik betreffend; erschütternd, ergreifend); -ste (↑ R 294)

Trag.korb, ...kraft (w; -); **trag|kräf|tig; Trag|last; Trag|luft|hal|le**

Tra|gö|de gr. (Heldendarsteller) m; -n, -n; **Tra|gö|die** [...iᵉ] (Trauerspiel); übertr. für: Unglück) w; -, -n; **Tra|gö|di|en.dar|stel|ler**, ...dich|ter; **Tra|gö|din** w; -, -nen

Trag.rie|men, ...ses|sel, ...tier, ...wei|te (w; -); **Trag|zeit** vgl. Trage|zeit

Traid|bo|den, Traid|ka|sten österr. (Getreidespeicher)

Train fr. [träng, österr. auch: trän] (Troß, Heeresfuhrwesen) m; -s, -s

Trai|ner (engl. [trän... od. treᵉner]) (jmd., der Menschen od. Pferde systematisch auf Wettkämpfe vorbereitet; schweiz. auch Kurzform für: Trainingsanzug) m; -s, -; **trai|nie|ren**; vgl. aber: dräinieren; **Trai|ning** [trän... od. tren...] (systematische Vorbereitung [auf Wettkämpfe]) s; -s, -s; **Trai|nings.an|zug**, ...ho|se, ...jacke [Trenn.: ...jak|ke], ...la|ger (Mehrz. ...lager), ...me|tho|de, ...mög|lich|keit, ...zeit

Tra|jans.säu|le [österr.: tra...] (↑ R 180; w; -), ...wall (m; -[e]s); **Tra|jan** [österr.: tra...], **Tra|ja|nus** (röm. Kaiser)

Tra|jekt lat. ([Eisenbahn]fährschiff; veralt. für: Überfahrt) m od. s; -[e]s, -e; **Tra|jekt|damp|fer; Tra|jek|to|rie** [...iᵉn] (Math.: Linien, die jede Kurve einer ebenen Kurvenschar unter gleichbleibendem Winkel schneiden) Mehrz.

Tra|kas|se|rie fr. (veralt. für: Quälerei) w; -, ...ien

Tra|keh|nen (Ort in Ostpreußen);

685 **transleithanisch**

¹Tra|keh|ner (↑ R 199); - Hengst;
²Tra|keh|ner (Pferd)
Trakl, Georg (österr. Dichter)
Trakt *lat.* (Gebäudeteil; Zug,
Strang, Gesamtlänge; Land-
strich) *m;* -[e]s, -e; trak|ta|bel (ver-
alt. für: leicht zu behandeln, um-
gänglich); ...a|bler Mensch;
Trak|ta|ment (veralt., aber noch
mdal. für: Behandlung; Bewir-
tung; veralt. für: Löhnung des
Soldaten) *s;* -s, -e; Trak|tan|den-
li|ste schweiz. (Tagesordnung);
Trak|tan|dum schweiz. (Ver-
handlungsgegenstand) *s;* -s,
...den; Trak|tat ([wissenschaft-
liche] Abhandlung; bes.: religiöse
Schrift usw.; veralt. für: Vertrag)
m od. s; -[e]s, -e; Trak|tät|chen,
Trak|tät|lein (abwertend für:
kleine Schrift [mit religiösem In-
halt]); trak|tie|ren (veralt. für:
behandeln; bewirten; unterhan-
deln; ugs. für: plagen, quälen;
ugs. für: in reichlicher Menge an-
bieten); Trak|tie|rung; Trak|tor
(Zugmaschine, Trecker, Schlep-
per) *m;* -s, ...oren; Trak|to|rie
[...*iᵉ*] *w;* -, -n; vgl. Traktrix; Trak-
to|rist *lat.-russ.* (DDR: Traktor-
fahrer); ↑ R 268; Trak|to|ri|stin *w;*
-, -nen
Tral|je *niederl.* landsch. (Gitter-
[stab], Geländerstab) *w;* -, -n
tral|la!; tral|la|[la]|la! [auch: *tra...*]
Träl|le|borg (frühere Schreibung
für: Trelleborg)
träl|lern; ich ...ere (↑ R 327)
¹Tram österr. (svw. Tramen) *m;*
-[e]s, -e u. Träme; ²Tram *engl.*
südd. u. österr. veraltend,
schweiz. (Straßenbahn[wagen])
w; -, -s (schweiz.: *s;* -s, -s); Tram-
bahn südd. (Straßenbahn); Trä-
mel landsch. (Balken; Stock) *m;*
-s, -; Tra|men südd. u. schweiz.
(Balken) *m;* -s, -; vgl. ¹Tram
Tra|min (Ort in Südtirol); ¹Tra|mi-
ner (↑ R 199); - Wein; ²Tra|mi|ner
(ein Wein)
Tra|mon|ta|na, Tra|mon|ta|ne *it.*
(„von jenseits des Gebirges";
Nordwind in Italien) *w;* -, ...nen
Tramp *engl.* [*trämp,* älter: *trạmp*]
(engl. Bez. für: Landstreicher) *m;*
-s, -s; Tram|pel (ugs. für: plumper
Mensch, meist von Frauen ge-
sagt) *m od. s;* -s, - (auch: *w;* -,
-n); tram|peln (ugs. für: mit den
Füßen stampfen); ich ...[e]le (↑ R
327); Tram|pel|pfad, ...tier (Ka-
mel; ugs. für: plumper Mensch);
tram|pen *engl.* [*trämpᵉn*] (eigtl.:
als Tramp leben; übertr. für: Au-
tos anhalten u. sich mitnehmen
lassen); Tram|per [*trämpᵉr*];
Tramp|fahrt (Fahrt eines Tramp-
schiffes); Tram|po|lin *it.* (Sprung-
gerät) *s;* -s, -e; - springen; Tram-

po|lin|sprung; Tramp_ree|der,
...schiff, ...schiffahrt [*Trenn.:*
...schiff|fahrt, ↑ R 236] (nicht an
feste Linien gebundene Fracht-
schiffahrt); tramp|sen (ugs. für:
trampeln; du trampst (tramp-
sest)
Tram|way *engl.* [*trạmwe[ᵢ],* auch
engl. Ausspr.: *träm...*] österr. ver-
alt. (Straßenbahn[wagen]) *w;* -,
-s
Tran (flüssiges Fett von Seesäuge-
tieren, Fischen) *m;* -[e]s, (Tran-
sorten:) -e
Tran|ce *fr.* [*trạngß⁽ᵉ⁾,* selten: *trạnß*]
(schlafähnlicher Zustand [in
Hypnose]) *w;* -, -n; Tran|ce|zu-
stand
Tranche *fr.* [*trạngsch*] (fingerdicke
Fleisch- od. Fischschnitte; Teil-
betrag einer Wertpapieremis-
sion) *w;* -, -n [...*schᵉn*]
Trän|chen, Trän|lein (kleine Trä-
ne)
tran|chie|ren, (österr.:) tran|schie-
ren *fr.* [...*schirᵉn*] ([Fleisch, Ge-
flügel, Braten] zerlegen); Tran-
chier|mes|ser (Vorlegemesser) *s;*
Tran|chie|rung
Trä|ne *w;* -, -n; trä|nen; Trä|nen-
drü|se; trä|nen|feucht, aber (↑ R
143): von Tränen feucht; Trä-
nen_fluß, ...gas (*s;* -es), ...gru|be;
trä|nen|reich; Trä|nen|sack
Trän|fun|sel od. ...fun|zel (ugs. für:
schlecht brennende Lampe)
tra|nig (Tran enthaltend, nach
Tran schmeckend; tranähnlich)
trä|nig (veralt. für: voller Tränen)
Trank *m;* -[e]s, Tränke; Tränk-
chen, Tränk|lein; Trän|ke
(Tränkplatz für Tiere) *w;* -, -n;
trän|ken; Trank_op|fer, ...sa|me
(schweiz. neben: Getränk; *w;* -);
Tränk|stoff; Trän|kung
Tran|lam|pe
Trän|lein, Trän|chen (kleine Trä-
ne)
Tran|qui|li|zer *engl.* [*trängk*ʷ*ilai-
sᵉr*] (beruhigendes Medikament)
m; -s, -; tran|quil|lo *it.* (Musik:
ruhig); Tran|quil|lo *s;* -s, -s u. ...lli
trans..., Trans... *lat.* ([nach] jen-
seits); Trans|ak|ti|on [...*zion*] (das
ein normales Maß überschreiten-
de finanzielle Geschäft)
trans_al|pin, ...al|pi|nisch *lat.* ([von
Rom aus] jenseits der Alpen lie-
gend)
trans|at|lan|tisch (überseeisch)
Trans|bai|ka|li|en [...*iᵉn*] (Land-
schaft östl. vom Baikalsee)
tran|schie|ren vgl. tranchieren
Tran|sept *engl.* (Querschiff, -haus
einer Kirche) *m od. s;* -[e]s, -e
Trans-Eu|rop-Ex|press (im inter-
nationalen Verkehr eingesetzter
Fernschnellzug; Abk.: TEE)
Trans|fer *engl.* (Zahlung ins Aus-

land in fremder Währung;
Sportspr.: Wechsel eines Berufs-
spielers zu einem anderen Verein)
m; -s, -s; Trans|fer|ab|kom|men;
trans|fe|rie|ren (Geld in eine
fremde Währung umwechseln;
österr. Amtsspr.: [dienstlich] ver-
setzen); Trans|fe|rie|rung; Trans-
fer_schwie|rig|keit, ...stra|ße
(Technik)
Trans|fi|gu|ra|ti|on [...*zion*]
(Verklärung [Christi])
Trans|for|ma|ti|on *lat.* [...*zion*]
(Umformung; Umwandlung);
Trans|for|ma|tor (Umspanner
[elektr. Ströme]; Kurzw.: Trafo)
m; -s, ...oren; Trans|for|ma|tor-
an|la|ge, Trans|for|ma|to|ren-
häus|chen, Trans|for|ma|tor-
häus|chen; trans|for|mie|ren (um-
formen, umwandeln; umspan-
nen); Trans|for|mie|rung
Trans|fu|si|on *lat.* ([Blut]übertra-
gung)
Tran|si|de|rei
Tran|si|stor *engl.* (Elektrotechnik:
Teil eines Verstärkers) *m;* -s,
...oren; tran|si|sto|rie|ren, (auch:)
tran|si|sto|ri|sie|ren; Tran|si|stor-
ra|dio
Tran|sit *it.* [auch: ...*it, trạn-
sit*] (Wirtsch.: Durchfuhr) *m;*
-s, -e; Tran|sit|han|del; tran|si-
tie|ren (Wirtsch.: durchgehen,
durchführen); Tran|si|ti|on *lat.*
[...*zion*] (veralt. für: Übergang;
Übergehung); tran|si|tiv [auch:
...*if*] (Sprachw.: zum persön-
lichen Passiv fähig; zielend); -es
Zeitwort; Tran|si|tiv [auch: ...*if*]
(zielendes Zeitwort; z. B. [den
Hund] „schlagen") *s;* -s, -e [...*wᵉ*];
tran|si|to|risch (vorübergehend);
Tran|si|to|ri|um (vorübergehen-
der Haushaltsposten [für die
Dauer eines Ausnahmezustan-
des]) *s;* -s, ...ien [...*iᵉn*]; Tran|sit-
_ver|bot (Durchfuhrverbot),
...ver|kehr (Zwischenauslands-
verkehr), ...wa|re, ...weg, ...zoll
Trans|jor|da|ni|en (früherer Name
für: Jordanien)
Trans|kau|ka|si|en [...*iᵉn*] (Land-
schaft zwischen Schwarzem
Meer u. Kaspischem Meer süd-
lich der Kaukasushauptkette);
trans|kau|ka|sisch
trans|kon|ti|nen|tal *lat.* (einen Erd-
teil durchquerend)
tran|skri|bie|ren *lat.* (einen Text,
der meist in lateinischen
Buchstaben geschrieben ist, in
phonetische Umschrift wieder-
geben; Musik: umsetzen); Tran-
skrip|ti|on [...*zion*]
Trans|lei|tha|ni|en [...*iᵉn*] (im
ehem. Österreich-Ungarn die
Länder der ung. Krone [jenseits
der Leitha]); trans|lei|tha|nisch

Trans|li|te|ra|ti|on [...*zion*]
(buchstabengetreue Umsetzung
eines nicht in lat. Buchstaben ge-
schriebenen Textes in lat. Schrift
mit zusätzlichen Zeichen); **trans-
li|te|rie|ren**
Trans|lo|ka|ti|on *lat.* [...*zion*] (ver-
alt. für: Ortsveränderung, Ver-
setzung; Biol.: Verlagerung eines
Chromosomenbruchstückes in
ein anderes Chromosom); **trans-
lo|zie|ren** (veralt. für: [an einen
anderen Ort] versetzen [Biol.])
trans_ma|rin, ...**ma|ri|nisch** *lat.*
(veralt. für: überseeisch)
Trans|mis|si|on *lat.* ([Vorrichtung
zur] Kraftübertragung u. -vertei-
lung auf mehrere Arbeitsmaschi-
nen); **Trans|mis|si|ons|rie|men**
(Treibriemen); **trans|mit|tie|ren**
(übertragen, übersenden)
Trans|oze|an_damp|fer, ...**flug**,
...**flug|zeug**; **trans|ozea|nisch** (jen-
seits des Ozeans liegend)
Transp. = Transport
trans|pa|da|nisch *lat.* ([von Rom
aus] jenseits des Po liegend)
trans|pa|rent *lat.-fr.* (durch-
scheinend; durchsichtig; auch
übertr.); **Trans|pa|rent** (durch-
scheinendes Bild; Spruch-
band) *s*; -[e]s, -e; **Trans|pa|rent-
pa|pier** (Pauspapier); **Trans|pa-
renz** (Durchscheinen; Durch-
sichtigkeit; auch übertr.) *w*; -
Tran|spi|ra|ti|on *lat.* [...*zion*]
(Schweiß; [Haut]ausdünstung;
Bot.: Abgabe von Wasserdampf
durch die Spaltöffnungen der
Pflanzen) *w*; -; **tran|spi|rie|ren**
Trans|plan|tat *lat.* (überpflanztes
Gewebestück) *s*; -[e]s, -e; **Trans-
plan|ta|ti|on** [...*zion*] (Med.:
Überpflanzung von Organen od.
Geweberteilen auf andere Kör-
perstellen od. auf einen anderen
Organismus; Bot.: Pfropfen,
Okulation); **trans|plan|tie|ren**
trans|po|nie|ren *lat.* (Musik: [Mu-
sikstück] umsetzen, übertragen);
Trans|po|nie|rung
Trans|port *lat.* (Versendung,
Beförderung; Kaufmannsspr.
veralt. für: Übertrag [auf die
nächste Seite; Abk.: Transp.]) *m*;
-[e]s, -e; **trans|por|ta|bel** (beweg-
lich, tragbar, beförderbar, fahr-
bar); ...a|bler Ofen; **Trans|port-
_an|la|ge** (Förderanlage), ...**ar-
bei|ter**; **Trans|por|ta|ti|on** [...*zion*]
(seltener für: Transportierung);
Trans|port_band (*Mehrz.* ...bän-
der), ...**be|häl|ter**; **Trans|por|ter**
engl. (Transportflugzeug, -schiff)
m; -s, -; **Trans|por|teur** *fr.* (...*tör*)
(jemand, der etwas transportiert;
Winkel-, Gradmesser; Zubringer
an der Nähmaschine) *m*; -s, -e;
trans|port|fä|hig; **Trans|port-**

_flug|zeug, ...**füh|rer**, ...**ge|fähr-
dung**, ...**ge|wer|be**; **trans|por|tie-
ren** (versenden, befördern; Kauf-
mannsspr. veralt. für: übertra-
gen); **Trans|port_ka|sten**, ...**ki-
ste**, ...**ko|sten** (*Mehrz.*), ...**mit|tel**
s, ...**schiff**, ...**un|ter|neh|men**,
...**we|sen** (*s*; -s)
Trans|po|si|ti|on *lat.* [...*zion*]
(Übertragung eines Musikstük-
kes in eine andere Tonart)
trans|si|bi|risch (Sibirien durch-
querend), aber (↑ R 224): die
Transsibirische Eisenbahn
Trans|sil|va|ni|en [...*wạniᵉn*] (alter
Name von: Siebenbürgen); **trans-
sil|va|nisch**, aber (↑ R 198): die
Transsilvanischen Alpen
Trans|sub|stan|tia|ti|on *lat.* [...*zia-
zion*] (Umwandlung von Brot
und Wein in Leib und Blut Chri-
sti); **Trans|sub|stan|tia|ti|ons-
leh|re** *w*; -
Trans|su|dat *lat.* (Med.: abgeson-
derte Flüssigkeit in Gewebelük-
ken od. Körperhöhlen) *s*; -[e]s,
-e
Trans|syl|va|ni|en [...*wạ*...] usw.
vgl. Transsilvanien usw.
Trans|uran *lat.*; *gr.* (künstlich ge-
wonnener radioaktiver Grund-
stoff mit höherem Atomgewicht
als Uran) *s*; -s, -e (meist *Mehrz.*)
Tran|su|se (ugs. abschätzig für:
langweiliger Mensch) *w*; -, -n
Trans|vaal [...*wạl*] (Prov. der Re-
publik Südafrika)
trans|ver|sal *lat.* [...*wär*...] (quer
verlaufend, schräg); **Trans|ver-
sa|le** (geometr. Gerade, die eine
Figur durchschneidet) *w*; -, -n;
drei -[n] (↑ R 291); **Trans|ver|sal-
wel|le**
Trans|ve|stis|mus vgl. Transvesti-
tismus; **Trans|ve|sti|tis|mus** *lat.*
[...*wäß*...] (Med.: krankhafte Nei-
gung, Kleidung des anderen Ge-
schlechts zu tragen) *m*; -; **Trans-
ve|stit** *m*; -en, -en (↑ R 268)
tran|szen|dent *lat.* (übersinnlich,
-natürlich); **tran|szen|den|tal**
(swv. transzendent [in der Scho-
lastik]; die a priori mögliche Er-
kenntnisart von Gegenständen
betreffend [Kant]); -e Logik;
Tran|szen|denz (das Überschrei-
ten der Grenzen der Erfahrung,
des Bewußtseins) *w*; -
Tra|pez *gr.* (Viereck mit zwei par-
allelen, aber ungleich langen
Seiten; Schaukelreck) *s*; -es, -e;
Tra|pez_akt (am Trapez ausge-
führte Zirkusnummer); **tra|pez-
för|mig**; **Tra|pez_künst|ler**, ...**li-
nie**; **Tra|pe|zo|eder** (Math.: Kör-
per, der von gleichschenkeligen
Trapezen begrenzt wird) *s*; -s, -;
Tra|pe|zo|id (Viereck ohne
gleichlaufende Seiten) *s*; -[e]s, -e

Tra|pe|zunt (türk. Stadt); vgl.
Trabzon
trapp!; **trapp, trapp, trapp!**
Trapp *schwed.* (großflächige, in
mehreren Lagen [„treppen"ar-
tig] übereinanderliegende Ba-
saltergüsse) *m*; -[e]s, -e
¹**Trap|pe** *slaw.* (ein Vogel) *m*; -n,
-n (Jägerspr. nur so), ↑ R 268,
(auch:) *w*; -, -n
²**Trap|pe** mdal. ([schmutzige]
Fußspur) *w*; -, -n; **trap|peln** (mit
kleinen Schritten rasch gehen);
ich ...[e]le (↑ R 327); **trap|pen**
(schwer auftreten)

Trap|per *engl.* („Fallensteller";
nordamerik. Pelzjäger) *m*; -s, -
Trap|pist [nach der Abtei La Trap-
pe (*latrạp*)] (Angehöriger des
1664 gegründeten Ordens der
reformierten Zisterzienser mit
Schweigegelübde);↑ R 268; **Trap-
pi|sten_klo|ster**, ...**or|den** (*m*; -s)
trapp, trapp!
Trap|schie|ßen *engl.-dt.* (Wurftau-
benschießen mit Schrotgeweh-
ren) *s*; -s
trap|sen (ugs. für: sehr laut auftre-
ten); du trapst (trapsest)
tra|ra!; **Tra|ra** (ugs. für: Lärm;
großartige Aufmachung, hinter
der nichts steckt; Schwindel) *s*;
-s
tra|sci|nan|do *it.* [*traschi*...] (Mu-
sik: schleppend); **Tra|sci|nan|do**
s; -s, -s u. ...di
Tra|si|me|ni|sche See (in Italien)
m; -n -s
Traß *niederl.* (vulkanisches Tuff-
gestein) *m*; Trasses, Trasse
Tras|sant *it.* (Aussteller eines ge-
zogenen Wechsels) *m*; -en, -en
(↑ R 268);**Tras|sat** (Wechselbezo-
gener) *m*; -en, -en (↑ R 268); **Tras-
se** *fr.* (im Gelände abgesteckte
Linie, bes. im Straßen- u. Eisen-
bahnbau) *w*; -, -n; **Tras|see**
(schweiz. für: Trasse; auch swv.
Bahnkörper, Bahn-, Straßen-
damm) *s*; -s, -s; **tras|sie|ren** (eine
Trasse abstecken, vorzeichnen;
einen Wechsel auf jmdn. ziehen
oder ausstellen); **Tras|sie|rung**
Tras|te|ve|re [...*tẹwere*] (röm.
Stadtteil „jenseits des Tibers") *s*;
-[s]; **Tras|te|ve|ri|ner** (↑ R 199)
Tratsch (ugs. für: Geschwätz,
Klatsch) *m*; -[e]s; **trat|schen**
(ugs.); du tratschst (tratschest);
trät|schen landsch. (tratschen);
du trätschst (trätschest); **Trat-
sche|rei** (ugs.)
Trat|te *it.* (gezogener Wechsel) *w*;
-, -n
Trat|to|ria *it.* (it. Bez. für: Wirts-
haus) *w*; -, ...ien
Trau|al|tar
Träub|chen, **Träub|lein**; **Trau|be**
w; -, -n; **trau|ben|för|mig**; **Trau-**

ben.kamm (Stiel, an dem die Beeren sitzen), ...kur, ...le|se, ...most, ...saft, ...zucker [Trenn.: ...zuk|ker]; trau|big; Träub|lein, Träub|chen

Traud|chen, Trau|de[l], Trudchen, Tru|de (Koseformen von: Gertrud[e], Gertraud[e])

trau|en; ich traue mich nicht (selten: mir nicht), das zu tun

Trau|er w; -; Trau|er.an|zei|ge, ...bin|de, ...bot|schaft, ...brief, ...de|ko|ra|ti|on, ...fall m, ...fei|er, ...flor, ...ge|fol|ge, ...ge|mein|de, ...haus, ...jahr, ...klei|dung, ...kloß (ugs. scherzh. für: langweiliger, energieloser, unlustiger Mensch), ...man|tel (ein Schmetterling), ...marsch m, ...mie|ne; trau|ern; ich ...ere (↑ R 327); Trauer.nach|richt, ...rand, ...schlei|er, ...spiel, ...wei|de, ...zeit, ...zug

Trau|fe w; -, -n; träu|feln; ich ...[e]le (↑ R 327); träu|fen (landsch. für: träufeln)

Trau|gott (m. Vorn.)

trau|lich; ein -es Heim; Trau|lichkeit w; -

Traum m; [e]s, Träume

Trau|ma gr. (seelische Erschütterung; Med.: Wunde) s; -s, ...men u. -ta; Trau|ma|plast® (ein Heftpflaster) s; -[e]s; trau|ma|tisch (das Trauma betreffend)

Traum.aus|le|ger, ...bild, ...buch, ...deu|ter, ...deu|tung, ...dich|tung

Trau|men (Mehrz. von: Trauma)

träu|men; ich träumte von meinem Bruder; mir träumte von ihm; es träumte mir; das hätte ich mir nicht - lassen (ugs. für: hätte ich nie geglaubt); das soll er sich ja nicht - lassen! (ugs. für: einbilden); Träu|mer; Träu|me|rei; Träu|me|rin w; -, -nen; träu|merisch; -ste (↑ R 294); Traum.fabrik (Welt des Films), ...ge|bil|de, ...ge|sicht (Mehrz. ...gesichte); traum|haft

Trau|mi|net österr. ugs. (Feigling) m; -s, -s

traum.ver|lo|ren, ...ver|sun|ken, ...wand|le|risch

traun! (veralt. für: fürwahr!)

Traun (r. Nebenfluß der Donau) w; -

Trau|ner österr. (ein flaches Schiff) m; -s, -

Traun|see (oberösterr. See); Traun|vier|tel (oberösterr. Landschaft) s; -s

trau|rig; Trau|rig|keit w; -

Trau.ring, ...schein

traut; ein -es Heim

Trau|tag

Traut|chen vgl. Traudchen; ¹Trau|te (w. Vorn.); vgl. Traude[l]

²Trau|te (volksm. für: Vertrauen, Mut) w; -; keine - haben

Trau|to|ni|um® [nach dem Erfinder F. Trautwein] (elektr. Musikinstrument) s; -s, ...ien [...i°n]

Trau|ung; Trau|zeu|ge

Tra|vel|ler|scheck engl. [träwe-l°r...] (Reisescheck)

tra|vers fr. [...wärß] (quer [gestreift]); -e Stoffe; Tra|vers [...wär, ...wärß] (Gangart beim Schulreiten) s; -; Tra|ver|se [...wärs°] (Querbalken, -träger, Ausleger; Querverbinder zweier fester oder parallel beweglicher Maschinenteile; Querbau zur Flußregelung; Bergsport: Querungsstelle an einer Wand; früher für: Schutzwehr) w; -, -n; traver|sie|ren (Reitsport: eine Reitbahn in der Diagonale durchreiten; Fechtsport: durch Seitwärtstreten dem Hieb od. Stoß des Gegners ausweichen; Bergsport: horizontal eine Wand od. einen Hang entlanggehen od. -klettern; veralt. für: quer durchgehen; durchkreuzen, hindern); Tra|ver|sie|rung

Tra|ver|tin it. [...wär...] (mineralischer Kalkabsatz bei Quellen u. Bächen) m; -s, -e

Tra|ve|stie lat. [wä...] [(scherzhafte] „Umkleidung", Umgestaltung [eines Gedichtes]) w; -, ...ien; tra|ve|stie|ren (auch: ins Lächerliche ziehen); Tra|ve|stie|rung

Trawl engl. [trǎl] (Grundschleppnetz) s; -s, -s; Traw|ler (Fischdampfer) m; -s, -

Trox schweiz. (Schürfkübelraupe) m; -es, -e

Treat|ment engl. [tritm°nt] (Vorstufe des Drehbuchs) s; -s, -s

Tre|ber (Rückstände [beim Keltern und Bierbrauen]) Mehrz.

Tre|cen|tist it. [...tschän...] (Dichter, Künstler des Trecentos); Tre|cen|to [tretschänto] (Kunstzeitalter in Italien: 14. Jh.) s; -[s]

Treck (Zug; Auszug, Auswanderung) m; -s, -s; trecken [Trenn.: trek|ken] (ziehen); Trecker [Trenn.: Trek|ker] ([Motor]zugmaschine, Traktor); Treck|schute (Zugschiff)

¹Treff fr. (Kleeblatt, Eichel [im Kartenspiel]) s; -s, -s

²Treff (veralt. für: Schlag, Hieb; Niederlage) m; -[e]s, -e

³Treff (ugs. für: Treffen, Zusammenkunft) m; -s, -s

Treff|as [zu: ¹Treff]

tref|fen; du triffst; du trafst (trafest); du träfest; getroffen; triff!; Tref|fen s; -s, -; tref|fend; -ste; Tref|fer; tref|flich; Treff|lich|keit w; -; Treff|nis schweiz. (Anteil, Betrag, der auf jmdn. entfällt) s; -ses, -se; Treff.platz, ...punkt; treff|si|cher; Treff|si|cher|heit w; -

Treib.ar|beit, ...eis; trei|ben; du triebst; du triebest; getrieben; treib[e]!; zu Paaren -; Trei|ben s; -s, (für: Treibjagd auch Mehrz.:) -; Trei|ber; Trei|be|rei; Treib.fäustel (Bergmannsspr.: schwerer Bergmannshammer; m; -s, -), ...gas, ...gut, ...haus; Treib.haus.ef|fekt, ...kul|tur, ...luft; Treib.holz, ...jagd, ...la|dung, ...mit|tel s, ...öl, ...rie|men, ...sand, ...satz, ...stoff

Trei|del (Zugtau zum Treideln) m; -s, -n; Trei|de|lei (Treidlergewerbe) w; -; Trei|de|ler, Treid|ler; trei|deln (ein Wasserfahrzeug vom Ufer aus stromaufwärts ziehen); ich ...[e]lo (↑ R 327); Treidel.pfad, ...weg (Leinpfad); Treid|ler, Trei|de|ler

trei|fe jidd. (unrein; verboten [von Speisen]; Ggs.: koscher)

Trel|le|borg [schwed. Aussspr.: träl°borj] (schwed. Stadt)

¹Tre|ma gr. (Trennpunkte, Trennungszeichen [über einem von zwei getrennt auszusprechenden Selbstlauten, z. B. fr. naïf „naiv"]; Med.: Lücke zwischen den mittleren Schneidezähnen) s; -s, -s u. -ta

²Tre|ma gr. (Zittern, Angst) s; -s

Tre|ma|to|de (Biol.: Saugwurm) w; -, -n (meist Mehrz.)

tre|mo|lan|do it. (Musik: bebend, zitternd); tre|mo|lie|ren, tre|mu|lie|ren (beim Gesang [fehlerhaft] beben und zittern); Tre|mo|lo (Musik: Beben, Zittern) s; -s u. ...li; Tre|mor lat. (Zittern der Erde; Med.: Zittern) m; -s, ...ores

Trems|e nordd. (Kornblume) w; -, -n

Tre|mu|lant lat. (Orgelhilfsregister) m; -en, -en (↑ R 268); tre|mu|lie|ren vgl. tremolieren

Trench|coat engl. [träntschko°t] (Wettermantel) m; -[s], -s

Trend engl. (Grundrichtung einer Entwicklung) m; -s, -s

tren|deln mdal. (nicht vorwärts kommen, langsam sein); ich ...[e]le (↑ R 327)

trenn|bar; Trenn|bar|keit w; -; tren|nen; sich -; Trenn.li|nie, ...mes|ser s, ...punkte (für: Trema); trenn|scharf (Funkw.); Trenn|schär|fe; Tren|nung; Tren|nungs.ent|schä|di|gung, ...li|nie, ...schmerz, ...strich, ...wand, ...zei|chen; Trenn|wand

Tren|se niederl. (leichter Pferdezaum) w; -, -n; Tren|sen|ring

Trente-et-qua|rante fr. [trangtekarangt] („dreißig und vierzig"; Kartenglücksspiel) s; -

Tren|to (it. Form von: Trient)

tren|zen (vom Hirsch: in besonderer Weise röhren)

Tre|pang *malai.* (getrocknete Seegurke [chinesisches Nahrungsmittel]) *m*; -s, -e u. -s
trepp|ab; trepp|auf; -, treppab laufen; Trepp|chen, Trepp|lein; Trep|pe *w*; -, -n; -n steigen
Trep|pel|weg österr. (Treidelweg)
Trep|pen_ab|satz, ...be|leuch|tung, ...flur *m*, ...ge|län|der, ...haus, ...lei|ter *w*, ...stu|fe, ...wan|ge (fachspr. für: Seitenverkleidung einer [Holz]treppe), ...witz (*m*; -es); Trepp|lein, Trepp|chen
Tre|sen nieder- u. mitteld. (Laden-, Schanktisch) *m*; -s, -
Tre|sor *fr.* [österr. auch: *tre̩...*] (Panzerschrank; Stahlkammer) *m*; -s, -e; Tre|sor|schlüs|sel
Tres|pe (ein Gras) *w*; -, -n; tres|pig (vom Korn: mit Trespe behaftet)
Tres|se *fr.* (Borte) *w*; -, -n; Tressen_rock, ...stern (vgl. ²Stern), ...win|kel; tres|sie|ren (in der Perückenmacherei: kurze Haare mit Fäden aneinanderknüpfen)
Tre|ster (Rückstände beim Keltern u. Bierbrauen) *Mehrz.*
tre|ten; du trittst; du tratst (tratest); du trätest; getreten; tritt!; er tritt ihn (auch: ihm) auf den Fuß; beiseite treten; Tre|ter (ugs. für: Schuhe); Tre|te|rei (ugs.); Tret_mi|ne, ...müh|le (ugs.), ...rad, ...schlit|ten
treu; -er, -[e]ste; zu -en Händen übergeben ([ohne Rechtssicherheit] anvertrauen, vertrauensvoll zur Aufbewahrung übergeben). I. *Getrenntschreibung in Verbindung mit Zeitwörtern:* treu sein, bleiben. II. *Schreibung in Verbindung mit dem 2. Mittelwort:* ein mir treuergebener Freund (↑ jedoch R 142), aber: der Freund ist mir treu ergeben; (↑ R 296:) treuer, am treu[e]sten ergeben; Treu|bruch *m*; treu|brü|chig; Treu|dienst; Treue *w*; -; (schweiz.:) in guten -n (im guten Glauben); auf Treu und Glauben (↑ R 241); meiner Treu!; Treu|eid; Treu|e[e]|pflicht; Treue_prä|mie, ...ra|batt; treu|er|ge|ben; vgl. treu, II; Treue|schwur, Treu|schwur; treu|ge|sinnt; vgl. treu, II; Treu|hand (Treuhandgesellschaft) *w*; -; Treu|hän|der (jmd., dem etwas ,,zu treuen Händen'' übertragen wird); Treu|hän|der|de|pot; treu|hän|de|risch; Treu|hand_ge|schäft, ...ge|sell|schaft; treu|her|zig; Treu|her|zig|keit *w*; -; treu|lich; treu|los; -este (↑ R 292); Treu|lo|sig|keit; Treu|schwur, Treu|schwur; treu|sor|gend; vgl. treu, II
Tre|vi|ra ⓦ [...*wi̩ra*] (ein aus synthetischer Faser hergestelltes Gewebe) *s*; -

Tre|vi|sa|ner [...*wi̩...*] (↑ R 199); Tre|vi|so (it. Stadt)
Tri|a|de *gr.* (Dreizahl, Dreiheit) *w*; -, -n
Tri|a|ge *fr.* [...*aseh̩e*] (Ausschuß [bei Kaffeebohnen])
Tria|kis_do|de|ka|eder *gr.* (Sechsunddreißigflächner), ...ok|ta|eder (Vierundzwanzigflächner)
Tri|al *engl.* [*trai̩el*] (Geschicklichkeitsprüfung von Motorradfahrern) *s*; -s, -s
Tri|an|gel *lat.* [österr.: ...*ang̩...*] (Musik: Schlaggerät) *m*; -s, -; tri|an|gu|lär [...*anggulär*] (dreieckig); Tri|an|gu|la|ti|on [...*zion*] (Festlegung eines Netzes von Dreiecken zur Landvermessung); Tri|an|gu|la|ti|ons|punkt (Zeichen: TP); tri|an|gu|lie|ren; Tri|an|gu|lie|rung
Tria|non [...*nong̩*] (Name zweier Versailler Lustschlösser) *s*; -s, -s
Tria|ri|er *lat.* [...*i̩er*] (altröm. Legionsveteran im 3. [letzten] Treffen; bildl.: letzte Hoffnung)
Tri|as *gr.* (,,Dreiheit''; Geol.: unterste Formation des Mesozoikums) *w*; -, (Musik für: Dreiklang auch *Mehrz.*:) -; Tri|as|for|ma|ti|on; tri|as|sisch (zur Trias gehörend)
Tri|ba|de *gr.* (lesbischer Liebe ergebene Frau) *w*; -, -n; Tri|ba|die (lesbische Liebe) *w*; -
Tri|bun *lat.* ([altröm.] Volksführer) *m*; -s u. -en, -e[n] (↑ R 268); Tri|bu|nal (hoher Gerichtshof) *s*; -s, -e; Tri|bu|nat (Amt, Würde eines Tribunen) *s*; -[e]s, -e; Tri|bü|ne *fr.* ([Redner-, Zuhörer-, Zuschauer]bühne; auch: Zuhörer-, Zuschauerschaft) *w*; -, -n; Tri|bü|nen|platz; tri|bu|ni|zisch *lat.* (Tribunen...); -e Gewalt; Tri|bus (Wahlbezirk im alten Rom; systematischer Begriff zwischen Gattung u. Familie in der Biologie) *w*; -, -; Tri|but (Opfer, Beisteuerung; schuldige Verehrung, Hochachtung) *m*; -[e]s, -e; Tri|but|ab|kom|men; tri|bu|tär (früher für: steuer-, zinspflichtig); Tri|but_last; tri|but|pflich|tig; Tri|but_pflicht|ig|keit (*w*; -), ...ver|pflich|tung
Tri|chi|ne *gr.* (schmarotzender Fadenwurm) *w*; -, -n; tri|chi|nen|hal|tig; Tri|chi|nen_schau, ...schau|er (vgl. ²Schauer); tri|chi|nös (mit Trichinen behaftet); -este (↑ R 292); Tri|chi|no|se (Trichinenkrankheit) *w*; -, -n
Tri|cho|to|mie *gr.* (Dreiteilung) *w*; -, ...ien; tri|cho|to|misch
Trich|ter *m*; -s, -; trich|ter|för|mig; Trich|ter|mün|dung; trich|tern; ich ...ere (↑ R 327)

Trick *engl.* (Kunstgriff; Kniff; Stich bei Kartenspielen) *m*; -s, -e u. -s; Trick_be|trü|ger, ...film; trick|sen (ugs. für: einen Gegner geschickt aus-, umspielen [vor allem beim Fußball]); Trick|track (Brett- und Würfelspiel; Puffspiel) *s*; -s, -s
Tri|dent *lat.* (Dreizack) *m*; -[e]s, -e
Tri|den|ti|ner [zu: Trient] (↑ R 199); - Alpen; tri|den|ti|nisch, aber (↑ R 224): das Tridentinische Konzil; das Tridentinische Glaubensbekenntnis; Tri|den|ti|num (Tridentinisches Konzil) *s*; -s
Tri|du|um *lat.* [...*du-um*] (Zeitraum von drei Tagen) *s*; -s, ...duen [...*u̩en*]
Trieb *m*; -[e]s, -e; trieb|ar|tig; Trieb_be|frie|di|gung, ...fe|der; trieb|haft; Trieb|haf|tig|keit *w*; -; Trieb_hand|lung, ...kraft, ...leben; trieb|mä|ßig; Trieb_rad, ...sand, ...tä|ter, ...wa|gen, ...werk
Tri|eder|bin|okel *gr.*; *lat.* (Doppelfernrohr)
Trief_au|ge; trief|äu|gig; trie|fen; du triefst; du trieftest (in gewählter Sprache: troffst [troffest]); du trieftest (in gewählter Sprache: tröffest); getrieft (selten noch: getroffen); trief[e]l!
¹Triel (ein Vogel) *m*; -[e]s, -e
²Triel südd. (Wamme; Maul) *m*; -[e]s, -e; trie|len südd. (sabbern); Trie|ler südd. (Sabberlätzchen)
Tri|en|ni|um *lat.* (veralt. für: Zeitraum von drei Jahren) *s*; -s, ...ien [...*i̩en*]
Tri|ent (it. Stadt); vgl. Trento u. Tridentiner
Trier (Stadt an der Mosel)
Trie|re *gr.* (Kriegsschiff mit drei übereinanderliegenden Ruderbänken) *w*; -, -n
Tri|e|rer [zu: Trier] (↑ R 199); trie|risch
Tri|est (Stadt an der Adria); Trie|ster (↑ R 199)
Tri|eur *fr.* [...*ör*] (Maschine zur Getreidereinigung) *m*; -s, -e
trie|zen (ugs. für: quälen, plagen); du triezt (triezest)
Trif|fle *engl.* [*trai̩fl*] (engl. Süßspeise) *s*; -[s], -s
Tri|fo|li|um *lat.* (Drei-, Kleeblatt) *s*; -s, ...ien [...*i̩en*]
Tri|fo|ri|um *lat.* (säulengetragene Galerie in Kirchen) *s*; -s, ...ien [...*i̩en*]
Trift (Weide; Holzflößung; auch sinnverwandt für Drift) *w*; -, -en; trif|ten (loses Holz flößen); ¹trif|tig (hochd. für: driftig)
²trif|tig ([zu]treffend); -er Grund; Trif|tig|keit *w*; -
Tri|ga *lat.* (Dreigespann) *w*; -, -s u. ...gen

Tri|ge|mi|nus lat. (Med.: aus drei Ästen bestehender fünfter Hirnnerv); **Tri|ge|mi|nus|neu|ral|gie**

Tri|glyph m; -s, -e u. **Tri|gly|phe** gr. (Bauw.: Dreischlitz [dreiteiliges Feld am Fries des dorischen Tempels] w; -, -n; **tri|go|nal** (dreieckig); **Tri|go|nal|zahl** (Dreieckszahl); **Tri|go|no|me|trie** (Dreiecksmessung, -berechnung) w; -, **tri|go|no|me|trisch**; -er Punkt

tri|klin, tri|kli|nisch gr. (Kristallform); **Tri|kli|ni|um** (altröm. Eßtisch, an drei Seiten von Speisesofas umgeben) s; -s, ...ien [...*i*ⁿn]

Tri|ko|li|ne (ein Gewebe) w; -; **tri|ko|lor** lat. (dreifarbig); **Tri|ko|lo|re** fr. („dreifarbige" [fr.] Fahne) w; -, -n

Tri|kot fr. [...*ko̱*, auch: *trịko*] (enganliegendes gewirktes [auch gewebtes] Kleidungsstück) s; -s, -s u. (für: maschinengestricktes Gewebe) m (selten: s); -s, -s; **Tri|ko|ta|ge** [...*asch*ᵉ, österr.: ...*asch*] (Wirkware)

Tril|ler *it*; **tril|lern;** ich ...ere (↑ R 327); **Tril|ler|pfei|fe**

Tril|li|on lat. (eine Million Billionen)

Tri|lo|bit gr. (urweltlicher Krebstier) m; -en, -en (↑ R 268)

Tri|lo|gie gr. (Folge von drei [zusammengehörenden] Dichtwerken, Kompositionen u. a.) w; -, ...ien

Tri|ly|sinⓌ (Haarwuchsmittel) s; -s

Tri|ma|ran lat.; tamil.-engl. (Segelboot mit drei Rümpfen) m; -s, -e

Tri|me|ster lat. (Zeitraum von drei Monaten; Drittel|jahr eines Unterrichtsjahres) s; -s, -

Tri|me|ter gr. (aus drei Versfüßen bestehender Vers) m; -s, -

Trimm engl. (Seemannsspr.: Lage eines Schiffes bezüglich Tiefgang u. Schwerpunkt; ordentlicher u. gepflegter Zustand eines Schiffes) m; -[e]s; **Trimm-Aktion** (des Dt. Sportbundes); **Trimm-dich-Pfad; trim|men** (Seemannsspr.: [Ladung, Ballast] von einer Stelle des Schiffes an eine andere befördern; das Schiff in ordentlichen u. gepflegten Zustand bringen; Funkgerät durch Abgleichen der Schaltungen u. a. Drehkondensatoren leistungsfähig machen; Hunden das Fell scheren; ugs. für: jmdn. od. etwas [mit besonderer Anstrengung] in einen gewünschten Zustand bringen); ein auf alt getrimmter Schrank; sich -; trimm dich durch Sport!; **Trimmer** (Seemannsspr.: Arbeiter, der auf Schiffen die Ladung trimmt,

Kohlen aus den Bunkern vor die Kessel schafft usw.; Technik: zum Abgleichen von Schwingkreisen benutzter, verstellbarer Kleinkondensator; ugs.: Person, die sich trimmt); **Trimm|spi|ra|le** (Testkarte der Trimm-Aktion)

Trim|mung (Längsrichtung eines Schiffes)

tri|morph gr. (dreigestaltig [z. B. von Pflanzenfrüchten]); **Tri|mor|phis|mus** (Dreigestaltigkeit [z. B. von Früchten]) m; -

¹**Tri|ne** (Kurzform von: Katharine); ²**Tri|ne** (ugs. Schimpfwort) w; -, -n; dumme -

Tri|ni|dad (südamerik. Insel); **Tri|ni|dad und To|ba|go** (Staat im Karibischen Meer)

Tri|ni|ta|ri|er lat. [...*i*ʳr] (Bekenner der Dreieinigkeit; Angehöriger eines kath. Bettelordens) m; -s, -; **Tri|ni|tät** (Dreieinigkeit, Dreifaltigkeit) w; -; **Tri|ni|ta|tis|fest** (Sonntag nach Pfingsten)

Tri|ni|tro|to|lu|ol (stoßunempfindlicher Sprengstoff; Abk.: TNT) s; -s; vgl. Trotyl

trink|bar; Trink|bar|keit w; -; **Trink.|be|cher, ...brannt|wein; trin|ken;** du trankst (trankest); du tränkest; getrunken; trink[e]!; **Trin|ker; Trin|ker.für|sor|ge, ...heil|an|stalt; trink|fest; Trink.|fla|sche, ...ge|fäß, ...ge|la|ge, ...geld, ...glas** (vgl. ¹Glas), **...halm, ...lied, ...scha|le, ...spruch, ...was|ser** (s; -s)

Tri|nom gr. (dreigliedrige Zahlengröße) s; -s, -e; **tri|no|misch**

Trio it. (Musikstück für drei Instrumente, auch: die drei Ausführenden; Dreizahl [von Menschen]) s; -s, -s; **Tri|o|de** gr. (Verstärkerröhre mit drei Elektroden) w; -, -n; **Trio|le** it. (Musik: Figur von 3 Noten an Stelle von 2 oder 4 gleichwertigen) w; -, -n; **Trio|lett** fr. (eine bestimmte Gedichtform) s; -[e]s, -e

Trip engl. (Ausflug, Reise; Rauschzustand durch Drogeneinwirkung, auch: die dafür benötigte Dosis) m; -s, -s

¹**Tri|pel** fr. (die Zusammenfassung dreier Dinge, z. B. Dreieckspunkte) s; -s, -; ²**Tri|pel** (veralt. für: dreifacher Gewinn) m; -s, -

³**Tri|pel** (Erde von Tripolis) (Geol.: Kieselerde) m; -s

Tri|pel|al|li|anz (Dreibund)

Tri|phthong gr. (Dreilaut, drei eine Silbe bildende Selbstlaute, z. B. fr. eau [o]) m; -s, -e

Tri|plé fr. [...*le̱*] (Billardspiel: Zweibandenball) s; -s, -s; **Tri|plik** lat. (selten für: die Antwort des Klägers auf eine Duplik) w; -, -en; **tri|pli|kat** (selten für: dritte

Ausfertigung) s; -[e]s, -e; **Tri|pli|zi|tät** (selten für: Dreifachheit; dreifaches Vorkommen) w; -; **Tri|plum** (veralt. für: Dreifaches) s; -s, ...pla; vgl. in triplo

Trip|ma|dam fr. (Pflanzenart der Fetthenne) w; -, -en

Tri|po|den (Mehrz. von: Tripus); **Tri|po|li|ta|ni|en** [...*i*ⁿn] (Teilgebiet von Libyen); **Tri|po|lis** (Hptst. von Libyen); **Tri|po|li|ta|ni|noch**

trip|peln (mit kleinen, schnellen Schritten gehen); ich ...[e]le (↑ R 327); **Trip|pel|schritt**

Trip|per [zu niederd. drippen = tropfen] (eine Geschlechtskrankheit)

Trip|tik (eindeutschend für: Triptyk); **Trip|ty|chon** gr. (dreiteiliger Altaraufsatz) s; -s, ...chen u. ...cha; **Trip|tyk, Trip|tik** lat. („drei"teiliger Grenzübertrittsschein für Kraft- und Wasserfahrzeuge) s; -s, -s; **Trip|pus** gr. (Dreifuß, altgr. Gestell für Gefäße) m; -, ...po̱den

Tri|re|me lat. (svw. Triere) w; -, -n

Tris|me|gi|stos gr. („der dreimalgröße" [nämlich] wunderträtige ägypt. Hermes) m; -

trist fr. (traurig, öde, trostlos); -este (↑ R 292)

Tri|stan (mittelalterl. Sagengestalt)

Tri|ste bayr., österr. u. schweiz. (um eine Stange aufgehäuftes Heu od. Stroh) w; -, -n

Tri|stesse fr. [*trißtäß*] (Traurigkeit, trübe Stimmung) w; -, -n [...*ß*ᵉn]; **Tri|sti|en** lat. [...*i*ⁿn] (Trauergedichte [Ovids]) Mehrz.

Trit|ago|nist gr. (dritter Schauspieler auf der altgr. Bühne); ↑ R 268; **Tri|the|is|mus** (Glaube an drei Einzelpersonen in der Dreieinigkeit) m; -

Tri|ti|um gr. [...*zium*] (schweres Wasserstoffisotop; Zeichen: T) s; -s; ¹**Tri|ton** (schwerer Wasserstoffkern) s; -s, ...onen

²**Tri|ton** (gr. fischleibiger Meergott, Sohn Poseidons); ³**Tri|ton** (einer der Meergötter im Gefolge Poseidons; Biol.: Salamander einer bestimmten Gattung) m; ...onen, ...onen (↑ R 268)

Tritt m; -[e]s, -e; - halten; **Tritt.brett, ...lei|ter** w

Tri|umph lat. (Siegesfreude, -jubel; großer Sieg, Erfolg) m; -[e]s, -e; **tri|um|phal** (herrlich, sieghaft); **Tri|um|pha|tor** (feierlich einziehender Sieger) m; -s, ...oren; **Tri|umph|bo|gen; tri|umph|ge|krönt; Tri|umph|ge|schrei; tri|um|phie|ren** (als Sieger einziehen; jubeln); **Tri|umph|zug**

Tri|um|vir lat. [...*wir*] (Mitglied

eines Triumvirats) *m*; -s u. -n, -n (↑ R 268); **Tri|um|vi|rat** (Dreimännerherrschaft [im alten Rom]) *s*; -[e]s, -e

tri|va|lent *lat.* [...*wa*...] (Chemie: dreiwertig)

tri|vi|al *lat.* [...*wi*...] (platt, abgedroschen); **Tri|via|li|tät** (Plattheit); **Tri|vi|al|li|te|ra|tur**; **Tri|vi|um** (,,Dreiweg''; der die Grammatik, Dialektik u. Rhetorik umfassende untere Lehrgang mittelalterl. Schulen) *s*; -s; **Tri|zeps** (,,Dreiköpfiger''; Höllenhund; Med.: Oberarmmuskel) *m*; -, -e

Trix, Tri|xi (Kurzform von: Beatrix)

Tro|as (im Altertum kleinasiat. Landschaft) *w*; -

Tro|ca|de|ro [...*ka*...] (Pariser Palast) *m*; -[s]

tro|chä|isch *gr.* [*troch*...] (aus Trochäen bestehend); **Tro|chä|us** ([antiker] Versfuß) *m*; -

Tro|chi|lus *gr.* [*troch*...] (Hohlkehle in der Basis ionischer Säulen) *m*; -, ...ilen

Tro|chit *gr.* [*troch*...] (Stengelglied versteinerter Seelilien) *m*; -s u. -en (↑ R 268); **Tro|cho|pho|ra** (Biol.: Larve der Ringelwürmer) *w*; -, ...phoren

trocken[1]; ↑ R 329. **I.** *Großschreibung* (↑ R 116): auf dem Trock[e]nen (auf trockenem Boden) stehen, im Trock[e]nen (auf trockenem Boden) sein. **II.** *Kleinschreibung* (↑ R 133) in folgenden Fügungen: auf dem trock[e]nen sein (ugs. für: festsitzen; nicht mehr weiterkommen, erledigt sein); im trock[e]nen (geborgen) sein (ugs.); auf dem trock[e]nen sitzen (ugs. für: nicht flott, in Verlegenheit sein); sein Schäfchen im trock[e]nen haben, ins trock[e]ne bringen (ugs.: sich wirtschaftlich gesichert haben, sichern). **III.** *Schreibung in Verbindung mit Zeitwörtern* (↑ R 139): trocken sein, werden, liegen, stehen; vgl. aber: trockenlegen, trockenreiben, trockensitzen, trockenstehen; **Trocken**[1]*⌐an|la|ge*, ...**ap|pa|rat**, ...**bee|ren|aus|le|se**, ...**bo|den**, ...**dock**, ...**ei** (Ei in Pulverform), ...**eis** (feste Kohlensäure), ...**ele|ment**, ...**far|be**, ...**füt|te|rung**, ...**ge|mü|se**, ...**ge|stell**, ...**hau|be**; **Trocken|heit**[1]; **trocken|le|gen**[1]; ↑ R 139 (mit frischen Windeln versehen); die Mutter hat das Kind trockengelegt, aber: **trok|ken**[1] **le|gen**; die Bretter müssen trocken (in trockenem Zustand) gelegt werden; **Trocken**[1]*⌐le|gung*, ...**milch**, ...**ofen**, ...**platz**, ...**ra|sie-**

rer (ugs.), ...**raum**; **trocken|rei|ben**[1]; ↑ R 139 (durch Reiben trocknen); das Kind wurde nach dem Bad trockengerieben, aber: **trocken**[1] **rei|ben** (ohne Zusatz von Flüssigkeit reiben); du mußt die Platte trocken reiben; **Trocken**[1]*⌐schi|kurs*, ...**schleu|der**; **trocken|sit|zen**[1]; ↑ R 139 (ugs. für: ohne Getränke sitzen); sie ließen uns bei diesem Fest -, aber: **trocken**[1] **sit|zen** (im Trockenen sitzen); wir wollen trocken sitzen; **Trocken|spi|ri|tus**[1]; **trocken|ste|hen**[1]; ↑ R 139 (keine Milch geben); die Kuh hat mehrere Wochen trockengestanden, aber: **trocken**[1] **ste|hen** (im Trockenen stehen); das Vieh soll trocken (nicht: feucht) stehen; **Trocken**[1]*⌐wä|sche*, ...**woh|ner**, ...**zeit**; **Tröck|ne** schweiz. (anhaltende Trockenheit) *w*; -; **trock|nen**; **Trock|nung** *w*; -

Trod|del (Quaste) *w*; -, -n; **Trod|del|chen, Tröd|del|chen**

Trö|del *m*; -s (ugs.); **Trö|del|bu|de** (ugs. abschätzig); **Trö|de|lei** (ugs.); **Trö|del|frit|ze** (ugs.), ...**kram** (ugs.), ...**la|den**; **trö|deln** (ugs.); ich ...[e]le (↑ R 327); **Tröd|ler; Tröd|le|rin** *w*; -, -nen

Tro|er vgl. Trojaner

Trog *m*; -[e]s, Tröge

Tro|glo|dyt *gr.* (Höhlenbewohner) *m*; -en, -en (↑ R 268)

Troi|er vgl. Troyer

Troi|ka *russ.* [*treuka*, auch: *troika*] (russ. Dreigespann) *w*; -, -s

troj|isch vgl. trojanisch

Trois|dorf [*troß*...] (Stadt in Nordrhein-Westfalen)

Tro|ja (antike kleinasiat. Stadt); **Tro|ja|ner** (Bewohner von Troja); **tro|ja|nisch**; die trojanischen Helden, aber (↑ R 224): der Trojanische Krieg, das Trojanische Pferd

Tröl|bu|ße (schweiz.); **trö|len** schweiz. ([den Gerichtsgang] leichtfertig od. frevelhaft verzögern); **Trö|le|rei** (schweiz.) *w*; -

Troll (Kobold, Dämon) *m*; -[e]s, -e; **Troll|blu|me; trol|len**, sich (ugs.)

Troll|ley|bus *engl.* [*troli*...] schweiz. (Oberleitungsbus)

Troll|hät|tan (Wasserfall und Kraftwerk am Götaälv in Schweden)

Trom|be *it.*(-*fr.*) (,,Trompete''; Wasser-, Sand-, Windhose) *w*; -, -n

Trom|mel *w*; -, -n; **Tröm|mel|chen; Trom|me|lei** (ugs.); **Trom|mel|fell**, ...**feu|er**; **heu|wen|der; trom|meln**; ich ...[e]le (↑ R 327);

Trom|mel|re|vol|ver, ...**schlag**, ...**schlä|ger**, ...**wasch|ma|schine**, ...**wir|bel; Trom|mler**

Trom|pe|te *fr. w*; -, -n; **trom|pe|ten**; er hat trompetet; **Trom|pe|ten⌐baum**, ...**blu|me**, ...**si|gnal**, ...**stoß; Trom|pe|ter; Trom|pe|ter|vo|gel**

Trom|sø [*tromsö*, norw. Aussspr.: *trumßö*] (norw. Stadt)

Trond|heim (norw. Schreibung von: Drontheim)

Tro|pe *w*; -, -n u. **Tro|pus** *gr.* (,,Wendung''; Vertauschung des eigentlichen Ausdrucks mit einem bildlichen, z. B. ,,Bacchus'' statt ,,Wein'') *m*; -, ...pen; **Tro|pen** (heiße Zone zwischen den Wendekreisen) *Mehrz.*; **Tro|pen⌐an|zug**, ...**fie|ber** (*s*; -s), ...**helm**, ...**in|sti|tut**, ...**kli|ma**, ...**kol|ler** (*m*; -s), ...**krank|heit**, ...**me|di|zin**, ...**pflan|ze**

Tropf (ugs. für: armer Einfältiger; Dummkopf) *m*; -[e]s, Tröpfe; **tropf|bar; tropf|bar|flüs|sig; Tröpf|chen, Tröpf|lein; Tröpf|chen|in|fek|ti|on; tröp|feln; ich** ...[e]le (↑ R 327); **trop|fen; Trop|fen** *m*; -s, -; **Trop|fen|fän|ger**, ...**form; trop|fen|wei|se; Tröp|fer|bad** ostösterr. ugs. (Brausebad); **Tropf|fla|sche; Tröpf|lein, Tröpf|chen; tropf|naß; Tropf⌐röhr|chen**, ...**stein; Tropf|stein|höh|le**

Tro|phäe *gr.* (im alten Griechenland) Siegesmal aus erbeuteten Waffen, Siegeszeichen; Jagdbeute [z. B. Geweih]) *w*; -, -n

tro|phisch *gr.* (Med.: mit der Ernährung zusammenhängend)

Tro|pi|cal *gr.-engl.* [...*k'l*] (,,tropisch''; luftdurchlässiger Anzugstoff in Leinenbindung) *m*; -s, -s; **Tro|pi|ka** *gr.* (schwere Form der Malaria) *w*; -; **tro|pisch** (zu den Tropen gehörend; südlich, heiß); **Tro|pis|mus** (Biol.: Krümmungsbewegung der Pflanze, die durch äußere Reize hervorgerufen wird) *m*; -, ...men

Tro|po|sphä|re [auch: *tropo*...] (Meteor.: unterste Schicht der Atmosphäre) *w*; -

Tro|pus *gr.* (sww. Trope; im Gregorianischen Gesang der Kirchenton u. die Gesangsformel für das Schlußamen; melodische Ausschmückung von Texten im Gregorianischen Choral) *m*; -, Tropen

troß! landsch. (schnell!)

Troß *fr.* (der die Truppe mit Verpflegung u. Munition versorgende Wagenpark; übertr.: Gefolge, Haufen) *m*; Trosses, Trosse; **Tros|se** (starkes Tau; Drahtseil) *w*; -, -n; **Troß⌐knecht**, ...**schiff**

Trost *m*; -es; **trost⌐be|dürf|tig**,

...**brin|gend**; **Tröst|ein|sam|keit**
(Bez. der Romantiker für: Trost
für einsame Menschen) *w*; -; **trö-
sten**; sich -; **Trö|ster**; **Trö|ste|rin**
w; -, -nen; **tröst|lich**; **trost|los**;
-este (↑ R 292); **Trost|lo|sig|keit**
w; -; **Trost_pfla|ster**, ...**preis** (vgl.
²Preis); **trost|reich**; **Trost|spruch**;
Trö|stung; **Trost|wort** (*Mehrz.*
...worte)

trott!; **Trott** (ugs. für: langweiliger,
routinemäßiger [Geschäfts]-
gang; eingewurzelte Gewohn-
heit) *m*; -[e]s, -e; **Trott|baum**;
Trot|te südwestd. u. schweiz. ([al-
te] Weinkelter) *w*; -, -n

Trot|tel (ugs. für: einfältiger
Mensch, Dummkopf) *m*; -s, -
Trot|te|lei; **trot|tel|haft**; **trot|te-
lig**; **Trot|te|lig|keit** *w*; -
trot|teln (ugs. für: schwerfällig da-
herkommen, gehen); ich ...[e]le
(↑ R 327); **trot|ten** (ugs. für:
schwer einherschreiten, einen
schweren Gang haben); **Trot|ti-
nett** *fr.* schweiz. (Kinderroller) *s*;
-s, -e; **Trot|toir** [...*toar*] (veralt.,
aber noch mdal. u. schweiz. für:
Bürgersteig, Geh-, Fußweg) *s*; -s,
-e u. -s

Tro|tyl (svw. Trinitrotoluol) *s*; -s
trotz (↑ R 130); *Verhältnisw.* mit
Wesf.: - des Regens; seltener
(aber bes. südd., schweiz. u.
österr. u. wenn der Artikel fehlt)
mit *Wemf.*: - dem Regen, trotz
nassem Asphalt; *Wemf.* in: ,,trotz
alle[e]dem, allem" u. wenn der
Wesf. der *Mehrz.* nicht erkenn-
bar ist: - Atomkraftwerken;
Trotz *m*; -es; aus -; dir zum -;
- bieten; **Trotz|al|ter**; **trotz|dem**
[auch: *trozdem*]; - ist es falsch;
(auch schon:) - zäiter - daß) du
nicht rechtzeitig eingegriffen
hast; **trot|zen**; du trotzt (trotzest);
Trot|zer (auch in der Landw.:
Rübe im zweiten Entwicklungs-
jahr); **trot|zig**

Trotz|ki (russ. Revolutionär);
Trotz|kis|mus (im kommunisti-
schen Sprachgebrauch: im Sinne
Trotzkis von der offiziellen Par-
teirichtlinie abweichende Hal-
tung) *m*; -; **Trotz|kist** (Anhänger
des Trotzkismus); ↑ R 268; **trotz-
ki|stisch**

Trotz|kopf; **trotz|köp|fig**; **Trotz-
re|ak|ti|on**

Trou|ba|dour *fr.* [*trubadur,* auch:
...*dur*] (provenzal. Minnesänger
des 12. bis 14. Jh.s) *m*; -s, -e u.
-s

Trou|pier *fr.* [*trupie*] (altgedienter
Soldat) *m*; -s, -s

Troy|er, **Troi|er** [*treu'r*] (Matro-
senunterhemd) *m*; -s, -

Troyes [*troa*] (fr. Stadt)
Troy|ge|wicht [*treu...;* zu: Troyes]
(Gewicht für Edelmetalle u. a.
in England u. in den USA)

Trub landsch. (Absatz beim Wein,
Bier) *m*; -[e]s; **trüb**, **trü|be**; (↑ R
133:) im trüben fischen; **Trü|be**
w; -

Tru|bel *m*; -s
trü|ben; sich -; **Trüb|heit** *w*; -; **Trüb-
nis** (veralt.) *w*; -, -se; **Trüb|sal** *w*;
-, -e; **trüb|se|lig**; **Trüb|se|lig|keit**
w; -; **Trüb|sinn** *m*; -[e]s; **trüb|sin-
nig**; **Trü|bung**

Truch|seß (im Mittelalter Hof-
beamter über Küche u. Tafel) *m*;
...sesses u. (älter:) ...sessen, ...ses-
se

Truck *engl.* [*trak*] (engl. Bez. für:
Tausch; amerik. Bez. für: Last-
kraftwagen) *m*; -s, -s; **Truck|sy-
stem** (frühere Form der Lohn-
zahlung in Waren, Naturalien)
s; -s

Trud|chen, **Tru|de**, **Trau|de[l]** vgl.
Traudchen
tru|deln (Fliegerspr.: drehend nie-
dergehen, abstürzen; auch
landsch. für: würfeln); ich ...[e]le
(↑ R 327)

Trüf|fel *fr.* (ein Pilz) *w*; -, -n (ugs.
meist. *m*, -s, -); **Trüf|fel|le|ber**;
trüf|feln (mit Trüffeln anrichten);
ich ...[e]le (↑ R 327); **Trüf|fel-
wurst**

Trug *m*; -[e]s; Lug und -; **Trug_bild**,
...**dol|de**; **trü|gen**; du trogst (tro-
gest); du trögest; getrogen; trü-
g[e]!; **trü|ge|risch**; -ste (↑ R 294);
Trug|ge|bil|de; **Trug|schluß**

Tru|he *w*; -, -n; **Tru|hen|deckel**
[*Trenn.:* ...dek|kel]

Trum *m* (auch: *s*); -[e]s, -e u. Trü-
mer u. Trumm (Bergmannsspr.:
Abteilung eines Schachtes; klei-
ner Gang) *m* (auch: *s*); -[e]s, -e
u. Trümmer

Tru|man [*trum'n*] (Präsident der
USA)

¹**Trumm** (svw. Trum); ²**Trumm**
mdal. (Ende, Stück, Brocken,
Fetzen) *s*; -[e]s, Trümmer; **Trüm-
mer** ([Bruch]stücke) *Mehrz.*; et-
was in - schlagen; **Trüm|mer_feld**,
...**flo|ra**, ...**ge|stein**, ...**grund-
stück**; **trüm|mer|haft**; **Trüm-
.hau|fen**, ...**mar|mor**

Trumpf *lat.* (eine der [wahlweise]
höchsten Karten bei Kartenspie-
len, mit denen Karten anderer
Farbe gestochen werden können)
m; -[e]s, Trümpfe; **Trumpf|as**;
trumpf|fen; **Trumpf_far|be**, ...**kar-
te**, ...**kö|nig**

Trunk *m*; -[e]s, (selten:) Trünke;
Trünk|chen, **Trünk|lein**; **trun|ken**;
er ist vor Freude -; **Trun|ken|bold**
(abschätzig) *m*; -[e]s, -e; **Trun-
ken|heit** *w*; -; **Trunk|sucht** *w*; -;
trunk|süch|tig

Trupp *fr.* *m*; -s, -s; **Trüpp|chen**,
Trüpp|lein; **Trup|pe** *w*, -, -n; **Trup-
pen** *Mehrz.*; **Trup|pen_ab|zug**,
...**be|we|gung**, ...**ein|heit**, ...**füh-
rer**, ...**pa|ra|de**, ...**teil** *m*, ...**übungs-
platz**; **trupp|wei|se**

Trü|sche (ein Fisch) *w*; -, -n

Trust *engl.* [meist engl. Ausspr.:
traßt] (Konzern) *m*; -[e]s, -e u.
-s; **trust|ar|tig**; **Tru|stee** [*traßti*]
(engl. Bezeichnung für: Treuhän-
der) *m*; -s, -s; **trust|frei**

Trut_hahn, ...**hen|ne**, ...**huhn**

Trutz *m*; -es; zu Schutz und -;
Schutz-und-Trutz-Bündnis (vgl.
d.); **trut|zen** (veralt.); du trutzt
(trutzest); **trut|zig** (veralt.)

Try|pa|no|so|ma *gr.* (Geißeltier-
chen) *s*; -s, ...men

Tryp|sin *gr.* (Med.: Ferment der
Bauchspeicheldrüse) *s*; -s

Tschad [*tschat*] (Staat in Afrika);
Tscha|der; **tscha|disch**; **Tschad-
[see]** (See im mittleren Sudan) *m*;
-s

Tschai|kow|ski [...*kofßki*] (russ.
Komponist)

Tscha|ko *ung.* (Kopfbedeckung
[der Polizisten]) *m*; -s, -s

Tscha|ma|ra *tschech.* u. *poln.* (zur
tschech. u. poln. Nationaltracht
gehörender Schnürrock) *w*; -, -s
u. ...ren

Tschan|du *Hindi* (zum Rauchen
zubereitetes Opium) *s*; -s

Tschap|ka *poln.* (Kopfbedeckung
der Ulanen) *w*; -, -s

Tschap|perl österr. ugs. (unbehol-
fener Mensch) *s*; -s

Tschar|dasch vgl. Csárdás

tschau! *it.* schweiz. (kamerad-
schaftlich-burschikoser [Ab-
schieds]gruß); vgl. ciao

Tsche|che (Angehöriger eines
westslaw. Volkes) *m*; -n, -n (↑ R
268); **Tsche|cherl** ostösterr. ugs.
(kleines, einfaches Gast-, Kaffee-
haus) *s*; -s, -n; **Tsche|chin** *w*; -,
-nen; **tsche|chisch**; **Tsche|chisch**
(Sprache) *s*; -[s]; vgl. Deutsch;
Tsche|chi|sche *s*; -n; vgl. Deut-
sche. **Tsche|cho|slo|wa|ke**
m; -n, -n (↑ R 268); **Tsche|cho|slo-
wa|kei** (Staat in Mitteleuropa;
Abk.: ČSSR) *w*; -; **Tsche|cho|slo-
wa|kin** *w*; -, -nen; **tsche|cho|slo-
wa|kisch** (↑ R 214); (↑ R 198:) die
Tschechoslowakische Sozialisti-
sche Republik

Tsche|chow [*tschechof*] (russ.
Schriftsteller)

Tsche|ki|ang (chin. Prov.)

Tscher|kes|se (Angehöriger einer
Gruppe kaukas. Volksstämme)
m; -n, -n (↑ R 268); **Tscher|kes|sin**
w; -, -nen; **tscher|kes|sisch**

Tscher|no|sem *russ.* [...*sjom*] u.
Tscher|no|sjom (,,Schwarzerde")
s; -s

Tsche|ro|ke|se (Angehöriger eines

nordamerik. Indianerstammes)
m; -n, -n (↑ R 268)
Tscher|per (Bergmannsspr. ver-
alt.: kurzes Messer) *m*; -s, -
Tscher|wo|nez (ehem. russ. Münz-
einheit) *m*; -, ...wọnzen; 3 - (↑ R
322)
Tsche|tsche|ne (Angehöriger eines
kaukas. Volkes) *m*; -n, -n (↑ R
268)
Tschi|ang|kai|schẹk, **Tschi|ang
Kai-schẹk** vgl. Chiang Kai-shek
Tschi|bụk *türk.* [österr.: *tschị...*]
(lange türkische Tabakspfeife)
m; -s, -s
Tschịck *it.* österr. ugs. (Zigaretten-
[stummel]) *m*; -s, -
Tschị|kosch [auch: *tschị...*] vgl.
Csikós
tschị|pen (vom Sperling: laute
Pieptöne hervorbringen)
Tschi|nẹl|len *it.* (Becken [messing-
genes Schlaginstrument]) *Mehrz.*
tschịng!
Tschịs|men *ung.* (niedrige, farbige
ung. Stiefel) *Mehrz.*
Tsch[o]u En-lai vgl. Chou En-lai
Tschụk|tsche (Angehöriger eines
altsibir. Volkes) *m*; -n, -n (↑ R
268)
tschüs! *fr.* [auch: *tschüß*] (ugs.-
fam. für: auf Wiedersehen!)
Tschụsch *slaw.* österr. ugs. ab-
schätzig (Ausländer, Fremder;
bes. Südslawe, Slowene) *m*; -en,
-en
Tschu|wạ|sche (Angehöriger eines
ostfinn.-turktatar. Mischvolkes)
m; -n, -n (↑ R 268)
Tsd. = ³Tausend
Tse|tse-flie|ge (Überträger der
Schlafkrankheit u. a.), ...**pla|ge**
Tsị|nan (chin. Stadt)
Tsing|tau (chin. Stadt)
Tsi|tsi|kar (chin. Stadt)
Tsjạo *chin.* (chin. Münze) *m*; -[s],
-[s]; 10 - (↑ R 322)
Tsụ|ga (Schierlings- od. Hem-
locktanne) *w*; -, -s u. ...gen
T-Trä|ger; ↑ R 149 (Bauw.) *m*;
-s, -
TU = technische Universität; vgl.
technisch
Tụa|reg [auch: *tua...*] (Gruppe ber-
ber. Volksstämme) *Mehrz.*; vgl.
Targi
Tụ|ba *lat.* (Blechblasinstrument;
Med.: Eileiter, Ohrtrompete) *w*;
-, ...ben
Tüb|bing (Bergmannsspr.: Tun-
nel-, Schachtring) *m*; -s, -s
Tụ|be *lat.* (röhrenförmiger Behäl-
ter [für Farben u. a.]; Med. auch
für: Stiefel) *w*; -, -n; **Tụ|ben**
(*Mehrz.* von: Tuba u. Tubus); **Tụ-
ben|schwan|ger|schaft**
Tụ|bẹr|kel *lat.* (Med.: Knötchen)
m; -s, - (österr. auch: *w*; -, -n);
Tụ|bẹr|kel.bak|te|rie, ...**ba**|zil-

lus; **tụ|bẹr|ku|lạr** (knotig); **Tu-
bẹr|ku|lịn** (Mittel gegen Tuber-
kulose) *s*; -s; **tụ|ber|ku|lös** (mit
Tuberkeln durchsetzt; schwind-
süchtig); -este (↑ R 292); **Tụ|ber-
ku|lo|se** (Schwindsucht; Abk.:
Tb, Tbc) *w*; -, -n; **Tụ|ber|ku|lö|se**
m u. w; -n, -n (↑ R 287 ff.); **Tụ|ber-
ku|lo|se|für|sor|ge**; **tụ|ber|ku|lo-
se|krank** (Abk.: Tbc-krank od.
Tb-krank; ↑ R 150 u. R 137)
Tụ|be|ro|se *lat.* (aus Mexiko stam-
mende stark duftende Zierpflan-
ze) *w*; -, -n
Tü|bin|gen (Stadt am Neckar); **Tü-
bin|ger** (↑ R 199)
tu|bu|lär, **tu|bu|lös** *lat.* (Med.:
röhrenförmig); -e Drüsen; **Tụ|bus**
(„Röhre"; bei optischen Geräten
das linsenfassende Rohr; bei
Glasgeräten der Rohransatz;
veralt. für: Fernrohr) *m*; -, ...ben
u. -se
Tụch *s*; -[e]s, Tücher u. (Tuchar-
ten:) -e; **Tụch|art**; **tụch|ar|tig**;
Tụch|bahn; **Tü|chel|chen**, Tüch-
lein; **tụ|chen** (aus Tuch)
Tụ|chent österr. (mit Federn ge-
füllte Bettdecke) *w*; -, -en
Tụch.fa|brik, ...**füh|lung** (leichte
Berührung zwischen zwei Perso-
nen; *w*; -), ...**han|del**; **Tüch|lein**,
Tü|chel|chen
Tu|chol|sky [...*ki*], Kurt (dt. Jour-
nalist u. Schriftsteller)
Tụch|rock
tüch|tig; **Tüch|tig|keit** *w*; -
Tücke [*Trenn.*: Tük|ke] *w*; -, -n
tuckern [*Trenn.*: tuk|kern] (vom
Motor)
tückisch [*Trenn.*: tük|kisch]; -ste
(↑ R 294); eine -e Krankheit; **tück-
schen** ostmitteld. u. nordd.
(heimlich zürnen); du tückschst
(tückschest)
tuck|tuck (Lockruf für Hühner)
Tü|der niederd. (Seil zum Anbin-
den von Tieren auf der Weide)
m; -s, -; **tü|dern** niederd. (Tiere
auf der Weide anbinden; in Un-
ordnung bringen) ...ere (↑ R
327)
Tu|dor [*tjud°r*, auch dt. Ausspra-
che: *tudor*] (Angehöriger eines
engl. Herrschergeschlechtes) *m*;
-[s], -s; **Tu|dor.bo|gen**, ...**stil** (*m*;
-[e]s)
Tue|rei (ugs. für: Sichzieren);
...**tue|risch** (z. B. großtuerisch)
Tuff (ein Gestein) *m*; -s, -e; **Tụffels**,
Tụffel|sen [*Trenn.*: Tuff|fe..., ↑ R
236]; **Tuff|stein**
Tüf|tel|ar|beit; **Tüf|te|lei** (ugs.);
Tüf|te|ler, Tüft|ler; **tüf|te|lig**,
tüft|lig; **tüf|teln** (ugs. für: müh-
sam und lange an etwas arbeiten,
über etwas nachdenken); ich
...[e]le (↑ R 327)
Tuf|ting... *engl.* [*tạf...*] (in Zus.:

Spezialfertigungsart für Teppi-
che, bei der Polschlingen in das
Grundgewebe eingenäht wer-
den); **Tuf|ting.schlin|gen|wa|re**,
...**tep|pich**, ...**ver|fah|ren**
Tüft|ler, Tüf|te|ler
Tụ|gend *w*; -, -en; **Tụ|gend|bold**
(spött. für: tugendhafter
Mensch) *m*; -[e]s, -e; **tụ|gend|haft**;
Tụ|gend|haf|tig|keit *w*; -; **Tụ-
gend|held** (auch spött.); **tụ|gend-
lich** (veralt.); **tụ|gend|los**; **tụ|gend-
sam**; **Tụ|gend|wäch|ter**
Tui|le|ri|en [*tüilᵉrỉᵉn*] („Ziegelei-
en"; ehem. Residenzschloß der
Könige in Paris) *Mehrz.*
Tu|ịs|ko, (richtiger:) **Tuị|sto**
(germ. Gottheit, Stammvater der
Germanen)
Tụ|kan *indian.* [auch: ...*ạn*] (Pfef-
ferfresser [mittel- u. südamerik.
spechtartiger Vogel]) *m*; -s, -e
Tụ|la (sowj. Stadt); **Tụ|la.ar|bei-
ten** (*Mehrz.*), ...**sil|ber** (↑ R 201)
Tu|lar|ämie *indian.*; *gr.* [erster
Wortteil nach der kaliforn.
Landschaft Tularẹ (Hasenpest,
die auf Menschen übertragen
werden kann) *w*; -
Tụ|li|pa|ne *pers.* (veralt. für: Tul-
pe) *w*; -, -n
Tüll [nach der fr. Stadt Tulle (*tül*)]
(netzartiges Gewebe) *m*; -s, -e
(Tüllarten:) -e; **Tüll|blu|se**
Tül|le landsch. ([Ausguß]röhr-
chen; kurzes Rohrstück zum Ein-
stecken) *w*; -, -n
Tüll|gar|di|ne
Tụl|lia (altröm. w. Eigenn.); **Tụl|li-
us** (altröm. m. Eigenname)
Tüll|vor|hang
Tụl|pe *pers.* (frühblühendes Zwie-
belgewächs) *w*; -, -n; **Tụl|pen-
zwie|bel**
...**tum** (z. B. Besitztum *s*¹; -s, ...tü-
mer)
tumb (scherzh. altertümelnd für:
einfältig); **Tumb|heit** *w*; -
Tụm|ba *gr.* (Scheinbahre beim
kath. Totengottesdienst; Über-
bau eines Grabes mit Grabplatte)
w; -, ...ben
...**tüm|lich** (z. B. eigentümlich)
Tụm|mel (scherz. altertümeld für:
Tụm|meln (bewegen); sich - ([sich
beʃeilen, auch für: herumtollen);
ich ...[e]le (↑ R 327) [mich]; **Tụm-
mel|platz**; **Tụmm|ler** („Taum-
ler"; früher für ein Trinkgefäß
mit einer bestimmten Form);
Tümm|ler (Delphin; Taube)

<hr>

¹ Die auf „tum" ausgehenden
Hauptwörter hatten ursprünglich
männliches Geschlecht, wie heute
noch „Irrtum" und „Reichtum";
die meisten dieser Wörter haben
heute jedoch sächliches Ge-
schlecht.

Tu|mor *lat.* (Med.: Geschwulst) *m*; -s, ...oren; Tu|mor.wachs|tum, ...zel|le

Tüm|pel, (österr. mdal. auch:) Tümp|fel *m*; -s, -

Tu|mu|li (*Mehrz.* von: Tumulus)

Tu|mult *lat.* (Lärm; Unruhe; Auflauf; Aufruhr) *m*; -[e]s, -e; Tu|mul|tu|ant (Unruhestifter; Ruhestörer, Aufrührer) *m*; -en, -en (↑ R 268); tu|mul|tu|a|risch (lärmend, unruhig, erregt); -ste (↑ R 294); tu|mul|tu|ös (svw. tumultuarisch); -este (↑ R 292)

Tu|mu|lus *lat.* (vorgeschichtliches Hügelgrab) *m*; -, ...li

tun; ich tu[e], du tust, er tut, wir tun, ihr tut, sie tun, du tatst (tatest), er tat; du tätest; tuend; getan; tu[e]!, tut!; vgl. dick[e]tun, guttun, schöntun, übeltun, wohltun; Tun *s*; -s; das - und Lassen; das - und Treiben

Tün|che *w*; -, -n; tün|chen; Tün|cher; Tün|cher|mel|ster

Tun|dra *finn.-russ.* (baumlose Kältesteppe jenseits der arktischen Waldgrenze) *w*; -, ...dren; Tun|dren|step|pe

Tu|nell landsch., vor allem südd. u. österr. (svw. Tunnel) *s*; -s, -e

Tu|ner *engl.* [*tjun[e]r*] (Rundfunk, Fernsehen: Kanalwähler) *m*; -s, -

Tu|ne|ser (↑ R 199), Tu|ne|si|er [...*i[e]r*]; Tu|ne|si|en [...*i[e]n*] (Staat in Nordafrika); tu|ne|sisch

Tun|gu|se (svw. Ewenke) *m*; -n, -n (↑ R 268)

Tu|nicht|gut *m*; - u. -[e]s, -e

Tu|ni|ka (altröm. Untergewand; später: modischer Doppelrock) *w*; -, ...ken; Tu|ni|ka|ten (Biol.: Manteltiere) *Mehrz.*

Tu|ning *engl.* [*tju...*] (nachträgliche Erhöhung der Leistung eines Kfz-Motors) *s*; -s

Tu|nis (Hptst. von Tunesien); Tu|ni|ser (↑ R 199); tu|ni|sisch

Tun|ke *w*; -, -n; tun|ken

tun|lich; tunlichst bald; Tun|lich|keit *w*; -

Tun|nel *engl. m*; -s, - u. -s; vgl. auch: Tunell

Tun|te (ugs. abschätzig für: langweilige, dumme Person, bes. Frau) *w*; -, -n; tun|tig

Tu|pa|ma|ro [nach dem Inkakönig Túpac Amaru] (uruguayischer Stadtguerilla) *m*; -s, -s (meist *Mehrz.*)

Tupf südd., österr. u. schweiz. (Tupfen) *m*; -[e]s, -e; Tüpf|chen, Tüpf|lein; Tüp|fel (Pünktchen) *m* od. *s*; -s, -; Tüp|fel|chen; das I-Tüpfelchen (↑ R 149), aber (weil das Tüpfelchen nur auf dem i stehen kann): das Tüpfelchen auf dem i (↑ R 123); Tüp|fel|farn; tüp|fe|lig, tüpf|lig; tüp|feln; ich ... [e]le (↑ R 327); tup|fen; Tup|fen (Punkt; [kreisrunder] Fleck) *m*; -s, -; Tup|fer; Tüpf|lein; Tu|pi (Angehöriger einer südamerik. Sprachfamilie im trop. Waldgebiet) *m*; -[s], -[s]; ²Tu|pi (indian. Verkehrssprache in Südamerika) *s*; -

Tur usw. (eindeutschende Schreibung für: Tour usw.)

Tür *w*; -, -en; von zu

Tu|ran (Tiefland im Süden der UdSSR)

Tu|ran|dot (Titelheldin bei Schiller)

Tür|an|gel

Tu|ra|ni|er [...*i[e]r*]; tu|ra|nisch (aus Turan)

Tu|ras (Kettenstern [bei Baggern]) *m*; -, -se

Tur|ban *pers.* ([mohammedan.] Kopfbedeckung) *m*; -s, -e; tur|ban|ar|tig

Tur|bel|la|rie *lat.* [...*i[e]*] (Strudelwurm) *w*; -, -n (meist *Mehrz.*); tur|bie|ren (veralt. für: beunruhigen, stören); Tur|bi|ne *fr.* (Kraftmaschine) *w*; -, -n; Tur|bi|nen.an|trieb, ...flug|zeug, ...haus; Tur|bo-.ge|ne|ra|tor, ...kom|pres|sor (Kreiselverdichter); Tur|bo-Prop-Flug|zeug (Turbinen-Propeller-Flugzeug) *s*; -[e]s, -e; Tur|bo|ven|ti|la|tor (Kreiselüfter); tur|bu|lent (stürmisch, ungestüm); Tur|bu|lenz (ungestümes Wesen; Auftreten von Wirbeln in einem Luft-, Gas- od. Flüssigkeitsstrom) *w*; -, -en

Tür|chen, Tür|lein; Tür|drücker [*Trenn.:* drük|ker]; Tü|re (landsch. neben: Tür) *w*; -, -n; tür|ein, tür|aus

Turf *engl.* (,,Rasen"; Rennbahn; Pferdesport) *m*; -s

Tür.fal|le (schweiz. für: Türklinke), ...flü|gel, ...fül|lung

Tur|gen|jew [...*gänjäf*] (russ. Dichter)

Tur|ges|zenz *lat.* (Med.: [An]schwellung; Blutreichtum) *w*; -, -en; tur|ges|zie|ren (anschwellen; von Fülle [bes. an Blut] strotzen); Tur|gor (Med.: Spannungszustand des Gewebes) *m*; -s

Tür.griff, ...he|ber, ...hü|ter; ...tü|rig (z. B. eintürig)

Tu|rin (it. Stadt); vgl. Torino; Tu|ri|ner (↑ R 199); tu|ri|nisch

Tür|ke (auch: nachträgliche Inszenierung im Fernsehen) *m*; -n, -n (↑ R 268); einen -n bauen (ugs.: etwas vortäuschen, vorspiegeln); Tür|kei *w*; -; Tür|ken südostösterr. (Mais) *m*; -s; Tür|ken-.bund (Lilienart; *m*; -[e]s, ...bünde), ...pfei|fe, ...sä|bel, ...tau|be;

Tür|ke|stan [auch: ...*ßtan*] (innerasiat. Gebiet); Tür|kin *w*; -, -nen; tür|kis *fr.* (türkisfarben); das Kleid ist -; ¹Tür|kis (ein Edelstein) *m*; -es, -e; ²Tür|kis (türkisfarbener Ton) *s*; -; tür|kisch; -es Pfund (Abk.: Ltq); Tür|kisch|rot; tür|kis|far|ben, tür|kis|far|big; tur|ki|sie|ren (türkisch machen)

Tür.klin|ke, ...klop|fer

Turk|me|ne (Angehöriger eines Turkvolkes) *m*; -n, -n (↑ R 268); Turk|me|ni|en [...*i[e]n*] vgl. turkmenisch; turk|me|nisch, aber (↑ R 224): Turkmenische SSR (Sowjetrepublik); Turk|me|ni|stan [auch: ...*tan*] vgl. turkmenisch; Tur|ko|lo|ge *türk.*; *gr.* (Wissenschaftler auf dem Gebiet der Turkologie) *m*; -n, -n (↑ R 268); Tur|ko|lo|gie (Erforschung der Turksprachen u. -kulturen) *w*; -; Turk.spra|che, ...stamm, ...ta|ta|ren (Turkvolk der Tataren; *Mehrz.*), ...volk (Volk mit einer türk. Sprache)

Tür|lein, Tür|chen

Turm *m*; -[e]s, Türme

Tur|ma|lin *singhal.-fr.* (ein Edelstein) *m*; -s, -e

Turm|bau (*Mehrz.* ...bauten); Türm|chen, Türm|lein; Turm-dreh|kran; ¹tür|men (aufeinanderhäufen)

²tür|men *hebr.* (ugs. für: weglaufen, ausreißen)

Tür|mer; Turm.fal|ke, ...hau|be; turm|hoch [auch: *turmhoch*]; ...tür|mig (z. B. zweitürmig); Türm|lein, Türm|chen; Turm-.sprin|gen (Sportspr.), ...uhr

Turn *engl.* [*t[ö]rn*] (Kehre im Kunstfliegen) *m*; -s, -s

Turn|an|zug; tur|nen; Tur|nen *s*; -s; Tur|ner; Tur|ne|rei *w*; -; tur|ne|risch; Tur|ner|schaft; Turn.fest, ...ge|rät, ...hal|le, ...hemd, ...ho|se

Tur|nier *fr.* (früher ritterliches, jetzt sportliches Kampfspiel; Wettkampf) *s*; -s, -e; tur|nie|ren (veralt.)

Turn.kunst (*w*; -), ...leh|rer, ...schuh, ...stun|de, ...übung, ...un|ter|richt

Tur|nus *gr.* (Reihenfolge; Wechsel; Umlauf; österr. auch für: Arbeitsschicht) *m*; -, -se; im -; tur|nus|ge|mäß

Tur|nva|ter, ...ver|ein (Abk.: TV); (vgl. (↑ R 145:) Turn- und Sportverein (Abk.: TuS); Turn-.wart, ...zeug

Tu|ron (Geol.: zweitälteste Stufe der oberen Kreide) *s*; -s

Tür.pfo|sten, ...rah|men, ...rie|gel, ...schlie|ßer, ...schloß, ...schnal|le (österr. für: Türklinke), ...schwel|le, ...spalt, ...ste|her, ...stock (Bergmannsspr.: beim Strecken-

ausbau senkrecht aufgestellter Holzpfahl; Streckenausbauteil; österr.: [Holz]einfassung der Türöffnung; *Mehrz.* ...stöcke) ...sturz (*Mehrz.* -e und ...stürze)

tur|teln (girren); ich ...[e]le (↑ R 327); Tur|tel|tau|be

TuS = Turn- und Sportverein

Tusch (Musikbegleitung bei einem Hoch) *m*; -es, -e; einen - blasen

Tu|sche *fr.* (Zeichentinte) *w*; -, -n

Tu|sche|lei; tu|scheln (heimlich [zu]flüstern); ich ...[e]le (↑ R 327)

¹tu|schen *fr.* (mit Tusche zeichnen); du tuschst (tuschest)

²tu|schen mdal. (zum Schweigen bringen, stillen); du tuschst (tuschest)

Tusch|far|be

tu|schie|ren *fr.* (ebene Metalloberflächen herstellen; veralt. für: beleidigen)

Tusch..ka|sten, ...ma|le|rei, ...zeich|nung

Tus|ku|lum *lat.* [nach dem altröm. Tusculum] (ruhiger, behaglicher) Landsitz) *s*; -s, ...la

Tus|nel|da vgl. Thusnelda

tut!; tut, tut!

Tut|anch|amun, (auch:) Tut|ench-amun (ägypt. König)

Tüt|chen, Tüt|lein; Tu|te (ugs. für: Tuthorn; mdal. auch für: Tüte) *w*; -, -n; Tü|te *w*; -, -n

Tu|tel *lat.* (Vormundschaft) *w*; -, -en; tu|te|la|risch (vormundschaftlich)

tu|ten (↑ R 120:) von Tuten und Blasen keine Ahnung haben (ugs.)

Tut|ench|amun vgl. Tutanchamun

Tut|horn (*Mehrz.* ...hörner)

Tu|tio|ris|mus *lat.* (Haltung, die zwischen zwei Möglichkeiten immer die sicherere wählt) *m*; -

Tüt|lein, Tüt|chen

Tu|tor *lat.* (jmd., der den Studienanfänger betreut; im röm. Recht für: Vormund) *m*; -s, ...oren

Tüt|tel (veralt., aber noch mdal. für: Pünktchen) *m*; -s, -; Tüt|tel|chen (ugs. für: ein Geringstes); kein - preisgeben

tut|ti *it.* (Musik: alle); Tut|ti (Musik: „alle" Stimmen) *s*; -[s], -[s]; Tut|ti|frut|ti (Gericht aus „allen Früchten"; veraltend für: Allerlei; auch: Durcheinander) *s*; -[s], -[s]

tut, tut!

TÜV = Technischer Überwachungs-Verein (vgl. technisch)

Tu|wort (für: Verb; *Mehrz.* ...wörter)

TV = Television; Turnverein

Tweed *engl.* [*twid*] (ein Gewebe) *m*; -s, -s u. -e; tweed|ähn|lich

Twen *anglisierend* (junger Mann, auch Mädchen um die Zwanzig) *m*; -[s], -s

Twen|ter nordwestd. (zweijähriges Schaf, Pferd) *s*; -s, -

Twie|te niederd. (Zwischengäßchen) *w*; -, -n

Twill *engl.* (Baumwollgewebe [Futterstoff]; Seidengewebe) *m*; -s, -s u. -e

Twin|set *engl.* (Pullover u. Jacke von gleicher Farbe u. aus gleichem Material) *m* od. *s*; -[s], -s

¹Twist *engl.* (mehrfädiges Baumwoll[stopf]garn) *m*; -es, -e; ²Twist *amerik.* (ein Tanz) *m*; -s, -s; twisten (Twist tanzen)

Two|step *engl.* (*tußtäp*) („Zweischritt"; ein Tanz) *m*; -s, -s

Ty|che [*tüche*] (gr. Göttin des Glücks u. des Zufalls); ²Ty|che (Schicksal, Zufall, Glück) *w*; -

Tym|pa|non, ¹Tym|pa|num *gr.* (Giebelfeld über Fenster u. Türen [oft mit Reliefs geschmückt] *s*; -s, ...na; ²Tym|pa|num *gr.* (Handpauke; trommelartiges Schöpfrad in der Antike; Med.: Paukenhöhle [im Ohr]) *s*; -s, ...na

Typ *gr.* (Philos.: nur *Einz.*: Urbild, Beispiel; Psychol.: bestimmte psych. Ausprägung; Technik: Gattung, Bauart, Muster, Modell) *m*; -s, -en; vgl. Typus; Ty|pe *fr.* (gegossener Druckbuchstabe, Letter; ugs. für: komische Figur; seltener, aber bes. österr. svw. Typ [Technik]) *w*; -, -n; ty|pen (industrielle Artikel in bestimmten notwendigen Größen herstellen); Ty|pen..be|schrän|kung, ...druck (*Mehrz.* ...drucke), ...he|bel, ...leh|re, ...psy|cho|lo|gie, ...setz|ma|schi|ne

Ty|phli|tis *gr.* (Med.: Blinddarmentzündung) *w*; -, ...itiden

ty|phös *gr.* (typhusartig); ²ty|phös (↑ R 292); Ty|phus (eine Infektionskrankheit) *m*; -; Ty|phus|ba|zil|len|trä|ger; Ty|phus..epi|de|mie, ...er|kran|kung

Ty|pik *gr.* (Lehre vom Typ [Psychol.]) *w*; -, -en; ty|pisch (gattungsmäßig; kenn-, bezeichnend; ausgeprägt; eigentümlich, üblich; veralt. für: mustergültig, vorbildlich); -ste (↑ R 294); ty|pi|sie|ren (typisch darstellen, gestalten, auffassen; typen); Ty|pi|sie|rung; Ty|po|graph¹ (Schriftsetzer; Zeilensetzmaschine) *m*; -en, -en (↑ R 268); Ty|po|gra|phie¹ (Buchdruckerkunst) *w*; -, ...ien; ty|po|gra|phisch¹; -er Punkt; Ty|po|lo|gie (Lehre von den Typen, Einteilung nach Typen; auch svw. Ty-

pik) *w*; -, ...ien; ty|po|lo|gisch; Ty|pung [zu: typen]; Ty|pus (svw. Typ [Philos., Psychol.]) *m*; -, Typen

Tyr (altgerm. Gott); vgl. Tiu, Ziu

Ty|rann *gr.* (Gewaltherrscher, Zwingherr, Unterdrücker; herrschsüchtiger Mensch) *m*; -en, -en (↑ R 268); Ty|ran|nei (Gewaltherrschaft; Willkür[herrschaft]) *w*; -; Ty|ran|nen|tum *s*; -s; Ty|ran|nin *w*; -, -nen; Ty|ran|nis (Gewaltherrschaft, bes. im alten Griechenland) *w*; -; ty|ran|nisch (gewaltsam, willkürlich); -ste (↑ R 294); ty|ran|ni|sie|ren (gewaltsam, willkürlich behandeln; [freiheitliche Regungen] unterdrücken); Ty|ran|ni|sie|rung

Ty|ras (ein Hundename)

Ty|ri|er [...*iᵉr*], (ökum.:) Ty|rer (Bewohner von Tyrus); ty|risch

Tyr|rhe|ner (Bewohner Etruriens); tyr|rhe|nisch, aber (↑ R 198): das Tyrrhenische Meer (Teil des Mittelländischen Meeres)

tyr|tä|isch, aber (↑ R 179): Tyr|tä-isch; Tyr|tä|us (altgr. Elegiker) *m*; -

Ty|rus (phöniz. Stadt)

Tz vgl. Tezett

U

U (Buchstabe); das U; des U, die U, aber: das u in Mut (↑ R 123); der Buchstabe U, u

U = Unterseeboot; chem. Zeichen für: Uran

u., (in Firmen auch:) & = und

u. a. = und and[e]re, und and[e]res, unter ander[e]m; unter ander[e]n

u. ä. = und ähnliche[s]

u. a. m. = und and[e]re mehr, und and[e]res mehr

u. [od. U.] A. w. g. = um [od. Um] Antwort wird gebeten

U-Bahn; ↑ R 149 (kurz für: Untergrundbahn) *w*; -, -en; U-Bahn-hof; (↑ R 155:) U-Bahn-Netz, U-Bahn-Tun|nel

übel; übler, übelste; die Nachrede; übler Ruf. I. *Großschreibung* (↑ R 116): er hat mir nichts, viel Übles getan. II. *Schreibung in Verbindung mit dem 2. Mittelwort* (↑ R 142), z. B. übelberaten (vgl. d.). III. *Schreibung in Verbindung mit Zeitwörtern* (↑ R 139): übel sein, werden, riechen; vgl. aber: übelnehmen, übeltun, übelwollen; Übel *s*; -s, -; das ist von (geh.: vom) -; übel|be|ra|ten; der übelberatene Herrscher (↑ jedoch R 142), aber: der Herrscher war

¹ Auch eindeutschend: Typograf, Typografie, typografisch.

übel beraten; **übel|ge|launt;** der übelgelaunte Mann (↑ jedoch R 142), aber: der Mann ist übel gelaunt; **übel|ge|sinnt;** der übelgesinnte Nachbar (↑ jedoch R 142), aber: der Nachbar ist übel gesinnt; **Übel|keit; übel|lau|nig; Übel|lau|nig|keit; übel|neh|men** (↑ R 139); er nimmt übel; übelgenommen; übelzunehmen; **Übel|neh|me|rei; übel|neh|me|risch**; -ste (↑ R 294); **übel|rie|chend;** -ste; **Übel_sein** (s; -s), ...stand, ...tat, ...tä|ter; **übel|tun** (↑ R 139); er hat ihm übelgetan; **übel|wol|len** (↑ R 139); er hat ihm übelgewollt; **Übel|wol|len** s; -s; **übel|wol|lend;** ato

¹**üben;** ein Klavierstück -; sich -; ²**üben** (mdal. für: drüben)

über (österr. Kanzleispr. auch svw. auf [über Wunsch = auf Wunsch]); *Verhältnisw.* mit *Wemf.* u. *Wenf.:* das Bild hängt über dem Sofa, aber: das Bild über das Sofa hängen; übersm, übers (vgl. d.); über Gebühr; über die Maßen; über Nacht (Bergmannsspr.:) über Tag; über kurz oder lang (↑ R 133); Kinder über acht Jahre; Gemeinden über 10 000 Einwohner; über dem Lesen ist er eingeschlafen; über die Wahl bin ich sehr erfreut; über einen Witz lachen; *Umstandsw.:* über und über (sehr; völlig); die ganze Zeit [über]; es waren über (= mehr als) 100 Gäste; wir mußten über (= mehr als) zwei Stunden warten; Gemeinden von über (= mehr als) 10 000 Einwohnern; die über Siebzigjährigen; er ist mir über (überlegen)

über... in Verbindung mit Zeitwörtern: a) *unfeste Zusammensetzungen* (↑ R 304), z. B. überbauen (vgl. d.), übergebaut; **b)** *feste Zusammensetzungen* (↑ R 304), z. B. überbauen (vgl. d.), überbaut

über|all; Über|all|her [auch: ...al̲her, ...al̲her]; aber: von überall her; **über|all|hin** [auch: ...al̲hin, ...al̲hin]

über|al̲tert; Über|al̲te|rung w; - **Über|an|ge|bot über|ängst|lich über|an|stren|gen;** sich -; ich habe mich überanstrengt; **Über|anstren|gung**

über|ant|wor|ten (übergeben, überlassen); die Gelder wurden ihm überantwortet; **Über|ant|wor|tung**

über|ar|bei|ten; er hat einige Stunden übergearbeitet; **über|ar̲bei|ten;** sich -; du hast dich völlig überarbeitet; er hat den Aufsatz überarbeitet (nochmals durchgearbeitet); **Über|ar̲bei|tung**

(gründliche Durcharbeitung; Erschöpfung)

über|aus [auch: ...*au̲ß, üb*ᵉ*rau̲ß*]

über|backen [*Trenn.:* ...bak|ken] (Kochk.); das Gemüse wird überbacken

¹**Über|bau** (vorragender Oberbau, Schutzdach; Rechtsspr.: Bau über die Grundstücksgrenze hinaus) m; -[e]s, -e u. -ten; ²**Über|bau** (Marxismus: auf den wirtschaftl., sozialen u. geistigen Grundlagen einer Epoche basierende Gesellschaftsschau u. die entsprechenden Institutionen) m; -[e]s, (selten:) -e; **über|bau|en;** er hat übergebaut (über die Baugrenze); **über|bau|en;** er hat die Brücke (mit einem Dach) überbaut; **Über|bau|ung über|be|an|spru|chen;** er ist überbeansprucht; **Über|be|an|spru|chung**

über|be|hal|ten (ugs. für: übrigbehalten)

Über|bein (zystische Geschwulst, die on Gelenkkapseln oder von Sehnenscheiden ausgeht)

über|be|kom|men; er hat das fette Essen -

über|be|la|sten; Über|be|la|stung über|be|le|gen; der Raum war überbelegt; **Über|be|le|gung über|be|lich|ten** (Fotogr.); die Aufnahme ist überbelichtet; **Über|be|lich|tung**

Über|be|schäf|ti|gung über|be|to|nen; er hat diese Entwicklung übertont; **Über|beto|nung**

über|be|trieb|lich; -e Mitbestimmung

über|be|völ|ke|rung über|be|wer|ten; er hat diese Vorgänge überbewertet; **Über|bewer|tung**

Über|be|zah|lung über|bie̲t|bar; über|bie|ten; sich -; der Rekord wurde überboten; **Über|bie|tung**

über|bin|den (Musik); diese Töne müssen übergebunden werden; **über|bin|den** schweiz. ([eine Verpflichtung] auferlegen); die Aufgabe wurde ihm überbunden

über|bla|sen (Musik: bei Holz- u. Blechblasinstrumenten durch stärkeres Blasen die höheren Töne hervorbringen)

über|blat|ten (Hölzer in bestimmter Weise verbinden); der Schrank wird überblattet; **Über|blat|tung**

über|blei|ben (ugs. für: übrigbleiben); es sind viele Pakete übergeblieben; **Über|bleib|sel** (Rest) s; -s, -

über|blen|den; die Bilder werden überblendet; **Über|blen|dung**

(Film: die Überleitung eines Bildes in ein anderes)

Über|blick m; -[e]s, -e; **über|blicken**¹; er hat den Vorgang überblickt; **über|blicks|wei|se über|bor|den** (,,über die Ufer treten''; schweiz. für: über das Maß hinausgehen, ausarten); der Betrieb ist (auch: hat) überbordet

Über|bor|säu|re w; -

Über|brettl (Kleinkunstbühne) s; -s, -

über|brin|gen; er hat die Nachricht überbracht; **Über|brin|ger; Über|brin|gung**

über|brücken¹ (meist bildl.); er hat den Gegensatz überbrückt; **Über|brückung**¹; **Über|brückungs-_[bei]hil|fe, ...kre|dit**

über|bür|den; er ist mit Arbeit überbürdet; **Über|bür|dung**

Über|chlor|säu|re w; -

Über|dach; über|da|chen; der Bahnsteig wurde überdacht; **Über|da|chung**

Über|dampf (der nicht für den Gang der Maschine notwendige Dampf) m; -[e]s

über|dau|ern; die Altertümer haben Jahrhunderte überdauert

Über|decke; über|decken¹ (ugs.); ich habe das Tischtuch übergedeckt; **über|decken**¹; mit einem Tuch überdeckt; **Über|deckung**¹

über|deh|nen ([bis zum Zerreißen] stark auseinanderziehen); das Gummiband ist überdehnt

über|den|ken; er hat es lange überdacht

über|deut|lich über|dies über|di|men|sio|nal; über|di|men|sio|niert; Über|di|men|sio|nie|rung über|do|sie|ren; Über|do|sie|rung; Über|do|sis; eine - Schlaftabletten

über|dre|hen; die Uhr ist überdreht **Über|druck** (zu starker Druck; nochmaliges Druckverfahren) m; -[e]s. (auf Geweben, Papier, Briefmarken u. a.:) ...drucke u. (Technik:) ...drücke; **über|druck|at|mo|sphä|re; über|drukken;** die Briefmarke wurde noch einmal überdruckt; **Über|druck-_ka|bi|ne** (↑ R 236), **...tur|bi|ne, ...ven|til**

über|druß m; ...drusses; **über|drüs|sig;** des Lebens, der Liebhabers - sein; seiner - sein; (gelegentlich, besonders beim persönl. Fürw. in bezug auf Personen, auch *Wenf.:*) ich bin ihn - **über|durch|schnitt|lich über|eck;** - stellen **Über|ei|fer; über|eif|rig**

¹ *Trenn.:* ...k|k...

über|eig|nen (überweisen; zu eigen [über]geben); das Haus wurde ihm übereignet; Über|eig|nung

Über|eile; über|ei|len; sich -; du hast dich übereilt; über|eilt (verfrüht); ein übereilter Schritt; Über|ei|lung

über|ein|an|der; *Schreibung in Verbindung mit Zeitwörtern* (↑R 139): übereinander (über sich gegenseitig) reden, sprechen, die Dosen übereinander aufstellen, a b e r: übereinanderlegen, übereinanderliegen, übereinanderschichten, [die Beine] übereinanderschlagen, übereinanderstellen, übereinanderwerfen, vgl. aneinander; übereinanderstehen, a b e r: übereinander stehen (nicht: liegen)

über|ein|kom|men; ich komme überein; übereingekommen; übereinzukommen; Über|ein|kom|men (Abmachung); Über|ein|kom|men (größeres Einkommen als angesetzt oder zu erwarten war); Über|ein|kunft w; -, ...künfte

über|ein|stim|men; Nachfrage und Angebot haben übereingestimmt; Über|ein|stim|mung

über|ein|tref|fen; vgl. übereinkommen

über|emp|find|lich; Über|emp|find|lich|keit

über|er|fül|len (DDR); er übererfüllt sein Soll; übererfüllt; überzuerfüllen; Über|er|fül|lung

Über|er|näh|rung

über|es|sen; ich habe mir die Speise übergegessen (ich mag sie nicht mehr); über|es|sen, sich; ich habe mich übergessen (zuviel gegessen)

über|fach|lich

über|fah|ren; ich bin übergefahren (über den Fluß); über|fah|ren; das Kind ist - worden; er hätte mich mit seinem Gerede bald - (ugs. für: überrumpelt); Über|fahrt; Über|fahrts|geld

Über|fall m; über|fal|len (nach der anderen Seite fallen); über|fal|len; man hat ihn -; Über|fall|ho|se; über|fäl|lig (von Schiffen u. Flugzeugen: zur erwarteten Zeit noch nicht eingetroffen); ein -er (verfallener) Wechsel; Über|fall|kom|man|do; Über|falls|kom|man|do (österr.)

über|fär|ben (abfärben); die Druckschrift hat übergefärbt; über|fär|ben; der Stoff braucht nur überfärbt zu werden

über|fein; über|fei|nern; überfeinert; Über|fei|ne|rung

über|fir|nis|sen; der Schrank wurde überfirnißt

über|fi|schen (den Fischbestand

durch zu viel Fischerei bedrohen); Über|fi|schung

Über|fleiß; über|flei|ßig

über|flie|gen (ugs. für: nach der anderen Seite fliegen); die Hühner sind übergeflogen; über|flie|gen; das Flugzeug hat die Alpen überflogen; ich habe das Buch überflogen

über|flie|ßen; das Wasser ist übergeflossen; er ist von Dankesbezeigungen übergeflossen; über|flie|ßen; die Wiese ist von Wasser überflossen

Über|flug (das Überfliegen) m; -[e]s; über|flü|geln; er hat seinen Lehrmeister überflügelt; der Feind wurde überflügelt; Über|flü|ge|lung, Über|flüg|lung

Über|fluß m; ...flusses; über|flüs|sig; über|flüs|si|ger|wei|se

über|flu|ten; das Wasser ist übergeflutet; über|flu|ten; der Strom hat die Dämme überflutet; Über|flu|tung

über|for|dern (mehr fordern, als man leisten kann); er hat mich überfordert; Über|for|de|rung

Über|fracht; über|frach|ten; Über|frach|tung

über|fra|gen (Fragen stellen, auf die man nicht antworten kann); über|fragt; ich bin -

über|frem|den; ein Land ist überfremdet; Über|frem|dung (Eindringen Fremder, fremden Volkstums; Eindringen unerwünschter fremder Geldgeber oder Konkurrenten in ein Unternehmen usw.)

über|fres|sen; du hast dich - (derb)

Über|fuhr (Fähre) w; -, -en

über|füh|ren, über|füh|ren (an einen anderen Ort führen); die Leiche wurde nach ... übergeführt od. überführt; über|füh|ren (einer Schuld); der Mörder wurde überführt; Über|füh|rung; - der Leiche; - einer Straße; - eines Verbrechers; Über|füh|rungs|ko|sten (*Mehrz.*)

Über|fül|le; über|fül|len; der Raum ist überfüllt; Über|fül|lung

Über|funk|ti|on; - der Schilddrüse

über|füt|tern; eine überfütterte Katze; Über|füt|te|rung

Über|ga|be; Über|ga|be|ver|hand|lun|gen (*Mehrz.*)

Über|gang (auch: Brücke; Besitzwechsel) m; Über|gangs.bahn|hof, ...be|stim|mung, ...er|schei|nung; über|gangs|los; Über|gangs.lö|sung, ...man|tel, ...pe|ri|ode, ...pha|se, ...sta|di|um, ...sta|ti|on, ...stel|le, ...stil, ...stu|fe, ...zeit, ...zu|stand

Über|gar|di|ne (meist *Mehrz.*)

über|gä|rig; -es Bier

über|ge|ben; (ugs.:) ich habe ihm

ein Tuch übergegeben (gegen die Kälte); ich habe ihm eins übergegeben (ugs. für: ich habe ihn geschlagen); über|ge|ben; er hat die Festung -; ich habe mich - (erbrochen)

Über|ge|bot (höheres Gebot bei einer Versteigerung)

Über|ge|bühr; vgl. a b e r: Gebühr

über|ge|hen (hinübergehen); er ist auf das linke Ufer übergegangen; er ist zum Feind übergegangen; das Grundstück ist in andere Hände übergegangen; die Augen sind ihm übergegangen (ugs. für: er war überwältigt; geh. für: er hat geweint); über|ge|hen (unbeachtet lassen); er hat den Hunger übergangen; Über|ge|hung w; -; mit -

über|ge|meind|lich

über|ge|nug; genug und -

über|ge|ord|net

Über|ge|päck, ...ge|wicht (s; -[e]s)

über|gie|ßen (in ein anderes Gefäß gießen; über einen Gefäßrand hinausgießen); er hat aus Versehen übergegossen; über|gie|ßen (oberflächlich gießen; oben begießen); er hat die Blumen nur übergossen; übergossen mit ..., a b e r (↑R 198): die Übergossene Alm (Gletscher auf dem Hochkönig in den Alpen); Über|gie|ßung

über|gip|sen; die Wand wurde übergipst; Über|gip|sung

über|gla|sen (mit Glas decken); du überglast (überglasest); er überglaste; der Balkon ist überglast; Über|gla|sung

über|glück|lich

über|gol|den (mit Gold überziehen; auch bildl.); der Ring wurde übergoldet

über|grei|fen; das Feuer, die Seuche hat übergegriffen; Über|griff

über|groß

Über|guß

über|ha|ben (ugs. für: satt haben; überdrüssig sein); er hat die ständigen Wiederholungen übergehabt; er hat den Mantel übergehabt

über|hal|ten (ugs. für: darüberhalten); er hat die Hand übergehalten, z. B. über den Kopf; über|hal|ten österr. veralt. (jmdn. beim Einkauf übervorteilen); man hat ihn übergehalten; Über|häl|ter (Forstw.: bes. starker Baum)

Über|hand|nah|me w; -; über|hand|neh|men; es nimmt überhand (↑R 132); es hat überhandgenommen; überhandzunehmen; die Verbrechen haben überhandgenommen

Über|hang; - der Zweige, des Obstes, der Felsen; (übertr. auch:) - der Waren; [1]über|hän|gen; die

Felsen hingen über; vgl. ¹hängen; ²über|hän|gen; er hat den Mantel übergehängt; vgl. ²hängen; über|hän|gen; er hat den Käfig mit einem Tuch überhängt; vgl. ²hängen; Über|hang|man|dat (in Direktwahl gewonnenes Mandat, das über die Zahl der einer Partei nach dem Stimmenverhältnis zustehenden Parlamentssitze hinausgeht); Über|hangs|recht s; -[e]s über|happs österr. mdal. (übereilt; ungefähr, annäherungsweise) über|ha|sten; das Tempo ist überhastet; Über|ha|stung über|häu|fen; er war mit Arbeit überhäuft; der Tisch ist mit Papieren überhäuft; Über|häu|fung über|haupt über|he|ben (ugs. für: hinüberheben); er hat das Kind übergehoben; über|he|ben; sich -; wir sind der Sorge um ihn überhoben; ich habe mich überhoben; über|heb|lich (anmaßend); Über|heb|lich|keit; Über|he|bung über|hei|zen (zu stark heizen); das Zimmer ist überheizt über|hin (oberflächlich); etwas - prüfen über|hit|zen (zu stark erhitzen); du überhitzt (überhitzest); der Ofen ist überhitzt; Über|hit|zung über|hö|hen; die Straße ist überhöht; Über|hö|hung über|ho|len (Seemannsspr.): die Segel wurden übergeholt; das Schiff hat übergeholt (sich auf die Seite gelegt); hol über! (früherer Ruf an den Fährmann); über|ho|len (hinter sich bringen, lassen; zuvorkommen; übertreffen; Technik, auch allg.: nachsehen, ausbessern, wiederherstellen); er hat ihn überholt; diese Anschauung ist überholt; die Maschine ist überholt worden; Über|hol|⌐ma|nö|ver, ...spur; Über|ho|lung; über|ho|lungs|be|dürf|tig (reparaturbedürftig); Über|hol|ver|bot, ...ver|such, ...vor|gang über|hö|ren; das möchte ich überhört haben! Über-Ich (Psychoanalyse); ↑R 147 über|in|di|vi|du|ell über|ir|disch über|jäh|rig (veralt.) über|kan|di|delt (ugs. für: überspannt) Über|ka|pa|zi|tät Über|kleid; Über|klei|dung (Überkleider); Über|klei|dung (eines Wandschadens u. ä.) über|kip|pen; er ist nach vorn übergekippt über|kle|ben; überklebte Plakate über|klet|tern; er hat den Zaun überklettert über|klug

über|ko|chen; die Milch ist übergekocht; über|ko|chen; das Eingemachte mußte nochmals überkocht werden über|kom|men landsch. (etw. endlich fertigbringen od. sagen); er ist damit übergekommen; über|kom|men; eine überkommene Verpflichtung; der Ekel hat ihn überkommen über|kom|pen|sie|ren (mehr als ausgleichen); Über|kom|pen|sa|ti|on über Kreuz; vgl. Kreuz; über|kreu|zen; sich - über|kru|sten; die Nudeln werden überkrustet über|küh|len österr. (langsam abkühlen); Speisen - lassen über|la|den (hinüberladen); die Kisten werden übergeladen; vgl. ¹laden; über|la|den; das Schiff war überladen; vgl. ¹laden; Über|la|dung (Hinüberladung); Über|la|dung (übermäßige Beladung mit ...) über|la|gern; überlagert; sich -; Über|la|ge|rung; Über|la|ge|rungs|em|pfän|ger (Rundfunkgerät) Über|land_bahn [auch: ...lant...], ...fahrt, ...flug, ...kraft|werk, ...lei|tung, ...ver|bin|dung, ...zen|tra|le (zur Übertragung von elektr. Strom über weite Strecken) über|lang; Über|län|ge über|lap|pen; überlappt; Über|lap|pung über|las|sen (ugs. für: übriglassen); er hat ihm etwas übergelassen; über|las|sen (abtreten; anheimstellen; auch: gestatten); er hat mir das Haus -; Über|las|sung über|la|sten; über|la|stet; über|la|stig; Über|la|stung Über|lauf (Ablauf für überschüssiges Wasser in Badewannen u. a.); über|lau|fen; das Wasser ist übergelaufen; er ist zum Feind übergelaufen; die Galle ist ihm übergelaufen; über|lau|fen; der tüchtige Arzt wird von Kranken -; er hat mich kalt -; Über|läu|fer (Fahnenflüchtiger; Jägerspr.: Wildschwein im zweiten Jahr) über|laut über|le|ben; er hat seine Frau überlebt; diese Vorstellungen sind überlebt; Über|le|ben|de m u. w; -n, -n (↑R 287 ff.); Über|le|bens|chan|ce (meist Mehrz.); über|le|bens|groß; Über|le|bens|grö|ße (eines Bildwerkes) w; - über|le|gen (ugs. für: darüberlegen); der Junge wurde übergelegt; ¹über|le|gen (bedenken); er hat lange überlegt; ich habe mir

das überlegt; (↑R 120:) nach reiflichem Überlegen; ²über|le|gen; er ist mir -; mit -er Miene; Über|le|gen|heit w; -; über|legt (auch: sorgsam); Über|le|gung; mit wenig - über|lei|ten; er hat vom ersten zum zweiten Teil seiner Abhandlung gut übergeleitet; Über|lei|tung über|le|sen ([schnell] durchlesen; [bei oberflächlichem Lesen] nicht bemerken); er hat den Brief nur -; er hat diesen Druckfehler - über|lie|fern; diese Gebräuche wurden uns überliefert; Über|lie|fe|rung; schriftliche - über|lie|gen (von Schiffen: länger als vorgesehen in einem Hafen liegen); Über|lie|ge|zeit Über|lin|gen (Stadt am Bodensee); Über|lin|ger See; ↑R 204 (Teil des Bodensees) m; - -s über|li|sten; der Feind wurde überlistet; Über|li|stung überm; ↑R 240 (ugs. für: über dem); - Haus[e] über|ma|chen (veraltend für: zukommen lassen; auch: letztwillig verfügen); er hat ihm sein Vermögen übermacht Über|macht w; -; über|mäch|tig über|ma|len (ugs.:) er hat [über den Rand] übergemalt; über|ma|len; das Bild war übermalt; Über|ma|lung über|man|gan|sau|er; übermangansaures Kali (Kaliumpermanganat) Über|mann; über|man|nen; der Feind wurde übermannt; die Rührung hat ihn übermannt; Über|manns|hoch; Über|man|nung Über|man|tel über|mar|chen (schweiz., sonst veralt. für: eine festgesetzte Grenze überschreiten) Über|maß s; -es; im -; über|mä|ßig über|mä|sten; übermästete Tiere Über|mensch m; Über|men|schen|tum s; -s; über|mensch|lich Über|mi|kro|skop (für: Elektronen-, Ultramikroskop) über|mit|teln (mit-, zuteilen); ich ...[e]le (↑R 327); er hat diese freudige Nachricht übermittelt; Über|mit|te|lung, Über|mitt|lung über|mor|gen; übermorgen abend (↑R 129) über|mü|den; über|mü|den; über|mü|det; - sein; Über|mü|dung Über|mut; über|mü|tig übern; ↑R 240 (ugs. für: über den); - Graben über|nächst; am -en Freitag über|nach|ten (über Nacht bleiben); er hat bei uns übernachtet; über|näch|tig (österr. nur so, sonst häufiger:) über|näch|tigt;

Über|nächt|ler schweiz. (in Stall, Schuppen usw. Übernachtender); Über|nach|tung

Über|nah|me w; -, -n; Über|nahmsstel|le österr. (Annahmestelle)

Über|na|me (Spitzname)

über|na|tio|nal

über|na|tür|lich

über|neh|men; er hat das Gewehr übergenommen; über|neh|men; er hat das Geschäft übernommen; ich habe mich übernommen; Über|neh|mer

über|ord|nen; er ist ihm übergeordnet; Über|ord|nung

Über|or|ga|ni|sa|ti|on (Übermaß von Organisation)

über|ört|lich

über|par|tei|lich

Über|pflan|ze (Biol.: Scheinschmarotzer); über|pflan|zen (ugs. für: an einen anderen Ort pflanzen); er hat die Sträucher übergepflanzt; über|pflan|zen; überpflanzt mit ...; Über|pflan|zung (für: Transplantation)

über|pin|seln

Über|preis

Über|pro|duk|ti|on

über|prüf|bar; über|prü|fen; sein Verhalten wurde überprüft; Über|prü|fung; Über|prü|fungskom|mis|si|on

über|quel|len (überfließen); der Eimer quoll über; der Teig ist übergequollen; überquellende Freude, Dankbarkeit

über|quer (veralt. für: über Kreuz); über|que|ren; er hat den Platz überquert; Über|que|rung

über|ra|gen (hervorstehen); der Balken hat übergeragt; ein überragender Balken; über|ra|gen; er hat alle überragt

über|ra|schen; du überraschst (überraschest); er wurde überrascht; über|ra|schend; -ste; in -ster Weise; über|ra|schen|derwei|se; Über|ra|schung; Über|ra|schungs_er|folg, ...mo|ment s, ...sieg

über|rech|nen (rechnerisch überschlagen); das Vorhaben wurde überrechnet

über|re|den; er hat mich überredet; Über|re|dung; Über|re|dungskunst

über|re|gio|nal

über|reich

über|rei|chen; überreicht

über|reich|lich

Über|rei|chung

über|reif; Über|rei|fe

über|rei|ten; sie haben den Gegner überritten

über|rei|zen; seine Augen sind überreizt; Über|reizt|heit w; -; Über|rei|zung

über|ren|nen

Über|re|prä|sen|ta|ti|on; über|reprä|sen|tiert

Über|rest

über|rie|seln; das Wasser ist übergerieselt; über|rie|seln; überrieselte Wiesen; Über|rie|se|lung, Über|ries|lung

Über|rock

über|rol|len

über|rum|peln; der Feind wurde überrumpelt; Über|rum|pe|lung, Über|rump|lung

über|run|den (im Sport); er wurde überrundet; Über|run|dung

übers; ↑ R 240 (ugs. für: über das); - Wochenende

über|sä|en (besäen); übersät (dicht bedeckt); der Himmel ist mit Sternen übersät

über|satt; über|sät|ti|gen; er ist übersättigt; eine übersättigte Lösung (Chemie); Über|sät|ti|gung

über|säu|ern; Über|säue|rung

Über|schall_flug, ...flug|zeug, ...ge|schwin|dig|keit

Über|schar Bergmannsspr.: zwischen Bergwerken liegendes, wegen geringen Ausmaßes nicht zur Bebauung geeignetes Land) w; -, -en

über|schat|ten; Über|schat|tung

über|schät|zen; überschätzt; Über|schät|zung

Über|schau w; -; über|schau|bar; Über|schau|bar|keit w; -; über|schau|en überschaut

über|schäu|men; der Sekt war übergeschäumt; überschäumende Lebenslust

Über|schicht (zusätzliche Arbeitsschicht im Bergwerk od. in der Industrie)

über|schie|ßen (übrigbleiben; überfließen); der überschießende Betrag

über|schläch|tig; -es [Wasser]rad (mit Zuleitung von oben her)

über|schla|fen; das muß ich erst-

Über|schlag m; -[e]s, ...schläge; über|schla|gen; die Stimme ist übergeschlagen; ¹über|schla|gen; ich habe die Kosten -; er hat sich -; ²über|schla|gen; das Wasser ist übergeschlagen (lauwarm); über|schlä|gig (svw. überschläglich); Über|schlag|la|ken (Teil der Bettwäsche); über|schläg|lich (ungefähr; etwa); vgl. überschlägig

über|schlie|ßen (Druckw.); einige Wörter wurden übergeschlossen

über|schnap|pen; der Riegel des Schlosses, das Schloß hat od. ist übergeschnappt; die Stimme ist übergeschnappt; du bist wohl übergeschnappt (ugs. für: du hast wohl den Verstand verloren)

über|schnei|den; sich -; ihre Arbeitsgebiete haben sich überschnitten; Über|schnei|dung

über|schnei|en; die überschneiten Dächer

über|schnell

über|schrei|ben; das Gedicht ist nicht überschrieben; die Forderung ist überschrieben (überwiesen); Über|schrei|bung (Überweisung [einer Forderung usw.])

über|schrei|en; er hat ihn überschrie[e]n

über|schrei|ten; über|schrei|ten; du hast die Grenze überschritten; (↑ R 120:) das Überschreiten der G[e]leise ist verboten; Über|schrei|tung

Über|schrift; über|schrift|lich

Über|schuh

über|schul|den (mit Schulden übermäßig belasten); überschuldet; Über|schul|dung

über|schuß; über|schüs|sig; Über|schuß_land, ...pro|dukt

über|schüt|ten (ugs.); er hat etwas übergeschüttet; über|schüt|ten; er hat mich mit Vorwürfen überschüttet; Über|schüt|tung

Über|schwang m; -[e]s; im - der Gefühle

über|schwap|pen (ugs. für: überlaufen, sich über den [Teller]rand ergießen); die Suppe ist übergeschwappt

über|schwem|men; die Uferstraße ist überschwemmt; Über|schwem|mung; Über|schwemmungs_ge|biet, ...ka|ta|stro|phe

über|schweng|lich; Über|schweng|lich|keit

Über|schwer

Über|see (die „über See" liegenden Länder); ohne Geschlechtsw.); nach - gehen; Waren von -; Briefe für -; Über|see-_brücke [Trenn.: ...brük|ke], ...damp|fer, ...ha|fen (vgl. ²Hafen); über|see|isch; -er Handel; Über|seer [...seer]; ↑ R 205 (Mann in oder aus Übersee, Bewohner überseeischer Länder); Überseedampfer)

über|seh|bar; über|se|hen (ugs. für: zu oft sehen u. deshalb überdrüssig werden); du hast dir dieses Kleid übergesehen; über|se|hen; ich habe den Fehler -; er konnte von seinem Fenster aus das weite Tal übersehen

über|sen|den; der Brief wurde ihm übersandt; Über|sen|dung

über|setz|bar; Über|setz|bar|keit w; -; über|set|zen (überfahren); ich habe den Wanderer übergesetzt; über|set|zen (in eine andere Sprache übertragen; landsch. auch für: überhöhen); ich habe den Satz übersetzt; übersetzte Preise; Über|set|zer; Über|set|ze|rin w; -, -nen; Über|set|zung (Überfahren [eines Stromes]);

Über|set|zung ([schriftliche]
Übertragung; Kraft-, Bewegungsübertragung); **Über|set-
zungs_ar|beit, ...bü|ro, ...deutsch,
...feh|ler**
Über|sicht *w*; -, -en; **über|sich|tig**
(veralt. für: weitsichtig); er hat
-e Augen; **Über|sich|tig|keit** *w*; -;
über|sicht|lich (leicht zu überschauen); **Über|sicht|lich|keit** *w*;
-, **Über|sichts_kar|te, ...ta|fel**
über|sie|deln, (auch:) über|sie|deln
(den Wohnort wechseln); ich
sied[e]le über (auch: ich über-
sied[e]le); ich bin übergesiedelt
(auch: übersiedelt); **Über|sied-
ler**, (auch:) **Über|sied|ler; Über-
sied|lung, Über|sie|de|lung, Über-
sied|lung; Über|sied|lungs|gut**
über|sie|den (überkochen)
über|sinn|lich; Über|sinn|lich|keit
Über|soll
über|sonnt
über|span|nen; ich habe den Bogen
überspannt; **über|spannt** (übertrieben); -e Anforderungen; -es
(halbverrücktes) Wesen; **Über-
spannt|heit; Über|span|nung** (zu
hohe Spannung in einer elektr.
Anlage); **Über|span|nung; Über-
span|nungs|schutz**
über|spie|len (besser, rascher spielen als ein anderer; auf einen Tonträger übertragen); er hatte
seinen Gegner völlig überspielt;
er hat den Schlager vom Tonband auf eine Schallplatte über-
spielt; **über|spielt** (Sportspr.:
durch [zu] häufiges Spielen
überanstrengt; österr. für: häufig
gespielt, nicht mehr neu [vom
Klavier])
über|spit|zen (eine schärfere Spitze
als gewöhnlich geben; übertr. für:
überstark betonen; einen im
Wort liegenden Sinn nach einer
Seite übermäßig stark ausdeuten); **über|spitzt** (übermäßig);
Über|spit|zung
über|spre|chen (Rundfunk, Fernsehen: in eine aufgenommene
[fremdsprachige] Rede einen anderen Text hineinsprechen)
über|spren|keln; übersprenkelt
über|sprin|gen; der Funke ist übergesprungen; **über|sprin|gen;** ich
habe eine Klasse übersprungen;
Über|sprin|gung
über|spru|deln
über|staat|lich
Über|stän|der (Forstw.: Baum od.
Bestand, der das Haubarkeitsalter überschritten hat und rückgängig wird); **über|stän|dig**
über|stark
über|ste|chen (im Kartenspiel eine
höhere Trumpfkarte draufle-
gen); er hat übergestochen; **über-
ste|chen;** er hat ihn überstochen

über|ste|hen; der Felsen hat über-
gestanden; **über|ste|hen;** die Gefahr ist überstanden
über|steig|bar; über|stei|gen (ugs.);
er ist übergestiegen; **über|stei-
gen;** er hat den Berg überstiegen;
das übersteigt meinen Verstand
über|stei|gern (überhöhen); die
Preise sind übersteigert; **Über-
stei|ge|rung**
Über|stei|gung
über|stel|len (Amtsspr.: [wei-
sungsgemäß] einer anderen Stelle übergeben); er wurde überstellt; **Über|stel|lung**
über|stem|peln
Über|sterb|lich|keit (höhere Sterblichkeit, als erwartet wurde) *w*; -
über|steu|ern (Funk- u. Radiotechnik: einen Verstärker überlasten, so daß der Ton verzerrt
wird; Kraftfahrzeugw.: zu starke
Wirkung des Lenkradeinschlags
zeigen); **Über|steue|rung**
über|stim|men; er wurde überstimmt; **Über|stim|mung**
über|stra|pa|zie|ren (zu häufig gebrauchen); ein überstrapaziertes
Schlagwort
über|strei|chen (übermalen); eine
überstrichene Wand
über|strei|fen; er hat den Handschuh übergestreift
über|streu|en; mit Zucker überstreut
über|strö|men; er ist von Dankesworten übergeströmt; **über|strö-
men;** der Fluß hat die Felder weithin überströmt
Über|strumpf (Gamasche)
über|stül|pen
Über|stun|de; -n machen; **Über-
stun|den_geld, ...zu|schlag**
über|stür|zen (übereilen); er hat die
Angelegenheit überstürzt; die
Ereignisse überstürzten sich;
Über|stür|zung (Übereilung)
über|ta|rif|lich; -e Bezahlung
über|täu|ben; das hat seinen
Schmerz übertäubt; **Über|täu-
bung**
über|tau|chen österr. ugs. (überstehen)
über|teu|ern; überteuerte Ware;
Über|teue|rung
über|töl|peln (ugs.); er wurde
übertölpelt; **Über|töl|pe|lung,
Über|töl|p|lung** (ugs.)
über|tö|nen; Über|tö|nung
Über|trag (Übertragung auf die
nächste Seite) *m*; -[e]s, ...träge;
über|trag|bar; Über|trag|bar|keit
w; -; **über|tra|gen** (ugs. für: nicht
mehr tragen mögen); diesen Hut
habe ich mir übergetragen; ¹**über-
tra|gen** (auftragen; anordnen;
übergeben; im Rundfunk wiedergeben); er hat mir das -; ich habe
ihm das Amt; -; sich - (übergehen)

auf ...; die Krankheit hat sich auf
mich -; ²**über|tra|gen;** -e Bedeutung; -e (österr. für: gebrauchte,
abgetragene) Kleidung; **Über-
tra|ger** (Fernmeldewesen für:
Transformator); **Über|trä|ger;
Über|tra|gung; Über|tra|gungs-
_ver|merk, ...wa|gen, ...wei|se** *w*
Über|trai|ning; über|trai|niert
(überanstrengt durch übermäßiges Training)
über|tref|fen; seine Leistungen haben alles übertroffen
über|trei|ben; er hat die Sache
übertrieben; **Über|trei|bung**
über|tre|ten (von einer Gemeinschaft in eine andere; Sport: beim
Absprung die Absprunglinie
überschreiten); er ist zur evangelischen Kirche übergetreten; er
hat, ist beim Weitsprung übergetreten; **über|tre|ten;** ich habe das
Gesetz -; ich habe mir den Fuß
-; **Über|tre|tung; Über|tre|tungs-
fall** *m*; im -[e]
über|trie|ben; vgl. übertreiben;
Über|trie|ben|heit
Über|tritt
über|trump|fen (überbieten, ausstechen); übertrumpft
über|tun (ugs.); ich habe mir einen
Mantel übergetan; **über|tun,** sich
landsch. (sich übernehmen); du
hast dich übertan
über|tün|chen; die Wand wurde
übertüncht
über|über|mor|gen
über|ver|si|chern; die Schiffsladung war überversichert; **Über-
ver|si|che|rung**
über|völ|kert; diese Provinz ist -;
Über|völ|ke|rung
über|voll
über|vor|sich|tig
über|vor|tei|len; er wurde übervorteilt; **Über|vor|tei|lung**
über|wach (mehr als wach; fast
hellseherisch); mit -en Augen;
über|wa|chen (beaufsichtigen); er
wurde überwacht
über|wach|sen; mit Moos -
über|wäch|tet (von einem
Schneeüberhang bedeckt); -e
Gletscherspalten
**Über|wa|chung; Über|wa|chungs-
_dienst, ...stel|le, ...sy|stem**
über|wal|len (geh. für: sprudelnd
überfließen); das Wasser ist übergewallt; **über|wal|len;** von Nebel
überwallt
über|wäl|ti|gen (bezwingen); der
Gegner wurde überwältigt; **über-
wäl|ti|gend** (ungeheuer groß);
Über|wäl|ti|gung
über|wäl|zen (über etwas hinrollen; abwälzen); der Lastwagen
hat ihn bei diesem Unglück über-
wälzt; die Kosten wurden auf das
Land überwälzt

über|wech|seln (hinübergehen);
das Wild ist in das Nachbarrevier
übergewechselt
Über|weg
über|wei|sen (übergeben; [Geld]
anweisen; österr. veralt. für:
überführen); er hat das Geld
überwiesen; (österr. veralt.:) der
überwiesene Dieb
über|wei|ßen (hell überstreichen);
er hat die Wand überweißt; Über-
wei|ßung
Über|wei|sung (Übergabe; [Geld]-
anweisung)
über|weit; Über|wei|te; Kleider in
Überweiten
Über|welt; über|welt|lich (über die
Welt hinaus)
über|wend|lich; - nähen (so nähen,
daß die Fäden über die aneinan-
dergelegten Stoffkanten hinweg-
gehen); -e Naht; über|wend|lings;
- nähen
über|wer|fen; er hat den Mantel
übergeworfen; über|wer|fen; wir
haben uns überworfen (verfein-
det); Über|wer|fung
über|wert; über|wer|ten; diese Ge-
danken werden überwertet; über-
wer|tig; Über|wer|tig|keit w; -;
Über|wer|tung Über|wer|tungs-
ge|fühl
Über|we|sen
über|wie|gen (ugs.: ein zu hohes
Gewicht haben); der Brief wiegt
über; über|wie|gen ([an Zahl od.
Einfluß] stärker sein); die Mittel-
mäßigen haben überwogen; über-
wie|gend [auch: üb...]
über|wind|bar; über|win|den (be-
zwingen); der Gegner wurde
überwunden; sich -; Über|win-
der; über|wind|lich (veralt.);
Über|win|dung
über|win|tern; ich ...ere (↑ R 327);
das Getreide hat gut überwintert;
Über|win|te|rung
über|wis|sen|schaft|lich
über|wöl|ben; der Raum wurde
überwölbt; Über|wöl|bung
über|wu|chern; das Unkraut hat
den Weg überwuchert; Über|wu-
che|rung
Über|wurf (Umhang; Sport: He-
begriff; österr. auch für: Zier-
decke)
Über|zahl; über|zäh|len (zu hoch
bezahlen); über|zäh|len (nach-
zählen); er hat den Betrag noch
einmal überzählt; über|zäh|lig
über|zeich|nen (ugs. für: über den
vorgesehenen Rand zeichnen);
übergezeichnete Buchstaben;
über|zeich|nen; die Anleihe ist
überzeichnet; Über|zeich|nung
Über|zeit[|ar|beit] schweiz. (Über-
stunden[arbeit]) w; -
über|zeu|gen; er hat ihn überzeugt;
sich -; über|zeu|gend; -ste; Über-

zeu|gung; Über|zeu|gungs︟kraft
(w; -), ...tä|ter (Rechtsspr.: jmd.,
der um einer [politischen, religiö-
sen o. a.] Überzeugung willen
straffällig geworden ist); über-
zeu|gungs|treu
über|zie|hen; er hat den Rock über-
gezogen; über|zie|hen; überzogen
mit Rost; er hat seinen Kredit
überzogen; Über|zie|her
über|züch|tet; ein -er Hund
Über|zug; Über|zugs︟kre|dit, ...pa-
pier
über|zwerch (mdal. für: quer, über
Kreuz; ugs. für: durchgedreht,
verworren)
Ubi|er (Angehöriger eines germ.
Volksstammes) m; -s, -
Ubi|quist lat. (Biol.: auf der gesam-
ten Erdkugel verbreitete Pflan-
zen- od. Tierart); ↑ R 268; ubi|qui-
tär (überall verbreitet)
üb|lich; (↑ R 116:) seine Rede ent-
hielt nur das Übliche, aber (↑ R
134:) es ist das übliche (üblich),
daß ein Olympiasieger in seinem
Heimatort feierlich empfangen
wird; ...üb|lich (z. B. ortsüblich);
üb|li|cher|wei|se; Üb|lich|keit
(veralt.) w; -
U-Bo|gen (↑ R 149)
U-Boot; ↑ R 149 (Unterseeboot;
Abk.: U-Boot); U-Boot-Krieg (↑ R 155)
üb|rig; übriges Verlorenes; übrige
kostbare Gegenstände; (↑ R 133:)
ein übriges tun (mehr tun, als
nötig ist); (↑ R 134:) im übrigen
(sonst, ferner); (↑ R 135:) das, al-
les übrige (andere; die, alle übri-
gen (anderen); Schreibung in Ver-
bindung mit Zeitwörtern (↑ R
139): übrig haben, sein; vgl.
aber: übrigbehalten, übrigblei-
ben, übriglassen; üb|rig|be|hal-
ten (↑ R 139); ich habe wenig
übrigbehalten; üb|rig|blei|ben
(↑ R 139); es ist wenig übriggeblie-
ben; übrig bleibt nur noch, ...(↑ R
144); üb|ri|gens; üb|rig|las|sen
(↑ R 139); du läßt (lässest) übrig;
übriggelassen; übriglassen
Übung; Übungs︟an|zug, ...ar|beit,
...auf|ga|be, ...buch; übungs|hal-
ber; Übungs︟platz, ...schie|ßen,
...stück
Ucht, Üch|te niederd. (Morgen-
dämmerung) w; -, ...ten
Ücht|land vgl. Üechtland
Ücker|mark[1] (Gebiet im Norden
von Brandenburg) w; -; Ucker-
mär|ker[1] (↑ R 199); ucker|mär-
kisch[1]
u. d. ä. = und dem ähnliche[s]
u. desgl. [m.] = und desgleichen
[mehr]
u. dgl. [m.] = und dergleichen
[mehr]

[1] Trenn.: ...k|ke...

u. d. M. = unter dem Meeresspie-
gel
ü. d. M. = über dem Meeresspie-
gel
Udo (m. Vorn.)
UdSSR = Union der Sozialisti-
schen Sowjetrepubliken
Üecht|land, (auch:) Ücht|land
(Teil des Schweizer Mittellandes)
s; -[e]s; vgl. Freiburg im Üecht-
land
U-Ei|sen; ↑ R 149 (Walzeisen von
U-förmigem Querschnitt); U-Ei-
sen-för|mig (↑ R 155)
Uel|zen [ül...] (Stadt in der Lüne-
burger Heide); Uel|ze|ner, Uel-
zer (↑ R 199)
Uer|din|gen [ür...] (Stadtteil von
Krefeld)
Ufa Ⓦ (Universum-Film-AG) w;
-: Ufa-Thea|ter (↑ R 150)
Ufer s; -s, -; Schreibung in Straßen-
namen: ↑ R 219ff.; Ufer︟bau
(Mehrz. ...bauten), ...be|fe|sti-
gung, ...bö|schung, ...geld (Hafen-
gebühr), ...land|schaft, ...läu|fer
(ein Vogel); ufer|los; (↑ R 116:)
das Uferlose; seine Niederge-
schlagenheit grenzt ans Uferlose;
aber (↑ R 134): seine Pläne gin-
gen ins uferlose (allzu weit); Ufer-
︟schnep|fe, ...schwal|be
u. ff. = und folgende [Seiten]
Uf|fi|zi|en [...i°n] (Palast mit Ge-
mäldesammlung in Florenz)
Mehrz.
Uffz. = Unteroffizier
UFO, Ufo = unbekanntes Flug-
objekt [für engl.: unidentified
flying object] s; -[s], -s
U-för|mig; ↑ R 149 (in Form eines
lat. U)
...uf|rig (z. B. linksufrig)
Ugan|da (Staat in Afrika); Ugan-
der; ugan|disch
ugrisch vgl. finnisch-ugrisch
uh!
U-Haft; ↑ R 150 (Untersuchungs-
haft)
U-Ha|ken (↑ R 149)
Uh|land (dt. Dichter)
Uhr w; -, -en; Punkt, Schlag acht
Uhr; es ist zwei Uhr nachts; es
ist ein Uhr, aber: es ist eins; es
ist 6.30 Uhr, 6³⁰ [Uhr] (gespro-
chen: sechs Uhr dreißig); es
schlägt 12 [Uhr]; um fünf [Uhr]
(volkstümlich: um fünfe) aufste-
hen; ich komme um 20 Uhr; der
Zug fährt um halb acht [Uhr]
abends; sie wartete bis zwei Uhr
nachmittags; Achtuhrzug mit
Ziffer: 8-Uhr-Zug; ↑ R 157); vgl.
hora; Uhr|band s (Mehrz. ...bän-
der); Uhr|chen, Uhr|lein, Uhr|ren-
in|du|strie; Uhr|ma|cher; Uhr|ma-
che|rei; Uhr︟ta|sche, ...werk,
...zei|ger; Uhr|zei|ger|sinn (Rich-

tung des Uhrzeigers) *m*; -[e]s; (häufig in:) im -; **Uhr|zeit**

Uhu (ein Vogel) *m*; -s, -s

Ukas *russ.* (früher: Erlaß des Zaren; allg.: Verordnung, Vorschrift, Befehl) *m*; -ses, -se

Uke|lei *slaw.* (ein Weißfisch) *m*; -s, -e u. -s

Ukrai|ne[1] (Unionsrepublik der UdSSR; Abk.: USSR) *w*; -; **Ukrai|ner**[1]; **ukrai|nisch**[1]; **Ukrai|nisch**[1] (Sprache) *s*; -[s]; vgl. Deutsch; **Ukrai|ni|sche**[1] *s*; -n; vgl. Deutsche *s*

UKW = Ultrakurzwellen; **UKW-Emp|fän|ger** (↑ R 150); **UKW-Sen|der** (↑ R 150)

Ul niederd. (Eule; Handbesen) *w*; -, -en

Ulan *türk.* (Lanzenreiter) *m*; -en, -en (↑ R 268); **Ulan|ka** (Waffenrock der Ulanen) *w*; -, -s

Ule|ma *arab.* (eigtl. *Mehrz.*: „Stand der Gelehrten"; islamischer [Rechts-, Gottes]gelehrter) *m*; -s, -s

ulen niederd. (reinigen); **Ulen|flucht** [Zeit des „Eulenfluges"] niederd. (Dämmerung; Dachöffnung des westfäl. Bauernhauses) *w*; -, (für Dachöffnung auch *Mehrz.*:) -en; **Ulen|spie|gel** (Nebenform von: Eulenspiegel)

Ul|fi|las, Wul|fi|la (Bischof der Westgoten)

Uli [auch: *uli*] (Kurzform von: Ulrich)

Ulix|es, Ulys|ses (lat. Name von: Odysseus)

Ulk (Spaß; Unfug) *m*; -s (seltener: -es), -e

Ulk niederd. (Iltis) *m*; -[e]s, -e

ul|ken; Ul|ke|rei; ul|kig

Ul|kus *lat.* (Med.: Geschwür) *s*; -, Ulzera

Ul|la (Kurzform von: Ursula od. Ulrike)

Ulm (Stadt an der Donau)

²**Ulm**, ¹**Ul|me** (Bergmannsspr.: seitliche Fläche im Bergwerksgang) *w*; -, ...men

²**Ul|me** *lat.* (ein Laubbaum) *w*; -, -n; **Ul|men|blatt**

Ul|mer; ↑ R 199 (aus ¹Ulm); **Ul|mer Weiß** *s*; - [-es]

Ul|rich (m. Vorn.); **Ul|ri|ke** (w. Vorn.)

¹**Ul|ster** *engl.* [engl. Ausspr.: *ạlßt*²*r*] (hist. Provinz im Norden der Insel Irland); ²**Ul|ster** (weiter Herrenmantel; schwerer Mantelstoff) *m*; -s, -

ult. = ultimo

Ul|ti|ma ra|tio *lat.* [- *razio*] (letztes Mittel) *w*; -; -; **ul|ti|ma|tiv** (in Form eines Ultimatums; nachdrücklich); **Ul|ti|ma|tum** („letzte", äu-

¹ Auch: *ukrai*...

ßerste Aufforderung) *s*; -s, ...ten (österr. nur so) u. -s; **ul|ti|mo** („am Letzten" [des Monats]; Abk.: ult.); - März; **Ul|ti|mo** („Letzter" [des Monats]) *m*; -s, -s; **Ul|ti|mo|ge|schäft**

Ul|tra (polit. Fanatiker, Rechtsextremist) *m*; -s, -s; **ul|tra|hart; ul|tra|kurz;** **Ul|tra|kurz|wel|len** (elektromagnetische Wellen unter 10 m Länge; Abk.: UKW) *Mehrz.*; **Ul|tra|kurz|wel|len.emp|fän|ger,** ...sen|der, ...the|ra|pie

ul|tra|lang

ul|tra|ma|rin *lat.* [„übers Meer" (eingeführt)] (kornblumenblau); **Ul|tra|ma|rin** *s*; -s

Ul|tra|mi|kro|skop *lat.; gr.* (Mikroskop zur Beobachtung kleinster Teilchen)

ul|tra|mon|tan *lat.* („jenseits der Berge [Alpen]"; streng päpstlich gesinnt); **Ul|tra|mon|ta|nis|mus** (streng päpstliche Gesinnung [im ausgehenden 19. Jh.]) *m*; -

ul|tra|rot (svw. infrarot)

ul|tra|schall (mit dem menschlichen Gehör nicht mehr wahrnehmbarer Schall) *m*; -[e]s; **Ul|tra|schall.be|hand|lung,...schwei|ßung,** ...the|ra|pie, ...wel|len (*Mehrz.*)

Ul|tra|strah|lung (kosmische Höhenstrahlung)

ul|tra|vio|lett [...*wi*...] ([im Sonnenspektrum] über dem sichtbaren Licht; Abk.: UV); -e Strahlen (Abk.: UV-Strahlen; ↑ R 150)

Ulys|ses vgl. Ulixes

Ul|ze|ra (*Mehrz.* von: Ulkus); **Ul|ze|ra|ti|on** *lat.* [...*zion*] (Med.: Geschwürbildung); **ul|ze|rie|ren** (Med.: geschwürig werden); **ul|ze|rös** (Med.: geschwürig); -es Organ

um; I. *Verhältniswort mit Wenf.*: um vieles, nichts, ein Mehrfaches; um alles in der Welt [nicht]; einen Tag um den anderen; um Rat fragen; ich komme um 20 Uhr (vgl. Uhr); (österr.:) ich gehe um Milch (um Milch zu holen) (↑ R 134:) um ein bedeutendes, ein beträchtliches, ein erkleckliches (sehr); um ... willen (mit *Wesf.*): um einer Sache willen, um jemandes willen, um Gottes willen, um meinetwillen, umeinander; umsonst; um so größer; um so mehr (vgl. d.), um so weniger (vgl. d.); ums (um das) vgl. ums. **II.** *Umstandswort*: um und um; [rinksum!; es waren um [die] (= etwa) zwanzig Mädchen; Gemeinden von um (= etwa) 10 000 Einwohnern. **III.** *Infinitivkonjunktion*: um zu (mit Grundform); er kommt, um uns zu helfen (↑ R 30). **IV.** *Großschreibung*

(↑R 119): das Um und Auf (österr. für: das Ganze, das Wesentliche)

um... *in Verbindung mit Zeitwörtern:* **a)** *unfeste Zusammensetzungen* (↑ R 304), z. B. **um|bauen** (vgl. d.), **um|gebaut; b)** *feste Zusammensetzungen* (↑ R 304), z. B. **um|bauen** (vgl. d.), **umbaut**

um|ackern [*Trenn.*: ...ak|kern]; **umgeackert**

um|adres|sie|ren; umadressiert

um|än|dern; umgeändert; **Um|än|de|rung**

um [od. **Um**] **Ant|wort wird ge|be|ten** (Abk.: u. [od. U.] A. w. g.)

um|ar|bei|ten; der Anzug wurde umgearbeitet; **Um|ar|bei|tung**

umar|men; er hat seine Mutter umarmt; sich -; **Um|ar|mung**

Um|bau *m*; -[e]s, -e u. -ten; **um|bauen** (anders bauen); das Theater wurde völlig umgebaut; **um|bauen** (mit Bauten umschließen); er hat seinen Hof mit Ställen und Scheunen umbaut; umbauter Raum

um|be|hal|ten (ugs.); er hat den Schal -

um|be|nen|nen; umbenannt; **Um|be|nen|nung**

¹**Um|ber** *m*; -s, u. **Um|bra** *lat.* (brauner Farbstoff) *w*; -

²**Um|ber** *lat.* (Speisefisch des Mittelmeeres) *m*; -s, -n

Um|ber|to (it. Form von: Humbert)

um|be|schrie|ben (Math.); der -e Kreis (Umkreis)

um|be|set|zen; die Rolle wurde umbesetzt (einem anderen Darsteller übertragen); **Um|be|set|zung**

um|be|sin|nen, sich (seine Meinung ändern); ich habe mich umbesonnen

um|bet|ten (einen Kranken umlagern; auch: Fluß verlegen); umgebettet; **Um|bet|tung**

um|bie|gen; er hat den Draht umgebogen

um|bil|den; das Ministerium wurde umgebildet; **Um|bil|dung**

um|bin|den; er hat ein Tuch umgebunden; **um|bin|den;** er hat den Finger mit Leinwand umbunden

um|bla|sen; er hat das Kartenhaus umgeblasen; **um|bla|sen;** von Winden -

Um|blatt (inneres Hüllblatt der Zigarre); **um|blät|tern;** umgeblättert

Um|blick; **um|blicken** [*Trenn.*: ...blik|ken], sich; du hast dich umgeblickt

Um|bra vgl. ¹Umber

Um|bra|glas Ⓦ (getöntes Brillenglas)

um|bran|den; von Wellen umbrandet

um|brau|sen; von Beifall umbraust
um|bre|chen; der Zaun ist umge-
brochen worden; um|bre|chen
(Druckw.: den Drucksatz ein-
teilen); er umbricht den
Satz; der Satz wird umbrochen,
ist noch zu -; Um|bre|cher
(Druckw.)
Um|brer (Angehöriger eines itali-
schen Volksstammes) m; -s, -;
Um|bri|en [...iᵉn] (it. Region)
um|brin|gen; umgebracht; sich -
um|brisch (aus Umbrien)
Um|bruch (Druckw.; allg.: [grund-
legende] Änderung) m; -[e]s,
...brüche; Um|bruch.kor|rek|tur,
...re|vi|si|on
um|bu|chen; der Betrag wurde um-
gebucht; Um|bu|chung
um|den|ken (von anderen Denk-
voraussetzungen ausgehen); Um-
denk|pro|zeß
um|deu|ten (anders deuten); Um-
deu|tung
um|dis|po|nie|ren (seine Pläne än-
dern); ich habe umdisponiert
um|drän|gen; er wurde von allen
Seiten umdrängt
um|dre|hen; sich -; er hat jeden
Pfennig umgedreht; er hat den
Spieß umgedreht (ugs. für: ist
seinerseits zum Angriff über-
gegangen); du hast dich umge-
dreht; Um|dre|hung; Um|dre-
hungs.ge|schwin|dig|keit, ...zahl
Um|druck (Vervielfältigungsver-
fahren; auch Mehrz.: Ergebnis
dieses Verfahrens; Mehrz.
...drucke); im -; Um|druck|ver-
fah|ren
um|ein|an|der; Schreibung in Ver-
bindung mit Zeitwörtern (↑ R
139): sich umeinander (gegensei-
tig um sich) kümmern, vgl. an-
einander
um|fä|cheln; der Wind hat mich
umfächelt
um|fah|ren (fahrend umwerfen;
fahrend einen Umweg machen);
er hat das Verkehrsschild umge-
fahren; ich bin [beinahe eine
Stunde] umgefahren; umfah|ren
(um etwas herumfahren); er hat
die Insel -; Um|fahrt; Um|fah-
rung (österr. auch svw. Umge-
hungsstraße); Um|fah|rungs-
stra|ße (österr.)
Um|fall (ugs. für: plötzlicher Ge-
sinnungswandel) m; -[e]s; um|fal-
len; er ist tot umgefallen; bei der
Abstimmung ist er doch noch
umgefallen; (↑ R 120:) sie war
zum Umfallen müde (ugs.)
Um|fang; um|fan|gen; ich halte ihn
-; um|fäng|lich; um|fang|reich;
um|fang[s]|mä|ßig
um|fas|sen (anders fassen); der
Schmuck wird umgefaßt; um|fas-
sen (umschließen; in sich begrei-

fen); ich habe ihn umfaßt; hierin
ist alles umfaßt; um|fas|send; -ste;
Um|fas|sung; Um|fas|sungs|mau-
er
um|fir|mie|ren (einen anderen
Handelsnamen annehmen); wir
haben umfirmiert
um|flech|ten; eine umflochtene
Weinflasche
um|flie|gen (fliegend einen Um-
weg machen); ugs. für: hinfallen);
das Flugzeug war eine weite
Strecke umgeflogen; das Schild
ist umgeflogen; um|flie|gen; er
hat die Stadt umflogen
um|flie|ßen; umflossen von ...
um|flort (geh.); mit -em (von Trä-
nen getrübtem) Blick
um|for|men; er hat den Satz umge-
formt; das Leben hat ihn umge-
formt; Um|for|mer (Elektrotech-
nik); Um|for|mung
Um|fra|ge; - halten; um|fra|gen; an
Hand der Liste hat er des öfteren
umgefragt
um|frie|den; umfriedet; u. um|frie-
di|gen (mit einem Zaum umge-
ben); umfriedigt; er hat seinen
Garten umfriedet oder umfrie-
digt; Um|frie|di|gung; Um|frie-
dung
um|fül|len; er hat den Wein umge-
füllt; Um|fül|lung
um|funk|tio|nie|ren (die Funktion
von etwas ändern; zweckent-
fremdet einsetzen); der Vortrag
wurde zu einer Protestversamm-
lung umfunktioniert; Um|funk-
tio|nie|rung
Um|gang m; -[e]s; um|gäng|lich;
Um|gäng|lich|keit w; -; Um-
gangs|form (meist Mehrz.),
...spra|che; um|gangs|sprach|lich
um|gar|nen; sie hat ihn umgarnt;
Um|gar|nung
um|gau|keln; der Schmetterling
hat die Blüten umgaukelt; Um-
gau|ke|lung, Um|gauk|lung
um|ge|ben; er hat ihr den Mantel
umgegeben (umgehängt); um|ge-
ben; von Kindern -; Um|ge|bung
Um|ge|gend
um|ge|hen; er ist umgegangen (hat
einen Umweg gemacht); ich bin
mit ihm umgegangen (habe mit
ihm verkehrt); es geht dort um
(es spukt); um|ge|hen; er hat das
Gesetz umgangen; um|ge|hend;
mit -er (nächster) Post; Um|ge-
hung; Um|ge|hungs|stra|ße
um|ge|kehrt; es verhält sich -, als
du denkst
um|ge|schaf|fen; er ist wie - (um-
gewandelt)
um|ge|stal|ten; er hat die Parkan-
lagen umgestaltet; Um|ge|stal-
tung
um|gie|ßen; er hat den Wein umge-
gossen

um|git|tern; umgittert
um|glän|zen; von Freude um-
glänzt
um|gol|den; umgoldet
um|gra|ben; er hat das Beet um-
gegraben; Um|gra|bung
um|grei|fen (svw. umfassen)
um|gren|zen; der Ort ist von gro-
ßen Wäldern umgrenzt; seine
Vollmachten wurden umgrenzt;
Um|gren|zung
um|grup|pie|ren; umgruppiert;
Um|grup|pie|rung
um|gucken [Trenn.: ...guk|ken],
sich (ugs.)
um|gür|ten; ich habe mir das
Schwert umgegürtet; um|gür|ten;
sich -; mit dem Schwert umgürtet
um|ha|ben (ugs.); er hat nichts um,
er hat keinen Mantel umgehabt
um|hacken [Trenn.: ...hak|ken];
der Baum wurde umgehackt
um|hal|sen; sie hat ihn umhalst;
Um|hal|sung
um|hang; um|hän|gen; ich habe
mir das Tuch umgehängt; ich
habe die Bilder umgehängt (an-
ders gehängt); vgl. ²hängen; um-
hän|gen (hängend umgeben); das
Bild war mit Flor umhängt; vgl.
²hängen; Um|hän|ge|ta|sche,
Um|häng|ta|sche; Um|hän|ge-
tuch, Um|häng|tuch, Um|hang-
tuch (Mehrz. ...tücher)
um|hau|en (abschlagen, fällen
usw.); er hieb (ugs. auch: haute)
den Baum um; das hat mich um-
gehauen (ugs. für: das hat mich
in großes Erstaunen versetzt)
um|he|ben (Druckw.); Silben,
Wörter od. Zeilen werden umho-
ben
um|he|gen; umhegt; Um|he|gung
um|her (im Umkreis); um|her...
(bald hierhin, bald dorthin ...),
z. B. um|her.blicken [Trenn.:
...blik|ken] (ich blicke umher,
umhergeblickt (↑ R 304), umher-
zublicken), ...fah|ren, ...flie|gen,
...ge|hen, ...gei|stern, ...ir|ren,
...ja|gen, ...krie|chen, ...lau|fen,
...lie|gen, ...rei|sen, ...schau|en,
...schlei|chen, ...schlen|dern,
...schwei|fen, ...strei|fen, ...tra-
gen, ...zie|hen
um|hin|kön|nen; ich kann nicht
umhin (z. zu tun); ich habe nicht
umhingekonnt; nicht um-
hinzukönnen
um|hö|ren, sich; ich habe mich
danach umgehört
um|hül|len; umhüllt mit ...; Um-
hül|lung
Um|in|ter|pre|ta|ti|on; um|in|ter-
pre|tie|ren (umdeuten)
um|ju|beln; umjubelt
um|kämp|fen; die Festung war
hart umkämpft
Um|kehr w; -; um|kehr|bar; um-

keh|ren; sich -; er ist umgekehrt; er hat die Tasche umgekehrt; um|gekehrt! (im Gegenteil!); Um|kehr|film (Film, der beim Entwickeln ein Positiv liefert); Um|kip|pen; er ist mit dem Stuhl umgekippt; er ist bei den Verhandlungen umgekippt (ugs. für: hat seinen Standpunkt geändert); Um|kip|pen (biolog. Absterben eines Gewässers) s; -s

um|klam|mern; er hielt ihre Hände umklammert; der Feind wurde umklammert; Um|klam|me|rung

um|klap|pen; er hat den Deckel umgeklappt; er ist umgeklappt (ugs. für: ohnmächtig geworden)

Um|klei|de (Umkleideraum) w; -, -n; um|klei|den, sich; ich habe mich umgekleidet (anders gekleidet); um|klei|den (umgeben, umhüllen); umkleidet mit, von ...; Um|klei|de|raum; Um|klei|dung w; -; Um|klei|dung

um|knicken [Trenn.: ...knik|ken]; er ist [mit dem Fuß] umgeknickt

um|kom|men; er ist bei einem Schiffbruch umgekommen; (↑R 120:) die Hitze ist ja zum Umkommen (ugs.)

um|ko|pie|ren (Fototechnik)

um|krän|zen; umkränzt; Um|kränzung

Um|kreis m; -es; um|krei|sen; der Raubvogel hat seine Beute umkreist; Um|krei|sung

um|krem|peln; er hat die Ärmel umgekrempelt

Um|la|de|bahn|hof; um|la|den; vgl. ¹laden; die Säcke wurden umgeladen; Um|la|dung

Um|la|ge (Steuer; Beitrag); um|la|gern (an einen anderen Platz bringen [zum Lagern]); die Waren wurden umgelagert; um|la|gern (umgeben, eng umschließen); umlagert von ...; vgl. lagern; Um|la|ge|rung; Um|la|ge|rung

Um|land (ländliches Gebiet um eine Großstadt) s; -[e]s

Um|lauf (auch für: Fruchtfolge; Med.: eitrige Entzündung an Finger oder Hand); in - geben, sein (von Zahlungsmitteln); Um|lauf|bahn; um|lau|fen (laufend umwerfen; einen Umweg machen; weitergegeben werden); wir sind umgelaufen; eine Nachricht ist umgelaufen; (Druckw.:) der Text läuft um (greift auf die nächste Zeile od. Seite über); um|lau|fen; ich habe den Platz -; Um|lauf|mit|tel (Geld; Mehrz.); Um|lauf[s]_ge|schwin|dig|keit, ...zeit; Um|lauf|ver|mö|gen (Wirtsch.)

Um|laut (Sprachw.: Veränderung, Aufhellung eines Selbstlautes unter Einfluß eines i oder j der Fol-

gesilbe, z. B. ahd. „turi" wird zu nhd. „Tür"; Umlaute sind ä, ö, ü); um|lau|ten; ein umgelautetes U ist ein Ü

Um|le|ge|kra|gen; um|le|gen (derb auch für: erlegen, töten); er hat den Mantel umgelegt; er hat die Karten umgelegt (gewendet od. anders gelegt); um|le|gen; ein Braten, umlegt mit Gemüse; Um|le|gung (auch für: Änderung); Um|le|gung

um|lei|ten (Verkehr auf andere Straßen führen); der Verkehr wurde umgeleitet; Um|lei|tung; Um|lei|tungs|schild s

um|len|ken; die Pferde wurden umgelenkt; Um|len|kung

um|ler|nen; er hat umgelernt

um|lie|gend; -e Ortschaften

um|man|teln; ein ummanteltes Kabel; Um|man|te|lung

um|mau|ern (mit Mauerwerk umgeben); das Tiergehege wurde ummauert

um|mel|den; ich habe mich polizeilich umgemeldet; Um|mel|dung

um|mo|deln; umgemodelt; Um|mo|de|lung, Um|mod|lung

um|mün|zen (umprägen); das Hartgeld wurde umgemünzt; Um|mün|zung

um|nach|tet (geisteskrank); Um|nach|tung

um|nä|hen; sie hat den Saum umgenäht (eingeschlagen u. festgenäht); um|nä|hen; eine umnähte (eingefaßte) Kante

um|ne|beln; ich ...[e]le (↑R 327); er hat ihn mit seinem Zigarrenrauch umnebelt; Um|ne|be|lung, Um|neb|lung

um|packen [Trenn.: ...pak|ken] (anders packen); der Koffer wurde umgepackt

um|neh|men; sie hat den Schal umgenommen

Um|or|ga|ni|sa|ti|on; um|or|ga|ni|sie|ren; der Betrieb wurde umorganisiert

um|pflan|zen (anders pflanzen); die Blumen wurden umgepflanzt; um|pflan|zen (mit Pflanzen umgeben); umpflanzt mit ...; Um|pflan|zung; Um|pflan|zung

um|pflü|gen (ein Feld mit dem Pflug aufreißen; niedrigen Pflanzenwuchs durch den Pflug vernichten); umgepflügtes Land; um|pflü|gen (mit Furchen umziehen; mit dem Pflug vorbeipflügen [z. B. an Bäumen in einem Feld]); er hat die Bäume umpflügt; Um|pflü|gung; Um|pflü|gung

um|po|len (Plus- u. Minuspol vertauschen; verändern, umdenken); umgepolt

um|prä|gen; die Goldstücke wurden umgeprägt; Um|prä|gung

um|quar|tie|ren (in ein anderes Quartier legen); er wurde umquartiert; Um|quar|tie|rung

um|rah|men (mit anderem Rahmen versehen); das Bild muß umgerahmt werden; um|rah|men (mit Rahmen versehen, einrahmen); die Vorträge wurden von musikalischen Darbietungen umrahmt; Um|rah|mung; Um|rah|mung

um|ran|den; er hat den Artikel mit Rotstift umrandet; um|rän|dert; seine Augen waren rot umrändert; Um|ran|dung

um|ran|gie|ren [...rangsehir⁰n] (Eisen-, Straßenbahnwagen umordnen); umrangiert

um|ran|ken; von Rosen umrankt; Um|ran|kung

um|räu|men; wir haben das Zimmer umgeräumt; Um|räu|mung

um|rech|nen; er hat DM in Schweizer Franken umgerechnet; Um|rech|nung; Um|rech|nungs|kurs

um|rei|ßen; er hat die Erde umreißt er hat den Zaun umgerissen; um|rei|ßen (im Umriß zeichnen; andeuten); mit wenigen Zügen umrissen

um|rei|ten (reitend umwerfen); er hat den Mann umgeritten; um|rei|ten; er hat das Feld umritten um|ren|nen; er hat das Kind umgerannt

um|rin|gen (umgeben); du umringtest; von Kindern umringt

Um|riß; Um|riß|zeich|nung

Um|ritt

um|rüh|ren; umgerührt

um|run|den; das Raumschiff hat den Mond umrundet

um|rüst|bar; um|rü|sten (für bestimmte Aufgaben technisch verändern); die Maschine wurde umgerüstet; Um|rü|stung

ums; ↑R 240 (um das); es geht ums Ganze; ein Jahr ums od. um das andere; aber (↑R 238): um's (ugs. für: um des) Himmels willen!; vgl. auch: Himmel

um|sä|gen; er hat den Baum umgesägt

um|sat|teln (übertr. ugs. auch für: einen anderen Beruf ergreifen); er hat sein Pferd umgesattelt; der Student hat umgesattelt (ein anderes Studienfach gewählt); Um|sat|te|lung, Um|satt|lung

Um|satz; Um|satz_ana|ly|se (Wirtsch.), ...an|stieg, ...pro|vi|si|on, ...rück|gang, ...stei|ge|rung, ...steu|er w, ...ver|gü|tung (für: Umsatzbonus, -prämie, -provision)

um|säu|men; das Kleid muß noch umgesäumt werden (der Saum muß umgelegt u. genäht werden);

um|säu|men; das Dorf ist von Bergen umsäumt (umgeben, eingeschlossen)

um|schaf|fen (umformen); er hat seinen Roman umgeschaffen; vgl. ²schaffen; Um|schaf|fung

um|schal|ten (Elektrotechnik); er hat den Motor umgeschaltet; Um|schal|ter; Um|schalt|he|bel; Um|schal|tung

Um|scha|lung

um|schat|ten; ihre Augen waren umschattet

Um|schau w; -; - halten; um|schau|en, sich; ich habe mich umgeschaut

Um|schicht (Bergmannsspr.: Wechsel); um|schich|ten; das Heu wurde umgeschichtet; um|schich|tig (wechselweise); Um|schich|tung; Um|schich|tungs_pro|zeß, ...vor|gang

um|schif|fen (veralt.: zu Schiff einen Umweg machen; [in ein anderes Schiff] umladen); es wurde umgeschifft; um|schif|fen (veralt.); er hat die Erde umschifft; Um|schif|fung (Umladung); Um|schif|fung; - der Erde

Um|schlag (auch für: Umladung); um|schla|gen (umsetzen; umladen); die Güter wurden umgeschlagen; das Wetter ist umgeschlagen (schweiz. auch: hat umgeschlagen); um|schla|gen (einpacken); die Waren sind nur leicht -; die Druckbogen werden - (Druckw.: gewendet); Um|schlag_bahn|hof, ...ent|wurf; Um|schla|ge|tuch, Um|schlag|tuch (Mehrz. ...tücher); Um|schlag_ha|fen (vgl. ²Hafen), ...platz, ...zeich|nung

um|schlei|chen (belauern); das Haus wurde umschlichen

um|schlie|ßen; von einer Mauer umschlossen; Um|schlie|ßung

um|schlin|gen; ich habe mir das Tuch umgeschlungen; um|schlin|gen; sie hielt ihn fest umschlungen; Um|schlin|gung; Um|schlin|gung

um|schmei|cheln; sie wird von der Katze umschmeichelt

um|schmei|ßen (ugs.); er hat den Tisch umgeschmissen

um|schmel|zen (durch Schmelzen umformen); das Altmetall wurde umgeschmolzen

um|schnal|len; umgeschnallt

um|schrei|ben (neu, anders schreiben; übertragen); er hat den Aufsatz umgeschrieben; die Hypothek wurde umgeschrieben; um|schrei|ben (mit anderen Worten ausdrücken); er hat die Aufgabe mit wenigen Worten umschrieben; Um|schrei|bung (Neuschreibung; andere Buchung); Um-

schrei|bung (andere Form des Ausdrucks); um|schrie|ben (Med. auch für: deutlich abgegrenzt, zirkumskript); eine -e Hautflechte; Um|schrift

um|schul|den (Wirtsch.: kurzfristige in langfristige Kredite umwandeln); umgeschuldet; Um|schul|dung

um|schu|len; umgeschult; Um|schü|ler; Um|schu|lung

um|schüt|ten; umgeschüttet

um|schwär|men; umschwärmt

um|schwe|ben; der Schmetterling hat die Blume umschwebt

Um|schwei|fe Mehrz.; ohne -e (geradeheraus); um|schwei|fen; umschweift

um|schwen|ken; er ist plötzlich umgeschwenkt

um|schwin|gen (im Kreis schwingen, umherschwingen); er hat das Lasso umgeschwungen; Um|schwung (schweiz. [nur Einz.] auch: Umgebung des Hauses; Wesf.: -s)

um|schwir|ren; von Mücken umschwirrt

um|se|geln (segelnd umwerfen; segelnd einen Umweg machen); er hat das Boot umgesegelt; er ist umgesegelt; um|se|geln; er hat die Insel umsegelt; Um|se|ge|lung, Um|seg|lung

um|se|hen sich; ich habe mich danach umgesehen; Um|se|hen s; -s; im - (plötzlich, sofort)

um|sein (ugs. für: vorbei sein); die Zeit ist um; die Zeit ist umgewesen, aber: daß die Zeit um ist, war

um|sei|tig; um|seits (Amtsdt.)

um|setz|bar; um|set|zen (anders setzen; verkaufen); sich -; die Pflanzen wurden umgesetzt; er hat alle Waren umgesetzt; ich habe mich umgesetzt; um|set|zen; umsetzt mit ...; Um|set|zung; Um|set|zung

Um|sich|grei|fen († R 120) s; -s

Um|sicht; um|sich|tig; Um|sich|tig|keit w; -

um|sie|deln; umgesiedelt; Um|sie|de|lung, Um|sied|lung; Um|sied|ler

um|sin|ken; er ist vor Müdigkeit umgesunken

um|sit|zen; sie haben den Kamin umsessen

um so ... (österr.: umso ...); um so (österr.: umso) eher[,] als († R 63); um so mehr (österr.: umsomehr [umso mehr]) [,] als († R 63)

um|sonst

um|sor|gen; umsorgt

um so we|ni|ger (österr.: umsoweniger [umso weniger]) [,] als († R 63)

um|span|nen (neu, anders spannen; auch für: transformieren); die Pferde wurden umgespannt; um|span|nen (umfassen); sein Geist hat viele Wissensgebiete umspannt; Um|span|ner (für: Transformator); Um|span|nung; Um|spann|werk

um|spie|len; er hat seinen Gegner umspielt

um|spin|nen; umsponnener Draht

um|sprin|gen; der Wind ist umgesprungen; er ist übel mit dir umgesprungen; um|sprin|gen (springend umgeben); umsprungen von Kindern; Um|sprung

um|spü|len (umlegen); die Wellen haben die Pflanzen umgespült; um|spü|len; von Wellen umspült

Um|stand; unter Umständen (Abk.: u. U.); in anderen Umständen (verhüllend für: schwanger); mildernde Umstände (Rechtsspr.); keine Umstände machen; gewisse Umstände halber, eines gewissen Umstandes halber, aber: umständehalber, umstandshalber; um|stän|de|hal|ber; vgl. Umstand; um|ständ|lich; Um|ständ|lich|keit; Um|stands-_an|ga|be, ...be|stim|mung, ...er|gän|zung, ...für|wort; um|stands|hal|ber; vgl. Umstand; Um|stands_ka|sten (ugs.: allzu umständlich handelnder Mensch), ...kleid, ...krä|mer (ugs.), ...satz, ...wort (für: Adverb; Mehrz. ...wörter); um|stands|wört|lich (für: adverbial)

um|ste|chen; wir haben das Beet umgestochen; um|ste|chen (rings mit Stichen umgeben); das Kleid wurde umstochen

um|stecken [Trenn.: ...stek|ken] (anders stecken); sie hat die Pflanzen umgesteckt; vgl. ²stecken; um|stecken [Trenn.: ...stek|ken]; umsteckt mit ...; vgl. ²stecken

um|ste|hen landsch. (sterben; verderben); umgestanden (von Flüssigkeiten: verdorben; von Tieren: verendet); um|ste|hen; umstanden von ...; um|ste|hend; († R 134:) im umstehenden (umstehend) finden sich die näheren Erläuterungen; († R 135:) er soll umstehendes (jenes [auf der anderen Seite]) beachten, aber († R 116:) das Umstehende (auf der anderen Seite Gesagte), die Umstehenden (Zuschauer); vgl. folgend

Um|stei|ge|kar|te, Um|steig|kar|te; um|stei|gen; er ist umgestiegen; Um|stei|ger (ugs. für: Umsteigekarte)

Um|stell|bahn|hof; um|stell|bar; um|stel|len (anders stellen); der Schrank wurde umgestellt; sich

-; um|stel|len (umgeben); die Polizei hat den Schlupfwinkel des Verbrechers umstellt; Um|stellung; Um|stel|lung; Um|stellungs|pro|zeß

um|stem|peln (neu, anders stempeln); der Paß wurde umgestempelt; um|stem|peln (mit Stempeln umgeben); das Paßbild ist umstempelt; vgl. stempeln

um|steu|ern (verändern, anders ausrichten); der Satellit soll umgesteuert werden; Um|steue|rung

um|stim|men; er hat sie umgestimmt; Um|stim|mung

um|sto|ßen; er hat den Stuhl umgestoßen; um|stöß|lich (veralt.); Um|sto|ßung

um|strah|len; umstrahlt von ...

um|stricken[1] (neu, anders stricken); sie hat den Pullover umgestrickt; um|stricken[1]; umstrickt ([unlösbar] umgeben, umgarnt) von ...; Um|strickung[1]; Um|strickung[1]

um|strit|ten

um|strö|men; umströmt von ...

um|struk|tu|rie|ren; umstrukturiert; Um|struk|tu|rie|rung

um|stül|pen; er hat das Faß umgestülpt; um|stül|pen (Druckw.); er hat das Papier umstülpt; Um|stül|pung

Um|sturz (Mehrz. ...stürze); Um|sturz|be|we|gung; um|stür|zen; das Gerüst ist umgestürzt; Um|stürz|ler; um|stürz|le|risch; Um|stür|zung; Um|sturz|ver|such

um|tan|zen; sie haben das Feuer umtanzt

um|tau|fen; er wurde umgetauft

Um|tausch m; -[e]s, (selten:) -e; um|tau|schen; umgetauscht

um|tip|pen (ugs. für: neu tippen)

um|ti|teln; der Film wurde umgetitelt

um|top|fen; der Gärtner hat die Blume umgetopft

um|to|sen; umtost von ...

um|trei|ben (planlos herumtreiben); umgetrieben; Um|trieb (Zeit von der Begründung eines Baumbestandes bis zum Fällen; Bergmannsspr.: Strecke, die an Schächten vorbei- od. um sie herumführt; [ungesetzliche] Machenschaften, meist Mehrz.)

Um|trunk

um|tun (ugs.); sich -; ich habe mich danach umgetan

um|ver|tei|len; die Lasten sollen umverteilt werden; Um|ver|tei|lung

um|wach|sen; mit Gebüsch -

um|wal|len; von Nebel umwallt; Um|wal|lung

Um|wälz|an|la|ge (Anlage für den

Abfluß verbrauchten u. den Zustrom frischen Wassers); um|wäl|zen; er hat den Stein umgewälzt; Um|wäl|zung

um|wan|deln (ändern); er war wie umgewandelt; um|wan|deln (geh. für: um etwas herumwandeln); er hat den Platz umwandelt; Um|wand|lung (seltener:) Um|wan|de|lung (Änderung); Um|wandlungs|pro|zeß

um|wan|den (mit Wänden umgeben); er hat die Fläche umwandet; Um|wan|dung

um|wech|seln; er hat das Geld umgewechselt; Um|wechs|lung, (seltener:) Um|wech|se|lung

Um|weg

um|we|hen (durch Wehen zu Fall bringen); die Hütte wurde umgeweht; um|we|hen; umweht von ...

Um|welt; um|welt|be|dingt, aber (↑ R 142): durch die Umwelt bedingt; Um|welt..be|din|gun|gen (Mehrz.), ...ein|fluß, ...for|schung; um|welt.freund|lich, ...neu|tral, ...schäd|lich; Um|welt..schutz, ...ver|schmut|zung

um|wen|den; er wandte od. wendete die Seite um, hat sie umgewandt od. umgewendet; sich -; Um|wen|dung

um|wer|ben; umworben; vgl. vielumworben

um|wer|fen; er hat den Tisch umgeworfen; diese Nachricht hat ihn umgeworfen (ugs. für: erschüttert); um|wer|fend; -e Komik

um|wer|ten; alle Werte wurden umgewertet; Um|wer|tung

um|wickeln[1] (neu, anders wickeln); er hat die Schnur umgewickelt; um|wickeln[1]; umwickelt mit ...; Um|wicke|lung[1], Um|wick|lung; Um|wicke|lung[1], Um|wick|lung

um|wid|men (Amtsspr.: für einen anderen Zweck bestimmen); in Industriegelände umgewidmetes Agrarland; Um|wid|mung

um|win|den; er wandte ein Tuch umgewunden; um|win|den; umwunden mit ...

um|wit|tern; ein Geheimnis umwitterte den Mann; von Gefahren umwittert

um|wo|ben; von Sagen -

um|wo|gen; umwogt von ...

um|woh|nend; (↑ R 116:) die Umwohnenden; Um|woh|ner

um|wöl|ken; seine Stirn war vor Unmut umwölkt; Um|wöl|kung

um|wüh|len; umgewühlt; Um|wüh|lung

um|zäu|nen; der Garten wurde umzäunt; Um|zäu|nung

um|zeich|nen (neu, anders zeich-

nen); er hat das Bild umgezeichnet

um|zie|hen; sich -; ich habe mich umgezogen; wir sind umgezogen; um|zie|hen; der Himmel hat sich umzogen; umzogen mit ...

um|zin|geln; der Feind wurde umzingelt; Um|zin|ge|lung, Um|zing|lung

um|zu; vgl. um, III

Um|zug; um|zugs|hal|ber; Um|zugs..ko|sten (Mehrz.), ...tag

um|zün|geln; umzüngelt von Flammen

UN = engl. United Nations [junaitid nē'sch⁵ns] (Vereinte Nationen) Mehrz.; vgl. auch UNO u. VN

un|ab|än|der|lich [auch: un...]; eine -e Entscheidung; Un|ab|än|der|lich|keit[1] w; -

un|ab|ding|bar [auch: un...]; Un|ab|ding|bar|keit[1] w; -; un|ab|ding|lich [auch: un...]

un|ab|hän|gig; Un|ab|hän|gig|keit w; -

un|ab|kömm|lich [auch: un...]; Un|ab|kömm|lich|keit[1] w; -

un|ab|läs|sig [auch: un...]

un|ab|seh|bar [auch: un...]; die Kosten steigern sich ins unabsehbare (↑ R 134); -e Folgen; Un|ab|seh|bar|keit[1] w; -

un|ab|setz|bar [auch: un...]; Un|ab|setz|bar|keit[1] w; -

un|ab|sicht|lich

un|ab|weis|bar [auch: un...]; Un|ab|weis|lich [auch: un...]

un|ab|wend|bar [auch: un...]; ein -es Verhängnis; Un|ab|wend|bar|keit[1] w; -

un|acht|sam; Un|acht|sam|keit

un|ähn|lich; Un|ähn|lich|keit

un|an|fecht|bar [auch: un...]; Un|an|fecht|bar|keit[1] w; -

un|an|ge|bracht; eine -e Frage

un|an|ge|foch|ten

un|an|ge|mel|det

un|an|ge|mes|sen; Un|an|ge|mes|sen|heit w; -

un|an|ge|nehm

un|an|ge|paßt; Un|an|ge|paßt|heit w; -

[1]un|an|ge|se|hen (nicht angesehen); [2]un|an|ge|se|hen (Amtsdt.: ohne Rücksicht auf); mit Wesf. od. Wenf.: - der Umstände od. - die Umstände

un|an|greif|bar [auch: un...]; Un|an|greif|bar|keit[1] w; -

un|an|nehm|bar [auch: un...]; Un|an|nehm|bar|keit[1] w; -; Un|an|nehm|lich|keit

[1] Für die Hauptwörter gilt, soweit nichts anderes angegeben, die gleiche schwankende Betonung wie für das zugehörige Eigenschafts- oder Mittelwort.

un|an|sehn|lich; Un|an|sehn|lich-
keit w; -
un|an|stän|dig; Un|an|stän|dig|keit
un|an|stö|ßig; Un|an|stö|ßig|keit
un|an|tast|bar [auch: un...]; Un|an-
tast|bar|keit[1] w; -
un|ap|pe|tit|lich; Un|ap|pe|tit|lich-
keit w; -
[1]Un|art (Unartigkeit); [2]Un|art
(unartiges Kind) m; -[e]s, -e; un-
ar|tig; Un|ar|tig|keit
un|ar|ti|ku|liert (ungegliedert; un-
deutlich ausgesprochen)
un|äs|the|tisch (unschön, ge-
schmacklos)
un|auf|dring|lich; Un|auf|dring-
lich|keit w; -
un|auf|fäl|lig; Un|auf|fäl|lig|keit
w; -
un|auf|find|bar [auch: un...]
un|auf|ge|for|dert
un|auf|ge|klärt
un|auf|halt|bar [auch: un...]; un-
auf|halt|sam [auch: un...]; Un|auf-
halt|sam|keit[1] w; -
un|auf|hör|lich [auch: un...]
un|auf|lös|bar [auch: un...]; Un-
auf|lös|bar|keit[1] w; -; un|auf|lös-
lich [auch: un...]; Un|auf|lös|lich-
keit[1] w; -
un|auf|merk|sam; Un|auf|merk-
sam|keit
un|auf|rich|tig; Un|auf|rich|tig-
keit
un|auf|schieb|bar [auch: un...]; Un-
auf|schieb|bar|keit[1] w; -; un|auf-
schieb|lich [auch: un...]
un|aus|bleib|lich [auch: un...]; -e
Wirkung
un|aus|denk|bar [auch: un...]
un|aus|führ|bar [auch: un...]; Un-
aus|führ|bar|keit[1] w; -
un|aus|ge|bil|det
un|aus|ge|füllt; Un|aus|ge|füllt-
sein s; -s
un|aus|ge|gli|chen; Un|aus|ge|gli-
chen|heit
un|aus|ge|go|ren
un|aus|ge|schla|fen
un|aus|ge|setzt
un|aus|ge|spro|chen
un|aus|lösch|lich [auch: un...]; ein
-er Eindruck
un|aus|rott|bar [auch: un...]; ein -es
Vorurteil
un|aus|sprech|bar [auch: un...]; un-
aus|sprech|lich [auch: un...]
un|aus|steh|lich [auch: un...]; Un-
aus|steh|lich|keit[1] w; -
un|aus|tilg|bar [auch: un...]
un|aus|weich|lich [auch: un...]
Un|band landsch. (Wildfang) m;
-[e]s, -e u. ...bände; un|bän|dig;
-er Zorn
un|bar (bargeldlos)
un|barm|her|zig; Un|barm|her|zig-
keit

un|be|ab|sich|tigt
un|be|ach|tet; un|be|acht|lich
(Rechtsspr.)
un|be|an|stan|det
un|be|ant|wort|bar [auch: un...];
un|be|ant|wor|tet
un|be|baut
un|be|dacht; eine -e Äußerung;
Un|be|dacht|heit; un|be|dacht-
sam; un|be|dach|ter|wei|se, un|be-
dacht|sa|mer|wei|se; Un|be-
dacht|sam|keit
un|be|darft (ugs. für: unerfahren;
naiv); Un|be|darft|heit w; -
un|be|denk|lich; Un|be|denk|lich-
keit; Un|be|denk|lich|keits|be-
schei|ni|gung (Rechtsspr.)
un|be|deu|tend; -ste; Un|be|deu-
tend|heit
un|be|dingt [auch: ...dingt]; ein -er
Reflex; Un|be|dingt|heit[1] w; -
un|be|ein|fluß|bar [auch: un...]; Un-
be|ein|fluß|bar|keit[1] w; -; un|be-
ein|flußt
un|be|fahr|bar [auch: un...]
un|be|fan|gen; Un|be|fan|gen|heit
w; -
un|be|fleckt, aber (↑ R 224): die
Unbefleckte Empfängnis [Ma-
riens]
un|be|frie|di|gend; seine Arbeit
war -; un|be|frie|digt; Un|be|frie-
digt|heit w; -
un|be|fugt; Un|be|fug|te m u. w; -n,
-n (↑ R 287 ff.)
un|be|gabt; Un|be|gabt|heit w; -
un|be|greif|lich [auch: un...]; un|be-
greif|li|cher|wei|se; Un|be|greif-
lich|keit[1]
un|be|grenzt [auch: ...gränzt]; -es
Vertrauen; Un|be|grenzt|heit[1]
w; -
un|be|grün|det; ein -er Verdacht
un|be|haart [auch: un...]
Un|be|ha|gen; un|be|hag|lich; Un-
be|hag|lich|keit
un|be|hau|en; aus -en Steinen
un|be|haust
un|be|hel|ligt [auch: un...]
un|be|herrscht
un|be|hilf|lich; Un|be|hilf|lich|keit
w; -
un|be|hin|dert [auch: un...]
un|be|hol|fen; Un|be|hol|fen|heit
un|be|irr|bar [auch: un...]; Un|be-
irr|bar|keit[1] w; -; un|be|irrt [auch:
un...]; Un|be|irrt|heit[1] w; -
un|be|kannt; ein -er Mann, aber
(↑ R 224): das Grab des Un-
bekannten Soldaten; [nach] un-
bekannt verzogen; (↑ R 116:) der
große Unbekannte; eine Glei-
chung mit mehreren Unbekann-
ten (Math.); ein Verfahren gegen
Unbekannt; un|be|kann|ter|wei-
se; Un|be|kannt|heit w; -
un|be|klei|det

un|be|küm|mert [auch: un...]; Un-
be|küm|mert|heit[1] w; -
un|be|la|stet
un|be|lebt; eine -e Straße
un|be|lehr|bar [auch: un...]; Un|be-
lehr|bar|keit[1] w; -
un|be|liebt; Un|be|liebt|heit w; -
un|be|mannt
un|be|merkt
un|be|mit|telt
un|be|nom|men [auch: un...]; es
bleibt ihm -
un|be|nutz|bar [auch: un...]; un|be-
nutzt
un|be|ob|ach|tet
un|be|quem; Un|be|quem|lich|keit
un|be|re|chen|bar [auch: un...]; Un-
be|re|chen|bar|keit[1]
un|be|rech|tigt; un|be|rech|tig|ter-
wei|se
un|be|rück|sich|tigt [auch: un...]
un|be|ru|fen! [auch: un...]
un|be|rührt; Un|be|rührt|heit w; -
un|be|scha|det [auch: un...] (ohne
Schaden für ...); mit Wesf.: (ohne
schadet seines Rechtes od. seines
Rechtes unbeschadet; un|be-
schä|digt
un|be|schäf|tigt
un|be|schei|den; Un|be|schei|den-
heit w; -
un|be|schol|ten; Un|be|schol|ten-
heit w; -; Un|be|schol|ten|heits-
zeug|nis
un|be|schrankt (ohne Schranken);
-er Bahnübergang; un|be-
schränkt [auch: un...] (nicht ein-
geschränkt); vgl. EGmuH; Un-
be|schränkt|heit[1] w; -
un|be|schreib|lich [auch: un...]; Un-
be|schreib|lich|keit[1] w; -; un|be-
schrie|ben
un|be|schützt [auch: un...]
un|be|schwert; Un|be|schwert|heit
un|be|seelt
un|be|se|hen
un|be|sieg|bar [auch: un...]; Un|be-
sieg|bar|keit[1] w; -; un|be|sieg|lich
[auch: un...]; Un|be|sieg|lich|keit[1]
w; -; un|be|siegt [auch: un...]
un|be|son|nen; Un|be|son|nen|heit
un|be|sorgt [auch: ...so...]
un|be|stän|dig; Un|be|stän|dig|keit
un|be|stä|tigt [auch: un...]; nach
-en Meldungen
un|be|stech|lich [auch: un...]; Un-
be|stech|lich|keit[1] w; -
un|be|stimm|bar [auch: un...]; Un-
be|stimm|bar|keit[1] w; -; un|be-
stimmt; -es Fürwort (für: Indefi-
nitpronomen); Un|be|stimmt-
heit w; -; Un|be|stimmt|heits|re-
la|ti|on (Begriff der Quanten-
theorie)
un|be|streit|bar [auch: un...]; -e
Verdienste; un|be|strit|ten [auch:
...schtri...]

un|be|tei|ligt [auch: *un*...]; Un|be|tei|ligt|heit[1] *w*; -

un|be|tönt

un|be|trächt|lich [auch: *un*...]; Un|be|trächt|lich|keit[1] *w*; -

un|be|tre|ten

un|beug|bar [auch: *un*...]; un|beug|sam [auch: *un*...]; -er Wille; Un|beug|sam|keit[1] *w*; -

un|be|wacht

un|be|waff|net

un|be|wäl|tigt [auch: ...*wäl*...]; die -e Vergangenheit

un|be|weg|lich [auch: ...*weg*...]; Un|be|weg|lich|keit[1]; un|be|wegt

un|be|wohn|bar [auch: *un*...]

un|be|wußt; Un|be|wuß|te *s*; -n (↑ R 28 / ff.); Un|be|wußt|heit *w*; -

un|be|zahl|bar [auch: *un*...]; Un|be|zahl|bar|keit[1] *w*; -

un|be|zähm|bar [auch: *un*...]; Un|be|zähm|bar|keit[1] *w*; -

un|be|zwei|fel|bar [auch: *un*...]

un|be|zwing|bar [auch: *un*...]; un|be|zwing|lich [auch: *un*...]

Un|bil|den (Unannehmlichkeiten) *Mehrz.*; die - der Witterung; Un|bil|dung (Mangel an Wissen) *w*; -; Un|bill (Unrecht) *w*; -; un|bil|lig; -e Härte (Rechtsspr.); Un|bil|lig|keit

un|blu|tig; eine -e Revolution

un|bot|mä|ßig; Un|bot|mä|ßig|keit

un|brauch|bar; Un|brauch|bar|keit *w*; -

un|bü|ro|kra|tisch

un|buß|fer|tig; Un|buß|fer|tig|keit

un|christ|lich; Un|christ|lich|keit

Uncle Sam [*angkl ßäm*] (scherzh. für: Nordamerikaner)

und (Abk.: u., bei Firmen auch: &); - ähnliche[s] (Abk.: u. ä.); - dem ähnliche[s] (Abk.: u. d. ä.); - and[e]re, - and[e]res (Abk.: u. a.); und and[e]re mehr, und and[e]res mehr (Abk.: u. a. m.); drei und drei ist, macht, gibt (nicht: sind, machen, geben) sechs

Un|dank; un|dank|bar; das ist eine -e Aufgabe; Un|dank|bar|keit

und der|glei|chen [mehr] (Abk.: u. dgl. [m.]); und des|glei|chen [mehr] (Abk.: u. desgl. [m.])

un|da|tiert

un|de|fi|nier|bar [auch: *un*...]

un|de|kli|nier|bar [auch: *un*...]

un|de|mo|kra|tisch [auch: *un*...]

un|denk|bar; un|denk|lich

Un|der|ground *engl.* [*ándᵉrgraund*] („Untergrund"; avantgardistische Protestbewegung [von Jungfilmern]) *m*; -s

Un|der|state|ment *engl.* [*ándᵉr-ßtᵉ'tmᵉnt*] (das Untertreiben, Unterspielen) *s*; -s

un|deut|lich; Un|deut|lich|keit

Un|de|zi|me *lat.* (Musik: elfter Ton [vom Grundton an]) *w*; -, -n

un|dicht; Un|dich|tig|keit

Un|di|ne *lat.* (weibl. Wassergeist) *w*; -, -n

Un|ding (Unmögliches; Unsinniges) *s*; -[e]s, -e; das ist ein -

un|dis|ku|ta|bel [auch: *un*...]

un|dis|zi|pli|niert (zuchtlos); Un|dis|zi|pli|niert|heit

Und|set, Sigrid (norw. Schriftstellerin)

und so fort (Abk.: usf.); und so wei|ter (Abk.: usw.)

Un|du|la|ti|on *lat.* [...*ziọn*] (Physik: Wellenbewegung; Geol.: Sattelu, Muldenbildung durch Gebirgsbildung); Un|du|la|ti|ons|theo|rie (Physik: Wellentheorie) *w*; -; un|du|la|to|risch (Physik: wellenförmig)

un|duld|sam; Un|duld|sam|keit *w*; - un|du|lie|ren *lat.* (Med., Biol.: sich wellenförmig bewegen)

un|durch|dring|bar [auch: *un*...]; un|durch|dring|lich [auch: *un*...]; Un|durch|dring|lich|keit[1] *w*; -

un|durch|führ|bar [auch: *un*...]; Un|durch|führ|bar|keit[1] *w*; -

un|durch|läs|sig; Un|durch|läs|sig|keit

un|durch|schau|bar [auch: *un*...]; Un|durch|schau|bar|keit[1]

un|durch|sich|tig; Un|durch|sich|tig|keit *w*; -

und vie|le[s] an|de|re [mehr] (Abk.: u. v. a. [m.]); und zwar (Abk.: u. zw.); ↑ R 19

un|eben; Un|eben|heit

un|echt; -e Brüche (Math.); Un|echt|heit *w*; -

un|edel; unedle Metalle

un|ehe|lich; ein -es Kind; Un|ehe|lich|keit *w*; -

Un|eh|re; un|eh|ren|haft; un|eh|ren|haf|tig|keit; un|ehr|er|bie|tig; Un|ehr|er|bie|tig|keit; un|ehr|lich; Un|ehr|lich|keit

un|ei|gen|nüt|zig; Un|ei|gen|nüt|zig|keit *w*; -

un|ei|gent|lich

un|ein|ge|schränkt [auch: ...*ä*...]

un|ein|ge|weiht

un|ei|nig; Un|ei|nig|keit

un|ein|nehm|bar [auch: *un*...]; Un|ein|nehm|bar|keit[1] *w*; -

un|eins; - sein

un|emp|fäng|lich; Un|emp|fäng|lich|keit *w*; -

un|emp|find|lich; Un|emp|find|lich|keit *w*; -

un|end|lich; (↑ R 134:) bis ins unendliche (unaufhörlich, immerfort), aber (↑ R 116:) der Weg scheint bis ins Unendliche (bis ans Ende der Welt) zu führen; un|end|li|che|mal, un|end|lich-

mal, aber: unendliche Male; Un|end|lich|keit *w*; -

un|ent|behr|lich [auch: *un*...]; Un|ent|behr|lich|keit[1] *w*; -

un|ent|deckt [auch: *un*...]

un|ent|gelt|lich [auch: *un*...]; Un|ent|gelt|lich|keit[1] *w*; -

un|ent|rinn|bar [auch: *un*...]; Un|ent|rinn|bar|keit[1] *w*; -

un|ent|schie|den; Un|ent|schie|den (Sport u. Spiel) *s*; -s, -; Un|ent|schie|den|heit

un|ent|schlos|sen; Un|ent|schlos|sen|heit

un|ent|schuld|bar [auch: *un*...]; un|ent|schul|digt

un|ent|wegt [auch: *un*...]

un|ent|wirr|bar [auch: *un*...]

un|er|ach|tet [auch: *un*...] (veraltend für: ungeachtet); mit *Wesf.*; - der Bitten

un|er|bitt|lich [auch: *un*...]; Un|er|bitt|lich|keit[1] *w*; -

un|er|fah|ren; Un|er|fah|ren|heit *w*; -

un|er|find|lich [auch: *un*...] (unbegreiflich)

un|er|forsch|lich [auch: *un*...]

un|er|freu|lich

un|er|füll|bar [auch: *un*...]; Un|er|füll|bar|keit[1] *w*; -; un|er|füllt; Un|er|füllt|heit *w*; -

un|er|gie|big; Un|er|gie|big|keit *w*; -

un|er|gründ|bar [auch: *un*...]; Un|er|gründ|bar|keit[1] *w*; -; un|er|gründ|lich [auch: *un*...]; Un|er|gründ|lich|keit[1] *w*; -

un|er|heb|lich; Un|er|heb|lich|keit

un|er|hört (unglaublich); sein Verhalten war -; [2]un|er|hört; seine Bitte blieb -

un|er|kannt

un|er|klär|bar [auch: *un*...]; Un|er|klär|bar|keit *w*; -; un|er|klär|lich [auch: *un*...]; Un|er|klär|lich|keit[1]

un|er|läß|lich [auch: *un*...] (unbedingt nötig, geboten)

un|er|laubt; eine -e Handlung (Rechtsspr.)

un|er|le|digt

un|er|meß|lich [auch: *un*...]; vgl. unendlich; Un|er|meß|lich|keit[1] *w*; -

un|er|müd|lich [auch: *un*...]; Un|er|müd|lich|keit[1] *w*; -

un|ernst

un|er|quick|lich; Un|er|quick|lich|keit

un|er|reich|bar [auch: *un*...]; Un|er|reich|bar|keit[1] *w*; -; un|er|reicht [auch: *un*...]

un|er|sätt|lich [auch: *un*...]; Un|er|sätt|lich|keit[1] *w*; -

un|er|schlos|sen

un|er|schöpf|lich [auch: *un*...]; Un|er|schöpf|lich|keit[1] *w*; -

[1] Vgl. Anm. S. 705, Sp. 3. [1] Vgl. Anm. S. 705, Sp. 3. [1] Vgl. Anm. S. 705, Sp. 3.

23*

un|er|schrocken [*Trenn.:* ...schrok-ken]; Un|er|schrocken|heit [*Trenn.:* ...schrok|ken...] *w;* -
un|er|schüt|ter|lich [auch: *un*...]; Un|er|schüt|ter|lich|keit[1] *w;* -
un|er|schwing|lich [auch: *un*...]; -e Preise
un|er|setz|bar [auch: *un*...]; un|er|setz|lich [auch: *un*...]; Un|er|setz-lich|keit[1] *w;* -
un|er|sprieß|lich [auch: *un*...]
un|er|träg|lich [auch: *un*...]; Un|er-träg|lich|keit[1] *w;* -
un|er|wähnt; es soll nicht - bleiben, daß ...
un|er|war|tet [auch: ...*war*...].
un|er|weis|bar [auch: *un*...]; un|er-weis|lich [auch: *un*...]
un|er|wi|dert
un|er|wünscht; Un|er|wünscht|heit *w;* -
un|er|zo|gen
UNESCO *engl.* [Kurzwort für: United Nations Educational, Scientific, and Cultural Organization; *junaitid ne'sch'ns ädjuke'-sch'n'l, ßai'ntifik 'nd kaltsch'r'l o'g'naise'sch'n*] (Organisation der Vereinten Nationen für Erziehung, Wissenschaft und Kultur) *w;* -
un|fä|hig; Un|fä|hig|keit
un|fair [...*fär*] (unlauter; unsportlich; unfein); Un|fair|neß
Un|fall *m;* Un|fall_arzt, ...be|tei-lig|te *m* u. *w,* ...fah|rer, ...flucht (vgl. [2]Flucht), ...fol|gen (*Mehrz.*); un|fall|frei; -es Fahren; Un|fall-_ge|schä|dig|te *m* u. *w,* ...hil|fe, ...ort, ...quo|te, ...ra|te, ...schutz, ...sta|ti|on, ...tod, ...to|te *m* u. *w;* un|fall|träch|tig; eine -e Kurve; Un|fall_ver|hü|tung, ...ver|letz|te *m* u. *w,* ...ver|si|che|rung, ...wa-gen (Wagen, der einen Unfall hatte; Rettungswagen), ...zeit, ...zeug|ge
un|faß|bar [auch: *un*...]; un|faß|lich [auch: *un*...]
un|fehl|bar [auch: *un*...]; eine -e Entscheidung des Papstes; Un-fehl|bar|keit[1] *w;* -; Un|fehl|bar-keits|glau|be[n]
un|fein; Un|fein|heit
un|fern; mit *Wesf.* od. mit „von"; - des Hauses, - von dem Hause
un|fer|tig; Un|fer|tig|keit
Un|flat *m;* -[e]s; Un|flä|te|rei; un-flä|tig; Un|flä|tig|keit
un|flott; das sieht nicht - aus
un|folg|sam; Un|folg|sam|keit *w;* -
Un|form; un|för|mig (formlos, mißgestaltet); un|förm|lich (formlos, plump)
un|fran|kiert (unfrei [Gebühren nicht bezahlt])
un|frei; Un|frei|heit; un|frei|wil|lig

un|freund|lich; ein -er Empfang; er war - zu ihm (selten: gegen ihn); Un|freund|lich|keit
Un|frie|de[n] *m;* ...dens
un|fromm
un|frucht|bar; Un|frucht|bar|keit *w;* -; Un|frucht|bar|ma|chung
Un|fug *m;* -[e]s
...ung (z. B. Prüfung *w;* -, -en)
un|ga|lant
un|gang|bar [auch: ...*gang*...]
Un|gar [*unggar*] *m;* -n, -n (↑ R 268); un|ga|risch, aber (↑ R 224): die Ungarische Rhapsodie [von Liszt]; Un|ga|risch (Sprache) *s;* -[s]; vgl. Deutsch; Un|ga|risch *s;* -n; vgl. Deutsche *s;* un|gar|län-disch; Un|garn
un|gast|lich; Un|gast|lich|keit *w;* -
un|ge|ach|tet [auch: ...*geh*...] (nicht geachtet); *Verhältniswort* mit *Wesf.:* - wiederholter Bitten od. wiederholter Bitten -; dessenun-geachtet od. desungeachtet; - daß, aber: - dessen, daß (↑ R 62)
un|ge|ahn|det [auch: ...*an*...] (unbestraft)
un|ge|ahnt [auch: ...*an*...] (nicht vorhergesehen)
un|ge|bär|dig; Un|ge|bär|dig|keit *w;* -
un|ge|be|ten; -er Gast
un|ge|beugt
un|ge|bil|det
un|ge|bräuch|lich; un|ge|braucht (neu)
un|ge|bro|chen
Un|ge|bühr *w;* -; un|ge|büh|rend [auch: ...*bür*...]; -ste; un|ge|bühr-lich [auch: ...*bür*...]; Un|ge|bühr-lich|keit[1]
un|ge|bun|den; ein -es Leben; Un-ge|bun|den|heit *w;* -
un|ge|deckt; -er Scheck
Un|ge|deih *m,* nur noch in: auf Gedeih und -
un|ge|dient (Militär: ohne gedient zu haben); Un|ge|dien|te *m;* -n, -n (↑ R 287 ff.)
un|ge|druckt
Un|ge|duld; un|ge|dul|dig
un|ge|eig|net
un|ge|fähr [auch: ...*fär*]; von - (zufällig); Un|ge|fähr[1] (Zufall) *s;* -s; un|ge|fähr|det [auch: ...*fär*...]; un-ge|fähr|lich; Un|ge|fähr|lich|keit *w;* -
un|ge|fäl|lig; Un|ge|fäl|lig|keit
un|ge|fragt
un|ge|früh|stückt (ugs. für: ohne gefrühstückt zu haben)
un|ge|fü|ge (unförmig)
un|ge|ges|sen (nicht gegessen; ugs. für: ohne gegessen zu haben)
un|ge|glie|dert
un|ge|hal|ten (ärgerlich); Un|ge-hal|ten|heit *w;* -

un|ge|hei|ßen
un|ge|heizt
un|ge|hemmt
un|ge|heu|er [auch: ...*heu*...]; ungeheurer, -ste; eine ungeheure Verschwendung; vgl. unendlich; Un-ge|heu|er *s;* -s, -; un|ge|heu|er|lich [auch: *un*...]; Un|ge|heu|er|lich-keit[1]
un|ge|hin|dert
un|ge|ho|belt [auch: ...*ho*...] (auch übertr. für: ungebildet; grob)
un|ge|hö|rig; ein -es Benehmen; Un|ge|hö|rig|keit; un|ge|hört
un|ge|hor|sam; Un|ge|hor|sam
Un|geist *m;* -[e]s; un|ge|i|stig
un|ge|kämmt
un|ge|klärt
un|ge|kocht
un|ge|kün|stelt
un|ge|kürzt
Un|geld (veralt. für: Abgabe, Steuer)
un|ge|le|gen (unbequem); sein Besuch kam mir -; Un|ge|le|gen|heit
un|ge|leh|rig; un|ge|lehrt
un|ge|lenk, un|ge|len|kig
un|ge|lernt; ein -er Arbeiter
un|ge|lo|gen
un|ge|löst; eine -e Aufgabe
Un|ge|mach (veraltend für: Unbequemlichkeit; Unbehaglichkeit) *s;* -[e]s; un|ge|mäch|lich (veralt.)
un|ge|mäß
un|ge|mein [auch: ...*main*...]
un|ge|mes|sen [auch: ...*mä*...]; vgl. unendlich
un|ge|mischt
un|ge|müt|lich; Un|ge|müt|lich-keit
un|ge|nannt
un|ge|nau; Un|ge|nau|ig|keit
un|ge|niert [...*sehe*..., auch: ...*nirt*] (zwanglos); Un|ge|niert|heit[1] (Zwanglosigkeit)
un|ge|nieß|bar [auch: ...*niß*...]; eine -e Speise; Un|ge|nieß|bar|keit[1] *w;* -
Un|ge|nü|gen *s;* -s; un|ge|nü|gend; vgl. ausreichend
un|ge|nutzt, (häufiger:) un|ge|nützt
un|ge|ord|net
un|ge|pflegt; Un|ge|pflegt|heit *w;* -
un|ge|prüft
un|ge|rächt
un|ge|ra|de, (ugs.:) un|gra|de; - Zahl (Math.)
un|ge|ra|ten; ein -es Kind
un|ge|rech|net; *Verhältniswort* mit *Wesf.:* - des Schadens
un|ge|recht; un|ge|rech|ter|wei|se; un|ge|recht|fer|tigt; Un|ge|rech-tig|keit
un|ge|re|gelt; er führt ein -es Leben
un|ge|reimt (nicht im Reim gebunden; der Wahrheit nicht entsprechend; sinnlos); Un|ge|reimt|heit

un|gern
un|ge|rührt; Un|ge|rührt|heit w; -
un|ge|rupft; er kam - davon (ugs. für: er kam ohne Verlust davon)
un|ge|sagt; vieles blieb -
un|ge|sal|zen
un|ge|sät|tigt; -e Lösung, -er Dampf
un|ge|säu|ert; -es Brot
¹un|ge|säumt [auch: ...seumt] (ohne Verzug); ²un|ge|säumt (ohne Saum)
un|ge|sche|hen; etwas - machen
un|ge|scheut [auch: ...scheut] (frei, ohne Scheu)
Un|ge|schick s; -[e]s; un|ge|schicklich; Un|ge|schick|lich|keit; un|ge|schickt; Un|ge|schickt|heit
un|ge|schlacht (plump, grobschlächtig); ein -er Mensch; Un|ge|schlacht|heit w; -
un|ge|schlecht|lich; -e Fortpflanzung
un|ge|schlif|fen (auch übertr.: unerzogen); Un|ge|schlif|fen|heit
un|ge|schmä|lert (ohne Einbuße)
un|ge|schmei|dig
un|ge|schminkt (auch: rein den Tatsachen entsprechend)
un|ge|scho|ren
un|ge|schrie|ben; ein -es Gesetz
un|ge|schult
un|ge|schützt
un|ge|sel|lig; Un|ge|sel|lig|keit
un|ge|setz|lich; Un|ge|setz|lich|keit
un|ge|si|ttet
un|ge|stalt (von Natur aus mißgestaltet); -er Mensch; un|ge|stal|tet (von Menschenhand); -e Masse
un|ge|stem|pelt; -e Briefmarken
un|ge|stillt
un|ge|stört; Un|ge|stört|heit w; -
un|ge|straft
un|ge|stüm (schnell, heftig); Un|ge|stüm s; -[e]s; mit -
un|ge|sund; ein -es Aussehen
un|ge|tan
un|ge|teilt
un|ge|treu
un|ge|trübt
Un|ge|tüm s; -[e]s, -e
un|ge|übt
un|ge|wandt; Un|ge|wandt|heit
un|ge|wa|schen
un|ge|wiß; I. Kleinschreibung (↑ R 133): ins ungewisse leben, im ungewissen (ungewiß) bleiben, lassen, sein. II. Großschreibung (↑ R 116): das Gewisse fürs Ungewisse nehmen; das Ungewisse steigern; eine Fahrt ins Ungewisse; Un|ge|wiß|heit
Un|ge|wit|ter
un|ge|wöhn|lich; Un|ge|wöhn|lich|keit w; -; un|ge|wohnt; Un|ge|wohnt|heit w; -
un|ge|wollt
un|ge|zählt; die Gehälter -er kleiner Beamter

un|ge|zähmt
Un|ge|zie|fer s; -s
un|ge|zie|mend; -ste
un|ge|zo|gen; Un|ge|zo|gen|heit
un|ge|zü|gelt
un|ge|zwun|gen; ein -es Benehmen; Un|ge|zwun|gen|heit
un|gif|tig; Un|gif|tig|keit
Un|glau|be[n]; un|glaub|haft; un|gläu|big; ein ungläubiger Thomas (ugs. für: ein Mensch, der an allem zweifelt); Un|gläu|big|keit w; -n, -n (↑ R 287ff.); un|glaub|lich [auch: un...]; es geht ins, grenzt ans Unglaubliche (↑ R 116); un|glaub|wür|dig; Un|glaub|wür|dig|keit
un|gleich; un|gleich|ar|tig, ...er|tig (für: heterozygot), ...för|mig, ...ge|schlecht|lich (Biol.); Un|gleich|ge|wicht; Un|gleich|heit; un|gleich|mä|ßig; Un|gleich|mä|ßig|keit; un|gleich|stof|fig (für: inhomogen); Un|gleich|stof|fig|keit (für: Inhomogenität) w; -; Un|glei|chung (Math.)
Un|glimpf m; -[e]s; un|glimpf|lich
Un|glück s; -[e]s, -e; un|glück|lich; Un|glück|li|che m u. w; -n, -n (↑ R 287ff.); un|glück|li|cher|wei|se; Un|glücks|bo|te; un|glück|se|lig; un|glück|se|li|ger|wei|se; Un|glücks|fah|rer, ...fall m, ...kind, ...mensch m, ...ra|be (ugs.); un|glücks|schwan|ger; Un|glücks|tag, ...wa|gen, ...wurm (ugs.; m; -[e]s, ...würmer)
Un|gna|de w; -; un|gnä|dig
un|grad (landsch.), un|gra|de vgl. ungerade
un|gra|zi|ös
Un|gu|la|ten lat. (Zool.: Huftiere) Mehrz.
un|gül|tig; Un|gül|tig|keit w; -; Un|gül|tig|keits|er|klä|rung; Un|gül|tig|ma|chung (Amtsdt.)
Un|gunst; zu seinen, zu seines Freundes Ungunsten, aber (↑ R 141): zuungunsten der Arbeiter; un|gün|stig
gu|su|sti|ös vgl. gustlös
un|gut; nichts für -
un|halt|bar [auch: ...ha...]; -e Zustände; Un|halt|bar|keit; un|hal|tig (Bergmannsspr.: kein Erz usw. enthaltend)
un|hand|lich; Un|hand|lich|keit
un|har|mo|nisch
Un|heil; un|heil|bar [auch: ...hail...]; eine -e Krankheit; Un|heil|bar|keit¹; un|heil|brin|gend, aber (↑ R 142): schweres Unheil bringend; un|heil|dro|hend; un|heil|lig; un|heil|schwan|ger; Un|heil|stif|ter; un|heil|ver|kün|dend, aber (↑ R 142): schweres Unheil verkündend; un|heil|voll

un|heim|lich (nicht geheuer; unbehaglich; fremd); Un|heim|lich|keit w; -
un|hi|sto|risch
un|höf|lich; Un|höf|lich|keit
un|hold (abgeneigt; feindselig); Un|hold (böser Geist; Teufel; Wüstling) m; -[e]s, -e; Un|hol|din w; -, -nen
un|hör|bar [auch: un...]; Un|hör|bar|keit¹ w; -
un|hy|gie|nisch
uni fr. [üni] einfarbig, nicht gemustert; ¹Uni [üni] (einheitliche Farbe) s; -s, -s; in verschiedenen Unis
²Uni (stud. Kurzw. für: Universität) w; -, -s
UNICEF engl. [unizäf; Kurzw. für: United Nations International Children's Emergency Fund; junaitid ne'sch'ns int'rnäsch'n'l tschildr'ns imördseh'n$i fand] (Weltkinderhilfswerk der UNO)
unie|ren fr. [unir'n] (vereinigen [bes. von Religionsgemeinschaften]); unierte Kirchen (die mit der röm.-kath. Kirche wiedervereinigten Ostkirchen), Uni|fi|ka|ti|on [...ziọn] (seltener für: Unifizierung); uni|fi|zie|ren (vereinheitlichen); Uni|fi|zie|rung (Vereinheitlichung, Vereinigung); uni|form (gleich-, einförmig; gleichmäßig); Uni|form [österr.: uni...] (einheitl. Dienstkleidung) w; -, -en; uni|for|mie|ren (einheitlich [ein]kleiden; gleichförmig machen); Uni|for|mie|rung; Uni|for|mi|tät (Einförmigkeit; Gleichmäßigkeit); Uni|form|ver|bot; uni|ge|färbt [üni...] (einfarbig, nicht gemustert); Uni|kat lat. [u...] (einzige Ausfertigung eines Schriftstückes) s; -[e]s, -e; Uni|kum [auch: u...] ([in seiner Art] Einziges, Seltenes; Sonderling) s; -s, ...ka (auch: -s); uni|la|te|ral (einseitig)
un|in|ter|es|sant (langweilig, reizlos); un|in|ter|es|siert (unbeteiligt; ohne innere Anteilnahme); Un|in|ter|es|siert|heit w; -
Uni|on lat. (Bund, Vereinigung, Verbindung [bes. von Staaten]); - der Sozialist. Sowjetrepubliken (Sowjetunion; dt. Abk.: UdSSR); Christlich-Demokratische Union [Deutschlands] (Abk.: CDU); Christlich-Soziale Union (Abk.: CSU); Unio|nist (Anhänger einer Union, z. B. im amerikanischen Unabhängigkeitskrieg 1776/83); ↑ R 268; Union Jack engl. [unj'n dsehäk] (brit. Nationalflagge) m; - -s, - -s; Uni|ons|kir|che, ...par|tei|en

¹ Vgl. Anm. S. 705, Sp. 3. ¹ Vgl. Anm. S. 705, Sp. 3.

(zusammenfassende Bez. für CDU u. CSU) *Mehrz.*
uni|pe|tal *lat.; gr.* (Bot.: einblättrig); uni|po|lar (Elektrotechnik: einpolig); -e Leitfähigkeit; Uni-po|lar|ma|schi|ne
un|ir|disch (nicht zur Erde gehörend; fremdartig)
uni|so|no *it.* (Musik: im Einklang [od. in der Oktave] singend od. spielend); Uni|so|no (Zusammenklingen mehrerer Stimmen in einem Ton gleicher od. verschiedener Oktaven) *s*; -s, -s u. ...ni
Uni|ta|ri|er *lat.* [...iᵉr] (Leugner der Dreifaltigkeit) *m*; -s, -; uni|ta-risch (Einigung bezweckend); Uni|ta|ris|mus (Streben nach Stärkung der Zentralgewalt; Lehre der Unitarier; Med.: Lehre von der ursächlichen Übereinstimmung verschiedener Krankheitsformen) *m*; -
Uni|ted Na|tions [*junaitid neᵉ'schᵉns*] usw. vgl. UN, UNO, UNESCO, VN; Uni|ted Press In|ter|na|tio|nal *engl.* [*junaitid präß intᵉrnäschᵉnᵉl*] (eine US-amerik. Nachrichtenagentur; Abk.: UPI) *w*; -; Uni|ted States [of Ame|ri|ca] [*junaitid ßteᵉ'tß (ᵉw ᵉmärikᵉ)*] (Vereinigte Staaten [von Amerika]; Abk.: US[A]) *Mehrz.*
uni|ver|sal *lat.* [...wär...], uni|ver-sell (allgemein, gesamt; [die ganze Welt] umfassend); Uni|ver|sal-ᵉer|be *m*, ...ge|nie, ...ge|schich|te (Weltgeschichte; *w*; -); Uni|ver-sa|li|en [...iᵉn] (die fünf obersten Allgemeinbegriffe in der Scholastik) *Mehrz.*; Uni|ver|sa|lis|mus (Vorrang des Allgemeinen, Ganzen; All-, Vielseitigkeit) *m*; -; Uni-ver|sa|li|tät (Allgemeinheit, Gesamtheit; Allseitigkeit; alles umfassende Bildung) *w*; -; Uni|ver-sal|mit|tel (Allerweltsmittel, Allheilmittel) *s*; uni|ver|sell vgl. universal; Uni|ver|sia|de (Studentenwettkämpfe nach dem Vorbild der Olympischen Spiele); uni|ver-si|tär (die Universität betreffend); Uni|ver|si|tät (,,Gesamtheit''; Hochschule; stud. Kurzw.: Uni); Uni|ver|si|täts_bi|blio|thek, ...in|sti|tut, ...lauf|bahn, ...pro-fes|sor, ...stu|di|um; Uni|ver|sum ([Welt]all) *s*; -s
un|ka|me|rad|schaft|lich
Un|ke (Froschlurch) *w*; -, -n; un|ken (ugs. für: Unglück prophezeien); Un|ken|art
un|kennt|lich; Un|kennt|lich|keit *w*; -; Un|kennt|nis *w*; -
Un|ken_ruf, ...tein
un|keusch; Un|keusch|heit
un|kind|lich; Un|kind|lich|keit
un|kirch|lich

un|klar; (↑ R 133:) im -en (ungewiß) bleiben, lassen, sein; Un-klar|heit
un|kleid|sam
un|klug
un|kol|le|gi|al
un|kom|pli|ziert
un|kon|trol|lier|bar [auch: ...lir...]; un|kon|trol|liert
un|kon|ven|tio|nell
un|kör|per|lich; Un|kör|per|lich-keit *w*; -
un|kor|rekt; Un|kor|rekt|heit
Un|ko|sten *Mehrz.*; sich in - stürzen (ugs.); Un|ko|sten|bei|trag
un|kraut
un|kri|tisch
Unk|ti|on *lat.* [...zion] (Med.: Einreibung, Einsalbung)
un|kul|ti|viert [...tiw...]; Un|kul|tur *w*; -
un|künd|bar [auch: ...kün...]; ein -es Darlehen; Un|künd|bar|keit[1]
un|kun|dig
Un|land (seltener für: nicht anbaufähiges Land) *s*; -[e]s, Unländer
un|längst
un|lau|ter; -er Wettbewerb
un|leid|lich; Un|leid|lich|keit
un|le|ser|lich [auch: ...le...]; Un|le-ser|lich|keit[1] *w*; -
un|leug|bar [auch: ...leu...]
un|lieb; un|lieb|sam; Un|lieb|sam-keit
un|li|mi|tiert (unbegrenzt; unbeschränkt)
un|lo|gisch
un|lös|bar [auch: ...lös...]; Un|lös|bar-keit[1] *w*; -; un|lös|lich (auch: ...lös...)
Un|lust *w*; -; Un|lust|ge|fühl; un|lu-stig
un|ma|nier|lich
un|männ|lich; Un|männ|lich|keit *w*; -
Un|maß (Unzahl, übergroße Menge; veralt. für: Unziemlichkeit) *s*; -es
Un|mas|se (sehr große Masse)
un|maß|geb|lich [auch: ...ge...]; un-mä|ßig; Un|mä|ßig|keit
un|me|lo|disch
Un|men|ge
Un|mensch (grausamer Mensch, Wüterich) *m*; un|mensch|lich [auch: unmänsch...]; Un|mensch-lich|keit[1]
un|merk|lich [auch: un...]
un|miß|ver|ständ|lich [auch: ...schtänt...]
un|mit|tel|bar; Un|mit|tel|bar|keit *w*; -
un|mö|bliert
un|mo|dern; un|mo|disch
un|mög|lich [auch: unmök...]; nichts Unmögliches (↑ R 116) verlangen; vgl. unendlich; Un-mög|lich|keit[1]

Un|mo|ral; un|mo|ra|lisch
un|mo|ti|viert [...tiw...] (unbegründet)
un|mün|dig; Un|mün|dig|keit *w*; -; un|mu|si|ka|lisch
Un|mut *m*; -[e]s; un|mu|tig; un-muts|voll
un|nach|ahm|lich [auch: ...am...]
un|nach|gie|big; eine -e Haltung; Un|nach|gie|big|keit *w*; -
un|nach|sich|tig; Un|nach|sich|tig-keit *w*; -; un|nach|sicht|lich (älter für: unnachsichtig)
un|nah|bar [auch: un...]; Un|nah-bar|keit[1] *w*; -
Un|na|tur *w*; -; un|na|tür|lich; Un-na|tür|lich|keit
un|nenn|bar [auch: un...]
un|nor|mal
un|nö|tig; un|nö|ti|ger|wei|se
un|nütz; sich - machen; un|nüt|zer-wei|se
UNO *engl.* (Kurzwort für: United Nations Organization [*junaitid neᵉ'schᵉns oᵉ'gᵉnaiseᵉ'schᵉn*]) (Organisation der Vereinten Nationen) *w*; -; vgl. UN u. VN
un|or|dent|lich; Un|or|dent|lich-keit; Un|ord|nung
un|or|ga|nisch; un|or|ga|ni|siert
un|or|tho|dox
un|or|tho|gra|phisch
un|paar; Un|paar|hu|fer; un|paa-rig; Un|paar|ze|her
un|päd|ago|gisch
un|par|tei|isch (neutral, objektiv, ohne Vorliebe od. Abneigung gegen die eine od. andere Seite); ein -es Urteil; Un|par|tei|ische *m* u. *w*; -n, -n (↑ R 287 ff.); un|par|tei-lich (keiner bestimmten Partei angehörend, nahestehend; nicht von der Haltung der Partei bestimmt); Un|par|tei|lich|keit *w*; -; un|paß (als *Umstandswort*: ungeschickt, zu unrechter Zeit; als *Eigenschaftswort* nur in der Satzaussage: unpäßlich, nicht bei rechter Gesundheit); un|pas-send; -ste
un|pas|sier|bar [auch: ...ßir...] (unbegehbar)
un|päß|lich ([leicht] krank; unwohl); Un|päß|lich|keit
un|pa|the|tisch
un|per|sön|lich; -es Zeitwort (für: Impersonale); Un|per|sön|lich-keit *w*; -
un|pfänd|bar [auch: ...pfänt...]
un|poe|tisch
un|po|liert
un|po|li|tisch
un|po|pu|lär
un|prak|tisch
un|prä|ten|ti|ös
un|prä|zis, un|prä|zi|se
un|pro|ble|ma|tisch

[1] Vgl. Anm. S. 705, Sp. 3.

[1] Vgl. Anm. S. 705, Sp. 3.

un|pro|duk|tiv; Un|pro|duk|ti|vi|tät w; -

un|pro|fi|liert

un|pro|por|tio|niert; Un|pro|por|tio|niert|heit

un|pünkt|lich; Un|pünkt|lich|keit

un|qua|li|fi|zier|bar [auch: ...zir...] (unglaublich, unerhört)

un|ra|siert

¹Un|rast (ruheloser Mensch, bes. Kind) m; -[e]s, -e; ²Un|rast (Ruhelosigkeit) w; -

un|rat (Schmutz) m; -[e]s

un|ra|tio|nell; ein -er Betrieb

un|rat|sam

un|re|al; un|rea|li|stisch

un|recht; in die unrechte Kehle kommen; in unrechte Hände gelangen; am unrechten Platze sein. *Großschreibung* (↑ R 116): etwas Unrechtes; an den Unrechten kommen; vgl. recht; Un|recht s; -[e]s; mit, zu Unrecht; besser Unrecht leiden als Unrecht tun; es geschieht ihm Unrecht; ein Unrecht begehen; im Unrecht sein; jmdn. ins Unrecht setzen; jmdm. ein Unrecht [an]tun. *Kleinschreibung* (↑ R 132): unrecht bekommen, geben, haben, sein, tun; vgl. Recht; un|recht|mä|ßig; -er Besitz; un|recht|mä|ßig|er|wei|se; Un|recht|mä|ßig|keit

un|red|lich; Un|red|lich|keit

un|re|di|giert ([von Zeitungsartikeln u. dgl.] vom Herausgeber nicht überarbeitet)

un|re|ell

un|re|flek|tiert (ohne Nachdenken [entstanden]; spontan)

un|re|gel|mä|ßig; -e Zeitwörter (Sprachw.); Un|re|gel|mä|ßig|keit

un|reif; Un|rei|fe

un|rein; ins unreine schreiben (↑ R 133); Un|rein|heit; Un|rei|nig|keit; un|rein|lich; Un|rein|lich|keit

un|ren|ta|bel; Un|ren|ta|bi|li|tät w; -

un|rett|bar [auch: un...]

un|rich|tig; un|rich|ti|ger|wei|se; Un|rich|tig|keit

un|rit|ter|lich

Un|ruh (Teil der Uhr, des Barometers usw.) w; -, -en; Un|ru|he (fehlende Ruhe; auch nichtfachmänn. für: Unruh); Un|ru|he|herd, Un|ruh|herd; Un|ru|he|stif|ter, Un|ruh|stif|ter; un|ru|hig un|rühm|lich; Un|rühm|lich|keit w; -

Un|ruh|stif|ter, Un|ru|he|stif|ter

un|rund (Technik)

uns

un|sach|ge|mäß; un|sach|lich; Un|sach|lich|keit

un|sag|bar; un|säg|lich

un|sanft

un|sau|ber; Un|sau|ber|keit

un|schäd|lich; ein -es Mittel; Un|schäd|lich|keit w; -; Un|schäd|lich|ma|chung

un|scharf; Un|schär|fe; Un|schär|fe_be|reich, ...re|la|ti|on (Physik)

un|schätz|bar [auch: un...]

un|schein|bar; Un|schein|bar|keit w; -

un|schick|lich (unanständig); Un|schick|lich|keit

un|schlag|bar [auch: un...]

Un|schlitt (Talg) s; -[e]s, -e; Un|schlitt|ker|ze

un|schlüs|sig; Un|schlüs|sig|keit w; -

un|schmelz|bar [auch: un...]

un|schön

Un|schön|fe|risch

Un|schuld w; -; un|schul|dig; ein -es Mädchen; aber (↑ R 224): Unschuldige Kinder (kath. Fest); Un|schul|di|ge m u. w; -n, -n (↑ R 287ff.); un|schul|di|ger_wei|se; Un|schulds_be|teue|rung (meist *Mehrz.*), ...lamm (scherzh.), ...mie|ne; un|schulds|voll

un|schwer (leicht)

Un|se|gen

un|selb|stän|dig; Un|selb|stän|dig|keit

un|se|lig

¹un|ser, uns[e]re, unser *Werf.* (unser Tisch usw.; unser und aller unterschriebener Brief; ↑ R 272); unseres Wissens (Abk.: u. W.); (↑ R 224:) Unsere Liebe Frau (Maria, Mutter Jesu); Uns[e]rer Lieben Frau[en] Kirche; dein; ²un|ser (*Wesf.* von „wir"); unser (nicht: unserer) sind drei; gedenke, erbarme dich unser (nicht: unserer); un|se|re, uns|re, un|se|ri|ge, uns|ri|ge; (↑ R 117:) die Unser[e]n, Unsren, Unsrigen; das Uns[e]re, Unsrige; vgl. deine, deinige; un|ser|ei|ner, un|ser|eins; un|se|rer|seits, un|se|r|seits, uns|re|r|seits, un|ser|res|glei|chen, uns|res|glei|chen; un|se|res|teils, uns|res|teils; un|se|ri|ge, uns|ri|ge vgl. uns[e]re

un|se|ri|ös

un|sert|hal|ben; un|sert|we|gen; un|sert|wil|len; um -

un|si|cher; im -n (zweifelhaft) sein (↑ R 133); Un|si|cher|heit; Un|si|cher|heits|fak|tor

un|sicht|bar; Un|sicht|bar|keit w; -; Un|sicht|bar|ma|chung w; -; un|sich|tig (trüb, undurchsichtig); die Luft wird -

Un|sinn m; -[e]s; un|sin|nig; Un|sin|nig|keit; un|sinn|lich

Un|sit|te; un|sitt|lich; ein -er Antrag; Un|sitt|lich|keit

un|so|lid, un|so|li|de; Un|so|li|di|tät

un|so|zi|al; -es Verhalten

un|spe|zi|fisch

un|sport|lich; Un|sport|lich|keit

uns|re vgl. unsere; uns|rer|seits, un|ser|seits, uns|re|r|seits; uns|res|glei|chen, un|se|res|glei|chen, un|sers|glei|chen; uns|res|teils, un|se|res|teils; uns|ri|ge vgl. un|sere

un|sta|bil; Un|sta|bi|li|tät

un|stän|dig; - Beschäftigte

Un|stä|te [in mittelhochd. Schreibweise erneuert; vgl. aber: unstet] (Ruhelosigkeit, Unruho) w;

un|statt|haft

un|sterb|lich; die -e Seele; Un|sterb|lich|keit w; -; Un|sterb|lich|keits_glau|be[n]

Un|stern (Unglück) m; -[e]s

un|stet; ein -es Leben; vgl. aber: Unstäte; un|ste|tig (älter für: unstet); Un|ste|tig|keit w; -

un|still|bar [auch: un...]

un|stim|mig; Un|stim|mig|keit

un|sträf|lich [auch: ...schträf...] (meist übertr. fur: sauber, ohne Vorwurf)

un|strei|tig [auch: ...schtrei...] (sicher, bestimmt), un|strit|tig [auch: ...schtrit...]

Un|strut (l. Nebenfluß der Saale) w; -

Un|sum|me (große Summe)

un|sym|me|trisch

un|sym|pa|thisch

un|sy|ste|ma|tisch

un|ta|de|lig, un|tad|lig [auch: ...ta...]; ein -es Leben

un|ta|len|tiert

Un|tat (Verbrechen); Un|tät|chen, (mdal.:) Un|tä|tel|chen (kleiner Makel) s, nur in: es ist kein - an ihm

un|tä|tig; Un|tä|tig|keit w; -

un|taug|lich; Un|taug|lich|keit w; -

un|teil|bar [auch: un...]; -e Zahlen; Un|teil|bar|keit¹ w; -; un|teil|haf|tig

un|ten; nach, von, bis -; nach - hin; nach - zu; von - her; von - hinauf; weiter -; man wußte kaum noch, was - und was oben war; - sein, - bleiben, - liegen, - stehen; un|ten|an; - stehen, - sitzen; un|ten|drun|ter (ugs.); un|ten|her, aber: von unten her; un|ten|hin, aber: nach unten hin; un|ten|lie|gend; un|ten|ste|hend; (↑ R 134:) im -en (weiter unten); (↑ R 135:) das (jenes folgende), aber (↑ R 116): das Untenstehende; vgl. folgend

un|ter; *Verhältnisw.* mit *Wemf.* u. *Wenf.*: unter dem Strich (in der

¹ Vgl. Anm. S. 705, Sp. 3.

Zeitung) stehen, a b e r : unter den Strich setzen; - der Bedingung, daß (↑ R 61); Kinder unter zwölf Jahren haben keinen Zutritt; unter ander[e]m, unter ander[e]n (Abk.: u. a.); unter einem (österr. für: zugleich); (Bergmannsspr.:) unter Tage; unter üblichem Vorbehalt (bei Gutschrift von Schecks; Abk.: u. ü. V.); *Umstandsw.*: es waren unter (= weniger als) 100 Gäste; unter (= noch nicht) zwölf Jahre alte Kinder; Gemeinden von unter (= weniger als) 10000 Einwohnern
Un|ter (Spielkarte) *m*; -s, -
un|ter... *in Verbindung mit Zeitwörtern:* a) *unfeste Zusammensetzungen* (↑ R 304), z. B. un-terhalten (vgl. d.), untergehalten; b) *feste Zusammensetzungen* (↑ R 304), z. B. unterhalten (vgl. d.), unterhalten
Un|ter|ab|tei|lung
Un|ter|arm
Un|ter|bau (*Mehrz.* ...bauten); un-ter|bau|en; er hat den Sockel unterbaut; Un|ter|bau|ung
un|ter|be|gabt
Un|ter|be|griff
un|ter|be|legt; ein -es Hotel
un|ter|be|lich|tet; Un|ter|be|lich-tung
un|ter|be|setzt; die Dienststelle ist - (hat nicht genug Personal)
Un|ter|bett
un|ter|be|wer|ten; eine unterbe-wertete Leistung; Un|ter|be|wer-tung
un|ter|be|wußt; Un|ter|be|wußt-sein
un|ter|be|zahlt; Un|ter|be|zah|lung
un|ter|bie|ten; er hat die Rekorde unterboten; Un|ter|bie|tung
Un|ter|bi|lanz (Fehlbetrag; Ver-lustabschluß)
un|ter|bin|den (ugs.); sie hat ein Tuch untergebunden; un|ter|bin-den; der Handelsverkehr ist un-terbunden; Un|ter|bin|dung
un|ter|blei|ben; die Buchung ist lei-der unterblieben
Un|ter|bo|den|schutz (Kraftfahr-zeugwesen)
un|ter|bre|chen; er hat die Reise unterbrochen; jmdn., sich -; Un-ter|bre|cher (Elektrotechnik); Un|ter|bre|chung
un|ter|brei|ten (ugs.); er hat das Tuch untergebreitet; un|ter|brei-ten (darlegen; vorschlagen); er hat ihm einen Vorschlag unter-breitet; Un|ter|brei|tung
un|ter|brin|gen; er hat das Gepäck im Wagen untergebracht; Un|ter-brin|gung
Un|ter|bruch (schweiz. neben: Un-terbrechung) *m*; -[e]s, ...brüche
un|ter|but|tern (ugs. für: jmdn. oh-

ne Verantwortlichkeit u. ohne besonderen Aufgabenbereich mit einsetzen od. etw. dazutun, ohne Gegenleistung zu erwar-ten); des Geld wurde noch mit untergebuttert
un|ter|chlo|rig [...*klo*...]
Un|ter|deck (Schiffsteil); Un|ter-deckung[1] (Kreditwesen)
un|ter|der|hand;↑ R 141 (im stillen, heimlich); etwas unterderhand tun, a b e r : unter der Hand (in Arbeit) haben
un|ter|des, un|ter|des|sen
Un|ter|druck *m*; -[e]s, ...drücke; un|ter|drük|ken[1]; er hat den Auf-stand unterdrückt; Un|ter-drücker[1]; un|ter|drücke|risch[1]; Un|ter|druck|kam|mer; Un|ter-drückung[1]
un|ter|ducken[1] (ugs.); er hat ihn im Bad untergeduckt
un|ter|durch|schnitt|lich
un|te|re; vgl. unterste
un|ter|ein|an|der; *Schreibung in Verbindung mit Zeitwörtern* (↑ R 139): untereinander tauschen usw., a b e r : untereinanderste-hen, -stellen, vgl. aneinander
Un|ter|ein|heit
un|ter|ent|wickelt[1]; Un|ter|ent-wick|lung
un|ter|er|nährt; Un|ter|er|näh|rung *w*; -
un|ter|fah|ren (Grundmauer[n] er-neuern, vertiefen); unterfahren
un|ter|fan|gen; du hast dich -; die Mauer wird -; Un|ter|fan|gen (Wagnis) *s*; -s
un|ter|fas|sen (ugs.); sie gehen un-tergefaßt
un|ter|fer|ti|gen (Amtsdt. für: un-terschreiben); unterfertigt; un-terfertigtes Protokoll; Un|ter|fer-tig|te *m* u. *w*; -n, -n (↑ R 287 ff.)
Un|ter|feue|rung (Technik)
un|ter|flie|gen; er hat den Radar-schirm unterflogen
Un|ter|flur⎽hy|drant (unter der Straßendecke liegende Zapfstel-le), ...mo|tor (unter dem Fahr-zeugboden eingebauter Motor)
Un|ter|fran|ken
un|ter|füh|ren (auch Druckw.); die Straße wird unterführt; Un|ter-füh|rer; Un|ter|füh|rung; Un|ter-füh|rungs|zei|chen (für gleiche untereinanderstehende Wörter; Zeichen: „
Un|ter|funk|ti|on
Un|ter|gang *m*; -[e]s, (selten:) ...gänge
un|ter|gä|rig; -es Bier; Un|ter|gä-rung
un|ter|ge|ben; Un|ter|ge|be|ne *m* u. *w*; -n, -n (↑ R 287 ff.)
un|ter|ge|hen; die Sonne ist unter-

gegangen; (↑ R 120:) sein Stern ist im Untergehen [begriffen]
un|ter|ge|ord|net; das sind unter-geordnete Fragen
Un|ter|ge|schoß
Un|ter|ge|stell
Un|ter|ge|wicht *s*; -[e]s; un|ter|ge-wich|tig
un|ter|glie|dern; Un|ter|glie|de-rung (das Untergliedern); Un|ter-glie|de|rung (Unterabteilung)
un|ter|gra|ben; der Gärtner hat den Dünger untergegraben; un-ter|gra|ben; das Rauchen hat seine Gesundheit -; Un|ter|gra-bung
Un|ter|grund *m*; -[e]s; Un|ter-grund⎽bahn (Kurzform: U-Bahn; ↑ R 149), ...be|we|gung; un|ter-grün|dig
Un|ter|grup|pe
un|ter|ha|ken (ugs.); sie hatten sich unterhakt
un|ter|halb; mit *Wesf.*: - des Dorfes
un|ter|hal|ten; er hat untergehal-ten, z. B. unter den Wasser-hahn; un|ter|hal|ten; ich habe mich gut -; er wird vom Staat - (fesselnd); Un|ter|halt|sam|keit *w*; -; Un|ter|halts|bei|trag; un|ter-halts|be|rech|tigt; Un|ter|halts-⎽ko|sten (*Mehrz.*), ...pflicht; un-ter|halts|pflich|tig, un|ter|halts-ver|pflich|tet; Un|ter|hal|tung; Un|ter|hal|tungs⎽bei|la|ge, ...film, ...ko|sten (*Mehrz.*), ...lek|tü|re, ...li|te|ra|tur, ...mu|sik, ...pro-gramm, ...ro|man, ...schrift|stel-ler, ...sen|dung, ...teil *m*
un|ter|han|deln; er hat über den Abschluß des Vertrages un-terhandelt; Un|ter|händ|ler; Un-ter|hand|lung
Un|ter|haus (Verfassungswesen) *s*; -es; das britische -; Un|ter|haus-⎽mit|glied, ...sit|zung
Un|ter|hemd
un|ter|höh|len; unterhöhlt
Un|ter|holz (niedriges Gehölz im Wald) *s*; -es
Un|ter|ho|se
Un|ter|in|stanz
un|ter|ir|disch
Un|ter|ita|li|en (↑ R 206)
Un|ter|jacke [*Trenn.*: ...*jak*|*ke*]
un|ter|jo|chen; die Minderheiten wurden unterjocht; Un|ter|jo-chung
un|ter|ju|beln (ugs.); das hat er ihm untergejubelt (heimlich [mit et-was anderem] zugesteckt, auf-genötigt)
un|ter|kel|lern; ich ...ere (↑ R 327); das Haus wurde nachträglich un-terkellert; Un|ter|kel|le|rung *w*; -
Un|ter|kie|fer *m*; Un|ter|kie|fer-⎽drü|se, ...ge|lenk, ...kno|chen

[1] *Trenn.*: ...k|k...

Un|ter‿kleid, ...klei|dung

un|ter|kom|men (österr. auch für: vorkommen); er ist gut untergekommen; das ist mir noch nie untergekommen; Un|ter|kom|men s; -s, (selten:) -

Un|ter|kör|per

un|ter|kö|tig mdal. (eitrig entzündet)

un|ter|krie|chen (ugs.); er ist bei Freunden untergekrochen

un|ter|krie|gen (ugs. für: bezwingen; entmutigen); wir werden ihn schon noch -; ich lasse mich nicht -

un|ter|küh|len (Technik: unter den Schmelzpunkt abkühlen); unterkühlt, Un|ter|küh|lung

Un|ter|kunft w; -, ...künfte; Un|ter-kunfts‿haus, ...raum

Un|ter|la|ge

Un|ter|land (tiefer gelegenes Land; Ebene) s; -[e]s; Un|ter|län|der m; Un|ter|län|de|rin w; -, -nen; un|ter|län|disch

Un|ter|län|ge

Un|ter|laß m, nur in: ohne -; un|ter-las|sen; er hat es -; Un|ter|lassung; Un|ter|las|sungs‿kla|ge, ...sün|de

Un|ter|lauf m; -[e]s; un|ter|lau|fen (veralt.); es sind einige Fehler untergelaufen (häufiger: unter-laufen; vgl. d.); un|ter|lau|fen; er hat ihn unterlaufen (Ringkampf); es sind einige Fehler unterlaufen (seltener; untergelaufen); un|ter|läu|fig; -e Mahl-gänge; Un|ter|lau|fung (Blutunterlaufung)

un|ter|le|gen; untergelegter Stoff; er hat etwas untergelegt; diese Absicht hat man mir untergelegt; ¹un|ter|le|gen; der Musik wurde ein anderer Text unterlegt; ²un|ter|le|gen (2. Mittelwort zu: unterliegen; vgl. d.); Un|ter|le|gen-heit w; -; Un|ter|le|gung (einer Absicht); Un|ter|le|gung (Verstärkung, Vermehrung usw.)

Un|ter|leib; Un|ter|leib|chen (Kleidungsstück); Un|ter|leibs‿krank-heit, ...lei|den, ...ope|ra|ti|on

Un|ter|lid

un|ter|lie|gen (ugs.); das Badetuch hat untergelegen; un|ter|lie|gen; er ist seinem Gegner unterlegen

Un|ter|lip|pe

un|term; ↑ R 240 (ugs. für: unter dem); - Dach

un|ter|ma|len; das gesprochene Wort wurde durch Musik untermalt; Un|ter|ma|lung w; -

Un|ter|mann (Artistik: unterster Mann einer Pyramide) m; -[e]s, ...männer

Un|ter|maß (selten für: nicht ausreichendes Maß) s

un|ter|mau|ern; er hat seine Be-weisführung gut untermauert; Un|ter|maue|rung

un|ter|mee|risch (in der Tiefe des Meeres befindlich)

un|ter|men|gen; die schlechte Ware wurde mit untergemengt; un-ter|men|gen (vermischen); untermengt mit ...

Un|ter|mensch m; Un|ter|men-schen|tum s; -s

Un|ter|mie|te; zur wohnen; Un|ter|mie|ter

un|ter|mi|nie|ren; die Stellung des Ministers war schon lange unterminiert; Un|ter|mi|nie|rung

un|ter|mi|schen; er hat das Wertlose mit untergemischt; un|ter-mi|schen; untermischt mit ...; Un-ter|mi|schung (von etwas Wertlosem); Un|ter|mi|schung (mit etwas)

un|ter|mo|to|ri|siert (mit einem zu schwachen Motor ausgestattet)

un|tern; ↑ R 240 (ugs. für: unter den); - Tisch stecken

Un|ter|näch|te landsch. (die Zwölf Nächte) Mehrz.

un|ter|neh|men (ugs. für: unter den Arm nehmen); er hat den Sack untergenommen; un|ter|neh-men; er hat nichts ohne ihren Rat unternommen; Un|ter|neh|men (s; -s, -), Un|ter|neh|mung; un-ter|neh|mend (aus, mit Unternehmungsgeist); -ste; Un|ter|neh-mens‿be|ra|tung, ...be|reich, ...lei-ter m, ...po|li|tik; Un|ter|neh|mer; Un|ter|neh|mer‿frei|heit, ...geist (m; -[e]s), ...ge|winn, Un|ter|neh-me|risch; Un|ter|neh|mer‿pfand-recht, ...schaft, ...tum (s; -s), ...ver-band; Un|ter|neh|mung vgl. Unternehmen; Un|ter|neh|mungs-‿geist (m; -[e]s), ...lust (w; -), un|ter-neh|mungs|lu|stig

Un|ter|of|fi|zier (Abk.: Uffz., in der Schweiz: Uof); Un|ter|of|fi-ziers¹‿mes|se, ...schu|le

un|ter|ord|nen; er ist ihm untergeordnet; un|ter|ord|nend; Un-ter|ord|nung

Un|ter|pfand

Un|ter|pfla|ster|stra|ßen|bahn (dafür kurz: U-Strab)

un|ter|pflü|gen; untergepflügt

Un|ter|pri|ma

un|ter|pri|vi|le|giert; Un|ter|pri|vi-le|gier|te m u. w (↑ R 287ff.) un-ter|que|ren; das Atom-U-Boot hat den Nordpol unterquert

un|ter|re|den, sich; du hast dich mit ihm unterredet; Un|ter|re|dung

un|ter|re|prä|sen|tiert; Frauen sind im Parlament -

un|ter|rich|ten; er ist gut unterrichtet; sich -; un|ter|richt|lich;

Un|ter|richts‿auf|ga|be, ...be-trieb (m; -[e]s), ...brief, ...ein|heit, ...fach, ...ge|gen|stand, ...me|tho|de (w; -); un|ter|richts|kund|lich; Un-ter|richts‿me|tho|de, ...pro-gramm, ...schritt, ...stun|de, ...wei|se w, ...we|sen (s; -s), ...ziel; Un|ter|rich|tung

Un|ter|rock

un|ter|rüh|ren; die Flüssigkeit wird vorsichtig untergerührt

un|ters; ↑ R 240 (ugs. für: unter das); - Bett

Un|ter|saat (Landw.: Zwischenfrucht)

un|ter|sa|gen; das Rauchen ist untersagt; Un|ter|sa|gung

Un|ter|satz; fahrbarer - (scherzh. für: Auto)

Un|ters|berg (Bergstock der Salzburger Kalkalpen) m; -[e]s; Un-ters|ber|ger Kalk|stein m; - -[e]s

un|ter|schät|zen; unterschätzt; Un-ter|schät|zung

un|ter|scheid|bar; un|ter|schei|den; die Bedeutungen müssen unterschieden werden; sich -; Un|ter-schei|dung; Un|ter|schei|dungs-‿merk|mal, ...ver|mö|gen

Un|ter|schen|kel

Un|ter|schicht

¹un|ter|schie|ben (darunterschieben); er hat ihr ein Kissen untergeschoben; ²un|ter|schie|ben, (auch:) un|ter|schie|ben; er hat ihm eine schlechte Absicht untergeschoben, (auch:) unterschoben; ein untergeschobenes Testament; Un|ter|schie|bung, (auch:) Un|ter|schie|bung

Un|ter|schied m; -[e]s, -e; zum - von; im - zu; un|ter|schie|den (verschieden); un|ter|schied|lich; Un-ter|schied|lich|keit; Un|ter-schieds|be|trag (für: Differenz); un|ter|schieds|los

un|ter|schläch|tig (durch Wasser von unten getrieben); ein -es Mühlrad

Un|ter|schlag (Schneidersitz; Druckw.: äußerstes [unteres] Ende der Seite) m; -[e]s, Unterschläge; un|ter|schla|gen; mit untergeschlagenen Beinen; un|ter|schla-gen (veruntreuen); er hat [die Beitragsgelder] unterschlagen; Un-ter|schla|gung

Un|ter|schleif (Unterschlagung) m; -[e]s, -e

un|ter|schlie|ßen (Druckw.); der Setzer hat hier und da ein Wort untergeschlossen

Un|ter|schlupf; un|ter|schlüp|fen od. (für: sich [vor Verfolgern, vor der Polizei] verbergen) un|ter-schlupfen; er ist untergeschlupft; die Hühner sind schon untergeschlüpft

un|ter|schnei|den (ein Bauglied auf

seiner Unterseite abschrägen);
das Gesims wurde unterschnitten
un|ter|schrei|ben; ich habe den
Brief unterschrieben; Un|ter-
schrei|bung
un|ter|schrei|ten; die Einnahmen
haben den Voranschlag unter-
schritten; Un|ter|schrei|tung
Un|ter|schrift; Un|ter|schrif|ten-
map|pe; un|ter|schrift|lich (selten
für: mit od. durch Unterschrift);
Un|ter|schrifts.be|stä|ti|gung,
...pro|be; un|ter|schrifts|reif
Un|ter|schuß (für: Defizit)
un|ter|schwef|li|ge Säu|re w; -n, -
un|ter|schwel|lig (unterhalb der
Bewußtseinsschwelle [liegend])
Un|ter|see (Teil des Bodensees) m;
-s
Un|ter|see|boot (Abk.: U-Boot,
U); Un|ter|see|boot|krieg (Abk.:
U-Boot-Krieg) (↑ R 148)
Un|ter|sei|te
Un|ter|se|kun|da
un|ter|set|zen; ich habe den Eimer
untergesetzt; un|ter|set|zen; un-
tersetzt (gemischt) mit ...; Un|ter-
set|zer (Schale für Blumentöpfe
u. a.); un|ter|setzt (von gedrunge-
ner Gestalt); Un|ter|setzt|heit w;
-; Un|ter|set|zung; Un|ter|set-
zungs|ge|trie|be
un|ter|sin|ken; das Schiff ist unter-
gesunken
un|ter|spickt österr. (mit Fett
durchzogen); -es Fleisch
un|ter|spie|len (als nicht so wichtig
hinstellen); die Meinungsver-
schiedenheiten wurden unter-
spielt
un|ter|spü|len; die Fluten hatten
den Damm unterspült
un|terst vgl. unterste
Un|ter|staats|se|kre|tär [auch:
un...]
Un|ter|stand; Un|ter|stän|der
(Stützbalken, -pfosten; Wap-
penk.: unterer Teil des Schildes);
un|ter|stän|dig (vom Fruchtkno-
ten, vom Baumwuchs, vom Feh-
ler am tierischen Körper); Un|ter-
stands|bau m; -[e]s, -ten; un|ter-
stands|los (österr. neben: ob-
dachlos)
un|ter|ste; der unterste Knopf,
a b e r (↑ R 116): das Unterste zu-
oberst, das Oberste zuunterst
kehren
un|ter|ste|hen (unter einem schüt-
zenden Dach stehen); er hat beim
Regen untergestanden; un|ter-
ste|hen; er verstand einem
strengen Lehrmeister; es hat
keinem Zweifel unterstanden (es
gab keinen Zweifel); du hast dich
unterstanden (gewagt); untersteh
dich [nicht], das zu tun!
un|ter|stel|len; ich habe den Wa-

gen untergestellt; sich -; ich habe
mich während des Regens unter-
gestellt; un|ter|stel|len; er ist
meinem Befehl unterstellt; man
hat ihm etwas unterstellt ([fälsch-
lich] behauptet, [Unbewiesenes]
als wahr angenommen); Un|ter-
stel|lung (Unterstellen); Un|ter-
stel|lung (befehlsmäßige Unter-
ordnung; [falsche] Behauptung)
un|ter|steu|ern (zu schwache Wir-
kung des Lenkradeinschlags zei-
gen); der Wagen ist untersteuert
Un|ter|stock; Un|ter|stock|werk
un|ter|stop|fen; ein untergestopf-
tes Kissen
un|ter|strei|chen; er hat mehrere
Wörter unterstrichen; er hat die-
se Behauptung nachdrücklich
unterstrichen (betont); (↑ R 120:)
etwas durch Unterstreichen her-
vorheben; Un|ter|strei|chung
Un|ter|strö|mung
Un|ter|stu|fe
un|ter|stüt|zen; er hat den Arm
[unter das Kinn] untergestützt;
un|ter|stüt|zen; er hat ihn mit
Geld unterstützt; der zu Unter-
stützende; Un|ter|stüt|zung; un-
ter|stüt|zungs|be|dürf|tig; Un|ter-
stüt|zungs.bei|hil|fe, ...emp|fän-
ger, ...geld, ...kas|se, ...satz
Un|ter|such (schweiz. neben: Un-
tersuchung) m; -s, -e; un|ter|su-
chen; der Arzt hat mich unter-
sucht; Un|ter|su|chung; Un|ter-
su|chungs.aus|schuß, ...be|fund,
...ge|fan|ge|ne, ...ge|fäng|nis,
...haft w (Abk.: U-Haft), ...me-
tho|de, ...rich|ter, ...sta|ti|on,
...ver|fah|ren
Un|ter|tag|ar|bei|ter, Un|ter|ta|ge-
ar|bei|ter; Un|ter|tag|bau, Un|ter-
ta|ge|bau m; -[e]s; un|ter|tags
österr. (tagsüber)
un|ter|tan (untergeben); Un|ter-
tan m; -s u. (älter:) -en, (Mehrz.:)
-en (↑ R 268); Un|ter|ta|nen.geist,
...pflicht, ...ver|stand (abschätzig;
m; -[e]s); un|ter|tä|nig (ergeben);
Un|ter|tä|nig|keit w; -
Un|ter|tas|se; fliegende -
un|ter|tau|chen; der Schwimmer
ist untergetaucht; der Verbrecher
war schnell untergetaucht (ver-
schwunden); un|ter|tau|chen; die
Robbe hat das Schleppnetz un-
tertaucht
Un|ter|teil s od. m; Un|ter|tei|len;
die Skala ist in 10 Teile unterteilt;
Un|ter|tei|lung
Un|ter|tem|pe|ra|tur
Un|ter|ter|tia
Un|ter|ti|tel; un|ter|ti|teln; ein un-
tertiteltes Foto
Un|ter|ton (Mehrz. ...töne)
un|ter|tou|rig (mit zu niedriger
Drehzahl); der Wagen darf nicht
- gefahren werden

un|ter|trei|ben; er hat untertrie-
ben; Un|ter|trei|bung
un|ter|tun|neln; ich ...[e]le (↑ R
327); der Berg wurde untertun-
nelt; Un|ter|tun|ne|lung
un|ter|ver|mie|ten; sie hat ein Zim-
mer untervermietet; Un|ter|ver-
mie|tung
un|ter|ver|si|chern (zu niedrig ver-
sichern); die Möbel sind unter-
versichert; Un|ter|ver|si|che|rung
Un|ter|wal|den nid dem Wald
(schweiz. Halbkanton; Kurz-
form: Nidwalden); Un|ter|wal-
den ob dem Wald (schweiz.
Halbkanton; Kurzform: Obwal-
den); Un|ter|wald|ner (↑ R 199);
un|ter|wald|ne|risch
un|ter|wan|dern (sich [als Fremder
od. heimlicher Gegner] unter eine
Gruppe mischen); das Volk, die
Partei wurde unterwandert; Un-
ter|wan|de|rung
un|ter|wärts
Un|ter|wä|sche w; -
un|ter|wa|schen; das Ufer ist -; Un-
ter|wa|schung
Un|ter|was|ser (Grundwasser) s;
-s; Un|ter|was|ser.be|hand|lung,
...ge|schoß, ...ka|me|ra, ...mas|sa-
ge, ...kraft|werk, ...streit|kräf|te
(Mehrz.)
un|ter|wegs (auf dem Wege)
un|ter|wei|len (veralt. für: biswei-
len; unterdessen)
un|ter|wei|sen; er hat ihn unterwie-
sen; Un|ter|wei|sung (schweiz.
auch für: Konfirmandenunter-
richt)
Un|ter|welt; un|ter|welt|lich
un|ter|wer|fen; sich -; das Volk
wurde unterworfen; du hast dich
dem Richterspruch unterworfen;
Un|ter|wer|fung
Un|ter|werks|bau (Bergmannspr.:
Abbau unterhalb der Fördersoh-
le) m; -[e]s
un|ter|wer|tig; Un|ter|wer|tig|keit
w; -
un|ter|win|den (veralt.); sich einer
Sache (Wesf.) -; unterwunden
un|ter|wür|fig [auch: un...]; in -er
Haltung; Un|ter|wür|fig|keit[1] w; -
un|ter|zeich|nen; er hat den Brief
unterzeichnet; sich -; Un|ter-
zeich|ner; Un|ter|zeich|ne|te m u.
w; -n, -n (↑ R 287ff.); die (Unter-
schriften:) der rechts, links Un-
terzeichnete od. der Rechts-,
Linksunterzeichnete; Un|ter-
zeich|nung
Un|ter|zeug (ugs.) s; -[e]s; un|ter-
zie|hen; ich habe eine wollene
Jacke untergezogen; un|ter|zie-
hen; du hast dich diesem Verhör
un|tief (seicht); Un|tie|fe (seichte
Stelle; geh., dicht. für: abgrund-
artige Tiefe)

Un|tier (Ungeheuer)
un|tilg|bar [auch: *un*...]
un|trag|bar [auch: *un*...]; Un|trag-
bar|keit[1] w; -
un|trai|niert
un|trenn|bar [auch: *un*...]
un|treu; Un|treue
un|tröst|lich [auch: *un*...]
un|trüg|lich [auch: *un*...]
Un|tu|gend
un|tun|lich (veraltend); Un|tun-
lich|keit (veraltend) w; -
un|über|biet|bar [auch: *un*...]
un|über|brück|bar [auch: *un*...]
un|über|legt; Un|über|legt|heit
un|über|schreit|bar [auch: *un*...]
un|über|seh|bar [auch: *un*...]
un|über|setz|bar [auch: *un*]
un|über|sicht|lich
un|über|steig|bar [auch: *un*...]
un|über|trag|bar [auch: *un*...]
un|über|treff|lich [auch: *un*...]; Un-
über|treff|lich|keit[1]; un|über|trof-
fen [auch: *un*...]
un|über|wind|bar [auch: *un*...]; un-
über|wind|lich [auch: *un*...]
un|üb|lich
un|um|gäng|lich [auch: *un*...] (un-
bedingt nötig); Un|um|gäng|lich-
keit[1] w; -
un|um|kehr|bar [auch: *un*...]
un|um|schränkt [auch: *un*...]
un|um|stöß|lich [auch: *un*...]; Un-
um|stöß|lich|keit[1]
un|um|strit|ten [auch: *un*...]
un|um|wun|den [auch: ...*wun*...]
(offen, freiheraus)
un|un|ter|bro|chen [auch: ...*bro*...]
un|ver|än|der|lich [auch: *un*...]; Un-
ver|än|der|lich|keit[1] w; -; un|ver-
än|dert [auch: ...*än*...]
un|ver|ant|wort|lich [auch: *un*...];
Un|ver|ant|wort|lich|keit[1]
un|ver|äu|ßer|lich [auch: *un*...]
un|ver|bes|ser|lich [auch: *un*...];
Un|ver|bes|ser|lich|keit[1] w; -
un|ver|bil|det
un|ver|bind|lich [auch: ...*bin*...];
Un|ver|bind|lich|keit[1]
un|ver|blümt [auch: *un*...] (offen;
ohne Umschweife)
un|ver|braucht
un|ver|brüch|lich [auch: *un*...]
un|ver|bürgt [auch: *un*...]
un|ver|däch|tig [auch: ...*däch*...]
un|ver|dau|lich [auch: ...*dau*...];
Un|ver|dau|lich|keit[1] w; -; un|ver-
daut [auch: ...*daut*]
un|ver|dient [auch: ...*dint*]; un|ver-
dien|ter|ma|ßen; un|ver|dien|ter-
wei|se
un|ver|dor|ben; Un|ver|dor|ben-
heit w; -
un|ver|dros|sen [auch: ...*dro*...]
un|ver|ehe|licht
un|ver|ein|bar [auch: *un*...]; Un|ver-
ein|bar|keit[1] w; -

un|ver|fälscht [auch: ...*fä*...]; Un-
ver|fälscht|heit[1] w; -
un|ver|fäng|lich [auch: ...*fä*...]
un|ver|fro|ren [auch: ...*fro*...]
(keck; frech); Un|ver|fro|ren|heit[1]
un|ver|gäng|lich [auch: ...*gäng*...];
Un|ver|gäng|lich|keit[1] w; -
un|ver|ges|sen; un|ver|geß|lich
[auch: *un*...]
un|ver|gleich|bar [auch: *un*...]; un-
ver|gleich|lich [auch: *un*...]
un|ver|go|ren; -er Süßmost
un|ver|hält|nis|mä|ßig [auch:
...*hält*...]
un|ver|hei|ra|tet (Zeichen: ∞)
un|ver|hofft [auch: ...*ho*...]
un|ver|hoh|len [auch: ...*ho*...]
un|ver|hüllt [auch: ...*üllt*]
un|ver|käuf|lich [auch: ...*käuf*...];
Un|ver|käuf|lich|keit[1]
un|ver|kenn|bar [auch: *un*...]
un|ver|langt; -e Manuskripte wer-
den nicht zurückgesandt
un|ver|letz|bar [auch: *un*...]; un|ver-
letz|lich [auch: *un*...]
un|ver|lier|bar [auch: *un*...]; -er Be-
sitz
un|ver|lösch|lich [auch: *un*...]
un|ver|mählt (Zeichen: ∞)
un|ver|meid|bar [auch: *un*...]; un-
ver|meid|lich [auch: *un*...]
un|ver|min|dert
un|ver|mit|telt; Un|ver|mit|telt-
heit w; -
Un|ver|mö|gen (Mangel an Kraft)
s; -s; un|ver|mö|gend; Un|ver|mö-
gend|heit (Armut) w; -; Un|ver-
mö|gen|heit (veralt. für: Kraft-
losigkeit; Nichtkönnen) w; -; Un-
ver|mö|gens|fall m; -[e]s; im -[e]
un|ver|mu|tet
Un|ver|nunft; un|ver|nünf|tig
un|ver|öf|fent|licht
un|ver|nutzt [auch: *utzt*]; der
Neubau ist noch -
un|ver|rich|tet; un|ver|rich|te|ter-
din|ge [auch: unverrichteter Din-
ge); un|ver|rich|te|ter|sa|che
(auch: unverrichteter Sache)
un|ver|rück|bar [auch: *un*...]
un|ver|schämt; Un|ver|schämt|heit
un|ver|schlos|sen [auch: ...*o*ß*n*]
un|ver|schul|det [auch: ...*schul*...]
un|ver|schul|de|ter|ma|ßen; un-
ver|schul|de|ter|wei|se
un|ver|se|hens [auch: ...*se*...]
(plötzlich)
un|ver|sehrt [auch: ...*sert*]; Un|ver-
sehrt|heit[1] w; -
un|ver|sieg|bar [auch: *un*...]; un-
ver|sieg|lich [auch: *un*...]
un|ver|söhn|lich [auch: ...*sön*...];
Un|ver|söhn|lich|keit[1] w; -
un|ver|sorgt
Un|ver|stand; un|ver|stan|den; un-
ver|stän|dig (unklug); Un|ver-
stän|dig|keit w; -; un|ver|ständ-

lich (undeutlich; unbegreiflich);
Un|ver|ständ|lich|keit w; -; Un-
ver|ständ|nis
un|ver|stellt [auch: ...*schtält*]
un|ver|steu|ert [auch: ...*schteu*...]
un|ver|sucht [auch: ...*sueht*]
un|ver|träg|lich [auch: ...*trä*...];
Un|ver|träg|lich|keit[1] w; -
un|ver|wandt; -en Blick[e]s
un|ver|wech|sel|bar [auch: *un*...]
un|ver|wehrt [auch: *un*...]
un|ver|weilt [auch: ...*wailt*]
un|ver|wes|lich [auch: ...*weß*...]
un|ver|wisch|bar [auch: *un*...]
un|ver|wund|bar [auch: *un*...]
un|ver|wüst|lich [auch: *un*...]
un|ver|zagt; Un|ver|zagt|heit w; -
un|ver|zeih|bar [auch: *un*...]; un-
ver|zeih|lich [auch: *un*...]
un|ver|zicht|bar [auch: *un*...]
un|ver|zins|lich [auch: *un*...]
un|ver|zollt
un|ver|züg|lich [auch: *un*...]
un|voll|en|det [auch: ...*än*...]
un|voll|kom|men [auch: ...*kom*...];
Un|voll|kom|men|heit[1]
un|voll|stän|dig [auch: ...*schtän*...];
Un|voll|stän|dig|keit[1] w; -
un|vor|be|rei|tet
un|vor|denk|lich; seit -en Zeiten
un|vor|ein|ge|nom|men; Un|vor-
ein|ge|nom|men|heit w; -
un|vor|greif|lich [auch: *un*...] (ver-
alt. für: unmaßgeblich, ohne dem
Urteil eines anderen vorgreifen
zu wollen); ,,Unvorgreifliche Ge-
danken" (eine Schrift von Leib-
niz)
un|vor|her|ge|se|hen
un|vor|schrifts|mä|ßig
un|vor|sich|tig; un|vor|sich|ti|ger-
wei|se; Un|vor|sich|tig|keit
un|vor|stell|bar [auch: *un*...]
un|vor|teil|haft
un|wäg|bar [auch: *un*...]
un|wahr; un|wahr|haf|tig; Un-
wahr|haf|tig|keit; Un|wahr|heit;
un|wahr|schein|lich; Un|wahr-
schein|lich|keit
un|wan|del|bar [auch: *un*...]; Un-
wan|del|bar|keit[1] w; -
un|weg|sam
un|weib|lich
un|wei|ger|lich [auch: *un*...]
un|weit; mit *Wesf.* od. mit „von";
- des Flusses od. - von dem Flusse
un|wert; Un|wert m; -[e]s
Un|we|sen s; -s; er trieb sein -; un-
we|sent|lich
Un|wet|ter
un|wich|tig; Un|wich|tig|keit
un|wi|der|leg|bar [auch: *un*...]; un-
wi|der|leg|lich [auch: *un*...]
un|wi|der|ruf|lich [auch: *un*...]
un|wi|der|spro|chen [auch: *un*...]
un|wi|der|steh|lich [auch: *un*...];
Un|wi|der|steh|lich|keit[1] w; -

un|wie|der|bring|lich [auch: ụn...];
Un|wie|der|bring|lich|keit[1] w; -
Ụn|wil|le[n] m; Unwillens; ụn|wil|lig; ụn|will|kom|men; ụn|will|kür|lich [auch: ...kǘr...]
ụn|wirk|lich; Ụn|wirk|lich|keit; ụn|wirk|sam; Ụn|wirk|sam|keit w; -
ụn|wirsch (unfreundlich); -[e]ste
(↑ R 292)
ụn|wirt|lich (unbewohnt, einsam;
unfruchtbar); eine -e Gegend;
Ụn|wirt|lich|keit w; -
ụn|wirt|schaft|lich; Ụn|wirt|schaft|lich|keit w; -
ụn|wis|send; -ste; Ụn|wis|sen|heit
w; -; ụn|wis|sen|schaft|lich; ụn|wis|sent|lich
ụn|wohl; ich bin -; mir ist -; - sein;
Ụn|wohl||sein; wegen -s
Ụn|wucht (ungleich verteilte Massen an einem Rad) w; -, -en
ụn|wür|dig; Ụn|wür|dig|keit w; -
Ụn|zahl (sehr große Zahl) w; -; un|zähl|bar [auch: ụn...]; un|zäh|lig
[auch: ụn...] (sehr viel); -e Notleidende; un|zäh|li|ge|mal, aber:
unzählige Male
un|zähm|bar [auch: ụn...]
[1]Un|ze lat. (Gewicht) w; -, -n
[2]Ụn|ze gr. (selten für: Jaguar) w;
-, -n
Ụn|zeit (unrechte Zeit) w, noch in:
zur -; ụn|zeit|ge|mäß; ụn|zei|tig
(auch vom Obst: unreif)
un|zen|siert
ụn|zen|wei|se
un|zer|brech|lich [auch: ụn...]; Unzer|brech|lich|keit[1] w; -
un|zer|reiß|bar [auch: ụn...]
un|zer|stör|bar [auch: ụn...]; Unzer|stör|bar|keit[1] w; -; ụn|zer|stört
un|zer|trenn|bar [auch: ụn...]; unzer|trenn|lich [auch: ụn...]
Un|zi|al|buch|sta|be; Un|zi|a|le lat.
(,,zoll"großer Buchstabe) w; -, -n;
Un|zi|al|schrift w; -
ụn|zie|mend; Ụn|zie|men|lich; Ụnziem|lich|keit
ụn|zi|vi|li|siert
Ụn|zucht w; -; ụn|züch|tig; Ụnzüch|tig|keit
ụn|zu|frie|den; Ụn|zu|frie|den|heit
w; -
ụn|zu|gäng|lich; Ụn|zu|gäng|lichkeit w; -
ụn|zu|kömm|lich österr. (unzulänglich; nicht ausreichend); eine
-e Nahrung; Ụn|zu|kömm|lich|keit
ụn|zu|läng|lich; Ụn|zu|läng|lichkeit
ụn|zu|läs|sig; Ụn|zu|läs|sig|keit w; -
ụn|zu|mut|bar; Ụn|zu|mut|bar|keit
ụn|zu|rech|nungs|fä|hig; Ụn|zurech|nungs|fä|hig|keit w; -
ụn|zu|rei|chend
ụn|zu|sam|men|hän|gend

[1] Vgl. Anm. S. 705, Sp. 3.

ụn|zu|stän|dig; Ụn|zu|stän|dig|keit
w; -
ụn|zu|träg|lich; Ụn|zu|träg|lichkeit
ụn|zu|tref|fend
ụn|zu|ver|läs|sig; Ụn|zu|ver|lässig|keit w; -
ụn|zweck|mä|ßig; Ụn|zweck|mäßig|keit
ụn|zwei|deu|tig; Ụn|zwei|deu|tigkeit w; -
ụn|zwei|fel|haft [auch: ...zwẹi...]
Ụpa|ni|schad sanskr. (Gruppe altind. philosophisch-theologischer
Schriften) w; -, ...schạden (meist
Mehrz.)
UPI [jupiai] = United Press International
Up|per|cut engl. [ạpᵉrkat] (Boxsport: Aufwärtshaken) m; -s, -s
üp|pig; Ụp|pig|keit
Ụpp|sa|la, (früher:) Ụp|sa|la
(schwed. Stadt); Ụpp|sa|la|er
[...aᵉr] (↑ R 199)
up to date engl. [ạp tu deᵢt]
(scherzh. für: zeitgemäß, auf der
Höhe)
Ụr (Auerochs) m; -[e]s, -e
Ụr|ab|stim|mung (Abstimmung
aller Mitglieder einer Gewerkschaft über die Ausrufung eines
Streiks; schweiz. für: schriftliche
Umfrage in einem Verein)
Ụr|adel
Ụr...ah|ne, ...ah|ne (Urgroßvater;
Vorfahr; m), ...ah|ne (Urgroßmutter; w)
Ural (Gebirge zwischen Asien u.
Europa; Fluß) m; -[s]; ural|al|taisch; -e Sprachen; Ural|ge|biet;
ura|lisch (aus der Gegend des
Ural)
ur|alt; Ụr|al|ter s; -s; von uralters
her (↑ R 129)
Ur|ämie gr. (Med.: Harnvergiftung) w; -; ur|ämisch (Med.: harnvergiftet)
Uran [nach dem Planeten Urạnus]
(chem. Grundstoff, Metall; Zeichen: U) s; -s; Urạn|berg|werk,
...bren|ner (svw. Reaktor), ...erz
Ụr|an|fang; ụr|an|fäng|lich
Ụr|angst
Ura|nia (Muse der Sternkunde;
Beiname der Aphrodite); Uranis|mus [nach Aphrodite Urania,
der nach der gr. Sage vom Gott
Uranos ohne Mithilfe einer Frau
erschaffenen Tochter] (Homosexualität) m; -; Ura|nist (Homosexueller); ↑ R 268; Urạn...mi|ne,
...pech|blen|de (radiumhaltiges
Mineral); Urạ|nos, [1]Ura|nus (gr.
Gott); [2]Ura|nus (Planet) m; -
ụrass|en österr. mdal. (verschwenden); du uraßt (urassest)
Urat gr. (Harnsäuresalz) s; -[e]s,
-e; ura|tisch (mit Harnsäure zusammenhängend)

ụr|auf|füh|ren; nur in der Grundform u. im 2. Mittelwort gebräuchlich: die Oper wurde uraufgeführt; Ụr|auf|füh|rung
Urä|us|schlan|ge gr.; dt. (afrik.
Hutschlange, als Sonnensymbol
am Diadem der altägypt. Könige)
ur|ban lat. (,,städtisch"; gebildet;
fein; höflich; weltmännisch); Ụrban (m. Vorn.); Ụr|ba|ni|sa|ti|on
[...zion]; ur|ba|ni|sie|ren (verstädtern); Ụr|ba|ni|sie|rung; Ụr|ba|nistik (Wissenschaft des Städtewesens) w; -; Ụr|ba|ni|tät (Bildung;
feines Wesen; Höflichkeit) w; -
ur|bar; - machen; Ụr|bar [auch: ụrbar]; s; -s, -e u. Ụr|ba|ri|um (veralt.
für: Grundbuch) s; -s, ...ien
[...iᵉn]; ur|ba|ri|sie|ren (schweiz.
neben: urbar machen); Ụr|ba|risie|rung schweiz. (Urbarmachung); Ụr|bar|ma|chung
Ụr|be|deu|tung
Ụr|be|ginn; von - der Welt
Ụr|be|stand|teil m
Ụr|be|völ|ke|rung
Ụr|be|woh|ner
ụr|bi et or|bi lat. [„der Stadt (d.
i. Rom) und dem Erdkreis"]; etwas - - - (allgemein) verkünden
Ụr|bild; ur|bild|lich
ụr|chig schweiz. (urwüchsig, echt);
-er, -ste
Ụr|chri|sten|tum; ụr|christ|lich
Ụrd (nord. Mythol.: Norne der
Vergangenheit)
Ụr|darm (erschlossene Urform in
Haeckels Entwicklungstheorie)
m; -[e]s; Ụr|darm|tier (für: Gasträa)
Ụr|du (eine neuind. Sprache,
Amtssprache in Pakistan) s; -
Ure|id gr. (jede vom Harnstoff abgeleitete chem. Verbindung) s;
-[e]s, -e
ur|ei|gen; ur|ei|gen|tüm|lich
Ụr|ein|woh|ner
Ụr|el|tern
Ụr|en|kel; Ụr|en|ke|lin
Ure|ter gr. (Med.: Harnleiter) m;
-s, ...teren (auch: -); Ure|thra
(Med.: Harnröhre) w; -, ...thren;
ure|tisch (Med.: harntreibend)
Ụr|fas|sung
Ụr|feh|de (im MA. eidliches Friedensversprechen mit Verzicht
auf Rache); - schwören
Ụr|form
Ụrft (r. Nebenfluß der Rur) w;
-; Ụrft|tal|sper|re w; -; ↑ R 201
ụr|ge|müt|lich; Ụr|ge|müt|lich|keit
w; -
ụr|gent lat. (selten für: unaufschiebbar, dringend); Ụr|genz
(selten für: Dringlichkeit) w; -,
-en
ụr|ger|ma|nisch
Ụr|ge|schich|te (allerälteste Ge

schichte; w; -); Ur|ge|schicht|ler;
ur|ge|schicht|lich
Ur|ge|stalt
Ur|ge|stein
Ur|ge|walt
ur|gie|ren *lat.* (bes. noch österr.
für: drängen; nachdrücklich be-
treiben)
Ur.groß|el|tern (*Mehrz.*), ...groß-
mut|ter; ur|groß|müt|ter|lich; Ur-
groß|va|ter; ur|groß|vä|ter|lich
Ur|grund
Ur|he|ber; Ur|he|be|rin w; -, -nen;
Ur|he|ber|recht; Ur|he|ber|schaft
w; -; Ur|he|ber|schutz
Uri (schweiz. Kanton)
Uria, Uri|as, (ökum.:), Uri|ja
(bibl. m. Eigenn.); vgl. Uriasbrief
Uri|an (unwillkommener Gast;
nur *Einz.*: Teufel) *m*; -s, -e
Uri|as vgl. Uria: Uri|as|brief
(Brief, der dem Überbringer Un-
heil bringt); Uri|el [...*iäl*] (einer
der Erzengel)
urig (urtümlich; komisch)
Uri|ja vgl. Uria
Ur|hei|mat
Urin *lat.* (Harn) *m*; -s, -e; Uri|nal
(Harnglas, -flasche) *s*; -s, -e; uri-
nie|ren (harnen); Urin|un|ter|su-
chung
Ur|in|stinkt
Ur|kan|ton (Kanton der Ur-
schweiz)
Ur|kir|che
ur|ko|misch
Ur|kraft
Ur|kun|de w; -, -n; ur|kun|den (in
Urkunden schreiben; urkundlich
erscheinen); Ur|kun|den.fäl-
schung, ...for|schung, ...leh|re,
...pro|zeß (Rechtsw.), ...samm-
lung; ur|kund|lich; Ur|kunds.be-
am|ter, ...re|gi|ster
Ur|land|schaft
Ur|laub *m*; -[e]s, -e; in od. im -
sein; ur|lau|ben; Ur|lau|ber; Ur-
laubs.dau|er, ...geld, ...ge|such,
...schein, ...sper|re, ...tag, ...zeit
Ur|meer
Ur|mensch *m*; ur|mensch|lich
Ur|me|ter (in Paris lagerndes, ur-
sprüngliches Normalmaß des
Meters) *s*; -s
Ur|mut|ter (Stammutter; *Mehrz.*
...mütter)
Ur|ne *lat.* ([Aschen]gefäß; Behäl-
ter für Stimm- und Wahlzettel)
w; -, -n; Ur|nen.feld, ...fried|hof,
...grab
Ur|ner (von Uri); ↑ R 199; - See
(Teil des Vierwaldstätter Sees);
ur|ne|risch (aus Uri)
Ur|ning (svw. Uranist) *m*; -s, -e
Uro|bi|lin *gr.*; *lat.* (Gallenfarbstoff
im Harn) *s*; -s; uro|ge|ni|tal (zu
den Harn- und Geschlechtsorga-
nen gehörend); Uro|ge|ni|tal|sy-
stem; Uro|lith *gr.* (Harnstein) *m*;

-s u. -en, -e[n] (↑ R 268); Uro|lo|ge
(Arzt für Krankheiten der Harn-
organe) *m*; -n, -n (↑ R 268); Uro-
lo|gie (Lehre von den Erkran-
kungen der Harnorgane) w; -;
uro|lo|gisch; Uro|sko|pie (Harn-
untersuchung) w; -, ...ien
Ur|pflan|ze
ur|plötz|lich
Ur|pro|duk|ti|on (Gewinnung von
Rohstoffen)
Ur|quell, Ur|quel|le
Urs (m. Vorn.)
Ur|sa|che; Ur|sa|chen|for|schung;
ur|säch|lich; Ur|säch|lich|keit
ur|schen ostmitteld. (vergeuden;
verschwenderisch umgehen); du
urschst (urschest)
Ur|schlamm
Ur|schleim
Ur|schrift; ur|schrift|lich
Ur|schweiz (Gebiet der ältesten
Eidgenossenschaft [Uri, Schwyz,
Unterwalden])
Ur|sel (Koseform von: Ursula)
Ur|sen|dung (erste Sendung, Erst-
aufführung im Funk od. Fernse-
hen)
Ur|se|ren|tal *s*; -[e]s, (auch:) Ur|se-
ren (Tal der oberen Reuß im Kan-
ton Uri); Urs|ner (↑ R 199)
urspr. = ursprünglich
Ur|spra|che
Ur|sprung; ur|sprüng|lich [auch:
...*schprüng*...] (Abk.: urspr.); Ur-
sprüng|lich|keit [auch: *ur*...] w; -;
Ur|sprungs.ge|biet, ...land,
...nach|weis, ...zeug|nis
Ur|stand (veralt. für: Urzustand)
m; -[e]s, Urständ; Ur|ständ (ver-
alt. für: Auferstehung) w; - noch
scherzh. in: fröhliche - feiern (aus
der Vergessenheit wieder auftau-
chen)
Ur|stoff; ur|stoff|lich
Ur|strom|tal
Ur|su|la (w. Vorn.); Ur|su|li|ne
[nach der hl. Ursula] w; -, -n u.
Ur|su|li|ne|rin (Angehörige eines
kath. Ordens) w; -, -nen; Ur|su|li-
nen|schu|le
Ur|teil *s*; -s, -e
Ur|teil|chen (Elementarteilchen)
ur|tei|len; Ur|teils|be|grün|dung;
ur|teils|fä|hig; Ur|teils.fä|hig|keit
(w; -), ...fin|dung, ...kraft w; ur-
teils|los, ...Ur|teils.rü|ge (veralt.
für: Revision), ...schel|te (Kritik
an einem Urteil), ...spruch, ...ver-
kün|dung, ...ver|mö|gen, ...voll-
streckung [*Trenn.*: ...strek|kung],
...voll|zug
Ur|text
Ur|tie|fe
Ur|tier|chen (einzelliges tierisches
Lebewesen)
Ur|trieb
ur|tüm|lich (ursprünglich; natür-
lich); Ur|tüm|lich|keit w; -

Ur|typ, Ur|ty|pus
[1]Uru|guay [...*guai*[1]] (Fluß in Süd-
amerika) *m*; -[s]; [2]Uru|guay[1]
(Staat in Südamerika); Uru|gua-
yer[1] (↑ R 199); uru|gua|yisch[1]
Ur.ur|.ahn, ...en|kel
Ur|va|ter (Stammvater); ur|vä|ter-
lich; Ur|vä|ter|zeit; seit -en
ur|ver|wandt; Ur|ver|wandt|schaft
Ur|viech, Ur|vieh (ugs. scherzh.
für: origineller Mensch)
Ur|vo|gel
Ur|volk
Ur.wahl, ...wäh|ler
Ur|wald; Ur|wald|ge|biet
Ur|welt; ur|welt|lich
ur|wüch|sig; Ur|wüch|sig|keit w; -
Ur|zeit; seit -en; ur|zeit|lich
Ur|zel|le
Ur|zeu|gung (elternlose Entste-
hung von Lebewesen)
Ur|zi|dil (österr. Schriftsteller)
Ur|zu|stand; ur|zu|ständ|lich
u. s. = ut supra
US[A] = United States [of Ameri-
ca] [*junaitid ßteʲz* (*ʷw ᵉmärikᵉ*)]
(Vereinigte Staaten [von Ameri-
ka]) *Mehrz.*; Nachrichten aus den
US[A]
Usam|ba|ra [auch: ...*bu*...] (Ge-
birgszug in Tanganjika); Usam-
ba|ra|veil|chen [auch: *..bu*...] (↑ R
201)
US-ame|ri|ka|nisch; ↑ R 150 u. R
137
Usance *fr.* [*üsangß*] (Brauch, Ge-
pflogenheit im Geschäftsver-
kehr) w; -, -n [...*ßᵉn*]; usance|mä-
ßig; Usan|cen|han|del (Devi-
senhandel in fremder Währung)
Us|be|ke (Angehöriger eines
Turkvolkes) *m*; -n, -n (↑ R 268);
us|be|kisch; Us|be|ki|sche SSR
(Unionsrepublik der UdSSR);
Us|be|ki|stan (kurz für: Usbeki-
sche SSR)
Use|dom (Insel in der Ostsee)
User *engl.* [*jusᵉr*] (gewohnheitsmä-
ßiger Drogenbenutzer) *m*; -s, -
usf. = und so fort
Uso *it.* ([Handels]brauch, Ge-
brauch, Gewohnheit) *m*, -s, vgl.
Usus
USSR = Ukrainische Sozialisti-
sche Sowjetrepublik
U-Strab (kurz für: Unterpflaster-
straßenbahn) w; -, -s
usu|ell *fr.* (gebräuchlich, üblich)
Usur|pa|ti|on *lat.* [...*zion*] (wider-
rechtliche Besitz-, Machtergrei-
fung); Usur|pa|tor (einer, der die Usurpa-
tion Erstrebender od. Durchfüh-
render; Thronräuber) *m*; -s,
...oren; usur|pa|to|risch; usur|pie-
ren; Usus ([Ge]brauch; Rechts-
brauch, Sitte) *m*; -

[1] Im Deutschen auch: *urugwai*
usw.

usw. = und so weiter

Utah [*jūta*] (Staat in den USA; Abk.: Ut.)

Ute (in der dt. Heldensage: Mutter der Nibelungenkönige; w. Vorn.)

Uten|sil [(notwendiges) Gerät, Gebrauchsgegenstand] *s*; -s, -ien [...*i*ⁿ*n*] (meist *Mehrz.*)

ute|rin *lat.* (Med.: auf die Gebärmutter bezüglich); Ute|rus (Med.: Gebärmutter) *m*; -, ...ri

Ut|gard (in der nord. Mythol.: Reich der Dämonen u. Riesen)

U Thant (birman. Politiker; ehem. Generalsekretär der UN)

uti|li|tär *lat.* (auf den Nutzen bezüglich); Uti|li|ta|ri|er [...*i*ⁿ*r*] (svw. Utilitarist); Uti|li|ta|ris|mus (Nützlichkeitslehre, -standpunkt) *m*; -; Uti|li|ta|rist (nur auf den Nutzen Bedachter, Vertreter des Utilitarismus; ↑ R 268; uti|li|ta|ri|stisch; Uti|li|tät (veralt. für: Nützlichkeit) *w*; -; Uti|li|täts|leh|re

Ut|lan|de („Außenlande"; Landschaftsbez. für die nordfries. Inseln, bes. die Halligen mit Pellworm u. Scharhörn) *Mehrz.*

Uto|pia, Uto|pi|en *gr.* [...*i*ⁿ*n*] (Nirgendland, erdachtes Land) *s*; -s (meist ohne Geschlechtswort); Uto|pie (als unausführbar geltender Plan ohne reale Grundlage, Schwärmerei, Hirngespinst) *w*; -, ...jen; Uto|pi|en vgl. Utopia; uto|pisch (schwärmerisch; unerfüllbar); -ste (↑ R 294); Uto|pis|mus (Neigung zu Utopien; utopische Vorstellung) *m*; -, ...men; Uto|pist (Schwärmer); ↑ R 268

Utra|quis|mus *lat.* (Lehre der Utraquisten) *m*; -; Utra|quist (Angehöriger einer hussitischen Richtung, die das Abendmahl in beiderlei Gestalt forderte); ↑ R 268; utra|qui|stisch

Ut|recht [niederl. Aussspr.: *üträeht*] (niederl. Provinz u. Stadt); Ut|rech|ter (↑ R 199)

Utril|lo [...*iljo*] (fr. Maler)

ut su|pra *lat.* (Musik: wie oben; Abk.: u. s.)

Utz (Kurzform von: Ulrich)

u. U. = unter Umständen

u. ü. V. = unter üblichem Vorbehalt

UV = ultraviolett (in: UV-Strahlen u. a.)

u. v. a. = und viele[s] andere

Uva lapis *indian.*; *dt.* [*ūwa*...] (Silber- od. Pampasgras, südamerik. Schmuckgras)

u. v. a. m. = und viele[s] andere mehr

UV-Filter (Fotogr.: Filter zur Dämpfung der ultravioletten Strahlen)

Uvi:ol:glas℗ [*uwi*...] (für ultravio-

lette Strahlen durchlässiges Glas) *s*; -es

UV-Lam|pe; ↑ R 150 (Höhensonne); UV-Strahlen; ↑ R 150 (Abk. für: ultraviolette Strahlen) *Mehrz.*; UV-Strah|lung (Höhenstrahlung) *w*; -

Uvu|la *lat.* [*ūwula*] (Med.: Gaumenzäpfchen) *w*; -, ...lae [...*lä*]

u. W. = unseres Wissens

Uwe (m. Vorn.)

Uz (ugs. für: Neckerei) *m*; -es, -e; Uz|bru|der (ugs. für: jmd., der gern andere neckt); uzen (ugs.); du uzt (uzest); Uz|rei (ugs.); Uz|name (ugs.)

u. zw. = und zwar

V

V (Buchstabe); das V; des V, die V, aber: das v in Steven (↑ R 123); der Buchstabe V, v

v = velocitas *lat.* [*welozi*...] (Geschwindigkeit)

V = chem. Zeichen für: Vanadin, Vanadium

V = Volt; Volumen (Rauminhalt)

V (röm. Zahlzeichen) = 5

V, vert. = vertatur

v. = vom; von; vor (vgl. d.)

v. = vide; vidi

V. = Vers

VA = Voltampere

Va. = ²Virginia

v. a. = vor allem

va banque *fr.* [*wabangk*] („es gilt die Bank"); - - spielen (alles aufs Spiel setzen); Va|banque|spiel *s*; -[e]s

va|cat *lat.* [*wakat*] („es fehlt"; nicht vorhanden, leer); vgl. Vakat

Vache|le|der *fr.*; *dt.* [*wasch*...] (glaciertes Sohlenleder)

Va|de|me|kum *lat.* [*wa*...] („geh mit mir"]; Taschenbuch; Leitfaden, Ratgeber) *s*; -s, -s

Va|di|um *germ.-mlat.* [*wa*...] (im älteren dt. Recht: Bürgschaftsgegenstand symbolischer Art; Anzahlung) *s*; -s, ...ien [...*i*ⁿ*n*]

va|dos *lat.* [*wa*...] (Geol.: in bezug auf Grundwasser: von Niederschlägen u. von Oberflächengewässern herrührend)

Va|duz [*faduz*, auch *waduz*] (Hptst. des Fürstentums Liechtenstein)

vae vic|tis! *lat.* [*wä wik*...] (wehe den Besiegten!)

vag vag. vage; Va|ga|bon|da|ge *fr.* [*wagabondasch*] (Landstreicherei) *w*; -; Va|ga|bund (Landstreicher) *m*; -en, -en (↑ R 268); Va|ga|bun|den.le|ben (*s*; -s), ...tum (*s*;

-s); va|ga|bun|die|ren ([arbeitslos] umherziehen, herumstrolchen); vagabundierende Ströme (Elektrotechnik); Va|gant (umherziehender, fahrender Student od. Kleriker im MA.) *m*; -en, -en (↑ R 268); Va|gan|ten.dich|tung, ...lied; va|ge [*wāg*ᵉ], vag [*wāk*] (unbestimmt; ungewiß); Vag|heit (Unbestimmtheit, Ungewißheit); va|gie|ren (geh.: umherschweifen, -ziehen; sich unruhig bewegen)

Va|gi|na *lat.* [*wa*...; auch: *wa*...] (Med.: weibl. Scheide) *w*; -, ...nen; va|gi|nal (die Scheide betreffend); Va|gi|nis|mus (Med.: Scheidenkrampf) *m*; -

Va|gus *lat.* [*wa*...] (ein Hirnnerv) *m*; -

va|kant *lat.* [*wa*...] (leer; erledigt, unbesetzt, offen, frei); Va|kanz (freie Stelle; mdal. für: Ferien) *w*; -, -en; Va|kat (Druckw.: leere Seite) *s*; -[s], -s; vgl. vacat; Va|kuo|le (Biol.: mit Flüssigkeit od. Nahrung gefülltes Bläschen im Zellplasma, insbesondere der Einzeller) *w*; -, -n; Va|ku|um (nahezu luftleerer Raum) *s*; -s, ...kua od. ...kuen; Va|ku|um.ap|pa|rat, ...brem|se, ...me|ter (Unterdruckmesser; *s*; -s, -), ...pum|pe ([Aus]saugpumpe), ...röh|re

Vak|zin *lat.* [*wak*...] (sww. Vakzine) *s*;; -s, -e; Vak|zi|na|ti|on [...*zion*], Vak|zi|nie|rung (Med. Schutzimpfung; früher nur: Impfung mit Kuhpockenlymphe); Vak|zi|ne (Med.: Impfstoff aus Krankheitserregern) *w*; -, -n; vak|zi|nie|ren; Vak|zi|nie|rung vgl. Vakzination

Va|land [*fa*...] (ältere Nebenform von: Voland)

va|le! *lat.* [*wale*] (lebe wohl!)

Va|len|cia [*walänzia*] (span. Stadt)

Va|len|ci|ennes|spit|ze [*walang ßiän*...; nach der fr. Stadt] (sehr feine Klöppelspitze mit Blumenmustern)

Va|lens [*wa*...] (röm. Kaiser); Va|len|tin (m. Vorn.); Va|len|ti|ne (w. Vorn.); Va|len|tins|tag (14. Febr.)

Va|lenz *lat.* [*wa*...] (Biol.: Stärke, Tüchtigkeit; Chemie: Wertigkeit; Sprachw.: Wertigkeit des Zeitwortes; Fähigkeit des Zeitwortes, Sinnergänzungen zu fordern, z. B. ich nenne „ihn einen Dummkopf") *w*; -, -en

Va|le|ri|an, Va|le|ri|a|nus [*wa*...] (m. Vorn.); Va|le|ri|a|na (Baldrian) *w*; -, ...nen; Va|le|rie [...*i*ᵉ] (w. Vorn.); Va|le|ri|us (röm. Kaiser)

Va|les|ka [*wa*...] (w. Vorn.)

¹Va|let *lat.* [*walät*, auch: *walet*]

(Lebewohl; veralteter Abschiedsgruß) *s*; -s, -s; - sagen, jmdm. das - geben

²**Va|let** *fr.* [*walé*] (Bube im fr. Kartenspiel) *m*; -s, -s

Va|leur *fr.* [*walör*] (veralt. für: Wert[papier]; Malerei [meist *Mehrz.*]: Ton-, Farbwerte, Abstufung von Licht u. Schatten) *m*; -s, -s (auch: *w*; -, -s)

val|le|ra! [*fa... od. wa...*]; **val|le|ri, val|le|ra!**

Va|lor *lat.* [*wa...*] (Kaufmannsspr. veralt.: Wert, Gehalt) *m*; -s; **Va|lo|ren** (Wertsachen, Schmucksachen, Wertpapiere) *Mehrz.*; **Va|lo|ren|ver|si|che|rung**; **Va|lo|ri|sa|ti|on** [*...zion*] (staatl. Preisbeeinflussung zugunsten der Produzenten); **va|lo|ri|sie|ren** (Preise durch staatl. Maßnahmen zugunsten der Produzenten beeinflussen); **Va|lo|ri|sie|rung** (svw. Valorisation)

Val|pa|rai|ser [*wal...*] (↑ R 199); **Val|pa|rai|so** [oft: *...raiso*] (Stadt in Chile)

Va|lu|ta *it.* [*wa...*] (Währungsgeld; [Gegen]wert) *w*; -, ...ten (Zinsscheine von ausländ. Effekten, deren Zinsen usw. in fremder Währung geleistet werden); **Va|lu|ta|an|lei|he**, ...**klau|sel**, ...**kre|dit**, ...**stand**; **va|lu|tie|ren** (ein Datum festsetzen, das für den Zeitpunkt der Leistung maßgebend ist; den Wert angeben, bewerten)

Val|va|ti|on *fr.* [*walwazion*] ([Ab]schätzung [von Münzen]; Wertbestimmung); **val|vie|ren** (veralt. für: valutieren)

Vamp *engl.* [*wämp*] (verführerische, kalt berechnende Frau) *m*; -s, -s; **Vam|pir** [*wam... od. ...pir*] (blutsaugendes Gespenst; Fledermausgattung; selten für: Wucherer, Blutsauger) *m*; -s, -e

van *niederl.* [*wan od. fan*] (von); z. B. - Dyck

Va|na|din, (auch:) **Va|na|di|um** [*wa...*] (chem. Grundstoff, Metall; Zeichen: V) *s*; -s

Van-Al|len-Gür|tel; ↑ R 182 [*wänälin...*; nach dem amerik. Physiker J. van Allen] (ein Strahlungsgürtel, der in großer Höhe um den Äquator der Erde liegt) *m*; -s

Van|cou|ver [*wänkuwᵉr*] (Insel u. Stadt in Kanada)

Van|da|le usw. vgl. Wandale usw.

Van-Dyck-Braun; ↑ R 182 [*wan... od. fandaik...*] *s*; -s; vgl. Đyck

Va|nil|le *lat.* [*wanil(j)ᵉ*] (trop. Orchideengattung; Gewürz) *w*; -; **Va|nil|le|eis**, ...**kip|ferl** (österr.: süßes Gebäck mit Vanille; *s*; -s, -n), ...**so|ße**, ...**zucker** [*Trenn.*: ...zuk|ker]; **Va|nil|lin** (Riechstoff; Vanilleersatz) *s*; -s

Va|peurs *fr.* [*wapörß*] (Blähungen; Launen) *Mehrz.*; **Va|po|ri|me|ter** *lat.*; *gr.* (Alkoholmesser) *s*; -s, -; **Va|po|ri|sa|ti|on** *lat.* [*...zion*], **Va|po|ri|sie|rung** (Med.: Anwendung von Wasserdampf zur Blutstillung) *w*; -; **va|po|ri|sie|ren** (verdampfen; den Alkoholgehalt in Flüssigkeiten bestimmen); **Va|po|ri|sie|rung** vgl. Vaporisation

var. = Varietät (bei naturwiss. Namen)

VAR = Vereinigte Arabische Republik; vgl. vereinigen

Var|an|ger|fjord [*wa...*] (der nordöstlichste Fjord in Norwegen) *m*; -[e]s

Va|rel [*fa...*] (Stadt in Niedersachsen)

Va|ria *lat.* [*wa...*] (Buchw.: Vermischtes, Mannigfaltiges, Allerlei) *Mehrz.*; **va|ria|bel** *fr.* (veränderlich, [ab]wandelbar, schwankend); ...a|ble Kosten; **Va|ria|bi|li|tät** (Veränderlichkeit); **Va|ria|ble** (Math.: veränderliche Größe) *w*; -n, -n; **Va|ri|an|te** (Abweichung, Abwandlung; verschiedene Lesart; Organismus mit abweichender Form, Abart, Spielart) *w*; -, -n; **Va|ri|a|ti|on** [*...zion*] (Abwechs[e]lung; Abänderung; Abwandlung); **Va|ria|ti|ons|brei|te**; **va|ria|ti|ons|fä|hig**; **Va|ria|ti|ons|mög|lich|keit**; **Va|rie|tät** [*wari-e...*] (Naturw.: geringfügig abweichende Art, Spielart; Abk.: var.); **Va|rie|té**[1] [*wari-ete*] (Gebäude, in dem ein buntes künstlerisches u. artistisches Programm gezeigt wird) *s*; -s, -s; **Va|rie|té|thea|ter**[1]; **va|ri|ie|ren** (verschieden sein; abweichen; verändern; [ab]wandeln)

va|ri|kös *lat.* [*wa...*] (Med.: krampfaderig; -este (↑ R 292); **Va|ri|ko|si|tät** (Med.: Krampfaderbildung); **va|ri|ko|ze|le** *lat.*; *gr.* (Med.: Krampfaderbruch) *w*; -, -n

Va|ri|nas [*wa...*, auch: *wari...*; nach der heutigen Stadt Barinas in Venezuela] (südamerik. Tabak) *m*; -, -

Va|rio|la *w*; -, ...olen u. **Va|rio|le** *lat.* [*wa...*] (Med.: Infektionskrankheit [Pocken]) *w*; -, -n; **Va|rio|la|ti|on** [*...zion*] (Pockenimpfung)

Va|rio|me|ter *lat.*; *gr.* [*wa...*] (Vorrichtung zur Messung von Luftdruck- od. erdmagnetischen Schwankungen) *s*; -s, -

Va|ris|ki|sche od. **Va|ris|zi|sche Ge|bir|ge** [*wa...* -] (mitteleurop. Gebirge der Steinkohlenzeit) *s*; -n -s

[1] In der Schweiz: Variété usw.

Va|ri|ty|per *engl.* [*wäritaipᵉr*] (auf dem Schreibmaschinenprinzip aufgebaute Setzmaschine) *m*; -s, -

Va|rix *lat.* [*wa...*] (Med.: Krampfader, Venenknoten) *w*; -, Vari|zen; **Va|ri|ze** (svw. Varix) *w*; -, -n; **Va|ri|zel|le** (Med.: Windpocken; meist *Mehrz.*) *w*; -, -n

Va|rus [*wa...*] (altröm. Feldherr)

Va|sall *fr.* [*wa...*] (Lehnsmann) *m*; -en, -en (↑ R 268); **Va|sal|len|staat** (*Mehrz.* ...staaten), ...**tum** (*s*; -s)

Väs|chen, **Väs|lein** [zu: Vase]

Vas|co da Ga|ma [*waßko* - - (port. Seefahrer)

Va|se *fr.* [*wa...*] ([Zier]gefäß) *w*; -, -n; **Vas|ek|to|mie** *lat.*; *gr.* (Med.: operative Entfernung eines Stückes des Samenleiters, Sterilisation) *w*; -, ...ien

Va|se|lin *s*; -s u. **Va|se|li|ne** [*wa...*] (mineral. Fett; Salbengrundlage) *w*; -

va|sen|för|mig [*wa...*]; **Va|sen|kun|de** *w*; -; **Va|sen|ma|le|rei**

Va|se|nol Ⓦ [*wa...*] (Salbengrundlage) *s*; -s; **Va|se|nol|pu|der** Ⓦ (med. Streupuder) *m*; -s

Väs|lein, **Väs|chen** [zu: Vase]; **Va|so|mo|to|ren** *lat.* (Med.: Gefäßnerven) *Mehrz.*; **va|so|mo|to|risch**

Va|ter *m*; -s, Väter; **Vä|ter|chen**, **Vä|ter|lein**; **Va|ter|fi|gur**, ...**haus**, ...**land** (*Mehrz.* ...länder); **va|ter|län|disch**; **Va|ter|lands|lie|be**, ...**los**; **Va|ter|lands|ver|tei|di|ger**; **Vä|ter|chen**; **vä|ter|lich**; ein -er Freund; das -e Handwerk; das -e Geschäft; **vä|ter|li|cher|seits**; **Vä|ter|lich|keit** *w*; -; **va|ter|los**; **Va|ter|lo|sig|keit** *w*; -; **Va|ter|mör|der** (ugs. auch für: hoher, steifer Kragen); **Va|ter|na|me**, **Va|ters|na|me** (Familien-, Zuname); **Va|ter|recht**; **Va|ters|bru|der**; **Va|ter|schaft** *w*; -; die natürliche -; **Va|ter|schafts|be|stim|mung**, ...**kla|ge**; **Va|ters|na|me** vgl. Vatername; **Va|ter|schwe|ster**, **Va|ters|schwe|ster**, ...**stadt**, ...**stel|le**; **Va|ter|un|ser** [auch: ...*un*...] *s*; -s, -; er als das Gebet: Vater unser, der du bist ...; **Va|ti** (Koseform von: Vater) *m*; -s, -s

Va|ti|kan *lat.* (Papstpalast in Rom; ugs. für: oberste Behörde der kath. Kirche) *m*; -s; **va|ti|ka|nisch**, aber (↑ R 224): die Vatikanische Bibliothek, das Vatikanische Konzil; **Va|ti|kan|stadt** *w*; -

Vau|de|ville *fr.* [*wodᵉwil*] (fr. volkstüml. Lied; Singspiel) *s*; -s, -s

Vaughan Wil|li|ams [*wǎn "ili͏ᵉms*], Ralph [*rǟlf*] (engl. Komponist)

V-Aus|schnitt (↑ R 149)

v. Chr. = vor Christo, vor Christus; **v. Chr. G.** = vor Christi Geburt

v. d. = vor der (bei Ortsnamen, z. B. Bad Homburg v. d. H. [vor der Höhe])

VDE = Verband Deutscher Elektrotechniker; VDE-geprüft (↑ R 150 u. R 137)

VDI = Verein Deutscher Ingenieure

VdK = Verband der Kriegsbeschädigten, Kriegshinterbliebenen und Sozialrentner

VDM = Verbi Divini Minister od. Ministra *lat.* schweiz. (ordinierter reformierter Theologe od. ordinierte reformierte Theologin)

VDS = Verband deutscher Studentenschaften

vdt. = vidit

VEB = volkseigener Betrieb (DDR); vgl. volkseigen

Vech|te [*fãcht*°] (ein Fluß) *w*; -

Ve|da [*we*...] vgl. Weda

Ve|de|te *fr.* [*we*...] (svw. ²Star; früher für: vorgeschobener Reiterposten, Feldwache) *w*; -, -n

ve|disch [*we*...] vgl. wedisch

Ve|du|te *it.* [*we*...] (Malerei: naturgetreue Darstellung einer Landschaft) *w*; -, -n

ve|ge|ta|bil [*we*...] vgl. vegetabilisch; **Ve|ge|ta|bi|li|en** *lat.* [...*bili-*°*n*] (pflanzl. Nahrungsmittel) *Mehrz.*; **ve|ge|ta|bi|lisch** (pflanzlich, Pflanzen...); **Ve|ge|ta|ria|ner** (svw. Vegetarier); **Ve|ge|ta|ri|er** [...*i*°*r*] (Pflanzenkostesser); **ve|ge|ta|risch** (pflanzlich, Pflanzen...); **Ve|ge|ta|ris|mus** (Ernährung durch Pflanzenkost) *m*; -; **Ve|ge|ta|ti|on** [...*zion*] (Pflanzenwelt, -wuchs); **Ve|ge|ta|ti|ons|ge|biet**, ...ge|schich|te (*w*; -), ...kult, ...kun|de (*w*; -), ...or|gan, ...pe|ri|ode, ...punkt; **ve|ge|ta|tiv** (zur Vegetation gehörend, pflanzlich; ungeschlechtlich; Med.: dem Willen nicht unterliegend, unbewußt); -es Nervensystem (dem Einfluß des Bewußtseins entzogenes Nervensystem); -e Vermehrung (eine Form der ungeschlechtl. Fortpflanzung); **ve|ge|tie|ren** (kümmerlich, kärglich [dahin]leben)

ve|he|ment *lat.* [*we*...] (heftig, ungestüm); **Ve|he|menz** *w*; -

Ve|hi|kel *lat.* [*we*...] (ugs. für: schlechtes, altmodisches Fahrzeug; Med.: wirkungsloser Stoff, in dem die wirksame Arznei gelöst od. verteilt ist) *s*; -s, -

Vei|ge|lein (veraltet für: Veilchen)

Vei|gerl bayr., österr. (Veilchen) *s*; -s, -n; **Veil|chen**; vgl. aber:

Feilchen; **veil|chen|blau; Veil|chen|duft**, ...wur|zel

Veit [*fait*] (m. Vorn.); vgl. Vitus; **Veits|boh|ne**, ...tanz (Nervenleiden; *m*; -es)

Vek|tor *lat.* [*wãk*...] (physikal. od. math. Größe, die durch Pfeil dargestellt wird u. durch Angriffspunkt, Richtung und Betrag festgelegt ist) *m*; -s, ...*oren*; **vek|to|ri|ell**; **Vek|tor|rech|nung**

Ve|la (*Mehrz.* von: Velum); **Ve|lar** *lat.* [*we*...] (Sprachw.: Gaumengellaut, Hintergaumenlaut, z. B. k [bes. vor u und o]) *m*; -s, -e

Ve|laz|quez [*welãßkäß*], (span. Schreibung:) **Ve|láz|quez** [...*qthkäth*] (span. Maler)

Ve|lin *fr.* [*we*..., auch fr. Ausspr.: *welãng*] (weiches Pergament; ungeripptes Papier) *s*; -s

Ve|lo [*welo*; verkürzt aus: Veloziped] schweiz. (Fahrrad) *s*; -s, -s; **Velo fahren** (radfahren); **Ve|lo|drom** [geschlossene] Radrennbahn) *s*; -s, -e; **Ve|lo|fah|ren** *s*; -s

Ve|lour *fr.* [*w*°*lur*, auch: *welur*] (fachspr. svw. ²Velours) *s*; -s, -s od. -e; **Ve|lour|le|der** (fachspr. svw. Veloursleder); **¹Ve|lours** [*w*°*lur*, auch: *welur*] (Samt; Gewebe mit gerauhter, weicher Oberfläche) *m*; - [*w*°*lurß*], - [*w*°*lurß*]; **²Ve|lours** [*w*°*lur*, auch: *welur*] (samtartiges Leder) *s*; - [*w*°*lurß*] - [*w*°*lurß*]; **Ve|lours|le|der**, ...tep|pich; **Ve|lo|zi|ped** *fr.* [*we*...] (veralt. für: Fahrrad) *s*; -[e]s, -e; **Ve|lo|zi|pe|dist** (veralt.)

Vel|pel *it.* [*fãl*...] (Nebenform von: Felbel) *m*; -s, -

Vel|ten [*fãl*...] (Kurzform von: Valentin); potz -! (veralt.)

Velt|lin [*wãlt*...; auch, bes. schweiz.: *fãlt*...] (Talschaft oberhalb des Comer Sees) *s*; -s; **¹Velt|li|ner** (↑ R 199); - Wein; **²Velt|li|ner** (Wein)

Ve|lum *lat.* [*we*...] ("Segel"; Teil der gottesdienstl. Kleidung kath. Priester; Kelchtuch; weicher Gaumen) *s*; -s, ...la; **Ve|lum pa|la|ti|num** (Med.: "Gaumensegel"; weicher Gaumen) *s*; - -, ...la ...na

Vel|vet *engl.* [*wãlw*°*t*] (Baumwollsamt) *m* od. *s*; -s, -s

Ven|dee [*wangde*], (fr. Schreibung:) **Ven|dée** (fr. Departement) *w*; -; **Ven|deer** (↑ R 199 u. R 205 Merke); **Ven|de|mi|aire** *fr.* [*wangd°miãr*] ("Weinmonat" der Fr. Revolution: 22. Sept. bis 21. Okt.) *m*; -[s], -s

Ven|det|ta *it.* [*wãn*...] ([Blut]rache) *w*; -, ...tten

Ve|ne *lat.* [*we*...] (Blutader) *w*; -, -n

Ve|ne|dig [*we*...] (it. Stadt); vgl. Ve-

nezia; **Ve|ne|di|ger|grup|pe** (Gebirgsgruppe) *w*; -

Ve|nen|ent|zün|dung [*we*...]

Ve|ne|ra|bi|le *lat.* [*we*...] (Allerheiligstes in der kath. Kirche) *s*; -[s]

ve|ne|risch [vom Namen der Venus; *we*...] (geschlechtskrank; auf die Geschlechtskrankheiten bezogen); -e Krankheiten

Ve|ne|ter [*we*...] (Bewohner von Venetien); **Ve|ne|ti|en** [...*zi*°*n*] (it. Region); **Ve|ne|zia** (it. Form von: Venedig); **Ve|ne|zia|ner**; ↑ R 199 (Bewohner von Venedig); **ve|ne|zia|nisch**

Ve|ne|zo|la|ner [*we*...] (↑ R 199); **ve|ne|zo|la|nisch**; **Ve|ne|zue|la** (Staat in Südamerika)

Ve|nia le|gen|di *lat.* [*we*... -] (Erlaubnis, an Hochschulen zu lehren) *w*; - -

ve|ni, vi|di, vi|ci *lat.* [*weni, widi, wizi*] (ich kam, ich sah, ich siegte)

Venn [*fän*] *s*; -s; (↑ R 199:) Hohes Venn (Teil der Eifel)

Ven|ner [*fã*...] schweiz. (ein Grad bei den Pfadfindern; hist.: Fähnrich; Bezirkskommandant) *m*; -s, -

ve|nös *lat.* [*we*...] (Med.: die Vene[n] betreffend; venenreich); -este (↑ R 292)

Ven|til *lat.* [*wän*...] (Absperrvorrichtung; Luft-, Dampfklappe) *s*; -s, -e; **Ven|ti|la|ti|on** [...*zion*] (Lüftung, Luftwechsel); **Ven|ti|la|tor** *m*; -s, ...oren; **ven|ti|lie|ren** (lüften; übertr.: sorgfältig erwägen); **Ven|ti|lie|rung**; **Ven|til|kol|ben**, ...steue|rung; **Ven|tose** *fr.* [*wangtos*] ("Windmonat" der Fr. Revolution: 19. Febr. bis 20. März) *m*; -[s], -s

ven|tral *lat.* [*wän*...] (den Bauch betreffend; bauchwärts); **Ven|tri|kel** (Med.: Kammer [in Herz, Hirn usw.]) *m*; -s, -; **ven|tri|ku|lar** (den Ventrikel betreffend); **Ven|tri|lo|quist** (Bauchredner); ↑ R 268

¹Ve|nus [*we*...] (röm. Liebesgöttin); **²Ve|nus** (ein Planet) *w*; -; **Ve|nus|berg**; ↑ R 180; **Ve|nus|son|de** (Raumsonde zur Erforschung des Planeten Venus)

ver... (*Vorsilbe von Zeitwörtern*, z. B. verankern, du verankerst, verankert, zu verankern; zum 2. Mittelw. ↑ R 304)

Ve|ra [*wera*] (w. Vorname)

ver|aa|sen (ugs. für: verschleudern, vergeuden)

ver|ab|fol|gen (aus-, abgeben)

ver|ab|re|den; **ver|ab|re|de|ter|ma|ßen**; **Ver|ab|re|dung**

ver|ab|rei|chen; **Ver|ab|rei|chung**

ver|ab|säu|men (besser nur: versäumen)

ver|ab|scheu|en; ver|ab|scheu|ens|wert; Ver|ab|scheu|ung; ver|ab|scheu|ungs|wür|dig
ver|ab|schie|den; Ver|ab|schie|dung
ver|ab|so|lu|tie|ren; Ver|ab|so|lu|tie|rung
ver|ach|ten; ver|ach|tens|wert; Ver|äch|ter; ver|ächt|lich; Ver|ächt|lich|ma|chung w; -; Ver|ach|tung w; -; ver|ach|tungs|voll
Ve|ra|cruz (eindeutschend.) Ve|ra|kruz [werakruß] (Staat u. Stadt in Mexiko)
Ver|ähn|li|chung
ver|al|bern (ugs.); Ver|al|be|rung (ugs.)
ver|all|ge|mei|nern; ich ...ere (↑ R 327); Ver|all|ge|mei|ne|rung
ver|al|ten
Ve|ran|da engl. [we...] (überdachter u. an den Seiten verglaster Anbau, Vorbau) w; -, ...den; ve|ran|da|ar|tig (↑ R 148); Ve|ran|da|auf|gang (↑ R 148)
ver|än|der|bar; ver|än|der|lich; Ver|än|der|lich|keit; Ver|än|der|li|che (eine mathemat. Größe, deren Wert sich ändern kann; Ggs.: Konstante) w; -n, -n (↑ R 287 ff.); ver|än|dern; sich -; Ver|än|de|rung
ver|äng|sti|gen; ver|äng|stigt
ver|an|kern; Ver|an|ke|rung
ver|an|la|gen (einschätzen); ver|an|lagt; gut, schlecht, künstlerisch - sein; Ver|an|la|gung (Einschätzung; Begabung); Ver|an|la|gungs_steu|er w, ...ver|fah|ren
ver|an|las|sen; du veranlaßt (veranlassest), er veranlaßt; du veranlaßtest; veranlaßt; veranlasse!; sich veranlaßt sehen; Ver|an|las|sung; Ver|an|las|sungs (Amtsdt.:) zur weiteren - (Abk.: z. w. V.); Ver|an|las|sungs|wort (für: Kausativ; Mehrz. ...wörter)
ver|an|schau|li|chen; Ver|an|schau|li|chung
ver|an|schla|gen; du veranschlagtest; er hat die Kosten falsch veranschlagt; Ver|an|schla|gung
ver|an|stal|ten; Ver|an|stal|ter; Ver|an|stal|tung
ver|ant|wor|ten; ver|ant|wort|lich; [voll] - sein für etwas; ein -er Ingenieur; eine -e Stellung; Ver|ant|wort|lich|keit w; -; Ver|ant|wor|tung; ver|ant|wor|tungs_be|wußt, ...freu|dig; Ver|ant|wor|tungs|ge|fühl s; -[e]s; ver|ant|wor|tungs|los; Ver|ant|wor|tungs|lo|sig|keit w; -; ver|ant|wor|tungs|voll
ver|äp|peln (ugs. für: verhöhnen); ich ...[e]le ihn (↑ R 327)
ver|ar|beit|bar; Ver|ar|beit|bar|keit w; -; ver|ar|bei|ten; Ver|ar|bei|tung
ver|ar|gen
ver|är|gern; Ver|är|ge|rung

ver|ar|men; Ver|ar|mung
ver|ar|schen (derb für: jmdn. zum besten haben, verspotten)
ver|arz|ten (ugs. scherzh. für: [ärztl.] behandeln); Ver|arz|tung (ugs.) w; -
ver|aschen (Chemie: ohne Flamme verbrennen)
ver|ästeln, sich; der Baum verästelt sich; Ver|äste|lung, Ver|äst|lung
Ve|ra|trin lat. [we...] (Alkaloidgemisch aus weißer Nieswurz) s; -s
ver|auk|tio|nie|ren (versteigern); Ver|auk|tio|nie|rung
ver|aus|ga|ben (ausgeben); sich -; Ver|aus|ga|bung
ver|aus|la|gen ([Geld] auslegen); Ver|aus|la|gung
ver|äu|ßer|lich (verkäuflich); ver|äu|ßer|li|chen (äußerlich, oberflächlich machen, werden); Ver|äu|ßer|li|chung; ver|äu|ßern (verkaufen); Ver|äu|ße|rung
Verb lat. [wärp] (Sprachw.: Zeitwort, Tätigkeitswort, z. B. „arbeiten, laufen, bauen") s; -s, -en; ver|bal (zeitwörtlich, als Zeitwort gebraucht; wörtlich; mündlich; - e Klammer; Ver|ba|le (Sprachw.: von einem Zeitwort abgeleitetes Wort; veralt. für: wörtl. Äußerung) s; -s, ...lien [...iᵉn] (meist Mehrz.); Ver|bal|in|ju|rie [wärbalinjuriᵉ] (Beleidigung mit Worten); Ver|ba|lis|mus (Vorherrschaft des Wortes statt der Sache im Unterricht) m; -; Ver|ba|list (jemand, der sich zu sehr ans Wort klammert); ↑ R 268; ver|ba|li|stisch; ver|ba|li|ter (veralt. für: wörtlich)
ver|bal|no|te lat. [wär...] (zu mündlicher Mitteilung bestimmte, nicht unterschriebene, vertrauliche diplomatische Note); Ver|bal|stil (Stil, der das Zeitwort, das Verb, bevorzugt; Ggs.: Nominalstil); Ver|bal|sub|stan|tiv (zu einem Verb gebildetes Substantiv, das [zum Zeitpunkt der Bildung] eine Geschehensbez. ist, z. B. „Gabe, Zerrüttung")
Ver|band m; -[e]s, ...bände; Ver|bands|kas|se; Ver|band[s]|ka|sten; Ver|bands|lei|ter m; Ver|band[s]_ma|te|ri|al, ...päck|chen, ...platz, ...stoff; Ver|bands|vor|sit|zen|de; Ver|band[s]_wat|te, ...zeug (s; -[e]s), ...zim|mer
ver|ban|nen; Ver|ban|nung
ver|bar|ri|ka|die|ren; Ver|bar|ri|ka|die|rung
Ver|bas|kum lat. [wär...] (Königskerze, Wollkraut) s; -s, ...ken

ver|bau|en
ver|bau|ern (ugs. für: [geistig] abstumpfen); ich ...ere (↑ R 327); Ver|baue|rung (ugs.) w; -
ver|bau|ung
ver|be|am|ten; Ver|be|am|tung w; -
ver|bei|ßen; die Hunde hatten sich ineinander verbissen; sich den Schmerz - (ugs. für: sich den Schmerz nicht anmerken lassen); sich in eine Sache - (ugs. für: hartnäckig an einer Sache festhalten)
ver|bel|len (Jägerspr.: den Jäger durch Bellen zum verwundeten od. verendeten Wild hinführen); tot -
Ver|be|ne lat. [wär...] (Eisenkraut) w; -, -n
ver|ber|gen; ver|ber|gung
ver|bes|se|rer, Ver|beß|rer; ver|bes|sern; Ver|bes|se|rung, Ver|beß|rung
ver|beu|gen, sich; Ver|beu|gung
ver|beu|len
ver|bie|gen; Ver|bie|gung
ver|bie|stern, sich (ugs. für: sich in eine Meinung verrennen); ich ...ere mich (↑ R 327); ver|bie|stert (ugs. für: verwirrt, verstört, verärgert)
ver|bie|ten; Betreten verboten!; vgl. verboten
ver|bil|den; ver|bild|li|chen; Ver|bild|li|chung; Ver|bil|dung
ver|bil|li|gen; Ver|bil|li|gung
ver|bim|sen (ugs. für: verprügeln)
ver|bin|den; ver|bind|lich (höflich, zuvorkommend; Kaufmannsspr.: verpflichtend); eine -e Zusage; Ver|bind|lich|keit; ver|bind|lich|keits|er|klä|rung; Ver|bin|dung; Ver|bin|dungs_gra|ben, ...li|nie, ...mann (Mehrz. ...männer u. ...leute; Abk.: V-Mann), ...of|fi|zier, ...stück, ...tür
ver|bis|sen; er ist ein -er (zäher) Gegner; ein -es (griesgrämiges, zorniges) Gesicht; Ver|bis|sen|heit w; -
ver|bit|ten; ich habe mir eine solche Antwort verbeten
ver|bit|tern; ich ...ere (↑ R 327), Ver|bit|te|rung
ver|bla|sen (schwülstig, verschwommen); ein -er Stil; Ver|bla|sen|heit
ver|blas|sen; du verblaßt (verblassest); die Erinnerungen an die Kindheit sind verblaßt
ver|blät|tern; eine Seite -
Ver|bleib m; -[e]s; ver|blei|ben; Ver|blei|ben s; -s; dabei muß es sein - haben (Papierdt.)
ver|blei|chen (bleich werden); du verblichst (verblichest); du verblichest; verblichen; vgl. ²blei|chen
ver|blei|en (mit Blei versehen, auslegen; auch für: plombieren [mit

einer Bleiplombe versehen]);
Ver|blei|ung
ver|blen|den (auch: [Mauerwerk
mit besserem Baustoff] verklei-
den); Ver|blen|dung
ver|bleu|en (ugs. für: verprügeln)
ver|bli|chen; -es Bild; Ver|bli|che-
ne (Tote) m u. w; -n, -n (↑ R 287ff.)
ver|blö|den; Ver|blö|dung w; -
ver|blüf|fen (bestürzt machen);
ver|blüf|fend; -ste; Ver|blüfft|heit
w; -; Ver|blüf|fung
ver|blü|hen
ver|blümt (andeutend)
ver|blu|ten; sich -; Ver|blu|tung
ver|bocken [Trenn.: ...bok|ken]
(ugs. für: fehlerhaft ausführen;
verderben, verpfuschen)
Ver|bod|mung (Bodmerei)
ver|bo|gen; -es Blech
ver|bohrt; er ist - (ugs. für:
starrköpfig); Ver|bohrt|heit w; -
¹ver|bor|gen (ausleihen)
²ver|bor|gen; eine -e Gefahr; (↑ R
133:) im verborgenen (unbe-
merkt) bleiben, aber (↑ R 116):
Gott, der im Verborgenen
wohnt, das Verborgene, ins Ver-
borgene sieht; Ver|bor|gen|heit
w; -
ver|bö|sern (scherzh. für: böser,
schlimmer machen); ich ...ere
(↑ R 327)
Ver|bot s; -[e]s, -e; ver|bo|ten; -er
Eingang; -e Früchte; ver|bo|te-
ner|wei|se; Ver|bots|schild
(Mehrz. ...schilder), ...ta|fel; ver-
bots|wid|rig; Ver|bots|zeit
ver|brä|men (am Rand verzieren;
übertr. für: [eine Aussage] ver-
schleiern, verhüllen); Ver|brä-
mung
Ver|brauch m; -[e]s, (gelegentl.
fachspr.:) ...bräuche; ver|brau-
chen; Ver|brau|cher; Ver|brau-
cher_ge|nos|sen|schaft (für: Kon-
sumgenossenschaft), ...preis (vgl.
²Preis); Ver|brauchs_ge|gen-
stand, ...gü|ter (Mehrz.), ...len-
kung (w; -), ...pla|nung; Ver-
brauchs|steu|er, Ver|brauch|steu-
er w (↑ R 334)
ver|bre|chen; Ver|bre|chen s; -s, -;
Ver|bre|chens|be|kämp|fung w; -;
Ver|bre|cher; Ver|bre|cher|al-
bum; Ver|bre|che|rin w; -, -nen;
ver|bre|che|risch; -ste (↑ R 294);
Ver|bre|cher|tum s; -s
ver|brei|ten; er hat diese Nachricht
verbreitet; die feindlichen Maß-
nahmen hatten überall Furcht
und Schrecken verbreitet; sich -
(etwas ausführlich darstellen);
Ver|brei|ter; ver|brei|tern (breiter
machen); ich ...ere (↑ R 327); sich
- (breiter werden); Ver|brei|te-
rung; Ver|brei|tung; Ver|brei-
tungs|ge|biet
ver|bren|nen; das

Holz ist verbrannt; du hast dir
den Mund verbrannt (ugs. für:
dir durch Reden geschadet); Ver-
bren|nung; Ver|bren|nungs_ma-
schi|ne, ...mo|tor
ver|brie|fen ([urkundlich] sicher-
stellen); ein verbrieftes Recht;
Ver|brie|fung
ver|brin|gen
ver|brü|dern, sich; ich ...ere mich
(↑ R 327); Ver|brü|de|rung
ver|brü|hen; Ver|brü|hung
ver|bu|chen (in das [Geschäfts-]
buch eintragen); dafür meist: bu-
chen (vgl. ²buchen); Ver|bu-
chung
ver|bud|deln (ugs. für: vergraben);
Ver|bum lat. [wär...] (svw. Verb)
s; -s, ...ba u. ...ben
ver|bum|fie|deln (ugs. für: ver-
schwenden); ich ...[e]le (↑ R 327)
ver|bum|meln; er hat seine Zeit ver-
bummelt (ugs. für: nutzlos ver-
tan); ver|bum|melt (ugs. für: her-
untergekommen); ein -es Genie
Ver|bund (Verbindung) m; -[e]s;
ver|bün|den, sich; Ver|bun|den-
heit w; -; - mit etwas od. jmdm.;
Ver|bün|de|te m u. w; -n, -n (↑ R
287ff.); Ver|bund_glas (s; -es),
...kar|te (im Lochkartensystem),
...lam|pe (Bergmannsspr.: elektr.
Lampe in Verbindung mit einer
Wetterlampe), ...ma|schi|ne,
...netz (die miteinander verbun-
denen Hochspannungsleitun-
gen), ...sy|stem, ...wirt|schaft
(moderne Wirtschaftsform, bei
der Energie u. Rohstoffe der ver-
schiedenen Erzeugungsstätten
und Fabriken ausgeglichen wer-
den)
ver|bür|gen; sich -
ver|bür|ger|li|chen; Ver|bür|ger|li-
chung
ver|bür|gung
ver|bü|ßen; eine Strafe -
ver|bü|xen landsch. (verprügeln);
du verbüxt (verbüxest)
Verb|zu|satz [wärp...] (Sprachw.:
der nichtverbale Bestandteil ei-
ner verbalen Zusammensetzung
mit einem Zeitwort als Grund-
wort, z. B. „durch" in „durchfüh-
ren, führe durch")
ver|char|tern [...(t)schart...] (ein
Schiff od. Flugzeug vermieten)
ver|chro|men [...krọ...] (mit Chrom
überziehen); Ver|chro|mung
Ver|cin|ge|to|rix [wärzinggẹ...]
(Gallierfürst)
Ver|dacht m; -[e]s; ver|däch|tig;
Ver|däch|ti|ge m u. w; -n, -n (↑ R
287ff.); ver|däch|ti|gen; Ver-
däch|ti|gung; Ver|dachts_grund,
...mo|ment s
ver|dam|men; Ver|dam|mens|wert;
Ver|dam|mer; Ver|damm|nis w; -;
Ver|dam|mung

ver|damp|fen; Ver|damp|fer; Ver-
damp|fung; Ver|damp|fungs|an-
la|ge
ver|dan|ken (schweiz. Amtsspr.
auch für: Dank abstatten)
ver|dat|tert (ugs. für: verwirrt)
ver|dau|en; ver|dau|lich; eine
leichtverdauliche, schwer|ver-
dauliche Speise (↑ jedoch R 143),
aber: die Speise ist leicht ver-
daulich, schwer verdaulich; Ver-
dau|lich|keit w; -; Ver|dau|ung w;
-; Ver|dau|ungs_ap|pa|rat, ...be-
schwer|den (Mehrz.), ...ka|nal,
...or|gan, ...stö|rung
Ver|deck s; -[e]s, -e; ver|decken
[Trenn.: ...dek|ken]; ver|deckt; ver-
wei|se; Ver|deckung [Trenn.:
...dek|kung]
ver|den|ken (All)er [fẹr...] (Stadt an
der Aller; ↑ R 199)
Ver|den (Aller) [fẹr...] (Stadt an
der Aller; ↑ R 199)
ver|den|ken; jmdm. etwas -
Ver|derb m; -[e]s; auf Gedeih und
-; ver|der|ben (schlechter werden);
zugrunde richten); du verdirbst;
du verdarbst; du verdörbest; ver-
dorben; verdirb!; das Fleisch ist
verdorben (schlecht geworden),
aber: er hat mir den ganzen Aus-
flug verdorben (verleidet); Ver-
der|ben s; -s; ver|der|ben|brin-
gend, aber (↑ R 142): ewiges Ver-
derben bringend; Ver|der|ber;
ver|derb|lich; -e Eßwaren; Ver-
derb|lich|keit w; -; Ver|derb|nis w;
-, -se; ver|derbt (verdorben [von
Stellen in alten Handschriften]);
Ver|derbt|heit w; -
ver|deut|li|chen; Ver|deut|li|chung
ver|deut|schen; du verdeutschst
(verdeutschest); Ver|deut|schung
Ver|di [wärdi] (it. Komponist)
ver|dicht|bar; ver|dich|ten; ver-
dich|ter (Technik); Ver|dich|tung
ver|dicken [Trenn.: ...dik|ken];
Ver|dickung [Trenn.: ...dik|kung]
ver|die|nen (↑ R 120:) das Verdie-
nen (der Gelderwerb) wird täg-
lich schwerer; Ver|die|ner; Ver-
die|ner|tum s; -s; ¹Ver|dienst (Er-
werb, Lohn, Gewinn) m; -[e]s, -e;
²Ver|dienst (Anspruch auf Dank
u. Anerkennung) s; -[e]s, -e; Ver-
dienst_aus|fall, ...gren|ze; ver-
dienst|lich; Ver|dienst_mög|lich-
keit, ...or|den, ...span|ne; ver-
dienst|voll; ver|dient; -er Mann,
aber in Titeln (↑ R 224): Verdien-
ter Aktivist (DDR); ver|dien|ter-
ma|ßen, ...wei|se
ver|die|seln (Eisenbahnw.: mit
Diesellokomotiven ausstatten);
ich ...[e]le (↑ R 327); Ver|die|se-
lung
Ver|dikt lat. [wär...] (Urteil) s;
-[e]s, -e
Ver|ding (svw. Verdingung) m;
-[e]s, -e; im -; Ver|ding|bub
schweiz. (durch die Wai-

senbehörde gegen Entschädigung bei Pflegeeltern untergebrachter Junge); ver|din|gen (veralt.); du verdingtest; du verdingtest; verdungen (auch: verdingt); verding[e]!; sich als Gehilfe -; Ver|din|ger (veralt.); ver|ding|li|chen; Ver|ding|li|chung; Ver|din|gung (veralt.)

ver|do|len [zu: Dole]

ver|dol|met|schen; er hat seine Rede verdolmetscht; Ver|dol|met|schung

ver|don|nern (ugs. für: verurteilen); ich ...ere (↑ R 327); ver|don|nert (ugs.); Ver|don|ne|rung (ugs.)

ver|dop|peln; Ver|dop|pe|lung, Ver|dopp|lung

ver|dor|ben; Ver|dor|ben|heit w; - ver|dor|ren; verdorrt; Ver|dor|rung

ver|dö|sen (ugs.); die Zeit -; vgl. dösen

ver|drah|ten (mit Draht versehen, verschließen)

ver|drän|gen; Ver|drän|gung

ver|dre|hen; Ver|dre|her; ver|dreht (ugs. für: verschroben); Ver|dreht|heit (ugs.), Ver|dre|hung

ver|drei|fa|chen

ver|dre|schen (ugs. für: schlagen, verprügeln)

ver|drie|ßen; du verdrießt (verdrießest), er verdrießt; du verdrossest, er verdroß; du verdrössest; verdrossen; verdrießfe]!; es verdrießt mich; ich lasse es mich nicht -; ver|drieß|lich; Ver|drieß|lich|keit

ver|dril|len (miteinander verdrehen); Ver|dril|lung (für: Torsion)

Ver|droß, Alfred [får...] (österr. Rechtsgelehrter)

ver|dros|sen; Ver|dros|senheit

ver|drücken [Trenn.: ...drük|ken] (ugs. auch für: etwas essen); sich - (ugs. für: sich heimlich entfernen)

Ver|druß m; ...drusses, ...drusse

ver|duf|ten; sich - (ugs. für: sich unauffällig entfernen)

ver|dum|men; Ver|dum|mung

ver|dump|fen; Ver|dump|fung

Ver|dun [wårdöng] (fr. Stadt)

ver|dun|keln; ich ...[e]le (↑ R 327); Ver|dun|ke|lung, Ver|dunk|lung; Ver|dun|ke|lungs|ge|fahr, Ver|dunk|lungs|ge|fahr (Rechtsspr.)

ver|dün|nen; ver|dün|ni|sie|ren, sich (ugs. für: sich entfernen); Ver|dün|nung

ver|dun|sten (zu Dunst werden; langsam verdampfen); ver|dün|sten (zu Dunst machen); Ver|dun|stung; Ver|dün|stung; Ver|dun|stungs|mes|ser m

Ver|du|re fr. [wårdür'] (ein in grünen Farben gehaltener Wandtep-

pich des MA. [auch noch im 18. Jh.]) w; -, -n

ver|dur|sten; Ver|dur|stung

ver|dü|stern; ich ...ere (↑ R 327)

ver|dutzt (ugs. für: verwirrt); - sein

ver|eb|ben

ver|edeln; ich ...[e]le (↑ R 327); Ver|ede|lung, Ver|ed|lung; Ver|ede|lungs|ver|fah|ren, Ver|ed|lungs|ver|fah|ren

ver|ehe|li|chen, sich; Ver|ehe|li|chung

ver|eh|ren; Ver|eh|rer; Ver|eh|re|rin w; -, -nen; Ver|eh|rung; ver|eh|rungs.voll, ...wür|dig

ver|ei|den, (älter für:) ver|ei|di|gen; vereidigte Sachverständige; Ver|ei|di|gung; Ver|ei|dung (älter für: Vereidigung)

Ver|ein m; -[e]s, -e; im - mit ...; - Deutscher Ingenieure (Abk.: VDI); vgl. eingetragen; ver|ein|bar; ver|ein|ba|ren; ver|ein|bar|ter|ma|ßen; Ver|ein|ba|rung; ver|ein|ba|rungs|ge|mäß; ver|ei|nen; ver|ei|ni|gen; vereint (vgl. d.); sich vereinen, vereinigen

ver|ein|fa|chen; Ver|ein|fa|chung

ver|ein|heit|li|chen; Ver|ein|heit|li|chung

ver|ei|ni|gen; (↑ R 224:) die Vereinigten Staaten [von Amerika]; vgl. United States [of America]; vgl. US[A] u. Ver. St. v. A.; Vereinigte Arabische Republik (hist.) [Abk.: VAR]; Vereinigtes Königreich Großbritannien u. Nordirland; Ver|ei|ni|gung; Ver|ei|ni|gungs|frei|heit w; -

ver|ein|nah|men (einnehmen, als Einnahme in Empfang nehmen); Ver|ein|nah|mung

ver|ein|sa|men; Ver|ein|sa|mung

Ver|eins.elf w, ...haus, ...lei|tung, ...lo|kal (Vereinsraum, -zimmer), ...mann|schaft, ...mei|er (ugs. abschätzig), ...meie|rei (ugs. abschätzig), ...we|sen (s; -s); ver|eint; mit -en Kräften, aber (↑ R 224:) die Vereinten Nationen (Abk.: UN, VN); vgl. auch: UNO, UNESCO

ver|ein|zeln; ich ...[e]le (↑ R 327); Ver|ein|ze|lung

ver|ei|sen (zu Eis werden); die Tragflächen verei|sten; ver|eist; -e (eisbedeckte) Wege; Ver|ei|sung

ver|ei|teln; ich ...[e]le (↑ R 327); Ver|ei|te|lung, Ver|eit|lung

ver|ei|tern; Ver|ei|te|rung

ver|ekeln; jmdm. etwas -; Ver|eke|lung, Ver|ek|lung

ver|en|den; Ver|en|dung

Ve|re|na [we...] (w. Vorn.)

ver|en|den; Ver|en|dung

ver|en|gen; ver|en|gern; ich ...ere (↑ R 327); Ver|en|ge|rung; Ver|en|gung

ver|er|ben; ver|erb|lich; Ver|er|bung; Ver|er|bungs_gang m, ...leh|re

ver|estern (zu Ester umwandeln); ich ...ere (↑ R 327); Ver|este|rung

ver|ewi|gen; sich -; Ver|ewig|te m u. w; -n, -n (↑ R 287ff.); Ver|ewi|gung

ver|fah|ren (vorgehen, handeln); ich bin so verfahren, daß ...; so darfst du nicht mit ihm - (umgehen); eine Sache - (falsch anfassen); eine -e Geschichte; sich - (einen falschen Weg fahren); ich habe mich -; (↑ R 120:) ein Verfahren ist auf dieser Strecke kaum möglich; Bergmannsspr.: eine Schicht (eine Schicht machen); Ver|fah|ren s; -s, -; ein neues -; ver|fah|rens|recht|lich; Ver|fah|rens_re|gel, ...tech|nik, ...wei|se w

Ver|fall m; -[e]s; in - geraten; ver|fal|len; das Haus ist -; er ist dem Tode -; die Strafe ist -; Ver|falls-.er|klä|rung, ...er|schei|nung; Ver|fall[s]_tag, ...zeit

ver|fäl|schen; er hat den Wein verfälscht; Ver|fäl|scher; Ver|fäl|schung

ver|fan|gen; sich -; du hast dich in Widersprüche -; ver|fäng|lich; eine -e Frage; Ver|fäng|lich|keit

ver|fär|ben; sich -; Ver|fär|bung

ver|fas|sen; er hat diesen Brief verfaßt; Ver|fas|ser; Ver|fas|ser|schaft w; -; Ver|fas|sung; ver|fas|sung|ge|bend, aber (↑ R 142:) eine Verfassung gebend; Ver|fas|sungs.än|de|rung, ...be|schwer|de, ...fra|ge, ...ge|richt; ver|fas|sungs|mä|ßig; ver|fas|sungs.ord|nung, ...recht, ...schutz; ver|fas|sungs|treu; Ver|fas|sungs|ur|kun|de; ver|fas|sungs|wid|rig

ver|fau|len; Ver|fau|lung

ver|fech|ten (verteidigen); er hat sein Recht tatkräftig verfochten; Ver|fech|ter; Ver|fech|tung

ver|feh|len (nicht treffen); sich - (geh. für: sich vergehen); Ver|feh|lung

ver|fein|den; sich mit jmdm. -; Ver|fein|dung

ver|fei|nern; ich ...ere (↑ R 327); Ver|fei|ne|rung

ver|fe|men (für vogelfrei erklären; ächten); Ver|fe|mung

ver|fer|ti|gen; Ver|fer|ti|gung

ver|fe|sti|gen; Ver|fe|sti|gung

ver|fet|ten; Ver|fet|tung

ver|fil|men; Ver|fil|mung

ver|fil|zen; die Decke ist verfilzt; Ver|fil|zung

ver|fin|stern; sich -; Ver|fin|ste|rung

ver|fit|zen (ugs. für: verwirren); sie hat die Wolle verfitzt; Ver|fit|zung

ver|fla|chen; Ver|fla|chung

ver|flech|ten; Ver|flech|tung
ver|flie|gen (verschwinden); der Zorn ist verflogen; sich - (mit dem Flugzeug vom Kurs abkommen)
ver|flie|ßen; vgl. verflossen
ver|flixt (ugs. für: verflucht; auch: unangenehm, ärgerlich)
Ver|floch|ten|heit w; -
ver|flos|sen; verflossene od. verfloßne Tage
ver|flu|chen; Ver|flu|chung
ver|flüch|ti|gen (in den gasförmigen Zustand überführen); sich - (in den gasförmigen Zustand übergehen; ugs.: sich heimlich entfernen); Ver|flüch|ti|gung
ver|flüs|si|gen; Ver|flüs|si|gung
Ver|folg (Amtsdt. für: Fortgang) m; -[e]s, (fast nur noch in:) im od. in - der Sache; Ver|fol|gen; Ver|fol|ger; Ver|folg|te m u. w; -n, -n (↑R 287ff.); Ver|fol|gung; Ver|fol|gungs.jagd, ...wahn
ver|for|men; Ver|for|mung
ver|frach|ten; Ver|frach|ter; Ver|frach|tung
ver|fran|zen, sich (Fliegerspr.: sich verfliegen; auch übertr.: sich verirren); du verfranzt (verfranzest) dich
ver|frem|den; Ver|frem|dung
ver|fres|sen (ugs. für: gefräßig); Ver|fres|sen|heit (ugs.) w; -
ver|fro|ren
ver|frü|hen, sich; ver|früht; sein Dank kam -; Ver|frü|hung
ver|füg|bar; Ver|füg|bar|keit w; -; ver|fü|gen (bestimmen, anordnen; besitzen)
ver|fu|gen; Ver|fu|gung
Ver|fü|gung; (↑R 145:) zur Verfügung u. bereithalten, a b e r: bereit- u. zur Verfügung halten; Ver|fü|gungs.ge|walt, ...recht
ver|füh|ren; Ver|füh|rer; ver|füh|re|risch; -ste (↑R 294); Ver|füh|rung; Ver|füh|rungs|kunst
ver|fuhr|wer|ken bes. schweiz. (verpfuschen)
ver|füt|tern (als ¹Futter verwenden)
Ver|ga|be w; -, (selten:) -n; - von Arbeiten; ver|ga|ben schweiz. (schenken, vermachen); Ver|ga|bung schweiz. (Schenkung, Vermächtnis)
ver|gack|ei|ern (ugs. für: verspotten, verulken); ich ...ere (↑R 327)
ver|gaf|fen, sich (ugs. für: sich verlieben); du hast dich in sie vergafft
ver|gagt dt.; engl.-amerik. [...gäkt] (voller Gags)
ver|gäl|len (verbittern; ungenießbar machen); er hat ihm die Freude vergällt; vergällter Spiritus; Ver|gäl|lung
ver|ga|lop|pie|ren, sich (ugs. für: [sich] irren, einen Mißgriff tun)

ver|gam|meln (ugs. für: verbummeln; alt werden; schlecht werden); vergammeltes Fleisch
Ver|gan|gen|heit; ver|gäng|lich; Ver|gäng|lich|keit w; -
ver|gan|ten [zu: Gant] südd., österr. mdal. veralt., schweiz. (zwangsversteigern); Ver|gan|tung
ver|ga|sen (Chemie: in gasförmigen Zustand überführen; mit [Kampf]gasen verseuchen, töten); Ver|ga|ser (Apparat zur Erzeugung des Brenngemisches für Verbrennungskraftmaschinen); Ver|ga|sung
ver|gat|tern (mit einem Gatter versehen; [die Wache durch Signal versammeln u. auf die Wachvorschriften] verpflichten); ich ...ere (↑R 327); Ver|gat|te|rung
ver|ge|ben; er hat diese Arbeit -; seine Sünden sind -; er hat seiner Ehre nichts -; ver|ge|bens; Ver|ge|ber; ver|geb|lich; Ver|geb|lich|keit; Ver|ge|bung
ver|ge|gen|ständ|li|chen; Ver|ge|gen|ständ|li|chung
ver|ge|gen|wär|ti|gen; Ver|ge|gen|wär|ti|gung
ver|ge|hen; die Jahre sind vergangen; sich - (gegen Gesetze verstoßen); du hast dich an diesem Mädchen vergangen; Ver|ge|hen s; -s, -
ver|gei|len (durch Lichtmangel aufschießen [von Pflanzen]); Ver|gei|lung
ver|gel|ten; er hat immer Böses mit Gutem vergolten; vergilt!; einem ein „Vergelt's Gott!" zurufen; Ver|gel|tung; Ver|gel|tungs.maß|nah|me, ...schlag,waf|fe
ver|ge|sell|schaf|ten; Ver|ge|sell|schaf|tung
ver|ges|sen; du vergißt (vergissest), er vergißt; du vergaßest; du vergäßest; vergessen; vergißt!; etwas (landsch., bes. südd., österr. ugs.: auf, an etwas) -; die Arbeit über dem Vergnügen -; Ver|geß|en|heit w; -; in - geraten; ver|geß|lich; Ver|geß|lich|keit w; -
ver|geu|den; Ver|geu|der; ver|geu|de|risch; -ste (↑R 294); Ver|geu|dung
ver|ge|wal|ti|gen; Ver|ge|wal|ti|gung
ver|ge|wis|sern, sich; ich vergewissere u. vergewißre mich seines Verantwortungsgefühls; Ver|ge|wis|se|rung, Ver|ge|wiß|rung
ver|gie|ßen
ver|gif|ten; Ver|gif|ter; Ver|gif|tung; Ver|gif|tungs|er|schei|nung
Ver|gil [wär...] (altröm. Dichter)
ver|gil|ben; vergilbte Papiere
Ver|gi|li|us [wär...] vgl. Vergil

Ver|giß|mein|nicht (eine Blume) s; -[e]s, -[e]
ver|git|tern; ich ...ere (↑R 327)
ver|glas|bar; ver|gla|sen; du verglast (verglasest); er vergla|ste; ver|glast; -e (hervorquellende, starre) Augen; Ver|gla|sung
Ver|gleich m; -[e]s, -e; im - mit, zu; ein gütlicher -; ver|gleich|bar; Ver|gleich|bar|keit w; -; ver|glei|chen; er hat diese beiden Bilder verglichen; sich-; die Parteien haben sich verglichen; die vergleichende Anatomie; vergleich[e]! (Abk.: vgl.); Ver|gleichs.gläu|bi|ger, ...ob|jekt, ...punkt, ...schuld|ner, ...sum|me, ...ver|fah|ren; ver|gleichs|wei|se; ver|gleichs|zahl; Ver|glei|chung
ver|glet|schern; Ver|glet|sche|rung
ver|glim|men
ver|glü|hen
ver|gnü|gen, sich; Ver|gnü|gen s; -s, -; viel -!; ein diebisches -; Ver|gnü|gens.hal|ber, ver|gnü|gungs.hal|ber; ver|gnüg|lich; ver|gnügt; Ver|gnü|gung (meist Mehrz.); Ver|gnü|gungs.in|du|strie, ...park; Ver|gnü|gungs.steu|er, Ver|gnü|gung|steu|er w (↑R 334); Ver|gnü|gungs|sucht w; -; ver|gnü|gungs|süch|tig
ver|gol|den; Ver|gol|de|pres|se; Ver|gol|der; Ver|gol|dung
ver|gön|nen ([aus Gunst] gewähren; mdal. für: mißgönnen); es ist mir vergönnt
ver|got|ten (zum Gott machen); gotthaft werden); ver|göt|tern (wie einen Gott verehren); ich ...ere (↑R 327); Ver|göt|te|rung; Ver|got|tung
ver|gra|ben; der Regenwurm hat sich tief in die Erde -; er ist tief in seine Bücher -; er hat seine Hände in den Hosentaschen -
ver|grä|men (verärgern; [Wild] verscheuchen); ver|grämt
ver|grät|zen landsch. (verstimmen, verärgern); du vergrätzt (vergrätzest)
ver|grau|len (ugs. für: verärgern [u. dadurch vertreiben])
ver|grei|fen; sich an jmdn., an einer Sache -; du hast dich an fremdem Gut, im Ton vergriffen; vgl. vergriffen
ver|grei|sen; du vergreist (vergreisest); er vergrei|ste; Ver|grei|sung (das Vergreistsein; Überalterung eines Volkes) w; -
ver|grif|fen; das Buch ist - (nicht mehr lieferbar)
ver|grö|bern; ich ...ere (↑R 327); Ver|grö|be|rung
Ver|grö|ße|rer, Ver|größ|rer; ver|grö|ßern; ich ...ere (↑R 327); Ver|grö|ße|rung; Ver|grö|ße|rungs.ap|pa|rat, ...glas

ver|groß|städ|tern (zum Großstäd-
ter, zur Großstadt werden); ich
...ere (↑ R 327); Ver|groß|städ|te-
rung w; -
ver|gucken [Trenn.: ...guk|ken],
sich (ugs. für: sich verlieben)
ver|gül|den (dicht. für: vergolden)
Ver|gunst (veralt. für: Erlaubnis),
nur noch in: mit - (mit Verlaub);
ver|gün|sti|gen (veralt.); Ver|gün-
sti|gung
ver|gü|ten (auch für: veredeln);
Ver|gü|tung
verh. (Zeichen: ∞) = verheiratet
Ver|hack (veralt. für: Verhau) m;
-[e]s, -e; ver|hack|stücken [Trenn.:
...stük|ken] (ugs. für: bis ins
kleinste besprechen u. kritisie-
ren)
Ver|haft (veralt. für: Verhaftung)
m; -[e]s; ver|haf|ten; ver|haf|tet
(auch [mit Wemf.] für: eng ver-
bunden); Ver|haf|te|te m u. w; -n,
-n (↑ R 287ff.); Ver|haf|tung; Ver-
haf|tungs_be|fehl, ...wel|le
ver|ha|geln; das Getreide ist verha-
gelt
ver|hal|len; sein Ruf verhallte
Ver|halt (veralt. für: Sachverhalt;
Sachverhalt) m; -[e]s, -e;
¹ver|hal|ten (anhalten, stehen-
bleiben; etwas zurückhalten;
schweiz. Amtsspr.: zu etwas ver-
pflichten, anhalten); sie verhielt
auf der Treppe; er verhält den
Harn, den Atem, das Lachen;
sich - (sich benehmen); ich habe
mich abwartend -; ²ver|hal|ten;
ein -er (gedämpfter, unterdrück-
ter) Zorn, Trotz; -er (verzögerter)
Schritt; -er (gezügelter) Trab;
Ver|hal|ten s; -s; Ver|hal|ten|heit
w; -; Ver|hal|tens_for|schung,
...fra|ge; Ver|hal|tens|maß|re|gel,
Ver|hal|tungs|maß|re|gel(veralt.);
Ver|hal|tens_mu|ster (Psych.),
...steue|rung, ...wei|se w; Ver|hält-
nis s; -ses, -se; geordnete Verhält-
nisse; ein geometrisches -; ver-
hält|nis|mä|ßig; ver|hält|nis|mä-
ßig|keit; die - der Mittel;
Ver|hält|nis_wahl, ...wahl|recht,
...wort (für: Präposition; Mehrz.
...wörter), ...zahl; Ver|hal|tung;
Ver|hal|tungs|maß|re|gel (ver-
alt.), Ver|hal|tens|maß|re|gel
ver|han|deln; über etwas -; Ver-
hand|lung; Ver|hand|lungs_ba|sis,
...be|reit|schaft, ...grund|la|ge,
...part|ner
ver|han|gen; ein -er Himmel; ver-
hän|gen; vgl. ²hängen); mit ver-
hängten (locker gelassenen) Zü-
geln; Ver|häng|nis s; -ses, -se; ver-
häng|nis|voll; ein -er Fehler; Ver-
hän|gung
ver|harm|lo|sen; du verharmlost
(verharmlosest); er verharmlo-
ste

ver|härmt
ver|har|ren; Ver|har|rung
ver|har|schen; Ver|har|schung
ver|här|ten; Ver|här|tung
ver|has|peln (verwirren); sich -
(ugs. für: sich beim Sprechen ver-
wirren); Ver|has|pe|lung, Ver-
hasp|lung
ver|haßt
ver|hät|scheln (ugs. für: verzär-
teln)₁ Ver|hät|oohe|lung, Vor
hätsch|lung
ver|hatscht österr. ugs. (ausgetre-
ten); -e Schuhe
Ver|hau m od. s; -[e]s, -e; ver|hau|en
(ugs. für: durchprügeln); er ver-
haute ihn; sich - (ugs. für: sich
grob irren); ich verhaute mich
ver|he|ben, sich; ich habe mich ver-
hoben; Ver|he|bung
ver|hed|dern (ugs. für: verwirren);
ich ...ere (↑ R 327); sich - (beim
Sprechen)
ver|hee|ren; ver|hee|rend; -ste;
(ugs.:) das ist - (sehr unange-
nehm; furchtbar); Ver|hee|rung
ver|heh|len; er hat die Wahrheit
verhehlt; vgl. verhohlen
ver|hei|len; Ver|hei|lung
ver|hei|li|chen; Ver|heim|li-
chung
ver|hei|ra|ten; sich -; ver|hei|ra|tet
(Abk.: verh.; Zeichen: ∞); Ver-
hei|ra|te|te m u. w; -n, -n (↑ R
287ff.); ver|hei|ra|tung
ver|hei|ßen; er hat mir das -; vgl.
¹heißen; Ver|hei|ßung; ver|hei-
ßungs|voll
ver|hei|zen; Kohlen -; jmdn. - (ugs.
für: jmdn. für eigene Zwecke
rücksichtslos einsetzen [u.
opfern])
ver|hel|fen; jmdm. zu etwas -; er
hat mir dazu verholfen
ver|herr|li|chen; Ver|herr|li|cher;
Ver|herr|li|chung
ver|het|zen; er hat die Nachbarn
verhetzt; Ver|het|zung
Ver|heue|rer, Ver|heu|rer (See-
mannsspr.); ver|heu|ern (anmu-
stern); Ver|heue|rung (See-
mannsspr.)
ver|heult (ugs. für: verweint); mit
-en Augen
ver|he|xen; (ugs.:) das ist wie ver-
hext; Ver|he|xung
Ver|hieb (Bergmannsspr.: Art u.
Richtung, in der der Kohlenstoß
abgebaut wird)
ver|him|meln (ugs. für: sehr
schwärmen für jmdn.); Ver|him-
me|lung (ugs.)
ver|hin|dern; Ver|hin|de|rung; Ver-
hin|de|rungs|fall m; im -[e]
ver|hoch|deut|schen
ver|hoh|len (verborgen); er sagte
dies mit kaum verhohlener Scha-
denfreude

ver|höh|nen; ver|hoh|ne|pi|peln
(ugs. für: verspotten, verulken);
ich ...[e]le (↑ R 327); Ver|höh|nung
ver|hö|kern (ugs. für: [billig] ver-
kaufen)
Ver|hol|bo|je (Seemannsspr.); ver-
ho|len ([Schiff] an eine andere
Stelle bringen)
ver|hol|zen; Ver|hol|zung
Ver|hör s; -[e]s, -e; ver|hö|ren; Ver-
hö|rung
ver|hu|deln (ugs. für: durch Hast,
Nachlässigkeit verderben)
ver|hül|len; ver|hüllt; eine kaum -e
Drohung; Ver|hül|lung
ver|hun|dert|fa|chen
ver|hun|gern; (↑ R 120:) vor dem
Verhungern retten
ver|hun|zen (ugs. für: verderben;
verschlechtern); du verhunzt
(verhunzest); Ver|hun|zung (ugs.)
ver|hurt (derb für: sexuellen Ver-
kehr mit vielen Männern aus-
übend)
ver|hü|ten (verhindern)
ver|hüt|ten (Erz auf Hüttenwerken
verarbeiten); Ver|hüt|tung
Ver|hü|tung; Ver|hü|tungs|mit|tel s
ver|hut|zeln (zusammenschrum-
pfen); ein verhutzeltes Männchen
Ve|ri|fi|ka|ti|on lat. [werifikazion]
(Bewahrheitung; Beglaubigung,
Beurkundung); ve|ri|fi|zier|bar
(nachprüfbar); Ve|ri|fi|zier|bar-
keit w; -; ve|ri|fi|zie|ren (bewahr-
heiten; beglaubigen
ver|in|ner|li|chen; Ver|in|ner|li-
chung
ver|ir|ren, sich; Ver|ir|rung
Ve|ris|mus lat. [we...] (kraß wirk-
lichkeitsgetreue künstlerische
Darstellung) m; -; Ve|rist (↑ R
268); ve|ri|stisch; -ste (↑ R 294)
ve|ri|ta|bel fr [we...] (wahrhaft;
echt); ...a|ble Größe
ver|ja|gen
ver|jäh|ren; ver|jäh|rung; Ver|jäh-
rungs|frist
ver|ju|beln (ugs. für: [sein Geld]
für Vergnügungen ausgeben)
ver|jün|gen; er hat das Personal
verjüngt; sich -; die Säule ver-
jüngt sich (wird [nach oben] dün-
ner); Ver|jün|gung; Ver|jün-
gungs_kur, ...trank
ver|ju|xen (ugs. für: vergeuden);
du verjuxt (verjuxest)
ver|kad|men vgl. kadmieren
ver|kal|ken (auch ugs. für: alt wer-
den, die geistige Frische verlie-
ren); Ver|kal|kung
ver|kal|ku|lie|ren, sich (sich ver-
rechnen, falsch veranschlagen)
ver|ka|mi|so|len (ugs. veralt. für:
schlagen, verprügeln)
ver|kannt; ein -es Genie
ver|kap|pen (unkenntlich ma-
chen); ver|kappt; ein -er Spion,
Betrüger; Ver|kap|pung

verkapseln726

ver|kap|seln; ich ...[e]le (↑ R 327); Ver|kap|se|lung, Ver|kaps|lung ver|kar|sten (zum Steinfeld werden); Ver|kar|stung ver|kar|ten (für eine Kartei auf Karten schreiben); Ver|kar|tung ver|kä|sen (zu Käse werden) ver|kä|steln (einschachteln); ver|kä|sten (Bergw.: auszimmern) Ver|kä|sung ver|kä|tert (ugs.: an den Folgen übermäßigen Alkoholgenusses leidend) Ver|kauf; der - von Textilien, in der Kaufmannsspr. gelegentl. auch:) der - in Textilien; ver|kau|fen; du verkaufst; er verkauft, verkaufte, hat verkauft (inkorrekt ist der landsch. Gebrauch: du verkäufst; er verkäuft); ver|käu|fer; Ver|käu|fe|rin w; -, -nen; ver|käuf|lich; Ver|käuf|lich|keit w; -; Ver|kaufs¸ab|tei|lung, ...be|din|gung, ...fah|rer, ...ge|spräch, ...kal|ku|la|ti|on, ...lei|ter m; ver|kaufs|of|fen; -er Sonntag; Ver|kaufs¸preis (vgl. ²Preis), ...pro|gramm, ...raum, ...schla|ger, ...stel|le Ver|kehr m; -s (seltener: -es), (fachspr.:) -e; im - mit ...; in - treten; ver|keh|ren; Ver|kehrs¸ader, ...am|pel, ...amt, ...be|trieb (meist Mehrz.), ...bü|ro, ...cha|os, ...de|likt, ...dich|te, ...dis|zi|plin (w; -), ...er|zie|hungs|wo|che, ...flug|zeug; ver|kehrs|frei; Ver|kehrs¸ge|nos|sen|schaft, ...hin|der|nis, ...in|sel, ...kno|ten|punkt, ...ma|schi|ne, ...mi|ni|ster, ...mit|tel s, ...netz, ...ord|nung, ...plan (vgl. ²Plan), ...pla|nung, ...po|li|zei, ...pro|blem, ...recht (s; -[e]s), ...re|ge|lung od. ...reg|lung; ver|kehrs|reich; Ver|kehrs¸schrift (erster Grad der Kurzschrift), ...schutz|mann; ver|kehrs|si|cher; Ver|kehrs¸si|cher|heit (w; -), ...spra|che, ...stär|ke, ...sta|ti|stik, ...stockung [Trenn.: ...stok|kung], ...stö|rung, ...sün|der (ugs.), ...sy|stem, ...teil|neh|mer, ...un|fall, ...ver|bin|dung, ...ver|ein, ...wert, ...we|sen (s; -s); ver|kehrs|wid|rig; Ver|kehrs|zei|chen; ver|kehrt; eine Antwort ist -; Kaffee - (ugs. für: mehr Milch als Kaffee); Ver|kehrt|heit; Ver|keh|rung ver|kei|len; sich -; einen Balken -; jmdn. - (ugs. für: jmdn. verhauen) ver|ken|nen; er wurde von allen verkannt; vgl. verkannt; Ver|ken|nung ver|ket|ten; Ver|ket|tung Ver|ket|ze|rer; ver|ket|zern (schmähen, herabsetzen); ich ...ere (↑ R 327); ver|ket|ze|rung

ver|kie|seln (mit Kieselsäure durchtränken); Ver|kie|se|lung ver|kit|schen (kitschig gestalten; ugs. für: [billig] verkaufen) ver|kit|ten (mit Kitt befestigen) ver|kla|gen ver|klam|men (vor Kälte erstarren); ver|klam|mern; Ver|klam|me|rung; Ver|klam|mung ver|kla|ren (über Schiffsunfälle eidlich aussagen) ver|klä|ren (ins Überirdische erhöhen) Ver|kla|rung (gerichtliche Feststellung bei Schiffsunfällen) Ver|klä|rung ver|klat|schen (ugs. für: heimlich angeben); man hat ihn verklatscht ver|klau|seln; ich ...[e]le (↑ R 327) u. (österr. nur:) ver|klau|su|lie|ren (einen Vertrag mit mehreren Klauseln versehen u. ihn dadurch unverständlich machen; allg. für: etwas unübersichtlich machen; einschränken); Ver|klau|se|lung, Ver|klau|su|lie|rung ver|kle|ben; Ver|kle|bung ver|klei|den; Ver|klei|dung ver|klei|nern; ich ...ere (↑ R 327); Ver|klei|ne|rung; Ver|klei|ne|rungs¸form, ...sil|be ver|klei|stern (ugs. für: verkleben) Ver|klei|ste|rung (ugs.) ver|klem|men; ver|klemmt ver|klin|gen ver|klom|men (vor Kälte erstarrt) ver|klop|pen (ugs. für: schlagen; verkaufen); sie haben ihn tüchtig verkloppt; der Schüler hat seine Bücher verkloppt ver|klüf|ten, sich (Jägerspr.: sich im Bau vergraben) ver|klum|pen (sich zusammenballen, verkleben, agglutinieren); Ver|klum|pung ver|knacken [Trenn.: ...knak|ken] jidd. (ugs. für: verurteilen) ver|knack|sen (ugs. für: verstauchen; verknacken); du verknackst (verknacksest) ver|knal|len, sich (ugs. für: sich verlieben); du hast dich, du bist in sie verknallt ver|knap|pen; Ver|knap|pung (Knappwerden) w; - ver|kna|sten (ugs. für: verurteilen) ver|knei|fen (ugs.); den Schmerz -; sich etwas - (ugs. für: entsagen, verzichten); ver|knif|fen (verbittert, verhärtet); Ver|knif|fen|heit w; - ver|knö|chern; ich ...ere (↑ R 327); ver|knö|chert (ugs. auch für: alt, weltfremd, verständnislos); Ver|knö|che|rung ver|kno|ten

ver|knüp|fen; Ver|knüp|fung ver|knu|sen, nur noch in: jmdn. nicht verknusen (ugs. für: nicht ausstehen) können ver|ko|chen ([zu] lange kochen) ¹ver|koh|len jidd. (ugs. für: scherzhaft belügen) ²ver|koh|len (organ. Stoffe der Luftabschluß erhitzen; in kohlenförmigen Zustand überführen, übergehen); Ver|koh|lung ver|ko|ken (zu Koks machen, werden); Ver|ko|kung ver|kom|men; -er Mensch; Ver|kom|men|heit w; -; Ver|komm|nis schweiz. veralt. (Abkommen, Vertrag) s; -ses, -se ver|kon|su|mie|ren (ugs. für: aufessen) ver|kop|peln; Ver|kop|pe|lung, Ver|kopp|lung (Landw.: Zusammenlegung von Grundbesitz in einer Gemeindeflur) ver|kor|ken (mit einem Kork verschließen); ver|kork|sen (ugs. für: verpfuschen); du verkorkst (verkorksest) ver|kör|nen (auch für: granulieren [Technik]) ver|kör|pern; ich ...ere (↑ R 327); Ver|kör|pe|rung ver|ko|sten (kostend prüfen); Wein -; Ver|ko|ster; Ver|kost|gel|den schweiz. (in Kost geben); ver|kö|sti|gen ver|kra|chen (ugs. für: scheitern); sich - (ugs. für: sich entzweien); ver|kracht (ugs. auch für: nicht zum Ziel gelangt); ein -er Student; eine -e Existenz ver|kraf|ten (ugs. für: etwas ertragen können) ver|kral|len, sich; das Eichhörnchen verkrallte sich in der Rinde, aber (bei übertr. Verwendung): du hast dich in diese Arbeit verkrallt ver|kra|men (ugs. für: verlegen) ver|kramp|fen, sich; ver|krampft; Ver|kramp|fung ver|krat|zen ver|krie|chen, sich ver|krö|pfen; Ver|krö|pfung (Kröpfung) ver|krü|meln, sich (ugs. für: im kleinen verlorengehen; sich unauffällig entfernen) ver|krüm|men; sich -; Ver|krüm|mung ver|krum|peln landsch. (zerknittern) ver|krüp|peln; ich ...[e]le (↑ R 327); Ver|krüp|pe|lung, Ver|krüpp|lung ver|kru|sten; etwas verkrustet ver|küh|len, sich; (sich erkälten); Ver|küh|lung ver|küm|mern; ver|küm|mert; Ver|küm|me|rung

ver|kün|d[i]|gen; Ver|kün|der, Ver|kün|di|ger; Ver|kün|di|gung, Ver|kün|dung; das kath. Fest Mariä Verkündigung (ugs.: Maria Verkündigung)
ver|kup|fern; ich ...ere († R 327); Ver|kup|fe|rung
ver|kup|peln; Ver|kup|pe|lung, Ver|kupp|lung
ver|kür|zen; der Rock wurde verkürzt; verkürzte Arbeitszeit; Ver|kür|zung
ver|la|chen (auslachen)
Ver|lad schweiz. (Verladung) m; -s; Ver|la|de.bahn|hof, ...brücke [Trenn.: ...brük|ke], ...kran; ver|la|den; vgl. ¹laden; Ver|la|der; Ver|la|de|ram|pe; Ver|la|dung
Ver|lag (von Büchern usw.; schweiz. auch: Herumliegen [von Gegenständen]) m; -[e]s, -e; ver|la|gern; Ver|la|ge|rung; Ver|lags_an|stalt, ...[buch|]hand|lung, ...haus, ...pro|gramm, ...recht, ...sy|stem, ...ver|trag, ...we|sen (s; -s)
Ver|laine [wärlän] (fr. Dichter)
ver|lan|den (von Seen usw.); Ver|lan|dung
ver|lan|gen; Ver|lan|gen s; -s, -; auf -
ver|län|gern; ich ...ere († R 327); ver|län|gert; -er Rücken (ugs. scherzh. für: Gesäß); Ver|län|ge|rung; Ver|län|ge|rungs_schnur, ...stück
ver|lang|sa|men; Ver|lang|sa|mung
ver|läp|pern (ugs. für: [Geld] vergeuden); Ver|läp|pe|rung (ugs.)
ver|lar|ven [...larf°n]; Ver|lar|vung
Ver|laß m; ...lasses; es ist kein - auf ihn; ¹ver|las|sen; sich auf eine Sache, einen Menschen -; er hatte sich auf ihn -; ²ver|las|sen (vereinsamt); das Dorf lag - da; Ver|las|sen|heit w; -; Ver|las|sen|schaft (mdal., österr. und schweiz. neben: Hinterlassenschaft); ver|läs|sig (veralt.), ver|läß|lich (zuverlässig); Ver|läß|lich|keit w; -; ver|lä|stern; Ver|lä|ste|rung
Ver|laub m, nur noch in: mit -
Ver|lauf; im -; ver|lau|fen; die Sache ist gut verlaufen; sich -; er hat sich verlaufen; Ver|laufs|form (Sprachw.: sprachl. Fügung, die ein Geschehen als zeitlich unbegrenzt kennzeichnet, z. B. „er ist am Arbeiten")
ver|lau|sen; Ver|lau|sung
ver|laut|ba|ren; es hat verlautbart (besser: es ist bekanntgeworden); man hat verlautbart (besser: bekanntgemacht); Ver|laut|ba|rung; ver|lau|ten; wie verlautet; nichts - lassen
ver|le|ben; ver|le|ben|di|gen (lebendig machen); Ver|le|ben|di|gung; ver|lebt (abwertend)

¹ver|le|gen [zu: legen] (auf eine andere Zeit festlegen; an einen unrechten Ort legen; [Buch] in Verlag nehmen; Technik: [Rohre u. a.] legen, zusammenfügen); († R 120:) [das] Verlegen von Rohren; ²ver|le|gen [zu: liegen] (befangen; durch Liegen verdorben); -er Mensch; er war -; -e Ware; Ver|le|gen|heit; in tödlicher i Ver|le|ger; ver|le|ge|risch; Ver|le|ger|zei|chen; Ver|le|gung
ver|lei|den (leid machen); es ist mir verleidet; Ver|lei|der schweiz. (Überdruß); er hat den - bekommen (ist der Sache müde geworden); Ver|lei|dung w; -
Ver|leih m; -[e]s, -e; ver|lei|hen; er hat das Buch verliehen; († R 120:) [das] Verleihen von Geld; Ver|lei|her; Ver|lei|hung
ver|lei|men (durch Leim verbinden)
ver|lei|ten (verführen)
ver|leit|ge|ben [zu: Leitgeb] mdal. (Bier od. Wein ausschenken)
Ver|lei|tung
ver|ler|nen
ver|le|sen (ablesen; falsch lesen; sondern [z. B. Erbsen]); er hat den Text verlesen; Ver|le|sung
ver|letz|bar; Ver|letz|bar|keit w; -; ver|let|zen; er ist verletzt; Ver|let|zend|ste; ver|letz|lich; Ver|letz|lich|keit w; -; ver|letzt; ver|letz|te m u. w; -n, -n († R 287ff.); Ver|let|zung
ver|leug|nen; Ver|leug|nung
ver|leum|den; Ver|leum|der; ver|leum|de|risch; -ste († R 294); Ver|leum|dung
ver|lie|ben, sich; ver|liebt; ein -es Paar; Ver|lieb|te m u. w; -n, -n († R 287ff.); Ver|liebt|heit
ver|lie|ren; du verlorst; du verlörest; verloren; verlier[e]!; sich -; verloren sein; verloren geben; vgl. aber: verlorengehen; vgl. verloren; Ver|lie|rer; Ver|lies ([unterird.] Gefängnis, Kerker) s; -es, -e
ver|lo|ben; sich -; Ver|löb|nis s; -ses, -se; Ver|lob|te m u. w; -n, -n († R 287ff.); Ver|lo|bung; Ver|lo|bungs_an|zei|ge, ...ring, ...zeit
ver|locken [Trenn.: ...lok|ken]; Ver|lockung [Trenn.: ...lok|kung]
ver|lo|dern
ver|lo|gen (lügenhaft); Ver|lo|gen|heit
ver|loh|nen (dicht. für: erlöschen)
ver|loh|nen; sich -; es verlohnt sich zu leben; vgl. lohnen
ver|lo|ren; -e Eier (eine Speise); der -e Sohn; auf -em Posten stehen; - sein (vgl. d.); ver|lo|ren ge|ben; sie haben das Spiel frühzeitig verloren gegeben; ver|lo|ren ge|hen;

es ist viel Vertrauen verlorengegangen; Ver|lo|ren|heit; ver|lo|ren sein; das Spiel ist längst verloren gewesen, als ...
¹ver|lö|schen: eine Schrift - (auslöschend verwischen); vgl. ¹löschen; ²ver|lö|schen; die Kerze verlischt; vgl. ²löschen; Ver|lö|schung
ver|lo|sen; Ver|lo|sung
ver|lö|ten, einen Blechkanister -, einen - (ugs. für: von einem alkohol. Getränk eine größere Menge trinken)
ver|lot|tern (ugs. für: verkommen); Ver|lot|te|rung (ugs.)
ver|lu|dern (ugs. für: verkommen)
ver|lum|pen (ugs. für: verkommen)
Ver|lust m; -es, -e; Ver|lust_be|trieb, ...ge|schäft
ver|lu|stie|ren, sich (ugs. scherzh. für: sich vergnügen)
ver|lu|stig; einer Sache verlustig gehen (besser: eine Sache verlieren, einbüßen, preisgeben müssen); Ver|lust_li|ste; ver|lust|reich
verm. (Zeichen: ∞) = vermählt
ver|ma|chen (durch letztwillige Verfügung zuwenden); Ver|mächt|nis s; -ses, -se; Ver|mächt|nis|neh|mer (Rechtsspr.)
ver|mah|len (zu Mehl machen); vgl. aber: vermalen
ver|mäh|len; sich -; ver|mählt (Abk.: verm. [Zeichen: ∞]); Ver|mähl|te m u. w; -n, -n († R 287ff.); Ver|mäh|lung; Ver|mäh|lungs|an|zei|ge
ver|mah|nen (ernst ermahnen); Ver|mah|nung
ver|ma|le|dei|en (veraltend ugs. für: verfluchen, verwünschen); ver|ma|le|dei|ung
ver|ma|len ([Farben] malend verbrauchen); vgl. aber: vermahlen
ver|männ|li|chen
ver|mar|ken (vermessen)
ver|mark|ten (Wirtsch.: bedarfsgerecht für den Markt zubereiten); Ver|mark|tung
Ver|mar|kung (Vermessung)
ver|mas|seln jidd. (Gaunerspr., ugs. für: verderben, Unglück bringen); ich vermassele u. vermaßle († R 327)
ver|mas|sen (ins Massenhafte steigern, vergröbern); du vermaßt (vermassest); vermaßt; Ver|mas|sung
ver|mau|ern; Ver|maue|rung
ver|meh|ren; Ver|meh|rung
ver|mei|d|bar; ver|mei|den; er hat diesen Fehler vermieden; ver|meid|lich; Ver|mei|dung
ver|meil fr. [wärmäj] (hochrot); Ver|meil (vergoldetes Silber) s; -s
ver|mei|nen (glauben); oft für: irrtümlich glauben); ver|meint|lich
ver|men|gen; Ver|men|gung

ver|mensch|li|chen; Ver|mensch|li|chung
Ver|merk m; -[e]s, -e; ver|mer|ken; etwas am Rande -
[1]ver|mes|sen; sich - (sich beim Messen irren; sich unterfangen); er hat sich -, alles zu sagen; [2]ver|mes|sen; ein -es (tollkühnes) Unternehmen; Ver|mes|sen|heit (Kühnheit); ver|mes|sent|lich (veralt.); Ver|mes|sung; Ver|mes|sungs_in|ge|nieur (Abk.: Verm.-Ing.), ...schiff, ...ur|kun|de
ver|mickert [Trenn.: ...mik|kert], ver|mie|kert landsch. (klein, schwächlich)
ver|mie|sen jidd. (ugs. für: verleiden); du vermiest (vermiesest); er vermie|ste
ver|mie|ten; Ver|mie|ter; Ver|mie|te|rin w (...-, -nen; Ver|mie|tung; Ver|mie|tungs|bü|ro
Ver|mil|lon fr. [wärmijǫng] (feinster Zinnober) s; -s
ver|min|dern; Ver|min|de|rung
ver|mi|nen (Minen legen; durch Minen versperren)
Verm.-Ing. = Vermessungsingenieur
Ver|mi|nung
ver|mi|schen; Ver|mi|schung
ver|mis|sen; als vermißt gemeldet; Ver|miß|te m u. w; -n, -n (↑ R 287ff.); Ver|miß|ten|an|zei|ge
ver|mit|teln; ich ...[e]le (↑ R 327); ver|mit|tels[t]; mit Wesf.: - des Eimers (besser: mit einem Eimer od. mit Hilfe eines Eimers); Ver|mitt|ler; Ver|mitt|ler|rol|le; Ver|mitt|lung; Ver|mitt|lungs_amt, ...ge|bühr, ...stel|le, ...ver|fah|ren, ...ver|such, ...vor|schlag
ver|mö|beln (ugs. für: tüchtig schlagen; vergeuden); ich ...[e]le (↑ R 327); Ver|mö|be|lung, Ver|möb|lung (ugs.)
ver|mo|dern; Ver|mo|de|rung, Ver|mod|rung
ver|mö|ge; mit Wesf.: - seines Geldes; ver|mö|gen; Ver|mö|gen s; -s, -; ver|mö|gend; -ste; Ver|mö|gens_ab|ga|be, ...be|steue|rung, ...bil|dung, ...er|klä|rung, ...la|ge; ver|mö|gens|los; Ver|mö|gens|recht s; -[e]s; Ver|mö|gens|steu|er; Ver|mö|gen|steu|er w (↑ R 334); Ver|mö|gens_über|nah|me, ...ver|si|che|rung, ...ver|tei|lung, ...ver|wal|tung; ver|mö|gens|wirk|sam; -e Leistungen; Ver|mö|gens|zu|wachs|theo|rie; ver|mög|lich südd. u. schweiz. (wohlhabend)
Ver|mont [wär...] (Staat in den USA; Abk.: Vt.)
ver|mor|schen; vermorscht
ver|mot|tet
ver|mückert [Trenn.: ...mük|kert], ver|mü|kert landsch. (klein, schwächlich)

ver|mum|men; Ver|mum|mung
[1]ver|mu|ren [zu: Mure] (durch Schutt verwüsten)
[2]ver|mu|ren engl. (ein Schiff vor zwei Anker legen); vgl. muren u. Muring
ver|murk|sen (ugs. für: verderben)
ver|mu|ten; ver|mut|lich; Ver|mu|tung; ver|mu|tungs|wei|se
ver|nach|läs|si|gen; Ver|nach|läs|si|gung
ver|na|geln; ver|na|gelt (ugs. auch für: äußerst begriffsstutzig); Ver|na|ge|lung, Ver|nag|lung
ver|nä|hen; eine Wunde -; sie hat das Garn vernäht
ver|nar|ben; Ver|nar|bung
ver|nar|ren; sich -; in jmdn., in etwas vernarrt sein; Ver|narrt|heit
ver|na|schen; sein Geld -; ein Mädchen - (ugs. für: mit ihm schlafen)
ver|ne|beln; ich ...[e]le (↑ R 327); Ver|ne|be|lung, Ver|neb|lung
ver|nehm|bar; ver|neh|men; er hat das Geräusch vernommen; der Angeklagte wurde vernommen; Ver|neh|men s; -s; dem - nach; gutem, sicherem - nach; Ver|nehm|las|sung schweiz. (Stellungnahme, Verlautbarung); ver|nehm|lich; ver|neh|mung ((gerichtl.) Befragung); ver|neh|mungs|fä|hig
ver|nei|gen, sich; Ver|nei|gung
ver|nei|nen; eine verneinende Antwort; Ver|nei|ner; Ver|nei|nung; Ver|nei|nungs|fall m; im -[e]
ver|nich|ten; eine vernichtende Kritik; ein vernichtendes Urteil; Ver|nich|ter; Ver|nich|tung; Ver|nich|tungs_werk, ...wut
ver|nickeln [Trenn.: ...nik|keln]; ich ...[e]le (↑ R 327); Ver|nicke|lung [Trenn.: ...nik|ke...], Ver|nick|lung
ver|nied|li|chen; Ver|nied|li|chung
ver|nie|ten (mit Nieten verschließen); Ver|nie|tung
Ver|nis|sa|ge fr. [wärnißaseʰ] (Ausstellungseröffnung)
Ver|nunft w; -; ver|nunft|be|gabt; Ver|nünf|te|lei; ver|nünf|teln; ich ...[e]le (↑ R 327); ver|nunft|ge|mäß; Ver|nunft_glau|be[n], ...hei|rat; ver|nünf|tig; ver|nünf|ti|ger|wei|se; Ver|nünft|ler; Ver|nunft|mensch m; ver|nunft|wid|rig
ver|nu|ten (durch Nut verbinden); Ver|nu|tung
ver|öden; Ver|ödung
ver|öf|fent|li|chen; Ver|öf|fent|li|chung
Ve|ro|na [we...] (it. Stadt); Ve|ro|nal ⌾ [we...; nach der Stadt Verona] (ein Schlafmittel) s; -s; [1]Ve|ro|ne|se [we...] m; -n, -n (↑ R 268) u. Ve|ro|ne|ser; ↑ R 199 (Einwohner von Verona) m; -s, -; [2]Ve|ro|ne|se (it. Maler); Ve|ro|ne|ser Er-

de (Farbe) w; --; Ve|ro|ne|ser Gelb s; - -s; ver|ro|ne|sisch
[1]Ve|ro|ni|ka [nach der hl. Veronika; we...] (Ehrenpreis [Pflanze]) w; -, ...ken
[2]Ve|ro|ni|ka (w. Vorn.)
ver|ord|nen; Ver|ord|ne|te m, w, s; -n, -n (↑ R 287ff.); Ver|ord|nung; Ver|ord|nungs|blatt
ver|paa|ren, sich (Biol.); ver|paart
ver|pach|ten; Ver|päch|ter|pfand|recht; Ver|pach|tung
ver|packen[1]; Ver|packung[1]; Ver|packungs|ma|te|ri|al[1]
ver|päp|peln (ugs. für: verzärteln); du verpäppelst dich
[1]ver|pas|sen (versäumen); er hat den Zug verpaßt; [2]ver|pas|sen (ugs. für: geben; schlagen) die Uniform wurde ihm verpaßt; dem werde ich eins -; Ver|pas|sung
ver|pat|zen (ugs. für: verderben); er hat die Arbeit verpatzt
ver|per|len (Kohlensäure verlieren)
ver|pe|sten; Ver|pe|stung
ver|pet|zen (ugs. für: verraten); er hat ihn verpetzt
ver|pfän|den; Ver|pfän|dung
ver|pfei|fen; (ugs. für: verraten); er hat ihn verpfiffen
ver|pflan|zen; die Blumen wurden verpflanzt; Ver|pflan|zung
ver|pfle|gen; Ver|pfle|gung; Ver|pfle|gungs_amt, ...geld, ...we|sen (s; -s)
ver|pflich|ten; sich -; er ist mir verpflichtet; Ver|pflich|tung; eine moralische -; Ver|pflich|tungs|ge|schäft (Rechtsw.)
ver|pfrün|den südd. u. schweiz. (jmdm. gegen Hergabe des Vermögens od. einzelner Vermögenswerte lebenslänglichen Unterhalt gewähren); Ver|pfrün|dung
ver|pfu|schen (ugs. für: verderben); er hat die Zeichnung verpfuscht; ein verpfuschtes Leben
ver|pi|chen (mit Pech ausstreichen)
ver|pim|peln (ugs. für: verzärteln); du verpimpelst dich
ver|pla|nen (falsch planen; auch für: in einen Plan einbauen, einplanen)
ver|plap|pern, sich (ugs. für: etwas voreilig u. unüberlegt heraussagen)
ver|plat|ten (mit Platten versehen); Ver|plat|tung
ver|plau|dern (mit Plaudern verbringen)
ver|plem|pern (ugs. für: verschütten; vergeuden); du verplemperst dich

―――――――
[1]Trenn.: ...ak|k...

ver|plom|ben (mit einer Plombe versiegeln)

ver|pö|nen *dt.; lat.* (mißbilligen; veralt. für: verbieten); ver|pönt ([bei Strafe] verboten, nicht statthaft); Ver|pö|nung

ver|pras|sen; er hat das Geld verpraßt; Ver|pras|sung

ver|prel|len (verwirren, einschüchtern)

ver|pro|le|ta|ri|sie|ren; Ver|pro|le|ta|ri|sie|rung

ver|pro|vi|an|tie|ren [...*wiantir*ᵉ*n*] (mit Mundvorrat, mit Lebensmitteln versorgen); Ver|pro|vi|an|tie|rung

ver|prü|geln (ugs.)

ver|puf|fen ([schwach] explodieren; übertr. für: unnütz verbrauchen; auch für: ohne Wirkung bleiben); Ver|puf|fung

ver|pul|vern (ugs. für: unnütz verbrauchen); Ver|pul|ve|rung (ugs.)

ver|pup|pen; Ver|pup|pung (Umwandlung der Insektenlarve in die Puppe)

ver|pu|sten; sich - (ugs. für: Luft schöpfen)

Ver|putz (Mauerbewurf), ver|put|zen (eine Mauer bewerfen; ugs. für: [Geld] durchbringen, vergeuden; [Essen] verzehren); jmdn. nicht - (ugs. für: nicht ausstehen) können

ver|qual|men (ugs.: mit Rauch, Qualm erfüllen)

ver|quält; -e (von Sorgen gezeichnete) Züge; - aussehen

ver|qua|sen nordd. ugs. (vergeuden); du verquast (verquasest); er verqua|ste

ver|quel|len; das Fenster verquillt; vgl. verquollen u. ¹quellen

ver|quer; mir geht etwas - (ugs. für: es mißlingt mir)

ver|quicken [*Trenn.:* ...quik|ken] (vermischen; durcheinanderbringen; Chemie: amalgamieren); Ver|quickung [*Trenn.:* ...quik|kung]

ver|qui|sten niederd. (vergeuden)

ver|quol|len; -e Augen; -es Holz

ver|ram|meln, ver|ram|men; Ver|ram|me|lung, Ver|ram|mung

ver|ram|schen (ugs. für: zu Schleuderpreisen verkaufen); vgl. ¹ramschen

ver|rannt (ugs. für: vernarrt; festgefahren); in jmdn., in etwas - sein

Ver|rat *m*; -[e]s; ver|ra|ten; sich -; dadurch hast du dich verraten; Ver|rä|ter; Ver|rä|te|rei; Ver|rä|te|rin *w*; -, -nen; ver|rä|te|risch; -ste (↑ R 294)

ver|rau|chen; ver|räu|chern

ver|rau|schen; der Beifall verrauschte

ver|rech|nen (in Rechnung bringen; abrechnen); sich - (sich beim Rechnen irren); Ver|rech|nung; Ver|rech|nungs_ein|heit, ...kon|to, ...preis (vgl. ²Preis), ...scheck

ver|recken [*Trenn.:* ...rek|ken] (derb für: verenden; elend zugrunde gehen)

ver|reg|nen; verregnet

ver|rei|ben; Ver|rei|bung

ver|rei|sen (auf die Reise gehen); er ist verreist

ver|rei|ßen; er hat das Theaterstück in seiner Besprechung verrissen (ugs. für: völlig negativ beurteilt)

ver|rei|ten, sich (einen falschen Weg reiten); er hat sich verritten

ver|ren|ken; sich -; Ver|ren|kung

ver|ren|nen; sich in etwas - (ugs. für: hartnäckig an etwas festhalten)

ver|ren|ten (Amtsdt.); Ver|ren|tung (Amtsdt.)

ver|rich|ten (ausführen); Ver|rich|tung

ver|rie|geln

ver|rin|gern; ich ...ere (↑ R 327); Ver|rin|ge|rung

ver|rin|nen

Ver|riß *m*; Verrisses, Verrisse; vgl. verreißen

ver|ro|hen

ver|roh|ren (mit Rohren versehen; Rohre verlegen)

ver|roht; Ver|ro|hung *w*; -

ver|ro|sten

ver|rot|ten (verfaulen, mürbe werden, zerbröckeln); Ver|rot|tung

ver|rucht; Ver|rucht|heit *w*; -

ver|rücken [*Trenn.:* ...rük|ken]; ver|rückt; Ver|rück|te *m, w, s*; -n, -n (↑ R 287ff.); Ver|rückt|heit; Ver|rückt|wer|den *s*; -s; das ist zum -; Ver|rückung [*Trenn.:* ...rük|kung]

Ver|ruf (schlechter Ruf) *m*, nur noch in: in - bringen, geraten, kommen; ver|ru|fen; sie ist sehr -

ver|ru|ßen; der Schornstein ist verrußt; Ver|ru|ßung

Vers *lat.* [*färß*] („Zeile"; Abk.: V.) *m*; -es, -e

ver|sach|li|chen; Ver|sach|li|chung

ver|sacken [*Trenn.:* ...sak|ken] (wegsinken; ugs. für: liederlich leben)

ver|sa|gen; er hat ihr keinen Wunsch versagt; seine Beine haben versagt; die Gewehr hat versagt; sich -; ich versagte mir diesen Genuß; (↑ R 120:) das Unglück ist auf menschliches Versagen zurückzuführen; Ver|sa|ger (nicht fähige Person); nicht einschlagende Leistung; nicht ex-

plodierende Patrone usw.); Ver|sa|gung

Ver|sail|ler [*wärßajᵉr*] (↑ R 199); - Vertrag; Ver|sailles [*wärßaj*] (fr. Stadt)

Ver|sal *lat.* [*wär...*] (großer [Anfangs]buchstabe) *m*; -s, -ien [...*iᵉn*] (meist *Mehrz.*); Ver|sal|buch|sta|be

ver|sal|zen (auch übertr. ugs.: verderben, die Freude an etwas nehmen); versalzt u. (übertr. nur:) versalzen; wir haben ihm das Fest versalzen; Ver|sal|zung

ver|sam|meln; Ver|samm|lung; Ver|samm|lungs_frei|heit (*w*; -), lo|kal, recht (*s*; -[e]s)

Ver|sand (Versendung) *m*; -[e]s; Ver|sand|ab|tei|lung; ver|sand|be|reit; Ver|sand|buch|han|del

ver|san|den (voll Sand machen, werden)

ver|sand|fer|tig; Ver|sand_ge|schäft, ...gut, ...han|del, ...haus, ...ka|sten, ...ko|sten (*Mehrz.*); ver|sandt, ver|sen|det; vgl. senden

Ver|san|dung

Vers_an|fang, ...art

Ver|satz (Versetzen, Verpfänden; Bergmannsspr.: Steine, mit denen Hohlräume ausgefüllt werden, die durch den Abbau entstanden sind) *m*; -es; Ver|satz_amt (bayr. u. österr. für: Leihhaus), ...stück (bewegliche Bühnendekoration; österr. auch für: Pfandstück)

ver|sau|en (derb für: verschmutzen; vernichten)

ver|sau|ern (sauer werden; auch: die [geistige] Frische verlieren); ich ...ere (↑ R 327); Ver|saue|rung

ver|sau|fen

ver|säu|men; Ver|säum|nis *s*; -ses, -se (veralt.: *w*; -, -se); Ver|säum|nis|ur|teil; Ver|säu|mung

ver|scha|chern (ugs. für: verkaufen)

ver|schach|telt; ein -er Satz

ver|schaf|fen; ¹schaffen; sich -; du hast dir Genugtuung verschafft

ver|scha|len (mit Brettern verschlagen)

ver|schal|ken (Seemannsspr.: [Luken] schließen)

Ver|scha|lung (Auskleidung mit Brettern; Bedeckung mit einer Schale)

ver|schämt; - tun; Ver|schämt|heit *w*; -; Ver|schämt|tun *s*; -s

ver|schan|deln (für: verunzieren); ich ...[e]le (↑ R 327); Ver|schan|de|lung, Ver|schand|lung

ver|schan|zen; das Lager wurde verschanzt; sich -; du hast dich hinter Ausreden verschanzt; Ver|schan|zung

ver|schär|fen; verschärfte Gegen-
sätze; die Lage verschärft sich;
Ver|schär|fung
ver|schär|ren
ver|schät|zen, sich
ver|schau|en, sich (bes. österr.: sich
irren; sich verlieben)
ver|schau|keln (ugs. für: betrügen,
hintergehen)
ver|schen|ken
ver|scher|beln (ugs. für: verkau-
fen)
ver|scher|zen ([durch Leichtsinn]
verlieren); sich etwas -; du hast
dir dein Glück, ihre Liebe ver-
scherzt
ver|scheu|chen
ver|scheu|ern (ugs. für: verkaufen)
ver|schicken [Trenn.: ...schik|ken];
Ver|schickung [Trenn.: ...schik-
kung]
ver|schieb|bar; Ver|schie|be_an|la-
ge (Rangieranlage), ...bahn|hof,
...gleis; ver|schie|ben (z. B. Eisen-
bahnwagen, Waren); die Wagen
wurden verschoben; Ver|schie-
bung
¹ver|schie|den (geh. für: gestorben;
Zeichen: †)
²ver|schie|den; verschieden lang. I.
Kleinschreibung (↑ R 135): ver-
schiedene (einige) sagen...; ver-
schiedenes (manches) war mir
unklar. II. Großschreibung: a)
(↑ R 116:) diese Vorschriften las-
sen nicht Verschiedenes (Dinge
verschiedener Art) zu (a b e r: las-
sen verschiedenes [manches]
nicht zu; vgl. I); Ähnliches und
Verschiedenes; b) (↑ R 116:) etwas
Verschiedenes; ver|schie|den|ar-
tig; Ver|schie|den|ar|tig|keit; ver-
schie|de|ne|mal, a b e r: verschie-
dene Male; ver|schie|de|ner|lei;
ver|schie|den_far|big, ...stal-
tig; Ver|schie|den|ge|stal|tig|keit
w; -; Ver|schie|den|heit; ver|schie-
dent|lich
ver|schie|ßen (auch: ausbleichen);
vgl. verschossen
ver|schif|fen; Ver|schiff|fung; Ver-
schif|fungs|ha|fen; vgl. ²Hafen
ver|schil|fen ([mit Schilf] zuwach-
sen)
ver|schim|meln; Ver|schim|me|lung
ver|schim|pfie|ren (ugs. für: verun-
stalten)
ver|schlacken [Trenn.: ...schlak-
ken]; verschlackt
¹ver|schla|fen; ich habe mich ver-
schlafen; er hat den Morgen ver-
schlafen; er hat verschlafen; ²ver-
schla|fen; er sieht - aus; Ver|schla-
fen|heit w; -
Ver|schlag m; -[e]s, Verschläge;
¹ver|schla|gen; der Raum wurde
mit Brettern -; es verschlägt
(nützt) nichts; ²ver|schla|gen

([hinter]listig); ein -er Mensch;
Ver|schla|gen|heit w; -
ver|schläm|men; der Fluß ist ver-
schlammt (verschlämmt sich (mit
Schlamm füllen); die Abfälle ha-
ben das Rohr verschlämmt; das
Rohr hat sich verschlämmt; Ver-
schlamm|mung; Ver|schläm|mung
ver|schläm|pen (ugs. für: verkom-
men lassen)
ver|schlech|tern; ich ...ere (↑ R
327); sich -; Ver|schlech|te|rung
ver|schlei|ern; ich ...ere (↑ R 327);
Ver|schlei|e|rung; Ver|schleie-
rungs_tak|tik, ...ver|such
ver|schlei|men; ver|schleimt; Ver-
schlei|mung
Ver|schleiß (Abnutzung; österr.
auch für: Kleinverkauf, Vertrieb)
m; -es, -e; ver|schlei|ßen; etwas
- (etwas [stark] abnutzen); jmdn.
- (jmdn. für eigene Zwecke rück-
sichtslos einsetzen); Waren ver-
schleißen (österr. für: verkaufen,
vertreiben); du verschlißt (ver-
schlissest); verschlissen; (Klein-
schlei|ßer österr. veralt. (Klein-
händler); Ver|schlei|ße|rin
(österr. veralt.) w; -, -nen; Ver-
schleiß|prü|fung
ver|schlem|men (verprassen)
ver|schlep|pen; Ver|schlep|pung;
Ver|schlep|pungs|tak|tik
ver|schleu|dern; Ver|schleu|de-
rung
ver|schließ|bar; ver|schlie|ßen; vgl.
verschlossen; Ver|schlie|ßung
ver|schlimm|bes|sern (ugs.); er hat
alles nur verschlimmbessert; Ver-
schlimm_bes|se|rung und ...beß-
rung (ugs.); ver|schlim|mern; ich
...ere (↑ R 327); Ver|schlim|me-
rung
ver|schlin|gen; Ver|schlin|gung
ver|schlos|sen (zugesperrt; ver-
schwiegen); Ver|schlos|sen|heit
w; -
ver|schlucken [Trenn.: ...schluk-
ken]; sich -
ver|schlu|dern (ugs.)
Ver|schluß; Ver|schluß_brett,
...deckel [Trenn.: ...dek|kel]; ver-
schlüs|seln; Ver|schlüs|se|lung,
Ver|schlüß|lung; Ver|schluß_laut
(für: Explosiv), ...ma|schi|ne,
...schrau|be, ...strei|fen
ver|schmäch|ten
ver|schmä|hen; Ver|schmä|hung
ver|schmä|lern; sich -; Ver|schmä-
le|rung
ver|schmau|sen
¹ver|schmel|zen (flüssig werden;
ineinander übergehen); vgl.
¹schmelzen; ²ver|schmel|zen (zu-
sammenfließen lassen); ineinan-
der übergehen lassen); vgl.
²schmelzen; Ver|schmel|zung
ver|schmer|zen
ver|schmie|ren; Ver|schmie|rung

ver|schmitzt (schlau, verschlagen);
Ver|schmitzt|heit
ver|schmut|zen; das Kleid ist ver-
schmutzt; ver|schmutzt; Ver-
schmut|zung
ver|schnap|pen, sich (veralt. ugs.
für: sich verplappern)
ver|schnau|fen; sich -; Ver|schnauf-
pau|se
ver|schnei|den (auch für: kastrie-
ren); verschnitten; Ver|schnei-
der; Ver|schnei|dung
ver|schneit; -e Wälder
Ver|schnitt (auch: Mischung alko-
holischer Flüssigkeiten) m; -[e]s;
Ver|schnitt|te|ne m; -n, -n (↑ R
287ff.)
ver|schnör|keln; verschnörkelt;
Ver|schnör|ke|lung, Ver|schnörk-
lung
ver|schnup|fen; ver|schnupft (er-
kältet; übertr.: gekränkt);
Ver|schnup|fung
ver|schnü|ren; Ver|schnü|rung
ver|schol|len (als tot betrachtet;
längst vergangen); Ver|schol|len-
heit w; -
ver|scho|nen; er hat mich mit sei-
nem Besuch verschont; ver|schö-
nen; sie hat das Fest verschönt;
Ver|schö|ne|rer; ver|schö|nern;
ich ...ere (↑ R 327); Ver|schö|ne-
rung; Ver|schö|nung w; -; Ver-
schö|nung w; -
ver|schor|fen; die Wunde ver-
schorft; Ver|schor|fung
ver|schos|sen (ausgebleicht); ein
-es Kleid; (ugs.:) in jmdn. - (ver-
liebt) sein
ver|schram|men; verschrammt
ver|schrän|ken; mit verschränkten
Armen; Ver|schrän|kung
ver|schrau|ben; Ver|schrau|bung
ver|schrecken [Trenn.: ...schrek-
ken] (selten für: [jmdn.] ängstigen
u. dadurch vertreiben); vgl.
²schrecken; ver|schreckt; die -e
Konkurrenz
ver|schrei|ben (falsch schreiben;
gerichtlich übereignen); sich -;
Ver|schrei|bung; Ver|schrieb
(schweiz. neben: Verschreibung,
falsche Schreibung) m; -s, -e
ver|schrei|en, ver|schrien; er ist als
Geizhals -
ver|schro|ben (seltsam; wunder-
lich); Ver|schro|ben|heit
ver|schro|ten (zu Schrot machen)
ver|schro|ten (Metallgegenstände
zerschlagen, als Altmetall ver-
werten); Ver|schro|tung
ver|schrum|peln; Ver|schrum|pe-
lung, Ver|schrump|lung; ver-
schrump|fen (seltener für: ver-
schrumpeln); Ver|schrump|fung
ver|schüch|tern; ich ...ere (↑ R 327);
das Mädchen machte einen ver-
schüchterten Eindruck; Ver-
schüch|te|rung

ver|schul|den; Ver|schul|den s; -s;
ohne [sein] -; ver|schul|det; ver-
schul|de|ter|ma|ßen; Ver|schul-
dung w; -
ver|schu|len (Sämlinge ins Pflanz-
bett umpflanzen); Ver|schu|lung
ver|schup|fen alemann. u. schles.
(fort-, verstoßen, stiefmütterlich
behandeln)
ver|schüt|ten
ver|schüt|ten|ge|hen Gaunerspr. (ugs.
für: verlorengehen)
Ver|schüt|tung
ver|schwä|gert; Ver|schwä|ge|rung
ver|schwei|gen; Ver|schwei|gung
w; -
ver|schwei|ßen
ver|schwen|den; Ver|schwen|der;
Ver|schwen|de|rin w; -, -nen; ver-
schwen|de|risch; -ste (↑ R 294);
Ver|schwen|dung; Ver|schwen-
dungs|sucht w; -; ver|schwen-
dungs|süch|tig
ver|schwie|gen; Ver|schwie|gen-
heit w; -
ver|schwim|men; die Berge sind im
Dunst verschwommen
ver|schwin|den; Ver|schwin|den s;
-s; Ver|schwind|fahr|werk (ein-
ziehbares Fahrgestell beim Flug-
zeug) s; -[e]s, -e
ver|schwi|stert (auch: zusammen-
gehörend); Ver|schwi|ste|rung
ver|schwit|zen (ugs. auch für: ver-
gessen); verschwitzt
ver|schwom|men; -e Vorstellun-
gen; Ver|schwom|men|heit
ver|schwö|ren, sich; Ver|schwö|re-
ne, Ver|schwor|ne m u. w; -n, -n
(↑ R 287ff.); Ver|schwö|rer; Ver-
schwö|rung
ver|se|hen; er hat seinen Posten
treu -; sich - (sich versorgen; sich
irren); ich habe mich mit Nah-
rungsmitteln -; ich habe mich -
(geirrt); Ver|se|hen (Irrtum) s; -s,
-; ver|se|hent|lich (aus Versehen);
Ver|seh|gang (Gang des kath.
Priesters zur Spendung der Sa-
kramente an Kranke, bes. an
Sterbende) m
ver|seh|ren (veralt. für: verletzen,
beschädigen); versehrt; Ver|sehr-
te (Körperbeschädigte[r]) m u. w;
-n, -n (↑ R 287ff.); Ver|sehr|ten-
sport; Ver|sehrt|heit w; -
ver|sei|fen; Ver|sei|fung (Spaltung
der Fette in Glyzerin u. Seifen
durch Kochen in Alkalien)
ver|selb|stän|di|gen, sich; Ver|selb-
stän|di|gung
Ver|se|ma|cher (abschätzig)
ver|sen|den; versandt u. versendet;
vgl. senden; Ver|sen|der; Ver|sen-
dung
ver|sen|gen; die Hitze hat den Ra-
sen versengt; Ver|sen|gung
ver|senk|bar; eine -e Nähmaschi-
ne; Ver|senk|büh|ne; ver|sen|ken

(untertauchen, [durch Untertau-
chen] zerstören); sich [in etwas]
- (sich [in etwas] vertiefen); Ver-
sen|kung
Ver|se|schmied (abschätzig)
ver|ses|sen (eifrig bedacht, er-
picht); Ver|ses|sen|heit w; -
ver|set|zen (Bergmannsspr. auch
für: einen durch Abbau entstan-
denen Hohlraum mit Steinen
ausfüllen); der Schüler wurde
versetzt; er hat ihn in Schrecken
versetzt; er hat sie versetzt (ugs.
für: vergeblich warten lassen); er
hat seine Uhr versetzt (ugs. für:
verkauft, ins Pfandhaus ge-
bracht); Ver|set|zung; Ver|set-
zungs|zei|chen (Musik: Zeichen
vor einer Note)
ver|seu|chen; Ver|seu|chung
Vers.form, ...fuß
ver|si|chern; ich versichere dich ge-
gen Unfall; ich versichere dich
meines Vertrauens, (seltener
auch:) ich versichere dir mein
Vertrauen; ich versichere dir (äl-
ter: dich), daß ...; Ver|si|cher|te
m u. w; -n, -n (↑ R 287ff.); Ver|si-
che|rung; Ver|si|che|rungs_agent,
...an|spruch, ...bei|trag, ...be|trug,
...fall m, ...ge|sell|schaft, ...kar|te,
...neh|mer, ...pflicht; ver|si|che-
rungs|pflich|tig; Ver|si|che|rungs-
_po|li|ce, ...prä|mie, ...recht,
...schein; Ver|si|che|rungs|steu-
er, Ver|si|che|rung|steuer w (↑ R
334); Ver|si|che|rungs_sum|me,
...trä|ger, ...ver|tre|ter, ...wert,
...we|sen (s, -s)
ver|si|ckern [Trenn.: ...sik|kern];
Ver|sicke|rung [Trenn.: ...sik-
ke...]
ver|sie|ben (ugs. für: verderben,
verlieren, vergessen); er hat [ihm]
alles versiebt
ver|sie|geln; ver|sie|ge|lung, (selte-
ner:) Ver|sieg|lung
ver|sie|gen (austrocknen); versieg-
te Quelle; Ver|sie|gung w; -
ver|siert lat. [wär...]; in etwas - (er-
fahren, bewandert) sein; Ver-
siert|heit w; -
Ver|si|fex lat. [wär...] (Verse-
schmied) m; -es, -e; Ver|si|fi|ka|ti-
on [...zion] (Umformung in Ver-
se; Versbildung); ver|si|fi|zie|ren
(in Verse bringen)
ver|sil|be|rer; ver|sil|bern (mit Sil-
ber überziehen; ugs. scherzh. für:
veräußern); ich ...ere (↑ R 327);
Ver|sil|be|rung
ver|sim|peln (ugs. für: beschränkt,
dumm machen, werden); Ver-
sim|pe|lung
ver|sin|ken; versunken
ver|sinn|bild|li|chen; Ver|sinn|bild|li-
chung; Ver|sinn|bild|li|chung
ver|si|on fr. [wär...] (Fassung; Les-

art; Wiedergabe; Darstellung;
veralt. für: Übersetzung)
ver|sippt (verwandt); Ver|sip|pung
ver|sit|zen (mit Sitzen hinbringen;
verdrücken [von Kleidern]; ver-
säumen); vgl. versessen
ver|skla|ven [...wᵉn, auch: ...fᵉn];
Ver|skla|vung
Vers.kunst (w; -), ...leh|re, ...maß
s
ver|snobt dt.; engl. (abschätzig für:
blasiert und in einem übertriebe-
nen Hang zur Exklusivität voller
Verachtung für den durch-
schnittlichen Geschmack)
Ver|so lat. [wär...] ([Blatt]rücksei-
te) s; -s, -s
ver|sof|fen (derb für: trunksüch-
tig)
ver|soh|len (ugs. für: verprügeln)
ver|söh|nen; sich -; Ver|söh|ner;
ver|söhn|lich; Ver|söhn|lich|keit
w; -; Ver|söh|nung; Ver|söh-
nungs_fest, ...tag
ver|son|nen (träumerisch); Ver-
son|nen|heit w; -
ver|sor|gen; Ver|sor|gung; Ver|sor-
gungs_amt, ...an|spruch; Ver|sor-
gungs|be|rech|tigt, Ver|sor-
gungs|be|rech|tig|te, ...la|ge,
...netz, ...schein, ...wirt|schaft
ver|sot|ten (Schornsteinmauer-
werk mit Teerausscheidungen
durchdringen); versottet; Ver-
sot|tung
ver|spakt niederd. (angefault,
stockfleckig, verschimmelt)
ver|spach|teln (landsch. auch für:
aufessen)
ver|span|nen; Ver|span|nung
ver|spä|ten, sich; ver|spä|tet; sein
Dank kam etwas -; Ver|spä|tung
ver|spei|sen; er hat den Braten ver-
speist; Ver|spei|sung w; -
ver|spe|ku|lie|ren
ver|spie|len; ver|spielt; ein -er Jun-
ge
ver|spil|lern (vergeilen); die Pflan-
ze verspillert; Ver|spil|le|rung
ver|spin|nen; versponnen
ver|spot|ten; Ver|spot|tung
ver|spre|chen; er hat ihr die Heirat
versprochen; sich - (beim Spre-
chen einen Fehler machen); ich
habe mich versprochen; Ver-
spre|chen (s, -s, -; Ver|spre|chung
(Verheißung; meist Mehrz.)
ver|spren|gen; Ver|spreng|te (Mili-
tär) m; -n, -n (↑ R 287ff.); Ver-
spren|gung
ver|sprit|zen
ver|spro|che|ner|ma|ßen, ——
spro|che|ner|ma|ßen
ver|spru|deln österr. (verquirlen)
ver|sprü|hen (zerstäuben)
ver|spun|den, ver|spün|den (mit ei-
nem Spund verschließen)
ver|spü|ren

ver|staat|li|chen (in Staatseigentum übernehmen); Ver|staat|li|chung

ver|städ|tern (städtisch machen, werden); ich ...ere († R 327); Ver|städ|te|rung; Ver|stadt|li|chung (selten für: Übernahme in städtischen Besitz od. städtische Verwaltung)

ver|stäh|len (Kupferdruckplatten mit einer Stahlschicht überziehen); Ver|stäh|lung

Ver|stand m; -[e]s; ver|stan|des|mä|ßig; Ver|stan|des_mensch m, ...schär|fe; ver|stän|dig (besonnen); ver|stän|di|gen; sich -; Ver|stän|dig|keit (Klugheit) w; -; Ver|stän|di|gung; Ver|stän|di|gungs_be|reit|schaft, ...ver|such; ver|ständ|lich; Ver|ständ|lich|keit (Klarheit) w; -; Ver|ständ|nis s; -ses, (selten) -se; ver|ständ|nis_in|nig, ...los (-este; † R 292); Ver|ständ|nis|lo|sig|keit w; -; ver|ständ|nis|voll

ver|stär|ken; in verstärktem Maße; Ver|stär|ker; Ver|stär|ker|röh|re; Ver|stär|kung; Ver|stär|kungs|pfei|ler

ver|stä|ten schweiz. (festmachen, bes. das Fadenende)

ver|stat|ten (älter für: gestatten); Ver|stat|tung (veralt.)

ver|stau|ben (sich mit Staub bedecken)

ver|stau|chen; ich habe mir den Fuß verstaucht; Ver|stau|chung

ver|stau|en (gut unterbringen)

Ver|steck s (selten: m); -[e]s, -e; Versteck spielen; ver|stecken[1]; vgl. [2]stecken; sie hat die Ostereier versteckt; sich -; du hattest dich hinter der Mutter versteckt; Ver|stecken[1] s; -s; Verstecken spielen; Ver|stecken|spiel|en[1] s; -s; Ver|steckerl|spiel[1] (österr. neben: Versteckenspielen) s; -s; Ver|steck|spiel s; -[e]s; Ver|steckt|heit w; -

ver|steh|bar; ver|ste|hen; verstanden; sich zu einer Sache -; jmdm. etwas zu - geben; Ver|ste|hen s; -s

ver|stei|fen (Bauw.: abstützen, unterstützen); sich - auf etwas (auf etwas beharren); Ver|stei|fung

ver|stei|gen, sich; er hatte sich in den Bergen verstiegen; du verstiegst dich zu der übertriebenen Forderung; vgl. verstiegen

Ver|stei|ge|rer; ver|stei|gern; Ver|stei|ge|rung

ver|stei|nen (veralt.: mit Grenzsteinen versehen); ver|stei|nern (zu Stein machen, werden); ich ...ere († R 327); wie versteinert; Ver|stei|ne|rung

ver|stell|bar; Ver|stell|bar|keit w; -; ver|stel|len; verstellt; sich -; Ver|stel|lung; Ver|stel|lungs|kunst

ver|step|pen (zu Steppe werden); das Land ist versteppt; Ver|steppung

ver|ster|ben; (nur noch:) verstarb, verstorben (vgl. d.)

ver|steu|ern; Ver|steue|rung

ver|stie|ben (veralt. für: in Staub zerfallen; wie Staub verfliegen); der Schnee ist verstoben

ver|stie|gen (überspannt); Ver|stie|gen|heit

ver|stim|men; ver|stimmt; verstimmt|heit w; -; Ver|stim|mung

ver|stockt (uneinsichtig, störrisch); Ver|stockt|heit w; -

ver|stoh|len; ver|stoh|le|ner|ma|ßen; ver|stoh|le|ner|wei|se

ver|stop|fen; Ver|stop|fung

ver|stor|ben (Zeichen: †); Ver|stor|be|ne m u. w; -n, -n († R 287ff.)

ver|stört; Ver|stört|heit w; - Ver|stoß; ver|sto|ßen; Ver|sto|ßung

ver|stre|ben; Ver|stre|bung

ver|strei|chen (auch für: vorübergehen, vergehen); die Zeit ist verstrichen

ver|streu|en

ver|stricken[1] sich [in Widersprüche] -; Ver|strickung[1]

ver|stüm|meln; ich ...ele († R 327); Ver|stüm|me|lung; Ver|stümm|lung

ver|stum|men; Ver|stum|mung w; -

Ver. St. v. A. = Vereinigte Staaten von Amerika

Ver|such m; -[e]s, -e; ver|su|chen; Ver|su|cher; Ver|suchs_ab|tei|lung, ...an|ord|nung, ...an|stalt, ...bal|lon, ...be|trieb, ...feld, ...ka|nin|chen (ugs.), ...lei|ter m, ...per|son (Psych.; Abk.: Vp., VP), ...sta|ti|on, ...tier; ver|suchs|wei|se; Ver|su|chung

ver|süh|nen (veraltend für: versöhnen)

ver|sump|fen; Ver|sump|fung

ver|sün|di|gen, sich; Ver|sün|di|gung

ver|sun|ken; in etwas - sein; Ver|sun|ken|heit w; -

ver|sü|ßen; Ver|sü|ßung

Vers|wis|sen|schaft (für: Metrik)

vert. (Druckw.: V) = vertatur

ver|tä|feln; ich ...[e]le († R 327); Ver|tä|fe|lung, Ver|täf|lung

ver|ta|gen (aufschieben); Ver|ta|gung

ver|tän|deln (nutzlos die Zeit hinbringen); Ver|tän|de|lung, Ver|tänd|lung

ver|ta|tur! lat. [wär...] (man wende!, man drehe um!; Abk.: vert. [Druckw.: V])

ver|tau|bung (Bergmannsspr.:

Taub-, Unhaltigwerden des Erzganges)

ver|täu|en (Seemannsspr.: Schiff durch Taue festmachen); das Schiff ist vertäut

ver|tausch|bar; ver|tau|schen; Ver|tau|schung

ver|tau|send|fa|chen; ver|tau|send|fäl|ti|gen (veraltend)

Ver|täu|ung (Seemannsspr.)

ver|te! lat. [wärte] (wende um!, wenden! [das Notenblatt beim Spielen]); ver|te|bral (Med.: zur Wirbelsäule gehörend, auf sie bezüglich); Ver|te|bra|ten (Wirbeltiere) Mehrz.

ver|tei|di|gen; Ver|tei|di|ger; Ver|tei|di|gung; Ver|tei|di|gungs_bei|trag, ...fall m, ...mi|ni|ster, ...pakt, ...schrift, ...stel|lung; ver|tei|di|gungs|wei|se; Ver|tei|di|gungs|zu|stand

ver|tei|len; Ver|tei|ler; Ver|tei|ler_netz, ...ta|fel; Ver|tei|lung; Ver|tei|lungs_plan (vgl. [2]Plan), ...stel|le

ver|te, si pla|cet! lat. [wärte - pla|zet] (bitte wenden! [das Notenblatt beim Spielen]; Abk.: v. s. pl.)

ver|teu|ern; sich -; ich ...ere († R 327); Ver|teue|rung

ver|teu|feln; jmdn., etwas - (zum „Teufel", Bösen machen, stempeln); ich ...[e]le († R 327); ver|teu|felt (Fluchwort); Ver|teu|fe|lung, Ver|teuf|lung

ver|tie|fen; sich in eine Sache -; Ver|tie|fung

ver|tie|ren (zum Tier werden, machen); ver|tiert (tierisch); Ver|tiert|heit; Ver|tie|rung

ver|ti|kal lat. [wär...] (senkrecht, lotrecht); Ver|ti|ka|le w; -, -n; vier -[n] († R 291); Ver|ti|kal_ebe|ne, ...krei|se (Astron.; Mehrz.)

Ver|ti|ko [wär...; angeblich nach dem ersten Verfertiger] (kleiner Zierschrank) s (selten: m); -s, -s

ver|til|gen; Ver|til|gung w; -, (selten:) -en; Ver|til|gungs|mit|tel s

ver|tip|pen (ugs. für: falsch tippen); sich -; vertippt

Ver|ti|zil|la|ten lat. [wär...] (austral. Bäume mit rutenförmigen Zweigen u. schuppenförmigen Blättern) Mehrz.

ver|to|nen; das Gedicht wurde vertont; Ver|to|ner (selten); [1]Ver|to|nung (Musikschöpfung)

[2]Ver|to|nung (Zeichnung des Bildes einer Küstenstrecke)

ver|tor|fen; Ver|tor|fung (Torfbildung)

ver|trackt (ugs. für: verwickelt; peinlich); Ver|trackt|heit (ugs.) w; -, (selten:) -en

Ver|trag m; -[e]s, ...träge; ver|tra|gen; er hat den Wein gut -; sich

-; die Kinder werden sich schon -; (schweiz.:) Zeitungen - (austragen); **Ver|trä|ger** (schweiz. für: jmd., der Zeitungen u. ä. austrägt); **ver|trag|lich** (dem Vertrage nach; durch Vertrag); **ver|träg|lich** (nicht zänkisch; bekömmlich); er ist sehr -; die Speise ist leicht -; **Ver|träg|lich|keit** w; -; **Ver|trags.ab|schluß**, ...**bruch** m; **vor|trags|brü|chig; Ver|trags|brü|chi|ge** m u. w; -n, -n (↑ R 287 ff.); **Ver|trags|schlie|ßen|de** m u. w; -n, -n (↑ R 287 ff.); **ver|trags|ge|mäß; ver|trag[s]|los;** ein -er Zustand; **Ver|trags.part|ner**, ...**spie|ler**, ...**text**, ...**ver|let|zung; ver|trags-wid|rig**

ver|trau|en; Ver|trau|en s; -s; **ver-trau|en|er|weckend** [Trenn.: ...**wek|kend], a b e r** (↑ R 142): großes Vertrauen erweckend; -ste; **Ver|trau|ens.arzt**, ...**be|weis**, ...**bruch** m, ...**fra|ge**, ...**mann** (Mehrz. ...**männer** u. ...**leute;** Abk.: V-Mann), ...**per|son**, ...**sa-che; ver|trau|ens|se|lig; Ver|trau-ens.se|lig|keit** (w; -), ...**stel|lung; ver|trau|ens|voll; Ver|trau|ens|vo-tum;** **ver|trau|ens|wür|dig; Ver-trau|ens|wür|dig|keit**
ver|trau|ern
ver|trau|lich; Ver|trau|lich|keit
ver|träu|men; ver|träumt; Ver-träumt|heit w; -, (selten:) -en
ver|trau|t;jmdn., sich mit etwas - machen; **Ver|trau|te** m, w, s; -n, -n (↑ R 287 ff.); **Ver|traut|heit**
ver|trei|ben; Ver|trei|bung
ver|tret|bar; -e Sache (BGB); **ver-tre|ten; Ver|tre|ter; Ver|tre|tung;** in - (Abk.: i. V., I. V. [vgl. d.]); **Ver|tre|tungs|stun|de; Ver|tre-tungs|wei|se**
Ver|trieb (Verkauf) m; -[e]s, -e
Ver|trie|be|ne m u. w; -n, -n (↑ R 287 ff.)
Ver|triebs.ab|tei|lung, ...**ge|sell-schaft**, ...**kar|tell**, ...**ko|sten** (Mehrz.), ...**lei|ter** m, ...**recht**
ver|trim|men (ugs. für: verprügeln)
ver|trin|ken
ver|trock|nen; Ver|trock|nung w; -
ver|trö|deln (ugs. für: [seine Zeit] unnütz hinbringen); **Ver|trö|de-lung, Ver|tröd|lung** (ugs.) w; -
ver|trö|sten; Ver|trö|stung
ver|trot|teln (ugs. für: zum Trottel werden); **ver|trot|telt;** ein -er alter Mann
ver|tru|sten [auch engl. Aussprache: ...traßt^en] (in einen Trust eingliedern, zum Trust machen); die Betriebe sind vertrustet; **Ver|tru-stung**
ver|tü|dern niederd. (verwirren); sich -
Ver|tum|na|li|en [wärtumnali^en] (altröm. Fest) Mehrz.

ver|tun (ugs. für: verschwenden); vertan
ver|tu|schen (ugs. für: verheimlichen); du vertuschst (vertuschest); **Ver|tu|schung** (ugs.)
ver|übeln (übelnehmen); ich ...[e]le (↑ R 327)
ver|üben
ver|ul|ken
ver|un|eh|ren (veralt.)
ver|un|ei|ni|gen; ver|un|ei|ni|gung
ver|un|fal|len schweiz. (verunglükken, durch Unfall zu Schaden kommen); **Ver|un|fall|te** m u. w; -n, -n (↑ R 287 ff.)
ver|un|glimp|fen (schmähen); **Ver-un|glimp|fung**
ver|un|glücken [Trenn.: ...**glük-ken]; Ver|un|glück|te** m u. w; -n, -n (↑ R 287 ff.)
ver|un|hei|li|gen (entweihen)
ver|un|mög|li|chen bes. schweiz. (verhindern, vereiteln)
ver|un|rei|ni|gen; **Ver|un|rei|ni-gung**
ver|un|si|chern (unsicher machen); **Ver|un|si|che|rung**
ver|un|stal|ten (ungestalt machen, entstellen); **Ver|un|stal-tung**
ver|un|treu|en (unterschlagen); **Ver|un|treu|er; Ver|un|treu|ung**
ver|un|zie|ren; Verun|zie|rung
ver|ur|sa|chen; **Ver|ur|sa|cher; Ver|ur|sa|chung**
ver|ur|tei|len; Ver|ur|tei|lung
Ver|ve fr. [wärv^e] (Begeisterung, Schwung) w; -
ver|viel|fa|chen, ver|viel|fa|chung; ver|viel|fäl|ti|gen; Ver|viel|fäl|ti-ger; Ver|viel|fäl|ti|gung; Ver|viel-fäl|ti|gungs.ap|pa|rat, ...**ver|fah-ren**, ...**zahl**
ver|vier|fa|chen
ver|voll|komm|nen; sich -; **Ver|voll-komm|nung;** **ver|voll|komm-nungs|fä|hig**
ver|voll|stän|di|gen; Ver|voll|stän-di|gung
verw. = verwitwet
¹**ver|wach|sen;** dic Narbe ist verwachsen; mit etwas - (innig verbunden) sein; sich - (mit dem Wachsen verschwinden); ²**ver-wach|sen;** -er (verkrüppelter, buckliger) Mensch; **Ver|wach-sung**
ver|wackeln [Trenn.: ...**wak|keln**]
Ver|wä|gung (veralt. für: Gewichtsfeststellung, Wägen)
ver|wäh|len, sich beim Telefonieren)
Ver|wahr m, nur in: in - geben, nehmen; **ver|wah|ren;** es ist alles wohl verwahrt; sich - gegen ... (etwas ablehnen); **Ver|wah|rer; ver|wahr|lo|sen;** du verwahrlost (verwahrlosest); **Ver|wahr|lo|ste** m u. w; -n, -n (↑ R 287 ff.); **Ver-**

wahr|lo|sung w; -; **Ver|wahr|sam** m; -s; in - geben, nehmen; **Ver-wah|rung**
ver|wai|sen (elternlos werden; einsam werden); du verwaist (verwaisest); er verwai|ste; **ver|waist; Ver|wai|sung** w; -
ver|wal|ken (ugs. für: verprügeln)
ver|wal|ten; Ver|wal|ter; Ver|wal-tung; Ver|wal|tungs.akt, ...**ap|pa-rat**, ...**be|am|te**, ...**be|hör|de**, ...**be-zirk**, ...**dienst**, ...**fach**, ...**ge|bäu|de**, ...**ge|richt**, ...**ge|richts|hof**, ...**ko-sten** (Mehrz.), ...**po|li|zei**, ...**rat** (Mehrz. ...**räte**), ...**recht** (s; -[e]s), ...**re|form**, ...**vor|schrift**, ...**zweig**
ver|wam|sen (ugs. für: verprügeln); du verwamst (verwamsest)
ver|wan|deln; Ver|wand|lung; Ver-wand|lungs|künst|ler; ver|wand-lungs|reich; ver|wandt (zur gleichen Familie gehörend); **Ver-wand|te** m u. w; -n, -n (↑ R 287 ff.); **Ver|wandt|schaft;** **ver|wandt-schaft|lich;** **Ver|wandt|schafts-grad**
ver|wanzt
ver|war|nen; Ver|war|nung
ver|wa|schen
ver|wäs|sern; **Ver|wäs|se|rung, Ver|wäß|rung**
ver|we|ben; (meist schwach gebeugt, wenn es sich um die handwerkliche Tätigkeit handelt:) bei dieser Matte wurden Garne unterschiedlicher Stärke verwebt; (meist stark gebeugt bei übertragener Bedeutung:) zwei Melodien sind miteinander verwoben
ver|wech|seln; (↑ R 120:) zum Verwechseln ähnlich; **Ver|wech|se-lung, Ver|wechs|lung**
ver|we|gen; Ver|we|gen|heit
ver|we|hen; vom Winde verweht
ver|weh|ren; jmdm. etwas - (untersagen); **Ver|weh|rung**
Ver|we|hung
ver|weich|li|chen; **Ver|weich|li-chung**
ver|wei|gern; **Ver|wei|ge|rung; Ver|wei|ge|rungs|fall** m; im -[e]
ver|wei|len; sich -
ver|weint
Ver|weis (ernste Zurechtweisung; Hinweis) m; -es, -e; ¹**ver|wei|sen** (tadeln); jmdm. etwas -; er hat dem Jungen seine Frechheit verwiesen; ²**ver|wei|sen** (einen Hinweis geben; verbannen); durch diese Fußnote wird der Leser auf eine frühere Stelle des Buches verwiesen; der Verbrecher wurde des Landes verwiesen; **Ver|wei-sung** (Hinweis, Verweis; Ausweisung)

ver|wel|ken
ver|wel|schen (veralt. abschätzig für: welsch machen); verwelscht; **Ver|wel|schung**

ver|welt|li|chen (weltlich machen); Ver|welt|li|chung
ver|wend|bar; Ver|wend|bar|keit w; -; ver|wen|den; ich verwandte od. verwendete, habe verwandt od. verwendet; Ver|wen|dung; zur besonderen Verwendung (Abk.: z. b. V.); Ver|wen|dungs_mög|lich|keit, ...wei|se
ver|wer|fen; der Plan wurde verworfen; (schweiz.:) die Arme - (heftig gestikulieren); ver|werf|lich; Ver|werf|lich|keit w; -; Ver|wer|fung (auch: geol. Schichtenstörung); Ver|wer|fungs|spal|te (Geol.)
ver|wert|bar; ver|wer|ten; verwertet; Ver|wer|ter; Ver|wer|tung
¹ver|we|sen (sich zersetzen, in Fäulnis übergehen)
²ver|we|sen (stellvertretend verwalten); du verwest (verwesest); Ver|we|ser
ver|wes|lich; Ver|wes|lich|keit w; -; Ver|we|sung; Ver|we|sungs|ge|ruch
ver|wet|ten
ver|wet|tert (veralt. für: verwittert, vom Wetter mitgenommen)
ver|wi|chen (veralt. für: vergangen); im -en Jahre
ver|wich|sen (ugs. für: schlagen; [Geld] vergeuden); der Vater hat ihn verwichst; er hat sein Vermögen verwichst
ver|wickeln¹; ver|wickelt¹; Ver|wicke|lung¹, Ver|wick|lung
ver|wie|gen (wiegen); Ver|wie|gung
ver|wil|dern; ver|wil|dert; Ver|wil|de|rung
ver|win|den (über etwas hinwegkommen, überwinden); verwunden; den Schmerz -; Ver|win|dung
ver|win|kelt (winklig)
ver|wir|ken; sein Leben -
ver|wirk|li|chen; Ver|wirk|li|chung
Ver|wir|kung
ver|wir|ren; ich habe das Garn verwirrt; ich bin ganz verwirrt; vgl. verworren; Ver|wirrt|heit w; -; Ver|wir|rung
ver|wirt|schaf|ten (mit etwas schlecht wirtschaften)
ver|wi|schen; die Unterschrift war verwischt; Ver|wi|schung
ver|wit|tern (durch den Einfluß der Witterung angegriffen werden); das Gestein ist verwittert; Ver|wit|te|rung; Ver|wit|te|rungs|pro|dukt
ver|wit|wet (Witwe[r] geworden; Abk.: verw.)
ver|wo|ben (eng verknüpft mit ...); vgl. verweben
ver|wo|gen (veralt., aber noch mdal. für: verwegen)

¹ *Trenn.: ...ik|ke...*

ver|woh|nen (durch Wohnen abnutzen); verwohnte Räume
ver|wöh|nen; ver|wöhnt; Ver|wöhnt|heit w; -; Ver|wöh|nung
ver|wor|fen; ein verworfenes Gesindel; Ver|wor|fen|heit w; -
ver|wor|ren; ein -er Kopf; vgl. verwirren; Ver|wor|ren|heit w; -
ver|wund|bar; Ver|wund|bar|keit w; -; ¹ver|wun|den (verletzen)
²ver|wun|den; vgl. verwinden
ver|wun|der|lich; ver|wun|dern; es ist nicht zu -; sich -; Ver|wun|de|rung
ver|wun|det; Ver|wun|de|te m u. w; -n, -n (↑ R 287 ff.); Ver|wun|de|ten|trans|port; Ver|wun|dung
ver|wün|schen (verzaubert); ein -es Schloß; ver|wün|schen (verfluchen; verwandeln); er hat sein Schicksal oft verwünscht; ver|wünscht (verflucht); - sei diese Reise!; Ver|wün|schung
Ver|wurf (svw. Verwerfung [Geol.])
ver|wur|steln (ugs.: durcheinanderbringen, verwirren)
ver|wur|zeln; Ver|wur|ze|lung, Ver|wurz|lung
ver|wü|sten; Ver|wü|ster; Ver|wü|stung
ver|za|gen; ver|zagt; Ver|zagt|heit w; -
ver|zäh|len, sich
ver|zah|nen (an-, ineinanderfügen); Ver|zah|nung
ver|zan|ken, sich (ugs. für: in Streit geraten)
ver|zap|fen (ausschenken; durch Zapfen verbinden; ugs. für: etwas [Übles oder Unsinniges] vorbringen, mitteilen, anstellen); Ver|zap|fung
ver|zär|teln; Ver|zär|te|lung
ver|zau|bern; Ver|zau|be|rung
ver|zäu|nen; Ver|zäu|nung
ver|zehn|fa|chen; ver|zehn|ten (veralt. für: den Zehnten von etwas zahlen)
Ver|zehr (Verbrauch, Verbrauchtes; Zeche) m; -[e]s; ver|zeh|ren; Ver|zeh|rer; Ver|zeh|rung w; -; Ver|zehr|zwang m; -[e]s
ver|zeich|nen (vermerken; falsch zeichnen); Ver|zeich|nis s; -ses, -se; Ver|zeich|nung; ver|zeich|nungs|frei (für: orthoskopisch)
ver|zei|gen schweiz. (gegen jmdn. Strafanzeige erstatten)
ver|zei|hen; er hat ihr verziehen; ver|zeih|lich; Ver|zei|hung w; -; ver|zer|ren; Ver|zer|rung
¹ver|zet|teln (für eine Kartei aufnehmen od. ausschreiben usw.)
²ver|zet|teln (vergeuden); sich -
¹Ver|zet|te|lung, ¹Ver|zett|lung (Aufnahme auf Zettel für eine Kartei)

²Ver|zet|te|lung, ²Ver|zett|lung (Vergeudung) w; -
Ver|zicht m; -[e]s, -e; - leisten; ver|zich|ten; Ver|zicht.er|klä|rung, ...lei|stung, ...po|li|tik
ver|zie|hen; die Eltern - ihr Kind; er ist nach Frankfurt verzogen; Rüben -; sich -; wir haben uns still verzogen (ugs. für: sind still verschwunden); Ver|zie|hung
ver|zie|ren; Ver|zie|rer; Ver|zie|rung
ver|zim|mern (Bauw.); Ver|zim|me|rung
¹ver|zin|ken (Gaunerspr.: verraten, anzeigen)
²ver|zin|ken (mit Zink überziehen; Holz durch Schwalbenschwanzzapfen verbinden); Ver|zin|kung
ver|zin|nen; Ver|zin|nung
ver|zins|bar; ver|zin|sen; ver|zins|lich; Ver|zins|lich|keit w; -; Ver|zin|sung
ver|zo|gen; ein -er Junge; vgl. auch: verziehen
ver|zö|gern; Ver|zö|ge|rung; Ver|zö|ge|rungs_mit|tel s, ...tak|tik
ver|zol|len; die Ware ist verzollt; vgl. franko; Ver|zol|lung
ver|zücken¹
ver|zuckern¹; Ver|zucke|rung¹
ver|zückt; Ver|zückt|heit w; -; Ver|zückung¹; in - geraten
Ver|zug (Bergmannsspr. auch: gitterartige Verbindung zwischen Ausbaurahmen) m; -[e]s; im - sein (im Rückstand sein); in - geraten, kommen; in - setzen; ohne - (sofort); Ver|zugs|zin|sen Mehrz.
ver|zwat|zeln südd. ([vor Ungeduld] vergehen, verzweifeln)
ver|zwei|feln; (↑ R 120:) es ist zum Verzweifeln; ver|zwei|felt; Ver|zweif|lung; ver|zwei|flungs|tat
ver|zwei|gen, sich; Ver|zwei|gung
ver|zwickt (ugs. für: verwickelt, schwierig); eine -e Geschichte; Ver|zwickt|heit
ver|zwir|nen (Garne zusammendrehen)
Ve|si|ka|to|ri|um lat. [we...] (Med.: blasenziehendes Mittel, Zugpflaster) s; -s, ...ien [...i*n]
Ves|pa ® it. [wäßpa] (ein Motorroller) w; -, -s
Ves|pa|si|an, Ves|pa|sia|nus [wäß...] (röm. Kaiser)
Ves|per lat. [fäß...] (Zeit gegen Abend; Abendandacht; Stundengebet; bes. südd. für: Zwischenmahlzeit, bes. am Nachmittag) w; -, -n (für Zwischenmahlzeit südd.: s; -s, -); Ves|per.bild, ...brot, ves|pern (südd. u. westösterr. für: [Nachmittags-, Abend]imbiß einnehmen); ich ...ere (↑ R 327)

¹ *Trenn.: ...k|k...*

Ves|puc|ci [*wäßpuțschi*] (it. See-fahrer)

Ve|sta [*wäßta*] (röm. Göttin des häusl. Herdes); Ve|sta|lin (Priesterin der Vesta) w; -, -nen

Ve|ste [*fä...*] (veralt. für: Feste) w; -, -n; Veste Coburg

Ve|sti|bül *fr.* [*wäß...*] (Vorhalle, -flur, Treppenhalle) *s*; -s, -e; Ve|sti|bu|lum *lat.* (Vorhalle des altröm. Hauses) *s*, -s, ...la

Ve|sti|tur *lat.* [*wäß...*] (svw. Investitur) w; -, -en

Ve|suv [*wesuf*] (Vulkan bei Neapel) *m*; -[s]; Ve|su|vi|an [*wesuwiąn*] (ein Mineral) *m*; -s, -e; ve|su|visch [*wesuwisch*]

Ve|te|ran *lat.* [*we...*] (altgedienter Soldat; im Dienst Ergrauter, Bewährter) *m*; -en, -en (↑ R 268)

ve|te|ri|när *fr.* [*we...*] (tierärztlich); Ve|te|ri|när (Tierarzt) *m*; -s, -e; Ve|te|ri|när|arzt; ve|te|ri|när|ärzt|lich; Ve|te|ri|när_me|di|zin (Tierheilkunde), ...rat (*Mehrz.* ...räte)

Ve|to *lat.* [*weto*] („ich verbiete"; Einspruch[srecht]) *s*; -s, -s; Ve|to|recht

Vet|tel [*fät'l*] (unordentliche [alte] Frau) w; -, -n

Vet|ter *m*; -s, -n (↑ R 270); Vet|te|rin (veralt.) w; -, -nen; vet|ter|lich; Vet|ter|li|wirt|schaft schweiz. (Vetternwirtschaft) w; -; Vet|tern|[n]|schaft; Vet|tern|wirt|schaft (abschätzig) w; -

Ve|xier|bild *lat.*; *dt.* [*wä...*]; ve|xieren *lat.* (irreführen; quälen; nek ken); Ve|xier_rät|sel, ...spie|gel

Ve|xil|lum *lat.* [*wä...*] (altröm. Fahne) *s*; -s, ...lla u. ...llen

Ve|zier usw. vgl. Wesir usw.

V-för|mig; ↑ R 149 (in der Form eines V)

vgl. = vergleich[e]!

v., g., u. = vorgelesen, genehmigt, unterschrieben

v. H., p. c., % = vom Hundert; vgl. Prozent, pro centum

via *lat.* [*wia*] ([auf dem Wege] über); - Triest; Via Ap|pia (Straße bei Rom) w; - -; Via|dukt [*wia...*] (Talbrücke, Überführung) *m*; -[e]s, -e; Via Ma|la (Schlucht in Graubünden) w; - -; Via|ti|kum (kath. Kirche: dem Sterbenden gereichte letzte Kommunion)

Vi|bra|phon *lat.*; *gr.* [*wi...*] (ein Musikinstrument) *s*; -s, -e; Vi|bra|pho|nist (↑ R 268); Vi|bra|ti|on *lat.* [*...zion*] (Schwingung, Beben, Erschütterung); Vi|bra|ti|ons|mas|sa|ge (kurz: Vibromassage); vi|bra|to *it.* (Musik: bebend); Vi|bra|to *s*; -s, -s u. ...ti; vi|brie|ren *lat.* (schwingen; beben, zittern); Vi|bro|mas|sa|ge (kurz für: Vibrationsmassage)

vi|ce ver|sa *lat.* [*wize wärsa*] (umgekehrt; Abk.: v. v.)

Vi|co [*wiko*] (it. m. Vorn.)

Vi|comte *fr.* [*wikonßt*] („Vizegraf", fr. Adelstitel) *m*; -s, -s; Vi|comtesse [*wikongtäß*] (dem Vicomte entsprechender weibl. Adelstitel) w; -, -n [*...ß'n*]

Vic|to|ria [engl. Aussspr.: *wiktąri'*] (Gliedstaat des Australischen Bundes); Vic|to|ria|fäl|le [*wik...*] (große Fälle des Sambesi) *Mehrz.*

Vic|to|ria re|gia [*wik...* -] (südamerik. Seerose) w; - -

vi|de! *lat.* [*wide*] (veralt. für: siehe!; Abk.: v.); Vi|deo|re|cor|der (Speichergerät für Fernsehaufnahmen); vi|di (veralt. für: ich habe gesehen; Abk.: v.); vi|die|ren (veralt., aber noch österr.: beglaubigen, unterschreiben); Vi|di|ma|ti|on [*...zion*] (Beglaubigung); Vi|di|ma|tum (veralt. für: Vidimation) *s*; -s, -s u. ...ta; vi|dit (veralt. für: hat [es] gesehen; Abk.: vdt.)

Viech (mdal. für: Vieh; ugs. als Schimpfwort) *s*; -[e]s, -er; Vie|che|rei (ugs. für: Gemeinheit, Niedertracht; große Anstrengung); Vieh w; -[e]s; Vieh_be|stand, ...fut|ter (vgl. ¹Futter), ...hal|ter, ...han|del (vgl. ¹Handel), ...händ|ler, ...her|de; vie|hisch; -ste (↑ R 294); Vieh_salz (-es), ...ver|si|che|rung, ...wa|gen, ...wei|de, ...zäh|lung, ...zeug (ugs.), ...zucht, ...züch|ter

viel (↑ R 135); in vielem, mit vielem, um vieles, wer vieles bringt, ...; ich habe viel[es] erlebt; um vieles gebe ich das nicht hin; viele sagen ...; (↑ R 116:) viel Gutes od. vieles Gute; vielen Schlafes; mit viel Gutem od. mit vielem Guten; (↑ R 280:) vieler schöner Schnee; mit vieler natürlicher Anmut; vieles milde Nachsehen; mit vielem kalten Wasser; (↑ R 286:) viel[e] gute Nachbildungen; vieler guter (seltener: guten) Nachbildungen; (↑ R 290:) viele Begabte, vieler Begabter (seltener: Begabten); viel[e] Menschen; die vielen Menschen; so viel arbeiten, daß ...; soviel (vgl. d.); soviel ich weiß ...; vielmal[s]; vieltausendmal tausend; vielmehr (vgl. d.); wir haben gleich viel; gleichviel ob du kommst oder ...; soundso viel; ein soundsovielten Mai; zuviel (vgl. d.), aber: zu viel; zu viele Menschen; viel zuviel; viel zu viele Menschen; viel zuwenig; es gab noch vieles, was (nicht: das od. welches) besprochen werden sollte; allzuviel, aber: die Vielen, Allzuvielen (Nietzsche). *In Verbindung mit dem 2. Mittelwort:* a)

Getrenntschreibung (↑ R 142): der Fall wurde viel besprochen; b) *Zusammenschreibung* (↑ jedoch R 142): vielbesprochen (häufig besprochen, in aller Munde), z. B. ein vielbesprochener Fall. *Steigerung der Zusammenschreibungen* ↑ R 296 u. 297; Viel *s*; -s; viele Wenig machen ein Viel

viel|bän|dig; ein -es Werk; viel|be|schäf|tigt; ein vielbeschäftigter Mann (↑ jedoch R 142), aber: der Mann ist viel beschäftigt; viel|be|spro|chen (häufig besprochen, in aller Munde); ein vielbesprochener Fall (↑ jedoch R 142), aber: der Fall wurde viel besprochen; viel|deu|tig; Viel|deu|tig|keit; viel|eck; viel|eckig [*Trenn.*: ...ek|kig]; Viel|ehe; viel|ehig; vie|len|orts, vie|ler|orts; vie|ler|lei; viel|er|ör|tert; ein vielerörtertes Ereignis (↑ jedoch R 142), aber: das Ereignis wurde viel erörtert; viel|er|orts, vie|len|orts; viel|fach; Viel|fa|che *s*; -n (↑ R 287ff.); kleinstes gemeinsames -s (Abk.: k. g. V., kgV); vgl. Achtfache; Viel|fach|ge|rät, Viel|fach|helt w; -; Viel|falt w; -; Viel|fal|tig (mit vielen Falten); viel|fäl|tig (mannigfaltig, häufig); Viel|fäl|tig|keit w; -; viel|far|big; ein -es Muster; Viel|fing|rig|keit w; -; Viel|flach *s*; -[e]s, -e u. Viel|fläch|ner (für: Polyeder); viel|flä|chig

Viel|fraß (Marderart; ugs. für: jmd., der gern u. viel ißt) *m*; -es, -e

viel|ge|braucht; ein vielgebrauchtes Fahrrad (↑ jedoch R 142), aber: das Fahrrad wurde viel gebraucht; viel|ge|kauft; ein vielgekauftes Buch (↑ jedoch R 142), aber: das Buch wird viel gekauft; viel|ge|nannt; ein vielgenannter Mann (↑ jedoch R 142), aber: der Mann wurde viel genannt; viel|ge|reist; ein vielgereister Mann (↑ jedoch R 142), aber: der Mann ist viel gereist; Viel|ge|rei|ste *m* u. w; -n, -n (↑ R 287ff.); viel|ge|schmäht; ein vielgeschmähter Mann (↑ jedoch R 142), aber: der Mann wurde viel geschmäht; viel|ge|stal|tig; Viel|ge|stal|tig|keit w; -; viel|glie|de|rig, viel|glied|rig; Viel|glie|de|rig|keit, Viel|glied|rig|keit; Viel|göt|te|rei (für: Polytheismus) w; -; Viel|heit w; -; viel|hun|dert|mal, aber: viele hundert Male; vgl. Mal; viel|köp|fig; viel|leicht; viel|lieb (veralt. für: sehr geliebt)

Viel|lieb|chen [Umdeutung aus dem w. Vorn. Valentine bzw. Philippine] (scherzh. Brauch)

viel|mal, viel|mals; viel|ma|lig; viel|mals, viel|mal; Viel|män|ne-

rei *w*; -; viel|mehr [auch: *fil*...];
er ist nicht dumm, weiß vielmehr
ziemlich gut Bescheid; a b e r: er
weiß viel mehr als du; viel|sa-
gend; -ste; viel|schich|tig; Viel-
schrei|ber (abschätzig); viel|sei-
tig; Viel|sei|tig|keit *w*; -; viel_sil-
big, ...spra|chig, ...stim|mig; viel-
tau|send|mal, a b e r : viele tausend
Male; vgl. Mal; viel|tau|send-
stim|mig; viel|um|wor|ben; ein
vielumworbenes Mädchen, (↑ je-
doch R 142), a b e r : das Mädchen
ist viel umworben; viel|ver|spre-
chend; -ste; Viel|völ|ker|staat
(*Mehrz.* ...staaten); Viel|wei|be-
rei *w*; -; Viel|wis|ser; Viel|zahl *w*;
-; Viel|zel|ler (Biol.); viel|zel|lig
vier; *Kleinschreibung* (↑ R 135): die
vier Elemente; die vier Jahreszei-
ten; die vier Evangelisten; die vier
Mächte (die Staaten USA,
UdSSR, England u. Frankreich
[als Sieger im 2. Weltkrieg]); et-
was in alle vier Winde [zer]streu-
en; in seinen vier Wänden (ugs.
für: zu Hause) bleiben; sich auf
seine vier Buchstaben setzen
(ugs. scherzh. für: sich hinset-
zen); unter vier Augen etwas be-
sprechen; alle viere von sich
strecken (um tüchtig zu schlafen
[ugs.]; ugs. auch für: tot sein);
auf allen vieren; wir sind zu vieren
oder zu viert; vgl. acht; Vier
(Zahl) *w*; -, -en; eine Vier würfeln;
er hat in Latein eine Vier ge-
schrieben; vgl. ¹Acht u. Eins;
Vier|ach|ser (Wagen mit vier
Achsen; mit Ziffer: 4achser; ↑ R
228); vier|ar|mig; Vier|bei|ner;
vier|bei|nig; vier|blät|te|rig, vier-
blätt|rig; Vier|bund (für: Quadru-
pelallianz) *m*; vier|di|men|sio|nal
(zur vierten Dimension gehö-
rend); Vier-drei-drei-Sy|stem
(mit Ziffern: 4-3-3-System;
Sportspr.: bestimmte Art der
Mannschaftsaufstellung) *s*; -s
(↑ R 155); Vier|eck; vier|eckig
[*Trenn.:* ...ek|kig]; vier|ein|halb,
vier|und|ein|halb; vie|ren; ge-
viert; Vie|rer; vgl. Achter; Vie-
rer|bob; vie|rer|lei; Vie|rer|rei|he;
in -n; Vie|rer|zug; vier|fach; Vier-
fa|che *s*; -n; vgl. Achtfache; Vier-
far|ben|druck (*Mehrz.* ...drucke);
Vier|flach *s*; -[e]s, -e u. Vier|fläch-
ner (für: Tetraeder); Vier|fürst
(für: Tetrarch); vier|fü|ßig; Vier-
.fü|ßer, ...füß|ler, ...ge|spann,
...git|ter|röh|re (Rundf.), ...hän-
der; vier|hän|dig; - spielen; vier-
hun|dert; vgl. hundert; Vier|jah-
res|plan (Seemannsspr.); vier|kant (See-
mannsspr.: waagerecht); Vier-
kant *s* od. *m*; -[e]s, -e (↑ R 228);
Vier|kant|ei|sen (↑ R 228); vier-
kan|tig; Vier|lan|de (hamburgi-

sche Landschaft) *Mehrz.*; Vier-
ling; Vier|mäch|te|kon|fe|renz;
vier|mal; vgl. achtmal; vier|ma-
lig; Vier|ma|ster; Vier|mast|zelt;
vier|mo|to|rig; Vier|paß (Bauw.:
Verzierungsform mit vier Bogen)
m; ...passes, ...passe; Vier|plät-
zer schweiz. (Viersitzer); vier-
plät|zig schweiz. (viersitzig);
Vier|rad_an|trieb, ...brem|se;
vier|rä|de|rig, vier|räd|rig; Vier-
röh|ren|ge|rät (Rundf.); Vier|ru-
de|rer (für: Quadrireme); vier|sai-
tig; ein -es Streichinstrument;
vier|schrö|tig (stämmig); vier|sei-
tig; Vier|sit|zer; vier|sit|zig; Vier-
spän|ner; vier|spän|nig; vier|stel-
lig; vier|stim|mig (Musik); ein -er
Satz; - singen; vier|stöckig
[*Trenn.:* ...stök|kig]; viert; vgl.
vier; Vier|takt|mo|tor; vier|tau-
send; vgl. tausend; vier|te; -e Di-
mension; der -e Stand (Arbeiter-
schaft); vgl. achte; vier|tei|len; ge-
vierteilt; vier|tei|lig; vier|tel
[*fir*...]; vgl. achtel; Vier|tel [*fir*...]
s (schweiz. meist: *m*); -s, -; es ist
[ein] - vor, nach eins; es hat [ein]
- eins geschlagen; es ist fünf Mi-
nuten vor drei -; wir treffen uns
um - acht, um drei - acht; vgl.
Achtel u. dreiviertel; Vier|tel.fi-
na|le [*fir*...] (Sportspr.), ...ge-
viert; Vier|tel.jahr [*fir*...], ...jahr-
hun|dert; vier|tel|jäh|rig [*fir*...,
auch: *firt^e*ljä...] (ein Vierteljahr
alt, dauernd); -e Kündigung (mit
einer ein Vierteljahr dauernden
Frist); vier|tel|jähr|lich [*fir*...,
auch: *firt^e*ljä...] (alle Vierteljahre
wiederkehrend); -e Kündigung
(alle Vierteljahre mögliche Kün-
digung); Vier|tel|li|ter; vgl. ach-
tel; vier|teln [*fir*...] (in vier Teile
zerlegen); ich ...[e]le (↑ R 327);
Vier|tel|no|te [*fir*...]; Vier|tel-
pfund [*fir*..., auch: *firt^e*lpfunt]; vgl.
achtel; Vier|tel|stun|de; eine Vier-
telstunde (eine Zeitspanne von 15
Minuten), a b e r: eine viertel
Stunde (der vierte Teil einer Stun-
de); vgl. dreiviertel; vier|tel|stün-
dig [*fir*..., auch: *firt^e*lschtü...] (eine
Viertelstunde dauernd); vier|tel-
stünd|lich [*fir*..., auch: *firt^e*l-
schtü...] (alle Viertelstunden wie-
derkehrend); Vier|tels|wen|dung
[*fir*...]; Vier|tel|ton [*fir*...] (*Mehrz.*
...töne); Vier|tel|zent|ner; vgl.
achtel; vier|tens; viert|letzt; vgl.
drittletzt; vier|tü|rig; vier|[und]-
ein|halb; vier|und|zwan|zig; vgl.
acht; Vier|und|zwan|zig|flach,
-[e]s, -e u. Vier|und|zwan|zig-
fläch|ner (für: Ikositetraeder);
Vie|rung (Geviert; Viereck); Vie-
rungs_kup|pel, ...pfei|ler; Vier-
vier|tel|takt [...*fir*...] *m*; -[e]s; vgl.
Achtel. Vier|wald|stät|ter See

(See am Nordrand der Alpen bei
Luzern) *m*; - -s; vier|wer|tig; vier-
zehn [*fir*...]; vgl. acht; Vier|zehn-
hei|li|gen (Wallfahrtskirche südl.
von Lichtenfels); vier|zehn_tä|gig
(vgl. ...tägig), ...täg|lich (vgl.
...täglich); vier|zei|ler; vier|zig
[*fir*...] usw.; vgl. achtzig usw.;
vier|zig|jäh|rig; vgl. achtjährig;
Vier|zig|stun|den|wo|che (mit Zif-
fern: 40-Stunden-Woche); ↑ R
157; Vier|zim|mer|woh|nung (mit
Ziffer: 4-Zimmer-Wohnung; ↑ R
157); Vier-zwei-vier-Sy|stem (mit
Ziffern: 4-2-4-System; Sportspr.:
eine bestimmte Art der Mann-
schaftsaufstellung *s*; -s (↑ R 155);
Vier|zy|lin|der (ugs. für: Vierzy-
lindermotor od. damit ausgerü-
stetes Kraftfahrzeug); Vier|zy-
lin|der|mo|tor; vier|zy|lin|drig
(mit Ziffer: 4zylindrig; ↑ R 228)
Vi|et|cong *indochin.* [*wiätkong*]
(polit. Bewegung in Südvietnam)
m; -, (für das einzelne Mitglied
der Bewegung): -[s]; Vi|et|nam
[*wiätnam*, auch: *wiät*...] (,,Land
des Südens"; Staat in Indo-
china); Vi|et|na|me|se *m*; -n, -n
(↑ R 268); vi|et|na|me|sisch; Vi|et-
na|mi|sie|rung (Einschränkung
der Beteiligung am Krieg in Viet-
nam auf die Vietnamesen) *w*; -
vif *fr.* [*wif*] (veralt., aber noch
mdal. für: lebendig, lebhaft)
Vi|gan|tol ® [*wi*...] (Vitamin-D-
Präparat) *s*; -s
Vi|gil *lat.* [*wi*...] (Vortag hoher
kath. Feste) *w*; -, -ien [...*i^e*n]; vi|gi-
lant mdal. (oberschlau, pfiffig,
aufgeweckt); Vi|gi|lanz (mdal.)
w; -; Vi|gi|lie [...*i^e*] (bei den
Römern die Nachtwache des
Heeres) *w*; -, -n; vi|gi|lie|ren mdal.
(wachsam sein, fahnden, aufpas-
sen); auf etwas -
Vi|gnet|te *fr.* [*winjät^e*] (Zier-, Titel-
bildchen, Randverzierung [in
Druckschriften]; Fotogr.: Mas-
kenband zur Verdeckung be-
stimmter Stellen des Negativs
beim Kopieren) *w*; -, -n
Vi|go|gne *indian.-fr.* [*wigonj^e*] (ur-
sprünglich Wolle der Lamaart
Vikunja; heute streichgarnähn-
lich gesponnenes Mischgarn aus
Wolle und Baumwolle) *w*; -, -n;
Vi|go|gne|wol|le
vi|go|ro|so *it.* [*wi*...] (Musik: kräf-
tig, stark, energisch)
Vi|kar *lat.* [*wi*...] (Stellvertreter in
einem geistl. Amt [kath. Kirche];
Kandidat der ev. Theologie nach
der ersten Prüfung); schweiz.
auch: Stellvertreter eines Leh-
rers) *m*; -s, -e; Vi|ka|ri|at (Amt
eines Vikars) *s*; -[e]s, -e; vi|ka|ri-
ie|ren (das Amt eines Vikars verse-
hen; veralt. für: jmdn. vertreten);

Vi|ka|rin (ev. weibl. Vikar) w; -, -nen

Vik|tor [wik...] (m. Vorn.); Vik|tor Ema|nu|el (it. Könige); ¹Vik|to|ria (Sieg); - rufen, - schießen; ²Vik|to|ria vgl. Vic|to|ria; ³Vik|to|ria (w. Vorn.); Vik|to|ria-blau, ...grün; Vik|to|ria|nisch (↑R 179); -e Zeit (der engl. Königin Viktoria); Vik|to|ria|schie|ßen s; -s Vik|tua|li|en lat. [wiktŭali̯ʷn] (veralt. für: Lebensmittel) Mehrz.

Vi|kun|ja indian. [wi...] (höckerloses südamerik. Kamel) s; -s, -s u. w; -, ...jen; Vi|kun|ja|wol|le; vgl. Vigognewolle

Vil|la lat. [wila] (Landhaus, Einzelwohnhaus) w; -, ...llen Vil|lach [fil...] (Stadt in Kärnten) Vil|la|nell it. s; -s, -e u. Vil|la|nel|le [wila...] (it. Bauern-, Hirtenliedchen, bes. des 16. u. 17. Jh.s) w; -, -n; vil|len|ar|tig; ein -es Haus; Vil|len..be|sit|zer, ...stra|ße, ...vier|tel, ...vor|ort Vil|lin|gen im Schwarz|wald [fil...- -] (Stadt an der Brigach) Vil|ma (wi...) (ung. Form von: Wilhelmine) Vil|mar [fil...] (dt. Theologe, Sprach- u. Literaturforscher) Vi|mi|nal [wi...] m; -s od. Vi|mi|na|lis col|lis [- ko̅liß] („Viminalischer Hügel" in Rom) m; - -

Vin|ai|gret|te fr. [winägrä̆tᵉ] (mit Essig bereitete Tunke) w; -, -n Vin|ci [wintschi], Leonardo da (it. Künstler) Vin|de|li|zi|er [windelizi̯ᵉr] (Angehöriger einer kelt. Volksgruppe) m; -s,-; vin|de|li|zisch; aber: Vindelizisches Gebirge* (Geol.: Landschwelle im Süddeutschland des Erdmittelalters) Vin|di|ka|ti|on lat. [windikazion] Vin|di|zie|rung (Rechtsw.: Herausgabeanspruch des Eigentümers einer Sache gegenüber deren Besitzer; vin|di|zie|ren Vi|ne|ta [wi...; verderbt aus: Jumneta] (sagenhafte untergegangene Stadt an der Ostseeküste) Vingt-et-un fr. [wängteö̃ng], Vingt-un [wängtö̃ng] („einundzwanzig"; ein Kartenglücksspiel) s; - Vintsch|gau [fi...] (Talschaft oberhalb von Meran) m; -[e]s Vin|zen|tia [winzänzia] (w. Vorn.); Vin|zenz (m. Vorn.) ¹Vio|la lat. [wi...] u. Vio|le (Bot.: Veilchen) w; -, Violen; ²Vio|la ³Vio|la it. [wi...] (Bratsche) w; -, ...len; Vio|la da brac|cio [- - bratscho] („Armgeige"; Bratsche) w; - - -, ...le - -; Vio|la da gam|ba (Kniegeige) w; - - -, ...le - -; Vio|la d'amo|re („Liebesgeige"; Gambenart in Altlage) w; - -, ...le -

Vio|la|ti|on lat. [wiolazion] (veralt. für: Verletzung, Schändung) Vio|le vgl. ¹Viola; Vio|len (Mehrz. von: ¹·³Viola) vio|lent lat. [wi...] (veralt. für: heftig, gewaltsam); Vio|lenz (veralt. für: Heftigkeit, Gewaltsamkeit) w; - vio|lett fr. [wi...] („veilchen"farbig); vgl. blau; Vio|lett (violette Farbe) s; -[s], (ugs.: -s); vgl. Blau; Vio|let|ta it. Verkleinerungsform von: Viola) Vio|lin|bo|gen; Vio|li|ne it. [wi...] (Geige) w; -, -n; Vio|li|nist (Geiger); ↑R 268; Vio|lin..kon|zert, ...schlüs|sel; Vio|lon|cell [wiolontschäl] s; -s, -e u. Vio|lon|cel|lo (Kniegeige, Kleinbaß); Vio|lon|cel|list (Cellist); Vio|lo|ne (Kontrabaß; eine Orgelstimme) m; -[s], -s u. ...ni; Vio|lo|phon (im Jazz gebräuchliche Violine, in deren Innerem eine Schalldose eingebaut ist) s; -s, -e

VIP od. V. I. P. = very important person[s] engl. [wäri impo̅rᵗᵉnt pö̅rβᵉn(s)] (sehr wichtige Person[en], Persönlichkeit[en]) Vi|per lat. [wi...] (²Otter) w; -, -n Vi|ra|gi|ni|tät lat. [wi...] (Med.: männliches Fühlen der Frau) w; -; Vi|ra|go (Med.: Mannweib) w; -, -s u. ...gines Vir|chow [firço] (dt. Arzt) Vi|re|ment fr. [wirᵉmang] (im Staatshaushalt die Übertragung von Mitteln von einem Titel auf einen anderen oder von einem Haushaltsjahr auf das andere) s; -s, -s Vi|ren (Mehrz. von: Virus) Vir|gil [wir...] (veraltete Schreibung von: Vergil) ¹Vir|gi|nia [wir...] (w. Vorn.); ²Vir|gi|nia [wirgi..., auch, österr. nur: wirdsehi...]; engl. Aussprache: wᵉrdschini̯ᵉ] (Staat in den USA; Abk.: Va.); ³Vir|gi|nia [wirgi..., auch: wirdsehi...] (Zigarre einer bestimmten Sorte) w; -, -s; Vir|gi|nia|ta|bak; Vir|gi|ni|er [...i̯ᵉr]; vir|gi|nisch; Vir|gi|ni|tät (Jungfräulichkeit; Unberührtheit) w; - vi|ri|bus uni|tis lat. [wi... -] („mit vereinten Kräften") vi|ril lat. [wi...] (Med.: männlich); Vi|ri|lis|mus (Vermännlichung [von Frauen]) m; -; Vi|ri|li|tät (Med.: männliche Kraft; Mannbarkeit) w; - Vi|ro|lo|ge lat. [wi...] (Virusforscher) m; -en, -en (↑R 268) vir|tu|ell fr. (der Kraft od. Möglichkeit nach vorhanden, scheinbar); -es Bild (Optik), -e Verrückung (Mech.)

vir|tu|os it. [wir...] (meisterhaft, technisch vollkommen); -este

(↑R 292); Vir|tuo|se ([techn.] hervorragender Meister, bes. Musiker) m; -n, -n; ↑R 268; Vir|tuo|sen|tum; s; -s; Vir|tuo|si|tät (Kunstfertigkeit; Meisterschaft, bes. als Musiker) w; -; Vir|tus lat. (Ethik: männliche Tüchtigkeit, Tapferkeit; Tugend) w; - vi|ru|lent lat. [wi...] (krankheitserregend, aktiv, ansteckend [von Krankheitserregern], giftig; vi|ru|lenz (Ansteckungsfähigkeit [von Bakterien]) w; -; Vi|rus (kleinster Krankheitserreger) s (außerhalb der Fachspr. auch: m); -, ...ren; Vi|rus|krank|heit

Vi|sa (Mehrz. von: Visum) Vi|sa|ge fr. [wisageᵉ] (ugs. verächtlich für: Gesicht); Vi|sa|gist [...sehißt] (Kosmetiker, Gesichts-, Maskenbildner); ↑R 268; vis-à-vis [wisawi] (gegenüber); Vi|sa|vis [wisawi] (Gegenüber) s; - [...wiß)], - [...wiß]

Vis|count engl. [waikaunt] („Vizegraf"; engl. Adelstitel) m; -s, -s; Vis|coun|tess [...tiß] (weibliche Form von Viscount) w; -, -ss [...tißß]

Vi|sen (Mehrz. von: Visum); Vi|sier fr. (beweglicher, das Gesicht deckender Teil des Helmes; Zielvorrichtung) s; -s, -e; vi|sie|ren (nach etwas sehen, zielen; eichen, ausmessen; veralt. für: beglaubigen; mit Ein-, Ausreisestempel, Visum versehen); Vi|sier-fern|rohr, ...li|nie, ...mar|ke, ...punkt Vi|si|on lat. [wi...] (Erscheinung; Trugbild); vi|sio|när (traumhaft; seherisch); Vi|sio|när (veralt. für: Geisterseher; Schwärmer) m; -s, -e; Vi|si|ons|ra|di|us (Optik; Sehachse) Vi|si|ta|ti|on lat. [wisitazion] (Durchsuchung, z. B. des Gepäcks oder der Kleidung; Besuchsdienst des vorgesetzten Geistlichen in den ihm unterstellten Gemeinden); Vi|si|te fr. (Krankenbesuch des Arztes; veralt. noch scherzh. für: Besuch) w; -, -n; Vi|si|ten|kar|te (Besuchskarte); vi|si|tie|ren (durch-, untersuchen; besichtigen); Vi|sit-kar|te (österr. neben: Visitenkarte) vis|kos, (selten:) vis|kös lat. [wiß...] (zäh[flüssig], leimartig); -e Körper; Vis|ko|se (Zelluloseverbindung) w; -; Vis|ko|si|me|ter lat.; gr. (Zähigkeitsmesser) s; -s, -; Vis|ko|si|tät lat. (Zähflüssigkeit) w; - Vis ma|jor lat. [wiß ...] (in der jurist. Fachsprache Bez. für: höhere Gewalt) w; - - Vi|sta it. [wi...] (Sicht, Vorzeigen eines Wechsels) w; -; vgl. a vista

u. a prima vista; Vi|sta|wech|sel (Sichtwechsel)

Vi|stra Ⓦ [wi...] (aus Viskose hergestellte Zellwolle) w; -

vi|su|ell fr. [wi...] (das Sehen betreffend); -er Typ (jmd., der Gesehenes besonders leicht in Erinnerung behält); Vi|sum lat. [wi...] (,,Gesehenes"; Sichtvermerk im Paß) s; -s, ...sa u. ...sen; Vi|sum-,an|trag, ...zwang

vis|ze|ral lat. [wiß...] (Med.: Eingeweide...)

Vi|ta lat. [wita] (Gesch.: Leben, Lebenslauf, -beschreibung) w; -, Viten u. Vitae [wität]; vi|tal [wi...] (das Leben betreffend; lebenskräftig, -wichtig; frisch, munter); Vi|tal|fär|bung (Mikroskopie: Färbung lebender Zellen u. Gewebe)

Vi|ta|lig|ner lat. [wi...; zu: Viktualien] (selten für: Vitalienbrüder) Mehrz.; Vi|ta|li|en|brü|der [...i^en...] (Seeräuber in der Nord- u. Ostsee im 14. u. 15. Jh.) Mehrz.

Vi|ta|lis|mus lat. [wi...] (philos. Lehre von der ,,Lebenskraft") m; -; Vi|ta|list (Anhänger des Vitalismus); ↑ R 268; vi|ta|li|stisch; Vi|ta|li|tät (Lebendigkeit, Lebensfülle, -kraft) w; -; Vit|amin ([lebenswichtiger] Wirkstoff) s; -s (bei Benennung eines Vitamins auch: -), -e; - C; des Vitamin[s] C; Vit|amin-B-hal|tig [...be...] (↑ R 155); Vit|amin-B-Man|gel [...be...] (↑ R 155) m; -s; Vit|amin-B-Man|gel-Krank|heit [...be...] (↑ R 155) w; -, -en; vit|ami|nie|ren, vit|ami|ni|sie|ren (mit Vitaminen anreichern); vit|amin|reich; -e Kost; Vit|amin|stoß (Zufuhr von großen Vitaminmengen auf einmal)

vite fr. [wit] (Musik: schnell, rasch); vi|te|ment [wit^(e)mang] (Musik: schnell, rasch)

Vi|tel|li|us [wi...] (röm. Kaiser)

Vi|ti|um lat. [wizium] (Med.: Fehler) s; -s, ...tia

Vi|tri|ne fr. (gläserner Schaukasten, Schauschrank) w; -, -n; Vi|tri|ol lat. (veralt. Bez. für: kristallisiertes, kristallwasserhaltiges Sulfat von Zink, Eisen od. Kupfer) s; -s, -e; vi|tri|ol|hal|tig; Vi|tri|ol|lö|sung

Vi|truv [witruf] (altröm. Baumeister); Vi|tru|vi|us [witruwiuß] vgl. Vitruv

Vi|tus [wi...] (lat. Form von: Veit)

Vitz|li|putz|li [wizli...; aus ,,Huitzilopochtli"] (Stammesgott der Azteken; Schreckgestalt, Kinderschreck; volksm. auch für: Teufel) m; -[s]

vi|va|ce it. [wiwatsche] (Musik: munter, lebhaft); Vi|va|ce (Musik: lebhaftes Tempo) s; -, -; vi|va|cis|si|mo [wiwatschiß...] (Musik: sehr lebhaft); Vi|va|cis|si|mo (Musik: äußerst lebhaftes Zeitmaß) s; -s, -s u. ...mi

Vi|val|di [wiwaldi] (it. Komponist)

vi|vant! lat. [wiwant] (sie sollen leben!); vi|vant se|quen|tes! (es sollen leben die Folgenden!); Vi|va|ri|um (Aquarium mit Terrarium; auch: Gebäude hierfür) s; -s, ...ien [...i^en]; vi|vat! [wiwat] (er lebe!); Vi|vat (Lebehoch) s; -s, -s; ein - ausbringen, rufen; vi|vat, cres|cat, flo|re|at! [-, ...kat, -] (er [sie, es] lebe, blühe und gedeihe!); vi|vat se|quens! (es lebe der Folgende!); vi|vi|par [wiwi...] (lebendgebärend); Vi|vi|sek|ti|on (Eingriff am lebenden Tier zu wissenschaftl. Versuchszwecken); vi|vi|se|zie|ren

Vi|ze... lat. [fiz^e, seltener: wiz^e] (,,an Stelle von"; stellvertretend); Vi|ze|kanz|ler, ...kö|nig, ...konsul, ...mei|ster (Sportspr.), ...prä|si|dent

Viz|tum lat. fiz..., auch: wiz...] (im MA. Verwalter weltl. Güter von Geistlichen u. Klöstern) m; -s, -e

v. J. = vorigen Jahres

Vla|me [fla...] usw. vgl. Flame usw.

Vlies niederl. [fliß] ([Schaf]fell; Rohwolle des Schafes; Spinnerei: breite Faserschicht) s; -es, -e; (↑ R 224:) das Goldene Vlies

Vlis|sin|gen [fli...] (niederl. Stadt)

vm. vgl. vorm.

V-Mann = Vertrauensmann, Verbindungsmann

VN = Vereinte Nationen (Mehrz.); vgl. UN u. UNO

v. o. = von oben

Vöck|la|bruck [fö...] (oberösterr. Stadt)

VÖEST = Vereinigte Österreichische Eisen- und Stahlwerke

Vo|gel m; -s, Vögel; Vo|gel|bau|er (Käfig) s (seltener: m); -s, -; Vo|gel|beer|baum; Vo|gel|bee|re; Vö|gel|chen, Vö|gel|lein, Vög|lein; Vo|gel|dunst (feinster Schrot) m; -es; Vo|gel|ler vgl. Vogler; Vo|gel-,fän|ger, ...fe|der, ...flug; Vo|gel-flug|li|nie (kürzeste Verkehrsverbindung zwischen Hamburg u. Kopenhagen) w; -; vo|gel|frei (rechtlos); Vo|gel|herd (Fangplatz), ...kir|sche, ...kun|de (für: Ornithologie; w; -), ...mie|re (eine Pflanze); vö|geln (derb für: Geschlechtsverkehr ausüben); ich ...[e]le (↑ R 327); Vo|gel|per|spek|ti|ve (Vogelschau; w; -); Vo|gels|berg (Teil des Hessischen Berglandes) m; -[e]s; Vo|gel.schau (w; -), ...scheu|che, ...schie|ßen, ...schutz, ...stel|ler; Vo|gel-Strauß-Po|li|tik (↑ R 155) w; -; Vo|gel.war|te, ...welt (w; -), ...zug; Vo|gerl|sa|lat österr. (Feldsalat, Rapunzel)

Vo|ge|sen [wo...] (südwestl. Randgebirge des Oberrheinischen Tieflandes; früher dt. auch: Wasgenwald) Mehrz.

Vög|lein, Vö|ge|lein, Vö|gel|chen; Vog|ler (Vogelsteller)

Vogt (früher für: Schirmherr; Richter; Verwalter; schweiz. auch für: Vormund) m; -[e]s, Vögte; Vog|tei (früher für: Amtsbezirk, Sitz eines Vogtes); vog|teilich; Vög|tin w; -, -nen; Vogt|land (Bergland zwischen Frankenwald, Fichtelgebirge u. Erzgebirge) s; -[e]s; Vogt|län|der (↑ R 199); vogt|län|disch; Vogt|schaft

voi|là fr. [woala] (sieh da!; da haben wir es; eigtl.: da ist ..., da sind ...)

Voile fr. [woal] (durchsichtiger Stoff) m; -, -s; Voile|kleid

Vo|ka|bel lat. [wo...] ([einzelnes] Wort) w; -, -n (österr. auch: s; -s, -); Vo|ka|bel|schatz m; -es; Vo|ka|bu|lar s; -s, -e u. (älter:) Vo|ka|bu|la|ri|um (Wörterverzeichnis) s; -s, ...ien [...i^en]

vo|kal lat. [wo...] (Musik: die Singstimme betreffend, gesangsmäßig); Vo|kal (Sprachw.: Selbstlaut, z. B. a, e) m; -s, -e; Vo|ka|li|sa|ti|on [...zion] (Aussprache eines Konsonanten wie ein Vokal; die Aussprache der Selbstlaute, bes. beim Gesang); vo|ka|lisch (selbstlautend); Vo|ka|li|se fr. (Musik: Gesangsübung, -stück auf einen od. mehrere Vokale) w; -, -n; vo|ka|li|sie|ren (einen Konsonanten wie einen Vokal sprechen; beim Singen die Vokale bilden u. aussprechen); Vo|ka|li|sie|rung; Vo|ka|lis|mus (Vokalbestand einer Sprache) m; -; Vo|ka|list (Sänger) ↑ R 268; Vo|ka|li|stin (Sängerin) w; -, -nen; Vo|kal-,mu|sik (Gesang), ...stück; Vo|ka|tiv [wo..., auch: wo...] od. wokatif] (Sprachw.: Anredefall) m; -s, -e [...w^e]

vol. = volumen; vgl. Volumen (Schriftrolle)

Vol.-% = Volumprozent

Vo|land [fo...] (alte Bez. für: Teufel) m; -[e]s; Junker -

Vo|lant fr. [wolang, schweiz.: wo...] (Besatz an Kleidungsstücken, Falbel; Lenkrad, Steuer [am Kraftwagen]) m (schweiz. meist s); -s, -s

Vo|la|pük [wo...] (überholte künstliche Weltsprache) s; -s

Vol-au-vent fr. [wolowang] (Hohlpastete aus Blätterteig, gefüllt

mit feinem Ragout) *m*; -, -s
[...*wɑns*]
Vo|lie|re *fr.* [*woliär^e*] (Vogelhaus)
w; -, -n
Volk *s*; -[e]s, Völker
Vol|kard vgl. Volkhard
volk|arm; Völk|chen, Völk|lein
Vol|ker (Spielmann der Nibe-
lungen; m. Vorn.)
Völ|ker.ball (Ballspiel; *m*; -[e]s),
...bund (hist.; *m*; -[e]s), ...kun|de
(*w*; -), ...kund|ler; völ|ker|kund-
lich; Völ|ker|recht *s*; -[e]s; völ|ker-
recht|lich; Völ|ker|rechts|kund-
ler
Vol|kert vgl. Volkhard
Völ|ker.ver|stän|di|gung, ...wan
de|rung
Volk|hard, Vol|kard, Vol|kert (m.
Vorn.)
völ|kisch; -ste (↑ R 294); Völk|lein,
Völk|chen; volk|lich (das Volk
betreffend)
Vulk|mar (m. Vorn.)
volk|reich; Volks.ab|stim|mung,
...ak|tie, ...ak|tio|när, ...ar|mee
(*w*; -; DDR), ...ar|mist (DDR; ↑ R
268), ...aus|ga|be, ...bad, ...bank
(*Mehrz.* ...banken), ...be|fra-
gung, ...be|geh|ren, ...be|lu|sti-
gung, ...bi|blio|thek; volks|bil-
dend; Volks.bil|dung (*w*; -),
...brauch, ...buch, ...bü|che|rei,
...de|mo|kra|tie (Staatsform
kommunist. Länder, bei der die
gesamte Staatsmacht in den Hän-
den der Partei liegt), ...deut|sche
(*m* u. *w*; -n, -n; ↑ R 287 ff.), ...dich-
te, ...dich|tung; volks|ei|gen
(DDR); ein -es Gut, ein -er Be-
trieb, a b e r (↑ R 224): „Volkseige-
ner Betrieb Leipziger Druck-
haus“; (Abk.: VEB ...), Volks-
.ein|kom|men, ...emp|fin|den (*s*;
-s), ...ent|scheid, ...er|mo|lo|gie
(Bez. für die naive Verdeut-
lichung eines unbekannten Wor-
tes [oft Fremdwortes] durch des-
sen Anlehnung an bekannte,
klangähnliche Wörter, z. B.
„Hängematte“ an „hängen“ u.
„Matte“ statt an indianisch „ha-
maca“), ...feind; volks|feind|lich;
Volks.fest, ...gan|ze (*s*; -n; ↑ R
287 ff.), ...geist (*m*; -es), ...ge-
sund|heit (*w*; -), ...glau|be[n],
...heil|mit|tel, ...held, ...herr-
schaft, ...hoch|schu|le, ...kam|mer
(höchstes staatl. Machtorgan der
DDR), ...kir|che, ...kun|de (*w*; -),
...kund|ler; volks|kund|lich;
Volks.kunst (*w*; -), ...lauf (Sport),
...le|ben, (*s*; -s), ...lied, ...mär-
chen; volks|mä|ßig; Volks.men-
ge, ...mund (*m*; -[e]s), ...mu|sik,
...nah|rungs|mit|tel *s*, ...po|li|zei
(*w*; -; DDR; Abk.: VP), ...po|li-
zist (DDR), ...red|ner, ...re|pu-
blik (Abk.: VR), ...schicht,

...schu|le, ...schü|ler, ...schü|le-
rin, ...schul|leh|rer, ...see|le (*w*; -),
...spra|che; volks|sprach|lich;
Volks.staat (*Mehrz.* ...staaten),
...stamm, ...stück, ...tanz,
...tracht, ...trau|er|tag, ...tri|bun,
...tum (*s*; -s); volks|tüm|lich;
Volks|tüm|lich|keit *w*; -; volks-
ver|bun|den; Volks.ver|bun|den-
heit (*w*; -), ...ver|mö|gen, ...ver|tre-
ter, ...ver|tre|tung, ...wa|gen ⓦ
(Abk.: VW); Volks|wa|gen|werk;
Volks.wei|se, ...wirt, ...wirt-
schaft; Volks|wirt|schaf|ter
(schweiz. überwiegend für:
Volkswirtschaftler); Volks|wirt-
schaft|lor; volks|wirt|schaft|lich;
Volks.wirt|schafts|leh|re, ...wohl,
...zäh|lung

voll; voll Wein[es], voll [des] süßen
Weines; voll[er] Angst; ein Eimer
voll[er] Wasser; der Saal war
voll[er] Menschen; voll heiligem
Ernst; (↑ R 133:) aus dem vollen
schöpfen; im vollen leben; ein
Wurf in die vollen (auf 9 Kegel);
in die vollen gehen (ugs. für: et-
was mit Nachdruck betreiben);
ins volle greifen; zehn Minuten
nach voll (ugs.: nach der vollen
Stunde); voll verantwortlich sein;
ein Armvoll (vgl. d.), eine Hand-
voll (vgl. d.), ein Mundvoll (vgl.
d.). *Schreibung in Verbindung mit
Zeitwörtern* (↑ R 139): voll sein,
werden; jmdm. die Hucke voll
hauen (ugs. für: jmdn. verprü-
geln); jmdm. die Hucke voll lügen
(ugs.: jmdn. sehr belügen); jmdn.
nicht für voll nehmen (ugs. für:
nicht ernst nehmen); den Mund
recht voll nehmen (ugs. für: prah-
len), etwas voll (ganz) begreifen;
vgl. a b e r: volladen, vollaufen,
vollbringen, vollenden, vollfüh-
ren, vollfüllen, vollgießen, voll-
machen, vollschreiben, vollstop-
fen, vollstrecken, volltanken, voll-
zeichnen, vollziehen
volla|den [*Trenn.*: voll|la..., ↑ R
236] (↑ R 139): ich lade den Wa-
gen voll; vollgeladen; vollzula-
den; vgl. ¹laden
voll|auf [auch: *follauf*]; - genug ha-
ben
vollau|fen [*Trenn.*: voll|lau..., ↑ R
236] (↑ R 139); es läuft voll; voll-
gelaufen; vollzulaufen; du hast
dich - lassen (ugs.: hast du dich be-
trunken) vgl. laufen
voll|au|to|ma|tisch; voll|au|to|ma-
ti|siert
Voll|bad
Voll|bart
voll|be|schäf|tigt; Voll|be|schäf|ti-
gung
voll|be|sitz; im - seiner Kräfte
Voll|blut (Pferd aus einer be-
stimmten Reinzucht); Voll|blü-

ter; voll|blü|tig; Voll|blü|tig|keit
w; -; Voll|blut|pferd
voll|brin|gen; ↑ R 139 (ausführen;
vollenden); ich vollbringe; voll-
bracht; zu -; Voll|brin|gung
voll|bu|sig
Voll|dampf *m*; -[e]s
vollei|big [*Trenn.*: voll|lei..., ↑ R
236]
voll|en|den (↑ R 139); ich vollende;
vollendet; zu -; Voll|en|der; voll-
ends; Voll|en|dung
vol|ler vgl. voll
Völ|le|rei
voll|es|sen, sich (ugs.); ↑ R 139; ich
esse mich voll; vollgegessen; voll-
zuessen
vol|ley *engl.* [*wǫli*]; einen Ball -
(voll aus der Luft) nehmen; Vol-
ley (Tennis: Flugball) *m*; -s, -s;
Vol|ley|ball [*wǫli...*] (ein dem
Korbball ähnliches Spiel; Flug-
ball) *m*; -[e]s
voll|füh|ren (↑ R 139); ich vollführe;
vollführt; zu -; Voll|füh|rung
voll|fül|len (↑ R 139); ich fülle voll;
vollgefüllt; vollzufüllen
Voll|gas *s*; -es; - geben
Voll|gat|ter (Säge)
Voll|ge|fühl; im -
voll.ge|pfropft, ...ge|stopft
voll|gie|ßen (↑ R 139); ich gieße
voll; vollgegossen; vollzugießen
voll|gül|tig
voll|in|halt|lich
voll|jäh|rig; Voll|jäh|rig|keit *w*; -;
Voll|jäh|rig|keits|er|klä|rung
voll|kas|ko|ver|si|chert; Voll|kas-
ko|ver|si|che|rung
Voll|kauf|mann
voll|kli|ma|ti|siert
voll|kom|men [auch: *fol*...]; Voll
kom|men|heit [auch: *fol*...]
Voll|korn|brot
Voll|kraft *w*; -
voll|ma|chen (↑ R 139); ich mache
voll; vollgemacht; vollzumachen
Voll|macht *w*; -, -en; Voll|macht-
ge|ber; Voll|machts.schein, ...ur-
kun|de
voll|mast; - flaggen; auf - stehen
Voll|milch
Voll|mond; Voll|mond|ge|sicht
ugs. scherzh. für: rundes Gesicht;
Mehrz. ...gesichter)
voll|mun|dig; -er Wein
Voll|pen|si|on
Voll|per|son (Rechtsw.)
voll|reif; Voll|rei|fe
Voll|ren|te
voll|schla|gen, in: sich den Bauch
-; ↑ R 139 (ugs.: sehr viel essen);
du schlägst dir den Bauch voll;
vollgeschlagen; vollzuschlagen
voll|schlank
voll|schrei|ben (↑ R 139); ich
schreibe voll; vollgeschrieben;
vollzuschreiben

Voll|sinn; im - des Wortes
Voll|spur (bei der Eisenbahn) w;
-; voll|spu|rig
voll|stän|dig; Voll|stän|dig|keit w;
-
voll|stock; - flaggen; auf - stehen
voll|stop|fen (↑ R 139); ich stopfe
voll; vollgestopft; vollzustopfen
voll|streck|bar; Voll|streck|bar-
keit w; -; voll|strecken¹ (↑ R 139);
ich vollstrecke; vollstreckt; zu -;
Voll|strecker¹; Voll|streckung¹;
Voll|streckungs¹ be|am|te, ...be-
fehl
voll|tan|ken (↑ R 139); ich tanke
voll; vollgetankt; vollzutanken
voll|tö|nend; voll|tö|nig
Voll|tref|fer
voll|trun|ken; Voll|trun|ken|heit
Voll|ver|samm|lung
Vollwai|se
voll|wer|tig; Voll|wer|tig|keit w; -
voll|wich|tig (volles Gewicht
habend)
voll|zäh|lig; Voll|zäh|lig|keit w; -
voll|zeich|nen (↑ R 139); der Bogen
ist vollgezeichnet, aber: die An-
leihe war sofort voll gezeichnet
voll|zieh|bar; Voll|zieh|bar|keit w;
-; voll|zie|hen (↑ R 139); ich voll-
ziehe; vollzogen; zu -; Voll|zie-
her; Voll|zie|hung; Voll|zie-
hungs|be|am|te; Voll|zug (Voll-
ziehung) m; -[e]s; Voll|zugs...an-
stalt (Gefängnis), ...ge|walt
Vo|lon|tär fr. [wolon̥tär̥. ⟨wolon̥tär̥⟩, auch:
wolon̥tär̥] („Freiwilliger"; ohne
od. nur gegen eine kleine Vergü-
tung zur berufl. [bes. kaufmänn.]
Ausbildung Arbeitender; An-
wärter) m; -s, -e; Vo|lon|tä|rin w;
-, -nen; Vo|lon|ta|ri|at (Ausbil-
dungszeit, Stelle eines Volontärs)
s; -[e], -e; vo|lon|tie|ren (als Vo-
lontär arbeiten)
Vols|ker [wolß...] (Angehöriger ei-
nes ital. Volksstammes in Mittel-
italien) m; -s, -; vols|kisch
Volt [wolt] nach dem it. Physiker
Volta] (Einheit der elektr. Span-
nung; Zeichen: V) s; - u. -[e]s,
-; 220 - (↑ R 322); Vol|ta|ele|ment
(↑ R 180)
Vol|taire [woltär̥] (fr. Schriftstel-
ler); Vol|tai|ria|ner (Anhänger
Voltaires)
vol|ta|isch [wol...] (nach Volta be-
nannt; galvanisch), aber (↑ R
179): Vol|ta|isch; Vol|ta|me|ter
(Stromzählmesser) s; -s, -. vgl.
aber: Voltmeter; Volt|am|pere
[...pär̥] (Maßeinheit der elektr.
Leistung; Zeichen: VA)
Vol|te fr. [wolt̥ᵉ] (Reitfigur; Kunst-
griff beim Kartenmischen; Ver-
teidigungsart beim Fechtsport)
w; -, -n; die - schlagen; Vol|ten-

schlä|ger; Vol|te|schla|gen s; -s;
vol|tie|ren (svw. voltigieren); Vol-
ti|ge [...tis̱ch̥ᵉ] (Sprung eines
Kunstreiters auf das Pferd) w; -,
-n; Vol|ti|geur [...sehör̥] (Kunst-
springer) m; -s, -e; vol|ti|gie|ren
[...tis̱ch̥ir̥ᵉn] (eine Volte ausfüh-
ren; Luft-, Kunstsprünge,
Schwingübungen auf dem Pferd
ausführen; veralt. für: plänkeln)
Volt|me|ter [wolt...] (Elektrotech-
nik: Spannungsmesser) s; -s, -;
vgl. aber: Voltameter
Vo|lu|men lat. [wo...] (Rauminhalt
eines festen, flüssigen od. gasför-
migen Körpers [Zeichen: V];
Schriftrolle, Band [Abk.: vol.];
Stromstärke einer Fernsprech-
od. Rundfunkübertragung) s; -s,
- u. ...mina; Vo|lu|men|ge|wicht,
Vo|lum|ge|wicht (spezifisches
Gewicht, Raumgewicht); Vo|lu-
men|pro|zent vgl. Volumprozent;
vo|lu|mi|nös fr. (umfangreich,
stark, massig); -este (↑ R 292); Vo-
lum|pro|zent (Hundertsatz vom
Rauminhalt; Abk.: Vol.-%)
Vo|lun|ta|ris|mus lat. [wo...] (philo-
los. Lehre, die allein den Willen
als maßgebend betrachtet) m; -;
Vo|lun|ta|rist (↑ R 268); vo|lun|ta-
ri|stisch
Vö|lu|spa altnord. [wö...] (Edda-
lied vom Ursprung u. vom Unter-
gang der Welt) w; -
Vo|lu|te lat. [wo...] (spiralförmige
Einrollung am Kapitell ionischer
Säulen, als Bauornament in der
Renaissance wieder aufgegrif-
fen) w; -, -n
Vol|vu|lus lat. [wolvu...] (Med.:
Darmverschlingung) m; -, ...li
vom (von dem; Abk.: v.)
Vom|hun|dert|satz; vgl. Hundert-
satz
vo|mie|ren lat. [wo...] (Med.: sich
erbrechen)
Vom|tau|send|satz (Promillesatz)
von (Abk.: v.¹); mit Wemf.: - dem
Haus; - der Art; - [ganzem] Her-
zen; - [großem] Nutzen, Vorteil
sein; - Gottes Gnaden; - Hand
zu Hand; - Sinnen; - seiten (vgl.
d.); - neuem; - nah u. fern; eine
Frau - heute; - links, - rechts;
- oben (Abk.: v.o.); - unten (Abk.:
v.u.); - ungefähr; - vorn[e]; - vorn-
herein; - jetzt an (ugs.: ab); - klein
auf; - Grund auf od. aus; - mir
aus; - Haus[e] aus; - Amts wegen;
- Rechts wegen; mit Grüßen -
Haus zu Haus; - weit her; - alters
her; - dorther; - jeher; - dannen,
hinnen gehen; - wegen! (ugs. für:
daraus wird nichts); von|ein|an-
der; Schreibung in Verbindung mit

Zeitwörtern (↑ R 139): etwas von-
einander haben, voneinander
wissen, scheiden usw., aber:
voneinandergehen (sich tren-
nen), vgl. aneinander
von|nöten; ↑ R 141; ([dringend]
nötig); - sein
von oben (Abk.: v. o.)
von Rechts we|gen (Abk.: v. R. w.)
von sei|ten; mit Wesf.: - - seines
Vaters
von|stat|ten (↑ R 141); - gehen
von un|ten (Abk.: v. u.)
von we|gen! (ugs. für: auf keinen
Fall!)
vor (Abk.: v.); mit Wemf. u. Wenf.:
vor dem Zaun stehen, aber: sich
vor den Zaun stellen; vor allem
(vgl. d.); vor diesem; vor alters
(vgl. d.); vor der Zeit; vor Zeiten;
Gnade vor Recht ergehen lassen;
vor sich gehen; vor sich hin brum-
men usw.; vor Christi Geburt
(Abk.: v. Chr. G.); vor Christo
od. Christus (Abk.: v. Chr.); vor
allem[,] wenn/weil (vgl. d.)
vor... (in Zus. mit Zeitwörtern, z.
B. vorsingen, du singst vor, vor-
gesungen, vorzusingen; zum 2.
Mittelw. ↑ R 304)
vor|ab (zunächst, zuerst)
Vor|ab|druck (Mehrz. ...drucke)
Vor|abend
Vor|ah|nung
vor al|lem (Abk.: v. a.); vor al-
lem[,] wenn/weil ... (↑ R 63)
Vor|al|pen Mehrz.
vor al|ters; ↑ R 129 (in alter Zeit)
vor|an; der Sohn voran, der Vater
hinterdrein; vor|an... (z. B. voran-
gehen;↑ R 304: er ist vorangegan-
gen); vor|an|ge|hen; ich gehe vor-
an; vorangegangen; voranzuge-
hen; vor|an|ge|hend; (↑ R 135:)
-es; (↑ R 134:) im -en (weiter
oben), aber (↑R 116): der, die,
das Vorangehende; vgl. folgend;
vor|an|kom|men; ich komme vor-
an; vorangekommen; voranzu-
kommen
Vor|an|schlag, ...an|zei|ge, ...ar-
beit; vor|ar|bei|ten; Vor|ar|bei|ter
Vor|arl|berg¹ (österr. Bundes-
land); Vor|arl|ber|ger¹ (↑ R 199);
vor|arl|ber|gisch¹
vor|auf; er war allen vorauf; vor-
auf... (z. B. voraufgehen;↑ R 304:
er ist voraufgegangen); vor|auf-
ge|hen; ich gehe vorauf; vorauf-
gegangen; voraufzugehen
vor|aus; (↑ R 134:) im, zum - [auch:
fo...]; er war allen voraus; Vor|aus
(vorab zufallendes Erbteil) m; -;
vor|aus... (z. B. vorausgehen;↑ R
304: er ist vorausgegangen); Vor-
aus|ab|tei|lung; vor|aus|be|din-
gen; ich bedinge voraus; voraus-

¹ Trenn.: ...ek|k...

¹ Über die Schreibung in Familien-
namen ↑ R 126.

¹ Auch: ...arl...

bedungen; vor|aus|zu|be|din|gen;
Vor|aus|be|din|gung; vor|aus|be-
rech|nen vgl. vorausbedingen;
vor|aus|be|zah|len; ich bezahle
voraus; vorausbezahlt; vor|aus-
zubezahlen; Vor|aus|be|zah|lung;
vor|aus|ge|ben (im Spiel u.
Sport); ich gebe voraus; vor|aus-
gegeben; vorauszugeben; vor-
aus|da|tie|ren (mit einem späte-
ren Datum versehen); ich datiere
voraus; vorausdatiert; voraus-
zudatieren; vor|aus|ge|hen; ich gehe
voraus; vorausgegangen; voraus-
zugehen; vor|aus|ge|hend; (↑ R
135:) -es; (↑ R 134:) im -en (weiter
oben), aber (↑ R 116): der, die,
das Vorausgehende; vgl. folgend;
vor|aus|ge|setzt, daß (↑ R 61); vor-
aus|ha|ben; ich habe voraus; vor-
ausgehabt; vorauszuhaben; et-
was jmdm. -; Vor|aus|sa|ge; vor-
aus|sa|gen; ich sage voraus; vor-
ausgesagt; vorauszusagen; vor-
aus|schicken [Trenn.: ...ik|ken];
ich schicke voraus; vorausge-
schickt; vorauszuschicken;
voraus|se|hen; ich sehe voraus;
vorausgesehen; vorauszusehen;
vor|aus|set|zen; ich setze voraus,
vorausgesetzt; vorauszusetzen;
Vor|aus|set|zung; vor|aus|set-
zungs|los; Vor|aus|sicht w; -; aller
- nach; in der -, daß ...; vor|aus-
sicht|lich; vor|aus|wis|sen; ich
weiß voraus; vorausgewußt; vor-
auszuwissen; vor|aus|zah|len; ich
zahle voraus; vorausgezahlt;
vorauszuzahlen; Vor|aus|zah-
lung
Vor|bau (Mehrz. ...bauten); vor-
bau|en (auch usg. für: vorbeu-
gen); ich baue vor; vorgebaut;
vorzubauen; ein kluger Mann
baut vor
vor|be|dacht; nach einem vorbe-
dachten Ziele; Vor|be|dacht m,
nur in: mit, ohne - handeln; vor-
be|däch|tig (veralt.)
Vor|be|deu|tung
Vor|be|din|gung
Vor|be|halt (Bedingung) m; -[e]s,
-e; mit, unter, ohne -; vor|be|hal-
ten; ich behalte es mir vor; ich
habe es mir -; vorzubehalten; vor-
be|halt|lich, (schweiz.:) vor|be-
hält|lich; mit Wesf.; (Amtsdt.:) -
unserer Rechte; vor|be|halt|los;
Vor|be|halts_gut, ...ur|teil
vor|bei; vorbei (vorüber) sein; als
er kam, war bereits alles vorbei;
vor|bei... (z. B. vorbeigehen; ↑ R
304: er ist vorbeigegangen); vor-
bei|be|neh|men, sich (ugs. für: ge-
gen Sitte u. Anstand verstoßen);
ich benehme mich vorbei; vorbei-
benommen; vorbeizubenehmen;
vor|bei|ge|hen; ich gehe vorbei;
vorbeigegangen; vorbeizugehen;

vor|bei|kom|men; bei jmdm. -
(ugs.: jmdn. kurz besuchen); ich
komme vorbei; vorbeigekom-
men; vorbeizukommen
Vor|bei|marsch m
vor|bei|re|den (das Wesentliche
nicht erwähnen); ich rede vorbei;
vorbeigeredet; vorbeizureden
vor|be|la|stet; erblich - sein
Vor|be|mer|kung
Vor|be|ra|tung
vor|be|rei|ten; ich bereite vor; vor-
bereitet; vorzubereiten; Vor|be-
rei|tung; Vor|be|rei|tungs_kurs
od. ...kur|sus
Vor|be|richt
vor|be|sagt (veraltend für: eben ge-
nannt); Vor|be|sag|te m u. w; -n,
-n (↑ R 287ff.)
Vor_be|scheid, ...be|spre|chung;
vor|be|straft; Vor_be|straf|te (m
u. w; -n, -n; ↑ R 287ff.), ...be|ter
Vor|beu|ge w; -; Vor|beu|ge|haft
(Rechtsw.) w; vor|beu|gen; ich
beuge vor; vorgebeugt; vorzu-
beugen; (↑ R 120:) Vorbeugen
(auch: vorbeugen) ist besser als
Heilen (auch: heilen); Vor|beu-
gung; zur gegen den Krieg; Vor-
beu|gungs_maß|nah|me, ...mit-
tel s
vor|be|zeich|net (veraltend für:
eben genannt, eben aufgeführt);
Vor|be|zeich|ne|te m u. w; -n, -n
(↑ R 287ff.)
Vor|bild; vor|bil|den; ich bilde vor;
vorgebildet; vorzubilden; vor-
bild|lich; Vor|bild|lich|keit w; -;
Vor|bil|dung
Vor|blick
Vor|bör|se (der eigtl. Börsenzeit
vorausgehende Börsengeschäfte)
w; -; vor|börs|lich
Vor|bo|te
vor|brin|gen; ich bringe vor; vorge-
bracht; vorzubringen
Vor|büh|ne
vor Chri|sti Ge|burt (Abk.: v. Chr.
G.); vor|christ|lich; vor Chri|sto,
vor Chri|stus (Abk.: v. Chr.)
Vor|dach
vor|da|tie|ren (mit einem früheren
Datum versehen [vgl. zurückda-
tieren]; mit einem späteren Da-
tum versehen [vgl. vorausdatie-
ren]); ich datiere vor; vordatiert;
vorzudatieren; Vor|da|tie|rung
vor|dem [auch: for...] (früher)
Vor|der_ach|se, ...an|sicht; vor-
der|asia|tisch; Vor|der_asi|en (↑ R
206), ...bein, ...deck; vor|de|re,
aber (↑ R 224): der Vordere Ori-
ent; vgl. vorderst; Vor|der_front;
...fuß, ...gau|men; Vor|der|gau-
men|laut (für: Palatal); vor|der-
gau|mig; Vor|der|grund; vor|der-
grün|dig
vor|der|hand [zu: vor]; ↑ R 141
(einstweilen)

Vor|der|hand [zu: vordere] w; -
Vor|der|haus
Vor|der|in|dien; ↑ R 206 (südasiat.
Subkontinent)
Vor|der_la|der (Feuerwaffe),
...mann (Mehrz. ...männer),
...rad; Vor|der|rad_an|trieb,
...brem|se, ...ga|bel, ...na|be; Vor-
der_schin|ken, ...sei|te, ...sitz
vor|derst; zuvorderst; der vorder-
ste [Mann], aber (↑ R 116): er
will immer der Vorderste sein
Vor|der_ste|ven, ...teil (s od. m),
...tür
vor|drän|gen; sich -; du drängst
dich vor; vorgedrängt; vorzu-
drängen
vor|dring|lich (besonders dring-
lich); Vor|dring|lich|keit w; -
Vor|druck (Mehrz. ...drucke)
vor|ehe|lich
vor|ei|lig; Vor|ei|lig|keit w; -
vor|ein|an|der; Schreibung in Ver-
bindung mit Zeitwörtern (↑ R 139):
sich voreinander fürchten; sich
voreinander hüten, sich vor-
einander hinstellen usw.; vgl. an-
einander
vor|ein|ge|nom|men; Vor|ein|ge-
nom|men|heit w; -
vor|eis|zeit|lich
Vor|el|tern Mehrz.
Vor|emp|fan|ge|ne (Rechtsspr.
für: das Vorerbe) s; -n
vor|ent|hal|ten; ich enthalte vor;
ich habe vorenthalten; vorzuent-
halten; Vor|ent|hal|tung
Vor|ent|scheid; Vor|ent|schei-
dung; Vor|ent|schei|dungs|kampf
¹Vor|er|be m; ²Vor|er|be s
vor|erst [auch: forerst]
vor|er|wähnt (Amtsdt.)
vor|es|sen schweiz. (Ragout)
Vor|fahr m; -en, -en (↑ R 268); vor-
fah|ren; ich fahre vor; vorgefah-
ren; vorzufahren; Vor|fah|rin w;
-, -nen; Vor|fahrt; [die] - haben,
beachten; vor|fahrt[s]|be|rech-
tigt; Vor|fahrt[s]_recht (s; -[e]s),
...re|gel, ...schild s, ...stra|ße,
...zei|chen
Vor|fall m; vor|fal|len; etwas fällt
vor; vorgefallen; vorzufallen
Vor|feld (Gelände vor der eigenen
Kampfstellung)
Vor|film
vor|fi|nan|zie|ren; Vor|fi|nan|zie-
rung
vor|fin|den; ich finde vor; vorge-
funden; vorzufinden
Vor|flu|ter (Abzugsgraben für
Schmutzwasser; Entwässe-
rungsgraben)
Vor|freu|de
vor|fri|stig; etwas - liefern
Vor|früh|ling
Vor|führ|da|me; vor|füh|ren; ich
führe vor; vorgeführt; vorzufüh-
ren; Vor|füh|rer; Vor|führ|raum;

Vor|füh|rung; Vor|füh|rungs-raum

Vor|gal|be (Sport: Vergünstigung für Schwächere; Bergmannsspr.: das, was an festem Gestein [od. Kohle] durch einen Sprengschuß gelöst werden soll)

Vor|gang; Vor|gän|ger

Vor|gar|ten

vor|ge|ben; ich gebe vor; vorgegeben; vorzugeben

Vor|ge|birge

vor|geb|lich

vor|gefaßt; -e Meinung

vor|ge|fer|tigt; -e Bauteile

Vor|ge|fühl

Vor|ge|gen|wart (für: Perfekt)

vor|ge|hen; ich gehe vor; vorgegangen; vorzugehen; Vor|ge|hen s; -s

Vor|ge|län|de

Vor|ge|le|ge (Technik: Übertragungsvorrichtung)

vor|ge|le|sen, ge|neh|migt, un|ter|schrie|ben (gerichtl. Formel; Abk.: v., g., u.)

vor|ge|nannt (Amtsdt.)

vor|ge|ord|net (früher auch für: übergeordnet)

Vor|ge|richt (Vorspeise)

vor|ger|ma|nisch

Vor|ge|schich|te w; -; Vor|ge|schicht|ler; vor|ge|schicht|lich; Vor|ge|schichts|for|scher, ...for|schung

Vor|ge|schmack m; -[e]s

vor|ge|schrit|ten; in -em Alter

Vor|ge|setz|te m u. w; -n, -n (↑ R 287ff.); Vor|ge|setz|ten|ver|hält|nis

vor|ge|stern; - abend (↑ R 129); vor|gest|rig

vor|grei|fen; ich greife vor; vorgegriffen; vorzugreifen; vor|greif|lich (veralt.); vgl. unvorgreiflich; Vor|griff

vor|ha|ben; ich habe vor; vorgehabt; vorzuhaben; etwas -; Vor|ha|ben (Plan, Absicht) s; -s, -

Vor|hal|le

Vor|halt (Musik: ein harmoniefremder Ton, der an Stelle eines benachbarten Akkordtones steht, in den er sich auflöst; schweiz. neben: Vorhaltung); vor|hal|ten; ich halte vor; vorgehalten; vorzuhalten; Vor|hal|tung (ernste Ermahnung, meist Mehrz.)

Vor|hand ([Tisch]tennis, Badminton, Hockey: ein bestimmter Schlag; beim Pferd: auf den Vorderbeinen ruhender Rumpfteil; Kartenspieler, der beim Austeilen die erste Karte erhält) w; -; in - sein, sitzen; die - haben

vor|han|den; - sein; Vor|han|den|sein (↑ R 120) s; -s

Vor|hang; ¹vor|hän|gen; das Kleid hing unter dem Mantel vor; vgl.

¹hängen; ²vor|hän|gen; er hat das Bild vorgehängt; vgl. ²hängen; Vor|hän|ge|schloß; Vor|hang-...stan|ge, ...stoff

Vor.haus (landsch. für: Hauseinfahrt, -flur), ...haut (für: Präputium)

vor|her; vor|her (früher) war es besser; einige Tage vorher. Schreibung in Verbindung mit Zeitwörtern (↑ R 139): a) Getrenntschreibung, wenn „vorher" im Sinne von früher gebraucht wird, z. B. vorher (früher) gehen; b) Zusammenschreibung, wenn „vorher" im Sinne von voraus verwendet wird; vgl. vorherbestimmen, vorhergehen, vorhersagen, vorhersehen; vor|her|be|stim|men; ↑ R 139 (vorausbestimmen); er bestimmt vorher; vorherbestimmt; vorherzubestimmen; aber: vorher be|stim|men; er hat den Zeitpunkt vorher (früher, im voraus) bestimmt; Vor|her|be|stim|mung; vor|her|ge|hen; ↑ R 139 (voraus-, vorangehen); es geht vorher; vorhergegangen; vorherzugehen; aber: vorher (früher) ge|hen; vor|her|ge|hend; (↑ R 135:) -es; (↑ R 134:) im -en (weiter oben), aber (↑ R 116): der, die, das Vorhergehende; vgl. folgend; vor|he|rig [auch: for...]

Vor|herr|schaft; vor|herr|schen; etwas herrscht vor; vorgeherrscht; vorzuherrschen

Vor|her|sa|ge w; -, -n; vor|her|sa|gen; ↑ R 139 (voraussagen); ich sage vorher; vorhergesagt; vorherzusagen; aber (↑ R 116:) das Vorhergesagte; aber: vorher (früher) sa|gen (↑ R 116:) das vorher Gesagte

vor|her|seh|bar; vor|her|se|hen; ↑ R 139 (ahnen, im voraus erkennen); ich sehe vorher; vorhergesehen; vorherzusehen; aber: vorher (früher) se|hen

vor|hin [auch: ...hín]

vor|hin|ein; im - (bes. österr. für: im voraus); vgl. vornhinein

Vor.hof, ...höl|le, ...hut w

vo|rig; vorigen Jahres (Abk.: v. J.); vorigen Monats (Abk.: v. M.); (↑ R 135:) der, die, das -e; (↑ R 134:) im -en (weiter vorher); aber (↑ R 116:) die Vorigen (Personen des Theaterstückes), das Vorige (die vorigen Ausführungen; die Vergangenheit); vgl. folgend

vor|in|do|ger|ma|nisch

Vor|jahr; vor|jäh|rig

Vor.kam|mer, ...kämp|fer

Vor|kauf; Vor|käu|fer; Vor|kaufs|recht

Vor|kehr schweiz. (Vorkehrung) w; -, -en; Vor|keh|rung ([sichernde] Maßnahme); -[en] treffen

Vor|keim (Bot.)

Vor|kennt|nis (meist Mehrz.)

vor|knöp|fen (ugs. für: jmdn. zurechtweisen); ich knöpfe mir ihn vor; vorgeknöpft; vorzuknöpfen

vor|koh|len (ugs. für: jmdm. etwas vorlügen); ich kohle vor; vorgekohlt; vorzukohlen; vgl. ²kohlen

vor|kom|men; etwas kommt vor; vorgekommen; vorzukommen; Vor|kom|men s; -s, -; vor|kom|men|den|falls. Fall m; Vor|komm|nis s; -ses, -se

Vor|kost (kleineres Essen, Gang vor dem Hauptgericht)

vor|kra|gen (Bauw.: herausragen; [seltener:] herausragen lassen)

Vor.kriegs.er|schei|nung, ...wa|re, ...zeit; vor|kriegs|zeit|lich

vor|la|den; vgl. ²laden; Vor|la|de|schein; Vor|la|dung

Vor|la|ge

Vor|land s; -[e]s

vor|las|sen; ich lasse vor; vorgelassen; vorzulassen

Vor|lauf (beim Destillieren: die zuerst übergehende Flüssigkeit; Sport: Ausscheidungslauf); Vor|läu|fer; vor|läu|fig; Vor|läu|fig|keit w; -

vor|laut

vor|le|gen; ich lege vor; vorgelegt; vorzulegen; vor|le|ge|steck, ...ga|bel; Vor|le|ger (kleiner Teppich); Vor|le|ge|schloß; Vor|le|gung

Vor|lei|stung

vor|le|sen; ich lese vor; vorgelesen; vorzulesen; Vor|le|se|pult; Vor|le|ser; Vor|le|sung; Vor|le|sungs-.ge|bühr, ...ver|zeich|nis

vor|letzt; zu -; der -e [Mann], aber (↑ R 118): er ist der Vorletzte [der Klasse]

vor|lieb vgl. fürlieb; Vor|lie|be w; -, -n; vor|lieb|neh|men; ich nehme vorlieb; vorliebgenommen; vorliebzunehmen; vgl. fürliebnehmen

vor|lie|gen; es liegt vor; hat vorgelegen; vorzuliegen; vor|lie|gend; (↑ R 135:) -es; (↑ R 134:) im -en (hier), aber (↑ R 116): das Vorliegende; vgl. folgend

vor|lü|gen; ich lüge vor; vorgelogen; vorzulügen

vorm; ↑ R 240 (meist ugs. für: vor dem); - Haus[e]

¹vorm. = vormals

²vorm., (bei Raummangel:) vm. = vormittags

vor|ma|chen (ugs. für: jmdm. etwas vorlügen; jmdn. täuschen); ich mache vor; vorgemacht; vorzumachen

Vor|macht; Vor|macht|stel|lung
Vor|ma|gen
vor|ma|lig; vor|mals (Abk.: vorm.)
Vor|mann (Mehrz. ...männer)
Vor|marsch m
Vor|märz m; -[es]; vor|märz|lich
Vor|mau|er
Vor|mensch (Bez. für den Menschen der frühesten faßbaren Stufe im Entwicklungsgang der Menschheit) m
Vor|merk|buch; vor|mer|ken; ich merke vor; vorgemerkt; vormerken; Vor|mer|kung (auch: vorläufige Eintragung ins Grundbuch); von etwas - nehmen (Papierdt., dafür besser: etwas vormerken)
Vor|mit|tag; vormittags; ↑ R 129 (Abk.: vorm., [bei Raummangel:] vm.), aber: des Vormittags; heute vormittag; vgl. ¹Mittag; vor|mit|tä|gig; vgl. ...tägig; vor|mit|täg|lich; vgl. ...täglich; vor|mit|tags; vgl. Vormittag; Vor|mit|tags_stun|de, ...vor|stel|lung
Vor|mund m; -[e]s, -e u. ...münder; Vor|mund|schaft; Vor|mund|schafts|ge|richt
¹vorn, vor|ne; von - beginnen
²vorn; ↑ R 240 (ugs. für: vor den); - Kopf
Vor|nah|me (Ausführung) w; -, -n
Vor|na|me
vorn|an¹ [auch: fo...]; vor|ne vgl. ¹vorn
vor|nehm; (↑ R 133:) vornehm und gering (veralt. für: jedermann), aber (↑ R 116): Vornehme und Geringe; vornehm tun
vor|neh|men; sich etwas -; ich nehme mir etwas vor; vorgenommen; vorzunehmen
Vor|nehm|heit w; -; vor|nehm|lich (besonders); Vor|nehm|tue|rei (abschätzig) w; -
vor|nei|gen; sich -; ich neige mich vor; vorgeneigt; vorzuneigen
vorn|her|ein¹ [auch: fornhärain]; von -; vorn|hin¹ [auch: fornhin]; vorn|hin|ein¹ [auch: fornhinain]; im - (mdal. für: von vornherein, im voraus); vgl. vorhinein; vorn-über¹; vorn|über|ge|beugt¹; vorn-weg¹ [auch: fornwäk]
Vor|ort m; -[e]s, ...orte; Vor|ort[s]-_ver|kehr, ...zug
Vor|platz
Vor_po|sten, ...pro|gramm, ...prü|fung
Vor|rang m; -[e]s; vor|ran|gig; Vor|rang|stel|lung
Vor|rat m; -[e]s, ...räte; vor|rä|tig; Vor|rats_ge|bäu|de, ...haus, ...kam|mer, ...po|li|tik, ...raum
Vor|raum, ...recht, ...re|de, ...red-ner, ...rei|ter

¹ Ugs.: vorne...

vor|rich|ten; ich richte vor; vorge-richtet; vorzurichten; Vor|rich|tung
vor|rücken [Trenn.: ...rük|ken]; ich rücke vor; vorgerückt; vorzurücken
Vor|run|de (Sportspr.); Vor|run-den|spiel (Sportspr.)
vors; ↑ R 240 (meist ugs. für: vor das); - Haus
Vors. = Vorsitzende[r], Vorsitzer
Vor|saal bes. obersächs. (Korridor, Hausflur)
vor|sa|gen; ich sage vor; vorgesagt; vorzusagen; Vor|sa|ger
Vor_sai|son, ...sän|ger
Vor|satz¹ m; -es, Vorsätze· Vor|satz|blatt (svw. Vorsatzpapier); vor|sätz|lich; Vor|sätz|lich|keit w; -; Vor|satz|pa|pier (Druckw.)
Vor|schalt|wi|der|stand (Elektrotechnik)
Vor|schein m, nur noch in: zum - kommen, bringen
vor|schie|ben; ich schiebe vor; vorgeschoben; vorzuschieben
vor|schie|ßen (Geld leihen); ich schieße vor; vorgeschossen; vorzuschießen
Vor|schiff
Vor|schlag auf -; vor|schla|gen; ich schlage vor; vorgeschlagen; vorzuschlagen; Vor|schlag|ham|mer; Vor|schlags|recht s; -[es]
Vor|schluß|run|de (Sportspr.)
Vor|schmack (veraltend für: Vorgeschmack, Bild des Kommenden, Vorgefühl) m; -[e]s
vor|schnell; - urteilen
vor|schrei|ben; ich schreibe vor; vorgeschrieben; vorzuschreiben; Vor|schrift; Dienst nach -; vor|schrifts_ge|mäß, ...mä|ßig
¹Vor|schub, nur noch in: - leisten (begünstigen, fördern); ²Vor|schub (Technik: Maß der vorwärtsbewegung eines Werkzeuges) m; -[e]s, Vorschübe; Vor|schub|lei|stung
vor|schu|hen (Schuhe vorn erneuern); ich schuhe vor; vorgeschuht; vorzuschuhen
Vor|schu|le; Vor|schul|er|zie|hung; vor|schu|lisch; Vor|schu|lung
Vor|schuß; vor|schuß|wei|se; Vor|schuß_lor|bee|ren (im vorhinein erteiltes Lob) Mehrz.; Vor|schuß-zah|lung
vor|schüt|zen (als Vorwand angeben); ich schütze vor; vorgeschützt; vorzuschützen; Vor|schüt|zung
vor|se|hen; ich sehe vor; vorgesehen; vorzusehen; Vor|se|hung
vor|set|zen; ich setze vor; vorgesetzt; vorzusetzen; Vor|set|zer

¹ In der Bedeutung von „Vorsatz-papier" fachspr. auch: s.

(veralt.: etwas, was vor etwas [z. B. vor den Ofen, das Fenster] gesetzt wird)
vor sich ... vgl. vor
Vor|sicht; -! (Achtung!); vor|sich-tig; Vor|sich|tig|keit w; -; vor-sichts|hal|ber; Vor|sichts|maß|re-gel
Vor|sil|be
vor|sin|gen; ich singe vor· vorge-sungen; vorzusingen
vor|sint|flut|lich (meist ugs. für: veraltet, unmodern); vgl. Sintflut
Vor|sitz m; -es; Vor|sit|zen|de (im Akten recht nur so; Abk.: Vors.) m u. w; -n, -n (↑ R 287ff.); Vor|sit-zer (Vorsitzender, Abk.. Vors.); Vor|sit|ze|rin w; -, -nen
Vor|som|mer
Vor|sor|ge w; -; vor|sor|gen; ich sorge vor; vorgesorgt; vorzusor-gen; vor|sorg|lich
Vor|spann (auch für: Titel, Dar-steller- u. Herstellerverzeichnis beim Film, Fernsehen; Einlei-tung eines Presseartikels, Aufhänger) m; -[e]s, -e; vgl. Nach-spann; vor|span|nen; ich spanne vor; vorgespannt; vorzuspannen; Vor|spann|mu|sik (Film, Fernse-hen)
Vor|spei|se
vor|spie|geln; ich spiege[l]e (↑ R 327) vor; vorgespiegelt; vorzu-spiegeln; Vor|spie|ge|lung, Vor-spieg|lung
Vor|spiel; vor|spie|len; ich spiele vor; vorgespielt; vorzuspielen; Vor|spie|ler
Vor|spinn|ma|schi|ne (Weberei; Flyer)
vor|spre|chen; ich spreche vor; vor-gesprochen; vorzusprechen
vor|sprin|gen; ich springe vor; vor-gesprungen; vorzuspringen
Vor|spruch
Vor|sprung
Vor_stadt, ...städ|ter; vor|städ-tisch; Vor|stadt_ki|no, ...thea|ter
Vor|stand (österr. auch svw. Vor-steher) m; -[e]s, Vorstände; Vor-stands_mit|glied, ...sit|zung
Vor|stecker [Trenn.: ...stek|ker] (Vorsteckkeil); Vor|steck|keil (↑ R 236), ...na|del
vor|ste|hen; ich stehe vor; vor-gestanden; vorzustehen; vor|ste-hend; (↑ R 135:) -es; (↑ R 134:) im -en (weiter oben), aber (↑ R 116): das Vorstehende; vgl. folgend; Vor|ste|her; ich ste|her|drü|se (für: Prostata); Vor|ste|he|rin w; -, -nen; Vor|steh|hund
vor|stell|bar; das ist kaum -; vor-stel|len; ich stelle vor; vorgestellt; vorzustellen; sich etwas - vor-stel|lig; - werden; Vor|stel|lung; Vor|stel|lungs_art, ...kraft (w; -), ...ver|mö|gen (s; -s), ...welt

Vor|ste|ven (Seew.)
Vor|stoß; vor|sto|ßen; ich stoße
vor; vorgestoßen; vorzustoßen
Vor|stra|fe; Vor|stra|fen|re|gi|ster
Vor|stu|fe
vor|sünd|flut|lich (volksm. Um-
deutung von: vorsintflutlich)
Vor|tag
Vor|tän|zer
vor|täu|schen; ich täusche vor; vor-
getäuscht; vorzutäuschen; Vor-
täu|schung
Vor|teil m; -s, -e; von -; im - sein;
vor|teil|haft
Vor|trab (veralt.) m; -[e]s, -e
Vor|trag m; -[e]s, ...träge; vor|tra-
gen; ich trage vor; vorgetragen;
vorzutragen; Vor|tra|gen|de m u.
w; -n, -n (↑ R 287ff.); Vor|trags-
_be|zeich|nung (Musik), ...fol|ge,
...kunst (w; -), ...künst|ler, ...rei-
he, ...we|sen (s; -s)
vor|treff|lich; Vor|treff|lich|keit
w; -
vor|tre|ten; ich trete vor; vorgetre-
ten; vorzutreten; Vor|tritt
(schweiz. auch für: Vorfahrt) m;
-[e]s
Vor|trieb (Physik, Technik [nur
Einz.]; Bergmannsspr.); Vor-
triebs_ver|lust
Vor|tuch landsch. (Schürze) s;
-[e]s, ...tücher
Vor|tur|ner; Vor|tur|ner|rie|ge
vor|über; es ist alles vorüber; vor-
über|ge|hen; ich gehe vorüber;
vorübergegangen; vorüberzuge-
hen; vor|über|ge|hend
Vor|übung
Vor|un|ter|su|chung
Vor|ur|teil; vor|ur|teils_frei, ...los;
-este (↑ R 292); Vor|ur|teils|lo|sig-
keit w; -
Vor|va|ter (meist Mehrz.)
Vor|ver|gan|gen|heit (für: Plus-
quamperfekt) w; -
Vor|ver|hand|lung (meist Mehrz.)
Vor|ver|kauf m; -[e]s
vor|ver|le|gen; ich verlege vor; vor-
verlegt; vorzuverlegen
Vor|ver|trag
vor|vor|ge|stern; vor|vo|rig (vor-
letzt); -e Woche
Vor|wahl; vor|wäh|len; ich wähle
vor; vorgewählt; vorzuwählen;
Vor|wähl|num|mer
Vor|wand (vorgeschützter Grund)
m; -[e]s, ...wände
Vor|wär|mer (Anwärmer des Kes-
selspeisewassers)
vor|wärts; vor- und rückwärts (↑R
145); (↑ R 224:) Marschall Vor-
wärts (Beiname Blüchers);
Schreibung in Verbindung mit
Zeitwörtern (↑ R 139): I. Ge-
trenntschreibung in ursprüng-
licher Bedeutung, z. B. vorwärts
gehen; er ist immer vorwärts
(nach vorn) gegangen. II. Zusam-

menschreibung, wenn durch die
Verbindung ein neuer Begriff
entsteht; vgl. vorwärtsbringen,
vorwärtsgehen, vorwärtskom-
men; vor|wärts|brin|gen; ↑ R 139
(fördern); er hat das Unterneh-
men vorwärtsgebracht; aber:
vor|wärts brin|gen; er hat den
Wagen nur mühsam vorwärts ge-
bracht; vor|wärts|ge|hen; ↑ R 139
(besser werden); nach der schlim-
men Zeit ist es endlich wieder
vorwärtsgegangen; aber: vor-
wärts ge|hen; er ist immer vor-
wärts gegangen; vor|wärts|kom-
men; ↑ R 139 (im Beruf u. a. vor-
ankommen); er ist in der letzten
Zeit schnell vorwärtsgekommen;
(↑ R 120:) es ist kein Vorwärts-
kommen; aber: vor|wärts kom-
men; er konnte im Schneesturm
kaum vorwärts kommen
vor|weg; Vor|weg|nah|me w; -; vor-
weg|neh|men; ich nehme vorweg;
vorweggenommen; vorwegzu-
nehmen
vor|weis m; -es, -e; vor|wei|sen; ich
weise vor; vorgewiesen; vorzu-
weisen; Vor|wei|sung
Vor|welt w; -; vor|welt|lich
vor|wer|fen; ich werfe vor; vorge-
worfen; vorzuwerfen
Vor|werk
vor|wie|gend
Vor|wis|sen; ohne mein -
Vor|witz; vgl. Fürwitz; vor|wit|zig;
vgl. fürwitzig
Vor|wo|che; vor|wö|chig
Vor|wort (Vorrede in einem Buch;
österr., sonst veralt. für: Verhält-
niswort) s; -[e]s, (Vorreden:) -e
u. (Verhältniswörter:) ...wörter
Vor|wurf; vor|wurfs_frei, ...voll
Vor|zei|chen; vor|zeich|nen; ich
zeichne vor; vorgezeichnet; vor-
zuzeichnen; Vor|zeich|nung
vor|zei|gen; ich zeige vor; vorge-
zeigt; vorzuzeigen; Vor|zei|ge-
ver|merk; Vor|zei|gung (Papier-
dt.)
Vor|zeit; vor|zei|ten, aber: vor
langen Zeiten; vor|zei|tig (ver-
früht); Vor|zei|tig|keit (Sprach-
wiss.); vor|zeit|lich (der Vorzeit
angehörend); Vor|zeit|mensch m
vor|zie|hen; ich ziehe vor; vorgezo-
gen; vorzuziehen; etwas, jmdn.
-; Vor|zie|hung
Vor|zim|mer (österr. auch für:
Hausflur, Diele, Vorraum); Vor-
zim|mer_da|me, ...wand (österr.
für: Garderobe, Kleiderablage)
Vor|zin|sen (für: Diskont) Mehrz.
Vor|zug; vor|züg|lich; vor|züg-
lich|keit w; -; Vor|zugs_ak|tie,
...milch, ...preis (vgl. ²Preis),
...schü|ler (österr.: Schüler mit
sehr guten Noten); ...stel|lung;
vor|zugs|wei|se

Vor|zu|kunft (für: Futurum exak-
tum) w; -
Voß (dt. Dichter); Voß' Überset-
zung (↑ R 310)
Vo|ta (Mehrz. von: Votum); Vo-
tant lat. [wo...] (der Votierende)
m; -en, -en (↑ R 268); Vo|ten
(Mehrz. von: Votum); vo|tie|ren
(sich entscheiden, stimmen für;
abstimmen); Vo|tiv_bild, ...ga|be,
...ka|pel|le, ...kir|che, ...mes|se;
Vo|tum (Gelübde; Urteil; Stim-
me; Entscheid[ung]; Gutachten)
s; -s, ...ten u. ...ta
Vou|te fr. [wutᵉ] (Bauw.: Versteif-
ungs- u. Verstärkungsteil zwi-
schen Wand u. Decke oder an
Einspannstellen von Balken zur
Vergrößerung der Balkenhöhe;
veralt. für: Gewölbe; Decke mit
breiter Kehle) w; -, -n
vox po|pu|li vox Dei lat. [wokß -
wokß -] (Volkes Stimme [ist]
Gottes Stimme)
Voya|geur fr. [woajasehör] (veralt.
für: Reisender) m; -s, -s u. -e;
vgl. Commis voyageur
Voy|eur fr. [woajör] (jmd., der als
Zuschauer den sexuellen Betäti-
gungen anderer Befriedigung er-
fährt) m; -s, -e
Vp., VP = Versuchsperson
VP = Volkspolizei (DDR)
VR = Volksrepublik
Vro|ni [wro..., auch: fro...] (südd.
Kurzform von: Veronika)
v. R. w. = von Rechts wegen
v. s. pl. = verte, si placet!
v. T., p. m., %₀ = vom Tausend;
vgl. pro mille
Vt. = Vermont
v. u. = von unten
vul|gär lat. [wul...] (gewöhnlich;
gemein; niedrig); Vul|ga|ri|tät;
Vul|gär_la|tein (Volkslatein),
...spra|che; Vul|ga|ta („allgemein
verbreitete“ [vom Konzil zu
Trient für authentisch erklärte]
lat. Bibelübersetzung des hl. Hie-
ronymus) w; -; Vul|gi|va|ga
[...waga] („Umherschweifende“;
herabsetzender Beiname der Lie-
besgöttin Venus) w; -; Venus
-; vul|go (gemeinhin, gewöhnlich,
allgemein [so genannt])
¹Vul|kan [wul...] (röm. Gott des
Feuers); ²Vul|kan lat. (feuer-
speiender Berg) m; -s, -e; Vul|kan-
aus|bruch; Vul|kan|fi|ber (Ersatz-
masse für Leder und Kautschuk)
w; -; Vul|ka|ni|sa|ti|on [...zion],
Vul|ka|ni|sie|rung (Anlagerung
von Schwefel an Kautschuk); vul-
ka|nisch (durch Vulkanismus
entstanden, von Vulkanen her-
rührend); Vul|ka|ni|si|er|an|stalt;
vul|ka|ni|sie|ren (Kautschuk
durch Schwefel festigen); Vul|ka-
ni|sie|rung vgl. Vulkanisation;

Vul|ka|nis|mus (zusammenfassende Bezeichnung für vulkanische Tätigkeit aller Art) *m*; -
Vul|va *lat.* [*wulwa*] (Med.: weibl. Scham) *w*; -, Vulven
v. v. = vice versa
VW Ⓦ (Volkswagen) *m*; -, -; **VW-Fah|rer** († R 150)
VWD = Vereinigte Wirtschaftsdienste

W

W (Buchstabe); das W; des W, die W, aber: das w in Löwe († R 123); der Buchstabe W, w
W = Watt; Werst; West[en]; chem. Zeichen für: Wolfram
Waadt [*wat*, auch: *wat*] (schweiz. Kanton) *w*; -; **Waadt|land** (svw. Waadt) *s*; -[e]s; **Waadt|län|der** († R 199); **waadt|län|disch**
¹**Waag** bayr. (Flut, Wasser) *w*; -
²**Waag** (l. Nebenfluß der Donau in der Tschechoslowakei) *w*; -
Waa|ge *w*; -, -n; **Waa|ge.amt**, ...**bal|ken**, ...**geld**, ...**mei|ster**; **Waa|gen|fa|brik**; **waa|ge|recht**, **waag|recht**; **Waa|ge|rech|te**, **Waag|rech|te** *w*; -n, -n; vier -[n] († R 291); **Waag|scha|le**
Waal (Mündungsarm des Rheins) *w*; -
wab|be|lig, **wabb|lig** (ugs. für: gallertartig wackelnd; unangenehm fett u. weich); **wab|beln** (ugs. für: hin u. her wackeln); der Pudding wabbelt
Wa|be (Zellenbau des Bienenstockes) *w*; -, -n; **Wa|ben.ho|nig**, ...**korb**
Wa|ber|lo|he (altnord. Dichtung: flackernde, leuchtende Flamme, Glut); **wa|bern** (veralt., aber noch landsch. für: sich hin u. her bewegen, flackern)
wach; *Schreibung in Verbindung mit Zeitwörtern* († R 139); **a)** *Getrenntschreibung* in ursprünglicher Bedeutung, z. B. wach bleiben, [er]halten, sein, werden; er ist wach geblieben; **b)** *Zusammenschreibung*, wenn durch die Verbindung ein neuer Begriff entsteht; vgl. wachhalten, wachrufen, wachrütteln
Wach|au (Engtal der Donau zwischen Krems u. Melk) *w*; -
Wach.ab|lö|sung, ...**boot**, ...**buch**, ...**dienst**; **Wa|che** *w*; -, -n; - halten, stehen; **Wa|che|be|am|te** österr. (Amtsspr. für: Polizist); **wa|chen**; über jmdn. -; **Wa|che|ste|hen** *s*; -s; **wa|che|ste|hend** († R 142); **Wach|feu|er**; **wach|ha|bend**; **Wach|ha|ben|de** *m* u. *w*; -n, -n († R 287 ff.); **wach|hal|ten**; † R 139 (lebendig erhalten); ich habe sein Interesse wachgehalten; aber: wach hal|ten; er hat sich mühsam wach gehalten (er ist nicht eingeschlafen); **Wach|heit** *w*; -; **Wach.hund**, ...**lo|kal**, ...**mann** (*Mehrz.* ...leute u. ...männer), ...**mannschaft**
Wa|chol|der (eine Pflanze) *m*; -, -; **Wa|chol|der.baum**, ...**bee|re**, ...**brannt|wein**, ...**dros|sel**, ...**schnaps**, ...**strauch**
wach|ru|fen; † R 139 (hervorrufen; in Erinnerung bringen); das hat seinen Ehrgeiz wachgerufen; er hat die längst vergessenen Leiden in ihm wieder wachgerufen; **wach|rüt|teln**; † R 139 (aufrütteln); diese Nachricht hat ihn wachgerüttelt
Wachs *s*; -es, -e; **Wachs|ab|guß**; **wach|sam**; **Wach|sam|keit** *w*; -; **Wachs|bild**; **wachs|bleich**; **Wachs-blei|che** (*w*; -), ...**blu|me**, ...**boh|ne**
wach|seln (österr. Sportspr. für: [Schier] wachsen); ich ...[e]le († R 327)
¹**wach|sen** (größer werden, im Wachsen sein); du wächst (wächsest), er wächst; du wuchsest, er wuchs; du wüchsest; gewachsen; wachs[e]!
²**wach|sen** (mit Wachs glätten); du wachst (wachsest), er wachst; du wachstest; gewachst; wachs[e]!; **wäch|sern** (aus Wachs); **Wachs-fi|gur**; **Wachs|fi|gu|ren|ka|bi-nett**; **Wachs.ker|ze**, ...**lein|wand** (österr. ugs. für: Wachstuch), ...**licht** (*Mehrz.* ...lichter), ...**ma|le|rei**, ...**mas|ke**, ...**mo|dell**, ...**pa-pier**, ...**plat|te**, ...**stock** (*Mehrz.* ...stöcke), ...**ta|fel**
Wachs|stu|be
Wachs|tuch
Wachs|tum *s*; -s; **wachs|tum|hem-mend**, aber († R 142): das Wachstum hemmend; **Wachs|tums.hor|mon**, ...**pro|zeß**, ...**stö|rung**, ...**ra|te**
wachs|weich; **Wachs|zie|her**
Wacht (geh. für: Wache) *w*; -, -en; - halten
Wäch|te (überhängende Schneemasse; schweiz. auch für: Schneewehe) *w*; -, -n
Wach|tel (ein Vogel) *w*; -, -n; **Wach|tel.hund**, ...**kö|nig** (ein Vogel), ...**ruf**, ...**schlag**, ...**wei|zen** (eine Pflanze)
Wäch|ten|bil|dung
Wäch|ter; **Wäch|ter|ruf**; **Wacht-mei|ster**, ...**pa|ra|de**, ...**po|sten**; **Wacht|traum**, **Wacht|turm**, **Wach|turm**; **Wach- und Schließ-ge|sell|schaft** († R 145); **Wach-zim|mer** (österr. für: Polizeibü-ro), ...**zu|stand**

Wacke¹ (veralt., noch mdal. für: bröckeliges Gestein) *w*; -, -n
Wacke|lei¹ *w*; -; **wacke|lig**¹, wack-lig; - stehen (auch ugs. für: dem Bankrott nahe sein); **Wackel-kon|takt**¹ (Elektrotechnik); **wa|keln**; ich ...[e]le († R 327)
wacker¹
Wacker|stein¹ südd. (Gesteins-brocken)
wack|lig vgl. wackelig
Wad *engl.* (ein Mineral) *s*; -s
Wa|dai (afrik. Landschaft)
Wad|di|ke niederd. (Molke, Käse-wasser) *w*; -
Wa|de *w*; -, -n; **Wa|den.bein**, ...**krampf**, ...**wickel**¹
Wa|di *arab.* (wasserloses Flußtal in Nordafrika u. im Vorderen Orient) *s*; -s, -s
Wa|di-Qum|ran [...*kumran*] vgl. Kumran
Wäd|li schweiz. (Eisbein) *s*; -s, -
Wafd (ehem. ägypt. nationalist. Partei) *m*; -
Waf|fe *w*; -, -n; atomare, konventionelle, nukleare Waffen
Waf|fel *niederl.* (ein Gebäck) *w*; -, -n; **Waf|fel|ei|sen**
Waf|fen.be|sitz, ...**bru|der**, ...**brü-der|schaft**; **waf|fen|fä|hig**; **Waf-fen.gang** *m*, ...**gat|tung**, ...**ge|walt** (*w*; -), ...**kam|mer**, ...**lie|fe|rung**; **waf|fen|los**; **Waf|fen.platz** (schweiz. für: Garnison), ...**ru|he**, ...**schein**, ...**still|stand**; **Waf-fen|still|stands|li|nie**; **Waf-fen.stu|dent**, ...**sy|stem**, ...**tanz**; **waff|nen** (veralt.); sich -
wäg (veralt. für: tüchtig, gut); -st; (schweiz. geh.:) die Wägsten u. Besten († R 116)
wäg|bar
Wa|ge.drang, ...**hals**; **wa|ge|hal-sig**, **wag|hal|sig**; **Wa|ge|hal|sig-keit**, **Wag|hal|sig|keit**
¹**Wä|gel|chen**, **Wä|ge|lein** (kleiner Wagen)
²**Wä|gel|chen**, **Wä|ge|lein** (kleine Waage)
Wa|ge|mut; **wa|ge|mu|tig**, **wa|gen**; du wagtest; gewagt; sich -
Wa|gen *m*; -s, - (südd. auch: Wä-gen)
wä|gen (selten, aber fachspr. u. noch dicht.: das Gewicht bestimmen; übertr. für: prüfend bedenken, nach der Bedeutung einschätzen); du wägst; du wogst; du wögest; gewogen; wäg[e]!; (selten schwache Beugung: du wägtest; gewägt); vgl. ²wiegen
Wa|gen.ach|se, ...**bau|er** (*m*; -s, -), ...**burg**, ...**deich|sel**, ...**füh|rer**, ...**he|ber**, ...**ka|sten**, ...**ko|lon|ne**, ...**la|dung**, ...**park** (*m*; -[e]s), ...**pla-ne**, ...**rad**, ...**raum**, ...**ren|nen**,

¹ *Trenn.*: ...k|k...

...run|ge, ...schlag, ...stand|geld, ...typ, ...wä|sche

Wa|ge|stück, Wag|stück

Wag|gerl (österr. Erzähler)

Wag|gon engl. [...go͞ng, dt. Ausspr.: ...go͞ng; österr.: ...go͞n] ([Eisenbahn]wagen) m; -s, -s (österr. auch: -e); wag|gon|wei|se wag|hal|sig, Wag|hal|sig; Wag|hal|sig|keit, Wa|ge|hal|sig|keit

Wäg|lein, Wä|gel|chen (kleine Waage)

¹Wag|ner südd., österr. u. schweiz. (Wagenbauer, Stellmacher) m; -s, -

²Wag|ner (dt. Komponist); Wag|ne|ria|ner (Anhänger Wagners); Wag|ner-Oper (↑ R 180) w; -, -n

Wag|nis s; -ses, -se; Wag|stück, Wa|ge|stück

Wä|gung

Wä|he südwestd., schweiz. (flacher Kuchen mit süßem od. salzigem Belag) w; -, -n

Wah|ha|bit arab. [waha...] (Angehöriger einer puritan. Reformsekte des Islams) m; -en, -en (↑ R 268)

Wahl w; -, -en; Wahl_al|ter, ...an|zei|ge, ...auf|ruf, ...auf|trag, ...aus|schuß; wähl|bar; Wähl|bar|keit w; -; Wahl|be|ein|flus|sung; wahl|be|rech|tigt; Wahl_be|rech|tig|te, ...be|rech|ti|gung, ...be|tei|li|gung, ...be|zirk, ...el|tern (österr. neben: Adoptiveltern); wäh|len; Wäh|ler; Wahl|er|geb|nis; Wäh|ler|in|itia|ti|ve; wäh|le|risch; -ste (↑ R 294); Wäh|ler_li|ste, ...schaft; Wahl_fach, ...feld|zug; wahl|frei; Wahl_frei|heit, ...gang m, ...ge|heim|nis, ...ge|schenk, ...ge|setz, ...hei|mat

wäh|lig niederd. (wohlig; munter, übermütig)

Wahl_ka|bi|ne, ...kampf, ...kind (österr. neben: Adoptivkind), ...kreis, ...lei|ter m, ...li|ste, ...lo|kal, ...lo|ko|mo|ti|ve (als zugkräftig angesehener Kandidat einer Partei); wahl|los; Wahl_mann (Mehrz. ...männer), ...ord|nung, ...pa|ro|le, ...pe|ri|ode, ...pflicht, ...pla|kat, ...pro|pa|gan|da, ...recht (s; -[e]s), ...re|de, ...schein, ...sieg, ...spruch

Wahl|statt (Ort in Schlesien); Fürst von - (Blücher)

Wahl_sy|stem, ...ur|ne, ...ver|fah|ren, ...ver|samm|lung; wahl|ver|wandt; Wahl_ver|wandt|schaft, ...vor|stand; wahl|wei|se; Wahl_wer|ber (österr. für: Wahlkandidat), ...zel|le, ...zuckerl (Trenn.: ...uk|k...; österr. ugs.: politisches Zugeständnis vor einer Wahl)

Wahn m; -[e]s; Wahn|bild; wäh|nen; Wahn_fried (Wagners Haus in Bayreuth); Wahn_idee, ...kan-

te (schiefe Kante am Bauholz); wahn|schaf|fen niederd. (häßlich, mißgestaltet)

Wahn|sinn m; -[e]s; wahn|sin|nig; Wahn_vor|stel|lung, ...witz (m; -es); wahn|wit|zig

wahr (wirklich); nicht -?; - od. nicht -, es wird geglaubt; eine -e Begebenheit; sein -es Gesicht zeigen; der -e Jakob (ugs. für: der rechte Mann); Schreibung in Verbindung mit Zeitwörtern (↑ R 139): a) Getrenntschreibung in ursprünglicher Bedeutung, z. B. wahr halten, machen, bleiben, werden, sein; er hat diese Erzählung für wahr gehalten; b) Zusammenschreibung, wenn durch die Verbindung ein neuer Begriff entsteht; vgl. wahrhaben, wahrsagen

wah|ren (bewahren); er hat den Anschein gewahrt

wäh|ren (dauern); wäh|rend; Bindew.: er las, - sie strickte; Verhältnisw. mit Wesf.: - des Krieges; veralt. od. ugs. mit Wemf.: - dem Schießen; hochspr. mit Wemf., wenn der Wesf. nicht erkennbar ist: - fünf Jahren, elf Monaten, aber: - zweier, dreier Jahre; wäh|rend|dem, wäh|rend|des, wäh|rend|des|sen

wahr|ha|ben (↑ R 139); er will es nicht - (nicht gelten lassen); wahr|haft (Eigenschaftsw.: wahrheitsliebend; Umstandsw.: wirklich); wahr|haf|tig (wahrhaft; beteuernd: wahrlich, fürwahr); Wahr|haf|tig|keit w; -; Wahr|heit; Wahr|heits|be|weis; wahr|heits_ge|mäß, ...ge|treu; Wahr|heits|lie|be w; -; wahr|heits|lie|bend; Wahr|heits_sinn (m; -[e]s), ...su|cher; wahr|lich

wahr|neh|men; Wahr|neh|men; ich nehme wahr; wahrgenommen; wahrzunehmen; Wahr|neh|mung

Wahr|sa|ge|kunst w; -; wahr|sa|gen; ↑ R 139 (prophezeien); du sagtest wahr od. du wahrsagtest; er hat wahrgesagt od. gewahrsagt; Wahr|sa|ger; Wahr|sa|ge|rei; Wahr|sa|ge|rin w; -, -nen; wahr|sa|ge|risch; Wahr|sa|gung

wahr|schaft (Gewähr bietend; dauerhaft, echt); Wahr|schaft schweiz. (Gewähr, Mängelhaftung)

Wahr|schau (Seemannsspr.: Wahrzeichen; Warnung; auch: Unfallverhütung); vgl. Wahrschau! (Vorsicht!); wahr|schau|en (Seemannsspr.: warnen); ich wahrschaue; gewahrschaut; zu -; Wahr|schau|er

wahr|schein|lich [auch: war...]; Wahr|schein|lich|keit; Wahr-

schein|lich|keits_be|weis, ...grad, ...rech|nung, ...theo|rie

Wahr|spruch

Wah|rung (Aufrechterhaltung, Behauptung) w; -

Wäh|rung (staatl. Ordnung des Geldwesens, Geldverfassung eines Staates); Wäh|rungs_aus|gleich, ...aus|gleichs|fonds, ...block (Mehrz. ...blöcke od. ...blocks), ...ein|heit, ...kon|fe|renz, ...po|li|tik, ...re|form, ...schnitt, ...sta|bi|li|sie|rung, ...sta|bi|li|tät

Wahr|zei|chen

Waib|lin|gen (Stadt nordöstl. von Stuttgart); hie Welf!, hie -! (Schlachtruf der welfischen u. staufischen Parteigänger im MA.); Waib|lin|ger m; -s, - (Beiname der Hohenstaufen)

waid..., Waid... in der Bedeutung „Jagd"; vgl. weid..., Weid...

Waid (eine Pflanze, u. a. Färberpflanze; blauer Farbstoff) m; -[e]s, -e

Wai|se (elternloses Kind; bei den Meistersingern eine einzelne reimlose Gedichtzeile) w; -, -n; Wai|sen_geld, ...ge|richt, ...haus, ...kind, ...kna|be, ...ren|te, ...va|ter (Waisenpfleger)

Wa|ke niederd. (Öffnung in der Eisdecke) w; -, -n

Wake|field [wēkfīld] (engl. Stadt)

Wal (Seesäugetier) m; -[e]s, -e

Wa|la (altnord. Weissagerin) w; -, Walen

Wa|la|che (Bewohner der Walachei) m; -n, -n (↑ R 268); Wa|la|chei (rumän. Landschaft) w; -; (↑ R 198:) die Große -, die Kleine -; wa|la|chisch

Wal|burg, Wal|bur|ga (w. Vorn.)

Wal|chen|see (See u. Ort in den bayerischen Voralpen) m; -s

Wald m; -[e]s, Wälder; Wald_amei|se, ...ar|bei|ter; wald|aus; wald_ein, -; Wald_be|stand, ...bo|den, ...brand; Wäld|chen, Wäld|lein

Wal|deck (Gebiet des ehem. dt. Fürstentums Waldeck in Hessen; Landkreis in Hessen; Stadt am Edersee); Wal|decker [Trenn.: ...dek|ker] (↑ R 199); wal|deckisch [Trenn.: ...dek|kisch]

wald|ein; wald_aus, -; Wald_ein|sam|keit

Wal|de|mar, Wol|de|mar (m. Vorn.)

Wal|den|ser [nach dem Lyoner Kaufmann Waldus] (Angehöriger einer südfr. vorreformatorischen Sekte)

Wald_erd|bee|re; Wal|des_dun|kel, ...rand, Wald|rand, ...rau|schen (s; -s); Wald_eu|le, ...farn, ...fre|vel, ...geist (Mehrz. ...geister), ...gren|ze, ...horn (Mehrz. ...hör-

ner), ...hü|ter; wal|dig; Wald⌣in-
ne|re, ...lauf, ...lehr|pfad; Wäld-
lein, Wäld|chen; Wald|lich|tung
Wald|mei|ster (eine Pflanze; Bow-
lenwürze, auch Pudding) m; -s;
Wald|mei|ster|bow|le
Wal|do (Kurzform von: Walde-
mar)
Wald|dorf|schu|le (Privatschule mit
besonderem Unterrichtssystem)
Wald|rand, Wal|des|rand; Wald-
re|be (eine Pflanze); wald|reich;
Wald|schrat[t] (Waldgeist);
Wald|städ|te (vier Städte am
Rhein: Rheinfelden, Säckin-
gen, Laufenburg u. Waldshut)
Mehrz.; Wald|statt (einer der drei
Urkantone [Uri, Schwyz, Unter-
walden], auch Luzern) w; -,
...stätte (meist *Mehrz.*); Wald-
tau|be; Wal|dung; Wald|vier|tel
(niederösterr. Landschaft) s; -s;
wald|wärts; Wald|weg
Wa|le (veralt. für: der Welsche;
[welscher] Goldsucher) m; -n, -n
(↑ R 268); Wa|len|buch (Buch, das
die Fundorte der Walen [Goldsu-
cher] anzeigt)
Wa|len|see (in der Schweiz) m; -s
Wales [¹u͜e'ls] (Halbinsel im We-
sten der Insel Großbritannien)
Wal|fang; Wal|fang|boot; Wal-
fän|ger; Wal|fang.flot|te, ...schiff;
wal|fang|trei|bend; Wal|fisch vgl.
Wal
wäl|gern mdal. ([Teig] glattrollen);
ich ...ere (↑ R 327); Wäl|ger|holz
(mdal.)
Wal|hall [auch: *walhal̄*], ¹Wal|hal-
la *altnord.* (nord. Mythol.: Halle
Odins, Aufenthalt der im Kampf
Gefallenen) w; -; ²Wal|hal|la
(Ruhmeshalle bei Regensburg)
w; -
Wa|li *arab.* (früher: höherer türk.
Verwaltungsbeamter) m; -s, -s
Wa|li|de *arab.* („Mutter"; früher:
Titel der Mutter des regierenden
türk. Sultans) w; -, -s
Wa|li|ser (Bewohner von Wales);
wa|li|sisch
Wal|ke (Verfilzmaschine; Vor-
gang des Verfilzens) w; -, -n; wal-
ken (Textil: verfilzen; ugs. für:
kneten; prügeln); Wal|ker; Walk-
müh|le
Wal|kü|re *altnord.* [auch: *wal...*]
(nord. Mythol.: Kampfjungfrau,
die die Gefallenen nach Walhall
geleitet) w; -, -n
¹Wall (Stückmaß [bes. für Fische];
80 Stück) m; -[e]s - u. -e; 2 -
(↑ R 322)
²Wall *lat.* (Erdaufschüttung,
Mauerwerk usw.) m; -[e]s, Wälle
Wal|lace, Edgar [*ä̱l̇²ß*] (engl.
Schriftsteller)
Wal|lach (verschnittener Hengst)
m; -[e]s, -e

¹wal|len (sprudeln, bewegt fließen)
²wal|len (veralt. für: pilgern)
wäl|len *landsch.* (wallen lassen,
zum Wallen bringen); gewällte
Kartoffeln
Wal|len|stein (Heerführer im
Dreißigjährigen Krieg)
¹Wal|ler vgl. Wels
²Wal|ler (veralt. für: Wallfahrer;
dicht. veralt. für: Wanderer);
wall|fah|ren; ich wallfahrte; ge-
wallfahrt; zu -; vgl. wallfahrten;
Wall|fah|rer; Wall|fah|re|rin w; -,
-nen; Wall|fahrt; wall|fahr|ten
(wallfahren); ich wallfahrtete, ge-
wallfahrtet; zu -; Wall|fahrts.kir-
che, ...ort (*m*; -[e]s, -e), ...otät|te
Wall|gra|ben
Wall|holz schweiz. (Nudelholz)
Wal|li (Kurzform von: Walbur-
ga[l])
Wal|lis (schweiz. Kanton) s; -;
Wal|li|ser (↑ R 199); Wal|li|ser Al-
pen *Mehrz.*; wal|li|se|risch
Wal|lo|ne (Nachkomme romani-
sierter Kelten in Belgien u. Nord-
frankreich) m; -n, -n (↑ R 268);
Wal|lo|ni|en [...*i⁰n*]; wal|lo|nisch;
-e Sprache; Wal|lo|nisch (Spra-
che) s; -[s]; vgl. Deutsch; Wal|lo-
ni|sche s; -n; vgl Deutsche
Wall|street *amerik.* [*u͜ál̇ßtrit*] (Ge-
schäftsstraße in New York
[Bankzentrum]; übertr. für:
Geld- u. Kapitalmarkt der USA)
w; -
Wal|lung
Wall|wurz (eine Heilpflanze); w; -
Wal|ly vgl. Walli
¹Walm *elsäss.* ([Wasser]wirbel,
Wallen) m; -[e]s
²Walm (Dachfläche) m; -[e]s, -e;
Walm|dach
Wal|nuß (ein Baum; eine Frucht),
Wal|nuß|baum
Wa|lo|ne *it.* (Gerbstoff enthalten-
der Fruchtbecher der Eiche) w;
-, -n
Wal|platz [auch: *wal...*] (veralt.
für: Kampfplatz)
Wal|pur|ga, Wal|pur|gis (w.
Vorn.); Wal|pur|gis|nacht
Wal|rat ([aus dem Kopf von Pott-
walen gewonnene] fettartige
Masse) m od. s; -[e]s; Wal|rat|öl
s; -[e]s; Wal|roß (Robbe) s; ...ros-
ses, ...rosse
¹Wal|ser, Martin (dt. Schriftstel-
ler)
²Wal|ser, Robert (schweiz. Lyri-
ker u. Erzähler)
Wal|ser|tal (benannt nach dem im
13. Jh. eingewanderten Walli-
sern) (Tal in Vorarlberg) s; -[e]s;
(↑ R 198:) das Große -, das
Kleine -
Wal|statt [auch: *wal...*] (veralt. für:
Kampfplatz; Schlachtfeld) w; -,
...stätten

wal|ten (gebieten; sich sorgend ei-
ner Sache annehmen); „wo rohe
Kräfte sinnlos walten"; Gnade
- lassen; (↑ R 120:) das Walten
der Naturgesetze
Wal|ter, (auch:) Wal|ther; ↑ R 191
(m. Vorn.)
Wal|tha|ri|lied [auch: ...*ta̱*...]; ↑ R
180 (Heldenepos) s; -[e]s
Wal|ther vgl. Walter
Wal|ther von der Vo|gel|wei|de
(dt. Dichter des MA.)
Wal|traud, Wal|trud (w. Vorn.);
vgl. Waltraut; Wal|traut (alte
Schreibung von: Waltraud)
Walt|run (w. Vorn.)
Wal|va|ter [auch: *wal...*] (Bez. für:
Odin)
Walz|blech; Wal|ze w; -, -n; wal-
zen; du walzt (walzest); wäl|zen;
du wälzt (wälzest); sich -; Wal-
zen|bruch m; -[e]s, ...brüche; wal-
zen|för|mig; Wal|zen.müh|le,
...spin|ne, ...stra|ße od. Walz-
stra|ße; Wal|zer (auch: Tanz);
Wäl|zer (ugs. scherzh. für: dick-
leibiges Buch); Wal|zer.mu|sik,
...tän|zer; wal|zig (walzenför-
mig); Wälz|la|ger; Walz.stahl,
...stra|ße od. Wal|zen|stra|ße,
...werk; Wäl|zer|lein|zeug|nis
Wam|me (vom Hals herabhängen-
de Hautfalte [des Rindes]) w; -,
-n; Wam|pe (svw. Wamme;
österr. ugs. abschätzig auch für:
dicker Bauch) w; -, -n; wam|pert
österr. ugs. abschätzig (dick,
bauchig)
Wam|pum *indian.* [auch: ...*pum*]
(bei nordamerik. Indianern
Schnur [Gürtel] mit Muschel-
schalen u. Schnecken, als Urkun-
de u. Zahlungsmittel dienend) m;
-s, -e
Wams (veralt., aber noch mdal.
für: Joppe) s; -es, Wämser;
Wäms|chen, Wäms|lein; wam|sen
(ugs. für: prügeln); du wamst
(wamsest)
Wand w; -, Wände
Wan|da (w. Vorn.)
Wan|da|le, Van|da|le (Angehöri-
ger eines germ. Volksstammes;
übertr. für: zerstörungswütiger
Mensch) m; -n, -n (↑ R 268); wan-
da|lisch, van|da|lisch (auch für:
zerstörungswütig); -ste (↑ R 294);
Wan|da|lis|mus, Van|da|lis|mus
(Zerstörungswut) m; -
Wand.arm, ...be|hang, ...be|klei-
dung, ...be|span|nung, ...be|wurf,
...bord (vgl. ¹Bord), ...brett
Wan|del m; -s; Wan|del|an|lei|he
(Wirtsch.); wan|del|bar; Wan|del-
bar|keit; Wan|del.gang m, ...hal-
le, ...mo|nat od. ...mond (alte Bez.
für: April); wan|deln; ich ...[e]le
(↑ R 327); sich -; Wan|del-
⌣ob|li|ga|ti|on (Wandelanleihe,

-schuldverschreibung), ...schuld|ver|schrei|bung, ...stern (veralt. für: Planet)

Wan|der_amei|se, ...ar|bei|ter, ...aus|stel|lung, ...büh|ne, ...dü|ne; Wan|de|rer, Wand|rer; Wan|der_fahrt, ...fal|ke, ...ge|wer|be (für: ambulantes Gewerbe), ...heu|schrecke [Trenn.: ...schrek|ke]; Wan|de|rin, Wand|re|rin w; -, -nen; Wan|der_jahr (meist Mehrz.), ...kar|te, ...le|ben (s; -s), ...le|ber, ...lust (w; -); wan|der|lu|stig; wan|dern; ich ...ere (↑ R 327); (↑ R 120:) das Wandern ist des Müllers Lust; Wan|der_nie|re, ...pre|di|ger, ...preis (vgl. ²Preis), ...rat|te; Wan|der|schaft w; -; Wan|ders|mann (Mehrz. ...leute); Wan|der|stab; Wan|de|rung; Wan|der_ver|si|che|rung, ...vo|gel, ...zir|kus, ...zwang (Zunftw.)

Wand_fach, ...ge|mälde; ...wan|dig (z. B. dünnwandig); Wand_ka|len|der, ...kar|te

Wand|lung; wand|lungs|fä|hig

Wand|ma|le|rei

Wand|rer, Wan|de|rer; Wand|re|rin, Wan|de|rin w; -, -nen

Wands|becker¹ [Trenn.: ...bek|ker] Bo|te (ehem. Zeitung) m; - -

Wands|bek (Stadtteil von Hamburg)

Wand_schirm, ...schrank, ...spie|gel, ...ta|fel, ...tep|pich, ...uhr; Wan|dung

Wand_ver|klei|dung, ...zei|tung

Wa|ne (nord. Mythol.: Gott aus dem Wanengeschlecht) m; -n, -n (meist Mehrz.); ↑ R 268

Wan|ge w; -, -n; Wan|gen_kno|chen, ...mus|kel

Wan|ger|oog [...ọk²] (früher auch für: Wangerooge); Wan|ger|ooge [...ọg^e²] (eine ostfries. Insel) ...wan|gig (z. B. rotwangig)

Wank (veralt. für: Wanken) m; -[e]s; keinen - tun (schweiz. mdal. für: sich nicht bewegen, keinen Finger rühren)

Wan|kel (dt. Ingenieur u. Erfinder; als Ⓦ für eine Motorkonstruktion); Wan|kel|mo|tor (↑ R 180)

Wan|kel|mut; wan|kel|mü|tig; Wan|kel|mü|tig|keit w; -; wan|ken; (↑ R 120:) ins Wanken geraten

wann

Wänn|chen, Wänn|lein; Wan|ne (Becken u. a.) w; -, -n

Wan|ne-Eickel [Trenn.: ...Eik|kel]; ↑ R 212 (Stadt im Ruhrgebiet)

wan|nen (veralt. für: woher); von -

¹ In alter Schreibung des Stadtnamens.
² Auch: ...wang^e r...

Wan|nen|bad; Wänn|lein, Wänn|chen

Wann|see (Havelsee im Südwesten von Berlin) m; -s

Wanst m; -es, Wänste; Wänst|chen, Wänst|lein; ...wan|stig (z. B. dickwanstig)

Want (Seemannsspr.: starkes Stütztau) w; -, -en (auch: Seemanns[faust]handschuhe); meist Mehrz.

Wan|ze (Wandlaus) w; -, -n; wan|zen (volksm. für: von Wanzen reinigen); du wanzt (wanzest); Wan|zen|ver|til|gung; Wan|zen|ver|til|gungs|mit|tel s

Wa|pi|ti indian. (eine nordamerik. Hirschart) m; -[s], -s

Wap|pen s; -s, -; Wap|pen_brief, ...feld, ...he|rold, ...kun|de (w; -), ...schild m od. s; ...spruch, ...tier; wapp|nen (bewaffnen); sich -

Wa|rä|ger schwed. (Wikinger) m; -s, -

Wa|ran arab. (trop. Echse) m; -s, -e (meist Mehrz.)

War|dein niederl. ([Münz]prüfer) m; -[e]s, -e; war|die|ren ([Wert der Münzen] prüfen)

Wa|re w; -, -n; Wa|ren_an|ge|bot, ...aus|fuhr, ...aus|tausch, ...au|to|mat, ...be|gleit|schein, ...be|lei|hung (Bankw.), ...be|stand, ...ex|port, ...han|del, ...haus, ...im|port, ...korb (Statistik), ...kre|dit, ...kre|dit|brief, ...kun|de (w; -), ...la|ger, ...pro|be, ...rück|ver|gü|tung, ...sor|ti|ment, ...stem|pel, ...test, ...um|satz, ...um|schlie|ßung (für: Verpackung u. Verpackungsgewicht), ...ver|zeich|nis, ...zei|chen, ...zoll

Warf (Weberei: Aufzug) m od. s; -[e]s, -e

Warf[t] (Wurt in Nordfriesland) w; -, -en

warm; wärmer, wärmste; -e Würstchen; -e Miete (einschließlich Heizung; ugs.); auf kalt und - reagieren; (↑ R 139:) das Essen warm halten, machen, stellen; vgl. aber den neuen Begriff: warmhalten; Warm_bier (s; -[e]s), ...blut (ein Pferd einer bestimmten Rasse), ...blü|ter; warm|blü|tig; Wär|me w; -, (selten:) -n; Wär|me_be|hand|lung, ...deh|nung, ...ein|heit, ...ener|gie, ...grad; wär|me|hal|tig; wär|me|iso|lie|rend; aber (↑ R 142:) die Wärme isolierend; Wär|me_ka|pa|zi|tät, ...leh|re (w; -), ...lei|ter m, ...leit|zahl, ...mes|ser m; wärme; sich -; Wär|me_quel|le, ...reg|ler, ...schutz, ...spei|cher, ...strah|len (Mehrz.), ...tech|nik (w; -), ...ver|lust, ...zäh|ler; Wärm|fla|sche; Warm|front (Meteor.); Warm|hal|te|fla|sche; warm|hal|ten; ↑ R

139 (ugs. für: sich jmds. Gunst erhalten); er hat sich diesen Geschäftsfreund besonders warmgehalten; aber: warm hal|ten (in warmem Zustand erhalten); die Mutter hat die Suppe lange warm gehalten; Warm_haus (Gewächshaus für Pflanzen mit hohen Wärmeansprüchen); warm|her|zig; Warm|her|zig|keit w; -; warm|lau|fen (von Motoren: im Leerlauf auf günstige Betriebstemperaturen kommen); den Motor - lassen, aber: sich warm lau|fen (ugs.: durch rasches Gehen warm werden); ich habe mich warm gelaufen; Warm_lau|fen (s; -s), ...luft (w; -); Warm|luft|hei|zung; Warm|was|ser_be|rei|ter, ...hei|zung, ...ver|sor|gung

War|na (bulgar. Stadt)

Warn_an|la|ge; Warn_blink_an|la|ge, ...leuch|te; Warn|drei|eck

Warndt (Berg- u. Hügelland westl. der Saar) m; -[e]s

war|nen; War|ner; Warn_ge|rät, ...leuch|te, ...licht (Mehrz. ...lichter), ...ruf, ...schild s, ...schuß, ...si|gnal, ...streik; War|nung; Warn|zei|chen

¹Warp engl. (Kettgarn) m od. s; -s, -e

²Warp niederl. (Seemannsspr.: Schleppanker) m; -[e]s, -e; Warp_an|ker (Seemannsspr.); war|pen (Seemannsspr.: durch Schleppanker fortbewegen); Warp_schiffahrt [Trenn.: ...schiff|fahrt, ↑ R 236] w; -

Warp|we|ber; vgl. ¹Warp

War|rant engl. [warạnt, engl. Ausspr.: "är^ent] (Lager[pfand]schein) m; -s, -s

War|schau (Hptst. Polens); War|schau|er (↑ R 199); War|schau|er-Pakt-Staa|ten (↑ R 155); war|schau|isch

Wart (veralt. für: Aufsichtsführender) m; -[e]s, -e; ...wart (z. B. Torwart)

Wart_burg w; -; Wart|burg|fest s; -[e]s (1817)

War|te (Wartturm u. a.) w; -, -n; War|te_frau, ...geld, ...hal|le, ...li|ste; war|ten; auf sich -lassen; (↑ R 120:) das Warten auf ihn hat ein Ende; War|ter; War|te|raum; War|te|rei; War|te|rin w; -, -nen; War|te_saal, (schweiz. auch:) Wart|saal, ...stand (m; -[e]s), ...zeit, ...zim|mer

War|the (r. Nebenfluß der unteren Oder) w; -

...wär|tig (z. B. auswärtig)

...wärts (z. B. anderwärts)

Wart|saal, (schweiz. neben:) War|te|saal

Wart_turm; War|tung; war|tungs|frei

war|um [auch: wa̱...]; - nicht?
Wärz|chen, Wärz|lein; War|ze w;
-, -n; war|zen|för|mig; War|zen‐
‑hof, ...schwein, ...stift m; war|zig
wa̱s; was ist los?; er will wissen,
was los ist; was für ein; was für
einer; (ugs. auch für: etwas:) was
Neues († R 116), irgendwas; das
ist das Schönste, was ich je erlebt
habe; all das Schöne, das Gute,
etwas anderes, Erschütterndes,
was wir erlebt haben; nichts, vie-
les, allerlei, manches, sonstiges
usw., was ...; aber: das Werk-
zeug, das ...; das Kleine, das sie
im Arm hielt
Wa̱|sa (Angehöriger eines schwed.
Königsgeschlechtes) m; -[s], -
Wasch.an|stalt, ...au|to|mat;
wasch|bar; Wasch..bär, ...becken
[Trenn.: ...bek|ken], ...ber|ge
(Bergmannsspr.: Steine, die bei
Aufbereitung der Kohle anfal-
len; Mehrz.), ...brett, ...büt|te;
Wä|sche w; -, -n; Wä|sche|beu-
tel; wasch|echt; Wä|sche.ge-
schäft, ...in|du|strie, ...klam|mer,
...knopf, ...korb od. Wasch|korb,
...lei|ne, ...man|gel w; wa̱|schen;
du wäschst (wäschest), er wäscht,
du wuschest; du wüschest; gewa-
schen; wasch[e]!; sich -; Wä|sche-
rei; Wä|sche|rin w; -, -nen; Wä-
sche.schleu|der, ...schrank, ...tin-
te, ...zei|chen; Wasch.faß, ...frau,
...ge|le|gen|heit, ...haus, ...kes|sel,
...korb od. Wä|sche|korb, ...kü-
che, ...lap|pen (auch ugs. verächtl.
für: Mensch ohne Tatkraft), ...le-
der; wasch|le|dern (aus Waschle-
der); Wasch.ma|schi|ne, ...mit|tel
s, ...pul|ver, ...raum, ...rum|pel
(landsch. für: Waschbrett),
...schüs|sel, ...sel|de, ...sei|fe,
...stra|ße, .tag, ...tisch, ...toi|let-
te, ...trog; Wa̱|schung; Wasch-
.weib (auch (derb für:
geschwätzige Frau), ...zet|tel
(vom Verleger selbst stammende
Bücherempfehlung), ...zeug (s;
-s), ...zu|ber, ...zwang (m; -[e]s)
¹Wa̱|sen nordd. (Reisigbündel)
Mehrz.
²Wa̱|sen (Rasen; feuchter Boden;
landsch. auch: feuchter Dunst)
m; -s, -
Wa̱|serl österr. ugs. (unbeholfener
Mensch) s; -s, -n
Wa̱s|gau m; -[e]s; Wa̱s|gen|wald m;
-[e]s; vgl. Vogesen
Wash. = Washington (Staat in
den USA)
wash and wear engl. [ʺa̱sch nd ʺa̱ʳ;
„waschen und tragen‟] (Bezeich-
nung von Textilien, die nach dem
Waschen [fast] ohne Bügeln wie-
der getragen werden können)
¹Wa̱|shing|ton [ʺa̱schingtʺn] (erster
Präsident der USA); ²Wa̱|shing-

ton (Staat in den USA [Abk.:
Wash.]; Bundeshauptstadt der
USA)
Wa̱s|ser s; -s, - u. (für Mineral-,
Spül-, Speise-, Abwasser u. a.
Mehrz.:) Wässer; leichtes -,
schweres -; zu - und zu Land[e];
was|ser.ab|sto|ßend, ...ab|wei-
send, ...arm; Wa̱s|ser..bad, ...ball,
...bau (m; -[e]s), ...be|hand|lung,
...bett, ...bom|be, ...burg; Wa̱s-
ser|chen; Wäs|ser|lein; Wa̱s|ser-
dampf; was|ser|dicht; Wa̱s|ser.ei-
mer, ...fahr|zeug, ...fall m, ...far-
be, ...flä|che, ...fla|sche, ...floh,
...flug|ha|fen, ...flug|zeug; wa̱s-
ser|ge|kühlt; ein -er Motor, aber
(† R 142): ein mit Wasser gekühl-
ter Motor; Wa̱s|ser.glas (Trink-
glas; Mehrz. ...gläser; Kalium-
od. Natriumsilikat; nur Einz.),
...gra|ben, ...hahn, ...haus|halt (m;
-[e]s), ...heil|ver|fah|ren, ...ho|se
(Wasser mitführender Wirbel-
sturm), ...huhn; wäs|se|rig, wäß-
rig; Wäs|se|rig|keit, Wäß|rig-
keit; Wa̱s|ser.jung|fer (Libelle),
...kan|te (nordd. Küste[ngebiet];
w; -; vgl. Waterkant), ...kes|sel,
...klo|sett (Abk.: WC [vgl. d.]),
...kopf, ...kraft w, ...krug, ...kunst,
...la|che, ...lauf; Wa̱s|ser|lein,
Wäs|ser|chen; Wa̱s|ser.lei|tung,
...lin|se, ...mann (ein Sternbild; m;
-[e]s), ...mes|ser m, ...müh|le; wa̱s-
sern (auf das Wasser niedergehen
[vom Flugzeug u. a.]); ich wassere
u. waßre († R 327); wä̱s|sern (be-
feuchten); ich wässere u. wäßre
(† R 327); Wa̱s|ser.ni|xe, ...not
(veralt. für: Mangel an Wasser;
w; -; vgl. aber: Wassersnot),
...pest (eine Wasserpflanze; w; -),
...pfei|fe, ...pflan|ze, ...po|li|zei,
...pro|be, ...rad, ...rat|te (ugs.
scherzh. auch für: Seemann,
tüchtiger Schwimmer), ...recht (s;
-[e]s); was|ser|reich; Wa̱s|ser.re-
voir, ...rohr, ...ro|se, ...säu|le,
...schei|de; wa̱s|ser|scheu; Wa̱s-
ser.scheu, ...schi, ...schlacht (ver-
alt. für: Seeschlacht), ...schlan|ge,
...schlauch, ...schloß; Wa̱s|sers-
not (veralt. für: Überschwem-
mung; vgl. aber: Wassernot);
Wa̱s|ser|spei|er, ...spen|der,
...spie|gel, ...sport; was|ser|sport-
lich; Wa̱s|ser.spü|lung, ...stand;
Wa̱s|ser|stands.an|zei|ger, ...mar-
ke, ...reg|ler; Wa̱s|ser|stoff
(chem. Grundstoff; Zeichen: H)
m; -[e]s; wa̱s|ser|stoff|blond; Wa̱s-
ser|stoff|bom|be (H-Bombe);
Wa̱s|ser|stoff|flam|me († R 237);
Wa̱s|ser|stoff|su|per|oxyd s; -[e]s;
vgl. Oxid; Wa̱s|ser.strahl, ...stra-
ße, ...sucht (für: Hydropsie; w;
-); wa̱s|ser|süch|tig; Wa̱s|ser.tem-
pe|ra|tur, ...tre|ten (s; -s), ...trop-

fen, ...turm, ...uhr; Wa̱s|se|rung
(das Wassern des Flugzeuges);
Wäs|se|rung; Wa̱s|ser.ver|drän-
gung, ...waa|ge, ...weg, ...wel|le,
...wer|fer, ...werk, ...wirt|schaft
(w; -), ...zäh|ler, ...zei|chen (im Pa-
pier); wä̱ß|rig, wäs|se|rig; Wä̱ß-
rig|keit, Wäs|se|rig|keit
Wa̱stl (südd. Kurzform von: Seba-
stian)
wg ten; er ist durch den Fluß gewa-
tet
Wa̱|ter|kant niederd. (Wasserkan-
te [nordd. Küste(ngebiet)]) w; -
Wa̱|ter|loo (belg. Ortsn.)
Wa̱|ter|proof engl. [ʺa̱ʳrpruf]
(wasserdichter Stoff; Regenman-
tel) m; -s, -s
Wa̱t|sche [auch: wa̱t...] w; -, -n u.
Wa̱t|schen bayr., österr. ugs.
(Ohrfeige) w; -, -
wa̱t|sche|lig, wa̱tsch|lig [auch:
wa̱t...] (ugs.); wa̱t|scheln [auch:
wa̱t...] (ugs. für: wackelnd ge-
hen); ich [e]le († R 327)
wa̱t|schen [auch: wa̱t...] (ugs. für:
ohrfeigen); wa̱t|schen [auch:
wa̱t...] vgl. Watsche; Wa̱t|schen-
mann österr. (Figur im Wiener
Prater; übertr.: Zielscheibe der
Kritik)
wa̱tsch|lig, wa̱t|sche|lig [auch:
wa̱t...]
¹Watt [ʺa̱t] (Erfinder der verbes-
serten Dampfmaschine); ²Watt
(Einheit der elektr. Leistung; Zei-
chen: W) s; -s, - u. 40 -
³Watt (seichter Streifen der Nord-
see zwischen Küste u. vorgela-
gerten Inseln) s; -[e]s, -en
Wat|te niederd. (lockeres Faserge-
spinst [Verbandstoff u. a.]) w; -,
-n; Wat|te|bausch
Wat|ten österr. (ein Kartenspiel)
s; -s
Wat|ten|meer
Wat|ten|scheid (Stadt im Ruhrge-
biet)
wat|tie|ren (mit Watte füttern);
Wat|tie|rung; wat|tig (watteartig)
Watt.me|ter (elektr. Meßgerät; s;
-s, -), ...se|kun|de (elektr. Ar-
beitseinheit; Abk.: Ws)
Wa̱t|vo|gel (ein Stelzvogel)
Wau (Färberpflanze) m; -[e]s, -e
wau, wau!; Wau|wau [auch: wau-
wau] (Kinderspr.: Hund) m; -s,
-s
WC [wezé] = engl. water closet
[ʺa̱ʳrkläsit] (Wasserklosett) s;
-[s], -[s]
WDR = Westdeutscher Rund-
funk
We̱|be (Gewebe [für Bett-
zeug]) w; -, -n; We̱|be|lei|ne (See-
mannsspr.: „gewebte‟ Sprosse
der Wanten); we̱|ben; du webtest
(geh. u. übertr. wobst [wobest]);
du webtest (geh. u. übertr.:

Weber

wöbest); gewebt (geh. u. übertr.: gewoben); web[e]!

¹We|ber, Carl Maria von (dt. Komponist)

²We|ber; We|be|rei; We|ber|kno|ten; We|ber|schiff|chen, Web|schiff|chen

We|bern, Anton von (österr. Komponist)

We|ber|vo|gel; Web_garn, ...pelz, ...stuhl, ...wa|re (meist Mehrz.)

Wech|sel m; -s, -; Wech|sel_bad, ...balg (mißgebildetes Zwergenkind, untergeschobenes Kind; m), ...bank (Mehrz. ...banken), ...be|zie|hung; wech|sel|be|züg|lich; -es Fürwort (für: reziprokes Pronomen); Wech|sel_bürg|schaft, ...dis|kont (Wechselvorzinsen), ...fäl|le (Mehrz.), ...fäl|schung, ...fie|ber (Malaria; s; -s), ...geld, ...ge|sang, ...ge|schäft, ...ge|setz (s; -es; Abk.: WG); wech|sel|haft; Wech|sel_jah|re (Mehrz.), ...kas|se, ...ko|pie (Wechselabschrift), ...kre|dit, ...kurs; wech|seln; ich ...[e]le (↑R 327); (↑R 120:) Wäsche zum Wechseln; Wech|sel_ord|nung (w; -; Abk.: WO), ...rah|men, ...recht (s; -[e]s), ...re|de (auch für: Diskussion), ...re|greß; Wech|sel|rei|te|rei (unlautere Wechselausstellung); Wech|sel|schal|ter; wech|sel|sei|tig; Wech|sel|sei|tig|keit w; -; Wech|sel_steu|er w, ...strom, ...stu|be, ...sum|me; Wech|se|lung, Wechs|lung; Wech|sel|ver|kehr (Verkehrsw.); wech|sel|svoll; wech|sel|wei|se; Wech|sel|wir|kung; Wechs|ler

¹Weck (Familienn.; als⦾ für Einkochgeräte)

²Weck m; -[e]s, -e u. Wecke¹ w; -, -n u. ¹Wecken¹ südd., österr. (Weizenbrötchen; Brot in länglicher Form) m

Weck|amin (stimulierendes Kreislaufmittel) s; -s, -e

Weck|ap|pa|rat ⦾ (↑R 180)

wecken¹; ²Wecken¹ s; -s; Wecker¹

Weckerl¹ bayr., österr. (längliches Weizenbrötchen) s; -s, -n; vgl. ²Weck

Weck|glas ⦾ (↑R 180; Mehrz. ...gläser)

Weck|ruf

We|da sanskr. („Kenntnis"; Name für heilige Schriften der alten Inder) m; -[s], ...den u. -s

We|de|kind (dt. Dramatiker)

We|del m; -s, -; We|del|kurs (Schisport); we|deln; ich ...[e]le (↑R 327)

we|der; - er noch sie hat (seltener: haben) davon gewußt

Wedg|wood|wa|re;¹↑R 180 ["ẹdsch-

¹ Trenn.: ...ek|k...

"ud...; nach dem engl. Erfinder] (berühmtes engl. Steingut)

we|disch (auf die Weden bezüglich)

Week|end engl. ["ik...] („Wochenende") s; -[s], -s; Week|end|haus

Weft engl. (Schußgarn aus harter engl. Cheviotwolle) s; -[e]s, -e

weg; weg da! (fort); sie ist ganz weg (ugs. für: begeistert, verliebt); frisch von der Leber weg (ugs. für: geradezu, offen); er ist längst darüber weg (hinweg); er war schon weg, als ...

Weg m; -[e]s, -e; Schreibung in Straßennamen: ↑R 219ff.; es hat gute -e; im Weg[e] stehen; wohin des Weg[e]s?; halbwegs; gerade[n]wegs; keineswegs; alle[r]-wege, allerwegen; unterwegs; (↑R 141:) zuwege bringen; auf es nicht zuwege gebracht (nicht vollendet)

weg... (in Zus. mit Zeitwörtern, z. B. weglaufen, du läufst weg, weggelaufen, wegzulaufen; zum 2. Mittelw. ↑R 304)

We|ga arab. (ein Stern) w; -

weg|ar|bei|ten; er hat alles weggearbeitet; weg|be|kom|men; die Regel hatte er - (ugs. für: verstanden); er hat einen Schlag - (ugs. für: erhalten)

Weg_be|rei|ter, ...be|schaf|fen|heit od. Weg|be|schaf|fen|heit, ...bie|gung

weg|bla|sen; er hat den Zigarrenrauch weggeblasen; er war wie weggeblasen (ugs. für: er war spurlos verschwunden); weg|blei|ben (ugs.); er ist auf einmal weggeblieben

We|ge|bau (Mehrz. ...bauten); We|ge|be|schaf|fen|heit od. Wegbe|schaf|fen|heit; Weg_en|ge, ...ga|be|lung, ...gab|lung; We|ge|geld, Weg|geld; We|ge|la|ge|rer; we|ge|la|gern; ich ...ere (↑R 327); gewegelagert; zu -; We|ge|la|ge|rung

¹we|gen (veralt. für: bewegen); sich regen und -

²we|gen (↑R 130); Verhältnisw. mit Wesf.: - Diebstahls - Mangels, - des Vaters od. (geh.:) des Vaters -, - der hohen Preise, der Leute -; (noch landsch.:) - meiner; ein alleinstehendes, starkgebeugtes Hauptw. steht in der Einz. oft schon ungebeugt: - Umbau, - Diebstahl; veralt., ugs. od. landsch. mit Wemf.: - dem Kinde, - mir; hochspr. mit Wemf. in bestimmten Verbindungen u. wenn bei Mehrzahlformen der Wesf. nicht erkennbar ist: - etwas anderem, - manchem, - Vergangenem u. Zukünftigem; - Geschäften; Zusammensetzungen u. Fügun-

gen: des- od. dessentwegen; meinet-, deinet-, seinet-, ihret-, unsert-, euret- od. euertwegen; von Amts -, von Rechts -, von Staats -; von -! (ugs. für: auf keinen Fall!)

We|ger (Schiffsplanke) m; -s, -

We|ge|recht

We|ge|rich (eine Pflanze) m; -s, -e

we|gern (Schiffbau: die Innenseite der Spanten mit Wegern belegen); ich ...ere (↑R 327); We|ge|rung

weg|es|sen; er hat mir alles weggegessen

weg|fah|ren; Weg|fall m; -[e]s; in - kommen (dafür besser: wegfallen); weg|fal|len (nicht mehr in Betracht kommen); weg|fe|gen; weg|fi|schen (ugs. auch für: vor der Nase wegnehmen); er hat ihm die besten Bissen weggefischt; weg|fres|sen; Weg|gang m; -[e]s; weg|ge|hen

Weg|gen schweiz. (¹Wecken) m; -s, -; Weg|gli schweiz. (Art Brötchen) s; -s, -

Weg|ge|nos|se

weg|ha|ben; er hat einen weggehabt (ugs. für: er war betrunken, nicht ganz bei Verstand); er hat das weggehabt (ugs. für: gründlich beherrscht); die Ruhe - (ugs. für: langsam sein); weg|hän|gen; vgl. ²hängen; weg|ho|len; weg|ja|gen; weg|keh|ren; weg|kom|men (ugs. für: verschwinden); weg|krat|zen

Weg|kreuz

weg|krie|gen

weg|kun|dig

weg|las|sen; weg|lau|fen; er ist weggelaufen; weg|le|gen

Weg|lei|tung schweiz. (Anweisung); weg|los

weg|ma|chen (ugs. für: entfernen); den Schmutz -

Weg_mar|ke; weg|mü|de (geh.)

weg|müs|sen (ugs. für: weggehen müssen, nicht mehr bleiben können); weggemußt

Weg_nah|me w; -, -n; weg|neh|men; weggenommen; weg|put|zen (ugs. auch für: verschwinden lassen; leer essen, aufessen); sie hat den Staub weggeputzt; er hat das ganze Fleisch weggeputzt; weg|ra|die|ren

Weg|rand

weg|räu|men; weg|rei|ßen; weg|ren|nen

weg|sam (veralt.)

weg|schaf|fen; vgl. ¹schaffen

Weg|scheid m; -[e]s, -e (österr.: w; -, -en) u. Weg|schei|de (Straßengabelung) w; -, -n

weg|sche|ren, sich (ugs. für: weggehen); scher dich weg!; weg|schicken [Trenn. ...schik|ken];

weg|schlei|chen; er ist wegge-
schlichen; sich -; du hast dich
weggeschlichen; weg|schmei|ßen
(ugs.); weg|schnap|pen; weg-
schnei|den; weg|schüt|ten; weg-
set|zen; er hat das Geschirr weg-
gesetzt; sich -; du hast dich über
den Ärger weggesetzt; weg|steh-
len; er hat die Bücher weggestoh-
len; sich -; du hast dich wegge-
stohlen (heimlich entfernt); weg-
sto|ßen
Weg|strecke [*Trenn.*: ...strek|ke]
weg|strei|chen; weg|tre|ten; weg-
ge|tre|ten!; weg|tun
Weg..über|füh|rung, ...über|gang,
...un|ter|füh|rung, ...wart (veralt.
für: Straßenwart), ...war|te (eine
Pflanze), ...wei|ser
weg|wer|fen; er hat alles wegge-
worfen; sich -; sie hat sich niemals
weggeworfen; weg|wer|fend; -ste
Weg..zeh|rung, ...zei|chen
weg|zie|hen; Weg|zug
[1]weh; (↑ R 132.) weh tun; hast du
dir weh getan?; er hat einen we-
hen Finger; es war ihm weh ums
Herz; vgl. wehe; Weh *s*; -[e]s, -e;
(↑ R 119:) Ach und -; vgl.
[2]Wehe; Weh|dag niederd.
(Schmerz; Unglück; Krankheit)
m; -s, -e; we|he, [2]weh weh[e] dir!;
o weh!; ach und weh schreien,
aber: ein „Wehe!" ausrufen;
[1]We|he (Schmerz bei der Geburt)
w; -, -n (meist *Mehrz.*); [2]We|he
(Nebenform von: Weh) *s*; -s
[3]We|he (zusammengewehte An-
häufung von Schnee od. Sand)
w; -, -n; we|hen
Weh|kla|ge; weh|kla|gen; ich weh-
klage; gewehklagt; zu -
Wehl *s*; -[e]s, -e u. Weh|le niederd.
(an der Binnenseite eines Deiches
gelegener Teich) *w*; -, -n
weh|lei|dig; Weh|lei|dig|keit
Weh|mut *w*; -; weh|mü|tig; Weh-
mü|tig|keit *w*; -; weh|muts|voll
Weh|mut|ter (veralt. für: Hebam-
me; *Mehrz.* ...mütter)
Weh|ne niederd. (Beule) *w*; -, -n
[1]Wehr (Befestigung, Verteidi-
gung, Abwehr; kurz für: Feuer-
wehr) *w*; -, -en; sich zur - setzen;
[2]Wehr (Stauwerk) *s*; -[e]s, -e;
wehr|bar; Wehr|be|ju|be|trag|te *m*,
...bei|trag, ...be|reich; Wehr|be-
reichs|kom|man|do; Wehr|dienst;
Wehr|dienst|ver|wei|ge|rer; weh-
ren; sich -; wehr|fä|hig; Wehr..fä-
hig|keit (*w*;-), ...gang *m*, ...ge|hän-
ge, ...ge|henk, ...ge|rech|tig|keit,
...ge|setz; wehr|haft; Wehr|haf-
tig|keit *w*; -; Wehr..ho|heit (*w*; -),
...kir|che (burgartig gebaute Kir-
che); wehr|los; -este (↑ R 292);
Wehr|lo|sig|keit *w*;-; Wehr|macht
(die gesamten Streitkräfte eines
Staates) *w*; -; Wehr|macht[s]..an-

ge|hö|ri|ge *m* u. *w*, Wehr..mann
(schweiz. für: Soldat; *Mehrz.*
...männer), ...paß, ...pflicht (*w*; -;
die allgemeine -); wehr|pflich|tig;
Wehr|ver|fas|sung
Weh|tag (svw. Wehdag) *w*; -
[auch: wewg] (Kinderspr. für:
Schmerz; kleine Wunde) *s*; -s, -s;
Weh|weh|chen (scherzh.) *s*; -s
Weib *s*; -[e]s, -er; Weib|chen *s*; -s,
- u. Weiberchen od. Weiblein *s*;
-s, - u. Weiberlein
Wei|bel (schweiz., sonst veralt.
für: Amtsbote) *m*; -s, -; wei|beln
schweiz. (werbend umhergehen);
ich ...ble (↑ R 327)
Wei|ber|chen (*Mehrz.* von: Weib-
chen); Wei|ber..feind, ...held (ver-
ächtl.); Wei|ber|lein (*Mehrz.* von:
Weiblein); wei|ber|toll; ...wei|big
(z. B. einweibig); wei|bisch; -ste
(↑ R 294); Weib|lein; fast nur in:
Männlein und Weiblein; vgl.
Weibchen; weib|lich; -es Ge-
schlecht; weib|li|cher|seits; Weib-
lich|keit *w*; -; Weibs|bild (ugs. ver-
ächtl. für: weibl. Person); Weib-
sen (ugs. verächtl. für: Frau) *s*;
-s, -; Weibs..leu|te (ugs. verächtl.
für: Frauen; *Mehrz.*), ...per|son
(ugs. verächtl. für: Frau), ...stück
(ugs. verächtl. für: Frau); Weib-
tum *s*; -s
weich; weich klopfen, kochen
usw.; vgl. aber: weichmachen;
*Schreibung in Verbindung mit
dem 2. Mittelwort, z. B.* weichge-
kochtes Fleisch (↑ jedoch R 142),
a b e r: das Fleisch ist weich ge-
kocht
Weich|bild („Ortsrecht"; Flur, Be-
zirk, wo das Ortsrecht gilt)
[1]Wei|che (Umstellvorrichtung bei
Gleisen) *w*; -, -n
[2]Wei|che (Weichheit [nur *Einz.*];
Körperteil) *w*; -, -n
wei|chen (ein-, aufweichen, weich
machen, weich werden); du
weichtest; geweicht; weich[e]!
[2]wei|chen (zurückgehen; nachge-
ben); du wichst (wichest); du wi-
chest; gewichen; weich[e]!
Wei|chen..stel|ler, ...wär|ter
weich|ge|dün|stet; (↑ R 296:) wei-
cher, am weich[e]sten gedünstet;
weichgedünstetes Gemüse (↑ je-
doch R 142); a b e r: das Gemüse
ist weich gedünstet; weich|ge-
klopft; (↑ R 296:) weicher, am
weich[e]sten geklopft; weichge-
klopftes Fleisch (↑ jedoch R 142),
a b e r: das Fleisch ist weich ge-
klopft; weich|ge|kocht; (↑ R 296:)
weicher, am weich[e]sten ge-
kocht; weichgekochtes Ei
(↑ jedoch R 142), a b e r: das Ei
ist weich gekocht; Weich|heit;
weich|her|zig; Weich|her|zig|keit;
Weich..holz, ...kä|se; weich|lich;

Weich|lich|keit *w*; -; Weich|ling
(abschätzig); weich|ma|chen; ↑ R
139 (ugs. für: zermürben); er wird
mich mit seinen Fragen noch -;
a b e r: weich ma|chen; einen Stoff
weich machen; Weich|ma|cher
(Chemie); weich|mü|tig; Weich-
mü|tig|keit *w*; -; weich|scha|lig
[1]Weich|sel (osteurop. Strom) *w*; -
[2]Weich|sel (ein Obstbaum) *w*; -,
-n, Weich|sel..kir|sche, ...rohr
(Pfeifenrohr aus Weichselholz)
Weich|sel|zopf (Haarverfilzung
durch Kopfläuse)
Weich..tei|le (*Mehrz.*), ...tier (für:
Molluske), ...wer|den (*s*; -s)
[1]Wei|de (ein Baum) *w*; -, -n
[2]Wei|de (Grasland) *w*; -, -n; Wei-
de|land (*Mehrz.* ...länder); Wei-
de|gras (auch für: Raigras) *s*; -es;
Wei|de|mo|nat (alte dt. Bez.,
meist für den Mai); wei|den; sich
an etwas -
Wei|den..baum, ...busch, ...ger|te,
...kätz|chen, ...rös|chen
Wei|de|platz
Wei|de|rich (Name verschiedner
Pflanzen) *m*; -s
Wei|de..recht, ...wirt|schaft (*w*;)
weid|ge|recht[1]
Wei|dicht (veralt. für: Weidenge-
büsch) *s*; -s
weid|lich („jagdgerecht"; gehörig,
tüchtig); Weid|ling südwestd. u.
schweiz. (Fischerkahn) *m*; -s, -e;
Weid|loch[1] (After beim Wild);
Weid|mann[1] (*Mehrz.* ...männer);
weid|män|nisch[1]; -ste (↑ R 294);
Weid|manns|dank[1]!; Weid-
manns|heil[1]!; Weid|mes|ser[1] *s*;
Weid|ner[1] (veralt. für: Weid-
mann; Jagdmesser) *m*; -s, -; Weid-
sack[1] (Jagdtasche); Weid|spruch[1]
(altd. Ratsefrage der Jägerei);
Weid|werk[1] *s*; -[e]s; weid|wund[1]
(verwundet durch Schuß in die
Eingeweide)
Wei|fe (Garnwinde) *w*; -, -n; wei-
fen ([Garn] haspeln)
Wei|gand (veralt. für: Kämpfer,
Held) *m*; -[e]s, -e
wei|gern, sich; ich ...ere mich (↑ R
327); Wei|ge|rung; Wei|ge|rungs-
fall *m*; im -fall
Weih *m*; -[e]s, -e u. Wei|he (ein
Vogel) *w*; -, -n
Weih|bi|schof
[1]Wei|he vgl. Weih
[2]Wei|he (Weihung) *w*; -, -n; Wei-
he|akt; wei|hen
Wei|hen|ste|phan (Stadtteil von
Freising)
Wei|her *lat.* (Teich) *m*; -s, -
Wei|he..re|de, ...stun|de; wei|he-

[1] Obwohl etymologisch nur „ei"
gerechtfertigt ist, findet sich fach-
sprachlich oft die Schreibung mit
„ai".

voll; **Weih**␣**ga**|**be**, ...**ge**|**fäß**, ...**ge**-
schenk, ...**kes**|**sel** (Weihwasser-
kessel); **Weih**|**ling** (Person, die ge-
weiht wird)
Weih|**nacht** w; -; **weih**|**nach**|**ten**; es
weihnachtet; geweihnachtet;
Weih|**nach**|**ten** (Weihnachtsfest)
s; -; - ist bald vorbei; - war kalt;
(landsch., bes. österr. u. schweiz.
als *Mehrz.*:) die[se] - waren ver-
schneit; nach den -; (in Wunsch-
formeln nach allg. als *Mehrz.*:)
fröhliche Weihnachten!; zu -,
(landsch., bes. südd. auch:) an
-; **weih**|**nacht**|**lich**; **Weih**|**nachts**-
␣**abend**, ...**baum**, ...**fe**|**ri**|**en**
(*Mehrz.*), ...**fest**, ...**geld**, ...**ge**-
schenk, ...**gra**|**ti**|**fi**|**ka**|**ti**|**on**,
...**krip**|**pe**, ...**lied**, ...**mann** (*Mehrz.*
...**männer**), ...**markt**, ...**spiel**,
...**stol**|**le** od. ...**stol**|**len** [vgl. [1]Stol-
len] (Backwerk), ...**tag**, ...**tel**|**ler**,
...**tisch**, ...**zeit** (w; -)
Weih|**rauch** (duftendes Harz);
weih|**räu**|**chern**; ich ...ere (↑R
327); **Weih**|**ung**; **Weih**|**was**|**ser** s;
-s; **Weih**|**was**|**ser**|**kes**|**sel**; **Weih**-
we|**del**
weil; [all]dieweil (veralt.)
weil. = weiland
weil|**land** (veralt., noch scherzh.
für: vormals; Abk.: weil.)
Wei|**le** w; -; Lang[e]weile; Kurz-
weil; alleweil[e], bisweilen, zu-
weilen; [all]dieweil; einstweilen;
mittlerweile; **wei**|**len** (geh. für:
sich aufhalten, bleiben)
Wei|**ler** *lat.* (mehrere beieinander
liegende Gehöfte; kleine Ge-
meinde) m; -s, -
Wei|**mar** (Stadt a. d. Ilm); **Wei**|**ma**-
rer (↑R 199); **wei**|**ma**|**risch**
Wei|**muts**|**kie**|**fer** vgl. Wey-
mouthskiefer
Wein *lat.* m; -[e]s, -e; **Wein**|**bau** m;
-[e]s; **wein**|**bau**|**end**; **Wein**|**bau**|**er**
(m; -s u. -n, -n), ...**bee**|**re**, ...**bei**|**ßer**
(österr.: eine Lebkuchenart;
Weinkenner), ...**berg**; **Wein**-
berg[**s**]**be**|**sit**|**zer**; **Wein**|**berg**-
schnecke [*Trenn.*: ...schnek|ke];
Wein|**brand** (Branntwein) m; -s,
...**brände**
wei|**nen**; (↑R 120:) in Weinen aus-
brechen; ihr war das Weinen nä-
her als das Lachen; das ist zum
Weinen!; **wei**|**ner**|**lich**
Wein␣**es**|**sig**, ...**faß**, ...**fla**|**sche**,
...**gar**|**ten** (veralt. für: Weinberg),
...**geist** (*Mehrz.* [für Sorten:]
...geiste), ...**glas** (*Mehrz.* ...glä-
ser), ...**gut**, ...**hau**|**er** (österr. für:
Winzer), ...**haus**, ...**he**|**fe**; **wei**|**nig**
(weinhaltig; weinartig); **Wein**-
␣**kar**|**te**, ...**kauf** (Trunk bei Besie-
gelung eines Geschäftes; Drauf-
gabe), ...**kel**|**ler**, ...**ken**|**ner**, ...**kö**-
ni|**gin**, ...**la**|**ge**, ...**le**|**se**, ...**lo**|**kal**,

...**mo**|**nat** od. ...**mond** (alte dt. Bez.
für: Oktober), ...**pan**|**scher** (ab-
schätzig), ...**pro**|**be**, ...**re**|**be**; **wein**-
␣**rot**, ...**se**|**lig**; **Wein**␣**stein** (kalium-
saures Salz der Weinsäure; m;
-[e]s), ...**steu**|**er** w, ...**stock** (*Mehrz.*
...stöcke), ...**stu**|**be**, ...**trau**|**be**,
...**zierl** (ostösterr. mdal. für: Win-
zer, Weinbauer; m; -s, -[n])
wei|**se** (klug); -ste; die - Frau (ver-
alt. für: Hebamme; Wahrsage-
rin); [1]**Wei**|**se** (kluger Mensch) m
u. w; -n, -n (↑R 287ff.); die Sieben
-n (↑R 224)
[2]**Wei**|**se** (Art; Singweise) w; -, -n;
auf diese -
...**wei**|**se**; *Zusammensetzung:* a) aus
Eigenschaftswort u. ...weise
(z. B. klugerweise) nur *Um-
standswort:* klugerweise sagte
er nichts dazu, a b e r : in kluger
Weise; b) aus Hauptwort u.
...**weise** (z. B. probeweise)
Umstandswort: er wurde probe-
weise eingestellt; auch *Eigen-
schaftswort* bei Bezug auf ein
Hauptwort, das ein Geschehen
ausdrückt; eine probeweise Ein-
stellung
Wei|**sel** (,,Anführer''; Bienen-
königin) m; -s, -; **wei**|**sen** (zeigen;
anordnen); du weist (weisest) er
weist; du wiesest, er wies; gewie-
sen; weis[e]!; **Wei**|**ser**; **Weis**|**heit**;
weis|**heits**|**voll**; **Weis**|**heits**|**zahn**;
weis|**lich** (wohl erwogen); **weis**-
ma|**chen** (ugs. für: vormachen,
belügen, einreden usw.); ich ma-
che weis; weisgemacht; weiszu-
machen; jmdm. etwas -
weiß (Farbe); -este (↑R 292); vgl.
blau. **I.** *Kleinschreibung:* **a)** (↑R
133:) etwas schwarz auf weiß
(schriftlich) haben, besitzen,
nach Hause tragen; aus schwarz
weiß, aus weiß schwarz machen;
b) (↑R 224:) die weiße Fahne his-
sen (als Zeichen des Sicherge-
bens); ein weißer Fleck auf der
Landkarte (unerforschtes Ge-
biet); weißer Fluß (svw. Weiß-
fluß); weiße Kohle (Wasser-
kraft); weißer Kreis (bestimmter
Kreis, in dem die Woh-
nungszwangswirtschaft aufge-
hoben ist; Ggs.: schwarzer
Kreis); die weiße Rasse; der wei-
ße Sport (Tennis; Schisport); ein
weißer Rabe (eine Seltenheit); ei-
ne weiße Weste haben (ugs.); wei-
ße Mäuse sehen (ugs. für: über-
triebene Befürchtungen haben);
weiße Maus (ugs. Bez. für: Ver-
kehrspolizist). **II.** *Großschrei-
bung:* **a)** (↑R 116:) ein Weißer
(weißer Mensch); eine Weiße
(Berliner Bier); das Weiße; die
Farbe Weiß; **b)** (↑R 198:) das
Weiße Meer; der Weiße Berg; **c)**

(↑ R 224:) die Weiße Frau (Un-
glück kündende Spukgestalt in
Schlössern); das Weiße Haus
(Amtssitz des Präsidenten der
USA in Washington); die Weiße
Rose (Name einer Widerstands-
gruppe während der Zeit des Na-
tionalsozialismus); der Weiße
Sonntag (Sonntag nach Ostern);
der Weiße Tod (Erfrieren). **III.**
*Schreibung in Verbindung mit
Zeitwörtern* (↑ R 139): **a)** *Ge-
trenntschreibung* in ursprüng-
licher Bedeutung, z. B. weiß ma-
chen, waschen, werden; **b)** *Zu-
sammenschreibung,* wenn durch
die Verbindung ein neuer Begriff
entsteht; vgl. weißnähen, weiß-
waschen. **IV.** *In Verbindung mit
dem 2. Mittelwort Getrennt- oder
Zusammenschreibung:* ein weiß-
gekleidetes Mädchen (↑ jedoch R
142), a b e r : das Mädchen ist weiß
gekleidet. **V.** *Farbenbezeichnun-
gen;* ↑ R 158; [1]**Weiß** (weiße Farbe)
s; -[es], -; in - mit -; in - gekleidet;
mit - bemalt; Stoffe in -
[2]**Weiß**, Ernst (österr. Schriftstel-
ler)
[3]**Weiß**, Konrad (dt. Lyriker, Dra-
matiker u. Essayist)
Weiss, Peter (dt. Schriftsteller)
weis|**sa**|**gen**; ich weissage; geweis-
sagt; zu -; **Weis**|**sa**|**ger**; **Weis**|**sa**-
ge|**rin** w; -, -nen; **Weis**|**sa**|**gung**
Weiß|**bier**, ...**bin**|**der** (mdal. für:
Böttcher; auch: Anstreicher),
...**blech**, ...**blu**|**ten** (in der Wen-
dung: bis zum - [ugs. für: sein,
in hohem Maße]), ...**brot**, ...**buch**
(Dokumentensammlung der dt.
Regierung zu einer bestimmten
Frage), ...**bu**|**che** (Hainbuche),
...**dorn** (*Mehrz.* ...dorne); [1]**Wei**|**ße**
(Bierart; auch: ein Glas Weiß-
bier) w; -, -n (↑R 287ff.); [2]**Wei**|**ße**
(Mensch mit heller Hautfarbe)
m u. w; -n, -n (↑R 287ff.); [3]**Wei**|**ße**
(Weißsein) w; -; **wei**|**ßeln** südd.
u. schweiz. (weißen); ich ...[e]le
(↑R 327); **wei**|**ßen** (weiß färben,
machen; tünchen); du weißt (wei-
ßest), er weißt; du weißtest; ge-
weißt; weiß[e]!
Wei|**ße**|**ritz** (l. Nebenfluß der mitt-
leren Elbe) w; -
Weiß␣**fisch**, ...**fluß** (Med.: weiß-
licher Ausfluß aus der Scheide;
m; ...flusses); **weiß**|**ge**|**klei**|**det**; ein
weißgekleidetes Mädchen (↑ je-
doch R 142), a b e r : das Mädchen
ist weiß gekleidet; **Weiß**|**ger**|**ber**;
Weiß|**ger**|**be**|**rei** (Alaungerberei);
weiß|**glü**|**hend**; **Weiß**|**glut** w; -;
weiß Gott!; für weiß Gott was
halten; **weiß**␣**grau** (↑R 158),
...**haa**|**rig**; **Weiß**␣**herbst** (hell ge-
kelterter Wein aus blauen Trau-
ben), ...**kä**|**se** (landsch. für:

Quark), ...kohl, ...kraut; weiß|lich (weiß scheinend); Weiß|lie|gen|de (Geol.: oberste Schicht des Rotliegenden) s; -n (↑ R 287 ff.); Weiß|ling (ein Schmetterling; svw. Wittling); weiß|nä|hen; ↑ R 139 (Wäsche nähen); ich nähe weiß; weißgenäht; weißzunähen; Weiß|nä|he|rin, ...pap|pel Weiß|rus|se; weiß|rus|sisch; Weiß|ruß|land (Gebiet in Westrußland) Weiß.sucht (für Albinismus; ...tan|ne; Wei|ßung (Weißfärbung, Tünchung); Weiß|wa|ren Mehrz.; weiß|wa|schen; ↑ R 139; sich, jmdn. - (ugs. für: sich od. jmdn. von einem Verdacht od. Vorwurf befreien); meist nur in der Grundform u. im 2. Mittelwort (weißgewaschen) gebräuchlich; aber: Wäsche weiß waschen; Weiß.wein, ...wurst, ...zeug (s; -[e]s)

Weis|tum (Aufzeichnung von Rechtsgewohnheiten u. Rechtsbelehrungen im MA.); Wei|sung (Auftrag, Befehl); Wei|sungs|be|fug|nis; wei|sungs|ge|bun|den; Wei|sungs|recht

weit; weiter, weiteste (↑ R 292). I. *Kleinschreibung:* a) (↑ R 134:) am weitesten; im weiteren, des weiter[e]n darlegen, berichten; b) (↑ R 133:) bei, von weitem; ohne weiteres (österr. auch: ohneweiters); bis auf weiteres; nur so breit; so weit, so gut. II. *Großschreibung:* a) (↑ R 116:) das Weite suchen (sich [rasch] fortbegeben); sich ins Weite verlieren (übertr. gebraucht); das Weitere hicrüber folgt alsbald; [ein] Weiteres (das Genauere, Ausführlichere) findet sich bei ihm; als Weiteres (weitere Sendungen) erhalten Sie; des Weiter[e]n enthoben sein; b) (↑ R 116:) alles, einiges Weitere demnächst. III. *In Verbindung mit dem 2. Mittelwort,* z. B. weitgereist; (↑ R 296:) weiter, am weitesten gereist; ein weitgereister Mann (↑ jedoch R 142), aber: der Mann ist weit gereist; das ist weit hergeholt. IV. *Schreibung in Verbindung mit Zeitwörtern* immer getrennt, z. B. weit fahren, springen, bringen. V. *Zus.:* weitgehend (vgl. d.); meilenweit (vgl. d.); weither (vgl. d.); soweit (vgl. d.), insoweit es angeht; inwieweit er recht hat; Weit (größte Weite [eines Schiffes]) s; -[e]s, -e; weit|ab; weit|aus; - größer; Weit|blick m; -[e]s; weit|blickend [*Trenn.:* ...blik|kend]; vgl. weitgehend; Wei|te w; -, -n; wei|ten (weit machen, erweitern); sich -; wei|ter; I. *Klein- u. Großschreibung:* vgl.

weit, I u. II. II. *In Verbindung mit Zeitwörtern* (↑ R 139): 1. *Getrenntschreibung:* a) wenn ein Umstand des Grades (d. h. weiter als) ausgedrückt wird; weiter gehen; er kann weiter gehen als ich; b) wenn ein Umstand der Zeit (d. h. weiterhin) ausgedrückt wird; weiter helfen; er hat dir weiter (weiterhin) geholfen; 2. *Zusammenschreibung:* a) wenn „weiter" in der Bedeutung von „vorwärts", „voran" gebraucht wird, z. B. weiterbefördern, weiterempfehlen; b) wenn die Fortdauer eines Geschehens od. eines Zustandes ausgedrückt wird, z. B. weiterspielen, weiterbestehen Wei|ter|ar|beit; wei|ter|ar|bei|ten; vgl. weiter, II wei|ter|be|för|dern; ich befördere weiter; der Spediteur hat die Kiste nach Berlin weiterbefördert; aber: der Kraftverkehr kann Stückgüter weiter befördern als die Eisenbahn; vgl. weiter, II; Wei|ter|be|för|de|rung wei|ter|be|ste|hen (fortbestehen); vgl. weiter, II wei|ter|bil|den (fortbilden); vgl. weiter, II; Wei|ter|bil|dung wei|ter|emp|feh|len; vgl. weiter, II wei|ter|ent|wickeln [*Trenn.:* ...wik|keln]; vgl. weiter, II; Wei|ter|ent|wick|lung wei|ter|er|zäh|len; vgl. weiter, II wei|ter|fah|ren (schweiz. auch neben: fortfahren); vgl. weiter, II; in seiner Rede -; Wei|ter|fahrt w; - wei|ter|füh|ren; vgl. weiter, II; wei|ter|füh|rend (vgl. S. 45, Merke, 2); die -en Schulen Wei|ter|ga|be Wei|ter|gang (Fortgang, Entwicklung) m; -[e]s wei|ter|ge|ben; vgl. weiter, II wei|ter|ge|hen (vorangehen; fortfahren); die Arbeiten sind gut weitergegangen; bitte weitergehen!; aber: wir kann weiter gehen als du; vgl. weiter, II; wei|ter|ge|hend (österr.) vgl. weitgehend wei|ter|hel|fen; vgl. weiter, II wei|ter|hin wei|ter|kom|men; vgl. weiter, II wei|ter|lau|fen; vgl. weiter, II u. weitergehen wei|ter|lei|ten; vgl. weiter, II; Wei|ter|lei|tung wei|ter|ma|chen; vgl. weiter, II wei|tern (selten für: erweitern); ich ...ere (↑ R 327) Wei|ter|rei|se; wei|ter|rei|sen; vgl. weiter, II wei|ters österr. (weiterhin, ferner)

wei|ter|sa|gen; vgl. weiter, II wei|ter|spie|len; vgl. weiter, II wei|ter|trei|ben; vgl. weiter, II Wei|te|rung (Schwierigkeit, Verwicklung; meist *Mehrz.*) wei|ter|ver|brei|ten; er hat das Gerücht weiterverbreitet; aber: diese Krankheit ist heute weiter verbreitet als früher; vgl. weiter, II; Wei|ter|ver|brei|tung Wei|ter|ver|kauf; wei|ter|ver|kau|fen; vgl. weiter, II wei|ter|ver|mie|ten (in Untermiete geben); vgl. weiter, II wei|ter|wol|len (ugs. für: weitergehen wollen); vgl. weiter, II wei|ter|zah|len; vgl. weiter, II wei|ter|zie|hen; vgl. weiter, II weit|ge|hend; Steigerung (↑ R 296 ff.): weiter gehend (österr.: weitergehend) u. weitgehender, weitestgehend u. weitgehendst; (↑ R 142:) das scheint mir zu weitgehend, aber: eine zu weit gehende Erklärung, das scheint mir zu weit zu gehen weit|ge|reist; (↑ R 296:) weiter, am weitesten gereist; ein weitgereister Mann (↑ jedoch R 142), aber: der Mann ist weit gereist; Weit|ge|rei|ste m u. w; -n, -n (↑ R 287 ff.) weit|grei|fend; -e Pläne weit|her (aus großer Ferne); aber: von weit her; das ist nicht weit her (nicht bedeutend) weit|her|zig; Weit|her|zig|keit w; - weit|hin; weit|hin|aus weit|läu|fig; Weit|läu|fig|keit Weit|ling bayr., österr. (große Schüssel) m; -s, -e weit|ma|schig weit|rei|chend; zur Steigerung vgl. weitgehend. -er Einfluß weit|schau|end; vgl. weitblickend weit|schich|tig weit|schwei|fig; Weit|schwei|fig|keit Weit|sicht w; -; weit|sich|tig; Weit|sich|tig|keit w; - weit|sprin|gen (nur in der Grundform gebr.); Weit|sprin|gen s; -s; Weit|sprung; Weit|sprung|re|kord weit|tra|gend; zur Steigerung vgl. weitgehend weit|um Wei|tung weit|ver|brei|tet; zur Steigerung vgl. weitgehend; eine weitverbreitete Zeitung (↑ jedoch R 142), aber: die Zeitung ist weit verbreitet; weit|ver|zweigt; zur Steigerung vgl. weitgehend; eine weitverzweigte Familie (↑ jedoch R 142), aber: die Familie ist weit verzweigt Weit|win|kel|ob|jek|tiv Wei|zen m; -s, (fachspr.:) -; Wei-

zen..ab|kom|men, ...bier, ...brot,
...feld, ...kauf, ...korn, ...mehl,
...preis (vgl. ²Preis)
Weiz|mann, Chaim [ch*a*im] (israel.
Staatsmann)
Weiz|säcker [Trenn.: ...säk|ker],
Carl Friedrich Freiherr von (dt.
Physiker u. Philosoph)
welch; -er, -e, -es; - ein Held; -
Wunder; - große Männer; (↑ R
277:) welches reizende Mädchen;
(↑ R 281:) welche großen (kaum
noch: große) Männer; (↑ R 290:)
welche Stimmberechtigten; wel-
chen Staates?, welches Zeugen?;
wel|che (ugs. für: etliche, einige);
es sind - hier; wel|cher|art; wir
wissen nicht, welcherart (was für
ein) Interesse sie veranlaßt ...,
aber: wir wissen nicht, welcher
Art (Sorte, Gattung) diese Bü-
cher sind; wel|cher|ge|stalt; wel-
cher|lei; wel|ches (ugs. für: et-
was); hat noch jemand Brot? Ich
habe -
Welf (Nebenform von: Welpe) m;
-[e]s, -e od. s; -[e]s, -er
Wel|fe (Angehöriger eines dt. Für-
stengeschlechtes) m; -n, -n (↑ R
268); wel|fisch
welk; wel|ken; Welk|heit w; -
Well..baum (um seine Achse be-
weglicher Balken [am Mühlrad
u. a.]), ...blech; Wel|le w; -, -n;
wel|len; gewelltes Blech, Haar;
wel|len|ar|tig; Wel|len..bad, ...be-
reich, ...berg, ...bre|cher; wel|len-
för|mig; Wel|len..gang m,
...kamm, ...län|ge, ...li|nie, ...rei-
ten (Wassersport; s; -s), ...rei|ter,
...schlag (m; -[e]s), ...sit|tich (ein
Vogel), ...tal; Wel|ler (Lehm,
Ton, mit Stroh vermischt zur
Ausfüllung von Fachwerk) m; -s,
-; Wel|ler|ar|beit (Kleinarbeit);
wel|lern (Weller herstellen, Holz-
werk der Fachwerkwand mit
Wellern ausfüllen; kleiben); ich
...ere (↑ R 327); Wel|ler|wand
(Fachwerkwand); Well|fleisch;
Well|horn|schnecke [Trenn.:
...schnek|ke]; wel|lig (wellenar-
tig, gewellt); Wel|lig|keit w; -;
Wel|li|né [...ne] (ein Gewebe) m;
-[s], -s
Wel|ling|ton [engl. Ausspr.: ⁿ*ä*ling-
t*e*n] (m. Eigenn.; häufiger Stadt-
name); Wel|ling|to|nia (svw. Se-
quoie) w; -, ...ien [...i*e*n]
Well..pap|pe, ...rad; Wel|lung
Wel|pe (das Junge von Hund,
Fuchs, Wolf) m; -n, -n (↑ R 268)
¹Wels (ein Fisch) m; -es, -e
²Wels (oberösterr. Stadt)
welsch kelt. (keltisch, dann: roma-
nisch, französisch, italienisch;
fremdländisch; schweiz. meist
svw. welschschweizerisch); Wel|-
sche m u. w; -n, -n (↑ R 287ff.);

wel|schen (welsch, unverständ-
lich reden; in seiner Sprache viele
entbehrliche Fremdwörter ge-
brauchen); du welschst (wel-
schest); Welsch..kraut (ober-
sächs. für: Wirsing; s; -[e]s),
...land (schweiz. für: fr. Schweiz;
s; -[e]s), ...schwei|zer (Schweizer
mit fr. Muttersprache); welsch-
schwei|ze|risch (die fr. Schweiz
betreffend)
Welt w; -, -en; die dritte - (die
Entwicklungsländer); Welt|all;
welt|an|schau|lich; Welt..an-
schau|ung, ...aus|stel|lung, ...bank
(w; -); welt..be|kannt, ...be|rühmt,
...be|ste; Welt|best|lei|stung;
welt|be|we|gend, aber (↑ R 142):
die Welt bewegend; Welt..bild,
...bumm|ler od. Wel|ten|bumm-
ler, ...bund, ...bür|ger, ...chro|nik;
Wel|ten..bumm|ler od. Welt-
bumm|ler, ...raum (geh. für:
Weltraum); welt|ent|rückt; wel-
ten|um|span|nend vgl. weltum-
spannend
Wel|ter|ge|wicht engl.; dt. (Kör-
pergewichtsklasse in der Schwer-
athletik)
welt..er|schüt|ternd (aber (↑ R
142): die Welt erschütternd),
...fern; Welt|flucht (vgl. ²Flucht);
welt|fremd; Welt|fremd|heit,
...frie|de[n], ...ge|fü|ge, ...geist (m;
-[e]s), ...geist|li|che m, ...gel|tung,
...ge|richt (s; -[e]s), ...ge|schich|te
(w; -); welt|ge|schicht|lich; Welt-
..ge|sund|heits|or|ga|ni|sa|ti|on
(w; -), ...ge|werk|schafts|bund
(Abk.: WGB; m; -[e]s), ...han|del
(vgl. ¹Handel), ...han|dels|flot|te,
...herr|schaft (w; -), ...hilfs|spra-
che, ...kar|te; Welt|kir|chen|kon-
fe|renz; welt|klug; Welt|krieg; der
erste (häufig bereits als Name:
Erste) -, der zweite (häufig bereits
als Name: Zweite) -; Welt|lauf;
welt|läu|fig; welt|lich; Welt-
..li|te|ra|tur, ...macht, ...mann
(Mehrz. ...männer); welt|män-
nisch; -ste (↑ R 294); Welt..mar|ke,
...markt (m; -[e]s), ...meer, ...mei-
ster, ...mei|ste|rin, ...mei|ster-
schaft, ...ord|nung; welt|po|li-
tisch; Welt..pres|se, ...prie|ster,
...rät|sel, ...raum (m; -[e]s), Welt-
raum..fah|rer, ...fahr|zeug, ...flug,
...for|schung, ...sonde, ...sta|ti|on,
...ver|trag, Welt..reich, ...rei|se,
...re|kord, ...rei|se, welt|vo|lu-
ti|on, ...ruf (Berühmtheit; m;
-[e]s), ...ruhm, ...schmerz (m;
-es), ...si|cher|heits|rat (m; -[e]s),
...spar|tag, ...spra|che, ...stadt;
welt|um|span|nend, aber (↑ R 142): die
Welt umspannend; ein -er Geist;
Welt..un|ter|gang, ...ver|bes|se-
rer, ...wäh|rungs|kon|fe|renz,

...weis|heit; welt|weit; Welt..wirt-
schaft (w; -), ...wirt|schafts|kri|se,
...wun|der
wem; Wem|fall (für: Dativ) m
wen
¹Wen|de (Drehung, Wendung;
Turnübung) w; -, -n
²Wen|de (Angehöriger eines west-
slaw. Volkes) m; -n, -n (↑ R 268)
Wen|de..hals (ein Vogel), ...kreis;
Wen|del (schraubenförmige Li-
nie) w; -, -n; Wen|del|boh|rer
Wen|de|lin (m. Vorn.)
Wen|del..rut|sche (Bergmanns-
spr.: Rutschenspirale zum
Abwärtsfördern von Kohlen u.
Steinen), ...trep|pe; wen|den; du
wandtest u. wendetest; du wende-
test; gewandt u. gewendet;
wend[e]!; in der Bedeutung „die
Richtung während der Fortbe-
wegung ändern" [z. B. mit dem
Auto] u. „umkehren, umdrehen
[u. die andere Seite zeigen]", z.
B. „einen Mantel usw., Heu wen-
den", nur schwach: er wendete,
hat gewendet; ein gewendeter
Rock; sich -; überwiegend stark:
sie wandte sich zu ihm, hat sich
zu ihm gewandt; gewandter (ge-
schickter) Mann; bitte wenden!
(Abk.: b. w.); Wen|de..platz,
...punkt; wen|dig (vom Pferd: gut
zugeritten; übertr.: geschickt,
geistig regsam, sich schnell an-
passend); Wen|dig|keit w; -
Wen|din w; -, -nen; wen|disch
Wen|dung
Wen|fall (für: Akkusativ) m
we|nig; ↑ R 135; ein wenig (etwas,
ein bißchen); ein weniges; mit ein
wenig Geduld; ein klein wenig;
einiges wenige; das, dies, dieses
wenige; dieses Kleine u. wenige;
weniges genügt; die wenigen; we-
nige glauben; einige wenige; mit
wenig[em] auskommen; in dem
wenigen, was erhalten ist; fünf
weniger drei ist, macht, gibt
(nicht: sind, machen, geben)
zwei; um so weniger (österr.: um-
soweniger od. umso weniger);
nichts weniger als; nicht[s] mehr
u. nicht[s] weniger; nichtsdesto-
weniger; wie wenig; du weißt
nicht, wie wenig ich habe; wie
wenig gehört dazu!; (↑ R 116:) we-
nig Gutes od. weniges Gutes, we-
nig Neues; (↑ R 135:) es ist das
wenigste; das wenigste, das du
tun kannst, ist ...; am, zum wenig-
sten; (↑ R 135:) er beschränkt sich
auf das wenigste; die wenigsten;
wenigstens; du hast für dieses
Amt zu wenig Erfahrung, aber:
du hast zuwenig Erfahrung; ein
Zuwenig an Fleiß. *Beugung der
Eigenschaftswörter in Verbin-
dung mit „wenige"* (↑ R 279): mit

weniger geballter Energie; mit wenigem guten Getränk; (↑ R 285:) wenige gute Nachbildungen; weniger guter Menschen; (↑ R 290:) wenige Gute gleichen viel[e] Schlechte aus; das Leiden weniger Guter; We|nig *s;* -s, -; viele - machen ein Viel; We|nig|keit; meine -; we|nig|stens wenn; wenn auch; wenngleich (doch auch durch ein Wort getrennt, z. B. wenn ich gleich Hans heiße); wennschon; wennschon—dennschon; aber: wenn ich schon mitmache; (↑ R 49:) komme doch [,] wenn möglich [,] schon um 17 Uhr. *Großschreibung* (↑ R 119): das Wenn u. das Aber; die Wenn u. die Aber; viele Wenn u. Aber; wenn|gleich; vgl. wenn; wenn|schon; vgl. wenn ¹Wen|zel (m. Vorn.); ²Wen|zel (Kartenspiel: Bube, Unter) *m;* -s, -; Wen|zels|kro|ne (böhm. Königskrone) *w;* -; Wen|zes|laus (m. Vorn.)

wer (fragendes, bezügliches u. [ugs.] unbestimmtes Fürw.); wer ist da?; Halt! Wer da? (vgl. Werda); wer (derjenige, welcher) das tut, [der] ...; (ugs.:) ist wer (jemand) gekommen?; - alles; irgendwer (vgl. irgend); wes (vgl. d.)

We|ra vgl. Vera
Wer|be|ab|tei|lung, ...agen|tu¹, ...an|teil (für: Provision), ...bü|ro, ...etat, ...fach|mann, ...fern|se|hen, ...film, ...funk, ...ge|mein|schaft, ...ge|schenk, ...kam|pa|gne; wer|be|kräf|tig; Wer|be|lei|ter *m,* ...mit|tel *s;* wer|ben; du wirbst; du warbst; du würbest; geworben; wirb!; Wer|ber; wer|be|risch; Wer|be|schrift, ...slo|gan, ...spot, ...spruch, ...text, ...tex|ter (jmd., der Werbetexte verfaßt), ...trä|ger, ...trom|mel; wer|be|wirk|sam; Wer|be|wirk|sam|keit; werb|lich (die Werbung betreffend); Wer|bung; Wer|bungs|ko|sten *Mehrz.*
Wer|da (Postenanruf) *s;* -[s], -s
Wer|dan|di (nord. Mythol.: Norne der Gegenwart)
Wer|de|ruf
Wer|de|gang *m;* wer|den; du wirst, er wird; du wurdest (dicht. noch: wardst), er wurde (dicht. noch: ward), wir wurden; du würdest; als volles Tätigkeitswort: geworden; er ist groß geworden; als Hilfszeitwort: worden; er ist gelobt worden; werd[e]!; (↑ R 120:) das ist noch im Werden; wer|dend; eine werdende Mutter
Wer|der (Flußinsel; Landstrich zwischen Fluß u. stehenden Gewässern) *m* (selten: *s*); -s, -

Wer|der (Havel) (Stadt westl. von Potsdam)
Wer|fall (für: Nominativ) *m*
Wer|fel, Franz (österr. Schriftsteller)
wer|fen (von Tieren auch: gebären); du wirfst; du warfst (warfest); du würfest; geworfen; wirf!; sich -; Wer|fer; ¹Werft (Kette eines Gewebes) *m;* -[e]s, -e
²Werft *niederl.* (Anlage zum Bauen u. Ausbessern von Schiffen) *w;* -, -en; Werft|ar|bei|ter
Werg (Flachs-, Hanfabfall, Hede) *s;* -[e]s
Wer|geld (Sühnegeld für Totschlag im germ. Recht)
wer|gen (aus Flachs od. Hanf); wergene Stricke
Werk *s;* -[e]s, -e; ans -! ans -, zu - gehen; ins - setzen; Werk|an|ge|hö|ri|ge¹, ...an|la|ge¹, ...ar|beit, ...arzt¹, ...aus|stel|lung¹, ...bank (*Mehrz.* ...bänke), ...bü|che|rei¹, ...bund *m* (Deutscher -); werk|ei|gen¹; Wer|kel österr. ugs. (Leierkasten, Drehorgel) *s;* -s, -[n]; Wer|kel|mann österr. (jmd., der das Werkel spielt, Drehorgelspieler; *Mehrz.* ...männer); wer|keln landsch. ([angestrengt] werken); ich ...[e]le (↑ R 327); Wer|kel|tag (veralt. für: Werktag); wer|ken (tätig sein; [be]arbeiten); Wer|ker; Werk_fah|rer¹, ...ge|rech|tig|keit (Theol.); wer|ge|treu; Werk|hal|le¹; Werk_ka|me|rad¹, ...kin|der|gar|ten¹, ...kü|che¹, ...lei|ter¹ *m,* ...lei|tung¹, ...leu|te (veralt.); werk|lich (veralt.); Werk_mei|ster, ...schu|le, ...spio|na|ge¹; Werk|statt, Werk|stät|te *w;* -, ...stätten; Werk|stoff; werk|stoff|ge|recht; Werk|stoff-in|ge|nieur; Werk|stoffor|schung [*Trenn.:* ...stoff|for..., ↑ R 236] *w;* -; Werk|stoff|prü|fung; Werk-_stück, ...stu|dent; Werk|tag (Wochentag); des Werktags, aber (↑ R 129): werktags; werk|täg|lich; werk|tags; vgl. Werktag; Werk|tags|ar|beit; werk|tä|tig; Werk|tä|ti|ge *m* u. *w;* -n, -n (↑ R 287ff.); Werk_treue, ...un|ter|richt, ...ver|trag, ...woh|nung¹, ...zeit|schrift¹, ...zeug; Werk|zeug_ka|sten, ...ma|cher, ...ma|ga|zin, ...ma|schi|ne, ...stahl ¹Stahl)
Wer|mut (eine Pflanze; Wermutwein; übertr. für: Bitteres, Bitterkeit) *m;* -[e]s; Wer|mut[s]-trop|fen; Wer|mut|wein
Wer|ner (m. Vorn.); vgl. Wernher
Wern|hard (m. Vorn.); Wern|her (alte Form von: Werner)

Wer|ra (Quellfluß der Weser) *w;* - Wer|re südd., westmitteld., österr. u. schweiz. mdal. (Maulwurfsgrille; Gerstenkorn) *w;* -, -n
Werst *russ.* (altes russ. Längenmaß; Zeichen: W) *w;* -, -en; 5 - (↑ R 322)
wert; - sein; du bist keinen Schuß Pulver wert (ugs.); das ist keinen Heller wert (ugs.); in der Bedeutung „würdig" mit *Wesf.:* das ist höchster Bewunderung wert; es ist nicht der Rede, Mühe wert; jmdn. des Vertrauens [für] wert (würdig) achten, halten, vgl. aber: wertachten, werthalten, wertschätzen; Wert (Bedeutung, Geltung) *m;* -[e]s, -e; auf etwas - legen; wert|ach|ten; ↑ R 139 (veralt. für: hochachten); ich achte wert; wertgeachtet; wertzuachten, aber: jmdn. des Vertrauens [für] wert (würdig) achten; vgl. wert; wert|ar|beit (*w;* -); wert|be|stän|dig; Wert|be|stän|dig|keit *w;* -; Wert-brief; wer|ten; Wert|er|mitt|lung (für: Taxation); wert|frei; Wert-ge|gen|stand, wert|hal|ten; ↑ R 139 (veraltend für: hochschätzen); ich halte wert; wertgehalten; wertzuhalten, aber: jmdn. des Vertrauens [für] wert (würdig) halten; vgl. wert
Wer|ther (Titelgestalt eines Romans von Goethe)
...wer|tig (z. B. minderwertig)
Wer|tig|keit; Wert|leh|re (Philos.); wert|los; -este (↑ R 292); Wert|lo|sig|keit *w;* -; Wert_mar|ke, ...maß *s;* wert|mä|ßig; Wert-_mes|ser *m,* ...min|de|rung, ...pa|ket, ...pa|pier; Wert|pa|pier_ab|tei|lung, ...steu|er *w;* Wert|sa|che (meist *Mehrz.*); wert|schät|zen (veraltend; ↑ R 139); du schätzt (schätzest) wert; wertgeschätzt; wertzuschätzen; Wert-schät|zung, ...schrift (schweiz. für: Wertpapier), ...sen|dung, ...stei|ge|rung, Wer|tung; Wert|ur|teil; wert|voll; Wert_vor|stel|lung, ...zei|chen, ...zu|wachs; Wert|zu|wachs|steu|er *w*
wer|wei|ßen schweiz. (hin u. her raten); du werweißt (werweißest); gewerweißt
Wer|wolf *m* (im Volksglauben Mensch, der sich zeitweise in einen Wolf verwandelt)
wes (ältere Form von: wessen); - das Herz voll ist, des gehet der Mund über; - Brot ich ess', des Lied ich sing'; weshalb (vgl. d.); weswegen (vgl. d.)
we|sen (veralt. für: überpersönliches Dasein haben; als lebende Kraft vorhanden sein); du west (wesest); er we|ste; We|sen *s;* -s,

¹ Auch, österr. nur: Werks..., werks...

-; viel -[s] machen; we|send (in reiner Daseinsform bestehend); we|sen|haft; We|sen|heit w; -; we|sen|los; -este (↑ R 292); We|sen|lo|sig|keit w; -; We|sens|art; we|sens-_ei|gen, ...fremd, ...ge|mäß, ...gleich, ...not|wen|dig; We|sens|zug; we|sent|lich (wesenhaft, wirklich; hauptsächlich); (↑ R 134:) im wesentlichen, aber (↑ R 116): das Wesentliche; (↑ R 116:) etwas, nichts Wesentliches

We|ser (dt. Strom) w; -; We|ser|berg|land s; -[e]s (↑ R 201); We|ser|ge|bir|ge (Höhenzug im Weserbergland) s; -s (↑ R 201)

Wes|fall (für: Genitiv) m; wes|halb [auch: wäß...]

We|sir arab. (,,Helfer"; Minister, höchster Würdenträger des türk. Sultans) m; -s, -e

Wes|ley [*äsli] (engl. Stifter des Methodismus); Wes|leya|ner

Wes|pe w; -, -n; Wes|pen_nest, ...stich, ...tail|le (scherzh.)

Wes|sel|bu|ren (Stadt in Schleswig-Holstein)

Wes|se|ly, Paula (österr. Schauspielerin)

wes|sen; vgl. wes; wes|sent|we|gen (veralt. für: weswegen); wes|sent|wil|len; um -

Wes|so|brunn (Ort in Oberbayern); Wes|so|brun|ner (↑ R 199); das - Gebet

¹West (Himmelsrichtung; Abk.: W); Ost u. West; (fachspr.:) der Wind kommt aus -; (bei Ortsnamen:) Frankfurt (West); vgl. Westen; ²West (dicht für: Westwind) m; -[e]s, (selten:) -e; der kühle West blies um das Haus; _afri|ka, ...au|stra|li|en; West-Ber|lin (↑ R 206); West|ber|li|ner (↑ R 199 u. R 206); west|deutsch, aber (↑ R 224): Westdeutscher Rundfunk (Abk.: WDR); Westdeutsche Rektorenkonferenz; West|deutsch|land

We|ste fr. w; -, -n

We|sten (Himmelsrichtung; Abk.: W) m; -s; gen -; vgl. ¹West; Wilder - (↑ R 224)

West|end engl. [engl. Ausspr.: "äßt...] (vornehmer Stadtteil Londons, danach auch anderer Großstädte, z. B. Berlins) s; -s, -s

We|sten_fut|ter (vgl. ²Futter), ...ta|sche

We|stern amerik. (Film, der während der Pionierzeit im sog. Wilden Westen [Amerikas] spielt) m; -[s], -; We|ster|ner (Held eines Westerns)

We|ster|wald (Teil des Rheinischen Schiefergebirges) m; -[e]s; We|ster|wäl|der m; we|ster|wäl|disch; -e Mundarten

West|eu|ro|pa; west|eu|ro|pä|isch; -e Zeit (Abk.: WEZ), aber (↑ R 224): die Westeuropäische Union (Abk.: WEU)

West|fa|le m; -n, -n (↑ R 268); West|fa|len; West|fä|lin w; -, -nen; west|fä|lisch; (↑ R 200 u. R 224:) -er Schinken, aber (↑ R 198): die Westfälische Pforte (vgl. Porta Westfalica); (↑ R 224:) der Westfälische Friede[n]; West|fä|li|sche Pfor|te vgl. Porta Westfalica

West|flan|dern (belg. Prov.)

west|ger|ma|nisch

West|in|di|en; west|in|disch, aber (↑ R 198): die Westindischen Inseln

We|sting|house|brem|se [...hauß...] (↑ R 180) Ⓦ₂

we|stisch; -e Kunst, -e Rasse; West|kü|ste; west|le|risch ([betont] westlich eingestellt); west|lich; - des Waldes, - vom Wald; -er Länge (Abk.: w. L.); die -e Hemisphäre; West|li|che Dwi|na; ↑ R 198 (russ.-lett. Strom; vgl. Dwina) w; -n -

West|mäch|te Mehrz.

West|min|ster|ab|tei (in London) w; -

¹West|nord|west (Himmelsrichtung; Abk.: WNW) u. West|nord|we|sten (Abk.: WNW) m; -s; ²West|nord|west (Wind; Abk.: WNW) m; -[e]s, -e

west|öst|lich; westöstlicher Wind, aber (↑ R 224): Westöstlicher Diwan (Gedichtsammlung Goethes); West-Ost-Ver|kehr (↑ R 155)

West|over [...ọw*r] (westenähnlicher Pullover) m; -s, -

West|rom; west|rö|misch, aber (↑ R 224): das Weströmische Reich

West|sa|moa (Inselstaat im Pazifischen Ozean); West|sa|moa|ner; west|sa|moa|nisch

¹West|süd|west (Himmelsrichtung; Abk.: WSW) u. West|süd|we|sten (Abk.: WSW) m; -s; ²West|süd|west (Wind; Abk.: WSW) m; -[e]s, -e

West Virginia [- wirgi..., auch: wirdsehi...]; engl. Ausspr.: "äst w*rdsehi*n*e] (Staat in den USA; Abk.: W. Va.)

west|wärts

wes|we|gen; vgl. wessentwegen

wett; - sein; vgl. aber: wetteifern, wettlaufen, wettmachen, wettrennen, wettstreiten, wetturnen; Wett_an|nah|me, ...be|werb (m; -[e]s, -e), ...be|wer|ber; wett|be|werb|lich; Wett|be|werbs_be|din|gung, ...ver|zer|rung, ...wirt|schaft (w; -); Wett|bü|ro; Wet|te w; -, -n; um die - laufen; Wett_ei-

fer, ...ei|fe|rer; wett|ei|fern; ich wetteifere (↑ R 327); gewetteifert; zu -; wett|ten; ¹Wet|ter (jmd., der wettet) m; ²Wet|ter (Bergmannsspr. auch: alle in der Grube vorkommenden Gase) s; -s, -; (Bergmannsspr.:) schlagende, böse, matte -; Wet|ter_amt, ...an|sa|ge Wet|ter|au (Senke zwischen dem Vogelsberg u. dem Taunus) w; - Wet|ter_aus|sicht, ...be|ein|flussung, ...be|richt, ...bes|se|rung; wet|ter|be|stän|dig; Wet|ter-_dach, ...dienst, ...fah|ne; wet|terfest; Wet|ter_fleck (österr. für: Lodencape), ...for|schung, ...frosch; wet|ter|füh|lig; Wet|ter-_füh|lig|keit (w; -), ...füh|rung (Bergmannsspr.), ...glas (veralt. für: Barometer; Mehrz. ...gläser), ...hahn, ...kar|te, ...kun|de (für: Meteorologie; w; -); wet|ter|kun|dig; wet|ter|kund|lich (für: meteorologisch); Wet|ter|la|ge; wet|ter|leuch|ten (↑ R 140); es wetterleuchtet; gewetterleuchtet; zu -; Wet|ter_leuch|ten (s; -s), ...man|tel; wet|tern (stürmen, donnern u. blitzen; laut schelten); ich ...ere (↑ R 327); es wettert; Wet|ter_pro|gno|se, ...pro|phet, ...re|gel, ...sa|tel|lit, ...schei|de, ...sei|te, ...sturz, ...um|schlag, ...vor|her|sa|ge, ...war|te; wet|ter|wendisch; -ste (↑ R 294)

Wetteu|fel [Trenn.: Wett|teu..., ↑ R 236]; Wett_fah|rer, ...fahrt

Wet|tin (Stadt a. d. Saale); Haus - (ehem. dt. Fürstengeschlecht); Wet|ti|ner (↑ R 199) m; -s, -; wet|ti|nisch, aber (↑ R 224): die Wettinischen Erblande

Wett_kampf, ...kämp|fer, ...lauf; wett|lau|fen (nur in der Grundform gebr.); Wett|lau|fen s; -s; Wett|läu|fer; wett|ma|chen (ausgleichen); ich mache wett; wettgemacht; wettzumachen; wettren|nen (vgl. wettlaufen); Wett-_ren|nen, ...ru|dern (s; -s), ...rü|sten (s; -s), ...schwim|men (s; -s), ...spiel, ...streit; wett|strei|ten (vgl. wettlaufen); wet|tur|nen [Trenn.: wett|tur..., ↑ R 236] (vgl. wettlaufen); Wet|tur|nen [Trenn.: Wett|tur..., ↑ R 236] s; -s, -; wet|zen; du wetzt (wetzest) Wetz|lar (Stadt an der Lahn) Wetz_stahl (vgl. ¹Stahl), ...stein WEU = Westeuropäische Union Wey|mouths|kie|fer [*ẹ*m*th...], (auch:) Wey|muts|kie|fer [nach Lord Weymouth] (eine nordamerik. Kiefer)

WEZ = westeuropäische Zeit

WG = Wechselgesetz

WGB = Weltgewerkschaftsbund

Whig engl. [*ig] (Angehöriger einer ehem. engl. Partei, aus der

sich die liberale Partei entwickelte) *m*; -s. -s; vgl. Tory

Whip|cord *engl.* [*"ipkord*] (Anzugstoff mit Schrägrippen) *m*; -s. -s

Whis|ky *gälisch-engl.* [*"ißki*] (Trinkbranntwein aus Getreide od. Mais) *m*; -s, -s

Whist *engl.* [*"ißt*] (ein Kartenspiel) *s*; -[e]s; **Whist|spiel**

White|cha|pel [*"ait-tschäp*ᵉ*l*] (Stadtteil von London)

Whit|man [*"itm*ᵉ*n*], Walt [*"ält*] (amerik. Lyriker)

Whit|worth|ge|win|de [*"it "ö*ᵗ*th...*]; ↑ R 180 (einheitliches Gewindesystem des engl. Ingenieurs Whitworth)

Who's who *engl.* [*hụs hụ*] („Wer ist wer?"; Titel biograph. Lexika)

wib|be|lig landsch. (nervös, zappelig)

Wịchs (Festkleidung der Studenten) *m*; -es, -e (österr. *w*; -, -en); in vollem -; sich in - werfen; **Wịchs|bür|ste; Wịch|se** (ugs. für: Schuhwichse; *Einz.* für: Prügel) *w*; -, -n; - kriegen (geprügelt werden); **wịch|sen;** du wichst (wichsest); **Wịchs|lein|wand** österr. ugs. (Wachstuch)

Wịcht (Wesen; Kobold; verächtl. für: elender Kerl) *m*; -[e]s, -e

Wịch|te (spezifisches Gewicht) *w*; -, -n

Wịch|tel|männ|chen (Heinzelmännchen)

Wịch|te|zahl

wịch|tig; (↑ R 116:) alles Wichtige, etwas, nichts Wichtiges, Wichtigeres; [sich] - tun; sich - machen; etwas, sich - nehmen; **Wịch|tig|keit; Wịch|tig|ma|cher** österr. (Wichtigtuer); **wịch|tig|tu|end; Wịch|tig|tu|er; Wịch|tig|tue|rei; wịch|tig|tue|risch;** -ste (↑ R 179)

Wịcke[1] *lat.* (eine Pflanze) *w*; -, -n

Wịckel[1] *m*; -s, -; **Wịckel**[1]**⌐band** (*s*; *Mehrz.* ...bänder), ...ga|ma|sche, ...kind, ...kis|sen, ...kom|mo|de; **wickeln**[1]; ich ...[e]le (↑ R 327); **Wịckel**[1]**⌐tisch, ...tuch** (*Mehrz.* ...tücher); **Wịcke|lung**[1], **Wịck|lung**

Wịcken[1]**⌐blü|te, ...duft**

Wịck|ler; Wịck|lung, Wịcke|lung[1]

Wịd|der (männl. Zuchtschaf; Sternbild [*Einz.*]; frühere Belagerungsmaschine) *m*; -s, -

wi|der ([ent]gegen); mit *Wenf.*: das war - meinen ausdrücklichen Wunsch; - alles Erwarten; - Willen; vgl. aber: wieder; das Für und [das] Wider

wider... *in Verbindung mit Zeitwörtern:* **a)** *in unfesten Zusammensetzungen* (↑ R 304), z. B. **wi|derhallen** (vgl. d.), widerge-

hallt; **b)** *in festen Zusammensetzungen* (↑ R 304), z. B. **widersprechen** (vgl. d.), widersprochen

wi|der|bor|stig (ugs. für: hartnäckig widerstrebend)

Wi|der|christ *m*; -[e]s u. -en, -e[n] (↑ R 268)

Wi|der|druck (Druckw.: Bedrucken der Rückseite des Druckbogens [vgl. Schöndruck]) *m*; -[e]s, ...drucke; vgl. aber: Wiederdruck

wi|der|ein|an|der, *Schreibung in Verbindung mit Zeitwörtern* (↑ R 139:) widereinander arbeiten, kämpfen usw., aber: widereinanderstoßen, vgl. aneinander

wi|der|fah|ren; mir ist ein Unglück -

Wi|der|ha|ken

Wi|der|hall (Echo) *m*; -[e]s, -e; **wi|der|hal|len;** das Echo hat widergehallt

Wi|der|halt (Widerstand, Gegenkraft) *m*; -[e]s

Wi|der|hand|lung schweiz. (Zuwiderhandlung)

Wi|der|klang; wi|der|klin|gen; der Schall hat widergeklungen

Wi|der|la|ger (massiver Baukörper, der den Druck von Bogen, Gewölben, Trägern, bes. bei Brücken, aufnimmt); **wi|der|le|gbar; wi|der|le|gen;** er hat diesen Irrtum widerlegt; **Wi|der|le|gung**

wi|der|lich; Wi|der|lich|keit; Wi|der|ling (widerlicher Mensch); **wi|dern** (ekeln); es widert mich

wi|der|na|tür|lich; Wi|der|na|tür|lich|keit

Wi|der|part (Gegner[schaft]) *m*; -[e]s, -e; - geben, bieten

wi|der|ra|ten; ich habe [es] ihm -

wi|der|recht|lich; Wi|der|recht|lich|keit

Wi|der|re|de; wi|der|re|den; er hat widerredet

Wi|der|rist (erhöhter Teil des Rückens bei Vierfüßern)

Wi|der|ruf; bis auf -; **wi|der|ru|fen** (zurücknehmen); er hat sein Geständnis -; **wi|der|ruf|lich** [auch: ...*ruf...*] (Rechtsspr.); **Wi|der|ruf|lich|keit** [auch: ...*ruf...*] *w*; -; **Wi|der|ru|fung** (veraltend für: Widerruf)

Wi|der|sa|cher *m*; -s, -; **wi|der|sa|che|risch**

wi|der|schal|len (veraltend für: widerhallen); der Ruf hat widerschallt

Wi|der|schein (Gegenschein); **wi|der|schei|nen;** das Licht hat widergeschienen

Wi|der|see (Seemannsspr.: rücklaufende Brandung) *w*

wi|der|set|zen, sich; ich habe mich dem Plan widersetzt; **wi|der|setz|lich; Wi|der|setz|lich|keit**

Wi|der|sinn (Gegensinn; Sinn, der sich einem anderen entgegenstellt) *m*; -[e]s; **wi|der|sin|nig; Wi|der|sin|nig|keit**

wi|der|spen|stig; Wi|der|spen|stig|keit

wi|der|spie|geln; die Sonne hat sich im Wasser widergespiegelt; **Wi|der|spie|ge|lung, Wi|der|spieg|lung**

Wi|der|spiel

wi|der|spre|chen; mir wird widersprochen; **Wi|der|spruch; wi|der|sprüch|lich; Wi|der|sprüch|lich|keit; Wi|der|spruchs_be|scheid, ...geist** (*m*; -[e]s; für jmd., der widerspricht, auch *Mehrz.*: ...geister), ...kla|ge; **wi|der|spruchs|los; wi|der|spruchs|voll**

Wi|der|stand; Wi|der|stands|be|we|gung; wi|der|stands|fä|hig; Wi|der|stands_fä|hig|keit (*w*; -), **...kämp|fer,** ...kraft *w*, ...li|nie; **wi|der|stands|los; Wi|der|stands|lo|sig|keit** *w*; -; **Wi|der|stands_nest, ...pflicht, ...recht** (*s*; -[e]s), ...wil|le; **wi|der|ste|hen;** er hat der Versuchung widerstanden

Wi|der|strahl; wi|der|strah|len; das Licht hat widergestrahlt

wi|der|stre|ben (entgegenwirken); es hat ihm widerstrebt; **Wi|der|stre|ben** *s*; -s; **wi|der|stre|bend** (ungern); -ste

Wi|der|streit; im - der Meinungen; **wi|der|strei|ten;** er hat ihm widerstritten

Wi|der|ton|moos (eine Pflanzengattung)

wi|der|wär|tig; Wi|der|wär|tig|keit

Wi|der|wil|le; wi|der|wil|lig; Wi|der|wil|lig|keit

Wi|der|wort (*Mehrz.* ...worte); Widerworte geben

wid|men (Amtsspr. auch: für die öffentliche Nutzung bestimmen); er hat ihm sein letztes Buch gewidmet; ich habe mich der Kunst gewidmet; in X wurde eine neue Straße gewidmet; **Wịd|mung; Wịd|mungs|ta|fel**

Wị|do (m. Vorn.); vgl. Guido

wịd|rig (zuwider; übertr. für: unangenehm); ein - es Geschick; **wịd|ri|gen|falls;** vgl. Fall *m*; **Wịd|rig|keit**

Wị|du|kind, Wịt|te|kind (Sachsenherzog)

Wị|dum („das Gewidmete"; österr. veralt. für: Pfarrgut) *s*; -s, -e

wie; wie geht es dir?; sie ist so schön wie ihre Freundin, aber (bei Ungleichheit): sie ist schöner als ihre Freundin; (↑ R 26:) sie ist so stark wie Ludwig; so schnell wie od. als möglich; im Krieg wie [auch] (und [auch]) im Frieden; die Auslagen [,] wie [z. B.] Post-

und Fernsprechgebühren sowie Eintrittsgelder [,] ersetzen wir; ich begreife nicht, wie so etwas möglich ist; komm so schnell, wie du kannst; († R 49:) er legte sich [,] wie üblich [,] ins Bett; wieso; wiewohl (vgl. d.); wie sehr; wie lange; wie oft; wie [auch] immer; († R 119:) es kommt auf das Wie an, es handelt sich hier nicht um das Was, sondern um das Wie

Wie|bel (Kornwurm, -käfer) *m;* -s, -; **wie|beln** (landsch. für: sich lebhaft bewegen; ostmitteld. für: sorgfältig flicken, stopfen); ich ...[e]le († R 327); vgl. wiefeln

Wie|chert (dt. Schriftsteller)

[1]Wied (r. Nebenfluß des Mittelrheins) *w;* -; **[2]Wied** (mittelrhein. Adelsgeschlecht)

Wie|de südd., südwestd. (Weidenband) *w;* -, -n

Wie|de|hopf (Vogel) *m;* -[e]s, -e

wie|der (nochmals, erneut; zurück); um, für nichts und wieder nichts; hin und wieder (zuweilen); wieder einmal; vgl. aber: wider. *In Verbindung mit Zeitwörtern:* I. *Zusammenschreibung:* **a)** wenn in „wieder" der Begriff „zurück" erkennbar ist, z. B. wiederbringen (zurückbringen); **b)** wenn in „wieder" der Begriff „erneut", „nochmals" erkennbar ist und übertragene Bedeutung vorliegt († R 139), z. B. wiederaufrichten (innerlich stärken). In der *Beugung* sind diese Zusammensetzungen unfest († R 304): ich bringe wieder, wiedergebracht, wiederzubringen; ich richte wieder auf, wiederaufgerichtet, wiederaufzurichten. II. *Getrenntschreibung,* wenn in „wieder" der Begriff „erneut", „nochmals" erkennbar ist und ursprüngliche Bedeutung vorliegt, z. B. wieder bringen (nochmals bringen)

Wie|der|ab|druck

Wie|der_an|pfiff (Sportspr.; *m;* -[e]s), ...**an|spiel** (*s;* -[e]s), ...**an|stoß** (*m;* -es)

Wie|der|auf|bau *m;* -[e]s; **Wie|der|auf|bau|ar|beit; wie|der|auf|bau-en;** vgl. wieder I, b; wir bauen den zerrütteten Staat wieder auf; der zerrüttete Staat wurde wiederaufgebaut; aber (vgl. wieder II): **wie|der auf|bau|en;** er wird die Mauer wieder aufbauen

wie|der|auf|he|ben; vgl. wieder I, a (rückgängig machen); ich hebe wieder auf; die Verordnungen wurden wiederaufgehoben; aber (vgl. wieder II): **wie|der auf|he-ben;** du sollst den Ball wieder aufheben

Wie|der|auf|nah|me; Wie|der|auf-

nah|me|ver|fah|ren (Rechtsspr.); **wie|der|auf|neh|men;** vgl. wieder I, b (sich mit einer Sache erneut befassen); ich nehme wieder auf; er hat seine Arbeiten wiederaufgenommen; aber (vgl. wieder II): **wie|der auf|neh|men;** sie hat den Korb wieder aufgenommen

wie|der|auf|rich|ten; vgl. wieder I, b (innerlich stärken); ich richte ihn wieder auf; ich habe ihn wiederaufgerichtet; aber (vgl. wieder II): **wie|der auf|rich|ten;** der Mast wurde wieder aufgerichtet; **Wie|der|auf|rich|tung**

wie|der|auf|su|chen[1]; vgl. wieder I, b (erneut besuchen); ich suche ihn wieder auf; ich habe ihn wiederaufgesucht

wie|der|auf|tau|chen; vgl. wieder I, b (erneut erscheinen); ich tauche wieder auf; er ist wiederaufgetaucht; aber (vgl. wieder II): **wie|der auf|tau|chen;** die Ente ist wieder aufgetaucht

Wie|der|be|ginn

wie|der|be|kom|men; vgl. wieder I, a (zurückerhalten); ich habe das Buch-; aber (vgl. wieder II): **wie|der be|kom|men** (erneut, ein zweites Mal erhalten); er wird diesen Ausschlag nicht wieder bekommen

wie|der|be|le|ben; vgl. wieder I, b (zu neuem Leben erwecken); in der Renaissance wurde die Antike wiederbelebt; aber (vgl. wieder II): **wie|der be|le|ben** (erneut beleben); das hat die Wirtschaft wieder belebt; **Wie|der|be|le-bung; Wie|der|be|le|bungs|ver-such**

wie|der|brin|gen; vgl. wieder I, a (zurückbringen); er hat das Buch wiedergebracht; aber (vgl. wieder II): **wie|der brin|gen** (nochmals bringen)

Wie|der|druck (Neudruck) *m;* -[e]s, -e; vgl. aber: Widerdruck

wie|der|ein|fal|len; vgl. wieder I, b (erneut ins Gedächtnis kommen); es fällt mir wieder ein; es ist mir wiedereingefallen; aber (vgl. wieder II): **wie|der ein|fal|len** (nochmals einfallen); die Stare sind wieder eingefallen

wie|der|ein|set|zen; vgl. wieder I, b (wieder mit einem früheren Amt, Posten betrauen); ich setze wieder ein; er wurde in sein Amt wiedereingesetzt; aber (vgl. wieder II): **wie|der ein|set|zen** (nochmals einsetzen); sie haben den gleichen Betrag wieder eingesetzt; **Wie|der|ein|set|zung,** - in den vorigen Stand (Rechtsw.)

[1] Auch Getrenntschreibung möglich.

Wie|der|ent|deckung[1]

wie|der|er|hal|ten; vgl. wieder I, a (zurückbekommen); ich erhalte wieder; ich habe das Buch -

wie|der|er|ken|nen; vgl. wieder I, b; ich erkenne wieder; er hat ihn wiedererkannt

wie|der|er|lan|gen; vgl. wieder I, a (zurückbekommen); ich erlange wieder; ich habe die früheren Rechte wiedererlangt

wie|der|er|obern; vgl. wieder I, a (zurückgewinnen); der Verein hat seine führende Stellung wiedererobert; **Wie|der|er|obe-rung**

wie|der|er|öff|nen; vgl. wieder, I, b; das Geschäft hat gestern wiedereröffnet; **Wie|der|er|öff-nung**

wie|der|er|set|zen; vgl. wieder, I, a (zurückgeben); ich ersetze wieder; er hat den Schaden wiederersetzt

wie|der|er|stat|ten; vgl. wieder, I, a (zurückgeben); ich erstatte wieder; er hat das Geld wiedererstattet; **Wie|der|er|stat|tung**

wie|der|er|wecken[1]; vgl. wieder, I, a (ins Leben zurückrufen); ich erwecke wieder; die wiedererweckte Natur; **Wie|der|er-weckung[1]**

wie|der|er|zäh|len; vgl. wieder I, b (wiedergeben; weitererzählen); ich erzähle wieder; er hat das Geheimnis wiedererzählt; aber: **wie|der er|zäh|len** (nochmals erzählen); die Großmutter hat das gleiche Märchen wieder erzählt

wie|der|fin|den; vgl. wieder I, a (zurückerlangen); ich finde wieder; er hat das Geld wiedergefunden

wie|der|for|dern; vgl. wieder I, a (zurückfordern); ich fordere wieder; er hat das Geld wiedergefordert; aber: **wie|der for|dern** (nochmals fordern); die Mannschaft wurde vom Gegner wieder gefordert

Wie|der|ga|be; die - eines Konzertes auf Tonband; **wie|der|ge|ben;** vgl. wieder I, a u. b (zurückgeben; darbieten); ich gebe wieder; die Freiheit wurde ihm wiedergegeben; er hat das Gedicht vollendet wiedergegeben; aber: **wie|der ge|ben** (nochmals geben); er hat ihm die Pistole [trotz meines Verbotes] wieder gegeben

wie|der|ge|bo|ren; Wie|der|ge|burt

wie|der|ge|win|nen; vgl. wieder, I, a (zurückgewinnen); ich gewinne alles wieder; er hat sein verlorenes Geld wiedergewonnen; aber: **wie|der ge|win|nen** (nochmals gewinnen)

[1] Trenn.: ...k|k...

wie|der|gut|ma|chen; vgl. wieder I, b (erneut in Ordnung bringen); ich mache wieder gut; er hat seinen Fehler wiedergutgemacht; aber (vgl. wieder II): wie|der gut ma|chen; du sollst deine Aufgaben wieder gut machen; Wie|der|gut|ma|chung; Wie|der|gut-ma|chungs_amt, ...ge|setz, ...ver-hand|lun|gen (Mehrz.)

wie|der|ha|ben (ugs. für: zurückbe-kommen); ich habe das Buch wieder; er hat es wiedergehabt

wie|der|her|rich|ten[1]; vgl. wieder I, b (etwas erneut in Ordnung bringen); ich richte wieder her; er hat sein Haus wiederhergerichtet

wie|der|her|stel|len; vgl. wieder I, b (etwas in einen bereits gewesenen Zustand versetzen); ich stelle wieder her; er hat die Beziehungen wiederhergestellt; aber: wie-der her|stel|len (nochmals anfertigen); Wie|der|her|stel|lung; Wie|der|her|stel|lungs|ko|sten Mehrz.

wie|der|hol|bar; wie|der|ho|len; vgl. wieder I, a (zurückholen); ich hole wieder; er hat seine Bücher wiedergeholt; aber (vgl. wieder II): wie|der ho|len (nochmals holen); wie|der|ho|len; vgl. wieder I, b (erneut sagen); ich wiederhole; er hat seine Forderungen wiederholt; wie|der|holt (noch-, mehrmals); Wie|der|ho-lung (Zurückholung); Wie|der-ho|lung (nochmaliges Sagen, Tun); Wie|der|ho|lungs_fall m (im -[e]), ...kurs (schweiz.: jährl. Militärübung; Abk.: WK), ...zei|chen

Wie|der|hö|ren s; -s; auf -! (Grußformel im Fernsprechverkehr, bes. im Rundfunk)

Wie|der|in|be|sitz|nah|me w; -

wie|der|käu|en; vgl. wieder I, b; die Kuh käut wieder; hat wiedergekäut; Wie|der|käu|er

Wie|der|kauf (Rückkauf); wie-der|kau|fen; vgl. wieder I, a (zurückkaufen, einlösen); Wie|der-kaufs|recht (Rechtsspr.)

Wie|der|kehr w; -; wie|der|keh|ren; vgl. wieder I, a (zurückkommen); ich kehre wieder; er ist wiedergekehrt

wie|der|kom|men; vgl. wieder I, a (zurückkommen); ich komme wieder; er ist heute wiedergekommen; aber: wie|der kom|men (nochmals kommen); Wie|der-kunft (Rückkehr) w; -

Wie|der|schau|en (landsch.) s; -; auf -!

wie|der|schen|ken; vgl. wieder I, a (zurückgeben); ich schenke es

ihm wieder; das wiedergeschenkte Leben

wie|der|se|hen; vgl. wieder I, b (erneut zusammentreffen); ich sehe ihn wieder; wir haben ihn einmal wiedergesehen; aber (vgl. wieder II): wie|der se|hen; nach der Operation wird er wieder sehen; Wie-der|se|hen s; -s; auf -!; auf - sagen

Wie|der_tau|fe, ...täu|fer

wie|der|tun[1]; vgl. wieder I, b (wiederholen); ich tue das nicht wieder; er hat das nicht wiedergetan

wie|der|um

wie|der|ver|ei|ni|gen; vgl. wieder I, b (die verlorene Einheit wiederherstellen); Deutschland muß wiedervereinigt werden; aber (vgl. wieder II): wie|der ver|ei|ni-gen (erneut zusammenführen); nach langer Trennung wurde die Familie wieder vereinigt; Wie-der|ver|ei|ni|gung

wie|der|ver|gel|ten; vgl. wieder I, b; ich vergelte wieder; er hat wiedervergolten; Wie|der|ver|gel-tung

Wie|der|ver|hei|ra|tung

Wie|der|ver|käu|fer (Händler)

Wie|der|vor|la|ge w; - (Amtsdt.:) zur Wiedervorlage (Abk.: z. Wv.)

Wie|der|wahl; wie|der|wäh|len; vgl. wieder I, b (jmdn. in das frühere Amt od. in die frühere Würde wählen); ich wähle wieder; er wurde wiedergewählt; aber (vgl. wieder II): wie|der wäh|len (ein zweites Mal, nochmals wählen)

Wie|de|wit|te niederd. (Champignon) w; -, -n

wie|feln landsch. (vernähen, stopfen); ich ...[e]le (↑ R 327); vgl. wiebeln

wie|fern (inwiefern)

Wie|ge w; -, -n; wie|geln (landsch. für: leise wiegen; selten für: aufwiegeln); ich ...[e]le (↑ R 327); Wie|ge_mes|ser s, [1]wie|gen (schaukeln; zerkleinern); du wiegst; du wiegtest; gewiegt; sich -

[2]wie|gen (das Gewicht feststellen; Gewicht haben); du wiegst; du wogst; du wögest; gewogen; wie-ge[t]!; ich wiege das Brot; das Brot wiegt (hat ein Gewicht von) zwei Kilo; vgl. wägen

Wie|gen_druck (Mehrz. ...drucke), ...fest (scherzh.), ...lied

wie|hern; ich ...ere (↑ R 327)

Wiek niederd. ((kleine) Bucht an der Ostsee) w; -, -en

[1]Wie|land (Gestalt der germ. Sage)

[2]Wie|land (dt. Dichter); wie|lan-disch, wie|landsch, aber (↑ R 179): Wie|lan|disch, Wie|landsch

Wie|lands|lied s; -[e]s

[1] Vgl. Anm. Sp. 1.

wie lang, wie lan|ge; - - ist das her?; - - ist das her!

Wie|ling (Seemannsspr.: Fender [aus Tau od. Leder] für Boote) w; -, -e

Wie|men niederd., westd. (Latte, Lattengerüst zum Trocknen u. zum Räuchern; Stange als Schlafsitz der Hühner) m; -s, -

Wien (Hptst. Österreichs); Wie-ner (↑ R 199); - Kalk; - Schnitzel; - Würstchen; wie|ne|risch; Wie-ner|le landsch. (Wiener Würstchen) s; -s, -; wie|nern (ugs. für: blank putzen [urspr. unter Verwendung von Wiener Putzkalk]); ich ...ere (↑ R 327), Wie|ner Neu-stadt; ↑ R 199 (österr. Stadt); Wie-ner|stadt (volkstüml. Bez. Wiens) w; -; Wie|ner|wald; ↑ R 204 (nordöstl. Ausläufer der Alpen) m; -[e]s; Wie|ner Wal|zer

wie oben (Abk.: w. o.)

Wie|pe niederd. (Strohwisch) w; -, -n

Wies|ba|den (Stadt im Vorland des Taunus); Wies|ba|de|ner, Wies-bad|ner (↑ R 199); wies|ba|densch, wies|ba|disch; Wies|ba|den Süd (↑ R 216)

Wies|baum, Wie|se|baum (Stamm über dem beladenen [Heu]wagen, Heubaum); Wies|chen, Wies|lein; Wie|se w; -, -n

wie sehr (als Bindewort österr.: wie|sehr)

Wie|sel (ein Marder) s; -s, -; wie-sel|flink; wie|sel|haft; wie|seln (sich [wie ein Wiesel] eilig, schnell bewegen); ich ...[e]le (↑ R 327)

Wie|sen_blu|me, ...bo|den, ...grund, ...schaum|kraut, ...tal, ...wachs od. Wies|wachs (veralt., noch mdal. für: Grasertrag der Wiesen; m; -es); Wies|land (schweiz.) s; -[e]s; Wies|lein, Wies|chen

Wie|so

Wies|wachs vgl. Wiesenwachs

wie|ten mdal. (Unkraut jäten)

wie|viel [auch: wi...]; wieviel Personen, aber ... wie viele Personen; wieviel Male, ich weiß nicht, wieviel er hat, aber (bei besonderer Betonung): wenn du wüßtest, wie viel ich verloren habe; [um] wieviel mehr; wie|vie|ler|lei [auch: wi...]; wie|viel|mal [auch: wi...], aber: wie viele Male; vgl. Mal u. wieviel; wie|viel|te [auch: wi...]; zum -n Male ich das schon gesagt habe, aber (↑ R 118): den Wievielten haben wir heute?

wie|weit (inwieweit); ich bin im Zweifel, wieweit ich mich darauf verlassen kann, aber: wie weit ist es von hier bis ...?

wie we|nig; vgl. wenig

wie|wohl; die einzige, wiewohl wertvolle Belohnung, aber: wie wohl du aussiehst!

Wight [*ait*] (engl. Insel)

Wig|wam *indian.-engl.* („Hütte" nordamerikanischer Indianer) *m*; -s, -s

Wi|king *m*; -s, -er u. Wi|kin|ger *altnord.* [auch: *wi...*] („Krieger"; Seefahrer, Normanne); Wi|kin|ger.sa|ge (↑ R 205; *w*; -), ...schiff (↑ R 205); wi|kin|gisch [auch: *wi...*]

Wi|klif vgl. Wyclif; Wi|kli|fit (Anhänger Wyclifs) *m*; -en, -en (↑ R 268)

Wi|la|jet *arab.-türk.* (türk. Verwaltungsbezirk) *s*; -[e]s, -s

wild; - wachsen; wilde Ehe; wildes Fleisch; wildes (Bergmannsspr.: taubes) Gestein; wilder Streik; wildes Tier; wilder Wein; er spielt den wilden Mann (ugs.); (↑ R 224:) Wilder Westen; die Wilde Jagd (Geisterheer); der Wilde Jäger (eine Geistergestalt); (↑ R 198:) Wilder Kaiser; Wilde Kreuzspitze; (↑ R 116:) sich wie ein Wilder gebärden (ugs.; vgl. ²Wilde); Wild *s*; -[e]s; Wild.bach, ...bahn; Wild|bret (Fleisch des geschossenen Wildes) *s*; -s; Wild|dieb; wild|die|ben; wild|die|bisch; gewilddiebt; zu -; Wild|die|be|rei

¹Wilde [*aild*], Oscar (engl. Dichter)

²Wil|de *m* u. *w*; -n, -n (↑ R 287ff.); Wild.eber, ...en|te; wil|den|zen landsch. (stark nach Wild riechen, schmecken); Wil|de|rer (Wilddieb); wil|dern (unbefugt jagen); ich ...ere (↑ R 327); Wild|fang (ausgelassenes Kind); wild|fremd (ugs. für: völlig fremd); Wild.gans, ...he|ger, ...heit, ...heu|er (jmd., der an gefährlichen Hängen in den Alpen Heu macht) *m*, ...hü|ter, ...kat|ze; wild|le|bend; Wild|le|der (Rehleder, Hirschleder u. ä.); Wild|ling (Unterlage für die Veredelung von Obst u. Ziergehölzen; ungezähmtes Tier; mutwilliger Mensch); Wild|nis *w*; -, ...kat|ze; wild|park; wild|reich; Wild|reich|tum; wild|ro|man|tisch; Wild.sau, ...scha|den

Wil|dschur *poln.* („Wolfspelz"; veralt. für: schwerer Reisepelz) *w*; -, -en

Wild|schütz (Jäger, Wilddieb) *m*; Wild|schwein; wild|wach|send; Wild.was|ser (Wildbach), ...wech|sel; Wild|west (ohne Geschlechtswort); Wild|wuchs; wild|wüch|sig

Wil|fried (m. Vorn.)

Wil|helm (m. Vorn.); Wil|hel|ma, Wil|hel|mi|ne (w. Vorn.); Wil|hel|mi|nisch (↑ R 179); -es Zeitalter

(des Kaisers Wilhelm II.); Wil|helms|ha|ven [...*haf°n*] (Hafenstadt an der Nordsee); Wil|helms|ha|ve|ner (↑ R 199)

Will (Kurzform von: Wilhelm)

Wil|le *m*; -ns, (selten:) -n; der Letzte - (↑ R 224); wider -n; jmdm. zu -n sein; voll guten -ns; willens sein (vgl. d.)

Wil|le|gis, Wil|li|gis (m. Vorn.)

wil|len; um ... willen (↑ R 129:) um Gottes willen, um seiner selbst -, um meinet-, deinet-, dessent-, derent-, seinet-, ihret-, unsert-, euretwillen; Wil|len (Nebenform von: Wille) *m*; -s, (selten:) -; wil|len|los; -este (↑ R 292); Wil|len|lo|sig|keit *w*; -; Wil|lens.akt, ...äu|ße|rung, ...bil|dung, ...er|klä|rung, ...frei|heit (*w*; -), ...kraft (*w*; -); wil|lens|schwach; Wil|lens|schwä|che *w*; -; wil|lens sein; ↑ R 132 (beabsichtigen); wil|lens|stark; wil|lens|stär|ke *w*; -; wil|lent|lich; will|fah|ren; (auch:) will|fah|ren; du willfahrst; du willfahrtest; (zu willfahren:) willfahrt (↑ R 304) od. (zu willfahren:) gewillfahrt (↑ R 304); zu -; wil|l|fäh|rig [auch: ...*fä...*]; Wil|l|fäh|rig|keit [auch: ...*fä...*]

Wil|li (Kurzform von: Wilhelm); Wil|liam [*ilj°m*] (engl. Form von: Wilhelm); Wil|li|bald (m. Vorn.); Wil|li|brord (m. Vorn.)

wil|lig (guten Willens; bereit); wil|li|gen (geh.); er willigte in die Heirat

Wil|li|gis vgl. Willegis

Wil|lig|keit *w*; -

Wil|li|ram (m. Vorn.)

Wil|l|komm *m*; -s, -e u. Will|kom|men *s* (auch: *m*; österr. nur: *s*); -s, -; einen Willkomm zurufen; ein fröhliches Willkommen!; will|kom|men; - heißen, - sein; herzlich -! Will|kom|mens.gruß, ...trunk

Wil|l|kür *w*; -; Wil|l|kür.akt, ...herr|schaft; wil|l|kür|lich; Wil|l|kür|lich|keit; Wil|l|kür|maß|nah|me (meist *Mehrz.*)

Wil|ly (engl. Kurzform von: William); Wil|m (Kurzform von: Wilhelm); Wil|ma (Kurzform von: Wilhelma); Wil|mar (m. Vorn.)

Wil|pert thüring. (Wildbret) *s*; -[e]s

Will|son [*ilß°n*] (Präsident der USA)

Wil|ster (Ortsn.); Wil|ster|marsch (Marsch nördl. der Niederelbe) *w*; -

Wil|traud, Wil|trud (w. Vorn.)

Wim (Kurzform von: Wilhelm)

Wim|ble|don [*imb°ld°n*] (Villenvorort von London; Austragungsort der inoffiz. Tennisweltmeisterschaften der Amateure)

wim|meln; es wimmelt von Ameisen

wim|men *lat.* schweiz. (Trauben lesen); gewimmt

¹Wim|mer (Knorren; Maser[holz]; auch, bes. südd.: kleines Geschwür, Warze) *m*; -s, -

²Wim|mer *lat.* mdal. (Weinlese) *w*; -, -n; ³Wim|mer mdal. (Winzer) *m*; -s, -

Wim|me|rer (Winseler); Wim|mer|holz (scherzh. ugs. für: Geige, Laute); wim|me|rig

Wim|merl bayr. u. österr. ugs. (Hitze- od. Eiterbläschen) *s*; -s, -n

wim|mern; ich ...ere (↑ R 327); (↑ R 120:) man hört ein leises Wimmern; das ist zum Wimmern (ugs. für: das ist furchtbar, auch für: das ist zum Lachen)

Wim|met *lat.* schweiz. (Weinlese) *m*; -s

Wim|pel (kleine) dreieckige Flagge) *m*; -s, -

Wim|per *w*; -, -n

Wim|perg *m*; -[e]s, -e u. Wim|per|ge (got. Spitzgiebel) *w*; -, -n

Wim|pern|tu|sche

Win|ckel|mann [zur *Trenn.* ↑ R 189] (dt. Altertumsforscher)

wind (veralt. für: verkrümmt), nur noch in: - u. weh (südwestd. u. schweiz. für: jämmerlich zumute, höchst unbehaglich, sterbenselend)

Wind *m*; -[e]s, -e; - bekommen (ugs. für: heimlich, zufällig erfahren); Wind|beu|tel (hohles Gebäck; übertr. ugs. für: leichtfertiger Mensch); Wind|beu|te|lei (ugs.); Wind.bö od. ...böe, ...bruch *m*, ...büch|se (Luftgewehr)

Win|de (Hebevorrichtung; eine Pflanze) *w*; -, -n

Wind|ei (Zool.: Vogelei mit weicher Schale; Med.: abgestorbene Leibesfrucht)

Win|del *w*; -, -n; win|deln (in Windeln wickeln); ich ...[e]le (↑ R 327); win|del|weich (ugs. für: ganz weich)

¹win|den (drehen); du wandest; du wändest; gewunden; wind[e]!; sich -

²win|den (windig sein; wittern); es windet; das Wild windet; Wind.er|hit|zer, Win|des.ei|le (in, mit -), ...flü|gel (auf -n); Wind.fang, ...gal|le (helle Stelle am Himmel, der Sonne in gleicher Höhe gegenüber); wind|ge|schützt; Wind.har|fe, ...hauch, ...ho|se (Wirbelsturm)

Wind|huk (Hptst. von Südwestafrika)

Wind|hund (auch übertr. ugs. für: schneller, leichtfertiger Mensch)

win|dig (winderfüllt; übertr. ugs. für: leer, leichtfertig, prahlerisch) **win|disch** (slowenisch); **Win|di|sche** (Slowene) *m* u. *w*; -n, -n (↑ R 287ff.)

Wind|jacke [*Trenn.*: ...jak|ke], ...**jam|mer** (großes Segelschiff; *m*; -s, -), ...**ka|nal** (an der Orgel), ...**licht** (*Mehrz.* ...lichter), ...**ma|cher** (ugs. für: Wichtigtuer); **Wind|ma|che|rei** (ugs. für: Wichtigtuerei); **Wind_mo|tor**, ...**müh|le**; **Wind|müh|len|flü|gel**; **Wind_pocken** [*Trenn.*: ...pok|ken] (eine Kinderkrankheit; *Mehrz.*), ...**rad**, ...**rich|tung**, ...**rös|chen** (Name verschiedener Anemonen), ...**rose** (Windrichtungs-, Kompaßscheibe), ...**sack** (an einer Stange aufgehängter Beutel, der Verkehrsteilnehmern Richtung u. Stärke des Windes anzeigt); **Winds|braut** (dicht. für: starker, tobender Wind) *w*; -; **Wind|schat|ten** (Leeseite eines Berges; geschützter Bereich unmittelbar hinter einem schnell fahrenden Fahrzeug) *m*; -s **wind|schief** (ugs. für: krumm, verzogen)

wind_schlüp|fig, ...**schnit|tig** (für: aerodynamisch), **Wind|schutz_schei|be**

Wind|sor [*ins*e*r*] (engl. Stadt; Name des engl. Königshauses)

Wind|spiel (kleiner Windhund) **Wind|stär|ke**; **wind|still**; **Wind_stil|le**, ...**stoß**, ...**sucht** (eine Tierkrankheit; *w*; -)

Win|dung

Wind|zug *m*; -[e]s

Win|fried (m. Vorn.)

Win|gert südd., westd. (Weingarten, Weinberg) *m*; -s, -e

Win|golf [*winggolf*] („Freundeshalle" der nord. Mythol.) *m*; -s, -e

Wink *m*; -[e]s, -e

Win|kel *m*; -s, -; **Win|kel_ad|vo|kat** (abwertend), ...**ei|sen**, ...**funk|ti|on** (Math.), ...**ha|ken** (Druckw.), ...**hal|bie|ren|de** (*w*; -n, -n; ↑ R 287ff.); **win|ke|lig**, **wink|lig**; **Win|kel_maß** *s*, ...**mes|ser** *m*; **win|keln**; ich ...[e]le den Arm (↑ R 327); **win|kel|recht** (veralt.)

Win|kel|ried (schweiz. Held)

Win|kel_schrei|ber (abwertend), ...**schu|le** (veralt.), ...**zug** (meist *Mehrz.*)

win|ken; gewinkt; **Win|ker**; **Win|ker|flag|ge**

wink|lig, **win|ke|lig**

Win|ne|tou [...*tu*] (idealisierte Indianergestalt bei Karl May)

Win|ni|peg (kanad. Stadt); **Win|ni|pe|gsee** *m*; -s

Winsch *engl.* (Seemannsspr.: Winde zum Heben schwerer Lasten) *w*; -, -en

Win|se|lei (ugs. für: das Winseln); **Win|se|ler**, **Wins|ler**; **win|seln**; ich ...[e]le (↑ R 327)

Win|ter *m*; -s, -; **Win|ter_an|fang**, **Win|ters_an|fang**; **Win|ter_an_ap|fel**, ...**bau** (das Bauen im Winter; *m*; -[e]s), ...**ein|bruch**, ...**fahr|plan**; **win|ter|fest**; -e Kleidung; **Win|ter_fri|sche** (*w*; -, -n), ...**frucht**, ...**gar|ten**, ...**ger|ste**, ...**ge|trei|de**, ...**ha|fen** (vgl. ²Hafen), ...**ha|fer**, ...**halb|jahr**, ...**käl|te**, ...**kar|tof|fel**, ...**kleid**, ...**kohl**, ...**kol|lek|ti|on** (Mode), ...**korn** (*Mehrz.* ...korne), ...**land|schaft**; **win|ter|lich**; **Win|ter|ling** (eine Pflanze); ¹**Win|ter|mo|nat** (in die Winterzeit fallender Monat); ²**Win|ter_mo|nat** od. ...**mond** (alte dt. Bez. für: Dezember; schweiz. [früher] für: November); **win|tern**; es wintert; **Win|ter_nacht**, ...**obst**, ...**öl**, ...**quar|tier** (meist *Mehrz.*), ...**pau|se**, ...**rei|fen**, ...**rei|se**; **win|ters** (↑ R 129), a b e r: des Winters; **Win|ter_saat**, ...**sa|chen** (Kleidung für den Winter; *Mehrz.*), ...**sai|son**; **Win|ters_an|fang**, **Win|ter_an|fang**; **Win|ter_schlaf**, ...**schluß_ver|kauf**, ...**se|me|ster**, ...**son|nen_wen|de**, ...**spie|le** (die Olympischen -; *Mehrz.*), ...**sport**; **win|ters_über**; a b e r: den Winter über; **Win|ter_zeit** *w*; -; **Win|ter|tag**; **win|ter|taug|lich**

Win|ter|thur (schweiz. Stadt)

Win|zer *m*; -s, -; **Win|zer_ge|nos|sen_schaft**, ...**mes|ser**

win|zig; **Win|zig|keit**

Wip|fel *m*; -s, -; **wip|fe|lig**, **wipf|lig**

wipp! niederd. (schwipp!); **Wip|pe** (Schaukel) *w*; -, -n; **wip|pen**; **Wip|per**; vgl. ¹Kipper (Münzverschlechterer); **wip|pern** landsch. (wackeln, schwanken); ich ...ere (↑ R 327); **Wipp|sterz** landsch. (Bachstelze)

wir (von Herrschern: Wir); - alle, - beide; (↑ R 275.) - bescheidenen Leute; (↑ R 290:) - Armen; - Deutschen (auch: - Deutsche)

Wir|bel *m*; -s, -; **wir|be|lig**, **wirb|lig**; **Wir|bel|los** (Zool.: zusammenfassende Bez. für alle Vielzeller außer den Wirbeltieren) *Mehrz.*; **wir|beln**; ich ...[e]le (↑ R 327); **Wir|bel_säu|le**, ...**sturm** (vgl. ¹Sturm), ...**tier**, ...**wind**; **wir|blig**, **wir|be|lig**

wir|ken (↑ R 120:) sein segensreiches Wirken; **Wir|ker**; **Wir|ke|rei**; **Wir|ke|rin** *w*; -, -nen; **Wirk_kraft** (Wirkungskraft), ...**lei|stung** (Elektrotechnik); **Wirkl.** Geh. Rat = Wirklicher Geheimer Rat; **wirk|lich**; **Wirk|li|che Ge|hei|me Rat** (Abk.: Wirkl.

Geh. Rat) *m*; -n -n -[e]s, -n -n Räte; **Wirk|lich|keit**; **wirk|lich_keits|fern**; **Wirk|lich|keits|form**; **Wirk|lich|keits|fremd**; **Wirk|lich_keits|mensch**; **wirk|lich|keits|nah**; **Wirk|lich|keits|sinn** *m*; -[e]s; er hat viel -; **wirk|sam**; **Wirk|sam_keit** *w*; -; **Wirk|stof|fe** (lebensnotwendige, in kleinsten Mengen im Körper vorkommende Stoffe) *Mehrz.*; **Wir|kung**; **Wir|kungs_be|reich**, ...**feld**, ...**grad**, ...**kraft** *w*, ...**kreis**; **wir|kungs|los**; -este (↑ R 292); **Wir|kungs_lo|sig|keit** (*w*; -), ...**me|cha|nis|mus**; **wir|kungs_reich**, ...**voll**; **Wir|kungs_wei|se** *w*; **Wirk|wa|ren** (gewirkte Waren) *Mehrz.*

wirr; **Wirr_ren** *Mehrz.*; **Wirr|heit** *w*; -; **wir|rig** mdal. (verworren, verwickelt; zornig); **Wirr|kopf** (abwertend); **Wirr|nis** *w*; -, -se; **Wirr_sal** *s*; -[e]s, -e; **Wir|rung**; Irrungen u. Wirrungen; **Wirr|warr** *m*; -s; **wirsch** landsch. (aufgeregt; ärgerlich); -este (↑ R 292)

Wir|sing *it.* *m*; -s u. **Wir|sing|kohl** *m*; -[e]s

Wirt *m*; -[e]s, -e

Wir|tel (Spulenring; Quirl) *m*; -s, -; **wir|tel|för|mig**; **wir|te|lig**, **wirt|lig** (quirlförmig)

wir|ten schweiz. (eine Gastwirtschaft führen); **Wir|tin** *w*; -, -nen; **wirt|lich** (gastlich); **Wirt|lich|keit** *w*; -

wirt|lig vgl. wirtelig

Wirt|schaft; **wirt|schaf|ten**; gewirtschaftet; **Wirt|schaf|ter** (Verwalter); **Wirt|schaf|te|rin** *w*; -, -nen; **Wirt|schaft|ler** (Wirtschaftskundler; leitende Persönlichkeit in Handel u. Industrie); **Wirt_schaft|le|rin** *w*; -, -nen; **wirt|schaft|lich**; **Wirt|schaft|lich|keit** *w*; -; **Wirt|schafts_ab|kom|men**, ...**ab|tei|lung**, ...**auf|schwung**, ...**aus|schuß**, ...**be|ra|ter**, ...**block** (*Mehrz.* ...blöcke od. ...blocks), ...**di|rek|tor**, ...**ge|bäu|de**, ...**ge|biet**, ...**geld**, ...**ge|mein|schaft** (Europäische -; Abk.: EWG), ...**geo_gra|phie**, ...**ge|schich|te** (*w*; -), ...**hoch|schu|le**, ...**jahr**, ...**kam_mer**, ...**kon|fe|renz**, ...**krieg**, ...**kri_se**, ...**la|ge**, ...**le|ben** (*s*; -s), ...**leh_re**, ...**len|kung**, ...**mi|ni|ster**, ...**ord_nung**, ...**po|li|tik**; **wirt_schafts|po_li|tisch**; -ste (↑ R 294); **Wirt_schafts_prü|fer**, ...**prü|fung**, ...**raum**, ...**re|form**, ...**sa|bo|ta|ge**, ...**spio|na|ge**, ...**sy|stem**, ...**teil** (einer Zeitung), ...**theo|rie**, ...**uni_on**, ...**wis|sen|schaft**, ...**wun|der**, ...**zweig**

Wirts_haus; **Wirts|haus|le|ben** *s*; -s; **Wirts_leu|te** (*Mehrz.*), ...**or|ga_nis|mus** (Biol.), ...**pflan|ze**, ...**stu_be**, ...**tier**

Wirz schweiz. (Wirsing) *m*; -es, -e

Wis. = ²Wisconsin

Wisch *m*; -[e]s, -e; wi|schen; du wischst (wischest); Wi|scher (ugs. auch für: Tadel); wisch|fest; wi|schig nordd. (zerstreut, kopflos); Wi|schi|wa|schi (ugs. für: Gewäsch, Unsinn) *s*; -s; Wisch|lappen (landsch.)

Wisch|nu (einer der Hauptgötter des Hinduismus)

Wisch|tuch (*Mehrz.* ...tücher)

¹Wis|con|sin [*"ißkonßin*] (l. Nebenfluß des Mississippis) *m*; -[s]; ²Wis|con|sin (Staat in den USA; Abk.: Wis.)

Wi|sent (Wildrind) *m*; -s, -e

Wis|mut (chem. Grundstoff, Metall; Zeichen: Bi) *s*; -[e]s; wis|mut|ten (von Wismut)

wis|peln landsch. (svw. wispern); ich ...[e]le (↑ R 327); wis|pern (leise sprechen, flüstern); ich ...ere (↑ R 327)

Wiß|be|gier[|de] *w*; -; wiß|be|gie|rig; wis|sen; du weißt, er weiß, ihr wißt; du wußtest; du wüßtest; gewußt; wisse!; (altertümelnd:) jmdm. etwas kund u. zu - tun; wer weiß!; Wis|sen *s*; -s; meines -s (Abk.: m. W.) ist es so; wider besseres -; wider - u. Willen; ohne -; Wis|sen|de (Eingeweihte[r]) *m* u. *w*; -n, -n (↑ R 287ff.); Wis|sen|schaft; Wis|sen|schaf|ter (schweiz., sonst veralt., österr. amtl. für: Wissenschaftler); Wis|sen|schaft|ler; wis|sen|schaft|lich; (↑ R 224:) Wissenschaftlicher Rat (Titel); Wis|sen|schaft|lich|keit *w*; -; Wis|sen|schafts_be|griff, ...be|trieb (*m*; -[e]s), ...rat (*Mehrz.* ...räte); Wis|sens_drang (*m*; -[e]s), ...dün|kel, ...durst; wis|sens|dur|stig; Wis|sens_ge|biet, ...spei|cher, ...stoff (*m*; -[e]s), ...trieb; wis|sens|wert; wis|sent|lich

Wiß|mann (dt. Afrikaforscher)

wißt! (Fuhrmannsruf: links!)

Wit|frau (veralt.); Wi|tib, (österr.:) Wit|tib (veralt. für: Witwe) *w*; -, -e; Wit|mann (*Mehrz.* ...männer; österr.:) Wit|ti|ber (veralt. für: Witwer)

Wi|told (m. Vorn.)

Wit|te|kind (m. Vorn.) Widukind

Wit|tels|bach (oberbayr. Stammburg); Haus - (Herrschergeschlecht); Wit|tels|ba|cher (Angehöriger eines dt. Herrschergeschlechtes) *m*; -s, -

Wit|ten|berg (Stadt an der mittleren Elbe); Wit|ten|ber|ge (Stadt im Bezirk Schwerin); Wit|ten|ber|ger (von Wittenberg od. Wittenberge) ↑ R 199; wit|ten|ber|gisch (von Wittenberg od. Wittenberge), aber (↑ R 224:) die

Wittenbergische Nachtigall (Bez. für: Luther)

wit|tern (dem Geruche nachspüren, bemerken; gewittern); ich ...ere (↑ R 327); Wit|te|rung; Wit|te|rungs_ein|fluß, ...um|schlag, ...ver|hält|nis|se (*Mehrz.*)

Witt|gen|stein (österr. Philosoph)

Wit|tib vgl. Witib; Wit|ti|ber vgl.

Witmann

Witt|ling (ein Fisch)

Witt|rung (Jägerspr.: das Wittern u. der vom Wild wahrzunehmende besondere Geruch, z. B. auch eines Köders)

Wit|tum (veralt. für: [der überlebenden Gattin] „gewidmetes Gut") *s*; -[e]s, ...tümer

Wit|we (Abk.: Wwe.) *w*; -, -n; Wit|wen_geld, ...ren|te, ...schaft, ...schlei|er, ...tum (*s*; -s); Wit|wer; Wit|wer_schaft, ...tum (*s*; -s)

Witz *m*; -es, -e; Witz_blatt, ...blatt|fi|gur, ...bold (*m*; -[e]s, -e); Wit|ze|lei; wit|zeln; ich ...[e]le (↑ R 327); Witz|fi|gur (abschätzig); wit|zig; Wit|zig|keit; witz|los; -este (↑ R 292); witz|sprü|hend; eine - Rede, aber (↑ R 142): von od. vor Witz sprühend; Witz|wort (*Mehrz.* ...worte)

WK = Wiederholungskurs (vgl. d.)

w. L. = westlicher Länge

Wla|di|mir [auch: *wlg...*] (m. Vorn.); Wla|dis|laus, Wla|dis|law (m. Vorn.); Wla|di|wo|stok [auch ...*woß...*] (Stadt in der UdSSR)

WNW = Westnordwest[en]

wo; wo ist er?; wo immer er auch sein mag; er wird immer hin, wo er hergekommen ist; der Tag, wo (an dem) er sie das erstemal sah; (↑ R 119:) das Wo spielt keine Rolle; vgl. woanders, woher, wohin, wohinaus, womöglich, wo nicht

w. o. = wie oben

WO = Wechselordnung

wo|an|ders (irgendwo sonst; an einem anderen Ort); ich werde ihn woanders suchen, aber: wo an|ders (wo sonst) als hier sollte ich ihn suchen?; wo|an|ders|hin

wob|beln (Rundf.: Frequenzen verschieben); die Welle wobbelt; Wob|bel|span|nung

wo|bei

Wo|che *w*; -, -n; Wo|chen_bett, ...blatt, ...en|de; Wo|chen|end|haus; Wo|chen|end|ler; Wo|chen|kar|te; wo|chen|lang; aber: fünf, viele Wochen lang; Wo|chen_lohn, ...markt, ...schau, ...spiel|plan, ...tag; wo|chen|tags (↑ R 129), aber: des Wochentags; wö|chent|lich (jede Woche); ...wö|chent|lich (z. B. dreiwöchentlich [alle drei Wochen wiederkeh-

rend]; mit Ziffer: 3wöchentlich; ↑ R 228); wo|chen|wei|se; Wo|chen_zei|tung; ...wo|chig vgl. ...wöchig; ...wö|chig (z. B. dreiwöchig [drei Wochen alt, dauernd]; mit Ziffer: 3wöchig; ↑ R 228); Wöch|ne|rin *w*; -, -nen

Wocken [*Trenn.:* Wok|ken] niederd. (Rocken) *m*; -s, -

Wol|dan (höchster germ. Gott); vgl. Odin u. Wotan

Wod|ka *russ.* („Wässerchen"; Branntwein) *m*; -s, -s

wo|durch; wo|fern; wo|für

Wo|ge *w*; -, -n

wo|gen

wo|gen; Wo|gen_prall, ...schlag

wo|her; woher er kommt, weiß ich nicht; er geht wieder hin, woher er gekommen ist, aber: er geht wieder hin, wo er hergekommen ist; wo|her|um; wo|hin; ich weiß nicht, wohin er geht; sieh, wohin er geht, aber: sieh, wo er hingeht; wo|hin|auf; wo|hin|aus; ich weiß nicht, wohinaus du willst, aber: ich weiß nicht, wo du hinauswillst; wo|hin|ein; wo|hin|ge|gen; wo|hin|ter; wo|hin|un|ter

wohl; besser, best u. wohler, wohlste; wohl ihm!; wohl od. übel (ob er wollte od. nicht) mußte er zuhören; das ist wohl das beste; leben Sie wohl!; wohl bekomm's!; ich bin wohl; mir ist wohl, wohler, am wohlsten; wohl sein (vgl. d.); sich wohl fühlen; es ist mir immer wohl ergangen; er wird es wohl (wahrscheinlich) tun; vgl. aber: wohltun; er wird es wohl (wahrscheinlich) wollen, vgl. aber: wohlwollen; gleichwohl; obwohl; sowohl; wiewohl; Wohl *s*; -[e]s; auf dein - !; aufs - !; zum - !

wohl|an!; wohl|an|stän|dig; eine -e Gesellschaft; Wohl|an|stän|dig|keit *w*; -; wohl|auf!; wohlauf sein; wohl|aus|ge|wo|gen

wohl|be|dacht; ein -er Plan; Wohl_be|fin|den, ...be|ha|gen

wohl|be|hal|ten; er kam -an

wohl|be|kannt; (↑ R 296:) besser bekannt, bestbekannt; ein -er Vorgang

wohl|be|ra|ten

wohl|be|stallt; ein -er Beamter

wohl|durch|dacht

wohl|er|fah|ren; ein -er Mann

Wohl_er|ge|hen *s*; -s

wohl|er|hal|ten

wohl|er|wo|gen; ein -er Plan

wohl|er|wor|ben; -e Rechte

wohl|er|zo|gen; ein -es Kind; Wohl|er|zo|gen|heit *w*; -

Wohl_fahrt *w*; -; Wohl|fahrts_mar|ke, ...pfle|ge, ...staat, ...theo|rie

wohl|feil; -er, -ste; eine -e Ware

wohl|ge|baut; die -e Stadt

wohl|ge|bo|ren (veralt.)

Wohl|ge|fal|len s; -s; wohl|ge|fäl-
lig; -er, -ste; er hat dieses Werk
- betrachtet
wohl|ge|formt
Wohl|ge|fühl s; -[e]s
wohl|ge|lit|ten; -er, -ste (↑ R 294);
er ist wegen seiner Hilfsbereit-
schaft -
wohl|ge|meint; -er Rat
wohl|ge|merkt!
wohl|ge|mut; -er, -este (↑ R 292);
er ist immer -
wohl|ge|nährt
wohl|ge|ord|net
wohl|ge|ra|ten; -er, -ste (↑ R 294);
ein -es Werk
Wohl|ge|ruch, ...ge|schmack
wohl|ge|setzt; in -en Worten
wohl|ge|sinnt; -er, -este (↑ R 292);
er ist mir -
wohl|ge|stalt (von Natur aus); ein
-er Mensch; wohl|ge|stal|tet (von
Menschenhand); -er, -ste (↑ R
294); eine -e Form
wohl|ge|tan; die Arbeit ist -; vgl.
wohltun
wohl|ha|bend; -er, -ste (↑ R 294);
er ist -; Wohl|ha|ben|heit w; -
wohl|lig; ein -es Gefühl; Wohl|lig-
keit w, -
Wohl|klang m; -[e]s; wohl|klin-
gend; -er, -ste (↑ R 294); -e Töne
Wohl|laut; wohl|lau|tend; -er, -ste
(↑ R 294); -e Lieder
Wohl|le|ben s; -s
wohl|mei|nend; -er, -ste (↑ R 294);
er ist -
wohl|rie|chend; -er, -ste (↑ R 294);
-e Blumen
wohl|schmeckend [Trenn.:
...schmek|kend]; -er, -ste (↑ R
294); eine -e Speise
wohl sein; laß es dir wohl sein!;
Wohl|sein s; -s; zum -!
wohl|si|tu|iert
Wohl|stand m; -[e]s; im - leben;
Wohl|stands.ge|sell|schaft, ...kri-
mi|na|li|tät, ...müll, ...ver|wahr-
lo|sung
Wohl|tat, ...tä|ter, ...tä|te|rin;
wohl|tä|tig; -er, -ste; ein - er
Mann; Wohl|tä|tig|keit; Wohl|tä-
tig|keits.ba|sar, ...ver|an|stal-
tung, ...ver|ein
Wohl|tem|pe|rier|te Kla|vier (die
von J. S. Bach so genannte
Sammlung von zweimal 24 Prä-
ludien u. Fugen in allen Tonarten
für Klavier mit temperierter
Stimmung) s; -n -s
wohl|tu|end (angenehm); -er, -ste
(↑ R 294); die Ruhe ist -; wohl|tun;
↑ R 139 (angenehm sein; Wohlta-
ten erweisen); ich tue wohl (↑ R
132); das hat mir, er hat vielen
wohlgetan; wohlzutun; jmdm.
wohltun; aber: wohl tun (wahr-
scheinlich tun); er wird es wohl
tun; Wohl|tun s; -s

wohl|über|legt; (↑ R 296:) besser
überlegt, bestüberlegt; ein -er
Plan
wohl|un|ter|rich|tet; (↑ R 296:) bes-
ser unterrichtet, bestunterrich-
tet; ein -er Mann
wohl|ver|dient
Wohl|ver|hal|ten
Wohl|ver|leih (Arnika) m; -[e]s, -[e]
wohl|ver|sorgt; (↑ R 296:) besser
versorgt, bestversorgt; eine -e Fa-
milie
wohl|ver|stan|den; ein -es Wort
wohl|ver|wahrt; (↑ R 296:) besser
verwahrt; bestverwahrt; ein -es
Kind
wohl|wei|se (veraltend für: sehr
weise; überlegt); ein -r Plan; wohl-
weis|lich; er hat sich - gehütet
wohl|wol|len (↑ R 139); er will mir
wohl; er hat mir stets wohlge-
wollt; wohlzuwollen; aber: wohl
wol|len (wahrscheinlich wollen);
er wird es wohl wol|len; Wohl-
wol|len s; -s; wohl|wol|lend; -er,
-ste; eine -e Gesinnung
Wohn|bau (Mehrz. ...bauten),
...block (Mehrz. ...blocks),
...dich|te, ...die|le, ...ein|heit, woh-
nen; Wohn|ge|bäu|de; wohn|haft
(wohnend); Wohn_haus, ...heim,
...kü|che, ...kul|tur (w; -), ...la|ge;
wohn|lich; Wohn|lich|keit w; -;
Wohn_ort, ...raum; Wohn_raum-
_be|schaf|fung, ...be|wirt|schaf-
tung; Wohn_sitz, ...stät|te, ...stu-
be, ...turm; Woh|nung; Woh-
nungs_amt, ...bau (m; -[e]s),
...bau|ge|nos|sen|schaft, ...be|set-
zer, ...fra|ge, ...geld; woh|nungs-
los, Woh|nungs_markt, ...not,
...su|che; woh|nung[s]|su|chend;
Woh|nung[s]|su|chen|de m u. w;
-n, -n (↑ R 287ff.); Woh|nungs-
_tausch, ...tür, ...wech|sel,
...zwangs|wirt|schaft; Wohn_vier-
tel, ...wa|gen, ...zim|mer
Wöhr|de niederd. (um die Wohn-
haus gelegenes Ackerland) w; -,
-n
Woi|lach russ. [weu...] (wollene
[Pferde]decke, Sattelunterlage)
m; -s, -e
Woi|wod, Woi|wo|de poln. [weu...]
(„Heerführer"; früher: Fürst;
heute: oberster Beamter einer
poln. Provinz, Statthalter) m;
...den, ...den (↑ R 268); Woi|wod-
schaft (Amt[sbezirk] eines Woi-
woden)
wöl|ben; sich -; Wöl|bung
Wol|de|mar vgl. Waldemar
¹Wolf (Kurzform von: Wolfgang,
Wolfhard, Wolfram)
²Wolf, Hugo (österr. Komponist)
³Wolf (ein Raubtier) m; -[e]s, Wöl-
fe; Wölf|chen, Wölf|lein
Wolf|diet|rich [auch: wolf...] (m.
Eigenn.)

wöl|fen (von Wolf u. Hund: gebä-
ren)
Wolf|gang (m. Vorn.); Wolf|gang-
see m; -s; vgl. Sankt-Wolfgang-
See; Wolf|hard (m. Vorn.)
Wöl|fin w; -, -nen; wöl|fisch; Wölf-
lein, Wölf|chen; Wölf|ling (jun-
ger Pfadfinder)
¹Wolf|ram (m. Vorn.)
²Wolf|ram (chem. Grundstoff,
Metall; Zeichen: W) s; -s; Wolf-
ra|mit (Wolframerz) s; -s
Wolf|ram-von-Eschen|bach-Aus-
ga|be (↑ R 182)
Wolfs_gru|be (überdeckte Grube
zum Fangen von Wölfen), ...hun-
ger (ugs. für: großer Hunger),
...milch (eine Pflanze), ...spitz
(Hund einer bestimmten Rasse),
...ra|chen (angeborene Gaumen-
spalte), ...schlucht
Wol|ga (russ. Strom) w; -
Wol|go|grad (russ. Stadt; früher:
Stalingrad)
Wo|lhy|ni|en usw. vgl. Wolynien
usw.
Wölk|chen, Wölk|lein; Wol|ke w;
-, -n; wöl|ken; sich -; Wol|ken-
_bruch m, ...decke [Trenn.: ...dek-
ke] (w; -), ...krat|zer (Hochhaus);
Wol|ken|kuckucks|heim [Trenn.:
...kuk|kucks...] (Luftgebilde,
Hirngespinst) s; -[e]s; wol|ken|los;
Wol|ken|wand w; -; Wölk|ping;
Wölk|lein, Wölk|chen
Wollap|pen [Trenn.: Woll|lap...,
↑ R 236] m; -s, -; Wollaus [Trenn.:
Woll|laus, ↑ R 236] w; -, ...läuse;
Woll|decke [Trenn.: ...dek|ke];
Wol|le w; -, - (für: Wollarten auch
Mehrz.:) -n; ¹wol|len (aus Wolle)
²wol|len; ich will, du willst; du
wolltest (Indikativ); du wolltest
(Konjunktiv), gewollt; wolle!; ich
habe das nicht gewollt, aber (↑ R
305): ich habe helfen wollen
wöl|len (Jägerspr.: das Gewölle
auswerfen)
Woll_garn, ...ge|we|be, ...haar,
...han|del; Woll|hand|krab|be;
wol|lig
Wol|lin (eine Ostseeinsel)
Woll_käm|mer; Woll|käm|me|rei;
Woll_kleid, ...knäu|el, ...markt;
Woll|spin|ne|rei; Woll_stoff,
...tuch (Mehrz. ...tuche u. ...tü-
cher; vgl. Tuch)
Woll_lust w; -, Wollüste; wol|lü|stig;
Woll|lüst|ling
Woll|wa|ren Mehrz.
Wo|ly|ni|en [...i'n] (ukrain. Land-
schaft); wo|ly|nisch; -es Fieber
(Fünftagefieber)
Wol|zo|gen (Adelsgeschlecht)
Wom|bat austral. (austral. Beutel-
tier) m; -s, -s
wo|mit; wo|mög|lich; womöglich
(vielleicht) kommt er, aber: wo
möglich (wenn es irgendwie

möglich ist)[,] kommt er; **wo-nach; wo|ne|ben; wo nicht;** er will ihn erreichen, wo nicht übertreffen

Won|ne w; -, -n; **Won|ne_ge|fühl,** ...**mo|nat** od. ...**mond** (für: Mai), ...**prop|pen** (landsch. für: niedliches, wohlgenährtes [Klein]-kind; m; -s, -); **won|ne|sam** (veralt.); **won|ne|trun|ken; won|ne-voll; won|nig; won|nig|lich** (veralt.)

Woog mdal. (Teich; tiefe Stelle im Fluß) m; -[e]s, -e

wor|an; wor|auf; wor|auf|hin; woraus

¹**Worb** m; -[e]s, Wörbe u. ²**Worb, Wor|be** (Handhabe am Sensenstiel) w; -, ...ben

Worce|ster|so|ße [ˈuβtˤr...]; ↑ R 201 (nach der engl. Stadt Worcester benannte scharfe Würztunke)

wor|ein

wor|feln (Getreide reinigen); ich ...[e]le (↑ R 327); **Worf|schau|fel** (bibl.)

Wörgl (österr. Stadt)

wor|in

Wör|litz (Ortsn.); Wörlitzer Park

Worms (Stadt am Rhein); **Worm-ser**(↑ R 199); - Konkordat; **worm-sisch**

Worps|we|de (Ort im Teufelsmoor, nördl. von Bremen)

Wort s; -[e]s, Wörter u. Worte; *Mehrz.* Wörter für: Einzelwort od. vereinzelte Wörter ohne Rücksicht auf den Zusammenhang, z. B. Fürwörter; dies Verzeichnis enthält 100 000 Wörter; *Mehrz.* Worte für: Äußerung, Ausspruch, Beteuerung, Erklärung, Begriff, Zusammenhängendes, z. B. Begrüßungsworte; auch für bedeutsame einzelne Wörter, z. B. drei Worte nenn' ich euch, inhaltsschwer; mit ander[e]n -en (Abk.: m. a. W.); mit guten, mit wenigen -en; dies waren seine [letzten] -e; ich will nicht viel[e] -e machen; geflügelte, goldene -e; aufs -; - für -; von - zu -; - halten; beim -[e] nehmen; er will es nicht - haben (veraltend für: nicht zugestehen), daß ...; zu -[e] kommen; **Wort_art,** ...**auf-wand,** ...**aus|wahl,** ...**be|deu|tung;** **Wort|be|deu|tungs|leh|re** (für: Semasiologie) w; -; **Wort_bild,** ...**bil-dung,** ...**bruch; wort|brü|chig; Wört|chen,** Wört|lein; **Wor|te-ma|cher** (abschätzig); **Wor|te-ma|che|rei** (abschätzig); **Wör|ter-_buch,** ...**ver|zeich|nis; Wort_fa-mi|lie,** ...**feld,** ...**fet|zen,** ...**fol|ge,** ...**form,** ...**for|schung,** ...**fü|gung,** ...**füh|rer,** ...**ge|fecht,** ...**ge|klin|gel** (abschätzig), ...**geo|gra|phie,**

...**ge|schich|te; wort_ge|schicht-lich,** ...**ge|treu**

Wör|ther See m; - -s, (auch:) **Wör-ther|see** (See in Kärnten) m; -s **Wörth|see** (See im oberbayr. Alpenvorland) m; -s

wort|karg; Wort_karg|heit (w; -), ...**klau|ber** (abschätzig); **Wort-klau|be|rei** (abschätzig); **Wort-_kreu|zung** (für: Kontamination), ...**laut** (m; -[e]s), ...**leh|re;** **Wört|lein,** Wört|chen; **wört|lich;** -e Rede; **wort|los; Wort_mel-dung,** ...**re|gi|ster; wort|reich; Wort_reich|tum** (m; -s), ...**schatz** (m; -es), ...**schöp|fung,** ...**schwall** (m; - [e]s), ...**sinn,** ...**spiel,** ...**stamm,** ...**streit,** ...**wech|sel; wort|wört|lich** (Wort für Wort); **Wort_zei|chen** (als Warenzeichen schützbares Emblem), ...**zu|sam-men|set|zung**

wor|über; wor|um; ich weiß nicht, - es sich dabei gehandelt hat; **wor|un|ter; wo|selbst**

Wo|tan (Nebenform von: Wodan)

Wo|tru|ba, Fritz (österr. Bildhauer)

wo|von; vo|vor; wo|zu; wo|zwi-schen

Woy|zeck [*weuzäk*] (Titel[held] eines Dramenfragments von G. Büchner; **Woz|zeck** (Titel[held] einer Oper nach A. Berg)

wrack (Seemannsspr.: beschädigt, ausbesserungsbedürftig; allg. für: unbrauchbar, nicht mehr ausbesserungsfähig; Kaufmannsspr.: schlecht [von der Ware]); - werden; **Wrack** (gestrandetes od. [in beschädigtem Zustand] hilflos treibendes, auch altes Schiff; auch übertr. für: gesundheitlich heruntergekommener Mensch) s; -[e]s, -s (selten: -e)

Wra|sen niederd. (Brodem) m; -s

wricken [*Trenn.:* wrik|ken] und **wrig|geln;** ich ...[e]le (↑ R 327) und **wrig|gen** niederd. (ein Boot durch einen am Heck hin u. her bewegten Riemen fortbewegen)

wrin|gen (nasse Wäsche auswinden); du wrangst (wrangest); du wrängest; gewrungen; wringe[e]!

Wro|claw [*wrọzʷaf*] (poln. Name von: Breslau)

Wru|ke [auch: *wrụkˤ*] nordostd. (Kohlrübe) w; -, -n

Ws = Wattsekunde

WSW = Westsüdwest[en]

Wu|cher m; -s; **Wu|che|rei; Wu-che|rer; Wu|che|rin** w; -, -nen; **wu-che|risch; -ste** (↑ R 294); **wu|chern;** ich ...ere (↑ R 327); **Wu|cher|preis;** vgl. ²Preis; **Wu|cher|tum** s; -s; **Wu-che|rung; Wu|cher|zin|sen** *Mehrz.*

Wuchs m; -es; ...**wüch|sig** (z. B. ur-

wüchsig); **Wuchs|stoff** (hormonartiger, das Wachstum der Zellen fördernder Stoff)

Wucht w; -; **Wucht|baum** landsch. (Hebebaum); **wuch|ten** (ugs. für: schwer heben); **wuch|tig; Wuch-tig|keit** w; -

Wühl|ar|beit; wüh|len; Wüh|ler; Wüh|le|rei (ugs. für: ständiges Wühlen, Aufhetzen); **wüh|le-risch; -ste** (↑ R 294); **Wühl|maus** **Wuhn**ne vgl. Wune

Wuhr s; -[e]s, -e u. **Wuh|re** bayr. u. aleman. (²Wehr; Buhne) w; -, -n; **Wuhr|baum**

Wul|fe|nit (ein Mineral) s; -s

Wul|fi|la vgl. Ulfilas

Wulst m; -es, Wülste od. w; -, Wülste; **Wülst|chen, Wülst|lein; wul-stig; Wulst|ling** (ein Pilz)

wum|mern (ugs. für: dumpf dröhnen); es wummert

wund; - sein, werden; sich - laufen, reiben; sich den Mund - reden; vgl. aber: wundliegen; **Wund-arzt** (veralt.); **wund|ärzt|lich** (veralt.); **Wund|brand; Wun|de** w; -, -n

wun|der vgl. Wunder; **Wun|der** s; -s, -; - tun, wirken; kein -; was -, wenn ...; du wirst dein blaues - erleben; er glaubt, wunder was getan zu haben; er glaubt, wunder[s] wie geschickt er sei; **wun-der|bar; wun|der|ba|rer|wei|se; Wun|der_blu|me,** ...**dok|tor,** ...**glau|be; wun|der|gläu|big; wun-der|hold** (veralt. dicht.); **wun|der-hübsch; Wun|der_ker|ze,** ...**kind,** ...**kraft** w, ...**kur; wun|der|lich** (eigenartig); **Wun|der|lich|keit; wun|der|mild** (veralt. dicht.); **Wun|der|mit|tel** s; **wun|dern;** es wundert mich, daß ...; mich wundert, daß ...; sich -; ich ...ere mich (↑ R 327); es nimmt mich wunder (↑ R 132); es nimmt mich wunder (schweiz. auch für: ich möchte wissen); es hat dich wundergenommen, braucht dich nicht wunderzunehmen; **wun|ders** vgl. Wunder; **wun|der|sam; wun|der-schön; Wun|der_sucht** (w; -), ...**tat,** ...**tä|ter,** ...**tier** (scherzh. ugs. auch vom Menschen), ...**tü|te; wun-der|voll; Wun|der|werk**

Wund_fie|ber, ...**in|fek|ti|on; wund-lie|gen,** sich; **Wund_mal** (s; -[e]s, -e), ...**sal|be,** ...**starr|krampf**

Wundt (dt. Psychologe u. Philosoph)

Wu|ne, Wuh|ne (ins Eis gehauenes Loch) w; -, -n

Wunsch m; -[e]s, Wünsche; **wünsch|bar** schweiz. (wünschenswert); **Wünsch|bild,** ...**den|ken** (s; -s); **Wün|schel|ru|te; wün|schen;** du wünschst (wünschest); **wün-schens|wert; Wunsch|form;**



Xe

766

(Längeneinheit für Röntgenstrahlen)

Xe = chem. Zeichen für: Xenon

Xe|nia (w. Vorn.)

Xe̱|nie gr. [...iᵉ] w; -, -n u. Xe̱|ni|on [auch: xẹn...] („Gastgeschenk"; kurzes Sinngedicht) s; -s, ...ien [...iᵉn]; Xe|no|kra|tie (selten für: Fremdherrschaft) w; -, ...ien; Xe̱non (chem. Grundstoff, Edelgas; Zeichen: Xe) s; -s

Xe|no̱|pha|nes (altgr. Philosoph)

Xe̱|no|phon (altgr. Schriftsteller); xe|no|pho̱n|tisch; -er Stil, aber (↑ R 179): Xe|no|pho̱n|tisch; -e Schriften

Xe̱|res usw. vgl. Jerez usw.

Xe|ro|gra|phie̱ gr. (Druckw.: ein in den USA erfundenes „Trokkendruck"- u. Vervielfältigungsverfahren) w; -, ...ien; xe|ro|gra̱phisch; Xe|ro|ko|pie̱ (xerographisch hergestellte Kopie) w; -, ...ien; xe|ro|ko|pie̱|ren; xe|ro|phi̱l (von Pflanzen: die Trockenheit liebend); Xe|ro|phyt (an trockene Standorte angepaßte Pflanze) m; -en, -en (↑ R 268)

Xe̱r|xes (Perserkönig)

x-fach (Math.: x-mal so viel); ↑ R 149; X-fa̱|che; ↑ R 149 (übertr. für: das unbestimmte Vielfache) s; -n (↑ R 287ff.); vgl. Achtfache

X-Ha̱|ken; ↑ R 149 (Aufhängehaken für Bilder)

Xi (gr. Buchstabe: Ξ, ξ) s; -[s], -s

x-mal (↑ R 149)

X-Strah|len; ↑ R 149 (Röntgenstrahlen) Mehrz.

x-te (↑ R 149); x-te Potenz; zum x-tenmal, aber: zum x-ten Male

Xy|lo|gra̱ph gr. (Holzschneider) m; -en, -en (↑ R 268); Xy|lo|gra̱phie̱ (Holzschneidekunst) w; -, (für: Holzschnitt auch Mehrz.:) ...ien; xy|lo|gra̱|phisch (in Holz geschnitten); Xy|lo̱l gr.; arab. (ein Lösungsmittel) s; -s; Xy|lo|lith⍟ gr. (Steinholz, ein Kunststein) m; -s od. -en, -e[n] (↑ R 268); Xy|lo|me̱|ter (Holzmesser) s; -s, -; Xy|lo|pho̱n (ein Musikinstrument) s; -s, -e; Xy|lo̱|se (Holzzucker) w; -

Y

(Selbstlaut u. Mitlaut)

Y [ü̱pßilon; österr. auch (als math. Unbekannte nur): üpßi̱lon] (Buchstabe); das Y; desY, die Y, aber: das y in Mayen od. Doyen (↑ R 123); der Buchstabe Y, y

Y (Bez. für eine veränderliche od. unbekannte math. Größe)

Y = chem. Zeichen für: Yttrium

¥ = Yen

Y, υ = ²Ypsilon

y., yd. = Yard

y-Ach|se; ↑ R 149 (Math.: Ordinatenachse im [rechtwinkligen] Koordinatensystem)

Ya̱cht vgl. Jacht

Ya̱k vgl. Jak

Ya|ma|shi̱|ta [...schi̱ta; nach dem jap. Kunstturner Yamashita] (bestimmter Sprung am Langpferd) m; -[s], -s

Ya̱ms|wur|zel vgl. Jamswurzel

Yan|kee amerik. [jängki] (Spitzname für den US-Amerikaner) m; -s, -s; Yan|kee-doodle [jängki-du̱dl] ([früheres] Nationallied der US-Amerikaner) m; -[s]; Yankee|tum s; -s

Ya̱rd engl. (angelsächs. Längenmaß; Abk.: y. od. yd., Mehrz. yds.) s; -s, -s; 5 -[s] (↑ R 322)

Yawl engl. [jå̱l] (zweimastiges [Sport]segelfahrzeug) w; -, -e u. -s

Yb = chem. Zeichen für: Ytterbium

¹Ybbs [ü̱pß] (r. Nebenfluß der Donau) w; -; ²Ybbs an der Do̱|nau (österr. Stadt)

Y-Chro|mo|som; ↑ R 149 (geschlechtsbestimmendes Chromosom)

yd., y. = Yard; yds. = Yards

Yel|low|stone-Na̱|tio|nal|park [jålo̱ᵘßto̱ᵘn...] m; -[e]s

Ye̱n jap. (Währungseinheit in Japan; 1 Yen = 100 Sen; Abk.: ¥) m; -[s], -[s]; 5 - (↑ R 322)

Ye̱|ti nepal. (vermuteter Schneemensch im Himalajagebiet) m; -s, -s

Yg̱g|dra|sil (nord. Mythol.: Weltesche, Weltbaum)

Yip|pie amerik. [jipi] (aktionistischer, ideologisch radikalisierter Hippie) m; -s, -s

Ylang-Ylang-Öl malai.; dt. [ilang-ilang...] (Öl eines trop. Baumes [als Duftstoff verwendet]) s; -[e]s

Y-Li|nie (↑ R 149)

YMCA [wai äm ßi e̱ᶦ] = Young Men's Christian Association [jang mäns krißtᶦᵉn eßoᵘßiᶦschᶜn] (Christlicher Verein Junger Männer)

Y̱mir (nord. Mythol.: Ahnherr der Reifriesen)

Yo̱|ga, Yo̱|gi vgl. Joga, Jogi

Yo̱|ghurt vgl. Joghurt

Yo̱|gin vgl. Jogin

Yo|him|bin Bantuspr. (Alkaloid aus der Rinde eines westafrik. Baumes) s; -s

Yo|ko|ha̱|ma (engl. u. postamtl. Schreibung für: Jokohama)

Yo̱nne [jon] (l. Nebenfluß der Seine)

Yo̱rck von Wa̱r|ten|burg (preuß. Feldmarschall)

Yo̱rk (engl. Stadt u. Grafschaft)

Young|plan [jang...]; nach dem amerik. Finanzmann Owen Young]; ↑ R 180 (Plan zur Regelung der dt. Reparationen 1930 bis 1932)

Yo-Yo̱ vgl. Jo-Jo

Ypern (belg. Stadt)

¹Yp|si̱|lon [üpßi̱lon]; vgl. Y (Buchstabe); ²Yp|si̱|lon (gr. Buchstabe: Y, υ) s; -[s], -s; ³Yp|si̱lon s; -s, -s u. Yp|si̱|lon|eu|le (Nachtschmetterling) w; -, -n

Ysop semit. [i̱sop] (eine Heil- u. Gewürzpflanze des Mittelmeergebietes) m; -s, -e

Ytong ⍟ (dampfgehärteter Porenbeton, Leichtkalkbeton) m; -s, -s

Yt|ter|bi|um [nach dem schwed. Ort Ytterby] (chem. Grundstoff, seltene Erde; Zeichen: Yb) s; -s

Yt|ter|er|den (seltene Erden, die hauptsächlich in den Erdmineralien von Ytterby vorkommen) Mehrz.; Yt|tri|um (chem. Grundstoff, seltene Erde; Zeichen: Y) s; -s

Yu̱|an chin. (Währungseinheit der Volksrepublik China) m; -[s], -[s]; 5 - (↑ R 322)

Yu|ca|tán [jukatan] vgl. Yukatan

Yuc|ca span. [juka] (Palmlilie) w; -, -s

Yu̱|ka|tan, (offz. Landesschreibung:) Yu|ca|tán [jukatan] (mex. Halbinsel u. Staat)

¹Yu̱|kon (nordamerik. Fluß) m; -; ²Yu̱|kon (Territorium von Kanada); Yu̱|kon-Ter|ri|to|ri|um s; -s

Yun, Isang (korean. Komponist)

Yver|don [iwärdong, schweiz.: iwärdong] (schweiz. Stadt)

Yvonne [iwon] (w. Vorn.)

YWCA [wai dablju bi eᶦ] = Young Women's Christian Association [jang ᵘimᶜns krißtᶦn eßoᵘßieᶦschᶜn] (Christlicher Verein Junger Mädchen)

Z

Vgl. auch C und K

Z (Buchstabe); das Z; des Z, die Z, aber: das z in Gazelle (↑ R 123); der Buchstabe Z, z; von A bis Z (vgl. A)

Z, ζ = Zeta

Z. = Zahl; Zeile

Za|cha̱|ri|as (m. Vorn.); vgl. Sacharja

Za|chä|us (bibl. Eigenn.)

za̱ck!; zack, zack!; Zäck|chen, Zäck|lein; Za̱cke¹ w; -, -n (Spit-

¹ Trenn.: ...ak|k...

ze); zacken¹ (mit Zacken versehen); gezackt; Zacken¹ (bes. südd., österr. Nebenform von: Zacke) m; -s, -; zacken|ar|tig¹; Zacken¹.kro|ne, ...li|nie zackern¹ südwestd., westmitteld. („zu Acker fahren"; ackern); ich ...ere (↑ R 327)

zackig¹ (ugs. auch für: schneidig; Zackig|keit¹ w; -; Zäck|lein, Zäck|chen; zack, zack!

zag (dicht. für: scheu)

Za|gel mdal. (Schwanz, Büschel) m, -s, -

za|gen (geh.); zag|haft; Zag|haf|tig|keit w; -; Zag|heit (geh.) w; -

Za|greb vgl. Agram

zäh; zäher, am zäh[e]sten (↑ R 134); Zä|heit (↑ R 163); zäh|flüs|sig; Zäh|flüs|sig|keit w; -; Zä|hig|keit w; -

Zahl (Abk.: Z.) w; -, -en; natürliche Zahlen (Math.); Zähl|ap|pa|rat; zahl|bar (zu [be]zahlen); zähl|bar (was gezählt werden kann); Zähl-brett

zäh|le|big

zah|len; er hat pünktlich gezahlt (häufig auch: bezahlt); Lehrgeld -; zäh|len; bis drei -; Zah|len|an|ga|be, ...fol|ge, ...ge|dächt|nis, ...grö|ße, ...lot|te|rie, ...lot|to; zah|len|mä|ßig; Zah|len|ma|te|ri|al, ...my|stik, ...rei|he, ...sy|stem, ...to|to; Zah|ler; Zäh|ler; Zahl-gren|ze; Zähl|kam|mer (Glasplatte mit Netzeinteilung zum Zählen von Blutkörperchen); Zahl.kar|te, ...kell|ner, zahl|los; Zahl|mei|ster; zahl|reich; Zähl-rohr (Gerät zum Nachweis radioaktiver Strahlen); Zahl.stel|le, ...tag, ...tel|ler; Zah|lung; - leisten (Kaufmannsspr.: zahlen); an -s Statt; Zäh|lung; Zah|lungs.an|wei|sung, ...auf|for|de|rung, ...auf|schub, ...be|din|gun|gen (Mehrz.), ...be|fehl, ...bi|lanz, ...er|leich|te|rung; zah|lungs|fä|hig; Zah|lungs.fä|hig|keit (w; -), ...frist, ...mit|tel s, ...ter|min (Zahlungsfrist); zah|lungs|un|fä|hig; Zah|lungs.un|fä|hig|keit (w; -), ...ver|kehr, ...ver|pflich|tung; Zähl|werk; Zähl|wort (Mehrz. ...wörter), ...zei|chen

zahm; ein -es Tier; zähm|bar; Zähm|bar|keit w; -; zäh|men; Zahm|heit w; -; Zäh|mung

Zahn m; -[e]s, Zähne; ein hohler -; künstliche Zähne; Zahn|arzt; zahn|ärzt|lich; Zahn.be|hand|lung, ...bein (für: Dentin), ...bett, ...bür|ste; Zähn|chen, Zähn|lein; Zahn.cre|me, ...durch|bruch (für: Dentition); zäh|ne|flet|schend; ein zähnefletschender Hund,

¹ *Trenn.:* ...ak|k...

aber (↑ R 142): die Zähne fletschend, stand der Hund vor ihm; Zäh|ne|klap|pern s; -s; zäh|ne|knir|schend; aber (↑ R 142): mit den Zähnen knirschend; zäh|neln (selten für: zähnen); ich ...[e]le (↑ R 327); zäh|nen (Zähne bekommen); zäh|nen (mit Zähnen versehen); Zahn.er|satz, ...fäu|le, ...fistel, ...fleisch, ...fül|lung, ...hals, ...heil|kun|de (w; -); zäh|nig (selten für. mit Zähnen versehen); ...zäh|nig, ...zäh|nig (z. B. scharfzahnig, scharfzähnig); Zahn-klemp|ner (ugs. scherzh. für: Zahnarzt); zahn|krank; Zahn-laut; Zähn|lein, Zähn|chen; zahn-los; Zahn|lo|sig|keit w; -; Zahn-lücke¹; Zahn|lücker¹ (Säugetier mit normalen Zahnlücken); zahn|lückig¹; Zahn.me|di|zin, ...pa|sta, (auch:) ...pa|ste, ...pfle|ge, ...pul|ver, ...rad; Zahn|rad-bahn; Zahn.schmelz, ...schmerz, ...span|ge, ...stein, ...sto|cher, ...tech|ni|ker; Zäh|nung (Philatelie); Zahn.wal, ...weh, ...wur|zel

Zäh|re (veralt. dicht., noch mdal. für: Träne) w; -, -n

Zäh|rin|ger (Angehöriger eines südd. Fürstengeschlechtes) m; -s, -

Zain (mdal. für: Zweig, Weidengerte; Metallstab; Rute; Jägerspr.: Schwanz des Dachses) m; -[e]s, -e; Zai|ne (veralt., aber noch mdal. für: Flechtwerk, Korb) w; -, -n; vgl. Zeine; zai|nen (veralt., aber noch mdal. für: Flechtwerk für Körbe bereiten, flechten)

Za|ire [sair] (neue Bez. für die Demokratische Republik Kongo); Zai|rer; zai|risch

Za|ko|pa|ne [sakopan°; poln.: sakopanä] (polnischer Wintersportplatz, Luftkurort)

Zam|ba span. [ßamba] (weibl. Mischling von Neger u. Indianerin) w; -, -s

Zam|be|zi [sämbisi] (engl. Schreibung von: Sambesi)

Zam|bo span. [ßambo] (männl. Mischling von Neger u. Indianerin) m; -s, -s

Zan|der slaw. (ein Fisch) m; -s, -

Za|nel|la it. (ein Gewebe) m; -s, -s

Zan|ge w; -, -n; Zän|gel|chen, Zäng|lein; Zan|gen|be|we|gung; zan|gen|för|mig; Zan|gen|ge-burt; Zäng|lein, Zän|gel|chen

Zank m; -[e]s; zank|ap|fel m; -s; zan|ken; sich -; Zän|ker; Zan|ke-rei (ugs. für: wiederholtes Zanken); Zän|ke|rei (kleinlicher Streit; meist Mehrz.); zän|kisch;

¹ *Trenn.:* ...ük|k...

-ste (↑ R 294); Zank|sucht w; -; zank|süch|tig

Zä|no|ge|ne|se, Zä|no|ge|ne|sis gr. (Auftreten von Besonderheiten während der stammesgeschichtl. Entwicklung der Tiere) w; -, ...nesen; zä|no|ge|ne|tisch (die Zänogenese betreffend)

Zapf (seltene Nebenform von: Zapfen: südd. selten für: Ausschank) m; -[e]s, Zäpfe; ¹Zäpf-chen (Teil des weichen Gaumens); ²Zäpf|chen, Zäpf|lein (kleiner Zapfen); Zäpf|chen-R (↑ R 149) s; -; Zapf|fen; Zap|fen m; -s, -; zap|fen|för|mig; Zap|fen-streich (Militär: Abendsignal zur Rückkehr in die Unterkunft); der Große-(↑ R 224); Zap|fen|zie|her aleman. (Korkzieher); Zap|fer; Zapf|hahn; Zäpf|lein, Zapf|chen (kleiner Zapfen); Zapf.säu|le (bei Tankstellen), ...stel|le (Ausgabestelle von Betriebsstoff für Kraftfahrzeuge)

za|po|nie|ren (mit Zaponlack überziehen); Za|pon|lack (farbloser Lack [als Metallschutz])

Zap|pe|ler, Zapp|ler; zap|pe|lig, zapp|lig; zap|peln; ich ...[e]le (↑ R 327); Zap|pel|phil|ipp (Gestalt aus einem Kinderbuch) m; -s, -e u. -s

Zap|pen|du|ster (ugs. für: sehr dunkel; endgültig vorbei)

Zapp|ler, Zap|pe|ler; Zapp|le|rin w; -, -nen; zapp|lig, zap|pe|lig

Zar lat. (ehem. Herrschertitel bei Russen, Serben, Bulgaren) m; -en, -en (↑ R 268)

Za|ra|go|za [tharagotha], (dt. auch:) Sa|ra|gos|sa (span. Stadt)

Za|ra|thu|stra (Neugestalter der altiran. Religion); vgl. Zoroaster

Za|ren|fa|mi|lie, ...reich; Za|ren|tum s; -s; Za|re|witsch (Sohn eines russ. Zaren: russ. Kronprinz) m; -[e]s, -e; Za|re|wna (Tochter eines russ. Zaren) w; -, -s

Zar|ge (Handw.: Einfassung; Seitenwand) w; -, -n

Za|rin (Gemahlin des Zaren) w; -, -nen; Za|ris|mus (unumschränkte Zarenherrschaft) m; -; za|ri|stisch

zart; -er, -este (↑ R 292); zartblau usw.; zart|be|sai|tet; Steigerung (↑ R 297): zartbesaiteter, zartbesaitetste od. (↑ R 296): zarter besaitet, zartest besaitet

¹Zär|te slaw. (ein Fisch) w; -, -n; vgl. Zährte

²Zär|te (veralt. für: Zartheit) w; -; Zär|te|lei; zär|teln (selten für: Zärtlichkeiten austauschen); ich ...[e]le (↑ R 327); zart|füh|lend; -er, -ste; Zart|ge|fühl s; -[e]s; Zart-heit; zärt|lich; Zärt|lich|keit

Za|sel, Za|ser (veralt., aber noch

mdal. für: Faser) w; -, -n; Za|sel|chen, Zä|ser|chen (nordd.), Zä|ser|lein (südd.); za|se|rig (veralt.); za|sern (veralt. für: fasern); ich ...ere (↑ R 327)

Zas|pel mdal. (ein Garnmaß) w; -, -n

Za|ster sanskr.-zigeun. (ugs. für: Geld) m; -s

Zä|sur lat. (Versbau: Einschnitt [im Vers]; Musik: Ruhepunkt; allg. für: [gedanklicher] Einschnitt) w; -, -en

zat|schen, zät|schen obersächs. (krähen, kläglich tun); du ...schst (...schest)

Zat|tel|tracht (mittelalterl. Kleidermode) w; -

Zau|ber m; -s, -; Zau|be|rei; Zau|be|rer, Zaub|rer; Zau|ber_flö|te, ...for|mel; zau|ber|haft; Zau|be|rin, Zaub|re|rin w; -, -nen; zau|be|risch; -ste (↑ R 294); Zau|ber_ka|sten, ...kraft w, ...kunst, ...künst|ler, ...macht; zau|bern; ich ...ere (↑ R 327); Zau|ber_spruch, ...stab, ...trank, ...wort (Mehrz. ...worte); Zaub|rer, Zau|be|rer; Zaub|re|rin vgl. Zauberin

Zau|che (veralt., aber noch mdal. für: Hündin; liederliches Frauenzimmer) w; -, -n

Zau|de|rei; Zau|de|rer, Zaud|rer; Zau|de|rin, Zaud|re|rin w; -, -nen; zau|dern; ich ...ere (↑ R 327); (↑ R 120:) da hilft kein Zaudern; Zaud|rer, Zau|de|rer; Zaud|re|rin vgl. Zauderin

Zaum (Kopflederzeug für Zug- u. Reittiere) m; -[e]s, Zäume; im - halten; Zäum|chen, Zäum|lein; zäu|men; Zäu|mung; Zaum|zeug

Zaun (Einfriedigung) m; -[e]s, Zäune; Zäun|chen, Zäun|lein; zaun|dürr österr. ugs. (sehr mager); Zaun|ei|dech|se; zäu|nen (einzäunen); Zaun_gast (Mehrz. ...gäste), ...kö|nig (ein Vogel); Zäun|lein, Zäun|chen; Zaun_pfahl; mit dem - winken (ugs. für: recht deutlich werden); Zaun_re|be (Name einiger Pflanzen, bes. des Waldnachtschattens), ...schlüp|fer (südd. und rhein. für: Zaunkönig)

Zau|pe süd- u. westmitteld. (Hündin; liederliches Frauenzimmer) w; -, -n

zau|sen; du zaust (zausest); er zauste; zau|sig österr. (zerzaust); -e Haare

Zä|zi|lie vgl. Cäcilie

z. B. = zum Beispiel

z. b. V. = zur besonderen Verwendung

z. D. = zur Disposition

z. d. A. = zu den Akten (erledigt)

ZDF = Zweites Deutsches Fernsehen

z. E. = zum Exempel

Zea gr. (Bot.: Mais) w; -

Ze|ba|oth, (ökum.:) Ze|ba|ot hebr. („himmlische Heerscharen") Mehrz.; der Herr - (alttest. Bez. des allmächtigen Gottes)

Ze|be|dä|us (bibl. Eigenn.)

Ze|bra afrik. (gestreiftes südafrik. Wildpferd) s; -s, -s; ze|bra|ar|tig; Ze|bra|strei|fen (Kennzeichen von Fußgängerüberwegen); Ze|bro|id afrik.; gr. (Kreuzung aus Zebra und Pferd) s; -[e]s, -e

Ze|bu tibet. (asiat. Buckelrind) m od. s; -s, -s

Zech_bru|der; Ze|che w; -, -n; die - prellen; ze|chen; Ze|chen_stille|gung [Trenn.: Still|le..., ↑ R 236]; Ze|cher; Ze|che|rei; Zech|ge|la|ge

Ze|chi|ne it. (alte venezian. Goldmünze) w; -, -n

Zech_kum|pan, ...prel|ler; Zech_prel|le|rei; Zech|stein (Abteilung des Perms; m; -[e]s); Zech|tour

¹Zeck landsch. (ein Kinderspiel [Haschen]) m od. s; -[e]s

²Zeck südd. u. österr. mdal. (Zecke) m; -[e]s, -e; Zecke [Trenn.: Zek|ke] (Spinnentier) w; -, -n

zecken [Trenn.: zek|ken] (landsch. für: ¹Zeck spielen; mdal. für: necken, sticheln); necken u. -; Zeck_spiel s; -[e]s

Ze|de|kia, (ökum.:) Zid|ki|ja (bibl. Eigenn.)

Ze|dent lat. (Gläubiger, der seine Forderung an einen Dritten abtritt); ↑ R 268

Ze|der gr. (immergrüner Nadelbaum) w; -, -n; ze|dern (aus Zedernholz); Ze|dern|holz

ze|die|ren lat. (eine Forderung an einen Dritten abtreten) lat.; dt. (veralt. für: Zitronenbaum)

Ze|dra|baum lat.; dt. (Holz des westind. Zedralbaumes)

Zee|se (Schleppnetz im Gebiet der Ostsee) w; -, -n; Zee|sen|boot

Ze|fa|nja vgl. Zephanja

Ze|he w; -, -n, (auch:) Zeh m; -s, -en; die kleine, große Zehe, der kleine, große Zeh; Ze|hen_spit|ze, ...stand; ...ze|her (z. B. Paarzeher); ...ze|hig (z. B. fünfzehig; mit Ziffer: 5zehig; ↑ R 228)

zehn; wir sind so zehnen od. zu zehnt; sich alle zehn Finger nach etwas lecken (ugs. für: sehr gierig sein); (↑ R 224:) die Zehn Gebote; vgl. acht; Zehn (Zahl) w; -, -en; vgl. ¹Acht; Zehn|eck; zehn|eckig [Trenn.: ...ek|kig]; zehn|ein|halb, zehn|und|ein|halb; Zehn|en|der (Jägerspr.); Zehn|ner (ugs. auch für: Zehnpfennigstück); vgl. Achter; Zeh|ner|jau|se (ostösterr. ugs.: Gabelfrühstück); zeh|ner-

lei; auf - Art; Zeh|ner_packung [Trenn.: ...pak|kung], ...stel|le; zehn|fach; vgl. achtfach; Zehn-fa|che w; -; vgl. Achtfache; Zehn|fin|ger-Blind_schrei|be|me|tho|de, ...schreib|me|tho|de w; -; Zehn|fin|ger|sy|stem s; -s; Zehn|flach s; -[e]s, -e, Zehn-fläch|ner (für: Dekaeder); Zehn-fuß_krebs (für: Dekapode); Zehn_jah|res|fei|er, ...jahr|fei|er; Zehn|jah|res|plan (mit Ziffern: 10-Jahres-Plan); ↑ R 157 u. ²Plan; zehn|jäh|rig; vgl. achtjährig; Zehn|kampf; zehn|mal; vgl. achtmal; zehn|ma|lig; Zehn|mark-schein (↑ R 157); Zehn|me|ter-brett (mit Ziffern: 10-Meter-Brett od. 10-m-Brett); ↑ R 157; Zehn|pfen|nig_brief|mar|ke, ...stück (↑ R 157); zehnt; vgl. zehn; Zehnt, Zehn|te (früher: Abgabe [urspr. des 10. Teiles]) m; ...ten, ...ten; den Zehnten fordern, geben; zehn|tau|send; die oberen Zehntausend (↑ R 118); vgl. tausend; zehn|te; die zehnte Muse (Muse der Kleinkunstbühne); vgl. achte; Zehn|te vgl. Zehnt; zehn|tel; vgl. achtel; Zehn|tel s (schweiz. meist: m); -s, -; vgl. Achtel; zehn|teln in dem Teile entstehen); ich ...[e]le (↑ R 327); Zehn-tel_gramm, ...se|kun|de; zehn|ten (urspr.: den zehnten Mann hinrichten; den Zehnten fordern, geben); zehn|tens; Zehn|ton|ner (mit Ziffer: 10tonner; ↑ R 228); Zehnt-recht s; -[e]s; zehn|[und]|ein_halb zeh|ren; Zehr_fie|ber (veralt.; s; -s), ...geld, ...pfen|nig; Zehr|ung

Zei|chen s; -s, -; setzen; Zei|chen_block (Mehrz. ...blocks), ...brett, ...deu|ter, ...fe|der, ...film, ...ge-rät, ...heft, ...kunst, ...leh|rer, ...ma|schi|ne, ...mu|ster, ...pa-pier, ...saal, ...schutz (für Warenzeichen), ...set|zung (für: Interpunktion; w; -), ...spra|che, ...stift m, ...stun|de, ...trick|film, ...un-ter|richt, ...vor|la|ge; zeich|nen; Zeich|nen s; -s; Zeich|ner; zeich-ne|risch (Zeich|nung; zeich|nungs-be|rech|tigt

Zei|del|mei|ster (veralt. für: Bienenzüchter); zei|deln (veralt. für: Honigwaben ausschneiden); ich ...[e]le (↑ R 327); Zeid|ler (veralt. für: Bienenzüchter); Zeid|le|rei (veralt. für: Bienenzucht)

Zei|ge_fin|ger (schweiz. auch:) Zeig|fin|ger; zei|gen; etwas -; sich [großzügig] -; Zei|ger; Zei|ger-am|pel (zur Verkehrsregelung an Kreuzungen); Zei|ge|stock (Mehrz. ...stöcke); Zeig|fin|ger vgl. Zeigefinger

zei|hen (geh.); du ziehst (ziehest); du ziehest; geziehen; zeih[e]!

Zei|le (Abk.: Z.) w; -, -n; Zei|len-
.ab|stand, ...gieß|ma|schi|ne od.
...guß|ma|schi|ne, ...ho|no|rar,
...län|ge, ...maß s, ...sprung
(Versl.); zei|len|wei|se; ...zei|ler
(z. B. Zweizeiler, mit Ziffer: 2zei-
ler; ↑ R 228); ...zei|lig (z. B. sechs-
zeilig, mit Ziffer: 6zeilig; ↑ R 228)
Zei|ne schweiz. (großer Korb mit
zwei Griffen, z. B. für Wäsche)
w; -, -n; vgl. Zaine
Zeis|chen, Zeis|lein (kleiner Zei-
sig)
Zei|sel|bär mdal. (Tanzbär); ¹zei-
seln (eilen, geschäftig sein); ich
...[e]le (↑ R 327)
²zei|seln schwäb. (anlocken); ich
...[e]le (↑ R 327)
Zei|sel|wa|gen [zu: ¹zeiseln] mdal.
(Leiterwagen)
zei|sen bayr. (Verworrenes aus-
einanderzupfen); du zeist (zei-
sest); er zei|ste
Zei|sig tschech. (ein Vogel; übertr.
für: leichtfertiger Mensch) m; -s,
-e; Zei|sig|fut|ter; vgl. ¹Futter;
zei|sig|grün
Zei|sing (Seemannsspr. für: Segel-
tuchstreifen, aus Tauwerk ge-
flochtener Stropp) s; -s, -e
Zeis|lein vgl. Zeischen
Zeiss (Familienn.; ⓦ: opt. u. fo-
togr. Erzeugnisse); Zeiss|glas (↑ R 180;
Mehrz. ...gläser)
zeit; mit Wesf.: - meines Lebens;
Zeit w; -, -en; zu meiner, seiner,
uns[e]rer -; zu aller Zeit (aber:
all[e]zeit); zur Zeit (Abk.: z. Z.,
z. Zt.); auf Zeit (Abk.: a. Z.);
eine Zeitlang, aber: einige, eine
kurze Zeit lang; es ist an der Zeit;
von Zeit zu Zeit; Zeit haben; bei-
zeiten; vorzeiten; zuzeiten (bis-
weilen), aber: zu der Zeit, zu
Zeiten Karls d. Gr.; jederzeit,
aber: zu jeder Zeit; derzeit;
seinerzeit (Abk.: s. Z.), aber: al-
les zu seiner Zeit; zeitlebens,
aber: zeit meines Lebens;
(Sportspr.:) auf Zeit spielen;
Zeit.ab|schnitt, ...al|ter, ...an|ga-
be (Sprachw.: Umstandsangabe
der Zeit), ...an|sa|ge (Rundfunk),
...ar|beit, ...auf|nah|me (Fotogra-
fie), ...auf|wand, ...druck (m; -
[e]s), ...ein|heit; Zeit.ten.fol|ge
(für: Consecutio temporum; w;
-), ...wen|de od. Zeit|wen|de;
Zeit.er|spar|nis, ...fah|ren (s; -s;
Sportspr.), ...form (für: Tempus),
...fra|ge; zeit|fremd; Zeit|ge|bun-
den; Zeit|geist m; -[e]s; zeit|ge-
mäß; Zeit|ge|nos|se; zeit|ge|nös-
sisch; zeit|ge|recht (österr. ne-
ben: rechtzeitig; Zeit.ge|schäft
(Kaufmannsspr.), ...ge|schich|te
(w; -), ...ge|schmack, ...ge|winn;
zeit|gleich; zeit|her (veralt., aber

noch mdal. für: seither, bisher);
zeit|he|rig (veralt., aber noch
mdal.); zei|tig; zei|ti|gen (reifen
lassen; veralt. für: reif werden);
Erfolge -; Zei|ti|gung (veralt. für:
Reifung); Zeit|kar|te; zeit|kri-
tisch; Zeit|lang w, nur in: eine
Zeitlang, aber: einige Zeit lang,
eine kurze Zeit lang; Zeit|lauf m;
-[e]s, ...läufte, seltener: ...läufe
(meist Mehrz.), zeit|le|bens,
aber: zeit meines Lebens; zeit-
lich (österr. ugs. auch für: zeitig,
früh); das Zeitliche (↑ R 116) seg-
nen (sterben); Zeit|lich|keit (Le-
ben auf Erden, irdische Vergäng-
lichkeit) w; -; Zeit|lohn; zeit|los;
Zeit|lo|se (Pflanze [meist für
Herbstzeitlose]) w; -, -n; Zeit.lu-
pe (w; -), ...man|gel, ...maß s,
...mes|ser (m; veralt. für: Uhr);
Zeit|mes|sung; zeit.nah, ...na|he;
Zeit.neh|mer (Sportspr.), ...not
(w; -),...per|so|nal, ...punkt, ...raf-
fer (Film); zeit|rau|bend; aber
(↑ R 142): die Zeit raubend;
Zeit.raum, ...rech|nung, ...schrift;
Zeit|schrif|ten.auf|satz, ...le|se-
saal, ...ver|le|ger; Zeit.sinn (m,
-[e]s), ...span|ne; zeit|spa|rend,
aber (↑ R 142): viel Zeit sparend;
Zeit|sprin|gen (Sportspr.); Zei-
tung; Zei|tung|le|sen s; -s; Zei-
tungs.ab|la|ge, ...an|zei|ge, ...ar-
ti|kel, ...aus|schnitt, ...be|richt,
...blatt, ...en|te, ...frau, ...in|se-
rat, ...ki|osk, ...kor|re|spon|dent,
...le|ser, ...nach|richt, ...pa|pier,
...ro|man, ...satz (m; -es), ...stel|le
(Postw.), ...trä|ger, ...ver|käu|fer,
...ver|lag, ...we|sen, ...wis|sen-
schaft; zeit|ver|geu|dend, aber
(↑ R 142): die Zeit vergeudend;
Zeit.ver|geu|dung, ...ver|lust,
...ver|säum|nis; Zeit|ver|treib m;
-[e]s, -e; zeit.wei|lig, ...wei|se;
Zeit.wen|de od. Zei|ten|wen|de,
...wert, ...wort (Mehrz. ...wörter),
...wort|form; zeit|wört|lich
Zeitz (Stadt im Bezirk Halle)
Zeit|zei|chen
Zeit|zer (↑ R 199)
Zeit|zün|der
Ze|le|brant lat. (die Messe lesen-
der Priester) m; -en, -en (↑ R 268);
Ze|le|bra|ti|on [...zion] (Feier [des
Meßopfers]); ze|le|brie|ren (feier-
lich begehen; die Messe lesen);
Ze|le|bri|tät (selten für: Be-
rühmtheit, berühmte Person)
Zel|ge südd. ([bestelltes] Feld,
Flurstück) w; -, -n
Zell (Name mehrerer Städte)
Zell-la-Meh|lis; ↑ R 212 (Stadt im
Thüringer Wald)
Zell|at|mung w; -; Zel|le lat. w; -,
-n; Zelleib [Trenn.: Zell|leib, ↑ R
236]; Zel|len|bil|dung; zel|len|för-
mig; Zel|len|ge|we|be, Zel|ge|we-

be; Zel|len.leh|re (w; -), ...schmelz
Zel|ler österr. mdal. (Sellerie) m;
-s
Zell|ge|we|be, Zel|len|ge|we|be;
Zell|ge|webs|ent|zün|dung; Zell-
.glas (eine Folie; s; -es), ...horn
(Kunststoff [Zelluloid]; s; -[e]s);
zel|lig; Zell.kern, ...mem|bran;
Zel|loi|din|pa|pier lat.; gr. [...o-
i...,] (Kollodiumschichtträger für
Bromsilber bei fotogr. Filmen);
Zell|stoff (techn. Zellulose); Zell-
stoffa|brik [Trenn.: ...stoff|fa...,
↑ R 236] w; -, -en; Zell|tei|lung;
zel|lu|lar lat. (aus Zellen gebil-
det); Zel|lu|lar|pa|tho|lo|gie
(Auffassung von Krankheiten als
Störungen des normalen Zell-
lebens); Zel|lu|li|tis (Entzün-
dung des Zellgewebes) w; -,
...itiden; Zel|lu|loid lat.; gr.
[meist: ...leut] (Kunststoff; Zell-
horn) s; -[e]s; Zel|lu|lo|se lat.
(Hauptbestandteil pflanzl. Zell-
wände; Zellstoff) w; -, -n; Zell-
wol|le w; -
Ze|lot gr. ([Glaubens]eiferer) m;
-en, -en (↑ R 268); ze|lo|tisch
([glaubens]eifrig); -ste (↑ R 294);
Ze|lo|tis|mus m; -
¹Zelt (wiegende Gangart von Pfer-
den) m; -[e]s
²Zelt s; -[e]s, -e; Zelt|bahn; Zelt-
blatt österr. (Zeltbahn); Zel|te m;
-n, -n (↑ R 268) u. Zel|ten südd.,
österr. (kleiner, flacher [Leb]ku-
chen) m; -s, -; zel|ten (in Zelten
übernachten, wohnen); gezelt
Zel|ter (auf Paßgang abgerichte-
tes Damenreitpferd; seltener für:
Zeltler) m; -s, -; Zelt|gang (Paß-
gang) m
Zelt.he|ring, ...la|ger (Mehrz. ...la-
ger), ...le|ben (s; -s); Zelt|lein-
wand; Zelt|ler (jmd., der zeltet)
Zelt|li schweiz. mdal. (Bonbon) s;
-s, -
Zelt.mast m, ...mis|si|on, ...pflock,
...pla|ne, ...platz, ...stadt, ...stan-
ge, ...stock (Mehrz. ...stöcke),
...stoff, ...wand
Ze|ment lat. (Bindemittel; Bau-
stoff; Bestandteil der Zähne) m;
-[e]s, -e; Ze|men|ta|ti|on [...zion]
(Härtung der Stahloberfläche;
Abscheidung von Metallen aus
Lösungen); Ze|ment.bo|den,
...dach; ze|men|tie|ren (mit Ze-
ment ausfüllen, verputzen; Stahl
an der Oberfläche härten; Metall
aus Lösung ausscheiden; übertr.
für: [einen Zustand, Standpunkt
u. dgl.] starr u. unverrückbar fest-
legen); Ze|men|tie|rung; Ze-
ment.roh|re, ...sack, ...si|lo,
...spritz|ver|fah|ren (s; -s)
Zen [sän] (jap. Richtung des Bud-
dhismus) s; -[s]
Zend.awe|sta pers. („Kommen-

tar-Grundtext"; veraltete Bez.
für: Awesta) s; -
Ze|nit arab. (Scheitelpunkt [des
Himmels]) m; -[e]s; Ze|nit|hö|he
Ze|no[n] (Name zweier altgr. Phi-
losophen; byzant. Kaiser)
Ze|no|taph vgl. Kenotaph
zen|sie|ren lat. (beurteilen, prüfen,
werten, eine Note geben); Zen-
sie|rung; Zen|sor (altröm. Beam-
ter; Beurteiler) m; -s, ...oren; zen-
so|risch (veralt. für: sittenrichter-
lich); -ste (↑ R 294); Zen|sur (Amt
des altröm. Zensors; behördl.
Prüfung [und Verbot] von
Druckschriften u. a.) w; -, (für:
[Schul]zeugnis, Note auch
Mehrz.:) -en; zen|su|rie|ren
österr. (prüfen, beurteilen); Zen-
sus (Schätzung; Volkszählung;
Bibliotheksw.: Verzeichnis aller
bekannten Exemplare von Früh-
drucken) m; -, -
Zent lat. („Hundertschaft"; germ.
Gerichtsverband) w; -, -en
Zen|taur gr. (Wesen der gr. Sage:
halb Pferd, halb Mensch) m; -en,
-en (↑ R 268)
Zen|te|nar lat. (Hundertjähriger)
m; -s, -e; Zen|te|nar.aus|ga|be,
...fei|er; Zen|te|na|ri|um (Hun-
dertjahrfeier) s; -s, ...ien [...$i^e n$];
zen|te|si|mal (hundertteilig);
Zen|te|si|mal|waa|ge; zent|frei
(dem Hundertschaftsgericht
nicht unterworfen); Zent.ge-
richt, ...graf; Zen|ti... (Hundert-
stel...; ein Hundertstel einer Ein-
heit, z. B. Zentimeter = 10^{-2} Me-
ter; Zeichen: c); Zen|ti|fo|lie [...i^e]
(„hundertblättrige" Rose); Zen-
ti.grad [österr.: zen...], ...gramm
[österr.: zen...] ($^1/_{100}$ g; Zeichen:
cg), ...li|ter [österr.: zen...] ($^1/_{100}$
l; Zeichen: cl), ...me|ter (Zeichen:
cm); Zen|ti|me|ter|maß s; Zent-
ner (100 Pfund = 50 kg; Abk.:
Ztr.; Österreich: 100 kg [Meter-
zentner], Zeichen: q) m; -s, -;
Zent|ner.ge|wicht, ...last; zent-
ner.schwer, ...wei|se
zen|tral gr. (in der Mitte; im Mit-
telpunkt befindlich; von ihm aus-
gehend; Mittel..., Haupt..., Ge-
samt...); Zen|tral|afri|ka; Zen-
tral|afri|ka|ner; zen|tral|afri|ka-
nisch, a b e r (↑ R 224): die Zentral-
afrikanische Republik; Zen|tral-
.bank, ...bau (Mehrz. ...bauten),
...be|hör|de (oberste Behörde);
Zen|tra|le (Mittel-, Ausgangs-
punkt; Mittelpunktslinie; Haupt-
ort, -geschäft, -stelle; Fern-
sprechvermittlung [in einem
Großbetrieb]; elektr. Kraftsta-
tion) w; -, -n; Zen|tral.fi|gur,
...flug|ha|fen (Flugw.: Flughafen,
der nach allen Flugrichtungen of-
fen ist und allen Fluggesellschaf-
ten dient; Ggs.: Satellitenflugha-
fen), ...ge|nos|sen|schaft, ...ge-
stalt, ...ge|walt, ...hei|zung (Sam-
melheizung), ...in|stanz; Zen|tra-
li|sa|ti|on fr. [...zion] (seltener für:
Zentralisierung); zen|tra|li|sie-
ren (zusammenziehen, in einem
[Mittel]punkt vereinigen); Zen-
tra|li|sie|rung (Zusammenzie-
hung, Vereinigung in einem [Mit-
tel]punkt; Verwaltung vorwie-
gend durch die Zentralbehör-
den); Zen|tra|lis|mus gr. (Streben
nach Zusammenziehung [der
Verwaltung u. a.]) m; -; zen|tra|li-
stisch (nach Zusammenziehung
strebend; vom Mittelpunkt, von
den Zentralbehörden aus be-
stimmt); -ste (↑ R 294); Zen|tra|li-
tät (Mittelpunktslage von Orten)
w; -; Zen|tral.ko|mi|tee (oberstes
Organ der kommunist. u. man-
cher sozialist. Parteien; Abk.:
ZK), ...kraft, ...markt, ...ner|ven|sy|stem,
...or|gan, ...per|spek|ti|ve, ...pla|teau
(in Frankreich; s; -s), ...pro|blem,
...stel|le, ...uh|ren|an|la|ge, ...ver-
band, ...ver|wal|tung; zen|trie|ren
(auf die Mitte einstellen); w),
...pum|pe
Zen|trie|rung; Zen|trier|vor|rich-
tung; zen|tri|fu|gal gr.; lat. (vom
Mittelpunkt weggstrebend,
Flieh...); Zen|tri|fu|gal.kraft
(Reaktionskraft eines um eine
Achse sich kreisförmig drehen-
den Massenkörpers, die die au-
ßen gerichtet ist; w), ...pum|pe
(Schleuderpumpe); Zen|tri|fu|ge
(Schleudergerät zur Trennung
von Flüssigkeiten) w; -, -n; Zen-
tri|fu|gen.but|ter; zen|tri|fu|gie-
ren (mit Hilfe der Zentrifuge zer-
legen); zen|tri|pe|tal (zum Mittel-
punkt hinstrebend); Zen|tri|pe-
tal.kraft w; zen|trisch (im Mit-
telpunkt befindlich, mittig); Zen-
tri|win|kel (Mittelpunktswinkel);
Zen|trum (Mittelpunkt; Innen-
stadt [postal. Zeichen: C];
Haupt-, Sammelstelle; nur Einz.:
nach der Sitzordnung benannte
kath. Partei des Bismarckreiches
u. der Weimarer Republik) s; -s,
...tren; Zen|trums.boh|rer, ...par-
tei w; -
Zen|tu|rie lat. [...i^e] (altröm. Sol-
datenabteilung von 100 Mann)
w; -, -n; Zen|tu|rio (Befehlshaber
einer Zenturie) m; -s, ...onen
Zen|zi (Kurzform für: Vinzentia
u. Kreszentia)
Zeo|lith gr. (ein Mineral) m; -s u.
-en, -e[n] (↑ R 268)
Ze|phan|ja (ökum.:) Ze|fan|ja
(bibl. Prophet)
Ze|phir (österr. nur so) Ze|phyr
gr. (ein Baumwollgewebe; veralt.
dicht., nur Einz.: milder Südwest-
wind) m; -s, -e (österr.: ...ire); ze-
phi|risch (österr. nur so), ze|phy-
risch (veralt. dicht. für: säuselnd,
lieblich, sanft); -ste (↑ R 294); Ze-
phir|wol|le, Ze|phyr|wol|le
¹Zep|pe|lin (Familienn.); ²Zep|pe-
lin (Luftschiff) m; -s, -e; Zep|pe-
lin|luft|schiff (↑ R 180)
Zep|ter (Herrscherstab) s (selte-
ner: m); -s, -
zer... (Vorsilbe von Zeitwörtern, z.
B. zerbröckeln, du zerbröckelst,
zerbröckelt, zu zerbröckeln; zum
2. Mittelw. ↑ R 304)
zer|ackern [Trenn.: ...ak|kern]
(veralt.)
Ze|rat lat. (Wachssalbe) s; -[e]s,
-e
Zer|be vgl. Zirbe
zer|bei|ßen
zer|ber|sten
Zer|be|rus (gr. Sage: der den Ein-
gang der Unterwelt bewachende
Hund; scherzh. für: grimmiger
Wächter) m; -, -se
zer|beu|len
zer|blät|tern
zer|bom|ben
zer|bre|chen; zer|brech|lich; Zer-
brech|lich|keit w; -; Zer|bre|chung
zer|bröckeln [Trenn.: ...brök-
keln]; Zer|bröcke|lung [Trenn.:
...brök|ke...], Zer|bröck|lung
Zerbst (Stadt in Anhalt); Zerb|ster
(↑ R 199)
zer|deh|nen
zer|dep|pern (ugs. für: [durch Wer-
fen] zerstören); ich ...ere (↑ R 327)
zer|drücken [Trenn.: ...drük|ken]
Ze|rea|lie lat. [...i^e] (Getreide;
Feldfrucht) w; -, ...ien [...$i^e n$]
(meist Mehrz.)
Ze|re|bel|lum (med. fachspr.:) Ce-
re|bel|lum [ze...] lat. (Kleinhirn)
s; -s, ...bella; ze|re|bral (das Zere-
brum betreffend; Gehirn...); Ze-
re|bral (Sprachw.: mit der Zun-
genspitze am Gaumen gebildeter
Laut) m; -s, -e; ze|re|bro|spi|nal
(Med.: Hirn u. Rückenmark be-
treffend); Ze|re|brum, (med.
fachspr.:) Ce|re|brum [ze...]
(Großhirn, Gehirn) s; -s, ...bra
Ze|re|mo|nie lat. [auch, österr.
nur: ...$moni^e$] (feierl. Handlung;
Förmlichkeit) w; -, ...ien [auch:
...$moni^e n$]; ze|re|mo|ni|ell (feier-
lich; förmlich, gemessen; steif,
umständlich); Ze|re|mo|ni|ell
(feierl. Vorschriften, Gebote,
Haltung; feierl. Wesen) s; -s, -e;
Ze|re|mo|ni|en|mei|ster [...$i^e n$...];
ze|re|mo|ni|ös (steif, förmlich; ge-
messen); -este (↑ R 292)
Ze|re|sin lat. (gebleichtes Erd-
wachs aus hochmolekularen
Kohlenwasserstoffen) s; -s
Ze|re|vis kelt. [...wiß] (Studen-
tenspr. veralt. für: Bier; Käpp-

chen der Verbindungsstudenten)
s; -, -

¹zer|fah|ren; die Wege sind -; ²zer-
fah|ren (verwirrt; gedankenlos);
Zer|fah|ren|heit w; -

Zer|fall (Zusammenbruch, Zer-
störung) m; -[e]s; zer|fal|len; die
Mauer ist sehr -; sie ist mit der
ganzen Welt - (nichts ist ihr
recht); Zer|falls_er|schei|nung,
...pro|dukt, ...stoff (meist Mehrz.)

zer|fa|sern

zer|fet|zen; Zer|fet|zung
bei|flat|tern

zer|fled|dern vgl. zerfledern; zer-
fle|dern (ugs.: durch häufigen Ge-
brauch [an den Rändern] abnut-
zen, zerfetzen [von Büchern, Zei-
tungen o. ä.]); ich ...ere (↑ R 327)

zer|flei|schen (zerreißen); du zer-
fleischst (zerfleischest); Zer|flei-
schung

zer|flie|ßen

zer|fres|sen

zer|furcht; eine -e Stirn

zer|ge|hen

zer|gen mitteld. u. nordostd. (nek-
ken)

Zer|glie|de|rer; zer|glie|dern; Zer-
glie|de|rung

zer|grü|beln; ich zergrübelte mir
den Kopf

zer|hacken [Trenn.: ...hak|ken]

zer|hau|en

zer|kau|en

zer|klei|nern; ich ...ere (↑ R 327);
Zer|klei|ne|rung; Zer|klei|ne-
rungs|ma|schi|ne

zer|klüf|tet; -es Gestein; Zer|klüf-
tung

Zer|knall; zer|knal|len

zer|knaut|schen

zer|knirscht; ein -er Sünder; Zer-
knirscht|heit w; -; Zer|knir|schung

zer|knit|tern; zer|knit|tert; nach
der Strafpredigt war er ganz -
(ugs. für: gedrückt); Zer|knit|te-
rung

zer|knül|len

zer|ko|chen

zer|kör|nen (für: granulieren
[Technik])

zer|krat|zen

zer|krü|meln

zer|las|sen; -e Butter

zer|lau|fen

zer|leg|bar; zer|le|gen; Zer|leg-
spiel; Zer|le|gung

zer|le|sen; ein zerlesenes Buch

Zer|li|ne (w. Eigenn.)

zer|lö|chern

zer|lumpt (ugs.); -e Kleider

zer|mah|len

zer|mal|men; Zer|mal|mung

zer|man|schen (ugs. für: völlig zer-
drücken, zerquetschen)

zer|mar|tern, sich; ich habe mir
den Kopf zermartert

Zermatt (schweiz. Kurort)

zer|mür|ben; zer|mürbt; -es Leder;
Zer|mür|bung

zer|na|gen

zer|nepft ostösterr. mdal. (zer-
zaust, verwahrlost)

zer|nich|ten (veralt. für: vernich-
ten)

zer|nie|ren (veralt. für: durch
Truppen einschließen)

Ze|ro arab. [sero] (Null, Nichts;
im Roulett: Gewinnfeld des
Bankhalters) w, -, -s od. s; -s, -s

Ze|ro|graph gr. (die Zerographie
Ausübender) m; -en, -en (↑ R
268); Ze|ro|gra|phie (Wachsgra-
vierung) w; -; ...jen; Ze|ro|pla|stik
(Wachsbildnerei); Ze|ro|tin|säu-
re (Bestandteil des Bienenwach-
ses) w, -

zer|pflücken [Trenn.: ...pflük|ken]

zer|plat|zen; eine zerplatzte Sei-
fenblase (ugs. für: enttäuschte
Hoffnung)

zer|pul|vern (für: pulverisieren)

zer|quält

zer|quet|schen; Zer|quet|schung

zer|rau|fen

Zerr|bild

zer|re|den

zer|reib|bar; zer|rei|ben; Zer|rei-
bung

zer|rei|ßen; sich -; zer|reiß|fest;
Zer|reiß|pro|be; Zer|rei|ßung

zer|ren; Zer|re|rei

zer|rin|nen

zer|ris|sen; ein -es Herz; Zer|ris-
sen|heit w; -

Zerr|spie|gel; Zer|rung

zer|rup|fen

zer|rüt|ten (zerstören); zer|rüt|tet;
eine -e Ehe; Zer|rüt|tung

zer|sä|gen

zer|schel|len (zerbrechen); zer-
schellt; Zer|schel|lung

zer|schie|ßen

zer|schla|gen; sich -; alle Glieder
sind mir wie -; Zer|schla|gen|heit
w; -; Zer|schla|gung

zer|schlei|ßen

zer|schlit|zen

zer|schmei|ßen

zer|schmet|tern; zer|schmet|tert, -e
Glieder; Zer|schmet|te|rung

zer|schnei|den; Zer|schnei|dung

zer|schrammt (völlig mit
Schrammen bedeckt); -e Hände

zer|schrun|det (völlig von
Schrunden, Rissen zerfurcht);
ein -es Gletscherfeld

zer|set|zen; zer|set|zung; Zer|set-
zungs_er|schei|nung, ...pro|dukt,
...pro|zeß

zer|sie|deln ([die Natur] durch
Siedlungen zerstören)

zer|spal|ten (durch Zusätze od.
Auslassungen den ursprüngl.
Wortlaut eines Volksliedes än-
dern)

zer|sorgt

zer|spal|ten; zerspalten u. zerspal-
tet; vgl. spalten; Zer|spal|tung

zer|spa|nen; Zer|spa|nung

zer|spei|len ([völlig] [auf]spalten)

zer|spel|len (veralt., geh. für: [völ-
lig] spalten)

zer|splei|ßen (veralt. für: [völlig]
[auf]spalten)

zer|split|tern (in Splitter zerschla-
gen; in Splitter zerfallen); sich -
(sich vielen Dingen widmen, da-
her nichts Rechtes erreichen);
Zer|split|te|rung

zer|sprat|zen (Geol.: sich aufblä-
hen u. zerbersten [von glühenden
Gesteinen])

zer|spren|gen; Zer|spren|gung

zer|sprin|gen

zer|stamp|fen

zer|stäu|ben; Zer|stäu|ber (Gerät
zum Versprühen von Flüssigkei-
ten); Zer|stäu|bung

zer|ste|chen

zer|stie|ben

zer|stör|bar; zer|stö|ren; Zer|stö-
rer; zer|stö|re|risch; -ste (↑ R 294);
Zer|stö|rung; Zer|stö|rungs-
_trieb, ...werk, ...wut

zer|sto|ßen

zer|strah|len; Zer|strah|lung

zer|strei|ten, sich

zer|streu|en; sich - (sich leicht un-
terhalten, ablenken, erholen);
zer|streut; ein -er Professor; -es
(diffuses) Licht; Zer|streut|heit;
Zer|streu|ung; Zer|streu|ungs|lin-
se

zer|stückeln [Trenn.: ...stük|keln];
Zer|stücke|lung [Trenn.: ...stük-
ke...], Zer|stück|lung

zer|talt (durch Täler stark geglie-
dert); ein -es Gelände

zer|tei|len; Zer|tei|ler; Zer|tei|lung

zer|tep|pern vgl. zerdeppern

Zer|ti|fi|kat lat. ([amtl.] Bescheini-
gung, Zeugnis, Schein) s; -[e]s,
-e; zer|ti|fi|zie|ren ([amtl.]
bescheinigen); zertifiziert

zer|tram|peln

zer|tren|nen; Zer|tren|nung

zer|tre|ten; Zer|tre|tung

zer|trüm|mern; ich ...ere (↑ R 327);
Zer|trüm|me|rung

Zer|ve|lat|wurst it.; dt. [zärweꞏ...,
auch: särweꞏ...] (eine Dauerwurst)

zer|vi|kal lat. [...wi...] (Med.: den
Hals, den Nacken betreffend)

zer|wer|fen, sich (sich entzweien,
verfeinden)

zer|wir|ken (Jägerspr.: die Haut
des Wildes abziehen u. das Wild
zerlegen)

zer|wüh|len

Zer|würf|nis s; -ses, -se

zer|zau|sen; Zer|zau|sung

zer|zup|fen

Zes|si|on lat. (Rechtsw.: Übertra-
gung eines Anspruchs von dem
bisherigen Gläubiger auf einen

Zessionar 772

Dritten); vgl. zedieren; **Zes|sio|nar** (jmd., an den eine Forderung abgetreten wird, neuer Gläubiger) *m*; -s, -e

Ze|ta (gr. Buchstabe: Z, ζ) *s*; -[s], -s

Ze|ter (veralt. für: Ruf um Hilfe; Wehgeschrei) *s*, noch in: Zeter u. Mord[io] schreien (ugs.); **Ze|ter|ge|schrei** (ugs.); **ze|ter|mor|dio!** (veralt.), noch in: zetermordio schreien (ugs.); **Ze|ter|mor|dio** (ugs.) *s*; -s; **ze|tern** (ugs. für: wehklagend schreien); ich ...ere (↑ R 327)

Zett; vgl. Z (Buchstabe)

¹**Zet|tel** (Weberei: Kette; Reihenfolge der Kettfäden) *m*; -s, -

²**Zet|tel** *lat.* (Streifen, kleines Blatt Papier) *m*; -s, -; **Zet|tel|bank** (veralt. für: Notenbank; *Mehrz.* ...banken) **Zet|te|lei** (Aufnahme in Zettelform, karteimäßige Bearbeitung; verächtl. für: Zettelwesen, -kram; unübersichtliches Arbeiten); **Zet|tel_kar|tei**, ...ka|sten, ...ka|ta|log, ...kram (abschätzig); **zet|teln** landsch. (verstreuen, weithin ausbreiten); ich ...[e]le (↑ R 327); vgl. ²verzetteln

zeuch!, **zeuchst**, **zeucht** (veralt. dicht. für: zieh[e]!, ziehst, zieht)

Zeug *s*; -[e]s, -e; jmdm. etwas an -flicken (ugs. für: an jmdm. kleinliche Kritik üben; **Zeug_amt** (veralt.: Lager für [Heeres]gerät), ...druck (gefärbter Stoff; *Mehrz.*: ...drucke); **Zeu|ge** *m*; -n, -n (↑ R 268); ¹**zeu|gen** (hervorbringen, erzeugen); ²**zeu|gen** (bezeugen); es zeugt von Fleiß (es zeigt Fleiß); **Zeu|gen_aus|sa|ge**, ...**bank** (*Mehrz.* ...bänke), ...**be|ein|flus|sung**, ...**ge|bühr**, ...**schaft** (*w*; -), ...**stand**, ...**ver|neh|mung**, ...**vor|la|dung**; **Zeug|haus** (veralt.); **Zeu|gin** *w*; -, -nen

Zeug|ma *gr.* (Sprachw.) *s*; -s, -s u. -ta

Zeug|nis *s*; -ses, -se; **Zeug|nis_ab|schrift**, ...**ver|wei|ge|rung**

Zeugs (ugs. abschätzig für: Gegenstand, Sache) *s*; -; so ein -

Zeu|gung; **Zeu|gungs|akt**; **zeu|gungs|fä|hig**; **Zeu|gungs|fä|hig|keit**, ...**glied**; **zeu|gungs|un|fä|hig**; **Zeu|gungs|un|fä|hig|keit** *w*; -

Zeus (höchster gr. Gott); **Zeus|tem|pel**; ↑ R 180

Zeu|te rhein., hess. (Zotte [Schnauze]) *w*; -, -n

Zeu|xis (altgr. Maler)

ZGB (in der Schweiz) = Zivilgesetzbuch

z. H. = zu Händen; zuhanden

Zib|be nordd., mitteld. (Mutterschaf, -kaninchen; verächtl.: Frau, Mädchen) *w*; -, -n

Zi|be|be *arab.-it.* bes. südd. (große Rosine) *w*; -, -n

Zi|be|li|ne *slaw.* (Wollgarn, -gewebe) *w*; -

Zi|bet *arab.* (als Duftstoff verwendete Drüsenabsonderung der Zibetkatze) *m*; -s; **Zi|bet|kat|ze**

Zi|bo|ri|um *gr.* (in der röm.-kath. Kirche Aufbewahrungsgefäß für Hostien; Altarbaldachin; Tabernakel) *s*; -s, ...ien [...iᵉn]

Zi|cho|rie *gr.* [...iᵉ] (Pflanzengattung der Korbblütler mit zahlreichen Arten [z. B. Wegwarte]; Kaffeezusatz) *w*; -, -n; **Zi|cho|ri|en|kaf|fee** *m*; -s

Zicke¹ (weibl. Ziege) *w*; -, -n; vgl. Zicken; **Zickel¹** (*s*; -s, -[n]), **Zickel|chen¹**, **Zick|lein**; **zickeln¹** (von der Ziege: Junge werfen); **Zicken¹** (ugs. für: Dummheiten) *Mehrz.*

Zick|zack *m*; -[e]s, -e; im Zickzack laufen, aber: zickzack laufen; **zick|zacken** [*Trenn.*: ...zak|ken]; gezickzackt; **Zick|zack_kurs**, ...**kur|ve**, ...**li|nie**

Zid|ki|ja vgl. Zedekia

Zi|der *hebr.* (Obst-, bes. Apfelwein) *m*; -s

Zie|che mdal. (Bettbezug u. a.) *w*; -, -n; vgl. Züchen

Ziech|ling (Ziehklinge, Schaber des Tischlers)

Zie|fer südwestd. (Federvieh) *s*; -s, -

zie|fern mitteld. (wehleidig sein od. tun; frösteln; vor Schmerz zittern); ich ...ere (↑ R 327)

Zie|ge *w*; -, -n

Zie|gel *m*; -s, -; **Zie|gel|bren|ner**; **Zie|gel|bren|ne|rei**; **Zie|gel|dach**; **Zie|ge|lei**; **zie|geln** (veralt. für: Ziegel machen); ich ...ele (↑ R 327); **Zie|gel|roh|bau**; **zie|gel|rot**; **Zie|gel_stein**, ...**strei|cher**

Zie|gel|bart (auch: ein Pilz), ...**bock**

Zie|gen|hai|ner [nach dem Dorf Ziegenhain bei Jena] (veralt. für: derber Stock)

Zie|gen_her|de, ...**kä|se**, ...**le|der**, ...**lip|pe** (ein Pilz), ...**mel|ker** (ein Vogel), ...**milch**; **Zie|gen_pe|ter** (Ohrspeicheldrüsenentzündung, Mumps) *m*; -s, -

Zie|ger alemann., bayr. (Quark-[käse], Kräuterkäse) *m*; -s, -; vgl. Ziger

Zieg|ler (Ziegelbrenner)

Zieh|brun|nen; **Zie|he** sächs. (Pflege u. Erziehung) *w*; -, -n; ein Kind in - geben; **Zieh|el|tern** *Mehrz.*; **zie|hen**; du zogst (zogest); du zögest; gezogen; zieh[e]!; vgl. zeuch! usw.; noch in: **Zieh|e** (Gerät zum Herausziehen [von

Korken usw.]; Ball beim Billardspiel); **Zieh_har|mo|ni|ka**, ...**hund**, ...**kind** (Pflegekind), ...**mut|ter** (Pflegemutter), ...**pfla|ster** (svw. Zugpflaster); **Zie|hung**; **Zieh|va|ter** (Pflegevater)

Ziel *s*; -[e]s, -e; **Ziel|band** *s* (*Mehrz.* ...bänder); **ziel|be|wußt**; **Ziel_be|wußt|heit**, ...**ein|rich|tung**; **zie|lend**; -es Zeitwort (für: Transitiv); **Ziel_fahrt** (Motorsport: kleinere Sternfahrt), ...**fern|rohr**, ...**fo|to_gra|fie**, ...**ge|ra|de** (Sport: letztes gerades Bahnstück vor dem Ziel); **ziel|ge|rich|tet**; **Ziel_kauf** (Wirtsch.),**li|nie**; **ziel|los**; -este (↑ R 292); **Ziel_lo|sig|keit** *w*; -; **Ziel_rich|ter**, ...**schei|be**, ...**set|zung** (ziel|si|cher; **Ziel_si|cher|heit**; **ziel|stre|big**; **Ziel|stre|big|keit** *w*; -; **ziel|vor|rich|tung**

Ziem (oberes Keulenstück [des Rindes]) *m*; -[e]s, -e

zie|men; es ziemt sich, es ziemt mir

Zie|mer (Rückenbraten [vom Wild]; männl. Glied [vom Ochsen u. a.]; Prügelwerkzeug) *m*; -s, -

ziem|lich (fast, annähernd)

Ziep|chen, **Zie|pel|chen** landsch. (Hühnchen); **Zie|pen** (ugs. für: zupfend ziehen; einen Pfeifton von sich geben)

Zier *w*; -; **Zie|rat** *m*; -[e]s, -e; **Zier_ben|gel** (veralt.); **Zier|de** *w*; -, -n; **zie|ren**; sich -; **Zie|re|rei**; **Zier_fisch**, ...**gar|ten**, ...**gras**, ...**kür|bis**, ...**lei|ste**; **zier|lich**; **Zier|lich|keit**; **Zier_pflan|ze**, ...**pup|pe**, ...**rand**, ...**schrift**, ...**strauch**, ...**stück**

Zie|sel *slaw.* (ein Nagetier) *m* (österr.: *s*); -s, -

Ziest *slaw.* (eine Heilpflanze) *m*; -[e]s, -e

Zie|t[h]en (preuß. Reitergeneral)

Ziff. = Ziffer

Zif|fer *arab.* (Zahlzeichen; Abk.: Ziff.) *w*; -, -n; arabische, römische -n; **Zif|fer|blatt**; ...**zif|fe|rig**, ...**zifflrig** (z. B. zweizifflrig, mit Ziffer: 2ziff[e]rig; ↑ R 228); **Zif|fer[n]|ka|sten** (Druckw.); **zif|fern|mä|ßig**; **Zif|fer|schrift**

-zig (ugs.) -zig Mark; mit -zig Sachen in die Kurve; zigfach, zighundert, zigmal, zigtausend; ein Zigfaches; Zigtausende von Menschen, Paketen usw.

Zi|ga|ret|te *fr.* -w; -, -n; **Zi|ga|ret|ten_au|to|mat**, ...**etui**, ...**fa|brik**, ...**kip|pe**, ...**län|ge** (auf eine - [ugs.]), ...**pa|pier**, ...**pau|se**, ...**rauch**, ...**rau|cher**, ...**schach|tel**, ...**spit|ze**, ...**stum|mel**; **Zi|ga|ril|lo** *span.* (höchster auch: ...*riljo*) (kleine Zigarre) *s* (seltener *m*); -s, -s (ugs. auch: *w*; -, -s); **Zi|gar|re** *w*; -, -n; **Zi-**

¹ *Trenn.*: ...ik|k...

gar|ren‿ab|schnei|der, ...asche,
...fa|brik, ...ki|ste, ...spit|ze,
...stum|mel
Zie|ger (schweiz. Schreibweise für:
Zieger) m; -s, -
Zi|geu|ner m; -s, -; zi|geu|ner|haft;
Zi|geu|ne|rin w; -, -nen; zi|geu|ne-
risch; Zi|geu|ner‿ka|pel|le, ...la-
ger (Mehrz. ...lager), ...le|ben (s;
-s), ...mu|sik; zi|geu|nern (ugs.
für: sich herumtreiben, auch: her-
umlungern); ich ...ere (↑ R 327),
Zi|geu|ner‿pri|mas, ...spra|che
zig|fach; zig|hun|dert; zig|mal; zig-
tau|send; vgl. -zig
Zi|ka|de lat. (ein Insekt); Zi|ka-
den|männ|chen
zi|li|ar lat. (Med.: an den Wimpern
befindlich; die Wimpern betref-
fend); Zi|li|ar‿ge|fäß, ...kör|per,
...neur|al|gie (Med.: Schmerzen
in Augapfel u. Augenhöhle); Zi-
lia|ten (Wimpertierchen [Einzel-
ler]) Mehrz.; Zi|lie [...iᵉ] (Med.:
Wimper) w; -, -n
Zi|li|zi|en usw. vgl. Kilikien usw.
¹Zil|le (dt. Zeichner)
²Zil|le slaw. ostd., österr. (Fluß-
fahrzeug, bes. flacher Fracht-
kahn) w; -, -n; Zil|len|schlep|per
(Schleppschiff)
Zil|ler|tal s; -[e]s; Zil|ler|ta|ler (↑ R
199); - Alpen
Zil|li (Kurzform von: Cäcilie)
Zim|bal gr. (mit Hämmerchen ge-
schlagenes Hackbrett; Vorläufer
des Cembalos) s; -s, -e u. -s; Zim-
bel (gemischte Orgelstimme; bei
den Römern eine Art kleines
Becken) w; -, -n
Zim|ber, Kim|ber (Angehöriger
eines germ. Volksstammes) m; -s,
-n; zim|brisch, kim|brisch aber
nur: die zimbrischen Sprachin-
seln u. (↑ R 198): die Zimbrische
Halbinsel (Jütland)
Zi|ment lat. bayr. u. österr. veralt.
(ein metalenes zylindr. Maßge-
fäß [der Wirte]) s; -[e]s, -e
Zi|mier gr. (Helmschmuck) s; -s,
-e
Zim|mer s; -s, -; Zim|mer|an|ten-
ne; Zim|mer|ar|beit, Zim|mer|ar-
ar|beit; Zim|mer|decke [Trenn.:
...dek|ke]; Zim|me|rei; Zim|mer-
ein|rich|tung, Zim|me|rer; Zim|-
me|rer|ar|beit, Zim|mer|ar|beit;
Zim|mer‿flucht (zusammenhän-
gende Reihe von Zimmern; vgl.
¹Flucht), ...ge|sel|le, ...hand-
werk, ...herr (möbliert wohnen-
der Herr); ...ge|mie|rig, ...zimm-
rig (z. B. zweizimm[e]rig; mit Zif-
fer: 2zimm[e]rig; ↑ R 228); Zim-
mer‿kell|ner, ...laut|stär|ke, ...lin-
de; Zim|mer|ling (Berg-
mannsspr.: Zimmermann); Zim-
mer‿mäd|chen, ...mann (Mehrz.
...leute), ...mei|ster; zim|mern; ich

...ere (↑ R 327); Zim|mer‿ofen,
...pflan|ze, ...su|che, ...tan|ne,
...thea|ter; Zim|me|rung; ...zimm-
rig vgl. ...zimmerig
zim|per|lich; Zim|per|lich|keit;
Zim|per|lie|se; ↑ R 195 landsch.
(zimperliches Mädchen) w; -, -n;
zim|pern landsch. ([leise] weinen;
zimperlich sein, tun); ich ...ere
(↑ R 327)
Zimt semit. (ein Gewürz) m; -[e]s,
-e; Zimt|baum; zimt‿far|ben od.
...far|big; Zimt‿öl (s; -[e]s), ...säu-
re (w; -), ...stan|ge
Zin|cke|nit [nach dem Bergrat
Zincken; zur Trenn.: vgl. ↑ R 189]
(ein Mineral) m; -s
Zin|cum (latinis. Nebenform von:
Zink) s; -s
Zin|del|taft gr.; pers. (Gewebe)
Zin|der engl. (ausgeglühte Stein-
kohle) m; -s, - (meist Mehrz.)
Zi|ne|ra|ria, Zi|ne|ra|rie lat. [...iᵉ]
(Zierpflanze) w; -, ...ien [...iᵉn]
¹Zin|gel (ein Fisch) m; -s, -[n]
²Zin|gel lat. (veralt. für: Ringmau-
er) m; -s, -; zin|geln (veralt. für:
umgürten, umzingeln); ich ...[e]le
(↑ R 327); Zin|gu|lum [...ngg...]
(Gürtel[schnur] der Albe [liturg.
Gewand]) s; -s, -s u. ...la
Zink (chem. Grundstoff, Metall;
Zeichen: Zn) s; -[e]s; vgl. Zincum;
Zink‿ät|zung, ...blech, ...blen|de
Zin|ke (Zacke; Blasinstrument;
[Gauner]zeichen) w; -, -n u. Zin-
ken (mdal. auch für: Weiler, Orts-
teil; ugs. für: grobe, dicke Nase)
m; -s, -; ¹zin|ken (mit Zinken ver-
sehen)
²zin|ken (von, aus Zink)
Zin|ken‿blä|ser; Zin|ke|nist
(schwäb., sonst veralt. für: Zin-
kenbläser, Stadtmusikant); ↑ R
268; ...zin|kig (z. B. dreizinkig)
Zin|ko|gra|phie¹ dt.; gr. (Zink-
flachdruck) w; -, ...ien; Zin|ko|ty-
pie (Zinkhochätzung) w; -, ...ien;
Zink‿oxyd od. (chem. fach-
sprachl.:) ‿oxid, ...sal|be, ...sul-
fat, ...wan|ne
Zinn (chem. Grundstoff, Metall;
Zeichen: Sn) s; -[e]s; vgl. Stannum
Zin|na|mom semit. (Zimt[baum])
s; -s
Zinn‿be|cher
Zin|ne (zahnartiger Mauerab-
schluß) w; -, -n
zin|nern (von, aus Zinn); Zinn‿fi-
gur, ...fo|lie (Blattzinn), ...ge-
schirr, ...gie|ßer
Zin|nie [...iᵉ; nach dem dt. Botani-
ker Zinn] (eine Gartenblume) w;
-, -n
Zinn|kraut (Ackerschachtelhalm)
s; -[e]s

¹ Auch eindeutschend: Zinkografie.

Zin|no|ber pers. (eine rote Farbe
[österr. nur: s]; ugs. für: Blödsinn)
m; -s, (für: ein Mineral auch
Mehrz.:) -; zin|no|ber|rot; Zin|no-
ber|rot
Zinn‿sol|dat, ...tel|ler
Zinn|wal|dit [nach dem Ort Zinn-
wald] (ein Mineral) m; -s
Zins lat. (Ertrag; Abgabe; südd.,
österr. u. schweiz. für: Miete) m;
-es, -en (Erträge) u. -e (Mieten)
(auch: ↑ R 327); zin|sen (schweiz., sonst
veralt. für: Zins[en] zahlen); du
zinst (zinsest); Zin|sen|dienst;
Zin|se|ner, Zins|ner (veralt. für:
Zinspflichtiger); Zins‿er|hö-
hung, ...er|trag; Zin|ses|zins
(Mehrz. ...zinsen); Zin|ses|zins-
‿ab|schrei|bung, ...rech|nung;
Zins‿fuß (Mehrz. ...füße), ...gro-
schen (hist.), ...haus (südd.,
österr. u. schweiz. für: Miets-
haus), ...herr|schaft (w; -),
...knecht|schaft; zins|los; Zins|ner
vgl. Zinsener; zins|pflich|tig;
Zins‿po|li|tik, ...satz, ...sen|kung,
...span|ne, ...staf|fel, ...ter|min
(Zinszahlungstag), ..theo|rie,
...ver|ord|nung, ...wu|cher, ...zahl
(Abk.: Zz.)
Zin|zen|dorf (Stifter der Herrnhu-
ter Brüdergemeine)
Zi|on hebr. (Tempelberg in Jerusa-
lem; auch [ohne Geschlechtsw.]:
Jerusalem) m; -[s]; Zio|nis|mus
(Bewegung zur Gründung u. Si-
cherung eines nationalen jüdi-
schen Staates) m; -; Zio|nist (An-
hänger des Zionismus; ↑ R 268;
zio|ni|stisch; Zio|ni|ten (schwär-
mer. christl. Sekte des 18. Jh.s)
Mehrz.
¹Zipf südd. u. ostmitteld. (Pips)
m; -[s]
²Zipf österr. mdal. (Zipfel; fader
Kerl) m; -[e]s, -e
Zip|fel m; -s, -; zip|fe|lig, zipf|lig;
Zip|fel|müt|ze
Zi|pol|le lat. niederd., auch md.
(Zwiebel) w; -, -n
Zipp ⓦ österr. (Reißverschluß)
m; -s, -s
Zipp|dros|sel, Zip|pe mitteld., ost-
niederd. (Singdrossel) w; -, -n
Zip|per|lein (veralt. für: Fußgicht)
s; -s
Zip|pus lat. (antiker Gedenk-,
Grenzstein) m; -, - u. Zippen
Zipp|ver|schluß engl.; dt. (österr.
für: Reißverschluß); vgl. Zipp ⓦ
Zips (Gebiet in der Slowakei) w;
-; Zip|ser (↑ R 199)
Zir|be, Zir|bel landsch. (eine Kie-
fer) w; -, -n; Zir|bel‿drü|se, ...kie-
fer (w; vgl. Arve), ...nuß
Zir|co|ni|um vgl. Zirkonium
zir|ka [eindeutschende Schrei-
bung für lat. circa] (ungefähr;
Abk.: ca.); dafür besser: unge-

fähr, etwa; Zir|ka|auf|trag (Börsenauftrag, bei dem der Kommissionär je nach Börsenlage um $^1/_4$ od. $^1/_2$ % vom gesetzten Limit abweichen darf)
Zir|kas|si|en [...i^en] (Land der Zirkassier); Zir|kas|si|er [...i^er] (alter Name für: Tscherkesse); Zir|kas|sie|rin w; -, -nen; zir|kas|sisch
Zir|kel gr. (Gerät zum Kreiszeichnen u. Strecken[ab]messen; [gesellschaftlicher] Kreis) m; -s, -; Zir|kel|ka|sten; zir|keln (Kreis ziehen; genau einteilen, [ab]messen); ich ...[e]le (↑ R 327); zir|kel|rund; Zir|kel|schluß
Zir|kon nlat. (ein Mineral) m; -s, -e; Zir|ko|ni|um, (chem. fachspr.:) Zir|co|ni|um (chem. Grundstoff, Metall; Zeichen: Zr) s; -s
zir|ku|lar, Zir|ku|lär gr. (kreisförmig); Zir|ku|lar (veralt. für: Rundschreiben) s; -s, -e; Zir|ku|lar|no|te (ine mehreren Staaten gleichzeitig zugestellte Note gleichen Inhalts); ...kre|dit|brief (Bankw.); Zir|ku|la|ti|on [...zion] (Kreislauf, Umlauf); zir|ku|lie|ren (in Umlauf sein, umlaufen, kreisen)
zir|kum... gr. (um..., herum...); Zir|kum... (Um..., Herum...); zir|kum|flek|tie|ren (mit Zirkumflex versehen); Zir|kum|flex (ein Dehnungszeichen: ^, z. B. â) m; -es, -e; Zir|kum|po|lar|stern (Stern, der für den Beobachtungsort nie untergeht); vgl. ^2Stern; zir|kum|skript (Med.: umschrieben, [scharf] abgegrenzt); Zir|kum|zi|si|on (Med.: Beschneidung); Zir|kus („Kreis"; altröm. Kampfspielbahn; großes Zelt od. Gebäude, in dem Tierdressuren u. a. gezeigt werden; ugs. verächtl., nur Einz. für: Durcheinander, Trubel) m; -, -se; Zir|kus_domp|teur, ...rei|ter, ...zelt
Zirm, Zirn tirol. (Zirbelkiefer) m; -[e]s, -e
Zir|pe (volkstüml. für: Grille, Zikade) w; -, -n; zir|pen
Zir|ren (Mehrz. von: Zirrus)
Zir|rho|se gr. (Med.: chronische Wucherung von Bindegewebe mit nachfolgender Verhärtung u. Schrumpfung) w; -, -n
Zir|ro|ku|mu|lus lat. (Meteor.: feingegliederte, federige Wolke in höheren Luftschichten, „Schäfchen"); Zir|ro|stra|tus (ungegliederte Streifenwolke in höheren Luftschichten) m; -, -; Zir|rus (Federwolke) m; -, - u. Zirren; Zir|rus|wol|ke
zir|zen|sisch gr. (den Zirkus betreffend, in ihm abgehalten); -e Spiele (die während der Zirkusspiele)

zis|al|pin, zis|al|pi|nisch lat. ([von Rom aus] diesseits der Alpen liegend)
Zi|sche|lei; zi|scheln; ich ...[e]le (↑ R 327); zi|schen; du zischst (zischest); Zisch|laut
Zi|se|leur fr. [...lör] m; -s, -e u. Zi|se|lie|rer (Metallstecher); zi|se|lie|ren ([Metall] mit dem Grabstichel bearbeiten, in Metall stechen)
^1Zis|ka (dt. Form von tschech. Žižka; Hussitenführer)
^2Zis|ka (Kurzform von: Franziska)
Zis|lei|tha|ni|en [...i^en] (ehem. Bez. für den österr. Anteil der habsburgischen Doppelmonarchie im Lande diesseits der Leitha); zis|lei|tha|nisch; zis|pa|da|nisch ([von Rom aus] diesseits des Pos liegend)
Zis|sa|li|en lat. [...i^en] (mißglückte Münzplatten od. Münzen, die wieder eingeschmolzen werden) Mehrz.
Zis|so|ide gr. (Math.: „Efeublattkurve"; ebene Kurve dritter Ordnung) w; -, -n
Zi|sta, Zi|ste gr. (altgr. zylinderförmiger Korb; frühgeschichtl. Urne) w; -, Zisten
Zi|ster|ne gr. (unterird. Behälter für Regenwasser) w; -, -n; Zi|ster|nen|was|ser s; -s
Zi|ster|zi|en|ser (Angehöriger eines kath. Ordens) m; -s, -; Zi|ster|zi|en|ser|or|den m; -s
Zist|rös|chen, Zist|ro|se gr.; dt. (eine Pflanze)
Zi|ta (w. Vorn.)
Zi|ta|del|le fr. (Befestigungsanlage innerhalb einer Stadt od. einer Festung) w; -, -n
Zi|tat lat. (wörtlich angeführte Belegstelle; auch: bekannter Ausspruch) s; -[e]s, -e; Zi|ta|ten|le|xi|kon, ...schatz; Zi|ta|ti|on [...zion] (veralt. für: [Vor]ladung vor Gericht; auch für: Zitierung)
Zi|ther gr. (ein Saiteninstrument) w; -, -n; Zi|ther|spiel s; -[e]s
zi|tie|ren lat. ([eine Textstelle] wörtlich anführen; vorladen); Zi|tie|rung
Zi|trat, (chem. fachspr.:) Citrat lat. [zi...] (Salz der Zitronensäure) s; -[e]s, -e; ^1Zi|trin (gelber Bergkristall) m; -s, -e; ^2Zi|trin (Wirkstoff im Vitamin P) s; -s; Zi|tro|nat fr. (kandierte Fruchtschale einer Zitronenart; auch: Getränk mit Zitronengeschmack) s; -[e]s, -e; Zi|tro|ne it. (Baum od. Strauch mit immergrünen Blättern, dessen Frucht w; -, -n; Zi|tro|nen_baum, ...fal|ter; zi|tro|nen_far|ben od. ...far|big, ...gelb; Zi|tro|nen_li|mo|na-

de, ...pres|se, ...saft (m; -[e]s), ...säu|re (w; -), ...scha|le, ...was|ser (s; -s); Zi|trul|le fr. (veralt. für: Wassermelone) w; -, -n; Zi|trus_frucht lat.; dt. (Zitrone, Apfelsine, Mandarine u. a.), ...öl, ...pflan|ze
Zit|scher|ling (veralt. für: Birkenzeisig)
Zit|ter_aal, ...gras; zit|te|rig, zittrig; zit|tern; ich ...ere (↑ R 327); (↑ R 120:) ein Zittern lief durch ihren Körper; er hat das Zittern (ugs.); Zit|ter_pap|pel, ...ro|chen (ein Fisch); zitt|rig, zit|te|rig
Zit|wer pers. (Korbblütler, dessen Samen als Wurmmittel verwendet werden) m; -s, -; Zit|wer|sa|men
Zitz Bengali-niederl. (selten für: Kattun) m; -es, -e
Zit|ze (Organ zum Säugen bei weibl. Säugetieren) w; -, -n
Zju (altgerm. Gott); vgl. Tiu, Tyr
zi|vil lat. [ziwil] (bürgerlich; -er (niedrige) Preise; -er Bevölkerungsschutz, Ersatzdienst; Zi|vil (bürgerl. Kleidung) s; -s; Zi|vil_an|zug, ...be|ruf, ...be|schä|dig|te (m u. w; -n, -n, -n; ↑ R 287 ff.), ...be|völ|ke|rung, ...cou|ra|ge, ...dienst, ...ehe (standesamtlich geschlossene Ehe), ...ge|setz|buch (Abk. [in der Schweiz]: ZGB); Zi|vi|li|sa|ti|on [...zion] (die durch den Fortschritt der Wissenschaft u. Technik verbesserten Lebensbedingungen); Zi|vi|li|sa|ti|ons|krank|heit (meist Mehrz.); zi|vi|li|sa|to|risch; zi|vi|li|sie|ren (der Zivilisation zuführen); Zi|vi|li|siert|heit w; -; Zi|vi|lis|ie|rung w; -; Zi|vi|li|st (Bürger, Nichtsoldat); ↑ R 268; zi|vi|li|stisch; Zi|vil_kam|mer (Spruchabteilung für privatrechtl. Streitigkeiten bei den Landgerichten), ...klei|dung, ...le|ben, ...li|ste (für den Landesherrn bestimmter Betrag im Staatshaushalt), ...per|son, ...pro|zeß (Gerichtsverfahren, dem die Bestimmungen des Privatrechts zugrunde liegen); Zi|vil_pro|zeß_ord|nung (Abk.: ZPO), ...recht; Zi|vil|recht s; -[e]s; zi|vil|recht|lich; Zi|vil|stand schweiz. (Familien-, Personenstand); Zi|vil|stands|amt schweiz. (Standesamt); Zi|vil|trau|ung
zi|zerl|weis bayr. u. österr. ugs. (nach und nach, ratenweise)
Žiž|ka [sehischka], (eindeutschende Schreibung:) Ziska
ZK = Zentralkomitee
Zl = Zloty, Zlotys
Zlo|ty poln. [sloti, auch: ßloti] (Münzeinheit in Polen; 1 Zloty = 100 Grosze; Abk.: Zl) m; -s, -s; 5 - (↑ R 322)

Zn = chem. Zeichen für: Zink
Znaim (mähr. Stadt)
Znüni bes. schweiz. mdal. (Vormittagsimbiß) *m* od. *s*; -s
Zo|bel *slaw.* (Marder; Pelz) *m*; -s, -; **Zo|bel|pelz**
Zo|ber mdal. (Zuber) *m*; -s, -
zockeln [*Trenn.*: zok|keln] (svw. zuckeln); ich ...[e]le († R 327)
Zocker [*Trenn.*: Zok|ker] *jidd.* (Gaunerspr. für: Glücksspieler) *m*; -s, -
Zo|dia|kal|licht *gr.* (Tierkreislicht, pyramidenförmiger Lichtschein in der Richtung des Tierkreises) *s*; -[e]s; **Zo|dia|kus** (Tierkreis) *m*; -
Zoe (Name byzant. Kaiserinnen)
Zöf|chen, **Zöf|lein**; **Zo|fe** *w*; -, -n; **Zo|fen|dienst**
Zoff landsch. (Ärger, Streit, Unfrieden) *m*; -s
Zö|ge|rer; **zö|gern**; ich ...ere († R 327); († R 120:) nach anfänglichem Zögern; ohne Zögern einspringen; **Zö|ge|rung** (veralt.)
Zög|ling
Zo|he südwestd. (Hündin) *w*; -, -n
Zo|la [*sola*] (fr. Schriftsteller)
Zöl|en|te|ra|ten (Hohltiere) *Mehrz.*
¹Zö|le|stin *lat.* (ein Mineral) *m*; -s, -e; **²Zö|le|stin**, **Zö|le|sti|nus** (m. Vorn.); **Zö|le|sti|ne** (w. Vorn.); **Zö|le|sti|ner** (Angehöriger eines ehem. kath. Ordens) *m*; -s, -; **zö|le|stisch** (veralt. für: himmlisch)
Zö|li|bat *lat.* (pflichtmäßige Ehelosigkeit aus religiösen Gründen, bes. bei kath. Geistlichen) *s* (Theologie: *m*); -[e]s; **Zö|li|bats|zwang** *m*; -[e]s
¹Zoll *gr.* (Abgabe) *m*; -[e]s, Zölle
²Zoll (Längenmaß; Zeichen: ″) *m*; -[e]s, -; 3 - († R 322) breit
Zoll|amt; **Zoll|ab|fer|ti|gung**, ...amt
zollang [*Trenn.*: zoll|lang, † R 236], aber: einen Zoll lang
Zoll|an|mel|dung, ...an|schluß; **zoll|bar**; **Zoll..be|am|te**, ...be|hör|de
zoll|breit; ein zollbreites Brett, aber: das Brett ist einen Zoll breit; **Zoll|breit** *m*; -, -; keinen - Landes aufgeben
Zoll|bürg|schaft, ...de|kla|ra|ti|on, ...ein|neh|mer (hist.)
zoll|len; jmdm. Achtung, Bewunderung -
...**zöl|ler** (z. B. Achtzöller)
Zoll|er|klä|rung, ...fahn|dungs|stel|le; **zoll|frei**; **Zoll..ge|biet**, ...grenz|be|zirk, ...gren|ze
zoll|hoch; einen Zoll hoch; **zöl|lig** (veralt. für: einen Zoll dick); ...**zol|lig**, u. (österr. nur:) ...**zöl|lig** (z. V. vierzollig, vierzöllig, mit Ziffer: 4zollig, 4zöllig; † R 229)
Zoll|in|halts|er|klä|rung; **Zolli|nie**

[*Trenn.*: Zoll|li..., † R 236] *w*; -, -n]; **Zöll|ner** (veralt. für: Zoll-, Steuereinnehmer; scherzh. für: Zollbeamter); **Zoll|ord|nung**; **zoll|pflich|tig**; **Zoll..po|li|tik**, ...recht, ...schran|ke
Zoll|stock (Maßstab; *Mehrz.* ...stöcke)
Zoll..ta|rif, ...uni|on, ...ver|trag, ...we|sen (*s*; -s)
Zö|lom *gr.* (Leibeshöhle, Hohlraum zwischen Darm u. Körperwand) *s*; -s, -e
Zö|me|te|ri|um *gr.* (Ruhestätte, Kirchhof, auch für: Katakombe) *s*; -s, ...ien [...*iᵉn*]
Zö|ng|kel *lat.* (selten für: Refektorium) *s*; -s
zo|nal *gr.* (zu einer Zone gehörend, eine Zone betreffend); **Zo|ne** ([Erd]gürtel; Gebiet[sstreifen]; geolog. Zeitabschnitt, der eine abgegrenzte Schicht umfaßt) *w*; -, -n; **Zo|nen..ein|tei|lung**, ...satz, ...ta|rif, ...zeit
Zo|no|bit *gr.* (im Kloster lebender Mönch) *m*; -en, -en († R 268); **Zo|no|bi|um** (Kloster; Biol.: Zellkolonie) *s*; -s, ...ien [...*iᵉn*]
Zoo *gr.* [*zo*] (Kurzform für: zoologischer Garten) *m*; -s, -s; **zoo|gen** [*zo-o...*] (bei Gesteinen: aus tierischen Resten gebildet); **Zoo|gra|phie** (Benennung u. Einordnung der Tierarten) *w*; -, ...ien; **Zoo|hand|lung** [*zo...*]; **Zoo|la|trie** [*zo-o...*] (Tierkult) *w*; -, ...ien; **Zoo|lith** (Tierversteinerung) *m*; -s od. -en, -e[n] († R 268); **Zoo|lo|ge** (Tierforscher) *m*; -n, -n († R 268); **Zoo|lo|gie** (Tierkunde) *w*; -; **zoo|lo|gisch** (tierkundlich); -er Garten, aber († R 224): der Zoologische Garten in Frankfurt
Zoom *engl.* [*sum*] (Objektiv mit veränderlicher Brennweite; Vorgang, durch den der Aufnahmegegenstand näher an den Betrachter herangeholt oder weiter von ihm entfernt wird) *s*; -s, (für Objektiv *Mehrz.*:) -s; **zoomen** [*sumᵉn*], gezoomt
Zo|on po|li|ti|kon *gr.* („geselliges Wesen"; Bez. des Menschen als gesellschaftsfähiges Wesen bei Aristoteles) ; - -; **Zoo-Or|che|ster** [*zo-o...*] († R 148); **Zoo|phyt** [*zo-o...*] („Pflanzentier", veralt. Bez. für Hohltier oder Schwamm) *m* od. -s; -en, -en († R 268); **Zoo|to|mie** (Tieranatomie) *w*; -
Zopf *m*; -[e]s, Zöpfe; das ist ein alter - (ugs. für: eine überlebte Gewohnheit, überholte Sache); **Zöpf|chen**, **Zöpf|lein**; **Zopf|fig**; **Zopf..mu|ster**, ...stil (*m*; -[e]s), ...zeit (*w*; -)
Zop|pot (Ort an der Danziger

Bucht); vgl. Sopot; **Zop|po|ter** († R 199)
Zo|res *jidd.* (ugs., bes. südwestdt. für: Wirrwarr, Ärger, Durcheinander) *m*; -
Zo|res|ei|sen; † R 180 [nach dem Erfinder] (Walz-, Belegeisen)
Zo|ril|la *span.* (Bandiltis, afrik. Marder) *m*; -s, -s (auch: *w*; -, -s)
Zorn *m*; -[e]s **Zorn..ader**, ...ausbruch, ...bin|kel (österr. ugs.: jähzorniger Mensch; *m*; -s, -); **zorn|ent|brannt**, aber († R 142): in hellem Zorn entbrannt; **Zor|nes..ader**, ...aus|bruch (geh. für: Zorn..ader, ...aus|bruch); **zorn|glü|hend**, aber († R 142): vor Zorn glühend; **zor|nig**; **zorn|mü|tig** (veraltend: zu Zorn neigend); **Zorn|rö|te**; **zorn|schnau|bend**, aber († R 142): vor Zorn schnaubend
Zo|roa|ster (Nebenform von: Zarathustra); **zo|roa|strisch**, aber († R 179): **Zo|roa|strisch**
Zo|te (unanständiger Ausdruck; unanständiger Witz) *w*; -, -n; **zo|ten**; **Zo|ten|rei|ßer**; **zo|tig**
Zot|te südwestd. u. mitteld. (Schnauze, Ausgießer)
Zot|tel (Haarbüschel; Quaste, Troddel u. a.) *w*; -, -n; **Zot|tel..bär** ...haar; **zot|te|lig**, **zot|tlig**; **zot|teln** mdal. (langsam gehen); ich ...[e]le († R 327); **zot|tig**
ZPO = Zivilprozeßordnung
Zr = chem. Zeichen für: Zirkonium
Zri|ny (so bei Th. Körner), **Zri|nyi** [*zrini*, auch: *zrinji*] (ung. Feldherr)
Zschok|ke (schweiz. Schriftsteller)
z. T. = zum Teil
Ztr. = Zentner (50 kg)
zu; mit *Wemf.*: zu dem Garten; zum Bahnhof; zu zwei[e]n, zu zweit; vier zu eins (4 : 1); zu viel, aber: zuviel (vgl. d.); zu wenig, aber: zuwenig (vgl. d.); zuletzt, aber: zu guter Letzt; zufrühst; zuäußerst; zuoberst; zuinnerst; zu weit; zu nahe; zu Haus[e] (vgl. d.) sein; zuzeiten (bisweilen), aber: zu meinen Zeiten; zu seiten (vgl. d.); zu Berge stehen; zu Ende gehen; zu Herzen gehen; zu Ohren kommen; zu Rate ziehen; zurecht, aber: zu Recht bestehen; zu Werke gehen; zu Willen sein; jmdm. etwas zu Dank machen; sich jmdm. zu Dank verpflichten; zu herzlichstem Dank verpflichtet; zu eigen geben; zum (zu dem; vgl. zum); zur (zu der; vgl. zur); *zu* (*zum, zur*) *im Eigennamen*: Bilden „zu", „zum", „zur" den *ersten Bestandteil* eines *Gebäudenamens*,

so sind sie groß zu schreiben (↑ R 224), z. B. Zum Löwen (Gasthaus), Zur Alten Post (Gasthaus), das Gasthaus [mit dem Namen] „Zum Löwen", „Zur Alten Post", aber: das „Gasthaus zum Löwen". Bei *Familiennamen* schwankt die Schreibung, z. B. Familie Zur Nieden, (auch:) Familie zur Nieden; *zu beim Zeitwort*: er befahl ihm zu gehen, aber: er befahl ihm, sofort zu gehen (zum *Beistrich* ↑ R 30ff.); er hofft, pünktlich zu kommen, aber: er hofft, pünktlich anzukommen; entsprechend: der zu versichernde Angestellte, der zu Versichernde, aber: der aufzunehmende Fremde, der Aufzunehmende; (*zu* als „*Vorwort*" des *Zeitwortes*:) der Hund ist mir zugelaufen, der Vogel ist mir zugeflogen, aber (*zu* als *Umstandswort*:) er wollte langsam dem Walde zu (= waldwärts) gehen, sie sind der Stadt zu (= stadtwärts) gegangen

zu... (*in Zus. mit Zeitwörtern*, z. B. zunehmen, du nimmst zu, zugenommen, zuzunehmen; zum 2. Mittelw. ↑ R 304)

zu|ackern [*Trenn.:* ...ak|kern]; zugeackert

zu|al|ler|al|ler|letzt; **zu|al|ler|erst**; **zu|al|ler|letzt**; **zu|al|ler|meist**; **zu|äu|ßerst**

Zua|ve *fr.* [...w^e] (Angehöriger einer ehem. aus Berberstämmen rekrutierten fr. [Kolonial]truppe) *m*; -n, -n (↑ R 268)

zu|bal|lern (ugs. für: die Tür hart ins Schloß werfen); zugeballert

Zu|bau österr. (Anbau); dieses Gebäude erhält einen -; **zu|bau|en**; zugebaut

Zu|be|hör *s* (seltener: *m*); -[e]s, -e (schweiz. auch: -den); vgl. Zugehör; **Zu|be|hör|in|du|strie**; **Zu|be|hör|teil** *s*; -[e]s, -e (meist *Mehrz.*)

zu|bei|ßen; zugebissen

zu|be|kom|men (ugs. für: dazu bebekommen; ugs. für: schließen können); zubekommen

zu|be|namt (veraltet.), **zu|be|nannt**

Zu|ber (Gefäß; altes Hohlmaß)

zu|be|rei|ten; zubereitet; **Zu|be|rei|ter**; **Zu|be|rei|tung**

Zu|bett|ge|hen *s*; -s; vor dem -

zu|bil|li|gen; zubilligt; **Zu|bil|li|gung**

zu|bin|den

Zu|biß

zu|blei|ben (ugs. für: geschlossen bleiben); zugeblieben

zu|blin|zeln; zugeblinzelt

zu|brin|gen; zugebracht; **Zu|brin|ger**; **Zu|brin|ger|dienst**, ...stra|ße, ...ver|kehr

Zu|brot landsch. (zusätzlicher Verdienst) *s*; -[e]s

Zu|bu|ße (veraltend für: Geldzuschuß)

zu|but|tern (ugs. für: [Geld] zusetzen); zugebuttert

Zuc|chet|to *it.* [zuk...] schweiz. (grüner Kürbis, gurkenähnl. Gemüse) *m*; -s, ...tti (meist *Mehrz.*)

Zü|chen mdal. (Bettbezug, Bettbezugsstoff) *m*; -s; vgl. Zieche

Zucht *w*; -, (landwirtschaftlich für: Züchtergebnisse:) -en; **Zucht-buch**, ...bul|le, ...eber; **züch|ten**; **Züch|ter**; **Zucht|er|folg**; **züch|te|risch**; **Zucht-haus**, ...häus|ler; **züch|ti|gen**; **Züch|tig|keit** *w*; -; **Züch|ti|gung**; **Züch|ti|gungs|recht**; **Züch|tling** (veralt. für: Zuchthäusler); **zucht|los**; -este (↑ R 292); **Zucht|lo|sig|keit**; **Zucht-mit|tel** *s*, ...ru|te, ...stier, ...tier; **Züch|tung**; **Zucht-vieh**, ...wahl

zuck! (schnell!; los!); **Zuck** (ugs.) *m*; -[e]s, -e; in einem -; **zuckeln**[1] (ugs. für: langsam dahintrotten, dahinfahren); ich ...[e]le (↑ R 327); vgl. auch: zockeln; **Zuckel-trab**[1] (ugs.); im -; **zucken**[1]; der Blitz zuckt; **zücken**[1] (ziehen, ergreifen); des Schwert -, das Portemonnaie -

Zucker[1] *sanskr. m*; -s, (für: Zuckersorten:) -; **Zucker|bäcker**[1] (südd. u. österr., sonst veralt. für: Konditor); **Zucker|bäcker|stil**[1] (abwertend für einen bestimmten Baustil in den Ostblockländern); **Zucker|brot**[1]; **Zucker|chen**[1] landsch. (Bonbon); **Zucker|cou|leur** (gebrannter Zucker zum Färben von Getränken; *w*; -), ...do|se, ...erb|se, ...fa|brik, ...gebacke|ne[1], ...guß; **zucker|hal|tig**[1]; **Zucker|harn|ruhr**[1] (Zuckerkrankheit); **Zucker|hut**[1] *m*; **zucker|rig**[1], **zuck|rig**; **Zucker-kand**[1] *m*; -[e]s u. **Zucker|kan|dis**[1] (volkstüml. für: Kandiszucker) *m*; -; **Zucker|kandl**[1] österr. veralt. (Kandiszucker) *s*; -s, -[n]; **zucker-krank**[1]; **Zuckerl**[1] österr. (Bonbon) *s*; -s, -[n]; **zuckern**[1] (mit Zucker süßen); ich ...ere (↑ R 327); **Zucker**[1]**plätz|chen** (veralt.), ...raf|fi|ne|rie, ...rohr, ...rü|be, ...steu|er *w*; **zucker|süß**[1]; **Zucker**[1]**was|ser**, ...zan|ge, ...zeug

Zuck|fuß (fehlerhafter Gang des Pferdes) *m*; -es

Zuck|may|er, Carl (dt. Schriftsteller u. Dramatiker)

zuck|rig, zucke|rig[1]

Zuckung[1]

[1] *Trenn.:* ...k|k...

zu|decken[1]; zugedeckt

zu|dem (überdies)

zu|die|nen schweiz. (Handreichung tun); zugedient

zu|dik|tie|ren; zudiktiert

Zu|drang *m*; -[e]s (veralt.)

zu|dre|hen; zugedreht

zu drei|en, zu dritt

zu|dring|lich; **Zu|dring|lich|keit**

zu dritt, zu drei|en

zu|drücken [*Trenn.:* ...drük|ken]; zugedrückt

zu ei|gen; - - geben; sich - - machen; **zu|eig|nen** ([ein Buch] widmen; zu eigen geben); zugeeignet; **Zu|eig|nung**

zu|ein|an|der; *Schreibung in Verbindung mit Zeitwörtern* (↑ R 139): zueinander sprechen, zueinander passen, aber: zueinanderfinden (zusammenfinden), vgl. aneinander

zu En|de

zu|er|ken|nen; er erkannte mir die Berechtigung zu; zuerkannt; **Zu|er|ken|nung**

zu|erst; der zuerst genannte Verfasser ist nicht mit dem zuletzt genannten zu verwechseln; aber: zu zweit

zu|er|tei|len; zuerteilt

zu|fach (↑ R 141); zufach kommen (ugs. landsch. für: sich in etwas hineinfinden)

zu|fä|cheln; zugefächelt

zu|fah|ren; zugefahren; **Zu|fahrt**; **Zu|fahrts_ram|pe**, ...stra|ße, ...weg

Zu|fall *m*; **zu|fal|len**; zugefallen; **zu|fäl|lig**; **zu|fäl|li|ger|wei|se**; **Zu|fäl|lig|keit**; **Zu|falls_be|ob|ach|tung**, ...er|geb|nis, ...streu|be|reich** (Statistik), ...streu|ung** (Statistik), ...tref|fer

zu|fas|sen; zugefaßt

zu|flie|gen; zugeflogen

zu|flie|ßen; zugeflossen

zu|flucht *m*; **Zu|flucht**[nah|me *w*; -; **Zu|fluchts_ort** (*m*; -[e]s, -e), ...stät|te

Zu|fluß

zu|flü|stern; zugeflüstert

zu|fol|ge (↑ R 141); demzufolge (vgl. d.); (bei Nachstellung mit *Wemf.*:) dem Gerücht -, aber (bei Voranstellung mit *Wesf.*:) des Gerüchtes -

zu|frie|den; - mit dem Ergebnis -; *Schreibung in Verbindung mit Zeitwörtern* (↑ R 139): **a)** *Getrenntschreibung* in ursprünglicher Bedeutung, z. B. zufrieden machen, sein, werden; er hat ihn zufrieden gemacht; **b)** *Zusammenschreibung*, wenn durch die Verbindung ein neuer Begriff entsteht; vgl. zufriedengeben, zu-

[1] *Trenn.:* ...k|k...

friedenlassen; zufrie|den|stel|len;
zu|frie|den|ge|ben († R 139), sich
(sich begnügen); ich gebe mich
zufrieden; zufriedengegeben; zu-
friedenzugeben; **Zu|frie|den|heit**
w; -; zu|frie|den|las|sen; ↑ R 139
(in Ruhe lassen); vgl. zufrieden-
geben; zu|frie|den|stel|len; ↑ R
139 (befriedigen); vgl. zufrieden-
geben; Zu|frie|den|stel|lung w; -
zu|frie|ren; zugefroren
zu|frühst
zu|fü|gen; zugefügt; **Zu|fü|gung**
Zu|fuhr (Herbeischaffen) w; -, -en;
zu|füh|ren; zugeführt; **Zu|füh-**
rung; **Zu|füh|rungs_rohr,**
...schlauch
Zu|fuß|ge|hen s; -s
¹**Zug** m; -[e]s, Züge; im -e des Wie-
deraufbaus; - um -; Dreiuhrzug
(mit Ziffer: 3-Uhr-Zug; ↑ R 157)
²**Zug** (Kanton u. Stadt in der
Schweiz)
Zu|ga|be; Zu|ga|be|we|sen s; -s
Zu|gang; zu|gan|ge († R 141); -
kommen, sein; **zu|gän|gig** (selte-
ner für: zugänglich); **zu|gäng|lich**
(leicht Zugang gewährend); **Zu-**
gäng|lich|keit w, -
Zug_ab|teil (vgl. Zugsabteil), ...an-
schluß, ...be|gleiter, ...be|leuch-
tung, ...brücke [Trenn.: ...brük-
ke]
zu|ge|ben; zugegeben (vgl. d.)
zu|ge|dacht; diese Auszeichnung
war eigentlich ihm -
zu|ge|ge|ben; zugegeben, daß er
recht hat; zu|ge|ge|be|ner|ma|ßen
zu|ge|gen; - bleiben, sein
zu|ge|hen; auf jmdn. -; auf dem
Fest ist es sehr lustig zugegangen;
der Koffer geht nicht zu; **Zu|ge-**
he|rin südd., westösterr. (Auf-
wartefrau); **Zu|geh|frau**
Zu|ge|hör (österr. u. schweiz. ne-
ben, sonst veralt. für: Zubehör)
s; -[e]s (schweiz.; w; -); zu|ge|hö-
ren (geh.); zugehört; zu|ge|hö|rig;
Zu|ge|hö|rig|keit w; -; **Zu|ge|hö-**
rig|keits|ge|fühl s; -[e]s
zu|ge|knöpft; er war sehr - (ugs.
für: verschlossen); **Zu|ge|knöpft-**
heit w; -
Zü|gel m; -s, -; **Zü|gel|hand** (linke
Hand des Reiters); zü|gel|los;
-este († R 292); **Zü|gel|lo|sig|keit;**
zü|geln (schweiz. mdal. auch für:
umziehen); ich ...[e]le († R 327);
Zü|ge|lung, Züg|lung
Zu|ge|mü|se (veralt.: Gemüsebei-
lage)
Zü|gen|glöck|lein bayr. u. österr.
(Sterbeglöckchen)
Zu|ger (von, aus ²Zug; ↑ R 199)
Zu|ge|rei|ste m u. w; -n, -n († R
287 ff.)
Zu|ger See m; - -s; zu|ge|risch
zu|ge|sel|len; zugesellt; sich -
zu|ge|stan|den; zugestanden, daß

dich keine Schuld trifft; zu|ge-
stan|de|ner|ma|ßen; **Zu|ge|ständ-**
nis; zu|ge|ste|hen; zugestanden
zu|ge|tan (auch: wohlwollend,
freundlich gesinnt); er ist ihm von
Herzen -
zu|ge|wandt, zu|ge|wen|det vgl. zu-
wenden
Zu|ge|winn; Zu|ge|winn|ge|mein-
schaft (Form des gesetzl. Güter-
rechts)
Zug_fe|stig|keit (w; -), ...fol|ge,
...füh|rer (vgl. Zugsführer)
Zug_hub (Bergmannsspr.: Gerät,
das das Heben schwerer Lasten
erleichtert) m; -[e]s, -e
zu|gie|ßen; zugegossen
zu|gig (windig); zü|gig (in einem
Zuge; schweiz. auch: zugkräftig);
...zü|gig (z. B. zweizügig [von
Schulen]); **Zug_kon|trol|le,**
...kraft w; zug|kräf|tig
zu|gleich
Zug|lei|ne; Züg|le|te schweiz.
mdal. (Umzug, Übersiedlung) w;
-, -n; **Zug|luft** w; -
Züg|lung, Zü|ge|lung
Zug_ma|schi|ne, ...mit|tel s,
...num|mer, ...per|so|nal, ...pferd,
...pfla|ster
zu|grei|fen; zugegriffen; **Zu|griff**
m; -[e]s, -e; zu|grif|fig schweiz.
(zugreifend, tatkräftig)
zu|grun|de († R 141); zugrunde ge-
hen, legen, liegen, richten; **Zu-**
grun|de_ge|hen (s; -s), ...le|gung
(unter - von ...); **Zu|grun|de|lie-**
gend, (auch:) zu|grun|de lie|gend
(† R 142)
Zugs_ab|teil (österr.), ...füh|rer
(österr.)
Zug|spitz|bahn; Zug|spit|ze (höch-
ster Berg Deutschlands) w; -
Zug|stück
Zugs_ver|kehr (österr., auch
schweiz.), ...ver|spä|tung (österr.)
Zug|tier
zu|gucken [Trenn.: ...guk|ken]
(ugs.); zugeguckt
Zug-um-Zug-Lei|stung; ↑ R 155
(Rechtswesen)
zu|gun|sten († R 141); (bei Voran-
stellung mit Wesf.:) - bedürftiger
Kinder, aber (bei seltener Nach-
stellung mit Wemf.:) dem Freund
-; vgl. Gunst
zu|gu|te († R 141); zugute halten,
kommen, tun
zu gu|ter Letzt; vgl. Letzt
Zug_ver|bin|dung, ...ver|kehr (vgl.
Zugsverkehr), ...vieh, ...vo|gel,
...vor|rich|tung, ...wa|gen; zug-
wei|se; **Zug_wind,** ...zwang; unter
- stehen
zu|hacken [Trenn.: ...hak|ken]; zu-
gehackt
zu|ha|ken; zugehakt
zu|hal|ten; zugehalten; **Zu|häl|ter;**
Zu|häl|te|rei w; -; zu|häl|te|risch

¹**zu|han|den** († R 141); zuhanden
kommen, sein; ²**zu|han|den, zu**
Hän|den († R 141; Abk.: z. H.);
zuhanden od. zu Händen des
Herrn ..., (meist:) zuhanden od.
zu Händen von Herrn ..., (auch:)
zuhanden od. zu Händen
Herrn ...
zu|hän|gen; vgl. ²hängen
zu|hau|en; zur Beugung vgl. hauen
zu|hauf († R 141); - legen, liegen
zu Haus, zu Hau|se; vgl. Haus; sich
wie zu Hause fühlen; **Zu|hau|se**
s; -; er hat kein - mehr; aber:
ich bin zu Hause od. Haus; **Zu-**
hau|se|ge|blie|be|ne m u. w; n, n
(† R 287 ff.)
zu|hef|ten; zugeheftet
zu|hei|len; zugeheilt
Zu|hil|fe|nah|me w; -; unter - von
zu|hin|terst
zu|höchst
zu|hor|chen landsch. (zuhören);
zugehorcht
zu|hö|ren; zugehört; **Zu|hö|rer;**
Zu|hö|rer|bank (Mehrz. ...bän-
ke); **Zu|hö|rer|schaft**
Zu|i|der|see [seud...] w; - od. m; -s;
vgl. IJsselmeer
zu|in|nerst
zu|ju|beln; zugejubelt
zu|keh|ren; zugekehrt
zu|klap|pen; zugeklappt
zu|kle|ben; zugeklebt
zu|knal|len; zugeknallt
zu|knei|fen; zugekniffen
zu|knöp|fen; zugeknöpft (vgl. d.)
zu|kom|men; zugekommen; er ist
auf mich zugekommen; **zu|kom-**
men las|sen; er hat ihm das Ge-
schenk - -, (seltener:) zukommen
gelassen († R 305); ihm etwas zu-
kommen zu lassen
zu|kor|ken; zugekorkt
Zu|kost
Zu|kunft w; - (selten:) Zukünfte;
zu|künf|tig; **Zu|künf|ti|ge** (Ver-
lobte[r]) m u. w; -n, -n († R 287ff.);
Zu|kunfts|aus|sich|ten (Mehrz.);
Zu|kunfts|freu|dig, Zu|kunfts-
hoff|nung, ...mu|sik (ugs.), ...plä-
ne (Mehrz.), zu|kunfts|reich; **Zu-**
kunfts_ro|man, ...si|che|rung,
...staat (Mehrz. ...staaten); zu-
kunfts_träch|tig, ...voll; zu-
kunft[s]|wei|send
zu|lä|cheln; zugelächelt
zu|lan|den († R 141 (daheim); bei uns
zulande, hierzulande, aber: zu
Wasser u. zu Lande
zu|lan|gen; zugelangt; zu|läng|lich
(hinreichend); **Zu|läng|lich|keit**
zu|las|sen; zugelassen; zu|läs|sig
(erlaubt); **Zu|läs|sig|keit** w; -; **Zu-**
las|sung; **Zu|las|sungs|stel|le**
zu La|sten vgl. Last
Zu|lauf; zu|lau|fen; zugelaufen

zu|le|gen; zugelegt
zu|leid, zu|lei|de (↑ R 141); - tun
zu|lei|ten; zugeleitet; Zu|lei|tung;
Zu|lei|tungs|rohr
zu|ler|nen (ugs.); zugelernt
zu|letzt, aber: zu guter Letzt
zu|lie|be, (österr. auch:) zu|lieb
(↑ R 141); dem -; - tun
Zu|lie|fe|rant, Zu|lie|fe|rer (Wirt-
schaft); Zu|lie|fe|rer|in|du|strie,
Zu|lie|fer|in|du|strie; Zu|lie|fe-
rung
zul|len fränk. (lutschend saugen);
Zulp ostmitteld. (Lutschbeutel)
m; -[e]s, -e; zul|pen ostmitteld.
(lutschend saugen)
Zu|lu (Angehöriger eines Südost-
bantustammes in Natal) m; -[s],
-[s]
zum; ↑ R 240 (zu dem); - höchsten,
mindesten, wenigsten; - ersten,
- zweiten, - dritten; - ersten Male,
aber: - erstenmal; - letzten Male,
aber: - letztenmal; - Teil (Abk.:
z. T.); (↑ R 133 u. 134:) - besten
geben, haben, halten, kehren,
lenken, wenden; es steht nicht -
besten (nicht gut), aber (↑ R 116):
- Besten der Armen; (↑ R 120:)
das ist - Weinen, - Totlachen.
Über die Schreibung von „zum"
als Teil eines Eigennamens vgl. zu
zu|ma|chen (schließen); zuge-
macht, aber: es ist nichts zu ma-
chen; auf - und zumachen
zu|mal (↑ R 141); - [da]
zum Bei|spiel (Abk.: z. B.); ↑ R 19
zu|mau|ern; zugemauert
zu|meist
zu|mes|sen; zugemessen
zum Ex|em|pel (zum Beispiel;
Abk.: z. E.)
zu|min|dest, aber: zum mindesten
zum Teil (Abk.: z. T.)
zu|mut|bar; Zu|mut|bar|keit
zu|mu|te (↑ R 141); mir ist gut,
schlecht -
zu|mu|ten; zugemutet; Zu|mu|tung
zum vor|aus [auch: -foraus] (selte-
ner für: im voraus); ↑ R 134
zu|nächst; - ging er nach Hause;
mit Wemf.: - dem Hause od. dem
Hause -; Zu|nächst|lie|gen|de s;
-n (↑ R 287ff.)
zu|na|geln; zugenagelt
zu|nä|hen; zugenäht
Zu|nah|me (Vermehrung, Er-
höhung) w; -, -n
Zu|na|me (Familienname; auch:
Spott-, Spitzname)
Zün|dapp ⓦ (Mopeds, Nähma-
schinen u. a.)
Zünd|ap|pa|rat; zünd|bar; Zünd-
blätt|chen; Zün|del (veralt. für:
Zunder) m; -s; zün|deln bes.
österr. mdal. (mit dem Feuer
spielen); ich ...[e]le (↑ R 327); zün-
den; zün|dend; -ste; Zün|der (ein
Pilz; Zündmittel; Metallkunde:

Oxydschicht [vgl. Oxid]) m; -s,
-; Zün|der ([Gas-, Feuer]anzün-
der; Zündvorrichtung in
Sprengkörpern; österr. auch
sww. Zündhölzer); Zün|der|pilz;
Zünd.flam|me, ...holz, ...hölz-
chen, ...hüt|chen, ...ka|bel, ...ker-
ze, ...la|dung, ...na|del; Zünd|na-
del|ge|wehr (hist.); Zünd.schlüs-
sel, ...schnur, ...stoff; Zün|dung;
Zünd|vor|rich|tung
zu|neh|men; zugenommen; vgl. ab
zu|nei|gen; zugeneigt; Zu|nei|gung
Zunft w; -, Zünfte; Zunft.ge|lehr-
te, ...ge|nos|se; zünf|tig (ugs. auch
für: ordentlich, tüchtig); Zünft-
ler (früher: Angehöriger einer
Zunft); Zunft.mei|ster, ...ord-
nung, ...recht, ...we|sen (s; -s),
...zwang
Zun|ge w; -, -n; Zün|gel|chen,
Züng|lein; zün|geln; zun|gen|fer-
tig; Zun|gen.fer|tig|keit (w; -),
...laut (für: Lingual); Zun|gen-R
(↑ R 149); Zun|gen.schlag, ...spit-
ze, ...wurst; Züng|lein, Zün|gel-
chen
zu|nich|te (↑ R 141); - machen,
werden
zu|nicken [Trenn.: ...nik|ken]; zu-
genickt
zu|nie|derst
Züns|ler (Kleinschmetterling) m;
-s, -
zu|nut|ze (↑ R 141); sich etwas -
machen, aber: zu Nutz u. From-
men
zu|oberst
zu|ord|nen; zugeordnet; Zu|ord-
nung
zu|packen [Trenn.: ...pak|ken]; zu-
gepackt
zu|paß, zu|pas|se (↑ R 141); zupaß
od. zupasse kommen
zup|fen; Zupf|gei|ge (ugs. für: Gi-
tarre); Zupf|gei|gen|hansl (Lie-
dersammlung) m; -s, -; Zupf|in-
stru|ment
zu|pres|sen; zugepreßt
zu|pro|sten; zugeprostet
zur; ↑ R 240 (zu der); - Folge haben;
sich - Ruhe begeben; sich - Ruhe
setzen; - Schau stellen; zur Zeit
(Abk.: z. Z.); vgl. Zeit. Über die
Schreibung von „zur" als Teil ei-
nes Eigennamens vgl. zu
zu|ra|ten; zugeraten
zu|rau|nen; zugeraunt
Zür|cher; ↑ R 199 (schweiz. Form
von: Züricher); zür|che|risch
(schweiz. Form von: züriche-
risch)
zur Dis|po|si|ti|on [- ...zion] (zur
Verfügung; Abk.: z. D.); - stellen;
Zur|dis|po|si|ti|on[s]|stel|lung
Zu|re|chen|bar|keit w; -; zu|rech-
nen; zugerechnet; Zu|rech|nung;
Zu|rech|nungs|fä|hig; Zu|rech-
nungs|fä|hig|keit w; -

zu|recht, nur in Zus. mit Zeitwör-
tern, z. B. zurechtkommen usw.,
aber: zu Recht bestehen; zu-
recht.ba|steln, ...bie|gen, ...fin-
den, sich, ...kom|men, ...le|gen,
...ma|chen (ugs.), ...rücken
[Trenn.: ...rük|ken], ...set|zen,
...stel|len, ...wei|sen; Zu|recht-
wei|sung; zu|recht|zim|mern
zu|re|den; zugeredet; Zu|re|den s;
-s; auf vieles -; trotz allem -, trotz
allen oder alles -s
zu|rei|chen; zugereicht; zu|rei-
chend; -e Gründe; Zu|rei|cher
österr. veralt. (Hilfsarbeiter)
zu|rei|ten; zugeritten
Zü|rich [schweiz.: zürich] (Kanton
u. Stadt in der Schweiz); Zü|rich-
biet; Zü|ri|cher, in der Schweiz
nur: Zür|cher (↑ R 199); zü|ri|che-
risch, in der Schweiz nur: zür|che-
risch; Zü|rich|see m; -s
Zü|rich|te|bo|gen; zu|rich|ten; zu-
gerichtet; Zu|rich|ten s; -s; Zu-
rich|ter; Zu|rich|te|rei; Zu|rich-
tung
zu|rie|geln; zugeriegelt
zür|nen
zu|rol|len; zugerollt
zur|ren niederl. (Seemannsspr.:
festbinden); Zur|ring (See-
mannsspr.: Leine zum Zurren) m;
-s, -s u. -e
Zur|ru|he|set|zung
Zur|schau|stel|lung
zu|rück; -seo; sing; (↑ R 119:) es gibt
kein Zurück mehr
zu|rück... (in Zus. mit Zeitwörtern,
z. B. zurücklegen, du legst zu-
rück, zurückgelegt, zurückzule-
gen; zum 2. Mittelw. ↑ R 304)
zu|rück|be|hal|ten; zurückbehal-
ten; Zu|rück|be|hal|tung; Zu-
rück|be|hal|tungs|recht s; -[e]s
zu|rück|be|kom|men; zurückbe-
kommen
zu|rück|be|ru|fen; zurückberufen;
Zu|rück|be|ru|fung
zu|rück|bil|den; zurückgebildet;
sich -
zu|rück|blei|ben; zurückgeblieben
zu|rück|blicken [Trenn.: ...blik-
ken]; zurückgeblickt
zu|rück|brin|gen; zurückgebracht
zu|rück|däm|men; zurückge-
dämmt
zu|rück|da|tie|ren; mit einem frü-
heren Datum versehen; zurück-
datiert
zu|rück|drän|gen; zurückge-
drängt; Zu|rück|drän|gung
zu|rück|dre|hen; zurückgedreht
zu|rück|dür|fen (ugs.); zurückge-
durft
zu|rück|er|bit|ten; zurückerbeten
zu|rück|er|hal|ten; zurückerhalten
zu|rück|er|obern; zurückerobert
zu|rück|er|stat|ten (weniger gut
für: erstatten); zurückerstattet

zu|rück|fah|ren; zurückgefahren

zu|rück|fal|len; zurückgefallen

zu|rück|fin|den; zurückgefunden

zu|rück|for|dern; zurückgefordert

zu|rück|fra|gen; zurückgefragt

zu|rück|füh|ren; zurückgeführt; Zu|rück|füh|rung

Zu|rück|ga|be (seltener für: Rückgabe); zu|rück|ge|ben; zurückgegeben

zu|rück|ge|hen; zurückgegangen

Zu|rück|ge|zo|gen|heit w; =

zu|rück|grei|fen; zurückgegriffen

zu|rück|ha|ben; etwas - wollen

zu|rück|hal|ten; zurückgehalten; Zu|rück|hal|tung

zu|rück|keh|ren; zurückgekehrt

zu|rück|kom|men; zurückgekommen

zu|rück|kön|nen (ugs.); zurückgekonnt

zu|rück|las|sen; zurückgelassen; Zu|rück|las|sung; unter -

zu|rück|le|gen; (österr. auch für: [ein Amt] niederlegen); zurückgelegt

zu|rück|leh|nen, sich; zurückgelehnt

zu|rück|lie|gen; zurückgelegen

zu|rück|müs|sen (ugs.); zurückgemußt

Zu|rück|nah|me w; -, -n; zu|rück|neh|men; zurückgenommen

zu|rück|ru|fen; zurückgerufen; rufen Sie bitte zurück!

zu|rück|schaf|fen; vgl. ¹schaffen

zu|rück|schal|ten; zurückgeschaltet

zu|rück|schau|dern; zurückgeschaudert

zu|rück|schla|gen; zurückgeschlagen

¹zu|rück|schrecken¹; er schrak zurück; er ist zurückgeschreckt, (selten:) er ist zurückgeschrokken; vgl. ¹schrecken; aber (übertr.): - vor etwas (etwas nicht wagen): er schreckte vor etwas zurück, von vor etwas zurückschreckt; ²zu|rück|schrecken¹; er schreckte ihn zurück; vgl. ²schrecken

zu|rück|seh|nen, sich; zurückgesehnt

zu|rück|sen|den; zurückgesandt u. zurückgesendet

zu|rück|set|zen; zurückgesetzt; Zu|rück|set|zung

zu|rück|stecken¹; zurückgesteckt

zu|rück|ste|hen; zurückgestanden

zu|rück|stel|len; (österr. auch für: zurückgeben, - senden); zurückgestellt; Zu|rück|stel|lung

zu|rück|sto|ßen; zurückgestoßen

zu|rück|strah|len; zurückgestrahlt; Zu|rück|strah|lung

zu|rück|tre|ten; zurückgetreten

¹ *Trenn.*: ...ek|k...

zu|rück|tun (ugs.); zurückgetan; einen Schritt -

zu|rück|über|set|zen (seltener für: rückübersetzen); zurückübersetzt

zu|rück|ver|fol|gen; zurückverfolgt

zu|rück|ver|lan|gen; zurückverlangt

zu|rück|ver|set|zen; zurückversetzt; sich -

zu|rück|ver|wei|sen; zurückverwiesen

zu|rück|wei|chen; zurückgewichen

zu|rück|wei|sen; zurückgewiesen; Zu|rück|wei|sung

zu|rück|wer|fen; zurückgeworfen; Zu|rück|wer|fung

zu|rück|wol|len (ugs.); zurückgewollt

zu|rück|zah|len; zurückgezahlt; Zu|rück|zah|lung

zu|rück|zie|hen; zurückgezogen; sich -; Zu|rück|zie|her (seltener für: Rückzieher)

Zu|ruf; zu|ru|fen; zugerufen

Zur|ver|fü|gung|stel|lung (Papierdt.)

zur Zeit (Abk.: z. Z,); vgl. Zeit, er ist zur Zeit (derzeit, augenblicklich) krank; aber: zur Zeit (zu der Zeit) Maria Theresias; schweiz. häufig u. österr.: zur|zeit; er ist zurzeit krank; aber: er lebte zur Zeit Maria Theresias

Zu|sa|ge w; -, -n; zu|sa|gen; zugesagt; zu|sa|gend (passend, willkommen)

zu|sam|men; - mit, - sein; *Schreibung in Verbindung mit Zeitwörtern* (↑ R 139): **1.** *Getrenntschreibung*, wenn „zusammen" bedeutet „gemeinsam, gleichzeitig", z. B. zusammen binden (gemeinsam, gleichzeitig binden); **2.** *Zusammenschreibung*, wenn das mit „zusammen" verbundene Verb „vereinigen" bedeutet, z. B. zusammenbinden (in eins binden); ich binde zusammen; zusammengebunden; zusammenzubinden (↑ R 304)

Zu|sam|men|ar|beit; zu|sam|men|ar|bei|ten (Tätigkeiten auf ein Ziel hin vereinigen); die beiden Firmen sind übereingekommen zusammenzuarbeiten; aber: zu|sam|men (gemeinsam) ar|bei|ten; es ist fraglich, ob die beiden zusammen arbeiten können (vgl. zusammen u. ↑ R 139)

zu|sam|men|bal|len (verdichten); die Wolken haben sich, das Verhängnis hat sich zusammengeballt (vgl. zusammen, 2 u. ↑ R 139); Zu|sam|men|bal|lung

Zu|sam|men|bau (für: Montage; *Mehrz.* -e)

zu|sam|men|bei|ßen; er hat die Zähne zusammengebissen (vgl. zusammen, 2 u. ↑ R 139)

zu|sam|men|bin|den (in eins binden); er hat die Blumen zusammengebunden; aber: zu|sam|men (gemeinsam) bin|den; die beiden Mädchen können heute die Blumen zusammen binden (vgl. zusammen u. ↑ R 139)

zu|sam|men|blei|ben (sich nicht wieder trennen); wir lieben uns und wollen zusammenbleiben; aber: zu|sam|men (gemeinsam) blei|ben; wir können ja noch zusammen bleiben und uns die Bilder ansehen (vgl. zusammen u. ↑ R 139)

zu|sam|men|brau|en (ugs. für: aus verschiedenen Dingen mischen); was für ein Zeug hast du da zusammengebraut! (vgl. zusammen, 2 u. ↑ R 139); sich -

zu|sam|men|bre|chen (einstürzen; schwach werden); die Brücke ist zusammengebrochen; sein Vater ist völlig zusammengebrochen; aber: zu|sam|men (gemeinsam) bre|chen; es steht fest, daß sie den Frieden zusammen gebrochen haben (vgl. zusammen u. ↑ R 139)

zu|sam|men|brin|gen (vereinigen); er hat die Gegner zusammengebracht; aber: zu|sam|men (gemeinsam) brin|gen; sie werden das Gepäck zusammen bringen (vgl. zusammen u. ↑ R 139)

Zu|sam|men|bruch m; -[e]s, ...brüche

zu|sam|men|drän|gen (auf engem Raum vereinigen); die Menge wurde von der Polizei zusammengedrängt (vgl. zusammen, 2 u. ↑ R 139); sich -

zu|sam|men|drücken [Trenn.: ...drük|ken] (durch Drücken verkleinern); er hat die Schachtel zusammengedrückt; aber: zu|sam|men (gemeinsam) drücken [Trenn.: drük|ken]; sie haben die Schulbank zusammen gedrückt (vgl. zusammen u. ↑ R 139); zu|sam|men|drück|bar

zu|sam|men|fah|ren (aufeinanderstoßen; erschrecken); die Radfahrer sind zusammengefahren; er ist bei dem Knall zusammengefahren; aber: zu|sam|men (gemeinsam) fah|ren; sie sind in diesem D-Zug zusammen gefahren (vgl. zusammen u. ↑ R 139)

Zu|sam|men|fall m; -[e]s; zu|sam|men|fal|len (einstürzen; gleichzeitig erfolgen); das Haus ist zusammengefallen; Sonn- und Feiertag sind zusammengefallen; aber: zu|sam|men (gemeinsam) fal|len; die Kinder sind zusammen gefallen (vgl. zusammen u. ↑ R 139)

zu|sam|men|fal|ten (durch Falten vereinigen); hast du das Papier zusammengefaltet? (vgl. zusammen, 2 u. ↑ R 139)

zu|sam|men|fas|sen (raffen); er hat den Inhalt der Rede zusammengefaßt; aber: zu|sam|men (gemeinsam) fas|sen; sie haben den Verbrecher zusammen gefaßt (vgl. zusammen u. ↑ R 139); Zu|sam|men|fas|sung

zu|sam|men|fin|den, sich (sich treffen); sie haben sich zu gemeinsamer Arbeit zusammengefunden (vgl. zusammen, 2 u. ↑ R 139)

zu|sam|men|flie|ßen (sich vereinen); Fulda und Werra sind zusammengeflossen (vgl. zusammen, 2 u. ↑ R 139); Zu|sam|men|fluß

zu|sam|men|fü|gen (vereinigen); er hat alles schön zusammengefügt (vgl. zusammen, 2 u. ↑ R 139); sich -; Zu|sam|men|fü|gung

zu|sam|men|füh|ren (zueinander hinführen); die Flüchtlinge wurden zusammengeführt; aber: zu|sam|men (gemeinsam) füh|ren; wir werden den Blinden zusammen führen (vgl. zusammen u. ↑ R 139); Zu|sam|men|füh|rung

zu|sam|men|ge|hö|ren (eng verbunden sein); wir beide haben immer zusammengehört; aber: zu|sam|men (gemeinsam) ge|hö|ren; das Auto wird uns zusammen gehören (vgl. zusammen u. ↑ R 139); zu|sam|men|ge|hö|rig; Zu|sam|men|ge|hö|rig keit w; -; Zu|sam|men|ge|hö|rig keits|ge|fühl

zu|sam|men|ge|setzt; -es Wort (für: Kompositum); -er Satz

zu|sam|men|ha|ben (ugs. für: gesammelt haben); ich bin froh, daß wir jetzt das Geld dafür zusammenhaben (vgl. zusammen, 2 u. ↑ R 139)

Zu|sam|men|halt; zu|sam|men|hal ten (sich nicht trennen lassen; vereinigen); die beiden Freunde haben immer zusammengehalten; er hat die beiden Stoffe [vergleichend] zusammengehalten; aber: zu|sam|men (gemeinsam) hal ten; sie werden den Baumstamm zusammen halten (vgl. zusammen u. ↑ R 139)

Zu|sam|men|hang; im od. in - stehen; [1]zu|sam|men|hän|gen; Ursache und Wirkung hängen zusammen; vgl. [1]hängen; [2]zu|sam|men|hän|gen; er hängte die Bilder zusammen; vgl. [2]hängen; (vgl. zusammen, 2 u. ↑ R 139); zu|sam men|hän|gend; zu|sam|men|hang[s]|los; Zu|sam|men|hang[s]lo|sig|keit w; -

zu|sam|men|hef|ten (durch Heften vereinigen); sie hat die Stoffreste zusammengeheftet (vgl. zusammen, 2 u. ↑ R 139)

zu|sam|men|keh|ren (auf einen Haufen kehren); hast du die Krumen zusammengekehrt?; aber: zu|sam|men (gemeinsam) keh|ren; später können wir dann die Straße zusammen kehren (vgl. zusammen u. ↑ R 139)

zu|sam|men|klap|pen (falten; ugs. für: erschöpft sein); sie hat den Fächer zusammengeklappt (ugs. für: am Ende seiner Kräfte); (vgl. zusammen, 2 u. ↑ R 139)

zu|sam|men|knei|fen (durch Kneifen [fast] schließen); er hat die Augen, Lippen zusammengekniffen (vgl. zusammen, 2 u. ↑ R 139)

zu|sam|men|knül|len (zu einer Kugel o. ä. knüllen); er knüllte die Zeitung zusammen (vgl. zusammen, 2 u. ↑ R 139)

zu|sam|men|kom|men (sich begegnen); die Mitglieder sind alle zusammengekommen; aber: zu|sam|men (gemeinsam) kom|men; wenn möglich, wollen wir zusammen kommen (vgl. zusammen u. ↑ R 139); Zu|sam|men|kunft w; -, ...künfte

zu|sam|men|läp|pern, sich (ugs.: sich aus kleinen Mengen ansammeln); die Ausgaben haben sich ganz schön zusammengeläppert (vgl. zusammen, 2 u. ↑ R 139)

zu|sam|men|lau|fen (sich treffen; gerinnen); die Menschen sind zusammengelaufen; (ugs.:) die Milch ist zusammengelaufen; aber: zu|sam|men (miteinander) lau|fen; während des Spazierganges wollen wir zusammen laufen (vgl. zusammen u. ↑ R 139)

zu|sam|men|le|ben, sich (sich aufeinander einstellen); sie haben sich gut zusammengelebt; aber: zu|sam|men (gemeinsam) le|ben; sie konnten nicht mehr zusammen leben (vgl. zusammen u. ↑ R 139); Zu|sam|men|le|ben s; -s

zu|sam|men|leg|bar; zu|sam|men|le|gen (vereinigen; falten); die Grundstücke wurden zusammengelegt; das Tischtuch wurde zusammengelegt; aber: zu|sam|men (gemeinsam) le|gen; wir wollen uns die Karten zusammen legen lassen (vgl. zusammen u. ↑ R 139); Zu|sam|men|le|gung

zu|sam|men|le|sen (sammeln); er hat die Früchte zusammengelesen; aber: zu|sam|men (gemeinsam) le|sen; wir wollen das Buch zusammen lesen (vgl. zusammen u.↑ R 139)

zu|sam|men|neh|men, sich (sich beherrschen); du hast dich heute sehr zusammengenommen; aber: zu|sam|men (gemeinsam) neh|men; ihr sollt euch diese Äpfel zusammen nehmen (vgl. zusammen u. ↑ R 139)

Zu|sam|men|prall; zu|sam|men|pral|len (mit Wucht aneinanderstoßen); zwei Autos sind auf der Kreuzung zusammengeprallt (vgl. zusammen, 2 u. ↑ R 139)

zu|sam|men|pres|sen (mit Kraft zusammendrücken); sie hatte die Hände zusammengepreßt (vgl. zusammen, 2 u. ↑ R 139)

zu|sam|men|raf|fen (gierig an sich bringen); er hat ein großes Vermögen zusammengerafft (vgl. zusammen, 2 u. ↑ R 139)

zu|sam|men|rei|ßen, sich (ugs. für: sich zusammennehmen); ich habe mich zusammengerissen (vgl. zusammen, 2 u. ↑ R 139)

zu|sam|men|rot|ten, sich; die Meuterer hatten sich zusammengerottet (vgl. zusammen, 2 u. ↑ R 139)

zu|sam|men|sacken [Trenn.: ...sak ken] (ugs. für: zusammenbrechen); er ist unter der Last zusammengesackt (vgl. zusammen, 2 u. ↑ R 139)

Zu|sam|men|schau w; -

zu|sam|men|schlie|ßen, sich (sich vereinigen); verschiedene Firmen haben sich zusammengeschlossen (vgl. zusammen, 2 u. ↑ R 139); Zu|sam|men|schluß

zu|sam|men|schmel|zen (in eins schmelzen; kleiner werden); die Metalle wurden zusammengeschmolzen; sein Vermögen ist zusammengeschmolzen (vgl. zusammen, 2 u.↑ R 139)

zu|sam|men|schnü|ren (miteinander verbinden; einengen); sie hat die Kleidungsstücke zusammengeschnürt; die Angst hat seine Kehle zusammengeschnürt; aber: zu|sam|men (gemeinsam) schnü|ren; wir wollen das Paket zusammen schnüren (vgl. zusammen u. ↑ R 139); Zu|sam|men|schnü|rung

zu|sam|men|schrecken [Trenn.: ...schrek|ken]; vgl. [1]schrecken

zu|sam|men|schrei|ben . (in eins schreiben; aus anderen Büchern od. Schriftstücken zusammenstellen); die beiden Wörter werden zusammengeschrieben; dieses Buch ist aus anderen Büchern zusammengeschrieben; aber: zu|sam|men (gemeinsam) schrei|ben; wir wollen dieses Buch zusammen schreiben (vgl. zusammen u. ↑ R 139); Zu|sam|men|schrei|bung

zu|sam|men|schrump|fen (kleiner werden); der Vorrat ist zusammengeschrumpft (vgl. zusammen, 2 u. ↑ R 139)

zu|sam|men|schwei|ßen (eng ver-
einigen); die Schienen wurden zu-
sammengeschweißt; die Gefahr
hat diese beiden Männer noch
mehr zusammengeschweißt;
aber: zu|sam|men (gemeinsam)
schwei|ßen; die beiden Arbeiter
wollten diese Schienen zusam-
men schweißen (vgl. zusammen
u. ↑ R 139)
Zu|sam|men|sein s; -s
zu|sam|men|set|zen (nebeneinan-
dersetzen, zueinanderfügen); sie
hatten sich zusammengesetzt;
sich -; aber: zu|sam|men (ge-
meinsam) set|zen; auf ein Zeichen
sollen sich alle zusammen setzen
(vgl. zusammen u. ↑ R 139); Zu-
sam|men|set|zung (vgl. auch:
Komposition, Kompositum)
Zu|sam|men|spiel (Sportspr.) s;
-[e]s; zu|sam|men|spie|len (plan-
voll, aufeinander abgestimmt
spielen); aber: zu|sam|men|spie-
len (gemeinschaftlich spielen);
die Kinder haben schön zusam-
men gespielt (vgl. zusammen u.
↑ R 139)
zu|sam|men|stel|len (nebeneinan-
derstellen; zueinanderfügen); die
Kinder haben sich zusammenge-
stellt; das Menü wurde zusam-
mengestellt; aber: zu|sam|men
(gemeinsam) stel|len; die Verbre-
cher wollten sich der Polizei zu-
sammen stellen (vgl. zusammen
u. ↑ R 139); Zu|sam|men|stel-
lung
zu|sam|men|stim|men (überein-
stimmen, harmonieren); seine
Angaben, die Instrumente ha-
ben nicht zusammengestimmt;
aber: zu|sam|men (gemeinsam)
stim|men; wir wollen unsere Gei-
gen zusammen stimmen (vgl. zu-
sammen u. ↑ R 139); Zu|sam|men-
stim|mung
Zu|sam|men|stoß; zu|sam|men-
sto|ßen (aufeinanderprallen);
zwei Autos sind zusammengesto-
ßen; aber: zu|sam|men (gemein-
sam) sto|ßen; sie wollten ihn mit
ihren Ellenbogen zusammen sto-
ßen (vgl. zusammen u. ↑ R 139)
zu|sam|men|strö|men (sich in gro-
ßer Menge vereinigen); die Men-
schen sind zusammengeströmt
(vgl. zusammen, 2 u. ↑ R 139)
zu|sam|men|stür|zen (einstürzen);
das Gerüst ist zusammenge-
stürzt; aber: zu|sam|men (ge-
meinsam) stür|zen; die Pferde
sind zusammen gestürzt (vgl. zu-
sammen u. ↑ R 139)
zu|sam|men|su|chen (von überall-
her suchend zusammentragen);
ich mußte das Werkzeug erst zu-
sammensuchen; aber: zu|sam-
men (gemeinsam) su|chen; laßt

uns zusammen suchen! (vgl. zu-
sammen u. ↑ R 139)
zu|sam|men|tra|gen (sammeln); sie
haben das Holz zusammengetra-
gen; aber: zu|sam|men (gemein-
sam) tra|gen; ihr sollt diesen
schweren Sack zusammen tragen
(vgl. zusammen u. ↑ R 139)
zu|sam|men|tref|fen (begegnen);
sie sind im Theater zusammenge-
troffen; aber: zu|sam|men (ge-
meinsam) tref|fen; wir wollen ihn
zusammen treffen (vgl. zusam-
men u. ↑ R 139); Zu|sam|men-
tref|fen s; -s
zu|sam|men|wach|sen (durch den
Wachstumsvorgang zu einer Ein-
heit werden), die siamesischen
Zwillinge sind an den Hüften zu-
sammengewachsen; aber: zu-
sam|men (gemeinsam) wach|sen;
ein Ort, an dem die verschieden-
sten Pflanzen zusammen wach-
sen können (vgl. zusammen u.
↑ R 139)
zu|sam|men|wir|ken (vereint wir-
ken); hier haben alle Kräfte zu-
sammengewirkt; aber: zu|sam-
men (gemeinsam) wir|ken; wir
wollen nur Gutes zusammen wir-
ken (vgl. zusammen u. ↑ R 139);
Zu|sam|men|wir|ken s; -s
zu|sam|men|zäh|len (addieren); sie
haben die vielen Zahlen zusam-
mengezählt; aber: zu|sam|men
(gemeinsam) zäh|len; ihr sollt die-
ses Geld zusammen zählen (vgl.
zusammen u. ↑ R 139); Zu|sam-
men|zäh|lung
zu|sam|men|zie|hen (verengern;
vereinigen; addieren); sie hat das
Loch im Strumpf zusammenge-
zogen; die Truppen wurden zu-
sammengezogen; er hat die Zah-
len zusammengezogen; sich -;
aber: zu|sam|men (gemeinsam)
zie|hen; sie haben den Wagen zu-
sammen gezogen (vgl. zusammen
u. ↑ R 139); zu|sam|men|zie|hend;
-es Mittel; Zu|sam|men|zie|hung
zu|sam|men|zucken [Trenn.:
...zuk|ken] (eine zuckende Be-
wegung machen); ich bin bei dem
Knall zusammengezuckt (vgl.
zusammen, 2 u. ↑ R 139)
zu|samt (veralt.); mit Wemf.: - den
Rindern
Zu|satz; Zu|satz_ab|kom|men,
...ar|ti|kel, ...be|stim|mung, ...ge-
rät; zu|sätz|lich (hinzukom-
mend); Zu|satz_steu|er w, ...ta-
rif, ...ver|si|che|rung, ...zahl (beim
Lotto)
zu|schan|den (↑ R 141); - machen,
werden
zu|schan|zen (ugs. für: jmdm. zu
etwas verhelfen); er hat ihm diese
Stellung zugeschanzt
zu|schau|en; zugeschaut; Zu-

schau|er; Zu|schaue|rin w; -, -nen;
Zu|schau|er_ku|lis|se (Sportspr.),
...rang, ...raum, ...tri|bü|ne
zu|schau|feln; zugeschaufelt
zu|schicken [Trenn.: ...schik|ken];
zugeschickt
zu|schie|ben (ugs. auch für: [heim-
lich] zukommen lassen); er hat
ihm diesen Vorteil zugeschoben
zu|schie|ßen (beisteuern); er hat ei-
ne Menge Geld zugeschossen
Zu|schlag; zu|schla|gen ([sich] laut
schließen; [bei einer Versteige-
rung] zuerteilen; losschlagen);
zugeschlagen; zu|schlag|frei; Zu-
schlag_kar|te, zu|schlag|pflich-
tig, Zu|schlag[s]_kal|ku|la|ti|on,
...prä|mie, ...satz; Zu|schlag|stoff
(Technik)
zu|schlie|ßen; zugeschlossen
zu|schnap|pen; zugeschnappt
Zu|schnei|de|ma|schi|ne; zu-
schnei|den; zugeschnitten; Zu-
schnei|der; Zu|schnitt
zu|schnü|ren; zugeschnürt
zu|schrau|ben; zugeschraubt
zu|schrei|ben; die Schuld an die-
sem Unglück wird ihm zuge-
schrieben; Zu|schrift
zu|schul|den (↑ R 141); sich etwas
- kommen lassen
Zu|schuß; Zu|schuß_be|trieb, ...bo-
gen, ...wirt|schaft (w; -)
zu|schu|stern (ugs. für: jmdm. et-
was heimlich zukommen lassen;
zusetzen); zugeschustert
zu|schüt|ten; zugeschüttet
zu|se|hen; zugesehen; (↑ R 120:) zu
genauerem Zusehen; zu|se|hends
(beim Zusehen; rasch; offenkun-
dig); Zu|se|her (österr. neben:
Zuschauer)
zu|sein (ugs. für: geschlossen sein);
der Laden ist zu, ist zugewesen;
aber: ... daß der Laden zu ist,
war
zu sei|ten (↑ R 141); mit Wesf.:
- - des Festzuges
zu|sen|den; vgl. senden
zu|set|zen; er hat mir tüchtig zuge-
setzt
zu|si|chern; zugesichert; Zu|si|che-
rung
Zu|spät|kom|men|de m u. w; -n,
-n (↑ R 287 ff.)
zu|sper|ren; zugesperrt
Zu|spiel (Sportspr.) s; -[e]s; zu-
spie|len; zugespielt
zu|spit|zen; die Lage hat sich zuge-
spitzt; Zu|spit|zung
zu|spre|chen; zugesprochen; Zu-
spre|chung; Zu|spruch (Anklang,
Zulauf; Trost) m; -[e]s; großen
-, viel - haben
Zu|stand; zu|stan|de (↑ R 141); -
bringen, kommen; Zu|stan|de-
brin|gen s; -s; Zu|stan|de|kom-
men s; -s; zu|stän|dig (maßge-

bend); (österr.:) - sein nach (an-
sässig sein in); zu|stän|di|gen|orts;
Zu|stän|dig|keit; zu|stän|dig-
keits|hal|ber; zu|länd|lich (selten
für: dem Zustand entsprechend;
in dem Zustand verharrend); Zu-
stands-.än|de|rung, ...glei|chung
(Physik), ...pas|siv (Sprachw.)
zu|stat|ten; - kommen
zu|stecken [Trenn.: ...stek|ken];
zugesteckt
zu|ste|hen; zugestanden
zu|stei|gen; zugestiegen
zu|stel|len; zugestellt; Zu|stell|ge-
bühr (Postw.); Zu|stel|lung; Zu-
stell|ver|merk (Postw.)
zu|steu|ern; zugesteuert
zu|stim|men; zugestimmt; Zu-
stim|mung
zu|stop|fen; zugestopft
zu|sto|ßen; es ist ihm ein Unglück
zugestoßen
zu|stre|ben; zugestrebt
Zu|strom m; -[e]s; zu|strö|men;
zugeströmt
zu|stut|zen; zugestutzt
zu|ta|ge (↑ R 141); - bringen, för-
dern, treten
Zu|tat (meist Mehrz.)
zu|teil (↑ R 141); - werden; zu|tei-
len; zugeteilt; Zu|tei|lung
zu|tiefst (völlig; im Innersten)
zu|tra|gen (heimlich berichten);
zugetragen; sich -; Zu|trä|ger;
Zu|trä|ge|rei; zu|träg|lich; Zu-
träg|lich|keit
zu|trau|en; er hat es mir zuge-
traut; Zu|trau|en s; -s; zu|trau-
lich; Zu|trau|lich|keit
zu|tref|fen; zugetroffen; zu|tref-
fend; -ste; Zu|tref|fen|de s; -n (↑ R
287 ff.); Nichtzutreffendes strei-
chen; zu|tref|fen|den|falls; vgl.
Fall m
zu|trei|ben; zugetrieben
zu|trin|ken; zugetrunken
Zu|tritt m; -[e]s
zut|schen landsch. (lutschen, sau-
gen); du zutschst (zutschest)
zu|tu|lich, zu|tun|lich (zutraulich,
anschmiegend); zu|tun (hinzufü-
gen; schließen); ich habe kein Au-
ge zugetan; Zu|tun (Hilfe, Unter-
stützung) s, noch in: ohne mein
-; zu|tun|lich vgl. zutulich
zu|un|gun|sten (zum Nachteil);
(↑ R 141); (bei Voranstellung mit
Wesf.:) - vieler Antragsteller,
(bei seltener Nachstellung mit
Wemf.:) dem Antragsteller -; vgl.
Gunst
zu|un|terst; das Oberste - kehren
zu|ver|läs|sig; Zu|ver|läs|sig|keit
w; -; Zu|ver|läs|sig|keits_fahrt,
...prü|fung, ...test
Zu|ver|sicht w; -; zu|ver|sicht|lich;
Zu|ver|sicht|lich|keit w; -
zu|viel, zu viel; zuviel des Guten;
er weiß zuviel, aber: er weiß viel,

ja zu viel davon; du hast viel zu-
viel gesagt; besser zuviel als zuwe-
nig; Zu|viel (↑ R 119) s; -s; ein
Zuviel ist besser als ein Zuwenig
zu vie|ren, zu viert
zu|vor (vorher); meinen herzlichen
Glückwunsch - ! Schreibung in
Verbindung mit Zeitwörtern (↑ R
139): a) Getrenntschreibung in ur-
sprünglicher Bedeutung, z. B. du
sollst zuvor (vorher) kommen;
b) Zusammenschreibung, wenn
durch die Verbindung ein neuer
Begriff entsteht, vgl. zuvorkom-
men, zuvortun
zu|vor|derst (ganz vorn); zu|vör-
derst (veraltend für: zuerst)
zu|vor|kom|men;↑ R 139 (schneller
sein); ich komme ihm zuvor; zu-
vorgekommen; zuvorzukom-
men; aber: zu|vor (vorher) kom-
men; du sollst zuvor kommen;
zu|vor|kom|mend (liebenswür-
dig); (↑ R 297:) -er, -ste; Zu|vor-
kom|men|heit
zu|vor|tun; ↑ R 139 (besser tun);
ich tue es ihm zuvor; zuvorgetan;
zuvorzutun; aber: zu|vor (vor-
her) tun; du sollst diese Arbeit
heute zuvor tun
Zu|waa|ge bayr., österr. (Kno-
chen[zugabe] zum Fleisch) w; -
Zu|wachs (Vermehrung, Er-
höhung) m; -es; zu|wach|sen
(größer werden); es ist immer
mehr Vermögen zugewachsen;
Zu|wachs|ra|te
zu|wan|de|rer, Zu|wand|rer; zu-
wan|dern; zugewandert; Zu|wan-
de|rung
zu|war|ten (untätig warten); zu-
gewartet; Zu|war|ten s; -s
zu|we|ge; ↑ R 141 (fertig, gut
imstande); - bringen; [gut] - sein
zu|we|hen; zugeweht
zu|wei|len
zu|wei|sen; zugewiesen; Zu|wei-
sung
zu|wen|den; ich wandte mich zu. wende-
te mich ihr zu; er hat sich ihr
zugewandt od. zugewendet; Zu-
wen|dung
zu|we|nig, zu wenig; du weißt zu-
wenig, du weißt viel zuwenig,
aber: du weißt auch zu wenig!;
Zu|we|nig (↑ R 119) s; -s; ein Zu-
viel ist besser als ein Zuwenig
zu|wer|fen; zugeworfen
zu|wi|der; - sein, werden; seinem
Gebot -; das, er ist mir zuwider
(↑ R 139): zu|wi|der|han|deln
(Verbotenes tun); ich handle
(handle) zuwider; zu|wi|derhan-
delt; zuwiderzuhandeln; zu|wi-
der|han|delnd; Zu|wi|der|han-
deln|de m u. w; -n, -n (↑ R 287 ff.);
Zu|wi|der|hand|lung; zu|wi|der-
lau|fen;↑ R 139 (entgegenstehen);
sein Verhalten läuft meinen Ab-

sichten zuwider; zuwiderge-
laufen; zuwiderzulaufen
zu|win|ken; zugewinkt
zu|zah|len; zugezahlt; zu|zäh|len;
zugezählt; Zu|zah|lung; Zu|zäh-
lung
zu|zei|ten; ↑ R 141 (bisweilen),
aber: zu Zeiten Karls d. Gr.
zu|zeln bayr. u. österr. ugs. (lut-
schen; lispeln); ich ...[e]le (↑ R
327)
zu|zie|hen; zugezogen; sich -; Zu-
zie|hung w; -; Zu|zug (Zuziehen);
zu|zü|ger schweiz. (Zuzügler);
Zu|züg|ler; zu|züg|lich (Kauf-
mannsspr.); Verhältnisw. mit
Wesf.: - des Rabattes; ein allein-
stehendes, stark gebeugtes
Hauptw. steht in der Einz. unge-
beugt - Porto; Zu|zugs|ge|neh-
mi|gung
zu zwei|en, zu zweit
zu|zwin|kern; zugezwinkert
Zvie|ri [zfî'ri] bes. schweiz. mdal.
(Nachmittagsimbiß) m od. s; -s
zwacken [Trenn.: zwak|ken] (ugs.
für: zupfen, zerren)
Zwang m; -[e]s, Zwänge; zwän|gen
(bedrängen; klemmen; einpres-
sen; nötigen); sich -; zwang|haft;
Zwang|huf (eine Hufkrankheit)
m; -[e]s; zwang|läu|fig (Technik);
vgl. aber: zwangsläufig; Zwang-
läu|fig|keit (Technik) w; -; vgl.
aber: Zwangsläufigkeit; Zwang-
lauf|leh|re (Technik: Getriebe-
lehre); zwang|los; -este (↑ R 292);
Zwang|lo|sig|keit; Zwangs_an-
lei|he, ...ar|beit, ...aus|he|bung,
...be|wirt|schaf|tung; Zwangs-
schie|ne (bei Gleiskrümmungen,
Weichen u. a.); Zwangs_ein|stel-
lung, ...ein|wei|sung, ...er|näh-
rung, ...er|zie|hung, ...hand|lung,
...hy|po|thek, ...jacke [Trenn.:
...jak|ke], ...kurs, ...la|ge; zwangs-
läu|fig; vgl. aber: zwangläufig;
Zwangs|läu|fig|keit w; -; vgl.
aber: Zwangläufigkeit; Zwangs-
li|zenz; zwangs|mä|ßig; Zwangs-
_maß|nah|me, ...mit|tel s, ...neu-
ro|se, ...re|gu|lie|rung (Börse),
...schlaf (für: Hypnose; vgl.
²Schlaf), ...spa|ren (s; -s), ...stall
(Vorrichtung zu operativen Ein-
griffen bei Pferden u. Rindern);
zwangs|um|sie|deln; zwangsum-
gesiedelt; nur in der Grundform
u. im 2. Mittelwort gebräuchlich;
Zwangs_ver|fah|ren, ...ver|gleich;
zwangs|ver|schicken [Trenn.:
...schik|ken]; vgl. zwangsumsie-
deln; zwangs|ver|schlep|pen; vgl.
zwangsumsiedeln; Zwangs|ver-
si|che|rung; zwangs|ver|stei|gern;
vgl. zwangsumsiedeln; Zwangs-
_ver|stei|ge|rung, ...ver|wal|tung,
...voll|streckung [Trenn.: ...strek-
kung], ...vor|füh|rung, ...vor|stel-

lung; zwangs|wei|se; Zwangs-
wirt|schaft
zwän|zig usw. vgl. achtzig usw.;
zwän|zi|ger; die goldenen - Jahre,
die goldenen Zwanziger; Zwan-
zig|flach s; -[e]s, -e, Zwan|zig-
fläch|ner (für: Ikosaeder); zwan-
zig|jäh|rig vgl. achtjährig; Zwan-
zig|mark|schein (mit Ziffern: 20-
Mark-Schein; ↑ R 157); Zwan-
zig|pfen|nig|mar|ke (mit Ziffern:
20-Pfennig-Marke, 20-Pf-Mar-
ke; ↑ R 157); zwan|zig|ste; (↑ R
224:) Zwanzigster (20.) Juli (20.
Juli 1944, der Tag des Attentats
auf Hitler); vgl. achte
zwar; er ist zwar alt, aber noch sehr
rüstig; viele Sorten, und zwar ...
zwat|ze|lig südwestd., bayr., west-
mitteld. (zappelig); zwat|zeln
südwestd., bayr., westmitteld.
(zappeln, unruhig sein); ich
...[e]le (↑ R 327)
Zweck (Ziel[punkt]; Absicht;
Sinn) m; -[e]s, -e; zwecks (vgl. d.);
zum Zweck[e]; Zweck.auf|wand
(Finanzw.), ...bau (Mehrz. ...bau-
ten), ...bin|dung (Finanzw.);
zweck|dien|lich; Zweck|dien|lich-
keit w; -; Zwecke [Trenn.: Zwek-
ke] (Nagel; Metallstift) w; -, -n;
zwecken [Trenn.: zwek|ken] (ver-
alt. auch für: mit Zwecken be-
schlagen); zweck|ent|frem|det;
Zweck|ent|frem|dung; zweck-
.ent|spre|chend (-ste), ...frei, ...ge-
bun|den, ...ge|mäß, ...haft, ...los;
Zweck|lo|sig|keit w; -; zweck|mä-
ßig; Zweck|mä|ßig|keit w; -;
Zweck|mä|ßig|keits|er|wä|gung,
Zweck|pro|pa|gan|da; zwecks;
↑ R 130 (Amtsdt. für: zum Zweck
von); mit Wesf.; zwecks eines
Handels (dafür besser Verhält-
niswort „zu" od. Gliedsatz);
Zweck.satz (für: Finalsatz),
...spa|ren (s; -s), ...spra|che,
...steu|er w; ...stil, ...ver|band
(Vereinigung von [wirtschaftl.]
Unternehmungen), ...ver|mö|gen
(Rechtsw.); zweck.voll, ...wid|rig
zween vgl. zwei
Zweh|le westmitteld. (Tisch-,
Handtuch) w; -, -n
zwei[1]; Wesf. zweier, Wemf. zwei-

[1] Die Formen „zween" für das
männliche, „zwo" für das weib-
liche Geschlecht sind veraltet. We-
gen der leichteren Unterschied-
barkeit von „drei" ist „zwo" (oh-
ne Unterschied des Geschlechtes)
in neuerer Zeit im Fernsprechver-
kehr üblich geworden und von da
in die großstädtische Umgangs-
sprache gedrungen. Die veraltete
Form „zwote" für die Ordnungs-
zahl „zweite" ist gleichfalls sehr
verbreitet.

en, zwei; wir sind zu zweien od.
zu zweit; herzliche Grüße von uns
zweien (↑ R 135); (↑ R 276:) zweier
guter (selten: guten) Menschen;
vgl. acht; Zwei (Zahl) w; -, -en;
eine Zwei würfeln; er hat in La-
tein eine Zwei geschrieben; vgl.
[1]Acht u. Eins; Zwei|ach|ser (Wa-
gen mit zwei Achsen; mit Ziffer:
2achser; ↑ R 228); zwei.ach|sig,
...ak|tig, ...ar|mig ...bei|nig,
...bet|tig; Zwei|bett|zim|mer (mit
Ziffer: 2-Bett-Zimmer; ↑ R 157)
Zwei|brücken[1] (Stadt in Rhein-
land-Pfalz); Zwei|brück|ner[1]
(auch:) Zwei|brücke|ner[1] (↑ R
199)
Zwei.hund (hist., m; -[e]s),
...decker [Trenn.: ...dek|ker] (ein
Flugzeugtyp); zwei|deu|tig;
Zwei|deu|tig|keit; zwei|di|men-
sio|nal; Zwei|drit|tel|mehr|heit;
zwei|ei|ig; zwei|ein|halb, zwei-
und|ein|halb; zwei.ach (ver-
alt. für: sich zueinandergesellen);
Zwei|er; vgl. Achter; Zwei|er-
.bob, ...ka|jak; zwei|er|lei; zwei-
fach; vgl. zwiefach; Zwei|fa|che
s; -n; vgl. Achtfache; Zwei.fa-
mi|li|en|haus, ...far|ben|druck
(Mehrz. ...drucke); zwei|far|big
[druck]ma|schi|ne; zwei|far|big
Zwei|fel m; -s, -; zwei|fel.haft,
...los; zwei|feln; ich ...[e]le (↑ R
327); Zwei|fels|fall m; im -[e];
Zwei|fels|fra|ge; zwei|fels|frei;
zwei|fels|oh|ne; Zwei|fel|sucht w;
-; Zweif|ler
zwei|flü|ge|lig, ...flüg|lig, Zwei-
flüg|ler (Insekt einer bestimmten
Gruppe) m; -s, -
Zwei|fron|ten|krieg
[1]Zweig, Arnold (dt. Schriftsteller)
[2]Zweig, Stefan (österr. Schriftstel-
ler)
[3]Zweig m; -[e]s, -e; Zweig|bahn
zwei.ge|lei|gig, ...gei|sig; zwei-
ge|schlech|tig; Zweig.ge|schlech-
tig|keit (w; -), ...ge|spann s, ...ge-
spräch (veralt., aber noch mdal.
für: Zwiegespräch)
zwei|ge|stri|chen (Musik); -e Note
Zweig|ge|schäft
zwei|glei|dig, zwei|fel|sig
zwei|glie|de|rig, ...glied|rig
Zweig.li|nie, ...nie|der|las|sung,
...post|amt, ...stel|le, ...werk
Zwei|hän|der (Schwert, mit zwei
Händen zu schwingen); zwei|hän-
dig; zwei|häu|sig (Bot.: männl. u.
weibl. Blüten nicht auf einer
Pflanze); Zweihäusigkeit (für: Dualis-
mus) w; -; zwei|hen|ke|lig, ...henk-
lig; zwei|hun|dert; vgl. hundert;
Zwei.kam|mer|sy|stem; Zwei-
kampf; zwei|keim|blät|te|rig,

[1] Trenn.: ...ük|ke...

zwei|keim|blätt|rig (Bot.); -e
Pflanzen (Pflanzen mit zwei
Keimblättern); Zwei|kin|der|sy-
stem s; -s; zwei|köp|fig; Zwei-
kreis.brem|se, ...sy|stem (Fi-
nanzw.); Zwei|lun|ger m; -s, -
(Hauptgruppe der Spinnen);
zwei|mäh|dig (svw. zweischürig);
zwei|mal; (↑ R 145:) ein- bis zwei-
mal (1- bis 2mal); vgl. achtmal;
zwei|ma|lig; Zwei|mann|boot (mit
Ziffer: 2-Mann-Boot; ↑ R 157);
Zwei|mark|stück (mit Ziffer: 2-
Mark-Stück; ↑ R 157); Zwei|ma-
ster (Segelschiff); zwei|mo|to|rig;
Zwei|par|tei|en|sy|stem; Zwei-
pha|sen|strom, 2π-lach [...pi...]
(↑ R 149); Zwei|rad|indu-
strie; zwei|rä|de|rig, ...räd|rig;
Zwei|rei|her; zwei|rei|hig; zwei-
sam (dicht.); Zwei|sam|keit
(dicht.); zwei|schlä|fe|rig, zwei-
schlä|fig, zwei|schläf|rig vgl. ein-
schlä|fe|rig; zwei|schnei|dig; zwei-
schü|rig (von der Wiese: zwei
Ernten liefernd); zwei|sei|tig;
zwei|sil|big; Zwei|sit|zer (Wagen,
Motorrad u. a. mit zwei Sitzen);
zwei|sit|zig; zwei|spal|tig; Zwei-
spän|ner (Wagen mit Zweige-
spann); zwei|spän|nig; zwei|spra-
chig; Zwei|spra|chig|keit w; -;
zwei|spu|rig; zwei|stim|mig; zwei-
stöckig [Trenn.: ...stök|kig]; zwei-
strah|lig; Zwei|strom|land; zwei-
stu|fen|ra|ke|te; zwei|stu|fig;
zwei|stün|dig (zwei Stunden alt,
dauernd); -e Fahrt; zwei|stünd-
lich (alle zwei Stunden [wieder-
kehrend]); - einen Eßlöffel voll;
zweit; vgl. zwei; Zwei|tak|ter;
Zwei|takt|mo|tor; Zwei|tau|tau-
tau|send; Zwei|takt|mo|tor od. da-
mit ausgerüstetes Kraftfahr-
zeug); Zwei|takt|mo|tor; zwei-
tau|send; Zweit.aus|fer|ti|gung; zweit|be|ste; Zweit-
druck (Mehrz. ...drucke), zwei-
te[1]; I. Kleinschreibung (↑ R 135):
er hat wie kein zweiter (anderer)
gearbeitet; zum ersten, zum zwei-
ten, zum dritten; die zweite Geige
spielen; er ist zweiter Geiger; et-
was aus zweiter Hand kaufen; er
ist sein zweites Ich (bester
Freund); in zweiter Linie; zweites
Mittelwort, Partizip (vgl. d.); das
ist ihm zur zweiten Natur gewor-
den; das zweite Programm; der
zweite Rang; er singt die zweite
Stimme; der zweite Stock eines
Hauses; der zweite (häufig bereits
als Titel: zweite) Weltkrieg. II.
Großschreibung: a) (↑ R 118:) es
ist noch ein Zweites zu erwähnen;
b) (↑ R 224:) Zweites Deutsches
Fernsehen (Abk.: ZDF); das

[1] Über die veraltete Form „zwo-
te" vgl. Anm. Sp. 1.

Zweite Gesicht (Gabe, Zukünftiges vorauszusehen); die Zweite Republik (Staatsform Österreichs nach 1945); vgl. achte; zwei|tei|lig; Zwei|tei|lung; zweitens; Zwei|te[r]-Klas|se-Ab|teil (↑ R 155); Zweit.fahr|zeug, ...frisur (Perücke), ...gerät; zweit-.größt, ...höchst; zweit|klas|sig; Zweit|klaß|wa|gen (schweiz.);. zweit|letzt; vgl. drittletzt; Zweit-mäd|chen (ein zweites Dienstmädchen [in großem Haushalt]); Zwei|tou|ren|ma|schi|ne [...tu...] (Druckw.); zwei|tou|rig [...tu...]; zweit|ran|gig; zweit|schlech|test; Zweit.schrift, ...stim|me, ...wagen; Zwei|und|drei|ßi|ger (Druckw.: Größenform); Zwei-und|drei|ßig|er|for|mat s; -[e]s; zwei|[und]|ein|halb; zwei|und-zwan|zig; vgl. acht; zwei|wer|tig; Zwei.zei|ler, ...schi|ne (mit zwei Zügen zu lösende Schachaufgabe; m; -s,-) ...zy|lin|der (ugs. für: Zweizylindermotor od. damit ausgerüstetes Kraftfahrzeug); Zwei.zy|lin|der|motor; zwei|zy|lin|drig (mit Ziffer: 2zylindrig; ↑ R 228) Zwen|ke (Gattung von Graspflanzen) w; -, -n zwerch (quer); Zwerch|fell; zwerch|fell|er|schüt ternd Zwerg m; -[e]s, -e; zwerg|ar|tig; Zwerg.baum, ...be|trieb; zwer|gen|haft, zwerg|haft; Zwerg|haf-tig|keit w; -; Zwerg|huhn; zwer-gig; Zwer|gin w; -, -nen; Zwerg-.kie|fer w, ...obst, ...pal|me, ...pin-scher, ...pu|del, ...staat (Mehrz. ...staaten), ...strauch, ...volk, ...wuchs Zwet|sche w; -, -n; Zwet|schen-.mus, ...schnaps; Zwetsch|ge südd., schweiz. (Zwetsche); Zwetsch|ke bes. österr. (Zwetsche); Zwetsch|ken|knö|del, Zwetsch|ken|rö|ster österr. (gedünstete Pflaumen) m; -s, - Zwickau[1] (Stadt im Bezirk Chemnitz); Zwickau|er[1] (↑ R 199) Zwicke[1] (Zange zum Zwicken; auch: als Zwilling mit einem männl. Kalb geborenes Kuhkalb; veralt. für: Zwecke) w; -, -n; Zwickel[1] (keilförmiger Stoffeinsatz; Bauw.: dreieckiges Verbindungsstück) m; -s, -; zwicken (ugs. für: kneifen); er zwickt ihn (auch: ihm) ins Bein; Zwicker (Klemmer, Kneifer; Gerät zum Zwicken); Zwick|müh|le (Stellung im Mühlespiel) Zwie|back (,,zweimal Gebackenes''; geröstetes Weizengebäck) m; -[e]s, ...bäcke u. -e

Zwie|bel lat. (Gewürzpflanze; gestauchter Sproß) w; -, -n; Zwie-bel|chen, Zwie|be|lein; Zwie|bel-.fi|sche (Druckw.: fälschlich aus anderen Schrifttypen gesetzte Buchstaben od. durcheinanderliegende Buchstaben verschiedener Schrifttypen; Mehrz.), ...ge-wächs, ...hau|be, ...ku|chen, ...muster (beliebtes Muster der Meißner Porzellanmanufaktur; s; -s); zwie|beln (ugs. für: quälen; übertriebene Anforderungen stellen); ich ...[e]le (↑ R 327); Zwie|bel-.ring, ...saft, ...scha|le, ...turm Zwie|bra|che (veralt. für: zweites Pflügen des Brachackers im Spätjahr) w; -, -n; zwie|bra|chen (veralt. für: zum zweitenmal pflügen); ich zwiebrache; gezwiebracht; zu -; zwie|fach, zwei|fach (vgl. d.); zwie|fäl|tig; Zwie|ge-sang; Zwie|ge|spräch; vgl. Zwiegespräch; Zwie|laut (für: Diphthong); Zwie|licht s; -[e]s; zwie-lich|tig; Zwie|na|tur [1]Zwie|sel (Stadt in Bayern) [2]Zwie|sel mdal. (Gabelzweig; Gabelung) w; -, -n (auch: m; -s, -); Zwie|sel.bee|re (mdal. für: Vogelkirsche), ...dorn (mdal. für: Stechpalme; Mehrz. ...dörner); zwie|se|lig, zwies|lig mdal. (zweispaltig, gezweit); zwie|seln, sich mdal. (sich gabeln, spalten) Zwie|spalt m; -[e]s, (selten:) -e u. ...spälte; zwie|späl|tig; Zwie|späl-tig|keit w; -; Zwie|spra|che; Zwie-tracht w; -; zwie|träch|tig Zwilch (svw. Zwillich) m; -[e]s, -e; zwil|chen (aus Zwilch); Zwilch-ho|se Zwil|le niederd. (Holzgabel; kleine Schleuder) w; -, -n Zwil|lich (doppelfädiges Gewebe) m; -s, -e Zwil|ling (auch: ♉) m; -s, -e; Zwil|lings.bru|der, ...for|mel (Sprachw.), ...for|schung, ...frucht, ...ge|burt, ...paar, ...rei-fen, ...schwe|ster Zwing.burg; Zwin|ge (Metallklappe, -beschlag, -schließe) w; -, -n; zwin|gen; du zwangst (zwangest); du zwängest; gezwungen; zwing[e]!; zwin|gend; Zwin|ger (Gang, Platz zwischen innerer u. äußerer Burgmauer; Burggraben; fester Turm; Käfig für wilde Tiere; umzäunter Auslauf für Hunde); Dresdener Zwinger (Meisterwerk des dt. Barocks); Zwing-.herr, ...herr|schaft Zwing|li (schweiz. Reformator); Zwing|lia|ner (Anhänger der Lehre Zwinglis) zwin|ken (veralt. für: blinzeln); zwin|kern (blinzeln); ich ...ere (↑ R 327)

zwir|beln (wirbelnd drehen); ich ...[e]le (↑ R 327) Zwirn m; -[e]s, (Kaufmannsspr. für: Zwirnarten:) -e; [1]zwir|nen (von, aus Zwirn); [2]zwir|nen (Garne zusammendrehen); Zwir|ne-rei (Zwirnarbeit; Zwirnfabrik); Zwirns|fa|den (Mehrz. ...fäden) zwi|schen; mit Wemf. oder Wenf.: - den Tischen stehen, aber: - die Tische stellen; inzwischen; die Gegensätze zwischen den Arbeitgebern und den Arbeitnehmern (= zwischen der Arbeitgeberschaft u. der Arbeitnehmerschaft), aber: die Gegensätze zwischen den Arbeitgebern (= innerhalb der Arbeitgeberschaft) und zwischen den Arbeitnehmern (= innerhalb der Arbeitnehmerschaft); Zwi|schen.akt; Zwi|schen|akt|mu|sik; Zwi-schen.ap|plaus, ...aus|lands|ver-kehr (für: Transitverkehr; m; -s), ...aus|weis (Bankw.), ...bahn|hof, ...be|mer|kung, ...be|scheid, ...bi-lanz; zwi|schen|blen|den (Film); zwischengeblendet; nur in der Grundform u. im 2. Mittelwort gebräuchlich; Zwi|schen.buch-han|del, ...deck, ...ding; zwi-schen|drein (ugs.; Frage: wohin?); - legen; zwischen|drin (ugs.; Frage: wo?); - liegen; zwi|schen-durch (ugs.); - fallen; zwi|schen-ein (seltener für: zwischendurch); Zwi|schen.er|geb|nis, ...fall m, ...fra|ge, ...gas, ...ge|richt (Gastr.), ...ge|schoß, ...glied, ...grö|ße, ...han|del, ...händ|ler; zwi|schen|hin|ein (ugs.); Zwi-schen.hirn, ...hoch (Meteor.); zwi|schen|in|ne (mdal.); Zwi-schen.kie|fer[kno|chen], ...knor-pel; zwi|schen|lan|den; zwischengelandet; meist nur in der Grundform u. im 2. Mittelwort gebräuchlich; Zwi|schen-.lan|dung, ...lauf (Sportspr.), ...lö|sung, ...mahl|zeit; zwi|schen-mensch|lich; Zwi|schen.pau|se, ...prü|fung, ...raum, ...reich, ...ruf, ...ru|fer, ...run|de, ...satz (Sprachw.), ...spiel, ...spurt; zwi-schen|staat|lich (auch für: international); Zwi|schen.sta|ti|on, ...stu|fe, ...text, ...trä|ger, ...ur-teil, ...wand, ...zeit; zwi|schen-zeit|lich; Zwi|schen.zeug|nis, ...zin|sen (Mehrz.) Zwist m; -es, -e; zwi|stig (veralt.); Zwi|stig|keit zwit|schern; ich ...ere (↑ R 327) Zwit|ter (Wesen mit männl. u. weibl. Geschlechtsmerkmalen) m; -s, -; Zwit|ter.bil|dung, ...blü-te, ...ding, ...form; zwit|ter|haft; Zwit|ter|haf|tig|keit w; -; zwit|te-rig, zwittrig; Zwit|ter.stel|lung,

...tum (s; -s), ...we|sen (s; -s); Zwitt|rig|keit w; -; zwitt|rig, zwit-te|rig

zwo vgl. zwei

zwölf; wir sind zu zwölfen od. zu zwölft; es ist fünf [Minuten] vor zwölf (ugs. auch übertr. für: es ist allerhöchste Zeit); die zwölf Apostel; (↑ R 224:) die Zwölf Nächte (nach Weihnachten), auch „Zwölften" genannt, vgl. acht; Zwölf (Zahl) w; -, -en; vgl. ¹Acht; Zwölf|ach|ser (Wagen mit zwölf Achsen; mit Ziffern: 12achser; ↑ R 228); zwölf|ach|sig (mit Ziffern: 12achsig; ↑ R 228); Zwölf|eck; zwölf|eckig [Trenn.: ...ek|kig]; zwölf|ein|halb, zwölf-und|ein|halb; Zwölf|en|der; Zwöl|fer; vgl. Achter; zwöl|fer-lei; zwölf|fach; Zwölf|fa|che s; -n; vgl. Achtfache; Zwölf|fin|ger-darm; Zwölf|flach; -[e]s, -e, Zwölf|fläch|ner (für: Dodeka-eder); zwölf|mal; vgl. achtmal; zwölf|ma|lig; Zwölf|mei|len|zo-ne; zwölft; vgl. zwölf; Zwölf|ta-fel|ge|set|ze Mehrz.; zwölf|tau-send; vgl. tausend; zwölf|te; vgl. achte; zwölf|tel; vgl. achtel; Zwölf|tel s (schweiz. meist: m); -s, -; vgl. Achtel; Zwölf|ten (die „Zwölf Nächte" zwischen Weih-nachten u. Dreikönigsfest) Mehrz.; zwölf|tens; Zwölf|tö|ner (Vertreter der Zwölftonmusik); Zwölf|ton|mu|sik (Kompositionsstil) w; -; Zwölf|ton|ner (mit Ziffern: 12tonner; ↑ R 228); zwölf|[und]ein|halb; Zwölf|zy|lin-der (ugs. für: Zwölfzylindermotor od. damit ausgerüstetes Kraftfahrzeug); Zwölf|zy|lin-der|mo|tor; Zwölf|zy|lin|drig (mit Ziffern: 12zylindrig ↑ R 228)

zwo|te vgl. zwei

z. Wv. = zur Wiedervorlage

z. w. V. = zur weiteren Veranlassung

Zy|an (chem. fachspr.:) Cy|an gr. [zü...] (chem. Verbindung aus Kohlenstoff u. Stickstoff) s; -s; Zya|ne (Kornblume) w; -, -n; Zya|nid (Salz der Blausäure) s; -s, -e; Zy|an|ka|li, (älter:) Zy|an-ka|li|um (stark giftiges Kaliumsalz der Blausäure) s; -s; Zya|no-phy|zee (Blaualge) w; -, ...een (meist Mehrz.); Zya|no|se (Med.: bläuliche Verfärbung der Haut infolge Sauerstoffmangels im Blut) w; -, -n; Zya|no|ty|pie (spez. Lichtpausverfahren) w; -, (für: Kopie nach diesem Verfahren auch Mehrz.:) ...ien

Zya|thus vgl. Kyathos

Zy|gä|ne gr. (ein Schmetterling; ein Fisch) w; -, -n

Zy|go|ma gr. [auch: zügoma] (Jochbogen [Schädelknochen]) s; -s, ...omata; zy|go|morph (Bot.: mit nur einer Symmetrieebene [von Blüten]); Zy|go|te (Biol.: die befruchtete Eizelle nach Verschmelzung der beiden Geschlechtskerne) w; -, -n

Zy|kas gr. (Palmfarn) w; -, -; Zy-kas|we|del

Zy|kla|den vgl. Kykladen; Zy|kla-me gr. österr. (Zyklamen) w, -, -n; Zy|kla|men (Alpenveilchen) s; -s, -; Zy|klen (Mehrz. von: Zyklus); Zy|kli|de (Math.: Fläche vierten Grades) w; -, -n; Zy|kli-ker [auch: zü...] (altgr. Dichter von Epen, die später zu einem Zyklus mit Ilias und Odyssee als Mittelpunkt gestaltet wurden); zy|klisch [auch: zü...] (chem. fachspr.:) cy|clisch (kreisläufig, -förmig; sich auf einen Zyklus beziehend; regelmäßig wiederkehrend); Zy|klo|ide (math. Kurve) w; -, -n; Zy|klo|id|schup|pe (dünne Fischschuppe mit hinten abgerundetem Rand); Zy|klon engl. (Wirbelsturm; als ®: Fliehkraftabscheider [für Staub]) m; -s, -e; Zy|klo|ne (Meteor.: Tiefdruckgebiet) w; -, -n; Zy|klop („Rundäugiger"; einäugiger Riese der gr. Sage) m; -en, -en (↑ R 268); Zy|klo|pen|mau|er (frühgeschichtl. Mauer aus unbehauenen Bruchsteinen) (Med.: Gesichtsmißbildung) w; -; zy|klo|pisch (riesenhaft); -ste (↑ R 294); Zy|klo|thym (Psych.: [seelisch] aufgeschlossen, zugänglich, gesellig mit wechselnder Stimmung); Zy|klo|tron [auch: zü..., ...tron] (Beschleuniger für positiv geladene Elementarteilchen) s; -s, ...one (auch: -s); Zy-klus [auch: zü...] (Kreis[lauf]; Zusammenfassung; Folge; Reihe) m; -, Zyklen

Zy|lin|der gr. [zi..., auch: zü...] (Walze; röhrenförmiger Hohlkörper; Stiefel [bei Pumpen]; hoher Herrenhut) m; -s, -; Sechszylinder (ugs. für: Sechszylindermotor od. damit ausgestattetes Kraftfahrzeug); Zy|lin|der|block (Mehrz. ...blöcke), ...glä|ser (nur in einer Richtung gekrümmte Augengläser; Mehrz.), ...hut m, ...pro|jek|ti|on (Kartendarstellung besonderer Art); ...zy|lin-drig (z. B. zweizylindrig, mit Ziffer: 2zylindrig [mit 2 Zylindern versehen]; ↑ R 228); zy|lin|drisch (walzenförmig)

Zy|ma|se gr. (Gärung bewirkende Fermente) w; -; Zy|mo|lo|gie (Gärungslehre) w; -; Zy|mo|tech|nik (Gärungstechnik) w; -; zy|mo-tisch (Gärung bewirkend)

Zy|ni|ker gr. (gemeiner, schamloser, frecher Mensch, bissiger Spötter; über die Wertgefühle anderer Spottender); vgl. aber: Kyniker; zy|nisch (gemein, spöttisch, frech); -ste (↑ R 294); Zy-nis|mus (philos. Richtung der Kyniker) m; -, (für: Gemeinheit, Schamlosigkeit, Frechheit auch Mehrz.:) ...men

Zy|per|gras (einjähriges Riedgras), ...kat|ze; Zy|pern (Inselstaat im Mittelmeer); Zy|per|sei-de, ...wein; Zy|prer (Bewohner von Zypern)

Zy|pres|se (Kiefernpflanze des Mittelmeergebietes) w; -, -n; zy-pres|sen (aus Zypressenholz); Zy-pres|sen|hain, ...holz, ...zweig

Zy|pri|an, Zy|pria|nus (ein Heiliger)

Zy|pri|di|nen|kalk gr.; dt. (kleine Muschelkrebse [Zypridinen] führende Schicht des Devons) m; -[e]s

Zy|pri|er, Zy|pri|ot m; -en, -en vgl. Zyprer; zy|prio|tisch vgl. zy-prisch; zy|prisch (von Zypern)

Zy|ria|kus (ein Heiliger)

zy|ril|lisch vgl. kyrillisch

Zyst|al|gie gr. (Med.: Blasenschmerz) w; -, ...ien; Zy|ste (Med.: Blase; Geschwulst) w; -, -n; Zy|stis (Med.: Blase, Harnblase) w; -, Zysten; zy|stisch (Med.: blasenartig; auf die Zyste bezüglich)

Zy|ti|sus gr. (Goldregen) m; -, -

Zy|to|de gr. (kernloses Protoplasmaklümpchen) w; -, -n; zy|to|gen (von der Zelle gebildet); Zy|to|lo-gie (Zellenlehre) w; -; Zy|to-plas|ma (Zellplasma) w; -; Zy|to|som s; -s, -e od. ...so|ma (Gebilde in Tier- u. Pflanzenzellen, das der Atmung u. dem Stoffwechsel der Zelle dient) w; -, ...somen; Zy|to|stom s; -s, -e u. Zy|to|sto|ma (Biol.: Zellmund der Einzeller) s; -s, -ta

Zz. = Zinszahl

z. Z., z. Zt. = zur Zeit; vgl. Zeit

Transkriptions- und Transliterationssysteme

Die Transkriptionstabelle für das Neugriechische wurde vom Ständigen Ausschuß für geographische Namen unter dem Vorsitz von Professor Dr. E. Meynen gutgeheißen (vgl. Duden, Wörterbuch geographischer Namen, Europa, Einleitung). Die Transkription des klassischen Griechisch entspricht dem im Deutschen üblichen Gebrauch.

Die Transkriptionstabellen für das Russische und das Bulgarische wurden am 2. März 1962 von einer Kommission aufgestellt, der folgende Herren angehörten: Karl Richter, Auswärtiges Amt; Dr. Schierbaum, Bundesministerium für gesamtdeutsche Fragen; Dr. Schmal, Presse- und Informationsamt der Bundesregierung; Dr. Wädekin, Redaktion „Osteuropa", Aachen; Dr. Koch, Deutscher Journalisten-Verband; Herr Wolter, Deutsche Journalisten-Union; Gerhard Kübler, Deutscher Normenausschuß; Professor Dr. Grebe, Dudenredaktion; W. Seibicke, Gesellschaft für deutsche Sprache; Herr Contius, Osteuropa-Institut in Berlin-Dahlem; Professor Dr. Meynen, Ständiger Ausschuß für die Rechtschreibung geographischer Namen; Professor Dr. Neumann als Slawist; Professor Dr. Mangold als Phonetiker und Dr. Reck als Einzelperson. Das Bundesministerium des Innern ließ sich durch Herrn Dr. Schierbaum vertreten. Der Börsenverein des Deutschen Buchhandels hatte sich schriftlich zum Beratungsgegenstand geäußert.

Die Transkriptionstabellen für das Arabische und das Persische wurden am 25. 1. 1964 von einer Kommission aufgestellt, der folgende Herren angehörten: Legationsrat Dr. von Savigny, Auswärtiges Amt; Dr. Kurt-Georg Cram vom Verlag de Gruyter für den Börsenverein des Deutschen Buchhandels; Herr Becker für den Deutschen Journalisten-Verband; Oberregierungsrat Hoffmann, Oberstudienrat Dr. W. Eggers und Dr. Telbis für den Ständigen Ausschuß für geographische Namen; die Arabisten Professor Dr. Dietrich, Göttingen, Professor Dr. Hans-Robert Roemer, Freiburg, Professor Dr. Anton Spitaler, Bonn, und Herr Johannes Meyer, Hamburg, als besonderer Kenner des Paschto; der Geograph Professor Dr. Hermann von Wißmann, Tübingen; Professor Dr. Mangold als Phonetiker; Professor Dr. Grebe, Dudenredaktion.

Die Transliterationstabellen entsprechen den Empfehlungen und Entwürfen der ISO [International Organization for Standardization]:

a) ISO [International Organization for Standardization] Second Draft, ISO Recommendation Nr. 315 Transliteration of Greek into Latin Characters, October 1960,

b) ISO [International Organization for Standardization], ISO Recommendation R 9, International System for the Transliteration of Cyrillic Characters, 1st edition, October 1955,

c) ISO [International Organization for Standardization], ISO Recommendation R 233, International System for the Transliteration of Arabic Characters, 1st edition, December 1961.

Griechisches Transkriptions- und Transliterationssystem

Die in den beiden ersten Spalten aufgeführten griechischen Buchstaben und Buchstabengruppen stehen im Griechischen am Wortanfang oder bilden ein selbständiges Wort. Die in der dritten Spalte aufgeführten griechischen Buchstaben und Buchstabengruppen stehen im Griechischen nicht am Wortanfang (d. h. sie stehen im Wortinnern oder am Wortende). Die Bemerkung „nicht vor" bedeutet, daß weiter unten in den drei ersten Spalten stehende griechische Buchstabengruppen zu beachten sind.

Griechischer Buchstabe				Neugriechische Transkription		Klassische Transkription		Transliteration	
		α	nicht vor ι, υ		a		a		a
ʼA	ά			A	a	A	a	A	a
ʻA	ά			A	a	Ha	ha	ʼA	ʼa
	ᾁ	ᾳ			a		a		aj
	ᾁ				a		ha		ʼaj
Aι	αι	αι		Ä	ä	Ai	ai	Ai	ai
Aι	αι			Ä	ä	Hai	hai	ʼAi	ʼai
ʻAι			wenn bei Kleinschreibung dafür ᾳ	A		A		Aj	
ʻAι			wenn bei Kleinschreibung dafür ᾁ	A		Ha		ʼAj	
ʼAϊ¹	άϊ²	αϊ		Ai	ai	Ai	ai	Aï	aï
ʻAϊ³	άϊ⁴			Ai	ai	Hai	hai	ʼAï	ʼaï
Aυ	αυ	αυ	1) vor ϑ, κ, ξ, π, ς, σα, σᾳ, σε, ση, σῃ, σϑ, σι, σκ, σο, σπ, στ, συ, σφ, σχ, σω, σψ, τ, φ, χ, ψ; am Wortende	Af	af	Au	Au	Au	Au
			2) sonst	Aw	aw	Au	Au	Au	Au
Aυ	αύ		1) vor ϑ, κ, ξ, π, ς, σα, σᾳ, σε, ση, σῃ, σϑ, σι, σκ, σο, σπ, στ, συ, σφ, σχ, σω, σψ, τ, φ, χ, ψ; am Wortende	Af	af	Hau	hau	ʼAu	ʼau
			2) sonst	Aw	aw	Hau	hau	ʼAu	ʼau
ʼAϋ⁵	άϋ⁶	αϋ		Ai	ai	Ay	ay	Aü	aü
ʻAϋ⁷	άϋ⁸			Ai	ai	Hay	hay	ʼAü	ʼaü
B	β	β		W	w	B	b	B	b
Γ	γ	γ	1) vor αι, ε, η, ῃ, ι, οι, υ	J	j	G	g	G	g
			2) sonst (nicht vor γ, κ, ξ, χ)	G	g	G	g	G	g
		γγ			ng		ng		gg
Γκ	γκ			G	g			Gk	gk
		γκ			ng		nk		gk
		γξ			nx		nx		gx
		γχ			nch		nch		gh
Δ	δ	δ		D	d	D	d	D	d
		ε	nicht vor ι, υ		e		e		e
ʼE	έ			E	e	E	e	E	e
ʻE	έ			E	e	He	he	ʼE	ʼe
Eι	εί	ει		I	i	Ei	ei	Ei	ei
Eι	εί			I	i	Hei	hei	ʼEi	ʼei
ʼEϊ⁹	έϊ¹⁰	εϊ		Ei	ei	Ei	ei	Eï	eï
ʻEϊ¹¹	έϊ¹²			Ei	ei	Hei	hei	ʼEï	ʼeï
Eυ	εύ	ευ	1) vor ϑ, κ, ξ, π, ς, σα, σᾳ, σε, ση, σῃ, σϑ, σι, σκ, σο, σπ, στ, συ, σφ, σχ, σω, σψ, τ, φ, χ, ψ; am Wortende	Ef	ef	Eu	eu	Eu	eu
			2) sonst	Ew	ew	Eu	eu	Eu	eu

¹ Auch: ʼAι; ³ auch: ʻAι; ⁵ auch: ʼAυ; ⁷ auch: ʻAυ; ⁹ auch: ʼEι; ¹¹ auch: ʻEι;
² auch: άι; ⁴ auch: ἁι; ⁶ auch: άυ; ⁸ auch: ἁυ; ¹⁰ auch: ἑι; ¹² auch: ἑι.

Griechischer Buchstabe				Neu-griechische Tran-skription		Klassische Tran-skription		Trans-literation	
Eύ	εύ		1) vor ϑ, κ, ξ, π, ς, σα, σᾳ, σε, ση, σῃ, σϑ, σι, σκ, σο, σπ, στ, συ, σφ, σχ, σω, σψ, τ, φ, χ, ψ; am Wortende	Ef	ef	Heu	heu	'Eu	'eu
			2) sonst	Ew	ew	Heu	heu	'Eu	'eu
'Eΰ[1]	έΰ[2]	εΰ		Ei	ei	Ey	ey	Eü	eü
'Eΰ[3]	έΰ[4]			Ei	ei	Hey	hey	'Eü	'eü
Z	ζ	ζ		S	s	Z	z	Z	z
		η	nicht vor ι, υ	i		e		ē	
'Η	ή			I	i	E	e	Ê	ē
'Η	ή			I	i	He	he	'Ê	'ē
	ἡ			i		e		ēi	
		ῃ		i		he		ēj	
'Ηι			wenn bei Kleinschreibung dafür ῃ	I		E		Êj	
'Ηι			wenn bei Kleinschreibung dafür ῃ	I		He		'Êj	
'Ηϊ[5]	ήϊ[6]	ηϊ		Ii	ii	Ei	Ei	Êï	ēï
'Ηϊ[7]	ήϊ[8]			Ii	ii	Hei	hei	'Êï	'ēï
Ηύ	ηύ	ηυ	1) vor ϑ, κ, ξ, π, ς, σα, σᾳ, σε, ση, σῃ, σϑ, σι, σκ, σο, σπ, στ, συ, σφ, σχ, σω, σψ, τ, φ, χ, ψ; am Wortende	If	if	Eu	eu	Êu	ēu
			2) sonst	Iw	iw	Eu	eu	Êu	ēu
Ηύ	ηύ		1) vor ϑ, κ, ξ, π, ς, σα, σᾳ, σε, ση, σῃ, σϑ, σι, σκ, σο, σπ, στ, συ, σφ, σχ, σω, σψ, τ, φ, χ, ψ; am Wortende	If	if	Heu	heu	'Êu	'ēu
			2) sonst	Iw	iw	Heu	heu	'Êu	'ēu
'Ηϋ[9]	ήϋ[10]	ηϋ		Ii	ii	Ey	ey	Êü	ēü
'Ηϋ[11]	ήϋ[12]			Ii	ii	Hey	hey	'Êü	'ēü
Θ	ϑ	ϑ		Th	th	Th	th	Th	th
		ι	vgl. aber αι, 'Αι, 'Αι, ει, 'Ηι, 'Ηι, οι, 'Ωι, 'Ωι	i		i		i	
'Ι	ι		vgl. aber Αι, αι, Ει, ει, Οι, οι	I	i	I	i	I	i
'Ι	ι		vgl. aber Αι, αι, Ει, ει, Οι, οι, Υι, υι	I	i	Hi	hi	'I	'i
		ι		i		i		ï	
Κ	κ	κ		K	k	K	k	K	k
Λ	λ	λ		L	l	L	l	L	l
Μ	μ	μ	nicht vor π	M	m	M	m	M	m
Μπ	μπ			B	b			Mp	mp
		μπ		mb		mp		mp	
Ν	ν		nicht vor τ	N	n	N	n	N	n
Ντ	ντ			D	d			Nt	nt
		ντ		nd		nt		nt	
Ξ	ξ	ξ		X	x	X	x	X	x
		ο	nicht vor ι, υ	o		o		o	
'Ο	ό			O	o	O	o	O	o
'Ο	ό			O	o	Ho	ho	'O	'o
Οι	οί	οι		I	i	Oi	oi	Oi	oi
Οι	οί			I	i	Hoi	hoi	'Oi	'oi
'Οϊ[13]	όϊ[14]	οϊ		Oi	oi	Oi	oi	Oï	oï
'Οϊ[15]	όϊ[16]			Oi	oi	Hoi	hoi	'Oï	'oï
Ού	ού	ου		U	u	U	u	Ou	ou
Ού	ού			U	u	Hu	hu	'Ou	'ou
Π	π	π	nicht vor σ, ς	P	p	P	p	P	p
Πσ	πσ	πς		Ps	ps	Ps	ps	P·s	p·s
Ρ[17]	ρ[18]			R	r	Rh	rh	R	r
		ρ		r		r		r	
		ρρ[19]		rr		rrh		rr	

[1] Auch: 'Ευ; [5] auch: 'Ηι; [9] auch: 'Ηυ; [13] auch: 'Οι; [17] auch: 'Ρ;
[2] auch: έυ; [6] auch: ήι; [10] auch: ήυ; [14] auch: όι; [18] auch: ρ;
[3] auch: 'Ευ; [7] auch: 'Ηι; [11] auch: 'Ηυ; [15] auch: 'Οι; [19] auch: ρρ.
[4] auch: έυ; [8] auch: ήι; [12] auch: ήυ; [16] auch: όι;

Griechischer Buchstabe				Neugriechische Transkription		Klassische Transkription		Transliteration	
Σ	σ	ς		S	s	S	s	S	s
T	τ	τ	nicht vor ζ. χ	T	t	T	t	T	t
Τζ	τζ	τζ		Ds	ds			Tz	tz
Τχ	τχ	τχ		Tch	tch			T·h	t·h
		υ	vgl. aber αυ, ευ, ηυ, ου, ωυ		i		y		u
'Υ	ὺ		vgl. aber Αὺ, αὺ, Εὺ, εὺ, Ηὺ, ηὺ, Οὺ, οὺ, Ωὺ, ωὺ	I	i	Y	y	U	u
'Υ	ὺ		vgl. aber Αὺ, αὺ, Εὺ, εὺ, Ηὺ, ηὺ, Οὺ, οὺ, Ωὺ, ωὺ	I	i	Hy	hy	'U	'u
		ϋ			i		y		ü
		υι			ii		yi		ui
Υἰ	υἰ	υἰ		I	i	Hyi	hyi	'Ui	'ui
'Υϊ[1]	ὑϊ[2]			Ii	ii	Hyi	hyi	'Uï	'uï
Φ	φ	φ		F	f	Ph	ph	F	f
Χ	χ	χ		Ch	ch	Ch	ch	H	h
Ψ	ψ	ψ		Ps	ps	Ps	ps	Ps	ps
'Ω	ὼ	ω		O	o	O	o	Ō	ō
'Ω	ὼ			O	o	Ho	ho	'Ō	'ō
	ῴ	ῳ			o		o		ōj
	ῴ				o		ho		'ōj
'Ωι			wenn bei Kleinschreibung dafür ῳ	O		O		Ōj	
'Ωι			wenn bei Kleinschreibung dafür ῳ	O		Ho		'Ōj	
'Ωϊ[3]	ὼϊ[4]	ωϊ		Oi	oi	Oi	oi	Ōï	ōï
'Ωϊ[5]	ὼϊ[6]			Oi	oi	Hoi	hoi	'Ōï	'ōï
Ωὺ	ωὺ	ωυ	1) vor ϑ, κ, ξ, π, ς, σα, σᾳ, σε, ση, σῃ, σϑ, σι, σκ, σο, σπ, στ, συ, σφ, σχ, σω, σῳ, τ, φ, χ, ψ; am Wortende	Of	of	Ou	ou	Ōu	ōu
			2) sonst	Ow	ow	Ou	ou	Ōu	ōu
Ωὺ	ωὺ		1) vor ϑ, κ, ξ, π, ς, σα, σᾳ, σε, ση, σῃ, σϑ, σι, σκ, σο, σπ, στ, συ, σφ, σχ, σω, σῳ, τ, φ, χ, ψ; am Wortende	Of	of	Hou	hou	'Ōu	'ōu
			2) sonst	Ou	ou	Hou	hou	'Ōu	'ōu
¨				Ou[7]	ou	Hou[7]	hou	¨	
'8				—		—			
'8				—		H[9]	h[9]	'[10]	
'				—[11]		—[11]		'[12]	
'				—[11]		—[11]		'[12]	
~				—[11]		—[11]		~[12]	

[1] Auch: 'Υι; [3] auch: 'Ωι; [5] auch: 'Ωι;
[2] auch: ὑι; [4] auch: ὼι; [6] auch: ὼι.

[7] Zur Auswirkung von ¨ auf die neugriechische Transkription, die klassische Transkription und die Transliteration vgl. die Vokalbuchstaben und Vokalbuchstabengruppen der Tabelle. Vokalbuchstaben sind: A, α, ᾳ, E, ε, H, η, ῃ, I, ι, O, o, Y, υ, Ω, ω, φ.

[8] Zur Auswirkung der Stellung von ' und ' auf die neugriechische Transkription, die klassische Transkription und die Transliteration vgl. die Vokalbuchstaben und Vokalbuchstabengruppen der Tabelle.

[9] H, h bilden den ersten Buchstaben des Wortes.

[10] ' steht vor dem ersten Buchstaben des Wortes.

[11] ' ' ~ werden in der neugriechischen Transkription und in der klassischen Transkription nicht berücksichtigt.

[12] Stehen ' ' ~ im Griechischen vor einer Majuskel, dann werden sie in der Transliteration auf die Majuskel gesetzt.

Russisches Transkriptions- und Transliterationssystem

Russischer Buchstabe¹		Tran-skription	Trans-literation	Russischer Buchstabe¹		Tran-skription	Trans-literation
А	а	a	a	П	п	p	p
Б	б	b	b	Р	р	r	r
В	в	w²	v	С	с	s¹⁰ ¹¹	s
Г	г	g²	g	Т	т	t	t
Д	д	d	d	У	у	u	u
Е	е	e³	e	Ф	ф	f	f
Е⁴	е⁴	jo⁵	e	Х	х	ch	h¹²
Ё	ё	jo⁵	ë	Ц	ц	z	c
Ж	ж	sch	ž	Ч	ч	tsch	č
З	з	s	z	Ш	ш	sch	š
И	и	i⁶	i	Щ	щ	schtsch	šč
Й	й	i⁷ ⁸	j	Ъ	ъ	¹³	"¹⁴
К	к	k⁹	k	Ы	ы	y	y
Л	л	l	l	Ь	ь	¹⁵	'¹⁶
М	м	m	m	Э	э	e	ė
Н	н	n	n	Ю	ю	ju	ju
О	о	o	o	Я	я	ja	ja

1 Russische Vokalbuchstaben sind: а, е, ё, и, о, у, ы, ю, э, я.
2 In den Genitivendungen -его und -ого wird г mit w wiedergegeben.
3 e = je am Wortanfang, nach russischem Vokalbuchstaben, nach ъ und nach ь.
4 Wenn im Russischen für Е, е auch Ё, ё geschrieben werden kann.
5 e, ё = o nach ж, ч, ш, щ.
6 и = ji nach ь.
7 й wird nach и und nach ы nicht wiedergegeben.
8 й = i nicht nach и, ы am Wortende sowie zwischen russischem Vokalbuchstaben (außer и, ы) und russischem Konsonantenbuchstaben.
9 кс = x in allen Fällen.
10 кс = x in allen Fällen.
11 c = ss zwischen russischen Vokalbuchstaben.
12 x = ch in der deutschen Bibliothekstransliteration.
13 ъ wird nicht wiedergegeben; vgl. aber Fußnote 3.
14 ъ = ″ oder " in der ISO-Transliteration; in der deutschen Bibliothekstransliteration mit Bindestrich wiedergegeben.
15 ь = j vor o; ь wird sonst nicht wiedergegeben, vgl. aber Fußnote 3 und 6.
16 ь = ′ oder ' in der ISO-Transliteration.

Bulgarisches Transkriptions- und Transliterationssystem

Bulgarischer Buchstabe [1]		Tran-skription	Trans-literation	Bulgarischer Buchstabe [1]		Tran-skription	Trans-literation
А	а	a	a	П	п	p	p
Б	б	b	b	Р	р	r	r
В	в	w	v	С	с	s [3] [4]	s
Г	г	g	g	Т	т	t	t
Д	д	d	d	У	у	u	u
Е	е	e	e	Ф	ф	f	f
Ж	ж	sch	ž	Х	х	ch	h
З	з	s	z	Ц	ц	z	c
И	и	i	i	Ч	ч	tsch	č
Й	й	i [2]	j	Ш	ш	sch	š
К	к	k [3]	k	Щ	щ	scht	št
Л	л	l	l	Ъ	ъ	a	ă
М	м	m	m	Ь	ь	j	' [5]
Н	н	n	n	Ю	ю	ju	ju
О	о	o	o	Я	я	ja	ja

[1] Vokalbuchstaben sind: а, е, и, о, у, ъ, ю, я.
[2] й = j am Wortanfang und zwischen bulgarischen Vokalbuchstaben. Nach и wird й am Wortende oder vor Konsonantenbuchstaben nicht transkribiert.
[3] кс = x in allen Fällen.
[4] с = ss zwischen bulgarischen Vokalbuchstaben.
[5] ь = ' oder ı in der ISO-Transliteration.

Persisches Transliterations- und Transkriptionssystem

Das untenstehende Transkriptionssystem gilt für neupersische Namen aus dem Iran bei bekannter voller persischer Schreibung.

Trans-literation	Tran-skription	Trans-literation	Tran-skription	Trans-literation	Tran-skription
a	a	ẖ	ch	t	t
ā	a	hh	hh	ṯ	s
à	a	hh	hh	ṱ	t
aʰ	e	ẖẖ	chch	tt	tt
aw	au [1]	i	e	ṯṯ	ss
aww	auw	ī	i	ṱṱ	tt
ay	ai [1]	iyy	ijj	u	o
ayy	aij	k	k	ū	u
b	b	kk	kk	uww	uww
bb	bb	l	l	uyy	ujj
č	tsch	ll	ll	w	w [2] [3]
d	d	m	m	y	j [4]
ḍ	s	mm	mm	z	s
ḏ	s	n	n	ẓ	s
dd	dd	nn	nn	z	sch
ḍḍ	ss	p	p	zz	ss
ḏḏ	ss	q	gh	ẓẓ	ss
f	f	qq	ghgh	ʻ	nicht wieder-gegeben
ff	ff	r	r		
ġ	g	rr	rr	'	nicht wieder-gegeben
ǧ	dsch	s	s		
ḡ	gh	ṣ	s	"	nicht wieder-gegeben
ǧǧ	ddsch	š	sch		
ḡḡ	ghgh	ss	ss	"	nicht wieder-gegeben
h	h	ṣṣ	ss		
ḥ	h	šš	schsch	Izafet	e [5]

[1] Vor Konsonantenbuchstabe der Transkription; am Wortende.
[2] Vgl. aber aw, aww.
[3] Wird am Wortanfang, wenn nach ẖ, vor Vokal nicht wiedergegeben.
[4] Vgl. aber ay, ayy.
[5] Getrennt, ohne Bindestrich davor und danach sowie mit Minuskelinitiale geschrieben.

Arabisches Transliterations- und Transkriptionssystem

Das untenstehende Transkriptionssystem gilt für klassisch-arabische Namen sowie neu-arabische Namen aus der Arabischen Halbinsel, aus dem Irak, Jordanien, dem Libanon, Libyen, Syrien und aus der Vereinigten Arabischen Republik (Ägypten) bei bekannter voller arabischer Schreibung. Namen aus der Republik Sudan sollen nach Möglichkeit ebenso behandelt werden.

Trans-literation	Tran-skription	Trans-literation	Tran-skription	Trans-literation	Tran-skription
a	a¹	ḥ	ch	šš	schsch
ā	a	hh	hh	t	t¹
à	a	ḥḥ	hh	ṯ	th¹
aʰ	a	ḥh	chch	ṭ	t¹
aw	au²	i	i	tt	tt
aww	auw	ī	i	ṯṯ	thth
ay	ai²	iyy	ijj	ṭṭ	tt
ayy	aij	k	k	u	u
b	b	kk	kk	ū	u
bb	bb	l	l	uww	uww
d	d¹	ll	ll	uyy	ujj
ḏ	dh¹	m	m	w	w⁵
ḍ	d¹	mm	mm	y	j⁶
dd	dd	n	n¹	z	s¹
ḏḏ	dhdh	nn	nn	ż	s¹
ḍḍ	dd	q	ḳ	zz	ss
f	f	qq	kk	żż	ss
ff	ff	r	r¹	ʿ	nicht wieder-gegeben
ǧ	dsch³	rr	rr	ʾ	nicht wieder-gegeben
ḡ	gh	s	s¹	"	nicht wieder-gegeben
ǧǧ	ddsch⁴	ṣ	s¹	"	nicht wieder-gegeben
ḡḡ	ghgh	š	sch¹		
ḥ	h	ss	ss		
ḥ	h	ṣṣ	ss		

¹ Der arabische Artikel al wird getrennt, ohne Bindestrich davor und danach sowie mit Majuskel-A geschrieben, z. B. Al Kahira. Das l des arabischen Artikels al wird dem folgenden Buchstaben oder der folgenden Buchstabengruppe angepaßt, und zwar: l D > d D, l Dh > dh Dh, l N > n N, l R > r R, l S > s S, l Sch > sch Sch, l T > t T, l Th > th Th, z. B. Al Raschid > Ar Raschid; in den übrigen Fällen bleibt das l des arabischen Artikels al erhalten, z. B. Al Dschauf, Al Kahira.

² Vor Konsonantenbuchstabe der Transkription; am Wortende.

³ Dafür g in Ägypten und Sudan bei geographischen Namen und bei modernen Personen-namen.

⁴ Dafür gg in Ägypten und Sudan bei geographischen Namen und bei modernen Personen-namen.

⁵ Vgl. aber aw, aww.

⁶ Vgl. aber ay, ayy.

Wußten Sie, daß es insgesamt zehn Dudenbände gibt? Daß die Rechtschreibung, der berühmte Duden, der erste Band dieser Reihe ist?

Auf den folgenden
Seiten stellen wir Ihnen die
Bände 2–10 vor.

Band 2: Das Stilwörterbuch
der deutschen Sprache. Die Verwendung der Wörter im Satz

6., völlig neu bearbeitete und stark erweiterte Auflage. Bearbeitet von Günther Drosdowski unter Mitwirkung folgender Mitarbeiter der Dudenredaktion: D. Berger, M. Dose, J. Ebner, D. Mang, C. Schrupp, J. Werlin. 846 Seiten.

Wie es verbindliche Formen des Umgangs gibt, so gibt es auch verbindliche sprachliche Umgangsformen. Voraussetzung für einen guten persönlichen Stil ist die Vertrautheit mit diesen Umgangsformen, ist die Kenntnis des Zusammenspiels der Wörter, die Sicherheit in der Wortwahl und die Beherrschung der stilistischen Mittel. Das Stilwörterbuch bietet jedem die Möglichkeit, ein gewandter Stilist zu werden. Es löst alle Probleme, wenn man Korrespondenz zu erledigen hat, einen Aufsatz schreiben oder eine Rede halten muß.

Das Stilwörterbuch stellt die Ausdrucksmöglichkeiten der deutschen Sprache dar. Außer den üblichen und typischen Wortverbindungen enthält dieser Band zahlreiche Wendungen, Redensarten und Sprichwörter. Er ist geradezu eine Fundgrube für idiomatisches Deutsch von der Dichtersprache bis zur derben Umgangssprache.

Der Stilduden ist ein Wörterbuch, das neue Wege geht. Es ist nach den modernsten linguistischen Erkenntnissen durchstrukturiert und trägt zu einem tieferen Verständnis der deutschen Sprache bei.

ben (ugs.; *ich mag das nicht*). **4.** *hinsichtlich einer Sache, im Hinblick darauf:* d. habe ich kein Verständnis; d. bekannt sein, daß ...; das Kind ist erst zwölf Jahre alt, d. ist es schon sehr selbständig. **5.** (ugs.) *dagegen:* die Tabletten sind gerade d. sehr gut; d. gibt es [noch] kein Mittel *(dagegen kann man nichts machen)*.

dafürkönnen ⟨in der Wendung⟩ etwas/nichts dafürkönnen (ugs.): *an etwas [keine] Schuld haben:* was kann ich dafür, daß der Zug Verspätung hat?

dagegen ⟨Pronominaladverb⟩: **1. a)** *gegen etwas, an etwas heran:* ein Brett, einen Blendschutz d. halten; wir können die Leiter jetzt d. stellen. **b)** /drückt eine Abneigung gegen etwas, ein Angehen gegen etwas, ein Entgegenwirken aus/ [grundsätzlich] d. sein; hat jmd. etwas d.?; d. ist nichts zu sagen; sich entschieden d. verwahren, daß ...; d. sind wir machtlos; man muß endlich etwas d. tun; das ist ein sehr gutes Mittel d. **3.** *im Vergleich dazu:* die Überschwemmungen im vergangenen Jahr waren furchtbar, d. sind diese noch harmlos. **4.** *hingegen, jedoch:* die eine Arbeit ist gut, d. ist die andere kaum zu gebrauchen; im Süden ist es schon warm, bei uns d. schneit es noch.

daheim ⟨Adverb⟩ (bes. südd.): *zu Hause:* d. sein, bleiben; bei uns am schönsten; bei uns d.; sich wie d. fühlen; wie geht's d. *(der Familie)*?; er ist in Bayern d. *(stammt aus Bayern).*

daher ⟨Adverb⟩: **1.** *von dort:* ich komme gerade d.; bist *(stammst)* du auch d.?; die Westflanke ist stark befestigt, von d. droht keine Gefahr. **2.** *aus diesem Grund, deshalb:* er war krank und

stellte sich d. **2.** *hinter der betreffenden Angelegenheit/hinter die betreffende Angelegenheit:* ich weiß nicht, was es bei ihm d. verbirgt *(die Sache hat einen realen Kern)*; viel Lärm und nichts d.!; wir müssen Dampf, Druck d. machen *(die Erledigung beschleunigen).*

dahinterkommen (ugs.): *herausfinden:* d., was jmd. vorhat; man ist dahintergekommen, daß er Spionage treibt.

dahinterstecken (ugs.): **a)** *der eigentliche Urheber, der Drahtzieher sein:* wer steckt denn [bei heber, der Drahtzieher sein:* wer steckt denn [bei der Sache] dahinter? **b)** ⟨etwas steckt dahinter⟩ *etwas ist das eigentliche Ziel, der wahre Grund:* man weiß noch nicht, was bei diesem Plan eigentlich dahintersteckt; wir werden schon herausfinden, was dahintersteckt *(was damit los ist).*

daliegen: *deutlich sichtbar an einer bestimmten Stelle liegen:* völlig erschöpft, leblos, wie tot, regungslos d.; die Stadt liegt wie ausgestorben da.

damals ⟨Adverb⟩: *zu jenem Zeitpunkt, in jener Zeit:* so etwas gab es d. noch nicht; d., als meine Eltern noch lebten, war hier noch unbebautes Land; d. und heute; d. wie heute/heute wie d.; das ist eine Erinnerung an d.; ich habe ich ihn nicht mehr gesehen; das Bild ist noch von d.

Dame, die: **1.** *gebildete, gepflegte Frau* /häufig lediglich als höflicher Ausdruck für *Frau*/: eine elegante vornehme, reiche, nette, ältere D.; eine D. in Schwarz; die D. des Hauses *(die Hausherrin, Gastgeberin)*; die D. seines Herzens *(seine Angebetete)*; eine D. von Welt; die erste D. des Staates/im Staat *(die Frau des Staats-*; D. des Staates ... D. möchte Sie sprechen;

Band 3: Das Bildwörterbuch
der deutschen Sprache

2., vollständig neu bearbeitete Auflage. Herausgegeben von den Fachredaktionen des Bibliographischen Instituts in Gemeinschaft mit der Dudenredaktion. 792 Seiten mit 368 Bildtafeln, davon 8 vierfarbig, und einem Register mit 25 000 Stichwörtern.

Häufig ist es unmöglich, Wörter ohne Zuhilfenahme des Bildes zu erklären. Die herkömmlichen Bedeutungsangaben und Definitionen sind oft ungenau und vermitteln keine Anschauung von dem, was mit dem Wort bezeichnet ist. Deshalb erklärt dieser Band, der schon das »reichhaltigste Bilderbuch der Welt« genannt worden ist, Wörter – vor allem Tausende von Fachausdrücken – durch das Bild. Um den Informationswert zu erhöhen, stehen die Wörter aus dem gleichen Anwendungsbereich zusammen auf einer Seite und einer Bildtafel.

Sprache wird in diesem Buch mit Leben erfüllt. Der Benutzer kann sich ansehen, welcher Teil beim Boot mit »Plicht« bezeichnet wird, wie ein Tukan oder ein Wassermolch aussieht, wie die Werkzeuge heißen, mit denen ein Böttcher arbeitet, oder wie ein Atommeiler gebaut ist.

Das Bildwörterbuch macht uns die Welt, die uns umgibt, vertrauter und vermittelt uns eine Fülle von Wissen.

Band 4: Die Grammatik
der deutschen Gegenwartssprache

3., neu bearbeitete und erweiterte Auflage. Bearbeitet von Paul Grebe unter Mitwirkung von Helmut Gipper, Max Mangold, Wolfgang Mentrup und Christian Winkler. 763 Seiten mit Sachregister, Wortregister und Register für Zweifelsfragen.

Der Band 4 des Großen Dudens stellt den Aufbau der deutschen Sprache dar. Von den Grundeinheiten Wort und Satz ausgehend, werden alle sprachlichen Erscheinungen wissenschaftlich exakt und umfassend behandelt, z. B. die Laute, die Formen und Funktionen der Wörter (Deklination, Konjugation usw.), die Wortbildung, die Gliederung des Wortschatzes, die Baupläne unserer Sätze und die Wortstellung. Umfangreiche Register am Schluß des Bandes bieten dem Benutzer die Möglichkeit, sich schnell über einen bestimmten Gegenstand zu informieren und sich über grammatische Zweifelsfragen Klarheit zu verschaffen.

Die Duden-Grammatik, die jetzt neu bearbeitet und erweitert in 3. Auflage vorliegt, hat sich überall hervorragend bewährt; Schule und Universität haben ihr höchstes Lob gezollt. Sie ist zuverlässig, umfassend und klar – im besten Sinne des Wortes eine moderne Grammatik.

Band 5: Das Fremdwörterbuch

3., völlig neu bearbeitete und erweiterte Auflage. Bearbeitet von Wolfgang Müller unter Mitwirkung folgender Mitarbeiter der Dudenredaktion: Dieter Berger, Maria Dose, Regine Elsässer, Claudia Kratschmer, Dieter Mang. 781 Seiten, rund 250 000 Angaben über Aussprache, Betonung und Silbentrennung, Herkunft und Grammatik zu 45 000 Fremdwörtern mit 90 000 Bedeutungsangaben.

In den letzten Jahrzehnten sind sich die Völker der Erde immer näher gekommen, und es findet ein reger Sprachaustausch statt. Auch in die deutsche Sprache sind sehr viele Wörter aus anderen Sprachen übernommen worden, und ständig kommen neue hinzu. Durch die Massenmedien Presse, Film, Funk und Fernsehen und am Arbeitsplatz kommen wir täglich mit Fremdwörtern und Fachausdrücken in Berührung, über die wir Bescheid wissen müssen.

Curriculum, Dialyse, Evaluation, Infothek, Ökotrophologie, Oligopson, Parablacks, Solarium, Spoiler, Talk-Show, Tempolimit ... Diese und über 45 000 andere Fremdwörter erklärt das Duden-Fremdwörterbuch. Es gibt ihre Bedeutungen und Anwendungsbereiche an, unterrichtet über Aussprache und Herkunft und macht zuverlässige grammatische Angaben. Der Fremdwörter-Duden − das moderne Wörterbuch, wissenschaftlich exakt und umfassend.

Airbus [*är...; engl.*] *der; -ses, -se:* Passagierflugzeug mit großer Sitzkapazität für Mittel- u. Kurzstrecken. **Air-condition** [*ärkondisch⁰n*] vgl. Air-conditioning. **Air-conditioner** [*ärkondisch⁰n⁰r*] *der; -s, - u.* **Air-conditioning** [*ärkondisch'ning*] *das; -s, -s:* Klimaanlage
Airedaleterrier [*ärde'l...*]; nach einem *Airdale* genannten Talabschnitt, durch den der engl. Fluß Aire fließt] *der; -s, -:* eine Hunderasse. ein → Terrier
Air Force [*är forß; engl.*] *die; - -:* [die engl. u. amerik.] Luftwaffe, Luftstreitkräfte. **Air-fresh** [*ärfräsch*] *das; -:* Mittel zur Luftverbesserung. **Air-hostess** [*ärhoßtäß*] *engl.*] *die; -, -en:* → Hostess, die im Flugzeug Dienst tut; Stewardeß. **Airotor** [*är...*] *der; -s, ...toren:* eine bestimmte Art von Zahnbohrer. **Airport** [*ärport; engl.*] *der; -s, -s:* Flughafen
...aise [*...äs°; fr.*]: Suffix weiblicher Fremdwörter aus dem Französischen, z. B. Marseillaise, Française, eingedeutscht: Majonäse
Aja [l.] *die; -, -s:* (veraltet) Erzieherin
à jour [*a schur; fr.*]; „zutage"]: 1. bis zum [heutigen] Tag; - - sein:

beiten bzw. von sich gerade bieftender Arbeit leben. 2. a) wissenschaftlich; b) (abwertend) trocken, theoretisch; c) müßig, überflüssig. **Akademismus** [*nlat.*] *der; -:* starre, dogmatische Kunstauffassung od. künstlerische Betätigung
Akalit Ⓦ [Kunstw.] *das; -s:* Kunststoff aus Kasein
Akanthit [*gr.-nlat.*] *der; -s:* Silberglanz (ein Mineral). **Akanthus** [*gr.-lat.*] *der; -, -:* 1. a) Bärenklau (stachliges Staudengewächs in den Mittelmeerländern); b) Ornament nach dem Vorbild der Blätter des Akanthus (z. B. an antiken Tempelgiebeln; Kunstw.)
Akardiakus [*gr.-nlat.*], **Akardius** *der; -:* Doppelmißgeburt, bei der einem Zwilling das Herz fehlt (Med.)
Akariasis [*gr.-nlat.*] *die; -:* durch Milben hervorgerufene Hauterkrankung. **Akarinose** *die; -, -n:* 1. durch Milben hervorgerufene Kräuselung des Weinlaubs. 2. = Akariasis. **Akarizid** [*gr.; lat.*] *das; -s, -e:* Milbenbekämpfungsmittel im Obst- u. Gartenbau. **Akaroidharz** [*gr.; dt.*]: *das; -es:* aus den Bäumen der Gattung Xanthorrhoea gewonnenes gelbes od. ro-

rend, der Gummiarabikum liefert; b) (ugs.) → Robinie
Akelei [auch: *a...; mlat.*] *die; -, -en:* Zier- u. Arzneipflanze (ein Hahnenfußgewächs)
akephal, selten: **akephalisch** [*gr.-nlat.*; „ohne Kopf"]: a) am Anfang um die erste Silbe verkürzt (von einem Vers; antike Metrik); b) ohne Anfang (von einem literarischen Werk, dessen Anfang nicht od. nur verstümmelt erhalten ist)
Akinakes [*pers.-gr.-lat.*] *der; -, -:* (hist.) Kurzschwert der Perser u. Skythen
Akinesie [*gr.-nlat.*] *die; -:* Bewegungsarmut, Bewegungshemmung von Gliedmaßen (Med., Psychol.). **Akineten** *die* (Plural): dickwandige unbewegliche Einzelzellen, Dauerzellen der Grünalgen zur Überbrückung ungünstiger Umweltbedingungen (Biol.). **akinetisch**: bewegungsgehemmt, unbeweglich (von Gliedmaßen; Med., Psychol.)
Akk. = Akkusativ
Akklamation [*...zion; lat.*]; „das Zurufen"] *die; -, -en:* 1. beistimmender Zuruf in der Einzelabstimmung [bei Parlamentsbeschlüssen]. 2. Beifall, Applaus. 3. liturgischer Grußwechsel zwischen Pfarrer u. Gemeinde. **ak-**

Band 6: Das Aussprachewörterbuch

Bearbeitet von Max Mangold in Zusammenarbeit mit der Dudenredaktion. 2., völlig neu bearbeitete und erweiterte Auflage. 791 Seiten mit ca. 130000 Stichwörtern.

Nicht nur die Schreibung, auch die Aussprache der Wörter und Namen bereitet oft Schwierigkeiten. Wie spricht man Skylab, Cholesterin oder den Namen des amerikanischen Außenministers Kissinger aus? Wo betont man den Familiennamen Nobel oder den Stammesnamen Massai?

Mit etwa 130000 Stichwörtern unterrichtet der Band 6 des Großen Dudens über die Aussprache des deutschen Grundwortschatzes und der Fremdwörter sowie zahlreicher Personennamen und geographischer Namen aus Deutschland, Europa und der übrigen Welt. Die Angaben der Aussprache sind in der Internationalen Lautschrift (IPA) gesetzt. Die Einleitung, die etwa 100 Seiten umfaßt, gibt eine Einführung in die Phonetik und behandelt dann die deutsche Standardaussprache mit ihrem Vokal- und Konsonantensystem, ihrer Silbentrennung und Wortbetonung. Daran schließen sich Anmerkungen zur Aussprachelehre einiger Fremdsprachen an.

Das Duden-Aussprachewörterbuch ist unentbehrlich für die Sprecherziehung und den Deutschunterricht, vor allem für den Deutschunterricht im Ausland.

Band 7: Die Etymologie
Herkunftswörterbuch der deutschen Sprache

Bearbeitet von Günther Drosdowski, Paul Grebe und weiteren Mitarbeitern der Dudenredaktion. In Fortführung der »Etymologie der neuhochdeutschen Sprache« von Konrad Duden. 816 Seiten.

Wörter haben ihr Schicksal – und die Biographie eines Wortes ist oft erregender als die einer bedeutenden Persönlichkeit. Dieser Band stellt die Geschichte unserer Wörter dar, sowohl der deutschen als auch der Lehn- und Fremdwörter. Er gibt Antwort auf die Frage, woher ein Wort kommt und was es ursprünglich bedeutete, woher z. B. das Wort »Pferd« stammt, was eigentlich »Pumpernickel« bedeutet, warum der vorstehende Schildknorpel des Mannes »Adamsapfel« heißt oder wie sich die Wendung »auf dem Holzweg sein« erklärt. Besonders sorgfältig arbeitet der Band die Wortfamilien heraus, um die mannigfaltigen verwandtschaftlichen Beziehungen der Wörter und die weitreichenden sprachlichen Zusammenhänge sichtbar zu machen.

Das Herkunftswörterbuch, das das wechselvolle Schicksal der Wörter beschreibt, läßt Sprache zum Erlebnis werden. Es führt uns durch vergangene Jahrhunderte und fremde Länder und ist voller erregender Spannung.